Nineteenth-Century Photography

An Annotated Bibliography

—— 1839–1879 ——

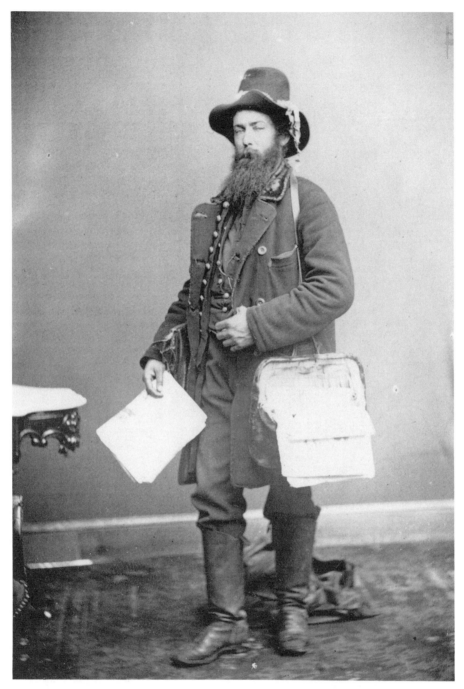

ALEXANDER GARDNER.
"Newspaper Man in Camp, Near Culpeper, Virginia, November, 1863,
American Civil War."
Credit: Visual Studies Workshop, Rochester, N.Y.

Nineteenth-Century Photography

An Annotated Bibliography

—— 1839–1879 ——

by WILLIAM S. JOHNSON

G.K. Hall & Co. • 70 Lincoln Street • Boston • Massachusetts

First published 1990
by G.K. Hall & Co.
70 Lincoln Street
Boston, Massachusetts 02111

10 9 8 7 6 5 4 3 2 1

Library of Congress Cataloging-in-Publication Data

Johnson, William, 1940-
 Nineteenth-century photography: an annotated bibliography /
William S. Johnson.
 p. cm.
 Includes index.
 ISBN 0-8161-7958-1
 1. Photography – History – 19th century – Bibliography. I. Title.
Z7134.J64 1990
[TR15]
016.77'09'034 – dc20 90-4897
 CIP

The paper used in this publication meets the minimum requirements of
American National Standard for Information Sciences – Permanence of
Paper for Printed Library Materials. ANSI Z39.48-1984.
MANUFACTURED IN THE UNITED STATES OF AMERICA

CONTENTS

FOREWORD

Without photography there would be no modern art. So profoundly has photography changed our sight that all the preceding thousands of years form but a single period of struggle before its advent. Our view of what is true about the world, about evidence, and finally about ourselves was altered once an objective description of our surroundings could be obtained.

To capture the flicker of history is as much a challenge as to glue light to a sheet. William Johnson's impressive work, though seemingly a documentary endeavor, can also be read for its inherent story – something like photography that beckoned because of its evidentiary potential, but surprised us with hidden truths. There is every chance that Johnson's accomplishment will be fully appreciated in its time.

This is a major and serious achievement; undeterred by the riches of pure information herein, the book also rewards a casual reader. Perusing an entry here or there yields a taste for the struggles and foibles of the emerging photography. Herein are the tales of frauds and fumblers, scientific and artistic giants and failures. Reading these entries we gather something of the early photographers' very great physical and financial bravery, their intellectual audacity, and the concomitant admiration in which they were held for their semi-divine craft. For example, we can read the tale of Frederick Scott Archer, the son of an English butcher, apprenticed to a bullion dealer, who learned the goldsmith's trade and enough practical metallurgy to invent the wet-collodian process. This improvement on the calotype revolutionized the growth of photography and opened photography to many who previously would never have considered it. In the spirit of collegial scientific brotherhood, Archer offered the wet-collodian process free to the world without attempting to secure copyright. His beneficence left his widow and children penniless, and the world immeasurably richer. A universal movement with philosophical and scientific foundations as much an emerging art form, photography's story freely crossed international borders with the irresistible speed of thought.

The craft's rapid geographic diffusion can be gleaned by looking at the entry of Antoine Claudet, which reveals how a Frenchman happened to open the first photography studio in London. By perusing Johnson's entry on Louis-Desire Blanquart-Evard we see the beginnings of the photographically illustrated book or the origins of the police mug shot. We can follow Andre Disderi's rise to opulence as the proprietor of a chain of photographic salons and his death in Paris "blind, deaf, destitute." Draper and Wolcott's claim to having made the first photographic portrait in America can be contemplated.

Johnson renders a coherent notion of a much-misunderstood artifact: Matthew Brady's tangled and important career. Along the way remarkable vistas are compactly limned, as when Johnson conjures Alfred Bierstadt, brother of the painter Albert – wandering purposefully through the paradisiacal western wilderness – attempting to photograph understandably distrustful Amerindians who were, "not very willing to have the brass tube of the camera pointed at them."

Self-evidently, William Johnson's work should be in every photographer's and every photography collector's library. Few will wish to read all of *Nineteenth-Century Photography: An Annotated Bibliography, 1839-1879*; many will consult passages as concomitant readings suggest further study, but even the most casually interested spectator of photography will gain from savoring the discussion that accompanied photography's birth and maturation. Phrases that were once current, but which are now obscure, leap from the page to remind us of the novelty and wonder of the subject. We eavesdrop on turns of elegant, ornamented, and opulent courtesy that reside side-by-side with antiquely quaint vehemence in legal contests fought about the consequences of originality. We *hear* the progress of this art with an ear that is envious of the lost conversations that must have accompanied the primordial appearance of sculpture, for example, or the more recent but unrecollected discussions about the discovery of oil painting.

Art historians will benefit immeasurably from this work, and it will, undoubtedly, start a new generation of research – now that a bibliographic map of the terrain has finally been rendered accurately. Johnson's bibliography will find avid users across the spectrum of modern studies in the humanities, and historians of science will be able to trace the flowering of the applied physics and chemistry upon which photographic progress depends, as well as the reciprocally beneficial scientific observations that photography increasingly came to record. With any luck, critics, and thereby criticism, will be improved, now that Johnson has supplied a check on fanciful or spurious claims. Students will be spared the drudgery of commonplace and repetitive excavation if they but avail themselves of this work. Perhaps best of all, all photographers who wish to be disenthralled from the general amnesia that clouds the beginnings of the craft can, herein, discover the ancestry, the "family tree," whose rich legacy is their reward to enlarge further.

It is not too much to suggest that William Johnson has opened a new era of precision in the study of the modern art most clearly partaking of the unequivocal spirit of modernism.

Harry Rand
Advisory Editor
Washington, D.C.

AN INFORMAL INTRODUCTION

This bibliography contains nearly twenty-one thousand references to books and periodical articles published from 1839 to the present about photography from 1839 to 1879. For this work I surveyed general-interest periodicals as well as specialist journals on photography published from 1839 to 1879. I selected representative examples of each significant type of journal from the general press and attempted to look at those examples in some depth. These include journals of news and culture, popularizing scientific journals, art journals, and journals of several scientific or artistic societies, all of which reported on photography and its growing impacts on the culture of the period. I also surveyed examples of illustrated weekly newspapers, illustrated monthly journals, and regional publications, which all actively used photography as part of their editorial practice. Thus, in addition to articles *about* photography, the bibliography contains examples *of* photographic practice during the period under consideration. I also looked at the specialist press devoted to photography itself, indexing several key titles in some depth and scanning scores of other journals, both from that time period and from later.

This bibliography also contains examples of the varied uses of photography in book publishing from that time, with references to books, manuals, and pamphlets about photography as well as books on any subject that are illustrated with photographs, or even by other processes when the original images were derived from photographs. In many traditional libraries the illustrations to a book, and its illustrator, were often placed in a role secondary to the author – even in situations when the illustrations were the dominant concern of that work. It is not unusual for major photographic works to be buried in an older library catalog under the name of some obscure author, without even a cross-reference to the photographer. And it is not too unusual that the photographs illustrating the work are not even mentioned on the catalog card. In this bibliography that situation is reversed, for here the work is located under the photographer and not the author. Books about the history of photographic practice or photographer's monographs are also listed here.

For the most part, I did not attempt to reference albums of photographic prints, as these may not have been "published," but simply gathered together by some unknown individual. Some of these albums, however, do appear in library catalogs and reference lists as published and cataloged works. Further, some albums were issued by the photographic studio with letterpress labels or commentary, and so could be described as "published." This matter, as are so many other bibliographic matters in this field, is not always clear. I have attempted to describe such works clearly when I have seen the pieces myself. Unlike the periodical references, however, where I personally looked at the primary reference itself to make the bibliographic record in all but a very few cases, probably less than fifty out of the twenty-odd thousand, in the book references I had to go to secondary sources (library catalogs, other bibliographies, etc.) for a much higher percentage of these references, and so am more dependant upon secondary descriptions in those cases.

Even though there are many references in this bibliography, it is a *selected* bibliography. Some external factors influenced the decisions that led to those selections, and some selections were based on my biases toward what I felt was significant in the literature I scanned. The external factors were those traditional issues of accessibility to sources and the size limitations of any reasonably usable reference work that could be produced from the effort. At a certain point in this project I realized I could not do all that I had wished. As the scale of this search grew, its scope narrowed. It gradually became clear that there was just too much material to fit into even the largest reference volume, and so I regretfully decided to limit the coverage to English language publications. It was painful to remove the hundreds of French book citations that were already in the database, but I did slip a few of those references back into the biographical statements on the French photographers and left a few score foreign-language periodical references in the files. The reader should not consider these random references to be in any way inclusive or even indicative of that literature on any particular individual or topic.

I also made the decision to break the work into two volumes. I decided that the first volume would cover the chronological period from the beginnings of the medium, which became a pulic concern in 1839, to the year 1979. The second volume would go from 1880 to the end of World War I, when any lingering traces of the nineteenth century were forcefully replaced by a new cultural, social, and political, order. I chose the year 1880 as the breakpoint between the two volumes because the "look" of photographic practice after 1880 became different in several significant ways from that which had gone on before.

There were several explosive periods of growth and change in the field of photography after its initial introduction to a marvelling crowd in 1839. Photography, conducted by the daguerreotype and calotype processes throughout the 1840s and early 1850s, made profound impacts upon the social polity of the industrializing world and within an astonishingly short time had become an established factor in that culture. From the early 1850s on, after the development and expansion of the wet collodion process, the medium grew even larger in all of its dimensions – the scale of its practice and the number of practitioners, its points of utility, interest, and value – until it became an

integral part of the matrix of Western culture. Photography was established as a practical science and as a staple activity of commerce, as an industry, and as a means of expression from the 1850s on through the 1870s, with thousands of individuals directly involved in the medium on a daily basis. Nevertheless, the difficulties associated with the wet-collodion and other early processes tended to limit photography to a professional activity – the few amateurs were the exception rather than the norm – and tended to limit the different ways professional photographers could practice their trade.

The early 1880s was yet another period of explosive change and growth in the medium, a period that saw a diversification and alteration of the practice of commercial photographers as new uses and disciplines of industrial photography, commercial photography, journalistic photography, editorial photography, and the like supplanted studio portrait photography as the major commercial activity of a photographer. New and larger industries were formed, new technologies for taking the photographs and for getting the photographs to new markets were developed and expanded. The period also saw a huge expansion in the growth of amateur photography and an evolution of many "serious" amateurs into the arena of artistic practice.

Naturally, there are precursors before 1880 for all of these activities, as there were individuals using the medium after 1880 in the same manner that they had in the midsixties; but the date is convenient and less arbitrary than some others.

Of course, although bibliographies can be arranged more or less neatly within chronological boundaries, people's lives are not so crisply contained by decade or within some artificially constructed unity. These issues led to hard decisions. There are individuals who had full careers on both sides of 1880, working well within both the older tradition and the new practice. Does one index references about their work up to 1879 and wait for volume two to index later entries? I decided that once an individual was included in the database, then *all* references to that individual, published both before and after 1880, would be included. I attempted to include as many of these individuals within the first volume as possible, since the second volume is still years from print – but some individuals who probably should be in this volume are not, and some others who probably shouldn't be here, are. For example, does one include or exclude Camillus Fly or Alfred Stieglitz, both of whom took some photographs befoe 1880, but more afterwords? I included Camillus Fry because he really worked within an earlier tradition of photography, the tradition presented in volume one, and excluded Alfred Stieglitz because his importance to the medium surfaces in the later period, the period to be covered in volume two.

The second major factor determining the selection of these references from the larger body of photographic literature of this time are my own biases. I am interested in the history of photography because for me it is a history of individuals engaged with a specific medium to communicate or persuade or express their understandings and feelings about their world. For me, that is the most important aspect of the history of this medium and, except as a means of understanding the limitations and possibilities of what individuals can achieve with their equipment and processes I am simply not very interested in the many types of equipment or processes evolved during this time. The largest number of articles from the photographic literature of this period were technical discussions of various processes or techniques. I included this type of reference only when I felt that it gave some indication of a working procedure or concern of the individual artist who was using or describing it or when it seemed that the article was providing a particularly cogent summation of some particular technology or process.

This work began when I had one idea of what its nature would be and evolved through several stages of progress before finally settling, rather late in the process, into its final form. For example, at a point well into this endeavor I concluded that more extensive annotations of the references were necessary, and so I began to include more information from the sources. This meant that the thousands of references gathered before this decision would be "underrepresented," which in turn meant either a course of remedial backtracking or acceptance of certain imbalances in the final texts. I did a little of both, going over some ground again, leaving other areas as they were. Thus, the fact that a particular reference is *not* annotated should not be taken to mean that it is less important than some others that may have more extensive commentary. Throughout this project, I made an effort to focus on biographical information about lesser-known practitioners, so that they often have more detailed biographical statements than better-known figures. Again, the size or amount of detail in a biographical summary should not be taken as an indication of that individual's worth, but as a result of the process.

These minor inconsistencies aside, I believe this is a strong bibliography that can, in itself, be a powerful educational tool, informative and even instructive far beyond its primary function of providing a pointer to other work. A bibliography can be a list – terse, little more than an indicator that the reader must go elsewhere for more information about the subject. Or a bibliography can itself contain a wealth of useful information. It can show aspects of an individual's life and career, the phases of activity within a medium, patterns of scholarship and directions of critical interest, or can even provide a structural overview that can help set up patterns for further inquiry. I have tried to make this work such an effort – believing that a reader might

learn a great deal about the history of the medium of photography and its practitioners through reading this work. And that belief has been the touchstone of my practice, rather than any too slavish following of any specific formula or routine in the process of noting the sources.

This leads me to an explanation of the very broad and simple subject headings under which these references have been collected. This work is, technically, a subject bibliography, with most of the references gathered under the subject area "By Artist or Author." The other subject categories are also very broad, for example, "History: By Country: USA" or "Exhibitions: Great Britain." I have deliberately kept the subject categories both very broad and very simple, and in selecting them have attempted to follow categories that were suggested by the literature itself. For example, I have little interest in astronomical photography as a subject, but over time concluded that many editors of this period were far more interested in it than I was. Consequently, I added a category for this type of reference, as I did for the others in this work.

Some subjects or topics that might seem to belong here are not represented. For example, processes, such as daguerreotype or wet collodion, would appear to make good subject categories. They are so broad, however, that they would be meaningless, at least during certain times within the period covered. Almost all references at one point would go under "Daguerreotype," and so on. For a time I placed all anonymous articles or uncredited references – of which there are many – under the heading "Artist: Unknown." Eventually, that category became so large as to be meaningless, and I had to reorganize those references, placing them under the country of publication and date of publication of the article or book. At least there, the reference can be seen in the context of other similar articles from the same time and locale instead of in a swollen collection of random and miscellaneous references. The same would have held true for subject categories based on processes.

Having said that, I must add that the sharp-eyed reader will notice that there seems to be some processed-based categories in this book – "Magic Lantern" and "Photomechanical Reproduction," for example. The category "Magic Lantern Photography," however, is really about visual education as it was being developed then, and "Photomechanical Reproduction" is really about that dogged quest to find some way to more successfully marry photography to the mass media that permeated so much of the literature of this period. In any case, I am a firm believer in the serendipity theory of learning, and I would argue that the reader of this volume can find much of interest by looking around in these subject categories a little.

The one time that I was truly angered by a review of one of my earlier publications occurred when the reviewer complained that the bibliography contained too *much* information. Be warned, any bibliography I gather will always contain too much information. I detest finding references that you have to verify in order to find out whether you even wanted to see it. When creating a reference for a magazine article I attempt to include the author, the title, the name of the publication, both the volume and number for the journal, the full date, the full pagination, and the number of reproductions published. The coding used to indicate the number of reproductions in an article or book needs some explanation: "b & w" stands for the number of photographs reproduced and "illus" represents the number of other illustrations – line drawings, reproductions of paintings, or record photographs of an object, a room, etc. If no number precedes either of these categories, then I knew that the original source had photographs or reproductions of photographs or illustrations in it, but I didn't know how many. If original photographs were tipped into the book or journal, I indicated that fact in the comments section. Often, particularly if the title of the article or book is uninformative out of its original context, I included a brief descriptive comment about the reference. Occasionally I excerpted directly from articles that contained information I found particularly interesting. When cumulated into some order, these references become interesting to read in their own right.

This work could have not been accomplished without the astonishing and wonderful advancements in computer technology that have occurred during the past decade. At the beginning of this project I delayed the purchase of a computer for two months to obtain one of the first IBM AT grade machines available to the general public. As I write this statement now on that same machine, it is almost obsolete – although still providing very good service. Some of the software I've used to complete this project did not exist at the project's inception. It's exciting to live and work through the natal period of a new technology. And instructive as well – I feel that I have some clearer understanding of the birth and diffusion of photography throughout the culture of the 1840s after watching the evolution of computers in my own time. Finally, I would like to say that all copy for this work was sent to the publisher in camera-ready form, enabling me to control the pace and movement of this entire publication, making any necessary changes right up to the moment of mailing in the finished copy.

I hope you enjoy this work and find it useful, and I wish you well.

William S. Johnson
Rochester, New York
May 1990

ACKNOWLEDGMENTS

Many years ago Professor Semour Slive, then the chairman of the Department of Fine Arts at Harvard University, took some time out of his very busy schedule to encourage and assist a very young bibliographer and novice historian. I have always appreciated that courtesy and the inspiration drawn from his aid and I would like to thank him now for his graciousness then. Dr. Wolfgang Freitag, then the librarian of fine arts in the Harvard College Library, also offered his steady guidance and caring patience.

For many years compiling bibliography has been an essential part of all that I've done as a teacher, writer, or administrator in the field of photographic history, remaining a constant activity, at times pushed into the background as other projects or jobs have held priority, at other times brought into the foreground. In 1984 and 1985 the National Endowment for the Humanities awarded me a grant that was absolutely indispensable to *this* particular effort. I was able to purchase the computer and software that enabled me to countenance the idea of trying an effort of this scale and to spend almost two years of concentrated work on this task in order to establish the core of the database upon which this work is based. The grant turned this effort from a background endeavor into a focused act of work, and I would like to thank the National Endowment for the Humanities for that opportunity. Since then my employers have also been most generous in allowing me to fill up the spare corners of my time completing this work. I would like to thank Harley P. Holden, curator of the Harvard University Archive, and Louis Tucker, director of the Massachusetts Historical Society and president of the New England Deposit Library, who understood the value of this project when they hired me as director of the New England Deposit Library in 1987, as did John Van de Wetering, Carl Chiarenza, Nathan Lyons, and the other members of the Academic Coordinating Committee to the International Museum of Photography at George Eastman House, who also countenanced support for this work when they hired me as director of University Educational Services at that institution.

I also wish to thank all the many other individuals who met their professional responsibilities to this work with care and good humor. A few went out of their way to held further, clearing away administrative or technical details to make some difficulty in the process easier to achieve. Thanks to Richard Simpson at the Fine Arts Library of the Harvard College Library and Eddie Doctorow at the Harvard College Library in Cambridge, Massachusetts, for their aid. After I moved to Rochester, New York, I had the good fortune to benefit from expertise and professionalism of the library of the International Museum of Photography at George Eastman House. I would like to thank the librarian Rachel Stuhlman, who with Becky Simmons and Barbara Schaefer helped in many ways to make the project stronger. Andrew Eskind, collections manager at the museum, and project director of the museum's photographers' biography file also lent his aid. I would particularly like to thank Greg Drake, who read through a stage of the manuscript and provided me with birth and death dates for many individuals out of the museum's records and out of his own files. Robin Bolger, Mike Sladden, and Ann Stevens all helped at times with the keyboarding, and I appreciate their efforts. I must also thank Paul Brest, the creator of Notebook II, who during a very long afternoon on the telephone patiently walked a very green computer neophyte through a recovery operation to save nine months' work, then suggested an answer to the machine problem causing all the trouble. And I thank Natalie Stone, a wonderful young lady and crack computer expert at the University of Rochester, who saved my life – or at least many weeks of painful reconstruction of a large file that had "disappeared."

I would also like to thank Meghan Wander and Donna Sanzone, editors at G.K. Hall, for their infinite patience and help. And Harry Rand, an old friend, now Curator, Painting and Sculpture, The National Museum of American Art, Smithsonian Institution, Washington, D.C., who offered advice and encouragement and helped proofread much of the final draft.

Finally, I would like to extend my gratitude and love to my family. Josh, who was born the same year that I received the NEH grant, learned to draw while sitting patiently by the keyboard as I entered or corrected "just a few more." My older children, Mallory, Michael, and Bethany, also learned patience in the face of this obsession of mine. And my wife, Susie Cohen, gave very, very much of her considerable professional skills and even more from her strong and sweet character. Thank you again.

W.S.J.

One intention in this volume was to show something of the variety and dimensions of the impacts of photography on the periodical literature of the period 1839 to 1879, and through that to infer something of those impacts on the culture of that time. To accomplish this I surveyed the general publications as well as the specialist journals on photography which were published during that time. I selected representative examples of each significant type of journal from the general press and attempted to look at those examples in some depth. There are the general journals of news and culture, such as *The Athenaeum*, the *Literary Gazette and Journal of the Belles Lettres, Arts, Science, Etc.*, or the *American Repertory of Arts, Sciences and Manufactures*, there are the popularizing scientific journals, such as the *Magazine of Science and School of Arts*, or the *Popular Science Review*, and the art journals, such as *Cosmopolitan Art Journal*, and *The Crayon*, all of which reported on photography and its growing impacts on the culture of the period. And there are the illustrated weekly newspapers, such as the *Illustrated London News, Frank Leslie's Illustrated Newspaper*, or *Harper's Weekly*, the illustrated monthly journals, such as *Good Words, Harper's New Monthly Magazine*, and *Scribner's Monthly*, the regional publications, such as the *California Mail Bag*, or the *Chicago Magazine: The West As It Is*, which all actively used photography as part of their editorial practice.

Then there was the specialist press devoted to photography itself. These journals range from the *Daguerrian Journal*, the *Photographic Art Journal*, the *American Journal of Photography and Allied Arts and Sciences*, the *Photographic News* to *Anthony's Photographic Bulletin*, and the *Photographic Times Magazine*. This bibliography also contains references drawn from many other periodicals published from 1879 to 1988. I surveyed those photographic journals which publish historical articles, such as *Image*, the *History of Photography*, the *Photographic Collector, Views*, and others, and I scanned a broad range of other titles for the occasional reference. I also made a moderately sustained effort to survey the periodical literature of American regional history and American popular culture. Scores of titles were scanned, and the most interesting articles from these titles which fell into the range of this effort have been included in this work. But the periodical titles listed below were treated in a much more thorough fashion. These titles were surveyed page by page through the period of time designated by the cited dates. While these titles were not *indexed* —because I made a *selection* of articles from the total number of articles in each periodical title— nevertheless, there was a fairly sustained and serious effort to provide a more inclusive coverage for the periodicals listed below.

A careful reading of this volume will show that it is strongest in its coverage of American periodical literature. There are, (To my regret, but I bowed to practicality.) some titles missing —such as the *Journal of the Franklin Institute, Silliman's Journal*, or the *St. Louis Photographer*. But, overall, the coverage of both the photographic literature and the general literature of or about this period is reasonably thorough. The British publications have not been so well served here. I attempted to have at least one representative type of publication for all of the time under survey, but I would not hope to claim that the coverage of the British literature of this period is in the same depth as is the literature of the United States. That task, however, would have immeasurably increased both the labor and the size of this effort, and again I bowed to practicality. One slight palliative for this lack is the fact the the American photographic journals reprinted many articles from the British journals during much of the early part of this period, and many of those articles appear here from those sources.

<div style="border:1px solid black">

LIST OF PERIODICALS INDEXED

</div>

AMERICAN ART REVIEW (BOSTON)
indexed:
vol. 1, no. 1 (1879) - vol. 1, no. 6 (1880);
vol. 2, no. 1 (1880) - vol. 2, no. 6 (1881) [all?]

AMERICAN JOURNAL OF PHOTOGRAPHY AND THE ALLIED ARTS & SCIENCES
indexed:
n. s. vol. 1, no. 1 (June 1, 1858) - vol. 8, no. 20 (Apr. 15, 1866); [vol. 8, nos. 21-24 not issued]
vol. 9, no. 1 (Sept. 1, 1866) - vol. 9, no. 5 (Oct. 15, 1866);
vol. 9, no. 8 (Mar. 1, 1867); vol. 9, no. 10 (May 1, 1867) - vol. 9, no. 12 (June 1, 1867)
missing: 9:6, 9:7, 9:9, 9:13 (June 1867) to end [indeterminate, the title probably ceased publication around Sept. 1867.]

AMERICAN REPERTORY OF ARTS, SCIENCES AND MANUFACTURES
indexed:
vol. 1, no. 1 (Feb. 1840) - vol. 4, no. 6 (Jan. 1842). [all?]

ANNUAL REPORT OF THE AMERICAN INSTITUTE, OF THE CITY OF NEW YORK
indexed:
vol. 28 (1867/68) - vol. 32 (1871/72)

ANTHONY'S PHOTOGRAPHIC BULLETIN
indexed:
vol. 1, no. 1 (Feb. 1870) - vol. 10, no. 12 (Dec. 1879)

APPLETON'S JOURNAL: A MAGAZINE OF GENERAL LITERATURE
indexed:
vol. 1 (Apr. 1869) - vol. 15 (June 1876);
n. s. vol. 1 (July 1876) - vol. 11 (Dec. 1881)

ART AMATEUR: A MONTHLY JOURNAL. DEVOTED TO ART IN THE HOUSEHOLD
indexed:
vol. 1, no. 1 (June 1879) - vol. 8, no. 6 (May 1883);
vol. 17, no. 1 (June 1887) - vol. 18, no. 6 (May 1888)

ART PICTORIAL AND INDUSTRIAL: AN ILLUSTRATED MAGAZINE, WITH HELIOTYPE ILLUSTRATIONS
indexed:
vol. 1, no. 2 (Aug 1870) - vol. 5, no. 30 (Dec. 1874) [all?]
missing: vol. 1, no. 1 (July 1870)

ART UNION, later ART JOURNAL
indexed:
vol. 1 (1839) - vol. 34 (1871);
vol. 42 (1890)
missing: 1844, 1845, 1849

ATHENAEUM
indexed:
no. 587 (Jan. 26, 1839) - no. 1835 (Dec. 27, 1862)

BALLOU'S PICTORIAL DRAWING ROOM COMPANION
[formerly GLEASON'S]
see GLEASON'S PICTORIAL

BRITISH JOURNAL OF PHOTOGRAPHY
[See also LIVERPOOL & MANCHESTER PHOTOGRAPHIC JOURNAL]
indexed:
vol. 7, no. 109 (Jan. 1, 1860) - vol. 12, no. 295 (Dec. 29, 1865)
missing: 8:135 (Feb. 1, 1861), 9:165 (May 1, 1862), 9:166 (May15, 1862)

BRITISH JOURNAL OF PHOTOGRAPHY ALMANAC
indexed:
vol. 1 (1866) - vol. 14 (1879)
missing: I also scanned the *Almanac* for obituary notices from 1880 through the 1920s.

CALIFORNIA MAIL BAG
indexed:
vol. 1, no. 1 (June 1871) - vol. 1, no. 6 (Jan./Feb. 1872)

CENTURY MAGAZINE (SCRIBNER'S MONTHLY)
indexed:
vol. 1, no. 1 (Nov. 1870) - vol. 90, no. 6 (Oct. 1915)

CHAMBERS'S JOURNAL OF POPULAR LITERATURE, SCIENCE AND ARTS
indexed:
vol. 41 (1864); vol. 46 (1869); vol. 70 (1893); vol. 71 (1894); vol. 75 (Dec. 1897 - Nov. 1898).

CHICAGO MAGAZINE: THE WEST AS IT IS
indexed:
vol. 1, no. 1 (Mar. 1857) - vol. 1, no. 5 (Aug. 1857) [all]

COMMERCIAL PHOTOGRAPHIC NEWS
indexed:
vol. 1 (1872)

COSMOPOLITAN ART JOURNAL: A RECORD OF ART, BIOGRAPHY, AND GENERAL LITERATURE
indexed:
vol. 1, no. 1 (July 1856) - vol. 5, no. 1 (Mar. 1861) [all?]
missing: 3:3 (June 1859), 3:4 (Sept. 1859)

CRAYON
indexed:
vol. 1, no. 1 (Jan. 1855) - vol. 8, no. 7 (July 1861) [all?]

DAGUERRIAN JOURNAL
indexed:
vol. 1, no. 1 (Nov. 1, 1850) - vol. 3, no. 3 (Dec. 15, 1851) [all]
Title change, to
HUMPHREY'S JOURNAL. Brief break in publication, then resumed with new name. Numbering and pagination continued in sequence.
vol. 4, no. 1 (Apr. 15, 1852) - vol. 13, no. 24 (Apr. 15, 1862); vol. 14, no. 4 (June 15, 1862) - vol. 20, no. 28 (Dec. 15, 1869)
missing: 14:4 starts with page 1, a note on p. 16 states that the editor had tried publishing the journal in Quarto form, but it had proved unsuccessful, and that he was going back to the old stye and renumbering the pages from 1. During the last year the publication schedule grew ragged and there were 28 numbers of the journal issued of volume 20, from 1868 till Dec. 15, 1869. There is a statement that *Humphrey's Journal* ran another six months until July 1870, before it finally folded, but I have not seen any of these issues.

ECLECTIC REVIEW
indexed:
n. s. vol. 10 (no. 102) (July - Dec. 1855);
n. s. vol. 12 (no. 104) (July - Dec. 1856);
n. s. vol. 1 (no. 105) (Jan. - June 1857);
n. s. vol. 2 (no. 110) (July - Dec. 1859);
missing: scanned 1855 - 1866.

FINE ARTS: A QUARTERLY REVIEW
indexed:
vol. 1 (May - Oct. 1863) - vol. 3 (Oct. 1864 - Jan. 1865);
n. s. vol. 1 (June - Oct. 1866) - n. s. vol. 2 (Jan. - June 1867).

FRANK LESLIE'S ILLUSTRATED NEWSPAPER
indexed:
vol. 1, no. 1 (Dec. 15, 1855) - vol. 49, no. 1265 (Dec. 27, 1879)

FRANK LESLIE'S NEW YORK JOURNAL OF ROMANCE, GENERAL LITERATURE, SCIENCE AND ART
indexed:
n. s. vol. 1, no. 1 (Jan. 1855) - vol. 5, no. 2 (Feb. 1857)

GLEASON'S PICTORIAL DRAWING ROOM COMPANION
indexed:
vol. 1, no. 1 (May 3, 1851) - vol. 7, no. 26 (Dec. 30, 1854) Title change, to
BALLOU'S PICTORIAL DRAWING ROOM COMPANION
vol. 8, no. 1 (Jan. 6, 1855) - vol. 17, no. 445 (Dec. 24, 1859) [all]

GOOD WORDS
indexed:
vol. 1, no. 1 (Jan. 1860) - vol. 22, no. 12 (Dec. 1881)

GREAT REPUBLIC MONTHLY
indexed:
vol. 1, no. 1 (Jan. 1859) - vol. 2, no. 5 (Nov. 1859) [all]

HARPER'S NEW MONTHLY MAGAZINE
indexed:
vol. 1, no. 1 (June 1850) - vol. 122, no. 6 (May 1911)

HARPER'S WEEKLY
indexed:
vol. 1, no. 1 (Jan. 3, 1857) - vol. 13, no. 678 (Dec. 25, 1869)

HUMPHREY'S JOURNAL see DAGUERRIAN JOURNAL.

ILLUSTRATED LONDON NEWS
indexed:
vol. 1, no. 1 (May 14, 1842) - vol. 75, no. 2115 (Dec. 27, 1879)
missing: nos. 1740, 1741, 1749, 1755, 1765, 1768, 1791 (1873)

ILLUSTRATED NEW YORK NEWS
indexed:
vol. 1, no. 1 (June 7, 1851) - vol. 1, no. 7 (July 19, 1851)
Title change, to ILLUSTRATED AMERICAN NEWS
vol. 1, no. 8 (July 26, 1851) - vol. 1, no. 23 (Nov. 8, 1851) [all]
missing: 1:24 (Nov. 15, 1851)

ILLUSTRATED NEWS (NEW YORK)
indexed:
vol. 1, no. 1 (Jan. 1, 1853) - vol. 2, no. 48 (Nov. 26, 1853) [all]

ILLUSTRATED NEWS OF THE WORLD (LONDON)
indexed:

vol. 1, no. 15 (May 15, 1858)

ILLUSTRATED TIMES (LONDON)
indexed:
vol. 2, no. 55 (May 27, 1856);
vol. 5, no. 115 (July 4, 1857);
vol. 6, no. 148 (Jan.30, 1858)

JOURNAL OF THE PHOTOGRAPHIC SOCIETY OF LONDON
indexed:
vol. 3, no. 40 (Mar. 21, 1856) - vol. 5, no. 86 (June 15, 1859); vol. 7, no. 102 (Oct.15, 1860) - vol. 8, no. 142 (Feb. 15, 1864)

JOURNAL OF THE SOCIETY OF ARTS (LONDON)
indexed:
vol. 1, no. 1 (Nov. 26, 1852) - vol. 1, no. 51 (Nov. 11, 1853); vol. 4, no. 157 (Nov.23, 1855) - vol. 4, no. 208 (Nov. 14, 1856)

LITERARY GAZETTE AND JOURNAL OF THE BELLES LETTRES, ARTS, SCIENCE, ETC.
indexed:
1839, 1840, 1841, 1842, 1845, 1852, 1855

LITTELL'S LIVING AGE
indexed:
vol. 2 (Aug. 10 - Oct. 26, 1844);
vol. 9 (Apr. - June 1846);
vol. 10 (July - Sept 1846)
missing: scanned vols. 72, 92, 217, 230, 239, 261, 279.

LIVERPOOL & MANCHESTER PHOTOGRAPHIC JOURNAL [BRITISH JOURNAL OF PHOTOGRAPHY]
indexed:
n. s. vol. 2, no. 1 (Jan. 1, 1858) - vol. 2, no. 24 (Dec. 15, 1858)

MAGAZINE OF SCIENCE, AND SCHOOL OF ARTS
indexed:
vol. 1, no. 1 (Apr. 1, 1839) - vol. 4, no. 208 (Mar. 18, 1843)

MASSACHUSETTS CHARITABLE MECHANIC ASSOCIATION: REPORT OF THE EXHIBITION
indexed:
vol. 1 (1837) - vol. 14 (1881);
vol. 16 (1887);
vol. 19 (1895)

NEW YORK ILLUSTRATED MAGAZINE ANNUAL
indexed:
1847

NEW YORK ILLUSTRATED NEWS
indexed:
vol. 3, no. 61 (Jan. 5, 1861) - vol. 9, no. 231 (Apr. 2, 1864)
missing: nos. 1-60, 104, 114-116, 118-156, 166-168, 171, 202, 216-230

NOTES AND QUERIES
indexed: vol. 5 (1852) - vol. 9 (1854)
missing: Interest in photography began in 1852. I looked at this many years ago and the references may not be complete.

ONCE A WEEK: AN ILLUSTRATED MISCELLANY OF LITERATURE, ART, SCIENCE & POPULAR INFORMATION (LONDON)
indexed:

vol. 1 (July - Dec. 1859) - vol. 11 (June - Dec. 1864);
n. s. vol. 1 (Jan. - June 1866) - vol. 4 (July - Dec. 1867)
missing: vols. 12, 13.

PENNY ILLUSTRATED PAPER
indexed:
no. 116 (Aug. 15, 1863)

PHILADELPHIA PHOTOGRAPHER
indexed:
vol. 1, no. 1 (Jan. 1864) - vol. 17, no. 204 (Dec. 1880)

PHOTOGRAPHERS FRIEND
indexed:
vol. 2 (1872)

PHOTOGRAPHIC ART JOURNAL, later PHOTOGRAPHIC AND FINE ART JOURNAL
indexed:
vol. 1, no. 1 (Jan. 1851) - vol. 11, no. 12 (Dec. 1858);
vol. 12, no. 1 (June 1859) - vol. 12, no. 2 (July 1859);
vol. 13, no. 1 (Jan. 1860) - vol. 13, no. 8 (Aug. 1860) [all]

PHOTOGRAPHIC NEWS
indexed:
vol. 1, no. 1 (Sept. 10, 1858) - vol. 1, no. 25 (Feb. 25, 1859); vol. 3, no. 53 (Sept.9, 1859) - vol. 4, no. 121 (Dec. 28, 1860)
missing: nos. 7, 13?, 93? I indexed this years ago and references may not be complete.

PHOTOGRAPHIC TIMES
indexed:
vol. 1, no. 1 (Feb. 1871) - vol. 9, no. 102 (Dec. 1879)

PHOTOGRAPHIC WORLD
indexed:
vol. 1 (1871), vol. 2 (1872)

POPULAR SCIENCE REVIEW (LONDON)
indexed:
vol. 1, no. 1 (Oct. 1861) - vol. 20, no. 81 (Oct. 1881)
missing: interest in photography tailed off after 1872

PRACTICAL MECHANIC'S JOURNAL
indexed:
vol. 1, no. 1 (Apr. 1848) - vol. 8, no. 96 (Mar. 1856);
vol. 14, no. 157 (Apr. 1861) - vol. 14, no. 168 (Mar. 1862)

PUTNAM'S MONTHLY: A MAGAZINE OF LITERATURE, SCIENCE AND ART
indexed:
vol. 1, no. 1 (Jan. 1853) - vol. 10, no. 59 (Dec. 1857)

SCRIBNER'S MONTHLY see CENTURY MAGAZINE

TRANSACTIONS OF THE SOCIETY FOR ENCOURAGEMENT OF THE ARTS
indexed:
vol. 54-55 (1841-44)

References
by Artist or Author

A

ABBE, ERNST. (1840-1905) (GERMANY)
A1 "Obituary of the Year: Professor Ernst Abbe (Jan. 14, 1905)." BRITISH JOURNAL PHOTOGRAPHIC ALMANAC 1906 (1906): 655-656. [Born Jan. 23, 1840 at Eisenach. Student at Jena and Goettingen. In 1866 Carl Zeiss associated with Prof. Abbe and together they revolutionized lens designs for microscopes, etc.]

ABBOTT, AUSTIN.
A2 Abbott, Austin. "The Eye and the Camera." HARPER'S MONTHLY 39, no. 232 (Sept. 1869): 476-482. 11 illus. [Discussion of camera optics, etc.]

ABBOTT, JACOB.
A3 Abbott, Jacob. "The Negative in Photography." HARPER'S MONTHLY 41, no. 246 (Nov. 1870): 845-848. 6 illus. [Engravings demonstrating the negative and positive image, view of a photographer photographing, etc.]

ABBOTT, JAMES. (1812-1888) (DUNDEE, SCOTLAND)
A4 "Obituary: James Abbott (Dundee)." BRITISH JOURNAL PHOTOGRAPHIC ALMANAC 1899 (1899): 655-656. [Born in Dundee 76 years ago. Apprenticed to the trade of mechanic, but showed artistic tendency from an early age. At the beginnings of photography he made his own cameras, ground lenses out of tumblers, and so on. Began a business in 1858. Good friend of Mr. Roger, of St. Andrews. Made many improvements to the art.]

ABBOTT, M. S. (NEW YORK, NY)
A5 Abbott, M. S. "A Bit of Experience." AMERICAN JOURNAL OF PHOTOGRAPHY AND THE ALLIED ARTS & SCIENCES n. s. vol. 7, no. 13 (Jan. 1, 1865): 309-310.

A6 Abbott, M. S. "A Bit of Experience. - No. 2." AMERICAN JOURNAL OF PHOTOGRAPHY AND THE ALLIED ARTS & SCIENCES n. s. vol. 7, no. 16 (Feb. 15, 1865): 373-374.

ABDULLAH BROTHERS. (ISTANBUL, TURKEY)
[The brothers Kervok and Wichen Biraderler worked for Rabach, the first photographer in Istanbul, then took over his studio when he left in 1858. In 1862 they became official photographers to the court of the Turkish sultans, converted to Islam, and changed their name to Abdullah. Opened additional studios in Egypt in 1870s.]

A7 R. A. S. "Notes of the Month." BRITISH JOURNAL OF PHOTOGRAPHY 10, no. 193 (July 1, 1863): 275. [Mentions that a petition of 25,000 signatures was gathered in order that the Sultan Abdul Aziz would sit for a carte-de-visite portrait by the Abdullah Frères. (Orthodox Muslims frown on portraits.)]

A8 Portraits. Woodcut engravings credited "From a photograph by Abdullah Brothers." ILLUSTRATED LONDON NEWS 51, (1867). ["Abdul Aziz Khan, Sultan of Turkey." 51:1436 (July 13, 1867): 33. "Ismail Pacha, Viceroy of Egypt." 51:1436 (July 13, 1867): 45.]

A9 Portrait. Woodcut engraving, credited "From a Photograph by Abdullah Brothers, Constantinople." FRANK LESLIE'S ILLUSTRATED NEWSPAPER 34, (1872). ["Mr. Henry M. Stanley." 34:876 (July 13, 1872): 284.]

A10 Portraits. Woodcut engravings credited "From a photograph by Abdullah Frères." ILLUSTRATED LONDON NEWS 68, (1876). ["Midhat Pasha, Hussein Avni Pasha, Halil Sherif Pasha and Mohamed Ruschidi Pasha, the Turkish Ministry (Four portraits)." 68:1926 (June 24, 1876): 601.]

A11 Portrait. Woodcut engraving credited "From a photograph by Abdullah Frères." ILLUSTRATED LONDON NEWS 69, (1876). ["Late Sir Philip Francis." 69:1937 (Sept. 9, 1876): 253.]

A12 Portraits. Woodcut engravings credited "From a photograph by Abdullah Frères." ILLUSTRATED LONDON NEWS 74, (1879). ["Prince Alexander Battenberg, Prince Elect of Bulgaria." 74:2087 (June 14, 1879): 557.]

A13 Portrait. Woodcut engraving credited "From a photograph by Abdullah Frères." ILLUSTRATED LONDON NEWS 75, (1879). ["Alexander Vogorides." 75:2090 (July 5, 1879): 21.]

ABNEY, SIR WILLIAM DE WIVELESLIE. (1844-1920) (GREAT BRITAIN)
[Born on July 24, 1843 in Derby, England. Studied at the Military Academy at Woolwich. In 1861 he was appointed a lieutenant in the Royal Engineers, made captain in 1873. Became a member of the Royal Photographic Society in 1870. Joined the photographic mission to observe the passage of Venus in 1874. Published *Thebes and its Five Greater Temples* in 1876. In 1877 he began to teach chemistry and photography at the School of Mining Engineers at Chatham. Wrote a photographic manual for this program which, with revisions and additions, was a standard text for years. Very active in chemical research. Retired from the army in 1881, and devoted his time to research and writing. In 1884 made Assistant Director, Department of Arts and Sciences, South Kensington Museum. In 1883 he was awarded the Rumford Medal of the Royal Society for his researches in photography and spectrum analysis. Many other awards through 1880s - 1890s. Papers published in the *Transactions of the Royal Society,* in the *Philosophical Magazine,* and elsewhere. Died on Dec. 2, 1920 at Folkstone, Kent.]

BOOKS
A14 Abney, Lieut. William. *Instruction in Photography, For use at the School of Mining Engineers, Chatham.* by Lieut. Abney ... 1871. Willets Point, NY: Privately printed., 1871. 120 pp. [First published privately for the Chatham, England School of Engineering, this work later published commercially and went through at least eleven editions with additions up to 676 pp.]

A15 Abney, Lieut. William. *Instruction in Photography.* "Photographic Handy-books, No. 1." London: Piper & Carter, 1874. 120 pp.

A16 Abney, Captain Sir William de Wiveslie. *Thebes and its Five Greater Temples.* Illustrated with Forty large Permanent Photographs by the author, and descriptive text. London: Sampson Low, Marston, Searle & Rivington, 1876. viii, 88 pp. 40 b & w. 2 illus.

A17 Abney, Sir WIlliam de W. *A Treatise on Photography.* "Text Books of Science." London: Longmans, Green & Co., 1878. 326 pp. illus.

A18 Robinson, Henry P. and Sir William de Wiveslie Abney. *The Art and Practice of Silver Printing.* London: Piper & Carter, 1881. viii, 128 pp. illus.

A19 Abney, Sir William de W. *Cantor Lectures on Photography,* by Capt. Abney. Delivered before the Society of Arts, Jan. and Feb., 1882. London: W. Trounce, 1882. 32 pp. illus.

A20 Abney, Captain W. de W. *Photography. With Emulsions:* A treatise on the theory and practical working of the collodion and gelatine

emulsion processes."Scovill's Photographic Series No. 5." New York: Scoville Mfg Co., 1882. viii, 248 pp. [London: Piper & Carter. (1882) [Photographic Handy Books, No. 2]. (1886) vii, 192 pp. illus.]

A21 Abney, Captain W. De W., R.E., F.R.S. *Instruction in Photography.* "Photographic Handy-Books No. 1" London: Piper & Carter, 1884. 340 pp. [6th edition. 11th ed., Rev. and reset., London Iliffe & Sons, Ltd. 1905. 676 pp.]

A22 Abney, Sir William de W. *Cantor Lectures on Photography and the Spectroscope,* by Capt. Abney. Delivered before the Society of Arts, Apr. 20th and 27th, 1885. London: W. Trounce, 1885. 13 pp. illus.

A23 Cunningham, C. D. and W. de W. Abney. *The Pioneers of the Alps.* London: Sampson Low, Marston, Searle & Rivington, 1887. x, 287 pp. 41 b & w. [Biographical sketches and portraits of pioneer mountain climbers. Copiously illustrated with photogravure plates that include informal portraits of the individuals and scenes of groups climbing, their towns etc. "The Portraits," by W. de W. Abney on pp. 80-84, describes his approach to photographing for the book.]

A24 Abney, Sir William de W. *Cantor Lectures on Photography,* by Capt. Abney. Delivered before the Society of Arts, Apr. 2, 9th and 16th, 1894. London: W. Trounce, 1894. 16 pp. 1 l. of plates. illus.

A25 Abney, Sir William de W. *Colour Vision: being the Tydall lectures delivered in 1894 at the Royal Institute,* by Capt. W. de W. Abney... with coloured plate and numerous diagrams. London; New York: Sampson Low, Marston & Co.; W. Wood & Co., 1895. ix, 231 pp. illus.

A26 Abney, Captain. *Instantaneous Photography.* "S&A Photographic Series No. 55" New York; London: Scoville & Adams Co.; Sampson Low, Marston & Co., 1895. 95 pp. illus.

A27 Abney, Sir William de W. and Lyonel Clark. *Platinotype: Its Preparation and Manipulation.* "Handbooks for Photographers" London: Sampson Low, Marston & Co., 1895. 174 pp. illus.

A28 Abney, Sir William de Wiveleslie. *Evening talks at the Camera Club on the action of light in photography,* by the President, Captain Abney... "Handbooks for Photographers" London: Sampson Low, Marston & Co., Ltd., 1897. ii, 201 pp. illus.

A29 Abney, Sir William de W. *Researchers in Colour Vision and the Trichromatic Theory.* London: Longmans, Green & Co., 1913. xi, 418 pp. illus. [plates.]

PERIODICALS
A30 Abney, W. de W., R.E., F.R.A.S. "Albumen Applied to Photography." ANTHONY'S PHOTOGRAPHIC BULLETIN 3, no. 3 (Mar. 1872): 491-494. [From "Photo. News."]

A31 Abney, Capt. W. de W., R.E. "A Stand for Mounting Plans for Copying." BRITISH JOURNAL PHOTOGRAPHIC ALMANAC 1874 (1874): 155-156. 2 illus.

A32 Abney, Captain, R.E., F.R.S. "On Blurring." BRITISH JOURNAL PHOTOGRAPHIC ALMANAC 1877 (1877): 60-61.

A33 Abney, Capt., R. E., F.R.S. "On Solarization." BRITISH JOURNAL PHOTOGRAPHIC ALMANAC 1879 (1879): 84-85.

A34 Abney, Captain W. de W., R.E., F.R.S. "Is Photography an Art?" MAGAZINE OF ART 3, (1880): 302-304. [Issue not dated, but covered exhibitions, Salons, etc. for 1880.]

A35 Abney, Capt. W. de W. "Utilization of Thin Gelatine Plates." PHOTOGRAPHIC TIMES 11, no. 128 (Aug. 1881): 278.

A36 Taylor, J. Traill. "General Notes." PHOTOGRAPHIC TIMES 11, no. 132 (Dec. 1881): 440-441. [Note of a forthcoming series of lectures to be given by Capt. Abney of the Society of Arts, London.]

A37 Abney, Capt. R.E., F.R.S. "The Photographic Image." PHOTOGRAPHIC TIMES 15, no. 200 (July 17, 1885): 392-394.

A38 Abney, Capt. W. de W. "The Theoretical Aspect of Ortho-Chromatic Photography." ANTHONY'S PHOTOGRAPHIC BULLETIN 19, no. 8-10 (Apr. 28 - May 26, 1888): 239-242, 272-275, 304-310.

A39 Abney, W. de W. "What Photography Will Not Do." PHOTOGRAPHIC TIMES 20, no. 449 (Apr. 25, 1890): 199-200. [From "London Daily Graphic." Abney states those things that photography will not accomplish in the future: there will not be any commercially feasible color process; transmitting the photographic image to a distance; balanced presentation of light and shade, or transmission by wire. [All of these have, in fact, been realized.]]

A40 Abney, Captain. "Captain Abney's Address to the British Association: As President of Section A (Mathematical and Physical Section)." ANTHONY'S PHOTOGRAPHIC BULLETIN 20, no. 21 (Nov. 9, 1889): 655-662. [Survey of technical developments in photography.]

A41 Abney, Capt. "Hand Camera Work." PHOTOGRAPHIC TIMES 22, no. 569 (Aug. 12, 1892): 418. [From "Photo Work".]

A42 Abney, Capt. "Slow vs. Rapid Plates for Landscapes." WILSON'S PHOTOGRAPHIC MAGAZINE 37, no. 517 (Jan. 1900): 9-10. [From "Photography."]

A43 Abney, Sir William. "Enlarged Negatives." WILSON'S PHOTOGRAPHIC MAGAZINE 38, no. 532 (Apr. 1901): 142-143. [From "Photography" (London).]

A44 "Obituary: Sir Wm. Abney (Dec. 2, 1920)." BRITISH JOURNAL PHOTOGRAPHIC ALMANAC 1922 (1922): 301-302. [Lieutenant in the Royal Engineers in 1861 and a captain in 1873. Instructor in chemistry to the Royal Engineers at Chatham for years. Retired from Army in 1881. 1884 Asst. Director for the Science and Art Department of South Kensington. Director in 1893. Asst. Sec. 1899. Wrote profusely on technical aspects, particularly on color in the 1880s. His textbooks became standards. Many honors, etc.]

A45 Jones, Chapman. "Memorial Lecture on the Life and Work of Sir William de Wiveleslie Abney, K.C.B., D.L.C., D.Sc., F.R.S., Hon. F.R.P.S., etc." PHOTOGRAPHIC JOURNAL 61, no. 7 (July 1921): 296-310. [Very detailed account of Abney's career from the 1870s through the 1920s. An extensive bibliography on pp. 308-309.]

ABRAHAMS, G. P. (d. 1923) (GREAT BRITAIN)
A46 Portrait. Woodcut engraving credited "From a photograph by G. P. Abrahams, Keswick." ILLUSTRATED LONDON NEWS 74, (1879). ["Late Sir John Woodford, K.C.B." 74:2078 (Apr. 12, 1879): 345.]

A47 "Obituary: G. P. Abrahams." BRITISH JOURNAL PHOTOGRAPHIC ALMANAC 1924. (1924) p. 268. ["Notable for his views of the Lake District."]

ACKLAND, WILLIAM. (d. 1895) (GREAT BRITAIN)
[Ackland was a surgeon-oculist, and an authority on spectacles, long connected with the London firm of Horne & Thornthwaite, opticians. Probably the first to introduce the collodion process commercially, in 1851-52.]

A48 Ackland, William. *How to Take Stereoscopic Pictures, Including a Detailed Account of the Necessary Apparatus, and a Minute Description of a Modified Collodio-Albumen Process.* London; New York: Simpkin, Marshall & Co., Horne & Thornthwaite; Scoville Mfg Co., 1857. 16 pp. 15 illus. [2nd ed. 33 pp.; 3rd ed. (1859) 49 pp.]

A49 Ackland, William. *Ackland's Hints on Fothergill's Process.* London: Horne & Thornthwaite, 1858. n. p. [Pamphlet.]

PERIODICALS
A50 Ackland, W. "The Difficulties of the Dry Process." AMERICAN JOURNAL OF PHOTOGRAPHY AND THE ALLIED ARTS & SCIENCES n. s. vol. 2, no. 16 (Jan. 15, 1860): 242-248.

A51 "The Fothergill Process - Important Modification." AMERICAN JOURNAL OF PHOTOGRAPHY AND THE ALLIED ARTS & SCIENCES n. s. vol. 8, no. 11 (Dec. 1, 1865): 248-252. [From "Br. J. of Photo."]

A52 Ackland. "On the Modified Fothergill Process." HUMPHREY'S JOURNAL OF PHOTOGRAPHY, AND THE ALLIED ARTS AND SCIENCES 17, no. 21 (Mar. 1, 1866): 330-334. [Read to the North London Photo. Soc.]

A53 Ackland, William. "On Albumen for Dry-Plate Photography." BRITISH JOURNAL PHOTOGRAPHIC ANNUAL 1875 (1875): 63-64.

ADAM-SALOMON, ANTOINE-SAMUEL. (1818-1881) (FRANCE)
[Born at La Ferté-sous-Jouarre, France on Jan. 9, 1818. He became a modeler and sculptor, studied under Vercelli. By 1844 he was exhibiting in the Salon, under his own name and under the assumed name Adama. Learned photography in 1858 from Franz Hanfstaengl in Munich. In 1859, in Paris, he opened a photographic portrait studio, while still practicing as a sculptor. His prices were high, but his work was considered very artistic by his peers. In 1865 he opened a second studio in Paris. Became a member of the Société française de Photographie, and exhibited at their salons throughout the 1860s. Decorated with the Légion d'Honneur in 1870, but forced by illness to stop photographing in 1873. Died in Paris in 1881.]

A54 "Miscellaneous: Parisian Photography." PHOTOGRAPHIC NEWS 1, no. 22 (Feb. 4, 1859): 262. [Extracted from "The Literary Gazette."]

A55 "Portraiture in Paris." HUMPHREY'S JOURNAL OF PHOTOGRAPHY, AND THE ALLIED ARTS AND SCIENCES 19, no. 7 (Aug. 1, 1867): 101-102. ["Among the French photographic portraitists Mr. Solomon, although he may not be superior in talent to several of his neighbors, enjoys a greater reputation than any other photographer...His price for a sitting is 200 francs; and rooms are always full;..."]

A56 Vogel, Dr. H. "German Correspondence." PHILADELPHIA PHOTOGRAPHER 4, no. 44 (Aug. 1867): 262-263. [Mentioned extensively in review of Paris International Exhibition of Photography.]

A57 "Photographic Studies." HUMPHREY'S JOURNAL OF PHOTOGRAPHY, AND THE ALLIED ARTS AND SCIENCES 19, no. 14 (Nov. 15, 1867): 222. [Adam-Salomon's (photographs) "...have been the wonder and admiration of all the world and have taken the first premiums (at the Paris Fair). Messrs. Anthony have imported some of these silver prints...."]

A58 "M. Salomon's Pictures." HUMPHREY'S JOURNAL OF PHOTOGRAPHY, AND THE ALLIED ARTS AND SCIENCES 19, no. 16 (Dec. 15, 1867): 251-252. [From "Photo. News." Praise.]

A59 North, Walter C. "Paris Correspondence." PHILADELPHIA PHOTOGRAPHER 4, no. 48 (Dec. 1867): 389-391. [Describes visit to Adam-Salomon and to Reutlinger, both in Paris.]

A60 "M. Salomon's Pictures." HUMPHREY'S JOURNAL OF PHOTOGRAPHY, AND THE ALLIED ARTS AND SCIENCES 19, no. 17 (Jan. 1, 1868): 268-269.

A61 "Fine Arts." ILLUSTRATED LONDON NEWS 52, no. 1464 (Jan. 11, 1868): 43. [Extensive discussion of Adam-Salomon and his work.]

A62 "New York Correspondence." PHILADELPHIA PHOTOGRAPHER 5, no. 49 (Jan. 1868): 26-27. [Discussion of Adam-Salomon's portrait-style, contrasted with the American style.]

A63 Pollack, W. E. "A Visit to the Studio of M. Adam-Salomon." PHILADELPHIA PHOTOGRAPHER 5, no. 49 (Jan. 1868): 27-29. [Also a note on p. 32 in the "Editor's Table" about an Adam-Salomon photo.]

A64 "New York Correspondence." PHILADELPHIA PHOTOGRAPHER 5, no. 50 (Feb. 1868): 52-54. 1 illus. [Discusses Adam-Salomon.]

A65 Simpson, G. Wharton. "Practical Notes on Various Photographic Subjects." PHILADELPHIA PHOTOGRAPHER 5, no. 51 (Mar. 1868): 67-69. [Discusses Adam-Salomon's photographs on pp. 68-69.]

A66 "Editor's Table: Photographs by M. Adam-Salomon." PHILADELPHIA PHOTOGRAPHER 5, no. 51 (Mar. 1868): 99.

A67 "M. Adam-Salomon." BRITISH JOURNAL PHOTOGRAPHIC ALMANAC 1869 (1869): 35, plus frontispiece. 1 b & w. [Illustrated with a photoelectric engraving by Duncan C. Dallas, from a self-portrait photograph of Adam-Salomon.]

A68 Vogel, Prof. "German Correspondence." PHILADELPHIA PHOTOGRAPHER 6, no. 67 (July 1869): 246-248. [States that Adam-Salomon makes three portraits a day, for 100 francs each. Claims that other photographers, who must meet demands of large numbers of people each day, cannot match A-S's quality.]

A69 "Our Picture." PHILADELPHIA PHOTOGRAPHER 7, no. 81 (Sept. 1870): frontispiece, 333-334. 1 b & w.

A70 "How M. Adam-Salomon Lights His Sitters." ANTHONY'S PHOTOGRAPHIC BULLETIN 2, no. 4 (Apr. 1871): 110-111. [From "Br. J. of Photo."]

A71 Adam-Salomon. "Vignetted Bust Portraits Obtained Direct upon the Negative." ANTHONY'S PHOTOGRAPHIC BULLETIN 3, no. 3 (Mar. 1872): 84. [From "Photo. News."]

A72 Adam-Salomon, A. "Vignetted Bust Portraits Obtained Direct Upon the Negative." PHOTOGRAPHER'S FRIEND 2, no. 2 (Apr. 1872): 39-40. [From "Photo News."]

A73 Simpson, G. Wharton. "Notes In and Out of the Studio." PHILADELPHIA PHOTOGRAPHER 9, no. 106 (Oct. 1872): 363-365. ['M. Adam-Salomon's new style of portraits,' on p. 364-365.]

A74 Wilson, Edward L. "Views Abroad and Across. No. 10." PHILADELPHIA PHOTOGRAPHER 11, no. 130 (Oct. 1874): 289-298. [Describes visit to Adam-Salomon and having his portrait made, on pp. 296-297.]

A75 Adam-Salomon. "The Dark Room." BRITISH JOURNAL PHOTOGRAPHIC ANNUAL 1875 (1875): 45.

A76 Adam-Salomon. "Our Foreign Make-Up: Novel and Brilliant Effects in Portraiture." PHOTOGRAPHIC TIMES 5, no. 51 (Mar. 1875): 61-62. [From the "Year Book."]

A77 Adam-Salomon. "On Positive Printing." BRITISH JOURNAL PHOTOGRAPHIC ALMANAC 1876 (1876): 43-44.

A78 Adam-Salomon. "Nitrated Sizing for the Preparation of Paper for Finishing in Water-Colour." BRITISH JOURNAL PHOTOGRAPHIC ALMANAC 1877 (1877): 53-54.

A79 Adam-Salomon. "The Improvement of Defective Negatives." BRITISH JOURNAL PHOTOGRAPHIC ALMANAC 1878 (1878): 65-67.

A80 Vidal, Leon. "French Correspondence." PHILADELPHIA PHOTOGRAPHER 17, no. 197 (May 1880): 154-155. [Adam-Salomon held up as an example of a creative artist.]

A81 Vidal, Leon. "French Correspondence." PHILADELPHIA PHOTOGRAPHER 17, no. 199 (July 1880): 224-227. [Discusses Adam-Salomon on pp. 226-227.]

A82 Taylor, J. Traill. "Home and Foreign News." PHOTOGRAPHIC TIMES 11, no. 126 (June 1881): 212-213. [Note of Adam-Salomon's death in Paris at age 63. "Up until the summer of 1867 he was comparatively unknown to fame, but during the International Exposition of that year he was written into a well deserved fame by the French correspondent of the London "Times." He confined his professional operations to portraits of 8 x 10 inches ... consisted in the great range of tones between the deepest blacks and the high lights his prints were greatly worked on by hand.]

A83 1 photo (Portrait of the editor Edward L. Wilson). PHOTOGRAPHIC MOSAICS:1888 (1888): frontispiece.

A84 Grubeman, Wilbur. "The Question of Studio Lighting." WILSON'S PHOTOGRAPHIC MAGAZINE 37, no. 520 (Apr. 1900): 185-186. [Argument for intelligent choices. Discusses Adam-Salomon of Paris choosing south light for his studio when he returned to Paris after the Franco-Prussian War.]

ADAMS. (EVANSVILLE, IN)
A85 "An Interesting Experiment." AMERICAN JOURNAL OF PHOTOGRAPHY AND THE ALLIED ARTS & SCIENCES n. s. vol. 6,

no. 7 (Oct. 1, 1863): 166-167. [From "Evansville (IN) Journal." Report that, at the request of individuals who had heard the story of the image of the murderer remaining on the retina of a victim, a Mr. Adams, of Evansville, ambrotyped a murdered man, then enlarged his negative and found therein a portrait. The editor is doubtful.]

ADAMS, C. (COLLIN'S CENTRE, NY)
A86 "Engraving Daguerreotypes." HUMPHREY'S JOURNAL 4, no. 17 (Dec. 15, 1852): 268-269. [Landscape view of Smithport, PA, by C. Adams of Collin's Centre, NY, described.]

ADAMS, DAN.
A87 Hart, Charles Henry, introduction and notes. "Life Portraits of Andrew Jackson." MCCLURE'S MAGAZINE 9, no. 3 (July 1897): 795-804. 1 b & w. 8 illus. [Eight painted portraits. One daguerreotype by Dan Adams, taken in Nashville, TN, in 1845. The caption includes information on the sitting, quoted from a letter by his granddaughter, Rachael Jackson Lawrence, who had attended the portrait session.]

ADAMS, RODNEY F.
A88 "The Ruins of the Lindell Hotel, St. Louis. - From a Photograph by R. F. Adams, St. Louis." FRANK LESLIE'S ILLUSTRATED NEWSPAPER 24, no. 603 (Apr. 20, 1867): 69. 1 illus. [View, of ruins.]

ADAMS, S. C.
A89 Adams, S. C. "Improvements in the Daguerreotypes." HUMPHREY'S JOURNAL 5, no. 20 (Feb. 1, 1854): 314-315.

ADAMS, S. F. (1844-) (NEW BEDFORD, MA)
[S. F. Adams was a stereo view maker, active in New Bedford and Oak Bluffs, MA from ca. 1860 - 1880.]

BOOKS
A90 Catalogue of Stereoscopic Views, published by S. F. Adams, (Successor to Bierstadt Bros.,) New Bedford, Mass. New Bedford, MA: E. Anthony & Sons, 67 Union St., 1867. 30 pp.

PERIODICALS
A91 "Editor's Table." PHILADELPHIA PHOTOGRAPHER 6, no. 70 (Oct. 1869): 356. [Adams spent "the season" on top of Mt. Washington, NH, making stereo views of visitors.]

ADAMS, WASHINGTON IRVING. (1832-1896) (USA)
A92 Adams, W. I. "The Tadema Picture." PHOTOGRAPHIC TIMES 11, no. 127 (July 1881): 248. [A new style, introduced by G. F. E. Pearsall of Brooklyn and his brother Alva Pearsall. A horizontal panel picture, with accessories and backgrounds, used for group portraits, etc.]

A93 Adams, W. Irving. "A Flying Visit to Chicago." PHOTOGRAPHIC TIMES 12, no. 143 (Nov. 1882): 426-427. [Adams discusses stockdealers, commercial aspects, which seemed to be prospering.]

A94 Adams, W. Irving. "Portraiture Without a Glass House." PHOTOGRAPHIC TIMES 14, no. 157 (Jan. 1884): 31-32.

A95 Adams, W. Irving. "Photographic Excursions Among the White Mountains:..." PHOTOGRAPHIC TIMES 16, no. 263 - 270 (Oct. 1 - Nov. 19, 1886): 518-519, 530-532, 543-544, 553-554, 565-566, 575-576, 578-579, 601-603. ["Mount Washington, The Glen, Through Crawford's Notch, The Franconia Notch, From the Summit of Mount Washington to Crawford's."]

A96 Adams, W. Irving. "Hints to Landscape Photographers." PHOTOGRAPHIC TIMES 16, no. 268 (Nov. 5, 1886):

A97 Adams, W. Irving. "A Retrospect of 1886." PHOTOGRAPHIC TIMES 16, no. 275 (Dec. 24, 1886): 659-660.

A98 Adams, W. Irving. "Timing Exposures In the Field." AMERICAN ANNUAL OF PHOTOGRAPHY AND PHOTOGRAPHIC TIMES ALMANAC FOR 1890 (1890): 76-77. 1 illus.

A99 Adams, W. Irving. "Making Portraits Out-of-Doors." AMERICAN ANNUAL OF PHOTOGRAPHY AND PHOTOGRAPHIC TIMES ALMANAC FOR 1893 (1893): 57-58.

A100 "Our Founder Gone." PHOTOGRAPHIC TIMES 28, no. 2 (Feb. 1896): 65-66. [Obituary.]

A101 Wilson, Edward L. "A Tribute to the Memory of Washington Irving Adams." WILSON'S PHOTOGRAPHIC MAGAZINE 33, no. 470 (Feb. 1896): 63-72. 3 illus. [W. I. Adams was a manufacturer and dealer of photographic supplies and equipment, and the father of W. I. Lincoln Adams, the editor/photographer. W. I. Adams born on Mar. 25, 1832, in New York, NY. Began working as a salesman for the Scoville Manufacturing Co. in 1858. By 1878 he was elected the director of the company. In 1889 the Scoville & Adams Co. replaced the photographic department of the Scoville manufacturing company, and Adams was made the President and Treasurer. Scoville & Adams became one of the largest and most influential manufacturing firms of photographic apparatus in the world. Adams was the First Vice President of the Centennial Photographic Co. in 1876, and a Chairman of the National Photographic Association for many years. He was also a Mason for many years. The biographical essay, by Wilson, is followed by letters from F. J. Kingsbury, Edward Cope, V. M. Wilcox, D. K. Cady, John Carbutt, E. Long, Jr., Clemons, Jas. H. Smith, J. F. Ryder, David Tucker, W. P. Buchanan, H. Littlejohn, James Landy, H. A. Hyatt, G. Cramer, Benj. French, Geo. R. Angell, S. T. Blessing, H. Q. Sargent, Clarence E. Woodman, W. H. Robey, Leonard Jacobi, J. C. Millen, P. C. Duchochois, O. H. Peck, J. C. Somerville, F. Hendricks & Co., and excerpts from several papers.]

ADAMSON, JOHN & ROBERT ADAMSON.
A102 Morrison-Low, A. D. "Dr. John and Robert Adamson: An Early Partnership in Scottish Photography." PHOTOGRAPHIC COLLECTOR 4, no. 2 (Autumn 1983): 198-214. 20 b & w. 1 illus.

A103 Harley, Ralph L., Jr. and Joanna L. Harley. "The 'Tartan Album' by John and Robert Adamson." HISTORY OF PHOTOGRAPHY 12, no. 4 (Oct. - Dec. 1988): 295-307. 24 illus. [Album of eighteen calotypes taken at or near St. Andrews, Fife, by the Adamson brothers in 1842. The article is illustrated with engravings from Dr. Grierson's "Delineations of St. Andrews" and full double-page spreads of all eighteen pages of the album.]

ADAMSON, JOHN. (1810-1870) (GREAT BRITAIN)
A104 Smith, Graham. "'Dr. Harry Goodsir', by Dr. Adamson of St. Andrews." HISTORY OF PHOTOGRAPHY 10, no. 3 (July - Sept. 1986): 229-236. 4 b & w. 5 illus. [Calotype of Dr. Goodsir, a member of Sir John Franklin's fatal Arctic expedition, taken by John Adamson in 1842. Article also discusses the expedition and its coverage in the "Illustrated London News" (Sept. 13, 1851), with engravings from daguerreotypes by Richard Beard.]

ADAMSON, ROBERT (1821-1848) see ADAMSON, JOHN & ROBERT ADAMSON, and HILL & ADAMSON.

ADDIS.
A105 Ehninger, John W. Ye Legende of St. Gwendoline. With Eight Photographs by Addis from Drawings by J. W. Ehninger. New York;

London: G. P. Putnam & Son; Sampson Low & Co., 1867. n. p. 8 b & w.

ADELE. (VIENNA, AUSTRIA)
A106 Portrait. Woodcut engraving credited "From a photograph by Adèle." ILLUSTRATED LONDON NEWS 72, (1878). ["Archduke Rudolf, Crown Prince of Austria." 72:2014 (Feb. 2, 1878): 109.]

AIGNER, AUGUST.
A107 Aigner, August. "On the Employment of Iceland Moss in the Dry Collodion Process." HUMPHREY'S JOURNAL OF PHOTOGRAPHY, AND THE ALLIED ARTS AND SCIENCES 19, no. 1, 6 (May 1, July 15, 1867): 12-13, 88-90. [From "Photo. Archiv."]

AIKIN, WILLIAM E. A. (1807-1888) (USA)
BOOKS
A108 Aikin, William E. A. ...Notice of the Daguerreotype. Baltimore: Printed by John Murphy, 1840. 16 pp. 6 illus. [At head of title: "From the Maryland Medical & Surgical Journal, Vol. I, No. 2, April, 1840."]

A109 Aikin, William E. A. Theory of the Daguerreotype Process. Baltimore: Printed by John Murphy, 1840. 4 pp. ["From the Maryland Medical & Surgical Journal, Vol. I, No. 3, July 1840."]

PERIODICALS
A110 Aikin, William E. A., M.D. "Miscellaneous: Theory of the Daguerreotype Process." AMERICAN REPERTORY OF ARTS, SCIENCES AND MANUFACTURES 2, no. 4 (Nov. 1840): 300-303. [From the "Maryland Medical and Surgical Journal" (July 1840). Aikin was the Professor of Chemistry and Pharmacy at the University of Maryland.]

AKERS. (MANCHESTER, ENGLAND)
A111 Portraits. Woodcut engravings credited "From a photograph by Akers." ILLUSTRATED LONDON NEWS 19, (1851). ["Sir John Potter, Mayor of Manchester." 19:* (Oct. 18, 1851): 485.]

ALBEE & COLE.
A112 "Pennsylvania. - The Women's Rowing Match, on the River Monongahela, Near Pittsburgh, on the 16th Inst. - The Contestants, Lottie McAlice and Maggie Lew. - From a Photograph by Albee & Cole." FRANK LESLIE'S ILLUSTRATED NEWSPAPER 30, no. 775 (Aug. 6, 1870): 328. 1 illus. [Distant view of crews, rowing on the river.]

ALBEE, S. V. (PITTSBURGH, PA)
A113 "The Railroad War: Labor Strife in Pittsburgh." STEREO WORLD 1, no. 1 (Mar. - Apr. 1974): 6-7. 4 b & w. [Four stereo views of aftermath of July 1877 strike.]

ALBERT, J. see also OBERNETTER.

ALBERT, JOSEPH. (1825-1886) (GERMANY)
[Born on March 5, 1825 at Munich. His father an engineer, Joseph studied chemistry and physics at the Munich Polytechnicum. Learned photography from Aloïs Löcherer, opened a studio at Augsburg in 1850. Made portraits, views, and reproductions of works of art. Became Court Photographer in 1858. In 1865 invented the Albertype printing process, which made phototypy practical for the first time. In 1870s worked on color processes, collaborating with Louis Ducos du Hauron in 1879. Died May 5, 1886 in Munich. His son Eugen (1856-1929) and widow continued the family business.]

BOOKS
A114 Malet, Sir Alexander. *The Conquest of England from Wace's Poem of the Roman de Rou.* London: Bell & Daldy, 1860. n. p. 35 b & w. [Photographs of the Bayeaux Tapestry, taken by Joseph Albert, of Munich.]

A115 Carolsfeld, Julius Schorr von. *The Nibelungen-Saga as Displayed in the Fresco Paintings of Julius Schorr von Carolsfeld in the Royal Palace at Munich.* Munich: J. Albert, n. d. [ca. 186-]. n. p. 20 b & w. [German edition, (1866 ?), 35 b & w.]

A116 Molloy, G. *The Passion Play at Oberammergau in the Summer of 1871.* London: Burns, Oates & Co., 1872. n. p. 12 b & w.

PERIODICALS
A117 C. B. "The Photographs of M. Albert, of Munich." ART JOURNAL (Dec. 1860): 363.

A118 "Useful Facts, Receipts &c.: Photography and Physiology." AMERICAN JOURNAL OF PHOTOGRAPHY AND THE ALLIED ARTS & SCIENCES n. s. vol. 4, no. 3 (July 1, 1861): 69. [From "Athenaeum." Albert's work for the "Photographic Atlas of the Nervous System of the Human Frame," published in Munich, mentioned.]

A119 "A Photographic Atlas of the Nervous System of the Human Frame." HUMPHREY'S JOURNAL OF PHOTOGRAPHY, AND THE ALLIED ARTS AND SCIENCES. 13, no. 12 (Oct. 15, 1861): 181. [From the "Athenaeum." Albert, in Munich, illustrating this "important scientific work..."]

A120 "Our Weekly Gossip." ATHENAEUM no. 1791 (Feb. 22, 1862): 262. [The Prince of Wales sat for the German photographer Albert, the only photographer then producing "life-sized portraits."]

A121 "Our Weekly Gossip." ATHENAEUM no. 1833 (Dec. 13, 1862): 773. [Albert's photos displayed in London, drew praise.]

A122 "Another Photo-Mechanical Printing Process." HUMPHREY'S JOURNAL OF PHOTOGRAPHY, AND THE ALLIED ARTS AND SCIENCES 20, no. 19 (Mar. 15, 1869): 297. [From "Photo. News." Albert's process described.]

A123 "Herr Albert's New Process." HUMPHREY'S JOURNAL OF PHOTOGRAPHY, AND THE ALLIED ARTS AND SCIENCES 20, no. 27 (Nov. 15, 1869): 419-421. [Albertype process discussed.]

A124 Portraits. Woodcut engravings credited "From a photograph by J. Albert." ILLUSTRATED LONDON NEWS 62, (1873). ["Late Baron Von Liebig." 62:1757 (May 3, 1873): 417.]

A125 Von Kramer, Oscar. "Photography in Natural Colors." PHILADELPHIA PHOTOGRAPHER 15, no. 173 (May 1878): 135-136. [Description of J. Albert's new invention.]

A126 "Obituary: Joseph Albert." ANTHONY'S PHOTOGRAPHIC BULLETIN 17, no. 11 (June 12, 1886): 330. [Born Mar. 5, 1825. Learned photography with Loecherer in Munich. Opened a studio in Augsberg in 1850. Moved to Munich in 1858, made life-sized portraits. Invented the Albertype photomechanical reproduction process. Died May 5, 1886.]

A127 "Obituary: Dr. Joseph Albert." PHOTOGRAPHIC TIMES 16, no. 248 (June 18, 1886): 324. [Albert was the inventor of Albertype printing process, died in Munich in the 61st year of his age.]

A128 Mackay-Smith, Rev. Alexander. "The Romance of a Mad King." HARPER'S MONTHLY 97, no. 580 (Sept. 1898): 594-605. 10 b & w. [King Louis II of Bavaria. Illustrations are portraits, views of buildings, etc. credited to Jos. Albert.]

A129 Eskildsen, U. "Joseph Albert: More than Just a Court Photographer." AFTERIMAGE 5, no. 4 (Oct. 1977): 4-5. 7 b & w.

A130 Zelevansky, Lynn. "Joseph Albert and His Sponsers." HISTORY OF PHOTOGRAPHY 12, no. 1 (Jan. - Mar. 1988): 1-21. 18 b & w.

ALBERT, JOSEPH. [?]
A131 "The Passion Play in Oberammergau in 1870." HARPER'S MONTHLY 42, no. 248 (Jan. 1871): 174-186. 12 illus. [Views of the pageant, portraits of the actors. Engravings, some probably from photographs. Perhaps by Albert?]

ALDEN, A. E. & A. J. ALDEN. (SPRINGFIELD, MA)
A132 "The Great Dam at South Hadley Falls, Massachusetts." HARPER'S WEEKLY 13, no. 657 (July 31, 1869): 493. 1 illus. ["Photographed by A. E. & A. J. Alden, Springfield, MA."]

ALDEN, AUGUSTUS E. (1837-) (USA) see ALDEN, A. E. & A. J. ALDEN.

ALDER.
A133 Portrait. Woodcut engraving, credited "Photographed by Alder." FRANK LESLIE'S ILLUSTRATED NEWSPAPER 38, (1874). ["Mr. John Magee, Br. Vice Council at Guatamala." 38:975 (June 6, 1874): 204.]

ALDHAM, C. J. (GRAHAMSTOWN, SOUTH AFRICA)
A134 "Ostrich Farming in South Africa." ILLUSTRATED LONDON NEWS 72, no. 2022 (Mar. 30, 1878): 291-293. 9 illus. [Pre-photographic essay. Nine views of various aspects of raising ostriches"...from photographs by Mr. C. J. Aldham, of Grahamstown, late chief operator at Messrs. Hill & Saunders."]

A135 "A Young Kaffir Chief." ILLUSTRATED LONDON NEWS 72, no. 2026 (Apr. 27, 1878): 377. 1 illus.

ALDIS, ELIJAH.
A136 Aldis, Elijah. *Carvings and Sculptures of Worcester Cathedral. Worcesterr.* London: E. Aldis, under the patronage of the Dean and Chapter; Benrose & Sons, 1873. 20 l. 69 b & w.

ALDRIDGE, R. W.
A137 Aldridge, R. W. "Retouching in Portraiture." BRITISH JOURNAL PHOTOGRAPHIC ANNUAL 1875 (1875): 140-142.

A138 Aldridge, R. W. "A Plea for Photography." BRITISH JOURNAL PHOTOGRAPHIC ALMANAC 1876 (1876): 173. [Poem.]

ALESSANDRI BROTHERS. (ROME, ITALY)
A139 Portraits. Woodcut engravings credited "From a photograph by Alessandri Brothers." ILLUSTRATED LONDON NEWS 69, (1876). ["The late Cardinal Antonelli." 69:1948 (Nov. 25, 1876): 500.]

A140 Portrait. Woodcut engraving credited "From a photograph by Alessandri Brothers." ILLUSTRATED LONDON NEWS 72, (1878). ["Late Father Secchi." 72:2020 (Mar. 16, 1878): 245.]

ALFIERI, CHARLES. (GREAT BRITAIN)
[Charles Alfieri was a schoolmaster at Stoke-on-Trent, and an amateur photographer from the 1860s on. His son, Bernard, born in 1860,

remembered helping his father carry the heavy equipment on photographic trips around the Yorkshire Dales or the Welsh Hills. Bernard also became an amateur photographer, a member of the Old Camera Club and the Linked Ring. (From "My Father and the early pictorialists," by Bernard Alfieri (grandson) in the "BJP" (Dec. 21, 1973: 1195-1197.)]

A141 "Our Editorial Table: The Potter's Art in the Stereoscope, by C. Alfieri." BRITISH JOURNAL OF PHOTOGRAPHY 11, no. 235 (Nov. 4, 1864): 438-439.

A142 "Our Editorial Table: Photographs by Mr. C. Alfieri." BRITISH JOURNAL OF PHOTOGRAPHY 11, no. 242 (Dec. 23, 1864): 532.

A143 Alfieri, C. "Occasional Papers: The Camera Campestra." BRITISH JOURNAL OF PHOTOGRAPHY 12, no. 264 (May 26, 1865): 278-279. 6 illus. [Portable camera and darkroom outfit developed by Alfieri for landscape work.]

A144 Alfieri, C. "On a Simple Method of Constructing Photographic Baths and Trays." BRITISH JOURNAL PHOTOGRAPHIC ALMANAC 1876 (1876): 126-128. 4 illus.

A145 Alfieri, C. "On the Reproduction and Enlargement of Negatives." BRITISH JOURNAL PHOTOGRAPHIC ALMANAC 1878 (1878): 76-77. 1 illus.

A146 Alfieri, C. "Pictorial Composition as Applied to Landscape Photography." PHOTOGRAPHIC TIMES 15, no. 180 (Feb. 27, 1885): 102-103. [Communicated to the North Staffordshire Photographic Association.]

ALINARI, GIUSEPPE (1836-1891) (ITALY) see ALINARI BROTHERS.

ALINARI, LEOPOLDO (1832-1865) (ITALY) see ALINARI BROTHERS.

ALINARI, ROMUALDO (1830-1891) (ITALY) see ALINARI BROTHERS.

ALINARI, VITTORIO (1859-1932) (ITALY) see ALINARI BROTHERS.

ALINARI BROTHERS. (FLORENCE, ITALY)
[Leopoldo Alinari apprenticed to the engraver Guisseppi Bardi in Florence in 1840s. Learned photography and opened a small photographic studio in 1852. In 1854 his brothers, Romualdo and Guiseppi, joined him and formed Fratelli Alinari. Leopoldo thought to be the photographer. Views, copies of works of art. Gained wide reputation, exhibiting in Paris, Brussels, elsewhere. Leopoldo died in 1865, to be replaced in the business by his son Vittorio. Highly successful by end of 1860s. In 1880 the company employed over one hundred people and it was a major producer of topographic views in Italy as well as a major source for photographic reproductions of the many works of art and architecture in the country. Fratelli Alinari was acquired by a Florentine group in 1920, who added the works of James Anderson and the Brogi family to the collections.]

BOOKS
A147 Hawthorne, Nathaniel. *Transformations: or, The Romance of Monte Beni.* Leipzig: Bernhard Tachnitz, 1860. 2 vol. Vol. 1: xii, 292 pp. Vol. 2: vi, 280 pp. [This work contains many variations in the

number of photographs tipped-in, from approximately 20 to more than 100 in some copies. The photos are for the most part of statuary and views of Rome. Also confusing is the printed date of 1860, when it seems to have been issued ca. 1868. R. W. Schultze claims that these volumes, with Alinari photographs tipped-in by hand, were sold to tourists visiting Florence —probably over many years.]

A148 *Masterpieces of the Pitti Palace and other Picture Galleries of Florence Photographed by Messrs. Alinari of Florence Direct from the Original Paintings.* London: Sampson Low, Marston & Searle, 1875. n. p. 35 l. of plates.

A149 Oliphant, Margaret (Wilson), Mrs. *The Makers of Venice; Doges, Conquerors, Painters and Men of Letters,* by Mrs. Oliphant... With Illustrations by R. R. Holmes, F.S.A. London: Macmillan & Co., 1898. xiv, 410 pp. 4 l. of plates. illus. [1st ed. 1887. Original photos, of works of art, etc. several topographic views of Venice, credited Alinari.]

A150 Zevi, Filippo, ed., with an intro. by John Berger. *Alinari, Photographers of Florence, 1852-1920.* Florence: Alinari Edizioni & Idea Editions, in association with the Scottish Arts Council, 1978. 94 pp. 101 illus. [Exhibition: Photographers Gallery, London, 1978.]

PERIODICALS
A151 "Photographs from the Campo Santo at Pisa, Florence, Bardi; London, Molino." ATHENAEUM no. 1461 (Oct. 27, 1855): 1245. [Review of photos.]

A152 "Extraordinary Application of Photography." HARPER'S WEEKLY 9, no. 426 (Feb. 25, 1865): 123. [Report that a murder victim in Florence, Italy retained the image of the murderer in the retinas of his eyes. These were reported to have been photographed by Alinari, and these photos led to the conviction of the murderer.]

A153 Cortissoz, Royal. "An American Academy at Rome." HARPER'S MONTHLY 90, no. 538 (Mar. 1895): 626-629. 2 b & w. ["From a photograph by the Fratelli Alinari".]

A154 Whelpley, James Davenport. "Italy's Economic Outlook." CENTURY MAGAZINE 83, no. 6 (Apr. 1912): 895-907. 8 b & w. [Photos by Alinari (3); Underwood & Underwood (2); Brown Brothers (2). Views, laborers, etc.]

A155 "The Major Shows: Spectacular Hommage to a Family Studio." PHOTOGRAPHY YEAR 1978 (1978): 214-222. 9 b & w. [Exhibition review: "The Alinaris - Photographers in Florence 1852-1920, Fort Belvedere, Florence, Italy.]

A156 F. A. "Le reporters du 19e." LE PHOTOGRAPHE no. 1355 (Dec. 1978): 7. 2 b & w. [Exhibition review: "Les trois freres Alinari," La Bibliotheque Publique de Information, Centre Pompidou, Paris.]

ALIQUIS.
A157 "Aliquis." "The Unpopularity of the Stereo Slide." ANTHONY'S PHOTOGRAPHIC BULLETIN 3, no. 12 (Dec. 1872): 764-766. [From "Br. J. of Photography."]

ALLEN, A. M. (1823-1907) (USA)
A158 Allen, A. M. "The Stamp Nuisance." HUMPHREY'S JOURNAL OF PHOTOGRAPHY, AND THE ALLIED ARTS AND SCIENCES 17, no. 20 (Feb. 15, 1866): 318.

A159 "View of the City of Pottsville, the Capitol of Schuylkill County, Where the Condemned Molly Maguires are Confined. - From a

Photograph by Allen, of Pottsville." FRANK LESLIE'S ILLUSTRATED NEWSPAPER 44, no. 1135 (June 30, 1877): 292. 1 illus. [View.]

ALLEN, CHARLES. (TENBY, ENGLAND)
A160 Gwynne, Mrs. F. P. *The Tenby Souvenir: A Table-book in Prose and Verse*.With Photographs by Charles Allen. Tenby, England: R. Mason, 1863. 81 pp. 25 b & w.

A161 Phillips, John Roland. *The History of Cilgerran: comprising a detailed account of the Castle, Church, Mansions, Old Families...* London: J. Russell Smith, 1867. n. p. 4 b & w.

ALLEN, CHESTER. (KEENE, NH)
A162 Portrait. Woodcut engraving, credited "From an ambrotype by Chester Allen, Keene, NH." BALLOU'S PICTORIAL DRAWING-ROOM COMPANION [GLEASON'S] 13, no. 315 (July 4, 1857): 12. 1 illus. ["Hon. William Haile, Gov. of NH." 13:315 (July 4, 1857): 12.]

ALLEN, EDWARD L. (BOSTON, MA)
A163 "Editor's Table." PHILADELPHIA PHOTOGRAPHER 5, no. 49 (Jan. 1868): 34. [10"x12" photos of the Masonic temple in Boston, MA, received.]

A164 "The Brewer Fountain, Near Park Street Mall, in the Common, Boston, Mass. - Presented to the City of Boston by Gardner Brewer, Esq. - From a Photograph by Allen." FRANK LESLIE'S ILLUSTRATED NEWSPAPER 28, no. 717 (June 26, 1869): 225. 1 illus. [View, with figures.]

A165 "Editor's Table." PHILADELPHIA PHOTOGRAPHER 6, no. 67 (July 1869): 251-252. [E. L. Allen supplying stereos of the N. P. A. exhibition in Boston, J. W. Black providing a group portrait of participants; all proceeds to the Relief Fund; Joseph Dixon (Jersey City, NJ) died; J. Gurney & Son occupied new gallery in New York, NY; others mentioned.]

A166 "Editor's Table." PHILADELPHIA PHOTOGRAPHER 7, no. 73 (Jan.1870): 30-31. [William Delius (Waterbury, CT), photolithographs; E. L. Allen (Boston, MA); J. W. Hurt; E. Kilburn; D. C. Hawkins (Sheboygan, WI); J. Carbutt; Fred C. Low (Cambridge, MA); Charles Stafford; W. M. Knight (Buffalo, NY) burned out; Fred C. Lowe (East Cambridge, MA); Amos F. Clough (Oxford, NH); J. W. & J. S. Moulton (Salem, NH); others mentioned.]

A167 Allen, E. L. "Old Times." PHILADELPHIA PHOTOGRAPHER 7, no. 74 (Feb. 1870): 46-48. [Reminiscences of his early career as a daguerreotypist in the 1840s.]

ALLEN, RICHARD. (NOTTINGHAM, ENGLAND)
A168 Allen, Richard. *Allen's Great Midland Almanac and General Advertiser*. Compiled and edited by Richard Allen. Nottingham; London: R. Allen; W. Kent & Co., for the Proprietors, R. & M. H. Allen, 187- ? n. p. illus.

A169 Tarbotton, M. O. *History of the Old Trent Bridge, with a descriptive account of the New Bridge, Nottingham*. Nottingham: Richard Allen & Son, 1871. n. p. 12 b & w.

A170 Allen, Richard. *The Home and Grave of Byron; A Souvenir of Newstead Abbey, Nottinghamshire*. Illustrated by Richard Allen. Nottingham: R. Allen, 1874. 40 pp. 30 l. of plates.

A171 Allen, Richard. *A Souvenir of Newstead Abbey, formerly the Home of Lord Byron*. Nottingham: R. Allen, 1874. 43 pp. illus.

A172 Allen, Richard. *Allen's Illustrated Guide to Matlock and Haddon Hall*. Nottingham: R. Allen, 1876. 16 pp. illus.

ALLEN, S. V. (FREEPORT, IL)
A173 "Our Picture." PHILADELPHIA PHOTOGRAPHER 16, no. 192 (Dec. 1879): frontispiece, 353-355. 1 b & w. [Studio portrait.]

ALLEN, W. A. (NEW YORK, NY)
A174 "Gossip." PHOTOGRAPHIC ART JOURNAL 3, no. 2 (Feb. 1852): 130. ["Mr. W. A. Allen and his brother will open shortly rooms at 308 Broadway."]

ALLEY, EXRA H. (1828-) (MORAVIA, NY)
A175 "Editor's Table." PHILADELPHIA PHOTOGRAPHER 2, no. 23 (Nov. 1865): 187. [Stereos of NY scenery received.]

A176 "Our Picture: Montville Falls, NY." PHILADELPHIA PHOTOGRAPHER 3, no. 27 (Mar. 1866): frontispiece, 93. 1 b & w. [Landscape. Also a letter, about sunlight, to the editor, p. 94 of same issue.]

ALLI, DAROGHA UBBAS. (INDIA)
A177 Alli, Darogha Ubbas. *The Lucknow Album; Containing a Series of Fifty Photographic Views of Lucknow and Its Environs Together with a Large Sized Plan of the City, Executed by Darogha Ubbas Alli*. Calcutta: G. H. Rouse, Baptist Mission Press, 1874. vi, 58 pp. 50 l. of plates.

ALMAN, LOUIS. (LAKE MAHOPAC, NY)
A178 "Editor's Table." PHILADELPHIA PHOTOGRAPHER 6, no. 62 (Feb. 1869): 64. [Stereos of NY scenery noted. Summer scenery, ice gatherers cutting frozen lake, views of buildings.]

A179 "Editor's Table." PHILADELPHIA PHOTOGRAPHER 6, no. 69 (Sept. 1869): 324. [Stereo gems of children, groups, landscapes, and horses.]

A180 "New Galleries: Louis Alman." ANTHONY'S PHOTOGRAPHIC BULLETIN 4, no. 1 (Jan. 1873): 26.

A181 Portrait. Woodcut engraving, credited "From a Photograph by Louis Alman, Lake Mahopac." FRANK LESLIE'S ILLUSTRATED NEWSPAPER 36, (1873). ["Hon. George W. Lane, New York, NY." 36:923 (June 7, 1873): 201.]

A182 "Note." ANTHONY'S PHOTOGRAPHIC BULLETIN 6, no. 3 (Mar. 1875): 83. [Louis Alman (172 5th Ave., New York, NY) forming partnership with Mrs. J. B. Lewis, to form Alman & Co.]

A183 Portrait. Woodcut engraving, credited "From a Photograph by Alman, New York. FRANK LESLIE'S ILLUSTRATED NEWSPAPER 41, (1875). ["The late Judge Lewis B. Woodruff." 41:1044 (Oct. 2, 1875): 53.]

A184 "Fire at Alman's. Heroic Conduct Commended." ANTHONY'S PHOTOGRAPHIC BULLETIN 8, no. 4 (Apr. 1877): 106. [From "NY Era." Alman, his partner, Mrs. Lewis, and their head printer, Mr. Atwood, all acted calmly in the face of a fire caused by exploding collodion, and saved lives, etc.]

A185 "New York City. - The Columbia College Boat Crew, Now Training to Participate in the Henley Regatta, to Come Off in England in July, and the International Regatta in Paris in August. - From a Photograph by Alman, New York." FRANK LESLIE'S ILLUSTRATED NEWSPAPER 46, no. 1181 (May 18, 1878): 184. 1 illus. [Outdoor

group portrait, with river and boats in background. A portion of this woodcut was reprinted in the July 20, 1878 issue, on p. 340, after the crew won the race.]

ALOPHE. [MARIE ALEXANDRE MENUT] (1812-1883) (FRANCE)

A186 Portrait. Woodcut engraving credited "From a photograph by Alophe." ILLUSTRATED LONDON NEWS 41, (1862). ["Baron Gros, French Ambassador to Great Britain." 41:1180 (Dec. 13, 1862): 625.]

A187 Harrison, W. "A Photographer's Dinner-Party: A Peep for Our Readers Behind the Scenes; Or, One of the Correspondent's Letters in Full." BRITISH JOURNAL OF PHOTOGRAPHY 12, no. 251 (Feb. 24, 1865): 100-101. [Harrison, Paris correspondent to "BJP" describes a large party given by Alophe "...to the eighteen heads of the different departments of his establishment."]

ALSCHULER & FLORENCE. (CHICAGO, IL)

A188 1 illustration (Ship "The Madeira Pet," at dock on Chicago waterfront). CHICAGO MAGAZINE 1, no. 5 (Aug. 1857): unnumbered leaf, before p. 81. [Woodcut credited "Photograph by Alschuler & Florence."]

ALSCHULER, SAMUEL D. & SIMON ALSCHULER.

A189 1 illustration (The Saloon Buildings - Lake Street) on p. 1; 1 illustration (South Water Street, Chicago) on p. 3 in: "Chicago Illustrated." CHICAGO MAGAZINE 1, no. 1 (Mar. 1857): 1, 3. 2 illus. [Two woodcuts credited "Photo by Alschuler Bro." in portfolio section, "Chicago Illustrated," at the front of the magazine.]

ALSCHULER, SAMUEL D. (CHICAGO, IL)

[Samuel D. Alschuler is listed in Chicago business directories from 1853 to 1878, although at times he also worked in partnerships with other photographers - including his brother Simon from 1856-57, Alschuler & Florence from 1857-60, and Alschuler & Westphal from 1866-1868. Simon Alschuler also worked his own studio in Chicago during 1861-62 and there was a Simon Alschuler working in Ottawa, OH in 1864-65.]

A190 1 illustration ("Munger & Armour's Grain Warehouse"). CHICAGO MAGAZINE 1, no. 3 (May 1857): unnumbered leaf, before p. 197. [Woodcut credited "Photo by Alschuler."]

A191 "City of Chicago, Illinois." FRANK LESLIE'S ILLUSTRATED NEWSPAPER 7, no. 178 (Apr. 30, 1859): 339. 1 illus. [Half-page engraving of a view of the Illinois and Michigan Canal, credited as "taken from a photograph by a Chicago artist." Very similar to Alschuler style, who took this type of waterfront view and who did send his work to both "FLIN" and "HW" for publication.]

A192 "The Great Murder Case of Chicago." FRANK LESLIE'S ILLUSTRATED NEWSPAPER 9, no. 213 (Dec. 31, 1859): 69-70. 3 illus. [Portraits of Henry Jumpertz (accused), John Van Arman (council), and ex-Gov. McComas (council). "Photographed by Samuel Alschuler, of Chicago."]

A193 "The Schooner 'Augusta' in Port at Chicago, after the Collision with the Steamer 'Lady Elgin,'" and "The Steamer 'Lady Elgin' Lying at Her Wharf at Chicago - From a Photograph by Samuel Alschuler, of Chicago." FRANK LESLIE'S ILLUSTRATED NEWSPAPER 10, no. 252 (Sept. 22, 1860): 271, 278. 2 illus.

A194 "The 'Lady Elgin' and the 'Augusta.'" ILLUSTRATED LONDON NEWS 37, no. 1053 (Oct. 6, 1860): 307. 2 illus. ["From a Photograph by S. Alschuler." Two boats, which later collided, photographed at dock at Chicago, IL.]

A195 "The Explosion of the Propeller 'Globe,' at Chicago, Illinois, on November 8, 1860." HARPER'S WEEKLY 4, no. 204 (Nov. 24, 1860): 743, 749. 1 illus. ["From a photograph taken by Mr. Alschuler, of Chicago, a picture of the 'Globe' whose boiler exploded in Chicago on the 8th inst."]

A196 "Early Home of the President of the United States, Elizabeth Town, Kentucky." ILLUSTRATED LONDON NEWS 37, no. 1065 (Dec. 22, 1860): 609. 1 illus. ["From a Photograph by S. Alschuler, Chicago."]

A197 "Terrible Accident at the Rush Street Bridge, Chicago." HARPER'S WEEKLY 7, no. 360 (Nov. 21, 1863): 763, 748. 1 illus. ["From a photograph by Alschuler."]

A198 "Funeral Services of President Lincoln at Chicago, Illinois, May 1 - Removing the Coffin from the Funeral Train to the Catafalque. - From a Photograph by Alschuler. Reception of the Remains at the Court House. - From a Photograph by Alschuler. Thirty-Six Young Ladies of the High School Strewing the Bier with Garlands and Immortelles. - Sketched by Our Special Artist, Thos. Hogan." FRANK LESLIE'S ILLUSTRATED NEWSPAPER 20, no. 503 (May 20, 1865): 136-137. 3 illus. [One sketch by Thos. Hogan, two views, with street crowds, from photographs by Alschuler. Photographs heavily altered by engraver with addition of figures.]

A199 "President Lincoln's Funeral - Procession in Chicago, Illinois." HARPER'S WEEKLY 9, no. 439 (May 27, 1865): 328. 1 illus. ["Photographed by Atschulet [sic. Alschuler], Chicago."]

AMATEUR.

A200 "Amateur." "Out-Door Photography." HUMPHREY'S JOURNAL OF PHOTOGRAPHY, AND THE ALLIED ARTS AND SCIENCES 12, no. 6 (July 15, 1860): 82-84. [An amateur photographing in Texas, describes being routed by a bear.]

AMBROSETTI. (TURIN, ITALY)

A201 Portrait. Woodcut engraving credited "From a photograph by Ambrosetti." ILLUSTRATED LONDON NEWS 68, (1876). ["Signor Rossi, Italian actor." 68:1918 (Apr. 29, 1876): 412.]

AMERICAN PHOTO-LITHOGRAPHIC CO. (USA)

A202 "The American Photo-Lithographic Company." PHILADELPHIA PHOTOGRAPHER 4, no. 42 (June 1867): 183-184.

A203 "Our Photo-Lithograph." PHILADELPHIA PHOTOGRAPHER 4, no. 44 (Aug. 1867): 256-257, plus tipped-in page. 1 illus. [Example of the work of the American Photo-Lithographic Co., with an accompanying letter by J. W. Osborne.]

AMERICAN PHOTOTYPE COMPANY. (USA)

A204 "The American Phototype Company." AMERICAN JOURNAL OF PHOTOGRAPHY AND THE ALLIED ARTS & SCIENCES n. s. vol. 5, no. 13 (Jan. 1, 1863): 305-306. [...producing by photography plates for printing with ink, ...founded on Pretsch's Photogalvanographic Process.]

AMERICAN STEREOSCOPIC COMPANY. (USA)

A205 American Stereoscopic Company. *American and Foreign Pictures and Instruments*. New York: Wiley & Halsted, 1858. 34 pp.

AMES. (USA)

A206 Portrait. Woodcut engraving, credited "From a Photograph by Ames." HARPER'S WEEKLY 5, (1861). ["General Prentis." 5:239 (July 27, 1861): 465.]

AMICUS.

A207 "Amicus." "Coating Metallic Plates with Iodine for the Daguerreotype." MAGAZINE OF SCIENCE AND SCHOOL OF ARTS 2, no. 81 (Oct. 17, 1840): 232.

AMOS. (DOVER, ENGLAND)

A208 "The Officer's New Barracks, Dover Castle." ILLUSTRATED LONDON NEWS 33, no. 951 (Dec. 25, 1858): 619. 1 illus. ["From a Photograph by Amos, of Dover."]

ANDERSON & JOHNSON. (USA)

A209 "The Late George Peabody at the White Sulphur Springs, Virginia. Surrounded by Southern Notabilities. - From a Photograph by Anderson & Johnson, Richmond." FRANK LESLIE'S ILLUSTRATED NEWSPAPER 29, no. 738 (Nov. 20, 1869): 160. 1 illus. [Outdoor group portrait.]

ANDERSON, A. (ELGIN, ENGLAND)

A210 Portrait. Woodcut engravings, credited to "From a Photograph by A. Anderson." ILLUSTRATED LONDON NEWS 60, (1872). ["Mary Winchester, Captive of the Looshais [India]" 60:1707 (May 25, 1872): 496.]

ANDERSON, A. A.

A211 Anderson, A. A. "The Lime Toning Process." HUMPHREY'S JOURNAL OF PHOTOGRAPHY, AND THE ALLIED ARTS AND SCIENCES 14, no. 24 (Apr. 15, 1863): 335-336. [Anderson's letter and Towler's reply.]

ANDERSON, DAVID H. (1827-) (RICHMOND, VA)

A212 Portrait. Woodcut engraving, credited "From a Photograph by Anderson, Richmond, Va." FRANK LESLIE'S ILLUSTRATED NEWSPAPER 24, (1867). ["Jefferson Davis." 24:622 (Aug. 31, 1867): 373.]

A213 "Photography in Richmond, Va." ANTHONY'S PHOTOGRAPHIC BULLETIN 2, no. 11 (Nov. 1871): 365.

A214 Portrait. Woodcut engraving, credited "From a Photograph by Anderson." FRANK LESLIE'S ILLUSTRATED NEWSPAPER 33, (1872). ["The late Bishop McGill, of Richmond, VA." 33:855 (Feb. 17, 1872): 364.]

A215 "Anderson's Photographic Gallery." ANTHONY'S PHOTOGRAPHIC BULLETIN 5, no. 10 (Oct. 1874): 339. [From the "Norfolk Virginian."]

A216 "Note." ANTHONY'S PHOTOGRAPHIC BULLETIN 6, no. 1 (Jan. 1875): 21. [From "Enquirer." Anderson moved into larger gallery.]

A217 Portrait. Woodcut engraving, credited "From a Photograph by Anderson, Richmond, VA." FRANK LESLIE'S ILLUSTRATED NEWSPAPER 40, (1875). ["Hon. Allen T. Caperton, Sen. from WV." 40:1016 (Mar. 20, 1875): 21.]

A218 Loomis, G. H. "Gallery Biographic. No. 7: D. H. Anderson." ANTHONY'S PHOTOGRAPHIC BULLETIN 6, no. 6 (June 1875): 175-176. [Born New York, NY in 1827. Anderson went into trade, then learned daguerreotyping in 1854. Worked in the South and West until about 1866. Located in Richmond, VA for "the past nine years."

One of the first in the USA to practice the Albertype process. Travelled to Europe in 1873 to study, visit the Vienna International Exhibition,. Met Dagron in Paris. (The Anderson & Co. Photographic Art Palace operated in Richmond from 1866 to 1880.)]

A219 "Richmond, Va. - Unveiling the Statue of 'Stonewall' Jackson in Capitol Square, Tuesday, October 26th. - Photographed by D. H. Anderson, Richmond." FRANK LESLIE'S ILLUSTRATED NEWSPAPER 41, no. 1050 (Nov. 13, 1875): 153. 1 illus. [View, with crowds.]

A220 "Stonewall Jackson at Richmond." ILLUSTRATED LONDON NEWS 67, no. 1893 (Nov. 20, 1875): 507, 509. 1 illus. ["Our Illustration of the scene at the unveiling ceremony is from a sketch by E. Trenifidi, of Richmond, aided by Mr. Anderson's photographs."]

A221 Portrait. Woodcut engraving, credited "From a Photograph by Anderson, Richmond." FRANK LESLIE'S ILLUSTRATED NEWSPAPER 43, (1876). ["The late Henry A. Wise, of VA." 43:1097 (Oct. 7, 1876): 69.]

A222 Portraits. Woodcut engravings, credited "From a Photograph by D. H. Anderson, Richmond, Va." FRANK LESLIE'S ILLUSTRATED NEWSPAPER 45, (1877). ["Most Reverend James Gibbons, Archbishop of Baltimore." 45:1154 (Nov. 10, 1877): 161.]

A223 "Virginia. - The City of Richmond Inundated by a Rise of the James River, November 24th. - From a Photograph by D. H. Anderson, Richmond." FRANK LESLIE'S ILLUSTRATED NEWSPAPER 45, no. 1159 (Dec. 15, 1877): 249. 1 illus. [View.]

A224 "Virginia. - The Inauguration of Governor F. W. M. Holliday, at Richmond, January 1st. - From a Photograph by Anderson, Richmond." FRANK LESLIE'S ILLUSTRATED NEWSPAPER 45, no. 1164 (Jan. 19, 1878): 345. 1 illus. [Outdoor view, with crowd.]

A225 "Our Picture." PHILADELPHIA PHOTOGRAPHER 15, no. 174 (June 1878): frontispiece, 182-183. 1 b & w. [Studio portrait by D. H. Anderson (Richmond, VA).]

A226 "Virginia. - Investigation of the Late Epidemic - Convention of the American Public Health Association in Mozart Hall, Richmond. - From Photographs by D. H. Anderson." FRANK LESLIE'S ILLUSTRATED NEWSPAPER 47, no. 1210 (Dec. 7, 1878): 236. 1 illus. [Interior of large hall, with crowds.]

A227 "Our Editorial Table: Portraits and Genre Pictures. By D. H. Anderson, New York." PHOTOGRAPHIC TIMES 11, no. 129 (Sept. 1881): 359.

A228 Taylor, J. Traill. "The Studios of America. No. 10. D. H. Anderson's Studio, New York." PHOTOGRAPHIC TIMES 13, no. 154 (Oct. 1883): 524-525. [Anderson's studio was at 785 Broadway, formerly occupied by M. B. Brady, but refitted.]

A229 "Notes and News." PHOTOGRAPHIC TIMES 19, no. 424 (Nov. 1, 1889): 545. [Note that Anderson, "the author of the famous composition photograph of the Seventh Regiment, has just completed an equally successful composition of Lafayette Post No. 140 G. A. R..."]

A230 Anderson, D. H. "Harmonizing Contrasts." PHOTOGRAPHIC MOSAICS:1897 33, (1897): 262-265. 1 b & w. [Studio portrait. "General John Newton."]

ANDERSON, ELBERT see also KURTZ.

ANDERSON, ELBERT.

BOOKS

A231 Anderson, Elbert. *The Skylight and Darkroom: A Complete Text-book on Portrait Photography... Containing the outlines of hydrostatics, pneumatics, acoustics, heat, optics, chemistry, and a full comprehensive system of the art photographic...* Philadelphia: Benerman & Wison, 1872. viii, 220 pp. 5 l. of plates. 12 b & w.

A232 Anderson, Elbert. *Elbert Anderson's photo-comic allmyknack.* Philadelphia: Benerman & Wilson, n. d. [ca. 1875]. n. p. illus.

PERIODICALS

A233 Anderson, Elbert. "One Hundred Days in a Fog." PHILADELPHIA PHOTOGRAPHER 7, no. 76-77 (Apr. - May 1870): 106-108, 151-154. [Column of anecdotes, advice, etc. Anderson was an "operator" (i.e. the actual photographer) in William Kurtz's New York, NY gallery.]

A234 Anderson, Elbert. "The Fog Dispersing (Sequel to 100 Days in a Fog)." PHILADELPHIA PHOTOGRAPHER 7, no. 78 (June 1870): 203-206. [Exchange of letters between A. B. Marshall and Elbert Anderson.]

A235 Anderson, Elbert. "Photographic Dialogues (Sequel to 100 days in a Fog, etc.)." PHILADELPHIA PHOTOGRAPHER 7, no. 79-84 (July - Dec. 1870): 261-264, 285-288, 305-309, 354-357, 392-394, 405-407.

A236 Anderson, Elbert, Operator, Kurtz's Gallery, 872 Broadway. "Photographic Dialogues (Sequel to 100 Days in a Fog)." PHILADELPHIA PHOTOGRAPHER 8, no. 85-89, 92-93, 95-96 (Jan. - May, Aug. - Sept., Nov. - Dec. 1871): 19-21, 55-57, 69-71, 107-109, 152-155, 251-254, 301-308, 348-349, 380-383. [Narrative Q & A, on techniques, posing practices, etc.]

A237 Anderson, Elbert. "Correspondence from the Country - Vassar College." PHILADELPHIA PHOTOGRAPHER 8, no. 90 (June 1871): 184-185.

A238 Anderson, Elbert. "The Vacation." PHILADELPHIA PHOTOGRAPHER 8, no. 94 (Oct. 1871): 338-339. [General musings, while on a rare vacation.]

A239 Anderson, Elbert. "Photographic Dialogues." PHILADELPHIA PHOTOGRAPHER 9, no. 97-98 (Jan. - Feb. 1872): 9-11, 38. [Anderson was the operator for Kurtz's Gallery, New York, NY.]

A240 Anderson, Elbert. "How Mr. Elbert Anderson Manages His Bath." PHILADELPHIA PHOTOGRAPHER 9, no. 101 (May 1872): 132-133.

A241 Anderson, Elbert. "Wanted - A First-Class Operator." PHILADELPHIA PHOTOGRAPHER 9, no. 104 (Aug. 1872): 291-292.

A242 "Elbert Anderson." PHILADELPHIA PHOTOGRAPHER 9, no. 104 (Aug. 1872): 296. [From the "Photo. News." A description of Anderson's activities at the Kurtz Gallery, New York, NY, by a British visitor.]

A243 Anderson, Elbert. "A Vision." PHILADELPHIA PHOTOGRAPHER 9, no. 105 (Sept. 1872): 319-321.

A244 Anderson, Elbert. "The Last Days of a 'Busted' Photographer. After 'The Raven' with a Sharp Stick." PHILADELPHIA PHOTOGRAPHER 9, no. 106 (Oct. 1872): 339-341. [Comic poem.]

A245 "The Skylight and the Darkroom." PHOTOGRAPHIC TIMES 2, no. 22 (Oct. 1872): 150-152. [Bk. rev.: "The Skylight and the Darkroom." Includes excerpts from the book.]

A246 "The Skylight and the Darkroom - Mr. Elbert Anderson's New Work of Photography." PHILADELPHIA PHOTOGRAPHER 9, no. 107 (Nov. 1872): 369-371.

A247 "The Skylight and the Darkroom." PHOTOGRAPHIC TIMES 2, no. 23 (Nov. 1872): 161-162. [Review.]

A248 Hull, Charles Wager. "Elbert Anderson." PHILADELPHIA PHOTOGRAPHER 9, no. 108 (Dec. 1872): 402-403. [Affectionate commentary on Anderson, who came to Hull with an introduction in 1868, wanting to become a photographer. After some difficulties, he was hired by William Kurtz to clean glass in his studio. Anderson then quickly worked his way up to a prominent position in the field.]

A249 Anderson, Elbert. "Dialogues on Diseases Photographic." PHILADELPHIA PHOTOGRAPHER 9, no. 108 (Dec. 1872): 423-424.

A250 "The Skylight and the Darkroom - Mr. Anderson's New Book." PHILADELPHIA PHOTOGRAPHER 9, no. 108 (Dec. 1872): 424-425. [Reviewed: quotes from J. C. Browne, Andrew Simson, Wm. Heighway, John L. Gihon, B. W. Kilburn.]

A251 Simpson, G. Wharton, M.A., F.S.A. "Notes In and Out of the Studio." PHILADELPHIA PHOTOGRAPHER 10, no. 109 (Jan. 1873): 22-23. [Technical review of Elbert Anderson's "Skylight & Darkroom."]

A252 "There Appears to Be A Sameness About Them, Don't There?" PHILADELPHIA PHOTOGRAPHER 10, no. 110 (Feb. 1873): 42. [Dialogue between Elbert Anderson, at Kurtz's Gallery, and a visiting "photographic artist from the south."]

A253 Anderson, Elbert. "Experimental: Mr. Anderson's Highly Iodized Collodion and Weak Bath." PHILADELPHIA PHOTOGRAPHER 10, no. 113 (May 1873): 130-132.

A254 Anderson, Elbert. "My Anomalous Position." PHILADELPHIA PHOTOGRAPHER 10, no. 114 (June 1873): 183-184.

A255 Anderson, Elbert. "Fifth Annual Meeting and Exhibit of the National Photographic Association of the U. S., held in Buffalo, N.Y., beginning July 5, 1873: The Negative Bath." PHILADELPHIA PHOTOGRAPHER 10, no. 117 (Sept. 1873): 324-326.

A256 "Editor's Table." PHILADELPHIA PHOTOGRAPHER 15, no. 174 (June 1878): 191-192. [Note that Elbert Anderson, after working for W. Kurtz for 11 years, has opened his own gallery at 889 Broadway, New York, NY, associated with Julius Ludovici.]

A257 "Note." PHOTOGRAPHIC TIMES 8, no. 92 (Aug. 1878): 171. ["Mr. Elbert Anderson, who is so well known as author and artist, and who for 11 years has been guilty of most of the dark doings at Kurtz's gallery, has engaged in business for himself, in partnership with Mr. Julius Ludovico, the well-known artist, at the gallery located at No. 889 Broadway."]

ANDERSON, GEORGE EDWARD. (1860-1928) (USA)

BOOKS

A258 Francis, Rell G. *The Utah Photographs of George Edward Anderson.* Fort Worth, TX: The Amon Carter Museum of Western Art and the University of Nebraska Press, 1979. n. p. b & w. illus.

PERIODICALS

A259 Francis, Rell G. "Views of Mormon Country: The Life and Photographs of George Edward Anderson." AMERICAN WEST 15, no. 6 (Nov./Dec. 1978): 14 - 29. 19 b & w. [George Edward Anderson was born on Oct. 28, 1860 in Salt Lake City, UT. Apprenticed in Charles R. Savage's gallery, and at age seventeen, with the assistance of his younger brothers, opened up his own portrait studio in Salt Lake City —making tintypes, ambrotypes and wet plate photographs. Quickly converted to the dry plate process when it became commercially available. Photographed throughout Utah with portable vans and tent studios, assisted by his brothers and the painter John Hafen. Opened a more permanent studio in Manti, UT in 1886. Then moved to Springville, UT to farm, and in 1892 he opened a studio there in partnership with Lucian D. Crandall. The financial panic of 1893 drove Anderson $3000 into debt and he had to go back to itinerant photography to survive, photographing the farmers and miners at work and in his studio. By 1900 he had paid off his debts, and then was ordained a Mormon bishop, a demanding role of community leadership, which he undertook in addition to his regular work as a professional photographer. In 1904 he attempted to build and new and larger studio, which never paid for its costs. From 1907 to 1909 Anderson travelled around the Eastern United States taking and extensive series of views of historic Mormon landmarks, before travelling to England. The photographs were used to illustrate a booklet titled *The Birth of Mormonism in Picture*, issued by the Mormon church in 1909. He remained in England until 1911, then returned to the USA, where he remained for two more years photographing Mormon church sites in Vermont before finally returning to Utah in 1913. He returned to itinerant photography but by now his processes were old-fashioned and he was reduced to a state of near poverty. He died in 1928.]

ANDERSON, J. A. (1829-) (USA)

A260 Anderson, J. A. "The Daguerreotype." AMERICAN PHOTOGRAPHY 9, no. 12 (Dec. 1915): 683-685. [Began daguerreotyping in 1846, at age seventeen. Worked the daguerreotype process for about two years, then quit. "About twenty-five years ago when I rejoined the amateur workers on dry plates."]

ANDERSON, JAMES. [ISAAC ATKINSON] (1813-1877) (GREAT BRITAIN, ITALY)

[Born Isaac Atkinson in Blencairn, Cumberland. Studied painting in Paris under the name William Nugent Dunbar. Moved to Rome in 1838, where he made small bronze models of sculptures, using the name James Anderson. Interested in photography in 1849, established a photographic studio in Rome in 1853. Published his first catalog in 1859. Specialist in reproductions of works of art, but took views of antiquities, sites, etc. Exhibited in London, elsewhere through 1860s. His son Domenico (1854-1939) took over the studio at Anderson's death in 1877. 40,000 glass-plate negatives acquired by Alinari Brothers in 1960.]

BOOKS

A261 Anderson, Giacomo [James]. *Fotografie di Roma.* Rome: Presso Guiseppe Spitover, n. d. [ca. 1855-60]. n. p. [Album of original prints, with letterpress front cover.]

PERIODICALS

A262 "Beatrice Cenci, in Prison the Night before the Execution, Statue by Miss Harriet Hosmer. From a Photograph by James Anderson, Rome." FRANK LESLIE'S ILLUSTRATED NEWSPAPER 4, no. 101 (Nov. 7, 1857): 353. 1 illus. [Portrait of the sculptress on the same page, not credited, but may be from photo.]

ANDERSON, SAMUEL. (USA)

A263 Portraits. Woodcut engravings, credited "Ambrotyped by Anderson." FRANK LESLIE'S ILLUSTRATED NEWSPAPER 2, (1856). ["Michael B. Menard, founder of Galveston, TX." 2:43 (Oct. 4, 1856): 269. (Samuel Anderson was born in PA. From 1850s he had galleries in Galveston, TX and New Orleans, LA. Anderson & Blessing partnership in New Orleans from 1856 to 1863. Other partnerships or alone through 1860s.)]

ANDERSON, T. GEORGE. (d. ca. 1895) (GREAT BRITAIN, CANADA)

A264 "T. George Anderson, Photographic Artist." ALBERTA HISTORY 25, no. 4 (Autumn 1977): 18-25. 13 b & w. [Born Leeds, England. Emigrated to Canada and in 1876 joined the North-West Mounted Police. Began photographing as a hobby. Took his discharge in 1879, became a professional photographer and also became a brewer. Photos of Indians, views, etc. including portraits of Sitting Bull and other Sioux. Died ca. 1895.]

ANDREWS, H. J. C.

A265 Andrews, H. J. C. "The Uranium Intensifier." HUMPHREY'S JOURNAL OF PHOTOGRAPHY, AND THE ALLIED ARTS AND SCIENCES 20, no. 20 (Apr. 15, 1869): 313. [From "Photo. News."]

ANDREWS, JAMES. (ca. 1830-1863) (USA)

A266 "View in Canal Street, New Orleans." BALLOU'S PICTORIAL DRAWING-ROOM COMPANION [GLEASON'S] 13, no. 319 (Aug. 1, 1857): 65. 1 illus. ["...from a fine photograph by Mr. James Andrews, of Nos. 3 and 5 St. Charles Street, New Orleans, whose photographic, daguerreotype and ambrotype pictures do great credit to the art." (Born in GA, died July 18, 1863, in New Orleans.)]

ANDROS, A. C.

A267 "Alicante." ILLUSTRATED LONDON NEWS 36, no. 1012 (Jan. 14, 1860): 41. 1 illus. [Spanish seaport. "Alicante - from a photograph by A. C. Andros."]

ANGEL, OWEN. (EXETER, ENGLAND)

A268 Portrait. Woodcut engraving credited "From a photograph by Owen Angel." ILLUSTRATED LONDON NEWS 64, (1874). ["Mr. Arthur Mills, M.P." 64:1810 (May 2, 1874): 416.]

ANGERER, LUDWIG. (1827-1879) (AUSTRIA)

[Born at Malaczka, Hungary in 1827. Worked in the Imperial Pharmacy of Donauländern from 1856-58. Practiced photography as an amateur at this time. In 1857 introduced the carte-de-visite to Vienna. Ludwig & Strassen studio in Vienna during 1858-59. Appointed photographer to the Imperial Court in 1861. Founded the Angerer firm in 1862. Died in Vienna in 1879. His brother Viktor (1839-1894) who had been a professional photographer since the 1860s and who had been in the Ludwig studio since 1873, took over the business and ran it under the name L. u. V. Angerer. In 1880s Victor and Goschl worked with phototypogravure half-tone screen processes. Viktor died in Vienna in 1894, the studio continued through 1914.]

A269 "Our Editorial Table: Pictures, by L. Angerer, Vienna." BRITISH JOURNAL OF PHOTOGRAPHY 11, no. 243 (Dec. 30, 1864): 545.

ANGERER, VICTOR see also ANGERER, LUDWIG.

ANGERER, VICTOR. (1839-1894) (AUSTRIA)

A270 Portrait. Woodcut engraving credited "From a photograph by Victor Angerer, Vienna." ILLUSTRATED LONDON NEWS 48, (1866). ["Baron von Wullerstorf." 48:* (Jan. 27, 1866): 89.]

A271 Portrait. Woodcut engraving credited "From a photograph by Victor Angerer." ILLUSTRATED LONDON NEWS 51, (1869). ["John L. Motley, U.S. Minister to G.B." (May 29, 1869): 545.]

ANNAN, THOMAS. (1829-1887) (GREAT BRITAIN)

[Thomas Annan opened his first studio, with his brother Robert, in Glasgow in 1855, made art reproductions, portraits and views. In 1866 the Glasgow City Improvement Trust hired him to photograph slums before they were torn down. In 1868 he produced two sets of 31 prints, then additional sets later. The Trust published an edition of 100 volumes of 40 prints in 1878-79. Republished. His firm published other illustrated books and albums.]

BOOKS

A272 Paton, J. Noel, R.S.A. *Bound and Free. Five Sketches illustrative of Slavery.* Glasgow: Art Union of Glasgow, 1863. n. p. 5 b & w. [Photographic copies, by Thomas Annan, of the artist's sketches.]

A273 Reid, John Eaton. *A History of the County of Bute, and Families connected therewith.* Glasgow: Thomas Murray & Son, 1864. n. p. 9 b & w.

A274 Scott, Sir Walter. *Marimon, a Tale of Flodden Field.* With Photographic Illustrations by T. Annan. London : A. W. Bennett, 1866. 206 pp. 15 b & w.

A275 MacDonald, Hugh. *Days at the Coast; or: The Firth of Clyde, Its Watering Places, Scenery and Associations.* Glasgow: Andrew Duthies, 1867. n. p. 12 b & w.

A276 Bell, Henry Glassford. *Illustrations of Mary, Queen of Scots, a Poem.* Glasgow: Art Union of Glasgow, 1867. n. p. 4 b & w. [Photographic reproductions, by Thomas Annan, of paintings by Robert Herdman.]

A277 Annan, Thomas. *The Painted Windows of Glasgow Cathedral;* A series of forty-three photographs, taken by Thomas Annan. Glasgow: Annan, 1867. 6 pp. 43 l. of plates. 43 b & w.

A278 *Photographs of Glasgow;* with Descriptive Letterpress by Rev. A. G. Forbes. Glasgow: A. Duthies, 1867. 93 pp. 13 b & w.

A279 *Illustrated Catalogue of the Exhibition of Portraits on Loan in the New Galleries of Art;* Photographed and Published by Thomas Annan. Glasgow: T. Annan, 1868. 140 pp. 120 b & w.

A280 *The Old Country Houses of the Old Glasgow Gentry;* One Hundred Photographs by Annan, of Well Known Places in the Neighborhood of Glasgow, with Descriptive Notices of the Houses and the Families. Glasgow: J. MacLehose, 1870. 245 pp. 100 b & w. [Original photographs. 120 copies printed.]

A281 Annan, Thomas, Photographer. *Memorials of the Old College of Glasgow.* Glasgow: James MacLehose, Publisher, 1871. 129 pp. 40 l. of plates. [40 Woodburytypes, interiors and exteriors of the College, portraits of teachers.]

A282 Moncrieff, Robert Scott. *The Scottish Bar Fifty Years Ago. Sketches of Scott and his Contemporaries.* Edinburgh: Andrew Elliott, 1871. n. p. 36 b & w. [Photographic copies, by Thomas Annan, of sketches, etc.]

A283 Fraser, Alexander. *Scottish Landscape. The Works of Horatio Macculloch;* Photographed by T. Annan and Described with a Sketch of His Life by Alexander Fraser. Edinburgh: A. Elliot, 1872. n. p. 21 b & w. [One portrait and twenty reproductions of Macculloch's art, by Thomas Annan.]

A284 Aikman, John L., ed. *Historical Notices of the United Presbyterian Congregation in Glasgow.* ...with Photographs by T. Annan. Glasgow: T. Annan, 1875. n. p. b & w.

A285 Annan, Thomas. *Glasgow Corporation Waterworks. Photographic Views of Loch Katrine, and of some of the principal works constructed for introduction of the water of Lock Katrine into the City of Glasgow.* by Thomas Annan, with descriptive notes by James M. Gale. Glasgow: M'Laren & Erskine, 1877. 291 pp. 28 l. of plates.

A286 Annan, Thomas. *Photographs of the Old Closes and Streets of Glasgow 1868 - 1877.* Glasgow: Glasgow City Improvement Trust, 1878-79. n. p. 40 b & w.

A287 *Portraits by Sir Henry Raeburn;* Photographed by T. Annan, with Biographical Sketches. Edinburgh: A. Eliot, 1887. n. p. b & w.

A288 *The Old Closes and Streets of Glasgow, a Series of Photogravures, 1868 - 1899;* Engravings by Annan from photographs taken for the City of Glasgow Improvement Trust, with an introduction by William Young... Glasgow: J. Maclehose & Sons, 1900. 23 pp. 55 b & w.

A289 Scottish Exhibition of National History, Art and Industry (1911: Glasgow, Scotland) *Souvenir Album of the Scottish Exhibition of National History, Art and Industry, Glasgow, 1911.* Glasgow: T. & R. Annan & Sons, 1911. 20 l. pp. 21 l. of plates. [Special edition, for private complimentary circulation. Illustrated with photogravures by T. & R. Annan & Sons.]

A290 Mozley, Anita Ventura. Introduction. *Thomas Annan: Photographs of the Old Closes and Streets of Glasgow 1868 - 1877.* With a Supplement of 15 Related Views. New York: Dover Publications, Inc., with the International Museum of Photography at the George Eastman House, 1977. xv, 55 pp. 55 b & w. [Reproduces 40 photographs from the 1878-79 edition and 15 photographs from the 1900 edition.]

PERIODICALS

A291 "Glasgow New Waterworks. Loch Katrine Outlet." ILLUSTRATED LONDON NEWS 35, no. 998 (Oct. 15, 1859): 359, 370. 1 illus. ["From a Photograph by Thomas Annan, Hope Street, Glasgow."]

A292 "The Glasgow Waterworks, Inaugurated by the Queen Last Week." ILLUSTRATED LONDON NEWS 35, no. 999 (Oct. 22, 1859): 402-404. 3 illus. ["The photographs...(by Thomas Annan...) were taken before the works were completed..." One sketch, two views from photos.]

A293 "The Glasgow Art Union Presentation Photographs." BRITISH JOURNAL OF PHOTOGRAPHY 10, no. 201 (Nov. 2, 1863):

BY ARTIST OR AUTHOR
ANSON, [RUFUS ?]

BY ARTIST OR AUTHOR
ANTHONY, EDWARD & HENRY T. ANTHONY & CO.

419-420. [Glasgow Art Union subscription of drawings by Paton, photographed and reproduced by T. Annan.]

A294 "Talk of the Studio: Art Photography." PHOTOGRAPHIC NEWS 8, no. 286 (Feb. 26, 1864): 107. ["We have just received from Mr. Annan of Glasgow, some charmingly artistic photographic landscapes... one 13" x 15" 'Willows by the Watercourses'"]

A295 Portrait. Woodcut engraving credited "From a photograph by Thomas Annan." ILLUSTRATED LONDON NEWS 68, (1876). ["Sir Daniel Macnee, P.R.S.A." 68:1919 (May 6, 1876): 436.]

A296 Harker, Margaret F. "The Annans of Glasgow." BRITISH JOURNAL OF PHOTOGRAPHY 120, no. 5908-5909 (Oct. 12 - Oct. 19, 1973): 932-935, 966-969. 10 b & w. 3 illus.

A297 Mozley, Anita V. "Thomas Annan of Glasgow." IMAGE 20, no. 2 (June 1977): 1-12. 8 b & w. 5 illus.

A298 Harker, Margaret. "From Mansion to Close: Thomas Annan, Master Photographer." PHOTOGRAPHIC COLLECTOR 5, no. 1 (1985): 81-95. 13 b & w. 1 illus.

A299 Fisher, J. A. "Thomas Annan's 'Old Closes and Streets of Glasgow.' A Catalog of the Images Part Due." SCOTTISH PHOTOGRAPHY BULLETIN (Autumn 1987): 3-13. 30 b & w. 1 illus. [Annan's "Old Closes and Streets..." was published in three editions - in 1871 (with albumen prints) in 1877 (with carbon prints) and in 1900 (with photogravures). This article presents a copy of each photographic view in these works, of which images arranged alphabetically by street or close name, with a notation of which of the copies holds which prints. A map of Glasgow in 1871 with the sites of the views is also included.]

ANSON, [RUFUS ?]
A300 Portrait. Woodcut engraving, credited "From a Photograph by Anson." HARPER'S WEEKLY 6, (1862). ["Maj.- Gen. O. M. Mitchell." 6:280 (May 10, 1862): 289.]

ANTHONY, DR. (BIRMINGHAM, ENGLAND)
A301 "Transparent Positives on Glass." AMERICAN JOURNAL OF PHOTOGRAPHY AND THE ALLIED ARTS & SCIENCES n. s. vol. 6, no. 17 (Mar. 1, 1864): 405-407. [From "Br. J. Almanac.]

ANTHONY, EDWARD & HENRY T. ANTHONY & CO.
BOOKS
A302 Anthony, Edward. A Comprehensive and Systematic Catalogue of Photographic Apparatus and Material Manufactured, Imported and Sold by E. Anthony. New York: H. H. Snelling, 1854. viii, 56 pp. 6 l. of plates.

A303 Anthony, E. & H. T. Anthony. Anthony's Bulletin of Photographic Invention and Improvement. New York: E. & H. T. Anthony & Co., Holman, printer, 1857. 22 pp.

A304 Anthony, E. & H. T. Catalogue of Card Photographs, published and sold by E. & H. T. Anthony ... New York, Nov. 1862. New York: E. & H. T. Anthony & Co., 1862. 16 pp. [Facsimile reprint: Watkins Glen, N.Y.: Century House, ca. 1950?]

A305 Anthony, E. & H. T. Co. New Catalogue of Stereoscopes and Views, Manufactured and Published by E. & H. T. Anthony & Co., Emporium of American and Foreign Stereoscopic Views. New York: E. & H. T. Anthony Co., 1864. 55 pp.

A306 Anthony, E. & H. T. New Catalogue of Card Photographs. Oct. 1865. New York: E. & H. T. Anthony & Co., 1865. 19 pp.

A307 Anthony, E. & H. T. New Catalog of Stereoscopes and Views. New York: E. & H. T. Anthony Co., 1867. 102 pp.

A308 Anthony, E. & H. T. Co. The Amateur Photographer, or Practical Instructions in the Art of Dry Plate Photography for Young and Old. New York: E. & H. T. Anthony & Co., 1882. 40 pp.

A309 Anthony, E. & H. T. Anthony. Anthony's Illustrated Catalogue of Amateur Photographic Equipment. New York: Anthony, 1884. 47 pp. l. of plates.

A310 Anthony, E. & H. T. & Co. A Half-Century of Manufacturing Photographic Apparatus and Supplies. New York: E. & H. T. Anthony & Co., 1889. 25 pp. 2 b & w. illus.

A311 Marder, William and Eslette Marder. Edited by Robert G. Duncan. Foreword by Beaumont Newhall. Anthony. The Man. The Company. The Cameras. An American Photographic Pioneer. 140 Year History of the Company from Anthony to Ansco to GAF. Amesbury, Mass.: Pine Ridge Publishing Co., 1982. 384 pp. b & w. illus.

PERIODICALS
A312 "The Anthony Prizes." GLEASON'S PICTORIAL DRAWING-ROOM COMPANION 4, no. 2 (Jan. 8, 1853): 21. 1 illus. [Announcement and commentary on the competition sponsored by Edward Anthony, with an engraving of the silver pitcher and goblets offered as the award.]

A313 "Premium for the Best Daguerreotype." PHOTOGRAPHIC ART JOURNAL 6, no. 1 (July 1853): 68. [Announcement by the E. & H. T. Anthony Co. of their contest published in every issue of the "P.A.J." at least from July to Dec. 1853.]

A314 "Gossip." PHOTOGRAPHIC ART JOURNAL 6, no. 5 (Nov. 1853): 320-322. [Defense of the Anthony Prize Pitcher Award. Includes a poem "To Helia," written by W. H. C. Hosmer, in response to seeing one of the portraits submitted to the competition, then published in the "NY Evening Post."]

A315 "Notices on Recently Published Stereographs: American Subjects. E. Anthony, Broadway, New York." BRITISH JOURNAL OF PHOTOGRAPHY 7, no. 116 (Apr. 16, 1860): 114. [Views of Niagara Falls, NY, Broadway, New York, NY, etc.]

A316 Portraits. Woodcut engravings, credited "From a Photograph furnished by E. Anthony." HARPER'S WEEKLY 5, (1861). ["General Beauregrad, C.S.A." 5:226 (Apr. 27): 269. "Brigidier-General Kelley, of Virginia." 5:255 (Nov. 16): 732.]

A317 Portrait. Woodcut engraving, credited "From a Photograph by E. & H. T. Anthony." NEW YORK ILLUSTRATED NEWS 5, (1861). ["Capt. Wilkes, of the "San Jacinto," who seized the rebel ambassadors..." 5:109 (Dec. 2, 1861): 69.]

A318 Portraits. Woodcut engravings, credited "Photographed by Anthony." FRANK LESLIE'S ILLUSTRATED NEWSPAPER 13, (1862). ["Farnsworth G. Brownlow, editor." 13:319 (Jan. 4, 1862): 112.]

A319 Portraits. Woodcut engravings, credited "From a Photograph by Anthony." FRANK LESLIE'S ILLUSTRATED NEWSPAPER 14, (1862). ["Maj.-Gen. Philip Kearny, killed." 14:364 (Sept. 20, 1862): 408. "Gen.

BY ARTIST OR AUTHOR
ANTHONY, EDWARD & HENRY T. ANTHONY & CO.

BY ARTIST OR AUTHOR
ANTHONY, EDWARD & HENRY T. ANTHONY & CO.

Isaac Ingalls Stevens, killed." 14:364 (Sept. 20, 1862): 409. "Gen. Jos. K. Fenno Mansfield, killed."]

A320 Portraits. Woodcut engravings, credited "From a Photograph by Anthony." FRANK LESLIE'S ILLUSTRATED NEWSPAPER 15, (1862-1863). ["Gen. Jos. K. Fenno Mansfield, killed." 15:366 (Oct. 4, 1862): 29. Brig.-Gen. Jesse L. Reno, killed." 15:368 (Oct. 18, 1862): 60. "Col. Thornton F. Broadhead, killed." 15:368 (Oct. 18, 1862):60. "Gen. Ormsby M. Mitchel." 15:370 (Nov. 1, 1862): 84. "Gen. H. French." 15:373 (Nov. 22, 1862): 133. "Rev. Dr. Berrian, Trinity Church, New York, NY" 15:374 (Nov. 29, 1862):149. "Gen. I. P. Rodman, killed." 15:376 (Dec. 13, 1862): 180. "Gen. Cuvier Grover." 15:381 (Jan. 17, 1863: 257. "Hon. John A. Andrew, Gov. of MA." 15:382 (Jan. 24, 1863): 276. "Gen. C. C. Augur." 15:382 (Jan. 24,1863): 276. "Gen. George W. Morgan, killed." 15:383 (Jan. 31, 1863): 301. "Rev. Lyman Beecher, D.D." 15:384 (Feb. 7, 1863): 317. "Gen. J. M. Brannan." 15:389 (Mar. 14, 1863): 396. "Gen. Robert A. Milroy." 15:389 (Mar. 14, 1863): 396.]

A321 Portraits. HARPER'S WEEKLY 6, (1862). ["Comm. Goldsborough, U.S.N." 6:264 (Jan. 18): 36. "Comm. Foote, U.S.N." 6:269 (Feb. 22): 113. "Brig.-Gen. Curtis." 6:271 (Mar. 8): 157. "Brig.-Gen. Stoneman." 6:284 (June 7): 353. "Brig.-Gen. Edwin V. Sumner, U.S.A." 6:287 (June 28): 404. "Brig.-Gen. Joseph Hooker, U.S.A." 6:288 (July 5): 421. "Rear-Admiral D. D. Porter, U.S.N." 6:308 (Nov. 22): 749.]

A322 "Help for Lancashire." BRITISH JOURNAL OF PHOTOGRAPHY 10, no. 187 (Apr. 1, 1863): 136. [Note that the E. & H. T. Anthony Co. sent 500 carte-de-viste portraits "of distinguished Americans, belonging to both the Federal and Confederate sections of the community..." to London for sale, the proceeds for donation to the Fund for the Relief of Distressed Lancashire Operatives.]

A323 Portraits. Woodcut engravings, credited "From a Photograph by Anthony." FRANK LESLIE'S ILLUSTRATED NEWSPAPER 16, (1863). ["Gen.John G. Foster." 16:391 (Mar. 28, 1863): 12. "Gen. Thomas L. Crittenden." 16:391 (Mar. 28, 1863): 12. "Admiral D. D. Porter." 16:394 (Apr. 18, 1863): 52. "Col. J. B. Fry, USA." 16:397 (May 9,1863): 108. "Wm. Rufus Blake, comedian." 16:398 (May 16, 1863): 128. Miss Ann Dickinson, orator." 16:399 (May 23, 1863): 141. "Maj.-Gen. Berry, killed at Chancellorsville." 16:399 (May 23, 1863): 141. "Gen. John Sedgwick." 16:401 (June 6, 1863): 173. "Maj.-Gen. T. Sherman." 16:402 (June 13, 1863): 188. "Brig.-Gen. Alvin P. Hovie." 16:402 (June 13, 1863): 188. "Brig.-Gen. J. H. Hobart Ward." 16:404 (June 27, 1863): 212. "Brig.-Gen. Godfrey Weitzel." 16:404 (June 27, 1863): 212. "Maj.-Gen. John F. Reynolds, killed at Gettysburg." 16:407 (July 18, 1863): 265. "Maj.-Gen. John A. Logan." 16:409 (Aug. 1, 1863): 297. "Maj.-Gen.James G. Blunt." 16:413 (Aug. 29, 1863): 361. "Gen. Fitzhugh Lee, C.S.A." 16:413 (Aug. 29, 1863): 369. "The late Wm. L. Yancy." 16:413 (Aug. 29, 1863): 369.]

A324 Portraits. Woodcut engravings, credited "From a Photograph by E. & H. T. Anthony." HARPER'S WEEKLY 7, (1863). ["Maj.-Gen. John A. Logan." 7:337 (June 13): 369. "Gen. Buford." 7:347 (Aug. 22): 541. "Gen. Pleasonton." 7:347 (Aug. 22): 541.]

A325 Portraits. Woodcut engravings, credited "From a Photograph by E. & H. T. Anthony." NEW YORK ILLUSTRATED NEWS 8, (1863).["Maj.-Gen. Milroy." 8:193 (July 11, 1863): 165. "Brig.-Gen. Q. A. Gilmore." 8:197 (Aug. 8, 1863): 225. "Maj.-Gen. W. T. Sherman." 8:197 (Aug. 8, 1863): 225. Gen. John A. Logan." 8:198 (Aug. 15, 1863): 245. "Maj.-Gen. John A. Dix." 8:198 (Aug. 15, 1863): 245.]

A326 Portraits. Woodcut engravings, credited "From a Photograph by Anthony." FRANK LESLIE'S ILLUSTRATED NEWSPAPER 17, (1863). ["Brig.-Gen. W. W. Averill." 17:426 (Nov. 28, 1863): 156. "Hon. Schuyler Colfax, Speaker of the House." 17:430 (Dec. 26, 1863): 203.]

A327 Portraits. Woodcut engravings, credited "Photographed by Anthony." FRANK LESLIE'S ILLUSTRATED NEWSPAPER 17, (1864). ["Brig.-Gen. J. T. Sprague, U.S.A." 17:433 (Jan. 16, 1864): 268. "Brig.-Gen. Alfred Pleasanton, U.S.A." 17:437 (Feb. 13, 1864): 324.]

A328 Portraits. Woodcut engravings, credited "From a Photograph by E. & H. T. Anthony." HARPER'S WEEKLY 8, (1864). ["Maj.-Gen. Philip H. Sheridan." 8:385 (May 14): 309. "Maj.-Gen. Philip H.Sheridan." 8:388 (June 4): 353. Gen. Horatio G. Wright." 8:389 (June 11): 369. "Late Maj.-Gen. James B. McPherson." 8:398 (Aug.13): 513. "Maj.-Gen. Oliver O. Howard." 8:398 (Aug. 13): 513. Late Gen. Russell." 8:406 (Oct. 8): 652. "Maj.-Gen. E. O. C. Ord." 8:407 (Oct. 15): 661. "Maj.-Gen. Torbert." 8:407 (Oct. 15):661. "Maj.-Gen. Godfrey Weitzel." 8:408 (Oct. 22): 684. "Gen. James B. Ricketts." 8:411 (Nov. 12): 733. "Gen. Cuvier Grover." 8:411 (Nov. 12): 733.]

A329 Portraits. Woodcut engravings, credited "Photographed by Anthony." FRANK LESLIE'S ILLUSTRATED NEWSPAPER 19, (1864). ["The late Gen. David A. Russell." 19:472 (Oct. 15, 1864): 49. "Hon. Roger B. Taney, late Chief-Justice of the Supreme Court." 19:474 (Oct. 29, 1864): 84.]

A330 "General Alfred H. Terry - Photographed by Anthony." HARPER'S WEEKLY 9, no. 423 (Feb. 4, 1865): 65, 76. 1 illus. [Studio portrait.]

A331 "Photography in America: A Gigantic Photographic Establishment." BRITISH JOURNAL OF PHOTOGRAPHY 13, no. 314 (May 11, 1866): 225. ["...the largest photographic warehouse in the world..."]

A332 Portraits. Woodcut engravings, credited "From a Photograph by E. Anthony." HARPER'S WEEKLY 10, (1866). ["The late Dean Richmond." 10:507 (Sept. 15): 589. "Gen. J. D. Cox." 10:511 (Oct. 13): 641.]

A333 Portraits. Woodcut engravings, credited "From a Photograph by E. Anthony & Co." FRANK LESLIE'S ILLUSTRATED NEWSPAPER 22, (1866). ["Hon. James R. Doolittle." 22:570 (Sept. 1, 1866): 369. "Maj. Gen. John A. Dix." 22:570 (Sept. 1, 1866): 369.]

A334 "An Hour Spent with Messrs. E. & H. T. Anthony & Co." HUMPHREY'S JOURNAL OF PHOTOGRAPHY, AND THE ALLIED ARTS AND SCIENCES 19, no. 2 (May 15, 1867): 29, 30.

A335 "Views of Public Buildings in San Francisco, Cal., Destroyed or Injured by the Earthquake, Oct. 21st. From Photographs Furnished by T. G. Dorland, at E. & H. T. Anthony & Co." FRANK LESLIE'S ILLUSTRATED NEWSPAPER 27, no. 684 (Nov. 7, 1868): 124. 4 illus. [Views, buildings.]

A336 "E. & H. T. Anthony & Co." HUMPHREY'S JOURNAL OF PHOTOGRAPHY, AND THE ALLIED ARTS AND SCIENCES 20, no. 18 (Feb. 15, 1869): 280. [Describes the "elegant new quarters at 591 Broadway.]

A337 Portrait. Woodcut engraving, credited "From a Photograph by E. & H. T. Anthony & Co." FRANK LESLIE'S ILLUSTRATED

NEWSPAPER 28, (1869). ["Senator Henry B. Anthony, Pres. Pro Tem, U.S. Senate, from RI." 28:704 (Mar. 27, 1869): 28.]

A338 Portrait. Woodcut engraving, credited "From a Photograph by E. & H. T. Anthony & Co." FRANK LESLIE'S ILLUSTRATED NEWSPAPER 28, (1869). ["His Royal Highness Prince Arthur of England." 28:728 (Sept. 11, 1869): 409.]

A339 "Unheard-of Cruelty!" HUMPHREY'S JOURNAL OF PHOTOGRAPHY, AND THE ALLIED ARTS AND SCIENCES 20, no. 26 (Oct. 15, 1869): 415. [Satiric commentary on a robbery of $12,000 from the E. & H. T. Anthony Co.]

A340 "Editor's Table." PHILADELPHIA PHOTOGRAPHER 6, no. 70 (Oct. 1869): 356. ["Picturesques" of the Pennsylvania Central Railroad, stereos from negatives taken by E. & H. T. Anthony, who also publish an "artistic series," 3 1/8 wide by 3 3/4 high (larger than normal) stereos.]

A341 Portraits. Woodcut engravings, credited "From a Photograph furnished by E. & H. T. Anthony." FRANK LESLIE'S ILLUSTRATED NEWSPAPER 30, (1870). ["The late Hon. Pierre Soule." 30:759 (Apr.16, 1870): 69. "The late William Gilmore Simms." 30:770 (July 2, 1870): 245. "William of Prussia, his advisors and his generals. (9 portraits, "furnished by E. & H. T. Anthony and P. Duchochois.") 30:776 (Aug. 13, 1870): 344.]

A342 "The Marvels of Binocular Vision." ANTHONY'S PHOTOGRAPHIC BULLETIN 2, no. 4 (Apr. 1871): 102-104. [Sort of an extolling of stereocards, with commentary on makers - mentions M. B. Brady's war views but focuses on Anthony's establishment, T. H. Roche's Yosemite Views, etc. From "NY Evening Telegram."]

A343 "Exhibition of the Photographic Society." ANTHONY'S PHOTOGRAPHIC BULLETIN 5, no. 1 (Jan. 1874): 5. [From "Br J of Photo. (Oct. 31,1873)." Description of the E. & H. T. Anthony Co. exhibit at the British exhibition.]

A344 "Distant View of Moqui, an Aztec City of Arizona, with Sheep Pens in the Foreground. - Photographed by E. A. Anthony & Co." FRANK LESLIE'S ILLUSTRATED NEWSPAPER 38, no. 979 (July 4, 1874): 268. 1 illus. [View of Pueblos. Anthony must have been the distributer.]

A345 "Selkirk's Cave and Monument, Island of San Fernandez. - Photographed by Anthony & Co." FRANK LESLIE'S ILLUSTRATED NEWSPAPER 39, no. 999 (Nov. 21, 1874): 172. 2 illus. [Views.]

A346 "Florida Scenes. - From Photographs by Anthony & Co." FRANK LESLIE'S ILLUSTRATED NEWSPAPER 39, no. 1002 (Dec. 12, 1874): 225,227. 3 illus. [Views, etc.]

A347 "Towah, an Aztec City of Arizona, Supposed to be at Least 350 Years Old. - Photographed by Anthony & Co." FRANK LESLIE'S ILLUSTRATED NEWSPAPER 39, no. 1003 (Dec. 19, 1874): 252. 1 illus.[View of Pueblos, with figures. Same source as earlier photos.]

A348 "Cuba. - An Autumn Tour from Matanzas Up the Yumuri Valley. - From Sketches by Our Own Artist, and Photographs by Anthony & Co." FRANK LESLIE'S ILLUSTRATED NEWSPAPER 39, no. 1004 (Dec. 26, 1874): 261-262. 7 illus. [Views, etc.]

A349 Anthony, E & H. T. "Uses of the Magic Lantern." ANTHONY'S PHOTOGRAPHIC BULLETIN 6, no. 5 (May 1875): 150-152.

[Extensive listing of educational and entertainment potentials of the magic lantern.]

A350 "Copartnership Notice." ANTHONY'S PHOTOGRAPHIC BULLETIN 6, no. 6 (June 1875): 191. [Note that W. H. Badeau retiring from the copartnership of E. & H. T. Anthony & Co., leaving as partners E. Anthony, H. T. Anthony and V. M. Wilcox.]

A351 Anthony, E. & H. T. & Co. "Success Cameras." ANTHONY'S PHOTOGRAPHIC BULLETIN 8, no. 10 (Oct. 1877): 313-314. 2 illus.

A352 Anthony, E. & H. T. & Co. "Photographic Lenses." ANTHONY'S PHOTOGRAPHIC BULLETIN 8, no. 11 (Nov. 1877): 342-344.

A353 Nichol, Dr. John. "As Others See Us." ANTHONY'S PHOTOGRAPHIC BULLETIN 9, no. 10 (Oct. 1878): 289-291. [From "Br J of Photo."]

A354 Lightfoot, Frederick S. "Two Enterprising Pioneers: E. and H. T. Anthony." STEREO WORLD 1, no. 2 (May - June 1974): 1, 3, 5. 2 b & w.

A355 "Recent Find." STEREO WORLD 5, no. 3 (July 1978): 24. 2 illus. [A letter from Anthony, which helps date his company's history.]

A356 Ryder, Richard C. "Personalities in Perspective: John C. Fremont." STEREO WORLD 7, no. 6 (Jan. - Feb. 1981): 16, 33. [Stereo portrait by E. & H. T. Anthony.]

A357 Ryder, Richard C. "Personalities in Perspective: Gideon Welles." STEREO WORLD 11, no. 1 (Mar. - Apr. 1984): 39, 51. 1 b & w. [Stereo card of Gideon Welles, Sec. of the U. S. Navy during the Civil War. Article is an account of Welles' role during the war.]

ANTHONY, EDWARD see also ANTHONY, EDWARD & HENRY T. ANTHONY & CO.

ANTHONY, EDWARD. [?]
A358 United States. Congress. House. Document No. 31. *Boundary between Maine and New Hampshire and the adjoining British Provinces*. Washington, DC: 1842. 49 pp. ["A report of the Board of Commissioners appointed to survey the Northeastern boundary." "Doc. No. 31." Includes references to daguerreotypes and views made from the camera lucida.]

ANTHONY, EDWARD. (1818-1888) (USA)
BOOKS
A359 *Edward Anthony, Pioneer*. Philadelphia: American Museum of Photography, 1942 [?]. 13 pp.

PERIODICALS
A360 1 photo (Portrait of E. Anthony reproduced in the Crystalotype process of James Whipple.). PHOTOGRAPHIC ART JOURNAL 5, no. 4 (Apr. 1853): frontispiece. 1 b & w. [Comment on pp. 254-255.]

A361 Anthony, Edward. "Gossip: Premium of the Best Daguerreotype." PHOTOGRAPHIC ART JOURNAL 6, no. 3 (Sept. 1853): 196. [Announcement of Anthony's intent to award a silver pitcher for the best daguerreotype in 1853.]

A362 "Daguerre and his Disciples." PHOTOGRAPHIC AND FINE ART JOURNAL 7, no. 4 (Apr. 1854): 120-121. [Actually a brief history of the first daguerreotypists in the USA, combined with publicity for the Anthony company.]

A363 "In Memoriam: Edward Anthony." ANTHONY'S PHOTOGRAPHIC BULLETIN 19, no. 24 (Dec. 22, 1888): frontispiece, 737-739. 1 b & w. [Obituary. Biographical information given. The frontispiece photo was a portrait of Anthony by Louis Alman. (See p. 27 in Jan. 12, 1889 issue).]

A364 "Notes and News." PHOTOGRAPHIC TIMES 18, no. 379 (Dec. 21, 1888):624. [Note that Edward Anthony, senior member of the firm, died suddenly on Dec. l4th, l888 at the 70th year of his age.]

A365 "Edward Anthony." PHOTOGRAPHIC TIMES 18, no. 380 (Dec. 28, 1888): 631-632. 1 illus. [Obituary. Born New York, NY, in 1819. Graduated from Columbia College in 1838 as civil engineer. Learned photography as an amateur. Accompanied Prof. James Renwick on his survey of the north-western boundary of the U.S., where his daguerreotypes were used as documentary evidence in the boundary dispute. Anthony then decided to set up as a professional portrait photographer. Worked in Washington, DC, briefly, then set up, with his brother, the larger business of supplying photographic materials. E. & T. H. Anthony and Co. became one of the largest stock dealers in the USA. See also "N. Y. Tribune" Dec. 15th.]

A366 Adams, W. I. "Some Personal Recollections of Edward Anthony." PHOTOGRAPHIC TIMES 18, no. 380 (Dec. 28, 1888): 632.

A367 "In Memoriam." PHOTOGRAPHIC TIMES 18, no. 380 (Dec. 28, 1888): 633.

A368 "Edward Anthony's Early Photography." ANTHONY'S PHOTOGRAPHIC BULLETIN 20, no. 10 (May 25, 1889): 295. [Discusses his work daguerreotyping during the border dispute between USA and Canada.]

A369 Bendix, Howard E. "Early Edward Anthony Stereo Views." STEREO WORLD 4, no. 3 (July - Aug. 1977): 8-11. 4 b & w. 1 illus. [Edward Anthony published approximately 600 stereo views in 1859, before the extensive publication of the E. & H. T. Anthony & Co. views from 1860 to 1880s.]

A370 "Recent Find." STEREO WORLD 5, no. 3 (July - Aug. 1978): 24. 2 illus. [Letter and envelope, dated 1860, from Edward Anthony employee to a customer reproduced.]

ANTHONY, H. MARK. (1817-1886) (GREAT BRITAIN)
[Mark Anthony was born in Manchester, England. Studied to be a painter, and met Corot and Dupré in Paris between 1834 and 1840. Landscape painter who exhibited regularly at the Royal Academy between 1837 and 1854. In the mid-50s he joined the Photographic Society of London.]

A371 Norton, Russell. "Foreign Affairs. Part I - Scenes in Our Village. Part II - Mark Anthony's Stereoscopic Groups Listed." STEREO WORLD 15, no. 1 (Mar. - Apr. 1988): 22-27. [Part I identifies T. R. Williams as the photographer of a stereo series published by the London Stereoscopic Co. in 1856. Part II identifies the British landscape painter Mark Anthony as the photographer of a stereo landscape series published in the late 1850s.]

ANTHONY, HENRY T. see also ANTHONY, EDWARD & HENRY T. ANTHONY & CO.

ANTHONY, HENRY TIEBOUT. (1814-1884) (USA)
A372 Seely, Charles A. "Editorial Department." AMERICAN JOURNAL OF PHOTOGRAPHY AND THE ALLIED ARTS & SCIENCES n. s. vol. 5, no. 14 (Jan. 15, 1863): 336. [Seely protesting the information apparently circulating that Henry T. Anthony had discovered some value to fuming albumenized paper with ammonia fumes, claims to have published that information first in his journal several years ago.]

A373 Seely, Charles A. "Astounding Developments-The Dealers in Photographic Materials Old Process Peddlers! - Humbug Forever!! - The Fulminating Process!!!" AMERICAN JOURNAL OF PHOTOGRAPHY AND THE ALLIED ARTS & SCIENCES n. s. vol. 5, no. 15 (Feb. 1, 1863): 353-356. [Pamphlets issued by an unknown manufacturer, (possibly E. & H. T. Anthony & Co.) with recommendations from "A. A. Turner, Photographer to D. Appleton & Co., New York," sarcastically attacked by Seely as being plagiarized from his journal.]

A374 Seely, Charles A. "Editorial Department." AMERICAN JOURNAL OF PHOTOGRAPHY AND THE ALLIED ARTS & SCIENCES n. s. vol. 5, no. 15 (Feb. 1, 1863): 359. [Seely gives his version of the history of the discovery of the ammonia-fuming process for albuminized paper. See article on pp. 353-356. W. J. Kuhns practicing the process successfully in 1859. Printed for two years (1860-1862) for E. & H. T. Anthony Co. Then moved to print for C. D. Fredericks & Co. (Apparently Anthony C. recently released publications on this process.)]

A375 Anthony, H. T. "Substitute for Silver Bath." HUMPHREY'S JOURNAL OF PHOTOGRAPHY, AND THE ALLIED ARTS AND SCIENCES 14, no. 22 (Mar. 15, 1863): 302.

A376 "Fuming Albumenized Paper with Ammonia." AMERICAN JOURNAL OF PHOTOGRAPHY AND THE ALLIED ARTS & SCIENCES n. s. vol. 5, no. 19 (Apr. 1, 1863): 447-451. [More on the fuming controversy.]

A377 Anthony, H. T. "Magic Lantern Slides." HUMPHREY'S JOURNAL OF PHOTOGRAPHY, AND THE ALLIED ARTS AND SCIENCES 15, no. 13 (Nov. 1, 1863): 202.

A378 Anthony, H. T. "Acetic Acid in Toning." HUMPHREY'S JOURNAL OF PHOTOGRAPHY, AND THE ALLIED ARTS AND SCIENCES 20, no. 18 (Feb.15, 1869): 287.

A379 Anthony, Henry T. "The Samuel Holmes Silver Medal for 1871." ANTHONY'S PHOTOGRAPHIC BULLETIN 3, no. 7 (July 1872): 597-598. [Response to having been awarded the medal.]

A380 Anthony, H. T. "To Silver Paper Which Will Keep Well and Produce Brilliant Prints." BRITISH JOURNAL PHOTOGRAPHIC ALMANAC 1874 (1874): 107.

A381 Anthony, H. T. "An Easy Method of Printing on Canvas." BRITISH JOURNAL PHOTOGRAPHIC ALMANAC 1874 (1874): 142.

A382 Anthony, H. T. "Recovering Silver from the Hyposulphite Solutions." BRITISH JOURNAL PHOTOGRAPHIC ALMANAC 1876 (1876): 63.

A383 Anthony, Henry T. "Dry Plate Negatives in the United States." ANTHONY'S PHOTOGRAPHIC BULLETIN 7, no. 8 (Aug. 1876): 228-229. [Anthony claims to have "done a great deal of dry plate work experimentally and successfully..." before the experiments of Charles Wager Hull, discussed by Newton in the July 1876 issue.]

A384 "The Late Henry T. Anthony." PHOTOGRAPHIC TIMES 14, no. 166 (Oct.1884): 537-539. [Born Sept. 18, 1814. Graduated Columbia College 1832. Chose to become a civil engineer, surveying for Erie R.R., NY Croton Aqueduct, etc. He and his brother became interested in photography. Then worked in the Bank of the State of NY, on construction of Hudson River R.R. until he became partner with his brother in business of manufacturing and sale of daguerrean and photographic supplies in 1852. Worked out many improvements, etc.]

A385 "The Anthony Memorial Tablet." ANTHONY'S PHOTOGRAPHIC BULLETIN 19, no. 20 (Oct. 27, 1888): 631-633. 1 illus. [Memorial tablet to Henry T. Anthony from the Photographers' Assoc. of America.]

A386 Welling, William. "Henry T. Anthony (1814-1884)." PHOTOGRAPHICA 10, no. 8 (Oct. 1978): 5. 1 illus.

ANTHONY, JOHN. (GREAT BRITAIN)
BOOKS
A387 Anthony, John. *The City of Our Lord. Twelve Photographs of Jerusalem.* London: Richard Griffin & Co., 1861. n. p. 12 l. of plates. 12 b & w.

PERIODICALS
A388 Anthony, John, M.D. "On a Tent for the Collodion Process." HUMPHREY'S JOURNAL 6, no. 17 (Dec. 15, 1854): 270-272. [From "J. of Photo. Soc., London."]

ANTISELL, T.
A389 Antisell, T., M.D. "Light." DAGUERREAN JOURNAL 1, no. 2-4 (Nov. 15, 1850 - Jan. 1, 1851): 42-44, 73-75, 109-110.

A390 Antisell, T., M.D. "Photography." DAGUERREIAN JOURNAL 1, no. 2-5 (Nov. 15, 1850 - Jan. 15, 1851): 53-55, 84-86, 150-152. [Technical report on current experiments.]

APGAR, JOHN FREDERICK. (1852-1884) (USA)
A391 "The Late John Frederick Apgar." PHOTOGRAPHIC TIMES 14, no. 165 (Sept. 1884): 497-498. [Born Hartford, CT, Apr. 20, 1852, died Aug. 28, 1884. Amateur, took many landscapes in the Adirondaks. One of the founders of the Society of Amateur Photographers of New York. Since 1873 connected with the Merchants Exchange National Bank of NY.]

APPERT, EUGENE. (PARIS, FRANCE)
A392 Portraits. Woodcut engravings credited "From a photograph by Appert." ILLUSTRATED LONDON NEWS 72, (1878). ["M. Waddington, French Minister of Foreign Affairs." 72:2031 (June 1, 1878): 509.]

A393 Forbes, Archibald."What I Saw of the Paris Commune." CENTURY MAGAZINE 44, no. 6 (Oct. 1892): 803-817. 7 b & w. 7 illus. [Seven photos credited to Appert. One is "from a composition photograph of the time. Assassination of Generals ..." Six are portraits of female Communard,"Types of the Pétroleuses." View of the cannon of Montmarte, Mar. 1, 1871, credited "from a photograph by Lecadre."]

A394 Forbes, Archibald. "What I Saw of the Paris Commune." CENTURY MAGAZINE 45, no. 1 (Nov. 1892): 48-61. 2 b & w. 11 illus. [Two composition photographs by Appert. View of the ruins of the Hotel-de-Ville, credited "from a photograph by Lecadre."]

A395 English, Donald E. "Political Photography and the Paris Commune of 1871: the Photographs of Eugene Appert." HISTORY OF PHOTOGRAPHY 7, no. 1 (Jan. 1983): 31-42. 10 b & w. [Composite narrative photographs of the events of the Communard uprising in 1871, created by Appert with models and existing portraits, after the Communard defeat, ca. 1873.]

APPLELEY, RICHARD B. (ROCHESTER, NY)
A396 "Gossip." PHOTOGRAPHIC ART JOURNAL 4, no. 1 (July 1852): 68. ["We understand Mr. R. B. Appleley of Rochester has made great improvements in his gallery."]

APPLETON & CO. (BRADFORD, ENGLAND)
A397 Portrait. Woodcut engraving credited "From a photograph by Appleton & Co." ILLUSTRATED LONDON NEWS 49, (1866). ["Rev. W. Arthur, M.A." 49:* (Aug. 25, 1866): 189.]

A398 Portraits. Woodcut engravings credited "From a photograph by Appleton & Co." ILLUSTRATED LONDON NEWS 55, (1869). ["Sir Titus Salt." 55:* (Oct. 2, 1869): 320.]

A399 Portrait. Woodcut engraving credited "From a photograph by Appleton & Co." ILLUSTRATED LONDON NEWS 58, (1870). ["Rev. John Farrar." 58:* (Aug. 6, 1870): 149.]

A400 Portrait. Woodcut engraving credited "From a photograph by Appleton & Co." ILLUSTRATED LONDON NEWS 71, (1877). ["Rev. W. B. Pope, D.D." 71:1986 (Aug. 4, 1877): 109.]

A401 Portrait. Woodcut engraving credited "From a photograph by Appleton & Co." ILLUSTRATED LONDON NEWS 73, (1878). ["Rev. Dr. James H. Rigg." 73:2041 (Aug. 10, 1878): 125.]

A402 Portrait. Woodcut engraving credited "From a photograph by Appleton & Co." ILLUSTRATED LONDON NEWS 75, (1879). ["Rev. Benjamin Gregory." 75:2095 (Aug. 9, 1879): 132.]

APPLETON, J. M. (1848-) (USA)
A403 Appleton, J. M. "Education." PHOTOGRAPHIC MOSAICS: 1890 26, (1890): 62-67. [Pres.- elect of the Photographer's Assoc. of America.]

A404 "A Study from Life." PHOTOGRAPHIC TIMES 20, no. 441 (Feb. 28, 1890): 99. 1 b & w. [Appleton, of Ryder & Appleton of Cleveland, is President of the Photographers' Assoc. of America. Studio portrait.]

A405 Appleton, J. M. "Presidential Address Delivered to the 11th Annual Convention of the Photographic Association of America." PHOTOGRAPHIC TIMES 20, no. 466 (Aug. 22, 1890): 416-417.

A406 "J. M. Appleton." PHOTOGRAPHIC TIMES 20, no. 464 (Aug. 8, 1890): frontispiece, 375-376. 1 b & w. [Portrait of Appleton, current President of the P.A. of A. by George G. Rockwood. Born Sept. 1848, and raised in Millersville, OH. In 1868 studied two months with B. F. Battels of Akron, OH, then returned to Millersburg to open a gallery. Moved to Columbus, OH in 1876 until 1880. Then to Dayton, OH, where he has remained - except briefly in 1889, when he was associated with J. F. Ryder in Cleveland. Awards and honors, etc.]

A407 Appleton, J. M. "Head." PHOTOGRAPHIC MOSAICS: 1891 27, (1891): 168-170. [Appleton was President of the Photographers' Assoc. of America, from Dayton, OH.]

A408 "Personal Paragraphs: J. M. Appleton." WILSON'S PHOTOGRAPHIC MAGAZINE 34, no. 486 (June 1897): 271-272. [From the "Cincinnati Commercial Tribune."]

A409 "Editor's Table." WILSON'S PHOTOGRAPHIC MAGAZINE 35, no. 498 (June 1898): 287. [Visiting New York, touring the galleries.]

A410 "A Few Portraits by J. M. Appleton." WILSON'S PHOTOGRAPHIC MAGAZINE 35, no. 502 (Oct. 1898): 449-458. 8 b & w.

APPLETON, WILLIAM R. (LYNN, MA)
A411 "John C. Vennard, First Signer of the List of Prices demanded by the Lynn Strikers. - Photograph by Wm. R. Appleton, of Lynn, Mass." FRANK LESLIE'S ILLUSTRATED NEWSPAPER 9, no. 226 (Mar. 31, 1860): 282. 1 illus.

ARAGO, FRANCIS. (1786-1853) (FRANCE)
A412 Arago, Francis. "Considerations Relative to the Chemical Action of Light" DAGUERREIAN JOURNAL 1, no. 3 (Dec. 2, 1850): 65-68. [From Lerebour's "Treatise on Photography." Includes Edmund Becquerel's experiments, other early workers in 1840s.]

A413 "Francis Arago." PHOTOGRAPHIC AND FINE ART JOURNAL 7, no. 2 (Feb.1854): 52-53. [Obituary from "La Lumiere."]

ARCHER, CHARLES MAYBURY.
A414 Archer, Charles Maybury. "The Anecdote History of Photography." RECREATIVE SCIENCE 1-2, (Jan. - Dec. 1860): 187-190, 231-233, 244-245, 348-351.

ARCHER, FREDERICK SCOTT. (1813-1857) (GREAT BRITAIN)
[Archer was born at Bishops Stortford, Hertfordshire, the son of a butcher. Orphaned while a child. Apprenticed to a bullion dealer, later became a goldsmith in London. Learned numismatics, engraving, and bust-making. Learned the calotype process from Dr. Hugh Diamond in 1847. Made portraits in sculpture and in photography commercially in London, from 1847. Experimented and developed chemical and technical improvements in cameras and lenses. Published, in 1851, a method of sensitizing collodion for photography. The wet-collodion process and its variants had a signal impact upon photography, causing another explosion of growth, expansion, and usage in the medium; and it would be the dominant technique used until almost the end of the era, in 1879. Archer released this process free to the world without attempting to hold copyright or demand fees. Unfortunately, he died virtually penniless on May 2, 1857; and subscription drives for the relief of his widow and children were launched by the photographic community.]

BOOKS
A415 Archer, Frederick Scott. *Photographic Views of Kenilworth.* Bloomsbury: Archer, 1851. n. p. b & w. [Although cited as a published work, this is a unique album of prints compiled by the artist and given to Jabez Hogg, then in turn given to the Royal Photographic Society.]

A416 Archer, Frederick Scott. *A Manual of the Collodion Process.* London: Printed by the author, 1852. n. p.

A417 Archer, Frederick Scott. *The Collodion Process on Glass.* Second Edition, Enlarged. London: Printed by the author, 1854. 100 pp. [Reprinted (1973), Arno Press.]

A418 Archer, Frederick Scott. *A Short Description of Archer's Registered Folding Camera, for Developing Pictures in the Open Air, without the Aid of a Tent.* Also, a Detailed Method of Using the Same. Bishops Stortford: Printed by J. M. Mullinger, 1858. 11 pp.

PERIODICALS
A419 Archer, Frederick Scott. "On the Use of Pyro-Gallic Acid in Photography." THE CHEMIST n. s. 1, (1850): 360.

A420 Archer, Frederick Scott. "On the Use of Collodion in Photography." THE CHEMIST n. s. 2, (Mar. 1851): 257-258.

A421 Hunt, Robert. "On the Applications of Science to the Fine and Useful Arts: Improvements in Photography." ATHENAEUM (BOSTON) 13, (July 1, 1851): 188-190. [Mentions Fr. S. Archer and Horne's work with collodion, Levi Hill's colored daguerreotypes.]

A422 Archer, Frederick Scott. "The Collodion Process in Photography." ATHENAEUM no. 1257 (Nov. 29, 1851): 1257-1258. [Letter from Archer.]

A423 Archer, Frederick Scott. "The Collodion Process in Photography." ATHENAEUM no. 1260 (Dec. 20, 1851): 1350-1351. [Paper on process.]

A424 "The Collodion Process in Photography." DAGUERREAN JOURNAL 3, no.3 (Dec. 15, 1851): 84.

A425 "Scientific Gossip." ATHENAEUM no. 1264 (Jan. 17, 1852): 87. [Comments by Fry on gutta percha and collodion. Reply by F. S. Archer to R. Hunt's letter (p. 23), where Archer doesn't dispute Hunt's claims.]

A426 "The Collodion Process in Photography." HUMPHREY'S JOURNAL 4, no.1 (Apr. 15, 1852): 4-5. [From "The Athenaeum."]

A427 "Photographic Correspondence: Collodion Process." NOTES AND QUERIES 6, no. 165 (Dec. 25, 1852): 612. [Letter from Archer asserting priority of discovery of Collodion process.]

A428 Archer, Frederick Scott. "Collodion on Glass." HUMPHREY'S JOURNAL 4, no. 22 (Mar. 1, 1853): 340-341. [From "The Chemist."]

A429 Archer, Frederick Scott. "The Collodion Photographic Process." PHOTOGRAPHIC AND FINE ART JOURNAL 7, no. 4 (Apr. 1854): 112-117.

A430 "H. M. Steam Floating-Battery "Glatton." ILLUSTRATED LONDON NEWS 27, no. 763 (Sept. 22, 1855): 373-374. 1 illus. ["From a photograph by T. [sic F.] Scott Archer."]

A431 Archer, Frederick Scott. "On Rendering the Collodion Film Permanent Independently of Glass Plates." PHOTOGRAPHIC AND FINE ART JOURNAL 9, no. 1 (Jan. 1856): 8. [From "J. of Photo. Soc., London."]

A432 "Mr. F. S. Archer's Patent Process for Transferring Collodion Pictures From the Glass Plate on to Gutta Percha." PHOTOGRAPHIC AND FINE ART JOURNAL 9, no. 2 (Feb. 1856): 45-46. [From "Journal of Photo. Society, London."]

A433 "Liverpool Photographic Society." PHOTOGRAPHIC AND FINE ART JOURNAL 10, no. 7 (July 1857): 201-202. [Address delivered by Charles Corey, Liverpool Photo. Society, on the occasion of F. S. Archer's death.]

A434 Root, M. A. "Frederick Scott Archer." PHOTOGRAPHIC AND FINE ART JOURNAL 10, no. 7 (July 1857): 218.

A435 "London Photographic Society: Ordinary Meeting, May 7, 1857." PHOTOGRAPHIC AND FINE ART JOURNAL 10, no. 7 (July 1857): 222-223. [Meeting was about setting up a committee to seek relief for the widow of Frederick Scott Archer. Includes a long statement about Archer by Mayall.]

A436 Archer, Frederick Scott. "Origin of the Collodion Process." PHOTOGRAPHIC AND FINE ART JOURNAL 10, no. 8 (Aug. 1857): 236. [From "Liverpool Photo. J."]

A437 Archer, Fanny G. "Le Gray and the Discovery of Collodion." PHOTOGRAPHIC AND FINE ART JOURNAL 11, no. 2 (Feb. 1858): 59. [Fanny was the wife of the photographer Fred S. Archer. From the "J. of the Photographic Society."]

A438 "Note." AMERICAN JOURNAL OF PHOTOGRAPHY 1, no. 2 (June 15, 1858): 32. [Mrs. Archer, the widow of Frederick Scott Archer (the discoverer of collodion for photographic purposes), died April 22, 1858.]

A439 H. D. F. "To the Memory of Frederick Scott Archer." ANTHONY'S PHOTOGRAPHIC BULLETIN 2, no. 1 (Jan. 1871): 9-12.

A440 Sutton, Thomas. "Some New Light Thrown upon the Early History of the Wet Collodion Process." ANTHONY'S PHOTOGRAPHIC BULLETIN 6, no. 3 (Mar. 1875): 73-75. [From "Br. J. of Photo." Question is the discoverer was Archer or Bingham. Gives brief outline of Bingham's career. Public lecturer on Chemistry at London Institute, Finsbury. A good daguerreotypist and calotypist, he wrote a manual. Moved to Paris ca. 1852, ran a successful photo. studio, acknowledged expert in copying paintings. Died in Paris a few years before this article. Claimed, in his final months, to have actually discovered the process while Archer observed.]

A441 Clemons, John R. "Bromide in Collodion." PHOTOGRAPHIC TIMES 12, no. 137 (May 1882): 144. [Argument that the Archer first used bromide in collodion, cites a book published by A. Hart of Carey & Hart, Philadelphia in 1853. Mentions Cutting Patent fight as well.]

A442 "Frederick Scott Archer." IMAGE 2, no. 2 (Jan. - Feb. 1953): 6. 2 b & w. [Invented collodion process, 1851.]

ARMSTEAD, G. W. see ELLIOTT & ARMSTEAD.

ARMSTRONG. (EDINBURGH, SCOTLAND)
A443 Portraits. Woodcut engravings credited "From a photograph by Armstong." ILLUSTRATED LONDON NEWS 36, (1860). ["Dr. D. S. MacGowan." 36:* (June 9, 1860): 557.]

ARMSTRONG, BEERE & HIME.
A444 "Reception of Sir Wm. Fenwick Williams, of Kars, to the City Hall, Toronto." FRANK LESLIE'S ILLUSTRATED NEWSPAPER 6, no. 153 (Nov. 6, 1858): 359-360. 2 illus. [Outdoor group portrait, of rowing club, credited "From a Photograph by Armstrong, Beere & Hime of Toronto. View, from a sketch, credited to the same company.]

ARMSTRONG, WILLIAM.
A445 Armstrong, William. "New Black Varnish." PHOTOGRAPHIC AND FINE ART JOURNAL 10, no. 1 (Jan. 1857): 23. [Letter from Armstrong, who describes himself as a "Photographist and Civil Engineer," and is from Toronto, Canada.]

A446 "Note." PHOTOGRAPHIC AND FINE ART JOURNAL 11, no. 2 (Feb. 1858): 64. [Several fine photographic views... noted.]

A447 "Our Photographic Illustrations: Humberford, C. W. (Canada). by William Armstrong." PHOTOGRAPHIC AND FINE ART JOURNAL 11, no. 3 (Mar. 1858): 84, plus photo opposite page 76. [Landscape.]

ARNAULD see BERTSCH & ARNAULD.

ARNOT. (GREAT BRITAIN)
A448 "Note." ANTHONY'S PHOTOGRAPHIC BULLETIN 5, no. 2 (Feb. 1874): 87. [From "Br. J. of Photo." Arnot, "a clever amateur photographer..." made "excellent marine views of breaking waves and boats dancing on restless seas..."]

ARTER, ALBERT. (1848-1877) (USA)
A449 "Editor's Table: Obituary." PHILADELPHIA PHOTOGRAPHER 14, no. 164 (Aug. 1877): 256. [Albert Arter (Zanesville, OH) died June 26. Aged 29 years.]

ASH. (KINGSBRIDGE, ENGLAND)
A450 Portrait. Woodcut engraving credited "From a photograph by Ash." ILLUSTRATED LONDON NEWS 48, (1866). ["Mr. Samuel Popplestone, the first recipient of the Albert Medal." 48:* (June 2, 1866): 537.]

ASHER, ALEXANDER.
A451 Asher, Alex. "Originality in Posing and Lighting." BRITISH JOURNAL PHOTOGRAPHIC ANNUAL 1875 (1875): 125-126.

ASHTON.
A452 "A New Race of Monkeys - The Gorillas." HARPER'S WEEKLY 3, no. 114 (Mar. 5, 1859): 148. 4 illus. ["...assisted by Mr. Ashton, in taking the photographs and stereoscopic views from which our engravings are copied." Photos of a dead gorilla sent to England, then preserved.]

ASPA & RUSSELL.
A453 "Chess Celebrities at the Late Chess Meeting." ILLUSTRATED LONDON NEWS 27, no. 752 (July 14, 1855): 44. 1 illus. ["From Photographs by Signor Aspa (Leamington Chess Club) and Mr. Russell." Group portrait, with chess board, perhaps engraved from several separate portraits.]

ASSER, E. J. (AMSTERDAM, NETHERLANDS)
A454 Asser, of Amsterdam. "Carbon Printing in Lithographic and Printing Inks." HUMPHREY'S JOURNAL OF PHOTOGRAPHY, AND THE ALLIED ARTS AND SCIENCES 11, no. 16 (Dec. 15, 1859): 253-255. [From "Liverpool Photo. J."]

A455 Asser. "Process for Printing Positives upon Paper either in Printing or Lithographic Ink." HUMPHREY'S JOURNAL OF PHOTOGRAPHY, AND THE ALLIED ARTS AND SCIENCES 12, no. 19 (Feb. 1, 1861): 293-294. [From "Photo. Notes."]

A456 Asser, E. J. "Photo-Lithography." AMERICAN JOURNAL OF PHOTOGRAPHY AND THE ALLIED ARTS & SCIENCES n. s. vol. 7, no. 19 (Apr. 1, 1865): 442-444. [From "Tidjschrift voor Photo."]

ATKINS, ANNA. (1797-1871) (GREAT BRITAIN)
BOOKS
A457 Atkins, Mrs. Anna. *Photographs of British Algae. Cyanotype Impressions.* London: Self-published, 1843-1854. 3 vol. (Vol. I, 75 pp., 162 illus.; Vol. II, 151 illus.; Vol. 3, 98 illus.) pp. 389 b & w. [Issued in parts. Contains 389 captioned plates.]

A458 Atkins, Anna, with Anne Dixon. *Cyanotypes of British and Foreign Flowering Plants and Ferns*. ca. 1850 ?

A459 Schaaf, Larry J., Organized by Hans P. Kraus, Jr. *Sun Gardens: Victorian Photograms by Anna Atkins*. New York: Aperture, 1985. 104 pp. 49 b & w.

PERIODICALS
A460 Schaaf, Larry. "The First Photographically Printed and Illustrated Book." THE PAPERS OF THE BIBLIOGRAPHICAL SOCIETY OF AMERICA 73, no. 2 (1979): 209-224. 4 b & w. 1 illus.

A461 Schaaf, Larry. "Anna Atkins' Cyanotypes: An Experiment in Photographic Publishing." HISTORY OF PHOTOGRAPHY 6, no. 2 (Apr. 1982): 151-172. 17 illus. [In 1843 Anna Atkins illustrated her book "British Algae: Cyanotype Impressions". Privately published in fasicules, predating Talbot's "Pencil of Nature."]

A462 Newhall, Beaumont. "Books in Review: Sun Gardens: Victorian Photograms by Anna Atkins." PRINT COLLECTOR'S NEWSLETTER 17, no. 1 (Mar. - Apr. 1986): 30-31. 1 b & w.

ATKINSON, JOHN. (1802-1875) (GREAT BRITAIN)
A463 "Atkinson's Portable Camera." PHOTOGRAPHIC AND FINE ART JOURNAL 10, no. 5 (May 1857): 133. [From "J. of Photo. Soc., London."]

A464 Atkinson, J. Beavington. "Photographs of National Portraits." ART JOURNAL 6, (Apr. 1867): 105. [964 photos of paintings. "The National Portraits," issued in 10 volumes at price of 62 pounds.]

A465 "Death of an Old Photographic Worthy." ANTHONY'S PHOTOGRAPHIC BULLETIN 6, no. 3 (Mar. 1875): 79. [From "Br. J. of Photo." Atkinson died at age 73 in Liverpool. Retired from his extensive photo business about nine years before. Been an amateur, then (apparently) went into business as a stock dealer.]

ATKINSON, R. E. (ca. 1840-1907) (TROY, NY)
A466 "Our Picture." PHILADELPHIA PHOTOGRAPHER 16, no. 183 (Mar. 1879): frontispiece, 93-94. 1 b & w. [Studio portrait.]

ATKINSON, WILLIAM. (1825-1907) (GREAT BRITAIN)
A467 "Death of Mr. William Atkinson (Life Fellow)." PHOTOGRAPHIC JOURNAL 47, no. 6 (June 1907): 286. [Born in 1825. Educated at the schools of the Society of Friends in Bristol and Falmouth. Trained to be a civil engineer in 1841. Built railway bridges in Spain, Egypt, etc. Joined the Royal Photographic Society in 1863. Occasionally contributed articles to the "BJP." Interested in photography to the end of his life, giving lantern slide exhibitions to within a few months of his death. Died April 8, 1907.]

ATWOOD, A. H. (NEW YORK, NY)
A468 "Matters of the Month." PHOTOGRAPHIC TIMES 10, no. 119 (Nov. 1880): 254. [Atwood (care of Mora) looking for a position in a first-class studio.]

A469 Atwood, A. H. "The Camera in the Land of Flowers." PHOTOGRAPHIC TIMES 12, no. 134 (Feb. 1882): 45-46. [Atwood recounts his photographic tour of Florida from November 1875 to April 1876, conducting a remunerative business from a tent.]

A470 Atwood, A. H. "A Photographic Tent." PHOTOGRAPHIC TIMES 12, no. 135 (Mar. 1882): 73-74.

A471 "Matters of the Month." PHOTOGRAPHIC TIMES 12, no. 138 (June 1882): 225. [Atwood, long associated with Mora's Studio, opening his own studio.]

A472 Atwood, A. H. "A Few Words to Photographic Printers and Their Employers." PHOTOGRAPHIC TIMES 12, no. 139 (July 1882): 251-252. ["Old and experienced photographic printers are becoming fewer in number. Their places must be filled, and it behooves the younger disciples in this highly important branch of art work to acquire the ability to manage the printing department and produce fine proofs..."]

AUBEL. (COLOGNE, GERMANY)
A473 "A New Heliographic Process - 'Aubeldruck.'" ANTHONY'S PHOTOGRAPHIC BULLETIN 6, no. 2 (Feb. 1875): 42-43. [From "Br. J. of Photo.," again from "Photographische Correspondence." Aubel's method.]

A474 "A New Mechanical Process." ANTHONY'S PHOTOGRAPHIC BULLETIN 6, no. 6 (June 1875): 176. [From "London Photographic News." The Aubeldruck process, from Mr. Aubel, of Cologne.]

A475 Baumann, C. "The Photographic Printing Processes, with Particular Reference to the Aubel Printing Process." ANTHONY'S PHOTOGRAPHIC BULLETIN 8, no. 5 (May 1877): 134-137. [From "Photographische Monats Blätter." Concise survey of seven photomechanical processes, with their histories.]

A476 Aubel. "Frankfort-on-Maine [sic] Photographic Society." ANTHONY'S PHOTOGRAPHIC BULLETIN 8, no. 7 (July 1877): 220-221. [From "Br. J. of Photo." Report of talk given by Mr. Aubel (Cologne) on his photomechanical process.]

AUBRY, CHARLES HIPPOLYTE. (1811-1877) (FRANCE)
A477 Prost, Charles. "Ch. Aubrey, Photographe." PHOTO-REVUE (Oct. 1977): 523-527. 6 b & w. [Floral still-lifes, taken in the 1860s.]

A478 McCauley, Anne. "Photographs for Industry: The Career of Charles Aubry." J. PAUL GETTY MUSEUM JOURNAL 14, (1986): 157-172. 10 b & w. 3 illus. [Born June 3, 1811 in Paris. Apprenticed to an industrial designer and supported himself for more than thirty years drawing patterns for carpet, wallpaper, and fabric manufacturers. In 1864 formed a company for the production of plaster casts and photographs of plants and flowers. Made at least 150 negatives of close-up still-lifes of plants during the first year. Wished to assemble a body of work useful to industrial designers, artists, and students. Bankrupt in 1865. His studio expropriated in 1867 for Haussman's restructuring of the city, Aubry moved to a village close to Paris and continued his photographing and his efforts to promote his plans. Returned to Paris in 1871/72 but seems to have produced little that was new. Died there in 1877.]

AUGERER. (VIENNA, AUSTRIA)
A479 Portraits. Woodcut engravings, credited "From a Photograph by Augerer, Vienna." FRANK LESLIE'S ILLUSTRATED NEWSPAPER 22, (1866). ["Marshal Benedek, Austrian army." 22:566 (Aug. 4, 1866):305.]

AULET, ESTEVAN MESTRE. (CUBA)
A480 Aulet, Estevan Mestre. "Letter from Havana." AMERICAN JOURNAL OF PHOTOGRAPHY 1, no. 6 (Aug. 15, 1858): 97-98.

A481 "Editor's Table." PHILADELPHIA PHOTOGRAPHER 3, no. 33 (Sept. 1866): 288. [Visiting card from Aulet (Havana, Cuba).]

AUSTEN, E. A. (CRADOCK, SOUTH AFRICA)
A482 "Dutch Reformed Church, Cradock, Cape of Good Hope." ILLUSTRATED LONDON NEWS 58, no. 1646/1647 (Apr. 22, 1871): 399. 1 illus.

AUSTIN, ALEXANDER I. (LONDON, ENGLAND)
A483 Austin, Alexander I. "Apparatus to Supersede the Use of a Tent." PHOTOGRAPHIC AND FINE ART JOURNAL 10, no. 1 (Jan. 1857): 4. [From "Photo. J." Austin an amateur in London.]

AUSTIN, JOHN. (SYRACUSE, NY)
A484 Austin, John. "Correspondence." ANTHONY'S PHOTO-GRAPHIC BULLETIN 2, no. 9 (Sept. 1871): 294-295. [Letter on saving silver. Austin from Syracuse, NY.]

AUSTIN, W. B.
A485 "Bunker Hill Monument." HARPER'S WEEKLY 10, no. 496 (June 30, 1866): 404. 1 illus. ["Photographed by W. B. Austin."]

A486 "Matters of the Month." PHOTOGRAPHIC TIMES 7, no. 73 (Jan. 1877):7. [Letter praising Morrison's lenses. Signed "W. B. Austin, Photographer, with Frank Leslie."]

AUTOTYPE CO.
A487 "Alarming Accident and Fire." ANTHONY'S PHOTOGRAPHIC BULLETIN 10, no. 12 (Dec. 1879): 371-372. [From "Autotype Notes." Fire burned down the building, starting over.]

AVERILL, H. K., JR. (DECORAH, IA)
A488 Averill, H. K., Jr. "How to Get Pure Water." AMERICAN JOURNAL OF PHOTOGRAPHY AND THE ALLIED ARTS & SCIENCES n. s. vol. 3, no. 21 (Apr. 1, 1861): 332-333.

A489 Averill, H. K., Jr. "Useful Facts about the Dry Process." AMERICAN JOURNAL OF PHOTOGRAPHY AND THE ALLIED ARTS & SCIENCES n. s. vol. 8, no. 7 (Oct. 1, 1865): 156-157. ["Mr. Averill is one of the few photographers who have had the enterprise to discover that the dry process is practically useful. It is a mistaken notion that the dry process should be the exclusive property of amateurs...." (Averill now working out of Plattsburgh, NY.)]

AVERY, A. S. (USA)
A490 "The Fire in Saratoga." HARPER'S WEEKLY 10, no. 495 (June 23, 1866): 397. 3 illus. ["Photographed by A. S. Avery." Ruins.]

A491 "Scene in Sugar Bush, Otsego County, New York." HARPER'S WEEKLY 11, no. 540 (May 4, 1867): 276. 1 illus. ["Photographed by A. S. Avery, Morris, NY." Gathering maple sugar.]

A492 "A New Portable Photograph Gallery." ANTHONY'S PHOTOGRAPHIC BULLETIN 2, no. 8 (Aug. 1871): 274. 1 illus. [Avery of Henderson, NY. Portable building.]

AXON, W. E. A. (MANCHESTER, ENGLAND)
A493 "Photography," on pp. 203-228 in: The Mechanic's Friend: a Collection of Receipts and Practical Suggestions. London: Trübner & Co., 1875. 339 pp. illus.

AYLES & BONNIWELL. (HASTINGS, ENGLAND)
A494 Portrait. Woodcut engraving credited "From a photograph by Ayles & Bonniwell." ILLUSTRATED LONDON NEWS 38, (1861). ["Volunteer Marine Artillery Private." 38:* (May 25, 1861): 495.]

A495 "The Albert Memorial, Hastings." ILLUSTRATED LONDON NEWS 44, no. 1239 (Jan. 2, 1864): 13. 1 illus. ["...from a photograph by Ayles & Bonniwell, Trinity House, Hastings."]

AYLING, STEPHEN.
BOOKS
A496 Pugin, Augustus Welby N. Photographs from Sketches by Augustus Welby N. Pugin. London: S. Ayling, 1865. 2 vol.500 b & w. [Original photos, by Stephen Ayling, after Boydell's engravings. 1st ed. (1864).]

A497 The Shakespeare Gallery. London, New York: G. Routledge & Sons,1867. xxx, 375 pp. 94 b & w.

PERIODICALS
A498 "Fine Arts: Photographs from A. W. Pugin's Sketches." ILLUSTRATED LONDON NEWS 47, no. 1340 (Oct. 28, 1865): 414. ["We must add a word of praise for the excellent manner in which the sketches have been photographed by Mr. Ayling."]

A499 "Note." ART JOURNAL (Feb. 1868): 38. [Views of the Abbey and the Palace of Westminster.]

AYRES, GEORGE B. (USA)
BOOKS
A500 Ayres, George B. ...How to Paint Photographs in Water Colors and in Oil, How to Work in Crayon, make the Chromo-photograph, Retouch Negatives and Instructions in Ceramic Painting... Philadelphia: Benerman & Wilson, 1869. 128 pp. illus.

PERIODICALS
A501 Ayres, George B. "Rembrandt and the 'Rembrandts'." PHILADELPHIA PHOTOGRAPHER 7, no. 83 (Nov. 1870): 379-381

A502 Ayers, George B. "Our Picture." PHILADELPHIA PHOTOGRAPHER 8, no. 96 (Dec. 1871): 383-384. [General commentary upon the photographs published in the "Phila. Photo."]

A503 Ayers, George B. "Fifth Annual Meeting and Exhibit of the National Photographic Association of the U.S., held in Buffalo, N.Y., beginning July 5, 1873: Relationship of the Photographer to the Artist." PHILADELPHIA PHOTOGRAPHER 10, no. 117 (Sept. 1873): 314-315.

AYRES, THOMAS.
A504 Ayres, Thomas. "On the Equal Diffusion of Natural Light, or Light from Space." HUMPHREY'S JOURNAL OF PHOTOGRAPHY, AND THE ALLIED ARTS AND SCIENCES 17, no. 22 (Mar. 15, 1866): 350-351. [From "Photo. News."]

AYRES, W. M. (GREAT BRITAIN)
A505 Ayres, W. M. "Natural Clouds in Landscape Negatives." BRITISH JOURNAL PHOTOGRAPHIC ALMANAC 1877 (1877): 175-176.

A506 Ayres, W. M. "On Commercial Collodion." BRITISH JOURNAL PHOTOGRAPHIC ALMANAC 1879 (1879): 98.

AYTON, A. (LONDONDERRY, ENGLAND)
A507 Portrait. Woodcut engraving credited "From a photograph by A. Ayton." ILLUSTRATED LONDON NEWS 65, (1874). ["Prof. Smyth, member of Parliament." 65:1821 (July 18, 1874): 52.]

AZEVEDO, HILITAO AUGUSTO DE. (d. 1905) (BRAZIL)

A508 Kossoy, Boris. "Militao Augusto de Azavedo of Brazil. The Photographic Documentation of Sao Paulo (1862-1889)." HISTORY OF PHOTOGRAPHY 4, no. 1 (Jan. 1980): 9-17. 22 b & w. 2 illus. [Azevedo documented the changing city of Sao Paulo in an album, "Album Comparativo da Citade Sao Paulo 1862-1887." Article includes information on other early photographers in Brazil.]

B

B.
B1 B. "On Ambrotypes." PHOTOGRAPHIC AND FINE ART JOURNAL 8, no. 11 (Nov. 1855): 348-349. [Some history, some techniques.]

B. (GREAT BRITAIN)
B2 B. "Where to Go with the Camera: A Photographer's Trip on the Kent Coast." BRITISH JOURNAL OF PHOTOGRAPHY 12, no. 284 (Oct. 13, 1865): 524-525.

A. S. B.
B3 "British West India Zouave Regiments." ILLUSTRATED LONDON NEWS 45, no. 1266 (July 2, 1864): 4. 1 illus. [We are obliged to our correspondent "A. S. B." for the photograph we have copied..." Portrait of a native sergeant of the 3rd West India Regiment, in uniform. Portrait made while the sergeant was at Chatham for training.]

CAPTAIN B.
B4 "Captain B." "Instantaneous Negatives." HUMPHREY'S JOURNAL OF PHOTOGRAPHY, AND THE ALLIED ARTS AND SCIENCES 12, no. 23 (Apr. 1, 1861): 366-368. [From "Br. J. of Photo." Letter with questions, with the editor's replies. "...what is best collodion to use for taking...portraits...of children? I am exceedingly anxious to get good portraits of them, as they will be very interesting in after life, or should anything happen to them."]

D. B. (LIBERTY, IN)]
B5 D. B. "A South Skylight." AMERICAN JOURNAL OF PHOTOGRAPHY AND THE ALLIED ARTS & SCIENCES n. s. vol. 6, no. 9 (Nov. 1, 1863): 210-211.

BACARD FILS. (PARIS, FRANCE)
B6 Portraits. Woodcut engravings credited "From a photograph by Bacard Fils." ILLUSTRATED LONDON NEWS 66, (1875) ["Late Mr. Ledru Rollin." 66:1849 (Jan. 16, 1875): 57. "Late Mr. DeRemusat." 66:1871 (June 19, 1875): 585.]

BACHELDER, E. W. (HAVANA, CUBA)
B7 "Note." PHOTOGRAPHIC ART JOURNAL 5, no. 6 (June 1853): 320.

BACHRACH & BROTHER. (USA)
B8 "The Recent Visit of the Veteran's of the Historic Massachusetts Sixth Regiment to Baltimore - The Procession Passing the City Hall. Photo by Bachrach & Bro." FRANK LESLIE'S ILLUSTRATED NEWSPAPER 72, no. 1860 (May 9, 1891): 234, 241. 1 b & w.

BACHRACH, DAVID, JR. see also LEVY & BACHRACH.

BACHRACH, DAVID, JR. (1845-1921) (GERMANY, USA)
[Born in Neukirchen, Hesse-Cassel, Germany, on July 16, 1845. Family moved to USA when David was a boy. He studied in the public schools of Hartford, CT. Apprenticed, at age fifteen, to Robert Vinton Lansdale, then worked for William H. Weaver, who was working then for *Harper's Weekly*. While working for Weaver, Bachrach photographed Abraham Lincoln delivering the Gettysburg address. He then worked at Fort Gilmour, VA, later taking charge of the surgical photography at St. John's College Hospital in Annapolis, MD. Bachrach there photographed many of the exchanged Union soldiers from Andersonville Prison. Commissioned a 1st Lieutenant. In 1866 he worked as a staff photographer for *Leslie's Weekly*. In 1868 appointed one of the official photographers for the United States Naval Academy. In 1869 Bachrach opened his own studio in Baltimore, MD. Florished. Bachrach wrote for the photographic journals and contributed improvements to several processes. Retired from managing his own studio in 1914, and died in Baltimore in 1921.]

B9 "Laying the Corner Stone of the New Masonic Temple at Baltimore, Maryland, on Tuesday, Nov. 25th. - From Photographs by David Bachrach." FRANK LESLIE'S ILLUSTRATED NEWSPAPER 23, no. 584 (Dec. 8, 1866): 178. 3 illus. [Views, only one credited to Bachrach.]

B10 "A Visit to Druid Hill Park, Baltimore, Md." FRANK LESLIE'S ILLUSTRATED NEWSPAPER 24, no. 615 (July 13, 1867): 269. 3 illus. [Three views, only one of which is credited "From a Photograph by David Bachrach, Baltimore." The others are probably also by Bachrach.]

B11 "Sailing of the Miniature Ship John T. Ford from Baltimore, Md., June 22. - From a Photograph by David Bachrach." FRANK LESLIE'S ILLUSTRATED NEWSPAPER 24, no. 616 (July 20, 1867): 280. 1 illus. [View of harbor, with figures.]

B12 "The Dedication of the Antietam National Cemetery, at Sharpsburg, Maryland, on Tuesday, Sept. 17. - From a Photograph by D. Bachrach, Baltimore, Md." FRANK LESLIE'S ILLUSTRATED NEWSPAPER 25, no. 627 (Oct. 5, 1867): 37. 1 illus. [View, with crowd.]

B13 "Kaminiskey's Inn, Mercer Street, Baltimore, Md. - From a Photograph by Bachrach." FRANK LESLIE'S ILLUSTRATED NEWSPAPER 25, no. 628 (Oct. 12, 1867): 61. 1 illus. [View.]

B14 "Laying the Corner-Stone of the New City Hall at Baltimore, Md. - From a Photograph by D. Bachrach." FRANK LESLIE'S ILLUSTRATED NEWSPAPER 25, no. 632 (Nov. 9, 1867): 113. 1 illus. [View, with crowd.]

B15 "Maryland. - Terrific Boiler Explosion in Baltimore. - From a Photo-graph by Bachrach." FRANK LESLIE'S ILLUSTRATED NEWSPAPER 30, no. 761 (Apr. 30, 1870): 108. 1 illus. [Ruins.]

B16 "Maryland. - The Steamer 'Hornet,' Recently Blockaded at Port-au-Prince by Spanish War-Vessels. From a Photograph by Bachrach." FRANK LESLIE'S ILLUSTRATED NEWSPAPER 33, no. 856 (Feb. 24, 1872): 373. 1 illus.

B17 Bachrach, David, Jr. "View Photography Generally Considered: Article 3." PHOTOGRAPHER'S FRIEND 2, no. 2 (Apr. 1872): 41-43.

B18 "Maryland. The Baltimore Convention. - Delegates in Consultation in the Conversation Room of Ford's Opera House. - From a Photograph by D. Bachrach." and "Maryland. - The National Democratic Convention in Session at Ford's Opera House, Baltimore. - From Photographs by Bachrach and Sketches by Schaffler." FRANK LESLIE'S ILLUSTRATED NEWSPAPER 34, no. 877 (July 20, 1872): 293, 296-297, 300. 2 illus. [Interiors, with people.]

B19 Bachrach, David, Jr. "Correspondence." ANTHONY'S PHOTOGRAPHIC BULLETIN 8, no. 11 (Nov. 1877): 348.

B20 Portrait. Woodcut engraving, credited "From a Photograph by Bachrach. FRANK LESLIE'S ILLUSTRATED NEWSPAPER 46, (1878) ["The late Mr. Thomas Winans." 46:1187 (June 29, 1878): 281.]

B21 Bachrach, David, Jr. "The Use of Salicylic Acid in Photography, Its Special Applications to Carbon Printing and Gelatine Processes."

ANTHONY'S PHOTOGRAPHIC BULLETIN 10, no. 1 (Jan. 1879): 21-23.

B22 Bachrach, David, Jr. "More About Artotype - Save Your Money." PHILADELPHIA PHOTOGRAPHER 16, no. 183 (Mar. 1879): 65-70.

B23 Bachrach, David, Jr. "The Value of Photographic Processes and Patents." PHILADELPHIA PHOTOGRAPHER 16, no. 184 (Apr. 1879): 97-100.

B24 Bachrach, David, Jr. "About Artotype." PHILADELPHIA PHOTOGRAPHER 16, no. 184 (Apr. 1879): 119-121.

B25 Anthony, E. & H. T. & Co. "The Bachrach Exposé." ANTHONY'S PHOTOGRAPHIC BULLETIN 10, no. 6 (June 1879): 185-186. [Apparently Bachrach had accused the Anthony Company of something, which accusation they refused to print.]

B26 Bachrach, David, Jr. "Baltimore Correspondence." PHILADELPHIA PHOTOGRAPHER 16, no. 186 (June 1879): 164-166.

B27 "Bachrach's Expose." PHILADELPHIA PHOTOGRAPHER 16, no. 186 (June 1879): 185-186.

B28 Bachrach, D., Jr. "Card." PHILADELPHIA PHOTOGRAPHER 16, no. 188 (Aug. 1879): 228.

B29 Bachrach, D., Jr. "Baltimore Correspondence." PHILADELPHIA PHOTOGRAPHER 16, no. 188 (Aug. 1879): 237-238.

B30 Bachrach, David, Jr. "Chloride of Gold: How to Make It - Its Uses in Photography." PHOTOGRAPHIC MOSAICS: 1888 24, (1888): 43-46.

B31 Bachrach, David, Jr. "The Value of a Settled Policy to Photographers." PHOTOGRAPHIC MOSAICS: 1889 25, (1889): 48-53.

B32 Bachrach, D., Jr. "On the Use of Slow Plates." PHOTOGRAPHIC MOSAICS: 1889 25, (1889): 73-74.

B33 Bachrach, D., Jr. "Fading." WILSON'S PHOTOGRAPHIC MAGAZINE 32, no. 457 (Jan. 1895): 23-26.

B34 Bachrach D., Jr. "The Electric Light For Studios." WILSON'S PHOTOGRAPHIC MAGAZINE. 32, no. 459 (Mar. 1895): 122-124.

B35 Bachrach, David, Jr. "Our Summer Studio." WILSON'S PHOTOGRAPHIC MAGAZINE. 32, no. 461 (May 1895): 203-206. 4 b & w.

B36 Bachrach, D. "The Success of a New Departure - Backward." WILSON'S PHOTOGRAPHIC MAGAZINE 33, no. 469 (Jan. 1896): 6-7.

B37 Bachrach, D. "Elements of Preservation versus Elements of Destruction." WILSON'S PHOTOGRAPHIC MAGAZINE 33, no. 471 (Mar. 1896): 140-141.

B38 Bachrach, D. "A Few Remarks to Dr. Baekeland." WILSON'S PHOTOGRAPHIC MAGAZINE 33, no. 472 (Apr. 1896): 180-181. [Exchange of criticisms over the permanency of certain printing papers.]

B39 Baekeland, Dr. Leo. "A Second Answer to Mr. Bachrach." WILSON'S PHOTOGRAPHIC MAGAZINE 33, no. 472 (Apr. 1896): 187-188.

B40 Bachrach, D. "The Business End at the Question." WILSON'S PHOTOGRAPHIC MAGAZINE 33, no. 473 (May 1896): 207-208.

B41 Bachrach, D. "A Topical Question Answered." WILSON'S PHOTOGRAPHIC MAGAZINE 33, no. 475 (July 1896): 292-293.

B42 Bachrach, D., Jr. "Business Methods." PHOTOGRAPHIC MOSAICS:1897 33, (1897): 131-139.

B43 Bachrach, D. "Progress - Backward." WILSON'S PHOTOGRAPHIC MAGAZINE 34, no. 482 (Feb. 1897): 82-83.

B44 Bachrach, D., Jr. "Printing Methods." WILSON'S PHOTOGRAPHIC MAGAZINE 34, no. 490 (Oct. 1897): 459-463.

B45 Bachrach, D. "Originality: The Craze for Novelty." WILSON'S PHOTOGRAPHIC MAGAZINE 35, no. 495 (Mar. 1898): 109-111.

B46 1 photo (Sculptor E. Keyser). WILSON'S PHOTOGRAPHIC MAGAZINE 37, no. 523 (July 1900): 307.

BACKUS, J. (ND)
B47 Backus, J. "More Indignation." HUMPHREY'S JOURNAL OF PHOTOGRAPHY, AND THE ALLIED ARTS AND SCIENCES 11, no. 21 (Mar. 1, 1860): 324-325. [Letter from Backus, angry at the "Am. J. of Photo.," asking questions of "Humphrey's Journal."]

BACON see GILBERT & BACON.

BACON.
B48 Portraits. Woodcut engravings, credited "From an Ambrotype by Bacon." FRANK LESLIE'S ILLUSTRATED NEWSPAPER 3, (1857) ["Dr. Harvey Burdell, "...ambrotype taken just four days before the murder." 3:62 (Feb. 14, 1857): 176. [Same image repeated next week on p. 181.]]

BACON & TAYLOR. (ROCHESTER, NY)
B49 "Scenes in Recent Disastrous Freshets." HARPER'S WEEKLY 9, no. 432 (Apr. 8, 1865): 220. 4 illus. [Two sketches; two views, from photos, of Rochester, NY by Bacon & Taylor, Rochester, and by J. W. Maser, Rochester.]

BACON, FRANKLIN W. see also BACON & TAYLOR.

BACON, FRANKLIN W. (1820-1901) (USA)
[Franklin W. Bacon began his business career as a sash and blind maker in Rochester, NY. About 1866 he formed a photographic partnership with John Wilson Taylor. Together they opened the Old Pioneer Gallery in Rochester, and ran it until 1870. In 1871 Baker and William F. Carnall formed a brief partnership, which produced stereo views of Rochester and the surrounding area. In 1872 Bacon was joined by his son George W. Bacon. That partnership lasted until 1898. The firm produced stereo views from negatives taken by themselves and others. From 1882 to 1891 the firm name was F. W. Bacon & Co., then it was changed to F. W. Bacon & Son. Franklin Bacon semi-retired around 1895, then moved to Sycamore, IL during 1898 and 1899, before returning to Rochester to live with his son. He died on May 23, 1901. His son retired from photography and became a carpenter.]

BAGGS, ISHAM.

B50 Baggs, Isham. "Dissolving Stereoscopic Views." AMERICAN JOURNAL OF PHOTOGRAPHY, AND THE ALLIED ARTS AND SCIENCES n. s. vol. 9, no. 8 (Mar. 1, 1867): 165-166. [From "English Patent."]

BAILEY. [METROPOLITAN GALLERY] (INDIANAPOLIS, IN)

B51 "Note." PHOTOGRAPHIC AND FINE ART JOURNAL 11, no. 3 (Mar. 1858): 96. [Article from "Indianapolis (IN) Journal."]

BAILEY, F. B. (HUNTSVILLE, TX)

B52 "Editor's Table." PHILADELPHIA PHOTOGRAPHER 6, no. 68 (Aug. 1869): 284.

BAILEY, THOMAS J. (COLUMBIA, TN)

B53 Bailey, Thomas I. "Engraving Daguerreotypes - Deposit in Gilding." HUMPHREY'S JOURNAL 5, no. 1 (Apr. 15, 1853): 15. [Bailey from Columbia, TN.]

B54 Bailey, Thomas J. "Observations on Cleaning the Daguerreotype Plate." PHOTOGRAPHIC AND FINE ART JOURNAL 7, no. 7 (July 1854): 212-213. [Bailey from Columbia, TN.]

B55 Bailey, Thomas J. "Communications: Coating Boxes." PHOTOGRAPHIC AND FINE ART JOURNAL 7, no. 10 (Oct. 1854): 311.

B56 Bailey, Thos. "New Invention for Toning Pictures." HUMPHREY'S JOURNAL OF PHOTOGRAPHY, AND THE ALLIED ARTS AND SCIENCES 16, no. 1 (May 1, 1864): 6-7.

BAIMBRIDGE, WILLIAM. (1819-1879) (GREAT BRITAIN)

B57 "Her Majesty the Queen Planting the 'Prince Consort's Oak' in Winsor Great Park." ILLUSTRATED LONDON NEWS 41, no. 1179 (Dec. 20, 1862): 645, 646. 1 illus. ["...from a photograph by Mr. Baimbridge, of Winsor..."]

BAINBRIDGE, J. T.

B58 Bainbridge, J. T. "Winter Photography." BRITISH JOURNAL PHOTOGRAPHIC ALMANAC 1876 (1876): 78-79.

BAINBRIDGE, W. F. [?]

B59 "China. - Arrival and Reception of Ex-President Grant at Shanghai, May 17th. - From Photographs Furnished by W. F. Bainbridge." FRANK LESLIE'S ILLUSTRATED NEWSPAPER 48, no. 1241 (July 12, 1879): 317-318. 2 illus. [Views, boat docking, etc.]

BAIRD, V. C. (GREAT BRITAIN)

B60 "Twenty Years of Amateur Photography." BRITISH JOURNAL OF PHOTOGRAPHY 36, no. 1507 (Mar. 22, 1889): 202-203. [Read to the Dundee and East of Scotland Photographic Association.]

BAKER. (PESHAWUR, INDIA)

B61 "The Old Fort, Calcutta." ILLUSTRATED LONDON NEWS 54, no. 1521 (Jan. 16, 1869): 56, 58. 2 illus. ["...from two photographs by Mr. Baker."]

B62 "Wild Afreedees and Khyberees at Peshawur During Lord Mayo's Visit." ILLUSTRATED LONDON NEWS 56, no. 1599 (June 18, 1870): 632-633. 1 illus. ["...from a photograph by Mr. Baker, of Peshawur." Outdoor crowd portrait.]

BAKER & RECORD. (SARATOGA, NY)

B63 Portrait. Woodcut engraving, credited "From a Photograph by Baker & Record, Saratoga." FRANK LESLIE'S ILLUSTRATED NEWSPAPER 36, (1873) ["Frank H. Walworth, murderer." 36:925 (June 21, 1873): 229.]

B64 "Saratoga, N. Y. - Monument of the Seventy-Seventh Regiment, New York Volunteers. - Photographed by Baker & Record, Saratoga." FRANK LESLIE'S ILLUSTRATED NEWSPAPER 41, no. 1046 (Oct. 16, 1875): 92. 1 illus. [View.]

B65 "Note." PHOTOGRAPHIC TIMES 9, no. 107 (Nov. 1879): 260. [Cabinets and panel photos.]

B66 "Matters of the Month." PHOTOGRAPHIC TIMES 12, no. 139 (July 1882): 276-277. [Baker & Record, of Saratoga Springs, NY, commissioned to photograph the Class of 1883 of Smith College, Northampton, MA. 53 pupils, 30 faculty, and the buildings and grounds.]

BAKER, FANNY.

B67 Baker, Fanny. "Ode to Photography." AMERICAN JOURNAL OF PHOTOGRAPHY AND THE ALLIED ARTS & SCIENCES n. s. vol. 1, no. 16 (Jan. 15, 1859): 251. [Poem.]

BAKER, G. R. (d. 1906) (GREAT BRITAIN)

B68 "Obituary of the Year: G. R. Baker." BRITISH JOURNAL PHOTOGRAPHIC ALMANAC 1906 (1906): 658. [Died Jan. 28, 1904. Contributed to the "BJP" of papers on lantern matters. Worked for J. H. Steward, London for over 30 years.]

BAKER, WILLIAM J. (BUFFALO, NY)

B69 B. "Organic Matter in Baths." HUMPHREY'S JOURNAL OF PHOTOGRAPHY, AND THE ALLIED ARTS AND SCIENCES 15, no. 3 (June 1, 1863): 39-41.

B70 "Photograph of Celebrities." HUMPHREY'S JOURNAL OF PHOTOGRAPHY, AND THE ALLIED ARTS AND SCIENCES 15, no. 9 (Sept. 1, 1863): 142. ["W. J. Baker, of Utica, N.Y. has sent us a fine photograph of Secretary Seward's diplomatic excursion party, on the rocks just below the High Falls at Trenton. The background is one of the most picturesque of natural scenery. The group includes the diplomatic representatives of the leading nations of the world."]

B71 "The Secretary of State and the Diplomatic Corps at Trenton Falls - From a Photograph by Mr. William J. Baker, of Utica, NY." HARPER'S WEEKLY 7, no. 351 (Sept. 19, 1863): 593, 603. 1 illus. [Group portrait, taken outdoors.]

B72 "Editor's Table." PHILADELPHIA PHOTOGRAPHER 4, no. 44 (Aug. 1867): 272. [Several cabinets.]

B73 "Diffusion of Focus." PHILADELPHIA PHOTOGRAPHER 4, no. 45 (Sept. 1867): 290-292. [Letter from Baker.]

B74 "Editor's Table." PHILADELPHIA PHOTOGRAPHER 5, no. 54 (June 1868): 215. [W. J. Baker is using the new cabinet size.]

B75 "Editor's Table." PHILADELPHIA PHOTOGRAPHER 6, no. 61 (Jan. 1869): 31-32. [Anthony; W. J. Baker; S. M. Fassett (Chicago, IL); A. J. Riddle (Macon, GA); Frederick H. Eales (Rochester, NY).]

B76 "Editor's Table." PHILADELPHIA PHOTOGRAPHER 6, no. 64 (Apr. 1869): 136. ['Little Nell' Rembrandt style 8" x 10" photo noted.]

B77 Baker, W. J. "Rembrandt Effects, and How to Produce Them." PHILADELPHIA PHOTOGRAPHER 6, no. 66 (June 1869): 176-178.

B78 "Our Picture." PHILADELPHIA PHOTOGRAPHER 6, no. 66 (June 1869): frontispiece, 194-195. 1 b & w. [Portrait.]

B79 "Rembrandt Effects." PHILADELPHIA PHOTOGRAPHER 6, no. 69 (Sept. 1869): 300-301.

B80 "Our Picture." PHILADELPHIA PHOTOGRAPHER 7, no. 79 (July 1870): frontispiece, 269-270. 1 b & w. [Claims to have introduced the "Rembrandt" effect into USA. Baker from Buffalo, NY.]

B81 Baker, W. J. "Letter from the Country." PHILADELPHIA PHOTOGRAPHER 7, no. 84 (Dec. 1870): 411-413. [Discusses, among other issues, H. P. Robinson's composite photo, "Moonlight Picture, the First Hour of Night."]

B82 Baker, W. J. "The New Size, etc." PHILADELPHIA PHOTOGRAPHER 8, no. 86 (Feb. 1871): 41-42. [A "Victorian card." - cabinet photos discussed.]

B83 Baker, W. J. "Pictorial Effect." PHILADELPHIA PHOTOGRAPHER 8, no. 92 (Aug. 1871): 265-268. 1 illus.

B84 Baker, W. J. "Correspondence." PHILADELPHIA PHOTOGRAPHER 8, no. 94 (Oct. 1871): 323-324. [Baker (Buffalo, NY) describes his difficulties using J. W. Black's nitrate bath solution process, other comments.]

B85 Baker, W. J. "Coloring Photographs." PHILADELPHIA PHOTOGRAPHER 8, no. 95 (Nov. 1871): 346-347.

B86 Baker, W. J. "A Word for the Success Camera." ANTHONY'S PHOTOGRAPHIC BULLETIN 2, no. 11 (Nov. 1871): 368.

B87 Baker, W. J. "Things Worth Knowing." PHILADELPHIA PHOTOGRAPHER 8, no. 96 (Dec. 1871): 378-380. [Mentions W. J. Black's process, letters from George K. Warren, etc.]

B88 Baker, W. J. "Something to Keep Cool Over: 'Photographer's Conventions.'" PHILADELPHIA PHOTOGRAPHER 9, no. 98 (Feb. 1872): 52-53. [Response to an excerpt from the "NY Tribune," June 10, 1871.]

B89 "Our Picture." PHILADELPHIA PHOTOGRAPHER 9, no. 101 (May 1872): 151-1153. 1 b & w. [Portrait, plus diagram of studio.]

B90 Baker, W. J. "Fourth Annual Meeting and Exhibition of the N. P. A. in St. Louis, Mo., May 1872: Portraiture." PHILADELPHIA PHOTOGRAPHER 9, no. 102 (June 1872): 174.

B91 Baker, W. J. "A Few Considerations for the Considerate, Concerning the Next Convention." PHILADELPHIA PHOTOGRAPHER 10, no. 115 (July 1873): 193-194.

B92 Baker, W. J. "Our Picture." PHILADELPHIA PHOTOGRAPHER 10, no. 115 (July 1873): Frontispiece, 222-223. 1 b & w.

B93 Baker, W. J. "Fifth Annual Meeting and Exhibit of the National Photographic Association of the U.S., held in Buffalo, N.Y., beginning July 5, 1873: Address of Welcome." PHILADELPHIA PHOTOGRAPHER 10, no. 117 (Sept. 1873): 259-260.

B94 Baker, W. J. "Fifth Annual Meeting and Exhibit of the National Photographic Association of the U.S., held in Buffalo, N.Y., beginning July 5, 1873: Address by a Sculptor." PHILADELPHIA PHOTOGRAPHER 10, no. 117 (Sept. 1873): 316-319.

B95 Baker, W. J. "Fifth Annual Meeting and Exhibit of the National Photographic Association of the U.S., held in Buffalo, N.Y., beginning July 5, 1873: Verbatim dialogue between Mr. Fabronius, the portrait painter and Mr. Baker on 'The Fine Arts.'" PHILADELPHIA PHOTOGRAPHER 10, no. 117 (Sept. 1873): 370-373. [Fabronius might be fictional.]

B96 Baker, W. J. "Fifth Annual Meeting and Exhibit of the National Photographic Association of the U.S., held in Buffalo, N.Y., beginning July 5, 1873: Lighting the Sitter." PHILADELPHIA PHOTOGRAPHER 10, no. 117 (Sept. 1873): 394-399.

B97 Baker, W. J. "'Billingsgate' and 'Such Stuff'." PHOTOGRAPHIC TIMES 4, no. 38 (Feb. 1874): 17-19. [Commentary, letters by Baker over some controversial issue.]

B98 "Editor's Table." PHILADELPHIA PHOTOGRAPHER 12, no. 137 (May 1875): 158. [W. J. Baker (Buffalo, NY), using the new promenade card format.]

B99 Baker, W. J. "Proofs Not To Be Shown to Customers." BRITISH JOURNAL PHOTOGRAPHIC ALMANAC 1877 (1877): 135-137.

B100 "Editor's Table: Be Generous." PHILADELPHIA PHOTOGRAPHER 15, no. 174 (June 1878): 191. [W. J. Baker (Buffalo, NY) took a test case to court contesting Jehylman Shaw's patent on saving silver wastes. See also a full page statement by Baker, following p. 192.]

B101 "Matters of the Month." PHOTOGRAPHIC TIMES 10, no. 116 (Aug. 1880): 179. [Cabinet photos of General Garfield.]

B102 Baker, W. J. "A Mistake." PHOTOGRAPHIC MOSAICS:1888 24, (1888): 52-53. ["Don't mistake mechanism (technique) for art."]

B103 Baker, W. J. "Vignetting." PHOTOGRAPHIC MOSAICS:1889 25, (1889): 76-78.

B104 Baker, W. J. "The Eye." PHOTOGRAPHIC MOSAICS:1890 26, (1890): 72. Baker, William J.

B105 "A Toast to Photography." AMERICAN ANNUAL OF PHOTOGRAPHY AND PHOTOGRAPHIC TIMES ALMANAC FOR 1891 (1891): 85-86.

B106 Baker, W. J. "Vanity of Vanities, All is Vanity." PHOTOGRAPHIC MOSAICS: 1892 (1892): 186-188.

B107 Baker, W. J. "Founded on Fact." AMERICAN ANNUAL OF PHOTOGRAPHY AND PHOTOGRAPHIC TIMES ALMANAC FOR 1892 (1892): 191-194. [Anecdotal narrative about demanding patrons of professional portrait photographers.]

BALCH.
B108 Portrait. Woodcut engraving, credited "Photographed by Balch." FRANK LESLIE'S ILLUSTRATED NEWSPAPER 38, (1874) ["Hon. Wm. B. Washburn, Gov. of MA." 38:970 (May 2, 1874): 124.]

BALDUS, EDOUARD-DENIS. (1813-1882) (FRANCE)
[Born in Westphalia in 1813. Trained as a painter, and displayed in the Paris Salon in 1842, 1847, 1850-51. Had learned photography by 1849. Founding member of the Société héliographique in 1851 and the Société française de Photographie in 1857. The Commission des Monuments Historiques chose Baldus and four others to form the Mission héliographique in 1851, to document the architectural

heritage of France region by region. Baldus photographed in the provinces of Burgandy, the Dauphiné, and Provence. Photographed Paris in 1852, and in 1855 he produced several albums of views of railroads for the Baron James de Rothschild. Worked out an elegant but not commercially useful photogravure process by 1854. In late 50s he documented the flooding of the Rhône, and the construction of the new Louvre. Highly respected by end of decade. Received the Cross of the Legion of Honor in 1860. Photographed Paris again in early 1860s, though that seems to have been the last of his active work. Photogravure publications of his work continued to be published in the 1870s Died in Paris in 1882.]

B109 Lacan, Ernest. "Foreign Correspondence." BRITISH JOURNAL OF PHOTOGRAPHY 7, no. 125 (Sept. 1, 1860): 259. [Commentary on Baldus receiving an official award for his work documenting the construction of the new Louvre. Mentions other photographers so honored in the past. Niépce de Saint Victor. Blanquart-Evrard, Maxime du Camp, A. Salzmann, Martens, E. Delessert, and Braun.]

B110 Thornton, Gene. "The Revolution in Reportage." NEW YORK TIMES (Apr. 23, 1978): Sect., pp. 29, 30. 1 b & w. [Ex. review: "Edouard Baldus," Daniel Wolf Gallery, New York, NY.]

B111 Sobieszek, Robert A. "Quintessentially Second Empire: The Photography of Edouard-Denis Baldus." THE FRIENDS OF PHOTOGRAPHY NEWSLETTER 8, no. 12 (Dec. 1985): 1-2. 3 b & w.

BALDUS, ÉDOUARD-DENIS. [?]
B112 "View of Meaux, on the Railroad Between Paris and Epernay." HOLDEN'S DOLLAR MAGAZINE (New York, NY) 4, no. 6 (Dec. 1849): 706-707. 1 illus. [Woodcut view of a railroad station and cathedral at Meaux. Possibly from a photograph by Baldus.]

BALDWIN, DAVID. (GODWINVILLE, NJ)
B113 Baldwin, David. "Employment of Black Lead in the Printing of Photographs." HUMPHREY'S JOURNAL OF PHOTOGRAPHY, AND THE ALLIED ARTS AND SCIENCES 10, no. 9 (Sept. 1, 1858): 140.

BALDWIN, E. (LAWRENCE, KA)
B114 "Editor's Table." PHILADELPHIA PHOTOGRAPHER 6, no. 72 (Dec. 1869): 428. ["Carte of little boy, photo of seven apples, measure 10" in diameter noted."]

BALDWIN, MYRON T.
B115 "Prize Print Hints." PHILADELPHIA PHOTOGRAPHER 15, no. 171 (Mar. 1878): 65-68. [Competitor in the "Phila. Photog." Gold Medal Prize, describing his working methods, etc.]

BALL & THOMAS. (CINCINNATI, OH)
[James P. Ball and A. S. Thomas were partners in Cincinatti, OH, ca. 1857, then a new partnership of Thomas Ball (brother to J. P. Ball) and Thomas formed.]

B116 Portrait. Woodcut engraving, credited "From a Photograph by Ball & Thomas." FRANK LESLIE'S ILLUSTRATED NEWSPAPER 15, (1862) ["J. V. Packham, fifer, 34th Ohio Zouaves." 15:371 (Nov. 8, 1862): 108.]

BALL, CASE & CO.
B117 "Scenes and Incidents of the Great Fire of Portland, Maine, July 4th and 5th. - From Sketches by...F. H. Schell and Photographs by Ball, Case & Co., of Boston." FRANK LESLIE'S ILLUSTRATED NEWSPAPER 22, no. 565 (July 28, 1866): 296-297. 9 illus. [Ruins, etc.]

BALL, JAMES PRESLEY. (ca. 1825-1905) (USA)
[James P. Ball was born around 1825. He learned photography in Boston in 1845, from another black photographer —John B. Bailey. Ball opened a gallery in Cincinnati, OH, then worked as an itinerant, travelling as far as Pittsburg, PA and Richmond, VA. He returned to Cincinnati and opened a large gallery that proved to be popular, employing, by 1854, a nine man staff. He displayed the landscape paintings of his friend Robert Scott Duncanson in the gallery. J. P. Ball was successful and wealthy, and could afford a trip to Europe in 1856. Thomas Ball and Robert G. Ball, brothers to James P. Ball, also worked as photographers in Cincinnati, often for J. P. Ball, or as his partner, or on their own during the 1850s. J. P. Ball also formed partnerships with others in the 1850s; including, in 1857, a brief partnership with Robert Harlin, who had made a fortune in California. In 1858, A white photographer, Alexander Thomas, first worked for Ball and then in 1859 became his partner for a while. J. B. Ball trained his son in photography and later took him into partnership as well. In the early 1870s Ball & Son moved to Helena, MT, where they made both studio portraits and photographed scenes and events in Helena. They also worked galleries in Minneapolis and in St. Paul, MN, through the 1880s and 1890s. Around 1900 J. P. Ball and Son moved to Seattle, WA. J. P. Ball died in 1905.]

B118 "Daguerrian Gallery of the West." GLEASON'S PICTORIAL DRAWING-ROOM COMPANION 6, no. 13 (Apr. 1, 1854): 208. 1 illus. [Ball's Daguerrian Gallery in Cincinnati, OH, extolled. The engraving of the grand waiting-room of the new gallery may be drawn from description. Ball began his career in Cincinnati in 1845, employs nine men in his new gallery.]

BALL, THOMAS C. see BALL & THOMAS.

BALL, WILLIAM. (GREAT BRITAIN)
B119 Sweeting, Walter Debenham. *Historical and Architectural Notes on the Parish Churches in and Around Peterborough; ...Photographs by William Ball.* London; Peterborough: Whittaker & Co.; E. T. Hamblin, 1868. iv, 226 pp. 34 l. of plates. b & w. illus. ["Many of the plates are mounted photographs."]

B120 Sweeting, Walter Debenham. *Notes on the History and Architecture of Peterborough Cathedral.* London; Peterborough: Marion & Co.; J. S. Clarke & Son, 1868. n. p. 6 b & w. [Original photos.]

BALSAMO, J. E.
B121 Balsamo, J. E., Prof. of Philosophy at Lucca. "The New Permanent Printing Process." HUMPHREY'S JOURNAL OF PHOTOGRAPHY, AND THE ALLIED ARTS AND SCIENCES 13, no. 10 (Sept. 15, 1861): 155-157. [From "Br. J. of Photo."]

BALTZLY, BENJAMIN see also NOTMAN, WILLIAM (Triggs)

BALTZLY, BENJAMIN. (1835-1883) (USA, CANADA)
B122 Birrell, A. *Benjamin Baltzly: Photographs and Journal of an Expedition through British Columbia, 1871.* Toronto: Coach House Press, 1978. 157 pp. 71 b & w. [Born in OH, worked in Montreal for Wm. Notman and then for himself, died Cambridge, MA in 1883.]

BAMBRIDGE, W. (GREAT BRITAIN)
B123 *Photographs of Dogs, the Property of Her Majesty the Queen, in the Royal Kennel, Windsor.* E. Bambridge, Photographer. London: Private printing, John Sanford, 1865-1867. n. p. 1 b & w. [Original photographs.]

BAMFORTH, JAMES. (GREAT BRITAIN)

B124 "The Lantern Slides of James Bamforth." PHOTOGRAPHIC COLLECTOR 4, no. 1 (Spring l983): 65-71. 18 b & w. 2 illus. [Worked in Holmfirth, Yorkshire in l870s through l890s making lantern slides. Bamforth & Co. began making postcards, etc. ca. l900. Made narrative genre scenes, tableaux, etc. for "illustrated songs, hymns, moral tales and recitations."]

BANCROFT, GEORGE W. (d. 1885) (USA)

B125 "Note: Obituary." PHOTOGRAPHIC TIMES 15, no. 218 (Nov. 20, 1885): 655. ["A veteran view photographer, George W. Bancroft, died November 2nd, at his late residence, No. 305 East 73d St., in this city."]

BANES, J. F. (JANESVILLE, WI)

B126 "Burning of the Hyatt House, Janesville, Wisconsin." HARPER'S WEEKLY 11, no. 527 (Feb. 2, 1867): 76. 1 illus. ["From a Photograph by J. F. Banes, Janesville, WI."]

BANKS, T. W. (LITTLE ROCK, AR)

B127 "Bank's Advice to Sitters." ANTHONY'S PHOTOGRAPHIC BULLETIN 3, no. 1 (Jan. 1872): 423. [Banks from Little Rock, AR.]

B128 Portraits. Woodcut engravings, credited "Photographed by T. W. Banks. FRANK LESLIE'S ILLUSTRATED NEWSPAPER 38, (1874) [Joseph Brooks and Elisha Baxter, both claiming to be the Governor of AK." 38:973 (May 23, 1874): 161.]

B129 Portrait. Woodcut engraving, credited "From a Photograph by Banks, Little Rock, AK." FRANK LESLIE'S ILLUSTRATED NEWSPAPER 40, (1875) ["Hon. A. H. Garland, Gov. of AK." 40:1021 (Apr. 24, 1875): 105.]

BANNER, G. J. (GREAT BRITAIN)

B130 Banner, G. J. "The Social Influences of Photography." BRITISH JOURNAL OF PHOTOGRAPHY 11, no. 234 (Oct. 28, 1864): 423. [Read before "Liverpool Amateur Photo. Assoc."]

BANNISTER. (NEWCASTLE-ON-TYNE, ENGLAND)
BOOKS

B131 Bannister. *How to Sit for Your Photograph*. Newcastle-on-Tyne: Bannister, 1863. n. p. [new ed. (1865).]

PERIODICALS

B132 "Cartes-de-Visite." BRITISH JOURNAL OF PHOTOGRAPHY 10, no. 184 (Feb. 16, 1863): 88. [Bannister from Carlisle, England.]

B133 "Lord Palmerston in Carlisle." BRITISH JOURNAL OF PHOTOGRAPHY 10, no. 188 (Apr. 15, 1863): 172. [From "Carlisle Examiner." Describes Lord Palmerston's portrait being taken at the railway station.]

B134 Bannister. "How to Sit for a Photograph." BRITISH JOURNAL OF PHOTOGRAPHY 12, no. 268 (June 23, 1865): 329-330. [From a manual published by Mr. Bannister, of Newcastle-on-Tyne.]

BARATTI, OTTAVIO, LT.-COL. (MILAN, ITALY)

B135 Baratti. "Instantaneous and Stable Dry Collodion." HUMPHREY'S JOURNAL OF PHOTOGRAPHY, AND THE ALLIED ARTS AND SCIENCES 15, no. 21 (Mar. 1, 1864): 324-325. [From "Camera Oscura," Milan. Additional note on p. 383.]

B136 Baratti, O. Col. "Dry Coffee-Collodion Process." AMERICAN JOURNAL OF PHOTOGRAPHY AND THE ALLIED ARTS & SCIENCES n. s. vol. 8, no. 15 (Feb. 1, 1866): 351-355. [From "Photo. Notes."]

B137 "Editor's Table." PHILADELPHIA PHOTOGRAPHER 3, no. 34 (Oct. 1866): 322. [Lieut.-Col. Ottavio Baratti, the editor of "La Camera Oscura," sent in pictures of natives of Island of Sardinia.]

B138 Baratti, O., Col. "Nitro-Gelatine Developer." HUMPHREY'S JOURNAL OF PHOTOGRAPHY, AND THE ALLIED ARTS AND SCIENCES 18, no. 22 (Mar. 15, 1867): 348. [From "Camera Obscura."]

B139 "Editor's Table." PHILADELPHIA PHOTOGRAPHER 4, no. 40 (Apr. 1867): 127. [Editor received stereographs and cameo cartes-de visite.]

B140 Baratti, Ottavio. "The Coffee Dry Process." PHILADELPHIA PHOTOGRAPHER 5, no. 55 (July 1868): 217-218. [Barrati described as the editor of "La Camera Obscura." (Ivre Piverone, Italy).]

BARBER, A. S. (HARTFORD, CT)

B141 Barber, A. S. "Formula for Albumenized Paper." HUMPHREY'S JOURNAL OF PHOTOGRAPHY, AND THE ALLIED ARTS AND SCIENCES 15, no. 18 (Jan. 15, 1864): 282.

BARBER, ALFRED. (NOTTINGHAM, ENGLAND)

B142 Barber. "On the Causes of Failure in the Oxymel Process." HUMPHREY'S JOURNAL OF PHOTOGRAPHY, AND THE ALLIED ARTS AND SCIENCES. 10, no. 16 (Dec. 15, 1858): 255-256. [From "Liverpool Photo. J."]

B143 Heathcote, P. F. "The First Ten Years of the Daguerreotype in Nottingham." HISTORY OF PHOTOGRAPHY 2, no. 4 (Oct. 1978): 315-324. 1 b & w. 6 illus. [A. Barber was the first professional photographer in Nottingham, England, in 1841. Retired in 1845. Later photographers there include Popowitz, Kaim and Booker.]

BARCALOW.

B144 Portrait. Woodcut engraving, credited "From a Photograph by Barcalow." HARPER'S WEEKLY 9, (1865) ["Col. John O'Mahoney, Head of the Fenian Order." 9:464 (Nov. 18, 1865): 721.]

BARDWELL, JEX J. (1824-1902) (USA)

B145 Bardwell, J. J. "Cleansing the Daguerreotype Plate." PHOTOGRAPHIC ART JOURNAL 6, no. 5 (Nov. 1853): 280.

B146 "Personal & Art Intelligence." PHOTOGRAPHIC AND FINE ART JOURNAL 7, no. 1 (Jan. 1854): 32. ["Mr. J. J. Bardwell has removed to St. Paul, Minn. Ter., and connected himself with Mr. J. G. Whitney."]

B147 Bardwell, J. J. "Back-Grounds." PHOTOGRAPHIC AND FINE ART JOURNAL 7, no. 2 (Feb. 1854): 41.

B148 Bardwell, J. J. "Cause and Effect." PHOTOGRAPHIC AND FINE ART JOURNAL 7, no. 9 (Sept. 1854): 270-271.

B149 J. J. B. "The Recollections and Reflections of a Country Operator." PHOTOGRAPHIC AND FINE ART JOURNAL 11, no. 6 (June 1858): 168-169.

B150 Bardwell, Jex. "Formula for Negatives." HUMPHREY'S JOURNAL OF PHOTOGRAPHY, AND THE ALLIED ARTS AND SCIENCES 16, no. 14 (Nov. 15, 1864): 221-222.

B151 Bardwell, Jex. "A Negative requiring no Developing or Intensifying." HUMPHREY'S JOURNAL OF PHOTOGRAPHY, AND THE ALLIED ARTS AND SCIENCES 16, no. 19 (Feb. 1, 1865): 301-302.

B152 Bardwell, Jex. "An excellent Method of Cleaning Varnished Plates." HUMPHREY'S JOURNAL OF PHOTOGRAPHY, AND THE ALLIED ARTS AND SCIENCES. 16, no. 21 (Mar. 1, 1865): 330.

B153 Bardwell, Jex. "Dry Plates - Coffee Process." PHILADELPHIA PHOTOGRAPHER 5, no. 55 (July 1868): 218-219.

B154 Bardwell, Jex. "Photographic Wastes." ANTHONY'S PHOTOGRAPHIC BULLETIN 4, no. 12 (Dec. 1873): 362-363.

B155 Bardwell, Jex. "Of the Past." ANTHONY'S PHOTOGRAPHIC BULLETIN 5, no. 4 (Apr. 1874): 154-155.

B156 Bardwell, Jex. "On Wastes." ANTHONY'S PHOTOGRAPHIC BULLETIN 5, no. 5 (May 1874): 182-183.

B157 Bardwell, Jex. "Letter from Jex Bardwell." ANTHONY'S PHOTOGRAPHIC BULLETIN 18, no. 23 (Dec. 10, 1887): 730-731.

B158 Bardwell, Jex. "Correspondence: A Letter from Jex Bardwell." PHOTOGRAPHIC TIMES 17, no. 324 (Dec. 2, 1887): 604.

B159 Bardwell, Jex. "Notes from a Veteran." PHOTOGRAPHIC MOSAICS: 1888 24, (1888): 106-107.

B160 J. B. "Notes and News: Concerning the Lighting of the Sitter." PHOTOGRAPHIC TIMES 19, no. 415 (Aug. 30, 1889): 441-442. [From "The American Journal of Photography."]

B161 "Fifteenth Annual Convention Photographers' Association of America: Held at Detroit Museum of Art, Ag. 6 to 9, 1895, inclusive." WILSON'S PHOTOGRAPHIC MAGAZINE 32, no. 466 (Oct. 1895): 435-446. 3 b & w. [Report of the session, including the speeches of President John S. Schneider, John Carbutt, F. Dundas Todd, G. Cramer, and Jex Bardwell. Bardwell's speech dealt with his fight against the "bromide patent" in 1866.]

B162 Wilson, Edward L. "Wanted: A Home for Jex Bardwell." WILSON'S PHOTOGRAPHIC MAGAZINE 33, no. 472 (Apr. 1896): 189.

B163 Bardwell, Jex. "Trials and Tribulations Photographic." WILSON'S PHOTOGRAPHIC MAGAZINE 33, no. 473 (May 1896): 229-230.

B164 "Mr. Bardwell's Home." WILSON'S PHOTOGRAPHIC MAGAZINE 33, no. 473 (May 1896): 231.

B165 Bardwell, Jex. "A Greeting." WILSON'S PHOTOGRAPHIC MAGAZINE 33, no. 476 (Aug. 1896): 370-371. 1 illus. [Read to the P. A. of A. convention at Celoron.]

B166 "The Jex Bardwell Home." WILSON'S PHOTOGRAPHIC MAGAZINE 33, no. 476 (Aug. 1896): 377-379. 1 b & w.

B167 Bardwell, Jex. "The Studio Light." WILSON'S PHOTOGRAPHIC MAGAZINE 34, no. 483 (Mar. 1897): 133-134. 1 illus.

B168 "The Bardwell Home Fund." WILSON'S PHOTOGRAPHIC MAGAZINE 34, no. 487 (July 1897): 324-325. [The P. A. of A. determined to raise funds to purchase a home for Jex Bardwell in its 1896 convention. Response from the membership was poor, leading to a series of articles and notes in the magazines urging the photographers to contribute.]

B169 Ryder, James F. "The Jex Bardwell Home. (To Be Built in Detroit, Mich.)." WILSON'S PHOTOGRAPHIC MAGAZINE 34, no. 490 (Oct. 1897): 435-436. [Letter urging photographers to contribute to the fund.]

B170 Ryder, J. F. "The Jex Bardwell Home: An Interior View by a Dream Camera." WILSON'S PHOTOGRAPHIC MAGAZINE 34, no. 491 (Nov. 1897): 518-519.

B171 Ryder, J. F. "The Jex Bardwell Home." WILSON'S PHOTOGRAPHIC MAGAZINE 34, no. 492 (Dec. 1897): 564-565. [Still trying to raise money.]

B172 Ryder, James F. "Editorial Notes: The Jex Bardwell Home to be Built in Detroit, Mich." PHOTOGRAPHIC TIMES 30, no. 1 (Jan. 1898): 38.

B173 "The Jex Bardwell Home." WILSON'S PHOTOGRAPHIC MAGAZINE 35, no. 493 (Jan. 1898): 43-44. [List of contributors.]

B174 Bardwell, Jex. "A Hint and a Formula." WILSON'S PHOTOGRAPHIC MAGAZINE 35, no. 499 (July 1898): 320-321.

B175 "Editor's Table: Important Notice." WILSON'S PHOTOGRAPHIC MAGAZINE 35, no. 502 (Oct. 1898): 480. [Note that insufficient funds raised to buy Jex Bardwell's home, statement asking those who had contributed if the funds could be given to Bardwell for their needs.]

B176 Ryder, James F. "Jex Bardwell's Lantern Show." WILSON'S PHOTOGRAPHIC MAGAZINE 37, no. 525 (Sept. 1900): 430-431. [Report on Bardwell's exhibit of lantern slides at the Ohio-Michigan Photographers' Association Convention.]

B177 "Optical Lanterns." WILSON'S PHOTOGRAPHIC MAGAZINE 34, no. 486 (June 1897): 279-280.

BARET see GILLOT & BARET.

BARHYDT, JACOB. (1822-1874) (USA)

B178 "Note." ANTHONY'S PHOTOGRAPHIC BULLETIN 4, no. 12 (Dec. 1873): 356. ["...large heads taken directly..."]

B179 "Rochester, N. Y. - The New Free Academy. - Photographed by J. Barhydt." FRANK LESLIE'S ILLUSTRATED NEWSPAPER 38, no. 974 (May 30, 1874): 188. 1 illus. [Building.]

B180 "Our Picture." PHILADELPHIA PHOTOGRAPHER 11, no. 128 (Aug. 1874): 253-254. 1 b & w. 1 illus. [Studio portrait and an etching of his skylight.]

B181 "Obituary." ANTHONY'S PHOTOGRAPHIC BULLETIN 5, no. 10 (Oct. 1874): 374. [From "Rochester Democrat & Chronicle." Barhydt born in Ogdensburg Nov. 25th, 1822. Moved to Rochester, worked with his father as a boat-builder. Became a photographer "a few years since...,and "rose to the very first rank of his profession..." Died suddenly of cholera morbus.]

B182 "Obituary." PHILADELPHIA PHOTOGRAPHER 11, no. 131 (Nov. 1874): 345. [Died on September 30th, in his 52nd year. Lived and worked in Rochester, NY. Active member of the N. P. A., and well-known throughout the photographic community.]

BARK, CYRUS VOSS. (CLIFTON, BRISTOL, ENGLAND)
B183 Portrait. Woodcut engravings, credited to "From a Photograph by C. V. Bark." ILLUSTRATED LONDON NEWS 61, (1872) ["Late Mr. Henry G. Blagrave." 61:1739 (Dec. 28, 1872): 633.]

B184 Portrait. Woodcut engraving credited "From a photograph by Cyrus Voss Bark." ILLUSTRATED LONDON NEWS 71, (1877) ["Late Miss Mary Carpenter." 71:1982 (July 7, 1877): 20.]

BARKER, ALFRED CHARLES. (1819-1873) (GREAT BRITAIN, NEW ZEALAND)
B185 Wilson, Edward L. "The Journalistic Instinct." WILSON'S PHOTOGRAPHIC MAGAZINE 38, no. 532 (Apr. 1901): 140-141. [Article starts as a review of a special extra-illustrated issue of the Christchurch, New Zealand "Weekly Press," containing many photos taken by Dr. Barker from ca. 1850 - 1880. Also commends the work of Walter Burke (80 prints in issue, a modern photographer).]

B186 Knight, Hardwicke. "Alfred Charles Barker (1819-1873) A Lonely Genius." HISTORY OF PHOTOGRAPHY 2, no. 2 (Apr. 1978): 123-133. 12 b & w. [Born London, Jan 6, 1819. To New Zealand 1850. Became a photographer around 1858, practiced until his death in 1873. Outdoor portraits, views, etc.]

BARKER, D. O. (NEW HAVEN, CT)
B187 Portrait. Woodcut engraving, credited "From Photographs by D. O. Barker, of New Haven. FRANK LESLIE'S ILLUSTRATED NEWSPAPER 40, (1875) ["The Cornell Crew." (6 portraits)." 40:1035 (July 31, 1875): 357.]

BARKER, GEORGE. (1844-1894) (USA)
BOOKS
B188 Gardner, James T., Director. *Special Report of New York State Survey of the Preservation of the Scenery of Niagara Falls, and Fourth Annual Report of the Triangulation of the State. For the Year 1879.* Albany, NY: C. Van Benthuysen & Sons, 1880. 96 pp. l. of plates. 9 b & w. 6 illus. [Views of Niagara Falls. Tipped-in heliotypes from negatives from George Barker, plus engravings and maps.]

PERIODICALS
B189 "Editor's Table." PHILADELPHIA PHOTOGRAPHER 6, no. 70 (Oct. 1869): 356. [12"x20" view of Niagara Falls, NY, by George Barker.]

B190 "Editor's Table." PHILADELPHIA PHOTOGRAPHER 7, no. 76 (Apr. 1870): 142-143. [Note that George Barker (Niagara Falls, NY) burned out 7th February 1870. Starting again. Stereo negatives rescued.]

B191 Welch, Jane Meade. "The City of Buffalo." HARPER'S MONTHLY 71, no. 422 (July 1885): 193-216. 16 illus.[Views, harbor scenes, etc. Engravings, some from photos, one credited to "From Photographs by George Barker."]

B192 Welch, Jane Meade. "The Neighborhood of the International Park." HARPER'S MONTHLY 75, no. 447 (Aug. 1887): 327-343. 7 b & w. 8 illus. ["From Photographs by George Barker." Seven engravings from photos, one half-tone screen.]

B193 "Notes and News: Death of Mr. George Barker." PHOTOGRAPHIC TIMES 25, no. 690 (Dec. 7, 1894): 375.

B194 "Editor's Table." WILSON'S PHOTOGRAPHIC MAGAZINE. 32, no. 457 (Jan. 1895): 45. ["Barker, the eminent photographer at Niagara Falls, died Nov. 27th..."]

BARKER, J.
B195 Barker, J. "Notes on Pyroxyline." BRITISH JOURNAL PHOTOGRAPHIC ALMANAC 1879 (1879): 85-86.

B196 Barker, J. "Reliable Varnish." BRITISH JOURNAL PHOTOGRAPHIC ALMANAC 1879 (1879): 134-135.

BARKER, N. B. (ROCHESTER, NY)
B197 "Mr. Seth Green's Trout Ponds, on Spring Creek, Near Mumford, Monroe Co., N. Y. - From a Photograph by N. B. Barker, Rochester, N. Y." FRANK LESLIE'S ILLUSTRATED NEWSPAPER 22, no. 570 (Sept. 1, 1866): 372. 1 illus. [View, with figures.]

BARLOW, E. A.
B198 Barlow, E. A. Tarma, Peru. "South American Photography." PHOTOGRAPHIC WORLD 1, no. 9 (Sept. 1871): 263-264.

BARNABY, S. B. (DAYTON, OH)
B199 "Gossip." PHOTOGRAPHIC ART JOURNAL 5, no. 6 (June 1853): 380.

BARNARD & NICHOLS.
B200 "Personal & Art Intelligence." PHOTOGRAPHIC AND FINE ART JOURNAL 9, no. 5 (May 1856): 160. [From "Syracuse Standard." Description of new rooms.]

B201 "Our Illustrations: Rev. Robert R. Raymond." PHOTOGRAPHIC AND FINE ART JOURNAL 9, no. 7 (July 1856): frontispiece, 224. 1 b & w. [Original photographic print, tipped-in.]

BARNARD & SOUDER.
B202 "Charleston, S. C. - Centennial Anniversary and Parade of the German Fusiliers, May 3d. - From Sketches by Henri Collin and Photographs by Barnard & Souder." FRANK LESLIE'S ILLUSTRATED NEWSPAPER 40, no. 1027 (June 5, 1875): 209. 6 illus. [Views, portraits.]

BARNARD.
B203 Portrait. Woodcut engraving credited "From a photograph by Barnard." ILLUSTRATED LONDON NEWS 38, (1861) ["Miss Fanny Stirling, actress." 38:* (Feb. 9, 1861): 123.]

BARNARD, EDWARD EMERSON.
B204 "A Remarkable Man." PHOTOGRAPHIC TIMES 22, no. 578 (Oct. 14, 1892): 526. [Barnard an astronomer at the Lick Observatory on Mount Hamilton. From "San Francisco Examiner." Very popular. Biography.]

B205 Burnham, S. W. "Edward Emerson Barnard." HARPER'S MONTHLY 87, no. 520 (Sept. 1893): 530-536. 5 b & w. [Portrait of Barnard, four landscape views of the Lick Observatory. Biographical article about Barnard, who became a professional photographer, then an astronomer responsible for many discoveries in astronomy.]

B206 Burnham, S. W. "A Photographer-Astronomer." PHOTOGRAPHIC TIMES 23, no. 624 (Sept. 1, 1893): 478-479. 1 illus. [From "Harper's Monthly." Biography. "Fatherless and destitute at the end of the war, he began to work at a photography studio in

Nashville at age eight or nine." Worked as a photographer until 1883, studying at night. Took up astronomy in 1876. Received a fellowship in Astronomy to Vanderbilt University in 1883, where he took charge of the observatory. Made many discoveries in astronomy.]

BARNARD, F. A. P. (TUSCALOOSA, AL)

B207 Barnard, F. A. P. "Improvement In the Daguerreotype Process of Photography." DAGUERREAN JOURNAL 1, no. 5 (Jan. 15, 1851): 145-146. [From Tuscaloosa, written July 1st, 1841. From "Silliman's Journal."]

BARNARD, GEORGE N. see also BARNARD & NICHOLS and BARNARD & SOUDER.

BARNARD, GEORGE N. (1819-1902) (USA)
BOOKS

B208 Gardner, Alexander. *Gardner's Photographic Sketch-Book of the War.* Washington, DC: Philip & Solomon's, 1866. n. p. 100 b & w. [Six photographs credited to Barnard & Gibson.]

B209 Barnard, George N. *Photographic Views of Sherman's Campaign; Embracing Scenes of the Occupation of Nashville, the Great Bluffs around Chattanooga and Lookout Mountain, the Campaign of Atlanta, March to the Sea, and the Great Raid through the Carolinas. From negatives taken in the field, by George N. Barnard, Official Photographer of the Military Division of the Mississippi...* New York: Wynkoop and Hallenbeck, 1866. 30 pp. 61 l. of plates. 61 b & w. [Album of original photographs.]

B210 Barnard, George N. *Photographic Views of Sherman's Campaign.* With a new preface by Beaumont Newhall. New York: Dover Publications, 1977. 80 pp. 61 b & w. [Facsimile reprint of original album.]

B211 Hoobler, James A. *Cities under the Gun: Images of Occupied Nashville and Chattanooga, ...photographs by George N. Barnard and others.* Nashville, TN: Rutledge Hill Press, 1986. 224 pp. illus.

B212 Davis, Keith F. *George N. Barnard: Photographer of Sherman's Campaign.* Kansas City: Hallmark Cards Inc., distributed by University of New Mexico Press, 1990. 240 pp. 61 b & w. 154 illus. [A full survey of Barnard's career, with information on all aspects of Barnard's life and work. Appendices and extensive notes.]

PERIODICALS

B213 Barnard, George N. "Gossip: Letter." PHOTOGRAPHIC ART JOURNAL 3, no. 5 (May 1852): 324. [Letter from Barnard describing the meeting of the NY Daguerrean Assoc. in Rochester, NY.]

B214 Barnard, George N. "Correspondence: Copying Daguerreotypes." PHOTOGRAPHIC ART JOURNAL 4, no. 3 (Sept. 1852): 151-152.

B215 "Gossip." PHOTOGRAPHIC ART JOURNAL 5, no. 1 (Jan. 1853): 63. [From "Oswego Palladium." Describes G. N. Barnard's new gallery.]

B216 Barnard, George N. "Communications." PHOTOGRAPHIC ART JOURNAL 6, no. 3 (Sept. 1853): 149-150. [Letter arguing that a national professional organization needed to be established.]

B217 "The Anthony Prize Pitcher." PHOTOGRAPHIC AND FINE ARTS JOURNAL 7, no. 1 (Jan. 1854): 6-11. 1 b & w. [Barnard's letter, describing his process, on p. 9. Description of his genre daguerreotype "A Wood-Sawer's Nooning," on pp. 9-10. "A Wood-Sawer's

Nooning," reproduced by the crystalotype process, tipped-in following page 26.]

B218 "Personal and Art Intelligence." PHOTOGRAPHIC AND FINE ARTS JOURNAL 7, no. 1 (Jan. 1854): 32. ["Mr. George N. Barnard, of Oswego, N. Y., has associated with him Mr. Nicholls of Fulton, and opened... in Syracuse..."]

B219 Barnard, George N. "Light." PHOTOGRAPHIC AND FINE ART JOURNAL 8, no. 5 (May 1855): 143-144. [Read before 2nd ordinary meeting of the NY Daguerrean Assoc.]

B220 Barnard, George N. "Taste." PHOTOGRAPHIC AND FINE ART JOURNAL 8, no. 5 (May 1855): 158-159. [Read before the 3rd ordinary meeting of the NY Daguerrean Assoc.]

B221 Barnard, G. N. "Taste." AMERICAN JOURNAL OF PHOTOGRAPHY AND THE ALLIED ARTS 1, no. 2 (May 15, 1855): 33-37. [Barnard's aesthetic statement. Read before the third ordinary meeting of the New York State Daguerrean Association.]

B222 Portraits. Woodcut engravings, credited "Photographed by George N. Barnard." HARPER'S WEEKLY 9, (1865) ["Brevet Major-General Hazen." 9:424 (Feb. 11, 1865): 93. "Col. O. M. Poe." 9:432 (Apr. 8, 1865): 212. "Brig.-Gen. H. A. Barnum." 9:432 (Apr. 8): 212. "Maj.-Gen. P. J. Osterhaus." 9:446 (July 15): 437.]

B223 "Exterior View...Interior View of the Prison-Pen at Millen, Georgia." HARPER'S WEEKLY 9, no. 419 (Jan. 7, 1865): 9. 2 illus. ["...by George W. [sic, N.] Barnard, to whom we are indebted for the graphic sketches of the Prison-Pen at Millen, published on p. 13 [sic, 9]." May be from drawings.]

B224 "The Capture at Savannah." HARPER'S WEEKLY 9, no. 419 (Jan. 7, 1865): 12-13. 2 illus. ["...two illustrations of General Sherman's Army in front of Savannah. One of these represents General Sherman and his Staff, and is reproduced from a photograph by George W. [sic, N.] Barnard."]

B225 "The Spot Where General James B. McPherson Fell, Near Decatur, Georgia, July 22, 1864 - Photographed by George N. Barnard." HARPER'S WEEKLY 9, no. 425 (Feb. 18, 1865): 101. 1 illus.

B226 "Ruins in the Heart of Charleston - View of King Street - Photographed by George N. Barnard." HARPER'S WEEKLY 9, no. 445 (July 8, 1865): 428. 1 illus. [Very graphic, powerful view.]

B227 "View of the Interior of Fort Sumter after its Evacuation by the Rebels, February 18, 1865 - Photographed by George N. Barnard." HARPER'S WEEKLY 9, no. 447 (July 22, 1865): 460-461. 1 illus.

B228 Portrait. Woodcut engraving, credited "From a Photograph by G. N. Barnard, Savannah, GA." HARPER'S WEEKLY 10, (1866) ["Maj.-Gen. Judson Kilpatrick, U. S. Minister to Chili." 10:490 (May 19, 1866): 305.]

B229 "Literary." HARPER'S WEEKLY 10, no. 519 (Dec. 8, 1866): 771. [Review: "Photographic Views of Sherman's Campaign," by George N. Barnard.]

B230 Barnard, George N. "The Alum Silver Bath for Printing." ANTHONY'S PHOTOGRAPHIC BULLETIN 2, no. 7 (July 1871): 242-243. [Letters from G. N. Barnard (Charleston, SC) and C. Meinerth (Newburyport, MA) praising the product.]

B231 "Correspondence." ANTHONY'S PHOTOGRAPHIC BULLETIN 9, no. 3 (Mar. 1878): 95. [Letter praising Anthony's Flint Varnish."I owe the safety of all the negatives I took, when I accompanied Gen. Sherman in Georgia, entirely to the Flint Varnish."]

B232 "South Carolina. - Bronze Bust of Wm. Gilmore Simms, Unveiled at Charleston, June 11th. - From a Photograph by G. N. Barnard." FRANK LESLIE'S ILLUSTRATED NEWSPAPER 48, no. 1242 (July 19, 1879): 337. 1 illus. [View.]

B233 "Meetings of Societies: Chicago Photographic Association." PHOTOGRAPHIC TIMES 11, no. 124 (Apr. 1881): 145-153. [Unusually long and detailed report of a meeting of this association on the impacts of the gelatine dry-plate process on commercial photographers. Brought forth reminiscences by the Society's President, Alfred Hall, (a photographer for thirty-three years); P. B. Green (a Chicago pioneer in the use of dry plates); A. Hesler; Joshua Smith; George N. Barnard (from Rochester, NY); and others.]

B234 "Obituary: George N. Barnard." ANTHONY'S PHOTOGRAPHIC BULLETIN 33, no. 4 (Apr. 1902): 127-128. [Born in CT, Dec. 23, 1819. Died at Cedarvale, Onondaga Co., NY, Feb. 4, 1902. Early life spent in Nashville, TN. Began daguerreotyping in 1843. First gallery in Oswego, NY, then moved to Syracuse, NY. (Active in promoting professionalism in the craft, advocating the formation of early photographic associations, published an article on "Taste" in 1855. Worked in Syracuse until 1857, then moved to New York, NY to work in Brady's gallery.) In 1860 visited Cuba, taking views of sugar and molasses making. In Washington, DC. at the outbreak of the war, began photographing the massing Union armies, the camps and fortifications. (He attempted, and failed to photograph the first battle of Bull Run, but he did successfully photograph the site in 1862. His early war views published as cartes-de-visite through E. & H. T. Anthony & Co.) Official photographer, with Dept. of Engineers, during Sherman's march to the sea. (Barnard followed Sherman's army from Nashville, TN, to Chattanooga, then to Atlanta, GA. Immediately after the war Barnard retraced the route of Sherman's army to photograph the sites of skirmishes and battles. He published this series in 1866, in a portfolio of sixty-one views titled "Photographic Views of Sherman's Campaign.") Opened a gallery in Chicago, IL, where, in 1871, his gallery and equipment were destroyed by the great Chicago fire which "drove him and his printer into the lake." Then moved to Charleston, SC, around 1875, where his gallery again burned. Went to Rochester, NY in 1883, where he worked with the dry plate process for Robert Furman and George Eastman, who employed him to introduce dry plates to the photographic community. Opened a studio in Plainsville, OH from 1884 to 1886. Worked for a number of years taking views for E. & H. T. Anthony, possibly in the late '50s, early '60s.]

B235 "Daguerreotypes of the Great Fire, Oswego, N. Y., by George N. Barnard." IMAGE 11, no. 1 (1962): 2. 2 b & w. [George Barnard made at least two daguerreotypes of the flour mills of Oswego, NY, burning in 1853.]

B236 Case, Richard G. "Puzzle Ends in Picture." SYRACUSE HERALD-JOURNAL (Fri., May 10, 1963): n. p., [1 p.].

B237 "Brady Didn't Take Them All." SYRACUSE POST-STANDARD MAGAZINE (Sun., June 2, 1963): 3-7. 12 b & w. 1 illus.

B238 Wright, Dick. "Last Years of a Pioneer Cameraman." SYRACUSE POST-STANDARD MAGAZINE (Sun., May 24, 1964): 4-7. 6 b & w. 1 illus.

B239 Lifson, Ben. "Barnard's Civil War Photographs." DIALOGUE (AKRON, OH) (Sept.- Oct. 1978): 8-9. 3 b & w. [Excerpted from the "Village Voice" July 18, 1977.]

B240 Davis, Keith. "'The Chattanooga Album' and George N. Barnard." IMAGE 23, no. 2 (Dec. 1980): 20-27. 8 b & w. [Album of forty-five Civil War photographs in the collection of the George Eastman House, Rochester, NY. Identified images by R. M. Cressey and H. Goldsticker, previously unknown photographers, as well as previously unpublished photographs by George N. Barnard.]

B241 Buerger, Janet E. "George N. Barnard (1819-1902)." IMAGE 25, no. 2 (June 1982): 8-11. 4 b & w.

B242 Davis, Keith F. "Death and Valor." THE REGISTER OF THE SPENCER MUSEUM OF ART (UNIVERSITY OF KANSAS) 6, no. 5 (1988): 13-25. 5 b & w. 3 illus. [Discussion of George N. Barnard's photographs of the site of General James McPherson's death during the Civil War, and the readings given to those photographs during the 19th century and afterward.]

BARNARDO, THOMAS J. see also ELLIOTT & FRY.

BARNARDO, THOMAS JOHN.

B243 "A London Rambler". *Children Reclaimed for Life: The Story of Dr. Barnardo's work in London...* London: Hodder & Stoughton, 1875. xvii, 169 pp. illus.

B244 Batt, John Herrage. *Dr. Barnardo: The Foster-Father of "Nobody's Children." A Record and an Interpretation.* London: S. W. Partridge & Co., 1904. 196 pp. 20 b & w. illus. ["With an appreciation by His Grace the Duke of Argyll, K. T".]

B245 Barnardo, Mrs. Syrie Louise. *Memoirs of the late Dr. Barnardo,* by Mrs. Barnardo and James Marchant. Introduction by W. Robertson Nicoll. London: Hodder & Stoughton, 1907. xxiii, 404 pp.

B246 Bready, John Wesley. *Doctor Barnardo: Physician, Pioneer, Prophet, Child Life Yesterday and Today.* London: G. Allen & Unwin, Ltd., 1935. 271 pp.

B247 Lloyd, Valerie. Introduction by Gillian Wagner. *The Camera and Dr. Barnardo.* London: National Portrait Gallery, 1974. 40 pp. 49 b & w. [Barnardo, founder of a home for homeless children, used photography to record the agency's operation as part of the publicity apparatus of his organization and as a training program.]

BARNES, GEORGE W. (ROCKFORD, IL)

B248 "Illinois. - Falling of the Walls of the Winnebago County Court House, at Rockford, May 11th, Killing Eight Men, and Dangerously Wounding Eleven Others. - From Photographs by G. W. Barnes, Rockford, Ill." FRANK LESLIE'S ILLUSTRATED NEWSPAPER 44, no. 1131 (June 2, 1877): 220. 2 illus. [Aftermath.]

BARNES, MARCELIA W. (LEONI, MN)

B249 Barnes, Marcelia W. "Communications." PHOTOGRAPHIC ART JOURNAL 5, no. 5 (May 1853): 301-302. [Letter from Ms. Barnes, about values of the daguerreotype.]

B250 "Letter." PHOTOGRAPHIC ART JOURNAL 5, no. 6 (June 1853): 301-302.

B251 Barnes, Marcelia W. "Communications." PHOTOGRAPHIC ART JOURNAL 6, no. 5 (Nov. 1853): 315. [Letter from Ms. Barnes,

about her attendance to the meeting of the NY State Daguerrean Assoc.]

B252 Barnes, M. W. "Communication." PHOTOGRAPHIC AND FINE ART JOURNAL 9, no. 1 (Jan. 1856): 24. [Letter from Barnes (Elkhorn, WI).]

B253 Barnes, Marcelia W. "Art." PHOTOGRAPHIC AND FINE ART JOURNAL 10, no. 4 (Apr. 1857): 122. [Letter from Ms. Barnes, who has "been in this city (Cincinnati, OH) for some time taking lessons in coloring photographs...," primarily about the value of Art to mankind.]

B254 Barnes, Mrs. M. W. "The Photograph." PHOTOGRAPHIC AND FINE ART JOURNAL 13, no. 1 (Jan. 1860): 16-17. [Poem.]

BARNES, ROBERT FREEMAN. (1823-1898) (GREAT BRITAIN)
BOOKS
B255 Barnes, R. F. *The Dry Collodion Process*. London: George Knight & Co., 1856. 32 pp. [2nd, enlarged ed. (1857) 42 pp.]

PERIODICALS
B256 "An Early Dry Process." HUMPHREY'S JOURNAL OF PHOTOGRAPHY, AND THE ALLIED ARTS AND SCIENCES 19, no. 10 (Sept. 15, 1867): 159-160. [From "Br. J. of Photo." "It is now twelve or thirteen years since this process was introduced."]

B257 "Obituary: R. Freeman Barnes." BRITISH JOURNAL PHOTOGRAPHIC ALMANAC 1899 (1899): 656. [75 years old at time of death. Brother to George Green Crawford Barnes, also a photographer who died "a few years since." Worked with daguerreotypes, vitrified enamel process. Early exponent of wet-collodion for many years the chief operator for Maull & Polyblank, then opened his own studio - first at New Bond Street, then at New Cross.]

BARNES, THOMAS J.
B258 Barnes, T. J. "On Developing Negatives with Salts of Iron." HUMPHREY'S JOURNAL OF PHOTOGRAPHY, AND THE ALLIED ARTS AND SCIENCES 10, no. 6 (July 15, 1858): 94-95. [From "London Photo. Soc. J."]

BARNES, THOMAS J. & SON. (LONDON, ENGLAND)
B259 Portrait. Woodcut engraving credited "From a photograph by Barnes & Son, Mile End Rd." ILLUSTRATED LONDON NEWS 66, (1875) ["Late Mr. W. G. Rogers, wood-carver." 66:1861 (Apr. 10, 1875): 345.]

B260 Portrait. Woodcut engraving credited "From a photograph by T. J. Barnes & Son." ILLUSTRATED LONDON NEWS 69, (1876) ["Rev. Alexander MacAulay." 69:1933 (Aug. 12, 1876): 156.]

BARNETT, JOHN. (ca. 1830-1893) (USA)
B261 "Editorial Notes." PHOTOGRAPHIC TIMES 23, no. 592 (Jan. 20, 1893): 26. [Note: Barnett, "...one of the oldest manufacturers and dealers in photographic materials in this country, died Jan. 6th, in the sixty-third year of his age...in New York City."]

BARNEY. (DECATUR, IL)
B262 Portrait. Woodcut engraving, credited "From a Photograph by Barney." HARPER'S WEEKLY 8, (1864) ["Maj.-Gen. Richard J. Oglesby." 8:407 (Oct. 15, 1864): 669.]

BARNUM, DE LOSS.
B263 "Out-door Photography." HUMPHREY'S JOURNAL OF PHOTOGRAPHY, AND THE ALLIED ARTS AND SCIENCES 12, no. 4 (June 15, 1860): 56-57. ["...very fine stereoscopic views from Mr. DeLoss Barnum, late of Boston, now of Roxbury. ...his 'American Historical Series.'" Views in Roxbury, Cambridge, MA, etc.]

B264 "Stereoscopic." HUMPHREY'S JOURNAL OF PHOTOGRAPHY, AND THE ALLIED ARTS AND SCIENCES 15, no. 20 (Feb. 15, 1864): 320. [Praise for his stereos and card pictures.]

B265 "Stereoscopic Views." HUMPHREY'S JOURNAL OF PHOTOGRAPHY, AND THE ALLIED ARTS AND SCIENCES 19, no. 4 (June 15, 1867): 63.["...veteran subscriber, Mr. De Loss Barnum, formerly of Boston, and now of Solon, N.Y...." Views of Central Park, West Point, Greenwood, NY City Hall, etc.]

B266 "Stereoscopic Views." HUMPHREY'S JOURNAL OF PHOTOGRAPHY, AND THE ALLIED ARTS AND SCIENCES 20, no. 15 (Dec. 1, 1868): 233. [Praise for Barnum's views of Congress Hall Hotel, Saratoga, NY, Lake George, NY, the Steamer Min-ne-ha-ha, etc. Barnum's address is here given as Cortland, NY.]

BAROUX, M. E.
B267 Baroux, M. E. "Photography on Wood." HUMPHREY'S JOURNAL OF PHOTOGRAPHY, AND THE ALLIED ARTS AND SCIENCES 15, no. 13 (Nov. 1, 1863): 198-200. [From "Photo. News."]

B268 Baroux, M. E. "Photography on Wood." AMERICAN JOURNAL OF PHOTOGRAPHY AND THE ALLIED ARTS & SCIENCES n. s. vol. 6, no. 10 (Nov. 15, 1863): 235-237. [From "Photo. News."]

BARR & YOUNG.
B269 1 photo ("Grant as Major-General.") CENTURY MAGAZINE 53, no. 4 (Feb. 1897): 1. ["Photographed by Barr & Young, Army Photographers. Vicksburg, August, 1863."]

BARR, H., MAJOR.
B270 "Sketches in the Persian Gulf." ILLUSTRATED LONDON NEWS 30, no. 852 (Apr. 4, 1857): 310-311. 10 illus. ["By the courtesy of Major H. Ban [sic. Barr?], Paymaster of the Field Force in the Persian Gulf, we are enabled to present to our readers the five accompanying characteristics Groups of official personages and officers of the expedition and inhabitants of Bushire, photographed by Major Barr." Five group portraits, from photos. Two sketches of scenery by A. Harrison, three portraits of Persians taken by "an officer of the Ahmednuggeur Brigade."]

B271 "Photographs from the Persian Gulf." ILLUSTRATED LONDON NEWS 31, no. 883 (Oct. 17, 1857): 380. 3 illus. ["The Bushire Gateway," "The Camp of the Persian Force," and, "Arabs supplying the Camp." "A friend of Major Barr, Paymaster to the Persian Forces, has placed at our disposal some photographs and notes, whence we select the following."]

BARRAUD & JERRARD. (LONDON, ENGLAND)
B272 Portraits. Woodcut engravings credited "From a photograph by Barraud & Jerrard." ILLUSTRATED LONDON NEWS 62, (1873) ["Late Prof. Partridge." 62:1753 (Apr. 5, 1873): 325. "Late Count Bernstorff." 62:1753 (Apr. 5, 1873): 325. "Late Dr. Bruce Jones." 62:1757 (May 3, 1873): 424.]

B273 Portraits. Woodcut engravings credited "From a photograph by Barraud & Jerrard, Gloucester Place, Portman Sq." ILLUSTRATED LONDON NEWS 64, (1874) ["Late Baron Meyer de Rothschild."

64:1800 (Feb. 2, 1874): 168. "Mr. Assheton Cross." 64: 1808 (Apr. 18, 1874): 365.]

B274 Portraits. Woodcut engravings credited "From a photograph by Barraud & Jerrard." ILLUSTRATED LONDON NEWS 65, (1874) ["Sir G. Burrows, M.D., Bart." 65:1831 (Sept. 26, 1874): 304. "Late Dr. F. E. Anstie, M.D." 65:1831 (Sept. 26, 1874): 305. "Late Sir Ranald Martin." 65:1842 (Dec. 12, 1874): 552.]

B275 Portrait. Woodcut engraving credited "From a photograph by Barraud & Jerrard." ILLUSTRATED LONDON NEWS 67, (1875) ["Late Prof. Hewitt Key, F.R.S." 67:1896 (Dec. 11, 1875): 581.]

B276 Portraits. Woodcut engravings credited "From a photograph by Barraud & Jerrard." ILLUSTRATED LONDON NEWS 68, (1876) ["Earl of Wharncliffe." 68:1903 (Jan. 15, 1876): 61. "Earl of Erne." 68:1903 (Jan. 15, 1876): 61. "Lord Harlech." 68:1903 (Jan. 15, 1876): 61. "Late Viscount Galway, M.P." 68:1909 (Feb. 26, 1876): 96. "Late Prof. Parkes, F.R.S." 68:1914 (Apr. 1, 1876): 325. "Late Dr. Letheby." 68:1916 (Apr. 15, 1876): 373.]

B277 Portraits. Woodcut engravings credited "From a photograph by Barraud & Jerrard." ILLUSTRATED LONDON NEWS 69, (1876) ["Col. Egerton Leigh." 69:1928 (July 15, 1876): 69. "Late Earl of Leven & Melville." 69:1940 (Sept. 30, 1876): 324.]

B278 Portrait. Woodcut engraving credited "From a photograph by Barraud & Jerrard." ILLUSTRATED LONDON NEWS 70, (1877) ["Lord Galway." 70:1961 (Feb. 10, 1877): 121.]

B279 Portraits. Woodcut engravings credited "From a photograph by Barraud & Jerrard." ILLUSTRATED LONDON NEWS 72, (1878) ["Late Earl Bathurst." 72:2020 (Mar. 16, 1878): 245.]

B280 Portraits. Woodcut engravings credited "From a photograph by Barraud & Jerrard." ILLUSTRATED LONDON NEWS 73, (1878) ["Late Admiral Sir G. Black." 73:2036 (July 6, 1878): 4. "Late Mr. G. H. Whalley, M.P." 73:2051 (Oct. 19, 1878): 377.]

B281 Portraits. Woodcut engravings credited "From a photograph by Barraud & Jerrard." ILLUSTRATED LONDON NEWS 74, (1879) ["Late Marquis of Tweeddale." 74:2066 (Jan. 18, 1879): 61. "Late Mr. Isaac Butt, M.P." 74:2083 (May 17, 1879): 469. "Late Baron Lionel de Rothschild." 74:2087 (June 14, 1879): 565.]

BARRAUD, HERBERT see also MAYALL, JOHN JABEZ EDWIN.

BARRAUD, HERBERT ROSE. (1845-1896) (GREAT BRITAIN)
B282 Barraud, Herbert. *Men and Women of the Day: A Picture Gallery of Contemporary Portraiture. With Portraits by Barraud in Permanent Photography.* London: R. Bently & So., 1888-1891. 4 vol. 36 b & w. illus. [Each volume contained nine portraits with a facing page of letterpress of biographical information. Volumes 3 and 4 published by Eglington & Co., and edited by Bernard Capes and Charles Eglington.]

BARRAUD, WILLIAM. (1810-1890?) (GREAT BRITAIN) see BARRAUD & JERRARD.

BARRINGER, W. (BELLEFONTAINE, OH)
B283 Barringer, W. "Some Experiments with Lenses - A New Combination." AMERICAN JOURNAL OF PHOTOGRAPHY AND THE ALLIED ARTS & SCIENCES n. s. vol. 8, no. 15 (Feb. 1, 1866): 346-348.

BARROW, RICHARD W. (KINGSTON, CANADA)
B284 Barrow, Richard W. "Canada Correspondence." PHILADELPHIA PHOTOGRAPHER 12, no. 143 (Nov. 1875): 324-325. [An amateur landscape photographer from Kingston, Ontario, Canada.]

BARRY, A. L. (POINT DEPOSIT, MD)
B285 "The Ice-Gorge at Point Deposit, Cecil County, Maryland. - From Photographs by A. L. Barry, of that Town." FRANK LESLIE'S ILLUSTRATED NEWSPAPER 35, no. 908 (Feb. 22, 1873): 388. 3 illus. [Views.]

BARRY, DAVID FRANCIS. (1854-1934) (USA)
[Barry was born on Mar. 6, 1854 in Honeoy Falls, NY. His family moved to Osego, WI in 1861. Barry met the itinerant photographer O. S. Goff when he was a child, and, in 1878, apprenticed with him in Bismark, DT. Eventually Barry took over Goff's studio. In the 1880s he began to photograph the Indian tribes gathered at the Standing Rock Agency and around the Dakotas and Montana. Sold his Bismark studio to William DeGraff in 1890 and moved to Superior, WI, where he opened a new studio. Moved to New York City in 1897 and opened a short-lived gallery on Broadway. Returned to Superior in 1898 and opened another gallery, which he operated through the early teens. Died on Mar. 6, 1934. Many of his photographs have been misattributed to F. J. Haynes and others.]

BOOKS
B286 Heski, Thomas M. *'Icastinyanka Cikala Hanzi': The Little Shadow Catcher, D. F. Barry, Celebrated Photographer of Famous Indians.* Seattle: Superior Publishing Co., 1978. n. p. b & w. illus.

PERIODICALS
B287 "The Standing Rock Conference." FRANK LESLIE'S ILLUSTRATED NEWSPAPER 67, no. 1718 (Aug. 18, 1888): 6, 12. 3 illus. [Report on the Standing Rock Conference between US Commissioners and the Sioux Indians. Three woodcut portraits of the Sioux chiefs John Grass, Gall, and Mad Bear, "From Photographs by Barry, of Bismark."]

B288 "Dakota - The Sioux Reservation Conference at Standing Rock Agency - Commissioner Pratt Addressing the Conference - From a Photograph by Barry, of Bismark." FRANK LESLIE'S ILLUSTRATED NEWSPAPER 67, no. 1721 (Sept. 8, 1888): 53, 55. 1 b & w. [Scene of the outdoor council meeting. Indian crowds, listening to the commissioner.]

B289 "Progress Among the Sioux Indians." FRANK LESLIE'S ILLUSTRATED NEWSPAPER 71, no. 1828 (Sept. 27, 1890): 135. 2 b & w. [Portrait of White Ghost and a view "House of an Advanced Sioux - Photo by Perry." (Barry?).]

B290 "The Indian Messiah." FRANK LESLIE'S ILLUSTRATED NEWSPAPER 71, no. 1836 (Nov. 22, 1890): 280. 2 illus. [The engraving from the photo is a full length figure portrait of Sitting Bull in a feathered headdress, credited - Photo by Barry. One sketch.]

B291 "The Indian Excitement in the Northwest-Scenes and Incidents in Indian Life - From Photos by Barry." FRANK LESLIE'S ILLUSTRATED NEWSPAPER 71, no. 1841 (Dec. 27, 1890): 395, 391. 4 b & w. [Standing Rock Agency - beef issue day, portrait of the late Sitting Bull. Text described the death of Sitting Bull in a fight with Indian police. Further view of "the Grand River Crossing to Sitting Bull's Camp" on p. 408, in Jan. 3, 1891 issue.]

B292 "The Indian Troubles - Grand River Crossing to Sitting Bull's Camp - Scene of the Capture and Death of the Sioux Chief - Photo by Barry." FRANK LESLIE'S ILLUSTRATED NEWSPAPER 71, no. 1842 (Jan. 3, 1891): 408. 1 b & w.

B293 "The Novel "Whale-Back" Boat Used for Freighting Purposes in Northwestern Waters Unloading Coal - Photo by Barry." FRANK LESLIE'S ILLUSTRATED NEWSPAPER 71, no. 1844 (Jan. 17, 1891): 456. 1 b & w.

B294 Godfrey, E. S., U.S.A. "Custer's Last Battle. By One of his Troop Commanders." CENTURY MAGAZINE 43, no. 3 (Jan. 1892): 358-384. 2 b & w. 23 illus. [Article illustrated with engravings from photographs and photographs, mostly taken by D. F. Barry, of West Superior, WI, as well as drawings by Frederick Remington.]

B295 Fechet, Major Edmund G., 6th Calvary, U.S.A. "The True Story of the Death of Sitting Bull." COSMOPOLITAN 20, no. 5 (Mar. 1896): 493-501. 13 b & w. [Portraits of Sitting Bull, other Indian leaders, and Indian police. Sitting Bull's portrait and a view of his house and family are copyrighted "1891, by D. F. Barry, West Superior, WI."]

B296 "D. F. Barry: Indian Photographer." NORTHLIGHT (JOURNAL OF THE PHOTOGRAPHIC HISTORICAL SOCIETY OF AMERICA) 1, no. 3 (Fall 1974): 12-15. 6 b & w. [Text reprinted from "Photographic Times" (1895): 314. Includes portions of an interview with Barry, describing his experiences while taking portraits of the Sioux Indians.]

BARTALL. (PARIS, FRANCE)
B297 Portrait. Woodcut engraving credited "From a photograph by Bartall." ILLUSTRATED LONDON NEWS 65, (1874) ["Late Jules Janin." 65:1819 (July 4, 1874): 13.]

BARTHELMESS, CHRISTIAN. (1854-1906) (GERMANY, USA)
[Born on Apr. 11, 1854, in Klingenberg, Germany. Became a career soldier in the U. S. Army, and a military musician. Around 1881 he began taking photographs of soldiers, Indians, etc. at Ft. Wingate, NM, where he was stationed. He aided the anthropoligist Dr. Washington Matthews in his studies of the Zuni tribe. Barthelmess was transferred to Fort Lewis, CO in 1886 and to Ft. Keogh, MT in 1888. He photographed the Northern Plains Indians at these posts, and the Army Indian Scouts under the command of E. W. Casey. Barthelmess died at Fort Keogh on Apr. 10, 1906.]

BOOKS
B298 Fink, Maurice, with Casey E. Bartelmess. *Photographer on an Army Mule*. Norman, Okla.: University of Oklahoma Press, 1965. 152 pp.

PERIODICALS
B299 "Indian Scouts in the Regular Army Service - The Late Lieutenant E. W. Casey, and His Work in Organizing This Force - From Photos by Charles Barthelmess, Furnished through the courtesy of Secretary Proctor." FRANK LESLIE'S ILLUSTRATED NEWSPAPER 72, no. 1850 (Feb. 28, 1891): 63, 73. 2 b & w. 3 illus. [Three photoengravings, three sketches from photos showing Indians cutting timber, building cabins, drilling etc. Two further sketches on p. 63. Article on p. 63 is "Lieutenant Casey and His Scouts." "...photographs supplied by the Secretary of War."]

BARTHOLOMEW, WILLIAM. (GREAT BRITAIN)
B300 Bartholomew, W. "Three New Dry Processes." HUMPHREY'S JOURNAL OF PHOTOGRAPHY, AND THE ALLIED ARTS AND SCIENCES 13, no. 20 (Feb. 15, 1862): 316-317. [From "Photo. News."]

B301 Bartholomew, Wm. "Gelatino-Iron Developer." HUMPHREY'S JOURNAL OF PHOTOGRAPHY, AND THE ALLIED ARTS AND SCIENCES 17, no. 23 (Apr. 1, 1866): 366. [From "Photo. Notes."]

BARTLETT, WILLIAM E. (BALTIMORE, MD)
B302 "An Excursion on the Baltimore and Ohio Railroad." THE CRAYON 5, no. 7 (July 1858): 210. [From the "Evening Post." [?] "Besides these [artists], were the photographers consisting of the amateurs G. W. Dobbin and son, and W. E. Bartlett, of Baltimore, Charles Guillou, of Philadelphia; and Robert O'Neil, a professional photographer, from Washington...."]

B303 "Domestic Art Items and Gossip." COSMOPOLITAN ART JOURNAL 2, no. 4 (Sept. 1858): 207. [Describes an excursion organized for artists and photographers on the Baltimore and Ohio Railroad. "The train consists of...a car expressly fitted up for photographic purposes... The rest of the party...including...the following gentlemen...Messrs. G. W. Dobbin, Charles Gillou, William E. Bartlett and Robert O'Neil, photographers. More than one hundred excellent photographic views were taken by the several operators, who had four sets of approved apparatus of their own in full play." (See the June 1859 issue of "Harper's New Monthly Magazine.")]

BARTON, SON & CO. (GREAT BRITAIN, INDIA)
B304 Furneaux, J. H., editor. *Glimpses of India; A Grand Photographic History of the Land of Antiquity, the Vast Empire of the East. With 500 ...camera views ...with full historical text.* London: International Art Co., 1896. 544 pp. 500 b & w. [Photographic illustrations by Bourne & Shepherd, Lala Deen Dayal, Nicols & Co, Barton, Son & Co., and B. D. Dadaboy.]

BASHFORD, S. (CHRISTCHURCH, N ZEALAND)
B305 "Fire at Lyttleton, New Zealand." ILLUSTRATED LONDON NEWS 58, no. 1631 (Jan. 7, 1871): 19, 20. 1 illus.

BASHFORD, W. T.
B306 Bashford, W. T. "Photography Abroad: Cause of Spots." PHOTOGRAPHIC TIMES 5, no. 50 (Feb. 1875): 35. [From "Photographic News."]

BASSANO, ALEXANDER. (1829-1913) (GREAT BRITAIN)
B307 Portraits. Woodcut engravings credited "From a photograph by A. Bassano, Piccadilly." ILLUSTRATED LONDON NEWS 64, (1874) ["Late Lieut. F. H. Eardley-Wilmont, R.A." 64:1793 (Jan. 3, 1874): 4. "Wm. Gordon, M.P." 64:1803 (Mar. 14, 1874): 249. "Late Major Baird." 64:1808 (Apr. 18, 1874): 373.]

B308 Portrait. Woodcut engraving credited "From a photograph by Bassano." ILLUSTRATED LONDON NEWS 66, (1875) ["Sir Arthur Gordon, Gov. of Fiji." 66:1861 (Apr. 10, 1875): 345.]

B309 Portrait. Woodcut engraving credited "From a photograph by Bassano." ILLUSTRATED LONDON NEWS 67, (1875) ["Mr. George Wilson, Master Cutler." 67:1882 (Sept. 4, 1875): 229.]

B310 Portraits. Woodcut engravings credited "From a photograph by Alexander Bassano." ILLUSTRATED LONDON NEWS 72, (1878) ["Lord Wharncliffe." 72:2012 (Jan. 19, 1878): 53. "Sir Michael Hicks-Beach." 72:2017 (Feb. 23, 1878): 172.]

B311 Portraits. Woodcut engravings credited "From a photograph by Alexander Bassano, Old Bond Road." ILLUSTRATED LONDON

NEWS 73, (1878) ["Princess Alice and her daughter Princess Maria Victoria Feodore Leopoldine." 73:2062 (Dec. 21, 1878): 573. "Princess Alice." 73:2062 (Dec. 21, 1878): following p. 596.]

B312 Portraits. Woodcut engravings credited "From a photograph by A. Bassano." ILLUSTRATED LONDON NEWS 74, (1879) ["Late Col. Home, C.B., R.E." 74:2071 (Feb. 22, 1879): 185.]

B313 Portrait. Woodcut engraving credited "From a photograph by A. Bassano." ILLUSTRATED LONDON NEWS 75, (1879) ["Col. Redvers Buller, V.C., C.B." 75:2104 (Oct. 11, 1879): 329.]

BASTIAN, Q. T.

B314 Portrait. Woodcut engraving, credited "From a Photograph by Q. T. Bastian." FRANK LESLIE'S ILLUSTRATED NEWSPAPER 48, (1879) ["John P. St. John, Gov. of KA." 48:1227 (Apr. 5, 1879): 77.]

BATCHELDER, BENJAMIN P. (ca. 1827-1891) (USA)

B315 "Editor's Table: Obituary." WILSON'S PHOTOGRAPHIC MAGAZINE 28, no. 407 (Dec. 5, 1891): 735. [Died in Stockton, CA at age 64."A native of Massachusetts, entered upon the practice of photography in Daguerreotype days, and spent some years in Australia, settling at last in California. An earnest and painstaking worker." Batchelder was a Mason, he was married, but had no children.]

BATCHELDER, PEREZ M. see BLACK & BATCHELDER.

BATEMAN, J. (CANTERBURY, ENGLAND)

B316 Portrait. Woodcut engraving credited "From a photograph by J. Bateman." ILLUSTRATED LONDON NEWS 67, (1875) ["Late Lord Fitzwalter." 67:1900 (Dec. 25, 1875): 629.]

BATES & NYE. (DENVER, CO)

B317 "Colorado. - The Late Ute Outbreak and Massacre at the White River Agency. - Miss Josephine Meeker, and Mrs. Prince and Her Two Children, in the Costumes Worn By Them When Captured. - From Photographs by Bates & Nye, of Denver." FRANK LESLIE'S ILLUSTRATED NEWSPAPER 49, no. 1260 (Nov. 22, 1879): 209. 1 illus. [Studio portrait.]

BATES, JOSEPH WILLIAM. (d. 1886) (GREAT BRITAIN, USA)

B318 "Obituary. Joseph William Bates." PHILADELPHIA PHOTOGRAPHER 23, no. 272 (Apr. 17, 1886): 244. [Bates was Director of the Commercial Bank, Philadelphia, and "one of the oldest amateurs of our country." Long-time member of the Photographic Society of Philadelphia and had been it's President for several years at his death. "He owned one of the largest collections of lantern slides in the world, and was a good photographer." He was well-liked.]

B319 "Obituary: Joseph W. Bates." PHOTOGRAPHIC TIMES 16, no. 239 (Apr. 16, 1886): 206. [Bates born in Great Britain, left for USA at age 23. Set up a successful dry goods business in Philadelphia, PA, in 1841. Was an amateur landscape painter, took up amateur photography in 1850s. (Apparently learned it from Charles Ehrmann.) Bates, Constant Gilby and Edward Tilghman close friends, photographic collaborators from 1854 on.]

BATES, WILLIAM L. see BATES & NYE.

BATES, WILLIAM. (1826-1904) (GREAT BRITAIN)

B320 "Obituary of the Year: William Bates." BRITISH JOURNAL PHOTOGRAPHIC ALMANAC 1905 (1905): 650-651. [Died June 14, 1904, at age 78. Studio in Chertsey, Surrey for many years.]

BATHO, W. E. (GREAT BRITAIN)

B321 Batho, W. E. "Excessive Retouching." ANTHONY'S PHOTOGRAPHIC BULLETIN 5, no. 2 (Feb. 1874): 79-80. [From "Br. J. of Photo."]

B322 Batho, W. E. "Photography for Decorative Purposes." BRITISH JOURNAL PHOTOGRAPHIC ALMANAC 1876 (1876): 136-137.

B323 Batho, W. E. "How to Make Ovals." BRITISH JOURNAL PHOTOGRAPHIC ALMANAC 1879 (1879): 146-148. 2 illus.

BATTELS, B. F. (d. 1896) (USA)

B324 "Editor's Table: Obituary." WILSON'S PHOTOGRAPHIC MAGAZINE 34, no. 481 (Jan. 1897): 48. [Died Nov. 25, 1896 in Akron, Ohio. Learned his profession at Mount Vernon, Ohio and occupied galleries at Wadsworth, Bucyrus, and Akron, where he remained for more than forty years.]

BATTERSBY, JOSEPH.

B325 "Editor's Table." PHILADELPHIA PHOTOGRAPHER 4, no. 39 (Mar. 1867): 96. [Paper read before the Northwest Photographic Society, Chicago, IL. "The Influence of Low Prices on the Art."]

BAUGH & BENSLEY.

B326 "Fine-Art Gossip." ATHENAEUM no. 1726 (Nov. 24, 1860): 717. [Praise for two portraits of the actor B. Webster, taken by Baugh & Bensley.]

BAUGH, SPENCER.

B327 Portrait. Woodcut engraving credited "From a photograph by Spencer Baugh." ILLUSTRATED LONDON NEWS 34, (1859) ["Henry Dorling." 34:* (June 4, 1859): 552.]

BAUM, M. (HUDDERSFIELD, ENGLAND)

B328 Portrait. Woodcut engraving credited "From a photograph by M. Baum." ILLUSTRATED LONDON NEWS 22, (1853) ["Viscount Goderich, M.P." 22:* (Apr. 30, 1853): 332. (photo)]

BAUMGAERTNER, ANTHON. (d. 1888) (GERMANY, USA)

B329 "Obituary. Anthon Baumgaertner." PHOTOGRAPHIC TIMES 18, no. 367 (Sept. 28, 1888): 458-459. [Baumgaertner, retoucher, died Aug. 1, 1888 at age 50. Vice-President of the German Photographic Society of New York. Born Salzburg, Tyrol. In Austrian army. To America in 1870. Gained prominence as a retoucher. Purchased a gallery in Hoboken last Spring. Unsuccessful. Spirits failed. Committed suicide.]

BAUSH, LOUIS S. (CLARKSBURGH, WV)

B330 Baush, Louis S. "Correspondence." ANTHONY'S PHOTOGRAPHIC BULLETIN 2, no. 6 (June 1871): 161-162. [Baush ran a gallery in Clarksburgh, WV.]

BAVASTRO, E. (KINGSTON, JAMAICA)

B331 "Correspondence." ANTHONY'S PHOTOGRAPHIC BULLETIN 10, no. 8 (Aug. 1879): 256. [Bavastro (Kingston, Jamaica, W.I.) working the Artotype process.]

BAXTER, W. RALEIGH. (DUBLIN, SCOTLAND)

[W. R. Baxter, M.R.C.S. was the Lecturer on Natural History at Dublin, on Physiology at the Polytechnic, etc.]

B332 Baxter, W. Raleigh. *Photography, Including the Daguerreotype, Calotype and Chrystalotype, &c. Familiarly Explained; Being a Treatise on its Objects and Uses, and on Methods of Preparing Sensitive Paper, Metallic Plates, &c for taking Pictures by the Agency of Light.* "2nd ed."

London: H. Renshaw, 1843. 23 pp. [1st ed. (1842). There may be a 3rd. ed. in 1843.]

BAYARD, HIPPOLYTE. (1801-1887) (FRANCE)

[Bayard born in Breteuil-sur-Noye, France, on Jan. 20, 1801. Moved to Paris and worked as a clerk in the Ministry of Finance. Long interested in the chemical action of light, he experimented with the effects of light on sensitized paper from 1837 until 1839, when hearing of Daguerre's discovery, he worked out a direct positive paper process in sixteen days. At Arago's request Bayard did not publish his process, thus allowing Daguerre the priority of announcement, but Bayard publicly exhibited thirty of his prints on June 24, 1839, two months before Daguerre explained his process. After 1842 Bayard made beautiful calotypes, using Talbot's process, and later he worked in the other processes as well. He photographed portraits, studies, views, and, in 1848, scenes of the revolutionary barricades. In 1851 he photographed for the Society of Historical Monuments. He was a founder-member of the Société française de Photographie, and left 400 photographs to that organization at his death in 1887. Opened a studio in Paris in 1858, then formed a partnership with Bertall from 1863-66. Then he retired to Nemours, France. Bayard received the Chevalier of the Legion of Honor. in 1863. Died on May 14, 1887 at Nemours.]

BOOKS

B333 Lo Duca, Joseph-Marie. *Bayard.* New York: Arno Press, 1979. 30 pp. 48 l. of plates.

PERIODICALS

B334 "Invention of Photography." JOURNAL OF THE SOCIETY OF ARTS (LONDON) 4, no. 198 (Sept. 5, 1856): 687-688. [Excerpt from Louis Figuier's "Les Applications Nouvelles de la Science à l'industrie et aux Arts in 1855."]

B335 Bayard, H. "Extracts from Foreign Publications - New Photographic Process on Paper." HUMPHREY'S JOURNAL 9, no. 2 (May 15, 1857): 17-18. ["Comptes Rendus."]

B336 "Invention of Photography." PHOTOGRAPHIC AND FINE ART JOURNAL 10, no. 6 (June 1857): 181. [From "Liverpool Photo. J."]

B337 "M. Bayard's Process for Transferring Collodion to Paper." PHOTOGRAPHIC AND FINE ART JOURNAL 10, no. 11 (Nov. 1857): 345. [From "Liverpool Photo. J."]

B338 Bayard, H. "Positive Process." PHOTOGRAPHIC AND FINE ART JOURNAL 10, no. 11 (Nov. 1857): 348-349. [From "Liverpool Photo. Journal."]

B339 "Invention of Photography." HUMPHREY'S JOURNAL 9, no. 15 (Dec. 1, 1857): 233-234. [From "J. of Soc. of Arts." Commentary on Bayard's early role.]

B340 Bayard. "Method of Toning Albumenized Prints." HUMPHREY'S JOURNAL OF PHOTOGRAPHY, AND THE ALLIED ARTS AND SCIENCES 10, no. 19 (Feb. 1, 1859): 298. [From "Photo. Notes."]

B341 "New Toning Processes of M. Bayard and M. Le Gray." AMERICAN JOURNAL OF PHOTOGRAPHY 1, no. 21 (Apr. 1, 1859): 336-338. [Reported from "Bulletin of Fr. Soc."]

B342 "General Notes." PHOTOGRAPHIC TIMES 17, no. 317 (Oct. 14, 1887): 512. [Note that a recent number of the "Belgium Photographic Bulletin" describes Bayard's method of making positives

direct in the camera. First described in the Nov. 13, 1839 "Moniteur." Process described.]

B343 La Manna, Frank. "Correspondence: Antedating Daguerre." PHOTOGRAPHIC TIMES 17, no. 324 (Dec. 2, 1887): 604. [Letter mentioning death of H. Bayard, and giving certain details of his early practices.]

B344 Torosian, Michael. "Thinking of Hippolyte." PHOTO COMMUNIQUE 2, no. 2 (May - Aug. 1980): 2-4.

BAYLISS, CHARLES see also **MERLIN, HENRY BEAUFOY.**

BAYLISS, CHARLES. (1850-1897) (GREAT BRITAIN, AUSTRALIA)

B345 "The Largest Photographs in the World." ANTHONY'S PHOTOGRAPHIC BULLETIN 7, no. 3 (Mar. 1876): 92-93. [From "Br. J. of Photo.," again from "Sydney Evening News." B. O. Holtermann, wealthy gold miner, employs a corps of photographers to document Australia, etc. Worked first with Beaufoy Merlin, who later died. Then employed C. Bayliss to take large (3 x 5 ft.) views of Sydney and harbor. 35 ft. long panorama of Sydney, etc. intends to travel to England, display these and other photographs to encourage emigration to Australia.]

B346 "The Largest Photographs in the World." PHOTOGRAPHIC TIMES 6, no. 65 (May 1876): 106-107. [Reprint from "Br J. of Photo."]

BAZIN. (FRANCE)

B347 "[Note.]" FRANK LESLIE'S ILLUSTRATED NEWSPAPER 23, no. 593 (Feb. 9, 1867): 328. ["M. Bazin, a noted French photographer, has contrived a very ingenious submarine photographic studio."]

BAZINET, A. & CO. (MONTREAL, CANADA)

B348 "The Great Railway Disaster Near Montreal, Canada." HARPER'S WEEKLY 8, no. 395 (July 23, 1864): 477. 1 illus. ["Photographed by A. Bazinet & Co., Montreal."]

BEACH, ALFRED E. (USA)

B349 "The Scientific American." HUMPHREY'S JOURNAL OF PHOTOGRAPHY, AND THE ALLIED ARTS AND SCIENCES 18, no. 20 (Feb. 15, 1867): 317-318. [Note that "The Scientific American "has, as one of its editors Alfred E. Beach, "an amateur photographer of experience and ability." Remainder of article is a reprint of several books published by Joseph H. Ladd, the publisher of "Humphrey's Journal" and several photographic books.]

BEAL, J. H. (NEW YORK, NY)

B350 "Note." PHOTOGRAPHIC TIMES 6, no. 70 (Oct. 1876): 232. [Beal, one of the leading view photographers of NY, has made two panoramic views from the Brooklyn Tower of the NY & Brooklyn Bridge.]

BEALE, LIONEL SMITH. (GREAT BRITAIN)

B351 Beale, Lionel Smith. *How to Work With the Microscope.* London: Churchill, 1857. 124 pp. [This book was drawn from a course of lectures delivered at King's Collece in 1856-57. The first edition had a section devoted to photography on pp. 95-97. The 5th ed. (1880), London: Harrison, 518 pp, 100 plates, contains the section "Photomicrography," on pp. 285-342, by Dr. Maddox. Indicative of the growth of importance of this subject.]

BEALS, ALBERT J. (GOLD HILL, NV)

B352 "Note." PHOTOGRAPHIC TIMES 1, no. 10 (Oct. 1871): 153. [Letter from A. J. Beals in Nevada, praising the "Photo Times"

"...formerly of 156 Broadway, New York, NY. Been in the business nearly 30 years. N.B. In haste; am working a silver mine and have not much time to write...and also taking photos because I love the art."]

B353 "Correspondence." ANTHONY'S PHOTOGRAPHIC BULLETIN 5, no. 10 (Oct. 1874): 354. [Beals from Gold Hill, NV.]

B354 "Table Talk." PHILADELPHIA PHOTOGRAPHER 13, no. 155 (Nov. 1876): 350-351. [Letters from A. J. Beals (Gold Hill, NV), "32 years in the business," and Frank F. Currier (Omaha, NB)]

BEAMAN, E. O. (USA)
BOOKS
B355 Dellenbaugh, Frederick S. *A Canyon Voyage; The Narrative of the 2nd Powell Expedition Down the Green-Colorado River from Wyoming and the Explorations on Land, in the Years 1871 and 1872.* New York, London: G. P. Putnam's Sons, 1908. xx, 277 pp. 50 illus. [Photographs by E. O. Beaman, J. K. Hillers, etc. Reprinted (c. 1962), New Haven: Yale Univ. Press.]

PERIODICALS
B356 Beaman, E. O. "The Colorado Exploring Expedition." ANTHONY'S PHOTOGRAPHIC BULLETIN 3, no. 2 (Feb. 1872): 463-465. [Letter from Beaman, written from Kanab, UT on Dec. 20, 1871, describing the expedition.]

B357 "A Tour Through the Grand Canyon of the Colorado." ANTHONY'S PHOTOGRAPHIC BULLETIN 3, no. 10 (Oct. 1872): 703-705. [From "N. Y. Sun." Author not given, but probably E. O. Beaman. Left Major Powell's expedition, exploring with G. W. Riley, a miner, and making stereo views.]

B358 Beaman, E. O. "Among the Aztecs - Colorado River, Arizona, Sept. 15, 1872." ANTHONY'S PHOTOGRAPHIC BULLETIN 3, no. 11 (Nov. 1872): 746-747. [Beaman describes his visit to the Moqui Pueblos.]

B359 "Pictures." ANTHONY'S PHOTOGRAPHIC BULLETIN 4, no. 11 (Nov. 1873): 336. [New Adirondack landscapes by Beaman, "...who so venturously and successfully photographed the ruined cities of Arizona and had previously been the photographer for Capt. Powell's Colorado River Exploration..."]

B360 Beaman, E. O. "The Cañon of the Colorado, and the Moquis Pueblos: A Wild Boat-Ride Through the Cañons and Rapids. - A Visit to the Seven Cities of the Desert. - Glimpses of Mormon Life." APPLETONS' JOURNAL 11, no. 265-271 (Apr. 18 - May 30, 1874): 481-484, 513-516, 545-548, 590-593, 623-626, 641-644, 686-689. 7 illus. [E. O. Beaman's journal of his participation in Powell's second expedition on the Colorado River, in 1871-1872. The engravings are views and Indian portraits, which may be from photographs.]

B361 "Arizona. - Interior View of an Aztec Village, on a Branch of the Colorado River. - From a Photograph by Beaman." FRANK LESLIE'S ILLUSTRATED NEWSPAPER 39, no. 1005 (Jan. 2, 1875): 285. 1 illus.

B362 Morgan, Dale L., editor. William C. Darrah et al. "The Exploration of the Colorado River and the High Plateus of Utah in 1871 - 72." UTAH HISTORICAL QUARTERLY 16-17, (Jan. 1948 - Dec. 1949.): 1-540. [These two volumes of the "Quarterly" published as a monographic volume dealing with the Powell Colorado River Exploring Expedition of 1871-1872. It contains much information, diaries, etc. of participants. See specifically William Culp Darrah's "Beaman, Fennemore, Hillers, Dellenbaugh, Johnson and Hattan," on pp. 491-503 for biographies of these members of the expedition.

E. O. Beaman, James Fennemore (1849-1941 b. Great Britain, USA), John K. Hillers (1843-1925 b. Germany, USA), and Frederick Samuel Dellenbaugh (1853-1935).]

BEAR, JOHN W. (b. 1800) (USA)
B363 Bear, John W. *The Life and Travels of John W. Bear, the "Buckeye Blacksmith."* Baltimore: D. Binswanger & Co., ca. 1873. 299 pp. [Mr. Bear born in MD in 1800. He operated as a professional daguerreotypist briefly, beginning in Nov. 1844. One chapter in this autobiography describes this part of his life and career.

BEARD & BEARD. [?]
B364 Portrait. Woodcut engraving credited "From a photograph by Beard & Beard." ILLUSTRATED LONDON NEWS 27, (1855) ["Right Hon. David Salomons." 27:* (Nov. 10, 1855): 560.]

BEARD & CO.
B365 *The Seats and Mansions of Berkshire*, photographically illustrated by Beard & Co., Twyford. Twyford: Beard & Co., 1866. 3 vol. 143 b & w. [Original photographs, views, etc. Vol. I, 43 b & w; vol. II, 69 b & w; vol. III, 31 b & w.]

BEARD & FOARD. (MANCHESTER, ENGLAND)
B366 Portrait. Woodcut engraving credited "From a photograph by Beard & Foard." ILLUSTRATED LONDON NEWS 30, (1857) ["E. Watkins, M.P." 30:* (Apr. 25, 1857): 386.]

BEARD & SHARP. (LONDON, ENGLAND)
B367 "Fine Arts: Photography on Ivory." ILLUSTRATED LONDON NEWS 32, no. 921 (June 5, 1858): 567. [Beard & Sharp, of Old Bond St., London.]

BEARD, RICHARD. (1801-1885) (GREAT BRITAIN)
[Born in East Stonehouse, Devon. Worked briefly in the family grocery business, then moved to London in 1833, where he became successful, owning a coal business by the end of the decade. Secured the British monopoly on the daguerreotype process in Britain, and opened the first public photographic studio in London. Sold licenses outside London and by 1841 had licensee's practicing in nine cities. Beard's only rival in London was Antoine Claudet, and Beard launched several lawsuits to protect his privileged status, but gradually through the 1840s he released licenses to other studios in London. In 1849 he declared bankruptcy, although apparently still wealthy. By the mid-50s Beard's London studios were vacated or had changed hands, and Beard's central position to British photography had eroded considerably - although he continued to form business partnerships. His son Richard carried on the family involvement in photography, and opened studios in Liverpool and Cheltenham. But in the 1860s all family facilities were closed and Beard retired to Hampstead, where he later died.]

BOOKS
B368 Mayhew, Henry. *London Labour and the London Poor: The Condition and Earnings of Those That Will Work, Cannot Work, and Will Not Work.* London: Charles Griffin & Co., 1851-61. 4 vol. illus. [First three volumes, published in 1851, are illustrated with many wood-engravings credited "from a photograph by Richard Beard." Volume four, published in 1861, has a section on street photographers on pp. 204-210.]

B369 Tallis, John. *Tallis's History and Description of the Crystal Palace, and the Exhibition of the World's Industry in 1851.* Illustrated by Beautiful Steel Engravings, from Original Drawings and Daguerreotypes by Beard, Mayall, etc. London: John Tallis & Co.,

1852. 3 vol. 15 illus. [Engravings, four credited from daguerreotypes by Mayall, eight from daguerreotypes by Beard.]

B370 Gaspey, William. *The Great Exhibition of the World's Industry held in London in 1851: Described and illustrated by ... engravings from daguerreotypes by Beard, Mayall, etc.* London: s. n., 1852-1861 [?] 4 vol.

B371 Fluckinger, Roy. "Beard and Claudet: A Further Inquiry," on pp. 91-96 in: *The Daguerreotype*, edited by John Wood. Iowa City: University of Iowa Press, 1989.

PERIODICALS

B372 "Varieties - Photographic Portraits." ART UNION (Apr. 15, 1841): 65.

B373 "Improvement of the Daguerreotype." MAGAZINE OF SCIENCE AND SCHOOL OF ARTS 3, no. 105 (Apr. 3, 1841): 2. [Wolcroft's process, patented in England by Beard. The Polytechnical Institution of London discussed.]

B374 "Photographic Portraits: Beard v. Claudet." ART UNION no. 31 (Aug. 1, 1841): 139. [Copyright conflict between Beard and Claudet.]

B375 "Colored Daguerreotypes. (A Patent taken out Recently by Mr. Beard.)" MAGAZINE OF SCIENCE AND SCHOOL OF ARTS 4, no. 195 (Dec. 24, 1842): 308.

B376 "Miscellanea: Daguerreotypes." ATHENAEUM no. 793 (Jan. 7, 1843): 21. [Beard's patent for hand-coloring daguerreotypes.]

B377 "Our Weekly Gossip." ATHENAEUM no. 805 (Apr. 1, 1843): 313. ["How [Prof. Boettiger has discovered a method of making colored daguerreotypes] this may be we know not; but certainly... Mr. Beard had discovered a mode of colouring daguerreotypes."]

B378 "Varieties: Photographic Portraits." ART UNION no. 53 (June 1, 1843): 150.

B379 "Jullien's Concerts: Mr. Joseph Richardson - Master Thirlwall - Mr. F. Baumann." ILLUSTRATED LONDON NEWS 4, no. 89 (Jan. 13, 1844): 29. 3 illus. ["The portraits of Master Thirlwall and of M. Baumann, are copied from photographic plates, taken by Beard's improved process, at his institution, King William Street; the portrait of Mr. Richardson is copied from an oil painting but is, in our opinion, by no means so good as the other two."]

B380 "M. Gabriel Julien Ouvrard." ILLUSTRATED LONDON NEWS 8, no. 202 (Mar. 14, 1846): 177. 1 illus. ["...a portrait (from a Daguerreotype, by Beard), ...of the celebrated French financier."]

B381 "Daguerreotype Portraiture." LITERARY GAZETTE, AND JOURNAL OF THE BELLES LETTRES no. 1526 (Apr. 18, 1846): 360. [Brief description of Beard's portrait studio and its practices.]

B382 "Topics of the Month: Photography." ART UNION (ART JOURNAL) (May 1846): 139. [Beard credited with improvements, which lead to better images for daguerreotypes.]

B383 "His Imperial Highness the Grand Duke Constantine of Russia." ILLUSTRATED LONDON NEWS 10, no. 226 (June 5, 1847): 361. 1 illus. ["From a Daguerreotype, by Mr. Beard."]

B384 "His Imperial Highness the Grand Duke Constantine of Russia, Admiral Lutke, M. Haurowitch, and Baron Friedricks." ILLUSTRATED LONDON NEWS 10, no. 227 (June 12, 1847): 372. 1 illus. ["From a Daguerreotype, by Mr. Beard." Group portrait.]

B385 "Parliamentary Portraits. - No. III. James Wilson, M.P." ILLUSTRATED LONDON NEWS 11, no. 292 (Dec. 4, 1847): 369. 1 illus. ["From a Daguerreotype by Beard."]

B386 "Daguerreotype Portraiture." ART UNION (ART JOURNAL) 10, no. 121 (July 1848): 223.

B387 "The Spitalfields Ball. Costume Portraits, From Daguerreotypes, by Beard." ILLUSTRATED LONDON NEWS 13, no. 326 (July 15, 1848): 24-26. 4 illus.

B388 [Advertisement.] ILLUSTRATED LONDON NEWS 13, no. 329 (Aug. 5, 1848): 79. ["Beard's Photographic Portraits, are taken at 85, King William St.; 34, Parliament St. and the Royal Polytechnic Institute, Regent St."]

B389 "The Lord Mayor - Sir James Duke." ILLUSTRATED LONDON NEWS 13, no. 343 (Nov. 11, 1848): 297-298. 1 illus. ["...from a Daguerreotype by Beard, of King William St., City."]

B390 "Mr. Frederick Peel, M.P. for Leominster." ILLUSTRATED LONDON NEWS 14, no. 370 (May 12, 1849): 307-308. 1 illus. ["The accompanying Portrait is from a Daguerreotype by Beard."]

B391 Portraits. Woodcut engravings credited "From a photograph by Beard" ILLUSTRATED LONDON NEWS 16, (1850) ["Mr. Alderman Kershaw, M.P." 16:* (Mar. 30, 1850): 212. (photo) "Right Hon. Andrew Rutherford, M.P." 16:* (May 11, 1850): 340. (colored photo)]

B392 Portraits. Woodcut engravings credited "From a photograph by Beard." ILLUSTRATED LONDON NEWS 17, (1850) ["Right Hon. W. G. Hayter, M.P." 17:* (July 20, 1850): 64. (photo) "Hon. E. P. Bouverie, M.P." 17:* (July 20, 1850): 64. (photo) "George Gore Ouseley Higgins, M.P." 17:* (Aug. 24, 1850): 169. (photo) "Joseph Labitzky, composer." 17* (Nov. 30, 1850): 417. (dag.)]

B393 Portraits. Woodcut engravings credited "From a photograph by Beard." ILLUSTRATED LONDON NEWS 18, (1851) ["Mr. Mitchell, M.P." 18:* (Feb. 15, 1851): 144. (photo) "Mr. Redgrave, R.A." 18:* (Mar. 15, 1851): 219. (photo) "Mr. Jacob Bell, M.P." 18:* (Apr. 12, 1851): 299. (photo) "The Chinese Family at the Crystal Palace Exhibition." 18:* (May 24, 1851): 450 (photo)]

B394 "Another Improvement in the Daguerreotypic Art." ILLUSTRATED LONDON NEWS 18, no. 479 (Apr. 19, 1851): 317. [Beard announces improved technique for insuring permanency of the daguerreotype image.]

B395 "Walks in the Galleries: Beard's Enamelled Daguerreotypes." ILLUSTRATED LONDON NEWS 18, no. 491 (June 7, 1851): 528.

B396 "The Russian Court." ILLUSTRATED LONDON NEWS 18, no. 493 (June 21, 1851): 598. 1 illus. [Views of exhibitions of the Crystal Palace - "From a Daguerreotype by Beard."]

B397 Portraits. Woodcut engravings credited "From a photograph by Beard." ILLUSTRATED LONDON NEWS 19, (1851) ["Mr. Alderman Salomons, M.P." 19:* (July 26, 1851): 105. (dag.) "Captain John Franklin and crew (14 portraits)." 19:* (Sept. 13, 1851): 329. "Commissioner of Crystal Palace (1)." 19:* (Oct. 18, 1851): 508. (dag.) "The Esquimaux Erasmus York." 19:* (Oct. 25, 1851): 513. (dag.) "The Tyrolese Minstrels." 19:* (Dec. 6, 1851): 669. (photo)]

B398 "The Zollverein Court." ILLUSTRATED LONDON NEWS 19, no. 505 (July 26, 1851): 121. 1 illus. [Exhibitions at the Crystal Palace. "From a Daguerreotype by Beard."]

B399 "Portraits of Captain Sir John Franklin, and his Crew." ILLUSTRATED LONDON NEWS 19, no. 515 (Sept. 13, 1851): 329-330. 14 illus.

B400 Portraits. Woodcut engravings credited "From a photograph by Beard." ILLUSTRATED LONDON NEWS 20, (1852) ["Miss Crichton, actress." 20:* (Feb. 21, 1852): 165. (photo) "Dr. David Boswell Reid." 20:* (Mar. 20, 1852): 237. (dag.) "The Earl of Malmesbury." 20:* (Mar. 20, 1852): 248. (dag.) "Mrs. Caroline Chisholm." 20:* (Apr. 17, 1852): 301. (dag.) "Capt. Sir E. Belcher, Capt. Pullen." 20:* (Apr. 24, 1852): 321. (photos) "Arctic Searching Squadron (5 portraits)." 20:* (May 1, 1852): 336. (photos)]

B401 Portraits. Woodcut engravings credited "From a photograph by Beard." ILLUSTRATED LONDON NEWS 21, (1852) ["Mr. Whiteside, M.P." 21:* (Nov. 6, 1852): 377. (photo) "Mr. Charles Geach, M.P." 21:* (Nov. 6, 1852): 377. (photo)]

B402 "'The Craig Telescope,' at Wandsworth Common." ILLUSTRATED LONDON NEWS 21, no. 576 (Aug. 28, 1852): 168. ["...from a photograph by Beard."]

B403 Portraits. Woodcut engravings credited "From a photograph by Beard." ILLUSTRATED LONDON NEWS 22, (1853) ["Mr. Digby Seymour, M.P." 22:* (Feb. 12, 1853): 132. (dag.) "Mr. Thomas Phinn, M.P." 22:* (Feb. 19, 1853): 152. (photo) "Mr. Kenneth MacAulay, M.P." 22:* (Feb. 19, 1853): 152. (photo) "Capt. J. N. Gladstone, R.N., M.P." 22:* (Mar. 12, 1853): 197. (dag.) "Mr. Apsley Pellatt, M.P." 22:* (Mar. 26, 1853): 237. (photo) "Mr. Benjamin Oliveira, M.P." 22:* (Apr. 9, 1853): 277. (photo) "Mr. Charles Gavan Duffy, M.P." 22:* (May 7, 1853): 341. (photo) "Mr. J. G. Phillimore, M.P." 22:* (May 14, 1853): 373. (dag.)]

B404 Portraits. Woodcut engravings credited "From a photograph by Beard." ILLUSTRATED LONDON NEWS 23, (1853) ["Mr. Sheriff Wire." 23:* (Nov. 19, 1853): 429. (dag.)]

B405 Portraits. Woodcut engravings credited "From a photograph by Beard." ILLUSTRATED LONDON NEWS 24, (1854) ["Sir Robert Harry Inglis, Bart." 24:* (Jan. 21, 1854): 49. (dag.) "Earl of Carnarvon." 24:* (Feb. 11, 1854): 120. (photo.) "Samuel Laing, M.P." 24:* (Mar. 4, 1854): 193. (dag.) "Nine ministers." 24:* (Apr. 29, 1854): 400-401. (dag.)]

B406 "Fast-Day Sermons: The Day of Humility and Prayer." ILLUSTRATED LONDON NEWS 24, no. 680 (Apr. 29, 1854): 398-402. 21 illus. [Includes texts of sermons and portraits of twenty-one ministers. Twenty-one portraits on pp. 400-401; 9 portraits credited "From a Daguerreotype by Beard;" 1 portrait credited "From a Daguerreotype by Claudet;" 1 portrait "From a Collodion;" 1 portrait "From a Photograph;" others from sketches.]

B407 Portraits. Woodcut engravings credited "From a photograph by Beard." ILLUSTRATED LONDON NEWS 25, (1854) ["Dr. Rae." 25:* (Oct. 28, 1854): 421. (dag.)]

B408 Portraits. Woodcut engravings credited "From a photograph by Beard." ILLUSTRATED LONDON NEWS 26, (1855) ["Rev. G. Fletcher." 26:* (Mar. 10, 1855): 221. (photo) "Four priests." 26:* (Mar. 24, 1855): 270. (photos, dag.) "E. L. Ward, R.A." 26:* (Mar. 31, 1855): 301. (dag.) "Leone Levi." 26:* (June 30, 1855): 653. (dag.)]

B409 "Fast-Day Sermons: The Day of Humiliation." ILLUSTRATED LONDON NEWS 26, no. 733 (Mar. 24, 1855): 268-270. 12 illus. [Excerpts from sermons and portraits of twelve priests. Three of the portraits are credited "from photographs by Beard," and one portrait is credited "from Daguerreotype by Beard."]

B410 "The Resolute. - (From a Photograph by Beard.)" FRANK LESLIE'S ILLUSTRATED NEWSPAPER 1, no. 5 (Jan. 12, 1856): 80. [British ship "Resolute," depicted here as being under sail. I question the attribution.]

B411 Portraits. Woodcut engravings, credited "From an Photograph by Beard." FRANK LESLIE'S ILLUSTRATED NEWSPAPER 1, (1856) ["Capt. Sir E. Belcher, of the "Resolute." 1:6 (Jan. 19, 1856): 89.]

B412 Portraits. Woodcut engravings credited "From a photograph by Beard, King William St." ILLUSTRATED LONDON NEWS 33, (1858) ["William Harrison, captain of the "Great Eastern" steamship." 33:* (Nov. 6, 1858): 435. "Maj. Gen. Sir Edward Lugard, K.G.B." 33:* (Dec. 18, 1858): 582.]

B413 Portrait. Woodcut engraving credited "From a photograph by Beard." ILLUSTRATED LONDON NEWS 34, (1859) ["Sir Charles E. Trevelyan, K.C.B." 34:* (Apr. 2, 1859): 333.]

B414 Odgers, Stephen L. "A Labelled Wolcott Daguerreotype." HISTORY OF PHOTOGRAPHY 2, no. 1 (Jan. 1978): 19-21. 3 illus.

B415 Gill, Arthur T. "Further Discoveries of Beard Daguerreotypes." HISTORY OF PHOTOGRAPHY 3, no. 1 (Jan. 1979): 94-98. 4 b & w. 3 illus.

B416 Heathcote, Bernard V. and Pauline F. Heathcote. "Richard Beard: an Ingenious and Enterprising Patentee." HISTORY OF PHOTOGRAPHY 3, no. 4 (Oct. 1979): 313-329. 6 b & w. 9 illus. [4 b & w by Beard, 1 b & w by J. Whitlock, 1 b & w by R. Low.]

B417 Wood, R. Derek. "The Daguerreotype in England; Some Primary Material Relating to Beard's Lawsuits." HISTORY OF PHOTOGRAPHY 3, no. 4 (Oct. 1979): 305-309. 2 illus.

B418 Heathcote, Bernard V. and Pauline F. Heathcote. "Richard Beard: Correspondence from Bernard V. and Pauline F. Heathcote." HISTORY OF PHOTOGRAPHY 5, no. 3 (July 1981): 268. 1 illus. [First publication of only known portrait of Richard Beard, obtained from his descendants.]

B419 Smith, Graham. "'Dr. Harry Goodsir', by Dr. Adamson of St. Andrews." HISTORY OF PHOTOGRAPHY 10, no. 3 (July - Sept. 1986): 229-236. 4 b & w. 5 illus. [Calotype of Dr. Goodsir, a member of Sir John Franklin's fatal Arctic expedition, taken by John Adamson in 1842. Article also discusses the expedition and its coverage in the "Illustrated London News" (Sept. 13, 1851), with engravings from daguerreotypes by Richard Beard.]

BEASLEY, F., JR.
B420 Beasley, F., Jr. "Mems. on Dry Plates and Transparencies." BRITISH JOURNAL PHOTOGRAPHIC ALMANAC 1877 (1877): 45-46.

BEATO, ANTONIO. (d. 1903) see BEATO, FELICE A.

BEATO, FELICE ANTONIO. (1825-ca. 1904) (GREAT BRITAIN, CHINA, JAPAN)

[Apparently a Venetian, who became a naturalized British citizen. Beato met James Robertson in Malta around 1853, and they worked as partners in Constantinople, Athens, Palestine, Egypt, and Syria, until 1856. Its unclear if Beato photographed with Robertson in the Crimean War of 1854, but he certainly photographed the aftermath of the Indian Mutiny in 1858, then maintained a studio with Shepherd in Calcutta in 1858-59. Beato went with the British troops into China in 1860 during the Anglo-Chinese War. He then followed the British forces into Japan in 1862, where he lived and worked as a photographer and general trader until late 70s, when he sold his negatives and studio to von Stillfried. In 1871 Beato joined the American expeditionary forces which briefly invaded Korea, and once again photographed combat. He also photographed the Wolseley Nile Expedition of 1884-1885. In the 1880s Beato moved to Burma, where he opened stores in Rangoon and Mandalay and a mail order business, selling furniture and general goods. His stores were disbanded in 1907, as he had probably died previously.]

BOOKS

B421 Beato, Felice Antonio. *Album eqiziano. Felice Antonio Beato;* presentazione di Italio Zannier. Milano: Editphoto, 1978. 23 pp. b & w. [Supplement to "Fotografia Italiana," no. 233.]

B422 Mukashi-mukashi. *La Japon de Pierre Loti; ... photographies par Beato et Stillfried;* presente par Chantal Edel. Paris: Arthaud, ca. 1984. 111 pp. b & w.

B423 Zannier, Italo. *Verso Oriente: Fotografie di Antonio e Felice Beato.* Florence: Alinari, 1986. 7 pp. 112 l. of plates.

PERIODICALS

B424 "Sir Hope Grant and the Staff of the British Expedition in China." ILLUSTRATED LONDON NEWS 37, no. 1053 (Oct. 6, 1860): 314. 1 illus. ["From a Photograph by Signor F. Beato."]

B425 "The War in China. - Encampment of British Forces at Talien-wan." ILLUSTRATED LONDON NEWS 37, no. 1056 (Oct. 27, 1860): 390-391. 2 illus. ["From Photographs by M. Beato, taken shortly before the departure of the troops for the Pehtang." Two panoramic views.]

B426 Portrait. Woodcut engraving credited "From a photograph by Beato." ILLUSTRATED LONDON NEWS 38, (1861) ["Chinese General Prince San-Ko-Lin-Sin." 38:* (Apr. 13, 1861): 357.]

B427 "Our Weekly Gossip." ATHENAEUM no. 1807 (June 14, 1862): 793-794. ["At Mr. Herings, Regent St., may be seen a large collection of photographic views and panoramas taken by Signor Beato during the Indian Mutiny and the Chinese War."]

B428 "Note." JOURNAL OF THE PHOTOGRAPHIC SOCIETY OF LONDON 8, no. 136 (Aug. 15, 1863): 335. [Mr. "Beats" views of Indian writing are mentioned as being pirated by an officer of the Indian Army and sold by Mr. Henry Hering in his defense of a claim against him.]

B429 Portraits. Woodcut engravings credited "From a photograph by F. Beato." ILLUSTRATED LONDON NEWS 44, (1864) ["Vice-Admiral Kuper, C.B." 44:* (Feb. 20, 1864): 189. "Lieut.-Col. Edward St. John Neale, C.B." 44:* (Feb. 27, 1864): 208.]

B430 Portrait. Woodcut engraving credited "From a photograph by F. Beato." ILLUSTRATED LONDON NEWS 45, (1864) ["Sir Rutherford Alcock, Envoy to Japan." 45:1270 (July 23, 1864): 97.]

B431 "Scenes in Japan. - The City of Jeddo and the British Fleet at Yokohama." ILLUSTRATED LONDON NEWS 45, no. 1285 (Oct. 29, 1864): 436-437. 2 illus. ["From a photograph taken by Signor Beato, of that place."]

B432 "Scenes in Japan. The Strait and Harbour of Simonosaki." ILLUSTRATED LONDON NEWS 45, no. 1287 (Nov. 12, 1864): 487-489. 5 illus. [As an accompaniment to those views of Simonosaki, we give...a view of the Night Guard of The Tycoon's Palace at Yeddo...a view of the...mountain Fusiyama...after photographs taken by Signor Beato, of Yokohama."]

B433 "The Late Action at Simonosaki, Japan." ILLUSTRATED LONDON NEWS 45, no. 1293-1294 (Dec. 24, 1864): 619-620, 624. 2 illus. ["The last mail has brought us a number of sketches by Mr. Wirgman, and photographs by Signor Beato, of Yokohama to serve as further illustrations of the conflict they witnessed on the 5th and 6th September between the allied British, French, and Dutch squadrons and the batteries and land forces of the Prince of Nagato." Illustrations are from Wirgman's sketches.]

B434 "The Murder of Two British Officers in Japan." ILLUSTRATED LONDON NEWS 46, no. 1300 (Feb. 4, 1865): 111. [Report from the "Illustrated London Times." Artist and Correspondent, Mr. Wirgiman, on the assassination of Major Baldwin and Lieut. Bird, describing his experience as he and Mr. Beato were out on a trip for five days sketching and photographing. Letter dated Nov. 30, 1864.]

B435 "The Chastisement of Corea." FRANK LESLIE'S ILLUSTRATED NEWSPAPER 32, no. 832 (Sept. 9, 1871): 433, 436, 440-441. 9 illus. [Views of aftermath of battle. Portraits, ships, views. (By Felice Beato.)]

B436 "The Corean Photographs." FRANK LESLIE'S ILLUSTRATED NEWSPAPER 33, no. 833 (Sept. 16, 1871): 9-10, 12. 7 illus. [Portraits, views, ships, etc. Praise for the newsworthiness and qualities of these photos, which were not credited to Beato, but which were taken by him.]

B437 "Japan. - State Opening by the Mikado of the Railroad Between Yokohama and Yeddo. - Presentation of the Address by the Foreign Residents. - From a Photograph by F. Beato & Co." FRANK LESLIE'S ILLUSTRATED NEWSPAPER 35, no. 898 (Dec. 14, 1872): 225. 1 illus.

B438 "The First Railway in Japan." ILLUSTRATED LONDON NEWS 61, no. 1735 (Dec. 7, 1872): 545-546. 2 illus. ["Our well-known artist and correspondent, Mr. C. Wirgman, has sent two sketches of the proceedings, with photographs by Signor Beato, and a letter..."]

B439 "Opening of the First Railway in Japan: Arrival of the Mikado." ILLUSTRATED LONDON NEWS 61, no. 1737/1738 (Dec. 21, 1872): 613-614. 1 illus. ["...furnished by the pencil of Mr. Wirgman and the photographic camera of Signor Beato."]

B440 "Opening of the First Railway in Japan: Mr. Marshall Reading the Address of the Leading Merchants of Yokohama to the Mikado." ILLUSTRATED LONDON NEWS 61, no. 1739 (Dec. 29, 1872): 637. 1 illus.

B441 Griffis, William Elliot. "American Relations With The Far East." NEW ENGLAND MAGAZINE 11, no. 3 (Nov. 1894): 257-272. 10 b & w. 7 illus. [This brief general survey of American activity in Japan

and Korea is illustrated with several photos of "Coreans" etc. There are also two photos "After the Battle: Sailors in Corea in 1871" and "Rear Admiral Homer C. Blake, Officers and Crew of the U.S.S. Corvette 'Alaska', 1872," which may have been taken by Beato.]

B442 Nilsson, Sten. "Egron Lundgren, reporter of the Indian Mutiny." APOLLO 92, no. 102 (Aug. 1970): 138-143. 1 b & w. [Discusses the painters and photographers who recorded the Indian mutiny in 1857.]

B443 Nobuo, Ina. "Beato in Japan." IMAGE 15, no. 3 (Sept. 1972): 10-11. 5 b & w. [Beato in Japan in 1860s.]

B444 Zannier, Italo. "Felice Antonio Beato, Album Egiziano." FOTOGRAFIA ITALIANA no. 233 (Jan. 1978): Supplement, 1-24. 28 b & w. [Also three b & w by Beato in India, Japan, and China and five b & w by James Robertson in the Crimea.]

B445 Meinwald, Dan. "A Professional Photographer and His Amateur Counterparts: A Comparative Study." IMAGE 22, no. 2 (June 1979): 1-10. 9 b & w by Beato, 9 b & w by unknown amateur photographers, 1 b & w on front cover. [Compares the handling of Egyptian subjects by a regional professional photographer and travelling amateurs.]

B446 White, Stephen. "Felix Beato and the First Korean War, 1871." PHOTOGRAPHIC COLLECTOR 3, no. 1 (Spring 1982): 76-85. 9 b & w. 1 illus.

B447 Crombie, Isobel. "China, 1860: A Photographic Album by Felice Beato." HISTORY OF PHOTOGRAPHY 11, no. 1 (Jan. - Mar. 1987): 25-37. 11 b & w.

BEATO, FELICE A. [?]
BOOKS
B448 Alcock, Sir Rutherford, K.C.B. *The Capitol of the Tycoon: A Narrative of Three Years Residence in Japan;...With Maps and numerous illustrations in chromolithography and on wood...* London; New York: Longman, Greene, Longman, Roberts & Greene; Harper & Brothers, 1863. 2 vol. illus. [Illustrated with woodcuts, some taken from photographs - possibly by Beato.]

B449 Wilson, Andrew. *Photographic Album accompanying 'Our "Ever Victorious Army"'.* Glasgow: A. Wilson [?], 1868. n. p. 22 b & w. [Twelve views, ten carte-de-visite portraits. Taken in 1863-64, of the Chinese campaign under Lieut. Col. C. G. Gordon. Foreword and picture selection by John Thomson, but he is not the photographer. The photographs of the campaign may be by Beato?]

PERIODICALS
B450 "Photography in Japan: Letter from F. B." JOURNAL OF THE PHOTOGRAPHIC SOCIETY OF LONDON 5, no. 80 (Mar. 5, 1859): 222. [Anecdote taken from series "A cruise in Japanese Waters" in "Blackwoods Mag." Jan, 1859. F. B. may be Felix Beato.]

B451 "The Emperor of China's Summer Palace - The Imperial Palace, Pekin." ILLUSTRATED LONDON NEWS 38, no. 1086 (Apr. 27, 1861): 390, 400. 2 illus. ["From a photograph taken on the 18th of October last, only one day before the Palace was destroyed by fire."]

B452 "The Imperial City, Pekin." ILLUSTRATED LONDON NEWS 38, no. 1087 (May 4, 1861): 414. 1 illus. ["Our View of the Gardens and the Buddhist Temple...from an excellent photograph which taken on the 29th of October last."]

BEATTIE, JOHN. (d. 1883) (GREAT BRITAIN)
B453 Portrait. Woodcut engraving credited "From a photograph by John Beattie, Preston." ILLUSTRATED LONDON NEWS 33, (1858) ["John Dove Harris, M.P." 33:* (July 24, 1858): 94.]

B454 Beattie, John. "Photographic Imitation of Ivory Miniatures." HUMPHREY'S JOURNAL OF PHOTOGRAPHY, AND THE ALLIED ARTS AND SCIENCES 11, no. 10 (Sept. 15, 1859): 151-152. [From "Photo. Notes."]

B455 Beattie, John. "Photographic Imitation of Ivory Miniatures." PHOTOGRAPHIC AND FINE ART JOURNAL 13, no. 1 (Jan. 1860): 2-3. [From "Photo. Notes." Beattie identified as the "well-known professional photographer from Bristol."]

B456 Beattie, John. "Double Printing." PHOTOGRAPHIC AND FINE ART JOURNAL 13, no. 2 (Feb. 1860): 40. [From "Photo. Notes."]

B457 Beattie, John. "On the Direction of Light as It Affects the Likeness and Mental Appearance of the Sitter." BRITISH JOURNAL PHOTOGRAPHIC ALMANAC 1870 (1870): 137-139.

B458 Beattie, John. "On the Ethics of Trifles." BRITISH JOURNAL PHOTOGRAPHIC ALMANAC 1871 (1871): 131-133.

B459 Beattie, John. "On Photo-Sculpture." BRITISH JOURNAL PHOTOGRAPHIC ALMANAC 1872 (1872): 123-125.

B460 Beattie, John. "The Story of a Life May Be Told in a Picture." BRITISH JOURNAL PHOTOGRAPHIC ALMANAC 1873 (1873): 139-141.

B461 Beattie, John. "Photography an Aid to Sociology." BRITISH JOURNAL PHOTOGRAPHIC ALMANAC 1874 (1874): 92-95. [Argument for socially committed documentary photography.]

B462 Portrait. Woodcut engraving credited "From a photograph by Beattie, Preston." ILLUSTRATED LONDON NEWS 64, (1874) ["Sir J. Holker, M.P., Solicitor General." 64:1813 (May 23, 1874): 493.]

B463 Beattie, John. "How to Light the Sitter - The Principal Question." BRITISH JOURNAL PHOTOGRAPHIC ANNUAL 1875 (1875): 143-144.

B464 Beattie, John. "Our Foreign Make-Up: Posing and Lighting." PHOTOGRAPHIC TIMES 5, no. 51 (Mar. 1875): 63. [From The "Year Book."]

BEATTY, DAVID. (d. 1868) (USA)
B465 "Suicide of a Photographer." HUMPHREY'S JOURNAL OF PHOTOGRAPHY, AND THE ALLIED ARTS AND SCIENCES 20, no. 13 (Nov. 1, 1868): 199. ["A well known Photo. in Brooklyn, named David Beatty, residing at 49 Myrtle Avenue, committed self-destruction on Saturday evening."]

BEATTY, F. S. see also TALBOT, WILLIAM H. F.

BEATTY, F. S.
B466 Beatty, F. S. "The Photoglypic Process." HUMPHREY'S JOURNAL OF PHOTOGRAPHY, AND THE ALLIED ARTS AND SCIENCES 11, no. 19 (Feb. 1, 1860): 301. [From "Photo. J." Proof of a photoglypic plate (process invented by Wm. H. F. Talbot), of College Green, Dublin, by F. S. Beatty.]

BEAUFORD. (HASTINGS, ENGLAND)

B467 "A Guide to the Great Industrial Exhibition: Daguerreotype Accelerator." ILLUSTRATED LONDON NEWS 19, no. 523 (Oct. 11, 1851): 462. [Mr. Beauford, of Hastings, displayed his device at the Crystal Palace, where it is discussed in this issue.]

BECK, JOSEPH see also SMITH, BECK & BECK.

BECK, JOSEPH. (GREAT BRITAIN)

B468 Beck, Joseph. "On Producing the Idea of Distance in the Stereoscope." BRITISH JOURNAL OF PHOTOGRAPHY 7, no. 125 (Sept. 1, 1860): 257-258.

B469 Beck, Joseph. "On Producing the Idea of Distance in the Stereoscope." HUMPHREY'S JOURNAL OF PHOTOGRAPHY, AND THE ALLIED ARTS AND SCIENCES 12, no. 12 (Oct. 15, 1860): 187-188. [Read to the British Assoc., 1859.]

BECKER, ERNST. (1826-1888) (GERMANY, GREAT BRITAIN)

B470 Adam, Hans Christian. "Dr. Ernst Becker (1826-1888) Amateur-photograph bei Hof." FOTOGESCHICHTE: BEITRAGE ZUR GESCHICHTE UND ASTHETIC DER FOTOGRAFIE 2, no. 6 (1982): 3-10. 6 b & w. 1 illus. [Biographical notes on Prince Albert's German librarian, tutor of the British Royal children, amateur photographer and "family photographer" to the Royal family in the 1850s. Returned to Germany in 1859. His photos in the Royal Archives, Winsor Castle. Portrait by Roger Fenton.]

BECKERS, ALEXANDER. (USA)

B471 "Photographic Section of the American Institute." ANTHONY'S PHOTOGRAPHIC BULLETIN 17, no. 10 (May 22, 1886): 310-314. [Minutes of the meeting of May 4, 1886. Includes a report by H. J. Lewis of the contributions of William Lewis and William H. Lewis (son), who made the first camera and daguerreotype equipment for Wolcott & Johnson, who opened the first daguerreotype portrait studio in America. J. Gurney's early career described as well as those of A. Bogardus and Alexander Beckers.]

B472 Beckers, Alexander. "Fifteen Years' Experience of a Daguerreotyper." ANTHONY'S PHOTOGRAPHIC BULLETIN 20, no. 5 (Mar. 9, 1889): 144-146. [Read before the Society of Amateur Photographers of New York. Beckers saw his first daguerreotype at Robert Cornelius' laboratory in Philadelphia. In 1843 he went to work for Fred Langenheim in Philadelphia. In 1844 went to New York, worked for Edward White, taking the first full-plate daguerreotypes in New York. Worked for White until Dec. 1844, then opened his own studio in New York, under the name of Langenheim & Beckers. In 1845 he photographed the High Bridge at New York while it was under construction; and in 1848 he obtained a sharp picture of a procession in motion. In 1849 the firm changed to Beckers & Piard. In 1854 Langenheim sent him glass stereo views to sell, but Beckers found them easily broken, and in 1857 he patented a revolving stereoscope viewer. This product flourished and demanded his attention, and he sold his daguerreotype business in 1858.]

B473 Beckers, Alexander. "Fifteen Years Experience of A Daguerreotyper." PHOTOGRAPHIC TIMES 19, no. 391 (Mar. 15, 1889): 131-132. [Read before the Society of Amateur Photographers of New York. Describes his career.]

B474 Beckers, Alexander. "My Daguerreotype Experience." ANTHONY'S PHOTOGRAPHIC BULLETIN 20, no. 7 (Apr. 13, 1889): 209-211. [Read before the Photographic Section of the American Institute. Similar but with some changes to the lecture reported in the Mar. 9, 1889 issue.]

B475 Beckers, Alexander. "My Daguerreotype Experience." NORTHLIGHT (JOURNAL OF THE PHOTOGRAPHIC HISTORICAL SOCIETY OF AMERICA) 2, no. 4 (Fall 1975): 12. [Reprint of the "Anthony's Photo. Bulletin" (Apr. 13, 1889) article.]

BECKETT, WILLIAM A.

B476 "Some Camera Curios from Abroad and Away." WILSON'S PHOTOGRAPHIC MAGAZINE 32, no. 466 (Oct. 1895): 453-456. 4 b & w. [1 photo by J. E. Middlebrook from Natal, South Africa, 1 photo by W. V. Alford in Panama, 2 photos by William A. Beckett, who worked as an itinerant photographer in the USA. Beckett born 1850, began photographing in 1876.]

BECKINGHAM, E. (GREAT BRITAIN)

B477 Beckingham, E. "Fine-Art Gossip." ATHENAEUM no. 1519 (Dec. 6, 1856): 1503. [Beckingham's note on the collodion process.]

BECKWITH, MARVIN E. (1823-1887) (USA)

B478 "Obituary: Marvin E. Beckwith." ANTHONY'S PHOTOGRAPHIC BULLETIN 19, no. 2 (Jan. 28, 1888): 53-54. [Born in Erie County, NY, Nov. 24, 1823. Moved to Cleveland, OH in 1839. Tried various trades, then learned the daguerreotype process with Samuel Crobaugh. In 1870 took his son Alva D. Beckwith in partnership. Successful business. Died Dec. 13, 1887.]

BECQUEREL, ANTOINE. (d. 1878) (FRANCE)

B479 "Obituaries - MM. Becquerel and Regnault." ANTHONY'S PHOTOGRAPHIC BULLETIN 9, no. 3 (Mar. 1878): 68. [From "Br J of Photo." Becquerel formerly an officer under Napoleon I, who presented him with the Cross of Chevalier of the Legion of Honor in 1812. Experimented in areas of electro-chemistry. Since 1838 professor in National Museum of Natural Science. Father of Alexandre Edmund Becquerel,(1820-1891) who studied solar spectra and color.]

BECQUEREL, [ALEXANDRE] EDMUND. (1820-1891) (FRANCE)

B480 "Colors Produced by Photography." DAGUERREAN JOURNAL 1, no. 3 (Dec. 2, 1850): 77. [Edmund Becquerel's experiments in 1849 discussed.]

B481 Becquerel. "On the Production of Natural Colours by Light." LIVERPOOL & MANCHESTER PHOTOGRAPHIC JOURNAL [BRITISH JOURNAL OF PHOTOGRAPHY] n. s. 2, no. 5-6 (Mar. 1 - Mar. 15, 1858): 59-60.

B482 Becquerel, M. E. "On the Production of Natural Colors by Light." PHOTOGRAPHIC AND FINE ART JOURNAL 11, no. 11 (Nov. 1858): 348-349. [From "Liverpool & Manchester Photo. J."]

B483 "Photographs in Natural Colors." HUMPHREY'S JOURNAL OF PHOTOGRAPHY, AND THE ALLIED ARTS AND SCIENCES 11, no. 13 (Nov. 1, 1859): 196-197. [Discusses Becquerel's studies.]

B484 "Photography in Natural Colors." HUMPHREY'S JOURNAL OF PHOTOGRAPHY, AND THE ALLIED ARTS AND SCIENCES 11, no. 18 (Jan. 15, 1860): 286-287. [From "Literary Gazette." Becquerel's experiments discussed.]

B485 "Photography in Natural Colors." AMERICAN JOURNAL OF PHOTOGRAPHY AND THE ALLIED ARTS & SCIENCES n. s. vol. 2, no. 15 (Jan. 1, 1860): 233-234. [E. Becquerel's experiments discussed. From "Literary Gazette."]

B486 "Photography in Natural Colors." PHOTOGRAPHIC AND FINE ART JOURNAL 13, no. 3 (Mar. 1860): 58. [From "Literary Gazette." Becquerel's process.]

BEDE, CUTHBERT. [BRADLEY, EDWARD] (1827-1889) (GREAT BRITAIN)
BOOKS
B487 Bede, Cuthbert, B.A. *Photographic Pleasures, Popularly Portrayed with Pen and Pencil*. London: T. McLean, 1855. xii, 88 pp. 70 illus. [Satire. 2nd ed. (1859), London: J. C. Hotten. 3rd ed. (1863), Day & Son.]

B488 Bede, Cuthbert. *The Visitor's Handbook to Rosslyn and Hawthorden*. Edinburgh: R. Grant & Son, 1864. n. p. 16 b & w. [Original photographs.]

B489 Gernsheim, Helmut. "Cuthbert Bede (The Rev. Edward Bradley, 1827-1889), Robert Hunt F.R.S. (1807-1887), and Thomas Sutton (1819-1875)," on pp. 60-67 in: *One Hundred Years of Photographic History. Essays in Honor of Beaumont Newhall*. Edited by Van Deren Coke. Albuquerque, NM: Univ. of New Mexico Press, 1975. 180 pp.

PERIODICALS
B490 "Fine Arts." ATHENAEUM no. 1428 (Mar. 10, 1855): 297. [Bk. rev.: "Photographic Pleasures, popularly portrayed with Pen and Pencil," by Cuthbert Bede. (B. A. M'Lean).]

B491 Henisch, B. A. and H. K. Henisch. "Cuthbert Bede." IMAGE 18, no. 3 (Sept. 1975): 20-25. 6 illus. [Discusses Cuthbert Bede, the author of "Photographic Pleasures," 1855.]

BEDFORD, FRANCIS. (1816-1894) (GREAT BRITAIN)
[Francis Bedford was the son of the noted architect Francis Octavius Bedford, and he joined the family practice as a young man. He exhibited architectural drawings, and by the 1850s he was a lithographer skilled in illustrating books, and specializing in architectural subjects. Regarded as a master in the chromolithographic process. He began to photograph as an amateur about 1852, to aid him in his lithographic work. The work *The Treasury of Ornamental Art* has been described as "probably the first important English work where photography was called into play to assist the draughtsman." In 1854 Queen Victoria commissioned him to photograph objects in the royal collections, and in 1857 Prince Albert commissioned him to make views of his birthplace in Coburg, Bavaria. In 1857 he also photographed the Art Treasures Exhibition in Manchester to provide sources for his chromolithograph illustrations for *Treasures of the United Kingdom*, published in 1858. In 1859 Bedford traveled to North Wales to make stereo landscapes, which he sold through Catherall & Prichard. He continued working in England making views into the early 1860s. In 1861 he was elected Vice-President of the Photographic Society. In 1862, he was invited to join the Prince of Wales on a four month tour of the Near East. Bedford made nearly 150 views on this trip, which he exhibited on his return and then published several books based on of this work. In 1863 Francis returned to photographing in North Wales, and he also documented the wedding presents of the Prince and Princess of Wales at the Marlborough House in that year. Francis photographed in North Wales and in Devonshire annually until 1884, when he relinquished his business to his son William. William (1846-1893) actively assumed much of operations of the family business and himself continued making the many architectural views and landscapes of British scenery. Francis Bedford apparently preferred the wet-plate process and remained with it throughout his entire career.]

BOOKS
B492 *A Chart Illustrating the Architecture of Westminster Abbey*. London: W. W. Robinson, n. d. [1840 ?]. n. p. 1 folded l. of plates.

B493 Monkhouse, W. and Francis Bedford. *The Churches of York;* by W. Monkhouse and F. Bedford, junr; with historical and architectural notes by the Rev. Joshua Fawcett. York : H. Smith, 1843. 3 pp. 43 l. of plates. 48 b & w.

B494 Bedford, Francis. *Sketches of York*. York, England: H. Smith, 1843. n. p.

B495 Bedford, Francis. *A Chart of Anglican Church Architecture: Arranged chronologically with examples of the different styles*. "5th ed." 'York: R. Sunter, 1844. n. p., folded pp. illus.

B496 Wyatt, Matthew Digby, Sir. *Industrial Arts of the Nineteenth Century at the Great Exhibition*. London: Day & son, 1851-1853. n. p. illus. [Over 150 of the lithographic illustrations for this work were created by Bedford.]

B497 Bedford, Francis. *Examples of Ornament. Selected chiefly from Works of Art in the British Museum, Museum of Economic Geology, the Museum of Ornamental Art in Marlborough House, and the new Crystal Palace. Drawn from Original Sources*, by Francis Bedford... and edited by Joseph Cundall. London: Bell & Daldy, 1855. 7 pp. 24 l. of plates. illus.

B498 Jones, Owen. *The Grammar of Ornament...* Illus. by examples from various styles of ornament. One hundred...plates, drawn on stone by Francis Bedford, and printed in colours by Day and Son. London: Day & Son, 1856. pp. 100 l. of plates. [Essays on the ornament of the Renaissance and the Italian periods by M. D. Wyatt, etc.]

B499 Bedford, Francis. *The Treasury of Ornamental Art*. Illustrations of objects of art and virtu, photographed from the originals and drawn on stone by F. Bedford, with descriptive notices by Sir John C. Robinson. London : Day & Son, 1857. 145 pp. 70 l. of plates. illus.

B500 Waring, J. B., ed. *Treasures of the United Kingdom; from the Art Treasures Exhibition, Manchester*. Chromo-lithographed by F. Bedford. The drawings on wood by R. Dudley, with essays by O. Jones, M. D. Wyatt, A. W. Franks, J. B. Waring, J. C. Robinson, G. Scharf Jun. London : s. n., 1858. n. p. illus.

B501 Bedford, Francis. *A Guide to Warwick, Kenilworth, Stratford-on-Avon, Coventry and the various places of interest in the neighborhood*. Warwick: H. T. Cooke & Son, n. d. 142 pp.

B502 Howitt, William & Mary Howitt. *Ruined Abbeys and Castles of Great Britain...* The photographic illustrations by Bedford, Sedgfield, Wilson, Fenton, and others. London: Alfred W. Bennett, 1862. viii, 228 pp. 27 b & w. [Original photos.]

B503 *Photographic Pictures made by Mr. Francis Bedford during the Tour in the East, in which, by command, he accompanied H. M. H. the Prince of Wales*. London: Day & Son, 1863. 3 vol. 172 b & w. [No. 1, "Egypt," 48 b & w; No. 2, "The Holy Land and Syria," 76 b & w; No. 3, "Constantinople, the Mediterranean & Athens," 48 b & w.]

B504 *History of the Recent Discoveries at Cyrene, made during an expedition to the Cyrenaica in 1860 - 61 under the auspices of Her Majesty's Government by Capt. R. Murdock Smith and Commander*

E. A. Porcher. London: Day & Son, 1864. n. p. 16 b & w. illus. [Sixteen original photographs by Francis Bedford and lithographs.]

B505 Howitt, William and Mary Howitt. *The Wye: Its Ruined Abbeys and Castles; Extracted from "The Ruined Abbeys and Castles of Great Britain"* by Wm. & M. Howitt. The photographic Illustrations by Bedford and Sedgfield. London: Alfred W. Bennett, 1863. n. p. 6 b & w. [Four original photographs by Francis Bedford, two by Russell Sedgfield.]

B506 Howitt, William and Mary Howitt. *The Ruined Castles of North Wales;* With photographic illustrations by Bedford, Sedgfield and Ambrose. London: Alfred W. Bennett, 1864. n. p. 6 b & w. [Original photos.]

B507 Newton, Sir Charles Thomas. *Travels and Discoveries in the Levant.* London: Day & Son, 1865. 2 vol. 10 illus. [Ten photo-lithographs by Francis Bedford, after drawings by Lady Newton.]

B508 Mott, Augusta. *The Stones of Palestine; Notes of a Ramble Through the Holy Land...* Illus. with photographs by F. Bedford. London: Seeley, Jackson & Halliday, 1865. viii, 88 pp. 12 b & w. [Original photographs.]

B509 Bedford, Francis. *The Holy Land, Egypt, Constantinople, Athens, etc, etc.* A series of forty-eight photographs taken by Francis Bedford for H. R. H. the Prince of Wales during the tour of the East, in which, by command, he accompanied his Royal Highness, with descriptive letterpress and interp. by W. M. Thomson. London: Day & Son, 1866. 2 vol. 48 l. of plates. 48 b & w. [Volume one contains viii, 99 pages of text. Volume two consists of 48 original photographs.]

B510 Bedford, Francis. *Photographic Views, of Beddgelest,* by Francis Bedford. Photographer to H. R. H. the Prince of Wales during the tour of the East. Chester: Catherall & Prichard, n. d. [ca. 1868]. 10 l. of plates. 10 b & w. [10 mounted prints. Title page, but no texts with the photos.]

B511 Bedford, Francis. *Photographic Views, of Bristol and Clifton,* by Francis Bedford. Photographer to H. R. H. the Prince of Wales during the tour of the East. Chester: Catherall & Prichard, n. d. [ca. 1868]. 16 l. of plates. 16 b & w. [16 mounted prints. Title page, but no texts with the photos. Another edition, 10 b & w.]

B512 Bedford, Francis. *Photographic Views, of Chester,* by Francis Bedford. Photographer to H. R. H. the Prince of Wales during the tour of the East. Chester: Catherall & Prichard, n. d. [ca. 1868]. 10 l. of plates. 10 b & w. [10 mounted prints. Title page, but no texts with the photos.]

B513 Bedford, Francis. *Photographic Views, of Devonshire,* by Francis Bedford. Photographer to H. R. H. the Prince of Wales during the tour of the East. Chester: Catherall & Prichard, n. d. [ca. 1868]. 20 l. of plates. 20 b & w. [20 mounted prints. Title page, but no texts with the photos.]

B514 Bedford, Francis. *Photographic Views, of Exeter,* by Francis Bedford. Photographer to H. R. H. the Prince of Wales during the tour of the East. Chester: Catherall & Prichard, n. d. [ca. 1868]. 10 l. of plates. 10 b & w. [10 mounted prints. Title page, but no texts with the photos.]

B515 Bedford, Francis. *Photographic Views, of Ilfracombe,* by Francis Bedford. Photographer to H. R. H. the Prince of Wales during the tour

of the East. Chester: Catherall & Prichard, n. d. [ca. 1868]. 10 l. of plates. 10 b & w. illus. [10 mounted prints. Title page, but no texts with the photos.]

B516 Bedford, Francis. *Photographic Views, of North Devonshire,* by Francis Bedford. Photographer to H. R. H. the Prince of Wales during the tour of the East. Chester: Catherall & Prichard, n. d. [ca. 1868]. 15 l. of plates. 15 b & w. [15 mounted prints. Title page, but no texts with the photos.]

B517 Bedford, Francis. *Photographic Views, of North Wales,* by Francis Bedford. Photographer to H. R. H. the Prince of Wales during the tour of the East. Chester: Catherall & Prichard, n. d. [ca. 1868]. 30 l. of plates. 30 b & w. [30 mounted prints. Title page, but no texts with the photos.]

B518 Bedford, Francis. *Photographic Views, of South Devon,* by Francis Bedford. Photographer to H. R. H. the Prince of Wales during the tour of the East. Chester: Catherall & Prichard, n. d. [ca. 1868]. 15 l. of plates. 15 b & w. [15 mounted prints. Title page, but no texts with the photos.]

B519 Bedford, Francis. *Photographic Views, on Stratford-on-Avon and Neighborhood,* by Francis Bedford. Photographer to H. R. H. the Prince of Wales during the tour of the East. Chester: Catherall & Prichard, n. d. [ca. 1868]. 10 l. of plates. 10 b & w. [10 mounted prints, about 4"x4". Title page, but no texts with the photos.]

B520 Bedford, Francis. *Photographic Views, of Tenby and Neighborhood,* by Francis Bedford. Photographer to H. R. H. the Prince of Wales during the tour of the East. Chester: Catherall & Prichard, n. d. [ca. 1868]. 16 l. of plates. 16 b & w. [16 mounted prints. Title page, but no texts with the photos.]

B521 Bedford, Francis. *Photographic Views of Warwickshire;* by Francis Bedford. Photographer to H. R. H. the Prince of Wales during the tour in the East. Chester: Catherall & Prichard, n. d. [ca. 1868]. 16 l. of plates. 16 b & w. [16 photographs, each plate bearing a title plus a number. The numbers run from 591 to 657, but with gaps in the numbering. Photos about 4"x6". Views, with people.]

B522 Bedford, Francis. *Pictorial Illustrations of Torquay and Its Neighborhood.* Chester: Catherall & Pritchard, n. d. [ca. 186-?]. 26 pp. 30 b & w. [30 original photographs. Scenery and views.]

B523 *Two Victorian Photographers: Francis Frith, 1822 - 1898 and Francis Bedford, 1816 - 1894;.* From the Collection of Dan Berley. Brockport, NY: State University of New York at Brockport, 1976. 24 pp. [Exhibition: Fine Arts Gallery, SUNY at Brockport, Sept. 19 - Oct. 11, 1976.]

PERIODICALS
B524 "Note." ART JOURNAL (Apr. 1860): 126. [Photographs and stereoscopic views of scenes in North Wales by Mr. F. Bedford have been issued by Messrs. Catherall & Prichard of Chester.]

B525 "Critical Notices: North Wales Illustrated. A series of views by Francis Bedford." PHOTOGRAPHIC NEWS 4, no. 120 (Dec. 21, 1860): 400-401. ["Chester Illustrated" noted on p. 401.]

B526 "Our Weekly Gossip." ATHENAEUM no. 1730 (Dec. 22, 1860): 874. [Praise for "a dozen stereoscopic views of Chester and North Wales, photographed by Mr. Bedford, and published by Mssrs. Catherall & Pritchard."]

B527 "Stereographs: Chester and North Wales Illustrated, by Francis Bedford." BRITISH JOURNAL OF PHOTOGRAPHY 7, no. 132 (Dec. 15, 1860): 368-369.

B528 "Photographic Engraving of Blocks, To Be Printed with Ordinary Letterpress. The Invention of Mr. Paul Pretsch." BRITISH JOURNAL OF PHOTOGRAPHY 7, no. 131 (Dec. 1, 1860): 347. 1 illus. [Photo by Francis Bedford, of Dorer Castle, reproduced by Pretsch's engraving process.]

B529 "Stereographs. North Wales and Chester Illustrated, by Francis Bedford. Chester: Catherall & Prichard." BRITISH JOURNAL OF PHOTOGRAPHY 8, no. 147 (Aug. 1, 1861): 272-273.

B530 "Notes." JOURNAL OF THE PHOTOGRAPHIC SOCIETY OF LONDON 7, no. 118 (Feb. 15, 1862): 368. [Bedford is to accompany His Royal Highness the Prince of Wales on his eastern tour....]

B531 "Eastward Ho!" BRITISH JOURNAL OF PHOTOGRAPHY 9, no. 160 (Feb. 15, 1862): 66. [Note that Bedford accompanying the Prince of Wales on his tour of the East.]

B532 "Miscellaneous Items: The Prince of Wales and Photography." AMERICAN JOURNAL OF PHOTOGRAPHY AND THE ALLIED ARTS & SCIENCES n. s. vol. 4, no. 19 (Mar. 1, 1862): 454-455. [From "Photo. News." Note that Francis Bedford, one of only eight gentlemen accompanying the Prince of Wales on his eastern tour.]

B533 "Review: Ruined Abbeys and Castles." JOURNAL OF THE PHOTOGRAPHIC SOCIETY OF LONDON 8, no. 121 (May 15, 1862): 57. [Bk. rev.: "Ruined Abbeys and Castles of Great Britain," by William and Mary Howitt. The Photographic Illustrations by Bedford, Sedgfield, Wilson, Fenton and others.]

B534 "The Prince of Wale's Visit to Egypt: His Royal Highness Examining the Negative Taken by Mr. Bedford, Photographist, at Philae." ILLUSTRATED LONDON NEWS 40, no. 1143 (May 10, 1862): 466, 488. 1 illus.

B535 "Note." JOURNAL OF THE PHOTOGRAPHIC SOCIETY OF LONDON 8, no. 123 (July 15, 1862): 97. ["Has returned from his Eastern tour in company with His Royal Highness... 200 negs. 12 x 10 plates."]

B536 "Mr. Bedford's Exhibition of Photographs (taken by command) of the Tour of his Royal Highness the Prince of Wales." JOURNAL OF THE PHOTOGRAPHIC SOCIETY OF LONDON 8, no. 124 (Aug. 15, 1862): 102-103.

B537 "Exhibitions: H. R. H. the Prince of Wales' Tour in the East, Photographically Recorded by Francis Bedford." BRITISH JOURNAL OF PHOTOGRAPHY 9, no. 171 (Aug. 1, 1862): 288. [German Gallery, London.]

B538 "Note." ART JOURNAL (Oct. 1862): 211. [Mr. Bedford's photographs of Egypt and the Holy Land.]

B539 "Jerusalem from the Mount of Olives - Principal Entrance to the Sultan's New Palace at Constantinople." ILLUSTRATED LONDON NEWS 41, no. 1175 (Nov. 22, 1862): 550, 552. 2 illus. ["From a photograph by Mr. F. Bedford, who accompanied the Prince of Wales in his tour of the East."]

B540 "Our Photo-Electric Engraving." PHOTOGRAPHIC NEWS 8, no. 278 (Jan. 1, 1864): frontispiece, 1-2. [Photoelectric engraving of landscape by F. Bedford.]

B541 "Note." ART JOURNAL (Feb. 1864): 58. [Stereo views of Stratford-on-Avon. 17 photos in the series. Mentions other series, total 247 stereo views.]

B542 "Critical Notices: Stereographs of English Scenery. By Frances Bedford. Chester: Catheral and Pritchard." PHOTOGRAPHIC NEWS 8, no. 289 (Mar. 18, 1864): 136.

B543 "Stereographs: English Scenery. Photographed by Francis Bedford." BRITISH JOURNAL OF PHOTOGRAPHY 11, no. 210 (Mar. 15, 1864): 99-100.

B544 Macleod, Norman, D.D. "Eastward." GOOD WORDS 6, no. 1-12 (Jan. - Dec. 1865): 33-40, 113-123, 233-241, 286-295, 389-396, 525-542, 587-601, 665-677, 753-764, 823-834, 914-924. 70 illus. [Macleod, the editor of the magazine, toured through the Near East and wrote about these travels through Malta, Egypt, Jerusalem and Palestine. All illustrated with woodcuts credited "From a Photograph." Several images credited to a specific photographer, e.g. "From a Photograph by Francis Bedford," on p. 393. The majority of the photos of Palestine, including several panoramic views of Jerusalem, are credited to James Graham.]

B545 "Note." ART JOURNAL (June 1865): 194. [Photos & stereo slides of Hereford Cathedral, by Bedford et al. Catherall & Pritchard, Chester, is the distributor.]

B546 Macleod, Norman, D.D. "Homeward." GOOD WORDS 7, no. 2-5 (Feb. - May 1866): 104-109, 172-180, 267-278. 8 illus. [Reports of a return journey through Russia, Near East. Woodcut views "from photographs." Four views in the May issue of Constantinople, etc. credited "From a Photograph by F. Bedford."]

B547 "Short Notices: Bedford's Photographs of the Holy Land, etc." FINE ARTS, A QUARTERLY REVIEW (Jan. 1867): 208. [Book review: "The Holy Land, Egypt, Constantinople etc.," by Francis Bedford.]

B548 Bedford, Francis. "Landscape Photography and its Trials." YEARBOOK OF PHOTOGRAPHY AND PHOTOGRAPHIC NEWS ALMANAC (1867): 23.

B549 Bedford, Francis. "Landscape Negatives, and Some Hints for Their Improvement." YEARBOOK OF PHOTOGRAPHY AND PHOTOGRAPHIC NEWS ALMANAC (1868): 24-25.

B550 "Minor Topics of the Month." ART JOURNAL (Jan. 1870): 29. [Bedford "recently visited" Worwick to take views.]

B551 Bedford, Francis. "Photography Applied to Architecture." YEARBOOK OF PHOTOGRAPHY AND PHOTOGRAPHIC NEWS ALMANAC (1873): 21.

B552 Bedford, Francis. "Landscape Photography and Its Trials." PHILADELPHIA PHOTOGRAPHER 13, no. 148 (Apr. 1876): 118-119. [Abstracted from the "Yearbook of Photography".]

B553 "Mr. Francis Bedford at Camden Road." PHOTOGRAPHIC NEWS 24, (Apr. 23, 1880): 195.

B554 "Francis Bedford." PHOTOGRAPHIC JOURNAL n.s. vol. 18, no. 9 (May 1894): 225. [Died May 15, 1894 at his residence 326,

Camden Road, N., at age 78. Elected to RPS in 1857, became a member of Council in 1857, and served to 1887. His son William, took his place after Francis retired from active photographic work "some years since." William died "some sixteen months ago."]

B555 "Francis Bedford." PHOTOGRAPHY: THE JOURNAL OF THE AMATEUR, THE PROFESSION & THE TRADE 6, no. 290 (May 31, 1894): 349-350. [Detailed, affectionate obituary.]

B556 "Notes and News." PHOTOGRAPHIC TIMES 24, no. 665 (June 15, 1894): 382. [Brief note that Bedford died.]

B557 Jay, Bill. "Francis Bedford, 1816 - 1894." UNIVERSITY OF NEW MEXICO BULLETIN OF ART no. 7 (1973): 16-21.

B558 "Photographic Pictures of Egypt, the Holy Land and Syria, Constantinople, The Mediterranean, Athens, Etc. taken during the Tour of the East in why, by Command, Mr. F. Bedford accompanied H.R.H. the Prince of Wales." PHOTOGRAPHIC COLLECTOR 3, no. 1 (Spring 1982): 106-107. [Facsimile reprint of Bedford's sales catalog of this series, listing 172 views.]

B559 Spencer, Stephanie. "Francis Bedford's Photographs of North Wales: Selection and Interpretation." HISTORY OF PHOTOGRAPHY 11, no. 3 (July - Sept. 1987): 237-245. 7 b & w. 2 illus.

BEDFORD, WILLIAM. (1846-1893) (GREAT BRITAIN)
[Son of Francis Bedford, Chairman of the Photographers' Benevolent Association, knowledgeable in the art of photography. Took over much of the family firm's activities by the late 1860s, including the making of views, etc., but died a year before his more famous father.]

B560 Bedford, William. "Improvement of Negatives." BRITISH JOURNAL PHOTOGRAPHIC ALMANAC 1873 (1873): 106.

B561 Bedford, William. "An Automatic Syphon." BRITISH JOURNAL PHOTOGRAPHIC ALMANAC 1874 (1874): 83-84. 2 illus.

B562 Bedford, William. "The Best Light for Toning." BRITISH JOURNAL PHOTOGRAPHIC ANNUAL 1875 (1875): 70-71.

B563 Bedford, William. "Transparencies for the Stereoscope and Lantern." BRITISH JOURNAL PHOTOGRAPHIC ALMANAC 1877 (1877): 46-48.

B564 Bedford, William. "Note on Washed Emulsion." BRITISH JOURNAL PHOTOGRAPHIC ALMANAC 1878 (1878): 55-56.

B565 "Notes and News: William Bedford." PHOTOGRAPHIC TIMES 23, no. 596 (Feb. 17, 1893): 88. ["Bedford, late President of the Photographic Convention of the United Kingdom at Great Britain, died of typhoid fever, January 13th, in the 46th year of his age."]

BEEBE, J. H. (USA)
B566 "Prize Print Hints." PHILADELPHIA PHOTOGRAPHER 15, no. 171 (Mar. 1878): 65-68. [Competitor in the "Phila. Photog." Gold Medal Prize, describing his working methods, etc.]

BEECHER, A. P. (PHILADELPHIA, PA)
B567 "The Photo-Miniature. Beecher's Formula." HUMPHREY'S JOURNAL OF PHOTOGRAPHY, AND THE ALLIED ARTS AND SCIENCES 17, no. 18 (Jan. 15, 1866): 279-280.

BEECHEY, ST. VINCENT see also LANGTON, ROBERT.

BEECHEY, ST. VINCENT, REV. CANON.
B568 Beechey, St. Vincent. "Photography Applied to Engraving on Wood." ART JOURNAL (Aug. 1854): 244. 1 illus. [Engraving of the moon.]

B569 Beechey, Rev. St. Vincent. "Photography Applied to Engraving on Wood." HUMPHREY'S JOURNAL 6, no. 10 (Sept. 1, 1854): 151-152. [From "London Art J."]

B570 "Photography Applied to Engraving On Wood." PHOTOGRAPHIC AND FINE ART JOURNAL 7, no. 9 (Sept. 1854): 284-285. 1 illus. [From "London Art J." Includes a letter from St. Vincent Beechey and a wood engraving from a block created by Robert Langton, Manchester. Discussion of the difficulties associated with this operation.]

B571 Beechey, Canon. "Carbon Printing for Amateurs." BRITISH JOURNAL PHOTOGRAPHIC ALMANAC 1877 (1877): 79-84. 1 illus.

B572 Beechey, Rev. Canon. "To Light - An Ode." BRITISH JOURNAL PHOTOGRAPHIC ALMANAC 1878 (1878): 193-196. [Poem.]

B573 Beechey, Rev. Canon. "Beechey, Dry Plates: Their Preparation, Properties, and Defects." BRITISH JOURNAL PHOTOGRAPHIC ALMANAC 1879 (1879): 43-47. 1 illus.

BEEGLE, S. D.
B574 Beegle, S. D. "Fuming before Silvering." HUMPHREY'S JOURNAL OF PHOTOGRAPHY, AND THE ALLIED ARTS AND SCIENCES 16, no. 18 (Jan. 15, 1865): 285.

BEER, M. S.
B575 "Robbing a Photo." HUMPHREY'S JOURNAL OF PHOTOGRAPHY, AND THE ALLIED ARTS AND SCIENCES 19, no. 21 (Mar. 1, 1868): 334. [Beer's assistant robbed of a heavy bag of chemicals, in broad daylight.]

BEER, S. (NEW YORK, NY)
B576 "Editor's Table." PHILADELPHIA PHOTOGRAPHER 4, no. 43 (July 1867): 234. [Stereos of interiors by S. Beer at 142 1/2 East Broadway, New York, NY.]

B577 "Photographing Interiors." PHILADELPHIA PHOTOGRAPHER 4, no. 44 (Aug. 1867): 249.

BEERE, DANIEL MANDERS. (1833-1909) (GREAT BRITAIN, CANADA, NEW ZEALAND)
B578 "View of the Accident taken N. W. from Hamilton Bay, Suspension Bridge in the Background. From a Photograph by D. C. [sic M.?] Beere, Esq." FRANK LESLIE'S ILLUSTRATED NEWSPAPER 3, no. 69 (Apr. 4, 1857): 272-273. 4 illus. [Views. Only one is from a photograph.]

B579 "1 engraving ("Scene of the recent accident on the Great Western Railway, near Hamilton, Canada West.")." ILLUSTRATED LONDON NEWS 30, no. 862 (Apr. 4, 1857): 323. 1 illus. [Not credited, but identified by J. M. Schwartz in "Archivaria," 25 (Winter 1987-88): 151.]

B580 Sullivan, John. "Correspondence: Daniel Manders Beere." HISTORY OF PHOTOGRAPHY 6 , no. 1 (Jan. 1982): 83. [More information about D. M. Beere. See "History of Photography" 5:2.]

B581 Schwartz, Joan M. "Daniel Manders Beere." HISTORY OF PHOTOGRAPHY 8, no. 2 (Apr. - June 1984): 77-82. 6 b & w. 3 illus.

[Beere worked in Canada during the 1850s, 1860s with the firms Armstrong & Beere, Armstrong, Beere & Hime. He then went to New Zealand, worked there from 1863 to the 1880s.]

BEERS & MANSFIELD.
B582 Portrait. Woodcut engraving, credited "Photographed by Beers & Mansfield." FRANK LESLIE'S ILLUSTRATED NEWSPAPER 21, (1866) ["Dr. Edwin Harwood, Rector, Trinity Church, New York, NY." 21:546 (Mar. 17, 1866): 405.]

BEERS, W. A. (1837-) see BEERS & MANSFIELD.

BELHOMME.
B583 "Modification of the Panoramic Camera." PHOTOGRAPHIC AND FINE ART JOURNAL 10, no. 2 (Feb. 1857): 45. [Belhomme's modifications of Martens techniques.]

BELL & BROTHER. (WASHINGTON, DC)
B584 "The Corcoran Art Depository, Washington, D.C." HARPER'S WEEKLY 13, no. 648 (May 29, 1869): 340. 1 illus. ["Photographed by Bell & Brother, Washington, D.C." View.]

BELL, CHARLES MILTON. (1848-1893) (USA)
B585 "Art Photography." ANTHONY'S PHOTOGRAPHIC BULLETIN 9, no. 10 (Oct. 1878): 316. [From "Baltimore Times." Mr. C. B. [sic M?] Bell (Washington, DC) "established there in 1873, having gained 10 years experience in some of the most noted galleries in New York and other eastern cities."]

B586 Portrait. Woodcut engraving, credited "Photographed by Bell, of Washington, D. C." FRANK LESLIE'S ILLUSTRATED NEWSPAPER 37, (1874) ["Hon. W. Crutchfield, U. S. Rep. from TN." 37:954 (Jan. 10, 1874): 301.]

B587 Portrait. Woodcut engraving, credited "From a Photograph by C. M. Bell, Washington, D. C." FRANK LESLIE'S ILLUSTRATED NEWSPAPER 46, (1878) ["M. Francis Berger, Council-General of Luxembourg." 46:1186 (June 12, 1878): 272.]

B588 Portrait. Woodcut engraving, credited "From a Photograph by C. M. Bell, Washington." FRANK LESLIE'S ILLUSTRATED NEWSPAPER 48, (1879) ["Mrs. Belva A. Lockwood." 48:1227 (Apr. 5, 1879): 65.]

B589 Taylor, J. Traill. "The Studios of America. No. 9. C. M. Bell's Gallery, Washington, D. C." PHOTOGRAPHIC TIMES 13, no. 153 (Sept. 1883): 474. [A very large gallery at nos. 459-465 Pennsylvania Ave. Part of this studio had earlier been the former Whitehurst studio.]

B590 "The Recent Frightful Calamity in Washington, D. C. and its Victims." FRANK LESLIE'S ILLUSTRATED NEWSPAPER 70, no. 1796 (Feb. 15, 1890): cover, 33, 39. 7, engravings from photos illus. [4 views of ruins of Sect. Tracy's Residence by C. M. Bell, 3 portraits (taken earlier) by Alva Pearsall.]

B591 "Representative Roswell P. Flower Tells Some of His Democratic Colleagues of a "Trap" He had Set for Certain Republicans of the House. Photo by Bell." FRANK LESLIE'S ILLUSTRATED NEWSPAPER 71, no. 1830 (Oct. 11, 1890): 166. 1 b & w. [Posed group portrait, but the group told to pretend to be in animated conversation.]

B592 1 photo ("James Gillespie Blaine, Sec. of State"). ILLUSTRATED AMERICAN 5, no. 49 (Jan. 24, 1891): 390. ["From a photograph by C. M. Bell, Washington, D. C."]

B593 1 photo (the Late David D. Porter, Admiral of the U.S. Navy). ILLUSTRATED AMERICAN 6, no. 54 (Feb. 28, 1891): 69.

B594 "Burial of the Late Admiral David D. Porter, H. Arlington, Va. - Performing the Last Rites - Photo by Bell." FRANK LESLIE'S ILLUSTRATED NEWSPAPER 72, no. 1851 (Mar. 7, 1891): 80. 1 b & w.

B595 "The Seven Sioux Warriors Lately On A Mission to Washington - Photo by C. M. Bell, Washington, D. C." FRANK LESLIE'S ILLUSTRATED NEWSPAPER 72, no. 1851 (Mar. 7, 1891): 89. 1 b & w.

B596 "The Late General Joseph E. Johnston, The Last Prominent Confederate General. Photo by Bell." FRANK LESLIE'S ILLUSTRATED NEWSPAPER 72, no. 1855 (Apr. 4, 1891): 148, 151. 1 b & w.

B597 "A Notable Family - From a Photograph by C. M. Bell." FRANK LESLIE'S ILLUSTRATED NEWSPAPER 72, no. 1871 (July 25, 1891): cover, 427. 1 b & w. 1 illus. [Wood engraving from photograph, of four members of the prominent Field family.]

B598 Bache, Rene. "The Government in War Time." COSMOPOLITAN 25, no. 3 (July 1898): 255-263. 8 b & w. [Portraits of American government officials in their studies, etc. "From a photograph by C. M. Bell."]

B599 1 photo (George B. Cortelyou, Dept. of Labor). WORLD'S WORK 5, no. 6 (Apr. 1903): 3260.

B600 1 photo (Congressman E. F. Loud). WORLD'S WORK 7, no. 2 (Dec. 1903): 4254.

B601 1 photo (Congressman Charles E. Townsend). WORLD'S WORK 9, no. 6 (Apr. 1905): 5998.

B602 1 photo (Theodore Shonts, Chairman, Panama Canal Commission). WORLD'S WORK 10, no. 1 (May 1905): 6111.

B603 1 b & w (Edward Everett Hale). OUTLOOK 80, no. 1 (May 6, 1905): 70. 1 b & w. ["From a new portrait by C. M. Bell, Washington."]

BELL, E. Y.
B604 Bell, E. Y. "Fourth Annual Meeting and Exhibition of the N. P. A. in St. Louis, Mo., May 1872: Address." PHILADELPHIA PHOTOGRAPHER 9, no. 102 (June 1872): 191-196.

BELL, H. F. (WESTVILLE, VA)
B605 "Correspondence." PHOTOGRAPHER'S FRIEND 2, no. 1 (Jan. 1872): 28. [Letter from Bell about fixing a skylight.]

BELL, THOMAS.
B606 Bell, Thomas, F. R. S. "Method of Mounting Waxed-Paper Negatives on Glass, and Varnishing Them." HUMPHREY'S JOURNAL OF PHOTOGRAPHY, AND THE ALLIED ARTS AND SCIENCES 10, no. 22 (Mar. 15, 1859): 352. [From "London Photo. J."]

BELL, WILLIAM. (d. 1888) (USA)
B607 "Note." PHILADELPHIA PHOTOGRAPHER 17, no. 203 (Nov. 1880): 345.["Mr. William Bell, photographer, Cincinnati, Ohio, committed suicide by blowing out his brains. He had shown signs of a disordered mind for some time, by becoming violently excited upon various trivial occasions."]

BELL, WILLIAM ABRAHAM. (1839-1915) (GREAT BRITAIN)
BOOKS

B608 Bell, William A. "Ten Days Journey in Southern Arizona," on pp. 142-148 in: *Illustrated Travels: A Record of Discovery, Geography, and Adventure.* With engravings from original drawings by celebrated artists. Edited by Henry Walter Bates. London; New York: Cassell, Petter, & Galpin, 1869-1875 . 6 vol. Bell's essay in volume 1.]

B609 Bell, William A. with contributions by General W. J. Palmer, Major A. R. Calhoun, C. C. Parry and Capt. W. F. Colton. *New Tracks in North America: A Journal of Travel and Adventure whilst engaged in a Survey for a Southern Railroad to the Pacific Ocean during 1867 - 68.* London; New York: Chapman & Hall; Scribner, Welford, 1869. 2 vol. illus. [2nd ed. (1870) xix; 564 pp. In: "Nineteenth Century American Literature on Microfiche. Series C: The Trans-Mississippi West."]

B610 Bell, William A. *A Paper on the Colonies of Colorado in their Relationship to English Enterprise and Settlement.* London: Chapman & Hall, Labour News Office, 1874. 70 pp. [Published with William Jackson Palmer's "The Westward Current of Population in the United States."]

B611 Bell, William A. *Wonderful Adventures; A Series of Narratives of Personal Experiences among the Native Tribes of America.* With forty-five Illustrations. London; New York: Cassell, Petter & Galpin, 1874 [?]. 313 pp. illus.

PERIODICALS
B612 "Late Indian Outrages." HARPER'S WEEKLY 11, no. 552 (July 27, 1867): 468. 5 illus. [Three sketches of fighting between Cheyenne Indians and settlers, photo of Fort Wallace, Kansas, and a photo of the dead and mutilated Sergeant Willyams. The photos credited to "Major A. R. Calhoun and Dr. Bell, who are associated with General Wright, now en route to make surveys in New Mexico, Arizona, California for the Union Pacific Railroad."]

B613 Browne, John C. "Photography on the Plains. Engineer's Camp. Smokey Hill River near Salina, Kansas." PHILADELPHIA PHOTOGRAPHER 4, no. 44 (Aug. 1867): 266-268. [States that the photographer of the Party will be Dr. Bell.]

BELL, WILLIAM H. see also GUTEKUNST.

BELL, WILLIAM H. (1830-1910) (GREAT BRITAIN, USA)
BOOKS
B614 Otis, George A. *Drawings, Photographs and Lithographs Illustrating the Histories of Seven Survivors of the Operation of Amputation at the Hip Joint, Together with Abstracts of these Seven Successful Cases.* Washington, DC: Surgeon General's Office, 1867. n. p. b & w. illus.

B615 Peabody Institute of the City of Baltimore. *The Founder's Letters and the Papers Relating to its Dedication and its History. Up to the 1st January, 1868.* Baltimore: Board of Trustees, Peabody Institute, 1868. 146 pp. 2 b & w. [Original photographs, copyrighted to W. H. Bell, in the District Court of the District of Columbia.]

B616 Wheeler, George Montague. *Progress-Report Upon Geographical and Geological Explorations and Surveys West of the One Hundredth Meridan, in 1872;* Under the Direction of Brig.- Gen. A. A. Humphreys, Chief of Engineers, United States Army, by First Lieut. George M. Wheeler. Washington, DC: Government Printing Office, 1874. 56 pp. 5 l. of plates. illus.

B617 U. S. Army, Corps of Engineers. *Photographs showing Landscapes, Geological and Other Features, of Portions of the Western Territory of the United States; Obtained in Connection with Geographical and Geological Explorations and Surveys West of the 100th Meridian. Seasons of 1871, 1872, 1873. 1st Lieut. George M. Wheeler, Corps of Engineers, U. S. Army.* Washington, DC: Government Printing Office, 1874. ii, 100 pp. 50 b & w. illus. [50 plates, 35 from photographs by Timothy H. O'Sullivan for 1871 and 1873 and 15 from photographs by William Bell for 1872. Atlas volume for the 6 volume "Report upon Geographical and Geological Explorations and Surveys West of the One Hundredth Meridian," published in volumes from 1875 to 1879.]

B618 United States. Geological Surveys West of the 100th Meridian. *Report upon United States Geological Surveys West of the One Hundredth Meridian; In Charge of First Lieut. Geo. M. Wheeler,* Under the Direction of the Chief of Engineers, U. S. Army. Published by Authority of the Secretary of War in accordance with acts of Congress of June 28, 1874, and February 15, 1875. In Seven Volumes and One Supplement, Accompanied by One Topographic and One Geologic Atlas. Washington, DC: Government Printing Office, 1875-1889. 7 vol. in 8, illus.

B619 Pitts, Terence R. *William Bell: Philadelphia Photographer.* Tucson, AZ: Department of Art, 1987. 114 pp. illus. [Master of Arts Thesis: University of Arizona, 1987.]

PERIODICALS
B620 "Government Photography." PHILADELPHIA PHOTO GRAPHER 3, no. 31 (July 1866): 214-215. [Report on the Federal government's use of photography. Army Medical Museum: William Bell. Treasury Department: L. E. Walker. Chief Examiner of Patent Office: Titian R. Peale (an amateur).]

B621 "Editor's Table." PHILADELPHIA PHOTOGRAPHER 3, no. 35 (Nov. 1866): 358. [L. E. Walker and Wm. Bell, of the Medical Museum, sent in a view of the Capitol, Washington, DC.]

B622 "Our Picture." PHILADELPHIA PHOTOGRAPHER 4, no. 43 (July 1867): frontispiece, 231-232. 1 b & w. [Views of the U. S. Capitol buildings, Washington, DC.]

B623 "The Use of Cyanide of Silver in Collodion." PHILADELPHIA PHOTOGRAPHER 5, no. 49 (Jan. 1868): 18-19. [William Bell, Photographer, Army Medical Museum. Washington, DC, Dec. 6, 1867.]

B624 Bell, William. "Albumen Opalotypes." PHILADELPHIA PHOTOGRAPHER 5, no. 50 (Feb. 1868): 40-41.

B625 "Voices from the Craft." PHILADELPHIA PHOTOGRAPHER 5, no. 54 (June 1868): 211-212. [Letter claiming to fight the Wing & Ormsbee patent sliding plate holder - vs. Schoonmaker, Pine and Bell. Signed by G. W. Price, C. C. Schoonmaker, Wm. H. Bell.]

B626 Bell, William. "Mixture for Retouching Negatives." PHILADELPHIA PHOTOGRAPHER 5, no. 55 (July 1868): 234.

B627 Bell, William. "'Aux Deux Crayons' or Tinted Photographs." PHILADELPHIA PHOTOGRAPHER 6, no. 62 (Feb. 1869): 53.

B628 "Editor's Table." PHILADELPHIA PHOTOGRAPHER 6, no. 62 (Feb. 1869): 63. [Note that Wm. Bell established a business at 1200 Chestnut St., Philadelphia, PA.]

B629 Bell, William. "Improved Albumen Process for Opalotypes." PHILADELPHIA PHOTOGRAPHER 6, no. 62 (Feb. 1869): 43-44.

B630 "Editor's Table." PHILADELPHIA PHOTOGRAPHER 6, no. 70 (Oct. 1869): 356. ["Porcelain" photos taken by Bell, agent for Mr. E. G. Fowx, of Baltimore, MD, for this process.]

B631 Bell, William. "Recovery of Gold from Used Solutions." PHILADELPHIA PHOTOGRAPHER 6, no. 71 (Nov. 1869): 369-370.

B632 "Editor's Table." PHILADELPHIA PHOTOGRAPHER 7, no. 78 (June 1870): 222-223. [Note about a severe hail storm in Philadelphia, PA, which destroyed all of the studio skylights. Mentions that William Bell made a stereo of the damage to his studio.]

B633 Bell, William. "To Work and Keep a Nitrate Bath Neutral." PHOTOGRAPHIC MOSAICS 5, (1870): 80-81.

B634 Bell, William. "On the Production of Proper Negatives for Retouching." PHILADELPHIA PHOTOGRAPHER 7, no. 83 (Nov. 1870): 372.

B635 Bell, William. "Printing Transparencies with the Magnesium Light." PHILADELPHIA PHOTOGRAPHER 8, no. 85 (Jan. 1871): 26-27.

B636 Bell, William. "Alkaline Development of Dry Plates and of Washed Plates Not Dried." PHILADELPHIA PHOTOGRAPHER 9, no. 104 (Aug. 1872): 282-283. [Bell's studio at 1202 Chestnut St., Philadelphia, PA.]

B637 "Correspondence from the Far West." PHOTOGRAPHIC WORLD 2, no. 22 (Oct. 1872): 296.

B638 Bell, William. "Photography in the Grand Gulch of the Colorado River." PHILADELPHIA PHOTOGRAPHER 10, no. 109 (Jan. 1873): 10.

B639 "Pennsylvania Photographic Association." PHILADELPHIA PHOTOGRAPHER 10, no. 112 (Apr. 1873): 116-117. [William Bell present, mentions using dry plate process while on the plains in the 1873 survey expedition.]

B640 Bell, William. "Exploration Field Photography." PHOTOGRAPHIC MOSAICS 9, (1874): 48-49.

B641 Bell, William. "A Summer in Kentucky with Gelatine Plates." PHILADELPHIA PHOTOGRAPHER 22, no. 266 (Feb. 1885): 51-53.

B642 Bell, William. "How Shall Success be Secured?" INTERNATIONAL ANNUAL OF ANTHONY'S PHOTOGRAPHIC BULLETIN 1, (1888): 87.

B643 Bell, William. "Line Work with Gelatine Plates." PHOTOGRAPHIC MOSAICS: 1889 25, (1889): 58-60.

B644 "Notes and News: William Bell." PHOTOGRAPHIC TIMES 19, no. 406 (June 28, 1889): 324. ["William Bell, our old friend from Philadelphia, sailed for Europe, June 19th, for the purpose of studying orthomatic methods in Vienna, Munich, and other cities. He will probably be gone several months."]

B645 Bell, William. "About Toning and Chloride of Gold." AMERICAN ANNUAL OF PHOTOGRAPHY AND PHOTOGRAPHIC TIMES ALMANAC FOR 1890 (1890): 51-53.

B646 Bell, William. Hydroquinine and Eikonogen Developer." WILSON'S PHOTOGRAPHIC MAGAZINE 28, no. 385 (Jan. 3, 1891): 19.

B647 Bell, William. "Use of Chrome Alum in Hardening Softened Albumen Prints." PHOTOGRAPHIC MOSAICS 28, (1892): 249-250.

B648 Bell, William. "Improved Developer and Isochromatic Plates." PHOTOGRAPHIC MOSAICS 32, (1897): 130-131.

B649 Bell, William. "Iodide of Silver Collodion for Process Work." PHOTOGRAPHIC MOSAICS: 1897 33, (1897): 130-131.

B650 Bell. William. "A Ticklish Experience Abroad." PHOTOGRAPHIC MOSAICS 34, (1898): 170-171.

B651 Bell, William. "Past and Present." PHOTOGRAPHIC MOSAICS 35, (1899): 209-211.

B652 Bell, William. "XL Sticking Paste." PHOTOGRAPHIC MOSAICS 36, (1900): 258.

B653 "Death of William Bell." BULLETIN OF PHOTOGRAPHY AND THE PHOTOGRAPHER 6, no. 130 (Feb. 2, 1910): 81. [Born Liverpool, England on September 4, 1830. Raised as a Friend (Quaker) with Jonathan Mathers in Abbington, Pennsylvania. In 1846 he enlisted as a volunteer in the 6th Regiment, U.S. Army and served in the Mexican War. In 1848 he entered into the daguerreotype business with his brother-in-law, John Keenan, in Philadelphia. In 1850 went to Havana, Cuba. Then returned, opened a daguerreotype gallery until 1862, then began using wet-plates with J. E. McClees and afterwards with E. P. Hipple. Gained a excellent reputation. Joined the Union Army at Civil War, fought at the battles of Antietam and Gettysburg. In 1865 he was appointed chief photographer of the Army Medical Museum at Washington, taking photos of "all the generals and numerous battlefields," which are now preserved in the archives in Washington. In 1869 established a studio in Philadelphia. Early member of the Philadelphia Photographic Society. In 1872 he went with Lieutenant Wheeler on the War Department survey west of the 100th meridian, to Arizona and surrounding country. In 1876 he made, for Mr. Gutekunst, a photo of the inauguration of the Centennial Exposition and also a view of the U.S. Capitol, that were both very well received in U.S. and Europe. Photographer for the Pennsylvania Railroad in 1878. In 1882 accompanied the U.S. Transit of Venus expedition to Patagonia. In 1885 he travelled widely in the USA, photographing for the Catholic Hierarchy Books Publishing House, of Philadelphia. In 1892 photographed fine art collections in Europe for the Columbian World's Fair book. Expert in the gelatine plate process.]

BELLOC, AUGUSTE. (d. ca. 1868) (FRANCE)

[Began as a watercolor painter, then became a portrait photographer. Lived in Paris in 1851, making portraits and giving lessons in photography. In 1853 he published *Traité théorique et pratique de la photographique sur collodion*. From 1854 he produced studies for painters. In 1855 he published *Les 4 branches de la photographie*, then, in 1857, *Le catéchisme de l'opérateur photographe*, followed by other books. Through the 1860s he was active in making inventions and improvements, manufacturing and selling supplies and equipment. Then, after 1868, he disappeared from the known history of photography.]

B654 Belloc. "The Dry Collodion Process - Photographic Paper." HUMPHREY'S JOURNAL OF PHOTOGRAPHY, AND THE ALLIED ARTS AND SCIENCES 10, no. 9 (Sept. 1, 1858): 140-142.

B655 Belloc, A. "The Future of Photography." PHOTOGRAPHIC NEWS 1, no. 2 (Sept. 17, 1858): 13-14.

B656 Belloc. "On a New Dry Collodion Process." HUMPHREY'S JOURNAL OF PHOTOGRAPHY, AND THE ALLIED ARTS AND SCIENCES 10, no. 20 (Feb. 15, 1859): 315-316. [From "Cosmos."]

BEMIS, SAMUEL A. (1793-1881) (USA)

B657 "Vermont Country Auction Yields Samuel Bemis Daguerreotypes." PHOTOGRAPHICA 12, no. 10 (Dec. 1980): 3.

B658 Buerger, Janet E. "Samuel A. Bemis (1793-1882)." IMAGE 25, no. 2 (June 1982): 4-7. 4 b & w. [Bemis was a dentist and jeweler living in Boston, MA. He purchased a daguerreotype outfit from François Gourand and made views of Boston in April 1840, thus becoming one of the earliest amateur photographers in the USA. He continued to photograph Boston views through the winter of 1840-41. He also daguerreotyped in Crawford's Notch, NH in 1840, then apparently quit.]

BENDANN BROTHERS. (BALTIMORE, MD)

[Daniel and David Bendann were born in Richmond, VA, from Prussian immigrants. Daniel apprenticed in Jesse Whitehurst's Richmond gallery at age sixteen. In 1854 he was sent to work in Whitehurst's Baltimore gallery. In 1856 he returned to Richmond to open his own gallery. In 1858 Daniel, with his younger brother David, returned to Baltimore. Daniel took views along the western line of the Baltimore & Ohio Railroad in 1858. The brothers opened a studio in Baltimore in 1859, which was to become a leading gallery in the city. The Bendann's were early makers of the carte-de-visite, and during the Civil War issued many portraits of Southern military and political leaders. David became a leading art connoisseur, and in 1866 the Bendann's opened an art gallery on 5th Avenue in New York City. Partners briefly with Abraham Bogardus in 1872. The Bendann partnership dissolved in 1874, and each brother pursued his own interests. Daniel's photographic galleries continued until 1898, though he himself retired earlier. He died Dec. 6, 1914. David's art galleries continued well into the 20th century, although David died on March 20, 1915.]

BOOKS

B659 Bendann Brothers. *Baltimore Past and Present.* Baltimore: Bendann Brothers, 1871. n. p. 62 b & w. ["APB" gives title "Baltimore as it Was and it Is." Large portraits of notables of Baltimore.]

PERIODICALS

B660 Portrait. Woodcut engraving, credited "From a Photograph by the Bendann Brothers. HARPER'S WEEKLY 10, (1866) ["'Blind Tom,' Celebrated Negro Pianist." 10:476 (Feb. 10, 1866): 92.]

B661 "Editor's Table: The Washington Delegation." PHILADELPHIA PHOTOGRAPHER 3, no. 29 (May 1866): 159. [Bendann Brothers (Baltimore, MD) made a group portrait of the photographers visiting Washington, DC, to fight the stamp tax. Bendann, Germon, Gurney, Brady, and Fredericks in the photograph.]

B662 "Archbishops and Bishops of the Second Roman Catholic Plenary Council, Assembled at Baltimore, Oct. 7, 1866." HARPER'S WEEKLY 10, no. 516 (Nov. 17, 1866): 724. 1 illus. ["Photographed by Bendann Brothers, 95 Fifth Ave., New York."]

B663 "Editor's Table." PHILADELPHIA PHOTOGRAPHER 4, no. 41 (May 1867): 160. [Note that senior partner ill. New York, NY house forced to close. Baltimore, MD house still open.]

B664 "Correspondence." ANTHONY'S PHOTOGRAPHIC BULLETIN 2, no. 11 (Nov. 1871): 369. [Bendann Brothers (Baltimore, MD) about alum fixer.]

B665 "Bendann's Background Negatives." ANTHONY'S PHOTOGRAPHIC BULLETIN 3, no. 5 (May 1872): 547.

B666 "Our Picture - Effects From One Sitting by Bendann Brothers Backgrounds." PHILADELPHIA PHOTOGRAPHER 9, no. 107 (Nov. 1872): 397-399. [Six portraits of a lady, with six variant backgrounds superimposed.]

BENDANN see also BOGARDUS & BENDANN.

BENDANN, DANIEL see also BENDANN BROTHERS.

BENDANN, DANIEL. (1835-1914) (USA)

B667 Portraits. Woodcut engravings, credited "Photographed by Bendann of Richmond." FRANK LESLIE'S ILLUSTRATED NEWSPAPER 3, (1857) ["Roger A. Prior, editor." 3:72 (Apr. 25, 1857): 321.]

B668 "Inauguration of the Virginian Monument to Washington. From a Photograph by D. Bendann, of Richmond, Va." FRANK LESLIE'S ILLUSTRATED NEWSPAPER 5, no. 117 (Feb. 27, 1858): 193, 196-197, 204-205. 4 illus. [View, with figures. This large engraving was a four-page foldout. Three portraits of dignitaries associated with the ceremonies; John R. Thompson, editor; James B. Hope, poet; R. M. T. Ruster, orator.]

B669 Bendann, Daniel. "Feeling and Intention." PHILADELPHIA PHOTOGRAPHER 9, no. 108 (Dec. 1872): 404.

B670 Bendann, D. "Thoroughness." PHILADELPHIA PHOTOGRAPHER 10, no. 116 (Aug. 1873): 235-236.

B671 Bendann, Daniel. "The Present State of Photography." BRITISH JOURNAL PHOTOGRAPHIC ALMANAC 1874 (1874): 66-67.

BENDANN, DAVID (1841-1915) (USA) see also BENDANN BROTHERS.

BENECKE, E.

B672 "Biographical Notes on a Number of Photographers Published by Blanquart-Evrard." CAMERA [LUCERNE] 57, no. 12 (Dec. 1978): 32, 41-42. [Benecke, Claine, DuCamp, Fortier, Greene, Le Secq, Loydreau, Marville, Regnault, Robert, Salzmann, Stewart, Sutton, and Tenison. Benecke was apparently a banker, who visited or lived in Egypt. His four photos published by B-E are all that remains of his known work.]

BENECKE, ROBERT see also HOELKE & BENECKE; HISTORY: USA: MO (Van Ravenswaay)

BENECKE, ROBERT. (1835-1903) (GERMANY, USA)

[Born at Stiege, Germany, in January, 1835. Graduated from school and spent a year in the German army in 1854-55. His profession was forestry, but he emigrated to Missouri in 1856, and settled in Brunswick. Worked at farming, as a cooper, a piano tuner, language teacher, etc. Benecke learned the daguerreotype process from E. Meier. Contributed articles to "P&FAJ" [?] Then worked in Knoxville, TN for two years. Joined the 18th Regiment, Missouri Volunteers when the Civil War broke out, but was discharged for an injury within a year. Returned to St. Louis, formed a partnership with H. Hoelke, and bought the Enoch Long gallery. Benecke travelled, made many views.

In 1871 he took a long trip down the Mississippi River, and he travelled through Indian Territory to Texas with Edward King, for *Scribner's Magazine* in 1873. Benecke took up the collotype photo-mechanical printing process in 1872. May have accompanied the Newton-Jenny Expedition into the Black Hills in 1875. Gradually added, in 1880s, more photoengraving techniques. Began to make his own photographic plates in 1883, and the dry plate manufacturer Gustav Cramer hired him as his plant superintendent and chemist. Died on November 3, 1903.]

B673 Benecke, Robert. "Salad for the Photographer." PHILADELPHIA PHOTOGRAPHER 4, no. 37 (Jan. 1867): 29. [Letter from Benecke (St. Louis, MO), with his formulae, suggestions.]

B674 "Voices from the Craft." PHILADELPHIA PHOTOGRAPHER 4, no. 44 (Aug. 1867): 264-265. [Letter from Benecke, St. Louis, MO.]

B675 "Editor's Table." PHILADELPHIA PHOTOGRAPHER 5, no. 49 (Jan. 1868): 34. [Pictures received.]

B676 "Letter on Apparatus Used in Landscape Work." PHILADELPHIA PHOTOGRAPHER 5, no. 56 (Aug. 1868): 276-277.

B677 "Editor's Table." PHILADELPHIA PHOTOGRAPHER 7, no. 81 (Sept. 1870): 336. [Note of stereos of the steamer "R. E. Lee."]

B678 Benecke, R. "A Few Dodges." PHOTOGRAPHIC WORLD 1, no. 2 (Feb. 1871): 47-48. [Note on pg. 128 in the April 1871 issue that Benecke was going to make long photo trip down Mississippi River.]

B679 "St. Louis, Mo. - Effects of the Tornado of March 8th - Cars Blown Off the Embankment into the Creek, East St. Louis." and "...The Lifeboat of Steamer 'Mollie Able,' Blown One Hundred Yards, and Bent around the Tree which Stopped It. - From a Photograph by R. Benecke." FRANK LESLIE'S ILLUSTRATED NEWSPAPER 32, no. 809 (Apr. 1, 1871): 37. 2 illus. [Views of destruction.]

B680 "Note: Panoramic View of Chicago." PHILADELPHIA PHOTOGRAPHER 8, no. 95 (Nov. 1871): 371.

B681 "Landscape Photography." PHILADELPHIA PHOTOGRAPHER 10, no. 114 (June 1873): 185-186. 1 illus. [Includes a letter, with suggestions, from Robert Benecke, St. Louis. Benecke mentions that he "accompanied gentlemen sent there (through Indian Territory to Dennison, TX) by the editors at "Scribner's Magazine."]

B682 King, Edward. "The Great South: The New Route to the Gulf." SCRIBNER'S MAGAZINE 6, no. 3 (July 1873): 257-288. 43 illus. [King describes the trip from the southeast, through the Indian Territory, to Texas. Many of the illustrations are views, which from their visual grammar, were assisted by photography. (In fact, Robert Benecke accompanied the artists on this trip, and many of these images are probably from his photos. See "Phila. Photo." (June 1873): 185.)]

B683 Benecke, R. "A Few Useful Hints." PHILADELPHIA PHOTOGRAPHER 11, no. 127 (July 1874): 204-205. 3 illus.

B684 Benecke, Robert. "Popular Practice." ANTHONY'S PHOTOGRAPHIC BULLETIN 5, no. 9 (Sept. 1874): 306-308. [Benecke's letter replying to questions about his working practices is unusually long and detailed.]

B685 Benecke, R. "More Dodges." PHILADELPHIA PHOTOGRAPHER 12, no. 135 (Mar. 1875): 81-82. 3 illus.

B686 "Missouri. - General O. E. Babcock, His Council and Friends, Arriving at the United States Circuit Court, St. Louis, Monday, February 7th. - The Opening Day of His Trial for Alleged Complicity in Whisky Frauds. - From Photographs by R. Benecke and Sketches by Harry Ogden." FRANK LESLIE'S ILLUSTRATED NEWSPAPER 41, no. 1065 (Feb. 26, 1876): 393. 1 illus. [Carriage arriving at a building.]

B687 "Missouri. - The Democratic National Convention Held in the New Merchant's Exchange in St. Louis, June 28th and 29th - The Chairman General McClernand, Announcing the Nomination of Governor Samuel L. Tilden, of New York, as Presidential Candidate. - From a Sketch by E. Jump and Photographs by Benecke, St. Louis." FRANK LESLIE'S ILLUSTRATED NEWSPAPER 42, no. 1085 (July 15, 1876): 308-309. 1 illus. [Interior, with crowd.]

B688 "Editor's Table." PHILADELPHIA PHOTOGRAPHER 14, no. 157 (Jan. 1877): 32. [Views of destruction of Mississippi river boats by ice, from R. Benecke (St. Louis, MO).]

B689 "Editor's Table: Pictures Received." PHILADELPHIA PHOTOGRAPHER 14, no. 163 (July 1877): 223. [Aaron Veeder (Albany, NY); Charles B. Melendy (Cedar Falls, IA); Robert Benecke (St. Louis, MO).]

B690 Benecke, R. "St. Louis Correspondence." PHILADELPHIA PHOTOGRAPHER 16, no. 183 (Mar. 1879): 81-83.

B691 Benecke, R. "How to Copy Daguerreotypes." PHOTOGRAPHIC MOSAICS: 1888 (1888): 110-111.

B692 Ryder, Richard C. "Personalities in Perspective: Calamity Jane." STEREO WORLD 8, no. 1 (Mar. - Apr. 1981): 11, 40. 1 b & w. [Stereo portrait, taken by R. Benecke in 1875, during Professor Jenney's Expedition to the Black Hills.]

BENEDICT, PHILANDER H. (SYRACUSE, NY)
B693 "Plan for a Mercury Bath." HUMPHREY'S JOURNAL 4, no. 6 (July 1, 1852): 95. [Mercury bath solution from Mr. Benedict, Syracuse, NY.]

BENICZKY, K. W.
B694 Portraits. Woodcut engravings, credited "Photographed by K. W. Beniczky." FRANK LESLIE'S ILLUSTRATED NEWSPAPER 13, (1861) ["Major Zagonyi." 13:313 (Nov. 23, 1861): 1.]

BENJAMIN, O. C. (d. 1895) (USA)
B695 "View of the Seventh Regiment Camp, Staten Island - Looking Towards the Lower Bay - The Regiment in Line. - From Photographs by O. C. Benjamin, of Newark." FRANK LESLIE'S ILLUSTRATED NEWSPAPER 10, no. 244 (July 28, 1860): 147, 148. 2 illus. [Distant views of the encampment.]

B696 "Notes and News." PHOTOGRAPHIC TIMES 19, no. 383 (Jan. 18, 1889): 32. ["O. C. Benjamin, an old-time daguerreotypist of Newark, NJ, showing signs of insanity, has been taken to an asylum where he can be properly cared for."]

BENNETT, A. W.
B697 "Note." ART JOURNAL (Oct. 1859): 319. [A set of coloured stereographs of ceremonies of the Roman Catholic Church, taken by A. W. Bennett.]

BENNETT, CHARLES. (1840-1927) (GREAT BRITAIN, AUSTRALIA)

B698 "Instantaneous Photography." ANTHONY'S PHOTOGRAPHIC BULLETIN 9, no. 11 (Nov. 1878): 342. [From "Br J of Photo." Bennett photographed water being poured from a jug with dry plates.]

B699 Bennett, Charles. "A Llyn Hunt in North Wales." BRITISH JOURNAL PHOTOGRAPHY ALMANAC 1879 (1879): 74-76. [A "llyn," apparently, is a Welsh word for mountain. Bennett describes a landscape photography trip.]

BENNETT, HENRY HAMILTON. (1843-1908) (CANADA, USA)

BOOKS

B700 Wanderings Amoung the Wonders and Beauties of Western Scenery. Published by H. H. Bennett, Photographer. Kilbourn City, WI: Bennett Studio, 1883. n. p. [Catalog of photographs.]

B701 Reese, Betsy. The Bennett Story: The Life and Work of Henry Hamilton Bennett. Wisconsin Dells, WI: Bennett Studio, 1975. 16 pp. illus.

B702 Hanson, David A. A Complete Catalogue of the Stereographic Photographs of Henry Hamilton Bennett, 1843 - 1908. Wisconsin Dells, WI: Bennett Studio, 1977. 30 pp.

B703 Henry Hamilton Bennett 1843 - 1908. New York: The Witkin Gallery, Inc., 1978. 16 pp. 22 b & w. [Exhibition checklist, edited by Cortia Worth.]

B704 Rath, Sara. Pioneer Photographers, Wisconsin's H. H. Bennett. by Sara Rath; Photographs selected by Rick Smith; With an Afterword by Miriam E. Bennett. Madison, WI: Tamarak Press, 1979. 192 pp. illus. [Bibliography, pp. 90-91.]

PERIODICALS

B705 "The Man with the Camera." PHOTOGRAPHIC TIMES 13, no. 146 (Feb. 1883): 74-75. [From the "Milwaukee Sentinel." Praise for Bennett, who had, with one hand crippled by a bullet during the Civil War, began photographing in Wisconsin, and who took beautiful views. An anecdote about being chased by a bear is recounted.]

B706 "Our Editorial Table: Stereoscopic Views of Wisconsin and Minnesota Scenery by H. H. Bennett, Kilbourne City, Wis." PHOTOGRAPHIC TIMES 13, no. 153 (Sept. 1883): 506-507.

B707 Scacheri, Mario. "Bennett Stopped Action Fifty Years Ago." POPULAR PHOTOGRAPHY 2, no. 5 (May 1938): 34-35, 92. 6 b & w. 1 illus.

B708 Bennett, A. C. "Wisconsin Pioneer in Photography." WISCONSIN MAGAZINE OF HISTORY 22, no. 3 (Mar. 1939): 268-279. 1 b & w. [Born Jan. 15, 1843 in Farnham, Canada, moved to Brattleboro, VT, in 1844, then to Kilbourn City, now Wisconsin Dells, Vermont, in 1857. Henry enlisted in the Union Army during the Civil War. In 1865 he and his brother bought out the photographic business of Leroy Gates. Specialized in landscape views of the nearby Wisconsin Dells.]

B709 Hanson, David A. "H. H. Bennett: A Portraitist to an American Discovering the Poetic Uses of the Wilderness." AMERICAN PHOTOGRAPHER 1, no. 1 (June 1978): 64-72. 8 b & w.

B710 "Stringing Along with H. H. Bennett. Riding Lumber Down the Wisconsin River in 1886: A Photographic Journey." AMERICAN HERITAGE 30, no. 6 (Oct. - Nov. 1979): 100-107. 14 b & w.

BENNETT, J. C. (ITHACA, NY)

B711 "The Town of Ithaca, New York, and Its Celebrated Waterfalls. - From Photographs by J. C. Bennett, Ithaca." FRANK LESLIE'S ILLUSTRATED NEWSPAPER 22, no. 561 (June 30, 1866): 232. 11 illus. [Views.]

BENNETT, N. S. (USA)

B712 "Daguerreotype Movements." HUMPHREY'S JOURNAL 5, no. 11 (Sept. 15, 1853): 175. [N. S. Bennett was injured when the boiler on the steamer "Empire" exploded while he was on his way from Washington, DC to open a gallery in Saratoga Springs, NY. An extensive list of "valuable Daguerreotype specimens" of Indians and statesmen lost during the wreck, is given in this notice.]

BENNETT, THOMAS.

B713 Bennett, Thos. "Improved Backgrounds." AMERICAN JOURNAL OF PHOTOGRAPHY AND THE ALLIED ARTS & SCIENCES n. s. vol. 7, no. 5 (Sept. 1, 1864): 107-108. [From "English Patent."]

BENNINGTON, CHARLES HECKFORD. (GREAT BRITAIN)

B714 Bennington, Charles Heckford. "A Method of Combining the Daguerreotype and Albumen Processes, with a View to Increased Facility in the Production of Instantaneous Photographs in the Field." PHOTOGRAPHIC AND FINE ART JOURNAL 9, no. 1 (Jan. 1856): 21-22. [From "J. of Photo. Soc., London."]

BENTLEY & JACKSON. (RANGOON, BURMA)

B715 "Rangoon, British Burmah." ILLUSTRATED LONDON NEWS 54, no. 1528 (Mar. 6, 1869): 239-240. 2 illus. ["...from photographs by Messrs. Bentley & Jackson, of Rangoon."]

BENTLEY, B. W. (GREAT BRITAIN)

B716 Bentley, B. W. Photographs of Chatsworth. Buxton: B. W. Bentley, n. d. [ca. 1876]. n. p. 12 b & w. [Original photographs.]

BERCHTOLD.

B717 Berchtold. "Improvement in Photographic Engraving." HUMPHREY'S JOURNAL OF PHOTOGRAPHY, AND THE ALLIED ARTS AND SCIENCES 11, no. 7 (Aug. 1, 1859): 100-102. [From "Liverpool Photo. J."]

BERESFORD. (GREAT BRITAIN, INDIA)

B718 "The Mutiny in India." ILLUSTRATED LONDON NEWS 31, no. 869 (July 18, 1857): 56-58. 4 illus. [Report of the Sepoy Rebellion, illustrated with views of Indian buildings, previously taken. "Three of the accompanying views have been engraved from photographs taken by Mr. Beresford, the secretary of the Delhi Bank, of whose fate in the recent outbreak there are contradictory rumors."]

BERGAMASCO, G. (ST. PETERSBURG, RUSSIA)

B719 Portrait. Woodcut engraving credited "From a photograph by Bergamasco." ILLUSTRATED LONDON NEWS 63, (1873) ["General Kaufmann, Russian Army." 63:1777 (Sept. 20, 1873): 269.]

B720 Portrait. Woodcut engraving, credited "From a Photograph by Bergmasco, [sic Bergamasco?] Paris." FRANK LESLIE'S ILLUSTRATED NEWSPAPER 40, (1875) ["Hon. Cassius M. Clay." 40:1037 (Aug. 14, 1875): 401.]

B721 Portrait. Woodcut engraving credited "From a photograph by G. Bergamasco." ILLUSTRATED LONDON NEWS 72, (1878) ["Count Schouvaloff, Russian Ambassador to Great Britain." 72:2031 (June 1, 1878): 513.]

B722 Portrait. Woodcut engraving credited "From a photograph by Bergamasco." ILLUSTRATED LONDON NEWS 69, (1876) ["Grand Duke Nicholas." 70:1975 (May 19, 1877): 464.]

BERGER, ANTHONY. (BROOKLYN, NY)
B723 Portrait. Woodcut engraving, credited "From a Photograph by A. Berger." HARPER'S WEEKLY 9, (1865) ["David C. Harold, accomplice to Lincoln assassination." 9:441 (June 10, 1865): 365.]

B724 "Launching of the United States Ship, 'Madawaska,' July 8, 1865." HARPER'S WEEKLY 9, no. 448 (July 29, 1865): 473. 1 illus. ["Photographed by Mr. A. Berger, Brooklyn, NY."]

B725 "'Dexter,' the Fastest Trotting Horse in the World." HARPER'S WEEKLY 9, no. 461 (Oct. 28, 1865): 681. 1 illus. ["Photographed by A. Berger, Brooklyn."]

BERGNER.
B726 Brey, William. "The Bergner Cutter." STEREO WORLD 8, no. 1 (Mar. - Apr. 1981): 12-13. 1 b & w. 1 illus. [The Bergner Cutter was the device that created the rounded corners on the tops of photographs which was the vogue in the 1860s and 1870s. Article illustrated with a patent drawing of the machine and a stereo card by John Carbutt, taken in 1867.]

BERGSTRESSER BROTHERS. (USA)
B727 "Useful Facts, Receipts, Etc.: Photography at the Seat of War." AMERICAN JOURNAL OF PHOTOGRAPHY AND THE ALLIED ARTS & SCIENCES n. s. vol. 5, no. 7 (Oct. 1, 1862): 164. [From "Corr. Tribune, Aug. 20th." "A camp is hardly pitched before one of the omnipresent artists in collodion and amber-bead varnish drives up his two-horse wagon, pitches his canvas-gallery, and unpacks his chemicals. Here,…near Gen. Burnside's headquarters (at Fredericksburg)…are two brothers from Pennsylvania…named Bergstresser. They have followed the army for more than a year…(taking) thousands of portraits (with the) melainotype (process)."]

BERKELEY, HERBERT B. (GREAT BRITAIN)
B728 Berkeley, Herbert B. "Thoughts Suggested by the Work of the Past Season." BRITISH JOURNAL PHOTOGRAPHIC ALMANAC 1878 (1878): 190-191.

B729 Berkeley, Herbert R. "A Plea for a Photographic Pop-Gun." BRITISH JOURNAL PHOTOGRAPHIC ALMANAC 1879 (1879): 71-73.

BERNIERI BROTHERS. (TURIN, ITALY)
B730 "Inauguration of the Cavour Canal." ILLUSTRATED LONDON NEWS 42, no. 1210 (June 27, 1863): 688, 702. 1 illus. ["From a photograph executed by the Brothers Bernieri, of Turin, the most eminent photographers of that city."]

BERNIERI, CESARE. (ITALY) see BERNIERI BROTHERS.

BERNIERI, LUIGI. (ITALY) see BERNIERI BROTHERS.

BERNOUD, ALPHONSE. (1820-1875) (FRANCE, ITALY)
[Probably born in Paris in 1820. In 1840 he was in Genoa, Italy, in partnership with Lossier. For the next decade he traveled throughout Italy, producing colored portraits and daguerreotypes. By 1850 he was living in Naples, where, for the next five years he operated a studio and wrote a paper on light. Successful, opened other studios in Florence. In 1864 published l'*Italia Contemporanea. Grand Album di celebritá artistiche, litterarie, diplomatiche, politiche, e militari.* Through the 1860s he photographed ships in the harbor, celebrations, events, and personages. Photographed the eruption of Vesuvius in 1872. Retired in 1872. Died in Naples in 1875.]

B731 "The Landslip at Naples." ILLUSTRATED LONDON NEWS 52, no. 1469 (Feb. 15, 1868): 149, 151-152. ["The photographs which I send were executed, by M. Bernoud, on the morning after the terrible disaster which they illustrated."]

B732 "Our Portraits of Prince Humbert and Princess Margaret." ILLUSTRATED LONDON NEWS 52, no. 1486 (June 6, 1868): 555. [Statement from the editors with letters verifying the authenticity of the portraits challenged by an Italian newspaper. Prince Humbert taken by Mr. Alphonse Bernoud of Florence, that of Princess Margaret by Mdme. La Lieure, of Turin. The portraits originally reproduced on p. 381 of the Apr. 18, 1868 issue.]

B733 Portrait. Woodcut engraving credited "From a photograph by Bernoud." ILLUSTRATED LONDON NEWS 72, (1878) ["Late General La Marmora." 72:2012 (Jan. 19, 1878): 65.]

BERRES, JOSEPH. (VIENNA, AUSTRIA)
B734 "Photographic Art: Engraving." LITERARY GAZETTE no. 1218 (May 23, 1840): 331-332. [Letters detailing a printing process from Daguerreotype.]

B735 Berres, Dr., of Vienna. "Method of Permanently Fixing Engraving, and Printing from Daguerreotype Pictures." ATHENAEUM no. 656 (May 23, 1840): 418-419. [Additional notes: (May 30), p. 436 and p. 518. (Aug. 1), p. 611. (Aug. 8), p. 629. (Aug. 26), p. 663.]

B736 Berres, Dr. "Method of Permanently Fixing, Engraving, and Printing from Daguerreotype Pictures." MAGAZINE OF SCIENCE AND SCHOOL OF ARTS 2, no. 62 (June 6, 1840): 78-79. [From the "Athenaeum." Read before the Imperial Society of Vienna.]

B737 "Miscellaneous: Daguerreotype Engraving." AMERICAN REPERTORY OF ARTS, SCIENCES AND MANUFACTURES 2, no. 2 (Sept. 1840): 141. [Dr. Berres (Vienna, Austria) experiments mentioned. From the "Athenaeum."]

B738 "Photographic Art: Engraving. [Further letter]." LITERARY GAZETTE no. 1233 (Sept. 5, 1840): 581-582. [Prof. of anatomy at University of Vienna.]

B739 "Our Weekly Gossip." ATHENAEUM no. 699 (Mar. 20, 1841): 227. [Note on Dr. Berres' work.]

BERRY.
B740 Portraits. Woodcut engravings, credited "Photographed by Berry." FRANK LESLIE'S ILLUSTRATED NEWSPAPER 17, (1864) ["Lieut. Braine, the pirate who seized the 'Chesapeake.'" 17:437 (Feb. 13, 1864): 324.]

BERRY, GEORGE ROBERT. (d. 1863) (GREAT BRITAIN)
B741 Berry, G. R. "Proceedings of the Scientific Societies. Meeting of the British Association at Liverpool. Section B. - Chemical Science.

Saturday, September 23. 'On Collodion Negatives,' by Mr. G. R. Berry." PRACTICAL MECHANIC'S JOURNAL 7, no. 81 [sic 82] (Jan. 1855): 231.

B742 "Proceedings of the Liverpool Photographic Society: Photographic Printing and Fixation of Photography." HUMPHREY'S JOURNAL 7, no. 11 (Oct. 1, 1855): 181-184. [From "Liverpool Photo. J." Berry was attempting to capture men and animals in motion by using electric sparks.]

B743 Berry, G. R. "Fancies of Photography." HUMPHREY'S JOURNAL 7, no. 14 (Nov. 15, 1855): 225-227. [From "J. of Liverpool Photo. Soc." Also a letter from Berry reproduced on p. 231.]

B744 "Photography as Applied to Pharmacy." HUMPHREY'S JOURNAL 7, no. 22 (Mar. 15, 1856): 353-354. [Paper on photo-micrography, read before the Liverpool Chemist's Association.]

B745 Berry, Mr. "On Photography, retrospective and prospective." HUMPHREY'S JOURNAL 7, no. 24 (Apr. 15, 1856): 378-380. [From "Liverpool Photo. J."]

B746 "Obituary." BRITISH JOURNAL OF PHOTOGRAPHY 10, no. 191 (June 1, 1863): 233. [Member of Liverpool Photo. Soc., important in founding the "Liverpool Photo. J." which later became the "British Journal of Photography." Died Apr. 24, 1863.]

BERT, A. (ASHTABULA, OH)
B747 Portrait. Woodcut engraving, credited "From a Photograph by A. Bert." HARPER'S WEEKLY 8, (1864) ["Late Joshua R. Giddings." 8:391 (June 25, 1864): 401.]

BERTALL. (1820-1882) (FRANCE)
[Bertall, the Vicomte Charles-Albert d'Arnoux, was a caricaturist and a book illustrator, very active creating wood engravings and lithographs for many books published in Paris. In 1855 he worked with Hippolyte Bayard, and then they formed a partnership from 1862 to 1866. In 1866 Bertell set up his own studio, Bertell & Cie., where many personalities from the fields of literature, art, and politics came to have their portraits made. In 1867 he published more designs for the *Journal Amusant*. In 1869-70 Bertall worked for the newspaper *Le Soir*, then founded the satirical journal *Le Grelot*. Through 1870s he continued to photograph and write novels, short stories, and satirical pieces. In 1875 he contributed work to the *Paris-Journal*. His portraits appeared in the *Galerie Contemporaine* from 1877. Died at Soyons in 1882.]

B748 Portrait. Woodcut engraving credited "From a photograph by Bertall." ILLUSTRATED LONDON NEWS 66, (1875) ["John Lemoinne." 66:1870 (June 12, 1875): 552.]

BERTOLACCI, C. C. & M. E. BERTOLACCI.
BOOKS
B749 Turner, J. M. W. *Turner's England and Wales, a Series of Photographic Copies by the Misses C. C. and M. E. Bertolacci*. London: Colnaghi, 1864. n. p. 96 b & w. [Originally issued in parts. Original photographic prints by the Bertolacci sisters, of Turner's artworks.]

B750 Turner. *Turner's Liber Studiorum*. London: Colnaghi, 1864. n. p. 72 b & w. [Originally published in parts. Photographic reproductions, by Miss C. C. Bertolacci, of works of art by Turner.]

B751 Turner, J. M. W. *'Richmondshire' by J. M. W. Turner, R. A. The Twenty Subjects Photographically reproduced by C. C. and M. E. Bertolacci*. London: Colnaghi, 1865. n. p. 20 b & w. [Portfolio. Photographic reproductions, by the Bertolacci sisters, of works of art by Turner.]

B752 Turner, J. M. W. *Turner's 'Rivers of England,'* Photographically reproduced by the Misses C. C. and M. E. Bertolacci. London: Bertolacci, 1865. n. p. 20 b & w. [Portfolio. Photographic reproductions, by the Bertolacci sisters, of works of art by Turner.]

PERIODICALS
B753 "Editor's Table: Turner Photographs." PHILADELPHIA PHOTOGRAPHER 1, no. 8 (Aug. 1864): 128. [From "Athenaeum." Misses C. C. and M. E. Bertolacci copying Turner's "England and Wales."]

B754 "Note." ART JOURNAL (Dec. 1865): 381-382. [The work of the Misses Bertolacci will in the future be handled by Messrs. Marion of Soho Square.]

B755 "The Misses Bertolacci's Photographs After Turner's Works." FINE ARTS, A QUARTERLY REVIEW n. s. vol. 2, (Jan. 1867): 202-204. [Two series of photographic reproductions of J. M. W. Turner's drawings held at the National Gallery and the South Kensington Museum: "'England and Wales,' by J. M. Turner, R.A. A Series of Photographic Reproductions in Six Parts, of Sixteen Subjects each," by C. C. and M. E. Bertolacci; and "Richmondshire," by J. M. W. Turner, R.A. The Twenty Subjects Photographically reproduced by C. C. and M. E. Bertolacci. Both published by Cundall, London.]

BERTSCH & ARNAULD.
B756 Bertsch and Arnauld. "The Recent Eclipse of the Moon. Lunar Photography." PHOTOGRAPHIC AND FINE ART JOURNAL 10, no. 3 (Mar. 1857): 92. [From "Liverpool Photo. J."]

BERTSCH.
B757 "The Automatic Camera of M. Bertsch." HUMPHREY'S JOURNAL OF PHOTOGRAPHY, AND THE ALLIED ARTS AND SCIENCES 12, no. 11 (Oct. 1, 1860): 172-173. [From "Br. J. of Photo."]

BEVERLEY, S.
B758 Beverley, S. "On Shortening Exposure in Winter." BRITISH JOURNAL PHOTOGRAPHIC ALMANAC 1878 (1878): 92.

BEYRICH, FREDERICH.
B759 Beyrich, Fred. "Concerning the Use of Albumenized Paper." HUMPHREY'S JOURNAL OF PHOTOGRAPHY, AND THE ALLIED ARTS AND SCIENCES. 16, no. 15 (Dec. 1, 1864): 236-237. [From "Photographische Mittheilungen."]

BEYSE & JOSS.
B760 Beyse and Joss. "Photographs in Fixed Colors." HUMPHREY'S JOURNAL OF PHOTOGRAPHY, AND THE ALLIED ARTS AND SCIENCES 18, no. 15-21 (Dec. 1, 1866 - Mar. 1, 1867): 255-228, 266-268, 275-278, 308-310, 326-328. [From "Photo. Corres."]

BIANCHI, BARTHELEMY-URBAN. (1821-1898) (FRANCE)
B761 "Pictures from the Collection." IMAGE 5, no. 4 (Apr. 1956): 116-117. 1 b & w. [Daguerreotype of the City Hall of Toulouse, taken on Feb. 27, 1840.]

BIEN, JULIUS. (GERMANY, USA)
B762 Mayer-Wegelin, Eberhard. "Entdeckung einer frühen amerikanischen Kalotypie." PHOTO-ANTIQUARIA no. 3 (1982): 12, 27. 1 b & w. [A calotype portrait, signed "Julius Bien, New York" and dated 1850, exists in Frankfort, Germany. The author speculates whether Bien, a merchant and bookdealer in New York City in the

1870s, made the calotype portrait in 1850, then sent it to friends or family in Germany.]

BIERSTADT BROTHERS. (NEW BEDFORD, MA)
[The Bierstadt Brothers, Albert, Charles, and Edward, were active in the New England area making and selling stereo views from ca. 1859 to 1867, working out of New Bedford, MA. In 1867 they sold their gallery to S. F. Adams. Albert went on to pursue his career as a landscape painter, Charles moved to Niagara Falls, NY and opened a gallery there, and Edward moved to New York, where he eventually developed a large artotype printing establishment and produced many books illustrated with photogravures.]

BOOKS
B763 *Catalogue of Photographs, Published by the Bierstadt Brothers, New Bedford, Massachusetts.* New Bedford, MA: Bierstadt Brothers, 1860. n. p.

B764 Bierstadt Brothers. *Stereoscopic Views among the Hills of New Hampshire;* Photographed by the Bierstadt Brothers. New Bedford, MA: Bierstadt Brothers, 1862. n. p. 48 b & w. [48 stereo views.]

B765 *Catalogue of Stereoscopic Views, Published by the Bierstadt Brothers, New Bedford, Mass.* New Bedford: Mercury Job Press, 92 Union St., 1865. 20 pp.

B766 *Pictorial Guide Book: Watkins and Havana Glens Illustrated with Photographs in Printing-Ink by the Albertype Process.* Niagara Falls, NY; New York: Charles Bierstadt; Edward Bierstadt, 1875. 6 pp. 24 l. of plates. 24 b & w. [Albertypes, probably from negatives by Charles Bierstadt.]

B767 *Gems of American Scenery:* Consisting of Stereoscopic Views among the White Mountains, with Descriptive Text. Illustrated by the Albertype Process. Niagara Falls, NY; New York: Charles Bierstadt; Edward Bierstadt, 1875. 4 p., 24 l. 25 l. of plates. 24 b & w.

PERIODICALS
B768 "Bierstadt Bros." HUMPHREY'S JOURNAL OF PHOTOGRAPHY, AND THE ALLIED ARTS AND SCIENCES 17, no. 16 (Dec. 15, 1865): 256. [Brief note that the Bierstadt Brothers, of New Bedford, have issued a catalog of some 600 stereo views.]

B769 "Bierstadt's Gems of Photography." PHILADELPHIA PHOTOGRAPHER 3, no. 35 (Nov. 1866): 350.

B770 "Bierstadt Brothers' Gallery." HUMPHREY'S JOURNAL OF PHOTOGRAPHY, AND THE ALLIED ARTS AND SCIENCES 18, no. 19 (Feb. 1, 1867): 304. [Bierstadt Brothers sold their gallery to S. F. Adams.]

B771 "Army Photography." DAILY EVENING STANDARD (NEW BEDFORD, MA) (Aug. 22, 1903): n. p. [Discusses the fact that the Bierstadt Brothers began by photographing soldiers in camp during the Civil War.]

BIERSTADT, ALBERT. (1830-1902) (GERMANY, USA)
BOOKS
B772 United States Congress. House. *Maps and Reports of the Fort Kearny, South Pass, and Honey Lake Wagon Road.* Executive Document, No. 64. 36th Congress. 2nd. Session. (Feb. 11, 1861) Washington, DC: Government Printing Office, 1861. n. p. [Colonel Frederick William Lander's report of the expedition. "A. Bierstadt, of New York City, and S. F. Frost, of Boston, accompanied the expedition... bearing their own expenses. They had taken sketches...

and a set of stereoscopic views of emigrant trains, Indians and camp scenes, etc." (p. 5).]

B773 *The Valley of the Grisly Bear.* London: Sampson Low & Marston, 1870. n. p. 100 plus b & w. [Album containing original photographs by Albert Bierstadt and Carleton E. Watkins. (Its unclear from the citation whether this a published album or a compilation.]

B774 Trump, Richard Shafer. *Life and Works of Albert Bierstadt.* Athens, OH: Ohio State University, 1963. 233 pp. b & w. illus. [Dissertation.]

B775 Hendricks, Gordon. *Albert Bierstadt: Painter of the American West.* New York: Harrison House, published by arrangement with Harry N. Abrams, Inc., in association with Amon Carter Museum of Western Art, 1974. 360 pp. 7 b & w. 428 illus. [Discusses Bierstadt's first trip to California from pp. 68 to 90, describing his activities with the stereo camera then and afterwards. The seven remaining identified views from this trip are published on pp. 66-67.]

B776 Anderson, Nancy. *Albert Bierstadt and the California Landscape School.* [Ph.D. thesis. University of Delaware, 1984)

PERIODICALS
B777 B. [Bierstadt, Alfred] "Country Correspondence - Rocky Mountains, July 10, 1859." THE CRAYON 6, no. 9 (Sept. 1859): 287. ["We have taken many stereoscopic views, but not so many of mountain scenery as I could wish, owing to the various obstacles attached to the process, but still a goodly number. We have a great many Indian subjects. We were quite fortunate in getting them, the natives not being very willing to have the brass tube of the camera pointed at them. Of course they were astonished when we showed them pictures they did not sit for; and the best we have taken have been obtained without the knowledge of the parties, which is, in fact, the best way to take any portrait."]

B778 "Art Gossip." COSMOPOLITAN ART JOURNAL 4, no. 3 (Sept. 1860): 126. ["Bierstadt, who made the Rocky Mountain tour with great success last year has gone into the White Mountain region to sketch, and to experiment photographically, along with his brother, a photographist of eminence." (Bierstadt's trip to the White Mountains is mentioned in the column again in the next issue (Dec. 1860), on p. 182.]

B779 "Sketchings: Domestic Art Gossip." THE CRAYON 8, no. 1 (Jan. 1861): 22. ["We would call the attention of admirers of photographs to a series of views and studies taken in the White Mountains, published by Bierstadt Brothers, of New Bedford, Mass. The plates are of large size and are remarkably effective. The artistic taste of Mr. Albert Bierstadt, who selected the points of view, is apparent in them. No better photographs have been published in this country."]

B780 "Bierstadt's Rocky Mountains." FRANK LESLIE'S ILLUSTRATED NEWSPAPER 22, no. 570 (Sept. 1, 1866): 375. [Review of the painting by Bierstadt, reprinted from the London "Saturday Review."]

B781 Vogel, Dr. H. "German Correspondence." PHILADELPHIA PHOTOGRAPHER 8, no. 87 (Mar. 1871): 82-85. [Art and photog. in Italy — Steinhall's new lens — Albert's lichtdruck — Bierstadt's pictures of the Yosemite Valley,]

B782 Snell, Joseph W. "Some Rare Western Photographs by Albert Bierstadt now in the Historical Society Collections." KANSAS HISTORICAL QUARTERLY 24, no. 2 (Spring, 1958): 1-5, plus unnumbered leave before p. 1, cover. 3 b & w. [Bierstadt, on his first

trip West in 1859, sketched and photographed scenery for his later paintings. May have taken 100 photos, fifty-one listed in an 1860 catalog, five remain, now at the Kansas State Historical Society. Views of emigrants, wagons, Indians, etc.]

B783 Hendricks, Gordon. "Bierstadt's Westward Journeys." AUCTION 3, no. 7 (Mar. 1970): 42-47. illus.

B784 Hendricks, Gordon. "The First Three Western Journeys of Albert Bierstadt." ART BULLETIN 46, no. 3 (Sept. 1964): 333-365. 1 b & w. 26 illus.

B785 Lindquist-Cock, Elizabeth. "Stereoscopic Photography and the Western Paintings of Albert Bierstadt." ART QUARTERLY 33, no. 4 (Winter 1970): 360-377. 11 b & w. 5 illus. [Influence of stereoscopic photography on Bierstadt's paintings, with stereos by Bierstadt, Muybridge, and Watkins cited.]

B786 Bendix, Howard E. "Discovered! Early Bierstadt Photographs." PHOTOGRAPHICA 6-7, no. 8-10, 1 (Sept. - Nov. 1974, Jan. 1975): (vol. 6) 8:4-5; 9:7, 10; 10:7 (vol. 7) 1:4. illus.

B787 Campbell, Catherine H. "Albert Bierstadt and the White Mountains." ARCHIVES OF AMERICAN ART JOURNAL 21, no. 3 (1981): 14-23. 6 b & w. 16 illus. [A documented chronology of the artist's visits to the White Mountains of New Hampshire. Includes discussion of his involvement in photography.]

BIERSTADT, CHARLES. (1819-1903) (GERMANY, USA)
BOOKS
B788 Goldman, Richard H. *Charles Bierstadt; 1819 - 1903, American Stereograph Photographer.* Kent, OH: Kent State University, 1974. 83 l. [M.A. Thesis, Kent State Univ.]

PERIODICALS
B789 "The New Suspension Bridge at Niagara Falls, Connecting the Village of Niagara Falls with Clifton, in Canada. - From a Photograph by C. E. Bierstadt." FRANK LESLIE'S ILLUSTRATED NEWSPAPER 28, no. 711 (May 15, 1869): 137. 1 illus. [View.]

B790 "The New Suspension Bridge, Niagara Falls." HARPER'S WEEKLY 13, no. 657 (July 31, 1869): 493-494. 1 illus.

B791 "Niagara Falls. — The Ice-Bridge of 1871. — View of the Canada Side. — From a Photograph by C. Bierstadt." FRANK LESLIE'S ILLUSTRATED NEWSPAPER 31, no. 805 (Mar. 4, 1871): 405. 1 illus. [View.]

B792 "Note." ANTHONY'S PHOTOGRAPHIC BULLETIN 5, no. 1 (Jan. 1874): 22. [Correction of error in reporting Charles Bierstadt's award of a medal of merit at the Vienna Exhibition. Charles Bierstadt at Niagara Falls, NY).]

B793 "Editor's Table — Mr. Charles Bierstadt's Views in Egypt and Palestine." PHILADELPHIA PHOTOGRAPHER 11, no. 132 (Dec. 1874): 384.

BIERSTADT, EDWARD. (1824-1907) (GERMANY, USA)
BOOKS
B794 Fox, George Henry. *Photographic Illustrations of Skin Diseases.* New York: E. Trast, 1880-1888. 2 vol. (vol. 1, 102 pp.; vol. 2, 207 pp.) 97 b & w. [First series credited to "Harroun & Bierstodt" [sic Bierstadt]. Second series credited to Edward Bierstadt. Each series illustrated with 48 prints, some of them hand colored.]

B795 Gorringe, Henry H. *Egyptian Obelisks.* New York: by the author, 1882. 187 pp. 32 b & w. 19 illus. [32 artotypes by Bierstadt, 18 engravings, and 1 chromolithograph. Series depict the removal of the obelisk from Egypt, its trip and setting up in Central Park, New York, NY.]

B796 Stoddard, Seneca Ray. *Lake George; ...Artotype Illustrations by Edward Bierstadt.* Glenn Falls, NY: S. R. Stoddard, 1883. 45 pp.

B797 Van Rensselaer, John King, Mrs. *The Van Rensselaers of the Manor of Rensselaerswyck.* New York: E. Bierstadt, 1888. 21 p., 51 l. 8 l. of plates. 45 b & w. illus. ["Artotypes by E. Bierstadt"]

B798 Bierstadt, Edward. *The Adirondacks. Artotype views in the North Woods.* New York.: 1889. 1 pp. 16 l. of plates. 16 b & w.

B799 Bierstadt, Edward. *Picturesque St. Augustine, views in the Old Florida city.* Printed in permanent inks, from original negatives, by the artotype process. St. Augustine: W. G. Foster, 1890. 2 pp. 40 b & w.

B800 Bierstadt, Edward. *Gems of Saint Augustine.* A collection of over fifty views in groups. Artotypes by E. Bierstadt. New York: The Artotype Publishing Co., 1891. 1 pp. 16 l. of plates. 16 b & w.

B801 Bierstadt, Edward. *Picturesque St. Augustine, views in the Old Florida city.* Printed in permanent inks, from original negatives, by the artotype process. New York, St. Augustine: The Artotype Publishing Co., 1891. 2 pp. 40 l. of plates. 40 b & w.

B802 Bierstadt, Edward. *Sunlight Pictures; Saint Augustine.* Artotypes by Edward Bierstadt. New York: The Artotype Publishing Co., 1891. 8 pp. 51 l. of plates. 51 b & w.

B803 Whittemore, Henry, Compiler. *Homes on the Hudson:* Historical, Illustrative, Descriptive. Illustrated by Bierstadt. New York, St. Augustine: The Artotype Publishing Co., 1895 [?]. 1 pp. 73 b & w.

PERIODICALS
B804 "An Explosion in the Studio Building." ANTHONY'S PHOTOGRAPHIC BULLETIN 2, no. 3 (Mar. 1871): 83-84. [Explosion in Bierstadt's chemical laboratory described. From "NY Daily Times." Building housed the studios of Page, Shattuck, Julian Scott and others, but fire was put out before it spread. Bierstadt identified as the brother of the painter, Albert.]

B805 "A Photographic Feat." ANTHONY'S PHOTOGRAPHIC BULLETIN 5, no. 6 (June 1874): 217. [Mr. Bierstadt made a negative of an engraving, which was enlarged to 13'6" x 9' by Paxton & Brothers.]

B806 "Bierstadt's Graphite Process." PHOTOGRAPHIC TIMES 4, no. 48 (Dec. 1874): 185-186. [Letters between the Scoville Manufacturing Co. and E. Bierstadt, with formulas, etc.]

B807 Bierstadt, E. "Paper of Photo-Mechanical Printing." PHOTOGRAPHIC TIMES 5, no. 53 (May 1875): 107-110. [Read before the Photographic Section of the American Institute, Apr. 6th. Includes a survey of the history of discoveries in photomechanical reproduction.]

B808 Bierstadt, E. "Photomechanical Printing." ANTHONY'S PHOTOGRAPHIC BULLETIN 6, no. 5 (May 1875): 129-136.

B809 "The Bierstadt Pocket Cameras." PHOTOGRAPHIC TIMES 5, no. 54 (June 1875): 123-124. [Camera constructed for E. Bierstadt by

the American Optical Co. proved successful, started marketing it. Includes letters of recommendation from W. H. Jackson (Office of U.S. Geological Survey of the Territories) and others.]

B810 Bierstadt, E. "Paper on Photo-Mechanical Printing." PHOTOGRAPHIC TIMES 5, no. 54 (June 1875): 145-151. [The first section of this paper was printed in May issue. Demand was so large that the copy went out of print and so the entire paper was reprinted in a special supplement to the June issue.]

B811 Bierstadt, Edward. "Concerning Wide Angle Photographs." PHOTOGRAPHIC TIMES 11, no. 125 (May 1881): 193-194.

B812 Bierstadt, Edward. "Wide Angle Photographs (Addendum)." PHOTOGRAPHIC TIMES 11, no. 126 (June 1881): 220. [Corrections to earlier article.]

B813 Taylor, J. Traill. "The Studios of America. No. 6. Bierstadt's Artotype Atelier, New York." PHOTOGRAPHIC TIMES 13, no. 149 (May 1883): 195-198.

B814 Bierstadt, E. "Orthochromatic Photography." PHOTOGRAPHIC TIMES 16, no. 240 (Apr. 23, 1886): 216-217.

B815 Bierstadt, Edward. "Orthochromatic Photography." ANTHONY'S PHOTOGRAPHIC BULLETIN 17, no. 12 (June 26, 1886): 370-372. [Read before the Photographic Section of the American Institute.]

B816 Bierstadt, Edward. "To Prevent Solarizing." AMERICAN ANNUAL OF PHOTOGRAPHY AND PHOTOGRAPHIC TIMES ALMANAC FOR 1887 (1887): 118.

B817 "General Notes." PHOTOGRAPHIC TIMES 17, no. 278 (Jan. 14, 1887): 14. [Note about photographing interiors. From the "Photographic Times Annual for 1887."]

B818 "General Notes." PHOTOGRAPHIC TIMES 17, no. 285 (Mar. 4, 1887): 104. [The entire photographic department of Mr. E. Bierstadt's establishment at Nos. 58 and 60 Reade Street, New York, NY was destroyed by fire Feb. 17th… negatives, apparatus, lenses all lost. Mr. Bierstadt is starting again at the Kurtz Gallery, and will continue his business at that place until he can establish himself in permanent quarters elsewhere.]

B819 Bierstadt, E. "Colored Screens in Out-Door Photography." AMERICAN ANNUAL OF PHOTOGRAPHY & PHOTOGRAPHIC TIMES ALMANAC FOR 1888 (1888): 72-73.

B820 Bierstadt, E. "Orthochromatic Screens." AMERICAN ANNUAL OF PHOTOGRAPHY AND PHOTOGRAPHIC TIMES ALMANAC FOR 1890 (1890): 154-155.

B821 Bierstadt, Edward. "Artistic Photographs." AMERICAN ANNUAL OF PHOTOGRAPHY AND PHOTOGRAPHIC TIMES ALMANAC FOR 1892 (1892): 79-80.

B822 Bierstadt, Ed. "Accessories." AMERICAN ANNUAL OF PHOTOGRAPHY AND PHOTOGRAPHIC TIMES ALMANAC FOR 1897 (1897): 154-155. [Argument for more natural accessories in portrait studios.]

B823 Bierstadt, Edward. "Color Photography." PHOTOGRAPHIC TIMES 37, no. 4 (Apr. 1904): 165.

BIGELOW, LYMAN G. (DETROIT, MI)
BOOKS
B824 Bigelow, Lyman G. *Album of Lighting and Posing.* s. l.: s. n., 1872. n. p. illus.

B825 Bigelow, Lyman G. *Illustrated Key to Bigelow's Album of Lighting and Posing,* by Lyman G. Bigelow. Philadelphia: Benerman & Wilson, ca. 1872. 11 pp. 24 l. of plates. 24 illus. [2nd ed., ca. 1873, 15 pp., 24 illus.]

B826 Bigelow, Lyman G. *Artistic Photography, and How to Attain It.* Philadelphia: Benerman & Wilson, 1876. 24 pp. 12 l. of plates. 12 b & w.

PERIODICALS
B827 "Bigelow's Album of Lighting and Posing." PHOTOGRAPHIC TIMES 2, no. 17-18, 20-23 (May - June, Aug. - Nov. 1872): 68, 87-88, 113-114, 136-138, 145, 163. [Reviewed, excerpted.]

B828 Bigelow, L. G. "Fifth Annual Meeting and Exhibit of the National Photographic Association of the U.S., held in Buffalo, N.Y., beginning July 5, 1873: Skylights." PHILADELPHIA PHOTOGRAPHER 10, no. 117 (Sept. 1873): 268-269.

B829 "Our Picture." PHILADELPHIA PHOTOGRAPHER 11, no. 126 (June 1874): frontispiece, 176. 1 b & w. [Studio portrait. Lyman at John F. Nice Studio, Williamsport, PA.]

B830 "Matters of the Month: Bigelow's Cloud Negatives." PHOTOGRAPHIC TIMES 4, no. 47 (Nov. 1874): 175-176.

B831 Bigelow, L. G. "DIrections for Making the Bigelow Cloud Portraits." PHOTOGRAPHIC TIMES 4, no. 48 (Dec. 1874): 186-187.

B832 Bigelow, L. G. "A Suggestion." PHILADELPHIA PHOTOGRAPHER 12, no. 140 (Aug. 1875): 250. [Author argues that photos should not be mixed with other graphic works at forthcoming Centennial Exhibition.]

B833 "Our Picture." PHILADELPHIA PHOTOGRAPHER 13, no. 145 (Jan. 1876): frontispiece, 24-25. 1 b & w. ['Promenade' style studio portrait. Bigelow working in Detroit, MI.]

B834 "Our Picture." PHILADELPHIA PHOTOGRAPHER 13, no. 149 (May 1876): frontispiece, 156-157. 1 b & w. [Promenade style studio portrait.]

B835 "Our Picture - Selection from 'Bigelow's Artistic Photography.'" PHILADELPHIA PHOTOGRAPHER 13, no. 156 (Dec. 1876): frontispiece, 372-374. 1 b & w.

B836 "Editor's Table: A New Enamel for Glace Pictures." PHILADELPHIA PHOTOGRAPHER 14, no. 162 (June 1877): 191.

B837 "The Illustration." ANTHONY'S PHOTOGRAPHIC BULLETIN 10, no. 4 (Apr. 1879): frontispiece, 128. 1 b & w. [Original photograph. Studio portrait by L. G. Bigelow, Detroit.]

B838 "Operating Notes." PHOTOGRAPHIC TIMES 20, no. 473 (Oct. 10, 1890): 505-506. [Read at the Washington Convention of the P. A. of A. Advice for running a studio, suggests that the "demonstrators" (men hired by photographic supply companies to tour and demonstrate the company's equipment and processes) are a force for education.]

B839 Bigelow, L. G. "Portraits By the Light of An Ordinary Window." AMERICAN ANNUAL OF PHOTOGRAPHY AND PHOTOGRAPHIC TIMES ALMANAC FOR 1891 (1891): 177-178.

BIGGS, T., COL. (GREAT BRITAIN, INDIA)
BOOKS
B840 Hope, Theodore C. *Architecture of Ahmedabad, the Capital of Goozerat,* Photographed by Colonel Biggs, R.A., With a Historical and Descriptive Sketch by Theodore C. Hope, Bombay Civil Service, And Architectural Notes by James Fergusson, F.R.S., M.R.A.S. Published for the Committee of Architectural Antiquities of Western India, under the Patronage of Premchund Raichund. London: John Murray, 1866. xv, 100 pp. 120 l. of plates. 120 b & w.

B841 Taylor, Philip Meadows and James Fergusson. *Architecture of Beejapoor,* an ancient Mahometan Capital in the Bombay Presidency, with an Historical and Descriptive memoir by Capt. Meadows Taylor and Architectural Notes by James Fergusson. London: John Murray, 1866. n. p. 31 b & w. 46 illus. [Original photos by Col. T. Biggs and Maj. Loch. Reproductions of drawings by Capt. Hart.]

B842 Taylor, Philip Meadows and James Fergusson. *Architecture in Dharwar and Mysore.* Photographed by Dr. Pigou, A. C. B. Neill and Colonel Biggs. With a historical and descriptive memoir by M. Taylor and architectural notes by J. Fergusson. London: John Murray, 1866. n. p. b & w. illus.

PERIODICALS
B843 Sharma, Brij Bhushan. "Architectural Photography in Western India and the Work of Colonel T. Biggs." HISTORY OF PHOTOGRAPHY 7, no. 2 (Apr. - June 1983): 143-146. 4 b & w.

BILL & ILLINGSWORTH see ILLINGSWORTH, WILLIAM H.

BILL, CHARLES K. (NEW YORK, NY)
B844 "Chas. K. Bill's Photograph Rooms." HUMPHREY'S JOURNAL OF PHOTOGRAPHY, AND THE ALLIED ARTS AND SCIENCES 15, no. 5 (July 1, 1863): 80. [Praise for Ch. K. Bill's gallery on Broadway, New York, NY.]

B845 "Hose Carriage Presented by the New York Fireman's Association to the Firemen of Columbia, South Carolina." HARPER'S WEEKLY 11, no. 533 (Mar. 16, 1867): 173. 1 illus. ["Photographed by Charles K. Bill, 747 Broadway."]

B846 "Note." PHOTOGRAPHIC TIMES 2, no. 22 (Oct. 1872): 148. [Charles K. Bill opening a new studio at Broadway near 27th St., New York, NY. "Mr. Bill does a good deal of outdoor work."]

BILLINGHURST, C. J. (MCARTHUR, OH)
B847 Billinghurst, C. J. "How to Use up Old Baths and Save the Silver. Opalotypes by Direct Printing, &c." AMERICAN JOURNAL OF PHOTOGRAPHY AND THE ALLIED ARTS & SCIENCES n. s. vol. 7, no. 24 (June 15, 1865): 568-570.

B848 Billinghurst, C. J. "Watered Silk Markings on Negatives, &c." AMERICAN JOURNAL OF PHOTOGRAPHY AND THE ALLIED ARTS & SCIENCES n. s. vol. 8, no. 7 (Oct. 1, 1865): 155-156.

BINDMAN, DANIEL. (BALTIMORE, MD)
B849 Portrait. Woodcut engraving, credited "Photographed by Daniel Bindman, of Baltimore. FRANK LESLIE'S ILLUSTRATED NEWSPAPER 37, (1874) ["John Hopkins, Philanthropist." 37:959 (Feb. 14, 1874): 373.]

BING. (GREAT BRITAIN)
B850 Bing. "On a New Actinometer." AMERICAN JOURNAL OF PHOTOGRAPHY, AND THE ALLIED ARTS AND SCIENCES n. s. vol. 9, no. 8 (Mar. 1, 1867): 167-170. [Presented before London Photo. Soc. From "Photo. News."]

BING, L.
B851 Bing, L. "A New Method of Tinting Photographs." HUMPHREY'S JOURNAL OF PHOTOGRAPHY, AND THE ALLIED ARTS AND SCIENCES 17, no. 21 (Mar. 1, 1866): 335-336. [From "Photo. News."]

BINGHAM BROTHERS.
B852 "Tennessee. - The Masonic Grand Lodge Laying the Corner-Stone of the U. S. Custom House, Court House and Post Office, at Memphis, June 24th." and "U. S. Custom House, Court House and Post Office, Memphis. - From a Photograph by Bingham Brothers." FRANK LESLIE'S ILLUSTRATED NEWSPAPER 48, no. 1242 (July 19, 1879): 336. 2 illus. [Views.]

BINGHAM, BENJAMIN see also BINGHAM BROTHERS.

BINGHAM, BENJAMIN. (d. 1897) (MEMPHIS, TN)
B853 "Editor's Table: Obituary." WILSON'S PHOTOGRAPHIC MAGAZINE 34, no. 488 (Aug. 1897): 384. [Died July 1st, 1897. Had followed photography forty-one years at the time of his death.]

BINGHAM, H. L. (KALAMAZOO, MI)
B854 "Editor's Table." PHILADELPHIA PHOTOGRAPHER 4, no. 48 (Dec. 1867): 403. [Cabinet portraits.]

B855 "Editor's Table." PHILADELPHIA PHOTOGRAPHER 10, no. 112 (Apr. 1873): 126-128. [H. L. Bingham wants to sell gallery.]

BINGHAM, H. L. (SAN ANTONIO, TX)
B856 "Photographs of Sorrow in Texas." PHOTOGRAPHIC TIMES 6, no. 68 (Aug. 1876): 179-180. [Apparently a tall tale about a young lady burying her grandma and pricing photos at the same time. Abstracted from the "San Antonio [TX] Herald."]

B857 "Texas. - The Progress of American Enterprise - Views in the Ancient American City of San Antonio. - From Photographs by H. L. Bingham and Doear & Jacobson." FRANK LESLIE'S ILLUSTRATED NEWSPAPER 47, no. 1205 (Nov. 2, 1878): 141. 7 illus. [Views, one outdoor portrait of a Mexican cowboy.]

BINGHAM, ROBERT JEFFERSON. (ca. 1800-1870) (GREAT BRITAIN, FRANCE)
[Worked as a chemistry aide for Professor Faraday, and a lecturer at the London Institute. Bingham became interested in photography as soon as it was announced. Published *Photogenic Manipulation* in 1848. In 1850 he suggested using collodion and gelatin in photography. In Paris by 1850s, and by the mid 50s he was photographing the works of many contemporary French artists. In 1858 he decided to become a professional photographer and opened a studio in Paris in 1859 with a partner, W. Thompson. A member of the Société française de Photographie in 1860. Experimented with electric light in 1860s. Died in Brussels on Feb. 21, 1870. His studio taken over by Ferrier & Lecadre.]

BOOKS
B858 Bingham, Robert J. *Photogenic Manipulation: Containing the Theory and Plain Instructions in the Art of Photography, or the Production of Pictures Through the Agency of Light.* London: Knight & Sons, 1852. In 2 parts. (Pt. 1, 87 pp.; Pt. 2, 60 pp.) 40 illus.

[Published first in 1848, went through at least eleven editions. 11th ed. (1854). Part 1: Various processes. Part 2: The Daguerreotype Process. Reprinted (1973), Arno Press.]

B859 Delaroche, Hippolyte. *Oeuvre de Paul Delaroche*, reproduit en photographie par Bingham accompagne d'une notice sur la vie et les ouvrages de Paul Delaroche par Henri Delaborde et du catalogue raisonné de oeuvre par Jules Godde. Paris: Goupil & Cie., 1858. 2 vol. 86 b & w. [Vol. 1, 8 pp., plates; vol. 2, 27 pp., plates.]

B860 *L'Album*. Recueil de dessins, tableaux et statues d'apres les ouvrages des meilleurs artists française et étrangers, "photographiés par M. Bingham. Publié avec des notes sous la direction de M. Louis Martinet." Paris: Goupil & Cie., 1859. 10 pp. 10 b & w. [Original photographs, by Bingham.]

B861 Meissonier, Jean Louis Ernst. *Oeuvres, reproduit en photographie*. Paris: Goupil & Cie., 1861. 2 vol. pp. 56 b & w. [Original photographs, of Meissonier's paintings, by Bingham.]

B862 *Oeuvre de Ary Scheffer*, reproduit et photographié par Bingham, accompagné d'une Notice sur la vie et les ouvrages d'Ary Scheffer, par L. Vitet, de l'Académie française. Paris: Goupil & Cie., 1860. 32 pp. 60 l. of pl. 60 b & w. [Issued in 15 parts, each with 5 photographs.]

PERIODICALS
B863 "Reviews of New Books." PRACTICAL MECHANIC'S JOURNAL 3, no. 26 (May 1850): 41. [Bk. Rev.: "Photogenic Manipulation. Part I, by R. J. Bingham. (6th ed.) The review contains an excerpt from the chapter "Photography on Glass."]

B864 "Our Literary Table." ATHENAEUM no. 1238 (July 19, 1851): 771. [Bk. rev.: "Photogenic Manipulation," by Robert J. Bingham. (8th ed.)]

B865 Bingham, Robert. J. "Photographic Manipulation." PHOTOGRAPHIC ART JOURNAL 2, no. 4-6 (Oct. - Dec. 1851): 239-244, 305-312, 365-372.

B866 Bingham, Robert. J. "Photographic Manipulation." PHOTOGRAPHIC ART JOURNAL 3, no. 1-4 (Jan. - Apr. 1852): 51-60, 115-124, 181-188, 232-235. [Continued from 2:6 p. 325.]

B867 Portrait. Woodcut engraving credited "From a photograph by Bingham of Paris." ILLUSTRATED LONDON NEWS 34, (1859) ["Marshal Randon, French Minister of War." 34:* (May 21, 1859): 493.]

B868 Portraits. Woodcut engravings credited "From a photograph by Bingham of Paris." ILLUSTRATED LONDON NEWS 48, (1866) ["Sir James Simpson, M.D." 48:* (Feb. 24, 1866): 177.]

B869 Portrait. Woodcut engraving credited "From a photograph by Bingham." ILLUSTRATED LONDON NEWS 64, (1874) ["Late Mr. Galignani." 64:1795 (Jan. 17, 1874): 48.]

B870 Sutton, Thomas. "Some New Light Thrown upon the Early History of the Wet Collodion Process." ANTHONY'S PHOTOGRAPHIC BULLETIN 6, no. 3 (Mar. 1875): 73-75. [From "Br. J. of Photo." Question is the discoverer was Archer or Bingham. Gives brief outline of Bingham's career. Public lecturer on Chemistry at London Institute, Finsbury. A good daguerreotypist and calotypist, he wrote a manual. Moved to Paris ca. 1852, ran a successful photo. studio, acknowledged expert in copying paintings. Died in Paris a few

years before this article. Claimed, in his final months, to have actually discovered the process while Archer observed.]

B871 Portrait. Woodcut engraving credited "From a photograph by Bingham." ILLUSTRATED LONDON NEWS 74, (1879) ["Late Mr. E. S. Dallas, author." 74:2069 (Feb. 8, 1879): 129.]

B872 Portrait. Woodcut engraving credited "From a photograph by Bingham." ILLUSTRATED LONDON NEWS 74, (1879) ["Late Mr. E. S. Dallas, author." 74:2069 (Feb. 8, 1879): 129.]

BIOT, JULIEN.
B873 Biot, Julien. "Improved Taupenot Process." HUMPHREY'S JOURNAL OF PHOTOGRAPHY, AND THE ALLIED ARTS AND SCIENCES 12, no. 21 (Mar. 1, 1861): 325-326. [From "Photo. Notes."]

BIRADERLER BROTHERS see ABDULLAH BROTHERS.

BIRD, GOLDING.
B874 Bird, Dr. Golding "A Treatise on Photogenic Drawing." MIRROR OF LITERATURE, AMUSEMENT AND INSTRUCTION 33, no. 945 (Apr. 1839): 241, 243-244. 1 illus. [Facsimile of a photogenic drawing on p. 241.]

BISBEE, ALBERT.
B875 Bisbee, A. *The History and Practice of Daguerreotyping*. Dayton, OH: L. F. Claflin, 1853. 104 pp. [Manual. Contains letter and ordinance granting Daguerre's pension by the French government. J. E. Mayall's description of collodion photography. Extract of Robert Hunt's description of Niépce de St. Victor's process and a note by James Campbell. Reprinted (1973), Arno Press.]

BISBEE, E. (HAMBURG, GERMANY)
B876 Portrait. Woodcut engraving, credited "From a Photograph by E. Bisbee, Hamburg. FRANK LESLIE'S ILLUSTRATED NEWSPAPER 41, (1875) ["Theodore Wachtel, German tenor." 41:1046 (Oct. 16, 1875): 85.]

BISCHOFF & SPENCER. (VALPARAISO, CHILE)
B877 "The Island of Juan Fernandez." ANTHONY'S PHOTOGRAPHIC BULLETIN 5, no. 11 (Nov. 1874): 362. ["Bischoff & Spencer have secured some... stereo views and 4" x 4" negatives of the island, rendered so famous by the story of Robinson Crusoe."]

B878 "Large Fire at Valparaiso. - Heroism of Messrs. Bischoff & Gray." ANTHONY'S PHOTOGRAPHIC BULLETIN 7, no. 2 (Feb. 1876): 52. [Mr. Bischoff and Mr. Gray, of Bischoff & Spencer (Valparaiso) saved two women from a fire next to their gallery.]

BISHOP, GILES. (1827-1909) (USA)
B879 Craig, John S. "Photographist's Family: 1876." NORTHLIGHT (JOURNAL OF THE PHOTOGRAPHIC HISTORICAL SOCIETY OF AMERICA) 3, no. 3 (Summer 1976): 10-11. 3 b & w. [Giles Bishop was born in Chesterfield, CT. He left his family's farm to join the gold rush in California in 1849. He mined, entered business, then moved to Vancouver, where he worked until the mid 1850s. He returned to New London, CT in 1858 and married. He then engaged in business for two years in Baltimore, MD, before returning to New London, where he opened a photographic studio which remained in business as Giles Bishop from 1860 to 1872, then Bishop & Kenyon from 1872 to 1876, before going back to Bishop alone, and then, after 1895, Giles Bishop & Son until 1909. His son Isaac continued the studio at least through 1915.]

BISHOP, T. B.

B880 Portraits. Woodcut engravings, credited "From a Photograph by T. B. Bishop." HARPER'S WEEKLY 8, (1864) ["Maj.-Gen. Palmer." 8:376 (Mar. 12, 1864): 165. "Brig.-Gen. James D. Morgan." 8:405 (Oct. 1, 1864): 637. "Brig.-Gen. William P. Carlin." 8:405 (Oct. 1, 1864): 637.]

B881 "The Escaped Slave — The Escaped Slave in the Union Army." HARPER'S WEEKLY 8, no. 392 (July 2, 1864): 422, 428. 2 illus. ["Photographed by T. B. Bishop." Negro man, before and after, used for propaganda.]

B882 Portrait. Woodcut engraving, credited "From a Photograph by T. B. Bishop." HARPER'S WEEKLY 9, (1865) ["Gen. G. D. Wagner." 9:424 (Feb. 11, 1865): 85.]

BISSON FRERES. (FRANCE)

[Louise-Auguste Bisson was an architect, employed by the City of Paris. Auguste-Rosalie, the younger brother, worked for their father, who was a heraldic painter. The firm of Bisson Père et Fils was established in Paris in 1840. In addition to portraits, they copied works of art and specimens of natural history. Made daguerreotype portraits of 900 members of the French National Assembly in 1849-51, which were later published as lithographs. Switched from the daguerreotype to wet collodion in early 1850s, and became highly regarded for their views of architecture and monuments. Published *Choix d'Ornaments Arabes de l'Alhambra.* in 1853 and *Reproductions photographiques des plus beaux types d'architecture et de sculpture d'apres les monuments les plus remarquables de l'Antiquité, du Moyen-Age, et de la Renaissance*, completed in 1862. Auguste-Rosalie photographed the Alps in 1860 and 1861. Other publications throughout 50s and 60s. They were made the official photographers to Emperor Napoleon III in 1860. Sold their studio to Emile Placet in 1864, and Louise-Auguste retired while Auguste-Rosalie worked for other photographers.]

BOOKS

B883 *Views of Swiss Glaciers, reduced from the originals by Bisson Freres.* Cambridge, England: s. n., 1863. 4 pp. 22 l. of plates. 22 b & w.

PERIODICALS

B884 "Application of Photography to Zoological Studies." HUMPHREY'S JOURNAL 5, no. 22 (Mar. 1, 1854): 350-351. [Source not given.]

B885 "Proceedings of the Liverpool Photographic Society: Seventh Monthly Meeting, Sept. 4, 1855." HUMPHREY'S JOURNAL 7, no. 13 (Nov. 1, 1855): 204-205. [Report of meeting, some of it given over to a discussion of a 3'2" x 2'6" print of the Tuilleries by the Bisson Freres.]

B886 "Ascent of Mont Blanc: M. Bisson's Photographic Expedition Leaving the Station of the Grands Mulets." ILLUSTRATED LONDON NEWS 41, no. 1158 (Aug. 9, 1862): 153, 171-172. 1 illus. [Detailed description of the expedition.]

B887 "Scraps and Fragments: Photography in the Alps." BRITISH JOURNAL OF PHOTOGRAPHY 9, no. 174 (Sept. 15, 1862): 357. [From "The Athenaeum." Describes difficulties encountered by M. Bisson while climbing Mont Blanc. Additional notes on p. 358 in "Foreign Correspondence."]

B888 "Photography on Mount Blanc." HUMPHREY'S JOURNAL OF PHOTOGRAPHY, AND THE ALLIED ARTS AND SCIENCES 14, no. 12 (Oct. 15, 1862): 142. [From "Moniteur de la Photographie."]

B889 "Useful Facts, Receipts, Etc.: Photography in the Alps." AMERICAN JOURNAL OF PHOTOGRAPHY AND THE ALLIED ARTS & SCIENCES n. s. vol. 5, no. 9 (Nov. 1, 1862): 209-210. [From "Athenaeum." Description of Bisson Freres ascent of Mt. Blanc.]

B890 "Note." ART JOURNAL (Oct. 1863): 211. ["Momuments of Italy" series by Bisson Freres published by Mr. V. Delarue of Chandos St., London.]

B891 "Note." PHILADELPHIA PHOTOGRAPHER 9, no. 101 (May 1872): 135. ["Mssrs. Leon & Levy presented to the Photographic Society of Paris a number of views taken by Messrs. Bisson and Welling during a nine months' journey to Egypt..." dry plates, developed a year later.]

BISSON, AUGUSTE-ROSALIE (1826-1900) (FRANCE) see BISSON FRERES.

BISSON, LOUISE-AUGUSTE (1814-1876) (FRANCE) see BISSON FRERES.

BLACK & BATCHELDER. (BOSTON, MA)

B892 "Chime of Thirteen Bells for Christ Church, Cambridge, Massachusetts, Manufactured by Messrs. Henry N. Hooper & Co., of Boston." HARPER'S WEEKLY 4, no. 178 (May 26, 1860): 324. 1 illus. [Group portrait of workmen, with large bells.]

B893 Seely, Charles A. "Editorial Department." AMERICAN JOURNAL OF PHOTOGRAPHY AND THE ALLIED ARTS & SCIENCES n. s. vol. 5, no. 6 (Sept. 15, 1862): 143. [Describes Black & Bachelder's elaborate process to save and reclaim silver wastes.]

BLACK & CASE. (BOSTON, MA)

B894 Portraits. Woodcut engravings, credited "From a Photograph by Black & Case, Boston, Mass." HARPER'S WEEKLY 10, (1866) ["Charles Sumner." 10:482 (Mar. 24, 1866): 180. "Gov. Paul Dillingham, of VT." 10:509 (Sept. 29, 1866): 620.]

B895 Portrait. Woodcut engraving, credited "Photographed by Black & Case." FRANK LESLIE'S ILLUSTRATED NEWSPAPER 39, (1874) ["Martin Millmore, Sculptor, Boston, MA." 39:991 (Sept. 26, 1874): 44.]

B896 Portrait. Woodcut engraving. HARPER'S WEEKLY 18, (1874). ["Charles Sumner." 18:900 (Mar. 28) (Not credited, but same photo published in Mar. 24, 1866 issue of "HW".)]

BLACK, ISA. (FRANKLIN, PA)

B897 "Editor's Table." PHILADELPHIA PHOTOGRAPHER 14, no. 166 (Oct. 1877): 319. [Isa Black (Franklin, PA) opened a new gallery.]

BLACK, JAMES WALLACE see also BLACK & BATCHELDER; BLACK & CASE; STILLMAN, W. J.; WHIPPLE & BLACK.

BLACK, JAMES WALLACE. (1825-1896) (USA)
BOOKS

B898 *Album of Photographic Prints of Views of New Hampshire.* Boston: Whipple & Black, n. d. [ca. 1855]. n. p. 35 b & w. [Bound album of photographic (crystalotype) prints, with letterpress stamping on spine. Collection of Fine Arts Library, Harvard University. Individual prints in the Metropolitan Museum of Art, New York, collections.]

B899 *Photographs from Doré's "Dante's Inferno,"* by J. W. Black. Boston: J. E. Tilton, 1868. n. p. 24 l. of plates. 24 b & w.

B900 Parmelee, Moses Payson. *Life Scenes among the Mountains of Ararat.* Boston: Sabbath School Society, ca. 1868. viii, 265 pp. 4 b & w. ["The photographs in the volume were taken from pictures in possession of the author, by J. W. Black, of Boston." (Costume native portraits, taken in Armenia, then reproduced for printing by Black.)]

B901 *Five Hundred Past and Present Citizens of Worcester, Mass.* Photographed by Claflin, Worcester, and Black, Boston. Boston: G. R. Peckham, 1870. xi pp. 56 l. of plates. 500 b & w. [Each plate contains 9 vignetted portraits, with the sitter's name written underneath, the ensemble then rephotographed and published as one plate. In some cases the original portraits are from paintings, but many are probably from Black's negatives.]

B902 Wheildon, William. *Semi-Centennial Celebration of the Opening of Faneuil Hall Market, August 26, 1876, with a History of the Market.* Prepared for the Committee of Arrangements. Boston: s. l., 1877. n. p. [Contains two albumen photographs taken by Black at the time of the celebration. No title or imprint on the photographs, but the text mentions Black's photographic activities.]

B903 Black, James Wallace. *The Photographs of James Wallace Black; Views of the Ruins of the Great Fire in Boston, November 1872; From the Collection of the Library of the Boston Athenaeum.* Catalogue and Exhibition by Stephen Robert Edidin. Williamstown, MA: Williams College Museum of Art, 1977. 31 pp. b & w. [Exhibition, Dec. 1 - Dec. 31, 1977.]

B904 Pierce, Sally. With a chronological Annotated Bibliography by William S. Johnson. *Whipple and Black: Commercial Photographers in Boston.* Boston: The Boston Athenaeum, 1987. 121 pp. 90 b & w. ["Chronology," pp. 105 - 108; "Appendices," pp. 109 - 112; "Bibliography," pp. 113 - 121. James Wallace Black was born in Francetown, NH on Feb. 10, 1825. He learned daguerreotype from John A. Lerow in Boston in 1846. Studied with L. H. Hale and then Loyal M. Ives, in Boston, from 1846 to 1850.
Began to work for John A. Whipple in 1850. Whipple patented a crystalotype process in 1850 which was an early variant of the calotype process, creating negatives from which many positive prints could be made, unlike the unique daguerreotype image. Thus Whipple and his assistant Black, who was a significant roleplayer in this activity, were among the earliest photographers to make photographic prints in this country. They attempted to exploit this priority by providing photographic illustrations for books and magazines, (In particular, by providing original prints from their own and other photographer's negatives to the "Photographic Art Journal" for several years.) by making albums, and by teaching the process to other photographers. Throughout the 1850s Black often travelled to New York and other cities to teach the process, and the list of those who first learned photography from him is long and, including such names as William J. Stillman and Oliver W. Holmes, prestigious. In 1854 Black photographed scenery in New Hampshire with the crystalotype process, and thus created some of the earliest landscape photographs (vs. daguerreotypes) taken in this country. In 1856 Black became Whipple's partner, and so remained until 1859. In 1857 Black went with Whipple to the Harvard Observatory to make the first collodion photographs of the moon, extending Whipple's feat of making the first clear daguerreotype view of the moon in 1851.
Black set up his own studio in 1860, this time with his own junior partner, Perez M. Batchelder. Black took the first aerial photographs in the USA, from a balloon near Providence, RI on Aug. 16, 1860, then repeated the feat over Boston on October 13th. While not always this spectacular, the Black studio would remain an active and energetic place throughout his lifetime, and in addition to the traditional portraits, Black produced many views, city scenes, crowd portraits, parades, and views of other ceremonial functions. Later he would start the mug shot collection of criminals for the Boston Police Department. In 1861 he began experimenting with "porcelain transparencies," or opal glass photographs and was considered to be the first to popularize that process.
The Black & Batchelder partnership dissolved in 1862 and Black formed a new partnership with John G. Case in 1864. He expanded his Boston studio at that time, and had the "...largest establishment in the city, with 40,000 negatives stored and 60 hands, male and female, employed..." He also opened a branch in Providence, RI. Black & Case dissolved in 1867.
In 1868 Black was active in fighting the legal but unfair Cutting patent, and he became an officer in the newly formed National Photographic Association, the first such national organization in America, which was formed, in part, to combat the patent. Black also helped in the formation of the Boston Photographic Union in 1869. Black had an open-handed generosity and spirit that made him both well-liked and highly respected by his peers, and a sense of that character even comes through in the dry references of hundred year old magazines.
In 1869 John L. Dunmore, an assistant representing the Black studio, sailed with the artist William Bradford on his expedition to the arctic. Dunmore made several hundred 14" x 18" negatives of icebergs, scenes and natives in Labrador, and of the expedition. Bradford later published a book, illustrated with nearly 140 magnificent photographs. These views, credited to the Black studio, as was the custom then, again refreshed Black's international reputation.
In the 1870s Black was an early practitioner of "stereopticon exhibitions," an entertainment and educational program where a lecturer showed lantern slides and discussed their subjects. These were very popular for a time, and often drew large audiences. The machinery was dangerous however, as when Black and his assistant Dunmore were injured in an explosion in 1870. But they continued giving these performances through the 70s, to popular acclaim.
In 1872 the Great Boston Fire, which destroyed much of the downtown business district, burned right up to his studio door, but Black was out photographing the ruins the next day with his accustomed enthusiasm and skill. Once again many of his powerful views of the Boston ruins were widely published in the illustrated weekly magazines in the USA and abroad.
The firm name was changed to Black & Co. in 1874. Dunmore was made a partner in 1876. Black died of pneumonia in 1896, one of the best liked and highly respected practitioners of his generation. Black & Co. went out of business in 1901, and, apparently, many of his negatives went to B. French at that time.]

PERIODICALS

B905 "Gossip." PHOTOGRAPHIC AND FINE ART JOURNAL 8, no. 5 (Nov. 1854): 352. [Black photographing scenery in the White Mountains, NH.]

B906 "Personal & Art Intelligence." PHOTOGRAPHIC AND FINE ART JOURNAL 10, no. 11 (Nov. 1857): 351. [Letter from Black describing his experience with covering negatives with varnish.]

B907 Helme, W. H. "Photographing from a Balloon." PHOTOGRAPHIC AND FINE ART JOURNAL 13, no. 8 (Aug. 1860): 274-275.

B908 "Photographing from a Balloon." AMERICAN JOURNAL OF PHOTOGRAPHY n. s. 3, no. 7 (Sept. 1, 1860): 105-106. [From the "Providence Journal." Describes Black's photographing from a balloon over Providence, RI.]

B909 "Aerial Photography." HUMPHREY'S JOURNAL OF PHOTOGRAPHY, AND THE ALLIED ARTS AND SCIENCES 12, no. 9 (Sept. 1, 1860): 132-133. [Black's photographing Providence, RI, from a balloon described.]

B910 "Balloon Photographing." BOSTON EVENING TRANSCRIPT 31, no. 9347 (Sat., Oct. 13, 1860.): 1.

B911 "The Artistic Balloonists." BOSTON EVENING TRANSCRIPT 31, no. 9349 (Mon., Oct. 15, 1860): 1.

B912 "Photographing from a Balloon." BOSTON HERALD (Oct. 13, 1860): 4.

B913 "The Balloon Ascension." BOSTON HERALD (Oct. 15, 1860): 2.

B914 "Photograph of Boston from a Balloon." AMERICAN JOURNAL OF PHOTOGRAPHY AND THE ALLIED ARTS & SCIENCES n. s. vol. 3, no. 11 (Nov. 1, 1860): 170-171. [From "Boston Journal."]

B915 "Aerial Photography." HUMPHREY'S JOURNAL OF PHOTOGRAPHY, AND THE ALLIED ARTS AND SCIENCES 12, no. 13 (Nov. 1, 1860): 195-197. [Views of the city of Boston, taken from a balloon.]

B916 King, Samuel A. "The Late Balloon Photographic Experiment." AMERICAN JOURNAL OF PHOTOGRAPHY AND THE ALLIED ARTS & SCIENCES n. s. vol. 3, no. 12 (Nov. 15, 1860): 188-190. [King's (the operator of the balloon) description of the Black's aerial photographing of Boston.]

B917 "Miscellaneous: Photograph of Boston from a Balloon." PHOTOGRAPHIC NEWS 4, no. 115 (Nov. 16, 1860): 347.

B918 Seely, Charles A. "The American Photographical Society: 22nd Meeting." AMERICAN JOURNAL OF PHOTOGRAPHY n. s. 3, no. 13 (Dec. 1, 1860): 204-206. [Joseph Dixon gave some of Black's balloon photographs to the Society, is reported to have claimed that Black also took the first photographs of the moon.]

B919 Dixon, Henry. "Letter: Who Made the Photograph of the Moon?" AMERICAN JOURNAL OF PHOTOGRAPHY n. s. 3, no. 14 (Dec. 15, 1860): 222. [Dixon's letter claims that he was misquoted in the report of the American Photographical Society meeting.]

B920 Black, James Wallace. "Letter: Who Made the Photograph of the Moon?" AMERICAN JOURNAL OF PHOTOGRAPHY n. s. 3, no. 16 (Jan. 15, 1861): 245-246. [Black credits his former partner John Whipple with being the first to make a daguerreotype of the moon, states that he took the first collodion negative of the moon.]

B921 Portrait. Woodcut engraving, credited "From a Photograph by J. W. Black." HARPER'S WEEKLY 6, (1862) ["Commodore Goldsborough." 6:282 (May 24, 1862): 333.]

B922 Holmes, Oliver W. "Doings of the Sunbeam." ATLANTIC MONTHLY 12, no. 49 (July 1863): 1-15. [Holmes describes learning to photograph from J. W. Black on pp. 3-7. Black's aerial photography from a balloon described on p. 12, and his use of the medium to copy documents on p. 14.]

B923 R. A. S. "Notes of the Month." BRITISH JOURNAL OF PHOTOGRAPHY 10, no. 193 (July 1, 1863): 275. [Discusses experiments with aerial photography from balloons, describing "Dr.

Helme's successes in Providence a few years ago..." (without actually mentioning J. W. Black's name), then discusses Negretti's current experiments.]

B924 "Photography In Boston." AMERICAN JOURNAL OF PHOTOGRAPHY AND THE ALLIED ARTS & SCIENCES n. s. vol. 6, no. 14 (Jan. 15, 1864): 321-323. [J. W. Black has "the largest establishment in the city. 40,000 negatives stored. 60 hands, male and female, employed in the establishment. One room is devoted to copying, one to groups, one to ordinary card work. One operator coats the plates, another exposes them, Mr. Black himself attends to the positions, and another assistant develops.... Nearly twenty tons of glass (negatives) must be stored away in this single establishment. Mr. Black also has rooms at Cambridge, near his residence." Mr. Whipple maintains his ancient fame, and keeps his old establishment at 96 Washington St. (More information on Whipple.) Ormsbee and Burnham mentioned. Boston maintains about seventy galleries.]

B925 Portraits. Woodcut engravings, credited "Photographed by Black, Boston." FRANK LESLIE'S ILLUSTRATED NEWSPAPER 18, (1864) ["Capt. John A. Winslow, U.S.N." 18:460 (July 23, 1864): 273.]

B926 Portrait. Woodcut engraving, credited "Photographed by Black, Boston." HARPER'S WEEKLY 8, (1864) ["Captain John A. Winslow, of the Kearsarge." - 8:395 (July 23, 1864): 477.]

B927 Seely, Charles A. "Editorial Department." AMERICAN JOURNAL OF PHOTOGRAPHY AND THE ALLIED ARTS & SCIENCES n. s. vol. 7, no. 13 (Jan. 1, 1865): 311. ["Photographs on white or opal glass seem lately to be much talked about...." About three years since Mr. J. W. Black, of Boston, made them a branch of his business. He was eminently successful, and his success induced others to follow in the same direction." Alex Hesler (Chicago, IL), Thomas Faris (New York, NY), Wenderoth (Philadelphia, PA) etc.]

B928 S. R. D. "A Visit to Boston." AMERICAN JOURNAL OF PHOTOGRAPHY AND THE ALLIED ARTS & SCIENCES n. s. vol. 7, no. 18 (Mar. 15, 1865): 410-412. [S. R. D., from New York, NY, visited Boston, MA., met Marshall, Whipple, Black and others. "Mr. Black very kindly conducted us through his immense photographic establishment. Mr. Black's business is colossal... Mr. Black has on hand nearly one hundred and fifty thousand negatives."]

B929 Portrait. Woodcut engraving, credited "From a Photograph by J. W. Black, Boston." 9, (1865). ["Admiral Louis M. Goldsborough," 9:446 (July 15, 1865): 437. (Same portrait published in July 1864 issue.)]

B930 "Statue of Horace Mann, Inaugurated in the State House Grounds, Boston, Mass., July 4. - From a Photograph by Black, of Boston." FRANK LESLIE'S ILLUSTRATED NEWSPAPER 20, no. 514 (Aug. 5, 1865): 317. 1 illus.

B931 "Editor's Table: Photographs Received." PHILADELPHIA PHOTOGRAPHER 3, no. 25 (Jan. 1866): 32. [Mentions "cartes of children." Describes Mr. Black's monster rolling press, which works by steam, used in processing photos. Notes premium won at the "late exhibition."]

B932 "Editor's Table: Photographs." PHILADELPHIA PHOTOGRAPHER 3, no. 26 (Feb. 1866): 64. [Describes photographs by J. W. Black.]

B933 "The College Regatta and Ball Match at Worcester, Mass., July 19, 1867. HARPER'S WEEKLY 11, no. 553 (Aug. 3, 1867): 488-489.

[Six man scull in the water. "From Sketches by Charles G. Bush and Photographs by J. W. Black."]

B934 "The Steam-Ship 'Ontario' of the New Boston and Liverpool Line." HARPER'S WEEKLY 11, no. 564 (Oct. 19, 1867): 669. 1 illus. ["Photographed by J. W. Black, Boston."]

B935 Boyle, C. B. "The Lens Controversy." PHILADELPHIA PHOTOGRAPHER 4, no. 46 (Oct. 1867): 324-327. [Boyle discusses a lens he made for J. W. Black, and describes how Black used the lens.]

[During 1868 - 1876 (and following) James W. Black was a key figure in the formation and early activities of the National Photographic Association, the first nationally-based organization for professional photographers in the United States, and the subsequent formation of the regional chapter of that organization, the Boston Photographic Union - later named the Boston Photographic Association, then the New England Photographic Association. One factor leading to the formation of this organization was to find a means to fight a restrictive copyright patent, called the "Cutting Patent." There are many mentions of Black and his activities in the *Philadelphia Photographer* during this time in relation to these issues. PHILADELPHIA PHOTOGRAPHER 5-13, no. 49 - 156 (Jan. 1868 - Dec. 1876): (1868) 130, 135, 136, 248, 250, 281-282, 287, 313; (1869) 18, 88, 129, 162, 212-213, 219, 234, 252, 318, 332, 334, 350, 422; (1870) 12, 33, 81-82, 99, 112, 160, 214, 226, 235, 239, 241, 252, 277, 279, 350; (1871) 139-140, 197, 254-259, 364; (1872) 170, 197, 215, 218, 257, 385; (1873) 12-13, 51-52, 81, 148-149; (1874) 18, 78-79, 113, 220, 248, 339-340, 373-374, 382-383; (1875) 57, 78, 187, 215, 287, 314, 333-334, 372 (1876) 46-47, 61, 91, 111-112, 143-144, 228.]

B936 "Anti-Bromide Pictures." PHILADELPHIA PHOTOGRAPHER 5, no. 55 (July 1868): 248. [Note that J. W. Black was making a group of "anti-bromide" photographs.]

B937 "Ball's Equestrian Statue of Washington, Public Garden, Boston." HARPER'S WEEKLY 13, no. 658 (Aug. 7, 1869): 509. 1 illus. ["Photographed by J. W. Black, Boston."]

B938 "Graduated Backgrounds." PHILADELPHIA PHOTOGRAPHER 6, no. 71 (Nov. 1869): 378. [J. W. Black mentioned as the first to use graduated backgrounds for portraiture.]

B939 "Birth-Place of George Peabody, South Danvers, Massachusetts." HARPER'S WEEKLY 13, no. 677 (Dec. 18, 1869): 808. 1 illus. ["Photographed by Black, Salem, Massachusetts." Events surrounding the burial of philanthropist, George Peabody.]

B940 "The Funeral Train of George Peabody, Philanthropist." HARPER'S WEEKLY 14, no. 684 (Feb. 5, 1870): 84. 1 illus.

B941 "The Peabody Funeral. Reception of the Remains at the City Hall, Portland, Maine." HARPER'S WEEKLY 14, no. 686 (Feb. 19, 1870): 113. 1 illus.

B942 "Editor's Table: Sad Accident." PHILADELPHIA PHOTOGRAPHER 7, no. 75 (Mar. 1870): 95. [J. W. Black and his assistant J. L. Dunmore injured in an explosion during a magic lantern exhibition.]

B943 "Funeral of Mr. Peabody in America." ILLUSTRATED LONDON NEWS 56, no. 1584 (Mar. 12, 1870): 277-278. 2 illus. ["...from photographs by Mr. J. W. Black, Washington St., Boston."]

B944 Portrait. Woodcut engraving, credited "From a photograph by J. W. Black, Boston." HARPER'S WEEKLY 14, (1870). ["William Lloyd Garrison, abolitionist." 14:699 (May 21): 113.]

B945 "The Cleveland Convention." ANTHONY'S PHOTOGRAPHIC BULLETIN 1, no. 5-6 (June - July 1870): 106, 110-115. [Black exhibition of antern slides of Dunmore's Arctic photographs at the NPA conference described on p.106, his participation in the NPA meeting and exhibition mentioned in the report of the conference.]

B946 Vogel, Dr. H. "German Correspondence." PHILADELPHIA PHOTOGRAPHER 8, no. 85 (Jan. 1871): 21. [Black's (i.e. Dunmore's) photographs of the Arctic praised by Vogel.]

B947 "Lantern Slides Wanted." PHILADELPHIA PHOTOGRAPHER 8, no. 89 (May 1871): 136. [Note that J. W. Black and Prof. Morton gathering slides for a demonstration at the 1871 NPA conference.]

B948 Portraits. Woodcut engravings, credited "From a photograph by J. W. Black, Boston." HARPER'S WEEKLY 15, (1871). ["Father Taylor, "the Sailor's Preacher." 15:749 (May 6): 401. "The late Rev. Ezra Stiles Gannett." 15:768 (Sept. 16): 861.]

B949 "Black's Acid Nitrate Bath." PHILADELPHIA PHOTOGRAPHER 8, no. 90 (June 1871): 177.

B950 Comments and notes about Black's participation at various National Photographic Association functions. PHOTOGRAPHIC WORLD 1-2, (June - July 1871, Jan., May 1872): (1871) 98, 175, 187; (1872) 12, 157.

B951 "Proceedings of the National Photographic Association of the United States." ANTHONY'S PHOTOGRAPHIC BULLETIN 2, no. 7 (July 871): 197-199. [Report of Black's demonstration of his nitrate bath solution at the 3rd annual NPA convention.]

B952 "Note." ANTHONY'S PHOTOGRAPHIC BULLETIN 2, no. 8 (Aug. 1871): 275. ["We are indebted to Mr. J. W. Black, of Boston, for portraits of Mr. Thos. Gaffield, Mr. A. S. Southworth, and Mr. D. T. Burrell of Boston".]

B953 Portrait. Woodcut engraving, credited "From a Photograph by J. W. Black." FRANK LESLIE'S ILLUSTRATED NEWSPAPER 33, no. 833 (Sept. 16, 1871): 13. ["The late Rev. Ezra Stiles Gannett."]

B954 "Note." PHOTOGRAPHIC TIMES 1, no. 10 (Oct. 1871): 154. ["Mr. William Bradford, the American artist, whose paintings of the Arctic Regions were made up from photographic studies, made by Mr. Dunmore with Mr. J. W. Black, in Boston, is in England, and has been given a reception by Lady Franklin. So much for photography!]

B955 "Editor's Table." PHILADELPHIA PHOTOGRAPHER 8, no. 96 (Dec. 1871): 407-408. ["Mr. J. W. Black is delighting New England and the rest of Boston with magnificent Stereopticon Exhibitions. His programme 'No. 1' includes views in the Polar Seas and in the Holy Land, and No. 2, Black's famous trip around the world. He is doing good work in photography too, for he exhibits none but its best productions."]

B956 "Photography Abroad - About the Acid Bath of Mr. Black in Boston. " PHOTOGRAPHIC WORLD 2, no. 13 (Jan. 1872): 1-2. [From the "Mittheillungen."]

B957 "The Geneva Conference - The American Arbitrator and Council." HARPER'S WEEKLY 16, no. 788 (Feb. 3, 1872): 100. 5 illus. [The portrait of Charles Francis Adams is by J. W. Black.]

B958 Vogel, Dr. H. "German Correspondence." PHILADELPHIA PHOTOGRAPHER 9, no. 99 (Mar. 1872): 88. ["Mr. Black, in Boston, MA, was probably not aware what an extraordinary effects the photographs of Greenland and Labrador,... would produce here."]

B959 Black, J. W. "Fourth Annual Meeting and Exhibition of the N.P.A. in St. Louis, Mo., May 1872: Demonstration of His Acid Bath Technique." PHILADELPHIA PHOTOGRAPHER 9, no. 102 (June 1872): 165-167.

B960 "Editor's Table." PHILADELPHIA PHOTOGRAPHER 9, no. 105 (Sept. 1872): 336. [From Mr. J. W. Black we have a 14" x 17" view of the Coliseum, and a large portrait of Horace Greeley. They are both excellent likenesses and capital photographs.]

B961 "Scenes and Incidents of the Great Fire in Boston." FRANK LESLIE'S ILLUSTRATED NEWSPAPER 35, no. 896 (Nov. 30, 1872): 187, 192. 6 illus. [Two views of ruins "from photographs by J. W. Black," Four drawings of activities associated with the fire "from sketches by James E. Taylor." Black's views are of the ruins of the Trinity Church and of Benjamin Franklin's birthplace, Boston, MA.]

B962 "The Great Fire at Boston." ILLUSTRATED LONDON NEWS 61, no. 1734 (Nov. 30, 1872): 521-522. 3 illus. [Ruins.]

B963 "Boston - Coal Heaps Burning on the Docks." HARPER'S WEEKLY 16, no. 832 (Dec. 7, 1872): 949. 1 illus. [Boston fire aftermath.]

B964 "The Great Fire at Boston." ILLUSTRATED LONDON NEWS 61, no. 1735 (Dec. 7, 1872): 548-549. 6 illus. ["...supplied by the photographs and sketches that have arrived by the last mail." Four of the six views are probably from photos - possibly by J. W. Black.]

B965 "Among the Ruins of the Boston Fire." FRANK LESLIE'S ILLUSTRATED NEWSPAPER 35, no. 898 (Dec. 14, 1872): 217, 221. 3 illus. [Views of Franklin Square, an archway of ruins on Milk St., from Summer St., near Washington St., Boston, MA.]

B966 "General View of the Ruins after the Great Fire at Boston." ILLUSTRATED LONDON NEWS 61, no. 1736 (Dec. 14, 1872): 560-562. 1 illus. [Panoramic view of ruins.]

B967 "Panoramic View of the Ruins after the Great Fire in Boston, From a Point Opposite Trinity Church in Summer Street. - From Photographs by James W. Black, Boston." FRANK LESLIE'S ILLUSTRATED NEWSPAPER 35, no. 901 (Jan. 4, 1873): supplement. 1 illus. ["Presented Gratuitously as a Supplement to No. 901 of "FLIN." "From Photographs by J. W. Black, Boston." Special fold-out panel panoramic view of the ruins, at least six regular pages wide, apparently issued as a special supplement to the regular weekly issue. (The copy I viewed was damaged, with some portion of the caption and image missing.)]

B968 "Editor's Table." PHILADELPHIA PHOTOGRAPHER 10, no. 109 (Jan. 1873): 31. ["Lantern slides of the Boston, MA, ruins - Mr. J. W. Black, Boston has sent us some admirable lantern slides of the Boston ruins, copies of which he offers for sale, together with many hundreds of other subjects of foreign and home scenery, comic pictures, etc. Please read his advertisement."]

B969 Portraits. Woodcut engravings, credited "From a Photograph by J. W. Black." FRANK LESLIE'S ILLUSTRATED NEWSPAPER 35, (1873) ["The late Mrs. Harrison Gray Otis, of Boston." 35:907 (Feb. 15, 1873): 365. "Oakes Ames, as he appeared before the investigating committee in Washington." 35:908 (Feb. 22, 1873): 377.]

B970 Portraits. Woodcut engravings, credited "From a Photograph by J. W. Black, Boston." FRANK LESLIE'S ILLUSTRATED NEWSPAPER 36, (1873) ["George S. Boutwell, Sen.-elect from MA." 36:913 (Mar. 29, 1873): 41. "The late Hon. Oakes Ames." 36:921 (May 24, 1873): 176.]

B971 "Editor's Table - Items of News." PHILADELPHIA PHOTOGRAPHER 10, no. 112 (Apr. 1873): 127. ["Mr. J. W. Black, of Boston, made us a hasty visit on the 7th instant. He accompanied Dr. I. I. Hayes the Arctic explorer, managing the lantern exhibition of views in the polar regions. The lecture and the exhibition both were most entertaining and instructive."]

B972 "Editor's Table." PHILADELPHIA PHOTOGRAPHER 10, no. 115 (July 1873): 223. [Black's New Stereopticon Manual, and Catalogue of Stereopticon Transparencies," by J. W. Black, Boston, free to applicants.]

B973 "The Acid Nitrate Bath." PHILADELPHIA PHOTOGRAPHER 10, no. 117 (Sept. 1873): 322-324, 329-331. [Text of Black's presentation of his process at the 1873 NPA conference, answers to questions. Report of Black's lantern exhibition on p. 454. Listed as exhibitor on p. 466, mentioned on p. 568, etc.]

B974 Black, J. W. "Fifth Annual Meeting and Exhibit of the National Photographic Association of the U.S., held in Buffalo, N.Y., beginning July 5, 1873: Acid Nitrate Bath." PHILADELPHIA PHOTOGRAPHER 10, no. 117 (Sept. 1873): 322-323.

B975 "Note." ANTHONY'S PHOTOGRAPHIC BULLETIN 5, no. 1 (Jan. 1874): 61. [Evening session for July 18th. "This evening Mr. Black gave the members of the Association a grand stereopticon exhibition in St. James Hall."]

B976 Portrait. Woodcut engraving, credited "From a photograph by J. W. Black, Boston." HARPER'S WEEKLY 18, (1874). ["Hon. William Gaston, Governor-elect of MA." 18:935 (Nov. 28).]

B977 Black's activities with the National Photographic Association or the Boston Photographic Society mentioned or discussed. ANTHONY'S PHOTOGRAPHIC BULLETIN 5-6, no. 1-12 (Jan. 1874 - Dec. 1875): (1874) 264, 409; (1875) 5, 51, 58, 155, 253 .

B978 Portrait. Woodcut engraving, credited "Photographed by James W. Black." FRANK LESLIE'S ILLUSTRATED NEWSPAPER 38, (1874) ["Hon. W. A. Simmons, Collector of the Port of Boston." 38:964 (Mar. 21, 1874): 28.]

B979 "Class in Landscape Photography." PHILADELPHIA PHOTOGRAPHER 11, no. 126 (June 1874): 174-175. [J. W. Black, Stewart Merrill, D. E. Smith, A. S. Murray quoted on procedures, etc.]

B980 "International Baseball. Boston and Philadelphia Champions." FRANK LESLIE'S ILLUSTRATED NEWSPAPER 38, no. 982 (July 25, 1874): 317. 2 illus. [Group portrait of the Boston, MA, baseball team, by J. W. Black. Group portrait of the Philadelphia, PA, baseball team, by Stoddards & Fennimore.]

B981 "The Last Whipping-Post Used in Massachusetts, Which Stood in the Charlestown Prison. - Photo. by J. W. Black, Boston." FRANK LESLIE'S ILLUSTRATED NEWSPAPER 39, no. 1003 (Dec. 19, 1874): 245. 1 illus.

B982 Loomis, G. H. "Gallery Biographic. No. 2. John [Sic] Wallace Black." ANTHONY'S PHOTOGRAPHIC BULLETIN 5, no. 12 (Dec. 1874): 389-391.

B983 "Massachusetts. - The Centennial Celebration at Lexington, April 19th, 1875. - From Photographs by J. W. Black, and Sketches by Harry Ogden and E. R. Morse." FRANK LESLIE'S ILLUSTRATED NEWSPAPER 40, no. 1023 (May 8, 1875): 137, 128, 140-141. 6 illus. [Views, crowds, dances, "The Scene on Lexington Common," etc.]

B984 "Ruins of Dow's Drug Store. - Photographed by J. W. Black." FRANK LESLIE'S ILLUSTRATED NEWSPAPER 40, no. 1028 (June 12, 1875): 224. 1 illus. [View of burned out building.]

B985 "Massachusetts. - The Washington Elm at Cambridge. - Photographed by J. W. Black." FRANK LESLIE'S ILLUSTRATED NEWSPAPER 40, no. 1033 (July 17, 1875): 329. 1 illus. [View.]

B986 "Greenough's Statue of Governor Winthrop of Massachusetts, to be Placed in the Capitol at Washington, D. C. - From a Photograph by Black, of Boston." FRANK LESLIE'S ILLUSTRATED NEWSPAPER 42, no. 1067 (Mar. 11, 1876): 13. 1 illus.

B987 Black, J. W. "Days Gone By." ST. LOUIS PRACTICAL PHOTOGRAPHER 1, no. 7 (July 1877): 220-221. [Anecdotes from his early career in Boston, MA.]

B988 "Society Gossip." PHILADELPHIA PHOTOGRAPHER 16, no. 184 (Apr. 1879): 116. [J. W. Black elected president of the Boston Photographic Society.]

B989 "Mrs. Hulls' Murderer: Capture and Confession of the Assassin in Boston." NEW YORK ILLUSTRATED TIMES 6, no. 143 (July 5, 1879): 208. 3 illus. [Two sketches and a portrait of "Chastine Cox, the confessed murderer...From a photograph by J. W. Black, Boston."]

B990 "The Frye Murder." NEW YORK ILLUSTRATED TIMES 6, no. 151 (Aug. 30, 1879): 321, 323, 336. 10 illus.[Three sketches, a portrait of the "Late Mr. Joseph F. Frye - From a photograph by Black" and six portraits of the murderers and their captors "From Photographs by Black and Sketches by H. R. Burdick."]

B991 "Matters of the Month - The Megatype." PHOTOGRAPHIC TIMES 10, no. 117 (Sept. 1880): 208. ["Mr. J. W. Black writes... "I have fully investigated the Megatype, and I find it easy, practical, and economical. With such an improvement every photographer can make his own enlargements."]

B992 "Pictures Received." PHILADELPHIA PHOTOGRAPHER 17, no. 203 (Nov. 1880): 356. [Prints of the regatta at Hull.]

B993 "Matters of the Month." PHOTOGRAPHIC TIMES 12, no. 137 (May 1882): 180. ["The veteran photographer, John W. Black, hailing, of course, from the Hub, made us a friendly visit prior to his departure for an extended tour through Denmark, Norway and Sweden... one objective to make lantern slides..."]

B994 "Matters of the Month: Home Again." PHOTOGRAPHIC TIMES 12, no. 139 (July 1882): 277. ["Mr. J. W. Black, of Boston, has returned from Europe, whither he went on a picture-making tour."]

B995 "Note." PHOTOGRAPHIC TIMES 14, no. 158 (Feb. 1884): 71. [Mentions a photographic soiree held at the studio of Mr. J. W. Black in honor of Mr. John Carbutt.]

B996 "Obituary: James W. Black." BOSTON EVENING TRANSCRIPT (Jan. 6, 1896): 7.

B997 "Well-Known Photographer Gone." BOSTON HERALD (Jan. 6, 1896): 4.

B998 "Obituary: James W. Black. Photographer." BOSTON DAILY EVENING TRANSCRIPT (Jan. 6, 1896): 7.

B999 "In Memoriam: J. W. Black." WILSON'S PHOTOGRAPHIC MAGAZINE 33, no. 471 (Mar. 1896): 120-121. 1 illus. [Born Francestown, N.H. Feb. 10, 1825. To Boston. Learned photography. Partnership Whipple & Black, later Black & Case. One of the earliest lantern operators, etc. Died Jan. 5, 1896. Obituary includes a letter from B. French.]

B1000 Pease, N. W. "Editor's Table: Panoramic Photography." WILSON'S PHOTOGRAPHIC MAGAZINE 34, no. 487 (July 1897): 334. [Letter from N. W. Pease (North Conway, NH) stating, in response to Franklin Nims' article on "Panoramic Photography" in Feb. issue, that J. W. Black had made panoramic photos thirty-four to thirty-eight years ago - thus preceeding other claims.]

B1001 1 photo (Authors General Halpine ('Miles O'Reilly') and B. P. Shillaber ('Mrs. Partington') on p. 57 in: "A Retrospect of American Humor," by W. P. Trent. CENTURY MAGAZINE 63, no. 1 (Nov. 1901): 45-64. 1 b & w. [This survey article has portraits of many 19th and early 20th-century authors. Black's photo is a carte-de-visite taken "at the time of the Civil War."]

B1002 1 photo (Group portrait of J. R. Lowell, J. Holmes, E. Howe and R. Carter at a game of whist, taken in 1859) in: "Memories of a Hundred Years, XIII," By Edward Everett Hale. OUTLOOK 72, no. 5 (Oct. 4, 1902): 311.

B1003 Welling, William. "More on the early development of photography in Boston." PHOTOGRAPHICA 12, no. 3 (Mar. 1980): 8-9, plus cover. 1, 1 portrait b & w. [Discusses John A. Whipple's daguerreotypes of the moon and magic lantern slide photographer, James Wallace Black.]

BLACKSHEAR. (USA)
B1004 "Georgia. Monument Erected at Macon to the Confederate Dead. - From a Photograph by Blackshear." FRANK LESLIE'S ILLUSTRATED NEWSPAPER 49, no. 1264 (Dec. 20, 1879): 280. 1 illus. [View.]

B1005 Portrait. Woodcut engraving, credited "From a Photograph by Blackshear." FRANK LESLIE'S ILLUSTRATED NEWSPAPER 49, (1879) ["The late Rev. Lovick Pierce, D.D., of GA." 49:1264 (Dec. 20): 280.]

BLAIR, R. H.
B1006 Blair, R. H. "Poisoning with Cyanide of Potassium." HUMPHREY'S JOURNAL OF PHOTOGRAPHY, AND THE ALLIED ARTS AND SCIENCES 16, no. 18 (Jan. 15, 1865): 285-286.

BLAIR, WILLIAM. (ca. 1820-1871) (GREAT BRITAIN)
[William Blair was a solicitor from Perth who practiced photography in his spare time. Worked on permanent printing processes. Drowned at age 51, while saving one of his sons from a similar fate.]

BOOKS

B1007 Blair, William. *Manual of Directions for Printing in Carbon and other Pigments by Different Processes without Transfer.* Perth: Published for the author, at Bridgend, Perth, 1869. 76 pp.

PERIODICALS

B1008 Blair, William. "Carbon Printing on Plain Paper." AMERICAN JOURNAL OF PHOTOGRAPHY AND THE ALLIED ARTS & SCIENCES n. s. vol. 6, no. 7 (Oct. 1, 1863): 158-164. [From "Photo. Notes." Blair from Bridgend, Perth.]

B1009 "Wm. Blair's Carbon Printing Process." AMERICAN JOURNAL OF PHOTOGRAPHY AND THE ALLIED ARTS & SCIENCES n. s. vol. 6, no. 15 (Feb. 1, 1864): 337-338. [From "Br. J. of Photo."]

BLAKE, L. R. (USA)

B1010 "Great Tornado in Wisconsin, June 28 - the almost entire Destruction of the Village of Viroqua. - From Photographs by L. R. Blake." FRANK LESLIE'S ILLUSTRATED NEWSPAPER 20, no. 513 (July 29, 1865): 301. 3 illus. [Ruins.]

BLANCHARD, J. W. F. (BELLOWS FALLS, VT)

B1011 "Photos Burned Out." HUMPHREY'S JOURNAL OF PHOTOGRAPHY, AND THE ALLIED ARTS AND SCIENCES 20, no. 8 (Aug. 15, 1868): 126. ["At a recent fire in Bellows Falls, Vt., J. W. F. Blanchard's room was badly damaged. The photograph saloon of P. W. Taft, an old settler in the village, being mounted on wheels was soon drawn out of danger."]

BLANCHARD, VALENTINE. (1831-1901) (GREAT BRITAIN)
BOOKS

B1012 *Annals of Christ's Hospital, from its formation to the present time and of the original conventual Church of the Grey Friars,* by a Blue. With Six Photographs by V. Blanchard. London: Lothian & Co., 1866. viii, 120 pp. 6 b & w. [(1877), 7 l. of plates.]

PERIODICALS

B1013 Blanchard, V. "Remarks upon Artistic Positive Printing." PHOTOGRAPHIC NEWS 4, no. 113 (Nov. 2, 1860): 315-316.

B1014 Blanchard, Valentine. "Intensifying Processes Considered as Adjuncts to Instantaneous Photography." BRITISH JOURNAL OF PHOTOGRAPHY 8, no. 139 (Apr. 1, 1861): 121-122.

B1015 Blanchard, Valentine. "A Prologue for the Season." BRITISH JOURNAL OF PHOTOGRAPHY 8, no. 156 (Dec. 16, 1861): 442-443.

B1016 Blanchard, Valentine. "A Prologue for the Season." AMERICAN JOURNAL OF PHOTOGRAPHY AND THE ALLIED ARTS & SCIENCES n. s. vol. 4, no. 17 (Feb. 1, 1862): 390-394. [From "Photo. News." Read to South London Photo. Soc.]

B1017 "Stereographs: Instantaneous Views, &c. Photographed by Valentine Blanchard, London." BRITISH JOURNAL OF PHOTOGRAPHY 9, no. 159 (Feb. 1, 1862): 46-47.

B1018 Blanchard, Valentine. "Some Experiments with a Nitrate Bath." HUMPHREY'S JOURNAL OF PHOTOGRAPHY, AND THE ALLIED ARTS AND SCIENCES 14, no. 4 (June 15, 1862): 13-14. [From "Photo. News."]

B1019 "Review: Instantaneous Photographs of London; and Marine Views." JOURNAL OF THE PHOTOGRAPHIC SOCIETY OF LONDON 8, no. 122 (June 16, 1862): 73.

B1020 "Stereographs: 'The Attractions of a Country Fair.' Photographed by Valentine Blanchard." BRITISH JOURNAL OF PHOTOGRAPHY 9, no. 168 (June 16, 1862): 230.

B1021 "Note." JOURNAL OF THE PHOTOGRAPHIC SOCIETY OF LONDON 8, no. 124 (Aug. 15, 1862): 117. [The inundations in the fens have recently been photographed...Mr. V. Blanchard...Stereo.]

B1022 "Stereographs. The Inundation in the Fens, Photographed by Valentine Blanchard, London." BRITISH JOURNAL OF PHOTOGRAPHY 9, no. 172 (Aug. 15, 1862): 310-311.

B1023 "Stereographs. Instantaneous Views of London, Photographed by Valentine Blanchard." BRITISH JOURNAL OF PHOTOGRAPHY 9, no. 176 (Oct. 15, 1862): 381-382.

B1024 Blanchard, Valentine. "A Valuable Preservative Process." AMERICAN JOURNAL OF PHOTOGRAPHY AND THE ALLIED ARTS & SCIENCES n. s. vol. 5, no. 13 (Jan. 1, 1863): 297-298. [From "Photo. News."]

B1025 Blanchard, Valentine. "Instantaneous Photography." BRITISH JOURNAL OF PHOTOGRAPHY 10, no. 181 (Jan. 1, 1863): 5-6.

B1026 "Stereographs: Mementoes of the Royal Marriage, Photographed by Valentine Blanchard, London." BRITISH JOURNAL OF PHOTOGRAPHY 10, no. 188 (Apr. 15, 1863): 167.

B1027 "Stereographs: Instantaneous Views of London, Photographed by Valentine Blanchard (London)." BRITISH JOURNAL OF PHOTOGRAPHY 10, no. 189 (May 1, 1863): 189-190.

B1028 Blanchard, Valentine. "On the Development and Intensification of the Negative Image." HUMPHREY'S JOURNAL OF PHOTOGRAPHY, AND THE ALLIED ARTS AND SCIENCES 15, no. 5 (July 1, 1863): 75-78. [From "Photo. News."]

B1029 "Waifs and Strays: Accident at Brighton: A Narrow Escape." BRITISH JOURNAL OF PHOTOGRAPHY 10, no. 197 (Sept. 1, 1863): 356. [V. Blanchard saves a companion from drowning while swimming.]

B1030 Blanchard, Valentine. "On the Production and Use of Cloud Negatives." AMERICAN JOURNAL OF PHOTOGRAPHY AND THE ALLIED ARTS & SCIENCES n. s. vol. 6, no. 8 (Oct. 15, 1863): 177-181. [From "Photo. News."]

B1031 "Critical Notices: Instantaneous Views of Brighton by Valentine Blanchard." PHOTOGRAPHIC NEWS 8, no. 278 (Jan. 1, 1864): 4.

B1032 "Stereographs. Instantaneous Sea and Land "Views at Brighton, Photographed by Valentine Blanchard." BRITISH JOURNAL OF PHOTOGRAPHY 11, no. 205 (Jan. 1, 1864): 13.

B1033 "Our Editorial Table: Instantaneous Views of Ramsgate, Photographed by Valentine Blanchard." BRITISH JOURNAL OF PHOTOGRAPHY 12, no. 245 (Jan. 13, 1865): 19.

B1034 "The Dangers of Cyanide." HUMPHREY'S JOURNAL OF PHOTOGRAPHY, AND THE ALLIED ARTS AND SCIENCES 17, no. 2 (May 15, 1865): 31. [From "Photo. News." A domestic, cleaning a floor, was poisoned through a cut on her hand. Became very ill.]

B1035 Blanchard, Valentine. "Hints for Out-Door Photographers. To be Read Over Carefully Before Taking a Trip From Home."

AMERICAN JOURNAL OF PHOTOGRAPHY AND THE ALLIED ARTS & SCIENCES n. s. vol. 8, no. 6 (Sept. 15, 1865): 127-129.

B1036 Blanchard, Valentine. "Hints for Out-Door Photographers To be Read Over Carefully Before Taking a Trip from Home." HUMPHREY'S JOURNAL OF PHOTOGRAPHY, AND THE ALLIED ARTS AND SCIENCES 17, no. 9 (Sept. 1, 1865): 136-137. [From "Photo. News."]

B1037 Blanchard, Valentine. "On the Importance of Art-Culture to Photographers." BRITISH JOURNAL OF PHOTOGRAPHY 12, no. 289 (Nov. 17, 1865): 582-583. [Read to South London Photo. Soc. Nov. 9, 1865.]

B1038 Blanchard, Valentine. "Maxims well-known, but frequently forgotten." AMERICAN JOURNAL OF PHOTOGRAPHY AND THE ALLIED ARTS & SCIENCES n. s. vol. 8, no. 18 (Mar. 15, 1866): 421-423. [From "Photo. News Almanac."]

B1039 "Mr. Blanchard's Method of Collodionized Prints." HUMPHREY'S JOURNAL OF PHOTOGRAPHY, AND THE ALLIED ARTS AND SCIENCES 19, no. 5 (July 1, 1867): 73-74. [From "Photo. News."]

B1040 Blanchard, Valentine. "A Useful Method for Hiding Defects in Skies." PHILADELPHIA PHOTOGRAPHER 4, no. 45 (Sept. 1867): 280-281.

B1041 Blanchard, Valentine. "How to Make Vignettes." HUMPHREY'S JOURNAL OF PHOTOGRAPHY, AND THE ALLIED ARTS AND SCIENCES 20, no. 4 (June 15, 1868): 55. [From "Photo. News. Almanac."]

B1042 Blanchard, Valentine. "On the Production of Instantaneous Photographs." BRITISH JOURNAL PHOTOGRAPHIC ALMANAC 1869 (1869): 57-60.

B1043 Blanchard, Valentine. "On Alkaline Wet Processes." HUMPHREY'S JOURNAL OF PHOTOGRAPHY, AND THE ALLIED ARTS AND SCIENCES 20, no. 27 (Nov. 15, 1869): 416-417. [Source not given.]

B1044 "Notes In and Out of the Studio." PHILADELPHIA PHOTOGRAPHER 7, no. 73 (Jan. 1870): 20. [Blanchard's studio gutted by fire and explosion caused by a collodion explosion.]

B1045 Blanchard, Valentine. "Transparencies for the Lantern on Wet Collodion." PHOTOGRAPHIC WORLD 1, no. 10 (Oct. 1871): 326-327.

B1046 Portrait. Woodcut engraving, credited to "From a Photograph by Valentine Blanchard, Albany Court Yard, Piccadilly." ILLUSTRATED LONDON NEWS 59, (1871) ["Late Mr. Young." 59:1676 (Oct. 28, 1871): 401.]

B1047 Blanchard, Valentine. "On A Method of Enlarging." ANTHONY'S PHOTOGRAPHIC BULLETIN 6, no. 8 (Aug. 1875): 246-247. [From "Br J of Photo."]

B1048 Blanchard, Valentine. "Our Foreign Make-Up: A Method of Enlarging." PHOTOGRAPHIC TIMES 5, no. 57 (Sept. 1875): 222. [Extracted from a paper read before the Photographic Society of Great Britain.]

B1049 Portraits. Woodcut engravings credited "From a photograph by Valentine Blanchard." ILLUSTRATED LONDON NEWS 70, (1877) ["Walter W. Ouless, A.R.A." 70:1962 (Feb. 17, 1877): 157.]

B1050 Bolas, Thomas. "English Notes." AMERICAN AMATEUR PHOTOGRAPHER 2, no. 7 (July 1890): 277-278. [Report on talk by Blanchard at the Photographic Society of Great Britain, who discussed style of stereo makers "of 20 years ago."]

B1051 Blanchard, Valentine. "Artistic Printing." WILSON'S PHOTO-GRAPHIC MAGAZINE 35, no. 501 (Sept. 1898): 412-416. [From "The Practical Photographer."]

B1052 "Valentine Blanchard." BRITISH JOURNAL PHOTOGRAPHIC ALMANAC, AND PHOTOGRAPHERS DAILY COMPANION, 1902 (1902): 695-697. [Apprenticed to a printer in Wisbech, England. Took up daguerreotyping. Expert at stereo views in 1860s, early 1870s; strong portraitist. Vice-President of the Royal Photographic Society. Retired from professional photography "some years before his death." Died November 14, 1901.]

B1053 "Notes and News." PHOTOGRAPHIC TIMES 34, no. 1 (Jan. 1902): 40. [Notice of Blanchard's death.]

B1054 Blanchard, Valentine. "Afield with the Wetplate." IMAGE 1, no. 4 (Apr. 1952): 2. [Reprinted from the "Practical Photographer," 1891, condensed.]

BLAND, W. R. (GREAT BRITAIN)
[W. R. Bland was an optician, a member of the firm of Bland & Long, Fleet Street, London.]

B1055 Bland, W. R. *Practical Photography on Glass and Paper.* London: Bland, 1862. n. p. [There may be earlier editions. A revised edition, in two parts, was published by Negretti & Zambra in 1869.]

BLANQUART-EVRARD, LOUIS-DÉSIRÉ. (1802-1872) (FRANCE)
BOOKS
B1056 Blanquart-Evrard, Louis-Désiré. *On the Intervention of Art in Photography.* Translated from the French by Alfred Harrad, with an introduction by Thomas Sutton. London: Sampson Low, 1864. 27 pp.

B1057 Peterich, Gerda. *The Calotype in France and Its Use in Architectural Documentation; a Study of the Development of the Calotype Photographic Process with Special Consideration of the Contribution made by Blanquart-Evrard and Gustave LeGray.* Rochester, NY: University of Rochester, 1956. viii, 144 l. pp. [MA thesis, University of Rochester. Photocopy of typescript,

PERIODICALS
B1058 "Miscellanea." ATHENAEUM no. 1050 (Dec. 11, 1847): 1281. [Note on the Paris Academy of Sciences on Blanquart-Everard's works and process.]

B1059 "Scientific Gossip." ATHENAEUM no. 1141 (Sept. 8, 1849): 914. [Note that Blanquart-Evrard is working with glass plates for negatives.]

B1060 "Minor Topic of the Month: Photography." ART JOURNAL (Nov. 1, 1849): 354. [Blanquart-Evrard suggested using glass plates for a base for negatives.]

B1061 "Scientific Gossip." ATHENAEUM no. 1196 (Sept. 28, 1850): 1025. [Comment that the French working hard to improve

photography, mentions Blanquart-Evrard's improvements to the calotype process. Mentions Niépce de Saint-Victor.]

B1062 "Minor Topics of the Month: Improvements in Photography." ART JOURNAL (Oct. 1850): 329-330.

B1063 "Note." ATHENAEUM no. 1212 (Jan. 18, 1851): 86. [Note on Blanquard-Evrard's paper to the Fr. Academy of Sciences on whitening the interior of the camera. Drew reply in opposition from Claudet on pp. 141-142, no. 1214 (Feb. 1, 1851).]

B1064 Blanquart-Evrard. "A Treatise on Paper Photographs." PHOTOGRAPHIC ART JOURNAL 2, no. 3-6 (Sept. - Dec. 1851): 172-178, 216-225, 276-285, 350-358.

B1065 Blanquart-Evrard. "A Treatise on Paper Photographs." PHOTOGRAPHIC ART JOURNAL 3, no. 1-4 (Jan. - Apr. 1852): 29-35, 96-105, 156-165, 215-222.

B1066 "Gossip." PHOTOGRAPHIC ART JOURNAL 4, no. 2 (Aug. 1852): 132. ["We have a few beautiful photographs by M. Evrard of Paris - copies of monuments, celebrated statues, buildings, etc. - price $4.00 each. Address the editor, H. H. Snelling."]

B1067 "M. Blanquart-Evrard's Method of Printing by Development." HUMPHREY'S JOURNAL OF PHOTOGRAPHY, AND THE ALLIED ARTS AND SCIENCES. 13, no. 23 (Apr. 1, 1862): 361-364. [From "Photo. News."]

B1068 Blanquart-Evrard. "On a New Method of Strengthening Negatives." BRITISH JOURNAL OF PHOTOGRAPHY 10, no. 185 (Mar. 2, 1863): 93-94.

B1069 Blanquart-Evrard. "New Qualities of the Action of Light." HUMPHREY'S JOURNAL OF PHOTOGRAPHY, AND THE ALLIED ARTS AND SCIENCES. 15, no. 1 (May 1, 1863): 9-12. [From "Bulletin of the Fr. Photo. Soc."]

B1070 Blanquart-Evrard. "On the Intervention of Art in the Practice of Photography." BRITISH JOURNAL OF PHOTOGRAPHY 10, no. 195-196 (Aug. 1 - Aug. 15, 1863): 302-304, 326-327.

B1071 "Dry Collodion." PHOTOGRAPHIC NEWS 8, no. 279 (Jan. 8, 1864): 18-19. [Communication to the Sociéte Française de Photographie.]

B1072 "Critical Notices: 'On the intervention of Art in Photography.' Translated from the French of Blanquart-Evrard, by Alfred Harrall, with an introduction by Thomas Sutton, B.A. London: Sampson Low, Son and Marston." PHOTOGRAPHIC NEWS 8, no. 289 (Mar. 18, 1864): 137.

B1073 "On the Intervention of Art in Photography." ART JOURNAL (July 1864): 199. [One-column length article, initiated at the publication of a brochure by M. Blanquart-Everard, translated by Alfred Harral, with an introduction by Mr. Sutton.]

B1074 "New Way of Strengthening Negatives." AMERICAN JOURNAL OF PHOTOGRAPHY AND THE ALLIED ARTS & SCIENCES n. s. vol. 7, no. 6 (Sept. 15, 1864): 122-126. [From "Photo. Notes."]

B1075 Marshall, Albert E. "All that's bright must fade?" AMERICAN ANNUAL OF PHOTOGRAPHY 1948 (1948): 50-59. illus. [Illustrated

with works from "Etudes Photographiques,""Melanges Photographiques," etc.]

B1076 "Blanquart-Evrard." IMAGE 1, no. 3 (Mar. 1952): 3. 1 b & w.

B1077 Peterich, Gerda. "Louis-Désiré Blanquart-Evrard: The Gutenberg of Photography." IMAGE 6, no. 4 (Apr. 1957): 80-89. 7 b & w. 1 illus.

B1078 "Blanquart-Evrard premier tireur industriel." PHOTOGRAPHE no. 1349 (May 1978): 35-37. 6 b & w. [Ex. rev.: "Blanquart-Evrard," Musee Niépce de Chalon-sur-Saone.]

B1079 Jammes, Isabelle. "Louis Désiré Blanquart-Evrard (1802-1872)." CAMERA (LUCERNE) 57, no. 12 (Dec. 1978): 4-42. 42 b & w. [Born at Lille, France, on August 2, 1802. Worked for Kuhlmann, the chemist for several years from 1826. Businessman in 1830s. Blanquart-Evrard learned about W. H. F. Talbot's negative-positive process around 1844, from Tanner. Worked on it and began communicating his papers in 1847. By 1851 he had made improvements so that 200 to 300 prints per day could be inexpensively created, which made photographically illustrated books possible. Opened a printing operation which lasted until 1855. Printed over twenty albums and works, made tens of thousands of photographs. Partner with Th. Sutton, Jersey, briefly. Wrote a history of photography in 1869. Interested in color. Died in 1872.]

B1080 "Biographical Notes on a Number of Photographers Published by Blanquart-Evrard." CAMERA (LUCERNE) 57, no. 12 (Dec. 1978): 32, 41-42. [Benecke, Claine, DuCamp, Fortier, Greene, Le Secq, Loydreau, Marville, Regnault, Robert, Salzmann, Stewart, Sutton, and Tenison.]

BLEES, JOHN. (GREAT BRITAIN, INDIA)
B1081 Blees, John. *Photography in Hindostan; or Reminiscences of a Travelling Photographer in India.* Bombay: Education Society Press, 1877. 202 pp.

BLESSING & BROTHER. (GALVESTON, TX)
B1082 "Pictures." ANTHONY'S PHOTOGRAPHIC BULLETIN 3, no. 9 (Sept. 1872): 675. ["A military group from Blessing & Bro. (Galveston, TX), arranged by L. Eyth." 25"x30" composite print, posed purposely for combination, cut out, placed in position and afterwards worked up in watercolors..."]

BLESSING & ROSE.
B1083 "Texas. - General Appearance of the Business Portion of Galveston after the Great Fire of June 8th. - From a Photograph by Blessing & Rose." FRANK LESLIE'S ILLUSTRATED NEWSPAPER 44, no. 1136 (July 7, 1877): 309. 1 illus. [View of destruction.]

BLESSING, SAMUEL T. (ca. 1832-1897) (USA)
B1084 "Matters of the Month." PHOTOGRAPHIC TIMES 12, no. 141 (Sept. 1882): 383. [Stock catalog. "31 years in the photographic business - first daguerreotyping, next ambrotyping then photographing, and for the last 20 years exclusively in the stock business." (In New Orleans, LA. Blessing born in MD, died Nov. 18, 1897, in St. Louis.)]

BLISS, HORACE LATHROP. (1823-1898) (USA)
B1085 "Burning of the American Hotel and Adjacent Buildings, at Buffalo, N. Y., Jan. 25. - From a Photograph by H. L. Bliss." FRANK LESLIE'S ILLUSTRATED NEWSPAPER 19, no. 490 (Feb. 18, 1865): 349. 1 illus. [Ruins, crowds, firemen fighting the fire. Figures may have been added by the engraver.]

B1086 "The International Industrial Exhibition at Buffalo, New York, October, 1869." HARPER'S WEEKLY 13, no. 670 (Oct. 30, 1869): 701. 1 illus. ["Photographed by H. L. Bliss." Interior.]

B1087 "The Giant Cheese Exhibited at the Agricultural Fair, Buffalo, N. Y. - From a Photograph by H. L. Bliss." FRANK LESLIE'S ILLUSTRATED NEWSPAPER 33, no. 838 (Oct. 21, 1871): 93. 1 illus.

BLIZZARD, J. E.
B1088 Blizzard, J. E. "Parkinson's Toning Formula. - Negative Collodion. - Photogenic Reflectors." HUMPHREY'S JOURNAL OF PHOTOGRAPHY, AND THE ALLIED ARTS AND SCIENCES 15, no. 20 (Feb. 15, 1864): 315-316. [Letter from J. E. Blizzard stating, "I have until recently been preaching, but, from necessity, was compelled to abandon it...and am now devoting my time to the picture business as the next best means to benefit my race;..." Towler's reply, "We congratulate you upon the change of vocation; for it is more easy to capture a picture than catch a soul;..."]

BLOEDE, VICTOR G.
B1089 Bloede, Victor G. "On a Substitute for Ground Glass in the Camera." HUMPHREY'S JOURNAL OF PHOTOGRAPHY, AND THE ALLIED ARTS AND SCIENCES 19, no. 1 (May 1, 1867): 7.

B1090 Bloede, Victor G. "A Chapter of Practical Recipes." HUMPHREY'S JOURNAL OF PHOTOGRAPHY, AND THE ALLIED ARTS AND SCIENCES 19, no. 14 (Nov. 15, 1867): 220.

BLOMFIELD & CO. (HASTINGS, ENGLAND)
B1091 Portrait. Woodcut engraving credited "From a photograph by Blomfield & Co." ILLUSTRATED LONDON NEWS 66, (1875) ["Late Mr. B. Attwood." 66:1849 (Jan. 16, 1875): 57.]

BLOOM'S NATIONAL GALLERY.
B1092 Portraits. Woodcut engravings, credited "From Bloom's National Gallery." FRANK LESLIE'S ILLUSTRATED NEWSPAPER 4, (1857) ["Mayor Thomas, of Cincinnati, OH." 4:80 (June 13, 1857): 17.]

BLOOM, LEWIS W. see BLOOM'S NATIONAL GALLERY.

BLUNT.
B1093 "Virginia. - Confederate Monument at Danville. - From a Photograph by Blunt." FRANK LESLIE'S ILLUSTRATED NEWSPAPER 47, no. 1215 (Jan. 11, 1879): 348. 1 illus. [View.]

BOCKETT, JOHN. (GREAT BRITAIN)
B1094 Bockett, J. "Binary Pictures." AMERICAN JOURNAL OF PHOTOGRAPHY AND THE ALLIED ARTS & SCIENCES n. s. vol. 7, no. 21 (May 1, 1865): 493-495. [Read to North London Photo. Soc.]

B1095 Bockett, John. "Backgrounds." BRITISH JOURNAL PHOTOGRAPHIC ALMANAC 1868 (1868): 83-84.

B1096 Bockett, John. "Backgrounds." HUMPHREY'S JOURNAL OF PHOTOGRAPHY, AND THE ALLIED ARTS AND SCIENCES 20, no. 9 (Sept. 1, 1868): 141-143. [From "Br. J. Photo. Almanac."]

BOEHME, E. H. (USA)
B1097 "Trinity Church, Watertown, N. Y., Rev. Theodore Babcock, Rector. - From a Photograph by E. H. Boehme." FRANK LESLIE'S ILLUSTRATED NEWSPAPER 27, no. 700 (Feb. 27, 1869): 380. 2 illus. [View. Portrait.]

B1098 "Universalist Church, Watertown, N. Y., Rev. D. C. Tomlinson. Pastor. - From a Photograph by E. H. Boehme." FRANK LESLIE'S ILLUSTRATED NEWSPAPER 27, no. 701 (Mar. 6, 1869): 389. 2 illus. [View. Portrait.]

B1099 "Christ Church, Sacket's Harbor, N. Y., Rev. J. Winslow, Rector. - From a Photograph by E. H. Boehme." FRANK LESLIE'S ILLUSTRATED NEWSPAPER 28, no. 704 (Mar. 27, 1869): 28. 2 illus. [View. Portrait.]

B1100 "First Lutheran Church of Dayton, Ohio. Rev. Irving Magee, Pastor." FRANK LESLIE'S ILLUSTRATED NEWSPAPER 28, no. 706 (Apr. 10, 1869): 53. 2 illus. [View. Portrait.]

B1101 "The Recent Freshet at Watertown, N. Y. - View of the Town, River, and Falls. - From a Photograph by E. H. Boehm." FRANK LESLIE'S ILLUSTRATED NEWSPAPER 28, no. 712 (May 22, 1869): 149. 1 illus. [View.]

BOETTIGER. (FRANKFORT, GERMANY)
B1102 "Our Weekly Gossip." ATHENAEUM no. 804 (Mar. 25, 1843): 292. [Brief note that Prof. Boettiger, of Frankfort, had discovered a mode of taking daguerreotypes in color, "only succeeded with three colors - the flesh tones most perfect..."]

BOGARDUS & BENDANN. (USA)
B1103 Portrait. Woodcut engraving, credited "From a Photograph by Bogardus & Bendann." FRANK LESLIE'S ILLUSTRATED NEWSPAPER 35, (1873) ["The late John Frederick Kensett, N.A." 35:901 (Jan. 4, 1873): 269.]

BOGARDUS, ABRAHAM. (1822-1908) (USA)
B1104 "Gossip." PHOTOGRAPHIC ART JOURNAL 3, no. 2 (Feb. 1852): 130. ["Mr. A. Bogardus, corner of Barclay & Greenwich Sts., N.Y. has long claimed our attention."]

B1105 "Rev. Eugenio Kincaid. Missionary to Burmah." HARPER'S WEEKLY 1, no. 36 (Sept. 5, 1857): ?? 1 illus. ["The portrait accompanying this sketch is from an excellent ambrotype by Bogardus."]

B1106 "Note." PHOTOGRAPHIC AND FINE ART JOURNAL 11, no. 2 (Feb. 1858): 63.

B1107 Seely, Charles A. "The Cutting Patents Sustained - Breakers Ahead!" AMERICAN JOURNAL OF PHOTOGRAPHY 1, no. 15 (Jan. 1, 1859): 237-239. [Case of Tomlinson vs. Bogardus. Bogardus lost.]

B1108 Seely, Charles A. "Editorial Miscellany." AMERICAN JOURNAL OF PHOTOGRAPHY AND THE ALLIED ARTS & SCIENCES n. s. vol. 4, no. 11 (Nov. 1, 1861): 264. [Bogardus gave a large party celebrating his 15th year of business at his gallery on Greenwich St.]

B1109 Portrait. Woodcut engraving, credited "From a Photograph." FRANK LESLIE'S ILLUSTRATED NEWSPAPER 13, (1862) ["Maj. E. A. Kimball, Hawkin's Zouaves." 13:329 (Mar. 5, 1862): 261.]

B1110 Portrait. Woodcut engraving, credited "From a Photograph by Bogardus." FRANK LESLIE'S ILLUSTRATED NEWSPAPER 16, (1863) ["Late Lieut.-Col. Edgar Addison Kimball, 9th NY." 16:397 (May 9, 1863): 108.]

B1111 Portrait. Woodcut engraving, credited "From a Photograph by Bogardus." NEW YORK ILLUSTRATED NEWS 8, (1863) ["Late Lieut.-Col. Kimball, Hawkin's Zouaves." 8:184 (May 9, 1863): 28.]

B1112 "Mr. Bogardus' Model Sky-Light." AMERICAN JOURNAL OF PHOTOGRAPHY AND THE ALLIED ARTS & SCIENCES n. s. vol. 6, no. 8 (Oct. 15, 1863): 190-191. [Bogardus gallery at No. 363 Broadway, bought and renovated "about a year ago." Formerly run by M. A. and S. Root. Describes the layout. "Mr. E. M. Howell, late of Fredericks, the skillful manager of the camera,..."]

B1113 "Glass Rooms with South Light." PHOTOGRAPHIC NEWS 8, no. 280 (Jan. 15, 1864): 30-31.

B1114 "Note." PHILADELPHIA PHOTOGRAPHER 3, no. 29 (May 1866): 157. [Note that Bogardus was elected a Vice President in the New York Photographic Society.]

B1115 Hull, C. Wager. "The 'Lights' and Formulas of Kurtz, Gurney and Sons and Bogardus of New York." PHILADELPHIA PHOTOGRAPHER 5, no. 59 (Nov. 1868): 404-407.

B1116 Portrait. Woodcut engraving, credited "From a Photograph by Bogardus." FRANK LESLIE'S ILLUSTRATED NEWSPAPER 27, (1869) ["Hon. Henry Alker, Justice of the NY Marine Court." 27:702 (Mar. 13, 1869): 405.]

B1117 "Note." PHILADELPHIA PHOTOGRAPHER 6, no. 65 (May 1869): 169. [Andrew Khrone, "The oldest man in the photographic business in this country, still making daguerreotypes for Bogardus."]

B1118 "Editor's Table." PHILADELPHIA PHOTOGRAPHER 6, no. 66 (June 1869): 198. [Excerpt from "NY Herald" commenting on a question asked Bogardus during the 'spirit photograph trial'.]

B1119 "New American Studios." PHILADELPHIA PHOTOGRAPHER 6, no. 71 (Nov. 1869): 368-369. 1 illus. [1153 Broadway, New York, NY.]

B1120 "Letter." PHILADELPHIA PHOTOGRAPHER 7, no. 75 (Mar. 1870): 66-67. [Open letter from Bogardus to the editor of "Philadelphia Photographer" promoting the forthcoming Annual Exhibition of the National Photographic Association.]

B1121 Portrait. Woodcut engraving, credited "From a Photograph by Bogardus." FRANK LESLIE'S ILLUSTRATED NEWSPAPER 30, (1870) ["John Jourdan, Supt. of Police." 30:761 (Apr. 30, 1870): 104.]

B1122 "Proceedings of the National Photographic Association of the United States." PHILADELPHIA PHOTOGRAPHER 8, no. 91 (July 1871): 194-240. [Report of the meeting. Pres. Bogardus's opening speech on p. 194, second speech on p. 233.]

B1123 "Editorial Notes." PHILADELPHIA PHOTOGRAPHER 8, no. 92 (Aug. 1871): 280. [Letter from Samuel F. B. Morse, "I take down with me today, on my way to Boston, the remains of the first photographic instrument ever made and used in this country; and I shall deposit them with my friend Mr. A. Bogardus."]

B1124 "Our Picture: Abraham Bogardus." PHILADELPHIA PHOTOGRAPHER 8, no. 94 (Oct. 1871): 313-315, plus portrait. 1 b & w. [Born Nov. 29, 1822. A farmer's son, Bogardus moved to New York City at age fourteen and worked as a clerk in a dry-goods store for seven or eight years. Studied the daguerreotype process with George W. Prosch, then opened a studio in New York, NY in 1846. Stayed at his first location 16 years, built up a good business. In 1860s took over a studio formerly run by M. A. Root during the carte-de-visite craze and flourished. In 1869 moved "uptown" to Broadway near 27th St. One of the originators of the National

Photographic Association, and in 1868 elected its first President. Since been reelected three times. Widely popular. (Retired in 1887, and died in Brooklyn, NY in 1908.)]

B1125 "Our Picture." PHILADELPHIA PHOTOGRAPHER 9, no. 97 (Jan. 1872): 1-4. 1 b & w. [Biography of Samuel F. B. Morse. The original photograph is a portrait of Morse, taken by A. Bogardus.]

B1126 "Chicago." PHOTOGRAPHER'S FRIEND 2, no. 1 (Jan. 1872): 12-14. [Letters and contributors to the relief fund for photographers burned out by the Chicago fire listed. Letters of support by A. Bogardus, H. Rocher, and Richard Walzl.]

B1127 "The Father of Telegraphy." FRANK LESLIE'S ILLUSTRATED NEWSPAPER 34, no. 864 (Apr. 20, 1872): 81, 85-86. 10 illus. [Includes a portrait of the late Morse, by Bogardus, with eight illustrations of his telegraph machines, medals, etc., and a sketch of Morse's funeral on the front cover.]

B1128 Bogardus, A. "Fourth Annual Meeting and Exhibition of the N. P. A. in St. Louis, Mo., May 1872: Speech." PHILADELPHIA PHOTOGRAPHER 9, no. 102 (June 1872): 164.

B1129 Bogardus, A. "Fourth Annual Meeting and Exhibition of the N. P. A. in St. Louis, Mo., May 1872: Annual Address." PHILADELPHIA PHOTOGRAPHER 9, no. 102 (June 1872): 183-185.

B1130 "Proceedings of the National Photographic Association of the United States." PHOTOGRAPHER'S FRIEND 2, no. 3 (July 1872): 70-95. [Report of the meeting. Speeches by Bogardus and others printed.]

B1131 Portrait. Woodcut engraving, credited "From a Photograph by Bogardus, 1153 Broadway." FRANK LESLIE'S ILLUSTRATED NEWSPAPER 36, (1873) ["The late Hon Peter Gilsey." 36:917 (Apr. 26, 1873): 105.]

B1132 "Fifth Annual Meeting and Exhibition of the National Photographic Association of the United States, Held in Buffalo, New York, beginning July 15, 1873." ANTHONY'S PHOTOGRAPHIC BULLETIN 4, no. 8 (Aug. 1873): 251-256. [Mr. Bakers' welcoming address, Pres. Bogardus's reply, report of the Executive Committee, 1873, report of the Committee on the Progress of Photography.]

B1133 Bogardus, Abraham. "Fifth Annual Meeting and Exhibit of the National Photographic Association of the U.S., held in Buffalo, N.Y., beginning July 5, 1873: Annual Address." PHILADELPHIA PHOTOGRAPHER 10, no. 117 (Sept. 1873): 296-303.

B1134 "Fifth Annual Meeting and Exhibition of the National Photographic Association of the United States, held in Buffalo, New York, beginning July 15, 1973 (continued)." ANTHONY'S PHOTOGRAPHIC BULLETIN 4, no. 10 (Oct. 1873): 305-320. [Report on the convention, including "Annual Address of the President," by A. Bogardus.]

B1135 Bogardus, Abraham. "Correspondence." ANTHONY'S PHOTOGRAPHIC BULLETIN 5, no. 6 (June 1874): 225-226. [Discussion of N.P.A. matters.]

B1136 Bogardus, Abm. "A Card." ANTHONY'S PHOTOGRAPHIC BULLETIN 6, no. 2 (Feb. 1875): 52. [Bogardus explains the confusions caused by his role in the formation of the National Photographer's Chemical Co. to deal with the Shaw silver recovery patent.]

B1137 "Two Valuable Pictures." PHOTOGRAPHIC TIMES 5, no. 51 (Mar. 1875): 67. [Portraits of William Cullen Bryant and the late Prof. Samuel F. B. Morse from A. Bogardus.]

B1138 Bogardus, Abraham. "A Card." PHILADELPHIA PHOTOGRAPHER 12, no. 135 (Mar. 1875): 88-89. [Bogardus defending his actions vs. the Shaw copyright patent suit.]

B1139 Portrait. Woodcut engraving, credited "From a Photograph by Bogardus in 1866." FRANK LESLIE'S ILLUSTRATED NEWSPAPER 40, (1875) ["The late Stephen Knapp, merchant." 40:1015 (Mar. 13, 1875): 5.]

B1140 "Matters of the Month: Removal." PHOTOGRAPHIC TIMES 5, no. 52 (Apr. 1875): 88. [Bogardus moving because a building which will destroy his light is being built.]

B1141 "Editor's Table: Abraham Bogardus Removal." PHILADELPHIA PHOTOGRAPHER 12, no. 138 (June 1875): 192. [A. Bogardus moving his studio because a new building blocked the light into his studio.]

B1142 "Note." PHOTOGRAPHIC TIMES 6, no. 69 (Sept. 1876): 198. [Extract from "NY Trade Journal" extolling Bogardus.]

B1143 "Editor's Table: Fires." PHILADELPHIA PHOTOGRAPHER 14, no. 159 (Mar. 1877): 96. [A. Bogardus (New York, NY) lost darkroom, studio to fire around 5th Feb. Carson & Graham (Hillsdale, MI) lost studio.]

B1144 Portrait. Woodcut engraving, credited "From a Photograph by Bogardus." FRANK LESLIE'S ILLUSTRATED NEWSPAPER 47, (1878) ["Hon. Rufus B. Cowling." 47:1208 (Nov. 23, 1878): 208.]

B1145 "Photographic News - A Bit of News from New York." PHILADELPHIA PHOTOGRAPHER 16, no. 190 (Oct. 1879): 313. ["Mr. Ritz, formerly operator with Dana, has succeeded Mr. Wells at Bogardus's, Wells takes the position of positionist with Pach Brothers."]

B1146 Portrait. Woodcut engraving, credited "From a Photograph by Bogardus." FRANK LESLIE'S ILLUSTRATED NEWSPAPER 49, (1879) ["Hon. Alonzo B. Cornwell, Gov.-elect of NY." 49:1260 (Nov. 22, 1879): 204.]

B1147 "Note." PHOTOGRAPHIC TIMES 9, no. 108 (Dec. 1879): 282. [Portrait of Senator Blaine.]

B1148 "Matters of the Month." PHOTOGRAPHIC TIMES 10, no. 117 (Sept. 1880): 208. [Photos of General Garfield.]

B1149 Taylor, J. Traill. "Home and Foreign News." PHOTOGRAPHIC TIMES 11, no. 126 (June 1881): 213. [Quotes Bogardus on the possibilities of color photography. The quote is from "the May number of his natty little sheet, "The New York Camera."]

B1150 "Correspondence: New York Hospitality and the Late Convention." PHOTOGRAPHIC TIMES 11, no. 130 (Oct. 1881): 398-399. [Letters from A. Bogardus and seven others referring to the controversy surrounding the convention.]

B1151 Bogardus, Abraham. "Thirty-Seven Years Behind a Camera." PHOTOGRAPHIC TIMES 14, no. 158 (Feb. 1884): 73-78. [Biographical anecdotes.]

B1152 Bogardus, Abraham. "All Together." PHOTOGRAPHIC TIMES 15, no. 177 (Feb. 6, 1885): 63-64.

B1153 Bogardus, A. "Opinions." PHOTOGRAPHIC TIMES 15, no. 189 (May 1, 1885): 230-231.

B1154 "Annual Dinner of the Photographic Section of the American Institute." PHOTOGRAPHIC TIMES 15, no. 208 (Sept. 11, 1885): 518-522. Excerpts from talks given during the dinner, by A. Bogardus, J. Traill Taylor, J. B. Gardner, A. D. Fisk, F. C. Beach, Thomas D. Stetson, Daniel R. Garden, Dr. Maurice N. Mitler, others.]

B1155 "Then and Now." PHOTOGRAPHIC TIMES 15, no. 212 (Oct. 9, 1885): 577-578. [Read before the Photographic Section of the American Institute, Oct. 6th, 1885.]

B1156 Bogardus, Abraham. "Brains." PHOTOGRAPHIC TIMES 15, no. 222 (Dec. 18, 1885): 699-700.

B1157 "Photographic Section of the American Institute." ANTHONY'S PHOTOGRAPHIC BULLETIN 17, no. 10 (May 22, 1886): 310-314. [Minutes of the meeting of May 4, 1886. Includes a report by H. J. Lewis of the contributions of William Lewis and William H. Lewis (son), who made the first camera and daguerreotype equipment for Wolcott & Johnson, who opened the first daguerreotype portrait studio in America. J. Gurney's early career described as well as A. Bogardus' and Alexander Becker's.]

B1158 Bogardus, A. "Forty Years Behind the Camera." PHOTOGRAPHIC TIMES 16, no. 270-271 (Nov. 19 - Nov. 26, 1886): 604-606, 614-615. [Read before the Photographic Section of the American Institute.]

B1159 Bogardus, A. "Forty Years Behind the Camera." ANTHONY'S PHOTOGRAPHIC BULLETIN 17, no. 22-23 (Nov. 27 - Dec. 11, 1886): 679-681, 714-716.

B1160 Bogardus, A. "Portrait Photography." AMERICAN ANNUAL OF PHOTOGRAPHY AND PHOTOGRAPHIC TIMES ALMANAC FOR 1887 (1887): 60-61.

B1161 Bogardus, A. "A Confession." PHOTOGRAPHIC TIMES 17, no. 282 (Feb. 11, 1887): 75. [Humorous narrative of taking a portrait of Noah with many puns based on the "wet process."]

B1162 Bogardus, A. "Remarks on Photographic Conventions by a Veteran." ANTHONY'S PHOTOGRAPHIC BULLETIN 18, no. 18 (Sept. 24, 1887): 554-555.

B1163 "A Veteran in Photography Retires." ANTHONY'S PHOTOGRAPHIC BULLETIN 18, no. 22 (Nov. 26, 1887): 697-698.

B1164 "Commercial Intelligence." PHOTOGRAPHIC TIMES 17, no. 322 (Nov. 18, 1887): advertising supplement, p. i. [Bogardus ad offering to sell his gallery. "After over forty years of active work I offer to dispose of the business... one block from Grand Central depot... over 30,000 registered negatives, many of them the most prominent men of the nation, from which orders are constantly received."]

B1165 "General Notes." PHOTOGRAPHIC TIMES 17, no. 323 (Nov. 25, 1887): 587-588. [Note that Bogardus is selling his studio. Includes a brief listing of some of the famous figures that he has photographed.]

B1166 "Mr. Bogardus Retires." PHOTOGRAPHIC TIMES 17, no. 324 (Dec. 2, 1887): 603-604. [From "New York Sun." Anecdotes from his career.]

B1167 Bogardus, Abraham. "The Trials and Tribulations of the Photographer." ANTHONY'S PHOTOGRAPHIC BULLETIN 20, no. 5-6 (Mar. 9 - Mar. 23, 1889): 139-142, 178-181. [Read before the Society of Amateur Photographers of New York.]

B1168 Bogardus, Abraham. "The Trials and Tribulations of the Photographer." BRITISH JOURNAL OF PHOTOGRAPHY 36, no. 1506-1507 (Mar. 15 - Mar. 22, 1889): 183-184, 200-201.

B1169 Bogardus, Abraham. "Fifty Years of Light, Fifty Years of Practice, Fifty Years of Advancement - What Are the Results?" ANTHONY'S PHOTOGRAPHIC BULLETIN 20, no. 7 (Apr. 13, 1889): 211-214. [Read before the Photographic Section of the American Institute.]

B1170 "Notes and News." PHOTOGRAPHIC TIMES 19, no. 396 (Apr. 19, 1889): 199. [Brief note that Abraham Bogardus' wife died.]

B1171 "Notes and News: Photographers Combining." PHOTOGRAPHIC TIMES 19, no. 401 (May 24, 1889): 260. [From the "Philadelphia Evening Star." Reported the "agents working in Boston, Buffalo and elsewhere to form a combination closely resembling a trust... plan of crushing out those who do not come into the association... Bogardus, the celebrated photographer of New York, is one of the originators of the scheme... The Association already has 40,000 members and $100,000 in the treasury..."]

B1172 "Notes and News: A Photographic Trust." PHOTOGRAPHIC TIMES 19, no. 407 (July 5, 1889): *. [From "The Philadelphia Beacon." Further commentary on the "Trust activities of Bogardus, which was named the Photographers' and Artists' Mutual Benefit Association."]

B1173 Bogardus, A. "Notes and News: Incidents in a Photographic Gallery." PHOTOGRAPHIC TIMES 21, no. 502 (May 1, 1891): 213. [Anecdotes, excerpted from May 1891 "Lippincott's Magazine."]

B1174 Bogardus, A. "The Experiences of a Photographer." LIPPINCOTT'S MAGAZINE 47, no. 5 (May 1891): 574-582.

B1175 "Notes: Bogardusiana." PHOTOGRAPHIC TIMES 26, no. 4 (Apr. l895): 252. [Anecdotes of early days of daguerreotyping. From the "St. Louis and Canadian Photographer."]

B1176 "The Photographers' Association of Virginia Convention." WILSON'S PHOTOGRAPHIC MAGAZINE 34, no. 485 (May 1897): 233. [Extract from a paper by Bogardus, presented to the Virginia convention.]

B1177 Bogardus, Abraham. "SUG-jest-IONS." PHOTOGRAPHIC TIMES 35, no. 2 (Feb. 1903): 75-76.

B1178 Bogardus, Abraham. "The Lost Art of the Daguerreotype." CENTURY MAGAZINE 68, no. 1 (May 1904): 83-91. 8 b & w. 2 illus. [The illustrations are by Bogardus, Richards, Henry Meade, others.]

B1179 Lawton, Harry W. "An Early Bogardus Portrait." HISTORY OF PHOTOGRAPHY 2, no. 1 (Jan. 1978): 88. 2 b & w. [Daguerreotype taken in 1848.]

B1180 Bogardus, Abraham. "A Day in the Skylight." PHOTOGRAPHICA 10, no. 8 (Oct. 1978): 7. [A poem by Bogardus, reprinted from Aug. 1884 "Wilson's Photographic Magazine."]

BOGARDUS, E. W. (NEW YORK, NY)
B1181 Portrait. Woodcut engraving, credited "From a Photograph by E. W. Bogardus, 363 Broadway." FRANK LESLIE'S ILLUSTRATED NEWSPAPER 35, (1873) ["Hon. J. Orr, US Minister to Russia." 35:909 (Mar. 1, 1873): 397.]

B1182 Portraits. Woodcut engravings, credited "From a Photograph by E. W. Bogardus. FRANK LESLIE'S ILLUSTRATED NEWSPAPER 36, (1873) ["George W. Matsell, New York, NY police Supt." 36:924 (June 14, 1873): 224. "The late John A. Kennedy, New York, NY police." 36:927: (July 5, 1873): 272.]

B1183 Portrait. Woodcut engraving, credited "Photographed by E. Bogardus." FRANK LESLIE'S ILLUSTRATED NEWSPAPER 39, (1874) ["Hon. S. B. H. Vance, Mayor of New York, NY." 39:1003 (Dec. 19, 1874): 241.]

B1184 Portrait. Woodcut engraving, credited "From a Photograph by E. W. Bogardus." FRANK LESLIE'S ILLUSTRATED NEWSPAPER 46, (1878) ["Col. Edward Richardson." 46:1191 (July 27, 1878): 361.]

BOHM, CHARLES. (1846-1885) (USA)
B1185 Portrait. Woodcut engraving, credited "From a Photograph by Chas. Bohm." FRANK LESLIE'S ILLUSTRATED NEWSPAPER 47, (1879) ["Hon Henry M. Teller." 47:1215 (Jan. 11, 1879): 348.]

B1186 Portrait. Woodcut engraving, credited "From a Photograph by Charles Bohm, Denver." FRANK LESLIE'S ILLUSTRATED NEWSPAPER 48, (1879) ["Hon. N. P. Hill, Sen.-elect from CO." 48:1223 (Mar. 8, 1879): 5.]

BOHN, J. G. (USA)
B1187 "Pennsylvania. - Monument Erected to the Memory of the Late James Lick, at Fredericksburg. - From a Photograph by J. G. Bohn." FRANK LESLIE'S ILLUSTRATED NEWSPAPER 46, no. 1183 (June 1, 1878): 221. 1 illus. [Outdoor view.]

BOLAS, THOMAS. (1848-1932) (GREAT BRITAIN)
[Thomas Bolas was the editor of *Photographic News* in the 1880s.]

BOOKS
B1188 Bolas, T. *Cantor Lectures. The Application of Photography to the production of Printing Surfaces and Pictures in Pigment.* London: Society of Arts, 1878. 15 pp. [Offprint from the "Journal of the Society of Arts."]

B1189 Bolas, T. *Cantor Lectures. Recent Improvements in Photo-Mechanical Printing Methods.* London, Society of Arts, 1884. 14 pp. [Offprint from the "Journal of the Society of Arts."]

PERIODICALS
B1190 Bolas, T. "Symbols and Equations." BRITISH JOURNAL PHOTOGRAPHIC ALMANAC 1878 (1878): 163-165.

B1191 Bolas, T. "The Stripping of Negatives." BRITISH JOURNAL PHOTOGRAPHIC ALMANAC 1879 (1879): 90-91.

B1192 "Obituary: Thomas Bolas." BRITISH JOURNAL PHOTOGRAPHIC ALMANAC 1933 (1933): 304. [Inventor of the hand or detective camera, shown to RPS around 1880. In 1870s published the "Photographic Review" briefly.]

BOLLES, CHARLES E. (1856-1869) (USA)

B1193 Bolles, Charles E. "Correspondence." ANTHONY'S PHOTOGRAPHIC BULLETIN 5, no. 5 (May 1874): 193. [Bolles from Brooklyn, NY.]

BOLTON, WILLIAM BLANCHARD. (1848-1899) (GREAT BRITAIN)

B1194 Bolton, W. B. "A New Preservative for Dry Plates." HUMPHREY'S JOURNAL OF PHOTOGRAPHY, AND THE ALLIED ARTS AND SCIENCES 20, no. 10 (Sept. 15, 1868): 149-151. [Read to Liverpool Amateur Photo. Assoc.]

B1195 Bolton, W. B. "The Functions of Organic Matter in Dry Collodion Films." BRITISH JOURNAL PHOTOGRAPHIC ALMANAC 1873 (1873): 82-83.

B1196 Bolton, W. B. "How to make a Gelatine Emulsion." BRITISH JOURNAL PHOTOGRAPHIC ALMANAC 1874 (1874): 135.

B1197 Bolton, W. B. "The Collodion Pellicle Process." BRITISH JOURNAL PHOTOGRAPHIC ANNUAL 1875 (1875): 52-55.

B1198 Bolton, W. B. "Collodion versus Gelatine." BRITISH JOURNAL PHOTOGRAPHIC ALMANAC 1876 (1876): 69-71.

B1199 Bolton, W. B. "On the Future of Wet-Plate Photography." BRITISH JOURNAL PHOTOGRAPHIC ALMANAC 1879 (1879): 39-43.

B1200 Bolton, W. B. "Collodio-Gelatine Dry Plates." PHOTOGRAPHIC TIMES 15, no. 203 (Aug. 7, 1885): 454-455.

B1201 Bolton, W. B. "Report on Photography at the International Inventors Exhibition." PHOTOGRAPHIC TIMES 15, no. 212 (Oct. 9, 1885): 578-580.

B1202 Bolton, W. B. "Report on Photography at the Inventions Exhibition. (Continued from p. 383)." ANTHONY'S PHOTOGRAPHIC BULLETIN 17, no. 19 (Oct. 9, 1886): 605-606. [Describes works by England, Blanchard, W. Willis Sr., Archer. Major Russell, etc.]

B1203 Bolton, W. B. "Modern Negatives and Printing Processes." WILSON'S PHOTOGRAPHIC MAGAZINE 34, no. 492 (Dec. 1897): 561-563. [From "British J. of Photography."]

B1204 "Deaths." PHOTOGRAPHIC JOURNAL 23, no. 9 (May 1899): 246. [Brief obituary notice.]

B1205 "Obituary of the Year: W. B. Bolton (May 12)." BRITISH JOURNAL PHOTOGRAPHIC ALMANAC 1900 (1900): 640. [Born at York in 1848. Published important article on collodio-bromide emulsion process in "BJP" in Sept. 1864. Hon. Sec. of Liverpool Amateur Photo. Assoc. in 1865. Contributed to "BJP" frequently, took over editorship in 1879 until 1885.]

BONAMY, CAPT. (GREAT BRITAIN)

B1206 "The Fothergill Process." HUMPHREY'S JOURNAL OF PHOTOGRAPHY, AND THE ALLIED ARTS AND SCIENCES 16, no. 11 (Oct. 1, 1864): 169-171. [From "Photo. News." "We have before us at this moment a series of very charming photographs on 11 by 9 plates, by Captain Bonamy, of Gurnsey...."]

BONELL & WILEY. (USA)

B1207 Portraits. Woodcut engravings, credited "From a Photograph by Bonell & Wiley." FRANK LESLIE'S ILLUSTRATED NEWSPAPER 31, (1871) ["Gen. G. W. Custiss Lee, new Pres. of Washington & Lee Univ." 31:805 (Mar. 4, 1871): 409.]

BONELLI, GAETAN.

B1208 Bonelli, Gaetan. "Microscopic Photography and the Phenakistoscope." HUMPHREY'S JOURNAL OF PHOTOGRAPHY, AND THE ALLIED ARTS AND SCIENCES 18, no. 6 (July 15, 1866): 92.

BONFILS, ADRIEN. (1861-1929) see BONFILS, FELICE.

BONFILS, FELICE ADRIEN. (1831-1885) (FRANCE, LEBANON)
BOOKS

B1209 *Palestine I*. Bradford: John Dale & Co., Booksellers & Stationers, ca. 1867-68. 36 l. of plates. [Album. Binder's title. Collection Boston Museum of Fine Arts. Typical of many similar albums, each with slightly different contents and cover titles.]

B1210 *Palestine II*. Bradford: John Dale & Co., Booksellers & Stationers, ca. 1867-68. 35 l. of plates. [Album. Binder's title. Collection Boston Museum of Fine Arts.]

B1211 Bonfils, Felix. *Catalogue des vues photographiques de l'Orient, photographies et edites par Felix Bonfils*. Alais: A. Brugueirolle et Cie., printer, 1876. n. p.

B1212 Bonfils, Felix, Photographie et edite. *Souvenirs d'Orient*. Album Pittoresque des Sites, Villes et Ruines les plus remarquables de la Terre Sainte, avec notice historique, archeologique et descriptive en regard de chaque planche. Alais: Bonfils Studio, 1878. 6 pp. 50 l. of plates. 100 b & w. [Preface by G. Charvet. Letterpress in French, English and German. Each plate consists of two photographs.]

B1213 *Catalogue General des Vues Photographiques de l'Orient; Basse et Haute Egypte, Nubie, Palestine, Phenicie, Moab, Syrie, Cote d'Asie, les Sept Eglises d'Asie, Caramanie Anatolie, Iles de Chypre, de Rhodes, de Pathmos de Syra, Athnes, Macdoine, Constantinople. Choix de plus de 300 Costumes Scenes et Types d'Egypte, de Palestine, et de Syrie*. Beyrouth: Photographie Bonfils successeur A. Guiragossian, ca. 1920. 52 pp. [On title page: "Maison fondee en 1867. Recompenses aux Expositions de Paris 1878 - Bruxels 1888."]

B1214 Sobieszek, Robert A. and Carney E. S. Gavin. *Remembrances of the Near East: The Photographs of Bonfils, 1867-1907*. Rochester, NY: International Museum of Photography at George Eastman House, 1980. 24 pp. 14 b & w. [Checklist for exhibition co-sponsored by the IMP/GEH and the Harvard Semitic Museum. Bibliography.]

PERIODICALS
B1215 Bonfils, Felix. "Felix Bonfils North African Images c. 1870." CREATIVE CAMERA no. 153 (Mar. 1977): 96-99. 7 b & w. [Portfolio.]

B1216 Gavin, Carney E. S. "Bonfils and the Early Photography of the Near East." HARVARD LIBRARY BULLETIN 26, no. 4 (Oct. 1978): 442-470. 16 b & w.

B1217 Carella, Elizabeth. "Bonfils and His Curious Composite." EXPOSURE 17, no. 1 (Spring 1979): 26-33. 9 b & w. 1 illus.

B1218 Thomas, Ritchie. "Bonfils & Son, Egypt, Greece and the Levant, 1867-1894." HISTORY OF PHOTOGRAPHY 3, no. 1 (Jan. 1979):

33-46. 20 b & w. 2 illus. [Felix Bonfils born in Saint Hippolyte du Fort, France, on Mar. 6, 1831. His son Adrien born there also on Aug. 7, 1861. Family moved permanently to Beirut, Lebanon in 1867, opened a studio there, then branches in Alexandria, Cairo, Alais, France, with a correspondent in New York. In 1878, at age seventeen, Adrien took charge of photographing while his parents managed the Studio. Felix died in 1885, Adrien continued "Photographie Bonfils" until 1894, when he sold the studio and built a hotel. Abraham Guiragossian took over the Bonfils Studio, kept the trade name and continued to issue prints. Adrien died Jan. 29, 1929 in Nice, France.]

B1219 Thomas, Ritchie. "Egypt on Glass." HISTORY OF PHOTOGRAPHY 4, no. 4 (Oct. 1980): 329-334. 11 b & w. 1 illus. [Discussion of glass slides, probably by F. Bonfils or his firm, of Egypt, brought back to America by wealthy amateur photographer on a "grand tour," 1890s.]

B1220 Sobieszek, Robert. "La Maison Bonfils." AMERICAN PHOTOGRAPHER 5, no. 5 (Nov. 1980): 48-57. 7 b & w.

B1221 Tassel, Janet Quinn. "Dragomans, Sheiks and Moon-Faced Beauties." ART NEWS 79, no. 10 (Dec. 1980): 106-109. 6 b & w. [Ex. rev.: "Photos. by Bonfils, 1867 - 1907," Jewish Museum, New York, NY.]

B1222 Gavin, Carney E. S. "The Work of the Photographers Bonfils, 1867 - 1916." NINETEENTH CENTURY 6, (Winter 1980): 42-47.

B1223 Chevedden, Paul E. "Correspondence from Paul E. Chevedden. Bonfils & Son, Egypt, Greece and the Levant." HISTORY OF PHOTOGRAPHY 5, no. 1 (Jan. 1981): 82. [Addenda, corrections to information in Ritchie Thomas' article in "HOP" 3:1 (1979):33.]

B1224 Gavin, Carney E. S., Elizabeth Carella, and Ingeborg O'Reilly. "The Photographers Bonfils of Beirut and Ales, 1867 - 1916." CAMERA (LUCERNE) 60, no. 3 (Mar. 1981): 4-36. 33 b & w. 2 illus. [Includes "Bibliography," on pp. 31-32; "Family Tree," on p. 32; "Chronology," on pp. 33-34.]

B1225 "Vignette: Bonfils in Syria." HISTORY OF PHOTOGRAPHY 11, no. 4 (Oct. - Dec. 1987): 306. 1 b & w. [View of ruined temple in Palmyra (Syria), taken ca. 1877-1878.]

BONFILS, LYDIE. (1837-1918) see BONFILS, FELICE.

BONINE, ELIAS A. (1843-1916) (USA)
BOOKS
B1226 Berezin, Ronna H. *Elias A. Bonine, 1843-1916. Forgotten Photographer of the West.* "History of Photography Monograph Series, No. 2." Tempe, AZ: Arizona State University, School of Art, April 1983. 16 pp. 4 b & w. [Bonine born in Lancaster, PA in 1843. One of three brothers, whom all worked as photographers. Archie Bonine worked in Lancaster, PA. Elias travelled, first to Florida in 1874, then to California in 1876. Throughout the 1870s and 1880s he travelled around California and Arizona, working as a tent photographer, with his home base in Pasadina, CA. Took views and Indian portraits. Submitted articles to magazines. In 1890s he married and concentrated on developing his citrus ranch in Pasadena. After the turn of the century, he wrote about labor issues and socialism. Died in 1916.]

PERIODICALS
B1227 Bonine, E. A. "Some Experiences While Nine Years a Tent Photographer." ANTHONY'S PHOTOGRAPHIC BULLETIN 17, no. 23 (Dec. 11, 1886): 712-713. [Bonine spent four years in California

and five years in Arizona as an itinerant photographer during the 1870s and 1880s. Now living in Los Angeles, still selling his Indian portraits and California views.]

B1228 Bonine, E. A. "Nine Years a Tent Photographer." ANTHONY'S PHOTOGRAPHIC BULLETIN 18, no. 4 (Feb. 26, 1887): 104-105.

B1229 Bonine, E. A. "Nine Years a Tent Photographer." ANTHONY'S PHOTOGRAPHIC BULLETIN 18, no. 19 (Oct. 8, 1887): 582.

B1230 Bonine, E. A. "Nine Years a Tent Photographer." ANTHONY'S PHOTOGRAPHIC BULLETIN 18, no. 22 (Nov. 26, 1887): 680-681. [Anecdotes of his experience in Arizona and California.]

BOOKHOUT, E. (WILLIAMSBURGH, NY)
B1231 Bookout, E. "Pinholes." AMERICAN JOURNAL OF PHOTOGRAPHY AND THE ALLIED ARTS & SCIENCES n. s. vol. 7, no. 17 (Mar. 1, 1865): 398-399.

B1232 Bookhout, E. "A Mystery Explained." AMERICAN JOURNAL OF PHOTOGRAPHY AND THE ALLIED ARTS & SCIENCES n. s. vol. 7, no. 24 (June 15, 1865): 566. [Mysterious lines in wet collodion negative, later discovered to be the tracks of a fly.]

B1233 Bookout, E. "Why Infringe the Cutting Patent?" AMERICAN JOURNAL OF PHOTOGRAPHY AND THE ALLIED ARTS & SCIENCES n. s. vol. 8, no. 15 (Feb. 1, 1866): 350. [A formula made without bromide.]

BOOL, ALFRED & JOHN BOOL. (GREAT BRITAIN)
BOOKS
B1234 Marks, Alfred, ed. *Society for Photographic Relics of Old London. Collection of Mounted Photographs.* London: The Society, 1875-1886. n. p. 120 b & w. [Woodburytype prints, with descriptive letterpress by A. Marks. Issued in series no 1-6, 1875; no. 7-12, 1876, etc. to no. 109-120, 1886. "I also thank the Messrs. Dixon, father & son, who have taken all negatives from no. 25 on." Negatives for nos. 1-24 taken by A. & J. Bool, printed in permanent carbon by Henry Dixon, nos. 25 on "photographed and printed in permanent carbon by Henry Dixon. 112 Albany St, London".]

B1235 *Old London: Photographed by Henry Dixon and Alfred & John Bool for the Society for Photographic Relics of Old London,* assembled by Graham Bush. London; New York: Academy Editions; St. Martin's Press, 1975. 144 pp. b & w.

PERIODICALS
B1236 Portrait. Woodcut engraving credited "From a photograph by A. Bool & J. Bool, Warwick St., Pimlico." ILLUSTRATED LONDON NEWS 74, (1879) ["Late Brevet Major Francis Russell, killed at Isanlwana." 74:2077 (Apr. 5, 1879): 332.]

B1237 Prescott, Gertrude Mae. "Architectural Views of Old London." LIBRARY CHRONICLE OF THE UNIVERSITY OF TEXAS AT AUSTIN. n. s. no. 15 (1981): 8-48. 15 b & w. 2 illus. [Article about the Society for Photographing Relics of Old London, its publication program from 1875 to 1886, issuing 120 views by the photographers, A. & J. Bool and Henry & T. J. Dixon. Includes surveys and chronologies of their careers. Bibliographies.]

BOOL, ALFRED see BOOL, A. & J. BOOL.

BOOL, ALFRED H. (GREAT BRITAIN)
B1238 "The Fire at the Patent Steam Wheel-Works, Pimlico." ILLUSTRATED LONDON NEWS 45, no. 1285 (Oct. 29, 1864): 452.

1 illus. ["Our Illustration is a view of the ruins, engraved after a photograph taken by Mr. A. Bool."]

B1239 Bool, A. H. "Concerning the Photographing of Steeples and Lofty Buildings." BRITISH JOURNAL PHOTOGRAPHIC ALMANAC 1877 (1877): 104.

B1240 Bool, A. H. "Post-Mortem Photography." BRITISH JOURNAL PHOTOGRAPHIC ALMANAC 1878 (1878): 84-85.

BOOL, JOHN see BOOL, A. & J. BOOL.

BOOZER, H. W. (GRAND RAPIDS, MI)
B1241 "Editor's Table." PHILADELPHIA PHOTOGRAPHER 6, no. 63 (Mar. 1869): 96. [Note that Boozer has opened a new gallery.]

BORDA & FASSITT & GRAFF.
B1242 "Report on the Comparative Merits of Several Lenses for Landscape Photography, by Messrs. F. Graff, F. T. Fassitt, John Moran and E. Borda." PHILADELPHIA PHOTOGRAPHER 1, no. 2 (Feb. 1864): 21-25. [Read before meeting of Philadelphia Photo. Soc., Jan. 6, 1864.]

B1243 "A Trip to Pike County, Pa." PHILADELPHIA PHOTOGRAPHER 1, no. 4-6 (Apr. - June 1864): 50-51, 76-77, 89-90. [Articles describe their experiences on this photographic excursion. Borda and Fassitt were amateur photographers.]

B1244 "Correction, by Messrs. Graff, Fassitt, Moran, and Borda." PHILADELPHIA PHOTOGRAPHER 1, no. 4 (Apr. 1864): 61. [More confusion around earlier report on landscape lenses.]

B1245 "Our Picture." PHILADELPHIA PHOTOGRAPHER 1, no. 5 (May 1864): frontispiece, 80. 1 b & w.

B1246 "Our Picture." PHILADELPHIA PHOTOGRAPHER 1, no. 6 (June 1864): frontispiece, 94. 1 b & w. [Landscape view, taken during the trip to Pike County, PA, described in the accompanying serial article. Prints for the magazine were made by A. H. Hemple, of Philadelphia.]

BORDA, EUGENE see also BORDA & FASSITT & GRAFF.

BORDA, EUGENE. (1825-1897) (USA)
B1247 Sellers, Coleman. "Wet Collodion on the Mountains." HUMPHREY'S JOURNAL OF PHOTOGRAPHY, AND THE ALLIED ARTS AND SCIENCES 13, no. 9-10 (Sept. 1 - Sept 15, 1861): 129-131, 145-147. [Describes a photographic trip. He stayed with Reubens Peale and met E. Borda. Sellers describes Borda and his darkroom, etc.]

B1248 Borda, E. "An Amateur's Experience.-In Re Humidus vs. Siccus." AMERICAN JOURNAL OF PHOTOGRAPHY AND THE ALLIED ARTS & SCIENCES n. s. vol. 4, no. 14 (Dec. 15, 1861): 333-335. [Borda describes how his friend Coleman Sellers continues to attempt to persuade him to use a "wet" process, but how he prefers his "dry" tannin process for landscape work. Borda, an amateur from Woodside, Schuylkill Co, PA. Further note on pp. 335-336.]

B1249 Borda, E. "An Amateur's Experience." BRITISH JOURNAL OF PHOTOGRAPHY 9, no. 158 (Jan. 15, 1862): 27. [From "Am. J. of Photo."]

B1250 Borda, E. "Practical Remarks on the Tannin Process." AMERICAN JOURNAL OF PHOTOGRAPHY AND THE ALLIED ARTS & SCIENCES n. s. vol. 4, no. 17 (Feb. 1, 1862): 403-408.

B1251 Borda, E. "Siccus Defendeth Himself and Carrieth the War into Africa." AMERICAN JOURNAL OF PHOTOGRAPHY AND THE ALLIED ARTS & SCIENCES n. s. vol. 4, no. 19 (Mar. 1, 1862): 449-451. [Pleasant feud between Borda and Sellers on best process for landscapes.]

B1252 Borda, E. "Dr. Henry Draper's Hot Water Process." AMERICAN JOURNAL OF PHOTOGRAPHY AND THE ALLIED ARTS & SCIENCES n. s. vol. 4, no. 21 (Apr. 1, 1862): 492-494. [R. Shriver and T. R. Peale are mentioned as prominent amateur practitioners.]

B1253 Borda, E. "A New Rapid Dry Process." AMERICAN JOURNAL OF PHOTOGRAPHY AND THE ALLIED ARTS & SCIENCES n. s. vol. 5, no. 2 (July 15, 1862): 41-45.

B1254 Borda, E. "On Dr. Henry Draper's Hot Water Process." BRITISH JOURNAL OF PHOTOGRAPHY 9, no. 167 (June 2, 1862): 210. [From "Am. J. of Photo."]

BORLAND, A. (GREAT BRITAIN)
B1255 Borland, A. "Color For Inside Studio." ANTHONY'S PHOTOGRAPHIC BULLETIN 10, no. 6 (June 1879): 178. [From "London Photographic News." Borland found that painting his studio green and white lessened the time necessary his exposures.]

BORLINETTO. (PADUA, ITALY)
B1256 Borlinetto, Signor. "Positive Printing with Salts of Iron." AMERICAN JOURNAL OF PHOTOGRAPHY AND THE ALLIED ARTS & SCIENCES n. s. vol. 6, no. 19 (Apr. 1, 1864): 440-441. [From "Le Moniteur de la Photographie."]

B1257 Borlinetto, Prof. "Phosphorescent Photographic Images." PHOTOGRAPHIC TIMES 10, no. 110 (Feb. 1880): 33. [Prof. Borlinetto, from Padua, working on phosphorescent images since 1872. Some results displayed at the Palace of Industry exhibit, Paris. From "Le Moniteur."]

BOSSARD, F. A. (PARIS, FRANCE)
B1258 Bossard, F. A. "The Iodides. - Their Chemistry applied to Photography." HUMPHREY'S JOURNAL OF PHOTOGRAPHY, AND THE ALLIED ARTS AND SCIENCES 13, no. 11-12 (Oct. 1-Oct. 15, 1861): 161-163, 177-181. [Note on p. 176 that Prof. F. A. Bossard, from Paris, would be a regular contributor. "Many of our subscribers at the West are well acquainted with the above-named gentleman, who is widely known as a skillful practical photographer...."]

B1259 Bossard, F. A. "The New Solar Camera Reflector." HUMPHREY'S JOURNAL OF PHOTOGRAPHY, AND THE ALLIED ARTS AND SCIENCES 13, no. 20 (Feb. 15, 1862): 305-307.

BOULTON, MATTHEW see also PREHISTORY.

BOULTON, MATTHEW.
BOOKS
B1260 Boulton, Matthew P. W. *Remarks on Some Evidence Recently Communicated to the Photographic Society*. London: Bradbury & Evans, 1863. 6 pp. [Mathew P. W. Boulton was the grandson of Mathew Boulton —the engineer who was James Watt's partner. W. P. Smith, of the Patent Office, believed he had found evidence to prove that Boulton had discovered a photographic process in the 1770s, and

he communicated this belief to the Photographic Society of Great Britain. This caused a storm of interested commentary in the photographic and general publications. The grandson published a number of papers at his own expense, to disprove this mistaken assumption by Smith.]

B1261 Boulton, Matthew P. W. *Remarks on Certain Photographs supposed to be of Early Date.* London: Bradbury & Evans, 1864. 55 pp. 3 illus. [2nd ed. 63 pp.; 3rd ed. 71 pp. 7 illus.]

B1262 Boulton, Matthew P. W. *Remarks concerning Certain Pictures, supposed to be Photographs of Early Date.* London: Bradbury & Evans, 1865. 29 pp. 4 illus. [2nd ed. 74 pp.]

PERIODICALS

B1263 "Surprising Discovery of Photographs Produced in the Last Century." BRITISH JOURNAL OF PHOTOGRAPHY 10, no. 189 (May 1, 1863): 183. [Boulton experiments discovered.]

B1264 "Discovery of Early Photographs." JOURNAL OF THE PHOTOGRAPHIC SOCIETY OF LONDON 8, no. 134 (June 15, 1863): 302-304. [By James Watt and Matthew Bolton.]

B1265 "Surprising Discovery of Photographs Produced in the Last Century." AMERICAN JOURNAL OF PHOTOGRAPHY AND THE ALLIED ARTS & SCIENCES n. s. vol. 5, no. 24 (June 15, 1863): 553-556. [From "Br. J. of Photo.," in turn from "Birmingham Daily Post." The Boulton discoveries.]

B1266 Gaudin, Mc.-A. "Strange Discovery. - Photography anterior to the Daguerreotype!" HUMPHREY'S JOURNAL OF PHOTOGRAPHY, AND THE ALLIED ARTS AND SCIENCES 15, no. 5 (July 1, 1863): 68-69. [From 'La Lumière.' French report on the Bolton/Watt discoveries.]

B1267 "Photographs in the Last Century." AMERICAN JOURNAL OF PHOTOGRAPHY AND THE ALLIED ARTS & SCIENCES n. s. vol. 6, no. 3 (Aug. 1, 1863): 68-69. [From "Photo. News." The Wedgewood discoveries mentioned.]

B1268 "Extracts from Letters from Mr. Edward Price, of Soho near Birmingham." JOURNAL OF THE PHOTOGRAPHIC SOCIETY OF LONDON 8, no. 138 (Oct. 15, 1863): 386-399. [Additional material on pages 403-407.]

B1269 "The Alleged Eighteenth-Century Photographs." BRITISH JOURNAL OF PHOTOGRAPHY 10, no. 202 (Nov. 16, 1863): 439-440. [Boulton. Further information, with copies of correspondence, in report of meeting of the London Photo. Soc. on pp. 447-453.]

B1270 "Fine Arts: Who Discovered Photography?" ILLUSTRATED LONDON NEWS 43, no. 1232 (Nov. 21, 1863): 530.

B1271 "Fine Arts: Who Discovered Photography?" ILLUSTRATED LONDON NEWS 43, no. 1233 (Nov. 28, 1863): 551.

B1272 "Fine Arts." ILLUSTRATED LONDON NEWS 43, no. 1235 (Dec. 12, 1863): 590. [Further information of M. P. W. Boulton's supposed invention of photography, including a letter from Mr. Websdale about "polygraphs."]

B1273 "The Alleged Eighteenth-Century Photographs." BRITISH JOURNAL OF PHOTOGRAPHY 11, no. 206-207 (Jan. 15 - Feb. 1, Apr. 1, 1864): 21, 36-38, 110.

B1274 "Early Sun-Pictures." ART JOURNAL (Jan. 1864): 27. [Mr. Eginton made photos c. 1780. Boulton mentioned.]

B1275 "Fine Arts Record - United Kingdom - Photography." FINE ARTS, A QUARTERLY RECORD 2, (Jan. 1864): 208-209. [Brief history, featuring Matthew Boulton, credited with inventing photography in 1783.]

B1276 "The Alleged Early Photographs." PHOTOGRAPHIC NEWS 8, no. 279 (Jan. 8, 1864): 14-15. [Controversy over Talbot, Wedgewood, et al. Further discussed in Proceedings of Societies: London Photographic Society p. 19-20.]

B1277 "Who Discovered Photography?" JOURNAL OF THE PHOTOGRAPHIC SOCIETY OF LONDON 8, no. 141 (Jan. 15, 1864): 428-439, 443-444. [Letters from photographers, extract from "Illustrated News" dealing with question of new discoveries, whether Watt was the discoverer.]

B1278 "The Alleged Early Photographs." PHOTOGRAPHIC NEWS 8, no. 280 (Jan. 15, 1864): 32-34. [Letters from Mr. Fairholt, Robert Hunt, F. P. Smith, Rev. R. C. Pole, M. P. W. Boulton, Mr. Stockdale, John J. Cole reproduced.]

B1279 "The Alleged Early Photographs." PHOTOGRAPHIC NEWS 8, no. 281 (Jan. 22, 1864): 37-38. [Letter from "H. G. H." to the "Society of Arts Journal" reprinted.]

B1280 "Was Photography known before the time of Niépce and Daguerre?" HUMPHREY'S JOURNAL OF PHOTOGRAPHY, AND THE ALLIED ARTS AND SCIENCES 15, no. 19 (Feb. 1, 1864): 293-297. [More detailed information on the Bolton & Watt discoveries.]

B1281 Seely, Charles A. "Editorial Department." AMERICAN JOURNAL OF PHOTOGRAPHY AND THE ALLIED ARTS & SCIENCES n. s. vol. 6, no. 16 (Feb. 15, 1864): 384. [Brief summation of the Bolton discoveries and final conclusions of all concerned.]

B1282 "The Last Century Photographs." PHILADELPHIA PHOTOGRAPHER 1, no. 3 (Mar. 1864): 46. [Report that the claims around Mr. Boulton in England of James Watt having worked out a photographic process in the 18th century now disproved. Further comment in Aug. 1864 issue, p. 127.]

B1283 "The Alleged Early Photographs." PHOTOGRAPHIC NEWS 8, no. 287 (Mar. 4, 1864): 111-112. [Abstracts from M. P. W. Boulton reprinted.]

B1284 "The Alleged Early Photographs." PHOTOGRAPHIC NEWS 8, no. 290 (Mar. 24, 1864): 146-147.

B1285 Carpenter, J. "A Suppressed Art." ONCE A WEEK 10, (Mar. 26, 1864): 368-371. [Story of Matthew Boulton's supposed discovery of photography in 1780s. (Later proven to be false).]

B1286 "The Eighteenth-Century Photographs." HUMPHREY'S JOURNAL OF PHOTOGRAPHY, AND THE ALLIED ARTS AND SCIENCES 15, no. 21 (Mar. 1, 1864): 325-326. [Summation of results of Boulton excitement.]

B1287 Tomlinson, Charles. "Unintended Photographs." ART JOURNAL (Apr. 1864): 98-99. [Boulton, etc.]

B1288 "'Brummagem' Photographs." AMERICAN JOURNAL OF PHOTOGRAPHY AND THE ALLIED ARTS & SCIENCES n. s. vol. 7, no. 4 (Aug. 15, 1864): 78-84. [From "Athenaeum." Discussion of the Bolton Photographic discoveries.]

B1289 "Photographs In the Last Century." CHAMBERS'S JOURNAL 41, no. 36 (Sept. 3, 1864): 565-568. [Discusses Matthew Boulton's experiments in the 1790s, other early experiments.]

B1290 Dancer, J. B. "Speculations on the Process employed by Messrs. Boulton and Watt in the Production of the Pictures called by them, 'Mechanical Pictures.'" AMERICAN JOURNAL OF PHOTOGRAPHY AND THE ALLIED ARTS & SCIENCES n. s. vol. 8, no. 17 (Mar. 1, 1866): 401-404. [Read to the Photographic Section of the Literary and Philosophical Society of Manchester.]

B1291 Wallis, George, South Kensington Museum. "The Ghost of an Art-Process Practiced at Soho, near Birmingham, about 1777 to 1780, Erroneously Supposed to Have Been Photography." ART JOURNAL (Aug. - Sept. 1866): 251-255, 269-272.

B1292 "Ancient Photography." PHOTOGRAPHIC TIMES 1, no. 8 (Aug. 1871): 119-120. [Abstract from article in "Cincinnati [OH] Gazette" claiming that Matthew Boulton, partner of James Watt had experimented with photo in 1791.]

BOURKE.
B1293 "Photographing the Ameer." ANTHONY'S PHOTOGRAPHIC BULLETIN 10, no. 8 (Aug. 1879): 247-248. [From "Br J of Photo," again from "Daily News."]

BOURNE & SHEPHERD. (GREAT BRITAIN, INDIA)
BOOKS
B1294 *Bourne and Shepherd's Royal Photographic Album of Scenes and Personages Connected with the Progress of H.R.H. The Prince of Wales through Bengal, the North West Provinces, the Punjab and Nepal,* with some descriptive letterpress. Calcutta, Bombay and Simla: Bourne & Shepherd, 1876. iv, 79 pp. 140 b & w.

B1295 Taylor, Roger. *Samuel Bourne, Photographic Views in India (1834-1912).* Sheffield: Sheffield City Polytechnic, 1980. n. p. [Exhibition.]

B1296 Marshall, William Elliot. *A Phrenologist amongst the Todas; or, A Study of a Primitive Tribe in South India.* London: Longmans, Green, 1873. xx, 271 pp. 13 b & w. [Same work published with slightly variant titles. Autotype plates of portraits and views, several credited to Bourne & Shepherd (Simla) and Nicholas & Curths.]

B1297 *Photographs of Architecture and Scenery in Gujarat and Rajputana,* Photographed by Bourne and Shepherd, with historical and descriptive letterpress by James Burgess. Calcutta: Bourne & Shepherd, 1874. 47 pp. b & w.

B1298 Burgess, James. *Photographs of Architecture and Scenery in Gujarat and Rajputana:* Photographed by Bourne and Shepherd, with Historical and Descriptive letterpress by James Burgess. Calcutta, Bombay, and Simla: Bourne and Shepherd, 1874. 47 pp. 30 l. of plates.

B1299 Wheeler, James Talboys. *The History of the Imperial Assemblage at Delhi; Held on the 1st January 1877, to Celebrate the Assumption of the Title of Empress of India by Her Majesty the Queen.* London: Longmans, Green, Reader & Dyer, 1877. xix, 248 pp. 33 l.

of plates. 26 b & w. [Woodburytypes of photographs taken in India, mostly by Bourne & Shepherd.]

B1300 Bourne & Shepherd. *Photographic Views in India.* Calcutta: Bourne & Shepherd, 1877. n. p. [Catalog of views for sale.]

B1301 *Photographic Views of India.* Calcutta: Calcutta Central Press, 1885. 94 pp.

B1302 *Photographic Views of India, Burmah, Ceylon and the Straits Settlements.* London: Marion, 1885. 105 pp.

B1303 Furneaux, J. H., editor. *Glimpses of India; A Grand Photographic History of the Land of Antiquity, the Vast Empire of the East.* With 500 ...camera views...with full historical text. London: International Art Co., 1896. 544 pp. 500 b & w. [Photographic illustrations by Bourne & Shepherd, Lala Deen Dayal, Nicols & Co, Barton, Son & Co., and B. D. Dadaboy.]

B1304 Houston, John, editor. *Representative Men of the Bombay Presidency.* A Collection of Biographical Sketches, with Portraits of the Princes, Chiefs, Philanthropists, Statesmen and Other Leading Residents of the Presidency. London, Bombay: C. B. Burrows, 1897. 144 pp. illus. ["...gratitude to Bourne & Shepherd, of Bombay, and Mr. Hammes, photographer, of Poona..."]

PERIODICALS
B1305 Macleod, Norman, D.D. "Days in North India." GOOD WORDS 11, no. 1-6 (Jan. - June 1870): 16-26, 176-189, 335-347, 426-440. 30 illus. [Note on p. 440 credits "Shepherd & Bourne, of Calcutta for the numerous illustrations copied from their photographs."]

B1306 "Indian Architecture." ILLUSTRATED LONDON NEWS 56, no. 1583, 1589 (Mar. 5, Apr. 2, 1870): 240-241, 364. 6 illus. ["...the examples of Indian architecture...are taken from a small publication of photographs recently issued by the Science and Art Department for the use of Schools of Art throughout the United Kingdom..." "Photographs...taken by...Lieutenant Waterhouse, Mr. Burke, of Peshawur, and by Mr. Bourne of Shepherd & Bourne, of Calcutta." Two photos on p. 364 also taken by Bourne.]

B1307 "Novelties. Large Photographs." ANTHONY'S PHOTOGRAPHIC BULLETIN 3, no. 2 (Feb. 1872): 467. ["The temples...other subjects of Southern India, by Messrs. Bourne & Shepherd, of Simla, are just added to our already extensive collection for the graphoscope ...Upwards to one thousand views..."]

B1308 Portrait. Woodcut engraving, credited to "From a Photograph by Bourne & Shepherd." ILLUSTRATED LONDON NEWS 60, (1872) ["Sir Albert Sassoon, C.S.I." 60:1708 (June 1, 1872): 520.]

B1309 Portrait. Woodcut engraving credited "From a photograph by Bourne & Shepherd." ILLUSTRATED LONDON NEWS 66, (1875) ["Lord Donoughmore." 66:1853 (Feb. 13, 1875): 144.]

B1310 "Interior of the Dewan-I-Khas, in the Palace at Delhi." ILLUSTRATED LONDON NEWS 68, no. 1908 (Feb. 19, 1876): 188. 1 illus. ["...the architectural details are taken from a photograph by Messrs. Shepherd and Bourne, Calcutta."]

B1311 Portraits. Woodcut engravings credited "From a photograph by Bourne & Shepherd." ILLUSTRATED LONDON NEWS 74, (1879) ["Gen. Sir Frederick Paul Haines." 74:2064 (Jan. 4, 1879): 8. "Gen. Donald Stewart, C.B." 74:2065 (Jan. 11, 1879): 86.]

B1312 Portraits. Woodcut engravings credited "From a photograph by Bourne & Shepherd." ILLUSTRATED LONDON NEWS 75, (1879) ["Late Mr. Wm. Jenkyns." 75:2101 (Sept. 20, 1879): 256. "Brig.-Gen. Doran, C.B." 75:2104 (Oct. 11, 1879): 256.]

B1313 Downing, J. de Grey. "The Cyclone of 1864." BENGAL: PAST & PRESENT (JOURNAL OF THE CALCUTTA HISTORICAL SOCIETY) 1, no. 2 (Oct. 1907): 112-123. 3 b & w. [Photos credited to "Bourne & Shepherd, 1864." They are of beached ships and other destruction caused by a cyclone in Calcutta, India, in 1864.]

BOURNE, ROWLAND. (GREAT BRITAIN)
B1314 "Birmingham Photographic Society." LIVERPOOL & MANCHESTER PHOTOGRAPHIC JOURNAL [BRITISH JOURNAL OF PHOTOGRAPHY] n. s. 2, no. 12 (June 15, 1858): 152. [Paper by Rowland Bourne, "On the Application of Photography to Business Purposes," advocating development of commercial photog. Photos by Padbury & Dickins to support the lecture mentioned on p. 139.]

B1315 Bourne. "The Application of Photography to Business Purposes." HUMPHREY'S JOURNAL OF PHOTOGRAPHY, AND THE ALLIED ARTS AND SCIENCES 10, no. 9 (Sept. 1, 1858): 142-144. [Read to Birmingham Photo. Soc.]

BOURNE, SAMUEL see also BOURNE & SHEPHERD.

BOURNE, SAMUEL. (1834-1912) (GREAT BRITAIN, INDIA, GREAT BRITAIN)
[Born in Muccleston, Shropshire. Worked as a clerk in a bank in England. Photographing as an amateur, taking views throughout the 1850s. In 1857 he left banking for photography, and was in a major exhibition held in Nottingham in 1859. In 1863 Bourne sailed to India, where he photographed landscape views and architecture. Formed partnership with Charles Shepherd in Simla in 1864. Bourne was extremely active, travelling into the Himalayas twice, in 1863 and 1866, and over large parts of India. Spent nine months photographing in the Kashmir region in 1864, and travelled to the source of the Ganges in 1866, taking six months for the journey. The firm became the largest producer of views of India, and opened a second studio in Calcutta. Bourne retired to England in 1870, where he established a cotton-doubling mill, then he retired from the photographic firm in 1874. Bourne continued to photograph, as an amateur again, and joined the Nottingham Camera Club, where he was made President in 1892, and the Photographic Society of Great Britain. Retired from business in 1896 and painted watercolors.]

BOOKS
B1316 Williams, Susan I. *Samuel Bourne. In Search of the Picturesque.* Williamstown, MA: Sterling and Francine Clark Art Institute, 1981. 22 pp. [Exhibition.]

B1317 Ollman, Arthur. *Samuel Bourne: Images of India.* Carmel, CA: Friends of Photography, 1983. 22 pp. 25 l. of plates. [Special issue of "Untitled," vol. 33]

PERIODICALS
B1318 Bourne, Mr. S. "On Some of the Requisites Necessary for the Production of a Good Photograph." PHOTOGRAPHIC NEWS 3, no. 77-83 (Feb. 24 - Apr. 5, 1860): 296-298, 308-309, 322-323, 334-335, 348-349, 357-358, 370-371.

B1319 "Birmingham Photographic Society: The Wet Process v. The Dry." BRITISH JOURNAL OF PHOTOGRAPHY 7, no. 109 (Apr. 2, 1860): 103-104. [A friendly challenge led Charles Breese to display and discuss his work with the wet process and Mr. Osborn and Dr.

Hill Norris displayed examples of their works and others in the dry processes. In effect, this report became a review. S. Bourne, (of Nottingham) discussed. Woodward (Nottingham) discussed. Seymour, Bright and Applewhaite mentioned.]

B1320 Bourne, S. "The Original Fothergill Process." BRITISH JOURNAL OF PHOTOGRAPHY 9, no. 157 (Jan. 1, 1862): 6-8.

B1321 "Note: Mr. S. Bourne." BRITISH JOURNAL OF PHOTOGRAPHY 10, no. 184 (Feb. 16, 1863): 79. ["Letters dated from the Cape...from Mr. S. Bourne, whose photographs, from Fothergill dry plates, are well known for their softness and beauty. This gentleman has forsaken banking and become a professional photographer, and is now on his way to India, under an engagement of two years;..."]

B1322 Bourne, S. "Photography in the East." BRITISH JOURNAL OF PHOTOGRAPHY 10, no. 193, 197 (July 1, Sept. 1, 1863): 268-270, 345-347.

B1323 Bourne, Samuel. "Foreign Correspondence: Ten Weeks with the Camera in the Himalayas." BRITISH JOURNAL OF PHOTOGRAPHY 11, no. 207-208 (Feb. 1 - Feb. 15, 1864): 50-51, 69-70.

B1324 Bourne, S. Narrative of a Trip to Kashmir (Cashmere) and adjacent Districts." BRITISH JOURNAL OF PHOTOGRAPHY 13-14, no. 335-353 (Oct. 5, 1866 - Feb. 8, 1867): 474-475, 498-499, 524-525, 559-560, 583-584, 617-619; 4-5, 38-39, 63-64. [Written in Simla, India.]

B1325 Bourne, S. "Landscape Photography." BRITISH JOURNAL PHOTOGRAPHIC ALMANAC 1872 (1872): 113-114.

B1326 Bourne, S. "Landscape Photography." PHOTOGRAPHER'S FRIEND 2, no. 4 (Oct. 1872): 105-106. [From "Br J of Photo. Almanac."]

B1327 Heathcote, Pauline F. "Samuel Bourne of Nottingham." HISTORY OF PHOTOGRAPHY 6, no. 2 (Apr. 1982): 99-112. 10 b & w. 1 illus. [Photographs are by Bourne, taken in England in 1850s - 1860s and 1890s-1900s, before he went to India and after he retired from India back to England.]

B1328 Ollman, Arthur. "Samuel Bourne: Images of India." UNTITLED no. 33 (1983): 5-22, 25 plates. 25 b & w. 6 illus.

BOVEY, W. T. (GREAT BRITAIN)
B1329 Bovey, W. T. "Photography Eclipsed." PHOTOGRAPHER'S FRIEND 2, no. 1 (Jan. 1872): 22-24. [From "Photo News."]

B1330 Bovey, W. T. "How to Avert One of the Perils that Threaten Stored Negatives." BRITISH JOURNAL PHOTOGRAPHIC ALMANAC 1874 (1874): 65-66.

B1331 Simpson, G. Wharton. "Notes from the News." PHOTOGRAPHIC TIMES 4, no. 47 (Nov. 1874): 173-174. [Excerpts from the "Photographic News." This article contains a long discussion of Mr. Bovey's methods of combination printing.]

B1332 Bovey, W. T. "Our Foreign Makeup - Seasonable Thoughts Shot at Random." PHOTOGRAPHIC TIMES 5, no. 57 (Sept. 1875): 219.

BOW, ROBERT H. (1827-1909) (GREAT BRITAIN)

B1333 Bow, Robert H. "On Photographic Distortion." BRITISH JOURNAL OF PHOTOGRAPHY 8, no. 155-156 (Dec. 2 - Dec. 16, 1861): 417-419, 440-443. 3 illus.

B1334 Bow, Robert H. "A Point to be Attended to in Lighting the Subject in Portrait Photography." BRITISH JOURNAL OF PHOTOGRAPHY 12, no. 284 (Oct. 13, 1865): 520.

B1335 "Obituary of the Year: R. H. Bow (Feb. 17, 1909)." BRITISH JOURNAL PHOTOGRAPHIC ALMANAC 1910 (1910): 475. [Bow died at Edinburgh on Feb. 17, 1909, at age 82. Pioneer in photographic optics, wrote papers on lenses, stereoscopic photography, etc. for the "BJP" and "BJPA." Member of the Edinburgh Photo Society since 1861.]

BOWDISH, N. S.

B1336 Portrait. Woodcut engraving, credited "From a Photograph by N. S. Bowdish." FRANK LESLIE'S ILLUSTRATED NEWSPAPER 33, (1871) illus. ["The late Ex-judge Sidney H. Stuart." 33:836 (Oct. 7, 1871): 53.]

BOWDOIN, D. W. see also CUTTING & BOWDOIN.

BOWDOIN, D. W. (BOSTON, MA)

B1337 "Col. Enoch Train." BALLOU'S PICTORIAL DRAWING-ROOM COMPANION [GLEASON'S] 9, no. 26 (Dec. 29, 1855): 412. 1 illus. ["...from an excellent photograph by D. W. Bowdoin, No. 49 Tremont Street."]

BOWER, J. (GREAT BRITAIN)

B1338 Bower, J. *Brief Directions for Producing Photographic Pictures by the Collodion Process.* London: Baker, 1853. n. p.

BOWERS, WILDER T. (LYNN, MA)

B1339 Bowers, W. T. "Correspondence." ANTHONY'S PHOTOGRAPHIC BULLETIN 6, no. 6 (June 1875): 189. [Letter from Bowers (Lynn, MA) correcting an error in reporting an issue.]

BOWMAN, ANDREW.

B1340 Bowman, Andrew. "A Word for Retouching." BRITISH JOURNAL PHOTOGRAPHIC ALMANAC 1879 (1879): 127-131.

BOWMAN, HENRY.

B1341 Bowman, Henry. "On a Concave Field for Photographic Pictures." HUMPHREY'S JOURNAL 7, no. 21 (Mar. 1, 1856): 340-343.

BOWMAN, WILLIAM EMORY. (1834-1915) (USA)
BOOKS
B1342 Jensen, James. *W. E. Bowman: General Photographer.* Chicago: Published by the author, 1979. 105 pp. 44 b & w. [Accompanied an exhibition at the LaSalle County Historical Society, Utica, Illinois, June 17 - August 17, 1979.]

PERIODICALS
B1343 "Editor's Table." PHILADELPHIA PHOTOGRAPHER 4, no. 43 (July 1867): 234. [Stereos of the West.]

B1344 "Editor's Table." PHILADELPHIA PHOTOGRAPHER 6, no. 69 (Sept. 1869): 324. [Stereo groups of picnics and excursion parties, residences and children at the Soldiers' Orphans Home, IA.]

B1345 "For Sale at a Bargain." ANTHONY'S PHOTOGRAPHIC BULLETIN 19, no. 23 (Dec. 8, 1888): advertising section, p. xxiv.

[Advertisement by William E. Bowman that his gallery in Ottawa, IL, open for more than 30 years, is for sale.]

B1346 Waldsmith, John. "Ottawa Celebrates the Fourth." STEREO WORLD 3, no. 3 (July - Aug. 1976): 13. 2 b & w. [Stereo views of Ottawa, IL, taken on July, 4, 1876.]

BOWNESS, M. (AMBLESIDE, ENGLAND)
B1347 Portrait. Woodcut engraving credited "From a photograph by M. Bowness." ILLUSTRATED LONDON NEWS 74, (1879) ["Lieut. Pender Porteous, killed." 74:2072 (Mar. 2, 1879): 193.]

BOWRON & COX. (ST. JOHN, CANADA)
B1348 "Mrs. Chipman's House. Formerly the Residence of the Duke of Kent, Grandfather to the Prince of Wales, and the Residence of the Prince in St. John, N. B. - From a Photograph by Bowron & Cox, St. John, N. B." FRANK LESLIE'S ILLUSTRATED NEWSPAPER 10, no. 248 (Aug. 25, 1860): 214. 1 illus. [View.]

BOWRON, GEORGE J. see BOWRON & COX.

BOYLE, C. B.
B1349 Boyle, C. B. "The Lens Controversy." HUMPHREY'S JOURNAL OF PHOTOGRAPHY, AND THE ALLIED ARTS AND SCIENCES 20, no. 7 (Aug. 1, 1868): 106-112. 1 illus. [Long letter describing his position, attacking Ed. Wilson (ed. of "Phila. Photog.," who had opposed him).]

BOYNTON & CO. (BOSTON, MA)
B1350 Portrait. Woodcut engraving, credited "Photographed by Boynton & Co., of Boston, MA." FRANK LESLIE'S ILLUSTRATED NEWSPAPER 37, (1874) ["The late Ralph Keeler, correspondent of the "Tribune." 37:955 (Jan. 17, 1874): 309.]

B1351 Boynton, Dr. "The Exhibition and Meetings of the National Photographic Association: The Lectures - Sunlight and Moonlight." PHILADELPHIA PHOTOGRAPHER 6, no. 67 (July 1869): 234. [First annual meeting held in Horticultural Hall, Boston, MA.]

BRACKENRIDGE, B. M.
B1352 Brackenridge, B. M. "On Impurities in Nitrate of Silver." HUMPHREY'S JOURNAL OF PHOTOGRAPHY, AND THE ALLIED ARTS AND SCIENCES. 10, no. 19 (Feb. 1, 1859): 294-295.

BRADBURY, HENRY. (GREAT BRITAIN)
B1353 Bradbury, Henry. *Ferns of Great Britain:* Nature Printed by Henry Bradbury. With full Descriptions of their different Species and Varieties by Thomas Moore, edited by Dr. Lindley. London: Bradbury & Evans, 1856. n. p. 51 illus. ["...mode of Nature Printing first practiced in the Imperial Printing Office at Vienna..."]

BRADFORD see CUTTING & BRADFORD.

BRADFORD, WILLIAM see also DUNMORE & CRITCHERSON.

BRADFORD, WILLIAM. (1822-1892) (USA)
BOOKS
B1354 *Arctic Scenes: Ice.* s. l.: s. n., n. d. [ca. 1873 ?]. 2 l. 47 b & w. [Binder's title. "Photographs taken by Mr. Bradford or by a photographer engaged by him in the course of a voyage in 1864 to Labrador." (from introduction.) It's more probable that these are prints taken by Dunmore & Critcherson in 1869.]

B1355 *Photographs of Arctic Ice.* s. l.: s. n., n. d. [ca. 1873 ?]. 3 l. 45 b & w. [Binder's title. "Photographs taken by two photographers - a Mr. Dunmore and a Mr. Critcherson... who were engaged by Mr. Bradford for a voyage in 1864 (sic 1869) to Labrador. Some photographs by Mr. Bradford." (from introduction.) This is a companion volume to "Arctic Scenes: Ice."]

B1356 *Photographs of the Expedition of Dr. Hayes and Mr. Bradford to the Arctic Regions.* s. l.: s. n., n. d. [ca. 1873 ?]. n. p. 26 b & w. [Album of 26 photographs, most different from those in "The Arctic Regions (1873)." NYPL collection.]

B1357 Wilmerding, John. "William Bradford, 1823 - 1892," on pp. 7-11 in:*William Bradford, Artist of the Arctic, An Exhibition of His Paintings and Photographs.* Lincoln, MA: DeCordova Museum, 1969. n. p. illus. [Exhibition catalog, DeCordova Museum, Lincoln, MA, Nov. 2 - Dec. 28, 1969, and the Whaling Museum of New Bedford, Jan. 11 - Feb. 15, 1970.]

PERIODICALS
B1358 "Royal Institution: The Esquimaux and Ice of Greenland." ILLUSTRATED LONDON NEWS 58, no. 1656 (June 24, 1871): 614. ["Mr. Wm. Bradford, an artist from New York...on Friday, June 16, gave an account of an Arctic exhibition...in 1869, illustrated by about seventy photographs, magnified and thrown upon the screen by means of the camera and electric lamp."]

B1359 "Royal Institution Lectures. Crevasses, Icicles, and Icebergs." ILLUSTRATED LONDON NEWS 60, no. 1688 (Jan. 13, 1872): 34. [Lecture given by Prof. Tyndall. "Among the numerous illustrations were photographs of icebergs taken during Mr. Bradford's Arctic expedition in 1869."]

B1360 "Sealers Crushed By Icebergs." ILLUSTRATED LONDON NEWS 61, no. 1729 (Oct. 26, 1872): 403-404. 1 illus. ["Mr. Bradford had the honor of exhibiting this picture to the Queen...He at the same time showed them his sketches and photographs taken in the expedition which he fitted out in 1869..."]

B1361 "The Paintings of Mr. William Bradford of New York." PHILADELPHIA PHOTOGRAPHER 31, no. 1 (Jan. 1884): 7-8. [Includes an interview with Bradford.]

B1362 "Editor's Table: Obituary." WILSON'S PHOTOGRAPHIC MAGAZINE 19, no. 418 (May 21, 1892): 319. [William Bradford, the marine painter, died Apr. 25, 1892. Born in Fairhaven, MA, in 1822. Made several voyages to the Arctic... "the camera was always his companion. Once Mr. J. W. Black, of Boston, accompanied him [untrue] and again Mr. Black's brother-in-law, Mr. John Dunmore.[true] Mr. Bradford was himself an enthusiastic amateur photographer, and lectured all over the country with the lantern.... "]

B1363 Horch, Frank. "Photographs and Paintings by William Bradford." AMERICAN ART JOURNAL 5, no. 2 (Nov. 1973): 61-70. 6 b & w. 5 illus.

BRADLEY & RULOFSON. (SAN FRANCISCO, CA)
BOOKS
B1364 "Bradley and Rulofson" in: *First Steamship Pioneers; Sketches, Lives and Doings of the Principle Pioneers of California,* edited by the Association of First Steamship Pioneers. San Francisco: Printed by H. S. Crocker & Co., for the Society, 1874. 389 pp. ["In the 'Introductory Notes,' a very flattering notice is given of the firm of Bradley & Rulofson as one of the pioneer houses in business." "Philadelphia Photographer" (Sept. 1874): 288.]

B1365 *The Pacific Coast Pulpit: Containing Sermons by Prominent Preachers of San Francisco and Vicinity.* San Francisco: n. p., 1875. n. p. 14 b & w. [Volume 1 contains 14 photographs of ministers, by Bradley & Rulofson.]

B1366 *Bradley and Rulofson's Celebrity Catalogue.* San Francisco: Bradley & Rulofson, 1878. n. p.

B1367 Shakespeare, William. *Gems from the Loves of the Heroes and Heroines of William Shakespeare. Arranged for Social Reading.* San Francisco: J. Winterburn & Co., 1884. 316 pp. 1 b & w. illus. [Tipped-in portrait of "Miss Neilson," who may be the editor of this sanitized version of the text, or an actress who specialized in dramatic readings - or both.]

PERIODICALS
B1368 Portrait. Woodcut engraving, credited "From a Photograph by Bradley & Rulofson." FRANK LESLIE'S ILLUSTRATED NEWSPAPER 30, (1870) ["Admiral Dot." 30:773 (July 23, 1870): 300.]

B1369 1 engraving (of the Photographic Gallery), plus the statement "Poetry of Photography." CALIFORNIA MAIL BAG 1, no. 1 (June 1871): advertising section, p. xxxii. 1 illus. [Advertisement for the Bradley & Rulofson Gallery, San Francisco, Calif.]

B1370 "Art Gallery - Mechanic's Fair." CALIFORNIA MAIL BAG 1, no. 3 (Aug. 1871): liv. [Note praising Bradley & Rulofson's photographic display at the 8th Annual Mechanic's Fair in San Francisco. "The great talent of their operator, Mr. Max Beckart, formerly operator of Sorony's [sic. Sarony ?] Gallery, in New York, is conspicuously shown in these productions...."]

B1371 "The Fine Arts." CALIFORNIA MAIL BAG 1, no. 4 (Oct.- Nov. 1871): xxviii. [Note that Bradley & Rulofson was awarded all the first premiums for portrait photography at the 8th annual Mechanic's Fair.]

B1372 Portrait. Woodcut engraving, credited "From a Photograph by Bradley & Rulofson. FRANK LESLIE'S ILLUSTRATED NEWSPAPER 33, (1871) ["Group portrait of the Commission of US Scientists appointed by the Japanese Govt. to study resources." 33:844 (Dec. 2, 1871): 189.]

B1373 Portrait. Woodcut engraving, credited "Photographed by Bradley & Rulofson, of San Francisco, CA." FRANK LESLIE'S ILLUSTRATED NEWSPAPER 37, (1874) ["Hon. Newton Booth, Gov. of CA." 37:962 (Mar. 7, 1874): 429.]

B1374 Portrait. Woodcut engraving, credited "Photographed by Bradley & Rulofson, of San Francisco, CA." FRANK LESLIE'S ILLUSTRATED NEWSPAPER 38, (1874) ["J. W. Wright, Grange Party leader." 38:963 (Mar. 14, 1874): 12.]

B1375 "Matters of the Month: The Latest Prize Pictures." PHOTOGRAPHIC TIMES 4, no. 41 (June 1874): 89. [Won prize offered by Benerman & Wilson ("Philadelphia Photographer") for cabinet photos.]

B1376 "Our Prize Picture." PHILADELPHIA PHOTOGRAPHER 11, no. 127 (July 1874): 205-209. 1 b & w. 4 illus. [One studio portrait, plus three floor plans of studio and an etching of studio.]

B1377 "Editor's Table: First Steamship Pioneers." PHILADELPHIA PHOTOGRAPHER 11, no. 129 (Sept. 1874): 288. [Bradley & Rulofson noted and praised in the book "First Steamship Pioneers," published by H. S. Crocker & Co., San Francisco.]

B1378 "Matters of the Month: Photographic Progress—The Chicago Convention." PHOTOGRAPHIC TIMES 4, no. 47 (Nov. 1874): 175. [From the "San Francisco [CA} News Letter." Report on Rulofson's participation at the N.P.A. Chicago Convention.]

B1379 "The Mechanic's Fair - Photographic Display." ANTHONY'S PHOTOGRAPHIC BULLETIN 5, no. 11 (Nov. 1874): 375-376. [From "[S.F.] Daily Evening Bulletin."]

B1380 Portrait. Woodcut engraving, credited "Photographed by Bradley & Rulofson, of San Francisco, CA." FRANK LESLIE'S ILLUSTRATED NEWSPAPER 39, (1874) ["James Lick, philanthropist." 39:999 (Nov. 21, 1874): 172.]

B1381 "The King Among the Photographers." PHOTOGRAPHIC TIMES 5, no. 49 (Jan. 1875): 2. [From "San Francisco [CA] Daily Evening Bulletin." About King Kalakaua of Hawaii visiting San Francisco, sitting for his portrait at Bradley & Rulofson's Gallery.]

B1382 "King Kalakaua & Suite in San Francisco." ANTHONY'S PHOTOGRAPHIC BULLETIN 6, no. 1 (Jan. 1875): 16. [From "San Francisco Evening Bulletin." Mentions visit of the Hawaiian King to Bradley & Rulofson's gallery for portraits, lists members of the party.]

B1383 Portrait. Woodcut engraving, credited "From a Photograph by Bradley & Rulofson." FRANK LESLIE'S ILLUSTRATED NEWSPAPER 39, (1875) ["His Majesty Kalakaua, King of the Sandwich Islands." 39:1005 (Jan. 2, 1875): 280. "Gov. John O. Dominis, Island of Oahu." 39:1007 (Jan. 16, 1875): 316. "Gov. John M. Kapena, Island of Maui." 39:1007 (Jan. 16, 1875): 316. "Hon. William Sharon, Sen. from NV." 39:1013 (Feb. 27, 1875): 413.]

B1384 "Editor's Table: Items of News." PHILADELPHIA PHOTOGRAPHER 12, no. 137 (May 1875): 160. [Bradley & Rulofson's views of Pacific coastline viewed in London.]

B1385 "Photography on the Pacific Coast." PHILADELPHIA PHOTOGRAPHER 12, no. 140 (Aug. 1875): 247-248.

B1386 Rulofson, Wm. H. "The Right Spirit." PHILADELPHIA PHOTOGRAPHER 12, no. 140 (Aug. 1875): 246-247.

B1387 "Editor's Table." PHILADELPHIA PHOTOGRAPHER 12, no. 141 (Sept. 1875): 288. [Praise for crayon studies.]

B1388 "Suspension of the Bank of California, August 26th - Scene on California Street Immediately After the Announcement of the Failure. From a Photograph by Bradley & Rulofson." FRANK LESLIE'S ILLUSTRATED NEWSPAPER 41, no. 1041 (Sept. 11, 1875): 1. 1 illus. [View, enhanced by the engraver.]

B1389 "California. - Belmont, the Country-Seat of the Late William C. Ralston." and "The Late William C. Ralston. - From a Photograph by Bradley & Rulofson, San Francisco." FRANK LESLIE'S ILLUSTRATED NEWSPAPER 41, no. 1042 (Sept. 18, 1875): 29. 2 illus. [View, portrait.]

B1390 Portraits. Woodcut engravings, credited "From a Photograph by Bradley & Rulofson, San Francisco." FRANK LESLIE'S ILLUSTRATED NEWSPAPER 41, (1875)'["Hon. William Irwin, Gov.-elect of CA." 41:1049 (Nov. 6, 1875): 141. "Dr. Henry R. Linderman, Supt. of US Mints." 41:1051 (Nov. 20): 169.]

B1391 "Presents on the Pacific." PHILADELPHIA PHOTOGRAPHER 13, no. 146 (Feb. 1876): 36.

B1392 "California. - The Japanese Corvette 'Tsukuba' and Her Officers, Now on a Visit to the Port of San Francisco. - From a Photograph by Bradley & Rulofson, San Francisco." FRANK LESLIE'S ILLUSTRATED NEWSPAPER 41, no. 1063 (Feb. 12, 1876): 365. 1 illus. [Twenty-two cartes of the Japanese sailors were photographed, then arranged around a view of the ship, then the ensemble rephotographed.]

B1393 Portraits. Woodcut engravings, credited "From a Photograph by Bradley & Rulofson. FRANK LESLIE'S ILLUSTRATED NEWSPAPER 42, (1876) ["James C. Flood, of the Bank of Nevada." 42:1070 (Apr. 1, 1876): 64. "William S. O'Brien, of the Bank of Nevada." 42:1070 (Apr. 1, 1876): 64. "Gen. T. Saigo, Centennial Commissioner from Japan." 42:1076 (May 13, 1875): 165.]

B1394 "Photographs." ANTHONY'S PHOTOGRAPHIC BULLETIN 7, no. 5 (May 1876): 160. [Portrait of Emperor of Brazil, taken by the firm.]

B1395 Portraits. Woodcut engravings credited "From a photograph by Bradley & Rulofson, San Francisco." FRANK LESLIE'S ILLUSTRATED NEWSPAPER 43, (1877) ["Gov. Lafayette Grover, of OR." 43:1112 (Jan. 20, 1877): 325.]

B1396 "Editor's Table." PHILADELPHIA PHOTOGRAPHER 14, no. 158 (Feb. 1877): 62. [Bradley & Rulofson received silver pitcher and silver fruit dish from their employees.]

B1397 "The Carbon Process and Its Introduction to San Francisco." ANTHONY'S PHOTOGRAPHIC BULLETIN 8, no. 3 (Mar. 1877): 76. [From "Daily Alta California and San Francisco Times."]

B1398 "Editor's Table." PHILADELPHIA PHOTOGRAPHER 14, no. 165 (Sept. 1877): 288. [Photos received from Bradley & Rulofson (San Francisco, CA).]

B1399 "California. - View of Sansome Street, Showing the Center of the Jobbing Trade of San Francisco and the Bank of California. - From a Photograph by Bradley & Rulofson." FRANK LESLIE'S ILLUSTRATED NEWSPAPER 46, no. 1190 (July 20, 1878): 333. 1 illus. [View, with figures.]

B1400 "Our Picture." PHILADELPHIA PHOTOGRAPHER 15, no. 176 (Aug. 1878): frontispiece, 249. 1 b & w. [Studio portrait.]

B1401 "California. - Banking and Express Offices of Wells, Fargo & Co., San Francisco. - From Photographs by Bradley & Rulofson." FRANK LESLIE'S ILLUSTRATED NEWSPAPER 46, no. 1193 (Aug. 10, 1878): 385. 4 illus. [Two views of buildings, credited to the photographers, two portraits, not credited, but probably from photographs.]

B1402 Portrait. Woodcut engraving, credited "From a Photograph by Bradley & Rulofson." FRANK LESLIE'S ILLUSTRATED NEWSPAPER 46, (1878) ["Chun Lan Pin, first Chinese ambassador to USA." 46:1196 (Aug. 31, 1878): 429.]

B1403 Portrait. Woodcut engraving, credited "From a Photograph by Bradley & Rulofson." FRANK LESLIE'S ILLUSTRATED NEWSPAPER 47, (1879) ["'Otto,' Son of the Nez Pierce's Chief Joseph." (The 12 year old boy is elaborately -and fancifully- dressed and shown here brandishing a rifle with bayonet.) 47:1219 (Feb. 8, 1879): 417.]

B1404 Portrait. Woodcut engraving, credited "From a Photograph by Bradley & Rulofson, San Francisco." FRANK LESLIE'S ILLUSTRATED

BY ARTIST OR AUTHOR
BRADSHAW & GODART. [LONDON SCHOOL OF PHOTOGRAPHY].

BY ARTIST OR AUTHOR
BRADY, MATTHEW B. (1823-1896) (USA)

NEWSPAPER 48, (1879) ["Chief Moses and his delegation of Oregon Indians, now in Washington, DC. (Six portraits)" 48:1231 (May 3, 1879): 133.]

B1405 "Our Picture." PHILADELPHIA PHOTOGRAPHER 17, no. 193 (Jan. 1880): frontispiece, 28-29. 1 b & w. [Studio portrait.]

B1406 Palmquist, Peter E. "Bradley & Rulofson's Funny Money." HISTORY OF PHOTOGRAPHY 4, no. 1 (Jan. 1980): 72. 2 illus. [About a coupon "Redeemable at par for photographs of Bearer," issued in 1874, by Bradley & Rulofson, San Francisco, CA.]

BRADLEY, HENRY W. (1813-1891) (USA) see BRADLEY & RULOFSON.

BRADSHAW & GODART. [LONDON SCHOOL OF PHOTOGRAPHY].

B1407 Portrait. Woodcut engraving credited "From a photograph by "Bradshaw & Godart, London School of Photography, Newgate St., London." ILLUSTRATED LONDON NEWS 70, (1877) ["Rev. Josiah Henson, 'Uncle Tom." 70:1966 (Mar. 17, 1877): 261.]

BRADY, GEORGE S.

B1408 Brady, George S., M.R.C.S. "Photographic Delineation of Microscopic Objects." HUMPHREY'S JOURNAL OF PHOTOGRAPHY, AND THE ALLIED ARTS AND SCIENCES 14, no. 15 (Dec. 1, 1862): 187-189. [From "Intellectual Observer."]

BRADY, MATTHEW B. see also GARDNER, ALEXANDER; PEARSALL, ALVA A.

BRADY, MATTHEW B. (1823-1896) (USA)

[Matthew Brady is the photographer most often associated with the American Civil War, and probably the best known American photographer of the nineteenth century. He is one of the few photographers to be named in school history textbooks, and many articles and books have been written about him in both the photographic and popular journals. A United States Air Force reconnaissance plane was named after him in the 1950s, and he has even been portrayed in Hollywood films and on television. To the photographic historian, Brady is the most obvious example of the problems which bedevil researchers of the nineteenth century. Brady, whose name is so intimately associated with the Civil War in the popular mind, took very few of the photographs for which he is so famous.

Brady was born on a farm near Lake George, NY, in 1822 or 1823. He began his career as a jewelry salesman, and sold daguerreotype cases after they started being constructed. About 1844, Brady became a professional daguerreotypist in New York City. Brady had a keen sense of promotion and was an early business success. Throughout the 1850s Brady built up a powerful publicity apparatus by providing many portraits for reproduction in the illustrated weekly and monthly journals, such as *Frank Leslie's Illustrated Newspaper* and *Harper's Weekly*. As he prospered he moved his gallery to better locations, enlarged his operations, and hired a larger staff. By the 1860s Brady was a wealthy proprietor of one of the largest of the "Broadway Galleries" which at that time provided one of the glamourous, urban features of New York City. Brady's gallery was located near another popular urban attraction, P. T. Barnum's amusement center and freak show. Brady was an active figure in the business community, and he had many friendly connections with members of Boss Tweed's Tammany Hall political organization, which controlled New York City during the period.

Brady, as did most of the other large galleries during this period, hired a large staff to actually make the photographs. The operation of scheduling appointments, collecting the fees, taking the portraits, developing the daguerreotype plates, (later the wet-collodion negatives), making the prints, retouching, and all the rest, was divided among many staff members. A large gallery could employ several actual cameramen, or "operators," and dozens of other staff. By the 1860s Brady himself actually participated in very few portrait sessions, unless the sitter were influential or famous.

Frequently, a successful gallery owner would open a second gallery, then a third, or even more galleries in other parts of the city or in other cities, staff those galleries with a manager, and never take a photograph there or even visit that site. In 1858 Brady opened a branch gallery in Washington, DC, under the management of Alexander Gardner.

When the Civil War threatened many photographers quickly followed the troops into the field, documenting the war preparations and fortifications, the sites of activities, and, after the conflict began, the sites of skirmishes and battles. Brady's gallery was strongly represented in this early documentation, and would later stay active in the field throughout the course of the war. Its an open question whether the driving force behind the Brady gallery's commitment to this documentation effort was Brady or his Washington manager, Alexander Gardner; but there is no question that during the first year of the conflict Alexander Gardner, Timothy O'Sullivan, James Gibson, and others working under Gardner's direction for Brady or marketing their work through Brady, provided some of the most coherent photographic coverage of the early phases of the war.

But Alexander Gardner grew restless working under Brady, and in 1862, after an argument over the rights and privileges of the photographer actually making the images as opposed to those of the employer, Gardner left Brady, and set up a rival operation in Washington. Gardner competed against Brady, both in portraiture of Washington dignitaries and in covering the war, with great success. Many of the best and most active of the outdoor photographers who had been working with Gardner also left Brady, joined Gardner, and continued to make some of the most extraordinary photographs of that conflict.

Brady organized other photographic teams, including David B. Woodbury, Silas Holmes, E. T. Whitney, Hodges, and others, to continue to cover the events in the field; but these individuals most often photographed the Union forces in camp, or the sites of battlefields long after the battle was over. On occasion Brady would come down from New York and accompany one of his teams into the field. With his shrewd sense of publicity, Brady often arranged to have his own portrait taken with the troops or officers during these visits. Brady's crews did actively document Grant's campaign against Lee in Virginia during the final year of the war with great success.

But while Brady may not have actually made many photographs of the field activities of the troops during the war, many portraits of the officers and soldiers were made in his galleries. Further, during and after the war Brady gathered together a large collection of war-related photographs by collecting negatives from as many sources as he could locate, and either buying or copying thousands of prints from other photographers.

The photographic community went through a severe economic depression after the war, and Brady's personal fortunes suffered. Brady had invested unwisely in silver mine stock deals offered by his Tammany friends, and his many (over ninety) creditor's lawsuits, held up for years in the Tammany courts, were finally heard. Brady lost his elegant New York gallery, and ultimately lost his Washington gallery. But throughout all the misfortune he held on to this collection and kept it together in a reasonably intact order.

By the end of his life Brady was poor, ill, and working again as an operator in galleries owned by others. He died in a charity hospital in New York City in 1896, of injuries sustained from a street accident. However, by then the collection, or portions of it, had been purchased by the United States government, and was maintained more or less

safely. Other collections of materials were also later found and preserved. And so, while thousands of negatives by Gardner and others were destroyed by dealers in second-hand glass, or through fire, or through other causes, the collections of Civil War photographic materials which were correctly or incorrectly identified as being by Brady had survived into the early twentieth century. Some of these materials were found during the teens, when Americans were experiencing a revived interest in the Civil War. New printing technologies, which could reproduce the photographs directly in books or in magazines, were available; and several major publishing efforts, illustrated with these photographs, were launched. There was at that time a very fragmented understanding of the photography of the nineteenth century. In fact, in order to authenticate the photographs against one challenge that they were contemporary fakes, one publisher had to bring old army veterans into a court to swear that they could remember being photographed during the war. These early publications tended to lump all Civil War photographs under Brady's name and to repeat the highly romantic tales that Brady had told in his declining years. And by the time, several decades later, photographic historians had come to some more measured and complete understanding of that period, the legend of Brady the Civil War Photographer had already become a part of popular American culture.]

BOOKS
B1409 Sampson, Marmaduke B. Edited by Eliza Farnham. *Rationale of Crime...* New York: Appleton, 1846. n. p. 19 illus. [Nineteen engravings by Tudor Horton, from daguerreotype portraits by Matthew B. Brady.]

B1410 Lester, Charles Edwards, ed. *The Gallery of Illustrious Americans, containing the portraits and biographical sketches of twenty-four of the most eminent citizens of the American republic since the death of Washington.* From daguerreotypes by Brady, engraved by D'Avignon. New York: Brady Gallery, 1850. 25 pp. 12 b & w. [Only twelve copies published.]

B1411 Ehninger, John W. *Illustrations of Longfellow's "Courtship of Miles Standish,"* ... Photographed from the Original Drawings by Brady. New York: Rudd & Carleton, 1859. 12 pp. 8 l. of plates. 8 b & w. illus. [Photographic copies of Ehninger's drawings.]

B1412 Brady, Matthew B. *Album Gallery of Civil War Photographs.* Washington, DC: M. B. Brady, 1862. 1 vol, boxed. b & w. [Copyrighted by Alexander Gardner. Mounted, numbered photographs, each with descriptive letterpress pasted on the verso.]

B1413 Brady, Matthew B. *Brady's Incidents of the War.* New York: Brady, 186-? n. p. 50 l. of plates. 50 b & w. [The Thurlow Weed Collection, Univ. of Rochester, contains two volumes of original photographs. These volumes have different sized pages and different bindings, but they do seem to have been assembled and published as a unit. The photos are all seated one per page, in a sized, embossed depression. Many have no titles or descriptive information, many have handwritten information only, which may have been created by a Brady employee, and some others have letterpress printed on the pages with the photographs. Several of these pages have the series title "Brady's Incidents of the War." In some six or seven photographs, such as the Antietam battlefield aftermath views, Gardner is credited as the photographer and Brady is credited as the publisher. There are no title pages, contents pages, or other texts, but the ensemble strongly presents the sense of a work interrupted in progress. Perhaps the work was being assembled under Gardner's direction until he had the rupture with Brady - a rupture caused in part by Brady refusing to credit photographs to his employees? This may be a set listed in the

Library of Congress Union List as "Album Gallery of the Civil War," with holdings in four other libraries.]

B1414 Anthony, E. & H. T. & Co. *Catalogue of Card Photographs, Published and Sold by E. & H. T. Anthony.* New York: Anthony & Co., 1862. 18 pp. ["This catalogue contains, together with other subjects, the celebrated of portraits, well known in Europe and America as 'Brady's National Photographic Gallery.'"]

B1415 *A Catalogue of Brady's Photographic Views of the Civil War ... New York, November, 1862.* New York: E. & H. T. Anthony & Co., 1862. 16 pp. [Facsimile reprint, n. d., [ca. 195?], Watkins Glen: Century House.]

B1416 Brady, Matthew B. *Recollections of the Art Exhibit. Metropolitan Fair, New York, April 1864.* Photographed and published by M. B. Brady. New York: Brady Gallery, 1864. ii pp. 20 l. of plates. 20 b & w. [20 albumen photographs of the display of paintings at the Metropolitan Fair, New York, NY in 1864. Second title page: "Catalogue of the Art Exhibition of the Metropolitan Fair in Aid of the U. S. Sanitary Commission."]

B1417 *Brady & Co.'s Catalogue of Photographs and Stereoscopes of Lt. Gen. Grant's Late Campaign, June 1864.* New York: Brady & Co., 1864. n. p.

B1418 *Brady's National Photographic Collection of War Views and Portraits of Representative Men.* New York, Washington, DC: Brady & Co., A. Alvord, Printer, 1869. 139 pp. [Microfilm copy: "American Culture Series, 120:2," University Microfilm, Ann Arbor, MI.]

B1419 *Brady and Handy's Album of the Fiftieth Congress of the United States.* Designed and Published by M. B. Brady and Levin C. Handy. Washington, DC: Brady & Handy, 1888. n. p. 84 b & w. [Original photographs.]

B1420 *List of Photographs and Photographic Negatives Relating to the War of the Union, Now in the War Department Library.* Washington, DC: Government Printing Office, 1897. 219 pp. [Subject Catalog No. 5.]

B1421 *Photographic Plates of Civil War Pictures.* New York: Review of Reviews, 1911. n. p. 21 l. of plates. 21 b & w. [21 plates in a portfolio, "being a few of the photographs contained in the "Photographic History of the Civil War.]

B1422 Meredith, Roy. *Mr. Lincoln's Camera Man, Matthew B. Brady.* New York: Charles Scribner's Sons, 1946. 368 pp. b & w. illus.

B1423 Meredith, Roy. *Mr. Lincoln's Contemporaries; An Album of Portraits by Matthew B. Brady.* New York: Scribner, 1951. 233 pp. b & w. illus.

B1424 Rogers, Frances. *Mr. Brady's Camera Boy.* Illustrated by Dudley G. Summers. Philadelphia: Lippincott, 1951. 248 pp. illus. [Juvenile fiction.]

B1425 Horan, James D. Picture Collation by Gertrude Horan. *Matthew Brady: Historian With a Camera.* New York: Crown Publishers, 1955. 244 pp. 453 b & w. illus. [Contains "A Pictorial Bibliography of Brady Pictures in 'Harper's Weekly,' 1861 - 1865 and 'Frank Leslie's Illustrated Newspaper, 1860 - 1865,'" on pp. 235-238, additional bibliography and source notes.

B1426 Komroff, Manuel. *Photographing History: Matthew Brady. Photographs from the Ansco Historical Collection, the Chicago Historical Society and the Kean Archives, Philadelphia.* "Great Lives for Young Americans" 'Chicago: Britannica Books, 1962. 192 pp. illus.

B1427 *Matthew B. Brady: Civil War Photographer.* New York: GAF Corporation, 1971. 24 pp. 10 b & w. illus. [A small pamphlet, apparently generated for an exhibition - however no documentation of that on the piece.]

B1428 Meredith, Roy. *The World of Matthew Brady: Portraits of the Civil War Period.* Los Angeles: Brooke House Publishers, 1971, 1976. 240 pp. b & w. illus.

B1429 Kunhardt, Dorothy Meserve and Philip B. Kunhardt, Jr. and the Editors of Time/Life Books. *Matthew Brady and His World: Produced by Time/Life Books from Pictures in the Meserve Collection.* Alexandria, Va.: Time/Life Books, 1977. 303 pp. b & w. illus.

B1430 Hoobler, Dorothy and Thomas Hoobler. *Photographing History: The Career of Matthew Brady.* New York: Putnam, 1977. 143 pp. illus. [Children's book.]

B1431 Meredith, Roy. *Matthew Brady's Portrait of an Era.* New York: W. W. Norton & Co., 1982. 160 pp. b & w. illus.

B1432 Hobart, George. *Matthew Brady.* "Masters of Photography." London: Macdonald, 1984. 39 l. b & w.

PERIODICALS

B1433 Portrait. Woodcut engravings credited "Daguerreotyped by Brady." ILLUSTRATED LONDON NEWS 17, (1850) ["President Taylor and His Cabinet." 17:* (July 27, 1850): 85.]

B1434 "Notes." DAGUERREIAN JOURNAL 1, no. 1 (Nov. 1, 1850): 17. [Actress Jenny Lind sits for M. B. Brady and for Marcus Root. Root, with gallery in Philadelphia, also opens a gallery in New York.]

B1435 Lester, C. Edwards. "M. B. Brady and the Photographic Art." PHOTOGRAPHIC ART JOURNAL. 1, no. 1 (Jan. 1851): 36-40. [Became interested in art as a young man through visits to the studio of painter William Page. Public announcement of the daguerreotype in 1839 sparked his interest and he began experimenting. First public exhibition at the American Institute Fair in 1844. One of first to use the skylight. 1845 began collecting portraits of distinguished and famous individuals. Ca. 1846 went to Washington, DC, photographed President Taylor and his cabinet. 1849 large picture at Pres. Taylor and cabinet. Began contributing to the "Gallery of Illustrious Americans." Miniatures on ivory early 1850's.]

B1436 "Gossip." PHOTOGRAPHIC ART JOURNAL 1, no. 1 (Jan. 1851): frontispiece, 62-63. 1 illus. [Commentary about D'Avignon as the engraver of the "Gallery of Illustrious Americans," a work based on Brady's photographs. His portrait of Brady was used as the frontispiece illustration of the magazine.]

B1437 Lyon, Caleb. "Stanzas Suggested by a visit to Brady's Portrait Gallery." PHOTOGRAPHIC ART JOURNAL 1, no. 1 (Jan. 1851): 63. [Poem.]

B1438 Portrait. Woodcut engraving credited "From a daguerreotype by Brady." ILLUSTRATED LONDON NEWS 18, (1851) ["Colonel Fremont." 18:* (Feb. 22, 1851): 168.]

B1439 "Gossip." PHOTOGRAPHIC ART JOURNAL 1, no. 3 (Mar. 1851): 189-190. [American entries to the London Crystal Palace exhibition described. Brady, Lawrence, Meade Brothers, others.]

B1440 "Gossip." PHOTOGRAPHIC ART JOURNAL 2, no. 1 (July 1851): 60-64. [Brady sailed for Europe to visit the London World's Fair.]

B1441 "Notice." DAGUERREAN JOURNAL 2, no. 7 (Aug. 15, 1851): 211. [John Brady, brother of M. B. Brady, died in New York, NY on 9th. Matthew Brady was in Europe.]

B1442 "James Fennimore Cooper." ILLUSTRATED AMERICAN NEWS 1, no. 17 (Sept. 27, 1851): 136. 1 illus. ["From a Daguerreotype by Brady."]

B1443 Snelling, H. H. "Gossip." PHOTOGRAPHIC ART JOURNAL 2, no. 5 (Nov. 1851): 320. [Snelling defends the committee appointed to visit Levi L. Hill and Matthew Brady from "a most caustic and libellous" article in "a Philadelphia Newspaper."]

B1444 "Gossip." PHOTOGRAPHIC ART JOURNAL 3, no. 2 (Feb. 1852): 130. ["Brady is still in Europe, gradually improving in health..."]

B1445 "Humphrey's Journal." HUMPHREY'S JOURNAL 4, no. 4 (June 1, 1852): 58-59. [Praise for Brady's daguerreotypes, sent to the World's Fair.]

B1446 Portrait. Woodcut engraving credited "From a daguerreotype by Brady." ILLUSTRATED LONDON NEWS 21, (1852) ["Henry Clay." 21:* (July 17, 1852): 36.]

B1447 Portraits. Woodcut engravings, credited "From a Daguerreotype by Brady." ILLUSTRATED NEWS (NY) 1, (1853) ["Purser Smith." 1:2 (Jan. 8, 1853): 29. "John Ericsson." 1:5 (Jan. 29, 1853): 69. "Thomas Sedgwick." 1:6 (Feb. 5, 1853): 84. "Captain Ericsson, explaining his Invention to the Editors of New York (composite group portrait)." 1:7 (Feb. 12, 1853): 97. "Hon. William R. King, Vice-President of the USA." 1:12 (Mar. 19, 1853): 177. "Cornelius Vanderbilt." 1:15 (Apr. 9, 1853): 233. "Asher B. Durand, artist." 1:18 (Apr. 30, 1853): 280. "David R. Atchison, Vice-President of the USA." 1:19 (May 7, 1853): 296. "Lucy Stone, Feminist." 1:22 (May 28, 1853): 345. "Azariah C. Flagg, Comptroller of NY." 1:24 (June 11, 1853): 377. "Major-General Riley." 1:26 (June 25, 1853): 409.]

B1448 "Ellis' Statuette of Lopez." ILLUSTRATED NEWS (NY) 1, no. 4 (Jan. 22, 1853): 53. 1 illus. ["From a Daguerreotype by Brady."]

B1449 "Have We a Bourbon Among Us?" PUTNAM'S MONTHLY 1, no. 2 (Feb. 1853): 194-217. 3 illus. [Includes a portrait of the Rev. Eleazer Williams, with comment, "It is from a daguerreotype taken from life by Brady, in December 1852."]

B1450 "M. B. Brady, Esq." ILLUSTRATED NEWS (NY) 1, no. 13 (Mar. 26, 1853): 203. [Note that Brady opened a new gallery on Broadway, New York, NY; praise for his work.]

B1451 "New Daguerreotype Establishments." HUMPHREY'S JOURNAL 4, no. 24 (Apr. 1, 1853): 378. [Describes opening of new galleries by Brady and by Lawrence.]

B1452 "Gossip." PHOTOGRAPHIC ART JOURNAL 5, no. 4 (Apr. 1853): 193. [Note that both Brady and Lawrence had opened their new galleries on Monday, March 14.]

B1453 "Photography - Brady's Daguerrean Salon." ILLUSTRATED NEWS (NY) 1, no. 24 (June 11, 1853): 384. 1 illus. [Includes an idealized view of the waiting room in Brady's gallery.]

B1454 "Brady's Daguerreotype Establishment." HUMPHREY'S JOURNAL 5, no. 5 (June 15, 1853): 73-74. [Description of Brady's new gallery.]

B1455 Portraits. Woodcut engravings, credited "From a Daguerreotype by Brady." ILLUSTRATED NEWS (NY) 2, (1853) ["Hon. James Buchanan, USA Minister to England." 2:34 (Aug. 20, 1853): 84. "Hon. Pierre Soule, USA Minister to Spain." 2:34 (Aug. 20, 1853): 84. "Lieut.-Col. Bliss 2:37 (Sept. 10, 1853): 121.]

B1456 "Firemen's Celebration - The Procession in Broadway." ILLUSTRATED NEWS (NY) 2, no. 46 (Nov. 12, 1853): 265. 1 illus. [View of parade, with Brady's Gallery prominently featured behind the marching firemen.]

B1457 "Daguerreotypes at the World's Fair." PHOTOGRAPHIC AND FINE ART JOURNAL 7, no. 1 (Jan. 1854): 14-16. [Brady one of many listed.]

B1458 "Personal and Art Intelligence." PHOTOGRAPHIC AND FINE ARTS JOURNAL 7, no. 1 (Jan. 1854): 32-34. ["Brady has carried the first prize at the New York Crystal Palace Exposition."]

B1459 "Personal and Art Intelligence." PHOTOGRAPHIC AND FINE ART JOURNAL 7, no. 2 (Feb. 1854): 63-64. ["The rumor that Mr. Brady had obtained the gold medalat the World's Fair Exposition in New York, appears to be incorrect. The awards of the Jurors have been published... M. Brady, (Bronze medal), 2nd premium)... We were in error in stating that a gold medal was awarded to Mr. Brady at the World's Fair in London. There were but two medals awarded for daguerreotypes. These were of bronze and were presented to Mr. Brady and Mr. Lawrence, both of New York city."] "Daguerreotype Movements." HUMPHREY'S JOURNAL 6, no. 1 (Apr. 15, 1854): 15-16. [Brady's advertisements, from the "NY Tribune, Apr. 18."]

B1460 "Putnam's Monthly Portraits: The Author of 'Visions of Hasheesh' (Bayard Taylor)." PUTNAM'S MONTHLY 4, no. 20 (Aug. 1854): frontispiece. 1 illus. ["Daguerreotype by Brady, N.Y." Engraved by Smithe.]

B1461 "Putnam's Monthly Authors: The Author of 'Japan' [name not given]." PUTNAM'S MONTHLY 5, no. 27 (Mar. 1855): frontispiece. 1 illus. ["Daguerreotype by Brady. Engd. by Forrest."]

B1462 "Cornelius Vanderbilt." BALLOU'S PICTORIAL DRAWING-ROOM COMPANION [GLEASON'S] 8, no. 13 (Mar. 31, 1855): 202 - 203. 1 illus. ["...we give a portrait, from a daguerreotype by Brady."]

B1463 "Col. Hiram Fuller, Editor of the 'New York Mirror.'" BALLOU'S PICTORIAL DRAWING-ROOM COMPANION [GLEASON'S] 9, no. 4 (July 28, 1855): 60. 1 illus. ["From a photograph by Brady."]

B1464 "Our Illustration. The Editor. Photographed by M. B. Brady, of New York City." PHOTOGRAPHIC AND FINE ART JOURNAL 8, no. 11 (Nov. 1855): frontispiece, 351. 1 b & w. [Portrait of H. H. Snelling, editor of the "P & FAJ."]

B1465 Portraits. Woodcut engravings, credited "From an Ambrotype by Brady." FRANK LESLIE'S ILLUSTRATED NEWSPAPER 1, (1855) ["Henry Grinnell, Esq." 1:1 (Dec. 15, 1855): 8. "Lieut. Hartstein." 1:1 (Dec. 15, 1855): 12. "Col. A. B. Grey, surveyor of the Great American Southern Pacific Railway." 1:1 (Dec. 15, 1855): 12. "George N. Barnett." 1:1 (Dec. 15, 1855): 12.]

B1466 "The Arctic Explorers. - Drawn by Wallin. From an Ambrotype by Brady." FRANK LESLIE'S ILLUSTRATED NEWSPAPER 1, no. 1 (Dec. 15, 1855): 1. 1 illus. [Group portrait. "In the magnificent picture given on our title-page,... We have presented, with unerring truthfulness, the appearance of our Arctic Explorers, in their dresses of skins and furs. So perfectly has Mr. Brady accomplished his work through his new improvement styled Ambrotype, that we can look in, as it were, upon the actors engaged in the recent great discoveries in the Arctic seas, and behold them as they appeared while prosecuting their daring undertakings. The original of this picture ia unquestionably one of the greatest triumphs of the Daguerrean art." p. 2.]

B1467 Portrait. Woodcut engraving, credited "From an excellent daguerreotype by Brady." BALLOU'S PICTORIAL DRAWING-ROOM COMPANION [GLEASON'S] 10, (1856) 1 illus. ["Dr. Sheldon MacKenzie." 10:236 (Jan. 12, 1856): 28.]

B1468 Portraits. Woodcut engravings, credited "From an Ambrotype by Brady." FRANK LESLIE'S ILLUSTRATED NEWSPAPER 1, (1856) ["Parker H. French." 1:5 (Jan. 12, 1856): 73. "Mrs. Myra Clark Gaines." 1:5 (Jan. 12, 1856): 77. "Ex-Gov. Hunt, of NY." 1:9 (Feb. 9, 1856): 129. "E. M. Fowler, Pres. of Board of School Officers, New York, NY." 1:9 (Feb. 9, 1856): 136. "Robert Toombs, of GA." 1:9 (Feb. 9, 1856): 137. "Dr. H. Delafield, consulting physician to the Woman's Hospital, New York, NY." 1:9 (Feb. 9, 1856): 144. "Dr. Alexander H. Stevens, Pres. of the National Medical Assoc." 1:9 (Feb. 9, 1856): 144. "Capt. Ezra Nye, of the U.S. Mail steamship 'Pacific.'" 1:10 (Feb. 16, 1856): 152. "Rev. William H. Milburn, 'The Blind Orator.'" 1:10 (Feb. 16, 1856): 153. "S. S. Randall, Supt. of Public School, New York, NY." 1:10 (Feb. 16, 1856): 153. "George R. West, Chinese traveller and artist." 1:10 (Feb. 16, 1856): 160. "Oscanyon, the Turkish lecturer." 1:11 (Feb. 23, 1856): 173. "J. Marion Sims, Surgeon of the Woman's Hospital." 1:11 (Feb. 23, 1856): 176. "Dr. John W. Francis." 1:11 (Feb. 23, 1856): 176. "Hon. George Mifflin Dallas, US Minister to England." 1:12 (Mar. 1, 1856): 184. "James T. Brady, orator." 1:12 (Mar. 1, 1856): 186. "Hon. James L. Orr, of SC." 1:13 (Mar. 8, 1856): 193. "Gen. John A. Quitman,of MS." 1:13 (Mar. 8, 1856): 193. "Bishop G. F. Pierce, D.D." 1:13 (Mar. 8, 1856): 208. "Rev. H. Cox, NJ." 1:13 (Mar. 8, 1856): 208. "Bishop M. Simpson." 1:13 (Mar. 8, 1856): 208. "Millard Fillmore, candidate for Pres." 1:14 (Mar. 15, 1856): 209. "Andrew Jackson Donelson, Vice-Pres. candidate." 1:14 (Mar. 15, 1856): 209. "Dr. Horace Green, NY Medical College." 1:15 (Mar. 22, 1856): 240. "R. V. Samuel L. Southard, Rector of St. John's Church, Buffalo." 1:16 (Mar. 29, 1856): 249. "Joseph Gales, editor of 'National Intelligencer.'" 1:16 (Mar. 29, 1856): 249. "Dr. Thomas Bond, late editor of 'Christian Advocate and Journal.'" 1:16 (Mar. 29, 1856): 256. "Mr. and Mrs. W. J. Florence (actors) as Pat Farbell and Nancy Stokes. (Costume portrait)." 1:17 (Apr. 5, 1856): 268. "Edward Everett." 1:18 (Apr. 12, 1856): 273. "Thomas Ritchie, editor." 1:18 (Apr. 12, 1856): 288. "Rev. John W. Shackelford, of Newark, NJ." 1:18 (Apr. 12, 1856): 288. "Hon. James Buchanan." 1:21 (May 3, 1856): 321. "William Cullen Bryant, editor." 1:21 (May 3, 1856): 328. "Major Noah." 1:22 (May 10, 1856): 349. "Ogden Hoffman, late Attny-Gen. of NY." 1:23 (May 17, 1856): 368. "Rev. Sidney Augustus Corey, Pastor 5th Ave. Baptist Church, New York, NY." 1:24 (May 24, 1856): 373. "Madame Anna de la Grange, Italian Prima Donna." 1:24 (May 24, 1856): 384. "James W. Wallace, actor, as Benedict." 1:25 (May 31, 1856): 385. "James Gordon Bennett, editor." 1:25 (May 31, 1856): 393. "Rev. R. N. T. Cook, Rector of the Memorial Church." 1:26 (June 7, 1856): 416.]

B1469 "Bust of George Law, by T. D. Jones. - From an Ambrotype by Brady." FRANK LESLIE'S ILLUSTRATED NEWSPAPER 1, no. 8 (Feb. 2, 1856): 128. 1 illus.

B1470 "Our Citizen Soldiery. - Costumes of the N. Y. National Guard. ...Ambrotyped by Brady." FRANK LESLIE'S ILLUSTRATED NEWSPAPER 1, no. 24 (May 24, 1856): 369. 1 illus. [Military group portrait. This article was one of several in a loose series, each illustrated with a group portrait. Although this image, of the 9th Regiment, was the first such to have the illus credited to a Brady ambrotype, I feel that an earlier portrait of the City Guard, published on p. 337 in the May 10th issue, was also from a Brady image.]

B1471 Portraits. Woodcut engravings, credited "From an Photograph by Brady." FRANK LESLIE'S ILLUSTRATED NEWSPAPER 2, (1856) ["Rev. James Roosevelt Bailey, D.D." 2:27 (June 14, 1856): 4. "Capt. James Price, 3rd Co., National Guard." 2:27 (June 14, 1856): 5. "Hon. Erastus C. Benedict." 2:27 (June 14, 1856): 13. "Henry Kiddle, New York, NY Supt. of Schools." 2:27 (June 14, 1856): 13. "Prof. James J. Mapes, editor." 2:28 (June 21, 1856): 28. "J. M. Carnochan, Chief Surgeon, NY State hospital." 2:28 (June 21, 1856): 32. "Col. John Charles Fremont." 2:31 (July 12, 1856): 65. "William L. Dayton, Vice-Pres. candidate." 2:31 (July 12, 1856): 68. "Andrew Jackson Donaldson, Vice.-Pres. candidate." 2:31 (July 12, 1856): 69. "Millard Fillmore, Pres. candidate." 2:31 (July 12, 1856): 72. "John C. Breckenridge, Vice-Pres. candidate." 2:31 (July 12, 1856): 77. "James Buchanan, Pres. candidate." 2:31 (July 12, 1856): 80. "Rev. H. Mattison, M. E. Church." 2:33 (July 26, 1856): 109. "Dion Bourcicault, actor, author." 2:33 (July 26, 1856): 112. "Mrs. Ann G. Stephens, author." 2:36 (Aug. 16, 1856): 160. "Henry J. Raymond, editor, "NY Daily Times.'" 2:37 (Aug. 23, 1856): 176. "George Marsh, actor, as 'Young Toddler.'" 2:37 (Aug. 23, 1856): 176. "Dr. E. K. Kane, U.S.N., Commander of the Arctic Exploring Expedition." 2:38 (Aug. 30, 1856): 177. "William M. Fleming." 2:39 (Sept. 6, 1856): 197. "Cornelius Bogart, Esq., deceased." 2:39 (Sept. 6, 1856): 205. "John E. Gavitt, Esq." 2:39 (Sept. 6, 1856): 205. "John Brougham, proprietor of the Bowery Theatre." 2:40 (Sept. 13, 1856): 220. "Brougham's Dancers at the Bowery Theatre." (Two actresses in costume) 2:42 (Sept. 27, 1856): 242. "George Peabody, American banker in London." 2:43 (Oct. 4, 1856): 271. "Leading American Chess Players. (Group portrait)." 2:43 (Oct. 4, 1856): 271. "Max Maretzek." 2:44 (Oct. 11, 1856): 277. "Lorenzo B. Shepherd." 2:44 (Oct. 11, 1856): 284. "George Steers, deceased." 2:44 (Oct. 11, 1856): 288. "Madame Cora de Wilhorst, opera singer." 2:45 (Oct. 18, 1856): 293. "Hon. Anson Burlingame, from MA." 2:45 (Oct. 18, 1856): 301. Heads of the New York Fire Dept. (Five separate portraits)." 2:46 (Oct. 25, 1856): 305. "'Harry Howard,' Engineer, New York, NY Fire Dept." 2:47 (Nov. 1, 1856): 325. "Distinguished Members of the New York, NY Fire Dept. (Group portrait - may be a composite print or engraving)." 2:47 (Nov. 1, 1856): 336. "James K. Leggett." 2:49 (Nov. 15, 1856): 368. "J. W. Buckley, Supt. of Schools, New York, NY." 2:50 (Nov. 22, 1856): 373. "Rev. E. H. Chapin." 2:51 (Nov. 29, 1856): 400.]

B1472 "Hon. James Buchanan and John C. Breckinridge, Democratic candidates for the Presidency and Vice-Presidency." BALLOU'S PICTORIAL DRAWING-ROOM COMPANION [GLEASON'S] 11, no. 264 (July 26, 1856): 49. 2 illus. ["...indebted to Mr. Brady, of New York, for the fine photograph of Mr. Buchanan... Our portrait of Mr. Breckinridge was drawn from an ambrotype taken expressly for us by an artist of Lexington, Ky."]

B1473 "The Bronze Statue of Washington, Union Park, New York. - From a Photograph by Brady." FRANK LESLIE'S ILLUSTRATED NEWSPAPER 2, no. 35 (Aug. 9, 1856): 129. 1 illus. [View, with figures.]

B1474 Portrait. Woodcut engraving credited "... from a daguerreotype engraving in 'The Gallery of Illustrious Americans.'" ILLUSTRATED LONDON NEWS 29, (1856) ["Colonel Fremont, the Republican Candidate for the American Presidency." 29:815 (Aug. 9, 1856): 138.]

B1475 "John C. Fremont, Republican candidate for President." BALLOU'S PICTORIAL DRAWING-ROOM COMPANION [GLEASON'S] 11, no. 267 (Aug. 16, 1856): 97. 1 illus.

B1476 "Professor Louis Agassiz. - Ambrotyped by Brady from a Bust by John C. Kong, of Boston." FRANK LESLIE'S ILLUSTRATED NEWSPAPER 2, no. 38 (Aug. 30, 1856): 185. 1 illus. [Statue.]

B1477 "Great Cricket Match Between the United States and Canada, at Hoboken, N. J., September 11 and 12. United States Victorious! Ambrotyped by Brady, while the Game was in Progress." FRANK LESLIE'S ILLUSTRATED NEWSPAPER 2, no. 43 (Oct. 4, 1856): 261. 1 illus. [View, with crowd.]

B1478 Portraits. Woodcut engravings, credited "From an original Daguerreotype to be Seen at Brady's Gallery." FRANK LESLIE'S ILLUSTRATED NEWSPAPER 2, (1856) ["Gen. Santos Guardiola." 2:47 (Nov. 1, 1856): 321.]

B1479 Portraits. Woodcut engravings, credited "From an Photograph by Matthew Brady." FRANK LESLIE'S ILLUSTRATED NEWSPAPER 3, (1856) ["William Stuart, manager of Wallack's Theatre." 3:52 (Dec. 6, 1856): 16. "Miss Laura Keene, actress." 3:53 (Dec. 13, 1856): 32. "Sigismund Thalberg." 3:54 (Dec. 20, 1856): 48.]

B1480 "'Wheatland,' Near Lancaster, Pennsylvania, the Residence of James Buchanan, President Elect. - From a Photographic View Taken by M. B. Brady, New York City." FRANK LESLIE'S ILLUSTRATED NEWSPAPER 3, no. 53 (Dec. 13, 1856): 24-25, 26. 1 illus. [Double-page engraving. "Our magnificent view of 'Wheatland,'...is from a photograph taken especially for this paper."]

B1481 Portraits. Woodcut engravings, credited "From a Photograph by Brady." BALLOU'S PICTORIAL DRAWING-ROOM COMPANION [GLEASON'S] 12, (1857) ["Erastus Brooks, of NY." 12:288 (Jan. 10, 1857):28. "John A. King, Gov. of NY." 12:296 (Feb. 21, 1857): 124. "Peter Cooper, founder of Cooper Institute, New York, NY." 12:298 (Mar. 7,1857): 156. "Miss Matilda Heron, actress." 12:302 (Apr. 4, 1857): 209.]

B1482 Portraits. Woodcut engravings, credited "From an Ambrotype by Brady." FRANK LESLIE'S ILLUSTRATED NEWSPAPER 3, (1857) ["Miss Matilda Heron, actress." 3:59 (Jan. 24, 1857): 128. "Samuel W. Seton, Asst.-Supt. of Schools, New York, NY." 3:59 (Jan. 24, 1857): 128. "Dr. Franklin Tuthill, editor." 3:61 (Feb. 7, 1857): 160. "Capt. George Dilks, New York, NY Police." 3:64 (Feb. 28, 1857): 196. "Mr. Farrell, witness at murder trial." 3:64 (Feb. 28, 1857): 200. "Coroner Edward Downes Connery." 3:64 (Feb. 28, 1857): 204. "Judge Capron." 3:64 (Feb. 28, 1857): 204. "Isaac V. Fowler, Postmaster, New York, NY." 3:70 (Apr. 11, 1857): 288. "Maj.- Gen. Frederick Henningsen, of the Nicaragua Army." 3:71 (Apr. 18, 1857): 304. "Robert J. Walker, Gov. of KN." 3:71 (Apr. 18, 1857): 308. "Lord Napier's Family. 'From an Imperial Photograph by Brady.'" 3:71 (Apr. 18, 1857): 308. "Lord Napier, British Minister to the USA." 3:71 (Apr. 18, 1857): 312. "Rev. Edwin F. Hatfield, D.D." 3:72 (Apr. 25, 1857): 324. "Rev. Rufus W. Clarke." 3:74 (May 9, 1857): 356. "A. Oakley Hall, prosecution; Henry E. Davies, judge; Henry L. Clinton, defense attorney; John Graham, defense attorney; Judge Dean, defense council; Attorney-General Cushing, prosecution. (Six portraits of

participants in the Burdell murder trial)." 3:75 (May 16, 1857): 368. "Mirabeau B. Lamar, of TX." 3:77 (May 30, 1856): 404. "Thomas J. Oakley, late Chief-Justice of the Supreme Court." 3:77 (May 30, 1857): 408.]

B1483 "M. B. Brady." FRANK LESLIE'S ILLUSTRATED NEWSPAPER 3, no. 57 (Jan. 10, 1857): 86, 96. 1 illus. [Portrait. Brief professional biography on p. 86. Discusses Brady's Gallery of National Portraiture.]

B1484 "Personal & Art Intelligence: The Capabilities of the Camera." PHOTOGRAPHIC AND FINE ART JOURNAL 10, no. 2 (Feb. 1857): 63. [Source not given.]

B1485 "Chief-Justice Taney Administering the Oath to Mr. Buchanan. Portraits from Ambrotypes by Brady." FRANK LESLIE'S ILLUSTRATED NEWSPAPER 3, no. 66 (Mar. 14, 1857): 217. 1 illus. [View of small group. The faces were taken from photographs, the grouping and activity was drawn by the engraver.]

B1486 Portraits. Woodcut engravings, credited "From a Photograph by Brady." HARPER'S WEEKLY 1, (1857) ["Seven Cabinet Members." 1:15 (Apr. 11, 1857): 228-229. "Samuel Morse, George Steers." 1:18 (May 2, 1857): 281-282. "Lord Napier, British Minister to U.S." 1:18 (May 2, 1857): 285. "J. C. Brigham, D.D." 1:20 (May 16, 1857): 316-318. "Doctor Rae, Arctic Explorer." 1:22 (May 30, 1857): 348-349. "Annie M. Andrews." 1:23 (June 6, 1857): 353. "Lord Elgin, British Ambassador to China 1:23 (June 6): 357; William L. Marcy." 1:29 (July 18, 1857): 461-462. "Hon. Henry C. Murphy." 1:32 (Aug. 8, 1857): 501. "Alexander Grant, sailor." 1:42 (Oct. 17, 1857): 655. "Louis Palsen, chess player." 1:43 (Oct. 24, 1857): 685. "Paul Morphy, chess player." 1:43 (Oct. 24, 1857): 685. "Hon. Nathaniel P. Banks, Gov. of MA." 1:47 (Nov. 21, 1857): 737. "Hon. Fernando Wood, Mayor of New York, NY." 1:50 (Dec. 12, 1857): 785. "Hon. Daniel F. Tiemann, Mayor Elect of New York, NY." 1:50 (Dec. 12, 1857): 785.]

B1487 "The Cabinet." HARPER'S WEEKLY 1, no. 15 (Apr. 11, 1857): 228-229. 1 illus. ["The likenesses, we are enabled to state, are perfect, and do great credit to Mr. Brady, of this city, from whose photographs they are designed." 7 portraits of the President's Cabinet. (First credited use of engravings from photos in this magazine).]

B1488 "The Laying of the Transatlantic Telegraph." HARPER'S WEEKLY 1, no. 18 (May 2, 1857): 280-282. 8 illus. [Engravings, of ships laying the telegraph, etc. and four portraits of leading men associated with the activity. Portrait of S. Morse and George Steers by Brady and of Captain Hudson, of the 'Niagara,' by Meade.]

B1489 "American Benevolent Societies." HARPER'S WEEKLY 1, no. 20 (May 16, 1857): 316-318. 5 illus. [Five portraits, probably engraved from photos. Only one, of J. C. Brigham, D.D., is credited, to Brady.]

B1490 Portraits. Woodcut engravings, credited "From an Ambrotype by Brady." FRANK LESLIE'S ILLUSTRATED NEWSPAPER 4, (1857) ["Andrew P. Butler, of SC." 4:80 (June 13, 1857): 17. "Dr. J. F. G. Mittag, of SC." 4:80 (June 13, 1857): 29. "Don Fermin Ferber, of Nicaragua." 4:82 (June 27, 1857): 56. "Col. S. A. Lockridge, Nicaraguan Army." 4:84 (July 11, 1857): 92. "Charles MacKay, editor." 4:100 (Oct. 31, 1857): 341.]

B1491 "St. Lukes Home for Indigent Females." HARPER'S WEEKLY 1, no. 26 (June 27, 1857): 413. 4 illus. [Engraving of the building, plus three portraits of indigent women, which are credited, "Ambrotyped by Brady."]

B1492 "An Hour's Visit to the Academy of Design." FRANK LESLIE'S ILLUSTRATED NEWSPAPER 4, no. 84 (July 11, 1857): 89. 9 illus. [Portraits. Geo. A. Baker, James Bogle, George H. Hall, S. Cole, C. L. Elliott, William Hart, A. D. Shattuck, A. F. Tait, J. McDougall.]

B1493 "Progress of Photography." HARPER'S WEEKLY 1, no. 42 (Oct. 17, 1857): 659. [Describes process of enlarging an image from an ambrotype, then overprinting a portrait on the photograph. Attributes discovery to Matthew B. Brady.]

B1494 Portraits. Woodcut engravings, credited "Photographed by Brady." FRANK LESLIE'S ILLUSTRATED NEWSPAPER 5, (1857) ["Maj.-Gen. W. J. Worth." 5:105 (Dec. 5, 1857): 1. "Daniel F. Tiemann, Mayor-Elect of New York, NY." 5:106 (Dec. 12, 1857): 28. "James L. Orr, of SC." 5:107 (Dec. 19, 1857): 44. "M. W. Wm. H. Milnor, Mason." 5:107 (Dec. 19, 1857): 44.]

B1495 Portraits. Woodcut engravings, credited "From a Photograph by Brady." HARPER'S WEEKLY 2, (1858) ["Hon. Charles O'Connor." 2:56 (Jan. 23, 1858): 52. "Rev. Stephen H. Tyng, D.D." 2:57 (Jan. 30, 1858): 65. "Hon. Edward Everett, of MA." 2:59 (Feb. 13, 1858): 97. "Rev. Beverly Waugh, D.D." 2:61 (Feb. 27, 1858): 140. "Hon. James M. Mason, of VA." 2:64 (Mar. 20, 1858): 177. "Hon. James Slidell, of LA." 2:65 (Mar. 27, 1858): 193. "Rear-Admiral Mohammed Pacha." 2:65 (Mar. 27, 1858): 196. "Hon. Alexander H. Stephens, of GA." 2:67 (Apr. 10, 1858): 229. "Monsiuer Musard." 2:67 (Apr. 10, 1858): 229. "Hon. Thomas H. Benton, MO." 2:68 (Apr. 17, 1858): 241. "Hon. John P. Hale, of NH." 2:69 (Apr. 24, 1858): 257. "Hon. Galsha A. Grow, of PA." 2:70 (May 1, 1858): 273. "Hon. James S. Green, of MO." 2:71 (May 8, 1858): 289. "Hon. Jacob Collamer, of VT." 2:72 (May 15, 1858): 305. "Rev. John MacClintock, D.D." 2:72 (May 15, 1858): 309. "Hon. William H. English, of IN." 2:73 (May 22, 1858): 321. "Hon. William M. Gwin, of CA." 2:74 (May 29, 1858): 337. "Hon. William Bigler, of PA." 2:75 (June 5, 1858): 353. "Lieut.-General Winfield Scott." 2:77 (June 19, 1858): 385. "Most Reverend John Hughes, D.D." 2:78 (June 26, 1858): 401. "James Gordon Bennett, Esq." 2:80 (July 10, 1858): 433. "Rev. Henry Ward Beecher." 2:81 (July 17, 1858): 449. "Dr. John W. Francis." 2:82 (July 24, 1858): 465. "Gen. John A. Quitman." 2:83 (July 31, 1858): 484. "Cyrus W. Field, Esq." 2:86 (Aug. 21, 1858): 529. "Sir Alexander Bannerman, Gov. of Newfoundland." 2:86 (Aug. 21, 1858) 536. "Jacob Little, Esq." 2:90 (Sept. 18, 1858): 593; Rev. Samuel I. Prince, D.D. 2:91 (Sept. 25, 1858): 609. "Gerald Hallock, Esq." 2:94 (Oct. 16, 1858): 637. "General Paez, of Venezuela." 2:96 (Oct. 30, 1858): 693. "Hon. Amasa J. Parker." 2:97 (Nov. 6, 1858): 705. "Hon. Edwin D. Morgan." 2:97 (Nov. 6, 1858): 705.]

B1496 Portraits. Woodcut engravings, credited "Photographed by Brady." FRANK LESLIE'S ILLUSTRATED NEWSPAPER 5, (1858) ["Gen. John Calhoun, Pres. of the LeCompton Convention." 5:124 (Apr. 17, 1858): 309. "Col. Thomas H. Benton, deceased." 5:125 (Apr. 24, 1858): 328.]

B1497 "The Atlantic Cable & Photography." AMERICAN JOURNAL OF PHOTOGRAPHY 1, no. 7 (Sept. 1, 1858): 111-113. [Detailed descriptions of the facades of major New York, NY galleries during the celebration commemorating the completion of the Atlantic cable - the Gurney, Brady, and Fredericks galleries specifically noted.]

B1498 "The Atlantic Cable Celebration. The 'Niagaras' in Broadway." HARPER'S WEEKLY 2, no. 89 (Sept. 11, 1858): 577. 1 illus. [Illustration of a parade celebrating the completion of the Atlantic telegraph cable. Brady's Gallery is shown in the background, behind the parade group.]

B1499 Portrait. Woodcut engraving, credited "From a Photograph by Brady." FRANK LESLIE'S ILLUSTRATED NEWSPAPER 6, (1858) ["Lindsey Blues, Independent Corps." (Group military portrait). 6:155 (Nov. 20, 1858): 386.]

B1500 "Brady's Gallery in New York." PHOTOGRAPHIC AND FINE ART JOURNAL 11, no. 12 (Dec. 1858): 378-379. [From the "NY Daily Tribune".]

B1501 Portraits. Woodcut engravings, credited "From a Photograph by Brady." FRANK LESLIE'S ILLUSTRATED NEWSPAPER 7, (1858) ["The late Isaac Newton." 7:157 (Dec. 4, 1858): 12. "The late Benjamin F. Butler." 7:157 (Dec. 4, 1858): 13. "Mrs. Hoey, actress." 7:160 (Dec. 25, 1858): 47. "Hon. Daniel L. Sickles." 7: 171 (Mar. 12, 1859): 230. "Mr. Sherman, Republican for the House of Representatives."]

B1502 "Photography in New York." AMERICAN JOURNAL OF PHOTOGRAPHY 1, no. 14 (Dec. 15, 1858): 223-225. [Brady and Gurney mentioned.]

B1503 Portraits. Woodcut engravings, credited "From a Photograph by Brady." HARPER'S WEEKLY 3, (1859) ["Hon. William Preston, U.S. Minister to Spain." 3:108 (Jan. 22, 1859): 60. "Rev. J. W. Cummings, D.D." 3:109 (Jan. 29, 1859): 65. "Hon. John Cochrane." 3:110 (Feb. 5, 1859): 92. "Cornelius Vanderbilt, Esq." 3:114 (Mar. 5, 1859): 145. "Lady Napier, Lord Napier (2 portraits)." 3:114 (Mar. 5, 1859): 153. "Daniel E. Sickles, Mrs. Sickles, P. Barton Key." 3:115 (Mar. 12, 1859) 168. "Postmaster-General A. V. Brown." 3:116 (Mar. 19, 1859): 188. "Capt. Page, leader of the Paraguay Expedition." 3:118 (Apr. 2, 1859): 217. "Judge Crawford, District Attorney Ould, Mrs. Sickles, Mr. Butterworth (4 portraits)." 3:119 (Apr. 9, 1859): 233. "James T. Brady, Esq." 3:120 (Apr. 16, 1859): 248. "Chancellor Bibb." 3:122 (Apr. 30, 1859): 272. "Prof. Wise, the Aeronaut." 3:129 (June 18, 1859): 393. "Governor Wise, of VA." 3:138 (Aug. 20, 1859): 541. "Rev. Dr. Bellows." 3:139 (Aug. 27, 1859): 548. "Prof. C. Lowe, balloonist." 3:143 (Sept. 24, 1859): 609. "All-English Cricket Team." 3:146 (Oct. 15, 1859): 660. "Don Juan Rafael Mora, Ex-President of Costa Rico." 3:146 (Oct. 15, 1859): 668. "Flag Officer Tattnall, U.S.N." 3:147 (Oct. 22, 1859): 676.]

B1504 "The Sickles Tragedy at Washington." HARPER'S WEEKLY 3, no. 115 (Mar. 12, 1859): 168-170. 7 illus. [Mr. Sickles shot Mr. Key, who was having an affair with Sickles' wife. 3 portraits, 2 views of the homes of the participants are from photographs by Brady.]

B1505 "The Trial of Hon. Daniel E. Sickles." HARPER'S WEEKLY 3, no. 119 (Apr. 9, 1859): 232-233. 7 illus. [Portraits of Judge, District Attorney, Mrs. Sickles and a witness, from photos by Brady. Additional photo of Sickles' lawyer on p. 248.]

B1506 "New York City and Environs, From the Spire of Dr. Springs New Brick Church, Fifth Avenue." HARPER'S WEEKLY 3, no. 121 (Apr. 23, 1859): 261, 264-265. 1 illus. ["We are again, in this matter, indebted to Mr. Brady the photographer for valuable aid; without the assistance of the views he took for us, it would have been difficult to insure perfect accuracy."]

B1507 [Brief note that Brady's Gallery has been moved to the corner of Broadway and Bleeker St.] HARPER'S WEEKLY 3, no. 146 (Oct. 15, 1859): 659.

B1508 "The Ups and Downs of the Daguerrean Art." FRANK LESLIE'S ILLUSTRATED NEWSPAPER 8, no. 203 (Oct. 22, 1859): 328. [Brief note. "Our friend, Brady, the Daguerreotypist, has gone up...it must not be supposed because [he] is located over a barber's shop he consequently shaves his customers..."]

B1509 Portraits. Woodcut engravings, credited "From a Photograph by Brady." FRANK LESLIE'S ILLUSTRATED NEWSPAPER 9, (1859-1860) ["Mr. Sherman, Republican for the House of Representatives." 9:212 (Dec. 24, 1859): 61. "Late Theodore Sedwick." 9:212 (Dec. 24, 1859): 61. "Judge James J. Roosevelt, of New York, NY." 9:217 (Jan. 28, 1860):133. "Hon. Thomas S. Bocock, House of Rep." 9:217 (Jan. 28, 1860): 133. "Richard Realf, associate of John Brown." 9:218 (Feb. 4, 1860): 160. "Hon. Wm. Pennington, NJ." 9:219 (Feb. 11, 1860): 164. "Hon. Mr. Smith, NC." 9:219 (Feb. 11, 1860): 164. "Hon. Mr. Faulkner, U.S. Minister to France." 9:219 (Feb. 11, 1860): 173. "Judge Abney, KA, witness to the Brown Committee, Wash." 9:219 (Feb. 11, 1860): 173. "Late Stephen Whitney." 9:222 (Mar. 3, 1860): 211. "Hon. John Cochrane addressing the 7th Regiment." 9:223 (Mar. 10, 1860): 223. "Late George Wood, NY Bar." 9:226 (Mar. 31, 1860): 275. "Mr. Thaddeus Hyatt, witness at John Brown Committee." 9:226 (Mar. 31, 1860): 283. "George Wilkes, newspaper editor." 9:227 (Apr. 7, 1860): 298. "Albert Pike, Grand Commander, Masonic Order." 9:229 (Apr. 21, 1860): 326. "Nathaniel Parker Willis, author." 9:231 (May 5, 1860): 354. "Late Col. Noah L. Farnham."]

B1510 Portraits. Woodcut engravings, credited "From a Photograph by Brady." HARPER'S WEEKLY 4, (1860) 66 illus. ["Hon. William Pennington, of NJ." 4:163 (Feb. 11): 81; "Hon. William Porcher Miles, of SC." 4:163 (Feb. 11): 84; "Hon. J. L. M. Curry, of Albany, NY." 4:164 (Feb. 18): 100; "Hon. Clement C. Clay, of AL." 4:165 (Feb. 25): 116; "Hon. John Sherman, of OH." 4:166 (Mar. 3): 132; "Hon. Robert M. T. Hunter, of VA." 4:167 (Mar. 10): 145; "Gen. Amos Pilsbury, NY Metropolitan Police." 4:167 (Mar. 10): 148; "Hon. Elihu B. Washburne, of IL." 4:168 (Mar. 17): 172; "Hon. Robert Toombs, of GA." 4:169 (Mar. 24): 180; "Miss Adelina Patti, prima donna." 4:169 (Mar. 24): 185; "Hon. John S. Phelps, of MS." 4:170 (Mar. 31): 196; "Hon. Thomas Corwin, of OH." 4:171 (Apr. 7): 212; "Hon. Martin J. Crawford, of GA." 4:172 (Apr. 14): 228; "Hon. Stephen A. Douglas, of IL." 4:173 (Apr. 21): 241; "Candidates for Democratic Party Nomination for President: Lane, Hunter, Breckenridge, Douglas, Houston, Pierce, Slidell, Guthrie, Davis, Orr, Stephens (11 portraits)." 4:173 (Apr. 21): 248-249; "Hon. John F. Potter, of WI." 4"173 (Apr. 21): 253; "Candidates for Republican Nomination for President: Bates, Banks, Pennington, Chase, Seward, McLean, Cameron, Fremont, Lincoln, John Bell, Cassius M. Clay (11 portraits)." 4:175 (May 12): 296-297; "Hon. Edward Everett, of MA." 4:177 (May 19): 305; "Hon. Abram [sic Abraham] Lincoln, of IL., Republican Candidate for President." 4:178 (May 26): 321; "Hon. Hannibal Hamlin, Rep. Vice-Presidential Candidate." 4:179 (June 2): 340; "'Tommy,' the Favorite of the Ladies, Tataiesi Owasjero, Japanese Ambassador to the U.S." 4:182 (June 23): 389; "Japanese Embassy and their Attendants (outdoor group portrait)." 4:182 (June 23): 396; "Our Visitors, the Republican Blues of Savannah, Ga. (group military portrait)." 4:188 (Aug. 4): 489; "The Prince of Wales and Suite." 4:201 (Nov. 3): 692; "Hon. Abraham Lincoln." 4:202 (Nov. 10): 705; "Hon. Roger B. Taney." 4:206 (Dec. 8): 769; "The Seceding South Carolina Delegation: Keitt, Boyce, Chesnut, MacQueen, Ashmore, Hammond, Bonham, Miles (8 portraits)." 4:208 (Dec. 22): 800.]

B1511 "Candidates for the Presidency in 1861." FRANK LESLIE'S ILLUSTRATED NEWSPAPER 9, no. 229 (Apr. 21, 1860): 327-328. 8 illus. [Eight portraits, collaged onto one page. Robert Hunter (VA), James Hammond (SC), (portraits by Brady); Andrew Johnson (TN), Howell Cobb (GA), James L. Orr (SC), Jefferson Davis (MS), Robert Toombs (GA), (portraits by Whitehurst); Samuel Houston (TX) (portrait by Webster & Brother, Louisville, KY).]

B1512 "M. B. Brady and 'Frank Leslie's' Artists Taking Photographs and Sketches of the Japanese Presents in the Reception-Room of the Embassy at Willard's Hotel, Washington." FRANK LESLIE'S ILLUSTRATED NEWSPAPER 10, no. 236 (June 6, 1860): 20, 27, 28, 29. 3 illus. ["Our artists, in the company of M. B. Brady, Esq., the celebrated photographist, were permitted to take sketches of the assembled Japanese in their reception-room... Mr. Brady also took many successful and beautiful photographs, which, together with others in his possession, will form a Japanese gallery of exceeding interest." Sketch of the photographers at work photographing the equipment, with views of saddles, vases, etc., credited "Photograph by Brady."]

B1513 "Monster Bowie Knife Presented to the Hon. John F. Potter, of Wisconsin, by the Republicans of Missouri. - Photographed by Brady." FRANK LESLIE'S ILLUSTRATED NEWSPAPER 10, no. 236 (June 6, 1860): 32. 1 illus. [View of a very large knife, stacked with rifles, swords, etc.]

B1514 "The Reception of the Japanese Embassy at the Navy Yard, Washington. - Photographed on the spot by Brady." FRANK LESLIE'S ILLUSTRATED NEWSPAPER 10, no. 237 (June 9, 1860): 40-41. 1 illus. [Outdoor group portrait of Japanese and American officials.]

B1515 "Group of Principal Officers of the Japanese Embassy in Full Costume. - Photographed by Brady." FRANK LESLIE'S ILLUSTRATED NEWSPAPER 10, no. 237 (June 9, 1860): 45. 1 illus.

B1516 "Note." AMERICAN JOURNAL OF PHOTOGRAPHY AND THE ALLIED ARTS & SCIENCES. n. s. vol. 3, no. 2 (June 15, 1860): 29-30. [Brady taking portraits of members of the House of Representatives, to make imperial prints for sale.]

B1517 "Presents from the Tycoon of Japan to the President of the United States. - Photographed by Brady." FRANK LESLIE'S ILLUSTRATED NEWSPAPER 10, no. 241 (July 7, 1860): 105, 110. 6 illus. [Swords, saddles, etc.]

B1518 "Mr. Brady's Photographic Picture of the House of Representatives." AMERICAN JOURNAL OF PHOTOGRAPHY AND THE ALLIED ARTS & SCIENCES n. s. vol. 3, no. 4 (July 15, 1860): 50-52. [From "NY Daily Times." 250 members in a group portrait 20" x 24". Unclear, but I think a lithograph.]

B1519 "The Savannah Blues, of Georgia. - From a Photograph by Brady." FRANK LESLIE'S ILLUSTRATED NEWSPAPER 10, no. 245 (Aug. 4, 1860): 161-162. 1 illus. [Group portrait.]

B1520 Portraits. Woodcut engravings, credited "Photographed by Brady." FRANK LESLIE'S ILLUSTRATED NEWSPAPER 10, (1860) ["Col. Ellsworth, U.S. Chicago Zouaves." 10:246 (Aug. 11, 1860): 190. "Girbaldi, taken in New York." 10:254 (Oct. 6, 1860): 303. "Mrs. Barney Williams, Prima Donna." 10:254 (Oct. 6, 1860): 315. "N. A. Woods, "London Times" correspondent." 10:256 (Oct. 20, 1860): 339. "Abraham Lincoln, Pres. candidate." 10:256 (Oct. 20, 1860): 347. "Mons. Berger, French Billards Player." 10:257 (Oct. 27, 1860): 366. "The late J. C. Adams, known as 'Grizzly Adams.'" 10:259 (Nov. 10, 1860): 386. "John C. Breckinridge, Pres. candidate." 10:259 (Nov. 10, 1860): 390.]

B1521 "A Broadway Valhalla: Opening of Brady's New Gallery." AMERICAN JOURNAL OF PHOTOGRAPHY AND THE ALLIED ARTS & SCIENCES n. s. vol. 3, no. 10 (Oct. 15, 1860): 151-153. [From "NY Times" (Oct. 6).]

B1522 "Editorial Miscellany." AMERICAN JOURNAL OF PHOTOGRAPHY AND THE ALLIED ARTS & SCIENCES n. s. vol. 3, no. 11 (Nov. 1, 1860): 176. [Prince of Wales visited USA, sat for Brady and Gurney, but apparently visited only Brady's gallery.]

B1523 "Talk of the Studio: American Portraits of the Prince." PHOTOGRAPHIC NEWS 4, no. 113 (Nov. 2, 1860): 324. ["The Prince of Wales visited the photographic establishment of Mr. Brady of New York."]

B1524 Portraits. Woodcut engravings, credited "Photographed by Brady." FRANK LESLIE'S ILLUSTRATED NEWSPAPER 11, (1860) ["James Chesnut, Jr., succeeding SC Senator; Robert Toombs, Senator from GA; Alexander H. Stephens, Ex-Senator from GA. (Three portraits)." 11:262 (Dec. 1, 1860): 24. "Lorenzo Sibert, inventor of the "Great Virginia Gun." (a rifle)." 11:263 (Dec. 8, 1860): 41.]

B1525 "Brady's New Photographic Gallery, Broadway and Tenth Street." FRANK LESLIE'S ILLUSTRATED NEWSPAPER 11, no. 267 (Jan. 5, 1861): 106. 108. 1 illus. [Extensive, (for the time) description of the new gallery, the collections, etc. The illustration is a view of the waiting room.]

B1526 Portraits. Woodcut engravings, credited "Photographed by Brady." FRANK LESLIE'S ILLUSTRATED NEWSPAPER 11, (1861) ["Adolphus H. Davenport, comedian." 11:270 (Jan. 26, 1861): 157. "Miss Isabella Hinkley, prima donna." 11:271 (Feb. 2, 1861): 165. "Lieut. Hall, U.S.A." 11:271 (Feb. 2, 1861): 168. "Mrs. John J. Crittenden." 11:272 (Feb. 9, 1861): 185. "Col. Isaac W. Hayne, bearer of the ultimatum from SC to the govt. in Washington." 11:273 (Feb. 16, 1861): 197. "John Tylor, ex-Pres. of USA, Pres of Peace Convention." 11:273 (Feb. 16, 1861): 204. "Jefferson Davis, Pres. of the Southern Confederacy." 11:276 (Mar. 9, 1861): 241. "The late Dr. John Francis." 11:276 (Mar. 9, 1861): 252. "President Lincoln's Cabinet (Six portraits)." 11:280 (Apr. 6, 1861): 812-813. "Messrs. Roman, Forsyth, Crawford, Commissioners at Washington of the Southern Confederacy." 11:281 (Apr. 13, 1861): 321.]

B1527 Portraits. Woodcut engravings, credited "From a Photograph by Brady." HARPER'S WEEKLY 5, (1861) ["Georgia Delegation in Congress: Underwood, Crawford, Hardeman, Toombs, Love, Jones, Iverson, Hill, Cartbell, Jackson (10 portraits)." 5:210 (Jan. 5, 1861): 1. "The Seceding Mississippi Delegation in Congress: Reuben Davis, L. C. G. Lamar, Jefferson Davis, Albert C. Brown, William Barksdale, Otto Singleton, John McRae (7 portraits)." 5:214 (Feb. 2, 1861): 65. "The Seceding Alabama Delegation in Congress: Benj. Fitzpatrick, C. C. Clay, J. Stallworth, James Pugh, David Clopton, Sydenham Moore, George S. Houston, Williamson Cobb, Jabez Curry (9 portraits)." 5:215 (Feb. 9, 1861): 81. "Hon. Joseph Holt, Sec. of War." 5:216 (Feb. 16, 1861): 109. "Davis & Stephens, Pres. and Vice-Pres. of C.S.A." 5:217 (Feb. 23, 1861): 125. "Hon. Salmon P. Chase, Sec. of Treasury." 5:221 (Mar. 23, 1861): 189. "Gen. Sam Houston, Gov. of Texas." 5:222 (Mar. 30, 1861): 204. "Hon. William H. Seward, Sec. of State." 5:223 (Apr. 6, 1861): 209. "Mrs. Gen. Gaines." 5:224 (Apr. 13, 1861): 225. "Hon. Charles F. Adams, U.S. Minister to England." 5:225 (Apr. 2, 1861): 241. "Pres. Lincoln ("...from a photograph just taken expressly for this paper")." 5:226 (Apr. 27, 1861): 268. "Col. Wilson." 5:228 (May 11, 1861): 289. "Col. Ellsworth." 5:232 (June 8): 357; "Frederick Douglass." 5:233 (June 15, 1861): 381. "Speaker Grow." 5:238 (July 20, 1861): 461. "Gen. MacDowell, Gen. Mansfield, Col. Blair (3 portraits)." 5:242 (Aug. 17, 1861): 516. "Flag Officer Stringham (credited and repeated on p. 577, 5:264, Sept. 14)." 5:242 (Aug. 17, 1861): 516. "Gen. McClellan and His Staff (4 portraits)." 5:243 (Aug. 24): 532. "Brig.-Gen. Burnside." 5:243 (Aug. 24, 1861): 541. "Gen. Lee, C.S.A." 5:243 (Aug. 24, 1861): 541.

"Major-Gen. McClellan." 5:247 (Sept. 21, 1861): 600-601. "Gen. E. D. Baker." 5:253 (Nov. 2, 1861): 693. "Capt. S. F. Dupont." 5:254 (Nov. 9, 1861): 705. "Gen. Hunter, U.S.A." 5:256 (Nov. 23, 1861): 741. "Thurlow Weed, Esq." 5:256 (Nov. 23, 1861): 749. "Capt. S. F. Dupont, U.S.N." 5:257 (Nov. 30, 1861): 764. "Comm. Wilkes, U.S.N." 5:257 (Nov. 30, 1861): 765. "Captured Rebel Commissioner Mason 5:257." (Nov. 30, 1861): 765. "Captured Rebel Commissioner Slidel." 5:257 (Nov. 30, 1861): 765. "Hon. George Opdyke, Mayor-elect of New York, NY." 5:260 (Dec. 21, 1861): 805.]

B1528 Portrait. Woodcut engraving, credited "From a Photograph by Brady." NEW YORK ILLUSTRATED NEWS 3, (1861) ["Horace Greeley, editor of the NY Tribune." 3:74 (Apr. 6, 1861): 349.]

B1529 Portraits. Woodcut engravings, credited "From a Photograph by Brady." NEW YORK ILLUSTRATED NEWS 4, (1861) ["Colonel Ellsworth." 4:79 (May 11, 1861): 5. [This portrait republished, with draperies, without credit in 4:83 after Ellsworth killed at Alexandria, VA.] "Hon. Galusha A. Grow, of PA." 4:90 (July 22, 1861): 192.]

B1530 "Colonel Ellsworth. From a Photograph by Brady." NEW YORK ILLUSTRATED NEWS 4, no. 79 (May 11, 1861): 5. 1 illus.

B1531 "The Late Colonel Ellsworth." NEW YORK ILLUSTRATED NEWS 4, no. 83 (June 8, 1861): 68. 1 illus. [Same portrait of Ellsworth, previously published in May 11 issue, reprinted here after Ellsworth killed.]

B1532 Portraits. Woodcut engravings, credited "Photographed by Brady." FRANK LESLIE'S ILLUSTRATED NEWSPAPER 12, (1861) ["Brig.-Gen. William S. Harney, U.S.A." 12:290 (June 8, 1861): 54. "Capt. Roger Jones, U.S.A." 12:292 (June 22, 1861): 87. "Late Col. Noah L. Farnham." 12:302 (Aug. 31, 1861): 245. "Mayor Berrett, of Washington, DC." 12:303 (Sept. 7, 1861): 272. "The late Col. E. D. Baker, Sen. from OR." 12:311 (Nov. 9, 1861): 389. "Gen. William I. Harder, C.S.A." 12:311 (Nov. 9, 1861): 395. "Brig.-Gen. Louis Blenker, U.S.A." 12:312 (Nov. 16, 1861): 410.]

B1533 Seely, Charles A. "Editorial Miscellany." AMERICAN JOURNAL OF PHOTOGRAPHY AND THE ALLIED ARTS & SCIENCES n. s. vol. 4, no. 5 (Aug. 1, 1861): 120. ["The irrepressible photographer, like the warhorse, snuffs the battle from afar. We have heard of two photographic parties in the rear of the Federal army, on its advance into Virginia. One of these got so far as the smoke of Bull's Run, and were aiming the never-failing tube at friends and foes alike when with the rest of our grand army they were completely routed and took to their heels, leaving their photographic accouterments on the ground, which the rebels no doubt pounced upon as trophies of victory. Perhaps they considered the camera an infernal machine. The soldiers live to fight another day, our special friends to make again their photographs. The other party, stopping at Fairfax, were quite successful. We have before us their fine stereo-view of the famed Fairfax Court House. When will photographers have another chance in Virginia?"]

B1534 "Photographs of War Scenes." HUMPHREY'S JOURNAL OF PHOTOGRAPHY, AND THE ALLIED ARTS AND SCIENCES 13, no. 9 (Sept. 1, 1861): 133. ["The public are indebted to Brady, of Broadway, for numerous excellent views of 'grim-visaged war.' He has been in Virginia with his camera, and many and spirited are the pictures he has taken."]

B1535 "Photographs of War Scenes." HUMPHREY'S JOURNAL OF PHOTOGRAPHY, AND THE ALLIED ARTS AND SCIENCES 13, no. 10 (Sept. 15, 1861): 158-159. ["Among the portraits in Brady's collection,...are those of many leading generals and colonels...Of the larger groups,...the army passing through Fairfax village, the battery of the 1st Rhode Island regiment at Camp Sprague,...Mr. Brady intends to take other Photographic scenes of the localities of our army and of battle scenes...But why should he monopolize this department?...There are numerous photographers close by the stirring scenes which are being daily enacted, and now is the time for them to distinguish themselves."]

B1536 "Photographs of War Scenes." BRITISH JOURNAL OF PHOTOGRAPHY 8, no. 151 (Oct. 1, 1861): 340. [Comments about Brady's war views, taken from "Humphrey's Journal."]

B1537 "[Untitled note]" HUMPHREY'S JOURNAL 13, no. 11 (Nov. 1861): 133. [Note that Matthew Brady followed the Union army to the battle of Bull Run.]

B1538 Portraits. Woodcut engravings, credited "Photographed by Brady." FRANK LESLIE'S ILLUSTRATED NEWSPAPER 13, (1861) ["Brig.-Gen. Samuel P. Heintzelman." 13:313 (Nov. 23, 1861): 6. "Brig.-Gen. John B. Floyd, C.S.A." 13:313 (Nov. 23, 1861): 11. "Commodore Samuel F. Dupont." 13:315 (Dec. 7, 1861): 37. "Commodore Charles Wilkes." 13:315 (Dec. 7, 1861): 44. "William M. Gwin, late Sen. from CA." 13:317 (Dec. 21, 1861): 70.]

B1539 Portraits. Woodcut engravings, credited "From a Photograph." FRANK LESLIE'S ILLUSTRATED NEWSPAPER 13, (1862) ["Brig.-Gen. Daniel F. Sickles, Excelsior Brigade 13:320 (Jan. 11, 1862): 128." Brig.-Gen. James Shields." 13:335 (Apr. 12, 1862): 356.]

B1540 Portraits. Woodcut engravings, credited "From a Photograph by Brady." FRANK LESLIE'S ILLUSTRATED NEWSPAPER 14, (1862) ["Maj. W. F. M. Arny, U.S. Indian Agent for the Territories." 14:352-353 (July 5, 1862): 213. "Lieut.-Col. Wm. Carey Massett, killed." 14:354 (July 12, 1862): 241. "Brig.-Gen. Joseph Hooker." 14:354 (July 12, 1862): 252. "Brig.-Gen. Henry w. Benham." 14:355 (July 19, 1862): 257. "Col. James McQuade." 14:355 (July 19, 1862): 268. "Capt. J. B. Ricketts." 14:355 (July 19, 1862): 268. "Gen. Edwin V. Sumner." 14:356 (July 26, 1862): 284. "Rebel Gen. Thomas J. Jackson (taken much earlier) 14:358 (Aug. 9, 1862): 305. "Gen. Henry Wager Halleck." 14:358 (Aug. 9, 1862): 309. "Brig.-Gen. John M. Schofield." 14:360 (Aug. 23, 1862): 348. "Brig.-Gen. Samuel D. Sturgis." 14:360 (Aug. 23, 1862): 348. "Brig.-Gen. Willis A. Gorman." 14:360 (Aug. 23, 1862): 349. "Brig.-Gen. Darius N. Couch." 14:360 (Aug. 23, 1862): 349. "Brig.-Gen. King. 14:361 (Aug. 30, 1862): 356. "Brig.-Gen. Tyler." 14:361 (Aug. 30, 1862): 365. "Brig.-Gen. Michael Corcoran." 14:362 (Sept. 6, 1862): 381. "Maj.-Gen. John Pope." 14:363 (Sept. 13, 1862): 385.]

B1541 Portraits. Woodcut engravings, credited "From a Photograph by Brady." FRANK LESLIE'S ILLUSTRATED NEWSPAPER 15, (1862) ["Gen. Robert E. Lee, Commander-in-Chief, C.S.A." (Earlier portrait.) 15:366 (Oct. 4, 1862): 29. "Brig.-Gen. Wm. Benj. Franklin." 15:367 (Oct. 11, 1862): 37. "Brig.-Gen. Don Carlos Buell." 15:367 (Oct. 11, 1862): 37. "Gen. George Stoneman." 15:369 (Oct. 25, 1862): 68. "Gen. Fitzjohn Porter." 15:369 (Oct. 25, 1862): 68. "Brig.-Gen. Geo. W. Cullum." 15:370 (Nov. 1, 1862): 85. "Mrs. Jefferson Davis, wife of the President of the so-called 'Southern Confederacy." 15:370 (Nov. 1, 1862): 88. "Col. Geo. W. Pratt, killed." 15:371 (Nov. 8, 1862): 108. "Brig.-Gen. Quincy Adams Gillmore." 15:372 (Nov. 15, 1862): 125. "Maj.-Gen. Israel B. Richardson, killed." 15:372 (Nov. 15, 1862): 125. "Hon. Horatio Seymour, Govt.-elect of NY." 15:373 (Nov. 22, 1862): 129. "T. Mason Jones, lecturer." 15:374 (Nov. 29, 1862): 156. "Madame Genevieve Guerrabella, singer." 15:375 (Dec. 6, 1862): 169. "Artemus Ward (Charles F. Brown)" 15:376 (Dec. 15, 1862): 188.

"Rev. Morgan Dix, Rector of Trinity Church." 15:377 (Dec. 20, 1862): 197. "Gen. George L. Hartsuff." 15:377 (Dec. 20, 1862): 197.]

B1542 Portraits. Woodcut engravings, credited "From a photograph by Brady." HARPER'S WEEKLY 6, (1862) ["Gen. Burnside." 6:264 (Jan. 18, 1862): 36. "Lord Lyons, British Ambassador to USA." 6:269 (Feb. 22, 1862): 116. "M. Mercier, French Minister to USA." 6:269 (Feb. 22, 1862): 116. "Baron Stoecker, Russian Minister to USA." 6:269 (Feb. 22, 1862): 116. "Brigider-Gen. Burnside." 6:270 (Mar. 1, 1862): 136. "Gen. F. W. Lander." 6:272 (Mar. 15, 1862): 165. "Hon. Andrew Johnson, Military Gov. of Tenn." 6:275 (Apr. 5, 1862): 221. "Lieut. Morris, U.S.N." 6:275 (Apr. 5, 1862): 221. "Maj.- Gen. Buell, U.S.A." 6:276 (Apr. 12, 1862): 225. "Brig. Gen. Shields, U.S.A." 6:276 (Apr. 12, 1862): 225. "Maj.- Gen. Pope, U.S.A." 6:278 (Apr. 26, 1862): 268. "Commodore Foote, U.S.N." 6:278 (Apr. 26, 1862): 268. "Martin Van Buren." 6:293 (Aug. 9, 1862): 497. "Brig.- Gen. Keyes, U.S.A." 6:293 (Aug. 9, 1862): 508. "Stonewall Jackson, C.S.A." 6:296 (Aug. 30, 1862): 556. [Portrait of Jackson as a cadet, taken much earlier.] "Gen. Isaac I. Stevens." 6:229 (Sept. 20, 1862): 604. "Gen. Phil. Kearney." 6:229 (Sept. 20, 1862): 604. "Maj.- Gen. Hooker." 6:301 (Oct. 4, 1862): 629. "Maj.- Gen. Franklin." 6:301 (Oct. 4, 1862): 629. "Gen. Mansfield." 6:301 (Oct. 4, 1862): 629. "Gen. Reno." 6:301 (Oct. 4, 1862): 629. "Brig.- Gen. Wadsworth." 6:304 (Oct. 25, 1862): 685. "Maj.- Gen. William S. Rosecrans." 6:306 (Nov. 8, 1862): 705. "Mrs. Lincoln, wife of the President." 6:306 (Nov. 8, 1862): 709. "Hon. Horatio Seymour, Gov.-Elect of NY." 6:308 (Nov. 22, 1862): 737. "Brig.- Gen. Thomas." 6:308 (Nov. 22, 1862): 749. "Maj.- Gen. A. E. Burnside." 6:309 (Nov. 29, 1862): 753. "Maj.- Gen. Nathaniel P. Banks." 6:310 (Dec. 6, 1862): 769. "Maj.- Gen. Burnside and the Division Commanders of the Army of the Potomac: Burnside, Sigel, Franklin, Hooker, Sumner.(Five portraits) 6:311 (Dec. 13, 1862): 785. "Rev. Morgan L. Dix." 6:311 (Dec. 13, 1862): 797.]

B1543 "American Photographs." AMERICAN JOURNAL OF PHOTOGRAPHY AND THE ALLIED ARTS & SCIENCES n. s. vol. 5, no. 7 (Oct. 1, 1862): 145-150. [From "London Times." Long article discussing the virtues of photography to record historical events and personages, initiated by seeing Brady's photographs. "We have before us a collection of photographs by one of the best American photographers, Mr. Brady, of New York, which includes...not merely the war scenes...but a number of interesting portraits of the most eminent Americans...the volume of portraits..."]

B1544 Seely, Charles A. "Editorial Department." AMERICAN JOURNAL OF PHOTOGRAPHY AND THE ALLIED ARTS & SCIENCES n. s. vol. 5, no. 7 (Oct. 1, 1862): 167. [Seely states that he is republishing the "London "Times" article on Brady, but explicitly disclaims that he agrees with their claim of Brady's prominence. "...we believe that no intelligent photographer would offer Mr. Brady's photographs as a representative of the highest condition of the art in America."]

B1545 "General View of Harper's Ferry and the Maryland Heights." HARPER'S WEEKLY 6, no. 301 (Oct. 4, 1862): 628. 1 illus. ["Photographed by Brady." This is the first photograph other than a studio portrait credited to Brady published in this magazine.]

B1546 "Scenes on the Battlefield of Antietam. - From Photographs by Brady." HARPER'S WEEKLY 6, no. 303 (Oct. 18, 1862): 663-665. 8 illus. ["From photographs by Mr. M. B. Brady." Double-page spread. The photographs credited to Brady were actually taken by Alexander Gardner and John F. Gibson. These are the first actual battlefield aftermath photographs, with bodies, published in this magazine.]

B1547 "Brady's Photographs. Pictures of the Dead at Antietam." NEW YORK TIMES 12, no. 3455 (Oct. 20, 1862): 5.

B1548 "American Photographs." JOURNAL OF THE PHOTOGRAPHIC SOCIETY OF LONDON 8, no. 128 (Dec. 15, 1862): 184-186. [Extensive review of photographs of the Civil War by Mr. Brady of New York. From the "London Times."]

B1549 Portraits. Woodcut engravings, credited "From a photograph by Brady." HARPER'S WEEKLY 7, (1863) ["Brig.- Gen. J. G. Foster." 7:315 (Jan. 10, 1863): 21. "Maj.- Gen. John A. M'Clernand." 7:319 (Feb. 7, 1863): 81. "Maj.- Gen. Joseph Hooker." 7:319 (Feb. 7, 1863): 93. "Maj.- Gen. Daniel Butterfield." 7:320 (Feb. 14, 1863): 109. "Mr. and Mrs. Charles S. Stratton (General Tom Thumb and Wife)." 7:321 (Feb. 21, 1863): 113. "Maj.- Gen. Hooker." 7:322 (Feb. 28, 1863): 129. "Hon. John Van Buren." 7:325 (Mar. 21, 1863): 176. "James T. Brady, Esq." 7:325 (Mar. 21, 1863): 176. "Maj.- Gen. Ulysses S. Grant, U.S.A." 7:336 (June 6, 1863): 365. "Clement L. Vallandigham." 7:336 (June 6, 1863): 365. "Maj.-Gen. George G. Meade." 7:341 (July 11, 1863): 433. "Rear-Admiral Foote." 7:341 (July 11, 1863): 445. "Major Kierman." 7:341 (July 11, 1863): 445. "Brig.- Gen. George C. Strong." 7:346 (Aug. 15, 1863): 525. "Maj.- Gen. Stoneman." 7:347 (Aug. 22, 1863): 541. "Rear-Admiral David G. Farragut." 7:348 (Aug. 29, 1863): 545. "Gen. Quincy A. Gilmore." 7:350 (Sept. 12, 1863): 584. "Maj.-General George H. Thomas." 7:354 (Oct. 10, 1863): 641. "Our Russian Visitors (group portrait)." 7:358 (Nov. 7, 1863): 708. "Rev. Henry Ward Beecher." 7:359 (Nov. 14, 1863): 733. "Maj.- Gen. C. C. Washburn." 7:361 (Nov. 28, 1863): 764. "Charles G. Gunther, Mayor-Elect of New York, NY." 7:364 (Dec. 19, 1863): 813. "Hon. Schuyler Colfax, Speaker of the House." 7:365 (Dec. 26, 1863): 817.]

B1550 Portrait. Woodcut engraving, credited "From a Photograph by Brady." NEW YORK ILLUSTRATED NEWS 7, (1863) ["The Tom Thumb Wedding. Miss Minnie Warren and Comm. Nutt." 7:173 (Feb. 21, 1863): 256.]

B1551 Portraits. Woodcut engravings, credited "From a Photograph by Brady." NEW YORK ILLUSTRATED NEWS 8, (1863) ["Col. Sir Percy Wyndham, commanding 1st NJ Cavalry 8:184 (May 9, 1863): 28. "Maj.-Gen. Sedgwick." 8:186 (May 23, 1863): 53. "Maj.-Gen. Stoneman." 8:186 (May 23): 64. "Maj.-Gen. Slocum." 8:187 (May 30, 1863): 65. "Flag of the 44th NY Volunteers." 8:187 (May 30, 1863): 65. "Hon. C. L. Vallandigham." 8:187 (May 30, 1863): 68. "Maj.-Gen. Daniel E. Sickles." 8:187 (May 30, 1863): 68. "Maj.-Gen. George G. Meade." 8:194 (July 18, 1863): 177.]

B1552 "John Burns, the Only Man in Gettysburg, Pa., Who Fought at the Battle" and "Views of the Gettysburg Battle-Field." HARPER'S WEEKLY 7, no. 347 (Aug. 22, 1863): 529, 532, 534. 11 illus. ["From Photographs by Brady." Portrait of Burns, view of his house, eight views of site of battlefield. Description of photos on p. 534. Brady's team arrived at Gettysburg a week after the battle, photographed the site and asked students from a nearby academy to pose as dead and wounded soldiers.]

B1553 Portrait. Woodcut engraving, credited "From a Photograph by Brady." FRANK LESLIE'S ILLUSTRATED NEWSPAPER 17, (1863) ["Rear-Admiral Lisovsky, of the Russian Navy. - From an Imperial Photograph by Brady." 17:423 (Nov. 7, 1863): 97.]

B1554 "Brady's Gallery." HARPER'S WEEKLY 7, no. 359 (Nov. 14, 1863): 722.

B1555 Portraits. Woodcut engravings, credited "From a photograph by Brady." HARPER'S WEEKLY 8, (1864) ["Gen. William Averill." 8:368 (Jan. 16, 1864): 36. "The late Archbishop John Hughes." 8:368 (Jan. 16, 1864): 44. "Maj.- Gen. Herron." 8:371 (Feb. 6, 1864): 85. "Brig.-Gen. George A. Custer." 8:377 (Mar. 19, 1864): 177. ["Photographed by Brady," but the image is of Custer on a galloping horse, which had to have been executed by the artist.] "Brig.-Gen. Judson Kilpatrick." 8:377 (Mar. 19, 1863): 180. "Late Col. Ulrick Dahlgren." 8:378 (Mar. 26, 1864): 193. "Gen. William F. Smith." 8:379 (Apr. 2, 1864): 209. "Brig.-Gen. Henry E. Davies." 8:379 (Apr. 2, 1864): 209. "Maj.- Gen. John A. Dix." 8:380 (Apr. 9, 1864): 228. "Rev. Henry W. Bellows, D.D." 8:380 (Apr. 9, 1864): 228. "Brig.- Gen. David M. Gregg." 8:384 (May 7, 1864): 300. "Gen. Thomas E. G. Ransom." 8:385 (May 14, 1864): 309. "Maj.- Gen. John Sedgwick." 8:387 (May 28, 1864): 349. "Gen. Governor K. Warren." 8:389 (June 11, 1864): 369. "Gov. Andrew Johnson, of Tenn." 8:391 (June 25, 1864): 401. "Clement L. Vallangdigham." 8:401 (Sept. 3, 1864): 573. "Hon. Fernando Wood." 8:401 (Sept. 3, 1864): 573. "Archbishop McCloskey." 8:402 (Sept. 10, 1864): 577. "Rear-Admiral David G. Farrigut, U.S.N." 8:403 (Sept. 17, 1864): 597. "Hon. George H. Pendleton." 8:403 (Sept. 17, 1864): 605. "Gen. Jeff. C. Davis, U.S.A." 8:403 (Sept. 17, 1864): 605. "Reuben E. Fenton, Union Candidate for Gov. of NY." 8:404 (Sept. 24, 1864): 620. "Private Miles O'Reilly." 8:404 (Sept. 24, 1864):620. "Maj. - Gen. Philip H. Sheridan." 8:406 (Oct. 8, 1864): 641. "Maj.- Gen. David B. Birney." 8:407 (Oct. 15, 1864):661. "Late Chief-Justice Roger B. Taney." 8:409 (Oct. 29, 1864): 693. "Capt. Napoleon Collins." 8:413 (Nov. 26, 1864): 753. "Maj.- Gen. Gershom Mott." 8:413 (Nov. 26, 1864): 764. "W. W. Wood, Chief Engineer U.S.N." 8:413 (Nov. 26, 1864): 764. "Maj.- Gen. George H. Thomas." 8:416 (Dec. 17, 1864): 801. "Maj.-Gen. William T. Sherman." 8:416 (Dec. 17, 1864): 808-809. (Outdoors, posed on horseback.)]

B1556 Portraits. Woodcut engravings, credited "Photographed by Brady." FRANK LESLIE'S ILLUSTRATED NEWSPAPER 17, (1864) ["Lieut. John F. Nickels." 17:438 (Feb. 20, 1864): 349.]

B1557 Portraits. Woodcut engravings, credited "Photographed by Brady." FRANK LESLIE'S ILLUSTRATED NEWSPAPER 18, (1864) ["John N. Pattison, pianist." 18:443 (Mar. 26, 1864): 5. "Col. Ulric Dahlgreen." 18:443 (Mar. 26, 1864): 13. "Gen. George A. Custer." 18:443 (Mar. 26, 1864): 13. "Rev. Henry W. Bellows, Pres. of the U. S. Sanitary Commission." 18:446 (Apr. 16, 1864): 53. "William P. Fressenden, of ME. (Correction: the portrait is actually of the late Theodore Frelinghuysen, see. p. 462)." 18:460 (July 23, 1864): 277. "William P. Fressenden of ME. "18:462 (Aug. 6, 1864): 315. "Maj.-Gen. Oglesby, of IL." 18:467 (Sept. 10, 1864): 389.]

B1558 "Execution of the Negro William Johnson, at Petersburg, Va." HARPER'S WEEKLY 8, no. 393 (July 9, 1864): 445. 1 illus. ["Photographed by Brady."]

B1559 "Lieutenant-General Grant at His Head-Quarters." HARPER'S WEEKLY. 8, no. 394 (July 16, 1864): 449. 1 illus. ["Photographed by Brady." Posed portrait, taken in the field.]

B1560 "General Meade and His Staff." and "General Burnside and His Staff." HARPER'S WEEKLY 8, no. 395 (July 23, 1864): 469. 2 illus. ["From a Photograph by Brady." Posed group portraits, taken in the field.]

B1561 "Photographs of the Virginia Campaign." HARPER'S WEEKLY 8, no. 397 (Aug. 6, 1864): 499. [Note that "Mr. Brady, the photographer, has lately returned from the army in Virginia with a series of views of the campaign, which are now on exhibition at his galleries 785 Broadway...includes scenes of operations at Cold Harbor, the Wilderness, Petersburg, etc."]

B1562 "Army of the Potomac - General Hancock and Staff" and "Army of the Potomac - General Warren and Staff." HARPER'S WEEKLY 8, no. 398 (Aug. 13, 1864): 517. 2 illus. ["Photographed by Brady." Field portraits.]

B1563 "Major General Wright and Staff." HARPER'S WEEKLY 8, no. 402 (Sept. 10, 1864): 589. 1 illus. ["Photographed by Brady."]

B1564 "Major-General Philip H. Sheridan - Photographed by Brady." HARPER'S WEEKLY 8, no. 406 (Oct. 8, 1864): 641. 1 illus.

B1565 "Major General William Tecumseh Sherman." HARPER'S WEEKLY 8, no. 416 (Dec. 17, 1864): 808-809. 1 illus. ["Photographed by Brady." Portrait of Sherman on horseback, in the open.]

B1566 Portraits. Woodcut engravings, credited "From a Photograph by Brady." FRANK LESLIE'S ILLUSTRATED NEWSPAPER 19, (1865) ["Late James Wm. Wallack, as Benedict, in 'Much Ado about Nothing.'" 19:485 (Jan. 14, 1865): 268. "Reubin Fenton, Gov. of NY." 19:485 (Jan. 14, 1865): 269. "Hon. Daniel S. Dickinson." 19:491 (Feb. 25, 1865): 365.]

B1567 Portraits. Woodcut engravings, credited "From a photograph by Brady." HARPER'S WEEKLY 9, (1865) ["The late Hon. Wm. L. Dayton." 9:420 (Jan. 14, 1865): 28. "Hon. Wm. Dennison, Postmaster-General." 9:422 (Jan. 28, 1865): 49. "Gen. H. W. Slocum." 9:422 (Jan. 28, 1865): 49. "Late Lieut. Samuel W. Preston." 9:423 (Feb. 4, 1865): 69. "Late Lieut. Benjamin H. Porter." 9:423 (Feb. 4, 1865): 69. "Brig.- Gen. Adelbert Ames." 9:423 (Feb. 4, 1865): 76. "Hon. Daniel S. Dickinson." 9:427 (Mar. 4, 1865): 141. "Hon. James Harlan, Sec. of Interior." 9:430 (Mar. 25, 1865): 181. "President Lincoln at Home [with son Todd.]" 9:436 (May 6, 1865): 273. "Sergeant Boston Corbett." 9:437 (May 13, 1865): 292. "Sherman and his Generals." 9:444 (July 1, 1865): 405. "The Prince Napoleon." 9:444 (July 1, 1865): 412. "Maj.- Gen. Charles Griffin." 9:449 (Aug. 5, 1865): 493. "Brev.- Maj.-Gen. Nathaniel A. Miles." 9:451 (Aug. 19, 1865): 513. "Rear-Admiral Henry Bell." 9:452 (Aug. 26, 1865): 540. "William Cullen Bryant." 9:453 (Sept. 2, 1865): 549. "Hon. Preston King." 9:453 (Sept. 2, 1865): 556. "Maj.- Gen. John G. Parke." 9:455 (Sept. 16, 1865): 589. "Gen. H. W. Slocum." 9:458 (Oct. 7, 1865): 628. "Bishop Quintard, of TN." 9:459 (Oct. 14, 1865): 652. "The Bey of Tunis and Embassy from Tunis." 9:460 (Oct. 2, 1865): 660, 661. "Maj.- Gen. Francis Barlow." 9:460 (Oct. 21, 1865): 669. "Hon. Charles F. Adams." 9:463 (Nov. 11, 1865): 704. "Late Hon. Preston King." 9:466 (Dec. 2, 1865): 757. "Hon. John T. Hoffman, Mayor-Elect of New York, NY." 9:469 (Dec. 23, 1865): 801.]

B1568 "Hon. James Harlan, Secretary of the Interior - Photographed by Brady." HARPER'S WEEKLY 9, no. 430 (Mar. 25, 1865): 181. 1 illus.

B1569 Portrait. Woodcut engraving credited "From a photograph by Brady." ILLUSTRATED LONDON NEWS 46, (1865) ["Lieut.-Gen. Ulysses S. Grant." 46:1311 (Apr. 22, 1865): 365.]

B1570 "President Lincoln at Home - Photographed by Brady." HARPER'S WEEKLY 9, no. 436 (May 6, 1865): 273. 1 illus. [Memorial tribute published a week after Lincoln's death. Photo is of Lincoln and his son Todd looking at a family album. The photo was taken much earlier.]

B1571 Portrait. Woodcut engraving, credited "From a Photograph by Brady." FRANK LESLIE'S ILLUSTRATED NEWSPAPER 20, (1865) ["Sergeant Boston Corbett, the man who shot Booth. 20:502 (May 13, 1865): 113.]

B1572 "Sergeant Boston Corbett." and "President Lincoln's Funeral-Procession in New York City - Photographed by Brady." HARPER'S WEEKLY 9, no. 437 (May 13, 1865): 292, 296-297. 2 illus. [1 portrait, 1 double-page view.]

B1573 "Grand Review at Washington, May 24 - President Johnson, Lieut-Gen. Grant and Others Inspecting Sherman's Army from the Reviewing Stand on Pennsylvania Avenue - From a Photograph by Brady." FRANK LESLIE'S ILLUSTRATED NEWSPAPER 20, no. 506 (June 10, 1865): 177. 1 illus. [Troops on horseback parading before a reviewing stand. If these images were taken from a photo at all, then they are heavily overworked by the engraver.]

B1574 Portrait. (Abraham Lincoln reading to his son Todd.) Woodcut engraving, from a photograph. HARPER'S MONTHLY 31, no. 182 (July 1865): 223. 1 illus. [From an article, "Personal Recollections of Abraham Lincoln," by Noah Brooks. The portrait is not credited, but it is a portrait attributed to Brady.]

B1575 "The Saratoga Races." FRANK LESLIE'S ILLUSTRATED NEWSPAPER 20, no. 517 (Aug. 26, 1865): 360-361. 3 illus. [Three engravings. "The Horses Starting," "The Home Stretch," "The Horses Passing the Judges Stand," are all credited to be from photographs by Brady. Perhaps the buildings were from photos, the horses, depicted in the classic rocking horse stretch, have been added by the engraver.]

B1576 "The Grizzly Bear Chair, Presented to President Andrew Johnson, by Seth Kinman, the California Hunter, Sept. 6. - Photographed by Brady." FRANK LESLIE'S ILLUSTRATED NEWSPAPER 21, no. 523 (Oct. 7, 1865): 44. 1 illus.

B1577 Portrait. Woodcut engraving, credited "From a Photograph by Brady." FRANK LESLIE'S ILLUSTRATED NEWSPAPER 21, (1865) ["Gen. Hashem, Ambassador from Tunis." 21:526 (Oct. 28, 1865): 84.]

B1578 "The Balloon Bridal Party Starting on its Aerial Tour from Prof. Lowe's Amphitheater, Central Park." HARPER'S WEEKLY 9, no. 465 (Nov. 25, 1865): 745. 2 illus. [Portrait and scene of balloon ascension. "Photographed by Brady."]

B1579 Portraits. Woodcut engravings, credited "From a Photograph by Brady & Co., Washington, DC." FRANK LESLIE'S ILLUSTRATED NEWSPAPER 21, (1866) ["Andrew Johnson, President of the USA." 21:536 (Jan. 6, 1866): 241. "Late Prof. James Mapes." 21:539 (Jan. 27, 1866): 300. "Late Robert B. Minturn." 21:540 (Feb. 3, 1866): 316.]

B1580 Portraits. Woodcut engravings, credited "From a photograph by Brady." HARPER'S WEEKLY 10, (1866) ["Edwin Forrest Booth." 10:472 (Jan. 13, 1866): 17. "Benito Juarez, Pres. of Mexico." 10:472 (Jan 13, 1866): 29. "General Carvajal." 10:472 (Jan. 13, 1866): 29. "Lafayette S. Foster, Vice-President." 10:473 (Jan. 20, 1866): 45. "Late Hon. Henry Winter Davis." 10:473 (Jan. 20, 1866): 45. "Late Rev. J. W. Cummings, D.D." 10:473 (Jan. 20, 1866): 45. "Late Gerard Hallock." 10:473 (Jan. 20, 1866): 45. "George Bancroft." 10:477 (Feb. 17, 1866): 100. "John William Draper." 10:480 (Mar. 10, 1866): 148. "Late Col. Theodore S. Bowers." 10:482 (Mar. 24, 1866): 177. "Hon. Thaddeus Stevens." 10:484 (Apr. 7, 1866): 212. "Robert E. Lee, in civil life." 10:485 (Apr. 14, 1866): 237. "Late Solomon Foot, Senator from VT." 10:485 (Apr. 14, 1866): 237. "Alexander H. Stephens." 10:488 (May 5, 1866): 276. ["Photographed by Brady & Co., Washington D.C."] Commodore John Rogers, U.S.N." 10:490 (May 19, 1866): 305. "Edwin M. Stanton." 10:491 (May 26, 1866): 324. ["...Brady & Co., Washington, D.C."] "Hon. James H. Lane." 10:499 (July 21, 1866): 461. ["Brady, Washington, D.C."] "Barbara Frietchie." 10:500 (July 28, 1866): 477. "Samuel F. B. Morse." 10:504 (Aug. 25, 1866): 532. "John T. Monroe, Mayor of New Orleans." 10:504 (Aug. 25, 1866): 540. ["Brady & Co., Washington D.C."] "Sen. J. R. Doolittle." 10:505 (Sept. 1, 1866): 545. ["Brady & Co., Washington, D.C."] "Late Rev. John Pierpont." 10:507 (Sept. 15, 1866): 589. "Adelaide Ristori, actress." 10:509 (Sept. 29, 1866): 609. "Distinguished Men of Methodism. (Twenty-five portraits)" 10:510 (Oct. 6, 1866): 632-633. [Photos by Brady, Hallet, and others.]

B1581 Portraits. Woodcut engravings, credited "From a Photograph by Brady." FRANK LESLIE'S ILLUSTRATED NEWSPAPER 22, (1866) ["Ralph Waldo Emerson." 22:548 (Mar. 31, 1866): 21. "Late Rev. John Pierpont." 22:572 (Sept. 15, 1866): 404.]

B1582 Portraits. Woodcut engravings, credited "From a Photograph by Brady & Co., Washington, DC." FRANK LESLIE'S ILLUSTRATED NEWSPAPER 22, (1866) ["Robert E. Lee, during his recent visit to Washington, DC." 22:547 (Mar. 24, 1866): 1. "Late Hon. Solomon Foot, Sen. from VT." 22:550 (Apr. 14, 1866): 60.]

B1583 Portraits. Woodcut engravings, credited "From a Photograph by Brady." FRANK LESLIE'S ILLUSTRATED NEWSPAPER 23, (1866) ["Madame Adelaide Ristori, actress." 23:575 (Oct. 6, 1866): 33. "Leonard W. Jerome." 23:576 (Oct. 12, 1866): 49. "Late Hon. John Van Buren." 23:579 (Nov. 3, 1866): 97. "Rev. K. H. Chapin." 23:582 (Nov. 24, 1866): 148.]

B1584 Portraits. Woodcut engravings, credited "Photographed by Brady & Co., Washington, D. C." FRANK LESLIE'S ILLUSTRATED NEWSPAPER 23, (1867) ["John H. Surratt, alleged Lincoln conspirator." 23:588 (Jan. 5, 1867): 241. "James Gordon Bennett, Jr., yacht owner and racer." 23:591 (Jan. 26, 1867): 293. "Hon. Roscoe Coneling, of NY." 23:592 (Feb. 2, 1867): 311. "The late Daniel Devlin." 23:597 (Mar. 9, 1867): 389.]

B1585 Portraits. Woodcut engravings, credited "From a photograph by Brady." HARPER'S WEEKLY 11, (1867) ["James Gordon Bennett, Jr." 11:525 (Jan. 19, 1867): 41. [Brady, New York.] "Hon. Rosco Conkling, NY Senator-Elect." 11:526 (Jan. 26, 1867): 49. [Brady & Co., Washington.] "Mr. George Peabody and the Board of Trustees of the Peabody Educational Fund (group portrait)." 11:537 (Apr. 13, 1867): 228. "Hon. Oliver P. Morton, of IN." 11:538 (Apr. 20, 1867): 252. "Daniel Drew, Esq." 11:539 (Apr. 27, 1867): 257. "Thomas Nast." 11:451 (May 11, 1867): 293. "Late Gen. Thomas F. Meagher." 11:552 (July 27, 1867): 477. "Late Charles Anthon, D.D., Columbia College." 11:555 (Aug. 17, 1867): 525. "Late Sir Frederick Bruce." 11:562 (Oct. 5, 1867): 625. "Rev. Stephen H. Tyng, Jr." 11:566 (Nov. 2, 1867): 700. [Photographed by Brady, Corner of Broadway & Tenth St.] "Late Fitz-Green Halleck, the Poet." 11:571 (Dec. 7, 1867): 769. [Photographed by Brady, 785 Broadway.]

B1586 Portraits. Woodcut engravings, credited "Photographed by Brady, N. Y." FRANK LESLIE'S ILLUSTRATED NEWSPAPER 24, (1867) ["Hon. Benjamin F. Wade, Pres. of U.S. Senate." 23:599 (Mar. 23, 1867): 1. "George Peabody, and the trustees of the Peabody Educational Fund (group portrait)." 23:602 (Apr. 13, 1867): 56. "Rev. Theodore L. Cutler." 24:608 (May 25, 1867): 149. "The late Charles Anthon, LL.D." 24:620 (Aug. 7, 1867): 341. "Maj.-Gen. Philip H. Sheridan." 24:623 (Sept. 7, 1867): 392.]

B1587 Portrait. Woodcut engraving, credited "From a Photograph by Brady." FRANK LESLIE'S ILLUSTRATED NEWSPAPER 25, (1867) ["The late Sir Frederick Bruce, Ambassador to the USA." 25:627 (Oct. 5, 1867): 48. "The late Rev. Dr. John M. Krebs." 25:629 (Oct. 19, 1867): 73. "The late Elias Howe, Jr. inventor." 25:630 (Oct. 26, 1867): 85. "The late John A. Andrew, of Boston." 25:633 (Nov. 16, 1867): 140. "Daniel Drew. Esq." 25:635 (Nov. 30, 1867): 165. "The late Fitzgreen Halleck." 25:636 (Dec. 7, 1867): 181.]

B1588 "Scenes and Incidents in Major-General Sheridan's Reception in New York and Brooklyn." FRANK LESLIE'S ILLUSTRATED NEWSPAPER 25, no. 629 (Oct. 19, 1867): 65, 67. 7 illus. [One of the sketched illustrations is, "Gen. Sheridan Visits Brady, the Photographer, Broadway and 10th St., and His Picture is Secured."]

B1589 Portraits. Woodcut engravings, credited "From a photograph by Brady." HARPER'S WEEKLY 12, (1868) ["Late Bishop Hopkins." 12:578 (Jan. 25, 1868): 61. "Late Rear-Admiral H. H. Bell, U.S.N." 12:583 (Feb. 29, 1868): 141. "Portraits of the Managers to Conduct the Impeachment of President Johnson (7 portraits)." 12:586 (Mar. 21, 1868): 177. [Photo. by Brady & Co., Washington.] "Late Daniel Lord." 12:587 (Mar. 28, 1868): 196. "Daniel Drew, Treasurer of the Erie R.R." 12:589 (Apr. 11, 1868): 237. "Cornelius Vanderbilt, Pres. of Central R.R." 12:589 (Apr. 11, 1868): 237. "Henry Stanbery, of OH." 12:590 (Apr. 18, 1868): 244. "Wm. S. Grosebeck, lawyer." 12:591 (Apr. 25, 1868): 260. "The Chinese Embassy (group portrait)." 12:598 (June 13, 1868): 376. "Hon. Reverdy Johnson, of MD." 12:601 (July 4, 1868): 420. "Hon. Horatio Seymour, Democratic Nominee for Pres." 12:604 (July 25, 1868): 465. "Gen. F. P. Blair, Dem. Nominee for V.P." 12:604 (July 25, 1868): 468. "Hon. John A. Griswold, of NY." 12:604 (Aug. 8, 1868): 477. "Hon. James Brooks, of NY." 12:606 (Aug. 8, 1868): 508. "The 'All-England Eleven' Cricketers and their Umpire (group portrait)." 12:614 (Oct. 3, 1868): 636.]

B1590 Portrait. Woodcut engraving, credited "From a Photograph by Brady." FRANK LESLIE'S ILLUSTRATED NEWSPAPER 25, (1868) ["The late Right. Rev. Bishop John Henry Hopkins." 25:643 (Jan. 25, 1868): 296.]

B1591 "The Managers of Impeachment. - From a Photograph by Brady & Co., Washington, D. C." FRANK LESLIE'S ILLUSTRATED NEWSPAPER 26, no. 654 (Apr. 11, 1868): 49. 1 illus. [Group portrait of the Impeachment Court.]

B1592 "The Chinese Embassy - Hon. Anson Burlingame and the Chinese Ambassadors and Secretaries of Legation Associated with the Mission. - From a Photograph by M. B. Brady." FRANK LESLIE'S ILLUSTRATED NEWSPAPER 26, no. 663 (June 13, 1868): 193. 1 illus. [Group portrait.]

B1593 Portrait. Woodcut engraving, credited "From a Photograph by Brady." FRANK LESLIE'S ILLUSTRATED NEWSPAPER 26, (1868) ["Hon. Anson Berlingham, Ambassador to China." 26:664 (June 20, 1868): 220. "Miss Adelaide Phillips, singer." 26:664 (June 20, 1868): 220. "The late Charles Loring Elliot, artist." 26:676 (Sept. 12, 1868): 412.]

B1594 "The Body of Thaddus Stevens Lying in State at the Capitol, Washington." HARPER'S WEEKLY 12, no. 609 (Aug. 29, 1868): 545, 548. 2 illus. ["Photographed by Brady, Washington." Portrait plus view of coffin.]

B1595 Portrait. Woodcut engraving, credited "From a Photograph by Brady." FRANK LESLIE'S ILLUSTRATED NEWSPAPER 27, (1868)

["Mme. de la Molinre (Olympe Audouard)." 27:680 (Oct. 10, 1868): 53. "Hon. Charles P. Daly, First Judge of the NY Supreme Court." 27:689 (Dec. 12, 1868): 204. "Hon. Anthony L. Robertson, Chief Justice of the NY State Supreme Court." 27:690 (Dec. 19, 1868): 213. "Hon. Gunning S. Bedford, Jr., New York, NY Judge-elect." 27:691 (Dec. 26, 1868): 229.]

B1596 "Cricket in America - The All-England Eleven and Umpire, Now on a Professional Visit to the United States. - From a Photograph by M. B. Brady." FRANK LESLIE'S ILLUSTRATED NEWSPAPER 27, no. 679 (Oct. 3, 1868): 40. 1 illus. [Group portrait.]

B1597 Portrait. Woodcut engraving, credited "From a Photograph by Brady." FRANK LESLIE'S ILLUSTRATED NEWSPAPER 27, (1869) ["Hon. Samuel B. Gavin, Justice of NY Superior Court." 27:692 (Jan. 2, 1869): 252. "Hon. John K. Hackett, Recorder of the City of NY." 27:693 (Jan. 9, 1869): 261."Thomas W. Clerke, Justice of the Supreme Court of NY." 27:694 (Jan. 16, 1869): 277. "Professor S. F. B. Morse." 27:694 (Jan. 16, 1869): 284. "Hon C. L. Monell, Justice of the Superior Court of New York, NY." 27:696 (Jan. 30, 1869): 309. "Hon. J. M. Barbour, Justice of the Superior Court of New York, NY." 27:696 (Jan. 30, 1869): 325. "J. W. Gerald, Esq." 27:697 (Feb. 6, 1869): 333.]

B1598 "The Inauguration of Ulysses S. Grant as President of the United States, March 4th, 1869 - Chief Justice Chambers Reading the Oath of Office - The Scene from near the East Portico of the Capitol, Washington, D. C. - From a Sketch by James E. Taylor, and Photographs by M. B. Brady." FRANK LESLIE'S ILLUSTRATED NEWSPAPER 28, no. 703 (Mar. 20, 1869): 8-9. 1 illus. [View, with crowd.]

B1599 "The Bronze Doors of the Capitol, Washington, D. C. - From Photographs by M. B. Brady." FRANK LESLIE'S ILLUSTRATED NEWSPAPER 28, no. 704 (Mar. 27, 1869): 28. 2 illus.

B1600 Portrait. Woodcut engraving, credited "From a Photograph by Brady." FRANK LESLIE'S ILLUSTRATED NEWSPAPER 28, (1869) ["Gen. John A. Rawlins; Hon. J. A. J. Creswell; Hon. George S. Boutell; all in Pres. Grant's Cabinet." 28:705 (Apr. 3, 1869): 40-41. "Hon. Moses H. Grinnell, Collector of the Port of NY." 28:707 (Apr. 17, 1869): 69. "Hon. John Jay, US Minister to Austria." 28:709 (May 1, 1869): 101. "Hon. J. Lothrop Motley, US Minister to England." 28:709 (May 1, 1869): 104. "Hon. Oscar Dunn, Lieut.-Gov. of LA." 28:711 (May 15, 1869): 141. "Hon. Zachariah Chandler, of MI." 28:711 (May 15, 1869): 141. "Gen. Francis C. Barlow." 28:712 (May 22, 1869): 149. "Hon. Edwards Pierrepont." 28:715 (June 12, 1869): 204. "Hon. George M. Rodeson, Sec. of Navy." 28:720 (July 17, 1869): 277. "D. J. G. Magalharns, Brazilian Minister to US." 28:725 (Aug,. 21, 1869): 357. "Gen. Alexander G. Webb, Pres. of College of the City of NY." 28:727 (Sept. 4, 1869): 396.]

B1601 "Chang, the Chinese Giant." FRANK LESLIE'S ILLUSTRATED NEWSPAPER 28, no. 728 (Sept. 11, 1869): 413. 1 illus. [This portrait not credited, but probably from a Brady photograph.]

B1602 Portrait. Woodcut engraving, credited "From a Photograph by Brady." FRANK LESLIE'S ILLUSTRATED NEWSPAPER 29, (1869) ["The late Gen. John A. Rawlins." 29:730 (Sept. 25, 1869): 28. "The late Hon. William Pitt Fessenden." 29:730 (Sept. 25, 1869): 28. "Jay Gould, Pres. of Erie Railway." 29:733 (Oct. 16, 1869): 73. "James Fisk, Comptroller of the Erie Railway." 29:733 (Oct. 16, 1869): 73. "The late Ex-President Franklin Pierce." 29:734 (Oct. 23, 1869): 100. "Father Hyacenthe (Charles Lotson)." 29:736 (Nov. 6, 1869): 121. "The late George Peabody." 29:738 (Nov. 20, 1869): 153. "Hon. Frederick F. Low, US Minister to China." 29:738 (Nov. 20, 1869): 161. "Commodore Cornelius Vanderbilt." 29:739 (Nov. 27, 1869): 169.

"The late Hon. Robert J. Walker." 29:739 (Nov. 27, 1869): 181. "The late Amos Kendall." 29:741 (Dec. 11, 1869): 213.]

B1603 "Obituary." HUMPHREY'S JOURNAL OF PHOTOGRAPHY, AND THE ALLIED ARTS AND SCIENCES 20, no. 28 (Dec. 15, 1869): 446. ["A singular coincidence has transpired in the death of two of Mr. M. B. Brady's bookkeepers...J. W. Gaw died Nov. 5, 1849. Wm. Healy, twenty years to the day died in 1869.]

B1604 Portrait. Woodcut engraving, credited "From a Photograph by Brady." FRANK LESLIE'S ILLUSTRATED NEWSPAPER 29, (1870) ["Hiram R. Revels, Black U.S. Sen.-Elect from MS." 29:752 (Feb. 26, 1870): 401. "The late Joseph Wesley Harper, editor and publisher." 29:753 (Mar. 5, 1870): 413. "The late Rev. James B. Hardenbergh, D.D." 29:754 (Mar. 12, 1870): 429. "The late Anson Burlingame, envoy from China." 29:754 (Mar. 12, 1870): 437.]

B1605 Portrait. Woodcut engraving, credited "From a Photograph by Brady." FRANK LESLIE'S ILLUSTRATED NEWSPAPER 30, (1870) ["Hon. Julian C. Verplanck." 30:758 (Apr. 9, 1870): 53. "The late Bishop Thomson, of the M. E. Church." 30:758 (Apr. 9, 1870): 61. "The late Maj. Gen. George H. Thomas, U.S.A." 30:759 (Apr. 16, 1870): 69. "The late Gen. Domingo de Giocouria, of Cuba." 30:765 (May 28, 1870): 173. "Horace B. Claflin, businessman, New York, NY." 30:767 (June 11, 1870): 197. "Group portrait of Red Dog and other Prominent Indians of the Sioux Nation [Brule tribe]." 30:771 (July 9, 1870): 261. "Hon. Amos T. Ackerman, Attorney-General." 30:772 (July 16, 1870): 284. "The late Rear-Admiral John A. Dahlgreen, U.S.N." (portrait taken aboard ship, probably during the Civil War) 30:774 (July 30, 1870): 309. "Frederick T. Frelinghuysen, Minister to England." 30:775 (Aug. 6, 1870): 332. "The late Benjamin Nathan." 30:776 (Aug. 3, 1870): 348. "Rev. John P. Newman, D.D." 30:779 (Sept. 3, 1870):397.]

B1606 Browne, John C. "The Solar Negative Prize Pictures." PHILADELPHIA PHOTOGRAPHER 7, no. 77 (May 1870): 149-150. [V. W. Horton, of Brady's Gallery, NYC, won a gold medal "for best negatives for enlarging in solar cameras," offered by Albert Moore, of Philadelphia.]

B1607 "The Great German War Meeting, Held at Steinway Hall, on Thursday Evening, July 20, 1870. - From a Photograph by Brady." FRANK LESLIE'S ILLUSTRATED NEWSPAPER 30, no. 775 (Aug. 6, 1870): 332. 1 illus. [Interior view, with crowd of a mass meeting held in New York, NY. (If actually from a photo, I suspect it was of an empty room.)]

B1608 Portrait. Woodcut portrait, credited "From a Photograph by Brady." FRANK LESLIE'S ILLUSTRATED NEWSPAPER 31, (1870) ["The late Gen. Robert E. Lee." 31:787 (Oct. 29, 1870): 101. "Gen. Robert C. Schenck, Ambassador to England." 31:796 (Dec. 31, 1870): 261.]

B1609 Portraits. Woodcut engravings, credited "From a Photograph by Brady." FRANK LESLIE'S ILLUSTRATED NEWSPAPER 31, (1871) ["Hon. J. H. Rainey, Black Am. representative." 31:798 (Jan. 14, 1871): 300. "The Commissioners to settle the "Alabama" claims: Geo. Williams, Hamilton Fish, Sam. Nelson, Gen. Rbt. Schrenk, Ebenezer Hoar. (Five portraits.)" 31:805 (Mar. 4, 1871): 412.]

B1610 Portraits. Woodcut engravings, credited "From a Photograph by Brady." FRANK LESLIE'S ILLUSTRATED NEWSPAPER 32, (1871) ["Olga, Countess of Catacazy." 32:808 (Mar. 25, 1871): 21. "The High Commissioners on the Part of England for the Settlement of the "Alabama," Fishery, and Other International Claims." (Group portrait.)

32:808 (Mar. 25, 1871): 25. "Henry D. Cooke, Gov,. of the DC." 32:808 (Mar. 25, 1871): 28. "The late Col. Burr Porter." 32:810 (Apr. 8, 1871): 53. "Avery D. Putnam." 32:816 (May 20, 1871): 153. "Gen. Spinner, Treasurer of USA." 32:818 (June 3, 871): 197. "The late Clement L. Vallandigham." 32:822 (July 1, 1871): 261. "Hon. Charles Francis Adams." 32:830 (Aug. 26, 1871): 405.]

B1611 "Captain Hall's Arctic Exploring Propeller, the 'Polaris,' - From a Photograph by Brady." FRANK LESLIE'S ILLUSTRATED NEWSPAPER 32, no. 822 (July 1, 1871): 261. 1 illus. [Ship in dock.]

B1612 Portraits. Woodcut engravings, credited "From a Photograph by Brady." FRANK LESLIE'S ILLUSTRATED NEWSPAPER 33, (1871) illus. ["Baron Von Schloezer, German Minister to USA." 33:833 (Sept. 16, 1871): 5. "The late Prof. D. H. Mahan." 33:836 (Oct. 7, 1871): 53. "Adm. David S. Porter, U.S.N." 33:838 (Oct. 21, 1871): 81.]

B1613 Pearsall, A. A., Brady's Gallery, N.Y. "Instantaneous Portraiture." PHILADELPHIA PHOTOGRAPHER 8, no. 96 (Dec. 1871): 385-386.

B1614 "Our Picture." PHOTOGRAPHIC WORLD 1, no. 12 (Dec. 1871): 379. 1 b & w. [1 portrait by Mr. A. A. Pearsall at Mr. M. B. Brady's Broadway Gallery. Note on pg. 384 that The Grand Duke Alexis was photographed by Pearsall in Brady's gallery and that he made 10 negs. in 45 minutes.]

B1615 Portraits. Woodcut engravings, credited "From a Photograph by Brady." FRANK LESLIE'S ILLUSTRATED NEWSPAPER 33, (1872) ["The late James H. Hackett." 33:851 (Jan. 20, 1872): 293. "The late Maj.-Gen Henry W. Wallace." 33:852 (Jan. 27, 1872): 317. "Hon. William M. Evarts." 33:855 (Feb. 17, 1872): 357. "Col. George K. Kent." 33:857 (Mar. 2, 1872): 396. "Brig.-Gen. Horace Porter." 33:857 (Mar. 2, 1872): 396. "Brig.-Gen. O. E. Babcock." 33:857 (Mar. 2, 1872): 396.]

B1616 Portrait. Woodcut engravings, credited "From a Photograph by Brady." FRANK LESLIE'S ILLUSTRATED NEWSPAPER 34, (1872) ["The late James Gordon Bennett." 34:873 (June 22, 1872): 236. "Hon. James B. Beck, of KY." 34:880 (Aug. 10, 1872): 341. "Alfredo Barill, pianist." 34:880 (Aug. 19, 1872): 348. "Hon. John F. Fransworth, of IL." 34:883 (Aug. 31, 1872): 396. "Hon. Thomas A. Hendricks, of ID." 34:884 (Sept. 7, 1872): 405.]

B1617 Portrait. Woodcut engraving, credited "From a Photograph by Brady." FRANK LESLIE'S ILLUSTRATED NEWSPAPER 35, (1872) ["Hon. James W. Nye, of NV." 35:885 (Sept. 14, 1872): 13.]

B1618 Portrait. Woodcut engraving, credited "From a Photograph by Brady." FRANK LESLIE'S ILLUSTRATED NEWSPAPER 35, (1873) ["Hon. William F. Havermeyer, Mayor of New York, NY." 35:902 (Jan. 11, 1873): 281.]

B1619 Portraits. Woodcut engravings, credited "From a Photograph by Brady." FRANK LESLIE'S ILLUSTRATED NEWSPAPER 36, (1873) ["Lieut.-Col. Fred Grant." 36:918 (May 3, 1873): 121. "The late Hon. James Brooks." 36:920 (May 17, 1873): 161. "The late Rev. Dr. Gardiner Spring, Presbyterian." 36:936 (Sept. 6, 1873): 416.]

B1620 "Captain Hall's Arctic Exploring Expedition. - Failure of the Enterprise. - The 'Polaris.'- From a Photograph by Brady." FRANK LESLIE'S ILLUSTRATED NEWSPAPER 36, no. 921 (May 24, 1873): 169. 1 illus. [The ship at dock.]

B1621 Portrait. Woodcut engraving, credited "From a Photograph by Brady." FRANK LESLIE'S ILLUSTRATED NEWSPAPER 37, (1873) ["Gen. W. A. C. Ryan." 37:947 (Nov. 22, 1873): 184.]

B1622 Portrait. Woodcut engraving credited "From a photograph by Matthew Brady." ILLUSTRATED LONDON NEWS 63, (1873) ["General Washington Ryan." 63:1789 (Dec. 13, 1873): 564.]

B1623 Portraits. Woodcut engravings, credited "Photographed by Brady." FRANK LESLIE'S ILLUSTRATED NEWSPAPER 38, (1874) ["Frederick A. Dockray, Am. citizen sentenced to death in Cuba." 38:971 (May 9, 1874): 140. "Hon. Aaron A. Sargent, Senator from CA." 38:973 (May 23, 1874): 173. "Mr. John Foley, editor." 38:976 (June 13, 1874): 220.]

B1624 "The Arctic Explorers. - Drawn by Wallin. - From an Ambrotype by Brady." FRANK LESLIE'S ILLUSTRATED NEWSPAPER 39, no. 1000 (Nov. 28, 1874): 193. 1 illus. [Special supplement issue, commemorating the 1000th issue of the "FLIN." Earlier articles were reprinted, including this group portrait published in the first number of the magazine, Dec. 15, 1855.]

B1625 Portrait. Woodcut engraving, credited "From a Photograph by Brady." FRANK LESLIE'S ILLUSTRATED NEWSPAPER 39, (1875) ["The late Dr. Edward Delafield." 39:1014 (Mar. 6, 1875): 429.]

B1626 Portraits. Woodcut engravings, credited "From a Photograph by Brady." FRANK LESLIE'S ILLUSTRATED NEWSPAPER 40, (1875) ["Hon. Carl Schurz." 40:1024 (May 15, 1875): 160. "Hon. Daniel D. Pratt." 40:1026 (May 29, 1875): 193.]

B1627 Portraits. Woodcut engravings, credited "From a Photograph by Brady." FRANK LESLIE'S ILLUSTRATED NEWSPAPER 41, (1875) ["The late William B. Astor." 41:1054 (Dec. 11, 1875): 224. "Maj.-Gen. E. O. C. Ord, U.S.A." 41:1055 (Dec. 18, 1875): 237. "Hon. Michael C. Kerr, Speaker of the House." 41:1056 (Dec. 25, 1875): 256.]

B1628 Portrait. Woodcut engraving, credited "From a Photograph by Brady." FRANK LESLIE'S ILLUSTRATED NEWSPAPER 41, (1876) ["The late Reverdy Johnson, Minister to England." 41:1065 (Feb. 26, 1876): 405.]

B1629 Portrait. Woodcut engraving, credited "From a Photograph by Brady." FRANK LESLIE'S ILLUSTRATED NEWSPAPER 42, (1876) ["Green B. Raum, Commissioner of Internal Revenue." 42:1091 (Aug. 26, 1876): 412.]

B1630 "Prominent Chiefs of the Sioux Nation. - From a Photograph by Brady." FRANK LESLIE'S ILLUSTRATED NEWSPAPER 42, no. 1086 (July 22, 1876): 336. 1 illus. [This is a studio portrait of an Indian delegation to Washington, taken several years previously. It is used here in the announcement of Gen. Custer's defeat and death at the Little Big Horn. The article, titled "The Late General George A. Custer, U.S.A." is also illustrated with an earlier, uncredited, portrait of Custer and a sketch of a gunfight between some Sioux warriors and a military scout, drawn in 1874.]

B1631 Portrait. Woodcut engraving, credited "From a Photograph by Brady.' FRANK LESLIE'S ILLUSTRATED NEWSPAPER 43, (1876) ["Hon. Samuel Randall, of PA." 43:1108 (Dec. 23, 1876): 261.]

B1632 Portraits. Woodcut engravings credited "From a photograph by Brady, Washington." FRANK LESLIE'S ILLUSTRATED NEWSPAPER 43, (1877) ["The members of the Electorial Commission. (fifteen portraits)." 43:1116 (Feb. 17, 1877): 396.]

B1633 Portraits. Woodcut engravings credited "From a photograph by Brady, Washington." FRANK LESLIE'S ILLUSTRATED NEWSPAPER 44, (1877) ["The New Administration. President Hayes's Cabinet. (seven portraits)." 44:1121 ((Mar. 24, 1877): 52-53.]

B1634 Portraits. Woodcut engravings, credited "From a Photograph by Brady, Washington." FRANK LESLIE'S ILLUSTRATED NEWSPAPER 45, (1877) ["The late Oliver Perry Morton." 45:1155 (Nov. 17, 1877): 181. The Forty-fifth Congress - Chairmen of the Leading Committee of the House. (12 portraits). 45:1158 (Dec. 8, 1877): 225.]

B1635 "District of Columbia. - Our Indian Allies - Interview of a Delegation of Indian Chiefs with President Hayes, in the East Room of the White House, September 27th. - Photographed by Brady, Washington." FRANK LESLIE'S ILLUSTRATED NEWSPAPER 45, no. 1150 (Oct. 13, 1877): 81. 1 illus. [View of group. This image enhanced by the engraver.]

B1636 Portraits. Woodcut engravings credited "From a photograph by Matthew B. Brady." ILLUSTRATED LONDON NEWS 70, (1877) ["Rutherford Hayes, candidate for Pres." 70:1964 (Mar. 3, 1877): 193. "S. J. Tilden, candidate for Pres." 70:1964 (Mar. 3, 1877): 209.]

B1637 Portrait. Woodcut engraving, credited "From a Photograph by M. B. Brady." FRANK LESLIE'S ILLUSTRATED NEWSPAPER 46, (1878) ["Mrs. Agnes D. Jenks, author." 46:1189 (July 13, 1878): 321.]

B1638 "Washington, D. C. - Statue of William King, First Governor of Maine, in Statuary Hall. - From a Photograph by Brady." FRANK LESLIE'S ILLUSTRATED NEWSPAPER 46, no. 1186 (June 12, 1878): 272. 1 illus.

B1639 Portraits. Woodcut engravings, credited "From a Photograph by M. B. Brady." FRANK LESLIE'S ILLUSTRATED NEWSPAPER 47, (1878) ["Simon B. Conover, Sen. from FL." 47:1198 (Sept. 14, 1878): 29. "Right Rev. John J. Keane, Bishop." 47:1201 (Oct. 5, 1878): 76.]

B1640 Portrait. Woodcut engraving, credited "From a Photograph by Brady." FRANK LESLIE'S ILLUSTRATED NEWSPAPER 47, (1879) ["Hon. D. W. Voorhees, Sen. from IA." 47:1222 (Mar. 1, 1879): 461.]

B1641 Portraits. Woodcut engravings, credited "From a Photograph by Brady." FRANK LESLIE'S ILLUSTRATED NEWSPAPER 48, (1879) ["Hon. James Shields, Sen. from MO." 48:1224 (Mar. 15, 1879): 29. "Hon. Henry G. Davis, Sen." 48:1230 (Apr. 26, 1879): 117. "Hon. William Hunter, Asst. Sec. of State." 48:1236 (June 7, 1879): 229. "Gen. Thomas Ewing, candidate for Pres." 48:1239 (June 28, 1879): 285.]

B1642 Portrait. Woodcut engraving, credited "From a Photograph by Brady." FRANK LESLIE'S ILLUSTRATED NEWSPAPER 49, (1879) ["Hon. Clarkson Nott Potter." 49:1260 (Nov. 22, 1879): 197.]

B1643 "Our Editorial Table: Album of Statesmen." PHOTOGRAPHIC TIMES 18, no. 368 (Oct. 5, 1888): 480. ["We learn from the 'N.Y. Sun' that Mr. M.B. Brady, so long and so well known to the people of this city and of Washington, has published an album containing recent photographs of the members of the United States Senate and House of Representatives, with a biography of each...."]

B1644 "Views Caught with the Drop Shutter." ANTHONY'S PHOTOGRAPHIC BULLETIN 20, no. 11 (June 8, 1889): 352. [Note. "W. B. Brady [sic], one of the earliest workers in photography, after some years of retirement, is again goimg to take up the photographic

art, and will open a new studio at Pennsylvania avenue and Thirteenth street, Washington, D.C."]

B1645 "The Editorial Table." PHOTOGRAPHIC TIMES 19, no. 403 (June 7, 1889): 290. [Note that Brady visited the editor and talked about old times.]

B1646 "The Chicago Worlds Fair Committee, the Winners in the Struggle for the Site in the House of Representatives - Instantaneous Photo by M. B. Brady." FRANK LESLIE'S ILLUSTRATED NEWSPAPER 70, no. 1800 (Mar. 15, 1890): 133. 1 b & w. [Large group portrait of the commission. This is a full-page photomechanical reproduction.]

B1647 "The Approaching Anniversary of General Grant's Birthday - From War-Time Photos by Brady." FRANK LESLIES ILLUSTRATED NEWSPAPER 70, no. 1806 (Apr. 26, 1890): 257. 2 illus. [Wood engravings, from photographs. Portrait of General Grant and family at City Point during the siege of Petersburg. Portrait of Grant in the field, before Petersburg.]

B1648 "Minnesota - Hon. William R. Merriam, Republican Nominee for Governor - Photo by M. B. Brady." FRANK LESLIE'S ILLUSTRATED NEWSPAPER 71, no. 1824 (Aug. 30, 1890): 65. 1 illus.

B1649 1 engraving (A. Lincoln and His Son Todd) as frontispiece. CENTURY MAGAZINE 41, no. 1 (Nov. 1890): 2. 1 illus. ["Photographed by Brady, engraved by R. G. Tietze."]

B1650 "The Recent Meeting of the American Historical Association at Washington, D.C. - A Group of Present and Former Officers - From a Photo by Brady." FRANK LESLIE'S ILLUSTRATED NEWSPAPER 71, no. 1843 (Jan. 10, 1891): 440. 1 b & w.

B1651 "Twenty Years Ago." PHOTOGRAPHIC TIMES 21, no. 487 (Jan. 16, 1891): 29-30. [Brief Note, "...now it comes out that the book in the photograph of Pres. Lincoln & his son was not a bible, but Brady's picture album..."]

B1652 "Correspondence: Stolen." PHOTOGRAPHIC TIMES 21, no. 498 (Apr. 3, 1891): 164. [Letter from Brady reporting that a Dallmeyer Rapid Rect. lens 21x25, no. 44,338 had been stolen from his gallery.]

B1653 Townsend, George Alfred. "Brady, the Grand Old Man of American Photography: An Interview." NEW YORK WORLD (Apr. 12, 1891): 26. [Reprinted in *Photography: Essays & Images: Illustrated Readings in the History of Photography,* edited by Beaumont Newhall. N.Y.: The Museum of Modern Art, distributed by the New York Graphic Society, Boston, 1980. pp. 44-49.]

B1654 "Notes and News: Photographers Disagree." PHOTOGRAPHIC TIMES 21, no. 501 (Apr. 24, 1891): 200. [Brief note that Brady claimed to have the only right to photograph the Patent Centennial Convention in Washington, DC, and that he had a "hot argument" with Mr. Prince, then swore out a warrant against him. From "Washington Critic," Apr. 9th.]

B1655 Townsend, George Alfred ("Gath"). "Correspondence: Brady, The Grand Old Man of American Photography." PHOTOGRAPHIC TIMES 21, no. 508 [sic 509] (June 19, 1891): 301-303. [Long anecdotal narrative from the "NY World".]

B1656 "The British Legation Building at Washington - The Ambassador and the Family - Photos by Brady." FRANK LESLIE'S ILLUSTRATED NEWSPAPER 73, no. 1893 (Dec. 26, 1891): 365, 367. 2 b & w. 2 illus.[Group portrait, interior views. Sketches from photos.]

B1657 "Items of Interest: M. B. Brady." PHOTOGRAPHIC TIMES 24, no. 659 (May 4, 1894): advertising supplement, p.i. [Note that on Apr. 16, on the corner of 15th & New York Ave., in Washington, DC, Brady was knocked down and injured. Expected to recover.]

B1658 "An Old-Time Photographer and His Reminiscences." PHOTOGRAPHIC TIMES 25, no. 681 (Oct. 5, 1894): 226. [From the "Washington Evening Star."]

B1659 1 photo (George Inness). CENTURY MAGAZINE 49, no. 4 (Feb. 1895): 531. 1 illus.

B1660 1 photo (Hermann von Helmholtz). CENTURY MAGAZINE 49, no. 5 (Mar. 1895): 689. 1 illus.

B1661 "In Memoriam: M. B. Brady." WILSON'S PHOTOGRAPHIC MAGAZINE 33, no. 471 (Mar. 1896): 121-123. 1 illus.[Obituary. Includes a letter from L. C. Handy.]

B1662 1 photo (Abraham Lincoln). OUTLOOK 58, no. 6 (Feb. 5, 1898): 322. ["From a photograph by Brady taken in 1864." Illustration for an article on Lincoln.]

B1663 "Editor's Table." WILSON'S PHOTOGRAPHIC MAGAZINE 35, no. 499 (July 1898): 336. ["Mr. David Proskey, of 853 Broadway, New York, has acquired a large selection of Brady's famous photographs of the War of the Rebellion, battle scenes, portraits of prominent Union and Confederate generals, etc. We understand that the collection may be had at a reasonable figure."]

B1664 1 photo (Portrait of Abraham Lincoln). CENTURY MAGAZINE 63, no. 4 (Feb. 1902): 561. 1 b & w. ["From a photograph by Brady in the collection of Robert Coster".]

B1665 1 photo (Nathaniel Hawthorne). CENTURY MAGAZINE 68, no. 3 (July 1904): 350. 1 b & w. [Full page portrait, credited to Brady - probably taken by Gardner - with a poem, "The Eyes of Hawthorne," by Edith W. Thomas on the following page.]

B1666 Tarbell, Ida M. "The Tariff in Our Times: Under Lincoln." AMERICAN MAGAZINE 63, no. 2 (Dec. 1906): 115-132. 8 b & w. ["Illus. with portraits, ...From a Brady negative made in the 60's" (7), "From a negative made in the 60's by Alexander Gardner. Copyrighted by M. P. Rice." (1).]

B1667 Tarbell, Ida M. "The Tariff in Our Times: An Outbreak of Protectionism." AMERICAN MAGAZINE 63, no. 3 (Jan. 1907): 270-283. 8 b & w. ["Illus. with portraits." Photos by: Brady (2), W. Kurtz (1), F. Gutekunst, Phila. (1), Gardner (3), Elmer Chickering, Boston, 1880, (1).]

B1668 Tarbell, Ida M. "The Tariff in Our Times: Under Grant." AMERICAN MAGAZINE 63, no. 5 (Mar. 1907): 473-488. 8 b & w. ["Illustrated with Portraits." Photos by: Brady (2), Rockwood (1).]

B1669 Tarbell, Ida M. "The Tariff In Our Times: Under Hayes and Garfield." AMERICAN MAGAZINE 63, no. 6 (Apr. 1907): 641-656. 18 b & w. ["Illus. with portraits." 4 credited to Brady, 1 to Gutekunst, 1 to Ludovici.]

B1670 "Suit Over War Photos Finished." BULLETIN OF PHOTOGRAPHY AND THE PHOTOGRAPHER 6, no. 135 (Mar. 9, 1910): 162-163. [Report of the settlement out of court of a lawsuit between Edward B. Eaton, purchaser of some 7,000 negatives of Civil War photographs credited to Brady and Gardner, and a H. C. McClurg

and the Davenport "Democrat and Leader" who had claimed that they couldn't be authentic. A great deal of testimony was held, with officers and men from the war testifying that they had seen photographers at their campsites and at the front and that they knew of their activities, etc. McClurg finally agreed he was wrong. Indicative of the loss of information about Civil War photography by 1900.]

B1671 Hale, William Bayard. "The Pension Carnival." WORLD'S WORK 21, no. 1 (Nov. 1910): 13611-13626. 8 b & w. [Article about abuses in the Civil War veterans' pension funds; illustrated with portraits credited to M. Brady (4), Handy (1), Clinedinst (1) and others.]

B1672 Hale, William Bayard. "The Pension Carnival: Second Article, Rolling Up the Big Snowball." WORLD'S WORK 21, no. 1 (Nov. 1910): 13611-13626. 12 b & w. [Article on Civil War Pension Fraud. Illustrated with portraits, etc. Also included are four photographs taken during the Civil War and credited "A war-time photograph by Brady." [not Brady's].]

B1673 Lanier, Henry Wysham. "Brady, the Civil War Photographer." WILSON'S PHOTOGRAPHIC MAGAZINE 48, no. 651 (Mar. 1911): 134-137. [Reprinted from "American Review of Reviews," Mar. 1911.]

B1674 "The March of Events: The South 1861 - 1911." WORLD'S WORK 21, no. 6 (Apr. 1911): 14178-14180, 14194. [News feature on economic recovery in Georgia, includes 3 photos of Atlanta, 2 of them contemporary, are by Brown Brothers and Stephenson, Atlanta; 1 from the Civil War is credited 'A war-time photography by Brady.'" [not Brady.]]

B1675 Flato, Charles. "Matthew B. Brady 1823 - 1896." HOUND AND HORN 7, (Oct. - Dec. 1933): 35-41. 11 b & w.

B1676 "Five Photographers - M. A. Root, Matthew Brady - L. Moholy-Nagy - Francis Bruguiere - Henri Cartier-Bresson." TRANSITION no. 25 (Fall 1936): 81-92. 5 b & w.

B1677 Milhollen, Hirst. "Matthew B. Brady Collection." LIBRARY OF CONGRESS QUARTERLY JOURNAL 1, no. 4 (Apr. - June 1944): 15-19.

B1678 Kunhardt, Dorothy Meserve. "Barnum and Brady: Pictures from the Collection of Frederick Hill Meserve." COLLIER'S WEEKLY 113, no. 18 (Apr. 29, 1944): 21-23. 18 b & w.

B1679 Meredith, Roy. "Mr. Lincoln's Camera Man - Matthew B. Brady." POPULAR PHOTOGRAPHY 18, no. 5 (May 1946): 33-39, 154, 156, 160, 162-170. 12 b & w. 1 illus.

B1680 "Discoveries About Brady." U.S. CAMERA MAGAZINE 12, no. 11 (Nov. 1949): 22-23. 2 b & w. 1 illus. [44 original glass-plate photos located in a barn led to the realization that many photos attributed to Brady actually taken by others.]

B1681 Brady, Matthew. "Case-Maker Brady." IMAGE 1, no. 3 (Mar. 1952): 2. [Text of a letter by Brady concerning daguerreotype cases.]

B1682 Cobb, Josephine. "Matthew B. Brady's Photographic Gallery in Washington." RECORDS OF THE COLUMBIA HISTORICAL SOCIETY OF WASHINGTON, D.C. 53, (1953): 28-69. 2 b & w. 4 illus. [A thoroughly researched, accurate account of Brady's life and career.]

B1683 Vanderbilt, Paul. "Two Photographs of Abraham Lincoln." QUARTERLY JOURNAL OF THE LIBRARY OF CONGRESS 10, no. 4 (Aug. 1953): 185-189. 1 b & w. [Ambrotype made by Calvin Jackson in 1858 and the negative of the Feb. 9, 1864 portrait of Lincoln, taken by Brady's Studio.]

B1684 Horan, James D. "'Photo by Brady.': The renowned photographer of the Civil War also caught for posterity the great faces of U. S. history, linking Washington's day to our own time." COLLIER'S WEEKLY 136, no. 12 (Dec. 9, 1955): 68-71. 19 b & w. [Portraits of celebrities, statesmen, etc.]

B1685 Parker, Alice Lee. "Photographs and Prints." QUARTERLY JOURNAL OF THE LIBRARY OF CONGRESS 13, no. 1 (Nov. 1955): 53-54. [Brady-Handy collection of 3000 glass-plate negatives and some daguerreotypes, taken in Brady's Gallery from 1840s to 1890s, in the collections.]

B1686 "Pictures from the Collection: Lt. General U. S. Grant, by Matthew B. Brady." IMAGE 7, no. 2 (Feb. 1958): 42-43. 1 b & w. ["Lt. Gen. U.S. Grant", by Matthew B. Brady.]

B1687 "Matthew Brady's Picture Men." U.S. CAMERA 1962 (1961): 58-67. 16 b & w.

B1688 Meredith, Roy. "How Brady Shot the Civil War." SCIENCE DIGEST 49, (Apr. 1961): 32-42.

B1689 Murphy, J. "Who Made Mathew Brady's Pictures?" U.S. CAMERA MAGAZINE 24, no. 8 (Aug. 1961): 50-55.

B1690 Brady, Thomas J. "Brady of Broadway." HISTORY TODAY 17, no. 6 (June 1967): 357-367. 7 b & w.

B1691 Stern, Madeline B. "Matthew B. Brady and the 'Rationale of Crime.'A Discovery in Daguerreotypes." LIBRARY OF CONGRESS QUARTERLY JOURNAL 31, no. 3 (July 1974): 127-135. 5 illus. [Marmaduke B. Sampson's "Rationale of Crime...," edited by Eliza Farnham, (NY: Appleton, 1846) was illustrated with nineteen engravings by Tudor Horton, from daguerreotypes by Matthew Brady.]

B1692 Russack, Richard. "Albert in America." NORTHLIGHT (JOURNAL OF THE PHOTOGRAPHIC HISTORICAL SOCIETY OF AMERICA) 2, no. 3 (Summer 1975): 3-5. 8 b & w. [Dicusses the photographers who documented the four month visit of Albert Edward, Prince of Wales to Canada and the USA in 1860. He mentions D. Appleton views, Deloss Barnum in Boston. George Stacy in Portland, ME, and the Brady Studio in New York. Some of the Brady images, curiously, are also credited to E. T. Whitney & Co., Norwalk, CT.]

B1693 Triggs, Stanley G. "Brady and the Prince." NORTHLIGHT (JOURNAL OF THE PHOTOGRAPHIC HISTORICAL SOCIETY OF AMERICA) 2, no. 4 (Fall 1975): 10. 1 b & w. [Response to the earlier article, describing a similar Brady portrait of Prince Albert.]

B1694 "The Civil War. Matthew B. Brady: Without Compromise, He Photographed the Face of a Dirty War." PHOTO WORLD no. 5 (Dec. 1976 - Jan. 1977): 36-43, 126-127. 11 b & w. 4 illus.

B1695 Kunhardt, Philip B., Jr. "Images of Which History Was Made Bore the Matthew Brady Label. (Part 1)." SMITHSONIAN 8, no. 4 (July 1977): 24-35, plus cover. 18 b & w.

B1696 Kunhardt, Philip B., Jr. "Hold Still - don't move a muscle: you're on Brady's Camera! (Part 2)" SMITHSONIAN 8, no. 5 (Aug. 1977): 58-67. 17 b & w.

B1697 Lowe, Dennis E. "Mathew Brady at Gettysburg." HISTORY OF PHOTOGRAPHY 2, no. 1 (Jan. 1978): 99. 1 b & w. 1 illus. [Discusses staged photographs made by Brady at Gettysburg a week after the battle was over.]

B1698 Frassanito, William A. "The Photographers of Antietam." CIVIL WAR TIMES ILLUSTRATED 17, no. 5 (Aug. 1978): 17-21. 6 b & w. [Alexander Gardner and James Gibson took 95 photographs after the battle of Antietam. Brady & Co. later sold these works under their name.]

B1699 Stern, Madeleine. "A Discovery in Daguerreotypes: Matthew Brady and the 'Rationale of Crime.'" PHOTOGRAPHICA 10, no. 7 (Sept. 1978): 4-6. 3 illus. [Reprinted from "Bookman's Weekly," Jan. 23, 1978.]

B1700 Stern, Madeleine B. "Matthew Brady Again." QUARTERLY JOURNAL OF THE LIBRARY OF CONGRESS 35, no. 4 (Oct. 1978): 242-243. 1 illus. [Postscript to article July 1974 in the "Quarterly Journal" on Brady's role in Marmuduke Sampson's "Rationale of Crime," 1846.]

B1701 "Barnum & Brady's Biggest." AMERICAN HERITAGE 30, no. 5 (Aug. - Sept. 1979): 106-107. 2 b & w. [Brady's portraits of Barnum's performers James Murphey and Anna Swan.]

B1702 Welling, William. "X-Ray of Painting Yields Lincoln Image." CAMERA (LUCERNE) 58, no. 9 (Sept. 1979): 34-35. 2 illus.

B1703 Todd, Jennifer. "The Rigors of Business: Matthew Brady's Photography in Political Perspective." AFTERIMAGE 7, no. 4 (Nov. 1979): 8-12. 7 b & w. 1 illus.

B1704 Kaland, Bill. "The New York Galleries of Matthew Brady." PHOTOGRAPHICA 11, no. 10 (Dec. 1979): 1, 3-7. 9, 1 port. b & w. 3 illus. [Includes excerpt from 1858 "New York Times."]

B1705 Bryan, Tom. "Letter: Brady's Politics." AFTERIMAGE 7, no. 7 (Feb. 1980): 2.

B1706 "Rare Lincoln Stereos Purchased at Auction." STEREO WORLD 7, no. 4 (Sept. - Oct. 1980): 24, 27. 2 b & w. [Three portraits of Lincoln and one of his wife purchased. Attributed to Brady's Washington gallery ca. 1861-1864. Advertisement on p. 27 offers modern copy prints of the group for sale.]

B1707 Gollin, Rita K. "The Matthew Brady Photographs of Nathaniel Hawthorne." STUDIES IN THE AMERICAN RENAISSANCE (1981): 379-391. 4 b & w. [Focuses on the dealings of Brady and Alexander Gardner [then employed by Brady] with Hawthorne in 1862, when Hawthorne had four portraits taken in Brady's Washington studio.]

B1708 Photograph of Matthew Brady's tombstone, Brady "the great Civil War photographer..." mentioned on p. 68 in: "America's First National Cemetery," by Wayne Barrett. AMERICAN HERITAGE 33, no. 4 (June - July 1982)

B1709 Ryder, Richard C. "Personalities in Perspective: John Burns." STEREO WORLD 12, no. 1 (Mar. - Apr. 1985): 33, 40. 1 b & w. [Portrait of John Burns, the "hero of Gettysburg," from a negative taken by M. B. Brady. Article is about Burn's activities during the war.]

B1710 Zinkham, Helena. "Pungent Salt: Matthew Brady's 1866 Negotiations with the New York Historical Society." HISTORY OF PHOTOGRAPHY 10, no. 1 (Jan. - Mar. 1986): 1-8. 3 b & w. 1 illus.

BRAGG, J. (USA)
B1711 "Political Campaign in the South. - Negroes at Montgomery, Alabama, Drawing Government Rations Donated by Congress to the Sufferers in the Overflowed Districts of Last Spring. - Photographed by J. Bragg." FRANK LESLIE'S ILLUSTRATED NEWSPAPER 39, no. 1000 (Nov. 28, 1874): 188. 1 illus. [View, street scene with crowds.]

BRAGGE, JAMES. (1833-1903) (GREAT BRITAIN, N. ZEALAND)
BOOKS
B1712 Main, William. *Wellington through a Victorian Lens.* Wellington, New Zealand: Millwood Press, 1972. 108 pp. b & w. illus.

B1713 Main, William. *Wellington and the Wairarapa*: A monograph on James Bragge. Wellington, New Zealand: Millwood Press, 1974. n. p. b & w. illus.

PERIODICALS
B1714 Main, William. "James Bragge (1833-1913) of Wellington, New Zealand." HISTORY OF PHOTOGRAPHY 4, no. 1 (Jan. 1980): 1-8. 6 b & w. [Born in England, to New Zealand in mid 1860s. Opened portrait studio in Wellington, but also made many views of the country.]

BRAITHWAITE, C. H. (LEEDS, GREAT BRITAIN)
B1715 Portrait. Woodcut engraving, credited "From a Photograph by Braithwaite, Leeds." ILLUSTRATED NEWS OF THE WORLD AND DRAWING ROOM PORTRAIT GALLERY OF EMINENT PERSONAGES 1, (1858) ["Sir Peter Fairbairn, Mayor of Leeds." 1:33 (Sept. 18, 1858): 181.]

B1716 Portrait. Woodcut engraving, credited to "From a Photograph by C. H. Braithwaite, Briggate, Leeds." ILLUSTRATED LONDON NEWS 61, (1872) ["John Barran, Mayor of Leeds." 61:1725 (Sept. 28, 1872): 301.]

B1717 Portrait. Woodcut engraving credited "From a photograph by C. H. Braithwaite." ILLUSTRATED LONDON NEWS 66, (1875) ["H. R. Marsden, Mayor of Leeds." 66:1866 (May 15, 1875): 456.]

B1718 Portrait. Woodcut engraving credited "From a photograph by Braithwaite." ILLUSTRATED LONDON NEWS 73, (1878) ["Late Mr. George Thompson." 73:2051 (Oct. 19, 1878): 377.]

B1719 Portrait. Woodcut engraving credited "From a photograph by C. H. Braithwaite." ILLUSTRATED LONDON NEWS 74, (1879) ["Sir Fitzjames Stephen." 74:2070 (Feb. 15, 1879): 157.]

BRAND, EDWIN L. (CHICAGO, IL)
B1720 "Editor's Table." PHILADELPHIA PHOTOGRAPHER 6, no. 68 (Aug. 1869): 284. [He has "recently fitted up elegant rooms ..."]

B1721 "Note." PHOTOGRAPHIC TIMES 6, no. 66 (June 1876): 135. [Studio opened.]

BRANDIS, BARON VON. (RUSSIA)
B1722 Brandis, Baron von. *Amur, Vostochnaya Siberia, Zapadmaya Sibir i Ural.* (Amur, Eastern Siberia, Western Siberia and the Urals.) St. Petersburg, Russia: Karl Rikker, 1870. 5 vol. pp. 371 b & w. [Vol. 1: ii pp., plates 1-64 (Amur); Vol. 2: ii pp., plates 65-142 (Eastern Siberia, 1st part); Vol. 3: ii pp., plates 143-149 (Eastern Siberia, 2nd part); Vol.

4: ii pp., plates 200-278 (Western Siberia); Vol. 5: ii pp., plates 279-371 (Urals). Captions in Russian and English.]

BRANTHWAITE, H. (GREAT BRITAIN)
B1723 Branthwaite, H., F.S.A. "Birmingham Photographic Society." LIVERPOOL & MANCHESTER PHOTOGRAPHIC JOURNAL [BRITISH JOURNAL OF PHOTOGRAPHY] n. s. 2, no. 18 (Sept. 15, 1858): 223-226. [Paper by Branthwaite, "The Chemistry of Photography," read before the Birmingham Photo. Soc., summing up contemporary theory and practice.]

BRAQUEHAIS, AUGUSTE B. (PARIS, FRANCE)
B1724 Dimock, George. "Twice Defeated: Photographs of the Paris Commune by Auguste B. Braquehais." VIEWS: THE JOURNAL OF PHOTOGRAPHY IN NEW ENGLAND. 6, no. 3 (Spring 1985): 21. 2 b & w.

BRASIER, THOMAS. (d. 1877) (USA)
B1725 Portrait. Woodcut engraving, credited "From a Photograph by Brasier, Brooklyn." FRANK LESLIE'S ILLUSTRATED NEWSPAPER 36, (1873) ["The late Sidney Dorlon, famous oyster dealer." 36:933 ((Aug. 16, 1873): 369.]

B1726 "Obituary." PHOTOGRAPHIC TIMES 7, no. 81 (Sept. 1877): 209. [From "Brooklyn Eagle" (Aug. 22, 1877). Proprietor of gallery on Fulton Street, Brooklyn, NY. Died at age 37.]

BRASSART, AUGUST P. (1819-1908) (FRANCE)
B1727 Von Ravenswaay, Charles. "August P. Brassart, An Associate of Daguerre." IMAGE 3, no. 3 (Mar. 1954): 18. [Brief biography of Frenchman who made silver plates for Daguerre's daguerreotypes. Came to USA 1854.]

BRAUN, ADOLPHE. (1812-1877) (FRANCE)
BOOKS
[Beginning in the late 1860s and lasting well into the 20th century, the firm established by A. Braun issued photographic reproductions of thousands of paintings, drawings, and other works of art held in many of the major museums throughout Europe. These prints, issued in series, could be purchased separately or as a set. As such, albums of some of or some parts of these sets have been bound and catalogued into library collections, and thus have appeared as bibliographic references. However, I have not attempted to list them here. I have also chosen to list only a representative sample of the many catalogs of these sets issued by the Braun firm.]

B1728 *Photographs by Ad. Braun & Cie., in the Boston Athenaeum, January 1, 1890. Alphabetical list and chronological list under countries.* Boston: Boston Athenaeum, 1890. 24 pp.

B1729 *La Seconde Empire vous regarde. A Collection of Photographs made by Adolphe Braun, the Elder, of Dornach.* With a foreword by Claude Roy. Souillac, Mulhouse: Le Point, 1958. 23 pp. b & w. illus. [Special issue No. 53/54 (1958) of "Le Point."]

B1730 New York. Metropolitan Museum of Art. *Four Victorian Photographers.* Edited by John J. McKendry. New York: Metropolitan Museum of Art, 1967. 120 pp. b & w. [Engagement calender for 1968, with photographs by Adolphe Braun, J. M. Cameron, Thomas Eakins, and D. O. Hill.]

PERIODICALS
B1731 "The Groups of M. Braun, for Pattern Designers." ART UNION 9, no. 103 (Jan. 1, 1847): 26-27, plates in following issues on pp. 47, 108, 130, 170, 213, 237, 290, 323. [Flower patterns for wallpaper, cloth designs - not photos, but engravings.]

B1732 "Miscellaneous: Studies of Flowers." HUMPHREY'S JOURNAL 7, no. 1 (May 1, 1855): 15-16. [From "Cosmos." A. Braun's (Dornach) studies of flowers presented to the French Academy by Regnault.]

B1733 "Note." ART JOURNAL (Feb. 1856): 63. [Braun's floral studies being sold by the London Stereoscopic Co.]

B1734 "Adolphe Braun." PHILADELPHIA PHOTOGRAPHER 4, no. 48 (Dec. 1867): 399.

B1735 "Editor's Table." PHILADELPHIA PHOTOGRAPHER 4, no. 48 (Dec. 1867): 401-402. [About Braun's Carbon photographs - landscape views of Swiss and Savoyard scenery.]

B1736 "Our Picture." PHILADELPHIA PHOTOGRAPHER 5, no. 50 (Feb. 1868): frontispiece, 62-63. 1 b & w. [An example of Braun's early carbon prints.]

B1737 "Art Principles Applicable to Photography: Part 4. Aerial Perspective." PHILADELPHIA PHOTOGRAPHER 5, no. 50 (Feb. 1868): 49-52. [Mentions A. Braun, F. Frith, Wm. England, and J. M. Cameron.]

B1738 Vogel, Dr. H. "German Correspondence." PHILADELPHIA PHOTOGRAPHER 5, no. 50 (Feb. 1868): 54-56. [Extensive discussion of Adolphe Braun's printing operation in Dornach.]

B1739 de Saint-Victor, Paul. "Beaux-arts. Les dessins originaux des grands maîtres reproduits d'apres les originaux par les photographies de M. Adolphe Braun de Dornach." LA LIBERTE (July 12, 1869): 1-2.

B1740 Conant, Miss Blandina. "The Latest Triumphs of Photography." PHOTOGRAPHIC TIMES 1, no. 4 (Apr. 1871): 52-53. [Extracted from Feb. 8, 1871 "Christian Union." Deals with Braun's carbon reproductions of old masters.]

B1741 Wilson, Edward L. "Views Abroad and Across. No. 10." PHILADELPHIA PHOTOGRAPHER 11, no. 130 (Oct. 1874): 289-298. [Mentions visiting Braun's studio in Dornach, etc. on pp. 290-291.]

B1742 "A Visit to Herr Braun's Establishment at Dornach." ANTHONY'S PHOTOGRAPHIC BULLETIN 7, no. 8 (Aug. 1876): 243. [From "Br. J. of Photo.," in turn from "Schweitzer Photographen Zeitung." Describes the printing establishment, now under the direction of Braun, Jr.]

B1743 "Carbon Photography: Processes Worked and Perfected by Ad. Braun & Co." PHILADELPHIA PHOTOGRAPHER 14, no. 159-160 (Mar. - Apr. 1877): 90-92, 112-114. 2 illus.

B1744 "Our Foreign Make-Up: Taking Impressions of Negatives (After Braun)." PHOTOGRAPHIC TIMES 7, no. 79 (July 1877): 149. [From "Photographische Mittheilungen."]

B1745 Braun, Ad. & Co. "Mons. Braun's Carbon Printing." ANTHONY'S PHOTOGRAPHIC BULLETIN 8, no. 12 (Dec. 1877): 360-361.

B1746 "Fine-Art Gossip." ATHENAEUM no. 2620 (Jan. 12, 1878): 64. [Note of Braun's death, brief summary of his work reproducing paintings, etc.]

B1747 "Photography In and Out of the Studio: The "Athenaeum" on Photographs for Book Illustration - M. Braun's Photographic Establishment at Dornach in Elsass." PHOTOGRAPHIC NEWS 22, no. 1011 (Jan. 18, 1878): 25. ["The "Athenaeum" had, in a review of a photographically illustrated book, suggested that woodcuts or steel engravings would have served better. The editor of "PN" takes issue. "Of course, for those who want to foster ideal fancies of the East, or retain their foolish ideas of its universal magnificence,... but, unfortunately, people are beginning to mistrust engravings..."]

B1748 "Obituary." PHILADELPHIA PHOTOGRAPHER 15, no. 170 (Feb. 1878): 50-51. [Adolphe Braun died Dec. 31, 1877, in Dornach, Alsace. Began as an industrial designer, took up photography seriously in 1858, taking beautiful views of flowers. Between 1858 and 1862 made more than 1500 negatives of landscape views in Europe. In 1864 the carbon process was perfected and the Braun studio began producing permanent prints of works of art. Braun photographed the Sistine Chapel and the opening of the Suez Canal in Egypt. In 1869 the Woodburytype introduced to the establishment and a stock company, Ad. Braun & Co. formed in 1876.]

B1749 "Death of Mr. A. Braun." ANTHONY'S PHOTOGRAPHIC BULLETIN 9, no. 2 (Feb. 1878): 63.

B1750 "Notes and News: Photographs Compared with Etchings." PHOTOGRAPHIC TIMES 18, no. 331 (Jan. 20, 1888): 33. [From Dec. 25, 1887 "Tribune." Discussion of relative merits of Braun & Cos. reproductions of works of art versus the etchings of M. Koepping drawn from the same works of art.]

B1751 "Notes: Braun's Carbon Work." PHOTOGRAPHIC TIMES 26, no. 6 (June 1895): 375. [Note that the Indianapolis Industrial School, Pratt Institute of Brooklyn, Drexel Institute of Philadelphia, each acquired a large assortment of Braun's carbon prints of reproductions of European art.]

B1752 Bicknell, Anna L. "Life in the Tuileries Under the Second Empire. By an Inmate of the Palace." CENTURY MAGAZINE 50, no. 5-6 (Sept. - Oct. 1895): 709-726, 915-931. 24 b & w. [Illustrated with portraits taken in the 1850s - 1860s. Credited to "Braun, Clement & Co.; Levitsky; Ladrey-Disderi."]

B1753 Moutard-Uldry, R. "L'exposition de photographies de 1850 a nos jours a la galerie d'art Braun." BEAUX ARTS (July 3, 1936): 1.

B1754 "Photographies Adolphe Braun 1855." LE POINT no. 14 (Apr. 1938): 56-57, 63. 5 b & w.

B1755 "La Photographie Ancienne." LE POINT no. 23 (1942): n. p. 16 b & w. 1 illus. [Sixteen photos by A. Braun, plus his portrait.]

B1756 "Pictures from the Collection." IMAGE 5, no. 2 (Feb. 1956): 42-44. 2 b & w. [1 b & w ("Columbus") by Adolphe Braun, 1 b & w by P. H. Emerson (attributed). Includes brief interpretation of each.]

B1757 Roy, Claude. "Le Photographe photographie: Le Second Empire vous regarde." LE POINT no. 53/54 (Jan. 1958): 3-4, 10-11, 14, 18, 22-23. 148 b & w. 1 illus. [Article about Braun, whose photographs were used to illustrate the entire issue of the magazine, on the theme of the Second Empire.]

B1758 Rosenblum, Naomi. "Adolphe Braun: A 19th Century Career in Photography." HISTORY OF PHOTOGRAPHY 3 , no. 4 (Oct. 1979): 357-372. 22 b & w. [Born in Besançon, but settled in Alsace in 1831 after artistic training in Paris. Draftsman for a textile firm in Mulhouse, then established his own studio by 1848. Began to use photography around 1853 to reproduce flower studies for artists. These photographs caused a sensation when exhibited at the Exposition Universelle in Paris in 1855. Braun gave up textile design for photography, and soon had a successful business. He published several large albums of floral studies in 1850s. Official photographer to the court of Napoleon III, where he actively documented the life of that society, and made a Chevalier of the Legion of Honor in 1860. By 1869 Braun had more than 4000 views of scenes all over Europe, taken by himself and others, which he published as stereo views and in larger sizes. In 1866 Braun purchased a franchise to use Joseph Swan's carbon process which he used with the Woodburytype process (after 1876) to produce permanent prints. Huge, worldwide business in reproducing works of art. Firm change to Braun & Cie in 1876, and Braun died a year later. The family continued the firm into the 20th century.]

B1759 Rosenblum, Naomi. "Adolphe Braun, Revisited." IMAGE 32, no. 1 (June 1989): 16. 13 b & w. [New information on the career of A. Braun and his company. Includes a checklist of IMP/GEH holdings, compiled by Sara Beckner.]

BRAUN, GASTON see also BRAUN, ADOLPHE.

BRAUN, GASTON. (b. 1845) (FRANCE)
B1760 "Photography in France." PHILADELPHIA PHOTOGRAPHER 11, no. 124 (Apr. 1874): 109-111. [Discusses the partnership of Pierson & Braun. Gaston Braun, Adolphe's son, being one partner.]

BREBER, MADAME. (GERMANY)
B1761 "Note." PHOTOGRAPHIC TIMES 8, no. 85 (Jan. 1878): 14. [Note that Fraulein Breber now photographs the German Imperial Court, entered the business 25 years ago with one assistant, she now employs about 30 assistants.]

BRECKENRIDGE, B. M. (TARENTUM, PA)
B1762 Breckenridge, B. M. "A Word or Two from an Amateur." PHOTOGRAPHIC AND FINE ART JOURNAL 11, no. 6 (June 1858): 187-188, 191. [Breckenridge an amateur from Tarentum, PA. Another letter on p. 191.]

BREEKS, JAMES WILKINSON. (1830-1872) (GREAT BRITAIN, INDIA)
B1763 Breeks, James Wilkinson. An Account of the Primitive Tribes and Monuments of the Nilagiris, by the late James Wilkinson Breeks, of the Madras Civil Service, Commissioner of the Nilagiris, edited by his widow. London: India Museum, W. H. Allen & Co., 1873. 137 pp. 82 l. of plates. 82 b & w. illus.

BREESE, CHARLES. (BIRMINGHAM, ENGLAND)
B1764 "Photography in Birmingham." PHOTOGRAPHIC AND FINE ART JOURNAL 11, no. 10 (Oct. 1858): 296-297. [From the "Birmingham [England] Journal". Breese's seascapes praised.]

B1765 "Birmingham Photographic Society: The Wet Process v. The Dry." BRITISH JOURNAL OF PHOTOGRAPHY 7, no. 115 (Apr. 2, 1860): 103-104. [A friendly challenge led Charles Breese to display and discuss his work with the wet process and Mr. Osborn and Dr. Hill Norris displayed examples of their works and others in the dry processes. In effect, this report became a review. S. Bourne, (of

Nottingham) discussed. Woodward (Nottingham) discussed. Seymour, Bright and Applewhaite mentioned.]

B1766 "Moonlight Stereographs." BRITISH JOURNAL OF PHOTOGRAPHY 8, no. 155 (Dec. 2, 1861): 416. [Breese, of Birmingham, England.]

B1767 "Note." ART JOURNAL (Nov. 1868): 247-248. [Note about moonlight effects in stereo views, by Mr. Breese.]

BRETZ, GEORGE MICHAEL. (1842-1895) (USA)

B1768 "Editor's Table." PHILADELPHIA PHOTOGRAPHER 14, no. 163 (July 1877): 224. [George M. Bretz (Pottsville, PA) praised.]

B1769 Bretz, George M. ("Beretz") "A Few Funny Things." PHILADELPHIA PHOTOGRAPHER 15, no. 178 (Oct. 1878): 303-304. [Anecdotes from his experiences as a portrait photographer.]

B1770 "Note." PHOTOGRAPHIC TIMES 14, no. 165 (Sept. 1884): 479. [Note that George Bretz, under the direction of J. T. Brown, made eight exposures of the interior of the Kohinoor coal mine, Shenandoah, Pa. with Arnoux electric lights for illumination.]

BREWSTER, DAVID, SIR. (1781-1868) (GREAT BRITAIN)

[Sir David Brewster was born at Jedburgh, in Scotland, in 1781. He invented the kaleidoscope in 1816. Brewster stayed with Talbot in 1836, during a meeting of the British Association at Bristol, and Talbot introduced him to his early experiments. Brewster's interest was aroused, and he played a significant role in the first years of the development of the medium through his writings on the process and the weight of his influence. Brewster was specifically interested in the stereoscope, and made some improvements in that process. Brewster died in 1868, at age 87.]

BOOKS

B1771 Brewster, Sir David. *The Stereoscope, Its History, Theory, and Construction.* With Its Application to the Fine and Useful Arts and to Education. London: J. Murray, 1856. iv, 235 pp. illus. [2nd ed. (1870), London: John Camden Hotten, 235 pp. 50 illus. Facsimile ed. (1971), New York: Morgan & Morgan. New introduction by Rudolf Kingslake.]

B1772 Brewster, David. *Memoir sur les modifications et las perfectionnements apports au streoscope.* Paris: Printed by Centrale de Napolon Chaix, 1858. 20 pp. [Reprint of the 1850 ed., published by la Societe Royale de Arts d'Ecosse.]

B1773 Gordon, Mrs. *The Home Life of Sir David Brewster.* Edinburgh: Edmonston & Douglas, 1869. n. p. 1 b & w. [Mrs. Gordon was Brewster's daughter. Frontispiece is an original photograph.]

B1774 Wade, Nicholas J., ed. *Brewster and Wheatstone on Vision.* London: Academic Press, 1983. 358 pp. illus. [Bibliography on pp. 329-339. Intro., obituaries, 35 papers reprinted.]

B1775 Morrison-Low, A. D. and J. R. R. Christie, eds. *Martyr of Science: Sir David Brewster 1781 - 1868.* Edinburgh: Royal Scottish Museum, 1984. 138 pp. illus. [Contains a thorough bibliography of Brewster's scientific writings, a catalog of scientific apparatus associated with Brewster, and the proceedings of a symposium held at the Royal Scottish Museum on Nov. 21, 1981.]

PERIODICALS

B1776 Brewster, Sir David. [?] "Art. VIII. Photography." NORTH BRITISH REVIEW 7, no. 14 (Aug. 1847): 465-504. [Review of eight books extends into a report on the state of the art. Brewster not named

as author, but his authorship cited elsewhere. Books are: R. Hunt's "Researches on Light," John W. Draper's "A Treatise on the Forces which produce the Organization of Plants," "Ch. Chevalier's "Nouvelles instructions sur l'usage du Daguerreotype," " Mélanges Photographiques," W. H. F. Talbot's "Pencil of Nature," Lerebours & Secretan's "Traité de photographie...," "Lerebours' "Des Papier photographiques," and "Excursions Daguerriennes."]

B1777 "Fifteenth Meeting of the British Association for the Advancement of Science: 'An Improvement in the Method of taking Positive Talbotypes (Calotypes),' by Sir David Brewster." ATHENAEUM no. 923 (July 5, 1845): 674.

B1778 "Nineteenth Meeting of the British Association for the Advancement of Science. Tuesday. Section A." ATHENAEUM no. 1145 (Oct. 6, 1849): 1015-1018. [Sir David Brewster's paper "On an Improved Photographic Camera," reported on p. 1016. Also a note that Brewster's other paper "On Circular Crystals" contained drawings presented to him for study by Mr. Fox Talbot.]

B1779 [Brewster, David.] "Photography and Talbotype." DAGUERREIAN JOURNAL 1, no. 2 (Nov. 15, 1850): 46-47. [Address by David Brewster to the British Association, Edinburgh, discussing recent technical advances in the medium and Talbot's role in the discovery of photography.]

B1780 Humphrey, S. D. "Controversy between Sir D. Brewster and M. Claudet." HUMPHREY'S JOURNAL 4, no. 7 (July 15, 1852): 105-106, 111. [Discussion of a controversy over relative merits of lenses between Sir David Brewster and A. Claudet, with commentary by the editor. Then a report of the issue follows on p. 111.]

B1781 "Some Remarks on the Dispute Between Sir D. Brewster and M. Claudet." HUMPHREY'S JOURNAL 4, no. 10 (Sept. 1, 1852): 158. [From "La Lumiere." Argument on lenses.]

B1782 "Meeting of the British Association for the Advancement of Science." HUMPHREY'S JOURNAL 4, no. 13 (Oct. 15, 1852): 202-204. [Sir David Brewster's papers "On the Form of Images produced by Lenses and Mirrors of different sizes," "On Account of a Rock-Crystal Lens and Decomposed Glass found in Nineveh," etc. abstracted.]

B1783 Brewster, Sir David. "The Stereoscope. Its History, Theory, and Construction." PHOTOGRAPHIC AND FINE ART JOURNAL 9, no. 9-12 (Sept. - Dec. 1856): 265-274, 298-309, 321-333, 353-366. 52 illus.

B1784 "Extracts from Foreign Publications: Address of Sir David Brewster, Delivered at the Opening of the Photographic Society of Scotland." HUMPHREY'S JOURNAL 8, no. 12 (Oct. 15, 1856): 181-184. [Discussed photoengraving experiments.]

B1785 "Our Literary Table." ATHENAEUM no. 1527 (Jan. 31, 1857): 148. [Bk. Rev.: "The Stereoscope: Its History, Theory, and Construction," by Sir David Brewster. (Murray).]

B1786 "The Original Invention of the Stereoscope." PHOTOGRAPHIC AND FINE ART JOURNAL 10, no. 3 (Mar. 1857): 81-85. [From "Liverpool Photographic J." Letters by Sir David Brewster, C. Wheatstone describing their experiences in this activity.]

B1787 Brewster, Sir David. "On the Optics of Photography; But Particularly on the Character of the Images Formed upon the Opaque

and Transparent Surfaces." PHOTOGRAPHIC AND FINE ART JOURNAL 11, no. 2 (Feb. 1858): 59-62.

B1788 "Note." AMERICAN JOURNAL OF PHOTOGRAPHY AND THE ALLIED ARTS & SCIENCES n. s. vol. 3, no. 2 (June 15, 1860): 29. [Note about Sir David Brewster's paper on the stereoscope in the 16th century.]

B1789 "Foreign Correspondence, Items, Etc.: The Stereoscope Fifteen Hundred Years Old." THE CRAYON 7, no. 7 (July 1860): 203. [Report on Sir John Brewster's paper "Notice respecting the Investigation of the Stereoscope in the Sixteenth Century, and of Binocular Drawings by Jacopo da Empoli, a Florintine Artist.]

B1790 "Editorial Note." BRITISH JOURNAL OF PHOTOGRAPHY 7, no. 124 (Aug. 15, 1860): 232. [Sir David Brewster, seeing two similar pictures by the 16th c. artist Jacobo Chimenti, stated that he may have experimented with stereovision. This statement caused a controversy. Discussed here again.]

B1791 Brewster, Sir David. "On Photographic and Stereoscopic Portraiture." BRITISH JOURNAL OF PHOTOGRAPHY 8, no. 137 (Mar. 1, 1861): 87.

B1792 Brewster, David, Sir. "On Photographic and Stereoscopic Portraiture." HUMPHREY'S JOURNAL OF PHOTOGRAPHY, AND THE ALLIED ARTS AND SCIENCES 13, no. 1 (May 1, 1861): 6-7. [Abstract from paper read to Photo. Soc. of Scotland. From "Br. J. of Photo."]

B1793 Brewster, Sir David. "On Photographic Micrometers." and "On Binocular Lustre." AMERICAN JOURNAL OF PHOTOGRAPHY AND THE ALLIED ARTS & SCIENCES n. s. vol. 4, no. 10 (Oct. 15, 1861): 232-235. [Read before the British Association, Sept. 9th.]

B1794 Brewster, Sir David. [?] "Recent Progress of Photographic Art." NORTH BRITISH REVIEW 36, no. 1 (Feb. 1862): 90-108. [Review of thirteen books on photography, which has been extended into an excellent survey of the state of the art of the medium in 1862.]

B1795 Brewster, David, Sir., K.H., F.R.S. "On the Stereoscopic Pictures Executed in the Sixteenth Century by Jacopo Chimenti." BRITISH JOURNAL OF PHOTOGRAPHY 9, no. 162 (Mar. 15, 1862): 105-106.

B1796 Carpenter, William B., M.D., F.R.S., etc. "On Binocular Vision and the Stereoscope." BRITISH JOURNAL OF PHOTOGRAPHY 9, no. 163 (Apr. 1, 1862): 122-127. 1 illus. [Lecture in response to Brewster's paper claiming that Chimenti created stereo pictures in 16th century.]

B1797 "Chimenti's Drawings." BRITISH JOURNAL OF PHOTOGRAPHY 9, no. 164 (Apr. 15, 1862): 141-142. [Editorial comment on debate between Brewster and W. Carpenter whether paintings, made in the 16th century by Chimenti, are examples of a discovery of stereoscopic vision.]

B1798 "Sir David Brewster on Photography." JOURNAL OF THE PHOTOGRAPHIC SOCIETY OF LONDON 8, no. 125 (Sept. 15, 1862): 124-128. [Extracts from Feb. 1862 "North British Review."]

B1799 "Sir David Brewster on Photography." AMERICAN JOURNAL OF PHOTOGRAPHY AND THE ALLIED ARTS & SCIENCES n. s. vol. 5, no. 8-9 (Oct. 15 - Nov. 1, 1862): 169-174, 193-198. [Reprinted from "North British Review."]

B1800 "Miscellaneous - Sir David Brewster and the Stereoscope." AMERICAN JOURNAL OF PHOTOGRAPHY AND THE ALLIED ARTS & SCIENCES n. s. vol. 6, no. 1 (July 1, 1863): 19. ["Daily Telegraph" accused Sir David Brewster of claiming to invent the stereoscope. His indignant reply.]

B1801 "Sir David Brewster on the Progress of Fine Art in Edinburgh, and on Photography." AMERICAN JOURNAL OF PHOTOGRAPHY AND THE ALLIED ARTS & SCIENCES n. s. vol. 6, no. 12 (Dec. 15, 1863): 268-269. [Discusses the value of photography in reproducing works of art for study and teaching.]

B1802 Brewster, David. "On the Photomicroscope." BRITISH JOURNAL OF PHOTOGRAPHY 11, no. 206 (Jan. 15, 1864): 22-23.

B1803 Brewster, David. "Correspondence: On the Stereoscopic Relief in the Chimenti Pictures." BRITISH JOURNAL OF PHOTOGRAPHY 11, no. 206 (Jan. 15, 1864): 33.

B1804 Brewster, David, Sir., K.H., F.R.S. "On the Photomicroscope." AMERICAN JOURNAL OF PHOTOGRAPHY AND THE ALLIED ARTS & SCIENCES n. s. vol. 6, no. 16 (Feb. 15, 1864): 364-369. [Read to Photo. Soc. of Scotland.]

B1805 Emerson, E. "The Chimenti Pictures: A Reply to Sir David Brewster." BRITISH JOURNAL OF PHOTOGRAPHY 11, no. 211-216 (Apr. 1 - June 15, 1864): 111-112, 132-133, 167-169, 202-204. 6 illus. [Prof. Emerson believes that Brewster's assertion that Baptista Porta's paintings were made with a stereoscopic device is incorrect.]

B1806 "The Chimenti Drawings." HUMPHREY'S JOURNAL OF PHOTOGRAPHY, AND THE ALLIED ARTS AND SCIENCES 16, no. 5 (July 1, 1864): 69-70.

B1807 Rood, Ogden N. "Experiments of Sir David Brewster and Helmholtz on the Solar Spectrum." PHILADELPHIA PHOTOGRAPHER 3, no. 25 (Jan. 1866): 1-4.

B1808 "The Late Sir David Brewster." ILLUSTRATED LONDON NEWS 52, no. 1470 (Feb. 22, 1868): 189-190. 1 illus.

B1809 "The Late Sir David Brewster." HARPER'S WEEKLY 12, no. 589 (Apr. 11, 1868): 236-237. 1 illus. [Obituary. Portrait not credited.]

B1810 "Statue of Sir David Brewster." ILLUSTRATED LONDON NEWS 58, no. 1646/1647 (Apr. 22, 1871): 398. 1 illus. [Statue by Mr. Brodie, in Edinburgh.]

B1811 Graham, Robert, L.L.D. "The Early History of Photography." GOOD WORDS 15, no. 7 (July 1874): 450-453. [Mentions Daguerre and Talbot, but discusses Sir David Brewster in detail.]

B1812 Graham, Robert, L.L.D. "The Early History of Photography." HISTORY OF PHOTOGRAPHY 8, no. 3 (July - Sept. 1984): 231-235. 3 b & w. [Reprinted from "Good Words," (1874).]

BREYER, ALBRECHT. (1812-1876) (GERMANY)
B1813 "Forgotten Pioneers: II: Albrecht Breyer (1812-1876)." IMAGE 1, no. 4 (Apr. 1952): 3-4. [Discovered "reflex" printing (contact printing) 1839.]

BRICE, WILLIAM A. (GREAT BRITAIN, CEYLON)
B1814 Brice, William A. "Foreign Correspondence." BRITISH JOURNAL OF PHOTOGRAPHY 12, no. 282 (Sept. 29, 1865):

503-504. [Brice from Ceylon, worked out a "small portable instrument for measuring the proper time to expose..."]

BRIDGES, GEORGE M.

[Bridges had known W. H. F. Talbot in England in 1845, then left for a seven year trip around the Mediterranean, visiting Malta, Sicily, Italy, Greece, and the Near East. He learned the calotype process in Malta from Calvert Richard Jones, and after initial problems, actively documented his journeys. After his return, he attempted to launch several publication projects, but its uncertain how much was actually completed.]

B1815 Bridges, Rev. George M. *Selections from Seventeen Hundred Genuine Photographs: (Views - Portraits - Statuary - Antiquities.) - Taken Around the Shores of the Mediterranean Between the Years 1846 - 1852, with or without Notes, Historical and Descriptive by a Wayworn Wanderer.* Cheltenham: Mary Hadley [possibly for private circulation], 1852. n. p. 12 l. of plates. illus. [Calotype prints tipped-in. Apparently several special sections or supplements to this work were also published. "The Acropolis of Athens in Its Different Aspects." [30 calotypes tipped-in], "A Supplement to the Illustrations of the Acropolis of Athens Comprehending the Ancient Remains Immediately around the Base." [35 calotypes tipped-in. (It may be that all these works never reached full publication.)]

B1816 Bridges, Rev. George M. *Palestine As It Is: In a Series of Photographic Views Illustrating the Bible* London: J. W. Hogarth, 1858-59, n. p. 26 b & w. [Salt paper prints, with descriptive letterpress. (This work was advertised, may never have reached publication.)]

BRIDGETT, RONALD.

B1817 "Main Street of Irkutsk, Siberia." ILLUSTRATED LONDON NEWS 54, no. 1534 (Apr. 17, 1869): 401, 404. 1 illus. ["We are indebted to Mr. Ronald Bridgett for the photograph."]

BRIER, J., JR. (GREAT BRITAIN)

B1818 Brier, J., Jr. "The Production of Enlarged Landscape Negatives." ANTHONY'S PHOTOGRAPHIC BULLETIN 5, no. 4 (Apr. 1874): 135-137. [From "Br. J. of Photo."]

BRIGGS, A. (LIVERPOOL, ENGLAND)

B1819 "Photographs of Microscopical Objects." HUMPHREY'S JOURNAL OF PHOTOGRAPHY, AND THE ALLIED ARTS AND SCIENCES 11, no. 13 (Nov. 1, 1859): 203-204. [From "Liverpool Photo. J." Discussion of photomicrographs, taken by A. Briggs, of Liverpool.]

BRIGGS, F.

B1820 "Scene of the Geological Discoveries at Swanage, Dorset." ILLUSTRATED LONDON NEWS 31, no. 895 (Dec. 26, 1857): 637. 1 illus. ["From a photograph by F. Briggs."]

BRIGGS, N. (LEAMINGTON, ENGLAND)

B1821 Portrait. Woodcut engraving credited "From a photograph by N. Briggs." ILLUSTRATED LONDON NEWS 66, (1875) ["George Smith, of the British Museum." 66:1861 (Apr. 10, 1875): 336.]

BRINCKERHOFF, J. DE WITT. (NEW YORK, NY)

B1822 "Gossip." PHOTOGRAPHIC ART JOURNAL 3, no. 3 (Mar. 1852): 195. [Mr. Brinckerhoff has opened a very fine suite of rooms.]

B1823 Brinckerhoff, J. De Witt. "Ectographic Engraving on Wood." PHOTOGRAPHIC AND FINE ART JOURNAL 8, no. 1 (Jan. 1855): 30. 1 illus. [Wood engraving portrait of C. C. Harrison, who taught photography to Brinckerhoff.]

B1824 Brinckerhoff, J. de Witt. "Photographic Engraving on Wood." PHOTOGRAPHIC AND FINE ART JOURNAL 8, no. 2 (Feb. 1855): 48. 1 illus. [Illustrated with a woodcut portrait of C. C. Harrison, Esq., who taught Brinckerhoff photography.]

B1825 Brinckerhoff, J. De Witt. "C. C. Harrison, Esq. Photographic Engraving on Wood." AMERICAN JOURNAL OF PHOTOGRAPHY AND THE ALLIED ARTS & SCIENCES n. s. vol. 3, no. 18 (Feb. 15, 1861): 279-280. 1 illus. [Portrait of Harrison, but the letter describes the technique of making "one of the earliest attempts at photography on wood for the use of engravers."]

B1826 Portrait. Woodcut engraving, credited "From a Photograph by Brinckerhoff." NEW YORK ILLUSTRATED NEWS 3, (1861) ["Gen. S. C. Pomerot." 3:73 (Mar. 30, 1861): 338.]

B1827 "Notes and News: Obituary." PHOTOGRAPHIC TIMES 19, no. 382 (Jan. 11, 1889): 21. [Born Bloomfield, NJ. In 1848 he opened a gallery in New York, NY, worked there for years. Semi-retired to a gallery in Morrisania, NY, then retired completely. Died Jan. 2, 1889, aged 76.]

BRITT, PETER. (1819-1905) (SWITZERLAND, USA)
BOOKS

B1828 Miller, Alan Clark. *Photographer of a Frontier: The Photographs of Peter Britt.* Eureka, CA.: Interface California Corporation, 1976. 107 pp. 96 b & w. illus. [Biography and an annotated portfolio of Britt's prints.]

PERIODICALS

B1829 "Unusual Ambrotype." AMERICAN WEST 15, no. 6 (Nov. - Dec. 1978): 2. 1 b & w. [Ambrotype of a man with a cat, taken in 1850s by Oregon photographer Peter Britt.]

B1830 Palmquist, Peter E. "The Stereographs of Peter Britt." STEREO WORLD 9, no. 2 (May - June 1982): 6-12. 10 b & w. [Britt born in Obstalden, Switzerland on Mar. 11, 1819. Immigrated from Switzerland and was working as a daguerrean as early as 1847 in Highland, IL. Moved to Jacksonville, OR in 1852. Made portraits and landscape views until 1900. He made thousands of photographs, but a relatively small number of stereographs - most of those in the 1870s. Article includes a checklist of about ninety-one stereographs.]

BRITTON, W., JR.

B1831 "Collodio - Chloride on Paper." AMERICAN JOURNAL OF PHOTOGRAPHY AND THE ALLIED ARTS & SCIENCES n. s. vol. 8, no. 12 (Dec. 15, 1865): 286. [From "Photo. News."]

BROADAWAY, J. S. (GREENVILLE, SC)

B1832 "North Carolina. - Governor Wade Hampton Indorsing the Policy of President Hayes at a Meeting at Anderson Court House, March 27th. - From a Photograph by J. S. Broadaway." FRANK LESLIE'S ILLUSTRATED NEWSPAPER 46, no. 1177 (Apr. 20, 1878): 116. 1 illus. [Outdoor crowd scene, photographed from the speakers' platform at a fairly close range, therefore displaying a sense of presence not usual to this type of photo at this time.]

B1833 "Mr. Broadaway's New Gallery." ANTHONY'S PHOTOGRAPHIC BULLETIN 9, no. 7 (July 1878): 224. [Note that Broadaway opening gallery in Greenville, SC.]

B1834 "Note." PHOTOGRAPHIC TIMES 9, no. 101 (May 1879): 114. [Gallery lost by fire. (Name spelled Broadway here, but spelled Broadaway in two other sources.)]

BROADBENT & PHILLIPS. (PHILADELPHIA, PA)

B1835 "The Wedding at the White House. - Invited Guests Viewing, in the Library, the Bridal Presents to Miss Nellie Grant. - Sketched by Our Special Artist, and Photographed by Broadbent & Phillips." FRANK LESLIE'S ILLUSTRATED NEWSPAPER 38, no. 975 (June 6, 1874): 205. 1 illus. [Crowded interior view.]

B1836 Portrait. Woodcut engraving, credited "From a Photograph by Broadhead [sic Broadbent?] & Phillips, Philadelphia." FRANK LESLIE'S ILLUSTRATED NEWSPAPER 42, (1876) ["J. Donald Cameron, Sec. of War." 42:1081 (June 17, 1876): 237.]

B1837 Portrait. Woodcut engraving, credited "From a Photograph by Broadbent & Phillips." FRANK LESLIE'S ILLUSTRATED NEWSPAPER 48, (1879) ["John W. Hall, Gov. of DE." 47:1227 (Apr. 5, 1879): 77.]

BROADBENT, SAMUEL see also BROADBENT & PHILLIPS.

BROADBENT, SAMUEL. (1810-1880) (USA)

B1838 Portrait. Woodcut engraving, credited "From a photograph by Broadbent, of Philadelphia." HARPER'S WEEKLY 1, (1857)1 illus. ["William B. Reed, U.S. Commissioner to China." 1:23 (June 6, 1857): 357.]

B1839 "Independence Hall, Philadelphia, A.D. 1858." HARPER'S WEEKLY 2, no. 79 (July 3, 1858): 420. 3 illus. ["From a photograph by S. Broadbent."]

B1840 Portrait. Woodcut engraving, credited "From a Photograph by Samuel Broadbent." NEW YORK ILLUSTRATED NEWS 8, (1863) ["Maj.-Gen. Howard." 8:187 (May 30, 1863): 76.]

B1841 "Matters of the Month." PHOTOGRAPHIC TIMES 10, no. 116 (Aug. 1880): 179. ["Mr. Samuel Broadbent, the eminent photographer is dead. ... a veteran in our art, ... one of the "fathers" of photography.]

B1842 "Obituary - Mr. Samuel Broadbent." PHILADELPHIA PHOTOGRAPHER 17, no. 202 (Oct. 1880): 309-310. [Samuel Broadbent died July 24, 1880, in the seventieth year of his age. Born in Wethersfield, CT. Practiced miniature and portrait painting until introduced to the daguerreotype process by Samuel Morse. Broadbent became active, first in the South, then at Wilmington, DL, then, in 1850, in Philadelphia, PA, - where he remained until his death. The business of Broadbent & Taylor will continue, with S. W. Broadbent, already there for three years, and Mr. Taylor.]

BROCKETT, JOHN. (GREAT BRITAIN)

B1843 Brockett, John. "Notes on the Ferrogelatine Developer." HUMPHREY'S JOURNAL OF PHOTOGRAPHY, AND THE ALLIED ARTS AND SCIENCES. 17, no. 18 (Jan. 15, 1866): 286-287. [Read to North London Photo. Assoc.]

BRONK, EDWIN. (USA)

B1844 "Daguerreotype Movements." HUMPHREY'S JOURNAL 5, no. 11 (Sept. 15, 1853): 175. [Mr. Bronk, formerly the principal operator at Brady's establishment, has made such arrangements with Dobyns & Spaulding of St. Louis, [MO] as to take him from our city..." (Later worked in Winchester and Columbus, OH.)]

BROOKE, C.

B1845 Brooke, C. "British Association for the Advancement of Science - Nineteenth Meeting - Birmingham, September 12, 1849. Section B. - Chemistry. 'On an Improvement in the preparation of Photographic Paper.'" PRACTICAL MECHANIC'S JOURNAL 2, no. 23 (Feb. 1850): 261. [Excerpt of his report.]

BROOKS see CHUTE & BROOKS.

BROOKS, DR.

B1846 "St. Paul's Church, Mahe, Seychelles." ILLUSTRATED LONDON NEWS 43, no. 1220 (Sept. 5, 1863): 248. 1 illus. ["...from a photograph taken by Dr. Brooks, the Government medical officer in the islands."]

BROOKS, D. H. (GREENWOOD, ID)

B1847 Brooks, D. H. "The Browning of Silver Solutions. The Defects of Earthenware." AMERICAN JOURNAL OF PHOTOGRAPHY AND THE ALLIED ARTS & SCIENCES n. s. vol. 8, no. 1 (July 1, 1865): 22.

BROOKS, E. T.

B1848 Brooks, E. T. "Ornamental Borders around Photographs." AMERICAN JOURNAL OF PHOTOGRAPHY AND THE ALLIED ARTS & SCIENCES n. s. vol. 7, no. 15 (Feb. 1, 1865): 345-346. [From "Photo News."]

BROOKS, H. (SALISBURY, ENGLAND)

B1849 "Salisbury New Market." ILLUSTRATED LONDON NEWS 34, no. 979 (June 18, 1859): 588. 1 illus. ["A photograph by H. Brooks, of Salisbury." Interior.]

BROOKS, WILLIAM. (d. 1916) (GREAT BRITAIN)

B1850 Brooks, William. "Ten Years' Experience with the Lime Toning Bath." BRITISH JOURNAL PHOTOGRAPHIC ALMANAC 1874 (1874): 135-137.

B1851 Brooks, W. "Our Foreign Make-Up: On a Novel System of Masking, and the Production of Brilliant Prints from Weak Negatives." PHOTOGRAPHIC TIMES 5, no. 58 (Oct. 1875): 247-248. [Read before the South London Photographic Society.]

B1852 Brooks, William. "Copying." BRITISH JOURNAL PHOTOGRAPHIC ALMANAC 1877 (1877): 71-72.

B1853 Brooks, William. "On Photographing White Objects." BRITISH JOURNAL PHOTOGRAPHIC ALMANAC 1879 (1879): 88-90.

B1854 Brooks, William. "Subterranean Photography: The Caves at Reigate and How I Photographed Them." ANTHONY'S PHOTOGRAPHIC BULLETIN 10, no. 6-7 (June - July 1879): 168-170, 204-206. [From "Br J of Photo."]

B1855 "Interiors." PHOTOGRAPHIC TIMES 20, no. 470 (Sept. 19, 1890): 472-474. [From "British J. of Photography."]

B1856 "Obituary of the Year: William Brooks." BRITISH JOURNAL PHOTOGRAPHIC ALMANAC 1916 (1916): 417. [Professional photographer of Reigate, Surrey. Technical and scientific specialties. For many years organized the photo section of the exhibition of the Cornwall Photo. Society. Early user of gelatin dry plates and in 1878 photographed the caves at Reigate, using paraffin lamps. Contributed to the "BJP."]

BROTHERS, ALFRED. (1826-1912) (GREAT BRITAIN)
BOOKS

B1857 Brothers, Alfred. *Catalogue of Binary Stars; With Introductory Remarks.* London: Printed by Taylor & Francis, 1867. 204-230 pp. ["From the third volume of the third series of "Memoirs of the Literary and Philosophical Society of Manchester. Session 1865-66."]

B1858 Solly, Nathaniel Neal. *Memoir of the Life of David Cox.* With Selections from his Correspondence and Some Account of his Works.

London: Chapman & Hall, 1873. n. p. 12 b & w. 3 illus. [Twelve original photos, three artotypes of paintings by Cox. Photos are by A. Brothers and R. W. Thrupp.]

B1859 *Views of Old Manchester.* Manchester: A. Brothers, 1875. n. p. b & w.

B1860 *Views of Modern Manchester.* Manchester: A. Brothers, 1878. n. p. b & w.

B1861 Brothers, Alfred. *Photography: Its History, Processes, Apparatus, and Materials.* Comprising working details of all the more important methods. London: C. Griffin, 1892. xiii, 364 pp. 24 l. of plates. illus. [2nd ed. (1899) xviii, 367 p.]

B1862 Pegnato, Paul, L. G. *Alfred Brothers.* History of Photography Monograph Series, No. 14. Tempe, AZ: Arizona State University, School of Art, Spring, 1985. [16 pp.] 3 b & w. [Born in Sheerness, Kent, England in 1826. Lifelong interest in astronomy. Became a professional photographer in 1856, taking over Lachlan McLachlan's studio in Manchester. In 1861 began creating large composite group portraits. Photographs with magnesium lights, creating photographs underground in mines in 1864. In 1865 began photographing lunar and solar eclipses. In 1870's he produced several books illustrated by photo-lithography.]

PERIODICALS
B1863 "Fine-Art Gossip." ATHENAEUM no. 1743 (Mar. 22, 1861): 401. [A. Brothers' portrait (see p. 505) of officers of the 84th Regiment, sold by Agnew & Co., Manchester.]

B1864 "Note." JOURNAL OF THE PHOTOGRAPHIC SOCIETY OF LONDON 7, no. 108 (Apr. 15, 1861): 166. [Noted that a composite group photo of the Officers of the 84th Regiment published by Agnew & Co., Manchester.]

B1865 "Note." ART JOURNAL (May 1861): 152. [4' x 2' photo, of officers of 84th Regiment in Manchester.]

B1866 "Grouping Large Numbers." BRITISH JOURNAL OF PHOTOGRAPHY 8, no. 141 (May 1, 1861): 167-168. [Discussion of a composite, group portrait, taken by Mr. Brothers, of Manchester.]

B1867 "Commemorative Photograph, Illustrative of the Manchester Meeting (1861) of the British Association for the Advancement of Science, under the Presidency of William Fairbairn, Esq., LLD., F.R.S., &c., Designed and Photographed by A. Brothers, Manchester." BRITISH JOURNAL OF PHOTOGRAPHY 9, no. 172 (Aug. 15, 1862): 310.

B1868 "Fine Arts." ILLUSTRATED LONDON NEWS 41, no. 1162 (Sept. 6, 1862): 274. ["Mr. A. Brothers, of Manchester, has published a so-called photographic group commemorative of the British Association to Manchester last autumn." 22 portraits.]

B1869 "Note." ART JOURNAL (Sept. 1862): 195. [Group photo of the British Assoc. for Advancement of Science.]

B1870 "Fine-Art Gossip." ATHENAEUM no. 1825 (Oct. 18, 1862): 505. [Review of a group portrait of the British Assoc. for the Advancement of Science.]

B1871 "Electricians and Telegraphic Engineers. Messrs. Brothers & Co., Manchester." BRITISH JOURNAL OF PHOTOGRAPHY 10, no. 200 (Oct. 15, 1863): 405.

B1872 "Reviews: Group of telegraphic engineers and electricians, Photographed by A. Brothers." JOURNAL OF THE PHOTOGRAPHIC SOCIETY OF LONDON 8, no. 138 (Oct. 15, 1863): 380-381.

B1873 "Photographs by Magnesium Light." AMERICAN JOURNAL OF PHOTOGRAPHY AND THE ALLIED ARTS & SCIENCES n. s. vol. 7, no. 1 (July 1, 1864): 2-5.

B1874 Brothers, A. "Patent Sun-Blinds." BRITISH JOURNAL OF PHOTOGRAPHY 11, no. 222 (Aug. 5, 1864): 286-287. [Letter from Brothers, on a controversial issue at that time. Other letters, etc. published throughout the period. (Brothers sued for patent infringement.)]

B1875 Brothers, A. "Hints on Portraiture by the Magnesium Light." BRITISH JOURNAL OF PHOTOGRAPHY 11, no. 239 (Dec. 2, 1864): 483.

B1876 Brothers, Alfred. "On the Supposed Origin of the Daguerreotype Process." BRITISH JOURNAL OF PHOTOGRAPHY 12, no. 249 (Feb. 10, 1865): 73. [Daguerre was supposed to have seen some Greek manuscripts, written ca. A.D. 500, by a Panselenus, of Thessalonica.]

B1877 "Miscellanea: Photographs of the Eclipse of the Moon." BRITISH JOURNAL OF PHOTOGRAPHY 12, no. 284 (Oct. 13, 1865): 527. [Series of sixteen views of eclipse of the moon, by A. Brothers.]

B1878 "Our Editorial Table: Photographs of the Eclipse of the Moon, by A. Brothers, F.R.A.S., Manchester." BRITISH JOURNAL OF PHOTOGRAPHY 12, no. 286 (Oct. 27, 1865): 549.

B1879 Brothers, A. "Celestial Photography." BRITISH JOURNAL OF PHOTOGRAPHY 12, no. 294 (Dec. 22, 1865): 642-646. 1 illus. [Read before Photo. Section of the Literary and Philosophical Society of Manchester, Dec. 14, 1865. Includes a survey (slightly inaccurate) of the history of celestial photography, discussion of his own experiences.]

B1880 "Salad for the Photographer." PHILADELPHIA PHOTOGRAPHER 3, no. 25 (Jan. 1866): 29. [A. Brothers has produced a series of eighteen photos. of the late lunar eclipse.]

B1881 Portrait. Woodcut engraving credited "From a photograph by A. Brothers." ILLUSTRATED LONDON NEWS 65, (1874) ["W. R. Callender, member of Parliament." 65:1823 (Aug. 1, 1874): 105.]

B1882 Brothers, A., F.R.A.S. "Photography as Applied to Eclipse Observation." BRITISH JOURNAL PHOTOGRAPHIC ALMANAC 1876 (1876): 87-90.

B1883 "The Late Mr. Alfred Brothers." PENROSE'S PICTORIAL ANNUAL 1912-1913 (1913): 181-184. [Obituary.]

B1884 Hallett, Michael. "Origin of the Daguerreotype." BRITISH JOURNAL OF PHOTOGRAPHY 128, no. 49 (Dec. 4, 1981): 1246-1247. [Alfred Brothers claimed, in 1865, to have found a sixth century A. D. manuscript which described daguerreotypes.]

B1885 Hallett, Michael. "Brothers' Group Photograph." HISTORY OF PHOTOGRAPHY 9, no. 4 (Oct. - Dec. 1985): 317-318. 1 b & w. [Composite portrait of the British Association for the Advancement of Science in 1861. Author discusses O. G. Rejlander's earlier composite photographs as well.]

B1886 Hallett, Michael. "Early Magnesium Light Portraits." HISTORY OF PHOTOGRAPHY 10, no. 4 (Oct. - Dec. 1986): 299-301. 5 b & w. [Examples of portraits taken by Alfred Brothers in Manchester, England, in 1864.]

B1887 Joseph, Stephen F. "Alfred Brothers (1826-1912) and His Role in Photographic Publishing." HISTORY OF PHOTOGRAPHY 11, no. 1 (Jan. - Mar. 1987): 63-76. 7 b & w. 2 illus. [Brothers born in Sheerness, Kent, on Jan. 2, 1826. Father died while he was a child, and he apprenticed to a bookseller from age 13 to 16. In 1848 became a clerk to a firm of solicitors. In 1853 appointed secretary to an insurance company, and he learned photography then. Joined the Manchester Photographic Society. From late 1850s to 1895 operated a professional photo studio. Made photomechanical reproductions of old books, other illustrated books, and albums of photographs. In 1892 wrote "Photography, Its History, Processes, Apparatus and Materials." Retired in 1901. Died Aug. 25, 1912.]

BROUGHAM, HENRY PETER. (1778-1860) (GREAT BRITAIN)
BOOKS
B1888 Brougham, Henry. *The Life and Times of Henry, Lord Brougham,* written by himself. Edinburgh: Blackwood & Sons, 1871. 3 vols.

PERIODICALS
B1889 Boland, John F. "Lord Brougham: The Inventor of Photography? Henry Peter Brougham 1778 - 1868." NORTHLIGHT no. 7 (Nov. 1977): 64-68. 1 b & w. [Henry Peter Brougham, Baron Brougham and Vaux, was born in Edinburgh in 1778. Entered the University of Edinburgh in 1792, and excelled in mathematics and physics. At sixteen he wrote a paper on the refraction of light, and in 1796 he wrote a paper "Experiments and Observations on Light," where he suggested forming a permanent image from an image obtained with a camera obscura by using ivory rubbed with nitrate of silver. However this suggestion was not published, nor was it, in itself, necessarily practical. Brougam himself had many other interests and he did not pursue the idea.]

BROWN & TROXEL. (USA)
B1890 Edwards, Richard. *Edward's Great West and Her Commercial Metropolis, Embracing a General View of the West and a Complete History of St. Louis, from the Landing of Ligueste, in 1764, to the Present Time; with Portraits and Biographies of Some of the Old Settlers, and Many of the Most Prominent business Men,* by Richard Edwards and M. Hopewell. St. Louis: Published at the office of "Edwards' Monthly.", 1860. 604 pp. illus. [Illustrated with engravings made from photos by Brown & Troxel.]

BROWN. (LESLIE, MI)
B1891 "Note." ANTHONY'S PHOTOGRAPHIC BULLETIN 8, no. 1 (Jan. 1877): 5. [A Mr. & Mrs. Brown (Leslie, MI) built two 18'x7' cars, for a travelling photo studio. One car as reception room, the second for operating.]

BROWN. (CONCORD, NH)
B1892 Portrait. Woodcut engraving, credited "Daguerreotyped by Brown, of Concord, NH." HARPER'S WEEKLY 1, (1857) ["Hon. William Haile, Gov. of NH." 1:22 (May 30, 1857): 337.]

BROWN, A., LIEUT. (GREAT BRITAIN, INDIA)
B1893 "The Bhurtpoor Gun." ILLUSTRATED LONDON NEWS 38, no. 1070 (Jan. 19, 1861): 66. 1 illus. ["From a photograph by Lieut. A. Brown, R.A."]

BROWN, A. J. (HALSTED, ENGLAND)
B1894 Forster, Reverend Charles. *Sinai Photographed, or Contemporary Records of Israel in the Wilderness.* London: Richard Bentley, 1862. xx, 352 pp. 16 l. of plates. 19 b & w. 7 illus. [Original photographs by A. J. Brown, and lithographs by Day & Son.]

BROWN, ARTHUR. (GREAT BRITAIN)
B1895 Tennyson, Alfred Lord. *Tennyson's Brook; Illustrated by Arthur Brown, with Photographic Views Taken at Saltburn-by-the-Sea.* Newcastle-on-Tyne: A. Brown, 1879. 4 pp. 13 l. of plates. [Photomechanical prints, from photos by Arthur Brown. There may be an earlier edition (1864), with original photographs.]

BROWN, D. (GREAT BRITAIN)
B1896 Brown, D. "On the Collodion Process: Its Pursuit under Difficulties." BRITISH JOURNAL OF PHOTOGRAPHY 8, no. 141 (May 1, 1861): 166-167. [Brown, a member of the City of Glasgow and West of Scotland Photo. Society, reminisces of his amateur experiences photographing from 1848 to the present - including his difficulties.]

B1897 Brown, D. "On the Collodion Process: its Pursuit under Difficulties." HUMPHREY'S JOURNAL OF PHOTOGRAPHY, AND THE ALLIED ARTS AND SCIENCES 13, no. 4 (June 15, 1861): 53-56. [Read to City of Glasgow and West of Scotland Photo. Soc. From "Br. J. of Photo." Brown states that he began photography in 1848, then describes the many experiences he went through learning and using the various processes.]

BROWN, ELIPHALET, JR. (1816-1886) (USA)
[Born in Newburyport, MA in 1816. Artist and lithographer. Made lithographs for Currier & Ives from 1839 to 1845, and later. Worked for others, and also published his own prints. Apparently also worked as a daguerreotypist, in New York, NY in the early 1850s. Was the daguerreotypist and artist on Commodore Perry's expedition to Japan from 1852-1854. Claims to have taken over 400 pictures on this expedition. Lithographs drawn from the daguerreotypes were subsequently used to illustrate Hawks' book of the expedition and as separate lithographic prints published later. Brown was employed by the Navy until 1875. Died in New York, NY on Jan. 23, 1886.]

BOOKS
B1898 Hawks, Francis L. *Narrative of the Expedition of an American Squadron to the China Seas and Japan,* Performed in the years 1852, 1853, and 1854, under the command of Commodore M. C. Perry, U. S. Navy, by order of the government of the U. S. Compiled from the original notes and journals of Commodore Perry by Francis L. Hawks. Washington, DC: Nicholson, Printer, 1856. 3 vol. illus. [Illustrated with lithographs made after Brown's daguerreotypes. 33rd Congress. 2nd Session. H. of R. Ex. Doc. No. 97.]

PERIODICALS
B1899 Portrait. Woodcut engraving, credited "From a Daguerreotype by Brown." ILLUSTRATED NEWS (NY) 1, (1853) ["Commodore Perry, U.S.N., Commander of the Japan Expedition." 1:2 (Jan. 8, 1853): 28.]

B1900 "Commodore Perry's Expedition to Japan." HARPER'S MONTHLY 12, no. 70, 72 (Mar., May 1856): 441-466, 733-756. 27 illus. [Views, portraits, natives. Engravings, some probably from photographs by E. Brown. "Temple at Tumai, Loo-Choo," on p. 452 depicts a photographer posing a group of Japanese in front of his camera. Studio portrait of Commodore Perry is credited "from a photograph by Brady."]

B1901 "Characteristics of Japan. - The United States' Expedition." ILLUSTRATED LONDON NEWS 29, no. 834 (Dec. 13, 1856): 590-591. 3 illus. [Bk. rev.: "Narrative of Commodore Perry's recent Expedition to the China Seas and Japan,"...edited by Dr. Francis Hawk. Illustrated with two portraits, from the daguerreotype, and a sketch by a Japanese artist.]

B1902 "Com. Perry's Expedition to Japan." FRANK LESLIE'S ILLUSTRATED NEWSPAPER 3, no. 57-58 (Jan. 10 - Jan. 17, 1857): 84-85, 100-101. 10 illus. [Book review and excerpt. From: "Narrative of the Expedition of an American Squadron to the Chinese Seas and Japan,..." compiled by Francis L. Hawks. The illustrations are portraits and views, most are probably not from Brown's daguerreotypes.]

B1903 "Our Japanese Visitors." FRANK LESLIE'S ILLUSTRATED NEWSPAPER 9, no. 234 (May 26, 1860): 402-404, 406, 410, 411. 7 illus. [Woodcut illus., of the ship bearing the ambassadors, of the embassy aboard the ship, etc. These were accompanied with illus. of Perry's expedition to Japan, including portraits of a priest and of a woman, credited "From a Photograph by Brown," as well as some non-credited views, etc.]

B1904 "East Meets West." HISTORY OF PHOTOGRAPHY 9, no. 4 (Oct. - Dec. 1985): 266. 1 illus. [Lithograph of an American daguerreotyping American sailors in Japan, published by Ackerman in New York City, from a drawing by Heine, Figures by Brown, in 1854.]

BROWN, FREDERICK. (WALSALL, GREAT BRITAIN)
B1905 "Photography Underground." ANTHONY'S PHOTOGRAPHIC BULLETIN 8, no. 1 (Jan. 1877): 13. [From "Birmingham (England) Post." Brown (Walsall, England) photographed at the Bradford Colliery (Bentley, England).]

B1906 "Photography In a Coal-Mine." PHOTOGRAPHIC TIMES 7, no. 73 (Jan. 1877): 9. [From "Birmingham [England] Post." Photographed underground in the Bradford Colliery, Bently, to provide evidence in a law suit.]

BROWN, G. W. (USA)
B1907 Brown, G. W. "How to Restore Yellow Prints." AMERICAN JOURNAL OF PHOTOGRAPHY AND THE ALLIED ARTS & SCIENCES n. s. vol. 7, no. 9 (Nov. 1, 1864): 213-214. [Brown's address given as Paola, KS.]

B1908 Brown, G. W. "Correspondence." PHILADELPHIA PHOTOGRAPHER 2, no. 21 (Sept. 1865): 147-148. [Letter from G. W. Brown, who had just purchased a gallery in Rockford, IL, describing his experiences and concerns.]

BROWN, GEORGE O. (BALTIMORE, MD)
B1909 "Editor's Table." PHILADELPHIA PHOTOGRAPHER 5, no. 54 (June 1868): 215-216. [Stereo views of fish skeletons, groups of wild game. Photographed at the Army Medical Museum.]

B1910 "Editor's Table." PHILADELPHIA PHOTOGRAPHER 5, no. 59 (Nov. 1868): 410. [The National Union; A. F. Styles (Burlington, VT); G. O. Brown (Baltimore, MD)]

B1911 Brown, George O. "Errors in the Study and Practice of Photography." PHILADELPHIA PHOTOGRAPHER 10, no. 110, 113 (Feb., Apr. 1873): 56-57, 110-111.

BROWN, J. (RHYL, ENGLAND)
B1912 Portrait. Woodcut engraving credited "From a photograph by J. Brown, of Rhyl." ILLUSTRATED LONDON NEWS 56, (1870) ["Right Rev. Joshua Hughes, D.D." 56:* (Apr. 30, 1870): 449.]

BROWN, J. B. (MILLVILLE, NJ)
B1913 "Editor's Table." PHILADELPHIA PHOTOGRAPHER 3, no. 32 (Aug. 1866): 255. [Erecting new gallery.]

BROWN, J. J. (USA)
B1914 Brown, J. J., Dr. "The Nitrate Bath and its Treatment." HUMPHREY'S JOURNAL OF PHOTOGRAPHY, AND THE ALLIED ARTS AND SCIENCES 18, no. 3,8 (June 1, Aug. 15, 1866): 40-41, 116-117.

B1915 Brown, J. J. "Ferro-Collodial Developers." HUMPHREY'S JOURNAL OF PHOTOGRAPHY, AND THE ALLIED ARTS AND SCIENCES 19, no. 12 (Oct. 15, 1867): 188-189.

B1916 Brown, Prof. J. J., A.M. "Carbon Photography." ANTHONY'S PHOTOGRAPHIC BULLETIN 8, no. 4 (Apr. 1877): 108-109. [From "Syracuse N. Y. Christian Advocate."]

BROWN, J. T. (GREAT BRITAIN)
B1917 Brown, J. T. "On the Application of Photography to Art and Art Purposes, but more particularly to architecture." HUMPHREY'S JOURNAL OF PHOTOGRAPHY, AND THE ALLIED ARTS AND SCIENCES 9, no. 21 (Mar. 1, 1858): 334-336, 342-350, 359-361. [Read to meeting of the Birmingham Photo. Soc.]

B1918 "Birmingham Photographic Society. General Meeting Sept. 27, 1859." PHOTOGRAPHIC AND FINE ART JOURNAL 13, no. 2 (Feb. 1860): 47-51. [J. T. Brown's paper "On the Application of Photography to Art and Art Purposes, but more especially to Painting."]

B1919 Brown, J. T., Jr. "Art - Photography." BRITISH JOURNAL OF PHOTOGRAPHY 8, no. 138 (Mar. 15, 1861): 103-104.

BROWN, JAMES A. (1819-) (USA)
B1920 "The Anthony Prize Pitcher." PHOTOGRAPHIC AND FINE ART JOURNAL 7, no. 1 (Jan. 1854): 6-11. [Letter describing Brown's process on p. 10. (Brown worked for Brady in 1840s, ran his own gallery in New York, NY 1848-54.)]

BROWN, JOSIAH. (ca. 1829-1874) (USA)
B1921 "Editor's Table - Obituary Notice." PHILADELPHIA PHOTOGRAPHER 11, no. 126 (June 1874): 191. [Josiah Brown, of East Mauch Chunk, NY, died on April 26, 1874, at forty-five years of age. One of the earliest photographers in the Lehigh Valley, with a studio in Mauch Chunk for nearly twenty years.]

BROWN, NICHOLAS & SONS. (ST. LOUIS, MO)
[Nicholas Brown was born in VT ca. 1830. He may have worked for Mathew Brady in New York City in the early 1850s, and he did work for James Fitzgibbon in St. Louis in the late 1850s. From 1859 to 1866 Nicholas Brown & Sons (William Henry and John) operated a studio in St. Louis. In 1866 the family moved to Santa Fe, NM and ran a studio there until at least 1869. They opened a second studio in Chihuahua, Mexico in 1867 or 1868 which operated until around 1871. The Brown family took photographs of the Apache, Navaho, and Taos Indians during this period.]

B1922 Portrait. Woodcut engraving, credited "From a Photograph by N. Brown & Sons. HARPER'S WEEKLY 10, (1866) ["Charlie Decker, smallest man living." 10:471 (Jan. 6, 1866): 13.]

BROWN, RICHARD. (d. 1889) (GREAT BRITAIN)

B1923 Brown, Richard. "How I Nearly Became a 'Great Inventor.'" BRITISH JOURNAL PHOTOGRAPHIC ALMANAC 1874 (1874): 76-78.

B1924 "A New Effect in Portraiture. The Mezzotint Vignette." ANTHONY'S PHOTOGRAPHIC BULLETIN 7, no. 8 (Aug. 1876): 235-236. [From "Br. J. of Photo." Richard Brown of Liverpool (formerly of Vandyke & Brown, now Brown & Barnes) introduces a new printing style.]

BROWN, T. (GREAT BRITAIN)

B1925 "The Great Breakwater at Holyhead." ILLUSTRATED LONDON NEWS 46, no. 1306 (Mar. 18, 1865): 252-253. 1 illus. ["The view presented in our Engraving is from a photograph taken by Mr. T. Brown."]

BROWN, T. W. (AUBURN, NY)

B1926 "Bloomerism. - New Costume for Ladies." ILLUSTRATED LONDON NEWS 19, no. 517 (Sept. 27, 1851): 395-396. 1 illus. ["The accompanying portrait is copied from the Sept. number of the "Lily," where it is stated to be from a Daguerreotype, taken by T. W. Brown, Auburn, NY." Of Mrs. Amelia Bloomer, editor of the "Lily" and advocate of pants for women.]

BROWN, W. (ROCKFORD, IL)

B1927 Brown, W. "Alum a Source of Fading." AMERICAN JOURNAL OF PHOTOGRAPHY AND THE ALLIED ARTS & SCIENCES n. s. vol. 8, no. 15 (Feb. 1, 1866): 348-349.

BROWN, WILLIAM HENRY. (d. 1886) (USA)

[William Henry Brown was the son of Nicholas Brown. He was also one of two photographers with the same name to operate studios in St. Louis in the 1860s. William H. moved with the rest of the family to Santa Fe, NM in 1866, then he opened and operated the family's branch studio in Chihuahua, Mexico. He returned to Santa Fe in 1869. He operated other studios (possibly in Minneapolis, MN in the 1870s), in Parral, Mexico in the 1880s, and in El Paso, TX in 1885. He died in El Paso on Dec. 19, 1886.]

B1928 Catalogue of Stereoscopic and Large Views of New Mexico Scenery. Photographed and Published by W. Henry Brown, Santa Fe, New Mexico. Santa Fe, MN: W. Henry Brown, 1879. 14 pp. [Lists 150 views.]

BROWN, W. J. (MACON, GA)

B1929 "John G. Eckman's Locomotive. - Photographed by W. J. Brown, Macon, Ga." FRANK LESLIE'S ILLUSTRATED NEWSPAPER 41, no. 1048 (Oct. 30, 1875): 125. 1 illus.

BROWNE, J. C., REV. (GREAT BRITAIN)

B1930 Browne, Rev. J. C., M.A. Emmanuel College, Cambridge. "Tour Through Melrose, Fountains, North Wales &c." BRITISH JOURNAL OF PHOTOGRAPHY 10, no. 195 (Aug. 1, 1863): 305-306.

B1931 Browne, J. C., Rev., M.A. "Tannin Process." HUMPHREY'S JOURNAL OF PHOTOGRAPHY, AND THE ALLIED ARTS AND SCIENCES 15, no. 10 (Sept. 15, 1863): 153-154. [From "Br. J. of Photo."]

BROWNE, JOHN COATES. (1838-1918) (USA)

[Born in Philadelphia. Manager of the Episcopal Hospital there. Collected minerals, prints, and broadsides. Active amateur photographer from the early 1860s and author of many articles, some signed "B. C. J." Took many trips to make landscape views, and travelled to the western frontier (Kansas) in 1867, but may not have made photographs of that trip. Member of the Amateur Photographic Club in 1850s. President of the Philadelphia Photographic Society in 1870s.]

BOOKS

B1932 Browne, John C. History of the Photographic Society of Philadelphia: Organized November 26, 1862: A Paper read before the Photographic Society, December 5, 1883. Philadelphia: Published by order of the Society, 1884. 36 pp.

PERIODICALS

B1933 Morton, Dr. "Our Picture - Tacony Creek Near Cheltenham, Pa." PHILADELPHIA PHOTOGRAPHER 2, no. 15 (Mar. 1865): frontispiece, 47-48. 1 b & w. [Includes a description of the scene of the photograph.]

B1934 "Our Picture - Study from Nature on Tacony Creek." PHILADELPHIA PHOTOGRAPHER 2, no. 16 (Apr. 1865): frontispiece, 64. 1 b & w.

B1935 "Our Picture - The Falls of Melsingah." PHILADELPHIA PHOTOGRAPHER 2, no. 17 (May 1865): frontispiece, 82-84. 1 b & w.

B1936 Morton, Rev. H. J. "Our Picture - Crumb Creek." PHILADELPHIA PHOTOGRAPHER 2, no. 20 (Aug. 1865): frontispiece, 137. 1 b & w.

B1937 "Our Picture - Portrait of Major-Generals Anderson & Burnside on Front Porch." PHILADELPHIA PHOTOGRAPHER 2, no. 23 (Nov. 1865): frontispiece, 186. 1 b & w.

B1938 Wilson, Edward L. "Photographing By Magnesium Light." PHILADELPHIA PHOTOGRAPHER 2, no. 24 (Dec. 1865): 189-190.

B1939 Browne, John C. "Trial of Lenses." PHILADELPHIA PHOTOGRAPHER 2, no. 24 (Dec. 1865): 197-198. [Discusses testing lenses for landscapes, actually gives much of his past working history and methods.]

B1940 "Our Picture." PHILADELPHIA PHOTOGRAPHER 3, no. 25 (Jan. 1866): frontispiece, 28-29. 1 b & w. [Interior group portrait made with magnesium light. Browne was an amateur photographer from Philadelphia, PA.]

B1941 Browne, John C. "More About Magnesium." PHILADELPHIA PHOTOGRAPHER 3, no. 27 (Mar. 1866): 85-86.

B1942 Brown [sic Browne], J. C. and Hugh Davis. "Experiments with Mr. M. Carey Lea's Collo-Developer." HUMPHREY'S JOURNAL OF PHOTOGRAPHY, AND THE ALLIED ARTS AND SCIENCES 18, no. 7 (Aug. 1, 1866): 107-109. [Read before the Philadelphia Photo. Soc.]

B1943 Morton, Rev. H. J., D.D. "Instantaneous Photography." PHILADELPHIA PHOTOGRAPHER 3, no. 35 (Nov. 1866): 332-334. [Describes Browne's activities, photographing along the Delaware River, near Philadelphia, PA.]

B1944 "Our Picture - Landscape Study." PHILADELPHIA PHOTOGRAPHER 3, no. 34 (Oct. 1866): frontispiece, 316-317. 1 b & w. [Negative by J. C. Browne, positive print by Hugh Davids.]

B1945 Morton, Rev. H. J., D.D. "Instantaneous Photography." PHILADELPHIA PHOTOGRAPHER 3, no. 35 (Nov. 1866): 332-334.

B1946 Browne, J. C. "Glass Positives." PHILADELPHIA PHOTOGRAPHER 4, no. 37 (Jan. 1867): 9-11.

B1947 "Our Pictures - Instantaneous Marine Views." PHILADELPHIA PHOTOGRAPHER 4, no. 38 (Feb. 1867): frontispiece, 60-62. 1 b & w. [Sailboats on the Delaware River. Article includes Browne's working formulas, procedures.]

B1948 Browne, John C. "The Zentmeyer Lens." PHILADELPHIA PHOTOGRAPHER 4, no. 39 (Mar. 1867): 80-81.

B1949 Browne, J. C. "A Photographer among the Prairie Dogs and Buffaloes." PHILADELPHIA PHOTOGRAPHER 4, no. 40 (Apr. 1867): 106-108. [Browne describes his experiences during a buffalo hunt, during a trip West. States he didn't have time to take photographs.]

B1950 Browne, John C. "Photography on the Plains. Engineer's Camp. Smokey Hill River near Salina, Kansas." PHILADELPHIA PHOTOGRAPHER 4, no. 44 (Aug. 1867): 266-268. [States that the photographer of the railroad survey party will be the Englishman, Dr. Bell. Browne was travelling through KS during this period, but it isn't clear if he actually took photographs on the trip.]

B1951 Browne, J. C. "Dark Tents." PHILADELPHIA PHOTOGRAPHER 5, no. 51 (Mar. 1868): 76-77. [Technical article.]

B1952 Browne, John C. "Redevelopment by Nitrate of Silver and Citric Acid." HUMPHREY'S JOURNAL OF PHOTOGRAPHY, AND THE ALLIED ARTS AND SCIENCES 20, no. 3 (June 1, 1868): 41-42. [Read to Photo. Soc. of Philadelphia.]

B1953 Browne, John C. "Enlargement of Small Landscape Negatives by the Solar Camera." PHILADELPHIA PHOTOGRAPHER 6, no. 65 (May 1869): 148. [Read before the Photo. Soc. of Phila. Apr. 7, 1869.]

B1954 Browne, John C. "Glass Positives for the Magic Lantern." PHILADELPHIA PHOTOGRAPHER 6, no. 68 (Aug. 1869): 276-279.

B1955 Browne, John C. "Comets." PHILADELPHIA PHOTOGRAPHER 6, no. 72 (Dec. 1869): 390. [Scratches on negatives.]

B1956 Browne, John C. "After-Intensification of Portrait and Landscape Negatives." PHILADELPHIA PHOTOGRAPHER 7, no. 75 (Mar. 1870): 72.

B1957 Morton, Rev. H. J. "Our Picture." PHILADELPHIA PHOTOGRAPHER 8, no. 87 (Mar. 1871): frontispiece, 93-94. 6 b & w. [Old mill, Germantown, PA. Additional discussion of the photo on pp. 125-126.]

B1958 Browne, John C. "A Suggestion for Mounting Glass Positives." PHILADELPHIA PHOTOGRAPHER 8, no. 89 (May 1871): 130-131.

B1959 Browne, John C. "A Rapid Exposing Shutter." PHILADELPHIA PHOTOGRAPHER 8, no. 90 (June 1871): 162-163. 1 illus.

B1960 "Our Picture - Sunshine & Shadow by J. C. Browne. Commentary by Rev. H. J. Morton, D.D." PHILADELPHIA PHOTOGRAPHER 8, no. 96 (Dec. 1871): frontispiece, 389-391. [Landscape.]

B1961 Browne, J. C. "Fourth Annual Meeting and Exhibition of the N.P.A. in St. Louis, Mo., May 1982: Landscape Photography." PHILADELPHIA PHOTOGRAPHER 9, no. 102 (June 1872): 173-174.

B1962 Browne, John C. "Photographic Excursion to Glen Onoko." PHILADELPHIA PHOTOGRAPHER 12, no. 139 (July 1875): 216-219.

B1963 Browne, John C. "Letter." PHILADELPHIA PHOTOGRAPHER 12, no. 140 (Aug. 1875): 228-229. [About the Photo. Soc. of Phila.]

B1964 Browne, John C. "The Waterfalls of Pike County, Pa." PHILADELPHIA PHOTOGRAPHER 13, no. 151 (July 1876): 208-211.

B1965 "Editor's Table." PHILADELPHIA PHOTOGRAPHER 14, no. 162 (June 1877): 192. [J. C. Browne, President of the Photo. Soc. of Philadelphia, PA., spending several weeks in the mountains of northeastern PA.]

B1966 Browne, John C. "Washed Emulsion." PHILADELPHIA PHOTOGRAPHER 14, no. 163 (July 1877): 195-196.

B1967 B. C. J. (Browne, John C.) "Excursion of the Photographic Society of Philadelphia." PHILADELPHIA PHOTOGRAPHER 14, no. 164 (Aug. 1877): 229-232.

B1968 Nichol, John, PH.D. "Transatlantic Notes." ANTHONY'S PHOTOGRAPHIC BULLETIN 9, no. 9 (Sept. 1878): 272-275. [From "Br J of Photo." Nichol, from England, visited the USA, gave his impressions. Here he describes his experiences in Philadelphia, where he met the amateurs Browne and Ellerslie Wallace. Discusses the professional, F. Gutekunst.]

B1969 "Matters of the Month." PHOTOGRAPHIC TIMES 12, no. 134 (Feb. 1882): 59. [Letter praising Carbutt's Keystone Dry Plates by John C. Browne, Philadelphia, stating that he was able to take exposures of one-fortieth of a second, with "results that are superior to the best wet collodion work that I have ever made in the past twenty years..."]

BROWNRIGG, THOMAS MARCUS. (ca. 1824-1901) (GREAT BRITAIN)
B1970 "Photographic Society of Ireland." JOURNAL OF THE PHOTOGRAPHIC SOCIETY OF LONDON 5, no. 85 (May 7, 1859): 282-284. [Thomas Brownrigg's paper "Remarks on Landscape Photography."]

B1971 Brownrigg, T. M. "On Method in Photography." BRITISH JOURNAL PHOTOGRAPHIC ALMANAC 1876 (1876): 124-125.

BRUBAKER & BROTHER. (HOUGHTON, MI)
B1972 "Editor's Table." PHILADELPHIA PHOTOGRAPHER 4, no. 42 (June 1867): 194. [Messrs. Brubaker & Brother, Houghton, MI, had sent whole plate views of silver mines.]

BRUCE, GEORGE.
B1973 Bruce, George. "Instantaneous Photography." BRITISH JOURNAL PHOTOGRAPHIC ALMANAC 1876 (1876): 170-171.

BRUCE, JOSIAH see also NOTMAN & FRASER.

BRUCE, JOSIAH. (CANADA)
B1974 Bruce, Josiah. "Our Profession. " PHOTOGRAPHIC WORLD 1, no. 3-4 (Mar. - Apr. 1871): 88-89, 114-116. [Paper read before the Photographic Society of Toronto by Josiah Bruce, operator with Messrs. Notman and Fraser.]

BRUCE, N. W. (LOCKPORT, NY)
B1975 "Four Volunteers of Capt. W. H. Bush's Company, of Lockport, N.Y., Who Were Drummed Out for Refusing to Take the Oath of Allegiance to the Federal Government." NEW YORK ILLUSTRATED NEWS 4, no. 86 (June 29, 1861): 124. 1 illus. ["From a photograph by N. W. Bruce, of Lockport, 'NY."]

BRUCE, R. & CO. (DUBUQUE, IA)
B1976 1 illustration (Portrait of James L. Langworthy, of Dubuque, IA). CHICAGO MAGAZINE 1, no. 3 (May 1857): unnumbered leaf, before p. 255. [Woodcut credited "Amb. by Bruce & Co." There is also an advertisement for "R. Bruce & Co., Ambrotype and Daguerreian Rooms, Dubuque, Iowa" on an unnumbered page in the "Advertising Department" following p. 276 in the same issue.]

BRUCKMAN, F. (LONDON, ENGLAND)
B1977 Portrait. Woodcut engraving credited "From a photograph by F. Bruckman, Henrietta St., Convent Garden." ILLUSTRATED LONDON NEWS 64, (1874) ["Late Wilhelm von Kaulbach." 64:1811 (May 9, 1874): 440.]

BRUNTON, H.
B1978 Brunton, H. "Developer for Positives." HUMPHREY'S JOURNAL OF PHOTOGRAPHY, AND THE ALLIED ARTS AND SCIENCES 11, no. 11 (Oct. 1, 1859): 164-165. [From "Photo. Notes."]

BRUTON & BARNARD. (CAPE TOWN, SOUTH AFRICA)
B1979 "Parliament House, Cape Town." ILLUSTRATED LONDON NEWS 68, no. 1919 (May 6, 1876): 452. 1 illus. [James Edward Bruton was born in Port Elizabeth, of British parents. Had photographic studios from 1858 to 1874, first at Port Elizabeth, then in Cape Town. Moved to Douglas, Isle of Man, in the 1890s.]

BRUTON, JAMES EDWARD. (1838-1918) (SOUTH AFRICA) see BRUTON & BARNARD.

BRYAN, C. M.
B1980 Bryan, C. M. "Arrangement of Light in Galleries." HUMPHREY'S JOURNAL OF PHOTOGRAPHY, AND THE ALLIED ARTS AND SCIENCES 15, no. 22 (Mar. 15, 1864): 342-343. [Letter from Bryan, with a reply by Towler.]

BRYANS, WILLIAM.
B1981 Bryans, William. *Antiquities of Cheshire in Photograph, with short descriptive notes to which are added Views of Several Ancient Building in Shropshire and North Wales.* Chester: Hugh Roberts, 1858. n. p. 25 b & w. [Original photographs, by the author.]

BUCHTEL & STOLTE. (PORTLAND, OR)
B1982 "Oregon. - Remains of the Late General Canby Lying in State at the Armory in Portland." and "Oregon. - The Funeral of the Late General Canby - The Cortege, after leaving the Armory,.. - From Photographs by Buchtel & Stolte, of Portland, Oregon." FRANK LESLIE'S ILLUSTRATED NEWSPAPER 36, no. 921 (May 24, 1873): 172. 2 illus. [Interior and exterior views.]

BUCHTEL, JOSEPH (1830-1916) (USA) see BUCHTEL & STOLKE.

BUCKLE, SAMUEL. (ca. 1819-1860) (GREAT BRITAIN)
BOOKS
B1983 Buckle, Samuel. *Calotype Pictures.* Peterborough: Samuel Buckle, 1853. 2 pp. 30 l. of plates. 30 b & w. [Calotypes.]

PERIODICALS
B1984 "Obituary." BRITISH JOURNAL OF PHOTOGRAPHY. 7, no. 120 (June 15, 1860): 183. [Brief note and biography. Buckle died May 29th, age 51. Leamington, England, formerly at Peterborough. Worked the Talbotype process, and did much work during the Great Exhibition in 1851. Helped form the Photographic Society. Never took up new processes and abandoned photography several years before his death.]

BUCKMAN. (DOVER, ENGLAND)
B1985 "Houses Destroyed at Dover by the Fall of a Cliff." ILLUSTRATED LONDON NEWS 61, no. 1735 (Dec. 7, 1872): 541. 1 illus.

BUEHMAN, HENRY see also HISTORY: USA: AZ: 19TH C. (Hooper).

BUEHMAN, HENRY. (1851-1912) (GERMANY, USA)
BOOKS
B1986 Buehman, Estelle M. *Old Tucson: A Hop, Skip and Jump History from 1539.* Tucson: Consolidated Publishing Co., 1911. n. p. illus.

PERIODICALS
B1987 "Graphic Arts on the Arizona Frontier: Mining in Arizona. Part 1." JOURNAL OF ARIZONA HISTORY 11, no. 1 (Spring 1970): 23-31. 13 b & w. [Photos by Henry Buehman and others.]

B1988 "Graphic Arts on the Arizona Frontier: Mining in Arizona. Part 2." JOURNAL OF ARIZONA HISTORY 11, no. 2 (Summer 1970): 115-125. 15 b & w. [1870s to 1900, photos of mines and mining by Henry and Albert Buckman.]

B1989 Peterson, Thomas H., Jr. "Graphic Arts On the Arizona Frontier: A Tour of Tucson - 1874." JOURNAL OF ARIZONA HISTORY 11, no. 3 (Autumn 1970): 179-201. 20 b & w. [Views of buildings, etc. taken in 1874.]

B1990 Hatch, Heather S. "Graphic Arts on the Arizona Frontier: Railroad Stations and Roundhouses." JOURNAL OF ARIZONA HISTORY 12, no. 2 (Summer 1971): 101-111. 13 b & w. [1880's views, from the Henry & Albert Buehman Memorial Collection, Arizona Pioneer's Historical Society.]

B1991 Evans, Susan. "Henry Buehman, Tucson Photographer 1874 - 1912." HISTORY OF PHOTOGRAPHY 5, no. 1 (Jan. 1981): 59-81. 30 b & w. 5 illus. [Born in Bremen, Germany, May 14, 1851. To USA at age seventeen. To San Francisco, CA, where he worked in a photography studio, then to Visalia, CA, where he opened his own studio, which he ran there for two years. Then he travelled throughout CA., NV, UT. In 1874 he went to Tucson, AZ. Worked there as a photographer, dentist, miner, land speculator, rancher, cattleman and public official for nearly forty years, and made 65,000 negatives. Article includes brief survey of early photography in Tucson.]

B1992 Cooper, Evelyn S. "The Buehman's of Tucson. A Family Tradition in Arizona Photography." JOURNAL OF ARIZONA HISTORY 30, no. 3 (Autumn 1989): 251-278. 10 b & w. 5 illus. [Henry Buehman, from Bremen, Germany, opened a portrait studio in Tucson, AZ in 1874. His son Albert joined the establishment in 1913, and his grandson Remick joined the family business in 1946.]

BUEL, VIRGIL. (LITCHFIELD, CT.)
B1993 Buel, Virgil. "Reddening of the Printing Bath." AMERICAN JOURNAL OF PHOTOGRAPHY AND THE ALLIED ARTS & SCIENCES n. s. vol. 6, no. 5 (Sept. 1, 1863): 115.

BUELL. (PITTSFIELD, MA)
B1994 "The Dedication of the Soldier's Monument at Stockbridge, Mass., on Wednesday, Oct. 17th. - From a Photograph by Buell, of Pittsfield, Mass." FRANK LESLIE'S ILLUSTRATED NEWSPAPER 23, no. 580 (Nov. 10, 1866): 121. 1 illus. [View, with crowd.]

BUELL, C. E. see WALKER, L. E.

BULLOCK, S. (USA)
B1995 "Christ Church, Binghampton, N. Y. The late Rev. Charles H. Platt, Pastor. - From a Photograph by S. Bullock." FRANK LESLIE'S ILLUSTRATED NEWSPAPER 28, no. 709 (May 1, 1869): 108. 2 illus. [View. Portrait.]

BUNDY see also BURROWS & BUNDY.

BUNDY & WILLIAMS. (NEW HAVEN, CT)
B1996 Portrait. Woodcut engraving, credited "From a Photograph by Bundy & Williams, Middletown, CT." NEW YORK ILLUSTRATED NEWS 4, (1861) ["Rev. S. Herbert Lancey, Chaplain of the 2nd Reg. CT Volunteers." 4:95 (Aug. 26, 1861): 268.]

B1997 Portrait. Woodcut engraving, credited "From a Photograph by Bundy & Williams, New Haven." FRANK LESLIE'S ILLUSTRATED NEWSPAPER 24, (1867) ["Hon. James B. English, Gov. of CT." 24:608 (May 25, 1867): 145.]

B1998 "Yale School of the Fine Arts, New Haven." HARPER'S WEEKLY 12, no. 619 (Nov. 7, 1868): 717. 1 illus. ["Photographed by Bundy & Williams, New Haven."]

BUNDY, JOSEPH K. see also BUNDY & WILLIAMS.

BUNDY, JOSEPH K. (NEW HAVEN, CT)
B1999 Bundy, J. K. "A Few Good Words from a Father in Photography." PHILADELPHIA PHOTOGRAPHER 9, no. 101 (May 1872): 133. [Letter from J. K. Bundy (New Haven, CT), praising the magazine. Statement that Bundy has worked "a quarter of a century."]

BUNKER, HOLLIS P.
B2000 "Ohio. - Reception of Mrs. Mary Lowell Putnam by the Veterans of the National Soldier's Home, at Dayton. - From a Photograph by H. P. Bunker." FRANK LESLIE'S ILLUSTRATED NEWSPAPER 34, no. 880 (Aug. 10, 1872): 357. 1 illus. [View of buildings, with crowds.]

BURGESS. (WASHINGTON, DC)
B2001 Portraits. Woodcut engravings, credited "Photographed by Burgess." FRANK LESLIE'S ILLUSTRATED NEWSPAPER 39, (1874) ["Miss Minnie E. Sherman." 39:994 (Oct. 17, 1874): 88. "Lieut. Thomas W. Fitch, U.S.N." 39:994 (Oct. 17, 1874): 88.]

BURGESS. [?] (WASHINGTON, DC)
B2002 Portrait. Woodcut engraving, credited "Photographed by Burgen [sic Burgess?], of Washington, DC." FRANK LESLIE'S ILLUSTRATED NEWSPAPER 38, (1874) ["Hon. Lucius Lamar, from MS." 38:978 (June 27, 1874): 252.]

BURGESS, J. M. (NORWICH, ENGLAND)
B2003 Burgess, J. M. "Instructions for Working Burgess's Eburneum Process." AMERICAN JOURNAL OF PHOTOGRAPHY AND THE ALLIED ARTS & SCIENCES. n. s. vol. 7, no. 22 (May 15, 1865): 517-522.

B2004 "Burgess's Eburneum Photographs." ART JOURNAL (July 1869): 209. [Ivory-type images.]

B2005 Burgess, J. "Gelatine Emulsions." ANTHONY'S PHOTOGRAPHIC BULLETIN 5, no. 1 (Jan. 1874): 12-13. [From "Br. J. of Photo."]

BURGESS, JAMES. (1832-1916) (GREAT BRITAIN, INDIA)
B2006 Burgess, James. Report of the First Season's Operations in the Belgaum and Kaladgi Districts. ... with Twenty Photographs. London: Wm. B. Allen & Co., 1874. n. p. 20 b & w.

B2007 Burgess, James. The Rock Temples of Elura or Verul. Bombay: Education Society's Press, 1877. iv, 77 pp. 12 b & w. [Original photos, by the author.]

B2008 Burgess, James. Report on the Antiquities in the Bidar and Aurangabad District in the Territories of His Highness the Nizam of Haidarabad, Being the result of the third season's operations of the Archeological Survey of Western India 1875-1876. By James Burgess. Printed and published by order of Her Majesty's Secretary of State for India in Council. London: W. H. Allen & Co., 1878. viii, 138 pp. 64 l. of plates, including photos, plans.

B2009 Fergusson, James. The Cave Temples of India. By James Fergusson, and James Burgess &c. London: W. H. Allen & Co., 1880. xx, 536 pp. 99 l. of plates.

B2010 Burgess, James. Report of the Buddhist Cave Temples and their Inscriptions. Being a part of the results of the Fourth, Fifth and Sixth Season's operations of the Archaeological Survey of Western India... Supplementary to the "Cave Temples of India." London: Trubner & Co., 1883. x, 40 pp. 60 l. of plates. b & w. illus.

B2011 Burgess, James. Report on the Ellora Cave Temples and the Brahmanical and Jaina Temples in Western India. Completing the results of the Fifth, Sixth and Seventh Seasons' Operations. London: Trubner & Co., 1883. vii, 89 pp. 50 l. of plates. b & w. illus.

BURGESS, NATHAN G. (ca. 1814-1870) (USA)
[Learned the daguerreotype process in Paris in 1840. He worked in New York, NY from 1844 to 1859. His manuals were standard guides, and frequently republished.]

BOOKS
B2012 Burgess, Nathan G. The Ambrotype Manual; A Practical Treatise on the Art of Taking Positive Photographs on Glass, Commonly Known as an Ambrotype. New York: Daniel Burgess & Co., 1856. 184 pp.

B2013 Burgess, Nathan G. The Photograph and Ambrotype Manual. A Practical Treatise on the Art of Taking Positive and Negative Photographs on Paper and Glass. Commonly known as Photography, In All Its Branches; Containing All the Various Recipes practiced by the Most Successful Operators in the United States. "4th ed." New York: Wiley & Halsted, 1858. 242 pp. [First published 1856, with title "The Ambrotype Manual." Went through many editions, with title changes. 8th ed. (1863) NY: Appleton & Co., 267 pp. 12th ed. (1865) 283 pp., reprinted Arno Press in 1973.]

B2014 Burgess, N. G. *The Photograph Manual: A Practical Treatise, Containing the Cartes de Visite Process, and the Method of Taking Stereoscopic Pictures, Including Albumen Process, the Dry Collodion Process, the Tannin Process, the Various Alkaline Toning Baths, etc.* 8th ed. New York: Appleton & Co., 1863. 267 pp. [First published 1856 under the title "The Ambrotype Manual." 12th ed. (1865) 283 pp. Reprinted (1973), Arno Press.]

PERIODICALS

B2015 Burgess, N. G. "Daguerreotype Chemistry." PHOTOGRAPHIC ART JOURNAL 1, no. 6 (June 1851): 364-365. [Burgess from Daguerrean, NY.]

B2016 Burgess, N. G. "Chloride of Gold - Gilding Solution, etc." PHOTOGRAPHIC ART JOURNAL 2, no. 5 (Nov. 1851): 275-276.

B2017 Burgess, N. G. "Correspondence: Enlargement of Daguerreotypes for Copying." PHOTOGRAPHIC ART JOURNAL 4, no. 1 (July 1852): 21-22.

B2018 Burgess, N. G. "Chloride of Gold." PHOTOGRAPHIC AND FINE ART JOURNAL 7, no. 8 (Aug. 1854): 246-247.

B2019 Burgess, N. G. "The Value of Daguerreotype Likenesses." PHOTOGRAPHIC AND FINE ART JOURNAL 8, no. 1 (Jan. 1855): 19.

B2020 Burgess, N. G. "An Allegory." PHOTOGRAPHIC AND FINE ART JOURNAL 8, no. 2 (Feb. 1855): 52-53.

B2021 Burgess, N. G. "Taking Portraits after Death." PHOTOGRAPHIC AND FINE ART JOURNAL 8, no. 3 (Mar. 1855): 80.

B2022 Burgess, N. G. "Considerations of the Various Theories by Which the Image is Formed on the Daguerreotype Plate by Action of Light, Etc., Etc." PHOTOGRAPHIC AND FINE ART JOURNAL 8, no. 4 (Apr. 1855): 100-101.

B2023 Burgess, N. G. "Amusing Incidents in the Life of a Daguerrean Artist." PHOTOGRAPHIC AND FINE ART JOURNAL 8, no. 6 (June 1855): 190. [Anecdotes from various operators, narrated by Burgess.]

B2024 Burgess, N. G. "Why?" PHOTOGRAPHIC AND FINE ART JOURNAL 10, no. 1 (Jan. 1857): 23-24. [Letter from Burgess, asking for greater openness between photographers.]

B2025 "The Photograph and Ambrotype Manual. [Edited by N. G. Burgess.]" HUMPHREY'S JOURNAL OF PHOTOGRAPHY, AND THE ALLIED ARTS AND SCIENCES. 12, no. 21 (Mar. 1, 1861): 323-324. [Bk. notice: "The Photograph and Ambrotype Manual, "by N. G. Burgess. 7th edition.]

B2026 Kent, William. "Burgess' Manual." HUMPHREY'S JOURNAL OF PHOTOGRAPHY, AND THE ALLIED ARTS AND SCIENCES 13, no. 12 (Oct. 15, 1861): 185-187. [Letter from Kent is in effect a negative review at Burgess' "Manual," accompanied by the suggestion that it is the editor's responsibility to review such works more stringently.]

B2027 "Editor's Table." PHILADELPHIA PHOTOGRAPHER 7, no. 81 (Sept. 1870): 336. [Died July 13, aged 56 years. From Brooklyn, NY.]

BURGMANN, G. (GREAT BRITAIN)

B2028 "Ascent of the Peter Botte Mountain, in the Mauritius." ILLUSTRATED LONDON NEWS 45, no. 1300 (Feb. 4, 1864): 103-104. 3 illus. ["...a few days later Mr. Greene and the same party made a second expedition, accompanied by Mr. G. Burgmann, R.A., for the purpose of taking photographic views.]

BURKE, JAMES. (GUNDAMUK, INDIA)

B2029 Portrait. Woodcut engraving credited "From a photograph by Burke." ILLUSTRATED LONDON NEWS 75, (1879) ["Late Sir Louis Cavagnari, K.C.B., C.S.I." 75:2100 (Sept. 13, 1879): 229.]

B2030 "Afghan War 1878-79: Catalogue of Photographs." PHOTOGRAPHIC COLLECTOR 5, no. 1 (Spring 1984): 106-107. 1 b & w. [Facsimile reproduction of Burke's catalog of photographs, published in 1880.]

BURKE, JOHN. (MURREE, INDIA)

B2031 Cole, Lieut. Henry Hardy. *Illustrations of Ancient Buildings in Kashmir.* Prepared under the authority of the Secretary of State for India in Council, from photographs, plans, and drawings taken by order of the Government of India. London: India Museum, 1869. n. p. 44 b & w. ["With 44 prints by M. Burke of Murree and Peshawar during the fall of 1868 and reproduced "in carbon and are therefore permanent."]

BURN, JOHN S.

B2032 Burn, John S. "Photography Foreshadowed." HUMPHREY'S JOURNAL OF PHOTOGRAPHY, AND THE ALLIED ARTS AND SCIENCES 13, no. 14 (Nov. 15, 1861): 216-217. [From "Notes and Queries." Discussion of the French book "Giphantia, or a View of What has passed, What is now passing, and during the present Century, What will pass, in the World,..." published in 1761, which had a reference which could be attributed to photography.]

BURNET.

B2033 "Practical Hints on Composition." PHILADELPHIA PHOTOGRAPHER 16, no. 190 (Oct. 1879): 291-292. [Extracts from "Burnet's Hints on Composition" pub. by Edward L. Wilson, of Philadelphia.]

BURNETT, CHARLES JOHN. (GREAT BRITAIN)
BOOKS

B2034 Burnett, Charles John. *Burnt-in Photography on Porcelain Glass and Allied Vitreous and Ceramic Fabrics...* Reprinted, with corrections, from the "Edinburgh Advertiser," etc. Edinburgh: James Wood, 1857. 4 pp.

B2035 Burnett, Charles John. *Photography in Colours: A Fragment.* By a Member of the Edinburgh Photographic Society. Edinburgh: Edmonston & Douglas, 1857. 8 pp.

B2036 Burnett, Charles John. *Photographic Negative Processes on Waxed and Plain Papers, and on Glass.* London: J. Sanford, 1859. iv, 16 pp.

PERIODICALS

B2037 "Fine-Art Gossip." ATHENAEUM no. 1541 (May 9, 1857): 604. [Includes a letter from C. J. Burnett explaining his "Hallotype" process.]

B2038 "Remarks on M. Niépce de St. Victor's Theory of a New Action of Light, with Speculations upon the Probable Interchange of the Forces of Heat, Light, and Actinism." LIVERPOOL & MANCHESTER

PHOTOGRAPHIC JOURNAL [BRITISH JOURNAL OF PHOTOGRAPHY] n. s. 2, no. 15 (Aug. 1, 1858): 193-195.

B2039 Burnett, C. J. "On the Application of Photography to Botanical and other Book Illustration." LIVERPOOL & MANCHESTER PHOTOGRAPHIC JOURNAL [BRITISH JOURNAL OF PHOTOGRAPHY] n. s. 2, no. 18 (Sept. 15, 1858): 227-228.

B2040 Burnett, C. J. "Mr. C. J. Burnett and M. Niépce de St. Victor." AMERICAN JOURNAL OF PHOTOGRAPHY AND THE ALLIED ARTS & SCIENCES n. s. vol. 2, no. 5 (Aug. 1, 1859): 77-78. [From "Photo. J." Letter claiming his priority of invention, challenging Niépce de St. Victor's claims.]

B2041 Burnett, C. J. "Plan to Keep Waxed or Plain Paper Pictures longer than usual before Development." HUMPHREY'S JOURNAL OF PHOTOGRAPHY, AND THE ALLIED ARTS AND SCIENCES 11, no. 11 (Oct. 1, 1859): 174-175. [From "Liverpool Photo. J."]

BURNETT, J.
B2042 Burnett, J. "Photographic Engraving on Metal Plates." PHOTOGRAPHIC AND FINE ART JOURNAL 11, no. 12 (Dec. 1858): 383. [From "Photo. J." A paper read to the Edinburgh Botanic Society.]

BURNHAM BROTHERS. (BANGOR, ME)
B2043 "Hon. Hannibal Hamlin, Gov.-Elect of Maine." BALLOU'S PICTORIAL DRAWING-ROOM COMPANION [GLEASON'S] 11, no. 279 (Nov. 8, 1856): 300. 1 illus.

B2044 "The Prince of Wales, Lord Lyons and Duke of Newcastle, with Mayor Howard, Passing Through Portland, Me., in the Mayor's Carriage, to the Great Eastern Dock, to Embark for England, Escorted by the Volunteer Troops of Maine, October 23, 1860. - From a Photograph by Burnham Bros., Portland, Me." FRANK LESLIE'S ILLUSTRATED NEWSPAPER 10, no. 260 (Nov. 17, 1860): 410-411. 3 illus. [Outdoor portrait, with crowds. Views, one credited to the Burnham Brothers.]

BURNHAM. (PORTLAND, ME)
B2045 "Editor's Table." PHILADELPHIA PHOTOGRAPHER 7, no. 76 (Apr. 1870): 143. [Note that Mr. Burnham (Portland, ME) burned out, intends to relocate further south.]

BURNHAM, ASA MARSH see BURNHAM BROTHERS.

BURNHAM, THOMAS RICE see also BURNHAM BROTHERS.

BURNHAM, THOMAS RICE. (1834-1893) (USA)
[Thomas R. Burnham was born in Winslow, ME in 1834. He began photographing in Boston, MA in 1863, and ran a successful portrait studio there until his death in 1893.]

B2046 "Editor's Table." PHILADELPHIA PHOTOGRAPHER 4, no. 44 (Aug. 1867): 272. [Four cabinet photographs from T. R. Burnham, of Boston, MA.]

B2047 "Editor's Table." PHILADELPHIA PHOTOGRAPHER 5, no. 54 (June 1868): 215. [Group of "cabinets" of ballet dancers.]

B2048 "Award of the $50 Prize." PHILADELPHIA PHOTOGRAPHER 5, no. 59 (Nov. 1868): 395-400. [Burnham was the winner. Lists and describes the work of the other twenty-five or so contestants as well.]

B2049 "Our Picture." PHILADELPHIA PHOTOGRAPHER 6, no. 62 (Feb. 1869): frontispiece, 61-62. 1 b & w. [$50 prize winner. Portrait.]

B2050 "The Boston Photographic Society." ANTHONY'S PHOTOGRAPHIC BULLETIN 6, no. 5 (May 1875): 156. [From "Sunday Herald." Discussion of Burnham's large (22" x 42" negatives) landscape views of Niagara Falls and others.]

B2051 Portrait. Woodcut engraving, credited "From a Photograph by Burnham, Boston." FRANK LESLIE'S ILLUSTRATED NEWSPAPER 43, (1876) ["G. Q. Richmond, of CO." 43:1096 (Sept. 30, 1876): 53.]

BURNITE & WELDON. (HARRISBURG, PA)
B2052 "The Ruins of Chambersburg." HARPER'S WEEKLY 8, no. 399 (Aug. 20, 1864): 541, 542. 3 illus. ["Photographed by Burnite & Weldon, Harrisburg, PA."]

BURNS, ARCHIBALD.
BOOKS
B2053 Ballantyne, Robert Michael. *Photographs of Edinburgh;* With Descriptive Letterpress. Glasgow; London; Dublin: Andrew Duthie; Simpkin, Marshall; W. H. Smith & Son, 1867. 28 l. of plates. 13 b & w. [Original photographs by A. Burns.]

B2054 Henderson, Thomas. *Picturesque 'Bits' from Old Edinburgh; A Series of Photographs by Archibald Burns;* with Descriptive and Historical Notes by Thomas Henderson. Edinburgh; London: Edmonston & Douglas; Simpkin, Marshall & Co., 1868. 64 pp. 15 b & w. [Original photos by A. Burns.]

PERIODICALS
B2055 "Critical Notices: Stereograms from Scotland, by Archibald Burns, Edinburgh." PHOTOGRAPHIC NEWS 3, no. 64 (Nov. 25, 1859): 135-136.

BURNS, W. R.
B2056 Burns, W. R. "Evaporation of Baths." HUMPHREY'S JOURNAL OF PHOTOGRAPHY, AND THE ALLIED ARTS AND SCIENCES 16, no. 9 (Sept. 1, 1864): 139-140. [Letter from Burns, reply by Towler. Burns states "I have been in the photographing business about four months."]

BURR & MOGO.
B2057 "Views In and About Salt Lake City." HARPER'S WEEKLY 2, no. 90-92 (Sept. 18, Sept. 25, Oct. 9, 1858): 605, 621, 653. 4 illus. ["From photographs by Burr & Mogo."]

B2058 "The Calaboose in Salt Lake City." HARPER'S WEEKLY 2, no. 97 (Nov. 6, 1858): 709-710. 1 illus.

B2059 "Interesting Facts About the Mormons." HARPER'S WEEKLY 2, no. 101 (Dec. 4, 1858): 781-782. 2 illus. ["'Social Hall, Salt Lake City' and 'Scene in Salt Lake City'- From photographs by Burr & Mogo."]

BURRELL, DAVID T. (BRIDGEWATER, MA)
B2060 "Editor's Table." PHILADELPHIA PHOTOGRAPHER 6, no. 63 (Mar. 1869): 96. [Views of Daniel Webster's mansion at Marshfield noted.]

BURRITT, JOSEPH CURTISS (1817-1889) (USA)
B2061 Spencer, Spence, ed. *The Scenery of Ithaca and the Head Waters of the Cayuga Lake; as Portrayed by Different Writers and Edited by the Publisher.* Ithaca, NY: S. Spencer, 1866. 150 pp. b & w. [Original photos by J. C. Burritt.]

B2062 Clarke, Frank Wigglesworth. *Views around Ithaca; Being a Description of the Waterfalls and Ravines of This Remarkable Locality.* Ithaca, NY: Andrus, McChain & Co., 1869. 157 pp. 10 b & w. [Original photos, most by J. C. Burritt.]

B2063 *With a Jeweler's Eye: The Photographs of Joseph C. Burritt.* Ithaca, NY: DeWitt Historical Society of Tompkins County, 1980. 51 pp.

BURROUGH, W. (DEVON, ENGLAND)

B2064 Portrait. Woodcut engraving credited "From a photograph by W. Burrough, Ottery St., Mary, Devon." ILLUSTRATED LONDON NEWS 34, (1859) ["Private Humphrey Wilson, 78th Highlanders." 34:* (Jan. 1, 1859): 5.]

BURROUGHS. (NEW YORK, NY)

B2065 Portrait. Woodcut engraving, credited "From a Photograph by Burroughs, 148 Chatham St. New York." FRANK LESLIE'S ILLUSTRATED NEWSPAPER 36, (1873) ["The late Charles Goodrich, Brooklyn." 36:914 (Apr. 5, 1873): 57.]

BURROWS & BUNDY. (MIDDLEBURY, CT)

B2066 "Editor's Table." PHILADELPHIA PHOTOGRAPHER 3, no. 31 (July 1866): 223. [View of manufacturing portion of Middlebury received.]

BURROWS & COLTON. (GREAT BRITAIN)
BOOKS

B2067 Ourdan, J. P. *Concise Instructions in the Art of Retouching,* by Burrows and Colton, with Lithographic Illustrations and Negatives. London: Marion, 1876. viii, 65 pp. 4 l. of plates. [Many revised editions, through 1900. (F. T. Burrows & J. D. Colton were the "Successors to Southwell Brothers, Photographers Royal, 22 Baker St.)]

PERIODICALS

B2068 Burrows and Colton. "The Application of Certain Rules to Composition." PHOTOGRAPHIC TIMES 7, no. 75 (Mar. 1877): 56-57. [From "Br J. of Photo."]

BURTON BROTHERS.
BOOKS

B2069 Burton Brothers., Dunedin, New Zealand. *The Maori at Home: A Catalogue of a Series at Photographs Illustrative of the Scenery and of Native Life in the Center of the North Island of New Zealand.* Dunedin, N. Z.: Burton Brothers, 1886 [?] 24 pp. b & w. illus. [Includes: "Through the King Country with the Camera, a Photographer's Diary."]

B2070 Knight, Hardwicke. *Burton Brothers, Photographers.* Dunedin: McIndoe, 1980. 139 pp. b & w. illus. [Bibliography pp. 134-136.]

B2071 Knight, Hardwicke, Anneke Groenveld and Paul Faber. *Burton Brothers.* Rotterdam: Museum voor Volkenkunde, 1987. 88 pp. b & w. illus. [Burton Brothers, of New Zealand, flourished from ca. 1866 - 1898.]

PERIODICALS

B2072 Knight, Hardwicke. "Burton Brothers of New Zealand." HISTORY OF PHOTOGRAPHY 3, no. 2 (Apr. 1979): 167-179. 19 b & w. [11 b & w by Burton Brothers, 2 b & w by Thomas M. B. Muir, 2 b & w by Muir and Moodie.]

BURTON, A. B. (MANCHESTER, NH)

B2073 The Amoskeag Fire Engine, of Manchester, N. H. - Photographed by A. B. Burton, Manchester, N. H." FRANK LESLIE'S ILLUSTRATED NEWSPAPER 11, no. 262 (Dec. 1, 1860): 21. 2 illus. [Outdoor scene of the engine, horse and driver. Portrait of N. S. Bean, builder of the Amoskeag Steam Fire Engine.]

BURTON, ALFRED HENRY. (1834-1914) (b. GREAT BRITAIN, NEW ZEALAND) see BURTON BROTHERS.

BURTON, CHARLES.

B2074 Burton, Charles. "Art Topics of Immediate Interest. No. XXI. Some Considerations Touching the Increased Facilities for Reproducing Works of Art." ART PICTORIAL AND INDUSTRIAL 2, no. 13 (July 1871): 2-3.

BURTON, H. J. (GREAT BRITAIN)

B2075 Burton, H. J. "Rapid and Perfect Filtration." BRITISH JOURNAL PHOTOGRAPHIC ALMANAC 1874 (1874): 137-138.

B2076 Burton, H. J. "Shortening the Camera Exposure." BRITISH JOURNAL PHOTOGRAPHIC ANNUAL 1875 (1875): 120-121.

B2077 "A New Form of Actinometer." ANTHONY'S PHOTOGRAPHIC BULLETIN 6, no. 8 (Aug. 1875): 241-242. 1 illus. [From "Br J of Photo." H. J. Burton's device.]

B2078 Burton, H. J. "A Method of Intensifying Carbon Transparencies." BRITISH JOURNAL PHOTOGRAPHIC ALMANAC 1879 (1879): 126-127.

BURTON, RICHARD F., CAPT. (GREAT BRITAIN, AFRICA)

B2079 "Photographic News." PHILADELPHIA PHOTOGRAPHER 15, no. 178 (Oct. 1878): 317. [Capt. Richard F. Burton explored 2500 miles in Nubia from Dec. 1877 to Apr. 1878. Returned with photos of ancient cities and mines, anthropology studies, etc...(Burton is English, I think.)]

BURTON, WALTER JOHN. (1836-1880) (GREAT BRITAIN, N ZEALAND) see BURTON BROTHERS.

BUSCHMANN, JOSEPH ERNEST. (1814-1853) (BELGIUM)

B2080 Roosens, Laurent. "Joseph Ernest Buschmann and Guillaume Claine: Two Belgian Calotypists." HISTORY OF PHOTOGRAPHY 2, no. 2 (Apr. 1978): 117-122. 3 b & w. 1 illus. [Correspondence between Claine and Buschmann, two amateur photographers, described. Buschmann was born in Sept-Fontaines, Luxemberg in 1814, then the family moved to Antwerp. He studied in Paris, worked at the Lycée National, and founded a literary review before returning to Antwerp in 1838. He became active in intellectual circles in Antwerp, and was a poet and editor. Elected to the Royal Belgian Academy in 1846. Opened a printing firm in the early 1850s, and also learned calotypy, as a hobby. Suffered from mental illness in 1852, and died in 1853, at age 41. The publishing firm continued under his wife's direction, and is still in business today.]

BUSEY, NORVAL H. (b. 1845) (USA)

[Born in Christiansburg, VA in 1845. Studied art under Bouguereau in Paris. Apprenticed in photography with Stanton & Butler in Baltimore, working his way from mounter and printer to manager of the gallery. In 1867 he opened his own galley in York, PA. Then formed a brief partnership with O. Hallwig which returned him to Baltimore. Busey then opened his own gallery there, and continued for many years.]

B2081 "Note." PHOTOGRAPHER'S FRIEND 2, no. 1 (Jan. 1872): 29-30. [Has again favored us with his exquisite photos. From Baltimore, MD.]

B2082 Busey, Norval H. "A Few Words of Defense." PHOTOGRAPHER'S FRIEND 2, no. 1 (Jan. 1872): 20-21. [Reply to the unsigned article "Photographs." on p. 19 of the same issue.]

B2083 "Editor's Table." PHILADELPHIA PHOTOGRAPHER 10, no. 112 (Apr. 1873): 126-128. [N. H. Busey opens gallery in Baltimore, MD.]

B2084 Busey, N. H. "Fifth Annual Meeting and Exhibit of the National Photographic Association of the U.S., held in Buffalo, N.Y., beginning July 5, 1873: Retouching." PHILADELPHIA PHOTOGRAPHER 10, no. 117 (Sept. 1873): 451-460.

BUSH, HENRY. (SAN FRANCISCO, CA)
B2085 Palmquist, Peter E. "Odyssey of a Cameraman." HISTORY OF PHOTOGRAPHY 7, no. 2 (Apr. - June 1983): 91-95. 1 b & w. 4 illus. [San Francisco, CA, photographer, published book of autobiographical poetry in 1865. Worked in Germany 1840's, in San Francisco 1850s-1870s.]

BUSS, R. W.
B2086 Buss, R. W. "On the Use of Photography to Artists." HUMPHREY'S JOURNAL 5, no. 7 (July 15 - Aug. 1, 1853): 100-104, 126-127. [From "J. of Photo. Soc." This paper led to an exchange of commentary about the possible artistic values of selective or softened focus in photographs, between Sir William Newton, George Shadbolt, Mr. Vignols, Dr. Percy, Henry Cooke and others.]

B2087 Buss, R. W. "Pictures at Night." HUMPHREY'S JOURNAL OF PHOTOGRAPHY, AND THE ALLIED ARTS AND SCIENCES 9, no. 23 (Apr. 1, 1858): 365-366.

BUTLER & DYER. (GREAT BRITAIN)
B2088 "Fall of Two Houses in Pilgrim-Street, City." ILLUSTRATED LONDON NEWS 33, no. 940 (Oct. 9, 1858): 339. 1 illus. ["From a photograph by Butler & Dyer, of Walnut Tree Walk, Lambeth."]

BUTLER, B. D. (THE DALLES, OR)
B2089 Butler, B. D. "Correspondence." ANTHONY'S PHOTOGRAPHIC BULLETIN 1, no. 8 (Sept. 1870): 163-164. [Letter from B. D. Butler (The Dalles, OR) includes biographical information, working process. "Learned the Daguerreotype business in April, 1844 from J. T. Cunningham, from New York."]

BUTLER, HOWARD RUSSELL. (1856-1934) (USA)
B2090 Princeton Scientific Expedition, 1877. *Topographic, Hypsometric and Meteorologic Report,* by William Libbey, Jr. and W. W. McDonald, of the Princeton Scientific Expedition, 1877. "Contributions from the F. M. Museum of Geology and Archeology of Princeton College. No. 2." 'New York: s. n., 1879. 55 pp. 28 l. of plates. 28 b & w. [Photomechanical prints by Harroun & Bierstadt, from photographs by W. B. Devereux and H. R. Butler.]

BUTLER, JOSEPH H. (TROY, NY)
B2091 Butler, Joseph H. "To Mr. Irving on His Beautiful Daguerreotype Portraits." DAGUERREAN JOURNAL 2, no. 8 (Sept. 1, 1851): 240. [Poem. Butler from Troy, NY.]

BUTLER, P. (SPRINGFIELD, IL)
B2092 Portraits. Woodcut engravings, credited "Photographed by Butler, of Springfield, Ill." FRANK LESLIE'S ILLUSTRATED

NEWSPAPER 11, (1860) [Portrait of Mrs. Abraham Lincoln and sons. 11:264 (Dec. 15, 1860): 49. "Abraham Lincoln, Pres.-elect of USA." 11:276 (Mar. 9, 1861): 248-249.]

B2093 "The City of Springfield, Illinois." FRANK LESLIE'S ILLUSTRATED NEWSPAPER 11, no. 265 (Dec. 22, 1860): 68-69. 4 illus. [Four views of the city, credited to "From a Photograph by P. Butler, Springfield, Ill."]

BUTLER, WILLIAM H.
B2094 "Daguerreotype Transfers." DAGUERREAN JOURNAL 2, no. 5 (July 15, 1851): 147. [The "Farmer's Cabinet" stated that Mr. Butler, proprietor of the Plumbe National Gallery, had discovered a method of transferring daguerreotypes to panels, which Butler disclaimed to Humphrey.]

BUTLER, WILLIAM R. (NEW YORK, NY)
B2095 Portrait. Woodcut engraving, credited "...from a daguerreotype likeness by Wm. R. Butler, 251 Broadway, New York, NY." GLEASON'S PICTORIAL DRAWING-ROOM COMPANION 1, (1851) ["Merchant Edward K. Collins." 1:21 (Sept. 20, 1851): 336.]

BUTTERFIELD, CHARLES. (GREAT BRITAIN)
B2096 Butterfield, Charles. "A Photographic Retrospect." BRITISH JOURNAL OF PHOTOGRAPHY 8, no. 134 (Jan. 15, 1861): 30-31.

B2097 Butterfield, C. "Where to Go with the Camera in Yorkshire." BRITISH JOURNAL OF PHOTOGRAPHY 9, no. 160 (Feb. 15, 1862): 67.

BUTTERFIELD, DAVID W. (1844-1933) (USA)
[David W. Butterfield began working in Boston in 1862 as a daguerreotypist. He is listed in Boston business directories from 1862 to 1865, then again from 1868 through the 1880s.]

B2098 Portrait. Woodcut engraving, credited "From a Photograph by D. W. Butterfield, Boston, MA." FRANK LESLIE'S ILLUSTRATED NEWSPAPER 35, (1872) ["John S. Damrell, Chief of the Boston Fire Dept." 35:897 (Dec. 7, 1872): 208.]

B2099 "New Hampshire. - Summit House, and Mount Washington Railroad. - From a Photograph by D. W. Butterfield, Boston." FRANK LESLIE'S ILLUSTRATED NEWSPAPER 40, no. 1038 (Aug. 21, 1875): 416. 1 illus. [View.]

BUXTON, E. C., JR. (GREAT BRITAIN, CHINA, INDIA)
B2100 Buxton, E. C., Jr. "Photographic Experience in India." BRITISH JOURNAL OF PHOTOGRAPHY 12, no. 253-254 (Mar. 10 - Mar. 17, 1865): 127, 140-141. [Buxton had photographed in Algeria and Egypt "about four years since taking photographs with both the wet and dry process." Started in Singapore in Sept. 1863 photographed there until Dec. To Island of Penang. Calcutta on Jan. 1. Photographed there and at Gaur, 200 miles away in Bengal. Then to Benares. Weather prevented photographing at Lucknow. Agra, Delhi. Left India in April with 55 negatives and 6 dozen stereos.]

BYRNE & CO. (RICHMOND, ENGLAND)
B2101 Portrait. Woodcut engraving credited "From a photograph by Byrne & Co." ILLUSTRATED LONDON NEWS 71, (1877) ["George Jamison, rifleman." 71:1985 (July 28, 1877): 93.]

C

G. R. C.

C1 G. R. C. "The Lessons of the Prize Pictures." PHILADELPHIA PHOTOGRAPHER 11, no. 126 (June 1874): 187-188. [Advice, suggestions of how to learn from "Prize Pictures," published by Bennerman & Wilson.]

CABSOLARIZ, SCILIO. (MILAN, ITALY)

C2 Portrait. Woodcut engraving, credited "From a Photograph by Scilio Cabsolariz, Milan." FRANK LESLIE'S ILLUSTRATED NEWSPAPER 41, (1875) ["Signorina Leontina Dassi, the Italian 'Prisoner's Friend.'" 41:1052 (Nov. 27, 1875): 192.]

CADETT.

C3 "Cadett's Patent Pneumatic Photographic Shutter." ANTHONY'S PHOTOGRAPHIC BULLETIN 10, no. 5 (May 1879): 159. 2 illus.

CADWALLADER. (USA)

C4 "Pointed Pictures." HUMPHREY'S JOURNAL OF PHOTOGRAPHY, AND THE ALLIED ARTS AND SCIENCES 15, no. 3 (June 1, 1863): 48. [Praise for some Card pictures from Cadwallader, of Kentucky.]

CADWALLADER, JOHN D. (1826-) (USA)

C5 "Editor's Table." PHILADELPHIA PHOTOGRAPHER 5, no. 54 (June 1868): 215. [Examples of "cabinet" photos. From Marietta, OH.]

C6 "Editor's Table." PHILADELPHIA PHOTOGRAPHER 10, no. 118 (Oct. 1873): 153. [Mr. John Cadwallader has opened a new gallery at the Beehive Corner, Indianapolis, IN.]

C7 "Indianapolis, Indiana. - Washington Street, Looking West from Meridian Street. - Photographed by Cadwallader." FRANK LESLIE'S ILLUSTRATED NEWSPAPER 39, no. 991 (Sept. 26, 1874): 45. 1 illus. [View, with figures.]

C8 Cadwallader, John. "Correspondence." ANTHONY'S PHOTOGRAPHIC BULLETIN 6, no. 2 (Feb. 1875): 61. [Letter protesting cite of next N. P. A. meeting in San Francisco - too far away.]

C9 Cadwallader, John. "Advance Pay or Not." PHILADELPHIA PHOTOGRAPHER 12, no. 134 (Feb. 1875): 53.

C10 "Matters of the Month: Fine Cabinet Pictures." PHOTOGRAPHIC TIMES 5, no. 59 (Nov. 1875): 262. [Cabinet photos noted. From Indianapolis, IN.]

C11 Cadwallader, John. "Shall Prices Come Down?" PHILADELPHIA PHOTOGRAPHER 14, no. 164 (Aug. 1877): 237-238. [Includes a list of prices for types of photos from his gallery in Indianapolis.]

CADY, J. (BRANDON, VT)

C12 "Editor's Table." PHILADELPHIA PHOTOGRAPHER 3, no. 31 (July 1866): 224. [View of Stephen Douglas birthplace received.]

C13 "The Birth-Place of Stephen A. Douglas, at Brandon, Vt. - From a Photograph by J. Cady." FRANK LESLIE'S ILLUSTRATED NEWSPAPER 23, no. 573 (Sept. 22, 1866): 13. 1 illus. [View, with figures.]

CAHILL, MILES S. (BOSTON, MA)

C14 Portrait. Woodcut engraving, credited "From a Daguerreotype by M. S. Cahill, 293 Washington St., Boston, MA." BALLOU'S PICTORIAL DRAWING-ROOM COMPANION [GLEASON'S] 12, (1857) ["Dr. Charles T. Jackson." 12:314 (June 27, 1857): 412.]

CAIRE, NICHOLAS JOHN. (1837-1918) (AUSTRALIA)

C15 Pitkethly, Anne and Don Pitkethly. N. J. Caire. Landscape Photographer. Victoria: A. & D. Pitkethly, 1988. 112 pp. 81 b & w. [Nicholas John Caire made landscape views around Victoria, Australia between 1875 and 1905. Born Feb. 28, 1837 on the Island of Guernsey. At fourteen was a hairdresser's apprentice. Family moved to Australia when Nicholas was 21. By 1867 he had begun to work in a studio in Adelaide. In economically difficult times he worked as a hairdresser and photographer, but by early 1870s, his photographic career began to predominate. He made studio portraits and, later, landscape views. "Views of Bendigo" in 1875. "Views of Victoria (General Series)." in 1876, marketed as the Anglo-Australasian Photographic Co. "The Public Buildings of Melbourne and Suburbs," in 1877. "Views of New South Wales," etc. In 1880 moved to Melbourne. In 1880s converted from wet collodion to dry plates, continued to expand the view series. His growing family helped run the studio. His photographs appeared in the books, Picturesque Victoria and how to get there: A Handbook for Tourists. Victoria Railways, 1897 (reissued 1910); Federated Australia. Its Sceneries and Splendors. (1901) 2 vol., Sunlight Album of Australian Views, in illustrated weekly magazines between 1897 and 1912, and elsewhere. Made postcards as well. Had taken most of his photos by 1905. Died on Feb. 13, 1918.]

CAITHNESS, EARL OF. (d. 1881) (GREAT BRITAIN)

BOOKS

C16 Menzies, William. The History of Windsor Great Park and Windsor Forrest. London: Longman, Green, Longman, Roberts & Green, 1864. xv, 48 pp. 18 b & w. 2 illus. [Illustrated with Photographs by the Earl of Caithness and Mr. Bembridge of Windsor.]

PERIODICALS

C17 Taylor, J. Traill. "Home and Foreign News Epitomized." PHOTOGRAPHIC TIMES 11, no. 124 (Apr. 1881): 131. [Obituary notice. Died 29th March. English amateur, specialized in winter landscapes. Fellow of Royal Society, a founder of the Amateur Photographic Assoc. (London).]

CALDESI & LOMBARDI.

C18 "From Across the Water." ANTHONY'S PHOTOGRAPHIC BULLETIN 6, no. 4 (Apr. 1875): 124-125. [Monthly column; this issue contains an article, "Reproductive Photography," from "The Telegraph," discussing Caldesi and Lombardi and their work with the Woodburytype.]

CALDESI & MONTECCHI. (ITALY, GREAT BRITAIN)

[Caldesi & Montecchi were from Florence, Italy. They came to London, and in the 1850s, established themselves as experts in the field of photographic reproductions of works of art.]

BOOKS

C19 Caldesi & Montecchi. Photographs of the 'Gems of the Art Treasures Exhibition,' Manchester, 1857, Ancient and Modern Series. London, Manchester: Paul & Dominic Colnaghi & Co., T. Agnew & Sons, 1858. 2 vol. 200 b & w. [Originally published in five volumes, each containing 50 photos., then reissued in a two volume set. Photographs of paintings at the exhibition.]

C20 The Gallery of the Most Noble The Marquess of Hertford, K. G., Photographed by Caldesi & Montecchi. London; Manchester: P. & D. Colnaghi; T. Agnew & Sons, 1859. n. p. 30 b & w. [Photographic copies of paintings. Title and contents pages.]

PERIODICALS
C21 "Fine Arts: New Publications." ATHENAEUM no. 1586 (Mar. 20, 1858): 375. [Bk. rev.: "Gems of the Manchester Art-Treasures Exhibition. Part IV. Ancient and Modern." Photographed by Caldesi & Montecchi. London: Colnaghi & Co.]

C22 Portrait. Woodcut engraving. HARPER'S WEEKLY 3, (1859) ["Queen Victoria and Her Family at Osborne." 3:130 (June 25, 1859): 401. (Taken without credit from "Illustrated London News.")]

C23 Portrait. Woodcut engraving credited "From a photograph by Caldesi & Montecchi." ILLUSTRATED LONDON NEWS 34, (1859) ["Group portrait - The Royal Family at Osborne." 34:* (June 4, 1859): 540.]

CALDESI, BLANFORD & CO. (GREAT BRITAIN)
C24 The Royal Collection of Pictures at Buckingham Palace. London: Colnaghi, 1860. n. p. pp. 40 l. of plates. 40 b & w. [Original photographs, with printed captions.]

CALDESI, L. & CO. see CALDESI, LUIGI.

CALDESI, LUIGI see also CALDESI & LOMBARDI; CALDESI & MONTECCHI; CALDESI, BLANDFORD & CO.

CALDESI, LUIGI. (ITALY, GREAT BRITAIN)
BOOKS
C25 The Photographic Historical Portrait Gallery consisting of a Series of Portraits, Principally from Miniatures, in the Most Celebrated Collections in England. London: P. & D. Colnaghi, Scott & Co., 1864. n. p. 50 l. of plates. [Fifty photographic plates, each containing an average of three portrait miniatures. Photographed by L. Caldesi & Co. Illustrative text by Amelia B. Edwards.]

C26 The Pictures by the Old Masters in the National Gallery. Photographed by Signor L. Caldesi. With letterpress descriptions, historical, biographical, and critical, by Ralph Nicholson Wornum, Keeper and Secretary, National Gallery. Part 1. London: Virtue & Co., 1868. n. p. 12 b & w. [Original photographs of paintings. This is probably the first fascicle of the complete set, later bound into eight volumes.]

C27 The National Gallery. A Selection of Photographs from Pictures of the Old Masters. L. Caldesi. With Notes by Ralph Nicholson Wornum. London: Edward Avery, 1872[?]. 8 vol. b & w. [40 original photographs per volume.]

PERIODICALS
C28 Portrait. Woodcut engraving credited "From a photograph by Caldesi & Co." ILLUSTRATED LONDON NEWS 40, (1862) ["Duke of Buckingham, commissioner of International Exhibition of 1862." 40:413 (Mar. 1, 1862): 215.]

C29 Portraits. Woodcut engravings, credited to "From a Photograph by Caldesi & Co., Pall Mall East." ILLUSTRATED LONDON NEWS 60, (1872) ["Lord Northbrook, Viceroy of India." 60:1697 (Mar. 16, 1872): 273. "Duke of Bedford." 60:1711 (June 22, 1872): 592.]

C30 Portrait. Woodcut engraving, credited to "From a Photograph by Caldesi." ILLUSTRATED LONDON NEWS 61, (1872) ["Late Col. Sykes, M.P." 61:1713 (July 6, 1872): 60.]

C31 Portrait. Woodcut engraving credited "From a photograph by Caldesi." ILLUSTRATED LONDON NEWS 63, (1873) ["Dr. Lyon Playfair." 63:1788 (Dec. 6, 1873): 528.]

C32 Portrait. Woodcut engraving credited "From a photograph by Caldesi." ILLUSTRATED LONDON NEWS 65, (1874) ["Late Lord George Manners." 65:1830 (Sept. 19, 1874): 281.]

C33 Portrait. Woodcut engraving credited "From a photograph by Caldesi & Co." ILLUSTRATED LONDON NEWS 67, (1875) ["Late Sir Charles Locock." 67:1878 (Aug. 7, 1875): 124.]

C34 Portrait. Woodcut engraving credited "From a photograph by Caldesi & Co." ILLUSTRATED LONDON NEWS 72, (1878) ["Right Hon. J. W. Henley." 72:2019 (Mar. 9, 1878): 221.]

CALVERT, F. GRACE.
C35 Calvert, F. Crace. "Photographs in Natural Colours." BRITISH JOURNAL OF PHOTOGRAPHY 12, no. 288 (Nov. 10, 1865): 573-574. [Discusses work of Becquerel, Niépce de St. Victor, etc.]

CAMALL, W. F. (ROCHESTER, NY)
C36 Portrait. Woodcut engraving, credited "From a Photograph by W. F. Camall, Rochester, NY." FRANK LESLIE'S ILLUSTRATED NEWSPAPER 40, (1875) ["The late Patrico Byrnes." 40:1021 (Apr. 24, 1875): 105.]

CAMERON, MRS. JULIA MARGARET. (1815-1879) (GREAT BRITAIN)
[Born in Calcutta in 1815, the daughter of James Pattle, a high official in the Bengal Civil Service. She was educated in England and France, then returned to India. In 1838 she married Charles Hay Cameron, a member of the Council of India, a jurist and classical scholar. Mrs. Cameron assumed the social leadership in the Anglo-Indian colony, raising money for victims of the Irish Famine and following literature and the arts with the energy and passion for which she would become famous. The Camerons returned to England in 1848, where Julia Margaret continued to follow her interests in the arts, meeting and hosting many of the creative individuals of her day - among them Thomas Carlyle, Frederick Watts, Dante Gabriel Rossetti, Sir John Herschel, Charles Darwin, and others. Impetuous, generous, devoted to the arts and to a concept of greatness in men, she moved with great style and flair through the circles she inhabited, and many fond and amusing stories about her personality and activities were told by her friends and neighbors. As many of these friends were literary figures, some of the tales were published.
In 1859 the Camerons moved to the Isle of Wight, where they were neighbors to Alfred Lord Tennyson, who was the Poet Laureate of England, and then at the height of his considerable popularity. In 1864 one of her daughters gave Julia Margaret a camera and wet collodion outfit, and, at age forty-eight, she became enthralled with the medium. She made portraits of her friends and acquaintances and posed genre scenes with a disregard of accepted convention, good technique, and known form. An early review of her work is still accurate. "A Lady, Julia Margaret Cameron, sends some rather extraordinary specimens of portraiture, very daring in style, and treading on the debateable ground which may lead to grand results or issue in complete failure." (Photographic News 8:300 (June 3, 1864): 266.) Contemporary judgement is that her vibrant, powerful portraits led to very grand results indeed, and she is regarded as one of the foremost photographers of the 19th century. In 1874 she created a series of illustrations for the two volume Illustrations to Tennyson's Idylls of the King and Other Poems.
The Camerons left England for Ceylon in 1875, where Julia Margaret continued to photograph until her death there, in 1879.]

BOOKS

C37 Buerger, Gottried. *Leonora*. Translated by Julia M. Cameron. With illustrations by D. Maclise, R.A., engraved by John Thompson. London: Longman, Brown, Green & Longmans, 1847. 38 pp. illus.

C38 Cameron, Julia M. *Portraits and Photographic Studies All from Life*. by Julia M. Cameron, Fresh Water Bay, Isle of Wright - Commenced year 1864. Given to Annie Thackeray by her friend Julia M. Cameron. n. p. 61 b & w. [Album of actual photographic prints, at Gernshiem Coll. University of Texas.]

C39 Cameron, Julia M. *Illustrations to Tennyson's Idylls of the King and Other Poems*. London: Henry S. King & Co., 1875. n. p. 24 l. of plates. [Pt. 1 "Idylls of the King." 12 plates. Pt. 2 "Other Poems." 12 plates.]

C40 Taylor, Henry. "Mrs. Cameron" on pp. 41-49, 153-165 in: *Autobiography of Henry Taylor*. Vol. 2 1844-1875. New York: Harper & Brothers, 1885. 2 vol. illus.

C41 Boord, William Arthur, ed. *Mrs. Cameron*. With a Descriptive Essay by Philip Henry Emerson. "Sun Artists no. 5" London: Keegan Paul & Co., 1890. 42 pp. 4 l. of plates. 8 b & w. [Reproductions of photographs with descriptive text.]

C42 *Alfred, Lord Tennyson and His Friends*. A Series of 25 portraits and frontispiece in photogravure from the negatives of Mrs. Julia Margaret Cameron and H. H. H. Cameron. Reminiscences by Anne T. Ritchie. With introduction by H. H. Hay Cameron. London: T. Fisher Unwin, 1893. 16 pp. 25 b & w.

C43 *Alfred Lord Tennyson: A Memoir by His Son*. New York, London: MacMillan Co., 1897. 2 vol. 516, 552 pp. 24 illus. [Includes photographs of Tennyson by O. G. Rejlander, John Mayall, J. M. Cameron, Poulton & Son, Cameron discussed on pp. 372, 513, 514 in vol. 1; pp. 84, 85 in vol. 2.]

C44 Cary, Elisabeth L. *Tennyson: His Homes, His Friends and His Work*. New York, London: G. P. Putnam's Sons, 1898. 314 pp. 22 illus. [22 photogravure plates of paintings by G. F. Watts, D. G. Rossetti and photographs by J. M. Cameron, H. H. Hay Cameron, and others. ["A portion of these illustrations were reproduced from the following English books: 'Alfred, Lord Tennyson, and His Friends,...'" by Julia M. Cameron and H. H. H. Cameron (and others.) Mrs. Cameron discussed on pp. 133, 143, 146-150.]

C45 J. P. S. "Cameron, Julia Margaret. (1815-1879)," on p. 752 in: *Dictionary of National Biography*, Vol. 3 (Brown-Chaloner). London: Oxford University Press, 1917.

C46 Cameron, Julia M. *Victorian Photographs of Famous Men and Fair Women*. By Julia Margaret Cameron. With Introductions by Virginia Woolf and Roger Fry. London; New York: L. & V. Woolf; Harcourt, Brace & Co., 1926. 15 pp. l. of plates. [London ed., 450 copies. NY ed., 250 copies.]

C47 Strasser, A. *Immortal Portraits*. Being a gallery of Famous Photographs by David Octavius Hill, Julia M. Cameron, Gaspard Felix Tournachon [Nadar]. London, New York: Focal Press, 1941. n. p. illus.

C48 Bell, Clive, introduction. *Julia Margaret Cameron, Her Life and Photographic Work*. "Famous Photographers" London: Fountain Press, 1948. 85 pp. 52 l. of plates.

C49 New York. Metropolitan Museum of Art. *Four Victorian Photographers*. Edited by John J. McKendry. New York: Metropolitan Museum of Art, 1967. 120 pp. illus. [Engagement calender for 1968, with photographs by Adolphe Braun, J. M. Cameron, Thomas Eakins, and D. O. Hill.]

C50 Hill, Brian. *Julia Margaret Cameron: A Victorian Family Portrait*. London; New York: Peter Owen; St. Martin's Press, 1973. 204 pp. 22 l. of plates. [Biography of the seven daughters of James Pattle, including Julia Margaret Cameron.]

C51 Woolf, Virginia and Roger Fry. Edited by Tristam Powell. *Victorian Photographs of Famous Men and Fair Women by Julia Margaret Cameron*. London; Boston: Hogarth Press; David R. Godine, 1973. 124 pp. 44 b & w. [Reprint of the 1926 edition. Additional photographs and a new preface by Tristram Powell.]

C52 *Mrs. Cameron's Photographs from the Life*. Stanford, CA: Stanford University Museum of Art, 1974. vii, 61 pp. 6 b & w. [(Jan. 22 - Mar. 10, 1974.) Curated by Anita Ventura Mozley. Essay by A. V. Mozley, on pp. 1-24, checklist of 50 prints, on pp. 25-50, xeroxes of earlier articles on pp. 51-61., all in a folder with 6 loose plates.]

C53 *Julia Margaret Cameron: Exhibition of Photographs from the "Mia" Album*. Southampton, England: Southampton University, Photographic Gallery and Library, 1975. 20 pp. [(May 2 - May 30, 1975.) Essays by L. Stable and R. V. Turley.]

C54 *The Herschel Album: An Album of Photographs. By Julia Margaret Cameron Presented to Sir John Herschel*. London: National Portrait Gallery, 1975. 31 pp. 31 b & w. [(Nov. 14, 1975 - Feb. 29, 1976.) 94 photos in the exhibition. Introduction by Colin Ford. Preface by J. Hayes.]

C55 Blunt, Wilfred. "Julia Margaret Cameron. Early Genius of the Camera," on pp. 127-136 in: *The British Eccentric*, edited by Harriet Bridgeman and Elizabeth Drury. New York: Clarkson N. Potter, Inc., 1975. n. p. 6 b & w. illus.

C56 Ford, Colin J. *The Cameron Collection: An Album of Photographs by Julia Margaret Cameron presented to Sir John Herschel*. Wokingham, England: Van Nostrand Reinhold Co., in assoc. with the National Portrait Gallery, 1975. 144 pp. 217 b & w.

C57 Gernsheim, Helmut. *Julia Margaret Cameron: Her Life and Photographic Work*. New York: Aperture, 1975. 200 pp. 100 b & w. [2nd ed. Expanded version of 1948 book. Includes Clive Bell's introduction. Additional photographs, biography, bibliography.]

C58 Gibbs-Smith, Charles Harvard. "Mrs. Julia Margaret Cameron, Victorian Photographer," on pp. 70-76 in: *One Hundred Years of Photographic History. Essays in Honor of Beaumont Newhall*. Edited by Van Deren Coke. Albuquerque, NM: University of New Mexico Press, 1975. 180 pp.

C59 Ovenden, Graham, Introduction by Lord David Cecil. *A Victorian Album: Julia Margaret Cameron and Her Circle*. London; New York: Secker & Warburg; Da Capo Press, 1975. 260 pp. 119 b & w. [The "Mia" album, in two sections. 1st section is of Cameron's work, the 2nd section has photos by Lewis Carroll, O. G. Rejlander, and Charles Somers-Cock.]

C60 Wheatcroft, Andrew. With an introduction by Sir John Betjeman. *The Tennyson Album: A Biography in Original Photographs*. London; Boston: Routledge & Kegan Paul, Ltd.; Henly & Co., 1980. 160 pp. illus. [Photographs by J. M. Cameron and O. G. Rejlander.]

C61 Weaver, Mike. *Julia Margaret Cameron, 1815 - 1879.* "A New York Graphic Society Book." Boston: Little, Brown, 1984. 160 pp. 143 illus.

C62 *Idylls of the King and Other Poems.* Photographically Illustrated by Julia Margaret Cameron. Text by Alfred Lloyd Tennyson. New York: Janet Lehr, Inc., 1986. 52 pp. 25 b & w. [Facsimile reproduction of Cameron's volume.]

C63 Lukitsh, Joanne. *Julia Margaret Cameron: Her Work, Her Career.* Rochester, NY: International Museum of Photography at George Eastman House, 1986. 103 pp. 123 b & w. illus. [Bibliography.]

C64 Waller, Bret. *Whisper of the Muse: The Work of Julia Margaret Cameron.* J. Paul Getty Museum, 1986. 1 sheet folded into 8 pages pp. 5 b & w. [Exhibition catalog: J. Paul Getty Museum, Sept. 10 - Nov. 16, 1986. Illustrations are photographs by J. M. Cameron.]

C65 Weaver, Michael. *Whisper of the Muse: The Overstone Album and Other Photographs by Julia Margaret Cameron.* Foreword by John Walsh, Preface by Weston J. Naef. Santa Monica: J. Paul Getty Museum, 1986. 103 pp. 110 b & w.

C66 Hopkinson, Amanda. *Julia Margaret Cameron.* London: Virago Press Ltd., 1986. 180 pp. b & w. [Bibliography on pp. 174-176.]

PERIODICALS

C67 "Waifs and Strays: Out of Focus." BRITISH JOURNAL OF PHOTOGRAPHY 11, no. 220 (July 22, 1864): 261. [Editors disagree with a critic of the "Athenaeum" who praised J. M. Cameron's out-of-focus photographs as creative.]

C68 "Soiree of the Photographic Society." BRITISH JOURNAL OF PHOTOGRAPHY 12, no. 262 (May 12, 1865): 249. [Soiree held by Photographic Society, awarded medals to Bedford, Buxton, England, Macfarlane, Mudd and H. P. Robinson. Quote from a statement by the Committee, disapproving of the careless technique of J. M. Cameron.]

C69 "George Frederick Watts, A.R.A." ILLUSTRATED LONDON NEWS 50, no. 1416 (Mar. 9, 1867): 224, 239. 1 illus. ["Our Portrait of Mr. Watts is engraved from one of Mrs. Cameron's very artistic photographs."]

C70 "Note." ART JOURNAL (Mar. 1868): 58. [Note and brief review of Cameron's works on exhibition at the German Gallery, London.]

C71 Stanley, A. P. "Science and Religion: A Sermon preached at Westminister Abbey, on May 21, 1871, being the Sunday following the funeral of Sir John Herschel." GOOD WORDS 12, no. 7 (July 1871): 453-459. 1 illus. [Woodcut portrait of Sir John Herschel on p. 457, "...from a Photo. by Mrs. Cameron."]

C72 "Studies from Life by Mrs. Cameron." ART PICTORIAL AND INDUSTRIAL 3, no. 20 (Feb. 1872): 25-26, plus plate tipped-in after p. 26. 1 b & w. [Heliotype reproduction of the genre scene, "A Study from Life."]

C73 "From Across the Water." ANTHONY'S PHOTOGRAPHIC BULLETIN 6, no. 4 (Apr. 1875): 123-124. [Monthly column; this issue contains an excerpt "Poetry and Photography," from the "London Times," reviewing J. W. Cameron's photographs of Tennyson's "Idylls of the King."]

C74 "My Neighbors at the Seaside. - Mrs. Cameron." ANTHONY'S PHOTOGRAPHIC BULLETIN 6, no. 10 (Oct. 1875): 311. [From "My Letter in Leisure," in the "Liverpool Journal."]

C75 Wilson, Edward L. "Lancelot and Guinevere." PHILADELPHIA PHOTOGRAPHER 14, no. 166 (Oct. 1877): 297-298. 1 illus. [From "Harper's Weekly." Engraving from Tennyson's "Idylls of the King' series by J. M. Cameron, exhibited at the International Exhibition at the Phila. Centennial Exhibition.]

C76 "Photography Recognized as a Fine Art." PHILADELPHIA PHOTOGRAPHER 14, no. 166 (Oct. 1877): 298-300. [Describes how Harper & Brothers, publishers of "Harper's Weekly," arranged to tour the photo exhibit at the Phila. Centennial with E. L. Wilson, select and publish examples of the best photographs - including one of J. M. Cameron's.]

C77 "The Late Mrs. Julia Cameron." BRITISH JOURNAL OF PHOTOGRAPHY 26, no. 983 (Mar. 7, 1879): 115-116. [From "The World".]

C78 "The Late Mrs. Julia Cameron." PHOTOGRAPHIC TIMES 9, no. 100 (Apr. 1879): 82-83. [From the "Br. J. of Photo."]

C79 1 photo (Thomas Carlyle). CENTURY MAGAZINE (SCRIBNER'S MONTHLY) 22, no. 1 (May 1881): frontispiece. 1 illus. ["Engraved by T. Cole, after a photograph by the late Mrs. Cameron."]

C80 Holden, Edward S. "The Three Herschels." CENTURY MAGAZINE 30, no. 2 (June 1885): 178-185. [Illustrated with 3 portrait engravings of Sir John Herschel (from a photo by Mrs. Cameron), William Herschel and Caroline Lucretia Herschel.]

C81 Archer, Talbot. "A Famous Lady Photographer." INTERNATIONAL ANNUAL ANTHONY'S PHOTOGRAPHIC BULLETIN, 1888 (1888): 3-5. [From "A Biographical Sketch of Lord Tennyson," by H. J. Jennings. London: Chatto & Windus, 1884.]

C82 Archer, Talbot. "A Famous Lady Photographer." ANTHONY'S PHOTOGRAPHIC BULLETIN 19, no. 18 (Sept. 22, 1888): 563-566. [A printer's error deleted a portion of Archer's article on J. M. Cameron in the "International Annual." The remainder published here.]

C83 Emerson, P. H. "The Artistic Aspects of Figure Photography." MAGAZINE OF ART 14, no. 9 (Aug. 1891): 310-316. 6 b & w. [Photos by Mrs. F. W. H. Myers (3) and J. M. Cameron (3).]

C84 Watts, Theodore. "The Portraits of Lord Tennyson. I." MAGAZINE OF ART 16, no. 2 (Jan. 1893): 36-43. 2 b & w. 6 illus. [Discusses portraits of the poet. Includes photos by Cameron, O. J. Rejlander and a painting by Girardot based on a photo by Mayall.]

C85 Watts, Theodore. "The Portraits of Lord Tennyson. II." MAGAZINE OF ART 16, no. 3 (Feb. 1893): 96-101. 9 illus.

C86 Martin, Edwin C. "Tennyson's Friendships." MCCLURE'S MAGAZINE 2, no. 1 (Dec. 1893): 54-60. 5 b & w. 2 illus. [Four portraits by J. M. Cameron, and a painted portrait of her by G. F. Watts. The article was]

C87 O'Connor, V. C. Scott. "Mrs. Cameron, Her Friends, and Her Photographs. Tennyson, Watts, Taylor, Herschel." CENTURY MAGAZINE 55, no. 1 (Nov. 1897): 3-10. 3 b & w. 1 illus. [Portrait of Cameron by G. F. Watts. Two of Cameron's portraits of Tennyson on pp. 241 and 252 in O'Connor's article on Tennyson in the next issue.]

C88 O'Connor, V. C. Scott. "Tennyson and His Friends at Freshwater." CENTURY MAGAZINE 55, no. 2 (Dec. 1897): 240-268. 4 b & w. 24 illus. [Portraits of Tennyson by J. M. Cameron (2); H. H. Hay Cameron (1); Bennett & Sons (1). Landscapes, etc.]

C89 "Notes and News: A Famous Amateur Photographer." PHOTOGRAPHIC TIMES 30, no. 4 (Apr. 1898): 190. [Excerpts from the article on Mrs. Cameron in the Nov. 1897 issue of "Century Magazine".]

C90 1 photo (Author James T. Fields). OUTLOOK 59, no. 9 (July 2, 1898): 554. 1 b & w. [Used to illustrate an article on James Russell Lowell and his friends,—part of a series.]

C91 "The Year's Best Books." OUTLOOK 60, no. 14 (Dec. 3, 1898): 812. [Annual review. This article contains a review of "The Life and Letters of Tennyson," edited by his son, Hallam, Lord Tennyson and a portrait of A. L. Tennyson on p. 812 by Julia Margaret Cameron.]

C92 "News and Notes." WILSON'S PHOTOGRAPHIC MAGAZINE 37, no. 520 (Apr. 1900): 175. [Brief anecdote reported "that Mrs. Cameron used to tell of her first meeting with Longfellow."]

C93 [Wilson, Edward L.] "Studio Accessories." WILSON'S PHOTOGRAPHIC MAGAZINE 38, no. 536 (Aug. 1901): 294-295. [From "Photographic Chronicle." Actually a discussion of the aesthetics of studio portraiture, and on p. 295 discusses J. M. Cameron's works as ideal examples of portraiture.]

C94 "Plates: Julia Margaret Cameron." CAMERA WORK no. 41 (Jan. 1913): 3-13. 5 b & w. [Commentary in "Our Plates," on pp. 41-42]

C95 Ritchie, Lady A. I. T. "From Friend to Friend. Mrs. Tennyson and Mrs. Cameron." CORNHILL MAGAZINE n. s. 41, no. 241 (July 1916): 21-43. [Includes quotes from exchange of letters between the two women.]

C96 Kuehn, Heinrich. "Die optischen Mittel fur malerische Photographie." CAMERA (LUCERNE) 2, no. 5 (Nov. 1923): 85-87. [Cameron discussed on p. 87.]

C97 Cameron, Julia M. "Annals of My Glass House." PHOTOGRAPHIC JOURNAL 67, no. 7 (July 1927): 296-301. 1 illus. [Contains an introduction by J. Dudley Johnston, then reprints the fragmentary statements by Mrs. Cameron of the first two years of her career.]

C98 Hunt, Violet. "Stunners." ARTWORK 6, no. 22 (Summer 1930): 77-87. 3 b & w. [Article about women associated with the Pre-Raphaelite Movement. Illustrated with several portraits in various media. 3 photographs of Mrs. W. J. Stillman by J. M. Cameron on pp. 83-84.]

C99 "Notes & News: Early Work of D. O. Hill and Mrs. J. M. Cameron shown at Museum of Modern Art." AMERICAN PHOTOGRAPHY 43, no. 7 (July 1949): 464.

C100 "Pictures from the Collection." IMAGE 5, no. 6 (June 1956): 138-139. 1 b & w. [Portrait of William Michael Rosetti, by Julia M. Cameron, ca. 1875.]

C101 Martinez, R. E. "The Feminine Touch in Photography." CAMERA (LUCERNE) 37, no. 1 (Jan. 1958): 3-5. 4 b & w.

C102 Jammes, André. "Photographic Incunabula." CAMERA (LUCERNE) 40, no. 12 (Dec. 1961): 25.

C103 Barrow, Thomas F. "'Talent.'" IMAGE 14, no. 5-6 (Dec. 1971): 29-31. 3 b & w. [Discussion of an album containing Cameron photos, held at the George Eastman House.]

C104 Millard, Charles W. "Julia Margaret Cameron and Tennyson's 'Idylls of the King.'" HARVARD LIBRARY BULLETIN 21, no. 2 (Apr. 1973): 187-201. 8 b & w. [Extensive, literate, discussion of Cameron's efforts with this publication. Includes a detailed account of the known variants held in public collections.]

C105 Harker, Margaret. "Photography's Great Eccentric." PHOTOGRAPHIC JOURNAL 114, no. 1 (Jan. 1974): 26-31. 6 b & w. [Bibliography.]

C106 "Lewis Carroll and Julia Margaret Cameron." ART IN AMERICA 62, no. 6 (Nov. - Dec. 1974): 118. 1 b & w. [Ex. rev.: 'Lewis Carroll & Julia M. Cameron,' Scott Elliott Gallery, New York.]

C107 Hopkins, Harry. "Julia Cameron's Photography." ILLUSTRATED LONDON NEWS 263, no. 6920 (Mar. 1975): 54-57. 10 b & w.

C108 "Julia Margaret Cameron: Photographs for the Nation." CREATIVE CAMERA no. 130 (Apr. 1975): 136-139. 4 b & w.

C109 Davis, Douglas. "Art: Mrs. Cameron's Special Eye." NEWSWEEK (Sept. 1, 1975): 70-71. 5 b & w. 1 illus.

C110 Ford, Colin. "Julia Margaret Cameron: Portraits." CREATIVE CAMERA no. 177 (Mar. 1979): 90-97. 7 b & w.

C111 Mann, Charles W. "The Poet's Pose." HISTORY OF PHOTOGRAPHY 3, no. 2 (Apr. 1979): 125-127. 2 b & w. 3 illus. [1 b & w by Cameron, 1 b & w by Elliott & Fry. Cameron's portrait of Henry Wadsworth Longfellow.]

C112 Ford, Colin. "Rediscovering Mrs. Cameron - And Her First Photograph." CAMERA (LUCERNE) 58, no. 5 (May 1979): 4, 13, 14, 23, 24, 34-35. 24 b & w. 10 illus. [This article was taken from a talk by Colin Ford, Curator of Film & Photography, National Portrait Gallery, London, that was broadcast by the BBC Jan. 26, 1979 in honor of the hundredth anniversary of Julia Margaret Cameron's death.]

C113 Fondiller, Harvey V. "Shows We've Seen." POPULAR PHOTOGRAPHY 86, no. 3 (Mar. 1980): 74. [Ex. rev.: "Photographs by Julia Margaret Cameron," Ashmolean Museum, Oxford, England.]

C114 Westerbeck, Colin L., Jr. "Reviews: Paris." ARTFORUM 19, no. 6 (Feb. 1981): 85-87. [Ex. rev.: "Julia M. Cameron," Maison de Victor Hugo, Paris.]

C115 Thomas, G. "Bogawantalawa, the final resting place of Julia Margaret Cameron." HISTORY OF PHOTOGRAPHY 5, no. 2 (Apr. 1981): 103-104. 2 illus. [Photographs of the church and tombstone in Shri Lanka where Cameron and husband are buried.]

C116 Mann, Charles W., Jr. "'Your Loving Auntie & God Mama, Julia Cameron.'" HISTORY OF PHOTOGRAPHY 7, no. 1 (Jan. 1983): 73-74. 1 illus. [Letter from J. M. Cameron to Julia P. Jackson, written in 1845, reproduced.]

C117 Wilsher, Ann and Benjamin Spear. "'A Dream of Fair Ladies,' Mrs. Cameron." HISTORY OF PHOTOGRAPHY 7, no. 2 (Apr. - June

1983): 118-120. [Anne Thackeray's description of Mrs. Cameron in her writings.]

C118 Williams, Val. "Only Connecting: Julia M. Cameron and Bloomsbury." PHOTOGRAPHIC COLLECTOR 4, no. 1 (Spring l983): 40-49. 8 b & w.

C119 Knight, Hardwicke. "Anne Isabella Thackery and Julia Margaret Cameron." HISTORY OF PHOTOGRAPHY 7, no. 3 (July - Sept. 1983): 247-248. 1 illus. [Thackery's critical review of Cameron's album of portraits.]

C120 Michaels, Barbara L. "Photography's Fantasist." CONNOISSEUR 215, no. 881 (June 1985): 38. 1 b & w. [Ex. rev.: "J. M. Cameron in Context," International Center of Photography, New York.]

C121 Fagan-King, Julia. "Cameron, Watts, Rossetti: The Influence of Photography on Painting." HISTORY OF PHOTOGRAPHY 10, no. 1 (Jan. - Mar. 1986): 19-29. 4 b & w. 6 illus.

C122 Lukitsch, Joanne. "Julia Margaret Cameron's Photographic Illustrations to Tennyson's 'Idylls of the King.'" ARTHURIAN LITERATURE 7, (1987): 145-157.

C123 Rule, Amy. "The Photography of Julia Margaret Cameron in America and Modern Oblivion." EXPOSURE 26, no. 1 (Spring 1988): 27-35. 7 b & w. [Five photos by Cameron, one by Lewis Carroll, and one by Joel-Peter Witkin.]

C124 Thomas, G. "That Oriental Streak in Julia Margaret Cameron's Ancestry." HISTORY OF PHOTOGRAPHY 12, no. 2 (Apr. - June 1988): 175-178. [Includes family tree and genealogy for the Brumet family.]

CAMP, DANIEL S. (d. 1877) (USA)
C125 "Editor's Table." PHILADELPHIA PHOTOGRAPHER 15, no. 175 (July 1878): 224. [Daniel S. Camp, "an old friend and active member of the [photographic] society," killed while fighting a fire in Hartford, CT. on May 22nd. "...a photographer of the first rank."]

CAMPBELL, A. (STIRLING, ENGLAND)
C126 Portrait. Woodcut engraving credited "From a photograph by A. Campbell." ILLUSTRATED LONDON NEWS 74, (1879) ["Brig. Evelyn Wood, V.C., C.B." 74:2082 (May 10, 1879): 450.]

C127 Portrait. Woodcut engraving credited "From a photograph by A. Campbell, Murray Place, Stirling." ILLUSTRATED LONDON NEWS 74, (1879) ["Brig. Evelyn Wood, V.C., C.B." 74:2082 (May 10, 1879): 450.]

CAMPBELL, J. W. (USA)
C128 Seely, Charles A. "Editorial Department." AMERICAN JOURNAL OF PHOTOGRAPHY AND THE ALLIED ARTS & SCIENCES n. s. vol. 7, no. 22 (May 15, 1865): 525. ["Mr. J. W. Campbell, late photographer to Gen. Sherman, has just published a series of stereo-views of Charleston and vicinity, comprising about forty slides. As photographs, war pictures, or an exposition of the punishment of treason, we know of nothing of the kind which is superior. A set of these views ought to be placed where they will be accessible to the people of every town in the Union."]

CAMPBELL, JAMES. (DAYTON, OH)
C129 Campbell, Jas. "Heliochromy." HUMPHREY'S JOURNAL 4, no. 21 (Feb. 15, 1853): 333-335. [Campbell an amateur experimenter from Dayton, OH.]

C130 Campbell, James. "Heliochromy." HUMPHREY'S JOURNAL 4, no. 23-24 (Mar. 15 - Apr. 1, 1853): 362-364, 378-380. [Survey of history of experiments in this field. Discussion of Niépce de Saint-Victor's work.]

C131 Campbell, James. "Heliochromy." HUMPHREY'S JOURNAL 5, no. 1 (Apr. 15, 1853): 11-12.

CAMPBELL, JOHN LOGAN. (NEW ZEALAND) [?]
C132 Campbell, John Logan. Poenamo; Sketches of the Early Days in New Zealand: Romance and Reality of Antipodean Life in the Infancy of a New Colony. London: Williams and Norgate, 1881. xii, 359 pp. 21 l. of plates. b & w. [Original photos of landscapes, natives, etc. - some from sketches. The "List of Illustrations" is hand written - this may be an extra illustrated volume. Photos seem the work of an amateur, may be by the author.]

CAMPBELL, WILLIAM. (JERSEY CITY, NJ)
C133 Campbell, W. "An Incident." AMERICAN JOURNAL OF PHOTOGRAPHY AND THE ALLIED ARTS AND SCIENCES n. s. vol. 1, no. 1 (June 1, 1858): 8-10. [Anecdote about a widower having a photograph made of his dead wife's clothing in order to have some memento.]

C134 Campbell, W. "New Mode of Printing - Ambrotypes in Colors." AMERICAN JOURNAL OF PHOTOGRAPHY AND THE ALLIED ARTS AND SCIENCES n. s. vol. 1, no. 4 (July 15, 1858): 57.

C135 Campbell, W. "Ambrotypes Permanent." AMERICAN JOURNAL OF PHOTOGRAPHY AND THE ALLIED ARTS AND SCIENCES n. s. vol. 1, no. 3 (July 1, 1858): 38-40.

C136 Campbell, W. "Curiosities of Vision." AMERICAN JOURNAL OF PHOTOGRAPHY AND THE ALLIED ARTS AND SCIENCES n. s. vol. 1, no. 9 (Oct. 1, 1858): 136-137. [Stereo vision discussed.]

C137 Campbell, W. "The Patents." AMERICAN JOURNAL OF PHOTOGRAPHY 1, no. 18 (Feb. 15, 1859): 287-288.

C138 "The Ectograph." AMERICAN JOURNAL OF PHOTOGRAPHY AND THE ALLIED ARTS & SCIENCES n. s. vol. 3, no. 22 (Apr. 15, 1861): 344. ["A colored portrait on glass..."]

C139 "A Funnygraph." AMERICAN JOURNAL OF PHOTOGRAPHY AND THE ALLIED ARTS & SCIENCES n. s. vol. 3, no. 24 (May 1, 1861): 380-381. [Short play, meant to be humorous]

C140 C[ampbell]. "Wooden Baths and Mouse Traps." AMERICAN JOURNAL OF PHOTOGRAPHY AND THE ALLIED ARTS & SCIENCES n. s. vol. 3, no. 24 (May 15, 1861): 372-373. [Anecdote about building mouse traps.]

C141 Campbell, Wm. "Permanent Photographs." AMERICAN JOURNAL OF PHOTOGRAPHY AND THE ALLIED ARTS & SCIENCES n. s. vol. 4, no. 5 (Aug. 1, 1861): 108-109.

C142 "The Ectograph. [Patented by William Campbell, Jersey City, N. J.]." AMERICAN JOURNAL OF PHOTOGRAPHY AND THE ALLIED ARTS & SCIENCES. n. s. vol. 7, no. 2 (July 15, 1864): 35-36. [From

Root's "Camera and Pencil." Seely claims that he perfected the process in 1855.]

C143 Campbell, Wm. "The Ectograph." HUMPHREY'S JOURNAL OF PHOTOGRAPHY, AND THE ALLIED ARTS AND SCIENCES 17, no. 23 (Apr. 1, 1866): 357-358.

C144 Campbell, Wm. "An Easy Mode of Obtaining the Position and Focus for Field Views." HUMPHREY'S JOURNAL OF PHOTOGRAPHY, AND THE ALLIED ARTS AND SCIENCES 20, no. 4 (June 15, 1868): 52-53. ["Many years ago, perhaps a dozen, I was very enthusiastic in my profession, indeed I am so still,..."]

C145 Campbell, William. "Correspondence." ANTHONY'S PHOTOGRAPHIC BULLETIN 7, no. 8 (Aug. 1876): 256. [Campbell from Jersey City, NJ.]

CANEY. (DURBAN, SOUTH AFRICA)
C146 "Cutting the First Turf of the Natal Government Railway at Durban." ILLUSTRATED LONDON NEWS 68, no. 1911 (Mar. 11, 1876): 261. 1 illus.

CARBUTT, JOHN. (1832-1905) (GREAT BRITAIN, USA)
BOOKS
C147 Carbutt, John. *Biographical Sketches of the Leading Men of Chicago; Photographically Illustrated.* Written by the best talent of the Northwest. Chicago: Wilson & St. Clair, 1868. 2 vol., 693 pp. 117 b & w. [Original photos, by J. Carbutt. New edition 1876, published by Wilson, Pierce.]

C148 Henry, J. T. *The Early and Later History of Petroleum; With Authentic Facts in Regard to Its Development in Western Pennsylvania;...* Philadelphia: J. B. Rodgers, 1873. 607 pp. 33 l. of plates. 27 b & w. illus. [Woodburytype portraits by the A. P. R. P. Co. (Carbutt) of Philadelphia. Frontispiece is a photograph's view of Titusville Oil Field Dec. 1861 by Mather. The author thanks John "Carbutt of Philadelphia, for the beautiful photographic illustrations,...especially in the department of Biographies."]

C149 Philadelphia Sketch Club. *Portfolio.* v. 1, no. 1 - 11/12 (Jan. - Nov./Dec. 1874). Philadelphia: Taylor & Smith, 1874. 12 nos. in 1 v. pp. 55 b & w. [Each monthly number comprises from four to six plates, the sketches being by members of the club and others... "One of the objects of the Portfolio will be the testing of new methods of reproduction." The plates are photo-lithographed reproductions by A. Dickens and J. Carbutt.]

C150 Brey, William. *John Carbutt: On the Frontiers of Photography.* Cherry Hill, NJ: Willowdale Press, 1984. 208 pp. illus. [Contains lists of Carbutt's stereo series, Carbutt's listings in business directories, a chronology, references and bibliography. John Carbutt was born at Sheffield, England on Dec. 2, 1832. He worked as a photographer for the Grand Trunk Railroad in Canada from 1853 to 1857. Then, in 1858-59, he worked in a gallery in Indiana, then returned to England and opened a gallery in Sheffield in 1861. But he then emigrated to Chicago, IL in 1861 and opened a gallery there, which he kept until 1868. Took field trips taking stereo views along the Mississippi river around 1864. Elected Vice-President and Corresponding Secretary of the Northwest Photographic Society in 1864. Carbutt had met Edward L. Wilson, the editor of *Philadelphia Photographer* in 1864 and throughout the decade their friendship deepened. Photographed the 100th Meridian Excursion for the Union Pacific Railroad in Oct. 1866. Trips to Lake Superior, and west to the Rocky Mountains. In 1868 his studio produced 50,000 portraits to illustrate *Biographical Sketches of the Leading Men of Chicago.* In August, 1869 he accompanied the Solar Eclipse Expedition to Iowa, and that fall he visited England to purchase rights to use the Woodbury photomechanical printing process. Demonstrated the Woodbury process at the National Photographic Association annual convention in 1870. In the fall of 1870 he moved to Philadelphia to produce Woodburytypes commercially, organized the American Photo-Relief Co., and was the Superintendent until 1874. In 1874 began using the Collotype process, and in 1875 attempted to introduce Commercial Dry Plates, but without much business success. From April to November, 1876 Carbutt was the Superintendent of the Photographic Hall at the Philadelphia Centennial Exhibition. Throughout the 1870s continued to manufacture plates, and in 1879 was able to introduce the first successful commercial gelatin-bromide dry plates. His business flourished and he continued to offer new products, including orthochromatic dry plates in 1886, celluloid dry plates in 1888, a hand camera in 1891, and the world's first commercial x-ray plates in 1896. The Carbutt Dry Plate and Film Company of Philadelphia was incorporated in 1902. Died in Philadelphia on July 26, 1905.]

PERIODICALS
C151 Carbutt, John. "Separation of Nitrate of Silver from Nitrate of Copper." HUMPHREY'S JOURNAL OF PHOTOGRAPHY, AND THE ALLIED ARTS AND SCIENCES. 11, no. 8 (Aug. 15, 1859): 117-118.

C152 "Off for Europe." HUMPHREY'S JOURNAL OF PHOTOGRAPHY, AND THE ALLIED ARTS AND SCIENCES 14, no. 7 (Aug. 1, 1862): 64. [Ch. Waldack and John Carbutt visiting Europe, sailing on the "Great Eastern."]

C153 Sellers, Coleman. "Foreign Correspondence." BRITISH JOURNAL OF PHOTOGRAPHY 10, no. 200 (Oct. 15, 1863): 415-416. 1 illus. [Extensive description of Carbutt's working practices, portable developing apparatus, used while taking the stereo views in his series "Glimpses of the Great West."]

C154 Carbutt, John. "New Salt of Gold." HUMPHREY'S JOURNAL OF PHOTOGRAPHY, AND THE ALLIED ARTS AND SCIENCES 16, no. 1 (May 1, 1864): 13. [Letter from Carbutt, reply from Towler.]

C155 Sellers, Coleman. "Things Photographic, at Home and Abroad." PHILADELPHIA PHOTOGRAPHER 1, no. 5 (May 1864): 72-76. [Read before the Phila. Photo. Society. General summation of events, Carbon printing, solar camera, etc. Mentions that J. Carbutt took an excursion to headwaters of Mississippi in 1863; used glycerine to keep his negatives until he could develop them on return to Chicago, IL.]

C156 "Editor's Table: Fine Stereoscopic Views." PHILADELPHIA PHOTOGRAPHER 1, no. 9 (Sept. 1864): 144. [Views of Chicago, IL, etc.]

C157 "Editor's Table: Carbutt's Stereos." PHILADELPHIA PHOTOGRAPHER 1, no. 11 (Nov. 1864): 175. [Views in NY, KY, etc. described.]

C158 "Our Picture - Deer Park, Ill." PHILADELPHIA PHOTOGRAPHER 2, no. 13 (Jan. 1865): frontispiece, 14-15. 1 b & w.

C159 "Carbutt's Portable Developing Box or Tent." PHILADELPHIA PHOTOGRAPHER 2, no. 13 (Jan. 1865): 4-6. 2 illus.

C160 Carbutt, John. "Rawhide Block for Cutting Card Pictures On." PHILADELPHIA PHOTOGRAPHER 2, no. 13 (Jan. 1865): 11-12.

C161 "Our Picture." PHILADELPHIA PHOTOGRAPHER 2, no. 14 (Feb. 1865): frontispiece, 30-31. 1 b & w. [Landscape view of Starved Rock, IL.]

C162 Morton, Rev. "Photography and the Wind." PHILADELPHIA PHOTOGRAPHER 2, no. 14 (Feb. 1865): 2-3. [Abstract of Morton's diary, text about an airless July day in the Hudson Highlands, juxtaposed against a photo of Starved Rock, IL, by John Carbutt.]

C163 Editor's Table - Photographic Novelties." PHILADELPHIA PHOTOGRAPHER 2, no. 14 (Feb. 1865): 32. [Double, triple and quadruple exposures of the same individual performing different roles.]

C164 Carbutt, John. "Practical Working Formula." PHILADELPHIA PHOTOGRAPHER 2, no. 15 (Mar. 1865): 39-40.

C165 "The Fair at Chicago." PHILADELPHIA PHOTOGRAPHER 2, no. 19 (July 1865): 115-116. [Reprint from "Chicago [IL] Evening Journal." Discusses the Chicago Sanitary Fair. Carbutt prominently mentioned.]

C166 "Editor's Table." PHILADELPHIA PHOTOGRAPHER 2, no. 23 (Nov. 1865): 187. [Carte: "Into Mischief" received.]

C167 "Editor's Table." PHILADELPHIA PHOTOGRAPHER 2, no. 24 (Dec. 1865): 206. [Stereoscope of Crosby's Opera House received.]

C168 Carbutt, John. "Correspondence." PHILADELPHIA PHOTOGRAPHER 2, no. 24 (Dec. 1865): 201-202. [Writes of visit to St. Paul, MN.]

C169 "Stereoscopes by J. Carbutt." PHILADELPHIA PHOTOGRAPHER 3, no. 26 (Feb. 1866): 59-60.

C170 Carbutt, J. "Watch-Dial Portraits." PHILADELPHIA PHOTOGRAPHER 3, no. 28 (Apr. 1866): 104-105.

C171 Carbutt, J. "Watch Dial Portraits." HUMPHREY'S JOURNAL OF PHOTOGRAPHY, AND THE ALLIED ARTS AND SCIENCES 17, no. 24 (Apr. 15, 1866): 381-383. [From "Photo. News."]

C172 "The Bromide Patent." HUMPHREY'S JOURNAL OF PHOTOGRAPHY, AND THE ALLIED ARTS AND SCIENCES 18, no. 4 (June 15, 1866): 58-59. [From the "Chicago Evening Journal." Report of meeting of the Northwest Photographic Society to challenge the patent. Includes a letter from James R. Hayden, Pres. of the Society and a letter from John Carbutt.]

C173 Carbutt, John. "A New Design for a Solar Camera." PHILADELPHIA PHOTOGRAPHER 3, no. 34 (Oct. 1866): 293-295. 1 illus.

C174 "Stereoscopic Pictures." PHILADELPHIA PHOTOGRAPHER 3, no. 34 (Oct. 1866): 300-302. [Carpenter & Mullen (KY scenery); John Carbutt (Chicago, IL, scenery); R. Newell (Cape Island bathers).]

C175 Hoyt, A. W. "Over the Plains to Colorado." HARPER'S MONTHLY 35, no. 205 (June 1867): 1-21. 14 illus. [About the construction of the Union Pacific Railroad. Although not credited, several of the images were taken from Carbutt's stereo views of the "Excursion to the 100th Meridian."]

C176 "Our Picture." PHILADELPHIA PHOTOGRAPHER 4, no. 42 (June 1867): frontispiece, 190-192. 1 b & w. [Landscape view "The Falls of Minnehaha".]

C177 "Editor's Table." PHILADELPHIA PHOTOGRAPHER 4, no. 44 (Aug. 1867): 272. [Twenty four photos of industry, sawmills, etc. around Lake Superior.]

C178 "Voices from the Craft." PHILADELPHIA PHOTOGRAPHER 4, no. 45 (Sept. 1867): 299-300. [Letter from Carbutt about using stereo lenses for landscapes.]

C179 "Editor's Table." PHILADELPHIA PHOTOGRAPHER 5, no. 49 (Jan. 1868): 34. [" Mr. Carbutt, of Chicago, IL, has been spending about a month on the Plains of the Pacific Railroad, among the Indians,..."]

C180 "Editor's Table." PHILADELPHIA PHOTOGRAPHER 5, no. 50 (Feb. 1868): 65. ["Mr.John Carbutt... has now near completion the largest order for portraits we ever heard of. 45,000 & 50,000 of 80 or 90 of the most prominent citizens of Chicago, IL... to illustrate a work shortly to be published here."]

C181 "Editor's Table." PHILADELPHIA PHOTOGRAPHER 5, no. 56 (Aug. 1868): 279. [Carbutt has moved to his new studio at 24 Washington St.]

C182 Carbutt, J. "Hints on Cutting Out Stereograph Pictures." PHILADELPHIA PHOTOGRAPHER 7, no. 73 (Jan. 1870): 15-17. [Illustrated with diagrams.]

C183 Carbutt, J. "Improved Photograph Washing Tank." PHILADELPHIA PHOTOGRAPHER 7, no. 74 (Feb. 1870): 35-36.

C184 "Editor's Table." PHILADELPHIA PHOTOGRAPHER 7, no. 75 (Mar. 1870): 95. [Offering Carbutt's Chicago, IL establishment for sale. Carbutt going into manufacturing the Woodbury process.]

C185 "Illinois. - The Proposed New Pacific Hotel in Chicago. - From a Photograph of the Architect's Plan by J. Carbutt." FRANK LESLIE'S ILLUSTRATED NEWSPAPER 30, no. 758 (Apr. 9, 1870): 53. 1 illus.

C186 "Editor's Table." PHILADELPHIA PHOTOGRAPHER 7, no. 80 (Aug. 1870): 304. [Carbutt sold his Chicago, IL studio to S. W. Sawyer of Bangor, ME; moving to Philadelphia, PA to work on Woodburytype relief process.]

C187 Carbutt, John. "Albumen Positives for Use in Reproducing Negatives." ANTHONY'S PHOTOGRAPHIC BULLETIN 4, no. 8 (Aug. 1873): 230-231. [Read before the Photographic Society of Pennsylvania. From "Photo News."]

C188 Carbutt, J. "Fifth Annual Meeting and Exhibit of the National Photographic Association of the U.S., held in Buffalo, N.Y., beginning July 5, 1873: How to Make Albumen Positives for Reproducing Negatives." PHILADELPHIA PHOTOGRAPHER 10, no. 117 (Sept. 1873): 374-376.

C189 Carbutt, John. "International Exhibition 1876." ANTHONY'S PHOTOGRAPHIC BULLETIN 7, no. 4 (Apr. 1876): 113. [Carbutt appointed superintendent of the Photographic Hall at the Centennial Exhibit in Philadelphia.]

C190 Carbutt, John. "Hints on Working Gelatin Plates." PHOTOGRAPHIC TIMES 11, no. 122 (Feb. 1881): 52-53.

C191 Carbutt, John. "Transparencies on Gelatine Plates." PHOTOGRAPHIC TIMES 11, no. 124 (Apr. 1881): 135-137. [Also commentary on Carbutt's Keystone Plates on pp. 132-133 of "Our Editorial Table."]

C192 Carbutt, John. "Carbutt's Lecture on Photography." PHOTOGRAPHIC TIMES 11, no. 127 (July 1881): 251-252. [Abstracted from Carbutt's lecture on the gelatino-bromide process before the Franklin Institute.]

C193 Carbutt, John. "Photography with a Microscope." PHOTOGRAPHIC TIMES 12, no. 139 (July 1882): 245-247. 1 illus.

C194 "Contemporary Press." PHOTOGRAPHIC TIMES 12, no. 139 (July 1882): 259. [From the "Chester Evening News." Report on John Carbutt's lecture at the Chester Institute of Science on microscopic photography. Carbutt's article on this topic printed on pp. 245-247]

C195 Taylor, J. Traill. "The Studios of America. No. 4. Carbutt's Dry Plate Factory, Philadelphia." PHOTOGRAPHIC TIMES 13, no. 147 (Mar. 1883): 104-106.

C196 Carbutt, John. "Reducing the Intensity of Negatives, Positives, and Over-Timed Albumen Prints." PHOTOGRAPHIC TIMES 14, no. 165 (Sept. 1884): 526-527.

C197 Carbutt, John. "Transparencies and How to Make Them." PHOTOGRAPHIC TIMES 16, no. 269 (Nov. 12, 1886): 590-591.

C198 "General Notes." PHOTOGRAPHIC TIMES 17, no. 281 (Feb. 4, 1887): 57. [Note that Carbutt displayed examples of slides developed with his new processes to the Society of Amateur Photographers in New York.]

C199 Carbutt, John. "Improvements in Lantern Slide Makeup." PHOTOGRAPHIC TIMES 17, no. 282 (Feb. 11, 1887): 70.

C200 Carbutt, John. "Hydrochinon." PHOTOGRAPHIC TIMES 17, no. 327 (Dec. 23, 1887): 652-653.

C201 Carbutt, John. "The Means to an End; Or, the Way to Secure a Perfect Photograph." PHOTOGRAPHIC MOSAICS: 1888 24, (1888): 122-124.

C202 Carbutt, John. "A Perfect Substitute for Glass as a Support for Gelatine Bromide of Silver for Use in Photography." PHOTOGRAPHIC TIMES 18, no. 376 (Nov. 30, 1888): 568-570. [A paper read before the Franklin Institute of Philadelphia.]

C203 "The Editorial Table." PHOTOGRAPHIC TIMES 19, no. 403 (June 7, 1889): 290. [Note that Carbutt sent "two orthochromatic studies made upon his own excellent color-sensitive plates..."]

C204 Carbutt, John. "Progressive Photography: Celluloid Positives." PHOTOGRAPHIC TIMES 19, no. 411 (Aug. 2, 1889): 377-378. ["Perhaps no greater improvements in photography can be chronicled for 1888-9 than the introduction of short celluloid as a substitute for glass..."]

C205 "Notes and News: John Carbutt." PHOTOGRAPHIC TIMES 20, no. 474 (Oct. 17, 1890): 521. [Note that Carbutt has returned from his European trip, sent a check for $100 to the Daguerre Memorial Fund.]

C206 "Editorial Notes." PHOTOGRAPHIC TIMES 22, no. 543 (Feb. 12, 1892): 78-79. [Brief description of Carbutt's Keystone Dry Plate Works in Philadelphia.]

C207 "Correspondence: A Letter from John Carbutt." PHOTOGRAPHIC TIMES 22, no. 564 (July 8, 1892): 356. [Carbutt touring Europe; letter is a note about his experiences.]

C208 Carbutt, John. "Orthochromatic Photography and Its Practical Application." PHOTOGRAPHIC TIMES 23, no. 624 (Sept. 1, 1893): 485-487.

C209 Carbutt, John. "A Standard Sensitometer." PHOTOGRAPHIC TIMES 24, no. 653 (Mar. 23, 1894): 188. [Read before the Photographic Society of Philadelphia.]

C210 "A Visit to Mr. Carbutt's X-Ray Laboratory." WILSON'S PHOTOGRAPHIC MAGAZINE 34, no. 482 (Feb. 1897): 88-89. [From "Philadelphia Ledger."]

C211 Carbutt, John. "Photographing the Invisible." WILSON'S PHOTOGRAPHIC MAGAZINE 34, no. 485 (May 1897): 221-225. [Read before the Photographic Society of Philadelphia, Mar. 10, 1897. About his experiments with x-rays, history of investigations of that process.]

C212 Carbutt, John. "Doctoring the Negative." AMERICAN ANNUAL OF PHOTOGRAPHY & PHOTOGRAPHIC TIMES ALMANAC FOR 1901 (1901): 237-240. 3 b & w.

C213 "Obituary." PHOTO ERA 15, no. 3 (Sept. 1905): 112.

C214 "John Carbutt." PHOTOGRAPHIC TIMES 37, no. 9 (Sept. 1905): 425. [Brief obituary. Born Sheffield, England in 1832. To America 1853, became photographer, photographic manufacturer. Died in Germantown, Philadelphia on July 26, 1905.]

C215 Brey, William. "Carbutt and the Union Pacific's Grand Excursion to the 100th Meridian." STEREO WORLD 7, no. 2 (May - June 1980): 4-9. 5 b & w. 2 illus. [John Carbutt, of Chicago, IL, accompanied the fund-raising and publicity "excursion" to the end of track of the Union Pacific R. R. in 1866. Includes a checklist of thirty-six views of the event, published by Carbutt.]

C216 Brey, William. "A Carbutt Chronology. 1832-1905." STEREO WORLD 9, no. 3 (July - Aug. 1982): 30-31. 1 b & w. [Chronological list of Carbutt's life and career, with a portrait of the photographer.]

CARJAT, ETIENNE. (1828-1906) (FRANCE)
[Born in Fareins on Apr. 1, 1828. Apprenticed in industrial design from 1841-44, but left to follow the theatre. A journalist, caricaturist, playwright, active participant in the Parisian cultural scene in the 1850s and 1860s. In 1854 wrote several vaudeville plays, published a series of lithographs. In 1856, with friends, established *Diogène*, a satirical review. Studied photography with Pierre Petit in 1858. From 1862-63 created the series "Le Panthéon Parisien." Opened the studio Carjat & Cie from 1862-64. Joined the Société française de Photographie in 1863. Ran a portrait studio through the 1870s. Published the "Galerie des célébrités contemporaines" in 1869 and collaborated on the "Paris-Théâtre" series in 1872. Wrote a book of poems in 1883. Died in Duboiss in 1906.]

BOOKS
C217 Fallaize, Elizabeth. *Etienne Carjat and "Le Boulevard." (1861-1863).* Geneva, Paris: Editions Slatkine, 1987. 229 pp. illus.

PERIODICALS

C218 Portrait. Woodcut engraving, credited "From a Photograph by Carjat, Paris." HARPER'S WEEKLY 10, (1866) ["James Stephens, the Fenian Chief." 10:488 (May 5, 1866): 285.]

C219 Portraits. Woodcut engravings, credited "From a Photograph by Carjat, Paris." FRANK LESLIE'S ILLUSTRATED NEWSPAPER 22, (1866) ["James Stephens, Fenian leader in Ireland." 22:555 (May 19, 1866): 144.]

C220 Portrait. Woodcut engraving credited "From a photograph by Etienne Carjat." ILLUSTRATED LONDON NEWS 68, (1876) ["Late Frederick Lemaitre." 68:1906 (Feb. 5, 1876): 133.]

C221 Adhémar, Jean. "Carjat." GAZETTE DES BEAUX-ARTS ser. 7 vol. 80, no. 1242/1243 (1972): 71-81.

C222 Baudelaire, Charles. "Latent Images: Baudelaire on Photography." AMERICAN PHOTOGRAPHER 2, no. 3 (Mar. 1979): 17. 1 b & w. [Carjat photo, quote from letter to editor of "Revue Française," 1859.]

CARLISLE, GEORGE. M. (1840-) (USA)

C223 Carlisle, G. M. "A Word for the Old Daguerreotype." ST. LOUIS PRACTICAL PHOTOGRAPHER 1, no. 1 (Jan. 1877): 13-14. [Carlisle from Providence, RI.]

C224 Carlisle, G. M. "The Background, Its Use and Abuse." PHOTOGRAPHIC TIMES 15, no. 201 (July 24, 1885): 409-411.

C225 "A Pleasant Event at Minneapolis: Testimonial to Treasurer Carlisle." ANTHONY'S PHOTOGRAPHIC BULLETIN 19, no. 15 (Aug. 11, 1888): 466-467. [Surprise party for Treasurer of P. A. of A. Carlisle.]

C226 Carlisle, G. M. "On the Business Management of a Photographic Establishment." ANTHONY'S PHOTOGRAPHIC BULLETIN 17, no. 15 (Aug. 14, 1886): 461-463. [Read at the St. Louis convention of the P. A. of A.]

C227 Carlisle, G. M. "On the Business Management of a Photographic Establishment." PHOTOGRAPHIC TIMES 16, no. 257 (Aug. 20, 1886): 439-440. [Read to the St. Louis Convention of the P. A. of A.]

CARNDEN, R. A.

C228 1 b & w (self-portrait by R. A. Carnden). PHOTOGRAPHIC AND FINE ART JOURNAL 9, no. 6 (June 1856): frontispiece. 1 b & w. [Original photographic print, tipped-in.]

CARPENTER.

C229 "New York. - First Presbyterian Church, Clinton. - From a Photograph by Carpenter." FRANK LESLIE'S ILLUSTRATED NEWSPAPER 47, no. 1217 (Jan. 25, 1879): 380. 1 illus. [View.]

CARPENTER & MULLEN. (LEXINGTON, KY)

C230 "Note." PHILADELPHIA PHOTOGRAPHER 2, no. 21 (Sept. 1865): 153. [Three 11" x 14" landscape views of Kentucky mentioned.]

C231 "Editor's Table." PHILADELPHIA PHOTOGRAPHER 3, no. 29 (May 1866): 159. [Receipt of stereos of Kentucky scenery.]

C232 "Stereoscopic Pictures." PHILADELPHIA PHOTOGRAPHER 3, no. 34 (Oct. 1866): 300-302. [Carpenter & Mullen (KY scenery); John Carbutt (Chicago, IL, scenery); R. Newell (Cape Island bathers).]

C233 Mullen, James. "Views in Kentucky." PHILADELPHIA PHOTOGRAPHER 4, no. 37 (Jan. 1867): 18-19.

CARPENTER, A. O. (UKIAH, CA)

C234 Carpenter, A. O. "Correspondence." ANTHONY'S PHOTOGRAPHIC BULLETIN 5, no. 2 (Feb. 1874): 98. [Carpenter from Ukiah, CA.]

C235 Carpenter, A. O. "Correspondence." ANTHONY'S PHOTOGRAPHIC BULLETIN 5, no. 5 (May 1874): 193. [Carpenter from Ukiah, CA.]

CARPENTER, J.

C236 Carpenter, J. "Chromo- and Photo-Lithography." ONCE A WEEK n. s. 1, no. 6 (Feb. 10, 1866): 147-151. 2 illus.

CARPENTER, M. (CINCINNATI, OH)

C237 Portraits. Woodcut engravings, credited "From an Ambrotype by Carpenter, of Cincinnati." FRANK LESLIE'S ILLUSTRATED NEWSPAPER 4, (1857) ["E. G. Megrue, Cincinnati Fire Dept." 4:79 (June 6, 1857): 12.]

CARPENTER, W. J. see CARPENTER & MULLEN.

CARR.

C238 Portrait. Woodcut engraving, credited "From a Photograph by Carr." FRANK LESLIE'S ILLUSTRATED NEWSPAPER 16, (1863) ["Acting Brig.-Gen. E. E. Cross, killed at Gettysburg." 16:408 (July 25, 1863): 289.]

CARR, A. P.

C239 "Falls of the Snoqualmie River, Washington Territory." HARPER'S WEEKLY 12, no. 595 (May 23, 1868): 324. 1 illus. ["Photographed by A. P. Carr."]

CARRICK, WILLIAM. (1827-1878) (GREAT BRITAIN, RUSSIA)

BOOKS

C240 Ashbee, Felicity and Julie Lawson. *William Carrick 1827 - 1878.* "Scottish Masters, 3" Edinburgh: National Galleries of Scotland, 1987. 32 pp. 24 b & w. 6 illus. [Bibliography. Born in Edinburgh on Dec. 31, 1827. Family moved to St. Petersburg, Russia in 1828, where the father was a timber merchant. William entered Academy of Arts in 1844 to study architecture, but shifted into watercolors. To Rome in 1853, for three years. Returned to St. Petersburg in 1856, decided to become a photographer. Went to Scotland, studied photography with James Good Tunny, and made friends with John MacGregor. Opened a studio finally in 1859 and MacGregor moved to Russia to join him. Partners for thirteen years. Carrick took many portraits of Russian street peddlers. Gradually went out into the countryside to photograph the people in their activities in natural settings. In 1871 took a trip to the Volga region. John MacGregor died in 1872. In 1875, Carrick made a second expedition into the Volga region, where he took 180 views of peasants, etc. Died 1878.]

PERIODICALS

C241 Ralston, W. R. S. "A Few Russian Photographs." GOOD WORDS 11, no. 10 (Oct. 1870): 667-673. 12 illus. ["Mr. Carrick...and his partner Mr. MacGregor... members of the Anglo-Russian community (in St. Petersburg) have for some years past been photographing all the best specimens of peasant men and peasant women, as well as all the other dwellers of the city..."]

C242 Schuyler, Eugene. "Out of My Window at Moscow." CENTURY MAGAZINE (SCRIBNER'S MONTHLY) 13, no. 6 (Apr. 1877):

821-831. 20 illus. [Woodcuts, from photos. Costume portraits, not credited, but resemble those of Mr. Carrick. (See "Good Words" (Oct. 1870.)]

C243 Ashbee, Felicity. "William Carrick: A Scots Photographer in St. Petersburg (1827-1878)." HISTORY OF PHOTOGRAPHY 2, no. 3 (July 1978): 207-222. 26 b & w. 2 illus.

C244 Morrison-Low, A. D. "William Carrick: Nineteenth-Century Photographs of Russia. Exhibition at the Scottish National Portrait Gallery." SCOTTISH PHOTOGRAPHY BULLETIN (Autumn 1987): 25-26. 1 b & w. [Ex. rev.]

CARROLL, J. M. (GREAT BRITAIN)
C245 Carroll, J. M. "The Gelatino - Bromide Process." BRITISH JOURNAL PHOTOGRAPHIC ALMANAC 1878 (1878): 101-104.

C246 Carroll, J. M. "Masks for Skies - Defects in Half-Tones." BRITISH JOURNAL PHOTOGRAPHIC ALMANAC 1878 (1878): 179-180.

C247 Carroll, J. M. "An Alkaline Intensifier." BRITISH JOURNAL PHOTOGRAPHIC ALMANAC 1879 (1879): 115-116.

CARROLL, LEWIS. [CHARLES LUTWIDGE DODGSON] (1832-1897) (GREAT BRITAIN)
[Lewis Carroll, was the pseudonym of the author Charles Lutwidge Dodgson, who was an amateur photographer. There are several exhaustive bibliographies of Dodgson's writings and works. These list in detail the copies of his photographs and photograph albums held in various collections. See, for example, *A Handbook of the Literature of the Rev. C. L. Dodgson (Lewis Carroll)*, by Sidney H. Williams and Falconer Madan. London: Oxford University Press, 1931, and supplement 1935; *The Harcourt Amory Collection of Lewis Carroll in the Harvard College Library*, compiled by Flora V. Livingston, Cambridge, MA: privately printed, 1932; and *A List of the Writings of Lewis Carroll (Charles L. Dodgson) in the Library of Dormy House, Pine Valley, New Jersey*, collected by M. L. Parrish. Privately printed, 1928.]

BOOKS
C248 Collingwood, Stuart Dodgson. *The Life and Letters of Lewis Carroll (Rev. C. L. Dodgson)*. London: T. Fisher Unwin, 1899. 448 pp. illus.

C249 Gernsheim, Helmut. *Lewis Carroll: Photographer*. London: Parish, 1949. 121 pp. b & w. illus. [2nd. ed. (1950) New York: Chanticleer Press, 126 pp. "With 64 plates in photogravure."]

C250 Carroll, Lewis. Edited by Stuart Dodgson Collingwood. *Diversions and Digressions of Lewis Carroll*. A Selection from the Unpublished Writings of Lewis Carroll, together with Scarce and Unacknowledged Work; edited by Stuart Dodgson Collingwood. With a New Selection of Lewis Carroll's Photographs. New York: Dover, 1961. 375 pp. b & w. illus. [First published, in 1899, with the title "The Lewis Carroll Picture Book."]

C251 *Lewis Carroll at Christ Church*. Introduction by Morton N. Cohen. London: National Portrait Gallery, 1974. 32 pp. 28 b & w.

C252 Guiliano, Edward, ed. *Lewis Carroll Observed; A Collection of Unpublished Photographs, Drawings, Poetry, and New Essays*. Edited by Edward Guiliano for the Lewis Carroll Society of North America. New York: Crown Publishers, Inc., 1976. viii, 216 pp. b & w. illus.

C253 Cohen, Morton N. *Lewis Carroll: Photographer of Children: Four Nude Studies*. Philadelphia; New York: Rosenbach Foundation; Clarkson N. Potter, Inc., 1979. 32 pp. 4 b & w.

C254 Carroll, Lewis. *Lewis Carroll and the Kitchins*: Containing twenty-five letters not previously published and nineteen of his photographs, edited by Morton N. Cohen. New York: Argosy Bookstore, 1980. xvi, 48 pp. 19 b & w. [Letters to Mrs. Kitchin from C. L. Dodgson, written between 1873 and 1891.]

C255 Gernsheim, Helmut. *Lewis Carroll, A Victorian Photographer*. Paris: Editions du Chêne, 1980. 92 pp. illus.

PERIODICALS
C256 Collingwood, S. D. "Some of Lewis Carroll's Child-Friends. With Unpublished Letters by the Author of 'Alice in Wonderland.'" CENTURY MAGAZINE 57, no. 2 (Dec. 1898): 231-240. 1 b & w. [Portrait of Alice Atkinson. Photographs are discussed in Dodgson's letters.]

C257 Grierson, S. "Grierson's Word in Edgewise: Modern Museum's Show of Photographs Made by Lewis Carroll." AMERICAN PHOTOGRAPHY 45, no. 2 (Feb. 1951): 112. [Ex. Rev.: "Lewis Carroll," Museum of Modern Art, New York, NY.]

C258 "Lewis Carroll at Christ Church." CREATIVE CAMERA no. 116 (Feb, 1974): 42-43. 6 b & w.

C259 Sincebaugh, Els. "Photpourri: Lewis Carroll's Child Nudes: Found." CAMERA 35 23, no. 9 (Oct. 1978): 10. 1 b & w.

C260 Perloff, Stephen. "Lewis Carroll." PHILADELPHIA PHOTO REVIEW 3, no. 4 (Nov. 1978): 10. 1 b & w. [Ex. rev.: "Lewis Carroll," Rosenbach Museum, Philadelphia, PA.]

C261 Mann, Charles. "The Delicious Harlequin." HISTORY OF PHOTOGRAPHY 3, no. 3 (July 1979): 211-214. 1 b & w. 3 illus. [About Connie Gilchrist and her portrait sitting for Lewis Carroll in 1877.]

C262 Wilsher, Ann. "'Hiawatha's Photographing': Lewis Carroll and A. B. Frost." HISTORY OF PHOTOGRAPHY 3 , no. 4 (Oct. 1979): 304. 1 b & w. [Caroll's poem "Hiawatha's Photographing" and the illustrations for it by A. B. Frost for the 1883 edition.]

C263 Bewick, Eileen. "Photographer of Innocence." PHOTOGRAPHIC COLLECTOR 1, no. 1 (Spring 1980): 5-12. 8 b & w.

C264 Disch, Thomas M. and Charles Naylor. "Encounters: A Day in the Country: Photographs by Lewis Carroll: A fictional account of how Charles Dodgson... photographed Dante Gabriel Rossetti's family on Oct. 7, 1863." CAMERA ARTS 1, no. 6 (Nov. - Dec. 1981): 32-39, 125. 6 b & w.

C265 Spria, S. F. "Carroll's Camera." HISTORY OF PHOTOGRAPHY 8, no. 3 (July - Sept. 1984): 175-177. 3 illus.

CARSON & GRAHAM. (HILLSDALE, MI)
C266 "Editor's Table: Fires." PHILADELPHIA PHOTOGRAPHER 14, no. 159 (Mar. 1877): 96. [A. Bogardus (NY) lost darkroom, studio to fire around 5th Feb. Carson & Graham (Hillsdale, MI) lost studio.]

CARTLEDGE, J.
C267 Cartledge, J. "'Humbugiana.'" PHOTOGRAPHIC AND FINE ART JOURNAL 10, no. 1 (Jan. 1857): 10-11. [Letter from a practitioner; disparaging process-sellers.]

CARVALHO, DAVID NUNES. (1848-1925) (USA)
C268 Carvalho, D. N. "Photographic Paint." ANTHONY'S PHOTOGRAPHIC BULLETIN 10, no. 3 (Mar. 1879): 79. [Further discussion of "orange pea green" colored galleries shortening exposure times.]

C269 Carvalho, D. N. "A New Departure." ANTHONY'S PHOTOGRAPHIC BULLETIN 10, no. 1 (Jan. 1879): 31. [Carvalho (2280 3rd Ave., New York, NY) advocates painting his gallery green and orange, to shorten exposures.]

CARVALHO, SOLOMON NUNES. (1815-1899) (USA)
[Born in Charleston, SC in 1815. Portrait and landscape painter, took up the daguerreotype late 1840s, with a gallery in Washington, DC and another in Baltimore, MD in 1849. From 1850-52 opened a gallery in Charleston, SC. Experimented with enameled daguerreotypes. Worked for Jeremiah Gurney in 1853. Went with Fremont across the Rocky Mountains in 1853-54. In Baltimore in late 50s and moved to New York, NY in 1860. Listed as an artist or a photographer in New York, NY until 1880, but photographed in Martinique in the 1870s. Died in New York, NY in 1899.]

BOOKS
C270 Carvalho, Solomon Nunes. *Incidents of Travel and Adventures in the Far West;* with Col. Fremont's Last Expedition Across the Rocky Mountains; Including Three Months' Residence in Utah, and a Perilous Trip across the Great American Desert to the Pacific. New York: Derby & Jackson, 1856. 380 pp. illus. [Reprinted 1954. Philadelphia: Jewish Publication Society of America. Edited with an introduction by Bertram Wallace Korn.]

C271 Fremont, John Charles. *Memoirs of My Life,* by John Charles Fremont. Including in the narrative five journeys of western exploration during the years 1842, 1843-4, 1845-6,7, 1848-9, 1853-4... vol. 1. Chicago, New York: Belford, Clark & Co., 1887. xix, 655 pp. illus. [Carvalho discussed on pp. xv and following in: "Some Account of the Plates," by Jessie Benton Fremont.]

C272 Merrick, Joan Sturhahn. *Carvalho: Artist, Photographer, Adventurer, Patriot;* Portrait of a Forgotten American. New York: Richwood Publishing Co., 1976. 226 pp.

PERIODICALS
C273 "Gossip: Letter." PHOTOGRAPHIC ART JOURNAL 3, no. 4 (Apr. 1852): 256-257. [Letter from Carvalho. "I have been before the public as an artist over 18 years...my paintings..."]

C274 Carvalho, S. N. "Daguerreotyping on the Rocky Mountains." PHOTOGRAPHIC AND FINE ART JOURNAL 8, no. 4 (Apr. 1855): 124-125. [A letter from Carvalho, claiming to have been successful taking daguerreotypes on Col. J. C. Fremont's expedition.]

C275 "The Grand Canyon of the Colorado River." FRANK LESLIE'S ILLUSTRATED NEWSPAPER 29, no. 736 (Nov. 6, 1869): 125, 127. 2 illus. [Article is about Major John W. Powell exploring the Grand Canyon. Illustrated with an uncredited portrait of Powell and "...a view of the Grand Canyon of the Colorado, from an original painting by Carvalho, an artist who accompanied General Fremont through the Rocky Mountains in 1854."]

C276 "Letter." PHOTOGRAPHIC TIMES 2, no. 21 (Sept. 1872): 136. [Letter from Carvalho, dated St. Pierre Martinique, July 25, 1872, stating that his Morrison stereo lenses worked well even in dense masses of foliage.]

C277 Carvalho, S. "Rambles in Martinique." HARPER'S MONTHLY 48, no. 284 (Jan. 1874): 161-177. 21 illus. [Views, portraits. Engravings, some probably from photographs.]

C278 "Letter." PHOTOGRAPHIC TIMES 6, no. 70 (Oct. 1876): 227. [Letter praising Morrison stereo lenses.]

C279 Carvalho mentioned as "the artist" in Fremont's 1853 expedition in "Resume of Fremont's Expeditions." CENTURY MAGAZINE 41, no. 5 (Mar. 1891): 759-766. 10 illus. [Illustrated with portraits (engraved "from a daguerreotype" but not credited to Carvalho), events of Fremont's various expeditions.]

CARY, PRESTON M.
C280 "The Anthony Prize Pitcher." PHOTOGRAPHIC AND FINE ART JOURNAL 7, no. 1 (Jan. 1854): 6-11. [Short note describing Cary's "process" on p. 10.]

CASE, J. T. (GREAT BRITAIN)
C281 Case, J. T. *Photographic Views of Lewes.* Lewes, England: J. T. Case, 1857. 8 pp. 14 l. of plates. 14 b & w. [Original photographs, by the author.]

CASE, JOHN G. (1808-1880) see BLACK & CASE; MASURY, SILSBEE & CASE.

[John Case was born in 1808. He joined the partnership of Masury & Silsbee in Boston in 1856. Masury left in 1858 and William H. Getchell (1829-1910) joined the firm of Silsbee, Case & Co. Silsbee left in 1863 and the Case-Getchell partnership lasted until 1865. Case then joined James W. Black, managing the shop at 163 Washington St., while Black managed the 173 Washington St. studio. In 1867 Case left photography and went into the fruit and confectionary business, and moved to Nantucket.]

CASH. (GREAT BRITAIN)
C282 "Extracts from Foreign Publications - Albumen Process: Mr. Cash." HUMPHREY'S JOURNAL 9, no. 1 (May 1, 1857): 14-16. [Manchester Photo. Soc.]

CASWELL & DAVY. (DULUTH, MN)
C283 "The Northern Pacific Railroad. - The Railway Bridge Over the Mississippi River, at Brainerd, Minnesota. - From a Photograph by Caswell & Day, Deluth. " FRANK LESLIE'S ILLUSTRATED NEWSPAPER 32, no. 8309 (Aug. 26, 1871): 404. 1 illus. [View.]

CATHERWOOD, FREDERICK. (1799-1854)
BOOKS
C284 Stephens, John Lloyd. *Incidents of Travel in Central America, Chiapas, and Yucatan.* New York: Harper & brothers, 1841. 2 vol. illus.

C285 Stephens, John Lloyd. *Incidents of Travel in the Yucatan.* New York: Harper & Brothers, 1843. 2 vol. illus. [Lithograph illustrations, taken from drawings, sketches with the camera lucida, and from daguerreotypes taken by Catherwood and Stephens.]

PERIODICALS
C286 "New Publications. Catherwood's 'Ancient Monuments in Central America.'" ATHENAEUM no. 868 (June 15, 1844): 556.

["...the daguerreotype drawings of these extraordinary ruins, which illustrate Mr. Stephens's volumes, did not stay the cravings of curiosity to see the buried forms of almost unknown art..."]

C287 "Early Photography in Yucatan." IMAGE 2, no. 5 (May 1953): 28-29. 1 b & w. 1 illus. [Daguerreotypes by Frederick Catherwood used to illustrate "Incidents of Travel in Yucatan," by John Lloyd Stephens, 1843.]

CAUBERT. (BROMPTON, ENGLAND)
C288 Portrait. Woodcut engraving credited "From a photograph by Caubert, Fulham Rd., Brompton." ILLUSTRATED LONDON NEWS 64, (1874) ["Late M. H. P. Parker, artist." 64:1813 (May 23, 1874): 493.]

CEILEUR, A. (NEW YORK, NY)
C289 Ceileur, A. "American versus Foreign Lenses." HUMPHREY'S JOURNAL OF PHOTOGRAPHY, AND THE ALLIED ARTS AND SCIENCES 11, no. 4 (June 15, 1859): 51-53. [A. Ceileur, Esq., an English gentleman who has practiced photography in London, and is a member of the Photographic Society of that city. He is now in New York, and has opened rooms in Broadway where he is taking pictures...."]

C290 Ceileur, A. "Atmospheric Air-Water-Temperature." HUMPHREY'S JOURNAL OF PHOTOGRAPHY, AND THE ALLIED ARTS AND SCIENCES 11, no. 6 (July 15, 1859): 81-83.

C291 Ceileur, A. "New Photographic Camera." HUMPHREY'S JOURNAL OF PHOTOGRAPHY, AND THE ALLIED ARTS AND SCIENCES 11, no. 10 (Sept. 15, 1859): 147-149.

C292 Ceileur, A. "Is Photography after all an Art?" HUMPHREY'S JOURNAL OF PHOTOGRAPHY, AND THE ALLIED ARTS AND SCIENCES 11, no. 8 (Aug. 15, 1859): 115-116.

C293 Ceileur, A. "On the Compounds of Iron." HUMPHREY'S JOURNAL OF PHOTOGRAPHY, AND THE ALLIED ARTS AND SCIENCES 11, no. 9 (Sept. 1, 1859): 130-131.

C294 Ceileur, A. "On the Compounds of Iron." HUMPHREY'S JOURNAL OF PHOTOGRAPHY, AND THE ALLIED ARTS AND SCIENCES 11, no. 14 (Nov. 15, 1859): 213-214.

C295 "Photographing Extraordinary!" HUMPHREY'S JOURNAL OF PHOTOGRAPHY, AND THE ALLIED ARTS AND SCIENCES 12, no. 1 (May 1, 1860): 2-3. [Ceileur made a copy negative 30" x 38" on 3/4" plate glass of a very elaborate drawing by L. Luthy titled "The Past and Present of the United States," created for James Meyer, Jr. 4,000 prints to be created from 36 of these negatives. "We believe that this is the most extensive Photographic Printing ever achieved in the world."]

CELIS, D. JOSE FERNANDEZ. (SPAIN)
C296 Celis, Jose Fernandez, Dr. "Dry Collodion Process - almost Instantaneous." HUMPHREY'S JOURNAL OF PHOTOGRAPHY, AND THE ALLIED ARTS AND SCIENCES 16, no. 4 (June 15, 1864): 55-58. [From "El Propagador de la Fotografia."]

C297 Celis, D. Jose Fernandez, Dr. "The Dry Tannin Process." HUMPHREY'S JOURNAL OF PHOTOGRAPHY, AND THE ALLIED ARTS AND SCIENCES. 16, no. 9 (Sept. 1, 1864): 134-135.

CELLA, LUIGI. (GREAT BRITAIN)
C298 "Freemason's Hall, Boston, Lincolnshire." ILLUSTRATED LONDON NEWS 43, no. 1213 (July 18, 1863): 69. 1 illus. ["...from a photograph by Luigi Cella, of Boston, Great Britain."]

CENTENNIAL PHOTOGRAPHIC CO. see also WILSON, EDWARD.

CENTENNIAL PHOTOGRAPHIC CO.
BOOKS
C299 Centennial Photographic Co., Phila. Catalogue of the Centennial Photographic Co.'s Views of the International Exhibition. Philadelphia: Centennial Photographic Co., 1876. 40 pp. illus. [Views of the International Exhibition, 1876.]

C300 Centennial Photographic Co., Phila. The Photographic Souvenir of the Centennial Exhibition; Containing Fifteen Elegant Views of the Statuary and Other Gems of Art. Philadelphia: Lippincott, 1877. n. p. 15 b & w.

PERIODICALS
C301 "International Exhibition, Philadelphia. - Interior View of the Machine Building, Just Completed. - From a Photograph by the Centennial Photographic Co." FRANK LESLIE'S ILLUSTRATED NEWSPAPER 41, no. 1049 (Nov. 6, 1875): 146-147. 1 illus. [Interior.]

C302 "Philadelphia, Pa. - The Centennial Exhibition - The Cigar Exhibit of Messrs. Kerbs & Spiess, No. 35 Bowery, New York. - Photographed by the Centennial Photo. Co." FRANK LESLIE'S ILLUSTRATED NEWSPAPER 42, no. 1082 (June 24, 1876): 253. 1 illus. [Interior, with figures.]

C303 "Our Picture." PHILADELPHIA PHOTOGRAPHER 14, no. 159 (Mar. 1877): frontispiece, 68-70. 1 b & w. [Moorish exhibition at the Philadelphia Centennial Exhibition.]

C304 B. C. J. "Lantern Exhibition of Centennial Subjects." PHILADELPHIA PHOTOGRAPHER 14, no. 159 (Mar. 1877): 85. [Review of lantern slide exhibition held by the Photographic Society of Philadelphia, from slides made by the Centennial Photographic Co., furnished by E. L. Wilson.]

C305 "Our Picture." PHILADELPHIA PHOTOGRAPHER 14, no. 160 (Apr. 1877): frontispiece, 116-117. 1 b & w. [Genre portrait 'In Ye Olden Days," from the New England exhibition at the Phila. Centennial Exhibition.]

C306 "Editor's Table: Prosecution of Infringement - Photographic Thievery." PHILADELPHIA PHOTOGRAPHER 14, no. 161 (May 1877): 160. [The Centennial Photographic Co. was prosecuting illegal copying of prints by others. Also located stolen prints and negatives.]

C307 "Our Picture." PHILADELPHIA PHOTOGRAPHER 14, no. 163 (July 1877): frontispiece, 201-204. 1 b & w. ["Italian Statuary," at the Phila. Centennial Exhibition. Includes an article, "The History of Sculpture," by Dr. S. P. Long on pp. 209-211, "to be read with 'Our Picture.'"]

C308 "Our Picture." PHILADELPHIA PHOTOGRAPHER 14, no. 167 (Nov. 1877): frontispiece, 337-341. 1 b & w. [Scene, with stuffed animals, from the Colorado exhibition in the Philadelphia Centennial Exhibition.]

C309 McMahon, Timothy J. "The Great Centennial Exhibition of 1876." STEREO WORLD 3, no. 3 (July - Aug. 1976): 4-7. 6 b & w. [Views by the Centennial Photographic Co.]

CESELLI, LUIGI. (ROME, ITALY)
C310 "Albuminizing of Photogenic Glasses." ATHENAEUM no. 1205 (Nov. 30, 1850): 1255. [Reprinted translation from a paper on "albuminizing photogenic glasses" by Mr. Luigi Ceselli, from the "Romana Corrispondenza Scientifica."]

CHADWICK, WITTIAM ISAAC. (d. 1913) (GREAT BRITAIN)
C311 Chadwick, Wittiam Isaac. The Magic Lantern Manual. London: F. Warne, 1878. 138 pp. illus. [2nd ed. (1885), 154 pp., illus.]

PERIODICALS
C312 Chadwick, W. I. "Registering Carrier for the Lantern." BRITISH JOURNAL PHOTOGRAPHIC ALMANAC 1878 (1878): 123-124. 1 illus.

C313 "Obituary of the Year: W. I. Chadwick (June 6, 1913)." BRITISH JOURNAL PHOTOGRAPHIC ALMANAC 1914 (1914): 573-574. [Chadwick from Thornton, near Blackpool, England. An active amateur, interested in microscopical and stereoscopic photography. Wrote. Lectured actively.]

CHAFFIN, JOHN. (SHERBORNE, ENGLAND)
C314 Chaffin, John. "Our Experience in Taking Direct Life-Sized Heads." ANTHONY'S PHOTOGRAPHIC BULLETIN 6, no. 1 (Jan. 1875): 15-16. [From "London Photo. News."]

C315 "Photography Abroad: Large Heads." PHOTOGRAPHIC TIMES 5, no. 50 (Feb. 1875): 34-35. [From "Photographic News."]

C316 Portrait. Woodcut engraving credited "From a photograph by Chaffin, Sherborne." ILLUSTRATED LONDON NEWS 66, (1875) ["Late Mr. D. Osment, Freemason." 66:1861 (Apr. 10, 1875): 345.]

CHAFFIN, THOMAS H.
C317 Chaffin, Thomas H. "A Few Hints." BRITISH JOURNAL PHOTOGRAPHIC ALMANAC 1877 (1877): 108-109.

CHAMBERLAIN, WILLIAM G. (1815-1910) (USA)
[William G. Chamberlain was born in Sept. 1815 in IA. Bought a daguerreotype outfit in 1847. Worked in Chicago, IL from 1852 to 1855. Moved to Denver, CO in 1861 and opened a studio. In 1864 opened a branch in Central City, CO, under the management of Frank M. Danielson. His son, Walter A. Chamberlain, Charles D. Kirkland, and Francis D. Storm all worked as assistants in the Denver studio, which had been enlarged in 1872. Chamberlain retired in 1881, selling his business to Francis D. Storm.]

C318 "Thank You!" HUMPHREY'S JOURNAL OF PHOTOGRAPHY, AND THE ALLIED ARTS AND SCIENCES 18, no. 18 (Jan. 15, 1867): 287. [Letter praising "HJ" from Wm. G. Chamberlain, of Colorado.]

C319 "Life and Scenes in Denver, Colorado. - From Sketches by J. Harrison Mills, and Photographs by W. G. Chamberlain." FRANK LESLIE'S ILLUSTRATED NEWSPAPER 37, no. 943 (Oct. 25, 1873): 101, 112-113. 9 illus. [Views, portraits.]

CHAMBERLIN, H. B. (SHULLSBERG, WI)
C320 "Correspondence." ANTHONY'S PHOTOGRAPHIC BULLETIN 2, no. 9 (Sept. 1871): 299. [Chamberlin (Shullsberg, WI). Letter about washing prints, complaint about isolation.]

CHAMEALION.
C321 "Cha-meal-ion." "The Lime Toning Bath and Its Difficulties." AMERICAN JOURNAL OF PHOTOGRAPHY AND THE ALLIED ARTS & SCIENCES n. s. vol. 6, no. 4 (Aug. 15, 1863): 83-86. [From "Photo. News." Includes a comic poem.]

CHAMP, WILLIAM A.
C322 "The Wadsworth Monument at Genesco, New York." HARPER'S WEEKLY 10, no. 476 (Feb. 10, 1866): 84. 1 illus. ["Photographed by Wm. A. Champ."]

CHAMPFLEURY.
C323 Champfleury. Drawings by E. Morin. "The Legend of the Daguerreotypist." IMAGE 14, no. 4 (Sept. 1971): 2-6. 16 illus. [A comic short story detailing the trials of a daguerreotypist, first published in French in 1864.]

CHAMPLOUIS, CAPT.
C324 Champlouis, Capt. "New Method of Employing Waxed Paper When Travelling." AMERICAN JOURNAL OF PHOTOGRAPHY AND THE ALLIED ARTS & SCIENCES. n. s. vol. 5, no. 2 (July 15, 1862): 29-31. [From "Photo. News." Capt. Champlouis used this method "during an expedition into Syria...to take photographic views."]

CHANCELLOR. (DUBLIN, IRELAND)
C325 Portraits. Woodcut engravings credited "From a photograph by Chancellor, Lower Sackville St., Dublin." ILLUSTRATED LONDON NEWS 72, (1878) ["Right Hon. James Lowther, Chief Sec. for Ireland." 72:2029 (May 18, 1878): 452. "Late Right Rev. Dr. Gregg." 72:2032 (June 8, 1878): 533.]

C326 Portraits. Woodcut engravings credited "From a photograph by Chancellor." ILLUSTRATED LONDON NEWS 73, (1878) ["Mr. Wm. Spottiswoode, F.R.S." 73:2045 (Sept. 7, 1878): 221. "Late Sir R. Griffith, Bart." 73:2050 (Oct. 12, 1878): 336. "Late Mr. Justice Keogh." 73:2050 (Oct. 12, 1878): 352.]

C327 Portrait. Woodcut engraving credited "From a photograph by Chancellor." ILLUSTRATED LONDON NEWS 75, (1879) ["Lord Belmore." 75:2114 (Dec. 20, 1879): 584.]

CHANNING, WILLIAM FRANCIS. (1820-1901) (USA)
C328 "Channing, William F." AMERICAN JOURNAL OF SCIENCE AND THE ARTS 43, (1842): 73. [Channing, from Boston, MA, practiced the calotype process.]

C329 Channing, W. F. "Observations on Photographic Processes." AMERICAN JOURNAL OF SCIENC AND ARTS 43, (1842): 73.

C330 Channing, W. F. "Observations on Photographic Processes." MAGAZINE OF SCIENCE AND SCHOOL OF ARTS 4, no. 189 (Nov. 12, 1842): 261-262. [From "Silliman's Journal."]

CHAPMAN & WILCOX. (NEW YORK, NY)
C331 Towler, John. "Card Picture Lens and Tube." HUMPHREY'S JOURNAL OF PHOTOGRAPHY, AND THE ALLIED ARTS AND SCIENCES 17, no. 21 (Mar. 1, 1866): 327-328. [Praise for lens manufactured by Chapman & Wilcox, New York, NY.]

CHAPMAN, DANIEL C. (1826-1895) (USA)
C332 Chapman, D. C. "A New Method of Rectifying the Printing Bath." AMERICAN JOURNAL OF PHOTOGRAPHY AND THE ALLIED ARTS & SCIENCES n. s. vol. 8, no. 5 (Sept. 1, 1865): 117-118.

C333 "Rectifying Discolored Printing Baths." AMERICAN JOURNAL OF PHOTOGRAPHY AND THE ALLIED ARTS & SCIENCES n. s. vol. 8, no. 12 (Dec. 15, 1865): 280-281.

C334 Chapman, D. C. "Paper on Astronomical Photography." PHOTOGRAPHIC TIMES 5, no. 54 (June 1875): 152-156. [Read before the Photographic Section of the American Institute, May 11, 1875.]

C335 "Notes and News." PHOTOGRAPHIC TIMES 20, no. 471 (Sept. 26, 1890): 487. [Note that D. C. Chapman of the United States Coast Survey at Washington, D.C., formerly a member of the Photographic Section of the American Institute, visited the editor.]

C336 Mason, O. G. "Daniel C. Chapman." PHOTOGRAPHIC TIMES 26, no. 3 (Mar. 1895): 176. [Obituary. Began photographing in New York in 1863, worked with Rutherford at his private observatory, then into scientific photography. In 1870's Chief Photographer of the U.S. Coast and Geodetic Survey at Washington.]

CHAPMAN, E. F. (GREAT BRITAIN, INDIA)
C337 Forsyth, Sir. T. D., K.C.S.I., C.B. *Report of A Mission to Yarkund in 1873;* Under command of Sir T. D. Forsyth...with Historical and Geographical Information Regarding the Possessions of the Ameer of Yarkund. Calcutta: Foreign Department Press, 1875. 573 pp. 102 b & w. [Original photos. Includes "List of Negatives, taken by Captains E. F. Chapman, (86 photos listed) and H. Trotter, (16 photos listed) on the Expedition to Yarkund, 1873-74."]

CHAPMAN, JAMES.
C338 Chapman, James. *Travels in the Interior of South Africa.* London: Bell & Daldy, 1868.

CHARDON, ALFRED. (d. 1897) (FRANCE)
C339 "News and Notes." WILSON'S PHOTOGRAPHIC MAGAZINE 34, no. 490 (Oct. 1897): 448. [Brief note of Alfred Chardon's death in France. "... a pioneer in emulsion work and latterly given attention to perfecting Poitevin's heliochromic process.]

CHARNAY, CLAUDE-JOSEPH-DESIRÉ. [called DESIRÉ] (1828-1915) (FRANCE, YUCATAN)
[Désiré Charnay was born in Fleurieux, Rhône. Studied at the Lycée Charlemagne in Paris, travelled through Germany and Great before 1850. Settled in New Orleans, LA in 1850, as a schoolteacher. Decided to explore, returned to France, and acquired the support of the French Ministry of Public Instruction for a trip to the Yucatan. Toured the United States for eight months in 1857, before going to Mexico. Mexico was in a civil war, and Charnay spent an additional ten months in Mexico City before finally reaching Yucatan, where he photographed the pre-Columbian ruins in 1858 and 1860. Returned to France in 1861 and published a portfolio of 49 views titled *Cités et ruines américaines, Mitla, Palenque, Izamal, Chichen-Itza, Uxmal.* An abridged edition of this work was published in 1864 under the title *Le Mexique et ses monuments.* by the publisher Emile Bondonneau, and the magazine *Le Magasin pittoresque* published articles in 1862 illustrated with woodcuts from the photographs. Charney was selected as the photographer and writer for a French expedition to Madagascar in 1863. He returned to Mexico in 1864, and, at the collapse of the Maximilian government in 1867, travelled to the USA. In 1875 he visited Brazil, Chile, and Argentina for the magazine *Le Tour de Monde.* Sent to Java and Australia by the government in 1878-79. Returned to Mexico in 1880 and spent two years excavating and photographing ruins in the Yucatan. *Les anciennes villes du Nouveau monde.* Paris: Hachette & Cie, 1885, and a host of books and articles resulted from this trip. Charnay visited Mexico again in

1886, visited the World Columbian Exposition in Chicago, IL in 1893, visited Yemen in 1897. Finally retired to Paris, where he wrote popular travelogues and fictional novels based on his travels. Made an Officer of the Legion of Honor in 1888. Died in Paris in 1915.]

BOOKS
C340 Charnay, Désiré. "A Bird's-Eye View of Madagascar" on pp.22-29, 49-57, 81-88 in: *Illustrated Travels,* Vol. 1 (1869), ed. by H. W. Bates. London: s. n., 1869. n. p.

C341 Charnay, Désiré. *The Ancient Cities of the New World; Being Voyages and Explorations in Mexico and Central America from 1857-1882...* With numerous Illustrations. London; New York: Chapman & Hall; Harper & Brothers, 1887. xvi, 514 pp. illus. [Translated from the French by J. Gonino and Helen S. Conant. The New York edition has an introduction by A. T. Rice.]

C342 Davis, Keith F. *Désiré Charnay, Expeditional Photographer.* Albuquerque, NM: University of New Mexico Press, 1981. xii, 212 pp. b & w. illus.

PERIODICALS
C343 "The Ruins of Central America." NORTH AMERICAN REVIEW 131, no. 286 (Sept. 1880): 185-204.

C344 "Early Photography in Yucatan." IMAGE 2, no. 5 (May 1953): 28-29. 1 b & w. 1 illus. [Daguerreotypes by Frederick Catherwood used to illustrate "Incidents of Travel in Yucatan," by John Lloyd Stephens, 1843.]

CHARNAY, EDUORD.
C345 "Panorama of the City of Mexico." ILLUSTRATED LONDON NEWS 42, no. 1184 (Jan. 17, 1863): 64-65, 83. 2 illus.

CHASE, G. W.
C346 Chase, G. W. "Chase's Portable Dark-Closet." PHILADELPHIA PHOTOGRAPHER 8, no. 87 (Mar. 1871): 76. 2 illus. [A portable wagon, for developing.]

CHASE, GEORGE B.
C347 Chase, Geo. B. "How to Save Gold and Silver." HUMPHREY'S JOURNAL OF PHOTOGRAPHY, AND THE ALLIED ARTS AND SCIENCES 16, no. 11 (Oct. 1, 1864): 173.

C348 Chase, George B. "Lightning Struck." HUMPHREY'S JOURNAL OF PHOTOGRAPHY, AND THE ALLIED ARTS AND SCIENCES 17, no. 14 (Nov. 15, 1865): 219.

CHASE, W. (HALIFAX, CANADA)
C349 "The Lion Monument at Halifax to the Gallant Soldiers, Major Welsford of the 97th and Captain Parker of the 74th, Who Fell at Sebastopol, Erected by the Citizens of Halifax. - From a Photograph by W. Chase, of Halifax." FRANK LESLIE'S ILLUSTRATED NEWSPAPER 10, no. 247 (Aug. 18, 1860): 199. 1 illus. [View, with crowd.]

C350 "View of the Ruins of the Duke of Kent's Lodge, Windsor Road, Three Miles from the City of Halifax. - From a Photograph by W. Chase." FRANK LESLIE'S ILLUSTRATED NEWSPAPER 10, no. 247 (Aug. 18, 1860): 202. 1 illus. [View.]

CHASE, W. (BUCYRUS, OH)
C351 "Photographic Swindlers. - More Quackery." AMERICAN JOURNAL OF PHOTOGRAPHY AND THE ALLIED ARTS & SCIENCES n. s. vol. 6, no. 20 (Apr. 15, 1864): 469-476. [W. Chase

(Bucyrus, OH) and Whiteman (Providence, RI) offered for sale certain formulas, which are reprinted here and claimed by the editor to be stolen from previously published works.]

CHASE, WILLIAM M. (1818/19-1894) (USA)
C352 Kelbaugh, Ross J. "The Stereo Negatives of William M. Chase." STEREO WORLD 10, no. 2 (May - June 1983): 12-17. 11 b & w. [200 negatives of Baltimore in 1870s, by Chase, found. During the Civil War Chase served as an officer of volunteers from Massachusetts, then as a sutler for the Union army. Began to work for the photographer R. D. Ridgeley in Baltimore, MD, in 1867. Met David Bachrach, Jr. and worked with him at the U. S. Naval Academy in Annapolis in 1868. Maintained the friendship throughout his career. Returned to Baltimore by 1872, working as a stereo photographer and publisher until 1890. Died 1894.]

CHEESEMAN, L. R.
C353 "St. Michael's Episcopal Church, Trenton, N. J. Rev. Christopher W. Knauff, Pastor. - From a Photograph by L. R. Cheeseman." FRANK LESLIE'S ILLUSTRATED NEWSPAPER 29, no. 731 (Oct. 2, 1869): 53. 2 illus. [View. Portrait.]

CHERRILL, NELSON K. see also ROBINSON, HENRY P.

CHERRILL, NELSON K. (GREAT BRITAIN, NEW ZEALAND)
C354 Cherrill, Nelson K. "The Wet Collodion Process without the Nitrate Bath." AMERICAN JOURNAL OF PHOTOGRAPHY AND THE ALLIED ARTS & SCIENCES n. s. vol. 7, no. 21 (May 1, 1865): 499-501. [From "Photo. News."]

C355 "Splitting of the Collodion Film." AMERICAN JOURNAL OF PHOTOGRAPHY AND THE ALLIED ARTS & SCIENCES n. s. vol. 8, no. 6 (Sept. 15, 1865): 121-123. [From "Photo. News."]

C356 Cherrill, Nelson K. "Gelatine Combinations with the Iron Developer." HUMPHREY'S JOURNAL OF PHOTOGRAPHY, AND THE ALLIED ARTS AND SCIENCES 17, no. 11 (Oct. 1, 1865): 173-175. [From "Photo. News."]

C357 "Penn's Marine-Engine Factory at Greenwich." ILLUSTRATED LONDON NEWS 47, no. 1339 (Oct. 21, 1865): 376-378. 2 illus. ["Both the present illustrations are from the photographs of Mr. Nelson K. Cherrill, of Lee, Kent;..." Interiors of machinery.]

C358 Cherrill, Nelson K. "The 'Reason Why' on Sun-Printing." HUMPHREY'S JOURNAL OF PHOTOGRAPHY, AND THE ALLIED ARTS AND SCIENCES. 18, no. 6 (July 15, 1866): 94-95. [From "Photo. News."]

C359 Cherrill, Nelson K. "Cutting Glass under Water with a Pair of Scissors." AMERICAN JOURNAL OF PHOTOGRAPHY, AND THE ALLIED ARTS AND SCIENCES. n. s. vol. 9, no. 10 (May. 1, 1867): 212-213. [From "Photo. News."]

C360 Cherrill, Nelson K. "Carbon Process." AMERICAN JOURNAL OF PHOTOGRAPHY, AND THE ALLIED ARTS AND SCIENCES n. s. vol. 9, no. 11 (May. 15, 1867): 252-253. [From "Photo. News."]

C361 "Photography on Board Ship." ANTHONY'S PHOTOGRAPHIC BULLETIN 7, no. 10 (Oct. 1876): 258-259. [From "London Photo. News." Cherrill on board the "S. S. Whampoa" in June, sailing from Plymouth to Melbourne, Australia.]

C362 "Editor's Table: New Zealand." PHILADELPHIA PHOTOGRAPHER 14, no. 160 (Apr. 1877): 128. [Mr. Nelson K. Cherrill, formerly of Robinson & Cherrill, Tunbridge Wells, England, recently located in New Zealand.]

C363 Cherrill, Nelson K. "Note on the Construction of Head-Rests." ANTHONY'S PHOTOGRAPHIC BULLETIN 8, no. 5 (May 1877): 150. 3 illus. [From "Br. J. of Photo."]

C364 Cherrill, Nelson K. "On a Very Simple Washing Trough." ANTHONY'S PHOTOGRAPHIC BULLETIN. 8, no. 11 (Nov. 1877): 332-333. [From "London Photo. News."]

C365 Cherrill, Nelson K. "A Very Simple Contrivance for Saving Silver." ANTHONY'S PHOTOGRAPHIC BULLETIN 9, no. 2 (Feb. 1878): 54. [From "London Photographic News."]

CHERRY, G. H., LIEUT. (GREAT BRITAIN, INDIA)
C366 "St. Saviour's Church, Labuan." ILLUSTRATED LONDON NEWS 50, no. 1433 (June 29, 1867): 649. 1 illus. [Island in Malay Peninsula (I think). "We are indebted to Lieutenant G. H. Cherry, of the Madras Army, now on detachment duty in Labuan, for the illustration ...which is engraved from a photograph taken by him."]

CHEVALIER, ARTHUR. (FRANCE)
C367 Chevalier, A. "Printing Process by Development for the Solar Camera." HUMPHREY'S JOURNAL OF PHOTOGRAPHY, AND THE ALLIED ARTS AND SCIENCES. 18, no. 8 (Aug. 15, 1866): 119-122. [From "Photo. Archiv." Arthur was Charles Chevalier's son.]

CHEVALIER, CHARLES. (1804-1859) (FRANCE)
C368 Kingslake, Rudolf. "Charles Chevalier and the 'Photographe à verres combinés.'" IMAGE 10, no. 5 (1961): 17-19. 3 illus. [Combination lenses perfected by Charles Chevalier in the 1850s. Chevalier was a manufacturer of camera obscura and, later, cameras. Lens maker for both Niépce and Daguerre.]

CHEVREUL. (FRANCE)
C369 Chevreul. "Considerations on Photography in an Abstract Point of View." HUMPHREY'S JOURNAL 6, no. 14 (Nov. 1, 1854): 213-216. [From "J. of Photo. Soc.," in turn from "Comptes Rendus." A summation of the approaches of Nicéphore Niépce, Niépce de Saint Victor, and his own experiments conducted in the 1830's.]

C370 Chevreul. "Considerations on Photography in an Abstract Point of View." PHOTOGRAPHIC AND FINE ART JOURNAL 7, no. 12 (Dec. 1854): 357-358. [From "J. of Photo. Soc." General comments on Daguerre's process, Niépce's process, Niépce de St. Victor's work.]

CHEYNE, LIEUT. (GREAT BRITAIN)
C371 "Note." ART JOURNAL (Aug. 1860): 254. [Naval officer on trip to the Arctic.]

C372 "Critical Notices: Fourteen stereoscopic slides of the Relics of Sir John Franklin's Expedition, brought home in the 'Fox' by Captain McClintock. Photographed by Lieut. Cheyne, R.N., at the United Service Museum, Whitehall." PHOTOGRAPHIC NEWS 4, no. 100 (Aug. 3, 1860): 165-166.

CHEYNE, LIEUT. [?]
C373 Steel, Jonathan and Victoria Steel. "The Franklin Expedition Disaster, 1847 from Stereographs taken in 1859: The Stereoscope and Collecting Stereocards: Part 5." PHOTOGRAPHIC COLLECTOR 2, no. 3 (Autumn 1981): 25-32. 15 b & w. [Northwest Passage expedition under Franklin in 1846 failed and was lost. A search party aboard the

"Fox" found the remains in 1859, and an unknown photographer aboard ship documented the remains, etc. (The photographer may have been a Lieut. Cheyne.)]

CHILD, G. F. (USA)
C374 Child, G. F. "Skylight Troubles." HUMPHREY'S JOURNAL OF PHOTOGRAPHY, AND THE ALLIED ARTS AND SCIENCES 17, no. 9 (Sept. 1, 1865): 138-139. [Letter from G. F. Child, reply by Towler.]

CHILLMAN & CO. (PHILADELPHIA, PA)
C375 Portrait. Woodcut engraving, credited "From a Photograph by Chillman & Co." FRANK LESLIE'S ILLUSTRATED NEWSPAPER 43, (1876) ["W. J. Phillips, Centennial exhibit. officer." 43:1104 (Nov. 25, 1875): 193.]

CHILTON, JAMES R. (ca. 1810-1863) (USA)
C376 "James R. Chilton, M.D., Analytical Chemist." PHOTOGRAPHIC AND FINE ART JOURNAL 10, no. 2 (Feb. 1857): 54-55. 1 illus. [From "American Druggist's Circular." Biography, praise for "a pioneer in photographic chemistry."]

C377 Seely, Charles A. "Editorial Department: Obituary." AMERICAN JOURNAL OF PHOTOGRAPHY AND THE ALLIED ARTS & SCIENCES n. s. vol. 6, no. 3 (Aug. 1, 1863): 71. [Dr. James R. Chilton died on July 24, aged 53 years. "One of the earliest American amateur photographers,..." Manufacturer of photographic chemicals. Member of Photographic Society.]

C378 "Death of Dr. Chilton." HUMPHREY'S JOURNAL OF PHOTOGRAPHY, AND THE ALLIED ARTS AND SCIENCES 15, no. 7 (Aug. 1, 1863): 112. [Dr. James R. Chilton, chemist of New York, NY, died July 24th.]

C379 Smith, Frank. "America's First Photographic Manual." IMAGE 1, no. 9 (Dec. 1952): 2. [Chilton published full description of the Daguerreotype Process as published by M. Daguerre, New York, 1840: a 16 page illustrated pamphlet.]

CHUGGS, JAMES. (USA)
C380 "A Photographer in Trouble." HUMPHREY'S JOURNAL OF PHOTOGRAPHY, AND THE ALLIED ARTS AND SCIENCES 19, no. 21 (Mar. 1, 1868): 382-383. [A James Chuggs, bored and out of work, counterfeited postage stamps "all for fun." Arrested - pleading for bail.]

CHURCH, W. R.
C381 Church, W. R. "Church Interiors." ANTHONY'S PHOTOGRAPHIC BULLETIN 1, no. 2 (Mar. 1870): 21-22. [From "London Photo. News."]

CHURCHILL & DENISON. (ALBANY, NY)
BOOKS
C382 New York (State). Constitutional Convention, 1867. *Photographic Album of the Constitutional Convention.* Albany: Churchill & Denison, 1867. n. p. 177 b & w. [177 Cartes-de-visite by Churchill & Denison, NYPL collection.]

C383 *Photographic Senatorial Album of the State of New York, 1866 - 1867.* Albany, NY: Churchill & Denison, Photographers, 1867. 36 l. of plates. [Printed title page, no other texts. Some photos autographed.]

PERIODICALS
C384 Portrait. Woodcut engraving, credited "From a Photograph by Churchill & Dennison, Albany, N. Y." HARPER'S WEEKLY 10, (1866) ["Hon. Ezra Cornell." 10:479 (Mar. 3, 1866): 141.]

C385 "Railroad Bridge Across the Hudson River at Albany, New York." HARPER'S WEEKLY 10, no. 481 (Mar. 17, 1866): 164. 1 illus. ["Photographed by Churchill & Dennison, Albany."]

C386 Portrait. Woodcut engraving, credited "From a Photograph by Churchill & Dennison." HARPER'S WEEKLY 12, (1868) ["Late Peter Cagger." 12:605 (Aug. 1, 1868): 484.]

C387 Portrait. Woodcut engraving, credited "From a Photograph by Churchill & Dennison." FRANK LESLIE'S ILLUSTRATED NEWSPAPER 30, (1870) ["Hon. George Opdyke, ex-mayor of New York, NY." 30:765 (May 28, 1870): 165.]

CHURCHILL, A. S.
C388 Churchill, A. S. "Alkaline Toning." HUMPHREY'S JOURNAL OF PHOTOGRAPHY, AND THE ALLIED ARTS AND SCIENCES 11, no. 20 (Feb. 15, 1860): 310. [From "Photo. Notes."]

CHURCHILL, REMMETT E. see also CHURCHILL & DENISON.

CHURCHILL, REMMETT E. (ALBANY, NY)
BOOKS
C389 *Photographic Senatorial Album of the State of New York, 1874-75.* Albany, NY: R. E. Churchill, 1875. 35 b & w. [Original photos, by R. E. Churchill.]

C390 New York (State). Constitutional Convention 1873. *Photographic Album of the Constitutional Commission of the State of New York, 1872-73.* Albany, NY: R. Churchill, 1873. 35 b & w. [Album, NYPL collection.]

PERIODICALS
C391 Portrait. Woodcut engraving, credited "From a Photograph by Churchill." FRANK LESLIE'S ILLUSTRATED NEWSPAPER 34, (1872) ["Dr. D. G. Dodge, Supt. of NY State Inebriate Asylum at Binghampton, NY." 34:869 (May 25, 1872): 172.]

C392 "Albany, N. Y. - Inauguration of Governor Samuel J. Tilden,... - Sketched by Harry Ogden. - Photographed by R. E. Churchill." FRANK LESLIE'S ILLUSTRATED NEWSPAPER 39, no. 1007 (Jan. 16, 1875): 317. 1 illus. [View of the Governor's house.]

C393 Portraits. Woodcut engravings, credited "From a Photograph by R. E. Churchill." FRANK LESLIE'S ILLUSTRATED NEWSPAPER 40, (1875) ["Hon. R. U. Sherman, NY legislator." 40:1021 (Apr. 24, 1875): 112. "Hon. James Mackin, NY legislator." 40:1021 (Apr. 24, 1875): 112. "Hon. John C. Jacobs, NY Senator." 40:1021 (Apr. 24, 1875): 112. "Hon. Alanson S. Page, NY legislator." 40:1024 (May 15, 1875): 161.]

C394 Portraits. Woodcut engravings, credited "From a Photograph by R. E. Churchill, Albany. FRANK LESLIE'S ILLUSTRATED NEWSPAPER 41, (1875) ["George D. Lord." 41:1047 (Oct. 23, 1875): 104. "Hon. George W. Schuyler, NY." 41:1049 (Nov. 6, 1875): 140. "Hon. James Makin, NY." 41:1049 (Nov. 6, 1875): 140.]

C395 Portrait. Woodcut engraving, credited "From a Photograph by Churchill, Albany. FRANK LESLIE'S ILLUSTRATED NEWSPAPER 41, (1876) ["NY State officers. (5 portraits)." 41:1061 (Jan. 29, 1876): 340.]

CHUTE & BROOKS see also GIHON, JOHN L.

CHUTE & BROOKS. (MONTEVIDEO, URAGUAY)

C396 "Editor's Table: Pictures Received." PHILADELPHIA PHOTOGRAPHER 8, no. 85 (Jan. 1871): 32. [Cabinet photos from Chute & Brooks (Montevideo, Brazil).]

CHUTE, L. W. see also CHUTE & BROOKS.

CHUTE, L. W. (MONTEVIDEO, URAGUAY)

C397 "Editor's Table: A Long Journey." PHILADELPHIA PHOTOGRAPHER 14, no. 157 (Jan. 1877): 31-32. [L. W. Chute of Chute & Brooks, Montevideo, South America, visited the Phila. Centennial.]

CHUTE, ROBERT J. (1833-1893) (USA)

C398 Portrait. Woodcut engraving, credited "From a Photograph by Robert J. Chute, Boston, Mass." HARPER'S WEEKLY 8, (1864) ["Edward W. Green." 8: 374 (Feb. 27, 1864): 140.]

C399 Portraits. Woodcut engravings, credited "Photographed by Chute." FRANK LESLIE'S ILLUSTRATED NEWSPAPER 17, (1864) ["Edward W. Green, the Malden Murderer." 17:440 (Mar. 5, 1864): 380.]

C400 "Editor's Table." PHILADELPHIA PHOTOGRAPHER 4, no. 47 (Nov. 1867): 368. [Stereographs of the Masonic Hall of Melrose, MA.]

C401 "Voices from the Craft." PHILADELPHIA PHOTOGRAPHER 4, no. 48 (Dec. 1867): 383. [Letter from Chute about how he made stereos.]

C402 Vanweike, Roland. [R. J. Chute]. "Under the Skylight. Nos. 1 - 10." PHILADELPHIA PHOTOGRAPHER 7-8, no. 75-76, 78, 80, 83, 86-87, 88, 90, 94 (Mar. - Apr., June, Aug., Nov. 1870; Jan. - Feb., Apr., June, Oct. 1871): 75-76,100-102, 206-208, 294-296, 373-375; 8-10, 35-37, 112-115, 166-168, 332-334. [Advice on how to pose sitters, etc.]

C403 Chute, R. J. "Negative Manipulation: Pinholes." PHILADELPHIA PHOTOGRAPHER 8, no. 92 (Aug. 1871): 249-250.

C404 "Editor's Table." PHILADELPHIA PHOTOGRAPHER 8, no. 92 (Aug. 1871): 279. [Mr. R. J. Chute ...well known in Boston, MA, where he conducted business for himself and others several years... He is now Sec. of Pa. Photo. Assoc. and the chief operator in the establishment of Mr. F. Gutekunst, Philadelphia, PA.]

C405 Vanweike, Roland. [R. J. Chute]. "Under the Skylight." PHILADELPHIA PHOTOGRAPHER 9, no. 97-102 (Jan. - June 1872): 4-6, 55-56, 83-84. [Advice.]

C406 Vanweike, Roland. [R. J. Chute]. "Under the Skylight and In the Darkroom." PHILADELPHIA PHOTOGRAPHER 9, no. 103-108 (July - Dec. 1872): 243-244, 294-296, 345-346, 372-374, 412-414. [Advice.]

C407 Chute, R. J. "How to Make Lantern Slides." PHILADELPHIA PHOTOGRAPHER 9, no. 98 (Feb. 1872): 48-49.

C408 Chute, R. J. "Fourth Annual Meeting and Exhibition of the N. P. A. in St. Louis, Mo., May 1872: Seeing What We Do." PHILADELPHIA PHOTOGRAPHER 9, no. 102 (June 1872): 186-87.

C409 Chute, R. J. "Seeing What We Do." COMMERCIAL PHOTOGRAPHIC NEWS 1, no. 4 (Oct. 1872): 4-5. [Read at NPA meeting in St. Louis, MO.]

C410 Chute, R. J. (Roland VanWeike). "Things Old and New."PHILADELPHIA PHOTOGRAPHER 10, no. 109-120 (Jan. - Dec. 1873): 19-20, 55, 99-100, 175-176, 234, 526-527.

C411 Chute, R. J. "Fifth Annual Meeting and Exhibit of the National Photographic Association of the U. S., held in Buffalo, N. Y., beginning July 5, 1873: Art Education." PHILADELPHIA PHOTOGRAPHER 10, no. 117 (Sept. 1873): 313-314.

C412 "Fifth Annual Meeting and Exhibition of the National Photographic Association of the United States, Held in Buffalo, New York, beginning July 15, 1873 (Continued)." ANTHONY'S PHOTOGRAPHIC BULLETIN 4, no. 11 (Nov. 1873): 337-352. [Discussion of members, letter from Jex Bardwell, "Art Education," by R. J. Chute, "The Relation of the Photographers and the Artist," by George B. Ayers, "Address by a Sculptor," by Mr. Baker.]

C413 Chute, R. J. "Things Old and New." PHILADELPHIA PHOTOGRAPHER 11, no. 121-123 (Jan. - Mar. 1874): 3-4, 40-41, 68-69. [Technical advice.]

C414 Chute, R. J. "Hints Under the Skylight." PHILADELPHIA PHOTOGRAPHER 11, no. 124-130 (Apr. - Oct. 1874): 102-103, 130-131, 210-211, 276-277, 313-314.

C415 Chute, R. J. "Art in Chicago." PHOTOGRAPHIC TIMES 4, no. 47 (Nov. 1874): 172-173. [Chicago, IL.]

C416 Chute, R. J. "Times Residues." PHOTOGRAPHIC TIMES 5, no. 52-59 (Apr. - Nov. 1875): 86-87, 128-129, 188-190, 216-217, 240-241, 259-261. [Homilies, advice, etc. Quotes Rejlander on p. 129.]

C417 Chute, R. J. "Landscape Photography." PHILADELPHIA PHOTOGRAPHER 12, no. 137 (May 1875): 139-140.

C418 "Editor's Table." PHILADELPHIA PHOTOGRAPHER 13, no. 145 (Jan. 1876): 32. ["Robert J. Chute is still connected with the editorial department of our magazine, as he has been for the past two years."]

C419 Chute, Robert J. "Photographic Accidents." PHILADELPHIA PHOTOGRAPHER 13, no. 146-147 (Feb. - Mar. 1876): 37-39, 68-70.

C420 Chute, Robert J. "Lessons in Photographic Hall." PHILADELPHIA PHOTOGRAPHER 13, no. 152 (Aug. 1876): 246-247. [General advice, recommendation to study the exhibitions at the Photographic Hall at the Philadelphia Centennial.]

C421 Chute, Robert J. "Overiodizing and Pinholes." PHILADELPHIA PHOTOGRAPHER 14, no. 158 (Feb. 1877): 35-38. [Chute, in his discussion of this problem, cites earlier discussions by R. Fenton in 1853, and later examples up to 1877.]

C422 Chute, R. J. "Skylights and Sidelights." PHILADELPHIA PHOTOGRAPHER 14, no. 163 (July 1877): 193-194.

C423 Chute, Robert J. "Seasonable Suggestions." PHILADELPHIA PHOTOGRAPHER 14, no. 164 (Aug. 1877): 244-245. [Advice on sittings, chemicals, etc.]

C424 Chute, Robert J. "Prices for Photographs." PHILADELPHIA PHOTOGRAPHER 14, no. 165 (Sept. 1877): 274-276. [Includes list of suggested prices.]

C425 "Our Picture." PHILADELPHIA PHOTOGRAPHER 14, no. 166 (Oct. 1877): frontispiece, 289-290. 1 b & w. [Portrait of a girl.]

C426 Chute, Robert J. "On the Saving of Silver." PHILADELPHIA PHOTOGRAPHER 14, no. 166 (Oct. 1877): 290-292.

C427 Chute, Robert J. "On Saving Silver and Gold in Printing." PHILADELPHIA PHOTOGRAPHER 14, no. 168 (Dec. 1877): 373-374.

C428 Chute, Robert J. "Attention!" PHILADELPHIA PHOTOGRAPHER 15, no. 171 (Mar. 1878): 68-69.

CIVIALE, AIME. (1821-1893) (FRANCE)
[Born in 1821, the son of a member of l'Académie des sciences. Studied at the l'Ecole polytechnique in Paris, and decides to learn photography and put that skill to the service of physical geography and geology. Became a member of the Société français de Photographie in 1857, and began to photograph in the Pyrénées Mountains. Invented a panoramic device, waxed paper process, and other improvements. Photographed in the Pyrénées again, then in the Alps from 1859 to 1868. Views of Mont Blanc, the Oberland, and others. Member of the Council of the Société française de Photographie from 1866-88. Died July 4, 1893.]

C429 Civiale, A. "Application of Photography to Physical Geography and Geology." PHOTOGRAPHIC NEWS 4, no. 91-92 (June 1 - June 8, 1860): 53, 62-23. [Dry waxed-paper negatives of the Bernais Oberland Lists views of the Alps. Also a "Description of the Travelling Camera of M. A. Civiale on pp. 63-64. Read before the Paris Academy of Sciences.]

CLAFLIN, CHARLES R. B. (1817-1897) (USA)
C430 Five Hundred Past and Present Citizens of Worchester, Mass. Photographed by Claflin, Worcester, and Black, Boston. Boston: G. R. Peckham, 1870. xi pp. 56 l. of plates. 500 b & w. [Each plate contains 9 vignetted portraits, with the sitter's name written underneath, the ensemble then rephotographed and published as one plate. In some cases the original portraits are from paintings, but many are probably from Black's negatives.]

CLAINE, GUILLAUME. (1811-1869) (BELGIUM)
C431 Roosens, Laurent. "Joseph Ernest Buschmann and Guillaume Claine: Two Belgian Calotypists." HISTORY OF PHOTOGRAPHY 2, no. 2 (Apr. 1978): 117-122. 3 b & w. 1 illus. [Correspondence between Claine and Buschmann discussed. Both were amateur photographers. Buschmann was a publisher. Claine was born in Marche, Belgium in 1811. He had moved to Brussels by 1847, where he worked as a journalist for the liberal newspaper "L'Observateur." Began making calotypes about 1848 or 1849.]

C432 "Biographical Notes on a Number of Photographers Published by Blanquart-Evrard." CAMERA (LUCERNE) 57, no. 12 (Dec. 1978): 32, 41-42. [Benecke, Claine, DuCamp, Fortier, Greene, Le Secq, Loydreau, Marville, Regnault, Robert, Salzmann, Stewart, Sutton, and Tenison. Guillaume Claine began to make calotypes in Brussels about 1848 or 1849, mostly as experiments, as an amateur. With Jacopssen, Claine developed an improved photographic paper in 1850. The Académie de Belgique gave Claine a grant to photograph Belgian architecture, examples of which were published by Blanquart-Evrard in the album Bruxelles Photographique.]

CLAPHAM, W.
C433 "Portland, Victoria." ILLUSTRATED LONDON NEWS 36, no. 1012 (Jan. 14, 1860): 41-42, 45. 1 illus. ["...from a photograph taken by Mr. W. Clapham;..."]

CLARK & BROTHERS. (NEW YORK, NY)
C434 "Editorials." DAGUERREAN JOURNAL 2, no. 4 (July 1, 1851): 114. [Lithograph of Masonic Hall, from a daguerreotype by Clark & Brothers (New York, NY).]

CLARK. (ITHICA, NY)
C435 "Gossip." PHOTOGRAPHIC ART JOURNAL 3, no. 4 (Apr. 1852): 257. [Studio burned down "...the amount of this young but deserving artist's loss we have not learned..."]

CLARK, CHARLES HENRY. (1847-) (USA)
C436 "Explosion of a Paper Mill at Schuylerville, New York. - From a Phot. by C. H. Clarke." FRANK LESLIE'S ILLUSTRATED NEWSPAPER 17, no. 441 (Mar 12, 1864): 388. 1 illus. [Ruins.]

CLARK, D. R. (LAFAYETTE, IN)
C437 "Editor's Table." PHILADELPHIA PHOTOGRAPHER 6, no. 62 (Feb. 1869): 64. [Cabinet photos noted.]

C438 "Editor's Table." PHILADELPHIA PHOTOGRAPHER 6, no. 64 (Apr. 1869): 136. [Photo of Judges of Supreme Court of IN noted.]

CLARK, FORESTER.
C439 Clark, Forester. "Photographing Children, Etc." ST. LOUIS PRACTICAL PHOTOGRAPHER 1, no. 1 (Jan. 1877): 4-5.

CLARK, HARRISON (d. 1866) (USA)
C440 Seely, Charles A. "Editorial Department." AMERICAN JOURNAL OF PHOTOGRAPHY AND THE ALLIED ARTS & SCIENCES n. s. vol. 9, no. 2 (Sept. 15, 1866): 48. ["Harrison Clark, a photographer at 421 Broadway, committed suicide on the 9th inst. An unfortunate attachment which he had formed for a courtesan, was the cause of the rash act. This is the eighth case of suicide which has occurred among photographers in this city since we commenced the publication of this magazine."]

CLARK, J. R. (NEW YORK, NY)
C441 "Burning of the National Daguerreotype Miniature Gallery." HUMPHREY'S JOURNAL 4, no. 1 (Apr. 15, 1852): 12-13. [The Gallery established in 1843 by Anthony, Edwards & Chilton, then Anthony, Clark & Co., with J. R. Clark managing the firm. Then to E. White, then to W. & F. Langenhiem, then purchased by D. E. Gavit, then burned - with the loss of many early portraits of statesmen, etc.]

CLARK, JOHN HAWLEY. (ca. 1831-1914) (USA)
C442 "Billy Bowlegs in New Orleans." HARPER'S WEEKLY 2, no. 76 (June 12, 1858): 376-378. 5 illus. [Five strong portraits of Seminole Indians and their Negro slave. "Our admirable photographer, Clark, placed the whole of his apparatus, together with the capital operator, Carden, at my disposal for this purpose." (Clark, or Clarke, born in Delaware, died July 16, 1914 in New Orleans. Worked in Washington, DC in 1850s, then to New Orleans from 1858 to 1870s.]

C443 "The Steamer 'Marquis de la Haban' - The Captured Mexican Steamer 'Miramon' with the U.S. Sloop 'Preble' Lying off Algiers, La." HARPER'S WEEKLY 4, no. 172 (Apr. 14, 1860): 225. 2 illus. ["From photographs by J. H. Clark, Esq., of New Orleans."]

C444 "Statue of Henry Clay, at New Orleans, Inaugurated April 12, 1860." HARPER'S WEEKLY 4, no. 174 (Apr. 28, 1860): 267-268. 1 illus. ["Photographed by J. H. Clark, Esq., of New Orleans."]

C445 "Views of the Flood in New Orleans - From Photographs by Clarke. [sic Clark.]" FRANK LESLIE'S ILLUSTRATED NEWSPAPER 32, no. 822 (July 1, 1871): 253. 4 illus. [Views of damage.]

C446 "Louisiana. - Grand Masquerade Mardi-Gras Procession through the Streets of New Orleans, on Tuesday, March 5th. The Column Marching Past the Statue of Henry Clay, on Canal Street, and Defiling into St. Charles Street. - From Sketches by Our Special Artists and Photographs by John H. Clark, New Orleans." FRANK LESLIE'S ILLUSTRATED NEWSPAPER 46, no. 1173 (Mar. 23, 1878): 40-41, 50. 1 illus. [View of parade, with crowds. Image embellished by the engraver.]

CLARK, JOSIAH LATIMER. (d. 1888) (GREAT BRITAIN)

C447 "Obituary: Josiah Latimer Clark." BRITISH JOURNAL PHOTOGRAPHIC ALMANAC 1899 (1899): 657-658. 1 illus. [Latimer Clark, father of Lyonal Clark, an amateur photographer. Latimer devised a technique for taking stereo photos with one camera, introduced vignetting in photography in 1850s, etc.]

CLARK, S. A. (LACONIA, NH)

C448 "One Day's Work Still Harder to Beat." ANTHONY'S PHOTOGRAPHIC BULLETIN 2, no. 10 (Oct. 1871): 320. [Clark (Laconia, NH), working in a 9x12 ft. saloon car, made $32.85 on one day, by making 5 frame pictures for $1.00 each and $1.00 per dozen for tintypes.]

CLARK, WILLIAM DONALDSON. (d. 1873) (GREAT BRITAIN)

C449 Clark, W. D. "Photographic Society of Scotland." BRITISH JOURNAL OF PHOTOGRAPHY 10, no. 189 (May 1, 1863): 194-195. [Text of Clark's paper to that organization, "Notes on the Collodio-Albumen Process."]

C450 Clark, W. D. "Notes on the Collodio-Albumen Process." JOURNAL OF THE PHOTOGRAPHIC SOCIETY OF LONDON 8, no. 133 (May 15, 1863): 280-284. [Clark describes his experiences photographing in Edinburgh, including the assistance he received from his friend D. O. Hill.]

C451 "On Photography as a Fine Art." JOURNAL OF THE PHOTOGRAPHIC SOCIETY OF LONDON 8, no. 133 (May 15, 1863): 286-288.

C452 Clark, W. D. "On Pictorial and Photographic Representations of Melrose Abbey." BRITISH JOURNAL OF PHOTOGRAPHY 13, no. 316 (May 25, 1866): 249-250.

CLARKE.

C453 Portraits. Woodcut engravings, credited "Photographed by Clarke." FRANK LESLIE'S ILLUSTRATED NEWSPAPER 18, (1864) ["Franz Muller, the English Railway Murderer." 18:467 (Sept. 10, 1864): 385.]

C454 Portrait. Woodcut engraving, credited "From a Photograph by Clarke." HARPER'S WEEKLY 8, (1864) ["Francis Muller, the Murderer of Mr. Briggs." 8:402 (Sept. 10, 1864): 589.]

CLARKE, CAPT. MELVILLE see MELVILLE-CLARKE.

CLARKE & HOLMES. (TROY, NY)

C455 "Fall of the Troy Union Railroad Depot. - From a Photograph by Clarke & Holmes, Troy." FRANK LESLIE'S ILLUSTRATED NEWSPAPER 9, no. 215 (Jan. 14, 1860): 104. 1 illus. [View of the collapsed building, with figures added by the engraver.]

CLARKE, J. J. (NEW YORK, NY)

C456 Clarke, J. J. "Imperfect Negatives, Streaks, &c." AMERICAN JOURNAL OF PHOTOGRAPHY AND THE ALLIED ARTS & SCIENCES n. s. vol. 6, no. 8 (Oct. 15, 1863): 184-185.

CLARKE, J. R.

C457 Clarke, J. R. "The Use of Gelatine Dry Plates in the Studio." ANTHONY'S PHOTOGRAPHIC BULLETIN 10, no. 5 (May 1879): 148. [From "London Photo. News."]

CLARKE, ROBERT & CO. (CINCINNATI, OH)

C458 Portrait. Woodcut engraving, credited "From a Photograph by Robert Clark & Co., Cincinnati, Ohio." HARPER'S WEEKLY 6, (1862) ["Gen. Robert L. McCook." 6:296 (Aug. 30, 1862): 556.]

CLARKE, T.

C459 Clarke, T. "On the Stereotrope." HUMPHREY'S JOURNAL OF PHOTOGRAPHY, AND THE ALLIED ARTS AND SCIENCES 13, no. 5 (July 1, 1861): 71. [From "Br. J. of Photo."]

CLARKINGTON, CHARLES. (GREAT BRITAIN)

C460 "Our Weekly Gossip." ATHENAEUM no. 1755 (June 15, 1861): 801. ["Mr. Clarkington has published the first portion of a Photographic Album Series of the Members of the House of Commons."]

CLAUDET, ANTOINE see also BREWSTER, DAVID, SIR; WILLIAMS, T. R.

CLAUDET, ANTOINE FRANÇOIS JEAN. (1797-1867) (FRANCE, GREAT BRITAIN)

[Born on July 16, 1797 in Lyons, France. At age 21 entered the banking business of his uncle. Later became the director of a firm of glass-makers at Choisy-le-Roi. Married a British woman, and opened a business in London, selling glassware. Learned of the daguerreotype process in 1839 from Daguerre, and purchased a licence to operate in England before Richard Beard was granted exclusive rights there - thus making Claudet's the only other photographic studio in London during the early years. Claudet opened a studio on Adele St. in 1841. Claudet was very active in experimenting in the medium, he was one of the first to reduce the daguerreotype's exposure time, and he worked out a host of other small improvements in techniques and processes. Claudet frequently presented papers to the scientific organizations and published many articles during the 1840s and 1850s. After 1851 he used the calotype and wet collodion processes in his studio as well. Joined the Photographic Society in 1853. He was interested in the stereoscope, and many of his best photographs are in this format. Claudet was made a Chevalier of the Légion d'Honner in France. Died on Dec. 27, 1867.]

BOOKS

C461 Broughton, Lord Henry. *Discours de Lord Brougham sur le droit de visite,* par Lord Henry Broughton. Traduit par A. Claudet, ... suivi des divers traites relatifs au droit de visite, de la lettre adresse par M. de Tocqueville a Lord Brougham et de la reponse du noble Lord. Paris: au Comptor des imprimeurs-reunis, 1843. 60 pp.

C462 Claudet, A. *Researches on the Theory of the Principal Phenomena of Photography in the Daguerreotype Process.* Read Sept. 14, 1849, by the Author before the British Assoc. at Birmingham.

London: 1849. 12 pp. ["From the London, Edinburgh and Dublin Philosophical Magazine and Journal of Science for Nov. 1849". Reprinted 1973, Arno Press.]

C463 Timbs, John. *The Year-Book of Facts in Science and Art.* London: s. n., 1849. 288 pp. [Article on "photographometer" by A. Claudet, and others on daguerreotypy.]

C464 Claudet, A. *Recherches sur la theorie des principaux phenomenes de photographie dans le procede du daguerreotype,* Memoire lu...le 14 Septembre 1849 dans le comite de chimie de l'Association britannique reunie a Birmingham. Paris: G. Balliere, 1850. 15 pp. 2 illus.

C465 Claudet, A. *Nouvelles recherches sur la difference entre les foyers visuels et photogeniques. Description du dynactionmetre, du focimetre, etc.,* ...Deuxieme memoire, lu...le 7 aout 1850, a l'Association britannique reunie a Edimbourg. Paris: Lerebours et Secretan, 1851. 30 pp.

C466 Claudet, A. et F. Colas. *Du Stereoscope et de ses applications a la photographie,* par A. Claudet...et Derniers perfectionnements apportes au daguerreotype, par F. Colas. Paris: Lerebour & Secretan, 1853. 55 pp. illus. ["Extrait d'un memoire lu par M. Claudet a la Societe des arts de Londres, le 19 janvier 1853...et d'un autre memoire lu...le 9 septembre, a l'Association britannique reunie à Hull." "Derniers perfectionnements apportes au daguerreotype, par F. Colas. Nouv. ed. considerablement augm."]

C467 Claudet, A. *Le stereomonoscope, nouvel instrument dont le principe est fonde sur la decouverte de la propriete inherente au verre depoli de presenter en relief l'image de la chambre obscure (sujet d'un memoire communique le 15 mars 1858 a la Societe royale de Londres).* Paris: Impr. de Bonaventure et Ducessois, 1858. 23 pp.

C468 Ellis, Joseph. *A. Claudet, F.R.S., a Memoir,* Reprinted from the "Scientific Review" for distribution at the meeting of the British Association at Norwich 19 August 1868. London: Basil Montagu Pickering, 1868. 32 pp. 1 b & w. [Frontispiece portrait of Claudet.]

C469 Fluckinger, Roy. "Beard and Claudet: A Further Inquiry," on pp. 91-96 in: *The Daguerreotype,* edited by John Wood. Iowa City: University of Iowa Press, 1989.

PERIODICALS

C470 "Memoranda: New Mode of Preparation of Daguerreotype Plates." MAGAZINE OF SCIENCE AND SCHOOL OF ARTS 3, no. 121 (July 24, 1841): *. [From the "Athenaeum."]

C471 "Photographic Portraits: Beard v. Claudet." ART UNION no. 31 (Aug. 1, 1841): 139. [Copyright conflict between Beard and Claudet.]

C472 "Letter." LITERARY GAZETTE no. 1301 (Dec. 25, 1841): 838. [Remarking on improvements in processes.]

C473 Claudet, A. "No. VIII. The Progress and Present State of the Daguerreotype Art." TRANSACTIONS OF THE SOCIETY OF ARTS, MANUFACTURES, AND COMMERCE (LONDON) 55, (1843/44): 89-110.

C474 "Scientific and Literary: Society of Arts - Dec. 13." ATHENAEUM no. 843 (Dec. 23, 1843): 1139. ["The Secretary next read a paper by Mr. Claudet, "On the Daguerreotype Art," "...one of Mr. Claudet's assistants showing, by means of artificial light, the whole process of producing a picture..."]

C475 "Scientific & Literary: Society of Arts Jan. 22." ATHENAEUM no. 901 (Feb. 1, 1845): 124. [Note & brief summary of Claudet's paper "On the Progress of Photography" read before the Society.]

C476 "Fine Art Gossip." ATHENAEUM no. 917 (May 24, 1845): 518. [Note that improvements made in "portraits from life by Claudet, of the Adelaide Gallery..."]

C477 "Fine Arts: Talbotypes." LITERARY GAZETTE, AND JOURNAL OF THE BELLES LETTRES no. 1477 (May 10, 1845): 300. [Notes a M. Manison, working in Claudet's studio retouching Talbotype.]

C478 "Varieties: The Talbotype." ART UNION 7, no. 80 (May 1845): 138. [Brief note that Claudet, at the Royal Adelaide Gallery, using the Talbotype to make portraits.]

C479 "Topics of the Month: Photographic Miniatures." ART UNION (ART JOURNAL) 1, (Jan. 1846): 19-20. [Claudet and Mansion improving their daguerreotype portraits.]

C480 "Society of Arts - Jan. 28." ATHENAEUM no. 954 (Feb. 7, 1846): 152. [Claudet's paper "On Some Principles and Practical Facts in the Art of Photography" described and discussed.]

C481 "Topics of the Month: Photography." ART UNION (ART JOURNAL) (Mar. 1846): 91. [Claudet's paper, "On Some Practical Facts in the Art of Photography," read before the Society of Arts.]

C482 "M. Claudet's Daguerreotype Portraits." ATHENAEUM no. 975 (July 4, 1846): 689.

C483 "Arts and Sciences: Photography." LITERARY GAZETTE, AND JOURNAL OF THE BELLES LETTRES no. 1537 (July 4, 1846): 601.

C484 "Topics of the Month: Daguerreotype Portraits." ART UNION (ART JOURNAL) (July 1846): 216. [Praise for Claudet's improvements.]

C485 "Society of Arts. Feb. 17." ATHENAEUM no. 1009 (Feb. 27, 1847): 236. [On the progress of Photography by Claudet read to meeting, described in article.]

C486 "Topics of the Month: Photography." ART UNION (Mar. 1, 1847): 109-110. [Briefly discusses paper on state of the art by Claudet, read at Society of Arts, 17th Feb.]

C487 Claudet, Antoine. "Photographic Colouration." ATHENAEUM no. 1018 (May 1, 1847): 472. [Letter arguing with Hunt's statement in Apr. 24, 1847 "Athenaeum."]

C488 Claudet, Antoine. "Photographic Experiments." ATHENAEUM no. 1023 (June 5, 1847): 602. [Letter stating historical precedents.]

C489 "Note." ATHENAEUM no. 1025 (June 19, 1847): 652. [Claudet has opened an exhibition of latest improvements in photo at the Colosseum.]

C490 "Report of the 17th meeting of the British Association for the Advancement of Science." ATHENAEUM no. 1027 (July 3, 1847): 713. [Claudet's paper "On different properties of various rays of the solar radiation on the daguerreotype plate.' briefly described.]

C491 "Memoir of Lord George Bentinck." ILLUSTRATED LONDON NEWS 13, no. 337 (Sept. 30, 1848): 200-201. 1 illus. [From a Daguerreotype by Claudet.]

C492 "The Photographometer." ART JOURNAL (Mar. 1, 1849): 96. 2 illus. [An early device for measuring light, constructed by A. Claudet.]

C493 Claudet, Antoine. "Researches on the theory of the principal phenomena of photography in the daguerreotype process." ART JOURNAL (Dec. 1849): 358-360.

C494 Claudet, A. "Researches on the Theory of the Principal Phenomena of Photography in the Daguerreotype Process." ART JOURNAL (Dec. 1, 1849): 358-360.

C495 "Twentieth meeting of the British Association for the Advancement of Science. Wednesday. Sect. A. - Mathematical and Physical Science." ATHENAEUM no. 1191 (Aug. 24, 1850): 904-906. [Paper read at the conference. "On the Dynactinometer," by A. Claudet, on p. 905.]

C496 Claudet, A. "Researches: On the Theory of the Principal Phenomena of Photography in the Daguerreotype Process." DAGUERREIAN JOURNAL 1, no. 1-2 (Nov. 1 - Nov. 15, 1850): 1-5, 33-38.

C497 "On the Dynactinometer." DAGUERREAN JOURNAL 1, no. 3 (Dec. 2, 1850): 76. [From "Proceedings of British Assoc. for the Advancement of Science," and "Silliman's American Journal."]

C498 Portraits. Woodcut engravings credited "From a photograph by Claudet." ILLUSTRATED LONDON NEWS 18, (1851) ["Hans Christian Oersted." 18:* (Apr. 5, 1851): 278. (photo) "Sir Henry Thomas de la Beche." 18:* (May 17, 1851): 422. (photo) "Richard Phillips, F.R.S." 18:* (June 14, 1851): 547. (dag.)]

C499 Portraits. Woodcut engravings credited "From a photograph by Claudet." ILLUSTRATED LONDON NEWS 19, (1851) ["Mr. W. Brown, M.P." 19:* (July 12, 1851): 70. (dag.) "J. L. M. Daguerre." 19:* (July 26, 1851): 117. (dag.) "T. Collins, Esq., M.P." 19:* (Aug. 9, 1851): 173. (dag.) "Mr. Hemans, railroad engineer." 19:* (Aug. 9, 1851): 208. (photo) "Commissioners of Crystal Palace (4 portraits)." 19:* (Oct. 18, 1851): 508-509. "M. Kossuth." 19:* (Nov. 15, 1851): 588. (dag.) "Mr. Kossuth's Children." 19:* (Nov. 15, 1851): 589. (dag.) "M. Kossuth." 19:* (Nov. 22, 1851): 609. (dag.)]

C500 "Letter." ATHENAEUM no. 1214 (Feb. 1, 1851): 141-142. [Letter from Claudet opposing Blanquart-Evrard's idea of whitening interior of camera (pg. 86, Jan. 8, 1851)]

C501 Claudet, A. "Solar Radiation. On Different Properties of Solar Radiation...." DAGUERREAN JOURNAL 1, no. 6 (Feb. 1, 1851): 161-168. [From "Philosophical Transcriptions for 1847, part II."]

C502 Claudet, A. "Accelerating Process: Question of Priority Respecting the Discovery of the Accelerating Process in the Daguerreotype Operation." DAGUERREAN JOURNAL 1, no. 6 (Feb. 1, 1851): 168. [From "Lon. Phil. J. of Science."]

C503 Claudet, A. "Photographic Phenomena: Referring to the Various Actions of the Red and Yellow Rays on Daguerreotype Plates When They Have Been Affected by Daylight." DAGUERREAN JOURNAL 1, no. 6 (Feb. 1, 1851): 169. [From "Lon. Phil. Mag." 1848.]

C504 "Letter." ATHENAEUM no. 1224 (Apr. 12, 1851): 410. [Reply to Kilburn & Mayall letters on issue of whitened camera.]

C505 Claudet, A. "On Different Properties of Solar Radiations." PHOTOGRAPHIC ART JOURNAL 1, no. 4 (Apr. 1851): 246-251.

C506 "Claudet's Specification: Sealed 21st November, 1843." DAGUERREAN JOURNAL 2, no. 2 (June 1, 1851): 44-48. [Copied from Patent Office, London. Claudet's system of transferring a daguerreotype into an engraving plate..]

C507 "The Ceylon Court, The East Indian Court - North Side, the East Indian Court - South Side." ILLUSTRATED LONDON NEWS 18, no. 492 (June 14, 1851): 562-563. 3 illus. [Interior views of the exhibitions at the Crystal Palace - "From a Photograph by Claudet."]

C508 "Pottery - By Messrs. Minton, Case of Furs...by Smith and Sons." ILLUSTRATED LONDON NEWS 18, no. 493 (June 21, 1851): 599. 2 illus. [Views of the exhibitions at the Crystal Palace - "From a Daguerreotype by Claudet."]

C509 Claudet, A., trans. by J. Russell Snelling. "Researches in the Theory of the Principal Phenomena of Photography in the Daguerreotype Process." PHOTOGRAPHIC ART JOURNAL 2, no. 1 (July 1851): 37-50. 6 illus.

C510 "Twenty-First Meeting of the British Association for the Advancement of Science. Monday. Sect. B. - Chemistry." ATHENAEUM no. 1238 (July 19, 1851): 776-787. [Brief survey of several papers read by Claudet. "On the Dangers of the Mercurial Vapors in the Daguerreotype Process," and "On the Use of a Polygon to Ascertain the Intensity of Light at Different Angles in the Photographic Room." On p. 778.]

C511 "The Carriage Department - Stuffed Frogs from Wurtemburg - Stuffed Cats from Wurtemburg." ILLUSTRATED LONDON NEWS 19, no. 505 (July 26, 1851): 128, 133. 3 illus. [Views, items displayed at the Crystal Palace. "From a Daguerreotype by Claudet."]

C512 Claudet, A. F. J., Esq. "Description of the Dynactinometer. An Instrument for Measuring the Intensity of the Photogenic Rays and Comparing the Power of Object Glasses, etc." PHOTOGRAPHIC ART JOURNAL 2, no. 2 (Aug. 1851): 81-89.

C513 "The Great Exhibition - The East Nave - The West Nave." ILLUSTRATED LONDON NEWS 19, no. 514 (Sept. 6, 1851): 296-297. 2 illus. [Views of Crystal Palace. "From a Daguerreotype by Claudet."]

C514 "State Howdah - Exhibited by the East India Company." ILLUSTRATED LONDON NEWS 19, no. 516 (Sept. 20, 1851): 365. 1 illus. [Exhibits at the Crystal Palace. "From a Photograph by Claudet."]

C515 "The Royal Commissioners, Executive Committee and Foreign Commissioners of the Great Exhibition." ILLUSTRATED LONDON NEWS 19, no. 524 (Oct. 18, 1851): 504, 508-509. 18 illus. [Eighteen portraits, four credited from daguerreotypes by Claudet, one credited to Beard, two credited to photographs by Kilburn.]

C516 "Distinguished Jurors and Celebrities of the Great Exhibition." ILLUSTRATED LONDON NEWS 19, no. 525 (Oct. 25, 1851): 536. 9 illus. [Nine portraits "From Daguerreotypes by Claudet."]

C517 Delariviorre, F. A. "Heliography on Metallic Plates; A Visit to M. Claudet." PHOTOGRAPHIC ART JOURNAL 2, no. 5 (Nov. 1851): 285-287.

C518 "Note." ART JOURNAL (Jan. 1852): 34. [Stereoscopic views of the Crystal Palace exhibition.]

CLAUDET, ANTOINE FRANÇOIS JEAN. (1797-1867) (FRANCE, GREAT BRITAIN)

C519 Portraits. Woodcut engravings credited "From a photograph by Claudet." ILLUSTRATED LONDON NEWS 20, (1852) ["Earl of Albemerle, Lord Leigh, Sir R. B. W. Bulkeley, Mr. Bonham Carter (4portraits)." 20:* (Feb. 7, 1852): 117. (dags.) "Hon. George Cathcart." 20:* (Feb. 7, 1852): 125. (dag.) "Sir Charles Barry, R.A." 20:* (Feb. 21, 1852): 161. (dag.) "Hon. S. T. Carnegie." 20:* (Feb. 28, 1852): 172. (dag.) "Attny.-Gen. Sir Frederick Thesiger." 20:* (Mar. 20, 1852): 225. (dag.) "Mr. Braham." 20:* (Mar. 20, 1852): 245. (dag.) "Henry James Baille, Esq., M.P." 20:* (Apr. 3, 1852): 268. (dag.) "Right Hon. Sir John Somerset Pakington." 20:* (Apr. 24, 1852): 321. (dag.) "Earl of Desart." 20:* (Apr. 24, 1852): 321. (dag.) "M. Arago." 20:* (May 22, 1852): 405. (dag.) "Thomas Cole, Robert Coombes, champion rowers." 20:* (May 29, 1852): 436. (dag.)]

C520 Portraits. Woodcut engravings credited "From a photograph by Claudet." ILLUSTRATED LONDON NEWS 21, (1852) ["The Ex-Rajah of Coorg, and his daughter, the Princess Gouramma, and Suite. From photos taken by Messrs. Claudet and Kilburn, by command of his majesty." 21:* (July 17, 1852): 33. (photo) "J. R. Hind, astronomer," 21:* (Aug. 28, 1852): 168. (dag.)]

C521 "Stereoscopic Daguerreotypes." ILLUSTRATED LONDON NEWS 20, no. 552 (Apr. 3, 1852): 227. 1 illus. [From "Times." Note that the Emperor of Russia has given a diamond ring to Claudet for his series of views of the Crystal Palace. Ring illustrated.]

C522 "Humphrey's Journal." HUMPHREY'S JOURNAL 4, no. 3 (May 15, 1852): 43. [Note that Emperor of Russia sent Claudet a diamond ring.]

C523 "Stereoscope by Claudet." HUMPHREY'S JOURNAL 4, no. 7 (July 15, 1852): 111. [Note of Claudet's and Wheatstone's experiments with stereoscopic cameras.]

C524 "Theory of the Daguerreotype Process." HUMPHREY'S JOURNAL 4, no. 13 (Oct. 15, 1852): 195-197. [Apparently this article abstracted from something published by A. Claudet, but not specifically credited.]

C525 "Meeting of the British Association for the Advancement of Science." HUMPHREY'S JOURNAL 4, no. 13 (Oct. 15, 1852): 204. [A. Claudet's paper "On a Manifold Binocular Camera," abstracted here.]

C526 Portraits. Woodcut engravings credited "From a photograph by Claudet." ILLUSTRATED LONDON NEWS 22, (1853) ["W. P. Frith, R.A." 22:* (Mar. 5, 1853): 189. (dag.) "M. Ravel." 22:* (Mar. 5, 1853): 189. (dag.) "Charles Turner, M.P." 22:* (Mar. 12, 1853): 197. (photo) "Capt. Inglefield, of H.M.S. 'Phoenix.'" 22:* (Oct. 15, 1853): 332. (photo) "Lieut. Bellot." 22:* (Oct. 15, 1853): 332. (photo)]

C527 "Editorial Notices." HUMPHREY'S JOURNAL 4, no. 19 (Jan. 15, 1853): 298. [Claudet moved from King William Street to No. 107 Regent St. (Quadrant). [London]]

C528 Claudet, Antoine. "The Stereoscope and Its Photographic Applications." JOURNAL OF THE SOCIETY OF ARTS (LONDON) 1, no. 9 (Jan. 21, 1853): 97-100.

C529 "Scientific: Societies: Society of Arts - Jan. 19." ATHENAEUM no. 1322 (Feb 26, 1853): 262. [Brief summation of Claudet's paper, "On the Stereoscope and its Photographic Applications."]

C530 "Society of Arts - Jan. 19." ATHENAEUM no. 1322 (Feb. 26, 1853): 262. [Brief summation of Claudet's report, "On the Stereoscope and Its Photographic Applications," read to the Society.]

C531 Claudet, Antoine. "Photography." JOURNAL OF THE SOCIETY OF ARTS (LONDON) 1, no. 13 (Feb. 18, 1853): 150-151. [Letter on technical matters, in response to a letter from a Mr. Reveley, on the usefulness of blue glass. Claudet refers to his articles in the "Philosophical Magazine" in Feb. 1848, Mar. 1848, Nov. 1848, and Nov. 1849.]

C532 Claudet, Antoine. "On the Dangers Resulting from the Use of Mercury." PHOTOGRAPHIC ART JOURNAL 5, no. 3 (Mar. 1853): 182-183. [From "La Lumiere."]

C533 Claudet, A. "Photography." JOURNAL OF THE SOCIETY OF ARTS (LONDON) 1, no. 18 (Mar. 25, 1853): 207-209. [Another letter, responding to Reveley in Mar. 11 issue.]

C534 "Society of Arts - Stereoscope, and Its Application to Photography, by A. Claudet, Esq." HUMPHREY'S JOURNAL 4, no. 24 (Apr. 1, 1853): 380-381. [Source not credited.]

C535 Claudet, Antoine. "On the Best Mode of Focusing the Photographic Apparatus." JOURNAL OF THE SOCIETY OF ARTS (LONDON) 1, no. 20 (Apr. 8, 1853): 234-235. ["a new mode of focusing the instrument in order to obtain a broader effect in portraiture."]

C536 "Engraving Daguerreotype Plates." HUMPHREY'S JOURNAL 5, no. 11 (Sept. 15, 1853): 170-174. [A. Claudet's process explained in detail. No source or author given.]

C537 Claudet, Antoine. "On the Introduction of Mercurial Vapor into the Camera in Daguerreotyping." PHOTOGRAPHIC ART JOURNAL 6, no. 6 (Dec. 1853): 334-336. [From "J. of Photo. Soc."]

C538 Claudet, A. "Mercurial Vapor: On the Introduction of Mercurial Vapor into the Camera, in Daguerreotypy." HUMPHREY'S JOURNAL 5, no. 16 (Dec. 1, 1853): 253-255. [Source not credited.]

C539 Portraits. Woodcut engravings credited "From a photograph by Claudet." ILLUSTRATED LONDON NEWS 25, (1854) ["Sir Edmund Lyons, G.C.B." 25:* (July 8, 1854): 21. (photo) "Professor Edward Forbes." 25:* (Dec. 2, 1854): 564. (dag.) "Frederick Fitzclarence." 25:* (Dec. 23, 1854): 640. (dag.) "Viscount Errington, M.P." 25:* (Dec. 30, 1854): 696. (dag.)]

C540 Claudet, A. "The Stereoscope and Its Application to Photography." PHOTOGRAPHIC AND FINE ART JOURNAL 7, no. 3 (Mar. 1854): 82-83. [From "La Lumiere."]

C541 "Photograph of Arago." HUMPHREY'S JOURNAL 5, no. 22 (Mar. 1, 1854): 351. [Claudet has made stereos from his earlier daguerreotype portrait of Arago, on learning of his death.]

C542 "Minor Topics of the Month: M. Claudet's Daguerreotype Gallery." ART JOURNAL (July 1854): 219.

C543 "Monthly Notes: Photography." PRACTICAL MECHANIC'S JOURNAL 7, no. 80 (Dec. 1854): 214. ["Mr. Claudet, the well-known photographer, has been adorning his gallery in London with a series of allegorical paintings, having reference to the art in which it is celebrated..."]

C544 Portrait. Woodcut engraving credited "From a photograph by Claudet." ILLUSTRATED LONDON NEWS 27, (1855) ["Meyerbeer." 27:* (Aug. 11, 1855): 173. (photo)]

C545 Portrait. Woodcut engraving credited "From a photograph by Claudet." ILLUSTRATED LONDON NEWS 28, (1856) ["General Cannon (Behram Pacha)." 28:* (Apr. 19, 1856): 405.]

C546 Portraits. Woodcut engravings credited "From a photograph by Claudet." ILLUSTRATED LONDON NEWS 29, (1856) ["Walpole Islanders at the Panopticon." 29:* (July 12, 1856): 41. "Earl Granville, Ambassador to Russia." 29:* (Sept. 6, 1856): 239. "Rev. Dr. Livingston, African explorer." 29:* (Dec. 27, 1856): 643.]

C547 "Fine-Art Gossip." ATHENAEUM no. 1505 (Aug. 30, 1856): 1089. [Praise for an exhibition of stereographs at Claudet's Gallery in the Quadrant. Note on p. 1147 (Sept. 13) that the paintings also exhibited were by M. Hervieu, of France.]

C548 "Ojibeway and Potawatamie Indians." FRANK LESLIE'S ILLUSTRATED NEWSPAPER 3, no. 58 (Jan. 17, 1857): 104. 1 illus. [Studio group portrait of Indians in costume, visiting England from Canada, taken in London. "...the original of the accompanying illustration has been photographed by Mr. Claudet for our journal." In spite of this statement, this image was probably copied from the "Illus. London News," where it had been published.]

C549 Claudet, Antoine. "A Newly-Discovered Stereoscopic Effect." HUMPHREY'S JOURNAL 9, no. 11 (Oct. 1, 1857): 171-172. [From "Photo. News." Claudet's paper "On the Phenomenon of Relief of the Image formed on the Ground Glass of the Camera Obscura," read before the Royal Society.]

C550 Claudet, A. "A Newly Discovered Stereoscopic Effect." PHOTOGRAPHIC AND FINE ART JOURNAL 10, no. 11 (Nov. 1857): 325-326. [From "Liverpool Photo. J."]

C551 Claudet, A. "Theory of the Daguerreotype Process, Etc." PHOTOGRAPHIC AND FINE ART JOURNAL 10, no. 11-12 (Nov. - Dec. 1857): 332, 364-365. [From "Liverpool Art J."]

C552 Claudet, A. "Theory of the Daguerreotype Process, Etc." HUMPHREY'S JOURNAL 9, no. 15 (Dec. 1, 1857): 230-232. [From "Liverpool Photo. J."]

C553 Portrait. Woodcut engraving credited "From a photograph by Claudet." ILLUSTRATED LONDON NEWS 32, (1858) ["G. B. Airy, Astronomer Royal." 32:* (Mar. 20, 1858): 308.]

C554 Portrait. Woodcut engraving credited "From a photograph by Claudet." ILLUSTRATED LONDON NEWS 33, (1858) ["Right Hon. Lord Brougham." 33:* (Oct. 30, 1858): 407.]

C555 Claudet, A. "On the Variation of the Foci of Lenses." LIVERPOOL & MANCHESTER PHOTOGRAPHIC JOURNAL [BRITISH JOURNAL OF PHOTOGRAPHY] n. s. 2, no. 2 (Jan. 15, 1858): 24-25.

C556 Claudet, A., F.R.S. "On the Phenomenon of Relief of the Image of the Camera Obscura." HUMPHREY'S JOURNAL OF PHOTOGRAPHY, AND THE ALLIED ARTS AND SCIENCES 9, no. 20 (Feb. 15, 1858): 305-308. [From "London Photo. J."]

C557 Claudet. "On the Variation of the Foci of Lenses." PHOTOGRAPHIC AND FINE ART JOURNAL 11, no. 3 (Mar. 1858): 93. [From "Liverpool Photo. J."]

C558 "Scientific: Societies: Royal - April 15." ATHENAEUM no. 1591 (Apr. 24, 1858): 532-533. [Discussion of Claudet's Stereomonoscope. (See "Proceedings of the Royal Society" May 1857).]

C559 Claudet. "On the Variation of the Foci of Lenses." HUMPHREY'S JOURNAL OF PHOTOGRAPHY, AND THE ALLIED ARTS AND SCIENCES 9, no. 24 (Apr. 15, 1858): 384. [From "Liverpool Photo. J."]

C560 "The Stereomonoscope." LIVERPOOL & MANCHESTER PHOTOGRAPHIC JOURNAL [BRITISH JOURNAL OF PHOTOGRAPHY] n. s. 2, no. 9 (May 1, 1858): 114-115.

C561 "M. Claudet's Stereomonoscope." HUMPHREY'S JOURNAL OF PHOTOGRAPHY, AND THE ALLIED ARTS AND SCIENCES 10, no. 3 (June 1, 1858): 42-43. [From "The Athenaeum."]

C562 "Stereomonoscope." PHOTOGRAPHIC AND FINE ART JOURNAL 11, no. 7 (July 1858): 211. [From "Liverpool Photographic J.," in turn from the "Athenaeum." Claudet's discoveries discussed.]

C563 "The Monostereoscope." LIVERPOOL & MANCHESTER PHOTOGRAPHIC JOURNAL [BRITISH JOURNAL OF PHOTOGRAPHY] n. s. 2, no. 14 (July 15, 1858): 179. [Extract from 'The Athenaeum,' "M. Gaudet, [sic Claudet ?] a pupil of Daguerre, has made an invention,...the Monostereoscope..."]

C564 Claudet, Antoine. "The Stereomonoscope." PHOTOGRAPHIC NEWS 1, no. 1-3 (Sept. 10 - Sept. 24,, 1858): 3-4, 14-15, 26-27.

C565 Claudet, A. "On the Stereomonoscope." HUMPHREY'S JOURNAL OF PHOTOGRAPHY, AND THE ALLIED ARTS AND SCIENCES 10, no. 18 (Jan. 15, 1859): 273-274. [From "London Photo. J."]

C566 Claudet, Antoine. "Voightlander versus Petzval." PHOTOGRAPHIC AND FINE ART JOURNAL 12, no. 2 (July 1859): 54. [From "Photo. Notes."]

C567 "Fine-Art Gossip." ATHENAEUM no. 1657 (July 30, 1859): 151. [Brief note and praise for large portraits by Claudet.]

C568 Portraits. Woodcut engravings credited "From a photograph by Claudet." ILLUSTRATED LONDON NEWS 37, (1860) ["Edward Ross, rifle champion." 37:* (July 21, 1860): 66. "J. W. Malcolm, M.P." 37:* (Nov. 17, 1860): 467.]

C569 Claudet, A. "On Photography In Its Relations to the Fine Arts." BRITISH JOURNAL OF PHOTOGRAPHY. 7, no. 118 (May 15, 1860): 146-147.

C570 Claudet, Antoine. "On Photography in its Relations to the Fine Arts." PHOTOGRAPHIC AND FINE ART JOURNAL 13, no. 6 (June 1860): 153-154. [From "Photographic Notes".]

C571 Claudet, A., F.R.S. "On the Principles of the Solar Camera." PHOTOGRAPHIC NEWS 4, no. 96 (July 6, 1860): 110-111.

C572 Claudet, Antoine, F.R.S. "Mr. Claudet on the Stereoscopic Angle." PHOTOGRAPHIC NEWS 4, no. 97 (July 13, 1860): 125.

C573 "Mr. Claudet on the Stereoscopic Angle." PHOTOGRAPHIC AND FINE ART JOURNAL 13, no. 7 (July 1860): 210. [From "Photo. News."]

C574 "British Association 'Oxford Meeting, 1860.'" BRITISH JOURNAL OF PHOTOGRAPHY 7, no. 122 (July 16, 1860): 207-209. ["On the Principles of the Solar Camera," by A. Claudet; "On the Means of Increasing the Angle of Binocular Instruments, in order to obtain a Stereoscopic Effect in proportion to their Magnifying Power," by A. Claudet; "On a Reflecting Telescope for Celestial Photography, erecting at Hastings, near New York," by Henry Draper, M.D.]

C575 Claudet. "On Photography in Its Relations to the Fine Arts." AMERICAN JOURNAL OF PHOTOGRAPHY AND THE ALLIED ARTS & SCIENCES n. s. vol. 3 , no. 3 (July 1, 1860): 33-35. [From "Photo. Notes."]

C576 Claudet, A. F.R.S. "On the Principles of the Solar Camera." AMERICAN JOURNAL OF PHOTOGRAPHY AND THE ALLIED ARTS & SCIENCES n. s. vol. 3, no. 6 (Aug. 15, 1860): 81-83.

C577 Claudet, A., F.R.S. "On the Means of Increasing the Angle of Binocular Instruments, In Order to Obtain a Stereoscopic Effect in Proportion to Their Magnifying Power." AMERICAN JOURNAL OF PHOTOGRAPHY AND THE ALLIED ARTS & SCIENCES n. s. vol. 3, no. 6 (Aug. 15, 1860): 86-87.

C578 Claudet, A. "On Photography in its Relations to the Fine Arts." HUMPHREY'S JOURNAL OF PHOTOGRAPHY, AND THE ALLIED ARTS AND SCIENCES. 12, no. 7 (Aug. 1, 1860): 108-110. [From "Br. J. of Photo."]

C579 Claudet, A. "On the Principles of the Solar Camera." HUMPHREY'S JOURNAL OF PHOTOGRAPHY, AND THE ALLIED ARTS AND SCIENCES 12, no. 9 (Sept. 1, 1860): 139-141. [From "Br. J. of Photo."]

C580 Claudet, A. "On the Means of Increasing the Angle of Binocular Instruments, in order to Obtain a Stereoscopic Effect in Proportion to their Magnifying Power." HUMPHREY'S JOURNAL OF PHOTOGRAPHY, AND THE ALLIED ARTS AND SCIENCES 12, no. 9 (Sept. 1, 1860): 143-144. [From "Br. J. of Photo."]

C581 Claudet, Antoine. "La photographie dans ses relations avec les beaux-arts." GAZETTE DES BEAUX-ARTS 1, no. 9 (1861): 101-114.

C582 Portrait. Woodcut engraving credited "From a photograph by Claudet." ILLUSTRATED LONDON NEWS 38, (1861) ["Sir Hugh Lyon Playfair." 38:* (Feb. 2, 1861): 103.]

C583 "Our Weekly Gossip." ATHENAEUM no. 1745 (Apr. 6, 1861): 469. [Review of a portrait of the Dutchess of Kent, by Claudet.]

C584 "Photographic Society of Scotland." BRITISH JOURNAL OF PHOTOGRAPHY 8, no. 140 (Apr. 15, 1861): 150. [Sir David Brewster's address, "On M. Claudet's Discoveries in Photography," reported. Claudet given a medal.]

C585 Brewster, David, Sir. "On M. Claudet's Discoveries in Photography." HUMPHREY'S JOURNAL OF PHOTOGRAPHY, AND THE ALLIED ARTS AND SCIENCES 13, no. 2 (May 15, 1861): 30-32. [From "Br. J. of Photo."]

C586 "Correspondence: Is Photography a Fine Art? à Monsieur Silvy." BRITISH JOURNAL OF PHOTOGRAPHY 8, no. 153 (Nov. 1, 1861): 392-393. [Letter contesting Silvy's statement that photography was not a fine art.]

C587 Portrait. Woodcut engraving credited "From a photograph by Claudet." ILLUSTRATED LONDON NEWS 40, (1862) ["Mr. Baring, Commissioner of International Exhibition of 1862." 40:* (Mar. 1, 1862): 215.]

C588 Portrait. Woodcut engraving credited "From a photograph by Claudet." ILLUSTRATED LONDON NEWS 41, (1862) ["Dr. Lankester." 41:* (July 26, 1862): 100.]

C589 Claudet, A., Esq., F.R.S. "The New Picture-Galleries." JOURNAL OF THE PHOTOGRAPHIC SOCIETY OF LONDON 8, no. 120 (Apr. 15, 1862): 33-36.

C590 Claudet, Antoine. "On the Enlargement of Photographs." BRITISH JOURNAL OF PHOTOGRAPHY 9, no. 168 (June 16, 1862): 225-226.

C591 Claudet, Antoine. "Rule for Finding at Once Both the Distances of Negative and Sensitive Surface for Any Degree of Enlargement, and Vice Versa." BRITISH JOURNAL OF PHOTOGRAPHY 9, no. 168 (June 16, 1862): 229-230.

C592 "Modes of Enlarging Photographs." AMERICAN JOURNAL OF PHOTOGRAPHY AND THE ALLIED ARTS & SCIENCES n. s. vol. 5, no. 3 (Aug. 1, 1862): 49-52. [From "Photo. News." Friendly challenge between Antoine Claudet and Vernon Heath, each arguing for their own technique for enlarging prints. Includes general discussion of the practices in use in Great and in Europe.]

C593 "Miscellania." JOURNAL OF THE PHOTOGRAPHIC SOCIETY OF LONDON 8, no. 126 (Oct. 15, 1862): 157. [Mention of Claudet's exhibition, "by the aid of the oxyhydrogenlight, the enlarged images of the solar camera thrown upon the screen..."]

C594 "Useful Facts, Receipts, Etc.: Illustrations of Enlargements." AMERICAN JOURNAL OF PHOTOGRAPHY AND THE ALLIED ARTS & SCIENCES n. s. vol. 5, no. 9 (Nov. 1, 1862): 210. [Claudet projected "enlarged images" of cartes, etc. to the British Association, including photos by the Compte de Montizon (of the zoo) and W. Woodbury's views in Java.]

C595 Portrait. Woodcut engraving credited "From a photograph by Claudet." ILLUSTRATED LONDON NEWS 43, (1863) ["Charles Robert Cockerell, Esq., R.A." 43:* (Oct. 3, 1863): 341.]

C596 "Photo-Sculpture." ART JOURNAL (May 1864): 141. 2 illus.

C597 "Editor's Table: Photosculpture." PHILADELPHIA PHOTOGRAPHER 1, no. 8 (Aug. 1864): 127. [Excerpt from "London Athenaeum."]

C598 Claudet, Antoine. "Correspondence: Photography and the Phenakitiscope." BRITISH JOURNAL OF PHOTOGRAPHY 12, no. 282 (Sept. 29, 1865): 504-505.

C599 "Note." AMERICAN JOURNAL OF PHOTOGRAPHY AND THE ALLIED ARTS & SCIENCES. n. s. vol. 8, no. 6 (Sept. 15, 1865): 129. ["Mr. Claudet, the eminent London Photographer, has recently been decorated by Louis Napoleon with the cross of the Legion of Honor."]

C600 Claudet, A. "Moving Photographic Figures. Illustrating Some Phenomena of Vision Connected with the Combination of the Stereoscope and the Phenakisticope by Means of Photography." HUMPHREY'S JOURNAL OF PHOTOGRAPHY, AND THE ALLIED ARTS AND SCIENCES. 17, no. 15 (Dec. 1, 1865): 231-235. [Read to the British Association.]

C601 "The Optics of Photography." ART JOURNAL (Oct. 1866): 321. [Abstract of a paper by Claudet, "On a new process for equalizing the definition of all the planes of a solid figure represented in a photographic picture." Read before the British Association.]

C602 Claudet, A., F.R.S. "Physiology of Binocular Vision." BRITISH JOURNAL PHOTOGRAPHIC ALMANAC 1867 (1867): 75-77. 1 illus.

C603 Claudet, A., F.R.S. "Physiology of Binocular Vision. Stereoscopic and Pseudoscopic Illusions." ART JOURNAL (Feb. - Mar. 1867): 49-51, 73-77.

C604 "Photosciagraphy, or the art of painting portraits, only from the shadow of the photography projected on the ordinary canvas or paper, while the artist is at work." ART JOURNAL (May 1867): 128. [Discussion of Claudet's method.]

C605 "How M. Claudet Took a Large Portrait on a Dull Day." PHILADELPHIA PHOTOGRAPHER 4, no. 41 (May 1867): 144-145. Description of the complex manuevers, including multiple exposures on the same plate, necessary to achieve a portrait on a dark day. illus. [From "Br J of Photo."]

C606 Portrait. Woodcut engraving credited "From a photograph by Claudet." ILLUSTRATED LONDON NEWS 51, (1868) ["Sir David Brewster." 51:* (Feb. 22, 1868): 189.]

C607 "New York Correspondence." PHILADELPHIA PHOTOGRAPHER 5, no. 53 (May 1868): 173-177. [A letter by A. Claudet, claiming discoveries, was read to the monthly meeting of the Photographic Section of the American Institute. (From the "Br J of Photo.") John Johnson, of Saco, ME, then stated the claims of Wolcott & Johnson.]

C608 "The Late M. Claudet." ART JOURNAL (June 1868): 123.

C609 Portrait. Woodcut engraving, credited to "From a Photograph by Antoine Claudet." ILLUSTRATED LONDON NEWS 59, (1871) ["Late Mr. Babbage." 59:1677 (Nov. 4, 1871): 424.]

C610 Portrait. Woodcut engraving credited "From a photograph by Antoine Claudet." ILLUSTRATED LONDON NEWS 61, (1872) ["Late Lord Kinloch." 61:1731 (Nov. 9, 1872): 452.]

C611 Portrait. Woodcut engraving credited "From a photograph by Claudet." ILLUSTRATED LONDON NEWS 64, (1874) ["Late Mr. Thomas Morson, Chemist." 64:1807 (Apr. 11, 1874): 353.]

C612 Portrait. Woodcut engraving credited "From a photograph by Antoine Claudet." ILLUSTRATED LONDON NEWS 68, (1876) ["Marquis of Abergavenny." 68:1903 (Jan. 15, 1876): 61.]

C613 Welford, Walter D. "The First Professional Photographer in England: Antoine Francois Jean Claudet." PHOTOGRAPHIC TIMES 27, no. 6 (Dec. 1895): 326-328. 1 illus. [Contains a bibliography of Claudet's scientific papers read before the British associations and societies.]

C614 "The Focimeter." IMAGE 1, no. 2 (Feb. 1952): 1-2.

C615 Mann, Charles W. "Photo-meubles." HISTORY OF PHOTOGRAPHY 4, no. 2 (Apr. 1980): 95-96. 1 illus. [Describes table inlaid with daguerreotypes, exhibited at the Crystal Palace in 1851.]

CLAUDET, FRANCIS G. (1837-1906) (GREAT BRITAIN, CANADA)

C616 "Wire Suspension Bridge over the Fraser River, British Columbia -Town of Yale, British Columbia." ILLUSTRATED LONDON NEWS 48, no. 1370 (May 12, 1866): 465, 470. 2 illus. ["The views of the Town of Yale and the Suspension bridge over the River Fraser...were photographed by Mr. F. G. Claudet, superintendent of the Government Assay Office, at New Westminister - a relative of Mr. Claudet, the eminent photographie artist, of Regent Street."]

CLAUDET, HENRI. (GREAT BRITAIN)

C617 Claudet, Henri. "Photography at Sea: Instantaneous Positive Paper." PHOTOGRAPHIC AND FINE ART JOURNAL 8, no. 5 (June 1855): 167. [From "La Lumiere." Henri Claudet "Captain in the Merchant Service," is identified as the son of Antoine Claudet.]

C618 Malone, T. A. "The Formic Acid Processes of Mr. H. Claudet." AMERICAN JOURNAL OF PHOTOGRAPHY AND THE ALLIED ARTS & SCIENCES n. s. vol. 6, no. 5 (Sept. 1, 1863): 97-99. [From "Br. J. of Photo."]

C619 Malone, T. A. "Further Remarks upon the Formic Acid Process of Mr. H. Claudet." AMERICAN JOURNAL OF PHOTOGRAPHY AND THE ALLIED ARTS & SCIENCES n. s. vol. 6, no. 7 (Oct. 1, 1863): 145-147. [From "Br. J. of Photo."]

C620 Malone, T. A. "The Formic Acid Process of Mr. H. Claudet." AMERICAN JOURNAL OF PHOTOGRAPHY AND THE ALLIED ARTS & SCIENCES n. s. vol. 6, no. 8 (Oct. 15, 1863): 181-184. [From "Br. J. of Photo."]

C621 Portrait. Woodcut engraving, credited "From a Photograph by Henri Claudet, London." HARPER'S WEEKLY 13, (1869) ["George Peabody, U.S. philanthropist." 13:677 (Dec. 18, 1869): 808.]

C622 Portrait. Woodcut engravings, credited to "From a Photograph by H. Claudet." ILLUSTRATED LONDON NEWS 60, (1872) ["Late Prof. Samuel Morse." 60:1704 (May 4, 1872): 428.]

C623 Portrait. Woodcut engraving credited "From a photograph by Henri Claudet." ILLUSTRATED LONDON NEWS 63, (1873) ["Late Mr. T. Baring, M.P." 63:1787 (Nov. 29, 1873): 501.]

C624 Portrait. Woodcut engraving credited "From a photograph by H. Claudet." ILLUSTRATED LONDON NEWS 67, (1875) ["Late Mr. C. Vignolles, C.E." 67:1896 (Dec. 11, 1875): 581.]

C625 Portrait. Woodcut engraving credited "From a photograph by H. Claudet." ILLUSTRATED LONDON NEWS 75, (1879) ["Late Sir Rowland Hill." 75:2099 (Sept. 6, 1879): 220.]

CLAYTON STUDIOS. (GREAT BRITAIN)

C626 Heathcote, Bernard V. & Pauline F. Heathcote. "The Clayton (Byron) Family in England." HISTORY OF PHOTOGRAPHY 9, no. 1 (Jan.- Mar. 1985): 57-73. 12 b & w. 8 illus. [Large family which established a number of commercial studios in Great Britain during 19th century. James Byron, Clayton & Walter Clayton, Joseph Byron Clayton, etc. Mentions Joseph Byron, who emigrated to New York City in 1880, formed Byron Studio there.]

CLAYTON, JAMES ATKIN. (SAN JOSE, CA)

C627 "Court House, San Jose, California." HARPER'S WEEKLY 12, no. 620 (Nov. 14, 1868): 725, 726. 1 illus. ["... from a photograph by Mr. J. A. Clayton, of San Jose."]

CLEAVER, C. P.

C628 Cleaver, C. P. "Observations on the Metagelatine Process." HUMPHREY'S JOURNAL OF PHOTOGRAPHY, AND THE ALLIED ARTS AND SCIENCES 10, no. 22 (Mar. 15, 1859): 338-340. [From "Photo. J., London."]

CLEMENTS, MICHEL. (d. 1869) (SHEBOYGAN, WI)

C629 "Editor's Table." PHILADELPHIA PHOTOGRAPHER 6, no. 72 (Dec. 1869): 427. [Died Nov. 3, 1869.]

CLEMONS, JOHN R. (1821-) (USA)

C630 "Letter." PHOTOGRAPHIC TIMES 2, no. 19 (July 1872): 104-105. [Letter from Clemons on the strike for the 8 hour day (humorous). Lists his workers Michael McLaughlin, Harry Holland, Alex Weaver, Gregory Mead.]

C631 "Photographers, Old and New." WILSON'S PHOTOGRAPHIC MAGAZINE 32, no. 467 (Nov. 1895): 506-507. 1 b & w. [Born 1821 in Radnor, Pa. Took up photography in early 1850's in Philadelphia. Had several studios, eventually turned to manufacturing albuminized paper. Portrait of Clemons by F. Gutekunst.]

CLENCH, F. B. (LOCKPORT, NY)

C632 Clench, F. B. "Cloudy Negatives." HUMPHREY'S JOURNAL OF PHOTOGRAPHY, AND THE ALLIED ARTS AND SCIENCES 14, no. 22 (Mar. 15, 1863): 300-301. [Letter from Clench describing his problem, with suggestions from Towler.]

C633 "Gallery for Sale." HUMPHREY'S JOURNAL OF PHOTOGRAPHY, AND THE ALLIED ARTS AND SCIENCES 19, no. 1 (May 1, 1867): 16.

C634 "Our Picture." PHILADELPHIA PHOTOGRAPHER 13, no. 146 (Feb. 1876): frontispiece, 58. ["Promenade' style studio portrait.]

CLEVELAND, R. D.

C635 Street, George G. Che! Wah! Wah! or, The Modern Montezumas in Mexico, by George G. Street, Illustrated with Photographs taken during the Trip by R. D. Cleveland, and woodcuts and sketches by the author. New York: E. R. Andrews, 1883. 115 pp. 21 l. of plates. [Cover title: "The Montezuma Club in Mexico." Views, people, railroads, etc. Colorado, the Southwest, Northern Mexico. A tour by this group.]

CLIFFORD, CHARLES. (ca. 1800-1863) (GREAT BRITAIN, SPAIN)

[Clifford was a British resident in Madrid in 1850s. The Court Photographer of Queen Isabella of Spain from 1852 on. Produced an album Voyage en Espagne. in 1854, another album of 50 views, Vistas dal Capricho., in 1856. Exhibited 400 prints at the Société française de Photographie in 1856. Ill in 1857, but took stereograph views of the Segovia region for Ferrier. Albums of views throughout early 60s. Died in 1863.]

C636 "Algesiras." ILLUSTRATED LONDON NEWS 35, no. 1005 (Dec. 3, 1859): 538. 1 illus. [Seaport in Spain. "From a Photograph by C. Clifford, Infantas, Madrid."]

C637 "Fine Arts." ILLUSTRATED LONDON NEWS 42, no. 1196 (Mar. 28, 1863): 358. [Note: "The carte-de-visite photograph of her Majesty the Queen, taken by Mr. Clifford for the Queen of Spain...has been published in a larger size by Messrs. Marion & Co., of Soho Square."]

C638 Gernsheim, Helmut. "Charles Clifford." IMAGE 9, no. 2 (June 1960): 73-77. 2 b & w. [Englishman living in Spain, 1850s. Court Photographer to Queen Isabella II.]

CLIFFORD, D. A. (1826-1887) (USA)

C639 "Our Editorial Table." PHOTOGRAPHIC TIMES 15, no. 210 (Sept. 25, 1885): 549. [Note of landscape views of New England and Canada by Mr. Clifford of St. Johnsbury, VT.]

C640 "Obituary. D. A. Clifford." ANTHONY'S PHOTOGRAPHIC BULLETIN 18, no. 13 (July 9, 1887): 410-411. [D. A. Clifford born at Wentworth, NH in 1826. Learned photography in Salem, MA. Went to St. Johnsburg, VT in 1870, worked there until his death on June 5, 1887.]

C641 "Obituary: D. A. Clifford." PHOTOGRAPHIC TIMES 17, no. 302 (July 1, 1887): 336. [Died June 12, in the 61st year of his age. "Learned photography at Salem, MA, but in 1870 went to St. Johnsbury, VT, where he ever after resided and followed his chosen profession." Worked with the daguerreotype and every succeeding process.]

CLOUGH, AMOS F. (1833-1872) (USA)

C642 "Voices from the Craft." PHILADELPHIA PHOTOGRAPHER 4, no. 48 (Dec. 1867): 383. [Letter about travelling dark-room tent.]

C643 "Editor's Table." PHILADELPHIA PHOTOGRAPHER 6, no. 68 (Aug. 1869): 284. [Stereos (flowers, etc.) noted.]

C644 "Mount Washington in the Winter." ANTHONY'S PHOTOGRAPHIC BULLETIN 1, no. 8 (Sept. 1870): 160-161, 164. [A. F. Clough (Warren, NH) photographer, accompanied a party of scientists, occupying the summit of Mt. Moosilauke, NH in 1869-70. Proposes to spend the winter of 1870-71 atop Mt. Washington, raising $2000 by subscription. Description of some of Clough's views on p. 164 under "Pictures."]

C645 "Obituary: A. F. Clough." PHILADELPHIA PHOTOGRAPHER 10, no. 109 (Jan. 1873): 9-10. [Amos F. Clough specialized in landscape views. Apparently raised in Warren, NH. Was Howard A. Kimball's partner in Concord in 1870, and saved Kimball's life then when both tried to climb Mt. Washington and Kimball fell victim to exhaustion. Clough opened his own business in Springfield, MA in 1871 but died there on November 29th, 1872, after a lingering illness.]

CLOUGH, AMOS F. & H. A. KIMBALL.

BOOKS

C646 Hitchcock, Charles H., J. H. Huntington et al. Mount Washington in Winter, or the Experiences of a Scientific Expedition Upon the Highest Mountain in New England, 1870 - 1871. Boston: Chick & Andrews, 1871. vii, 363 pp. illus. ["Written by C. H. Hitchcock, J. H. Huntington, S. A. Nelson, A. F. Clough, H. A. Kimball, Theodore Smith and L. L. Holden. Clough and Kimball were the photographers.]

PERIODICALS

C647 Clough, A. F. "Winter On a Mountain - Parts 1 - 2." PHILADELPHIA PHOTOGRAPHER 7, no. 78, 81 (June, Sept. 1870): 217-218, 326-327. [Note on page 224 of a number of stereo views of snow and ice scenes that parallel the article.]

C648 Clough, A. F. "Correspondence - Up Mt. Washington in Winter." PHILADELPHIA PHOTOGRAPHER 8, no. 87-88 (Mar. - Apr. 1871): 72-74, 99-101.

C649 Hitchcock, C., and Huntington, J. H. "An Interesting Book - Mount Washington in Winter, or the Experiences of a Scientific Expedition Upon the Highest Mountain in New England. 1870 - 1871." PHILADELPHIA PHOTOGRAPHER 8, no. 93 (Sept. 1871): 291. [Clough and Kimball were the photographers in this party.]

CLULEE, REV. C. [?]
C650 "Laying the Foundation Stone of an English Church at Philippolis, Orange Free State, South Africa." ILLUSTRATED LONDON NEWS 44, no. 1262 (June 4, 1864): 536. 1 illus. ["...to the Rev. C. Clulee of Fauresmith and Philippolis, for sending us half a dozen photographs illustrative of that remote place."]

COALE, GEORGE BUCHANAN. (1819-1887) (USA)
BOOKS
C651 Coale, George B. *Manual of Photography Adapted to Amateur Practice. Whipple's Albumen Process.* Philadelphia: J. B. Lippincott, 1858. vi, 81 pp.

PERIODICALS
C652 Coale, George B. "Whipple's Process." HUMPHREY'S JOURNAL 9, no. 3 (June 1, 1857): 33-34. [Coale from Baltimore, MD, using a variant of John A. Whipple's Albumen Process.]

C653 Coale, G. B. "Collodio-Albumen Process." HUMPHREY'S JOURNAL OF PHOTOGRAPHY, AND THE ALLIED ARTS AND SCIENCES 9, no. 23 (Apr. 1, 1858): 357-358.

C654 Coale, Geo. B. "Exposure Tables again." HUMPHREY'S JOURNAL OF PHOTOGRAPHY, AND THE ALLIED ARTS AND SCIENCES 10, no. 5 (July 1, 1858): 66-67.

C655 Coale, Geo. B. "Fothergill's Process." HUMPHREY'S JOURNAL OF PHOTOGRAPHY, AND THE ALLIED ARTS AND SCIENCES 10, no. 19 (Feb. 1, 1859): 291-292.

C656 Coale, Geo. B. "Defects in 'Fothergill.'" HUMPHREY'S JOURNAL OF PHOTOGRAPHY, AND THE ALLIED ARTS AND SCIENCES 11, no. 8 (Aug. 15, 1859): 117.

C657 Coale, Geo. B. "Le Gray's Toning Process - A New Formula." HUMPHREY'S JOURNAL OF PHOTOGRAPHY, AND THE ALLIED ARTS AND SCIENCES. 11, no. 16 (Dec. 15, 1859): 243.

COBB, GEORGE N. (BINGHAMTON, NY)
C658 "Note." PHOTOGRAPHIC TIMES 8, no. 92 (Aug. 1878): 170. [Cabinet photos noted.]

C659 "Our Picture." PHILADELPHIA PHOTOGRAPHER 17, no. 194 (Feb. 1880): frontispiece, 48-49. 1 b & w. [Portrait.]

COBB, J. V.
C660 Wilsher, Ann. "Frontispiece: Studio Sharp-Shooters." HISTORY OF PHOTOGRAPHY 12, no. 1 (Jan. - Mar. 1988): frontispiece. 1 b & w. [Carte-de-visite of British riflemen, ca. 1860.]

COBB, WILLIAM. (GREAT BRITAIN)
C661 "Removal of a Chapel at Melton." ILLUSTRATED LONDON NEWS 39, no. 1111 (Oct. 5, 1861): 358. 1 illus. ["...from a photograph by Mr. Cobb, of Ipswich."]

C662 "Our Editorial Table: Pictures by William Cobb, Ipswich." BRITISH JOURNAL OF PHOTOGRAPHY 12, no. 254 (Mar. 17, 1865): 143.

C663 Cobb, William. "Combination Printing." BRITISH JOURNAL PHOTOGRAPHIC ALMANAC 1877 (1877): 124-126. [Cobb Instructor in Photography, Royal Military Academy, Woolwich.]

C664 Portraits. Woodcut engravings credited "From a photograph by W. Cobb." ILLUSTRATED LONDON NEWS 74, (1879) ["Lieut. Nicholson, R.A., killed in S. Africa." 74:2082 (May 10, 1879): 450.]

COBDEN, A. (TROY, NY)
C665 "Startling Accident at the Draw Bridge of the Rensselaer and Saratoga Railroad, Federal Street, Troy, N. Y., Saturday, Sept. 23. - From a Photograph by A. Cobden, of Troy." FRANK LESLIE'S ILLUSTRATED NEWSPAPER 21, no. 524 (Oct. 14, 1865): 61. 1 illus. [Train wreck.]

C666 Portrait. Woodcut engraving, credited "From a Photograph by A. Cobden." FRANK LESLIE'S ILLUSTRATED NEWSPAPER 30, (1870) ["The late Mrs. Emma Willard." 30:764 (May 21, 1870): 156.]

COCCO, M. G. L.
C667 Cocco, M. G. L. "On a Method of Restoring Discolored and Insensitive Collodion." HUMPHREY'S JOURNAL OF PHOTOGRAPHY, AND THE ALLIED ARTS AND SCIENCES 19, no. 1 (May 1, 1867): 9-10. [From "Repertoire Encyclopedique de Photographie."]

COCKING, EDWIN. (d. 1892) (GREAT BRITAIN)
C668 Cocking, Edwin. "The Particular Kind of Art-Study To Which Photographers Should Give Their Attention." BRITISH JOURNAL OF PHOTOGRAPHY 13, no. 316 (May 25, 1866): 246-247.

C669 Cocking, Edwin. "On Photographing Children." BRITISH JOURNAL PHOTOGRAPHIC ALMANAC 1869 (1869): 93-94.

C670 Cocking, Edwin. "A Suggestion for Enriching Photographic Portraiture." BRITISH JOURNAL PHOTOGRAPHIC ALMANAC 1870 (1870): 150-152.

C671 Cocking, Edwin. "On the Art Education of the Future Photographer." BRITISH JOURNAL PHOTOGRAPHIC ALMANAC 1871 (1871): 129-131.

C672 Cocking, Edwin. "The Old Masters from a Photographic Point of View." ANTHONY'S PHOTOGRAPHIC BULLETIN 3, no. 4 (Apr. 1872): 512-513. [From "London Photo. News." Discusses photographic portraiture and how studying painters can help provide some solutions.]

C673 Cocking, Edwin. "Stray Thoughts." BRITISH JOURNAL PHOTOGRAPHIC ALMANAC 1873 (1873): 94-95.

C674 Cocking, Edwin. "On Framing Photographs." BRITISH JOURNAL PHOTOGRAPHIC ALMANAC 1876 (1876): 138-139. [For annual exhibitions.]

C675 Cocking, Edwin. "The Subjective and Objective of Pictorial Photography." PHOTOGRAPHIC TIMES 9, no. 98 (Feb. 1879): 35-37. [Read before the Photo. Soc. of Gr. Br.]

C676 "An Experiment with Orange Pea-Green Colors for Studios." ANTHONY'S PHOTOGRAPHIC BULLETIN 10, no. 7 (July 1879): 211. [From "London Photographic News."]

C677 Cocking, Edwin. "A Few Hints about Composition Lines in Photography." PHOTOGRAPHIC TIMES 10, no. 111 (Mar. 1880): 56-57. [Communicated to the South London Photographic Society.]

C678 "Summary." BRITISH JOURNAL PHOTOGRAPHIC ALMANAC 1893 (1893): 504. [Cocking died Feb. 12, from a fit of apoplexy. Trained as an artist. The Hon. Secretary of the original South London Photographic Society from 1867. For fifteen years the Asst. Sec. to the Photographic Society of Great Britain. Contributed to the "BJP" and the "BJPA".]

COCKING, H. GARRETT.
C679 Cocking, H. Garrett. "Little Mites." BRITISH JOURNAL PHOTOGRAPHIC ALMANAC 1879 (1879): 103-104.

CODDINGTON. (NEW YORK, NY)
C680 Portraits. Woodcut engravings, credited "Photographed by Coddington." FRANK LESLIE'S ILLUSTRATED NEWSPAPER 17, (1864) ["Right Rev. John Timon, Bishop of Buffalo; Right Rev. John McClosky, Bishop of Albany. (Two portraits)." 17:434 (Jan. 23, 1864): 276.]

C681 Portrait. Woodcut engraving, credited "From a Photograph by Coddington, 366 Bowery, New York, NY." FRANK LESLIE'S ILLUSTRATED NEWSPAPER 21, (1866) ["Late Rt. Rev. J. D. Fitzpatrick." 21:545 (Mar. 10, 1866): 389.]

COGHILL, JOSCELYN J.
C682 Coghill, Sir J. J., Bart. "Photography, as Adapted for Tourists. Exemplified by a Recent Visit to the Spanish Coast." JOURNAL OF THE PHOTOGRAPHIC SOCIETY OF LONDON 5, no. 82 (Apr. 9, 1859): 249-254.

COHILL, CHARLES. [ROOT GALLERY] (PHILADELPHIA, PA)
C683 Woodcut engraving, credited "From a Photograph by Charles Cohill." HARPER'S WEEKLY 10, (1866) ["Antoine Probst, Murderer of the Dearing Family." 10:487 (Apr. 28, 1866): 270.]

C684 Portraits. Woodcut engravings, credited "From a Photograph by Charles Cohill, Philadelphia, PA." FRANK LESLIE'S ILLUSTRATED NEWSPAPER 22, (1866) ["Antoine Gauter, or Probst, the murderer..." 22:553 (May 5, 1866): 97.]

COHNER, SAMUEL A. (d. 1868) (USA, CUBA)
C685 "Murder of Mr. Cohner." HUMPHREY'S JOURNAL OF PHOTOGRAPHY, AND THE ALLIED ARTS AND SCIENCES 20, no. 18 (Feb. 15, 1869): 286. [Cohner once lived in Philadelphia, where he worked as a photographer. He also worked in Washington, DC in 1857-1858. He moved to Havana, Cuba in 1859. He was accidently killed in a shoot-out between some "volunteer troops and regular troops."]

C686 "Editor's Table." PHILADELPHIA PHOTOGRAPHER 6, no. 62 (Feb. 1869): 64. [Note that Cohner, "...a genial gentleman, a thorough artist... was killed during a disturbance by the Spanish volunteers."]

COLE. (ZANESVILLE, OH)
C687 "Editorials." HUMPHREY'S JOURNAL 5, no. 7 (July 15, 1853): 111. [Cole (Zanesville, OH) praised.]

COLE, F.
C688 Billing, Archibald. The Science of Gems, Jewels, Coins and Medals, Ancient and Modern. London: Bell & Daldy, 1867. xi, 221 pp. 18 l. of plates. b & w. [Original photographs, by F. Cole, Brompton.]

COLE, HENRY H. (PEORIA, IL)
C689 Portrait. Woodcut engraving, credited "From a Photograph by H. H. Cole, Peoria, Ill." HARPER'S WEEKLY 6, (1862) ["Mrs. Major Belle Reynolds." 6:281 (May 17, 1862): 317.]

C690 "The Railroad Draw-Bridge over the Illinois River at Peoria, Illinois." HARPER'S WEEKLY 11, no. 556 (Aug. 24, 1867): 541, 542. 1 illus. ["Photographed by H. H. Cole."]

C691 "Editor's Table." PHILADELPHIA PHOTOGRAPHER 6, no. 64 (Apr. 1869): 136. [Burned out, started again.]

COLLARD, A. (FRANCE)
[In 1855 Collard exhibited at the Paris Universal Exhibition, winning several awards. Collard & Cie. in Paris in 1857. Sold supplies and equipment, and photographed city views, construction of buildings, reproductions of artworks, manufactured items, etc. In 1866 worked for l'Administration des Ponts et Chaussées in Paris. Photographed the Commune and the street barricades in 1871. Worked through the 1870s. Death date uncertain.]

C692 "Photography at Night." HUMPHREY'S JOURNAL OF PHOTOGRAPHY, AND THE ALLIED ARTS AND SCIENCES 11, no. 4 (June 15, 1859): 55-56. [From "Revue Photographique." Use of artificial light for portraits.]

COLLEN, HENRY. (1800-1875) (GREAT BRITAIN)
C693 Collin, [sic Collen] Henry. "Earliest Stereoscopic Portraits." HUMPHREY'S JOURNAL 6, no. 5 (June 15, 1854): 73-74. [From "J. of Photo. Soc., London." Collen describes his experience in making stereo portraits at Mr. Wheatstone's request in 1841.]

C694 Collen, Henry. "Earliest Stereoscopic Portraits." PHOTOGRAPHIC AND FINE ART JOURNAL 7, no. 7 (July 1854): 213. [From "J. of Photo. Soc." Collen made daguerreotype stereoscopic portrait with Wheatstone in 1841.]

C695 Collen, Henry. "On the Application of Photography to Miniature Painting." BRITISH JOURNAL OF PHOTOGRAPHY 11, no. 240 (Dec. 9, 1864): 499.

C696 Collen, Henry. "Natural Colour in Photography." BRITISH JOURNAL OF PHOTOGRAPHY 12, no. 286 (Oct. 27, 1865): 547. ["The following speculation...by one who, when miniature painter to the Queen, was the first to take a photograph on paper professionally, will...be received...with much interest."]

C697 Collen, Henry. "Correspondence: Photography in Natural Colors." BRITISH JOURNAL OF PHOTOGRAPHY 12, no. 290 (Nov. 24, 1865): 600-601. 1 illus.

C698 Collen, Henry. "On Fixing Drawings." BRITISH JOURNAL PHOTOGRAPHIC ALMANAC 1871 (1871): 94-95.

C699 Schaaf, Larry. "Henry Collen and the Treaty of Nanking." HISTORY OF PHOTOGRAPHY 6, no. 4 (Oct. 1982): 353-366. 10 b & w. 2 illus. [Calotypes used to reproduce official documents, 1842.]

COLLIE, WILLIAM. (1810-1896) (GREAT BRITAIN)
C700 "Topics of the Month: Calotypes." ART UNION (June 1, 1847): 231. ["Mr. W. Collie, of Belmont House, Jersey, an artist of repute, has forwarded to us Calotypes taken from life. They are copies chiefly of market women. We have seen nothing at all comparable to them, except those of D. O. Hill..."]

COLLIER, JOSEPH M. (1836-1910) (USA)

C701 Harrington, Charles. *Summering in Colorado*. Denver: Richards & Co., 1874. 158 pp. 10 b & w. [Original photos, by J. Collier.]

COLLIER, JOHN. (PETERHEAD, ENGLAND.)

BOOKS
C702 Anderson, William. *The Howes o'Buchan. Being Notes, Local, Historical and Antiquarian, Regarding the Various Places of Interest along the Route of the Buchan Railway*. Edinburgh; Peterhead: W. P. Nimmo; "Sentinel Office" Press, 1865. 100 pp. 9 l. of plates. 9 b & w. [Original photographs by John Collier, of Peterhead.]

PERIODICALS
C703 "Our Editorial Table: Pictures by J. Collier, Peterhead." BRITISH JOURNAL OF PHOTOGRAPHY 12, no. 252 (Mar. 3, 1865): 116.

C704 "Our Editorial Table: 'The Howes o'Buchan,' by William Armstrong. With Photographic Illustrations by J. Collier, Peterhead." BRITISH JOURNAL OF PHOTOGRAPHY 12, no. 277 (Aug. 25, 1865): 441. [Book review.]

COLLINS. (LYNN, MA)

C705 *Centennial Memorial of Lynn, Essex County, Massachusetts. Embracing an Historical Sketch, 1629 - 1876 by James R. Newhall, and Notices of the Mayors, with Portraits.* With seven Albertypes (views of Lynn and Its Buildings) from Photographs by Collins. Lynn, MA.: 1876. 204 pp. 7 b & w.

COLLINS, CHARLES W. (GREAT BRITAIN)

C706 Collins, Charles W. *The Hand-Book of Photography. Illustrating the Process of Producing Pictures by the Chemical Influences of Light on Silver, Glass, Paper, and Other Surfaces, with Instructions for the Preparation and Use of the Materials Employed*. London: Charles W. Collins, Royal Polytechnic Institute, 1853. 91 pp. illus. [2nd ed. (1853), 96 pp.]

COLLINS, G. H. (BUCKSPORT, ME)

C707 Portraits. Woodcut engravings, credited "From a Photograph by G. H. Collins, Bucksport, ME." FRANK LESLIE'S ILLUSTRATED NEWSPAPER 22, (1866) ["The late William Hutchings, of Penobscot, ME." 22:556 (May 26, 1866): 156.]

COLLINS, H. G.

C708 Collins, H. G. "On Electro-Block Printing, especially as applied to Enlarging or Reducing and Printing Surface or Original Drawing." HUMPHREY'S JOURNAL OF PHOTOGRAPHY, AND THE ALLIED ARTS AND SCIENCES 12, no. 19-20 (Feb. 1 - Feb. 15, 1861): 300-304, 311-316. [From "Photo. Notes."]

COLLINSON, COLONEL. [?]

C709 "Prehistoric Ruins in Malta and Gozo." ILLUSTRATED LONDON NEWS 53, no. 1512 (Nov. 21, 1868): 488, 496. 2 illus. [Deputy Assistant Commissary-General Furse... laid before the Congress [of the Society of Archaeology] an album, containing twenty-one very well-executed photographs of the four temples... taken at Malta, under the direction of Colonel Collinson, R. E., and of himself."]

COLLIS, G. L. (CORNHILL, ENGLAND)

C710 Portrait. Woodcut engraving credited "From a photograph by G. L. Collis, of Cornhill." ILLUSTRATED LONDON NEWS 56, (1870) ["Mr. Pendlebury, Cambridge Senior Wrangler." 56:* (Feb. 26, 1870): 225.]

COLMER, S. A. (HAVANA, CUBA)

C711 "Cuban Insurgents Recently Surrendered to the Spanish Authorities at Villa Clara, Cuba. - Photographed by S. A. Colmer, Havana." FRANK LESLIE'S ILLUSTRATED NEWSPAPER 39, no. 1003 (Dec. 19, 1874): 252. 1 illus. [Portrait.]

COLNAGHI, P. & D. COLNAGHI. (LONDON, ENGLAND)

C712 "The Late Royal Bridesmaids." LIVERPOOL & MANCHESTER PHOTOGRAPHIC JOURNAL [BRITISH JOURNAL OF PHOTOGRAPHY] n. s. 2, no. 6 (Mar. 15, 1858): 68. [Review of group portrait by "the Messrs. Colnaghi." From the "London Times," Mar. 8th.]

COLTON see BURROWS & COLTON.

COMSTOCK, THEODORE B. (ITHACA, NY)

C713 "Correspondence." ANTHONY'S PHOTOGRAPHIC BULLETIN 3, no. 9 (Sept. 1872): 674. [Brief letter from Comstock (Ithaca, NY) praising Anthony's collodion, in which the author mentions using it on two trips to Brazil (within the last three years or so).]

CONDER, F. ROUBILIAC.

C714 Conder, F. Roubiliac. "Heliography." ART JOURNAL (Nov. 1870): 325-321.

CONKLIN, C. L.

C715 "Mexico. - The Tri-Presidential Revolution of 1876 - Scenes In and Around the City of Mexico. - Photographed by C. L. Conklin." FRANK LESLIE'S ILLUSTRATED NEWSPAPER 43, no. 1117 (Feb. 24, 1877): 405. 15 illus. [Scenes, vernacular portraits, etc.]

CONKLIN, E. (USA)

C716 "The Salmon Nursery on the McCloud River, Shasta County, Cal. - From Photographs Furnished by Mr. Conklin." FRANK LESLIE'S ILLUSTRATED NEWSPAPER 39, no. 1014 (Mar. 6, 1875): 428. 11 illus. [2 views, 9 photos of fish.]

C717 "Idaho. - The Defeat of the Non-treaty Nez Perces by General N. A. Miles. - Portraits of Chief Joseph and Two of His Aids. - From Photographs by Our Special Artist and Correspondent, E. Conklin." FRANK LESLIE'S ILLUSTRATED NEWSPAPER 45, no. 1152 (Oct. 27, 1877): 114. 1 illus.

C718 "Arizona Territory. - The Extension of the Southern Pacific Railroad - Views of the Town of Yuma, on the Colorado River. - From Photographs by Our Artist and Correspondent E. Conklin." FRANK LESLIE'S ILLUSTRATED NEWSPAPER 48, no. 1230 (Apr. 26, 1879): 124, 125. 5 illus. [Views, trains.]

C719 "California. - The Largest Ferry-Boat in the World - Side View of the 'Solano.' Built to Transport Passengers and Freight Across San Francisco Bay." and "Stern View... - From Photographs by E. Conklin." FRANK LESLIE'S ILLUSTRATED NEWSPAPER 49, no. 1265 (Dec. 27, 1879): 289. 2 illus. [Views.]

CONLEY, C. F. (1846-1892) (USA)

C720 "Our Illustration." ANTHONY'S PHOTOGRAPHIC BULLETIN 17, no. 19 (Oct. 9, 1886): frontispiece, 595. [A portrait by Mr. Conley of Boston; not bound in this copy.]

C721 "Our Illustration." ANTHONY'S PHOTOGRAPHIC BULLETIN 18, no. 22 (Nov. 26, 1887): frontispiece, 698. 1 b & w. [Portrait head by Conley of Boston.]

C722 "Our Illustration." ANTHONY'S PHOTOGRAPHIC BULLETIN 19, no. 23 (Dec. 8, 1888): frontispiece, 726. 1 b & w. [C. F. Conley a Boston studio photographer. Photo not bound in this copy.]

C723 "A Portrait Study." PHOTOGRAPHIC TIMES 21, no. 490 (Feb. 6, 1891): frontispiece, 61. 1 b & w. [Professional photographer, Boston, MA.]

C724 "C. F. Conley." PHOTOGRAPHIC TIMES 22, no. 588 (Dec. 23, 1892): 659. [Born Milford, MA 46 years ago. Purchased Warren's studio in Boston, MA about 10 years ago. Well-known photographer. Died Dec. 14th, 1892.]

CONNON, JOHN. (1861-1931) (CANADA) see CONNON, THOMAS.

CONNON, THOMAS. (1832-1899) (CANADA)
C725 "Thomas and John Connon photographs acquired." THE ARCHIVIST (PUBLIC ARCHIVES OF CANADA) 12, no. 1 (Jan. - Feb. 1985): 10. 1 b & w. [Archives acquired daguerreotypes and photos by Thomas Connon (1832-1899) an amateur in the 1850s who later opened a studio in Elora, Ontario. His son John (1861-1931) also operated the studio and produced the book "Elora, the Early History of Elora Ontario and Vicinity." (1930)]

CONNOP & WHITE. (GREAT BRITAIN)
C726 "The Fallen East Cliff, at Hastings." ILLUSTRATED LONDON NEWS 21, no. 597 (Dec. 18, 1852): 549. 1 illus. ["From a Daguerreotype by Connop & White."]

CONSTABLE, F. A. (NEW YORK, NY)
C727 "Editor's Table." PHILADELPHIA PHOTOGRAPHER 10, no. 110 (Feb. 1873): 63. [F. A. Constable, a talented amateur...of New York.]

CONSTANT. (LAUSANNE, SWITZERLAND)
C728 "On the Employment of Sulphocyanide and Gold Bath in Producing Prints with a Double Tone." HUMPHREY'S JOURNAL OF PHOTOGRAPHY, AND THE ALLIED ARTS AND SCIENCES 19, no. 9 (Sept. 1, 1867): 141-143. [From "Camera Obscura." "M. Constant, of Lausanne has favored us with a number of very beautiful views, ...the Lake of Geneva, etc."]

CONTENCIN, J. (GREAT BRITAIN)
C729 Contencin, J. "Photography on Wood for Engraving." BRITISH JOURNAL OF PHOTOGRAPHY 8, no. 137 (Mar. 1, 1861): 88-89.

C730 Contencin, J. "Photography on Wood Engraving." HUMPHREY'S JOURNAL OF PHOTOGRAPHY, AND THE ALLIED ARTS AND SCIENCES 13, no. 1 (May 1, 1861): 11-14. [Read to South London Photo. Soc. From "Br. J. of Photo."]

CONTINENT STEREOSCOPIC COMPANY. (USA)
C731 Catalogue of Stereoscopic Views. New York: Continent Stereoscopic Co., ca. 1877. 23 pp. [Lists about 1000 views.]

COOK, GEORGE SMITH. (1819-1902) (USA)
BOOKS
C732 Kocher, Alfred Lawrence and Howard Dearstyne. Shadows in Silver. A Record of Virginia, 1850 - 1900 in Contemporary Photographs by George and Huestis Cook. New York: Charles Scribner's Sons, 1954. 264 pp. b & w. [George Smith Cook was born in Stratford, CT in 1819. Brought up in Newark, NJ, but moved to the South at age 14. Began to paint, and moved to New Orleans. Learned the daguerreotype process around 1843. From 1845 to 1849 Cook travelled throughout the South as an itinerant portrait photographer. Opened a gallery in Charleston, SC in 1850, but apparently without a great deal of success, for he was in New York City in 1851, managing a gallery for Brady, then opening one of his own. Through the 1850s he moved to Philadelphia, then to Chicago. Cook returned to Charleston in 1861. He photographed the scenes and personages of the Ft. Sumter fight in Charleston harbor, which began the war. Much of his early work was destroyed in a fire in 1864. In 1874 he opened another studio in New York City, which again lasted only a short time, then he returned to Charleston again. In 1880 he moved to Richmond, VA and opened another gallery. Cook died in Bon Air, near Richmond, VA in 1902. His son, Huestis Pratt Cook (1868 - 1951), maintained his father's photography business into the 20th century.]

PERIODICALS
C733 Cohen, Rev. A. D. "George S. Cook and the Daguerrean Art." PHOTOGRAPHIC ART JOURNAL 1, no. 5 (May 1851): frontispiece, 285-287. 1 illus. [Portrait (lithograph by D'Avignon.) Cook began as a merchant, but didn't enjoy it. In 1843 he visited New Orleans, where he learned about the arts in general and learned the daguerreotype process. After operating in New Orleans for several years, he then toured throughout MS, AL, TN, MO, and GA, making daguerreotypes and training daguerreotypists. Finishes his images with a pencil for delicate tonalities.]

C734 "Note" PHOTOGRAPHIC ART JOURNAL 2, no. 3 (Sept. 1851): 190. ["Passing along Broadway our eyes arrested by a most exquisite picture... Mr. Cook's Gallery, executed by Mr. Perry, the principle operator for Mr. Cook... portrait of an actress.]

C735 "Gossip." PHOTOGRAPHIC ART JOURNAL 3, no. 4 (Apr. 1852): 257-258. [A maddened horse ran into G. S. Cook's studio and smashed his showcase.]

C736 Portraits. Woodcut engravings, credited "Photographed by Cook, Charleston, S. C." FRANK LESLIE'S ILLUSTRATED NEWSPAPER 11, (1861) ["Government officials of the Palmetto Republic (SC): C. G. Memminger, Sect. of the Treasury; W. F. Colcock, Collector of the Port; Alfred Higer, Postmaster (Three portraits)." 11:272 (Feb. 9, 1861): 184. "Robert Barnwell Rhett, of SC." 11:272 (Feb. 9, 1861): 188. "James Simons, Brig.-Gen. of 4th Brigade, S.C. Militia." 11:277 (Mar. 16, 1861): 208.]

C737 Portrait. Woodcut engraving, credited "From a Photograph by George S. Cook, Charleston." HARPER'S WEEKLY 12, (1868) ["Hon. Frederick A. Sawyer, Sen. from SC." 12:613 (Sept. 26, 1868): 621.]

C738 "Confederate Home and School, Charleston, S. C." FRANK LESLIE'S ILLUSTRATED NEWSPAPER 38, no. 971 (May 9, 1874): 140. 1 illus. [Street view of buildings.]

C739 Cook, George S. "From Away Down South." ST. LOUIS PRACTICAL PHOTOGRAPHER 1, no. 1 (Jan. 1877): 23.

C740 "Ingenious Advertising." ANTHONY'S PHOTOGRAPHIC BULLETIN 10, no. 1 (Jan. 1879): 8. [From "London Photo. News," in turn from the article "Drolleries of Advertising" in "Chambers Journal," which reprints an advertisement from the "NY Tribune" published in Feb. 1861. States that George Cook (Charleston, SC) photographed Major Anderson at Fort Sumter "on the 8th instant," which portrait "is now on sale in the shape of exquisite card photographs by E. Anthony, etc."]

C741 Taylor, J. Traill. "The Studios of America. No. 11. George S. Cook's Gallery, Richmond, Va." PHOTOGRAPHIC TIMES 13, no. 155 (Nov. 1883): 571-572. 1 illus.

C742 Deschin, Jacob. "New Civil War Photographs." U.S. CAMERA MAGAZINE 16, no. 3 (Mar. 1953): 39-41. 9 b & w.

C743 Edwards, Conley L., III. "'The Photographer of the Confederacy': From the first victory to final surrender, George S. Cook captured the wartime spirit of the South." CIVIL WAR TIMES ILLUSTRATED 13, no. 3 (June 1974): 27-33. 8 b & w. 2 illus.

COOKE, A. [MRS.]

C744 Gill, Arthur T. "Further Discoveries of Beard Daguerreotypes." HISTORY OF PHOTOGRAPHY 3, no. 1 (Jan. 1979): 94-98. 4 b & w. 2 illus. [Daguerreotypes by individuals subleasing patent under Beard. Mrs. A. Cook of Hull, etc.]

COOLEY, SAMUEL A. (USA)
BOOKS
C745 "Mr. Cooley of Beaufort and Mr. Moore of Concord: A Portfolio: Two of hundreds of unsung artists, these photographers captured South Carolina long before the Federals," on pp. 86-111 in: The Guns of '62: Volume Two of the Image of War: 1861 - 1865, edited by William C. Davis. Garden City, NY: Doubleday & Co., Inc., 1982. 464 pp. [23 photographs by Cooley, on pp. 86-99. Samuel Cooley operated several galleries in South Carolina and in Jacksonville, FL during the Civil War. He made views of the towns of Beaufort, SC, Hilton Head, SC, and elsewhere while the Confederate forces held South Carolina, but he also made photographs under the Union Army's Department of the South during their period of occupation.]

PERIODICALS
C746 "Cooley's Daguerrean Gallery." HUMPHREY'S JOURNAL 4, no. 21 (Feb. 15, 1853): 325-326. [From "Springfield Daily Post."]

C747 Portrait. Woodcut engraving, credited "From a Photograph by Samuel A. Cooley." HARPER'S WEEKLY 12, (1868) ["Late Rev. B. F. Randolph, of SC. - Assassinated Oct. 17, 1868)." 12:621 (Nov. 21, 1868): 740.]

COOLEY, W. DESBOROUGH.
C748 Cooley, W. Desborough. "Mystery of Inverted Vision." ATHENAEUM no. 1525 (Jan. 17, 1857): 83. [Letter from Cooley describing the phenomenon of inverted vision, displayed through the stereoscope.]

COOMBS, FREDERICK C. (1803-1874) (GREAT BRITAIN, USA)
C749 Jarrett, S. William. "San Francisco's Eccentric Daguerrean." PHOTOGRAPHICA 12, no. 10 (Dec. 1980): 7. 2 b & w.

C750 Palmquist, Peter E. "Frederick Coombs: Eccentric daguerrean in early California." AMERICAN WEST 19, no. 4 (July - Aug. 1982): 60-61. 1 b & w. [Born in England, Coombs had emigrated to the United States by the 1830s. He practiced several trades or professions, lecturing and writing on animal and phreno-magnetism, phrenology, and similar scientific/popular disciplines. Learned daguerreotypy in St. Louis in 1846. Active in Chicago in 1848, then went to California. Founded a gallery in San Francisco in 1849, but burned out three times before 1851. Quit photographing in early 1850s, turned to lecturing and promoting again. Died in 1874.]

COONLEY, JACOB F. see also DAY, D.; MORA.

COONLEY, JACOB FRANK. (NEW YORK, NY)
C751 "Personal & Art Intelligence." PHOTOGRAPHIC AND FINE ART JOURNAL 11, no. 10 (Oct. 1858): 320. [From "Syracuse [NY] Daily News."]

C752 "Pictures." ANTHONY'S PHOTOGRAPHIC BULLETIN 2, no. 8 (Aug. 1871): 275. ["From J. F. Coonley, with Mr. Y. Day, of Memphis, three very fine imperial cards."]

C753 "Scenes in the Sun-Lands - Incidents of a Trip from New York to Nassau and Havana - Sketches of Nassau, New Providence. - From Photographs by J. F. Coonley and Sketches by Walter Yeager." FRANK LESLIE'S ILLUSTRATED NEWSPAPER 46, no. 1182, 1184 - 1186 (May 25, June 8 - June 29, 1878): 204-205, 240, 256, 288. 15 illus. [This series ran each week for several months. However, only certain issues credited the illustrations to photos by Coonley, and the majority are from sketches. Views, with figures, group portraits, crowds, etc.]

C754 "Note." PHOTOGRAPHIC TIMES 9, no. 106 (Oct. 1879): 236. [Coonley's studio at 509 Hudson St. Stereo views of Brighton Beach, Manhattan Beach, Coney Island.]

C755 Coonley, J. F. "Is Photography a Fine Art?" PHOTOGRAPHIC TIMES 10, no. 120 (Dec. 1880): 273.

C756 Coonley, J. F. "Wet Plates versus Dry." PHOTOGRAPHIC TIMES 11, no. 122 (Feb. 1881): 50. [Coonley identified as the chief operator in Mora's Gallery, New York, NY.]

C757 Coonley, J. F. "On the Sensitiveness of Gelatin as Compared With Wet Collodion Plates." PHOTOGRAPHIC TIMES 11, no. 126 (June 1881): 217-218.

C758 Coonley, J. F. "Photographic Reminiscences of the Late War. No. 2." ANTHONY'S PHOTOGRAPHIC BULLETIN 13, no. 9 (Sept. 1882): 311-312. 1 illus.

C759 Coonley, J. F. "Quality of Photographic Light Necessary to Best Results." PHOTOGRAPHIC TIMES 12, no. 142 (Oct. 1882): 397-398.

C760 Coonley, J. F. "'A Defense of Collodion.'" PHOTOGRAPHIC TIMES 13, no. 148 (Apr. 1883): 155-157.

C761 Coonley, J. F. "The Element of Art in Connection with Photography." PHOTOGRAPHIC TIMES 14, no. 160 (Apr. 1884): 185-188. [Paper read before the Photographic Section of the American Institute.]

C762 Coonley, J. F. "Pages from a Veteran's Note-Book: Some Account of the Career of Mr. J. F. Coonley." WILSON'S PHOTOGRAPHIC MAGAZINE 44, no. 603 (Mar. 1907): 105-108. [J. F. Coonley was painting landscapes in Syracuse, NY in 1856, when he met George N. Barnard, "the leading photographer of that city." He colored portraits in oils and retouched for Barnard, and learned photography from him. When the financial panic of 1857 ruined Coonley's prospects as a painter, he took up photography as a profession. Coonley introduced the new ambrotype process into upper New York State. In 1858 he took a position as manager of the stereo printing shop for E. & H. T. Anthony & Co. in New York City. He worked as a stereoscopic printer from 1858 to 1860, then himself began making stereo negatives for the Anthony company. In 1860 he took a long excursion making stereo views along the Pennsylvania Railroad to Altoona, Pittsburgh, and the Alleghanies. In 1861 the Anthony firm sent Coonley to Brady's gallery in New York to copy Brady's portraits of distinguished people, for the carte-de-visite trade, then down to

the Brady gallery in Washington, DC, to do the same. While Coonley was in Washington the war broke out and he spent a hectic time making portraits of the civilian and military personnel flooding into Washington during the crises. Coonley then went out of the studio to photograph the camps and military posts which were being built all around Washington. Coonley joined his old friend George N, Barnard to photograph groups of soldiers, the line and staff officers, regimental bands, and campsites of the Army of the Potomac. At times Timothy O'Sullivan and David Woodbury assisted him, at times he worked alone. In 1861 and 1862 he documented Annapolis, Fort Monroe, and Harper's Ferry.

Coonley then returned to New York where he married, moved to Philadelphia and opened a studio. But after six months of moderate success he returned to New York City, where he managed Clark's Union Gallery until 1864. In 1864 Coonley obtained a contract from the U.S. Army Quartermaster General to photograph "all bridges, trestles, buildings, boats, etc. under the control of the department" along the lines of the railroad that began in Nashville, TN. Coonley photographed along the lines of the railroad, often while under threat of raids from the Confederate cavalry of General Hood. He photographed Nashville during the battle for that city between Hood and the Union army's General Thomas. The following spring, after Savannah and Charleston had fallen to Union forces, Coonley sailed to Fort Sumter and photographed the raising of the American flag over the fort again. When peace was declared, Coonley returned to Washington, DC, where he photographed, with David Woodbury's assistance, the Final Parade and Mustering Out of the Grand Army of the Republic.

After the war, Coonley returned to New York, then spent some time in Naussau in the Bahamas. In the mid- seventies he worked as an operator for Mora's New York gallery, then returned to Nassau, where he operated a gallery until 1904. In 1904 he took three trips to Cuba to photograph for the Museum of Natural History in New York. He sold his business in 1904 and retired from the profession. He was still alive in 1907.]

COOPER, B. S. (WAVERLY, MO)

C763 Cooper, B. S. "Correspondence." ANTHONY'S PHOTOGRAPHIC BULLETIN 3, no. 2 (Feb. 1872): 462-463. [Cooper from Waverly, MO.]

COOPER, DAVID. (1855-1889) (JAMAICA, USA)

C764 Cooper, David. "Improvements in Photographic Printing and Enlarging." ANTHONY'S PHOTOGRAPHIC BULLETIN 17, no. 14-15 (July 24 - Aug. 14, 1886): 425-429,465-478. 5 illus. [Presented at the St. Louis convention of the P. A. of A.]

C765 "A Farewell Tribute to David Cooper." ANTHONY'S PHOTOGRAPHIC BULLETIN 19, no. 22 (Nov. 24, 1888): 690-691. [Subscription gift to Cooper, retiring to Jamaica for his health, with a thank you letter from Cooper.]

C766 "Obituary: David Cooper." ANTHONY'S PHOTOGRAPHIC BULLETIN 20, no. 9 (May 11, 1889): 285. [Born at Falmouth, Jamaica, W.I. in 1855. In 1876 came to USA. Worked in dry plate manufacturing with Cramer & Norden. Went to work for the Anthony Company in 1884. Developed various chemical and mechanical improvements. Returned to Jamaica for his health, but died Apr. 5, 1889.]

C767 "Notes and News: Obituary." PHOTOGRAPHIC TIMES 19, no. 400 (May 17, 1889): 248. ["David Cooper, the well-known photographic worker, who returned to his home at Jamaica, W.I., last October in search of health, died there on the morning of April 5th."]

COOPER, HENRY (d. 1880) (GREAT BRITAIN)
BOOKS
C768 Cooper, Henry, Jr. Hints on the Collodio-Bromide Process. London: Horne & Thornthwaite, opticians, 1871. n. p.

PERIODICALS
C769 Cooper, H. "Modified Resin Process." HUMPHREY'S JOURNAL OF PHOTOGRAPHY, AND THE ALLIED ARTS AND SCIENCES 13, no. 15 (Dec. 1, 1861): 238-239. [From "Photo. News."]

C770 "Double Printing." AMERICAN JOURNAL OF PHOTOGRAPHY AND THE ALLIED ARTS & SCIENCES n. s. vol. 5, no. 17 (Mar. 1, 1863): 403-404. [From "Photo. News Almanac." Technique introduced by R. Harmer, carried out by H. Cooper.]

C771 Cooper, Henry, Jr. "On Double Printing." AMERICAN JOURNAL OF PHOTOGRAPHY AND THE ALLIED ARTS & SCIENCES n. s. vol. 6, no. 18 (Mar. 15, 1864): 420-422. [Read before London Photo. Soc.]

C772 Cooper, H. "Printing in Carbon." HUMPHREY'S JOURNAL OF PHOTOGRAPHY, AND THE ALLIED ARTS AND SCIENCES 16, no. 9 (Sept. 1, 1864): 137-139. [From "Photo. News."]

C773 "A Good, Cheap, and Easily Prepared Varnish. (Used for four years by H. Cooper, Jun.)." HUMPHREY'S JOURNAL OF PHOTOGRAPHY, AND THE ALLIED ARTS AND SCIENCES 18, no. 1 (May 1, 1866): 15-16. [From "Br. J. of Photo."]

C774 Cooper, H., Jr. "Photography on Silk." HUMPHREY'S JOURNAL OF PHOTOGRAPHY, AND THE ALLIED ARTS AND SCIENCES 18, no. 3 (June 1, 1866): 47. [Read to London Photo. Soc.]

C775 Cooper, Henry, Jr. "On the Preservation of Silver Prints by Means of Paraffine, etc." HUMPHREY'S JOURNAL OF PHOTOGRAPHY, AND THE ALLIED ARTS AND SCIENCES 20, no. 6 (July 15, 1868): 83-87. [From "Br. J. Almanac."]

C776 Cooper, Henry. "The Collodio - Bromide Process." BRITISH JOURNAL PHOTOGRAPHIC ALMANAC 1872 (1872): 41-50.

C777 Cooper, H. "Landscape Negatives for the Magic Lantern." BRITISH JOURNAL PHOTOGRAPHIC ALMANAC 1873 (1873): 93-94.

C778 Cooper, Henry. "Lantern Lectures." BRITISH JOURNAL PHOTOGRAPHIC ALMANAC 1874 (1874): 74-76.

C779 Cooper, Henry. "Lantern Lights." BRITISH JOURNAL PHOTOGRAPHIC ALMANAC 1876 (1876): 129-130.

C780 Cooper, Henry. "The Lime Light and the Lantern." BRITISH JOURNAL PHOTOGRAPHIC ALMANAC 1877 (1877): 49-50.

C781 Cooper, Henry. "Spots on Emulsion Plates." BRITISH JOURNAL PHOTOGRAPHIC ALMANAC 1878 (1878): 44-46.

C782 Cooper, Henry. "Hints from Practice in a Small Studio." BRITISH JOURNAL PHOTOGRAPHIC ALMANAC 1878 (1878): 79-80.

C783 Cooper, Henry. "A Reliable Dry Process." BRITISH JOURNAL PHOTOGRAPHIC ALMANAC 1879 (1879): 37-39.

C784 Cooper, Henry. "A New Safety Retort." BRITISH JOURNAL PHOTOGRAPHIC ALMANAC 1879 (1879): 146. 1 illus.

C785 "Home and Foreign News Epitomized." PHOTOGRAPHIC TIMES 10, no. 114 (June 1880): 131. ["In the death of Mr. Henry Cooper, London... the world has lost one of the ablest and most painstaking experimental photographers...".]

C786 "Obituary." PHOTOGRAPHIC JOURNAL n. s. vol. 5, no. 5 (Feb. 18, 1881): 71. ["Henry Cooper, late of Torquay, formerly of Highbury Grove, London ...many years an amateur in connection with the London societies ...chemist and experimentalist ...musician and artist ...early death."]

COOPER, JAMES. (d. 1871) (GREAT BRITAIN)
C787 Portrait. Woodcut engraving credited "From a photograph by James Cooper." ILLUSTRATED LONDON NEWS 51, (1867) ["Rev. John Bedford." 51:* (Aug. 31, 1867): 232.]

C788 Portrait. Woodcut engraving credited "From a photograph by James Cooper." ILLUSTRATED LONDON NEWS 63, (1873) ["Rev. G. T. Perks." 63:1772 (Aug. 16, 1873): 149.]

COPELAND, EDWARD A. (GREAT BRITAIN)
C789 Copeland, Edward. *Photography for the Many; Containing Practical Directions for the Production of Photographic Pictures on Glass and Paper, with details of the most improved processes, including negative and positive collodion, by dry collodion for tourist's stereoscopics, with on camera, and the whole art of printing from negatives on glass and paper, with particulars of the cost of the apparatus and chemicals for each process.* "Manuals for the Many, No. XI." London: Cottage Gardener Office, 1858. 32 pp. 20 illus.

COPELIN & SON. (CHICAGO, IL)
[A. J. Copelin and L. M. Melander ran a gallery on Lake St., Chicago from 1870 to 1871. (When they were probably burned out in the Chicago Fire.) In 1872 A. J. Copelin & Son opened a new gallery on Washington St., which operated until 1877. The firm then moved to Madison St., and continued from that address until 1883. This gallery was renamed the Copelin Gallery in 1883, but stayed open only to 1884. Copelin & Son opened a second gallery on Dearborn St. in 1883, which ran until at least 1900.]

C790 "Scenes During the Jubilee Week in New Chicago. - From Sketches by J. B. Beale and Photo. by Copelin & Son." FRANK LESLIE'S ILLUSTRATED NEWSPAPER 36, no. 925 (June 21, 1873): 236-237. 6 illus. [Views, scenes.]

C791 "The Procession - The Stone Contractors Exhibiting a Stone of Twenty-Eight Tons Weight, To Be Used in the Construction of the New Building. [Post Office and Custom House, Chicago, IL.]. - From a Photograph by Copelin & Son." FRANK LESLIE'S ILLUSTRATED NEWSPAPER 38, no. 980 (July 11, 1874): 281. 1 illus. [Parade, with crowds.]

C792 "Conflagration on Tuesday, July 14th - Scene on Wabash Avenue, Near Harrison Street, A Few Moments Previous to the Burning of the Temporary Post Office. - From Photographs by Copelin & Son, and Sketches by J. B. Beale." FRANK LESLIE'S ILLUSTRATED NEWSPAPER 38, no. 983 (Aug. 1, 1874): 333. 1 illus. [View, with crowds.]

C793 "Illinois. - The Frustrated Raid of Communists upon the Relief and Aid Society of Chicago. - From Photographs by Copelin & Son, and Sketches by Joseph B. Beale." FRANK LESLIE'S ILLUSTRATED NEWSPAPER 40, no. 1016 (Mar. 20, 1875): 21. 1 illus. [View of buildings, street, and crowd. The buildings are from a photograph.

COPELIN, A. J. W. (CHICAGO, IL)
C794 "Editor's Table." PHILADELPHIA PHOTOGRAPHER 14, no. 163 (July 1877): 224. [A. J. W. Copelin, Chicago, IL, praised.]

C795 "Illinois. - The Singular Grounding of a Schooner in Lincoln Park, Chicago, During the Late Storm. - From a Photograph by Copelin." FRANK LESLIE'S ILLUSTRATED NEWSPAPER 45, no. 1158 (Dec. 8, 1877): 229. 1 illus. [View.]

C796 "Illinois. - The Stephen A. Douglas Monument at Chicago. - Photographed by Copelin." FRANK LESLIE'S ILLUSTRATED NEWSPAPER 46, no. 1194 (Aug. 17, 1878): 409. 1 illus.

C797 Jenkins, C. Francis. "Photographs in Advertising." PHOTOGRAPHIC TIMES 30, no. 5 (May 1898): 218-221. 13 b & w. [Copelin photos.]

CORLIES, SAMUEL FISHER. (1830-1888) (USA)
C798 Corlies, S. Fisher. "The Uranium Toning Bath." AMERICAN JOURNAL OF PHOTOGRAPHY AND THE ALLIED ARTS & SCIENCES n. s. vol. 4, no. 24 (May 15, 1862): 559-560. [Corlies was an amateur, from Philadelphia, PA.]

C799 "Views Caught with the Drop Shutter." ANTHONY'S PHOTOGRAPHIC BULLETIN 19, no. 12 (June 23, 1888): 384. [Note, from the "Philadelphia Ledger," Corlies died on June 13, 1888, aged 58. "This gentleman was one of the members of the Old Photographic Club."]

C800 "The Photographic Society of Philadelphia: Special Meeting." PHOTOGRAPHIC TIMES 18, no. 354 (June 29, 1888): 309. [Announcement of death of S. Fisher Corlies, treasurer of the Photographic Society of Philadelphia.]

CORNELIUS, ROBERT. (1809-1893) (USA)
BOOKS
C801 Stapp, William F. *Robert Cornelius: Portraits from the Dawn of Photography.* Washington, DC: National Portrait Gallery, 1983. 148 pp. 30 b & w. [Exhibition, Oct. 20, 1983 - Jan. 22, 1984. Marian S. Carson. "The Eclipse and Rediscovery of Robert Cornelius," on pp. 13 - 24. William F. Stapp. "Robert Cornelius and the Dawn of Photography," on pp. 25 - 44. "Catalogue," on pp. 45 - 109. "M. Susan Barger. "Robert Cornelius and the Science of Daguerreotypy," on pp. 111 - 128. "Appendixes," on pp. 129 - 148. "Bibliography," on pp. 149 - 152. Robert Cornelius was born in 1809. His family owned the Cornelius & Co. Lamp and Chandelier Store in Philadelphia. In the weeks following the exciting announcements of Daguerre's discovery, Robert had discussed the new process with Joseph Saxton (1799-1873) and Dr. Paul Beck Goddard (1811-1866). In the fall of 1839 Robert made a self portrait in the yard behind the family store, one of the earliest photographic portraits taken. By December 1839 Cornelius had taken portraits of his father and other relatives, and with Dr. Goddard, a physician and professor of chemistry and medicine, as his silent partner, he opened a public portrait studio, in May 1840. The exposure times were shorter than others could then achieve and the studio was successful. Cornelius sent examples of his work to Daguerre in Paris, and taught daguerreotypy to others. In 1842 Dr. Goddard announced an improved, faster process using iodide of gold. After two and a half years, Cornelius, even though successful, returned to the family firm to exploit the growth of interest in gas light fixtures then coming into more common use. He died in 1893.]

PERIODICALS

C802 Cornelius, William A. "Brief History of Robert Cornelius." PAPERS READ BEFORE THE HISTORICAL SOCIETY OF FRANKFORD 3, no. 5 (1937): 110-113.

C803 Carson, Marian S. "A Very Good Specimen of the Daguerreotype." AMERICAN HERITAGE 32, no. 2 (Feb. - Mar. 1981): 92-93. 2 b & w. [Paul Beck Goddard and Robert Cornelius, of Philadelphia, created a portrait of Goddard in 1839.]

C804 "Cornelius Brings Top Dollar." PHOTOGRAPHICA 13, no. 5 (May 1981): 14. [Sale of sixth-plate daguerreotype at Swann Galleries auction.]

C805 Finkel, K. "A Robert Cornelius Daguerreotype." HISTORY OF PHOTOGRAPHY 10, no. 2 (Apr. - June 1986): 84. 1 b & w. [Robert Cornelius made daguerreotype portraits from Oct. or Nov. 1839 to 1842. Thirty had been previously identified. Another one, recently located, is published here.]

CORNELL, C. D. V. (USA)

C806 "Opal Pictures." HUMPHREY'S JOURNAL OF PHOTOGRAPHY, AND THE ALLIED ARTS AND SCIENCES 18, no. 23 (Apr. 1, 1867): 366. [Praise for C. D. V. Cornell's opal pictures. "...we really did not expect to meet such excellent workmanship in a small country village."]

CORRY, DR.

C807 "House in Belfast, Ireland, Where the Members of the Phoenix Society were Arrested." HARPER'S WEEKLY 3, no. 109 (Jan. 29, 1859): 76. 1 illus.

COTTON, ARTHUR B.

C808 Cotton, Rev. Arthur B., B.A. "Memoranda of a Photographic Trip in Norway." BRITISH JOURNAL OF PHOTOGRAPHY 10, no. 183 (Feb. 2, 1863): 48-49.

COURRET BROTHERS. (LIMA, PERU)

C809 Portraits. Woodcut engravings, credited "From a Photograph by Courret Hermanos, Lima, Peru." FRANK LESLIE'S ILLUSTRATED NEWSPAPER 22, (1866) ["Gen. Don Antonio Lopez de Santa Anna." 22:557 (June 2, 1866): 164.]

C810 "Peru. - Assassination of Ex-President Pardo in the Corridor of the Senate Chamber, at Lima, November 16th. - From a Photograph by Corret & Co." FRANK LESLIE'S ILLUSTRATED NEWSPAPER 47, no. 1216 (Jan. 18, 1879): 360.1 illus. [Since this shows the actual assassination (which was impossible to have been photographed), I assume the photograph is of the building, with figures added by the engraver.]

COURRET, E. (LIMA, PERU)

C811 Portrait. Woodcut engraving credited "From a photograph by E. Courret." ILLUSTRATED LONDON NEWS 75, (1879) ["late Mr. G. H. Nugent, British Consul at Arica." 75:2111 (Nov. 29, 1879): 505.]

COURRIER & JONES.

C812 Portraits. Woodcut engravings, credited "From a Photograph by Courrier & Jones." FRANK LESLIE'S ILLUSTRATED NEWSPAPER 31, (1871) ["The late Alice Cary, poetess." 31:805 (Mar. 4, 1871): 409]

COVENTRY, ARTHUR.

C813 Coventry, Arthur. "On a New Modification of Portable Camera." HUMPHREY'S JOURNAL OF PHOTOGRAPHY, AND THE ALLIED ARTS AND SCIENCES 19, no. 5 (July 1, 1867): 74-76. [Read to Manchester Photo. Soc.]

COWAN, ALEXANDER.

C814 Cowan, Alexander. "A Glass - Cutting Table." BRITISH JOURNAL PHOTOGRAPHIC ALMANAC 1879 (1879): 139-140. 1 illus.

C815 Cowan, Alexander. "A Simple Method of Adapting the Ordinary Studio Camera and Stand for Copying Purposes." BRITISH JOURNAL PHOTOGRAPHIC ALMANAC 1879 (1879): 167-168. 1 illus.

COWAN, J. GALLOWAY. (d. 1875) (GREAT BRITAIN)

C816 Cowan, J. Galloway, Rev. "The Taupenot (Rapid) Process." AMERICAN JOURNAL OF PHOTOGRAPHY AND THE ALLIED ARTS & SCIENCES n. s. vol. 4, no. 6 (Aug. 15, 1861): 140-141. [From "Photo. News."]

COX see BOWRON & COX (CANADA).

COX, E. H.

C817 Portraits. Woodcut engravings, credited "Photographed by Cox." FRANK LESLIE'S ILLUSTRATED NEWSPAPER 3, (1857) ["Rev. Charles Spurgeon, London." 3:70 (Apr. 11, 1857): 285.]

C818 Portraits. Woodcut engravings credited "From a photograph by Cox." ILLUSTRATED LONDON NEWS 33, (1858) ["Mr. John Thwaites." 33:* (July 24, 1858): 74.]

C819 Portrait. Woodcut engraving credited "From a photograph by E. H. Cox." ILLUSTRATED LONDON NEWS 62, (1873) ["Late Sir W. Tite." 62:1757 (May 3, 1873): 424.]

C820 "General Notes." PHOTOGRAPHIC TIMES 17, no. 294 (May 6, 1887): 233. [The "Lounger" in the "Critic" Apr. 23rd describes Walt Whitman having his portrait taken by Mr. Cox. No date given - ca. 1860s - 1870s.]

COX, FREDERICK JAMES. (LONDON, ENGLAND)

[F. J. Cox was an optician who ran a business at 22 Skinner Street, London until 1866, then removed to Ludgate Hill. One of the first to supply inexpensive sets of apparatus.]

C821 Cox, Frederick, James. *A Compendium of Photography, Containing Simple & Concise Directions for Obtaining Photographic Pictures on Paper, Glass and Metal Plates, Including the Collodion, Albumenized, Waxed Paper, Calotype & Daguerreotype Processes.* London: F. J. Cox, optician, 1855. 50 pp. 20 illus. [12th revised ed. (1879), 64 pp.]

C822 Cox, F. J. *The Photographic Tourist: Containing Full and Concise Directions for the Production of Landscape and Stereoscopic Views by the Albumenized Collodion Process; with Instructions for Printing Positive Copies on Albumenized Paper, and on Glass for Transparent Stereoscopic Views; also for the Preparation of Magic Lantern Sliders.* London: F. J. Cox, optician, 1858. 46 pp. 15 illus. [3rd ed. (1859); 4th ed. (1861).]

C823 Cox, F. J. *Natural Phenomena: being a Description of the most Interesting Phenomena in Nature.* London: F. J. Cox, 1860. n. p.

C824 Cox, F. J. *Spectacles, and their Scientific Adaptation to Defective Vision.* London: F. J. Cox, 1868. n. p.

COZZO, P. T. (LONDON, ENGLAND)

C825 Cozzo, P. T. "Correspondence: A Hint for Posing the Sitter." BRITISH JOURNAL OF PHOTOGRAPHY 12, no. 244 (Jan. 6, 1865): 10-11. [Cozzo at 166 Great Portland St., London.]

C826 Cozzo, P. T. "Vignetting Portraits." BRITISH JOURNAL OF PHOTOGRAPHY 12, no. 247 (Jan. 27, 1865): 40.

CRACROFT, BERNARD.

C827 Cracroft, Bernard. "Our Photographic Portraits." ANTHONY'S PHOTOGRAPHIC BULLETIN 5, no. 5 (May 1874): 173-175. [From "NY Times," in turn from "Saturday Review." Commentary on human nature, when photographed.]

CRAFT & FERRY.

C828 Portrait. Woodcut engraving, credited "From a Photograph by Craft & Ferry." FRANK LESLIE'S ILLUSTRATED NEWSPAPER 32, (1871) ["The Late William Chambers, Odd Fellow." 32:821 (June 24, 1871): 244.]

CRAIG, WILLIAM. (CANADA)

C829 Craig, Wm. "Intensifying Negatives. - Pinholes." AMERICAN JOURNAL OF PHOTOGRAPHY AND THE ALLIED ARTS & SCIENCES n. s. vol. 6, no. 19 (Apr. 1, 1864): 454-455. [Letter Addressed Chatam, C. W.]

C830 Craig, Wm. "Zinco-Photography." AMERICAN JOURNAL OF PHOTOGRAPHY AND THE ALLIED ARTS & SCIENCES n. s. vol. 7, no. 16 (Feb. 15, 1865): 369-370. [Wm. Craig from Brampton, C. W.]

CRAMB, JOHN. (GREAT BRITAIN)
BOOKS

C831 Buchanan, Rev. R., D.D. *Palestine in 1860*. A Series of Photographic Views by John Cramb, with Descriptions by Rev. R. Buchanan, D.D. Glasgow: William Collins, 1860. n. p. 24 b & w. [Original photos.]

PERIODICALS

C832 Cramb, John. "Palestine in 1860; Or, A Photographer's Journal of a Visit to Jerusalem." BRITISH JOURNAL OF PHOTOGRAPHY 7, no. 131 (Dec. 1, 1860): 344-345.

C833 Cramb, John. "Palestine in 1860; Or, a Photographer's Journal of a Visit to Jerusalem." BRITISH JOURNAL OF PHOTOGRAPHY 8, no. 134-156 (Jan. 15 - Dec. 16, 1861): 32-33, 46-47, 130-131, 146-147, 237-238, 255-256, 287-289, 364-365, 388-389, 425-426, 444-445.

C834 Cramb, John. "The Negative Albumen Process on Glass." HUMPHREY'S JOURNAL OF PHOTOGRAPHY, AND THE ALLIED ARTS AND SCIENCES 13, no. 4-7 (June 15 - Aug. 1, 1861): 61-64, 87-89, 108-111. [Read to Photo. Soc. of Scotland. From "Br. J. of Photo."]

C835 "Stereoscopic Camera without Slides, for Dry-Plate Photography, and Ten by Eight Camera on One Stand: As used by John Cramb during his Photographic Tour in Palestine in 1860." BRITISH JOURNAL OF PHOTOGRAPHY 8, no. 147 (Aug. 1, 1861): 265. 3 illus.

C836 Cramb, John. "Photographic Competition and Moonlight Pictures." BRITISH JOURNAL OF PHOTOGRAPHY 8, no. 156 (Dec. 16, 1861): 443-444.

CRAMER, GUSTAV see also HISTORY: USA: MO (Van Ravenswaay)

CRAMER, GUSTAV. (1838-1914) (GERMANY, USA)
BOOKS

C837 Zundt, E. A. *Dramatische und Lyrische Dichtungen*. St. Louis, MO: s. n., 1879. n. p. b & w. [Illustrated with photos by Gustav Cramer.]

PERIODICALS

C838 "Editor's Table." PHILADELPHIA PHOTOGRAPHER 6, no. 65 (May 1869): 169. [Cabinets noted, from Cramer & Gross, St. Louis, MO.]

C839 Cramer, G. "Correspondence: The Alum-Silver Bath a Success." ANTHONY'S PHOTOGRAPHIC BULLETIN 2, no. 10 (Oct. 1871): 335-336. [Cramer from St. Louis, MO.]

C840 "General Notes." PHOTOGRAPHIC TIMES 16, no. 246 (June 4, 1886): 299. [Note about a party given to Gustav Cramer on his 48th birthday.]

C841 Cramer, G. "On the Treatment of Very Sensitive Plates." ANTHONY'S PHOTOGRAPHIC BULLETIN 18, no. 17 (Sept. 10, 1887): 518-519.

C842 Cramer, G. "Dry Plates." PHOTOGRAPHIC TIMES 18, no. 359 (Aug. 3, 1888): 365-366. [Presented at the Minneapolis Convention of the P. A. of A. "Since the introduction of the dry-plate into practical use, about eight years ago,..."]

C843 Cramer, G. "Orthochromatic Photography." PHOTOGRAPHIC TIMES 20, no. 471 (Sept. 26, 1890): 483-484. [Read before the Washington Convention of the P.A. of A.]

C844 "Cramer, Gustav." ENCYCLOPEDIA OF THE HISTORY OF ST. LOUIS 1, (1899): 510-512. 1 illus. [Gustav Cramer born in Eschwege, Germany, May 20, 1838. Graduated from school at 16, went into trade. Emigrated to USA in 1859 and joined his elder brother in St. Louis. Learned photography from John A. Scholten. Opened his own gallery in 1860, but joined the Union Army in 1861 and served the standard three months enlistment, fighting in the battle of Carthage, MO. Returned to photography, and in 1864 formed a partnership with J. Gross (Cramer & Gross). Successful gallery for years. In 1880 Cramer associated himself with H. Norton to manufacture dry-plates, then since 1883 ran it alone. One of the earliest and most successful manufacturers of dry-plates. In 1887 Cramer was elected President of the Photographers' Assoc. of America. Many charities, associations, etc. Four children, the three males working in the family company.]

C845 "Dornroschen." HISTORY OF PHOTOGRAPHY 9, no. 4 (Oct. - Dec. 1985): 319. 1 b & w. [Cramer born in Germany, worked in St. Louis, MO. Illustrated a book "Dramatische und Lyrische Dichtungen," by E. A. Zundt, published in St. Louis in 1879.]

CRANE, J. F. & CO. (USA)

C846 "The Latter-Day Saints. - The Original Joseph Smith Mormons, Not Polygamists - Their September Encampment at Council Bluffs, Iowa. - Photographed by J. F. Crane & Co." FRANK LESLIE'S ILLUSTRATED NEWSPAPER 37, no. 940 (Oct. 4, 1873): 60-61. 9 illus. [One view, at Council Bluffs. Eight portraits of the Mormon leaders.]

CRANFIELD, THOMAS. (DUBLIN, IRELAND)

C847 Portraits. Woodcut engravings credited "From a photograph by Cranfield." ILLUSTRATED LONDON NEWS 46, (1865) ["Mr.

Barrington, Lord Mayor of Dublin, Mr. Benjamin Guiness." 46:* (Mar. 4, 1865): 209.]

C848 Portraits. Woodcut engravings credited "From a photograph by Cranfield." ILLUSTRATED LONDON NEWS 48, (1866) ["Lord Mayor of Dublin, James McCay." 48:* (Mar. 3, 1866): 217. "Sir Dominic J. Corrigan, Bart., M.D." 48:* (Mar. 17, 1866): 253.]

C849 Portrait. Woodcut engraving credited "From a photograph by Cranfield." ILLUSTRATED LONDON NEWS 53, (1868) ["Earl of Mayo." 53:* (Dec. 12, 1868): 569.]

C850 Portraits. Woodcut engravings credited "From a photograph by Thomas Cranfield." ILLUSTRATED LONDON NEWS 58, (1871) ["Lieut.-Gen. Sir William Mansfield, Lord Sandhurst." 58:1648 (Apr. 29, 1871): 432.]

C851 Portrait. Woodcut engraving, credited to "From a Photograph by T. Cranfield." ILLUSTRATED LONDON NEWS 60, (1872) ["Sir James Murray, M.D." 60:1687 (Jan. 6, 1872): 16.]

C852 Portrait. Woodcut engraving credited "From a photograph by T. Cranfield." ILLUSTRATED LONDON NEWS 66, (1875) ["Sir A. E. Guiness, Bart." 66:1859 (Mar. 27, 1875): 301.]

C853 Portrait. Woodcut engraving credited "From a photograph by T. Cranfield." ILLUSTRATED LONDON NEWS 69, (1876) ["Late Chief Justice Whiteside, of Ireland." 69:1950 (Dec. 9, 1876): 561.]

CRAWFORD.
C854 Portrait. Woodcut engraving, credited "From a Photograph by Crawford." FRANK LESLIE'S ILLUSTRATED NEWSPAPER 48, (1879) ["Col. M. G. Barnett, US citizen arrested in Cuba." 48:1247 (Aug. 23, 1879): 409.]

CRAWFORD, JAMES GILMORE. (1850-) (USA)
C855 Crawford, J. Gilmore. "Wrinkles and Dodges." PHILADELPHIA PHOTOGRAPHER 9, no. 106 (Oct. 1872): 351-352. [Crawford from Harrisburg, OR.]

CRAWFORD, JOHN. (GREAT BRITAIN)
C856 Crawford, John. "On the Assistance Photographers May Derive from a Knowledge of Fine Art." BRITISH JOURNAL OF PHOTOGRAPHY 10, no. 192, 194 (June 15, July 15, 1863): 252-253, 289.

C857 Crawford, John. "The Future of Photography." BRITISH JOURNAL OF PHOTOGRAPHY 11, no. 205 (Jan. 1, 1864): 10-11.

CRAWFORD, L. W. (FORT WORTH, TX)
C858 Crawford, L. W. "Boiling Lenses and Burnishing Tintypes." PHILADELPHIA PHOTOGRAPHER 13, no. 152 (Aug. 1876): 239-240. [Crawford from Forth Worth, TX.]

CRAWFORD, W. H. STANLEY. (BOMBAY, INDIA)
BOOKS
C859 Crawford, W. H. S. Treatise on Photography. Bombay: s. n., sold by Horne & Co., opticians, London, 1853. n. p. [Written for photographers travelling in India and other hot, humid countries.]

PERIODICALS
C860 "On the Daguerreotype." HUMPHREY'S JOURNAL 5, no. 23 (Mar. 15, 1854): 353-355. [From "Photo. J., London." Crawford from Bombay, India. Argument with A. Claudet over procedures.]

C861 Crawford, W. H. Stanley. "Photographic Processes, on the Daguerreotype." PHOTOGRAPHIC AND FINE ART JOURNAL 7, no. 5 (May 1854): 139-140. [From the "Journal of the Photo Soc."]

CRAWSHAY, ROBERT THOMPSON. (1817-1879) (GREAT BRITAIN)
C862 "Editor's Table - Obituary." PHILADELPHIA PHOTOGRAPHER 16, no. 187 (July 1879): 223. [Eminent amateur of Cheltenham, England.]

CRELLIN. (GREAT BRITAIN)
C863 "Note." ART JOURNAL (Mar. 1868): 59. [Mr. Crellin has issued a series of "cartes" of the examiners and professors of the University of London.]

CREMER, JAMES. (1821-1893) (GREAT BRITAIN, USA)
C864 "Our Picture." PHILADELPHIA PHOTOGRAPHER 5, no. 56 (Aug. 1868): frontispiece, 277. 1 b & w. [Posed double-portrait of two men in an office (arranged in studio). Cremer was the Vice Pres. of the National Photo Convention.]

C865 Adams, Washington Irving. "Obituary. James Cremer." PHOTOGRAPHIC TIMES 23, no. 594 (Feb. 3, 1893): 54. [Cremer born in England, to USA in 1843. To Philadelphia where he learned and practiced photography for forty years. Retired in 1882. Died Jan. 25, 1893 in the 72nd year of his age.]

C866 Ehrmann, Charles. "Personal Recollections of James Cremer." PHOTOGRAPHIC TIMES 23, no. 596 (Feb. 17, 1893): 84. [Born of German parents in England. To USA, worked as photographic salesman, later opened a photographic supply house, was a dealer until retiring in 1882. Well-liked.]

C867 Brey, William. "James Cremer: Philadelphia's Photographer." STEREO WORLD 6, no. 3 (July - Aug. 1979): 4-14. 9 b & w. 7 illus. [Cremer born in London on June 14, 1821. Immigrated to USA at age 22. Cremer worked for photographic manufacturers in early 1850s, then established his own photographic supply house in Philadelphia in 1856. In 1860 he began to concentrate on the sale of stereoscopic views, and soon thereafter apparently to make his own. Cremer was active in helping form the National Photographic Association in 1868 and he supported the organization throughout the early 1870s. By 1872 he was the largest publisher of stereo views in Philadelphia. Business flourished, until he retired in 1882. Died in January 1893.]

C868 Ryder, Richard C. "The Launching of the Chattanooga." STEREO WORLD 6, no. 3 (July - Aug. 1979): 15-17. 4 b & w. [Views.]

C869 Brey, William. "Fairmount Park Water Works." STEREO WORLD 9, no. 2 (May - June 1982): 14-19. 8 b & w. 3 illus. [Views of the Philadelphia plant by James Cremer (6); R. Newell; others.]

CREMIERE & CO. (PARIS, FRANCE)
C870 Portrait. Woodcut engraving credited "From a photograph by Cremière & Co." ILLUSTRATED LONDON NEWS 71, (1877) ["Late Dr. Conneau." 71:1991 (Sept. 8, 1877): 233.]

CRESPON.
C871 Crespon. "Enlarged, etc., Positives." HUMPHREY'S JOURNAL OF PHOTOGRAPHY, AND THE ALLIED ARTS AND SCIENCES 16, no. 7 (Aug. 1, 1864): 107-108. [From "Moniteur de la Photographie."]

CRESSEY, R. M. see BARNARD, GEORGE M. (1980).

CRESSON, R. C.

C872 "Monthly Notes: Collodionized Glass Photographs." PRACTICAL MECHANIC'S JOURNAL 5, no. 54 (Sept. 1852): 143. [Mentions that Dr. Rand exhibited photos by Dr. R. C. Cresson called "Hyalotypes" at the Franklin Institute, Philadelphia, in April and May.]

CRESSY, JUSTIN S. (LANSING, MI)

C873 Portraits. Woodcut engravings credited "From a photograph by Justin S. Cressy." ILLUSTRATED LONDON NEWS 34, (1859) ["Okemos, Pottawatamie Indian." 34:* (Mar. 5, 1859): 229. ["...from an ambrotype forwarded to us by Mr. Justin S. Cressy, of Lansing, Michigan, United States."]

CRIDLAND, T. W. (USA)

C874 "Great Fire at Dayton, Ohio - Destruction of Turner's Opera-House." HARPER'S WEEKLY 13, no. 649 (June 5, 1869): 356. 1 illus. ["Photographed by T. W. Cridland."]

CRIHFIELD, A. R.

C875 Crihfield, A. R. "Relation of Backgrounds to Subjects." PHILADELPHIA PHOTOGRAPHER 8, no. 86 (Feb. 1871): 54-55. 1 illus.

CRITCHERSON, GEORGE P. see also DUNMORE & CRITCHERSON.

CROCKER, J. (USA)

C876 "Scene of the Rochester Murder. Mrs. Littles and Ira Stout, with the Body of Littles on the Edge of the Precipice. From a Daguerreotype by J. S. Crocker." FRANK LESLIE'S ILLUSTRATED NEWSPAPER 5, no. 110 (Jan. 9, 1858): 92. 1 illus. [View.]

CROCKETT, A. B. (NORWAY, ME)

C877 Crockett, A. B. "A New Developer." AMERICAN JOURNAL OF PHOTOGRAPHY AND THE ALLIED ARTS & SCIENCES n. s. vol. 7, no. 15 (Feb. 1, 1865): 347-348.

CROFT, RICHARD BENYON. (1843-) (GREAT BRITAIN)

C878 Harker, Margaret. "Richard Benyon Croft." PHOTOGRAPHIC COLLECTOR 3, no. 2 (Autumn 1982): 134-145. 11 b & w. 4 illus. [British naval officer in 1860s. Collected albums of photographs of naval activities from that time. In 1870s became an amateur photographer, took portraits and genre views in the mode of Cameron and Robinson in 1880s and 1890s.]

CROMBIE. (AUCKLAND, NEW ZEALAND)

C879 "New Zealand Insurance Office." ILLUSTRATED LONDON NEWS 62, no. 1748 (Mar. 1, 1873): 201. 1 illus.

CROOKES, WILLIAM, SIR. (1832-1919) (GREAT BRITAIN)

[William Crookes was a famous chemist, the discoverer of the element thallium, and the inventor of the radiometer. In the 1850s he was very interested in photography, edited the *Manchester and Liverpool Photographic Journal*, then the *Photographic News*, and he wrote many articles on the technical aspects of photography.]

BOOKS

C880 Crookes, William. *A Handbook to the Waxed-Paper Process in Photography.* London: Chapman & Hall, 1857. 55 pp.

PERIODICALS

C881 Crookes, William. "The Wax-Paper Process." NOTES AND QUERIES 6, no. 158 (Nov. 6, 1852): 443-444. [Notice of typographic error on page 470, No. 159, Nov. 13, 1852 N & Q.]

C882 Crookes, W. "On Wax and Waxing Paper." PHOTOGRAPHIC AND FINE ART JOURNAL 8, no. 11 (Nov. 1855): 346. [From the "Description of the Photographic Process employed in the Radcliffe Observatory, Oxford."]

C883 Crookes, William. "Photographic Researches on the Spectrum. The Spectrum Camera, and Some of its Applications." PHOTOGRAPHIC AND FINE ART JOURNAL 9, no. 3 (Mar. 1856): 85-87. 1 illus.

C884 Crookes, William. "Remarks on the Photography of the Moon." PHOTOGRAPHIC AND FINE ART JOURNAL 10, no. 4 (Apr. 1857): 103. [From "Liverpool Photo. J."]

C885 Crookes, William. "Description of the Photographic Process, Used in Taking the Photograph of the Moon." PHOTOGRAPHIC AND FINE ART JOURNAL 10, no. 6 (June 1857): 163-164. [From "Liverpool Photo. J."]

C886 Crookes, William. "On the Photography of the Moon." HUMPHREY'S JOURNAL 9, no. 5 (July 1, 1857): 73-79. [From "J. of Photo. Soc., London."]

C887 Crookes, William. "The Albumen Process on Collodion." PHOTOGRAPHIC AND FINE ART JOURNAL 10, no. 8 (Aug. 1857): 242-244. [From "Liverpool Photo. J."]

C888 Crookes, W. "Descriptive of the Wax-Paper Photographic Process: Employed for the Photo-meteorographic registrations at the Radcliffe Observatory, Oxford." PHOTOGRAPHIC AND FINE ART JOURNAL 10, no. 9 (Sept. 1857): 277-278. [From "Liverpool Photo. J."]

C889 "Photography by Artificial Light." AMERICAN JOURNAL OF PHOTOGRAPHY AND THE ALLIED ARTS & SCIENCES n. s. vol. 3, no. 16 (Jan. 15, 1861): 249-251. [Experiments of Mr. Crookes by electric light. From "Photo. News."]

C890 Crookes, William, F.R.S. "Photographic Printing and Engraving."BRITISH JOURNAL OF PHOTOGRAPHY 10, no. 199 (Oct. 1, 1863): 383-384.

C891 Crookes, William, F.R.S. "Photographic Printing and Engraving." POPULAR SCIENCE REVIEW 3, no. 9 (Oct. 1863): frontispiece, 1-5. 1 illus.

C892 Crookes, William, F.R.S. "Notes on Permanganate of Silver." AMERICAN JOURNAL OF PHOTOGRAPHY, AND THE ALLIED ARTS AND SCIENCES n. s. vol. 9, no. 8 (Mar. 1, 1867): 179-181. [From "Photo. News."]

C893 "Two Astronomic Discoveries." ANTHONY'S PHOTOGRAPHIC BULLETIN 6, no. 7 (July 1875): 193-195. [From "New York Times." William Crookes, Fellow of the Royal Society.]

C894 Crookes, William. "Portraiture." PHOTOGRAPHIC TIMES 31, no. 8 (Aug. 1899): 379-383. [Read before the Edinburgh Photographic Society.]

C895 "Obituary: Sir William Crookes (April 4, 1919)." BRITISH JOURNAL PHOTOGRAPHIC ALMANAC 1920 (1920): 339-340. [Eminent chemist and physicist, died at age 87. Worked with Spiller, when 22 years old, on dry collodion processes. Many other technical and chemical experiments. Editor of the "Liverpool and Manchester

Photo. J." (now the "BJP") in 1857, then, in 1859, the "Photographic News."]

CROSBY, GEORGE L. (d. 1877) (USA)

C896 "Editor's Table." PHILADELPHIA PHOTOGRAPHER 3, no. 31 (July 1866): 223. [View of the Mississippi River from George L. Crosby (Hannibal, MO)]

C897 Crosby, George L. "Mr. Rhoads' Discovery." PHILADELPHIA PHOTOGRAPHER 9, no. 107 (Nov. 1872): 382. [Crosby (Hannibal, MO) claims to have discovered the same trick of placing a coin in the center of the lens to improve overall sharpness, described by Rhoads in an earlier issue, in 1860 while running a gallery in Marlborough, MA. Crosby used the trick until he "sold out and went to war in 1861, then forgot the dodge, even though I have been in business constantly since the war, and a part of the time during the war."]

C898 "Editor's Table: Obituary." PHILADELPHIA PHOTOGRAPHER 14, no. 164 (Aug. 1877): 256. [George L. Crosby, his wife and two children, drowned in a flash flood near Hannibal, MO. on June 27.]

CROSS, FRANK L. (USA)

C899 Cross, Frank L. "A Few Words to Country Photographers." ANTHONY'S PHOTOGRAPHIC BULLETIN 6, no. 3 (Mar. 1875): 85-86.

C900 Cross, Frank L. "Correspondence." ANTHONY'S PHOTOGRAPHIC BULLETIN 6, no. 7 (July 1875): 223-224.

CROSTHWAITE, J. (GREAT BRITAIN)

C901 Crosthwaite, J. "Carbon Printing Atelier." ANTHONY'S PHOTOGRAPHIC BULLETIN 8, no. 3 (Mar. 1877): 77. 1 illus. [Engraving displaying darkroom setting for carbon printing.]

C902 Crosthwaite, J. "Art in Photography." ANTHONY'S PHOTOGRAPHIC BULLETIN 10, no. 4 (Apr. 1879): 99-101. [From "London Photo. News." Read before the West Riding of Yorkshire Photo. Soc.]

CROUCHER, JOHN H. (GREAT BRITAIN)
BOOKS

C903 Croucher, John H. *Practical Hints on the Daguerreotype: Being Simple Directions for Obtaining Portraits, Views, Copies of Engravings, Drawings, Sketches of Machinery, Etc., Etc. by the Daguerreotype Process; Including the Latest Improvements in Fixing, Colouring, and Engraving the Pictures; with a Description of the Apparatus.* Illustrated with Engravings. "2nd ed." London; Sherwood: T. & R. Willats, optician; Gilbert & Piper, 1846. 60 pp. 17 illus. [1st ed. (1845); 3rd ed. (1850).]

C904 Croucher, J. H. *Plain Directions for Obtaining Photographic Pictures by the Calotype and Energiatype; Also upon Albumenized Paper and Glass, by Collodion and Albumen, &c. &c. Including a Practical Treatise on Photography; with a Supplement, Containing the Heliochrome Process. Also, Practical Hints on the Daguerreotype, being Simple Directions for Obtaining Portraits, Views, Copies of Engravings, Drawings, Sketches of Machinery, &c. by the Daguerreotype Process; Including the Latest Improvements in Fixing, Colouring, and Engraving with Pictures; with an Description of the Apparatus.* Illustrated with Engravings. London; Philadelphia: T. & R. Willats, optician; A. Hart, 1853. 224 pp. 47 illus. [1st ed. (1844) 40 pp. 4th ed. (1851). Issued in various formats in 1840s, 1850s. In 3 parts. Part 1 contains various processes, Part 2 has a translation of Gustave LeGray's *Treatise on Photography,* and a reprint of Frederick

S. Archer's article on Collodion from "The Chemist," etc. Part 3 is on the daguerreotype. Reprinted 1973, Arno Press.]

PERIODICALS

C905 "Photographic Societies: The Photographic Society of Philadelphia." PHOTOGRAPHIC TIMES 22, no. 537 (Jan. 1, 1892): 11-12. [Includes excerpts from a book on the daguerreotype written by J. H. Croucher in 1853.]

CROUGHTON, GEORGE HANMER. (1843-1920) (GREAT BRITAIN, USA)

C906 Croughton, George. "Practical Hints on Art as Applied to Photographic Portraiture." ANTHONY'S PHOTOGRAPHIC BULLETIN 2, no. 5-9 (May - Sept. 1871): 139-141, 167-170, 259-261, 280-283. [From "Br J of Photo."]

C907 Croughton, George. "Carbon as a Basis For Finished Work." ANTHONY'S PHOTOGRAPHIC BULLETIN 2, no. 12 (Dec. 1871): 375-378. [From "Br. J. of Photo." Carbon printing.]

C908 Croughton, George. "Vignette Portraits How to Light and How to Print Them." PHOTOGRAPHER'S FRIEND 2, no. 2 (Apr. 1872): 34-35.

C909 Croughton, George. "Photographic vs. Literal Truth." ANTHONY'S PHOTOGRAPHIC BULLETIN 3, no. 8 (Aug. 1872): 629-633. [From "Br. J. of Photo." Good descriptions of visual translation problems inherent in the lenses and processes in use.]

C910 Croughton, George. "Backgrounds." ANTHONY'S PHOTOGRAPHIC BULLETIN 4, no. 8 (Aug. 1873): 243-245. [Read before the South London Photographic Society. From "Photo. News." Backgrounds for photographic portraiture.]

C911 Croughton, George. "Enlarging and Enlarging Processes." BRITISH JOURNAL PHOTOGRAPHIC ALMANAC 1876 (1876): 99-100.

C912 Croughton, George. "A Few Words About Lighting." PHILADELPHIA PHOTOGRAPHER 13, no. 149 (May 1876): 138-139. [Croughton a member of the Glasgow Photographic Assoc.]

C913 Croughton, G. Hammer. "The Art Side of Photography." PHOTOGRAPHIC TIMES 19, no. 414 (Aug. 23, 1889): 424-426. [Read at the Boston Convention of the P.A. of A.]

C914 Croughton, G. Hammer. "The Art Side of Photography." ANTHONY'S PHOTOGRAPHIC BULLETIN 20, no. 17 (Sept. 14, 1889): 526-529. [Read before the P. A. of A. convention in Boston.]

C915 Croughton, G. Hammer. "Art in Photography." AMERICAN AMATEUR PHOTOGRAPHER 3, no. 8 (Aug. 1891): 305-308. [Paper read at the 12th annual convention of the Photographers' Assoc. of America.]

C916 Croughton, G. Hammer. "Art in Photography." PHOTOGRAPHIC TIMES 21, no. 516 (Aug. 7, 1891): 391-393. ["Presented at the Buffalo Convention."]

C917 Croughton, G. Hammer. "Choice of Subject." AMERICAN AMATEUR PHOTOGRAPHER 3, no. 10 (Oct. 1891): 374-375. [Croughton was the president of the Camera Club of Rochester, NY.]

C918 "Obituary: George Hanmer Croughton (Apr. 15, 1920)." BRITISH JOURNAL PHOTOGRAPHIC ALMANAC 1921 (1921): 315.

[Born in England in 1843. Trained as an artist, gained prominence as a miniature painter, making miniatures of Queen Victoria and King Edward VII. Interested in photography. Moved to Rochester, NY in 1883. Demonstrated the working up of bromide paper for George Eastman, for over two years. Popular lecturer, writer.]

CROWE, GEORGE.
C919 Portrait. Woodcut engraving credited "From a photograph by George Crowe." ILLUSTRATED LONDON NEWS 68, (1876) ["Eyre Crowe, A.R.A." 68:1919 (May 6, 1876): 436.]

CROWE, RICHARD.
C920 Crowe, Richard. "An Universal Negative Holder for Use When Copying." BRITISH JOURNAL PHOTOGRAPHIC ALMANAC 1879 (1879): 150-151. 2 illus.

CROWELL, FRED S. (1844-) (USA)
C921 "Matters of the Month: The Whiskey War." PHOTOGRAPHIC TIMES 4, no. 41 (May 1874): 72. [Note of receipt of stereos about "The Whiskey War" in Ohio. Crowell from Mt. Vernon, OH.]

CROWTHER. (d. 1864) (GREAT BRITAIN)
C922 Towler, Prof. "Fatal Explosion of Oxygen Gas in a Photographic Establishment." HUMPHREY'S JOURNAL OF PHOTOGRAPHY, AND THE ALLIED ARTS AND SCIENCES 16, no. 19 (Feb. 1, 1865): 291-293. [Crowther, of Manchester, England, killed in an explosion while preparing oxygen gas for a magic lantern exhibition.]

CROZAT, LEANDRO. (MADRID, SPAIN)
C923 Crozat, Leandro. "Double Backgrounds and Instantaneous Coloring." AMERICAN JOURNAL OF PHOTOGRAPHY AND THE ALLIED ARTS & SCIENCES n. s. vol. 8, no. 16-17 (Feb. 15 - Mar. 1, 1866): 376-377, 391-392. [From "Photo. News."]

CRUCES & CAMPA.
C924 Stevenson, Sara Y. "The Fall of Maximilian. A Woman's Reminiscences of Mexico during the French Intervention, with Glimpses of Maximilian, His Allies and Enemies." CENTURY MAGAZINE 55, no. 6 (Apr. 1898): 853-866. 8 illus. [Illustrated with drawings of portraits of military figures, the firing squad, etc. Credited to be from photographs, one credited to Cruces & Campa.]

CRUCES & CO. (MEXICO)
C925 Palmquist, Peter E. "Mexican Miscellany." HISTORY OF PHOTOGRAPHY 5, no. 2 (Apr. 1981): 97-101. 17 b & w. [17 cartes-de-visite Mexican occupationals, taken in the 1870s by Cruces and Co., Mexico City.]

CRUM, W. C. (PENN YAN, NY)
C926 "A Fine Chance." HUMPHREY'S JOURNAL OF PHOTOGRAPHY, AND THE ALLIED ARTS AND SCIENCES 19, no. 19 (Feb. 1, 1868): 298. [W. C. Crum, (Penn Yan, NY) offering his gallery and apparatus for sale.]

CRUTTENDEN, J. (GREAT BRITAIN)
C927 Martin, Charles Wykeham. The History and Description of Leeds Castle, Kent. Westminster: Nichols and Sons, 1869. x, 210 pp. 8 b & w. [Original photos, by J. Cruttenden.]

CUDLIP, CHARLES S. (ca. 1845-1889) (USA)
C928 "Notes and News: Obituary." PHOTOGRAPHIC TIMES 19, no. 421 (Oct. 11, 1889): 511-512. [Died in Washington, DC at age 41. Lived in Washington all his life, been a photographer for about the last 15 years, and "one of the most prominent in the city."]

C929 "Views Caught with the Drop Shutter." ANTHONY'S PHOTOGRAPHIC BULLETIN 20, no. 19 (Oct. 12, 1889): 608. [Brief note of Cudlip's death at 44 years of age. Had been a photographer about 15 years; worked in Washington.]

CUMMINGS, JAMES S. (1843-1894) (USA)
C930 "Practical Photography." PHOTOGRAPHER'S FRIEND 2, no. 4 (Oct. 1872): 109-111.

C931 Bachrach, D., Jr. "Editor's Table: Obituary." WILSON'S PHOTOGRAPHIC MAGAZINE 32, no. 460 (Apr. 1895): 191. [Letter from Bachrach. Cummings began at the studio of the Bendann Brothers, for last 18 years ran his own studio (in Baltimore?). 51 years old when he died.]

CUMMINGS, THOMAS. (LANCASTER, PA)
C932 Cummings, T. "Photo-Sculpture. - A Novel Process." AMERICAN JOURNAL OF PHOTOGRAPHY AND THE ALLIED ARTS & SCIENCES n. s. vol. 4, no. 5 (Aug. 1, 1861): 106-108.

CUNDALL & DOWNES & CO. (LONDON, ENGLAND)
BOOKS
C933 Views on the Vartry and of Wicklow Harbour. Photographs by Joseph Cundall and George Downes. London: Cundall, Downes & Co., 1861. n. p. 20 l. of plates. 20 b & w. [Original photographs.]

C934 Collins, Wilkie. The Woman in White. London: Sampson Low, Son & Co., 1861. n. p. 1 b & w. [Original photographic portrait of the author as frontispiece, by Cundall, Downes & Co.]

C935 Architectural Details of Wells Cathedral and Close. London: Cundall, Downes & Co., 1862. n. p. 40 b & w. [Albumen prints.]

C936 Photographs from the Sculptures in the West Front of Wells Cathedral, taken for the Architectural Photographic Association by Cundall, Downes & Co. London: Cundall, Downes & Co., 1862. n. p. 35 b & w. [Albumen prints.]

C937 Turner, Joseph Mallord William. Turner's Liber Studiorum, Second Series. Photographs from Twenty-One Original Drawings...in the South Kensington Museum. London; Manchester: Cundall, Downes; Agnew & Sons, 1862. n. p. 21 b & w. [Photographs of Joseph M. W. Turner's drawings.]

C938 Friswell, J. Hain. Life Portraits of William Shakespeare. A History of the Various Representations of the Poet, with an Examination into their Authenticity. By J. Hain Friswell: Illustrated by Photographs by Cundall, Downes & Co. London: Sampson Low, Son & Marston, 1864. n. p. pp. 9 b & w. [Views of locations associated with Shakespeare.]

C939 Stephens, Frederic George. Normandy, Its Gothic Architecture and History; As Illustrated by Twenty-five Photographs from Buildings in Rouen, Caen, Nantes, Bayeux, and Falaise, a Sketch by F. G. Stephens. London: Alfred W. Bennett, 1865. 47 pp. 25 l. of plates. 25 b & w. [Original photos by Cundall & Downes and others, tipped-in.]

PERIODICALS
C940 Portraits. Woodcut engravings credited "From a photograph by Cundall & Downes, New Bond Street." ILLUSTRATED LONDON NEWS 43, (1863) ["William Mulready, R.A." 43:* (July 25, 1863): 93. "J.D. Harding, painter." 43:* (Dec. 26, 1863): 657.]

C941 "Critical Notices: "Life Portraits of William Shakespeare. A History of the various Representations of the Poet, with an

Examination into their Authenticity," by J. Hain Friswell. Illustrated by Photographs by Cundall, Downes and Co. London: Sampson Low, Son & Marston." PHOTOGRAPHIC NEWS 8, no. 289 (Mar. 18, 1864): 135-136.

C942 "Note." ART JOURNAL (June 1864): 191. [Notice of 12 photos in series on Shakespeare.]

C943 Wilsher, Ann. "Vanitas Vanitatum." HISTORY OF PHOTOGRAPHY 2, no. 3 (July 1978): 206. 1 b & w. [Carte-de-visite of W. M. Thackeray, with his commentary on photography.]

CUNDALL & FLEMING. (LONDON, ENGLAND)

C944 Cundall, Joseph, ed. The Great Works of Raphael Sanzio of Urbino; a Series of Thirty Photographs from the Best Engravings of his Most Celebrated Paintings. London: Bell & Daldy, 1866. viii, 76 pp. 30 b & w. [Original photos of prints by Cundall & Fleming.]

C945 Stephens, Frederic George. Flemish Relics: Architectural, Legendary, and Pictorial; As Connected with Public Buildings in Belgium. Gathered by Frederic G. Stephens. Illustrated with Photographs by Cundall & Fleming. London: Alfred W. Bennett, 1866. 178 pp. l. of plates. 15 b & w. [Original photos by Cundall & Fleming.]

C946 Cundall, Joseph, ed. The Life and Genius of Rembrandt; the Most Celebrated of Rembrandt's Etchings. London; Cambridge: Bell & Daldy; Deighton, Bell, 1867. n. p. 30 b & w. [Original photos, by Cundall & Fleming, of etchings by Rembrandt.]

C947 Stephens, Frederic George. Memorials of William Mulready; Collected by Frederic G. Stephens and Illustrated with Fourteen Photographs of His Most Celebrated Paintings. London: Bell & Daldy, 1867. viii, 134 pp. l. of plates. 14 b & w. [Original photos, by Cundall & Fleming, of Mulready's paintings.]

C948 Henderson, John. Works of Art in Pottery, Glass, and Metal in the Collection of John Henderson, M.A., F.S.A. London: Cundall & Fleming, 1868. n. p. 18 b & w. [Original photos by Cundall & Fleming.]

C949 Seddon, John Pollard. Rambles in the Rhine Provinces; Illustrated with Chromo-Lithographs, Photographs, and Wood Engravings. London: John Murray, 1868. xiv, 156 pp. 14 b & w. 70 illus. [14 photos by Cundall & Fleming, tipped-in. 70 woodcuts or chromolithographs. (1878) London: S. B. Barrett, 20 b&w.]

C950 Heaton, Mary. The History of the Life of Albrecht Dürer of Nürnberg. London, New York: Macmillan, 1870. n. p. 10 b & w. [Autotypes, by Cundall & Fleming.]

C951 Turner, Joseph Mallord Willam. Turner's Celebrated Landscapes; Sixteen of the Most Important Works. London: Bell & Daldy, 1872. n. p. 16 b & w. [Autotypes, after engravings by Cundall & Fleming.]

PERIODICALS

C952 Portrait. Woodcut engraving credited "From a photograph by Cundall & Co., New Bond St." ILLUSTRATED LONDON NEWS 53, (1868) ["G. H. Thomas, artist." 53:* (Aug. 22, 1868): 177.]

CUNDALL & HOWLETT.

C953 Portrait. Woodcut engraving credited "From a photograph by Cundall & Howlett." ILLUSTRATED LONDON NEWS 29,(1856)["Ser.-Major Edwards." 29:* (Aug. 30, 1856): 210.]

C954 "Crimean Heroes and Trophies." ILLUSTRATED LONDON NEWS 28, no. 793 (Apr. 12, 1856): 369-370. 1 illus. ["Crimean Heroes and Trophies," at Woolwich. - From photographs by J. Cundall & R. Howlett.]

C955 "Crimean Heroes and Trophies." FRANK LESLIE'S ILLUSTRATED NEWSPAPER 1, no. 22 (May 10, 1856): 348-349. 1 illus. [Group portrait of British soldiers, returned from the Crimea, here taken from the "ILN," without credit to either that journal or the original photographic source.]

CUNDALL, GEORGE S. (GREAT BRITAIN)

[Cundall was a British amateur who made an important contribution to photography in 1844. "Mr. G. S. Cundall, of Finsbury Circus, diluted the sensitive wash (Talbot's) with water, instead of floating the paper. (As Talbot had done.) Amateurs date their success from the time Mr. Cundall published this simple modification of the original process." From "Progress in Photography," a letter in "Notes & Queries," republished on p. 133 in the Aug. 15, 1854 issue of "Humphrey's Journal."]

C956 Cundall, George S., Esq. "XLVIII: On the Practice of the Calotype Process of Photography." LONDON, EDINBURGH AND DUBLIN PHILOSOPHICAL MAGAZINE AND JOURNAL OF SCIENCE. Ser. 3, vol. 24, no. 160 (May 1844): 321-332.

CUNDALL, JOSEPH. (1818-1895) (GREAT BRITAIN)

[Born in Norwich in 1818, the son of a linen draper. Trained as a painter in Ipswich, but went to London in 1834 and worked for the bookseller and publisher Charles Tilt. He also became an author and publisher, specializing in children's books, books on antiquities, and, later, in books illustrated by photography. Cundall was involved in photography at least as early as 1848, and he was one of the founders of the Calotype Society. In 1852 he founded the Photographic Institution, a business which was important to the development of photography in England in the 1850s, taking over the publication of The Photographic Album in 1853. Cundall published Delamotte's The Practice of Photography and Progress of the Crystal Palace at Sydenham as well as his own The Photographic Primer, and Twenty Views in Gloucestershire. Robert Howlett entered into partnership with Cundall around 1855, until his death in 1858. The firm (Its name changed from Cundall, Howlett & Co. (later Cundall, Howlett & Downes, then Cundall, Downes & Co.) produced cartes-de-visite as well as larger photographs, and publications. At the end of the 1850s they had three studios. In the 1860s the firm, listed as Cundall & Fleming, was producing a series of art books illustrated by photographs after engravings. Cundall continued to publish until his death in 1875, turning to the autotype process for illustrations after 1870. Cundall was himself a photographer who made both portraits and landscape views, and a member of the Photographic Society of London.]

BOOKS

C957 Cundall, Joseph. The Photographic Primer: for the Use of Beginners in the Collodion Process. Illustrated with a Facsimile of a Photographic Picture of Birds, showing the Difference of Tone produced by various colours. London: Photographic Institute, 1854. 32 pp. illus. [2nd ed. (1856), Sampson Low & Son.]

C958 Cundall, Joseph. Twenty Views in Gloucestershire. London: Photographic Institute, 1854. n. p. 20 b & w.

C959 A Series of Historical Portraits selected from the National Portrait Exhibition in 1866. Photographed from the Original Paintings by

Joseph Cundall. London: Arundel Society, 1866. n. p. 964 b & w. [Photographic reproductions of works of art.]

C960 Duplessis, Georges. *The Wonders of Engraving, ...Illustrated with Ten Reproductions in Autotype; and Thirty-Four Wood Engravings,* by P. Sellier. London: Sampson Low, Son and Marston, 1871. x, 338 pp. 9 l. of plates. 34 illus. [9 plates by Cundall, of engravings.]

C961 McLean, Ruari. *Joseph Cundall: A Victorian Publisher. Notes on His Life and a Checklist of His Books.* Dollar, Scotland: Private Library Association, 1976. n. p.

PERIODICALS

C962 "The Graphic Society." ATHENAEUM no. 1050 (Dec. 11, 1847): 1278. [Note that Cundall contributing landscape calotypes at the 1st meeting of the 16th session of the Graphic Society.]

C963 "The Graphic Society." ATHENAEUM no. 1063 (Mar. 11, 1848): 274. [Note of three calotype specimens shown and favorably received at the fourth meeting of the Graphic Society.]

C964 Cundall, Joseph. (Polytechnic Institute). "Twenty views in Gloucestershire." ATHENAEUM no. 1406 (Oct. 7, 1854): 1200.

C965 Cundall, Joseph. (Polytechnic Institute). "Photographic Views: 1. Hastings Castle, 2. Hastings Cliff, 3. Hastings Boatman." ATHENAEUM no. 1406 (Oct. 7, 1854): 1200-1201. [Reviews.]

C966 "Photography: Cundall's Photographic Primer and Views of Hastings." HUMPHREY'S JOURNAL 6, no. 15 (Nov. 15, 1854): 227. [From "Notes & Queries." Cundall, of the Photographic Institution, New Bond St. (London) published "The Photographic Primer for the Use of Beginners..." and views of Hasting, England.]

C967 Cundall, Joseph. "The Photographic Primer. For the Use of Beginners in the Collodion Process." PHOTOGRAPHIC AND FINE ART JOURNAL 7, no. 12 (Dec. 1854): 353-357. illus. [From the book.]

C968 "Reviews." ATHENAEUM no. 1439 (May 26, 1855): 618. [Bk. rev.: "The Photographic Primer," by J. Cundall. (Cundall).]

C969 "Her Majesty's Inspection of the Wounded Troops at Chatham." ILLUSTRATED LONDON NEWS 27, no. 753 (July 21, 1855): 69. 4 illus. [Group portraits. "...photographs...were executed by Mr. Joseph Cundall, of the firm of Cundall & Howlett, Photographic Institution, New Bond Street."]

C970 Portrait. Woodcut engraving credited "From a photograph by Cundall." ILLUSTRATED LONDON NEWS 28, (1856) ["Peter Cunningham, F.S.A." 28:* (Feb. 23, 1856): 205.]

CURENIUS & QUIST. (STOCKHOLM, SWEDEN)

C971 Portrait. Woodcut engraving credited "From a photograph by Curenius & Quist." ILLUSTRATED LONDON NEWS 61, (1872) ["Oscar II, King of Sweden and Norway." 61:1726 (Oct. 5, 1872): 316.]

CURRIER, FRANK F. (OMAHA, NB)

C972 "Table Talk." PHILADELPHIA PHOTOGRAPHER 13, no. 155 (Nov. 1876): 350-351. [Letters from A. J. Beals (Gold Hill, NV), "32 years in the business," and Frank F. Currier (Omaha, NB).]

C973 "Editor's Table." PHILADELPHIA PHOTOGRAPHER 14, no. 157 (Jan. 1877): 32. [Note of Frank F. Currier's work, praised in Omaha papers.]

C974 "Iowa. - Partial Destruction by a Cyclone, August 25th, of the Union Pacific Railroad Bridge, Connecting Council Bluffs with Omaha. - Photo by F. F. Currier, Omaha." FRANK LESLIE'S ILLUSTRATED NEWSPAPER 45, no. 1147 (Sept. 22, 1877): 45. 1 illus.

CURTIS, EDWARD. (USA)

C975 Curtis, Edward, Asst. Surgeon, U. S. Army. "The Des Moines Eclipse Expedition." PHILADELPHIA PHOTOGRAPHER 6, no. 69 (Sept. 1869): 309-310.

C976 "Editor's Table: Reports of the Total Eclipse of the Sun of August 7th, 1869." PHILADELPHIA PHOTOGRAPHER 7, no. 75 (Mar. 1870): 95. [Report of the various parties observing the eclipse, with Dr. Curtis's photographs of the eclipse.]

CURTIS, GEORGE E. (1830-1910) (USA)

C977 "George E. Curtis Dies at His Home." DAILY CATARACT JOURNAL (NIAGARA FALLS, NY) (Dec. 17, 1910): 1.

C978 "Geo. E. Curtis Died Last Night." NIAGARA FALLS GAZETTE (NIAGARA FALLS, NY) (Dec. 17, 1910): 1.

C979 "George Curtis Left No Will." NIAGARA FALLS GAZETTE (NIAGARA FALLS, NY) (Dec. 30, 1910): 1.

CURTISS, EDWARD R. (1836-) (USA)

C980 "'Old Abe' - Eagle of the Eighth Wisconsin Volunteers." HARPER'S WEEKLY 10, no. 506 (Sept. 15, 1866): 580. 1 illus.

CUSSANS, JOHN E.

C981 Cussans, John E. "The Past and Future of Photography." HUMPHREY'S JOURNAL OF PHOTOGRAPHY, AND THE ALLIED ARTS AND SCIENCES 17, no. 1 (May 1, 1865): 6-9.

C982 Cussans, John F. "Concerning Backgrounds." AMERICAN JOURNAL OF PHOTOGRAPHY AND THE ALLIED ARTS & SCIENCES n. s. vol. 7, no. 18 (Mar. 15, 1865): 413-416. [From "Photo. News."]

C983 Cussans, John F. "Concerning Backgrounds." HUMPHREY'S JOURNAL OF PHOTOGRAPHY, AND THE ALLIED ARTS AND SCIENCES 16, no. 21 (Mar. 1, 1865): 327-329.

C984 Cussans, John E. "Art and Photographic Artists." HUMPHREY'S JOURNAL OF PHOTOGRAPHY, AND THE ALLIED ARTS AND SCIENCES 17, no. 5 (July 1, 1865): 75-78. [From "Photo. News."]

CUTTING & BOWDOIN. (BOSTON, MA)

C985 "Ambrotype Likenesses." PHOTOGRAPHIC AND FINE ART JOURNAL 8, no. 6 (June 1855): 167. [From "Boston Atlas."]

C986 Portrait. Woodcut engraving, credited "From an ambrotype by Cutting & Bowdoin, 49 Tremont St., Boston, MA." BALLOU'S PICTORIAL DRAWING-ROOM COMPANION [GLEASON'S] 10, (1856) ["Benjamin P. Shillaber, Esq.- Alias Mrs. Ruth Partington." 10:257 (June 7, 1856): 364.]

CUTTING & BRADFORD. (BOSTON, MA)

C987 "Photo-Lithography of Messrs. L. H. Bradford & Co." PHOTOGRAPHIC AND FINE ART JOURNAL 11, no. 3 (Mar. 1858): frontispiece, 93. [Portrait of J. A. Cutting in photolithography.]

C988 "Photolithography." HUMPHREY'S JOURNAL OF PHOTOGRAPHY, AND THE ALLIED ARTS AND SCIENCES 10, no.

7 (Aug. 1, 1858): 101-102. [Announcement of a rumor that Cutting, Bradford & Turner working on a photolithographic process.]

C989 "Our Illustration. IV. - A Photo-Lithographic Head." PHOTOGRAPHIC AND FINE ART JOURNAL 11, no. 8 (Aug. 1858): 245, plus unnumbered leaf. 1 b & w.

C990 "Carbon-Printing and Photo-Lithographs." PHOTOGRAPHIC AND FINE ART JOURNAL 11, no. 11 (Nov. 1858): 322-325. [From "Photo. Notes." Pouncy's carbon printing process. Cutting, Bradford & Turner's photo-lithographic process. Joseph Dixon's photoengraving process.]

C991 "Photo-Lithography, Specification of J. A. Cutting and J. H. Bradford." PHOTOGRAPHIC AND FINE ART JOURNAL 11, no. 11 (Nov. 1858): 337-338. [Text of patent specification.]

C992 "Photo-Lithography. Specifications of Cutting & Bradford's Patent." AMERICAN JOURNAL OF PHOTOGRAPHY AND THE ALLIED ARTS & SCIENCES n. s. vol. 1, no. 14 (Dec. 15, 1858): 219-221.

C993 Humphrey, S. D. "Important Announcement. A New Discovery! Photo-Lithography." HUMPHREY'S JOURNAL OF PHOTOGRAPHY, AND THE ALLIED ARTS AND SCIENCES 10, no. 19 (Feb. 1, 1859): 289-290. [Cutting & Bradford's photoengraving process. Two pages of photolithographs - one an engraving advertisement for L. H. Bradford & Co. (Boston), and the second a photographic view "Indian Hut, Vt.," from a photolithograph by Cutting & Turner are bound into the end of the volume. They probably were associated with this article or the article in the next issue.]

CUTTING & TURNER. (BOSTON, MA)
C994 "Personal & Art Intelligence: A Great Art Establishment." PHOTOGRAPHIC AND FINE ART JOURNAL 9, no. 12 (Dec. 1856): 383. [From "Boston [MA] Ledger."]

C995 Portraits. Woodcut engravings, credited "From a Photograph by Cutting & Turner." BALLOU'S PICTORIAL DRAWING-ROOM COMPANION [GLEASON'S] 12, (1857) ["Major Benjamin Perley Poore." 12:287 (Jan. 3, 1857): 12. "Master George W. Marsh, the Juvenile Comedian." (Nine portraits.) 12:287 (Feb. 28, 1857): 141, 144.]

C996 "Personal & Art Intelligence." PHOTOGRAPHIC AND FINE ART JOURNAL 10, no. 10 (Oct. 1857): 318-320. [A. A. Turner, of Cutting & Turner, nearly blinded by accident.]

C997 "Boston Evening Street Scene, at the Corner of Court and Brattle Streets." BALLOU'S PICTORIAL DRAWING-ROOM COMPANION [GLEASON'S] 13, no. 333 (Nov. 7, 1857): 289. 1 illus. ["Mr. Homer has drawn for us a spirited and graphic picture... Across the way, in Tremont Row, we see Cutting & Turner's great daguerreotype establishment, ...a group collected around one of Alvan Clark's fine telescopes ...gazing at the moon."]

C998 "Our Illustrations." PHOTOGRAPHIC AND FINE ART JOURNAL 11, no. 12 (Dec. 1858): frontispiece, unnumbered page, 384. 2 b & w. [2 photolithographs: one a view, one for architectural design, tipped-in. (Not in this copy.)]

CUTTING, JAMES AMBROSE see also CUTTING & BOWDOIN; CUTTING & TURNER.

CUTTING, JAMES AMBROSE. (1814-1867) (USA)
[An inventor, who secured a patent for a beehive design in 1842. He was first listed as a daguerreotypist in the Boston city directories in 1853. In 1854 he secured patents for three modifications of the collodion process, including the ambrotype variant, which were basic to the practice of the process. His patents were upheld in the law courts for years, although a large body of evidence was brought forward that these modifications had been in common practice for many years before he patented them. One of his modifications, a bromide accelerator process, was essential to the production of paper photographs as well. The selling of rights to use these basic practices caused years of consternation, frustration, and divisiveness for the American photographic community. In 1858 Cutting formed a partnership with Lodowick H. Bradford to patent a photolithographic printing process, which was used in the 1860s. Cutting and Austin A. Turner were partners from 1857 through 1859. Cutting retired from photography in 1860. He owned a yacht from which he collected aquatic specimens which first he displayed at the "Aquarial Gardens" in Boston, another business concern which he partnered with H. D. Butler. These specimens were later acquired by P. T. Barnum in New York, NY. Cuttin was committed to the Worcester Hospital for the Insane in 1863, where he died on Aug. 12, 1867. And when Tomlinson, the new holder of the patents, attempted to continue the implementation of the patent rights it was finally defeated, but this experience had been so bitter to the photographic community that it was a major factor leading to the formation of the National Photographic Society.]

C999 Humphrey, S. D. "Editorial: A Yankee Sharper "Selling" Messrs. Cutting and Whipple's Processes, in the West." HUMPHREY'S JOURNAL 6, no. 12 (Oct. 1, 1854): 183. [Humphrey charges that an agent offered Cutting's process for a fee and also illegally offered to teach the paper process of Whipple.]

C1000 "Actinic Patents: Cutting's Patent for the Use of Balsam of Fir, Bromide of Potassium, Alcohol as a Displacing Agent, and Camphor in the Collodion Process." HUMPHREY'S JOURNAL 7, no. 1 (May 1, 1855): 9-11. [Excerpts of letters of patent.]

C1001 "Personal and Art Intelligence." PHOTOGRAPHIC AND FINE ART JOURNAL 8, no. 8 (Aug. 1855): 255-256. [Letter from Cutting's lawyer to G. N. Barnard, concerning prices for the use of his ambrotype patent.]

C1002 Root, M. A. "The Ambrotype Patent." PHOTOGRAPHIC AND FINE ART JOURNAL 8, no. 12 (Dec. 1855): 356.

C1003 Simons, M. P. "Ambrotype Patent: Gibbs vs. Simons." PHOTOGRAPHIC AND FINE ART JOURNAL 9, no. 1 (Jan. 1856): 27. [Simons challenged Cutting's ambrotype patent claim, won his case.]

C1004 Root, Marcus A. "Photographic Patents." PHOTOGRAPHIC AND FINE ART JOURNAL 9, no. 2 (Feb. 1856): 60-61.

C1005 "Ambrotype Patents." HUMPHREY'S JOURNAL 7, no. 20 (Feb. 15, 1856): 325-327. [Letters between James A. Cutting and the U.S. Patent Office.]

C1006 "Personal & Art Intelligence." PHOTOGRAPHIC AND FINE ART JOURNAL 9, no. 2 (Feb. 1856): 63-64. [Commentary on the Cutting patent controversy.]

C1007 Simons, M. P. "The Ambrotype Patent." PHOTOGRAPHIC AND FINE ART JOURNAL 9, no. 3 (Mar. 1856): 67. [Simons

(Richmond, VA) being threatened with a second court action by the Cutting patent holders.]

C1008 "Personal & Art Intelligence." PHOTOGRAPHIC AND FINE ART JOURNAL 9, no. 4 (Apr. 1856): 126-128. [Brady being sued by Cutting patent holders.]

C1009 "Personal & Art Intelligence." PHOTOGRAPHIC AND FINE ART JOURNAL 9, no. 5 (May 1856): 158-160. [Cutting patent controversy, with a letter from F. Langenheim.]

C1010 Simons, M. P. "The Cutting Patent." PHOTOGRAPHIC AND FINE ART JOURNAL 9, no. 6 (June 1856): 187. [Letter from Simons, stating that he has not yet been served with the threatened lawsuit.]

C1011 "The Ambrotype - Gibbs vs. Simons." PHOTOGRAPHIC AND FINE ART JOURNAL 9, no. 8 (Aug. 1856): 240. [Letter from A. Judson Crane, counsel for P. E. Gibbs, Richmond, VA suing Simons for ambrotype infringement.]

C1012 "Personal & Art Intelligence." PHOTOGRAPHIC AND FINE ART JOURNAL 9, no. 10 (Oct. 1856): 319-320. [A. A. Turner forming partnership with J. A. Cutting, to open a gallery in Boston; more comment on Cutting patent.]

C1013 Simons, M. P. "Balsam Patent." PHOTOGRAPHIC AND FINE ART JOURNAL 9, no. 11 (Nov. 1856): 349-350.

C1014 "The Ambrotype Patent Case." PHOTOGRAPHIC AND FINE ART JOURNAL 10, no. 2 (Feb. 1857): 56.

C1015 "Personal & Art Intelligence." PHOTOGRAPHIC AND FINE ART JOURNAL 10, no. 2 (Feb. 1857): 62-64. [Cutting & Rehn suing F. Keeler; Brady.]

C1016 "Ambrotypes; The State Courts have no jurisdiction over cases growing out of a Patent." PHOTOGRAPHIC AND FINE ART JOURNAL 10, no. 3 (Mar. 1857): 77-78. [Text of decree, read before Judge Duer.]

C1017 "Correspondence upon Cutting's Patents." HUMPHREY'S JOURNAL 8, no. 21 (Mar. 1, 1857): 326-328. [Letters from M. A. Root, H. Pollock and James A. Cutting.]

C1018 "Photo. Lithography of Messrs. Litl. Bradford & Co." PHOTOGRAPHIC AND FINE ARTS JOURNAL 11, no. 3 (Mar. 1858): 93, plus frontispiece. [Portrait of J. A. Cutting in photolithography.]

C1019 "Our Illustration. IV. - A Photo-Lithographic Head." PHOTOGRAPHIC AND FINE ART JOURNAL 11, no. 8 (Aug. 1858): 245, plus unnumbered leaf. 1 b & w.

C1020 "Personal & Art Intelligence." PHOTOGRAPHIC AND FINE ART JOURNAL 11, no. 11 (Nov. 1858): 350. [Cutting patent copyright battle. Discusses Abraham Bogardus's role.]

C1021 "Personal & Art Intelligence." PHOTOGRAPHIC AND FINE ART JOURNAL 11, no. 11 (Nov. 1858): 350-352. [Tomlinson vs. Bogardus on Cutting patent; confusions with the photographers of Albany, NY; Fitzgibbon; Louis Seebohm (Dayton, OH); others mentioned.]

C1022 "Personal & Art Intelligence." PHOTOGRAPHIC AND FINE ART JOURNAL 11, no. 12 (Dec. 1858): 383-384. [Cutting patent sustained.]

C1023 "Ambrotypes; The State Courts have no jurisdiction over causes growing out of a Patent. Superior Court-Before Judge Duer." AMERICAN JOURNAL OF PHOTOGRAPHY AND THE ALLIED ARTS & SCIENCES n. s. vol. 1, no. 16 (Jan. 15, 1859): 252-256.

C1024 Seely, Charles A. "The Cutting Patents Sustained-Breakers Ahead!" AMERICAN JOURNAL OF PHOTOGRAPHY AND THE ALLIED ARTS AND SCIENCES n. s. vol. 1, no. 15 (Jan. 1, 1859): 237-239. [Case of Tomlinson vs. Bogardus. Bogardus lost.]

C1025 Seely, Charles A. "The Cutting Patents." AMERICAN JOURNAL OF PHOTOGRAPHY AND THE ALLIED ARTS AND SCIENCES n. s. vol. 1, no. 16 (Jan. 15, 1859): 256-257.

C1026 Garbanati, H. "On the Use of Bromine in Collodion. The Cutting Patent." AMERICAN JOURNAL OF PHOTOGRAPHY AND THE ALLIED ARTS AND SCIENCES n. s. vol. 1, no. 17 (Feb. 1, 1859): 265-268.

C1027 Campbell, W. "The Patents." AMERICAN JOURNAL OF PHOTOGRAPHY AND THE ALLIED ARTS AND SCIENCES n. s. vol. 1, no. 18 (Feb. 15, 1859): 287-288.

C1028 D. B. "Cutting's Patent." AMERICAN JOURNAL OF PHOTOGRAPHY AND THE ALLIED ARTS AND SCIENCES n. s. vol. 1, no. 18 (Feb. 15, 1859): 289-290.

C1029 Garbanati, H. "The Cutting Patent again." AMERICAN JOURNAL OF PHOTOGRAPHY AND THE ALLIED ARTS AND SCIENCES n. s. vol. 1, no. 18 (Feb. 15, 1859): 280-282.

C1030 "Letters on the Bromide Patents." AMERICAN JOURNAL OF PHOTOGRAPHY AND THE ALLIED ARTS AND SCIENCES n. s. vol. 1, no. 19 (Mar. 1, 1859): 298-301.

C1031 Tompkins, H. H. "The Cutting Bromide Patent." PHOTOGRAPHIC AND FINE ART JOURNAL 12, no. 1 (June 1859): 5.

C1032 "Personal and Art Intelligence." PHOTOGRAPHIC AND FINE ART JOURNAL 12, no. 1 (June 1859): 31-32. [Cutting patent.]

C1033 "The Cutting Patents." PHOTOGRAPHIC AND FINE ART JOURNAL 12, no. 2 (July 1859): 44.

C1034 "The Cutting patents in Court: Tomlinson vs. Fredericks." AMERICAN JOURNAL OF PHOTOGRAPHY AND THE ALLIED ARTS AND SCIENCES n. s. vol. 2, no. 3 (July 1, 1859): 40-42.

C1035 "The Cutting Patents." HUMPHREY'S JOURNAL OF PHOTOGRAPHY, AND THE ALLIED ARTS AND SCIENCES 11, no. 5 (July 1, 1859): 65-67. [History of the patent, excerpts from newspapers, letters from C. D. Fredericks, etc.]

C1036 "Personal & Art Intelligence." PHOTOGRAPHIC AND FINE ART JOURNAL 12, no. 2 (July 1859): 63-64. [Description of court activities during the trial of Wm. Tomlinson vs. C. D. Fredericks over the Cutting patent.]

C1037 Snelling, H. H. "The Cutting Patents. Meeting of New-York Photographers." PHOTOGRAPHIC AND FINE ART JOURNAL 13, no. 2 (Feb. 1860): 46-47. [Indignation meeting of New York photographers against the Cutting ambrotype patent. Gives history of the patent, history of the suits launched against photographers, etc.]

Group determined to fight the patent. C. A. Seely elected Chairman, H. H. Snelling Secretary.]

C1038 "The Balsam and Bromide Patents." HUMPHREY'S JOURNAL OF PHOTOGRAPHY, AND THE ALLIED ARTS AND SCIENCES 11, no. 20 (Feb. 15, 1860): 305-307. [Brady, Gurney, Lawrence, Bogardus paid Tomlinson (representative of Cutting). Fredericks fought the claim. Meetings held, call for support for Fredericks.]

C1039 "Editorial Matters." PHOTOGRAPHIC AND FINE ART JOURNAL 13, no. 2 (Feb. 1860): 56. [Cutting patent.]

C1040 "The Cutting Patents Denounced! The New York Photographers assembled for defense! Profound excitement!" AMERICAN JOURNAL OF PHOTOGRAPHY AND THE ALLIED ARTS AND SCIENCES n. s. vol. 2, no. 19 (Mar. 1, 1860): 289-295.

C1041 "The Contested Patent of James A. Cutting of Boston, Mass. Letters patent, No. 11, 266 dated July 11, 1854." AMERICAN JOURNAL OF PHOTOGRAPHY AND THE ALLIED ARTS AND SCIENCES n. s. vol. 2, no. 19 (Mar. 1, 1860): 296-297. [Text of patent.]

C1042 "The Cutting Patents." PHOTOGRAPHIC AND FINE ART JOURNAL 13, no. 3 (Mar. 1860): 89-90. [Committee meeting to fight the Cutting patent, seeking funds, etc.]

C1043 "The Balsam and Bromide Patents." HUMPHREY'S JOURNAL OF PHOTOGRAPHY, AND THE ALLIED ARTS AND SCIENCES 11, no. 21 (Mar. 1, 1860): 323-324.

C1044 "Origin of Bromides. Mr. Cutting's claim examined. - Synopsis of Evidence given by Mr. Ceileur in the Suit of Tomlinson vs. Fredericks. - France and America contrasted." HUMPHREY'S JOURNAL OF PHOTOGRAPHY, AND THE ALLIED ARTS AND SCIENCES 11, no. 22-23 (Mar. 15 - Apr. 1, 1860): 339-341, 353-355.

C1045 "Editorial Matters." PHOTOGRAPHIC AND FINE ART JOURNAL 13, no. 3 (Mar. 1860): 92. [Cutting patent.]

C1046 "Resistance to the Cutting Patents. [circular.]" HUMPHREY'S JOURNAL OF PHOTOGRAPHY, AND THE ALLIED ARTS AND SCIENCES 11, no. 23 (Apr. 1, 1860): 355-357. [List of a score or so of photographers, with addresses, from around the country who are proposing to resist the Cutting Patent.]

C1047 "Editorial Matters." PHOTOGRAPHIC AND FINE ART JOURNAL 13, no. 4 (Apr. 1860): 115-116. [Cutting patent, including a list of contributors to fund.]

C1048 Anthony, Edward, Treasurer of the Cutting Defense Fund. "Letter." AMERICAN JOURNAL OF PHOTOGRAPHY AND THE ALLIED ARTS AND SCIENCES n. s. vol. 2, no. 24 (May 15, 1860): 372-375. [Lists of contributors to the fund.]

C1049 Asquith, Thomas. "The Cutting Patent." PHOTOGRAPHIC AND FINE ART JOURNAL 13, no. 5 (May 1860): 140-141. [Also "Treasurer's Second Report" on p. 141, which is a list of contributors to fight the patent.]

C1050 "The Frederick's Fund." HUMPHREY'S JOURNAL OF PHOTOGRAPHY, AND THE ALLIED ARTS AND SCIENCES 12, no. 2 (May 15, 1860): 17-19.

C1051 Asquith, Thomas. "The Patent Case." HUMPHREY'S JOURNAL OF PHOTOGRAPHY, AND THE ALLIED ARTS AND SCIENCES 12, no. 3 (June 1, 1860): 43-44.

C1052 Fitzgibbon, J. H. "The Fredericks' Fund - A Letter from the Other Side." HUMPHREY'S JOURNAL OF PHOTOGRAPHY, AND THE ALLIED ARTS AND SCIENCES 12, no. 3 (June 1, 1860): 38-39.

C1053 "The Cutting Patents. Treasurer's Third Report." PHOTOGRAPHIC AND FINE ART JOURNAL 13, no. 6 (June 1860): 176-177. [Includes list of contributors. Letters from W. H. Harrington, Tucker & Perkins, Thomas Asquith.]

C1054 "Assistance." "The Fredericks' Fund. - Reply to Mr. Fitzgibbon's Letter." HUMPHREY'S JOURNAL OF PHOTOGRAPHY, AND THE ALLIED ARTS AND SCIENCES 12, no. 4 (June 15, 1860): 55-56.

C1055 Asquith, Thos. "The Cutting Patents." AMERICAN JOURNAL OF PHOTOGRAPHY AND THE ALLIED ARTS & SCIENCES n. s. vol. 3, no. 1 (June 1, 1860): 8-10. [Asquith on committee collecting money to fight Cutting patent.]

C1056 "The Cutting Patents. Treasurer's Third Report." PHOTOGRAPHIC AND FINE ART JOURNAL 13, no. 6 (June 1860): 176-177. [Includes list of contributors. Letters from W. H. Harrington, Tucker & Perkins, Thomas Asquith.]

C1057 Fitzgibbon, J. H. "The Fredericks' Fund." HUMPHREY'S JOURNAL OF PHOTOGRAPHY, AND THE ALLIED ARTS AND SCIENCES 12, no. 5 (July 1, 1860): 71-72.

C1058 Gage, F. B. "The Patent Case. - Reply to Mr. Fitzgibbon." HUMPHREY'S JOURNAL OF PHOTOGRAPHY, AND THE ALLIED ARTS AND SCIENCES 12, no. 6 (July 15, 1860): 84-85.

C1059 "Assistance." "The Fredericks' Fund." HUMPHREY'S JOURNAL OF PHOTOGRAPHY, AND THE ALLIED ARTS AND SCIENCES 12, no. 6 (July 15, 1860): 90-91.

C1060 Asquith, Thomas. "The Frederick's Patent Case." HUMPHREY'S JOURNAL OF PHOTOGRAPHY, AND THE ALLIED ARTS AND SCIENCES 12, no. 7 (Aug. 1, 1860): 98-99.

C1061 "The Fredericks' Fund." HUMPHREY'S JOURNAL OF PHOTOGRAPHY, AND THE ALLIED ARTS AND SCIENCES 12, no. 7 (Aug. 1, 1860): 104. [$710.25 raised.]

C1062 "The Fredericks' Fund. Reply to Mr. Gage. - Mr. Fitzgibbon looked after." HUMPHREY'S JOURNAL OF PHOTOGRAPHY, AND THE ALLIED ARTS AND SCIENCES 12, no. 8 (Aug. 15, 1860): 113-114.

C1063 Gage, F. B. "The Cutting Patents. - Another Item from Mr. Gage." HUMPHREY'S JOURNAL OF PHOTOGRAPHY, AND THE ALLIED ARTS AND SCIENCES 12, no. 8 (Aug. 15, 1860): 115-116.

C1064 Fitzgibbon, J. H. "A Reply from Mr. Fitzgibbon to 'Assistance.'" HUMPHREY'S JOURNAL OF PHOTOGRAPHY, AND THE ALLIED ARTS AND SCIENCES 12, no. 8 (Aug. 15, 1860): 116-117.

C1065 "More from the Opposition." HUMPHREY'S JOURNAL OF PHOTOGRAPHY, AND THE ALLIED ARTS AND SCIENCES 12, no. 10 (Sept. 15, 1860): 145-146.

C1066 Davie, D. D. T. "The Cutting Patents. Letter from an old artist. - Mr. Frederick's motives called to question. - Advice to operators. - Will Mr. Tomlinson succeed?" HUMPHREY'S JOURNAL OF PHOTOGRAPHY, AND THE ALLIED ARTS AND SCIENCES 12, no. 10 (Sept. 15, 1860): 147-149.

C1067 Masury, Samuel. "The Cutting Patents." HUMPHREY'S JOURNAL OF PHOTOGRAPHY, AND THE ALLIED ARTS AND SCIENCES 12, no. 11 (Oct. 1, 1860): 161-163.

C1068 Masury, Samuel. "The Cutting Patents." HUMPHREY'S JOURNAL OF PHOTOGRAPHY, AND THE ALLIED ARTS AND SCIENCES 12, no. 11 (Oct. 1, 1860): 161-163.

C1069 "The Cutting Patents." HUMPHREY'S JOURNAL OF PHOTOGRAPHY, AND THE ALLIED ARTS AND SCIENCES 12, no. 16 (Dec. 15, 1860): 243.

C1070 "The Cutting Patents - Who Paid for Fredericks' Gallery?" AMERICAN JOURNAL OF PHOTOGRAPHY AND THE ALLIED ARTS & SCIENCES n. s. vol. 4, no. 9 (Oct. 1, 1861): 210. [Editorial reply to letter, claiming the Fredericks had misused the Cutting Defense Fund.]

C1071 Davie, D. D. T. "Tomlinson vs. Fredericks & Co." HUMPHREY'S JOURNAL OF PHOTOGRAPHY, AND THE ALLIED ARTS AND SCIENCES 14, no. 7 (Aug. 1, 1862): 56-57.

C1072 "'Opposition to the Cutting Patents!'" and "The Cutting Patent Card of C. D. Fredericks & Co." HUMPHREY'S JOURNAL OF PHOTOGRAPHY, AND THE ALLIED ARTS AND SCIENCES 17, no. 14 (Nov. 15, 1865): 217-219. [Fredericks published a letter stating that he no longer felt it possible to legally oppose the Cutting patent. A note, signed by the Scoville Mfg. Co.; E. & H. T. Anthony & Co.; Charles D. Fredericks & Co.; Willard & Co.; O. S. Follett; and Wilcox & Graves all assert the same conclusion.]

C1073 Fredericks, Charles D. & Co. "The Cutting Patent Card from C. D. Fredericks & Co." AMERICAN JOURNAL OF PHOTOGRAPHY AND THE ALLIED ARTS & SCIENCES n. s. vol. 8, no. 10 (Nov. 15, 1865): 235-236.

C1074 Seely, Charles A. "239-240" AMERICAN JOURNAL OF PHOTOGRAPHY AND THE ALLIED ARTS & SCIENCES n. s. vol. 8, no. 10 (Nov. 15, 1865): 239-240. [Discusses the collapse of opposition to the Cutting Patent.]

C1075 Fredericks, Charles D. & Co. "The Cutting Patent Card from C. D. Fredericks & Co." AMERICAN JOURNAL OF PHOTOGRAPHY AND THE ALLIED ARTS & SCIENCES n. s. vol. 8, no. 10 (Nov. 15, 1865): 235-236.

C1076 "Resistance to the Cutting Patents." HUMPHREY'S JOURNAL OF PHOTOGRAPHY, AND THE ALLIED ARTS AND SCIENCES 17, no. 15 (Dec. 1, 1865): 235-237. [Meeting of about 150 photographers in New York, NY, to see if any resistance possible.]

C1077 "The Cutting Patents. - Second Meeting and Third Meeting." HUMPHREY'S JOURNAL OF PHOTOGRAPHY, AND THE ALLIED ARTS AND SCIENCES 17, no. 16 (Dec. 15, 1865): 248-253. [Tumultuous meetings, out of which was formed "a Society, by means of which they would be better enabled to defeat the Cutting-Bromide and Ormsbee & Wing's Multiplying Camera Box Patents..." (This led to formation of first national photographic organization.).]

C1078 "Opposition to Patents - The New York Photographers in Council." AMERICAN JOURNAL OF PHOTOGRAPHY AND THE ALLIED ARTS & SCIENCES n. s. vol. 8, no. 11 (Dec. 1, 1865): 259-261. [Angry meeting. Burgess, W. Peale, L. D. Fredericks and Dr. Fredericks (brothers of C. D. Fredericks); T. L. Matthews; Brazier; Matthews; Groetcloss; Taylor; Pratt; Wood; Balch; Heimburg; Douglass; Burns; Talbott; T. Johnson; Kuhns; Hollenbeck; Seely, others at meeting formed to offer resistance to the Cutting patents. Further commentary on pp. 263-264.]

C1079 "A Blow at American Photographers - The 'Cutting Bromide Patent.'" BRITISH JOURNAL OF PHOTOGRAPHY 12, no. 292 (Dec. 8, 1865): 618-619.

C1080 "The 'Cutting Bromide Patent.'" PHILADELPHIA PHOTOGRAPHER 3, no. 25 (Jan. 1866): 10-12.

C1081 "The Cutting Patents. - Fourth Meeting." HUMPHREY'S JOURNAL OF PHOTOGRAPHY, AND THE ALLIED ARTS AND SCIENCES 17, no. 17 (Jan. 1, 1866): 265-266. [The "Photographer's Protective Union of the Union States" met at the Cooper Institute on Dec. 19, to fight the Cutting Patent. Article includes an attack on Seely (ed. of the "Am. J. of Photo.).]

C1082 Ferris, C. "The Bromide Patent." AMERICAN JOURNAL OF PHOTOGRAPHY AND THE ALLIED ARTS & SCIENCES n. s. vol. 8, no. 14 (Jan. 15, 1866): 315-318. [Angry letter demanding to know why Fredericks & Co. didn't defend the court suit more vigorously, with questions about where the Fredericks' defense monies went. Elicits a response from Seely describing the defense that was attempted, the results, and the final decision to give in.]

C1083 Seely, Charles A. "Editorial Department." AMERICAN JOURNAL OF PHOTOGRAPHY AND THE ALLIED ARTS & SCIENCES n. s. vol. 8, no. 13 (Jan. 1, 1866): 310-312. [Discusses anger in photographic community that the Cutting patents upheld. Discusses other processes, etc.]

C1084 Ladd, Joseph H. "The Cutting Patent." HUMPHREY'S JOURNAL OF PHOTOGRAPHY, AND THE ALLIED ARTS AND SCIENCES 17, no. 21 (Mar. 1, 1866): 321-324. [Long detailed argument claiming that the patent cannot be defeated.]

C1085 "The Cutting Patent vs. the Government." HUMPHREY'S JOURNAL OF PHOTOGRAPHY, AND THE ALLIED ARTS AND SCIENCES 17, no. 21 (Mar. 1, 1866): 324.

C1086 "The Cutting Patent in Cincinnati." AMERICAN JOURNAL OF PHOTOGRAPHY AND THE ALLIED ARTS & SCIENCES n. s. vol. 8, no. 18 (Mar. 15, 1866): 426-430. [Detailed recount of a protest meeting of nearly all Cincinnati photographers.]

C1087 "The Cutting Patent." PHILADELPHIA PHOTOGRAPHER 3, no. 28 (Apr. 1866): 109-110. [History of the patent, including a letter from Titian A. Peale, describing the history of the patent grant, etc.]

C1088 "The Bromide Question. - Beware of Humbug, by A St. Louis Photographer." AMERICAN JOURNAL OF PHOTOGRAPHY AND THE ALLIED ARTS & SCIENCES n. s. vol. 8, no. 20 (Apr. 15, 1866): 479-480.

C1089 Dennis, M. J., Secretary. "The Bromide Patent: Results of the Photographic Meeting in Cincinnati." HUMPHREY'S JOURNAL OF PHOTOGRAPHY, AND THE ALLIED ARTS AND SCIENCES 18, no. 1 (May 1, 1866): 14.

C1090 "The Bromide Patent." HUMPHREY'S JOURNAL OF PHOTOGRAPHY, AND THE ALLIED ARTS AND SCIENCES 18, no. 2 (May 15, 1866): 26. [Some history from 1850s, criticism of Ed. L. Wilson of "Philadelphia Photographer" for keeping the issue alive.]

C1091 "Bromide Again!!" PHILADELPHIA PHOTOGRAPHER 3, no. 29 (May 1866): 146-148. [More on the Cutting patent.]

C1092 "The Bromide Patent." HUMPHREY'S JOURNAL OF PHOTOGRAPHY, AND THE ALLIED ARTS AND SCIENCES 18, no. 4 (June 15, 1866): 58-59. [From the "Chicago Evening Journal." Report of meeting of the Northwest Photographic Society to challenge the patent. Includes a letter from James R. Hayden, Pres. of the Society and a letter from John Carbutt.]

C1093 "Mr. Hubbard's Letter." HUMPHREY'S JOURNAL OF PHOTOGRAPHY, AND THE ALLIED ARTS AND SCIENCES 18, no. 7 (Aug. 1, 1866): 106. ["We publish in this number a most interesting letter from the Assignee of the Cutting Patent,...as to whether infringers will be prosecuted."]

C1094 Hubbard, T. H., Assignee Bromide Patent. "The Bromide Patent. - A Letter from Mr. Hubbard." HUMPHREY'S JOURNAL OF PHOTOGRAPHY, AND THE ALLIED ARTS AND SCIENCES 18, no. 7 (Aug. 1, 1866): 109-111.

C1095 Hubbard, T. H. "Special to the Photographers from the Assignee of the Bromide Patent." AMERICAN JOURNAL OF PHOTOGRAPHY AND THE ALLIED ARTS & SCIENCES n. s. vol. 9, no. 1 (Sept. 1, 1866): 11-14.

C1096 "The Bromide Patent - Beware of Humbug." PHILADELPHIA PHOTOGRAPHER 3, no. 33 (Sept. 1866): n.p., 2 pp. following p. 288. [Insert from T. H. Hubbard, "General Assignee Bromide Patent."]

C1097 Sinclair, A. "The Bromide Patent. - Permanent Toning Bath." AMERICAN JOURNAL OF PHOTOGRAPHY, AND THE ALLIED ARTS AND SCIENCES n. s. vol. 9, no. 3 (Oct. 1, 1866): 68-69.

C1098 "Once More the 'Bromide Question,' French Formula, Etc." PHILADELPHIA PHOTOGRAPHER 3, no. 34 (Oct. 1866): 323-324. [Includes a letter from T. H. Hubbard.]

C1099 "Zephir," (St. Paul, MN) "The Bromide Patent." AMERICAN JOURNAL OF PHOTOGRAPHY, AND THE ALLIED ARTS AND SCIENCES n. s. vol. 9, no. 6 (Nov. 15, 1866): 128-130. [Protests.]

C1100 "More about Bromide." PHILADELPHIA PHOTOGRAPHER 3, no. 35 (Nov. 1866): 350-351. [Includes a letter from H. Le Vasseur.]

C1101 Seely, Charles A. "The Bromide Patent. Explanatory and Personal." AMERICAN JOURNAL OF PHOTOGRAPHY, AND THE ALLIED ARTS AND SCIENCES n. s. vol. 9, no. 6 (Nov. 15, 1866): 135-138. [Gives history of the struggle against the patent and his role, as editor of the "Am. J. of Photography," in that struggle. States how it seems impossible to keep opposing the patent at this time, as so many others have made accommodations with the patentee.]

C1102 "The Bromide Patent in California." HUMPHREY'S JOURNAL OF PHOTOGRAPHY, AND THE ALLIED ARTS AND SCIENCES 18, no. 23 (Apr. 1, 1867): 363. [Report of the opinion of Judge Deady, of the U. S. Circuit Court, San Francisco, Feb. 27 in "The Photographers Association against Robertson, et al."]

C1103 "The Cutting Patents!" HUMPHREY'S JOURNAL OF PHOTOGRAPHY, AND THE ALLIED ARTS AND SCIENCES 19, no. 9 (Sept. 1, 1867): 138. [Note that judges in Maine sustained the patent.]

C1104 "The Cutting Bromide Patent Sustained." HUMPHREY'S JOURNAL OF PHOTOGRAPHY, AND THE ALLIED ARTS AND SCIENCES 19, no. 12 (Oct. 15, 1867): 177-179. [Decision of Maine Court.]

C1105 "The Bromide Patent." HUMPHREY'S JOURNAL OF PHOTOGRAPHY, AND THE ALLIED ARTS AND SCIENCES 19, no. 13 (Nov. 1, 1867): 208.

C1106 Dussauce, H., Prof. "The Cutting Patent." HUMPHREY'S JOURNAL OF PHOTOGRAPHY, AND THE ALLIED ARTS AND SCIENCES 19, no. 16 (Dec. 15, 1867): 243-244. [Dussauce (from France) wrote a letter stating that Cutting's claims were incorrect. This reprinted with the comment that everyone already knows that, but the courts upholding the claim anyway.]

C1107 Cutting, James. "The Bromide Patent." HUMPHREY'S JOURNAL OF PHOTOGRAPHY, AND THE ALLIED ARTS AND SCIENCES 19, no. 16 (Dec. 15, 1867): 244-245. ["At the request of many subscribers, we republish the Letters Patent granted to James A. Cutting for the use of the Bromides in collodion."]

C1108 Dussauce, H. "The Bromide Patent." HUMPHREY'S JOURNAL OF PHOTOGRAPHY, AND THE ALLIED ARTS AND SCIENCES 19, no. 17 (Jan. 1, 1868): 262-263. [Dussauce stated he knows of a book giving use of bromide published before the issuance of the patent. The editor responded that all this was known, but that the courts ruled in favor of the patent anyway.]

C1109 "The Mass Convention - The Bromide Patent - Taxation." HUMPHREY'S JOURNAL OF PHOTOGRAPHY, AND THE ALLIED ARTS AND SCIENCES 19, no. 23 (Apr. 1, 1868): 358-360. [Text of a circular, signed by J. W. Black, G. H. Loomis, Bendann Brothers, E. & H. T. Anthony & Co., A. Bogardus and others, calling for a large meeting of the photographic community to be held in New York, NY to form a national organization. "Cutting is dead; he died in a mad-house, and left no heirs....However that may be,...no one has any legal right to speak for him...but there is nothing like keeping a good look out..." This meeting led to the formation of the National Photographers Association.]

C1110 "More Patent Suits." HUMPHREY'S JOURNAL OF PHOTOGRAPHY, AND THE ALLIED ARTS AND SCIENCES 19, no. 23 (Apr. 1, 1868): 360. [Tomlinson, the holder of the Cutting Patent still suing Chamberlin, Vaughan and eight or ten others in New York, NY.]

C1111 "The Bromide Patent Defeated." HUMPHREY'S JOURNAL OF PHOTOGRAPHY, AND THE ALLIED ARTS AND SCIENCES 20, no. 7 (Aug. 1, 1868): 100-102.

C1112 "The Defeat of the Bromide Patent." PHILADELPHIA PHOTOGRAPHER 5, no. 56 (Aug. 1868): 249-250.

C1113 Wilson, Edward L. "Report of the Secretary of the National Photographic Convention, held in New York, April 7th & 8th, 1868." PHILADELPHIA PHOTOGRAPHER 5, no. 56 (Aug. 1868): 281-314. [First meeting was in opposition to the extension of the Cutting patent, the report deals with the trial testimony, etc.]

C1114 "The News of the Defeat." PHILADELPHIA PHOTOGRAPHER 5, no. 57 (Sept. 1868): 237-239. [Letters responding to the defeat of the Bromide patent.]

C1115 Newhall, Beaumont. "Ambrotype. A Short and Unsuccessful Career." IMAGE 7, no. 8 (Oct. 1958): 171-177. 6 b & w. 1 illus. [Invented by James A. Cutting, 1854. By 1862 ambrotypes hardly requested.]

CUYLER, BEN. (ROMEO, MI)

C1116 "Another Facetious Business Card." ANTHONY'S PHOTOGRAPHIC BULLETIN 3, no. 12 (Dec. 1872): 782. [Cuyler from Romeo, MI.]

D

DABBS, B. L. H. (1839-1899) (GREAT BRITAIN, USA)

D1 "Notes and News." PHOTOGRAPHIC TIMES 25, no. 692 (Dec. 21, 1894): 407. [Note that printing dept. of Dabbs, of Pittsburgh destroyed by fire, with loss of negatives.]

D2 "A 'Grand Prize' Picture." WILSON'S PHOTOGRAPHIC MAGAZINE 34, no. 486 (June 1897): 268-269. 1 b & w. [Portrait.]

D3 "Editor's Table: Fire." WILSON'S PHOTOGRAPHIC MAGAZINE 34, no. 486 (June 1897): 288. [New studio burned.]

D4 Dabbs, B. L. H. "A Veteran's Greeting to the Craft." WILSON'S PHOTOGRAPHIC MAGAZINE 35, no. 495 (Mar. 1898): 119-120. 9 b & w. [9 portraits on one panel, with letter.]

D5 "Obituary: B. L. H. Dabbs." WILSON'S PHOTOGRAPHIC MAGAZINE 37, no. 518 (Feb. 1900): 93-94. [Born in England in 1839, Dabbs came to the USA in his early youth. He opened a modest studio in Pittsburgh in the 1860s and worked diligently and well there for many years. Died Dec. 13, 1899.]

DADABOY, B. D.

D6 Furneaux, J. H., editor. *Glimpses of India; A Grand Photographic History of the Land of Antiquity, the Vast Empire of the East.* With 500 ...camera views...with full historical text. London: International Art Co., 1896. 544 pp. 500 b & w. [Photographic illustrations by Bourne & Shepherd, Lala Deen Dayal, Nicols & Co, Barton, Son & Co., and B. D. Dadaboy.]

DAFT, LEO. (TROY, NY)
BOOKS

D7 Mowbray, George M. *Tri-nitro-glycerin: As Applied to the Hoosac Tunnel, Submarine Blasting, &c.* by George M. Mowbray. North Adams, MA: Robinson, 1872. 97 pp. 14 l. of plates. [Original photographs.]

PERIODICALS

D8 Daft, Leo. "Photographing Electric Sparks." PHOTOGRAPHIC TIMES 5, no. 56 (Aug. 1875): 192-194. 4 illus.

D9 "Editor's Table." PHILADELPHIA PHOTOGRAPHER 13, no. 154 (Oct. 1876): 320. [Leo Daft (Troy, NY) created a pamphlet 'Notes on the Hudson,' to accompany 30 stereo views.]

DAGES & HARMAN.

D10 Cruikshank, Percy. *The Comic Adventures of the Young Man from the Country (Who Thought No One Could Get Over Him) on His Way to Visit the International Exhibition of 1862, and Who Went Back Without Seeing it.* Photographed by Dages & Harman from Designs by Percy Cruikshank. London: Ward & Lock, 1863. i, 16 pp. 17 b & w. ["Photography, as applied to book illustration has been in use now for some years; but we believe the present work is the first that has been offered to the public, in which the illustrations consist exclusively of photographs."]

DAGRON, PRUDENT RENE PATRICE. (1819-1900) (FRANCE)

[Born in Beaumont, France in 1819. Ran a shop selling office articles and objects in Paris in 1860s. Patented the idea of microscopic photographs mounted on rings as jewelry. By 1864 he was a specialist in producing tiny portraits, which must be viewed through special lenses, and in 1865 produced photographs on enamel and on porcelain. Wrote and published *Traité de photographie microscopique* in 1864. In 1870, during the Seige of Paris, Nadar enlisted Dagron's special skills to make microscopic photographs of official dispatches, which were then flown out of Paris by carrier pigeon. Dagron escaped from Paris in a balloon in November 1870. Throughout 1880s and 1890s he continued to make even smaller images, achieving an image on a needle head in 1889. Died in Paris in June 1900.]

D11 "Dagron's Microphotographs." AMERICAN JOURNAL OF PHOTOGRAPHY AND THE ALLIED ARTS & SCIENCES n. s. vol. 5, no. 12 (Dec. 15, 1862): 273. [From "Intellectual Observer."]

D12 "Note." HUMPHREY'S JOURNAL OF PHOTOGRAPHY, AND THE ALLIED ARTS AND SCIENCES 16, no. 8 (Aug. 15, 1864): 128. [From "Photo. News." Curved glass placed over small portrait, to enlarge, then cut into items of jewelry.]

D13 "The Story of the Pigeon Post." PHOTOGRAPHIC WORLD 1, no. 10 (Oct. 1871): 304-309. [Abridged from a pamphlet "La Poste par Pigeons Voyageurs" by M. Dagron.]

D14 "Pigeons and Microphotography." IMAGE 1, no. 1 (Jan. 1952): 4. [Technique of microphotography worked out by Rene Prudent Dagron during siege of Paris 1870-1871.]

D15 Koster, John. "Winging It: In the Autumn of 1870 Paris found..." AMERICAN PHOTOGRAPHER 5, no. 3 (Sept. 1980): 60-62. 4 illus. [Article is about French photographer/inventor Dagron and his service of microfilming mail and sending it by carrier pigeon and balloon over German Army lines surrounding Paris during the Prussian War at the end of 1870.]

DAGUERRE, LOUIS-JACQUES-MANDE. (1787-1851) (FRANCE)

[Born November 18, 1787 at Cormeilles-en-Parisis, France. Attended the Oréans public school, then studied design at an architect's office. By 1803 in Paris, he was working in the studio of the opera decor painter Degotti. Between 1807 and 1815 Daguerre painted large panoramas of city scenes. From 1816 to 1822 he was the painter-decorator at the Ambigu-Comique Theatre, then at the Opéra. From 1822 to 1830 he and Bouton built and operated The Diorama in Paris. The Diorama is a form of popular entertainment -a theatre without actors, where illusionistic visual effects were created with trompe-d'oeil paintings on stage scrims and controlled lighting. Daguerre painted the decor for the Holyrood Chapel in 1824, and received the Chevalier de la Légon d'Honneur. In 1823, Giroux showed him a "dessin-fumée." In 1826-27 he met Nicéphore Niépce, they exchange ideas and works, and very cautiously agree to collaborate in the chemical investigations they had been pursuing independently. Niépce died in 1833 and Daguerre assumed the dominant role in the new partnership with Isidore Niépce, Nicéphore's son. Through the latter half of the 1830s Daguerre gradually worked out a feasible photochemical process. He began to discuss it in public and then show his results to selected individuals, without disclosing the secret. In 1839 the Diorama burned down and Daguerre was financially ruined. In July the scientist Arago reported on the process to the French Academy of Sciences, and made a public display of the daguerreotype in August. Awards, honors, and a government stipend for Daguerre soon follow. In 1841 Daguerre retired to Bry-sur-Marne, where he continued to experiment in a small way, while he painted as a pastime. He died on July 10, 1851.]

BOOKS

D16 Daguerre, L. J. M. *History and Practice of Photogenic Drawing, or the True Principles of the Daguerréotype, with the New Method of Dioramic Painting; Secrets Purchased by the French government and by their command published for the benefit of the Arts and Manufactures.* By the inventor, L. J. M. Daguerre,...

D17 Translated from the original by J. S. Memes, LL.D. London: Smith, Elder & Co., 1839. vi, 76 pp. 6 l. of plates. [1st English edition, dated May 1839, Preface dated Sept. 13, 1839. 2nd ed., published in Oct. 1839, has xii pp. introduction.]

D18 Daguerre, L. J. M. *History and Practice of Photogenic Drawing by means of the Daguerreotype. Published, by order of the French Government, by L. J. M. Daguerre, Officer of the Legion of Honor. With Notes and Explanations by M. Arago, Member of the Chamber of Deputies. Illustrated by six engravings.* London: W. Strange, 1839. 46 pp. 6 illus.

D19 Daguerre, L. J. M. *A Practical Description of that Process called the Daguerreotype. This process consists in the Spontaneous Reproduction of the Image of Nature received in the Camera Obscura, not with their color, but with great nicety in the gradation of shades. By M. Daguerre, Painter, Inventor of the Diorama, Officer of the Legion of Honor, etc.* Translated by J. P. Simon, M.D., a native of France, M.R.C.S. London: John Churchill, 1839. 38 pp. 2 plates. [Preface is dated Oct. 1839.]

D20 Daguerre, Louis Jacques Mandé. *An Historical and Descriptive Account of the Various Processes of the Daguerreotype and the Diorama.* London: McLean, Nutt, 1839. 86 pp. 6 l. of plates. [Reprinted (1969), Krauss Reprint. Reprinted (1971), with introduction by Beaumont Newhall.]

D21 *The Hand-book of Heliography; or, The Art of Writing or Drawing by the Effect of Sun-Light. With the Art of Diorama Painting, as Practiced by M. Daguerre.* London: R. Tyas, 1840. iv, 100 pp. illus.

D22 *A Full Description of the Daguerreotype Process, As Published by M. Daguerre, Illustrated by Numerous Woodcuts.* New York: For sale by J. R. Chilton, 1840. 16 pp. ["Translated from the original paper of L. J. M. Daguerre, by J. S. Memes, LL.D." "Extracted from the 'American Reperatory,' edited by Prof. J. J. Mapes."]

D23 "Daguerre." on pp. 157-158 in: Cummings, Thomas S. *Historic Annals of the National Academy of Design from 1825 to the Present Time.* Philadelphia: George Childs, 1865. [Includes a letter, written by François Pamsel [Gourand?] to Cummings in 1839 announcing his visit to New York, NY.]

D24 Gernsheim, Helmut and Allison Gernsheim. *L. J. M. Daguerre, The World's First Photographer.* Cleveland, New York: World Publishing Co., 1956. 216 pp. 124 illus.

D25 Gernsheim, Helmut and Alison Gernsheim. *L. J. M. Daguerre: The History of the Diorama and the Daguerreotype.* New York: Dover Publications, Inc., 1968. 226 pp. 124 illus. [Unabridged and revised republication of the 1956 edition published by Secker & Warburg in London. This edition contains a new preface.]

D26 Daguerre, Louis Jacques Mandé. *An Historical and Descriptive Account of the Various Processes of the Daguerreotype and the Diorama by Daguerre.* Illustrated and with an introduction by Beaumont Newhall. New York: Winter House, 1971. 282 pp. 50 b & w. illus. [Facsimile reprint of the first French edition, together with the "McLean" English edition, and an introduction and bibliography by Newhall and reproductions of 50 daguerreotypes.]

PERIODICALS

D27 "Faits divers." L'ARTISTE Ser. 2, vol. 3, (1839): 64. [Note about Daguerre, Talbot, etc.]

D28 "Fine Arts: The Daguerotype." LITERARY GAZETTE, AND JOURNAL OF THE BELLES LETTRES no. 1147 (Jan. 12, 1839): 28. [Includes excerpt from "Gazette de France" (Jan. 6, 1839) by H. Gaucheraud.]

D29 "Foreign Correspondence." ATHENAEUM no. 587 (Jan. 26, 1839): 69. [Arago's announcement of Daguerre's discovery to the Academie des Sciences. Public curiosity aroused by the announcement.]

D30 "Fine Arts: The Daguerreotype." GENTLEMAN'S MAGAZINE n. s. 11, (Feb. 1839): 185-186. [Abstract of M. Arago's memoir on Daguerre's invention.]

D31 L. H. "M. Daguerre et la cocotte." LA CARICATURE PROVISOIRE (Feb. 24, 1839): 2.

D32 "The New Art." LITERARY GAZETTE, AND JOURNAL OF THE BELLES LETTRES no. 1156 (Mar. 16, 1839): 171. [Report of Daguerre's diorama burning down.]

D33 "Miscellanea." ATHENAEUM no. 594 (Mar. 16, 1839): 205. [Note of the burning of Daguerre's Diorama, in Paris, France.]

D34 "IX. - Daguerre - Photogenic Drawings." FOREIGN QUARTERLY REVIEW (LONDON) 23, no. 45 (Apr. 1839): 213-218. [Both Daguerre and Talbot discussed.]

D35 "Our Weekly Gossip." ATHENAEUM no. 606 (June 8, 1839): 435-436. [Letter from "J. R.", describing daguerreotypes that he saw in Paris.]

D36 "Faits divers." LE NATIONAL DE 1834 (PARIS) (July 7, 1839): 1-2. [Briefly discusses an exhibition of work by Daguerre and Niépce at the Chamber of Deputies, Paris.]

D37 "Our Weekly Gossip." ATHENAEUM no. 611 (July 13, 1839): 523. [Note that Daguerre and Niépce receiving pensions from the French government.]

D38 "Fine Arts: Daguerreotype." LITERARY GAZETTE, AND JOURNAL OF THE BELLES LETTRES no. 1173 (July 13, 1839): 444. [Report of Daguerre's exhibition of his works at the Chamber of Deputies.]

D39 Robison, John. "Notes on Daguerre's Photography." MAGAZINE OF SCIENCE, AND SCHOOL OF ARTS 1, no. 15 (July 13, 1839): 116-117. [From. "Edinburgh Philosophical Journal." Robison describes his visit to Daguerre's studio, where he saw daguerreotypes.]

D40 "Note." ATHENAEUM no. 611 (July 20, 1839): 542. [That no further substantial developments had occurred.]

D41 "Fine Arts: The Daguerreotype." LITERARY GAZETTE, AND JOURNAL OF THE BELLES LETTRES no. 1174 (July 20, 1839): 459. [Note that Arago's report has been published.]

D42 "The Gatherer." MIRROR OF LITERATURE, AMUSEMENT, AND INSTRUCTION no. 959 (July 20, 1839): 48. [Brief report of Daguerre's exhibition of his works at the Chamber of Deputies in Paris.]

D43 "Fine Arts: The Daguerre Secret." LITERARY GAZETTE, AND JOURNAL OF THE BELLES LETTRES no. 1179 (Aug. 24, 1839): 538-539. [Report of the public demonstration of Daguerre's process at the Academy of Sciences.]

D44 "Varieties: The Daguerreotype." LITERARY GAZETTE, AND JOURNAL OF THE BELLES LETTRES no. 1180 (Aug. 31, 1839): 558. [Note, from "La Quotidienne," stating that Daguerre intends to publish a manual and offer lessons.]

D45 "Principle of the Daguerreotype." ATHENAEUM no. 617 (Aug. 24, 1839): 636-637. [Report on proceedings of the Academie des Sciences in Paris, 1st public announcement.]

D46 "Foreign Art: The Daguerrotype." ART-UNION no. 7 (Aug. 15, 1839): 116.

D47 "Principle of the Daguerreotype." MAGAZINE OF SCIENCE, AND SCHOOL OF ARTS 1, no. 22 (Aug. 31, 1839): 173-175. ["From a Correspondent of the Athenaeum." Report on Arago's presentation to the Academie de Sciences in August, 1839.]

D48 "Fine Arts: New Publications." LITERARY GAZETTE, AND JOURNAL OF THE BELLES LETTRES no. 1183 (Sept. 21, 1839): 605. [Bk. rev.: "History and Practice of Photogenic Drawing, on the True Principles of the Daguerreotype; With the Method of Dioramic Painting," by L. J. M. Daguerre. Translated by J. S. Memes. (Smith, Elder & Co.). Mention that Mr. St. Croix, from Paris, giving demonstrations at the Argyll Rooms, London.]

D49 "Our Literary Table: "History and Practice of Photogenic Drawing on the True Principles of the Daguerreotype, with the true method of Dioramic Painting," by L. J. M. Daguerre, translated by J. S. Manes, L.L.D." ATHENAEUM no. 621 (Sept. 21, 1839): 717-718. [Extensive review, with quotes.]

D50 "Fine Arts: The Daguerrotype [sic]." GENTLEMAN'S MAGAZINE n. s. 12, (Sept. 1839): 289.

D51 "The Secret of M. Daguerre." ART-UNION no. 8 (Sept. 15, 1839): 132-133.

D52 "Mr. Talbot's Remarks on the Daguerreotype." MAGAZINE OF SCIENCE, AND SCHOOL OF ARTS 1, no. 23 (Sept. 7, 1839): 182-183. [Read before the British Association, Aug. 26, 1839.]

D53 "M. Daguerre's Process of Engraving." MIRROR OF LITERATURE, AMUSEMENT, AND INSTRUCTION no. 973 (Oct. 19, 1839): 257-258.

D54 Daguerre, L. J. M., translated by J. F. Frazer. "Physical Science. Practical Description of the Daguerreotype." JOURNAL OF THE FRANKLIN INSTITUTE OF THE STATE OF PENNSYLVANIA 24, no. 4 (Oct. 1839): 303-311. 3 illus.

D55 "Attempts at Engraving the Daguerreotype Pictures." ATHENAEUM no. 624 (Oct. 12, 1839): 780-781. [Quotes from Daguerre detailing his experiences.]

D56 "Our Weekly Gossip." ATHENAEUM no. 626 (Oct. 26, 1839): 813-814. [Note - with letter from Daguerre - stating that Daguerre has patented his process in England.]

D57 "Foreign Art: Paris - The Daguerreotype." ART-UNION no. 9 (Oct. 15, 1839): 155.

D58 Daguerre. "Dioramic Painting." MAGAZINE OF SCIENCE, AND SCHOOL OF ARTS 1, no. 29 (Oct. 19, 1839): 227-229.

D59 "Editor's Table:The 'Daguerreotype.'" KNICKERBOCKER, OR NEW YORK MONTHLY MAGAZINE 14, no. 6 (Dec. 1839): 560-561. [Review, by an unnamed American, of Daguerre's images, displayed in Paris, with a recommendation to attend Gouraud's lectures, soon to occur in New York, NY. "M. Gourand,...the proprietor of the only legitimate specimens of the art in this country..."]

D60 "Our Weekly Gossip." ATHENAEUM no. 692 (Jan. 30, 1841): 95-96. [Note on Daguerre's improvements.]

D61 "Our Weekly Gossip." ATHENAEUM no. 716 (July 17, 1841): 539-540. [Commentary of Daguerre's latest work.]

D62 "Improvements in the Daguerreotype." MAGAZINE OF SCIENCE AND SCHOOL OF ARTS 3, no. 122 (July 31, 1841): 141. [Daguerre described as still working, with imperfect success, on attempting to accelerate his process, by using electricity.]

D63 "Announcement of Daguerre's Discovery." DAGUERREAN JOURNAL 1, no. 4 (Jan. 1, 1851): 118-120. [From "Academic des Sciences," and the "Athenaeum."]

D64 "M. Daguerre." ILLUSTRATED LONDON NEWS 19, no. 504 (July 26, 1851): 117-118. 1 illus. [Obituary. Portrait from a daguerreotype by Claudet.]

D65 "Death of M. Daguerre." DAGUERREAN JOURNAL 2, no. 6 (Aug. 1, 1851): 177. [Brief note that Daguerre died July 13th.]

D66 Robison, Sir John. "Daguerre's Photography." DAGUERREAN JOURNAL 2, no. 7 (Aug. 15, 1851): 202*. [Source not credited, but from an account rendered to the Royal Society in June, 1839 by its Secretary, Sir J. Robison, describing his visit to Daguerre's studio in Paris.]

D67 "Dumas and Daguerre." ILLUSTRATED AMERICAN NEWS 1, no. 11 (Aug. 16, 1851): 81. [Anecdote about Daguerre's wife asking M. Dumas in 1827 if it were possible to chemically fix images in the camera; Mme. Daguerre stated her husband was obsessed with the idea.]

D68 "M. Daguerre." GLEASON'S PICTORIAL DRAWING-ROOM COMPANION 1, no. 18 (Aug. 30, 1851): 281. 1 illus. [Brief biographical sketch, occasioned by his recent death. Engraved portrait from [Meade Brothers] daguerreotype, not credited.]

D69 "Louis Jacques Mande Daguerre." PHOTOGRAPHIC ART JOURNAL 2, no. 3 (Sept. 1851): 159-160. [Obituary. From "International Magazine."]

D70 "The Late M. Daguerre." DAGUERREAN JOURNAL 2, no. 9 (Sept. 15, 1851): 274-276. [From "International Magazine."]

D71 "Communications: Address to Daguerre." DAGUERREAN JOURNAL 2, no. 10 (Oct. 1, 1851): 309. [Poem praising Daguerre, poet's name not given.]

D72 "Anecdote of Daguerre." DAGUERREAN JOURNAL 3, no. 1 (Nov. 15, 1851): 20. [Daguerre's wife approached the chemist Dumas 12 years before discovery of photography, asking if it were possible.]

D73 "Daguerre's Monument." HUMPHREY'S JOURNAL 4, no. 16 (Dec. 1, 1852): 254. [Monument to Daguerre raised in Petit-Brie in the Marne.]

D74 "Disposal of the Daguerreotype by the Discoverers." HUMPHREY'S JOURNAL 5, no. 1 (Apr. 15, 1853): 6-7. [Transcript of agreement between French government with Daguerre and Niépce to publish the daguerreotype process in 1839.]

D75 "Inauguration of the Monument to Daguerre at Bry-Sur-Marne." ILLUSTRATED NEWS (NY) 1, no. 14 (Apr. 2, 1853): 220. 1 illus. [Sketch of the monument.]

D76 Snelling, H. H. "Gossip: Daguerre." PHOTOGRAPHIC ART JOURNAL 6, no. 5 (Nov. 1853): 324. [Mr. Dumas, a lecturer in chemistry, was approached by Daguerre's wife in 1825, and asked if it were possible to chemically fix the image of a camera. Her husband seemed consumed with the idea and she was worried. Dumas replied that it wasn't possible with known information, but anything might be discovered.]

D77 "Daguerre's Monument." GLEASON'S PICTORIAL DRAWING-ROOM COMPANION 6, no. 6 (Feb. 11, 1854): 88. 1 illus. [Monument erected in Daguerre's memory at Bry-San-Marne, France. Woodcut shows the monument.]

D78 "M. Daguerre, the Inventor of the Daguerreotype, and the Diorama." AMERICAN JOURNAL OF PHOTOGRAPHY AND THE ALLIED ARTS & SCIENCES n. s. vol. 4, no. 1 (June 1, 1861): 15-17. 1 illus. [Portrait. Brief biography.]

D79 "Miscellaneous: Daguerreotype Portrait by Daguerre." AMERICAN JOURNAL OF PHOTOGRAPHY AND THE ALLIED ARTS & SCIENCES n. s. vol. 7, no. 2 (July 15, 1864): 41. [From "Photo. Notes." Portrait of the artist M. Gosse, taken by Daguerre in 1843 presented to the French Photographic Society.]

D80 "Ancient Photography." PHILADELPHIA PHOTOGRAPHER 3, no. 33 (Sept. 1866): 281-284. [Daguerre's process from the "Journal of the Franklin Institute."]

D81 Simons, M. P. "M. Daguerre and the Daguerreotype." ANTHONY'S PHOTOGRAPHIC BULLETIN 1, no. 9 (Oct. 1870): 167-168. [Actually more of a fond reminiscence by Simons of his own experiences with the daguerreotype, with a call on photographers to honor Daguerre.]

D82 Mentienne, Mr. "Daguerre." ANTHONY'S PHOTOGRAPHIC BULLETIN 19, no. 21 (Nov. 10, 1888): 663-666. ["Notes from a manuscript written by M. Mentienne, ex-Maire de Bry-sur-Marne, a Personal Friend of the Inventor of Photography. Kindly communicated to Prof. Stebbing by M. Glaise." From "Br. J. of Photo."]

D83 "Editorial Notes." PHOTOGRAPHIC TIMES 19, no. 385 (Feb. 1, 1889): 53. 2 illus. [2 engravings of busts of Daguerre and Poitevin, taken from "La Nature" magazine plus an excerpt from Mr. Albert Londe's "The Inventors of Photography."]

D84 "Notes and News: The First Man to Make Daguerreotype Plates." PHOTOGRAPHIC TIMES 19, no. 386 (Feb. 8, 1889): 73-74. [Mr. August Brassart living in Paris in 1838, worked in a factory where Daguerre asked him to make special plates. From the Waterbury "Daily Republican." Brassert moved to USA in 1853.]

D85 "Notes and News: Daguerre." PHOTOGRAPHIC TIMES 19, no. 411 (Aug. 2, 1889): 391-392. [From the "Semi-Centennial Souvenir of a P.A. of A."]

D86 Sherman, W. H. "The Daguerre Memorial." PHOTOGRAPHIC TIMES 20, no. 465 (Aug. 15, 1890): 400, 402-403. [Includes a survey of Daguerre's accomplishments, occasioned by the completion of the Daguerre Memorial.]

D87 Harrison, W. Jerome. "The Chemistry of Fixing." PHOTOGRAPHIC TIMES 20, no. 470 (Sept. 19, 1890): 470-471. [Daguerre, Talbot.]

D88 Harrison, W. Jerome. "The Chemistry of Fixing. Hypo Adopted by Daguerre and by Talbot as a Fixing Agent." PHOTOGRAPHIC TIMES 20, no. 477 (Nov. 7, 1890): 555-556. [Daguerre, Talbot.]

D89 Canfield, C. W. "Portraits of Daguerre." AMERICAN ANNUAL OF PHOTOGRAPHY AND PHOTOGRAPHIC TIMES ALMANAC FOR 1891 (1891): 23-36. 12 illus. [Portraits by J. S. Mayall, Chas. Meade, Charpentier, G. Kruell, others.]

D90 "Les éloges de la photographie par des hommes célèbres." and "l'Invention de la photographie." L'INTERMÉDIAIRE DES CHERCHERS ET DES CURIEUX 26, no. 591, 593, 597, 599 (Aug. 20, Sept. 10, Oct. 20, Nov. 10, 1892): 165-166, 245-246, 435-436, 505-507. [A laudatory poem about Daguerre, written by Pope Leo XIII, draws forth a series of comments by several authors, upon the roles of Daguerre and N. Niépce in the discovery of photography.]

D91 Canfield, C. W. "More Portraits of Daguerre." AMERICAN ANNUAL OF PHOTOGRAPHY AND PHOTOGRAPHIC TIMES ALMANAC FOR 1893. (1893): 77-81, plus 2 unnumbered leaves between pp. 80-81. 3 b & w. 4 illus. [Survey of representations of Daguerre, sequel to a similar article published in the 1891 issue of the Annual.]

D92 "The Fathers of Photography. III. Louis Jacques Mande Daguerre." PHOTOGRAPHIC TIMES 23, no. 636 (Nov. 24, 1893): 674. 2 illus.

D93 "A Diorama by Daguerre." WILSON'S PHOTOGRAPHIC MAGAZINE 32, no. 460 (Apr. 1895): 154-156. 2 illus. [Includes a reproduction of a diorama painting of Unterseen, Switzerland by Daguerre and a painted portrait of Daguerre by Paul Carpentier.]

D94 "Niépce and Daguerre." AMERICAN AMATEUR PHOTOGRAPHER 11, no. 10 (Oct. 1899): 418, 420-422, 424. [A copy of the deed of partnership between Niépce and Daguerre, reprinted from the "Bulletino della Societa Fotografica Italiana." (Translated into English).]

D95 Johnson, Dr. Lindsay. "The History of Daguerre." PHOTOGRAPHIC TIMES 37, no. 6 (June 1905): 269-270. ["As told by Dr. Lindsay Johnson in the 'Photographic Journal'."]

D96 Thompson, J. "Daguerre and His Invention." PHOTO ERA 30, no. 4 (Apr. 1913): 158-160. illus.

D97 French, W. A. "Louis Jacques Mande Daguerre, Inventor of Photography." PHOTO ERA 35, no. 11 (Nov. 1915): 216-223. illus.

D98 Zimmerman, J. Ernest. "The Daguerreotype." AMERICAN ANNUAL OF PHOTOGRAPHY:1919 33, (1919): 170, 172-174. 2 illus. [Brief description of Daguerre's accidental discovery of chemical intensification. Mentions that Niépce was an early partner, experimenter.]

D99 Scherer, Margaret R. "Photography - Presage and Practice." BULLETIN OF THE METROPOLITAN MUSEUM OF ART 25, no. 10 (Oct. 1930): 249-250. [Report on Arago's presentation of Daguerre's invention, from the Abbe Migne's "Dictionnaire des musées." (Volume four of his "Encyclopédie theologique." (1855).]

D100 Epstean, Edward. "Daguerre." PHOTO-ENGRAVERS BULLETIN (Oct. 1934): 28-45.

D101 Newhall, Beaumont. "A Chronicle of the Birth of Photography." HARVARD LIBRARY BULLETIN 7, no. 2 (Spring 1953): 208-228. 3 illus. [Discussion of "Rapport de M. Arago sur le daguerréotype." (Paris: Bachelier, Imprimeur Libraire, 1839)]

D102 Newhall, Beaumont. "Five Daguerreotypes by Daguerre." IMAGE 4, no. 3 (Mar. 1955): 18-21, plus cover. 5 b & w. 1 illus.

D103 "Index to Resources: Daguerre, continued." IMAGE 5, no. 3 (Mar. 1956): 66-67. 6 illus. [Daguerre's letters, paintings, drawings, and lithographs.]

D104 "Index to Resources: Lithographs by Daguerre." IMAGE 5, no. 4 (Apr. 1956): 92-93. 3 illus.

D105 "Index to Resources: Daguerre's Apparatus." IMAGE 5, no. 5 (May 1956): 114-115. 6 illus.

D106 Daguerre, L. J. M. "An Announcement by Daguerre." IMAGE 8, no. 1 (Mar. 1959): 32-36. [Unique photographic broadside by Daguerre with his account of the invention of daguerreotypy; George Eastman House Collection. Includes translation into English.]

D107 "An Announcement by Daguerre." INFINITY 8, no. 1 (Mar. 1959): 32-36. [Copy of a broadside announcement by Daguerre, with translation.]

D108 Harmant, Pierre G. "Daguerre's Manual: A Bibliographical Enigma." HISTORY OF PHOTOGRAPHY 1, no. 1 (Jan. 1977): 79-83. 4 illus.

D109 Wilsher, Ann. "Myth and Monument." HISTORY OF PHOTOGRAPHY 2, no. 4 (Oct. 1978): 374. 2 illus. [Contemporary accounts of the unveiling of the Daguerre monument in France in 1853.]

D110 Schaaf, Larry. "Daguerre and Niépce in a Pub." HISTORY OF PHOTOGRAPHY 4, no. 4 (Oct. 1980): 262. 1 illus. [Author found and discusses a wall tile in Cafe Royal, Edinburgh, Scotland, depicting the "Joint Discoverers of Photography."]

D111 Palmquist, Peter E. "Daguerrean Memory." HISTORY OF PHOTOGRAPHY 5, no. 1 (Jan. 1981): 17-19. 2 illus. [Transcript of "My Recollections of Daguerre," from "Camera Craft" 3:2 (June 1901): 43-45, by Gus Henriod, who published an account of a meeting with Daguerre, in 1840.]

D112 Buerger, Janet E. and David Kwasigroh. "Daguerre: The Artist." IMAGE 28, no. 2 (June 1985): 2-20. 26 illus. [Paintings, woodcuts, lithographs, etc. by Daguerre.]

D113 Robinson, Sir John. "*?" CHAMBERS'S EDINBURGH JOURNAL 8, no. 395 (Aug. 24, 1839): 243-244. [Account of Sir. John Robinson's visit to Daguerre's studio in Paris.]

D114 "*?" CHAMBERS'S EDINBURGH JOURNAL 8, no. 405 (Nov. 2, 1839): 327-328. [Account of Arago's report to the French Chamber of Deputies.]

DALEE, A. G. (d. 1879) (LAWRENCE, KS)
D115 "Editor's Table - Obituary." PHILADELPHIA PHOTOGRAPHER 16, no. 189 (Sept. 1879): 287. [Note of death.]

DALGLISH. (GLASGOW, SCOTLAND)
D116 "The Application of Photography to the Production of Printing Surfaces." PRACTICAL MECHANIC'S JOURNAL 2nd ser., 7 (14), no. 162 (Sept. 1861): 149-150. 1 illus. [Describes the process of A. A. Dalglish, Glasgow.]

DALLAS, DUNCAN C.
D117 Highley, Samuel, F.G.S., F.C.S., &c. "Notices of Photographic Inventions: Dallas's Photo-Electric Engraving." BRITISH JOURNAL OF PHOTOGRAPHY 10, no. 196 (Aug. 15, 1863): 330.

D118 Dallas, Duncan C. "A Few Words on Delineation." PHOTOGRAPHIC NEWS 8, no. 278 (Jan. 1, 1864): 5-6.

D119 Dallas, Duncan C. "A Batch of 'Don'ts.'" BRITISH JOURNAL PHOTOGRAPHIC ALMANAC 1876 (1876): 159.

D120 Dallas, Duncan C. "Matt Stains: The Saddle on the Right Horse." BRITISH JOURNAL PHOTOGRAPHIC ALMANAC 1879 (1879): 96-98.

DALLAS, E. W.
D121 Dallas, E. W. "Microscopic Photographs." ATHENAEUM no. 1282 (May 22, 1852): 580-581.

DALLMEYER, JOHN HENRY. (1830-1883) (PRUSSIA, GREAT BRITAIN)
[Dallmeyer was a famous manufacturer of photographic lenses living in London. He was the son-in-law of Andrew Ross, another famous optician.]

BOOKS
D122 Dallmeyer, John Henry. *Photographic Lenses: On Their Choice and Use.* London: J. H. Dallmeyer, optician, n. d. 12 pp.

D123 Dallmeyer, John Henry. *Photographic Lenses: On Their Choice and Use.* Special Edition, edited for American Photographers. "s. l." [N.Y.?]: s. n. [Anthony?], 1874. 34 pp.

D124 Dallmeyer, John Henry. *On the Choice and Use of Photographic Lenses.* New York: E. & H. T. Anthony, 1884. 12 pp. [5th edition.]

PERIODICALS
D125 Dallmeyer, J. H. "On the Nature of Distortion, Etc." PHOTOGRAPHIC AND FINE ART JOURNAL 13, no. 6 (June 1860): 175-176. [From "Photo. Notes."]

D126 "On Lenses." PHOTOGRAPHIC AND FINE ART JOURNAL 13, no. 6 (June 1860): 173-174. [From "Photo. Notes." Contains account of a paper read by Mr. Dallmeyer to the London Photo. Soc."]

D127 Dallmeyer. "The Photo-Heliograph." AMERICAN JOURNAL OF PHOTOGRAPHY AND THE ALLIED ARTS & SCIENCES n. s. vol. 6, no. 24 (June 15, 1864): 560-562. [Read to London Photo. Soc. A telescope-camera.]

D128 Dallmeyer, J. H. "On a New Form of Landscape Lenses Including a Large Angle of View." BRITISH JOURNAL OF PHOTOGRAPHY 12, no. 260 (Apr. 28, 1865): 221-222. 1 illus.

D129 "Wide-Angle Landscapes, and Lenses for Their Production." BRITISH JOURNAL OF PHOTOGRAPHY 12, no. 283 (Oct. 6, 1865): 510-511. 1 illus. [Dallmeyer lenses.]

D130 "Panoramic Lens." HUMPHREY'S JOURNAL OF PHOTOGRAPHY, AND THE ALLIED ARTS AND SCIENCES 18, no. 12 (Oct. 15, 1866): 192. [Dallmeyer's lens.]

D131 Dallmeyer, J. H. "A Card - The Medals for Lenses at the Paris Exhibition." ANTHONY'S PHOTOGRAPHIC BULLETIN 3, no. 2 (Feb. 1872): 459-460. [Complex fight about medals awarded to lensmakers at the Paris Universal Exhibition and subsequent statements made in the "Phil. Photographer" and "Anthony's Photo. Bulletin." Ross and Dallmeyer, Mr. Stuart, others involved.]

D132 "Mr. Dallmeyer's Reply to Mr. Stuart." ANTHONY'S PHOTOGRAPHIC BULLETIN 3, no. 10 (Oct. 1872): 708-708.

D133 "A New Portrait Lens." ANTHONY'S PHOTOGRAPHIC BULLETIN 6, no. 1 (Jan. 1875): 24-25. [From "Br. J. of Photo." Description of a new lens manufactured by J. H. Dallmeyer.]

D134 "General Notes." PHOTOGRAPHIC TIMES 14, no. 157 (Jan. 1884): 5. [Well-known optician of London, died on 30th Dec. 1883. Native of Prussia, came to London, worked for the optician Ross, became partner eventually. Died at age 53 off the coast of New Zealand.]

DALLY, FREDERICK. (1838-1914) (GREAT BRITAIN, CANADA)

D135 Birrell, Andrew. "Frederick Dally: Photo Chronicler of B. C. a Century Ago." CANADIAN PHOTOGRAPHY (Feb. 1977) *

D'ALMEIDA, J. C.

D136 "Editorial." LIVERPOOL & MANCHESTER PHOTOGRAPHIC JOURNAL [BRITISH JOURNAL OF PHOTOGRAPHY] n. s. 2, no. 17 (Sept. 1, 1858): 209-210. [Descriptions of M. J. C. d'Almèida's stereo exhibits, "...with the assistance of magic lanterns."]

DALTON, CHARLES.

D137 Dalton, Charles. "Correspondence: Photography Not a Fine Art." BRITISH JOURNAL OF PHOTOGRAPHY 11, no. 231 (Oct. 7, 1864): 396. [...a photograph is, in fact, a mere "scientific curiosity."]

D138 W. H. "Correspondence: Photography and Fine Art." BRITISH JOURNAL OF PHOTOGRAPHY 11, no. 232 (Oct. 14, 1864): 407. [Letter responding to Dalton's earlier claim that photography is not a fine art.]

D139 Dalton, Charles. "Correspondence: Photography "Not" a Fine Art." BRITISH JOURNAL OF PHOTOGRAPHY 11, no. 234 (Oct. 28, 1864): 431-432. [Another response, by Dalton, to his critics.]

D140 "Correspondence: Photography Not a Fine Art." BRITISH JOURNAL OF PHOTOGRAPHY 11, no. 235 (Nov. 4, 1864): 442-443. [Second letter on this topic from G. W. Wilson, plus a letter from James M. McKay, both arguing with Dalton's claim.]

D141 "Correspondence: Photography Not a Fine Art." BRITISH JOURNAL OF PHOTOGRAPHY 11, no. 236 (Nov. 11, 1864): 454-455. [Letters from Ch. Dalton (again); and letters from T. Runciman; D. Winstanley, Jr.; T. D. Westness.]

DAMMANN, CARL.
BOOKS
D142 Dammann, C. and F. W. Dammann. *Ethnological Photographic Gallery of the Various Races of Men.* London: Truebner & Co., 1876. 14 pp. 24 l. of plates. approx. 200 b & w. [Cover title "Races of Mankind." This drawn from the larger work, published in Berlin, in 1873, by Wiegandt, Hempel & Parey.]

PERIODICALS
D143 Tylor, Edward B. "Dammann's Race-Photographs." NATURE 13, no. 323 (Jan. 6, 1876): 184-185. [Book review: "Ethnological Photographic Gallery of the Various Races of Man," by C. and F. W. Dammann.]

D144 "Dammann's Race-photographs." ANTHONY'S PHOTOGRAPHIC BULLETIN 7, no. 9 (Sept. 1876): 278. [From "Br. J. of Photo." Carl Dammann (Hamburg) "completed some little time ago a magnificent work termed the "Anthropologische-Ethnologisches Album" (50 plates, portfolio size, with 10 to 20 photographs for each plate, depicting the various races of man.) Messrs. Truebner & Co. have published a smaller edition of the Hamburg Album, still with nearly 200 portraits of men and women of the world.]

DAMON, H. F.
D145 Damon, H. F. *Photographs of Skin Disease,* Taken from Life by H. F. Damon. 24 Photographs with Descriptions. Boston, London: s. n., 1870. n. p. 24 l. of plates. 24 b & w.

DANCER, JOHN BENJAMIN see also HISTORY: MICROPHOTOGRAPHY: 1839.

DANCER, JOHN BENJAMIN. (1812-1877) (GREAT BRITAIN)
BOOKS
D146 Hallett, Michael, comp. and ed. *John Benjamin Dancer, 1812 - 1877; Selected Documents and Essays.* Worcester, England: Michael Hallett, 1979. n. p. illus.

PERIODICALS
D147 "Forgotten Pioneers: V. John Benjamin Dancer (1812-1887)." IMAGE 1, no. 8 (Nov. 1952): 2. [Developer of microphotography, lantern slide.]

D148 Isenberg, Matthew R. "A Closer Look: J. B. Dancer's Camera." STEREO WORLD 2, no. 2 (May - June 1975): 1, 11. 1 illus. [Dancer's stereoscopic camera, patented 1856 in England.]

D149 Hallett, Michael. "John Benjamin Dancer 1812 - 1887: a perspective." HISTORY OF PHOTOGRAPHY 10, no. 3 (July - Sept. 1986): 237-255. 13 b & w. 9 illus. [Dancer was a maker of scientific and optical instruments in London in the 1830s to 1840. Then he moved to Manchester in 1841, and opened a portrait gallery. Made and sold daguerreotype apparatus and supplies, made daguerreotypes, microphotographs, etc. Associated with many early photographers, movements, etc. Died in 1877.]

DANIEL, H. A. H. (GREAT BRITAIN)
D150 Daniel, H. A. H. "Light, Exposure, and Development." PHOTOGRAPHIC TIMES 7, no. 75-76 (Mar. - Apr., 1877): 52-56, 80-83. [Communicated to the Bristol and West of England Amateur Photographic Association. In the midst of this rather technical discussion is a fascinating description of creating artificial casings out of "vegetable parchment" for the "pea-sausage, one of the most important articles of food for the army in the German campaign of 1870."]

DANIELL, J. H. (LONDON, ENGLAND)
[J. F. Daniel, F.R.S., was Professor of Chemistry at King's College, London, inventor of an electric battery.]

D151 "Photography," on pp. 452-461 in: *Introduction to the Study of Chemical Philosophy*, by J. H. Daniell. London: J. W. Parker, 1843. 764 pp. [New ed. (1851).]

D'ARGE, CHARLES.
D152 d'Argé, Charles. "Publications artistiques. l'Oeuvre de Rembrandt, reproduit par la photographie, décrit et commenté par M. Ch. Blanc, ancien directeur des beaux-arts." GAZETTE DES BEAUX-ARTS (Dec. 15, 1853): 47-48. [This is an earlier, short-lived magazine with the same title as the later "GBA."]

DARNAY. (PARIS, FRANCE)
D153 "'Academies.'" AMERICAN JOURNAL OF PHOTOGRAPHY AND THE ALLIED ARTS AND SCIENCES n. s. vol. 1, no. 10 (Oct. 15, 1858): 161-162. [Translated extract from "Revue Photographique," stating how a Mr. Darnay, a photographer 27 yrs. of age, with his assistants Mr. Fontaine and Mr. Coanus, painter and 5 young women models were arrested on the charge of outrage of public morality.]

DAUBNEY.
D154 Daubney, Prof. "Photogenic Actinometer." MAGAZINE OF SCIENCE, AND SCHOOL OF ARTS 1, no. 23 (Sept. 7, 1839): 179-180. [Read before the British Association, Aug. 26, 1839.]

DAUTHENDEY, CARL. (1819-1896) (GERMANY, RUSSIA, GERMANY)
D155 Henisch, Heinz K. "Carl Dauthendey Pioneer Photographer." HISTORY OF PHOTOGRAPHY 2, no. 1 (Jan. 1978): 11-18. 9 b & w. 1 illus. [Dauthendey was born in Germany in 1819. He apprenticed at Tauber's Optical Institute at Lindenau, and was there in 1840, when Tauber purchased one of the first daguerreotype outfits in Germany. Dauthendey experimented with the apparatus and was making portraits by June 1841. Held an exhibit of his works at the Leipzig Stock Exchange in May 1842 and lectured at Leipzig University. In 1843 he moved to St. Petersburg, Russia, and opened a studio. In the late 1840s he returned to Leipzig and studied with Eduard Wehuert to learn the calotype process. Returned to Russia, and his studio prospered and Dauthenday grew wealthy. He returned to Germany in 1862, where, in 1864, he opened a studio in Würzburg. He invented a collodion lacquer which sold well in Germany. Died in 1896.]

DAVANNE & GIRARD.
D156 Davanne & Girard. "On the Fading of Prints and Their Restoration." AMERICAN JOURNAL OF PHOTOGRAPHY AND THE ALLIED ARTS & SCIENCES n. s. vol. 6, no. 20 [sic 21] (May 1, 1864): 481-487. [Source not credited.]

D157 Davanne and Girard. "Researches on Positive Printing. - Where the Silver Goes." AMERICAN JOURNAL OF PHOTOGRAPHY AND THE ALLIED ARTS & SCIENCES n. s. vol. 7, no. 3 (Aug. 1, 1864): 63-67. [From "Photo. News."]

DAVANNE & JOUET.
D158 Davanne and Jouet. "Method of Obtaining Pure Whites in Direct Positives." HUMPHREY'S JOURNAL OF PHOTOGRAPHY, AND THE ALLIED ARTS AND SCIENCES 11, no. 9 (Sept. 1, 1859): 139-140.

DAVANNE, LOUIS-ALPHONSE. (1824-1912) (FRANCE)
[Born in Paris on Apr. 12, 1824. He was a chemist, teacher, author, and photographer. Studied with Aimé Girard, and together throughout the 1850s they attempted to find methods of making permanent positive prints. Worked out an early photolithographic process in 1854. A founding member of the Societé Française de Photographie. Published, with C. L. Barreswil, *Chimie photographique* (Paris: Mallet-Bachelier, 1854), which went through four editions, *L'Hiver à Menton*, with texts by Alfred de Longperier-Grimoard, in 1862, *Impressions Photographiques aux encres grasses analogues à la lithographie* in 1877, and other books in 1880s. In 1872 he taught photographic technique at the Ecole des Ponts et Chaussées, and at the Sorbonne in 1879. His views exhibited widely between 1855 and 1898. Travelled throughout France and to Germany, Italy, Spain and Algeria taking photographs of landscapes, buildings, urban life, and reproductions of artworks. Lectured at the Conservatoire des Arts et Métiers in 1891. Died at Saint-Cloud in 1912.]

D159 Davanne, A. "Remarks Upon the Fixing of Negatives Obtained by the Emulsion Process." BRITISH JOURNAL PHOTOGRAPHIC ALMANAC 1878 (1878): 146-147.

D160 Davanne, A. "Development after Fixing." AMERICAN JOURNAL OF PHOTOGRAPHY AND THE ALLIED ARTS AND SCIENCES n. s. vol. 1, no. 23 (May 1, 1859): 367-369. [Trans. from the "Bulletin of the Fr. Soc."]

DAVENPORT, W.
D161 "The Hurricane at Nassau, New Providence." ILLUSTRATED LONDON NEWS 49, no. 1400 (Nov. 24, 1866): 504-505. 2 illus. ["...from photographs by Mr. W. Davenport, of that place [Nassau].]

DAVIDSON, THOMAS. (EDINBURGH, SCOTLAND)
D162 Davidson, Thomas. *The Art of Daguerreotyping, with the Improvements of the Process and Apparatus*. Edinburgh: Printed by Neill & Co., 1841. 8 pp.

DAVIE & FRANÇOIS.
D163 "Personal Art Intelligence." PHOTOGRAPHIC AND FINE ART JOURNAL 10, no. 12 (Dec. 1857): 383. [Excerpts from Albany, NY papers describing oil paintings "Adam & Eve" displayed in Davie & François' photo gallery.]

DAVIE, DANIEL D. T. (1819-) (USA)
BOOKS
D164 Davie, D. D. T. *The Photographer's Pocket Companion; Being a Practical Treatise on the Collodion Process, Both Negative and Positive, also the New German Process*. New York: H. H. Snelling, 1857. vi, 184 pp. illus.

D165 *Photographic Senatorial Album of the Empire State, 1858-59*. Saratoga Springs, NY: D. D. T. Davie, 1859. n. p. 36 b & w. [Thirty-six original photographic portraits of NY State Senators.]

D166 Davie, D. D. T. *Secrets of the Dark Chamber; Being Photographic Formulas at Present Practiced in the Galleries of Messrs. Gurney, Fredericks, Bogardus, etc. of New York City...* New York: Joseph H. Ladd, 1870. 74 pp.

PERIODICALS

D167 Tracy, J. W., Esq. "D. D. T. Davie; First President of the Association of Daguerreotypists." PHOTOGRAPHIC ART JOURNAL 2, no. 3 (Sept. 1851): frontispiece, 164-165. 1 illus. [Portrait. Davie 32 years old at publication of article. Made his first daguerreotype in 1846, training himself. Perfected several practical devices useful to the field. Since last three years lived in Utica, NY. In 1850 he visited Washington, DC, taking portraits of members of both Houses of Congress. In 1850 he daguerreotyped Daniel Webster.]

D168 Davie, D. D. T. "Gossip: Letter." PHOTOGRAPHIC ART JOURNAL 3, no. 5 (May 1852): 323-324. [Letter from Davie about NY Daguerrean Assoc., with an anecdote about an inept photographer, who had refused to join.]

D169 Davie, D. D. T. "Galvanizing Plates." PHOTOGRAPHIC ART JOURNAL 3, no. 6 (June 1852): 351-352.

D170 Davie, D. D. T. "Correspondence: The Prize Pitcher." PHOTOGRAPHIC ART JOURNAL 4, no. 3 (Sept. 1852): 150-151. [Letter from Davie, praising Anthony's award.]

D171 Davie, D. D. T. "Picture Making Nos. 1 - 6." PHOTOGRAPHIC ART JOURNAL 4-6, no. 5, 2-4, 1-2 (Nov. 1852, Feb. - Apr., July - Aug. 1853): (vol. 4) 298-300, (vol. 5) 103-104, 165-167, 248-249, (vol. 6) 47-49, 115-116. [From "Scientific Daguerrean."]

D172 "Communications. " PHOTOGRAPHIC ART JOURNAL 6, no. 1 (July 1853): 31-32. [Letter from Davie on his methods.]

D173 "Letter." PHOTOGRAPHIC AND FINE ART JOURNAL 7, no. 5 (May 1854): 153.

D174 Davie, D. D. T. "Letter." PHOTOGRAPHIC AND FINE ART JOURNAL 7, no. 5 (May 1854): 153. [Letter dated 'Utica, April 5th, 1854, from D. D. T. Davie. General exhortation to improve the quality of the daguerrean art and praising the "P&FAJ."]

D175 Davie, D. D. T. "Precipitating Old Silvering Solutions." PHOTOGRAPHIC AND FINE ART JOURNAL 7, no. 5 (May 1854): 159.

D176 "Suit for Insurance." PHOTOGRAPHIC AND FINE ART JOURNAL 8, no. 4 (Apr. 1855): 121. [Letter from Davie explaining his court battle with the Atlantic Fire and Marine Insurance Co. of Providence, RI., which refused to pay him his evaluation for portraits of U. S. Senators, etc., lost by fire. In this he states having made a portrait by Henry Clay while "...spending seven or eight weeks in Washington, DC with an assistant for the purpose of collecting a gallery of portraits..."]

D177 Johnson, D. B. "Suit for Insurance - Report of Referees." PHOTOGRAPHIC AND FINE ART JOURNAL 8, no. 9 (Sept. 1855): 275. [Davie lost his case, claiming particular value for his portraits of senators, etc.]

D178 "Personal & Art Intelligence: Davie's Gallery." PHOTOGRAPHIC AND FINE ART JOURNAL 9, no. 12 (Dec. 1856): 381-382. [From "Utica (NY) Daily Gazette."]

D179 Davie, D. D. T. "The Negative and Positive Collodion Processes." PHOTOGRAPHIC AND FINE ART JOURNAL 10, no. 1 (Jan. 1857): 1-3.

D180 Davie, D. D. T. "The Albumen Process." PHOTOGRAPHIC AND FINE ART JOURNAL 10, no. 1 (Jan. 1857): 27-28. 3 illus.

D181 Davie, D. D. T. "Miscellaneous Processes and Recipes." PHOTOGRAPHIC AND FINE ART JOURNAL 10, no. 2 (Feb. 1857): 48-49.

D182 Davie, D. D. T. "The German Process." PHOTOGRAPHIC AND FINE ART JOURNAL 10, no. 2 (Feb. 1857): 33-34.

D183 Davie, D. D. T. "Miscellaneous Items." PHOTOGRAPHIC AND FINE ART JOURNAL 10, no. 2 (Feb. 1857): 61.

D184 Davie, D. D. T. "Albany Photographic Meeting." PHOTOGRAPHIC AND FINE ART JOURNAL 12, no. 1 (June 1859): 13-14. [Davie's letter is in response to some complaint aired in an earlier issue.]

D185 Davie, D. D. T. "Manipulation of Large Plates." HUMPHREY'S JOURNAL OF PHOTOGRAPHY, AND THE ALLIED ARTS AND SCIENCES 12, no. 2 (May 15, 1860): 22-23.

D186 Davie, D. D. T. "Albumen Photography." HUMPHREY'S JOURNAL OF PHOTOGRAPHY, AND THE ALLIED ARTS AND SCIENCES 12, no. 1-14 (May 1 - Nov. 15, 1860): 1, 19-20, 37-38, 151-152, 212-213.

D187 "A 'Photo' Burned Out." HUMPHREY'S JOURNAL OF PHOTOGRAPHY, AND THE ALLIED ARTS AND SCIENCES 14, no. 8 (Aug. 15, 1862): 80. [D. D. T. Davie's gallery burned down.]

D188 Davie, D. D. T. "The Fulminating Process." HUMPHREY'S JOURNAL OF PHOTOGRAPHY, AND THE ALLIED ARTS AND SCIENCES 15, no. 2 (May 15, 1863): 24-25. [Additional note on p. 32.]

D189 Davie, D. D. T. "Printing with the Solar Camera." HUMPHREY'S JOURNAL OF PHOTOGRAPHY, AND THE ALLIED ARTS AND SCIENCES 15, no. 3 (June 1, 1863): 38-39.

D190 Davie, D. D. T. "Gold Toning. - To a Correspondent." HUMPHREY'S JOURNAL OF PHOTOGRAPHY, AND THE ALLIED ARTS AND SCIENCES 15, no. 3 (June 1, 1863): 47.

D191 Davie, D. D. T. "To Prepare Glass for Printing Negatives." HUMPHREY'S JOURNAL OF PHOTOGRAPHY, AND THE ALLIED ARTS AND SCIENCES 15, no. 4 (June 15, 1863): 62.

D192 Davie, D. D. T. "Sensitizing Albumen Paper." HUMPHREY'S JOURNAL OF PHOTOGRAPHY, AND THE ALLIED ARTS AND SCIENCES 15, no. 10 (Sept. 15, 1863): 154.

D193 Davie, D. D. T. "Chloride of Gold." HUMPHREY'S JOURNAL OF PHOTOGRAPHY, AND THE ALLIED ARTS AND SCIENCES 15, no. 22 (Mar. 15, 1864): 350-352.

D194 Davie, D. D. T. "Dodge's New Portrait of Washington." HUMPHREY'S JOURNAL OF PHOTOGRAPHY, AND THE ALLIED ARTS AND SCIENCES 16, no. 8 (Aug. 15, 1864): 121-122.

D195 Davie, D. D. T. "The Chinese Solvent." HUMPHREY'S JOURNAL OF PHOTOGRAPHY, AND THE ALLIED ARTS AND SCIENCES 18, no. 5 (July 1, 1866): 74.

D196 Davie, D. D. T. "An Old Photo on Mumler: The Spirit-Humbug Exposed - Mumler and Barnum - Judge Dowling - ..." HUMPHREY'S JOURNAL OF PHOTOGRAPHY, AND THE ALLIED ARTS AND SCIENCES 20, no. 23 (July 15, 1869): 358-362.

D197 Davie, D. D. T. "The Boston Convention." HUMPHREY'S JOURNAL OF PHOTOGRAPHY, AND THE ALLIED ARTS AND SCIENCES 20, no. 24 (Aug. 15, 1869): 372-376. [This is basically a diatribe against the activities of those forming the National Photographic Association. "I was not at the Boston Meeting, nor did I see the show;...I am decidedly in favor of organizing a photographic society, providing one can be started properly."]

D198 "A New York Photo." "Davie's Instantaneous Gun Cotton." HUMPHREY'S JOURNAL OF PHOTOGRAPHY, AND THE ALLIED ARTS AND SCIENCES 20, no. 25 (Sept. 15, 1869): 390-392. [D. D. T. Davie, apparently manufactured "Helion Cotton," used in photography. In 1866 he went into the opera house business on Broadway and sold his gun cotton business to Mr. Cooper. Davie failed in the opera house business, took a position in the Custom House. Then decided to go back into manufacturing gun cotton, as Cooper was not doing it well. Cooper charged that Davie had not given him the proper formulas. Davie defended here.]

D199 Davie, D. D. T. "Photographic College." HUMPHREY'S JOURNAL OF PHOTOGRAPHY, AND THE ALLIED ARTS AND SCIENCES 20, no. 25-27 (Sept. 15 - Nov. 15, 1869): 388-389, 401-404, 421-423. [Article ends with "(To be continued)" on p. 423, but the Journal ceased before more could be published. This is a carefully thought-out discussion of a program to establish a photographic school in New York City. The idea was not realized.]

D200 "New Photographic Book." HUMPHREY'S JOURNAL OF PHOTOGRAPHY, AND THE ALLIED ARTS AND SCIENCES 20, no. 26 (Oct. 15, 1869): 410-411. [Prepublication announcement and description of D. D. T. Davie's book, "Secrets of the Dark Chamber." Davie is described as "a New York photographer of nearly thirty years experience, well-known as a manufacturer of Soluble Cotton, and now manufacturer of 'The Instantaneous Cotton.'" Davie obtained formulas from "Fredericks, Gurney's and Bogardus's establishments."]

D201 Davie, D. D. T. "Boiling Cotton-Negative Baths." ANTHONY'S PHOTOGRAPHIC BULLETIN 3, no. 6 (June 1872): 566-568. [Davie's address is given as Cuba.]

D202 Davie, D. D. T. "On Keeping a Negative Bath in Order." PHOTOGRAPHER'S FRIEND 2, no. 4 (Oct. 1872): 103-104.

D203 Davie, D. D. T. "Saving Wastes." PHOTOGRAPHER'S FRIEND 2, no. 4 (Oct. 1872): 116-117.

D204 "Note." ANTHONY'S PHOTOGRAPHIC BULLETIN 5, no. 3 (Mar. 1874): 116. [Note that Davie, a long-time photographer in USA, then moved to Cuba, was offering for sale "The Yankee Clothes Washer" in the "Cuban Herald." Draws forth several puns from the editor.]

DAVIES & CO. (MELBOURNE, AUSTRALIA)
D205 "The New South Wales Rifle Champions." ILLUSTRATED LONDON NEWS 42, no. 1209 (June 20, 1863): 681. 1 illus. ["...portraits of the New South Wales party were photographed by Mr. Davis, [sic Davies] of Bourke Street, Melbourne." Group portrait.]

D206 "The Floods at Melbourne, Australia." ILLUSTRATED LONDON NEWS 44, no. 1247 (Feb. 27, 1864): 213-214. 3 illus. ["...from photographs by Messrs. Davies, of Bourke St., Melbourne..."]

D207 "Talk in the Studio: Photographs of Floods." PHOTOGRAPHIC NEWS 8, no. 286 (Feb. 26, 1864): 107. [Note reprinted from "Melbourne Argus" of Dec. 17, 1863.]

D208 "The Cricket-Match at Melbourne between the All-England Eleven and Twenty-Two of Victoria." ILLUSTRATED LONDON NEWS 44, no. 1254 (Apr. 9, 1864): 337. 1 illus. ["...from a photograph by Messrs. Davies & Co., of Bourke Street, Melbourne." View of an actual match, with spectators.]

DAVIES, W. H. (d. 1894) (GREAT BRITAIN)
D209 Davies. "On Gold as a Photographic Agent." HUMPHREY'S JOURNAL OF PHOTOGRAPHY, AND THE ALLIED ARTS AND SCIENCES 13, no. 5 (July 1, 1861): 75-78. [From "Br. J. of Photo."]

D210 Davies, W. H. "A Few Hints on Composition as Applied to PHotographic Pictures." BRITISH JOURNAL OF PHOTOGRAPHY 8, no. 154 (Nov. 15, 1861): 396-399. 10 illus.

D211 Davies, W. H. "Hints on the Nature of Pictorial Beauty and the Principles of Composition." BRITISH JOURNAL OF PHOTOGRAPHY 9, no. 157-158, 164-165 (Jan. 1 - Jan. 15, Apr. 15 - May 1, 1862): 3-6, 23-24, 147-149, 165-16?*. [*Missing issue.]

D212 Davies, W. H. "Applications of Photography to Art Manufactures." HUMPHREY'S JOURNAL OF PHOTOGRAPHY, AND THE ALLIED ARTS AND SCIENCES 15, no. 16 (Dec. 15, 1863): 246-249. [Read to Edinburgh Photo. Soc.]

D213 Davies, W. H. "Finger Posts for Landscape Photographers." BRITISH JOURNAL PHOTOGRAPHIC ALMANAC 1869 (1869): 113-115.

D214 Davies, W. H. "Crayon Painting Applied to Albumenized Photographs." BRITISH JOURNAL PHOTOGRAPHIC ALMANAC 1874 (1874): 123-125.

D215 Davies, W. H. "Direct Single Carbon Transfers on Cardboard." BRITISH JOURNAL PHOTOGRAPHIC ALMANAC 1878 (1878): 110-111.

DAVIS & PERRY. (BOSTON, MA)
D216 "Gossip." PHOTOGRAPHIC ART JOURNAL 3, no. 3 (Mar. 1852): 195. ["Messrs. Davis & Perry have opened rooms at 257 Washington St., Boston."]

DAVIS, GEORGE W. (ca. 1823-1892) (USA)
D217 "Notes and News." PHOTOGRAPHIC TIMES 20, no. 456 (June 13, 1890): 287. ["Mr. Davis, the Richmond photographer, has two beautiful photographs of the Lee Monument taken just before and immediately after the unveiling."]

D218 "Editor's Table: Obituary." WILSON'S PHOTOGRAPHIC MAGAZINE 19, no. 425 (Sept. 3, 1892): 544. [Died in Richmond, Va., on August 12, 1892, aged sixty-nine years. Had, at his death, five galleries - three in Richmond, one at Portsmouth, and one at Fredericksburg. His son-in-law, B. T. Archer, will continue the business.]

DAVIS, HENRY.
D219 Davis, Henry. "Streaky Negatives, etc." HUMPHREY'S JOURNAL OF PHOTOGRAPHY, AND THE ALLIED ARTS AND SCIENCES 16, no. 4 (June 15, 1864): 58-59. [Davis' letter and Towler's reply.]

DAVIS, J. R. (BUFFALO, NY)
D220 Davis, J. R. "Panoramic Photographs." AMERICAN JOURNAL OF PHOTOGRAPHY AND THE ALLIED ARTS & SCIENCES n. s. vol. 3, no. 23 (May 1, 1861): 365. [Letter claiming that practice earlier described (p. 345) to make panoramic photos in England, long practiced in USA.]

DAVIS, THOMAS SEBASTIAN. (d. 1907) (GREAT BRITAIN)
D221 Davis, T. "Stereo-Manipulating Camera." HUMPHREY'S JOURNAL OF PHOTOGRAPHY, AND THE ALLIED ARTS AND SCIENCES 12, no. 18 (Jan. 15, 1861): 277-278. [From "Br. J. of Photo."]

D222 Davis, T. Sebastian. "Lines in the Direction of the Dip of the Plate and their Avoidance." AMERICAN JOURNAL OF PHOTOGRAPHY AND THE ALLIED ARTS & SCIENCES n. s. vol. 7, no. 16 (Feb. 15, 1865): 361-364. [Read before South London Photo. Soc.]

D223 Davis, T. Sebastian. "A Word on Photographic Portraiture." BRITISH JOURNAL PHOTOGRAPHIC ALMANAC 1870 (1870): 134.

DAVIS, W. H.
D224 Davis, W. H. "Weak versus Strong Baths." AMERICAN JOURNAL OF PHOTOGRAPHY, AND THE ALLIED ARTS AND SCIENCES n. s. vol. 9, no. 4 (Oct. 15, 1866): 81-84. [Source not credited.]

DAVISON, J. ROBERT.
D225 Davison, J. Robert. "Turning a Blind Eye: THe Historians Use of Photographs." BC STUDIES no. 52 (Winter 1981/82): 16-38. 10 b & w. [Essay in a special issue "The Past In Focus: Photography & British Columbia, 1858-1914." Discusses photography's uses to a cultural and social historian.]

DAVY, SIR HUMPHREY. (1778-1829) (GREAT BRITAIN)
[Born "...of humble parents at Penzance in 1778." Davy became a leading chemist, was made Professor of Chemistry at the Royal Institution, London, in 1802, and President of the Royal Society in 1820. He and Thomas Wedgewood experimented with silver nitrate in the early 1800s, but failed to find a method of fixing the prints.]

D226 "An Account of a Method of Copying Paintings upon Glass, and of Making Profiles by the Agency of Light upon the Nitrate of Silver. Invented by T. Wedgwood, Esq., with observations by H. Davy," on pp. 240-245, vol. II in: *Collected Works of Sir H. Davy*, edited by J. Davy. London: Smith, Elder & Co., 1839. 9 vols. [This paper first appeared in vol. 1 (1802) "Journal of the Royal Institution."]

DAWSON, EDWARD. (GREAT BRITAIN)
D227 "Monkstone Rock Beacon." ILLUSTRATED LONDON NEWS 35, no. 993 (Sept. 17, 1859): 284. ["From a Photograph by Edward Dawson."]

D228 "The Thames Embankment Works, viewed from King's College." ILLUSTRATED LONDON NEWS 45, no. 1274 (Aug. 20, 1864): 193-194. 1 illus. ["Our Engraving is from a photograph by Mr. Dawson."]

DAWSON, F. (SECUNDERABAD, INDIA)
D229 Dawson, Col. F. "Gelatine Plates in India." ANTHONY'S PHOTOGRAPHIC BULLETIN 10, no. 7 (July 1879): 196-199. [From "London Photographic News." Dawson at Secunderabad.]

DAWSON, GEORGE (1820-1897) (GREAT BRITAIN)
BOOKS
D230 Dawson, George, M.A., Ph.D. *A Manual of Photography, founded on Hardwich's Photographic Chemistry.* London: J. & A. Hardwich, 1873. 276 pp. illus.

D231 Dawson, George. *A Popular Treatise of Modern Photography, useful alike to the Professional and the Amateur, as a Guide and Companion in their Daily Practice.* Glasgow: G. Mason & Co., 1884. 95 pp.

PERIODICALS
D232 Dawson, G. "The Waxed Paper Process." HUMPHREY'S JOURNAL OF PHOTOGRAPHY, AND THE ALLIED ARTS AND SCIENCES 9, no. 19 (Feb. 1, 1858): 291-298. [From "London Photo. J."]

D233 "King's College Photographic Lectureship." BRITISH JOURNAL OF PHOTOGRAPHY 8, no. 155 (Dec. 2, 1861): 416. [George Dawson replacing Thomas Sutton, who had replaced Mr. Hardwich, the first lecturer on photography at King's College, London.]

D234 Dawson, George, M.A. "On Instantaneous Photography." BRITISH JOURNAL OF PHOTOGRAPHY 10, no. 187 (Apr. 1, 1863): 138-139.

D235 Dawson, George, M.A. Lecturer on Photography at Kings College, London. "On Instantaneous Photography." AMERICAN JOURNAL OF PHOTOGRAPHY AND THE ALLIED ARTS & SCIENCES n. s. vol. 5, no. 23 (June 1, 1863): 539-543.

D236 Dawson, George, M.A. "Experiments on the Use of Nitrate of Soda in the Printing Bath." AMERICAN JOURNAL OF PHOTOGRAPHY AND THE ALLIED ARTS & SCIENCES n. s. vol. 6, no. 20 [sic 21] (May 1, 1864): 489-492. [From "Br. J. of Photo." Dawson was the Lecturer on Photography at King's College.]

D237 Dawson, George. "Remarks on the Tannin Process." AMERICAN JOURNAL OF PHOTOGRAPHY AND THE ALLIED ARTS & SCIENCES n. s. vol. 7, no. 10 (Nov. 15, 1864): 220-224. [Read to Edinburgh Photo. Soc.]

D238 Dawson, George. "Varnishes." AMERICAN JOURNAL OF PHOTOGRAPHY, AND THE ALLIED ARTS AND SCIENCES n. s. vol. 9, no. 11 (May. 15, 1867): 238-242. [From "Br. J. of Photo."]

D239 Dawson, George, M.A., Ph.D. "Photography on Wood." ANTHONY'S PHOTOGRAPHIC BULLETIN 2, no. 1 (Jan. 1871): 1-4. [From "Br. J. of Photo." Dawson discusses his experiences using Gruen's method of making a negative of any size, used to produce a collodion positive for the wood block. Dawson worked for "London Illus. News" since at least the early 1860s.]

D240 Dawson, George, M.A. Ph.D. "A Plea for Waxed Paper." BRITISH JOURNAL PHOTOGRAPHIC ANNUAL 1875 (1875): 114-115. [Dawson lecturer on photography, King's College, London.

D241 "Obituary: George Dawson (July 11, 1897)." BRITISH JOURNAL PHOTOGRAPHIC ALMANAC 1898 (1898): 640. [Died at

age 77. Professor of Photography at King's College. Editor of "BJP." Authored technical books and articles.]

DAWSON, R. W.
D242 "Prize Print Hints." PHILADELPHIA PHOTOGRAPHER 15, no. 171 (Mar. 1878): 65-68. [Competitor in the "Phila. Photo." Gold Medal Prize, describing his working methods, etc.]

DAY & DAY.
D243 Portrait. Woodcut engraving credited "From a photograph by Day & Day." ILLUSTRATED LONDON NEWS 37, (1860) ["Duke of Norfolk." 37:* (Dec. 8, 1860): 539.]

DAY, Y. (MEMPHIS, TN)
D244 "Photography in Memphis." ANTHONY'S PHOTOGRAPHIC BULLETIN 2, no. 11 (Nov. 1871): 364-365. [From "Memphis [TN] Daily Appeal." Y. Day's Photographic Parlors, "J. F. Coonley, the competent and tasteful artist, who made the work."]

DAYAL, LALA DEEN. (1844-1910) (INDIA)
BOOKS
D245 Griffin, Sir Lepel Henry. *Famous Monuments of Central India.* Illustrated by a series of photographs by Lala Deen Dayal, prepared by the direction of Sir L. Griffin. With descriptive letterpress. London: Sotheran, Autotype Co., 1886 [?] n. p. 89 b & w. [Autotype prints.]

D246 Furneaux, J. H., editor. *Glimpses of India; A Grand Photographic History of the Land of Antiquity, the Vast Empire of the East.* With 500 ...camera views...with full historical text. London: International Art Co., 1896. 544 pp. 500 b & w. [Photographic illustrations by Bourne & Shepherd, Lala Deen Dayal, Nicols & Co, Barton, Son & Co., and B. D. Dadaboy.]

PERIODICALS
D247 Praus, Ed. "Lala Deen Dayal: 19th Century Indian Photographer." IMAGE 16, no. 4 (Dec. 1973): 7-15. 8 b & w. [Dayal trained as an engineer, graduated from the Univ. of Roorkee in 1862. Began to photograph around 1864, commissioned to photograph the Government Generals tour in Central India in 1865. Founded firm Lala Deen Dayal & Sons. 1868 commissioned to photograph temples and palaces of India. Flourishing though 1880s.]

DAYTON, A. O.
D248 Dayton, A. O. "Coloring Photographs." HUMPHREY'S JOURNAL 6, no. 21 (Feb. 15, 1855): 338.

DE BANES see also FREDERICKS, CHARLES D. & CO.

DE BANES, JOHN. (1825-1894) (USA)
D249 "Editors Table: John De Banes." WILSON'S PHOTOGRAPHIC MAGAZINE 32, no. 460 (Apr. 1895): 190. [Brief obituary. "...Long the operator for C. D. Fredericks & Co., New York,... once being considered the very best operator in New York City... In 1894 worked for A. L. Fowler of Meadville, Pa.]

DE BEAUREGARD, TESTED
D250 Beauregard, Testud de. "Method of Obtaining Several of the Natural Colors in Photographic Pictures." PHOTOGRAPHIC AND FINE ART JOURNAL 8, no. 10 (Oct. 1855): 297. [Communicated to the "Soc. Française de Photographie" by M. Durieu.]

D251 "Photographs in Natural Colours." ART JOURNAL (Sept. 1855): 260.

D252 "Photographs in Natural Colors." PHOTOGRAPHIC AND FINE ART JOURNAL 8, no. 10 (Oct. 1855): 318-319. [From "London Art. J." Discusses work of Testud de Beauregard.]

D253 "Naturally-Colored Photographs." HUMPHREY'S JOURNAL 7, no. 11 (Oct. 1, 1855): 172-174. [Testud de Beauregard's process explained, from "Bulletin de la Societé Française de Photographie."]

DE BEERSKI, J. (ALDERSHOTT, ENGLAND)
D254 Portrait. Woodcut engraving credited "From a photograph by J. DeBeerski." ILLUSTRATED LONDON NEWS 43, (1863) ["Colonel Crawley." 43:* (Dec. 26, 1863): 661.]

DE BLOCQUEVILLE.
D255 "Miscellanea: An Unfortunate Photographic Artist." BRITISH JOURNAL OF PHOTOGRAPHY 12, no. 266 (June 9, 1865): 306. [Story, perhaps fictional, from "A Journey from London to Persepolis," of a Parisian photographer named de Blocqueville who travelled to Teheran, where he photographed the Shaw and his court. He was then ordered to accompanying a military expedition launched against the revolting Turcomans. The expedition failed and de Blocqueville captured. Then, through a series of confusions, over the belief that he was a military officer, his ransom price rose from about $10 to $5000, until he was finally ransomed after months of captivity.]

DE BREBISSON, LOUIS-ALPHONSE. (1798-1872) (FRANCE)
D256 De Brebisson, Alphonse. "The Collodion Process in Photography for the Production of Instantaneous Proofs." PHOTOGRAPHIC ART JOURNAL 4, no. 2-6 (Aug.- Dec. 1852): 116-119,177-178, 232-235, 287-293, 362-366. [Includes a new commentary by Frederick Scott Archer.]

D257 De Brebisson. "On the Uranium Printing Process." HUMPHREY'S JOURNAL OF PHOTOGRAPHY, AND THE ALLIED ARTS AND SCIENCES 10, no. 12 (Oct. 15, 1858): 188-190. [From "Photo. Notes."]

D258 De Brebisson, Alphonse. "The Collodion Process in Photography for the Production of Instantaneous Proofs." PHOTOGRAPHIC ART JOURNAL 4, no. 5-6 (Nov. - Dec. 1852): 287-293, 366-366. [Continued from 4:4 p. 235]

D259 Saint Edme, Ernest. "Alphonse De Brebisson's Instantaneous Dry Collodion Process." AMERICAN JOURNAL OF PHOTOGRAPHY AND THE ALLIED ARTS & SCIENCES n. s. vol. 6, no. 14 (Jan. 15, 1864): 330-333. [From "Cosmos."]

DE CAMARSAC, LAFON see LAFON DE CAMARSAC.

DE CHAMPLOUIS, CAPT.
D260 De Champlouis, Capt. "The Wax-Paper Process." HUMPHREY'S JOURNAL OF PHOTOGRAPHY, AND THE ALLIED ARTS AND SCIENCES 14, no. 4 (June 15, 1862): 1-2. [From "Fr. Photo. Soc. Bulletin."]

DE CONSTANT, A.
D261 DeConstant, A. "The Collodio-Chloride Process with Ammonia Vapor, and Mezzotint Printing." HUMPHREY'S JOURNAL OF PHOTOGRAPHY, AND THE ALLIED ARTS AND SCIENCES 20, no. 24 (Aug. 15, 1869): 369-371. [Source not given.]

D262 DeConstant, A. "Flattering Portraits." ANTHONY'S PHOTOGRAPHIC BULLETIN 2, no. 2 (Feb. 1871): 42-44. [From "London Photo. News." Retouching.]

DE COURTEN, L.

D263 De Courten, L. "Hints on Operating." HUMPHREY'S JOURNAL OF PHOTOGRAPHY, AND THE ALLIED ARTS AND SCIENCES 19, no. 2 (May 15, 1867): 25-26. [From "Le Mon. de la Phot."]

DE LA BLANCHERE, HENRI. (1821-1880) (FRANCE)

[Born at La Flèche, France in 1821. Studied natural science, at Nantes in 1848. Settled in Paris in 1855, where he worked as a painter and photographer. Made landscape photographs along the Loire in 1856. Published a book, *L'Art du Photographe comprenant les Procédés completssur papier et sur glace négatifs et positifs* in 1859, and from 1863-66, six volumes of *Répertoire Encyclopédique de Photographie: comprenant par ordre alphabétique tout ci qui a Paru et paraît en France et à l'étranger depuis la découverte par Niépce et Daguerre de l'Art d'imprimer au moyen de la lumière et les notions de chimie physique et persprctive qui s'y rapportent.* Published other illustrated works on natural history. Died in Paris in 1880.]

D264 De La Blanchere, H. "Miniature and Photographic Painting." BRITISH JOURNAL OF PHOTOGRAPHY 12, no. 264, 266 (May 26, June 9, 1865): 275-276, 302-303. [From "Répertoire Encylopédique de Photographie.]

DE LA RUE, WARREN. (1815-1889) (GREAT BRITAIN)

[Born Jan. 18, 1815 in Gurnsey. Scientist, inventor, industrialist. Active member in many scientific societies. Interested in photography and astronomy. Attempted to photograph the moon in 1853. Made stereos of the moon in 1857. First stereo view of the sun in 1860. In 1861 submitted a paper to the British Association on reproduction of stars. In 1862, interested in Pretsch's photogalvanic reproduction process. In 1871 he took over the direction of his father's company De la Rue & Co., makers of stationary and fancy paper. Gave his observatory to Oxford University in 1873. Made a Commander in the Legion of Honor in 1888. Died on Apr. 19, 1889 in London.]

BOOKS

D265 De la Rue, Warren. *Celestial Photography in England.* London: s. n., 1860. n. p. [Probably an offprint.]

D266 De la Rue, Warren. *The Bakerian Lecture on the Total Eclipse of July 18th, 1860: Observed at Rivabellosa, near Mirando de Ebro, in Spain.* London: Taylor & Francis, 1862. 84 pp. 14 l. of plates. 1 b & w. 1 illus. ["From the Philosophical Transactions, Pt. I, 1862."]

D267 "Astronomical Photography," on pp. 164-172 in: *Report of the Conferences, Scientific Apparatus Loan Exhibition, South Kensington. Vol. I, Physics and Mechanics.* London: Chapman & Hall, 1876.

PERIODICALS

D268 "Photographs of the Moon." PHOTOGRAPHIC AND FINE ART JOURNAL 11, no. 5 (May 1858): 134-135. [From "Photo. Notes," abstracted from "Athenaeum." Discusses Warren De la Rue's work, assisted by Thornthwaite, then by Howlett. Whipple & Black's work in USA also mentioned.]

D269 De La Rue, Warren, F.R.S. "Papers on Photography Read before the Last Session of the British Association: Celestial Photography." AMERICAN JOURNAL OF PHOTOGRAPHY AND THE ALLIED ARTS & SCIENCES n. s. vol. 2, no. 12 (Nov. 15, 1859): 180-186.

D270 De la Rue, Warren. "Instantaneous Photography." PHOTOGRAPHIC AND FINE ART JOURNAL 13, no. 8 (Aug. 1860): 215-216. [From "Photo. News."]

D271 "The Solar Eclipse." BRITISH JOURNAL OF PHOTOGRAPHY 7, no. 123 (Aug. 1, 1860): 215, 219-220. [The British expedition to Spain to observe the eclipse of the sun successful. Editorial note on p. 215 as well.]

D272 Beck, Walter. "The Recent Solar Eclipse. The British Astronomical Expedition: A Personal Narrative of the Phenomena Observed." BRITISH JOURNAL OF PHOTOGRAPHY 7, no. 124 (Aug. 15, 1860): 233-235.

D273 De La Rue, Warren. "The Recent Solar Eclipse. The British Astronomical Expedition." BRITISH JOURNAL OF PHOTOGRAPHY 7, no. 124 (Aug. 15, 1860): 235-237.

D274 De La Rue, Warren "Celestial and Instantaneous Photography." BRITISH JOURNAL OF PHOTOGRAPHY 7, no. 124 - 127 (Aug. 15, 1860): 238-239, 251-252, 271-272, 283-284.

D275 De la Rue, Warren. "The Recent Solar Eclipse as Seen in Spain." ILLUSTRATED LONDON NEWS 36, no. 1047 (Aug. 25, 1860): 170, 188-189. 3 b & w. [Two photos of sun's eclipse, view of the Kew Photoheliograph and temporary observatory at Rivabellosa, near Miranda del Ebro.]

D276 De la Rue, Warren. "Remarkable Faculae and Spots Seen on the Sun on the 19th and 20th of July." ILLUSTRATED LONDON NEWS 37, no. 1049 (Sept. 8, 1860): 232. 1 illus.

D277 De la Rue, Warren, F.R.S., F.R.A.S., etc. "Celestial and Instantaneous Photography." HUMPHREY'S JOURNAL OF PHOTOGRAPHY, AND THE ALLIED ARTS AND SCIENCES 12, no. 11-14 (Oct. 1 - Nov. 15, 1860): 174-176, 189-192, 197-198, 217-220.

D278 "Our Weekly Gossip." ATHENAEUM no. 1833 (Dec. 13, 1862): 772. [Smith & Beck published twelve lunar photographs by Warren De La Rue.]

D279 De la Rue, Warren. "Report of the Progress of Celestial Photography Since the Meeting of Aberdeen." AMERICAN JOURNAL OF PHOTOGRAPHY AND THE ALLIED ARTS & SCIENCES n. s. vol. 4, no. 11 (Nov. 1, 1861): 241-246.

D280 "Celestial Photography: Presentation of the Gold Medal to Mr. Warren De la Rue, F.R.S., &c., by the President of the Royal Astronomical Society." BRITISH JOURNAL OF PHOTOGRAPHY 9, no. 162 (Mar. 15, 1862): 107-109. [De la Rue's work discussed and praised.]

D281 "Useful Facts, Receipts, Etc.: Astronomical Photography." AMERICAN JOURNAL OF PHOTOGRAPHY AND THE ALLIED ARTS & SCIENCES n. s. vol. 5, no. 2 (July 15, 1862): 40-41. [From "Br. J." Warren de la Rue exhibited engravings from negatives of spots on the sun, taken in Sept. 1861.]

D282 De la Rue, Warren. "Lunar Photographs." BRITISH JOURNAL OF PHOTOGRAPHY 10, no. 184 (Feb. 16, 1863): 87-88. 2 illus. [De La Rue states that he had made the negative of an image of the moon in 1858, which was apparently copied later by a Dr. D'Orsan and claimed to have been taken by himself, then published in the book, "Our Satellite." An accompanying letter from the publisher admits the fraud and states it is withdrawing the book. See also pp. 41 and 61 for a discussion of activities leading up to this event. There is also a letter of reply by D'Orsan on pp. 110-111 of the same volume.]

D283 "Who Photographed the Moon?" JOURNAL OF THE PHOTOGRAPHIC SOCIETY OF LONDON 8, no. 131 (Mar. 16, 1863): 247-249. [D'Orsan or De la Rue. From "London Review."]

D284 "Photographs of the Moon. Enlarged from Original Negatives taken by Warren de la Rue, F.R.S. London:Smith, Beck & Beck." BRITISH JOURNAL OF PHOTOGRAPHY 10, no. 187 (Apr. 1, 1863): 148.

D285 "Scientific News: Photographic Images of the Moon." ILLUSTRATED LONDON NEWS 43, no. 1230 (Nov. 7, 1863): 483. [Note that Warren De La Rue produced a photo of the moon, about 39" in diameter.]

D286 "Photographs of the Moon. Enlarged from Original Negatives taken by Warren De La Rue, F.R.S." AMERICAN JOURNAL OF PHOTOGRAPHY AND THE ALLIED ARTS & SCIENCES n. s. vol. 5, no. 21 (May 1, 1863): 487-489. [From "Br. J. of Photo."]

D287 "Salad for the Photographer: Photography and Astronomy." PHILADELPHIA PHOTOGRAPHER 3, no. 30 (June 1866): 190. [From "Scientific Review." De La Rue's photos of the moon being enlarged to 3 ft. size.]

D288 Pritchard, Rev. C., F.R.S. "A Journey in the Service of Science: Being a Description of the Phenomena of a Total Solar Eclipse, Chiefly as Observed at Gujuli, in Spain, on July 18, 1860." GOOD WORDS 8, no. 9-10 (Sept. - Oct. 1867): 608-614, 694-701. 1 illus. [Report of an 1860 expedition. Warren de la Rue's work in astronomical photography praised on p. 614; his participation in the expedition discussed in second paper. C. Piazzi Smyth, the Astronomer Royal, was also on expedition.]

DE LANGUE, C.
D289 De Langue, C. "The Daguerreotype Anticipated." HUMPHREY'S JOURNAL OF PHOTOGRAPHY, AND THE ALLIED ARTS AND SCIENCES 13, no. 15 (Dec. 1, 1861): 234. [From "Photo. News." Excerpt from a French book "Les Fables of Fenelon," published ca. 1690, describing a very detailed visual representation system.]

DE LONG, EUGENE. (d. 1878) (USA)
D290 "Editor's Table." PHILADELPHIA PHOTOGRAPHER 15, no. 173 (May 1878): 160. [Eugene De Long died in Minneapolis, MN. Still young, worked for the Centennial Photographic Co. for two years.]

DE LOSTALOT, ALFRED.
D291 de Lostalot, Alfred. "La photographie des couleurs." LES BEAUX-ARTS ILLUSTRÉS ser. 2 3rd yr., no. 33 (1879): 259-261.

DE PLANQUE, LOUIS. (1842-1898) (USA)
D292 De Planque, Louis. "A Photographer's Narrow Escape." PHILADELPHIA PHOTOGRAPHER 12, no. 144 (Dec. 1875): 358-359. [Cyclone, tidal wave in Corpus Christi, Texas.]

DE ROTH, K.
D293 De Roth, K. "Contributions to the History of Photography." HUMPHREY'S JOURNAL OF PHOTOGRAPHY, AND THE ALLIED ARTS AND SCIENCES 15, no. 4 (June 15, 1863): 56-59. [From "Photographisches Archiv." Tiphaine de la Roche (1760).]

DE RUMINI.
D294 De Rumini. "Application of Photography to Oil Painting upon Canvas." AMERICAN JOURNAL OF PHOTOGRAPHY AND THE ALLIED ARTS & SCIENCES n. s. vol. 7, no. 22 (May 15, 1865): 511-512. [From "Le Genie Industriel."]

DE SELGAS, FRANCISCO.
D295 De Selgas, Francisco. "Substitution of a Bath of Oxy-Ethylate of Silver for the Nitrate of Silver Bath." AMERICAN JOURNAL OF PHOTOGRAPHY AND THE ALLIED ARTS & SCIENCES n. s. vol. 6, no. 20 [sic 21] (May 1, 1864): 500-502. [From "El Eco de la Fotografie, Cadiz."]

DE SHONG, W. H.
D296 De Shong, W. H. "Negatives by Gas Light." PHOTOGRAPHIC AND FINE ART JOURNAL 8, no. 6 (June 1855): 170. [De Shong a daguerreotypist from Memphis, TN.]

DE SILVA, ABRAHAM M. (d. 1890) (USA)
D297 De Silva, Abraham M. "Correspondence." ANTHONY'S PHOTOGRAPHIC BULLETIN 6, no. 5 (May 1875): 158-159. [Letter.]

D298 De Silva, Abraham M. "How To Avoid Some Troubles." ANTHONY'S PHOTOGRAPHIC BULLETIN 6, no. 9 (Sept. 1875): 264-265. [Developing problems.]

D299 De Silva, A. M. "Printing in Winter." ANTHONY'S PHOTOGRAPHIC BULLETIN 8, no. 1 (Jan. 1877): 20.

D300 "Pennsylvania. - The Arab Horses 'Djeytan' and 'Missirli,' Presented by the Sultan of Turkey to General Grant, Now at Suffolk Park, Philadelphia. - From Photographs by A. M. De Silva, New Haven." FRANK LESLIE'S ILLUSTRATED NEWSPAPER 48, no. 1238 (June 21, 1879): 257. 1 illus.

D301 "Notes and News: Suicide of Photographer de Silva." PHOTOGRAPHIC TIMES 20, no. 470 (Sept. 19, 1890): 475. ["He was a photographer of wide reputation and was about to join an expedition up the Congo River with a party of New Yorkers..."]

DE ST. FLORENT.
D302 "Photography in Natural Colors." ANTHONY'S PHOTOGRAPHIC BULLETIN 5, no. 2 (Feb. 1874): 81-83. [From "Br. J. of Photo." De St. Florent's experiments.]

DE SZATHMARI, CAROL POPP. (1812-1887) (RUMANIA)
D303 "Minor Correspondence and the War." HUMPHREY'S JOURNAL 7, no. 6 (July 15, 1855): 104. [Note, from "La Lumiere," describing the return of Count Szathmari to Paris from Wallachia with 200 views, portraits of generals, etc. of both the Russians and the Turks, both occupying the Danube provinces - the seige of Lithuania, etc. (Note: The "Illustrated London News" may have used these materials without credit during 1855.)]

D304 "Gold Medal for M. Szathmari." HUMPHREY'S JOURNAL 7, no. 12 (Oct. 15, 1855): 199. [From "La Lumiere." Announcement that Queen Victoria, Prince Albert and the King of Belgium questioned Szathmari on his experiences photographing "the war in the East." Queen Victoria intends to give him a medal.]

D305 "Prince Gortschakoff, Commander-in-Chief of the Russian Army in the Crimea." ILLUSTRATED LONDON NEWS 27, no. 728 (Nov. 3, 1855): 528. 1 illus. ["From a Photograph by Skathmari. [sic Szathmari]"]

D306 "Bucharest, in Wallachia, the Scene of the Late Inundation." ILLUSTRATED LONDON NEWS 46, no. 1308 (Apr. 1, 1865): 300-301. 5 illus. ["We publish...a view of the city of Bucharest...and

a few illustrations of the costumes of different classes of the population. They are engraved from photographs by M. Szathmari, of that city."]

D307 Savulescu, Constantin. "The First War Photographic Reportage." IMAGE 16, no. 1 (Mar. 1973): 13-16. 1 b & w. 2 illus. [Born in Satu-Mare (Transylvania) in 1812. Lived in Bucharest after 1830. Began as a daguerreotypist, changed to calotype in 1848. In Apr. 1854 de Szathmari photographed both the Russian and Turkish troops during the first stages of the Crimean War.]

D308 Fort, Paul. "Carol Popp de Szathmari." PHOTOGRAPHIC COLLECTOR 2, no. 2 (Summer 1981): 8-14. 3 b & w. [Article includes a translation of a section of "Esquisies Photographiques," by Ernest Lacan, Paris, 1856, pp. 155-167. De Szathmari photographed the Russian and Turkish armies during their conflicts of 1854 in Romania (Preceeds Crimean War).]

DE VALICOURT,E.

D309 De Valicourt, E. "A New and Complete Photographic Manual for Metal Plates and Paper - Containing all the Latest Discoveries." PHOTOGRAPHIC AND FINE ART JOURNAL 7, no. 2-12 (Feb. - Dec. 1854): 42-47, 89-94, 145-149, 186-189, 213-215, 238-243, 264-268, 302-307, 333-338, 365-371.

D310 De Valicourt, E. "Photographic Miscellanies." PHOTOGRAPHIC AND FINE ART JOURNAL 8, no. 1-2 (Jan. - Feb. 1855): 12-17, 43-47. [From E. De Valicourt's book.]

D311 De Valicourt, E., trans. by W. Grigg. "Photography on Paper." PHOTOGRAPHIC AND FINE ART JOURNAL 8, no. 3-6 (Mar. - June 1855): 81-86, 114-118, 151-156, 164-165. [Includes sections by W. H. F. Talbot, R. Hunt and articles about the work of Herschel and others.]

D312 De Valicourt. "Photographic Portraiture." HUMPHREY'S JOURNAL OF PHOTOGRAPHY, AND THE ALLIED ARTS AND SCIENCES 13, no. 21-23 (Mar. 1 - Apr. 1, 1862): 330-332, 347-349, 359-360. [From "Photo. News."]

DE WILDE. [?]

D313 Young, Allen, R. N. R. Cruise of the "Pandora." From the Private Journal Kept by Allen Young, Commander of the Expedition. London: W. Clowes & Sons, 1876. 90 pp. 12 b & w. [Original photos, probably by "Mr. de Wilde, Artist," on the crew list.]

DEAN, JOHN. (1822-1882) (GREAT BRITAIN, USA)

D314 Taylor, J. Traill. "General Notes." PHOTOGRAPHIC TIMES 12, no. 134 (Feb. 1882): 36. [John Dean born in Clitheroe, England, on Aug. 30, 1822. To USA at an early age. Learned the trade of an engraver but in 1858 commenced, in Worcester, MA, the manufacture of Daguerreotype mats & preservers with H. M. Hedden. Later manufactured the Ferrotype plate. Firm later dissolved into two separate companies: John Dean & Co. and Phenix Plate Co. Dean wealthy and upright citizen, etc.]

DEAN, JOHN, DR. (1831-1888) (GREAT BRITAIN, USA)

D315 Dean, Dr. John. ...The Gray Substance of the Medulla Oblongata and Trapezium. "Smithsonian Contributions to Knowledge, Vol. 16, Art. 2." Washington, DC: Smithsonian Institution, 1864. 75 pp. 16 l. of plates. [The photolithographs, by L. H. Bradford, are from negatives made by the author.]

DEANE, JAMES. (1801-1858) (USA)
BOOKS

D316 Deane, James. Ichnographs from the Sandstone of the Connecticut River. Boston; London: Little, Brown & Co.; Samson Low & Son, 1861. 61 pp. 46 l. of plates. 22 b & w. [Twenty-two mounted salt prints, plus lithographs. Nine of the plates "are direct photographs from the original stone, -in photo-lithography." The others are reproductions of drawings. "Biographical Notice," by Henry L. Bowditch on pp. 5-12. James Deane born Feb. 24, 1801 at Coleraine, Franklin Co., MA, to a family of farmers. He went to public school, then spent a term at the Deerfield Academy. Became a clerk at age 21, continued his studies, and became a doctor of medicine in 1831. He practiced in Greenfield, MA, for the rest of his life. Contributed many papers of practical matters to the medical journals, elected Vice President of the Massachusetts Medical Society in 1854. For many years he studied fossil footprints, presenting papers to various scientific organizations. He died on June 8, 1858. (It is not clear if Deane himself took the photographs, or if he had them taken by someone else.)]

DEANS, W. B.

D317 Deans, W. B. "Correspondence." DAGUERREAN JOURNAL 1, no. 4 (Jan. 1, 1851): 115-116. [Letter from W. B. Deans, of Montrose, PA, with a poem.]

DEBENHAM, W. E. (LONDON, ENGLAND)

D318 Portraits. Woodcut engravings credited "From a photograph by W. E. Debenham, Regent St." ILLUSTRATED LONDON NEWS 64, (1874) ["Late Sir Sydney Cotton." 64:1806 (Apr. 4, 1874): 312. "Capt. Glover, R.N." 64:1809 (Apr. 25, 1874): 384.]

D319 Debenham, W. E. "Retouching in Comfort." BRITISH JOURNAL PHOTOGRAPHIC ALMANAC 1877 (1877): 184-185. 2 illus. [Illustrations are line drawings of a woman retouching photographs - "Healthy Work" and "Unhealthy Work."]

D320 Portrait. Woodcut engraving credited "From a photograph by W. E. Debenham, Regent St. and Haverstock Hill." ILLUSTRATED LONDON NEWS 72, (1878) ["Late Mr. G. W. Lovell." 72:2032 (June 8, 1878): 533.]

D321 Taylor, J. Traill. "Our Editorial Table: Gelatino-Emulsion Plates by W. E. Debenham, London." PHOTOGRAPHIC TIMES 11, no. 127 (July 1881): 245-246. [Debenham, a professional studio photographer in London, also maker of photographic plates.]

D322 "General Notes." PHOTOGRAPHIC TIMES 14, no. 160 (Apr. 1884): 176. [Paragraph about W. E. Debenham's efforts to find a safe-light for his London studio.]

D323 Debenham, W. E. "Dark-Room Illumination." PHOTOGRAPHIC TIMES 14, no. 160 (Apr. 1884): 178-180.

D324 Debenham, W. E. "The Practice of Retouching Negatives." ANTHONY'S PHOTOGRAPHIC BULLETIN 19, no. 21-24 (Nov. 10 - Dec. 22, 1888): 656-658, 684-687, ———, 756-758. 2 illus. [From "Photographic News."]

D325 Debenham, W. E. "The Cult of Indistinctness." PHOTOGRAPHIC TIMES 21, no. 518 (Aug. 21, 1891): 420-422. ["Read before the Convention of the United Kingdom." Angry attack on arguments of Maskell and Pennell, based on the photographs and theories of P. H. Emerson and George Davison, for soft-focus photography.]

D326 Debenham, W. E. "Portraiture for Amateurs." PHOTOGRAPHIC TIMES 30, no. 11 (Nov. 1898): 510-512. [Lecture delivered before the Gospel Oak Photographic Society.]

DECKER, EDGAR. (1832-1905) (USA)
BOOKS
D327 *Cleveland, Past and Present: Its Representative Men; Comprising Biographical Sketches of Its Commerce, Manufacture, Ship Building, Railroads, Telegraphy, Schools, Churches, etc.* Cleveland: Maurice Joblin, 1869. n. p. 82 b & w. [Original prints, by E. Decker.]

PERIODICALS
D328 Portrait. Woodcut engraving, credited "From a Photograph by Decker." NEW YORK ILLUSTRATED NEWS 9, (1863) ["John Brough, Gov. of OH." 9:209 (Oct. 31, 1863): 1.]

D329 "Our Illustration." ANTHONY'S PHOTOGRAPHIC BULLETIN 20, no. 15 (Aug. 10, 1889): 472, plus frontispiece. 1 b & w. [Child portrait by E. Decker, Ex. Pres. of the Photographers' Association of America. Photo not bound in this copy.]

D330 "Portrait of a Lady." PHOTOGRAPHIC TIMES 22, no. 581 (Nov. 4, 1892): 557, plus frontispiece. 1 b & w. [Studio portrait.]

DEFONDS, ÉMILE.
D331 Defonds, Émile. "De la photographie au point de vue de l'art." L'ARTISTE ser. 6 , no. 16 (Apr. 17, 1859): 246-247.

DELAMOTTE, PHILIP HENRY. (1820-1889) (GREAT BRITAIN)
[Delamotte's father was William De La Motte, landscape painter, watercolorist, and lithographer, the drawing master at Sandhurst Military Academy. Philip H. Delamotte also became an artist, and taught drawing and perspective at King's College, Cambridge from 1855 to 1887. He was elected a Fellow of the Society of Antiquities in 1852, where he met and befriended Dr. Hugh W. Diamond. He became interested in photography in the late 1840s and exhibited photographs at the first commercial photographic exhibition in 1852, which he organized. His manual *The Practice of Photography:...* came out in 1853, while he was advertising his services as a calotype printer. He also began an association with the publisher Joseph Cundall, which led to the publication of a number of photographically illustrated volumes, including the *Photographic Views of Progress of the Crystal Palace, Sydenham.* After he took his post as drawing master of King's College his photographic activities slackened, although he continued to photograph and exhibit. He edited *The Sunbeam: A Photographic Magazine* in 1857, and published illustrations for several books in the late 1850s. He published a number of books on drawing in the 1870s and 1880s, but returned to photography to illustrate Princess Marie Lichtenstein's *Holland House* in 1874.]

BOOKS
D332 *On the Various Applications of Anastatic Printing and Papyrography.* With illustrative examples by Philip DelaMotte. London: D. Bogue, 1849. 24 pp. 16 l. of plates. 16 b & w.

D333 *Choice Examples of Art Workmanship Selected From the Exhibition of Ancient and Medieval Art at the Society of Arts.* Drawn and Engraved under the Superintendence of Philip DelaMotte. London: Cundall & Abbey, 1851. 2 pp. 59 l. of plates.

D334 Delamotte, Philip H. *The Practice of Photography; A Manual for Students and Amateurs...Illustrated with a calotype portrait taken by the collodion process.* London: Joseph Cundall, 1853. viii, 150 pp. 1

b & w. illus. [Paper processes of Talbot, Cundall, Le Gray, and Dr. Hugh Diamond described in the appendix. 2nd ed. (1855), London: Sampson Low & Son, viii, 166 pp. [Facsimile reprint of 1855 ed. (1973), Arno Press.]

D335 Delamotte, Philip H. *The Practice of Photography: A Manual for Students and Amateurs.* New York: Office of the Photographic & Fine Art Journal, 1854. vi, 67 pp. [Republication of the 1853 London edition, which had been published serially in "Humphrey's Journal" and in the "Photographic Art Journal".]

D336 *Pictures of the Crystal Palace.* Engraved on Wood by W. Thomas and H. Harrai, from Photographs by Philip H. Delamotte, and Original Drawings by G. H. Thomas and other Artists. London: G. Bell, ca. 1854. n. p. illus. [Part I.]

D337 Phillips, Samuel, LL.D. *A Guide to the Palace and Park.* s. l.: s. n., 1854. n. p. illus. [Illustrated by Philip H. Delamotte.]

D338 Delamotte, Philip H. *Photographic Views of the Progress of the Crystal Palace, Sydenham.* Taken during the progress of the works, by the desire of the directors, by P. H. Delamotte. Together with a list of the directors and officers of the company, etc. London: Photographic Institution, 1855. 2 vol. 160 b & w. [Original photos. Each volume has printed title page, contents page and printed captions under each photograph. Apparently several slightly variant albums were produced. The Gernsheim Collection, Un. of TX, Austin, contains 160 prints. The Marshall Collection contained 80 prints.]

D339 Delamotte, Philip H. *The Oxymel Process in Photography; For the use of Tourists, Including the Collodion Process, the Best Methods of Printing, and a Chapter on the Preservation of Photographic Pictures.* Illustrated with a few woodcuts by the author. London: Chapman & Hall, 1856. viii, 32 pp. illus.

D340 *A Photographic Tour Among the Abbeys of Yorkshire,* by Philip H. Delamotte and Joseph Cundall. With descriptive notices, by John Richard Walbran ...and William Jones, F.S.A. London: Bell & Daldy, 1856. 50 pp. 23 b & w. [Original photographs.]

D341 Reverley, Henry. *The Reveley Collection of Drawings at Brynygwin, North Wales.* Photographed by Philip H. Delamotte ... and T. Frederick Harwich. London: Bell & Daldy, 1858. 2 pp. 60 l. of plates. 60 b & w. [Photographs of drawings. Published in six parts, each containing ten original photographs.]

D342 Delamotte, Philip H., editor. *The Sunbeam. A Book of Photographs from Nature.* London: Chapman & Hall, 1859. 44 pp. 20 b & w. [Photographs by P. H. Delamotte, F. R. Pickersgill, Francis Bedford, Joseph Cundall and others. This volume grew out of the magazine of the same name.]

D343 *Memoirs Illustrative of the Art of Glass Painting.* By the late Charles Winston, of the Inner Temple. Illustrated with Engravings from the Author's Original Drawings, by Philip H. Delamotte, F.S.A. London: J. Murray, 1866.

D344 *The Art of Sketching From Nature.* By Philip H. Delamotte, Professor of Drawing in King's College and King's College School. London: Bell & Dalby, 1871. 74 pp. 25 l. of plates.

D345 Liechtenstein, Marie Henriette Norberte, Prinzessin von. *Holland House.* London: Macmillian & Co., 1874. 2 vol. (vol. 1 xvi, 289 p. vol. 2 xvii, 255 p.) 37 b & w. illus. [Issued in two editions. The ordinary edition was illustrated with five steel engravings by C. H.

Jeens, after paintings by Watts and other artists, and numerous illustrations drawn by Prof. P. H. Delamotte and engraved on wood by J. D. Cooper, W. Palmer, and Jewitt & Co. The extra-illustrated edition contained an additional 37 Woodburytype prints from negatives by P. H. Delamotte, as well as India Proofs of Jeens' steel engravings.]

D346 Wheatley, Henry B. and Philip H. Delamotte. ...*Art Work in Gold and Silver Medieval.* "Handbooks of Practical Art" New York: Scribner & Welford, 1882. 64 pp.

D347 Delamotte, Philip H. *Trees, and How to Draw Them.* "One Shilling Handbooks on Art, No. 41" London: Winsor & Newton, Ltd., [1886]. 79 pp.

D348 Delamotte, Philip Henry. *The Art of Sketching from Nature.* London: G. Bell, 1888. 69 pp. 20 l. of plates. illus.

D349 Oliphant, Margaret Oliphant (Wilson), Mrs. *The Makers of Florence: Dante, Giotto, Savonarola and Their City;* ...with portrait of Savonarola engraved by C. H. Jeens and Illustrations from drawings by Delamotte. London: Macmillan, 1892. xx, 422 pp. 41 b & w. illus. ["First printed 1876." Original photos, of drawings by Delamotte.]

D350 *The Crystal Palace:* Photographs by Philip H. Delamotte. Rochester, NY: International Museum of Photography at George Eastman House, 1980. 20 pp. 11 b & w. [Exhibition: Mar. 28 - June 22, 1980. Introduction by Janet E. Buerger. Sixty-two prints and an album were in the exhibition.]

PERIODICALS

D351 "Fine Arts. New Publications. 'The Photographic Album. Parts I and II.'" ATHENAEUM no. 1307 (Nov. 13, 1852): 1247. [Review, 4 photographs by Fenton, 2 by Delamotte.]

D352 Delamotte, P. H. "Portable Camera for Travellers." NOTES AND QUERIES 7, no. 170 (Jan. 29, 1853): 116.

D353 "Spirit of the London Art Journal: Photographic Publications." PHOTOGRAPHIC ART JOURNAL 5, no. 1 (Jan. 1853): 16. [Reviews: *Photographic Album* by R. Fenton and P. Delamotte, and *Egypte, Nubie, Palestine et Syrie*" by Du Camp. Reprinted from "London Art Journal."]

D354 "The Photographic Exhibition." ATHENAEUM no. 1331 (Apr. 30, 1853): 535. [Review of exhibition on New Bond Street organized by Delamotte - containing his and others work. M. Bresolin, R. Helle, F. Martens, H. LeSecq, R. J. Bingham mentioned.]

D355 Delamotte, Philip H. "Photography: Portable Camera for Travelers." HUMPHREY'S JOURNAL 5, no. 8 (Aug. 1, 1853): 119. [From "Notes & Queries."]

D356 "View from the South Gallery of the Crystal Palace, at Sydenham." ILLUSTRATED LONDON NEWS 23, no. 653 (Nov. 12, 1853): 401. 1 illus. [From a Photograph by H. P. [sic P. H.] Delamotte. Under construction.]

D357 Delamotte. "Collodion Process." HUMPHREY'S JOURNAL 5, no. 17 (Dec. 15, 1853): 268-271. ["As the collodion process is now exciting some considerable attention, we present the following as furnished in "Delamotte's Practice of Photography."]

D358 "Photography as a Fine Art." MAGAZINE OF ART 3, no. 13 (1854): 1-2. 1 illus. [Illustrated with a woodcut of a photo by Delamotte.]

D359 Delamotte. "Processes on Paper." HUMPHREY'S JOURNAL 5, no. 22 (Mar. 1, 1854): 337-343. [From Delamotte's *Practice of Photography*.]

D360 Delamotte, Philip H., B.A. "The Practice of Photography." PHOTOGRAPHIC AND FINE ART JOURNAL 7, no. 1-4 (Jan. - Apr. 1854): 1-4, 33-37, 65-71, 97-100.

D361 "Note." NOTES AND QUERIES 9, no. 242 (June 17, 1854): 571. [Delamotte's photos of the Crystal Palace, Queen Victoria, etc. mentioned.]

D362 "The English Medieval Court, at the Crystal Palace, Sydenham." ILLUSTRATED LONDON NEWS 25, no. 698 (Aug. 19, 1854): 153-154. 1 illus. ["The illustration upon the preceding page has been photographed and drawn on the wood by Mr. Philip H. Delamotte." There are other, equally complex views of the Crystal Palace interiors, scattered throughout 1854, but not all are credited.

D363 "Pictures of the Crystal Palace." ART JOURNAL (Nov. 1854): 325. 1 illus. [Bk rev: "Pictures of the Crystal Palace." Engraved on Wood by W. Thomas and H. Harrai, from Photographs by Philip H. Delamotte, and Original Drawings by G. H. Thomas and other artists. Part I. London: G. Bell.]

D364 "The Renaissance Court, at the Crystal Palace." ILLUSTRATED LONDON NEWS 25, no. 711 (Nov. 11, 1854): 457. 1 illus. ["Mr. Delamotte, by the aid of photography, has drawn for our Engraver a portion of the elaborate beauty of this Court..."]

D365 "[The Crystal Palace Reviewed.]" LONDON QUARTERLY REVIEW no. 192 (Apr. 1855): 157-183. [Extensive review of sixteen books about the Crystal Palace, London. *A Guide to the Palace and Park*, by Samuel Phillips, with Illustrations by P. H. Delamotte is included in this group.]

D366 Delamotte. "Practice of Photography." HUMPHREY'S JOURNAL 7, no. 3-4 (June 1 - June 15, 1855): 42-49, 65-68.

D367 Delamotte, Philip H., et. al. "First Report of the Committee Appointed to take into Consideration the Question of the Fading of Positive Photographic Picture upon Paper." PHOTOGRAPHIC AND FINE ART JOURNAL 9, no. 1 (Jan. 1856): 23-24. [From "J. of Photo. Soc., London."]

D368 Delamotte, Philip H. "Photographic Facsimiles of Old Documents." PHOTOGRAPHIC AND FINE ART JOURNAL 9, no. 2 (Feb. 1856): 49-50. [From "Notes & Queries."]

D369 Delamotte, Philip H. "Photographic Facsimiles of Old Documents." HUMPHREY'S JOURNAL 7, no. 22 (Mar. 15, 1856): 352-353. [From "London Times."]

D370 Portraits. Woodcut engravings credited "From a photograph by Delamotte." ILLUSTRATED LONDON NEWS 29, (1856) ["Hormuzd Rassam." 29:* (Nov. 8, 1856): 467.]

D371 "New Publications." ATHENAEUM no. 1529 (Feb. 14, 1857): 218. [Bk. rev.: "The Sunbeam: A Photographic Magazine," edited by Philip H. DelaMotte. No. 1. (Chapman & Hall). 4 illus. by J. D. Llewellyn, Sir Jocelyn Coghill, P. H. DelaMotte, and J. Bedford.]

D372 "The Great Clock at Westminister." ILLUSTRATED LONDON NEWS 30, no. 843-844 (Feb. 7, 1857): 123. 1 illus. ["...has been engraved from a photograph by Mr. Freeman De la Motte."]

D373 "1 engraving (Unpacking the Art-Treasures at the Exhibition Building, Manchester)." ILLUSTRATED LONDON NEWS 30, no. 856 (May 2, 1857): 399. 1 illus. ["From a photograph by De La Motte."]

D374 "Oxford in the Stereoscope." PHOTOGRAPHIC AND FINE ART JOURNAL 10, no. 9 (Sept. 1857): 269. [From "London Art J." Review of stereo series by P. H. Delamotte.]

D375 Delamotte, Philip H. "The Panoramic Lens." JOURNAL OF THE PHOTOGRAPHIC SOCIETY OF LONDON 7, no. 107 (Mar. 15, 1861): 144-145.

D376 Delamotte. "Reviews: Photographs of Strawberry Hill." JOURNAL OF THE PHOTOGRAPHIC SOCIETY OF LONDON 8, no. 136 (Aug. 15, 1863): 337-338. [12 views.]

D377 "Holland House." ILLUSTRATED LONDON NEWS 63, no. 1789 (Dec. 13, 1873): 564. 1 illus. [Bk. notice "Holland House," by Princess Marie Liechenstein, with drawings, engravings and photographs, by Philip Delamotte and others. (Macmillan & Co.)]

D378 "Views of the Crystal Palace." GEORGE EASTMAN HOUSE NEWSLETTER 2, no. 2 (Spring 1980): 4. [Ex rev: "The Crystal Palace: Photographs by Philip H. Delamotte." George Eastman House, Rochester, NY.]

DELLENBAUGH, FREDERICK SAMUEL. (1853-1935)
D379 Dellenbaugh, F. S. "A New Valley of Wonders." SCRIBNER'S MAGAZINE 35, no. 1 (Jan. 1904): 1-18. 17 b & w. ["Illustrations from photographs by the author." Scenery in Utah.]

D380 Morgan, Dale L., editor. William C. Darrah et al. "The Exploration of the Colorado River and the High Plateaus of Utah in 1871-72." UTAH HISTORICAL QUARTERLY 16-17, (Jan. 1948 - Dec. 1949.): 1-540. [These two volumes of the "Quarterly" were published as a monographic volume, dealing with the Powell Colorado River Exploring Expedition of 1871-1872. It contains much information, diaries etc. of participants. See specifically William Culp Darrah's "Beaman, Fennemore, Hillers, Dellenbaugh, Johnson and Hattan," on 491-503 for biographies of these members of the expedition. E.O. Beaman, James Fennemore (1849-1941 b. Great Britain, USA), John K. Hillers (1843-1925 b. Germany, USA), and Frederick Samuel Dellenbaugh (1853-1935).]

DEMIER. (ST. PETERSBURG, RUSSIA)
D381 "Extract from the Report of the Berlin Photographic Society." ANTHONY'S PHOTOGRAPHIC BULLETIN 4, no. 6 (June 1873): 184. [From "Br J of Photo." Discusses work of Mr. Demier, of St. Petersburg.]

DENISON see CHURCHILL & DENISON.

DENISON. (ALBANY, NY)
D382 Portrait. Woodcut engraving, credited "From a Photograph by Denison, Albany, N. Y." FRANK LESLIE'S ILLUSTRATED NEWSPAPER 40, (1875) ["Hon. George S. Batcheller." 40:1026 (May 29, 1875): 192.]

DENNY, CONRAD B. see also WHITNEY & DENNY.

DENTON & POPJAY.
D383 "New York City. - The New Dredging Steamer Intended for Clearing the Mouth of the Mississippi River. - From a Photograph by Denton & Popjay." FRANK LESLIE'S ILLUSTRATED NEWSPAPER 34, no. 870 (June 1, 1872): 188. 1 illus.

DERHAM, E. H. (ca. 1849-1887) (USA)
D384 "Old World Gleanings." PHOTOGRAPHIC TIMES 14, no. 165 (Sept. 1884): 479. [Brief report of a developer formula given by Mr. Derham, of Boston, MA, at a recent meeting of the London and Provincial Photographic Association.]

D385 "Obituary: E. H. Derham." PHOTOGRAPHIC TIMES 17, no. 290 (Apr. 8, 1887): 169. [Died at age 38, in an accident at Forest Hills. Worked for fifteen years for Allen & Rowell. Contributed articles to the "PT".]

DERRON. (BRUSSELS, BELGIUM)
D386 Portrait. Woodcut engraving credited "From a photograph by Derron." ILLUSTRATED LONDON NEWS 61, (1872) ["Late Baron de Beaulieu, Belgian Ambassador." 61:1730 (Nov. 2, 1872): 412.]

DESMAISONS, E. (PARIS, FRANCE)
D387 Portrait. Woodcut engraving credited "From a photograph by M. E. Desmaisons, Pont Neuf, Paris." ILLUSTRATED LONDON NEWS 53, (1868) ["Gioacchino Rossini, composer." 53:* (Nov. 28, 1868): 520.]

DESPLANQUES, E.
D388 "Biographical Notes on a Number of Photographers Published by Blanquart-Evrard." CAMERA 57, no. 12 (Dec. 1978): 32, 41-42. [Benecke, Claine, DuCamp, Fortier, Greene, Le Secq, Loydreau, Marville, Regnault, Robert, Salzmann, Stewart, Sutton, and Tenison.]

DESPRATZ, L'ABBE.
D389 Despratz, L'Abbe. "On Instantaniety in Photography." HUMPHREY'S JOURNAL OF PHOTOGRAPHY, AND THE ALLIED ARTS AND SCIENCES 13, no. 18 (Jan. 15, 1862): 281-283. [From "Le Moniteur de la Photographie."]

D390 Desprats, LeAbbe. [sic?] "Collodion: Wet and Dry." AMERICAN JOURNAL OF PHOTOGRAPHY AND THE ALLIED ARTS & SCIENCES n. s. vol. 6, no. 19 (Apr. 1, 1864): 436-440. [From "Le Moniteur de la Photographie."]

DETROIT PUBLISHING CO.
D391 Lowe, James L. and Ben Papell. *The Detroit Publishing Company Collectors' Guide.* Newtowne Square, PA: Deltiogists of America, 1975. 288 pp. 300 illus. [Contains over 300 illustrations of Detroit postcards and checklists of more than 20,000 issues published from 1898 to 1932. William H. Jackson joined the firm in 1898, which subsequently published many of his negatives taken before that date, as well as his work taken later.]

D'ETTINGHAUSEN, C.
D392 A. T. L. "Natural Impression: La Flore il Autriche." PHOTOGRAPHIC AND FINE ART JOURNAL 9, no. 9 (Sept. 1856): 262-263. [Discussion of the book "Flore Autrichienne," engraved by Dr. C. D'Ettingshausen and Alois Pokorny. Published in Austria. Auer somehow involved. 500 plates of Austrian flowers.]

DEVEREUX, W. B.
D393 Princeton Scientific Expedition, 1877. *Topographic, Hypsometric and Meteorologic Report,* by William Libbey, Jr. and W. W. McDonald, of the Princeton Scientific Expedition, 1877.

"Contributions from the F. M. Museum of Geology and Archeology of Princeton College. No. 2." New York: s. n., 1879. 55 pp. 28 l. of plates. 28 b & w. [Photomechanical prints by Harroun & Bierstadt, from photographs by W. B. Devereux and H. R. Butler.]

DEVERIL, HERBERT. (NEW ZEALAND)
D394 Deveril, Herbert. "Photo-Lithography in New Zealand." ANTHONY'S PHOTOGRAPHIC BULLETIN 7, no. 1 (Jan. 1876): 1-5. [From "London Photo. News." Herbert Deveril's report on the use of photo-lithography at the Government Establishment, Wellington, New Zealand.]

DEW, GEORGE F.
D395 Dew, George F. "A Developing Stand for Large Plates." BRITISH JOURNAL PHOTOGRAPHIC ALMANAC 1879 (1879): 148. 1 illus.

D396 Dew, George F. "A Fixing Tray for Landscape Work." BRITISH JOURNAL PHOTOGRAPHIC ALMANAC 1879 (1879): 179-180. 1 illus.

DEWY, GEORGE W.
D397 Dewy, George W. "Portraiture." DAGUERREAN JOURNAL 1, no. 12 (May 1, 1851): 366-367. [From "Hill's Treatise." Discussion of portraiture by painters, but mentions the daguerreotype.]

DIAMOND, HUGH WELCH. (1809-1886) (GREAT BRITAIN)
[Born in Kent, the son of a surgeon with the East India Company. Royal College of Surgeons in 1824. Moved to the Betham Hospital in 1833, where he studied madness. Elected to the Royal College of Surgeons in 1834. Diamond was interested in antiquities, and became a Fellow of the Society of Antiquities in 1834. In 1839, hearing of Talbot's discoveries, Diamond made some photograms. His interest in photography continued and he was a founding member of the Calotype Society. In 1848 Diamond was appointed superintendent of the female department of the Surrey County Asylum, and he made many portrait studies of his patients in the early 1850s, which he attempted to use as therapeutic tools. During this time, before any British photographic journals had been founded, Diamond was a major contributor of advice on photographic processes and techniques through the weekly antiquarian journal *Notes and Queries*, and he encouraged many young men to learn photography - including Henry Peach Robinson. Diamond later became Secretary of the Photographic Society of London and an editor of the *Photographic Journal*.]

BOOKS
D398 *Reports of the Jurors, International Exhibition of 1862, at South Kensington. Class XIV, Photography.* London: published for the Society by Clowes & Son, 1862. 17 pp.

D399 Gilman, Sander L., ed. *The Face of Madness: Hugh W. Diamond and the Origin of Psychiatric Photography.* New York: Brunner/Mazel, Publishers, 1976. 112 pp. 54 b & w. [Introduction by Eric T. Carlson, M.D.; Essay by Saunder L. Gilman, Ph.D.; "On the Application of Photography to the Physiognomic and Mental Phenomena of Insanity," by Hugh W. Diamond (1856); "Case Studies from the Physiognomy of Insanity," by John Conolly (1858).]

D400 Bloore, Carolyn. *Hugh Welch Diamond: Doctor, Antiquary, Photographer.* Twickenham: Orleans House Gallery, 1980. n. p. [Exhibition catalog.]

PERIODICALS
D401 Diamond, Hugh W. "Photography Applied to Archaeology and Practiced in the Open Air." NOTES AND QUERIES 6, no. 151-157 (Sept. 18 - Oct. 30, 1852): 276-278, 295-296, 319-320, 371-373, 395-396, 421-422.

D402 "Note." NOTES AND QUERIES 6, no. 163 (Dec. 11, 1852): 562. [Note by Dr. Diamond of his early use of the collodion process to make microscope slides.]

D403 Diamond, Hugh W. "Photographic Correspondence: Processes Upon Paper." NOTES AND QUERIES 7, no. 166 (Jan. 1, 1853): 20-22.

D404 "Letter." NOTES AND QUERIES 7, no. 169 (Jan. 22, 1853): 93. [A signed letter from "we, the undersigned amateurs of photography in the city of Norwich" thanking Dr. Diamond for his services in writing in "Notes & Queries" signed by 10 people.]

D405 "Dr. Diamond's Process for Paper Photographs." HUMPHREY'S JOURNAL 4, no. 22 (Mar. 1, 1853): 341-344. [Source not credited.]

D406 "Photography Applied to Archaeology, and Practiced in the Open Air." HUMPHREY'S JOURNAL 5, no. 2/3-4 (May 1-15 - June 1, 1853): 17-25, 52-53. [Extracted from "Notes & Queries."]

D407 "On the Simplicity of the Calotype Process by Dr. Diamond (read before the Photographic Society on Nov. 3, 1853)." NOTES AND QUERIES 8, no. 216 (Dec. 17, 1853): 596-600.

D408 "Process for Printing on Albumenized Paper." PHOTOGRAPHIC AND FINE ART JOURNAL 7, no. 1 (Jan. 1854): 12-13. [From "Notes & Queries."]

D409 "London Photographic Society." PHOTOGRAPHIC AND FINE ART JOURNAL 7, no. 1 (Jan. 1854): 27-29. [Reports of Dr. Hugh Diamond's "On the Simplicity of the Collodion Process."]

D410 Diamond, Dr. "The Simplicity of the Colotype Process." HUMPHREY'S JOURNAL 5, no. 18 (Jan. 1, 1854): 279-280, 282-284. [From "London J. of the Photo Society."]

D411 "Minor Correspondence: Testimonial to Dr. Diamond." HUMPHREY'S JOURNAL 7, no. 6 (July 15, 1855): 104.

D412 Diamond, Hugh W. "The Application of Photography to the Copying of Ancient Documents, Prints, Pictures, Coins, Etc." PHOTOGRAPHIC AND FINE ART JOURNAL 9, no. 3 (Mar. 1856): 92-93. [From "Notes & Queries."]

D413 Diamond, Hugh W. "On the Application of Photography to the Copying of Ancient Documents, Etc." HUMPHREY'S JOURNAL 8, no. 2 (May 15, 1856): 17-18. [From "Notes and Queries."]

D414 "On Photography Applied to the Phenomena of Insanity." JOURNAL OF THE PHOTOGRAPHIC SOCIETY OF LONDON 3, no. 44 (July 21, 1856): 88-89. [Abstract of Diamond's paper "On the Application of Photography to the Physiognomic and mental phenomena of insanity" read before the Royal Society. From the "Saturday Review" May 24, 1856.]

D415 "On Photography Applied to the Phenomena of Insanity." PHOTOGRAPHIC AND FINE ART JOURNAL 9, no. 9 (Sept. 1856): 277. [From "Saturday Review, May 24."]

D416 "The Late Mr. Douglas Jerrold." ILLUSTRATED LONDON NEWS 30, no. 864 (June 20, 1857): 598. 1 illus. ["From a Photograph by Dr. Diamond."]

D417 "Our Weekly Gossip." ATHENAEUM no. 1560 (Sept. 19, 1857): 1178. [Mentions that four portraits of the late Douglas Jerrold, taken by Mr. Diamond only a few days before Jerrold's death, published by Bradbury & Evans.]

D418 "Our Weekly Gossip." ATHENAEUM no. 1607 (Aug. 14, 1858): 202. [Dr. Diamond appointed Secretary to the Photographic Society.]

D419 "Photography One of the Fine Arts." BRITISH JOURNAL OF PHOTOGRAPHY 9, no. 171 (Aug. 1, 1862): 283. [From the "Journal of the Photographic Society."]

D420 Diamond, Dr. "Negative Paper Process." AMERICAN JOURNAL OF PHOTOGRAPHY AND THE ALLIED ARTS & SCIENCES n. s. vol. 8, no. 18 (Mar. 15, 1866): 413-414. [From "Br. J. of Photo."]

D421 "Editorial Notes." ANTHONY'S PHOTOGRAPHIC BULLETIN 17, no. 14 (July 24, 1886): 420. [Brief note of death of Dr. Diamond, once editor of the "Journal of the Photographic Society.".]

D422 "General Notes." PHOTOGRAPHIC TIMES 17, no. 297 (May 27, 1887): 269. ["Among the possessions of the late Dr. Diamond,... was a curious old objective which had once been the property of the famous Daguerre..."]

DICKENS, CHARLES. (1812-1870) (GB)

D423 "Photography." PHOTOGRAPHIC ART JOURNAL 5, no. 6 (June 1853): 325-333. [From "Household Words." Mentions Daguerre, Talbot, Beard. Discusses Claudet, Mayall, and others.]

D424 Vanderweyde, J. J., compiler. "Charles Dickens on Photographers." AMERICAN JOURNAL OF PHOTOGRAPHY AND THE ALLIED ARTS AND SCIENCES n. s. vol. 2, no. 24 (May 15, 1860): 380-382.

D425 Dickens, Charles [?]. "Photography 1853." HISTORY OF PHOTOGRAPHY 5, no. 1 (Jan. 1981): 51-57. [Reprint of article printed in "Household Words" Mar. 19, 1853, possibly by Dickens. Article sent in by M. Lindsay Lambert.]

D426 Cohn, Alan M. "Photography, 1853: by Charles Dickens?" HISTORY OF PHOTOGRAPHY 5 , no. 4 (Oct. 1981): 356. [This is a follow-up to the article in "History of Photography" 5:1 (Jan. 1981), pp. 51-57.]

D427 Jackson, Arlene M. "Dickens and 'Photography' in 'Household Words.'" HISTORY OF PHOTOGRAPHY 7, no. 2 (Apr. - June 1983): 147-149. 2 illus. [The authors of an article on photography in Dickens' (Mar. 19, 1853) 'Household Words' are Henry Morley and William Henry Wills.]

DICKENSON & TUCKER. (WEATHERFORD, TX)

D428 "Correspondence." ANTHONY'S PHOTOGRAPHIC BULLETIN 1, no. 11 (Dec. 1870): 230-231. [Letter describing portable traveling gallery, built by these Texas photographers. "We have tried tents, and they would not do, on account of the wind in this country."]

DICKINSON. (LONDON, ENGLAND)

D429 Portrait. Woodcut engraving credited "From a photograph by Dickinson, New Bond St." ILLUSTRATED LONDON NEWS 64, (1874) ["Late Mr. Herman Merivale." 64:1800 (Feb. 21, 1874): 168.]

DICKSON, ROBERT.

D430 Dickson, Robert. "On a Simple Method of Obtaining Stereoscopic Pictures with a Simple Camera." PHOTOGRAPHIC AND FINE ART JOURNAL 8, no. 8 (Aug. 1855): 245-246. [From "J. of Photo. Soc., London."]

DIMMERS, T. G. (NEW YORK, NY)

D431 Portrait. Woodcut engraving, credited "From a Photograph by T. G. Dimmers, New York, NY." FRANK LESLIE'S ILLUSTRATED NEWSPAPER 40, (1875) ["Hon. John Kelly." 40:1018 (Apr. 3, 1875): 53.]

DISDERI & CO.

D432 Portrait. Woodcut engraving credited "From a photograph by Disderi & Co. ILLUSTRATED LONDON NEWS 27, (1855) ["Colonel Fleury." 27:* (Sept. 8, 1855): 296. (photo)]

D433 Portrait. Woodcut engraving credited "From a photograph by Disderi & Co." ILLUSTRATED LONDON NEWS 48, (1866) ["Chinese Commissioner, Pin-Ta-Chun." 48:* (June 23, 1866): 609.]

D434 Portrait. Woodcut engraving credited "From a photograph by Disderi & Co." ILLUSTRATED LONDON NEWS 51, (1867) ["Johann Strauss." 51:* (Oct. 19, 1867): 424.]

D435 Portraits. Woodcut engravings credited "From a photograph by Disderi of Brook St., London and Boulevard des Italiens, Paris." ILLUSTRATED LONDON NEWS 53, (1868) ["Marshall Seprano, Duke de la Torre." 53:* (Oct. 31, 1868): 425. "General Prim." 53:* (Nov. 7, 1868): 449.]

D436 "The Photo-Relief Process." HUMPHREY'S JOURNAL OF PHOTOGRAPHY, AND THE ALLIED ARTS AND SCIENCES 20, no. 5 (July 1, 1868): 80. ["We learn that the firm of Disderi & Co., formed in England a short time since for working Mr. Walter Woodbury's photo-relief process, has come to grief."]

D437 "The Disderi Gallery Sold Out." ANTHONY'S PHOTOGRAPHIC BULLETIN 1, no. 9 (Oct. 1870): 183. [Disderi & Co., of London, sold at auction. Lost heavily in trying to introduce the Woodburytype process to England commercially.]

D438 Portrait. Woodcut engraving credited "From a photograph by Disderi, Brook St., London." ILLUSTRATED LONDON NEWS 63, (1873) ["Lord Mayor Andrew Lusk." 63:1785 (Nov. 15, 1873): 454.]

DISDERI, ANDRÉ-ADOLPH-EUGENE. (1819-1889) (FRANCE, GREAT BRITAIN)

[Born in Paris on Mar. 28, 1819. Son of an unsuccessful cloth merchant, Disderi tried painting, acting, selling hosiery, before he took up photography in late 1840s. Started a studio in Brest in 1849, then to Paris in 1854, while his wife managed the studio in Brest until 1858. Financial collapse in 1856, but he adopted the carte-de-visite just as the craze for collecting these portraits swept the cities of Europe and the USA, and by 1859 he had an opulent studio in Paris. By 1861 there were branches in Saint-Cloud, Nice, Madrid and, in 1865, London. Business reversals in the late 60s caused him to lose it all. In 1870-71 he photographed the ruins in Paris, after the Franco-Prussian War and Commune. Disderi turned his studio over to Délié in 1877. Opened a photographic store in Nice in 1879, and worked there

through the 1880s. Returned to Paris, and died there on Oct. 4, 1889, blind, deaf, destitute. Wrote several books: *Manuel opératoire de photographie sur collodion instantané.* Paris: A. Gaudin, 1853. *Reseignments photographiques induspensables à tous.* Paris: Disderi, 1855. *Application de la photographie à la reproduction des oeuvres d'art.* Paris: Disderi, 1861. *L'Art de la photographie.* Paris: Disderi, 1862.]

BOOKS

D439 Disderi. *The Universal Text Book of Photography, or, Manual of the Various Photographic Processes, Instruments, Art Desiderata, Etc., with a Chapter on the Aesthetics of Photography, from the French of Monsieur Disderi.* Leeds: Harvey, Reynolds & Fowler, 1863. 130 pp. [Includes an extended essay by Disderi, "The Aesthetics of Photography." 2nd ed.(1864).]

D440 Disderi, A. A. *The Osborne Album.* Thirty-three Photographic Views of the Queen's Marine Residence at Osborne photographed by the gracious permission of Her Majesty the Queen, by Mr. Disderi. London, Paris: A. A. Disderi, 1867. n. p. 33 b & w. [Original photos.]

D441 Disderi, A. A. *Windsor Castle.* Thirty Photographic Views of the Interiors of Winsor Castle photographed by the gracious permission of Her Majesty the Queen, by Mr. Disderi. London, Paris: A. A. Disderi, 1867. n. p. 30 b & w.

D442 McCauley, Elizabeth Anne. *A. A. E. Disdéri and the Carte de Visite Portrait Photograph.* New Haven, CT: Yale University Press, 1985. 262 pp. 205 illus.

PERIODICALS

D443 Disderi. "Deutochloride of Mercury." PHOTOGRAPHIC ART JOURNAL 6, no. 6 (Dec. 1853): 375.

D444 Disderi. "On the Employment of Bichloride of Mercury (Corrosive Sublimate), with Paper Photographs." HUMPHREY'S JOURNAL 5, no. 23 (Mar. 15, 1854): 364. [From "La Lumiere, Sept. 24, 1853."]

D445 "Photography in Paris." HUMPHREY'S JOURNAL OF PHOTOGRAPHY, AND THE ALLIED ARTS AND SCIENCES 12, no. 8 (Aug. 15, 1860): 125. [Discusses the popularity of "visiting card" photographs, mentioning that Pierre Petit and Disderi actively making them. Describes Disderi's operating procedures, etc.]

D446 "Disderi's Collodion Process." HUMPHREY'S JOURNAL OF PHOTOGRAPHY, AND THE ALLIED ARTS AND SCIENCES 14, no. 15 (Dec. 1, 1862): 177-179. [From "L'Art de La Photographie."]

D447 Disderi. "The Aesthetics of Photography." HUMPHREY'S JOURNAL OF PHOTOGRAPHY, AND THE ALLIED ARTS AND SCIENCES 15, no. 7-10 (Aug. 1 - Sept. 15, 1863): 110-111, 124-132, 141-142, 154-157. [From "Aesthetics of Photo..."]

D448 "The Mosaic Card-Picture." HUMPHREY'S JOURNAL OF PHOTOGRAPHY, AND THE ALLIED ARTS AND SCIENCES 15, no. 8 (Aug. 15, 1863): 122-123. [From "Photo. Archiv." Describes Disderi's invention. 320 portraits of celebrated contemporaries montaged in a photo the size of "an ordinary card of address."]

D449 "M. Disderi's Patent." ART JOURNAL (Apr. 1868): 75.

D450 Portrait. Woodcut engraving credited "From a photograph by Disderi & Co." ILLUSTRATED LONDON NEWS 56, (1870) ["Henri Rochefort, newspaper owner." 56:* (Jan. 29, 1870): 125.]

D451 Portrait. Woodcut engraving credited "From a photograph by Disderi of Paris." ILLUSTRATED LONDON NEWS 58, (1870) ["General Trochu, Governor of Paris." 58:* (Sept. 10, 1870): 265.]

D452 Johnston, Frances Benjamin. "The Genius of Photography." AMERICAN ANNUAL OF PHOTOGRAPHY AND PHOTOGRAPHIC TIMES ALMANAC FOR 1893. (1893): 162-164. 1 illus. [A bronze statuette of a female figure symbolizing the genius of photography commissioned by the French professional photographer Disderi from the sculptor L. Cocheret ca. 1860-1870. When Disderi's business failed the statue was sold, later purchased by F. B. Johnston.]

D453 1 engraving (Emperor Louis Napoleon). CENTURY MAGAZINE 46, no. 4 (Aug. 1893): 517. 1 illus. [From a photograph by Disderi.]

D454 Bicknell, Anna L. "Life in the Tuileries Under the Second Empire. By an Inmate of the Palace." CENTURY MAGAZINE 50, no. 5-6 (Sept. - Oct. 1895): 709-726, 915-931. 24 b & w. [Illustrated with portraits taken in the 1850s - 1860s. Credited to "Braun, Clement & Co.; Levitsky; Ladrey-Disderi."]

D455 Palmquist, Peter. "The San Francisco Morning Globe (19th Aug. 1856)." HISTORY OF PHOTOGRAPHY 3, no. 4 (Oct. 1979): 329. [A short notice of Disderi's imprisonment for bankruptcy. It lists details of his varied career prior to becoming a photographer.]

D456 Wilsher, Ann. "Prince and Photographer." HISTORY OF PHOTOGRAPHY 3, no. 4 (Oct. 1979): 355-356. 1 b & w. 1 illus. [Photo by Disderi, engraving by Charles de Forest Fredericks. Portrait of Prince Napoleon and his wife, and a woodcut of same, from "Harper's Weekly".]

D457 Marien, Mary Warner. "Image, Class and Culture." VIEWS: THE JOURNAL OF PHOTOGRAPHY IN NEW ENGLAND. 7, no. 3 (Spring 1986): 16-17. 5 b & w. [Bk. rev.:"A. A. E. Disdéri and the Carte-de-Visite Portrait Photograph," by Elizabeth Anne McCauley.]

DISMORR, J. S.
D458 Dismorr, J. S. "Notes for Beginners." BRITISH JOURNAL PHOTOGRAPHIC ALMANAC 1873 (1873): 67-69.

DISTON, ADAM. (LEVEN, ENGLAND)
D459 Nichol, John, Ph.D. "Notes from the North." ANTHONY'S PHOTOGRAPHIC BULLETIN 7, no. 12 (Dec. 1876): 353-367. [From "Br. J. of Photo." Diston from Leven, England. Made "composition pictures," 10" x 8" in size, from several negatives. Genre scenes, etc.]

D460 1 b & w (Genre, "The Smithy"). AMERICAN AMATEUR PHOTOGRAPHER 3, no. 7 (July 1891): frontispiece, 249. [Diston from Leven, Fife, Scotland. Combination print, with the interior and figure photographed separately and then printed in.]

DIVINE, SILAS R. see also HESLER, ALEXANDER (1863).

DIVINE, SILAS R.
BOOKS

D461 Divine, Silas R. *A Practical Treatise on Albumen Photography; Containing the Collodion Negative Process and the Methods of Preparing, Printing and Toning Albumenized Paper; Also the Most Approved Modes of Making Cartes de visite.* New York: J. R. Ladd, 1862. iv, 70 pp.

D462 Divine, Silas R. *Photographic Manipulation, or, System of Practice for the Chemical Department of the Portrait Gallery.* New York: Seely & Boltwood, 1864. vi, 88 pp.

PERIODICALS

D463 Divine, S. R. "The Qualifications of a Good Photographer." AMERICAN JOURNAL OF PHOTOGRAPHY AND THE ALLIED ARTS & SCIENCES n. s. vol. 4, no. 2 (June 15, 1861): 39-40.

D464 Divine, S. R. "Hints on Card Pictures." HUMPHREY'S JOURNAL OF PHOTOGRAPHY, AND THE ALLIED ARTS AND SCIENCES 13, no. 16 (Dec. 15, 1861): 241-242.

D465 Divine, S. R. "Card Pictures - How to make them." HUMPHREY'S JOURNAL OF PHOTOGRAPHY, AND THE ALLIED ARTS AND SCIENCES 13, no. 17 (Jan. 1, 1862): 259-260.

D466 Divine, S. R. "Remarks on Albumen Photography." HUMPHREY'S JOURNAL OF PHOTOGRAPHY, AND THE ALLIED ARTS AND SCIENCES 13, no. 18 (Jan. 15, 1862): 276-277.

D467 Divine, S. R. "What has yet to be Accomplished in Photography." HUMPHREY'S JOURNAL OF PHOTOGRAPHY, AND THE ALLIED ARTS AND SCIENCES 13, no. 19 (Feb. 1, 1862): 291-292.

D468 Divine, S. R. "Intensifying Processes." HUMPHREY'S JOURNAL OF PHOTOGRAPHY, AND THE ALLIED ARTS AND SCIENCES 13, no. 20 (Feb. 15, 1862): 310-311.

D469 "Just Published, and Now Ready! A New Book, on Albumen Photography & Cartes de Visite." HUMPHREY'S JOURNAL OF PHOTOGRAPHY, AND THE ALLIED ARTS AND SCIENCES 13, no. 21 (Mar. 1, 1862): 335-336. [Book rev.: "A Practical Treatise on Albumenin Photography,...by S. R. Divine.]

D470 Divine, S. R. "Difficulties in Practical Photography." HUMPHREY'S JOURNAL OF PHOTOGRAPHY, AND THE ALLIED ARTS AND SCIENCES 13, no. 23 (Apr. 1, 1862): 358-359.

D471 Divine, S. R. "Card Pictures - And How To Make Them." BRITISH JOURNAL OF PHOTOGRAPHY 9, no. 170 (July 15, 1862): 272.

D472 Divine, S. R. "A Few Words on Negative Baths." AMERICAN JOURNAL OF PHOTOGRAPHY AND THE ALLIED ARTS & SCIENCES n. s. vol. 6, no. 23 (June 1, 1864): 548-549.

D473 "Toning." AMERICAN JOURNAL OF PHOTOGRAPHY AND THE ALLIED ARTS & SCIENCES n. s. vol. 6, no. 24 (June 15, 1864): 567-570. [From "Divine's Manipulation.]

D474 Seely, Charles A. "Editorial Department." AMERICAN JOURNAL OF PHOTOGRAPHY AND THE ALLIED ARTS & SCIENCES n. s. vol. 7, no. 10 (Nov. 15, 1864): 240. ["S. R. Divine, the author of the popular treatise on Photography, has recently been appointed to the professorship of chemistry in the Hygeio-Therapeutic Medical College of this city..." (New York, NY).]

D475 Divine, S. R., M.D. "On the Durability of Photographs." AMERICAN JOURNAL OF PHOTOGRAPHY AND THE ALLIED ARTS & SCIENCES n. s. vol. 8, no. 4 (Aug. 15, 1865): 85-86.

D476 Divine, S. R. "Organic Matter in the Nitrate Bath." AMERICAN JOURNAL OF PHOTOGRAPHY AND THE ALLIED ARTS AND SCIENCES n. s. vol. 9, no. 11 (May. 15, 1867): 248-249.

DIXON, HENRY & SONS.

D477 Le Plongeon, Alice. "Art Photography in London." PHOTOGRAPHIC TIMES 20, no. 484 (Dec. 26, 1890): 647-648. [Dixon & Sons copying of art works discussed. Some of their history given.]

D478 Madder, Max. "Photography At the Zoo." AMERICAN ANNUAL OF PHOTOGRAPHY & PHOTOGRAPHIC TIMES ALMANAC FOR 1898 (1898): 164-168. 9 b & w. ["Photos by Henry Dixon & Sons, London".]

DIXON, HENRY see also BOOL, A. & J. BOOL.

DIXON, HENRY. (1820-1893) (GREAT BRITAIN)

[Dixon had apprenticed as a copperplate printer, but he became a professional photographer by 1864. He and his son T. J. Dixon began to make the carbon prints of the buildings photographed by Alfred and John Bool for the Society for Preserving Old London, then themselves began to photograph for the project in 1879. Dixon & Son, founded in 1887, remained in business until World War II.]

BOOKS

D479 Marks, Alfred, ed. *Society for Photographic Relics of Old London. Collection of Mounted Photographs.* London: The Society, 1875-1886. n. p. 120 b & w. [Woodburytype prints, with descriptive letterpress by A. Marks. Issued in series no. 1-6, (1875); no. 7-12, (1876), etc. to no. 109-120, (1886). "I also thank the Messrs. Dixon, father & son, who have taken all negatives from no. 25 on." Negatives for nos. 1-24 taken by A. & J. Bool, printed in permanent carbon by Henry Dixon, nos. 25 on "photographed and printed in permanent carbon by Henry Dixon. 112 Albany St, London".]

D480 *Old London; Photographed by Henry Dixon and Alfred and John Bool for the Society for Preserving Old London;* assembled by Graham Bush. London; New York: Academy Editions; St. Martin's Press, 1975. 144 pp. b & w. illus.

PERIODICALS

D481 Foote, Kenneth E. "Relics of Old London: Photographs of a Changing Victorian City." HISTORY OF PHOTOGRAPHY 11, no. 2 (Apr. - June 1987): 133-151. 14 b & w. [About the Society for Photographing Relics of Old London and the photographers hired by this organization. Henry Dixon and A. & J. Bool. The Society issued 120 photographs in its series, between 1875 and 1886. A catalog of the series is included in the article.]

DIXON, HENRY. (1824-1883) (GREAT BRITAIN, INDIA)

D482 Thomas, G. "The Temple Town of Conjeevaram, and Henry Dixon." HISTORY OF PHOTOGRAPHY 5, no. 2 (Apr. 1981): 129-131. 2 b & w. 1 illus. [Album of 10 photos by Dixon, published 1868, found in Connemara Library, Madras: "The Temples of Conjeveram." Dixon born at Naples, Mar. 29, 1824 of British parents. Sailed to India 1842 as ensign to the 22nd MNI. Retired, Lieutenant Colonel in 1872, died Mar. 16, 1883.]

DIXON, HENRY HALL. (1822-1870) (GREAT BRITAIN)

D483 Dixon, Henry Hall. *Field and Fern; or, Scottish Flocks and Herds (South).* London: Pogerson & Tuxford, 1865. 409 pp. b & w. [Original photos.]

DIXON, JOSEPH. (d. 1869) (JERSEY CITY, NJ)

D484 Dixon, Joseph. "The Methods of Enlarging Photographs or Other Pictures." PHOTOGRAPHIC AND FINE ART JOURNAL 11, no. 3 (Mar. 1858): 82-83.

D485 Seely, Charles A. "Mr. Dixon's Collodion Filter." AMERICAN JOURNAL OF PHOTOGRAPHY AND THE ALLIED ARTS & SCIENCES n. s. vol. 1, no. 1 (June 1, 1858): 1-2. 1 illus.

D486 Dixon, Joseph. "Photo-Lithography." AMERICAN JOURNAL OF PHOTOGRAPHY AND THE ALLIED ARTS AND SCIENCES n. s. vol. 1, no. 2 (June 15, 1858): 24-26. [Dixon is from Jersey City, NJ.]

D487 Garbanati, H. "Photo-Lithography." AMERICAN JOURNAL OF PHOTOGRAPHY AND THE ALLIED ARTS AND SCIENCES n. s. vol. 1, no. 3 (July 1, 1858): 35-36. [Notes on letter from Dixon on early experiments in process dated, July 2, 1840.]

D488 Dixon, Joseph. "Nitrate of Silver." AMERICAN JOURNAL OF PHOTOGRAPHY AND THE ALLIED ARTS AND SCIENCES n. s. vol. 1, no. 6 (Aug. 15, 1858): 83-84.

D489 Dixon, Joseph. "On Sensitizing Albumenized Paper." AMERICAN JOURNAL OF PHOTOGRAPHY AND THE ALLIED ARTS AND SCIENCES n. s. vol. 1, no. 24 (May 15, 1859): 382-383.

D490 Dixon, Joseph. "Permanent Photographic Printing." AMERICAN JOURNAL OF PHOTOGRAPHY AND THE ALLIED ARTS & SCIENCES n. s. vol. 2, no. 24 (May 15, 1860): 378-380.

D491 Dixon, Joseph. "New York Correspondence." PHILADELPHIA PHOTOGRAPHER 5, no. 50 (Feb. 1868): 52-54. [Joseph Dixon addressed a meeting of the Photographic Section of the American Institute of New York, NY, mentioned the claims of Draper and of Wolcott to making the first portrait in America, claimed to have made a portrait in Sept. 1839.]

D492 "Editor's Table." PHILADELPHIA PHOTOGRAPHER 6, no. 67 (July 1869): 252. [Death of Joseph Dixon. Began photography in 1839. Perfected a reversing mirror for daguerreotypes, a photolithographic process, better lenses, etc.]

DIXON, SAMUEL JOHN. (1852-1891) (USA, CANADA)
D493 "Notes and News: A Photographer Crosses Niagara on a Wire." PHOTOGRAPHIC TIMES 20, no. 470 (Sept. 19, 1890): 475.

D494 "Notes and News." PHOTOGRAPHIC TIMES 21, no. 525 (Oct. 9, 1891): 505. ["S. J. Dixon, the photographer who acquired so great notoriety from walking over the Whirlpool Rapids on a three-quarter inch wire, and other daring athletic feats, was drowned Saturday morning, October 3d, at Woodlake, Moskoga."]

D495 "Notes and News: S. J. Dixon." PHOTOGRAPHIC TIMES 21, no. 526 (Oct. 16, 1891): 518. [Further particulars on Dixon's death by drowning.]

D496 Brey, William, and J. P. H. Weber. "Dixon - Daredevil Photographer!" STEREO WORLD 6, no. 5 (Nov. - Dec. 1979): 4-7. 3 b & w. 1 illus. [Dixon was a high-wire daredevil, also a photographer.]

D497 Schwartz, Joan M. "Hazardous Feat at Niagara." HISTORY OF PHOTOGRAPHY 11, no. 1 (Jan. - Mar. 1987): 23-24. 1 b & w. [S. J. Dixon, a photographer from Toronto, crossed the gorge at Niagara Falls on a tightrope twice in the 1890s. Born in New York State, of Irish parents, and grew up in Clarksburg, Ontario. Became a photographer in the 1870s and owned the Electric Light Photo Gallery in Toronto in 1880s. Planning to move to New York in 1891, but drowned in Ontario, at age 39. His wife Sarah continued the studio for a few years. His brother, James Dixon, also ran a studio in Toronto, until 1920s.]

DIXON, T. J. see also BOOL, A. & J. BOOL.

DOANE, THOMAS COFFIN. (1814-) (CANADA)
D498 "Gossip: Daguerreotype Likenesses." PHOTOGRAPHIC ART JOURNAL 6, no. 2 (Aug. 1853): 132. [From "The Pilot." Praise for Mr. Doane, of Place d'Armes, Montreal.]

D499 Carey, Brian. "An Imperial Gift." HISTORY OF PHOTOGRAPHY 10, no. 2 (Apr. - June 1986): 147-149. 1 b & w. [Gift from France to Canadian National Photography Collection of a 1/2 plate daguerreotype taken in 1855 by Thomas Coffin Doane, of Montreal.]

DOBBIN, G. W.
D500 "An Excursion on the Baltimore and Ohio Railroad." THE CRAYON 5, no. 7 (July 1858): 210. [From the "Evening Post." [?] "Besides these [artists], were the photographers consisting of the amateurs G. W. Dobbin and son, and W. E. Bartlett, of Baltimore, Charles Guillou, of Philadelphia; and Robert O'Neil, a professional photographer, from Washington."]

D501 "Domestic Art Items and Gossip." COSMOPOLITAN ART JOURNAL 2, no. 4 (Sept. 1858): 207. [Describes an excursion organized for artists and photographers on the Baltimore and Ohio Railroad. "The train consists of...a car expressly fitted up for photographic purposes. The rest of the party...including...the following gentlemen...Messrs. G. W. Dobbin, Charles Gillou, William E. Bartlett and Robert O'Neil, photographers. More than one hundred excellent photographic views were taken by the several operators, who had four sets of approved apparatus of their own in full play." (See also the June 1859 "Harper's New Monthly Magazine."]

DOBBS.
D502 "Our Mammoth Cannon. - The 20 Inch Rodman Gun Recently Cast at the Fort Pitt Foundry. - From a Photograph by Dobbs." FRANK LESLIE'S ILLUSTRATED NEWSPAPER 18, no. 445 (Apr. 9, 1864): 36. 1 illus. [View, with figures.]

DOBYNS & HARRINGTON. (NEW ORLEANS, LA)
D503 "Note." PHOTOGRAPHIC ART JOURNAL 5, no. 5 (May 1853): 320. [Note that Dobyns & Harrington of New Orleans in connection with V. L. Richardson, have opened a gallery in New York, NY.]

DOBYNS, RICHARDSON & CO.
D504 Humphry, S. D. "Editorials." HUMPHREY'S JOURNAL 5, no. 8 (Aug. 1, 1853): 121. [Dobyns, Richardson & Co. opened a gallery in New York, NY, under the management of V. L. Richardson.]

DOBYNS, THOMAS JEFFERSON see also DOBYNS & HARRINGTON.

DOBYNS, THOMAS JEFFERSON. (ca. 1802-) (USA)
D505 "Note." HUMPHREY'S JOURNAL 4, no. 16 (Dec. 1, 1852): 250. [Note that T. J. Dobyns, a daguerreotypist, also owns extensive land holdings.]

DODDS, W. H.
D506 "Fearful Boiler Exposure at Wolverhampton." ILLUSTRATED LONDON NEWS 30, no. 856 (May 2, 1857): 410. 1 illus. ["...from a photograph by W. H. Dodds, of Wolverhampton."]

D507 "The Fatal Boiler Explosion near Wolverhampton." ILLUSTRATED LONDON NEWS 40, no. 1141 (Apr. 26, 1862):

414-415. 2 illus. ["...from photographs taken by W. H. Dodds, photographer, Railway Street, Wolverhampton."]

DODGE & WENDEROTH.
D508 "Our Illustrations." PHOTOGRAPHIC AND FINE ART JOURNAL 9, no. 12 (Dec. 1856): frontispiece, 380. 1 b & w. ["We endeavor this month to make up to our subscribers...present them with ten photographs...A Portrait of Millard Fillmore by Meade Brothers; two views of Hoboken, NJ, by an amateur; White Mts. view by F. White (Lancaster, NH); four statuettes, photos by Whipple and Black (Boston, MA); Court House, and Market Square, Nashville, TN by Dodge & Wenderoth." It is unclear from this if all ten original photographic prints were included in the December issue, or whether 10 separate negatives were used to make up the number of photos needed to illustrate the entire run. In any case, this copy contains only the "Market Square, Nashville," by Dodge & Wenderoth.]

DODGE, EDWARD SAMUEL. (1816-1857) (USA)
[Born July 8, 1816. A miniature painter and daguerreian. Painted in New York, NY 1836, Poughkeepsie, NY 1837-1842, in Richmond, VA in 1844. Worked as daguerreian in Augusta, GA from 1850-1852. Died Apr. 6, 1857.]

D509 "Dodge's Daguerrean Gallery." DAGUERREAN JOURNAL 1, no. 11 (Apr. 15, 1851): 339. [From "Georgia Weekly Constitutionalist," Augusta, GA.]

D510 "Letter." HUMPHREY'S JOURNAL 4, no. 19 (Jan. 15, 1853): 292. [E. S. Dodge, miniature painter and daguerreotypist, received an award at the Charleston [SC] Fair.]

DODGE, RICHARD IRVING, LIEUT-COL. [?]
D511 Dodge, Richard Irving, Lieut.-Col., U. S. Army. *The Black Hills. A Minute Description of the Routes, Scenery, Soil, Climate, Timber, Gold, Geology, Zoology, Etc.; with an Accurate Map, Four Sectional Drawings, and Ten Plates from Photographs Taken On the Spot.* New York: James Miller, 1876. n. p. 15 illus. [Illustrations are actually color lithographs, drawn, from photos. Taken by the author?]

DODGSON, CHARLES LUTWIDGE see CARROLL, LEWIS.

DOERR & JACOBSON.
D512 "Texas. - The Progress of American Enterprise - Views in the Ancient American City of San Antonio. - From Photographs by H. L. Bingham and Doerr & Jacobson." FRANK LESLIE'S ILLUSTRATED NEWSPAPER 47, no. 1205 (Nov. 2, 1878): 141. 7 illus. [Views, one outdoor portrait of a Mexican cowboy..]

DOERR, HENRY A. (ca. 1824-1885) (USA)
D513 Lynch, Arthur A. "San Antonio: As Viewed by Henry A. Doerr, Photographic Artist." STEREO WORLD 8, no. 3 (July - Aug. 1981): 6-12. 11 b & w. [The photographers Engle & Doerr began photographing in San Antonio, TX in 1865. The firm changed to Doerr & Jesse in 1866. Doerr apparently worked alone from 1872 to 1876, when he was joined by Samuel Jacobson. This partnership lasted until 1879. Doerr continued to work through the 1880s. Died Nov. 22, 1885, at about 61 years of age.]

DOLAMORE & BULLOCK.*
BOOKS
D514 Dolamore & Bullock. *Scenery of the English Lakes.* Photographed and published by Messrs. Dolamore & Bullock. London: Dolamore & Bullock, 1856. n. p. 5 b & w. [This may not be a volume, but loose prints. Verify.]

PERIODICALS
D515 "Fine Arts." ATHENAEUM no. 1495 (June 21, 1856): 782-783. [Maull & Polyblank's "Photographic Portraits" mentioned, Rejlander briefly praised, Dolamore & Bullock's "Memorials of Remarkable Places;...British Scenery" reviewed.]

DOLAMORE, WILLIAM. (LONDON, ENGLAND)
D516 Portrait. Woodcut engraving credited "From a photograph by Dolamore, Regent Street." ILLUSTRATED LONDON NEWS 61, (1872) ["Sir George Gilbert Scott, R.A." 61:1717 (Aug. 3, 1872): 109.]

DONNELLY, J. F. D., CAPT.
[J. F. D. Donnelly was in the Royal Engineers, British Army. He later made Colonel, and became Director of the Science and Art Department, South Kensington.]

D517 Donnelly, Capt. J. F. D. *Outline of the Chemical Theory of Photography, for the use of the Royal Engineers.* London: s. n. , 1859. 24 pp.

D518 Donnelly, Capt. J. F. D., R.E. *Photography, and Its Application to Military Purposes.* London: United Services Institution, 1861. 18 pp. 1 illus. [Offprint from the "Journal of the United Services Institution," vol. 5 (1861).]

DORATT, CHARLES.
D519 Doratt, Charles. "Chromatic Background." PHOTOGRAPHIC ART JOURNAL 3, no. 1 (Jan. 1852): 21. [Dr. Doratt experimented with photographic processes and chemistry, and he was the Corresponding Secretary of the American Photographic Institute.] "Cyanogen and Its Compounds." PHOTOGRAPHIC ART JOURNAL 3, no. 1 (Jan. 1852): 26-35.

DORÉ, F.
D520 Doré, F. "The 'Electric Light' for Portraiture." BRITISH JOURNAL PHOTOGRAPHIC ALMANAC 1879 (1879): 131-132.

D521 Doré, Frank. "A Useful Screen and Reflector for the Studio." BRITISH JOURNAL PHOTOGRAPHIC ALMANAC 1878 (1878): 131. 1 illus.

DOREMUS, JOHN P. (PATERSON, NJ)
D522 "Processes which have been proved. - No. 3: The Process of John P. Doremus, of Paterson, N. J." AMERICAN JOURNAL OF PHOTOGRAPHY AND THE ALLIED ARTS & SCIENCES n. s. vol. 6, no. 14 (Jan. 15, 1864): 333-334.

D523 "Art Afloat-How a New Jersey Man is to "Do" the Mississippi Valley." ANTHONY'S PHOTOGRAPHIC BULLETIN 5, no. 10 (Oct. 1874): 343-346. [From "St. Paul News."]

D524 "Our Picture under Difficulties." ANTHONY'S PHOTOGRAPHIC BULLETIN 6, no. 1 (Jan. 1875): 23. [From the "Exchange." Author describes standing under a waterfall for half an hour so that Doremus could photograph him.]

D525 "Communication." ANTHONY'S PHOTOGRAPHIC BULLETIN 6, no. 2 (Feb. 1875): 41. [From "Taylor's Falls Journal."]

DORNBACH, LOUIS M. (ca. 1832-1862) (USA)
D526 Dornbach, L. M., S.B. "The present Opinion of some Chemists with reference to the Primary Elements." HUMPHREY'S JOURNAL OF PHOTOGRAPHY, AND THE ALLIED ARTS AND SCIENCES 10, no. 20-21 (Feb. 15 - Mar. 1, 1859): 308-309, 321-323.

D527 Dornbach, L. M., S.B. "The Sensitiveness of Photographic Reagents." HUMPHREY'S JOURNAL OF PHOTOGRAPHY, AND THE ALLIED ARTS AND SCIENCES 10, no. 22 (Mar. 15, 1859): 337-338.

D528 Dornbach, L. M., S.B. "Photographic Apparatus." HUMPHREY'S JOURNAL OF PHOTOGRAPHY, AND THE ALLIED ARTS AND SCIENCES 10, no. 23 (Apr. 1, 1859): 354.

D529 Dornbach, L. M. "Photographic Apparatus." HUMPHREY'S JOURNAL OF PHOTOGRAPHY, AND THE ALLIED ARTS AND SCIENCES 11, no. 1-16 (May 1 - Dec. 15, 1859): 3-4, 19, 36-38, 68-69, 84-85, 99-100, 129-130, 161-163, 177, 193, 212-213. [Laws of Intensity of Light. Reflection and Refraction of Light. Laws of Refraction and the Compound Nature of Light. Achromatism, Different Kinds of Lenses. The Camera Obscura. Of the Chemical Rays in a Photographic Point of View. On the Manufacture of Glass employed in the Construction of Lenses. Construction of Furnace. Uniting the Materials into Glass.]

D530 Dornbach, L. M., S.B. "Photographic Apparatus. - Construction of Photographic Instruments." HUMPHREY'S JOURNAL OF PHOTOGRAPHY, AND THE ALLIED ARTS AND SCIENCES 11, no. 17-24 (Jan. 1 - Apr. 15, 1860): 260-261, 273-275, 291-292, 323, 337-338, 359-360. [Modeling the Glass into the Shape of Lenses - The Setting and Construction of Lenses - etc.]

D531 Dornbach, L. M., S.B. "Photographic Apparatus." HUMPHREY'S JOURNAL OF PHOTOGRAPHY, AND THE ALLIED ARTS AND SCIENCES 12, no. 1-7 (May 1, - Aug. 1, 1860): 4-5, 35-36, 53-55, 73, 86-88, 97-98.

D532 Dornbach, L. M. "An Instantaneous Process." HUMPHREY'S JOURNAL OF PHOTOGRAPHY, AND THE ALLIED ARTS AND SCIENCES 12, no. 6 (July 15, 1860): 89-90. [Dornbach "a chemist and stockdealer, of this city..."]

D533 Dornbach, L. M., S.B. "Applied Photography." HUMPHREY'S JOURNAL OF PHOTOGRAPHY, AND THE ALLIED ARTS AND SCIENCES 12, no. 11-24 (Oct 1, 1860 - Apr. 15, 1861): 164-165, 177-178, 225-226, 257-258, 274-275, 338-340, 355-357. [Illumination of the Object to be Taken, The Operating Room, Grouping and Artistic Expression, the Grouping of two or more Persons, Artistic Designs.]

D534 Dornbach, L. M., S.B. "Applied Photography." HUMPHREY'S JOURNAL OF PHOTOGRAPHY, AND THE ALLIED ARTS AND SCIENCES 13, no. 1, 8 (May 1, Aug. 15, 1861): 20-21, 113-114. [Chemical Background.]

D535 "Another Fearful Explosion." HUMPHREY'S JOURNAL OF PHOTOGRAPHY, AND THE ALLIED ARTS AND SCIENCES 13, no. 16 (Dec. 15, 1861): 255-256. [Dornbach, a contributor to "HJ" was also a chemist. This report claims that there had been four or five explosions due to his experimenting. His laboratory was under Chas. A. Seely's apartment. Dornbach forced to move.]

D536 "Editorial Department: Obituary." AMERICAN JOURNAL OF PHOTOGRAPHY AND THE ALLIED ARTS & SCIENCES n. s. vol. 5, no. 1 (July 1, 1862): 23. [Dornbach died June 23 in Brooklyn, NY, aged 30 years. Grew up in PA, went to Harvard University and studied chemistry. Manufacturer of photographic chemicals and a writer on photographic subjects. Killed as a result of an explosion of gun-cotton, which he was manufacturing for waterproof cartridges.]

D537 "Obituary." HUMPHREY'S JOURNAL OF PHOTOGRAPHY, AND THE ALLIED ARTS AND SCIENCES 14, no. 5 (July 1, 1862): 21-22. [Died at Brooklyn on June 21, 1862, as a consequence of an explosion of gun-cotton.]

DOUGALL, JOSEPH. (d. before 1882) (GREAT BRITAIN, INDIA)

D538 Dougall, W. "On Photography as a Handmaid to Medical, Surgical, and Other Sciences, And As a Pleasant Recreation for a Cultivated Mind." PHOTOGRAPHIC TIMES 12, no. 139 (July 1882): 258-259. [A Communication to the Edinburgh Photographic Society. From the "British J. of Photography. Actually a survey of the activities of Dr. Joseph Dougall, F.R.C.P.E., for twenty years in the Indian medical service, working in India, Burma, and China. At the Chinese War of 1860, in 1864-65 used photography to record surgical operations. In 1873-74 recording leprosy in Andaman Islands. Anthropological studies of the aborigines of the Andaman and Nicobar Islands. Illustrations of second memoir on the osteology of the Andamanose by Prof. Flower, F.R.S. Dougall also photographed the shells and corals of India. In 1875 travelled 4000 miles with Sir General Donald M. Stewart, through Northern India. Views of Andaman Islands published by the Woodburytype Company.]

DOUGLASS, GAYTON A.

D539 Douglass, G. A. "Losses of Photographers in Chicago." PHOTOGRAPHIC WORLD 1, no. 11 (Nov. 1871): 338-339.

D540 "Inaugural Address of the President of the C. P. A." ANTHONY'S PHOTOGRAPHIC BULLETIN 3, no. 4 (Apr. 1872): 522-523. [Douglass new President of the Chicago Photographic Association.]

D541 Douglass, Gayton, A. "Are You Friend or Foe?" PHOTOGRAPHIC TIMES 11, no. 125 (May 1881): 198-199. [Argument for support for the Photographers' Association of America.]

D542 Douglass, Gayton A. "Amateur Photography." PHOTOGRAPHIC TIMES 12, no. 138 (June 1882): 208-209.

D543 "General Notes." PHOTOGRAPHIC TIMES 17, no. 323 (Nov. 25, 1887): 587. [Douglass has been making official photos for the police authorities in the hospitals and elsewhere.]

D544 Douglass, Gayton A. "A Paper by Gayton A. Douglass Read Before the Photographic Merchants Board of Trade, at Their Annual Meeting, held in New York City, February 10, 1885." PHOTOGRAPHIC TIMES 15, no. 180 (Feb. 27, 1885): 107-111. [Collection of statistics (apparently the first compiled) of photographic manufacturing and supplies, professional photographers, etc. in the U.S.]

DOUGLASS, RANALD. (WASHINGTON, DC)

D545 Douglass, Ranald. "Some Remarks about Photographing Interiors, and About Porcelain Baths." PHOTOGRAPHIC TIMES 4, no. 47 (Nov. 1874): 170.

D546 Douglass, Ranald. "How to Get Clear Sky in Outdoor Negatives." PHOTOGRAPHIC TIMES 5, no. 54 (June 1875): 160.

D547 "Matters of the Month." PHOTOGRAPHIC TIMES 10, no. 103 (Jan. 1880): 10. ["reputation as a landscape operator is growing..." Excerpt from "Outside Work," in "Photographic Mosaics, 1880."]

DOUGLASS, S. W. (OPERATOR FOR J. D. CADWALLADER) (MARIETTA, OH)

D548 "Editor's Table." PHILADELPHIA PHOTOGRAPHER 6, no. 64 (Apr. 1869): 136. [Cartes noted.]

DOWE, L. (SYCAMORE, IL)

D549 Dowe, L. "More Testimony on the Fuming Process - A Good Toning Process." AMERICAN JOURNAL OF PHOTOGRAPHY AND THE ALLIED ARTS & SCIENCES n. s. vol. 5, no. 22 (May 15, 1863): 522-523.

DOWNES, G. (BEDFORD, ENGLAND)

D550 "The Bunyan Festival at Bedford." ILLUSTRATED LONDON NEWS 64, no. 1817 (June 20, 1874): 584-585. 6 illus.

DOWNES, GEORGE.

D551 "Our Weekly Gossip." ATHENAEUM no. 1621 (Nov. 20, 1858): 651. ["Mr. George Downes, of the Photographic Institute, has produced, in the manner of M. Le Grai [sic, Le Gray] four stereoscopic marine views, singularly bright and instantaneous in effect..."]

DOWNEY, W. & D. DOWNEY.
BOOKS

D552 *The Royal Visit to Wolverhampton.* Wolverhampton, England: E. Roden, 1867. 95 pp. 5 l. of plates. b & w. [Original photos, by R. W. Thrupp and Downey & Downey.]

D553 Cassell & Co., London. *The Cabinet Portrait Gallery;* Reproduced from Original Photographs by W. & D. Downey. London: Cassell, 1890-1894. 5 vol. b & w. illus. [Photomechanical plates, from photos by W. & D. Downey.]

PERIODICALS

D554 "Festivity in Connection with Photography." BRITISH JOURNAL OF PHOTOGRAPHY 11, no. 236 (Nov. 11, 1864): 449. [Downey & Downey, at Newcastle-on-Tyne, opened a new gallery.]

D555 Portrait. Woodcut engraving credited "From a photograph by Downey Brothers." ILLUSTRATED LONDON NEWS 46, (1865) ["Richard Cobden, M.P." 46:* (Apr. 15, 1865): 349.]

D556 Portrait. Woodcut engraving credited "From a photograph by Downey Brothers." ILLUSTRATED LONDON NEWS 52, (1868) ["Lord Brougham." 52:* (May 16, 1868): 485.]

D557 Portrait. Woodcut engraving credited "From a photograph by Downey Brothers." ILLUSTRATED LONDON NEWS 53, (1868) ["Lord Cranworth." 53:* (Aug. 15, 1868): 153.]

D558 Portrait. Woodcut engraving credited "From a photograph by Downey Brothers." ILLUSTRATED LONDON NEWS 55, (1870) ["General the Hon. C. Grey." 55:* (Apr. 23, 1870): 416.]

D559 Portraits. Woodcut engravings, credited to "From a Photograph by W. & D. Downey." ILLUSTRATED LONDON NEWS 59, (1871) ["Signor Mario." 59:1666 (Aug. 26, 1871): 193. "Late James Benforth, oarsman." 59:1668 (Sept. 9, 1871): 229. "John Ruskin, Lord Rector of St. Andrews University." 59:1682 (Dec. 9, 1871): 549.]

D560 Portraits. Woodcut engravings, credited to "From a Photograph by W. Downey & D. Downey." ILLUSTRATED LONDON NEWS 60, (1872) ["Her Majesty the Queen [Victoria]." 60:1695 (Mar. 2, 1872): 197. "Signor Italio Campanini." 60:1708 (June 1, 1872): 525.]

D561 "Napoleon III, After His Death." ILLUSTRATED LONDON NEWS 62, no. 1742 (Jan. 18, 1873): 80. 1 illus. [Post-mortem portrait. "From the Photograph by Messrs. Downey."]

D562 Portrait. Woodcut engraving credited "From a photograph by W. Downey & D. Downey." ILLUSTRATED LONDON NEWS 62, (1873) ["Prince Albert Victor of Wales." 62:1751 (Mar. 21, 1873): n.p. before 285.]

D563 Portraits. Woodcut engravings credited "From a photograph by W. Downey & D. Downey." ILLUSTRATED LONDON NEWS 64, (1874) ["Late Sir Joseph Cowen, M.P." 64:1794 (Jan. 10, 1874): 36. "Right Hon. Benjamin Disraeli." 64:1799 (Feb. 14, 1874): 149. "C. M. Palmer, M.P." 64:1802 (Mar. 7, 1874): 233. "Mr. T. Burt, M.P." 64:1802 (Mar. 7, 1874): 233. "Mr. Cowen, M.P." 64:1810 (May 2, 1874): 416. "Mr. Hamond, M.P." 64:1810 (May 2, 1874): 416.]

D564 Portraits. Woodcut engravings credited "From a photograph by W. Downey & D. Downey, Elbury St., Easton Square, London." ILLUSTRATED LONDON NEWS 66, (1875) ["Late Mr. J. B. Philip, sculptor." 66:1857 (Mar. 13, 1875): 257. "Mdlle. Signelli, singer." 66:1872 (June 26, 1875): 609.]

D565 Portraits. Woodcut engravings credited "From a photograph by W. Downey & D. Downey." ILLUSTRATED LONDON NEWS 68, (1876) ["Mourad V, the New Sultan of Turkey." (Taken in July, 1867, when visiting England). 68:1924 (June 10, 1876): 560.]

D566 Portraits. Woodcut engravings credited "From a photograph by W. Downey & D. Downey." ILLUSTRATED LONDON NEWS 69, (1876) ["Abdul Hamid II, New Sultan of Turkey." 69:1938 (Sept. 16, 1876): 273.]

D567 Portrait. Woodcut engraving credited "From a photograph by W. Downey & D. Downey." ILLUSTRATED LONDON NEWS 72, (1878) ["Duke of Northumberland." 72:2017 (Feb. 23, 1878): 172.]

D568 "Royal Sailor Boys: The Sons of the Prince of Wales Learning How to Splice a Rope. - From a Photograph by Messrs. Downey." ILLUSTRATED LONDON NEWS 72, no. 2030 (May 25, 1878): 471. 1 illus.

D569 Portrait. Woodcut engraving credited "From a photograph by W. Downey & D. Downey." ILLUSTRATED LONDON NEWS 74, (1879) ["Lady Cecilia Hay, Lady Mabel Bridgman and Lady Louisa Bruce." 74:2074 (Mar. 15, 1879): 241.]

D570 Portraits. Woodcut engravings credited "From a photograph by W. Downey & D. Downey." ILLUSTRATED LONDON NEWS 75, (1879) ["Late Lieut. George Rowley." 75:2097 (Aug. 23, 1879): 176 "Late J. B. Buckstone, comedian." 75:2109 (Nov. 15, 1879): 457.]

D571 1 b & w ("A Type of Beauty") as frontispiece. EVERYBODY'S MAGAZINE 3, no. 13 (Sept. 1900): 202. 1 b & w.

D572 Senelick, Lawrence. "Ladies of the Gaiety." HISTORY OF PHOTOGRAPHY 9, no. 1 (Jan. - Mar. 1985): 39-4l. 1 b & w. [British actresses ca. 1880, 1890. Composite cabinet card photograph.]

DOWNEY, DANIEL see DOWNEY, W. & D. DOWNEY.

DOWNEY, WILLIAM see DOWNEY, W. & D. DOWNEY.

DOWNEY, WILLIAM. (1820-1916) (GREAT BRITAIN)

D573 "Obituary of the Year: William Downey." BRITISH JOURNAL PHOTOGRAPHIC ALMANAC 1916 (1916): 417-418. [Head of W. & D. Downey, Ebury St. Considered a leading professional portrait photographer. Native of South Shields, began business on the Tyne; photographer to Royalty for more than forty years. Recognized the commercial value of the picture postcard, very successful. 86 years old at death.]

DOWNEY, W. E. (d. 1908) (GREAT BRITAIN) see DOWNEY, W. & D. DOWNEY.

[W. E. Downey was the son of William Downey, and inherited his photographic firm.]

DOWNING, GEORGE.

D574 Filippelli, Ronald L. "Greenback Shutterbug." HISTORY OF PHOTOGRAPHY 5, no. 3 (July 1981): 263-264. 1 illus. [Topeka, Kansas Gallery ca. 1870s. Carte-de-visite drawing of giant locusts photographing, stealing grain, etc. Political cartoon.]

DOWNING, J. C. (DALLAS, TX)

D575 "Editor's Table." PHILADELPHIA PHOTOGRAPHER 15, no. 174 (June 1878): 192. ["Mr. Downing, a well-known photographer of Dallas, Texas, supposed to have taken his own life in a hotel room in Waxahachie, TX, on May 15th."]

DOWVILLE, E.

D576 "Home Incidents, Accidents, &c.: Mill Explosion at Manister, Michigan." FRANK LESLIE'S ILLUSTRATED NEWSPAPER 26, no. 660 (May 23, 1868): 157. 1 illus. [View.]

DRAKE, CHARLES.

D577 Pitcairn, R. *Uppingham.* With Nine Photographs by Charles Drake. "Our Public Schools." London: Provost & Co., 1870. n. p. 9 b & w. [Original photos.]

DRAPER & HUSTED.

D578 "Charlie Ross, the Stolen Child." FRANK LESLIE'S ILLUSTRATED NEWSPAPER 38, no. 985 (Aug. 15, 1874): 357. 1 illus. [Portrait.]

DRAPER, EDWARD. (GREAT BRITAIN)

D579 Fuller, John C. "An Un-Victorian Photograph of the 1860's." ART JOURNAL 29, no. 3 (Spring 1970): 303-308, 400. 1 b & w. 4 illus. [Article discusses the photograph "Boy with Parrots" (ca. 1865), by a British amateur, and shows how it differs from approaches found in Pre-Raphaelite painting and photography which emulated these paintings.]

DRAPER, HENRY see also HISTORY: BY APPLICATION: ASTRONOMICAL PHOTOGRAPHY.

DRAPER, HENRY. (1837-1882) (USA)
BOOKS

D580 Draper, Henry. ...*On the Construction of a Silvered Glass Telescope, Fifteen and a Half Inches in Aperture, and Its Uses in Celestial Photography.* Washington, DC: Smithsonian Institution, 1864. 55 pp. illus. [From "Smithsonian Contributions to Knowledge," (vol. 14, art. 4.)]

D581 Draper, Henry. ...*On Diffraction Spectrum Photography...* Illustrated by a photograph printed by the Albertype process. New Haven, CT: s. n., 1873. n. p. [From "Am. J. of Science & Arts," (Dec. 1873).]

PERIODICALS

D582 Draper, Henry, M.D. "On a New Method of Darkening Collodion Negatives." AMERICAN JOURNAL OF PHOTOGRAPHY AND THE ALLIED ARTS AND SCIENCES n. s. vol. 1, no. 24 (May 15, 1859): 374-376.

D583 "British Association 'Oxford Meeting, 1860.'" BRITISH JOURNAL OF PHOTOGRAPHY 7, no. 122 (July 16, 1860): 207-209. ["On the Principles of the Solar Camera," by A. Claudet; "On the Means of Increasing the Angle of Binocular Instruments, in order to obtain a Stereoscopic Effect in proportion to their Magnifying Power," by A. Claudet; "On a Reflecting Telescope for Celestial Photography, erecting at Hastings, near New York," by Henry Draper, M.D.]

D584 Hull, Charles Wager. "Dr. Henry Draper's Hot Water Process." AMERICAN JOURNAL OF PHOTOGRAPHY AND THE ALLIED ARTS & SCIENCES n. s. vol. 4, no. 20 (Mar. 15, 1862): 474-476. [On p. 480, Ch. Seely, the editor, states "The discovery of Dr. Draper is truly a great one; this is the capital discovery since the introduction of collodion: in ten years we have had nothing which is worthy of more praise."]

D585 "Dr. Henry Draper's Telescope and Photographs of the Moon." AMERICAN JOURNAL OF PHOTOGRAPHY AND THE ALLIED ARTS & SCIENCES n. s. vol. 6, no. 9 (Nov. 1, 1863): 197-200. [Read before the Am. Photo. Soc., Oct. 12, 1863.]

D586 "Dr. Henry Draper's Photographs of the Moon." HARPER'S WEEKLY 8, no. 377 (Mar. 19, 1864): 184-185, 186-187. 2 illus. [Includes a double-page engraving of the moon on pp. 184-185. Additional note p. 307 (May 14, 1864) that Draper's photo was "...exciting great attention in Europe."]

D587 Draper, Prof. "Celestial Photography." BRITISH JOURNAL OF PHOTOGRAPHY 12, no. 244 (Jan. 6, 1865): 5. [From "Q. J. of Science."]

D588 Draper, Henry. "On the Use of Silvered Glass in the Daguerreotype Process." AMERICAN JOURNAL OF PHOTOGRAPHY AND THE ALLIED ARTS & SCIENCES n. s. vol. 8, no. 14 (Jan. 15, 1866): 313-314. [Read before the Am. Photo. Soc., Jan 8, 1866.]

D589 Draper, Henry, M.D. "'Are there Other Inhabited Worlds?'" HARPER'S MONTHLY 33, no. 193 (June 1866): 45-54. 3 illus. ["A lecture delivered before the Young Men's Christian Assoc. of New York..." Illustrated with lantern-slide views of the moon and other planets, taken from photographs by Henry Draper. Draper discusses the difficulties associated with astronomical photography, then discusses his father's (John) work taking early portraits in the United States.]

D590 Draper, Henry. "On Diffraction Spectrum Photography." BRITISH JOURNAL PHOTOGRAPHIC ALMANAC 1874 (1874): 47-49.

D591 "Professor Draper's Formula." PHOTOGRAPHIC TIMES 5, no. 57 (Sept. 1875): 212-213.

D592 "Professor Henry Draper's Observatory." FRANK LESLIE'S ILLUSTRATED NEWSPAPER 44, no. 1134 (June 23, 1877): 276-277. 1 illus. [View of the telescope.]

D593 "Matters of the Month." PHOTOGRAPHIC TIMES 7, no. 81 (Sept. 1877): 194-195. [From "NY Tribune." Discovered several non-metallic substances in the sun, with spectroscopic experiments.]

D594 "Prof. Draper and his Pictures of the Corona." ANTHONY'S PHOTOGRAPHIC BULLETIN 9, no. 8 (Aug. 1878): 246.

D595 "The Examiners of the Sun" ANTHONY'S PHOTOGRAPHIC BULLETIN 9, no. 8 (Aug. 1878): 252-254. [From "New York Times." (Aug. 8) Prof. Henry Draper's expedition to Rawlings, Wyoming Territories, to observe the recent eclipse of the sun.]

D596 "Editor's Table: The Total Eclipse of the Sun." PHILADELPHIA PHOTOGRAPHER 15, no. 177 (Sept. 1878): 288. [Notice that "NY Times" has published article on the work of Prof. Draper, Prof. Barker and Prof. Morton, observing an eclipse in Rawlings, MT. Territory, and that Draper's account will be published in the "Photo. Times."]

D597 "Death of Dr. Draper." ANTHONY'S PHOTOGRAPHIC BULLETIN 13, no. 11 (Nov. 1882): 377-381. [Excerpted from "NY Times," Nov. 21, 1882.]

D598 "The Late Henry Draper." PHOTOGRAPHIC TIMES 12, no. 144 (Dec. 1882): 482-484. [Henry Draper, son of John William Draper, died suddenly on 29th Nov. 1882 in New York. Born Prince Edward's County, VA on May 7, 1837. Formerly by New York in 1847. Studied photography with his father, using it to aid his astronomical studies, taking photos of the moon, etc. in 1860s. Article includes an extensive bibliography of his scientific papers.]

D599 "Obituary. Professor Henry Draper." PHILADELPHIA PHOTOGRAPHER 20, no. 229 (Jan. 1883): 28-29. [Henry Draper died in New York on Nov. 20, 1882. At age twenty, while an undergraduate in medicine, Henry made microphotographs in his study of the spleen. In 1858 became interested in astronomy, built a reflecting telescope, and made well-known photographs of the moon. Some of which were printed up to 50 inches in diameter from his 1 inch negatives. In 1872 he constructed another reflecting telescope, which he used to study astral and, in 1876, solar spectra. In 1874 he directed the photographic department observing the transit of Venus. In 1876 he was a judge in the photographic department of the Centennial Exposition. In 1878 he organized a party to observe and photograph the sun's eclipse, at Rawlings, Wyoming. Since 1880 he has been photographing the nebula of Orion.]

D600 "A Unique Memorial." PHOTOGRAPHIC TIMES 17, no. 295 (May 13, 1887): 254. [From "Exchange." Draper's widow provided photographic apparatus for further scientific experiments.]

D601 "Editorial Notes." PHOTOGRAPHIC TIMES 18, no. 335 (Feb. 17, 1888): 74. [Notes about Dr. Draper's spectroscopic photographic researches.]

DRAPER, JOHN CHRISTOPHER. (1835-1885) (USA)

D602 Draper, John C., M.D. "Determination of the Diurnal Amount of Light by the Precipitation of Gold. (Read before the Photographical Society, June 13th)." AMERICAN JOURNAL OF PHOTOGRAPHY AND THE ALLIED ARTS AND SCIENCES n. s. vol. 2, no. 3 (July 1, 1859): 36-38. 1 illus.

D603 "Obituary: Prof. John Christopher Draper, M.D., Ll.D." ANTHONY'S PHOTOGRAPHIC BULLETIN 17, no. 1 (Jan. 9, 1886): 20. [Born in Prince Edward County, Va. in 1835, the eldest son of Prof. John W. Draper. Studied medicine at Univ. of City of New York. Prof.

of Chemistry at the College of the City of New York in 1858 for 10 years. In Army 1862. Wrote articles, books; experimented.]

D604 "Obituary: Prof. John Christopher Draper, M.D., LL.D." PHOTOGRAPHIC TIMES 16, no. 224 (Jan. 1, 1886): 8-9. [Born in Virginia on March 31, 1835. Oldest son of Prof. John W. Draper. Studied at University of City of New York, then studied medicine. Professor of chemistry at University of City of New York, author of chemical texts.]

DRAPER, JOHN WILLIAM. (1811-1882) (GREAT BRITAIN, USA)
BOOKS
[This is a partial listing of Draper's many writings on science and culture.]

D605 Draper, John William. *Experiments in Solar Light*. Philadelphia: s. n., 1837. 34 pp., 1 l. of plates. [From "J. of the Franklin Institute," (June-Oct. 1837).]

D606 Draper, John W. *An Introductory Lecture on the History of Chemistry, Delivered in the University of New York,...* New York: Medical Class of the University, Hopkins & Jennings, printers, 1841. 15 pp. [Similar lectures were printed annually through the 1840s.]

D607 Kane, Robert John, Sir. *Elements of Chemistry; Including the Most Recent Discoveries and Applications of the Science to Medicine and Pharmacy, and to the Arts, by Robert Kane,...An American Edition, with Additions and Corrections...by John William Draper.* New York: Harper & Brothers, 1843. xii, 704 pp. illus.

D608 Draper, John W. *A Text-book on Chemistry. For the Use of Schools and Colleges*. New York: Harper & brothers, 1846. xi, 408 pp. illus. [Many editions, into the 1860s.]

D609 Draper, John W., M.D., L.L.D, Prof. of Chemistry and Physiology in the University of New York. *Human Physiology, Statical and Dynamical, or a Treatise on the Conditions and Course of the Life of Man; being the Lectures delivered in the Medical Department of the University*. New York: Harper & Brothers, 1856. xvi, 649 pp. 296 illus. ["Illustrated with nearly 300 wood engravings." 2nd ed. (1858). This book was one of the first to use photography to translate the artist's sketches directly to the wood blocks for engraving.]

D610 Draper, John William. *A History of the Intellectual Development of Europe*. New York: Harper & brothers, 1863. xii, 631 pp.

D611 Draper, John W. *A Text-book on Natural Philosophy for the Use of Schools and Colleges. Containing the Most Recent Discoveries and Facts Compiled from the Best Authorities.* ...With nearly four hundred illustrations. "3rd. ed." New York: Harper & brothers, 1867. viii, 381 pp. illus. [Many editions.]

D612 Draper, John W. *History of the American Civil War*. New York: Harper & brothers, 1867-1870. 3 vol. illus.

D613 Draper, John William. *Scientific Memoirs: Being Experimental Contributions to a Knowledge of Radiant Energy*. New York: Harper & Brothers, 1878. 473 pp. 2 l. of plates. 100 illus. [Includes a memoir of his activities in taking portraits in 1840. Reprinted (1973), Arno Press.]

D614 Armytage, Dudley. "Who took the First Photographic Portrait?" on p. 28 in: *The Field Naturalist and Scientific Student,* edited by William E. A. Axon. London: Simpkin, Marshall & Co., 1883. 208 pp.

[This work was first issued as a serial, then published as a volume of 208 pp. Edited by William E. A. Axon.]

D615 Draper Memorial Park. [The Story of John William Draper and His Brother, Henry, and Their Contributions to Astronomy and Photography.] s. l. [Hastings-on-Hudson, NY]: s. n. [Draper Memorial Park], 195- ? 32 pp. illus. [Contains a reproduction of first portrait taken by Draper.]

PERIODICALS
D616 West, Charles E. "Portraiture in Daguerreotype." LONDON AND EDINBURGH PHILOSOPHICAL MAGAZINE AND JOURNAL OF SCIENCE Ser. 3, vol. 16, no. 105 (June 1840): 535. ["Professor Draper, of the University of New York, informs us in a note dated March 31st, that he has succeeded during the winter in procuring portraits by the Daguerreotype..."]

D617 Draper, John W., M.D. "Remarks on the Daguerreotype." AMERICAN REPERTORY OF ARTS, SCIENCES AND MANUFACTURES 1, no. 6 (July 1840): 401-404.

D618 Draper, John William, M.D. "XXXII. On the Process of Daguerreotype, and its application to taking Portraits from the Life." LONDON, EDINBURGH, AND DUBLIN PHILOSOPHICAL MAGAZINE, AND JOURNAL OF SCIENCE 3rd Ser. 17, no. 109 (Sept. 1840): 217-225.

D619 Draper, John W. "Progress of Science: On the Daguerreotype and its application to taking portraits from the life." AMERICAN REPERTORY OF ARTS, SCIENCES AND MANUFACTURES 2, no. 3 (Oct. 1840): 209-214. [From the "London and Edinburgh Philosophical Magazine."]

D620 Draper, John W. "Tithonotype." DAGUERREAN JOURNAL 1, no. 5 (Jan. 15, 1851): 140-142. [Written in 1843, source not given, possibly "Silliman's Journal."]

D621 Draper, John William, M.D. "On Tithonized Chlorine." DAGUERREAN JOURNAL 1, no. 11 (Apr. 15, 1851): 321-327. [Two letters, dated June 20, 1843 and Apr. 26, 1844. Source not given.]

D622 Draper, John W. "On Certain Spectral Appearances, and On the Discovery of Latent Light." DAGUERREAN JOURNAL 1, no. 12 (May 1, 1851): 353-354. [Letter dated Sept. 26, 1842. Source not given.]

D623 Draper, John W. "Daguerreotype: On the Process of Daguerreotype, and Its Application to Taking Portraits from Life." DAGUERREAN JOURNAL 2, no. 1 (May 15, 1851): 1-7. [From "Phil. Mag. S. 17:109 (Sept. 1840)."]

D624 "Some Facts Connected with the Early History of Photography in America." PHOTOGRAPHIC AND FINE ART JOURNAL 7, no. 12 (Dec. 1854): 381-382.

D625 Ross, William. "Retrospective Criticism: First Application of the Daguerreotype to Taking Portraits." HUMPHREY'S JOURNAL 7, no. 6 (July 15, 1855): 96-98. [Wm. Ross and Humphrey criticize John H. Draper for claiming to be the first to take a portrait, stating that priority should go to Wolcott & Johnson.]

D626 Draper, John W. "On the Application of Photography to Printing." HARPER'S MONTHLY 13, no. 76 (Sept. 1856): 433-441. 26 illus. [Excerpted from Draper's book, "Human Physiology, Statical and Dynamical, ..." The article states that this is the first sustained

attempt "...to illustrate a book on exact science with the aid of Photography." The book is actually illustrated with engravings that were made with photoengraving techniques.]

D627 Draper, John W., M.D. "On the Measurement of the Chemical Action of Light." HUMPHREY'S JOURNAL 9, no. 13 (Nov. 1, 1857): 199-201. [From "Philosophical Magazine."]

D628 Draper, John W. "On the Measurement of the Chemical Action of Light." PHOTOGRAPHIC AND FINE ART JOURNAL 11, no. 1 (Jan. 1858): 13-14. [From "Philosophical Magazine, Sept. 1857".]

D629 "The First Daguerreotype Portrait." HUMPHREY'S JOURNAL OF PHOTOGRAPHY, AND THE ALLIED ARTS AND SCIENCES 9, no. 22 (Mar. 15, 1858): 352. [Report that J. Draper claims to be the first to make a portrait, asserts that Wolcott & Johnson were first.]

D630 Draper, Dr. John W. "Who Made the First Photographic Portrait?" AMERICAN JOURNAL OF PHOTOGRAPHY AND THE ALLIED ARTS AND SCIENCES n. s. vol. 1, no. 1 (June 1, 1858): 2-6.

D631 Draper, John W., Dr. "Who Made the First Photographic Portraits?" PHOTOGRAPHIC AND FINE ART JOURNAL 11, no. 7 (July 1858): 221-222. [Draper describes his experiments.]

D632 "Dr. Draper's Palladium Process." AMERICAN JOURNAL OF PHOTOGRAPHY AND THE ALLIED ARTS & SCIENCES n. s. vol. 2, no. 5 (Aug. 1, 1859): 68-70. [From "Photo. Notes."]

D633 "President Draper's Address before the Photographical Society." AMERICAN JOURNAL OF PHOTOGRAPHY 2, no. 18 (Feb. 15, 1860): 275-280.

D634 "Our Photograph: President Draper." AMERICAN JOURNAL OF PHOTOGRAPHY AND THE ALLIED ARTS & SCIENCES n. s. vol. 3, no. 15 (Jan. 1, 1861): frontispiece, 237. 1 b & w. [Includes biography, from "American Cyclopedia." Original photo (not in this issue) by Ch. Frederick's gallery.]

D635 Draper, John W. "Address to the American Photographical Society." AMERICAN JOURNAL OF PHOTOGRAPHY AND THE ALLIED ARTS & SCIENCES n. s. vol. 3, no. 19 (Mar. 1, 1861): 289-293. [Survey of the field.]

D636 Draper, John W. "President Draper's Address Before the Photographical Society." AMERICAN JOURNAL OF PHOTOGRAPHY AND THE ALLIED ARTS & SCIENCES n. s. vol. 4, no. 19 (Mar. 1, 1862): 433-441.

D637 "Photological." HUMPHREY'S JOURNAL OF PHOTOGRAPHY, AND THE ALLIED ARTS AND SCIENCES 16, no. 1 (May 1, 1864): 8-9. ["Prof. Draper, in a late discourse, thus speaks of the impressions made upon us by light:..." (I assume this is John Draper).]

D638 Draper, John William. "Annual Address to the American Photographical Society." AMERICAN JOURNAL OF PHOTOGRAPHY AND THE ALLIED ARTS & SCIENCES n. s. vol. 7, no. 19 (Apr. 1, 1865): 433-438. [Actually a survey of the current situation in America.]

D639 "John William Draper." HARPER'S WEEKLY 10, no. 480 (Mar. 10, 1866): 148-149. 1 illus. [Biographical sketch. Portrait by Brady.]

D640 "Culture and Progress: Early Photography." CENTURY MAGAZINE (SCRIBNER'S MONTHLY) 6, no. 1 (May 1873): 124. [Letter from Draper claiming to have taken the first portrait photograph in the United States, written in reference to the Morse article in the March issue.]

D641 Draper, John. "The Nature of Sunlight." PHOTOGRAPHIC TIMES 4, no. 38 (Feb. 1874): 22-23. [Excerpt from the "Exchange," discussing Draper's experimental results.]

D642 Draper, John W. "Heat, Light, and Actinism." PHOTOGRAPHIC TIMES 7, no. 81 (Sept. 1877): 200-201. [From "Harper's Magazine." (Aug. 1877).]

D643 "The Late Professor Draper, M.D., L.L.D." PHOTOGRAPHIC TIMES 12, no. 133 (Jan. 1882): 1-2. [Died at Hastings-on-Hudson, NY, on the 4th Jan. 1882. Born May 5, 1811 at St. Helens, near Liverpool, England. To America in 1833. Prof. of Chemistry and Physiology at Hampten-Sidney College, VA, then after three years Professor of Chemistry and Natural History in the Univ. of the City of New York, where he stayed until 1882. At Daguerre's announcement Draper began experimenting, was one of the first to make a portrait. Draper and Prof. Morse joined to establish a photographic business. Left three sons, all scientists, one Dr. Henry Draper, involved in astronomical researches and photography.]

D644 Wilson, Edward L. "Professor Draper." PHILADELPHIA PHOTOGRAPHER 19, no. 218 (Feb. 1882): 34-35. [Announcement of Draper's death, general comments upon his life and photographic activities.]

D645 "The Moon's First Photography." PHOTOGRAPHIC TIMES 12, no. 137 (May 1882): 165. [Assertion that John W. Draper took first daguerreotype of the moon on March 23, 1840. Description of a lecture on topic by John K. Rees at the NY Academy of Sciences.]

D646 "The First Photographic Portrait." JOURNAL OF THE SOCIETY OF ARTS [EDINBURGH] 30, no. 1552 (Aug. 18, 1882): 932. [Excerpted from an article by Dudley Armytage in "The Field Naturalist." Brief account of Draper's early experiments and the first commercial studio in New York.]

D647 "Editorial Note." PHOTOGRAPHIC TIMES 23, no. 611 (June 2, 1893): 287. [Note that Draper's portrait "... of Sir. W. Herschel's sister, taken by Professor Draper in New York early in 1840, which was exhibited at the Chicago exhibition..." was causing arguments in England about who took the first portrait.]

D648 "Editorial Notes." PHOTOGRAPHIC TIMES 34, no. 1 (Jan. 1902): 33-34. 1 b & w. [Discusses the making of Dorothy Draper's portrait, one of the first taken.]

D649 "Centenary of Dr. John William Draper - First Portrait Photographer." WILSON'S PHOTOGRAPHIC MAGAZINE 48, no. 654 (June 1911): 246-250. 1 illus. [An engraved portrait of Draper faces p. 241.]

D650 "Minutes of the Meeting, February 13, 1860." PHOTOGRAPHICA 12, no. 4 (Apr. 1979): 11. 1 portrait b & w. [Excerpted minutes of meeting of the American Photographical Society, New York.]

DREW & JACOBSON. (SAN ANTONIO, TX)
D651 "Texas. - Market-Day on the Military Plaza in San Antonio. - From a Photograph by Drew & Jacobson, San Antonio." FRANK

LESLIE'S ILLUSTRATED NEWSPAPER 42, no. 1091 (Aug. 26, 1876): 413. 1 illus. [View, with figures.]

DRUMMOND, ALONZO JOHN. (NEW YORK, NY)
BOOKS
D652 Drummond, Alonzo John. *The Carbon Process; or, How to Make Photographs in Pigments.* New York: Joseph B. Ladd, 1868. xii, 113 pp.

PERIODICALS
D653 Drummond, A. J. "Serum Processing for Enlarging." AMERICAN JOURNAL OF PHOTOGRAPHY, AND THE ALLIED ARTS AND SCIENCES n. s. vol. 9, no. 12 (June 1, 1867): 266-268. [Source not given.]

D654 "Nitro Glucose." HUMPHREY'S JOURNAL OF PHOTOGRAPHY, AND THE ALLIED ARTS AND SCIENCES 19, no. 3 (June 1, 1867): 43. ["Mr. Alonzo J. Drummond, sends us a fine solar camera picture, taken on canvas."]

D655 Drummond, A. J. "Serum Process for Enlarging." HUMPHREY'S JOURNAL OF PHOTOGRAPHY, AND THE ALLIED ARTS AND SCIENCES 19, no. 9 (Sept. 1, 1867): 143-144. [From "Br. J. of Photo."]

D656 Drummond, A. J. "Notes on the Carbon Process." HUMPHREY'S JOURNAL OF PHOTOGRAPHY, AND THE ALLIED ARTS AND SCIENCES 19, no. 20 (Feb. 15, 1868): 314-315.

DRUMMOND, DAVID THOMAS KERR.
D657 Drummond, Rev. D. T. K. "The Malt Process." AMERICAN JOURNAL OF PHOTOGRAPHY AND THE ALLIED ARTS & SCIENCES n. s. vol. 6, no. 12 (Dec. 15, 1863): 265-268. [Read to Photo. Soc. of Scotland.]

DRYER, G. W.
D658 Dryer, G. W. "Correspondence: Climatic Differences Make No Difference." PHOTOGRAPHIC TIMES 5, no. 53 (May 1875): 101. [Letter from G.W. Dryer, Irvin Stanley, "... just returned from the transit of Venus Expedition at Kerguelen Island..." praising Scoville equipment.]

DU CAMP, MAXIME. (1822-1894) (FRANCE)
[Du Camp was born in Paris on Feb. 8, 1822. He was a poet, novelist, art critic, historian, and explorer. He travelled to the Near East in 1844-45 and wrote the book, *Souvenirs et paysages d'Orient*, published in 1848. In 1847 he travelled with Gustave Flaubert through Brittany and Touraine. He fought in the French National Guard during the revolution of 1848, was wounded and decorated. He learned photography from Gustave Le Gray in 1849 and then travelled throughout the Near East with Gustave Flaubert between 1849 and 1851, visiting Greece, Egypt, Syria, and Nubia. Du Camp made approximately 200 waxed-paper negatives on this trip, of which 125 were printed by Blanquart-Evrard in *Egypte, Nubie, Palestine et Syrie, dessins photographiques recuillis pendant les années 1849, 1850 et 1851, accompagnés d'un texte explicatif et précédés d'une introduction par Maxime Du Camp, chargé d'une mission archéologique en Orient par le Ministère de l'Instruction publique.* in 1852. This was the first major book illustrated with photographs published in France. In 1853 Du Camp received the Cross of the Legion of Honor in 1851 Du Camp helped found the *Revue de Paris*, and authored other works for the next two decades. Member of the Académie Français in 1880. Died in Feb., 1894 in Baden-Baden.]

BOOKS

D659 Du Camp, Maxime. *Egypt, Nubia, Palestine, and Syria; Photographic Pictures collected during the Years 1849, 1850, and 1851.* London: E. Gambert & Co., 1853. 4 pp. 125 l. of plates. 125 b & w. [Original calotypes.]

D660 "Flaubert et Maxime Du Camp," on pp. 77-128, vol. 2 in: *Voyageurs et ecrivains Française en Egypt,* by J. M. Carré. Cairo: 1932. 2 vol.

D661 Steegmuller, Francis, comp. and ed. *Flaubert in Egypt: A Sensibility on Tour; a Narrative drawn from Gustave Flaubert's travel notes and letters,...* Boston, Toronto: Little, Brown & Co., 1972. 231 pp. illus. [Describes Flaubert and Du Camp's tour through Egypt and the Holy Land.]

PERIODICALS

D662 "Du Camp's Photography." HUMPHREY'S JOURNAL 4, no. 12 (Oct. 1, 1852): 191. [Brief description of DuCamp's practice while in the Near East, with formula.]

D663 "Literature: Photography." ILLUSTRATED LONDON NEWS 21, no. 596 (Dec. 11, 1852): 530. [Bk. rev.: "Egypt, Nubie, Palestine et Syrie." par Maxime Du Camp.]

D664 "Spirit of the London Art Journal: Photographic Publications." PHOTOGRAPHIC ART JOURNAL 5, no. 1 (Jan. 1853): 16. [Reviews: "Photographic Album" by R. Fenton and P. Delamotte, and "Egypte, Nubie, Palestine et Syrie" by Du Camp. Reprinted from "London Art Journal."]

D665 "Fine Arts: New Publications." ATHENAEUM no. 1348 (Aug. 27, 1853): 1017. [Bk. rev.: "Egypt, Nubia, Palestine and Syria," Photographic Pictures collected during the years 1849, 1850, and 1851. By Maxime Du Camp. Gambart & Co. 125 plates.]

D666 "Pictures from the Collection." IMAGE 6, no. 3 (Mar. 1957): 70-71. 1 b & w. [Discusses Du Camp's photograph of the Colossus of Amen-opht III, 1852.]

D667 Cottin, Madeline. "Un image méconnue: la photographie de Flaubert prise en 1850 au Caire par son ami Maxime Du Camp." GAZETTE DES BEAUX-ARTS ser. 6 vol. 66, (Oct. 1865): 235-238. 1 b & w. 2 illus.

D668 Bauchard, Raoul. "Maxime Du Camp et la Saumurois." SOCIETE DES LETTRES, SCIENCES ET ARTS DU SAUMUROIS (SAUMUR) 63, no. 121 (1972): 41-47.

D669 "Biographical Notes on a Number of Photographers Published by Blanquart-Evrard." CAMERA (LUCERNE) 57, no. 12 (Dec. 1978): 32, 41-42. [Benecke, Claine, DuCamp, Fortier, Greene, Le Secq, Loydreau, Marville, Regnault, Robert, Salzmann, Stewart, Sutton, and Tenison.]

DU CHAILLU, PAUL B.

D670 "Curious African Fashions." HARPER'S WEEKLY 11, no. 537 (Apr. 13, 1867): 237. 4 illus. [Bk. rev.: "A Journey to Ashang-Land," by Du Chaillu. No mention that the illustrations are from photos, but Du Chaillu states in the preface that he learned photography from Claudet and took materials necessary for 2000 pictures on this journey.]

DU HAURON, ARTHUR LOUIS DUCOS. (1837-1920) (FRANCE)

D671 Ducos du Hauron. "Heliochromy." PHOTOGRAPHIC TIMES 6, no. 61 (Jan. 1876): 3-6. [From the "Moniteur de la Photographie."]

D672 "Editorial Notes." PHOTOGRAPHIC TIMES 25, no. 677 (Sept. 7, 1894): 156. [Notes receipt of several of M. Ducos du Hauron's anaglyphs. (3-D images of red/blue viewed through red/blue glasses).]

D673 Sachse, Julius F. "The Anaglyph." PHOTOGRAPHIC TIMES 25, no. 692 (Dec. 21, 1894): 403-406. [Read before the Photographic Society of Philadelphia Nov. 14, 1894. Ducos du Hauron's process of 3 dimensional printing.]

D674 "Louis Ducos du Hauron." PHOTOGRAPHIC TIMES 35, no. 5 (May 1903): 206-209. [Includes a chronological list of his inventions.]

D675 "Obituary: Louis Ducos du Hauron (Aug. 31, 1920)." BRITISH JOURNAL PHOTOGRAPHIC ALMANAC 1921 (1921): 316-317. ["The French inventor and pioneer in colour photography died in poverty at the age of eighty-three." In 1859, at age 22, Du Hauron began investigating color photography. Published many books, articles. Not commercially successful and lived for many years in poverty. Received Progress Medal of the RPS in 1900 and in 1912 made a Chevalier of the Legion of Honor.]

D676 "Portrait Distortion." U. S. CAMERA 13, no. 3 (Mar. 1950): 37. 4 b & w. [Ex. rev.: "Roots of French Photography," Museum of Modern Art, NY.]

D677 "Forgotten Pioneers: IV: Louis Ducos du Hauron (1837-1920)." IMAGE 1, no. 6 (Sept. 1952): 2. 1 b & w. [Described and practiced a method of color photography 1869 in book "Photography in Colors," solution of the problem.]

D678 "An 1877 Color Photograph." IMAGE 3, no. 5 (May 1954): 33-34 plus 1 color insert.

DU MOTAY see MARECHAL & DU MOTAY.

DUBRONI.

D679 "Pocket Photography." BRITISH JOURNAL OF PHOTOGRAPHY 12, no. 254 (Mar. 17, 1865): 134. [Dubroni camera described.]

D680 "Pocket Photography." AMERICAN JOURNAL OF PHOTOGRAPHY AND THE ALLIED ARTS & SCIENCES n. s. vol. 8, no. 1 (July 1, 1865): 9-11. [From "Br. J. of Photo." Dubroni's small camera described.]

D681 "Photography Made Easy." HUMPHREY'S JOURNAL OF PHOTOGRAPHY, AND THE ALLIED ARTS AND SCIENCES 17, no. 11 (Oct. 1, 1865): 175. [From "Photo. News."]

D682 "M. Dubroni's Photographic Apparatus." ART JOURNAL (1869): 383. [Dubroni, a French engineer and amateur photographer, reported to have developed a compact developing apparatus for traveling photographers.]

DUCHENNE DE BOULOGNE, GUILLAUME-BENJAMIN-AMANT. (1806-1875) (FRANCE)

[Born Sept. 18, 1806 at Boulogne-sur-mer, Pas-de-Calais. Studied medicine and became a doctor in 1831. Interested in physiological studies, and experimented with electo-therapy. Learned photographic techniques from Adrien Tournachon in 1852, began a

long course of photographing studies of facial expressions in response to electrical shocks. Published a series of these studies throughout the 1850s and, in 1862, the book *Mécanisme de la Physionomie Humaine ou Analyse Electro-Physiologique de l'Expression de Passions A[[licable à la Pratique des Arts Plastiques*. From 1870-75 he consulted for two days of each week to the poor for free. Died Sept. 17, 1875. in Paris.]

D683 Roth, Nancy Ann. "Electrical Expressions: The Photographs of Duchenne de Boulogne." VIEWS: THE JOURNAL OF PHOTOGRAPHY IN NEW ENGLAND. 6, no. 2 (Special Issue: Winter 1985): 17-22. 17 b & w. [Discussion of Duchenne de Boulougne's "Mécanisme de la Physionomie Humaine" (1862) with 71 photographs.]

DUCHOCHOIS, P. C.
D684 Duchochois, P. C. "On a Seine for Photographic Purposes." AMERICAN JOURNAL OF PHOTOGRAPHY AND THE ALLIED ARTS & SCIENCES n. s. vol. 1, no. 2 (June 15, 1858): 17-19.

D685 Duchochois, P. C. "Dry Collodion." AMERICAN JOURNAL OF PHOTOGRAPHY AND THE ALLIED ARTS & SCIENCES n. s. vol. 1, no. 3 (July 1, 1858): 33-35.

D686 Duchochois, P. C. "Dry Collodion Process." LIVERPOOL & MANCHESTER PHOTOGRAPHIC JOURNAL [BRITISH JOURNAL OF PHOTOGRAPHY] n. s. 2, no. 17 (Sept. 1, 1858): 211-213. [From "Am. J. of Photo."]

D687 "Note." AMERICAN JOURNAL OF PHOTOGRAPHY AND THE ALLIED ARTS AND SCIENCES n. s. col. 1, no. 8 (Sept. 15, 1858): 130. ["Our correspondent P. C. Duchochois has returned from a very successful photographic trip in New Jersey & Staten Island. Stereos..." He wrote a technical column for "Am. J. of Photo."]

D688 Duchochois, P. C. "Albumen Process." AMERICAN JOURNAL OF PHOTOGRAPHY AND THE ALLIED ARTS & SCIENCES n. s. vol. 1, no. 19 (Mar. 1, 1859): 304-305.

D689 Duchochois, P. C. "A New Dry Collodion Process." AMERICAN JOURNAL OF PHOTOGRAPHY AND THE ALLIED ARTS & SCIENCES n. s. vol. 1, no. 24 (May 15, 1859): 381-383.

D690 "Glycyrrhyzine as a Preservative Agent." HUMPHREY'S JOURNAL OF PHOTOGRAPHY, AND THE ALLIED ARTS AND SCIENCES 11, no. 9 (Sept. 1, 1859): 137. [From "Liverpool Photo. J."]

D691 Duchochois, P. C. "A New Dry Collodion Process." AMERICAN JOURNAL OF PHOTOGRAPHY AND THE ALLIED ARTS & SCIENCES n. s. vol. 2, no. 15 (Jan. 1, 1860): 225-226. [Read before Photographical Society, New York, NY.]

D692 "Editorial Miscellany." AMERICAN JOURNAL OF PHOTOGRAPHY AND THE ALLIED ARTS & SCIENCES n. s. vol. 3, no. 5 (Aug. 1, 1860): 80. [P. C. Duchochois accompanied the Labrador expedition (as photographer). On its way home, Hayes' Arctic expedition sailed without Mr. Peale. A Mr. Sontag, of the original party will try to take photos.]

D693 "Editorial Miscellany." AMERICAN JOURNAL OF PHOTOGRAPHY AND THE ALLIED ARTS & SCIENCES n. s. vol. 3, no. 6 (Aug. 15, 1860): 96. [The Labrador expedition has returned...Mr. Duchochois has brought home twelve good negatives made during the progress of the eclipse, and also a few of the wild region in which they pitched their camp.]

D694 "The Labrador Expedition." AMERICAN JOURNAL OF PHOTOGRAPHY AND THE ALLIED ARTS & SCIENCES n. s. vol. 3, no. 7 (Sept. 1, 1860): 97-103. [Prof. Alexander leader of party, under patronage of the Coast Survey which observed and photographed a total eclipse in Labrador in 1860. Long, detailed report by Alexander printed here. P. C. Duchochois was the photographer on this expedition.]

D695 "The American Photographical Society." AMERICAN JOURNAL OF PHOTOGRAPHY AND THE ALLIED ARTS & SCIENCES n. s. vol. 3, no. 8 (Sept. 15, 1860): 126-128. [Duchochois' photos from the Labrador expedition displayed and Duchochois explained his methods.]

D696 Duchochois, P. C. "Wooden Silver Baths." AMERICAN JOURNAL OF PHOTOGRAPHY AND THE ALLIED ARTS & SCIENCES n. s. vol. 3, no. 24 (May 15, 1861): 379.

D697 Duchochois, P. C. "A New Developer. - Time of Exposure Shortened." AMERICAN JOURNAL OF PHOTOGRAPHY AND THE ALLIED ARTS & SCIENCES n. s. vol. 6, no. 15 (Feb. 1, 1864): 356-357.

D698 Duchochois, P. C. "The Fading of Photographs." AMERICAN JOURNAL OF PHOTOGRAPHY AND THE ALLIED ARTS & SCIENCES n. s. vol. 6, no. 19 (Apr. 1, 1864): 446-447. [Read to Am. Photo. Soc.]

D699 Duchochois, P. C. "A New Intensifying Process." AMERICAN JOURNAL OF PHOTOGRAPHY AND THE ALLIED ARTS & SCIENCES n. s. vol. 6, no. 24 (June 15, 1864): 566-567.

D700 Seely, Charles A. "Editorial Department." AMERICAN JOURNAL OF PHOTOGRAPHY AND THE ALLIED ARTS & SCIENCES n. s. vol. 8, no. 8 (Oct. 15, 1865): 192. [Duchochois to accompany a party to Illinois to photograph an eclipse of the sun.]

D701 Duchochois, P. C. "Chlorides in Collodion. - A Developer without Acetic Acid." AMERICAN JOURNAL OF PHOTOGRAPHY AND THE ALLIED ARTS & SCIENCES n. s. vol. 8, no. 18 (Mar. 15, 1866): 430-431.

D702 Duchochois, P. C. "Cuttings of Fixed Prints Worth Saving." PHILADELPHIA PHOTOGRAPHER 6, no. 69 (Sept. 1869): 316. [He wrote many technical articles for the "American Journal of Photography" in the 1850s.]

D703 "Correspondence." ANTHONY'S PHOTOGRAPHIC BULLETIN 8, no. 8 (Aug. 1877): 256. [Letter about a technical aspect of the carbon printing process.]

D704 Duchochois, P. C. "Gelatine for Photographic Uses." PHOTOGRAPHIC TIMES 11, no. 125 (May 1881): 188-191.

D705 Duchochois, P. C. "On Albumen Paper and Blistering of Prints." PHOTOGRAPHIC TIMES 11, no. 129 (Sept. 1881): 361-363.

D706 Duchochois, P. C. "On the Action of Light Upon Photographic Silver Compounds." PHOTOGRAPHIC TIMES 14, no. 162 (June 1884): 286-290. [A paper read before Photographic Section of the American Institute.]

D707 Duchochois, P. C. "Much Ado About a Daguerreotype." ANTHONY'S PHOTOGRAPHIC BULLETIN 19, no. 15 (Aug. 11, 1888): 454-456. [Anecdote by an older photographer about being

approached by a younger photographer and a formula for cleaning daguerreotypes.]

D708 Duchochois, P. C. "Phosphorescent Photographs." ANTHONY'S PHOTOGRAPHIC BULLETIN 19, no. 17 (Sept. 8, 1888): 517-519.

D709 Duchochois, P. C. "Fluorine and Its Applications In Photography." ANTHONY'S PHOTOGRAPHIC BULLETIN 19, no. 18 (Sept. 22, 1888): 552-555.

D710 Duchochois, P. C. "On Toning Aristotypes." ANTHONY'S PHOTOGRAPHIC BULLETIN 19, no. 19 (Oct. 13, 1888): 597-600.

D711 Duchochois, P. C. "The Lighting in Photographic Studios." ANTHONY'S PHOTOGRAPHIC BULLETIN 19-20, no. 22-24, 1-2, 4 (Nov. 24 - Dec. 22, 1888, Jan. 12 - Jan. 26, Feb. 23, 1889): 679-683, 718-724, 745-749; 5-7, 44-47, 104-107. 5 illus.

D712 Duchochois, P. C. "Rules and Effects of Lighting." PHOTOGRAPHIC TIMES 20, no. 448 (Apr. 18, 1890): 184-186. [From Duchochois' book "The Lighting of Photographic Studios."]

D713 Duchochois, P. C. "The Origins and Processes of Photo-Engraving." PHOTOGRAPHIC TIMES 20, no. 450-460 (May 2 - July 11, 1890): 212-214, 220-222, 256-259, 282-283, 294-296, 305-308, 318-321, 331-333.

D714 Duchochois, P. C. "The Lighting in Photographic Studios: Mr. Ficken and the Old Masters." PHOTOGRAPHIC TIMES 20, no. 453 (May 23, 1890): 245. [Written in response to Edwards-Ficken's article in May 9, 1890 issue.]

D715 Duchochois, P. C. "The Old Masters: A Last Word to Mr. Edwards-Ficken." PHOTOGRAPHIC TIMES 20, no. 465 (Aug. 15, 1890): 403.

D716 Duchochois, P. C. "The Carbon Process." PHOTOGRAPHIC TIMES 30, no. 8 (Aug. 1898): 351-354.

DUCHOCHOIS-MAQUINGHAM, C.
D717 Duchochois-Maquingham, C. "The Waxed-Paper Process." PHOTOGRAPHIC AND FINE ART JOURNAL 8, no. 8 (Aug. 1855): 233-234. [Duchochois-Maquingham at Utica, NY.]

D718 Duchochois-Maquingham, C. "Acetate of Lead Baths." PHOTOGRAPHIC AND FINE ART JOURNAL 8, no. 11 (Nov. 1855): 337.

DUFTY, F. H. (LEVUKA, FIJI ISLANDS)
D719 "The Fiji Islands." ILLUSTRATED LONDON NEWS 62, no. 1749 (Mar. 8, 1873): 231-232. 5 illus.

DUHEM, CONSTANT & BROTHER.
D720 "New Mexico." HUMPHREY'S JOURNAL OF PHOTOGRAPHY, AND THE ALLIED ARTS AND SCIENCES 20, no. 6 (July 15, 1868): 96. ["Constant Duhem & Bro. send us a very fine stereoscopic view of Fort Union, New Mexico,."]

DUMAS.
D721 Dumas, Prof. "Observations on Mr. Daguerre's Process." DAGUERREAN JOURNAL 2, no. 8 (Sept. 1, 1851): 238.

DUMAS, ALEXANDER. (1802-1870) (FRANCE)
D722 Dumas, Alexander. "Alexander Dumas on Photography." AMERICAN JOURNAL OF PHOTOGRAPHY AND THE ALLIED ARTS & SCIENCES n. s. vol. 9, no. 2 (Sept. 15, 1866): 31-37. [Account of travels in Hungary by Alex Dumas published in a Paris daily paper. Dumas describes his visit to a woman photographer - Madame Willhelmine Stockman in Vienna. Stockman was Hungarian. "At Vienna photography is generally practiced by women."]

DUNCAN, DAVID.
D723 Duncan, David. "The Management of Sitters." AMERICAN JOURNAL OF PHOTOGRAPHY AND THE ALLIED ARTS & SCIENCES n. s. vol. 6, no. 21 [sic 22] (May 15, 1864): 511-512. [From "Photo. News."]

D724 Duncan, David. HUMPHREY'S JOURNAL OF PHOTOGRAPHY, AND THE ALLIED ARTS AND SCIENCES 20, no. 9 (Sept. 1, 1868): 135-136. [From "Photo. News."]

D725 Duncan, David. "An Interesting Experiment in Photolithography with Bichromated Gum-Arabic." HUMPHREY'S JOURNAL OF PHOTOGRAPHY, AND THE ALLIED ARTS AND SCIENCES 20, no. 11 (Oct. 1, 1868): 161-163.

D726 Duncan, David. "Some Causes of Failures in Carbon Printing and Remedies for the Same." HUMPHREY'S JOURNAL OF PHOTOGRAPHY, AND THE ALLIED ARTS AND SCIENCES 20, no. 13 (Nov. 1, 1868): 193-196.

D727 Duncan, David. "My Idea of Lighting the Sitter." HUMPHREY'S JOURNAL OF PHOTOGRAPHY, AND THE ALLIED ARTS AND SCIENCES 20, no. 14-15 (Nov. 15 - Dec. 1, 1868): 209-211, 225-228.

D728 Duncan, David. "A Simple Modification of Lime Toning for the Commercial Photographer." HUMPHREY'S JOURNAL OF PHOTOGRAPHY, AND THE ALLIED ARTS AND SCIENCES 20, no. 16 (Dec. 15, 1868): 241-243.

D729 Duncan, David. "Some Causes of Failures in Carbon Printing with Remedies for the Same." HUMPHREY'S JOURNAL OF PHOTOGRAPHY, AND THE ALLIED ARTS AND SCIENCES 20, no. 17 (Jan. 15, 1869): 259-261.

D730 Duncan, David. "Olla Podrida." HUMPHREY'S JOURNAL OF PHOTOGRAPHY, AND THE ALLIED ARTS AND SCIENCES 20, no. 18 (Feb. 15, 1869): 275-278. [Varnishing Negatives. Porcelain Pictures. Pictures on White Wax, etc.]

D731 Duncan, David. "A Little About Gelatine." HUMPHREY'S JOURNAL OF PHOTOGRAPHY, AND THE ALLIED ARTS AND SCIENCES 20, no. 20-22 (Apr. 15 - June 15, 1869): 305-306, 321-323, 337-339.

DUNCANSON, ROBERT. (ca. 1820-1872) (USA)
D732 "Robert Duncanson," in: Donaldson, Mary Katherine. *Composition in Early Landscapes of the Ohio River Valley: Backgrounds and Components.* Pittsburgh: University of Pittsburgh, 1971.[Ph.D. Dissertation, University of Pittsburgh, 1971. Duncanson, born in New York, educated in Canada by his Scotch-Canadian father. Also sent to study in Edinburgh, by the Anti-Slavery League. Joined his Negro mother in Ohio about 1842. Earned his living as a daguerreotypist in Cincinnati from about 1842 to 1855. Was also an painter, and apparently became a full-time artist from about 1858 on. See pp. 201 - 203.]

DUNMORE & CRITCHERSON see also BLACK, JAMES W.; see also BRADFORD, WILLIAM.

[John L. Dunmore, employee of Whipple & Black from 1856 to 1859, then employee of James Black until 1876, then partner in Black & Co. George Critcherson, was a photographer from Worcester, MA, who accompanied Dunmore and the artist William Bradford on the expedition to the Arctic in 1869. Many of these photographs were attributed to Bradford, although most, if not all, were taken by the team of Dunmore & Critcherson.]

DUNMORE & CRITCHERSON.
BOOKS
D733 Bradford, William. *The Arctic Regions.* Illustrated with Photographs taken on an Art Expedition to Greenland. With Descriptive Narrative by the Artist. London: Sampson Lowe, Marston, Low & Searle, 1873. x, 89 pp. 141 b & w. [350 copies. Photographs, credited to William Bradford, were taken by the team of Dunmore & Critcherson, of J. W. Black's studio.]

PERIODICALS
D734 "Mr. Bradford's Polar Expeditions. His Photographs Showing the Formation of Glaciers and Icebergs." FRANK LESLIE'S ILLUSTRATED NEWSPAPER 31, no. 799 (Jan. 21, 1871): 310-311, 312. 10 illus. [Five engravings of icebergs, from Dunmore & Critcherson's photographs. Five sketches.]

D735 "Pictures of Esquimaux Life. - Engraved from Photographs Collected by Mr. William Bradford During the Northern Expedition." FRANK LESLIE'S ILLUSTRATED NEWSPAPER 31, no. 800 (Jan. 28, 1871): 332. 4 illus. [Portraits, huts.]

DUNMORE, EDWARD. (GREAT BRITAIN)
BOOKS
D736 Smith, Rev. Richard Henry. *Expositions of Raphael's Bible.* By the Author of "Expositions of Raphael's Cartoons" [Rev. R. H. Smith], With Photographs by Dunmore. London: A. Miall, 1868. 134 pp. 12 b & w. illus. [Original photographs by Edward Dunmore, of engravings after Raphael's Frescos at the Vatican.]

D737 Smith, Richard Henry. *Expositions of Great Pictures,* by Richard Henry Smith; Illustrated with Photographs. London: J. Nisbet, 1863. 101 pp. b & w. illus. [Original photos, probably by Edward Dunmore, after Raphael's paintings.]

PERIODICALS
D738 Dunmore, E. "Vignetting Negatives." HUMPHREY'S JOURNAL OF PHOTOGRAPHY, AND THE ALLIED ARTS AND SCIENCES 15, no. 23 (Apr. 1, 1864): 366-367.

D739 Dunmore, E. "On the Connection of Photography with the Fine Arts." BRITISH JOURNAL OF PHOTOGRAPHY 13, no. 306 (Mar. 16, 1866): 126-127.

D740 Dunmore, E. "Foregrounds and their Value in Landscape Photography." BRITISH JOURNAL OF PHOTOGRAPHY 13, no. 314 (May 11, 1866): 223-224.

D741 Dunmore, E. "Concentration of Light in the Studio." HUMPHREY'S JOURNAL OF PHOTOGRAPHY, AND THE ALLIED ARTS AND SCIENCES 20, no. 1 (May 1, 1868): 3. [Read to London Photo. Soc.]

D742 Dunmore, E. "Vignetting Negatives." AMERICAN JOURNAL OF PHOTOGRAPHY AND THE ALLIED ARTS & SCIENCES n. s. vol. 6, no. 20 (Apr. 15, 1864): 468-469. [From "Photo. News."]

D743 Dunmore, Edward. "A Few Thoughts on 'What Shall We Do This Dark Weather?'" HUMPHREY'S JOURNAL OF PHOTOGRAPHY, AND THE ALLIED ARTS AND SCIENCES 17, no. 20 (Feb. 15, 1866): 318-319. [From "Photo. News."]

D744 Dunmore, Edward. "Remarks upon Landscape Photography and Apparatus Employed." PHILADELPHIA PHOTOGRAPHER 4, no. 43 (July 1867): 215-218. [Paper read before the North London Photographic Assoc.]

D745 Dunmore, Edward. "Description of a New Studio." BRITISH JOURNAL PHOTOGRAPHIC ALMANAC 1870 (1870): 147-148. 1 illus.

D746 Dunmore, Edward. "A Simple Method of Double Printing, Especially Suitable for the Addition of Landscape and Other Backgrounds to Figure Subjects." BRITISH JOURNAL PHOTOGRAPHIC ALMANAC 1871 (1871): 80-81.

D747 Dunmore, Edward. "Negatives and Studios: Their Relations to Each Other." BRITISH JOURNAL PHOTOGRAPHIC ALMANAC 1873 (1873): 144-145.

D748 "How to avoid Granularity in Copying Photographs." BRITISH JOURNAL PHOTOGRAPHIC ALMANAC 1876 (1876): 98-99. 1 illus

D749 Dunmore, E. "A New Method of Imparting Artistic Finish to Photographs." ANTHONY'S PHOTOGRAPHIC BULLETIN 7, no. 2 (Feb. 1876): 45. [From "Br. J. of Photo."]

D750 Dunmore, Edward. "Thoughts on Plain Subjects." ANTHONY'S PHOTOGRAPHIC BULLETIN 7, no. 8 (Aug. 1876): 237-238. [From "Br. J. of Photo." Portraits of "plain" people, and how to cope with the difficulties.]

D751 Dunmore, Edward. "How to Mend a Negative." BRITISH JOURNAL PHOTOGRAPHIC ALMANAC 1877 (1877): 121-122.

D752 Dunmore, Edward. "On the Color of Photographic Pictures." PHOTOGRAPHIC TIMES 7, no. 74 (Feb. 1877): 33-35. [Read before the South London Photographic Society.]

D753 Dunmore, E. "Picture Hanging." PHOTOGRAPHIC TIMES 7, no. 75 (Mar. 1877): 63-64. [From "Br J of Photo."]

D754 Dunmore, Edward. "Varieties." ANTHONY'S PHOTOGRAPHIC BULLETIN 9, no. 12 (Dec. 1878): 356-358. [From "London Photo. News." Read before the South London Photo. Soc.]

D755 Dunmore, Edward. "Change in Varnished Negatives." BRITISH JOURNAL PHOTOGRAPHIC ALMANAC 1879 (1879): 101-102.

D756 Dunmore, Edward. "Varieties." PHOTOGRAPHIC TIMES 9, no. 97 (Jan. 1879): 3-5. [Read before the South London Photo Soc.

D757 Dunmore, Edward. "Sunshine or Shade?" PHILADELPHIA PHOTOGRAPHER 16, no. 191 (Nov. 1879): 345-347.

D758 Dunmore, Edward. "Troubles and Pitfalls in Out-Door Photography." PHOTOGRAPHIC TIMES 15, no. 215 (Oct. 30, 1885): 613-616. [Read before the South London Photographic Society.]

D759 Dunmore, Edward. "Photography from One Point of View." ANTHONY'S PHOTOGRAPHIC BULLETIN 18, no. 22-23 (Nov. 26 - Dec. 10, 1887): 692-693, 727-728. [Read before the British Photographic Convention at Glasgow.]

D760 Dunmore, Edward. "Size and Shape as Factors in Artistic Representation." PHOTOGRAPHIC TIMES 18, no. 370 (Oct. 19, 1888): 499-501. [Read at the Photographer's Convention of Great Britain in Birmingham.]

D761 Dunmore, Edward. "Photographs, Plain or Colored." PHOTOGRAPHIC TIMES 20, no. 442 (Mar. 7, 1890): 116-117. [From "Br J of Photo."]

D762 Dunmore, Edward. "Portrait Negatives." PHOTOGRAPHIC TIMES 21, no. 531 (Nov. 20, 1891): 580-581. [From the "Br J of Photo."]

D763 Dunmore, Edward. "Studio Blinds and Reflectors." WILSON'S PHOTOGRAPHIC MAGAZINE 34, no. 483 (Mar. 1897): 110-111. [From "British J. of Photography."]

D764 Dunmore, Edward. "Lighting the Landscape." WILSON'S PHOTOGRAPHIC MAGAZINE 35, no. 496 (Apr. 1898): 174-178. [From "Br J of Photo."]

D765 Dunmore, E. "Some Old Expedients Worth Remembering." WILSON'S PHOTOGRAPHIC MAGAZINE 35, no. 497 (May 1898): 203-206.

DUNMORE, JOHN L. see also BLACK, JAMES W.; DUNMORE & CRITCHESON.

DUNMORE, JOHN L.
D766 "Gossip." PHILADELPHIA PHOTOGRAPHER 6, no. 71 (Nov. 1869): 388. ["Mr. John Dunmore, one of Mr. J. W. Black's operators in Boston, has just returned from a photographic trip among the icebergs in the Arctic regions. We hope for some interesting details of his journey."]

D767 Dunmore, John L. "The Camera Among the Icebergs." PHILADELPHIA PHOTOGRAPHER 6, no. 72 (Dec. 1869): 412-414.

D768 Porter, Russell W. "The Artist in Greenland." NEW ENGLAND MAGAZINE 16, no. 3 (May 1897): 289-303. 22 b & w. 2 illus. [Discusses the artist William Bradford and his explorations of Greenland in 1869, mentions the photography favorably but doesn't mention the photographers by name. Includes 4 photos "from a photograph in the Bradford Collection," portrait of Bradford, 2 of his painting, etc. Article then discusses author's own experience in Greenland in 1894, with illustrative photos.]

D769 "The Arctic Regions." IMAGE 1, no. 8 (Nov. 1952): 1. 1 b & w. [300 to 400 photographs made in 1869 on William Bradford's expedition to the Arctic by the team of Dunmore & Critcheson of the studio of J. W. Black, Boston. 139 collected in book, "The Arctic Regions," by Wm. Bradford in 1873; collection George Eastman House.]

DUNWICK, W. H.
D770 Dunwick, W. H. "Correspondence." ANTHONY'S PHOTOGRAPHIC BULLETIN 3, no. 2 (Feb. 1872): 462. [Dunwick of McKernan's Gallery (Saratoga Springs, NY).]

D771 Dunwick, W. H. "Correspondence." ANTHONY'S PHOTOGRAPHIC BULLETIN 7, no. 6 (June 1876): 191-192. [Dunwick from Washington, DC.]

DUPERTZ BROTHERS. (KINGSTON, JAMAICA)
D772 Portrait. Woodcut engraving, credited "From a Photograph by Dupertz Brothers, Kingston, Jamaica." HARPER'S WEEKLY 9, (1865) ["Rev. George W. Gordon." 9:466 (Dec. 2, 1865): 757.]

DUPERTZ, A. KINGSTON, JAMAICA.
D773 Portrait. Woodcut engraving, credited "From a Photograph by A. Dupertz, Kingston, Jamaica." HARPER'S WEEKLY 8, (1864) ["The Pirate Raphael Semmes." 8:395 (July 23, 1864): 477.]

DUPONT, AIME. (1842-1900) (BELGIUM)
D774 Portrait. Woodcut engraving credited "From a photograph by Dupont, of Antwerp." ILLUSTRATED LONDON NEWS 55, (1869) ["Baron Henri Leys, painter." 55:* (Sept. 18, 1869): 281.]

DUPPER, BRYAN E.
D775 Portrait. Woodcut engraving credited "From a photograph by Bryan E. Dupper, Esq." ILLUSTRATED LONDON NEWS 27, (1855) ["The Late Sir William Molesworth, Bart." 27:* (Oct. 27, 1855): 489.]

DUPUIS, A.
D776 Brewster, Sir David. "Account of a New Photographic Process by M. Dupuis, Officer of Health to the French Army of Occupation in Rome." PHOTOGRAPHIC AND FINE ART JOURNAL 11, no. 2 (Feb. 1858): 55-56. [From "J. of Photo. Soc., London." Read before the Photo. Soc. of Scotland, Nov. 5, 1857. "When I was in Rome last winter I became acquainted with M. M. Dupuis, a celebrated amateur photographer, who had produced the finest binocular pictures of the public buildings in that city..."]

DURAND, C.
D777 Durand, C. "Large Eburneum Pictures." BRITISH JOURNAL PHOTOGRAPHIC ANNUAL 1875 (1875): 82-83.

DURAND, J. [?]
D778 Durand, J [?] "Sketchings: The Photographic Portrait." THE CRAYON 4, no. 5 (May 1857): 154-155. [Commentary about the difficulties of photographic portraiture, apparently engendered by a recent article by N. P. Willis in "Home Journal."]

DURANDELLE, LOUIS-ÉMILE. (1839-1917) (FRANCE)
[Born Feb. 14, 1839, at Verdun. Partner with Hyacinthe César Delamet (1828-1862) from 1854 until Delamet's death in 1862. Clémance Jacob Delamet, the widow may have continued the partnership. Views of houses, buildings in Paris throughout 1860s. In 1868 the firm photographs the rebuilding of the Hôtel-Dieu. In 1870-71 photographs the Commune. Throughout 1870s views of Mont-Saint-Michel, the Bibliothèque Nationale, Sacré-Couer, and other public buildings. Photograph the construction of the Eiffel Tower in 1887-89. Durandelle stops photography in 1890, dies at Bois-Colombes on Mar. 12, 1917.

D779 Keller, Ulrich. "Durandelle, the Paris Opera, and the Aesthetic of Creativity." GAZETTE DES BEAUX-ARTS (Feb. 1988): 109-118. 6 b & w. [Durandelle documented the building of the Paris Opera over a ten to twelve year span, starting in 1862, and making some 200 photographs. The photographs were published in four of the eight volumes of Le nouvel Opéra de Paris. Paris: Ducher & Cie., 1875-1881.]

DURIEU, JEAN-LOUIS-MARIE-EUGENE. (1800-1874) (FRANCE)

[Born in Nîmes in 1800. He was a jurist and an administrator for the government. Founded the periodical *Le Mémorial des Precepteurs* in 1824. Began to make daguerreotypes in the 1840s and assisted Baron Gros with astronomical daguerreotypes around 1845. In 1847 appointed the head of an administrative section in the Ministry of Interior, the Inspector-General of Hospices and Public Utilities, later an active figure working with the Commission for Historic Monuments, which hired photographers to document historical sites and buildings throughout France. Retired from his post in the Direction des Cultes in 1850, then met and collaborated with Eugène Delacroix in the 1850s to create a series of nude genre studies, which the painter frequently used as reference materials. A founding member and active figure in the Société heliographique in 1851 and the Société française de Photographique in 1854. Died in Paris in 1874.]

D780 Newhall, Beaumont. "Delacroix and Photography." MAGAZINE OF ART 45, no. 7 (Nov. 1952): 300-303. 5 b & w. 4 illus

D781 Coke, Van Deren. "Two Delacroix Drawings Made from Photographs." ART JOURNAL 21, no. 3 (Spring 1962): 172-174. 2 b & w. 2 illus. [Delacroix used Durieu's photos as source material for several of his sketches.]

DURYEA, T.

D782 "Prince Alfred in South Australia." ILLUSTRATED LONDON NEWS 52, no. 1470 (Feb. 22, 1868): 175-177, 180. 5 illus. ["We have engraved a series of photographs, taken by Mr. T. Duryea, of Adelaide, which represents the landing of the Prince at Glenelg on Oct. 31..." Views, crowds, etc.]

DUSSAUCE, HIPPOLYTE. (1829-1869) (FRANCE)

D783 Dussauce, H., Prof. "Chemicals used in Photography." HUMPHREY'S JOURNAL OF PHOTOGRAPHY, AND THE ALLIED ARTS AND SCIENCES 19, no. 18-24 (Jan. 15 - Apr. 15, 1868): 273-274, 289-291, 305-307, 321-322, 337-338, 376-377. [Dussauce was the Chemist in the Imperial Laboratories of the French Government, and an amateur photographer. See p. 272.]

DUTKIEWICZ, MELETIUS. (1836-1897) (POLAND)

D784 Kaes, Simon. "Photographic Target." HUMPHREY'S JOURNAL OF PHOTOGRAPHY, AND THE ALLIED ARTS AND SCIENCES 19, no. 13 (Nov. 1, 1867): 207. [From "Photo. Corres." "During my late journey to Russia I visited my friend Mr. Dutkiewicz in Warsaw, and saw in his gallery,..."]

D785 Plutecka, Grazyna. "Meletius Dutkiewicz (1836-1897) Polish Photographer." HISTORY OF PHOTOGRAPHY 2, no. 4 (Oct. 1978): 283-290. 9 illus.

DUTTON, J. & J. DUTTON.

D786 "Stereographs: St. Mary Magdalene's Church, Tetbury, by Messrs. Dutton." BRITISH JOURNAL OF PHOTOGRAPHY 7, no. 122 (July 16, 1860): 209.

D787 "Stereographs. Ecclesiastical Interiors of Bath and Bristol, Photographed by J. & J. Dutton." BRITISH JOURNAL OF PHOTOGRAPHY 10, no. 196 (Aug. 15, 1863): 335.

DUTTON.

D788 Dutton. "Experiments upon the Waxed Paper Process." HUMPHREY'S JOURNAL OF PHOTOGRAPHY, AND THE ALLIED ARTS AND SCIENCES 10, no. 2 (May 15, 1858): 20-22. [Read to North London Photo. Soc. From "Liverpool Photo. J."]

DUVAL, C. A. & CO. (MANCHESTER, ENGLAND)

D789 Portrait. Woodcut engraving credited "From a photograph by C. A. Duval & Co., Exchange St., Manchester." ILLUSTRATED LONDON NEWS 42, (1863) ["John Pender, Esq., M.P." 42:* (Feb. 21, 1863): 205.]

D790 Portrait. Woodcut engraving credited "From a photograph by C. A. Duval & Co." ILLUSTRATED LONDON NEWS 66, (1875) ["Frederick Walker, A.R.A." 66:1865 (May 8, 1875): 445.]

DWIGHT.

D791 "Choosing and Handling the Subject." PHILADELPHIA PHOTOGRAPHER 16, no. 190 (Oct. 1879): 294-297. [Extracted from Dwight's "Study of Art."]

DYBALL, R. H.

D792 Dyball, R. H. "You don't know what you can do till you Try." AMERICAN JOURNAL OF PHOTOGRAPHY AND THE ALLIED ARTS & SCIENCES n. s. vol. 7, no. 7 (Oct. 1, 1864): 163. [From "Photo. News."]

DYER see BUTLER & DYER.

E

R. D. E. (PETERBORO, CANADA)

E1 R. D. E. "Correspondence: A Voice from the Far West." BRITISH JOURNAL OF PHOTOGRAPHY 10, no. 187 (Apr. 1, 1863): 152-153. [Letter from R. D. E. at Peterboro, Canada West, dated Mar. 7, 1863, asking for technical advice.]

R. E. (BOMBAY, INDIA)

E2 R. E. (Bombay, India) "The Gelatine Iron Developer, Etc. in India." HUMPHREY'S JOURNAL OF PHOTOGRAPHY, AND THE ALLIED ARTS AND SCIENCES 18, no. 13 (Nov. 1, 1866): 200-201.

EADIE. (GLASGOW, SCOTLAND)

E3 "The New Graving Dock, Glasgow." ILLUSTRATED NEWS OF THE WORLD AND DRAWING ROOM PORTRAIT GALLERY OF EMINENT PERSONAGES 1, no. 8 (Mar. 27, 1858): 124. 1 illus. ["From a Photograph by Mr. Eadie, of Glasgow."]

EADS, J. B., CAPT. [?]

E4 "Louisiana. - Opening the South Pass of the Mississippi River for Navigation. - Views of the Eads Jetties. From Photographs Furnished by Captain J. B. Eads." FRANK LESLIE'S ILLUSTRATED NEWSPAPER 44, no. 1124 (Apr. 14, 1877): 101. 4 illus. [Views.]

EALES, FREDERICK H. (ROCHESTER, NY)

E5 "Editor's Table." PHILADELPHIA PHOTOGRAPHER 6, no. 61 (Jan. 1869): 32. [F. Eales starting, going to do stereo views.]

EARL OF CAITHNESS a.k.a. JAMES SINCLAIR (1821-1881) (GREAT BRITAIN)

EARL, FRANCIS CHARLES. (GREAT BRITAIN)

E6 Earl, F. C. "Landscape Photography." ANTHONY'S PHOTOGRAPHIC BULLETIN 4, no. 2 (Feb. 1873): 37-40. [Read before the Photographic Society of London.]

E7 Hallett, Michael. "The Hopkins Memorial Stone." HISTORY OF PHOTOGRAPHY 11, no. 2 (Apr. - June 1987): 119-122. 2 illus. [Post-mortem photograph on a memorial stone in Worcester, England. Of a boy who died in 1871, taken by Francis Charles Earl, a professional photographer who worked in Worcester from 1860 to 1872 and in Malvern from 1873 to 1879.]

EASTERLY, THOMAS see also HISTORY: USA: MO (Van Ravenswaay)

EASTERLY, THOMAS M. (1809-1882) (USA)

E8 Ewers, John C. "Thomas M. Easterly's Pioneer Daguerreotypes of Plains Indians." MISSOURI HISTORICAL SOCIETY BULLETIN 24, no. 4 pt. 1 (July 1968): 329-339. 9 b & w. 1 illus. [Took first daguerreotypes of Plains Indians, while working as an itinerant photographer in the vicinity of Liberty, MO, in the late 1840s.]

E9 Davidson, Carla. "The View from Fourth and Olive: A remarkable collection of daguerreotypes by the St. Louis Photographer Thomas Easterly." AMERICAN HERITAGE 31, no. 1 (Dec. 1979): 76-93. 22 b & w. [Daguerreotypist, working in St. Louis, MO, from 1847 to 1880. Born in VT in 1809, to Missouri by 1846, in St. Louis by 1847. Died in 1882, a pauper. Nearly 400 views of streets, events in the city, wrecks, etc.]

EASTHAM & BASSANO. (LONDON, ENGLAND)

E10 Portrait. Woodcut engraving credited "From a photograph by Eastham & Bassano, Regent St." ILLUSTRATED LONDON NEWS 37, (1860) ["Rev. William Wood Stamp." 37:* (Aug. 18, 1860): 162.]

EASTHAM, JOHN. (MANCHESTER, ENGLAND)

E11 "Eastham's Picture 'The Treaty of Commerce, 1860, Between France and England.'" ILLUSTRATED LONDON NEWS 40, no. 1133 (Mar. 1, 1862): 230-231. 1 illus. [Composite group portrait by Mr. Eastham, who was from Manchester.]

E12 "Fine Arts." ILLUSTRATED LONDON NEWS 41, no. 1153 (July 12, 1862): 51. ["We have received from Mr. Eastham, of Manchester, some specimens of photographic portraiture... on opal glass."]

E13 Portrait. Woodcut engraving credited "From a photograph by John Eastham, of Manchester." ILLUSTRATED LONDON NEWS 41, (1862) ["Rev. Charles Prest." 41:* (Aug. 23, 1862): 204.]

E14 Portraits. Woodcut engravings credited "From a photograph by John Eastham, of Manchester." ILLUSTRATED LONDON NEWS 42, (1863) ["Sir Tatton Sykes, Esq." 42:* (Apr. 11, 1863): 413. "Rev. Henry Mildred Birch." 42:* (Apr. 25, 1863): 456.]

E15 "Our Editorial Table: Portraits of Roger Fenton, by J. Eastham, Manchester." BRITISH JOURNAL OF PHOTOGRAPHY 12, no. 254 (Mar. 17, 1865): 143.

E16 "Our Editorial Table: Pictures by John Eastham." BRITISH JOURNAL OF PHOTOGRAPHY 12, no. 292 (Dec. 8, 1865): 622.

E17 "English Photography at the Vatican." ANTHONY'S PHOTOGRAPHIC BULLETIN 10, no. 1 (Jan. 1879): 6-7. [From "London Photo. News." John Eastham (Manchester) summoned to Vatican to take portraits of Pope Leo XIII.]

EASTHAM, SILAS. (EASTHAM, ENGLAND)

E18 Portrait. Woodcut engraving credited "From a photograph by Silas Eastham." ILLUSTRATED LONDON NEWS 69, (1876) ["Late Sir Elkanah Armitage." 69:1953 (Dec. 16, 1876): 581.]

EASTLAKE, MARY.

E19 Eastlake, Lady. "Photography." LONDON QUARTERLY REVIEW no. 202 (Apr. 1857): 241-255. [Extensive, astute discussion of the practical and aesthetic possibilities of photography in the 1850s, based on a review of seven books and articles recently published.]

E20 Eastlake, Lady Mary [sic, Elizabeth]. "A Kind of Republic." IMAGE 2, no. 2 (Jan. - Feb. 1953): 4-5. 1 b & w. [Condensed critical article reprinted from April 1857, "London Quarterly Review." Portrait photograph of Lady Eastlake, by Hill & Adamson, 1845.]

EASTON, DR. (d. 1861) (GREAT BRITAIN)

E21 "Meetings of Societies: Edinburgh Photographic Society." BRITISH JOURNAL OF PHOTOGRAPHY 8, no. 149 (Sept. 2, 1861): 312. [Obituary, brief biography. Dr. Easton entered Navy after medical school, served in Syrian naval campaign of 1840-41. Then three years aboard the "Sealark," on the west coast of Africa. Then on the "Cossack" in the Baltic Fleet during the Crimean War. Captured, sent to Russia. After war, on the "Pembroke," for three years. Then returned to Edinburgh, where he apparently joined the Edinburgh Photographic Society. Not clear if he photographed during any of this time.]

EATON & WEBBER. (CINCINNATI, OH)
E22 Portraits. Woodcut engravings, credited "Photographed by Eaton & Webber, Cincinnati." FRANK LESLIE'S ILLUSTRATED NEWSPAPER 12, (1861) ["Gov. Dennison, of OH." 12:290 (June 8, 1861): 55.]

EATON, EDRIC L. (1835-) (USA)
BOOKS
E23 Edmunds, A. C. *Pen Sketches of Nebraskans;* with Photographs. Lincoln, Omaha: R. & J. Wilber, 1871. 510 pp. 19 l. of plates. 19 b & w. [Original photographs. Portraits by E. L. Eaton.]

PERIODICALS
E24 "Love and Photography." PHOTOGRAPHIC TIMES 2, no. 16 (Apr. 1872): 54-55. [Humorous story taken from Omaha newspaper about a disappointed swain attempting to have Eaton jailed for retouching his unseen fiance's photo so heavily to make her look beautiful.]

E25 "Our Picture." PHILADELPHIA PHOTOGRAPHER 10, no. 118 (Oct. 1873): frontispiece, 511-512. 9 b & w.

E26 "Matters of the Month." PHOTOGRAPHIC TIMES 7, no. 74 (Feb. 1877): 35. ["...for years a flourishing gallery, now selling photographic materials in connection with his gallery."]

E27 "Matters of the Month." PHOTOGRAPHIC TIMES 7, no. 77 (May 1877): 101. [Photos of children posing.]

E28 "Editor's Table: News." PHILADELPHIA PHOTOGRAPHER 15, no. 171 (Mar. 1878): 95. [E. L. Eaton (Omaha, NE), a photographer for 21 years, praised in "Omaha Daily Herald."]

E29 "Note." PHOTOGRAPHIC TIMES 8, no. 87 (Mar. 1878): 63. [Eaton photographing in Omaha for 21 years opening at 238 Farnam St., immediately under his old gallery. Reprinted from "Omaha Herald," Feb. 3.]

E30 "Mr. Eaton's New Establishment." ANTHONY'S PHOTOGRAPHIC BULLETIN 9, no. 4 (Apr. 1878): 120. [Eaton (Omaha, NE) photographing 21 years in Omaha.]

E31 "Nebraska. - The Remains of Major Thornburgh Lying in State in the Masonic Temple, Omaha. - From a Photograph by E. L. Eaton." FRANK LESLIE'S ILLUSTRATED NEWSPAPER 49, no. 1259 (Nov. 15, 1879): 185. 1 illus. [Interior.]

EBELL, ADRIAN J. see also WHITNEY, JOEL; HISTORY: USA: MN (Woolworth).

EBELL, ADRIAN J.
E32 [Ebell, A. J.] "The Indian Massacres and the War of 1862." HARPER'S MONTHLY MAGAZINE 27, no. 157 (June 1863): 1-24. 17 illus. [Seventeen wood engravings of white refugees, Indian encampments, etc. illustrate this report. One engraving, on p. 13, resembles the scene of the photograph of refugee women and children credited to Ebell in Aug. 1981 "American History Illustrated," p. 32. Other sources credit this photo to Whitney.]

E33 Ebell, Adrian J. "Collodion for Dry Plates." HUMPHREY'S JOURNAL OF PHOTOGRAPHY, AND THE ALLIED ARTS AND SCIENCES 15, no. 4 (June 15, 1863): 59-60. [Letter from Ebell, reply from Towler.]

E34 Ebell, Adrian J. "A Freak in the Tannin Process." AMERICAN JOURNAL OF PHOTOGRAPHY AND THE ALLIED ARTS & SCIENCES n. s. vol. 6, no. 10 (Nov. 15, 1863): 225-226.

E35 Ebell, A. J. "Experiments with the Dry Process." HUMPHREY'S JOURNAL OF PHOTOGRAPHY, AND THE ALLIED ARTS AND SCIENCES 15, no. 22 (Mar. 15, 1864): 344-345. [Letter from Ebell, reply by Towler.]

E36 "Historic diary of a photographer's assistant describes prelude to 1862 Indian massacre." PHOTOGRAPHICA 11, no. 10 (Dec. 1979): 13. 1 illus. [Diary of Edwin R. Lawton, assistant to a Mr. Ebell.]

ECKERT, MARY A. [MRS.] (1844-) (USA)
E37 "Matters of the Month: Helena Art Gallery." PHOTOGRAPHIC TIMES 7, no. 73 (Jan. 1877): 6-7. [Mrs. Eckert ran a gallery in Helena, Montana Territory.]

E38 "Note." PHOTOGRAPHIC TIMES 8, no. 93 (Sept. 1878): 206-207. [Mentions that Mrs. Eckert has been in business a few years.]

E39 "Matters of the Month." PHOTOGRAPHIC TIMES 10, no. 120 (Dec. 1880): 275. [Cabinet photos. Mentions that, through an oversight, her name was omitted from the list of exhibitors at the late Chicago Convention.]

ECNEROLF. (ASTABULA, OH)
E40 Ecnerolf. "Correspondence." ANTHONY'S PHOTOGRAPHIC BULLETIN 4, no. 3 (Mar. 1873): 92-93.

EDELBAUER, F.
E41 Edelbauer, F. "Photography on Silk, Satin, Linen, Etc." HUMPHREY'S JOURNAL OF PHOTOGRAPHY, AND THE ALLIED ARTS AND SCIENCES 17, no. 24 (Apr. 15, 1866): 373-374. [From "Photographische Correspondenz."]

EDER, JOSEPH MARIA. (1855-1944) (AUSTRIA)
E42 "Contemporary Press. Extracts from French and German Authorities: Dr. Joseph Maria Eder." PHOTOGRAPHIC TIMES 14, no. 157 (Jan. 1884): 21-22. [From: Association Belge de Photographie, Brussels. Born 1855 at Krems, near Vienna. At age 17 finished studies at Krems Gymnasium, to Vienna to study chemistry at the Polytechnic. Published chemical treatises, discoveries through 1870s. In 1882 published "A Manual of Photography."]

E43 Eder, Dr. J. M. "The Progress of Photography in Germany and Austria." ANTHONY'S PHOTOGRAPHIC BULLETIN 17, no. 12 (June 26, 1886): 362-368.

E44 Eder, Dr. J. M. "The Progress of Photography in Germany and Austria." PHOTOGRAPHIC TIMES 16, no. 259-260 (Sept. 3 - Sept. 10, 1886): 461-463, 483-486.

E45 Eder, Dr. J. M. "The International Astronomical Congress for the Production of Photographic Celestial Charts, Paris." ANTHONY'S PHOTOGRAPHIC BULLETIN 18, no. 12 (June 25, 1887): 356-358.

EDGE, THOMAS. (d. 1900) (GREAT BRITAIN)
E46 Simpson, G. Wharton. "Practical Notes on Various Photographic Subjects." PHILADELPHIA PHOTOGRAPHER 5, no. 51 (Mar. 1868): 67-69. [Mentions a Mr. Edge, of England, making composite photos with landscape backgrounds printed into portraits.]

E47 "Obituary of the Year: Thomas Edge." BRITISH JOURNAL PHOTOGRAPHIC ALMANAC 1901 (1901): 670. [Successful portrait

photographer for nearly thirty years in the earlier days. Pioneer in carbon and platinum processes. After retiring continued photography as a hobby until failing eyesight prevented him. Made tabletop tableaus.]

E48 Wilson, Edward L. "Genre Portraiture." WILSON'S PHOTOGRAPHIC MAGAZINE 38, no. 532 (Apr. 1901): 145-147. [Edge, a Welshman, credited with initiating genre portraits "forty years ago".]

EDMONSON, J. J. (BALTIMORE, MD)
E49 "Baltimore, Md. - Dedication of the New City Hall by the State and Municipal Authorities, Monday, October 25th. - Photographed by J. J. Edmonson, Baltimore." FRANK LESLIE'S ILLUSTRATED NEWSPAPER 41, no. 1050 (Nov. 13, 1875): 153. 1 illus. [View, with crowds.]

E50 "Baltimore, Md. - Unveiling and Dedication of the Monument to Edgar Allen Poe, Wednesday, November 17th, in Westminster Churchyard, Under the Auspices of the Baltimore Teacher's Association. - From Sketches by Harry Ogden and Photographs by J. J. Edmonson." FRANK LESLIE'S ILLUSTRATED NEWSPAPER 41, no. 1053 (Dec. 4, 1875): 197. 2 illus. [View of the unveiling, with inset portrait of Poe.]

EDWARDS, B. J. (1838-1914) (GREAT BRITAIN)
E51 Edwards, B. J. "Cracked Negatives." HUMPHREY'S JOURNAL OF PHOTOGRAPHY, AND THE ALLIED ARTS AND SCIENCES 20, no. 20 (Apr. 15, 1869): 315. [From "Photo. News."]

E52 Edwards, B. J. "Hints on Combination Printing." BRITISH JOURNAL PHOTOGRAPHIC ALMANAC 1871 (1871): 89-91.

E53 Edwards, B. J. "Landscape Photography. The Wet Process without Water." BRITISH JOURNAL PHOTOGRAPHIC ALMANAC 1873 (1873): 118-119.

E54 Edwards, B. J. "Concerning Redevelopment." BRITISH JOURNAL PHOTOGRAPHIC ALMANAC 1874 (1874): 130-131. [Correction for errors published in his report at the N.P.A. Convention in Buffalo in 1873.]

E55 "Photography From a Paddle-box." ANTHONY'S PHOTOGRAPHIC BULLETIN 9, no. 11 (Nov. 1878): 340. [From "Br J of Photo." B. J. Edwards, from England, touring, photographing in Australia, South Pacific to San Francisco.]

EDWARDS, C. E. (BRIDGETON, NJ)
E56 "Editor's Table." PHILADELPHIA PHOTOGRAPHER 3, no. 32 (Aug. 1866): 255. [Building new gallery.]

EDWARDS, ERNEST & BULT EDWARDS. (LONDON, ENGLAND)
E57 Portrait. Woodcut engraving credited "From a photograph by Ernest & Bult Edwards, Baker St." ILLUSTRATED LONDON NEWS 52, (1868) ["Earl of Cardigan." 52:* (Apr. 11, 1868): 353.]

EDWARDS, ERNEST. (1837-1903) (GREAT BRITAIN, USA)
BOOKS
E58 Edwards, Ernest. Photographic Portraits of Men of Eminence in Literature, Science and Art. With Biographical Memoirs. The Photographs from Life, by Ernest Edwards, B.A. London: Lovell, Reeve & Co., 1863. n. p. [Issued in parts. Parts 1 & 2 issued in 1863, published by Lovell, Reeve & Co. Part 29 was published in 1865 by

A. W. Bennett. Each part contained about three portraits, with accompanying biographical memoirs.]

E59 Jephson, Rev. John Mounteney, B.A., F.S.A. Shakespeare: His Birthplace, Home, and Grave; A Pilgrimage to Stratford-on-Avon in the Autumn of 1863,... With Photographic Illustrations by Ernest Edwards, B.A. A Contribution to the Tercentenary Commemoration of the Poet's Birth. London: L. Reeve, 1864. ix, 203 pp. 15 b & w. [Original photographs. Some editions had a separate boxed set of ninety stereos available.]

E60 George, Herford Brooks, M.A., F.R.G.S. The Oberland and its Glaciers; Explored and Illustrated with Ice-Axe and Camera, by H. B. George, M.A., F.R.G.S., Editor of the "Alpine Journal." With Twenty-eight Photographic Illustrations by Ernest Edwards, B.A. And a Map of the Oberland. London: Alfred W. Bennett, 1866. xii, 244 pp. 28 b & w. 1 illus. [Includes a 7-page chapter "Notes by the Photographer." Photographs are by Ernest Edwards.]

E61 Photographs of Eminent Medical Men of All Countries, with Brief Analytical Notices of Their Works. Edited by T. Herbert Baker. The Photographic Portraits from Life by Ernest Edwards. London: John Churchill & Sons, 1867. 2 vol. 48 b & w. [Cartes-de-visite. Originally issued in parts, once a month from July 1865. Republished, in two volumes, in 1867.]

E62 Walford, Edward. Representative Men in Literature, Science, and Art; by Edward Walford, the Photographic Portraits by Ernest Edwards. London: Albert W. Bennett, 1868. 139 pp. 20 l. of plates. 20 b & w. [Biographies of twenty men, each with a tipped-in photograph by Edwards.]

E63 Edwards, Ernest. The Heliotype Process. Boston: J. R. Osgood, 1876. 18 pp. 28 l. of plates. illus.

E64 Edwards, Ernest and W. I. L. Adams, compilers. Twelve Photographic Studies. New York : Scovill & Adams Co., 1893. 12 pp. 12 b & w. [12 photo-engravings on 11" x 14" Japan paper, in a box. Photographers represented: H. P. Robinson (2), H. McMichael (1), J. E. Ryder (1), B. J. Falk (1), John E. Dumont (1), F. A. Jackson (1), W. H. Jackson (1), J. J. Montgomery (1), Jas. F. Cowee (1), Geo. Barker (1), Geo. B. Wood (1).]

E65 Sweetser, Moses F. Niagara Falls. Boston: Joseph Knight Co., 1893. n. p. [Illustrated by Photogravures from Original Photographs by Ernest Edwards.]

PERIODICALS
E66 Edwards, Ernest, B.A. Cambridge. "A Series of Pictures Contributed to the Amateur Photographic Association." JOURNAL OF THE PHOTOGRAPHIC SOCIETY OF LONDON 8, no. 124 (Aug. 15, 1862): 109. [Reviewed.]

E67 "Cabinet Pictures, Photographed by Ernest Edwards." BRITISH JOURNAL OF PHOTOGRAPHY 9, no. 172 (Aug. 15, 1862): 309-310.

E68 "Reviews: Portraits of Men of Eminence in Literature, Science and Art." ART JOURNAL (Sept. 1863): 192. [Book review: "Portraits of Men of Eminence in Literature, Science, and Art .," by Ernest Edwards.]

E69 "Reviews: Shakespeare: His Birthplace, Home, and Grave." ART JOURNAL (May 1864): 156. [Book review: "Shakespeare: His

Birthplace, Home, and Grave .", by Rev. J. M. Jephson. Illustrations by Ernest Edwards.]

E70 Portrait. Woodcut engraving credited "From a photograph by Ernest Edwards, Baker St." ILLUSTRATED LONDON NEWS 47, (1865) ["Sir W. J. Hooker, Director of Royal Gardens at Kew." 47:* (Aug. 26, 1865): 193.]

E71 "Reviews: Photographic Portraits of Men of Eminence No. 29." ART JOURNAL (Jan. 1866): 31. [Book review: "Photographic Portraits of Men of Eminence No. 29," by Ernest Edwards.]

E72 Portrait. Woodcut engraving credited "From a photograph by Ernest Edwards." ILLUSTRATED LONDON NEWS 48, (1866) ["Captain M. F. Maury, Marine Geographer." 48:* (June 23, 1866): 613.]

E73 "Reviews: The Oberland and Its Glaciers." ART JOURNAL (Oct. 1866): 323-324. [Book review: "The Oberland and Its Glaciers." by H. B. George, illustrated by Ernest Edwards.]

E74 Morton, Rev. H. J., D.D. "The Glaciers." PHILADELPHIA PHOTOGRAPHER 4, no. 38 (Feb. 1867): 38-41. [Review of book "The Oberland & its Glaciers". written by H. B. George, illus. with photos by Ernest Edwards.]

E75 Portraits. Woodcut engravings credited "From a photograph by Ernest Edwards." ILLUSTRATED LONDON NEWS 50, (1867) ["Sir George Smart." 50:* (Mar. 16, 1867): 251. "Oxford and Cambridge Rowing crews." 50:* (Apr. 20, 1867): 397.]

E76 Edwards, Ernest. "Small Cameras and Enlargements." BRITISH JOURNAL PHOTOGRAPHIC ALMANAC 1869 (1869): 105-108.

E77 Portraits. Woodcut engravings credited "From a photograph by Ernest Edwards." ILLUSTRATED LONDON NEWS 58, (1871) ["Charles Darwin." 58:1640 (Mar. 11, 1871): 244.]

E78 Edwards, Ernest. "New Improvements in Heliotype." ANTHONY'S PHOTOGRAPHIC BULLETIN 3, no. 2 (Feb. 1872): 444-445. [From "Br. J. of Photo."]

E79 "Our Pictures." PHILADELPHIA PHOTOGRAPHER 10, no. 116 (Aug. 1873): Frontispiece, 253-255. 2 illus. [Description of Ernest Edwards' version of the Heliotype process, with two engravings as frontispiece to the issue.]

E80 "Dyed Images by Photography." ANTHONY'S PHOTOGRAPHIC BULLETIN 7, no. 9 (Sept. 1876): 259-261. [From "London Photo. News."]

E81 Portrait. Woodcut engraving credited "from a photograph by Ernest Edwards." ILLUSTRATED LONDON NEWS 70, (1877) ["Lord Grey de Wilton." 70:1961 (Feb. 10, 1877): 121.]

E82 Edwards, Ernest. "The Reproduction and Multiplication of Negatives." PHOTOGRAPHIC TIMES 11, no. 128 (Aug. 1881): 272-273.

E83 Taylor, J. Traill. "General Notes." PHOTOGRAPHIC TIMES 12, no. 134 (Feb. 1882): 38. [Report on the second annual dinner of the employees of the Heliotype Printing Co., Boston at Paine Memorial Hall. 100 people present, including Mr. Ernest Edwards, the president of the firm.]

E84 Edwards, Ernest. "Photography in the Printing-Press."PHOTOGRAPHIC TIMES 14, no. 159 (Mar. 1884): 113-119. [A lecture delivered before the Christian Union.]

E85 "Our Picture." PHOTOGRAPHIC TIMES 16, no. 263 (Oct. 1, 1886): frontispiece, 518. 1 b & w. [Landscape view by Mr. Edwards [Photograph not bound in this volume].]

E86 "General Notes." PHOTOGRAPHIC TIMES 16, no. 268 (Nov. 5, 1886): 576-577. [Description of visit to the works of the Photo-Gravure Company in Boston, owned by Ernest Edwards.]

E87 Edwards, Ernest. "Progress and Methods of Photo-Mechanical Printing." AMERICAN ANNUAL OF PHOTOGRAPHY AND PHOTOGRAPHIC TIMES ALMANAC FOR 1887 (1887): 134-137.

E88 Edwards, Ernest. "The Art of Making Photo-Gravures." PHOTOGRAPHIC TIMES 17, no. 300-304 (June 17 - July 15, 1887): 313-314, 336-338, 350-351, 361-362. [Read before the Photographic Section of the American Institute.]

E89 Edwards, Ernest, President of the Photo-gravure Company. "The Art of Making Photo-Gravure." ANTHONY'S PHOTOGRAPHIC BULLETIN 18, no. 12-14 (June 25 - July 23, 1887): 367-370, 400-403, 430-432. [Includes a photogravure frontispiece, a landscape by Dr. J. L. Williams, that illustrates the process.]

E90 "Our Illustration." PHOTOGRAPHIC TIMES 17, no. 317 (Oct. 14, 1887): frontispiece, 511. 1 b & w. [Landscape view. Prominently labelled "Specimen of a New Process of Photo-Lithography by the Photo Gravure Co., N.Y."]

E91 Edwards, Ernest. "Theatre Photography by Electric Light." AMERICAN ANNUAL OF PHOTOGRAPHY & PHOTOGRAPHIC TIMES ALMANAC FOR 1888 (1888): 218-221.

E92 "Our Illustration." ANTHONY'S PHOTOGRAPHIC BULLETIN 19, no. 2 (Jan. 28, 1888): frontispiece, 54. 1 b & w. [Negative by Ernest Edwards of the Photo-gravure Company of New York. Photo not bound in this copy.]

E93 "Editorial Notes." PHOTOGRAPHIC TIMES 18, no. 332 (Jan. 27, 1888): frontispiece, 38. 2 b & w. [2 landscape photogravures presented together on one page with decorative titles.]

E94 "Notes and News: The Best Size for a Camera." PHOTOGRAPHIC TIMES 18, no. 347 (May 11, 1888): 224. [Edwards feels that the best camera for landscapes is the 5 x 7.]

E95 Edwards, Ernest. "The Growth of Photo-Mechanical Printing." AMERICAN ANNUAL OF PHOTOGRAPHY AND PHOTOGRAPHIC TIMES ALMANAC FOR 1889 (1889): 37-39.

E96 "By the River." PHOTOGRAPHIC TIMES 19, no. 382 (Jan. 11, 1889): 15. 1 b & w. [Landscape view. Edwards was the president of the Photogravure Company.]

E97 "By the River Again." PHOTOGRAPHIC TIMES 19, no. 392 (Mar. 22, 1889): frontispiece, 139. 1 b & w. [Landscape.]

E98 Edwards, Ernest. "Photo-Gravure Processes." ANTHONY'S PHOTOGRAPHIC BULLETIN 20, no. 6 (Mar. 23, 1889): 171-172. [Read before the Society of Amateur Photographers of New York.]

E99 1 photo (Niagara Falls). PHOTOGRAPHIC TIMES 21, no. 513 (July 17, 1891): frontispiece, 353. 1 b & w.

E100 1 photo (Figure group in landscape, "By The Sea"). PHOTOGRAPHIC TIMES 21, no. 528 (Oct. 30, 1891): frontispiece, 533. 1 b & w. [Note on p. 533. Edwards, President of the New York Photogravure Company.]

E101 "Notes and News: The Photogravure Process." PHOTOGRAPHIC TIMES 21, no. 531 (Nov. 20, 1891): 580. [Abstract from an article "Modern Methods of Illustration," by W. H. Hyslop in Nov. 1891 "Westward Ho!" magazine. Discusses Edwards' preeminence in the field of landscape photogravures.]

E102 Edwards, Ernest. "The Limitations of Photography." AMERICAN ANNUAL OF PHOTOGRAPHY AND PHOTOGRAPHIC TIMES ALMANAC FOR 1892 (1892): 200-202.

E103 Edwards, Ernest. "The Copyright Act of March, 1891." PHOTOGRAPHIC MOSAICS: 1892 28, (1892): 130-134.

E104 Edwards, Ernest. "My Method of Development." PHOTOGRAPHIC TIMES 22, no. 537 (Jan. 1, 1892): 2-3.

E105 1 photo (At Palensville in the Catskills"). PHOTOGRAPHIC TIMES 22, no. 566 (July 22, 1892): frontispiece, 373. 1 b & w. [Note on p. 373]

E106 5 photos ("Instantaneous photographs of the Naval Review"). PHOTOGRAPHIC TIMES 23, no. 621 (Aug. 11, 1893): frontispiece, 429. 5 b & w. [Note on p. 429.]

E107 "'From The Battery.'" PHOTOGRAPHIC TIMES 23, no. 630 (Oct. 13, 1893): frontispiece, 573. 1 b & w.

E108 Edwards, Ernest. "Photography in Colors." PHOTOGRAPHIC TIMES 25, no. 678 (Sept. 14, 1894): 172. [Argument that the future of photography will rest in color.]

E109 1 color photo ("Study of Rhododendrons in Prospect Park, Brooklyn"). PHOTOGRAPHIC TIMES 25, no. 690 (Dec. 7, 1894): before p. 361. [Printed in three colors by the Chrome-Gelatine Process of the N.Y. Photogravure Co.]

E110 "Our Pictures." WILSON'S PHOTOGRAPHIC MAGAZINE 32, no. 465 (Sept. 1895): frontispiece, 409. [A three-color gelatin print ("The Feather Fan").]

E111 "Personal Paragraphs: Mr. Ernest Edwards." WILSON'S PHOTOGRAPHIC MAGAZINE 34, no. 486 (June 1897): 272. ["President of the Photogravure and Color Co., N.Y. has perfected a very compact camera for the making of animated photographs. The camera will accommodate l50 feet of film."]

E112 Coke, Van Deren and Marian Hollinger Pope. "The Oberland and its Glaciers." HISTORY OF PHOTOGRAPHY 3, no. 2 (Apr. 1979): 129-131. 2 illus. [Discussion of H. B. George's book "The Oberland and its Glaciers"; illustrated with 28 tipped-in albumen prints, by Ernest Edwards.]

EDWARDS, F. W. (d. 1897) (GREAT BRITAIN)
E113 "Obituary: F. W. Edwards (Oct. 16, 1897)." BRITISH JOURNAL PHOTOGRAPHIC ALMANAC 1898 (1898): 642. [Architectural photographer, first in the Albany-Road, then at Peckham, then for W. H. Ward & Co., then for himself on Newman St. Statuary groups at

the erection of the Albert Memorial, Tinworth panels, cathedral interiors, etc. Exhibited at the Royal and Falmouth. President of the second South London Photo. Society in 1889.]

EDWARDS, J. B. (GREAT BRITAIN, CANADA)
E114 "Note." PHOTOGRAPHIC TIMES 2, no. 13 (Jan. 1872): 26. [Mr. J. B. Edwards, now operator with Mr. William Notman, and lately from London, where his contributions to photographic magazines are highly valued, called upon us a few days ago."]

EDWARDS, J. W.
E115 Portrait. Woodcut engraving, credited "From a Photograph by J. W. Edwards." FRANK LESLIE'S ILLUSTRATED NEWSPAPER 46, (1878) ["The late John F. McDaniel." 46:1183 (June 1, 1878): 233.]

EDWARDS, JAY DEARBORN. (1831-1900) (USA)
BOOKS
E116 Jensen, Leslie D. "Photographer of the Confederacy: J. D. Edwards," on pp. 344-363 in: Shadows of the Storm: Volume One of The Image of War: 1861 - 1865, edited by William. C. Davis. Garden City, NY: Doubleday & Co., Inc., 1981. 464 pp. 24 b & w. [Twenty-four photographs by J. D. Edwards. Edwards was born in New Hampshire in 1831. He moved to New Orleans, LA in 1860, coming from Massachusetts. Worked as an ambrotype portraitist. Photographed construction projects on the Mississippi River by the U.S. Army Engineers, under P. T. G. Beauregard's direction, before the war. When the war broke out Edwards left New Orleans for Pensacola Bay, FL, where a major battle was expected. In April 1861 he photographed Confederate army preparations, but as no battle developed, he then returned to New Orleans. These are early, rare views of Confederate troops. Edwards may have continued to photograph troops into 1862, but nothing more is known about him.]

PERIODICALS
E117 "The Henry Clay Statue in New Orleans. - Photographed by J. D. Edwards, N. O." FRANK LESLIE'S ILLUSTRATED NEWSPAPER 9, no. 231 (May 5, 1860): 362. 1 illus. [(Edwards born July 14, 1831 in NH, died June 6, 1900 in Atlanta, GA.)]

E118 "Inauguration of the Clay Statue at New Orleans, - From a Photograph by J. D. Edwards." FRANK LESLIE'S ILLUSTRATED NEWSPAPER 9, no. 233 (May 19, 1860): 393, 394. 1 illus. [View of crowd, taken from the New Custom House.]

EGERTON, PHILIP HENRY. (GREAT BRITAIN)
E119 Egerton, Philip Henry. Journal of a Tour Through Spiti, to the Frontier of Chinese Thibet, with photographic illustrations, by Philip Henry Egerton, Deputy Commissioner of Kangra. London: Cundall, Downes, & Co., 1864. 68 pp. 35 b & w. 1 illus. [Thirty-five original photos plus one photographic map tipped-into the text pages. Views, tribesmen, Buddhist priests, etc.]

EHRMANN, CHARLES. (1822-1894) (GERMANY, USA)
E120 Ehrmann, Charles. "Gelatine In Relation to Its Photographic Employment." PHOTOGRAPHIC TIMES 11, no. 125 (May 1881): 197-198. Ehrmann, Charles. "The Theory of Toning." PHOTOGRAPHIC TIMES 12, no. 134 (Feb. 1882): 47-49. [Presented to the Association of Operative Photographers of New York.]

E121 Ehrmann, Charles. "Color Toning." PHOTOGRAPHIC TIMES 12, no. 139 (July 1882): 247-248.

E122 Ehrmann, Charles. "Photographic Progress." PHOTOGRAPHIC TIMES 14, no. 159 (Mar. 1884): 119-122. [Paper read before the Photographic Section of the American Institute.]

E123 Ehrmann, Charles. "Correspondence." PHOTOGRAPHIC TIMES 14, no. 159 (Mar. 1884): 159. [Letter from Ehrmann responding favorably to Brach's letter calling for the formation of an amateur society in New York, but saying that a much broader spectrum of people should be allowed to participate.]

E124 Ehrmann, Charles. "A Chapter in the History of Photography." PHOTOGRAPHIC TIMES 14, no. 160 (Apr. 1884): 181-182. [Discussion of the technical history of emulsion processes in the 1850s.]

E125 Ehrmann, Charles. "A Few Remarks on Fixing." PHOTOGRAPHIC TIMES 14, no. 161 (May 1884): 231-233. [Technical, but contains theory and some history of investigations.]

E126 Ehrmann, Charles. "Technical Photography and Mechanical Printing." PHOTOGRAPHIC TIMES 14, no. 161 (May 1884): 234-236. [Paper read before the Photographic Section of the American Institute.]

E127 Ehrmann, Charles. "The Action of Light on Salts of Silver." PHOTOGRAPHIC TIMES 14, no. 162 (June 1884): 294-298.

E128 Ehrmann, Charles. "American Photographic Literature Considered." PHOTOGRAPHIC TIMES 14, no. 168 (Dec. 5, 1884): 631-632. [Read before the Photographic Section of the American Institute.]

E129 Ehrmann, Charles. "Applied Photography." PHOTOGRAPHIC TIMES 15, no. 174 (Jan. 16, 1885): 26-27.

E130 Ehrmann, Charles. "Influences Affecting the Quality of Plates." PHOTOGRAPHIC TIMES 15, no. 179 (Feb. 20, 1885): 86-87.

E131 Ehrmann, Charles. "Artificial Lighting." PHOTOGRAPHIC TIMES 15, no. 182 (Mar. 13, 1885): 126-127. [Discusses various experimenters with electric lighting. Capt. E. Himly, William Kurtz, and Lewitzky (St. Petersburg, Russia) mentioned.]

E132 Ehrmann, Charles. "Employers and Assistants." PHOTOGRAPHIC TIMES 15, no. 186 (Apr. 10, 1885): 183-184.

E133 Ehrmann, Charles. "Correspondence: Buffalo Convention." PHOTOGRAPHIC TIMES 15, no. 187 (Apr. 17, 1885): 208. [Ehrmann calling for the P.A. of A. to discuss adopting the decimal system of measurement.]

E134 Ehrmann, Charles. "Remedy for Business Depression." PHOTOGRAPHIC TIMES 15, no. 205 (Aug. 21, 1885): 480-481.

E135 Ehrmann, Charles. "Elimination of hyposulphite of Soda by the Salts of Lead." PHOTOGRAPHIC TIMES 16, no. 227 (Jan. 22, 1886): 52-53.

E136 Ehrmann, Charles. "Photographing at Home." PHOTOGRAPHIC TIMES 16, no. 231 (Feb. 19, 1886): 105-106.

E137 Ehrmann, Charles. "Spectrum Photography." PHOTOGRAPHIC TIMES 16 , no. 235 (Mar. 19, 1886): 153-154.

E138 Ehrmann, Charles. "Photography and the Graphic Arts." PHOTOGRAPHIC TIMES 16, no. 258 (Aug. 27, 1886): 448-451.

E139 Ehrmann, Charles. "A Brief Account of the Progress and Development of Orthochromatic Photography." PHOTOGRAPHIC TIMES 16, no. 275 (Dec. 24, 1886): 673-675.

E140 Ehrmann, Charles. "Photographing Colored Objects on Plates Bathed with Erythrosin." ANTHONY'S PHOTOGRAPHIC BULLETIN 18, no. 10 (May 28, 1887): 302-303. [Read before the Photographic Section of the American Institute.]

E141 Ehrmann, Charles. "Color-Sensitive Methods and How to Work Them, With Especial Reference to Erythrosin." ANTHONY'S PHOTOGRAPHIC BULLETIN 18, no. 11-12 (June 11 - June 25, 1887): 338-339, 366-367. [Read before the Photographic Section of the American Institute.]

E142 Ehrmann, Charles. "A Talk to Beginners." AMERICAN ANNUAL OF PHOTOGRAPHY & PHOTOGRAPHIC TIMES ALMANAC FOR 1888 (1888): 198-202.

E143 "Editorial Notes: At Chautauqua." PHOTOGRAPHIC TIMES 18, no. 336 (Feb. 24, 1888): frontispiece, 87. 1 b & w. [Landscape view. A "half-tone" engraving direct from negative.]

E144 "Editorial Notes." PHOTOGRAPHIC TIMES 18, no. 340 (Mar. 23, 1888): 135. [The largest blizzard in New York City's memory brought out many enterprising photographers. One such was Charles Ehrmann, who took "remarkable street scenes with his Waterbury detective camera."]

E145 "Charles August Theodore Ehrmann." PHOTOGRAPHIC TIMES 18, no. 349 (May 25, 1888): frontispiece, 241-242. 1 b & w. [Portrait of Ehrmann. Carl August Theodor Ehrmann was born in Prussian Silesia on June 28, 1822. He attended the University of Berlin in 1846. Became involved in the revolutions of 1848 and was sentenced to prison, but he fled to England, then to Canada, and from there to Michigan in 1849. Went to Mexico, but returned to the USA and was in Philadelphia in 1852, where he began to work for McClees & Germon. He learned both crystalotypy (the calotype process) and the daguerreotype there. Much later, in the 1880s, he began to write and edit for the "Photographic Times." and became well known as one of the foremost teachers of his time.]

E146 Ehrmann, Charles. "Some Well-Meant Advice for "Union" Photographers." PHOTOGRAPHIC TIMES 18, no. 352 (June 15, 1888): 285-286.

E147 Ehrmann, Charles. "Reducing the Density of Negatives By Various Agents." ANTHONY'S PHOTOGRAPHIC BULLETIN 19, no. 14 (July 28, 1888): 428-430. [Read before the P. A. of A. convention in Minneapolis.]

E148 Ehrmann, Charles. "The Modern Practice of Photography." PHOTOGRAPHIC TIMES 18, no. 363 (Aug. 31, 1888): 411-415. [A lecture delivered at Chautauqua on Photographic Day. Brief survey of the history of photographic discoveries, description of the practice and throng of current practice.]

E149 Ehrmann, Charles. "The Modern Practice of Photography." ANTHONY'S PHOTOGRAPHIC BULLETIN 19, no. 17 (Sept. 8, 1888): 526-530. [Lecture delivered at Chautauqua on the Photographic Day.]

E150 Ehrmann, Charles. "A Talk to Beginners." AMERICAN ANNUAL OF PHOTOGRAPHY AND PHOTOGRAPHIC TIMES ALMANAC FOR 1889 (1889): 174-178.

E151 Ehrmann, Charles. "A Potash Developer." PHOTOGRAPHIC MOSAICS:1889 25, (1889): 60-62.

E152 "Professor Ehrmann." PHOTOGRAPHIC TIMES 19, no. 415 (Aug. 30, 1889): 431, plus frontispiece. 1 b & w. [Portrait of Ehrmann.]

E153 Ehrmann, Charles. "Tannin A Substitute for Alum." AMERICAN ANNUAL OF PHOTOGRAPHY AND PHOTOGRAPHIC TIMES ALMANAC FOR 1890 (1890): 78-80, unnumbered leaf following p. 80. 1 b & w. [Photo is a still-life of a basket of fruit.]

E154 Ehrmann, Charles, Ph.D. "Remarks on Orthochromatic Methods." PHOTOGRAPHIC MOSAICS: 1890 26, (1890): 91-94.

E155 "Editorial Notes." PHOTOGRAPHIC TIMES 20, no. 443 (Mar. 14, 1890): 125. [Brief survey of Ehrmann's career and accomplishments.]

E156 Ehrmann, Charles. "Lantern-Slides." AMERICAN ANNUAL OF PHOTOGRAPHY AND PHOTOGRAPHIC TIMES ALMANAC FOR 1891 (1891): 131-133.

E157 Ehrmann, Charles. "A Review of the Year." AMERICAN ANNUAL OF PHOTOGRAPHY AND PHOTOGRAPHIC TIMES ALMANAC FOR 1891 (1891): 280-283.

E158 Ehrmann, Charles. "The Albumen Process. Part 1." PHOTOGRAPHIC TIMES 21, no. 506 [sic 507]-510 (June 5 - June 26, 1891): 269-270, 281-283, 293-294, 305-306. [This series is a survey of the inventors and practitioners of albumen processes in photography. Given the historiography of the period this is, in effect, a historical article. Part 1 deals with American practitioners, mentioning Frederick Langenheim and discussing John A. Whipple. Describes Whipple's "celebrated albumen honey process" which was called by Whipple "crystalotypy". Part 2: Niepce, Blanquart-Evrard, J. R. LeMoyne, Groll, Humbolt de Molard, Mayall. Part 3: Mayall, Dr. R. L. Maddox, John Craud, Duchoclois, F. Richards, Coale & Shadboldt, et al. Part 4. William Ackland (1856), Fothergill.]

E159 Ehrmann, Charles. "Additional Remarks on Orthochromatic Methods." PHOTOGRAPHIC MOSAICS: 1891 27, (1891): 274-276.

E160 Ehrmann, Charles. "Printing by Electric Light." PHOTOGRAPHIC MOSAICS: 1892 28, (1892): 155-158.

E161 Ehrmann, Charles. "Heliochromy." PHOTOGRAPHIC TIMES 22, no. 556 (May 13, 1892): 257-258. [A brief historical survey of color experiment from 1860s to 1890s.]

E162 "Fireworks at Chautauqua." PHOTOGRAPHIC TIMES 22, no. 580 (Oct. 28, 1892): 541, plus unnumbered leaf following p. 552. 2 b & w. [Photo of fireworks made on new orthochromatic plates.]

E163 Ehrmann, Charles. "Credit Where Credit Is Due." PHOTOGRAPHIC TIMES 23, no. 602 (Mar. 31, 1893): 165-166. [Ehrmann protesting that a chemical process that he perfected was credited to Mr. H. J. Newton in an article published by the "American Amateur Photographer."]

E164 Ehrmann, Charles. "The "Wet" Vs. the "Dry" Process." PHOTOGRAPHIC TIMES 23, no. 606 (Apr. 28, 1893): 217-218. [Wemyss' Mar. 3rd article draws critical commentary. Ehrmann mentions having an argument about the merits of each process with F. C. Coonley in 1882-1883.]

E165 Ehrmann,Charles. "Notes on the Address to the Franklin Institute." PHOTOGRAPHIC TIMES 23, no. 610 (May 26, 1893): 278-279. [Ehrmann comments on Julius Saches' address to the Franklin Institute on the early history of photography in Philadelphia. Mentions James McClees, others.]

E166 Ehrmann, Charles. "A Plea for a Holiday." PHOTOGRAPHIC TIMES 23, no. 617 (July 14, 1893): 365-366. [Discussion of rights and responsibilities of the gallery owner and of his employees.]

E167 Ehrmann, Charles. "A Photographic Anthropological Excursion." PHOTOGRAPHIC TIMES 23, no. 641 (Dec. 29, 1893): 777-779. 3 illus. [Report of excursion from Chautauqua Assembly Grounds to an Indian reservation.]

E168 Ehrmann, Charles. "Correspondence: Spirit Photography." PHOTOGRAPHIC TIMES 24, no. 666 (June 22, 1894): 395-397. 1 b & w. [Letter responding to previous article on the subject.]

E169 Ostberg, Carl. "Proposed Presentation to Charles Ehrmann." PHOTOGRAPHIC TIMES 25, no. 681 (Oct. 5, 1894): 229. [Letter from Carl Ostberg, proposing that a fund be raised to support Charles Ehrmann, long-time teacher of the Chautauqua School of Photography, now in failing health.]

E170 "Death of Charles Ehrmann." PHOTOGRAPHIC TIMES 25, no. 684 (Oct. 26, 1894): 278.

E171 "Charles Ehrmann." PHOTOGRAPHIC TIMES 25, no. 685 (Nov. 2, 1894): 281-283. 1 illus. [Obituary. Born Prussian Silesia in 1822, learned photography from McClees in Phila. late 1840's, early 1850's photographed and wrote. In 1886 Ehrmann began teaching at the Chautauqua School of Photography. Includes excerpts from some of Ehrmann's reminiscences of early photography. Brief note about the funeral on p. 295.]

ELIOT, FRANCIS G.

E172 Eliot, Francis G. "Alcoholic Collodion." HUMPHREY'S JOURNAL OF PHOTOGRAPHY, AND THE ALLIED ARTS AND SCIENCES 10, no. 15 (Dec. 1, 1858): 237-239. [From "J. of Photo. Soc."]

E173 Eliot, Francis G. "On Printing with old Collodion Nitrate Baths." HUMPHREY'S JOURNAL OF PHOTOGRAPHY, AND THE ALLIED ARTS AND SCIENCES 10, no. 21 (Mar. 1, 1859): 333-334. [From "J. of Photo. Soc., London."]

E174 Eliot. "Photography in the Country." JOURNAL OF THE PHOTOGRAPHIC SOCIETY OF LONDON 7, no. 108 (Apr. 15, 1861): 154-156.

E175 Eliot, Francis G. "On Measles; Its Diagnosis and Treatment." AMERICAN JOURNAL OF PHOTOGRAPHY AND THE ALLIED ARTS & SCIENCES n. s. vol. 4, no. 5 (Aug. 1, 1861): 116-118. [From "Photo. News."]

E176 Eliot, F. G. "Process for Strengthening Iron Negatives." HUMPHREY'S JOURNAL OF PHOTOGRAPHY, AND THE ALLIED ARTS AND SCIENCES 13, no. 8 (Aug. 15, 1861) [From "Photo. News."]

E177 Eliot, Francis G. "Camera Versus Palette." JOURNAL OF THE PHOTOGRAPHIC SOCIETY OF LONDON 7, no. 115 (Nov. 15, 1861): 311-312.

E178 Eliot, Francis G. "Suggestions for a New Pigment Process." AMERICAN JOURNAL OF PHOTOGRAPHY AND THE ALLIED ARTS & SCIENCES n. s. vol. 7, no. 2 (July 15, 1864): 36-39. [From "Photo. News."]

E179 Eliot, Francis G. "On Rapidity." BRITISH JOURNAL PHOTOGRAPHIC ALMANAC 1877 (1877): 65-66.

E180 Eliot, Francis G. "On Fuming Sensitive Paper." BRITISH JOURNAL PHOTOGRAPHIC ALMANAC 1879 (1879): 107-108.

ELITE STUDIO.
E181 "Elite Studio." ANTHONY'S PHOTOGRAPHIC BULLETIN 9, no. 11 (Nov. 1878): 336. [From "San Francisco Journal of Commerce." "T. H. Jones, A. Robertson and T. Calverley, for nine years the main stay of Bradley & Rulofson, ...seceded from that establishment and opened...the Elite Studio."]

ELLIOT, G. (GREAT BRITAIN)
E182 Portraits. Woodcut engravings, credited "Photographed by G. Elliot, Staffordshire Potteries, England." FRANK LESLIE'S ILLUSTRATED NEWSPAPER 11, (1860) ["Chaunchy J. Filley, Esq." 11:261 (Nov. 24, 1860): 13.]

ELLIOTT & ARMSTEAD. (COLUMBIUS, OH)
E183 Portraits. Woodcut engravings credited "From a photograph by Elliott & Armstead, Columbus, O." FRANK LESLIE'S ILLUSTRATED NEWSPAPER 44, (1877) ["Mrs. President Hayes." 43:1120 (Mar. 17, 1877): 17.]

ELLIOTT & FRY see also ELLIOTT, ERNEST C.; ELLIOTT, JOSEPH J.; FALL, THOMAS.

ELLIOTT & FRY. (GREAT BRITAIN)
[Joseph J. Elliott was the founder of the firm of Elliott & Fry, and the father of Ernest C. Elliott. When his father retired, Ernest C. Elliott took his place in the firm of Elliott & Fry.]

BOOKS
E184 Putnam, George Haven, ed. *Prose Masterpieces from Modern Essayists; Comprising Twelve Unabridged Essays,* by Irving [et all]; With Twelve Portraits in Permanent Photography. London: Bickers, 1886. 395 pp. 12 b & w. [Woodburytype prints, from photos by Elliott & Fry, Frear, and the London Stereoscope Co.]

E185 Hillier, Bevis, with contributions by Brian Coe, Russell Ash, and Helen Varley. *Victorian Studio Photographs from the Collections of Studio Bassano and Elliott & Fry, London.* Boston: David R. Godine, 1976. 144 pp. 67 b & w.

PERIODICALS
E186 "Note." ART JOURNAL (Nov. 1865): 354. [Portraits of Tennyson and Carlyle, by Elliott & Fry.]

E187 Portraits. Woodcut engravings credited "From a photograph by Elliott & Fry, of the Talbotype Gallery, Baker Street." ILLUSTRATED LONDON NEWS 50, (1867) ["Edward Armitage, R.A." 50:* (Mar. 9, 1867): 224. "John Phillip, R.A." 50:* (Mar. 23, 1867): 285.]

E188 Portrait. Woodcut engraving credited "From a photograph by Elliott & Fry, of Baker St." ILLUSTRATED LONDON NEWS 53, (1868) ["Hon. C. F. Adams, American Minister to Great Britian." 53:* (July 4, 1868): 4.]

E189 Portrait. Woodcut engraving credited "From a photograph by Elliott & Fry, of Baker St." ILLUSTRATED LONDON NEWS 58, (1870) ["Prof. Huxley, F.R.S." 58:* (Sept. 17, 1870): 297.]

E190 Portrait. Woodcut engraving, credited to "From a Photograph by Elliott & Fry." ILLUSTRATED LONDON NEWS 59, (1871) ["Mr. J. A. Froude, historian." 59:1661 (July 22, 1871): 69.]

E191 Portraits. Woodcut engravings, credited to "From a Photograph by Elliott & Fry, Baker St." ILLUSTRATED LONDON NEWS 60, (1872) ["Mr. Odo Russell." 60:1689 (Jan. 20, 1872): 57. "Late Signor Mazzini." 60:1698 (Mar. 23, 1872): 280. "Sir John Goode, C.E." 60:1703 (Apr. 27, 1872): 400. "Late Dr. Norman Macleod." 60:1712 (June 29, 1872): 625.]

E192 Portraits. Woodcut engravings credited "From a photograph by Elliott & Fry." ILLUSTRATED LONDON NEWS 61, (1872) ["Sir Richard Wallace, Bart." 61:1723 (Sept. 14, 1872): 253. "Sir Roundell Palmer, Baron Selborn." 61:1730 (Nov, 2, 1872): 420.]

E193 Portraits. Woodcut engravings credited "From a photograph by Elliott & Fry." ILLUSTRATED LONDON NEWS 62, (1873) ["T. O. Barlow, A.R.A." 62:1746 (Feb. 15, 1873): 157. "Late Rev. Dr. Guthrie." 62:1749 (Mar. 8, 1873): 216.]

E194 Portraits. Woodcut engravings credited "From a photograph by Elliott & Fry." ILLUSTRATED LONDON NEWS 63, (1873) ["Sir Henry Rawlinson, K.C.B., F.R.S." 63:1767 (July 12, 1873): 44. "Mr. Henry Bright." 63:1782 (Oct. 25, 1873): 389. "Sherriff Johnson." 63:1785 (Nov. 15, 1873): 454.]

E195 Portraits. Woodcut engravings credited "From a photograph by Elliott & Fry." ILLUSTRATED LONDON NEWS 64, (1874) ["Late Mr. Shirley Brooks." 64:1802 (Mar. 7, 1874): 225. "Late Capt. Herbert W. Thompson." 64:1806 (Apr. 4, 1874): 312. "Lord Derby." 64:1808 (Apr. 18, 1874): 364. "Col. Sir J. C. MacLeod." 64:1808 (Apr. 18, 1874): 373. "Col. Festing, C.B." 64:1809 (Apr. 25, 1874): 384. "Late Prof. Phillips, F.R.S." 64:1812 (May 16, 1874): 457. "Mr. Marten, M.P." 64:1816 (June 13, 1874): 552. "Late Sir Charles Fox, C.E." 64:1818 (June 27, 1874): 609.]

E196 Portraits. Woodcut engravings credited "From a photograph by Elliott & Fry." ILLUSTRATED LONDON NEWS 66, (1875) ["Late Augustus R. Margary." 66:1857 (Mar. 13, 1875): 257. "Late Gen. Sir Hope Grant, G.C.B." 66:1858 (Mar. 20, 1875): 273. "Sir William Jervois." 66:1861 (Apr. 10, 1875): 345. "H. S. Marks, A.R.A." 66:1865 (May 8, 1875): 445. "Commander Albert Markham, Sub-Lieut. G. L. Egerton, Lieut. G. A. Gifford, officers of the "Alert"." 66:1868 (May 29, 1875): 505. "Rev. C. E. Hodson, chaplain of "Discovery," Lieut. Fillford, officer of "Discovery." 66:1869 (June 5, 1875): 528.]

E197 Portraits. Woodcut engravings credited "From a photograph by Elliott & Fry." ILLUSTRATED LONDON NEWS 67, (1875) ["Sheriff Knight, London." 67:1892 (Nov. 13, 1875): 476. "Sir Matthew Begbie." 67:1896 (Dec. 11, 1875): 581.]

E198 Portrait. Woodcut engraving, credited "From a Photograph by Elliott & Fry, London, England. FRANK LESLIE'S ILLUSTRATED NEWSPAPER 41, (1875) ["Madame Arabella Goddard." 41:1049 (Nov. 6, 1875): 136.]

E199 Portrait. Woodcut engraving credited "From a photograph by Elliott & Fry." ILLUSTRATED LONDON NEWS 68, (1876) ["John W. Oakes, A.R.A." 68:1920 (May 13, 1876): 469.]

E200 Portrait. Woodcut engraving credited "From a photograph by Elliott & Fry." ILLUSTRATED LONDON NEWS 69, (1876) ["Mr. Justice Manisty." 69:1945 (Nov. 4, 1876): 428.]

E201 Portraits. Woodcut engravings credited "From a photograph by Elliott & Fry." ILLUSTRATED LONDON NEWS 70, (1877) ["Henry Compton, actor." 70:1964 (Mar. 3, 1877): 212. "Late Mr. F. W. Topham." 70:1970: 340.]

E202 Portraits. Woodcut engravings credited "From a photograph by Elliott & Fry." ILLUSTRATED LONDON NEWS 72, (1878) ["Earl of Loudoun." 72:2012 (Jan. 19, 1878): 53. "R. Tennant, M.P." 72:2012 (Jan. 19, 1878): 53.]

E203 Portraits. Woodcut engravings credited "From a photograph by Elliott & Fry," ILLUSTRATED LONDON NEWS 73, (1878) ["Sir Charles Whetham, Mayor of London." 73:2054 (Nov. 9, 1878): 441. "Late Mr. G. H. Lewes." 73:2061 (Dec. 14, 1878): 565.]

E204 Portrait. Woodcut engraving, credited "From a Photograph by Elliott & Fry, London." FRANK LESLIE'S ILLUSTRATED NEWSPAPER 47, (1878) ["The Marquis of Lorne, Gov.-Gen. of Canada." 47:1210 (Dec. 7, 1878): n. p. (Supplement)]

E205 Portraits. Woodcut engravings credited "From a photograph by Elliott & Fry." ILLUSTRATED LONDON NEWS 74, (1879) ["Lieut. Gonville Bromhead." 74:2072 (Mar. 2, 1879): 192. "Lieut. Anstey, killed." 74:2073 (Mar. 8, 1879): 216. "Late Mr. Le Neve Foster." 74:2073 (Mar. 8, 1879): 224. "Lady Adelaide Taylor." 74:2074 (Mar. 15, 1879): 241. "Late Elihu Burritt." 74:2075 (Mar. 22, 1879): 297.]

E206 Portraits. Woodcut engravings credited "From a photograph by Elliott & Fry." ILLUSTRATED LONDON NEWS 75, (1879) ["Late Lord Lawrence." 75:2090 (July 5, 1879): 17. "Late Prof. Alfred H. Garrold, F.R.S." 75:2108 (Nov. 8, 1879): 424. "Col. J. W. Fry." 75:2110 (Nov. 22, 1879): 472.]

E207 "Some London Poets." HARPER'S MONTHLY 64, no. 384 (May 1882): 874-892. 9 illus. [Engravings from photographs. Portraits by Elliott & Fry; Fradule; W. M. Ostroga; Lambert Weston & Co.; E. Forhead; Ferrando; Geruzet Freres (Brussells.)]

E208 "Glimpses of Great Britains. (Caught at Westminster.)" HARPER'S MONTHLY 65, no. 386 (July 1882): 163-184. 23 illus. [Engravings, many from photographs. Portraits, credited to Elliott & Fry; London Stereoscopic Co.; W. Lawrence (Dublin). Interior of the House of Parliament, not credited.]

E209 Bowker, R. R. "London as a Literary Center." HARPER'S MONTHLY 76, no. 456 (May 1888): 814-826. 28 illus. [Engravings, from photographic portraits by Elliott & Fry; London Stereoscopic Co.; Abel Lewis; Sarony; Cameron Studio (H. H. Hay Cameron); Alexander Bassano; Frederick Hollyer; Apollony; Barraud; N. H. King; Mayall.]

E210 Stead, W. T. "Mr. Gladstone at Eighty-Six." MCCLURE'S MAGAZINE 7, no. 3 (Aug. 1896): 194-207. 12 b & w. [Photos by Elliott & Fry (London); F. Rowlands (Hawarden); Currey (Morecambe).]

E211 1 photo (George Wyndham, M.P.). WORLD'S WORK 6, no. 1 (May 1903): 3375.

E212 Goodrich, Arthur. "They Which Were Lost: The Story of Dr. Barnardo." AMERICAN ILLUSTRATED MAGAZINE (LESLIE'S

MONTHLY) 61, no. 3 (Jan. 1906): 243-253. 9 b & w. [Eight views of institutions, students in classrooms, etc. One copyrighted to Elliott & Fry, others probably by Elliott & Fry. One portrait of Dr. Barnardo, copyrighted to Stepney Causeway Studio.]

E213 "The Camera Shy Phillips Brooks." PHOTOGRAPHICA 10, no. 8 (Oct. 1978): 4. 1 b & w. 1 illus. [B & W by Elliott & Fry.]

ELLIOTT BROTHERS. (MARSHALLTOWN, IA)
E214 "Voices from the Craft." PHILADELPHIA PHOTOGRAPHER 5, no. 56 (Aug. 1868): 274-275. [Letter from the Elliott Brothers.]

ELLIOTT, C. E.
E215 Elliott, C. E. "Photography from a Commercial Point of View." BRITISH JOURNAL PHOTOGRAPHIC ALMANAC 1872 (1872): 122-123.

ELLIOTT, ERNEST C. see also ELLIOTT & FRY.

ELLIOTT, ERNEST C. (d. 1912) (GREAT BRITAIN)
E216 "Our Weekly Gossip." ATHENAEUM no. 1789 (Feb. 8, 1862): 195. [Stereo views of London.]

ELLIOTT, J. M. see ELLIOTT & ARMSTEAD.

ELLIOTT, J. PERRY. (INDIANAPOLIS, IN)
E217 Elliott, J. Perry. "How an Operator, who 'don't want no Journal,' was 'sold.'" HUMPHREY'S JOURNAL OF PHOTOGRAPHY, AND THE ALLIED ARTS AND SCIENCES 15, no. 17 (Jan. 1, 1864): 263-264.

E218 Elliott, J. P. "Intense Negatives." HUMPHREY'S JOURNAL OF PHOTOGRAPHY, AND THE ALLIED ARTS AND SCIENCES 16, no. 4 (June 15, 1864): 60-61. [Elliott's letter and Towler's reply.]

E219 Elliott, J. Perry. "Our Profession. What Is It?" PHILADELPHIA PHOTOGRAPHER 9, no. 100 (Apr. 1872): 106-107. [Read before the Indianapolis [IN] Photographic Assoc.]

E220 Elliott, J. Perry. "Dogmatism." PHILADELPHIA PHOTOGRAPHER 9, no. 106 (Oct. 1872): 355-356. [Elliott from Indianapolis, IN.]

E221 Elliott, J. Perry. "What Mottoes Should We Hang In Our Galleries?" ANTHONY'S PHOTOGRAPHIC BULLETIN 4, no. 3 (Mar. 1873): 13.

E222 Elliott, J. Perry. "Relief or No Relief - The Question Is." PHILADELPHIA PHOTOGRAPHER 10, no. 112 (Apr. 1873): 101-102. [About stereos.]

ELLIOTT, JOSEPH JOHN see also ELLIOTT & FRY.

ELLIOTT, JOSEPH JOHN. (1835-1903) (GREAT BRITAIN)
E223 "Note." ART JOURNAL (Dec. 1858): 373. ["Mr. Elliott has submitted to us a series of stereoscopic pictures - the subject of which is the sacking of a Jew's house. These works are thus novelties to the art as a consecutive series which tell a story."]

E224 Elliott, J. "Critical notices: Stereographic Illustrations of Compositive Photography." PHOTOGRAPHIC NEWS 1, no. 16 (Dec. 24, 1858): 184-185.

E225 "Obituary of the Year: J. J. Elliott." BRITISH JOURNAL PHOTOGRAPHIC ALMANAC 1904 (1904): 672-674. [Born near

Croyden, on Oct. 14, 1835, died Mar. 30, 1903. Old Scottish family. Left for Australia at age 15, in 1850. Hunted for gold, without success. Returned to England in 1859. Married sister of Clarence E. Fry, who had learned photography from George Washington Wilson. Elliott was the business partner, Fry had the photographic skills. Began partnership in 1863. Business rapidly grew. Branch, run by Fry opened in South Kensington in 1886. Also manufactured dry plates and paper. Wealthy. Partnership dissolved in 1893. Elliott travelled widely, collected art.]

ELLIOTT, W.
E226 Elliott, W. "Portable Dark-Room." HUMPHREY'S JOURNAL OF PHOTOGRAPHY, AND THE ALLIED ARTS AND SCIENCES 15, no. 9 (Sept. 1, 1863): 141.

ELLIS, JOSEPH.
E227 Ellis, Joseph. *Progress of Photography; Collodion; and the Stereoscope. A lecture delivered at the Brighton Literary and Scientific Institution, November 13, 1855.* London; Brighton: H. Bailliere; Robert Folthorp, 1856. 62 pp. [Apparently an earlier lecture by Ellis was also given in February, 1847, and (presumably) also published.]

ELLIS, M. H.
E228 Ellis, M. H. *The Ambrotype and Photographic Instructor; or, Photography on Glass and Paper.* Philadelphia: M. Shew, 1856. 81 pp. ["A fair compilation from standard authors." Photo. & Fine Art J. (Mar. 1856).]

ELLIS, ROBERT.
E229 Ellis, Robert. "The Process of Development in Photography." ATHENAEUM no. 1217 (Feb. 22, 1851): 224-225.

E230 Ellis, Robert. "Photography: The Proto-Nitrate of Iron in Photography." ATHENAEUM no. 1263, 1267 (Jan. 10, Feb. 7, 1852): 55-56, 175-176.

E231 "The Ferrotype." HUMPHREY'S JOURNAL 5, no. 19 (Jan. 15, 1854): 300-301. [Not credited, but may be from the "Athenaeum." Process by Robert Ellis.]

ELLIS, WILLIAM. (1794-1872) (GREAT BRITAIN)
BOOKS
E232 Ellis, Rev. William, F.H.S. *Three Visits to Madagascar during the Years 1853 - 1854 - 1856. Including a Journey to the Capital, with Notices of the Natural History of the Country and of the Present Civilization of the People... Illustrated by a Map and Woodcuts from Photographs, etc.* New York; London: Harper & Brothers; John Murray, 1858. xvii, 470 pp. 25 illus. [Ellis also the author of "Polynesian Researches." Published in 1829. "I am indebted to photography for the chief part of the illustrations of the volume." (p. x.) "Engravings most from photos, taken by the author. Ellis' narrative includes sections such as: "Astonishment of the Natives on Witnessing the Effects of Photography," pp. 134-139.]

PERIODICALS
E233 "Madagascar." ILLUSTRATED LONDON NEWS 33, no. 950 (Dec. 18, 1858): 573-574. 3 illus. [Bk. rev.: "Three Visits to Madagascar,." by Rev. William Ellis.]

E234 Ellis, Rev. William. "The Christian Martyrs of Madagascar." HARPER'S MONTHLY 18, no. 107 (Apr. 1859): 586-602. 16 illus. [From Ellis's book, "Three Visits to Madagascar during the Years 1853 - 1854 - 1856,." Comments on his experiences while photographing throughout the article.]

ELLISON, GEORGE W. & CO. (QUEBEC, CANADA)
E235 "Commencement of the European and North American Railway." ILLUSTRATED LONDON NEWS 23, no. 655 (Nov. 26, 1853): 440. 2 illus. ["City of St. Johns - From a Daguerreotype by Ellison." "Suspension Bridge across the Falls of the River St. John - From a Daguerreotype by Ellison."]

E236 Portraits. Woodcut engravings, credited "Photographed by Ellison & Co., Quebec." FRANK LESLIE'S ILLUSTRATED NEWSPAPER 10, (1860) ["The Right Rev. George J. Mountain, Lord Bishop of Quebec." 10:249 (Sept. 1, 1860): 234. "Rear Admirable Milne, British navy." 10:259 (Nov. 10, 1860): 386.]

E237 "The Prince's State Dinner Party at the Government House, Quebec, on Monday Evening, August 20, 1860," "Reception of the Prince of Wales in Quebec - Mechanics Arch Erected in the St. John's Street," "...Beautiful Arch near Hall's Store," and "The Royal Stud of Thoroughbred Horses. - Photographed by Ellison & Co., Quebec." FRANK LESLIE'S ILLUSTRATED NEWSPAPER 10, no. 249 (Sept. 1, 1860): 227, 235. 4 illus. [Interior, with crowd. Three exterior views, with figures.]

E238 "Double-Dealing." FRANK LESLIE'S ILLUSTRATED NEWSPAPER 10, no. 250 (Sept. 8, 1860): 241. [Editorial, charging that Gurney attempted to buy Ellison's views of the Prince of Wales' visit to Quebec, apparently with the intention of reselling them to a rival publication.]

E239 "Mr. Gurney, the Photographer, Again." FRANK LESLIE'S ILLUSTRATED NEWSPAPER 10, no. 256 (Oct. 20, 1860): 336. [Signed deposition by George W. Ellison, photographer of Quebec, stating that Gurney attempted to buy scenes of the Prince of Wales' visit to Quebec, which he apparently intended to resell as his own work.]

E240 "Proposed Union of the British North-American Provinces." ILLUSTRATED LONDON NEWS 45, no. 1287 (Nov. 12, 1864): 496. 4 illus. [View of the Province Building, Prince Edward Island, by Mr. G. P. Roberts, of St. John, New Brunswick. Three portraits of members of Canadian government by Ellison & Co., Quebec.]

ELMER & TENNEY see VANCE, GEORGE I.

ELROD, J. C. see also HISTORY: USA: MO (Van Ravenswaay)

ELROD, J. C.
E241 "The Lynching of William Barker at Lexington, Kentucky." HARPER'S WEEKLY 2, no. 83 (July 31, 1858): 481. 1 illus. ["From a Melainotype by J. C. Elrod, of Lexington."]

E242 "Editor's Table." PHILADELPHIA PHOTOGRAPHER 14, no. 164 (Aug. 1877): 256. [J. C. Elrod (Louisville, KY) conducting a fine gallery.]

ELSBEE, JOHN.
E243 "The Clubhouse at Christchurch, New Zealand." ILLUSTRATED LONDON NEWS 44, no. 1248 (Mar. 5, 1864): 237, 241. 1 illus. ["...from a photograph by Mr. John Elsbee, photographer, of Christchurch."]

ELTING, N. D. (NEW PALTZ LANDING, NY)
E244 N. D. E. "The Arrangements for Lighting." AMERICAN JOURNAL OF PHOTOGRAPHY AND THE ALLIED ARTS &

SCIENCES n. s. vol. 6, no. 3 (Aug. 1, 1863): 65-66. [N. D. E. from New Paltz Landing, NY.]

E245 Elting, N. D. "A New Toning Bath." AMERICAN JOURNAL OF PHOTOGRAPHY AND THE ALLIED ARTS & SCIENCES n. s. vol. 6, no. 13 (Jan. 1, 1864): 309-310.

ELTON, GEORGE M. (ca. 1848-1927) (USA)

E246 "Our Picture." PHILADELPHIA PHOTOGRAPHER 11, no. 131 (Nov. 1874): frontispiece, 344. 1 b & w. [Studio Portrait.]

E247 "Our Picture." PHILADELPHIA PHOTOGRAPHER 13, no. 148 (Apr. 1876): frontispiece, 109. 1 b & w. ["Promenade" style studio portrait.]

E248 "Prize Print Hints." PHILADELPHIA PHOTOGRAPHER 15, no. 171 (Mar. 1878): 65-68. [Competitor in the "Phila. Photo." Gold Medal Prize, describing his working methods, etc.]

E249 "Our Picture." PHILADELPHIA PHOTOGRAPHER 15, no. 172 (Apr. 1878): frontispiece, 122-124. 1 b & w. 1 illus. [Portrait that won the "Phila. Photo." Gold Medal Prize. Illustration is an engraving of Elton's studio.]

E250 "Editor's Table." PHILADELPHIA PHOTOGRAPHER 15, no. 178 (Oct. 1878): 320. [G. M. Elton (Palmyra, NY) praised for his panel photographs.]

E251 "Our Picture." PHILADELPHIA PHOTOGRAPHER 16, no. 187 (July 1879): frontispiece, 223. 1 b & w. [Studio portrait.]

E252 "Our Illustration." ANTHONY'S PHOTOGRAPHIC BULLETIN 17, no. 21 (Nov. 13, 1886): frontispiece, 661. 1 b & w. [Apparently a cabinet photo; not bound in this issue.]

E253 "Our Illustration." ANTHONY'S PHOTOGRAPHIC BULLETIN 19, no. 13 (July 14, 1888): frontispiece, 403. 1 b & w. ["Study in Posing," by G. M. Elton, of Palmyra, NY. Photo not bound in this copy.]

ELWELL, F. R.

E254 Elwell, F. R., M.A. "Notes on Instantaneous Photography." ANTHONY'S PHOTOGRAPHIC BULLETIN 4, no. 7 (July 1873): 207-208. [A communication to the London Photographic Society.]

ELY, COOK. (1847-) (USA)

E255 "Our Picture." PHILADELPHIA PHOTOGRAPHER 15, no. 179 (Nov. 1878): frontispiece, 347-348. 1 b & w. [Cook Ely (Oshkosh, WI). Genre scene, a woman collecting wood in a snowstorm.]

EMANUEL.

E256 "The International Exhibition: Stereoscope by Mr. Emanuel." ILLUSTRATED LONDON NEWS 41, no. 1161 (Aug. 30, 1862): 252. 1 illus. [Engraving of an elaborate stereo viewer.]

EMDEN, E. (GERMANY)

E257 Christie, Manson & Woods. *Catalogue of the Celebrated Collection of Works of Art and Vertue, known as "The Vienna Museum."* London: Christie, Manson, & Woods., 1860. 90 pp. 35 b & w. 5 illus. [Photographs of objects in an auction sale, held Mar. 12 - 21, 1860, of a collection owned by the Lowenstein Brothers, of Frankfurt-am-Main. Emden was a photographer in Frankfurt-am-Main.]

EMERSON, EDWIN. (1823-1908) (USA)

E258 Emerson, Edwin, Prof., Troy, N.Y. "Proposed Improvements in the Camera." HUMPHREY'S JOURNAL OF PHOTOGRAPHY, AND THE ALLIED ARTS AND SCIENCES 13, no. 11 (Oct. 1, 1861): 166-169. [From "Am. J. of Science and Arts." Emerson extending ideas proposed by Sir David Brewster.]

E259 Emerson, Edwin. "Upon Some Improvements Proposed by Sir David Brewster in the Photographic Camera." BRITISH JOURNAL OF PHOTOGRAPHY 8, no. 153 (Nov. 1, 1861): 380-383. 2 illus. [Emerson from Troy University, NY. From "Silliman's Journal."]

E260 Emerson, E., Prof. "On an Improvement in the Lenticular Stereoscope." HUMPHREY'S JOURNAL OF PHOTOGRAPHY, AND THE ALLIED ARTS AND SCIENCES 13, no. 15 (Dec. 1, 1861): 230-234. 3 illus.

E261 Emerson, Prof., of Troy. "The Tannin Process." AMERICAN JOURNAL OF PHOTOGRAPHY AND THE ALLIED ARTS & SCIENCES n. s. vol. 5, no. 3 (Aug. 1, 1862): 52-53. [From "Silliman's J."]

E262 Emerson, Prof. E. "The Tannin Process." HUMPHREY'S JOURNAL OF PHOTOGRAPHY, AND THE ALLIED ARTS AND SCIENCES 14, no. 8 (Aug. 15, 1862): 70-72.

E263 "Another Photographer Sailed." HUMPHREY'S JOURNAL OF PHOTOGRAPHY, AND THE ALLIED ARTS AND SCIENCES 14, no. 8 (Aug. 15, 1862): 80. [Prof. Emerson and his family, of Troy, NY sailed for Europe.]

E264 Emerson, Edwin, Prof. "On the Perception of Relief." HUMPHREY'S JOURNAL OF PHOTOGRAPHY, AND THE ALLIED ARTS AND SCIENCES 14, no. 16 (Dec. 15, 1862): 193-197. [From "Am. J. of Science and Arts." Emerson at Troy University.]

E265 Emerson, Prof. Edwin. "On Visual Perception." BRITISH JOURNAL OF PHOTOGRAPHY 10, no. 190 (May 15, 1863): 204-205.

EMERY, A. G.

E266 "Views About Lake Superior." HARPER'S WEEKLY 9, no. 455 (Sept. 16, 1865): 588. 6 illus. [Views, boat, portrait of Chippewa Indian. "From Photographs by A. G. Emery."]

EMSLEY, JOSEPH. (GREAT BRITAIN)

E267 Emsley, Joseph. "Photographs of the Eclipse." PHOTOGRAPHIC AND FINE ART JOURNAL 11, no. 6 (June 1858): 165. [From "Liverpool Photo. J." Six photos of sun in eclipse, by J. Emsley.]

ENGLAND, WILLIAM see also LONDON STEREOSCOPIC CO.

ENGLAND, WILLIAM. (1816-1896) (GREAT BRITAIN)

[William England worked as a daguerreotypist in London between 1840-45. In 1854 he became the chief photographer for the London Stereoscopic Co. and made thousands of stereo views for that organization until 1862. Traveled to Ireland in 1858, to the USA in 1859, Paris, France in 1861, the London International Exhibition in 1862. From 1863 on, England worked for himself. In 1863 he photographed in Switzerland and Italy. Took many alpine views, and published an album of panoramic views of Switzerland, Savoy and Italy in 1865. In 1868 published an album of views of the Rhine. Member of the Photographic Society, and, in 1886, a Vice President. Ran the Solar Club in 1890. Died in London in 1896.]

BOOKS

E268 England, William. *Panoramic Views of Switzerland, Savoy, and Italy.* London: A. Marion & Son & Co., n. d. [ca. 1865]. 1 pp. 77 l. of plates. 77 b & w. [Original photos, with printed captions, and title page.]

PERIODICALS

E269 "Reviews: Instantaneous Views in Paris, and Interiors of Public Buildings in Paris taken by Mr. England for the London Stereoscopic Company." JOURNAL OF THE PHOTOGRAPHIC SOCIETY OF LONDON 7, no. 118 (Feb. 15, 1862): 372-373.

E270 England, William. "On a Method of Producing Photographic Transparencies and Instantaneous Negatives." JOURNAL OF THE PHOTOGRAPHIC SOCIETY OF LONDON 8, no. 120 (Apr. 15, 1862): 24-28.

E271 England, William. "On a Rapid Dry Process, Printing Transparencies, and Remarks on 'Instantaneous' Photography." BRITISH JOURNAL OF PHOTOGRAPHY 9, no. 164 (Apr. 15, 1862): 143-144.

E272 "The Interior of the Exhibition." HUMPHREY'S JOURNAL OF PHOTOGRAPHY, AND THE ALLIED ARTS AND SCIENCES 14, no. 8 (Aug. 15, 1862): 77. [From "Photo. News." Wm. England's views of the International Exhibition praised.]

E273 "Stereographs. Illustrations of the International Exhibition. Photographed by W. England. London Stereoscopic Co." BRITISH JOURNAL OF PHOTOGRAPHY 9, no. 178 (Nov. 15, 1862): 428.

E274 "The Commerce of Photography." AMERICAN JOURNAL OF PHOTOGRAPHY AND THE ALLIED ARTS & SCIENCES n. s. vol. 5, no. 13 (Jan. 1, 1863): 296. [From "Photo. News." Wm. England made and sold 200 gross of stereo photos and many thousands of card photos of the London International Exhibition. 200 gallons of Albumen, 70 reams of paper, 2,400 ounces of Nitrate of Silver and 35 ounces of gold, etc. into making these photos.]

E275 "Miscellanea." JOURNAL OF THE PHOTOGRAPHIC SOCIETY OF LONDON 8, no. 129 (Jan. 15, 1863): 217. ["Mr. England states that in producing stereoscopic and card pictures of the interior of the International Exhibition, he has used the following quantities of material...albumen 200 gallons, etc. ...over 9 1/4 million slides."]

E276 England, William. "Choosing Glass for the Operating Room." HUMPHREY'S JOURNAL OF PHOTOGRAPHY, AND THE ALLIED ARTS AND SCIENCES 14, no. 24 (Apr. 15, 1863): 334-335. [From "Br. J. of Photo."]

E277 England, William. "A Simple Method of Choosing Glass Suited for the Operating Room." AMERICAN JOURNAL OF PHOTOGRAPHY AND THE ALLIED ARTS & SCIENCES n. s. vol. 5, no. 20 (Apr. 20, 1863): 469-470. [Letter to London Photo. Soc.]

E278 "Critical Notices: Views of Switzerland and Savoy. Photographed by Wm. England." PHOTOGRAPHIC NEWS 8, no. 278 (Jan. 1, 1864): 4.

E279 "Stereographs. Views of Switzerland and Savoy. Photographed by W. England." BRITISH JOURNAL OF PHOTOGRAPHY 11, no. 206 (Jan. 15, 1864): 26-27.

E280 "England's Rapid Dry Process." AMERICAN JOURNAL OF PHOTOGRAPHY AND THE ALLIED ARTS & SCIENCES n. s. vol. 6, no. 17 (Mar. 1, 1864): 401-402. [From "Br. J. Almanac."]

E281 "Our Editorial Table: Views of Switzerland and Savoy - New Series, Photographed by W. England, and dedicated, by permission to the Alpine Club." BRITISH JOURNAL OF PHOTOGRAPHY 12, no. 245 (Jan. 13, 1865): 18-19.

E282 "A London Photographic Establishment." BRITISH JOURNAL OF PHOTOGRAPHY 12, no. 246 (Jan. 20, 1865): 28-29.

E283 "Note." ART JOURNAL (Mar. 1865): 24. [250 views of Switzerland, made by Wm. England.]

E284 England, William. "Practical Hints for Out-Door Photography." BRITISH JOURNAL PHOTOGRAPHIC ALMANAC 1866 (1866): 71-72.

E285 England, William. "Recovering the Gold from Old Toning Baths." HUMPHREY'S JOURNAL OF PHOTOGRAPHY, AND THE ALLIED ARTS AND SCIENCES 18, no. 3 (June 1, 1866): 44. [From "Photo. News."]

E286 England, Wm. "Resin in Collodion." AMERICAN JOURNAL OF PHOTOGRAPHY AND THE ALLIED ARTS & SCIENCES n. s. vol. 9, no. 2 (Sept. 15, 1866): 38-40. [From "Photo. News."]

E287 England, W. "Recovering Silver from Ashes." HUMPHREY'S JOURNAL OF PHOTOGRAPHY, AND THE ALLIED ARTS AND SCIENCES 18, no. 16 (Dec. 15, 1866): 253. [From "Photo. News."]

E288 England, William. "On the Preservation, Restoration and Perfecting of Negatives." PHILADELPHIA PHOTOGRAPHER 4, no. 40 (Apr. 1867): 108-110. [Read before the London Photographic Society, Jan. 8, 1867.]

E289 England, William. "Recovering the Gold from Old Toning Baths." AMERICAN JOURNAL OF PHOTOGRAPHY, AND THE ALLIED ARTS AND SCIENCES n. s. vol. 9, no. 10 (May. 1, 1867): 209-210. [From "Photo. News Almanac."]

E290 England, William. "A Modification of the Collodio-Albumen Process, Requiring but one Sensitizing Bath." AMERICAN JOURNAL OF PHOTOGRAPHY AND THE ALLIED ARTS AND SCIENCES n. s. vol. 9, no. 11 (May. 15, 1867): 243-247. [Read to London. Photo. Soc. From "Br. J. of Photo."]

E291 England, William. "A Modified Collodio-Albumen Process." BRITISH JOURNAL PHOTOGRAPHIC ALMANAC 1868 (1868): 71-72.

E292 England, William. "England's Collodio - Albumen Process." and "Remarks on the Coffee Process." BRITISH JOURNAL PHOTOGRAPHIC ALMANAC 1869 (1869): 47-48, 54-55.

E293 "A Developing Tray for Dry Plates." HUMPHREY'S JOURNAL OF PHOTOGRAPHY, AND THE ALLIED ARTS AND SCIENCES 20, no. 21 (May 15, 1869): 331. [From "Br. J. of Photo. Almanac."]

E294 England, William. "How to Make a Negative Nitrate Bath." BRITISH JOURNAL PHOTOGRAPHIC ALMANAC 1871 (1871): 81-82.

E295 Nagis, R. de. "View in the Tyrol." ART PICTORIAL AND INDUSTRIAL 1, no. 11 (May 1871): 252-253, plus 1 page following p. 252. 1 b & w. [Heliotype reproduction of Wm. England's landscape view, with brief commentary.]

E296 England, William. "Talc as a Protection to Negatives." BRITISH JOURNAL PHOTOGRAPHIC ALMANAC 1872 (1872): 52-53.

E297 England, William. "Cleaning and Copying Daguerreotypes." BRITISH JOURNAL PHOTOGRAPHIC ALMANAC 1873 (1873): 116-117.

E298 "Photography Abroad: Cold Weather and Photography." PHOTOGRAPHIC TIMES 5, no. 50 (Feb. 1875): 37-38. [From "Photographic News." Discusses William England's experiences photographing in US and Canada; Lieut. Chermside's experiences photographing Arctic regions.]

E299 "Old World Gleanings." PHOTOGRAPHIC TIMES 14, no. 165 (Sept. 1884): 478. [Note about the development process discussed by W. England, "...a high-class landscape photographer." at the Photographic Society of Great Britain.]

E300 "Note." PHOTOGRAPHIC TIMES 28, no. 10 (Oct. 1896): 496. [Death of William England in September 1896.]

ENSMINGER, J. C. (INDEPENDENCE, IO)
E301 Ensminger, J. C. "Coloring Photographs." PHILADELPHIA PHOTOGRAPHER 9, no. 108 (Dec. 1872): 412. [Ensminger from Independence, IO. "I have been photographing and working in ink and water colors for nine or ten years now."]

ERICSON, AUGUSTUS WILLIAM. (1848-1927) (USA)
E302 Palmquist, Peter. *Fine California Views: The Photographs of A. W. Ericson.* Eureka, Calif.: Interface California Corporation, 1975. 112 pp. 92 b & w. 21 illus.

ESCOTT, JAMES V. (1816-1892) (GREAT BRITAIN, USA)
E303 "Obituary: James V. Escott." PHOTOGRAPHIC TIMES 22, no. 541 (Jan. 29, 1892): 50-51. [Photographic merchant in Louisville from 1850s through 1880s. Born England in 1816, to US in 1838.]

ESMAY, JOHN. (SABULA, IA)
E304 Esmay, John. "The South Light a Success." AMERICAN JOURNAL OF PHOTOGRAPHY AND THE ALLIED ARTS & SCIENCES n. s. vol. 7, no. 19 (Apr. 1, 1865): 452-453.

E305 Esmay, John. "The Albumen Developer - Mottling of Varnish." AMERICAN JOURNAL OF PHOTOGRAPHY AND THE ALLIED ARTS & SCIENCES n. s. vol. 9, no. 1 (Sept. 1, 1866): 14. [Esmay from Iowa.]

ESTABROOKE, EDWARD M.
BOOKS
E306 Estabrooke, E. M. *The Ferrotype and How To Make It.* Cincinnati: Gatchell & Hyatt, 1872. 200 pp. illus. [2nd ed. (1873) 167 pp. New edition, (1881) NY: E. & H. T. Anthony.]

E307 *The Ferrotyper's Friend;* by a Practical Photographer, Illustrated by E. M. Estabrooke. Baltimore: R. Walzl, 1880. 50 pp. 1 b & w. illus. [Last chapter written by Estabrooke, original tintype, tipped-in.]

E308 Estabrooke, E. M. *Photography in the Studio and In the Field.* New York: E. & H. T. Anthony & Co., 1887. 239 pp. illus. [Estabrooke

apparently travelled throughout the United States as a demonstrator of dry plates for the Anthony company. "A practical guide."]

PERIODICALS
E309 "Editor's Table." PHILADELPHIA PHOTOGRAPHER 4, no. 43 (July 1867): 234. [Ferrotypes.]

E310 "Ferrotypes in England." ANTHONY'S PHOTOGRAPHIC BULLETIN 3, no. 9 (Sept. 1872): 670. [Estabrook (from Brooklyn) to open a ferrotype (tintype) gallery in London.]

E311 "Note." PHOTOGRAPHIC TIMES 2, no. 24 (Dec. 1872): 180. ["Some beautiful ferrotypes."]

E312 "New Books." ANTHONY'S PHOTOGRAPHIC BULLETIN 4, no. 1 (Jan. 1873): 11. [Bk. rev.: "The Ferrotype and How to Make It," by E. M. Estabrook.]

E313 "Matters of the Month: For Sale." PHOTOGRAPHIC TIMES 4, no. 41 (June 1874): 89. [Offering his gallery for sale.]

E314 Portrait. Woodcut engraving, credited "From a Photograph by Estabrook, New York. FRANK LESLIE'S ILLUSTRATED NEWSPAPER 41, (1875) ["Rev. Cyrus D. Ross." 41:1046 (Oct. 16, 1875): 92.]

E315 "Our Editorial Table." PHOTOGRAPHIC TIMES 11, no. 125 (May 1881): 184-186. [Bk. rev: "The Ferrotype and How To Make It," by E. M. Estabrook. Includes a long excerpt on the creative aspects of portraiture from the book.]

E316 Estabrook, E. M. "Observations." AMERICAN ANNUAL OF PHOTOGRAPHY & PHOTOGRAPHIC TIMES ALMANAC FOR 1888 (1888): 206-207. [His observations are of the consequences of the introduction of dry-plates, newer lenses upon photographic style. Harder images, etc. Estabrook from New York.]

E317 Estabrook, E. M. "Greetings." PHOTOGRAPHIC MOSAICS: 1888 24, (1888): 87-90. [Estabrook a travelling demonstrator of the dry plate process for the Stanley Dry Plate Co., Lewiston, Me.]

E318 Estabrook, E. M. "Posing and Illumination." PHOTOGRAPHIC TIMES 23, no. 627 (Sept. 22, 1893): 530, 532-534. [Read at the World's Congress of Photographers.]

ETYNGE, C.
E319 Portrait. Woodcut engraving, credited "From a Photograph by C. Etynge." HARPER'S WEEKLY 9, (1865) ["*." 9:449 (Aug. 5, 1865): 493.]

EVANS & PRINCE. (YORK, PA)
E320 Portrait. Woodcut engraving, credited "From a Photograph by Evans & Prince, York, Pa." FRANK LESLIE'S ILLUSTRATED NEWSPAPER 12, (1861) ["Brig.-Gen. J. S. Negley, commanding the 3rd Brigade of PA." 12:294 (July 6, 1861): 123.]

EVANS, CHARLES H.
E321 Evans, Charles H. "Portraits with Motto Margins, and How to Make Them." ANTHONY'S PHOTOGRAPHIC BULLETIN 10, no. 3 (Mar. 1879): 89. [From "London Photo. News."]

EVANS, G. (WORCESTER, ENGLAND)
E322 Portrait. Woodcut engraving credited "From a photograph by G. Evans." ILLUSTRATED LONDON NEWS 64, (1874) ["Late Mr. Albert Way." 64:1809 (Apr. 25, 1874): 397.]

EVANS, GURDON.
E323 Evans, Gurdon, A.M. "Chemistry - No. 1." PHOTOGRAPHIC ART JOURNAL 4, no. 5 (Nov. 1852): 316-317. [From the "Scientific Daguerrean."]

EVANS, J. G. (IA)
E324 "Stereoscopic Views." HUMPHREY'S JOURNAL OF PHOTOGRAPHY, AND THE ALLIED ARTS AND SCIENCES 20, no. 11 (Oct. 1, 1868): 176. ["Mr. J. G. Evans, of Iowa, sends us views of interesting scenes and landscapes in the Great West. Views around Muscatine, IA. Grapes, farms, etc. Plans to go to the Rocky Mountains next summer."]

EVANS, O. B. (BUFFALO, NY)
E325 "Ruins of the Fallen Building, Buffalo, N. Y." ILLUSTRATED NEWS (NY) 1, no. 22 (May 28, 1853): 340, 346. 1 illus. ["From a Daguerreotype by Evans."]

EVERETT, EDWARD or EDWIN. [?]*
E326 Everett, Edward. "The Literary and Judicial Application of Photography." PHILADELPHIA PHOTOGRAPHER 1, no. 3 (Mar. 1864): 35-36.

E327 Everett, E. "Processes That Will Not Work. - A Raid on the Editors." AMERICAN JOURNAL OF PHOTOGRAPHY AND THE ALLIED ARTS & SCIENCES n. s. vol. 6, no. 18 (Mar. 15, 1864): 428-429.

E328 Everett, Edwin. "Disordered Baths." AMERICAN JOURNAL OF PHOTOGRAPHY AND THE ALLIED ARTS & SCIENCES n. s. vol. 7, no. 1 (July 1, 1864): 21-22.

EVERETT, L. C. (TROY, NY)
E329 Everett, L. C. "A Great Institution." HUMPHREY'S JOURNAL OF PHOTOGRAPHY, AND THE ALLIED ARTS AND SCIENCES 18, no. 5 (July 1, 1866): 78. [Praise for selling his gallery through an ad placed in "Humphrey's Journal."]

EWING & CO. (TORONTO, CANADA)
E330 "Note." ANTHONY'S PHOTOGRAPHIC BULLETIN 6, no. 3 (Mar. 1875): 82. [Ewing & Co. (Toronto) offering their large gallery for sale.]

EWING, JACOB.
E331 Ewing, Jacob. "Photography: Its Success Attributable to the Careful Preservation of the Authentic Data of Its Various Discoveries." BRITISH JOURNAL OF PHOTOGRAPHY 11, no. 215 (June 1, 1864): 185.

EWING, JAMES. (d. 1866) (GREAT BRITAIN)
E332 Ewing, James. "Remarks on the Positive Collodion Process." BRITISH JOURNAL OF PHOTOGRAPHY 8, no. 142 (May 15, 1861): 182-183. [Not technical, but commentary on growth of photography. Ewing also a member of the City of Glasgow and West of Scotland Photo. Society.]

E333 Ewing, James. "Remarks on the Positive Collodion Process." HUMPHREY'S JOURNAL OF PHOTOGRAPHY, AND THE ALLIED ARTS AND SCIENCES 13, no. 5 (July 1, 1861): 72-74. [From "Br. J. of Photo."]

E334 Ewing, James. "On the Comparative Value of the Daguerreotype, Collodiotype, and Calotype Photographic Results (As Regards Portraiture) in Point of Beauty, Permanence, &c." BRITISH JOURNAL OF PHOTOGRAPHY 10, no. 203 (Dec. 1, 1863): 463-465.

EXCELSIOR.
E335 'Excelsior.' "The Processes used by a successful Photographer." AMERICAN JOURNAL OF PHOTOGRAPHY, AND THE ALLIED ARTS AND SCIENCES n. s. vol. 9, no. 3 (Oct. 1, 1866): 69-71.

F

J. G. F.

F1 J. G. F. "The Photographic Tourist: A Tour on the Borders of Devon and Cornwall." PHOTOGRAPHIC NEWS 4, no. 95-98 (June 29 - July 20, 1860): 102-103, 126-127, 137-138.

W. A. F.

F2 W. A. F. "A Photographer's Opinion about the Solar Camera Quarrel." PHILADELPHIA PHOTOGRAPHER 2, no. 23 (Nov. 1865): 183-184.

FAHRENBERG, ALBERT. (MONTEREY, MEXICO)

[An Albert Fahrenberg, born in Cologne, Germany, ca. 1825 emigrated to USA ca. 1850 and worked for G. T. Shaw, Louisville, KY in 1859-60. Also listed as a portrait painter.]

F3 "Stereoscopic Views." HUMPHREY'S JOURNAL OF PHOTOGRAPHY, AND THE ALLIED ARTS AND SCIENCES 20, no. 20 (Apr. 15, 1869): 319. ["...Albert Fahrenberg, a subscriber for over seven years, residing in Monterey, Mexico, for a lot of beautiful stereoscopic views, taken in and around Monterey,...of streets, public buildings, mountains and valleys, of extensive mining operations, and numerous views of the heterogeneous population."]

FALK, BENJAMIN JOSEPH. (1853-1925) (USA)

F4 Falk, B. J. "Correspondence." ANTHONY'S PHOTOGRAPHIC BULLETIN 5, no. 12 (Dec. 1874): 418. [Falk claims to have made a crayon group, 53" x 66", copied from an imperial photograph by Rockwood, which is larger than others. Editor comments that he has seen even larger by M. B. Brady.]

F5 "Matters of the Month." PHOTOGRAPHIC TIMES 11, no. 129 (Sept. 1881): 376. [Note that B.J. Falk, for the last four years at 347 E. 14th Street, has moved to 947-949 Broadway.]

F6 "Boston vs. New York." PHOTOGRAPHIC TIMES 14, no. 161 (May 1884): 230. [Comment on exchange of claims in New York, NY and Boston papers about B. J. Falk in New York successfully photographing a theatrical performance by electricity of Wallack's Theatre in 1883 and Notman, of Boston, successfully doing the same at Saunders Theatre, Harvard in 1880.]

F7 "Correspondence: Photographic Claims." PHOTOGRAPHIC TIMES 15, no. 213 (Oct. 16, 1885): 596. [Huffy letter from Falk disputing the claim that the theatrical organization was the first to take a group portrait of more than 1000 individuals. He claims to have made such a photo in 1883.]

F8 "General Notes." PHOTOGRAPHIC TIMES 16, no. 262 (Sept. 24, 1886): 505. [Comment that Falk has raised his prices, praise for his courage.]

F9 "Photographer Falk a Buyer of Patents." PHOTOGRAPHIC TIMES 17, no. 287 (Mar. 18, 1887): 136. [Report from "N. Y. Tribune," that a newspaper claimed that Falk was supporting inventors and how he was then delayed with bizarre propositions.]

F10 Falk, B. J. "Photographing Theatrical Scenes by Electric Light." PHOTOGRAPHIC TIMES 17, no. 296 (May 20, 1887): 255.

F11 "Commercial Intelligence: Thousands of Negatives Destroyed." PHOTOGRAPHIC TIMES 18, no. 341 (Mar. 30, 1888): advertising section p. i. [Note that fire at 947 Broadway destroyed an estimated 10,000 negatives of celebrities. Further note in next issue that "...the 'New York World' of recent date gave an extended graphic account of the fire in Falk's studio."]

F12 "Our Illustration." ANTHONY'S PHOTOGRAPHIC BULLETIN 19, no. 7 (Apr. 14, 1888): 220, plus frontispiece. 1 b & w. [Portrait by B. J. Falk of New York. Photo not bound in this copy.]

F13 "Commercial Intelligence." PHOTOGRAPHIC TIMES 18, no. 346 (May 4, 1888): advertising section p. i. [Note that Lafayette W. Seavey, the well-known artist, is engaged upon an entire new outfit of backgrounds and accessories for Falk's recently burned-out gallery ...already painted thirty grounds of new design.]

F14 "Our Illustration." ANTHONY'S PHOTOGRAPHIC BULLETIN 19, no. 9 (May 12, 1888): 276, plus frontispiece. 1 b & w. [Photo not bound in this copy.]

F15 Falk, B. J. "Correspondence. Improved Copyright for Photographs." PHOTOGRAPHIC TIMES 18, no. 371 (Oct. 26, 1888): 511-512. [Letter includes a circular written and circulated by Falk calling for improved copyright protection.]

F16 Falk, Benjamin J. "Photographic Copyright." ANTHONY'S PHOTOGRAPHIC BULLETIN 19, no. 20 (Oct. 27, 1888): 629-631.

F17 "'A Portrait Study.'" PHOTOGRAPHIC TIMES 19, no. 389 (Mar. 1, 1889) [Portrait of the actress Isabella Irving.]

F18 1 photo (Portrait of Thomas Edison) as first frontispiece. AMERICAN ANNUAL OF PHOTOGRAPHY AND PHOTOGRAPHIC TIMES ALMANAC FOR 1890 (1890): 27, unnumbered leaf before title page. 1 b & w. [Note on p. 37.]

F19 1 photo (Portrait of Thomas A. Edison). PHOTOGRAPHIC TIMES 21, no. 525 (Oct. 9, 1891): 497, plus frontispiece. 1 b & w.

F20 "The Studios of New York: Part 4." PHOTOGRAPHIC TIMES 22, no. 550 (Apr. 1, 1892): 171-172. [Alman Studio. Falk's Studio.]

F21 "Our Gallery of Players. XLVIII. Emma Eames Story." ILLUSTRATED AMERICAN 11, no. 119 (May 28, 1892): 62, 70. 1 b & w.

F22 "Notes and News: An Interesting Interview with Mr. B. J. Falk." PHOTOGRAPHIC TIMES 23, no. 592 (Jan. 20, 1893): 33-34. [From the "St. Louis Times-Democrat."]

F23 "A Copyright Case." PHOTOGRAPHIC TIMES 23, no. 619 (July 28, 1893): 410. [Falk sued R. M. Donaldson for infringement of copyright in using his phooto of he actress Julia Marlowe for a lithograph. Falk won his suit.]

F24 1 photo ("Violinist Leonora von Stosch.") as frontispiece. PHOTOGRAPHIC TIMES 23, no. 623 (Aug. 25, 1893): 461, plus frontispiece. 1 b & w. [Note on p. 461.]

F25 1 photo ("Julia Marlow") as frontispiece. PHOTOGRAPHIC TIMES 24, no. 658 (Apr. 27, l894): before p. 257. [Note on p. 259.]

F26 Schwab, Frederick A. "A Year's Amusements." COSMOPOLITAN 17, no. 1 (May 1894): 18-29. 13 b & w. [Portraits of actors and actresses. Photographers are: The Cameron Studio [H. H. Hay Cameron]; B. J. Falk; Sarony; Reutlinger; Van Bosch; Benque & Co.; Bettini; Davis & Sanford.]

F27 Sandow, Eugen. "How to Preserve Health and Attain Strength." COSMOPOLITAN 17, no. 2 (June 1894): 169-176. 12 b & w. [Photos of the strongman Sandow, "copyright 1894, B. J. Falk, N.Y."]

F28 Woodbury, Walter E. "Child Studies." AMERICAN ANNUAL OF PHOTOGRAPHY AND PHOTOGRAPHIC TIMES ALMANAC FOR 1895 (1895): 128-135. 9 b & w.

F29 "Process of the Automatic Photographic Co." WILSON'S PHOTOGRAPHIC MAGAZINE 32, no. 465 (Sept. 1895): 393-394. [Automated printing of large groups of photos. The organization issued a publication(?) titled "Celebrities Monthly," each issue contining "10 actual photographs of prominent persons, of cabinet size, sold at the newstands at 25 cents a copy." Almost all negatives used so far from B. J. Falk.]

F30 16 photos in one panel ("Selected Studies"). WILSON'S PHOTOGRAPHIC MAGAZINE 32, no. 466 (Oct. 1895): unnumbered leaf following p. 472. 16 b & w. [Portraits of actors, actresses, models.]

F31 "Editor's Table: The Calendar of Beauty & a Holiday Souvenir." WILSON'S PHOTOGRAPHIC MAGAZINE 32, no. 466 (Oct. 1895): 479. ["12 elegant cabinet cards, each one bearing the portrait of a celebrated actress with the calendar of the month under the picture... knotted together with a silken cord... sold for 75 cents, printed by the Automatic Photograph Co.," pictures all from negatives by Mr. B. J. Falk."]

F32 "Benjamin Joseph Falk: A Professional Interview." WILSON'S PHOTOGRAPHIC MAGAZINE 32, no. 467 (Nov. 1895): 500-502, plus unnumbered leaf after p. 500. 1 illus. [Born New York, NY in 1853. Studied at the NY Academy of Design, with G. G. Rockwood. Opened his own studio in 1877. Developed a reputation as one of the leading photographer of actors, actresses, etc. in America. Portrait of Falk, by Max Platz.]

F33 16 photos on one plate ("Professional Photographs"). WILSON'S PHOTOGRAPHIC MAGAZINE 32, no. 467 (Nov. 1895): unnumbered leaf following p. 512. [16 views of actresses.]

F34 "Our Pictures." WILSON'S PHOTOGRAPHIC MAGAZINE 32, no. 468 (Dec. 1895): 571-572, plus frontispiece. 1 b & w. [Genre portrait "Colombe."]

F35 "On the Ground Glass." WILSON'S PHOTOGRAPHIC MAGAZINE 33, no. 473 (May 1896): 194. [Note that 48 studies by B. J. Falk available for $1.00, published by the Automatic Photographic Co.]

F36 8 photos ("Photographic Studies"). WILSON'S PHOTOGRAPHIC MAGAZINE 33, no. 475 (July 1896): as frontispiece before p. 289. [Studio portraits.]

F37 16 photos in one plate ("Children of the Stage") WILSON'S PHOTOGRAPHIC MAGAZINE 33, no. 475 (July 1896): unnumbered leaf following p. 320. 16 b & w. [Brief note on p. 325.]

F38 "Forty-Eight Photographic Studies by Falk for $1." WILSON'S PHOTOGRAPHIC MAGAZINE 33, no. 475 (July 1896): 328-329.

F39 16 photos on one panel ("A Variety of Studies"). WILSON'S PHOTOGRAPHIC MAGAZINE 33, no. 479 (Nov. 1896): unnumbered leaf following p. 496. 16 b & w. [Portraits by: W. M. Morrison, Chicago (4); B. J. Falk, N.Y., (4); R. H. Furman, San Diego,

(1); S. L. Stein, Milwaukee, (2); J. F. Ryder, Cleveland, (3). Brief note on pp. 519-520]

F40 Falk, Benjamin J. "A Suggestion." PHOTOGRAPHIC MOSAICS: 1897 33, (1897): 107-109.

F41 "Thomas Aquinas." "About Studying the Work of Others." PHOTOGRAPHIC MOSAICS: 1897 33, (1897): 266-270. 4 b & w. ["Studies in Posing, Series II," by B. J. Falk, published by Edward L. Wilson.]

F42 Frohman, Daniel. "Actress Aided by Camera." COSMOPOLITAN 22, no. 4 (Feb. 1897): 413-420. 13 b & w. [Discusses the evolution of theatrical publicity portrait. Mentions B. J. Falk. Photos are by Downey (London); B. J. Falk (New York); Aime Dupont (New York); Schloss (New York).]

F43 "Some Examples of Recent Art." COSMOPOLITAN 22, no. 4 (Feb. 1897): 457-464. 8 b & w. [Portfolio of photographs. James L. Breese (3); B. J. Falk (2); Aime Dupont (1); George Rockwood (1); Rudolph Eickemeyer, Jr. (1).]

F44 "Recent Photographic Art." COSMOPOLITAN 23, no. 1 (May 1897): 6 unnumbered leaves after p. 112. 21 b & w. [Portfolio. Primarily actresses or models. Photos by B. J. Falk (6); Sarony (2); Baker Art Gallery (7); E. J. McCullagh (2); Kate Matthews (3); Th. Pentlarge (1). (May be binder's error of placement in this issue).]

F45 Wilson, Edward L. "On the Ground Glass." WILSON'S PHOTOGRAPHIC MAGAZINE 34, no. 485 (May 1897): 193. [Comment on work from B. J. Falk's Studio.]

F46 DeKoven, Reginald. "Music-Halls and Popular Songs." COSMOPOLITAN 23, no. 5 (Sept. 1897): 531-540. 28 b & w. [Actresses. Portraits by J. Hall (9); B. J. Falk (8); Charlot, Paris (5); Nadar, Paris (3); Reutlinger, Paris (3).]

F47 "The Falk Studio, New York." WILSON'S PHOTOGRAPHIC MAGAZINE 35, no. 496 (Apr. 1898): 161-165, plus frontispiece. 1 b & w. 5 illus. [Views of the Falk Studio.]

F48 "Without Prejudice." "Some Plays and Their Actors." COSMOPOLITAN 26, no. 3 (Jan. 1899): 4 unnumbered leaves after p. 360. 12 b & w. [Portraits of actresses. Photos by B. J. Falk; Pach; Aime Dupont; Strauss.]

F49 "Without Prejudice." "Some Plays and Their Actors." COSMOPOLITAN 26, no. 4 (Feb. 1899): 4 unnumbered leaves after p. 472. 8 b & w. [Portraits of actresses. Photos by Aime Dupont; J. Schloss; Ogerau, Paris; B. J. Falk.]

F50 "The New Falk Studio, N.Y." WILSON'S PHOTOGRAPHIC MAGAZINE 37, no. 520 (Apr. 1900): 160-166, plus unnumbered leaf, plus frontispiece. 7 b & w. 11 illus. [7 portraits, 11 views of the Falk studio interior.]

F51 "News and Notes." WILSON'S PHOTOGRAPHIC MAGAZINE 37, no. 525 (Sept. 1900): 400. [About new Falk Studio at the Waldorf-Astoria Hotel.]

F52 "Summer Days in the Poorest and Richest Districts of the Metropolis of America." COLLIER'S WEEKLY 29, no. 18 (Aug. 2, 1902): 10-11, 13. 2 b & w. [Double-page spread with 1 panoramic view of New York ghetto, 1 panoramic view of Wall & Broad Streets.]

F53 1 photo (NY politician Charles F. Murphy). WORLD'S WORK 7, no. 1 (Nov. 1903): 4047.

F54 1 photo (Late Rev. Samuel H. Hadley). WORLD'S WORK 11, no. 6 (Apr. 1906): 7359.

F55 Falk, B. J. "A Novel Shutter Release." AMERICAN ANNUAL OF PHOTOGRAPHY: 1912 26, (1912): 254-255, plus unnumbered leaf following p. 9. 2 b & w.

F56 "Celebrities Monthly: The sad story of a magazine born eighty years too soon." AMERICAN HERITAGE 33, no. 2 (Feb. - Mar. 1982): 64-67. 9 illus. [Benjamin Joseph Falk publisher of "Celebrities Monthly," beginning in 1895. Contained tipped-in photographs. A photo and a page of biography placed side by side. Each issue contained about 10 prints. Lasted two years. Brief biography of Falk.]

FALKENSHIELD, ANDREW. (1821-1896) (DENMARK, USA)
[Born on Dec. 1, 1821 in Copenhagen, Denmark. He may have worked for Alexander Hesler in Chicago in the 1850s. By 1856 he was in St. Paul, MN, working for J. E. Whitney. Opened his own studio in St. Paul in 1863. Operated the studio until 1873, but apparently concentrated on painting in the latter years. He worked with C. A. Zimmerman in 1879. Falkenshield photographed the Northern Plains Indian tribes in the 1860s and 1870s. He died in St. Paul in Oct. 1896.]

F57 White, Helen McCann. ""His World Was Art": Dr. Andrew Falkenshield." MINNESOTA HISTORY 47, no. 5 (Spring 1981): 184-188. 6 illus. [Falkenshield photographed and painted portraits in St. Paul, MN from ca. 1856-1890s. Emmigrated from Denmark in 1852. Took cartes-de-visite in 1850s-1860s —portraits, views. Colored portraits for the photographer Moses C. Tuttle in St. Paul in 1856. Then worked for Joel E. Whitney until 1863, when he established his own gallery. Died Oct. 1896.]

FALL, THOMAS. (ca. 1833-1900) (GREAT BRITAIN)
F58 Portrait. Woodcut engraving credited "From a photograph by Fall." ILLUSTRATED LONDON NEWS 73, (1878) ["Late Lord Chelmsford." 73:2051 (Oct. 19, 1878): 360.]

F59 Portraits. Woodcut engravings credited "From a photograph by T. Fall." ILLUSTRATED LONDON NEWS 75, (1879) ["Late Lieut. F. C. Frith." 75:2095 (Aug. 9, 1879): 140. "Col. Noel Money." 75:2112 (Dec. 6, 1879): 529. "Sir Daniel Cooper." 75:2114 (Dec. 20, 1879): 585.]

F60 "Obituary of the Year: Thomas Fall." BRITISH JOURNAL PHOTOGRAPHIC ALMANAC 1901 (1901): 674. [Died at age 67. Born at Leyburn, in North Yorkshire. Apprenticed to lithographic printing but took up photography in his early manhood, first as a travelling worker, then with a studio in Bedale. Came to London and joined the new firm of Elliott & Fry, where he gained a wide reputation for portraiture of children and later, animals.]

FALL, W. (GREAT BRITAIN)
F61 "The Albert Edward Bridge over the Severn, on the Coalbrookdale Railway." ILLUSTRATED LONDON NEWS 45, no. 1286 (Nov. 5, 1864): 463, 465. 1 illus. ["Our Engraving is executed from an excellent photograph taken by Mr. W. Fall, photographer, of Market-square, Ironbridge, Salop."]

FALLON.
F62 "Fallon's Stereopticon." AMERICAN JOURNAL OF PHOTOGRAPHY AND THE ALLIED ARTS & SCIENCES n. s. vol. 6, no. 6 (Sept. 15, 1863): 138-139. [A Stereopticon display at Irving Hall

(New York, NY?). Glass stereoscopic views, projected. Over 1000 views.]

FALLOWFIELD, JONATHAN. (GREAT BRITAIN)
F63 Fallowfield, Jonathan. Edited by W. Hunt Lee. *A Simple and Practical Guide to Photography*. Lambeth: South London Photographic Depot, 1863. n. p.

FANNON, G. see MARCHANT, G. & G. FANNON.

FARAREL.
F64 "The Imperial Chinese Despatch-Boat Keang Soo." ILLUSTRATED LONDON NEWS 43, no. 1223 (Sept. 26, 1863): 320. 1 illus. ["...from a photograph by Mr. Fararel, of the Chinese Government service."]

FARDON, GEORGE ROBINSON. (1807-1886) (GREAT BRITAIN, USA, CANADA)
BOOKS
F65 Fardon, George R. *San Francisco Album: Photographs of the Most Beautiful Views and Public Buildings of San Francisco;* Photographed by G. R. Fardon. San Francisco: Herre & Bauer, 1856 3 l. 30 l. of plates. 33 b & w [Original photos.]

F66 Dana, Richard Henry. *Two Years Before the Mast...* Edited from the original manuscript...by John Haskell Kemble. With original illustrations by Robert A. Weinstein. Los Angeles: Ward Ritchie Press, 1964. 2 vol. pp. b & w. illus. [A gallery of photographs by G. R. Fardon and E. Muybridge, on pp. 496-527.]

F67 Sobieszek, Robert A., introduction by. *San Francisco in the 1850s: 33 Photographic Views by G. R. Fardon*. New York: Dover Publications, Inc. with the International Museum of Photography at the George Eastman House, 1977. viii, 72 pp. 33 b & w. [Unabridged republication of "San Francisco Album. Photographs of the Most Beautiful Views and Public Buildings of San Francisco," San Francisco: Herre & Bauer, 1856. With a new introduction by Robert A. Sobieszak.]

PERIODICALS
F68 "Victoria, Vancouver Island." ILLUSTRATED LONDON NEWS 42, no. 1183 (Jan. 10, 1863): 45, 50. 2 illus. ["...copy of a clever photographic panorama by Mr. Geo. R. Fardon, a pioneer of the art in Vancouver Island, whose views in that department at the International Expedition were examined with interest by many."]

F69 Schwartz, Joan M. "G. R. Fardon, photographer of early Vancouver." AFTERIMAGE 6, no. 5 (Dec. 1978): 5, 21. 2 b & w. [Bk. rev.: "San Francisco in the 1850s: 33 Photographic Views by G. R. Farden," introduction by Robert Sobieszek. Although a review, this essay provides previously unknown information about Fardon. Born Birmingham, England in 1807. Emigrated to New York, then to San Francisco, California in 1849. Made the albums of views there, which were first published in 1856. In 1858 moved to Victoria, Canada. Visited England in 1865, leaving his gallery in the hands of Noah Shakespeare. Returned in 1866 and worked until he retired in the early 1870s. Died in Victoria in August, 1886.]

FARGIER.
F70 Fargier. "Carbon Printing." HUMPHREY'S JOURNAL OF PHOTOGRAPHY, AND THE ALLIED ARTS AND SCIENCES 12, no. 21 (Mar. 1, 1861): 334-336. [From "Photo. Notes."]

FARIS & HAWKINS. (CINCINNATI, OH)

F71 "Note." PHOTOGRAPHIC ART JOURNAL 1, no. 3 (Mar. 1851): 187-188. [An extract from "Arthur's Home Journal" claiming that the daguerreotypes of America superior to those of Europe and mentioning Faris & Hawkins as examples.]

FARIS, THOMAS see also FARIS & HAWKINS.

FARIS, THOMAS. (USA)

[Portrait painter, began making daguerreotypes in Ohio ca. 1841. Partner with E. C. Hawkins in Cincinnati, OH in 1843. From 1844 to 1857 he opened a series of galleries in Cincinatti. Bought Root's New York, NY gallery in 1858, but Root repossessed the gallery in 1859. Made several genre portraits in late 1850s, successfully worked with opal glass photographs in 1860s, was active until the 1880s.]

F72 "Editorials." DAGUERREAN JOURNAL 2, no. 4 (July 1, 1851): 114. [Lithograph of Julia Dean, drawn by S. Gengembre & W. Anderson, from a daguerreotype by T. Faris, of Cincinnati, OH.]

F73 "Funeral Honors Paid to General Persifer F. Smith at Cincinnati." HARPER'S WEEKLY 2, no. 76 (June 12, 1858): 373. 2 illus. ["These views were photographed by Faris, of Cincinnati."]

F74 "Our Illustrations. - I. Mr. H. Watkins." PHOTOGRAPHIC AND FINE ART JOURNAL 11, no. 8 (Aug. 1858): frontispiece, 245. 1 b & w. [Original photograph, of "Mr. H. Watkins as Waundering Walter, in the drama of "The Maid of Penrith", tipped in.]

F75 "Note." AMERICAN JOURNAL OF PHOTOGRAPHY AND THE ALLIED ARTS AND SCIENCES n. s. vol. 1, no. 9 (Oct. 1, 1858): 146. [Series of five pictures, symbolizing the five senses [portrayed by two very pretty little girls] mentioned. Five verses, on light, sound, smell, taste, and feeling, used to display the photos.]

F76 Seely, Charles A. "Editorial Department." AMERICAN JOURNAL OF PHOTOGRAPHY AND THE ALLIED ARTS & SCIENCES n. s. vol. 7, no. 1 (July 1, 1864): 23. [Praise for Thomas Faris' opal glass photos.]

F77 Faris, Thomas. "Personal Reminiscences." PHOTOGRAPHIC TIMES 14, no. 165 (Sept. 1884): 490-493. [Paper read before the Photographic Section of the American Institute. Recounts his first daguerreotype self-portrait, which required a five minute exposure time in full sunlight, through a blue glass plate. Describes how Mr. Johnson, "one of Plumbe's operators in New York City," accidentally discovered an improvement that made portraiture more possible. Discusses early events, including his photographing elephants for publicity.]

FARR, H. R. (1839-1893) (USA)

F78 "Wisconsin. - Artesian Well at the Corner of Bluff and Wisconsin Streets, Prairie du Chein. - From a Photograph by H. R. Farr." FRANK LESLIE'S ILLUSTRATED NEWSPAPER 44, no. 1143 (Aug. 25, 1877): 425. 1 illus.

FARRAND, CAMILLUS. (ca. 1821-1879) (USA, PERU)

F79 "Our Illustrations." PHOTOGRAPHIC AND FINE ART JOURNAL 10, no. 2 (Feb. 1857): unnumbered p., 58-59. 1 b & w. [Original photographic print, tipped-in. Portrait of an Iowa Indian Chief, by Farrand, from a daguerreotype. Image missing from this volume.]

F80 "Our Illustrations." PHOTOGRAPHIC AND FINE ART JOURNAL 10, no. 12 (Dec. 1857): unnumbered page, 376. 1 b & w. ["Portrait of Rev. Uriah Marvine," negative by C. Farrand.]

F81 Farrand, C. "Correspondence: An Echo From the Andes." ANTHONY'S PHOTOGRAPHIC BULLETIN 3, no. 4 (Apr. 1872): 527-528. [Farrand, an American, gave up portrait photography "some years ago," went to Equador and Columbia taking views. Mentions having worked in Riobamba, Equador, moving from Bogata to Cali, Columbia.]

F82 "Obituary." ANTHONY'S PHOTOGRAPHIC BULLETIN 10, no. 3 (Mar. 1879): 95. [From "NY Herald." Camellus Farrand, a photographer in New York, NY in 1850's travelled to South America in 1857 to take stereo views of scenery. Stayed in South America for the rest of his life, with two short visits back to USA. Travelled and photographed in New Grenada, Equador, Bolivia and Peru, making between 2,000 and 3,000 views. Sent a collection of mummified heads of Incas found near Cuzco, to Smithsonian Institution. 58 at death, left a wife, son, and daughter in Piura, Peru.]

FARREN, W. (CAMBRIDGE, ENGLAND)

F83 Portrait. Woodcut engravings, credited to "From a Photograph by W. Farren." ILLUSTRATED LONDON NEWS 60, (1872) ["Late Rev. F. D. Maurice." 60:1701 (Apr. 13, 1872): 353.]

FASSETT, SAMUEL MONTAGUE. (1824/25-) (USA)

[Artist and daguerreotypist. Had a gallery in Chicago, IL as early as 1856. Partnership Fassitt & Cook from 1857 through 1860. Enlarged his gallery in 1862, his chief operator then being S. R. Divine. Worked through the 1870s at least.]

F84 "Personal and Art Intelligence." PHOTOGRAPHIC AND FINE ART JOURNAL 12, no. 1 (June 1859): 32. [From "NY Daily Times." Fassett is from Chicago, IL.]

F85 "Editorial Department." AMERICAN JOURNAL OF PHOTOGRAPHY AND THE ALLIED ARTS & SCIENCES n. s. vol. 5, no. 1 (July 1, 1862): 24. [Report of an article in the "Chicago Tribune," by S. R. Divine, the chief photographer in S. M. Fassit's Chicago gallery stating that the gallery is being enlarged and improved.]

F86 Portrait. Woodcut engraving, credited "From a Photograph by S. M. Fassett." FRANK LESLIE'S ILLUSTRATED NEWSPAPER 33, (1871) illus. ["Hon. R. B. Mason, Mayor of Chicago." 33:842 (Nov. 18, 1871): 152.]

F87 "The German Peace Jubilee in Chicago. - The Procession Passing into Wright's Grove, Through the Triumphal Arch on Wells Street, near Clark. - From a Photograph by Fassett." FRANK LESLIE'S ILLUSTRATED NEWSPAPER 32, no. 820 (June 17, 1871): 221. 1 illus. [Street scene, with crowds.]

F88 Portrait. Woodcut engraving, credited "From a Photograph by S. M. Fassett, Chicago. FRANK LESLIE'S ILLUSTRATED NEWSPAPER 47, (1879) ["The late Gen. D. C. McCallum." 47:1217 (Jan. 25, 1879): 380.]

FASSITT, FRANCIS T. see also BORDA & FASSITT & GRAFF.

FASSITT, FRANCIS T. (d. 1905) (USA)

F89 Fassitt, F. T. "A Few Words in Favor of an Old Friend. - The Malt Process." AMERICAN JOURNAL OF PHOTOGRAPHY AND THE ALLIED ARTS & SCIENCES n. s. vol. 6, no. 1 (July 1, 1863): 12-16. [Fassitt from Philadelphia. Describes his photographic trip to take landscape view in northern PA.]

F90 Fassitt, F. T. "How to Make Stereoscopic Positives. On Glass in the Camera." PHILADELPHIA PHOTOGRAPHER 1, no. 6 (June 1864): 81-81.

FAST, FREDERICK. (GREAT BRITAIN)
F91 Fast, Frederick. "The Camera Chora." PHOTOGRAPHIC AND FINE ART JOURNAL 9, no. 5 (May 1856): 139. [From "J. of Photo. Soc., London." Mr. Fast describes his camera and apparatus.]

FAUGHT see JOHNS & FAUGHT.

FAULKNER, ROBERT. (d. 1890) (GREAT BRITAIN)
F92 "A New Method of Preparing Graduated Backgrounds." ANTHONY'S PHOTOGRAPHIC BULLETIN 3, no. 12 (Dec. 1872): 761-762. [From "London Photo. News." Faulkner had a reputation as a children's photographer.]

F93 Portrait. Woodcut engraving credited "From a photograph by R. Faulkner, Kensington Gardens Sq." ILLUSTRATED LONDON NEWS 62, (1873) ["H. W. B. Davis, A.R.A." 62:1746 (Feb. 15, 1873): 157.]

F94 Faulkner, Robert. BRITISH JOURNAL PHOTOGRAPHIC ALMANAC 1875 (1875): 77-78.

F95 "Simplicity." BRITISH JOURNAL PHOTOGRAPHIC ALMANAC 1876 (1876): frontispiece. 1 b & w. [Genre portrait by R. Faulkner, Kensington Garden. Reproduced by Taylor Brothers, Fox & Co.'s photo-mechanical process.]

F96 Faulkner, Robert. "The Powder Carbon Process." BRITISH JOURNAL PHOTOGRAPHIC ALMANAC 1876 (1876): 55-57.

F97 Faulkner, Robert. "Drapery." BRITISH JOURNAL PHOTOGRAPHIC ALMANAC 1877 (1877): 130-131.

F98 Faulkner, Robert. "Framing and Mounting Photographs." BRITISH JOURNAL PHOTOGRAPHIC ALMANAC 1879 (1879): 151-152.

F99 "Fracas in a Studio." ANTHONY'S PHOTOGRAPHIC BULLETIN 10, no. 9 (Sept. 1879): 279-280. [From "Br J of Photo." Faulkner (London) assaulted by an irate customer.]

FAUVEL-GOURAUD, FRANÇOIS see also DAGUERRE, LOUIS J.-M.

FAUVEL-GOURAUD, FRANÇOIS. (FRANCE, USA)
F100 Fauvel-Gouraud, François. Description of the Daguerreotype Process, Or A Summary of M. Gouraud's Public Lectures, According to the Principles of M. Daguerre. With a Description of a Provisory Method for Taking Human Portraits. Boston: Dutton & Wentworth, 1840. 8 pp. illus. [Reprinted 1973, Arno Press]

F101 Phreno-mnemotechy; or The Art of Memory: The Series of Lectures, Explanatory of the Principles of the System, Delivered in New York and Philadelphia, in the Beginning of 1844, by Francis Fauvel-Gouraud... Now First Published Without Alterations or Omissions in the Practical Applications of the System. New York, London: Wiley & Putnam, 1845. 566 pp. illus.

PERIODICALS
F102 "The 'Daguerreotype.'" KNICKERBOCKER, OR NEW YORK MONTHLY MAGAZINE 14, no. 6 (Dec. 1839): 560-561. [Review, by an unnamed American, of Daguerre's images, displayed in Paris, with a recommendation to attend Gouraud's lectures soon to occur in New York, NY.]

F103 "The Dagguereolite." CINCINNATI DAILY CHRONICAL 1, no. 38 (Jan. 17, 1840): 2, (col. 1).

F104 "Letter from Gouraud." NEW YORK EVENING POST no. 11556 (Jan. 7, 1840): 2, (col. 5).

F105 "Gouraud annuouncement of public lectures on daggereotype process." NEW YORK DAILY CHRONICAL 5, no. 233 (Feb. 17, 1840): 1, (col. 3).

F106 "Gouraud Public Demonstration in Boston." BOSTON DAILY EVENING TRANSCRIPT 11, no. 2949 (Mar. 7, 1840): 2, (col. 2). [This announcement appeared in the paper on Mar. 11, 17, 24, 28 and Apr. 4, and 14.

F107 "The Daguerreotype in Providence." PROVIDENCE JOURNAL (May 19, 1840): n. p. [Advertisment.]

F108 "The Daguerreotype." PROVIDENCE JOURNAL (May 23, 1840): n. p.

F109 Gouraud, François. "A Description of the Daguerreotype Process by Daguerre's Agent in America." IMAGE 9, no. 1 (Mar. 1960): 18-37. [Facsimile reproduction of "Description of the Daguerreotype Process," published in Boston in 1840 and summary of public lectures given by François Gouraud in Boston, in 1840.]

FAY & FARMER. (MALONE, NY)
F110 "The Adirondack Mountains." HARPER'S WEEKLY 11, no. 557 (Aug. 31, 1867): 548. 9 illus. ["...the photographers Fay & Farmer, of Malone, NY." Views.]

FAY & FERRIS. (MALONE, NY)
F111 "Honor to Whom Honor Is Due." ANTHONY'S PHOTOGRAPHIC BULLETIN 2, no. 9 (Sept. 1871): 296. [Letter from Fay & Ferris (Malone, NY) claiming that the design for the portable gallery building, published earlier, had not been designed by N. L. Stone, but by themselves.]

FAYEL.
F112 Fayel, Mr. "Our Foreign Make-Up: New Process of Photomicrography." PHOTOGRAPHIC TIMES 7, no. 77 (May 1877): 112. ["From "Moniteur de la Photographie" (Mar. 1., 1877).]

FEHRENBACHS.
F113 "Garibaldian Volunteers." ILLUSTRATED LONDON NEWS 37, no. 1055 (Oct. 20, 1860): 371. 1 illus. ["From a photograph by Herr Fehrenbachs." British volunteers to Italy. Studio group portrait.]

FEILBERG, K.
F114 "The Duke of Edinburgh at Penang." ILLUSTRATED LONDON NEWS 56, no. 1579 (Feb. 5, 1870): 135-137. 3 illus. [Penang an island in the Strait of Malacca, near Malaya. "Views from photographs taken by Mr. K. Feilberg, of Penang."]

FELLOWS see also ROBERTS & FELLOWS.

FELLOWS, CHARLES T. (d. 1898) (USA)
F115 Fellows, Charles T. "The Transit of Mercury." WILSON'S PHOTOGRAPHIC MAGAZINE. 32, no. 457 (Jan. 1895): 15-18. 3 b & w. [Fellows at the U.S. Naval Observatory, Washington, DC.]

F116 "Obituary: Charles T. Fellows." WILSON'S PHOTOGRAPHIC MAGAZINE 35, no. 497 (May 1898): 233-234. [Began photographing over twenty years ago in Philadelphia. Assisted Ed. L. Wilson at the photographic department at both the Philadelphia Centennial and New Orleans Expositions. Formed firm of Roberts & Fellows, dealers in stereo views, lantern slides. A few years later became the official photographer at the Naval Observatory at Washington, D.C., where he worked until his death. Died on April 8th, 1898.]

FELLOWS, H. I. (ALBANY, NY)
F117 "Burning of the Academy of Music, Albany." HARPER'S WEEKLY 12, no. 581 (Feb. 15, 1868): 109. 1 illus. ["Photographed by H. I. Fellows, Albany."]

FENNEMORE, GEORGE H. & F. S. KEELER.
F118 "Our Picture - Cabinet Portrait." PHILADELPHIA PHOTOGRAPHER 4, no. 41 (May 1867): 157-159. [Negs. made by George H. Fennemore at F. S. Keeler's establishment.]

F119 "Our Picture." PHILADELPHIA PHOTOGRAPHER 5, no. 53 (May 1868): frontispiece, 181. 1 b & w. [The actual photographer is George H. Fennemore of Keeler's Gallery in Philadelphia, PA.]

F120 "Editor's Table." PHILADELPHIA PHOTOGRAPHER 6, no. 62 (Feb. 1869): 63. [Note that George H. Fennemore has entered into partnership with F. S. Keeler at 8th and Market Sts., Philadelphia, PA.]

FENNEMORE, GEORGE H. [SUDDARDS & FENNEMORE]
F121 "Editor's Table: Burnt-in Enamels." PHILADELPHIA PHOTOGRAPHER 8, no. 93 (Sept. 1871): 310-311.

FENNEMORE, GEORGE H.
F122 Fennemore, George H. "A Few Words On Collodion." PHILADELPHIA PHOTOGRAPHER 5, no. 49-50 (Jan. - Feb. 1868): 17-18, 47-49.

F123 Fennemore, George H. "On Intensifying Negatives." PHILADELPHIA PHOTOGRAPHER 5, no. 60 (Dec. 1868): 414-416.

F124 Fennemore, George H. "Stepping Stones Over Rough Places." PHILADELPHIA PHOTOGRAPHER 6, no. 64-72 (Apr. - Dec. 1869): 102-104, 180-181, 238-240, 270-271, 399-400.

F125 Fennemore, George H. "Intensity." PHILADELPHIA PHOTOGRAPHER 8, no. 96 (Dec. 1871): 386-387.

FENNEMORE, JAMES H. (1849-1941) (GREAT BRITAIN, USA)
[Born in London, England on Sept. 7, 1849. Worked for Savage & Ottinger in Salt Lake City, UT in 1870. In 1872 served as the survey photographer for Powell's U. S. Topographical and Geological Survey of the Colorado of the West. Opened his own gallery in Salt Lake City in 1874. Died in Phoenix, AZ on Jan. 25, 1941.]

F126 "Utah. - The Mountain Meadows Massacre. - The Body of the Mormon Elder, John D. Lee, Deposited in Its Coffin Immediately after His Execution, March 23d," "Scenes and Incidents of the Execution," and "John D. Lee Sitting for His Photograph a Few Minutes Previous to His Execution - From a Photograph, Taken Expressly for this Paper, by Fennimore, [sic Fennemore ?] Beaver City." FRANK LESLIE'S ILLUSTRATED NEWSPAPER 44, no. 1124 (Apr. 14, 1877): 109-111. 6 illus. [Views of the execution, portrait, etc.]

F127 Morgan, Dale L., editor. William C. Darrah et al. "The Exploration of the Colorado River and the High Plateus of Utah in

1871-72." UTAH HISTORICAL QUARTERLY 16-17, (Jan. 1948 - Dec. 1949): 1-540. [These two volumes of the "Quarterly" published as a monographic volume dealing with the Powell Colorado River Exploring Expedition of 1871-1872. It contains much information, diaries etc. of participants. See specifically William Culp Darrah's "Beaman, Fennemore, Hillers, Dellenbaugh, Johnson and Hattan," on 491-503 for biographies of these members of the expedition. E. O. Beaman, James Fennemore (1849-1941 b. Great Britian, USA), John K. Hillers (1843-1925 b. Germany, USA), and Frederick Samuel Dellenbaugh (1853-1935).]

F128 Jones, William A. "James Fennemore's Photographs of John Doyle Lee." HISTORY OF PHOTOGRAPHY 8, no. 1 (Jan.-Mar. 1984): 65-66. 2 b & w. [Fennemore, who once worked for C. R. Savage in Salt Lake City, UT, photographed convicted killer John Doyle Lee in 1877.]

FENTON, A. B.
F129 Fenton, A. B. "The Itinerant Artist." DAGUERREAN JOURNAL 3, no. 3 (Dec. 15, 1851): 82-84.

FENTON, ROGER. (1819-1869) (GREAT BRITAIN)
[Born in March, 1819 at Crimble Hall, Lancashire —one of seventeen children. Studied at University College, London. Studied art, first with Charles Lucy, then, in 1841, he went to Paris, and studied with Paul Delaroche. Apparently learned photography in Paris. Returned to London, read law, and became a barrister in 1847, but also continued to paint. He showed paintings at the Royal Academy, London from 1849 to 1851. Experimented with the calotype through the early 1840s. In 1847 he joined the Calotype Club in London. In 1852 he was commissioned to photograph the construction of a bridge over the Dnieper, in Russia, by the engineer Charles Vignoles. Photographed Kiev, Moscow, St. Petersburg. Instrumental in organizing a major photographic exhibition at the Society of Arts in 1852, and in founding the Photographic Society in 1853. Fenton was its Honorary Secretary until 1856. In 1853 or 1854 Fenton made a number of formal and informal portraits of the British Royal Family, a body of work that extended over a number of photographic sessions, and produced some of the best portraits of Prince Albert and Queen Victoria. He was commissioned by the British Museum to photograph objects in its collections, but this activity was interrupted in 1855 when Fenton went to the Crimea to document the Allied troops in the war. He brought back more than 350 wet-collodion negatives. Through the 1850s Fenton was active in several commercial ventures in photography, making and selling views, and engaged in a variety of publishing ventures, including the *Photographic Album* and the series *Photographic Art Treasures*, for the Photo-Galvanographic Company. Throughout the 1850s and early 1860s Fenton photographed landscape views in England, then turned to still-life. By the 1860s Fenton was widely considered to be a leader in the field. In 1862, at the height of his critical reputation, Fenton abruptly quit photography, auctioned his cameras, negatives and photographs off for large sums, and returned to his career as a barrister. Francis Frith obtained some of his negatives and republished those views later in portfolios or as single prints. Fenton retired from the law in 1865, and died on Aug. 8, 1869 in London.]

BOOKS
F130 *The Photographic Album*. London: Joseph Cundall, Photographic Institution, 1852-1853.[Issued in parts, with 4 original photographs in each number. At least the first two numbers were issued by Nov. 1852, containing 6 photos by Roger Renton and 2 by P. Delamotte. Views, scenes, etc. Parts III, IV, and V contain four calotypes each, by Alfred Rosling, P. H. Delamotte, Hugh Owen and Joseph Cundall.]

F131 Fenton, Roger. *Photographic Views in Yorkshire.* Manchester: Thomas Agnew, 1854. n. p. 18 l. of plates. 18 b & w. [18 original prints, from negatives by Roger Fenton.]

F132 Fenton, Roger. *Exhibition of the Photographic Pictures taken in the Crimea by Roger Fenton, Esq. during the Spring and Summer of the Present Year, at the Gallery of the Water Colour Society, No. 5 Pall Mall East. (London).* London: Thomas Agnew & Sons, 1855. 15 pp.

F133 Fenton, Roger. *The War in the Crimea,* (to Her Most Gracious Majesty Queen Victoria This Series of Landscapes & Views Photographed in Crimea during the Spring and Summer of 1855). Manchester: Thomas Agnew & Sons, 1855 - 1856. iv pp. l. of plates. 360 b & w. [Issued in parts, up to 360 photographs were issued from Nov. 1855 to Apr. 1856.]

F134 Fenton, Roger. *Incidents of Camp Life (or, Historical Portraits; or, Landscapes and Views), Photographed in the Crimea during the Spring and Summer of 1855.* London: 1856. 3 vol. pp. [Portfolio of actual photograhs. This is actually one in the series "The War in the Crimea."]

F135 Fenton, Roger. *Catalogue of the Entire Remaining Copies of Simpson's 'Seat of War in the East' and Roger Fenton's Photographic Pictures of the War in the Crimea; Together with the Original Glass Negatives... which will be sold by Auction by Southgate & Barrett at Their Rooms, 22 Fleet Street, London, on Monday Evening December 15th, 1856 and Seven Following Evenings.* London: Southgate & Barrett, 1856. 94 pp.

F136 *Photographic Art Treasures; or, Nature and Art illustrated by Art and Nature.* Islington, England: Published by the Patent-Photo-Galvano-Graphic Company., 1856 - 1857. 20 l. of plates. 20 b & w. [Issued in five parts from Nov. 1856 to July 1857. Each issue consisted of a wrapper and four plates. Paul Pretsch mentioned as "Inventor," Roger Fenton as "Resident Photographer." Photographic negatives by Roger Fenton (9 of the 20), William Lake Price, Cundall & Howlett, etc. Part 1: Chantras Cathedral.]

F137 *Photographic Facsimiles of the Remains of the Epistles of Clement of Rome made from the unique copy preserved in the Codex Alexandrinus.* London: The Trustees of the British Museum, 1856. iv pp. 22 l. of plates. 22 b & w. [Foreword by Sir F. Madden. 22 salt prints.]

F138 Davidson, James Bridge. *The Conway in the Stereoscope.* Illustrated by Roger Fenton, Vice-President of the Photographic Society. With Notes, Descriptive and Historical. London: Lovell Reeve, 1860. xii, 187 pp. 20 b & w.

F139 Howitt, William & Mary Howitt. *Ruined Abbeys and Castles of Great Britain.* The photographic illustrations by Bedford, Sedgfield, Wilson, Fenton, and others. London : Alfred W. Bennett, 1862. viii, 228 pp. 27 b & w. [Original photos tipped in.]

F140 Howitt, William and Mary Howitt. *Ruined Abbeys and Castles of Great Britian.* Photographic illustrations by Bedford, Sedgfield, Wilson, Fenton and others. "2nd series" London: Alfred W. Bennett, 1864.

F141 *The Works of Roger Fenton: Cathedrals.* Reigate: Frith, ca. 1869. xx pp. 21 b & w. [Mounted photographs.]

F142 *The Works of Roger Fenton: Landscapes.* Reigate: Francis Frith, 1869. xx pp. 21 b & w. [Twenty albumen prints and a photographic title page.]

F143 de Vries, Leonard. *The War Against Russia, and the Crimea Expedition: Mr. Fenton's Crimean Photographs.* "Panorama 1842 - 1865" Boston: Houghton Mifflin, 1909. 104-108 pp. 7 illus. [Woodcuts of the Crimean war. The section on Fenton is on pp. 106-107, and includes the woodcut of Fenton's photographic van on p. 106.]

F144 Gernsheim, Helmut and Alison Gernsheim. *Roger Fenton, Photographer of the Crimean War. His Photographs and His Letters From the Crimea.* London: Secker & Warburg, 1954. 106 pp. 85 b & w.

F145 Buckland, Gail. *Roger Fenton (1819-1869).* London: Royal Photographic Society, 1972. 4 pp. [Checklist for exhibition Sept. - Oct. 1972. 46 prints.]

F146 Barker, A. J. *The War against Russia, 1854-1856.* New York: Holt, Rinehart & Winston, 1971. xvii, 348 pp. illus. [Crimean War.]

F147 Hannavy, John. *Roger Fenton of Crimble Hall.* Boston: David R. Godine, 1976. 184 pp.

F148 James, Lawrence. *Crimea 1854-56; The War with Russia from Contemporary Photographs.* London; New York: Hayes Kennedy; Van Nolstrand Reinhold, 1981. 200 pp. 85 b & w. [Photographs by Fenton, Robertson and Szathmari presented with explanatory texts or excerpts from combatant's diaries.]

F149 Lloyd, Valerie. *Roger Fenton: Photographer of the 1850s.* London: South Bank Board and Yale University Press, 1988. 184 pp. b & w. illus.

PERIODICALS
F150 "Photographic Publications." ART JOURNAL (Sept. 1852): 374. [Bk. rev.: "The Photographic Album. Parts I and II." Six photos by Roger Fenton and two by Philip Delamotte. Maxine DuCamp's views of Egypt also discussed.]

F151 "Literature and Art. The Photographic Album." ILLUSTRATED LONDON NEWS 21, no. 587 (Oct. 30, 1852): 362-363. [Bk. rev.: "The Photographic Album," Bogue. Four calotypes by Roger Fenton.]

F152 "Fine Arts: New Publications." ATHENAEUM no. 1307 (Nov. 13, 1852): 1247. [Bk. rev.: 'The Photographic Album. Parts I and II." Six views by Roger Fenton, two by Philip Delamotte discussed.]

F153 "Literature: Photography." ILLUSTRATED LONDON NEWS 21, no. 596 (Dec. 11, 1852): 530. [Bk. Rev.: "The Photographic Album. Part II." Bogue. Views by Fenton and Delamotte (I think).]

F154 Fenton, Roger. "Fifth Ordinary Meeting: On the Present Position and Future Prospects of the Art of Photography." JOURNAL OF THE SOCIETY OF ARTS 1, no. 5 (Dec. 24, 1852): 50-53. [Paper read at the Society.]

F155 "Spirit of the London Art Journal: Photographic Publications." PHOTOGRAPHIC ART JOURNAL 5, no. 1 (Jan. 1853): 16. [Reviews: "Photographic Album" by R. Fenton and P. Delamotte, and "Egypte, Nubie, Palestine et Syrie" by Du Camp. Reprinted from "London Art Journal."]

F156 "Photography." PHOTOGRAPHIC ART JOURNAL 5, no. 1 (Jan. 1853): 58-59. [From "Illus. London News." Review of Fenton's exhibit at the Society of Arts. Abstracts from Fenton's paper "On the Present Position and Future Prospects of Photography."]

F157 "Priest of the Greek Church." ILLUSTRATED LONDON NEWS 23, no. 654 (Nov. 19, 1853): 425. 1 illus. ["From a Calotype by Fenton."]

F158 Fenton, Roger. "On the Nitrate Bath." HUMPHREY'S JOURNAL 5, no. 18-19 (Jan. 1 - Jan. 15 1854): 284-286, 289-295. [From "J. of Photo. Soc., London."]

F159 "London Photographic Society." PHOTOGRAPHIC AND FINE ARTS JOURNAL 7, no. 2 (Feb. 1854): 47-51. [Reports on Roger Fenton's "On the Nitrite Bath."]

F160 "A Group of Russian Peasants." ILLUSTRATED LONDON NEWS 24, no. 666 (Feb. 4, 1854): 88. 1 illus. ["From a photograph, by Fenton."]

F161 "Photography and War." JOURNAL OF THE SOCIETY OF ARTS 2, no. 70 (Mar. 24, 1854): 320.

F162 "Minor Topics of the Month: Photography Applied to the Purposes of War." ART JOURNAL (May 1854): 152-153.

F163 "Fine Arts: Exhibition of the Photographic Society." ILLUSTRATED LONDON NEWS 26, no. 725, 727-728, 736 (Jan. 27, Feb. 10-Feb. 17, Apr. 14, 1855): 95, 140-141, 164-166, 349. 3 illus. [The second notice (Feb. 10) is actually a reproduction of Lake Price's genre study "Genevra," with brief comment. The third notice (Feb. 17) contains a reproduction of Roger Fenton's landscape "Valley of the Wharfe," as well as a discussion of the exhibition. The last notice (Apr. 14) has a landscape by Llewellyn.]

F164 "Photographs from the Crimea." ATHENAEUM no. 1457 (Sept. 29, 1855): 1117-1118. [Extensive review.]

F165 "Photographs From Sebastopol." ART JOURNAL (Oct. 1, 1855): 285.

F166 Shadbolt, George. "Photographic Correspondence: Fenton's Photographs From the Crimea." NOTES AND QUERIES 12, no. 310 (Oct. 6, 1855): 272-273.

F167 "General Bosquet." ILLUSTRATED LONDON NEWS 27, no. 764 (Oct. 6, 1855): 405. 1 illus. ["From the Exhibition of Photographic Pictures Taken In the Crimea, by Roger Fenton." "...pictures taken by Mr. Fenton, in the Crimea, during the spring and summer of the present year, and now being exhibited in Pall Mall East."]

F168 "General Simpson, Commander of Her Majesty's Forces In the Crimea." ILLUSTRATED LONDON NEWS 27, no. 765 (Oct. 13, 1855): 425-426. 1 illus. ["From a Photograph by Fenton. Mr. Fenton had arranged to leave the Crimea on the 14th of June; but, having heard at headquarters that an attack was contemplated, he remained until the day, and then took the accompanying portrait."]

F169 "Omar Pacha." ILLUSTRATED LONDON NEWS 27, no. 766 (Oct. 20, 1855): 472. 1 illus. ["From a Photograph by Fenton." Portrait on horseback.]

F170 "Note." ATHENAEUM no. 1461 (Oct. 27, 1855): 1245. [Portrait of W. H. Russell, "Our Special Correspondent" Drawn by J. H. Lynch, from a photograph by R. Fenton. Lithographed by N & M Hanhart. Colnaghi & Co.]

F171 "General Sir William John Codrington, the New Commander-in-Chief in the Crimea." ILLUSTRATED LONDON NEWS 27, no. 768 (Nov. 3, 1855): 520. 1 illus. ["From Fenton's Crimean Photographs." Portrait, with horse.]

F172 "Spahi and Zouave." ILLUSTRATED LONDON NEWS 27, no. 768 (Nov. 3, 1855): 524. 1 illus.

F173 "Mr. Fenton's Crimean Photographs." ILLUSTRATED LONDON NEWS 27, no. 769 (Nov. 10, 1855): 557. 1 illus. [Includes a view of "Mr. Fenton's Photographic Van." Praise for the beauty and quality of Fenton's work.]

F174 "Extracts from Foreign Publications: Photographs from Sebastopol." HUMPHREY'S JOURNAL 7, no. 14 (Nov. 15, 1855): 223-225. [From "London Art J., Oct."]

F175 "Photographs from Sebastopol." PHOTOGRAPHIC AND FINE ART JOURNAL 8, no. 12 (Dec. 1855): 377. [From "London Art J."]

F176 "Croats - From a Photograph by Mr. Fenton, in the Crimean Exhibition." ILLUSTRATED LONDON NEWS 27, no. 777 (Dec. 29, 1855): 753. 1 illus.

F177 "Retrospective Criticism: Exhibition in High Street of the Photographs of the Crimea." HUMPHREY'S JOURNAL 7, no. 17 (Jan. 1, 1856): 226. [From "Liverpool Photo. J."]

F178 Fenton, Roger. "Narrative of a Photographic Trip to the Seat of War in the Crimea." JOURNAL OF THE PHOTOGRAPHIC SOCIETY *, no. * (Jan. 21, 1856): 284-291.

F179 Fenton, Roger. "Extracts from Foreign Publications: Narrative of a Photographic Trip to the Seat of War in the Crimea." HUMPHREY'S JOURNAL 7, no. 21 (Mar. 1, 1856): 329-336. [Source not given.]

F180 "Crimean Photographic Van." FRANK LESLIE'S NEW YORK JOURNAL n. s. 3, no. 3 (Mar. 1856): 180. 1 illus. [The woodcut of Roger Fenton's photographic van which first appeared in the "London Illustrated News" is reproduced here without credit or even text other than the three word caption. Another of Fenton's photographs, a portrait of a Greek priest, is also published in the May issue, p. 280, without credit, taken from the "ILN."]

F181 Fenton, Roger. "Narrative of a Photographic Trip to the Seat of War in the Crimea." PHOTOGRAPHIC AND FINE ART JOURNAL 9, no. 3 (Mar. 1856): 76-80. [Source not given, but probably the "Journal of Photographic Society, London."]

F182 "Reviews." ART JOURNAL (Apr. 1856): 128. [Brief notice of "Photographs taken, under the Patronage of Her Majesty, by Robert Fenton, Esq. Published by Agnew & Sons, Manchester." Crimean photographs.]

F183 "Note." ART JOURNAL (July 1856): 226. [Augustus Egg, A.K.A. is exhibiting a painting of the allied generals in a tent at Balaklava. "It is based on the photograph with which the public is familiar." (i.e. Fenton).]

F184 "Fine-Art Gossip." ATHENAEUM no. 1500 (July 26, 1856): 934. [Mentiona nd comment that Fenton's Crimean photographs "...have been removed to the city."]

F185 "Fine Arts: New Publications." ATHENAEUM no. 1524 (Jan. 10, 1857): 54. [Bk. rev.: "Photographic Art-Treasures," Patent Photo-Galvanographic Society. Part I. Review of Roger Fenton's photographs.]

F186 "Fine-Arts." ATHENAEUM no. 1546 (June 13, 1857): 763. [Bk. rev.: "Photographic Art-Treasures," Parts III and IV. (Photo-Galvano-Graphic Co.) Pt. III has photos "after Mrs. Anderson," by Roger Fenton. Pt. IV has photos by Lake Price, O. G. Rejlander, O. F. Barnes and "after Mrs. Anderson."]

F187 "Fine-Art Gossip." ATHENAEUM no. 1548 (June 27, 1857): 826. [Note that Roger Fenton's photos and photogalvanographs on exhibit at Colnaghi's.]

F188 "Fine-Art Gossip." ATHENAEUM no. 1551 (July 18, 1857): 915. [Bk. rev.: "Photographic Art-Treasures. Part IV." (Photo-Galvano-Graphic Co.) Plates by L. Price, R. Fenton, H. White and a copy of a drawing.]

F189 "London Photographic Society." LIVERPOOL & MANCHESTER PHOTOGRAPHIC JOURNAL [BRITISH JOURNAL OF PHOTOGRAPHY] n. s. 2, no. 6 (Mar. 15, 1858): 69-70. [Fenton reports on his experiments with Petzval lenses.]

F190 "Note." ART JOURNAL (Mar. 1860): 96. [Lord MaCauley in his study, photographed by Roger Fenton, from the Picture by E. M. Ward, R.A. Published by E. Gambart & Co.]

F191 "Our Weekly Gossip." ATHENAEUM no. 1689 (Mar. 10, 1860): 343. [Brief, mixed review of Roger Fenton's 15 views of Stonyhurst.]

F192 "Government in Competition with Professional Photographers." BRITISH JOURNAL OF PHOTOGRAPHY 7, no. 125 (Sept. 1, 1860): 257. [Report of Select Committee on the South Kensington Museum, Robert Fenton protesting.]

F193 "Scraps and Fragments: Another Distinguished Deserter." BRITISH JOURNAL OF PHOTOGRAPHY 9, no. 174 (Sept. 15, 1862): 357. [Announcement that Roger Fenton quitting photography, with commentary.]

F194 Fenton, Roger. "Miscellanea: Retirement of Mr. Fenton from Photographic Pursuits." JOURNAL OF THE PHOTOGRAPHIC SOCIETY OF LONDON 8, no. 126 (Oct. 15, 1862): 157-158.

F195 "Note." JOURNAL OF THE PHOTOGRAPHIC SOCIETY OF LONDON 8, no. 127 (Nov. 15, 1862): 178. ["Mr. Fenton's sale was well attended, and in general, the lots fetched very good prices. The lenses especially sold very well, many wishing no doubt to possess an instrument which had been used by one so generally esteemed by the photographer as Mr. Fenton had been."]

F196 "Our Editorial Table: Portraits of Roger Fenton, by J. Eastham, Manchester." BRITISH JOURNAL OF PHOTOGRAPHY 12, no. 254 (Mar. 17, 1865): 143.

F197 "The War in Crete." HARPER'S WEEKLY 11, no. 527 (Feb. 2, 1867): 68-69. 4 illus. [Illus. consist of a map, two sketches and a photograph of "A Greek Priest," by Fenton, originally published in the "ILN" and used here without credit to either photographer or journal.]

F198 Santeul, Claude de, vicomte. "Le premier reportage photographique de guerre, 1854-55." PHOTO-ILLUSTRATION (PARIS) no. 6 (1934): 3-8, 24. 23 b & w. 1 illus. [Photographs of the Crimean War by James Robertson and Robert Fenton discussed.]

F199 Oakes-Jones, Captain H., M.B.E., F.S.A. "Photogaphy In the Crimean War." SOCIETY FOR ARMY HISTORICAL RESEARCH JOURNAL 17, (1938): 67-70, 133-134, 221-222. 6 b & w. [Article

actually a discussion of the military uniforms worn by the Allied forces during the Crimean War, using Fenton's photos as reference sources.]

F200 Fenton, Lena R. "First War Photographer; at the Crimea in 1855." ILLUSTRATED LONDON NEWS 199, no. 5351 (Nov. 8, 1941): 590-591. 10 b & w.

F201 Gernsheim, Helmut. "Photographer of the Crimean War. Helmut Gernsheim on Roger Fenton." THE LISTENER (May 22, 1952): 838-839. 2 b & w.

F202 "Fenton's Photo Van." IMAGE 1, no. 9 (Dec. 1952): 1. 1 illus.

F203 Peterich, Gerda. "Book Reviews: 'Roger Fenton, Photographer of the Crimean War.'" IMAGE 4, no. 4 (Apr. 1955): 28-30. 3 b & w.

F204 Jammes, M. Th. and A. Jammes. "The First War Photographs." CAMERA (LUCERNE) 43, no. 1 (Jan. 1964): 2-38. * [Photography in the Crimean War. Roger Fenton, James Robertson, and Charles Langlois discussed.]

F205 Brady, T. J. "Fenton and the Crimean War: An early photographer at a Victorian front." HISTORY TODAY 18, no. 2 (Feb. 1968): 75-83. 6 b & w.

F206 Hannavy, J. "Roger Fenton at Stonyhurst." PHOTOGRAPHIC JOURNAL 112, no. 7 (July 1972): 219-222. 3 b & w. [Fenton visited Stonyhurst College in 1858, 1859.]

F207 Stone, P. "Roger Fenton." PHOTOGRAPHIC JOURNAL 112, no. 10 (Oct. 1972): 297-304. 7 b & w. [Ex. rev.: 'Roger Fenton,' Royal Photographic Society, London.]

F208 Bennett, S. "Cricket on Camera." ANTIQUE COLLECTOR 47, no. 6 (June 1976): 38-39. 4 b & w. [Description of 5 photos of a cricket match taken by Fenton.]

F209 Badger, Gerry. "Viewed: Roger Fenton at Thomas Agnew & Sons, Ltd." BRITISH JOURNAL OF PHOTOGRAPHY *, no. * (Apr. 27, 1979): 400-403. 4 b & w.

F210 Lloyd, Valerie. "Landscapes: Roger Fenton." CREATIVE CAMERA no. 177 (Mar 1979): 76-89, plus cover. 14 b & w.

F211 Badger, Gerry. "Viewed: Roger Fenton at Thomas Agnew & Sons Ltd." BRITISH JOURNAL OF PHOTOGRAPHY 128, no. 6196 (Apr. 29, 1979): 400-404. 4 b & w.

F212 Reed, David. "Roger Fenton: Victorian Superstar." AFTERIMAGE 6, no. 10 (May 1979): 12-13, front cover. 5 b & w.

F213 Jones, T. Herbert. "A Loan Exhibition of Photographs. Roger Fenton (1819 - 1869). In aid of the Royal Photographic Society's Appeal for a National Photographic Centre." PHOTOGRAPHIC JOURNAL *, no. * (May/June 1979): 120-123. 3 b & w.

F214 Benton-Harris, John. "Letter: From London." AMERICAN PHOTOGRAPHER 3, no. 2 (Aug. 1979): 90-91. 1 b & w. [Ex. rev.: 'Roger Fenton,' Thomas Agnew & Sons Gallery, London.]

F215 Fort, Paul. "Roger Fenton and Col. E. G. Hallewell: A Crimean Friendship." PHOTOGRAPHIC COLLECTOR 2, no. 1 (Spring 1981): 12-25. 11 b & w. [Describes, discusses an album of photographs that contains photographs of Crimea and in England by Fenton and of the

Crimea by James Robertson. The album was compiled by Colonel Edmund Gilling Hallewell, a long-time friend of Fenton.]

F216 Fort, Paul. "Roger Fenton and Col. E. G. Hallewell: A Crimean Friendship." PHOTOGRAPHIC COLLECTOR 2, no. 1 (Spring 1981): 12-25. 11 b & w. [Discusses an album containing photographs by Roger Fenton and James Robertson.]

F217 Joseph, Steven F. "Wheatstone and Fenton: A Vision Shared." HISTORY OF PHOTOGRAPHY 9, no. 4 (Oct.-Dec. 1985): 305-309. 4 b & w. [Charles Wheatstone's private collection of stereos, made in 1850s by Roger Fenton, John Percy, Jules Duboscq, and others. Photos by Fenton, Percy and Duboscq.]

F218 Hannavy, John. "Roger Fenton and the British Museum." HISTORY OF PHOTOGRAPHY 12, no. 3 (July - Sept. 1988): 193-204. 10 b & w.

FENTON, ROGER. [?]
F219 "Ismail Pacha (General Kmetty)." ILLUSTRATED LONDON NEWS 27, no. 770 (Nov. 17, 1855): 584. 1 illus. [Not identified, but in the style of Fenton's outdoor portrait -horse, several men grouped together, etc.]

F220 "The Earl of Cardigan, Commander of the Light Brigade in Crimea." BALLOU'S PICTORIAL DRAWING-ROOM COMPANION [GLEASON'S] 11, no. 263 (July 19, 1856): 33. 1 illus. ["...engraved after an English photograph."]

FERGUSON, WILLIAM.
F221 Ferguson, William. "Toning." BRITISH JOURNAL PHOTOGRAPHIC ALMANAC 1879 (1879): 127.

FERGUSSON, JAMES.
F222 *Tree and Serpent Worship: or Illustrations of Mythology and Art in the First and Fourth Centuries after Christ.* From the sculptures of the Buddhist Topes at Sanchi and Amravath. Introduction and description of photographs by James Fergusson, Esq., F.R.S. London: n. p., 1868. n. p. 54 b & w. [54 gold-toned prints, 13" x 9 1/2".]

FERNELEY, CHARLES ALLAN.
F223 Ferneley, Charles Allan. "Landscape Photography." BRITISH JOURNAL PHOTOGRAPHIC ALMANAC 1874 (1874): 131-133.

FERRANTI,C. (LIVERPOOL, ENGLAND)
F224 Portrait. Woodcut engraving credited "From a photograph by Ferranti, Sandon Terrace, Upper Duke St., Liverpool." ILLUSTRATED LONDON NEWS 41, (1862) ["Capt. Semmes, of the Confederate Navy." 41:* (Dec. 6, 1862): 589.]

F225 Ferranti, C. "Medals." BRITISH JOURNAL PHOTOGRAPHIC ALMANAC 1877 (1877): 104-106. [Argument for awards at photo exhibits, etc.]

F226 Ferranti, C. "Art Portraits." ANTHONY'S PHOTOGRAPHIC BULLETIN 9, no. 2 (Feb. 1878): 42-44. [From "Br J of Photo." Ferranti from Liverpool, Eng.]

FERRARI, A. ALONZO.
F227 Ferrari, A. Alonzo. "To Produce Charming Cloud Effects." BRITISH JOURNAL PHOTOGRAPHIC ALMANAC 1877 (1877): 122-123.

F228 Ferrari, A. Alonzo. "A Ventilated Dark Room." BRITISH JOURNAL PHOTOGRAPHIC ALMANAC 1878 (1878): 138. 1 illus.

FERRIER & SOULIER.
F229 "[Note.]" HUMPHREY'S JOURNAL OF PHOTOGRAPHY, AND THE ALLIED ARTS AND SCIENCES 15, no. 15 (Dec. 1, 1863): 231. ["M. Soulier, partner of M. Ferrier, has added 200 more stereoscopic views in Switzerland to his already large collection, numbering now over 5,000 views."]

F230 Lacan, Ernest. "Foreign Correspondence." BRITISH JOURNAL OF PHOTOGRAPHY 11, no. 222 (Aug. 5, 1864): 285. [Discussion of glass stereoscopic views by Ferrier & Soulier (Paris). Mentions Macaire. Also that Ferrier is the son.]

FERRIER, CLAUDE-MARIE. (1811-1889) (FRANCE) see FERRIER & SOULIER; OWEN, HUGH.

[Claude-Marie Ferrier was born in 1811. Lived in Paris, but in 1851 he photographed the Crystal Palace Exhibition in London. His salt-paper prints, along with photographs by Hugh Owen, were used to illustrate that organization's *Reports of the Juries.* in 1852. In 1855-56 he photographed in Rome, Venice, Reims and Rouen. In 1856 photographed the Rhône flood. In 1857 photographed in Nice. In 1859 photographed Napoleon III's Austrian campaign. Partner with his son from 1859-67. Claude-Marie became a member of the Société français de Photographie in 1855, and he was member of the board and treasurer from 1862 to 1882. In 1867 Léon & Lévy succeed the firm of Ferrier & Soulier. Claude-Marie died on June 13, 1889, and his son donated 5000 francs to the Société, for an award.]

FERRIER, JACQUES-ALEXANDRE. (d. 1912) (FRANCE)
[Jacques-Alexandre Ferrier was Claude-Marie Ferrier's son, and presumably, learned photography from him. By 1857 Alexandre was acknowledged as a specialist in albumen, and he patented a collodion process in 1857. Photographs the French campaign in Italy during the Franco-Austrian War in 1859, making views of troop movements in Genoa. He and his father form a partnership in Paris in 1859, and make many glass stereo views of scenes throughout Europe through the 1860s.]

F231 "Ferrier's Albumen Process." AMERICAN JOURNAL OF PHOTOGRAPHY AND THE ALLIED ARTS & SCIENCES n. s. vol. 4, no. 2 (June 15, 1861): 30-31. [From "Photo. Notes."]

F232 Jocelyn, Nassau. "M. Ferrier's Method of Working the Collodio-Albumen Process." HUMPHREY'S JOURNAL OF PHOTOGRAPHY, AND THE ALLIED ARTS AND SCIENCES 19, no. 8 (Aug. 15, 1867): 125-127.

F233 Ferrier, M. "Keeping Properties of Taupenot Plates." BRITISH JOURNAL PHOTOGRAPHIC ALMANAC 1879 (1879): 67-68.

FERRIS, L. P. (USA)
F234 Ferris, L. P. "Indoor Portraiture for Amateurs." PHOTOGRAPHIC TIMES 17, no. 317 (Oct. 14, 1887): 513-515. [Ferris an amateur since 1868, wrote a brief pamphlet with the same title. Excerpted from that. A student at the Columbia College School of Mines, embraced photography as a means of assistance in scientific research.]

FERRY see CRAFT & FERRY.

FETTER, H. G.

F235 Portrait. Woodcut engraving, credited "From a Photograph by H. G. Fetter." HARPER'S WEEKLY 13, (1869) ["Hon. Daniel D. Pratt, from Indiana." 13:634 (Feb. 20, 1869): 116.]

FIGUEIER.

F236 Figueier. "Influence of Photography Upon the Fine Arts." DAGUERREAN JOURNAL 2, no. 12 (Nov. 1, 1851): 372. [From "American Art Union," translated from "Illustrations."]

FILKINS.

F237 "Destruction of the Dutch Church, Poughkeepsie. From a Photograph by Filkins." FRANK LESLIE'S ILLUSTRATED NEWSPAPER 3, no. 61 (Feb. 7, 1857): 160. 1 illus. [View, with crowd. Figures may have been added by the engraver.]

FINCH, E. (ALVAREDO, TEX)

F238 Finch, E. "Texas Correspondence." PHILADELPHIA PHOTOGRAPHER 9, no. 103 (July 1872): 253. [Finch in Waxahachie, TX.]

F239 "A Word From Texas." PHILADELPHIA PHOTOGRAPHER 12, no. 141 (Sept. 1875): 285-286. [Announcing his retirement.]

F240 Finch, E. "Texas Correspondence." PHILADELPHIA PHOTOGRAPHER 13, no. 150 (June 1876): 169-170.

FINCH, W. J. (AYLWHAM, ENGLAND)

F241 "Blickling Hall, Norfolk, Lately Injured by Fire." ILLUSTRATED LONDON NEWS 65, no. 1836 (Oct. 31, 1874): 423, 424. 1 illus. ["The view we have engraved is partly drawn from a set of photographs by Mr. W. J. Finch, of Aylsham, photographic artist."]

FINLAYSON, L.

F242 Portrait. Woodcut engraving credited "From a photograph by L. Finlayson." ILLUSTRATED LONDON NEWS 35, (1859) ["Gov. Seward, of New York." 35:* (Aug. 13, 1859): 155.]

FINLEY, MARSHALL. (1813-1893) (USA)

F243 Finley, M. "Correspondence: Proportions of Iodine and Bromine in Coating the Daguerreotype Plate." DAGUERREAN JOURNAL 1, no. 6 (Feb. 1, 1851): 179-180.

F244 Finley, M. "Mercury: On the Development of the Daguerrean Image by Exposure to Mercury." DAGUERREAN JOURNAL 1, no. 9 (Mar. 15, 1851): 275-276.

F245 "On Whitened Cameras." DAGUERREAN JOURNAL 2, no. 1 (May 15, 1851): 25-26. [M. Finley from Canandaigua, NY.]

F246 "Original Correspondence." HUMPHREY'S JOURNAL 4, no. 8 (Aug. 1, 1852): 123. [Finley from Canandaigua, NY.]

FINLEY, MARSHALL. [?]

F247 Cheney, C. D. and U. T. Clark. "Correspondence: An Old Daguerreotypist." PHOTOGRAPHIC TIMES 21, no. 493 (Feb. 27, 1891): 105-106. [Letter, quoting an article written by U. T. Clark, describing early experiments, 1840, of Mr. Finley, then the development of his career in Hoboken, NJ, from 1848.]

FISCHER & BROTHERS.

F248 "The Remains of Wells and McComas Lying in State in the Hall of the Maryland Institute, Baltimore. - From a Photograph by Fischer & Brothers." FRANK LESLIE'S ILLUSTRATED NEWSPAPER 6, no. 147 (Sept. 25, 1858): 263, 264. 1 illus. [Coffins. Figures added by engraver?]

F249 "New Steamship, Built in Baltimore by Messrs. T. & R. Winans. - From a Photograph by Fischer & Bro., Baltimore." FRANK LESLIE'S ILLUSTRATED NEWSPAPER 6, no. 151 (Oct. 23, 1858): 323. [Ship in drydock.]

FISHER.

F250 "The Manor-House, Woolsthorpe - The Birth-Place of Sir Isaac Newton." ILLUSTRATED NEWS OF THE WORLD AND DRAWING ROOM PORTRAIT GALLERY OF EMINENT PERSONAGES 1, no. 35 (Oct. 2, 1858): 212. 1 illus.

FISHER, FANNY.

F251 Fisher, Fanny. *Killarney; Illustrated with the Principal Photographic Views*, by Fanny Fisher. s. l.: s. n., 1868. 23 l. 13 l. of plates. [Original photos.]

FISHER, GEORGE THOMAS, JR.
BOOKS

F252 Fisher, George Thomas, Jr. *Photogenic Manipulation, Containing Plain Instructions in the Theory and Practice of the Art of Photography, Calotype, Cyanotype, Ferrotype, Chrysotype, Anthotype, Daguerreotype, Thermography. Illustrated by Woodcuts.* London: G. Knight, 1843. xviii, 50 pp. illus. [2nd ed. (1845) Philadelphia: Carey & Hart. 2 parts. (Pt. 1, 60 pp.; Pt. 2, 48 pp.)]

F253 Fisher, George Thomas, Jr. *Photographische künst. Gründlicher Unterricht über die Theorie und Praxis des Daguerreotypiren, Photographiren, Kalotypiren, Cyanotypiren, Anthotypiren, Chrystotypiren, Thermographiren, mit Einschluss der Kunst, farbige Daguerreotype-Portraits hervorzubringen. Mit Abbildungen.* Pesth; Leipzig: Berlags-Magazin; Händel, 1844. 50 pp. illus.

F254 Fisher, George Thomas, Jr. *Photogenische kunsten. Grondig onderrigt in de theorie en de praktijk der Daguerreotypie, photographie, kalotypie, terrotypie, anthotypie, crysotypie, thermographie en energiatypie; alsmede in de kunst om gekleurde Daguerreotypie-portraits te vervaardigen. Uit het Hoogduitsch vertaald. Met afbeeldingen.* Arnhem: J. G. Stenfert Kroese, 1844. 50 pp. illus.

PERIODICALS

F255 Fisher, G. T. "Thermography - Electrical and Galvanic Impressions." PHOTOGRAPHIC ART JOURNAL 2, no. 3 (Sept. 1851): 165-169.

FISHER, J. K.

F256 Fisher, J. K. "Photography, the Handmaid of Art." PHOTOGRAPHIC ART JOURNAL 1, no. 1 (Jan. 1851): 19-20.

F257 "Gossip." PHOTOGRAPHIC ART JOURNAL 1, no. 5 (May 1851): 320. ["Our friend J. F. Fisher, Esq. has removed his studio to 179 Broadway."]

F258 Fisher, J. K. "Institutions for Promoting the Fine Arts." PHOTOGRAPHIC ART JOURNAL 2, no. 3 (Sept. 1851): 150-153.

F259 Fisher, J. K. "The American Art - Union." PHOTOGRAPHIC ART JOURNAL 4, no. 5 (Nov. 1852): 314-316.

FISK-WILLIAMS, F.

F260 "Letter." JOURNAL OF THE PHOTOGRAPHIC SOCIETY OF LONDON 7, no. 102 (Oct. 15, 1860): 14. [Letter from Fisk-Williams

complaining about an earlier complaint of Capt. Biggs of the Bombay Artillery, who had complained of high prices, etc. Fisk-Williams defending Indian policies.]

FISKE, GEORGE. (1835-1918) (USA)
BOOKS
F261 Hickman, Paul Addison. *The Life and Photographic Works of George Fiske, 1835 - 1918.* Tempe, AZ, 1979. [M.A. Thesis, Arizona State University, 1979.]

F262 Hickman, Paul and Terence Pitts. *George Fiske, Yosemite Photographer.* Flagstaff, AZ: Northland Press, in cooperation with the Center for Creative Photography, Univ. of Arizona., 1980. 118 pp. 80 b & w. [Preface by Beaumont Newhall. Introduction by James Enyeart.]

F263 Curran, Thomas. *Fiske, the Cloudchaser: A Portfolio of Yosemite Photographs by George Fiske.* Oakland, CA: Oakland Museum, in cooperation with the Yosemite Natural History Association, 1981.

PERIODICALS
F264 Muir, John. "The Treasures of the Yosemite." CENTURY MAGAZINE 40, no. 4 (Aug. 1890): 483-500. 3 b & w. 11 illus. [Article arguing for conservation, illustrated with engravings of Yosemite's natural wonders. Also includes 3 views titled "Destructive Work in Yosemite Valley," labeled "Process" Reproduction of Photograph for veracity. "Pictures from photographs by George Fiske."]

F265 Muir, John. "Features of the Proposed Yosemite National Park." CENTURY MAGAZINE 40, no. 5 (Sept. 1890): 656-667. 11 illus. ["Pictures from photographs by George Fiske."]

F266 "The Editorial Table: Mr. George Fisk [sic]." PHOTOGRAPHIC TIMES 20, no. 477 (Nov. 7, 1890): 560. [Received set of 5" x 8" Yosemite Valley views.]

F267 "The Editor's Table." PHOTOGRAPHIC TIMES 22, no. 550 (Apr. 1, 1892): 180. [Note about receiving winter landscape photos of Yosemite by George Fiske.]

F268 I photo ("Yosemite, Winter") as frontispiece. PHOTOGRAPHIC TIMES 25, no. 671 (July 27, 1894): before p. 57.

F269 4 b & w (Landscape views of Yosemite). CRAFTSMAN 11, no. 5 (Feb. 1907): 601-604. 4 b & w. [Portfolio of landscape views -apparently not with a specific article. (Unusual for this magazine.)]

F270 "Fiske's Views of Yosemite and Big Trees." PHOTOGRAPHIC COLLECTOR 5, no. 2 (1984): 206-211. 10 b & w. [Facsimile of Fiske's catalog, with photographs added.]

FITCH, NOEL E.
F271 Fitch, Noel E. "Recollections of an Amateur Photographer in Portraiture." BRITISH JOURNAL OF PHOTOGRAPHY 9, no. 162 (Mar. 15, 1862): 103-105.

F272 "Glass Rooms with Top Light." AMERICAN JOURNAL OF PHOTOGRAPHY AND THE ALLIED ARTS & SCIENCES n. s. vol. 4, no. 23 (May 1, 1862): 538-539. 1 illus. [Fitch an amateur in the South London Photo Society. From "Photo. News."]

FITT, GEORGE ROBERT.
F273 Fitt, Mr. "On Positive Printing." HUMPHREY'S JOURNAL 7, no. 24 (Apr. 15, 1856): 380-385. [From "Liverpool Photo. J."]

F274 "The Albumen Surface Corroding during the Washing of Prints." AMERICAN JOURNAL OF PHOTOGRAPHY AND THE ALLIED ARTS & SCIENCES n. s. vol. 7, no. 6 (Sept. 15, 1864): 129. [From "Photo. Notes."]

F275 Fitt, G. Robert. "Vignetting Portraits." ANTHONY'S PHOTOGRAPHIC BULLETIN 1, no. 3 (Apr. 1870): 43-44.

FITZ, HENRY. (1808-1863) (USA)
F276 Seely, Charles A. "Editorial Department: Obituary." AMERICAN JOURNAL OF PHOTOGRAPHY AND THE ALLIED ARTS & SCIENCES n. s. vol. 6, no. 9 (Nov. 1, 1863): 215. [Henry Fitz died Oct. 31, 1863, aged 55 years. Born in Newburyport, MA. His family moved to New York, NY in 1818. Worked as a locksmith, then became interested in Astronomy and Optical Instruments and began to manufacture telescopes. Learned the daguerreotype from Wolcott & Johnson and opened a gallery then returned to New York, NY and returned to making telescopes, one of 16 inches in Buffalo, NY. Made many photographic cameras and instructed C. C. Harrison and others in this craft. A founder of the Photographical Society. Working with lenses at end of his life. Died after brief illness.]

F277 "Obituary. - Henry Fitz." HUMPHREY'S JOURNAL OF PHOTOGRAPHY, AND THE ALLIED ARTS AND SCIENCES 15, no. 14 (Nov. 15, 1863): 217-219. [Manufacturer of telescopes and camera lenses. Born Newburyport, MA in 1808. Obituary similar to that found in "Am. J. of Photo," but with more specific information and description.]

FITZGERALD, HENRY.
F278 Fitzgerald, H. "Extracts from Foreign Publications: Portable Tent for Outdoor Work." HUMPHREY'S JOURNAL 9, no. 3 (June 1, 1857): 46-47. [From "J. of Photo. Soc., London."]

F279 Fitzgerald, Henry. "Portable Tent for Outdoor Work." PHOTOGRAPHIC AND FINE ART JOURNAL 10, no. 6 (June 1857): 191. [From "J. of Photo. Soc., London." Fitzgerald lists an address in Dresden, Germany.]

FITZGIBBON, JOHN H. see also HISTORY: USA: MO (Van RAVENSWAAY)

FITZGIBBON, JOHN H. (ca. 1817-1882) (USA)
BOOKS
F280 "John Fitzgibbon," on pp. 311-314 in : *The Sketch Book of Saint Louis: Containing a Series of Sketches of the Early Settlement, Public Buildings, Hotels, Railroads,* by Jacob N. Taylor. St. Louis: Taylor & Crooks, G. Knapp & Co., printers, 1858. 430 pp. illus.

F281 Fitzgibbon, J. H., ed. *The New Practical Photographic Almanac for 1879; A Daily Guide of Photographic References and Yearly Compendium to the "St. Louis Practical Photographer."* St. Louis, O.: Fitzgibbon, 1879. 131 pp. illus.

PERIODICALS
F282 Fitzgibbon, J. H. "Daguerreotyping." THE WESTERN JOURNAL OF AGRICULTURE, MANUFACTURING, MECHANIC ARTS, INTERNAL IMPROVEMENT, COMMERCE, AND GENERAL LITERATURE 6, no. 3 (June 1851): 200-203.

F283 Fitzgibbon, J. H. "Daguerreotyping." DAGUERREAN JOURNAL 2, no. 6 (Aug. 1, 1851): 167-169.

F284 Fitzgibbon, J. H. "Daguerreotyping." PHOTOGRAPHIC ART JOURNAL 2, no. 2 (Aug. 1851): 91-94. [From the "Western Journal."]

F285 Fitzgibbon, J. H. "Daguerreotyping Simplified." PHOTOGRAPHIC ART JOURNAL 2, no. 5 (Nov. 1851): 288-291. [From the "Western World."]

F286 "Humphrey's Journal." HUMPHREY'S JOURNAL 4, no. 1 (Apr. 15, 1852): 10. [Daguerreotypes of Jenny Lind and Julia Dean described.]

F287 "Humphrey's Journal: Daguerrean in Missouri." HUMPHREY'S JOURNAL 4, no. 4 (June 1, 1852): 59.

F288 "Letter." PHOTOGRAPHIC ART JOURNAL 5, no. 1 (Jan. 1853): 65-66. [Letter on Anthony's prize silver pitcher offer, suggestion that a national museum for photography be formed.]

F289 "Daguerreotype Movements." HUMPHREY'S JOURNAL 5, no. 14 (Nov. 1, 1853): 222. [Detailed description of a break-in robbery at J. H. Fitzgibbon's gallery in St. Louis, MO.]

F290 Humphrey, S. D. "Editorials: Interesting Experiments in the Practice of the Daguerreotype." HUMPHREY'S JOURNAL 5, no. 21 (Feb. 15, 1854): 329-330. [Fitzgibbon photographed two people at separate times, exposing half of the plate each time, and thus achieved a double portrait on one plate. Insley made multiple exposures on a single plate to create the impression of a two-headed boy or of a man with four arms, etc.]

F291 "Daguerreotype Movements." HUMPHREY'S JOURNAL 6, no. 13 (Oct. 15, 1854): 207. [Anecdote, from the Fayetteville, AK "South West Independent."]

F292 "Daguerreotyping in the Back-Woods, Transcribed from a Daguerreotypist's Journal." PHOTOGRAPHIC AND FINE ART JOURNAL 7, no. 11 (Nov. 1854): 324-326. [Fitzgibbon identified as the author on p. 352.]

F293 "Personal and Art Intelligence: Fitzgibbon's Daguerrean Gallery." PHOTOGRAPHIC AND FINE ART JOURNAL 8, no. 1 (Jan. 1855): 32.

F294 "Mr. Charles Pope. Photographed by J. H. Fitzgibbon of St. Louis, Mo." PHOTOGRAPHIC AND FINE ART JOURNAL 9, no. 3 (Mar. 1856): 76.1 b & w. [Original photographic print of the actor Charles Pope.]

F295 "Personal & Art Intelligence: Fitzgibbon's Gallery." PHOTOGRAPHIC AND FINE ART JOURNAL 9, no. 4 (Apr. 1856): 128. [From a St. Louis paper. Describes Fitzgibbon's activities, his gallery, etc.]

F296 "Kansas Meeting at St. Louis. From a Photograph by Fitzgibbon." FRANK LESLIE'S ILLUSTRATED NEWSPAPER 2, no. 40 (Sept. 13, 1856): 209, 210. 1 illus. [View, with crowd.]

F297 "Great Fair of the St. Louis Agricultural and Mechanical Association." FRANK LESLIE'S ILLUSTRATED NEWSPAPER 2, no. 48 (Nov. 8, 1856): 344-345. 4 illus. [Trotting Horse "Silver Heels," Prize bull "Lexington," view of the pagoda and flagstaff, distant view of the fairgrounds - all credited "Photographed by Fitzgibbons [sic], of St. Louis."]

F298 "St. Louis Agricultural Fair." FRANK LESLIE'S ILLUSTRATED NEWSPAPER 2, no. 49 (Nov. 15, 1856): 363-365. 5 illus. [Trotting Horse "Young St. Lawrence," stallion "True Prince," stallion "St. Louis," brood mare "Florizelle," view of the principal entrance to the fairground - all "photographed by Fitzgibbons [sic], of St. Louis."]

F299 "Photographic Ware: J. H. Fitzgibbon." HUMPHREY'S JOURNAL 9, no. 1 (May 1, 1857): Additional section; 8. ["Now on a tour through the New England States, exhibiting a panoramic painting of the war in "bleeding Kansas."]

F300 Portraits. Woodcut engravings, credited "Photographed by Fitzgibbon." FRANK LESLIE'S ILLUSTRATED NEWSPAPER 4, (1857) ["Judge John M. Wimer, Mayor of St. Louis." 4:81 (June 20, 1857): 37. "Dred Scott; His wife, Darriet; Eliza and Lizzie, children of Dred Scott. (Three portraits). 4:82 (June 27, 1857): 49. "Edward Bates, orator." 4:82 (June 27, 1857): 52.]

F301 "Ohio and Mississippi Railroad Celebration, the Procession Passing Up Market Street, St. Louis. Photographed by Fitzgibbon." FRANK LESLIE'S ILLUSTRATED NEWSPAPER 4, no. 81 (June 20, 1857): 37. 1 illus. [View, with crowds.]

F302 "J. H. Fitzgibbon, Esq., Daguerrean Artist, of St. Louis." FRANK LESLIE'S ILLUSTRATED NEWSPAPER 4, no. 92 (Sept. 5, 1857): 213. 1 illus. [Portrait. Biography. Fitzgibbon used the pen-name "Justice" when writing about photography. "He has also written sketches under the titles "Life in a Daguerrean Galley," "The Arkansas Traveller," "Daguerreotyping in the Backwoods," and " The Elevation and Degration of the Arts." Has a large collection of Indian portraits, and "colored photographs" (Overpainted).]

F303 "St. Louis Agricultural and Mechanical Fair - Second Exhibition." FRANK LESLIE'S ILLUSTRATED NEWSPAPER 4, no. 99 (Oct. 24, 1857): 328-329. 5 illus. ["The Press, as Represented at the St. Louis Agricultural and Mechanical Association." (Group portrait, taken at the fairgrounds. The twenty or so individuals are named.); "The Gallinarium, or Chicken Palace. (View of chicken coop.) "'Addison,' the Vermont Horse," "'Tulip,' first premium cow," "The sacred Brahmin Bull of India." - Photographed by Fitzgibbon.]

F304 "St. Louis Agricultural and Mechanical Fair." FRANK LESLIE'S ILLUSTRATED NEWSPAPER 4, no. 100 (Oct. 31, 1857): 348. 3 illus. ["J. Richard Barrett, Pres. of the Assoc.;" "'Royal Oak,' 4 year old horse;" "'Lord Albert,'a prize bull."]

F305 "How to Take Cheap Ambrotypes." PHOTOGRAPHIC AND FINE ART JOURNAL 11, no. 11 (Nov. 1858): 343. [From "Fitzgibbon's Bulletin." Sarcastic advice for taking bad ambrotypes.]

F306 Fitzgibbon, J. H. "The Fredericks' Fund." HUMPHREY'S JOURNAL OF PHOTOGRAPHY, AND THE ALLIED ARTS AND SCIENCES 12, no. 5 (July 1, 1860): 71-72.

F307 Fitzgibbon, J. H. "A Reply from Mr. Fitzgibbon to 'Assistance.'" HUMPHREY'S JOURNAL OF PHOTOGRAPHY, AND THE ALLIED ARTS AND SCIENCES 12, no. 8 (Aug. 15, 1860): 116-117.

F308 Fitzgibbon, J. H. "A Heliographic Gallery." HUMPHREY'S JOURNAL OF PHOTOGRAPHY, AND THE ALLIED ARTS AND SCIENCES 12, no. 13 (Nov. 1, 1860): 193-195.

F309 Fitzgibbon, J. H. "The Fredericks' Fund - A Letter from the Other Side." HUMPHREY'S JOURNAL OF PHOTOGRAPHY, AND THE ALLIED ARTS AND SCIENCES 12, no. 3 (June 1, 1860): 38-39.

F310 Fitzgibbon, J. H. "The 'Arkansas Traveller' Daguerreotyped." AMERICAN JOURNAL OF PHOTOGRAPHY AND THE ALLIED ARTS & SCIENCES n. s. vol. 4, no. 4 (July 15, 1861): 92-94.

F311 Fitzgibbon, J. H. "Photography in Central America." AMERICAN JOURNAL OF PHOTOGRAPHY AND THE ALLIED ARTS & SCIENCES n. s. vol. 4, no. 5 (Aug. 1, 1861): 109-112. [Trip through Guatemala, etc. "The above was intended for Mr. Snelling's Journal, and reached Mr. Snelling about the time his editorship expired."]

F312 Seely, Charles A. "Editorial Department." AMERICAN JOURNAL OF PHOTOGRAPHY AND THE ALLIED ARTS & SCIENCES n. s. vol. 6, no. 6 (Sept. 15, 1863): 143. ["We have recently had the pleasure of welcoming to our office our old friend and correspondent Mr. J. H. Fitzgibbon, lately of the Rebel Confederacy. Mr. Fitzgibbon left Vicksburg just before its fall, tried to run the blockade, was captured, sent to New Orleans, and from that city came directly to New York." Goes on to describe difficulties facing photographers in the South.]

F313 Fitzgibbon, J. H. "Something New." HUMPHREY'S JOURNAL OF PHOTOGRAPHY, AND THE ALLIED ARTS AND SCIENCES 16, no. 17 (Jan. 1, 1865): 271. [Fitzgibbon states that he made a double portrait on one plate of the actor G. V. Brooke, as the Corsican Brothers, eleven years ago, and that he would gladly tell anyone how it was done in order to confound the process sellers who were offering the information for $25.]

F314 Fitzgibbon, John H. "The Double Picture." HUMPHREY'S JOURNAL OF PHOTOGRAPHY, AND THE ALLIED ARTS AND SCIENCES 16, no. 20 (Feb. 15, 1865): 314-315. [Fitzgibbon, because of the volume of response to his earlier offer to tell individuals of the double printing process, published the information here.]

F315 Fitzgibbon, J. H. "Another New Developer." HUMPHREY'S JOURNAL OF PHOTOGRAPHY, AND THE ALLIED ARTS AND SCIENCES 17, no. 19 (Feb. 1, 1866): 298-299.

F316 "Chinese Solvent." HUMPHREY'S JOURNAL OF PHOTOGRAPHY, AND THE ALLIED ARTS AND SCIENCES 18, no. 10 (Sept. 15, 1866): 160. ["Mr. Fitzgibbons [sic], the veteran photographer is in town. He has removed his gallery to St. Louis where he occupies five floors opposite the Planter's House." Fitzgibbon then is said to have praised the Chinese Solvent, a hand cleaner.]

F317 "Editor's Table." PHILADELPHIA PHOTOGRAPHER 6, no. 65 (May 1869): 169. [Several cartes & ferrotypes made at night, by aid of Mr. Proctor's apparatus.]

F318 Fitzgibbon, J. H. "The Boston Convention. A Letter from Mr. Fitzgibbon. - He Throws Down the Glove to Mr. Davie." HUMPHREY'S JOURNAL OF PHOTOGRAPHY, AND THE ALLIED ARTS AND SCIENCES 20, no. 26 (Oct. 15, 1869): 407-409.

F319 "Voices from the Craft." PHILADELPHIA PHOTOGRAPHER 6, no. 72 (Dec. 1869): 424. [Letter in column, "Voices From the Craft," on swindler.]

F320 Fitzgibbon, J. H. "The Next Convention." PHOTOGRAPHER'S FRIEND 2, no. 2 (Apr. 1872): 38.

F321 Fitzgibbon, J. H. "Fourth Annual Meeting and Exhibition of the N. P. A. in St. Louis, Mo., May 1872: Opening Remarks." PHILADELPHIA PHOTOGRAPHER 9, no. 102 (June 1872): 163.

F322 Fitzgibbon, J. H. "Fourth Annual Meeting and Exhibition of the N.P.A. in St. Louis, Mo., May 1872: On the Establishment of a Photographic Fine Art Gallery." PHILADELPHIA PHOTOGRAPHER 9, no. 102 (June 1872): 223. [Proposed establishment of museum in New York, NY.]

F323 Fitzgibbon, J. H. "Classifying the Work at the Buffalo Convention." PHILADELPHIA PHOTOGRAPHER 10, no. 114 (June 1873): 179-180.

F324 "Pictures." ANTHONY'S PHOTOGRAPHIC BULLETIN 4, no. 11 (Nov. 1873): 336. [Stereo views of St. Louis, the construction of the enormous bridge across the Mississippi River.]

F325 "Views on the Line of the Atlantic and Pacific Railroad." ANTHONY'S PHOTOGRAPHIC BULLETIN 5, no. 6 (June 1874): 226. [Fitzgibbon accompanied "a tour of capitalists and gentlemen connected with railroad enterprises..." over the proposed line of the Atlantic & Pacific R.R.]

F326 "Matters of the Month: The Capitalists' Tour Illustrated." PHOTOGRAPHIC TIMES 4, no. 43 (July 1874): 109. [20 views of scenery, taken by J. H. Fitzgibbon, St. Louis, for "the excursion party of capitalists on their recent tour through the Southwest..."]

F327 "Photographs of the Merchant's Exchange." ANTHONY'S PHOTOGRAPHIC BULLETIN 5, no. 7 (July 1874): 236. [From "St. Louis Exchange."]

F328 "Matters of the Month: Wooden Wedding." PHOTOGRAPHIC TIMES 4, no. 46 (Oct. 1874): 154-155. [Description of celebration of Fitzgibbon's wedding anniversary.]

F329 "Dred Scott. - Photographed by Fitzgibbon, of St. Louis." FRANK LESLIE'S ILLUSTRATED NEWSPAPER 39, no. 1000 (Nov. 28, 1874): 198. 1 illus. [Special supplement issue, commemorating the 1000th issue of the magazine. Earlier articles were reprinted, including this portrait published in the June 27, 1857 issue.]

F330 Loomis, G. H. "Gallery Biographic. No. 4. J. H. Fitzgibbon." ANTHONY'S PHOTOGRAPHIC BULLETIN 6, no. 3 (Mar. 1875): 81-82. [Working with a daguerreotype outfit in Lynchburg, Va. in 1841. In 1846 went traveling to Cincinnati and St. Louis (then the Western Frontier), photographing "Picturesque scenes and Indian camps." Summer 1854 toured through Southwest Missouri to the camps of the Indian Nation. Ten townships in thirty-two days, averaging a hundred dollars a day—the first "image man" ever seen in those parts. 1854-55, with C. D. Fredericks of New York, began producing larger and life-sized portraits. 1858 toured Central and South America. Took views for "Leslie's" and other illustrated publications. Opened a branch gallery in Vicksburg as the Civil War broke out and was trapped there, photographing Confederate soldiers, until a shell destroyed his "improvised laboratory." Tried to run the union blockade, was captured and eventually went to New York. Active in the National Photographic Association.]

F331 "Matters of the Month." PHOTOGRAPHIC TIMES 5, no. 54 (June 1875): 135. [Visited editor, left photos (from negatives by Bogardus) of the children of the lamented Dan. Bryant, who are also Fitzgibbon's grandchildren. Fitzgibbon claimed to have made theatrical photography "years ago."]

F332 Fitzgibbon, J. H. "National Photographic Association: Old Guard to the Front." PHILADELPHIA PHOTOGRAPHER 13, no. 149 (May

- June 1876): 129-130, 163-164. [Letter from Fitzgibbon protesting the dissolution of the N.P.A.]

F333 "Note." PHOTOGRAPHIC TIMES 6, no. 66 (June 1876): 135. [Stereo interior of main saloon of Mississippi steamer "Grand Republic. Excerpt from the "St. Louis [MO] Globe-Democrat."]

F334 Fitzgibbon, J. H. "Centennial and Photography." ANTHONY'S PHOTOGRAPHIC BULLETIN 7, no. 7 (July 1876): 211-212.

F335 [Fitzgibbon, J. H.] "Photography." ST. LOUIS PRACTICAL PHOTOGRAPHER 1, no. 1 (Jan. 1877): 2. [Brief statement about the medium's values.]

F336 Fitzgibbon, J. H. "Editorial Chit-Chat." ST. LOUIS PRACTICAL PHOTOGRAPHER 1, no. 1 (Jan. 1877): 31. [Note by Fitzgibbon that he was selling his old gallery to Gibson & Clifford to devote his energies to the magazine. Moved to St. Louis from Lynchburg, VA thirty years previously. Active photographer with longest service in St. Louis now becomes A. J. Fox.]

F337 "Editor's Table." PHILADELPHIA PHOTOGRAPHER 14, no. 166 (Oct. 1877): 319. [Fitzgibbon visited the Eastern states, tried to rouse interest in the ailing N.P.A.]

F338 "Note." PHOTOGRAPHIC TIMES 9, no. 103 (July 1879): 164. [Mr. & Mrs. J. W. Fitzgibbon opened their new parlor gallery...reprinted from the "St. Louis Globe-Democrat."]

F339 "Cincinnati". "What Photographers Say: Mr. Fitzgibbon as a Permanent Secretary of the N. P. A." PHILADELPHIA PHOTOGRAPHER 17, no. 196 (Apr. 1880): 130. [Attack on Fitzgibbon's management as the Secretary of the National Photographers Association.]

F340 Taylor, J. Traill. "Home and Foreign News Epitomized." PHOTOGRAPHIC TIMES 11, no. 124 (Apr. 1881): 131-132. [Note that Mrs. Fitzgibbon had taken a fine portrait of her husband on his 64th birthday. Mentions that Fitzgibbon's St. Louis studio was actually managed by his wife.]

F341 "The Late John H. Fitzgibbon." PHOTOGRAPHIC TIMES 12, no. 140 (Aug. 1882): 338-340, plus frontispiece. 1 b & w. [Illus. is a portrait of Fitzgibbon printed in the Artotype process. Born in London, came to USA as a child. Started his adult life as an apprentice to a saddlery, then kept a hotel in Lynchburg, VA, until he learned about the daguerreotype in 1839, and then went into photography. Successful, after a few years, moved to St. Louis, opening a gallery there 1852. By the Civil War he had the largest gallery in St. Louis. Moved to Vicksburg, opened a gallery there at the outbreak of the war. Tried to run the Union blockade, captured, sent to Cuba, then to New York, where he opened business again. In 1869 he returned to St. Louis and opened another gallery. About 1876 he retired from actively managing the gallery, turned it over to his wife. At that time he began publication of the "St. Louis Practical Photographer." Died at age 65.]

F342 "Obituary. John H. Fitzgibbon." PHILADELPHIA PHOTOGRAPHER 19, no. 226 (Oct. 1882): 315-316. [Born in London, emigrated to the USA as a child. Apprenticed in the saddlery business in Philadelphia, PA, then moved to Lynchburg, VA, and ran a hotel there until he heard of Daguerre's discovery, when he went into the picture-taking business. After a few years of success there he removed to the West, sailing down the Ohio, and making his way up to St. Louis, MO, where he opened a large galley. At the beginning of

the war he moved to Vicksburg, MS, where he opened a gallery, then tried to run the Federal blockade to Cuba, was caught and taken to New York, NY, where he again opened for business. His first wife died during the war, leaving five daughters and a son. Fitzgibbon married his second wife in New York, then in 1869, opened another gallery in St. Louis. About 1876 he retired from active gallery work, leaving the gallery in the hands of his wife, who ran it until about 1881. Fitzgibbon had started the "St. Louis Practical Photographer" magazine and then turned to editing it full time after retiring from the gallery. President of the Photographic Assoc. of St. Louis, active member of the old National Photographic Assoc. and the new Photographer's Assoc. of America. Was in his sixty-fifth year when he died. [1882]]

F343 1 b & w (Actor Edwin Booth). CENTURY MAGAZINE 47, no. 1 (Nov. 1893): 2. 1 illus. [Portrait from a photograph taken by Sidney Brown at Fitzgibbon's Gallery in St. Louis, MO, in 1853.]

FITZGIBBON, JOHN H. [MRS.] see FITZGIBBON, JOHN H.

FITZGIBBON, WILLIAM.

F344 "The Churches of 'The Jesuits' and 'San Francisco' at Antigua de Guatamala (Old Guatamala)." ILLUSTRATED LONDON NEWS 34, no. 964 (Mar. 12, 1859): 255-256. 2 illus. ["...drawn from photographs taken on the spot by Mr. Fitzgibbon, of Guatamala, and were collected by the writer in his recent travels there."]

F345 Fitzgibbon, Wm. "India Rubber Collodion: Photography in the Tropics." AMERICAN JOURNAL OF PHOTOGRAPHY AND THE ALLIED ARTS & SCIENCES n. s. vol. 3, no. 14 (Dec. 15, 1860): 218-219. [Letter from Fitzgibbon, in Guatemala.]

F346 Fitzgibbon, Wm. "Photography in the Tropics." AMERICAN JOURNAL OF PHOTOGRAPHY AND THE ALLIED ARTS & SCIENCES n. s. vol. 4, no. 22 (Apr. 15, 1862): 516-520. [Fitzgibbon writing from Guatemala. Mar. 6, 1862. "...owing to a large number of operators traversing the country, the photographic business is pretty well ruined, as to a fair price of an amount of work. This city, which will hardly support one establishment, has four,...and three or four (other) young men. At the present time I am preparing...for a trip up towards the Mexican frontier, to add to my collection of views and Indian costumes."]

FITZJAMES, F.

F347 Sikandar Began, Nawab of Bhopal. *A Pilgrimage to Mecca.* Translated and edited by Mrs. Willoughby-Osborne. London: W. H. Allen, 1870. 240 pp. 13 b & w. [Autotypes by F. Fitzjames and Capt. Waterhouse.]

FIZEAU, LOUIS ARMAND HIPPOLYTE. (1819-1896) (FRANCE)

[Born Sept. 23, 1819 in Paris. Studied optics and physics, became a disciple of Arago. From 1839 through 1846 he worked to improve the daguerreotype process, often in collaboration with Foucault. Worked on accelerating agents, light intensity, etc. Suggested gold toning and worked out a photoengraving technique directly from the daguerreotype. Superintendat of the Ecole Polytechnique in Paris from 1863. Elected to the Académie des Sciences in 1860, and its President in 1878. Died on Sept. 18, 1896 at the Château de Venteuil, Seine-et-Marne.]

F348 "Miscellanies: Photography." MAGAZINE OF SCIENCE AND SCHOOL OF ARTS 2, no. 77 (Sept. 19, 1840): 200. [From the "Taunton Courier." Discusses Fuseau's [sic Fizeau] gold toning of daguerreotypes to improve and fix the image.]

F349 "Miscellanea: Improvement in Photography." ATHENAEUM no. 686 (Dec. 19, 1840): 1013. [Note on Fitzeau's gold toning of daguerreotypes.]

F350 "Our Weekly Gossip." ATHENAEUM no. 698 (Mar. 13, 1841): 212. ["M. Fiscau has succeeded in applying the galvanic method to pictures obtained by the Daguerrean process, by which an engraved plate is produced."]

F351 "Miscellaneous: New Applications of the Daguerreotype." AMERICAN REPERTORY OF ARTS, SCIENCES AND MANUFACTURES 3, no. 4 (May 1841): 306. [Fiseau (sic Fizeau) applying Jacobi's electrotypic process to the daguerreotype. Has already improved the daguerreotypr by introducing gold toning.]

F352 "Etching Daguerreotypes." PHOTOGRAPHIC AND FINE ART JOURNAL 9, no. 7 (July 1856): 223. [Describes processes of Prof. Grove and Mr. Figeau (sic Fizeau?) in 1841.]

F353 Fowler. "Some New Properties of Iodide of Silver." AMERICAN JOURNAL OF PHOTOGRAPHY, AND THE ALLIED ARTS AND SCIENCES n. s. vol. 9, no. 10 (May. 1, 1867): 222-224. [From "Br. J. of Photo." Discusses Fizeau's experiments.]

F354 "Forgotten Pioneers: III: Hippolyte-Louis Fizeau (1819-1896)." IMAGE 1, no. 5 (May 1952): 3-4. 1 b & w. [Used gold chloride to increase brilliance of daguerreotype, 1840. Also used daguerreotype as etched printing plate.]

FLACHÉRON, JEAN-FRANÇOIS-CHARLES-ANDRÉ (called FRÉDÉRIC) (1813-1883) (FRANCE)
[Born on Oct. 26, 1813 in Lyons, the son of one of the town's official architects. He studied sculpture under David d'Angers about 1836. Won the Prix de Rome in 1839 and studied there. Began to photograph in Rome around 1848 or 1849, and through the 50s was a prominant calotypist and an important figure in a group of amateurs centered in that city. Flachéron left Rome in 1867. Died in Paris in 1883.]

F355 "Negative Photography on Paper - Flacheron's Process." AMERICAN JOURNAL OF PHOTOGRAPHY AND THE ALLIED ARTS & SCIENCES n. s. vol. 8, no. 7 (Oct. 1, 1865): 165-166. [From "Br. J. of Photo."]

FLACK.
F356 "The English Coast. - The Steamer 'Deutschland,' of the North German Lloyds, Wrecked on the Kentish Knock Sands, December 6th. - From a Photograph by Flack." FRANK LESLIE'S ILLUSTRATED NEWSPAPER 41, no. 1056 (Dec. 25, 1875): 260. 1 illus. [View of the ship, taken before the disaster.]

FLAGLOR, AMASA PLUMMER. (1848-1918) (USA)
F357 Palmquist, Peter. "Amasa Plummer Flaglor: Northern California Photographer." PACIFIC HISTORIAN 25, no. 1 (Spring 1981): 28-35. 10 b & w. [Trained in San Francisco with William Shaw and others. Ran his own studio in Eureka, Calif. Abandoned photography in 1893, then sold insurance.]

FLEMING see also CUNDALL & FLEMING.

FLEMING, GILBERT.
F358 Fleming, Gilbert. First Steps in Photography, being a Concise and Practical Treatise on the Collodion Process enabling the Beginner to produce Positive or Negative Views or Portraits, etc. To which are added Simple Directions for Printing on to Paper for the Negative.

Likewise a Chapter on Some of the Principal Causes of Failure in Photography. London: G. Fleming, 1855. 12 pp.

FLETCHER, ABEL. (MASSILON, OH)
F359 "Communications." PHOTOGRAPHIC AND FINE ART JOURNAL 8, no. 3 (Mar. 1855): 69-70. [Letter from Fletcher, a photographer from Massilon, OH. Claims to have been "laboring in the Photographic Art" for more than ten years, and experimenting with paper "nearly seven years ago."]

FLETCHER, JAMES. [?]
F360 "Recent Discoveries in the Buried City of Pompeii." ILLUSTRATED LONDON NEWS 45, no. 1295 (Dec. 31, 1864): 665. 4 illus. ["The illustrations which we have engraved are selected from a large collection of photographs placed at our disposal by the Rev. James Fletcher, of Newburyport, Massachusetts, author of a treatise on the remains of Pompeii.]

FLOOD, C.
F361 "The Suspension Bridge Over the River St. John, N.B., Visited by the Prince of Wales on the 7th of August, and a View of the City of St. John." ILLUSTRATED LONDON NEWS 37, no. 1049 (Sept. 8, 1860): 235. 1 illus. ["From a Photograph by C. Flood."]

FLORENCE, HERCULES. (1804-1879) (BRAZIL)
BOOK
F362 Pressacco, Alfredo Santos. "Hercules Florence, Primer fotografo de America?" FOTOCAMERA no. 172 (Dec. 1965): 61-62.

F363 Naef, Weston. "Hercules Florence 'Inventor do Photographia.'" ARTFORUM 16, no. 6 (Feb. 1976): 57-59. 4 illus.

F364 Kossoy, Boris, with an introduction by Robert Sobieszek. "Hercules Florence, Pioneer Photography in Brazil." IMAGE 20, no. 1 (Mar. 1977): 12-21. 4 illus. [Independent discovery of photography by Frenchman living in Brazil, 1930s.]

F365 Kossoy, Boris. "Hercules Florence." CAMERA (LUCERNE) 57, no. 10 (Oct. 1978): 39-42. 3 illus.

FLOWER, FREDERICK WILLIAM. (1815-1889) (GREAT BRITAIN, PORTUGAL)
F366 Magalhaes, Manuel. "Frederick William Flower: Fotografias," on pp. 63-72 in: Foto Porto. Me*s de Fotografia Porto, Portugal: Casa de Serralves. Secretaria de Estado da Cultura, 1988. 154 pp. 4 b & w. [Exhibition catalog for a "month of photography" festival in Porto. [Sept. 9 - Oct. 5, 1988] An exhibition of Frederick Flower's calotypes was among the exhibits of contemporary and historicl photography. The catalog includes a portfolio of four of Flower's calotype views of Porto, with a biographical summary [in Portugese]. Flower was born on February 23, 1815 in Leith or Edinburgh. At age 19, in 1834, he went to Porto, Portugal, to work for the import/export firm of Smith, Woodhouse & Co. Began to take calotype views of Porto and surrounding villages in 1853. In 1858 he returned to Britian, where he imported wine and spirits from Portugal. He returned to Portugal on business trips many times during his career. Died in 1899.]

FLY, CAMILLUS S. (1849-1901) (USA)
BOOKS
F367 Newman, Gregory, S. Camillus S. Fly. "History of Photography Monograph Series, No. 4." Tempe, AZ: Arizona State University, School of Art, 1983. 16 pp. 4 l. of plates. [Born ca. 1849 in Missouri, family moved to California when Camillus Fly was a child. In 1879 he and his wife moved to Tombstone, AZ in 1879, where he worked as a studio portrait photographer and ran a boarding house. In 1881 the

famous "gunfight at the O. K. Corral" between the Earps and the Clantons occurred in front of Fly's studio, and according to some eyewitness accounts, Fly disarmed the wounded Billy Clanton after the shooting was over. Fly photographed the Apache Indian, Geronimo, and his band in 1886. In 1887 he photographed the aftermath of an earthquake in Mexico. The silver mines began to fail in 1890s, and Fly abandoned photography to become Sheriff for two years, then ranched. Died on Oct. 12, 1901, of alcholism.]

PERIODICALS

F368 "Closing Scenes of the Apache War. - Photographed by C. S. Fly, Tombstone, Arizona." HARPER'S WEEKLY 30, no. 1531 (Apr. 24, 1886): cover, 266, 270. * b & w.

F369 Serven, James E. "C. S. Fly, Tombstone, A. T. Premier Photographer - Historian of the Old West." ARIZONA HIGHWAYS 46, no. 2 (Feb. 1970): 1-4, 47. 13 b & w. 3 illus.

F370 Cooper, Evelyn S. "C. S. Fly of Arizona; the Life and Times of a Frontier Photographer." HISTORY OF PHOTOGRAPHY 13, no. 1 (Jan. - Mar. 1989): 31-47. 17 b & w. [Fly was born in Andrew County, MO in 1849. His family moved to CA. Fly began a photographic studio in San Francisco in 1878. Moved to Tombstone, AZ in Dec. 1879. Took portraits, landscape views in southern Arizona, photographs of the Apache Indian during the 1880s - 18890s.]

F371 Vaughan, Thomas. "C. S. Fly. Pioneer Photojournalist." JOURNAL OF ARIZONA HISTORY 30, no. 3 (Autumn 1989): 303-318. 1 b & w. 5 illus.]

F372 Van Orden, Jay. "C. S. Fly at Cañon de Los Embudos. American Indians as Enemy in the Field. A Photographic First." JOURNAL OF ARIZONA HISTORY 30, no. 3 (Autumn 1989): 319-346. 18 b & w. [On Mar. 25-26, 1886, C. S. Fly photographed the Apache band led by Geronimo, as they were negotiating for peace with U. S. military forces. Includes a portfolio of these photographs, with information about each print.]

FOARD, J. T.

F373 Foard, J. T. "Permanence of Daguerreotypes." PHOTOGRAPHIC AND FINE ART JOURNAL 9, no. 10 (Oct. 1856): 297-298. [From "Photo. J." letter from Foard "...as the qoundam partner of Mr. Beard, and his successor in these regions...(Liverpool)," protesting statements about the impermanency of daguerreotypes.]

F374 Foard. "Artistic Pose in Photographic Portraiture." LIVERPOOL & MANCHESTER PHOTOGRAPHIC JOURNAL [BRITISH JOURNAL OF PHOTOGRAPHY] n. s. 2, no. 23 (Dec. 1, 1858): 295-296. [Paper read at Liverpool Photo. Soc.]

F375 Foard. "Artistic Pose in Photographic Portraiture." HUMPHREY'S JOURNAL OF PHOTOGRAPHY, AND THE ALLIED ARTS AND SCIENCES 10, no. 18 (Jan. 15, 1859): 281-283. [From "Liverpool Photo. J."]

FOLSOM, JOSEPH H. (1841-1883) (USA)

F376 Folsom, J. H. "Photographic Rights." PHILADELPHIA PHOTOGRAPHER 12, no. 138 (June 1875): 190.

FONG. [?]

F377 "China. - The Terrible Typhoon of September, 1874. - From a Photograph by Afong. [sic Fong?]" FRANK LESLIE'S ILLUSTRATED NEWSPAPER 40, no. 1017 (Mar. 27, 1875): 37. 3 illus. [Ruins. "Destruction of the village of Yow-Mah-Tee," "The Steamship 'Alaska,'" "Hong Kong Harbor."]

FONTAIGNE.

F378 Portraits. Woodcut engravings, credited "Photographed by Fontaigne." FRANK LESLIE'S ILLUSTRATED NEWSPAPER 4, (1857) ["Madame Keller as the 'Goddess of Liberty." 4:88 (Aug. 8, 1857): 156. "Mr. Keller in the 'Last Days of Pompeii.'" 4:88 (Aug. 8, 1857): 157.]

FONTAYNE & PORTER.

F379 Vitz, Carl. "The Cincinnati Water Front - 1848." BULLETIN OF THE HISTORICAL AND PHILOSOPHICAL SOCIETY OF OHIO 6, no. 1-2 (Apr. 1948): 28-39. 8 b & w. [Fontayne & Porter's eight plate panorama view of Cincinnati, with commentary on the buildings represented.]

FONTAYNE, CHARLES H. see also FONTAYNE & PORTER.

FONTAYNE, CHARLES H. (1814-1901) (USA)

F380 "$50.00 Reward." HUMPHREY'S JOURNAL 6, no. 1 (Apr. 15, 1854): 16. [Announcement of theft of cameras, other equipment - offer of reward for its return. Fontayne from Cincinnati, OH.]

F381 "The First Life Size Photograph." PHOTOGRAPHIC AND FINE ART JOURNAL 10, no. 11 (Nov. 1857): 349. [Letter, with article from the "Cincinnati [OH] Gazette" in 1855, by Fontayne claiming that he had made life sized portraits before J. Gurney, as previously stated. Fontayne, probably formerly of Fontayne & Porter (Cincinnati) signed his letter as "Practical Photographer at Ryder's Gallery, Cleveland, OH."]

F382 Babcock, G. H. "On the Adaptation of Machinery to Photography." AMERICAN JOURNAL OF PHOTOGRAPHY AND THE ALLIED ARTS & SCIENCES n. s. vol. 3, no. 7 (Sept. 1, 1860): 104-105. [Describes Charles Fontayne's methods of printing photographs in large quantities-useful for book illustration, etc. Editorial note on p. 112.]

F383 Babcock, G. H. "On the Adaptation of Machinery to Photography." BRITISH JOURNAL OF PHOTOGRAPHY 7, no. 127 (Oct. 1, 1860): 285. [From "Am. J. of Photo." Presentation of Charles Fontayne's (Cincinnati, OH) process for mass reproduction of photos.]

F384 "Photograph Drying Machine." AMERICAN JOURNAL OF PHOTOGRAPHY AND THE ALLIED ARTS & SCIENCES n. s. vol. 3, no. 21 (Apr. 1, 1861): 326-328. 1 illus. [Fontayne's machine for producing photographic prints in large quantities.]

F385 Fontayne, Charles. "A Few Facts about the Solar Camera and its Improvements." PHILADELPHIA PHOTOGRAPHER 2, no. 22 (Oct. 1865): 162-163. [Fontayne describes how an optician named Frederick Hall built a solar camera for the W. S. Porter Gallery, Cincinnati, OH, in 1859, which was used by Mr. Fontayne to make solar enlargements.]

F386 Fontayne, Charles. "Correspondence: The Practice of Daguerrotyping a Cure for Consumption." PHOTOGRAPHIC TIMES 21, no. 489 (Jan. 30, 1891): 57-58. [Fontayne began working 1841, sickly with consumption, fumes of chemicals seemed to cure him.]

F387 Fontayne, Charles. "Correspondence: 'Out-of-the Way' Photography." PHOTOGRAPHIC TIMES 21, no. 497 (Mar. 27, 1891): 152-153. [Letter about photos taken by moonlight by Mr. Fontayne, including his negative comments on the new art movement in the medium.]

F388 Ryder, James F. "Editor's Table: Obituary." WILSON'S PHOTOGRAPHIC MAGAZINE 38, no. 533 (May 1901): 192. [Letter from Ryder notifying Wilson of the death of Charles H. Fontayne at age 87 on Mar. 18 at Clifton, NJ. Very brief biography of Fontayne & Porter of Cincinnati, OH, fifty years earlier. In 1856, Fontayne joined Ryder in Cleveland, and taught him negative making. Then a few years later moved to New York, worked as an inventor and manufacturer.]

FORBES, JAMES L.
F389 "Note." PHOTOGRAPHIC TIMES 2, no. 19 (July 1872): 106. [Note that James L. Forbes, the well-known assistant of Mr. G. Frank E. Pearsall, corner Fulton & Tillary St., Brooklyn, N.Y. has recently been severely ill, but is now recovered."]

FORBES, JAMES W. (d. 1891) (USA)
F390 "Notes and News." PHOTOGRAPHIC TIMES 21, no. 525 (Oct. 9, 1891): 505. [Operator for Gurney and Brady in the first days of wet-plate photography. Latterly he had been demonstrator for the Eagle Dry-Plate.]

FORBES, R. L.
F391 "Views from Oregon." HUMPHREY'S JOURNAL OF PHOTOGRAPHY, AND THE ALLIED ARTS AND SCIENCES 14, no. 15 (Dec. 1, 1862): 192. ["...received some very good views of scenery, etc., in Oregon, taken by Mr. R. L. Forbes,...who has recently removed to that far West country and is doing first-rate with his camera...views of settlements along the banks of the Columbia..." Also a note in "To Correspondents" on some page stating that Forbes had moved from "Lyons" (NY?).]

FORD, C. L. (BUFFALO, NY)
F392 "Home Incidents, Accidents, &c.: The Wreck of the Propeller Gov. Cushman, Destroyed by Explosion, May 1, 1868 in Buffalo Harbor, N. Y." FRANK LESLIE'S ILLUSTRATED NEWSPAPER 26, no. 660 (May 23, 1868): 157. 1 illus. [View.]

FORD, D. (CAIRO, IL)
F393 Portraits. Woodcut engravings, credited "Photographed by D. Ford, Cairo, Ill." FRANK LESLIE'S ILLUSTRATED NEWSPAPER 12, (1861) ["Capt. William Hemstreet, Maj. S. D. Baldwin, Henry Binmore (Three portraits)." 12:291 (June 15, 1861): 74.]

FORD, FRANK. (RAVENNA, OH)
F394 "Note." PHOTOGRAPHIC AND FINE ART JOURNAL 11, no. 1 (Jan. 1858): 32. [An excellent positive view on albumen paper.]

F395 "Note." PHOTOGRAPHIC AND FINE ART JOURNAL 11, no. 3 (Mar. 1858): 96. [Picture prints mentioned.]

FORD, J. M. (SAN FRANCISCO, CA)
F396 Spira, S. F. "Ford's Daguerrean Gallery." HISTORY OF PHOTOGRAPHY 12, no. 4 (Oct. - Dec. 1988): 385. [Poem, reprinted from the "Daily Alta California," [San Francisco, CA] (Jan. 1, 1853). The first letter of each line, when read down, spells out the phrase Daguerreotype Miniatures. The poem praises the Ford's Daguerrean Gallery.]

FORMAN, ISRAEL. (d. 1900) (USA).
F397 "Editor's Table: Obituary." WILSON'S PHOTOGRAPHIC MAGAZINE 38, no. 529 (Jan. 1901): 32. [Began his photographic career in 1862, established himself in Fairmont, W. Va. in 1864. Worked there for the rest of his life, well-respected—elected mayor of the town twice, etc. Daughters carrying on the business.]

FORREST, JAMES ALEXANDER. (1813-1905) (GREAT BRITAIN)
F398 Forrest, J. A. "Printing upon Opal Glass." HUMPHREY'S JOURNAL OF PHOTOGRAPHY, AND THE ALLIED ARTS AND SCIENCES 11, no. 8 (Aug. 15, 1859): 124. [From "Photo. Notes."]

F399 Forrest, J. A. "Photography on Opal Glass." AMERICAN JOURNAL OF PHOTOGRAPHY AND THE ALLIED ARTS & SCIENCES n. s. vol. 6, no. 17 (Mar. 1, 1864): 392-394. [Read before Historic Society of Lancashire & Cheshire.]

F400 Forrest, J. Alexander. "A Visit to the North of Ireland with a Camera, and Its Results." PHOTOGRAPHIC TIMES 15, no. 217 (Nov. 13, 1885): 638-639. [Read before the Birkenhead Photographic Association.]

F401 Forrest, James Alexander. "Photography's Value as an Historic Record." PHOTOGRAPHIC TIMES 21, no. 529 (Nov. 6, 1891): 556. ["A Communication to the Birkenhead Photographic Society." Actually a discussion about the permancy of various photographic printing processes.]

F402 "Obituary of the Year: James Alexander Forrest." BRITISH JOURNAL PHOTOGRAPHIC ALMANAC 1905 (1905): 647-648. [Died Sept. 9, 1903, in his 90th year. Connected with the "Liverpool Photo. J." Member of Liverpool Town Council. Owned a glass manufacturing firm. Member of Liverpool Photo. Soc. Interested in astronomical photography. Wrote articles on those topics.]

FORRESTER, JOSEPH JAMES. (1809-1861) (GREAT BRITAIN, PORTUGAL)
BOOKS
F403 Forrester, Joseph James. *Portugese Scenery with Illustrative Notes.* Oporto, London: Forrester, J. Dickinson, 1835. n. p. illus. [Lithographic sketches.]

F404 Forrester, Joseph James. *Portuguese Douro and the Adjacent Country and So Much of the River as Can Be Made Navigable in Spain.* Oporto: Forrester, 1848. n. p. illus.

PERIODICALS
F405 Seiberling, Grace "The Photographs of Joseph James Forrester." HISTORY OF PHOTOGRAPHY 7, no. 1 (Jan. 1983): 51-61. 4 b & w. 4 illus. [English amateur. Born in Hull in 1809, he was a partner of the firm of wine merchants Offlry, Webber, & Forrester and a wine grower living at Operto, Portugal from 1831 until his death in 1861. He was an amateur artist, antiquary and author who wrote and made the lithographic illustration for *Portugese Scenery with Illustrative Notes,* published in 1835. During the 1840s he surveyed the Douro River and published the map of the Portugese Douro and the Adjacent Country. He learned photography from Dr. Hugh Diamond, and later began photographing in the Duoro River area for his researches. He made 220 calotype views on this project, and contributed examples of this work to Photographic Exchange Club activities in the middle 1850s and exhibited them at the Photographic Society's London exhibitions during this period. Forrester drowned in some rapids in the Douro River on May 12, 1862.]

FORRIS, J. (PORTSEA, ENGLAND)
F406 Portrait. Woodcut engraving credited "From a photograph by J. Forris, Queen St., Portsea." ILLUSTRATED LONDON NEWS 58, (1870) ["Capt. Cowper Coles, R.N." 58:* (Sept. 24, 1870): 329.]

FORSTER, CHARLES.

F407 Forster, Charles. *Sinai photographed; or Contemporary Records of Israel in the Wilderness.* London: s. n., 1862. n. p. 18 b & w. [Original photographs of Semetic inscriptions.]

FORSTER, R. W.

F408 Forster, R. W. "The Calotype Process." HUMPHREY'S JOURNAL 9, no. 5 (July 1, 1857): 70-71. [From "Liverpool and Manchester Photo J."]

FORTIER. (d. 1882) (FRANCE)

F409 "Biographical Notes on a Number of Photographers Published by Blanquart-Evrard." CAMERA (LUCERNE) 57, no. 12 (Dec. 1978): 32, 41-42. [Benecke, Claine, DuCamp, Fortier, Greene, Le Secq, Loydreau, Marville, Regnault, Robert, Salzmann, Stewart, Sutton, and Tenison. Fortier was a founding member and active participant in the Société française de Photographie. Published many articles on collodion and albumen processes. About thirty of his architectural views of Paris and other cities in France were published in *Souvenirs photographiques* and *Monuments de Paris*.]

FOSS, ELIPHALET J. (1840-1922) (USA)

F410 Portraits. Woodcut engravings, credited "From a Photograph by Foss, Boston, Mass." HARPER'S WEEKLY 13, (1869) ["Carl Zerahn, of the Peace Jubilee." 13:653 (July 3, 1869): 429. "Eben Tourjee, of the Peace Jubilee." 13:653 (July 3, 1869): 429. "Julius Eichman, of the Peace Jubille." 13:654 (July 10, 1869): 444. "Mathias Keller, of the Peace Jubilee." 13:654 (July 10, 1869): 444.]

F411 Foss, E. J. "Correspondence." ANTHONY'S PHOTOGRAPHIC BULLETIN 1, no. 6 (July 1870): 118-119. [Letter about his portrait lighting techniques.]

FOSTER see LOVEJOY & FOSTER.

FOSTER, J. M.

F412 "Antioch College, Yellow Springs." HARPER'S WEEKLY 11, no. 569 (Nov. 23, 1867): 748, 749. 1 illus. ["Photographed by J. M. Foster."]

FOSTER, PETER LE NEVE. (1809-1879) (GREAT BRITAIN)

[Peter Le Neve Foster was for many years Secretary of the Society of Arts, where London photographers often gathered.]

BOOKS

F413 Foster, Peter Le Neve. "Photography," on pp. 145-175 in Vol. VIII of: *British Manufacturing Industries.* London: Stanford, 1876. n. p.

PERIODICALS

F414 Le Neve Foster, P. "A Hint to Contributors." BRITISH JOURNAL PHOTOGRAPHIC ALMANAC 1874 (1874): 87.

F415 Le Neve Foster, P., M.A. "Stray Thoughts on Dry Plates." BRITISH JOURNAL PHOTOGRAPHIC ALMANAC 1877 (1877): 131-132.

F416 Le Neve Foster, P, M.A. "Stray Thoughts on Dry Plates." PHOTOGRAPHIC TIMES 7, no. 75 (Mar. 1877): 51-52. [From the "Br J of Photo. Almanac."]

F417 "Mr. Le Neve Foster, M.A." ANTHONY'S PHOTOGRAPHIC BULLETIN 10, no. 4 (Apr. 1879): 111. [From "London Photo. News." Foster born Aug. 17, 1809, at Lenwade, Norfolk. Studied at the Norwich Grammar School and Trinity Hall, Cambridge. Elected Fellow of his College. Called to the Bar in 1836, practiced as a conveyancer until 1853, when he became Secretary of the Society of Arts. Ardent amateur photographer, founder member of the Photographic Society. Editor of "Journal of the Society of Arts."]

F418 Gill, Arthur T. "Peter Le Neve Foster and Cleopatra's Needle." HISTORY OF PHOTOGRAPHY 3, no. 4 (Oct. 1979): 289-294. 2 b & w. 2 illus. [Foster, an amateur photographer in Britain from the 1840s, 1850s, documented the re-erecting of the Egyptian column in London in 1878.]

FOSTER, R. W.

F419 Foster, R. W. "The Calotype Process." PHOTOGRAPHIC AND FINE ART JOURNAL 10, no. 5 (May 1857): 152-153. [From "Liverpool Photo. J."]

FOTHERGILL & BRANFILL.

F420 "Our Weekly Gossip." ATHENAEUM no. 1793 (Mar. 8, 1862): 334. [Views of Genoa.]

FOTHERGILL, THOMAS.

F421 "A New Rapid Dry Process." AMERICAN JOURNAL OF PHOTOGRAPHY AND THE ALLIED ARTS & SCIENCES n. s. vol. 6, no. 10 (Nov. 15, 1863): 218-220. [Fothergill's process. From "Photo. Notes."]

F422 Fothergill, Thomas. "Rapid Dry Process." AMERICAN JOURNAL OF PHOTOGRAPHY AND THE ALLIED ARTS & SCIENCES n. s. vol. 6, no. 11 (Dec. 1, 1863): 254-255. [From "Br. J. of Photo."]

F423 Fothergill, T. "Rapid Dry Process." HUMPHREY'S JOURNAL OF PHOTOGRAPHY, AND THE ALLIED ARTS AND SCIENCES 15, no. 16 (Dec. 15, 1863): 245-246. [From "Br. J. of Photo."]

FOUNTAINE, C. G.

F424 *Photographic Views taken in Egypt and Greece by C. G. Fountaine.* London: P. & D. Colnaghi, Scott & Co., 1862. n. p. 36 b & w. [Albumen prints.]

FOWLER, E. W. (MILWAUKEE, WI)

F425 Fowler, E. W. "New Positive Process." HUMPHREY'S JOURNAL OF PHOTOGRAPHY, AND THE ALLIED ARTS AND SCIENCES 11, no. 13 (Nov. 1, 1859): 195.

F426 Fowler, E. W. "A Photographic Process." HUMPHREY'S JOURNAL OF PHOTOGRAPHY, AND THE ALLIED ARTS AND SCIENCES 11, no. 23 (Apr. 1, 1860): 357-359.

FOWLER, JOHN. (USA)
BOOKS
F427 Fowler, J. *Porcelain Picture.* London: Simpkins, 1865. n. p.

F428 Fowler, J. "How to Keep a Bath." HUMPHREY'S JOURNAL OF PHOTOGRAPHY, AND THE ALLIED ARTS AND SCIENCES 11, no. 23 (Apr. 1, 1860): 368. [Fowler from Medical College, NY. "It is now three years since I made the nitrate of silver bath for negatives which I continue still to use."]

FOWLER, R. J.

F429 Fowler, R. J. "To Change Positive Pictures on Glass into Negatives." HUMPHREY'S JOURNAL OF PHOTOGRAPHY, AND THE ALLIED ARTS AND SCIENCES 11, no. 20 (Feb. 15, 1860): 316-317. [From "Photo. Notes."]

FOWX, EGBERT GUY. [FOX, FOUX] (1821-) (USA)
[Fowx, from Baltimore, worked as an assistant to Capt. A. J. Russell during the Civil War. Known to have photographed along the James River and near City Point, VA.]

F430 "Editor's Table." PHILADELPHIA PHOTOGRAPHER 7, no. 74 (Feb. 1870): 62-64. [Fowx; Wm. Notman (Montreal); Whitney & Zimmerman (St. Paul, MN).]

F431 "Editor's Table: Photographs in Baltimore." PHILADELPHIA PHOTOGRAPHER 10, no. 112 (Apr. 1873): 128. ["Mr. E. G. Fowx found as enthusiastic as ever over his porcelain process."]

FOX. (GREAT BRITAIN)
F432 Kingsbridge Estuary; With Rambles in the Neighbourhood. Kingsbridge, Hamilton; London: G. P. Friend; Hamilton, Adams & Co., 1864. n. p. 26 b & w. [Original photographs compiled by Sarah Prideaux Fox, from photographs taken by her brother.]

FOX, ANDREW J. see also HISTORY: USA: MO (Van Ravenswaay)

FOX, ANDREW J. (1826-1919) (USA)
F433 "Editor's Table." PHILADELPHIA PHOTOGRAPHER 5, no. 49 (Jan. 1868): 34. [Pictures received. Fox from St. Louis, MO.]

F434 "Our Picture." PHILADELPHIA PHOTOGRAPHER 6, no. 65 (May 1869): frontispiece, 163. 1 b & w. [Genre, "The May Queen."]

FOX, DANIEL M.
F435 "The Serra Viaduct, St. Paul's Railroad, Brazil." ILLUSTRATED LONDON NEWS 53, no. 1509 (Oct. 31, 1868): 433. 1 illus. ["Mr. Daniel M. Fox, C. E., the resident engineer of the railroad... furnished us with the photograph."]

FOX, E. (GREAT BRITAIN)
F436 The Anatomy of Foliage. Brighton: T. Hatton, 1866. n. p. [Issued in parts, Original photographs of forest trees, each taken from the same point in the summer and winter.]

FOX, EDWARD H. (DANVILLE, KY)
F437 "Kentucky. - Bridge of the Cincinnati Southern Railway, Crossing the Kentucky River. - From a Photograph by E. H. Fox, Danville, Ky." FRANK LESLIE'S ILLUSTRATED NEWSPAPER 44, no. 1134 (June 23, 1877): 277. 1 illus. [View.]

F438 "Kentucky. - Monument in Honor of Dr. Ephriam McDowell, 'The Father of Ovariatomy,' at Danville, Dedicated May 14th. - From a Photograph by Edward H. Fox." FRANK LESLIE'S ILLUSTRATED NEWSPAPER 48, no. 1235 (May 31, 1879): 213. 1 illus. [View.]

FOX, J. B. C., CAPT.
F439 Fox, Captain. "Oleo - Bromide Emulsion Pellicle." BRITISH JOURNAL PHOTOGRAPHIC ALMANAC 1875 (1875): 55-58.

F440 Fox, J. B. C., Captain. "Chloroleo-Bromide Pellicle." BRITISH JOURNAL PHOTOGRAPHIC ALMANAC 1876 (1876): 101-103.

F441 Fox, Capt. J. B. C. "On Washed Collodion Emulsion Pellicle." BRITISH JOURNAL PHOTOGRAPHIC ALMANAC 1877 (1877): 84-86.

F442 Fox, Capt. J. B. C. "On Precipitated Collodion Emulsion." BRITISH JOURNAL PHOTOGRAPHIC ALMANAC 1878 (1878): 46-48.

F443 Fox, Capt. J. B. C. "Development of Precipitated or Washed Collodion Emulsion Dry Plates." BRITISH JOURNAL PHOTOGRAPHIC ALMANAC 1879 (1879): 49-51.

FOX, THOMAS.
F444 Fox, Thomas. "New Method of Photographic Printing." AMERICAN JOURNAL OF PHOTOGRAPHY AND THE ALLIED ARTS & SCIENCES n. s. vol. 7, no. 12 (Dec. 15, 1864): 282-284. [Read before Photo. Soc. of Scotland.]

FOXLEE, E. W.
F445 Foxlee, E. W. "On the Preservation of Negatives and On Varnishing." BRITISH JOURNAL PHOTOGRAPHIC ALMANAC 1874 (1874): 143. [Foxlee was a commercial portrait photographer.]

F446 Foxlee, E. W. "Practical Notes on the Preparation of Backgrounds." BRITISH JOURNAL PHOTOGRAPHIC ALMANAC 1875 (1875): 80-81.

F447 Foxlee, E. W. "The Albumen Process." BRITISH JOURNAL PHOTOGRAPHIC ALMANAC 1876 (1876): 164-166.

F448 Foxlee, E. W. "Practical Notes on Failures in Carbon Printing, and Their Causes." BRITISH JOURNAL PHOTOGRAPHIC ALMANAC 1877 (1877): 74-77.

F449 Foxlee, E. W. "Improvements in the Gelatino - Bromide Process." BRITISH JOURNAL PHOTOGRAPHIC ALMANAC 1878 (1878): 95-96.

FRADELLE & MARSHALL. (LONDON, ENGLAND)
F450 Portraits. Woodcut engravings credited "From a photograph by Fradelle & Marshall, Regent St." ILLUSTRATED LONDON NEWS 66, (1875) ["Mr. H. H. Armstead, A.R.A." 66:1854 (Feb. 20, 1875): 185. "Signor Salvini, Italian actor." 66:1862 (Apr. 17, 1875): 369. "Madame Patey, Madame A. Sterling, Miss E. Wynne, eminent singers." 66:1863 (Apr. 24, 1875): 393. "Count Muenster, German Ambassador." 66:1870 (June 12, 1875): 552.]

F451 Portrait. Woodcut engraving credited "From a photograph by Fradelle & Marshall." ILLUSTRATED LONDON NEWS 67, (1875) ["Right Hon. T. E. Headlam," 67:1900 (Dec. 25, 1875): 629.]

F452 Portraits. Woodcut engravings credited "From a photograph by Fradelle & Marshall." ILLUSTRATED LONDON NEWS 68, (1876) ["Lord Alington." 68:1906 (Feb. 5, 1876): 133. "Alma Tadema, A.R.A." 68:1919 (May 6, 1876): 436. "G. A. Storey, A.R.A." 68:1919 (May 6, 1876): 436. "Wm. F. Woodington, A.R.A." 68:1920 (May 13, 1876): 469.]

F453 1 b & w ("Mrs. Rousby (as Charlotte Corday).") as frontispiece. BRITISH JOURNAL PHOTOGRAPHIC ALMANAC 1877 (1877): frontispiece. 1 b & w. [Woodburytype print, from a photograph by Fradelle & Marshall.]

F454 Portrait. Woodcut engraving credited "From a photograph by Fradelle & Marshall." ILLUSTRATED LONDON NEWS 70, (1877) ["Late R. T. Landells." 70:1958 (Jan. 20, 1877): 61.]

F455 Portraits. Woodcut engravings credited "From a photograph by Fradelle & Marshall." ILLUSTRATED LONDON NEWS 72, (1878) ["Mr. Briton Rivière, A.R.A." 72:2015 (Feb. 9, 1878): 116. "J. E. Boehm, A.R.A." 72:2015 (Feb. 9, 1878): 116.]

FRADELLE, A. E.

F456 Portrait. Woodcut engraving credited "From a photograph by Fradelle." ILLUSTRATED LONDON NEWS 72, (1878) ["Mr. H. W. F. Blockow, M.P." 72:2035 (June 29, 1878): 613.]

F457 Portraits. Woodcut engravings credited "From a photograph by A. E. Fradelle." ILLUSTRATED LONDON NEWS 73, (1878) ["Frank Holl, A.R.A." 73:2038 (July 20, 1878): 53. "J. H. Zukertort, chess player." 73:2045 (Sept. 7, 1878): 236.]

F458 Portrait. Woodcut engraving credited "From a photograph by Fradelle, Baker St." ILLUSTRATED LONDON NEWS 74, (1879) "Late Mr. William Howitt." 74:2075 (Mar. 22, 1879): 297. illus. [1879/00]

FRANCIS, H. D.

F459 Francis, H. D. "Correspondence." ANTHONY'S PHOTOGRAPHIC BULLETIN 1, no. 3 (Apr. 1870): 48-49. [Two letters from Francis, who was the "Founder and proprietor of the School of Photography in London, Photographer to the British Museum, the Royal Asiatic Society, the Royal Society of Literature, etc."]

FRANCK (FRANÇOIS-MARIE-LOUIS-ALEXANDER GOBINET DE VILLECHOLLES.) (1816-1906) (FRANCE)

[Born on Dec. 21, 1816 at the Château de Voyennes, in the Somme department. Took up literature, then in, 1845, became interested in daguerreotypy. From 1849 to 1857 lived as a voluntary exile in Barcelona, where he ran a studio. Returned to Paris in 1859 where he maintained a popular portrait studio in Paris under the pseudonom Franck, until 1880. In 1862 he became a professor of photography at the Ecole Centrale, Paris, then, from 1863, at the Ecole Impériale Centrale des Arts et Manufactures. In 1862 began the "Galerie Universitaire des Célébrites," and, in 1866, he produced the 300 portaits for the album l'*Album contemporain contenant les biographies de 300 personnages de notre epoque*. In 1871 he photographed the Commune and the destruction in Paris. In 1880 he sold his studio and then began manufacturing plates for slides. Belonged to many societies, and held many honors. Died on Jan. 16, 1906.]

F460 Portrait. Woodcut engraving credited "From a photograph by Franck." ILLUSTRATED LONDON NEWS 42, (1863) ["Monseigneur Darboy, Archbishop Elect of Paris." 42:* (Jan. 31, 1863): 112.]

F461 Lacan, Ernest. "Photography in France." PHILADELPHIA PHOTOGRAPHER 12, no. 140 (Aug. 1875): 236-238.

F462 Portrait. Woodcut engraving credited "From a photograph by Franck." ILLUSTRATED LONDON NEWS 69, (1876) ["Compte de Chaudordy, France." 69:1950 (Dec. 9, 1876): 549.]

F463 Portrait. Woodcut engraving credited "From a photograph by Franck." ILLUSTRATED LONDON NEWS 71, (1877) ["M. Jules Grévy." 71:2001 (Nov. 17, 1877): 468.]

F464 Portrait. Woodcut engraving credited "From a photograph by Franck." ILLUSTRATED LONDON NEWS 73, (1878) ["Late Monseigneiur Dupanloup." 73:2052 (Oct. 26, 1878): 385.]

FRANÇOIS see DAVIE & FRANÇOIS.

FRASER, WILLIAM.

F465 Fraser, Wm. "The Stereoscopic Panopticon." PHOTOGRAPHIC AND FINE ART JOURNAL 10, no. 9 (Sept. 1857): 258-259.

FRAUNHOFER, JOSEF.

F466 H. D. "1787 - 1887. In Memoriam. Josef Fraunhofer." ANTHONY'S PHOTOGRAPHIC BULLETIN 18, no. 8 (Apr. 23, 1887): 245-247. [Josef Fraunhofer born Mar. 6, 1787 in Strausburg, Germany; became a lensmaker, builder of telescopes.]

FRAYSER, WALTER G. R. (RICHMOND, VA)

F467 "Another Fine Gallery." ANTHONY'S PHOTOGRAPHIC BULLETIN 2, no. 8 (Aug. 1871): 273. [Frayser opened gallery in Richmond, VA, with W. P. Powers as assistant.]

F468 "The University of Virginia at Charlottesville. - Photographed by W. G. R. Frayser." FRANK LESLIE'S ILLUSTRATED NEWSPAPER 42, no. 1079 (June 3, 1876): 205. 1 illus. [View.]

FRAZER, J. A. see also NOTMAN, WILLIAM.

FRAZER, J. A. (1838-1898) (GREAT BRITAIN, CANADA)

F469 "Our Picture." PHILADELPHIA PHOTOGRAPHER 7, no. 82 (Oct. 1870): frontispiece, 399. 1 b & w. [Frazer of Notman & Frazer, Toronto. "Mr. Frazer, being the resident partner & photographer."]

FRAZER, JOHN F. (1812-1872) (USA)

F470 "Obituary: Professor John F. Frazer." PHILADELPHIA PHOTOGRAPHER 9, no. 107 (Nov. 1872): 396-397. [John F. Frazer died on Oct. 12, 1872. He had been a professor at the University of Pennsyvania. He was one of the first to make a daguerreotype in Philadelphia, PA, and continued interested in the medium. A member of the Franklin Institute, and editor of it's "Journal" for several years.]

FREDERICKS & O'NEIL.

F471 Portrait. Woodcut engraving, credited "From a Photograph by Fredericks & O'Neill. FRANK LESLIE'S ILLUSTRATED NEWSPAPER 46, (1878) ["The late William Cullen Bryant." 46:1178 (June 29, 1878): 277.]

F472 "Our Illustration." ANTHONY'S PHOTOGRAPHIC BULLETIN 10, no. 3 (Mar. 1879): frontispiece, 95. 1 b & w. [Portrait photo, either by Fredericks & O'Neil (New York, NY) as in this issue, or by Powelson (Detroit, MI).]

F473 "Important Decision." HUMPHREY'S JOURNAL OF PHOTOGRAPHY, AND THE ALLIED ARTS AND SCIENCES 20, no. 18 (Feb. 15, 1869): 285. [Note that the Supreme Court upheld an injunction obtained by Fredericks & Co. to restrain Mr. O'Neil, who purchased one of their branch establishments, from using their name.]

FREDERICKS, CHARLES D. see also DE BANES, J.; FREDERICKS & O'NEIL; O'NEIL, HUGH.

FREDERICKS, CHARLES DEFOREST. (1823-1894) (USA)

F474 "Personal & Art Intelligence." PHOTOGRAPHIC AND FINE ART JOURNAL 7, no. 1 (Jan. 1854): 32. ["Mr. C. D. Fredericks has returned from Paris to establish himself in New York. . ."]

F475 "1 photo ('Ruins of Mr. Anthony's Factory, After the Fire, Apr. 28, 1856')." PHOTOGRAPHIC AND FINE ART JOURNAL 9, no. 7 (July 1856): following p. 208. 1 b & w. [Original photographic print, tipped-in. Brief note on p. 224.]

F476 Portraits. Woodcut engravings, credited "Photographed by Fredericks." FRANK LESLIE'S ILLUSTRATED NEWSPAPER 3, (1857) ["Madame Cora de Wilhorst, actress, as 'The Daughter of the Regiment.'" 3:68 (Mar. 28, 1857): 264. "Col. John E. Gowan,

contractor for raising the Russian ships sunken at Sebastopol." 3:74 (May 9, 1857): 360.]

F477 "The Howard Engine Company No. 34, of New York City, on the Way to Washington to Attend the Inauguration of President Buchanan. From a Photograph by Fredericks." FRANK LESLIE'S ILLUSTRATED NEWSPAPER 3, no. 70 (Apr. 11, 1857): 289. 1 illus. [Group portrait of firefighters, drawn up in front of Charles Frederick's Broadway gallery.]

F478 Portraits. Woodcut engravings, credited "Photographed by Fredericks." FRANK LESLIE'S ILLUSTRATED NEWSPAPER 4, (1857) ["Gen. William Walker, Pres. of Nicaragua; Col. John T. Waters, Nicaraguan Army; Capt. C. F. Fayssoux, Nicaraguan Navy. (Three portraits). 4:82 (June 27, 1857): 56. "Simeon Draper, Ex-Commissioner of New York, NY Police." 4:86 (July 25, 1857): 125. "Samuel E. Catlin, physician to Mrs. Cunningham." 4:89 (Aug. 15, 1857): 168. "Mr. David Uhl." 4:89 (Aug. 15, 1857): 168. "Signorina Teresa Rolla, dancer." 4:92 (Sept. 5, 1857): 209. "One of the Survivors of the 'Central America' sinking." 4:96 (Oct. 3, 1857): 281. "Capt. Johnston, of the Noregian bark 'Ellen.'" 4:96 (Oct. 3, 1857): 288. "Miss Laura Keene, actress." 4:103 (Nov. 21, 1857): 397.]

F479 "The Privateer Brig 'Gen. Armstrong.'" FRANK LESLIE'S ILLUSTRATED NEWSPAPER 6, no. 131 (June 5, 1858): 12. 2 illus. [View of the boat, portrait of its captain during the War of 1812, Capt. Samuel C. Reid.]

F480 Portraits. Woodcut engravings, credited "Photographed by C. D. Fredericks." FRANK LESLIE'S ILLUSTRATED NEWSPAPER 6, (1858) ["Officers of the Boston Light Infantry. (group portrait)." 6:134 (June 26, 1858): 49.]

F481 "The Atlantic Cable & Photography." AMERICAN JOURNAL OF PHOTOGRAPHY AND THE ALLIED ARTS AND SCIENCES n. s. vol. 1, no. 7 (Sept. 1, 1858): 111-113. [Detailed descriptions of decorations on the facades of the major New York, NY galleries during celebration of laying Atlantic cable - Gurney's, Brady's, and Frederick's galleries specifically noted.]

F482 Portrait. Woodcut engraving, credited "From a Photograph by C. D. Fredericks." HARPER'S WEEKLY 2, (1858) ["Gen. James Watson Webb." 2:88 (Sept. 4, 1858): 561.]

F483 1 engraving ("Frederick's Photographic Gallery, 585 and 587 Broadway, New York, Illuminated on the Evening of the Telegraphic Jubilee, Sept. 1, 1858."). FRANK LESLIE'S ILLUSTRATED NEWSPAPER 6, no. 145 (Sept. 11, 1858): 235. 1 illus. [This issue contains many engravings of New York, NY buildings decorated to celebrate the completion of the Atlantic Cable.]

F484 Portrait. Woodcut engraving, credited "From a Photograph by Fredericks." FRANK LESLIE'S ILLUSTRATED NEWSPAPER 6, (1858) ["Madame Gazzaniga, opera singer." 6:155 (Nov. 20, 1858): 383.]

F485 Portrait. Woodcut engraving, credited "From a Photograph by Fredericks." FRANK LESLIE'S ILLUSTRATED NEWSPAPER 7, (1859) ["Gen. Superintendent of Police Daniel Carpenter." 7:181 (May 21, 1859):349.]

F486 "The Cutting patents in court: Tomlinson vs. Fredericks." AMERICAN JOURNAL OF PHOTOGRAPHY 2, no. 3 (July 1, 1859): 40-42.

F487 Portraits. Woodcut engravings, credited "From a Photograph by Fredericks." FRANK LESLIE'S ILLUSTRATED NEWSPAPER 8, (1859) ["A. B. Durand, Pres. of the National Academy of Design." 8:194 (Aug. 20, 1859): 187. "Amos Pilsbury, Gen. Supt. of Police." 8:195 (Aug. 27, 1859): 202. "Col. Daniel E. Delevan, City Inspector." 8:196 (Sept. 3, 1859): 219.]

F488 Portraits. Woodcut engravings, credited "From a Photograph by Fredericks." FRANK LESLIE'S ILLUSTRATED NEWSPAPER 9, (1860) ["Madame Anna B. Schultz, prima donna." 9:218 (Feb. 4, 1860): 149. "The Leland Brothers (5 seperate portraits)." 9:220 (Feb. 18, 1860): 187. "Dr. Isaac Hayes, commander of the Artic expedition." 9:228 (Apr. 14, 1860): 314. "Capt. Egbert Viela, Chairman of the Artic Committee." 9:228 (Apr. 14, 1860): 314. "John Cassell, publisher." 9:231 (May 5, 1860): 355.]

F489 "The Prizes Contested for by the New York Yacht Club, June 7, 1860 - Manufactured by Tiffany, - Photographed by Fredericks." FRANK LESLIE'S ILLUSTRATED NEWSPAPER 10, no. 238 (June 16, 1860): 60. 1 illus. [Trophy cups, etc.]

F490 "Gold Coin of Japan - In the Possession of E. W. Burr, 573 Broadway. - Photographed by Fredericks." FRANK LESLIE'S ILLUSTRATED NEWSPAPER 10, no. 241 (July 7, 1860): 105. 2 illus.

F491 "Talk at the Studio: American Photography." PHOTOGRAPHIC NEWS 4, no. 106 (Sept. 14, 1860): 239. [Note about 24" x 24" [Imperial] portrait of Mr. John Cassell made by Frederick's Gallery, New York, NY. The operator [cameraman] was Mr. DeBone.]

F492 Portraits. Woodcut engravings, credited "Photographed by Fredericks." FRANK LESLIE'S ILLUSTRATED NEWSPAPER 10, (1860) ["Gen. George F. Morris, poet." 10: 254 (Oct. 6, 1860): 306.]

F493 "American Photography." AMERICAN JOURNAL OF PHOTOGRAPHY AND THE ALLIED ARTS & SCIENCES n. s. vol. 3, no. 10 (Oct. 15, 1860): 159-160. [From "Photo. News." Review of a 24"x24" portrait of Mr. John Cassell, editor of "Photo News" visiting USA, taken by Mr. De Bane, of the Fredericks' studio, New York, NY.]

F494 "Our Photograph: President Draper." AMERICAN JOURNAL OF PHOTOGRAPHY AND THE ALLIED ARTS & SCIENCES n. s. vol. 3, no. 15 (Jan. 1, 1861): frontispiece, 237. 1 b & w. [Includes biography, from "American Cyclopedia." Original photo (not in this issue) by Ch. Frederick's gallery.]

F495 Seely, Charles A. "Editorial Miscellany." AMERICAN JOURNAL OF PHOTOGRAPHY AND THE ALLIED ARTS & SCIENCES n. s. vol. 4, no. 4 (July 15, 1861): 95-96. [Describes the newly renovated gallery of C. D. Fredericks.]

F496 Portrait. Woodcut engraving, credited "From a Photograph by C. D. Fredericks." HARPER'S WEEKLY 5, (1861) ["Prince Napoleon and his wife, the Princess Clotilde." 5:245 (Sept. 7, 1861): 573.]

F497 Portrait. Woodcut engraving, credited "From a Photograph by Charles D. Fredericks & Co." NEW YORK ILLUSTRATED NEWS 4, (1861) ["Prince Napoleon Bonaparte and the Princess Clotilde." 4:96 (Sept. 2, 1861): 276.]

F498 Portrait. Woodcut engraving, credited "From a Photograph by Charles D. Fredericks & Co." NEW YORK ILLUSTRATED NEWS 5, (1861) ["The Rebel Amnassadors, James M. Mason and John Slidell." 5:109 (Dec. 2, 1861): 65.]

F499 "Lewis M. Rutherford, Esq. Vice-President of the Photographical Society. (Illustrated by a Photograph.)" AMERICAN JOURNAL OF PHOTOGRAPHY AND THE ALLIED ARTS & SCIENCES n. s. vol. 4, no. 24 (May 15, 1862): 567. 1 b & w. [Portrait made by C. D. Fredericks & Co. Operator was Hugh O'Neil, the printer W. J. Kuhns. Little biographical info. - Rutherford "especially eminent in the photographic world for his valuable contributions to celestial photography." (Photo missing from this issue.)]

F500 Portrait. Woodcut engraving, credited "From a Photograph by Fredericks." FRANK LESLIE'S ILLUSTRATED NEWSPAPER 15, (1862) ["Col. C. H. Burtis." 15:369 (Oct. 25, 1862): 68.]

F501 "C. D. Fredericks & Co's Photographic Rooms." HUMPHREY'S JOURNAL OF PHOTOGRAPHY, AND THE ALLIED ARTS AND SCIENCES 15, no. 4 (June 15, 1863): 62-63.

F502 Portraits. Woodcut engravings, credited "From a Photograph by Fredericks." NEW YORK ILLUSTRATED NEWS 8, (1863) ["George W. Dilkes, NY Police." 8:197 (Aug. 8, 1863): 229. Daniel Carpenter, NY Police." 8:197 (Aug. 8, 1863): 236. "James Leonard, NY Police." 8:197 (Aug. 8, 1863): 236.]

F503 Portraits. Woodcut engravings, credited "From a Photograph by Fredericks." FRANK LESLIE'S ILLUSTRATED NEWSPAPER 17, (1863) ["Madame Giuseppina Medori, prima donna." 17:419 (Oct. 10, 1863): 37. "Signor Francesco Mazzoleni as Glauco, in the opera 'Ione.'" 17:428 (Dec. 12, 1863): 189.]

F504 Portraits. Woodcut engravings, credited "Photographed by Fredericks. FRANK LESLIE'S ILLUSTRATED NEWSPAPER 17, (1864) ["The First U.S. Hussars (military group portrait)." 17:432 (Jan. 9, 1864): 252.]

F505 Portraits. Woodcut engravings, credited "Photographed by Fredericks." FRANK LESLIE'S ILLUSTRATED NEWSPAPER 18, (1864) ["Maj.-Gen. George McClellan, Democratic candidate for President." 18:468 (Sept. 17, 1864): 401.]

F506 Portrait. Woodcut engraving, credited "From a Photograph by C. D. Fredericks." HARPER'S WEEKLY 8, (1864) ["Late Col. Grower." 8:406 (Oct. 8, 1864): 652.]

F507 Portraits. Woodcut engravings, credited "From a Photograph by Fredericks." FRANK LESLIE'S ILLUSTRATED NEWSPAPER 21, (1865) ["Madame Euphrosyne Parepa." 21:525 (Oct. 21, 1865): 76.]

F508 Portrait. Woodcut engraving, credited "From a Photograph by C. D. Fredericks & Co." HARPER'S WEEKLY 9, (1865) ["A. Oakey Hall." 9:460 (Oct. 21, 1865): 669.]

F509 "The Ram 'Stonewall' in the Harbor of Havana.- From a Photograph by Fredericks." FRANK LESLIE'S ILLUSTRATED NEWSPAPER 21, no. 532 (Dec. 9, 1865): 181. 1 illus. [Ship at anchor.]

F510 Portraits. Woodcut engravings, credited "From a Photograph by Fredericks." FRANK LESLIE'S ILLUSTRATED NEWSPAPER 21, (1866) ["Prof. Henry W. Longfellow." 21:536 (Jan. 6, 1866): 245. "Late Rev. J. J. Cummings." 21:539 (Jan. 27, 1866): 293. "Edwin Booth." 21:544 (Mar. 3, 1866): 372.]

F511 Portraits. Woodcut engravings, credited "From a Photograph by C. D. Fredericks & Co." FRANK LESLIE'S ILLUSTRATED NEWSPAPER 22, (1866) ["The late Lieut.-Gen. Winfield Scott." 22:559 (June 16,

1866): 193. "Her Majesty Emma, Queen Dowager of the Sandwich Islands." 22:570 (Sept. 1, 1866): 380.]

F512 Portraits. Woodcut engravings, credited "From a Photograph by C. D. Fredericks & Co." HARPER'S WEEKLY 10, (1866) ["Matias Romero, Mexican Minister to USA." 10:472 (Jan. 13, 1866): 29. "Lieut.-Gen. Prim of Spain." 10:478 (Feb. 24, 1866): 125.]

F513 Portrait. Woodcut engraving, credited "From a Photograph by Fredericks & Co." FRANK LESLIE'S ILLUSTRATED NEWSPAPER 24, (1867) ["Isabella II, Queen of Spain." 24:604 (Apr. 27, 1867): 97. "Lieut-Gen. W. T. Sherman." 24:609 (June 1, 1867): 169.]

F514 "'In the Stocks.' - From a Photograph by C. D. Fredericks, Havana." FRANK LESLIE'S ILLUSTRATED NEWSPAPER 24, no. 607 (May 18, 1867): 140. 1 illus. [View of a prisoner, in stocks.]

F515 Portrait. Woodcut engraving, credited "From a Photograph by C. D. Fredericks." FRANK LESLIE'S ILLUSTRATED NEWSPAPER 24, (1867) ["Mrs. F. W. Lander, actress, as Queen Elizabeth." 24:624 (Sept. 14, 1867): 401.]

F516 "Editor's Table." PHILADELPHIA PHOTOGRAPHER 4, no. 47 (Nov. 1867): 366. [" The old established galleries of Messrs. Chas. D. Fredericks & Co., New York, NY, have been purchased by Mr. Hugh O'Neil, [who] has so long been connected with the operating room of the concern that we can say nothing that is not known of him."]

F517 Portrait. Woodcut engraving, credited "From a Photograph by Fredericks & Co., 587 Broadway, New York, NY." HARPER'S WEEKLY 11, (1867) ["Edward Payson Weston, the Pedestrian." 11:568 (Nov. 16, 1867): 725.]

F518 "The Ruins of Barnum's American Museum, After the Fire of 13d. inst. - From a Photograph by C. D. Fredericks & Co." FRANK LESLIE'S ILLUSTRATED NEWSPAPER 26, no. 651 (Mar. 21, 1868): 8. 1 illus. [View.]

F519 Portrait. Woodcut engraving, credited "From a Photograph by C. D. Fredericks & Co." FRANK LESLIE'S ILLUSTRATED NEWSPAPER 26, (1868) ["The late Gen. Charles Halpine." 26:673 (Aug. 22, 1868): 357. "M. M. Pomeroy." 26:674 (Aug. 29, 1868): 373.]

F520 Hull, Charles Wager. "The 'Lights' and Formula of Fredericks and Sarony." PHILADELPHIA PHOTOGRAPHER 5, no. 58 (Oct. 1868): 353-355. [Describes working methods of Fredericks' studio. Hugh O'Neil was a partner (who specially superintends the chemical department. John De Bains "whose skill under the light cannot be excelled." was the operator.]

F521 "Cuban Affairs." HARPER'S WEEKLY 12, no. 622 (Nov. 28, 1868): 753-754. 2 illus. [View of El Moro Castle, scene of "Punishing Slaves in Cuba" from photographs by "C. D. Fredericks, Calle de Habana, 108."]

F522 "Panoramic View of Havana, Cuba - Photographed by C. D. Fredericks, No. 108 Calle de la Habana in: "The Cuban Revolution." HARPER'S WEEKLY 13, no. 635 (Feb. 27, 1869): 135-137. 3 illus. [Three engravings, one credited to a Fredericks photo.]

F523 "A Straw." HUMPHREY'S JOURNAL OF PHOTOGRAPHY, AND THE ALLIED ARTS AND SCIENCES 20, no. 19 (Mar. 15, 1869): 299. [Editor notes that he saw one sign in F. D. Fredericks & Co.'s gallery, offering the first floor and basement for rent. Continuing to

occupy the upper floors. "...this movement on the part of Messrs. F. & Co., show that the picture business in New York is at a low ebb."]

F524 "Editor's Table." PHILADELPHIA PHOTOGRAPHER 6, no. 64 (Apr. 1869): 135. [C. D. Frederics & Co. were preparing to move upstairs (same address).]

F525 Portrait. Woodcut engraving, credited "From a Photograph by Fredericks." FRANK LESLIE'S ILLUSTRATED NEWSPAPER 29, (1869) ["Maj.-Gen. W. M. Belknap, Sec. of War." 29:736 (Nov. 6, 1869): 128.]

F526 "Sketch of Charles D. Fredericks, Esq. (With a Photograph.)." HUMPHREY'S JOURNAL OF PHOTOGRAPHY, AND THE ALLIED ARTS AND SCIENCES 20, no. 27 (Nov. 15, 1869): 429-431. 1 b & w. [Born in New York City in 1823. Sent to Havana, Cuba for a year as a child, where he learned Spanish. Returned to New York, NY. The financial crash of 1837 wiped out his family's wealth, and Fredericks went into business. Working with the banking house of Cammann & Whitehouse on Wall Street in 1843. Then sailed for Venezuela with a stock of merchandise to join his brother, but before he left he learned daguerreotypy from J. Gurney, from whom he also purchased a camera. Arriving in Venezuela, he was asked to take the portrait of the deceased child of his host. A furor was caused by the novelty and he made $4,000 in three weeks. Restocked and began again. Long, adventurous journey down the Orinoco River into Brazil. Photographed in Brazil and Paraguay, Buenos Aires, Montevideo, etc. Then went to Paris and opened a gallery there in 1853 for six months. Then back to New York, NY at end of 1853 to form a partnership with J. Gurney, which lasted until 1855, when he opened his own gallery on Broadway. "In the crisis of 1857, having a large number of artists under engagement, he sent some of them to Havana, and established a branch house, which has been successfully continued." Fredericks brought "to this country, under contract, many talented artists, such as Santain, Nehlig, Piot, Wust, Eberhard, Herlich, Schultz, Constant Mayer, etc." "His able assistant, Mr. Hugh O'Neil...widely known as one of the best photographers which this country has ever produced.]

F527 Portrait. Woodcut engraving, credited "From a Photograph by C. D. Fredericks & Co." FRANK LESLIE'S ILLUSTRATED NEWSPAPER 30, (1870) ["Capt. Lahrbush, the oldest man in America." 30:771 (July 9, 1870): 269.]

F528 Portrait. Woodcut portrait, credited "From a Photograph by C. D. Fredericks & Co.." FRANK LESLIE'S ILLUSTRATED NEWSPAPER 31, (1870) ["James M. MacGregor." 31:796 (Dec. 31, 1870): 269.]

F529 Portraits. Woodcut engravings, credited "From a Photograph by C. D. Fredericks & Co. FRANK LESLIE'S ILLUSTRATED NEWSPAPER 31, (1871) ["The Late James Watson." 31:803 (Feb. 18, 1871): 385.]

F530 Portrait. Woodcut engraving, credited "From a Photograph by C. D. Fredericks & Co., New York." FRANK LESLIE'S ILLUSTRATED NEWSPAPER 36, (1873) ["The late Maj.-Gen. Canby, Modoc Indian war." 36:918 (May 3, 1873): 128.]

F531 Portrait. Woodcut engraving, credited "From a Photograph by C. D. Fredericks & Co." FRANK LESLIE'S ILLUSTRATED NEWSPAPER 37, (1873) ["Miss Nellie Grant." 37:937 (Sept. 13, 1873): 1.]

F532 "Studies of Children for Sale." ANTHONY'S PHOTOGRAPHIC BULLETIN 5, no. 1 (Jan. 1874): 31. [Silver medal at American Institute Fair, for studies of children. Studies for sale.]

F533 Portrait. Woodcut engraving, credited "Photographed by C. D. Fredericks." FRANK LESLIE'S ILLUSTRATED NEWSPAPER 38, (1874)

["Mrs. Algernon C. F. Sartoris, Pres. Grant's daughter." 38:975 (June 6, 1874): 197.]

F534 Portraits. Woodcut engravings, credited "From a Photograph by C. D. Fredericks & Co." FRANK LESLIE'S ILLUSTRATED NEWSPAPER 40, (1875) ["Hon. Thomas S. Brennan." 40:1019 (Apr. 10, 1875): 69. "Police Super. George W. Walling." 40:1027 (June 5, 1875): 201.]

F535 Portrait. Woodcut engraving, credited "From a Photograph by Fredericks." FRANK LESLIE'S ILLUSTRATED NEWSPAPER 42, (1876) ["Gen. W. W. Belknap, Sec. of War." 42:1068 (Mar. 18, 1876): 24.]

F536 Portrait. Woodcut engraving, credited "From a Photograph by C. Fredericks & Co. FRANK LESLIE'S ILLUSTRATED NEWSPAPER 46, (1878) ["The late Moses A. Wheelock." 46:1189 (July 13, 1878): 325.]

F537 Portrait. Woodcut engraving, credited "From a Photograph by C. D. Fredericks & Co." FRANK LESLIE'S ILLUSTRATED NEWSPAPER 47, (1879) ["The late Bishop J. B. P. Wilmer." 47:1214 (Jan. 4, 1879): 305.]

F538 "Editor's Table." PHILADELPHIA PHOTOGRAPHER 16, no. 190 (Oct. 1879): 313. [Fredericks is making pictures of oarsmen in shell boats; very realistic. Ludivici is making the same with background representing a club boathouse on Harlem River. He puts one, four, or six men in the boat, as required. The background was painted by Seavey, of course."]

F539 "Note." PHOTOGRAPHIC TIMES 9, no. 107 (Nov. 1879): 260. ["Mr. C. D. Fredericks, who for over 20 years occupied the immense studios, recently destroyed, at 585 & 587 Broadway has just opened his new 'Knickerbocker Portrait Gallery' at 770 Broadway."]

F540 "Our Illustration. - How Fredericks Became a Photographer." ANTHONY'S PHOTOGRAPHIC BULLETIN 12, no. 4 (Apr. 1881): 110-112. [From "Humphrey's Photographic Journal." Born in New York, NY in 1823. The financial crash of 1837 "swept away his father's entire fortune, and compelled... young Fredericks to seek some occupation." Worked as a clerk, then in a banking house. In 1843 he decided to travel to Venezuela and sell goods. Decided to learn photography as a back-up. He took a few lessons from J. Gurney and bought a daguerreotype outfit. His daguerreotype outfit was a novel sensation in South America and he began photographing seriously. He photographed in Venezuela, Tobago and St. Vincent, then took a nine-month trip up the Orinoco River to the Amazon River and Brazil. Returned to New York, then back to South America, working galleries in Brazil, then traveling to Paraguay, trading daguerreotypes for horses. About 1852 he returned to New York on his way to Paris, to open a studio there in 1853. He took "life-sized heads" there. Returned to New York, briefly joined in partnership with J. Gurney and in 1855 opened his own studio.]

F541 "The Daguerreotype and Wet Collodion Processes." PHOTOGRAPHIC TIMES 15, no. 179 (Feb. 20, 1885): 89-90. [Abstract of an address made to the Society of Amateur Photographers of New York, by Lucien C. Laudy. Technical demonstration of the processes. Mentions that a number of portraits of prominant Americans taken by Fredericks & Co. were purchased much later by the School of Mines, Columbia College and retained in their collections.]

F542 "C. D. Fredericks and His Work." ANTHONY'S PHOTOGRAPHIC BULLETIN 17, no. 1 (Jan. 9, 1886): 4-6.

F543 "Commercial Intelligence: Photographic Art. The Magnificent Atelier of New York's Most Popular Artist, Fredericks." PHOTOGRAPHIC TIMES 16, no. 228 (Jan. 29, 1886): advertising section, pp. i-ii.

F544 "General Notes." PHOTOGRAPHIC TIMES 16, no. 253 (July 23, 1886): 385. [Comment on C. D. Frederick's sailing for Europe with his youngest son, praise of Frederick's character, hard work.]

F545 "Notes and News: The New Photograph Gallery." PHOTOGRAPHIC TIMES 18, no. 377 (Dec. 7, 1888): 585-586.

F546 "The Studios of New York: No. 3." PHOTOGRAPHIC TIMES 22, no. 548 (Mar. 18, 1892): 144-146. [Discusses Frederick's studio and George Rockwood's studio.]

F547 Adams, W. I. L. "The Late Charles D. Fredricks." PHOTOGRAPHIC TIMES 24, no. 664 (June 8, 1894): 355-356. 1 illus. [Biographical information.]

F548 Wilsher, Ann. "Prince and Photographer." HISTORY OF PHOTOGRAPHY 3, no. 4 (Oct. 1979): 355-356. 1 b & w. 1 illus. [Photo by Disderi, 1 illus. from a photo by Charles de Forest Fredericks. Portrait of Prince Napoleon and his wife, and a woodcut of same from "Harper's Weekly".]

F549 Senelick, Lawrence. "Face Cards." HISTORY OF PHOTOGRAPHY 8, no. 1 (Jan. - Mar. 1984): 43-46. 2 b & w. [Two "Theatrical Portrait Galleries", montaged groups of heads of actors created by the New York, NY photographer Fredericks in the 1860s.]

F550 Levine. Robert M. "American Influence in Cuba, 1855." HISTORY OF PHOTOGRAPHY 13, no. 1 (Jan. - Mar. 1989): 5-7. 3 b & w.

FREEBORN, L. M. (DES MOINES, IO)
F551 Freeborn, L. M. "Deeds, Not Words." ANTHONY'S PHOTOGRAPHIC BULLETIN 2, no. 11 (Nov. 1871): 367-368. [Letter from Freeborn (Des Moines, IO) praising Dallmeyer's lenses.]

FREEMAN, ALFRED. (DALLAS, TX)
F552 "Editor's Table." PHILADELPHIA PHOTOGRAPHER 14, no. 157 (Jan. 1877): 32. [Alfred Freeman (Dallas, TX) exhibited at Phila. Centennial and at North Texas Fair. See Dallas Daily Herald in Oct.]

FREEMAN, JAMES.
F553 "Agricultural Exhibition at Roorkee, North-West Provinces of India." ILLUSTRATED LONDON NEWS 45, no. 1279 (Sept. 24, 1864): 324. 2 illus. ["...we have now received a set of photographs, taken by Mr. James Freeman."]

FRENCH & CO. (VICKSBURG, MS)
F554 "Grant-Pemberton Monument, Vicksburg, Mississippi, Erected July 4, 1864, on the Site of the Interview between Lieut.-Gen. Grant and the Rebel Gen. Pemberton, on the Surrender of Vicksburg. - From a Photograph by French & Co., Vicksburg." FRANK LESLIE'S ILLUSTRATED NEWSPAPER 20, no. 515 (Aug. 12, 1865): 333. 1 illus. [View, with figures.]

FRENCH & SAWYER. (KEANE, NH)
F555 "Editor's Table." PHILADELPHIA PHOTOGRAPHER 3, no. 29 (May 1866): 160. [French & Sawyer, Keene, NH, burned out, rebuilding.]

FRENCH, BENJAMIN. (1819-1900) (USA)
F556 "Our Picture." PHILADELPHIA PHOTOGRAPHER 10, no. 111 (Mar. 1873): frontispiece, 92-93. 1 b & w. [Portrait of French, from a negative by Warren & Heald, Boston. French was born in Lebanon, NH in 1819. Moved to Boston, MA, where he became a principal in a business college. Became interested in daguerreotypy in 1844 and purchased a gallery. Later he began to sell photographic supplies as well. In 1848 he stopped taking daguerreotypes himself and became a full-time photographic stock dealer. Honest and successful, supportive of the field. In 1856 he introduced Jamin & Darlot lenses into the USA. In 1859 he became the American agent for Voigtlaender lenses. His son Wilfred A. French entered the business in 1884. Benjamin died in Boston on Jan. 1, 1900.]

F557 "The Late Benjamin French." PHOTO ERA 4, no. 2 (Feb. 1900): 53.

F558 "Obituary: Benjamin French." WILSON'S PHOTOGRAPHIC MAGAZINE 37, no. 518 (Feb. 1900): *. [French began photography in Boston in 1844, began selling photographic supplies and gave up his studio in 1848. Sold supplies for years. Born in Lebanon, NH, in 1819. Died Jan. 1900.]

FRENCH, C. M. (YOUNGSTOWN, OH)
F559 "Our Picture." PHILADELPHIA PHOTOGRAPHER 12, no. 144 (Dec. 1875): frontispiece, 356-357. 1 b & w. [Studio portrait in promenade style.]

FRENCH, JOTHAM A. (1834-1898) (USA) see FRENCH & SAWYER.

FREUND.
F560 Freund, Prof. "Paper Collodion." HUMPHREY'S JOURNAL OF PHOTOGRAPHY, AND THE ALLIED ARTS AND SCIENCES 20, no. 15 (Dec. 1, 1868): 230-232.

FREW.
F561 "*[Accident at a Coal Mine.]" ILLUSTRATED LONDON NEWS 36, no. 1022 (Mar. 17, 1860): 260, 266. 1 illus. ["Our Engraving of the pit's mouth shortly after the terrible accident is from a photograph taken from the waggon-way by Mr. Frew, of North Shields.]

FREWAN, RICHARD.
F562 Frewan, Richard. "The Journal of Richard Frewan," on pp. 144-145 in: Zambesia and Matabeleland in the Seventies, ed. by Edward C. Tabler. London: Chatto & Windus, 1960. n. p. [Frewan attempted to photograph the Victoria Falls in 1877, for the "Illustrated London News," but failed in the attempt.]

FRICKE & JUNG.
F563 "Views of Guzeral, in the Punjaub." ILLUSTRATED LONDON NEWS 45, no. 1274 (Aug. 27, 1864): 208-209. 1 illus. ["...a series of photographs, taken by Messrs. Fricke and Jung."]

FRISTON, F. E. (GRIMSBY, ENGLAND)
F564 Portrait. Woodcut engraving credited "From a photograph by F. E. Friston." ILLUSTRATED LONDON NEWS 71, (1877) ["Mr. Alfred Mellor Watkin, M.P." 71:1989 (Aug. 25, 1877): 185.]

FRITH, FRANCIS. (1822-1898) (GREAT BRITAIN)
[Born at Chesterfield, Devonshire in 1822. Attended Ackworth School and the Quaker Camp Hill School in Birmingham. Apprenticed in a cutlery shop, then, from 1845 to 1855, made a success with a wholesale grocery firm. Opened a studio with a partner in 1850 in Liverpool, Frith & Hayward. Began making views, and between 1855 and 1870 he made or published over 100,000 views. In 1856 he took

his first trip to Egypt. Negretti & Zambra published 100 stereo views of this work in 1857. Agnew published the large format photographs. In 1858 Frith went to Palestine and Syria, to make stereoscopic views for Negretti & Zambra again. In 1859 Frith travelled up the Nile in Egypt again, this time as far as the Fifth Cataract. Back in Britian in 1859, Frith opened his own firm, F. Frith & Co. at Reigate, Surrey; and published stereo cards, portfolios, illustrated books, and, later, postcards. Died in Reigate in 1898. The family continued to run the firm until 1968, when it was sold, then closed in 1971.]

BOOKS

F565 Frith, Francis. *Margate and Ramsgate,* Photographed. London: James S. Virtue, 1857. n. p. 15 b & w. [Album, original photos, no text. Albert Marshall Collection.]

F566 Frith, Francis. *Egypt and Nubia.* Descriptive Catalogue of One Hundred Stereoscopic Views of the Pyramids, the Nile, Karnak, Thebes, Aboo-Simbel, and All the Most Interesting Objects of Egypt and Nubia. London: Negretti & Zambra, ca. 1858. 18 pp. [Catalog of views by Frith, with notices from the press.]

F567 Frith, Francis. *Egypt, Sinai and Jerusalem.* A Series of Twenty Photographic Views by Francis Frith. With descriptions by Mrs. Sophia Poole and Reginald Stuart Poole. London: Wm. Mackenzie, 1858. n. p. 20 b & w.

F568 Frith, Francis. *Egypt and Palestine.* Photographed and Described by Francis Frith. London: James S. Virtue, 1858-1859. 2 vol. (vol. 1, 108 pp., 37 b & w ; vol. 2, 60 pp., 39 b & w) pp. 76 b & w. [Seventy-six albumen prints. Originally issued in twenty-five monthly parts, each containing three prints. Then reissued in two volumes in 1859.]

F569 Cooper, Charles Henry, F.S.A. *Memorials of Cambridge,* Thomas Wright and Harry L. Jones. With Photographs printed by F. Frith. A New Edition (entirely rewritten by Charles H. Cooper.) Cambridge, England: William Metcalfe, 1860. 2 vol. pp. 21 b & w. [Original photos.]

F570 Frith, Francis. *Cairo, Sinai, Jerusalem and the Pyramids of Egypt.* A Series of Sixty Photographic Views by Francis Frith. With descriptions by Mrs. Sophia Poole and Reginald Stuart Poole. London: James S. Virtue, 1860. 122 pp. 60 b & w.

F571 Frith, Francis. *Egypt, Sinai and Jerusalem: A Series of Twenty Photographic Views.* London: James S. Virtue, 1860. 44 pp. 20 b & w. [Illustrated with 20 mammoth albumen photographs.]

F572 Frith, Francis. *Egypt, Nubia and Ethiopia.* Illustrated by One Hundred Stereoscopic Photographs, taken by Francis Frith for Messrs. Negretti & Zambra. With Descriptions and Numerous Wood Engravings by Joseph Bonomi... and Notes by Samuel Sharpe. London: Smith, Elder & Co., 1862. 239 pp. 100 b & w. illus.

F573 *Gems of Photographic Art.* Photo-Pictures Selected from the Universal Series by Francis Frith. Reigate: Printed and published by Francis Frith, 1862. 1 pp. 20 l. of plates. 20 b & w. [Title page and twenty original photographs. Six by F. Bedford, two by H. Eaton, one by R. Fenton, five by F. Frith, one by Meteyard, five by A. Rosling.]

F574 Bible. English. 1862. Authorized. *The Holy Bible: Containing the Old and New Testaments,...* Illustrated with Photographic Views of Biblical Scenery from Nature by Frith. Glasgow: Wm. MacKenzie, 1862-1863. 2 vol., 1344 pp. 56 l. of plates. 56 b & w. [Half-title: "The Queen's Bible." Original photos.]

F575 Frith, Francis. *Sinai and Palestine.* London: Wm. Mackenzie, 1863. n. p. 37 b & w. [Vol. I of the second, enlarged edition of "Egypt, Palestine & Nubia."]

F576 Frith, Francis. *Lower Egypt and Thebes.* London: Wm. Mackenzie, 1863. n. p. 37 b & w. [Vol. II of the second, enlarged edition of "Egypt, Palestine & Nubia."]

F577 Frith, Francis. *Upper Egypt and Ethiopia.* London: Wm. Mackenzie, 1863. 148 pp. 37 b & w. [Vol. III of the second, enlarged edition of "Egypt, Palestine & Nubia."]

F578 Frith, Francis. *Egypt, Sinai, and Palestine.* Supplementary Volume. London: Wm. Mackenzie, 1863. 76 pp. 37 b & w. [Sometimes described as volume IV, following the other three volumes of the second, enlarged edition of "Egypt, Palestine & Nubia," containing 111 photographs, published by Mackenzie in 1862 and 1863.]

F579 Frith, Francis. *Photographs.* Printed and Published by F. Frith, Reigate. Reigate: Francis Frith, 1864. n. p. 15 b & w. [The June 1864 issue of "Art Journal," p. 192, contains an announcement of a proposal to publish a series of 6" x 8" photographs, in sets of fifteen, over the next four years. The first installment in this series contained four photographs each by Francis Bedford, Roger Fenton, and Rosling aa well as at least one photograph by Goodman. I do not know how many in the series were finally published.]

F580 Frith, Francis. *F. Frith's Photo-Pictures from the Lands of the Bible, illustrated by Scripture Words.* Reigate: Francis Frith, 1864. n. p. 50 b & w. [Fifty albumen prints. Title page and printed captions.]

F581 Frith, Francis. *The Gossiping Photographer at Hastings.* Photographs, with Descriptive Letterpress. Reigate: Frith, 1864. 29 pp. 16 b & w. [Original photographs. Views, etc.]

F582 Frith, Francis. *The Gossiping Photographer on the Rhine.* Reigate: Frith, 1864. 32 pp. 16 b & w. [Original photographs. Views, etc.]

F583 Longfellow, Henry Wadsworth. *Hyperion: A Romance.* Illustrated with Twenty-four Photographs of the Rhine, Switzerland, and the Tyrol, and with a Preface by Francis Frith. London: Alfred W. Bennett, 1865. 272 pp. 24 b & w. [Four page preface, by Frith. 2nd ed. (1868).]

F584 Frith, Francis. *Swiss Views.* Reigate: Francis Frith, 1866. 3 vol. 200 b & w. [a series of approximately 200 views, published both in seperate portfolios and in a three volume set.]

F585 Frith, Francis. *Frith's Photo-Pictures: English Scenery.* Reigate: Francis Frith, 1867. n. p. 20 b & w. [Albumen prints. Printed captions.]

F586 Frith, Francis. *Frith's Photo-Pictures: The Lake District.* Reigate: Francis Frith, 1867. n. p. 20 b & w. [Albumen prints. Printed captions.

F587 Hall, Samuel C. and Anna M. Hall. *The Book of the Thames, From Its Rise to Its Fall.* ...Illustrated by Francis Frith. London: Alfred W. Bennett, Virtue & Co., 1867. 208 pp. 15 b & w. 140 illus. [There were both earlier (1859) and later (1877) editions of this work. Apparently, only the 1867 edition also had original photographs by Frith tipped-in.]

F588 Frith, Francis. *Frith's Photo-Pictures. Dovedale.* Ashbourne, Eng.: Sold by E. Bamford., 1868. 11 l. 10 b & w. [Original photos.]

F589 Frith, Francis. *Canterbury Cathedral.* Photographed by Francis Frith. Canterbury: Sold by Hal Drury, 1870. n. p. 20 b & w. [Album of photographs, with printed title page. Fogg Art Library Collection. Similar album, GEH Collection, titled "Photo-Views of Canterbury."]

F590 Frith, Francis. *Fountains Abbey, Ripon, Bolton, Knaresborough, etc. Photographed and Printed by Francis Frith.* Harrogate: G. R. Parker, 1870. n. p. 20 b & w. [Albumen prints. Printed title page.]

F591 Frith, Francis. *Liverpool; Its Public Buildings, Docks, Churches, Etc.* Liverpool: Philip, Son & Nephew, 1870. n. p. pp. 35 b & w. [Album of original photos by Francis Frith. NYPL Collection.]

F592 Drew, Frederick. *The Jummo and Kashmir Territories; A Geographical Account.* London: Edward Stanford, 1875. n. p. 4 b & w. [4 Woodburytypes, after photos by Francis Frith.]

F593 Drew, Frederick. *The Northern Barrier of India; A Popular Account of the Jummoo and Kashmir Territories.* London: Edward Stanford, 1877. n. p. 3 b & w. [3 Woodburytypes, after photos by Francis Frith.]

F594 *"Evangelicalism" from the Standpoint of the Society of Friends.* London: s. n., 1877. n. p.

F595 *Frith's Photo Pictures.* Reigate: Frith, 1888-1892. 682 pp. [Catalog.]

F596 Frith & Co., Reigate, Surrey. *Catalogue of the Principal Series of Photo-Pictures Printed and Published by F. Frith & Co., Reigate, Surrey.* Surrey: Frith, 1892. 733 pp. [Cover title: "Frith's Photographs. Catalogue of the English and foreign series."]

F597 *The Quaker Ideal.* "British Friend Series, No. 1." Birkenhead: William E. Turner, 1893. 102 pp.

F598 Jay, Bill. *Victorian Cameraman: Francis Frith's Views of Rural England, 1850-1898.* Newton Abbott, England: David & Charles, 1973. 112 pp. 110 b & w.

F599 Frith, Francis. *A Victorian Maritime Album:* 100 Photographs from the Francis Frith Collection at the National Maritime Museum. Chosen, introduced and explained by Basil Greehill. Cambridge, England: Patrick Stephens Ltd., 1974. 142 pp. 100 b & w.

F600 *Two Victorian Photographers: Francis Frith, 1822-1898 and Francis Bedford, 1816-1894; From the Collection of Dan Berley.* Brockport, NY: State University of New York at Brockport, 1976. 24 pp. illus. [Exhibition: Fine Arts Gallery, SUNY at Brockport, Sept. 19 - Oct. 11, 1976.]

F601 *The Day Before Yesterday: A Photographic Album of Daily Life in Victorian and Edwardian Britain;* Introduced by Peter Quennell, Photographic research by Harold Chapman and Thelma Shumsky; Captions by Joanna Smith. New York: Scribner, ca. 1978. 250 pp. 300 b & w. illus. ["Over 300...photographs by Francis Frith and others."]

F602 *Comparative Photography: A Century of Change in Egypt and Israel,* Photographs by Francis Frith and Jane Reese Williams. Introduction by Brian M. Fagan. Carmel, CA: Friends of Photography, 1979. 55 pp. b & w. [Photographs taken by Frith in 1850s compared to photographs taken by Williams in the 1970s.

F603 Frith, Francis. Selection and Commentary by Jon E. Manchip White. *Egypt and the Holy Land; In Historic Photographs, 77 Views by Francis Frith.* Introduction by Julia Van Haaften. New York: Dover, 1980. 112 pp. 77 b & w. illus.

F604 Wilson, Derek. *Francis Frith's Travels: A Photographic Journey through Victorian Britain.* London: J. M. Dent & Sons, Ltd., 1985. 192 pp. 198 l. of plates. ["In association with the Francis Frith Collection."]

PERIODICALS

F605 "Manchester Mechanics' Institution: Photographic Dissolving Views." LIVERPOOL & MANCHESTER PHOTOGRAPHIC JOURNAL [BRITISH JOURNAL OF PHOTOGRAPHY] n. s. 2, no. 2 (Jan. 15, 1858): 26. [Negretti & Zambras views, from Frith's negatives, of Egypt displayed at Manchester Mechanic's Institution.]

F606 "Stereoscopes; Or; Travel Made Easy." ATHENAEUM no. 1586 (Mar. 20, 1858): 371-372. [Review of 100 stereo views of Egypt and Nubia by Francis Frith.]

F607 "Our Weekly Gossip." ATHENAEUM no. 1590 (Apr. 17, 1858): 500. [Note: "At the last meeting of the Astronomical Society, a very remarkable Daguerreotype, of the recent eclipse was exhibited, made by Mr. Williams, of Regent Street." Note: Mssrs. Negretti & Zambra [wish to correct the error that] Mr. Frith is [their] photographer...he is a gentleman of independent means, who travels for his own pleasure...Negretti & Zambra fortunate to acquire Frith's Egyptian views."]

F608 "London Photographic Society." LIVERPOOL & MANCHESTER PHOTOGRAPHIC JOURNAL [BRITISH JOURNAL OF PHOTOGRAPHY] n. s. 2, no. 12 (June 15, 1858) [Paper by Hardwich "On the Solarization of Negatives" read; Francis Frith was in the audience and was called forward, with applause, to describe his experiences in Egypt with solarization. (p. 150); Bedford, Davies, Malone and others also commented.]

F609 "Egypt and Palestine." ART JOURNAL (Aug. 1858): 229-230. [Bk. Rev.: "Egypt and Palestine," by F. Frith.]

F610 "Reviews: Stereoscipic Views in the Holy Land." ART JOURNAL (Dec. 1858): 375. [Review of "Stereoscopic Views in the Holy Land, Egypt, Nubia & c., from negatives taken by F. Frith, 1858." Published by Negritti & Zambra.]

F611 Frith, Francis. "The Art of Photography." ART JOURNAL (Mar. 1859): 71-72.

F612 "Photographic Contributions to Knowledge: 'Egypt and Palestine,' by Francis Frith - Illustrated with Photographs." BRITISH JOURNAL OF PHOTOGRAPHY 7, no. 111-113 (Feb. 1, Mar. 1, 1860): 32-33, 60-61.

F613 "Frith's photographs of Egypt and Palestine and the Collection of Egyptian Products at the Crystal Palace." ART JOURNAL (Nov. 1860): 348-349.

F614 "The National Magazine." JOURNAL OF THE PHOTOGRAPHIC SOCIETY OF LONDON 7, no. 116 (Dec. 15, 1861): 333-335. [The "Nat. Mag." has issued two photographic illustrations by Frith in the Nov./Dec. 1861 issue, printed by Frith & Hayward. Note that another view by Frith was published in the Jan. 15, 1861 issue, on page 360.]

F615 "Note." JOURNAL OF THE PHOTOGRAPHIC SOCIETY OF LONDON 7, no. 117 (Jan. 15, 1862): 360. [A Photographically

Illustrated Bible published by Eyre & Spottiswood, Fleet Street c. 1861. "There are 20 of Frith's Oriental photos bound up in the work."]

F616 "Review." JOURNAL OF THE PHOTOGRAPHIC SOCIETY OF LONDON 7, no. 118 (Feb. 15, 1862): 379. ["Egypt, Nubia, and Ethiopia." Illustrated by one hundred stereoscopic photographs, taken by Francis Frith, for Messrs. Negretti & Zambra with descriptions and numerous wood engravings by Joseph Bonomi, F.R.S.L., and notes by Samuel Sharpe. London: Smith & Elder [c. 1862]. From "The Critic."]

F617 "Reviews: Egypt, Nubia, and Ethiopia." ART JOURNAL (Mar. 1862): 96. [Book review: "Egypt, Nubia, and Ethiopia," by Francis Frith.]

F618 "Miscellaneous Items: Egypt in the Stereoscope." AMERICAN JOURNAL OF PHOTOGRAPHY AND THE ALLIED ARTS & SCIENCES n. s. vol. 4, no. 19 (Mar. 1, 1862): 455. [From "Athenaeum." "Mr. Bonomi has arranged a hundred stereoscopic views in Egypt, taken by Mr. Frith in 1859 and 1860, into a volume, which Messrs. Smith and Elder have published."]

F619 "Note." ART JOURNAL (Mar. 1863): 91. [Frith "...announces has in preparation a series of 60 photos by the best artists of the day to be published in four parts - 1 part a year."]

F620 "New Publications: The Gossiping Photographer at Hastings - The Gossiping Photographer on the Rhine." BRITISH JOURNAL OF PHOTOGRAPHY 11, no. 215 (June 1, 1864): 195-196. [Each book contains 16 original photos.]

F621 "The Pictures Exhibited at the Photographic Society." BRITISH JOURNAL OF PHOTOGRAPHY 12, no. 290 (Nov. 24, 1865): 597. [Fifty or sixty landscape views by Francis Frith, exhibited by Ross to demonstrate his landscape lens. Dallmeyer exhibited works by R. Manners Gordon and Mr. Wardley to demonstrate his lenses.]

F622 "The Photographs of Mr. F. Frith, of Reigate." ART JOURNAL (Oct. 1866): 323.

F623 "Editor's Table." PHILADELPHIA PHOTOGRAPHER 4, no. 42 (June 1867): 196. [Swiss Alpine, English & Welsh photos by Frith in whole plate and 7"x9" received by Wilson & Hood (dealers).]

F624 "Twenty-four Thousand Pounds!" ART JOURNAL (May 1869): 159. ["A paragraph has been going the rounds of the press to the effect that Mr. Graves, the print publisher, had given 24,000 pounds for Mr. Frith's 'Railway Station' and copyright." The paragraph asserts that the statement was made in a public court during one of the hundred prosecutions Mr. Graves has instituted against photographers. "Mr. Graves ought ere this to have contradicted an assertion so utterly opposed to truth. That is all we need say about it - for the present."]

F625 "News and Notes." WILSON'S PHOTOGRAPHIC MAGAZINE 35, no. 498 (June 1898): 256. [Brief mention of Francis Frith's death. "It is claimed that Mr. Frith was the first person to take a camera up the Nile."]

F626 Van Dyke, Henry. "A Day Among the Quantok Hills." SCRIBNER'S MAGAZINE 37, no. 6 (June 1905): 668-675. 7 b & w. illus. [Landscape views credited to F. Frith & Co.]

F627 Hemphill, C. "Frith's Photographic Views of Egypt." NINETEENTH CENTURY 3, no. 1 (Summer 1977): 70-73. 6 b & w.

F628 Fagan, B. M., Introduction. "Comparitive Photography: A Century of Change In Egypt and Israel." UNTITLED no. 17 (1979): 1-55. 46 b & w. [Comparitive study of Frith's photographs of Egypt, taken in 1859 and those of Jane Williams taken in 1976.]

F629 Van Haafton, Julia. "Francis Frith and Negretti & Zambra." HISTORY OF PHOTOGRAPHY 4, no. 1 (Jan. 1980): 35-37. 1 b & w. 2 illus. [Stereo views by Frith "Egypt & Nubia" in 1857.]

F630 Van Haaften, Julia. "Francis Frith's Grand Tour." PORTFOLIO: THE MAGAZINE OF THE VISUAL ARTS 2, no. 3 (Summer 1980): 56-61. 8, 1 port. b & w. [Frith's tours of the Middle East, 1856-1860.]

F631 "Views of Manchester: A Selection from the Frith Series." CREATIVE CAMERA 193-194, (July - Aug. 1980): 218-222. 4 b & w.

F632 Wilsher, Ann. "The Sphinx Transfixed." HISTORY OF PHOTOGRAPHY 11, no. 1 (Jan. - Mar. 1987): 13. 1 illus. [Cartoon from "Punch," (June 7, 1862); with commentary about British photographers in Egypt.]

FRITH, H. A.
F633 "The Last Surviving Aborigines of Tasmania." ILLUSTRATED LONDON NEWS 46, no. 1296 (Jan. 7, 1865): 13. 1 illus. ["...from a portrait by H. A. Frith, from Hobart Town, Tasmania." Four natives, dressed in European clothing, in posed group portrait.] @BULLET = FRITZ, F. Z. (LAMBERTVILLE, NJ)

F634 "Note." PHOTOGRAPHIC TIMES 14, no. 167 (Nov. 1884): 585. [From "Lambertville, (NJ) Record." Fritz opening new studio, been photographing in the town for fifteen years.]

FROEBE, THOMAS W. (GERMANY, USA)
F635 Froebe, Th. W. "Photography in San Francisco and Honolulu." BRITISH JOURNAL OF PHOTOGRAPHY 10, no. 196 (Aug. 15, 1863): 329-330. [From "Photographisches Archiv." The author, a German, discusses a process learned from William Shew, "while we were both staying in San Francisco five years since...", then describes using the process in the Sandwich Islands.]

F636 Froebe, Th. W. "Photography in San Francisco and Honolulu." HUMPHREY'S JOURNAL OF PHOTOGRAPHY, AND THE ALLIED ARTS AND SCIENCES 15, no. 9 (Sept. 1, 1863): 134-136. [From "Photographisches Archiv." "Whilst I was in San Francisco, five years ago, such pictures (on canvas) were made by Mr. Wm. Shew in the following manner:... in the Sandwich Islands (in Honolulu) where I practiced as a photographer." (during 1850's).]

FROTHINGHAM.
F637 Frothingham, Rev. Mr. "Fifth Annual Meeting and Exhibit of the National Photographic Association of the U.S., held in Buffalo, N.Y., beginning July 5, 1873: Address." PHILADELPHIA PHOTOGRAPHER 10, no. 117 (Sept. 1873): 431-432.

FRY, CLARENCE E. see also ELLIOTT & FRY.

FRY, CLARENCE E. & SON. (LONDON, ENGLAND)
F638 "A Notable English Studio: The Studio and Work of Messrs. C. E. Fry & Son, London." WILSON'S PHOTOGRAPHIC MAGAZINE 34, no. 492 (Dec. 1897): 545-548. 7 b & w. 6 illus. [7 portraits, 6 illus. of the studio.]

FRY, PETER WICKENS. (d. 1860) (GREAT BRITAIN)
F639 "Obituary." BRITISH JOURNAL OF PHOTOGRAPHY 7, no. 127 (Oct. 1, 1860): 280. [Active calotypist, formerly a member of the

Photographic Club, founder and member of the Photographic Society. Well-liked.]

F640 "Obituary Note: Peter W. Fry." PHOTOGRAPHIC NEWS 4, no. 109 (Oct. 5, 1860): 276.

FRY, SAMUEL & CO.

F641 Portrait. Woodcut engraving credited "From a photograph by Samuel Fry & Co." ILLUSTRATED LONDON NEWS 70, (1877) ["Mr. John Parry, actor." 70:1966 (Mar. 17, 1877): 252.]

FRY, SAMUEL. (d. 1890) (GREAT BRITAIN)

F642 "Critical Notices: The Moon in the Stereoscope. Photographed by Samuel Fry, Brighton." PHOTOGRAPHIC NEWS 3, no. 62 (Nov. 11, 1859): 112.

F643 "Note." ART JOURNAL (Aug. 1860): 254. [A stereograph of the moon noted.]

F644 "Talk in the Studio: Instantaneous Photography." PHOTOGRAPHIC NEWS 4, no. 115 (Nov. 16, 1860): 348. [Note about photo "The Break in the Clouds" by Mr. Samuel Fry.]

F645 Fry, Samuel. "Instantaneous Photography and Composition Printing." PHOTOGRAPHIC NEWS 4, no. 116 (Nov. 23, 1860): 350-351. [Read at meeting of the South London Photographic Society on Nov. 16, 1860.]

F646 Fry, Samuel. "Instantaneous Photography and Composition Printing." BRITISH JOURNAL OF PHOTOGRAPHY 7, no. 131 (Dec. 1, 1860): 348-349.

F647 Fry, Samuel. "Instantaneous Photography and Composition Printing." AMERICAN JOURNAL OF PHOTOGRAPHY AND THE ALLIED ARTS & SCIENCES n. s. vol. 3, no. 15 (Jan. 1, 1861): 225-228. [From "Br. J. of Photo."]

F648 Fry, Samuel. "Instantanious Photography and Composition Printing." HUMPHREY'S JOURNAL OF PHOTOGRAPHY, AND THE ALLIED ARTS AND SCIENCES 12, no. 17 (Jan. 1, 1861): 261-264. [From "Br. J. of Photo."]

F649 Fry, Samuel. "Lunar Photography." BRITISH JOURNAL OF PHOTOGRAPHY 8, no. 134 (Jan. 15, 1861): 24-26.

F650 Fry, Samuel. "On Printing Transparencies." AMERICAN JOURNAL OF PHOTOGRAPHY AND THE ALLIED ARTS & SCIENCES n. s. vol. 4, no. 1 (June 1, 1861): 1-4. [From "Photo. News."]

F651 Fry, Samuel. "Instantaneous Photography." AMERICAN JOURNAL OF PHOTOGRAPHY AND THE ALLIED ARTS & SCIENCES n. s. vol. 4, no. 14 (Dec. 15, 1861): 322-325. [From "Photo. Notes."]

F652 Fry, Samuel. "Mealiness in Toning." HUMPHREY'S JOURNAL OF PHOTOGRAPHY, AND THE ALLIED ARTS AND SCIENCES 13, no. 22 (Mar. 15, 1862): 349-351. [Read to South London Photo. Soc.]

F653 Fry, Samuel. "Instantaneous Photography." HUMPHREY'S JOURNAL OF PHOTOGRAPHY, AND THE ALLIED ARTS AND SCIENCES 13, no. 24 (Apr. 15, 1862): 378-382. [From "Photo. News."]

F654 Fry, Samuel. "On Developing Rooms." HUMPHREY'S JOURNAL OF PHOTOGRAPHY, AND THE ALLIED ARTS AND

SCIENCES 14, no. 16 (Dec. 15, 1862): 203-205. [From "Photo. News."]

F655 Fry, Samuel. "Portraiture in 1870." BRITISH JOURNAL PHOTOGRAPHIC ALMANAC 1871 (1871): 134-135.

F656 Fry, Samuel. "Photography: Its Retrospects and Prospects." BRITISH JOURNAL OF PHOTOGRAPHY 10, no. 182 (Jan. 15, 1863): 28.

F657 Fry, Samuel. "A Simplification of Photography." BRITISH JOURNAL PHOTOGRAPHIC ALMANAC 1874 (1874): 73-74. ["I am one of those stubborn individuals who still persist in doing outdoor photography with wet collodion."]

F658 Fry, Samuel. "On Outdoor Photography from a Professional Point of View." BRITISH JOURNAL PHOTOGRAPHIC ALMANAC 1875 (1875): 124-125.

F659 Fry, Samuel. "Amateurs and Professional Photographers." BRITISH JOURNAL PHOTOGRAPHIC ALMANAC 1876 (1876): 162-163.

F660 Fry, Samuel. "A Silent Revolution." BRITISH JOURNAL PHOTOGRAPHIC ALMANAC 1877 (1877): 127-128.

F661 Fry, Samuel. "A New Studio." ANTHONY'S PHOTOGRAPHIC BULLETIN 9, no. 12 (Dec. 1878): 364-365. 1 illus. [From "Br. J. of Photo." Fry describes designing and rebuilding his studio after a devastating fire.]

F662 Fry, Samuel. "Dry Plates in Professional Photography." BRITISH JOURNAL PHOTOGRAPHIC ALMANAC 1879 (1879): 59-60.

F663 Fry, Samuel. "A Review of Twelve Months of Gelatine Studio Work." ANTHONY'S PHOTOGRAPHIC BULLETIN 10, no. 11 (Nov. 1879): 340-342. [From "Br J of Photo."]

FRY, W. & A. H. FRY. (BRIGHTON, ENGLAND)

F664 Portrait. Woodcut engraving credited "From a photograph by W. & A. H. Fry." ILLUSTRATED LONDON NEWS 64, (1874) ["Mr. Ashbury, M.P." 64:1815 (June 6, 1874): 536.]

F665 Portrait. Woodcut engraving credited "From a photograph by W. Fry & A. H. Fry." ILLUSTRATED LONDON NEWS 74, (1879) ["Late Lieut. Herbert Willis, R.A." 74:2073 (Mar. 8, 1879): 224.]

FUQUA, T. G.

F666 "Fuqua's Developer." HUMPHREY'S JOURNAL OF PHOTOGRAPHY, AND THE ALLIED ARTS AND SCIENCES 18, no. 3 (June 1, 1866): 46.

FURMAN, ROBERT HENRY. (1840-1905) (USA)

F667 "South America. - The Head of Tibi, a Former Chief of the Tribe of Antipas Indians, From a Photograph by R. H. Furman, of Para." FRANK LESLIE'S ILLUSTRATED NEWSPAPER 35, no. 910 (Mar. 8, 1873): 421. 1 illus.

F668 "Editor's Table." PHILADELPHIA PHOTOGRAPHER 15, no. 180 (Dec. 1878): 383. [R. H. Furman (Rochester, NY) praised.]

F669 Furmam, R. H. "Artotyping." ANTHONY'S PHOTOGRAPHIC BULLETIN 10, no. 4 (Apr. 1879): 115. [Furman (Rochester, NY) describes his decision to purchase the license to use the Artotype

process rather than Carbutt's. Good example of the decisions made by professional studio photographers during the period.]

F670 16 photos on one panel ("A Variety of Studies"). WILSON'S PHOTOGRAPHIC MAGAZINE 33, no. 479 (Nov. 1896): unnumbered leaf following p. 496. 16 b & w. [Portraits by: W. M. Morrison, Chicago (4); B. J. Falk, N.Y., (4); R. H. Furman, San Diego, CA (1); S. L. Stein, Milwaukee, (2); J. F. Ryder, Cleveland, (3). Brief note on pp. 519-520]

F671 "Our Pictures." WILSON'S PHOTOGRAPHIC MAGAZINE 35, no. 494 (Feb. 1898): 74-75, plus frontispiece. 6 b & w. [Furman in San Diego, CA.]

FURNE & H. TOURNIER.
[Furne & Tournier published many stereo sets in the late 1850s through the middle 1860s, views of Paris, Brittany, the Pyrenees, Provence and Languedoc, Normandy, and elsewhere in France, Switzerland, and Italy. Also made genre scenes and historical genre, animals, etc. Published a monthly newsletter *La Photographie, journal des publications légalement autorisées,* issued from Oct. 1858 to May 1859. Furne left the partnership in 1862, then A. Varroquier apparently took over the firm in 1866.]

F672 "Alphabet des Costumes." STEREO WORLD 9, no. 4 (Sept. - Oct. 1982): 12-13. 4 b & w. [Genre scenes, each including a large letter of the alphabet, created by the French firm in the 1850s.]

FURNESS, W. H.
F673 Furness, Rev. W. H. "The Value of Knowledge." PHOTOGRAPHIC ART JOURNAL 4, no. 1 (July 1852): 34-41. [From "Sartain's Magazine."]

FURY, THOMAS. (NEW YORK, NY)
F674 "Editor's Table." PHILADELPHIA PHOTOGRAPHER 6, no. 65 (May 1869): 169. [Two cabinets noted.]

FYFE, ANDREW. (1792-1861) (GREAT BRITAIN)
F675 Fyfe, Andrew. "Photography." DAGUERREAN JOURNAL 2, no. 7 (Aug. 15, 1851): 193-199. [Source not given, Fyfe describes his experiments, apparently during 1839 or 1840.]

F676 Fyfe, Andrew. "On Daguerreotype." DAGUERREAN JOURNAL 2, no. 7 (Aug. 15, 1851): 199-202. [Lecture apparently delivered before the Society for Arts for Scotland on 15th Jan., 1840. The previous article, published together here, apparently was given to the same organization "a few months ago."]

F677 Harrison, W. Jerome. "The Chemistry of Fixing." PHOTOGRAPHIC TIMES 20, no. 473 (Oct. 10, 1890): 503-505. [Dr. Andrew Fyfe, J. C. Constable [excerpts from their articles published in 1839].]

FYNES-CLINTON, C. H., REV.
F678 Fynes-Clinton, Rev. C. H. "An Amateur's Experience with Carbon Printing." BRITISH JOURNAL PHOTOGRAPHIC ALMANAC 1877 (1877): 77-79.

F679 Fynes-Clinton, Rev. C. H. "Transparencies." BRITISH JOURNAL PHOTOGRAPHIC ALMANAC 1878 (1878): 72-73.

G

A. B. G.

G1 A. B. G. "On the Advantageous Employment of Stereoscopic Photographs for the Representation of Scenery." PHOTOGRAPHIC AND FINE ART JOURNAL 11, no. 9 (Sept. 1858): 281-282. [From "Photo. Notes." Discusses Prof. Smyth's book on Teneriffe, De La Rue's stereos of the moon; author's own (?) view of the Swiss Alps.]

G. G.

G2 G. G. "Art Education." ANTHONY'S PHOTOGRAPHIC BULLETIN 6, no. 10 (Oct. 1875): 314. [No source or author given.]

GAFFIELD, THOMAS.

G3 Gaffield, Thomas. "Leaf, of 'Nature' Printing." PHILADELPHIA PHOTOGRAPHER 9, no. 101 (May 1872): 130-131, plus unnumbered p. 1 b & w. [Letter correcting errors in an earlier issue, with an original print tipped-in.]

GAGE & ROWELL.

G4 Gage & Rowell. "How Is It?" PHOTOGRAPHIC AND FINE ART JOURNAL 10, no. 9 (Sept. 1857): 281.

G5 Gage & Rowell. "Humbugs vs. Anti-Humbugs." PHOTOGRAPHIC AND FINE ART JOURNAL 10, no. 9 (Sept. 1857): 287.

GAGE, FRANKLIN BENJAMIN. (1824-1874) (USA)
BOOKS

G6 Gage, F. B. *Theoretical and Practical Photography: On Glass and Paper; With Positive Rules for Obtaining Intense Negatives with Certainty.* New York: S. D. Humphrey, 1859. 60 pp.

G7 "Franklin Gage," on p. 488 in: *The Town of St. Johnsbury, Vt., a Review of One Hundred Twenty-five Years to the Anniversary Pageant.* by Edward T. Fairbanks. St. Johnsbury: The Cowles Press, 1914. 592 pp.

PERIODICALS

G8 Gage, F. B. "Photography in St. Johnsbury, Vermont." HUMPHREY'S JOURNAL 8, no. 19 (Feb. 1, 1857): 289-292. [Letter from F. B. Gage, plus the editor's description of seventeen photographs - primarily views - of New Hampshire, taken by Gage.]

G9 Gage, F. B. "Collodion Process." HUMPHREY'S JOURNAL 9, no. 1 (May 1, 1857): 2-4. [Gage from St. Johnsbury, VT.]

G10 Gage, F. B. "The Solar Camera - Printing Process - Glass Cleaning." PHOTOGRAPHIC AND FINE ART JOURNAL 11, no. 4 (Apr. 1858): 105.

G11 Gage, F. B. "More about Saltpetre - Light in the Dark Room, &c." HUMPHREY'S JOURNAL OF PHOTOGRAPHY, AND THE ALLIED ARTS AND SCIENCES 9, no. 23 (Apr. 1, 1858): 358-359.

G12 Gage, F. B. "Dark Room again - Lemon-yellow," and "Effect of Light upon White Lead and Ivory Black." HUMPHREY'S JOURNAL OF PHOTOGRAPHY, AND THE ALLIED ARTS AND SCIENCES 9, no. 24 (Apr. 15, 1858): 371.

G13 Gage, F. B. "Remedy for Foggy Nitrate Baths." HUMPHREY'S JOURNAL OF PHOTOGRAPHY, AND THE ALLIED ARTS AND SCIENCES 10, no. 1 (May 1, 1858): 3-5.

G14 Gage, F. B. "Adaptation." HUMPHREY'S JOURNAL OF PHOTOGRAPHY, AND THE ALLIED ARTS AND SCIENCES 10, no. 3 (June 1, 1858): 36-37.

G15 Gage, F. B. "Theory of the Negative Process." HUMPHREY'S JOURNAL OF PHOTOGRAPHY, AND THE ALLIED ARTS AND SCIENCES 10, no. 4 (June 15, 1858): 49-51.

G16 Gage, F. B. "Quick versus Slow Processes; their comparative Merits.." HUMPHREY'S JOURNAL OF PHOTOGRAPHY, AND THE ALLIED ARTS AND SCIENCES 10, no. 5 (July 1, 1858): 65-66.

G17 Gage, F. B. "Foggy Baths again." and "Cleaning Glass." HUMPHREY'S JOURNAL OF PHOTOGRAPHY, AND THE ALLIED ARTS AND SCIENCES 10, no. 5 (July 1, 1858): 68-69.

G18 Gage, F. B. "Washing Prints." HUMPHREY'S JOURNAL OF PHOTOGRAPHY, AND THE ALLIED ARTS AND SCIENCES 10, no. 6 (July 15, 1858): 83-84.

G19 Gage, F. B. "Keeping Collodion Plates Sensitive." HUMPHREY'S JOURNAL OF PHOTOGRAPHY, AND THE ALLIED ARTS AND SCIENCES 10, no. 6 (July 15, 1858): 84-86. [For fieldwork.]

G20 Gage, F. B. "Backgrounds, &c." HUMPHREY'S JOURNAL OF PHOTOGRAPHY, AND THE ALLIED ARTS AND SCIENCES 10, no. 7 (Aug. 1, 1858): 102-104.

G21 Gage, F. B. "The Saltpetre Subject again." HUMPHREY'S JOURNAL OF PHOTOGRAPHY, AND THE ALLIED ARTS AND SCIENCES 10, no. 8 (Aug. 15, 1858): 117-118.

G22 Gage, F. B. "Positive Collodion Process." HUMPHREY'S JOURNAL OF PHOTOGRAPHY, AND THE ALLIED ARTS AND SCIENCES 10, no. 10 (Sept. 15, 1858): 145-146.

G23 Gage, F. B. "The Saltpetre subject again." HUMPHREY'S JOURNAL OF PHOTOGRAPHY, AND THE ALLIED ARTS AND SCIENCES 10, no. 10 (Sept. 15, 1858): 150.

G24 Gage, F. B. "Photographic Trip to Memphremagog Lake." HUMPHREY'S JOURNAL OF PHOTOGRAPHY, AND THE ALLIED ARTS AND SCIENCES 10, no. 12-14 (Oct. 15 - Nov. 15, 1858): 179-181, 192-195, 211-213.

G25 Gage, F. B. "Cleaning Glass." and "To Transfer Ambrotypes." HUMPHREY'S JOURNAL OF PHOTOGRAPHY, AND THE ALLIED ARTS AND SCIENCES 10, no. 15 (Dec. 1, 1858): 225.

G26 Gage, F. B. "Poisonous Effects of Cyanide of Potassium." and "Albumen Printing." HUMPHREY'S JOURNAL OF PHOTOGRAPHY, AND THE ALLIED ARTS AND SCIENCES 10, no. 16 (Dec. 15, 1858): 241-242.

G27 Gage, F. B. "Photolithographs." HUMPHREY'S JOURNAL OF PHOTOGRAPHY, AND THE ALLIED ARTS AND SCIENCES 10, no. 19 (Feb. 1, 1859): 290-291.

G28 Gage, F. B. "Enlarging Photographs." HUMPHREY'S JOURNAL OF PHOTOGRAPHY, AND THE ALLIED ARTS AND SCIENCES 10, no. 19 (Feb. 1, 1859): 292-294.

G29 Gage, F. B. "Enlarging Photographs." HUMPHREY'S JOURNAL OF PHOTOGRAPHY, AND THE ALLIED ARTS AND SCIENCES 10, no. 21 (Mar. 1, 1859): 323-325. [Includes a letter from A. A. Thayer

(Jefferson, OH) and a letter from D. A. Woodward, inventor of the solar camera.]

G30 Gage, F. B. "Apparatus for freezing Alcohol from Water." HUMPHREY'S JOURNAL OF PHOTOGRAPHY, AND THE ALLIED ARTS AND SCIENCES 10, no. 24 (Apr. 15, 1859): 371-372.

G31 Gage, F. B. "Iodizing and Bromizing Solution." HUMPHREY'S JOURNAL OF PHOTOGRAPHY, AND THE ALLIED ARTS AND SCIENCES 11, no. 1 (May 1, 1859): 4-5.

G32 Gage, F. B. "Improved Toning Bath for the Ammonio-Nitrate Process." HUMPHREY'S JOURNAL OF PHOTOGRAPHY, AND THE ALLIED ARTS AND SCIENCES 11, no. 4 (June 15, 1859): 49-50.

G33 Gage, F. B. "Apparatus for Distilling Water." HUMPHREY'S JOURNAL OF PHOTOGRAPHY, AND THE ALLIED ARTS AND SCIENCES 11, no. 4 (June 15, 1859): 53-54.

G34 Gage, F. B. "Photography on Wheels." HUMPHREY'S JOURNAL OF PHOTOGRAPHY, AND THE ALLIED ARTS AND SCIENCES 11, no. 7 (Aug. 1, 1859): 97-99.

G35 Gage, F. B. "Temperature of Toning Bath." HUMPHREY'S JOURNAL OF PHOTOGRAPHY, AND THE ALLIED ARTS AND SCIENCES 11, no. 10 (Sept. 15, 1859): 146-147.

G36 Gage, F. B. "Ammonio-Nitrate Toning Baths." HUMPHREY'S JOURNAL OF PHOTOGRAPHY, AND THE ALLIED ARTS AND SCIENCES 11, no. 11 (Oct. 1, 1859): 163-164.

G37 Gage, F. B. "Photography on Wheels. - No. 2." HUMPHREY'S JOURNAL OF PHOTOGRAPHY, AND THE ALLIED ARTS AND SCIENCES 11, no. 14, 16 (Nov. 15, Dec. 15, 1859): 209-210, 241-243. [Gage describes a photographic trip to Mount Washington, NH. Bad weather, expensive.]

G38 Gage, F. B. "New Toning Agent." HUMPHREY'S JOURNAL OF PHOTOGRAPHY, AND THE ALLIED ARTS AND SCIENCES 11, no. 15 (Dec. 1, 1859): 228-229.

G39 Gage, F. B. "The New Toning Process." HUMPHREY'S JOURNAL OF PHOTOGRAPHY, AND THE ALLIED ARTS AND SCIENCES 11, no. 16 (Dec. 15, 1859): 243-244.

G40 Gage, F. B. "The New Toning Agent." HUMPHREY'S JOURNAL OF PHOTOGRAPHY, AND THE ALLIED ARTS AND SCIENCES 11, no. 17 (Jan. 1, 1860): 259-260.

G41 Gage, F. B. "More about the New Toning Agent." HUMPHREY'S JOURNAL OF PHOTOGRAPHY, AND THE ALLIED ARTS AND SCIENCES 11, no. 18 (Jan. 15, 1860): 275-276.

G42 Gage, F. B. "Old Processes Analyzed, Criticized, and Systemized. The Positive Collodion Process. - No. 1." HUMPHREY'S JOURNAL OF PHOTOGRAPHY, AND THE ALLIED ARTS AND SCIENCES 11, no. 19-21 (Feb. 1 - Mar. 1, 1860): 289-290, 307-309, 321-323.

G43 Gage, F. B. "Cleaning Glass with Burning Fluid." HUMPHREY'S JOURNAL OF PHOTOGRAPHY, AND THE ALLIED ARTS AND SCIENCES 12, no. 1 (May 1, 1860): 3.

G44 Gage, F. B. "Vegetable and Mineral Photography." HUMPHREY'S JOURNAL OF PHOTOGRAPHY, AND THE ALLIED ARTS AND SCIENCES 12, no. 2 (May 15, 1860): 23-24.

G45 "Portrait of Mr. F. B. Gage." HUMPHREY'S JOURNAL OF PHOTOGRAPHY, AND THE ALLIED ARTS AND SCIENCES 12, no. 8 (Aug. 15, 1860): 117-118. [Verbal description of F. B. Gage, who had visited the editor of "HJ."]

G46 Gage, F. B. "Tent for Field Use." HUMPHREY'S JOURNAL OF PHOTOGRAPHY, AND THE ALLIED ARTS AND SCIENCES 12, no. 11 (Oct. 1, 1860): 166.

G47 "Correspondence." PHILADELPHIA PHOTOGRAPHER 2, no. 17 (May 1865): 80-81. [Letter from F. B. Gage of St. Johnsbury, VT, including stereos of eighteen landscapes taken five years ago, before "the rebellion drove me out of view taking into portraiture."]

G48 "Correspondence." PHILADELPHIA PHOTOGRAPHER 2, no. 19 (July 1865): 111-112. [Long letter with technical discussion about proper lenses for landscape work.]

G49 "Editor's Table." PHILADELPHIA PHOTOGRAPHER 6, no. 63 (Mar. 1869): 96. [Stereos of snow scenes noted.]

G50 "Editor's Table." PHILADELPHIA PHOTOGRAPHER 6, no. 64 (Apr. 1869): 136. [Stereos noted.]

G51 "Editor's Table." PHILADELPHIA PHOTOGRAPHER 6, no. 69 (Sept. 1869): 324. [Stereos from dry plates noted.]

G52 "New Pictures." ANTHONY'S PHOTOGRAPHIC BULLETIN 2, no. 6 (June 1871): 184. [Gage (St. Johnsbury, VT) sends stereoscopic prints.]

G53 Gage, F. B. "Bronchitis Cured By Photography." ANTHONY'S PHOTOGRAPHIC BULLETIN 3, no. 1 (Jan. 1872): 405.

G54 Gage, F. B. "How to Get Excellent Cotton with Little Trouble." ANTHONY'S PHOTOGRAPHIC BULLETIN 3, no. 2 (Feb. 1872): 438-441.

G55 "Obituary." ANTHONY'S PHOTOGRAPHIC BULLETIN 5, no. 10 (Oct. 1874): 374. [Brief note that F. B. Gage (St. Johnsbury, VT) died.]

G56 "Obituary - A Veteran Gone." PHILADELPHIA PHOTOGRAPHER 11, no. 130 (Oct. 1874): 318. [F. B. Gage born July 29, 1824. Learned daguerreotyping about 1848. In 1850 he opened a studio in St. Johnsbury, VT, and worked there for twenty-four years, until his death. Always worked out new processes and procedures. Contributed to "Humphrey's Journal," "Phila. Photo.," etc.]

G57 Dexter, Lorraine. "Gage of St. Johnsbury - Hills and Dales, 1859." VERMONTER 4, no. 8 (1966): 23-29. illus.

GAILLARD, PAUL. (d. 1890) (FRANCE)

[Founder-member of the Société française de Photographie in 1854. In 1850s he made views of Paris, the Valley of Hyères, Vosges, and elsewhere in France. Views of the Forest of Fontainebleau in 1861. From 1861 to 1874 he was on the administrative council of the Société, and in 1879 established the annual Prix Gaillard. Died in November, 1890 in Paris.]

G58 Gaillard, Paul. "Dry Tannin Process." HUMPHREY'S JOURNAL OF PHOTOGRAPHY, AND THE ALLIED ARTS AND SCIENCES 17, no. 8 (Aug. 15, 1865): 118-119. [From "Bulletin de la Société Française de Photographie."]

GALE.
G59 "Gale's Patent Solar Camera." PHILADELPHIA PHOTOGRAPHER 3, no. 27 (Mar. 1866): 73. [1]

GALLOWAY, T. K.
G60 Galloway, T. K. "Ammonio-Nitrate." HUMPHREY'S JOURNAL OF PHOTOGRAPHY, AND THE ALLIED ARTS AND SCIENCES 12, no. 9 (Sept. 1, 1860): 131-132.

G61 Galloway, T. K. "Surface-Finishing Photographs." HUMPHREY'S JOURNAL OF PHOTOGRAPHY, AND THE ALLIED ARTS AND SCIENCES 13, no. 19 (Feb. 1, 1862): 293-294.

GARBANATI, H.
G62 Garbanati, H. "The Wonders of the Photographic Art." AMERICAN JOURNAL OF PHOTOGRAPHY AND THE ALLIED ARTS AND SCIENCES n. s. vol. 1, no. 1 (June 1, 1858): 13-15.

G63 Garbanati, H. "Process vs. Journals." AMERICAN JOURNAL OF PHOTOGRAPHY AND THE ALLIED ARTS AND SCIENCES n. s. vol. 1, no. 2 (June 15, 1858): 22-24.

G64 Garbanati, H. "The Camera - Its Properties, Qualities and Selection." AMERICAN JOURNAL OF PHOTOGRAPHY AND THE ALLIED ARTS AND SCIENCES n. s. vol. 1, no. 4 (July 15, 1858): 62-64.

G65 Garbanati, H. "Camera Shields - The Silver Corner." AMERICAN JOURNAL OF PHOTOGRAPHY AND THE ALLIED ARTS AND SCIENCES n. s. l. 1, no. 5 (Aug. 1, 1858): 75-76.

G66 Garbanati, H. "New Apparatus and Union Cases - a New Style of Head Rest." AMERICAN JOURNAL OF PHOTOGRAPHY 1, no. 6 (Aug. 15, 1858): 93-95.

G67 Garbanati, H. "Negatives of Valuable Documents." AMERICAN JOURNAL OF PHOTOGRAPHY AND THE ALLIED ARTS AND SCIENCES n. s. vol. 1, no. 7 (Sept. 1, 1858): 100-102.

G68 Garbanati, H. "A New View Camera Box." AMERICAN JOURNAL OF PHOTOGRAPHY 1, no. 8 (Sept. 15, 1858): 119-120. ["Photographic views are coming in vogue amongst us. A crop of amateurs is springing up all around."]

G69 Garbanati, H. "Focal Adjustment." AMERICAN JOURNAL OF PHOTOGRAPHY AND THE ALLIED ARTS AND SCIENCES n. s. vol. 1, no. 8 (Sept. 15, 1858): 123-129.

G70 Garbanati, H. "The Influence of the Operator on the Sitter." AMERICAN JOURNAL OF PHOTOGRAPHY AND THE ALLIED ARTS AND SCIENCES n. s. vol. 1, no. 9 (Oct. 1, 1858): 134-136.

G71 Garbanati, H. "Now and Then." AMERICAN JOURNAL OF PHOTOGRAPHY AND THE ALLIED ARTS AND SCIENCES n. s. vol. 1, no. 10 (Oct. 15, 1858): 152-154.

G72 Garbanati, H. "On Backgrounds." AMERICAN JOURNAL OF PHOTOGRAPHY AND THE ALLIED ARTS AND SCIENCES n. s. vol. 1, no. 11 (Nov. 1, 1858): 163-165.

G73 Garbanati, H. "Photography a le Fresco." AMERICAN JOURNAL OF PHOTOGRAPHY AND THE ALLIED ARTS AND SCIENCES n. s. vol. 1, no. 14 (Dec. 15, 1858): 221-223.

G74 Garbanati, H. "On the Use of Bromine in Collodion. The Cutting Patent." AMERICAN JOURNAL OF PHOTOGRAPHY 1, no. 17 (Feb. 1, 1859): 265-268.

G75 Garbanati, H. "The Cutting Patent Again." AMERICAN JOURNAL OF PHOTOGRAPHY 1, no. 18 (Feb. 15, 1859): 280-282.

G76 Garbanati, H. "'Parallels.'" AMERICAN JOURNAL OF PHOTOGRAPHY AND THE ALLIED ARTS AND SCIENCES n. s. vol. 1, no. 20 (Mar. 15, 1859): 311-312.

G77 Garbanati, H. "On Washing Gun-Cotton." AMERICAN JOURNAL OF PHOTOGRAPHY AND THE ALLIED ARTS AND SCIENCES n. s. vol. 1, no. 24 (May 15, 1859): 376.

GARD, EMERY R. (CHICAGO, IL)
G78 Portrait. Woodcut engraving, credited "From a Photograph by E. R. Gard, Chicago, IL." HARPER'S WEEKLY 8, (1864) ["Capt. Francis DeGress." 8:401 (Sept. 3, 1864): 564.]

GARDNER, A. B. (UTICA, NY)
G79 "Editor's Table: Fire!" PHILADELPHIA PHOTOGRAPHER 15, no. 173 (May 1878): 160. [A. B. Gardner (Utica, NY) lost studio to fire in Jan.]

GARDNER, ALEXANDER see also HISTORY: USA: VA: GENERAL (Waldsmith).

GARDNER, ALEXANDER. (1821-1882) (GREAT BRITAIN, USA)
[Alexander Gardner was born at Paisley, Scotland in 1821. Although his father died when Gardner was still a child, he managed to obtain an education and while still a young man, he actively participated in the exciting cultural ferment which was then causing Scotland to be a strong focus for cultural and social ideas. During the 1840s and 50s Gardner was an advocate of the social philosophy of Robert Owens, and he was active as an author, editor, and lecturer on social reform. He helped organize an utopian social community of Scottish emigrants to Iowa, then on the western frontier of the United States. In 1856 he and his family also emigrated to the USA to join the community, but on landing, they were shocked to learn that the community had been decimated by an epidemic disease. Gardner brought his family to New York instead. Trained in chemistry and physics, and apparently familiar with photography, Gardner began to work in Matthew Brady's gallery. In the late 50s or early 60s Brady reopened a gallery in Washington, DC, and sent Gardner to be the manager. Gardner quickly developed the gallery into one of the most active and best respected studios in the city. As the possibility of a war continued to mount, Gardner organized the gallery to produce cartes-de-visite - which he felt would soon be in high demand - and arranged to sell negatives to E. & H. T. Anthony & Co., who had the capacity to produce large numbers of prints for mass distribution. Gardner sent both Brady Gallery negatives and negatives purchased from other photographers through this system of distribution, and was soon generating a solid income. The Brady National Art Gallery name was printed on the verso of all cartes produced in this way. This business practice made no claims to the authorship of the actual negatives.
As the war actually lurched into open conflict Gardner continued to run the Washington gallery and either organize teams of photographers to go into the field to document the massing Union armies, their campsites and fortifications and the sites of earlier skirmishes, or provide a venue for independent operators who had already done so. Early in 1862 Gardner joined the headquarters staff of General George B. McClellan of the Army of the Potomac as a civilian aide. Gardner was attached to the U. S. Topographical

Engineers, and undoubtedly helped make the accurate photographic copies of maps and orders which were so important to successful planning. Later, Gardner and several other photographers recorded scenes and sites along McClellan's Peninsular Campaign.

In September 1862 Gardner and James E. Gibson photographed the immediate aftermath of the battle of Antietam. These photographs depicted the dead soldiers of both armies and the carnage of a battle. They were published in *Harper's Weekly* under Brady's trademark. The images caused a sensation, and gathered what was, for the time, an extraordinary amount of written acclaim. The praise, of course, all went to Brady. Brady also steadfastly insisted that he held rights to all photographs made by anyone in his employment. This event exacerbated frictions already in play between Brady and Gardner, and sometime in late 1862 or early 1863 Gardner left the Brady gallery and set up his own rival gallery in Washington. Very quickly Gardner's gallery became the premiere gallery in the city.

Several of the photographers who had worked in the field with Gardner also left Brady and went to work for Gardner.

In July 1863 Gardner learned that the Confederate General Lee was striking north into Pennsylvania and that a major battle was imminent near the town of Gettysburg. Gardner had earlier placed his fifteen year old son in a school near there to keep him out of the war zone. Gardner immediately rushed to Gettysburg, talked his way through the Confederate picket lines -the seminary was now in the hands of the Confederate forces- picked up his son, and returned to the Union side. Thus Gardner, with Timothy O'Sullivan and James Gibson, were at the site during the battle of Gettysburg. They began to photograph the battlefield immediately after the Union victory, before the dead were buried and the debris of the battle was cleared away. These photographs displayed the horror of war with great force and immediacy.

During most of 1864-65 Gardner worked in his Washington gallery, and his employees photographed Grant's campaign in Virginia. When Richmond fell, Gardner went there in April 1865 and made nearly fifty views of the destroyed city. Gardner had established a healthy working relationship with *Harper's Weekly* by the end of the war, and during the final months of the war and the first months of confusion following Lincoln's assassination, Gardner's photographs of the principles in the assassination drama were extensively published in that journal. This extensive use of woodcuts derived from photographs in a national illustrated newsmagazine during a critical period of public uncertainty following a national crisis is an interesting example of early photojournalism in the United States.

After the war Gardner published his *Photographic Sketch-book of the War* and then Henry Moulton's photographs of Peru, *Rays of Sunlight from South America* in 1865. Gardner went to Kansas in 1867 and photographed along the proposed line of the Eastern Division of the Union Pacific Railroad, in 1867 and 1868, travelling along the 35th Parallel through New Mexico and Arizona. In the early 1870s Gardner's gallery made the Rogues' Gallery portraits for the Washington police force. In his later years Gardner was a financially comfortable, highly respected, prominent member of the Washington business community. He had an instrumental role in developing several life insurance programs for workers, which grew out of his continued interest in social betterment. He died in Washington in 1882.]

BOOKS

G80 *Catalogue of Photographic Incidents of the War, from the Gallery of Alexander Gardner, Photographer to the Army of the Potomac in Washington, D.C. September 1863*. Washington, DC: A. Gardner, H. Polkinhorn, Printer, 1863. 28 pp. [Lists about 700 views, taken by a number of photographers, who are credited.]

G81 *Monument in Memory of the Patriots who fell in the First Battle of Bull Run, July 21st, 1861*. Designed and built by Lieut. J. McCullum. Alexander Gardner, photographer. Boston: Prang & Co., 1865. [Size 7 1/2" x 9 5/8", colored lithograph.]

G82 Gardner, Alexander and others. *Gardner's Photographic Sketch-Book of the War*. Washington, DC: Philip & Solomons, 1865-1866. 2 vol. 100 b & w. [Portfolio of 100 original photographs. Negatives made by many photographers, prints made by Gardner.]

G83 Gardner, Alexander. *The Lincoln Conspiracy*. Washington, DC: s. n., ca. 1865. n. p. 38 b & w. 12 illus. [Unique album, compiled by U. S. Army Col. Arnold A. Rand soon after the execution of the conspirators, and consisting of 38 original photographs and 12 engravings of the events surrounding the assassination, chase, and capture of the assassins. Most of the photos are by Gardner. In IMP/GEH collection.]

G84 Burns, Robert. *Tam O'Shanter,...with Illustrations by E. R. Miller*, photographed by Gardner. New York: Widdleton, 1868. 20 pp. 8 illus. [8 illustrations by E. H. Miller, photographed by A. Gardner.]

G85 Palmer, General W. J. *Report of Surveys Across the Continent, in 1867 - 1868, on the Thirty-fifth and Thirty-second Parallels, for a Route Extending the Kansas Pacific Railway to the Pacific Ocean at San Francisco and San Diego*. Illustrated with a Series of 19 Ambrotype Photographs of Scenes on the Way, Indians, &c., by Alexander Gardner. Philadelphia: s. n., 1869. 250 pp. 19 b & w. [Rare illustrated edition.]

G86 Gardner, Alexander. *Across the Continent on the Kansas Pacific Railroad (Route of the 35th Parallel)*. Washington, DC: Alexander Gardner, 1869. n. p. 125 b & w. [Portfolio of mounted photographs. Boston Public Library collection.]

G87 *Photographs of Red Cloud and Principal Chiefs of Dacotah Indians. Taken on Their Visit to Washington, D. C., May, 1872*, By Alexander Gardner, for Trustees of Blackmore Museum, Salisbury, England. Washington, DC: A. Gardner, 1872. n. p. 34 b & w. [Title, plus mounted photographs. Seventeen Sioux chiefs, photographed both in full-face and profile.

G88 Gardner, Alexander. *The Assessment Plan for Life Insurance: An Address Delivered Before the Fifth Annual Convention of Mutual Benefit Societies*. Washington, DC: R. Beresford, 1880. n. p.

G89 Wilson, Joseph M. *A Eulogy on the Life and Character of Alexander Gardner. Delivered at a Stated Communication of Lebanon Lodge, No. 7, F. A. A. M., Jan. 19, 1883*. Washington, DC: R. Beresford, 1883. n. p.

G90 Wilcox, Col. V. M. *[Memorial Address]* s. l. [Philadelphia?]: s. n., 1888. n. p. 2 b & w. [Address delivered by Wilcox at the first reunion of his regiment, the 132 Pennsylvania Volunteers, at Danville, Pa. on Sept. 17, 1888. Printed copy, embellished with a portrait of Wilcox, taken by Chase in 1862, and a view of the trenches after the battle of Antietam, taken by A. Gardner. Wilcox worked for Anthony's. "Anthony's Photo Bulletin" (Nov. 24, 1888): 675.]

G91 Gardner, Alexander. Introduction by E. F. Bleiler. *Gardner's Photographic Sketch-Book of the War*. New York: Dover Publishing Co., 1959. n. p. 100 b & w. [Facsimile edition of the 1865 volume, with a new introduction.]

G92 Walther, Susan Danly. *The Landscape Photographs of Alexander Gardner and Andrew Joseph Russell*. Ann Arbor, MI: University Microfilms, 1984. 231 pp. 95 b & w. [Ph.D. Dissertation, Brown University, 1983. "Bibliography," pp. 160-182.]

PERIODICALS

G93 "Scenes on the Battlefield of Antietam. - From Photographs by M. B. Brady." HARPER'S WEEKLY 6, no. 303 (Oct. 18, 1862): 663-665. 8 illus. [Photographs of aftermath of Antietam battle, credited to Brady, were actually taken by Alexander Gardner and James Gibson.]

G94 "Brady's Photographs. Pictures of the Dead at Antietam." NEW YORK TIMES 12, no. 3455 (Oct. 20, 1862): 5. [Credited to Brady, these photographs were taken by Gardner and others.]

G95 "Photographs of War Scenes." HUMPHREY'S JOURNAL OF PHOTOGRAPHY, AND THE ALLIED ARTS AND SCIENCES 14, no. 12 (Oct. 15, 1862): 143-144. ["We have recently seen a series of very fine views of Battle Fields taken by some of our New York photographers. Some of these views were taken at South Mountain and Antietam." The author then describes specific photographs: "It can with truth be said that the photographic art has never contributed to the historical memorials of our time anything that at all approaches it in value."]

G96 Portrait. Woodcut engraving, credited "From a Photograph by Alexander Gardner, Washington, D. C." HARPER'S WEEKLY 8, (1864) ["Late Rev. Gordon Winslow." 8:392 (July 2, 1864): 421.]

G97 "General Grant's Campaign in Virginia - From Photographs by Gardner, Washington, District of Columbia." HARPER'S WEEKLY 8, no. 393 (July 9, 1864): 440-441, 442. 13 illus. [Double-page spread. The central picture is of Grant's council of war at Massaponax Church (by O'Sullivan), surrounded by twelve sketches of dead soldiers, equipment, sites, etc. Includes statement about Gardner's photographs on p. 442. "Of course it is impossible for photography to lie, and we may therefore regard these portraitures as faithful to the minutest feature of the original scene,"]

G98 "The War in Virginia - Lieutenant-General Grant in a Council of War at Massaponax Church. - From a Photograph by Gardner." FRANK LESLIE'S ILLUSTRATED NEWSPAPER 18, no. 459 (July 16, 1864): 257, 263. 1 illus. [This is the well-known image by Timothy O'Sullivan, here credited to Gardner. "The public calls for action, and our battle scenes cannot be painted in the stereotyped fashion of European art,... Our illustrated papers have opened a new path, and its influence is felt in Europe. The scenery is given truthfully, the moving masses of men, the steady progress of the shot and shell of the great guns, with the cloud of the volley of small arms, the rising dust, all are now given. Formerly a few officers made a battle, now we see armies contending, and can recognize the spot. The sketch which we give of General Grant at Massaponax Church deserves to live in history... In these careless hats, these scarce military dresses, devoid of all but the faintest show of rank, are the true heroes of the republic."]

G99 "Rear Admiral David D. Porter - Photographed by A. Gardner, Washington, D.C." HARPER'S WEEKLY 9, no. 421 (Jan. 21, 1865): 37. 1 illus. [Portrait of Porter on board his flagship, surrounded by his officers.]

G100 "President Lincoln Taking the Oath at His Second Inauguration, March 4, 1865" and "President Lincoln's Reinauguration at the Capitol, March 4, 1865 - Photographed by Gardner, Washington." HARPER'S WEEKLY 9, no. 429 (Mar. 18, 1865): 161, 164, 168-169.

2 illus. [Portrait group, but taken at the event. Crowd view in front of the Capitol building.]

G101 Portraits. Woodcut engravings, credited "From a Photograph by Alexander Gardner." HARPER'S WEEKLY 9, (1865) ["Hon. Hugh M'Cullough, Sec. of Treasury." 9:430 (Mar. 25, 1865): 177. "Andrew Johnson." 9:437 (May 13, 1865): 289. "Hon. William H. Seward, Sec. of State." 9:442 (June 17, 1865): 369. "Maj.-Gen. William T. Sherman." 9:442 (June 17, 1865): 372. "Sheridan and His Generals (group portrait around a map)." 9:443 (June 24, 1865): 389. "Wm. W. Holden, Gov. of NC." 9:443 (June 24, 1865): 397. "Frederick Seward." 9:444 (July 1, 1865): 412. "Late. Brig.-Gen. Alexander Schimmelpfennig." 9:458 (Oct. 7, 1865): 629.]

G102 "Ruins of the Norfolk Navy-Yard - Photographed by A. Gardner, Washington, D.C." HARPER'S WEEKLY 9, no. 432 (Apr. 8, 1865): 213-214. 1 illus.

G103 "Andrew Johnson." and "Planning the Capture of Booth and Harold. - Photographed by Gardner, Washington, D.C." HARPER'S WEEKLY 9, no. 437 (May 13, 1865): 289, 292. 2 illus. [Studio portrait. Group portrait of three officers gathered around a map.]

G104 "Lewis Payne the Assassin - Photographed by A. Gardner, Washington, D.C." HARPER'S WEEKLY 9, no. 439 (May 27, 1865): 321. 1 illus.

G105 "The Grand Review at Washington - General Meade and Staff Passing the Principal Stand, May 23, 1865.," "Public School Children Greeting the Soldiers," "Sheridan's Cavalry Passing Capitol Hill," "Sheridan's Cavalry Passing Through Pennsylvania Avenue," "Sheridan's Veterans Crossing the Long Bridge - Photographed by Gardner, Washington, D.C." HARPER'S WEEKLY 9, no. 441 (June 10, 1865): 351, 356-357, 364-365. 6 illus.

G106 "Capture of Davis." HARPER'S WEEKLY 9, no. 442 (June 17, 1865): 373. 2 illus. [Includes a group portrait of the "Officers Engaged in the Capture of Davis" and "The Clothes in Which Davis Disguised Himself" ("From a Photograph Taken at the War Department by Alexander Gardner").]

G107 "Panoramic View of Richmond from General Henningsen's House," HARPER'S WEEKLY 9, no. 442 (June 17, 1865): 376-377. 2 illus. ["Photographed by Alex. Gardner."]

G108 "The Bull Run Monuments." HARPER'S WEEKLY 9, no. 444 (July 1, 1865): 401, 404. 4 illus. ["Photographed by Gardner, and Published by Philip & Solomons, Washington, D.C."]

G109 "The Conspirators and the Conspiracy." HARPER'S WEEKLY 9, no. 444 (July 1, 1865): 408-409. 7 illus. [Portraits of six of the Lincoln assassination conspirators and a group portrait of the Military Commission engaged in the trial. "Photographed by Gardner."]

G110 "Gardner's Photographs." AMERICAN JOURNAL OF PHOTOGRAPHY AND THE ALLIED ARTS & SCIENCES n. s. vol. 8, no. 2 (July 15, 1865): 33-34. [From "Harper's Weekly." (This is on p. 451 in the July 22, 1865 issue.)]

G111 "Gardner's Photographs." HARPER'S WEEKLY 9, no. 447 (July 22, 1865): 451. [A brief discussion of Gardner's Gallery, and mentions publication of the series of war views titled "Memories of the Rebellion" and the book "Rays of Sunlight From South America."]

G112 "The Gettysburg Monument." HARPER'S WEEKLY 9, no. 447 (July 22, 1865): 452-454. 3 illus. [Includes a view of the dedication of the Gettysburg monument, a portrait of Maj.-Gen. Oliver Howard, and a scene of dead soldiers taken two years earlier at the Gettysburg battlefield. All images credited to "Gardner, Washington."]

G113 "Execution of the Conspirators at Washington, July 7, 1865 - Photographed by Gardner, Washington, D. C." HARPER'S WEEKLY 9, no. 447 (July 22, 1865): 454, 456-457. 8 illus. [Six engravings from Gardner photos, two engravings from sketches.]

G114 "The Tredegar Iron Works at Richmond, Virginia - Photographed by Gardner, Washington, D. C." HARPER'S WEEKLY 9, no. 449 (Aug. 5, 1865): 490, 493. 1 illus.

G115 "A Freedman's Village, Hampton, Virginia - Photographed by Gardner, Washington, D. C." HARPER'S WEEKLY 9, no. 457 (Sept. 30, 1865): 613, 614. 1 illus.

G116 "Our Baby-Show." HARPER'S WEEKLY 9, no. 455 (Sept. 16, 1865): 581. 1 illus. ["From photographs furnished mainly by A. Gardner, Washington." Sketches of portrait heads of about seventy children.]

G117 "Execution of Captain Wirz." HARPER'S WEEKLY 9, no. 465 (Nov. 25, 1865): 748, 749. 4 illus. ["Photographed by Gardner." Two sequential views of hanging, one of the prison, Members of the Press.]

G118 "Spain and Chili." HARPER'S WEEKLY 9, no. 467 (Dec. 9, 1865): 780-781. 3 illus. [Views of guano gathering in Chili. "Photographed by Gardner, Washington, D.C." "...from 'Rays of Sunlight' - a collection of interesting photographs by Mr. A. Gardner, recently published by Messrs. Philip & Solomons, Washington." (Photos actually by Moulton.)]

G119 Portraits. Woodcut engravings, credited "From a Photograph by Alexander Gardner." HARPER'S WEEKLY 10, (1866) ["Andrew Jackson, the 17th Pres. of the USA." 10:507 (Sept. 15, 1866): 584. "John H. Surratt." 10:522 (Dec. 29, 1866): 828.]

G120 "Indian Delegation of Iowas, Sacs, and Foxes From Nebraska to Washington." HARPER'S WEEKLY 10, no. 474 (Jan. 27, 1866): 49, 50. 1 illus. ["Photographed by A. Gardner," Washington, D.C."]

G121 "Views in Lima, Peru." HARPER'S WEEKLY 10, no. 483 (Mar. 31, 1866): 197, 199. 3 illus. ["Our 'Views in Lima' are photographic leaves from "Rays of Sunshine,' photographed by A. Gardner, and published by Philip & Solomons, Washington."]

G122 "Reviews: Gardner's Photographic Sketch-Book of the War." ART-JOURNAL (Apr. 1866): 127-128.

G123 Portrait. Woodcut engraving, credited "From a Photograph by Alexander Gardner. FRANK LESLIE'S ILLUSTRATED NEWSPAPER 22, (1866) ["Andrew Johnson, Pres. of the USA." 22:555 (May 19, 1866): 129.]

G124 "Collecting the Remains of Union Soldiers for Re-Interment in National Cemeteries." HARPER'S WEEKLY 10, no. 517 (Nov. 24, 1866): 740. 1 illus. ["Photographed by A. Gardner, Washington, D.C."]

G125 "The United States Treasury Department at Washington - The State Department at Washington." HARPER'S WEEKLY 10, no. 520 (Dec. 15, 1866): 788. 2 illus.

G126 "Military Asylum, Washington, D.C." HARPER'S WEEKLY 11, no. 523 (Jan. 5, 1867): 4. 1 illus. ["Photographed by A. Gardner."]

G127 "Statue of Gen. Jackson, Washington." HARPER'S WEEKLY 11, no. 524 (Jan. 12, 1867): 21. 1 illus. ["Photographed by A. Gardner."]

G128 "United States Patent-Office Department, Washington, D.C." HARPER'S WEEKLY 11, no. 530 (Feb. 23, 1867): 117. 1 illus. ["Photographed by A. Gardner, Washington, D.C."]

G129 Portrait. Woodcut engraving, credited "From a Photograph by Alexander Gardner." HARPER'S WEEKLY 11, (1867) ["Hon. Benjamin F. Wade, Pres. of U.S. Senate." 11:534 (Mar. 23, 1867): 177.]

G130 "Indian Delegations at Washington - Presentation to the President." HARPER'S WEEKLY 11, no. 533 (Mar. 16, 1867): 164, 173. 1 illus. ["From a Photograph by A. Gardner, Washington, D.C."]

G131 "The Chief Justice and Associate Justices of the Supreme Court of the United States." HARPER'S WEEKLY 12, no. 579 (Feb. 1, 1868): 72-73, 74. 1 illus. ["Photographed by A. Gardner, Washington, D.C." Group portrait on double-page spread.]

G132 Browne, John C. "Photographic Society of Philadelphia." PHILADELPHIA PHOTOGRAPHER 5, no. 52 (Apr. 1868): 129. [Browne describes Gardner's photos of Kansas, taken along the line of the Union Pacific Railroad after the war, shown at a monthly meeting of the Philadelphia Photographic Society.]

G133 "The Inauguration of President Grant, March 4, 1869." HARPER'S WEEKLY 13, no. 638 (Mar. 20, 1869): 184-185, 186. 1 illus. ["From Photographs by Gardner and Brady." One view of crowd in front of Capitol, illustration freely drawn from photos supplied by the photographers.]

G134 "Indian Burial Place on Deer Creek, Near Fort Laramie - From a Photograph by A. Gardner." HARPER'S WEEKLY 13, no. 636 (Mar. 6, 1869): 152, 157. 1 illus. [Photo is of three Indian braves on horses in front of a tree containing funeral bundles. Note on p. 157.]

G135 Portrait. Woodcut engraving, credited "From a Photograph by Gardiner [sic Gardner] of Washington." FRANK LESLIE'S ILLUSTRATED NEWSPAPER 28, (1869) ["Hon. Jacob D. Cox, Pres. Grant's Cabinet." 28:705 (Apr. 3, 1869): 40.]

G136 "Maryland. - The Famous Seneca Sandstone Quarry, on the Bank of the Potomac, in Montgomery County. - From a Photograph by Gardner of Washington." FRANK LESLIE'S ILLUSTRATED NEWSPAPER 34, no. 864 (Apr. 20, 1872): 92. 1 illus. [View.]

G137 "Death of Mr. Gardner." ANTHONY'S PHOTOGRAPHIC BULLETIN 13, no. 12 (Dec. 1882): 408. [Obituary.]

G138 Wilson, Joseph M. "Obituary." PHILADELPHIA PHOTOGRAPHER 20, no. 231 (Mar. 1883): 92-95. [Born Oct. 17, 1821, in Paisley, Scotland. Family moved to Glasgow. Father died when Alexander was a child, but he still managed to get an education. At fourteen he apprenticed to a jeweler, and served him for seven years. Associated with educated people, and interested in social issues. At 21 he became an editor of the "Glasgow Sentinel." At some point he learned photography and first practiced as an amateur. In 1848 he developed the idea of founding a cooperative society colony in the United States, which actually was later founded in Iowa - then on the western frontier of the United States. Gardner emigrated to the United States in 1856 to join the colony, only to learn that it had been

decimated by an epidemic disease. Gardner then obtained a position (in Brady's Gallery) in New York and there introduced the "Imperial Photographs" which became so popular. Moved to Washington in February 1858. (To run Brady's gallery there.) Became a member of General George B. McClellan's military family at the beginning of the Civil War and remained with him throughout all of McClellan's campaigns in Virginia, returning to Washington when McClellan retired from the command of the Army of the Potomac. The Union Pacific Railroad Company secured his services in photographing important points on that continental highway to the Pacific coast, prior to the building of the road. [After the war his interest in social issues, ameliorating the plight of the poor and working classes continued unabated.] "...he was called upon to take charge of the Masonic Mutual Relief Association of the District of Columbia." which he reorganized into a successful entity. Later an important voice in another relief organization, the Washington Beneficial Endowment Association. Died in December, 1882.]

G139 1 engraving (Charles Sumner and Longfellow). COSMOPOLITAN 4, no. 1 (Sept. 1887): frontispiece. 1 illus. [Engraving by E. Clement, "From a Photograph by A. Gardner."]

G140 "Four Lincoln Conspiracies. Including New Particulars of the Flight and Capture of the Assassin." CENTURY MAGAZINE 51, no. 6 (Apr. 1896): 889-911. 15 b & w. 14 illus. [Portraits of the conspirators, credited to Gardner. View of the scaffold, credited to Gardner. Portrait of John Wilkes Booth, credited to Brady. Views of memorabilia.]

G141 Taft, Robert. "Additional Notes on the Gardner Photographs of Kansas." KANSAS HISTORICAL QUARTERLY 6, no. 2 (May 1937): 175-177.

G142 Cobb, Josephine. "Alexander Gardner." IMAGE 7, no. 6 (June 1958): 124-136. 5 b & w. 2 illus. [Thorough, well-researched biography.]

G143 Cobb, Josephine. "Book Review: Gardner's Photographic Sketch-book of the War." IMAGE 8, no. 3 (Sept. 1959): 164-166. [This review contains additional historical information about Gardner.]

G144 Ray, Frederick. "The Case of the Rearranged Corpse." CIVIL WAR TIMES ILLUSTRATED 3, no. 6 (Oct. 1961): 19. 3 b & w. [Three photographs of Devil's Den at Gettysburg, showing that the body of a confederate sharpshooter was moved "for a better picture."]

G145 Ray, Frederick. "No Finer Picture of an Engagement?" CIVIL WAR TIMES ILLUSTRATED 1, no. 10 (Feb. 1963): 1-13. 1 b & w. 4 illus. ["Upon closer inspection, a photograph of the Battle of Antietam by Alexander Gardner is found to be a portrait of reserve troops waiting to be sent into the battle, then a mile away.]

G146 Richmond, Robert W. "Kansas Through a Camera in 1867: Stereographs from Alexander Gardner's Photographic Art Gallery." AMERICAN WEST 2, no. 3 (Summer 1965): 51-57. 12 b & w. 1 illus.

G147 Ciampoli, Judith. "The Kansas-Pacific Railway Survey, 1867." MISSOURI HISTORICAL SOCIETY BULLETIN. 24, no. 3 (Apr. 1968): 212-213, plus 8 unnumbered pages. 8 b & w. [Series of photographs by Gardner in the Society's collections, including a portfolio on eight views.]

G148 Lorant, Stefan. "Two New Lincoln Finds." LOOK 33, no. 21 (Oct. 21, 1969): 117-118. 7 b & w. 1 illus. [New portrait of Lincoln by Alexander Gardner, taken in 1863 and a poem by Lincoln located, published here for the first time.]

G149 Sobieszek, Robert A. "Alexander Gardner's Photographs Along the 35th Parallel." IMAGE 14, no. 3 (June 1971): 6-13. 4 b & w, plus cover.

G150 Sobieszek, Robert A. "Conquest by Camera: Alexander Gardner's 'Across the Continent on the Kansas Pacific Railroad." ART IN AMERICA 60, no. 2 (Mar. - Apr. 1972): 80-85. 7 b & w.

G151 Miller, Alan Clark. "A Gardner Album." IMAGE 15, no. 4 (Dec. 1972): 13-16. 5 b & w. [An album containing portraits of the Lincoln assassination conspirators.]

G152 "The Executive Director's Notebook: Alexander Gardner, Photographer of the West." MISSOURI HISTORICAL SOCIETY BULLETIN 31, no. 2 (Jan. 1975): 139-141. [Detailed description of Gardner materials in the Society's collections, including works from several series -"Across the Continent on the Kansas-Pacific Railway." and "Scenes in Indian Country."]

G153 Waldsmith, John. "Execution! Hanging of the Conspirators." STEREO WORLD 2, no. 2 (May - June 1975): 18. 2 b & w. [Two views of the hanging of Lincoln assassins, from stereo cards credited to Taylor & Huntington reprint series. Not credited to Gardner.]

G154 Taft, Robert. "A Photographic History of Early Kansas." STEREO WORLD 3, no. 2 (May - June 1976): 4-5. [Third part of an article reprinted from "Kansas Historical Quarterly," (Feb. 1934, May 1937). Contains a checklist of the Gardner Stereographs in the possession of the Kansas State Historical Society, which lists (with omissions) 153 views.]

G155 "Obituary." NORTHLIGHT (JOURNAL OF THE PHOTOGRAPHIC HISTORICAL DOCIETY OF AMERICA) 3, no. 4 (Fall 1976): 11-14. [Reprint of the obituary in "Philadelphia Photographer" (Mar. 1883).]

G156 Frassanito William A. "The Photographers of Antietam." CIVIL WAR TIMES ILLUSTRATED 17, no. 5 (Aug. 1978): 17-21. 6 b & w. [Alexander Gardner and James F. Gibson took 95 photos of the Antietam battlefield. Brady & Co. later displayed them under his name.]

G157 J. T. "In Camera: Honest Abe's Dubious Day." AMERICAN PHOTOGRAPHER 2, no. 2 (Feb. 1979): 6. 1 b & w. [Portrait of Lincoln offered for sale at $20,000]

G158 Ciampoli, Judith. "Alexander Gardner, Photographer: Along the 35th Parallel in the 1860s." GATEWAY HERITAGE 1, no. 3 (Winter 1980): 14-17. 7 b & w. [Wm. J. Palmer surveyed a transcontinental railroad along the 35th Parallel in New Mexico, Arizona and California for the Kansas Pacific R. R. Company from July 1867 - Sept. 1868. Palmer submitted several hundred Gardner photos with his survey report. Photos in Missouri Historical Society.]

G159 DeMallie, Raymond J. "'Scenes in the Indian Country': A Portfolio of Alexander Gardner's Stereographic Views of the 1868 Fort Laramie Treaty Council." MONTANA: THE MAGAZINE OF WESTERN HISTORY 31, no. 3 (July 1981): 42-59. 24 b & w. 2 illus. [Gardner's 200 photos of Northern Plains Indians - Brule, Oglala and Minneconjou Sioux, Crow, Northern Cheyenne and Arapaho, during the Council in 1868, from a collection held in the Newberry Library, Chicago.]

G160 Babbitt, James E. "Surveyors Along the 35th Parallel: Alexander Gardner's Photographs of Northern Arizona 1867 - 1869." JOURNAL

OF ARIZONA HISTORY 22, no. 3 (Autumn 1981): 325-348. 20 b & w.

GARDNER, JAMES (ca. 1832-) see GARDNER, ALEXANDER.

[James Gardner was Alexander Gardner's younger brother. He was born in Scotland ca. 1832. He worked with Alexander throughout the Civil War. Specifically, James photographed General Grant's campaign against Lee in Virginia, beginning with the battles of Belle Plain and Fredericksburg in May 1864. James Gardner photographed Union wounded and Confederate prisoners from the Wilderness battles, then he photographed the crossing of the James River which preceded the battle of Petersburg in June.]

GARDNER, JOHN see GARDNER, ALEXANDER.

[Alexander Gardner's younger brother, who worked in his studio from the 1860s to the 1880s.]

GARDNER, JOHN B. (1825-1890) (USA)

G161 Gardner, J. B. "Correspondence." ANTHONY'S PHOTOGRAPHIC BULLETIN 4, no. 3 (Mar. 1873): 93. [Letter about a "porcelain surface" varnish that Gardner has perfected after many trials.]

G162 Gardner, John B. "A Cursory Glance at Photography in America." BRITISH JOURNAL PHOTOGRAPHIC ALMANAC 1874 (1874): 80-81.

G163 Gardner, J. B. "Photographic Literature." PHOTOGRAPHIC TIMES 14, no. 165 (Sept. 1884): 527-529. [Paper read before the Photographic Section of the American Institute. Generalized commentary on value of periodicals and books, with little specific information.]

G164 Gardner, J. B. "Photographic Section of the American Institute: The Early History of Photography." ANTHONY'S PHOTOGRAPHIC BULLETIN 17, no. 8 (Apr. 24, 1886): 248-251. [Report of a paper read before the Photographic Section of the American Institute, by J. B. Gardner.]

G165 Gardner, J. B. "Personal Recollections." ANTHONY'S PHOTOGRAPHIC BULLETIN 18, no. 18 (Sept. 24, 1887): 555-557. [Prepared for the United Annual Reunion of the Photographic Societies of New York.]

G166 Gardner, J. B. "The Daguerreotype Process." ANTHONY'S PHOTOGRAPHIC BULLETIN 20, no. 7 (Apr. 13, 1889): 214-216. [Survey of the early history of photography in the USA; mentions Samuel Morse, John Johnson, Draper, Langenheim, Root, Simons, Plumb, Mayall, J. Gurney and others. J. B. Gardner was himself an early daguerreotypist in New York City.]

G167 "Notes and News." PHOTOGRAPHIC TIMES 20, no. 443 (Mar. 14, 1890): 131. [Note that J. B. Gardner, "an old-time photographer, and for many years Chairman of the Executive Committee of the Photographic Section of the American Institute," died Mar. 5th, in the 65th year of his age.]

GARDNER, LAWRENCE (ca. 1848-1899) (GREAT BRITAIN, USA)

[Lawrence Gardner was the son of Alexander Gardner. He was born in Scotland ca. 1848. Lawrence worked in his father's Washington, DC studio, as did his uncles John and James, from the 1860s through the 1880s. Lawrence died on Sept. 19, 1899 in Washington, DC.]

GARDNER, WHEELOCK M. (d. 1886) (USA)

G168 "Obituary: Wheelock M. Gardner." PHOTOGRAPHIC TIMES 16, no. 269 (Nov. 12, 1886): 596. [Gardner of Gardner & Co., Brooklyn, died of typhoid fever Nov. 5, 1886. Been a photographer for more than 30 years.]

GARLICK, THEODATUS.

G169 Garlick, Theodatus, M.D. "Miscellaneous: On the Preparation of Daguerreotype Plates." AMERICAN REPERTORY OF ARTS, SCIENCES AND MANUFACTURES 2, no. 4 (Nov. 1840): 303-304. [From the "Maryland Medical and Surgical Journal." (July 1840). Theodatus Garlick and Augustus Barnum, from Baltimore, MD, experimented with the process.]

GARNERI.

G170 Garneri, Sig., of Turin. "Photergimetry." AMERICAN JOURNAL OF PHOTOGRAPHY AND THE ALLIED ARTS & SCIENCES n. s. vol. 6, no. 6 (Sept. 15, 1863): 135-136. [From "Bulletin Chimique."]

GARNETT, JOHN.
BOOKS

G171 Payn, James. *The Lakes in Sunshine; Being Photographic and Other Pictures of the Lake District of Westmoreland and North Lancaster;* with Descriptive Letterpress by James Payn. London: Simpkin, Marshall, 1868. 105 pp. 14 l. of plates. 14 b & w. [Original photos. Several editions, slightly different. Photographers for some editions were John Garnett and R. J. Sproat.]

G172 Payn, James. *The Lakes in Sunshine; Being Photographic and Other Pictures of the Lake District of Cumberland.* with Descriptive Letterpress by James Payn. London; Windermere: Simpkin, Marshall; John Garnett, 1870. n. p. 10 l. of plates. illus. [Volume two of the series. Original photos by Garnett & Sproat, Garnett & Bowers, and R. J. Sproat.]

PERIODICALS

G173 "Literature." ILLUSTRATED LONDON NEWS 56, no. 1597 (June 4, 1870): 590. [Bk. rev.: "The Lakes in Sunshine: Being Photographic and other Pictures of the Lake District of Cumberland. With Descriptive Letterpress by James Payn." (Simpkin, Marshall & Co., and Windermere: J. Garnett.)]

GARREAUD, E. & CO. (VALPARAISO, URUGUAY)

G174 Portrait. Woodcut engraving credited "From a photograph by E. Garreaud & Co." ILLUSTRATED LONDON NEWS 69, (1876) ["Sir C. Wyville Thomson." 69:1927 (July 8, 1876): 38.]

[GARRETT, ELWOOD A. see also HISTORY: USA: DELEWARE (Williams)

GARRETT, ELLWOOD A. (1813-1910) (USA)
[Ellwood A. Garrett was born in Upper Darby, PA on Dec. 19, 1813, the first of five children of Thomas and Mary Sharpless Garrett. In 1822 the family moved to Wilmington, DE, where his father went into the iron and hardware trade. Thomas Garrett was an active abolitionist who was severely fined in 1848 for aiding fugitive slaves, but who realized a substancial income by the 1860s. Ellwood Garrett attended Friends School, then apprenticed as a machinist. He opened a machine shop in Wilmington and in 1846 patented a machine for manufacturing screws. However he always suffered ill health and when his shop burned to the ground in 1849, he closed that business. Ellwood then studied daguerreotypy with Samuel Broadbent in 1849 and opened his own daguerreotype studio in 1850. The Garrett Studio remained open until 1888, although his sons Maurice and Warren took over its management in 1870. Ellwood then travelled to

California before returning to Wilmington to retire. Ellwood Garrett died in Wilmington in May, 1910.]

G175 "Note." ANTHONY'S PHOTOGRAPHIC BULLETIN 2, no. 9 (Sept. 1871): 303. [Note that E. A. Garrett (Wilmington, DE) has returned from his trip to California, much improved in health, with a large lot of 8" x 10" negatives of Yosemite Valley, etc.]

GATEHOUSE, J. W.
G176 Gatehouse, J. W. "The Effect of Collodion on the Nervous System." HUMPHREY'S JOURNAL OF PHOTOGRAPHY, AND THE ALLIED ARTS AND SCIENCES 18, no. 6 (July 15, 1866): 88-89. [From "Photo. News."]

GATES, GEORGE F. (WATKINS GLEN, NY)
BOOKS
G177 Ells, M. *Illustrated and Descriptive Guide Book of the Watkins Glen... And Its Romantic Surroundings.* Syracuse: Hitchcock, 1871. n. p. pp. 5 b & w. [Original photos, half stereoviews, probably by G. F. Gates.]

G178 Halsey, Lewis. *The Falls of Taughannock; Containing a Complete Description of This the Highest Fall in the State of New York.* With Descriptive Sketches by Lewis Halsey. Illustrated by Views of the Falls. New York: Cutter, Tower & Co., 1872. 92 pp. 4 b & w. [4 half stereoviews by G. F. Gates. NYPL copy, HUL copy dated 1866. First edition (1866), has wood-engraved illustrations.]

PERIODICALS
G179 "Editor's Table." PHILADELPHIA PHOTOGRAPHER 4, no. 43 (July 1867): 235. [Stereos of Watkins Glen, NY.]

GATES, LE ROY. (KILBOURN CITY, WI)
G180 "Six Pictures Representing the Terrible Effects of the Great Tornado in Illinois, June 3, 1860. - From Photographs by LeRoy Gates, Morrison, Ill." FRANK LESLIE'S ILLUSTRATED NEWSPAPER 10, no. 239 (June 23, 1860): 69. 6 illus. [Views of the destruction.]

G181 Gates, Leroy. "A New Printing Stand." AMERICAN JOURNAL OF PHOTOGRAPHY AND THE ALLIED ARTS & SCIENCES n. s. vol. 8, no. 7 (Oct. 1, 1865): 158-159. 2 illus.

G182 Gates, Leroy. "A New Developer - Ferro-Albumen." AMERICAN JOURNAL OF PHOTOGRAPHY AND THE ALLIED ARTS & SCIENCES n. s. vol. 8, no. 11 (Dec. 1, 1865): 262-263.

G183 Gates, Leroy. "An Improved Uranium Toning Bath." AMERICAN JOURNAL OF PHOTOGRAPHY AND THE ALLIED ARTS & SCIENCES n. s. vol. 8, no. 5 (Sept. 1, 1865): 116-117.

G184 Gates, Le Roy. "The Albumen Developer." AMERICAN JOURNAL OF PHOTOGRAPHY, AND THE ALLIED ARTS AND SCIENCES n. s. vol. 9, no. 3 (Oct. 1, 1866): 67-68.

GATES, THEODORE N. (WESTBOROUGH, MA)
G185 Gates, Theodore N. "Correspondence." ANTHONY'S PHOTOGRAPHIC BULLETIN 3, no. 2 (Feb. 1872): 461. [Gates from Westborough, MA.]

G186 "Editor's Table." PHILADELPHIA PHOTOGRAPHER 14, no. 166 (Oct. 1877): 319. [T. N. Gates (Westboro, MA), after four years' absence, returned and opened a new gallery.]

G187 "Matters of the Month." PHOTOGRAPHIC TIMES 7, no. 82 (Oct. 1877): 218. [From the "Westboro' Chronotype." Description of

newly remodelled studio, recently occupied by O. C. Knox and now by T. N. Gates.]

GAUDIN, ALEXIS see also GAUDIN, MARC-ANTOINE-AUGUS-TIN.

GAUDIN, ALEXIS.
G188 Gaudin. "Preparation of Collodion." HUMPHREY'S JOURNAL 4, no. 15 (Nov. 15, 1852): 228-232. [From "La Lumiere."]

G189 Gaudin, A. "Actinic Printing." HUMPHREY'S JOURNAL 6, no. 19, 21 (Jan. 15, Feb. 15, 1855): 309-311, 343-344. [From "La Lumiere, Oct. 14, 1854."]

G190 Gaudin, A. "On Dry Collodion." HUMPHREY'S JOURNAL OF PHOTOGRAPHY, AND THE ALLIED ARTS AND SCIENCES 12, no. 17 (Jan. 1, 1860): 267-269. [From "Br. J. of Photo." "At the present moment the stereoscope has become the most important branch of photography."]

G191 Gaudin. "On a Sensitive Dry Collodion Process." HUMPHREY'S JOURNAL OF PHOTOGRAPHY, AND THE ALLIED ARTS AND SCIENCES 12, no. 22-24 (Mar. 15, Apr. 15, 1861): 352, 380-382. [From "La Lumière."]

G192 Gaudin, A. "The Original Gelatine Emulsion in 1861." ANTHONY'S PHOTOGRAPHIC BULLETIN 10, no. 12 (Dec. 1879): 366-367. [From "La Lumiére, Apr. 15, 1861."]

GAUDIN, MARC-ANTOINE-AUGUSTIN. (1804-1880) (FRANCE)
[Born at Saintes, Lower Charente in 1804. He and his younger brother Alexis worked and collaborated together throughout their lives. Marc-Antoine is a physicist, chemist and inventor, who worked for the Bureau of Longitudes in Paris from 1835 until his death. Marc-Antoine attended a lecture on the daguerreotype given on August 19th and made a daguerreotype on the 20th. Throughout early 1840s he presented various chemical improvements and technical innovations to the process. Alexis proposed instantaneous portraits in 1843, and opened a studio in 1844. In 1851 Alexis bought the journal *La Lumière*. Throughout 1850s and 1860s Alexis and Marc-Antoine offered improvements to various collodion processes. Marc-Antoine died in Paris in 1880.]

G193 "Note in Paris Letter." LITERARY GAZETTE no. 1293 (Oct. 30, 1841): 704. [Gaudin's use of bromide increasing the speed of daguerreotype.]

G194 "Daguerreotype and Electrotype." LITERARY GAZETTE no. 1215 (Nov. 13, 1841): 739. [Further information.]

G195 Gaudin, M. A., Translated from the French by Mrs. A. L. Snelling. "A General Review of the Daguerreotype." PHOTOGRAPHIC ART JOURNAL 5, no. 1-3, 6 (Jan. - Mar., June 1853): 5-12, 69-73, 133-136, 352-360.

G196 Gaudin, M. A. "A General Review of the Daguerreotype." PHOTOGRAPHIC ART JOURNAL 6, no. 1-5 (July - Nov. 1853): 42-47, 69-73, 152-156, 212-220, 261-270.

G197 Gaudin, Mc. A. "Hyponitrite of Lead Silver Bath." AMERICAN JOURNAL OF PHOTOGRAPHY AND THE ALLIED ARTS & SCIENCES n. s. vol. 4, no. 2 (June 15, 1861): 27-29. [From "Br. J. of Photo."]

G198 Gaudin, Mc. A. "New Photogen For Obtaining Portraits at Night." AMERICAN JOURNAL OF PHOTOGRAPHY AND THE ALLIED ARTS & SCIENCES n. s. vol. 6, no. 13 (Jan. 1, 1864): 289-290. [From "La Lumière."]

G199 Gaudin, Mc.-A. "The Magnesium Light." AMERICAN JOURNAL OF PHOTOGRAPHY AND THE ALLIED ARTS & SCIENCES n. s. vol. 7, no. 5 (Sept. 1, 1864): 109-112. [From "La Lumière."]

G200 Gaudin, Mc. A. "New Artifices in the Employment of the Stereoscope." AMERICAN JOURNAL OF PHOTOGRAPHY AND THE ALLIED ARTS & SCIENCES n. s. vol. 7, no. 10 (Nov. 15, 1864): 217-220. [From "La Lumière."]

G201 Gaudin, Mc.-A. "New Articles in the Employment of the Stereoscope." HUMPHREY'S JOURNAL OF PHOTOGRAPHY, AND THE ALLIED ARTS AND SCIENCES 16, no. 15 (Dec. 1, 1864): 234-236. [From "La Lumière."]

G202 Gaudin, Mc. A. "Simple Process of Carbon Printing." AMERICAN JOURNAL OF PHOTOGRAPHY AND THE ALLIED ARTS & SCIENCES n. s. vol. 7, no. 13 (Jan. 1, 1865): 308-309. [From "La Lumière."]

G203 Gaudin, Mc. A. "Perfection of Iron Developers." AMERICAN JOURNAL OF PHOTOGRAPHY AND THE ALLIED ARTS & SCIENCES n. s. vol. 8, no. 8 (Oct. 15, 1865): 175-176. [From "La Lumière."]

G204 Gaudin, Mc.-A. "Prints Developed with Ferroso-Acetate of Iron." HUMPHREY'S JOURNAL OF PHOTOGRAPHY, AND THE ALLIED ARTS AND SCIENCES 18, no. 7 (Aug. 1, 1866): 102-103. [From "La Lumiére."]

G205 Gaudin, Mc.-A. "New Process of Photographic Engraving." HUMPHREY'S JOURNAL OF PHOTOGRAPHY, AND THE ALLIED ARTS AND SCIENCES 18, no. 13 (Nov. 1, 1866): 201-202.

G206 Gaudin, Mc.-A. "On the Employment of Blue Glass in Photography." AMERICAN JOURNAL OF PHOTOGRAPHY, AND THE ALLIED ARTS AND SCIENCES n. s. vol. 9, no. 10 (May. 1, 1867): 215-216. [From "Photo. News."]

G207 Harrison, W. Jerome. "The Chemistry of Fixing. Gaudin Introduces Fixing with Cyanide of Potassium." PHOTOGRAPHIC TIMES 20, no. 481 (Dec. 5, 1890): 611-612. [Gaudin (1853); Peter Armand Le Comte de Fontaine Moreau (1854).]

GAVIT, DANIEL E. (1819-1875) (USA)
[Born in 1819. Active in Albany, NY in 1850. Moved to New York, NY 1850-1852. Purchased Anthony, Clark & Co.'s "National Miniature Daguerreotype Gallery" in 1850, only to have it burn, with its contents, in 1852. Apparently Gavit left photography soon afterwards. Published a newspaper in Jersey City, NJ. Died in New York, NY in 1875.]

G208 "Gossip." PHOTOGRAPHIC ART JOURNAL 3, no. 4 (Apr. 1852): 257. ["Mr. D. E. Gavit, 247 Broadway, burned out early March - Mr. Gavit's gallery contained the largest, best, and most valuable collection of daguerreotypes in the world."]

GAY, DAVID.
G209 "New Process of Photosculpture." BRITISH JOURNAL OF PHOTOGRAPHY 12, no. 284 (Oct. 13, 1865): 522. ["...is the invention of Mr. Gay, of Cheapside, who has secured it by patent."]

G210 Gay, David. "Photo-Sculpture. - English Patent." AMERICAN JOURNAL OF PHOTOGRAPHY AND THE ALLIED ARTS & SCIENCES n. s. vol. 8, no. 18 (Mar. 15, 1866): 414-415. [From "Photo. News." "...object...to produce portrait busts and statuettes by the aid of photography by simpler means than those devised by M. Willeme."]

GAY, HENRY LORD.
G211 "Lebanon, Connecticut." FRANK LESLIE'S ILLUSTRATED NEWSPAPER 7, no. 178 (Apr. 30, 1859): 338. 3 illus. [Views of houses, landscapes, with added figures. Credited "From a Photograph by Henry Lord Gay."]

GAYLORD, ALFRED B. (ROCK ISLAND, IL)
G212 "Albumen Prints." HUMPHREY'S JOURNAL OF PHOTOGRAPHY, AND THE ALLIED ARTS AND SCIENCES 11, no. 14 (Nov. 15, 1859): 215. [Letter from Gaylord, response from the editor.]

GAYNOR, EDWARD J. (GREAT BRITAIN, INDIA)
G213 Gaynor, Dr. Edward J. "The Fading of Albumenized Prints." ANTHONY'S PHOTOGRAPHIC BULLETIN 4, no. 3 (Mar. 1873): 76. [Dr. Gaynor, "of the Indian Army," contributed this article to the "Photographic News."]

GEHRES, G. L. (MARSHALLVILLE, OH)
G214 Gehres, G. L. "On Printing, Toning, and Fixing." AMERICAN JOURNAL OF PHOTOGRAPHY AND THE ALLIED ARTS & SCIENCES n. s. vol. 3, no. 20 (Mar. 15, 1861): 319.

GEIGER, JOHN LEWIS
G215 Geiger, John Lewis, F.R.G.S. A Peep at Mexico; Narrative of a Journey across the Republic of the Pacific to the Gulf in December 1873 and January 1874. London: Truebner & Co., 1874. 353 pp. 44 b & w. illus. [Autotype prints, 23 of 44 credited to the author.]

GELDMACHER, W. F. (FRANKFURT, GERMANY)
G216 Geldmacher, W. F. "Why the Carbon Process is not More Generally Adopted." ANTHONY'S PHOTOGRAPHIC BULLETIN 8, no. 2 (Feb. 1877): 35-37. [From "London Photo. News," again from "Photographische Correspondenz." Geldmacher from Frankfurt, Germany.]

GENEVE. (PARIS, FRANCE)
G217 Portraits. Woodcut engravings, credited "Photographed by Geneve, Paris." FRANK LESLIE'S ILLUSTRATED NEWSPAPER 3, (1857) ["Adj.-Gen. Francis Todtleben, of the Russian Army." 3:77 (May 30, 1857): 404]

GENTILE, CHARLES. (1835-1893) (CANADA, USA)
G218 "Editor's Table: Carbon Photographs Received." PHILADELPHIA PHOTOGRAPHER 14, no. 163 (July 1877): 223, 224. [Carbon photographs by C. C. Gentile (Chicago, IL). Statement that Gentile still making prints promised for the magazine.]

G219 "Our Picture." PHILADELPHIA PHOTOGRAPHER 14, no. 165 (Sept. 1877): frontispiece, 284-285. 1 b & w. [Composite portrait print, with General P. H. Sherman and staff, posed as if in front of a battery of cannon firing. Made up in the studio by C. Gentile (Chicago, IL). Background from views in Arizona and Camp Crittenden, AZ. Portraits taken in the Chicago gallery.]

G220 Gentile, C. "Report on the Progress of Photography." PHOTOGRAPHIC TIMES 14, no. 164 (Aug. 1884): 411-413. [Report read to the P. A. of A. Gentile's statement prefaced with the comment that J. Traill Taylor had resigned (apparently suddenly) from the committee to report on progress. Taylor's report is published elsewhere in this issue.]

G221 Gentile, C. "Advertising and Prices." PHOTOGRAPHIC TIMES 17, no. 310 (Aug. 26, 1887): 436-437.

G222 Gentile, C. "Advertising and Prices." ANTHONY'S PHOTOGRAPHIC BULLETIN 18, no. 16 (Aug. 27, 1887): 492-493. [Read before the Chicago Convention of the P. A. of A.]

G223 Mattison, David. "Gentile's Lost Square Deal Box." HISTORY OF PHOTOGRAPHY 11, no. 4 (Oct. - Dec. 1987): 261-263. 2 b & w. [Views of British Columbia, taken ca. 1865. Charles Gentile worked in British Columbia from 1863 to 1867. Then moved to San Francisco, CA, and opened a studio. Worked as an itinerant photographer throughout the southwest for the next decade. Settled in Chicago, IL, ca. 1878, where he died.]

GERMAN, CHRISTOPHER SMITH. (USA)
G224 "C. S. German." HUMPHREY'S JOURNAL OF PHOTOGRAPHY, AND THE ALLIED ARTS AND SCIENCES 15, no. 9 (Sept. 1, 1863): 143. [Praise for cartes-de-visite of Gov. Yates of IL, etc. German from Springfield, IL.]

G225 "Voices from the Craft." PHILADELPHIA PHOTOGRAPHER 5, no. 56 (Aug. 1868): 273-274. [Letter from C. S. German.]

G226 "Cover Photos." PHOTOGRAPHICA 13, no. 2 (Feb. 1981): 2, plus cover. 1 b & w. 1, 1 port. illus. [Remarks on Christopher Smith German, maker of January 13, 1861 photographs of Lincoln which were used for first U.S. postage stamp made "from a photograph."]

GERMON, C. S. (CANADA)
G227 "Patents and Improvements." HUMPHREY'S JOURNAL 6, no. 2 (May 1, 1854): 27-28. [Germon from Nappanee, Canada West. His letter complains about someone stealing his process for making "illuminated daguerreotypes" and selling the process.]

GERMON, WASHINGTON L. see also MCCLEES & GERMON.

GERMON, WASHINGTON LAFAYETTE. (1822-1877) (USA)
G228 "The Artillery Corps of the Washington Greys of Philadelphia. Photograph by German, [sic Germon?] Philadelphia." FRANK LESLIE'S ILLUSTRATED NEWSPAPER 3, no. 70 (Apr. 11, 1857): 296. 1 illus. [Group military portrait.]

G229 "Obituary." PHILADELPHIA PHOTOGRAPHER 15, no. 169 (Jan. 1878): 22-24. [Died Dec. 1, 1877, aged 55 yrs. Biographical statement by "his old partner J. E. McClees." Germon apprenticed as a steel engraver in Philadelphia, then began card engraving business. Later formed partnership with William H. Gihon. An elderly lithographer named Watson persuaded Germon to buy a daguerreotype apparatus, at a time when it was "...then an almost purely experimental art..." and they began a business, but fared poorly due to inability to make the daguerreotypes. McClees, then working as an operator for M. P. Simmons, showed him how to work the process, then the two formed a partnership that lasted seven years, first at 8th and Chestnut (until 1848), then moved several times until burned out in March, 1855. (Made paper photographs early, first in Philadelphia to do so after the Langenheim Brothers - with John Whipple's patented "crystalotype" process in 1853). Partnership

dissolved after eight years. William Bell and John McCaffery later associated with Germon.]

GETCHELL, W. H.
G230 Portrait. Woodcut portrait, credited "From a Photograph by W. H. Getchell." FRANK LESLIE'S ILLUSTRATED NEWSPAPER 31, (1870) ["The late John Simmons, of Boston, MA." 31: 786 (Oct. 22, 1870): 93.]

GHÉMAR BROTHERS. (BRUSSELS, BELGIUM)
G231 "The Bishop of Oxford Laying the Foundation Stone of an New English Church at Brussels." ILLUSTRATED LONDON NEWS 44, no. 1256 (Apr. 23, 1864): 384. 1 illus. ["...from a photograph by Messrs. Ghémar, of that city."]

G232 Portrait. Woodcut engraving credited "From a photograph by Ghémar Brothers, of Brussels." ILLUSTRATED LONDON NEWS 48, (1866) ["Leopold II, King of the Belgians; Marie, Queen of the Belgians." 48:* (Jan. 20, 1866): 60-61.]

G233 Portraits. Woodcut engravings credited "From a photograph by Ghémar Brothers, of Brussels." ILLUSTRATED LONDON NEWS 53, (1868) ["Duke of Brabant, Prince Royal of Belgium." 53:* (Nov. 21, 1868): 488.]

G234 "La Catastrophe de la Houillere de Frameries (Belgique)." L'ILLUSTRATION 73, no. 1888 (May 3, 1879): 277-281. ["After the photos of Mm. Ghemar Freres." Three views of aftermath of a mining explosion.]

GHÉMAR, LOUIS see also GHÉMAR BROTHERS.

GHÉMAR, LOUIS. (1819-1873) (BELGIUM)
[Louis was active in Brussels in 1845 as a painter and lithographer. Set up a photographic studio in 1855 with his brother (whose first name is not known). Active and popular, the studio became "Photographers to the King" in 1856. In 1850s and 1860s they made many portraits of the Belgian intelligencia, artists, society members. In 1867 Louis photographed along the Senne River in Brussels. They made many views in Switzerland in 1868, and Louis published Voyage en Suisse, Impressions d'un Photographe. Louis died in 1873.]

G235 Portrait. Woodcut engraving credited "From a photograph by Ghémar." ILLUSTRATED LONDON NEWS 61, (1872) ["Sheriff Perkins." 61:1731 (Nov. 9, 1872): 440.]

G236 "Note." ILLUSTRATED LONDON NEWS 62, no. 1759 (May 17, 1873): 458. ["M. Louis Ghémar, the well-known artist and photographer in Brussels, died recently in that city, in his fifty-fourth year."]

GHIRARDINI, M. L.
G237 Ghirardini, M. L. "Correspondence." ANTHONY'S PHOTOGRAPHIC BULLETIN 3, no. 1 (Jan. 1872): 430. [Ghiarardini from North Providence, RI.]

GIBBLE, JOHN. (GREAT BRITAIN)
G238 Stewart, A. A. "Glasgow's 'Broomielaw'." HISTORY OF PHOTOGRAPHY 10, no. 1 (Jan. - Mar. 1986): 70. 1 b & w. [View of Glasgow's harbour, taken Mar. 1854.]

GIBBS, L. E. (0TTAWA, IL)
G239 Gibbs, L. E. "Plan for Fuming." AMERICAN JOURNAL OF PHOTOGRAPHY AND THE ALLIED ARTS & SCIENCES n. s. vol. 7, no. 20 (Apr. 15, 1865): 476.

GIBBS, WILLIAM BRICKELL.

G240 Grey, James. *His Island Home and Away in the Far North; A Narrative of Travels in that Part of the Colony North of Auckland.* Wellington, N. Z.: Lyon & Blair, 1879. 54 pp. 9 b & w. [Original photos by William Brickell Gibbs.]

GIBERNE, GEORGE.

G241 Giberne, George. "Leaves from My Notebook." BRITISH JOURNAL PHOTOGRAPHIC ALMANAC 1872 (1872): 75-78. [Giberne began in 1858, working calotypes and waxed-paper process, taking landscape views. Includes excerpts from his 1858 daybook.]

GIBSON, JAMES F. (1828/29-) (GREAT BRITAIN, USA)

[James F. Gibson born in Scotland in 1828 or 1829. By 1860 he was in Washington, DC, working for the Brady Studio under the management of Alexander Gardner. Gibson worked for the Brady Studio until November 1862, photographing scenes and events of the war with both large plate and stereo cameras. Worked with George N. Barnard in 1862, photographing the site of the first battle of Bull Run which had occurred eight months earlier. The Union General George McClellan launched the Peninsular Campaign in April 1862. This led to the battle of Fair Oaks in May, the Confederate retreat and counterattack, then the Seven Days battles in June, the battle of Gaines Mill, the attack on Savage's Station, and the battle of Malvern Hill, and stalemate. James Gibson and John Wood followed closely in the train of the Union Army during this campaign, and produced the first photographs taken during an active field campaign, thus proving that it was possible to make dramatic and timely photographs under these conditions. In September 1862 Gibson and Alexander Gardner reached the battlefield at Antietam before the dead soldiers were buried. These photographs created a large public response when they were displayed and published by their employer, Matthew Brady. Gibson also left when Gardner split away from Brady in 1862, and he briefly formed a partnership with Gardner. Gibson was with Gardner again at the aftermath of the Gettysburg battle. Gibson photographed at Falmouth, Fredericksburg, Brandy Station, and elsewhere in Virginia during 1863 and 1864. He made approximately 150 known photographs of the Civil War.
In 1864 Gibson left Gardner to take over the management of Brady's Washington gallery, which was then in severe financial difficulties. Then Gibson was made a co-partner in the gallery, but he failed to make it successful against Gardner's competition, and several years of increasing bitterness between Gibson and Brady dissolved the partnership in a welter of lawsuits. Gibson left Washington in 1868 when the business went bankrupt, and apparently moved to Kansas -but this is uncertain.]

BOOKS

G242 Gardner, Alexander. *Gardner's Photographic Sketch-Book of the War.* Washington, DC: Philip & Solomon's, 1866. 2 vol. pp. 100 b & w. [Six photographs credited to Barnard & Gibson and four photographs credited to Wood & Gibson.]

PERIODICALS

G243 "Infernal Machines Discovered in the Potomac Near Aquia Creek, By the Flotilla, For Whose Destruction They Were Intended." NEW YORK ILLUSTRATED NEWS 4, no. 90 (July 22, 1861): 177, 186. 1 illus. ["Sketched by A. Waud, from a photograph by James F. Gibson."]

G244 Waldsmith, Thomas. "James F. Gibson: Out of the Shadows." STEREO WORLD 2, no. 6 (Jan. - Feb. 1976): 1, 5, 20. 4 b & w.

GIERS, CARL CASPER. (1828-1877) (GERMANY, USA)

G245 Portrait. Woodcut engraving, credited "From a Photograph by C. C. Giers." HARPER'S WEEKLY 11, (1867) ["Sen. Almon Case, of TN." 11:529 (Feb. 16, 1867): 100.]

G246 "Editor's Table." PHILADELPHIA PHOTOGRAPHER 5, no. 56 (Aug. 1868): 279-280. [Stereo views of memorabilia associated with Gen. Andrew Jackson.]

G247 Portraits. Woodcut engravings, credited "From a Photograph by C. C. Giers." HARPER'S WEEKLY 13, (1869) ["Gov. Senter, of Tenn." 13:662 (Sept. 4, 1869): 561. "Henry Cooper, of Tenn." 13:673 (Nov. 20, 1869): 749.]

G248 Portrait. Woodcut engraving, credited "From Photographs by C. C. Giers." FRANK LESLIE'S ILLUSTRATED NEWSPAPER 36, (1873) ["College of Bishops of the Methodist Church, South. (9 portraits)." 36:923 (June 7, 1873): 208.]

G249 "Compliment to Nashville Art." ANTHONY'S PHOTOGRAPHIC BULLETIN 4, no. 9 (Sept. 1873): 269. [Quotes a letter from General Meigs, U.S.A., complimenting C. C. Giers' photographs of the National Cemetery of Nashville. Meigs compares Giers' photos to the work of Carlo Ponti of Venice.]

G250 "Nashville, Tennessee. The Tornado of April 15th: Effects on the Opera House" and "Effects on Cherry Street Grocery and Stable. - Photographed by C. C. Giers." FRANK LESLIE'S ILLUSTRATED NEWSPAPER 38, no. 971 (May 9, 1874): 140. 2 illus. [Ruins.]

G251 Portrait. Woodcut engraving, credited "From a Photograph by C. C. Giers. FRANK LESLIE'S ILLUSTRATED NEWSPAPER 41, (1876) ["Hon. John F. House, of TN." 41:1059 (Jan. 15, 1876): 309.]

G252 "What Shall We Do About It?" ANTHONY'S PHOTOGRAPHIC BULLETIN 7, no. 4 (Apr. 1876): 114. [From "Lebanon Herald, Nov. 14." Editor claims to have had his picture taken while visiting C. C. Giers in Nashville, TN, then being forced to flee his office by the crowd of young ladies ardently seeking copies of the prints.]

G253 Portrait. Woodcut engraving, credited "From a Photograph by C. C. Giers, Nashville." FRANK LESLIE'S ILLUSTRATED NEWSPAPER 42, (1876) ["The late Chief-Justice Nicholson." 42:1072 (Apr. 15, 1876): 93.]

G254 "Tennessee. - The Colored National Convention Held at Nashville, April 5th, 6th and 7th. - From a Photograph by C. C. Giers, Nashville." FRANK LESLIE'S ILLUSTRATED NEWSPAPER 42, no. 1075 (May 6, 1876): 145. 1 illus. [Interior, with crowd.]

G255 "Death of Hon. C. C. Giers." ANTHONY'S PHOTOGRAPHIC BULLETIN 8, no. 6 (June 1877): 183. [From "Nashville (TN) Banner." Giers born in Bonn, Germany on Apr. 28, 1828. At seventeen, emigrated to USA and arrived at Nashville, TN. Worked as a conductor on the Nashville & Chattanooga RR for three years, then opened a photographic gallery in Nashville, which he ran until his death. In 1874 he was elected to the House of Representatives. Active, for Tennessee, at the Vienna International Exhibition.]

G256 "Editor's Table: Death of Hon. C. C. Giers." PHILADELPHIA PHOTOGRAPHER 14, no. 163 (July 1877): 224. [C. C. Giers (Nashville, TN) died on June 24. Member of House of Representatives from TN. Represented Vienna Exhibition and the Centennial Exhibition at Phila., "one of the most active of our fraternity."]

GIFFORD, B. S.
G257 "Leslie Art at the Country Fair." ANTHONY'S PHOTOGRAPHIC BULLETIN 2, no. 12 (Dec. 1871): 396. [From "Exchange." Praise for Gifford's work at the Mason Country Fair.]

GIHON, JOHN L. see also CENTENNIAL PHOTOGRAPHIC CO.

[Gihon was the actual photographer for the Centennial Photographic Co., working for Edward L. Wilson.]

GIHON, JOHN LAWRENCE. (1839-1878) (USA)
BOOKS
G258 Gihon, John L. *The Photographic Colorists' Guide:* Contains Explanations of the Methods by which Photographs are Colored in Oil, Water Colors, and Pastel. Philadelphia: Edward L. Wilson, 1878. viii, 96 pp. illus.

PERIODICALS
G259 "Composition Pictures." PHILADELPHIA PHOTOGRAPHER 4, no. 39 (Mar. 1867): 80. [Composition print of trotting horse "Dexter", picture of horse made instantaneously, photos of bystanders pasted in, hotel and buildings painted in, the whole then copied and colored.]

G260 "Our Picture." PHILADELPHIA PHOTOGRAPHER 6, no. 64 (Apr. 1869): 134. 1 b & w. [Genre Study. Gihon & Jones.]

G261 "Editor's Table." PHILADELPHIA PHOTOGRAPHER 7, no. 82 (Oct. 1870): 367. ["Mr. John L. Gihon advertises his establishment at 812 Arch Street for sale. It was formerly occupied by Messrs. Henzey & Co."]

G262 "Our Picture." PHILADELPHIA PHOTOGRAPHER 8, no. 91 (July 1871): frontispiece, 245. 1 b & w. [Portrait. Gihon & Thompson.]

G263 Gihon, John L. "A Little Talk About Photography." PHILADELPHIA PHOTOGRAPHER 8, no. 91 (July 1871): 245-247.

G264 Gihon, John L. "Ornamental Printing." PHILADELPHIA PHOTOGRAPHER 8, no. 93 (Sept. 1871): 291-293.

G265 Gihon, John L. "Curious Photographic Experiences." PHILADELPHIA PHOTOGRAPHER 8, no. 95 (Nov. 1871): 349-352. [Anecdotes from his experiences as a professional photographer.]

G266 "Editor's Table." PHILADELPHIA PHOTOGRAPHER 8, no. 95 (Nov. 1871): 376. [Gihon photographing for the bi-monthly magazine "Photographic Review of Medicine and Surgery," edited by Drs. F. F. Maury and L. A. Duhring. (Phila: J. B. Lippincott). Four photos per issue, twenty-four per volume were planned.]

G267 Gihon, John L. "Instantaneous Photography." PHILADELPHIA PHOTOGRAPHER 9, no. 97 (Jan. 1872): 6-9. [Read before Pa. Photo. Assoc. Nov. 13, 1871.]

G268 Gihon, John L. "Fourth Annual Meeting and Exhibition of the N. P. A. in St. Louis, Mo., May 1872: Views That May Not Be Well Received." PHILADELPHIA PHOTOGRAPHER 9, no. 102 (June 1872): 197-198.

G269 "Our Illustration: The Village Belle." PHOTOGRAPHER'S FRIEND 2, no. 3 (July 1872): plus frontispiece, 67-69. 1 b & w. [Genre portrait.]

G270 Gihon, John L. "Rustic Work." PHOTOGRAPHER'S FRIEND 2, no. 3 (July 1872): 66-67.

G271 "Sketches of Prominent Photographers. No. 9: John L. Gihon." PHOTOGRAPHER'S FRIEND 2, no. 3 (July 1872): 69-70.

G272 Gihon, John L. "Hints From the Record of an Artist and Photographer. Nos. 1 - 5." PHILADELPHIA PHOTOGRAPHER 9, no. 104-108 (Aug. - Dec. 1872): 283-285, 306-308, 343-345, 394-396, 425-426.

G273 Chute, R. J. "Wanted - An Operator to Go To South America." PHILADELPHIA PHOTOGRAPHER 9, no. 105 (Sept. 1872): 322-323. [Gihon will eventually be the operator who will go to South America for Chute. See note on p. 366 of the "PP".]

G274 Gihon, John L. "Views That May Not Be Well Received." PHOTOGRAPHER'S FRIEND 2, no. 4 (Oct. 1872): 122-124. [Read at the N.P.A. convention in St. Louis.]

G275 Chute, R. J. "South America." PHILADELPHIA PHOTOGRAPHER 9, no. 106 (Oct. 1872): 358-359. [Chute advertising for an operator to go to South America to run a studio for him. Gihon will take this position.]

G276 "Editors Table." PHILADELPHIA PHOTOGRAPHER 9, no. 108 (Dec. 1872): 439. [Notes: Gihon about to sail for South America... some time past superintending gallery of Mr. C. D. Mosher in Chicago, IL. In a testimonial of his services, the gallery presented him a gold-headed cane.]

G277 Gihon, John L. "Hints from the Record of an Artist and Photographer. Nos. 6-11." PHILADELPHIA PHOTOGRAPHER 10, no. 110-120 (Feb. - Dec. 1873): 46-47, 163-165, 197-199, 490-492, 521-522, 552-554.

G278 Gihon, John L. "Fifth Annual Meeting and Exhibit of the National Photographic Association of the U.S., held in Buffalo, N.Y., beginning July 5, 1873: A Contribution to the Pow Wow." PHILADELPHIA PHOTOGRAPHER 10, no. 117 (Sept. 1873): 291-295.

G279 "Fifth Annual Meeting and Exhibition of the National Photographic Association of the United States, Held in Buffalo, New York, beginning July 15, 1873 (continued)." ANTHONY'S PHOTOGRAPHIC BULLETIN 4, no. 10 (Oct. 1873): 305-320. ["On Skylight Constructions," by E. Z. Webster; "A Contribution to the Pow-Wow, by John L. Gihon; [mailed from S. America], "How Many Positions Shall We Make to Oblige the Fastidious Patrons of our Photographic Art?" by J. Pitcher Spooner; "Annual Address of the President," by A. Bogardus, other discussions.]

G280 Gihon, John L. "Hints from the Record of an Artist and Photographer." PHILADELPHIA PHOTOGRAPHER 11, no. 122 (Feb. 1874): 41-42.

G281 "Class in Landscape Photography." PHILADELPHIA PHOTOGRAPHER 11, no. 127 (July 1874): 214-215. [Monthly article printing hints & formulas of various photographers. In July, discussed the work of G. W. Wilson, (Aberdeen) and John L. Gihon, (Montevidio, S.A.)]

G282 "Class in Landscape Photography." PHILADELPHIA PHOTOGRAPHER 11, no. 127 (July 1874): 214-215. [Monthly column printing hints & formulas of various photographers. In July

discussed the work of G. W. Wilson, (Aberdeen) and John L. Gihon (Montevidio, S.A.).]

G283 Gihon, John L. "Rambling Remarks." PHILADELPHIA PHOTOGRAPHER 11, no. 128 (Aug. 1874): 232-235.

G284 Gihon, John L. "Rambling Remarks." PHILADELPHIA PHOTOGRAPHER 12 , no. 133-134 (Jan. - Feb. 1875): 18-20, 40-42. [Gihon in Montevideo, Uruguay.]

G285 Gihon, John L. "Our Picture." PHILADELPHIA PHOTOGRAPHER 12, no. 140 (Aug. 1875): frontispiece, 227-228. 1 b & w. [Studio portrait of a Gaucho. Descriptive letter by Gihon signed "John L. Gihon, with Chute & Brooks, Montevideo, S. A."]

G286 Gihon, John L. "South American Correspondence." PHILADELPHIA PHOTOGRAPHER 12, no. 143 (Nov. 1875): 325-327. ["Fotografia Norte Americana, 70 Calle Defensa, Buenos Ayres."]

G287 "Note." PHILADELPHIA PHOTOGRAPHER 13, no. 145 (Jan. 1876): n. p. [Notice in situations wanted column of Jan. 1876 "Phila. Photo." that John L. Gihon will return from South America to the USA about the 1st of Jan., 1876, and is looking for a job.]

G288 "Our Picture." PHILADELPHIA PHOTOGRAPHER 13, no. 155 (Nov. 1876): frontispiece, 349-350. 1 b & w. [View of International Exhibition buildings, by John L. Gihon.]

G289 Gihon, John L. "R. R. R. - Rambling Remarks Resumed." PHILADELPHIA PHOTOGRAPHER 14, no. 157-168 (Jan. - Dec. 1877): 3-6, 38-42, 70-74, 119-123, 134-137, 165-169, 198-201, 233-237, 279-283, 300-304, 329-331. [Description of the activities of the photographer (Gihon) of the Centennial Photographic Co. [organized by Edward L. Wilson and W. Irving Adams] at the Philadelphia Centennial Exhibition, and of the Exhibition itself.]

G290 "Editor's Table: Feline Photography." PHILADELPHIA PHOTOGRAPHER 14, no. 160 (Apr. 1877): 128. ["John L. Gihon (Philadelphia, PA), 1328 Chestnut St., the photographer of the Phila. Centennial Exhibition, also taking portraits of cats."]

G291 Gihon, John L. "Gihon's Photographic Scraps: Introductory." PHILADELPHIA PHOTOGRAPHER 14, no. 168 (Dec. 1877): 375. [New series of articles on practical issues, to be in 1878 issue. Describes nature of series.]

G292 Gihon, John L. "Gihon's Photographic Scraps." PHILADELPHIA PHOTOGRAPHER 15, no. 169-180 (Jan. - Dec. 1878): 6-11, 34-38, 70-75, 107-111, 140-144, 169-174, 200-205, 236-241, 260-264, 306-310, 323-328, 381-382. [Series of technical hints, historical notes, etc.]

G293 Gihon, John L. "Bibliographic: Gihon's Photographic Colorist's Guide." PHILADELPHIA PHOTOGRAPHER 15, no. 173 (May 1878): 129-134. 2 illus. [Extracts from Gihon's book.]

G294 "Photography in Venezuela." PHILADELPHIA PHOTOGRAPHER 15, no. 177 (Sept. 1878): 266-267. [Anecdotes.]

G295 "Editor's Table: Obituary." PHILADELPHIA PHOTOGRAPHER 15, no. 178 (Oct. 1878): 320. [John L. Gihon died on Sept. 16th, at sea while returning from Venezuela. Left a wife and three children.]

G296 "John Lawrence Gihon." PHILADELPHIA PHOTOGRAPHER 15, no. 179 (Nov. 1878): 321-323. [John Lawrence Gihon born Milford, NJ, Apr. 21, 1839. Family soon returned to Philadelphia, where he grew up. Graduated from the Philadelphia High School, applied to the U.S. Naval Academy, but rejected for medical reasons. Went briefly to Kansas, then on to the western frontier. Cousin of William B. Gihon, a distinguished American designer and draughtsman. In 1857, while studying art, deaths in the family made it necessary for Gihon to earn a living. He and Edward L. Morgan opened a photo gallery in Philadelphia, PA. Continued his career as an artist, a member of the Philadelphia Sketch Club. Took plates of pathological specimens for the "Photographic Journal of Medicine." Morgan retired but Gihon continued successfully until 1868, when he opened a huge gallery which failed in about three years. In 1871 he moved, with his new wife, to Montevideo, where he worked for Chute & Brooks for several years, and Buenos Aires until 1876, when he returned to Philadelphia to work for the Centennial Photographic Co. until 1877. Then he went back to South America, to Venezuela, working for the Callao Mining Co. His health failing, he left for Philadelphia in 1878, but died at sea.]

G297 "Gihon's Gatherings; Compiled by the Late John L. Gihon. Pt. 1." PHILADELPHIA PHOTOGRAPHER 16, no. 181 (Jan. 1879): 11-14. [Technical and mechanical hints. This series continued throughout the following issues as well.]

G298 Gihon, John L. "A Lesson or Two in Perspective." PHILADELPHIA PHOTOGRAPHER 16, no. 191 (Nov. 1879): 332-333. 1 illus. [Abstracted from Gihon's "The Photographic Colorist's Guide."]

GILBERT & BACON. (PHILADELPHIA, PA)
G299 "Our Picture." PHILADELPHIA PHOTOGRAPHER 13, no. 151 (July 1876): frontispiece, 221-222. 1 b & w. [Promenade portrait.]

G300 "Our Picture." PHILADELPHIA PHOTOGRAPHER 16, no. 184 (Apr. 1879): frontispiece, 113-114. 1 b & w. [Studio portrait.]

G301 "Commercial Intelligence: Gilbert & Bacon." PHOTOGRAPHIC TIMES 19, no. 394 (Apr. 5, 1889): Advertising supplement p. I. [Letter describing the new studio of Gilbert & Bacon.]

GILBERT, CLAY H.
G302 Gilbert, Clay H. "Lighting and Posing." ANTHONY'S PHOTOGRAPHIC BULLETIN 7, no. 7 (July 1876): 209.

GILL, DE LANCEY W. (1859-1940) (USA)
G303 Glenn, James R. "De Lancey W. Gill: Photographer for the Bureau of American Ethnology." HISTORY OF PHOTOGRAPHY 7, no. 1 (Jan. 1983): 7-22. 14 b & w. [Article includes a survey of the career of Gill, supervisor of the Illustrations section of the United States Geological Survey in 1880s until 1932. Also includes a description of various other government agencies using photography at that time. References pp. 21-22.]

GILL, G. R.
G304 Gill, G. R. "On taking Two or More Positions of the Same Person in One Negative." AMERICAN JOURNAL OF PHOTOGRAPHY AND THE ALLIED ARTS & SCIENCES n. s. vol. 7, no. 17 (Mar. 1, 1865): 405-406. [From "Photo. News."]

GILL, ROBERT, MAJOR. (1804-1879) (GREAT BRITAIN, INDIA)

BOOKS

G305 Fergusson, James. *The Rock-Cut Temples of India; Illustrated by Seventy-four photographs taken on the Spot by Major Gill.* Described by James Fergusson. London: J. Murray, 1864. xx pp. 77 l. of plates. 74 b & w. 3 illus.

G306 Fergusson, James. *The Rock-Cut Temples of India: One Hundred Stereoscopic Illustrations of Architecture and Natural History in Western India;* Photographed by Major Gill and described by James Fergusson. London: Cundall, Downes, 1864. n. p. 100 b & w.

PERIODICALS

G307 Thomas, G. "Major Robert Gill in the Nizam's Dominion of Berar." HISTORY OF PHOTOGRAPHY 7, no. 4 (Oct. - Dec. 1983): 323-327. 7 b & w. [Major Gill of 44th Madras Native Infantry, photographer in 1870's.]

GILL, WILLIAM L. (1827-1893) (USA)

G308 Portrait. Woodcut engraving, credited "From a Photograph by William L. Gill, Lancaster, Pa." FRANK LESLIE'S ILLUSTRATED NEWSPAPER 7, (1859) ["The late Lieutenant Cornelius Van Camp." 7:174 (Apr. 2, 1859): 275.]

G309 "Notes and News." PHOTOGRAPHIC TIMES 24, no. 643 (Jan. 12, 1894): 29. [Brief note of William Gill's death, worked in Lancaster, PA. Studied there with Charles Ehrmann in 1856.]

GILLOT, YVES & BARET.

G310 Gillot, Yves and Baret. "La Paniconographie et la Photogravure." L'ARTISTE (1878): 410-411.

GILMAN & MOSER.

G311 Gilman & Moser. *The Photographer's Guide, In Which the Daguerrean Art is Familiarly Explained.* Lowell: Samuel O. Dearborn, printer, 1842. 16 pp.

GINTER, DAVID. (CONNEAUTVILLE, PA)

G312 Ginter, David. "Correspondence." ANTHONY'S PHOTOGRAPHIC BULLETIN 2, no. 10 (Oct. 1871): 337. [Ginter from Conneautville, PA.]

G313 Ginter, David. "Correspondence." ANTHONY'S PHOTOGRAPHIC BULLETIN 2, no. 11 (Nov. 1871): 368. [Ginter (Conneautville, PA) writes about toning baths.]

GIRARD see also DAVANNE & GIRARD.

GIRARD, M. J.

G314 Girard, Jules. "Microphotographer." HUMPHREY'S JOURNAL OF PHOTOGRAPHY, AND THE ALLIED ARTS AND SCIENCES 20, no. 17 (Jan. 15, 1869): 266. [No source given.]

G315 Girard, M. J. "Photography Abroad: Micro-Photography." PHOTOGRAPHIC TIMES 5, no. 50 (Feb. 1875): 35-36. [From "Photographic News."]

GLAISHER, JAMES. (ca. 1809-) (GREAT BRITAIN)

[Glasier "...attained fame as an aeronaut and meteorologist. For many years past he has presided over the meetings of the Photographic Society of Great Britain."]

BOOKS

G316 Glaisher, James, reporter. "Class X: Photography," on pp. 243-245 and 274-279 in: *Reports of the Juries on the Exhibition of 1851.* London: Spicer Brothers and Clowes & Sons, 1852. n. p.

PERIODICALS

G317 "Society of Arts. Jan. 26." ATHENAEUM no. 1322 (Feb. 26, 1853): 262. [Report and brief summation of J. Glaiser's report "On the Chief Points of Excellence in the Different Processes of Photography, as Illustrated by the present Exhibition." Note that Glaiser will prepare the juror's report on the Great Exhibition.]

G318 Glaisher, J., F.R.S. "The Application of Photography to Investigations in Terrestrial Magnetism & Meterology, as practiced by the Royal Observatory, Greenwich." AMERICAN JOURNAL OF PHOTOGRAPHY AND THE ALLIED ARTS & SCIENCES n. s. vol. 2, no. 5 (Aug. 1, 1859): 65-68.

G319 "Useful Facts, Receipts, Etc.: Balloon Photography." AMERICAN JOURNAL OF PHOTOGRAPHY AND THE ALLIED ARTS & SCIENCES n. s. vol. 5, no. 7 (Oct. 1, 1862): 165. [From "London Times." Glaisher ascended in a balloon, attempting to photograph clouds.]

G320 "The Lines in the Spectrum and Actinic Force." BRITISH JOURNAL OF PHOTOGRAPHY 10, no. 189 (May 1, 1863): 190-191. [From "Athenaeum." Glaisher attempting to photograph from a balloon, unsuccessful as yet - but accomplishing other experiments, as described here.]

GLASSHOFF. (d. 1871) (GERMANY)

G321 "Editor's Table." PHILADELPHIA PHOTOGRAPHER 9, no. 98 (Feb. 1872): 64. [Mr. Glasshoff (Berlin, Germany), died Dec. 11, 1871.]

GLOSSER, D.

G322 Portrait. Woodcut engraving, credited "From a Photograph by D. Glosser." FRANK LESLIE'S ILLUSTRATED NEWSPAPER 28, (1869) ["Hon. William M. Tweed." 28:721 (July 24, 1869): 293.]

GLOVER, JOHN. (1831-1864) (GREAT BRITAIN)

G323 Portrait. Woodcut engraving credited "From a photograph by Glover." ILLUSTRATED LONDON NEWS 31, (1857) ["R. N. Philips, M.P." 31:* (Oct. 17, 1857): 389.]

G324 Glover, J. "A Modified Dry Process." HUMPHREY'S JOURNAL OF PHOTOGRAPHY, AND THE ALLIED ARTS AND SCIENCES 10, no. 5 (July 1, 1858): 73.

G325 Glover, John. "Dark Slides versus Latent Light." HUMPHREY'S JOURNAL OF PHOTOGRAPHY, AND THE ALLIED ARTS AND SCIENCES 11, no. 2 (May 15, 1859): 21-22. [From "Liverpool Photo. J."]

G326 Glover, John. "Remarks on the Tannin Process." AMERICAN JOURNAL OF PHOTOGRAPHY AND THE ALLIED ARTS & SCIENCES n. s. vol. 5, no. 8 (Oct. 15, 1862): 174-176. [From "Br. J. of Photo."]

G327 Glover, John. "Modification of the Resinized Printing Process." HUMPHREY'S JOURNAL OF PHOTOGRAPHY, AND THE ALLIED ARTS AND SCIENCES 14, no. 24 (Apr. 15, 1863): 329-331. [From "Br. J. of Photo."]

G328 Glover, John. "An Autumn Photographic Excursion to the Isle of Man, under High Pressure." BRITISH JOURNAL OF PHOTOGRAPHY 10, no. 190, 194 (May 15, July 15, 1863): 211-212, 290-291.

G329 Glover, John. "The Art-Bearings of Photography." BRITISH JOURNAL OF PHOTOGRAPHY 11, no. 210 (Mar. 15, 1864): 96-97.

G330 Glover, John. "Preparations for Our Coming Photographic Campaign." BRITISH JOURNAL OF PHOTOGRAPHY 11, no. 211 (Apr. 1, 1864): 115-116.

G331 Glover, John. "On the Bromide Difficulties." BRITISH JOURNAL OF PHOTOGRAPHY 11, no. 223 (Aug. 12, 1864): 292.

G332 "Our Editorial Table: Pictures by J. Glover." BRITISH JOURNAL OF PHOTOGRAPHY 11, no. 231 (Oct. 7, 1864): 391.

G333 "Obituary." BRITISH JOURNAL OF PHOTOGRAPHY 11, no. 235 (Nov. 4, 1864): 438. [John Glover, of Liverpool, died on Oct. 30, 1864, of typhus fever, in the 33rd year of his age. Sec. of Liverpool Amateur Photo. Assoc. Contributed articles, etc.]

G334 "The Late Mr. John Glover." BRITISH JOURNAL OF PHOTOGRAPHY 11, no. 236 (Nov. 11, 1864): 449. [Subscription for Glover's family.]

G335 Glover, J. "The Bromide Difficulties and Details of a Modified Tannin Process." HUMPHREY'S JOURNAL OF PHOTOGRAPHY, AND THE ALLIED ARTS AND SCIENCES 16, no. 16 (Dec. 15, 1864): 248-251. [From "Br. J. of Photo." with note "Glover is no more! He died so young and in the midst of his energies."]

GLOVER, RIDGEWAY. (1831-1866) (USA)

G336 Glover, Ridgeway. "Salad for the Photographer: Letter from Ridgeway Glover." PHILADELPHIA PHOTOGRAPHER 3, no. 26 (Feb. 1866): 61. [Letter from Glover on using magnesium light for photography.]

G337 "White Deer in Logan Square, Philadelphia. - From a Photograph by Ridgeway Glover, of Philadelphia." FRANK LESLIE'S ILLUSTRATED NEWSPAPER 22, no. 557 (June 2, 1866): 172. 1 illus. [Portrait of a deer, taken outdoors.]

G338 Glover, Ridgeway. "Photography Among the Indians, Fort Laramie, June 30, 1866." PHILADELPHIA PHOTOGRAPHER 3, no. 32 (Aug. 1866): 239-240. ["I have been in [Fort Laramie area] nearly a month taking scenes in connection with the Treaty... with the Sioux, Arapahos, and Cheyennes and have secured twenty-two negatives to send to Wenderoth, Taylor & Brown.]

G339 "The Fate of a Frank Leslie 'Special.'" FRANK LESLIE'S ILLUSTRATED NEWSPAPER 23, no. 577 (Oct. 27, 1866): 94. [Two letters, one from David White, Post Chaplain at Fort Philip Kearney, Dakota Terr., the second from Samuel L. Peters, 18th U.S. Infantry, both describing the killing of Ridgeway Glover by Arapaho Indians. To which is added a statement about the risks taken by the magazine's correspondents and artists while they gather the news. In fact, Glover had only one photograph, taken in Philadelphia, published in the magazine and none of the writing or photographs which he generated during this Western trip appeared in this magazine.]

G340 Glover, Ridgeway "Photography Among the Indians - No. 2, Fort Philip Kearney, Montana Territory, July 29, 1866." PHILADELPHIA PHOTOGRAPHER 3, no. 35 (Nov. 1866): 339. [Brief

note on p. 358, stating that the editor has heard that Glover was killed by Indians.]

G341 Wilson, Edward L. "Editor's Table: Death of Mr. Glover." PHILADELPHIA PHOTOGRAPHER 3, no. 36 (Dec. 1866): 358.

G342 Glover, Ridgeway. "Photography Among the Indians - No. 3." PHILADELPHIA PHOTOGRAPHER 3, no. 36 (Dec. 1866): 367-369.

G343 Wilson, Edward L. "Obituary." PHILADELPHIA PHOTOGRAPHER 3, no. 36 (Dec. 1866): 371. [Notice that Glover was killed by Indians on September 14th.]

G344 R. G. "On Photography." PHILADELPHIA PHOTOGRAPHER 4, no. 37 (Jan. 1867): 16.

G345 Watson, Elmo Scott. "The Indian Wars and the Press: 1866 - 1867." JOURNALISM QUARTERLY 17, no. 4 (Dec. 1940): 301-312. [Slightly inaccurate version of Glover's death is retold here.]

GLOVER, THOMAS GEORGE.

G346 Glover, Thomas George. The Ganges Canal; Illustrated by Photographs. Taken by T. G. Glover. Roorkee, India: Thompson Civil Engineering College Press, 1867. 26 pp. 32 l. of plates. 32 b & w. [Original photos.]

GOADLEY.

G347 Goadley, Mr. "Fifteenth Meeting of the British Association for the Advancement of Science: 'On Fizeau's Process of etching Daguerreotype plates, and its Application to Objects of natural history.'" ATHENAEUM no. 924 (July 12, 1845): 700.

GODBOLD, H. J.

G348 Godbold, H. J. "Restoration of Faded Photographs." HUMPHREY'S JOURNAL OF PHOTOGRAPHY, AND THE ALLIED ARTS AND SCIENCES 15, no. 21 (Mar. 1, 1864): 327-328. [Read to North London Photo. Soc.]

G349 Godbold, J. H. "On the Restoration of Faded Photographs." AMERICAN JOURNAL OF PHOTOGRAPHY AND THE ALLIED ARTS & SCIENCES n. s. vol. 6, no. 17 (Mar. 1, 1864): 402-404. [Read before North London Photo. Assoc.]

GODDARD, JAMES T.

G350 Goddard, James T. "Double Periscopic Landscape Lenses, Etc." PHOTOGRAPHIC AND FINE ART JOURNAL 13, no. 5 (May 1860): 137-138. [From "Photo. Notes."]

GODDARD, JOHN FREDERICK see also WOLCOTT & JOHNSON.

GODDARD, JOHN FREDERICK. (d. 1866) (GREAT BRITAIN)

G351 Hughes, Jabez. "The Discoverer of the Use of Bromine in Photography: A Few Facts and an Appeal." BRITISH JOURNAL OF PHOTOGRAPHY 10, no. 204 (Dec. 15, 1863): 487-488.

G352 Hughes, Jabez. "The Discoverer of the Use of Bromine in Photography. - A Few Facts and an Appeal." HUMPHREY'S JOURNAL OF PHOTOGRAPHY, AND THE ALLIED ARTS AND SCIENCES 15, no. 17-18 (Jan. 1 - Jan. 15, 1864): 269-271, 278-279.

G353 Hughes, Jabez. "The Discoverer of the Use of Bromine in Photography: A Few Facts and an Appeal." AMERICAN JOURNAL OF PHOTOGRAPHY AND THE ALLIED ARTS & SCIENCES n. s. vol.

6, no. 14 (Jan. 15, 1864): 323-327, 335-556. [From "Br. J. of Photo." History of Goddard's discoveries in 1841, linked to an appeal to assist him in his declining years. The committee for this consisted of Dr. Diamond, G. Shadbolt, G. W. Simpson, T. R. Williams and Jabez Hughes; and their addresses (in 1863) are listed here (to receive contributions). Further information on this issue published on pp. 335-336. John F. Goddard associated with Wolcott & Johnson. A Dr. Paul Beck Goddard, then associated with Robert Cornelius, also involved. Confusions.]

G354 Hughes, Jabez. "The Bromine Question and Mr. J. F. Goddard. Two Chapters Connected with the Early History of Photography." BRITISH JOURNAL OF PHOTOGRAPHY 11, no. 214 (May 16, 1864): 166-167. [Includes excerpts from texts published in 1840, letters etc.]

G355 Gill, Arthur T., B.Sc. (Associate). "J. F. Goddard and the Daguerreotype Process." PHOTOGRAPHIC JOURNAL 106, (Nov. - Dec. 1966): 370-376, 389-395. 8 b & w. 4 illus. [John Frederick Goddard, a lecturer in optics and natural philosophy at the Adelaide Gallery, London, was engaged by Richard Beard to improve upon Alexander S. Wolcott & John Johnson's portraiture camera, which Beard had just purchased. A successful trial was made by Sept. 12, 1840. Goddard also discovered the useful "bromide of iodine" by December 1840, which made portraiture practical. Beard opened a studio at the Royal Polytechnic Institute in March 1841.]

GODDARD, JOSIAH. (USA)
G356 "Ralph Farnham. The Sole Survivor of the Battle of Bunker Hill." HARPER'S WEEKLY 4, no. 197 (Oct. 6, 1860): 629. 2 illus. ["I have been fortunate in obtaining from Mr. Josiah Goddard, formerly of Worcester, Mass., a photographic likeness of Mr. Farnham." Portrait of 105 year old man; view of his house in Acton, ME.]

GODDARD, PAUL BECK, DR. (PHILADELPHIA, PA)
G357 "The Daguerre Memorial: Letter." PHOTOGRAPHIC TIMES 20, no. 450 (May 2, 1890): 215. [In a letter from Edwards-Ficken, contributing to the Daguerre Memorial Fund, he mentions his many years of pleasure as an amateur; his cousin Mr. Morse and his wife's uncle, "the late Dr. Paul Beck Goddard, who made the first Daguerreotype ever produced in Philadelphia." Paul Beck Goddard was for about seventy years erroneously credited, through no claim of his own, to be the discoverer of the bromide of iodine, which made portraiture practical—instead of John F. Goddard.]

GODKIN, W. R.
G358 "The Recent Freshets in New York - Ruins of Hadcock's Factory, Watertown. - From a Photograph by W. R. Godkin." FRANK LESLIE'S ILLUSTRATED NEWSPAPER 28, no. 711 (May 15, 1869): 140. 1 illus. [View.]

GOLDSTICKER, H. see BARNARD, GEORGE (1980)

GOOD, FRANK MASON. (GREAT BRITAIN, PALESTINE, GREAT BRITAIN)
[Joined the Photographic Society of London in 1864. He lived at Hartley Wintney, Winchfield, Hampshire and photographed the nearby Isle of Wight. J. R. Ware's *Isle of Wight,* published in London in 1869 is illustrated with tipped-in photographs by Good and Russell Sedgfield. Photographed in Egypt and the Holy Land in 1860s or early 1870s. His stereo slides of Egypt and the Nile were published by Léon Levy in Paris. A book, *Glimpses of the Holy Land* was published in 1880.]

BOOKS
G359 Ware, James Redding. *The Isle of Wight;* The Photographic Illustrations by Russell Sedgfield and Frank M. Good. London: Provost & Co., Successor to A. W. Bennett, 1869. 16 l. of plates, 21 b & w. [Illustrated with four original photographs by Frank M. Good, sixteen by Russell Sedgfield, plus one illus. of a painting. A "Library Edition" was also published, containing only fifteen original prints. 2nd ed. (1872), with twenty-four prints.]

G360 *Holy Land Pictures.* London: W. A. Mansell & Co., 1870. n. p. 50 b & w. [Albumen prints. Printed title page and captions.]

G361 Good, Frank Mason. *Selected Photographs of the Nile and Its Scenery. Including Some of the Most Ancient and Interesting Temples.* London: s. n., 1873. n. p. 20 b & w. [Albumen prints, with printed captions on the mounts.]

PERIODICALS
G362 "Note." ART JOURNAL (Apr. 1863): 82. [Photographs of St. Pauls Cathedral, village of Barfreston, etc.]

G363 "Note." ART JOURNAL (Jan. 1867): 30. [Photos of Canterbury Cathedral, by Frank Mason Good.]

G364 "Note." ART JOURNAL (Jan. 1868): 18. [Mr. Frank M. Good, of the Minorities, has issued a series of views in Egypt, Syria, and the Holy Land.]

G365 Good, Frank M. "A Few Practical Hints." ANTHONY'S PHOTOGRAPHIC BULLETIN 5, no. 1 (Jan. 1874): 6-7.

G366 "Photography in Palestine." PHILADELPHIA PHOTOGRAPHER 13, no. 145 (Jan. 1876): 2-4.

G367 "One of the Secrets of Success." PHILADELPHIA PHOTOGRAPHER 13, no. 152 (Aug. 1876): 247-249. ["British landscape photographer at the head of his profession."]

G368 "Lantern Slides." ANTHONY'S PHOTOGRAPHIC BULLETIN 7, no. 12 (Dec. 1876): 384. ["A fine lot of slides of the Holy Land from original negatives by F. M. Good, taken during a recent visit to Palestine."]

G369 "Editor's Table." PHILADELPHIA PHOTOGRAPHER 11, no. 127 (July 1874): 224. [Frank M. Good's views of Egypt, Nubia, etc. sold by W. A. Mansell & Co., London.]

GOODE, W. H. (USA)
G370 "Notices: Daguerreotype Improvement." AMERICAN REPERTORY OF ARTS, SCIENCES AND MANUFACTURES 2, no. 3 (Oct. 1840): 200. ["Mr. Goode of the University... succeeded... in copying microscopic objects."]

G371 Goode, W. H. "The Daguerreotype and Its Applications." DAGUERREAN JOURNAL 1, no. 9 (Mar. 15, 1851): 257-261. [From "Silliman's Journal," 1841.]

GOODRIDGE BROTHERS. (SAGINAW, MI)
BOOKS
G372 *The Goodridge Brothers: Saginaw's Pioneer Photographers.* Saginaw, MI: The Saginaw Art Museum, 1982. n. p. b & w. [Exhib. cat.: Jan. 10 - Feb. 28, 1982.]

PERIODICALS

G373 "The Goodridge Brothers: Saginaw Valley Photographic Historians." MICHIGAN HISTORY 53, no. 3 (Fall 1969): 240-246. 8 b & w. [Glenalvin, William, and Wallace Goodridge, sons of a Maryland slave, began their careers in York, PA in the 1850s, then immigrated to Michigan and maintained a studio in East Saginaw between 1868 and the 1920s. Lumbering, street scenes, Great Lakes shipping, and views were favorite subjects.]

GOODRIDGE BROTHERS.
G374 Jezierski, John V. "Photographing the Lumber Boom: The Goodridge Brothers of Saginaw, Michigan (1868 - 1922)." MICHIGAN HISTORY 64, no. 6 (Nov. - Dec. 1980): 28-33. 15 b & w. [Goodridge Brothers ran a photographic service (1866 - 1922) documenting the lumber industry. The Goodridges were black.]

GOODWIN & DICKINSON.
G375 "Birth-Place of Lieut.-General Grant, at Point Pleasant, Ohio." HARPER'S WEEKLY 9, no. 465 (Nov. 25, 1865): 737. 1 illus. ["Photographed by Goodwin & Dickinson."]

GOODWIN & KEET. (LIVERPOOL, ENGLAND)
G376 Portrait. Woodcut engraving credited "From a photograph by Goodwin & Keet, Renshaw St., Liverpool." ILLUSTRATED LONDON NEWS 35, (1859) ["Joseph Rodgers, seaman." 35:* (Nov. 26, 1859): 502.]

GOODWIN, J. A. (FORT WAYNE, IN)
G377 "Birthplace of U. S. Grant, Point Pleasant, Clermont County, Ohio. - From a Photograph by J. A. Goodwin, Fort Wayne." FRANK LESLIE'S ILLUSTRATED NEWSPAPER 21, no. 532 (Dec. 9, 1865): 189. 1 illus.

GORDON, RUSSELL MANNERS.
G378 "Stereographs. Illustrations of Scenes in Madeira, taken by Russell M. Gordon, London: Murray & Heath." BRITISH JOURNAL OF PHOTOGRAPHY 8, no. 146 (July 15, 1861): 258-259.

G379 Gordon, Russell M. "Review Stereograms taken at Maderia." JOURNAL OF THE PHOTOGRAPHIC SOCIETY OF LONDON 7, no. 112 (Aug. 15, 1861): 255.

G380 Gordon, Russell Manners. "Modified Gum Process." HUMPHREY'S JOURNAL OF PHOTOGRAPHY, AND THE ALLIED ARTS AND SCIENCES 19, no. 21 (Mar. 1, 1868): 331-332. [From "Photo. News Almanac."]

G381 "Gum Plate Experiences." HUMPHREY'S JOURNAL OF PHOTOGRAPHY, AND THE ALLIED ARTS AND SCIENCES 20, no. 13 (Nov. 1, 1868): 203-204. [From "Br. J. of Photo." Gordon's gum process described.]

GORGAS, JOSEPH R. (b. 1829) (MADISON, IN)
G382 "Editor's Table." PHILADELPHIA PHOTOGRAPHER 6, no. 69 (Sept. 1869): 324. [Views on the Ohio River mentioned.]

GOSSIP.
G383 "Gossip." "Letter from Gossip." AMERICAN JOURNAL OF PHOTOGRAPHY AND THE ALLIED ARTS AND SCIENCES n. s. vol. 2, no. 1 (June 1, 1859): 9-11.

GOSTICK, JESSE.
G384 Gostick, Jesse. *Mechanical Photography: Including Positive, Negative, and Dry-plate Pictures - Photographic Printing - Transparencies - Microphotographs, and life-size Portraits -*

Photographic Difficulties - Backgrounds, Solutions, and Miscellaneous Instructions. London: G. T. Stevenson, 1860. 48 pp. [2nd ed. (1863)]

GOTHARD.
G385 "The Cotton Famine: Operatives Waiting for their Breakfast in Mr. Chapman's Courtyard, Mottram, Near Manchester." ILLUSTRATED LONDON NEWS 41, no. 1179 (Dec. 20, 1862): 655-656. 1 illus. ["...from a photograph by Mr. Gothard, of Victoria Street South, Grimsby."]

GOUGH, J. W. (d. 1879) (GREAT BRITAIN, INDIA)
G386 Gough, J. W. "Art in Photography and Photography in Art." BRITISH JOURNAL PHOTOGRAPHIC ALMANAC 1874 (1874): 149-151.

G387 Gough, J. W. "On Building Studios." PHOTOGRAPHIC TIMES 6, no. 62 (Feb. 1876): 36-37. [Abstracted from the "Br J of Photo."]

G388 Gough, J. W. "An Historical Note on Organic Pyroxyline." BRITISH JOURNAL PHOTOGRAPHIC ALMANAC 1877 (1877): 133. [Gough was the Divisional Engineer (Darjeeling).]

G389 Gough, J. W. "Photography in India." BRITISH JOURNAL PHOTOGRAPHIC ALMANAC 1878 (1878): 173.

GOUIN, ALEXIS. (d. 1855) (FRANCE)
G390 "Stereoscopic Portraits." PHOTOGRAPHIC AND FINE ART JOURNAL 7, no. 1 (Jan. 1854): 17. [Work of A. Gouin discussed, also discussed previously in July 2, 1833 issue. From "La Lumiére."]

G391 "Obituary: A. Gouin." HUMPHREY'S JOURNAL 7, no. 1 (May 1, 1855): 15. [From "La Lumiére." Gouin, a painter and a pupil of Girodet, studied the daguerreotype when it was first announced. Opened a studio in 1849, and advertised as operating in the "procéde américain." Specialized in hand-painting over his images. Invented a plate-polishing machine in 1854. Died in 1855, but his studio was continued by his wife and his daughter through early 1860s.]

GOULD, A. R. (CARROLLTON, OH)
G392 Gould, A. R. "Correspondence." ANTHONY'S PHOTOGRAPHIC BULLETIN 3, no. 1 (Jan. 1872): 429-430. [Gould from Carrollton, OH.]

GOULD, F. T. (GRAVESEND, ENGLAND)
G393 "The Great Disaster at Sea." ILLUSTRATED LONDON NEWS 66, no. 1848 (Jan. 9, 1875): 11, 12. 4 illus. [The Emigrant Ship "Cospatrick," destroyed by fire at Sea. "Our Illustration of the Cospatrick is from a photograph by F. C. Gould, of Gravesend, taken just before she sailed from the Thames... The portrait of Captain Elmslie is from a photograph by Mr. Lonsdale, Mrs. Elmslie by F. C. Gould, and that of the child by Mr. T. Monk, of Gravesend."]

GOUPIL-FESQUET, FRÉDÉRIC. (PARIS, FRANCE)
G394 "The Art Publications of MM. Goupil, of Paris." PHOTOGRAPHIC AND FINE ART JOURNAL 9, no. 3 (Mar. 1856): 93. [From "London Art Journal." Goupil was the largest publisher of art engravings, with offices in France, England, and the USA. Background.]

G395 Newhall, Beaumont. "The Daguerreotype and the Traveller." MAGAZINE OF ART 44, no. 5 (May 1951): 175-178. 6 illus. [Discusses F. Goupil-Fesquet's trip to Egypt in 1839, with Horace Vernet. His photos were reproduced in "Excursions daguerriennes. Vues Monuments les plus remarquables du globe."]

GOURAUD, FRANÇOIS see FAUVEL-GOURAUD, FRANÇOIS.

GOWLAND, W. T. & R. GOWLAND. (YORK, ENGLAND)
G396 Portrait. Woodcut engraving credited "From a photograph by W. T. Gowland & R. Gowland." ILLUSTRATED LONDON NEWS 74, (1879) ["Lieut.-Col. H. B. Pulleine, killed." 74:2073 (Mar. 8, 1879): 216.]

G397 Portrait. Woodcut engraving credited "From a photograph by W. T. Gowland & R. Gowland." ILLUSTRATED LONDON NEWS 74, (1879) ["Lieut.-Col. H. B. Pulleine, killed." 74:2073 (Mar. 8, 1879): 216.]

GRAFF. (BERLIN, GERMANY)
G398 Portraits. Woodcut engravings, credited "From a Photograph by Graff, Berlin, Germany." FRANK LESLIE'S ILLUSTRATED NEWSPAPER 22, (1866) ["Prince Frederick Charles, Prussian army." 22:566 (Aug. 4, 1866): 305.]

GRAFF, FREDERIC see also BORDA & FASSITT & GRAFF.

GRAFF, FREDERIC. (1817-1890) (USA)
G399 Bullock, John G. Vice President of Photographic Society of Philadelphia. "In Memoriam: Frederic Graff." PHOTOGRAPHIC TIMES 20, no. 447 (Apr. 11, 1890): 174. [Graff a founder-member, President of the Photographic Society of Philadelphia.]

G400 "Obituary." WILSON'S PHOTOGRAPHIC MAGAZINE 27, no. 369 (May 3, 1890): 276-277. [Died Mar. 30, 1890, in Philadelphia, nearly seventy-three years of age. Amateur. President of the Photographic Society of Philadelphia, associated with the organization since its formation. For many years the Chief Engineer of the Water Department of Philadelphia. Founder of the Philadelphia Zoological Society, onetime President of the American Assoc. of Civil Engineers, Vice-President of the Franklin Institute, etc.]

GRAFTON, WILLIAM HENRY, DUKE OF.
G401 Grafton, William Henry, Duke of. *Eastern Tour, 1843, 1844. Cruises in 'The Dream' 1849, 1850, 1852 - The Baltic, 1852. The Crimea, 1854 - 1855.* s. l.: self published, n. d. [ca. 1865]. 2 vol. pp. 23 b & w. 6 illus. [24 copies only printed. Photographic views of the United States, the Holy Land, Egypt, and Greece by this amateur photographer. "Eastern Tour":iv, 180 pp.; "Baltic and Crimea": viii, 61 pp.]

GRAHAM, E. D.
G402 Portrait. Woodcut engraving, credited "Photographed by E. D. Graham." FRANK LESLIE'S ILLUSTRATED NEWSPAPER 39, (1874) ["Hon. Charles H. Hardin, Gov.-elect of MO." 39:1000 (Nov. 28, 1874): 188.]

GRAHAM, JAMES. (GREAT BRITAIN, INDIA)
BOOKS
G403 Macleod, Norman. *Eastward,* by Norman Macleod. With Seventy Illustrations from Photographs, Engraved by Joseph Swain. London, New York: A. Strahan, 1866. vi, 304 pp. illus. [Engravings, after photos by James Graham of views and scenes in the Near East.]

PERIODICALS
G404 "The American College and Sheik's House at Abeih, Near Dheir-el-Kamar, Syria." HARPER'S WEEKLY 4, no. 195 (Sept. 22, 1860): 597. 1 illus. ["Photographed by Mr. Graham."]

G405 Macleod, Norman, M.D. "Eastward." GOOD WORDS 6, no. 1-12 (Jan. - Dec. 1865): 33-40, 113-123, 233-241, 286-295, 389-396, 525-542, 587-601, 665-677, 753-764, 823-834, 914-924. 70 illus. [The editor of "Good Words," Norman Macleod, toured the Near East and published reports of his travels through Malta, Egypt, Jerusalem and Palestine. Reports were illustrated with woodcuts all credited "From a Photograph." In some cases the individual views were credited to specific photographers, ie. "Jaffa from the South. [From a Photograph by James Graham]" on p. 289 and "From a Photograph by Francis Bedford" on p. 393. There are several panoramic views of Jerusalem credited to James Graham and the majority of the Palestine photos are so credited.]

GRAINGER, ALFRED & C. M. GIRDLER.
G406 Grainger, Alfred and C. M. Girdler. "Photographic Portraits on Ceramic Ware." HUMPHREY'S JOURNAL OF PHOTOGRAPHY, AND THE ALLIED ARTS AND SCIENCES 18, no. 6 (July 15, 1866): 93.

GRANT, ALONZO G. (NEW YORK, NY)
G407 Grant, A. G. "A Letter from London." AMERICAN JOURNAL OF PHOTOGRAPHY AND THE ALLIED ARTS AND SCIENCES n. s. vol. 1, no. 8 (Sept. 15, 1858): 115-116. [Mentions having a Broadway Gallery, discusses skylights.]

G408 Grant, A. G. "On Fuming with Ammonia." AMERICAN JOURNAL OF PHOTOGRAPHY AND THE ALLIED ARTS & SCIENCES n. s. vol. 7, no. 14 (Jan. 15, 1865): 316-319. [Read before South London Photo. Soc.] "Photography in a Lead Mine." BRITISH JOURNAL OF PHOTOGRAPHY 12, no. 277 (Aug. 25, 1865): 442. [A. Grant photographed, 140 ft. below surface in a lead mine in Derbyshire.]

G409 "The Magnesium Light in a Lead Mine." HUMPHREY'S JOURNAL OF PHOTOGRAPHY, AND THE ALLIED ARTS AND SCIENCES 17, no. 11 (Oct. 1, 1865): 173. [From "Photo. News."]

G410 Grant, Alonzo G. "Notes on Magnesium." AMERICAN JOURNAL OF PHOTOGRAPHY AND THE ALLIED ARTS & SCIENCES n. s. vol. 8, no. 98 (Nov. 1, 1865): 205-206. [Grant, an American, in England in 1865.]

G411 Grant, A. G. "Negative Baths." ANTHONY'S PHOTOGRAPHIC BULLETIN 5, no. 11 (Nov. 1874): 374-375. [From "Br. J. of Photo." "After nearly thirty years' experience of landscape and portrait photography in Great Britain and America - often crossing the Atlantic twice a year,...from Canada to Florida."]

G412 "Editor's Table." PHILADELPHIA PHOTOGRAPHER 14, no. 162 (June 1877): 192. [Catalog of Florida views issued by Alonzo G. Grant (Jacksonville, FL).]

GRANT, G. W.
G413 "Scene of the Gunpowder Explosion at Agra Port, India." ILLUSTRATED LONDON NEWS 60, no. 1687 (Jan. 6, 1872): 9. 1 illus.

GRANT, MARTIN HOWE. (ca. 1835-1889) (CANADA, USA)
G414 Palmquist, Peter E. "Martin Howe Grant - a historian's photographer." THE HUMBOLDT HISTORIAN 30, no. 6 (Nov. - Dec. 1982): 16-18. 6 b & w. [Born in New Brunswick, Nova Scotia about 1835. Learned and practiced photography there before he came to CA in the mid-1870s. Opened a gallery in Eureka, CA, and also made landscape views. Probably taught A. W. Ericson photography. Worked in Eureka until his death, on February 13, 1889.]

GRANT, W. G. A.

G415 "The Dutch Arctic Expedition." ILLUSTRATED LONDON NEWS 74, no. 2067 (Jan. 25, 1879): 81, 82. 2 illus. [Views, one showing a photographer with his camera set up to a photograph. Expedition under Commodore Jansen, with Lieut. Koolemens Beynen, on the "Willem Barents." "The photographer was Mr. W. G. A. Grant, a most enthusiastic young explorer, who was with Sir Allan Young in the "Pandora" in the same capacity, and who in the present voyage succeeded in executing an admirable series of photographs under the greatest possible difficulties."]

GRASSHOFF, JOHANNES. (BERLIN, GERMANY)

G416 Grasshoff, Johannes. "A Simple Method of Preparing Prints Intended to be Colored with Aniline Colors." AMERICAN JOURNAL OF PHOTOGRAPHY AND THE ALLIED ARTS & SCIENCES n. s. vol. 7, no. 22 (May 15, 1865): 516-517. [From "Photo. Mittheilungen."]

G417 Grasshoff, J. "A New Photographic Varnish for Pictures and Negatives." AMERICAN JOURNAL OF PHOTOGRAPHY, AND THE ALLIED ARTS AND SCIENCES n. s. vol. 9, no. 10 (May. 1, 1867): 226-228. [From "Photographische Mittheilungen."]

G418 Grasshoff, J. "Retouching Negatives." HUMPHREY'S JOURNAL OF PHOTOGRAPHY, AND THE ALLIED ARTS AND SCIENCES 19, no. 4 (June 15, 1867): 58. [From "Photogrpahische Mittheilungen."]

G419 Petsch, Max. "On the Influence of Individuality in Portrait Photography." PHOTOGRAPHIC WORLD 1, no. 3 (Mar. 1871): 70-72.

G420 "Our Picture." PHOTOGRAPHIC WORLD 1, no. 3 (Mar. 1871): frontispiece, 92-94. 25 b & w. [25 miniature portrait views on one page. Mentions Adam-Salomon as someone to emulate.]

G421 "Our Picture" PHOTOGRAPHIC WORLD 1, no. 4 (Apr. 1871): 125.

G422 Baker, W. J. "Photographing By Moonlight. Mr. Grasshoff's Picture in the March 'Photographic World.'" PHILADELPHIA PHOTOGRAPHER 8, no. 89 (May 1871): 143-144. [Also mentions E. P. Ogier (Jersey, Channel Islands.)]

G423 Grashoff, Johannes. "Portraits and Pictures." PHOTOGRAPHIC WORLD 1, no. 6 (June 1871): 188-189. [Extracted from "Photographische Mittheilungen".]

GRAVES, E.

G424 Portrait. Woodcut engraving, credited "From a Photograph by E. Graves." FRANK LESLIE'S ILLUSTRATED NEWSPAPER 35, (1873) ["George Le Barre, oldest man." 35:908 (Feb. 22, 1873): 381.]

GRAVES, JESSE ALBERT. (ca. 1835-1895) (USA)
BOOKS

G425 Brodhead, Luke Wills. *The Delaware Water Gap: its Scenery, its Legends and its Early History. Illustrated by Photographs.* Philadelphia: Sherman & Co., Printers, 1867. xii, 9-220 pp. 10 tipped-in b & w. [Second edition 1870 276 pp.]

PERIODICALS

G426 "The New Jersey Editorial Convention." FRANK LESLIE'S ILLUSTRATED NEWSPAPER 22, no. 564 (July 21, 1866): 276. 3 illus. [One outdoor group portrait of the assembled editors - credited "From a Photograph by Jesse A. Graves Esq., Delaware Water Gap. Two

landscape views of the Gap are also printed. These are not credited, but are probably also from photographs.]

GRAY & CO. (NEW YORK, NY)

G427 "West Washington Market - Wholesale Meat and Provision Dealer's Stands. Extending from Barclay to Fulton Streets. - From a Photograph by Gray & Co." FRANK LESLIE'S ILLUSTRATED NEWSPAPER 22, no. 556 (May 26, 1866): 152-153. 2 illus. [This view, which is credited, is accompanied by a similar view, of the Washington Market, which is not credited, but which is, most probably, by the same artist.]

GRAY, FRANCIS CALLEY. (b. 1790) (USA)

G428 Cohn, Marjorie B. "Francis Calley Gray and an Early Boston Daguerreotype." HISTORY OF PHOTOGRAPHY 9, no. 2 (Apr. - June 1985): 155-157. 1 b & w. [Gray, a wealthy Bostonian, took daguerreotype lessons from François Gouraud in Feb. 1840, then made a few daguerreotypes. One surviving image may predate the view of King's Chapel, Boston, MA, taken by Samuel Bemis in April 1840.]

GRAY, J. C. (JAMESTOWN, NY)

G429 "Note." PHOTOGRAPHIC AND FINE ART JOURNAL 11, no. 1 (Jan. 1858): 27-28. [A specimen of his skill (beginner) plus the letter.]

GRAZ, H. SCHWARZ.

G430 Graz, H. Schwarz, Prof. "Direct Printing Process of Glass-Positives." HUMPHREY'S JOURNAL OF PHOTOGRAPHY, AND THE ALLIED ARTS AND SCIENCES 18, no. 14 (Nov. 15, 1866): 213-214. [From "Photo. Archiv."]

GREATHED, MRS. [?]

G431 "Fine-Art Gossip." ATHENAEUM no. 1633 (Feb. 12, 1859): 226. ["A series of twenty-six photographic views of Lucknow, which illustrate the war as well as the domestic life of that city... added to the Photographic Society exhibition,... collection contributed by Mrs. Greathed.]

GREEN, O. R.

G432 "Note." ANTHONY'S PHOTOGRAPHIC BULLETIN 5, no. 1 (Jan. 1874): 67. [Visit from Green, formerly president of the Liverpool Photographic Society, travelling in USA.]

G433 "An Amateur Trapper." "A Run for Sunshine; the Find and Capture." BRITISH JOURNAL PHOTOGRAPHIC ALMANAC 1876 (1876): 173-179. [Long description of a trip across France, Italy, Croatia, Dalmatia, Albania, Corfu to Egypt, where he began to photograph, then back through Italy, etc. Signed O. R. Green at the end of the article.]

GREEN, P. B. (d. 1892) (USA)

G434 "Meetings of Societies: Chicago Photographic Association." PHOTOGRAPHIC TIMES 11, no. 124 (Apr. 1881): 145-153. [Unusually long and detailed report of a meeting of this association on the impacts of the gelatine dry-plate process on commercial photographers. Brought forth reminiscences by the Society's President, Alfred Hall, (a photographer for thirty-three years); P. B. Green (a Chicago pioneer in the use of dry plates); A. Hesler; Joshua Smith; George N. Barnard (from Rochester, NY); and others.]

G435 "Notes and News." PHOTOGRAPHIC TIMES 22, no. 582 (Nov. 11, 1892): 578. [Brief note that P. B. Green, the veteran photographer of Chicago, IL, died Oct. 25th.]

GREENE.

G436 "Chicago Photographic Association." ANTHONY'S PHOTOGRAPHIC BULLETIN 8, no. 4-5 (Apr. - May 1877): 122-125, 155-158. [Report of Prof. Greene's talk on whether photography could be classified with the fine arts, with extensive quotes by Ruskin. Second talk is a discussion of several contemporary photos, published in "Phila. Photo.']

GREENE, B.

G437 *The Ascent of the Pieterboth Mountain, Mauritius, 13 October, 1864.* s. l. [Port Louis, Mauritius ?]: s. n. [E. Dupuy & P. Dubois], 1864. 15 pp. 6 l. of plates. 6 b & w. [Photographs by B. Greene.]

GREENE, GEORGE MILES. (1830-1895) (USA)

G438 "George Miles Green." PHOTOGRAPHIC TIMES 27, no. 3 (Sept. 1895): 186. 1 illus. [Obituary. Worked Johnstown, PA.]

GREENE, J. M.

G439 "Ohio. - Funeral of the Late Right Rev. Bishop Rappe, at Cleveland, September 13th - Arrival of the Cortege at the Cathedral. - From Photographs by J. M. Greene." FRANK LESLIE'S ILLUSTRATED NEWSPAPER 45, no. 1149 (Oct. 6, 1877): 77. 1 illus. [Outdoor view, with crowds.]

GREENE, JOHN BULKLEY. (1832-1856) (USA, EGYPT)
BOOKS

G440 *Le Nil - Monuments - Paysages - Explorations photographiques par J. B. Greene.* Lille: Imprimerie photographique de Blanquart-Evrard, 1854. n. p. 93 b & w. [Original photographs.]

G441 Greene, John B. *Fouilles exécutées à Thèbes dans l'année 1855: textes hiéroglypiques et documents inédits.* Paris: s. n., 1855. n. p. illus. [Illustrated with lithographs made after his photographs.]

PERIODICALS

G442 "Personal & Fine Art Intelligence." PHOTOGRAPHIC AND FINE ART JOURNAL 7, no. 10 (Oct. 1854): 320. [John Greene, an American, travelled through Egypt up to the second cataracts of the Nile. Goupil & Co. intends to publish 60 of his views, etc.]

G443 "Biographical Notes on a Number of Photographers Published by Blanquart-Evrard." CAMERA (LUCERNE) 57, no. 12 (Dec. 1978): 32, 41-42. [Benecke, Claine, DuCamp, Fortier, Greene, Le Secq, Loydreau, Marville, Regnault, Robert, Salzmann, Stewart, Sutton, and Tenison. Greene's photos of Upper Egypt published by Blanquart-Evrard in 1854. Greene also published "Fouilles exécutées à Thèbes dans l'année 1855: textes hiéroglypiques et documents inédits" in 1855.]

G444 Jammes, Bruno. "John B. Greene, an American Calotypist." HISTORY OF PHOTOGRAPHY 5, no. 4 (Oct. 1981): 305-324. 14 b & w. 6 illus. [The son of an American also named John B. Greene, who managed a branch of a bank in Paris. Green took a trip to Egypt in 1853 and made some two hundred waxed-paper negatives. These photographs published by Blanquart-Evrard in 1854 in "Le Nil -Monuments - Paysages - Explorations photographiques par J. B. Greene" and in several other albums. Founder-member of the Société française de Photographie in 1854 and member of the Société asiatique. Returned to Egypt in 1854, where he excavated at Deir-el-Bahari and the Temple of Rameses III at Thebes. Studied and photographed Egyptian remains in Algeria in 1855. Returned briefly to France, then set off, although ill, for a third trip to Egypt in 1856. Died in Egypt, at age twenty-four. References on pp. 320-324.]

G445 Newhall, Beaumont. "John Beasley Greene 1832 - 1856." UNTITLED [Carmel, CA] no. 25 (1981): 33-40. 7 b & w.

GREENISH, THOMAS. (GREAT BRITAIN)
BOOKS

G446 Greenish, Thomas. *A List of Photographic Apparatus and Materials; to which is added Ample Directions for Use and Instructions for Amateurs.* London: Greenish, 1861. n. p.

PERIODICALS

G447 "Note." ART JOURNAL (Jan. 1857): 34. [Photographic views of Lincoln Cathedral noted.]

GREENWOOD, HENRY.

G448 Taylor, J. Traill. "Henry Greenwood." PHOTOGRAPHIC TIMES 14, no. 171 (Dec. 26, 1884): 698. [Greenwood painter and publisher of the 1854 "Liverpool Photographic Journal" which then became the "British Journal of Photography."]

GREGORY, JAMES A. (d. 1867) (USA)

G449 "Horrible Tragedy in a Photograph Gallery! - A Photographer Murders a Girl and Commits Suicide!" HUMPHREY'S JOURNAL OF PHOTOGRAPHY, AND THE ALLIED ARTS AND SCIENCES 19, no. 15 (Dec. 1, 1867): 230-232. [James H. Gregory (Cleveland, OH).]

GRESLEY, F., MAJOR.

G450 Gresley, Major. "On the Improvement of Photographic Landscapes." BRITISH JOURNAL OF PHOTOGRAPHY 10, no. 196 (Aug. 15, 1863): 322-323.

GREY & CO.

G451 Portrait. Woodcut engraving, credited "From a Photograph by Grey." FRANK LESLIE'S ILLUSTRATED NEWSPAPER 13, (1862) ["Capt. John Ericsson, inventor of the steam, floating, and iron battery monitor." 13:332 (Mar. 29, 1862): 305.]

G452 Portrait. Woodcut engraving, credited "From a Photograph by Grey & Co." HARPER'S WEEKLY 6, (1862) ["Capt. John Ericsson." 6:274 (Mar. 29, 1862): 205.]

GRICE, HEZEKIAH. (1801-1864) (USA, HAITI)
G453 Seely, Charles A. "Editorial Department." AMERICAN JOURNAL OF PHOTOGRAPHY AND THE ALLIED ARTS & SCIENCES n. s. vol. 7, no. 5 (Sept. 1, 1864): 119-120. [Hezekiah Grice, "of Port au Prince, Hayti... died on May 22nd. Mr. Grice was born in Baltimore in 1801, emigrated to Hayti in 1832, where for many years he served his government as the director of public works. He was a noble specimen of the Negro race; he was well acquainted with prominent business and scientific men in this city; in his presence the distinction of color was forgotten. He was for many years a subscriber to this Journal, and a zealous friend of the art; he introduced photography to his countrymen." (Apparently, Hezekiah Grice was not a photographer, but his son, Francis, was. Francis made daguerreotypes and photographs and worked as a sculptor in wax in New York City in the 1850s, then he moved to San Francisco, CA in 1866, and worked there through the 1870s. See *Black Photographers, 1840 - 1940. An Illustrated Bio-Bibliography,* by Deborah Willis-Thomas.)]

GRIER, R. M.
G454 Grier, R. M. "A New Process." HUMPHREY'S JOURNAL OF PHOTOGRAPHY, AND THE ALLIED ARTS AND SCIENCES 10, no. 18 (Jan. 15, 1859): 285-286. [From "J. of Photo. Soc., London."]

GRIFFIN & CO. (GREAT BRITAIN)

G455 Portrait. Woodcut engraving credited "From a photograph by Griffin & Co., Portsmouth and London" ILLUSTRATED LONDON NEWS 66, (1875) ["Capt. Nares, of the "Alert." 66:1868 (May 29, 1875): 505.]

GRIFFING, A.

G456 Griffing, A. "Rectifying the Bath." AMERICAN JOURNAL OF PHOTOGRAPHY AND THE ALLIED ARTS & SCIENCES n. s. vol. 7, no. 15 (Feb. 1, 1865): 358-359.

GRIFFING, L. S. (JERSEY CITY, NJ)

G457 Portrait. Woodcut engraving, credited "From a Photograph by L. S. Griffing, Jersey City." FRANK LESLIE'S ILLUSTRATED NEWSPAPER 40, (1875) ["Rev. Henry Boehm." 40:1031 (July 3, 1875): 281.]

GRIFFING, NERESTAN (1786-1866) (USA)

G458 Griffing, N. "A New Dipper. - How to Save the Silver." AMERICAN JOURNAL OF PHOTOGRAPHY AND THE ALLIED ARTS & SCIENCES n. s. vol. 6, no. 15 (Feb. 1, 1864): 342-343. ["(Griffing) is one of the fathers of practical photography. In 1840 he was associated with Messrs. Wolcott & Johnson, and for some years thereafter was engaged in the manufacture of photographic materials. At the advent of the collodion process, he became a very successful amateur."]

G459 Griffing, N. "A New Kind of Funnel." AMERICAN JOURNAL OF PHOTOGRAPHY AND THE ALLIED ARTS & SCIENCES n. s. vol. 7, no. 4 (Aug. 15, 1864): 94.

G460 "Death of Nerestan Griffing." AMERICAN JOURNAL OF PHOTOGRAPHY AND THE ALLIED ARTS & SCIENCES n. s. vol. 9, no. 2 (Sept. 15, 1866): 46. [Capt. Griffing died in Guilford, CT, July 24, at the age of 80 years and 25 days. Employed in the West India trade when young. Associated with Wolcott & Johnson in their earliest experiments, and he was a skillful and successful operator. Made cameras and lenses. During past ten years he "found photography a constant source of amusement. Honorary member of the American Photographical Society, contributed to "Am. J. of Photo."]

GRIFFITHS, LEWIS R.

G461 Griffiths, Lewis R., M.A., Oxon. "Calotype Process." PHOTOGRAPHIC AND FINE ART JOURNAL 10, no. 3 (Mar. 1857): 92-93. [From "J. of Photo. Soc., London."]

GRIGGS, G. see WATERHOUSE, LIEUT.

GRIGGS, WILLIAM.

G462 Griggs, William. "The Practice of Photolithography." BRITISH JOURNAL PHOTOGRAPHIC ALMANAC 1869 (1869): 75-76.

G463 Griggs, William. "On Making Surfaces for Block-Printing by Means of Photography." BRITISH JOURNAL PHOTOGRAPHIC ALMANAC 1870 (1870): 94.

GRILLET. (NAPLES, ITALY)

G464 Portrait. Woodcut engraving credited "From a photograph by Grillet, of Naples." ILLUSTRATED LONDON NEWS 38, (1861) ["General Cialdini and his staff at Gaeta." 38:* (Apr. 13, 1861): 338.]

G465 Portrait. Woodcut engraving credited "From a photograph by Grillet." ILLUSTRATED LONDON NEWS 70, (1877) ["Late Mr. Alfred Smee, F.R.S." 70:1959 (Jan. 27, 1877): 85.]

GRISWOLD, M. M. (COLUMBUS, OH)

G466 "Voices from the Craft." PHILADELPHIA PHOTOGRAPHER 5, no. 56 (Aug. 1868): 273. [Letter from Griswold.]

G467 "Griswold's Photographic Compositions." PHILADELPHIA PHOTOGRAPHER 11, no. 123 (Mar. 1874): 88-89. [Twenty-seven stereo genre compositions discussed.]

G468 "Our Picture." PHILADELPHIA PHOTOGRAPHER 7, no. 74 (Feb. 1870): frontispiece, 58-59. 1 b & w. [Genre (blowing bubbles), Griswold from Columbus, OH.]

G469 "Our Picture." PHILADELPHIA PHOTOGRAPHER 9, no. 102 (June 1872): 233-234. 1 b & w. [Genre scene with children, "The Hens Nest". Griswold in Lancaster, OH.]

GRISWOLD, VICTOR MOREAU. (1819-1872) (USA)

G470 "Photographic Patents: Patent for the Use of Albumenized Collodion - Patent for Sensitized Black Varnish." HUMPHREY'S JOURNAL 8, no. 20 (Feb. 15, 1857): 305-306. [Letters patent from V. M. Griswold, Lancaster, OH.]

G471 Griswold, V. M. "The Wothlytype." HUMPHREY'S JOURNAL OF PHOTOGRAPHY, AND THE ALLIED ARTS AND SCIENCES 16, no. 14 (Nov. 15, 1864): 224. ["In view of the excitement in Europe growing out of the recently discovered Wothlytype process, I have concluded to make known the fact that I have for the last six or seven years been printing successfully upon collodion films variously prepared."]

G472 "Opal Ferrotypes." HUMPHREY'S JOURNAL OF PHOTOGRAPHY, AND THE ALLIED ARTS AND SCIENCES 18, no. 13 (Nov. 1, 1866): 205-206. ["The new style of photograph, resembling the opal or porcelain picture, but...taken on a malainotype plate. It is the invention of V. M. Griswold."]

G473 Pine, Leighton. "The Ferro-Photographic Process." HUMPHREY'S JOURNAL OF PHOTOGRAPHY, AND THE ALLIED ARTS AND SCIENCES 18, no. 14 (Nov. 15, 1866): 219-220. ["Having received an invitation from V. M. Griswold, to visit him... and see the working of his new process."]

G474 Griswold, V. M. "Collodio-Chloride." HUMPHREY'S JOURNAL OF PHOTOGRAPHY, AND THE ALLIED ARTS AND SCIENCES 18, no. 14 (Nov. 15, 1866): 222.

G475 "Editor's Table: Griswold's Carbon Direct Prints." PHILADELPHIA PHOTOGRAPHER 4, no. 40 (Apr. 1867): 128.

G476 Griswold, M. M. "V. M. Griswold." PHOTOGRAPHIC TIMES 2, no. 20 (Aug. 1872): 118-119. [Obituary, containing a letter from his brother, M. M. Griswold, who was living in Boston at this time. Another relative, G. G. Griswold was living on Beekman St, New York, NY at this time as well. Victor M. Griswold died on June 18, 1872 at his residence in Peekskill, NY. (Born on Apr. 14, 1819 in Worthington, OH. Studied painting under William Wolcott in Columbus, OH. Exhibited at the American Art Union and the National Academy from 1849 to 1858.) V. M. and M. M. Griswold began daguerreotypy in Tiffin, OH in 1850. Victor had been a professional painter of landscapes at the time. He was inventive and innovative, trying out new processes and techniques. Early practitioner of the calotype and wet-collodion. "He made calotype pictures in Delaware, Ohio, I think, before he commenced with the daguerreotype." Practiced differential focus in Tiffin to produce portraits with a pleasing overall effect. Moved to Lancaster, OH a few years later and perfected the

ferrotype plate there. Experimenting with ferro-porcelain, direct printing, and carbon processes for several years before his death in 1872.]

G477 "The Late Victor M. Griswold." COMMERCIAL PHOTOGRAPHIC NEWS 1, no. 4 (Oct. 1872): 2. [Obituary.]

G478 Griswold, V. M. "Jottings from the Journal of an Experimentalist." PHILADELPHIA PHOTOGRAPHER 10, no. 115, 119-120 (July, Nov. - Dec. 1873): 219-220, 539-541, 559-560. [Published posthumously.]

G479 Griswold, E. P. "The History of the Ferrotype." AMERICAN AMATEUR PHOTOGRAPHER 1, no. 6 (Dec.1889): 235-237.

GROOM & CO. (GREAT BRITAIN)
G480 "Loss of the Conqueror." ILLUSTRATED LONDON NEWS 40, no. 1130 (Feb. 8, 1862): 151. 2 illus. ["From photographs by Groom & Co., of Plymouth and Exeter." View of the ship "H.M.H. Conqueror" and its officers.]

GROSSMAN, A. (DOVER, ENGLAND)
G481 "The Regimental Pet Tiger of the Royal Madras Fusiliers." ILLUSTRATED LONDON NEWS 56, no. 1591 (Apr. 30, 1870): 465. 1 illus. ["Photograph by Mr. A. Grossman, of Dover."]

GROTECLOSS, JOHN H. (NEW YORK, NY)
G482 Portrait. Woodcut engraving, credited "From a Photograph by Grotecloss, 226 Bleeker St., New York, NY" HARPER'S WEEKLY 11, (1867) ["Champion Nine of the Union Base-ball Club of Morrisania, NY." 11:565 (Oct. 26, 1867): 684.]

G483 Portrait. Woodcut engraving, credited "From a Photograph by John H. Grotecloss." FRANK LESLIE'S ILLUSTRATED NEWSPAPER 28, (1869) ["Rev. Alfred Cookman." 28:728 (Sept. 11, 1869): 412.]

GROVE, H. B. (d. 1865) (USA)
G484 Seely, Charles A. "Editorial Department." AMERICAN JOURNAL OF PHOTOGRAPHY AND THE ALLIED ARTS & SCIENCES n. s. vol. 8, no. 9 (Nov. 1, 1865): 216. [H. B. Grove, a photographer in Baltimore, MD, robbed and murdered in his studio.]

G485 "Murder of a Photographer in Baltimore." HUMPHREY'S JOURNAL OF PHOTOGRAPHY, AND THE ALLIED ARTS AND SCIENCES 17, no. 14 (Nov. 15, 1865): 223.

G486 "Editor's Table." PHILADELPHIA PHOTOGRAPHER 2, no. 24 (Dec. 1865): 207. [Grove murdered by a patron. Worked in Carlisle, PA.]

GROVE, WILLIAM (d. 1906) (GREAT BRITAIN) see WINDOW & GROVE.

GROVE, SIR W. R. (GREAT BRITAIN)
[Sir W. R. Grove, M.A., F.R.S., was a Judge of the Court of Common Pleas in the 1880s. In the 1840s and 1850s he "...was an active experimenter in almost every department of physics." Professor of Experimental Philosophy at the London Institution in the early 1840s.]

BOOKS
G487 Grove, W. R. A Lecture on the Progress of Physical Science since the Opening of the London Institution, delivered January 19, 1842. London: privately printed, 1842. 46 pp.

G488 Grove, W. R. The Correlation of the Physical Forces; with other Contributions to Science. "6th ed." London: Longmans, 466 pp. illus.

["A Voltaic Process for Etching Daguerreotypes," on pp. 241-247; "Natural Photography," on p. 436. 1st ed. (1846) London: S. Highley, 52 pp.]

PERIODICALS
G489 "Etching Daguerreotype Plates." MAGAZINE OF SCIENCE AND SCHOOL OF ARTS 3, no. 128 (Sept. 11, 1841): 189. [W. Grove's voltaic process of etching daguerreotype plates discussed.]

G490 Grove, W. R. "Etching Daguerreotype Plates." DAGUERREAN JOURNAL 1, no. 8 (Mar. 1, 1851): 225-228. [Source not given.]

G491 "Miscellaneous: Etching Daguerreotype Plates." AMERICAN REPERATORY OF ARTS, SCIENCES AND MANUFACTURES 4, no. 5 (Dec. 1841): 379. [W. R. Grove communicated a method for etching daguerreotypes with a voltaic process to the Electrical Society, in the Adelaide Gallery.]

GRUBB, THOMAS.
G492 Grubb, Thomas. "On Lunar Photography." PHOTOGRAPHIC AND FINE ART JOURNAL 10, no. 7 (July 1857): 210-211. [From "J. of Photo. Soc., London."]

GRUEN see also DAWSON, GEORGE.

GRUEN.
G493 "Photography for Wood Engraving." ANTHONY'S PHOTOGRAPHIC BULLETIN 1, no. 7 (Aug. 1870): 138-140. [From "London Photographic News." A process developed by Mr. Gruen, reported to be the process adapted by "The Graphic," "Illustrated London News," and the "Illustrated Times."]

G494 W. B. "Photography on Wood. Practical Directions for Practicing Gruen's Process." ANTHONY'S PHOTOGRAPHIC BULLETIN 2, no. 2 (Feb. 1871): 37-41. [From "Br J of Photo." Peeling of collodion skin and continuing chemical reactions, or poor image fixation were two problems long unsolved. Gruen's process apparently resolved them.]

GRUNDY, WILLIAM MORRIS. (1806-1859) (GREAT BRITAIN)
BOOKS
G495 Sunshine in the Country: A Book of Rural Poetry. Embellished with Photographs from Nature. London: Richard Griffin & Co., 1861. viii, 152 pp. 20 b & w. [Original photos illustrating an anthology of poetry. "The Photographs were taken by the late Mr. Grundy, of Sutton Coldfield, near Birmingham."]

PERIODICALS
G496 "Photography as Employed for the Illustration of Books." ART JOURNAL (Feb. 1861): 48. [Bk. rev.: "Sunshine in the Country," with illustrations by Mr. Grundy, of Sutton Coldfield, near Birmingham.]

GUBBINS, J. E.
G497 Gubbins, Capt. J. E. "Direct Positives for Enlarging." ANTHONY'S PHOTOGRAPHIC BULLETIN 7, no. 11 (Nov. 1876): 331. [From "Br. J. of Photo." Capt. J. E. Gubbins, R. A. stationed at Ercand, India.]

GUBELMAN, THEODORE. (GERMANY, USA)
G498 Portrait. Woodcut engraving, credited "From a Photograph by Gubleman, Jersey City. FRANK LESLIE'S ILLUSTRATED NEWSPAPER 36, (1873) ["Chief McWilliams, Jersey City police." 36:932 (Aug. 9, 1873): 353.]

G499 Portraits. Woodcut engravings, credited "Photographed by Gubleman, of Jersey City." FRANK LESLIE'S ILLUSTRATED NEWSPAPER 39, (1874) ["Hon. Joseph D. Bedle, Judge in NJ." 39:997 (Nov. 7, 1874): 140. "The late Hon. Dudley S. Gregory, Judge in NJ." 39:1004 (Dec. 26, 1874): 269.]

G500 "The Studios of America: Theodore Gubelman's Atlier, Jersey City, N. J." PHOTOGRAPHIC TIMES 14, no. 170 (Dec. 19, 1884): 678-679. [Gubelman born in Germany. To USA "when approaching manhood." Learned lithography, then photography. "Travelled to the far Southwest where he joined a well-established firm as partner." When the Civil War broke out, he returned North, joined and served in the Army of the Potomac. After the war started a gallery in Jersey City, NJ, and prospered.]

GÜNTHER, CARL. (BERLIN, GERMANY)
G501 Portrait. Woodcut engraving credited "From a photograph by Carl Günther, of Berlin." ILLUSTRATED LONDON NEWS 58, (1870) ["Baron Von Moltke, Prussian Army." 58:* (Aug. 27, 1870): 221.]

GUERIN, FITZ W. (1846-1903) (GREAT BRITAIN, USA)
G502 Hegyessy, J. "Our Dark-Room Practice." PHOTOGRAPHIC MOSAICS: 1888 24, (1888): 104-106. [Hegyessy was the assistant operator and dark-room man of F. W. Guerin's Studio in St. Louis.]

G503 "'Cupid After Wings'" PHOTOGRAPHIC TIMES 21, no. 486 (Jan. 9, 1891): frontispiece, 13. 1 b & w. [Genre. Guerin was a professional photographer of St. Louis, Mo.]

G504 "Notes and News: Fire." PHOTOGRAPHIC TIMES 21, no. 524 (Oct. 2, 1891): 493. [Guerin's gallery in St. Louis was totally destroyed by fire.]

G505 1 photo ("The Queens"). PHOTOGRAPHIC TIMES 22, no. 548 (Mar. 18, 1892): 141, plus frontispiece. 1 b & w.

G506 "F. W. Guerin." PHOTOGRAPHIC TIMES 22, no. 548 (Mar. 18, 1892): 141-142. [Biographical sketch. Born Mar. 17, 1846 in New York, NY. To St. Louis in 1859. Served in union army during Civil War. After war worked in a gallery, then railroading, then itinerant photographer. Finally worked as operator for Fitzgibbon and others in St. Louis. In 1876 opened his own gallery, worked hard and succeeded.]

G507 "Notes and News." PHOTOGRAPHIC TIMES 22, no. 576 (Sept. 30, 1892): 503. [Note that Guerin saved a young girl from drowning at Martha's Vineyard.]

G508 "The Editor's Table." PHOTOGRAPHIC TIMES 30, no. 10 (Oct. 1898): 478-479. 3 b & w. [Bk. rev.: "Portraits in Photography by the Aid of Flashlight," by F. W. Guerin.]

G509 1 b & w (Genre, "I Want You, My Honey, for My Christmas.") LESLIE'S WEEKLY 87, no. 2259 (Dec. 29, 1898): 512. [Negro boy chasing a wild turkey. "Copyright 1898 by Guerin, St. Louis."]

G510 1 photo ("Who Is It, Grandpa?"). PHOTOGRAPHIC TIMES 33, no. 11 (Nov. 1901): frontispiece. 1 b & w.

G511 "The Very Odd Vision of F. W. Guerin." AMERICAN HERITAGE 33, no. 3 (Apr. - May 1982): 65-73. 14 b & w. [Born in Ireland in 1846, joined the Union Army at 15, then photographed in St. Louis until shortly before his death in 1903. Posed genre scenes.]

GUGGENHEIM, J. (OXFORD, ENGLAND)
G512 Portraits. Woodcut engravings credited "From a photograph by J. Guggenheim." ILLUSTRATED LONDON NEWS 46, (1865) ["The Oxford Crew." (9 portraits) 46:* (Apr. 22, 1865): 381.]

G513 Portrait. Woodcut engraving credited "From a photograph by J. Guggenheim." ILLUSTRATED LONDON NEWS 47, (1865) ["Prof. Phillips, Univ. of Oxford." 47:* (Sept. 23, 1865): 288.]

G514 Portrait. Woodcut engraving credited "From a photograph by Guggenheim." ILLUSTRATED LONDON NEWS 72, (1878) ["Prof. Max Mueller." 72:2027 (May 4, 1878): 412.]

GUILD, W. H., JR.
G515 Perkins, Frederic Beecher. The Central Park: Photographed by W. H. Guild, Jr., with Descriptions and a Historical Sketch by Frederick Beecher Perkins. New York: Carleton, 1864. 78 pp. 50 l. of plates. 52 b & w. [Fifty views, two others. Original photographs, tipped-In.]

GUILLEMIN, AMEDEE. (FRANCE)
G516 "Photography," on pp. 289-328 in: The Applications of the Physical Forces. By Amedee Guillemin. Translated from the French by Mrs. Lockyer, and edited by Norman Lockyer, F.R.S. Illustrated. London: Macmillan & Co., 1876. n. p. illus.

GUILLOU, CONSTANT. (1812-1872) (USA)
G517 "Durability of Photographs." HUMPHREY'S JOURNAL 9, no. 3 (June 1, 1857): 34. [C. Guillou, a Philadelphia, PA, amateur, deposited several photocopies of the architect's drawings in the cornerstone of the Holy Trinity Church, Philadelphia in 1857.]

G518 C. G. "Beware of Saltpeter." HUMPHREY'S JOURNAL OF PHOTOGRAPHY, AND THE ALLIED ARTS AND SCIENCES 9, no. 22 (Mar. 15, 1858): 341.

G519 "An Excursion on the Baltimore and Ohio Railroad." THE CRAYON 5, no. 7 (July 1858): 210. [From the "Evening Post." [?] "Besides these [artists], were the photographers consisting of the amateurs G. W. Dobbin and son, and W. E. Bartlett, of Baltimore, Charles [sic Constant] Guillou, of Philadelphia; and Robert O'Neil, a professional photographer, from Washington.]

G520 "Domestic Art Items and Gossip." COSMOPOLITAN ART JOURNAL 2, no. 4 (Sept. 1858): 207. [Describes an excursion organized for artists and photographers on the Baltimore and Ohio Railroad. "The train consists of... a car expressly fitted up for photographic purposes. The rest of the party...including...the following gentlemen...Messrs. G. W. Dobbin, Charles Guillou, William E. Bartlett and Robert O'Neil, photographers. More than one hundred excellent photographic views were taken by the several operators, who had four sets of approved apparatus of their own in full play." (See also the June 1859 issue of "Harper's New Monthly Magazine.")]

G521 C. G. "The Saltpetre Question." HUMPHREY'S JOURNAL OF PHOTOGRAPHY, AND THE ALLIED ARTS AND SCIENCES 10, no. 9 (Sept. 1, 1858): 131-138.

G522 Guillou, C. "Blue Photographs." HUMPHREY'S JOURNAL OF PHOTOGRAPHY, AND THE ALLIED ARTS AND SCIENCES 15, no. 14 (Nov. 15, 1863): 217. [From "Amat. Photo. Print."]

G523 "Obituary: Constant Guillou, Esq." PHILADELPHIA PHOTOGRAPHER 9, no. 107 (Nov. 1872): 396-397. [Guillou was a lawyer, a scholar, and one of the first amateur photographers in the

USA. For several years he was the President of the Photographic Society of Philadelphia. Died on Oct. 20, 1872, at age 61.]

GULLIVER, THOMAS.

G524 Gulliver, T. "Glass House for Photographic Purposes." HUMPHREY'S JOURNAL OF PHOTOGRAPHY, AND THE ALLIED ARTS AND SCIENCES 9, no. 18 (Jan. 15, 1858): 281-282. [From "Liverpool Photo. J."]

G525 Gulliver, Thomas. "On a Convenient Method for Working with Wet Collodion in the Open Air." LIVERPOOL & MANCHESTER PHOTOGRAPHIC JOURNAL [BRITISH JOURNAL OF PHOTOGRAPHY] n. s. 2, no. 20 (Oct. 15, 1858): 256.

G526 Gulliver, Thomas. "On a Convenient Method for Working with Wet Collodion in the Open Air." PHOTOGRAPHIC AND FINE ART JOURNAL 11, no. 10 (Oct. 1858): 319. [From the "Liverpool and Manchester Photographic Journal."]

G527 "The Fatal Railway Accident at Swansea." ILLUSTRATED LONDON NEWS 47, no. 1346 (Dec. 9, 1865): 568-569. 1 illus. ["Our Illustration is from a photograph by Mr. Gulliver, of Swansea."]

G528 Gulliver, Thomas. "The Lime Light of Former Days." BRITISH JOURNAL PHOTOGRAPHIC ALMANAC 1877 (1877): 50-51. ["Some 27 years ago."]

G529 Gulliver, Thomas. "Painting Backgrounds." BRITISH JOURNAL PHOTOGRAPHIC ALMANAC 1878 (1878): 145.

GUNDLACH, ERNEST. (b. 1834) (GERMANY)

G530 Kingslake, Rudolph. "Ernest Gundlach: Nineteenth-Century Pioneer Optician." HISTORY OF PHOTOGRAPHY 2, no. 4 (Oct. 1978): 361-364. 4 illus.

GURNEY, BENJAMIN see GURNEY, JEREMIAH.

GURNEY, H. D. (NATCHEZ, MS)

G531 "Gallery for Sale." HUMPHREY'S JOURNAL OF PHOTOGRAPHY, AND THE ALLIED ARTS AND SCIENCES 19, no. 20 (Feb. 15, 1868): 320. ["Mr. H. D. Gurney, of Natchez, Miss., offers for sale his gallery which has been established eighteen years."]

GURNEY, JEREMIAH & SONS see GURNEY, JEREMIAH.

GURNEY, JEREMIAH see also ELLISSON, GEORGE W.; HALL & GURNEY.

GURNEY, JEREMIAH. (1812-1886) (USA)
BOOKS
G532 Gurney, Jeremiah. *Etchings on Photography.* New York: J. P. Prall, 1856. 24 pp. 3 l. of plates. 4 illus. [Contains an essay "Photography," pp. 3-12, which is a brief history of photography and its uses to society - e.g. mentions Felton's [sic Fenton's] Crimean War photos, etc.; "A Visit to Gurney's Palace of Art," by J. T. Van Buren, on pp. 12-14, (from the "Cincinnati Daily Dispatch"); "Mr. E. Anthony's Card to the Daguerrean World," on pp. 14-15; Report of the Anthony Awards Committee, on p. 16, (awarding the Anthony prize to Gurney); and "Sunlight Paintings," (from "Glances of the Metropolis"), on pp. 23-24. The engravings are an exterior view of Gurney's gallery in New York, NY, a view of the Anthony Prize Pitcher, and some medals awarded to Gurney.]

G533 *The Royal Album; A series of photographs taken from life of H. R. H. the Prince of Wales and suite at the Revere House, Boston on the 19th October 1860 the day before their departure from America,* by J. Gurney & Son. New York: Gurney & Son, 707 Broadway, 1860. n. p. 11 b & w. [Original photos, bound album with letterpress.]

G534 Fevret de Saint-Mémin, C.B.J. *The Saint-Mémin Collection of Portraits;* Consisting of the Seven Hundred and Sixty Medallion Portraits...Photographed by J. Gurney & Son of New York from Proof Impressions of the Original Copper-Plates, Engraved by M. de St. Mémin, from Drawings Taken from Life by Himself, during this Exile in the United States in from 1793 to 1814. New York: Dexter, 1862. n. p. 62 b & w.

G535 New York (City). Metropolitan Fair, 1864. *A Record of the Metropolitan Fair...Held at New York in April 1864.* New York: Hurd & Houghton, 1867. 261 pp. 8 l. of plates. 8 b & w. [Original prints, views of the exhibition. Six by J. Gurney & Son, two by M. Stadtfeld. (NYPL collection).]

PERIODICALS
G536 Gurney, J. "Correspondence." DAGUERREAN JOURNAL 2, no. 1 (May 15, 1851): 21-23. [Letter from Gurney praising L. L. Hill's addition to the editorial board of the "Daguerrean Journal," discussing the need for adequate training in the profession.]

G537 "Gurney's American Compound." DAGUERREAN JOURNAL 3, no. 1 (Nov. 15, 1851): 20-21.

G538 "Gossip." PHOTOGRAPHIC ART JOURNAL 3, no. 3 (Mar. 1852): 195. ["Mr. Gurney, of this city, has added to his extensive gallery of Daguerreotypes Mr. R. H. Vance's splendid views of scenes in Calif. . ."]

G539 "Gossip." PHOTOGRAPHIC ART JOURNAL 3, no. 4 (Apr. 1852): 257. ["Small fire in Gurney's studio."]

G540 "Humphrey's Journal: A Warning to All." HUMPHREY'S JOURNAL 4, no. 2 (May 1, 1852): 28. [Gurney ill from mercury poisoning.]

G541 "Mr. Gurney's New Establishment." HUMPHREY'S JOURNAL 4, no. 8 (Aug. 1, 1852): 127. [Mr. Gurney, of 189 Broadway, has bought out Mr. J. H. Whitehurst's Establishment, corner of Leonard St. and Broadway.]

G542 "Gossip." PHOTOGRAPHIC ART JOURNAL 4, no. 2 (Aug. 1852): 131. ["Mr. Gurney has purchased the Whitehurst gallery in the city of N.Y."]

G543 Portraits. Woodcut engravings, credited "From a Daguerreotype by J. Gurney." ILLUSTRATED NEWS (NY) 1, (1853) ["Madame Henrietta Sontag, singer." 1:8 (Feb. 19, 1853): 128. "Madame Altoni, musician." 1:9 (Feb. 26, 1853): 136. "Thomas F. Meagher." 1:12 (Mar. 19, 1853): 185.]

G544 "Daguerrean Sketches in New York. Gurney's Daguerrean Rooms, Broadway, New York." ILLUSTRATED NEWS (NY) 2, no. 46 (Nov. 12, 1853): 277. 1 illus. [Includes idealized view of waiting room of Gurney's gallery.]

G545 "Gossip." PHOTOGRAPHIC ART JOURNAL 6, no. 5 (Nov. 1853): 323. [Gurney won a diploma at the American Institute Fair, won a gold medal last year.]

G546 "The Anthony Prize Pitcher." PHOTOGRAPHIC AND FINE ART JOURNAL 7, no. 1 (Jan. 1854): 6-11. [Gurney was the prize winner. A letter detailing his process published on p. 7-8.]

G547 "Presentation of a Silver Pitcher to J. Gurney, and Report of the Proceedings at a Supper on the Occasion." HUMPHREY'S JOURNAL 5, no. 18 (Jan. 1, 1854): 273-278. [E. Anthony Prize Pitcher award.]

G548 "The Anthony Daguerrean Prize: Presentation to Mr. J. Gurney." PHOTOGRAPHIC AND FINE ART JOURNAL 7, no. 2 (Feb. 1854): 37-39.

G549 Portrait. Woodcut engraving, credited "From a Daguerreotype by Gurney." FRANK LESLIE'S ILLUSTRATED NEWSPAPER 1, (1855) ["General Wool, U.S.A." 1:3 (Dec. 29, 1855): 33.]

G550 Portraits. Woodcut engravings, credited "From an Photograph by Gurney." FRANK LESLIE'S ILLUSTRATED NEWSPAPER 1, (1856) ["Mr. "George Steers." 1:13 (Mar. 8, 1856): 200.]

G551 "Photography in New York." HUMPHREY'S JOURNAL 8, no. 16 (Dec. 15, 1856): Additional section; 7. [Praise for Gurney.]

G552 "Our Illustrations." PHOTOGRAPHIC AND FINE ART JOURNAL 10, no. 2 (Feb. 1857): frontispiece, 58-59. 1 b & w. [Original photographic print, tipped-in. View of a group of statuary by Powers, negative by J. Gurney. From a daguerreotype.]

G553 Portraits. Woodcut engravings, credited "Photographed by Gurney." FRANK LESLIE'S ILLUSTRATED NEWSPAPER 5, (1858) ["John Brougham, actor, as 'Columbus.'" 5:112 (Jan. 23, 1858): 124. "Miss Agnes Robertson, actress, as 'Jessie Brown of Lucknow.'" 5:119 (Mar. 13, 1858): 236. "Mr. Dion Bourcicault, actor, in "Jessie Brown, or the Relief of Lucknow.'" 5:119 (Mar. 13, 1858): 236. "Mohamed Pasha, Rear-Admiral of the Turkish Navy." 5:120 (Mar. 20, 1858): 241. "Admiral Mohamed Pasha and Suite ar reception given by Mayor Tiemann and New York, NY officials. (group portrait)." 5:120 (Mar. 20, 1858): 248. "Frederick Stanton, late Gov. of KS." 5:121 (Mar. 27, 1858): 257. "Delegation of Chiefs from Poncah Tribe of Nebraska Indians. (group portrait). 5:124 (Apr. 17, 1858): 305.]

G554 "Our Photographic Illustrations: Jeremiah Gurney, Esq." PHOTOGRAPHIC AND FINE ART JOURNAL 11, no. 3 (Mar. 1858): frontispiece, 84. 1 b & w. [Self portrait.]

G555 "Delegation of Chiefs from the Poncah Tribes of Nebraska Indians - Photographed by Gurney." FRANK LESLIE'S ILLUSTRATED NEWSPAPER 5, no. 124 (Apr. 17, 1858): 305. 1 illus. [Group portrait. Individuals named.]

G556 Portraits. Woodcut engravings, credited "Photographed by J. Gurney." FRANK LESLIE'S ILLUSTRATED NEWSPAPER 6, (1858) ["David T. Valentine, New York, NY." 6:133 (June 19, 1858): 45.]

G557 "The Atlantic Cable & Photography." AMERICAN JOURNAL OF PHOTOGRAPHY AND THE ALLIED ARTS AND SCIENCES n. s. vol. 1, no. 7 (Sept. 1, 1858): 111-113. [Detailed description of facades of mayor New York, NY Galleries during celebration of laying Atlantic cable - Gurney's, Brady's, and Fredericks' galleries specifically noted.]

G558 "Photography and the Law. Has an Artist the Right to Exhibit a Portrait? Jeremiah Gurney vs. Elias Howe." AMERICAN JOURNAL OF PHOTOGRAPHY AND THE ALLIED ARTS AND SCIENCES n. s. vol. 1, no. 10 (Oct. 15, 1858): 160-161. [Gurney won $750 suit for payment of portrait.]

G559 "Pictures on Broadway." PHOTOGRAPHIC AND FINE ART JOURNAL 11, no. 11 (Nov. 1858): 344-346. [From "New York Daily Times." About opening of Gurney's Broadway gallery.]

G560 "Personal & Art Intelligence." PHOTOGRAPHIC AND FINE ART JOURNAL 11, no. 11 (Nov. 1858): 351-352. [Gurney opens new gallery at 707 Broadway.]

G561 "Mr. Gurney's New Gallery, the Inauguration." AMERICAN JOURNAL OF PHOTOGRAPHY AND THE ALLIED ARTS AND SCIENCES n. s. vol. 1, no. 13 (Dec. 1, 1858): 209-210. [Humorous report of aftermath of big reception.]

G562 Portrait. Woodcut engraving, credited "From a Photograph by Gurney." FRANK LESLIE'S ILLUSTRATED NEWSPAPER 7, (1858) ["Harry Howard, Chief Engineer of the New York, NY fire dept." 7:157 (Dec. 4, 1858): 8.]

G563 "Photography in New York." AMERICAN JOURNAL OF PHOTOGRAPHY AND THE ALLIED ARTS AND SCIENCES n. s. vol. 1, no. 14 (Dec. 15, 1858): 223-225. [Gurney mentioned, Brady mentioned.]

G564 "J. Gurney, Photographist." FRANK LESLIE'S ILLUSTRATED NEWSPAPER 8, no. 199 (Sept. 24, 1859): 266. 1 illus. [Portrait of Gurney. Brief, uninformative biographical note.]

G565 "The Eutaw House, Baltimore, Maryland. - From a Photograph by Gurney, 707 Broadway." FRANK LESLIE'S ILLUSTRATED NEWSPAPER 9, no. 209 (Dec. 3, 1859): 13-14. 2 illus. [View of the hotel and portrait of its owner, Capt. Robert Coleman.]

G566 Portraits. Woodcut engravings, credited "From a Photograph by Gurney." FRANK LESLIE'S ILLUSTRATED NEWSPAPER 9, (1859-1860) ["Hon. Wm. F. Havemeyer, Democratic candidate for mayor, New York, NY." 9:209 (Dec. 3, 1859): 8. "Capt. Robert Coleman." 9:209 (Dec. 3, 1859): 13. "Hinton Rowan Helper, author." 9:212 (Dec. 24, 1859): 49. "Fernando Wood, Mayor of New York, NY." 9:214 (Jan. 7, 1860): 88. "Col. Abraham Lurver, 7th Reg., National Guard." 9:214 (Jan. 7, 1860): 89. "Signora Adelina Patti, prima donna." 9:214 (Jan. 7, 1860): 96. "Mrs. Martha H. Butt, author." 9:215 (Jan. 14, 1860): 112. "Clark Mills, sculptor." 9:222 (Mar. 3, 1860): 219. "Phineas T. Barnum, showman." 9:227 (Apr. 7, 1860): 291.]

G567 "William Evans Burton, the Comedian." FRANK LESLIE'S ILLUSTRATED NEWSPAPER 9, no. 221 (Feb. 25, 1860): 202. 4 illus. [Four costume portraits of the late actor. One credited to Silsbee, Case & Co., Boston, two credited to J. Gurney, one credited "from Weston's Photograph."]

G568 "The Chicago Zouaves Executing Their Drill in New York, July 1860." HARPER'S WEEKLY 4, no. 187 (July 28, 1860): 468. 1 illus. ["From a photograph by Gurney."]

G569 "The Zouave Cadets of Chicago." FRANK LESLIE'S ILLUSTRATED NEWSPAPER 10, no. 244 (July 28, 1860): 145, 152-154. 14 illus. [Sketches of the Zouaves maneuvering. One group portrait credited to Gurney.]

G570 Portraits. Woodcut engravings, credited "Photographed by Gurney." FRANK LESLIE'S ILLUSTRATED NEWSPAPER 10, (1860) ["Group portrait of Distinguished Knights Templars (9 men, named)." 10:246 (Aug. 11, 1860): 175.]

G571 "Front View of Bailey & Co's. Jewellery Establishment. - From a Photograph by Gurney." FRANK LESLIE'S ILLUSTRATED NEWSPAPER 10, no. 246 (Aug. 11, 1860): 179. 1 illus. [View.]

G572 "Double-Dealing." FRANK LESLIE'S ILLUSTRATED NEWSPAPER 10, no. 250 (Sept. 8, 1860): 241. [Editorial, charging that Gurney attempted to buy Ellison's views of the Prince of Wales' visit to Quebec, apparently with the intention of reselling them to a rival publication.]

G573 "Mr. Gurney, the Photographer, Again." FRANK LESLIE'S ILLUSTRATED NEWSPAPER 10, no. 256 (Oct. 20, 1860): 336. [Signed deposition by, George W. Ellisson, photographer of Quebec, stating that Gurney attempted to buy scenes of the Prince of Wales' visit to Quebec, which he apparently intended to resell as his own work.]

G574 "Editorial Miscellany." AMERICAN JOURNAL OF PHOTOGRAPHY AND THE ALLIED ARTS & SCIENCES n. s. vol. 3, no. 11 (Nov. 1, 1860): 176. [Prince of Wales visited USA, sat for Brady and Gurney, but apparently visited only Brady's gallery.]

G575 Portraits. Woodcut engravings, credited "From a Photograph by J. Gurney." NEW YORK ILLUSTRATED NEWS 3, (1861) ["Gen. Winfield Scott." 3:65 (Feb. 2, 1861): 193. "Dr. Rosenberg, the Indian Horse Curer." 3:68 (Feb. 23, 1861): 252.]

G576 Portrait. Woodcut engraving, credited "From a Photograph by J. Gurney & Sons." NEW YORK ILLUSTRATED NEWS 4, (1861) ["Karl Herrmann." 4:99 (Sept. 23, 1861): 332.]

G577 "Princely Reward." HUMPHREY'S JOURNAL OF PHOTOGRAPHY, AND THE ALLIED ARTS AND SCIENCES 13, no. 12 (Oct. 15, 1861): 191-192. [Note that Prince of Wales sent a medal and letter to the Messrs. Gurney, of Broadway in response to the portrait album and oil portrait that they made during the visit. The text of the letter is also printed.]

G578 Portrait. Woodcut engraving, credited "From a Photograph by J. Gurney & Son." NEW YORK ILLUSTRATED NEWS 5, (1862) ["Mr. A. MacMillan, the great skater on DeBrame's Patent Skates. (Outdoor portrait on ice skates.)" 5:113 (Jan. 4, 1862): 140.]

G579 Seely, Charles A. "Editorial Department." AMERICAN JOURNAL OF PHOTOGRAPHY AND THE ALLIED ARTS & SCIENCES n. s. vol. 6, no. 20 [sic 21] (May 1, 1864): 503-504. [Report that the Sanitary Commission Fair was successful, raising over one million dollars. Praises Gurney & Sons for opening a photographic gallery at the Fair, the proceeds of which went to the fund. Mentions Philadelphia about to hold a similar Fair, and that the association has already approached the Phila. Photo. Soc.]

G580 "Sharp Practice." HUMPHREY'S JOURNAL OF PHOTOGRAPHY, AND THE ALLIED ARTS AND SCIENCES 17, no. 1 (May 1, 1865): 16. ["It is known that Messrs. Gurney took some very fine negatives of scenes in and around the hall where the remains of our late lamented President laid in state in this city. They had uninterrupted possession of the premises for several hours; and no other artist was allowed any similar privileges by the city authorities. This did not please some other photographers in New York, so they sent on a statement of facts in the case to Secretary Stanton, when that official immediately dispatched officers to Gurneys and seized all the above mentioned negatives they could lay their hands upon, and sent them off to Washington. Mr. Gurney followed after, post haste, but whether he succeeded in recovering the negatives we are not informed."]

G581 "Gurney and Our Dead President." HUMPHREY'S JOURNAL OF PHOTOGRAPHY, AND THE ALLIED ARTS AND SCIENCES 17, no. 2 (May 15, 1865): 29-30. [Letter, signed "Union," which is a bitter attack on Gurney, Jr. calling him "...for four years past, a Copperhead of the deepest dye." "...the negatives were totally destroyed by order of Secretary Stanton, and thus ends Mr. Gurney's disgraceful speculation."]

G582 Portrait. Woodcut engraving, credited "From a Photograph by Gurney." HARPER'S WEEKLY 9, (1865) ["Late Right Rev. Alonzo Potter." 9:449 (Aug. 6, 1865): **]

G583 Portrait. Woodcut engraving, credited "From a Photograph by Gurney & Son, New York, NY." HARPER'S WEEKLY 10, (1866) ["Erastus W. Smith, A.P.D." 10:503 (Aug. 18, 1866): 525.]

G584 "Editor's Table." PHILADELPHIA PHOTOGRAPHER 4, no. 41 (May 1867): 160. [Messrs. J. Gurney & Son, 707 Broadway, New York, NY, have made cabinet portraits of Madame Parepa-Rosa, the Prima Donna.]

G585 Portrait. Woodcut engraving, credited "From a Photograph by Gurney." HARPER'S WEEKLY 11, (1867) ["Gen. Lopez de Santa Anna." 11:551 (July 20, 1867): 461.]

G586 Portrait. Woodcut engraving, credited "From a Photograph by Gurney & Sons." FRANK LESLIE'S ILLUSTRATED NEWSPAPER 24, (1867) ["Admiral David G. Farragut." 24:616 (July 20, 1867): 285.]

G587 Portrait. Woodcut engraving, credited "From a Photograph by Gurney & Son." FRANK LESLIE'S ILLUSTRATED NEWSPAPER 25, (1867) ["Leopold De Meyer, pianist." 25:630 (Oct. 26, 1867): 85.]

G588 "Editor's Table," PHILADELPHIA PHOTOGRAPHER 4, no. 47 (Nov. 1867): 366. [Gurney's cabinet portraits.]

G589 "Editor's Table." PHILADELPHIA PHOTOGRAPHER 4, no. 48 (Dec. 1867): 403. [A catalog of their publications.]

G590 "Our Picture." PHILADELPHIA PHOTOGRAPHER 5, no. 49 (Jan. 1868): frontispiece, 31. 1 b & w.

G591 Portrait. Woodcut engraving, credited "From a Photograph by Gurney." HARPER'S WEEKLY 12, (1868) ["Mr. William B. Astor." 12:593 (May 9, 1868): 292.]

G592 "Our Picture." PHILADELPHIA PHOTOGRAPHER 5, no. 55 (July 1868): Frontispiece, 246-247. 1 b & w. [Portrait of a young girl. Explanation that overwork made Wilson borrow negatives from "several of our friends" to get the monthly photo. Prints were made by Schreiber & Son. However, photograph is identified to J. Gurney & Son in the annual index.]

G593 "Our Picture." PHILADELPHIA PHOTOGRAPHER 5, no. 57 (Sept. 1868): frontispiece, 343-344. 1 b & w. [Genre portrait.]

G594 Hull, Charles Wager. "The 'Lights' and Formulas of Kurtz, Gurney and Sons and Bogardus of New York." PHILADELPHIA PHOTOGRAPHER 5, no. 59 (Nov. 1868): 404-407.

G595 Portrait. Woodcut engraving, credited "From a Photograph by J. Gurney & Son." FRANK LESLIE'S ILLUSTRATED NEWSPAPER 27,

(1869) ["Hon. George M. Curtis, Judge of NY Marine Court." 27:698 (Feb. 13, 1869): 341.]

G596 "Editor's Table." PHILADELPHIA PHOTOGRAPHER 6, no. 62 (Feb. 1869): 63. [J. Gurney & Son are erecting a new photographic establishment at North & 5th Avenue, New York, NY.]

G597 "Editor's Table." PHILADELPHIA PHOTOGRAPHER 6, no. 63 (Mar. 1869): 96. [Note that Gurney moving in April to new quarters, corner 5th Ave. & 16th Street, New York, NY.]

G598 Portrait. Woodcut engraving, credited "From a Photograph by J. Gurney & Son." FRANK LESLIE'S ILLUSTRATED NEWSPAPER 28, (1869) ["The late Charles C. B. Seymour." 28:712 (May 22, 1869): 157.]

G599 "Gurney's New Rooms." HUMPHREY'S JOURNAL OF PHOTOGRAPHY, AND THE ALLIED ARTS AND SCIENCES 20, no. 22 (June 15, 1869): 351-352. [The editor reports that business is bad for the new gallery. "The fact is, business up there, among the 'big bugs' is not what was expected."]

G600 "Editor's Table." PHILADELPHIA PHOTOGRAPHER 6, no. 67 (July 1869): 252. [Guerney & Son have occupied their new gallery at the corner of Fifth Avenue and Sixteenth Street, New York, NY.]

G601 "Editor's Table." PHILADELPHIA PHOTOGRAPHER 6, no. 69 (Sept. 1869): 324. [Note that the employees of E. & H. T. Anthony & Co. and J. Gurney & Son had a race in double scull working boats on Sat., July 31st. Each house started three boats. The Anthony crew won.]

G602 Portraits. Woodcut engravings, credited "From a Photograph by Gurney & Son." HARPER'S WEEKLY 13, (1869) ["Henry Ward Beecher & Harriet Beecher Stowe." 13:670 (Oct. 30, 1869): 689. "Gen. J. L. Alcorn, Gov.-Elect of MS." 13:677 (Dec. 18, 1869): 813.]

G603 "Gurney's Gallery." HUMPHREY'S JOURNAL OF PHOTOGRAPHY, AND THE ALLIED ARTS AND SCIENCES 20, no. 26 (Oct. 15, 1869): 412. [Description of the gallery. "Twenty-six rooms and apartments in the establishment, six artists' rooms...among the corps of photographers at Gurney's... James Forbes, of the 'Dark Chamber,' Frank E. Pearsall, Positionist, and Charles Hoffman, Superintendent of the printing department." Benjamin Gurney is the son. Additional note on p. 416 praising "Gurney Studies," which apparently were samples of cartes, etc. offered for sale by the studio.]

G604 Davie, D. D. T. "Sketch of J. Gurney, Esq. - [With a Photograph.]." HUMPHREY'S JOURNAL OF PHOTOGRAPHY, AND THE ALLIED ARTS AND SCIENCES 20, no. 26 (Oct. 15, 1869): 413-414. 1 b & w. [Gurney born "on the banks of the beautiful Hudson River," in 1812, in New York. Learned the jewelry trade in his youth, pursued it until 1840, when he learned about photography. Opened a gallery at No. 189 Broadway (apparently in 1840s). Moved to 349 Broadway in 1852. Moved to 707 Broadway sometime later. Opened another gallery at 16th St. and 5th Ave., Gurney & Son. Took daguerreotypes of Daniel Webster. The portrait taken by Gurney & Son.]

G605 "Editor's Table." PHILADELPHIA PHOTOGRAPHER 6, no. 70 (Oct. 1869): 356. ["Messrs. F. A. Pearsall & J. L. Forbes, with Messrs. J. Gurney & Son, have sent us some exquisite specimens."]

G606 D. "An Infamous Slander." HUMPHREY'S JOURNAL OF PHOTOGRAPHY, AND THE ALLIED ARTS AND SCIENCES 20, no.

27 (Nov. 15, 1869): 427-428. ["Who started the report that the Messrs. J. Gurney and Son had failed?" Then goes on to attack the "A. P. A.s" and Wilson again.]

G607 "Miscellaneous." HUMPHREY'S JOURNAL OF PHOTOGRAPHY, AND THE ALLIED ARTS AND SCIENCES 20, no. 28 (Dec. 15, 1869): 444-445. ["...called on J. Gurney & Son,...took a peep into the darkroom...with Mr. James L. Forbes...turning out negatives."]

G608 "American Studios." PHILADELPHIA PHOTOGRAPHER 6, no. 72 (Dec. 1869): 409-412. 2 illus. [Diagrams and etchings of studio interiors. Studio at Fifth Avenue & Sixteenth Street, New York, NY.]

G609 Portrait. Woodcut engraving, credited "From a Photograph by Gurney." FRANK LESLIE'S ILLUSTRATED NEWSPAPER 30, (1870) ["General Quesada, of Cuba." 30:758 (Apr. 9, 1870): 60. "William L. Peake, dry-goods merchant." 30:779 (Sept. 3, 1870): 389.]

G610 Portrait. Woodcut portrait, credited "From a Photograph by Gurney." FRANK LESLIE'S ILLUSTRATED NEWSPAPER 31, (1870) ["James T. Wehli, pianist." 31:786 (Oct. 22, 1870): 93.]

G611 "Gurney's Colossal Photographs." ANTHONY'S PHOTOGRAPHIC BULLETIN 2, no. 5 (May 1871): 155. [Two 10 ft. high portraits of O. W. Brennan and W. M. Tweed for decoration of the Blossom Club, New York, NY.]

G612 "Indian Chiefs Now Visiting the Eastern States: Little Robe (Tak-kee-o-mah), Chief of the Cheyennes, Little Raven, Head Chief of the Arapahos, Bird Chief, War-Chief of the Arapahos. - From Photographs by Gurney." FRANK LESLIE'S ILLUSTRATED NEWSPAPER 32, no. 821 (June 24, 1871): 233. 3 illus. [Portraits.]

G613 Portrait. Woodcut engraving, credited "From a Photograph by Gurney." FRANK LESLIE'S ILLUSTRATED NEWSPAPER 32, (1871) ["The late Gen. Oliver S. Halstead, Jr." 32:825 (July 22, 1871): 305.]

G614 Portrait. Woodcut engraving, credited "From a Photograph by Gurney." FRANK LESLIE'S ILLUSTRATED NEWSPAPER 34, (1872) ["S. B. Mills, pianist." 34:866 (May 4, 1872): 117.]

G615 Portraits. Woodcut engravings, credited "From a Photograph by Gurney & Son." FRANK LESLIE'S ILLUSTRATED NEWSPAPER 36, (1873) ["The late Mansfield Tracy Walworth, murdered." 36:925 (June 21, 1873): 229. "Hon. John A. Bingham, Minister to Japan." 36:925 (June 21, 1873): 241. "The late Hon. Horace F. Clark." 36:927 (July 5, 1873): 272.]

G616 Portrait. Woodcut engraving, credited "From a Photograph by Gurney & Son." FRANK LESLIE'S ILLUSTRATED NEWSPAPER 39, (1875) ["Hon. Simon B. Chittenden, M. C. from NY." 39:1006 (Jan. 9, 1875): 301.]

G617 "Gurney's Colored Glacé Photographs." ANTHONY'S PHOTOGRAPHIC BULLETIN 6, no. 4 (Apr. 1875): 127.

G618 "General Notes: Jeremiah Gurney." PHOTOGRAPHIC TIMES 13, no. 146 (Feb. 1883): 58. ["After an extended tour, embracing over three years of travel in Europe, Mr. Jeremiah Gurney is back again in his native land."]

G619 "Photographic Section of the American Institute." ANTHONY'S PHOTOGRAPHIC BULLETIN 17, no. 10 (May 22, 1886): 310-314. [Minutes of the meeting of May 4, 1886. Includes a report by H. J.

Lewis of the contributions of William Lewis and William H. Lewis (son), who made the first camera and daguerreotype equipment for Wolcott & Johnson, who opened the first daguerreotype portrait studio in America. J. Gurney's early career described as well as A. Bogardus' and Alexander Becker's.]

G620 1 b & w (Henry Ward Beecher and Harriet Beecher Stowe). MCCLURE'S MAGAZINE 7, no. 1 (June 1896): 5. 1 b & w.

G621 "Censored Likeness." HISTORY OF PHOTOGRAPHY 1, no. 3 (July 1977): 174. 1 b & w. [Group family portrait, taken c. 1855 by Gurney of Broadway, New York, NY, which has had one person scratched out later.]

G622 Ryder, Richard C. "Personalities in Perspective: Henry Ward Beecher." STEREO WORLD 6, no. 2 (May - June 1979): 21. 1 b & w. [Illustrated with a stereo portrait by Gurney.]

G623 Averell, Thomas W. "Personalities in Perspective: Charles Dickens." STEREO WORLD 6, no. 4 (Sept. - Oct. 1979): 21. 1 b & w. [Stereo portrait by J. Gurney & Sonn.]

G624 "Who Photographed Lincoln in His Casket?" PHOTOGRAPHICA 13, no. 5 (May 1981): 8-10. 2 b & w. [Benjamin Gurney, son of Jeremiah Gurney took the photographs.]

G625 Ryder, Richard C. "Personalities in Perspective: Ned Buntline." STEREO WORLD 10, no. 3 (July - Aug. 1983): 13, 28. 1 b & w. [Stereo portrait by J. Gurney & Son.]

G626 Patterson, Norman B. "The Society - from the Society Notebook." STEREO WORLD 11, no. 3 (July - Aug. 1984): 22-24, 37. 4 b & w. [Discussion of relative small production of stereo portraits, accompanied with some stereos of actresses, etc., by J. Gurney & Sons, taken in the 1870s.]

GURNEY, MARSH J. (d. 1858) (NATCHEZ, MS)
G627 "Note." PHOTOGRAPHIC AND FINE ART JOURNAL 11, no. 3 (Mar. 1858): 96.

G628 "Death of M. J. Gurney of Natchez, Miss." PHOTOGRAPHIC AND FINE ART JOURNAL 11, no. 10 (Oct. 1858): 320.

GURNSEY, B. H. (COLORADO SPRINGS, CO)
G629 "Views Near Pike's Peak." FRANK LESLIE'S ILLUSTRATED NEWSPAPER 38, no. 979 (July 4, 1874): 268. 2 illus. [Views of Monument Park, CO. Tourists in the foreground. Credited to Gurnsey.]

G630 "The Mammoth Anvil Rock, in Monument Park, Colorado. - Photographed by Gurnsey." FRANK LESLIE'S ILLUSTRATED NEWSPAPER 39, no. 991 (Sept. 26, 1874): 44. 1 illus. [View.]

G631 "Balancing Rock, on the Road from the Manitou House to the Garden of the Gods, Colorado. - Photo. by Gurnsey." FRANK LESLIE'S ILLUSTRATED NEWSPAPER 39, no. 999 (Nov. 21, 1874): 172. 1 illus. [View.]

GUTCH, JOHN WHEELEY GOUGH. (1806-1862) (GREAT BRITAIN)
BOOKS
G632 Gutch, J. W. G. Photographic Illustrations of Scotland; by J. W. G. Gutch. s. l.: s. n., 1857. 50 l. of plates. 50 b & w. [Calotypes.]

PERIODICALS
G633 Gutch, J. W. G., M.R.C.S.L. "Recollections and Jottings of a Photographic Tour, Undertaken During the Year 1856 - 57." PHOTOGRAPHIC AND FINE ART JOURNAL 11, no. 5, 7-8, 10 (May, July - Aug., Oct. 1858): 149-151, 196-197, 229-231, 302-303. [From "Photo Notes." Gutch describes his tour through England.]

G634 Gutch, J. W. G. "Recollections and Jottings of a Photographic Tour During 1858." PHOTOGRAPHIC AND FINE ART JOURNAL 12, no. 1 (June 1859): 14-16. [From "Photo. Notes." Tour of Cornwall.]

G635 Gutch, J. W. G. "Positive Pictures Taken From the Camera of a Peripatetic Photographer, in Search of Health and the Picturesque, 1859." PHOTOGRAPHIC AND FINE ART JOURNAL 13, no. 1 (Jan. 1860): 1-2, 45-46. [From "Photo. Notes." Gutch is identified as "Late Foreign Service Queen's Messenger."]

G636 "Scraps and Fragments: In Memoriam." BRITISH JOURNAL OF PHOTOGRAPHY 9, no. 167 (June 2, 1862): 218. [J. W. G. Gutch died Apr. 30, 1862. Born in Bristol, a surgeon by training, practiced in Italy. Then accepted the position of Queen's Messenger (for what would become the Foreign Office, I suppose). An ardent amateur photographer, published, for 21 years, an almanac "The Literary and Scientific Register."]

G637 "Note." JOURNAL OF THE PHOTOGRAPHIC SOCIETY OF LONDON 8, no. 122 (June 16, 1862): 78. [Note that J. W. G. Gutch died 30th of April last.]

GUTEKUNST, FREDERICK. (1831-1917) (USA)
[Frederick Gutekunst was either born Germany or in Germantown, PA in 1831. He opened his first photographic studio in Philadelphia in 1854 and remained active for over sixty years. He was very successful and ran a large studio. In 1868 he sued a lithographic company for pirating his popular portrait of General Ulysses S. Grant and won. In 1873 his studio provided twenty-two prints to illustrate a printed report on the therapeutic value of Condurango for the U. S. Bureau of Medicine and Surgery and thirteen prints to illustrate a book dedicating the opening of the new Masonic Temple built in Philadelphia. One thousand copies of the second work were known to have been printed, thus his studio had the capacity to print at least thirteen to fifteen thousand photographs that year in addition to the normal busy trade in portraits. In 1876 the studio (photographs actually taken by his brother) made a panorama of the Philadelphia Centennial Grounds, which was printed from seven negatives onto one sheet of albumen paper. This print was ten feet by eighteen inches, then considered the world's largest print. In 1878 he purchased the U. S. rights to the phototype process. He submitted work to many international exhibitions, and the work won him the Cross of the Knights of Franz-Joseph of Austria in 1878 and a pair of metal vases from the Emperor of Japan in 1879. He was active at least through the 1890s. Died in 1917.]

BOOKS
G638 Kerlin, Isaac Newton. The Mind Unveiled; or A Brief History of Twenty-two Imbecile Children. Philadelphia: V. Hunt, 1858. 147 pp. 2 b & w. [Photographs by F. Gutekunst. The 2nd edition has five albumen prints tipped-in.]

G639 United States. Bureau of Medicine and Surgery. A Report on the Origin and Therapeutic Properties of Condurango, by W. S. W. Ruschenberger. Published by order of the Navy Department. Washington, DC: Government Printing Office, 1873. 28 pp. 22 l. of plates. [Twenty-two original photographs by Frederick Gutekunst of the condurango plant's leaves, bark, etc.].]

G640 Freemasons. Pennsylvania Grand Lodge. *Dedication Memorial of the New Masonic Temple, Philadelphia, September 26th, 29th, 30th, 1873.* Compiled by the Library Committee of the R. W. Grand Lodge of Pennsylvania, Free and Accepted Masons. Philadelphia: Claxton, Remsen & Haffelfinger for the Library Committee of the Grand Lodge of Pennsylvania., 1875. xv, 236 pp. 13 b & w. illus. [Original photos by Gutekunst. 1000 copies.]

G641 Bement, William Barnes. *Catalogue of Works of Art; with Illustrations and Descriptions; also, Views of the Summer and Winter Homes, etc., of William B. Bement.* Text by Charles M. Skinner. Illustrations by F. Gutekunst. Philadelphia: Press of J. B. Lippincott, 1884. 150 l. 142 l. of plates. b & w. illus. [Phototype prints.]

PERIODICALS

G642 Portrait. Woodcut engraving, credited "From a Photograph by Gutekunst." HARPER'S WEEKLY 7, (1863) ["Admiral Samuel F. Dupont." 7:330 (Apr. 25, 1863): 257.]

G643 "Editor's Table: Singular Phenomena." PHILADELPHIA PHOTOGRAPHER 1, no. 4 (Apr. 1864): 64. ["Assisted by Mr. Peale, Mr. Gutekunst had made an Imperial Negative of a bride... odd appearance of highlights."]

G644 Portrait. Woodcut engraving, credited "From a Photograph by Gutekunst." HARPER'S WEEKLY 8, (1864) ["Adj.-Gen. Lorenzo Thomas." 8:384 (May 7, 1864): 300.]

G645 Portraits. Woodcut engravings, credited "Photographed by F. Gutekunst, Phila. FRANK LESLIE'S ILLUSTRATED NEWSPAPER 19, (1864) ["Right Rev. James F. Wood, Bishop of Philadelphia." 19:481 (Dec. 17, 1864): 205.]

G646 "Editor's Table." PHILADELPHIA PHOTOGRAPHER 2, no. 18 (June 1865): 103. [Photos of General Grant being taken by Gutekunst, notes that Wenderoth, Taylor & Brown and Newhall also made photos of Grant.]

G647 Portrait. Woodcut engraving, credited "From a Photograph by Frederick Gutekunst, Philadelphia." HARPER'S WEEKLY 9, (1865) ["Lieut.-Gen. Ulysses S. Grant." 9:467 (Dec. 9, 1865): 772.]

G648 "Editor's Table: Mr. Gutekunst's New Gallery." PHILADELPHIA PHOTOGRAPHER 3, no. 28 (Apr. 1866): 128.

G649 "Editor's Table." PHILADELPHIA PHOTOGRAPHER 4, no. 48 (Dec. 1867): 403. [Gutekunst won a silver medal at the Maryland Institute in Baltimore, MD.]

G650 "Can A Photograph Be Copyrighted? Important Lawsuit." PHILADELPHIA PHOTOGRAPHER 5, no. 59 (Nov. 1868): 379-381. [F.Gutekunst sued Weise & Co., lithographers, who violated his copyright on a portrait of General Grant. Lost his case.]

G651 Portraits. Woodcut engravings, credited "From a Photograph by Gutekunst." HARPER'S WEEKLY 13, (1869) ["Hon. Andrew G. Curtin, Minister to Russia." 13:645 (May 8, 1869): 297. "Gov. J. W. Geary, of PA." 13:671 (Nov. 6, 1869): 705.]

G652 Portrait. Woodcut engraving, credited "From a Photograph by F. Gutekunst." FRANK LESLIE'S ILLUSTRATED NEWSPAPER 28, (1869) ["Hon. John Bigelow, Editor 'NY Daily News.'" 28:727 (Sept. 4, 1869): 396.]

G653 "Philadelphia. - The New Masonic Temple - Interior Rooms As Thrown Open to the Public Previous to the Dedication. From Photographs by F. Gutekunst, Philadelphia." FRANK LESLIE'S ILLUSTRATED NEWSPAPER 37, no. 941 (Oct. 11, 1873): 75-76. 6 illus. [Interiors.]

G654 "Note." ANTHONY'S PHOTOGRAPHIC BULLETIN 5, no. 5 (May 1874): 183. [From "Phila. Evening Chronicle." Praise for Gutekunst for winning two of the awards offered by the Anthony Co. for portraits.]

G655 "The Exhibition of the Belgium Photographic Association." PHILADELPHIA PHOTOGRAPHER 12, no. 143 (Nov. 1875): 347-348. [Brief discussion of this exhibition, listing of judges and prizewinners, followed by extensive praise of F. Gutekunst, one of the award winners.]

G656 Portraits. Woodcut engravings, credited "From a Photograph by Gutekunst." FRANK LESLIE'S ILLUSTRATED NEWSPAPER 42, (1876) ["John Welsh, financier." 42:1080 (June 10, 1876): 221. "Alfred T. Goshorn, Director of the Phila. Centennial." 42:1083 (July 1, 1876): 277.]

G657 Portrait. Woodcut engraving credited "From a photograph by F. Gutekunst." ILLUSTRATED LONDON NEWS 69, (1876) ["Col. H. B. Sandford, R.A." 69:1931 (July 29, 1876): 109.]

G658 Portrait. Woodcut engraving, credited "From a Photograph by Gutekunst." FRANK LESLIE'S ILLUSTRATED NEWSPAPER 43, (1876) ["Myer Asch, architect of Centennial Expo." 43:1104 (Nov. 25, 1876): 193.]

G659 "A Large Photograph of the Exhibition Buildings." ANTHONY'S PHOTOGRAPHIC BULLETIN 7, no. 12 (Dec. 1876): 375-376. [From "Philadelphia Ledger."]

G660 "Editor's Table: A Remarkable Photograph." PHILADELPHIA PHOTOGRAPHER 14, no. 157 (Jan. 1877): 32. [Panoramic view of Phila. Centennial, 10 feet long and 18 inches wide, made from 7 negatives by F. Gutekunst. Further description of the making of this photo appears on pp. 47-48 of the Feb. issue, in the report of the Photo Soc. of Philadelphia.]

G661 Spencer, F. M. "Scattered Thoughts: First Paper." PHILADELPHIA PHOTOGRAPHER 14, no. 158 (Feb. 1877): 46-47. [Discussion of printing photographs, discusses the work of F. Gutekunst, mentions his panoramic view at the Philadelphia Exhibition.]

G662 "Photo-Etchings." ANTHONY'S PHOTOGRAPHIC BULLETIN 9, no. 1 (Jan. 1878): 2-3. [From "Br J of Photo."]

G663 "Note." ANTHONY'S PHOTOGRAPHIC BULLETIN 9, no. 1 (Jan. 1878): 32. [Gutekunst awarded Cross of the Knights of Franz-Joseph, of Austria.]

G664 Portrait. Woodcut engraving credited "From a photograph by Gutekunst." ILLUSTRATED LONDON NEWS 72, (1878) ["Mr. John Welsh, New American Minister." 72:2011 (Jan. 12, 1878): 37.]

G665 "Editor's Table: A Worthy Decoration." PHILADELPHIA PHOTOGRAPHER 15, no. 170 (Feb. 1878): 62. [Frederick Gutekunst (Philadelphia, PA) received the "Cross of the Knights of the Austrian Order of Franz Josef" from the Emperor of Austria.]

G666 "Note." PHOTOGRAPHIC TIMES 8, no. 89 (May 1878): 112. [F. Gutekunst, made some striking cabinet glace portraits of Mr. Bayard Taylor. . .]

G667 Nichol, John, PH.D. "Transatlantic Notes." ANTHONY'S PHOTOGRAPHIC BULLETIN 9, no. 9 (Sept. 1878): 272-275. [From "Br J of Photo." Nichol, from England, visited the USA, gave his impressions. Here he describes his experiences in Philadelphia, where he met the amateurs Browne and Ellerslie Wallace. Discusses the professional, F. Gutekunst.]

G668 Portrait. Woodcut engraving, credited "From a Photograph by Gutekunst." FRANK LESLIE'S ILLUSTRATED NEWSPAPER 47, (1878) ["D. L. Holden, inventor of an ice making machine." 47:1212 (Dec. 21, 1878): 268.]

G669 Portraits. Woodcut engravings, credited "From a Photograph by Gutekunst." FRANK LESLIE'S ILLUSTRATED NEWSPAPER 47, (1879) ["The late Morton McMichael, Mayor of Philadelphia, editor." 47:1217 (Jan. 25, 1879): 380. "The late John Cadwalader, Judge." 47:1221 (Feb. 22, 1879): 449.]

G670 Portraits. Woodcut engravings, credited "From a Photograph by Gutekunst." FRANK LESLIE'S ILLUSTRATED NEWSPAPER 48, (1879) ["The late Judge Asa Packer." 48:1236 (June 7, 1879): 233. "Daniel O. Barr, of PA." 48:1248 (Aug. 30, 1879): 425.]

G671 "Editor's Table." PHILADELPHIA PHOTOGRAPHER 16, no. 189 (Sept. 1879): 287. [Mr. F. Gutekunst has received a pair of elegantly wrought metal vases from the Emperor of Japan, as a slight token of his appreciation of Mr. Gutekunst's talent as a photographer, examples of which were sent to him.]

G672 Portrait. Woodcut engraving, credited "From a Photograph by Gutekunst." FRANK LESLIE'S ILLUSTRATED NEWSPAPER 49, (1879) ["George F. Barker, M.D." 49:1230 (Sept. 13, 1879): 29.]

G673 "Editor's Table: Phototype Pictures." PHILADELPHIA PHOTOGRAPHER 17, no. 194 (Feb. 1880): 63-64.

G674 "Our Picture." PHILADELPHIA PHOTOGRAPHER 17, no. 196 (Apr. 1880): 101-103, plus frontispiece. 1 b & w. [Portrait of the actress Adelaide Detchon.]

G675 Lathrop, George Parsons. "'A Clever Town Built by Quakers.'" HARPER'S MONTHLY 64, no. 381 (Feb. 1882): 323-328. 17 illus. [About Philadelphia. Wood engravings, from photographs. Views, buildings, etc., not credited. Portraits, credited to "F. Gutekunst, Philadelphia."]

G676 Taylor, J. Traill. "The Studios of America. No. 12. The Studio of F. Gutekunst, Philadelphia, Pa." PHOTOGRAPHIC TIMES 13, no. 155 (Nov. 1883): 572-574. 1 illus.

G677 Gutekunst, F. "Correspondence." PHOTOGRAPHIC TIMES 14, no. 161 (May 1884): 272. [Gutekunst writing to protest that a notice of "a large transparency of the Capitol buildings," mentioned in the report of the proceedings of the Philadelphia Photographic Society was credited to "William Bell, the maker of the negative. As Mr. Bell was at that time in my employ, and sent to Washington at my expense for the purpose of making these negatives, I think the credit was not given to the proper person..."]

G678 "Phototypy." PHOTOGRAPHIC TIMES 16, no. 275 (Dec. 24, 1886): 663-664, frontispiece. 1 b & w. [A genre photo by Gutekunst, [Not bound into this volume] reproduced in the phototypy process.]

G679 "The Editorial Table." PHOTOGRAPHIC TIMES 19, no. 427 (Nov. 22, 1889): 586. [Mr. F. Gutekunst...is making a notable collection of famous Americans...a portrait of Walt Whitman.]

G680 1 photo ("A Merry Tale."). AMERICAN ANNUAL OF PHOTOGRAPHY AND PHOTOGRAPHIC TIMES ALMANAC FOR 1890 (1890): 48, unnumbered leaf following p. 48. 1 b & w. [Note on p. 48]

G681 "The Editorial Table." PHOTOGRAPHIC TIMES 20, no. 435 (Jan. 17, 1890): 35. [Description of "one of the finest illustrated souvenirs we have ever seen...issued by F. Gutekunst containing specimens of photogravure and phototype specialties..."]

G682 "Thoughts of Puss on Life." PHOTOGRAPHIC TIMES 20, no. 447 (Apr. 11, 1890): 171. 1 b & w. [Cat portrait.]

G683 "The Editorial Table." PHOTOGRAPHIC TIMES 20, no. 479 (Nov. 21, 1890): 584. [Mentions the addition of Longfellow to Gutekunst's series of portraits of eminent Americans "all taken from life and published in phototype..."]

G684 "The Editorial Table." PHOTOGRAPHIC TIMES 21, no. 500 (Apr. 17, 1891): 192. [Note that Gutekunst is compiling a series of portraits of "eminent Americans in every walk of life..."]

G685 1 photo (Actor Lawrence Barrett) PHOTOGRAPHIC TIMES 21, no. 503 (May 8, 1891): 216-217.

G686 1 photo (Portrait of P. T. Barnum) PHOTOGRAPHIC TIMES 21, no. 506 [sic 507] (June 5, 1891): 268-269.

G687 1 photo (James Russell Lowell) as frontispiece. PHOTOGRAPHIC TIMES 21, no. 511 (July 3, 1891): 317, plus frontispiece.

G688 1 photo (Portrait of George William Curtis). PHOTOGRAPHIC TIMES 21, no. 523 (Sept. 25, 1891): 473, plus frontispiece. 1 b & w.

G689 "Notes and News." PHOTOGRAPHIC TIMES 21, no. 528 (Oct. 30, 1891): 540. [Note about a panoramic photograph of the Philadelphia harbor that is 10" x 35".]

G690 1 photo (Portrait, Bishop Phillips Brooks). PHOTOGRAPHIC TIMES 21, no. 529 (Nov. 6, 1891): 549, plus frontispiece.

G691 1 photo (Portrait of General W. T. Sherman). PHOTOGRAPHIC TIMES 21, no. 536 (Dec. 25, 1891): 660, plus frontispiece. 1 b & w. [Note on p. 660.]

G692 1 photo ("The Sisters"). PHOTOGRAPHIC TIMES 22, no. 541 (Jan. 29, 1892): 49, plus frontispiece. 1 b & w.

G693 1 photo (Portrait of Walt Whitman). PHOTOGRAPHIC TIMES 22, no. 543 (Feb. 12, 1892): 77, plus frontispiece. 1 b & w. [Note on p. 77 includes brief biography of Whitman.]

G694 "Editorial Notes." PHOTOGRAPHIC TIMES 22, no. 543 (Feb. 12, 1892): 78. [Brief description of Gutekunst's studio in Philadelphia.]

G695 1 photo (Portrait of General Grant). PHOTOGRAPHIC TIMES 22, no. 545 (Feb. 26, 1892): 101, plus frontispiece. 1 b & w.

G696 1 photo (Portrait of Sir Edwin Arnold). PHOTOGRAPHIC TIMES 22, no. 547 (Mar. 11, 1892): 129, plus frontispiece. 1 b & w. [Note on p. 129.]

G697 1 photo (Portrait of Frederic E. Ives). PHOTOGRAPHIC TIMES 22, no. 553 (Apr. 22, 1892): 209, plus frontispiece. 1 b & w. [Note on p. 209.]

G698 1 photo (Portrait of Henry W. Longfellow) PHOTOGRAPHIC TIMES 22, no. 568 (Aug. 5, 1892): 397, plus frontispiece. 1 b & w. [Note on p. 397.]

G699 "Bayard Taylor." PHOTOGRAPHIC TIMES 22, no. 582 (Nov. 11, 1892): 569, plus frontispiece. 1 b & w. [Portrait of the author Bayard Taylor.]

G700 1 photo (Portrait of Edwin Booth). PHOTOGRAPHIC TIMES 23, no. 613 (June 16, 1893): 309, plus frontispiece. 1 b & w. [Note on p. 309 includes a biography of the actor Edwin Booth.]

G701 1 b & w (Actor Edwin Booth). MCCLURE'S MAGAZINE 1, no. 3 (Aug. 1893): 257.

G702 1 photo (Little Miss Gutekunst"). PHOTOGRAPHIC TIMES 24, no. 643 (Jan. 12, 1894): frontispiece, before p. 17.

G703 1 photo ("The First Communion"). PHOTOGRAPHIC TIMES 24, no. 648 (Feb. 16, 1894): frontispiece, before p. 97. [Note on p. 99.]

G704 "Our Picture." WILSON'S PHOTOGRAPHIC MAGAZINE 32, no. 466 (Oct. 1895): 462, plus unnumbered leaf following p. 464. [Portrait. Photo titled "Possibilities in Half-tone" and was printed to show that process by F. Gutekunst & Co.]

G705 Gutekunst, Frederick. "Panoramic Photography: A Correction." WILSON'S PHOTOGRAPHIC MAGAZINE 34, no. 483 (Mar. 1897): 141-142. [Letter from F. Gutekunst stating his brother made a panoramic photo of the Centennial Exhibition in 1876, thus proceeding W. H. Jackson as claimed in Franklin Nius in Feb. issue.]

G706 1 photo (Wayne MacVeagh). WORLD'S WORK 6, no. 1 (May 1903): 3374.

G707 1 photo (Portrait of Dr. William Osler). WORLD'S WORK 9, no. 1 (Nov. 1904): 5441.

G708 1 photo (John Weaver, Mayor of Philadelphia). WORLD'S WORK 10, no. 3 (July 1905): 6336.

G709 1 photo (Alexander Simpson, Jr., lawyer). WORLD'S WORK 12, no. 4 (Aug. 1906): 7810.

GUYOT, L. & CO. (PARIS, FRANCE)

G710 Portrait. Woodcut engraving credited "From a photograph by L. Guyot & Co., Rue Montmarte, Paris" ILLUSTRATED LONDON NEWS 43, (1863) ["Prince De La Tour d'Auvergne." 43:* (Nov. 14, 1863): 488.]

GUYTON, JOSEPH. (LIVERPOOL, ENGLAND)

G711 Walton, Elijah, F. G. S. *Clouds: Their Forms and Combinations.* London: Longmans, Green, and Co., 1868. 31, 42 plates pp. 46 b & w. [" ...the author... produced the drawings from which the photographs in this volume have been taken....thanks are due to Joseph Guyton, Esq., of Liverpool, for his great care in the production of the photographs." Original prints of drawings.]

H

M. H.
H1 M. H. "Photographic Tourist: A Few Days on Dartmoor. Parts 1 - 8." PHOTOGRAPHIC NEWS 4, no. 106-118 (Sept. 14 - Dec. 7, 1860): 235, 250, 258, 282, 307-308, 342-343, 367-368, 376-377.

HAARSTICK. (DÜSSELDORF, GERMANY)
H2 Portrait. Woodcut engraving credited "From a photograph by Haarstick." ILLUSTRATED LONDON NEWS 73, (1878) ["Ernest Crofts, A.R.A." 73:2038 (July 20, 1878): 53.]

HAAS & PEALE.
BOOKS
H3 "Partners in Posterity - A Portfolio: Haas & Peale and Their Incomparable Record of Siege in South Carolina," on pp. 153-172 in: *The South Besieged: Volume Five of the Image of War 1861 - 1865.* Garden City, NY: Doubleday & Co., 1983. 32 b & w.

PERIODICALS
H4 Kaplan, Milton. "The Case of the Disappearing Photographers." QUARTERLY JOURNAL OF THE LIBRARY OF CONGRESS 24, no. 1 (Jan. 1967): 41-45. 12 b & w. [Civil War photographs by Haas & Peale from twenty-five glass plate negatives held at the Library of Congress. Views and portraits of Union Army activities in 1863 on islands off coast of South Carolina. Probably a Lieut. Philip Haas of Company A, 1st NY Engineers.]

HAAS, PHILIP see also HAAS & PEALE.

HAAS, PHILIP.
[Philip Haas worked as a lithographer and publisher of lithographs between 1837 and 1845, making views, portraits, and technical prints. He took up the daguerreotype and ran a photographic studio on Broadway, New York, NY from 1844 to 1857. Operated in Washington, DC in 1849, perhaps on a working visit. When the Civil War broke out Haas enlisted in Company A, 1st NY Engineers, where he was promoted to lieutenant. His company spent part of 1863 among the forces involved in the blockade of the Confederacy. Haas, with a partner Peale, photographed the activities of these troops patrolling the string of islands off of the coast of South Carolina.]

H5 "Fernando Wood, Mayor-Elect of New York." GLEASON'S PICTORIAL DRAWING-ROOM COMPANION 7, no. 24 (Dec. 16, 1854): 380. 1 illus. ["...engraved from a fine daguerreotype taken by P. Haas, No. 371 Broadway."]

H6 Portrait. Woodcut engraving, credited "From a Photograph by Lieut. Haas." HARPER'S WEEKLY 6, (1862) ["Brig.-Gen. Quincy A. Gilmore." 6:280 (May 10, 1862): 301.]

H7 Portrait. Woodcut engraving, credited "From a Photograph by Haas." HARPER'S WEEKLY 7, (1863) ["Gen. Quincy A. Gilmore." 7:346 (Aug. 15, 1863): 525.]

HAASE, E. & CO. (BERLIN, GERMANY)
H8 "Note." PHOTOGRAPHIC NEWS 4, no. 105 (Sept. 7, 1860): 227. [Series of portraits of Royal Family of Prussia published.]

H9 "Our Weekly Gossip." ATHENAEUM no. 1781 (Dec. 14, 1861): 809. [Herren Haase & Co. (Berlin) issued photos of individuals attending the coronation in that city.]

H10 "Note." JOURNAL OF THE PHOTOGRAPHIC SOCIETY OF LONDON 7, no. 116 (Dec. 15, 1861): 340. [King of Prussia, at time of recent coronation had photos made by Haase & Co.]

H11 Portrait. Woodcut engraving credited "From a photograph by E. Haase & Co." ILLUSTRATED LONDON NEWS 50, (1867) ["Peter Von Cornelius." 50:* (Apr. 6, 1867): 341.]

HADDOCK, WILLIAM. (CIRCLEVILLE, OH)
H12 Haddock, William. "A New Opalotype Process, and a New Developer." AMERICAN JOURNAL OF PHOTOGRAPHY AND THE ALLIED ARTS & SCIENCES n. s. vol. 9, no. 2 (Sept. 15, 1866): 44-46.

HADOW, E. see MASKELYNE.

HAERTWIG, GUSTAVE.
H13 Haertwig, Gustave. "A Portable Travelling Tent." ANTHONY'S PHOTOGRAPHIC BULLETIN 6, no. 3 (Mar. 1875): 84-85. [From "Photographisches Archiv." Haertwig from Magdeburg.]

HAES, FRANK. (1832-1916) (GREAT BRITAIN)
H14 "Stereographs. Australian Botanical Illustrations, &c., Photographed by Frank Haes, London: McLean, Melhuish & Haes." BRITISH JOURNAL OF PHOTOGRAPHY 9, no. 170 (July 15, 1862): 271-272. [Taken at the Sydney Botanical Gardens, the Sydney Observatory, etc.]

H15 "Mementoes of the Royal Wedding: The Royal Yacht at the Nore. Photographed by F. Haes. London: McLean & Haes." BRITISH JOURNAL OF PHOTOGRAPHY 10, no. 191 (June 1, 1863): 237.

H16 "Our Editorial Table: Stereoscopic Pictures of Wild Beasts." BRITISH JOURNAL OF PHOTOGRAPHY 12, no. 251 (Feb. 24, 1865): 102.

H17 "Editor's Table." PHILADELPHIA PHOTOGRAPHER 2, no. 16 (Apr. 1865): 66. [Stereograms of wild beasts from London Zoo.]

H18 "Note." ART JOURNAL (July 1865): 227. [Photos of animals from life at London Zoo, published by Mr. McLean.]

HAGGERTY, WILLIAM see NOTMAN, WILLIAM (Triggs).

HAIGH.
H19 Haigh. "On Photography." HUMPHREY'S JOURNAL OF PHOTOGRAPHY, AND THE ALLIED ARTS AND SCIENCES 10, no. 22 (Mar. 15, 1859): 343-345. [Read to Halifax Literary and Philosophical Society.]

H20 Portrait. Woodcut engraving credited "From a photograph by Haigh." ILLUSTRATED LONDON NEWS 67, (1875) ["Capt. George Pearse, champion shot." 67:1877 (July 31, 1875): 117.]

HAIGH & HEMERY. (LONDON, ENGLAND)
H21 Portraits. Woodcut engravings credited "From a photograph by Haigh & Hemery, Regent St." ILLUSTRATED LONDON NEWS 69, (1876) ["Sir Thomas White, Lord Mayor of London, Sheriff Hadley, Sheriff Quatermaine East." 69:1947 (Nov. 18, 1876): 485.]

HAIGH, EDWARD. (MELBOURNE, AUSTRALIA)
H22 "Congregational Church of Saltaire." ILLUSTRATED LONDON NEWS 35, no. 1009 (Dec. 24, 1859): 627-628. 1 illus. [Interior. "From a Photograph by E. Haigh."]

H23 "Note." ART JOURNAL (Aug. 1862): 178. [A series of Photographic Views of Melbourne taken by Mr. Edward Haigh and published in England by Mr. H. B. Randall, King Street, Liverpool.]

H24 "Views of Melbourne." ILLUSTRATED LONDON NEWS 43, no. 1213 (July 18, 1863): 60-61. 1 illus. [Mr. Edward Haigh (of the Firm of Moira & Haigh) having lately returned from Australia, is now exhibiting a collection of views by him in and about Melbourne."]

H25 "Views in Melbourne, Australia - The Treasury and Government Printing-Offices, Bourke Street." ILLUSTRATED LONDON NEWS 43, no. 1215 (Aug. 1, 1863): 112. 2 illus.

H26 Portraits. Woodcut engravings credited "From a photograph by E. M. Haigh." ILLUSTRATED LONDON NEWS 66, (1875) ["Sir Albert Woods, Freemason, Mr. John Hervey, Freemason, Mr. J. B. Monckton, Freemason, Rev. R. P. Bent, Freemason, Mr. T. Fenn, Freemason. (5 portraits) " 66:1865 (May 8, 1875): 432.]

HAINES & WICKES. (ALBANY, NY)
H27 "Photographs Received: Magnesium Pictures." PHILADELPHIA PHOTOGRAPHER 3, no. 26 (Feb. 1866): 64. [Haines & Wickes from Albany, NY. Cartes and Stereo views of studio interiors, taken with magnesium flash.]

H28 Towler, Prof. "Mastodon." HUMPHREY'S JOURNAL OF PHOTOGRAPHY, AND THE ALLIED ARTS AND SCIENCES 18, no. 15 (Dec. 1, 1866): 228-229. [Stereo of Mastodon fossil by Haines & Wickes, of Albany, NY, causes Towler to write an essay on this newly discovered phenomenon.]

H29 "Bones of the Mastodon Recently Discovered at Cohoes, New York." HARPER'S WEEKLY 10, no. 519 (Dec. 8, 1866): 772. 1 illus. ["Photographed by Haines & Wickes, Albany, NY."]

HAINES, C. L.
H30 Haines, C. L. "Birmingham Photographic Society: The Rise and Progress of Photography." HUMPHREY'S JOURNAL OF PHOTOGRAPHY, AND THE ALLIED ARTS AND SCIENCES 9, no. 21 (Mar. 1, 1858): 328-333. [From "Photo. Notes." Haines gives prehistory, Niépce, Daguerre and Talbot, etc.]

H31 Haines, C. L. HUMPHREY'S JOURNAL OF PHOTOGRAPHY, AND THE ALLIED ARTS AND SCIENCES 10, no. 2 (May 15, 1858): 31. [From "Photo. Notes."]

H32 Haines, C. L. "On the Abuses of Photography." HUMPHREY'S JOURNAL OF PHOTOGRAPHY, AND THE ALLIED ARTS AND SCIENCES 10, no. 20 (Feb. 15, 1859): 311-313. [From "Photo. Notes."]

HAINES, E. M. (CHICAGO, IL)
H33 Portrait. Woodcut engraving, credited "From a Photograph by E. M. Haines, Chicago, IL." NEW YORK ILLUSTRATED NEWS 4, (1861) ["Richard Yates, Gov. of IL." 4:88 (July 13, 1861): 156.]

HAINES, E. S. M. (ALBANY, NY)
H34 "Editor's Table." PHILADELPHIA PHOTOGRAPHER 6, no. 65 (May 1869): 169. [Stereos of physiological specimens noted.]

H35 "The New State Capitol at Albany." HARPER'S WEEKLY 13, no. 667 (Oct. 9, 1869): 647, 648. 1 illus. ["Photographed by E. S. M. Haines."]

H36 Portraits. Woodcut engravings, credited "From a Photograph by Haines." FRANK LESLIE'S ILLUSTRATED NEWSPAPER 40, (1875) ["Hon. James M. Oakley, NY State Assembly." 40:1024 (May 15, 1875): 161. "Hon. S. S. Lowrey, NY State Assembly." 40:1024 (May 15, 1875): 161.]

HAINES, H.
H37 Haines, H. "Fothergill's Process." HUMPHREY'S JOURNAL OF PHOTOGRAPHY, AND THE ALLIED ARTS AND SCIENCES 11, no. 5 (July 1, 1859): 72. [From "Photo. Notes."]

HAINS.
H38 Hains. "On the Uses and Abuses of Photography." AMERICAN JOURNAL OF PHOTOGRAPHY 1, no. 20 (Mar. 15, 1859): 317-321. [Abstracted from "Photo News"]

HALE, EDWARD EVERETT. (1822-1909) (USA)
H39 Canfield, C. W. "Notes on Photography in Boston In 1839-40." AMERICAN ANNUAL OF PHOTOGRAPHY AND PHOTOGRAPHIC TIMES ALMANAC FOR 1894 (1894): 261-263. [Includes a letter from Rev. E. E. Hale detailing his early experiments with the daguerreotype in 1839, 1840.]

HALE, F. F. (PORTLAND, ME)
H40 "Photography in Maine." ANTHONY'S PHOTOGRAPHIC BULLETIN 6, no. 4 (Apr. 1875): 110. [From "Portland [ME] Advertiser."]

HALE, LUTHER HOLMAN. (1823-1885) (USA)
H41 Keyes, R. W. "Luther Holman Hale and the Daguerrean Art." PHOTOGRAPHIC ART JOURNAL 1, no. 6 (June 1851): frontispiece, 357-359. 1 illus. [Portrait. (Lithograph by D'Avignon.) Hale born at Milbury, MA, on Sept. 21, 1823. His father was a wealthy scythe manufacturer. Luther was mechanically inclined, he entered Hopkinton Academy at age 16. Then he worked as a salesman, then learned the daguerreotype process "at the office of his brother in Milk Street, Boston." Left once, then returned, finally "commenced his labors in 1842." Several years later he began his own gallery on Washington St., in Boston, MA. He also began to manufacture photographic chemicals with Benjamin French. At this time he is 28 years old, and has been in the business 9 years.]

HALEY, W. S.
H42 Haley, W. S. The Daguerreotype Operator; A Practical Work, Containing the Most Approved Methods for Producing Daguerreotypes; Together with All the Late Improvements. New York: Printed for the author, 1854. 80 pp.

HALL & GURNEY.
H43 "Tinted Ambrotypes." HUMPHREY'S JOURNAL 8, no. 7 (Aug. 1, 1856): 97-98. [M. A. Root (Philadelphia, PA) and J. B. Hall (of J. Gurney's Gallery, New York, NY) hand tinted ambrotypes.]

H44 "Hallotypes. - Important to the Photographic Public." HUMPHREY'S JOURNAL 8, no. 17 (Jan. 1, 1857): 257-258. [John Bishop Hall, partner with J. Gurney, in new printing process for portraits.]

H45 "Personal & Art Intelligence." PHOTOGRAPHIC AND FINE ART JOURNAL 10, no. 2 (Feb. 1857): 62. [Includes letters from J. Gurney and John Bishop Hall on their Hallotype process.]

H46 "Hallotype." HUMPHREY'S JOURNAL 8, no. 21 (Mar. 1, 1857): 321-323. [Letter from Hall & Gurney, describing their relief printing process, plus praise from the editor.]

H47 Antisell, Thomas, M.D. "Hallotype." HUMPHREY'S JOURNAL 8, no. 21 (Mar. 1, 1857): 324-325. [Description, praise of the relief printing process.]

H48 "Hallotypes. - Specification of Mr. Hall's Patent Process for Treating Photographic Impressions." HUMPHREY'S JOURNAL 8, no. 22 (Mar. 15, 1857): 337-339. [Includes text of patent by John Bishop Hall and remarks by Thomas Antisell, M.D., on p. 339.]

HALL & HUBBELL. (USA)
H49 "Note." PHOTOGRAPHIC TIMES 8, no. 85 (Jan. 1878): 14. ["The firm of Hall & Hubbell, view photographers No. 78 Fulton St., have just completed the largest photographic view of N. Y. City ever made; 90" in length by 30" in width."]

HALL, ALFRED.
H50 Hall, Alfred. "Fifth Annual Meeting and Exhibit of the National Photographic Association of the U.S., held in Buffalo, N.Y., beginning July 5, 1873: On Copying Enlargements." PHILADELPHIA PHOTOGRAPHER 10, no. 117 (Sept. 1873): 424-430.

H51 "Meetings of Societies: Chicago Photographic Association." PHOTOGRAPHIC TIMES 11, no. 124 (Apr. 1881): 145-153. [Unusually long and detailed report of a meeting of this association on the impacts of the gelatine dry-plate process on commercial photographers. Brought forth reminiscences by the Society's President, Alfred Hall, (a photographer for thirty-three years); P. B. Green (a Chicago pioneer in the use of dry plates); A. Hesler; Joshua Smith; George N. Barnard (from Rochester, NY); and others.]

HALL, B. F. (LANSING, MI)
H52 Hall, B. F. "Spirit Photography Revived." PHILADELPHIA PHOTOGRAPHER 10, no. 110 (Feb. 1873): 44-46. [B. F. Hall (Lansing, MI) squelches another attempt of a "spirit photographer" to defraud people.]

H53 Portrait. Woodcut engraving, credited "From a Photograph by B. F. Hall, Lansing, MI." FRANK LESLIE'S ILLUSTRATED NEWSPAPER 40, (1875) ["Hon. I. P. Christiancy, Sen. from MI." 40:1015 (Mar. 13, 1875): 12.]

HALL, CHARLES H., REV. (1820-1895) (USA)
H54 Troxell, B. F., Secretary. "Brooklyn Photographic Art Association." ANTHONY'S PHOTOGRAPHIC BULLETIN 4, no. 11 (Nov. 1873): 331-334. [Rev. Dr. Charles H. Hall, an amateur, was elected president of the Brooklyn Photographic Art Assoc. Dr. Hall related some incidents from his experience in taking pictures of landscapes during the war, then made a statement about the importance of the medium which was excerpted on pp. 331-332. Lecture "The Decline of Art," by C. H. Williamson, also printed.]

HALL, F. C. (PORT GIBSON, MS)
H55 "Editor's Table." PHILADELPHIA PHOTOGRAPHER 15, no. 178 (Oct. 1878): 320. [F. C. Hall (Port Gibson, MS), five children sick with yellow fever - resources drained, asking for help.]

HALL, JAMES.
H56 Hall, James. "Binocular Perspective." PHOTOGRAPHIC ART JOURNAL 4, no. 1, 3 (July, Sept. 1852): 45-49, 169-173. 2 illus. [From "London Art Journal." Letter addressed to Prof. Wheatstone.]

H57 Hall, James. "Binocular Perspective and Binocular Photography." ART JOURNAL (July 1854): 203.

H58 Hall, James. "Binocular Perspective and Binocular Photography." PHOTOGRAPHIC AND FINE ART JOURNAL 7, no. 8 (Aug. 1854): 249-250. [From "London Art. J."]

HALL, JOHN BISHOP see also HALL & GURNEY.

HALL, JOHN BISHOP.
H59 Hall, John Bishop. "The Hallotype Patent: Specifications." PHOTOGRAPHIC AND FINE ART JOURNAL 10, no. 3 (Mar. 1857): 75.

H60 "Relief Pictures." PHOTOGRAPHIC AND FINE ART JOURNAL 10, no. 4 (Apr. 1857): 121-122. [From "Scientific American."]

H61 Burnett, C. J. "The 'Athenaeum' on the Hallotype." PHOTOGRAPHIC AND FINE ART JOURNAL 10, no. 8 (Aug. 1857): 254. [From "Liverpool Photo. J."]

HALL, JOSEPH.
BOOKS
H62 Gems from Green-Wood. Photographed by Joseph Hall, Brooklyn. New York: Caldwell & Co., 1868. x, 24 pages alternating with the plates. 31 b & w.

PERIODICALS
H63 Ward, John Montgomery. "Our National Game." COSMOPOLITAN 5, no. 6 (Oct. 1888): 442-455. 17 b & w. [Baseball players, group portraits, spectators, etc. Several credited to Joseph Hall.]

HALL, JULIUS. (GREAT BARRINGTON, MA)
H64 Hall, Julius. "Outdoor Work with but Little Water." PHILADELPHIA PHOTOGRAPHER 9, no. 106 (Oct. 1872): 356. [Hall from Stockbridge, MA.]

H65 Hall, Julius. "Letter." PHOTOGRAPHER'S FRIEND 2, no. 4 (Oct. 1872): 118. [About stereos.]

H66 "Note." PHOTOGRAPHIC TIMES 2, no. 22 (Oct. 1872): 148-149. [Six exquisite stereo views of Rocky Mountain scenery "The Old Monument Mt." and "A glimpse of Stockbridge Valley from Monument Mountain."]

H67 "Matters of the Month: Mr. Julius Hall." PHOTOGRAPHIC TIMES 4, no. 46 (Oct. 1874): 154. [Julius Hall, of Great Barrington, MA, sent views of Bash Bish Falls, etc.]

H68 "Matters of the Month: Stereoscopic Interiors." PHOTOGRAPHIC TIMES 5, no. 60 (Dec. 1875): 295-296.

H69 "Note." PHOTOGRAPHIC WORLD 6, no. 70 (Oct. 1876): 231. [Landscape, interiors, stereos noted.]

H70 "Matters of the Month." PHOTOGRAPHIC TIMES 7, no. 75 (Mar. 1877): 58. ["Mr. Julius Hall, of Great Barrington, Mass., whose reputation as a landscape photographer is well known throughout the East, has sent us some very fine specimens of portrait work."]

H71 "Editor's Table." PHILADELPHIA PHOTOGRAPHER 14, no. 163 (July 1877): 224. [Julius Hall (Great Barrington, MA) praised.]

H72 "Matters of the Month: Photographic Interiors." PHOTOGRAPHIC TIMES 7, no. 84 (Dec. 1877): 267-268. [Describes photographs of interiors.]

H73 "Matters of the Month." PHOTOGRAPHIC TIMES 10, no. 112 (Apr. 1880): 81. [Cabinet photos.]

HALL, SAMUEL CARTER. (GREAT BRITAIN)
H74 Wilsher, Ann. "Hall of Fame." HISTORY OF PHOTOGRAPHY 3, no. 2 (Apr. 1979): 133-134. 2 illus. [This article is about Samuel Carter Hall, founder of the periodical, "Art Union" (later called "Art Journal") and its involvement with photography.]

HALL, SAMUEL W. (d. 1877) (USA)
H75 "Obituary: Samuel W. Hall." PHOTOGRAPHIC TIMES 7, no. 76 (Apr. 1877): 88-89. [President of Scoville Manufacturing Co.]

HALLENBECK, JOHN H. (d. 1893) (USA)
H76 Hallenbeck, J. H. "Unbromized Collodion." HUMPHREY'S JOURNAL OF PHOTOGRAPHY, AND THE ALLIED ARTS AND SCIENCES 17, no. 24 (Apr. 15, 1866): 383-384.

H77 Hallenbeck, J. H. "Photographs on Vases, Urns, etc., etc." HUMPHREY'S JOURNAL OF PHOTOGRAPHY, AND THE ALLIED ARTS AND SCIENCES 18, no. 4 (June 15, 1866): 60.

H78 Hallenback, John H. "Inklings from the Workers in Photography: Uranium Salt for Positive Printing and Measuring the Actinic force of Direct Sunlight." HUMPHREY'S JOURNAL OF PHOTOGRAPHY, AND THE ALLIED ARTS AND SCIENCES 19, no. 20 (Feb. 15, 1868): 312-313. [Prof. Joy's prints, Mr. Newton's process described.]

H79 Hallenbeck, John H. "Secrets of the Dark Chamber." HUMPHREY'S JOURNAL OF PHOTOGRAPHY, AND THE ALLIED ARTS AND SCIENCES 20, no. 27 (Nov. 15, 1869): 426-427. [Letter from J. H. Hallenbeck ("a well-known New York amateur.") praising D. D. T. Davie's new book.]

H80 "Vox" [J. H. Hallenbeck] "Items from Boston." PHILADELPHIA PHOTOGRAPHER 10, no. 119 (Nov. 1873): 536-537.

H81 Hallenbeck, J. H. "Occasional Notes for Beginners. No. 3. The Wet Process - Sensitizing Albumen Paper - Toning and Fixing the Prints." PHOTOGRAPHIC TIMES 15, no. 184 (Mar. 27, 1885): 153.

H82 "Obituary: John H. Hallenbeck." PHOTOGRAPHIC TIMES 23, no. 599 (Mar. 10, 1893): 123. [Hallenbeck began photography with the Meade Brothers in Albany, NY during the Daguerrean era. Associated with photography ever since. Was with Clark & Remington of Memphis in 1860. Later worked for the Scoville & Adams Co. Contributed articles to journals under his own name and under the nom de plume of "Vox." Died Mar. 2, 1893, at Bright's Disease.]

HALLER, HENRY. (BROOKLYN, NY)
H83 Portrait. Woodcut engraving, credited "From a Photograph by Henry Haller, Brooklyn." FRANK LESLIE'S ILLUSTRATED NEWSPAPER 42, (1876) ["Rev. Father Henry Lemke." 42:1076 (May. 13, 1876): 157.]

HALLEUR, C. G. HERMANN.
[Dr. G. C. Halleur was the Director of the Royal Technical School at Bochum, Germany. His book was first published in Germany in 1853, then translated into English.]

BOOKS
H84 Halleur, G. C. Hermann. *The Art of Photography: Instructions in the Art of Producing Photographic Pictures in any Color, and on any Material*, by G. C. Hermann Halleur; With Practical Hints on the Locale Best Suited for Photographic Operations, and on the Proper

Posture, Attitude and Dress, for Portraiture, by F. Schubert and an appendix; translated from the German by G. L. Strauss. "Weale's Elementary Series, No. 79." London: J. Weale, 1854. xii, 108 pp. 10 illus.

PERIODICALS
H85 Halleur, Dr. G. C. Hermann. "The Art of Photography, Instructions in the Art of Producing Photographic Pictures in Any Color, and on any Material." PHOTOGRAPHIC AND FINE ART JOURNAL 7, no. 5 (May 1854): 129-134. [With practical hints on the locale best-suited for photographic operations, and on the proper posture, attitude, and dress for portraiture by F. Schubert, painter... with an appendix of chemical terms, trans by the German by J.G. Haase.]

H86 Halleur. "Talbotype; or, Photography on Paper." HUMPHREY'S JOURNAL 6, no. 6-8 (July 1 - Aug. 1, 1854): 81-88, 97-104, 113-117. [From Mr. Halleur's "Art of Photography."]

H87 Halleur, Dr. "The Early History of Photography." AMERICAN JOURNAL OF PHOTOGRAPHY AND THE ALLIED ARTS & SCIENCES n. s. vol. 3, no. 23-24 (May 1 - May 15, 1861): 359-363, 369-371. [Prehistory; Wedgewood; Niépce; Daguerre; Talbot; Herschel mentioned in first article. Robert Hunt; Dr. Fyfe; Talbot; Draper; Dr. Woods mentioned in the second.]

HALLIER, HARRY.
H88 Hallier, Harry. "On Engine Photography." ANTHONY'S PHOTOGRAPHIC BULLETIN 5, no. 9 (Sept. 1874): 316-317. [From "Br. J. of Photo." Industrial photographer describes his techniques for photographing railway locomotives.]

HALLOWAY, R. W. (PHILADELPHIA, PA)
H89 "Young Friend's Agency." HUMPHREY'S JOURNAL OF PHOTOGRAPHY, AND THE ALLIED ARTS AND SCIENCES 20, no. 20 (Apr. 15, 1869): 313. [Letter from Halloway.]

HALSEY, S. W. & CO.
H90 "The City of Victoria, Hong-Kong." ILLUSTRATED LONDON NEWS 48, no. 1369 (May 5, 1866): 435-437. 1 illus. ["...a general view of the City of Victoria, engraved from a photograph by Messrs. S. W. Halsey & Co., of that place."]

HAMERTON.
H91 "The New Art-Writer on Photography." BRITISH JOURNAL OF PHOTOGRAPHY 10, no. 190 (May 15, 1863): 216-217. [Hamerton apparently has written something critical of the creative potential of photography, the editor here takes issue with that position.]

HAMILTON.
H92 McGhie, J. *Photographs of Tweeddale Scenery, etc. A Series of 22 Photographs of the Most Interesting Places on the Tweed between Rachan House and Kelso*. Edinburgh: Blackwood, 1864. n. p. 22 b & w. [Original photographs, by Hamilton.]

HAMILTON, GEORGE D. (BOSTON, MA)
H93 Portrait. Woodcut engraving, credited "...taken from a daguerreotype by Mr. Hamilton, 63 Court St., Boston, Mass." GLEASON'S PICTORIAL DRAWING-ROOM COMPANION 2, (1852) 1 illus. ["Govt. Samuel Dinsmore, of NH." 2:13 (Mar. 27, 1852): 208.]

HAMILTON, J. H. (1833-) (OMAHA, NB)
H94 "Western Work." HUMPHREY'S JOURNAL OF PHOTOGRAPHY, AND THE ALLIED ARTS AND SCIENCES 16, no.

2 (May 15, 1864): 32. ["Mr. J. Hamilton, of Nebraska Territory, sends us some very fine card pictures made in his gallery."]

H95 "Yankton Sioux Indians Receiving Provisions from the U. S. Agents, near Fort Randall, Dakotah Territory. - From a Photograph by J. H. Hamilton, Omaha." FRANK LESLIE'S ILLUSTRATED NEWSPAPER 25, no. 623 (Nov. 9, 1867): 113. 1 illus. [View, with crowd.]

HAMMER, LUDWIG F. (1834-1921) (GERMANY, USA)
H96 "Photographers, Old and New." WILSON'S PHOTOGRAPHIC MAGAZINE 31, no. 446 (Feb. 1894): 56-57. 1 illus. [L. F. Hammer born in Wurtemberg, Germany, and came to New York in 1854. Located permanently in St. Louis in 1858. Learned photography from M. Saettele and William Latour. When Latour moved to Sedalia, MO, to open a studio, Hammer replaced him as the manager of Saettele's gallery. Started his own gallery in 1867 and kept growing into larger and more profitable galleries until 1891, when he turned the latest over to his son, L. F. Hammer, Jr. Then he organized a manufacturing company, which became the Hammer Dry Plate Co., which was successful.]

HAMMES. (POONA, INDIA)
H97 Houston, John, editor. *Representative Men of the Bombay Presidency*. A Collection of Biographical Sketches, with Portraits of the Princes, Chiefs, Philanthropists, Statesmen and Other Leading Residents of the Presidency. London, Bombay: C. B. Burrows, 1897. 144 pp. illus. ["...gratitude to Bourne & Shepherd, of Bombay, and Mr. Hammes, photographer, of Poona."]

HAMMOND.
H98 "Long Island. - The Horton Homestead at Southold, Built in 1639. - From a Photograph by Hammond." FRANK LESLIE'S ILLUSTRATED NEWSPAPER 47, no. 1207 (Nov. 16, 1878): 185. 1 illus. [View.]

HANCE, ALFRED L.
H99 Hance, Alf. L. "Fifth Annual Meeting and Exhibit of the National Photographic Association of the U.S., held in Buffalo, N.Y., beginning July 5, 1873: Collodion & Its Troubles." PHILADELPHIA PHOTOGRAPHER 10, no. 117 (Sept. 1873): 448-449.

HANDSOME, WILLIAM. (CHICAGO, IL)
H100 "Correspondence." ANTHONY'S PHOTOGRAPHIC BULLETIN 3, no. 12 (Dec. 1872): 783. [Handsome from Chicago, IL. Describes photographing a dead man, mentions that his gallery is going again after the fire.]

HANFSTAENGL, EDGAR. (1842-1910) (GERMANY) see HANFSTAENGL, FRANZ.

[Edgar was born on July 15, 1842 in Dresden, the son of Franz Hanfstaengl. Studied at the Witzhumsche Gymnasium in Dresden, then travelled all over the world until 1845. Took over the management of his father's studio in 1868, extending its size and reputation. Died in Munich in 1910.]

HANFSTAENGL, FRANZ. (1804-1877) (GERMANY)
[Born 1804 in Baiernrain. Studied at the Fine Arts Academy, Munich. Made lithographic portrait series *Corpus Imaginum* from 1825-1835. Founded a lithographic art publishing firm in 1834, which remained active until 1853, made lithographic copies of paintings. Met Löcherer in 1845 and probably learned photography from him. In 1852 Franz opened a photographic studio in Munich. Became the court photographer of the Royal Court of Bavaria. From 1861-65 produced

installments of *Zeitgenossen*, an album of portraits of contemporary personalities. In 1868 Franz turned over the management of the studio to his son Edgar, who enlarged the business. Died in Munich in 1877.]

H101 "Topics of the Times: Mr. Franz Hanfstaengl." PHOTOGRAPHIC TIMES 7, no. 80 (Aug. 1877): 185. [Note about his recent death at age 73. "His later years have been devoted principally to the reproduction of oil paintings by photography."]

H102 Sobieszek, Robert A. "Franz Hanfstaengl: Munich Portraits, 1853-1863." IMAGE 21, no. 3 (Sept. 1978): 15-19. 4 b & w.

HANNAY, H. H.
H103 Hannay, H. H. "Correspondence." ANTHONY'S PHOTOGRAPHIC BULLETIN 5, no. 2 (Feb. 1874): 97-98. [Letter describing in detail, a situation involving the Shaw silver waste reclamation system.]

HANNEFORD, MICHAEL.
H104 Hanneford, Michael. "Iron Printing Process." HUMPHREY'S JOURNAL OF PHOTOGRAPHY, AND THE ALLIED ARTS AND SCIENCES 10, no. 22 (Mar. 15, 1859): 350-351. [From "Liverpool Photo. J."]

HANSEN, GEORG EMIL. (1833-1891) (COPENHAGEN, DENMARK)
H105 Portrait. Woodcut engraving credited "From a photograph by George Hansen." ILLUSTRATED LONDON NEWS 74, (1879) ["Princess Thyra, of Denmark, Dutchess of Cumberland." 74:2064 (Jan. 4, 1879): 21.]

HANSEN, GEORGE P.
H106 "Gossip." PHOTOGRAPHIC ART JOURNAL 2, no. 2 (Aug. 1851): 127. [From "Chicago [IL] Tribune."]

H107 "Gossip." PHOTOGRAPHIC ART JOURNAL 5, no. 1 (Jan. 1853): 63-64. [From "Charlotteville (VA) Jeffersonian."]

HANSEN, M. (STOCKHOLM, SWEDEN)
H108 Portraits. Woodcut engravings credited "From a photograph by M. Hansen." ILLUSTRATED LONDON NEWS 36, (1860) ["Queen and King of Sweden." 36:* (May 26, 1860): 505. "Portraits of the Royal Family of Sweden and Norway." 36:* (June 6, 1860): 589.]

HANSEN, SCHOU & WELLER HANSEN. (DENMARK)
H109 Portrait. Woodcut engraving credited "From a photograph by Schou & Weller Hansen, Copenhagen." ILLUSTRATED LONDON NEWS 66, (1875) ["Hans Christian Andersen." 66:1862 (Apr. 17, 1875): 360.]

HANSON, WILLIAM. (LEEDS, ENGLAND)
H110 "Note." ART JOURNAL (Oct. 1860): 319. [10 stereo views by W. Hanson (of Leeds), of the scenery of Yorkshire.]

H111 "Stereographs. Instantaneous Views, photographed by William Hanson, Leeds." BRITISH JOURNAL OF PHOTOGRAPHY 8, no. 153 (Nov. 1, 1861): 386-387.

H112 "Cabinet Pictures, Miscellaneous Subjects, Photographed by Wm. Hanson, Leeds." BRITISH JOURNAL OF PHOTOGRAPHY 9, no. 175 (Oct. 1, 1862): 370.

H113 Hanson, William. "The Position of Photography as a Fine Art." BRITISH JOURNAL OF PHOTOGRAPHY 10, no. 188 (Apr. 15, 1863): 165-166.

H114 "On the Disposition of the Glass in Photographic Studios, with a Description of Mr. Hanson's New Atelier." BRITISH JOURNAL OF PHOTOGRAPHY 11, no. 213 (May 2, 1864): 145-146. 3 illus. [Hanson, an "artist-photographer" from Leeds, England.]

H115 "Where to Go with the Camera: Localities in Yorkshire." BRITISH JOURNAL OF PHOTOGRAPHY 11, no. 213 (May 2, 1864): 151-152.

H116 Hanson, William. "How to Cause a Wet Collodion Film to Remain Moist a Long Time." BRITISH JOURNAL PHOTOGRAPHIC ALMANAC 1876 (1876): 77-78. ["Some years ago, when engaged in landscape work."]

HARDING, LEWIS. (1806-1893) (GREAT BRITAIN)

H117 Lanyon, Andrew. "A Polperro Fishwife." HISTORY OF PHOTOGRAPHY 8, no. 2 (Apr. - June 1984): 89-98. 11 b & w. [Photos of Polperro, Cornwall by Francis Frith, James Valentine, L. E. Comley, and the local photographer, Lewis Harding.]

HARDINGE, MRS.

H118 "Mrs. Hardinge's Pearletta Pictures." PHILADELPHIA PHOTOGRAPHER 6, no. 66 (June 1869): 185.

HARDWICH, T. F. see also MASKELYNE.

HARDWICH, THOMAS FREDERICK. (1829-1890) (GREAT BRITAIN)

[Hardwich photographed from 1852 to 1860, and held the position of Lecturer on Photography at King's College, London. He then resigned his post, became a clergyman of the Church of England, and moved to the North of England, where he "...labored diligently in that sphere." In the 1870s he "...once more came to the front as an authority on all matters connected with the optical lantern."]

BOOKS

H119 Hardwich, T. Frederick. Edited by George Dawson and Edward Hadow. *A Manual of Photographic Chemistry Including the Practice of the Collodion Process. Part I, The Science of Photography. Part II, Practical Details of the Collodion Process. Part III, Outlines of General Chemistry.* London: John Churchill & Sons, 1855. 384 pp. [2nd ed. (1855) xvi, 344 pp., illus. Seven editions through to the 1860s, continued, with new editors throughout 1880s.]

H120 Hardwich, T. Frederick. *A Manual of Photographic Chemistry, Including the Practice of the Collodion Process.* "4th ed." New York: H. H. Snelling, 1858. xii, 257 pp. illus. [Many editions of this work through 1880s. Published in England and Germany as well.]

PERIODICALS

H121 "Reviews." ATHENAEUM no. 1446 (July 14, 1855): 811. [Bk. Rev.: "A Manual of Photographic Chemistry; including the Practice of the Collodion Process," by T. Frederick Hardwich. (Churchill).]

H122 Hardwich, T. F. "Extracts from Foreign Publications - On the Manufacture of Collodion." HUMPHREY'S JOURNAL 9, no. 1-2 (May 1 - May 15, 1857): 9-11, 19-26. [From "J. of Photo. Soc., London." Comments on lecture by W. J. Newton, R. Fenton, Crookes, Malone, Long, Anthony, Shadbolt.]

H123 Hardwich, Mr. "Extracts from Foreign Publications: On Fused Nitrate of Silver." HUMPHREY'S JOURNAL 9, no. 3 (June 1, 1857): 48.

H124 Hardwich, T. F. "On the Printing of Stereoscopic Transparencies." HUMPHREY'S JOURNAL OF PHOTOGRAPHY, AND THE ALLIED ARTS AND SCIENCES 9, no. 24 (Apr. 15, 1858): 372-378. [From "London Photo. J."]

H125 "London Photographic Society." LIVERPOOL & MANCHESTER PHOTOGRAPHIC JOURNAL [BRITISH JOURNAL OF PHOTOGRAPHY] n. s. 2, no. 12 (June 15, 1858): 148-151. [Paper by Hardwich "On the Solarization of Negatives" read; Francis Frith was in the audience and was called forward, with applause, to describe his experiences in Egypt with solarization. (p. 150); Bedford, Davies, Malone and others also commented.]

H126 Hardwich, T. F. "On the Solarization of Negatives." HUMPHREY'S JOURNAL OF PHOTOGRAPHY, AND THE ALLIED ARTS AND SCIENCES 10, no. 6 (July 15, 1858): 86-91. [From "Liverpool Photo. J."]

H127 Hardwich, T. F. "The Strength of Iodizer." HUMPHREY'S JOURNAL OF PHOTOGRAPHY, AND THE ALLIED ARTS AND SCIENCES 11, no. 20 (Feb. 15, 1860): 309-310. [From "Photo. Notes."]

H128 Hardwich, T. F. "On Collodion for the Dry Process." HUMPHREY'S JOURNAL OF PHOTOGRAPHY, AND THE ALLIED ARTS AND SCIENCES 11, no. 21-23 (Mar. 1 - Apr. 1, 1860): 329-332, 347-348, 360-363. [Read to London Photo. Soc. From "Br. J. of Photo."]

H129 Hardwich, F. "How to Economize Old Toning Baths." HUMPHREY'S JOURNAL OF PHOTOGRAPHY, AND THE ALLIED ARTS AND SCIENCES 11, no. 22 (Mar. 15, 1860): 349-350. [From "Br. J. of Photo."]

H130 Hardwich, T. F. "Photographic Comments. - Transparencies for the Stereoscope." HUMPHREY'S JOURNAL OF PHOTOGRAPHY, AND THE ALLIED ARTS AND SCIENCES 13, no. 6 (July 15, 1861): 89-92. [From "Br. J. of Photo."]

H131 S. T. "In Memoriam." BRITISH JOURNAL OF PHOTOGRAPHY 8, no. 147 (Aug. 1, 1861): 266. [Praise, few hard facts. Mock obituary, occasioned by Hardwich's retirement from photography to join the clergy.]

H132 "Secession of Mr. Hardwich from Photographic Pursuits." JOURNAL OF THE PHOTOGRAPHIC SOCIETY OF LONDON 7, no. 112 (Aug. 15, 1861): 252-254. [Apparently he joined the clergy.]

H133 S. T. "In Memoriam." AMERICAN JOURNAL OF PHOTOGRAPHY AND THE ALLIED ARTS & SCIENCES n. s. vol. 4, no. 8 (Sept. 15, 1861): 180-181. [From "Br. J. of Photo." Hardwich retired from editing photo journal in England to join the clergy. This essay, written in the style of an obituary, praises his efforts.]

H134 "Critical Notices: A Manual of Photographic Chemistry, by T. Frederick Hardwich. 7th ed. Edited by George Dawson, M.A. & Edward Hadow, F.C.S., M.R.C.S., London: John Churchill & Sons." PHOTOGRAPHIC NEWS 8, no. 278 (Jan. 1, 1864): 4-5.

H135 "Photography: Art. VII. 1. A Manual of Photographic Chemistry, by T. Hardwich. 2. The Tannin Process, by C. Russell." LONDON QUARTERLY REVIEW 116, no. 232 (Oct. 1864): 147-269. [Review of the books listed expands into an extensive discussion of the role of photography in society, etc.]

H136 "Editor's Table: Rev. Mr. Hardwich's Appeal to Photographers." PHILADELPHIA PHOTOGRAPHER 3, no. 28 (Apr. 1866): 127. [Mr. Hardwich, author of a book on photographic chemistry, now laboring as a clergyman - appealing to photographers for aid to erect a church in Durham, England.]

H137 Hardwich, Rev. F. "Experiments to Test the Illuminating Powers of Various Oils used in Lantern Illumination." BRITISH JOURNAL PHOTOGRAPHIC ALMANAC 1875 (1875): 112-113.

H138 Hardwich, T. Frederick. "Reminiscences of Twenty Years Ago." ANTHONY'S PHOTOGRAPHIC BULLETIN 6, no. 4 (Apr. 1875): 97-100. [From "Br. J. of Photo." Hardwich, in response to an earlier article by Sutton, argues that F. S. Archer, not Bingham, truly did invent the wet-collodion process. Describes his own experiences, those of Henry Pollock, Frith, Fenton, etc.]

H139 Hardwich, T. Frederick. "Reminiscences of Twenty Years Ago. - No. II." ANTHONY'S PHOTOGRAPHIC BULLETIN 6, no. 10 (Oct. 1875): 293-295. [From "Br J of Photo." Mentions Roger Fenton; the committee to investigate fading under the author's direction; F. Frith.]

H140 Hardwich, Rev. F. "On the Lime Light." BRITISH JOURNAL PHOTOGRAPHIC ALMANAC 1877 (1877): 41-45.

H141 "The Rev. T. F. Hardwich on the Limelight." ANTHONY'S PHOTOGRAPHIC BULLETIN 8, no. 1 (Jan. 1877): 10-13. [From "Br. J. of Photo."]

H142 Hardwich, Rev. F. "The Oxyhydrogen Lime Light." BRITISH JOURNAL PHOTOGRAPHIC ALMANAC 1878 (1878): 148.

H143 Hardwich, Rev. T. Frederick. "On the Oxyhydrogen Lime Light." BRITISH JOURNAL PHOTOGRAPHIC ALMANAC 1879 (1879): 66-67.

H144 Hardwich, Rev. T. Frederick. "An Interesting Letter from Rev. T. Frederick Hardwich." PHOTOGRAPHIC TIMES 18, no. 368 (Oct. 5, 1888): 476. [Letter thanks editor for a copy of the "Annual of Photography," states "...It is a source of regret to me that I have for many years suffered from such constant ill-health as to prevent my doing anything practically in that pleasant art."]

H145 "Notes and News: Obituary." PHOTOGRAPHIC TIMES 20, no. 462 (July 25, 1890): 360. [Born Wells, England in 1829. In 1849 appointed Curator of the Museum and Demonstrator of Practical Chemistry in King's College, London. Took up photography with the daguerreotype. Author of the "Standard Photographic Chemistry." Biography in "BJP" October 15, 1875; "Newcastle Daily Journal" June 26, 1890.]

HARDWICK, P.
H146 Hardwick, P. "Light Portable Tent." BRITISH JOURNAL PHOTOGRAPHIC ALMANAC 1878 (1878): 134-136. 5 illus.

HARDY, A. N. (BOSTON, MA)
H147 Portrait. Woodcut engraving, credited "Photographed by Hardy, of Boston." FRANK LESLIE'S ILLUSTRATED NEWSPAPER 38, (1874) ["The late Elder Jacob Knapp, Odd-Fellow." 38:977 (June 20, 1874): 236.]

H148 "Editor's Table: A New Gallery in Boston." PHILADELPHIA PHOTOGRAPHER 15, no. 170 (Feb. 1878): 63. [A. N. Hardy occupying his new studio at 493 Washington St., Boston, MA.]

H149 Portrait. Woodcut engraving, credited "From a Photograph by Hardy. FRANK LESLIE'S ILLUSTRATED NEWSPAPER 48, (1879) ["The late William Lloyd Garrison." 48:1236 (June 7, 1879): 236.]

H150 "An Inside View of a Boston Photographic Studio." PHOTOGRAPHIC TIMES 12, no. 135 (Mar. 1882): 77-78. [From "The Boston Photographer," a "modest sheet issued by Hardy.]

HARDY, F. W. (BANGOR, ME)
H151 "Processes which have been proved - The Processes of F. W. Hardy, of Bangor, Me." AMERICAN JOURNAL OF PHOTOGRAPHY AND THE ALLIED ARTS & SCIENCES n. s. vol. 6, no. 12 (Dec. 15, 1863): 286-287.

HARE. (GREAT BRITAIN)
H152 "New Stereoscopic Camera." HUMPHREY'S JOURNAL OF PHOTOGRAPHY, AND THE ALLIED ARTS AND SCIENCES 12, no. 7 (Aug. 1, 1860): 111-112. [From "Br. J. of Photo." Mr. Hare exhibited camera to the North London Photo. Soc.]

HARE, AUGUSTUS JOHN CUTHBERT. (1834-1903) (GREAT BRITAIN)
H153 Hare, Augustus John Cuthbert. *Walks in London.* London: Daldy, Isbister & Co., 1878. 2 vol. b & w. illus. [Original photos, by the author, tipped-in. Also engravings. Texts in part, from "Good Words," 1877. This may be an extra-illustrated version, GEH collection.]

HARGREAVES, R.
H154 Hargreaves, R. "Collodion Transparencies." HUMPHREY'S JOURNAL OF PHOTOGRAPHY, AND THE ALLIED ARTS AND SCIENCES 14, no. 22 (Mar. 15, 1863): 303-304.

H155 Hargreaves, R. "Trouble with Positives." HUMPHREY'S JOURNAL OF PHOTOGRAPHY, AND THE ALLIED ARTS AND SCIENCES 16, no. 1 (May 1, 1864): 7-8. [Hargreaves' letter and Towler's reply.]

HARKNESS, WILLIAM. (1837-1903) (USA)
H156 "Matters of the Month." PHOTOGRAPHIC TIMES 5, no. 55 (July 1875): 170. ["Prof. Harkness...just returned from his expedition for the observation of the transit of Venus at Bluff Harbor, New Zealand,... made hundreds of negatives...some at every station the "Swatara" touched except Melbourne.]

H157 Harkness, William and D. Russell Holmes. "Reports from the Transit of Venus Expeditions." PHOTOGRAPHIC TIMES 5, no. 56 (Aug. 1875): 190. [Harkness was the Chief Astronomer, Transit of Venus Expedition, at Bluff Harbor, New Zealand. Holmes was the Chief Photographer, Transit of Venus Expedition, at Kerguelen Island.]

H158 Harkness, Prof. William, U.S.N. "Theory of the Horizontal Photo-Heliograph: Including its application to the determination of the solar parallax by means of transits of Venus." PHOTOGRAPHIC TIMES 7, no. 76 (Apr. 1877): 83-84. [Communicated by the Astronomer-Royal to the Royal Astronomical Society, England. From "Photographic News."]

H159 Harkness, William. "Telescopes for Astronomical Photography." PHOTOGRAPHIC TIMES 14, no. 158 (Feb. 1884): 60-61. [Harkness at the U.S. Naval Observatory, Washington, DC.]

H160 Harkness, William. "On Stellar Photography." AMERICAN ANNUAL OF PHOTOGRAPHY AND PHOTOGRAPHIC TIMES ALMANAC FOR 1893 (1893): 204-206.

H161 Harkness, William. "On the Photographic Search for Asteroids." AMERICAN ANNUAL OF PHOTOGRAPHY AND PHOTOGRAPHIC TIMES ALMANAC FOR 1894 (1894): 107-108.

HARMAN see DAGES & HARMAN.

HARMAN, R. V.
H162 Harman, R. V. "Clouds in Landscapes." BRITISH JOURNAL PHOTOGRAPHIC ALMANAC 1877 (1877): 156-157.

HARMER, JOHN.
H163 Harmer, John. "Combination Printing for the Stereoscope." ANTHONY'S PHOTOGRAPHIC BULLETIN 9, no. 6 (June 1878): 169-171. [From "London Photographic News." Harmer's response to earlier article by Oakes.]

H164 Harmer, John. "Retouching - A Point of Practice." BRITISH JOURNAL PHOTOGRAPHIC ALMANAC 1879 (1879): 114-115.

H165 Harmer, John. "Contemporary Press: Stereoscopic Work." PHOTOGRAPHIC TIMES 12, no. 144 (Dec. 1882): 472-476. [From "Br. J. of Photo."]

HARMER, R.
H166 Harmer, R. "On Double or Fancy Printing." BRITISH JOURNAL OF PHOTOGRAPHY 10, no. 191 (June 1, 1863): 225. [Printing in clouds, borders, etc.]

HARRINGTON, JOHN.
H167 *The Abbey and Palace of Westminster;* Photographed by John Harrington, Architectural Photographer, Brighton. London: Sampson Low, Son & Marston, 1869. n. p. 25 b & w. [25 photographs, each briefly described. Another copy, with 40 photographs.]

H168 *Sun Pictures of Eton College;* with Brief Descriptive Passages, by John Harrington, author of "The Abbey and Palace of Westminster," etc. Eton: R. Inglaton Drake, 1871. n. p. 17 b & w. [Original photos, interleaved with descriptive material.]

H169 *Georges Chapel, Windsor.* London: Sampson Low, Marston, Low & Searle, 1872. n. p. [40 p.] pp. 18 b & w. [Woodburytype prints, from negatives by John Harrington.]

HARRINGTON, WILLIAM H. see also DOBYNS & HARRINGTON.

HARRINGTON, WILLIAM H. (ca. 1810-) (USA)
[Born ca. 1810 in PA. In 1840 he was teaching at La Grange College in Alabama. In Oct. 1841 he began to experiment with the daguerreotype with Frederick A. P. Barnard, and opened a gallery in Tuscaloosa. In 1842 he moved to New Orleans, LA. Back to Tuscaloosa in 1845, painting landscapes. Back to New Orleans in 1847, managing James Maguire's studio. He and Maguire became partners in 1850. Purchased the patent rights to the talbotype process for Louisiana, Alabama, Florida, Georgia, and Texas and advertised halotypes. Became one of the many partners of T. J. Dobyns, and the actual manager of the New Orleans gallery in 1852-59. Wrote articles for *Humphrey's Journal* in 1853. Burned out in 1857. Taking ambrotypes in early 1860s.]

H170 Harrington, Wm. H. "Hints on Practical Photography." HUMPHREY'S JOURNAL 5, no. 1-5 (Apr. 15 - June 15, 1853): 12-15, 45-48, 57-62, 77-80.

HARRIS, EDWARD P.
H171 Bierstadt, Edward. *Sunlight Pictures. Amherst.* Artotypes from original negatives by Edward P. Harris. New York: Artotype Publishing Co., 1891. 3, 50 pp. 50 b & w.

HARRIS, T. C.
H172 Harris, T. C. "A Convenient Dark-Tent." PHILADELPHIA PHOTOGRAPHER 11, no. 127 (July 1874): 212-213. 1 illus.

HARRIS, THEODORE.
H173 "Dry Sensitives - Germon's New Daguerreotypes." HUMPHREY'S JOURNAL 6, no. 13 (Oct. 15, 1854): 202. [Harris an operator from Louisville, KY.]

HARRISON. (CLINTON CO., NY)
H174 Harrison. "Yellow Albumen Paper." HUMPHREY'S JOURNAL OF PHOTOGRAPHY, AND THE ALLIED ARTS AND SCIENCES 15, no. 12 (Oct. 15, 1863): 183. [Letter from Harrison, plus the editor's reply.]

HARRISON. (OSHKOSH, WI)
H175 "Our Illustrations." PHOTOGRAPHIC AND FINE ART JOURNAL 10, no. 5 (May 1857): unnumbered page, 153. 1 b & w. [Original photographic print, tipped-in. "The Young Bachelor's Sunday Morning." Negative by C. Farrand, of New York, NY, from a Daguerreotype by Mr. Harrison, of Oshkosh, WI. (Print not in this copy.)]

HARRISON, C. C. see also BRINCKERHOFF, J. DE WITT.

HARRISON, CHARLES C. (d. 1864) (USA)
[Charles Harrison operated a daguerreotype gallery in New York, NY in 1851. Sold his gallery to George S. Cook and specialized in making cameras and lenses. Highly regarded in his day, both as a craftsman and as an individual. Died in 1864.]

H176 "New Invention." DAGUERREAN JOURNAL 1, no. 1 (Nov. 1, 1850): 20. [Harrison, of New York, NY, improved the camera for taking views.]

H177 "Camera for Views." DAGUERREAN JOURNAL 1, no. 2 (Nov. 15, 1850): 56. 1 illus. [Camera for taking views, developed by C. C. Harrison (New York, NY).]

H178 "Harrison's Buff Wheel." DAGUERREAN JOURNAL 1, no. 9 (Mar. 15, 1851): 272. 1 illus.

H179 "Harrison's New Camera Tube." DAGUERREAN JOURNAL 2, no. 4 (July 1, 1851): 112. 1 illus.

H180 "A Card." HUMPHREY'S JOURNAL 4, no. 20 (Feb. 1, 1853): 311-312. [C. C. Harrison, manufacturer of cameras, wrote letter to protest activities of competitors claiming that he was no longer manufacturing cameras.]

H181 "Gossip." PHOTOGRAPHIC ART JOURNAL 6, no. 5 (Nov. 1853): 323. [C. C. Harrison introduced two new sizes of cameras.]

H182 Humphrey, S. D. "Editorial: American Cameras and Their Manufacturers." HUMPHREY'S JOURNAL 6, no. 16 (Dec. 1, 1854): 249. [Praise for C. C. Harrison; Holmes, Booth & Haydens.]

H183 Brinckerhoff, J. de Witt. "Photographic Engraving on Wood." PHOTOGRAPHIC AND FINE ART JOURNAL 8, no. 2 (Feb. 1855):

48. 1 illus. [Illustrated with a woodcut portrait of C. C. Harrison, Esq., who taught Brinkerhoff photography.]

H184 Brinkerhoff, J. De Witt. "C. C. Harrison, Esq. Photographic Engraving on Wood." AMERICAN JOURNAL OF PHOTOGRAPHY AND THE ALLIED ARTS & SCIENCES n. s. vol. 3, no. 18 (Feb. 15, 1861): 279-280. 1 illus. [Portrait of Harrison, but the letter describes the technique of making "one of the earliest attempts at photography on wood for the use of engravers."]

H185 G. W. E. "Mr. C. C. Harrison." AMERICAN JOURNAL OF PHOTOGRAPHY AND THE ALLIED ARTS & SCIENCES n. s. vol. 7, no. 11 (Dec. 1, 1864): 260-261. [Obituary notice. Anecdote about Harrison's generosity to the author in 1851.]

H186 "Obituary." HUMPHREY'S JOURNAL OF PHOTOGRAPHY, AND THE ALLIED ARTS AND SCIENCES 16, no. 15 (Dec. 1, 1864): 240. ["We regret to be obliged to chronicle the death of C. C. Harrison, Esq., the manufacturer of the celebrated Harrison lenses...sudden and unexpected...apoplexy."]

H187 Davie, D. D. T. "In Memoriam." HUMPHREY'S JOURNAL OF PHOTOGRAPHY, AND THE ALLIED ARTS AND SCIENCES 16, no. 16 (Dec. 15, 1864): 256.

H188 "Obituary." BRITISH JOURNAL OF PHOTOGRAPHY 11, no. 242 (Dec. 23, 1864): 533. [Note that the lensmaker C. C. Harrison died on Nov. 23, 1864.]

H189 Morrison, R. "Honor To Whom Honor Is Due." PHOTOGRAPHIC TIMES 5, no. 54 (June 1875): 122. [Morrison, a lens maker himself, reminds everyone that the late C. C. Harrison, of Globe Lens fame..." should receive more credit for his discoveries.]

HARRISON, GABRIEL. (1817-1902) (USA)
BOOKS
H190 Harrison, Gabriel. *The Stratford Bust of William Shakespeare, and a Critical Inquiry into Its Authenticity and Artistic Merits.* Illustrated with two photographic views. Brooklyn, NY: s. n., 1865. 13 pp. 2 b & w. [75 copies, with circular.]

H191 Harrison, Gabriel. *The Life and Writings of John Howard Payne.* Albany, NY: J. Munsell, 1875. ix, 410 pp. 2 illus.

H192 Harrison, Gabriel. *A Centennial Dramatic Offering. A Romantic Drama, In Four Acts, Entitled, The Scarlet Letter, Dramatized from Nathanial Hawthorne's Masterly Romance.* Brooklyn, NY: Printed by H. M. Gardner, Jr., 1876. 50 pp. illus.

H193 Chandler, Virginia. "Gabriel Harrison," on pp. 47-54 in: *History of Kings County,* edited by Henry R. Styles. New York: W. W. Munsell & Co., 1884.

H194 Harrison, Gabriel. *A History of the Progress of the Drama, Music and Fine Arts in the City of Brooklyn.* Brooklyn, NY: s. n., 1884. 64 pp. 1 l. of plates. illus. [Edition of 100, reprinted from "The Illustrated History of Kings County", edited by H. R. Stiles.]

H195 Harrison, Gabriel. *John Howard Payne, Dramatist, Poet, Actor, and Author of "Home, Sweet Home!" His Life and Writings.* Rev. ed. Philadelphia.: Lippincott & Co., 1885. 404 pp. illus.

H196 Harrison, Gabriel. *Edwin Forrest: The Actor and the Man. Critical and Reminiscent..*Brooklyn, NY: s. n., 1889. 210 pp. illus.

H197 [Whitman] *Portrait: Japan paper proof. From the steel plate engraved in 1855 by Samuel Hollyer, after a daguerreotype by Gabriel Harrison.* [Boston ?]: s. n., 1897. 1 b & w.

H198 "Harrison, Gabriel," on p. 218-219 (Vol. 5) in: *The National Cyclopedia of American Biography* New York: James T. White & Co., 1907. [An engraved portrait and signature included.]

PERIODICALS
H199 Harrison, Gabriel. "Letter." PHOTOGRAPHIC ART JOURNAL 1, no. 1 (Jan. 1851): 64. [Letter from Harrison wishing the magazine good luck.]

H200 Harrison, Gabriel. "The American Art-Union and National Academy." PHOTOGRAPHIC ART JOURNAL 1, no. 2 (Feb. 1851): 114-116.

H201 Harrison, Gabriel. "Lights and Shadows of Daguerrean Life." PHOTOGRAPHIC ART JOURNAL 1, no. 3-4 (Mar. - Apr. 1851): 179-181, 229-232. [Anecdotes of sitters, etc.]

H202 Burr, S. J. "Gabriel Harrison and the Daguerrean Art." PHOTOGRAPHIC ART JOURNAL 1, no. 3 (Mar. 1851): frontispiece, 169-177. 1 illus. [Portrait. (Lithograph by Sarony & Major, New York, NY) Harrison born in Philadelphia, on March 25, 1817. Family PA, moved to New York, where at age 11 he learned presswork, assisting his father in printing banknotes. Claimed to have been taught to read at age 13 by the aged Aaron Burr. Continued learning on his own, became interested in the theatre. In 1838 performed as Othello at the National Theatre in New York City, followed by a brief career as an actor. Then took up painting, and in the early 1840s organized a project to build a monument to Captain James Lawrence which failed, but which spurred the civic authorities into building one. Began to photograph in 1844, studying at one of Plumb's galleries, then working there for three years. In 1849 Harrison went to work for M. M. Lawrence. Credited with being the first to produce "descriptive daguerreotypes," - i.e. genre studies - as well as very large daguerreotypes.]

H203 Harrison, Gabriel. "Brooklyn Art-Union." PHOTOGRAPHIC ART JOURNAL 2, no. 5 (Nov. 1851): 295-298.

H204 Harrison, Gabriel. "Lights and Shadows of Daguerrean Life." PHOTOGRAPHIC ART JOURNAL 2, no. 6 (Dec. 1851): 336-341. [Anecdotes of sitters, etc.]

H205 Harrison, Gabriel. "The Dignity of Our Art." PHOTOGRAPHIC ART JOURNAL 3, no. 4 (Apr. 1852): 230-232.

H206 "Fairy Fay." "Scenes in an Artist's Studio: No. 1." PHOTOGRAPHIC ART JOURNAL 3, no. 4 (Apr. 1852): 222-226. [Short story. Harrison is the daguerreotypist involved in the narrative..]

H207 "Gossip." PHOTOGRAPHIC ART JOURNAL 3, no. 5 (May 1852): 320. [Description of Harrison's new gallery in Brooklyn, from an unnamed source.]

H208 Harrison, Gabriel. "Correspondence: Letter on the Anthony Prize Competition." PHOTOGRAPHIC ART JOURNAL 4, no. 3 (Sept. 1852): 151.

H209 L. "A Poetical Picture, To G.- H.-." PHOTOGRAPHIC ART JOURNAL 5, no. 2 (Feb. 1853): 109. [Poem.]

H210 Harrison, Gabriel. "Gossip: Crystal Palace Daguerreotypes vs. The New York Tribune." PHOTOGRAPHIC ART JOURNAL 6, no. 3 (Sept. 1853): 194-195. [Harrison's letter is in response to a critical review titled "American Art - Daguerreotypes" published ca. Aug. or Sept. in the "New York Tribune," then republished in the "PAJ."]

H211 "The Anthony Prize Pitcher." PHOTOGRAPHIC AND FINE ART JOURNAL 7, no. 1 (Jan. 1854): 6-11. [Harrison's "process" described on pages 8-9. He also describes four "compositions" that were submitted for the contest "Young America," "Helia, or the genres of Daguerreotyping," "The Infant Savior Bearing the Cross," and "Mary Magdalene."]

H212 Harrison, Gabriel. "Letter on the Anthony Prize Competition." PHOTOGRAPHIC ART JOURNAL 7, no. 1 (Jan. 1854): 6-9.

H213 Harrison, Gabriel. "Reality, in a Dream." PHOTOGRAPHIC AND FINE ART JOURNAL 9, no. 1 (Jan. 1856): 27.

H214 Harrison, Gabriel. "Reality, in a Dream. - An Allegory." PHOTOGRAPHIC AND FINE ART JOURNAL 9, no. 1 (Jan. 1856): unnumbered page before p. 27, 27-30. 1 b & w. [Fictional story by Harrison, illustrated by a genre tableau photograph, also taken by Harrison, tipped-in into the issue.]

H215 Romer, Grant B. "Gabriel Harrison - The Poetic Daguerrean." IMAGE 22, no. 3 (Sept. 1979): 8-18. 9 b & w. 2 illus. [(See above for early biography.) Harrison's posed genre subjects quickly brought him critical attention and acclaim. His whole plate daguerreotype "Past, Present, and Future," then credited to the gallery owner M. M. Lawrence -as was the custom, was considered both a technical and an artistic triumph when it was displayed at the Crystal Palace Exhibition in 1851.
Harrison was also extremely active in a variety of other concerns. He was elected president of the White Eagle Club of New York in 1844, which was a Democratic Party action group. Harrison stayed active in the campaign in 1848, and he became a powerful advocate of the Free Soil platform which argued for the abolition of slavery in the new territories and states entering the Union. A speech of his is credited with leading to the abolishment of slavery in Washington, DC.
Harrison also acted professionally, as a member of the Park Theatre Company, through these years.
In 1852 Harrison moved to Brooklyn and opened a studio there in partnership with the artist George Hill. Harrison also wrote about the aesthetic issues of daguerreotypy at this time. In the 1850s Harrison was an active promoter and participant in the photographic organizations, and he was the corresponding secretary for the New York Daguerrean Association for several years. He joined the Photographic Exchange Club in 1856, but he left photography for good some time during the late 1850s or early 1860s.
Harrison was heavily involved in managing the new Park Theatre in 1863, which failed in 1864, causing him severe financial and emotional stress. He continued to play an active role in the arts, wrote several plays, produced and acted in others throughout the 1860s and 1870s. Elected to the Brooklyn Academy of Design in 1867, taught painting and exhibited at the Brooklyn Art Association. He also wrote books about John Howard Payne (1885) and Edwin Forrest (1889), and a history of the drama in Brooklyn, published in 1884. Taught elocution and acting at the end of his life. Died in Brooklyn on Dec. 14, 1902.]

HARRISON, J. A. (d. 1900) (GREAT BRITAIN)
H216 "Obituary of the Year: J. A. Harrison." BRITISH JOURNAL PHOTOGRAPHIC ALMANAC 1901 (1901): 671-672. ["Harrison and the late J. R. Johnson invented the Pantascopic Camera over thirty years ago. Exhibited many ingenious mechanical photographic devices at various societies, including the South London, the Photographic Club, the London and Provincial, the London, etc."]

HARRISON, WILLIAM H. (d. 1897) (GREAT BRITAIN)
H217 Harrison, William H. "Out-Door Photography." BRITISH JOURNAL OF PHOTOGRAPHY 12, no. 260 (Apr. 28, 1865): 216-217. [Discusses Blanchard's processes.]

H218 "Miscellanea: Photography on the Great Eastern." BRITISH JOURNAL OF PHOTOGRAPHY 12, no. 275 (Aug. 11, 1865): 420. [Mr. W. H. Harrison, sec. to Mr. C. F. Varley, Engineer-in-Chief to the Atlantic Telegraph Co., took cameras, etc. aboard the "Great Eastern" to record its cable laying expedition. He was stopped by the directors of the company who wanted secrecy and taken off the ship while at sea.]

H219 Harrison, W. H. "Photography on the Great Eastern." BRITISH JOURNAL OF PHOTOGRAPHY 12, no. 276 (Aug. 18, 18C5): 425-426. [Harrison describes his experiences photographing aboard the "Great Eastern" steamship, before it tried to lay the first telegraph cable across the Atlantic.]

H220 Harrison, W. "How to take Photographs of Views and Interiors by the Wet Process." HUMPHREY'S JOURNAL OF PHOTOGRAPHY, AND THE ALLIED ARTS AND SCIENCES 17, no. 13 (Nov. 1, 1865): 198-199. [From "Photographisches Archiv."]

H221 Harrison, William H. "Light and Lighting." BRITISH JOURNAL OF PHOTOGRAPHY 12, no. 292 (Dec. 8, 1865): 619-620. 3 illus.

H222 Harrison, William H. "Out-Door Photography." HUMPHREY'S JOURNAL OF PHOTOGRAPHY, AND THE ALLIED ARTS AND SCIENCES 18, no. 5 (July 1, 1866): 67-69. [From "Br. J. of Photo."]

H223 Harrison, William H. "An Improved Wet Process." HUMPHREY'S JOURNAL OF PHOTOGRAPHY, AND THE ALLIED ARTS AND SCIENCES 19, no. 6 (July 15, 1867): 85-86. [From "Br. J. of Photo."]

H224 Harrison, William H. "The Glycerine Process." HUMPHREY'S JOURNAL OF PHOTOGRAPHY, AND THE ALLIED ARTS AND SCIENCES 19, no. 11 (Oct. 1, 1867): 170-173. [From "Br. J. of Photo."]

H225 Harrison, William H. "The Preparation of Pure Iodide Films." HUMPHREY'S JOURNAL OF PHOTOGRAPHY, AND THE ALLIED ARTS AND SCIENCES 20, no. 4 (June 15, 1868): 61-64.

H226 Harrison, W. H. "Experiments in Photographic Prints. No. II." ANTHONY'S PHOTOGRAPHIC BULLETIN 3, no. 12 (Dec. 1872): 758-761. [From "Br. J. of Photo."]

H227 Harrison, W. H. "Miscellaneous Subjects: Photographic Novelties." PHOTOGRAPHIC TIMES 15, no. 212 (Oct. 9, 1885): 581-582. [From "Br J of Photo."]

H228 Harrison, W. H. "Mr. W. H. Harrison's Experience in Taking 'At Home' Portraits and Groups." ANTHONY'S PHOTOGRAPHIC BULLETIN 20, no. 15 (Aug. 10, 1889): 459-461. [From "The Photographic Review."]

H229 Harrison, W. H. "Is the Present Construction of Photographic Studios Wrong in Principle?" PHOTOGRAPHIC TIMES 23, no. 614 (June 23, 1893): 329-330. 1 illus. [Read before the London and Provincial Photographic Association.]

H230 "News and Notes." WILSON'S PHOTOGRAPHIC MAGAZINE 34, no. 490 (Oct. 1897): 448. [Died Aug. 10th, 1897. More than 30 years an active worker in Scientific Photography... for some years editor of "Photographic News" and European correspondent of "Anthony's Bulletin."]

H231 "Obituary: W. H. Harrison (August 10, 1897)." BRITISH JOURNAL PHOTOGRAPHIC ALMANAC 1898 (1898): 639-640. [Harrison began working in the Telegraph Department of the Great Western Railway. In 1868 wrote a paper on a bromide emulsion dry plate process to the "BJP." Later an editor for the "Photographic News." Lectured at the Royal Institution and elsewhere, published many scientific articles.]

HARRISON, WILLIAM H. [?]
H232 "1 engraving ("The 'Great Eastern' Steamship: Building on the Stocks, Millwall.")." ILLUSTRATED LONDON NEWS 30, no. 861 (May 30, 1857): 518-519. 1 illus. ["From a photograph in the possession of Mr. Scott Russell."]

H233 "The 'Great Eastern' Steam-Ship: Construction of the Central Compartment, at Millwall." ILLUSTRATED LONDON NEWS 30, no. 863 (June 13, 1857): 559. 1 illus. [From a Photograph in the Possession of Mr. John Scott Russell.]

H234 "The Building and Launching of the 'Great Eastern.'" FRANK LESLIE'S ILLUSTRATED NEWSPAPER 8, no. 198 (Sept. 17, 1859): 239-242, 246-247, 250-251. 8 illus. [Portrait of the architect Scott Russell, views of the ship under construction, etc. No credits to photographic sources, but some possibly drawn from photos, perhaps copied from "ILN" originals. W. H. Harrison was photographing the "Great Eastern during this time. See "BJP" (Aug. 18, 1865): 425-426.]

H235 "[The 'Great Eastern.']" FRANK LESLIE'S ILLUSTRATED NEWSPAPER 8, no. 200 (Oct. 1, 1859): 279, 282-283. 3 illus. [Views of crowd at launching, interior, exterior views. May be from photographic sources, may be from "ILN."]

H236 "The First Voyage of the 'Great Eastern.'" FRANK LESLIE'S ILLUSTRATED NEWSPAPER 8, no. 201 (Oct. 8, 1859): 287, 290, 294-295, 298. 8 illus. [Views of Woolwich Dockyard, the ship anchored at Greenwich, etc. Many could be from photographs.]

HARRISON, WILLIAM JEROME. (1845-1909)
[As Harrison began writing in 1881, a more extensive listing of his work will appear in the second part of this bibliography, covering the chronological period 1880 to 1919. But since many of his references appear in this volume, a few biographical references are included here.]

H237 Harrison, W. Jerome. "Chapters in the History of Photography." PHOTOGRAPHIC TIMES 16-17, nos. 275-309 (Dec. 24, 1886 - Aug. 19, 1887): (vol. 16) 668-670, 690-691; (vol. 17) 7-9, 17-18, 31, 43, 59-60, 71-72, 82-83, 93-94, 107-108, 120, 130-131, 143-144, 155-156, 167-169, 202, 213-214, 225, 237-238, 248-249, 260-261, 272, 287-288, 300-301, 313, 322, 335-336, 347-349, 360-361, 372, 385-386, 397-398, 407-408, 422-424. [Chapter 1. The Origin of Photography. Chapter 2. The Daguerreotype Process. Daguerre, the Daguerreotype, Fitzeau, Draper and Morse, Claudet. Chapter 3. Some Pioneers of Photography. Charles, Matthew Boulton, Wedgewood, Davy. Joseph Nicéphore Niépce, lithography and photography. Niépce and Daguerre. Chapter 4. Fox-Talbot and the Calotype Process. Photographic Negatives and Positives, "Pencil of Nature." Defects of the Calotype Process. Claudet. Herschel Introduces Glass Plates. Herschel, Le Gray. Discovery of Gun Cotton,

Collodion Introduced into Photography. Gustave Le Gray, Robert J. Bingham, Frederick Scott Archer. Chapter 5. Outline of the Collodion Process, Collodion Positives, Popularization of Photography. Development of Professional Photography; Some Defects of the Wet Collodion Process, Some Achievements of the Workers with Collodion, Effects of Recent Improvements in Photography. Chapter 6. The Oxymel Process, Collodion Dry Plates, Fothergill Process, etc. Dr. Hill Norris' Collodio-Gelatine Process, Resin Process, Tannin Process, Gum-Gallic Process, Albumen-Beer Process, etc. Chapter 6. Collodion Dry Plates with the Bath. Inconvenience of Wet Plates, Device for Preventing Evaporation, A Moist Collodion Process, The Honey Process, The Taupenot, or Collodio-Albumen Dry Plate Process. Chapter 7. Collodion Emulsion. Sayce and Bolton's Collodion Emulsion Process, Washed Collodion Emulsion Process, Beechy Dry Plates. Chapter 8. Gelatin Emulsion with Bromide of Silver. Nature and Manufacture of Gelatine, Early Workers in Gelatine. An Early Experiment with Gelatino-Bromide. W. H. Harrison. Dr. R. L. Maddox. Chapter 9. Introduction of Gelatino-Bromide Emulsion as an Article of Commerce by Burgess and Kennett. Removal of Extraneous Substances from the Gelatine Emulsion, Kennett's Pellicle. Processes worked in 1877, Other Pioneers of Gelatino-Bromide. Chapter 10. Gelatine Displaces Collodion. Researches of M. J. S. Stas. Bennett obtains Great Sensitiveness by "Stewing" the Emulsion. Researches of Monckhoven. Chapter II. History of Roller-Slides; and of Negative-Making on Paper and on Films. Captain Barr's "Dark Slide," Warnerke's Roller-Slide. Modern Forms of Roller-Slides. Film or "Tissue" Negatives. Chapter 12. History of the Introduction of Developers - Summing Up. (Conclusion).]

H238 "William Jerome Harrison." PHOTOGRAPHIC TIMES 17, no. 302 (July 1, 1887): 331-333, plus frontispiece. 1 b & w. [Portrait of Harrison by Harold Baker (Birmingham, England). Born March 16, 1845 in Henisworth, Yorkshire, England. Educator in sciences. Began photography 1881. Contributed articles and books. Further note on Baker's portrait on p. 332.]

H239 "Our Editorial Table: A History of Photography." PHOTOGRAPHIC TIMES 17, no. 319 (Oct. 28, 1887): 545-546. [Book Rev.: "A History of Photography," by W. Jerome Harrison. New York: Scoville, Manufacturing Co., 1887.]

H240 Harrison, W. Jerome. "Orthochromatic Photography." PHOTOGRAPHIC TIMES 20, no. 455, 463-464 (June 6, Aug. 1 - Aug. 8, 1890): 269-271, 368-370, 384-385. [Harrison's articles on a process or technique are so filled with citations to earlier practitioners that they become histories of the medium as well as specific discussions.]

H241 Harrison, W. Jerome. "The Chemistry of Fixing." PHOTOGRAPHIC TIMES 20-21 nos. 465-488 (Aug. 15, 1890 - Jan. 23, 1891): (vol. 20) 403-404, 470-471, 481-482, 503-505, 540-542, 555-556, 587-589, 611-612, 632-633, 647; (vol. 21) 4-6, 28-29, 39-43. [Serial article. This section is actually a history of technical photography, with reprints of articles and reports from the 1850s, articles first published in the "Journal of the London Photographic Society" and elsewhere. Wedgewood, Davy, Niépce. Daguerre, Talbot. Dr. Andrew Fyfe, J. C. Constable (excerpts from their articles published in 1839) Sir John Herschel. John Spiller (1862). Hypo Adopted by Daguerre and by Talbot as a Fixing Agent. Gaudin Introduces Fixing with Cyanide of Potassium. Gaudin (1853); Peter Armand Le Comte de Fontaine Moreau (1854). Sulphocyanide of Ammonium Used by Meynier for Fixing. Meynier (1863), Abney (1885), R. E. Liesegang (1890). Water as a fixing agent; the Acid Sulphite fixing bath. Why do Photographs Fade? Reprint of May 8, 1866 paper to Photo. Society of Scotland by Dr. Angus Smith, F. W.

Hart's 1864 paper to the "BJP" reprinted. The final section of this article includes an extensive bibliography on the "literature of fixing processes".]

H242 Harrison, W. Jerome. "The Toning of Photographs Considered Chemically, Historically, and Generally." PHOTOGRAPHIC TIMES 21, nos. 498-510 (Apr. 3 - June 26, 1891): 161-162, 171-173, 196-198, 206-208, 217-219, 233-234, 243-244, 257-259, 272-274, 285-286, 296-298, 308. [Survey of toning processes and techniques used in the past and present. Names prominent figures, includes formulas, and contains bibliographies of earlier articles. Given the dominant historiography of that time, this series is, in effect, a historical survey. Chapter 1. Fitzeau Discovers How To Tone Daguerreotypes. (Fizeau's 1841 report, translated from the French.) Chapter 2. Talbot and Hunt on the Toning of Paper Prints. Chapter 3. History of Toning Processes. Discusses work of T. F. Harwich in 1855, publishes excerpts from his book. Chapter 4. Alkaline Toning With Carbonates and With Borax. Discusses processes of T. F. Hardwich, Waterhouse, Gustave LeGray, etc. Chapter 5. The Acetate Bath. Discusses processes of Hannaford & Laborde in 1859 and C. B. Barnes in 1889. Chapter 6. Alkaline Toning (Continued); The Phosphate Bath, And Lime Baths. Discusses work of Maxwell Lyte (1859), Gustave Le Gray, Thomas Sutton, and others. Chapter 7. Alkaline Toning Baths (Continued). Discusses the processes of John Heywood (1859), G. Spiller (1863), A. Hughes (1865), etc. Chapter 8. Investigations of Sutton, and of Davanne and Girard Into Toning Processes. Discusses the processes of Thomas Sutton (1859), Davanne & Girard (1863). Chapter 9. Modern Ideas About the Chemistry of Toning. Chapter 10. Mixed and Miscellaneous Toning Baths. Discusses the processes of W. T. Bovey (1868), Nelson K. Cherrill (1868), Durand (1876), Heisch (1865), Abel Lewis (1879), Dunmore (1887), Sarony et al. Chapter 11. Some General Notes. Chapter 12. The Literature of Toning with Gold in Photography. Bibliography of 40 references.]

H243 Harrison, W. Jerome. "Photography on Wheels." AMERICAN ANNUAL OF PHOTOGRAPHY AND PHOTOGRAPHIC TIMES ALMANAC FOR 1892 (1892): 90-93. 3 illus. [Bicycles fit for touring camera enthusiasts.]

H244 Harrison, W. Jerome. "The Chemistry of Photography. Part 1." PHOTOGRAPHIC TIMES 22, no. 539 - 554 (Jan. 22 - Apr. 29, 1892): 27-29, 41-42, 54-56, 72-73, 83-84, 95-96, 108-109, 123-125, 133-135, 146-148, 159-160, 172, 197-199, 214-216, 225-226. [This serialized survey is a history of investigations and discoveries in the chemistry of photography from the early 1800s to the 1890s. Harrison credits individuals, gives their formulas, and cites his sources.]

H245 "W. Jerome Harrison." PHOTOGRAPHIC TIMES 22, no. 557 (May 20, 1892): 263-264. 1 illus. [Biography, taken from Birmingham, England "Town Crier." Harrison born 1845 in Yorkshire. Geologist, chemist, taught science to children of Birmingham. Amateur photographer, author of "A History of Photography," "The Chemistry of Photography."]

HARROUN & BIERSTADT see also BIERSTADT, EDWARD.

HARROUN & BIERSTADT. (NEW YORK, NY)
BOOKS
H246 *Gems of American Scenery; Consisting of Stereoscopic Views Among the White Mountains, with Descriptive Text.* New York: Harroun & Bierstadt, 1878. 99 pp. 24 b & w. [Twenty-four stereographs, printed by the Autotype process. Stereo lenses built into binding.]

H247 Gorringe, Henry H. *Egyptian Obelisks. ...Fifty-one full-page illustrations, thirty-one artotypes, eighteen engravings, and one chromolithograph.* New York: Published by the author, 1882. x, 187 pp. 48 pl. [Illustrations by E. Bierstadt and Harroun & Bierstadt.]

PERIODICALS
H248 "The Artotype Process." ANTHONY'S PHOTOGRAPHIC BULLETIN 10, no. 11 (Nov. 1879): 350. [Artotype Process rights for North America purchased by Harroun & Bierstadt, New York, NY.]

H249 "Matters of the Month: Artotypes Received." PHOTOGRAPHIC TIMES 10, no. 110 (Feb. 1880): 34.

H250 Taylor, J. Traill. "Our Editorial Table: Panoramic Views by Harroun and Bierstadt." PHOTOGRAPHIC TIMES 11, no. 126 (June 1881): 216-217. [Panoramic views taken with a panoramic camera driven by a clockwork mechanism. Apparently of Central Park. Printed in the artotype process.]

HART, A., JR.
H251 Hart, A., Jr. *The World in the Stereoscope. A Series of Sketches.* "2nd ed." New York: Hart & Anderson, 1872. 411 pp. illus.

HART, ALFRED A. (1816-1908) (USA)
BOOKS
H252 Hart, Alfred A. *The Traveler's Own Book. A Souvenir of overland travel, via the great and attractive route, Chicago, Burlington & Quincy R. R. to Burlington. Union Pacific R. R. to Ogden. Central Pacific R. R. to Sacramento. Burlington and Missouri R. R. to Omaha. Utah Central Railroad to Salt Lake City. Western Pacific Railroad to San Francisco.* Chicago: Horton & Leonard, printers, 1870. 44 pp. [Chromo-lithographs by C. Shober, from photographs by A. A. Hart.]

H253 Kraus, George. *High Road to Promontory: Building the Central Pacific [now the Southern Pacific] Across the High Sierra.* Palo Alto, New York: American West Publishing Co., Castle Books, 1969. 317 pp. illus. [History of the building of the Central Pacific R. R. in the 1960s, illustrated with photographs drawn from A. A. Hart's stereographs.]

PERIODICALS
H254 "The Central Pacific Railroad." HARPER'S WEEKLY 11, no. 571 (Dec. 7, 1867): 771-772. 5 illus. [Map and four views of construction of the Central Pacific R. R. Although not credited, they are from stereos by Hart.]

H255 "The Central Pacific Railway, North America." ILLUSTRATED LONDON NEWS 52, no. 1464 (Jan. 11, 1868): 37, 42. 2 illus. ["We have engraved two illustrations of the scenery traversed by this railway, which were supplied by Mr. Geo. E. Grey, the consulting engineer." (It's possible that these were derived from Hart's stereo views.)]

H256 "Map of the Central Pacific Railroad." CALIFORNIA MAIL BAG 1, no. 1 (June 1871): unnumbered leaf following p. vi. 24 illus. [A fold-out sheet 13 1/2 x 35 1/2" with a map of the Central Pacific R.R. and 24 engravings of views along the line of the route. Not credited, but the views are taken from stereographs made by Alfred Hart. The other side contains train schedules, routes, etc. This mapped was tipped into the first few issues of the magazine.]

H257 "The Muscle, the Gold, and the Iron: Documenting the Construction of the Central Pacific, The Stereographs of Alfred A. Hart." AMERICAN WEST 6, no. 3 (May 1969): 13-19. 13 b & w. 1 illus.

H258 Palmquist, Peter E. "Alfred A. Hart and the ILLUSTRATED Traveller's Map of the Central Pacific Railroad." STEREO WORLD 6, no. 6 (Jan. - Feb. 1980): 14-18. 4 b & w. 4 illus. [Alfred A. Hart authored a railroad guidebook, and the "Traveller's Map of the Central Pacific Railroad," (ca. 1870), illustrated with twenty-four engravings taken from his own stereographic views of the building of the C. P. R. R.]

H259 Willumson, Glenn G. "Alfred Hart: Photographer to the Central Pacific Railroad." HISTORY OF PHOTOGRAPHY 12, no. 1 (Jan. - Mar. 1988): 61-75. 13 b & w. 6 illus. [Alfred Hart was born in Norwich, CT, on Mar. 28, 1816. His father was a silversmith. Alfred Hart went to New York, NY in 1838 to study art, then he returned to Norwich in 1840, where he married and began a career as an itinerant portrait painter. Hart moved to Hartford, CT in 1848, where he painted portraits and large scroll-like panoramas of religious scenes and landscapes. Hart formed a partnership with the Hartford daguerreotypist Henry H. Bartlett in 1857. In the early 1860s Hart moved to Cleveland, OH, where he ran a store selling picture frames, engravings, and photographic supplies. By 1863 Hart was working as a portrait photographer. By 1865 Hart was in California, making stereo views along the line of track under construction for the Central Pacific Railroad. After January 1866 Hart was named the official photographer for the C. P. R. R. and for the next three years he documented the construction of the road across the mountains and onto the high plains of Utah. Hart photographed the joining of the rails at Promitory Point, UT in 1869. The C. P. R. R. selected 364 stereographs for their official series of the construction, and Hart sold additional views to Lawrence & Houseworth for publication and distribution. Hart probably made other views at Yosemite and elsewhere in California for Lawrence & Houseworth as well. In the early 1870s Hart lived in Denver, CO, where he returned to painting portraits and landscapes. He continued this activity in San Francisco from 1872 to 1878, then returned to New York, NY. He apparently moved back and forth between New York and California during the latter years of his life, working at a variety of jobs. He died in California on March 5, 1908.]

HART, F. W.
H260 Hart, F. W. "A Few Remarks on the Management of Photographic Residues, and Estimating their Proper Value." AMERICAN JOURNAL OF PHOTOGRAPHY, AND THE ALLIED ARTS AND SCIENCES n. s. vol. 9, no. 11 (May. 15, 1867): 233-238. [From "Photo. News."]

HART, L.
H261 Hart, L. "Foreign Correspondence." BRITISH JOURNAL OF PHOTOGRAPHY 12, no. 252-271 (Mar. 3 - July 14, 1865): 118-119, 130-131, 158-159, 270-271, 307-308, 346, 371-372. [Hart describes his trip through south of France to Italy, Corfu, Egypt and Syria. On p. 346 Hart describes photographing the daughter of the Emir of the Druses at Shouaifat, on the way to Damascus. Had to return to England suddenly.]

H262 "Our Editorial Table: "Hart's Eastern Costumes," Paris A. Varroguier & Co." BRITISH JOURNAL OF PHOTOGRAPHY 12, no. 278 (Sept. 1, 1865): 453. [Photographs of natives in costume in Egypt, Syria, etc., taken by Mr. Hart, who had described his experiences in a series of letters to the "BJP." "The present is, we believe, a continuation of another series of 'costumes' already published by the same firm and photographed by the same artist, illustrating... dress prevailing among the natives of Wurtenberg, Alsace, Baden, etc."]

HART, LUDOVICO WOLFGANG. (GREAT BRITAIN)
[Ludovico Wolfgang Hart was a sapper in the Royal Engineers, and worked in the Ordinance Map Office, Southampton, where photography was used in the reproduction of maps and documents.]

H263 Hart, Ludovico Wolfgang. *Photography Simplified: A Practical Treatise on the Collodion and Albumen Processes*. Southampton, London: Simpkin, Marshall & Co., 1857. viii, 63 pp. 13 l. of plates.

HART, W.
H264 "The Fatal Explosion at the Percussion Cap Manufactory in Graham Street, Birmingham." ILLUSTRATED LONDON NEWS 41, no. 1152 (July 5, 1862): 4, 23-24. 1 illus. ["...from a photograph by Mr. W. Hart, of Livery St., Birmingham."]

HARTLEY, EDWARD F. (1847-1887) (USA)
H265 "Obituary: Edward F. Hartley." ANTHONY'S PHOTOGRAPHIC BULLETIN 18, no. 20 (Oct. 22, 1887): 627. [Born at Wadsworth, OH on Nov. 9, 1847; became a photographer in 1873 in Jacksonville, IL. In 1876, moved to Chicago, IL and worked there at his studio on W. Madison St.; died Oct. 9, 1887.]

H266 "General Notes." PHOTOGRAPHIC TIMES 17, no. 318 (Oct. 21, 1887): 524. [Brief obituary notice.]

HARTMANN.
H267 Portraits. Woodcut engravings, credited "From an Daguerreotype by Hartmann." FRANK LESLIE'S ILLUSTRATED NEWSPAPER 1, (1856) ["Gen. Pedro Santana, First Pres. of the Republic of Dominica." 1:8 (Feb. 2, 1856): 120.]

HARTMAN, JAY J. (NEW YORK, NY)
H268 Hartman, J. "To make Negatives very Intense." HUMPHREY'S JOURNAL OF PHOTOGRAPHY, AND THE ALLIED ARTS AND SCIENCES 15, no. 22 (Mar. 15, 1864): 344. [Hartman's letter, reply by Towler.]

H269 "Photographing By Lightning: A Ghost Holding an Anchor that Ordinary Mortals Cannot See." PHOTOGRAPHIC TIMES 7, no. 82 (Oct. 1877): 218-219. [From "New York Sun." Hartman claimed to be able to make spirit photographs.]

HARTNUP
H270 "Photograph of the Moon, Exhibited to the British Association, at Liverpool, by Mr. Hartnup." ILLUSTRATED LONDON NEWS 25, no. 704 (Sept. 30, 1854): 300-302. 1 illus. [Engraving covers pp. 300-301. "...lastly, by the projection of the moon on a fifty-foot disk, from photographs taken by Mr. Hartnup, the astronomer of the Liverpool Observatory, and by the Photographic Society of Liverpool."]

H271 "The Moon by Collodion, as an Exhibition." HUMPHREY'S JOURNAL 6, no. 19 (Jan. 15, 1855): 304. [From "Cosmos." Photographs by Mr. Hartnup, of the Astronomical Society of London.]

HARTT, CHARLES FREDERICK.
H272 Hartt, Charles Frederick. "Correspondence." ANTHONY'S PHOTOGRAPHIC BULLETIN 3, no. 1 (Jan. 1872): 431. [Hartt, Professor of Geology at Cornell Univ., praises Dallmeyer lenses. A note states that he is "at present in Brazil, and we trust his Dallmeyer's will assist him in his labors."]

HARVEY, E. (d. 1869) (MINNEAPOLIS, MN)
H273 "Editor's Table." PHILADELPHIA PHOTOGRAPHER 6, no. 62 (Feb. 1869): 64. [Views of Minnehaha and St. Anthony's Falls noted.]

H274 "Editor's Table." PHILADELPHIA PHOTOGRAPHER 6, no. 71 (Nov. 1869): 388. [Died July 18th.]

HARWICH, T. FREDERICK.
BOOKS
H275 Reveley, Henry. *The Reveley Collection of Drawings at Brynygwin, North Wales*. Photographed by Philip H. Delamotte... and T. Frederick Harwich. London: Bell & Daldy, 1858. 2 p. pp. 60 l. of plates. 60 b & w. [Photographs of drawings. Published in six parts, each with ten prints.]

PERIODICALS
H276 Harrison, W. Jerome. "The Toning of Photographs Considered Chemically, Historically, and Generally. Chapter 3. History of Toning Processes." PHOTOGRAPHIC TIMES 21, no. 501 (Apr. 24, 1891): 196-198. [Discusses work of T. F. Harwich in 1855, publishes excerpts from his book.]

HASLETT, MAJOR. (1839-1880) (GREAT BRITAIN)
H277 "Obituary." PHOTOGRAPHIC JOURNAL n. s. vol 5, no. 5 (Feb. 18, 1881): 71. [Many years a member of RPS. Died of typhoid fever at Gibraltar on Nov. 14, 1880. Born 1839. Educated at Dublin University and entered the Royal Military Academy, Woolwich, and obtained a Commission in the Royal Engineers in 1858. Captain in 1872. Major in 1879, posted to be in Gibraltar. In charge of photography and telegraphy branches of Royal Engineer duties in Gibraltar.]

HASTINGS, WHITE & FISHER.
H278 "Tricks and Truths; or, Doctor and Artist." PHOTOGRAPHIC TIMES 7, no. 73 (Jan. 1877): 7-8. [Dialogue between Artist and Doctor in Hastings, White & Fisher's Gallery. Describes portraiture techniques and problems in a professional studio.]

HATFIELD, D. H. N. (USA)
H279 Krainik, Cliff. "The Flight of the Buffalo." STEREO WORLD 3, no. 3 (July - Aug. 1976): 8-9. 2 b & w. 1 illus. [Illustration is a stereo view of the ascension of the balloon "Buffalo" from Cleveland, OH on July 4, 1875, taken by Johnson & Mentzel. A second stereo and a woodcut of the balloon in flight are the other illustrations. Samuel A. King, aeronaut, (and former photographer?), several newspapermen, and a local photographer, D. H. N. Hatfield, were on the flight, which went from Ohio to Pennsylvania.]

HAUGK, FRITZ.
H280 Haugk, Fritz. "Practical Hints in Operating." HUMPHREY'S JOURNAL OF PHOTOGRAPHY, AND THE ALLIED ARTS AND SCIENCES 20, no. 16 (Dec. 15, 1868): 247-250.

HAUSRATH, MICHAEL. (d. 1886) (USA)
H281 "Obituary: Michael Hausrath." PHOTOGRAPHIC TIMES 16, no. 267 (Oct. 29, 1886): 568. [Hausrath died Oct. 10, 1886. "He was one of the old and well-known photographic operators who, during the time of the wet-collodion process, gained much popularity and a wide reputation."]

HAVELL, E.
H282 Havell, E. "A Few Observations on Enlargements." BRITISH JOURNAL PHOTOGRAPHIC ALMANAC 1875 (1875): 144-146. ["I am a portrait painter of some forty years' practice, and about eight years ago I took up photography as an aid."]

HAVELL, WILLIAM.
H283 "Our Weekly Gossip." ATHENAEUM no. 597 (Apr. 6, 1839): 259. [Discussion of Wm. Havell's experiments based on Talbot's suggestions.]

HAVENS, O. PIERRE. (1838-1912) (USA)
H284 "Matters of the Month." PHOTOGRAPHIC TIMES 10, no. 120 (Dec. 1880): 275. [Havens added a stock-house to his gallery business.]

H285 Taylor, J. Traill. "The Studios of America. No. 1. Haven's Gallery, Savannah, Ga." PHOTOGRAPHIC TIMES 13, no. 145 (Jan. 1883): 5-7. 2 illus.

H286 Taylor, J. Traill. "Photography in Florida and the Southern States." PHOTOGRAPHIC TIMES 15, no. 188 (Apr. 24, 1885): 213-214. [Actually a description of his visit to O. Pierre Haven's studio in Savannah, GA.]

H287 "The Editorial Table." PHOTOGRAPHIC TIMES 19, no. 403 (June 7, 1889): 290. [Received collection of 5" x 8" photos showing the two sides of Southern life. Views of fine houses and pictures of cabin life in Florida. Havens in Jacksonville, FL.]

H288 "The Editorial Table." PHOTOGRAPHIC TIMES 19, no. 407 (July 5, 1889): 338. ["Another batch of cabinets, child pictures, the like."]

H289 "Babyhood." AMERICAN ANNUAL OF PHOTOGRAPHY AND PHOTOGRAPHIC TIMES ALMANAC FOR 1890 (1890): 178-179, plus unnumbered leaf following p. 178. 1 b & w. [Child portrait.]

H290 "'Tick! Tick!'" PHOTOGRAPHIC TIMES 20, no. 434 (Jan. 10, 1890): 13, plus frontispiece. 1 b & w. [Child portrait.]

H291 "Notes and News." PHOTOGRAPHIC TIMES 20, no. 455 (June 6, 1890): 276. [Note that Havens has opened a gallery in Saratoga Springs, NY, and continues to maintain a gallery in Jacksonville, FL.]

H292 "Notes and News." PHOTOGRAPHIC TIMES 21, no. 512 (July 10, 1891): 349. [Note that Havens winters in Florida, where he had made 14" x 17" views, summers in Saratoga Springs, NY.]

H293 "O. P. Havens died in this city yesterday." FLORIDA TIMES UNION (JACKSONVILLE, FL) (Oct. 19, 1912): sect. 2, p. 11. [Born in Ossining, NY in 1838, went south in 1872. First to Savannah, GA, then to Jacksonville, FL in 1888. Worked as photographer in Jacksonville until he died.]

HAVILAND, EDWIN.
H294 Haviland, Edwin. "Process for a Hot Climate." PHOTOGRAPHIC AND FINE ART JOURNAL 10, no. 10 (Oct. 1857): 304. [From "J. of Photo. Soc., London." Haviland from Sydney, N. S. Wales (Australia).]

HAWARDEN, CLEMENTIA ELP, VISCOUNTESS. (1822-1865) (GREAT BRITAIN)
BOOKS
H295 Hawarden, Clementia, Viscountess. Edited by Graham Ovenden. *Clementia, Lady Hawarden*. London; New York: Academy Editions; St. Martins Press, 1974. 112 pp. 107 b & w. illus.

PERIODICALS
H296 O. G. R. "Obituary - In Memoriam." BRITISH JOURNAL OF PHOTOGRAPHY 12, no. 247 (Jan. 27, 1865): 38.

HAWES, JOSIAH J. see also SOUTHWORTH & HAWES.

HAWES, JOSIAH JOHNSON. (1808-1901) (USA)

[Born on Feb. 20, 1808 at East Sudbury, MA. Apprenticed as a carpenter, studied painting on his own. From 1829 to 1841 he worked as an itinerant portrait painter and lecturer. Saw François Gouraud's Boston lecture on the daguerreotype in 1840 and took up the new medium. In 1843 formed a partnership with Albert Sands Southworth in Boston, MA. Continued the studio when Southworth went to California from 1849 to 1851. Throughout the 1850s Southworth & Hawes were one of the best studios in the United States, and they made more than 1500 portraits. In 1860 he took up the wet-collodion process. In 1862 the partnership dissolved and each subsequently ran their own studio in Boston. Hawes made many views of buildings and monuments in Boston throughout the 1860s and 1870s. Died on Aug. 7, 1908 at Crawford Notch, NH.]

BOOKS
H297 Brown, Buckminster. *Cases in Orthopedic Surgery. Read before The Massachusetts Medical Society, at its Annual Meeting, June 3, 1868. With Photographic illustrations of the cases presented.* Boston: David Clapp & Son, 1868. 23 pp. 8 b & w. [Original photos, tipped-in.]

H298 Hawes, Josiah Johnson. *The Legacy of Josiah Johnson Hawes: 19th Century Photographs of Boston.* Edited, with an introduction, by Rachel Johnston Homer. Barre, MA: Barre Publishers, 1972. 131 pp. 104 b & w. 5 illus.

PERIODICALS
H299 1 photo (Portrait of John G. Whittier, taken ca. 1855). NEW ENGLAND MAGAZINE 7, no. 3 (Nov. 1892): 274. 1 b & w.

H300 1 photo (Portrait of Rufus Choate) as frontispiece. NEW ENGLAND MAGAZINE 15, no. 3 (Nov. 1896): 258. 1 b & w.

H301 Sanborn, F. B. "The Portraits of Emerson." NEW ENGLAND MAGAZINE 15, no. 4 (Dec. 1896): 386, 449-468. 11 b & w. 10 illus. [Frontispiece: "From an untouched negative by J. J. Hawes." Also 5 portraits ca. 1860 by James W. Black; Marshall (1); Allen & Rowell (1); Foss (1); Gutekunst (1); as well as paintings, sketches, etc.]

H302 1 photo (Portrait of Daniel Webster) as frontispiece. NEW ENGLAND MAGAZINE 23, no. 4 (Dec. 1900): 354. 1 b & w.

H303 1 photo (Portrait of Rufus Choat, taken between 1855 and 1860). CENTURY MAGAZINE 62, no. 5 (Sept. 1901): 732. 1 b & w.

H304 Hawes, Josiah Johnson. "Stray Leaves From the Diary of the Oldest Professional Photographer in the World." PHOTO ERA 16, no. 2 (Feb. 1906): 104-107.

HAWKE, JOHN. (PLYMOUTH, ENGLAND)

H305 Hawke, John. "Hints on Portraiture." AMERICAN JOURNAL OF PHOTOGRAPHY AND THE ALLIED ARTS & SCIENCES n. s. vol. 4, no. 20 (Mar. 15, 1862): 464-466. [From "Photo. News."]

H306 Portrait. Woodcut engraving credited "From a photograph by J. Hawke." ILLUSTRATED LONDON NEWS 74, (1879) ["Lieut. John R. Chard, R.E." 74:2072 (Mar. 2, 1879): 192.]

HAWKES, BENJAMIN F. (BALTIMORE, MD)

H307 "Personal & Art Intelligence." PHOTOGRAPHIC AND FINE ART JOURNAL 10, no. 12 (Dec. 1857): 383-384. [From "Baltimore [MD] Dispatch."]

H308 Portraits. Woodcut engravings, credited "Photographed by B. F. Hawkes, Baltimore." FRANK LESLIE'S ILLUSTRATED NEWSPAPER 5, (1858) ["Joseph Heico, Japanese." 5:126 (May 1, 1858): 345.]

HAWKINS, C. W.

H309 "Departure of the Duke of Edinburgh from the Parall Station of the Great Indian Peninsular Railway." ILLUSTRATED LONDON NEWS 56, no. 1590 (Apr. 23, 1870): 416. 1 illus. ["We are obliged to Mr. C. W. Hawkins, the locomotive superintendent, for the photograph."]

HAWKINS, EZEKIEL C. see also FARIS & HAWKINS.

HAWKINS, EZEKIEL C. (CINCINNATI, OH)

[Landscape and portrait painter, commercial artist, and daguerrean artist. Worked in Baltimore, MD in 1806, as a window-shade painter in Stubenville, OH in 1811, at Wheeling, WV in 1829. Opened daguerrean rooms with Thomas Faris in Cincinnati, OH in 1843. He was supposed to have made a collodion photograph in Cincinnati in 1847. His Cincinnati studio burned down in 1851, but apparently he started again. Worked for Dobyns & Harrington, New Orleans, LA. Operated a daguerreotype studio in New Orleans, LA in 1856. From 1844 to 1860 held partnership with other artists in other cities. Brother of Thomas Hawkins.]

H310 "Note." DAGUERREAN JOURNAL 2, no. 5 (July 15, 1851): 147. [Note that E. C. Hawkins (Cincinnati, OH) burned out.]

H311 "Notice." DAGUERREAN JOURNAL 2, no. 8 (Sept. 1, 1851): 242. [Extensive discussion of E. C. Hawkins' loss by fire.]

H312 "Editorial Notices." HUMPHREY'S JOURNAL 4, no. 18 (Jan. 1, 1853): 282. [E. C. Hawkins won award at the 12th Annual exhibition of the Mechanics Institute of Cincinnati, OH.]

H313 Portrait. Woodcut engraving, credited "From a Daguerreotype by E. C. Hawkins, Cincinnati." ILLUSTRATED NEWS (NY) 1, (1853) ["Frances Wright D'Arusmot." 1:3 (Jan. 15, 1853): 45.]

H314 Sanders, J. Milton. "Who Made the First Collodion Picture?" AMERICAN JOURNAL OF PHOTOGRAPHY AND THE ALLIED ARTS AND SCIENCES n. s. vol. 1, no. 7 (Sept. 1, 1858): 99-100. [E. C. Hawkins, with the assistance of Professor Joseph Locke and at the suggestion of J. Milton, made a collodion photograph in 1847, in Cincinnati, OH.]

HAWKS, M. S.

H315 "Railroad Disaster at Buckfield, Maine, April 27, 1869." HARPER'S WEEKLY 13, no. 647 (May 22, 1869): 333. 1 illus. ["Photograph by M. S. Hawks."]

HAYES, ISAAC I. (ca. 1845-) (USA)

H316 "Editorial Miscellany." AMERICAN JOURNAL OF PHOTOGRAPHY AND THE ALLIED ARTS & SCIENCES n. s. vol. 4, no. 12 (Nov. 15, 1861): 287-288. ["Dr. Hayes has recently returned from the Arctic regions,... brought with him over two hundred photographs... it was concluded that the expedition, poorly equipped in other respects, could not afford a special photographic attachment. All thanks to Dr. Hayes who was willing to add to his other responsible and arduous duties the labor of a practical photographer."]

H317 "The Iceland Celebration." FRANK LESLIE'S ILLUSTRATED NEWSPAPER 39, no. 989 (Sept. 12, 1874): 13-14. 3 illus. [Three views, of Rejkiavik and Thingvalla, Iceland. Not credited to be from photographs, but possible. The source of the illustrations was the expedition led by Dr. Hayes and Bayard Taylor.]

H318 Russack, Richard. "Dr. Isaac Hayes: Explorer, Photographer, Bigot." NORTHLIGHT (JOURNAL OF THE PHOTOGRAPHIC HISTORICAL SOCIETY OF AMERICA) 2, no. 2 (Spring 1975): 5-7, 11. 9 b & w. [Dr. Isaac I. Hayes, a twenty-five year old physician sailed from Boston on July 7, 1860 to explore the northern coast of Greenland. He had accompanied Dr. Kane's expedition there in 1855. Unable to afford a professional photographer, Hayes himself learned photography and took stereo views of the expeditionary party, the region, and the inhabitants. When Hayes returned the USA was in the Civil War and he enlisted in the Union Army, where he came to command a field hospital. About one hundred of Hayes' stereos were marketed and sold by T. C. Roche in 1862. Hayes also wrote a book, *The Open Polar Sea,* published in 1866.]

HAYNES, FRANK JAY. (1853-1921) (USA)
[Frank Jay Haynes was born in Saline, MI on Oct. 28, 1853. By age twenty-three he had apprenticed as a photographer and opened his first photographic studio in Moorehead, MN in 1876. In 1877 he made a four hundred mile trip by stage coach from Bismark, Dakota Territory, to Deadwood, taking photographs of the country, and its people. In 1878 took a photographic trip from Bismark to the Pacific coast, and a three thousand mile trip down the Missouri River and back. In 1881 he went through Yellowstone National Park, photographing the Mammoth Hot Springs, the Great Falls, and Grand Canyon. In 1882 he left Billings, MT and discussed the possibility of establishing a permanent studio in the Yellowstone Park with its superintendant. In August 1883 he accompanied President Chester A. Arthur's expedition through the Yellowstone area, and photographed the driving of the last spike on the Northern Pacific Railroad later in that year. He became the official photographer for the Northern Pacific, and, in addition to his regular studio, from 1885 on, he maintained a pullman railroad car converted into a travelling studio and darkroom, called the Haynes Palace Studio Car, on the railroad. Haynes maintained this car for nearly twenty years. In addition to making the typical studio portraits, Haines travelled about the country photographing the mining towns, miners, cattlemen, and Indians in the region. He specialized in views of the Yellowstone region in the 1880s, and published many tourist view books and inexpensive photogravure portfolios of the scenery, the first guide book coming out in 1888. In 1889 he moved his studio from Fargo, ND to St. Paul, MN and, in 1895, he enlarged and modernized the business. In 1897 he built the Haynes' Log Cabin Studio at the Old Faithful geyser, and in 1898 organized a stage line for tourists at the park. Haynes retired from business in 1916, his second son, J. E. Haynes taking over the photographic concession at the Yellowstone Park. He died in March 1921, and a mountain in the Yellowstone park was named after him to commemorate his long connection with that area.]

BOOKS
H319 Haynes, F. Jay. *Yellowstone National Park: Photogravures from Nature.* Photographed and Published by F. Jay Haynes. Fargo, ND: F. J. Haynes, ca. 1887. 2 l. 25 l. of plates.

H320 Tilden, Freeman. *Following the Frontier with F. Jay Haynes - Pioneer Photographer of the Old West.* New York: Alfred A. Knopf, 1964. 406 pp. b & w. illus.

H321 Montana Historical Society. *F. Jay Haynes, Photographer.* Helena, MT: Montana Historical Society, 1981. n. p. b & w. illus.

H322 Nolan, Edward W. *Northern Pacific Views: The Railroad Photography of F. Jay Haynes, 1876 - 1905.* Helena, MT: Montana Historical Society, 1983. n. p. b & w. illus.

PERIODICALS
H323 "Dakota Territory. - The Great Wheat Fields in the Valley of the Red River of the North, Threshing by Steam on the Dalrymple Farm, Formerly a Barren Prairie. - From Sketches George H. Ellsbury and Photographs by F. Jay Haynes." FRANK LESLIE'S ILLUSTRATED NEWSPAPER 47, no. 1203 (Oct. 19, 1878): 112-113. 3 illus. [Views, with figures.]

H324 "Our Editorial Table: Northern Pacific." PHOTOGRAPHIC TIMES 11, no. 125 (May 1881): 187. [Describes Haynes' stereo views of the Northern Pacific Railroad. Haynes is described as the official photographer of this railroad.]

H325 Haynes, F. Jay. "To Dry Albumen Paper Without Curling." PHOTOGRAPHIC TIMES 14, no. 161 (May 1884): 241.

H326 "Note." PHOTOGRAPHIC TIMES 14, no. 167 (Nov. 1884): 585. [F. Jay Haynes has received the appointment of Superintendent of the Wyoming Art Gallery at the World's Exhibition in New Orleans in 1885. Haynes plans to open a studio and display rooms at the Mammoth Hot Springs, National Park.]

H327 Haynes, F. Jay. "Mounting Large Photographs." PHOTOGRAPHIC TIMES 15, no. 185 (Apr. 3, 1885): 169.

H328 "Publications: A Palace Car Studio." PHOTOGRAPHIC TIMES 15, no. 215 (Oct. 30, 1885): 619. [Handbill, describing F. Jay Haynes car-studio on the Northern Pacific Railway, for which Haynes has been the official photographer "... since the opening of the road."]

H329 Haynes, F. Jay. "A Photographic Studio on Wheels." PHOTOGRAPHIC TIMES 16, no. 238 (Apr. 9, 1886): 192-192A. 1 illus. [Haynes describes a railroad car he designed and had built for use as a studio on the Northern Pacific Rail Road at a cost of $13,000. Includes a woodcut view of the car and a plan of its interior.]

H330 "The Great Falls of the Yellowstone." PHOTOGRAPHIC TIMES 19, no. 381 (Jan. 4, 1889): frontispiece, 2. 1 b & w. [Brief note.]

H331 Guptill, A. B. "Yellowstone Park." OUTING 16, no. 4 (July 1890): 256-263. 6 b & w. 2 illus. ["From Photographs by Haynes."]

H332 Haynes, J. E. "F. Jay Haynes, A Synopsis of His Life." HAYNES' BULLETIN (ST. PAUL, MN) (Mar. 1922): 1-2. 3 illus.

H333 Galusha, Hugh D., Jr. "Yellowstone Years: A Story of the Great National Park as Chronicled in Pictures, Words and Deeds by the Venerable House of Haynes." MONTANA: THE MAGAZINE OF WESTERN HISTORY 9, no. 3 (Summer 1959): 2-21. b & w.

H334 "Frontier Photographer." AMERICAN HERITAGE. 15, no. 6 (Oct. 1964): 22-35. 18 b & w. [Photos of Montana in the 1880s. Railroads, forts, mining camps, Indians, etc. From Freeman Tildon's book "Following the Frontier."]

H335 "Pacific Photographer: A Photographic Studio on Wheels." NORTHLIGHT (JOURNAL OF THE PHOTOGRAPHIC HISTORICAL SOCIETY OF AMERICA) 3, no. 4 (Fall 1976): 3. 1 illus. [Reprinted from "Photo. Times" (Apr. 9, 1886).]

H336 Morrow, Delores J. "The Haynes Photograph Collection at the Montana Historical Society." SOUTH DAKOTA HISTORY 12, no. 1 (Spring 1982): 65-73. 7 b & w. [23,000 negatives and prints at the Montana Historical Society of Frank J. Haynes and his son, Jack Ellis Haynes (1876-1962).]

H337 Mattison, David. "Photographing the Frontier: Frank J. Haynes in Canada." BEAVER 67, (1987): 24-36.

H338 Mattison, David. "Sitting Bull in Canada: The Last Photographs by F. Jay Haynes." HISTORY OF PHOTOGRAPHY 12, no. 2 (Apr. - June 1988): 121-122. 1 b & w. 1 illus. [Last photographs of Sitting Bull, Sioux Indian chief, taken in 1881.]

HAYWARD, ROBERT.
H339 Abel, John, ed. *Memorials of Queen Eleanor; Illustrated by Photography. With a Short Account of Their History and Present Condition.* London: Published for the proprietor, 1864. 15 pp. 8 b & w. [Photographs by Robert Hayward.]

H340 Brown, J. W., Mrs. *Muriel's Dreamland; A Fairy Tale,...* with Illustrations by the Authoress and Her Daughter, Alberta Brown. London: Griffith & Farran, 1871. 85 pp. 6 l. of plates. 6 b & w. [Photographs of other art works, "Photographed by Robert Hayward, Finchley."]

HAYWOOD.
H341 Portrait. Woodcut engraving, credited "From a Daguerreotype by Haywood." BALLOU'S PICTORIAL DRAWING-ROOM COMPANION [GLEASON'S] 12, (1857) ["Derastus Clapp, Esq." 12:302 (Apr. 4, 1857): 220.]

HAYWOOD, CHARLES. (d. 1878) (USA)
H342 "Editor's Table." PHILADELPHIA PHOTOGRAPHER 15, no. 173 (May 1878): 160. [Charles Haywood, a young photographer of Bourbon, IN, shot his wife and then himself on Feb. 22.]

HEADSMAN, SIMON.
H343 "Headsman, Simon." "Letters to a Photographic Friend." BRITISH JOURNAL OF PHOTOGRAPHY 7, no. 122-132 (July 16 - Dec. 15, 1860): 209-210, 224-226, 241-243, 258-259, 274-276, 286-288, 302-303, 317-318, 352-353, 371-372. 24 illus. [Amiable discussion of "the Novelties at the Various Photographic Warehouses." (New cameras and other apparatus), cast in the frame of letters from a tourist.]

HEARN, CHARLES W.
BOOKS
H344 Hearn, Charles W. *The Practical Printer. A Complete Manual of Photographic Printing... Containing Full Details Concerning... Plain and Albumen Paper Printing and of Printing on Porcelain.* "2nd ed." Philadelphia: Benerman & Wilson, 1874. viii, 192 pp. 1 b & w. illus. [2nd ed. (1878) 208 pp.]

H345 Hearn, Charles W. *Hearn's Studies in Artistic Printing. A Complete Manual of Photographic Printing... With Six Fine Cabinet and Promenade Portrait Studies.* Philadelphia: Printed for the author by Sherman & Co., 1877. 22 pp. 6 b & w. [(1882) Philadelphia: Edward L. Wilson.]

PERIODICALS
H346 Hearn, Ch. W. "Fifth Annual Meeting and Exhibit of the National Photographic Association of the U.S., held in Buffalo, N.Y., beginning July 5, 1873: Printing, Toning, Washing & Finishing Photographs." PHILADELPHIA PHOTOGRAPHER 10, no. 117 (Sept. 1873): 384-387.

H347 "The New Alba Plate." PHOTOGRAPHIC TIMES 5, no. 50 (Feb. 1875): 25-28. [Letters, information concerned with this technical issue by Hearn, author of "The Practical Printer."]

H348 Hearn, Charles W. "Are Our Portraits Artistic? A Few Remarks on the Lighting of the Model, and the Exposing, Developing, Fixing and Retouching of the Negative." PHILADELPHIA PHOTOGRAPHER 15, no. 180 (Dec. 1878): 361-365. [Continued in 1879.]

H349 "Our Picture." WILSON'S PHOTOGRAPHIC MAGAZINE 38, no. 529 (Jan. 1901): frontispiece, 31. 1 b & w. [Genre portrait of a monk. The model was another photographer named Ben Eichelman. The note contains some brief career information about both Charles Hearn and Ben Eichelman.]

HEATH & BULLINGHAM. (PLYMOUTH, ENGLAND)
H350 Portrait. Woodcut engraving credited "From a photograph by Heath & Bullingham." ILLUSTRATED LONDON NEWS 74, (1879) ["Lady Victoria Edgecumbe." 74:2074 (Mar. 15, 1879): 241.]

HEATH, Allen S. & A. H. HEATH. (USA)
H351 Heath. *Photography. A New Treatise, Theoretical and Practical, of the Processes and Manipulations on Paper and Glass.* New York: Heath & Brother, 1855. 161 pp.

HEATH, FRANCIS GEORGE.
H352 Heath, Francis George. *The Fern World.* London: Sampson Low, Marston, Searle and Rivington, 1877. xii, 459 pp. [1 frontispiece in Woodburytype and 12 colored plates based on photographs.]

HEATH, JAMES.
H353 "Aqueduct at Rochester." HUMPHREY'S JOURNAL 4, no. 6 (July 1, 1852): 95. [Praise for view of the Aqueduct at Rochester, NY, by James Heath.]

HEATH, VERNON. (1819-1895) (GREAT BRITAIN)
H354 "Note." JOURNAL OF THE PHOTOGRAPHIC SOCIETY OF LONDON 7, no. 104 (Dec. 15, 1860): 73. [Note that "Mr Heath, of Piccadilly to photograph for the stereoscope the interiors of Windsor Castle and Buckingham Palace."]

H355 Heath, Vernon. "On Manipulating Wet Collodion Plates in the Field." BRITISH JOURNAL OF PHOTOGRAPHY 8, no. 139 (Apr. 1, 1861): 124-125.

H356 Heath, Vernon. "On Manipulating Wet Collodion Plates in the Field." JOURNAL OF THE PHOTOGRAPHIC SOCIETY OF LONDON 7, no. 109 (May 15, 1861): 187-189. [Read before the Blackheath Photo Soc. Mar. 18, 1861.]

H357 "Cabinet Pictures." BRITISH JOURNAL OF PHOTOGRAPHY 9, no. 157 (Jan. 1, 1862): 9. [Review of Vernon Heath's work.]

H358 "Letter." JOURNAL OF THE PHOTOGRAPHIC SOCIETY OF LONDON 7, no. 118 (Feb. 15, 1862): 372. [Letter from Heath protesting a reviewers remarks about the Exhib. of the Photo. Soc. of Scotland.]

H359 "Mason vs. Heath." JOURNAL OF THE PHOTOGRAPHIC SOCIETY OF LONDON 7, no. 119 (Mar. 15, 1862): 20-21. [Note page 97, July 15, 1862 that the action finally went in favor of Heath.]

H360 "A Dispute about a Negative: Mason V. Heath." BRITISH JOURNAL OF PHOTOGRAPHY 9, no. 162 (Mar. 15, 1862): 112-113. [Argument over ownership of a negative of a portrait of Prince Albert, taken by Heath, claimed by Mason - the publisher of the series "British Portrait Gallery."]

H361 "Note." ART JOURNAL (Apr. 1862): 110. [Photos of Prince Albert.]

H362 "Note." JOURNAL OF THE PHOTOGRAPHIC SOCIETY OF LONDON 8, no. 122 (June 16, 1862): 77. ["The Japanese Ambassadors, on the Day Previous to their Leaving England, honored Mr. Vernon Heath with a sitting."]

H363 "Scraps and Fragments: Mr. Heath's Exhibition." BRITISH JOURNAL OF PHOTOGRAPHY 9, no. 167 (June 2, 1862): 218.

H364 "Note." ART JOURNAL (July 1862): 163. [Exhibition of landscape photos at his gallery at 43 Piccadilly, London.]

H365 "Modes of Enlarging Photographs." AMERICAN JOURNAL OF PHOTOGRAPHY AND THE ALLIED ARTS & SCIENCES n. s. vol. 5, no. 3 (Aug. 1, 1862): 49-52. [From "Photo. News." Friendly challenge between Antoine Claudet and Vernon Heath, each arguing for their own technique for enlarging prints. Includes general discussion of the practices in use in Great Britian and in Europe.]

H366 "Royal Condescension." BRITISH JOURNAL OF PHOTOGRAPHY 9, no. 178 (Nov. 15, 1862): 424. [Queen Victoria allowing her negative of Prince Albert, taken by Vernon Heath, to be used to print portraits for members of the Photographic Society.]

H367 "Her Majesty, Queen Victoria." HUMPHREY'S JOURNAL OF PHOTOGRAPHY, AND THE ALLIED ARTS AND SCIENCES 14, no. 17 (Jan. 1, 1863): 211-212. [Portrait of the Late Prince Albert, taken by Vernon Heath, will be presented to each member of the London Photo. Soc.]

H368 "Mr. Vernon Heath's Private Exhibition." BRITISH JOURNAL OF PHOTOGRAPHY 10, no. 190 (May 15, 1863): 213.

H369 "Note." ART JOURNAL (Sept. 1863): 191. [Photographs of Prince of Wales' house and grounds at Frogmore.]

H370 "Our Editorial Table: Wimbledon Views and Pictures of Camp Life, by Vernon Heath, Piccadilly." BRITISH JOURNAL OF PHOTOGRAPHY 12, no. 275 (Aug. 11, 1865): 419.

H371 "Note." ART JOURNAL (Sept. 1865): 290. ["The late Wimbledon Meeting of volunteer [shooting] matches have been photographed by Vernon Heath. At least 25 photos.]

H372 "The Visit of the French Fleet to Spithead." BRITISH JOURNAL OF PHOTOGRAPHY 12, no. 281 (Sept. 21, 1865): 493. [Note that Heath commissioned by the Admiralty to photograph visit of the French fleet to England.]

H373 "Note." ART JOURNAL (Feb. 1866): 62. [Vernon Heath has joined the firm of Messrs. Day.]

H374 "Enlarged Landscapes." ANTHONY'S PHOTOGRAPHIC BULLETIN 5, no. 2 (Feb. 1874): 75-76. [From "Br J of Photo."]

H375 Heath, Vernon. "Royal Institution Lectures: The Autotype Process." ILLUSTRATED LONDON NEWS 64, no. 1801 (Feb. 28,

1874): 206. [Excerpts of Vernon Heath's lecture on the Autotype Process.]

H376 Portrait. Woodcut engraving credited "From a photograph by Vernon Heath." ILLUSTRATED LONDON NEWS 66, (1875) ["Late Admiral Sherard Osborn, C.B." 66:1867 (May 22, 1875): 489.]

H377 "Beech-Tree Blown Down at the Burnham Beeches." ILLUSTRATED LONDON NEWS 67, no. 1876 (July 24, 1875): 84, 86. 1 illus.

H378 "Easton Neston, Northamptonshire, the Hunting Seat of the Empress of Austria: From a Photograph by Vernon Heath." ILLUSTRATED LONDON NEWS 68, no. 1914 (Apr. 1, 1876): 316. 1 illus. [(Unusual to credit the photographer in the caption.)]

H379 "The Autotype." ANTHONY'S PHOTOGRAPHIC BULLETIN 7, no. 10 (Oct. 1876): 308. [From "London Times." Vernon Heath's photos of trees described.]

H380 Heath, Vernon. "Landscape Photography." BRITISH JOURNAL PHOTOGRAPHIC ALMANAC 1877 (1877): 54-57. [Heath describes his method of working.]

HEATHER, J. F. (GREAT BRITAIN)
H381 Heather, J. F., M.A. *Optical Instruments; including (more especially) Telescopes, Microscopes, and Apparatus for producing Copies of Maps and Plans by Photography.* "Weale's Series, Vol. 169, enlarged edition." Ludgate Hill: Lockwood & Co., 1877. n. p.

HEDDON, J.
H382 "Negative Collodion." HUMPHREY'S JOURNAL OF PHOTOGRAPHY, AND THE ALLIED ARTS AND SCIENCES 15, no. 15 (Dec. 1, 1863): 238-239. [Heddon notes in his letter that he has been working for sixteen years in, "...daguerreotypes, ambrotypes and photographs." praises the Journal.]

HEERING, JOHN H. (1815-1873) (USA)
H383 "San Jose, Cal." HUMPHREY'S JOURNAL OF PHOTOGRAPHY, AND THE ALLIED ARTS AND SCIENCES 20, no. 6 (July 15, 1868): 96. ["Mr. J. H. Heering, [of San Jose, CA]...sends us a specimen of his work...a view of the County Court House."]

HEID, H., DR. (1834-1891) (AUSTRIA)
H384 "Vignette: The Collector." HISTORY OF PHOTOGRAPHY 11, no. 4 (Oct. - Dec. 1987): frontispiece. 1 b & w. [Photomontaged double portrait of Henry S. Ashbee, taken by Dr. Heid in Vienna ca. 1860.]

HEIGHWAY, WILLIAM.
BOOKS
H385 Heighway, William. *Practical Portrait Photography: a Hand-book for the Dark Room, the Sky-light, and the Printing Room.* London: Piper & Carter, 1876. 152 pp. illus. [2nd ed. (1878). First published in "Photographic News", in 1875.]

H386 Heighway, William. *Aesthetics of Photography; being Hints on Posing and Lighting the Sitter.* London: Piper & Carter, 1879. n. p.

H387 Heighway, William. *Photographic Printer's Assistant.* London: Richardson & Best, 1879. 86 pp.

H388 Heighway, William. *The Hand-book of Photographic Terms.* London: Piper & Carter, 1881. n. p.

PERIODICALS

H389 Heighway, William. "Operator Wanted." PHILADELPHIA PHOTOGRAPHER 9, no. 105 (Sept. 1872): 326-327. [Heighway's letter in response to an earlier article by E. Anderson. Heighway worked in Estabrooke's Gallery, New York, NY.]

H390 Heighway, William. "Photography as an Art." PHILADELPHIA PHOTOGRAPHER 9, no. 107 (Nov. 1872): 378-379.

H391 Heighway, William. "Concerning Customers." PHILADELPHIA PHOTOGRAPHER 9, no. 108 (Dec. 1872): 414-415.

H392 Heighway, William. "Farewell to the Subject." PHILADELPHIA PHOTOGRAPHER 10, no. 109 (Jan. 1873): 8-9. [Rebuttal of Snelling's argument on p. 6 in same issue.]

H393 Heighway, William. "Our Noble Selves." PHILADELPHIA PHOTOGRAPHER 10, no. 109 (Jan. 1873): 20-22.

H394 Heighway, William. "Brains." PHILADELPHIA PHOTOGRAPHER 10, no. 115 (July 1873): 195-196.

H395 Heighway, William. "Art and Photography." PHILADELPHIA PHOTOGRAPHER 10, no. 116 (Aug. 1873): 236-237.

H396 Heighway, W. "A Word For Our Profession." PHILADELPHIA PHOTOGRAPHER 11, no. 123 (Mar. 1874): 74-75.

H397 Heighway, William. "Practical Portrait Photography." PHILADELPHIA PHOTOGRAPHER 14, no. 157 (Jan. 1877): 11-13. [From the book.]

HEISCH, CHARLES. (GREAT BRITAIN)

[Charles Heisch, F.C.S. was a member of the firm of Murray & Heath, Opticians, in London and Lecturer on Chemistry, Middlesex Hospital Medical College. He was interested in photography from the very beginnings in 1839.]

BOOKS

H398 Heisch, Charles, ed. *Photographic Manuals No. 1, Part II. Plain Directions for obtaining Photographic Pictures upon Waxed and Albumenized Paper and Glass, by Collodion and Albumen.* Including a 3rd edition of Le Gray's 'Treatise on Photography'; A Description of the Stereoscope and the Manner of taking Pictures for It; Also the Process for Copying Microscopic Objects, etc. London: Richard Willats, 1853. 74 pp.

H399 Heisch, Charles. *Elements of Photography.* London.: Murray & Heath, 1863. iv, 54 pp.

PERIODICALS

H400 Heisch, Charles, F. C. S. "The Solar Eclipse of 18th July." BRITISH JOURNAL OF PHOTOGRAPHY 7, no. 125 (Sept. 1, 1860): 251. 5 illus.

H401 Heisch, Charles, F. C. S. "Simple method of taking Stereo-Micro-Photographs." HUMPHREY'S JOURNAL OF PHOTOGRAPHY, AND THE ALLIED ARTS AND SCIENCES 14, no. 13 (Nov. 1, 1862): 154.

H402 "Lime-Toning." AMERICAN JOURNAL OF PHOTOGRAPHY AND THE ALLIED ARTS & SCIENCES n. s. vol. 8, no. 3 (Aug. 1, 1865): 60-63. [From "Br. J. of Photo.]

HELE, H. H.

H403 Hele, H. H. "The Calotype Process." HUMPHREY'S JOURNAL 7, no. 16 (Dec. 15, 1855): 261. [From "Liverpool Photo. J."]

H404 Hele, H. "Faded Positives on Glass, Carbon Prints, etc." HUMPHREY'S JOURNAL OF PHOTOGRAPHY, AND THE ALLIED ARTS AND SCIENCES 12, no. 8 (Aug. 15, 1860): 127-128. [From "Br. J. of Photo."]

HELIO. (BOSTON)

H405 "Helio." "The Omnifocal Camera - Sel D'Or." HUMPHREY'S JOURNAL 6, no. 21 (Feb. 15, 1855): 340-341. [Discussion of panoramic cameras, criticism of L. L. Hill.]

H406 "Helio." "An Entire Process for producing Collodion Positives and Negatives with one bath, and in much less time than by any other known Process." HUMPHREY'S JOURNAL 8, no. 16 (Dec. 15, 1856): 241-245. ["Helio" was from Boston.]

HELIOS. (CYPRUS)

H407 "Summer Encampment of the British Government of Cyprus on Mount Troodos (Olympus)." ILLUSTRATED LONDON NEWS 75, no. 2105 (Oct. 18, 1879): 365, 366. 8 illus. [Views of soldiers' campsites. [Perhaps John Thomson?]]

HELLER, LOUIS HERMAN. (1839-1928) (GERMANY, USA)

[Born in Darmstadt, Germany on Aug. 11, 1839. To New York City ca. 1855. Learned photography in the 1860s. Moved to California around 1862 and opened a studio in Yreka, CA in 1864. Also travelled around CA. In 1869 Heller sold his Yreka studio to Jacob Hansen and opened a studio at Ft. Jones. In 1873 Heller photographed the Modoc War. In 1900 he sold his Ft. Jones studio and moved to San Francisco. Died in San Francisco on June 25, 1928.]

H408 "Our Indian Allies in the Modoc War." HARPER'S WEEKLY 17, no. 859 (June 14, 1873): 499, 500. 8 illus. ["...engraved, with one exception from recent photographs." (Research shows these photographs to have been made by Louis Heller. See Peter Palmquist, "Imagemakers of the Modoc War," "Journal of California Anthropology" 4:2 (Winter 1977).)]

H409 Portrait. Woodcut engraving, credited "From a Photograph by C. F. [sic E.] Watkins, San Francisco." FRANK LESLIE'S ILLUSTRATED NEWSPAPER 36, (1873) ["The Modoc Indians: Captain Jack and his braves. (11 portraits)." 36:928 (July 12, 1873): 277. (These photos credited to C. E. Watkins, but research shows them to have been made by Louis Heller.)]

H410 "The Modoc Trial. - The Warm Spring Indians. From a Photograph by C. F. [sic E.] Watkins, of San Francisco, California." FRANK LESLIE'S ILLUSTRATED NEWSPAPER 36, no. 930 (July 26, 1873): 313. 1 illus. [Outdoor portrait of sixteen Indian braves on horseback. (These photos credited to C. E. Watkins, but research shows them to have been made by Louis Heller.)]

H411 Palmquist, Peter E. "Imagemakers of the Modoc War: Louis Heller and Eadweard Muybridge." JOURNAL OF CALIFORNIA ANTHROPOLOGY 4, no. 2 (Winter 1977): 206-241. 25 b & w. 4 illus. [Includes a summary of events of the Modoc War in 1872-73, biographies of L. H. Heller and E. J. Muybridge, a discussion of the photographic coverage of the conflict, a catalogue and notes on the Modoc War photographs, and a portfolio of photographs and five full-page spreads from "Harper's Weekly," of articles illustrated with engravings taken from these photographs. Comments on how the

photographs were altered in the magazine, and how they were misattributed.]

H412 Palmquist, Peter E. "Photographing the Modoc Indian War: Louis Heller versus Eadweard Muybridge." HISTORY OF PHOTOGRAPHY 2, no. 3 (July 1978): 187-205. 23 b & w. 3 illus.

HELSBY & CO.
H413 Helsby. "Helioaristotypia." AMERICAN JOURNAL OF PHOTOGRAPHY AND THE ALLIED ARTS & SCIENCES n. s. vol. 7, no. 17 (Mar. 1, 1865): 399-400. [From "Photo. Notes." On printing on enamelled white glass.]

H414 "The MacKay Gun." ILLUSTRATED LONDON NEWS 51, no. 1451 (Oct. 19, 1867): 416. 2 illus. ["The photographs of the guns and targets were taken by the staff of Messrs. Helsby & Co., of Liverpool." Cannon.]

HELSBY, TOMAS C. (USA, ARGENTINA)
[An American, active in Buenos Aires in 1846 until ?]

H415 "The Valparasio and Santiago Railway." ILLUSTRATED LONDON NEWS 22, no. 608 (Feb. 12, 1853): 123-124. 1 illus. ["We owe to the Daguerreotype, in the skillful hands of a gentleman at Valparasio, a spirited Illustration of the inauguration of the Valparasio and Santiago Railway." "From a Daguerreotype by Mr. Helsby."]

H416 "Valparaiso and Santiago Railroad." ILLUSTRATED NEWS (NY) 2, no. 43 (Oct. 22, 1853): 220. 1 illus. [View of construction of railroad in Chili. Not credited, but this image taken from the "Illustrated London News," where it was credited "from a daguerreotype by Mr. Helsby."]

HEMERY, T. G.
H417 Hemery, T. G. "A New Phase of Business." BRITISH JOURNAL PHOTOGRAPHIC ALMANAC 1879 (1879): 120-122. [Hemery apparently a professional, was asked to make photographic copies of business ledgers, accounts, etc.]

HEMPHILL, WILLIAM DESPARD. (CLONMEL, IRELAND)
BOOKS
H418 Hemphill, W. D., M.D. Stereoscopic Illustrations of Clonmel and Surrounding County, Including Abbeys, Castles, and Scenery. With descriptive letterpress by W. D. Hemphill, M. D. Dublin; London: Curry & Co. and T. Cranfield; A. W. Bennett, 1860. n. p.

PERIODICALS
H419 "New Books: Stereoscopic Illustrations of Clonmel and the Surrounding County, Including Abbeys, Castles, and Scenery." ART JOURNAL (Sept. 1860): 320. [Review.]

H420 "Note: Among Amateur Photographists." ART JOURNAL (Dec. 1865): 382. [Amateur. Took first prize at the Amateur Photo Assoc. in 1864 and a medal at the Dublin International Exhib. Hemphill from Clonmel, England.]

HENDERSON, ALEXANDER L. (d. 1907) (GREAT BRITAIN)
H421 Portrait. Woodcut engraving credited "From a photograph by Henderson, King William St." ILLUSTRATED LONDON NEWS 66, (1875) ["H. D. Young, Capt. of "Ilala." 66:1870 (June 12, 1875): 552.]

H422 "A Day with a Photo-Enameller." ANTHONY'S PHOTOGRAPHIC BULLETIN 7, no. 4 (Apr. 1876): 110-112. [From "Br. J. of Photo."]

H423 "Home and Foreign News Epitomized." PHOTOGRAPHIC TIMES 10, no. 112 (Apr. 1880): *. [Henderson reported to have taken a landscape photograph by moonlight. 7 hour exposure.]

H424 Henderson, A. L. "Collodion vs. Gelatine." PHOTOGRAPHIC TIMES 11, no. 129 (Sept. 1881): 368-369. [Communication to the Photographic Club (of London). Costs out the relative expenses of using collodion plates and gelatine plates. Henderson was apparently a commercial studio photographer in London.]

HENDERSON, ALEXANDER. (1831-1913) (GREAT BRITAIN, CANADA)
BOOKS
H425 Canadian Views and Studies by an Amateur. Montreal: Alex. Henderson , 1865. 20 l. of plates. 20 b & w. [Album, Boston Public Library Collection.]

H426 Photographic Views and Studies of Canadian Scenery. Montreal: Alex. Henderson , 1865. 20 l. of plates. 20 b & w. [Album, Boston Museum of Fine Arts Collection.]

H427 C. R. Chisom & Co., ed. The All Round Route Guide: the Hudson River, Trenton Falls, Niagara, Toronto, the Thousand Islands and the River St. Lawrence, Ottawa, Montreal, Quebec, the Lower St. Lawrence and the Saguenay Rivers, the White Mountains, Boston, New York. Montreal: Montreal Printing and Publishing Co., 1869. n. p. 11 b & w. [Original photographs.]

H428 Snow and Flood After the Great Storms of 1869, Alexander Henderson, Photographer. Montreal: Alex. Henderson, 1870. 1 pp. 18 l. of plates. 18 b & w. [Original prints, half-stereos, with titles of photos on title page. Other copies with twenty prints.] Henderson, Alexander. Photographs of Montreal. Photographed and Published by Alex. Henderson. Montreal: Alex. Henderson, 1870. 1 pp. 20 l. of plates. 20 b & w. [Original photographs, half-stereos. GEH Collection.]

H429 Henderson, Alexander. Album of Photographs of Wrought Iron Railroad Bridges Constructed and Erected for the Government of Ottawa and Occidental Railway. Montreal: Alex. Henderson, 1878 [?]. 1 pp. l. of plates. [Original photographs, in album. National Gallery of Canada Collection.]

PERIODICALS
H430 Henderson, Alexander. "Mr. M. Carey Lea's Chlorido-Bromide Emulsion." BRITISH JOURNAL PHOTOGRAPHIC ALMANAC 1876 (1876): 80-81.

H431 Henderson, Alexander. "On Print Washing and Emulsions." BRITISH JOURNAL PHOTOGRAPHIC ALMANAC 1876 (1876): 118-119.

H432 Henderson, Alex. "Notes on Mr. M. Carey Lea's Chloriodo - Bromide Emulsion Process and Gelatine Plates." BRITISH JOURNAL PHOTOGRAPHIC ALMANAC 1877 (1877): 97-99.

H433 Henderson, Alexander. "A Few Notes on Last Year's Experience with Dry Plates, Emulsions, &c." BRITISH JOURNAL PHOTOGRAPHIC ALMANAC 1878 (1878): 57-58.

H434 "Notes and News." PHOTOGRAPHIC TIMES 20, no. 438 (Feb. 7, 1890): 72. [Received several photos by Alexander Henderson, landscape photographer of Montreal.]

H435 Henderson, Alexander. "The Hand Camera in the Woods." AMERICAN ANNUAL OF PHOTOGRAPHY AND PHOTOGRAPHIC TIMES ALMANAC FOR 1891 (1891): 193-194.

H436 Henderson, Alexander. "Canadian Views." PHOTOGRAPHIC TIMES 21, no. 488 (Jan. 23, 1891): 37-38, plus frontispiece. 1 collage of 6 images b & w. [Professional photographer in Montreal, president of the Montreal Camera Club. Includes a letter explaining circumstances of taking the photos during a trip on the Canada Pacific Rail Road in 1888.]

H437 Guay, Louise. "Alexander Henderson, Photographer." HISTORY OF PHOTOGRAPHY 13, no. 1 (Jan. - Mar. 1989): 79-94. 16 b & w. [Alexander Henderson born in Scotland in 1831. He was inspired by a visit to the Crystal Palace Exhibition of 1851 to want to become an artist. Trained as an accountant. Emigrated to Canada in 1855 and settled in Montreal. By 1859 he was a self-employed commission merchant. Began to photograph around 1857, as an amateur. Interested in the stereo and was a member of the Stereoscopic Exchange Club. Contributed articles to *Photographic News* and the *British J. of Photography Almanac* in late 1850s. Throughout 1860s, 1870s he won awards at exhibitions, and published a widely seen and well-regarded album of *Canadian Views and Studies* in 1865. Opened a studio for portrait photography in Montreal in 1866-1867, but also continued to take landscapes - working from time to time for the Grand Truck Railway and the Intercolonial Railway. In 1874 moved studio and concentrated on views. Through 1880s photographed for railroads, others. Active through early 1890s, died in 1913.]

HENDERSON, JAMES. (GREAT BRITAIN)
H438 Heathcote, Bernard V. and Pauline F. Heathcote. "The Collapse." HISTORY OF PHOTOGRAPHY 7, no. 2 (Apr. - June 1983): 87-89. 1 b & w. 2 illus. [Anecdote about an early British photographer, who witnessed the collapse of a building in 1853.]

HENDERSON, JOHN.
H439 Henderson, John. "Photography and Stereoscope." ANTHONY'S PHOTOGRAPHIC BULLETIN 2, no. 6 (June 1871): 162-163. [From "London Photo. News."]

HENDERSON, P.
H440 Henderson, P. "On Naturally Colored Photographs." PHOTOGRAPHIC AND FINE ART JOURNAL 8, no. 4 (Apr. 1855): 125. [From "J. of Photo. Soc., London."]

H441 Henderson, P. and William Ross. "Retrospective Criticism: On Naturally-Colored Photographs." HUMPHREY'S JOURNAL 7, no. 2 (May 15, 1855): 23-28. [Criticism of earlier article by Ross, with his reply to that criticism.]

H442 Henderson, P. "New Carbon Process. - Mounting." HUMPHREY'S JOURNAL OF PHOTOGRAPHY, AND THE ALLIED ARTS AND SCIENCES 16, no. 5 (July 1, 1864): 71. [From "Photo. News."]

HENDRICKS, T.
H443 Portrait. Woodcut engraving, credited "From a Photograph by T. Hendricks. FRANK LESLIE'S ILLUSTRATED NEWSPAPER 43, (1876) ["D. W. Marshall, first discoverer of gold in CA." 43:1095 (Sept. 23, 1876): 44.]

HENKEL.
H444 Portrait. Woodcut engraving, credited "From a Photograph by Henkel." FRANK LESLIE'S ILLUSTRATED NEWSPAPER 40, (1875) ["The late Alexander Hamilton." 40:1038 (Aug. 21, 1875): 416.]

HENNAH & KENT. BRIGHTON, ENGLAND.
H445 Portrait. Woodcut engraving credited "From a photograph by Hennah & Kent." ILLUSTRATED LONDON NEWS 75, (1879) ["Late Mr. Edward Blore, F.R.S." 75:2102 (Sept. 27, 1879): 280.]

HENNAH, THOMAS H. see also HENNAH & KENT.

HENNAH, THOMAS H. (GREAT BRITAIN)
[Hennah was a professional photographer, working in Brighton, England.]

BOOKS
H446 Hennah, T. H. *Directions for Obtaining both Positive and Negative Pictures upon Glass, by Means of the Collodion Process, and for Printing from the Negative Glasses on to Paper*. Also Gustave Le Gray's recently published method of obtaining Black and Violet Colors in the Positive Proofs. Translated from the French. London: Delatouche & Co., 1853. 36 pp.

H447 Hennah, Thomas H. *Photographic Manipulation. The Collodion Process*. "2nd ed." London: George Knight & Sons, 1854. viii, 48 pp. [3rd ed. (1855), viii, 58 pp.; NY: H. H. Snelling (1856) 47 pp. 5th ed. (1857), xii, 60 pp.]

PERIODICALS
H448 "Reviews of New Books." PRACTICAL MECHANIC'S JOURNAL 7, no. 76 (July 1854): 85. [Bk. Rev.: "Directions for Obtaining both Positive and Negative Pictures upon Glass, by Means of the Collodion Process." by T. H. Hennah.]

H449 Hennah, T. H. "Positive Printing." AMERICAN JOURNAL OF PHOTOGRAPHY AND THE ALLIED ARTS & SCIENCES n. s. vol. 6, no. 23-24 (June 1 - June 15, 1864): 549-550, 555-558. [Read to London Photo. Soc.]

H450 Hennah, T. H. "Positive Printing." HUMPHREY'S JOURNAL OF PHOTOGRAPHY, AND THE ALLIED ARTS AND SCIENCES 16, no. 7 (Aug. 1, 1864): 103-106. [Read to London Photo. Soc.]

HENNEMAN & MALONE.
H451 "Sir David Brewster." ILLUSTRATED LONDON NEWS 17, no. 440 (Aug. 10, 1850): 120-121. 1 illus. [Brief biography. "The accompanying portrait is engraved from a beautifully executed Talbotype by Messrs. Henneman & Malone, of Regent Street."]

HENNEMAN, NICHOLAS. (1813-1893) (HOLLAND, GREAT BRITAIN)
H452 M. "Amateur's Column." LIVERPOOL & MANCHESTER PHOTOGRAPHIC JOURNAL [BRITISH JOURNAL OF PHOTOGRAPHY] n. s. 2, no. 2 (Jan. 15, 1858): 23-24. [Describes printing the photos for Talbot's "Pencil of Nature," etc. Henneman mentioned.]

H453 Gill, A. T. "Call Back Yesterday: The Reading Establishment." PHOTOGRAPHIC JOURNAL 114, no. 12 (Dec. 1974): 610-611. 2 illus. [Discussion of the calotype printing plant that Talbot set up in Reading, England, then placed under Nicholas Henneman's direction.]

H454 Gill, Arthur T. "Nicholas Henneman 1813-1893. Chronological notes." HISTORY OF PHOTOGRAPHY 4, no. 4 (Oct. 1980): 313-322. 4 b & w. 2 illus. [Includes appendices consisting of excerpts from Henneman's advertisements in the "London Times" in the 1840s and 1850s.]

H455 Gill, Arthur T. "Nicholas Henneman." HISTORY OF PHOTOGRAPHY 5, no. 1 (Jan. 1981): 84-86. 2 illus. [Addenda to article by Gill, "History of Photography" 4:4 (Oct. 1980). Discusses business agreements between Talbot and Henneman.]

HENRY.
H456 "Vermont. - The Grave of the Late James Fisk, Jr., at Brattleboro. - From a Photograph by Henry." FRANK LESLIE'S ILLUSTRATED NEWSPAPER 33, no. 853 (Feb. 3, 1872): 333. 1 illus. [View.]

HENRY, E. G. (LEAVENWORTH, KS)
H457 "Altar of the Cathedral of the Immaculate Conception, Leavenworth, Kansas." HARPER'S WEEKLY 13, no. 630 (Jan. 23, 1869): 60. 1 illus. ["Photograph by E. G. Henry."]

H458 "Editor's Table." PHILADELPHIA PHOTOGRAPHER 6, no. 69 (Sept. 1869): 324. [A group portrait of the M. E. Conference of Kansas noted.]

H459 "Perambulator" "'Kansas Correspondence,' Leavenworth, Kan." PHOTOGRAPHIC TIMES 1, no. 3 (Mar. 1871): 35. ["Perambulator," writing a column, puffs the artistic poser, Mr. Tom Garret and the proprietor Mr. Henry.]

H460 "The New Bridge of the Kansas and Missouri Railroad Company, Over the Missouri River (General W. W. Wright, Engineer). - From a Photograph by E. G. Henry." FRANK LESLIE'S ILLUSTRATED NEWSPAPER 34, no. 867 (May 11, 1872): 140. 1 illus. [View.]

HENRY, W. F.
H461 Henry, W. F. "Blurring." BRITISH JOURNAL PHOTOGRAPHIC ALMANAC 1879 (1879): 125-126.

HENSCHEL & BENQUE. (RIO DE JANEIRO, BRAZIL)
H462 Portrait. Woodcut engraving, credited "From a Photograph by Henschel & Benque, Rio Janeiro." FRANK LESLIE'S ILLUSTRATED NEWSPAPER 42, (1876) ["Dom Pedro II, Emperor of Brazil." 42:1074 (Apr. 29, 1876): 121.]

HENSZEY & CO. (PHILADELPHIA, PA)
H463 "Editor's Table." PHILADELPHIA PHOTOGRAPHER 2, no. 23 (Nov. 1865): 187. [Portraits of Grant and Farrigut mentioned.]

H464 "The Glass House." PHILADELPHIA PHOTOGRAPHER 3, no. 30 (June 1866): frontispiece, 161-164. 1 b & w. 3 illus.

H465 "Editor's Table." PHILADELPHIA PHOTOGRAPHER 4, no. 42 (June 1867): 195. [Note that Henszey & Co., 812 Arch Street, Philadelphia, PA, are vigorously pushing the cabinet photo.]

HENWOOD, C. (GREAT BRITAIN)
H466 Portrait. Woodcut engraving credited "From a photograph by C. Henwood, West Place, Turnham Green." ILLUSTRATED LONDON NEWS 75, (1879) "Late Mr. A. Keith Johnston, F.R.G.S." 75:2097 (Aug. 23, 1879): 176. illus. [1879/00]

HEPWORTH, T. C. (d. 1905) (GREAT BRITAIN)
[T. C. Hepworth, F.C.S., was a lecturer on popular science at the Polytechnic Institution in London. In the early 1880s he became the manager for the London Stereoscopic Company.]

BOOKS
H467 Hepworth, T. C. *How to Photograph; or, Simple Directions to Enable a Beginner to take Successful Pictures on Dry Plates.* London: Browning, Optician, 1883. 47 pp.

H468 Hepworth, T. C. *Photography for Amateurs.* London: Cassell & Co., 1884. 160 pp. 26 illus.

PERIODICALS
H469 Hepworth. "The Chemistry of the Collodion Process." HUMPHREY'S JOURNAL OF PHOTOGRAPHY, AND THE ALLIED ARTS AND SCIENCES 9, no. 17 (Jan. 1, 1858): 257-259. [From "Liverpool Photo. J."]

H470 Hepworth. "Chorlton Photographic Society." PHOTOGRAPHIC AND FINE ART JOURNAL 11, no. 4 (Apr. 1858): 111-114. [Paper read to the Society by Mr. Hepworth, "An Historical Sketch of the Photographic Art. Its Present Influences and Prospectives, Development, Applications, and Uses.]

H471 Hepworth, T. C. "The Evolution of the Magic-Lantern." CHAMBERS'S JOURNAL 75, no. 4 (Apr. 1, 1898): 213-215.

H472 Hepworth, T. C. "Living Photographs." CHAMBERS'S JOURNAL 75, no. 4 (Apr. 1, 1898): 228-231. [About early moving picture experiments, etc. Mentions the Zoetrope, Muybridge's experiments, Edison's kinetoscope.]

H473 Hepworth, T. C. "Film Photography." CHAMBERS'S JOURNAL 75, no. 7 (July 1, 1898): 437-439. [Evolution of film base for photographs.]

H474 "Obituary of the Year: T. C. Hepworth (June 14, 1905)." BRITISH JOURNAL PHOTOGRAPHIC ALMANAC 1906 (1906): 656. [Proprietor, editor of "Photo. News." Author of textbooks, often wrote anonymously. Outstanding lecturer.]

HERBERT, A. (MADRID, SPAIN)
H475 Portrait. Woodcut engraving credited "From a photograph by Herbert." ILLUSTRATED LONDON NEWS 72, (1878) ["King Alfonso XII, of Spain and Princess Maria de Mercedes, Queen." 72:2014 (Feb. 2, 1878): 109.]

HERBERT, J. D. (KANDY, CEYLON)
H476 "An Elephant Kraal in Ceylon." ILLUSTRATED LONDON NEWS 45, no. 1273 (Aug. 13, 1864): 167-169. 6 illus. ["We lately received from Mr. J. D. Herbert, of Kandy, Ceylon, a series of photographs which he has published, representing various scenes... of the great elephant-catching expedition to a place called Ebbewellepittia."]

HERBRUGER, E., JR. (PANAMA)
H477 "Editor's Table." PHILADELPHIA PHOTOGRAPHER 6, no. 71 (Nov. 1869): 388. [Large number of 8"x10" views of Panama, Panama City, etc.]

HERBRUGER, E., SR. (ANTIQUE, GUATEMALA)
H478 "Editor's Table." PHILADELPHIA PHOTOGRAPHER 6, no. 69 (Sept. 1869): 324. [Stereos of Guatemala noted.]

HERFORD, WILHELM VON. (1814-1866) (GERMANY, EGYPT)

H479 "View from the Top: Wilhelf von Herford on the Great Pyramid, 1856." HISTORY OF PHOTOGRAPHY 9, no. 4 (Oct. - Dec. 1985): 321-324. 2 b & w. [German amateur, photographed in Egypt in 1856.]

HERING, HENRY. (LONDON, ENGLAND)

H480 Portrait. Woodcut engraving credited "From a photograph by Hering, Regent St." ILLUSTRATED LONDON NEWS 46, (1865) ["Gen. Sir Wm. Manfield." 45:* (May 13, 1865): 464.]

H481 Portrait. Woodcut engraving credited "From a photograph by H. Hering." ILLUSTRATED LONDON NEWS 50, (1867) ["E. J. Eyre, late Governor of Jamaica." 50:* (Apr. 6, 1867): 329.]

H482 Portraits. Woodcut engravings credited "From a photograph by H. Hering, of Regent St." ILLUSTRATED LONDON NEWS 58, (1871) ["The late Sigismund Thalberg." 58:1655 (June 17, 1871): 588.]

H483 "Photographs of Lord and Lady Canning, Walter Bourne, M.D., Hon. Sec. of Bengal Photographic Society, Calcutta." JOURNAL OF THE PHOTOGRAPHIC SOCIETY OF LONDON 8, no. 135-136 (July 1- July 15, 1863): 312, 334-335 . [Controversy over photos of Lord & Lady Canning, which were made by Mr. Rome of Calcutta, then copyrighted by Mr. Hering, photographer to the Queen (London) without his permission. Henry Hering's reply in Aug. issue. In his reply he mentions purchasing 400 views of India and China several years ago from Mr. Beats [sic Beato?], then having them pirated and sold by competition.]

HERMET. [SUCCESSOR TO MAUNOURY] (PARIS, FRANCE)

H484 Portrait. Woodcut engraving credited "From a photograph by Hermet." ILLUSTRATED LONDON NEWS 70, (1877) ["Late General Chargarnier." 70:1963 (Feb. 24, 1877): 189.]

HERRON.

H485 "President Johnson's Reception in New York - Review of Troops at Delmonico's." HARPER'S WEEKLY 10, no. 507 (Sept. 15, 1866): 577. 1 illus. ["Photographed by Herron, New York." Parade and viewing stand.]

HERSCHEL, JOHN FREDERICK WILLIAM, SIR. (1792-1871) (GREAT BRITAIN)

[Born on March 7, 1792 at Slough, near Windsor. Studied at St. John's College, Cambridge. Taught mathematics and conducted scientific experiments. Co-founder of the Royal Astronomical Society in 1820, served as its Secretary from 1824 until 1827, and its President from 1848. Experimented with optics, camera lucida, astronomical observations throughout 1820s-30s. Began to investigate photography in 1839, associate of Talbot and others, and an important figure during the medium's first few years. Died on May 11, 1871 at Collingwood, Kent.]

BOOKS

H486 Herschel, John F. W. "Light," on p. 341-586 in: *Encyclopedia Metropolitana* Vol. 4 London: s. n. [John Joseph Griffin & Co. ?], ca. 1828. 14 l. of plates. illus.

H487 Herschel, John Frederick William. *On the Chemical Action of the Rays of the Solar Spectrum on Preparations of Silver and Other Substances, both Metallic and Non-Metallic, and on Some Photographic Processes,* by Sir John F. W. Herschel. London: s. n., 1840. 59 pp. 2 l. of plates. illus. [Offprint from "Philosophical Transactions of the Royal Society of London for the Year 1840, Part 1."]

H488 Herschel, Sir John Frederick William. *Herschel at the Cape; Diaries and Correspondence of Sir John Herschel, 1834-1838.* Edited, with an introduction by David S. Evans. Austin: University of Texas Press, 1969. xxxv, 308 pp. illus.

H489 Buttmann, Gunther. *The Shadow of the Telescope: A Biography of John Herschel.* New York: Charles Scribner's Sons, 1970. 219 pp. [Translated by B. E. J. Pagel, edited and with an introduction by David S. Evans. From the original German edition in 1965.]

H490 Schaff, Larry J. *Tracings of Light: Sir John Herschel & the Camera Lucida.* San Francisco; Pasadena, CA: Friends of Photography, distributed by ArtBooks, 1989. 120 pp. 40 l. of plates. 40 illus.

PERIODICALS

H491 Herschel, Sir John F. W., Bart. "Scientific and Literary: Royal Society March 7. 2. "Note on the Art of Photography or the Application of the Chemical Rays of Light to the purposes of Pictorial Representation." ATHENAEUM no. 595 (Mar. 23, 1839): 223.

H492 Herschel, Sir John F. W., Bart., K.H., V.P.R.S. "On the Chemical Action of the Rays of the Solar Spectrum on Preparations of Silver and other Substances, both Metallic and Non-Metallic, and on some Photographic Processes." PHILOSOPHICAL TRANSACTIONS (1840): 1-60.

H493 Herschel, Sir John F. W. "Scientific and Literary: Royal Society. On the Chemical Action of the Rays of the Solar Spectrum on Preparations of Silver and other Substances, both Metallic and non-metallic; and on some Photographic Processes." ATHENAEUM no. 648 (Mar. 28, 1840): 254-255.

H494 Herschel, Sir J. F. W. "On Certain Photographic Effects." ATHENAEUM no. 773 (Aug. 20, 1842): 748.

H495 Herschel, Sir J. F. W. "13th Meeting of the British Assoc. for the Advancement of Science: On a Remarkable Photographic Process." ATHENAEUM no. 829 (Sept. 16, 1843): 847.

H496 Hershel, Sir John. "14th Meeting of the British Association for the Advancement of Science: Contributions to Actino-Chemistry. On the Amphetype, a new Photographic process." ATHENAEUM no. 886 (Oct. 19, 1844): 954 - section b, p. 955.

H497 Portrait. (Sir John V. Herschel). Woodcut engraving, from a photograph. ILLUSTRATED LONDON NEWS 6, no. 165 (June 28, 1845): 405. 1 illus. [A portrait of Herschel accompanies an article on the annual meeting of the British Assoc. for the Advancement of Science, which he chaired in 1845.]

H498 "Scientific Gossip." ATHENAEUM no. 1155 (Dec. 15, 1849): 1278. [Note stressing Herschel's priority in using glass for a negative base.]

H499 Herschel, Sir John F. W. "On the Action of the Rays of the Solar Spectrum on Vegetable Colors, and On Some New Photographic Process." DAGUERREAN JOURNAL 2, no. 3-6 (June 16 - Aug. 1, 1851): 65-72, 97-106, 129-136, 161-165. [From "Philosophical Transactions, 1842."]

H500 Herschel, Sir John. "The Coloring Matter of Flowers." HUMPHREY'S JOURNAL 5, no. 24 (Apr. 1, 1854): 380-384.

H501 "Anthotype: Photography with Vegetable Juices." HUMPHREY'S JOURNAL 6, no. 5 (June 15, 1854): 80.

H502 Herschel, John, Sir. "Meeting of the British Association." HUMPHREY'S JOURNAL OF PHOTOGRAPHY, AND THE ALLIED ARTS AND SCIENCES 10, no. 14 (Nov. 15, 1858): 216-217. [Extract from Herschel's speech to the British Association.]

H503 "Useful Facts, Receipts, &c.: Anthotype." AMERICAN JOURNAL OF PHOTOGRAPHY AND THE ALLIED ARTS & SCIENCES n. s. vol. 4, no. 3 (July 1, 1861): 70. [Describes Sir John Herschel's experiments with vegetable juices, flower juices, etc.]

H504 Herschel, Sir John F. W. "On Forms of Lenses Suited for Destroying Spherical Aberration." BRITISH JOURNAL OF PHOTOGRAPHY 8, no. 153 (Nov. 1, 1861): 384-385. 7 illus.

H505 Herschel, Sir John. "About Volcanos and Earthquakes." GOOD WORDS 4, no. 1 (Jan. 1863): 53-58. [Background.]

H506 Herschel, Sir John. "On the History of Earthquakes and Volcanos." GOOD WORDS 4, no. 2 (Feb. 1863): 141-148. [Background.]

H507 Herschel, Sir John. "The Sun." GOOD WORDS 4, no. 4 (Apr. 1863): 273-284.

H508 Herschel, Sir John F. W. "The Weather and Weather Reports." GOOD WORDS 5, no. 1 (Jan. 1864): 57-64.

H509 Herschel, J. F. W. "The Supply and Preparation of Uranium." AMERICAN JOURNAL OF PHOTOGRAPHY AND THE ALLIED ARTS & SCIENCES n. s. vol. 7, no. 11 (Dec. 1, 1864): 250-251. [From "Photo. News."]

H510 Herschel, Sir John F. W. "On Light. Parts I - 3." GOOD WORDS 6, no. 4-5, 7-9, 11-12 (Apr. - May, July - Sept., Nov. - Dec. 1865): 320-326, 358-364, 496-502, 567-574, 653-659, 815-822, 892-900. 15 illus.

H511 Herschel, J. F. W., Sir. "Photography in Natural Colors, &c." AMERICAN JOURNAL OF PHOTOGRAPHY AND THE ALLIED ARTS & SCIENCES n. s. vol. 8, no. 15 (Feb. 1, 1866): 342-345.

H512 "The Late Sir John Herschel." ILLUSTRATED LONDON NEWS 58, no. 1652 (May 27, 1871): 511, 513. 1 illus. [Portrait by S. Walker. Biography.]

H513 "Obituary Notice." PHOTOGRAPHIC WORLD 1, no. 7 (July 1871): 201-202.

H514 Harrison, W. Jerome. "The Chemistry of Fixing." PHOTOGRAPHIC TIMES 20, no. 476 (Oct. 31, 1890): 540-542. [Sir John Herschel.]

H515 "Sir John F. W. Herschel." IMAGE 1, no. 1 (Jan. 1952): 4. 1 illus. [Portrait of Herschel by J. M. Cameron published as a supplement in 1:2 "Image."]

H516 Wood, Rupert Derek. "The Involvement of Sir John Herschel in the Photographic Patent Case, Talbot v. Henderson, 1854." ANNALS OF SCIENCE 27, no. 3 (Sept. 1971): 239-264. 3 illus.

H517 Gill, A. T. "Call Back Yesterday: Other Workers." PHOTOGRAPHIC JOURNAL 113, no. 3 (Mar. 1973): 129, 152. 1 b & w.

H518 Schaaf, Larry. "Sir John Herschel's 1839 Royal Society Paper on Photography." HISTORY OF PHOTOGRAPHY 3, no. 1 (Jan. 1979): 47-60. 3 b & w. 7 illus.

HERSHEY, S. O.

H519 "Ariel Martin, the Murderer of Jennison Wheelock and L. E. Ainsworth." FRANK LESLIE'S ILLUSTRATED NEWSPAPER 7, no. 175 (Apr. 9, 1859): 298-299. 4 illus. [Portraits of the principals in the case, taken by S. O. Hershey, at Calais, VT.]

HERVE, ALFRED.

H520 Herve, Alfred. "Positive Collodion Pictures on Glass-(An Ambrotype Process.)" AMERICAN JOURNAL OF PHOTOGRAPHY AND THE ALLIED ARTS & SCIENCES n. s. vol. 3, no. 16 (Jan. 15, 1861): 246-248. [From "Photo. News."]

HESLER PHOTOGRAPHIC CO. see HESLER, ALEXANDER.

HESLER, ALEXANDER. (1823-1895) (CANADA, USA)

[Born in Montreal, Canada in 1823, grew up in Vermont. Moved to Racine, WI in 1833. Learned the daguerreotype process in Buffalo, NY in 1847 and opened a gallery in Madison, WI. Moved to Galena, IL in 1848. Daguerreotyped along the Mississippi River from Galena to St. Paul from the "S. S. Nominee" in 1851, to make views for *Harper's Traveller's Guide*. In August 1851 Hesler, with J. E. Whitney from St. Paul as an assistant, took eighty-five daguerreotype views in Minnesota in one day, and during that day he photographed the Falls where the city of Minneapolis now stands. Later, through a complicated series of incidents, one of these views of the Falls came into the possession of the poet Longfellow, who was moved by the image to write the narrative poem "Hiawatha." Hesler moved to Chicago in 1853, where his gallery flourished. Claimed to have daguerreotyped lightning in 1854. Made several genre daguerreotypes "The Three Pets,""Driving a Bargain," which were reproduced by crystalotype in the *Photographic & Fine Art Journal* in 1854. In 1857 many of his portraits of Chicago's political, social, and business leaders were published in the *Chicago Magazine*. In 1863 he was elected President of the Chicago Photographic Society, and he was an active member of the National Photographic Association, giving a lecture at the Buffalo conference in 1873 and, as Local Secretary, hosting the Chicago conference in 1874. The Chicago fire of 1872 burned his studio, as it did almost everything else, and he opened his new studio in Evanston, IL, with his son in 1872. However he returned his gallery to Chicago in 1880. He continued to work, and was supposed to have died while actually making a group portrait in 1895.]

BOOKS

H521 Hesler, Alexander. *Picturesque Evanston* Chicago: A. Hesler, n. d. [ca. 1880], n. p. [Book of views.]

H522 *Lincoln Park.* Chicago: Hesler Photographic Co., 1888. n. p. 12 b & w. [Twelve 8" x 10" photomechanical reproductions of views of Lincoln Park, Chicago, IL.]

PERIODICALS

H523 Hesler, A., practical photographer. "Practical Photography - Cleaning and Coating the Plate." PHOTOGRAPHIC ART JOURNAL 2, no. 1 (July 1851): 50-51.

H524 Hesler, A. "Note." PHOTOGRAPHIC ART JOURNAL 2, no. 3 (Sept. 1851): 188. ["We have seen some exquisite side-light Daguerreotype by Mr. A. Hesler of Galena, Ill."]

H525 Hesler, A. "Mr. Hesler's New Process - Buffing Plate." PHOTOGRAPHIC ART JOURNAL 3, no. 3 (Mar. 1852): 154-155.

H526 "Gossip." PHOTOGRAPHIC ART JOURNAL 3, no. 3 (Mar. 1852): 193. [From the Galena, IL "Jeffersonian," on Hesler's daguerreotypes.]

H527 "Gossip." PHOTOGRAPHIC ART JOURNAL 3, no. 6 (June 1852): 383. [Note about five daguerreotypes by Hesler, plus excerpt from the "Galena Advertiser."]

H528 "Gossip: Another Achievement in Daguerreotyping." PHOTOGRAPHIC ART JOURNAL 3, no. 6 (June 1852): 383. [From "Galena Advertiser."]

H529 Hesler, A. "Correspondence: Arrangement of Light." PHOTOGRAPHIC ART JOURNAL 4, no. 1 (July 1852): 21.

H530 "Gossip." PHOTOGRAPHIC ART JOURNAL 5, no. 2 (Feb. 1853): 125. [Praise for Hesler's photos.]

H531 "Letter." PHOTOGRAPHIC ART JOURNAL 5, no. 3 (Mar. 1853): 183-184.

H532 "Daguerreotype Movements." HUMPHREY'S JOURNAL 5, no. 17 (Dec. 15, 1853): 272. [Note contains a description of the daguerreotypes which won A. Hesler (Galena, IL) a gold medal at the Chicago Mechanics Institute exhibition.]

H533 "The Anthony Prize Pitcher." PHOTOGRAPHIC AND FINE ART JOURNAL 7, no. 1 (Jan. 1854): 6-11. [Letter describing Hesler's "process" on pages 10-11.]

H534 "Something Rich." PHOTOGRAPHIC AND FINE ART JOURNAL 7, no. 3 (Mar. 1854): 87-88. [Several letters to and replies by Mr. A. Hesler from individuals desiring the use of his knowledge.]

H535 "The Three Pets." PHOTOGRAPHIC AND FINE ART JOURNAL 7, no. 4 (Apr. 1854): frontispiece, 123-124. 1 b & w. [The genre scene, a daguerreotype taken by A. Hesler, then reproduced with the crystalotype process by J. Whipple for the magazine.]

H536 "Driving a Bargain. Daguerreotyped by Hesler. - Crystalotyped by Whipple." PHOTOGRAPHIC AND FINE ART JOURNAL 7, no. 9 (Sept. 1854): frontispiece, 278-279. 1 b & w. [Original photograph, tipped-in. Genre tableau, young boy selling a found horseshoe to a blacksmith.]

H537 "Hesler's Gallery, Chicago." PHOTOGRAPHIC AND FINE ART JOURNAL 8, no. 2 (Feb. 1855): 61-62. [From "Daily Press, Chicago."]

H538 "Tremont House, Chicago. - Presentation of Flag to Light Guards, by Duquesne Greys of Pittsburgh. - From a Photograph by Hesler.'" FRANK LESLIE'S ILLUSTRATED NEWSPAPER 2, no. 33 (July 26, 1856): 100. 1 illus. [Street view, from above. Crowds.]

H539 "Dearborn Military Encampment Near the City of Chicago, Illinois. Formed July 1, 1856. - From a Photograph by Hesler." FRANK LESLIE'S ILLUSTRATED NEWSPAPER 2, no. 33 (July 26, 1856): 101. 1 illus. [View, with figures.]

H540 "Masonic Celebration in Chicago, Ill. (From an Ambrotype by Hesler.)" FRANK LESLIE'S ILLUSTRATED NEWSPAPER 2, no. 34 (Aug. 2, 1856): 113. 1 illus. [Group portrait.]

H541 "Our Illustrations." PHOTOGRAPHIC AND FINE ART JOURNAL 10, no. 1 (Jan. 1857): unnumbered page, 25. 1 b & w. [Original photographic print, tipped-in. "Falls of Minnehaha (Laughing Water), by A. Hesler.]

H542 "How Miss Hobbs Found Her Bracelet." PHOTOGRAPHIC AND FINE ART JOURNAL 10, no. 2 (Feb. 1857): 34-35. [Anecdote, possibly fictional, that took place in A. Hesler's gallery in Chicago, IL.]

H543 "Publisher's Record." CHICAGO MAGAZINE 1, no. 2 (Apr. 1857): 187. ["By some neglect we have failed to attach Mr. A. Hesler's name to the portraits in this or the former number." Woodcuts from Hesler's photographs appear in 1:1 (Mar. 1857) on p. 30 (Hon. Wm. Ogden); p. 36 (Wm. H. Brown); p. 42 (J. Young Scammon); p. 50 (Charles Walker). In 1:2 (Apr. 1857) on p. 118 (Benjamin W. Raymond); p. 124 (Thomas Church); and p. 155 (James Langworthy). Except for the last, these were all in a section titled "Biographies," and possibly were taken for the book later published on this subject.]

H544 1 photo (Hon. Wm. B. Egan). CHICAGO MAGAZINE 1, no. 3 (May 1857): unnumbered leaf before p. 207. [Woodcut credited "Photograph by Hesler."]

H545 1 photo (George F. Foster); 1 photo (George M. Gray); 1 photo (Jason Gurley). CHICAGO MAGAZINE 1, no. 4 (June 1857): unnumbered leaves before p. 293. [Not credited but probably by Hesler.]

H546 1 photo (Group composition portrait of 20 Chicago leaders) on unnumbered leaf before p. 381; 1 b & w (Charles N. Holden) on unnumbered leaf before p. 381; 1 photo (Mayor John Wentworth) on unnumbered leaf before p. 391. CHICAGO MAGAZINE 1, no. 5 (Aug. 1857) [Woodcuts credited "Photographs by Hesler." There is also a full-page advertisement for Hesler's Photograph & Fine Art Gallery on an unnumbered page in the "Advertising Department" following p. 451 in this issue.]

H547 Portrait. Woodcut engraving credited "From a photograph by Hesler, of Chicago, U.S." ILLUSTRATED LONDON NEWS 33, (1858) ["Louis Paulsen, American Chess Player." 33:931 (Aug. 14, 1858): 162.]

H548 Portrait. Woodcut engraving, credited "From a Photograph by Hesler." FRANK LESLIE'S ILLUSTRATED NEWSPAPER 6, (1858) ["John C. Haines, Mayor of Chicago, IL." 6:153 (Nov. 6, 1858): 355.]

H549 "Editorial Matters." PHOTOGRAPHIC AND FINE ART JOURNAL 13, no. 1 (Jan. 1860): 32. [From the "Chicago [IL] Daily Press." An announcement that A. Hesler had worked out a color process.]

H550 Seely, Charles A. "Editorial Department." AMERICAN JOURNAL OF PHOTOGRAPHY AND THE ALLIED ARTS & SCIENCES n. s. vol. 6, no. 4 (Aug. 15, 1863): 96. ["We have before us an album of cartes, from Hesler's gallery in Chicago,... his neighbors have acknowledged his eminence by choosing him to be the President of their Photographic Society. The photographer-in-chief of the establishment is... S. R. Divine."]

H551 Hesler, A. "Chicago Correspondence." PHILADELPHIA PHOTOGRAPHER 9, no. 97 (Jan. 1872): 17.

H552 "A Veteran at Work." PHOTOGRAPHIC TIMES 2, no. 20 (Aug. 1872): 120-121. [Circular announcing Hesler & Son opened a studio in Evanston, IL, reprinted.]

H553 "Fifth Annual Meeting and Exhibition of the National Photographic Association of the United States, Held in Buffalo, New York, beginning July 15, 1873. (Continued)." ANTHONY'S PHOTOGRAPHIC BULLETIN 4, no. 9 (Sept. 1873): 277-287. [Report of the Committee on the Progress of Photography, "Germany" by H. Vogel, "Skylights" by L. G. Bigelow, "Posing, Lighting, and Expression," by A. Hesler, "Posing, Lighting, and Expression" by Frank Jewell.]

H554 Hesler, A. "Fifth Annual Meeting and Exhibit of the National Photographic Association of the U.S., held in Buffalo, N.Y., beginning July 5, 1873: Posing, Lighting and Expression." PHILADELPHIA PHOTOGRAPHER 10, no. 117 (Sept. 1873): 270-272.

H555 "Advice by an Old Photographer to Those Having Photographs Taken." ANTHONY'S PHOTOGRAPHIC BULLETIN 4, no. 12 (Dec. 1873): 365. [From the "Evanston Index." Sarcastic advice.]

H556 Hesler, Alexander. "Come to Chicago!" ANTHONY'S PHOTOGRAPHIC BULLETIN 5, no. 5 (May 1874): 166. [Hesler was the Local Sec. for N. P. A. for 1874, therefore the chief organizer at the Chicago conference.]

H557 Hesler, A. "Local Secretary Hesler's Appeal to the Photographers." PHILADELPHIA PHOTOGRAPHER 11, no. 125 (May 1874): 145-146. [About the N. P. A.]

H558 Hesler, A. "Chips. Home Made Trays and Baths.- How They are Done." ANTHONY'S PHOTOGRAPHIC BULLETIN 5, no. 11 (Nov. 1874): 360.

H559 Hesler, A. "Preparing Pictures for Exhibitions." PHILADELPHIA PHOTOGRAPHER 12, no. 133 (Jan. 1875): 16.

H560 "New Pictures." ANTHONY'S PHOTOGRAPHIC BULLETIN 7, no. 4 (Apr. 1876): 128.

H561 "Prize Print Hints." PHILADELPHIA PHOTOGRAPHER 15, no. 171 (Mar. 1878): 65-68. [Competitor in the "Phila. Photo." Gold Medal Prize, describing his working methods, etc.]

H562 "Photograph of the Human Voice." ANTHONY'S PHOTOGRAPHIC BULLETIN 9, no. 7 (July 1878): 214. [From "Chicago [IL] Evening Journal."]

H563 "Note." PHOTOGRAPHIC TIMES 8, no. 92 (Aug. 1878): 170. [Extract from "Chicago [IL] Evening Journal," June 19, 1878, noting photo of a human voice.]

H564 Hesler, Alexander. "Hesler's Process For Solar Printing by Development." PHILADELPHIA PHOTOGRAPHER 15, no. 176 (Aug. 1878): 229-230.

H565 "Voices from the Craft." PHILADELPHIA PHOTOGRAPHER 15, no. 179 (Nov. 1878): 335-337. [A. Hesler from Chicago, IL.]

H566 Hesler, Alexander. "On the Fading of Photographs and Its Remedy." PHILADELPHIA PHOTOGRAPHER 16, no. 181 (Jan. 1879): 4.

H567 "Meetings of Societies: Chicago Photographic Association." PHOTOGRAPHIC TIMES 11, no. 124 (Apr. 1881): 145-153. [Unusually long and detailed report of a meeting of this association on the impacts of the gelatine dry-plate process on commercial photographers. Brought forth reminiscences by the Society's President, Alfred Hall, (a photographer for thirty-three years); P. B.

Green (a Chicago pioneer in the use of dry plates); A. Hesler; Joshua Smith; George N. Barnard (from Rochester, NY); and others.]

H568 "Note." PHOTOGRAPHIC TIMES 14, no. 157 (Jan. 1884): 41. [Alexander Hesler's son Frank died.]

H569 "Our Editorial Table." PHOTOGRAPHIC TIMES 18, no. 368 (Oct. 5, 1888): 480. [Book Rev.: "Lincoln Park," by the Hesler Photographic Co. Twelve 8" x 10" photographic reproductions of Lincoln Park, Chicago, IL. Paper covers.]

H570 Hesler, A. "Some Practical Experiences of a Veteran Daguerreotypist." PHOTOGRAPHIC TIMES 19, no. 391 (Mar. 15, 1889): 130-131. [Discusses daguerreotyping a series of views along the Mississippi for "Harper's Travellers Guide" in 1851.]

H571 Hesler, A. "A Wrinkle in Copying." AMERICAN ANNUAL OF PHOTOGRAPHY AND PHOTOGRAPHIC TIMES ALMANAC FOR 1891 (1891): 198.

H572 Fontayne, Charles. "Correspondence: Early Photographers of Lightning." PHOTOGRAPHIC TIMES 21, no. 499 (Apr. 10, 1891): 177. [Fontayne reports seeing a large daguerreotype portrait of lightning hanging in Hesler's Chicago, IL, gallery in 1856.]

H573 Hesler, A. "Photographing Lightning." AMERICAN ANNUAL OF PHOTOGRAPHY AND PHOTOGRAPHIC TIMES ALMANAC FOR 1892 (1892): 96-97. [Hesler claims to have taken his first photograph of lightning on July 4, 1854.]

H574 Hesler, Alexander. "Inspired by a Daguerreotype." PHOTOGRAPHIC TIMES 22, no. 572 (Sept. 2, 1892): 448. [Hesler narrates the events of taking a daguerreotype landscape in 1851 which is reputed to have inspired Longfellow to write the poem "Hiawatha."]

H575 Hesler, Alexander. "The Practical Experience of an 'Old Timer.'" AMERICAN ANNUAL OF PHOTOGRAPHY AND PHOTOGRAPHIC TIMES ALMANAC FOR 1893 (1893): 168-169.

H576 "Editor's Table: Alexander Hesler Is Dead." WILSON'S PHOTOGRAPHIC MAGAZINE 32, no. 464 (Aug. 1895): 382. [Brief obituary.]

H577 "Alexander Hesler." PHOTOGRAPHIC TIMES 27, no. 3 (Sept. 1895): 186-187. 1 illus. [Portrait. From "The Chicago (IL) Evening Post".]

H578 Manchester, Ellen. "Alexander Hesler: Chicago Photographer." IMAGE 16, no. 1 (Mar. 1973): 7-10. 4 b & w.

HEWITT, GEORGE W. (1841-1917) (USA)
H579 Hewitt, G. W. "Gelatino-Bromide process." PHILADELPHIA PHOTOGRAPHER 13, no. 150 (June 1876): 186-187. [Read before the Photo Soc. of Philadelphia, PA.]

H580 Hewitt, George W. "Dry-Plate Photography." PHILADELPHIA PHOTOGRAPHER 14, no. 159 (Mar. 1877): 85-89. [Read before Photo. Soc. of Phila.]

HEYL, JAMES BELL.
H581 Heyl, Edith Stowe Godfrey. *Bermuda Through the Camera of James B. Heyl 1868 - 1897*. A Newspaper Record, illustrated by photographs of Bermuda's ever-changing scenes, compiled by Edith

Stowe Godfrey Heyl. Hamilton, Bermuda: Bermuda Book Stores, dist. , 1951. 240 pp. b & w.

HEYWOOD, JOHN B. (BOSTON, MA)

H582 Portrait. Woodcut engraving, credited "From a Daguerreotype by John B. Heywood, Boston." BALLOU'S PICTORIAL DRAWING-ROOM COMPANION [GLEASON'S] 13, (1857) ["Rev. Edward Everett Hale." 13:340 (Dec. 26, 1857): 412.]

H583 Heywood, J. B., Boston. "Our Photographic Illustrations: A Group." PHOTOGRAPHIC AND FINE ART JOURNAL 11, no. 1 (Jan. 1858): 9, plus unnumbered page. 1 b & w.

H584 "Our Photographic Illustrations: Portrait of Mrs. J. M. Mozart. Neg. by J. B. Heywood." PHOTOGRAPHIC AND FINE ART JOURNAL 11, no. 2 (Feb. 1858): 52, plus photo opposite page 48.

H585 "Our Photographic Illustrations. I. Mrs. Gladstone. II. J. B. Howe, as Richard III, Negatives by J. B. Heywood, Boston." PHOTOGRAPHIC AND FINE ART JOURNAL 11, no. 4 (Apr. 1858): frontispiece, unnumbered page, 114-115. 2 b & w. [Original photographs, tipped-in. (No prints in this copy.)]

H586 "Our Illustrations. I. Ralph Smith, Esq. Negative by J. B. Heywood - H. H. Snelling, Print.'" PHOTOGRAPHIC AND FINE ART JOURNAL 11, no. 5 (May 1858): frontispiece, 149. 1 b & w. [Original photographic print, tipped-in.]

H587 "Captain Charles O. Rogers, Editor of the 'Boston Journal.'" BALLOU'S PICTORIAL DRAWING-ROOM COMPANION [GLEASON'S] 15, no. 11 (Sept. 11, 1858): 172. 1 illus. ["...drawn by Alfred Hill, and engraved by Mr. Pierce, faithfully reproducing one of the most admirable photographs we have yet seen by J. B. Heywood, 172 Washington Street, Boston, MA."]

H588 Heywood, John. "Toning Positive Prints." HUMPHREY'S JOURNAL OF PHOTOGRAPHY, AND THE ALLIED ARTS AND SCIENCES 11, no. 16 (Dec. 15, 1859): 249-250. [From "Liverpool Photo. J."]

H589 "Winter Views of Niagara." PHILADELPHIA PHOTOGRAPHER 3, no. 29 (May 1866): 150-151. [Extended description of 25 views of Niagara Falls, NY.]

H590 "New Stereoscope Pictures." PHILADELPHIA PHOTOGRAPHER 3, no. 33 (Sept. 1866): 267-268. [Views of Lake Winnipiseogee and White Mountain scenery.]

H591 "Editor's Table." PHILADELPHIA PHOTOGRAPHER 4, no. 44 (Aug. 1867): 271. [Stereos, marines, landscapes, interiors. His views are published by Frank Powell, 25 Winter Street, Boston, MA.]

H592 Lowden, Ronald D., Jr. "Heywood: A Mysterious Stereo Artist." STEREO WORLD 1-2, no. 6, 1 (Jan. - Feb., Mar. - Apr. 1975): (1:6) 1, 11, 16, 20; (2:1) 2, 7, 10. 2 b & w. [Heywood photographed landscape views in and around Gloucester, MA. and Boston, MA in the 1860s. His work was published by other dealers.]

HICKEY, ROBERT T.

H593 "View of Murree, One of the Sanitariums in India, from the Observatory Hill." ILLUSTRATED LONDON NEWS 43, no. 1229 (Oct. 31, 1863): 445-446. 1 illus. [See p. 480 for credit.]

H594 "Abbottabad." ILLUSTRATED LONDON NEWS 43, no. 1230 (Nov. 7, 1863): 480. 1 illus. ["...from a series of photographic views in

India, in course of publication by Messrs. MacLean & Co., of the Haymarket, for Robert T. Hickey, Esq., Captain 101st Foot.]

H595 "The Rookum Alum, Mooltan." ILLUSTRATED LONDON NEWS 43, no. 1234 (Dec. 5, 1863): 577. 1 illus. ["...from a photograph by Captain Hickey, 101st Regiment, who has brought home numerous negatives of the Punjaub."]

HICKS, L. S. (WILLIAMSBURGH, LI)

H596 Portrait. Woodcut engraving, credited "From a Photograph by L. S. Hicks." HARPER'S WEEKLY 5, (1861) ["Colonel Smith." 5:253 (Nov. 2, 1861): 693.]

HIGGENBOTTOM, O. [?] (MANCHESTER, ENGLAND)

H597 "Cataracts of the Nile." ILLUSTRATED LONDON NEWS 65, no. 1834 (Oct. 17, 1874): 367-368. 2 illus. ["...from photographs which Mr. O. Higgenbottom, of Manchester, as lent us."]

HIGGINS, T. H. (WHEELING, WV)

H598 "The Burning of the Grant House, in Wheeling, March 28th. - Photographed by T. Higgins, Wheeling." FRANK LESLIE'S ILLUSTRATED NEWSPAPER 44, no. 1125 (Apr. 21, 1877): 125. 1 illus. [View, with crowd.]

H599 "Note." ANTHONY'S PHOTOGRAPHIC BULLETIN 9, no. 10 (Oct. 1878): 310. [T. H. Higgins' Gallery (Wheeling, WV) reopened.]

HIGGINSON, MONTAGU. (NEW ZEALAND)

H600 "The War in New Zealand." ILLUSTRATED LONDON NEWS 45, no. 1270 (July 23, 1864): 80-81, 91-93. 2 illus. ["We have in the last twelve month been abundantly supplied with illustrations of the Maori War by the courtesy of many of our correspondents belonging to the military or naval services employed in that tedious and difficult undertaking. Our thanks are due to all the skillful draftsmen and amateur photographers who have found time amidst the labors of such a campaign to send us a great variety of subjects for engraving. Mr. Montagu Higginson, of "H.M.S. Curaçoa," has favored us with a number of photographic views on the Waikato, some of which have been engraved." (The illustrations in this issue are not by Higginson, rather they are from sketches by a Lieut. Robley.)]

HIGHLEY, SAMUEL. (d. 1900) (GREAT BRITAIN)

H601 Highley, Samuel, Jr. "On the Practical Application of Photography to the Illustration of Works on Microscopy, Natural History, Anatomy, &c." PHOTOGRAPHIC ART JOURNAL 6, no. 2 (Aug. 1853): 74-90. 15 illus. [From "Q. J. of Microscopical Science."]

H602 Highley, S. "On Lantern Construction in Relation to Photography." HUMPHREY'S JOURNAL OF PHOTOGRAPHY, AND THE ALLIED ARTS AND SCIENCES 20, no. 22 (June 15, 1869): 349-350. [No source given.]

H603 Highley, Samuel. "The Application of Photography to the Magic Lantern, Educationally Considered." BRITISH JOURNAL OF PHOTOGRAPHY 10, no. 182-187 (Jan. 15 - Apr. 1, 1863): 33-34, 50-51, 97-98, 143-144. 13 illus. [Read to Photo. Soc. of London, Jan. 6, 1863.]

H604 "Samuel Highley." BRITISH JOURNAL OF PHOTOGRAPHY ALMANAC & PHOTOGRAPHER'S DAILY COMPANION, 1902 (1902): 688. [Highley was an assistant editor of the "British Journal of Photography" and the "Almanac" during the 1860s. Secretary of the Photographic Society of Great Britain in 1857. Interested in microscopy, magic lanterns, etc., but left photography some time ago. Died at age 75.]

HIGHSCHOOL, PROFESSOR see MAYALL, JOHN JABEZ EDWIN.

HIGWIGHT, J. D.
H605 Higwight, J. D. "Granulated Negatives." HUMPHREY'S JOURNAL OF PHOTOGRAPHY, AND THE ALLIED ARTS AND SCIENCES 16, no. 4 (June 15, 1864): 60. [Higwight's letter and Towler's reply.]

HILGARD, J. E.
H606 Hilgard, J. E. "Trial of Harrison's Globe Lens, at the U. S. Coast Survey Office." AMERICAN JOURNAL OF PHOTOGRAPHY AND THE ALLIED ARTS & SCIENCES n. s. vol. 5, no. 20 (Apr. 20, 1863): 457-459. [Report on value of lens for copying, etc. "Communicated by authority of the Treasury Department."]

HILL. (MELBOURNE, AUSTRALIA)
H607 Portrait. Woodcut engraving credited "From a photograph by Hill." ILLUSTRATED LONDON NEWS 40, (1862) ["Mr. Burke and Mr. Wills, Australian explorers." 40:* (Feb. 1, 1862): 127.]

HILL & ADAMSON.
BOOKS
H608 A Series of Calotype Views of St. Andrews; Published by D. O. Hill and R. Adamson, at their Calotype Studio, Calton Stairs, Edinburgh, 1846. Edinburgh: Hill & Adamson, 1846. n. p. 22 b & w. 1 illus. [Album, put together by the studio in a limited edition.]

H609 One Hundred Calotype Sketches; by D. O. Hill... and R. Adamson (To the Right Hon. James Wilson on his departure for India, 1859) An Album of Photographs. Edinburgh: Hill & Adamson, 1848. xii pp. 210 l. of plates. 100 b & w.

H610 The Disruption of the Church of Scotland: An Historical Painting Representing the Signing of the Deed of Demission by the Ministers of the First General Assembly of the Free Church. Painted by D. O. Hill, R.S.A. Secretary of the Royal Scottish Academy of Painting, Sculpture and Architecture, one of the Commissioners of the Honorable Board of Trustees for Manufactures in Scotland, etc. etc. Edinburgh: Schenck and M'Farlane, 1866. 38 pp. illus. [With key-plate and index.]

H611 Ballantyne, James. The Life of David Roberts, R. A. Edinburgh: Adam & Charles Black, 1866. n. p. 1 b & w. [Calotype portrait of Roberts, as frontispiece. Limited edition.]

H612 Andrew, Elliot. Calotypes by David Octavius Hill and Robert Adamson, Illustrating an Early Stage in the Development of Photography. Edinburgh: Privately printed, 1928. n. p. 47 l. of plates. 48 b & w. [38 copies. Introduction by Andrew Elliot and John Miller Gray. Articles by Thomas Bonnar, James L. Caw, Alexander Fraser, John M. Gray, Peter E. Landreth, David Mason, etc. 48 calotype reprints from the collection of Andrew Elliot.]

H613 Schwartz, Heinrich. David Octavius Hill. Der Meister der Photographie. Mit 80 Bildtafeln. Leipzig: Insel Verlag, 1931. 61 pp. 80 b & w.

H614 Schwartz, Heinrich. David Octavius Hill, Master of Photography. Translated from the German by Herbert E. Fraenkel. New York; London: Viking Press; George G. Harrap, 1931; 1932. 68 pp. 30 b & w. [With thirty reproductions made from original photos and printed in Germany.]

H615 Strasser, Alex. Immortal Portraits: Being a Gallery of Famous Photographs by David Octavius Hill, Julia M. Cameron, Gaspard Felix Tournachon (Nadar). London, New York: Focal Press, 1941. n. p. illus.

H616 Strasser, Alex. Victorian Photography, Being an Album of Yesterday's Camera-work by William Henry Fox Talbot, David Octavius Hill, Julia Margaret Cameron, Roger Fenton, Frank M. Sutcliffe and others. "Classics of Photography, I" London, New York: Focal Press, 1942. n. p. illus.

H617 Catalogue of an Exhibition of the Works of D. O. Hill. In the Hunterian Museum from 11th May - 5th June, 1954. Glasgow: University of Glasgow, Hunterian Museum, 1954. 12 pp.

H618 Nickel, Dr. Heinrich L. David Octavius Hill. Halle, Saale: VEB Fotokinoverlag Halle, 1963. 96 pp. 44 b & w.

H619 Steinert, Otto and Mark Steinert. David Octavius Hill, Robert Adamson: Inkunabeln der Photographie. Essen: Folkwang Museum, 1963. 18 pp. 41 b & w. [Exhibition; Mar. 16 - Apr. 14, 1963.]

H620 New York. Metropolitan Museum of Art. Four Victorian Photographers. Edited by John J. McKendry. New York: Metropolitan Museum of Art, 1967. 120 pp. illus. [Engagement calender for 1968, with photographs by Adolphe Braun, J. M. Cameron, Thomas Eakins, and D. O. Hill.]

H621 Hommage à Hill et Adamson. Paris: Galerie la Demaure, 1969. n. p. 9 b & w. [Foreword by Andre Jammes. Exhibition catalog. Issued bound with "Apocalypse - Jean Pierre Sudre."]

H622 Michaelson, Katherine. A Centenary Exhibition of the Work of David Octavius Hill 1802-1870 and Robert Adamson 1821-1848. Edinburgh: Scottish Arts Council, 1970. 86 pp. 31 b & w.

H623 The Hill/Adamson Albums. A Selection from the early Victorian photographs acquired by the National Portrait Gallery in January 1973. London: Times Newspapers Limited, 1973. xiv, 64 pp. 64 b & w. [Essays by Colin Ford and Roy Strong.]

H624 Bruce, David. Sun Pictures: the Hill - Adamson Calotypes. Greenwich, CT; London: New York Graphic Society, Ltd.; Studio Vista, 1973. 247 pp. 128 b & w.

H625 Ford, Colin. Edited and with an introduction. A Commentary by Roy Strong. An Early Victorian Album: The Hill/Adamson Collection. London; New York: Jonathan Cape; Alfred A. Knopf, 1974. 350 pp. 258 b & w.

H626 Ovenden, Graham, ed. Introduction by Marina Henderson. Hill & Adamson Photographs. London; New York: Academy Editions; St. Martin's Press, 1974. 96 pp. 88 b & w.

H627 Michaelson, Katherine. "The First Photographic Record of a Scientific Conference," on pp. 109-116 in: One Hundred Years of Photographic History. Essays in Honor of Beaumont Newhall. Edited by Van Deren Coke. Albuquerque, NM: University of New Mexico Press, 1975. 180 pp. 7 b & w. [Hill & Adamson met with W. H. Fox Talbot at a scientific conference of the British Association, held in York in late Sept. 1844, where they took calotype portraits of many of the participants.]

H628 Borcoman, James, introduction. The Painter as Photographer: David Octavius Hill, August Salzmann, Charles Negre. Vancouver, BC: Vancouver Art Gallery, 1978. 8 pp. 8 l. of plates. 8 b & w. [Exhibition; Dec. 1978 - Jan. 14, 1979.]

H629 Stevenson, Sara. David Octavius Hill and Robert Adamson: Catalogue of their Calotypes Taken Between 1843 and 1847 in the

Collection of the Scottish National Portrait Gallery. Edinburgh: National Galleries of Scotland, 1981. 220 pp. illus. [Catalogue raisonné, containing 73 illustrations in the text and over a 1000 illustrations in the catalog.]

H630 Ward, John and Sara Stevenson. *Printed Light: The Scientific Art of William Henry Fox Talbot and David Octavius Hill, with Robert Adamson.* Edinburgh: Scottish National Portrait Gallery, 1986. 174 pp.

PERIODICALS

H631 "Fine Art Gossip." ATHENAEUM no. 1017 (Apr. 24, 1847): 440. [At the fifth meeting of the Graphic Society... a volume of talbotypes of a very superior description, done by D. O. Hill at Edinburgh, brought by Mr. Stanfield.]

H632 "Photography in Scotland." ART JOURNAL (Apr. 1854): 100. [Hill & Adamson mentioned.]

H633 1 engraving (Author John Wilson "Christopher North."). CENTURY MAGAZINE 45, no. 3 (Jan. 1893): 360. 1 illus. [Photo by Hill & Adamson, but not credited to them.]

H634 "Plates: David Octavius Hill, R.S.A.—1802-1870." CAMERA WORK no. 11 (July 1905): 3-15. 6 b & w.

H635 Annan, J. Craig. "David Octavius Hill, R.S.A.—1802 - 1870." CAMERA WORK no. 11 (July 1905): 17-21.

H636 Sharp, Mrs. William. "D.O. Hill, R.S.A." CAMERA WORK no. 28 (Oct. 1909): 17-19.

H637 Inglis, Francis Caird. "D. O. Hill, R.S.A. and His Work." EDINBURGH PHOTOGRAPHIC SOCIETY 19, no. 258 (June 1909): 75.

H638 Sharp, Mrs. William. "D. O. Hill, R.S.A." CAMERA WORK no. 37 (1912): 48.

H639 "Plates: David Octavius Hill." CAMERA WORK no. 37 (Jan. 1912): 3-13, 27-35. 9 b & w. [Additional information in "Our Plates," on p. 48.]

H640 Inglis, Francis Caird, F.S.A. "D. O. Hill, R.S.A, and His Work." PHOTOGRAPHIC JOURNAL OF AMERICA 52, no. 1 (Jan. 1915): 3-6, 17-24. 8 b & w.

H641 Cursiter, Stanley. "D. O. Hill. Famous Calotypes." SCOTSMAN (Nov. 28, 1928): 13-14. * b & w.

H642 Rosenfield, Paul. "The Old Master of Photography" NEW REPUBLIC 69, no. 892 (Jan. 6, 1932): 214-215.

H643 Freund, Gisele. "David Octavius Hill." VERVE no. 5-6 (July - Oct. 1939): 151-153. 7 b & w. 1 illus.

H644 Schwarz, Heinrich. "David Octavius Hill." THE COMPLETE PHOTOGRAPHER 6, no. 31 (1941): 1974-1978. * b & w.

H645 "Calotypist Hill; One-man exhibition at Manhattan's Museum of Modern Art." TIME 38, (Sept. 22, 1941): 65-66. 1 b & w.

H646 Schwarz, Heinrich. "Calotypes by D. O. Hill and R. Adamson." MUSEUM NOTES (MUSEUM OF ART, RHODE ISLAND SCHOOL OF DESIGN) 2, no. 8 (Dec. 1944): 1-2.

H647 "Note." AMERICAN PHOTOGRAPHY 43, no. 7 (July 1949): 464. [Ex. rev.: 'Hill & Adamson, J. M. Cameron,' Museum of Modern Art, NY.]

H648 "Camera Pioneer." NEW YORK TIMES MAGAZINE (Jan. 19, 1958): 36. 3 b & w.

H649 "Index to Resources: David O. Hill & Robert Adamson." IMAGE 7, no. 5 (May 1958): 118-119. 4 b & w. [Photographs by Hill & Adamson, with descriptions.]

H650 "Index to Resources: Calotype Positives by Hill & Adamson." IMAGE 7, no. 6 (June 1958): 142-143. 6 b & w. [Photographs by Hill & Adamson. George Eastman House holds 273 calotypes.]

H651 Schwarz, Heinrich. "An Exhibition of Victorian Calotypes." VICTORIAN STUDIES 1, no. 4 (June 1958): 354-356. [Ex. rev.: 'Hill & Adamson,' Metropolitan Museum of Art, New York.]

H652 Schwarz, Heinrich. "Shorter Notes: William Etty's 'Self-Portrait' in the London National Portrait Gallery." ART QUARTERLY *, no. * (Winter 1958): 391-396. 2 b & w. 1 illus. [Etty's painting drawn from Hill & Adamson's calotype portrait.]

H653 Mayor, A. Hyatt. "The First Victorian Photographer." METROPOLITAN MUSEUM OF ART BULLETIN n. s. vol. 17, (Dec. 1958): 113-119. 12 b & w.

H654 Dunbar, Alexander. "The Work of David Octavius Hill, R.S.A." PHOTOGRAPHIC JOURNAL 104, no. 3 (Mar. 1964): 53-65. 3 b & w. 4 illus.

H655 Schwarz, Heinrich. "Hill - Adamson Calotypes." SCOTTISH ART REVIEW 12, no. 4 (1970): 1-5, 33. 9 b & w.

H656 "A Centenary Exhibition of the Work of David Octavius Hill 1802 - 1870 and Robert Adamson 1821 - 1848, sponsored by the Scottish Arts Council, Edinburgh 2-31 May 1970." PHOTOGRAPHIC JOURNAL 110, no. 7 (July 1970): 262-265. 3 b & w.

H657 "David Octavius Hill and Robert Adamson." CREATIVE CAMERA no. 74 (Aug. 1970): 241-248, plus cover. 8 b & w.

H658 Jones, T. Herbert. "David Octavius Hill (1802-80) and Robert Adamson (1821-48): Centenary Exhibition." JOURNAL OF THE ROYAL SOCIETY OF ARTS 118, no. 5171 (Oct. 1970): 720-721. 1 b & w. [Ex. rev.: 'Hill & Adamson,' Scottish Arts Council, Edinburgh, then travelling.]

H659 Neve, Christopher. "Serendipity and a Mass Portrait: The Calotypes of Hill and Adamson." COUNTRY LIFE 150, no. 3865 (July 8, 1971): 104-105. 3 b & w.

H660 Roberts, K. "David Octavius Hill and Robert Adamson, National Portrait Gallery." BURLINGTON MAGAZINE 113, no. 821 (Aug. 1971): 483, 485. 3 b & w.

H661 Gernsheim, Helmut. "The David Octavius Hill Memorial Lecture, delivered at Edinburgh University on 9 May 1970." CREATIVE CAMERA no. 87 (Sept. 1971): 300-305. 11 b & w.

H662 Schwarz, Heinrich. "The Calotypes of D. O. Hill and Robert Adamson: Some Contemporary Judgments." APOLLO 95, no. 120 (Feb. 1972): 123-128. 9 b & w.

H663 Edwards, R. "Masterpieces of Photography?" APOLLO 101, no. 155 (Jan. 1975): 66-67.

H664 "D. O. Hill and Robert Adamson: the New Haven Pictures June 1845." CREATIVE CAMERA no. 135 (Sept. 1975): 306-313. 16 b & w.

H665 Smith, Graham. "Hill & Adamson: St. Andrews, Burnside & The Rock & Spindle." PRINT COLLECTOR'S NEWSLETTER 10, no. 2 (May - June 1979): 45-48. 7 b & w.

H666 Smith, Graham. "Hill & Adamson at St. Andrews: The Fishergate Calotypes." PRINT COLLECTOR'S NEWSLETTER 12, no. 2 (May - June 1981): 33-37. 6 b & w.

H667 Stevenson, Sara. "David Octavius Hill without Robert Adamson: the reputation of their Calotypes after 1848." PHOTOGRAPHIC COLLECTOR 2, no. 3 (Autumn 1981): 14-24. 10 b & w.

H668 Wolk, Linda. "Calotype Portraits of Elizabeth Rigby by David Octavius Hill and Robert Adamson." HISTORY OF PHOTOGRAPHY 7, no. 3 (July - Sept. 1983): 167-181. 10 b & w. 4 illus.

H669 Smith, Graham. "'Calotype Views of St. Andrews' by David Octavius Hill and Robert Adamson." HISTORY OF PHOTOGRAPHY 7, no. 3 (July - Sept. 1983): 207-236. 35 b & w. 3 illus. [Discussion of rare album "Calotype Views of St. Andrews" 1846, Scotland; variations among known albums.]

H670 Stevenson, Sara. "Cold buckets of ignorant criticism: Qualified success in the partnership of David Octavius Hill and Robert Adamson." PHOTOGRAPHIC COLLECTOR 4, no. 3 (Winter 1983): 336-347. 7 b & w. 3 illus.

H671 Harley, Ralph L., Jr. "The Partnership Motive of D. O. Hill and Robert Adamson." HISTORY OF PHOTOGRAPHY 10, no. 4 (Oct. - Dec. 1986): 303-312. 7 illus.

HILL, D. W.
H672 Hill, D. W. "On a Modification of the Metagelatine Process." HUMPHREY'S JOURNAL OF PHOTOGRAPHY, AND THE ALLIED ARTS AND SCIENCES 11, no. 4 (June 15, 1859): 56. [From "Liverpool Photo. J."]

H673 Hill, D. W. "A Photographer's Holiday in Derbyshire." BRITISH JOURNAL OF PHOTOGRAPHY 7, no. 131 (Dec. 1, 1860): 349-350. [Read before the North London Photographic Assoc.]

HILL, DAVID OCTAVIUS see also HILL & ADAMSON; CAMERON, JULIA MARGARET.

HILL, DAVID OCTAVIUS. (1802-1870) (GREAT BRITAIN)
[Born in Perth, Scotland in 1802, one of nine children born to a bookseller and publisher. Studied landscape painting under Andrew Wilson. Published his first lithographic illustrations for books at age nineteen, in 1821. Followed by five other books published throughout the 1830s-40s. Co-founder and Secretary of the Royal Scottish Academy from 1829 to 1869. In 1843 Hill sought out Robert Adamson in order to use the calotype to make portrait studies of some four hundred and fifty clergymen for a large commemorative painting he wished to create. A partnership formed, which lasted until 1847 and resulted in more than 2500 portraits, views, and costume portraits -a body of work which was a significant contribution to the medium of photography. Hill was senior in age, reputation, and artistic training to Adamson, who was initially regarded as simply the technician. But it now seems that both were critical to this extraordinary creative enterprise. When Adamson died in 1848, Hill concentrated on his painting activities for several years, then formed a second brief partnership with the photographer A. MacGlashon in 1862. The photographic work generated by this team simply does not match the quality of Hill & Adamson's. Hill completed his painting of the "Signature of the Act of Separation of the Free Church of Scotland" in 1866. Hill died in Edinburgh in 1870.]

BOOKS
H674 Hill, D. O. *Sketches of Scenery in Perthshire Drawn from Nature and on Stone.* Perth: Thomas Hill, 1821. 30 l. of plates. 30 illus.

H675 *Views of the Opening of the Glasgow and Garnkirk Railway; by D. O. Hill... Also, an Account of That and Other Railways in Lanarkshire* Drawn up by George Buchanan. Edinburgh: A. Hill, 1832. 11 pp. 5 l. of plates. illus.

H676 Hogg, James. *Tales and Sketches by the Ettrick Shepherd James Hogg; Including... several pieces not before printed, with... engravings... by D. O. Hill.* Glasgow: Blackie & Son, 1837. 6 vol. illus.

H677 *The Poetical Works of the Ettrick Shepherd; with a Life of the Author,* by Prof. Wilson... and Illustrative Engravings from Original Drawings by D. O. Hill. Glasgow: Blackie & Son, 1838/1840. 5 vols

H678 Wilson, John. *The Land of Burns; A Series of Landscapes and Portraits Illustrative of the Life and Writings of the Scottish Poet...* The landscapes from paintings made expressly for the work by D. O. Hill. The literary department by Prof. Wilson and Robert Chambers. Glasgow: Blackie & Son, 1846. 2 vol. 81 plates.

H679 *Scotland Delineated in a Series of Views;* by C. Stanfield... G. Cathermore... Drawn in lithography by J. D. Harding. With historical, antiquarian and descriptive letterpress by John Parker Lawson. London: 1847-54. 2 vols.

H680 Hill, David Octavius and Andrew McGlashan. *Some Contributions toward the Use of Photography as an Art.* Edinburgh: s. n., 1862. n. p. 15 b & w. [Portfolio of original photographs.]

H681 *Catalogue of the Valuable Collection of Pictures, Engravings, Sketches, Drawings, Calotypes and Other Art Property of the Late D. O. Hill, Esq., R.S.A., Secretary to the R.S.A.* Edinburgh: T. Chapman, 1870. n. p. [Auction of T. Chapman, Edinburgh, (November 18, 19, and 21, 1870.)]

H682 *The Painter as Photographer: David Octavius Hill, Auguste Salzmann, Charles Negre:* Works from the National Gallery of Canada, introduction by James Borcoman. Vancouver, B. C.: Vancouver Art Gallery, 1978. 8 pp. 8 l. of plates. b & w. [Ex. catalog: Vancouver Art Gallery, Dec. 9, 1978 - Jan. 14, 1979.]

PERIODICALS
H683 "Fine Arts: Windsor Castle from the North-West." LITERARY GAZETTE, AND JOURNAL OF THE BELLES LETTRES no. 1609 (Nov. 20, 1847): 818. [Review of a line engraving. Painted by D. O. Hill, R.S.A, Engraved by W. Richardson, Edinburgh. Alexander Hill, publisher.]

H684 "D. O. Hill." ART JOURNAL (Oct. 1850): 309. [An engraved portrait bust of Hill, with a brief description of his artistic career.]

H685 Taylor, J. T. "'Notes,' Harmonious and Discordant, On Various Subjects: Who Should Get the Medal?" BRITISH JOURNAL OF PHOTOGRAPHY 9, no. 163 (Apr. 1, 1862): 129. [Photo. Soc. of Scotland awarded a medal to the team of D. O. Hill and A. McGlashon, then later solely to Hill. (The artist, not the photographer.) Leads to commentary.]

H686 "Minor Topics of the Month: The Disruption of the Church of Scotland." ART JOURNAL (June 1867): 158.

H687 Dafforne, James. "British Artists: Their Style and Character. No. 87 - David Octavius Hill." ART JOURNAL (Oct. 1869): 317-319. 3 illus. [Hill's engravings of Scottish landscapes.]

H688 "Obituary." EDINBURGH EVENING COURANT no. 24545 (May 18, 1870): n. p.

H689 "Obituary of D. O. Hill." SCOTSMAN (May 18, 1870): n. p.

H690 Dafforne, James. "Obituary: David O. Hill, R.S.A." ART JOURNAL (July 1870): 203.

H691 Armstrong, Walter. "Scottish Painters: D. O. Hill." PORTFOLIO 18, (1887): 135.

H692 "Note." AMATEUR PHOTOGRAPHER & PHOTOGRAPHIC NEWS 49, (June 1, 1909): 524. [Note that Mr. Francis Caird Inglis lectured to the Edinburgh Photographic Society on the work of D. O. Hill.]

H693 Becker, William B. "Daguerrean Bookbindings." HISTORY OF PHOTOGRAPHY 5, no. 1 (Jan. 1981): frontispiece. 1 illus. [Describes a two volume set of the writings of David Burnes, with daguerreotypes mounted on the cover and eighty-one engravings after designs by David Octavius Hill.]

HILL, LEVI L. (1816-1865) (USA)

[Born in Athens, NY in 1816. His father was murdered in 1828. From 1829 to 1831 he apprenticed as a printer at the *Hudson Gazette*. From 1831 worked as a printer, at the *Ulster Plebian*. In 1833 he joined the Baptist Church and studied at the Hamilton, NY, Literary and Theological Seminary. Baptist pastor in Westkill, NY ca. 1836. Published *The Baptist Library* in 1843 and *The Baptist Scrapbook* in 1845. Became a daguerreotypist ca. 1845 and published his *Treatise on Daguerreotype* in 1849. In 1850 he announced that he had found a process to make color daguerreotypes. This created a storm of excitement in the photographic community, followed by consternation when the Reverend Hill did not come forth with the process. S. D. Humphrey, editor of the *Daguerrean Journal* supported Hill strongly at first, even offering him co-editorship of the magazine, then as the months passed without any information coming forth, finally withdrawing his support for the embattled Hill, who had shown his colored daguerreotypes to leading figures in photography, to several official committees of professional photographers, and even to the U. S. Senate and the Patent Office, but who could not actually demonstrate his process to anyone. For years there was bitter feelings and controversy over whether Hill was a charlatan or not. When his long awaited *Treatise on Heliochromy* came out in 1856 it contained only some inefficient methods of hand-coloring the plates. Contemporary opinion is that he accidentally discovered a process which could generate faint colors in the daguerreotype (partially through solarization), then spent months and years in fruitless attempts to reduplicate his effort. Hill moved to Hudson, NY in 1856. In the late 1850s he experimented on and patented several processes involved with illuminating and heating gases. He moved to New York, NY in 1863 and died there in 1865.]

BOOKS

H694 Hill, Levi L. *The Baptist Library*. A Republication of Standard Baptist Works. Edited by Charles G. Sommers, William R. Williams, Levi L. Hill. Vol. 1 - 3. Prattsville, NY: Hill, 1843. 3 vol.

H695 Hill, Levi L., and W. McCarthy, Jr. *A Treatise on Daguerreotype*. Lexington, NY: Holman & Gray, printer, 1850. 93, 88, 21 pp. [Parts I, II and IV by Levi L. Hill, part III by W. McCarthy, Jr. Reprinted 1973, Arno Press.]

H696 Hill, Levi L. *Photographic Researches and Manipulations, Including the Author's Former Treatise on Daguerreotype*. Philadelphia: Myron Shew, 1854. iv, 198 pp. [2nd ed., rev. and enlarged. The first edition may be referring to a 15 page prospectus, with the same title page, dated April 8, 1851.]

H697 Hill, Levi L. *To the Daguerreotypists of the United States, and the Public At Large. A Statement Respecting the Natural Colors*. Westkill, Green County, NY: L. L. Hill, 1852. 24 pp.

H698 Hill, Levi L. *A Treatise on Heliochromy; or The Production of Pictures, by Means of Light, in Natural Colors. Embracing a full, plain, and unreserved description of the process known as the hillotype, including the author's newly discovered collodio-chrome, or natural colors on collodionized glass*. New York: Robinson & Caswell, 1856. xii, 175 pp. ["Autobiography" on p. 1037. (1972) Facsimile edition. State College, PA: Carnation Press. Foreword by William B. Becker.]

H699 Hill, Levi L. *A Treatise on Daguerreotype: The Whole Art Made Easy, and all the Recent Improvements Revealed,... Containing also the Process of Galvanizing Plates, and the whole Art of Electrotype;...* Westkill, Greene Co., NY: L. L. Hill, 1851. 181 pp. [3rd edition issued Apr. 1851 with title "Photographic Researches and Manipulations, including the Author's Former Treatise on Daguerreotype."]

PERIODICALS

H700 "Gossip." PHOTOGRAPHIC ART JOURNAL 1, no. 1 (Jan. 1851): 62. [Note that L. Hill has been reported as succeeded in "...impressing on the daguerreotype plate all the beauty of natural colors."]

H701 Hill, L. L. "The Natural Colors." PHOTOGRAPHIC ART JOURNAL 1, no. 2 (Feb. 1851): 116-118. [The letter is from Levi Hill, claiming to have found a method of producing daguerreotypes in color. There is an editorial comment on pp. 124-125 in the same issue.]

H702 Humphrey, S. D. "Editorial: New and Valuable Discovery: Hillotypes." DAGUERREAN JOURNAL 1, no. 7 (Feb. 15, 1851): 209-211.

H703 "New Publication." DAGUERREAN JOURNAL 1, no. 7 (Feb. 15, 1851): 219-220. [Bk. review.: "A Treatise on Daguerreotype: the whole art made easy." by L. L. Hill... An excerpt from the volume is also printed on pp. 217-218.]

H704 Humphrey, S. D. "Editorial: Hillotype." DAGUERREAN JOURNAL 1, no. 8 (Mar. 1, 1851): 241-242. [Includes a letter from L. L. Hill.]

H705 Humphrey, S. D. "Editorial: Hillotypes." DAGUERREAN JOURNAL 1, no. 9 (Mar. 15, 1851): 273-274. [Includes a letter from L. L. Hill.]

H706 Humphrey, S. D. "Editorial: L. L. Hill." DAGUERREAN JOURNAL 1, no. 11 (Apr. 15, 1851): 337. [Additional note on Hill on same page.]

H707 "Gossip." PHOTOGRAPHIC ART JOURNAL 1, no. 5 (May 1851): 316. [The Hillotype discussed further.]

H708 Humphrey, S. D. "To the Reader." DAGUERREAN JOURNAL 2, no. 1 (May 15, 1851): Frontispiece, 17-18. 1 illus. [Praise for Levi L. Hill's Hillotype, announcement that L. Hill would, in the future, co-edit the "Daguerrean Journal," letter from Hill, engraved portrait of Hill, from the daguerreotype taken by Humphrey, as frontispiece.]

H709 Horsford, E. N. "Correspondence: Mr. Hill's Colored Daguerreotypes." DAGUERREAN JOURNAL 2, no. 1 (May 15, 1851): 21.

H710 Snelling, H. H. "The Hillotype." PHOTOGRAPHIC ART JOURNAL 1, no. 6 (June 1851): 333-340. [Includes letters from Anthony, Morse, Snelling, et al. on whether Hill's revolutionary discovery was fraudulent or not.]

H711 Hill, Levi L. "Editorial." DAGUERREAN JOURNAL 2, no. 2 (June 1, 1851): 50-51. [Letter from L. L. Hill, describing some of his plans for distributing the Hillotype process.]

H712 Hill, Levi L. "The Natural Colors in Photography." DAGUERREAN JOURNAL 2, no. 2 (June 1, 1851): 52. [Statement written by Hill, for distribution to editors, asking for privacy to allow him to finish his research.]

H713 Hunt, Robert. "On the Applications of Science to the Fine and Useful Arts: Improvements in Photography." ATHENAEUM (BOSTON) 13, (July 1, 1851): 188-190. [Mentions Fr. S. Archer and Hornes work with collodion, Levi Hill's colored daguerreotypes.]

H714 Hill, Levi L. "Editorial." DAGUERREAN JOURNAL 2, no. 4 (July 1, 1851): 113-114. [Letter from L. L. Hill, describing his current work, promising advances.]

H715 Humphrey, S. D. "Editorial." DAGUERREAN JOURNAL 2, no. 5 (July 15, 1851): 145-147.

H716 "Perils of Inventors." DAGUERREAN JOURNAL 2, no. 5 (July 15, 1851): 152. [From "Phila. [PA] Saturday Courier." Letter discussing whether Levi L. Hill should patent his color process or sell it by subscription.]

H717 Hill, Levi L. "The Hillotype." PHOTOGRAPHIC ART JOURNAL 2, no. 2 (Aug. 1851): 76-81.

H718 "Gossip." PHOTOGRAPHIC ART JOURNAL 2, no. 2 (Aug. 1851): 124-126. [Excerpts from "Philadelphia Saturday Courier," plus editorial comments.]

H719 Humphrey, S. D. "Editorial." DAGUERREAN JOURNAL 2, no. 10 (Oct. 1, 1851): 305. [Promise that Hill's long-promised announcement would soon be released.]

H720 Fitzgibbon, J. H. "Hillotype." DAGUERREAN JOURNAL 2, no. 10 (Oct. 1, 1851): 312-314. [From the "Missouri Republican."]

H721 Humphrey, S. D. "Editorial: Hillotype." DAGUERREAN JOURNAL 2, no. 11 (Oct. 15, 1851): 337-338. [Humphrey announces finally that he feels that L. L. Hill has not advanced his color experiments during the past six months.]

H722 "Gossip." PHOTOGRAPHIC ART JOURNAL 2, no. 5 (Nov. 1851): 313-320. [Report of NY State Daguerreotype Committee to investigate Levi L. Hill's claims; excerpts from British reviews of Mayall (London, England); letter from Austin T. Earle reviewing the Ohio Mechanic's Fair Exhibition; Mme Daguerre's letter replying to Mead Brother's condolence letter; Renard (Paris , FR) paper photos; Barnard (Oswego, NY); Davie (Utica, NY).]

H723 "The Hillotype; or Daguerreotypes in the Colors of Nature." PHOTOGRAPHIC ART JOURNAL 3, no. 1 (Jan. 1852): 47-50.

H724 "Gossip: Letter." PHOTOGRAPHIC ART JOURNAL 3, no. 2 (Feb. 1852): 131-132. [Letter, from the "Prattville Advocate," on the L. L. Hill controversy.]

H725 Lacan, Earnest "Gossip." PHOTOGRAPHIC ART JOURNAL 3, no. 5 (May 1852): 322. [From "La Lumiére." About the L. L. Hill controversy.]

H726 "Gossip: Hill and the Hillotype." PHOTOGRAPHIC ART JOURNAL 4, no. 1 (July 1852): 63-66.

H727 "Gossip." PHOTOGRAPHIC ART JOURNAL 4, no. 2 (Aug. 1852): 129-130. [Hill's claim to discovery of daguerreotypes in natural colors raised again.]

H728 "Mr. Hill and His Manifesto." PHOTOGRAPHIC ART JOURNAL 4, no. 4 (Oct. 1852): 249-253. [Includes statement from Hill plus testimonials from P. C. Wyeth (reporter), A. E. Clark (pastor, Baptist Church), George W. Halcot (Sheriff, Green Co.), M. A. Root, J. Gurney, C. C. Harrison, John A. Whipple, D. England, Samuel F. B. Morse.]

H729 "The Hillotype." PHOTOGRAPHIC ART JOURNAL 4, no. 5 (Nov. 1852): 293-296. [Includes letters from J. H. Fitzgibbon, L. L. Hill, and the suggestion for a plan to form an investigatory committee.]

H730 "Editorial." HUMPHREY'S JOURNAL 4, no. 14 (Nov. 1, 1852): 217-219. [Includes a letter about L. L. Hills color experiments written by Samuel F. B. Morse to the "National Intelligencer."]

H731 "Hillotype." HUMPHREY'S JOURNAL 4, no. 14 (Nov. 1, 1852): 219-224. [Letters of recommendation of Hill's color process, reprinted from the "New York Daily Times." Letter by L. L. Hill; A. E. Clark, Pastor; George W. Halcott (Sheriff); M. A. Root; J. Gurney; C. C. Harrison; John A. Whipple; B. England (England & Gunn, Phila.); W. & W. H. Lewis; James Heath (Rochester, NY); Prof. Samuel F. B. Morse.]

H732 "Hill's Circular." HUMPHREY'S JOURNAL 4, no. 15 (Nov. 15, 1852): 239.

H733 "Mercury." "Communication on the Hillotype." PHOTOGRAPHIC ART JOURNAL 4, no. 6 (Dec. 1852): 377-380.

H734 "Gossip." PHOTOGRAPHIC ART JOURNAL 4, no. 6 (Dec. 1852): 382-383. [More on Hill, letters, on controversy.]

H735 "Hillotype." HUMPHREY'S JOURNAL 4, no. 16 (Dec. 1, 1852): 254. [Letter, signed, "An Old Operator," expressing his disgust at L. L. Hill's circular.]

H736 "Hill and Hillotype." HUMPHREY'S JOURNAL 4, no. 17 (Dec. 15, 1852): 267-268. [Letter from Hill, defending himself, with editorial comments by S. D. Humphrey.]

H737 Fitzgibbon, J. B. "The Hillotype." HUMPHREY'S JOURNAL 4, no. 17 (Dec. 15, 1852): 269-271. [From "St. Louis [MO] Republican." Fitzgibbon describes his experience visiting Levi L. Hill.]

H738 "A Review of the Circular of L. L. Hill Addressed to the Daguerrean Fraternity and the Public at Large." PHOTOGRAPHIC ART JOURNAL 5, no. 1 (Jan. 1853): 38-41.

H739 "Letter from L. L. Hill." HUMPHREY'S JOURNAL 4, no. 18 (Jan. 1, 1853): 285. [Letter, plus editorial comments.]

H740 "Hillotype." HUMPHREY'S JOURNAL 4, no. 19 (Jan. 15, 1853): 298-301. [Letter from Hill, with editorial comment.]

H741 "Gossip." PHOTOGRAPHIC ART JOURNAL 5, no. 3 (Mar. 1853): 187-188. [Hill exhibited his Heliochromatype to a committee of U.S. Senate, unfavorable comments.]

H742 "Gossip." PHOTOGRAPHIC ART JOURNAL 5, no. 3 (Mar. 1853): 191-193.

H743 "The Hillotype." HUMPHREY'S JOURNAL 4, no. 22 (Mar. 1, 1853): 347.

H744 "Editorial: Hillotype." HUMPHREY'S JOURNAL 4, no. 23 (Mar. 15, 1853): 361-362. [Includes a report by Mr. James, Chairman of the Committee on Patents, U.S. Senate.]

H745 Hill, Levi L. "Gossip." PHOTOGRAPHIC ART JOURNAL 5, no. 4 (Apr. 1853): 253-254. [Note. 'New way to make mirrors' from the "Prattsville Advocate".]

H746 "Hillotype." HUMPHREY'S JOURNAL 6, no. 18 (Jan. 1, 1855): 290.

H747 "Helio." "The 'Hillotype.'" HUMPHREY'S JOURNAL 6, no. 20 (Feb. 1, 1855): 313-319. [Letter attacking Hill for failure to live up to his claims.]

H748 Humphrey, S. D. "Editorial: Hillotype." HUMPHREY'S JOURNAL 6, no. 20 (Feb. 1, 1855): 321. [Editorial stating that the journal was not printing many of the more violent outburst against Hill, occasioned by his recent call for more aid.]

H749 Humphrey, S. D. "Personal and Art Intelligence." PHOTOGRAPHIC AND FINE ART JOURNAL 8, no. 3 (Mar. 1855): 94-95. [Editorial comment on Levi L. Hill controversy, with a letter on the issue by John A. Whipple included.]

H750 "Obituary: Mrs. Hill." HUMPHREY'S JOURNAL 7, no. 1 (May 1, 1855): 15. [Emeline B. Hill, wife of Levi L. Hill died at age of 38.]

H751 "Obituary.- Mrs. L. L. Hill." PHOTOGRAPHIC AND FINE ART JOURNAL 8, no. 5 (May 1855): 157. [Obituary, with poem, of wife of L. L. Hill.]

H752 "Over the Left." "The Hillotype." PHOTOGRAPHIC AND FINE ART JOURNAL 9, no. 8 (Aug. 1856): 243. [Sarcastic letter from a photographer in Utica, NY.]

H753 Snelling, H. H. "Personal & Art Intelligence." PHOTOGRAPHIC AND FINE ART JOURNAL 9, no. 8 (Aug. 1856): 254-255. [Sarcastic attack on new venture by L. L. Hill to publish another "circular."]

H754 "Original: Hillotype." HUMPHREY'S JOURNAL 8, no. 7 (Aug. 1, 1856): 97. [Editorial comment by S. D. Humphrey, claiming the L. L. Hill's process not valid. Includes a letter from G. W. B. on same subject later in the issue [mispaged pp.8-9].]

H755 "Hillotype." HUMPHREY'S JOURNAL 8, no. 15 (Dec. 1, 1856): Additional section; 7-8. [Letter, from "a correspondent," critical of L. L. Hill's "Treatise on Heliochromy."]

H756 Davie, D. D. T. "Rev. L. L. Hill." HUMPHREY'S JOURNAL OF PHOTOGRAPHY, AND THE ALLIED ARTS AND SCIENCES 14, no. 7 (Aug. 1, 1862): 61-62.

H757 "Rev. L. L. Hill. - Threatened Libel Suit." HUMPHREY'S JOURNAL OF PHOTOGRAPHY, AND THE ALLIED ARTS AND SCIENCES 14, no. 8 (Aug. 15, 1862): 77-78.

H758 Seely, Charles A. "Editorial Department." AMERICAN JOURNAL OF PHOTOGRAPHY AND THE ALLIED ARTS & SCIENCES n. s. vol. 7, no. 16 (Feb. 15, 1865): 383. [Very brief, restrained announcement of L. L. Hill's death. Rev. Levi L. Hill, aged 48 years, 11 months, and 12 days.]

H759 "Obituary. Rev. Levi L. Hill." HUMPHREY'S JOURNAL OF PHOTOGRAPHY, AND THE ALLIED ARTS AND SCIENCES 16, no. 20 (Feb. 15, 1865): 315-316.

H760 "The Lounger - Poor Levi Hill is Dead." BRITISH JOURNAL OF PHOTOGRAPHY 12, no. 255 (Mar. 24, 1865): 155.

H761 Bachrach, David Jr. "On the Value of Certificates; Some Scraps Photographic History." PHILADELPHIA PHOTOGRAPHER 16, no. 191 (Nov. 1879): 324-326. [Reproduces statements of photographers in 1850's verifying that L. L. Hill's colored daguerreotypes were genuine. Statements by M. A. Root, C. C. Harrison, Gurney, Whipple, Fitzgibbon.]

H762 Becker, William B. "Inventive Genius or Ingenious Fraud?: The Enduring Mystery of Levi L. Hill." CAMERA ARTS 1, no. 1 (Jan. - Feb. 1931): 28-31, 125-127. 1 b & w. 1 illus.

H763 "The Misadventures of L. L. Hill." IMAGE 1, no. 5 (May 1952): 2. [In 1850 Hill apparently created some daguerreotypes in color by accident, probably through solarization. Announced that he had discovered a color process, then apparently never could repeat his original discoveries. His announcement threw the field into a furor.]

H764 Becker, William B. "Are These the World's First Color Photographs?" AMERICAN HERITAGE 31, no. 4 (June - July 1980): 4-7. 6 b & w. [Controversial colored daguerreotypes produced by Levi L. Hill (ca. 1817 - 1865).]

HILLARD, ELIAS BREWSTER, REV. see MOORE, NELSON AUGUSTUS & ROSWELL A. MOORE.

HILLERS, JOHN K. (1843-1925) (GERMANY, USA)

[Born in Hannover, Germany in 1843, immigrated to the USA in 1852. Joined the Union Army during the Civil War, and fought in the battles of Petersburg and Richmond. Moved west after the war and worked as a teamster. Hired by John Westley Powell to serve as a boatman on the second survey of the Green and Colorado Rivers in 1871. Learned photography on this trip from E. O. Beaman and later from James Fennemore. Fennemore became ill in August 1872 and Hiller became the photographer of the expedition and he continued to photograph for several later expeditions. He photographed the Grand Canyon in Arizona, and made many ethnographic studies of American Indian tribes in the Southwest -the Moquis, the Hopis, the Zuni, the Navahos, the Utes, Paiutes, and others. When J. W. Powell was made the head of the U. S. Geological Survey in 1881, Hillers became the chief photographer, spending much of his time in Washington, DC. He did make several shorter trips west in the 1880s and photographed then as well. He retired in 1900, and died in Washington in 1925.]

BOOKS

H765 *Photographs of Hopi, Zuni and Navaho Indians, and Their Communal Life.* s. l. [Washington, DC ?]: s. n. [Hillers ?], 1873 ? n. p. [25 mounted photos in a box. NYPL Collection has an album with the same title, but only 13 prints.]

H766 Dutton, Clarence Edward. *Report on the Geology of the High Plateaus of Utah.* Washington, DC: Government Printing Office, 1880. n. p. 11 b & w. [Heliotypes of photos taken during the Powell survey of the Rocky Mountains in 1875-77. Photos could be by John Hillers and/or W. H. Jackson.]

H767 Morgan, Lewis Henry. *Houses and House-life of the American Aborigines.* "Contributions to North American Ethnology. Vol. IV." Washington, DC: Government Printing Office, 1881. xiv, 281 pp. 4 l. of plates. b & w. illus. [Heliotype prints. At head of title: Department of the Interior. U.S. Geographical and Geological Survey of the Rocky Mountain Region. J. W. Powell, in charge."]

H768 Dallenbaugh, Frederick S. *The Romance of the Colorado River, the story of its discovery in 1540, with an account of the later explorations, and with special reference to the voyages of Powell through the line of the Grand Canyons.* New York, London: G. P. Putnam's Sons, 1909. 402 pp. many b & w. many illus.

H769 Steward, Julian Haynes. *Notes on Hillers' Photographs of the Paiute and Ute Indians taken on the Powell Expedition of 1873,* "Smithsonian Miscellaneous Collections, vol. 98, no. 18" Washington, DC: Smithsonian Institution, 1939. 23 pp. 31 l. of plates. 31 b & w.

H770 Powell, John Wesley. *Selected Prose of John Wesley Powell,* Edited and introduced by George Grossette. Boston: D. R. Godine, 1970. 122 pp. illus.

H771 Fowler, Don D., editor. *"Photographed All the Best Scenery."* Jack Hiller's Diary of the Powell Expeditions 1871 - 1875. "University of Utah Publications in the American West, 9" Salt Lake City: University of Utah Press, 1972. 226 pp. 44 b & w.

H772 Fowler, Don D. *Myself in the Water: The Western Photographs of John K. Hillers.* Washington, DC: Smithsonian Institution Press, 1989. 166 pp. 117 b & w.

PERIODICALS

H773 Hillers, J. K. "The "Venus" Box." PHOTOGRAPHIC TIMES 4, no. 47 (Nov. 1874): 170. [Letter from Hillers, "...having just returned from Major Powell's Colorado River Exploring Expedition." praising the Scovill Camera.]

H774 Powell, Major J. W. "The Canyons of the Colorado." CENTURY MAGAZINE (SCRIBNER'S MONTHLY) 9, no. 3 - 5 (Jan. - Mar. 1875): 293-310, 394-409, 523-537. 33 illus. [Illustrated with woodcuts, some taken from photographs. "The Camp at Flaming Gorge," p. 299, seems to show a stereo view camera set up. Not credited, but probably by John K. Hillers.]

H775 "Matters of the Month." PHOTOGRAPHIC TIMES 5, no. 54 (June 1875): 135. [J. K. Hillers, photographer to Major Powell's Colorado Exploring Expedition, issuing a set of stereo views "Canyons of the Colorado." Sold exclusively by William B. Holmes & Co., NY.]

H776 Powell, Major J. W. "An Overland Trip to the Grand Canyon." CENTURY MAGAZINE (SCRIBNER'S MONTHLY) 10, no. 6 (Oct. 1875): 659-678. 10 illus. [View, Indians, etc. Woodcuts, some from photographs. Description of the 1870 trip. Photos not credited, but probably either John K. Hillers or E. O. Beaman.]

H777 Swanson, E. B. "Photographing the Grand Canyon Fifty Years Ago." MENTOR 12, no. 6 (July 1924): 50-54. 5 b & w. ["Illustrated by the first photographs made of the giant abyss."]

H778 Morgan, Dale L., editor. William C. Darrah et al. "The Exploration of the Colorado River and the High Plateaus of Utah in 1871-72." UTAH HISTORICAL QUARTERLY 16-17, (Jan. 1948 - Dec. 1949): 1-540. [These two volumes of the "Quarterly" were published as a monographic volume dealing with the Powell Colorado River Exploring Expedition of 1871-1872. It contains much information, diaries etc. of participants. See specifically William Culp Darrah's "Beaman, Fennemore, Hillers, Dellenbaugh, Johnson and Hattan," on pp. 491-503 for biographies of these members of the expedition. E. O. Beaman, James Fennemore (1849-1941 b. Great Britian, USA), John K. Hillers (1843-1925 b. Germany, USA), and Frederick Samuel Dellenbaugh (1853-1935).]

H779 Fowler, Don D. and Catherine S. Fowler. "John Wesley Powell's Journal: Colorado River Exploration 1871-1872." SMITHSONIAN JOURNAL OF HISTORY 3, no. 2 (Summer 1968): 1-44. 25 b & w. 5 illus. [Profusely illustrated with photographs by John K. Hillers and E. O. Beaman. Notes on pp. 40-44.]

H780 Weinberg, Adam D. "John K. Hillers (1843-1925)." IMAGE 25, no. 2 (June 1982): 12-15. 5 b & w. [Includes one image on inside back cover.]

H781 Hooper, Bruce. "Windows on the Nineteenth Century World: John K. Hillers Glass Window Transparencies." HISTORY OF PHOTOGRAPHY 12, no. 2 (Apr. - June 1988): 185-192. 4 b & w. 2 illus. [The Riordan House, a private dwelling built in 1903/04 in Flagstaff, AZ, is decorated with window transparencies created from John K. Hillers' negatives, taken on Government Surveys in the 1870s.]

HILLERS, JOHN K. [?]

H782 "Distant View of Moqui, an Aztec City of Arizona." FRANK LESLIE'S ILLUSTRATED NEWSPAPER 38, no. 981 (July 18, 1874): 300. 1 illus. [View of a Pueblo. Not credited, but clearly from the same source as the image published in the July 4 issue, therefore possibly by either Hillers or O'Sullivan.]

HILLS & SAUNDERS. (ETON, ENGLAND)

H783 Portraits. Woodcut engravings credited "From a photograph by Hills & Saunders, of Oxford and Eton." ILLUSTRATED LONDON

NEWS 52, (1868) ["Rev. James John Hornby, Eton College." 52:* (Jan. 25, 1868): 80. "Sir Charles Wheatstone." 52:* (Feb. 8, 1868): 145.]

H784 Portraits. Woodcut engravings credited "From a photograph by Hills & Saunders." ILLUSTRATED LONDON NEWS 64, (1874) ["Late M. Van der Weyer, Belgian Minister in London." 64:1815 (June 6, 1874): 541. "Colonel Alexander, M.P." 64:1816 (June 13, 1874): 552.]

H785 Portrait. Woodcut engraving credited "From a photograph by Hills & Saunders." ILLUSTRATED LONDON NEWS 72, (1878) ["Late Mr. Wm. Evans." 72:2014 (Feb. 2, 1878): 108.]

H786 Portrait. Woodcut engraving credited "From a photograph by Hills & Saunders." ILLUSTRATED LONDON NEWS 73, (1878) ["Late Sir T. Biddulph." 73:2052 (Oct. 26, 1878): 400.]

H787 Portrait. Woodcut engraving credited "From a photograph by Hills & Saunders." ILLUSTRATED LONDON NEWS 74, (1879) ["Capt. Mostyn, killed." 74:2073 (Mar. 8, 1879): 216.]

HILLS, CHARLES G.
H788 Portrait. Woodcut engraving, credited "From a Photograph by Charles G. Hills." FRANK LESLIE'S ILLUSTRATED NEWSPAPER 9, (1860) ["Napoleon Wood, leader of the shoemaker's riot at Lynn, MA." 9:224 (Mar. 17, 1860): 239.]

HILLS, ROBERT. (d. 1882) (GREAT BRITAIN)
H789 "The Oxfordshire Militia in the Garden of St. John's College, Oxford." ILLUSTRATED LONDON NEWS 31, no. 887 (Nov. 14, 1857): 479-480. 1 illus. ["...from a photograph taken during the inspection by Mr. Robert Hills, Cornmarket St., Oxford."]

H790 "Memorial Fountain to be Erected at Oxford to King Alfred the Great." ILLUSTRATED NEWS OF THE WORLD AND DRAWING ROOM PORTRAIT GALLERY OF EMINENT PERSONAGES 1, no. 36 (Oct. 9, 1858): 229. 1 illus. ["From a photograph by Mr. Robert Hills, of Oxford."]

HILLYER, HAMILTON BISCOE. (1835-1903) (USA)
H791 "Editor's Table." PHILADELPHIA PHOTOGRAPHER 6, no. 64 (Apr. 1869): 136. [Photos noted. Hillyer from Austin, TX.]

H792 "Editor's Table." PHILADELPHIA PHOTOGRAPHER 6, no. 65 (May 1869): 169. [Photos noted.]

H793 "Editor's Table." PHILADELPHIA PHOTOGRAPHER 6, no. 69 (Sept. 1869): 324. [Stereos of TX noted.]

H794 Hillyer, H. B. "Model for a Cheap Gallery." PHILADELPHIA PHOTOGRAPHER 9, no. 100 (Apr. 1872): 120-122. 1 illus. [Hillyer from Austin, TX.]

H795 Hillyer, H. B. "How to Dispatch Work." PHILADELPHIA PHOTOGRAPHER 9, no. 104 (Aug. 1872): 277-278.

HIME, HUMPHREY LLOYD. (1833-1903) (GREAT BRITAIN, CANADA)
[Hime was born in Ireland in 1833. Emigrated to Canada in 1854, where he became a partner in the photographic firm of Armstrong, Beere & Hime. In 1858 Hime joined the Assinibone and Saskatchewan Exploring Expedition, led by Henry Youle Hind, to survey western Canada. A portfolio of thirty photographs from that trip was published in London in 1860 and his photographs were used to illustrate Hind's books on this subject. Hime left photography about

1860 to form the firm of H. L. Hine & Co., stockbrokers, real estate and insurance agents. He was successful, and was elected President of the Toronto Stock Exchange in 1868 and in 1888. He died in Toronto in 1903.]

BOOKS
H796 Hind, Henry Youle. *North-West Territory. Reports of Progress; Together with a Preliminary and General Report on the Assiniboine and Saskatchewan Expeditions, Made Under Instructions from the Provincial Secretary, Canada.* Toronto: Legislative Assembly, printed by J. Lovell, 1859. xii, 201 pp. illus.

H797 Hind, Henry Youle, Humphrey Lloyd Hime, photographer. *Photographs Taken at Lord Selkirk's Settlement on the Red River of the North, To Illustrate a Narrative of the Canadian Exploring Expeditions in Rupert's Land.* London: J. Hogarth, 1859 [?]. 2 pp. 30 l. of plates. 30 b & w.

H798 Hind, Henry Youle. *Narrative of the Canadian Red River Exploring Expedition of 1857, and of the Assiniboine and Saskatchewan Exploring Expedition of 1858.* London: Longman, Green, Longman & Roberts, 1860. 2 vol. illus. [Many of the illustrations copied from the photographs of Humphrey Lloyd Hime. Reprinted (1971) Rutland, VT: C. E. Tuttle & Co.]

H799 Hime, H. L. *Camera in the Interior, 1858: H. L. Hime, Photographer: The Assiniboine and Saskatchewan Exploring Expedition.* Compiled by Richard J. Huyda. Toronto: Coach House Press, 1975. 55 pp. b & w. illus.

PERIODICALS
H800 "The Assiniboine and Saskatchewan Exploring Expedition." ILLUSTRATED LONDON NEWS 33, no. 941 (Oct. 16, 1858): 366-367. 2 illus.

H801 Greenhill, Ralph. "Early Canadian Photographer, Humphrey Lloyd Hime." IMAGE 11, no. 3 (1962): 9-11. 5 b & w.

HIMES, CHARLES FRANCIS. (1838-1918) (USA)
BOOKS
H802 Himes, Charles Francis. *Leaf Prints; or Glimpses at Photography.* Philadelphia.: Benerman & Wilson, 1868. 38 pp. 1 b & w.

H803 Himes, Charles Francis. *Theory, History and Construction of the Stereoscope: With Contributions to the Subject of Binocular Vision and Suggestions as to the Use, Selection, and c., of a Stereoscope,...* Illustrated with woodcuts. Philadelphia: Journal of the Franklin Institute, 1872. 49 pp. illus.

H804 Himes, Charles Francis. *A Sketch of Dickinson College, Carlisle, Penn'a, Including the List of Trustees and Faculty from the Foundation, and a more Particular Account of the Scientific Department.* Harrisburg, PA: Hart, 1879. 155 pp. b & w. illus.

H805 Bell, J. Whitfield and Charles Coleman Sellers. *Charles Francis Himes, 1838 - 1918, Local Historian and Charles Francis Himes and the Photographic Exchange Club.* Carlisle, PA: Hamilton Library Association, 1935. n. p.

PERIODICALS
H806 Himes, Charles F., Prof. of Troy Univ. "On the Convergency of the Optic Axes in Binocular Vision." AMERICAN JOURNAL OF PHOTOGRAPHY AND THE ALLIED ARTS & SCIENCES n. s. vol. 5, no. 5 (Sept. 1, 1862): 114-119. [From "Am. J. of Science," vols. 20-21.]

H807 Himes, Prof. Charles F., of Troy University. "On the Convergency of the Optic Axes in Binocular Vision." BRITISH JOURNAL OF PHOTOGRAPHY 9, no. 175 (Oct. 1, 1862): 371-372.

H808 Himes, C. F., Prof. "A Word about Toning." HUMPHREY'S JOURNAL OF PHOTOGRAPHY, AND THE ALLIED ARTS AND SCIENCES 15, no. 12 (Oct. 15, 1863): 184. [From "The Amateur Photographic Print."]

H809 Himes, Charles F. "Tannin Plates on the Battle-Field." BRITISH JOURNAL OF PHOTOGRAPHY 11, no. 211 (Apr. 1, 1864): 114-115. [Himes, Prof. of Natural Sciences at Dickinson College, Carlisle, PA, was present during the Battle of Gettysburg. After the battle and after aiding the wounded, he attempted to photograph the field several times, with little success.]

H810 Himes, Charles, F. "Discussion of the Phenomenon of the Horizontal Moon by Aid of the Stereoscope." BRITISH JOURNAL OF PHOTOGRAPHY 11, no. 230-231 (Sept. 30 - Oct. 7, 1864): 377-378, 390-391. 2 illus.

H811 "The Stereoscope." AMERICAN JOURNAL OF PHOTOGRAPHY AND THE ALLIED ARTS & SCIENCES n. s. vol. 7, no. 9 (Nov. 1, 1864): 197-198. [From "Br. J. of Photo."]

H812 Himes, Charles F. "On the Comparative Brightness of Objects Seen by One and By Both Eyes, and Photographic Reproduction of Lustre." BRITISH JOURNAL OF PHOTOGRAPHY 12, no. 244 (Jan. 6, 1865): 1-2. 2 illus.

H813 "Editor's Table." PHILADELPHIA PHOTOGRAPHER 3, no. 32 (Aug. 1866): 255. [Prof. Himes, a photographer, came from Germany a year ago to fill the Chair of Natural Science at Dickenson College, Carlisle, Pa.]

H814 "Leaf Prints; or Glimpses at Photography." HUMPHREY'S JOURNAL OF PHOTOGRAPHY, AND THE ALLIED ARTS AND SCIENCES 19, no. 16 (Dec. 15, 1867): 255-256. [Bk. rev.: "Leaf Prints; or Glimpses at Photography." by Charles F. Himes, Ph.D.]

H815 Himes, Prof. C. F. "The Stereoscope." ANTHONY'S PHOTOGRAPHIC BULLETIN 3, no. 10 (Oct. 1872): 701-703. [Excerpt from the book, of the same title and author.]

H816 "Notes and News." PHOTOGRAPHIC TIMES 19, no. 382 (Jan. 11, 1889): 21. [Himes, an amateur, Professor at the Dickenson College, to give a lecture at the Franklin Institute.]

HIMLEY, AUGUST FRIEDRICH KARL. (1811-1885) (GERMANY)

H817 Hoerner, Ludwig. "Photohistorica Gottingensis Part One: August Friedrich Karl Himley (1811-1885)." HISTORY OF PHOTOGRAPHY 6, no. 1 (Jan. 1982): 59-63. 1 b & w. [Early experimenter in Gottingen, worked with daguerreotypes.]

HINCKLEY, A. S.

H818 "Opening of the New Railroad Bridge of the Hudson River, at Albany, N. Y., Feb. 22, 1866 - From a Photograph by A. S. Hinckley." FRANK LESLIE'S ILLUSTRATED NEWSPAPER 22, no. 547 (Mar. 24, 1866): 9. 1 illus. [View of the bridge, with a train.]

HINTON, H. (INDIA)

H819 "Proclamation of the Queen's Rule in India - The Illuminations." ILLUSTRATED LONDON NEWS 34, no. 953 (Jan. 1, 1859): 17-18. 2 illus. [Views of crowds, illuminated buildings. One view in Calcutta,

taken by James Mandy. One view, in Bombay, photographed by H. Hinton.]

H820 "The Sir Jamsetjee Hospital and Grant Medical College at Bombay." ILLUSTRATED LONDON NEWS 35, no. 997 (Oct. 8, 1859): 339, 342. 1 illus. [From a Photograph by H. Hinton.]

HINTON. (MONTGOMERY, AL)

H821 Portrait. Woodcut engraving, credited "From a Photograph by Hinton." HARPER'S WEEKLY 5, (1861) ["The Cabinet of the Confederate States at Montgomery." ("From photographs by Whitehurst, of Washington, and Hinton, of Montgomery, Alabama.") 5:231 (June 1, 1861): 340.]

HISLOP, WILLIAM.

H822 Hislop. "On the Method of producing Minute Photographs." HUMPHREY'S JOURNAL OF PHOTOGRAPHY, AND THE ALLIED ARTS AND SCIENCES 9, no. 17 (Jan. 1, 1858): 270-272. [Read to North London Photo. Assoc. From "J. of London Photo. Soc.]

H823 Hislop, Wm. F.R.A.S. "Some Additional Notes on Plain Washed Collodion for Dry Plates." AMERICAN JOURNAL OF PHOTOGRAPHY AND THE ALLIED ARTS & SCIENCES n. s. vol. 5, no. 13 (Jan. 1, 1863): 293-296. [Read to London Photo. Assoc.]

H824 Hislop, Wm., F.R.A.S. "A Word for Sugar in the Iron Developer." AMERICAN JOURNAL OF PHOTOGRAPHY AND THE ALLIED ARTS & SCIENCES n. s. vol. 8, no. 18 (Mar. 15, 1866): 415-417. [Read to North London Photo. Assoc.]

H825 Hislop, Wm., F.R.A.S. "A Word for Sugar in the Iron Developer." HUMPHREY'S JOURNAL OF PHOTOGRAPHY, AND THE ALLIED ARTS AND SCIENCES 17, no. 22 (Mar. 15, 1866): 348-349. [Read to the North London Photo. Assoc.]

HITE, GEORGE H.

H826 Hite, George H. "Theory of Combining Artistic Principles with the Mechanical Operations of Taking Likenesses by the Daguerrean Process." DAGUERREAN JOURNAL 2, no. 1 (May 15, 1851): 23-24.

HIX, W. P.

H827 "Portraits of Some of the Leading State Officials and Members of the Legislature of South Carolina. - Photographed by W. P. Hix." FRANK LESLIE'S ILLUSTRATED NEWSPAPER 39, no. 990 (Sept. 19, 1874): 37. 19 illus. [Nineteen separate portraits.]

HOAG, D. R. [HOAG & QUICK] (d. 1864) (USA)

H828 Portrait. Woodcut engraving, credited "From a Photograph." FRANK LESLIE'S ILLUSTRATED NEWSPAPER 14, (1862) ["Lieut. Charles Allen." 14:350 (June 21, 1862): 181.]

H829 Portrait. Woodcut engraving, credited "From a Photograph by D. R. H. Hoag & Quick." HARPER'S WEEKLY 8, (1864) ["Late Brig.-Gen. Daniel McCook." 8:401 (Sept. 3, 1864): 564.]

H830 Seely, Charles A. "Editorial Department." AMERICAN JOURNAL OF PHOTOGRAPHY AND THE ALLIED ARTS & SCIENCES n. s. vol. 7, no. 7 (Oct. 1, 1864): 167. ["Mr. D. R. Hoag, of the firm of Hoag & Quick, of Cincinnati, after a short illness, died on the 17th ult."]

H831 "Obituary." HUMPHREY'S JOURNAL OF PHOTOGRAPHY, AND THE ALLIED ARTS AND SCIENCES 16, no. 12 (Oct. 15, 1864): 188. ["We are pained to notice the death, at Cincinnati, on the 17th

ult., of Mr. D. R. Hoag, of the firm of Hoag & Quick, one of the best artists in the Western country."]

H832 "Editor's Table: Death of Mr. D. R. H. Hoag." PHILADELPHIA PHOTOGRAPHER 1, no. 11 (Nov. 1864): 176. ["...demise at Cincinnati, OH, on the 17th of September. One of the earliest and best practical photographers in the country."]

HOAG, JAMES M. (1839-1879) (USA)
H833 "Obituary." PHILADELPHIA PHOTOGRAPHER 16, no. 187 (July 1879): 201. [James Hoag died in Adrian, MI on May 13, 1879 at age 40. He had been a photographer for the last twenty years. Honest and generous, and a good husband and father.]

HOBDAY.
H834 "U.S. Steamer 'Powattan' (Japan Expedition), at Anchor." ILLUSTRATED NEWS (NY) 1, no. 10 (Mar. 5, 1853): 149. 1 illus. ["From an excellent Daguerreotype by Mr. Hobday, Portsmouth, VA."]

HOCKIN, JOHN BRENT. (LONDON, ENGLAND)
[Member of a London firm of chemists and dealers in photographic apparatus.]

BOOKS
H835 Hockin, John Brent. *How to Obtain Positive and Negative Pictures on Collodionized Glass, and Copy the Latter upon Paper. A Short Sketch adapted to the Tyro in Photography.* London: J. B. Hockin, 1853. xii, 23, plus a catalog of 8 pp.

H836 Hockin, John Brent. *Practical Treatise on the Photographic Processes on Glass and Paper.* "3rd ed." London: J. B. Hockin, 1855. xii, 68 pp.

H837 Hockin, J. B. *Practical Hints on Photography: Its Chemistry and Its Manipulations.* "4th ed." London: Hockin, 1860. 167 pp. 2 l. of plates. illus.

PERIODICALS
H838 Hockin, J. B. "Scientific Photography." ATHENAEUM no. 1294 (Aug. 14, 1852): 875-876. [Hockin's letter details his formulae.]

H839 Hockin, J. B. "On Instantaneous Pictures by the use of Formic Acid in the Developer." HUMPHREY'S JOURNAL OF PHOTOGRAPHY, AND THE ALLIED ARTS AND SCIENCES 14, no. 24 (Apr. 15, 1863): 331-333. [From "Br. J. of Photo."]

H840 "The Albumen Process." AMERICAN JOURNAL OF PHOTOGRAPHY AND THE ALLIED ARTS & SCIENCES n. s. vol. 8, no. 18 (Mar. 15, 1866): 418-419. [From "Br. J. Photo. Almanac." Formula "...of Mr. Hockin, of Duke St., Manchester Square."]

HOELKE & BENECKE. (ST. LOUIS, MO)
H841 "Editor's Table." PHILADELPHIA PHOTOGRAPHER 6, no. 64 (Apr. 1869): 136. [Stereos, including Gen. Grant's farm house noted.]

HOELKE, H. E. (ST. LOUIS, MO)
H842 Portraits. Woodcut engravings, credited "Photographed by H. E. Hoelke, St. Louis." FRANK LESLIE'S ILLUSTRATED NEWSPAPER 12, (1861) ["Brig.-Gen. Sterling Price, of MO." 12:303 (Sept. 7, 1861): 268.]

H843 Hoelke, H. E. "Landscape Photography in Germany." PHILADELPHIA PHOTOGRAPHER 4, no. 47 (Nov. 1867): 347-348.

HOFFMEIER, S. B. (EASTERN, PA)
H844 "Photographers, Old and New: S. B. Hoffmeier." WILSON'S PHOTOGRAPHIC MAGAZINE 32, no. 462 (June 1895): 267-268. 1 illus. [Hoffmeier began in 1858 in Lancaster, Pa., with James Fortney, taking ambrotypes. Worked with J. E. McClees of Phila. After Civil War, worked for J. C. Lusher, etc. started a gallery in Eastern, Pa., in 1865 which he ran for twenty-nine years before retiring.]

HOGARTH, J.
H845 Macbean, Major. *Views in Lucknow: From Sketches made During the Siege;* by Major MacBean, Photographed by J. Hogarth. London: J. Hogarth, 1858. 8 pp. 12 l. of plates. 12 b & w. [Original photos of sketches.]

HOGG, JABEZ. (1817-1889) (GREAT BRITAIN)
[Jabez Hogg, M.R.C.S., was a surgeon, who had an interest in microscopy and photography.]

BOOKS
H846 [Hogg, Jabez.] *Photography Made Easy; A Practical Manual of Photography; Containing Full and Plain Directions for the Economical Production of Really Good Daguerreotype Portraits, and Every Other Variety of Photographic Pictures, according to the Latest Improvements etc., also, the Injustice and Validity of the Patent Considered, With suggestions for rendering such a Patent a virtual Dead Letter, etc., by a Practical Chemist and Photographist.* London: E. MacKenzie, 1845. 62 pp.

H847 Hogg, Jabez. *A Practical Manual of Photography,* by A Practical Photographer. Illustrated with Woodcuts. "3rd ed." London: W. M. Clark, 1852. 64 pp. illus. [4th ed. (1853) 76 p., states that the author is J. Hogg.]

H848 Hogg, Jabez, M.R.C.S. *A Practical Manual of Photography; containing a Concise History of the Science, and its Connection with Optics, together with Simple and Practical Details for the Production of Pictures by the Action of Light upon Prepared Surfaces of Silvered Plates, Paper and Glass, by the processes known as Daguerreotype, Talbotype, Collodion, Albumen, etc.* London: W. M. Clark, 1856. 80 pp. 28 illus. [5th ed.]

H849 Hogg, Jabez. *The Microscope: its History, Construction and Application. Being a familiar introduction to the Use of the Instrument and the Study of Microscopic Science.* "11th ed." London: G. Routledge & Sons, 1886. 764 pp. 363 illus. [355 woodcuts, eight colored plates. First ed. (1854).]

PERIODICALS
H850 Bennett, Stuart. "Jabez Hogg Daguerreotype." HISTORY OF PHOTOGRAPHY 1, no. 4 (Oct. 1977): 318. 1 b & w. 1 illus. [Daguerreotype of Jabez Hogg taking a portrait of Richard Beard's studio in 1842.]

H851 "'Jabez Hogg and Mr. Johnson' 1/4 plate daguerreotype, c. 1843." PHOTOGRAPHIC COLLECTOR 4, no. 1 (Spring l983): 8-9. 1 b & w. 1 illus. [Jabez Hogg (1817-1899), author of "Practical Manual of Photography." The daguerreotype is of Hogg daguerreotyping William S.Johnson, father of John Johnson, partner in first daguerrean studio in London.]

HOLDSWORTH, ISRAEL.
H852 Holdsworth, Israel. "Collodion Positives." AMERICAN JOURNAL OF PHOTOGRAPHY AND THE ALLIED ARTS & SCIENCES n. s. vol. 3, no. 2 (June 15, 1860): 20-22. [From "Br. J. of Photo."]

HOLLENBECK, J. H.
H853 "Value of one Number of Humphrey's Journal." HUMPHREY'S JOURNAL OF PHOTOGRAPHY, AND THE ALLIED ARTS AND SCIENCES 17, no. 9 (Sept. 1, 1865): 138. ["Mr. J. H. Hollenbeck, now with Scoville Manufacturing Co., was, in the Fall of 1861, an operator with one of the photographic artists in Memphis, Tenn., and he tells us the following good one."]

HOLLISTER, E. S.
H854 "Great Flood at Marietta, Ohio, April 13th, 1860." FRANK LESLIE'S ILLUSTRATED NEWSPAPER 9, no. 233 (May 19, 1860): 391-392. 3 illus. [Three views of flooding, "Photographed by E. S. Hollister."]

HOLMES, BOOTH & HAYDENS see also HARRISON, C. C.

HOLMES, OLIVER WENDELL. (1809-1894) (USA)
BOOKS
H855 Holmes, Oliver Wendell. *Soundings from the Atlantic.* Boston: Ticknor & Fields, 1864. 468 pp. [(1880) Houghton Mifflin & Co. Includes essays "My Hunt after The Captain," "The Stereoscope and the Stereography," "Sun Painting and Sun-Sculpture," "With a Stereoscopic Trip Across the Atlantic," "Doings of the Sunbeam," etc.]

H856 Hamilton, George E. *Oliver Wendell Holmes - His Pioneer Stereoscope and the Later Industry.* New York: Newcomen Society in North America, 1949. 32 pp. illus.

PERIODICALS
H857 Holmes, Oliver W. "The Stereoscope and the Stereograph." ATLANTIC MONTHLY 3, no. 20 (June 1859): 738-748.

H858 Holmes, Oliver Wendell. "The Stereoscope and the Stereography." AMERICAN JOURNAL OF PHOTOGRAPHY AND THE ALLIED ARTS AND SCIENCES n. s. vol. 2, no. 1 (June 1, 1859): 1-9. [Extracts from the "Atlantic Monthly."]

H859 Holmes, Oliver W. "Sun-Painting and Sun-Sculpture; With a Stereoscopic Trip Across the Atlantic." ATLANTIC MONTHLY 8, no. 45 (July 1861): 13-29.

H860 Holmes, Oliver Wendell. "Sun-Painting and Sun-Sculpture, with a Stereoscopic Trip across the Atlantic." AMERICAN JOURNAL OF PHOTOGRAPHY AND THE ALLIED ARTS & SCIENCES n. s. vol. 4, no. 4 (July 15, 1861): 81-84. [Excerpted from "Atlantic Monthly."]

H861 Holmes, Oliver W. "Doings of the Sunbeam." ATLANTIC MONTHLY 12, no. 69 (July 1863): 1-27.

H862 Holmes, Dr. O. W. "Doings of the Sunbeam." BRITISH JOURNAL OF PHOTOGRAPHY 10, no. 195-197 (Aug. 1 - Sept. 1, 1863): 308-309, 332-333, 351-352. [From "Atlantic Monthly."]

H863 Holmes, Oliver Wendell. "History of the "American Stereoscope." PHILADELPHIA PHOTOGRAPHER 6, no. 61 (Jan. 1869): 1-3.

H864 "The 'Holmes Stereoscope.'" PHILADELPHIA PHOTOGRAPHER 6, no. 61 (Jan. 1869): 23-25. 2 illus. [Diagrams of stereo viewers.]

H865 "Note." ANTHONY'S PHOTOGRAPHIC BULLETIN 8, no. 6 (June 1877): 183. [From "Burlington Hawk-Eye." Joking commentary on Holmes's parlor hand-stereoscope.]

H866 Underwood, Francis H. "Oliver Wendell Holmes." CENTURY MAGAZINE (SCRIBNER'S MONTHLY) 18, no. 1 (May 1879): frontispiece, 117-127. 4 illus.

H867 Holmes, O. W. "Notes and News: Origin of the Stereoscope." PHOTOGRAPHIC TIMES 23, no. 606 (Apr. 28, 1893): 223-224. [From the "Boston Transcript," Mar. 23, 1893. Holmes describes how his stereoscope evolved.]

H868 "Editorial Notes." PHOTOGRAPHIC TIMES 25, no. 683 (Oct. 19, 1894): 251-252. [Notes that Oliver Wendell Holmes was interested in photography, mentions his writings on the subject published in his book "Soundings from the Atlantic." Contains excerpts of Holmes's writings.]

H869 1 photo (Portrait of James Russell Lowell, 1864) as frontispiece. NEW ENGLAND MAGAZINE 17, no. 4 (Dec. 1897): 390. 1 b & w.

H870 1 photo (Author James Russell Lowell, taken in 1865). OUTLOOK 59, no. 5 (June 4, 1898): 314. 1 b & w. [Informal portrait of Lowell by Oliver W. Holmes illustrating an article on Lowell.]

H871 Holmes, Oliver Wendell. "The American Stereoscope." IMAGE 1, no. 3 (Mar. 1952): 1. 1 illus. [Reprinted from the "Philadelphia Photographer," Jan. 1869.]

H872 Severson, Doublas G. "Oliver Wendell Holmes: Poet of Realism (1809 - 1894)." HISTORY OF PHOTOGRAPHY 2, no. 3 (July 1978): 235-236. 3 b & w.

H873 "The Sun Paintings of Dr. Oliver Wendell Holmes." AMERICAN HERITAGE 30, no. 2 (Feb. - Mar. 1979): 104-107. 8 b & w. [Portraits, taken outdoors in the 1860s.]

H874 "Dr. Holmes' Stereoscope." STEREO WORLD 7, no. 5 (Nov. - Dec. 1980): 9. [Photograph of Dr. Holmes' original model for his stereoscope, now in the Oliver Wendell Holmes Library at Phillips Academy, Andover, MA.]

H875 Shloss, Carol. "Oliver Wendell Holmes as an Amateur Photographer." HISTORY OF PHOTOGRAPHY 5, no. 2 (Apr. 1981): 119-123. 5 b & w.

HOLMES, SILAS A. (1820-1886) (USA)
H876 "Our Illustrations." PHOTOGRAPHIC AND FINE ART JOURNAL 10, no. 4 (Apr. 1857): unnumbered page, 121. 1 b & w. [Original photographic print, tipped-in. Portrait of Major Bradley of the Nicaraguan Army under Gen. Walker, returned to New York to recover from wounds. Negative by S. A. Holmes, (New York, NY) (Print not in this copy.)]

H877 "Scene of the Fearful Accident near the Niagara Falls Suspension Bridge. - From a Photograph by Holmes." FRANK LESLIE'S ILLUSTRATED NEWSPAPER 3, no. 72 (Apr. 25, 1857): 320. 1 illus. [View.]

H878 "The Corvette Japanese, built by W. H. Webb, for the Russian Government. Photographed by Holmes." FRANK LESLIE'S ILLUSTRATED NEWSPAPER 5, no. 126 (May 1, 1858): 345. 1 illus.

H879 Portrait. Woodcut engraving, credited "From a Photograph by Silas A. Holmes." HARPER'S WEEKLY 5, (1861) ["Brigidier-General Lyon, U.S.A." 5:237 (July 13, 1861): 433.]

H880 Holmes, S. A. "A New Plan of Vignetting." AMERICAN JOURNAL OF PHOTOGRAPHY AND THE ALLIED ARTS & SCIENCES n. s. vol. 6, no. 20 (Apr. 15, 1864): 476-477.

H881 "Happy Family." HUMPHREY'S JOURNAL OF PHOTOGRAPHY, AND THE ALLIED ARTS AND SCIENCES 16, no. 8 (Aug. 15, 1864): 125-126. ["At the door of Mr. Holmes, photographer, Broadway, a very interesting portrait of Father Abraham (Lincoln) is exhibited.... a striking outline of the President studded all along with minute portraits in juxtaposition."]

H882 Seely, Charles A. "Editorial Department." AMERICAN JOURNAL OF PHOTOGRAPHY AND THE ALLIED ARTS & SCIENCES n. s. vol. 7, no. 14 (Jan. 15, 1865): 336. ["Mr. S. A. Holmes, who is exclusively devoted to landscape photography, as been out among the oil wells of Pennsylvania."]

H883 "The Grand Terrace at Central Park, New York." FRANK LESLIE'S ILLUSTRATED NEWSPAPER 22, no. 566 (Aug. 4, 1866): 313. 1 illus. [Full-page view, with figures (which may have been added by the engraver.)]

H884 "The ABC of Photography." HUMPHREY'S JOURNAL OF PHOTOGRAPHY, AND THE ALLIED ARTS AND SCIENCES 18, no. 10 (Sept. 15, 1866): 151-152. [Charming anecdote about overhearing the photographer Holmes explain how the photographic process worked to a six year old.]

H885 "Artists' Studio Buildings, Tenth Street, New York. - From a Photograph by Holmes." FRANK LESLIE'S ILLUSTRATED NEWSPAPER 24, no. 602 (Apr. 13, 1867): 53. 1 illus. [View.]

H886 "Breaking Ground for the New Post Office on City Hall Park, New York City, August 9th. - From a Photograph by S. A. Holmes." FRANK LESLIE'S ILLUSTRATED NEWSPAPER 28, no. 726 (Aug. 28, 1869): 380. 1 illus. [View, with crowd.]

H887 Holmes, S. A. "Correspondence." ANTHONY'S PHOTOGRAPHIC BULLETIN 3, no. 1 (Jan. 1872): 430. [Holmes recommends the Dallmeyer lenses.]

H888 "Obituary: Silas A. Holmes." ANTHONY'S PHOTOGRAPHIC BULLETIN 17, no. 3 (Feb. 13, 1886): 89. [Silas A. Holmes a successful photographer in New York City for 35 years. Died Jan. 27, 1886 in his 66th year.]

H889 "Obituary." PHOTOGRAPHIC TIMES 16, no. 229 (Feb. 5, 1886): 84. [Began in 1845 in partnership with C. C. Harrison, in New York City, until Harrison quit in 1847 to make lenses. Holmes continued and was popular once, but lost money in investments and so died poor. Died January 27, 1886, in the 66th year of his age.]

H890 Miller, Steven H. "Bridge over Broadway." HISTORY OF PHOTOGRAPHY 5, no. 2 (Apr. 1981): 151-154. 2 b & w. 2 illus. [Article is about the photographer taking photographs of people on a pedestrian bridge over Broadway in New York City from the window of his studio, in the 1860s.]

HOLROYD, T. & J. HOLROYD. (LONDON, ENGLAND)
H891 Portraits. Woodcut engravings credited "From a photograph by T. Holroyd & J. Holroyd, Harrogate." ILLUSTRATED LONDON NEWS 72, (1878) ["Late Mr. Joseph Bonomi." 72:2020 (Mar. 16, 1878): 245.]

HOLTERMAN, B. O. (AUSTRALIA)
H892 "Editor's Table: Holterman's Great Negative." PHILADELPHIA PHOTOGRAPHER 13, no. 152 (Aug. 1876): 255-256. [B. O. Holterman created a 3' x 2' negative of a view of Sydney, Australia. This displayed in Bradley & Rulofson's studio in San Francisco.]

H893 "Editor's Table: The Largest Negative in the World." PHILADELPHIA PHOTOGRAPHER 13, no. 154 (Oct. 1876): 320. [Holterman's 3'x2' negative of Sydney, Australia on display at Gutekunst's studio in Philadelphia.]

HOMERSHAM, JOHN.
H894 Homersham, John. "Compound Negatives." BRITISH JOURNAL PHOTOGRAPHIC ALMANAC 1871 (1871): 95-96.

HONG KONG PHOTOGRAPHIC CO.
H895 "The Typhoon at Hong-Kong." ILLUSTRATED LONDON NEWS 65, no. 1839 (Nov. 21, 1874): 495, 496. 2 illus.

HOOD.
H896 "Boiler Explosion and Loss of Life at Airdrie." ILLUSTRATED LONDON NEWS 36, no. 1030 (May 12, 1860): 459-460. 1 illus. ["Our Engraving of the pit's mouth is from a photographic view taken by Mr. Hood, of Airdrie, shortly after the fatal occurrence.]

HOOK, WILLIAM M.
H897 Hook, William M. "Correspondence." ANTHONY'S PHOTOGRAPHIC BULLETIN 5, no. 12 (Dec. 1874): 419. [Hook from Ft. Smith, AK.]

HOOPER.
H898 Hooper. "On the Turpentine Waxed-paper Process." HUMPHREY'S JOURNAL OF PHOTOGRAPHY, AND THE ALLIED ARTS AND SCIENCES 11, no. 22 (Mar. 15, 1860): 343-347. [Read to Chorlton Photo. Assoc. From "Br. J. of Photo."]

HOOPER, GEORGE.
H899 Hooper, George. "A Word on Tents in General, and One in Particular." BRITISH JOURNAL PHOTOGRAPHIC ALMANAC 1874 (1874): 160-162.

H900 Hooper, George. "On Photographing Children." BRITISH JOURNAL PHOTOGRAPHIC ALMANAC 1876 (1876): 113-114.

H901 Hooper, George. "On Photographing Children." ANTHONY'S PHOTOGRAPHIC BULLETIN 7, no. 2 (Feb. 1876): 43-44. [From "London Photo. News."]

HOOPER, WILLOUGHBY WALLACE. (1837-1912) (GREAT BRITAIN, INDIA)
H902 Falconer, John. PHOTOGRAPHIC COLLECTOR 4, no. 3 (Winter 1983): 258-286. 35 b & w. [British officer in Light Cavalry in Madras Army in India 1850s - 1880s. Photographed Madras Famine victims in the 1870s, the Military Expedition into Burma in the 1880s.]

HOPPER.
H903 Portrait. Woodcut engraving, credited "(From a Daguerreotype Taken In Prison Expressly for This Paper. By Hopper) FRANK LESLIE'S ILLUSTRATED NEWSPAPER 1, (1856) ["Samuel Sly." 1:5 (Jan. 12, 1856): 72.]

HORETZKY, CHARLES GEORGE. (1838-1900) (CANADA)
H904 Birrell, Andrew. "Fortunes of a Misfit; Charles Horetzky." ALBERTA HISTORICAL REVIEW (Winter 1971)

HORNE, F.
H905 Horne, F. "On the Calotype Process." HUMPHREY'S JOURNAL 8, no. 6 (July 15, 1856): 88-92.

HORSBURGH, JOHN. (EDINBURGH, SCOT)
H906 "Our Editorial Table: Views in Edinburgh, and Other Subjects, by J. Horsburgh." BRITISH JOURNAL OF PHOTOGRAPHY 12, no. 263 (May 19, 1865): 269

H907 Portrait. Woodcut engraving credited "From a photograph by J. Horsburgh." ILLUSTRATED LONDON NEWS 65, (1874) ["James Cowan, M.P., member of Parliament." 65:1821 (July 18, 1874): 52.]

H908 Portrait. Woodcut engraving credited "From a photograph by J. Horsburgh." ILLUSTRATED LONDON NEWS 69, (1876) ["Late Lord Ardmillan." 69:1939 (Sept. 23, 1876): 284.]

H909 Portrait. Woodcut engraving credited "From a photograph by John Horsburgh." ILLUSTRATED LONDON NEWS 70, (1877) ["Late Lord Neaves." 70:1956 (Jan. 6, 1877): 4.]

HORSLEY, J.
H910 "Chromo-Photography." PHOTOGRAPHIC AND FINE ART JOURNAL 12, no. 2 (July 1859): 48. [From "Photo. Notes." J. Horsley's process of producing tinted prints.]

HORTON. (BOSTON, MA)
H911 "Rev. Theodore Parker." BALLOU'S PICTORIAL DRAWING-ROOM COMPANION [GLEASON'S] 15, no. 19 (Nov. 6, 1858): 289. 1 illus. ["...from a photograph by Horton, 113 Washington Street."]

HORTON, V. W. see also BRADY, MATHEW B.; GURNEY, JEREMIAH & SON.

HORTON, V. H.
[Horton was the photographer for Gurney & Son in 1860s and for Brady in 1870.]

H912 "Note." HUMPHREY'S JOURNAL OF PHOTOGRAPHY, AND THE ALLIED ARTS AND SCIENCES 18, no. 23 (Apr. 1, 1867): 356. ["We thank Mr. V. H. Horton, photographer to Messrs. Gurney & Son, for a number of excellent cabinet portraits."]

H913 Browne, John C. "The Solar Negative Prize Picture." PHILADELPHIA PHOTOGRAPHER 7, no. 77 (May 1870): 149-150. [Gold medal offered by Albert Moore, Philadelphia, PA, "for best negative for enlarging in the solar camera." Browne was judge. Thirty four negatives submitted. Prize went to Mr. V. W. Horton of Brady's Gallery, New York, NY.]

HOUGH, EUGENIO K.
[Artist, worked in pastels in VT ca. 1850. In Chataqua, NY in 1858. Settled in Petersburg, VA in 1858, worked as an artist and photographer. In Salem, NC in 1860.]

H914 Hough, E. K. "A New Method of Preserving Collodion Pictures." AMERICAN JOURNAL OF PHOTOGRAPHY AND THE ALLIED ARTS & SCIENCES n. s. vol. 1, no. 2 (June 15, 1858): 19-20. [Hough at Chatauqua, NY.]

H915 Hough, E. K. "Photo-Kaleidoscopes." AMERICAN JOURNAL OF PHOTOGRAPHY AND THE ALLIED ARTS & SCIENCES n. s. vol. 1, no. 8 (Sept. 15, 1858): 126-128. [Suggests these devices useful for entertaining customers waiting for their portraits.]

H916 Hough, E. K. "Art and Artists." AMERICAN JOURNAL OF PHOTOGRAPHY AND THE ALLIED ARTS AND SCIENCES n. s. vol. 1, no. 10 (Oct. 15, 1858): 157-159.

H917 Hough, E. K. "Expressing Character in Photographic Pictures." AMERICAN JOURNAL OF PHOTOGRAPHY AND THE ALLIED ARTS AND SCIENCES n. s. vol. 1, no. 11-12, 14 (Nov. 1 - Dec. 15, 1858): 171-173, 183-187, 211-213.

H918 Hough, E. K. "Expressing Character in Photographic Pictures." AMERICAN JOURNAL OF PHOTOGRAPHY AND THE ALLIED ARTS AND SCIENCES n. s. vol. 1, no. 14 (Dec. 15, 1858): 211-216.

H919 Hough, E. K. "Collodion Varnish." AMERICAN JOURNAL OF PHOTOGRAPHY AND THE ALLIED ARTS AND SCIENCES n. s. vol. 1, no. 24 (May 15, 1859): 383-384.

H920 Hough, E. K. "Redeveloped Ambrotypes." AMERICAN JOURNAL OF PHOTOGRAPHY AND THE ALLIED ARTS & SCIENCES n. s. vol. 2, no. 16 (Jan. 15, 1860): 250.

H921 Hough, E. K. "Photographic Artists." AMERICAN JOURNAL OF PHOTOGRAPHY 2, no. 20 (Mar. 15, 1860): 207-311.

H922 Hough, E. K. "Acid in Ammonia-Nitrate." AMERICAN JOURNAL OF PHOTOGRAPHY AND THE ALLIED ARTS & SCIENCES n s. vol. 3, no. 10 (Oct. 15, 1860): 158-159. [Hough at Salem, NC.]

H923 Hough, E. K. "Wooden Bath for Silver Solutions." AMERICAN JOURNAL OF PHOTOGRAPHY AND THE ALLIED ARTS & SCIENCES n. s. vol. 3, no. 23 (May 1, 1861): 356-357.

H924 Seely, Charles A. "To Hold the Mirror up to Nature." AMERICAN JOURNAL OF PHOTOGRAPHY AND THE ALLIED ARTS & SCIENCES n. s. vol. 4, no. 21 (Apr. 1, 1862): 496-497. [A Mr. Edward L. Porter suggested to photographers in "Scientific American," (Mar. 22) to attach a mirror to the camera so that the sitter could see what he or she looked like. E. K. Hough (North Carolina) had tried two years ago - with utter failure, as everyone postured.]

H925 Hough, E. K. "The New Tax Law." AMERICAN JOURNAL OF PHOTOGRAPHY AND THE ALLIED ARTS & SCIENCES n. s. vol. 7, no. 6 (Sept. 15, 1864): 141-142. [Additional note on p. 144.]

H926 Hough, E. K. "Photographic Rights." PHILADELPHIA PHOTOGRAPHER 12, no. 136-142 (Apr. - Oct. 1875): 115-116, 141-143, 204-206, 229-231, 266-268, 295-297, 338-339.

H927 Hough, E. K. "An Easy Method of Removing Varnish from Negatives and Ferrotypes." ANTHONY'S PHOTOGRAPHIC BULLETIN 7, no. 3 (Mar. 1876): 87.

H928 Hough, E. K. "Photographic Rights: Resume." PHILADELPHIA PHOTOGRAPHER 13, no. 149 (May 1876): 147-148.

H929 Hough, E. K. "A Little Gentle Criticism." PHILADELPHIA PHOTOGRAPHER 13, no. 154 (Oct. 1876): 317-319.

H930 Hough, E. K. "Lambertype." PHILADELPHIA PHOTOGRAPHER 14, no. 157-158 (Jan. - Feb. 1877): 18-23, 50-52. [Includes letters by E. K. Hough and others about this process.]

H931 Hough, E. K. "Photographic Duties." PHILADELPHIA PHOTOGRAPHER 14, no. 159-168 (Mar. - Dec. 1877): 89-90,

102-103, 140-142, 196-197, 241-242, 343-345, 357-358. [Letter from Hough also on pp. 184-185.]

H932 Hough, E. K. "Enthusiasm." PHILADELPHIA PHOTOGRAPHER 15, no. 180 (Dec. 1878): 354-355.

H933 Hough, E. K. "Friends in Council. Pts. 1 - 2." PHILADELPHIA PHOTOGRAPHER 16, no. 181, 184 (Jan., Apr. 1879): 27, 102-103.

H934 Hough, E. K. "About Pictorial Photography." PHOTOGRAPHIC TIMES 29, no. 4 (Apr. 1897): 166-169.

H935 Hough, E. K. "The Best Advertising for a Photographer." WILSON'S PHOTOGRAPHIC MAGAZINE 34, no. 484 (Apr. 1897): 156-157.

H936 Hough, E. K. "Value of Illustration in Teaching Art, and Originality vs. Imitation." PHOTOGRAPHIC TIMES 30, no. 6 (June 1898): 251-252.

H937 Hough, E. K. "Modern Warfare and Photographic Competition - A Comparison." PHOTOGRAPHIC TIMES 31, no. 5 (May l899): 220, 222.

H938 Hough, E. K. "Analogy in Expression Between Portraits and Landscapes." AMERICAN ANNUAL OF PHOTOGRAPHY AND PHOTOGRAPHIC TIMES ALMANAC FOR 1902 (1902): 209-210.

HOUGHTON & TANNER. (GREAT BRITAIN, INDIA)
BOOKS
H939 *Sind Photographs:* 73 Photographs of Notables of the Province of Sind, Tribes, Families and Classes of People, and, Trades, Professions and Callings. Of the photographs, 50 are by Capt. William Robert Houghton and the rest 23 are by Lieut. Henry Charles Baskerville Tanner. s. l., s. n., 1861-62. 73 b & 3. [Bound album, British Museum Library Collection.]

PERIODICALS
H940 Thomas, G. "The "Peccavi" Photographs." HISTORY OF PHOTOGRAPHY 4, no. 1 (Jan. 1980): 46-52. 12 b & w. [Captain William Robert Houghton (1826-1897) and Lieutenant Tanner, officers of the British Army in India, made photographic portraits of various ethnic groups in India, seventy-three of which are contained in an album "Sind Photographs," also known as the "Peccavi" Photographs, now in the collection of the Asiatic Society Library of Bombay.]

HOUGHTON, GEORGE H. (ca. 1824-1870) (USA)
H941 "Houghton at the Front: A Portfolio. The Little-Known Vermont Photographer G. H. Houghton went to the War in 1862 for an Unforgettable Series," on pp. 122-145 in: *The End of an Era.* Volume Six of The Image of War: 1861 - 1865, edited by William. C. Davis. Garden City, NY: Doubleday & Co., Inc., 1984. 496 pp. 37 b & w. illus. [Thirty-seven photographs by G. H. Houghton, from Brattleboro, VT, who made two trips to the Virginia front in 1862 and 1863, where he took views of Vermont troops in camp, training, etc.]

HOUGHTON, JAMES M. (LEWISBURG, ME)
H942 "To Correspondents: James M. Houghton, Lewisburg." HUMPHREY'S JOURNAL OF PHOTOGRAPHY, AND THE ALLIED ARTS AND SCIENCES 19, no. 5 (July 1, 1867): 80.

H943 "Letter." PHILADELPHIA PHOTOGRAPHER 6, no. 67 (July 1869): 241. [Letter in column "Wrinkles and Dodges" discussing difficulties overcome in making a photograph of a corpse.]

HOUGHTON, WILLIAM ROBERT, CAPT. (1826-1897) see HOUGHTON & TANNER.

HOUPPE, CELESTIN.
H944 Houppe, Celestin. "Leptographic Paper." HUMPHREY'S JOURNAL OF PHOTOGRAPHY, AND THE ALLIED ARTS AND SCIENCES 18, no. 16 (Dec. 15, 1866): 241-243. [From "Le Moniteur de la Photographie."]

HOUSEWORTH, THOMAS see also HART, ALFRED; LAWRENCE & HOUSEWORTH; WEED, C. L.

HOUSEWORTH, THOMAS. (1828-1915) (USA)
BOOKS
H945 *Catalogue of Photographic Views of the Scenery on the Pacific Coast,* and Views in China and Japan, for the Stereoscope, Portfolio, and Mammoth Size for Framing. San Francisco, CA: Thomas Houseworth & Co., 1869. 89 pp. Lists about 2000 views. illus. [5th ed. Xerox copies of this catalog were sold by the National Stereoscopic Association in the 1970s.]

H946 Houseworth, Thomas & Co. *Views of the Big Trees of Calaveras County, Cal.* San Francisco, CA: Thomas Houseworth & Co., ca. 1870.

H947 Houseworth, Thomas & Co. *Views of the Yo-Semite Valley for the Stereoscope.* San Francisco, CA: Thomas Houseworth & Co., ca. 1870.

H948 Houseworth, Thomas, Editor. *Pacific Coast Scenery: A Choice Collection of Photographic Views of the Yo-Semite Valley, Mammoth Trees, Trans-Continental Railroad, Great Geyser Springs, Hydraulic and Placer Mining, and San Francisco.* Published by Thomas Houseworth & Co. Landscape Artists, Yo-Semite Gallery, Etc. San Francisco: Thomas Houseworth & Co., 1872. 4 pp. 200 l. of plates. 200 b & w

H949 Houseworth, Thomas & Co. *Catalogue No. 1: Large Views of Yo Semite Valley and the Big Trees, from New Points of Interest.* San Francisco, CA: Thomas Houseworth & Co., ca. 1872.

H950 Houseworth, Thomas & Co. *Stereoscopic Views of the Great Geyser Springs.* San Francisco, CA: Thomas Houseworth & Co., ca. 1873.

H951 Houseworth, Thomas & Co. *Tourists' Guide and Correct Map of Routes to Yo-Semite Valley and Big Trees.* San Francisco, CA: Thomas Houseworth & Co., ca. 1873.

H952 Houseworth, Thomas & Co. *Yosemite, Big Trees, and Geysers by All Routes.* San Francisco, CA: Thomas Houseworth & Co., ca. 1873.

H953 Coyne & Relyea, firm, publishers, Chicago. *Sun Pictures of the Yo Semite Valley, California.* Chicago: Coyne & Relyea, pub., Knight & Leonard, 1874. n. p. 44 b & w. [Original photos, credited to Thomas Houseworth & Co., from negatives taken by C. L. Weed in 1860s then sold to Houseworth in 1870s.]

H954 *Houseworth's Photographs of California and Arizona Indians.* San Francisco: Houseworth, 1875 [?] n. p. 29 b & w. [Album, NYPL collection.]

H955 Crofutt, George A. *Crofutt's New Overland Tourist and Pacific Coast Guide, Containing a Condensed and Authentic Description of*

Over One Thousand Two Hundred Cities, Towns, Villages, Stations, Government Fort and Camps, Mountains, Lakes, Rivers, Sulphur, Soda and Hot Springs, Scenery, Watering Places, and Summer Resorts; ...While passing Over the Union, Central and Southern Pacific Railroads,... From Sunrise to Sunset, and Part the Way Back Again;... Vol. 1 - 1878-9. Chicago: The Overland Publishing Co., 1878. 322 pp. illus. ["...illustrated with nearly 100 beautiful engravings, most of which were photographed, designed, drawn, and expressly engraved for the author of this work... engraved by R. S. Bross, of New York, and C. W. Chandler, of Ravenswood, Illinois,... The photographs were by Savage, of Salt Lake City, and Watkins and Houseworth, of San Francisco. All these artists, we take pleasure in recommending."]

H956 *Houseworth's Souvenir Photographs of North American Indians.* San Francisco: Houseworth, 1880 [?]. n. p. 10 b & w. [Album, NYPL collection.]

PERIODICALS
H957 "Eleventh Industrial Fair of the Mechanic's Institute, at San Francisco, Cal. - From a Photograph by Thomas Houseworth & Co." FRANK LESLIE'S ILLUSTRATED NEWSPAPER 29, no. 739 (Nov. 27, 1869): 173. [Interior view, with figures.]

H958 "California. - The Cliff House on the Presideo Road, San Francisco, and the Seal Rocks off the Coast. - From a Photograph by Houseworth & Co., San Francisco."" FRANK LESLIE'S ILLUSTRATED NEWSPAPER 30, no. 768 (June 18, 1870): 217. 1 illus. [View.]

H959 Advertisement for "Stereoscopic Views of Yosemite Valley, the Mammoth Trees of the Calaveras, Mariposa." CALIFORNIA MAIL BAG 1, no. 2 (July 1871): unpaged leaf following p. 116. [A fold-out sheet containing a map of the valley and the advertisement "Tourist's Guide to the Shortest Route to Yo-Semite Valley, by Thomas Houseworth & Co., Authorized Ticket Agents." is also in the issue.]

H960 "Note." ANTHONY'S PHOTOGRAPHIC BULLETIN 4, no. 8 (Aug. 1873): 229. ["Messrs. Thomas Houseworth & Co. inform us that they have purchased the gallery of Mr. I. W. Taber, No. 12, Montgomery St., San Francisco."]

H961 "The Great Snow-Storm on the Central Pacific Railway - Miners' Train Passing Through a Cut in a Snow Drift," and "A Relief Train Going to the Drifts. - From a Photo. by Thomas Houseworth & Co., San Francisco." FRANK LESLIE'S ILLUSTRATED NEWSPAPER 38, no. 967 (Apr. 11, 1874): 76. 2 illus. [Both images "improved" by the engraver.]

H962 "The Great Snow-Storm in the Sierra Nevada Mountains - The Snow Plow on the Central Pacific Railway. - Photographed by Thomas Houseworth, San Francisco." FRANK LESLIE'S ILLUSTRATED NEWSPAPER 38, no. 969 (Apr. 25, 1874): 108. 1 illus. [View of the plow, and the engine.]

H963 "'Nick of the Woods.' - A Tree Curiosity in the Valley of Lake Tahoe, California. - From a Photograph by Thomas Houseworth & Co., San Francisco." FRANK LESLIE'S ILLUSTRATED NEWSPAPER 38, no. 971 (May 9, 1874): 140. 1 illus. [Photograph of an irregularity in the trunk of a tree, which resembles a grotesque human face.]

H964 "San Francisco Buildings." FRANK LESLIE'S ILLUSTRATED NEWSPAPER 39, no. 998 (Nov. 14, 1874): 149. 5 illus. [Five views of buildings.]

H965 "The Silver Mines, Virginia City, Nevada. - Weighing a Load of Ore. - Photographed by Houseworth & Co." FRANK LESLIE'S ILLUSTRATED NEWSPAPER 39, no. 999 (Nov. 21, 1874): 172. 1 illus. [View, with a team of horses pulling a wagon full of ore.]

H966 "Eastern Portal of Tunnel No. 2, Head of Echo Canyon, on the Union Pacific Railroad. - Photograph by Houseworth, San Francisco." FRANK LESLIE'S ILLUSTRATED NEWSPAPER 39, no. 1005 (Jan. 2, 1875): 285. 1 illus.

H967 "San Francisco, California. - Interior of the Chinese Methodist Chapel, 620 Jackson Street - Chinese Worshipers Listening to an Address by the Rev. O. Gibson. - Photographed by Houseworth & Co., San Francisco." FRANK LESLIE'S ILLUSTRATED NEWSPAPER 41, no. 1052 (Nov. 27, 1875): 192. 1 illus. [Interior, with crowd.]

H968 "Mines and Mining at Virginia City, Nevada. - From Photographs by Houseworth & Co., San Francisco, Cal." FRANK LESLIE'S ILLUSTRATED NEWSPAPER 41, no. 1052 (Nov. 27, 1875): 193-194. 4 illus. [Views, workers.]

H969 "The Other Side of the Photographic Rupture." ANTHONY'S PHOTOGRAPHIC BULLETIN 6, no. 12 (Dec. 1875): 367-368. [From "Daily Evening Bulletin." T. Houseworth, Pres. of the Photo. Soc. of the Pacific, responds to Rulofson's charge that he used the name of the Society incorrectly to his own advantage.]

H970 "San Francisco, Cal. - The Seal Pond at Woodward's Gardens. - From a Photograph by Houseworth & Co." FRANK LESLIE'S ILLUSTRATED NEWSPAPER 41, no. 1053 (Dec. 4, 1875): 201. 1 illus. [View, with seals.]

H971 "San Francisco, Cal. - A Chinese Rag-Picker." and "A Chinese Rag-Picker's House on Dupont Street. - Photo by Houseworth & Co." FRANK LESLIE'S ILLUSTRATED NEWSPAPER 41, no. 1055 (Dec. 18, 1875): 244. 2 illus. [Outdoor portrait. Interior.]

H972 "California. - Chinese Mission-School at the Methodist Chapel, Jackson Street, San Francisco. - Photographed by Houseworth & Co." FRANK LESLIE'S ILLUSTRATED NEWSPAPER 42, no. 1072 (Apr. 15, 1876): 97. 1 illus. [Interior, with people reading.]

H973 "California. - Election Day in the Mining Regions - Scene on Main Street, Dutch Flat, Placer County, on the Morning of November 7th. - From a Photograph by Houseworth & Co." FRANK LESLIE'S ILLUSTRATED NEWSPAPER 43, no. 1106 (Dec. 9, 1876): 226. 1 illus. [Street scene, with a crowd.]

H974 "California. - Attractions of the Metropolis of the Pacific Slope - The Famous Seal Rocks as Seen from the Cliff House, Five Miles from San Francisco. - From a Photograph by Houseworth & Co." FRANK LESLIE'S ILLUSTRATED NEWSPAPER 48, no. 1241 (July 12, 1879): 321, 322-323. 1 illus. [Large, double-page view.]

H975 "California. - Arrival of General Grant and Family at San Francisco. - Grand Arch Erected on New Montgomery Street. - From a Photograph by Houseworth & Co." FRANK LESLIE'S ILLUSTRATED NEWSPAPER 49, no. 1255 (Oct. 18, 1879): 108. 1 illus. [View.]

H976 Palmquist, Peter E. "Gold, photos and optical goods." THE DISPENSING OPTICIAN (June 1982): 25-28. 4 b & w. 2 illus. [Contains the text of a speech given by Houseworth in 1908, describing his activities as an optician in California in the early 1850s.]

HOVELL, JOHN RAYNER.
H977 Hovell, J. R. "On taking Clouds with Landscapes." HUMPHREY'S JOURNAL OF PHOTOGRAPHY, AND THE ALLIED

ARTS AND SCIENCES 9, no. 22 (Mar. 15, 1858): 350-351. [From "Photo. Notes."]

H978 Hovell, John Rayner. "On Taking Clouds with Landscapes." PHOTOGRAPHIC AND FINE ART JOURNAL 11, no. 5 (May 1858): 138-139. [From "Photo. Notes."]

HOVEY, DOUGLAS. (1828-1886) (USA)
H979 "Obituary." PHOTOGRAPHIC TIMES 16, no. 231 (Feb. 19, 1886): 112-113. [Born Hampton, Connecticut on February 22, 1828. Moved to Grandville, Ohio at age eight, lived with G. Parsons until age 21, then, with S. Root, opened a business in Philadelphia. From there to New York, then to Rochester and opened a gallery, Hovey & Hartmann. Began to manufacture albumenized paper and in the 1860's began doing that exclusively. President of the American Albumen Paper Co. Died February 8, 1886. Son, C. F. Hovey, a photographer in Rochester, New York.]

H980 "Obituary: Douglas Hovey." ANTHONY'S PHOTOGRAPHIC BULLETIN 17, no. 4 (Feb. 27, 1886): 123-124. [Hovey born at Hampton, Ct. on Feb. 22, 1828. Moved to Granville, lived with G. Parsons until age 21; went to Philadelphia with S. Root and "engaged in the photographic business." Worked in New York several years. In 1854 to Rochester, N.Y., opened a gallery with J. Kelsey. Afterward, the firm known as Hovey & Hartmann. Began to manufacture albumen paper and left the portrait business around 1865. Died Rochester Feb. 8, 1886.]

HOW, JAMES. (d. 1873) (GREAT BRITAIN)
[James How began as an "Assistant in the Philosophical Establishment of G. Knight & Sons," a firm of "philosophical instrument makers" dating back to 1680. He later succeeded to that business, and ran it until his death in 1873.]

BOOKS
H981 How, J. *On the Production of Positive Prints from Waxed Paper, Collodion and Other Negatives, read before the Chemical Discussion Society on 11 January 1855.* London: George Knight & Sons, 1855. 23 pp. 7 illus.

PERIODICALS
H982 How, James. "On the Production of Waxed Paper Negatives." HUMPHREY'S JOURNAL 6, no. 6 (July 1, 1854): 90-95. [From "The Chemist."]

HOWARD, SHEPHERD & BOURNE. [BOURNE & SHEPHERD]
H983 "Camel-Carriage Used by the Lieutenant-Governor of the Punjaub." ILLUSTRATED LONDON NEWS 44, no. 1260 (May 21, 1864): 497. 1 illus. ["...from a photograph taken by Messrs. Howard, Shepherd & Bourne, of Calcutta, and was taken at Government House, Lahore.]

H984 "The Oudh Industrial Exhibition at Lucknow." ILLUSTRATED LONDON NEWS 46, no. 1304 (Mar. 4, 1865): 213. 1 illus. ["Our Engraving is from one of a set of photographic views of the exhibition, by Messrs. Howard, Shepherd, and Bourne."]

HOWARD, FRANK. (d. 1866) (GREAT BRITAIN)
H985 Howard, Frank. "Photography as Connected with the Fine Arts." HUMPHREY'S JOURNAL 5, no. 21 (Feb. 15, 1854): 325-328, 332-333. [From "J. of the Photo. Soc., London."]

H986 Howard, Frank. "Photography as Connected with the Fine Arts." PHOTOGRAPHIC AND FINE ART JOURNAL 7, no. 4 (Apr.

1854): 105-107. [Read before the Liverpool Photographic Society, June 7, 1853. From "J. of Photo. Soc."]

H987 "Harmony of Shades in the Photograph, as Relating to the Background." HUMPHREY'S JOURNAL 7, no. 7 (Aug. 1, 1855): 115-117. [From "Liverpool Photo. J."]

H988 Howard, Frank. "Photography in Connection with Art." LIVERPOOL & MANCHESTER PHOTOGRAPHIC JOURNAL [BRITISH JOURNAL OF PHOTOGRAPHY] n. s. 2, no. 23 (Dec. 1, 1858): 294. [Excerpt from paper read at Liverpool Photo. Soc.]

H989 Howard, F. "A Few Remarks on Amateur Photography." BRITISH JOURNAL OF PHOTOGRAPHY. 7, no. 117, 119 (May 1, June 1, 1860): 131-132, 163-164.

H990 Howard, Frank. "The Practical Details of the Fothergill Process." HUMPHREY'S JOURNAL OF PHOTOGRAPHY, AND THE ALLIED ARTS AND SCIENCES 13, no. 1 (May 1, 1861): 7-11. [From "Br. J. of Photo."]

H991 Howard, Frank. "Some of the Defects in Landscape Photography." BRITISH JOURNAL OF PHOTOGRAPHY 12, no. 254 (Mar. 17, 1865): 135. [Read before South London Photo. Soc.]

H992 Howard, Frank. "Some of the Defects in Landscape Photography." HUMPHREY'S JOURNAL OF PHOTOGRAPHY, AND THE ALLIED ARTS AND SCIENCES 16, no. 24 (Apr. 15, 1865: 379-381. [Read to South London Photo. Soc.]

H993 Howard, F. "Alkaline Development for Dry Plates." HUMPHREY'S JOURNAL OF PHOTOGRAPHY, AND THE ALLIED ARTS AND SCIENCES 20, no. 23 (July 15, 1869): 367. [Read to South London Photo. Soc.]

H994 Howard, F. "A Talk about Old Negatives." BRITISH JOURNAL PHOTOGRAPHIC ALMANAC 1873 (1873): 132-134.

H995 Howard, F. "A Portable Tent for Working the Wet Collodion Process in the Field." ANTHONY'S PHOTOGRAPHIC BULLETIN 4, no. 8 (Aug. 1873): 237-238. 1 illus. [From "Br J of Photo."]

H996 Taylor, J. Traill. "Howard's Tent." BRITISH JOURNAL PHOTOGRAPHIC ALMANAC 1874 (1874): 55-58. 1 illus.

H997 Howard, F. "Stereoscopic Transparencies." PHOTOGRAPHIC TIMES 5, no. 53 (May 1875): 102-103. [Communication to the South London Photographic Society.]

H998 Howard, Frank. "Among By-Paths and Field-Lanes With the Camera." PHOTOGRAPHIC TIMES 21, no. 505 (May 22, 1891): 248-249. ["Paper read before the London Camera Club".]

HOWARD, G. M.
H999 Portraits. Woodcut engravings, credited "Photographed by G. M. Howard's Theatrical Portrait Gallery, 122 1/2 Fulton St., N. Y." FRANK LESLIE'S ILLUSTRATED NEWSPAPER 10, (1860) [The late T. D. Rice, actor." 10:254 (Oct. 6, 1860): 318.]

HOWARD, JASON.
H1000 Howard, Jason. "What a Country Photographer Saw at St. Louis." PHILADELPHIA PHOTOGRAPHER 9, no. 104 (Aug. 1872): 273-274. [Letter from Howard (Plattsburg, NY), praising the annual NPA convention.]

HOWARD, UNA. (d. 1870) (GREAT BRITAIN)

H1001 Howard, Una. "On Coloring Photographs." HUMPHREY'S JOURNAL OF PHOTOGRAPHY, AND THE ALLIED ARTS AND SCIENCES 18, no. 24 (Apr. 15, 1867): 374. [From "Br. J. of Photo. Almanac.]

HOWARD, W. D.

H1002 *Photographs among the Dolomite Mountains. Photographed by W. D. Howard and F. H. Lloyd.* s. l.: s. n., 1865. n. p. 24 b & w. [Original photographs. Printed title page.]

HOWARTH, JOHN.

H1003 Howarth, John. "Getting Over One of Our Usual Difficulties." BRITISH JOURNAL PHOTOGRAPHIC ALMANAC 1876 (1876): 106-107. [Cast iron pipe kept in water tank helps purify water.]

HOWE, CALEB L.

H1004 "Monument to the Late Colonel James Fisk, Jr., Erected at Brattleboro, Vt., and Dedicated May 30th. - Photographed by C. L. Howe." FRANK LESLIE'S ILLUSTRATED NEWSPAPER 38, no. 976 (June 13, 1874): 220. 1 illus. [View with figures, which may have been added by the engraver.]

HOWE, N. S. (BRATTLEBORO, VT)

H1005 "Editor's Table." PHILADELPHIA PHOTOGRAPHER 6, no. 64 (Apr. 1869): 136. [Cartes noted.]

HOWELL, E. M. see also BOGARDUS, ABRAHAM (1863) and FREDERICKS, CHARLES.

HOWELL, WILLIAM R. (d. 1890) (USA)

H1006 "The Tomb of Aaron Burr, Princeton, New Jersey." HARPER'S WEEKLY 13, no. 639 (Mar. 27, 1869): 196, 198. 1 illus. ["Photographed by Wm. R. Howell, 867 Broadway."]

H1007 "The Halsted Observatory at Princeton, New Jersey." HARPER'S WEEKLY 13, no. 646 (May 15, 1869): 817. 1 illus. ["Photographed by Wm. R. Howell, 867 Broadway." View.]

H1008 "Our Picture." PHILADELPHIA PHOTOGRAPHER 9, no. 108 (Dec. 1872): 437. 1 b & w. [Portrait.]

H1009 "Mr. Howell's Display for Vienna." ANTHONY'S PHOTOGRAPHIC BULLETIN 4, no. 5 (May 1873): 142.

H1010 "Howell's Album of Studies." ANTHONY'S PHOTOGRAPHIC BULLETIN 4, no. 8 (Aug. 1873): 248. [Twenty-four different cabinet photographs of a woman - sitting, standing, etc. - handsomely mounted on 8" x 10" cards and bound together in cloth with gilded edges. On sale for $10.00]

H1011 J. J. V. "Howell's Studies." ANTHONY'S PHOTOGRAPHIC BULLETIN 5, no. 5 (May 1874): 166-168. ["This is by far the finest collection of photographic portraits that has ever appeared in book form."]

H1012 Portrait. Woodcut engraving, credited "From a Photograph by Howell, New York." FRANK LESLIE'S ILLUSTRATED NEWSPAPER 40, (1875) ["The American Rifle Team. (6 portraits)." 40:1033 (July 17, 1875): 332.]

H1013 "The Illustration." ANTHONY'S PHOTOGRAPHIC BULLETIN 10, no. 7 (July 1879): frontispiece, 221. 1 b & w. [Original photo. "Miss Clayton," by W. R. Howell.]

H1014 "Notes and News: Obituary." PHOTOGRAPHIC TIMES 20, no. 484 (Dec. 26, 1890): 653. ["Died Dec. 13th, at the residence of his last employer, Mr. L. C. Perkinson... About 20 years ago Mr. Howell occupied one of the foremost positions in the fraternity, and his studio at the corner of Broadway and 18th St. was the resort of New York's beau monde."]

HOWITT, WILLIAM & MARY HOWITT.

H1015 Schmaltz, Gwen. "Ruined Abbeys - and the Howitts. William Howitt 1792 - 1879; Mary Howitt 1799 - 1888." NORTHLIGHT no. 7 (Nov. 1977): 46-53. 1 b & w.

HOWLAND, CHARLES W. (CINCINNATI, OH)

H1016 "Another Luxurious Gallery." ANTHONY'S PHOTOGRAPHIC BULLETIN 1, no. 11 (Dec. 1870): 228. [Opening of Ch. W. Howland's gallery in Cincinnati, OH.]

HOWLETT, ROBERT. (1831-1858) (GREAT BRITAIN)

[Born in 1831. He became a commercial photographer and was associated with Joseph Cundall and P. H. Delamotte and the Photographic Institution in London about 1855. Published his manual *On the Various Methods...* in 1856 and made and marketed a portable photographic tent. Although a professional photographer, he was active participant in numerous amateur activities - contributing to photographic exchanges, etc. In 1856 the painter William Powell Frith commissioned him to attend the Derby to make photographs of the crowds attending the horse racing festivities, which Frith would later use as studies for his large painting "Derby Day," finished in 1858. In the latter 1850s Howlett also made an extended group of photographs documenting the construction and launching of the steamship "The Great Eastern." Howlett died in December 1858, at age twenty-seven. Some felt that his death was hastened by his exposure to photographic chemicals.]

BOOKS

H1017 Howlett, Robert. *On the Various Methods of Printing Photographic Pictures Upon Paper; With Suggestions for their Preservation tested by Practice.* London: Sampson Low & Son, 1856. xii, 36 pp. [2nd ed. (1857).]

PERIODICALS

H1018 Howlett, Robert. "On taking Instantaneous Pictures." HUMPHREY'S JOURNAL OF PHOTOGRAPHY, AND THE ALLIED ARTS AND SCIENCES 9, no. 19 (Feb. 1, 1858): 298-299. [From "Photo. Notes."]

H1019 "Note." ART JOURNAL (Aug. 1858): 255. [Series of stereo views of the steamship "Leviathan" published by Howlett & Downes (New Bond Street).]

H1020 "Obituary." PHOTOGRAPHIC AND FINE ART JOURNAL 11, no. 12 (Dec. 1858): 380. [From "Photo. Notes." High praise, little information.]

H1021 "Note." PHOTOGRAPHIC NEWS 1, no. 14 (Dec. 10, 1858): 165. [Notice of Howlett's death in notice of the 7th Dec. ordinary general meeting of Photographic Society.]

H1022 Hardwich, Mr. "Remarks on the Death of Mr. Howlett." JOURNAL OF THE PHOTOGRAPHIC SOCIETY OF LONDON 5, no. 75 (Dec. 21, 1858): 111-112.

H1023 "Editorial." LIVERPOOL & MANCHESTER PHOTOGRAPHIC JOURNAL [BRITISH JOURNAL OF PHOTOGRAPHY] n. s. 2, no. 24 (Dec. 15, 1858): 309. [Brief note of Robert Howlett's death.]

H1024 Hardwich, T. F. "Remarks on the Death of Mr. Howlett." HUMPHREY'S JOURNAL OF PHOTOGRAPHY, AND THE ALLIED ARTS AND SCIENCES 10, no. 21 (Mar. 1, 1859): 334-336. [From "J. of Photo. Soc., London."]

HOWSON. (BROOKLYN, NY)
H1025 Portrait. Woodcut engraving, credited "From a Photograph by Howson, Brooklyn. FRANK LESLIE'S ILLUSTRATED NEWSPAPER 41, (1875) ["The late Rev. Dr. George B. Porteous." 41: 1046 (Oct. 16, 1875): 92.]

HOWSON, W. (BLACKBURN, ENGLAND)
H1026 "Burning of a Cotton-Mill." ILLUSTRATED LONDON NEWS 36, no. 1014 (Jan. 28, 1860): 77. 2 illus. ["...from Photographs by W. Howson, New Market St., Blackburn."]

HOYT, G. P. B. (WASHINGTON, DC)
H1027 Portrait. Woodcut engraving, credited "From a Photograph by Hoyt, Washington, DC." FRANK LESLIE'S ILLUSTRATED NEWSPAPER 40, (1875) ["Hon. Godlove S. Orth." 40:1022 (May 1, 1875): 121.]

H1028 "Note." ANTHONY'S PHOTOGRAPHIC BULLETIN 6, no. 12 (Dec. 1875): 378. [Hoyt disposed of his Washington, DC studio, making photos with pocket camera.]

H1029 Portrait. Woodcut engraving, credited "From a Photograph by Hoyt." FRANK LESLIE'S ILLUSTRATED NEWSPAPER 48, (1879) ["Hon. Charles Foster, of OH." 48:1237 (June 14, 1879): 249.]

HUBBARD & MIX.
H1030 "St. Helena Episcopal Church, at Beaufort, S. C. - From a Photograph by Hubbard & Mix." FRANK LESLIE'S ILLUSTRATED NEWSPAPER 23, no. 576 (Oct. 13, 1866): 53. 1 illus. [View.]

HUDSON, FREDERICK. (d. 1889) (VENTNOR, ENGLAND)
H1031 Portrait. Woodcut engraving, credited to "From a Photograph by Frederick Hudson." ILLUSTRATED LONDON NEWS 60, (1872) ["Rev. Dr. Moffat." 60:1705 (May 11, 1872): 452.]

H1032 Hudson, Frederick. "Aim High." BRITISH JOURNAL PHOTOGRAPHIC ALMANAC 1876 (1876): 157-158.

HUDSON, JOHN.
H1033 Hudson, John. *Photography of Irish Scenery: Killarney.* By John Hudson, with Descriptive Letterpress. Dublin: Andrew Duthie, 1866. 15 pp. 12 l. of plates. 12 b & w. [Original photographs.]

H1034 *Photographic Gems of Irish Scenery:* With Descriptive Letterpress. Photographs by J. Hudson and F. H. Mares. Glasgow: Andrew Duthie, c. 1867. 56 pp. 12 l. of plates. 12 b & w. [Original photos. Eight by J. Hudson and four by F. H. Mares.]

HUENERJAEGER. (BRUNSWICK, GERMANY)
H1035 "Personal." PHOTOGRAPHIC TIMES 14, no. 160 (Apr. 1884): 193. [From "Deutsche Photographen Zeitung. "Mr. Huenerjaeger, more than 80 years old, a pupil of Daguerre, now in indigent circumstances... Restlessly following his profession in various parts of the world, and having experienced many changes of fortune, he a few years ago returned to his fatherland." Shipwrecked on voyage home, lost all. Then worked in one of the ateliers of his native town, Brunswick. Now too old. Call for donations from the photographic community.]

H1036 "Contributions to the Fund for the Relief of Herr Huenerjaeger." PHOTOGRAPHIC TIMES 14, no. 161 (May 1884): 237. [List of contributors from Chicago and New York who contributed to relief fund.]

H1037 "Herr Huenerjaeger Relief Fund." PHOTOGRAPHIC TIMES 14, no. 163 (July 1884): 358. [Note that Huenerjaeger has died, suggestion that the moneys of the relief fund be turned over to other poor.]

HUFF, F. L.
H1038 Portrait. Woodcut engraving, credited "From a Photograph by F. L. Huff." FRANK LESLIE'S ILLUSTRATED NEWSPAPER 28, (1869) ["The Cincinnati (Red Stockings) Base-ball Club (Nine Portraits)." 28:720 (July 17, 1869): 284.]

HUFFMAN, LAYTON ALTON. (1854-1931) (USA)
[L. A. Huffman was born in Iowa in 1854. He opened a photographic studio on the military post at Fort Keogh, Montana Territory, in December 1878. He began taking portraits of the soldiers and the Indians at or near the fort, and took his camera outside the studio to make views of the towns, buffalo herds and buffalo hunters, cowboys, and others living and working nearby. He photographed the Custer battlefield site and made other views about the Western frontier. He moved his studio to nearby Miles City a few years later, where he settled in as a respectable businessman. He was elected to the school board there in the early 1880s, then later to the office of county commissioner. He ranched briefly, and purchased land. He switched from stereos to a dry-plate camera in the 1880s. The sportsman/author Granville Stuart used Huffman's photographs to illustrate an article in *The American Field* magazine in 1880, and Huffman's work was published in the magazine thereafter. The economic depression of 1890 destroyed his business successes, and he closed the Miles City studio. Then he travelled to California, then to Chicago, where he worked for a time in another photographer's studio. In 1896 he returned to Montana and opened his own studio in Billings. After a brief period he moved back to Miles City, where he maintained a studio until 1905. Then he closed the studio, but continued to make and sell prints from his earliest negatives for years. He died on Dec. 28, 1931.]

BOOKS
H1039 Brown, Mark Herbert and W. R. Felton. *The Frontier Years: L. A. Huffman, Photographer of the Plains.* New York: Holt, 1955. 272 pp. 124 b & w. [Bibliography pp. 259-261.]

H1040 Brown, Mark Herbert and W. R. Felton. *Before Barbed Wire,... L. A. Huffman, Photographer on Horseback.* New York: Holt, 1956. 256 pp. 125 b & w. [Bibliography pp. 237-243.]

PERIODICALS
H1041 Huffman, L. A., Illus from photos by the author. "The Last Busting at the Bow-Gun." SCRIBNER'S MAGAZINE 42, no. 1 (July 1907): 75-87. 16 b & w. [Taming horses.]

H1042 Hornaday, William T., Photographic illus by L. A. Huffman. "Diversions in Picturesque Game Lands. Grand Bad-Lands and Mule Deer." SCRIBNER'S MAGAZINE 44, no. 1 (July 1908): 1-17. 10 b & w. Hornaday, William T., Photographically illus. by L. A. Huffman.

H1043 "Diversions in Picturesque Game-Lands. Golden days in the Shoshone Mountains." SCRIBNER'S MAGAZINE 44, no. 5 (Nov. 1908): 575-588. 8 b & w.

H1044 Brown, Mark H. and W. R. Felton. "L.A. Huffman, Brady of the West." MONTANA: MAGAZINE OF WESTERN HISTORY 6, no. 1 (Winter 1956): 29-37. 13 b & w. 1 illus. [Layton A. Huffman came to Montana Territory in 1878 as post photographer at Fort Keough. He photographed there and in nearby Miles City for nearly 50 years.]

H1045 "Latent Images: Red Armed Panther." AMERICAN PHOTOGRAPHER 1, no. 2 (July 1978): 27. 1 b & w. [Excerpt from "Faces" by Ben Maddow.]

HUGHES & MULLENS. (RYDE, ISLE OF WIGHT)
H1046 "Life Portraits of Queen Victoria." MCCLURE'S MAGAZINE 9, no. 2 (June 1897): 685-700. 13 b & w. 12 illus. [Paintings, etc. Photographs by Lombardi & Co. (London, 1860); Day (London, 1861); Hughes & Mullens (Ryde, Isle of Wight, nine photographs taken from the 1860s to the 1880s.); Gunn & Stuart (London, 1897); Russell & Sons (London, 1897).]

HUGHES, ALBERT WILLIAM. [?]
H1047 Hughes, Albert William. *The Country of Balochistan: Its Geography, Topography, Ethnology, and History;* With a Map, Photographic Illustrations, and Appendices Containing a short vocabulary of the Principal Dialects in Use among the Balochis, and a List of Authenticated Road Routes. London: G. Bell, 1877. vi, 294 pp. 7 l. of plates. 7 b & w. illus. [Original photos. Views, natives, etc. Photos may have been taken by the author or associate.]

HUGHES, ALFRED.
H1048 Hughes, Alfred. "Minor Improvements Connected with Printing." HUMPHREY'S JOURNAL OF PHOTOGRAPHY, AND THE ALLIED ARTS AND SCIENCES 17, no. 3-4 (June 1 - June 15, 1865): 44-45, 55-58. [Read to Glasgow Photo. Assoc. From "Photo. News."]

H1049 Hughes, Alfred. "Negative Retouching." BRITISH JOURNAL PHOTOGRAPHIC ALMANAC 1876 (1876): 60-62.

H1050 Hughes, Alfred. "An Experience." BRITISH JOURNAL PHOTOGRAPHIC ALMANAC 1878 (1878): 72.

HUGHES, C. C. (NASHVILLE, TN)
H1051 "The Chatham Artillery Company, Captain Claghorn, at the Hermitage, Jackson, Tennessee. - From a Photograph by C. C. Hughes, of Nashville, Tenn." FRANK LESLIE'S ILLUSTRATED NEWSPAPER 8, no. 189 (July 16, 1859): 104, 106. 1 illus. [Outdoor group portrait.]

H1052 Portrait. Woodcut engraving, credited "From a Photograph by Hughes." HARPER'S WEEKLY 4, (1860) ["Hon. John Bell, of TN, "Union" Candidate for President." 4:177 (May 19, 1860): 305.]

H1053 "Champ Ferguson and His Guard." HARPER'S WEEKLY 9, no. 456 (Sept. 23, 1865): 593. 1 illus. ["Photographed by C. C. Hughes, Nashville, Tenn." Ferguson, a guerrilla under Morgan, surrendered after the Civil War, arrested for atrocities.]

HUGHES, CORNELIUS JABEZ. (1819-1884) (GREAT BRITAIN)
[Born in England in 1819. Became one of the best known professional photographers in England. In 1847 he was an assistant to Mayall in London. Moved to Glasgow, worked for Bernard, then opened his own studio. Active in the Glasgow Photographic Society through the early 1850s. John Werge bought his studio in 1855, and he, in turn, moved back to London and bought Mayall's studio. In 1862 Hughes took over Lacy's studio in Ryde, Isle of Wight. His "splendid studio at Ryde" was often visited by Queen Victoria and other members of the Royal Family. He died in 1884.]

BOOKS
H1054 Hughes, C. Jabez and John Werge. *How to Learn Photography: A Manual for Beginners. Containing the Positive Collodion Process; the Negative Collodion Process; Printing on Albumenized Paper, and Toning by the Alkaline Gold Process; Copying Pictures so as to Enlarge or Reduce Them; Life-Sized Portraits; and How to Produce Them by Solar Camera. Dry-Plate Photography; Including the Collodio-Albumen, Fothergill, and Tannin Processes. How to Colour and Mount Photographs. "Waterhouse" and Other Diaphragms in Lenses, and How to Use Them, &c.* London; New York: C. Jabez Hughes; John Werge, 1861. n. p.

H1055 Hughes, C. Jabez. *The Principles and Practice of Photography familiarly explained. In a Course of Easy Lessons.* "2nd ed." London: Published by the author, 1861. iv, 83 pp. [5th ed. (1863) viii, 151 pp.; 6th ed. (1864) London: Simpkin, Marshall, with subtitle: Being a Manual for Beginners.; 13th ed. (1883), by J. Werge. 104 pp.]

PERIODICALS
H1056 Hughes, C. J. "The Stereoscope." PHOTOGRAPHIC AND FINE ART JOURNAL 8, no. 4 (Apr. 1855): 119-121. [Paper read by C. J. Hughes to the Glasgow Photographic Society, forwarded to the "P & FAJ" by John Werge.]

H1057 Hughes, C. J. "On Glass Positives." HUMPHREY'S JOURNAL OF PHOTOGRAPHY, AND THE ALLIED ARTS AND SCIENCES 10, no. 12 (Oct. 15, 1858): 181-183.

H1058 Hughes, C. Jabez. "Observations on Albumenized Paper and Alkaline Gold Toning." HUMPHREY'S JOURNAL OF PHOTOGRAPHY, AND THE ALLIED ARTS AND SCIENCES 12, no. 13-22 (Nov. 1, 1860 - Mar. 15, 1861): 201-204, 214-217, 229-232, 342-348. [From "Br. J. of Photo."]

H1059 Hughes, C. Jabez. "Observations on Albumenized Paper and Alkaline Gold Toning." AMERICAN JOURNAL OF PHOTOGRAPHY AND THE ALLIED ARTS & SCIENCES n. s. vol. 3, no. 11 (Nov. 1, 1860): 171-175. [From "Br. J. of Photo."]

H1060 Hughes, C. Jabez. "On Art Photography; and How Far Composition Printing is Capable of Aiding Cultivation." BRITISH JOURNAL OF PHOTOGRAPHY 8, no. 133 (Jan. 1, 1861): 5-8. [Discusses Fry, Fenton, Robinson.]

H1061 Hughes, C. Jabez. "On Albumenised Paper and Alkaline Gold Toning." BRITISH JOURNAL OF PHOTOGRAPHY 8, no. 136 (Feb. 15, 1861): 59-61.

H1062 Hughes, C. Jabez. "On Art-Photography. And how far Composition Printing is Capable of Aiding Collodion." AMERICAN JOURNAL OF PHOTOGRAPHY AND THE ALLIED ARTS & SCIENCES n. s. vol. 3, no. 17-18 (Feb. 1, - Feb. 15, 1861): 260-263, 273-277. [From "Br. J. of Photo."]

H1063 Hughes, C. Jabez. "How to ascertain the amount of Nitrate of Silver in a Solution: with Remarks on Silver Bath Meters." HUMPHREY'S JOURNAL OF PHOTOGRAPHY, AND THE ALLIED ARTS AND SCIENCES 12, no. 23 (Apr. 1, 1861): 357-362. [From "Br. J. of Photo."]

H1064 Hughes, C. Jabez. "Carte de Visite Portraits." HUMPHREY'S JOURNAL OF PHOTOGRAPHY, AND THE ALLIED ARTS AND SCIENCES 13, no. 12 (Oct. 15, 1861): 187-189. [From "C. J. Hughe's, "The Principles and Practice of Photography."]

H1065 "Fine Arts." ATHENAEUM no. 1780 (Dec. 7, 1861): 771. [Bk. Rev.: "The Principles and Practice of Photography," by C. Jabez Hughes. (Lemaire).]

H1066 "Useful Facts, Receipts, Etc.: Royal Patronage." AMERICAN JOURNAL OF PHOTOGRAPHY AND THE ALLIED ARTS & SCIENCES n. s. vol. 5, no. 1 (July 1, 1862): 12-13. [From "Photo. News." Hughes moved to Ryde, purchased Mr. Lacy's business. Hughes taking portraits of Royal Family, making photographs of Royal art collection and views of Whippingham Church, restored by Queen Victoria.]

H1067 Hughes, C. Jabez. "The Toning Bath." AMERICAN JOURNAL OF PHOTOGRAPHY AND THE ALLIED ARTS & SCIENCES n. s. vol. 6, no. 4 (Aug. 15, 1863): 75-79.

H1068 Hughes, C. Jabez. "The Difficulties of Lime Toning." AMERICAN JOURNAL OF PHOTOGRAPHY AND THE ALLIED ARTS & SCIENCES n. s. vol. 6, no. 5 (Sept. 1, 1863): 102-104. [From "Photo. News."]

H1069 Hughes, Jabez. "A Tribute to Amateurs." BRITISH JOURNAL OF PHOTOGRAPHY 10, no. 203 (Dec. 1, 1863): 466-467.

H1070 "Our Editorial Table: Tannin Pictures, by Jabez Hughes." BRITISH JOURNAL OF PHOTOGRAPHY 11, no. 232 (Oct. 14, 1864): 403.

H1071 Hughes, Jabez. "On the Tannin Process." AMERICAN JOURNAL OF PHOTOGRAPHY AND THE ALLIED ARTS & SCIENCES n. s. vol. 7, no. 14-15 (Jan. 15 - Feb. 1, 1865): 332-335, 337-344. [Read to the London Photographic Society.]

H1072 Hughes, Jabez. "About Light, and About Lighting the Sitter; with Some Reflections About the Room in Which He is Lighted." BRITISH JOURNAL OF PHOTOGRAPHY 12, no. 259, 261, 262 (Apr. 21, May 5, May 12, 1865): 201-202, 234-235, 246-247.

H1073 "Our Editorial Table: Royal Portraits, Photographed by Jabez Hughes, Ryde." BRITISH JOURNAL OF PHOTOGRAPHY 12, no. 275 (Aug. 11, 1865): 419.

H1074 Hughes, Jabez. "On the Preparation of the Iron Developer as to Produce Dense Negatives." AMERICAN JOURNAL OF PHOTOGRAPHY AND THE ALLIED ARTS & SCIENCES n. s. vol. 8, no. 11-12 (Dec. 1 - Dec. 15, 1865): 255-258, 265-269.

H1075 "On the Management of Light." BRITISH JOURNAL PHOTOGRAPHIC ALMANAC 1866 (1866): 72-74.

H1076 Hughes, Jabez. "Further Observations on the Preparation of the Iron Developers so as to Produce Dense Negatives." HUMPHREY'S JOURNAL OF PHOTOGRAPHY, AND THE ALLIED ARTS AND SCIENCES 17, no. 21 (Mar. 1, 1866): 325-327. [Read to the London Photographic Society.]

H1077 "Bibliography." HUMPHREY'S JOURNAL OF PHOTOGRAPHY, AND THE ALLIED ARTS AND SCIENCES 17, no. 24 (Apr. 15, 1866): 374-377. [Bk. rev.: "Newman's Manual of Harmonious Coloring, as Applied to Photographs. Together with valuable Papers on Lighting and Posing the Sitter." Edited, by M. Carey Lea. Jabez Hughes' article "About Light and about Lighting the Sitter, and about the Room in which he is Lighted." reprinted.]

H1078 Hughes, C. Jabez. "On Reducing the Intensity of Negatives." HUMPHREY'S JOURNAL OF PHOTOGRAPHY, AND THE ALLIED ARTS AND SCIENCES 20, no. 6 (July 15, 1868): 94-95. [From "Photo. News Almanac."]

H1079 Portrait. Woodcut engraving credited "From a photograph by Jabez Hughes." ILLUSTRATED LONDON NEWS 64, (1874) ["Capt. Percy Luxmoore, C.B." 64:1812 (May 16, 1874): 473.]

H1080 Portrait. Woodcut engraving credited "From a photograph by Jabez Hughes, Ryde." ILLUSTRATED LONDON NEWS 66, (1875) ["Late Capt. Johannes G. Thomas." 66:1867 (May 22, 1875): 489.]

H1081 Hughes, Jabez. "About Carbon Printing." BRITISH JOURNAL PHOTOGRAPHIC ALMANAC 1876 (1876): 51-53.

H1082 Hughes, Jabez. "Useful Things for Photographers: Geysers, Metal Fires and Calorigens." BRITISH JOURNAL PHOTOGRAPHIC ALMANAC 1876 (1876): 104-106.

H1083 Portrait. Woodcut engraving credited "From a photograph by Jabez Hughes." ILLUSTRATED LONDON NEWS 69, (1876) ["Late Sir Thomas Henry." 69:1927 (July 1, 1876): 4.]

H1084 Hughes, Jabez. "Get Money! And, With All Thy Getting, Get Cash *At the Time of Sitting!*" BRITISH JOURNAL PHOTOGRAPHIC ALMANAC 1878 (1878): 151-153.

H1085 "Our Editorial Table: A Group of the Royal Family of England at Osborne, by Jabez Hughes, Ryde." PHOTOGRAPHIC TIMES 13, no. 153 (Sept. 1883): 507.

H1086 Taylor, J. Traill. "General Notes." PHOTOGRAPHIC TIMES 14, no. 165 (Sept. 1884): 471. [Obituary. In his early life a student and lecturer on phrenology and subjects conjugate thereto, learned to daguerreotype from Mr. Mayall in London and set up a business in Glasgow, Scotland. Successful, returned to London and started a stock-house. Then built the splendid Regina House Studio in Ryde, Isle of Wight, which the Queen frequently patronized. regular contributor to the British magazines. His "Principles and Practice of Photography" attained great popularity, going through 12 revised issues. Died Aug. 11, 1884, aged 65 years.]

HUGHES, W. W.
H1087 Hughes, W. W. "The Photographic Tourist: A Tour in the Department in Ain, France." PHOTOGRAPHIC NEWS 4, no. 90 (May 25, 1860): 40-41.

HUGO, CHARLES VICTOR. (1826-1871) (FRANCE)
H1088 "The Victor Hugo Album." IMAGE 1, no. 7 (Oct. 1952): 1-2. 1 b & w. [Album of forty photographs of Victor Hugo, images made by Charles Hugo (son) and Auguste Vacquerie. Collection George Eastman House.]

H1089 Greenhill, Gillian. "The Jersey Years; Photography in the Circle of Victor Hugo." HISTORY OF PHOTOGRAPHY 4, no. 2 (Apr. 1980): 113-120. 8 b & w. 2 illus. [Images by Victor Hugo's son Charles, and friend Auguste Vacquerie, while in exile in the 1850s. Discusses Charles' teacher, Edmund Bacot.]

HULL, ARUNDEL C. (1846-1908) (USA)
BOOKS
H1090 Miller, Nina Hull. *Shutters West*. Denver: Sage Books, 1962. 152 pp. 74 b & w. illus. [Photographer of the American West, in 1867-68. Born Ft. Wayne, IN on Apr. 14, 1846. Learned photography

in 1860s in St. Paul, MN. Established first studio in St. Cloud, MN in 1863, where he remained about three years. To Omaha, Neb. 1866, worked for E. L. Eaton. Then worked in Colorado, Utah, Wyoming 1866-1868. Then in 1868 went to work for Jackson Brothers, began working along the line of Union Pacific Rail Road with Wm. H. Jackson in 1869. Established his own studio in Fremont, Neb. in 1870. Sold out in 1895 to Fritz & Good. Died Dec. 30, 1908.]

PERIODICALS

H1091 "Home Incidents, Accidents, &c.: Lynch Law in Laramie." FRANK LESLIE'S ILLUSTRATED NEWSPAPER 27, no. 690 (Dec. 19, 1868): 221. 2 illus. [Two views of hanged men in Laramie, WY Territory. "A traveller who was present procured photographs of the terrible scene,..." (Probably by Arundel C. Hull, who was photographing along the line of the Union Pacific Railroad with W. H. Jackson during this time.)]

HULL, CHARLES WAGER. (d. 1895) (USA)

H1092 Hull, C. Wager. "The Tannin Process." AMERICAN JOURNAL OF PHOTOGRAPHY AND THE ALLIED ARTS & SCIENCES n. s. vol. 4, no. 7 (Sept. 1, 1861): 157-159. [Note on p. 163]

H1093 Hull, C. Wager. "The Tannin Process." AMERICAN JOURNAL OF PHOTOGRAPHY AND THE ALLIED ARTS & SCIENCES n. s. vol. 4, no. 15 (Jan. 1, 1862): 346-347.

H1094 Hull, Charles Wager. "The Tannin Process. - An Error Corrected." AMERICAN JOURNAL OF PHOTOGRAPHY AND THE ALLIED ARTS & SCIENCES n. s. vol. 4, no. 22 (Apr. 15, 1862): 523-524.

H1095 Hull, Charles Wager. "The Cost of Silvering Paper and Toning Prints." AMERICAN JOURNAL OF PHOTOGRAPHY AND THE ALLIED ARTS & SCIENCES n. s. vol. 5, no. 5 (Sept. 1, 1862): 106-107.

H1096 Hull, C. W. "A Photographic Trouble." HUMPHREY'S JOURNAL OF PHOTOGRAPHY, AND THE ALLIED ARTS AND SCIENCES 15, no. 13 (Nov. 1, 1863): 201-202.

H1097 Hull, C. W. "Something New." HUMPHREY'S JOURNAL OF PHOTOGRAPHY, AND THE ALLIED ARTS AND SCIENCES 15, no. 14 (Nov. 15, 1863): 216-217. [From "Amat. Photo. Print." Comic discourse on his difficulties with his printing bath.]

H1098 "Trenton Falls." HUMPHREY'S JOURNAL OF PHOTOGRAPHY, AND THE ALLIED ARTS AND SCIENCES 16, no. 21 (Mar. 1, 1865): 326. [Praise for Stereographs from tannin negatives, taken by the amateur C. Wager Hull.]

H1099 Hull, C. W. "Tannin again!" HUMPHREY'S JOURNAL OF PHOTOGRAPHY, AND THE ALLIED ARTS AND SCIENCES 16, no. 22-23 (Mar. 15 - Apr. 1, 1865): 339-342, 363-366.

H1100 Hull, Charles Wager. "Automatic Washing Box." AMERICAN JOURNAL OF PHOTOGRAPHY AND THE ALLIED ARTS & SCIENCES n. s. vol. 7, no. 21 (May 1, 1865): 501. [Hull coming forward as the inventor of this device, which he first published as "H." in the Aug. 1, 1860 issue of "Am J. Of P." Device later claimed by others.]

H1101 Hull, Charles Wager. "Photographic Societies." AMERICAN JOURNAL OF PHOTOGRAPHY AND THE ALLIED ARTS & SCIENCES n. s. vol. 7, no. 21 (May 1, 1865): 503-505.

H1102 Hull, Charles Wager. "Dry Plate Photography." PHILADELPHIA PHOTOGRAPHER 4, no. 38 (Feb. 1867): 36-38. [Hull an amateur photographer.]

H1103 Hull, Charles Wager. "The Use of Albumen as a Substratum." PHILADELPHIA PHOTOGRAPHER 8, no. 93 (Sept. 1871): 282-283.

H1104 Hull, Charles Wager. "Under a Tent." PHOTOGRAPHIC TIMES 2, no. 20-21 (Aug. - Sept. 1872): 116-118, 133-136. [Humorous anecdotes while photographing the building of the Baltimore & Potomac Tunnel in Baltimore, MD. Includes working practices and solutions for landscape photography.]

H1105 Hull, Charles Wagner. "Photographic Instruction." PHOTOGRAPHIC TIMES 2, no. 23 (Nov. 1872): 165-166. [Mr. Carl Hecker, instructor at the Cooper Union, females only are taught.]

H1106 "Report of the Photographic Section of the American Institute." ANTHONY'S PHOTOGRAPHIC BULLETIN 7, no. 7 (July 1876): 220-221. [H. J. Newton discusses dry-plate processes, mentions the early experiments of Charles Wager Hull in this area, which he believes to have been the first such effort.]

H1107 "Letter from Charles Wager Hull." PHOTOGRAPHIC TIMES 7, no. 84 (Dec. 1877): 266-267. [Old time amateur. Note on p. 269 describes his activities briefly. "...one of the pioneer amateurs of the art of photography... Mr. Hull has been for years the superintendent of the great American Institute Fairs in New York."]

H1108 Hull, Charles Wager. "Sizes of Photographic Portraits." PHOTOGRAPHIC TIMES 12, no. 138 (June 1882): 195.

H1109 Hull, Charles Wager. "Amateur Photography: "What Are You Intending to do This Summer?" PHOTOGRAPHIC TIMES 12, no. 139 (July 1882): 262-263. [Hull, photographing since 1857, discusses how easy it is to learn photography now. Advocates taking up photography as a hobby.]

H1110 Hull, Charles Wager. "Art and Artists Among Photographers." PHOTOGRAPHIC TIMES 12, no. 141 (Sept. 1882): 353-354.

H1111 Hull, Charles Wager. "Light for Developing - Washing Apparatus." PHOTOGRAPHIC TIMES 14, no. 160 (Apr. 1884): 188.

H1112 Hull, Charles Wager. "Development." PHOTOGRAPHIC TIMES 14, no. 162 (June 1884): 301-302. 1 illus. [Technical suggestions.]

H1113 Hull, Charles Wager. "Hot Weather vs. Development." PHOTOGRAPHIC TIMES 14, no. 163 (July 1884): 358-359.

H1114 Hull, Charles Wager. "Keeping Properties of Gelatin Plates after Exposure." PHOTOGRAPHIC TIMES 15, no. 177 (Feb. 6, 1885): 64.

H1115 Hull, Charles Wager. "Let Well Enough Alone." PHOTOGRAPHIC TIMES 16, no. 231 (Feb. 19, 1886): 110-111. [Advice to beginners from this experienced amateur photographer.]

H1116 Hull, Charles Wager. "High Prices vs. Low Prices." PHOTOGRAPHIC TIMES 16, no. 270 (Nov. 19, 1886): 603.

H1117 Hull, Charles Wager. "To the Tyro." AMERICAN ANNUAL OF PHOTOGRAPHY AND PHOTOGRAPHIC TIMES ALMANAC FOR 1887 (1887): 79-82.

H1118 Hull, Charles Wager. "The Stereoscopic Picture." PHOTOGRAPHIC TIMES 17, no. 289 (Apr. 1, 1887): 153-155. [Advocating return to stereos.]

H1119 Hull, Charles Wager. "Always and Never." PHOTOGRAPHIC TIMES 18, no. 352 (June 15, 1888): 277-278.

H1120 "Notes and News: Charles Wager Hull." PHOTOGRAPHIC TIMES 21, no. 518 (Aug. 21, 1891): 422. [Statement that Hull, Superintendent of the American Institute Fair, is oldest amateur photographer in U.S. Organizer of the Photographic Section of the American Institute before the Civil War, etc.]

H1121 1 photo ("Yachting"). PHOTOGRAPHIC TIMES 22, no. 570 (Aug. 19, 1892): frontispiece, 421. 1 b & w. [Hull was Superintendent of the American Institute, and an enthusiastic amateur.]

H1122 Mason, O. G. "Charles Wager Hull." PHOTOGRAPHIC TIMES 27, no. 3 (Sept. 1895): 183-184. [Obituary. Amateur photographer from New York City. Began ca. 1850. Elected Secretary of the American Photographical Society in 1860. In early 1870s he became the general superintendent of the Fairs of the American Institute, a position so time consuming that he had to forego photography until the gelatin dry plate process was perfected, when he took up the camera again. (The American Institute Fairs always had a strong showing of commercial photographers throughout the 1870s - 1880s.) Superintended the School of Photography at the Chautauqua University in the 1880s. Wrote for "Photographic Times" and other magazines. Died suddenly on July 24, 1895 while travelling out West.]

H1123 "Editor's Table: Charles Wager Hull." WILSON'S PHOTOGRAPHIC MAGAZINE 32, no. 466 (Oct. 1895): 479. [Died July 24 in Tacoma, WA, home was Larchmont, NY. "...perhaps the oldest American amateur... a most enthusiastic dry plate worker in the early days, etc."]

HULL, S. S. (GALVESTON, TX)
H1124 "Pictures Received." ANTHONY'S PHOTOGRAPHIC BULLETIN 10, no. 10 (Oct. 1879): 320. [S. S. Hull, of Galveston, TX.]

HUMPHREY, SAMUEL DWIGHT.
[Humphrey worked as a practicing daguerrean artist in 1840s, active in Fayetteville, NC, and Wilmington, Columbus, OH, Newark and Granville, OH, Albany, Rome, Auburn, Batavia, Canandaigua, Geneva, Brockport, and New York, NY. He moved to New York, NY in 1850 and, while operating a studio, became the editor and publisher of the world's first photographic magazine, the *Daguerreian Journal*, which began in November, 1850. In 1852 the title was changed to *Humphrey's Journal*. In 1853 he claimed to have made sixty-one daguerreotypes on one day, working in his own studio. Humphrey was also a photographic stockdealer through the middle 1850s. In 1859 he sold the journal. Also published several books.]

BOOKS
H1125 Humphrey, S. D. and M. Finley. *A System of Photography Containing an Explicit Detail of the Whole Process of Daguerreotype According to the Most Approved Methods of Operating; including All the Late Valuable Improvements, by S. D. Humphrey and M. Finley.* Canandaigua, NY: Printed at the office of the "Ontario Messenger.", 1849. 81 pp. [2nd ed. (1849) Albany: C. Van Benthuysen, 144 pp.; (1851), NY: Humphrey. xviii, 144 pp. Reprinted (1973), Arno Press.]

H1126 Humphrey, S. D. *American Hand-Book of the Daguerreotype giving the most Approved and Convenient Methods for preparing the Chemicals, and the Combinations used in the Art; containing the Daguerreotype, Electrotype, and various Other Processes employed in making Heliographic Impressions.* New York: S. D. Humphrey, 1853. 144 pp. [5th ed. (1858), xiii, 214 p. Reprinted (1973), Arno Press.]

H1127 Humphrey, S. D. *A Practical Manual of the Collodion Process; Giving in Detail a Method for Producing Positive and Negative Pictures on Glass and Paper; Ambrotypes: Also, Cutting's Collodion Patents; Specifications of his Processes, as filed in the United States Patent Office; Accompanied with Correspondence Relating Thereto.* "2nd ed." New York: S. D. Humphrey, 1856. 108 pp. [3rd ed., revised and greatly enlarged. (1857) New York: Humphrey's Journal, printer. 216 pp.]

PERIODICALS
H1128 Humphrey, S. D. "Editorial: March of Discovery." DAGUERREAN JOURNAL 1, no. 2 (Nov. 15, 1850): 49.

H1129 Humphrey, S. D. "Editorial: Light and Sky-Lights." DAGUERREAN JOURNAL 1, no. 6 (Feb. 1, 1851): 177.

H1130 Humphrey, S. D. "Notice." DAGUERREAN JOURNAL 2, no. 7 (Aug. 15, 1851): 209. [General commentary, praise for the organizers of the N. Y. State Daguerrean Assoc.]

H1131 Humphrey, S. D. "Editorial." DAGUERREAN JOURNAL 2, no. 12 (Nov. 1, 1851): 369. [Narrative of his experiences working as a studio photographer while editing the journal.]

H1132 Humphrey, S. D. "Humphrey's Journal." HUMPHREY'S JOURNAL 4, no. 3 (May 15, 1852): 41-42. [Article on importance of the medium, the place of the photographers, and the potential of photography as an art form.]

H1133 Humphrey, S. D. "Humphrey's Journal." HUMPHREY'S JOURNAL 4, no. 5 (June 15, 1852): 73-74. [Editorial on present and future potential of the daguerreotype and paper processes.]

H1134 Humphrey, S. D. "Editorial." HUMPHREY'S JOURNAL 4, no. 8 (Aug. 1, 1852): 121-122. [Editorial on technical issues, electroplating, skylights, etc.]

H1135 Humphrey, S. D. "Editorial - On the Spherometer." HUMPHREY'S JOURNAL 4, no. 9 (Aug. 15, 1852): 137-138. [On lenses.]

H1136 Humphrey, S. D. "Editorial: On the Employment of Iron as a Photographic Agent." HUMPHREY'S JOURNAL 4, no. 10 (Sept. 1, 1852): 153-154. [Discusses Talbot's process, Muller's (India) process.]

H1137 Humphrey, S. D. "Production of the Daguerrean Image." HUMPHREY'S JOURNAL 4, no. 17-22 (Dec. 15, 1852 - Mar. 1, 1853): 265-266, 281-282, 297-298, 329-333, 345-346. [Describes the process, mentions that Whipple (Boston) was first to introduce steam power to buff the plate. Gurney also uses steam (p. 266); mentions S. L. Walker was his instructor (p. 282).]

H1138 Humphrey, S. D. "Editorial Notices." HUMPHREY'S JOURNAL 4, no. 18 (Jan. 1, 1853): 283. [Note that S. D. Humphrey preparing "...a work upon the subject of the Daguerreotype operation." Further note that he was ill in bed all summer.]

H1139 Humphrey, S. D. "Letter: Colored Daguerreotypes." HUMPHREY'S JOURNAL 5, no. 13 (Oct. 15, 1853): 201. [Letter from

S. D. Humphrey (editor), on the matter of colored daguerreotypes, first published in the Sept. 28 issue of the "NY Tribune," republished here with additional commentary.]

H1140 Humphrey, S. D. "Editorial: Particular works of the Editor of Humphrey's Journal." HUMPHREY'S JOURNAL 5, no. 18 (Jan. 1, 1854): 281. [The editor, Humphrey, takes the occasion of the new year to give some of his own background. "We were the first to carry gilded Daguerreotypes into the State of North Carolina... (worked in) Fayetteville, NC, and Wilmington... Columbus, OH, Newark and Granville, OH, Albany, Rome, Auburn, Batavia, Canandaigua, Geneva, Brockport, and New York, NY. On Dec. 26, 1853 made 61 daguerreotypes between 9:30 and 4:00, working in his own studio.]

H1141 Humphrey, S. D. "Editorials: Value of a Daguerreotype." HUMPHREY'S JOURNAL 5, no. 19 (Jan. 15, 1854): 297.

H1142 "Editorial Note." HUMPHREY'S JOURNAL 6, no. 9 (Aug. 15, 1854): 137. [Humphrey announcing that he intends to visit his friend Finley in Canandaigua, NY for several weeks and take portraits there, as he had done previously as a professional.]

H1143 Humphrey, S. D. "Editorial: Photography on Paper, and the Daguerreotype." HUMPHREY'S JOURNAL 6, no. 11 (Sept. 15, 1854): 169-170. [Editor's commentary on shifting roles of the various processes, in light of Talbot's lawsuits, then in the news.]

H1144 Humphrey, S. D. "Editorial: Types." HUMPHREY'S JOURNAL 6, no. 20 (Feb. 1, 1855): 321-322. [Argument for new words for the various processes.]

H1145 Humphrey, S. D. "Talbotype and Patents in General." HUMPHREY'S JOURNAL 6, no. 22 (Mar. 1, 1855): 353-354.

H1146 Humphrey, S. D. "Editorial: Life-Sized Pictures." HUMPHREY'S JOURNAL 6, no. 23 (Mar. 15, 1855): 369-370. [Humphrey comments on the claim of the Frenchman Breton claiming it mathematically impossible to make a life-sized daguerreotype, claiming it was a matter of cost only.]

H1147 Humphrey, S. D. "The Collodion Process - its Use and Abuse." HUMPHREY'S JOURNAL 7, no. 18 (Jan. 15, 1856): 281-282. [Commentary on implications of the process to photographers, etc.]

H1148 Humphrey, S. D. "A Plain Practical Process for producing Collodion Negatives; also a Printing Process, accompanied with the Method of Preparing the Chemical Agents employed." HUMPHREY'S JOURNAL OF PHOTOGRAPHY, AND THE ALLIED ARTS AND SCIENCES 9, no. 21-23 (Mar. 1 - Apr. 1, 1858): 321-327, 337-341, 353-357. 4 illus.

H1149 Humphrey, S. D. "Collodion Filter - Preparation of Collodion." HUMPHREY'S JOURNAL OF PHOTOGRAPHY, AND THE ALLIED ARTS AND SCIENCES 10, no. 1 (May 1, 1858): 1-3.

H1150 Humphrey, S. D. "Photo-Lithography." HUMPHREY'S JOURNAL OF PHOTOGRAPHY, AND THE ALLIED ARTS AND SCIENCES 10, no. 20 (Feb. 15, 1859): 305-307.

H1151 Humphrey, S. D. "On the Daguerreotype." HUMPHREY'S JOURNAL OF PHOTOGRAPHY, AND THE ALLIED ARTS AND SCIENCES 10, no. 20 (Feb. 15, 1859): 307-308.

HUMPHREYS & WHAITE.
H1152 "Our Editorial Table: Pearla Chromotypes, by Messrs. Humphreys & Whaite, Cheltenham." BRITISH JOURNAL OF PHOTOGRAPHY 12, no. 280 (Sept. 15, 1865): 469.

HUMPIDGE & HUMPIDGE.
H1153 "Prince Alfred in India: Waiting for the Arrival of the Duke of Edinburgh at Government House, Calcutta." ILLUSTRATED LONDON NEWS 56, no. 1582 (Feb. 26, 1870): 224, 230. 1 illus. ["...from a photograph by the Messrs. Humpidge."]

HUNT. (USA)
H1154 Portrait. Woodcut engraving, credited "From a Photograph by Hunt." FRANK LESLIE'S ILLUSTRATED NEWSPAPER 47, (1879) ["Hon. Z. B. Vance, Sen. from NC." 47:1222 (Mar. 1, 1879): 461.]

HUNT, CALEB. (CLEVELAND, OH)
H1155 "Daguerreotype Movements." HUMPHREY'S JOURNAL 5, no. 21 (Feb. 15, 1854): 335. [Excerpt from a Cleveland, OH, paper, describing his practices.]

HUNT, ROBERT. (1807-1887) (GREAT BRITAIN)
[Robert Hunt was born at Devonport in 1807. He became Professor of Mechanics and "Keeper of Mining Records" at the Government School of Mines and Geological Museum in London from the early 1840s until his retirement in 1883. Hunt was an early experimenter in photography, discovering the value of ferrous sulphate as a developing agent, the use of mercury bichloride, and other processes. His early articles and text-books on the medium made a valuable contribution to the literature of photography. He died in 1887.]

BOOKS
H1156 Hunt, Robert. A Popular Treatise on the Art of Photography, Including Daguerreotype, and All the New Methods of Producing Pictures by the Chemical Agency of Light. by Robert Hunt, Secretary of the Royal Cornwall Polytechnic Society. Illustrated by Engraving. Glasgow: Richard Griffin & Co., 1841. viii, 96 pp. 29 illus. [facsimile ed. (1973) Athens, Ohio: Ohio University Press. Introduction and Notes by James Yingpeh Tong.]

H1157 Hunt, Robert. Researches on Light: An Examination of All the Phenomena Connected with the Chemical and Molecular Changes Produced by the Influence of the Solar Rays; Embracing All the Known Photographic Processes, and New Discoveries in the Art. London: Longman, Brown, Green & Longmans, 1844. vii, 303 pp. 5 illus. [2nd ed. (1854), xx, 396 pp.; Reprinted (1973), Arno Press.]

H1158 Hunt, Robert. The Poetry of Science, or Studies of the Physical Phenomena of Nature. London: Reeve, Benham & Reeve, 1848. xxiv, 463 pp.

H1159 Hunt, Robert. Panthea, The Spirit of Nature. [A Sketch]. London: Reeve, Benham & Reeve, 1849. x, 358 pp.

H1160 Hunt, Robert, F.R.S. Elementary Physics, An Introduction to the Study of Natural Philosophy. London: Reeve & Benham, 1851. vi, 486 pp. illus., colored plate illus. [new ed., corrected. (1855), London: Bohn.]

H1161 Hunt, Robert. Hand-book to the Official Catalogues of the Exhibition of 1851. London: Spicer Brothers and W. Clowes, 1851. 2 vol. ["Photography," on pp. 397-411 in vol. 1.]

H1162 Hunt, Robert. A Manual of Photography. London: J. J. Griffin & Co., 1851. 234 pp. 2 l. of plates. 52 illus. [3rd ed. (1853), x, 321

pp.; 5th ed. (1857) xiii, 342 pp.; Reprinted (1973), Arno Press. (Principle text-book of the wet-collodion era.)]

H1163 Hunt, Robert. *Photography: A Treatise on the Chemical Changes Produced by Solar Radiation, and the Production of Pictures from Nature, by the Daguerreotype, Calotype, and Other Photographic Processes.* "Encyclopaedia Metropolitana. Second Division. Applied Sciences." London, Glasgow: John J. Griffin, Richard Griffin & Co., 1851. 234 pp. illus. [2nd, enlarged and much revised ed. of "A Popular Treatise on the Art of Photography," 1841.]

H1164 Hunt, Robert. *Photography: A Treatise on the Chemical Changes Produced by Solar Radiation, and the Production of Pictures from Nature, by the Daguerreotype, Calotype, and Other Photographic Processes.* With Additions by the American Editor [S. D. Humphrey]. With Plates and Woodcuts. New York: S. D. Humphrey, 1852. ix, 290 pp. 4 l. of plates. 73 illus. [Illustrations are of early equipment, apparatus and portraits of Daguerre and Niépce.]

H1165 Hunt, Robert. *The Practice of Photography,... with Woodcuts.* London; Philadelphia: R. Griffin & Co.; Henry Carey Baird, 1857. 126 pp. illus. [Part II of "A Manual of Photography." The second edition of "A Popular Treatise."]

H1166 Hunt, Robert, ed. *A Supplement to Ure's Dictionary of Arts, Manufactures and Mines;* edited by Robert Hunt; Illustrated with Seven Hundred Engravings on Wood. New York: Appleton, 1863. 1096 pp. 700 illus.

H1167 Hunt, Robert. *The History of Discoveries in Photography.* Washington, DC: Government Printing Office, 1905. 287-308 pp. illus. [Offprint of Smithsonian Report for 1904, pages 287-308, with plates I-VII, Revised by T. W. Smillie, from Chapter II-IV of "A Manual of Photography," by Robert Hunt. (1854).]

H1168 Gernsheim, Helmut. "Cuthbert Bede (The Rev. Edward Bradley, 1827 - 1889), Robert Hunt F.R.S. (1807 - 1887), and Thomas Sutton (1819 - 1875)," on pp. 60-67 in: *One Hundred Years of Photographic History. Essays in Honor of Beaumont Newhall.* Edited by Van Deren Coke. Albuquerque, NM: University of New Mexico Press, 1975. 180 pp.

PERIODICALS

H1169 Hunt, Robert. "Art of Copying Engravings or any Printed Characters from Paper on Metal Plates; and on the Recent Discovery of Moser, relative to the Formation if Images in the Dark." ATHENAEUM no. 786 (Nov. 19, 1842): 989-990.

H1170 "Researches on Light." ILLUMINATED MAGAZINE 3, (May - Oct. 1844): 183. [Book review: "Researches on Light," by Robert Hunt.]

H1171 Hunt, Robert. "Energiatype: A New Photographic Process." ATHENAEUM no. 866 (June 1, 1844): 500-501.

H1172 Hunt, Robert. "The Energiatype." ATHENAEUM no. 869 (June 22, 1844): 575.

H1173 Hunt, Robert. "On the Energiatype and the Property of Sulphate of Iron in Developing Photographic Images." ATHENAEUM no. 885 (Oct. 12, 1844): 929.

H1174 Hunt, Robert. "On the Influence of Light on the Chemical Compounds and Electro-Chemical Actions." ATHENAEUM no. 886 (Oct. 19, 1844): 955.

H1175 Hunt, Robert. "Photographic Colouration." ATHENAEUM no. 1017 (Apr. 24, 1847): 440.

H1176 Hunt, Robert. "The Applications of Science to the Fine and Useful Arts: Photography. Pts. 1 - 2." ART UNION 10, no. 119, 122 (May, Aug. 1848): 133-136, 237-238. Line engravings. illus.

H1177 Hunt, Robert. "On the Applications of Science to the Fine and Useful Arts." ART JOURNAL (Feb., May 1850): 38-40, 147-149. [Photography on Glass Plates. The Photographic Camera. The Trinoptic Magic Lantern.]

H1178 Hunt, Robert. "Improvements in Photography." JOURNAL OF THE FRANKLIN INSTITUTE 52, (1851): 196.

H1179 Hunt, Robert. "Researches on Light." PHOTOGRAPHIC ART JOURNAL 1-2, no. 1-6, 1-2 (Jan. - Aug. 1851): (vol. 1) 3-19, 65-91, 129-135, 193-208, 257-264, 321-333 (vol. 2) 1-14, 65-76.

H1180 Hunt, Robert. "Photography on Glass." PHOTOGRAPHIC ART JOURNAL 1, no. 4 (Apr. 1851): 233-237. [From "London Art. J."]

H1181 Hunt, Robert. "Photography. Recent Improvements." DAGUERREAN JOURNAL 2, no. 5 (July 15, 1851): 148-151. [From "London Art Journal."]

H1182 Hunt, Robert. "The Science of the Expedition. Electrotype, Electricity, and Daguerreotype." DAGUERREAN JOURNAL 2, no. 6 (Aug. 1, 1851): 169-176. [From "London Art Journal."]

H1183 "Phenomena of Light." DAGUERREAN JOURNAL 2, no. 7 (Aug. 15, 1851): 207-208. [Report of an address given by Robert Hunt to the Royal Cornwall Polytechnic Society. Source not given.]

H1184 Hunt, Robert. "The Poetry of Science, or Studies of the Physical Phenomena of Nature." PHOTOGRAPHIC ART JOURNAL 2-3, no. 3-6, 1-5 (Sept. 1851 - May 1852): (vol. 2) 129-147, 193-206, 257-269, 321-335 (vol. 3) 5-20, 69-84, 133-148, 197-208, 261-270.

H1185 "New Publication on the Heliographic Science." DAGUERREAN JOURNAL 3, no. 2 (Dec. 1, 1851): 51-52. [Book review: "Photography - A Treatise." by Robert Hunt.]

H1186 Hunt, Robert. "Researches on Light." DAGUERREAN JOURNAL 2, no. 9-12 (Sept. 15 - Nov. 1, 1851): 257-272, 289-303, 321-336, 353-368.

H1187 Hunt, Robert. "On the Application of Science to the Fine and Useful Arts." PHOTOGRAPHIC ART JOURNAL 2, no. 5 (Nov. 1851): 291-294.

H1188 Hunt, Robert. "Researches on Light." DAGUERREAN JOURNAL 3, no. 1-3 (Nov. 15, 1851 - Dec. 15, 1851): 1-16, 33-48, 65-70.

H1189 Hunt, Robert. "Heliochrome." DAGUERREAN JOURNAL 3, no. 1 (Nov. 15, 1851): 21-25. [From "London Art Journal." Survey of experiments with color.]

H1190 Hunt, Robert. "Photography." ATHENAEUM no. 1262 (Jan. 3, 1852): 23. [Letter from Hunt claiming priority of discovery of the collodion process.]

H1191 Hunt, Robert. "On the Applications of Science to the Fine and Useful Arts. The Stereoscope." ART JOURNAL (Feb. 1852): 59-60. [Diagrams.]

H1192 Hunt, Robert. "Photography, With Some of Its Peculiar Phenomena." ART JOURNAL (Apr. 1852): 101-102. [General commentary, specific reference to a collodion process by Peter Fry, mentions Daguerre, Niépce, Talbot, Ellis, Archer, Le Gray.]

H1193 "Scientific." ATHENAEUM no. 1278 (Apr. 24, 1852): 461-462. [Bk. Rev.: "Photography: A Treatise on the Chemical Changes produced by Solar Radiation, and the Production of Pictures from Nature, by the Daguerreotype, Calotype, and other Photographic Processes," by Robert Hunt. (Griffon & Co.) Extended review.]

H1194 Hunt, Robert. "On the Applications of Science to the Fine and Useful Arts: the Stereoscope." PHOTOGRAPHIC ART JOURNAL 3, no. 4 (Apr. 1852): 226-229. [From "London Art Journal."]

H1195 Hunt, Robert. "The Stereoscope." HUMPHREY'S JOURNAL 4, no. 2 (May 1, 1852): 17-21. 4 illus.

H1196 Hunt, Robert. "Photography, with Some of Its Peculiar Phenomena." HUMPHREY'S JOURNAL 4, no. 4-5 (June 1 - June 15, 1852): 53-54, 68-71.

H1197 Hunt, Robert. "Photography." PHOTOGRAPHIC ART JOURNAL 3, no. 6 (June 1852): 325-342. 1 illus. [Early technical history.]

H1198 Hunt, Robert. "Photography with Some of Its Peculiar Phenomena." PHOTOGRAPHIC ART JOURNAL 3, no. 6 (June 1852): 373-377. [From the "London Art Journal."]

H1199 Hunt, Robert. "Photography." PHOTOGRAPHIC ART JOURNAL 4, no. 1-6 (July - Dec. 1852): 5-20, 69-85, 133-150, 197-222, 261-276, 325-353. 50 illus. [Early technical history.]

H1200 Hunt, Robert. "The Useful Application of Abstract Science: Photography." ART JOURNAL (Jan. 1853): 13-14.

H1201 Hunt, Robert. "The Useful Application of Abstract Science: Photography." PHOTOGRAPHIC ART JOURNAL 5, no. 2 (Feb. 1853): 90-94.

H1202 Hunt, Robert. "The Useful Application of Abstract Science: Photography." HUMPHREY'S JOURNAL 4, no. 21 (Feb. 15, 1853): 321-325. [From "London Art Journal."]

H1203 Hunt, Robert. "Early Researches on the Chemical Action of the Solar Rays." HUMPHREY'S JOURNAL 4, no. 24 (Apr. 1, 1853): 369-375. [From "Hunt's Photography."]

H1204 Hunt, Robert. "The Talbotype as Now Practiced and Its Modifications." PHOTOGRAPHIC ART JOURNAL 5, no. 4 (Apr. 1853): 218-226.

H1205 Hunt, Robert. "On Lenses for the Photographic Camera." PHOTOGRAPHIC ART JOURNAL 5, no. 4 (Apr. 1853): 244-248. 8 illus. [Source not given.]

H1206 Hunt, Robert. "On the Principles upon which the Construction of Photographic Lenses should be regulated."

HUMPHREY'S JOURNAL 5, no. 2-3 (May 1 - 15, 1853): 25-34. 3 illus. [From "J. of the Photo. Soc."]

H1207 Hunt, Robert. "The Stereoscope." PHOTOGRAPHIC ART JOURNAL 5, no. 5 (May 1853): 274-276.

H1208 Hunt, Robert. "General Remarks on the Use of the Camera Obscura." PHOTOGRAPHIC ART JOURNAL 5, no. 5 (May 1853): 277-279. 2 illus.

H1209 "Photography." HUMPHREY'S JOURNAL 5, no. 13 (Oct. 15, 1853): 204-205. [Excerpt of R. Hunt's "On the Chemical Action of the Solar Radiations," from the "Athenaeum."]

H1210 Hunt, Robert. "Selection of Paper for Photographic Purpose." PHOTOGRAPHIC ART JOURNAL 6, no. 6 (Dec. 1853): 337-341.

H1211 Hunt, Robert. "On the Chemical Action of the Solar Radiations." HUMPHREY'S JOURNAL 5, no. 19 (Jan. 15, 1854): 295-296. [From "Proc. of Br. Assoc." in the "Athenaeum" no. 1352.]

H1212 Hunt, Robert. "Chemistry, in Its Relations to Art and Art Manufacture Considered as a Branch of Education." PHOTOGRAPHIC AND FINE ART JOURNAL 7, no. 5 (May 1854): 134-136. [From "London Art Journal."]

H1213 Hunt, Robert. "Professor Hunt's Photographic Studies." PHOTOGRAPHIC AND FINE ART JOURNAL 7, no. 6 (June 1854): 168-169.

H1214 Hunt, Robert. "On the Fading of Photographic Pictures." ART JOURNAL (July 1855): 210-211.

H1215 Hunt, Robert. "On the Fading of Photographic Pictures." PHOTOGRAPHIC AND FINE ART JOURNAL 8, no. 8 (Aug. 1855): 249-251. Hunt, Robert. "The Stereoscope." ART JOURNAL (Apr. 1856): 118-120. 2 illus.

H1216 Hunt, Robert. "The Stereoscope." PHOTOGRAPHIC AND FINE ART JOURNAL 9, no. 6 (June 1856): 171-174. 7 illus. [Source not given.]

H1217 Hunt, Robert. "Photogalvanography; or Engraving by Light and Electricity." ART JOURNAL (July 1856): 215-216.

H1218 Hunt, Robert. "Photogalvanography; or, Engraving by Light and Electricity." PHOTOGRAPHIC AND FINE ART JOURNAL 9, no. 8 (Aug. 1856): 240-242. [From "London Art J."]

H1219 Hunt, Robert. "Extracts from Foreign Publications: Photogalvanography; or, Engraving by Light and Electricity." HUMPHREY'S JOURNAL 8, no. 12 (Oct. 15, 1856): 184-187. [From "London Art Journal." Discusses Niépce, Talbot, Pretsch.]

H1220 Hunt, Robert. "Solar Phenomena." HUMPHREY'S JOURNAL 9, no. 11 (Oct. 1, 1857): 163-165. [From "British Q. Rev." Describes early physics experiments by Sir Isaac Newton, others.]

H1221 Hunt, Robert. "Lithography, and Other Novelties in Printing." PHOTOGRAPHIC AND FINE ART JOURNAL 10, no. 10 (Oct. 1857): 300-304. [From "London Art J."]

H1222 Hunt, Robert. "Collodion and Photography." PHOTOGRAPHIC AND FINE ART JOURNAL 11, no. 4 (Apr. 1858): 115-117. [From "London Art J."]

H1223 "The Historic Society of Lancashire and Cheshire." PHOTOGRAPHIC AND FINE ART JOURNAL 11, no. 6 (June 1858): 183. [Report of meeting, where a Mr. Towson described his experiences in late 1830's, when he worked with Robert Hunt and was in correspondence with Sir J. Herschel and Wm. H. F. Talbot about photographic experiments.]

H1224 Hunt, Robert. "Photography: Considered in Relation to Its Educational and Practical Value." ART JOURNAL (Sept. 1858): 261-262.

H1225 Hunt, Robert. "The Stereoscope and Its Improvements. Mr. G. C. Cooke's Stereoscope, Mr. Claudet's Stereoscope, and M. D'Almeida's New Stereoscopic Apparatus." ART JOURNAL (Oct. 1858): 305-306. 1 illus.

H1226 Hunt, Robert. "Application of Photography to Wood-Engraving." ART JOURNAL (Nov. 1858): 335-336.

H1227 Hunt, Robert. "Photo-Zincography." ART JOURNAL (May 1860): 133.

H1228 [Hunt, Robert.] "Photo-Zincography." PHOTOGRAPHIC AND FINE ART JOURNAL 13, no. 6 (June 1860): 155-156. [From "London Art Journal."]

H1229 Hunt, Robert, F.R.S. "Iron and Steel." POPULAR SCIENCE REVIEW 1, no. 1 (Oct. 1861): 61-79.

H1230 Hunt, Robert, F.R.S. "Solar Chemistry." POPULAR SCIENCE REVIEW 1, no. 2 (Jan. 1862): 205-215. 1 color plate illus.

H1231 Hunt, Robert, F.R.S. "Light and Colour." POPULAR SCIENCE REVIEW 1, no. 3 (Apr. 1862): 310-316. 1 color plate illus.

H1232 Hunt, Robert, F.R.S. "The Physics of a Sunbeam." POPULAR SCIENCE REVIEW 1, no. 4 (July 1862): 438-443. 1 color plate illus.

H1233 Hunt, Robert, F.R.G.S. "Tin Mining in Cornwall and Its Traditions." GOOD WORDS 8, no. 2 (Feb. 1867): 126-131. [Actually about prehistoric cultures.]

H1234 "General Notes." PHOTOGRAPHIC TIMES 17, no. 321 (Nov. 11, 1887): 565. [Robert Hunt, F.R.S., eminent scientist and photographic investigator passed away on Oct. 17 at age 81. Wrote "Hunt's Researches on Light." In 1851 he compiled a general summary of history of photography." A founder of the Photographic Society of Great Britain, author of scientific texts, etc.]

H1235 "Obituary: Robert Hunt." ANTHONY'S PHOTOGRAPHIC BULLETIN 18, no. 21 (Nov. 12, 1887): 661-662.

HUNT, ROBERT. [?]
H1236 "Light, Philosophically and Photogenically Considered." DAGUERREAN JOURNAL 2, no. 6 (Aug. 1, 1851): 181-186. [From "Photographic Researches." Author not credited, possibly Robert Hunt's "Researches on Light," or a work by the editor, S. D. Humphrey.]

HUNTER. (CORK, IRELAND)
H1237 "The Neapolitan Exiles." FRANK LESLIE'S ILLUSTRATED NEWSPAPER 7, no. 175 (Apr. 9, 1859): 290. 1 illus. [Five portraits of Italian priests, banished to Ireland? "From a Photograph by Mr. Hunter, Cork."]

HUNTER, ALEXANDER, DR. (GREAT BRITAIN, INDIA)
H1238 Hunter, Alexander Dr. "On the Selection of Subjects from Nature." PHOTOGRAPHIC TIMES 9, no. 102 (June 1879): 134-136. [From a paper read before the Edinburgh Photo Soc. "After 32 years of photographic and artistic labors in India, I propose...]

HUNTER, JOHN. (MUSCATIN, IA)
H1239 Hunter, John. "Communications: To Clean Leather from Buffing Daguerreotype plates." PHOTOGRAPHIC ART JOURNAL 4, no. 4 (Oct. 1852): 226-227.

HUNTER, W. G. (d. 1877) (GREAT BRITAIN)
H1240 Hunter, W. G. "Positive Collodion Portraits on Tin or Metallic Cards." HUMPHREY'S JOURNAL OF PHOTOGRAPHY, AND THE ALLIED ARTS AND SCIENCES 9, no. 21 (Mar. 1, 1858): 327-328. [From "Photo. Notes."]

HUNTER, WILLIAM F. (NEW YORK, NY)
H1241 Portrait. Woodcut engraving, credited "From a Crystal Miniature, Taken by Wm. F. Hunter, 476 Broadway, New York, NY." FRANK LESLIE'S ILLUSTRATED NEWSPAPER 8, (1859) ["The Late Fanny Deane Halsey." 8:186 (June 25, 1859): 64.]

HURLBUT, GEORGE H.
H1242 "Correspondence: Developers and Developing." PHOTOGRAPHIC TIMES 12, no. 133 (Jan. 1882): 22-23. [Letter from Hurlbut in Lima, Peru. "I had hoped to send you, before this, some account of the work done among the magnificent scenery of this country, but, unfortunately, the state of things here is such that it is not safe to go outside of the city. I have been obliged, therefore, to confine my work to experiments..."]

H1243 Hurlbut, George H. "Proposed American Amateur Club." PHOTOGRAPHIC TIMES 12, no. 141 (Sept. 1882): 352-353.

H1244 Hurlbut, George H. "Small Plates for Amateurs." PHOTOGRAPHIC TIMES 18, no. 375 (Nov. 23, 1888): 554-555. ["Having been for over fifteen years an amateur photographer,..."]

HURN, J. W. (PHILADELPHIA, PA)
H1245 "Editor's Table." PHILADELPHIA PHOTOGRAPHER 4, no. 43 (July 1867): 235. [8" x 10" view of Laurel Hill Cemetery, Philadelphia, PA.]

H1246 Portrait. Woodcut engraving, credited "From a Photograph by J. W. Hurn." HARPER'S WEEKLY 13, (1869) ["Ebenezer D. Bassett, Colored Minister to Hayti." 13:644 (May 1, 1869): 285.]

HURST & SONS. (ALBANY, NY)
H1247 "Photography as an Assistant to the Study of Natural History. A New Application." PHOTOGRAPHIC TIMES 1, no. 10 (Oct. 1871): 149-150. [24 stereo views (colored) of stuffed animals.]

H1248 "Hurst's Stereoscopic Studies of Natural History." PHILADELPHIA PHOTOGRAPHER 10, no. 110 (Feb. 1873): 38-39. [Hurst & Son (Albany, NY).]

H1249 Laird, John David. "Hurst's Stereoscopic Studies of Natural History." STEREO WORLD 3, no. 2 (May - June 1976): 12-13. 2 b & w. 1 illus. [James A. Hurst & Sons operated a taxidermy shop and natural museum in Albany, NY from 1850s to 1880s. In late 1860s and early 1870s the firm published several series of stereos of the these animals, as well as some genre scenes with animals. The actual photographer is identified as Haines.]

HURST, JOSHUA S.
H1250 Hurst, Josh. S. "The Tannin Process: Is It Slow or Rapid." AMERICAN JOURNAL OF PHOTOGRAPHY AND THE ALLIED ARTS & SCIENCES n. s. vol. 6, no. 14 (Jan. 15, 1864): 319-321. [From "Photo. News."]

HUSHER.
H1251 Husher, Mr. "Fifth Annual Meeting and Exhibit of the National Photographic Association of the U.S., held in Buffalo, N.Y., beginning July 5, 1873: Landscape Photography." PHILADELPHIA PHOTOGRAPHER 10, no. 117 (Sept. 1873): 443-444.

HUSNIK, J.
H1252 Husnik, Prof. J. "An Excellent Lichtdruck Process." ANTHONY'S PHOTOGRAPHIC BULLETIN 7, no. 1 (Jan. 1876): 5-7. [From "London Photo. News," again from "Photographische Correspondenz." Husnik from Tabor.]

HUSTON & KURTZ. (NEW YORK, NY)
H1253 "Photo-Sculpture." AMERICAN JOURNAL OF PHOTOGRAPHY, AND THE ALLIED ARTS AND SCIENCES n. s. vol. 9, no. 8 (Mar. 1, 1867): 161-165.

H1254 "Photosculpture." PHILADELPHIA PHOTOGRAPHER 4, no. 40 (Apr. 1867): 105-106.

H1255 Portrait. Woodcut engraving, credited "From a Photograph by Huston & Kurtz." FRANK LESLIE'S ILLUSTRATED NEWSPAPER 27, (1869) ["Hon. George C. Barrett, Judge of the Court of Common Pleas, NY." 27:699 (Feb. 20, 1869): 364.]

HUSTON, WILLIAM. (NEW YORK, NY)
H1256 Huston, William. "The Opalotype and the Collodio-Chloride Process." AMERICAN JOURNAL OF PHOTOGRAPHY AND THE ALLIED ARTS & SCIENCES n. s. vol. 8, no. 7 (Oct. 1, 1865): 154-155.

HUTCHINGS, SAMUEL. (d. 1879) (GREAT BRITAIN, USA)
H1257 "Suicide." ANTHONY'S PHOTOGRAPHIC BULLETIN 10, no. 10 (Oct. 1879): 320. [Hutchings, from England "...about a year since," working for A. & G. Taylor, committed suicide.]

HUTCHINSON, GEORGE.
H1258 Hutchinson, George. "A Simple Method of Using Carbonate of Silver Paper." HUMPHREY'S JOURNAL OF PHOTOGRAPHY, AND THE ALLIED ARTS AND SCIENCES 20, no. 20 (Apr. 15, 1869): 311-312. [From "Photo. News." "...my brother amateurs."]

I

IBBETSON, L. L. BOSCAWEN.

BOOKS

I1 Ibbetson, Capt. L. L. Boscawen. *Le Premier Livre Imprime par le soleil - L. L. Boscawen Ibbetson, Esq., 1840.* Geneva: Privately printed, 1840 (Jan. 1839). n. p. l. of plates. b & w. [Album of contact prints, "Photographs from ferns, grasses and flowers," the title-page and preface as well as the flowers were "sun-printed" (Shown at the 1st Exhibition of Photographic Pictures at the Society of Arts, London in 1853.)]

PERIODICALS

I2 Ibbetson, L. L. Boscawen. "Photography." JOURNAL OF THE SOCIETY OF ARTS (LONDON) 1, no. 6 (Dec. 31, 1852): 69. [Claims to have produced the first book illustrated with photograms. "Le premier livre imprimé par le soliel," in 1839. Began experimenting in Switzerland in 1839, with suggestions from Prof. Gerber, on nitrate of silver. (Apparently produced a variant of calotype, but stopped working when Arago informed him that Talbot had proceeded him.)]

I3 "Our Weekly Gossip." ATHENAEUM no. 1586 (Mar. 20, 1858): 372. [Mentions Niépce de St.-Victor's experiments. Discusses Capt. Ibbetson's claim that he had "printed a book by the sun, containing botanical specimens, titled "Le Premier Livre imprime par le Soleil" in 1830s.]

ILLEX, M.

I4 Illex, M. "Miscellanea: Durability of Photographic Impressions." ATHENAEUM no. 793 (Jan. 28, 1843): 92-93.

ILLINGWORTH, WILLIAM H. (1842-1893) (GREAT BRITAIN, USA)

BOOKS

I5 Newson, T. M. "William Illingworth," on p. 234 in: *Pen Pictures of St. Paul, Minnesota and Bibliographical Sketches of Old Settlers.* St. Paul, Minn.: s. n., 1886. n. p.

I6 Krause, Herbert and Gary D. Olson. "Illingworth the Photographer" pp. 33-37; "Illustration Index," pp.273-275 in: *Prelude to Glory: A Newspaper Accounting of Custer's 1874 Expedition to the Black Hills.* Sioux Falls, SD: Brevet Press, 1974. 280 pp. illus. [Approximately seventy photographs by Illingworth, one portrait. The "Illustration Index" gives a history of the Illingworth Collection at the South Dakota State Historical Society, quotes Illingworth, lists prints.]

I7 Progulske, Donald. *Yellow Ore, Yellow Hair, Yellow Pine.* "Bulletin No. 616" Brookings, S.D.: South Dakota State University, 1977. n. p. illus. [Illingworth's 1874 photographs of South Dakota rephotographed by Progulske one hundred years later.]

PERIODICALS

I8 "Note: Crossing the Plains to Montana with Captain Fisk's Expedition, 1866." PHILADELPHIA PHOTOGRAPHER 4, no. 42 (June 1867): 194. [Mention that thirty stereo views on the topic by Bill & Illingworth sent to the magazine by John Carbutt of Chicago, IL, who was issuing them for sale.]

I9 "The Black Hills Expedition." HARPER'S WEEKLY 18, no. 924 (Sept. 12, 1874): 753. 3 illus.

I10 "A New Eldorado. - Views in the Black Hills Country. - From Photographs by E. & H. T. Anthony Co." FRANK LESLIE'S ILLUSTRATED NEWSPAPER 40, no. 1022 (May 1, 1875): 127, 129.

8 illus. [Views of General George Custer's expedition into the Black Hills. Custer with a dead Grizzly bear, the Cannon Ball River, Golden Park, Index Butte, etc. "We give illustrations, from views taken by a photographer who accompanied General Custer's expedition..."]

I11 Wilson, General James Grant. "The Modern Knights Errant." COSMOPOLITAN 11, no. 3 (July 1891): 295-302. 4 b & w. 5 illus. [Brief popularized biographies of William Barker Cushing, Naval Officer in Civil War and of George Armstrong Custer, Army Officer in Civil War and Indian conflicts. Includes drawings, portraits and a photo of Custer and his scouts with a grizzly bear which Custer had shot.]

I12 Grosscup, Jeffrey P. "Stereoscopic Eye on the Frontier West." MONTANA: THE MAGAZINE OF WESTERN HISTORY 25, no. 2 (Spring 1975): 36-50. 27 b & w. 1 illus. [Born Sept. 20, 1842 in Leeds, England. Brought to USA with family in the 1840s, which moved to St. Paul, MN in 1850. In 1862 William went to Chicago and learned photography, then returned to St. Paul to work for his father as clocksmith. Apparently also photographing as well. In 1866 he joined the Fisk expedition to establish an overland route from Minnesota across the northern plains to Montana for immigrants. Temporary partnership with George Bill, who afterwards gave up photography and settled as a tinsmith in St. Cloud. Made thirty stereo views during the two month trip. First attempted to publish these views himself, then sold the negatives to John Carbutt from Chicago, who republished them under his own name in 1867. From 1867 to 1874 Illingworth worked out of several locations in St. Paul, while making several hundred stereo views for a series titled "Stereographs of Minnesota Scenery." These were published by Illingworth, and also by Burritt & Pease and Huntington & Winne. In 1874 Illingworth joined the Black Hills Expedition under Gen. George A. Custer, listed as a teamster, and contracted to produce six sets of his photographs to Col. William Ludlow. Generated fifty-five views during the expedition. Embroiled in financial and personal problems in 1880s, being divorced by his third wife in 1888, for, among other issues, habitual drunkenness. In 1893, impoverished and in ill health, Illingworth shot and killed himself. He made approximately 1,600 negatives during his career, many which have gone into the collections of the Minneapolis Public Library, the Minnesota Historical Society, and the South Dakota Historical Society.]

I13 Ryder, Richard C. "Custer's Black Hills Expedition of 1874." STEREO WORLD 3, no. 2 (May - June 1976): 16. 1 b & w. [W. H. Illingworth accompanied the expedition, made fifty-five views.]

IMPEY, EUGENE CLUTTERBUCK. (1836-1904) (GREAT BRITAIN, INDIA)

BOOKS

I14 Impey, Eugene Clutterbuck. *Delhi, Agra and Rajpootana.* London: Cundall, Downes & Co., 1865. n. p. 72 b & w. [Album of photos.]

PERIODICALS

I15 Thomas, G. "Colonel E. C. Impey and his Indian Connection." HISTORY OF PHOTOGRAPHY 7, no. 3 (July - Sept. 1983): 239-246. 9 b & w. [Worked in India 1851-1879, photographs ca. 1860s.]

INGLEFIELD.

I16 "The Arctic Expedition." ILLUSTRATED LONDON NEWS 25, no. 706 (Oct. 7, 1854): 348. 1 illus. ["Captain MacClure, in his Arctic dress - from a photograph by Captain Inglefield." Relief expedition searching for Sir John Franklin's lost expedition.]

INGLIS, JAMES. (1835-1904) (CANADA, USA)

I17 "Editor's Table." PHILADELPHIA PHOTOGRAPHER 3, no. 34 (Oct. 1866): 322. [Carte group sent to editor.]

118 "Our Picture - 'Right Still Now.'" PHILADELPHIA PHOTOGRAPHER 3, no. 35 (Nov. 1866): frontispiece, 356. 1 b & w. [Genre picture of a baby taking a photo of a young lady.]

119 Inglis, J. "Formulae for Children's Pictures." PHILADELPHIA PHOTOGRAPHER 3, no. 36 (Dec. 1866): 369-371.

120 "Our Picture." PHILADELPHIA PHOTOGRAPHER 5, no. 54 (June 1868): frontispiece, 213. 1 b & w. [Portrait.]

121 "Editor's Table." PHILADELPHIA PHOTOGRAPHER 5, no. 56 (Aug. 1868): 279. [Some "rustic cabinet pictures and some interior compositions received."]

122 "Our Picture." PHILADELPHIA PHOTOGRAPHER 5, no. 60 (Dec. 1868): frontispiece, 441. 1 b & w. [A couple in a boat. Inglis in Montreal, Canada.]

123 Maitland, G. F. "Correspondence: "The Most Perfect Photograph." ANTHONY'S PHOTOGRAPHIC BULLETIN 8, no. 9 (Sept. 1877): 287. [Letter from G. F. Maitland (Stratford, Ontario) stating that a photo credited to him and praised in an earlier issue of the "APB," was in fact, taken by Inglis (Montreal).]

124 Inglis, J. "Correspondence." ANTHONY'S PHOTOGRAPHIC BULLETIN 8, no. 9 (Sept. 1877): 287-288. [Letter, on reticulation of the carbon process.]

125 "Our Editorial Table: Rapid Photography." PHOTOGRAPHIC TIMES 15, no. 197 (June 26, 1885): 345. [Photos of a bicycle rider in motion. Inglis in Rochester, NY.]

INNES, COSMO.

126 Innes, Cosmo. "Short Notes of Photographic Tours." JOURNAL OF THE PHOTOGRAPHIC SOCIETY OF LONDON 8, no. 130, 132 (Feb. 16, Apr. 16, 1863): 231-232, 258-260.

INSLEY, HENRY E. (1811-1894) (USA)

127 "The Nineteenth Century." DAGUERREAN JOURNAL 2, no. 1 (May 15, 1851): 24-25.

128 "Humphrey's Journal: Illuminated Daguerreotypes." HUMPHREY'S JOURNAL 4, no. 1 (Apr. 15, 1852): 10.

129 "Daguerreotype Movements." HUMPHREY'S JOURNAL 5, no. 19 (Jan. 15, 1854): 303. [Insley patented "Illuminated Daguerreotype" process.]

130 "The Early Days." ANTHONY'S PHOTOGRAPHIC BULLETIN. 14, no. 9 (Sept. 1883): 313-314. [Two letters from H. A. Insley and his father H. E. Insley describing H. E. Insley's role in the history of early photography in the United States. Mr. Insley, the brother-in-law of George W. Prosch, experimented with him, taking portraits and then during 1840 operated the gallery of Insley & Prosch.]

131 Humphrey, S. D. "Editorials: Interesting Experiments in the Practice of the Daguerreotype." HUMPHREY'S JOURNAL 5, no. 21 (Feb. 15, 1854): 329-330. [Fitzgibbon photographed two people at separate times, exposing half of the plate each time, and thus achieved a double portrait on one plate. Insley made multiple exposures on a single plate to create the impression of a two-headed boy or of a man with four arms, etc.]

132 "Notes and News: A Veteran Photographer." PHOTOGRAPHIC TIMES 25, no. 675 (Aug. 24, 1894): 134. [From the "Philadelphia Photographer." Obituary for Insley, who began in 1839, with Morse.]

IOTA.
133 "Iota". "The Isle of Wight from a Photographic Point of View. Pts. 1 - 2." PHOTOGRAPHIC NEWS 3, no. 54-55 (Sept. 16 - Sept. 23, 1859): 22-23, 33-34.

IRVINE. (EDINBURGH, SCOT)
134 Portrait. Woodcut engraving credited "From a photograph by Irvine, Prince St., Edinburgh." ILLUSTRATED LONDON NEWS 64, (1874) ["Sir Archibald Alison, Bart., K.C.B." 64:1808 (Apr. 18, 1874): 373.]

ISAACS, ALBERT AUGUSTUS.
135 Isaacs, Albert Augustus. The Dead Sea, or Notes and Observations Made During a Journey to Palestine in 1856-7 on M. de Saulcy's Discovery of the Cities of the Plain. By the Rev. Albert Augustus Isaacs ...Illustrated from photographs taken on the spot by the author. London; Edinburgh: Hatchard & Sons.; Johnstone, Hunter & Co., 1857. 100 pp. b & w. illus.

ISING, CHARLES M.
136 "Letter." PHOTOGRAPHIC ART JOURNAL 5, no. 3 (Mar. 1853): 184-185.

ISRAEL, MORRIS.
137 Israel, Morris. "What I Know About Making Interior Views." PHILADELPHIA PHOTOGRAPHER 10, no. 113 (May 1873): 137-138.

ITIER, ALPHONSE-EUGENE-JULES. (1802-1877) (FRANCE)
138 Gimon, Gilbert. "Jules Itier, Daguerreotypist." HISTORY OF PHOTOGRAPHY 5, no. 3 (July 1981): 225-244. 22 b & w. 7 illus. [Itier born Paris, Apr. 8, 1802. Studied in France, entered the Customs Service in 1819. Worked in France. In 1830s and 1840s he was active in scientific circles in Perpignan, so knew of the daguerreotype early. In 1842 he travelled to Sengal, took a daguerreotype outfit. In Guyana and Guadaloupe in 1843. Then from 1843-1846, appointed chief of a commercial mission to China, the Indies and Pacific Islands, where he daguerreotyped in his spare time. Travelled back through Borneo, Manila, Egypt in 1846. Returned to France, flourished, retired in 1857. Continued to photograph. Died Oct. 13, 1877. About 120 daguerreotypes survive.]

IVES, FREDERICK EUGENE. (1856-1937) (USA)
[Born on Feb. 17, 1856 on a farm near Litchfield, CT. Father then opened a general store. His father died in 1868 and Frederick left school and worked in the store. Began to apprentice at the town newspaper, where he gathered some experience in woodcuts and photography. Worked in a printing office and later as a photographer's assistant for his cousin in Ithica, NY. In 1874 he opened his own photography studio in Ithica, and worked as a photographer for Cornell University. Began to do research on photogravure and on color. In 1878 moved to Philadelphia to commercially exploit his photogravure process. In 1880 took out a patent for processing images with halftone screens. From 1880 to 1916 he perfected several color processes and stereo techniques. Invents Polychrome color process in 1929. Took out over seventy patents and received many awards and honors in his lifetime. Died May 27, 1937 in Philadelphia. The major portion of the Ives bibliography will appear in volume two of this work.]

BOOKS

139 Sipley, Louis Walton. *Frederick E. Ives [1856-1937], Photographic-Arts Inventor.* Philadelphia: American Museum of Photography, 1956. 30 pp. illus. [Worked as a photographer in Greene, NY, and as an apprentice printer in CT and NY. Worked on photoengraving processes, half-tone screen printing techniques, and color processes. Established the Hess-Ives Corporation, Philadelphia, PA, from 1878 to 1937.]

PERIODICALS

140 Ives, Frederick E. "Correspondence: Isochromatic Photography." PHOTOGRAPHIC TIMES 15, no. 217 (Nov. 13, 1885): 644. [Letter responding to some issues claiming priority with inventions.]

141 Ives, F. E. "Photo-Mechanical Engraving." PHOTOGRAPHIC TIMES 18, no. 346 (May 4, 1888): 208-210.

142 Ives, Frederick E. "Heliochromy." PHOTOGRAPHIC TIMES 18, no. 376 (Nov. 30, 1888): 571-573. [Paper read before the Franklin Institute of Philadelphia.]

143 Ives, Fred. "Heliochromy." ANTHONY'S PHOTOGRAPHIC BULLETIN 19, no. 23 (Dec. 8, 1888): 716-718. [Read before the Franklin Institute, Philadelphia.]

144 Ives, Frederick E. "Captain Abney on Heliochromy." PHOTOGRAPHIC TIMES 19, no. 425 (Nov. 8, 1889): 554-555. [Ives disagrees with Abney's conclusions, in: "A Communication to the Franklin Institute."]

145 Ives, F. E. "Photography in the Colors of Nature." PHOTOGRAPHIC TIMES 21, no. 491 (Feb. 13, 1891): 80-81.

146 Ives, F. E. "Photography in the Colors of Nature." PHOTOGRAPHIC TIMES 21, no. 492-494 (Feb. 20 - Mar 6, 1891): 91-93, 103-105, 112-114.

147 Ives, F. E. "Color in the Camera - Light Thrown on Photography's Newest Achievement." PHOTOGRAPHIC TIMES 22, no. 552 (Apr. 15, 1892): 202-203. ["An interesting illustrated lecture before the Photographic Society of Philadelphia by F. E. Ives."]

148 "F. E. Ives." PHOTOGRAPHIC TIMES 22, no. 553 (Apr. 22, 1892): 209. [Born Litchfield, CT, in 1856. At 13 apprenticed to a printer, learned photography as a hobby. At 18 worked as operator in a portrait gallery, then worked as photographer to Cornell University for four years. Perfected photo-engraving processes, the first commercially successful half-tone block process. Then for thirteen years in charge of the photo-engraving department of the Crosscup & West Engraving Co. in Philadelphia, PA. Experimented with three-color processes, etc.]

149 Ives, F. E. "Photography in Colors." PHOTOGRAPHIC TIMES 22, no. 558 (May 27, 1892): 280. [Lecture before the Royal Institution, London. From the "London Daily Graphic" May 11, 1892.]

150 Ives, Frederick. "Photography in Colors." PHOTOGRAPHIC TIMES 22, no. 559 (June 3, 1892): 299. [2nd lecture at the Royal Institution. From "London Daily Graphic."]

151 Ives, F. E. "The Heliochromoscope." PHOTOGRAPHIC TIMES 22, no. 579 (Oct. 21, 1892): 533-534.

152 Ives, F. E. "Color Photography. Part III. The Seven Pictures Shown." PHOTOGRAPHIC TIMES 23, no. 640 (Dec. 22, 1893): 767-768.

153 Ives, F. E. "Color Photography: Part I. A Critical Description of the Lumiere-Lippman Results." PHOTOGRAPHIC TIMES 23, no. 638 (Dec. 8, 1893): 712. [Read at the Photographic Society of Philadelphia.]

154 Ives, Frederick. "Kromskop Color Photography." CAMERA NOTES 4, no. 1 (July 1900): 35-36. 2illus. [Excerpted from Ives' lecture.]

155 Ives, Frederick E. "A Photographic Ray-Filter Which is Not a Color-Screen." CAMERA WORK no. 7 (July 1904): 44-45.

156 Leighton, Howard B. "Frederick Eugene Ives, Forgotten Pioneer in Color Photography and the Halftone." IMAGE 19, no. 3 (Sept. 1976): 33-34. 4 illus.

IVES, LOYAL MOSS. (BOSTON, MA)
[Portrait painter and daguerreotypist. From 1844 to 1846 he and Lorenzo Chase were partners in Boston, MA. Ives then operated his own gallery in Boston from 1847 to 1852. During the latter part of the 1850s he painted portraits in New Haven, CT, and then worked in New York, NY from ca. 1863 to 1890.]

157 Portrait. Woodcut engraving, credited "We are indebted to Ives, daguerreotypist, 142 Washington Street, for the likeness which our artist has drawn..." GLEASON'S PICTORIAL DRAWING-ROOM COMPANION 1, (1851) ["Actress Adelaide Phillips." 1:6 (June 7, 1851): 84.]

IVIN. (ATLANTA, GA)
158 Portrait. Woodcut engraving, credited "From a Photograph by Ivin, Atlanta, Ga. FRANK LESLIE'S ILLUSTRATED NEWSPAPER 47, (1878) ["The late Lieut. H. H. Benner." 47:1208 (Nov. 23, 1878): 208.]

IWONSKI, CARL G. VON.
159 *Iwonski in Texas: Painter and Citizen.* San Antonio: Little Memorial Museum, 1976. 96 pp. 80 illus. [Exhibition catalog. (Aug. 1 - Sept. 30, 1976.) Iwonski was a self-taught artist, photographer, teacher and politician who lived in Texas in the 19th Century.]

IZARD, J. EDWIN.
160 Izard, J. Edwin. "Collodion on a Journey." HUMPHREY'S JOURNAL 7, no. 21 (Mar. 1, 1856): 337-338. [From J. of "Photo. Soc.," London." Having lately returned from a successful photographic excursion through France,..."]

161 "Collodion on a Journey." PHOTOGRAPHIC AND FINE ART JOURNAL 9, no. 3 (Mar. 1856): 72. [From "Journal of Photographic Society, London."]

<div style="text-align:center">

J

</div>

JACKSON & CO. (SOUTHSEA, ENGLAND)

J1 Portrait. Woodcut engraving credited "From a photograph by Jackson & Co." ILLUSTRATED LONDON NEWS 66, (1875) ["Capt. Stephenson, of the "Discovery." 66:1868 (May 29, 1875): 505.]

JACKSON BROTHERS. (JUMBO, near MANCHESTER, ENGLAND)

J2 "Art Photographs." PHOTOGRAPHIC NEWS 5, no. 148 (July 5, 1861): 312-313. [Views of Medlark Valley listed and described.]

J3 "Note." ART JOURNAL (Nov. 1862): 227. [Views of manufacturing destitution in Manchester.]

J4 "Note." ART JOURNAL (Sept. 1864): 282. [Notice of views of Yorkshire.]

JACKSON, ANDREW.

J5 "Long Island. - The New Long Island Club House - From a Photograph by Andrew Jackson." FRANK LESLIE'S ILLUSTRATED NEWSPAPER 32, no. 823 (July 8, 1871): 277. 1 illus. [View.]

JACKSON, WILLIAM. (LANCASTER, ENGLAND)

J6 "Communications." PHOTOGRAPHIC ART JOURNAL 5, no. 5 (May 1853): 302-303. [From "J. of Photo. Soc., London." Jackson, from Lancaster, England, claims to have made many successful photos of waves in motion.]

JACKSON, WILLIAM H. see also DETROIT PUBLISHING CO.

JACKSON, WILLIAM HENRY. (1843-1942) (USA)

[Born on Apr. 4, 1843 at Keesville, NY. Worked as a photographic retoucher and print colorist for C. C. Schoonmaker in Troy, NY in 1858. Worked for the Mowrey Studio in Rutland, VT in 1861. Jackson joined Company K, 12th Vermont Infantry, and served from 1862 to 1865. In 1866 he travelled west, working as a muleskinner and freight-hauler, and in a variety of odd jobs. During this time he sketched and painted in watercolors. In 1866 he set up a photographic studio in Omaha, NB, with his brother Edward. But very soon he began travelling and photographing views and taking portraits of Indians. In 1869 he photographed along the right of way of the newly completed Union Pacific Railroad with A. C. Hull. In 1870 he met Ferdinand V. Hayden, who invited Jackson to join his team making the U. S. Geological Survey of the Territories. Jackson closed his Omaha studio and worked as the official photographer for the Survey for the next eight years, travelling into Wyoming and Oregon in 1870, into the Yellowstone area in 1871 and 1872, then to Colorado, Utah, and Wyoming in 1873-74. In 1874-75 he photographed in New Mexico, and Utah. Back in Wyoming in 1876. This work gained for him an international reputation, and his work was well-known and frequently published in both the photographic and the general interest magazines. In 1879 he founded the Jackson Photo Co. in Denver, Colorado, which is the base from which he made extended photographic journeys throughout the West and the Southwest. Through 1880s and 1890s he travelled all over the United States and into Mexico, often photographing for various railroads, for example he photographed along the line of the Central Mexico railroad in 1883-84, the New York Central railroad in 1890, and the Baltimore & Ohio Railroad in 1892. In the mid 90s Jackson's photographs formed the core of several book publishing ventures, all illustrated with the cheap new photogravure methods becoming ore common to publishers. For example his photographs appear in *Camera Mosaics* in 1894, and his views of the Columbian World's Fair Exposition in 1894 were published in the *The White City Artfolio* and in several other formats. In 1895 Jackson was asked travel around the world, photographing and writing a series of articles for *Harper's Weekly* titled "Around the World with the Transportation Commission of the Field Columbian Museum," which appeared almost every week from February 1895 until August 1897. In 1898 Jackson became a partner in the Detroit Photographic Company and continued to travel and photograph all over the Eastern United States. Later he worked as the plant manager and promoter for the company until it failed in 1924. Jackson lived to be almost a hundred years old, not dying until 1942. In 1935 the National Park Service hired Jackson, then age 92, to paint four murals to illustrate each of the four federal surveys of the territories west of the Mississippi. After retirement from the Detroit Photographic Co. he often described his experiences as an explorer of the American West to the historical associations and groups which grew up in the 1920s and 1930s, and publishing several articles and books on his work. His advanced age and reputation, continued activity, and personality led him to become something of a minor celebrity in his latter years —in a period fueled by the prewar patriotism which was interested in recapturing American history and defining American values, added to the publication of his autobiography in 1940— and notices about his activities appeared in the *NY Times* and a variety of historical and art journals towards the end of his life. His death was noticed publicly more widely than any but a few other photographers. One published claim states that Jackson made over 54,000 glass plate negatives in his lifetime.]

BOOKS

J7 Jackson, William H. *Diaries 1867 - 69 and 1870, Aug. 1 - Nov. 1.* [In the manuscript collections of the New York Public Library.]

J8 *Catalogue of Stereoscopic 6" x 8" and 8" x 10" photographs by William H. Jackson, Photographer to the U. S. Geological Survey of the Territories;* Omaha, Nebraska. Washington, DC: Cunningham & McIntosh, Printers, 1871. 11 pp. [377 photographs listed. Views along the Union Pacific Rail Road. Cover notice: "Elegantly illus. books published by subscription" 1. "Sun Pictures of Rocky Mountain Scenery," text by F. V. Hayden, photos by W. H. Jackson. 2. "Camp Life in the Rocky Mountains" by F. V. Hayden; photographically illustrated with 19 camp views 6 x 8 and 28 vignettes by Wm. H. Jackson $10 150 copies to be pub. Mar. 1871. 3. "Rocky Mountain Album" will contain 60 to 100 views 6" x 8" with 50 to 75 pages descriptive text. 500 copies to be issued Spring '72. (Apparently something went wrong with this planned series. Hayden's "Sun Pictures" was issued, with photos by A. J. Russell, by another publisher and apparently the other titles did not appear either.)]

J9 *U. S. Geological and Geographical Survey of the Territories. Photographs of the Yellowstone National Park and Views in Montana and Wyoming Territories. W. H. Jackson, photographer.* Washington, DC: Government Printing Office, 1873. 37 b & w. [37 original prints.]

J10 U. S. Department of the Interior, United States Geoleogical Survey of the Territories. F. V. Hayden, U. S. Geologist-in-charge. *Descriptive Catalogue of the Photographs of the United States Geological Survey of the Territories, for the years 1869 to 1873, inclusive. W. H. Jackson, photographer.* "U. S. Geological and Geographical Survey of the Territories Misc. publications no. 5" Washington, DC: Government Printing Office, 1874. 83 pp. [2nd ed. (1875). Facsimile reprint of 1875 ed. Milwaukee, WI: Q Press, 1978. 81 pp.]

J11 Jackson, William H. *A Notice of the Ancient Ruins in Arizona and Utah Lying About the Rio San Juan.* Washington, DC: Government Printing Office, 1876. 20 pp. 8 l. of plates. 1 illus. [Offprint from "U.S.

Geological and Geographical Survey of the Territories Bulletin" 2:1 (1876): 24-45.]

J12 Hayden, F. V. *Ninth Annual Report of the United States Geological and Geographical Survey of the Territories, embracing Colorado and Parts of Adjacent Territories: Being a Report of Progress of the Exploration for the Year 1875.* Washington, DC: Government Printing Office, 1877. n. p. [References to photographic work of W. H. Jackson.]

J13 Jackson, W. H. ...*Descriptive Catalogue of Photographs of North American Indians.* "United States Geological and Geographical Survey of the Territories. Misc. Publication, 9." Washington, DC: Government Printing Office, 1877. vi, 124 pp.

J14 Jackson, W. H. *Report on the Ancient Ruins Examined in 1875 and 1877.* United States Geological and Geographical Survey of the Territories. Washington, DC: Government Printing Office, 1878. 150 pp. 24 illus. [Excerpt : U. S. Geological and Geographical Survey of the Territories Annual Report, 1878.]

J15 Jackson, William H. *Collection of Original Photographic Prints of Important Views in the Far West,* Many of which are evidently the earliest depictions ever made of the scenes. Several represent the art of F. Jay Haynes and Ezra Meeker, but the large majority are by the famous Pioneer Photographer. s. l.: s. n., 1880. n. p. 55 b & w. [Album. In all, 55 17" x 22" prints, mounted, tabbed and bound in one elephant folio volume., dated circa 1870. In the Eberstadt Collection of Americana. (The 1870 designation is too early).]

J16 Dutton, Clarence Edward. *Report on the Geology of the High Plateaus of Utah.* Washington, DC: Government Printing Office, 1880. n. p. 11 b & w. [Heliotypes of photos taken during the Powell survey of the Rocky Mountains in 1875-77. Photos could be by John Hillers and/or W. H. Jackson.]

J17 *Album of 52 Photographic Views made by W. H. Jackson during his scenic explorations in the interior of Colorado and Utah in the 70's.* Denver: s. n. [Jackson ?], ca. 1880. n. p. 52 b & w. [Album, in the Eberstadt Collection of Americana.]

J18 *Folding Album of 14 photographs of Streets and Scenes in Denver.* Denver: W. H. Jackson, ca. 1875. n. p. 14 b & w. [Album, in Eberstadt Collection of Americana.]

J19 *Descriptive Catalogue of Photographs of Rocky Mountain Scenery.* Denver: W. H. Jackson, 1882. 40 pp.

J20 Jackson, William H. *Colorado.* Denver: W. H. Jackson, 1882? n. p. 12 l. of plates. 12 b & w. [Album, George Eastman House collection.]

J21 *Twelfth Annual Report of the United States Geological and Geographical Survey of the Territories; A Report of Progress of the Exploration of Wyoming and Idaho for the Year 1878, by F. V. Hayden.* Washington, DC: Government Printing Office, 1883. 2 vol. illus.

J22 *Folder of 15 Photographic Views Including Pike's Peak, Long's Peak, Grand Canyon, Holy Cross, Silverton, and Alpine Pass.* Denver: s. n. [Jackson ?], ca. 1880. n. p. 15 b & w. [Album, in Eberstadt Collection of Americana.]

J23 *Picturesque Colorado.* Phototype illustrations by F. Gutekunst from original photographs by W. H. Jackson. Descriptive Text and sonnet by M. Virginia Donaghe. Denver: F. S. Thayer, 1887. n. p. [This work

is listed in the British Museum Catalogue. There are statements that Jackson's photographs were destroyed in a fire in Gutekunst's printing plant before the work was published. Perhaps an author's preliminary copy or macquette?]

J24 *Six Aquarelles from the Rockies,* with descriptive text by Stanley Wood. Denver: Denver Lithograph Co., 1891. 6 l. of plates. 6 illus. [Based on Jackson photos, subjects included Sitting Bull, Marshall Pass, Royal Gorge, etc. This attribution from the Eberstadt Collection of Americana, which may be incorrect.]

J25 *Gems of Colorado Scenery.* Denver: s. n., 1892. n. p. 45 b & w. [Illustrated with reproductions of over 45 photographs by Jackson. 10th ed. Denver: P. S. Thayer, 37 p.]

J26 *Camera Mosaics. A Portfolio of National Photography.* Introduction written by Mural Halstead, under the art direction of Harry C. Jones, text by Hjalmar H. Boyesen, et al. Published Weekly by Harry C. Jones, 92-94 5th Ave, N. Y. New York: Harry C. Jones, 1894. 1 vol. in 20 parts, many b & w. [First issued in twenty parts, then republished as a volume. Pt. 1, Mar. 31, 1894 - Pt. 20, Sept. 1, 1894. Nearly eighty photographers were published in this series. Wm. H. Jackson was the largest single contributor with forty-four 11" x 14" photos reproduced. William Notman had thirty-six photos printed. Most of the other contributors averaged around six to eight photos.]

J27 *Wonder-Places. The Most Perfect Pictures of Magnificent Scenes in the Rocky Mountains. The Master-works of the Worlds Greatest Photographic Artist, W. H. Jackson...* Chicago, Denver: The Great Divide Publishing Co., 1894. 8 pp. 21 l. of plates.

J28 Jackson, William H., Photographs. Descriptive text by Stanley Wood. *The White City Artfolio.* Chicago, Denver: White City Art Co., 1894. 1 vol. in 20 parts. 80 l. of plates. [Issued weekly, each fasicule consisted of four 14" x 17" plates, each with letterpress captions. The cumulated set consisted of eighty plates, in twenty parts. This set was probably also issued as a bound volume, with the title "The White City As It Was, Photographs of the World's Fair Columbian Exposition by William H. Jackson." "Jackson's Famous Pictures of the World's Fair" was another edition of the same materials, presented in a different format.]

J29 Stoddard, Charles Augustus. *Beyond the Rockies: A Spring Journey in California.* New York: Charles Scribner's Sons, 1894. 214 pp. 23 b & w. [" ...thanks are due Messrs. W. H. Jackson Co. of Denver, Taber of San Francisco and Watkins of San Francisco for the use of their photographs from which the illustrations in this book are made".]

J30 Jackson, William Henry. *Jackson's Famous Pictures of the World's Fair.* Chicago: White City Art Co., 1895. 2 pp. 84 l. of plates. [Text by Selim H. Peabody and Stanley Wood. Issued in 7 parts.]

J31 *Seeing Denver.* Denver: s. n. [Jackson?], 1895 ? 2 pp. 7 l. of plates. ["Photos by W. H. Jackson & H. F. Pierson."]

J32 Detroit Photographic Company. *List of Views from the W. H. Jackson Negatives in Silver, Carbon and Special Hand Colored Prints.* Detroit: Detroit Photographic Company, 1898. 104 pp. illus. [Cover title: Catalogue of W. H. Jackson's views.]

J33 Detroit Photographic Company. *Catalogue J: Part 2 and Part 2 Supplement: Photographs of American Scenery and Architecture.* Detroit: Detroit Photographic Company, 1901-1905. n. p. illus.

J34 Detroit Photographic Company. *Little "Phostint" Journeys.* Detroit: Detroit Photographic Company, 1912-1913. 38 vol. pp. illus

J35 Jackson, William H., in collaboration with Howard R. Driggs. *William H. Jackson. The Pioneer Photographer;* Rocky Mountain Adventures with a Camera… Illustrated with Sketches and Photographs made by the Author. "Pioneer Life Series." Yonkers-on-Hudson, NY: World Book Co., 1929. xii, 314 pp. illus.

J36 *Drawings of the Oregon Trail.* New York: s. n., 1920-1930. 6 l. of plates. illus. [Photostat reproduction of six drawings signed W. H. Jackson or W. H., some with ms. notes; scrapbook, including 1 mounted illus., made by the New York Public Library, 1930. Binder's title.]

J37 Blossom, F. A., editor. *Told to the Explorers Club. True Tales of Modern Exploration.* New York: The Explorers Club, 1931. 425 pp. illus. [Contains personal narrative of W. H. Jackson's trip across the plains by ox-team.]

J38 Driggs, Howard R. Illustrated by Wm. H. Jackson. *The Pony Express Goes Through; An American Saga Told by Its Heroes.* New York: F. A. Stokes Co., 1935. n. p. illus.

J39 Jackson, William H. *Time Exposure; the Autobiography of William H. Jackson; Profusely Illustrated with Photographs, Paintings, and Drawings by the Author.* New York: G. P. Putnam's Sons, 1940. 341 pp. b & w. illus. [(1970) reprinted. NY: Cooper Square Publishers. (1986) reprinted. Albuquerque, NM: Univ. of New Mexico Press. New introduction by Ferenc M. Szasz.]

J40 Driggs, Howard R., with reproductions of forty water-color paintings by Wm. H. Jackson. *Westward America.* "Trails Edition" New York: G. P. Putnam's Sons, 1942. x, 312 pp. 40 illus.

J41 Jackson, Clarence S. *Picture Maker of the Old West: William H. Jackson.* New York: Charles Scribner's Sons, 1947. x, 308 pp. 393 b & w. illus. [Photographs, sketches and paintings reproduced.]

J42 Jackson, Clarence S. and Lawrence W. Marshall. *Quest of the Snowy Cross.* Denver: Univ. of Denver Press, 1952. 135 pp. illus.

J43 Driggs, Howard R. Water-color paintings by Wm. H. Jackson. *The Old West Speaks…* Englewood Cliffs, NJ: Prentice-Hall, 1956. 220 pp. illus.

J44 Jackson, Clarence S. *Pageant of the Pioneers; the Veritable Art of William H. Jackson, Picture Maker of the Old West.* [Text] by C. S. Jackson. Minden Neb.: Harold Warp Pioneer Village, 1958. 89 pp. illus.

J45 Jackson, William. "With Moran in the Yellowstone," on pp. 49-61 in: *Thomas Moran, Explorer in Search of Beauty,* edited by Fritiof Melvin Fryxell. East Hampton, NY: East Hampton Free Library, 1958.

J46 Hafen, Leroy R. and Ann W. Hafen, editors, with introduction and notes. *The Diaries of William Henry Jackson, Frontier Photographer, to California & Return, 1866-67, and with the Hayden Surveys to the Central Rockies, 1873, and to the Utes and Cliff Dwellings, 1874.* "The Far West and the Rockies Historical Series, No. 10." Glendale, CA: A. H. Clark, 1959. 345 pp.

J47 Fielder, Mildred. *Railroads of the Black Hills.* Seattle, WA: Superior Publishing Co., 1964 [?]. 175 pp. illus. [Contains a portfolio from glass plate negatives taken by W. H. Jackson, from the Colorado State Historical Society.]

J48 Forsee, Aylesa. Illustrated with drawings by Douglas Gorshine, and with photographs by William Henry Jackson. *William Henry Jackson, Pioneer Photographer of the West.* New York: Viking Press, 1964. 206 pp. b & w. illus.

J49 Collman, Russ and Dell A. McCoy. Edited by Jackson C. Throde. *William Henry Jackson's Rocky Mountain Railroad Album: Steam and Steel across the Great Divide.* Silverton, CO: Sundance Press, 1965. n. p. b & w. illus.

J50 Miller, Helen Markley. *Lens on the West: The Story of William Henry Jackson.* Garden City, NY: Doubleday & Co., Inc., 1966. 192 pp. ["Illustrated with Photographs and Drawings by William Henry Jackson."]

J51 "William Henry Jackson," on pp. 90-93 in: *Great Photographers.* "Life Library of Photography" New York: Time/Life Publications, 1971. 4 b & w.

J52 U. S. Department of the Interior, Geological Survey. *Ferdinand Vandeveer Hayden and the Founding of the Yellowstone National Park.* Washington, DC: Government Printing Office, 1973. n. p.

J53 Mangan, Terry William. *Jackson's Colorado Negatives: A catalogue of plates from the William H. Jackson Collection.* Denver: Documentary Resources Department, State Historical Society of Colorado, 1974. 41 l. pp. 2 l. of plates.

J54 Newhall, Beaumont and D. E. Edkins. With a critical essay by William L. Broecker. *William H. Jackson.* Dobbs Ferry, NY: Morgan & Morgan, with the Amon Carter Museum of Art, 1974. 158 pp. 100 b & w.

J55 Jones, William C. and Elizabeth B. Jones. *William Henry Jackson's Colorado.* Foreword by Marshall Sprague. Boulder, CO: Pruett Publishing Co., 1975. xx, 172 pp. b & w. illus.

J56 Clark, Carol. *Thomas Moran: Watercolors of the American West.* Text and catalogue raisonné, by Carol Clark. Exhibition: Amon Carter Museum of Western Art, May 23 - July, 1980. Austin, TX: Univ. of Texas Press for the Amon Carter Museum of Western Art, 1980. 180 pp. 2 l. of plates. b & w. illus. [Contains photos taken by W. H. Jackson.]

J57 Hales, Peter B. *William Henry Jackson and the Transformation of the American Landscape.* Philadelphia: Temple University Press, 1988. xii, 356 pp. b & w. illus.

PERIODICALS

J58 Jackson, William H. "Reminiscences of a Summer Jaunt." PHOTOGRAPHIC WORLD 1, no. 3 (Mar. 1871): 72-74. [Discusses the Hayden expedition. A note on p. 128 in the Apr. 1871 issue mentions a new catalog of views of the Pacific R. R. and the Rocky Mountains by Jackson.]

J59 Langford, N. P. "The Wonders of the Yellowstone (Part 1)." SCRIBNER'S MONTHLY MAGAZINE 2, no. 1 (May 1871): 1-17. 12 illus. [The author describes his first trip to the Yellowstone area with the H. D. Washburn party in 1870. The illustrations are wood engravings. Langford will in a later issue (June 1873) also describe his second trip, this time with the Hayden Survey of 1872, accompanied by W. H. Jackson. (Background, interesting to see how the visual

representation of the landscape alters after photographs are available.)]

J60 Langford, N. P. "The Wonders of the Yellowstone (Part 2)." SCRIBNER'S MONTHLY MAGAZINE 2, no. 2 (June 1871): 113-128. 20 illus. [The wood-engravings, although designed to provide geological information (slate formations, geysers, etc.) are distorted by the artist's visual grammar and are not visually accurate. (Background.)]

J61 "'The New Wonder-Land.'" FRANK LESLIE'S ILLUSTRATED NEWSPAPER 33, no. 849 (Jan. 6, 1872): 263, 264-265. 1 illus. [Description of the Hayden survey. View of Yellowstone region, drawn by Henry W. Elliott, with a letter by Elliott. Jackson isn't mentioned. (Background.)]

J62 Hayden, F. V. "The Wonders of the West - II. More About the Yellowstone." CENTURY MAGAZINE (SCRIBNER'S MONTHLY) 3, no. 4 (Feb. 1872): 388-396. 11 illus. [N. P. Langford had written several articles about the Yellowstone area in May and June, 1871 "Scribner's Monthly." The articles were illustrated with woodcuts of the natural wonders, which were for the most part drawn from descriptions or sketches. Hayden's article is also illustrated with woodcuts, which are clearly more accurate representations and many are taken from W. H. Jackson's photos, although Jackson is not credited.]

J63 "Editor's Table." PHILADELPHIA PHOTOGRAPHER 9, no. 100 (Apr. 1872): 128. [Praise for Jackson's Yellowstone photos. "We have rarely if ever seen more interesting views..."]

J64 "Editor's Table - Landscape Work." PHILADELPHIA PHOTOGRAPHER 9, no. 100 (Apr. 1872): 128. [Mentions W. H. Jackson, J. J. Reilly as photographers of Western mountains, W. McLeish of St. Paul, MN.]

J65 "Summit of Mount Baker, Washington Territory." ILLUSTRATED LONDON NEWS 60, no. 1712 (June 29, 1872): 621, 624. 2 b & w. ["The views we have engraved from the photographs taken in the summer of last year by Hayden's Geological Surveying Expedition..."]

J66 "Editor's Table - Stereoscopic Views of the West." PHILADELPHIA PHOTOGRAPHER 10, no. 110 (Feb. 1873): 64.

J67 "The Geysers of North America." ILLUSTRATED LONDON NEWS 62, no. 1744 (Feb. 1, 1873): 104-105, 106. 2 illus. ["Mr. W. H. Jackson, photographer to these expeditions, supplied the views..."]

J68 Langford, N. P. "The Ascent of Mount Hayden: A New Chapter of Western Discovery." CENTURY MAGAZINE (SCRIBNER'S MONTHLY) 6, no. 2 (June 1873): 129-157. 15 illus. [Langford invited to join the Hayden Survey of July 1872, to explore the Yellowstone area. Illustrated with wood engravings, including one of W. H. Jackson at his camera titled "Photographing in High Places" on p. 140. Describes Jackson's work briefly on p. 140.]

J69 "Our National Park. - The Yellowstone Region. From Photographs Furnished by Professor F. V. Hayden, of the Yellowstone Expedition." FRANK LESLIE'S ILLUSTRATED NEWSPAPER 36, no. 924 (June 14, 1873): 223, 225. 5 illus. [Views. "We are constrained, from the poverty of language, to fly to the pencil so that we may give an adequate idea of some of the wonders that people this vast and mysterious valley; and hence we publish today a series of engravings, from photographs taken on the spot by our artist, which cannot fail to excite the deepest interest,..."]

J70 "The Yellowstone Expedition. - The Great National Park." FRANK LESLIE'S ILLUSTRATED NEWSPAPER 36, no. 934 (Aug. 23, 1873): 383, 385. 4 illus. [Views.]

J71 "Meum et Tuum." ANTHONY'S PHOTOGRAPHIC BULLETIN 4, no. 11 (Nov. 1873): 321. [Advertisement for a camera incorporates a letter from W. H. Jackson praising its working "...although it has been over the great snowy ranges of Colorado, has rolled down steep hills on mules, been under the river, but...has suffered...no...injury."]

J72 W. D. W. "Colorado Photographed." ANTHONY'S PHOTOGRAPHIC BULLETIN 5, no. 2 (Feb. 1874): 76-78. [Extracted from "American J. of Arts and Sciences, Vol. 6 (Dec. 1873)." Detailed description of Jackson's photographs taken during Hayden's 1873 survey.]

J73 "The Yellowstone Lake Region of North America." ILLUSTRATED LONDON NEWS 64, no. 1815 (June 6, 1874): 527-528. 2 illus. ["We are indebted to Mr. Serjeant Sleigh, who has travelled in that part of North America, for the use of some finely-executed photographs, taken under the direction of Professor F. V. Hayden..."]

J74 "The Yellowstone Hot Springs." ILLUSTRATED LONDON NEWS 65, no. 1822 (July 25, 1874): 81. 2 illus. ["We were lately indebted to Serjeant Sleigh for the opportunity of copying a set of photographs brought from America by him..."]

J75 "Liverpool Amateur Photographic Association." ANTHONY'S PHOTOGRAPHIC BULLETIN 5, no. 8 (Aug. 1874): 280. [Excerpt from "Br. J. of Photo. (Apr. 10, 1874)," describing O. R. Green showing 40 prints of Colorado, etc. taken by William H. Jackson on Hayden's Survey Expedition, to the Liverpool Photo. Society and the favorable response engendered.]

J76 "Dr. F. V. Hayden, United States Geologist." FRANK LESLIE'S ILLUSTRATED NEWSPAPER 38, no. 986 (Aug. 22, 1874): 380. 2 illus. [Studio portrait of Hayden (Photographer not identified.), with a biography, and an outdoor group portrait of "Professor F. V. Hayden's Expedition in Camp, on the North Platte River, Colorado. - Photographed by W. H. Jackson."]

J77 "The Mammoth Hot Springs, Yellowstone, North America." ILLUSTRATED LONDON NEWS 65, no. 1827 (Aug. 29, 1874): 199-200. 1 illus. ["...from a set of photographs presented to Serjeant Sleigh by the United States Government officers during his visit to America." Mentions the "small book" 'Wonders of the Yellowstone Region,' edited by James Richardson (Blackie & Son), compiled from reports of Dr. F. V. Hayden, Mr. Langford, Cd. Barlors, Lieut. Doane, and others.]

J78 "Professor Hayden's Expedition to the Rocky Mountains - Packers 'Sinching' Up. - Photographed by W. H. Jackson." and "Professor Hayden's Expedition to the Rocky Mountains. - Major Pease's Ranch on the Yellowstone. - Photographed by W. H. Jackson." FRANK LESLIE'S ILLUSTRATED NEWSPAPER 39, no. 990 (Sept. 19, 1874): 21, 23. 2 illus. [Muleskinners loading a pack on a mule. Two men in a corral, with a pet deer.]

J79 "Quarrying Granite for the Mormon Temple, in Cottonwood Canyon, Utah. - Photographed by W. H. Jackson." FRANK LESLIE'S ILLUSTRATED NEWSPAPER 39, no. 997 (Nov. 7, 1874): 141, 142. 1 illus. [Men outdoors, at work.]

J80 Jackson, William H. "Correspondence." ANTHONY'S PHOTOGRAPHIC BULLETIN 5, no. 12 (Dec. 1874): 419. [Letter praising "Z Success camera."]

J81 "Colorado. - The Gateway to the Garden of the Gods." and "Wyoming Territory. - Unitah Mountains, at the Head of the Black Fork River. - Photographed by Professor W. H. Jackson, of Professor Hayden's Expedition." FRANK LESLIE'S ILLUSTRATED NEWSPAPER 39, no. 1001 (Dec. 5, 1874): 212. 2 illus. [Two large landscape views.]

J82 "Editor's Table - U.S. Geological Survey of the Territories." PHILADELPHIA PHOTOGRAPHER 12, no. 133 (Jan. 1875): 30. [Hayden survey 1874. New Mexico, Rio Grande.]

J83 "Fire." PHILADELPHIA PHOTOGRAPHER 12, no. 134 (Feb. 1875): 54. [Report of Fire at Photo-Plate Printing Co. of Mr. E. Bierstadt, New York, NY, on Jan 13, 1875. "greatest loss was negatives ... to be used for an illus. book of Western scenery, and their loss will make it impossible to do the work at all....Negatives made by Mr. Jackson in the Yellowstone Park."]

J84 Jackson, William H. "Field Work." PHILADELPHIA PHOTOGRAPHER 12, no. 135 (Mar. 1875): 91-93.

J85 "Colorado. - 'Robber's Roost,' at Virginia Dale, on Dale Creek. - Photographed by W. H. Jackson." FRANK LESLIE'S ILLUSTRATED NEWSPAPER 40, no. 1026 (May 29, 1875): 193. 1 illus. [View of buildings. "The worst specimens of the mining element held high carnival there."]

J86 "Landscape Photography and Pocket Cameras." PHOTOGRAPHIC TIMES 5, no. 55 (July 1875): 168-169. 1 illus. [Primarily an article promoting the Scovill equipment, it contains an extract from a letter by W. H. Jackson, photographer to Professor Hayden's Expedition,... stating his pleasure with the camera.]

J87 "The Hayden Expedition. - A Beaver Dam on Henry's Fork of Green River, Utah. - From a Photograph by W. H. Jackson." FRANK LESLIE'S ILLUSTRATED NEWSPAPER 41, no. 1043 (Sept. 25, 1875): 44. 1 illus. [View.]

J88 Powell, Major J. W. "The Ancient Province of Tusayan." CENTURY MAGAZINE (SCRIBNER'S MONTHLY) 11, no. 2 (Dec. 1875): 193-213. 19 illus. [Woodcuts, from photos, of Pueblo Indian villages and prehistoric ruins. Jackson's investigations of the cliff-dwellings mentioned on p. 213.]

J89 Jackson, W. H. "Return of Mr. W. H. Jackson." ANTHONY'S PHOTOGRAPHIC BULLETIN 7, no. 1 (Jan. 1876): 31. [Letter from Jackson, praising the 20" x 24" outfit supplied him by the Anthony Co.]

J90 "Wyoming Territory. - Natural Bridge - La Prele Canon on the North Platte - View from Below. - Photo. by W. H. Jackson." FRANK LESLIE'S ILLUSTRATED NEWSPAPER 41, no. 1058 (Jan. 8, 1876): 285, 286. 1 illus. [View.]

J91 "Interesting American Scenery." PHILADELPHIA PHOTOGRAPHER 13, no. 148 (Apr. 1876): 120-122.

J92 "Letter." PHOTOGRAPHIC TIMES 6, no. 64 (Apr. 1876): 75. [Letter from W. H. Jackson describing how some negative plates for the Scovill Pocket Camera worked in the field on a Geological Survey mission. Apparently a Mr. Gannett, a Mr. Holmes, and/or a Mr. H. Loring actually used the materials to make pictures. Gannett's work lost to an Indian raid. Holmes or Loring made about 75 exposures.]

J93 "Photographs of Rocky Mountain Scenery, and its Prehistoric Ruins." ANTHONY'S PHOTOGRAPHIC BULLETIN 7, no. 6 (June 1876): 187. [From "Denver, Rocky Mountain Presbyterian."]

J94 Hardacre, Emma C. "The Cliff-Dwellers." CENTURY MAGAZINE (SCRIBNER'S MONTHLY) 17, no. 2 (Dec. 1878): 266-276. 10 illus. [Prehistoric pueblos. W. H. Jackson's investigations of these ruins in 1874 discussed. Jackson and W. H. Holmes credited with supplying "sketches and valuable information" to the author.]

J95 Skertchly, Sydney, B. J. "The Cliff-Dwellers of the Far West." GOOD WORDS 20, no. 7 (July 1879): 486-492. 1 illus. [The author describes his experience visiting the Indian ruins, praises Jackson and W. H. Holmes for their work producing the "Tenth Annual Report of the U. S. Geological Survey of the Territories," by F. V. Hayden. Washington, 1878.]

J96 "Editor's Table." PHILADELPHIA PHOTOGRAPHER 16, no. 188 (Aug. 1879): 255. ["We notice by the "Tribune," Denver, Colorado, that Mr. William Jackson, ex-photographer of the U. S. Geological Survey, has settled in Denver, and will continue to follow his profession in that city, both as portrait and landscape photographer."]

J97 "Matters of the Month - Photography in Denver." PHOTOGRAPHIC TIMES 9, no. 106 (Oct. 1879): 234. [Jackson opening Denver studio.]

J98 "Correspondence." ANTHONY'S PHOTOGRAPHIC BULLETIN 10, no. 11 (Nov. 1879): 352. [Jackson (Denver, CO) praising equipment.]

J99 "Matters of the Month." PHOTOGRAPHIC TIMES 10, no. 119 (Nov. 1880): 254. [Letter from Jackson praising the equipment... "I start off tomorrow with it for a long trip into the San Juan mountains, on the southern border of our State (Colorado) dated Oct. 2, 1880.]

J100 "General Notes." PHOTOGRAPHIC TIMES 16, no. 230 (Feb. 12, 1886): 94. [Note that Jackson "...now appears as the prime mover in a scheme to form a fund for the exploring of sites of settlements in Colorado made by vanished races of men...and the establishment of a museum in Denver..."]

J101 "El Capitan." PHOTOGRAPHIC TIMES 19, no. 404 (June 14, 1889): 291. 1 b & w. [Yellowstone view.]

J102 "Editorial Notes." PHOTOGRAPHIC TIMES 20, no. 437 (Jan. 31, 1890): 53-54. [Note that Jackson visited the editor in New York on his way to Florida.]

J103 "The Aspen (Colorado) Mining District: Colorado - Properties of the Grand River Coal and Coke Company." FRANK LESLIE'S ILLUSTRATED NEWSPAPER 70, no. 1797 (Feb. 22, 1890): 67-68. 7 illus. [Sketches from photographs, on p. 67. Mining buildings, etc. Engraved from photos by Jackson & Co., Denver.]

J104 Codman, John. "The Shoshone Falls." CENTURY MAGAZINE 39, no. 6 (Apr. 1890): 924-927. 2 illus. ["Engraved by E. Kingsley from photographs by W. H. Jackson & Co." (Radically altered.)]

J105 1 b & w ("Untitled view."). SUN AND SHADE no. 23 (July 1890): n. p.

J106 "Notes and News." PHOTOGRAPHIC TIMES 20, no. 460 (July 11, 1890): 336. ["Mr. W. H. Jackson, of Denver, Col., is photographing the Hudson River scenery in the interest of the NY Central R. R."]

J107 "Notes and News: Advertising a Railroad by Photographs." PHOTOGRAPHIC TIMES 20, no. 476 (Oct. 31, 1890): 544. [W. H. Jackson's photos of the New York Central R.R. displayed at the Company's office in New York.]

J108 "Editorial Comment: Danger Attending the Transportation of Flash Powder." AMERICAN AMATEUR PHOTOGRAPHER 3, no. 3 (Mar. 1891): 103. [Note that some baggage of Jackson's, containing flash powder, exploded through rough handling by railway employees.]

J109 "Notes and News." PHOTOGRAPHIC TIMES 21, no. 503 (May 8, 1891): 225. [Mr. W. H. Jackson, of Denver, has recently returned from Mexico, where he made about 600 negatives of the best scenery Mexico affords...]

J110 1 photo (Ice Formations; Luna Island, Niagara Falls, in Winter). FRANK LESLIE'S ILLUSTRATED NEWSPAPER 74, no. 1907 (Mar. 31, 1892): 152. 1 b & w. ["From a photograph by W. H. Jackson, Denver, CO, Published by permission of New York Central and Hudson River Railroad."]

J111 Gunckel, Lewis W. "In Search of a Lost Race. V. Ruins and Picture-Writing in the Canyons of the McElmo and Hovenweep." ILLUSTRATED AMERICAN 11, no. 124 (July 2, 1892): 325-328. [Series of articles on "'The Illustrated American's' Expedition, Sent to Explore the Ruined Pueblos of the Southwest." On p. 328, this article mentions W. H. Jackson's prior visit "sixteen years ago," gives reference. W. H. Jackson's "Report of the ancient ruins in Arizona and Utah, lying about the Rio San Juan, p. 28."]

J112 Moran, Thomas. "A Journey to the Devil's Tower in Wyoming. (Artist's Adventures.)" CENTURY MAGAZINE 47, no. 3 (Jan. 1894): 450-454. 4 illus. ["With pictures by the Author." "We were on our way to the Yellowstone... Our party consisted of Jackson, the photographer, of Denver; young Millet, his assistant; and myself."]

J113 "William H. Jackson." WILSON'S PHOTOGRAPHIC MAGAZINE. 32, no. 458 (Feb. 1895): 77-78. 1 illus. [Portrait of Jackson by W. M. Morrison of Chicago. The article mentions the start of Jackson's three year journey around the world with the World Transportation Commission of the Field Columbian Museum.]

J114 Jackson, William H. "Around the World with the Transportation Commission of the Field Columbian Museum: In Tunis and on the Site of Ancient Carthage." HARPER'S WEEKLY (Feb. 23, 1895): 180-182. 13 b & w.

J115 Jackson, William H. "Around the World with the Transportation Commission of the Field Columbian Museum: Biserte and the Outskirts of Constantine." HARPER'S WEEKLY (Mar. 2, 1895): 208-209. 10 b & w.

J116 Jackson, William H. "Around the World with the Transportation Commission of the Field Columbian Museum: Algiers and Oran." HARPER'S WEEKLY (Mar. 9, 1895): 229, 234. 8 b & w.

J117 Jackson, William H. "Around the World with the Transportation Commission of the Field Columbian Museum: Tangier, Morocco." HARPER'S WEEKLY (Mar. 23, 1895): 278, 285. 3 b & w. 1 illus. [Drawing by Edward Winchell.]

J118 Jackson, William H. "Around the World with the Transportation Commission of the Field Columbian Museum: The Pyramids and the Site of Ancient Memphis." HARPER'S WEEKLY (Mar. 30, 1895): 303-304. 6 b & w.

J119 Jackson, William H. "Around the World with the Transportation Commission of the Field Columbian Museum: The Isthmus of Suez." HARPER'S WEEKLY (Apr. 6, 1895): 327-329. 14 b & w.

J120 Jackson, William H. "Around the World with the Transportation Commission of the Field Columbian Museum: In Aden." HARPER'S WEEKLY (Apr. 13, 1895): 353. 3 b & w.

J121 Jackson, William H. "Around the World with the Transportation Commission of the Field Columbian Museum: Ceylon and its Capital Colombo." HARPER'S WEEKLY (Apr. 27, 1895): 398-399. 5 b & w.

J122 Jackson, William H. "Around the World with the Transportation Commission of the Field Columbian Museum: Native Methods of Transportation." HARPER'S WEEKLY (May 11, 1895): 439-444. 6 b & w.

J123 Jackson, William H. "Around the World with the Transportation Commission of the Field Columbian Museum: Ceylon." HARPER'S WEEKLY (May 18, 1895): 463, 465. 6 b & w.

J124 Jackson, William H. "Around the World with the Transportation Commission of the Field Columbian Museum: Ceylon - Railways." HARPER'S WEEKLY (May 25, 1895): 487-488. 6 b & w.

J125 "Our Pictures." WILSON'S PHOTOGRAPHIC MAGAZINE. 32, no. 461 (May 1895): frontispiece, 235. 1 b & w. [Original photo tipped-in, scenery on the Denver & Rio Grande R.R.]

J126 "Editor's Table: Carbutt's Films in Hot Countries." WILSON'S PHOTOGRAPHIC MAGAZINE. 32, no. 461 (May 1895): 238. [Letter from Jackson (in Calcutta) praising Carbutt's films. Jackson was on a round-the-world trip at this time.]

J127 Jackson, William H. "Around the World with the Transportation Commission of the Field Columbian Museum: Ceylon - Railway Stations." HARPER'S WEEKLY (June 8, 1895): 541-542. 6 b & w.

J128 Jackson, William H. "Around the World with the Transportation Commission of the Field Columbian Museum: Ceylon - Bungalows." HARPER'S WEEKLY (June 15, 1895): 559-560. 7 b & w.

J129 Jackson, William H. "Around the World with the Transportation Commission of the Field Columbian Museum: Ceylon: Tea-Growing." HARPER'S WEEKLY (June 1, 1895): 511, 520. 8 b & w.

J130 Jackson, William H. "Around the World with the Transportation Commission of the Field Columbian Museum: India - Tuticorin." HARPER'S WEEKLY (July 13, 1895): 653, 662. 6 b & w.

J131 Jackson, William H. "Around the World with the Transportation Commission of the Field Columbian Museum: Southern India - Madura." HARPER'S WEEKLY (July 20, 1895): 680, 686. 6 b & w.

J132 Jackson, William H. "Around the World with the Transportation Commission of the Field Columbian Museum: Southern India - Trichninopolyu." HARPER'S WEEKLY (July 27, 1895): 705, 707. 6 b & w.

J133 Jackson, William H. "Around the World with the Transportation Commission of the Field Columbian Museum: Southern India - South

India Railway." HARPER'S WEEKLY (Aug. 3, 1895): 722, 724. 8 b & w.

J134 Jackson, William H. "Around the World with the Transportation Commission of the Field Columbian Museum: Southern India - Madras." HARPER'S WEEKLY (Aug. 10, 1895): 760, 762. 8 b & w.

J135 Jackson, William H. "Around the World with the Transportation Commission of the Field Columbian Museum: Great Indian Peninsular Railway." HARPER'S WEEKLY (Aug. 17, 1895): 781-782. 8 b & w.

J136 Jackson, William H. "Around the World with the Transportation Commission of the Field Columbian Museum: India Northwest Provinces." HARPER'S WEEKLY (Aug. 31, 1895): 825, 830. 9 b & w.

J137 1 photo ("A Mexican Wash-House"). WILSON'S PHOTOGRAPHIC MAGAZINE 32, no. 464 (Aug. 1895): unnumbered leaf. [Photograph. This unnumbered leaf is bound in after page 368 (Aug. 1895), but I think that was a binder's error - one of several in this volume.]

J138 Jackson, William H. "Around the World with the Transportation Commission of the Field Columbian Museum: Great Military Railway." HARPER'S WEEKLY (Sept. 14, 1895): 866, 869. 6 b & w.

J139 Jackson, William H. "Around the World with the Transportation Commission of the Field Columbian Museum: Northwest India - Lahore." HARPER'S WEEKLY (Sept. 21, 1895): 893-894. 7 b & w.

J140 Jackson, William H. "Around the World with the Transportation Commission of the Field Columbian Museum: Northwest India and the Khyber Pass." HARPER'S WEEKLY (Sept. 28, 1895): 927, 928. 8 b & w.

J141 Jackson, William H. "Around the World with the Transportation Commission of the Field Columbian Museum: Northern India - Delhi." HARPER'S WEEKLY (Oct. 5, 1895): 938, 942. 8 b & w.

J142 Jackson, William H. "Around the World with the Transportation Commission of the Field Columbian Museum: Kashmir." HARPER'S WEEKLY (Oct. 12, 1895): 974. 4 b & w.

J143 Jackson, William H. "Around the World with the Transportation Commission of the Field Columbian Museum: Agra." HARPER'S WEEKLY (Oct. 19, 1895): 986, 1000. 6 b & w.

J144 Jackson, William H. "Around the World with the Transportation Commission of the Field Columbian Museum: Benares, the Holy City." HARPER'S WEEKLY (Oct. 26, 1895): 1015-1016. 9 b & w.

J145 Jackson, William H. "Around the World with the Transportation Commission of the Field Columbian Museum: The Ganges." HARPER'S WEEKLY (Nov. 2, 1895): 1046. 4 b & w.

J146 Jackson, William H. "Around the World with the Transportation Commission of the Field Columbian Museum: India River Transport." HARPER'S WEEKLY (Nov. 9, 1895): 1058. 4 b & w.

J147 Jackson, William H. "Around the World with the Transportation Commission of the Field Columbian Museum: The Burmah Railway." HARPER'S WEEKLY (Nov. 23, 1895): 1106, 1120. 5 b & w.

J148 Jackson, William H. "Around the World with the Transportation Commission of the Field Columbian Museum: Upper Burmah and Mandalay." HARPER'S WEEKLY (Nov. 30, 1895): 1142. 4 b & w.

J149 Jackson, William H. "Around the World with the Transportation Commission of the Field Columbian Museum: Elephant Workers." HARPER'S WEEKLY (Dec. 21, 1895): 1221. 6 b & w.

J150 Jackson, William H. "Around the World with the Transportation Commission of the Field Columbian Museum: Siam and its Capital." HARPER'S WEEKLY (Dec. 28, 1895): 1246-1247. 12 b & w.

J151 Jackson, William H. "Around the World with the Transportation Commission of the Field Columbian Museum: Singapore and the Straits Settlements." HARPER'S WEEKLY (Feb. 15, 1896): 161. 5 b & w.

J152 "Editor's Table: Visitors." WILSON'S PHOTOGRAPHIC MAGAZINE 33, no. 472 (Apr. 1896): 190. [Note that Jackson visited Wilson on his return from his around-the-world trip for the Columbian Field Museum.]

J153 Jackson, William H. "Around the World with the Transportation Commission of the Field Columbian Museum: Siam and Penang." HARPER'S WEEKLY (May 9, 1896): 465-466. 6 b & w.

J154 Jackson, William H. "Around the World with the Transportation Commission of the Field Columbian Museum: Java." HARPER'S WEEKLY (May 16, 1896): 491-492. 6 b & w.

J155 Jackson, William H. "Around the World with the Transportation Commission of the Field Columbian Museum: China Today. Pt. 1." HARPER'S WEEKLY (May 30, 1896): 537, 539. 11 b & w.

J156 Jackson, William H. "Around the World with the Transportation Commission of the Field Columbian Museum: China Today. Pt. 2. " HARPER'S WEEKLY (June 6, 1896): 561-563, 566. 17 b & w.

J157 1 photo ("The Falls of Yellowstone, Yellowstone National Park"). DEMOREST'S MONTHLY MAGAZINE 32, no. 11 (Sept. 1896): 600. 1 b & w.

J158 Jackson, William H. "Around the World with the Transportation Commission of the Field Columbian Museum: The Revolt in the Philippine Islands - Scenes in Manila and its Suburbs." HARPER'S WEEKLY (Jan. 2, 1897): 4-5, 18. 16 b & w.

J159 Jackson, William H. "The Wool Growing Industry in Australia." HARPER'S WEEKLY (Jan. 16, 1897): 60, 62. 4 b & w.

J160 Jackson, William H. "Korea and its People." HARPER'S WEEKLY (July 24, 1897): 728-729.

J161 Jackson, William H. "Scenes in New Zealand." HARPER'S WEEKLY (July 17, 1897): 717, 720. 8 b & w.

J162 Jackson, William H. "By Sledge and Rail across Siberia. From Vladivostok to Khabarovka." HARPER'S WEEKLY (Aug. 14, 1897): 805-810. 28 b & w.

J163 Jackson, William H. "By Sledge and Rail across Siberia. Pt. 2 - Khabarovka to Lake Baikal." HARPER'S WEEKLY (Aug. 21, 1897): 829-834. 28 b & w.

J164 Jackson, William H. "By Sledge and Rail across Siberia. Pt. 3 - Lake Baikal to Europe." HARPER'S WEEKLY (Aug. 28, 1897): 853-857. 33 b & w.

J165 "The Trouble in Northern India - Kyber Pass, Captured by the Revolting Afridis, and its Vicinity." HARPER'S WEEKLY (Sept. 4, 1897): 872-873, 886. 14 b & w. [Photographs by Jackson and others.]

J166 1 photo ("Festival of Mountain and Plains at Denver Colorado - Procession of October 6 Passing the Grand Stand.") HARPER'S WEEKLY 41, no. 2132 (Oct. 30, 1897): 1073, 1074. ["After a Photograph by W. H. Jackson." Chinese dragon float in parade.]

J167 Jackson, William H. "Across Korea on Horseback." HARPER'S WEEKLY (Jan. 15, 1898): 59-61. b & w.

J168 "Picturesque America in Colors." WILSON'S PHOTOGRAPHIC MAGAZINE 35, no. 496 (Apr. 1898): 178-179. [From the "Detroit Journal." Jackson closed his Denver Studio, moving to Detroit to join the Photochrome Publishing Co.]

J169 Bonsal, Stephen. "Eastern Siberia." HARPER'S MONTHLY 97, no. 578 (July 1898): 240-259. 5 b & w. 10 illus. ["Illustrated from Drawings...and from Photographs by W. H. Jackson and by the Author." The drawings were probably taken from photos.]

J170 Bonsal, Stephen. "The Convict System in Siberia." HARPER'S MONTHLY 97, no. 579 (Aug. 1898): 327-342. 6 b & w. 6 illus. ["Illustrated with Drawings...and from Photographs by W. H. Jackson."]

J171 Walker, Francis. "Colorado Springs and Round About Pike's Peak." NEW ENGLAND MAGAZINE 25, no. 2 (Oct. 1901): 236-255. 17 b & w. 2 illus. [Views of Colorado Springs, surrounding territory. Two views credited to the "Detroit Publishing Co." (Wm. Henry Jackson).]

J172 Fairman, Charles E. "The Direction of Photographic Progress." AMERICAN ANNUAL OF PHOTOGRAPHY AND PHOTOGRAPHIC TIMES-BULLETIN ALMANAC FOR 1904 (1904): 132-134. [W. H. Jackson's landscapes held up as examples of work not topped by present day photographers.]

J173 Jackson, W. H. "First Official Visit to the Cliff Dwellings." COLORADO MAGAZINE 1, no. 4 (May 1924): 151-159. 1 b & w. [Account of the U.S. Geological Survey Expedition of 1874.]

J174 Jackson, William H. "Who First Photographed the Rockies?" THE TRAIL (Feb. 1926): 12-16. [Article ia about S. Carvalho in 1853.]

J175 Jackson, W. H. "Photographing the Colorado Rockies Fifty Years Ago for the U.S. Geological Survey." COLORADO MAGAZINE 3, no. 1 (Mar. 1926): 11-22. 3 b & w.

J176 Jackson, William H. "Address Regarding First Photographing the Tetons." ANNALS OF WYOMING 6, no. 1 (July 1929): 189-191. [Photographing the Teton mountains in 1872.]

J177 Greenleaf, C. J. "William H. Jackson, Photographer." PHOTO ERA 65, no. 9 (Sept. 1930): 135-138. 1 illus.

J178 Greenleaf, C. J. "William H. Jackson: A Short Sketch of His Life, Service, and What He Hopes to Accomplish." AMERICAN PHOTOGRAPHY 24, no. 10 (Oct. 1930): 520-528. 4 b & w. 1 illus.

J179 Jackson, William H. "The Most Important Nebraska Highway, Nebraska City - Fort Kearny - Denver Trail, or 'Steam Wagon Road.'" NEBRASKA HISTORY MAGAZINE 13, no. 3 (July - Sept. 1932): 137-159. 2 illus. [From W. H. Jackson's diary of 1866, when he worked as a muleskinner and trail driver; before he took up photography.]

J180 Fryxell, Fritiof. "The Mount of the Holy Cross." TRAIL AND TIMBERLINE (DENVER) no. 183 (Jan. 1934): 7-8.

J181 "Jackson Revisits Santa Fe." EL PALACIO (SANTA FE) 41, (July - Aug. 1936): 28-29.

J182 Jackson, William H. "Famous American Mountain Paintings I: With Moran in the Yellowstone." APPALACHIA (Dec. 1936): *.

J183 Jackson, W. H. "A Visit to the Los Pinos Indian Agency in 1874; Extract from the Diary of W. H. Jackson, with an introduction and notes by the original diarist." COLORADO MAGAZINE 15, no. 6 (Nov. 1938): 201-209. 2 b & w. 2 illus.

J184 Fryxell, Fritiof. "William H. Jackson, Photographer, Artist, Explorer." AMERICAN ANNUAL OF PHOTOGRAPHY 1939 53, (1939): 208-220. 6 b & w. 1 illus.

J185 Detzer, K. "Portrait of a Pioneer: Father of the Picture Postcard and Discoverer of Yellowstone National Park." READERS DIGEST 34, no. 6 (June 1939): 29-32.

J186 Borland, H. "Camera Historian: W. H. Jackson, Pioneer Photographer of the West." NEW YORK TIMES MAGAZINE (Apr. 7, 1940): 4, +. illus.

J187 "Camera Pioneer." TIME (Apr. 15, 1940): 43-44. 1 illus.

J188 "His Adventures of 97 Years told by Pioneer Photographer." NEWSWEEK (July 29, 1940): 41. illus.

J189 Nevins, A. "Pioneer in Photography." SATURDAY REVIEW OF LITERATURE 22, no. 7 (Sept. 7, 1940): 7. illus.

J190 "Time Exposure: The Autobiography of W. H. Jackson." U. S. CAMERA 1, no. 11 (Oct. 1940): 64.

J191 Jackson, William H., Pictures. Text by Hartley Howe. "William Henry Jackson, Frontier Lensman." U. S. CAMERA ANNUAL 1941 (VOL. 1) (1941): 65-92. 29 b & w.

J192 Jackson, William. "Mountaineering Photography, Old Style." AMERICAN ALPINE JOURNAL no.2 (1941): 214-218. b & w.

J193 Jackson, William. "Finding the Lost Cities: Excerpt from 'Time Exposure.'" SCHOLASTIC (Mar. 24, 1941): 20-21. 1 illus. [Also a biographical note and portrait.]

J194 "Photographer-Painter Nears 100 Mark." HOBBIES 46, no. 6 (June 1941): 46.

J195 "Obituary." NY TIMES (July 1, 1942): n. p.

J196 "Obituary." PUBLISHERS WEEKLY 142, (July 11, 1942): 120.

J197 "Obituary." TIME 40, (July 13, 1942): 51.

J198 "Obituary." ART DIGEST 16, (Aug. 1942): 20.

J199 "Obituary." MUSEUM NEWS 20, (Sept. 1, 1942): 3.

J200 "William Henry Jackson." U. S. CAMERA 5, no. 9 (Sept. 1942): 22-23, 65. 5 b & w.

J201 "He Pictured the West." NEWSWEEK (Sept. 15, 1947): 94. illus.

J202 Beebe, L. "Pioneer with Camera: Review of 'Picture Maker of the Old West,' by C. S. Jackson." SATURDAY REVIEW OF LITERATURE (Sept. 6, 1947): 11-12. illus.

J203 Dibble, Charles E. "Records by Pen and Camera." UTAH HUMANITIES REVIEW 2, no. 3 (Oct. 1948): 347-350. [Jackson in Utah, 1866-1877.]

J204 Vanderbilt, Paul. "William Henry Jackson in the East." U. S. CAMERA 12, no. 5 (May 1949): 44-47. 9 b & w. [Discussion of Jackson's photography in the Eastern half of the United States, for the Detroit Publishing Co., etc.]

J205 "Prints and Photographs." QUARTERLY JOURNAL OF THE LIBRARY OF CONGRESS 7, no. 1 (Nov. 1949): *. [History and description of the collection of 30,000 glass-plate negatives made in the Eastern United States by William H. Jackson, when he was associated with the Detroit Publishing Co. Jackson's negatives taken west of the Mississippi River are held at the State Historical Society of Colorado, Denver.]

J206 Robinson, Harry B. "The William H. Jackson Memorial Wing at Scott's Bluff National Monument." NEBRASKA HISTORY 31, (June 1950): 126-146. illus.

J207 "Last of the Pioneers." IMAGE 1, no. 2 (Feb. 1952): 4.

J208 Jackson, William H. "Nine Colorado Photographs by William Henry Jackson." COLORADO QUARTERLY 2, no. 2 (Summer 1953): 25-36. 9 b & w.

J209 Culver, D. J. "Mr. Jackson's Bulky Box." TIME (June 14, 1954): 12. illus.

J210 Jackson, William H. "Roll Out, Roll Out, the Bulls are Coming." WESTERNERS BRAND BOOK (DENVER) 11, (1955): 1-16. illus. [Includes a letter written by Jackson on Oct. 30, 1866.]

J211 Mercaldo, Vincent. "Bearding a Gentle Lion." WESTERNERS BRAND BOOK (NEW YORK) (1955): 42. [Author remembers his interviews with Jackson.]

J212 Racanicchi, Piero. "William Henry Jackson." POPULAR PHOTOGRAPHY ITALIANA 51, no. 3 (Sept. 1961): 43-54. 32 b & w.

J213 Doty, Robert. "Gift of Jackson and O'Sullivan Photographs." IMAGE 11, no. 5 (1962): 21-22. 2 b & w. [364 photos of American exploration, predominately by W. H. Jackson and T. O'Sullivan, given to George Eastman House by the Department of the Geological Sciences of Harvard University. 140 prints by W. H. Jackson, 134 prints by T. O'Sullivan.]

J214 Mann, Margery. "William Jackson, Bolles." ARTFORUM 2, no. 3 (May - June 1964): 60. [Exhibition review.]

J215 Vestal, David. "Frontier Photographers: O'Sullivan and Jackson." TRAVEL & CAMERA 32, no. 6 (June 1969): 48-52, +. * illus.

J216 Selmeier, L. "First Camera on the Yellowstone." MONTANA: MAGAZINE OF WESTERN HISTORY 22, no. 3 (July 1972): 42-53. 9 b & w. [Jackson's photos taken on the 1871 Hayden expedition.]

J217 Lowe, R. L. "William Henry Jackson, Pioneer Photographer." MANKIND 5, no. 1 (June 1975): 38-42. 6 b & w. 1 illus. [Introduction to Jackson, written for a general audience.]

J218 Blaurock, Carl, P.M. "William Henry Jackson, Pioneer Photographer." WESTERNERS BRAND BOOK (DENVER) 30, (1977): 379-402. 11 b & w.

J219 Jones, William C. "William Henry Jackson in Mexico." AMERICAN WEST 14, no. 4 (July - Aug. 1977): 10-21. 10 b & w. 1 illus. [Jackson commissioned to photograph the new Central Mexico Railroad in 1883-1884. Made several hundred photographs.]

J220 Holmes, Jon and Glenn Rifkin. "Rocky Mountain Fervor." 35MM PHOTOGRAPHY (Summer 1978): 56-63, 119-120. 8 b & w. 4 illus. [A team of contemporary photographers from the Colorado Mountain College: Ellen Manchester, Mark Klett, and Jo Ann Verberg: followed Jackson's steps and rephotographed the same sites 100 years later.]

J221 Fisch, Mathias S. "The Quest for the Mount of the Holy Cross." AMERICAN WEST 16, no. 2 (Mar. - Apr. 1979): 32-37, 57-58. 1 b & w. 3 illus. [Describes Jackson's photograph taken in 1873.]

J222 "W. H. Jackson - Photographer and Painter." GEOTIMES 24, no. 3 (Mar. 1979): 37. 4 illus. [Jackson's paintings.]

J223 Verburg, Jo Ann and Mark Klett. "Rephotographing Jackson." AFTERIMAGE 6, no. 1-2 (Summer 1979): 6-7. 4 b & w. [Verburg and Klett rephotographed the same areas that Wm. Henry Jackson had photographed in the 1870s.]

J224 Merritt, J. I. "William Henry Jackson: Photographer of the Scenic West." AMERICAN WEST 17, no. 5 (Sept. - Oct. 1980): 22-27, 52-53, 56-59. 8 b & w. [Jackson produced 54,000 glass plate negatives, large murals and watercolors during his lifetime. Bibliography.]

J225 "Images from the Past." PHOTOGRAPHICA 12, no. 8 (Oct. 1980): 16-17. [Portrait of Jackson, age 97.]

J226 "In 1893, W. H. Jackson Said Only Some Exposure Tables Were Useful." PHOTOGRAPHICA 13, no. 7 (Aug. - Sept. 1981): 9. [Reprint of article first published in the "Rocky Mountain Druggist," later republished in May 1893 "Wilson's Photographic Magazine."]

J227 Buerger, Janet E. "William Henry Jackson (1843-1942)." IMAGE 25, no. 2 (June 1982): 20-23. 5 b & w. [Includes one image on front/back cover.]

J228 Bossen, Howard. "A Tall Tale Retold: The Influence of the Photographs of William Henry Jackson on the Passage of the Yellowstone Park Act of 1872." STUDIES IN VISUAL COMMUNICATION 8, (Winter 1982): 98-109.

J229 "For those who love authentic Old West Art...top quality reproductions of watercolors of W.H. Jackson sold by the Oregon-California Trails Association ..." AMERICAN WEST 21, no. 6 (Nov. - Dec. 1984): 57. [Full Page Advertisement: Three watercolors by Jackson reproduced and sold for $225 by the Oregon-California Trails Association - a non-profit organization. The three watercolors and a portrait of Jackson are displayed in the ad.]

J230 Martz, John. "William Henry Jackson's Visit to High Places." STEREO WORLD 12, no. 2 (May - June 1985): 14-19. 8 b & w. [Jackson's stereo views taken during F. V. Hayden's 1872 survey into the Teton Range in Utah and Idaho.]

J231 Paddock, Eric. "William Henry Jackson: Photographer and Entrepreneur." BOOKMAN'S WEEKLY 82, no. 18 (Oct. 31, 1988): 1665-1671, plus cover. 5 b & w. 1 illus. [Short, lucid survey of Jackson's

career. Discusses the Detroit Photographic Co., problems of attribution, etc.]

J232 Panzer, Mary. "How the West was Won: Reinventing the Myth of William Henry Jackson." AFTERIMAGE 16, no. 8 (Mar. 1989): 17-19. 3 b & w. [Book rev.: "William Henry Jackson and the Transformation of the American Landscape," by Peter B. Hales. Extensive review, with critical commentary.]

JACOBI. (BERLIN, GERMANY)

J233 "Electrotyping." MAGNET: DEVOTED TO THE INVESTIGATION OF HUMAN PHYSIOLOGY 1, no. 5 (Oct. 1842): 104. [Discussion of the electrotyping process of Professor Jacobi, of Berlin. "Daguerotype [sic] plates have been copied by means of the Electrotype."]

JACOBI & PRAGER. (BERLIN, GERMANY)

J234 Duby, Ernest. "Photography in Germany: My Visit to the Berliner Phototypisches Institut." ANTHONY'S PHOTOGRAPHIC BULLETIN 9, no. 4 (Apr. 1878): 116-117. [From "London Photographic News." Firm of Jacobi & Prager.]

JACOBS, EDWARD. (ca. 1810-) (GREAT BRITAIN, USA)

J235 "Daguerreotype Movements." HUMPHREY'S JOURNAL 6, no. 2 (May 1, 1854): 31. [Extensive article from New Orleans, LA, newspaper.]

J236 Portraits. Woodcut engravings, credited "Photographed by Jacobs, N. O." FRANK LESLIE'S ILLUSTRATED NEWSPAPER 12, (1861) ["Gen. Braxton Bragg, C.S.A." 12:292 (June 22, 1861): 91.]

J237 Portraits. Woodcut engravings, credited "From a Photograph by Jacobs, of New Orleans." FRANK LESLIE'S ILLUSTRATED NEWSPAPER 14, (1862) ["Gen. George Shepley." 14:356 (July 26, 1862): 284. "Capt. Jonas H. French." 14:358 (Aug. 9, 1862): 309. "Capt. John Clark." 14:358 (Aug. 9, 1862): 309. "Maj. Joseph M. Bell." 14:369 (Oct. 25, 1862):65.]

J238 Portrait. Woodcut engraving, credited "From a Photograph by Jacobs, of New Orleans." FRANK LESLIE'S ILLUSTRATED NEWSPAPER 15, (1862) ["Maj. Joseph M. Bell. 14:369 (Oct. 25, 1862):65.]

J239 Portrait. Woodcut engraving, credited "From a Photograph by Jacobs, of New Orleans." FRANK LESLIE'S ILLUSTRATED NEWSPAPER 16, (1863) ["Col. Benj. H. Grierson." 16:401 (June 6, 1863): 161.]

J240 Portrait. Woodcut engraving, credited "From a Photograph by Jacobs, New Orleans." HARPER'S WEEKLY 7, (1863) ["From a Photograph by Jacobs, of New Orleans." "Colonel Grierson, 6th Illinois Cavalry." 7:336 (June 6, 1863): 353. (Actually, a sketch of Grierson on a rearing horse; if any photo was involved, it would have to have been a portrait used for the face.)]

J241 Portraits. Woodcut engravings, credited "Photographed by E. Jacobs, New Orleans." FRANK LESLIE'S ILLUSTRATED NEWSPAPER 18, (1864) ["Gen. Banks and Staff (Group portrait)." 18:450 (May 14, 1864): 113.]

JACOBSON.

J242 Jacobson, Dr. "Photo-Engraving on Copper." HUMPHREY'S JOURNAL OF PHOTOGRAPHY, AND THE ALLIED ARTS AND SCIENCES 20, no. 25 (Sept. 15, 1869): 393-394. [Source not given.]

JACOBY, WILLIAM H. (1841-1905) (USA)

J243 "Our Picture." PHOTOGRAPHIC WORLD 1, no. 7 (July 1871): 220-221. 1 b & w. [Portrait.]

J244 "Our Picture." PHILADELPHIA PHOTOGRAPHER 10, no. 112 (Apr. 1873): frontispiece, 126-127. 1 b & w.

J245 "Our Picture." PHILADELPHIA PHOTOGRAPHER 10, no. 119 (Nov. 1873): frontispiece, 547-548. 1 b & w. [Portrait.]

J246 "Matters of the Month: Jacoby's Palace of Art." PHOTOGRAPHIC TIMES 4, no. 46 (Oct. 1874): 155. [Describes Jacoby's new gallery. From the "St. Paul (MN) Pioneer".]

J247 "Matters of the Month." PHOTOGRAPHIC TIMES 5, no. 56 (Aug. 1875): 191. [Stereo interiors of his own gallery discussed briefly.]

JAGERSPACHER. (GRUNDEN, GERMANY)

J248 Portrait. Woodcut engraving credited "From a photograph by Jagerspacher." ILLUSTRATED LONDON NEWS 74, (1879) ["Duke of Cumberland." 74:2064 (Jan. 4, 1879): 21.]

JAMES. (IOWA CITY, IA)

J249 Portrait. Woodcut engraving, credited "From a Photograph by James, Iowa City." FRANK LESLIE'S ILLUSTRATED NEWSPAPER 42, (1876) ["Hon. S. J. Kirkwood, Sen.-elect from IA." 42:1077 (May 20, 1876): 181.]

JAMES, HENRY, COL. SIR see also SCOTT, ALEXANDER.

JAMES, HENRY, COL. SIR. (GREAT BRITAIN)

J250 "Photo-Lithography." PHOTOGRAPHIC AND FINE ART JOURNAL 13, no. 6 (June 1860): 163-164. [From "Photo. Notes." Includes Sir Henry James' process, Mr. Osborne's process, etc.]

J251 James, Colonel Sir Henry, R. E. "The Practical Details of Photo-Zincography, As Applied at the Ordinance Survey Office, Southhampton, For the Production and Multiplication of Facsimiles of Ancient Manuscripts, Maps, and Line Engravings." BRITISH JOURNAL OF PHOTOGRAPHY 7, no. 125 (Sept. 1, 1860): 249-251.

J252 James, Henry, Sir. "The Practical Details of Photo-Zincography: As Applied at the Ordinance Survey Office, Southampton. For the Production and Multiplication of Facsimiles of Ancient Manuscripts, Maps, and Line Engravings." AMERICAN JOURNAL OF PHOTOGRAPHY AND THE ALLIED ARTS & SCIENCES n. s. vol. 3, no. 9 (Oct. 1, 1860): 129-183. [From "Br. J. of Photo."]

JAMES, J. R.

J253 Portrait. Woodcut engraving credited "From a photograph by J. R. James." ILLUSTRATED LONDON NEWS 34, (1859) ["Miss Edith Heraud, actress." 34:* (Apr. 30, 1859): 428.]

JAMES, W. E.

J254 "Gran'ma Downing, Patience, her Daughter, Gran'ma Mayflower, Deborah, and Aunt Tabitha. The New England Kitchen Spinners, at the Brooklyn Sanitary Fair. - From a Photograph by W. E. James." FRANK LESLIE'S ILLUSTRATED NEWSPAPER 17, no. 441 (Mar. 12, 1864): 385. 1 illus. [Group portrait.]

J255 "Stereoscopic Views." HUMPHREY'S JOURNAL OF PHOTOGRAPHY, AND THE ALLIED ARTS AND SCIENCES 20, no. 19 (Mar. 15, 1869): 302. [William B. Holmes has published a catalog of stereoscopic views for sale at his stock depot. Views in and around New York, NY. W. E. James' celebrated series of fifty views taken in

the Holy Land, during his recent visit there in the steamship 'Quaker City.' Holmes sole agent of the American Stereoscopic Company.]

JANSSEN, M.
J256 "Sun Spots Studied by Solar Photography." ANTHONY'S PHOTOGRAPHIC BULLETIN 9, no. 2 (Feb. 1878): 52. [From "Scientific American." Work of Mr. Janssen.]

J257 Janssen, M. "Note Upon the Solar Photospheric Network, and on Photography Regarded as a Means of Discoveries in Physical Astronomy." ANTHONY'S PHOTOGRAPHIC BULLETIN 9, no. 4 (Apr. 1878): 108-112. [From "Br J of Photo."]

JARMAN, A. J.
J258 "Topics of the Times: Photographing by Means of Lightning." PHOTOGRAPHIC TIMES 7, no. 82 (Nov. 1877): 256. [From "Photographic News."]

J259 Jarman, A. J. "Moonlight Photography." ANTHONY'S PHOTOGRAPHIC BULLETIN 8, no. 12 (Dec. 1877): 365. [From "London Photographic News."]

JARVIS, JAMES F. (WASHINGTON, DC)
[James F. Jarvis was a stereographer active in Washington, D. C. from the 1870s through the 1890s. He documented many post Civil War events, including the Presidential inaugurations of Hayes and Garfield, and Coxey's Army's 1894 march.]

J260 Catalogue of Stereoscopic Cabinet and Large Views of Washington. Published by J. F. Jarvis, 135 Pennslyvania Avenue, (One Block from the Capitol,) Washington, D. C. Washington, DC: Jarvis, n. d. [ca. 1880?]. 12 pp. 1 illus.

JAVARY, CAPT.
J261 "Photographic Maps." AMERICAN JOURNAL OF PHOTOGRAPHY AND THE ALLIED ARTS & SCIENCES n. s. vol. 7, no. 18 (Mar. 15, 1865): 412-413. [From "Art Journal." Capt. Javary created a map of the town of Greenoble, produced in Paris from twenty-nine photographic views taken from eighteen points.]

JAYNE, A. D.
J262 "First Presbyterian Church, Corning, N. Y. Rev. William A. Niles, Pastor. - From a Photograph by A. D. Jayne." FRANK LESLIE'S ILLUSTRATED NEWSPAPER 28, no. 710 (May 8, 1869): 117. 2 illus. [View. Portrait.]

JAYNE, B. G. & CO.
J263 "Great Freshet and Destruction of Property at Ithaca, New York. Effects of the Flood as Exhibited on Cayuga Street, near Pleasant. From an Ambrotype by B. G. Jayne & Co." FRANK LESLIE'S ILLUSTRATED NEWSPAPER 4, no. 85 (July 18, 1857): 105. 1 illus. [Ruins.]

JEANNERET, F. C. (CHELTENHAM, ENGLAND)
J264 "Note." ART JOURNAL (Oct. 1866): 323. [Mr. F. C. Jeanneret, a young amateur photographist at Cheltenham made a fine series of stereoscopic slides. Landscapes of Wales and elsewhere.]

JEFFERS & MCDONNALD.
J265 Portrait. Woodcut engraving, credited "From a Photograph by Jeffers & McDonald." FRANK LESLIE'S ILLUSTRATED NEWSPAPER 30, (1870) ["Elbridge T. Gerry." 30:761 (Apr. 30, 1870): 101.]

JEFFREY, W. (LONDON, ENGLAND)
J266 Portrait. Woodcut engraving credited "From a photograph by W. Jeffrey, Great Russell St." ILLUSTRATED LONDON NEWS 44, (1864) ["Alfred Tennyson, poet laureate." 44:* (Feb. 13, 1864): 165.]

J267 Portrait. Woodcut engraving credited "From a photograph by W. Jeffrey." ILLUSTRATED LONDON NEWS 45, (1864) ["Thomas Carlyle." 45:* (Sept. 10, 1864): 261.]

J268 Portrait. Woodcut engraving credited "From a photograph by W. Jeffrey." ILLUSTRATED LONDON NEWS 46, (1865) ["Sir Charles Lyell, Bart., D.C.L., F.R.S." 46:* (Mar. 11, 1865): 229.]

J269 Portrait. Woodcut engraving, credited "From a Photograph by W. Jeffrey." HARPER'S WEEKLY 9, (1865) ["Alfred Tennyson." 9:459 (Oct. 14, 1865): 645.]

J270 Portrait. Woodcut engraving credited "From a photograph by W. Jeffrey." ILLUSTRATED LONDON NEWS 66, (1875) ["Late Sir Charles Lyell, Bart." 66:1855 (Feb. 27, 1875): unpaged extra supplement, before p. 214.]

JENIK, ROSA [MRS.] (VIENNA, AUSTRIA)
J271 Portrait. Woodcut engraving credited "From a photograph by Rosa Jenik." ILLUSTRATED LONDON NEWS 72, (1878) ["Archduke Francis Charles of Austria." 72:2021 (Mar. 23, 1878): 260.]

JENKINS, SOLON, JR. (d. 1854) (USA)
J272 "Note." HUMPHREY'S JOURNAL 6, no. 19 (Jan. 15, 1855): 311. [Brief obituary. Solon Jenkins, Jr. died at Columbia, SC on 19th Nov. 1854 of yellow fever. Worked for Whitehurst's Gallery in Richmond, VA for some time, then ran his own establishment in New York, NY. At his death he was working for Mr. Tucker in his gallery in Columbia, SC.]

JENNEY, JAMES A. (FLINT, MI)
J273 Hornstein, Hugh and David Tender. "T-I-M-M-M-B-E-R-R-R !!!" STEREO WORLD 7, no. 1 (Mar. - Apr. 1980): 4-11. 16 b & w. [Stereo views of logging operations, a series titled "Gems in the Pineries of Michigan," by James A. Jenney, of Flint, MI, taken in the 1870s.]

JENNINGS, H. C.
J274 Jennings, H. C. "Hints on Winter Photography." BRITISH JOURNAL PHOTOGRAPHIC ALMANAC 1874 (1874): 69-71.

J275 Jennings, H. C. "Lighting the Studio." BRITISH JOURNAL PHOTOGRAPHIC ALMANAC 1876 (1876): 153-154. 1 illus.

J276 Jennings, H. C. "Matters of Daily Practice." BRITISH JOURNAL PHOTOGRAPHIC ALMANAC 1879 (1879): 100-101.

JENNINGS, OLIVER. (OREGON CITY, OR)
J277 Prior, Harris K. "Art Note: Oliver Jennings, Daguerreotypist." OREGON HISTORICAL QUARTERLY 52, no. 3 (Sept. 1951): 186-188. [Oliver Jennings came to Oregon City in Jan. 1851. March to May moved on to Fort Vancouver, then Salt Lake City. His daguerreotype equipment stolen, failed to take the photos of Cayuse Indians he had planned, thus failing to be first photographer of Northwest Indians. John Mix Stanley achieved this in 1853 on the Stevens Railroad Survey. (From a diary at Yale University Library.)]

JENNINGS, PAYNE. (d. 1926) (GREAT BRITAIN)
J278 Jennings, Payne. "Remarks on Landscape Photography." BRITISH JOURNAL PHOTOGRAPHIC ALMANAC 1878 (1878): 149-150.

J279 Jennings, Payne. "Landscape Work and Its Relationship to Art." PHOTOGRAPHIC TIMES 8, no. 90 (June 1878): 130-132. [Read before the Edinburgh Photo Soc.]

J280 Hind, C. Lewis. "East Anglia." ART JOURNAL (1889): 193-199, 232-237. [Landscape views by Payne Jennings.]

JENNS, PERCIVAL.
J281 Jenns, Percival. "The Camera of Nature." HUMPHREY'S JOURNAL OF PHOTOGRAPHY, AND THE ALLIED ARTS AND SCIENCES 10, no. 14 (Nov. 15, 1858): 217-221. [From "Photo. Notes."]

JERRARD see BARRAUD & JERRARD.

JESSUP, EDWIN.
J282 "Movements of the Daguerreotypists." HUMPHREY'S JOURNAL 4, no. 10 (Sept. 1, 1852): 159. [Edwin Jessup, Middletown [NY?] praised.]

J283 "New York. - Monument to the Soldiers of the Town of Wallkill. - From a Photo. by E. Jessup." FRANK LESLIE'S ILLUSTRATED NEWSPAPER 48, no. 1226 (Mar. 29, 1879): 61. 1 illus. [View.]

JEWELL, FRANK. (SCRANTON, PA)
J284 "Our Picture." PHILADELPHIA PHOTOGRAPHER 10, no. 113 (May 1873): frontispiece, 135-137. 1 b & w. [Portrait.]

J285 Jewell, F. "Fifth Annual Meeting and Exhibit of the National Photographic Association of the U.S., held in Buffalo, N.Y., beginning July 5, 1873: Posing, Lighting & Expressions." PHILADELPHIA PHOTOGRAPHER 10, no. 117 (Sept. 1873): 273-276.

JOBARD. (BRUSSELS, BELGIUM)
J286 "Miscellanies: Improvements in the Daguerreotype." MAGAZINE OF SCIENCE, AND SCHOOL OF ARTS 1, no. 34 (Nov. 23, 1839): 272. [Jobard (Brussels, Belgium) making portraits, by painting the faces white, etc. "Paint in dead white the face of the patient; powder his hair, and fix the back of his head between two or three planks solidly attached to the back of an armchair, and wound up with screws;..."]

JOHNS & FAUGHT.
J287 "Kentucky. - Celebration of the One Hundredth Anniversary of the Settlement of Lexington - The Procession Passing Down Main Street. - From a Photograph by Johns & Faught." FRANK LESLIE'S ILLUSTRATED NEWSPAPER 48, no. 1230 (Apr. 26, 1879): 117. 1 illus. [View.]

JOHNSON & ARMSTRONG.
J288 "The Louisiana Outrage. - The Federal Soldiery Awaiting Orders on St. Louis Street, New Orleans. - From Photographs by Johnson & Armstrong." FRANK LESLIE'S ILLUSTRATED NEWSPAPER 39, no. 1009 (Jan. 30, 1875): 349. 1 illus. [View of troops in the street.]

JOHNSON. (PHILADELPHIA, PA)
J289 Portraits. Woodcut engravings, credited "From an Ambrotype by Johnson, of Philadelphia." FRANK LESLIE'S ILLUSTRATED NEWSPAPER 3, (1857) ["W. B. Reed, US Commissioner to China." 3:74 (May 9, 1857): 353.]

JOHNSON. (d. 1867) (USA)
J290 "Editor's Table." PHILADELPHIA PHOTOGRAPHER 4, no. 47 (Nov. 1867): 367. [The photographers McPherson and Johnson in New Orleans, LA, died of the Yellow Fever.]

JOHNSON, ALFRED S. (WAUPUN, WI)
J291 Johnson, Alfred S. "A Raid on Aniline Colors." AMERICAN JOURNAL OF PHOTOGRAPHY AND THE ALLIED ARTS & SCIENCES n. s. vol. 7, no. 22 (May 15, 1865): 522-523.

JOHNSON, ANDREW.
J292 Johnson, Andrew, M.A. "Notes on the Collodio-Bromide Process." HUMPHREY'S JOURNAL OF PHOTOGRAPHY, AND THE ALLIED ARTS AND SCIENCES 20, no. 28 (Dec. 15, 1869): 434-436. [From "Br. J. of Photo."]

JOHNSON, C. A. (CINCINNATI, OH)
J293 "Camp Dennison, Cincinnati, Ohio, East of the Railroad." HARPER'S WEEKLY 5, no. 244 (Aug. 31, 1861): 554. 1 illus. ["Photographed by C. A. Johnson, Cincinnati."]

JOHNSON, CHARLES E. (CLEVELAND, OH)
[Engraver and daguerreotypist. Studio in Cleveland, OH 1850-51. Partnership of Johnson & Fellows, Cleveland in 1851. Moved to CA in 1853.]

J294 "Note." HUMPHREY'S JOURNAL 5, no. 1 (Apr. 15, 1853): 16. [Johnson moving from Cleveland, OH, to CA.]

JOHNSON, CHARLES WALLACE JACOB. (1833-1903) (USA)
J295 Palmquist, Peter E. "Earliest surviving photos of Arcata..." THE HUMBOLT HISTORIAN 29, no. 3 (May - June 1981): 8-9, plus cover. 5 b & w. [Charles Wallace Jacob Johnson (1833-1903) worked in Arcata and Eureka, CA in late 1860s and through the 1870s.]

JOHNSON, EDWARD. (GREAT BRITAIN)
J296 *The Fen and Marshland Churches.* Wisbech; London: Leach & Sons; Simpkin, Marshall & Co., 1868. n. p. 46 b & w. [Albumen prints by Edward Johnson, with short historical and critical notes.]

JOHNSON, F. W.
J297 "Destruction of the Olean Advertiser Office, Olean, N. Y. - From a Photograph by F. W. Johnson." FRANK LESLIE'S ILLUSTRATED NEWSPAPER 10, no. 237 (June 9, 1860): 41, 42. 1 illus. [View of ruined building.]

JOHNSON, G. H. (SAN FRANCISCO, CA)
J298 "Mr. R. C. Gridley and His Sack of Flour." HARPER'S WEEKLY 9, no. 420 (Jan. 14, 1865): 28. 1 illus. [Mr. Gridley, losing a bet, carried 50 pound bag of flour around San Francisco, then auctioned and reauctioned the bag to raise thousands of dollars for the Sanitary Commission.]

JOHNSON, H. J. (TILSHEAD, ENGLAND)
J299 "New Method of Obtaining Various Stereoscopic Effects." HUMPHREY'S JOURNAL 9, no. 8 (Aug. 15, 1857): 125. [From "J. of Photo. Soc., London." Johnson from Tilshead, England, describes his practices for making landscapes, copying works of art, etc.]

JOHNSON, J. ORVILLE. (1836/37-) (USA)
J300 "The Millie Gaines Jury - Six White and Six Colored Men - The First Mixed Jury Empaneled in the District of Columbia. - From a Photograph by J. Orville Johnson." FRANK LESLIE'S ILLUSTRATED NEWSPAPER 28, no. 724 (Aug. 14, 1869): 341. 1 illus. [Group portrait.]

JOHNSON, J. R. (ca. 1817-1881) (GREAT BRITAIN)

J301 Johnson, J. R. "Dish for Sensitizing Paper." AMERICAN JOURNAL OF PHOTOGRAPHY AND THE ALLIED ARTS & SCIENCES n. s. vol. 7, no. 1 (July 1, 1864): 17. [From "Photo. J."]

J302 "Johnson's Panoramic Camera, and Inventions Generally," and "The Pantascopic Camera." BRITISH JOURNAL OF PHOTOGRAPHY 12, no. 251 (Feb. 24, 1865): 106-107. [Letters from T. C. Lever and J. R. Johnson, about the camera, and controversy stirred by it.]

J303 Johnson, J. R. "A Suggestion for a New Mode of Treating an Old Negative Bath." HUMPHREY'S JOURNAL OF PHOTOGRAPHY, AND THE ALLIED ARTS AND SCIENCES 20, no. 4 (June 15, 1868): 56-57. [Read before the London Photo. Soc.]

J304 Johnson, J. R. "On a New Application of the Autotype Process." BRITISH JOURNAL PHOTOGRAPHIC ALMANAC 1876 (1876): 119-121. [Johnson in North London Photo. Soc.]

J305 Johnson, J. R. "A Simple Carbon Process." BRITISH JOURNAL PHOTOGRAPHIC ALMANAC 1879 (1879): 77.

J306 Johnson, J. R. "Improvements in Carbon Printing." BRITISH JOURNAL PHOTOGRAPHIC ALMANAC 1878 (1878): 108-110.

J307 Taylor, J. Traill. "Home and Foreign News Epitomized." PHOTOGRAPHIC TIMES 11, no. 123 (Mar. 1881): 88-89. [J. R. Johnson died. A clever theoretical mechanic, able chemist, skillful mathematician and skillful photographer. Friend of the noted French chef Soyer, and an excellent cook himself. Johnson and J. Harrison of London perfected the pantascopic camera. Worked out the double transfer process of carbon printing. Held patents in type-founding and a host of other fields. Founder of the Autotype Co. Age 64 when he died.]

JOHNSON, JOHN see also WOLCOTT & JOHNSON.

JOHNSON, JOHN.
[Made some of the first daguerreotype portraits in USA with Alexander Wolcott. In 1841 patented a daguerreotype buffing wheel.]

J308 "Photography at the American Institute." AMERICAN JOURNAL OF PHOTOGRAPHY AND THE ALLIED ARTS AND SCIENCES n. s. vol. 1, no. 1 (June 1, 1858): 10-13. [Report on John Johnson's role in early portraiture.]

J309 "Mr. John Johnson's Paper on the Effect of Colored Light on the Germination of Seeds, and the Growth of Plants." AMERICAN JOURNAL OF PHOTOGRAPHY AND THE ALLIED ARTS & SCIENCES n. s. vol. 6, no. 9 (Nov. 1, 1863): 209-210.

J310 Johnson, John. "On the Action of Light through Colored Media." AMERICAN JOURNAL OF PHOTOGRAPHY AND THE ALLIED ARTS & SCIENCES n. s. vol. 7, no. 18 (Mar. 15, 1865): 428-431. [Read to Am. Photo. Soc.]

J311 "New York Correspondence." PHILADELPHIA PHOTOGRAPHER 4, no. 41 (May 1867): 141-144. [Notes where Prof. Johnson claims that he and Wolcott took first portrait in America in Oct. 1839, predating John W. Draper by several months.]

JOHNSON, THOMAS H. (SCRANTON, PA)
J312 "Editor's Table: Fine Stereoscopic Views." PHILADELPHIA PHOTOGRAPHER 1, no. 4 (Apr. 1864): 63. ["...from Mr. Thomas H. Johnson, of Scranton, Pa....stereo views of the coal regions of Scranton, Honesdale and Carbondale..."]

J313 "Editor's Table: Views near Scranton, Pa." PHILADELPHIA PHOTOGRAPHER 1, no. 10 (Oct. 1864): 160. [Note that Thomas H. Johnson making views.]

J314 "National Photographers' Convention." FRANK LESLIE'S ILLUSTRATED NEWSPAPER 30, no. 774 (July 30, 1870): 316-317. 1 illus. [Review of the exhibition in Cleveland, OH, associated with the annual meeting of the National Photographers Association. Illustrated with a group portrait of the NPA membership, taken by T. H. Johnson.]

JOHNSON, W. M.
BOOKS
J315 Johnson, W. M. *Hints on Photography*. Waupum, WI: W. M. Johnson, J. H. Brickerhoff, printer, 1863. 8 pp. [Describes a method of double printing.]

PERIODICALS
J316 "Process Humbug - the Waupun Pamphlet." AMERICAN JOURNAL OF PHOTOGRAPHY AND THE ALLIED ARTS & SCIENCES n. s. vol. 5, no. 22 (May 15, 1863): 524-527. [Critical review of pamphlet "Hints on Photography," by W. M. Johnson, which suggests a technique for double printing.]

JOHNSON, W. P. (ALGONA, IO)
J317 "Correspondence." ANTHONY'S PHOTOGRAPHIC BULLETIN 2, no. 12 (Dec. 1871): 397-398. [Johnson (Algona, IO) made 6 dozen tintypes, 1/9 gems, six for 50 cents, 54 sittings, bontons, four for 50 cents, 7 sittings to a total of $37.80 in a car 8 1/2'x 22', in one day in Viroqua, WI. And in a small gallery in Sparta, WI last July ninety-seven sittings for plate pictures in one day.]

JOHNSON, WILLIAM J. (GREAT BRITAIN, INDIA)
J318 Johnson, William J. *The Oriental Races and Tribes, Residents and Visitors of Bombay: A Series of Photographs, with Letterpress Descriptions. Vol. 1.: Gujarât, Kutch, and Kâthiawâr.* London: W. J. Johnson, 1863. 107 pp. 26 b & w. *Vol. 2. Maharashtra or Maratha Country.* 25 b & w. [Original photos, by Johnson. Texts by Rev. Dr. Wilson and Alex. Kinloch Forbes. Stated intent was to publish three volumes, number two being portraits of natives of Maratha Country, number three, a Miscellaneous Collection. (Don't know if completed). These are composite prints, of group portraits, clearly taken in a studio, then laboriously set into a natural photographic view of landscape setting. Each setting, presumably, appropriate for the type of persons in the portrait. Volumes II and III apparently published by 1866, with a total of sixty-one original photographs.]

JOHNSON, WILLIAM S. (1841-) (USA)
J319 Craig, John S. "Photographer: Almost Unknown." NORTHLIGHT (JOURNAL OF THE PHOTOGRAPHIC HISTORICAL SOCIETY OF AMERICA) 3, no. 1 (Winter 1975/76): 10-11. 4 b & w. [The article is about George W. Sittler, however it contains a biography of William S. Johnson. William S. Johnson was born in 1841, and he enlisted in the Union Army in 1861. He served with the 1st Arkansas Cavalry and was promoted Captain in February, 1863. Wounded at Fayetteville, he was transferred to Washington, DC. He was present at the Ford Theatre the night President Lincoln was assasinated, and was in charge of the battalion that escorted the President's body to the White House. He retired from the Army with the rank of Captain in 1871, then moved to Springfield, MO where he opened a photographic gallery. He maintained the gallery there until he sold it to George W. Sittler in 1882.]

JOHNSTON, ALEXANDER. (d. 1896) (GREAT BRITAIN)
BOOKS
J320 Johnston, Alexander. *On the Production of Combination Negatives*. Wick, England: Northern Ensign Office, 1870. 6 pp.

PERIODICALS
J321 Johnston, A. "Combination Printing Practically Applied." BRITISH JOURNAL PHOTOGRAPHIC ALMANAC 1877 (1877): 116

JOHNSTON, HENRY M.
J322 "The $2,500 Formula, or, H. M. Johnston's Process for making Opal Pictures." HUMPHREY'S JOURNAL OF PHOTOGRAPHY, AND THE ALLIED ARTS AND SCIENCES 17, no. 14 (Nov. 15, 1865): 214-217.

J323 Johnston, Henry M. "The $2,500 Process. - Letter from Mr. Johnston." HUMPHREY'S JOURNAL OF PHOTOGRAPHY, AND THE ALLIED ARTS AND SCIENCES 17, no. 15 (Dec. 1, 1865): 237-238. [Reply to article published by Seely in "Am. J. of Photo."]

JOHNSTON, K. P.
J324 Johnston, K. P. "Fourth Annual Meeting and Exhibition of the N.P.A. in St. Louis, Mo., May 1872: Poem: 'Photography'" PHILADELPHIA PHOTOGRAPHER 9, no. 102 (June 1872): 216-217.

JOHNSTON, R. G. (USA)
J325 "The Bromide Patent. - Card from Mr. Johnston." HUMPHREY'S JOURNAL OF PHOTOGRAPHY, AND THE ALLIED ARTS AND SCIENCES 17, no. 17 (Jan. 1, 1866): 470. [R. G. Johnston, 867 Broadway, wrote a note stating that he was not at an earlier protest meeting against bromide as reported in "Humphrey's Journal."]

JOHNSTON, T. B. (GREAT BRITAIN)
J326 Johnston, T. B. "The Perils of a Photographer." AMERICAN JOURNAL OF PHOTOGRAPHY AND THE ALLIED ARTS & SCIENCES n. s. vol. 4, no. 14 (Dec. 15, 1861): 318-320. [From "Photo. J." Johnston related an anecdote to the Photo. Soc. of Scotland, about being harassed by a Lord Abercromby, who was offended at him taking views.]

JOHNSTONE & O'SHANNESSY. (MELBOURNE, AUSTRALIA)
J327 Portrait. Woodcut engraving credited "From a photograph by Johnstone & O'Shannessy." ILLUSTRATED LONDON NEWS 71, (1877) ["Late Col. Anderson, C.B." 71:1996 (Oct. 13, 1877): 348.]

J328 "A New Nation - Members of the Federation Conference Recently Held at Melbourne, Australia. From a Photo by Johnstone, O'Shaunessy & Co., Melbourne." FRANK LESLIE'S ILLUSTRATED NEWSPAPER 70, no. 1805 (Apr. 19, 1890): 236. 1 b & w. [Group portrait, seated formally, but shot outdoors.]

JOHNSTONE, W.
J329 "Fine-Art Gossip." ATHENAEUM no. 1774 (Oct. 26, 1861): 548. [Suggests that stereo card mounts be black.]

JOLLEY.
J330 Portrait. Woodcut engraving, credited "From a Photograph by Jolley, Portage City." HARPER'S WEEKLY 9, (1865) ["Joseph Crele, Oldest Man in the World, at 139." 9:445 (July 15, 1865): 445.]

JONES & MOFFITT.
J331 Jones & Moffitt. "A Multiplying Camera Attachment." PHILADELPHIA PHOTOGRAPHER 13, no. 149 (May 1876): 140-142. 5 illus. [Jones & Moffitt from Pilot Point, Denton Co., TX.]

JONES. [?]
J332 Portraits. Woodcut engravings, credited "From an Melinotype by Jones.[?]" FRANK LESLIE'S ILLUSTRATED NEWSPAPER 4, (1857) ["Elder P. Parker Pratt, Mormon." 4:79 (June 6, 1857): 1.]

JONES, BAYNHAM. (1806-1890) (GREAT BRITAIN)
J333 Jones, Baynham. "Focusing Glass. - Stereoscopic Camera." HUMPHREY'S JOURNAL OF PHOTOGRAPHY, AND THE ALLIED ARTS AND SCIENCES 10, no. 24 (Apr. 15, 1859): 384. ["Having broken my glass in Venice,..."]

J334 Jones, Baynham. "Improved Sky and View Shade." BRITISH JOURNAL PHOTOGRAPHIC ALMANAC 1876 (1876): 79-80. 1 illus.

J335 Jones, Baynham. "A Portable Camera Stand." BRITISH JOURNAL PHOTOGRAPHIC ALMANAC 1877 (1877): 183-184. 1 illus.

J336 Jones, Baynham. "A Portable Camera and Stand." BRITISH JOURNAL PHOTOGRAPHIC ALMANAC 1878 (1878): 132-133. 1 illus.

JONES, CALVERT T. (1804-1877) (GREAT BRITAIN)
J337 "Meeting of the British Association, at Swansea." ILLUSTRATED LONDON NEWS 13, no. 331 (Aug. 19, 1848): 109-110. 2 illus. ["Swansea, and the Harbour, from a Daguerreotype by the Rev. Calvert T. Jones." "The Royal Institution of South Wales, from a Talbotype by the Rev. Calvert Jones; negatived by Messrs. Henneman & Malone, Photographers on paper to the Queen, 122 Regent St."]

J338 Jones, C. "Letter: Photographs." HUMPHREY'S JOURNAL 8, no. 15 (Dec. 1, 1856): 235-236. [C. Jones' letter to "Journal of the Photographic Society, Liverpool" is actually a statement of his aesthetics.]

JONES, E.
J339 Jones, E. "The Stereoscopic Angle." PHOTOGRAPHIC AND FINE ART JOURNAL 10, no. 11 (Nov. 1857): 350. [From "J. of Photo. Soc., London."]

JONES, FREDERICK. (LONDON, ENGLAND)
J340 "Note." ART JOURNAL (Feb. 1860): 62. [Stereoscopes from Athens, issued by Mr. Jones.]

J341 "Our Weekly Gossip." ATHENAEUM no. 1704 (June 23, 1860): 857. [Brief comment on Frederick Jones' set of stereoscopic views of the interior of the Chapel Royal of St. Georges, Winchester.]

J342 "Critical Notices: Twelve Stereoscopic Views of the Interior of St. George's Chapel, Windsor by Frederick Jones, London." PHOTOGRAPHIC NEWS 4, no. 100 (Aug. 3, 1860): 165.

J343 "Critical Notices: Six Stereoscopic Views of the Interior of the College Chapel, Eton, by F. Jones, Oxford Street." PHOTOGRAPHIC NEWS 4, no. 110 (Oct. 12, 1860): 283.

J344 "Noted: Stereo views of Eton Chapel." ART JOURNAL (Dec. 1860): 379.

J345 "Note." ART JOURNAL (Jan. 1863): 19. [30 stereo views of the Middle and Inner Temple mentioned. Jones' gallery at 146 Oxford St.]

JONES, J. H.
J346 Jones, J. H. "The Photographic Tourist: A Photographic Trip to the Vale of Heath. Parts 1 - 4." PHOTOGRAPHIC NEWS 3-4, no. 84,

87-89 (Apr. 13 - May 18, 1860): (vol. 3) 388-389, (vol. 4) 3-4, 16-17, 28-29.

JONES, JOHN WESLEY. (USA)
[John Wesley Jones, an artist, and William N. Bartholomew, a teacher of drawing from Boston, went to California in 1850. In 1850-51 Jones and his friends travelled overland back to the East, and claimed to have made 1500 landscape daguerreotype scenes of California, the Rocky Mountains and the High Plains to the Missouri River during the trip. None of these images seem to have survived into the present day. Jones then toured during 1853-54, lecturing about his travels, using sketches and paintings taken from daguerreotypes. In 1854 a lottery was held to sell the paintings, and the book *Amusing and Thrilling Adventures of a California Artist...* was published. Jones seems not to have continued with photography after this trip, and there is even some question whether he actually made daguerreotypes on the journey.]

BOOKS
J347 Dix, John Ross. *Amusing and Thrilling Adventures of a California Artist, While Daguerreotyping a Continent.* Boston: J. W. Jones, 1854. n. p. illus.

J348 Van Nostrand, J. [*John Wesley Jones.*] Berkeley, CA: n. d. [M.A. Thesis, University of California at Berkeley, n. d.]

PERIODICALS
J349 "Editor's Drawer." HARPER'S NEW MONTHLY MAGAZINE 7, no. 42 (Nov. 1853): 851. [Anecdote about frightening off an Indian attack by pretending that the daguerreotype camera was a cannon.]

J350 "Jones' Pantoscope of California: A "Lecture" by J. Wesley Jones Together with Pencil Sketches Depicting the Journey across the Plains to California." CALIFORNIA HISTORICAL QUARTERLY 6, no. 2-3 (June - Sept. 1927): 108-131, 238-253. 6 sketches from photographs. illus.

J351 Hoover, Catherine. "Pantoscope of California." CALIFORNIA HISTORICAL COURIER 40, no. 3 (1978): 3, 7.

JONES, N. P.
J352 Durrie, Daniel S. *A History of Madison, The Capital of Wisconsin: Including the Four Lake Country: To July 1874,...*Madison: Atwood & Culver, 1874. 420 pp. 10 b & w. [Original photos, by N. P. Jones.]

JONES, P. B.
J353 Jones, P. B. "Stamps on Cartes." HUMPHREY'S JOURNAL OF PHOTOGRAPHY, AND THE ALLIED ARTS AND SCIENCES 17, no. 18 (Jan. 15, 1866): 286.

JONES, ROBERT S. (CHARLOTTESVILLE, VA)
J354 "Gossip." PHOTOGRAPHIC ART JOURNAL 5, no. 1 (Jan. 1853): 64. [Notice from "Charlottesville (Va.) Jeffersonian" mentioning that Robert S. Jones replacing Mr. Retzer as the daguerrean.]

JONES, T. M. (MOLINE, IL)
J355 "Grand Results." ANTHONY'S PHOTOGRAPHIC BULLETIN 10, no. 5 (May 1879): 151. [From "Moline, IL Evening Dispatch."]

JONES, T. WHARTON.
J356 Jones, T. Wharton. *On the Invention of Stereoscopic Glasses for Single Pictures, with Preliminary Observations on the Stereoscope, etc.* London: John Churchill, 1860. 31 pp.

JORDAN & CO. (NEW YORK, NY)
J357 "Our Picture." HUMPHREY'S JOURNAL OF PHOTOGRAPHY, AND THE ALLIED ARTS AND SCIENCES 19, no. 1 (May 1, 1867): 14. 1 b & w. [Original portrait of a young girl, tipped-in. The "positionist" was A. Twitchell, the printer and toner "A. Hargrave," both employed by the Jordan & Co. Gallery, New York, NY.]

JORDAN, ANDREW. (d. 1871) (USA)
J358 "Death of Andrew Jordan." ANTHONY'S PHOTOGRAPHIC BULLETIN 2, no. 4 (Apr. 1871): 125. ["...well-known photographer in Greenwich St., New York....must have been verging closely toward three-score years and ten..."]

J359 "Obituary: Andrew Jordan." PHOTOGRAPHIC TIMES 1, no. 4 (Apr. 1871): 57. [Associated for years as business manager for Bogardus, replaced him in the gallery when Bogardus moved "uptown."]

JORDAN, J. H.
J360 "Baptist Church, Brockport, N. Y. Rev. Emerson Mills, Pastor. - From a Photograph by J. H. Jordan." FRANK LESLIE'S ILLUSTRATED NEWSPAPER 28, no. 720 (July 17, 1869): 277. 2 illus. [View. Portrait.]

JORDAN, JAMES L. & HENRY A. JORDAN.
J361 "Singular Accident to a Steam Fire Engine at Syracuse, New York. - From a Photograph by Jordan Brothers." FRANK LESLIE'S ILLUSTRATED NEWSPAPER 28, no. 712 (May 22, 1869): 157. 1 illus. [View.]

JORDAN, PRIVATE. (BANKIPORE, BENGAL)
J362 "Panther Presented to the Prince of Wales at Bankipore by the 109th Regiment." ILLUSTRATED LONDON NEWS 68, no. 1913 (Mar. 25, 1876): 299, 300. 1 illus. ["A photograph was taken by Private Jordan, of the 109th, from which we get our Illustration."]

JOSELLY. (ITALY)
J363 "Note." PHOTOGRAPHIC TIMES 2, no. 13 (Jan. 1872): 26. [Note that Joselly taken submarine views with aid of a diving bell.]

JOSLYN, G. H.
J364 "The Great Tornado." HARPER'S WEEKLY 4, no. 182 (June 23, 1860): 392-394. 4 illus. ["...from photographs taken for us on the ground by Messrs. William Field, of Fulton City and G. H. Joslyn of Camanche." Ruins of Albany City, IL, and Camanche, IA, from tornado June 3, 1860.]

JOSLYN, J. E.
J365 "The New Vicksburg Monument." HARPER'S WEEKLY 11, no. 524 (Jan. 12, 1867): 21. 1 illus. ["Photographed by J. E. Joslyn, Vicksburg."]

JOSS see BEYSE & JOSS.

JOUBERT, F.
J366 "New Process for Engraving, and Other Items." PHOTOGRAPHIC AND FINE ART JOURNAL 11, no. 12 (Dec. 1858): 373. [From "Photo. Notes." Joubert's process.]

J367 "Our Weekly Gossip." ATHENAEUM no. 1623 (Feb. 12, 1859): 224. [Brief discussion of Joubert's photoengraving process.]

J368 "Carbon Printing." AMERICAN JOURNAL OF PHOTOGRAPHY AND THE ALLIED ARTS & SCIENCES n. s. vol. 3, no. 3 (July 1, 1860): 43-47. [Joubert's process.]

J369 "Fine-Art Gossip." ATHENAEUM no. 1745 (Apr. 6, 1861): 471. [Joubert perfected a process for transferring photographs to glass.]

J370 "Photographic Pictures on Glass." ART JOURNAL (Aug. 1861): 238. [Joubert's process.]

J371 Joubert, F. "On a New Method of Producing on Glass Photographs or Other Pictures, in Enamel Colors." AMERICAN JOURNAL OF PHOTOGRAPHY AND THE ALLIED ARTS & SCIENCES n. s. vol. 4, no. 7 (Sept. 1, 1861): 150-157. [Read to Society of Arts (London).]

J372 "Exhibitions." BRITISH JOURNAL OF PHOTOGRAPHY 8, no. 154 (Nov. 15, 1861): 409-410. [Exhibit of "Pictures in Enamel Colours Burnt on Glass, from Photographs, etc. by M. Joubert at his home in London.]

J373 Joubert. "On Enamel Photographs." AMERICAN JOURNAL OF PHOTOGRAPHY AND THE ALLIED ARTS & SCIENCES n. s. vol. 4, no. 22 (Apr. 15, 1862): 512-516. [From "Photo. News." Read to London Photo. Soc. Mar. 5, 1862.]

J374 Portraits. Woodcut engravings credited "From a photograph by F. Joubert." ILLUSTRATED LONDON NEWS 43, (1863) ["Royal Highness Prince Alfred." 43:* (Feb. 7, 1863): 141.]

J375 "Note." ART JOURNAL (Aug. 1865): 258. [Joubert's "Heliopaline" pictures mentioned.]

JOUET see DAVANNE & JOUET.

JOVANOVIC, ANASTAS. (1817-1899) (YUGOSLAVIA)
J376 Mitrovic, R. "Anastas Jovanovic (1817 - 1899)." CAMERA (LUCERNE) 59, no. 1 (Jan. 1980): 38-39. 1 illus. [First Serbian lithographer and photographer.]

J377 Djordjevic, Miodrag. "Anastas Jovanovic, The First Serbian Photographer." HISTORY OF PHOTOGRAPHY 4, no. 2 (Apr. 1980): 139-163. 29 b & w. 1 illus. [Includes chronology.]

JUDD & MCLEISH.
J378 Smith, Henry Perry. *Syracuse and its Surroundings.* Syracuse, NY: Hamilton Child, 1878. 148 pp. 103 l. of plates. 103 b & w. [103 pairs of stereographs by Judd & McLeish.]

JUDD.
J379 "Georgia. - The New Shorter College, at Rome. - From a Photograph by Judd." FRANK LESLIE'S ILLUSTRATED NEWSPAPER 48, no. 1246 (Aug. 16, 1879): 401. 1 illus. [View.]

JUDD, C. S. (SHELBYVILLE, TN)
J380 "Editor's Table." PHILADELPHIA PHOTOGRAPHER 6, no. 65 (May 1869): 169. [Four outdoor views noted.]

JUDGE, J. A.
J381 "North London Photographic Association." LIVERPOOL & MANCHESTER PHOTOGRAPHIC JOURNAL [BRITISH JOURNAL OF PHOTOGRAPHY] n. s. 2, no. 10-11, 13 (May 15, June 1, July 1, 1858): 123-124, 142-143, 164-166.

J382 Judge, J. A. "On the Wet Collodion Process." HUMPHREY'S JOURNAL OF PHOTOGRAPHY, AND THE ALLIED ARTS AND SCIENCES 10, no. 5, 7 (July 1 - Aug. 1, 1858): 69-72, 109-112. [From "Liverpool Photo. J."]

J383 Judge, J. A. "On the Wet Collodion Process." PHOTOGRAPHIC AND FINE ART JOURNAL 11, no. 8 (Aug. 1858): 243. [From the "Liverpool Photographic Journal."]

JUDKINS, L. D. (INDIANAPOLIS, ID)
J384 Judkins, L. D. "A Voice from the West." PHILADELPHIA PHOTOGRAPHER 9, no. 105 (Sept. 1872): 321-322. [Letter from L. D. Judkins (Indianapolis, ID).]

JULIET.
J385 Juliet. "Bromo-Iodide Salt, for Sensitizing Collodion." AMERICAN JOURNAL OF PHOTOGRAPHY AND THE ALLIED ARTS & SCIENCES n. s. vol. 6, no. 20 [sic 21] (May 1, 1864): 498-499. [From "Le Moniteur de la Photographie."]

JUMP, E.
J386 "Arkansas.- Corn-Hole at the Hot Springs." and "The Hot Springs in the Ozark Mountains. - From a Photograph by E. Jump." FRANK LESLIE'S ILLUSTRATED NEWSPAPER 42, no. 1071 (Apr. 8, 1876): 77. 2 illus. [View. View, with figures.]

JUNIUS.
J387 "Junius." "Sun-Painting." PHOTOGRAPHIC AND FINE ART JOURNAL 12, no. 2 (July 1859): 63.

JUSTICE.
J388 "Justice." "The Elevation and Degradation of the Daguerrean Art." PHOTOGRAPHIC AND FINE ART JOURNAL 7, no. 6 (June 1854): 169-170.

K

B. K. (PARIS, FRANCE)
K1 Wing, Paul. "Devil Tissues: The B. K. Diableries." STEREO WORLD 1, no. 4 (Sept. - Oct. 1974): 3, 15. 1 b & w. ["Tissues," issued by B. K. (Paris) from about 1860 to 1890s.]

K2 Wing, Paul. "The French Theatrical Tissues." STEREO WORLD 9, no. 5 (Nov. - Dec. 1982): 4-14. 10 b & w. 6 illus. [Genre scenes, plays, Diableries, etc. by "B. K. Photographie Paris"; J. M. (Paris); others, from the 1860s to 1890s.]

K3 Wing, Paul. "The BK Diableries." STEREO WORLD 11, no. 1 (Mar. - Apr. 1984): 22-24, 46-47. 8 b & w. 2 illus. ["Tissue" stereos, genre scenes of the devils in Hell, published by B. K. Editeur (A. Block ?) of Paris, from 1860 to 1900. This is an expanded version of the article first published in issue 1:1 (1974).]

W. K.
K4 W. K. "Nitrate of Silver Bath, its Condition - Fogging, etc." HUMPHREY'S JOURNAL OF PHOTOGRAPHY, AND THE ALLIED ARTS AND SCIENCES 10, no. 11 (Oct. 1, 1858): 161-164. [Practical "operator," includes reflections on the state of the art, customer relations, etc.]

KAISER, P. J.
K5 Kaiser, P. J. "New Method of Dry Collodion." AMERICAN JOURNAL OF PHOTOGRAPHY AND THE ALLIED ARTS & SCIENCES n. s. vol. 7, no. 1 (July 1, 1864): 1-2. [From "Tijdschrift von Photographie."]

K6 Kaiser, P. J., Dr. "On the Employment of Carbolic Acid in Photography." HUMPHREY'S JOURNAL OF PHOTOGRAPHY, AND THE ALLIED ARTS AND SCIENCES 18, no. 24 (Apr. 15, 1867): 371-373. [From "Bulletin Belge de la Photographie."]

KAULBACH'S GOETHE GALLERY see WALLIS, OSCAR J.

KEELER, F. S. (PHILADELPHIA, PA)
K7 "Our Picture." PHILADELPHIA PHOTOGRAPHER 5, no. 58 (Oct. 1868): 375. [Portrait.]

K8 "New American Studios." PHILADELPHIA PHOTOGRAPHER 6, no. 68 (Aug. 1869): 282-283. 2 illus. [The Keeler, Suddards & Fennemore Gallery. Keeler is the photographer, Suddards the business manager, and Fennemore the chemist.]

KEEN, L. W. (JONESBORO, TN)
K9 "Stereos Received." ANTHONY'S PHOTOGRAPHIC BULLETIN 6, no. 11 (Nov. 1875): 352. [Keen (Jonesboro, TN) stereo views of Greenville, TN, occasioned by the funeral of Ex-president Andrew Johnson.]

KEENE, ALFRED. (LEAMINGTON, ENGLAND)
BOOKS
K10 Keene, Alfred. *Instructions for the Successful Practice of the Fothergill Dry Practice; also remarks upon the Preservative Dry Processes generally.*. Leamington: Keene, chemist, 1859. n. p.

PERIODICALS
K11 Keene, A. "Mr. Fothergill's Dry Process." HUMPHREY'S JOURNAL OF PHOTOGRAPHY, AND THE ALLIED ARTS AND SCIENCES 10, no. 10 (Sept. 15, 1858): 160. [From "J. of London Photo. Soc."]

K12 Keene, Alfred. "Modus operandi of Preservative Agent in the Fothergill Process, etc." HUMPHREY'S JOURNAL OF PHOTOGRAPHY, AND THE ALLIED ARTS AND SCIENCES 10, no. 18 (Jan. 15, 1859): 286-288. [From "Photo. J., London."]

K13 Keene, Alfred. "The Fothergill Process." HUMPHREY'S JOURNAL OF PHOTOGRAPHY, AND THE ALLIED ARTS AND SCIENCES 11, no. 2 (May 15, 1859): 27-29. [From "Liverpool Photo. J."]

K14 Keene, A. "Defects in Fothergill's Process." HUMPHREY'S JOURNAL OF PHOTOGRAPHY, AND THE ALLIED ARTS AND SCIENCES 11, no. 9 (Sept. 1, 1859): 133-134. [From "Photo. J."]

KEENS, H. L.
K15 Keens, H. L. "The Proportions found in Figures produced by Art and Photography." HUMPHREY'S JOURNAL OF PHOTOGRAPHY, AND THE ALLIED ARTS AND SCIENCES 11, no. 19 (Feb. 1, 1860): 296-298. [From "Liverpool Photo. J."]

KEIFER, C. E.
K16 O'Brien, J. Emmet. "Telegraphing in Battle." CENTURY MAGAZINE 38, no. 5 (Sept. 1889): 782-793. 7 illus. [Signal Corps telegraph wire system used during the Civil War. Illustrated with etchings credited "With drawings by W. Taber and Thomas Hogan, from war-time photographs by C. E. Keifer and Gardner. At least four of the etchings are from photos.]

KEITH, GEORGE SKENE.
K17 Whyte, William & Co. *Views in the Holy Land.* Edinburgh: William Whyte & Co., n. d. [ca. 1847 ?]. n. p. 18 l. of plates. 18 illus. [Portfolio of seventeen engravings, by W. Miller or by W. Forrest, from daguerreotypes taken by G. S. Keith, M.D., and one engraving by W. Miller from a drawing by Max Schmidt.]

KEITH, THOMAS. (1827-1895) (GREAT BRITAIN)
BOOKS
K18 "Thomas Keith," on p. 780 (Vol. 2) in: *Chamber's Information for the People.* 15th Edition London: Chambers, 1851.

K19 Keith, Thomas. *Contributions to the Surgical Treatment of Tumors of the Abdomen.* Edinburgh: Oliver & Boyd, 1885. n. p.

K20 *Thomas Keith 1827 - 1895, Surgeon and Photographer. The Hurd bequest of photographic paper negatives.* Notes on the collection by C. S. Minto. "Libraries and Museums Department Occasional Publications, 6." Edinburgh: Corporation of the City, Libraries & Museums Committee, 1966. 16 pp. 32 b & w.

K21 Hannavy, John. *Dr. Thomas Keith: A Scottish Photography Group Exhibition with Research and Selection by John Hannary.* Edinburgh, Scotland: Scottish Photography Group, 1977. 16 pp. 3 b & w.

K22 Hannavy, John. *Thomas Keith's Scotland: The Work of a Victorian Amateur Photographer 1852 - 57.* Edinburgh: Cannongate, 1981. x, 86 pp. b & w. [Bibliography, p. 85.]

PERIODICALS
K23 Newhall, Beaumont. "Critic's Choice: 'Soon after sunrise...the light is much softer.'" POPULAR PHOTOGRAPHY 61, no. 2 (Aug. 1967): 88-89, 126. 1 b & w. [Born St. Cyrus, Kincardineshire in 1827. A surgeon, his activity as an amateur was limited to a few weeks during the summers of 1854, 1855 and 1856, producing some 220 beautiful calotype landscapes. Died in Edinburgh in 1895.]

K24 Hannavy, John. "Thomas Keith at Iona." HISTORY OF PHOTOGRAPHY 2, no. 1 (Jan. 1978): 29-33. 6 b & w. [Waxed paper negatives taken in 1856.]

K25 Badger, Gerry. "Dr. Thomas Keith, Surgeon and Photographer." PHOTOGRAPHIC COLLECTOR 2, no. 3 (Autumn 1981): 74-89. 11 b & w.

KEITH, WILLIAM. (d. 1883) (GREAT BRITAIN)
K26 Keith, Wm. "On the Glass Room." HUMPHREY'S JOURNAL OF PHOTOGRAPHY, AND THE ALLIED ARTS AND SCIENCES 9, no. 19 (Feb. 1, 1858): 299-301. ["London Photo. J."]

K27 Keith, Wm. "The Tannin Process." HUMPHREY'S JOURNAL OF PHOTOGRAPHY, AND THE ALLIED ARTS AND SCIENCES 13, no. 4 (June 15, 1861): 64. [From "Br. J. of Photo."]

K28 "Our Editorial Table: Photographs by Mr. William Keith." BRITISH JOURNAL OF PHOTOGRAPHY 12, no. 244 (Jan. 6, 1865): 6.

KELHAM, AUGUSTUS.
K29 *Photographic Views of Seats in Cheshire, Shropshire, Flintshire and Denbighshire.* s. l.: s. n., 1865. n. p. 36 b & w. [Original photographs. Printed title page.]

KELLAND.
K30 Kelland, Professor. "Photographic Society of Scotland." LIVERPOOL & MANCHESTER PHOTOGRAPHIC JOURNAL [BRITISH JOURNAL OF PHOTOGRAPHY] n. s. 2, no. 5 (Mar. 1, 1858): 57-58. [Paper. "On the Education of the Senses; with its bearings on the subject of Photographic Portraiture," by Prof. Kelland.]

K31 Kelland, Prof. "On the Education of the Senses, with its Bearings on the Subject of Photographic Portraiture." HUMPHREY'S JOURNAL OF PHOTOGRAPHY, AND THE ALLIED ARTS AND SCIENCES 9, no. 23 (Apr. 1, 1858): 361-363. [Read to Photo. Soc. of Scotland.]

KELLER. (NEWBERG, NY)
K32 Portraits. Woodcut engravings, credited "From an Daguerreotype by Keller, of Newberg, N. Y." FRANK LESLIE'S ILLUSTRATED NEWSPAPER 1, (1856) ["Sergeant Uzal Knapp, the last of Washington's Life Guards." 1:8 (Feb. 2, 1856): 120.]

KELLOGG BROTHERS. (HARTFORD, CT)
K33 "The Putnam Phalanx, of Hartford, Connecticut. - Photographed by Kellogg Bros., Hartford." FRANK LESLIE'S ILLUSTRATED NEWSPAPER 10, no. 259 (Nov. 10, 1860): 383, 391. 2 illus. [Group military portrait. View. Military group parading in the street.]

KELLOGG. (HARTFORD, CT)
K34 Portrait. Woodcut engraving, credited "From a Photograph by Kellogg, Hartford." FRANK LESLIE'S ILLUSTRATED NEWSPAPER 46, (1878) ["The late James Williams." 46:1185 (June 15, 1878): 249.]

KELSEY.
K35 Three views. Woodcut engravings, "Daguerreotyped for us by Kelsey, and drawn by Rowse." GLEASON'S PICTORIAL DRAWING-ROOM COMPANION 1, no. 14 (Aug. 2, 1851): 216-217. 3 illus. ["Procession passing up Pennsylvania Avenue," "Laying the cornerstone of the new Capitol," "Scene of Webster's oration."] on pp. 216-217. Credit on p. 205.]

KELSEY, C. C. (CHICAGO, IL)
[Portrait painter and daguerreotypist. Ran a gallery in Chicago from 1848 until at least 1858.]

K36 "Illuminated Daguerreotypes." HUMPHREY'S JOURNAL 4, no. 16 (Dec. 1, 1852): 248. [Excerpts from "Chicago Daily Democrat," and "Chicago Daily Tribune," praising C. C. Kelsey, 96 Lake St., Chicago, IL.]

KEMP, GEORGE. (d. 1885) (GREAT BRITAIN)
[George Kemp, M.D., of St. Peter's College, Cambridge.]

BOOKS
K37 Kemp, George, M.D. *A Description of Certain Dry Processes in Photography: Specially Adapted for the Use of the Tourist, with Supplementary Notice of Plans Useful to the Scientific Traveller and Missionary.* London: J. W. Davies, 1863. 84 pp.

PERIODICALS
K38 "Dr. Kemp's Dry Process." AMERICAN JOURNAL OF PHOTOGRAPHY AND THE ALLIED ARTS & SCIENCES n. s. vol. 6, no. 17 (Mar. 1, 1864): 395-396. [From "Br. J. Almanac."]

KEMPSTER, WALTER, DR. (USA)
K39 Robinson, Charles D. "Insanity and Its Treatment." CENTURY MAGAZINE (SCRIBNER'S MONTHLY) 12, no. 4 (Aug. 1876): 634-648. 6 b & w. 7 illus. [Illustrated with woodcut views, interiors of insane asylums in the U. S. Also six "sections of the human brain" from photographs taken through a microscope by Dr. Walter Kempster at the Utica, NY, asylum, in 1871. Kempster's investigations described.]

KEN, A. (PARIS, FRANCE)
K40 Portrait. Woodcut engraving credited "From a photograph by A. Ken, Boulevard Montmarte, Paris." ILLUSTRATED LONDON NEWS 70, (1877) ["Late Queen of Holland." 70:1979 (June 16, 1877): 565.]

KENDALL, GEORGE H. (AUSTRALIA)
K41 *Echuca Illustrated.* Echuca, Victoria, Australia: [G. H. Kendall], 1872. n. p. 41 b & w. [Photographs are by George H. Kendall. One frontispiece portrait, twenty carte-de-visite portraits, and nineteen larger albumen prints of views of Australia.]

KENNEDY, J. F. (HOT SPRINGS, AR)
K42 "Arkansas. - The Hot Springs of the Ozark Mountains. - From Photographs by J. F. Kennedy, Hot Springs." FRANK LESLIE'S ILLUSTRATED NEWSPAPER 42, no. 1070 (Apr. 1, 1876): 65. 9 illus. [Views.]

KENNETT, R. (1817-1896) (GREAT BRITAIN)
K43 "Obituary: R. Kennett (December 4, 1896)." BRITISH JOURNAL PHOTOGRAPHIC ALMANAC 1898 (1898): 640. [Died at age 79. In 1874 worked with gelatino-bromide process, etc.]

KEMP, GEORGE.
K44 Kemp, Geo., M.D., Cantab. "Clouds, from a Photographic Point of View." BRITISH JOURNAL PHOTOGRAPHIC ALMANAC 1877 (1877): 51-52.

KENT, JOHN HOWE. (1827-1910) (USA)
[John H. Kent was born in Plattsburg, NY, on Mar. 14, 1827. In 1848 he moved to Brockport, NY, where he lived and worked as a landscape painter. Sometime around 1864 he opened a gallery where he sold both his landscapes and made photographs. In 1867 Kent moved to Rochester, NY, where he became one of Rochester's leading portrait photographers. His innovative techniques for handling studio

lighting situations and his elaborate backgrounds steadily gained him a national reputation. In 1872 Kent was elected Secretary of the National Photographic convention, and in 1883 he was elected President of the National Association of Photographers. He exhibited an impressive group of very large prints at the Philadelphia Centennial Exposition in 1876. George Eastman was a friend of Kent and Kent was a Vice-president in the Eastman Dry Plate Co. and became one of the original incorporators of the Eastman Kodak Co. He served as a director and Vice-president of the Kodak Co. until he retired. Kent maintained a gallery in downtown Rochester until his death, although by then he was financially secure. He died in Rochester, NY on Nov. 25, 1910.]

K45 "Cabinet Portraits." HUMPHREY'S JOURNAL OF PHOTOGRAPHY, AND THE ALLIED ARTS AND SCIENCES 19, no. 4 (June 15, 1867): 63. [Kent from Brockport, NY.]

K46 "Editor's Table." PHILADELPHIA PHOTOGRAPHER 4, no. 42 (June 1867): 194. [Cabinet portraits by Kent.]

K47 "Cabinet Pictures." HUMPHREY'S JOURNAL OF PHOTOGRAPHY, AND THE ALLIED ARTS AND SCIENCES 19, no. 6 (July 15, 1867): 96. [Praise for Kent's work, including a portrait of Horace Greeley.]

K48 "Our Picture." PHILADELPHIA PHOTOGRAPHER 4, no. 44 (Aug. 1867): frontispiece, 271. 1 b & w.

K49 "Our Picture." PHILADELPHIA PHOTOGRAPHER 4, no. 45 (Sept. 1867): frontispiece, 302-303. 1 b & w. [Staged portrait of three children.]

K50 Wilson, Edward L. "Editorial Correspondence." PHILADELPHIA PHOTOGRAPHER 4, no. 46 (Oct. 1867): 305-308. [Wilson describes a visit to Kent at Brockport, then to Notman in Montreal.]

K51 "Editor's Table." PHILADELPHIA PHOTOGRAPHER 5, no. 50 (Feb. 1868): 64. [Note that Kent is printing from twenty-eight negatives in order to make the frontispiece photograph for the next issue of "Philadelphia Photographer."]

K52 "Our Picture." PHILADELPHIA PHOTOGRAPHER 5, no. 51 (Mar. 1868): frontispiece, 96-97. 1 b & w. [Cabinet portrait.]

K53 "Our Picture." PHILADELPHIA PHOTOGRAPHER 6, no. 63 (Mar. 1869): frontispiece, 91. 1 b & w. [Portrait.]

K54 "Our Picture." PHILADELPHIA PHOTOGRAPHER 8, no. 90 (June 1871): frontispiece, 183-184. 1 b & w. 1 illus. [Portrait, plus woodcut of studio.]

K55 "Kent's Device for Modifying the Light on the Head and Face of the Subject. Kent's Tally-Board." PHILADELPHIA PHOTOGRAPHER 8, no. 93 (Sept. 1871): 289, 297-298. 2 illus. [J. H. Kent (Rochester, NY) presents suggestions.]

K56 Portrait. Woodcut engraving, credited "From a Photograph by J. H. Kent." FRANK LESLIE'S ILLUSTRATED NEWSPAPER 33, (1871) ["Hon. E. Peshine Smith, Chief of the Foreign Office of Japan." 33:844 (Dec. 2, 1871): 189.]

K57 Portrait. Woodcut engraving, credited "From a Photograph by J. H. Kent." FRANK LESLIE'S ILLUSTRATED NEWSPAPER 33, (1871) ["Hon. E. Peshine Smith, Chief of the Foreign Office of Japan." 33:844 (Dec. 2, 1871): 189.]

K58 Kent, J. H. "Kent's Hand-Screen." PHILADELPHIA PHOTOGRAPHER 9, no. 97 (Jan. 1872): 16.

K59 Hough, Eugene K. "'What Will He Do With It?'" [and] "J. H. Kent's Hand-Screen Once More." PHILADELPHIA PHOTOGRAPHER 9, no. 99 (Mar. 1872): 73-76. [Kent patented a device he had first published in the "Phila. Photo." This created a small controversy that ran through several issues.]

K60 Webster, I. B. "Patents and Patents." PHILADELPHIA PHOTOGRAPHER 9, no. 100 (Apr. 1872): 122-123. [More on the Kent patent controversy.]

K61 Kent, J. H. "Fourth Annual Meeting and Exhibition of the N. P. A. in St. Louis, Mo., May 1872: Retrospective & Otherwise." PHILADELPHIA PHOTOGRAPHER 9, no. 102 (June 1872): 181-183.

K62 "Our Picture." PHILADELPHIA PHOTOGRAPHER 11, no. 130 (Oct. 1874): frontispiece, 289. 1 b & w. [Studio portrait.]

K63 "Our Picture." PHILADELPHIA PHOTOGRAPHER 13, no. 150 (June 1876): frontispiece, 190-191. 1 b & w. [Promenade studio portrait.]

K64 "Photo-Criticism." PHILADELPHIA PHOTOGRAPHER 13, no. 152 (Aug. 1876): 252-253. [Letter from J. H. Kent (Rochester, NY) in response to earlier criticism of his work.]

K65 Hough, E. K. "Mr. Kent and His Handscreen." PHILADELPHIA PHOTOGRAPHER 15, no. 179 (Nov. 1878): 328-329. [Kent worked in Rochester, NY. His portraiture methods described here.]

K66 "Our Picture." PHOTOGRAPHIC TIMES 17, no. 292 (Apr. 22, 1887): 210-211, plus frontispiece. 1 b & w. [Portrait by Mr. Kent of Rochester, NY.]

K67 Pedzich, Joan. "John Howe Kent." IMAGE 27, no. 1 (Mar. 1984): 1-11. 18 b & w. 2 illus. [Describes 45 year career of professional studio photographer in upstate New York.]

KENT, S. H.

K68 Kent, S. H. *Within the Arctic Circle; Experience of Travels through Norway, to the North Cape, Sweden and Lapland.* London: Richard Bentley & Son, 1877. 2 vol. in 1 4 b & w. illus. [Woodburytype illustrations.]

K69 Kent, S. H. *Gath to the Cedars: Travels in the Holy Land and Palmyra,...* New Edition, with Photographs and Illustrations. London: F. Warne, 1879. xix, 373 pp. 17 l. of plates. illus. [1 photo as frontispiece; 6 engravings (possibly from photos).]

KENT, WILLIAM.

K70 Kent, Wm. "The Camera." HUMPHREY'S JOURNAL OF PHOTOGRAPHY, AND THE ALLIED ARTS AND SCIENCES 12, no. 16 (Dec. 15, 1860): 243-244.

K71 Kent, Wm. "Gleanings arranged from an Amateur's Scrap-Book for the Aid of Beginners." HUMPHREY'S JOURNAL OF PHOTOGRAPHY, AND THE ALLIED ARTS AND SCIENCES 12, no. 18 (Jan. 15, 1861): 273-274.

K72 Kent, Wm. "Hints to Authors." HUMPHREY'S JOURNAL OF PHOTOGRAPHY, AND THE ALLIED ARTS AND SCIENCES 12, no. 20 (Feb. 15, 1861): 306-307. [Actually, sort of a review of S. B. Gage's and Ch. Waldack's books.]

K73 Kent, Wm. "Gleanings arranged from an Amateur's Scrap-Book for the Aid of Beginners." HUMPHREY'S JOURNAL OF PHOTOGRAPHY, AND THE ALLIED ARTS AND SCIENCES 13, no. 13 (Nov. 1, 1861): 194-196.

KENYON, W. (CRAWFORDSVILLE, IN)
K74 "Editor's Table." PHILADELPHIA PHOTOGRAPHER 5, no. 56 (Aug. 1868): 279. [Series of vignettes received.]

KER, DAVID.
K75 Ker, David. *On the Road to Khiva... With Photographic Illustrations and Military Map.* London: Henry S. King, 1874. n. p. 7 b & w. [Albumen prints. Landscape views.]

KERR. (MELBOURNE, AUSTRALIA)
K76 "The King of the Feejee Islands." ILLUSTRATED LONDON NEWS 54, no. 1535 (Apr. 24, 1869): 417. 1 illus. [Portrait of King Thackenban. "[Photograph] taken by Mr. Kerr, of Melbourne, the photographic artist who accompanied "H.M.S. Curaçoa" in her cruise among the South Sea Islands in 1865."]

KERSHAW, J.
K77 Kershaw, J. "On the Development of Collodio-Albumen Plates by Alkaline Pyrogallic Acid." AMERICAN JOURNAL OF PHOTOGRAPHY AND THE ALLIED ARTS & SCIENCES n. s. vol. 7, no. 24 (June 15, 1865): 562-564. [Read to Manchester Photo. Soc.]

KEYES. (DIXON, IL)
K78 "Illinois. - Scenes and Incidents During and After the Terrible Accident at Rock River Bridge, Dixon. - From Sketches by Jos. H. Beale and Photographs by Keyes, of Dixon, Ill." FRANK LESLIE'S ILLUSTRATED NEWSPAPER 36, no. 921 (May 24, 1873): 173. 4 illus. [Views, portraits.]

KHRONE, ANDREW. (NEW YORK, NY)
K79 "Editor's Table." PHILADELPHIA PHOTOGRAPHER 6, no. 65 (May 1869): 169. [About Andrew Khrone "The oldest man in the photo business in this country, still making daguerreotypes for Bogardus."]

KIBBE, WILLIAM H. (1846-1910) (USA)
K80 "Photographers, Old and New." WILSON'S PHOTOGRAPHIC MAGAZINE 32, no. 464 (Aug. 1895): 359-360. 1 illus. [Began photography in 1869, started his own studio in 1871 in Johnstown, NY.]

KIBBLE, JOHN. (1818-1894) (GREAT BRITAIN)
K81 Church, Wm., Jr. "Mr. Kibble's Instantaneous Pictures in a Dry Process." HUMPHREY'S JOURNAL OF PHOTOGRAPHY, AND THE ALLIED ARTS AND SCIENCES 11, no. 11 (Oct. 1, 1859): 165-166. [From "Liverpool Photo. J."]

K82 "City of Glasgow and West of Scotland Photographic Society." BRITISH JOURNAL OF PHOTOGRAPHY 8, no. 134 (Jan. 15, 1861): 35-36. [J. Kibble's talk "On the Light We Use," reprinted.]

K83 Kibble, J. "On the Light we Use." HUMPHREY'S JOURNAL OF PHOTOGRAPHY, AND THE ALLIED ARTS AND SCIENCES 12, no. 21 (Mar. 1, 1861): 330-334. [Read to the City of Glasgow and West of Scotland Photo. Soc. This lecture includes references to the power of light to affect human emotions as well as its uses in industry and agricultural pursuits.]

KILBURN BROTHERS. (LITTLETON, NH)
[Benjamin West Kilburn formed a partnership with his brother Edward in Littleton, NH in 1865, and began producing stereo views. The company became one of the leading publishers of views during the 19th century. Benjamin, who was the photographer, began making views in the White Mountains of New Hampshire and continued to make thousands of views all over the world. He made every negative for the company until 1876. Edward retired in 1877 and Benjamin continued the business until 1904. The Kilburn negatives were later sold to the Keystone View Co.]

BOOKS
K84 *List of Stereoscopic Views Photographed and Published by Kilburn Brothers, Littleton, New Hampshire. For Sale by Joseph L. Bates, 129 Washington St., Boston.* Boston: Bates [?], n. d. [1867 ?]. 8 pp. [Lists 282 views. Xerox copies of this work offered for sale by the National Stereoscopic Association in 1970s.]

K85 *Catalogue of Stereoscopic Views, Embracing a varied assortment ov Views of American Scenery, such as the Principal Points of Interest at the White Mountains,...Martha's Vineyard,...California....* Littleton, NH: Kilburn Brothers, 1875. 44 pp. [Lists about 2100 views.]

K86 Southall, Thomas. *The Kilburn Brothers Stereoscopic Company.* s. l.: T. Southall, 1977. xvi, 189 l. [M. A. Thesis, University of New Mexico, 1977. IMP/GEH collections.]

PERIODICALS
K87 "May-Day on Mount Washington - Vernal Aspect of the Tip-Top House." and "...The Railroad and Lizzie Bourne Monument. - From a Photograph by Kilburn Brothers, Littleton, N. H." FRANK LESLIE'S ILLUSTRATED NEWSPAPER 32, no. 816 (May 20, 1871): 165. 2 illus. [Views.]

K88 "New Hampshire. - The Mount Washington Railway - A Train of Summer Tourists Descending from the Summit House. - From a Photograph by Kilburn Brothers, Littleton, N. H." FRANK LESLIE'S ILLUSTRATED NEWSPAPER 47, no. 1198 (Sept. 14, 1878): 18, 23. 1 illus. [View.]

K89 Treadwell, T. K. "A Perspective: Comments on Kilburn." STEREO WORLD 1, no. 1 (Mar. - Apr. 1974): 1, 3, 12. 1 b & w.

K90 Hepburn, Freeman. "Not Quite on the Level Stereo: The Mt. Washington Cog Railway." STEREO WORLD 13, no. 1 (Mar. - Apr. 1986): 8-14. 11 b & w. 2 illus. [Illustrations are views by the Kilburn Brothers.]

K91 Wolfe, Laurance. "Littleton's Kilburn Cache: Early Kilburn Views Come to Light In One-Time Stereo Capitol of the World." STEREO WORLD 14, no. 2 (May - June 1987): 29-33. 4 b & w. 2 illus. [Large collection of Kilburn stereos in the collection of the Littleton, NH public library.]

K92 Duncan, Robert G. "Kilburn Brothers Stereograph Titles." THE PHOTOGRAPHIC COLLECTOR 2, no. 3 (Fall 1981): 27-33.

KILBURN, BENJAMIN WEST. (1827-1909) (USA) **see also** KILBURN BROTHERS.

KILBURN, BENJAMIN WEST. (1827-1909) (USA)
K93 "Editor's Table." PHILADELPHIA PHOTOGRAPHER 3, no. 27 (Mar. 1866): 96. ["Received parcel of very beautiful stereos of White Mountain scenery...We were surprised...they had only been...eight months in the business..."]

K94 "New Stereoscope Pictures." PHILADELPHIA PHOTOGRAPHER 3, no. 33 (Sept. 1866): 266-267. [Includes a letter from the Kilburn Brothers.]

K95 "Editor's Table." PHILADELPHIA PHOTOGRAPHER 3, no. 34 (Oct. 1866): 322. [More stereo views received by editor.]

K96 "Editor's Table." PHILADELPHIA PHOTOGRAPHER 4, no. 44 (Aug. 1867): 271-271. [Stereos of White Mountains, Niagara Falls, NY.] "Editor's Table." PHILADELPHIA PHOTOGRAPHER 5, no. 52 (Apr. 1868): 134. [Stereo views of "frost work" and of game.]

K97 "Editor's Table." PHILADELPHIA PHOTOGRAPHER 6, no. 62 (Feb. 1869): 64. [Stereo views of White Mountain scenery noted.]

K98 "Editor's Table." PHILADELPHIA PHOTOGRAPHER 6, no. 65 (May 1869): 167. [Snow scenes, stereos mentioned.]

K99 "Editor's Table." PHILADELPHIA PHOTOGRAPHER 6, no. 66 (June 1869): 196. [Note in column 'Wrinkles and dodges' on negative cracking & hypowashing.]

K100 "Into Cloudland by Cars." HARPER'S WEEKLY 13, no. 660 (Aug. 21, 1869): 533. 6 illus. ["...some of Kilburn Brothers' admirable stereoscopic pictures...." Mt. Washington cog railway.]

K101 "Editor's Table." PHILADELPHIA PHOTOGRAPHER 6, no. 68 (Aug. 1869): 284. [Views of White Mountain scenery stereos noted.]

K102 Kilburn, B. W. "Comets and Their Cause." PHILADELPHIA PHOTOGRAPHER 6, no. 69 (Sept. 1869): 315-316. [Streaking on negatives discussed.]

K103 "New American Studios. Kilburn Brothers' Model Stereographic Establishment." PHILADELPHIA PHOTOGRAPHER 6, no. 70 (Oct. 1869): 342-343.

K104 Wilson, Edward L. "The White Mountains and Mount Washington Railway." PHILADELPHIA PHOTOGRAPHER 6, no. 72 (Dec. 1869): 394-399.

K105 "Note." PHOTOGRAPHIC TIMES 1, no. 8 (Aug. 1871): 121. [Note of stereos - views of the Au Sable Chasm, Fort Ticonderoga, Saratoga, naval scenes, instantaneous farm scenes, etc.]

K106 "Editor's Table - The White Mountains." PHILADELPHIA PHOTOGRAPHER 8, no. 94 (Oct. 1871): 343-344.

K107 "Note." PHOTOGRAPHIC TIMES 1, no. 10 (Oct. 1871): 154. [Stereo views of Saratoga Springs, the hotels recently burned down, etc. for sale.]

K108 "Editor's Table: Landscape Work." PHILADELPHIA PHOTOGRAPHER 9, no. 105 (Sept. 1872): 334.

K109 Wilson, Edward L. "Ramblings With the Camera." PHILADELPHIA PHOTOGRAPHER 9, no. 108 (Dec. 1872): 407-408. [Wilson describes a two week vacation with George B. Durfee (Fall River, MA) and B. W. Kilburn, spent cruising along the New England coast, followed by a week in the mountains with Kilburn.]

K110 "Photography in Mexico." PHILADELPHIA PHOTOGRAPHER 10, no. 116 (Aug. 1873): 241. [Kilburn took a trip to Mexico.]

K111 "Natural Composition Pictures for the Stereoscope." PHILADELPHIA PHOTOGRAPHER 11, no. 122 (Feb. 1874): 55-56. [Tableaux based on J. R. Lowell's "Vision of Sir Launfal." Loescher & Petsch, Griswold, Weller, also mentioned.]

K112 Wilson, Edward L. "To Mount Washington and Return." PHILADELPHIA PHOTOGRAPHER 11, no. 125 (May 1874): 137-139. 3 illus. [Wilson describes visit to Mt. Washington, mentions meetings with stock dealers, photographers, etc. during his trip, describes new buildings of Kilburn Brothers, with diagrams of the floor plans.]

K113 "Matters of the Month: Kilburn Bros. Views." PHOTOGRAPHIC TIMES 4, no. 41 (May 1874): 72. [Ice views to illustrate Lowell's poem "Vision of Sir Launfaul." Also views of Saratoga and Mexico. "...the Kilburn Bros. have just occupied the largest establishment in the world devoted to landscape photography."]

K114 "Matters of the Month: B. W. Kilburn." PHOTOGRAPHIC TIMES 4, no. 44 (Aug. 1874): 126-127. [Note that Kilburn spent a month in New York, NY, taking views of Central Park, etc.]

K115 "Matters of the Month." PHOTOGRAPHIC TIMES 5, no. 51 (Mar. 1875): 66. ["The Co-partnership heretofore existing under the firm of Kilburn Brothers, Littleton, N.H., is dissolved. The business of publishing stereos... will be continued by B. W. Kilburn." Further note that B. W. Kilburn just returned with views of Bermuda.]

K116 "Editor's Table: Views of Bermuda." PHILADELPHIA PHOTOGRAPHER 12, no. 135 (Mar. 1875): 95.

K117 "Editor's Table." PHILADELPHIA PHOTOGRAPHER 12, no. 137 (May 1875): 158. [Ice grotto views described.]

K118 "Editor's Table." PHILADELPHIA PHOTOGRAPHER 14, no. 168 (Dec. 1877): 384. [Catalogs of views.]

K119 "Editor's Table." PHILADELPHIA PHOTOGRAPHER 14, no. 168 (Dec. 1877): 384. [Catalogues of views.]

K120 "Note." PHOTOGRAPHIC TIMES 8, no. 87 (Mar. 1878): 63. [Visit from B. W. Kilburn to editor "Mr. Kilburn has gradually and steadily become one of the most important view publishers of our country."]

K121 "Note." PHOTOGRAPHIC TIMES 8, no. 88 (Apr. 1878): 88. [Mr. B. W. Kilburn has appointed Scoville Manufacturing Co. trade agents for the sale of his stereoscopic views.]

K122 "Note." PHOTOGRAPHIC TIMES 8, no. 94 (Oct. 1878): 230. [The most extensive landscape photographer in the U.S. has just sent us some prints from his recent negatives of Boston and vicinity, Hoosac Tunnel, Hoosac Mtn. One secret of Mr. Kilburn's success is, that he makes his own negatives, and they are always very fine.]

K123 "Personal." PHOTOGRAPHIC TIMES 14, no. 160 (Apr. 1884): 193-194. ["Mr. B. W. Kilburn, the well-known landscape photographer, having secured negatives of all points of interest and of beauty within a radius of many miles around his home of Littleton, N.H., sailed on the 19th ult. for Havre, intending to make an extended tour of France... took over two thousand Inglis plates. Previously made a successful trip through Mexico and the South with his camera."]

K124 "Photography at the Columbian Fair." PHOTOGRAPHIC TIMES 23, no. 594 (Feb. 3, 1893): 54. [Note that B. W. Kilburn granted the

sole right to make stereoscopic photos of the Columbian Fair in Chicago, IL.]

K125 "Benjamin West Kilburn." PHOTOGRAPHIC TIMES 23, no. 609 (May 19, 1893): 257-259, plus frontispiece. 1 b & w. 1 illus. [Portrait of Kilburn by W. G. C. Kimball (Concord, N.H.) as frontispiece. Kilburn born in Littleton, NH on Dec. 10, 1827. Lived on a farm. Took up photography in 1855, formed partnership with his brother Edward. B.W. was the active photographer. By 1890's had accumulated approximately 75,000 negatives from all over the world - "almost all the negatives were exposed personally by Mr. Kilburn..." Article also has a brief statement about James M. Davis, Business Manager of the B. W. Kilburn Stereo Company.]

K126 "Kilburn & Davis vs. Underwood, et al." PHOTOGRAPHIC TIMES 23, no. 626 (Sept. l5, 1893): 520. [Kilburn had sole right to make stereoscopic views at the World's Fair Exposition in Chicago, IL, suing others for infringement.]

K127 "A Photographer's Deer Hunt." PHOTOGRAPHIC TIMES 24, no. 643 (Jan. 12, 1894): 25-26. 2 b & w. [Letter from Kilburn, describing his hunt.]

K128 "Notes and News: Mr. B. W. Kilburn." PHOTOGRAPHIC TIMES 24, no. 666 (June 22, 1894): 399. [Excerpts from a letter by Kilburn discussing his trip to Yosemite, mentions the photographer Fiske.]

K129 Adams, W. I. Lincoln. "Some Cloud Effects." PHOTOGRAPHIC TIMES 41, no. 2 (Feb. 1909): 38, 55-57, 65. 5 b & w. ["With illustrations by the late B. W. Kilburn".]

K130 Adams, W. I. Lincoln. "Benjamin West Kilburn." PHOTOGRAPHIC TIMES 41, no. 2 (Feb. 1909): 52-55. 1 illus.

K131 "An Old Friend". "Reminiscences of B. W. Kilburn. " PHOTOGRAPHIC TIMES 41, no. 2 (Feb. 1909): 73-74. [From the "Littleton (NH) Courier".]

KILBURN, DOUGLAS T. (AUSTRALIA)
K132 "Australia Felix." ILLUSTRATED LONDON NEWS 16, no. 410 (Jan. 26, 1850): 53. 4 illus. [Three portraits of native Australians. "It appears that Mr. Kilburn, the brother of the eminent Photographer, of Regent-street, has long resided in Australia, and felt anxious to portray the curious race of Aborigines by aid of the Daguerreotype..."]

KILBURN, EDWARD (1830-1884) (USA) see also KILBURN BROTHERS.

KILBURN, WILLIAM EDWARD. (GREAT BRITAIN)
[William Edward Kilburn operated daguerreotype studios in London from ca. 1846 to about 1862. Very popular with Society, and he was commissioned to take portraits of the Royal Family from 1846 to 1852. Exhibited at the Crystal Palace Exhibition in 1851. Patented a Stereoscopic daguerreotype case in 1853. Introduced the Woodward Solar Camera (i.e. enlarged portraits) into his studio in 1859.]

K133 Fine Arts: The Graphic Society. ATHENAEUM no. 1012 (Mar. 20, 1847): 312-313. [Kilburn colored daguerreotypes mentioned, "a Daguerreotype view of Paris, panorama-like, by Martin, one of the largest and most complete Sun paintings yet done -"]

K134 "Society of Arts - Feb. 24." ATHENAEUM no. 1013 (Mar. 27, 1847): 341. [Note of letter and commentary from Kilburn on [hand] colored photographs.]

K135 "Daguerreotype Studies: Messrs. Kilburn and Highschool." ATHENAEUM no. 1016 (Apr. 17, 1847): 415.

K136 "Fine-Art Gossip." ATHENAEUM no. 1019 (May 8, 1847): 498. [Note of new studies by Kilburn, mention that Kilburn has been appointed Her Majesty's Daguerreotypist.]

K137 "The Horticultural Society's Fete, at Chiswick." ILLUSTRATED LONDON NEWS 13, no. 326 (July 15, 1848): 28. 2 illus. ["The Band Near the Rhododendron Circle - (From a Daguerreotype by Kilburn.)" "The Great Conservatory. (From a Daguerreotype by Kilburn.)"]

K138 "Monthly Notes: Preparation of Daguerreotype Plates by the Electrotype." PRACTICAL MECHANIC'S JOURNAL 1, no. 6 (Sept. 1848): 119.

K139 "Fine-Art Gossip." ATHENAEUM no. 1125 (May 19, 1849): 521. [Disapproving note of "oil picture painted by Mr. A. Solomon from the Daguerreotype of Jenny Land taken by Mr. Kilburn", felt to be hard and severe.]

K140 Portraits. Woodcut engravings credited "From a photograph by William Edward Kilburn, Regent Street." ILLUSTRATED LONDON NEWS 16, (1850) ["John Sandler, M.P." 16:* (Mar. 9, 1850): 156. (dag.) "W. Keogh, Esq." 16:* (Apr. 20, 1850): 261. (photo.) "Henry Tufnell, M. P." 16:* (May 18, 1850): 349. (photo.) "George Cornwell Lewis, M. P." 16:* (June 1, 1850): 388. (photo.) "Lord Nass, M.P." 16:* (June 22, 1850): 429. (photo.) "Lawrence Heyworth, M.P." 16:* (June 22, 1850): 444. (photo.)]

K141 "Fine-Art Gossip." ATHENAEUM no. 1174 (Apr. 27, 1850): 456-457. ["... we have long felt that the Parisian practicers of that art exceed the best of our own in their successful results. We have seen two portraits of Lord Gough, however, by Mr. Kilburn, which rival even those of M. Andrieu himself, the best of the French manipulators."]

K142 Portraits. Woodcut engravings credited "From a photograph by William Edward Kilburn, Regent St." ILLUSTRATED LONDON NEWS 17, (1850) ["A. J. E. Cockburn, M.P." 17:* (Aug. 10, 1850): 121. (photo) "Right Rev. Dr. Fulford." 17:* (Aug. 24, 1850): 168 (photo) "Jenny Lind." 17:* (Sept. 28, 1850): 253. (photo) "Robert Stephenson, Esq., M.P." 17:* (Oct. 19, 1850): 309. (photo)]

K143 "Letter." ATHENAEUM no. 1215 (Feb. 8, 1851): 170. [Letter from Kilburn supporting Blanquart-Evrard (pg. 86, Jan. 18, 1851) and opposing Claudet (pg. 141-142, Feb. 1, 1851) on issue of whitening the interior of the camera. "W. E. Kilburn, Photographer to the Queen."]

K144 Portraits. Woodcut engravings credited "From a photograph by William Edward Kilburn." ILLUSTRATED LONDON NEWS 18, (1851) ["Marquis of Kildare, M.P." 18:* (Feb. 8, 1851): 105. (photo) "Sir Denis Le Marchant, Bart." 18:8 (Feb. 22, 1851): 168. (photo) "Lord Duncan, M.P." 18:* (Mar. 15, 1851): 209. (photo) "Arthur Anderson, M.P." 18:* (Mar. 22, 1851): 233. (photo) "Henry Edwards, M.P." 18:* (Mar. 22, 1851): 233. (photo) "Sir Robert Peel, Bart., M.P." 18:* (Mar. 29, 1851): 254. (photo) "Mr. Calvert, M.P." 18:* (Apr. 5, 1851): 278. (photo) "Mr. R. A. Slaney, M.P." 18:* (Apr. 12, 1851): 291. (photo) "Mr. R. Bethel, Q.C., M.P." 18:* (Apr. 19, 1851): 314. (photo) "Sir William Molesworth, Bart., M.P." 18:* (Apr. 26, 1851): 342. (photo) "Joseph Paxton, Architect of Crystal Palace." 18:* (May 3, 1851): 327. (photo) "Lord Torrington." 18:* (June 7, 1851): 515. (dag.) "The Cruvelli Sisters, musicians." 18:8 (June 14, 1851): 555. (dag.) "Madame Ugalde, actress." 18:8 (June 28, 1851): 618. (photo)]

K145 "Walks in the Galleries: Kilburn's Photographic Portraits." ILLUSTRATED LONDON NEWS 18, no. 491 (June 7, 1851): 528. [Brief review of Kilburn's exhibition at the Crystal Palace.]

K146 Portraits. Woodcut engravings credited "From a photograph by William Edward Kilburn." ILLUSTRATED LONDON NEWS 19, (1851) ["Earl of Arundel and Surrey." 19:* (July 19, 1851): 77. (photo) "Commissioners of Crystal Palace." (2 portraits) 19:* (Oct. 18, 1851): 508-509. "Sir Henry R. Bishop." 19:* (Dec. 6, 1851): 669. (photo) "Louis Napoleon Bonaparte." 19:* (Dec. 13, 1851): 681. (photo)]

K147 Portraits. Woodcut engravings credited "From a photograph by William Edward Kilburn." ILLUSTRATED LONDON NEWS 20, (1852) ["Right Hon. Earl Granville." 20:* (Jan. 3, 1852): 9. (photo) "Solicitor General Sir Fitzroy Kelly." 20:* (Mar. 20, 1852): 225. "Right Hon. The Earl of Eglinton." 20:* (Mar. 20, 1852): 241. (dag.) "Marquess of Lansdowne, K.G." 20:* (Apr. 3, 1852): 273. (dag.) "Capt. Kellett." 20:* (Apr. 24, 1852): 321. (photo)]

K148 "Fine-Art Gossip." ATHENAEUM no. 1288 (July 3, 1852): 729. ["Mr. Kilburn, the eminent daguerreotypist...a cleverly arranged group of portraits of the ex-Rajah of Koorg and the Princess his daughter."]

K149 Portrait. Woodcut engraving credited "From a photograph by William Edward Kilburn." ILLUSTRATED LONDON NEWS 21, (1852) ["Right Hon. Thomas Challis, M.P." 21:* (Nov. 13, 1852): 396. (photo)]

K150 "Fine-Art Gossip." ATHENAEUM no. 1326 (Mar. 26, 1853): 391. [Note that "Mr. Kilburn, the eminent daguerreotypist, has effected an improvement in the Stereoscope..."]

K151 "Portable Stereoscope." HUMPHREY'S JOURNAL 5, no. 2/3 (May 1-15, 1853): 40. [From the "Athenaeum."]

K152 Portraits. Woodcut engravings credited "From a photograph by William Edward Kilburn." ILLUSTRATED LONDON NEWS 23, (1853) ["Lieut.-Gen. Sir Charles J. Napier." (2 portraits) 23:* (Sept. 3, 1853): 192. (photo)]

K153 Portraits. Woodcut engravings credited "From a photograph by William Edward Kilburn." ILLUSTRATED LONDON NEWS 26, (1855) ["Bernese Girl." 26:* (Feb. 3, 1855): 108. (photo) "The Earl of Carlisle." 26:* (Mar. 24, 1855): 280. (photo) "Sir George Cornewall Lewis." 26:* (May 5, 1855): 441. (dag.)]

K154 Portraits. Woodcut engravings credited "From a photograph by William Edward Kilburn." ILLUSTRATED LONDON NEWS 27, (1855) ["James Morgan." 26:* (Dec. 29, 1855): 760. (photo)]

K155 Portrait. Woodcut engraving credited "From a photograph by William Edward Kilburn." ILLUSTRATED LONDON NEWS 29, (1856) ["Lord Wodehouse, Minister to Russia." 29:* (Sept. 6, 1856): 239.]

K156 Portrait. Woodcut engraving credited "From a photograph by William Edward Kilburn." ILLUSTRATED LONDON NEWS 31, (1857) ["Brigadier-General Nicholson." 31:* (Dec. 5, 1857): 564.]

K157 Portrait. Woodcut engraving credited "From a photograph by William Edward Kilburn." ILLUSTRATED LONDON NEWS 33, (1858) ["Samuel Gurney, M.P." 33:* (July 24, 1858): 94.]

K158 "Fine Arts: Enlarged Photograph by Woodward's Solar Camera." ILLUSTRATED LONDON NEWS 35, no. 990 (Aug. 27, 1859): 220. [Report on Woodward's Solar Camera at Kilburn's Studio in London.]

K159 Portraits. Woodcut engravings, credited "From a Photograph by Kilburn, Regent Street." ILLUSTRATED LONDON NEWS 36, (1860) ["Gen. Sir W. F. P. Napier." 36:* (Feb. 25, 1860): 172. "Mrs. Jameson." 36:* (Mar. 31, 1860): 300.]

K160 "Fine-Art Gossip: The British Photographic Portrait Gallery." ATHENAEUM no. 1762 (Aug. 3, 1861): 159. [Review of nos. 3 - 6 in the series, photographed by Kilburn, published by Mason & Co.]

KIMBALL & COOPER.
K161 "Felix Sanches, Missing Since Jan. 6, 1859. - From an Ambrotype by Kimball & Cooper." FRANK LESLIE'S ILLUSTRATED NEWSPAPER 7, no. 178 (Apr. 30, 1859): 335. 1 illus.

KIMBALL BROTHERS. (NORFOLK, VA)
K162 Portrait. Woodcut engraving, credited "From a Photograph by Kimball Brothers." HARPER'S WEEKLY 10, (1866) ["Pierre Carme." 10:483 (Mar. 31, 1866): 193. "Michael Phelan." 10:483 (Mar. 31, 1866): 193.]

KIMBALL.
K163 Portrait. Woodcut engraving, credited "From a Photograph by Kimball." FRANK LESLIE'S ILLUSTRATED NEWSPAPER 9, (1860) ["Late Lieut. Thomas J. Rogers, 1st Reg., NY Vols. 9:221 (Feb. 25, 1860): 203.]

KIMBALL, HOWARD. A. see CLOUGH & KIMBALL.

KIMBALL, HOWARD A. (CONCORD, NH)
K164 "Correspondence." ANTHONY'S PHOTOGRAPHIC BULLETIN 1, no. 11 (Dec. 1870): 231. [Kimball mentions his invitation to "share the work, cold, and profits" with Mr. Clough atop Mt. Washington this winter.]

K165 Kimball, Howard A. "Flakes from Mount Washington." ANTHONY'S PHOTOGRAPHIC BULLETIN 2, no. 2-3 (Feb.-Mar. 1871): 34-37, 70-71. [From "The Concord Independent Democrat." A. F. Clough and the author were the photographers on this team. Second article, from "Concord Daily Patriot," pp. 36-37, identified Kimball.]

K166 "Flakes from Mount Washington. No. 3." ANTHONY'S PHOTOGRAPHIC BULLETIN 2, no. 3 (Mar. 1871): 70-71. [From "NY Daily Times." Description of the over-winter expedition. H. A. Kimball and A. F. Clough, the photographers.]

K167 "Pictures." ANTHONY'S PHOTOGRAPHIC BULLETIN 2, no. 3 (Mar. 1871): 93. [Description of photos of atmospheric conditions atop Mount Washington in the winter.]

K168 "The Colombia College Boat-Crew, Winners of the Inter-Collegiate Race on Lake Saratoga, July 18th. - From Photographs by Sarony, New York; Kimball, Concord, N. H., and Moore Brothers, Springfield, Mass." FRANK LESLIE'S ILLUSTRATED NEWSPAPER 38, no. 983 (Aug. 1, 1874): 321, 326-327, 328-329. 2 illus. [Group portrait of the crew, individual portraits of which must have been copied from different photographs by the engraver, since three separate photographers are credited for the one image. The second image is an artist's sketch.]

KIMBALL, M. H.
K169 "Mounting Photographs - M. H. Kimball's Plan." AMERICAN JOURNAL OF PHOTOGRAPHY AND THE ALLIED ARTS & SCIENCES n. s. vol. 6, no. 9 (Nov. 1, 1863): 211-212.

KINDER, J. (AUKLAND, N ZEALAND)

K170 "Illustrations of New Zealand." ILLUSTRATED LONDON NEWS 43, no. 1230 (Nov. 7, 1863): 469, 472, 476-477. 6 illus. ["Three of these scenes are from photographs forwarded to us by Mr. J. Kinder, of Aukland. Others are from drawings."]

KINDERMAN, CONRAD. (1842-) (GERMANY)

K171 "Notes: Conrad Kinderman." PHOTOGRAPHIC TIMES 29, no. 11 (Nov. 1897): 543. [Brief biographical statement. Born 1842 in Lübeck, Germany. Established a studio there in 1863, gained a reputation as a photographer of children. Early exponent of the gelatine-emulsion plate in the 1880s. Member of the Deutsche Photographen Verein since 1881.]

KINDLER, FREDERICK. (1826-) (GERMANY, USA)

K172 Portraits. Woodcut engravings, credited "Photographed by Kindler, of Newport, R. I." FRANK LESLIE'S ILLUSTRATED NEWSPAPER 18, (1864) ["Miss Ida Lewis, of Lime Rock Lighthouse." 23:592 (Feb. 2, 1867): 311.]

KING, HORATIO NELSON. (1830-1905) (GREAT BRITAIN)

K173 "Stereographs: Bath and Its Environs, by H. N. King." BRITISH JOURNAL OF PHOTOGRAPHY 7, no. 128 (Oct. 15, 1860): 304.

K174 "Obituary of the Year: Horatio Nelson King (May 25, 1905)." BRITISH JOURNAL PHOTOGRAPHIC ALMANAC 1906 (1906): 656. [Died at age 75. His business embraced an immensely wide field of portraiture and landscape, one of largest publishers of stereos and views. Collection of views of Royal palaces. Controlled Vernon Heath's negatives after Heath's death, including the "Cottage Porch," which was printed constantly for six years, brought in 6000 pounds. Railroad photography. A photo of his appeared in the "Illustrated London News" in 1858. "He was early in the field when reproduction fees promised to add to the photographer's income."]

KING, J. (BOMBAY, INDIA)

K175 King, J. "On a New Method of Vignetting Proofs." BRITISH JOURNAL PHOTOGRAPHIC ALMANAC 1875 (1875): 79.

K176 King, J., M.A. (Cantab.), Bombay C.S. "Practical Instructions for Preparing Gelatino-Bromide Plates." BRITISH JOURNAL PHOTOGRAPHIC ALMANAC 1874 (1874): 102-105.

KING, J. W. (HAWAII)

K177 King, J. W. "Correspondence: A Tourist Photographer's Reminiscences." PHOTOGRAPHIC TIMES 17, no. 279 (Jan. 21, 1887): 34. [King claims to have been the first photographer to work with paper processes in the Hawaiian Islands, beginning in Honolulu in 1859.]

K178 "Reminiscences: A Photographic Excursion to the Crater 'Haleakala.'" PHOTOGRAPHIC TIMES 17, no. 283 (Feb. 18, 1887): 83-84. [King describes his 13 years of experiences travelling around and photographing the Hawaiian Islands. Particularly long discussion of a trip to the extinct volcano of Haleakala in 1860 or 1861.]

K179 King, J. W. "A Tourist Photographers Reminiscences. Part 2. My First View of a Volcanic Eruption." PHOTOGRAPHIC TIMES 17, no. 288 (Mar. 25, 1887): 144-145.

K180 King, J. W. "A Tourist Photographer's Reminiscences - 3. Among the Lepers." PHOTOGRAPHIC TIMES 17, no. 292 (Apr. 22, 1887): 214-215. [Hawaii.]

K181 King, J. W. "Reminiscences of a Tourist Photographer - 4. Death of Captain Cook." PHOTOGRAPHIC TIMES 17, no. 308 (Aug. 12, 1887): 410-411.

KING, MARQUIS FAYETTE. (1835-1904) (USA)

K182 Portrait. Woodcut engraving, credited "From a Photograph by Kimball." FRANK LESLIE'S ILLUSTRATED NEWSPAPER 9, (1860) ["Late Lieut. Thomas J. Rogers, 1st Reg., NY Vols. 9:221 (Feb. 25, 1860): 203.]

K183 "Great Fire in Portland, Maine." HARPER'S WEEKLY 10, no. 500 (July 28, 1866): 465, 466, 468, 472-473. 9 illus. [Views of ruins. Sketches by Stanley Fox; 2 photos by M. F. King, Portland, Maine; 1 photo view by B. F. Smith & Son, Portland.]

K184 "Temple of the New Jerusalem Society, Portland, Me., Mr. Rev. Wm. S. Hatden, Pastor - From a Photograph by M. F. King." FRANK LESLIE'S ILLUSTRATED NEWSPAPER 27, no. 696 (Jan. 30, 1869): 325. 2 illus. [View. Portrait.]

K185 "Portland, Maine. - The Peabody Funeral - Departure of the Remains by Special Train for Peabody, Near Danvers, Massachusetts. - From a Photograph by M. F. King." FRANK LESLIE'S ILLUSTRATED NEWSPAPER 29, no. 751 (Feb. 19, 1870): 384, 385, 388. 5 illus. [One image credited to a photograph. There are several other illustrations in this and earlier issues of "FLIN" about the funeral procession of Peabody, some of which were probably also by King.]

K186 Portrait. Woodcut engraving, credited "From a Photograph by M. F. King, Portland, ME." FRANK LESLIE'S ILLUSTRATED NEWSPAPER 39, (1875) ["Hon. Josiah H. Drummond, a Mason." 39:1005 (Jan. 2, 1875): 285.]

KING, PAULINE.

K187 King, Pauline. "The Charming Daguerreotype." CENTURY MAGAZINE 68, no. 1 (May 1904): 81-82. 1 illus. [Brief reflections on the beautiful qualities of this obsolete process. Leads to the following article, "The Lost Art of the Daguerreotype," by Abraham Bogardus.]

KING, W. WARWICK.

K188 King, W. W. "Remarks on the Tannin Process." AMERICAN JOURNAL OF PHOTOGRAPHY AND THE ALLIED ARTS & SCIENCES n. s. vol. 6, no. 13 (Jan. 1, 1864): 292-296. [Read before North London Photo Society. From comments, it would seem that W. W. King had taken at least one photographic trip to Denmark.]

K189 King, W. Warwick. "On Neglected Art Fields for Photographers." BRITISH JOURNAL OF PHOTOGRAPHY 11, no. 243 (Dec. 30, 1864): 544-545. [Suggestions of what paintings to copy for photographers.]

K190 King, W. Warwick. "Where to Go with the Camera: Notes on a Photographic Trip in the Isle of Man." BRITISH JOURNAL OF PHOTOGRAPHY 12, no. 276 (Aug. 18, 1865): 430.

KINGHAM, RICHARD. (GREAT BRITAIN)

K191 Kingham, Richard, ed. The Amateur's Manual of Photography. London: Thomas Kingham, 1864. 85 pp. illus. [6 editions by 1870.]

KINGSLEY, W. TOWLER.

K192 Kingsley, Rev. W. Towler. "On the Application of the Microscope to Photography." PHOTOGRAPHIC ART JOURNAL 6, no. 5 (Nov. 1853): 271-274. 1 illus. [From "J. of Photo. Soc."]

KINNEAR, C. G. H.

K193 Kinnear, C. G. H., Hon. Sec. "Abstract of an Account of an Architectural and Photographic Tour in the North of France." JOURNAL OF THE PHOTOGRAPHIC SOCIETY OF LONDON 4, no. 61 (Dec. 21, 1857): 116-121. [Kinnear, Alexander, and James Adam, both from the Photo. Soc. of Scotland, toured France.]

K194 Kinnear, C. G. H. "Abstract of an Account of an Architectural and Photographic Tour in the North of France." HUMPHREY'S JOURNAL OF PHOTOGRAPHY, AND THE ALLIED ARTS AND SCIENCES 9, no. 20 (Feb. 15, 1858): 316-320. [Mr. Kinnear, Alexander Adam and James Adam together made a photographic tour of Northern France.]

KIPLING, ARTHUR.

K195 "The Lady Daly, an Australian River Steamer." ILLUSTRATED LONDON NEWS 43, no. 1234 (Dec. 5, 1863): 573. 1 illus. ["...from a photograph taken by Mr. Arthur Kipling..."]

KIRCHHOFF, GUSTAVE ROBERT. (1824-1887) (GERMANY)

K196 "Obituary: Gustave Robert Kirchhoff." ANTHONY'S PHOTOGRAPHIC BULLETIN 18, no. 21 (Nov. 12, 1887): 661. [Born in Koenigsberg in 1824. Studied medicine in Berlin. From 1850s-1870s he experimented and conducted photographic research.]

KIRK, H.

K197 "Connecticut. - The Russell Library at Middletown. - Photographed by H. Kirk." FRANK LESLIE'S ILLUSTRATED NEWSPAPER 42, no. 1072 (Apr. 15, 1876): 93. 1 illus. [View.]

KIRK, SIR JOHN. (1832-1922) (GREAT BRITAIN, AFRICA)

BOOKS

K198 Coupland, Reginald. *Kirk On the Zambesi. A Chapter of African History.* Oxford: The Claredon Press, 1928. vi, 286 pp. illus.

K199 Foskett, Robert, ed. *The Zambesi Journal and Letters of Dr. John Kirk 1858-63.* London: Oliver & Boyd, 1965.

K200 Allen, Dana L. *Dr. Kirk, I Presume. Photography Along the Zambesi, 1858-1863.* "History of Photography Monograph Series, No. 9." Tempe, AZ: Arizona State University, School of Art., May 1984. 16 pp. 4 b & w. 1 illus. [Dr. John Kirk, company physician and botanist to the 1858 Zambesi River expedition of Livingston. Born at Barry, Forfarshire, Scotland, on Dec. 19, 1832. Studied at Edinburgh University. Trained as a surgeon and studied botany. Asked to join Livingston's expedition. David Livingston's brother Charles was the official photographer, with the wet-collodion process - which was difficult to operate. Kirk also photographed using waxed-paper process and dry collodion plates, with more success. Remained in Africa until 1863. Then returned in 1866 to become Agency Surgeon at Zanzibar. He spent the next twenty years in the Service of the British Government, concluding with his appointment as Consul General for East Africa. Continued to photograph as well. Knighted. Died Jan. 15, 1922.]

PERIODICALS

K201 Lawson, Julie. "Dr. John Kirk and Dr. William Robertson: Photographers in the Crimea." HISTORY OF PHOTOGRAPHY 12, no. 3 (July - Sept. 1988): 227-241. 21 b & w. [Dr. John Kirk (1832-1922) was a Scottish physician, and an ardent amateur photographer. Dr. William Robertson (1818-1882) was a Scottish physician. Both took calotypes of military facilities and personnel at Renkioi, in the Crimea, during the Crimean War.]

KISCH BROTHERS. (DURBAN, NATAL)

K202 Portrait. Woodcut engraving credited "From a photograph by Kisch Brothers." ILLUSTRATED LONDON NEWS 72, (1878) ["Late Capt. F. Elton." 72:2019 (Mar. 9, 1878): 221.]

KITCHENER, HORATIO HERBERT, LIEUT.

K203 Kitchener, Lieut. H. H., R.E. *Photographs of Biblical Sites.* London: Edward Stanford, for the Palestine Exploration Fund, 1875. n. p. 12 b & w. [Albumen prints. Views by Lieut. Kitchener, who worked as an amateur photographer assisting the Palestine Exploration Survey in 1874. He made approximately fifty photographs during this period and offered prints for sale to benefit the Fund. Kitchener would later become famous as the British military leader at Khartoum.]

KITTLITZ.

K204 Seemann, Berthold, texts. *Twenty-Four Views of the Vegetation of the Coasts and Islands of the Pacific.* London: Longmans & Co., 1861. n. p. illus. [Photographic reproductions of artist's plates. Plates by Kittlitz, descriptive letterpress by Berthold Seemann.]

KLARY, C. (1837-) (FRANCE)

K205 "Rapid Portraiture." ANTHONY'S PHOTOGRAPHIC BULLETIN 9, no. 8 (Aug. 1878): 250-251. [From "London Photographic News." Mr. Klary (at Maison Franck in Paris) "working M. Boissonas' rapid (dry) process," for quicker portrait exposures.]

K206 "The Extra Rapid Wet Process." ANTHONY'S PHOTOGRAPHIC BULLETIN 9, no. 12 (Dec. 1878): 368. [From "London Photo. News."]

K207 "Photographers, Old and New." WILSON'S PHOTOGRAPHIC MAGAZINE 33, no. 469 (Jan. 1896): 31-32. 1 illus. [Born Nancy, France in 1837. Telegraphic department of French Army in 1860, spent several years in Algiers. In 1863 resigned, returned to Paris, then London and learned photography professionally. In 1865 established an extensive photographic establishment in Algiers. Returned to Paris 1879. To New York 1884. Studied with W. Kurtz, returned to Paris, set up portrait studio and the "School of Practical Photography", where he teaches amateurs and professionals.]

KLAUBER, EDWARD. (ca. 1835-1918) (USA)

BOOKS

K208 Joblin, Maurice & Co. *Louisville Past and Present; Its Industrial History as Exhibited in the Life-Labors of Its Leading Men.* Louisville: M. Joblin & Co., 1875. n. p. 55 b & w. [Cabinet photo portraits, by E. Klauber.]

PERIODICALS

K209 Portrait. Woodcut engraving, credited "Photographed by E. Klauber, of Louisville." FRANK LESLIE'S ILLUSTRATED NEWSPAPER 38, (1874) ["Henry Watterson, ed. of the Louisville, KY, "Courier Journal." 38:980 (July 11, 1874): 277.]

K210 "Novel Entertainment." ANTHONY'S PHOTOGRAPHIC BULLETIN 8, no. 4 (Apr. 1877): 109. [Announcement of a lecture by Prof. T. W. Tobin on "The Wonders of Photography, Illustrated by E. Klauber" in Louisville, KY.]

K211 "Correspondence." ANTHONY'S PHOTOGRAPHIC BULLETIN 10, no. 4 (Apr. 1879): 112. [Letter from Klauber (Louisville, KY).]

K212 "Our Illustration." ANTHONY'S PHOTOGRAPHIC BULLETIN 10, no. 10 (Oct. 1879): frontispiece, 320. 1 b & w. [Original photo. Studio portrait. Klauber from Louisville, KY.]

K213 "The Louisville Disaster." FRANK LESLIE'S ILLUSTRATED NEWSPAPER 70, no. 1804 (Apr. 12, 1890): cover, 215, 218-219. 3 b & w. 8 illus. [From photos by E. Klauber and sketches by C. Upham. 3 b & w from Klauber's photos. Three other, sketchier images credited from photos by W. Stuber & Bro.]

K214 1 photo (Rear-Admiral John Crittenden, USN). WORLD'S WORK 1, no. 2 (Dec. 1900): 125.

KLAUSER, WILLIAM. (1828-1885) (RUSSIA, USA)
K215 Portrait. Woodcut engraving, credited "From a Photograph by Klauser." FRANK LESLIE'S ILLUSTRATED NEWSPAPER 47, (1878) ["Hon. Benjamin K. Phelps." 47:1208 (Nov. 23, 1878): 208.]

K216 "The Late Mr. William Klauser." PHOTOGRAPHIC TIMES 15, no. 191 (May 15, 1885): 266. [Born St. Petersburg, Russia in 1828. To USA in 1848. Associated with P. C. Duchochois a number of years, then continued in his own name for the last twenty-five years. Obliged by sickness to give up his gallery, he became a very popular instructor in gelatine work for amateurs.]

KLEFFEL, L. G.
K217 "Hints Respecting the Production of Clean Negatives in Hot Weather." HUMPHREY'S JOURNAL OF PHOTOGRAPHY, AND THE ALLIED ARTS AND SCIENCES 20, no. 15 (Dec. 1, 1868): 239-240.

K218 Kleffel, L. G. "On Cleaning Glass Plates for Photographic Purposes." HUMPHREY'S JOURNAL OF PHOTOGRAPHY, AND THE ALLIED ARTS AND SCIENCES 20, no. 23 (July 15, 1869): 362-364.

KLEIR, P. (MOULMEIN, BURMA)
K219 "'Imperial' Festivities in British Burmah." ILLUSTRATED LONDON NEWS 70, no. 1966 (Mar. 17, 1877): 259, 260. 2 illus.

KLINGEMANN, C.
K220 "Birthplace of Handel, at Halle, Saxony." ILLUSTRATED LONDON NEWS 34, no. 980 (June 25, 1859): 617. 1 illus.

KLUMB, REVERT HENRIQUE. (GERMANY, BRAZIL)
K221 Pereira, Cecilia Deprat de Britto. "Revert Henrique Klumb: Fotógrafo da Familia Imperial Brasileira." ANAIS DA BIBLIOTECA NACIONAL no. 102 (1982): 221-234. 1 illus. [Listing of the photos by Klumb held at the National Library of Brazil, in Rio de Janeiro.]

KNICKERBOCKER, S. (ST. JOHNSVILLE, NY)
K222 "Letter from a Soldier." HUMPHREY'S JOURNAL OF PHOTOGRAPHY, AND THE ALLIED ARTS AND SCIENCES 17, no. 10 (Sept. 15, 1865): 152. ["I have just returned from the war, where I have been a soldier for nearly two years...My business for the time being is such, that I cannot pay any practical attention to the most fascinating of all arts-Photography;..."]

KNIGHT.
K223 "Knight's Cosmorama Stereoscope." HUMPHREY'S JOURNAL 8, no. 12 (Oct. 15, 1856): 192. [From "London Art J."]

KNIGHT, D. H. (TERRE HAUTE, IN)
K224 "Editor's Table." PHILADELPHIA PHOTOGRAPHER 6, no. 68 (Aug. 1869): 284. ["Thanks for their work."]

KNIGHT, EDWARD H.
K225 Knight, Edward H. "The First Century of the Republic. [Fifth Paper.] Mechanical Progress (Concluded). Printing - Stereotyping - Electrotyping - The Printing Press - Lithography - Photography - Photolithography - Photo-Micrography." HARPER'S MONTHLY 50, no. 298 (Mar. 1875): 518-543. 31 illus. [This is part of a series on the history of technological improvements during the past decade. Contains brief summaries of the technological changes in the photographic and printing industries. Illustration are of cameras, etc.]

KNIGHT, J. LEE. (TOPEKA, KS)
K226 Knight, J. Lee. "Correspondence." ANTHONY'S PHOTOGRAPHIC BULLETIN 2, no. 9 (Sept. 1871): 299, 301. [Letter from Knight describing how he converted two lenses into a stereo pair. Knight from Topeka, KS. The poem "The Old Pedagogue," on p. 301 was also either written by, or sent to, the "APB." by Knight. Additional note on page 303 that Knight will sell photographic stock at his establishment.]

K227 "Pictures." ANTHONY'S PHOTOGRAPHIC BULLETIN 3, no. 1 (Jan. 1872): 435. [J. Lee Knight (Topeka, KS); Schaub (Griffin, GA); Mr. Root (Dubuque).]

K228 Knight, J. Lee. "Correspondence." ANTHONY'S PHOTOGRAPHIC BULLETIN 3, no. 4 (Apr. 1872): 528. [About lenses, correcting an error.]

K229 Knight, J. Lee. "The Grand Duke taken by J. Lee Knight." ANTHONY'S PHOTOGRAPHIC BULLETIN 3, no. 4 (Apr. 1872): 530. [From "Kansas Daily Commonwealth." The Grand Duke (of Russia?) on "his excursion on the plains," accompanied by Lt. Gen. Sheridan and staff, photographed by Knight in Topeka, KS.]

K230 Knight, J. Lee. "Fourth Annual Meeting and Exhibition of the N.P.A. in St. Louis, Mo., May 1872: Poem "Tinkering Jim"." PHILADELPHIA PHOTOGRAPHER 9, no. 102 (June 1872): 199-200.

K231 "Note." ANTHONY'S PHOTOGRAPHIC BULLETIN 5, no. 2 (Feb. 1874): 87. [From "Topeka Commonwealth." "During his six year residence in Topeka, Capt. J. Lee Knight, of the Riverside Gallery, has received twenty-nine first premiums at State fairs..."]

K232 Knight, J. Lee. "Something about Stereographs." PHILADELPHIA PHOTOGRAPHER 11, no. 122 (Feb. 1874): 48-49.

K233 "Some Pictures." ANTHONY'S PHOTOGRAPHIC BULLETIN 5, no. 11 (Nov. 1874): 376. [From "Topeka Commonwealth." Knight contracted to provide 4,400 8"x10" prints of the Kansas Pacific Railroad for publicity.]

K234 Stark, Amy E. "Taking and Being Taken." HISTORY OF PHOTOGRAPHY 6, no. 2 (Apr. 1982): 150. 1 illus. [Engraving of a buffalo routing a photographer, destroying his camera, with excerpt from an 1873 book "Buffalo Land: an authentic account of the discoveries..." by William Edwards Webb, describing the incident.]

KNIGHT, W. M. (BUFFALO, NY)
K235 "Editor's Table." PHILADELPHIA PHOTOGRAPHER 6, no. 62 (Feb. 1869): 63. [Note of a frame containing forty whole size portraits of the members of Eagle Hose Co., No. 2, Buffalo, NY.]

K236 Portrait. Woodcut engraving, credited "From a Photograph by Knight. FRANK LESLIE'S ILLUSTRATED NEWSPAPER 34, (1872) ["Christopher G. Fox, of Buffalo, NY, a Mason." 34:877 (July 20, 1872): 300.]

KNOTT. (OLDHAM, ENGLAND)
K237 Portrait. Woodcut engraving, credited to "From a Photograph by Knott." ILLUSTRATED LONDON NEWS 60, (1872) ["Late Mr. John Platt, M.P." 60:1708 (June 1, 1872): 537.]

KNOWLES, CHARLES D.
K238 Knowles, Charles D. "How it Goes." HUMPHREY'S JOURNAL OF PHOTOGRAPHY, AND THE ALLIED ARTS AND SCIENCES 17, no. 1 (May 1, 1865): 15. ["We are getting letters like this daily: - Richmond, Va., April 29, 1865....Please send my Journal hereafter to Weedsport, Cayuga County, New York, for this war is played out, and I expect to soon be at home...Charles D. Knowles, Battery K, 3rd NYV Artillery, 24th Army Corps." "Our brave boys are coming home at last. The war must certainly be over when we get such letters. Hundreds of operators who have been in the army will now be welcomed home...The Photographic profession has been well represented in this war, and many have nobly distinguished themselves."]

KNOWLTON, FRANKLIN S. (1836/37-1921) (USA)
BOOKS
K239 *Burt's Stereoscopic Views of Mount Holyoke, Northampton, Sugar Loaf Mountain, &c.* Northampton, NH?; Burt, n. d. [ca. 1866?] 2 pp. [Flyer listing stereo views. "The Subscriber has just published a large variety of Stereoscopic Views of some of the most beautiful scenery in the Connecticut Valley, recently photographed expressly for him by Mr. F. S. Knowlton, of the firm of Lovell & Knowlton, Northampton, who has had extensive experience in this department of photography, having accompanied an expedition several years since to the northern part of British America, where he was the first to make photographs of Icebergs, Esquimaux, and the wonderful scenery of that region."]

PERIODICALS
K240 Hallock, Charles. "Three Months in Labrador." HARPER'S MONTHLY 22, no. 131-132 (Apr. - May 1861): 577-599, 743-765. 28 illus. ["To F. S. Knowlton, of Portsmouth, New Hampshire, the writer is greatly indebted for admirable photographic views of coast and interior landscapes. They are believed to be the only photographs of Labrador scenery ever taken." One of the illustrations, "An Artist's Trials," shows the photographer harassed by curious sled dogs while trying to take photographs.]

KNOWLTON, I. (CUMBERLAND, OH)
K241 "Editor's Table." PHILADELPHIA PHOTOGRAPHER 6, no. 68 (Aug. 1869): 284. [Card photos of an old opossum and eight young ones listed.]

KRAFT, LEON.
K242 Kraft, M. Leon., pupil of M. Gay Luzzac. "Analysis of English Collodion." PHOTOGRAPHIC ART JOURNAL 5, no. 1 (Jan. 1853): 13-14. [From "La Lumiére."]

KRONE, HERMANN. (1827-1916) (GERMANY)
K243 Krone, Paul R. "Bromides used in Collodion in 1849!" HUMPHREY'S JOURNAL OF PHOTOGRAPHY, AND THE ALLIED ARTS AND SCIENCES 11, no. 24 (Apr. 15, 1860): 369. ["I am a German, born in Prussia, and my brother is now, and has been since 1844, one of the best artists in Europe, particularly in Saxony,...In 1849 I was with him, and at this period he used collodion composed of iodide and bromide of ammonium for negatives and positives on glass...etc." (Paul Krone's brother was probably Hermann Krone, who had a commercial studio in Dresden, where he made both portraits and landscape views. Published an album of thirty-six views, *Album der Sächsischen Schwiz*, in 1853. In 1870 he became instructor of photography at the Dresden Polytechnikum, later becoming a full professor. Retired in 1907, and died in 1916.]

KRONE, PAUL R. (FORT SMITH, AK)
K244 Krone, P. R. "Whitening Positives." HUMPHREY'S JOURNAL OF PHOTOGRAPHY, AND THE ALLIED ARTS AND SCIENCES 11, no. 19 (Feb. 1, 1860): 294.

KRUGER.
K245 "Kruger's Photographic Rest." HUMPHREY'S JOURNAL OF PHOTOGRAPHY, AND THE ALLIED ARTS AND SCIENCES 20, no. 17 (Jan. 15, 1869): 261-263. 2 illus.

KRZIWANEK, CARL.
K246 Krziwanek, Carl. "On Developing and Printing." HUMPHREY'S JOURNAL OF PHOTOGRAPHY, AND THE ALLIED ARTS AND SCIENCES 19, no. 17 (Jan. 1, 1868): 269-270. [Read to Vienna Photo. Soc.]

KUHNS, W. & SONS. (ATLANTA, GA)
K247 "The Presidential Party Passing Down Whitehall Street, Atlanta. - From a Photo. by W. Kuhns & Sons, Atlanta." FRANK LESLIE'S ILLUSTRATED NEWSPAPER 45, no. 1150 (Oct. 13, 1877): 92. 1 illus. [View, with crowds.]

KUHNS, W. J. see also ANTHONY, HENRY T. (1862).

KUHNS, W. J. (d. 1885) (USA)
K248 Kuhns, W. J. "Rectifying the Bath." AMERICAN JOURNAL OF PHOTOGRAPHY AND THE ALLIED ARTS & SCIENCES n. s. vol. 4, no. 4 (July 15, 1861): 90-91.

K249 "Editorial Miscellany." AMERICAN JOURNAL OF PHOTOGRAPHY AND THE ALLIED ARTS & SCIENCES n. s. vol. 3, no. 9 (Oct. 1, 1860): 143-144. [Microphotographs-of the "Great Eastern," a Broadway store interior, New York, NY harbor, pages from the bible and pages from the "Am. J. of Photo." taken by W. J. Kuhns, deposited in a locked box in a cornerstone of the Hanson Place Chapel, Brooklyn.]

K250 "Balloon Photography." AMERICAN JOURNAL OF PHOTOGRAPHY AND THE ALLIED ARTS & SCIENCES n. s. vol. 3, no. 17 (Feb. 1, 1861): 266-267. [In 1859, Mr. Kuhns (New York, NY) attempted to take photo from the balloon "Atlantic" captained by Prof. Wise. Problems, delays - never happened.]

K251 Kuhns, W. J. "Vignette Glasses." AMERICAN JOURNAL OF PHOTOGRAPHY AND THE ALLIED ARTS & SCIENCES n. s. vol. 4, no. 7 (Sept. 1, 1861): 167-168.

K252 Kuhns, W. J. "The Collodio-Chloride. - An Improvement." AMERICAN JOURNAL OF PHOTOGRAPHY AND THE ALLIED ARTS & SCIENCES n. s. vol. 8, no. 7 (Oct. 1, 1865): 160-161.

K253 Kuhns, W. J. "How the Haverstraw Tunnel was Photographed." PHOTOGRAPHIC TIMES 12, no. 134 (Feb. 1882): 46-47.

K254 "General Notes." PHOTOGRAPHIC TIMES 15, no. 199 (July 10, 1885): 376. [Brief note of W. J. Kuhns' death "...one of the oldest photographers in New York,...recently devoted much of his time to the production of lantern transparencies."]

KURTZ, WILLIAM see also ANDERSON, ELBERT.

KURTZ, WILLIAM. (1834-1904) (USA)

K255 Hull, C. Wager. "The 'Lights' and Formulas of Kurtz, Gurney and Sons and Bogardus of New York." PHILADELPHIA PHOTOGRAPHER 5, no. 59 (Nov. 1868): 404-407.

K256 Portrait. Woodcut engraving, credited "From a Photograph by William Kurtz, 895 & 897 Broadway, New York, NY." HARPER'S WEEKLY 13, no. 639 (Mar. 27, 1869): 193. 1 illus. ["Hon. Hamilton Fish, Sec. of State." 13:639 (Mar. 27, 1869): 193.]

K257 Portrait. Woodcut engraving, credited "From a Photograph by W. Kurtz." FRANK LESLIE'S ILLUSTRATED NEWSPAPER 28, (1869) ["Hon. Hamilton Fish, Pres. Grant's Cabinet." 28:705 (Apr. 3, 1869): 40.]

K258 Kurtz, W. "Rembrandt Effects." PHILADELPHIA PHOTOGRAPHER 6, no. 67 (July 1869): 244-245.

K259 "Editor's Table." PHILADELPHIA PHOTOGRAPHER 6, no. 68 (Aug. 1869): 284. [Kurtz has recently occupied his new studio at Eighteenth & Broadway, New York, NY; commendation on his excellent work.]

K260 "New American Studios." PHILADELPHIA PHOTOGRAPHER 6, no. 69 (Sept. 1869): 292-294. 1 illus.

K261 "Editor's Table." PHILADELPHIA PHOTOGRAPHER 6, no. 72 (Dec. 1869): 426-427. [Kurtz had a party for his employees in recognition of their share in his winning a First Prize at the Fair of American Institute. Considered unusual.]

K262 Portrait. Woodcut engraving, credited "From a Photograph by Kurtz." FRANK LESLIE'S ILLUSTRATED NEWSPAPER 29, (1869) ["Henry C. Watson, art critic." 29:740 (Dec. 4, 1869): 196.]

K263 "Kurtz's Conic Background." ANTHONY'S PHOTOGRAPHIC BULLETIN 1, no. 4 (May 1870): 71-72. 4 illus. [Detailed explanation of the use of an apparatus to achieve graduated tones throughout the background of a studio portrait.]

K264 Portrait. Woodcut engraving, credited "From a Photograph by Kurtz." FRANK LESLIE'S ILLUSTRATED NEWSPAPER 30, (1870) ["Henry Clews, banker, New York, NY." 30:763 (May 14, 1870): 133.]

K265 "Our Picture." PHILADELPHIA PHOTOGRAPHER 7, no. 78 (June 1870): frontispiece, 216-217. 1 b & w.

K266 Kurtz, William. "'Rembrandt-ish'" PHILADELPHIA PHOTOGRAPHER 8, no. 85 (Jan. 1871): 2-5.

K267 "Note." PHOTOGRAPHIC TIMES 1, no. 3 (Mar. 1871): 41. [Quality of the "artistic photography" of Mr. William Kurtz, No. 872 Broadway noted. His chief operator was Elbert Anderson and "Mr. Jimmy Forbes, so many years of Gurney's, now stands beside Mr. Anderson as second in rank. They are a strong team."]

K268 Hallenbeck, J. H. and Forbes. "Letter." PHOTOGRAPHIC TIMES 1, no. 4-5 (Apr. - May 1871): 58, 87. [The statement that Forbes "...stands beside Mr. Anderson as second in rank..." (printed earlier) drew a waspish letter from Hallenbeck in April, claiming that Forbes was second to none. This, in turn, drew a conciliatory letter from Forbes in May, "...there is no rank and file in Mr. Kurtz's gallery....He is the artist himself, and is supported in one skylight by Mr. E. Anderson, and in the other by myself, and between us we try to beat the world in making the best work..."]

K269 "Editor's Table - Another Medal Awarded to Mr. Kurtz." PHILADELPHIA PHOTOGRAPHER 8, no. 94 (Oct. 1871): 344. [Fr. Photo Soc. & Paris Exhibition awarded Kurtz a medal.]

K270 "Distinguished Honor to an American Artist." PHOTOGRAPHIC WORLD 1, no. 12 (Dec. 1871): 371. [Reprint from N. Y. "Evening Mail." 1st class medal awarded for portrait heads at Annual Exposition of Fine Arts in Paris - 1st Salon where photos admitted as works of art.]

K271 Portrait. Woodcut engraving, credited "From a Photograph by Kurtz." FRANK LESLIE'S ILLUSTRATED NEWSPAPER 33, (1872) ["Edward S. Stokes, lawyer." 33:853 (Feb. 3, 1872): 325.]

K272 "Mr. Kurtz's Display for Vienna." ANTHONY'S PHOTOGRAPHIC BULLETIN 4, no. 4 (Apr. 1873): 117. [Note about the photographic display W. Kurtz is organizing for the Vienna exhibition.]

K273 "Editor's Table: Photographs for Vienna." PHILADELPHIA PHOTOGRAPHER 10, no. 112 (Apr. 1873): 128. [Wm. Kurtz sending prints to the Vienna Exposition.]

K274 Portrait. Woodcut engraving, credited "From a Photograph by W. Kurtz, New York City." FRANK LESLIE'S ILLUSTRATED NEWSPAPER 36, (1873) ["Dr. Josiah C. Nott." 36:925 (June 21, 1873): 233.]

K275 "The Medal for Progress." ANTHONY'S PHOTOGRAPHIC BULLETIN 4, no. 11 (Nov. 1873): 322. [Excerpts of award given by the Vienna International Exposition to Kurtz.]

K276 "Mr. Kurtz' New Art Gallery." ANTHONY'S PHOTOGRAPHIC BULLETIN 5, no. 4 (Apr. 1874): 151.

K277 "Mr. Kurtz's New Gallery." PHOTOGRAPHIC TIMES 4, no. 41 (May 1874): 70-71. [Excerpts from a pamphlet 'To My Patrons,' issued by Kurtz on the opening of his new gallery on Madison Square, New York, NY.]

K278 "Matters of the Month: A Wonder of Photography." PHOTOGRAPHIC TIMES 4, no. 44 (Aug. 1874): 127. [Excerpts from the press praising Kurtz, mentions his portrait of S. F. B. Morse.]

K279 "Kurtz's Art Gallery." FRANK LESLIE'S ILLUSTRATED NEWSPAPER 38, no. 983 (Aug. 1, 1874): 325, 327. 1 illus. [View of the front facade of Kurtz's new gallery on East 23rd St., opposite Madison Square, New York, NY. Praise and some brief description of the gallery. States that Kurtz was a leader in popularizing the "Rembrandt" portrait style in this country.]

K280 "The International Rifle Match at Creedmore, Long Island. - The American Team of the Amateur Rifle Association. - Photographs by William Kurtz." FRANK LESLIE'S ILLUSTRATED NEWSPAPER 39, no. 993 (Oct. 10, 1874): 69. 13 illus. [Thirteen separate portraits.]

K281 Portrait. Woodcut engraving, credited "Photographed by William Kurtz." FRANK LESLIE'S ILLUSTRATED NEWSPAPER 39, (1874) ["Samuel J. Tilden, candidate for President." 39:993 (Oct. 10, 1874): 77.]

K282 Portrait. Woodcut engraving, credited "From a Photograph by W. Kurtz. FRANK LESLIE'S ILLUSTRATED NEWSPAPER 39, (1875) ["Late Hon. Gerrit Smith, abolitionist." 39:1007 (Jan. 16, 1875): 309. "Late William H. Aspinwall." 39:1010 (Feb. 6, 1875): 365.]

K283 Portrait. Woodcut engraving, credited "From a Photograph by W. Kurtz." FRANK LESLIE'S ILLUSTRATED NEWSPAPER 40, (1875) ["Miss Linda Gilbert, philanthropist." 40:1019 (Apr. 17, 1875): 96. "William A. Potter, Architect of the U.S. Treasury." 40:1019 (Apr. 17, 1875): 96.]

K284 Portraits. Woodcut engravings, credited "From a Photograph by W. Kurtz." FRANK LESLIE'S ILLUSTRATED NEWSPAPER 42, (1876) ["Walt Whitman." 42:1071 (Apr. 8, 1876): 84. "J. Marion Sims, M.D." 42:1082 (June 24, 1876): 253.]

K285 "Mr. Kurtz's "Mainacht." ANTHONY'S PHOTOGRAPHIC BULLETIN 8, no. 2 (Feb. 1877): 64. [Kurtz (New York, NY) genre photograph illustrating the poem by the German George Asmus.]

K286 "A New Departure in American Photography." PHILADELPHIA PHOTOGRAPHER 14, no. 159 (Mar. 1877): 82-83. [Describes a genre picture, based on a German poem, by William Kurtz (New York, NY).]

K287 "The Microscopical Society." ANTHONY'S PHOTOGRAPHIC BULLETIN 8, no. 4 (Apr. 1877): 116. [From "NY Times." A highly successful reception held at Kurtz's Art Gallery, by the NY Microscopical Society, which had microscopes scattered around for public viewing of shells, etc.]

K288 "A New Move." ANTHONY'S PHOTOGRAPHIC BULLETIN 8, no. 10 (Oct. 1877): 315-316. [Kurtz opens a gallery in the old Post Office building on Nassau Street, near the business district.]

K289 "Our Illustration." ANTHONY'S PHOTOGRAPHIC BULLETIN 10, no. 5 (May 1879): frontispiece. 1 b & w. [Portrait of "Gehrhardt Rolfs, the African Traveller," by Kurtz (New York, NY).]

K290 Portrait. Woodcut engraving, credited "From a Photograph by Kurtz." FRANK LESLIE'S ILLUSTRATED NEWSPAPER 48, (1879) ["Hon. Miles Peach, Judge." 48:1234 (May 24, 1879): 185.]

K291 "Editor's Table." PHILADELPHIA PHOTOGRAPHER 17, no. 197 (May 1880): 163.

K292 Taylor, J. Traill. "The Studios of America. No. 8. Kurtz's Electric Light Studio, New York." PHOTOGRAPHIC TIMES 13, no. 151 (July 1883): 316-317.

K293 "General Notes." PHOTOGRAPHIC TIMES 17, no. 290 (Apr. 8, 1887): 165. [Note that the editor recently shown photographic proofs of the negatives... in the orthochromatic process... for the illustration of the forthcoming catalogue of the celebrated Probasco collection of paintings.]

K294 "Our Picture." PHOTOGRAPHIC TIMES 17, no. 296 (May 20, 1887): frontispiece, 261. 1 illus. [A crayon drawing portrait of Reverend Beecher, by Kurtz.]

K295 "Ishamel". "American Artists on the Seine." ILLUSTRATED AMERICAN 4, no. 34 (Oct. 11, 1890): 97-101. 3 b & w. [Artists posed in their studios. G. P. A. Healy, Frederick Bridgeman, Walter Gay.]

K296 "The Studios of New York: 2." PHOTOGRAPHIC TIMES 22, no. 546 (Mar. 4, 1892): 122-123. [Discusses Napoleon Sarony and Kurtz.]

KUSEL, E. A.

K297 Kusel, E. A. "Pinholes in Negatives." HUMPHREY'S JOURNAL OF PHOTOGRAPHY, AND THE ALLIED ARTS AND SCIENCES 15, no. 15 (Dec. 1, 1863): 239-240.

K298 Kusel, E. A. "A New Collo-Developer." HUMPHREY'S JOURNAL OF PHOTOGRAPHY, AND THE ALLIED ARTS AND SCIENCES 17, no. 18 (Jan. 15, 1866): 280.

K299 Kusel, E. A. "The Ergot Developer." HUMPHREY'S JOURNAL OF PHOTOGRAPHY, AND THE ALLIED ARTS AND SCIENCES 18, no. 9 (Sept. 1, 1866): 135-136.

K300 Kusel, E. A. "The Ergot Developer." HUMPHREY'S JOURNAL OF PHOTOGRAPHY, AND THE ALLIED ARTS AND SCIENCES 18, no. 24 (Apr. 15, 1867): 375.

L

L.

L1 L. "The Stereoscope." ART JOURNAL (Jan. 1857): 29. 1 illus.

L2 L. "The Stereoscope." PHOTOGRAPHIC AND FINE ART JOURNAL 10, no. 2 (Feb. 1857): 45-46. [From "London Art J."]

LA LIEURE, MDME. (TURIN, ITALY)

L3 "Our Portraits of Prince Humbert and Princess Margaret." ILLUSTRATED LONDON NEWS 52, no. 1486 (June 6, 1868): 555. [Statement from the editors with letters verifying the authenticity of the portraits challenged by an Italian newspaper. Prince Humbert taken by Mr. Alphonse Bernoud of Florence, that of Princess Margaret by Mme. La Lieure, of Turin. The portraits originally reproduced on p. 381 of the Apr. 18, 1868 issue.]

LACAN, ERNST. (1829-1879) (FRANCE)

L4 Lacan, Ernest. "Advantages of Photography." HUMPHREY'S JOURNAL OF PHOTOGRAPHY, AND THE ALLIED ARTS AND SCIENCES 11, no. 3 (June 1, 1859): 43-44. [From "La Lumière."]

L5 Lacan, Ernest. "Photography on Canvas." AMERICAN JOURNAL OF PHOTOGRAPHY AND THE ALLIED ARTS & SCIENCES n. s. vol. 7, no. 7 (Oct. 1, 1864): 149-151. [From "Br. J. of Photo."]

L6 Lacan, Ernest. "Leptographic Paper." HUMPHREY'S JOURNAL OF PHOTOGRAPHY, AND THE ALLIED ARTS AND SCIENCES 18, no. 15 (Dec. 1, 1866): 235-237. [From "Photo. News."]

L7 Lacan, Ernest. "Photography - a Physiological Sketch." PHOTOGRAPHIC ART JOURNAL 5, no. 4 (Apr. 1853): 210-215. [From "La Lumière."]

L8 "Editor's Table - Obituary." PHILADELPHIA PHOTOGRAPHER 16, no. 183 (Mar. 1879): 95. [Ernst Lacan became a photographic editor and author in 1850. Died, at age 50, on Jan. 18, 1879, "...of a congestion of the brain."]

LACEY.

L9 Portrait. Woodcut engraving, credited "From a Photograph by Lacey." FRANK LESLIE'S ILLUSTRATED NEWSPAPER 48, (1879) ["Nathaniel Niles, Gov.-Dir. U.P.R.R." 48:1239 (June 28, 1879): 277.]

LACOMBE. (FRANCE)

L10 "Photography at Long Range." ANTHONY'S PHOTOGRAPHIC BULLETIN 18, no. 1 (Jan. 8, 1887): 13-16. 5 illus. [Discusses the telephotographic work of Mr. Lacombe and Emile Mathieu. From "La Nature." Includes a brief statement by J. B. Sayce describing a telephoto picture taken by George Thomas, of Rock Ferry, England, in 1854.]

LACY. (RYDE, ENGLAND)

L11 "A Few Words about Toning." AMERICAN JOURNAL OF PHOTOGRAPHY AND THE ALLIED ARTS & SCIENCES n. s. vol. 5, no. 6 (Sept. 15, 1862): 132-135. [From "Photo. News." Lacy, of Ryde, acquired formula from Mr. Ken, in Paris. Gives it here.]

LADD, JOSEPH H. ?

L12 "The Science of Photography - The Importance of its Discovery." HUMPHREY'S JOURNAL OF PHOTOGRAPHY, AND THE ALLIED ARTS AND SCIENCES 10, no. 23 (Apr. 1, 1859): 355-356. [First unsigned article after J. H. Ladd took over "H. J." Could it be by him?]

L13 [Ladd, Joseph H. ?] "The Negative." HUMPHREY'S JOURNAL OF PHOTOGRAPHY, AND THE ALLIED ARTS AND SCIENCES 19, no. 13 (Nov. 1, 1867): 193-195.

LAFON DE CARMASAC, PIERRE MICHEL. (1821-1905) (FRANCE)

[Born April 26, 1821 in Bordeaux. Studied painting in Paris, and learned photography there. In 1850s experimented with vitrified enamels and carbon printing processes, and published several manuals on these techniques. Worked with Disdéri in 1860s. In 1866 he opened his own studio in Paris. Made portraits of many notables. Retired in 1870s. Died November 9, 1905 in Bordeaux.]

L14 Lafon de Carmasac. "Permanent Positives." HUMPHREY'S JOURNAL OF PHOTOGRAPHY, AND THE ALLIED ARTS AND SCIENCES 11, no. 10 (Sept. 15, 1859): 149-150. [From "Cosmos."]

L15 Lafon de Camarsac. "Photography and the Fine Arts." PHOTOGRAPHIC NEWS 3, no. 62 (Nov. 11, 1859): 110. [Note, abstraction and commentary upon M. Camarsac's article in the "Bulletin of the French Photographic Society". Mostly about copying works of art.]

LAIGHTON, JOHN. (1844-1886) (USA)

L16 "Obituary: John Laighton." ANTHONY'S PHOTOGRAPHIC BULLETIN 17, no. 24 (Dec. 25, 1886): 758. [Died Dec. 8, 1886 at the age of 42. Member of the firm Laighton Brothers of Norwich, Ct. Born Farmington, NH in 1844; grew up in Greenwich, RI.; studied with James Lincoln in Providence and Jones & Tenney in New Haven. Opened studio with his brother William about 1876.]

LALLEMAND.

L17 "Photography and Engraving on Wood." HUMPHREY'S JOURNAL OF PHOTOGRAPHY, AND THE ALLIED ARTS AND SCIENCES 9, no. 18 (Jan. 15, 1858): 280-281. [From "La Lumière." Lallemand's process described.]

L18 "Photography and Engraving on Wood." PHOTOGRAPHIC AND FINE ART JOURNAL 11, no. 3 (Mar. 1858): 76. [From "La Lumiére." Lallemand's process. Additional brief note by Lallemand, on p. 77.]

LAMB, JAMES. (d. 1863) (SOMERSTOWN, ENGLAND)

L19 "Another Warning." HUMPHREY'S JOURNAL OF PHOTOGRAPHY, AND THE ALLIED ARTS AND SCIENCES 15, no. 16 (Dec. 15, 1863): 256. [Note of suicide of James Lamb, an amateur photographer in England, warning to take care with dangerous chemicals.]

LAMBERSON & JAMES. (GALENA, IL)

L20 "General Grant at Galena." HARPER'S WEEKLY 9, no. 454 (Sept. 9, 1865): 565. 2 illus. [Views of Galena, IL, preparing for the homecoming of Grant. "Photographed by Lamberson & James, Galena, Ill."]

L21 The Reception of General Grant at His Home, Galena, Ill., Friday, August 18, 1865." and "The Residence Presented to General Grant by the Citizens of Galena, Ill., on His Arrival, Friday, August 18. - From Photographs by Lamberson & James, Galena, IL." FRANK LESLIE'S ILLUSTRATED NEWSPAPER 20, no. 520 (Sept. 16, 1865): 404. 2 illus. [Views.]

L22 "Galena and Its Lead Mines." HARPER'S NEW MONTHLY MAGAZINE 32, no. 192 (May 1866): 681-696. 12 b & w. [Buildings, views of the town, festival greeting the return of General Grant. Not

credited, but two of the images reproduced earlier in "Harper's Weekly," (Sept. 9, 1865).]

LAMBERT & CO. (CHINA)

L23 "G. R. Lambert & Co. and Some Notes on Early Photographers in Singapore." PHOTOGRAPHIC COLLECTOR 5, no. 2 (1984): 212-231. 32 b & w. [Lambert & Co. founded in 1875 in Singapore, flourished there for forty years. Article also discusses early photographs - Gaston Dutronquoy (1840s), John Thompson (1860s). G. R. Lambert born Germany, firm closed during WWI.]

LAMBERT, PATRICK J.

L24 Lambert, Patrick J. "A New Dark Tent." BRITISH JOURNAL PHOTOGRAPHIC ALMANAC 1879 (1879): 178-179. 1 illus.

LAMBERT, THEODORE S. see also HISTORY: USA: 1876-1879

LAMBERT, THEODORE S. (1843-1888) (CANADA)

L25 Hughes, Jabez. "Lambertype and Chromotype." ANTHONY'S PHOTOGRAPHIC BULLETIN 6, no. 9 (Sept. 1875): 260-262. [From "London Photographic News."]

L26 "The Lambertype." ANTHONY'S PHOTOGRAPHIC BULLETIN 7, no. 6 (June 1876): 189, plus 16 pages in advertising section. [The Lambertype and Chromotype processes of the enlargements and prints being introduced into USA through E. & H. T. Anthony & Co. The advertising section contained 16 pages of quotes from British and French photographers praising the process.]

L27 "The Lambertype Process." ANTHONY'S PHOTOGRAPHIC BULLETIN 7, no. 8 (Aug. 1876): 254-255. [Letters from photographers praising the process. W. Kurtz (New York, NY); H. Broich & Co. (Milwaukee, WI); Joseph Kirk (Newark, NJ); Dimmers & Jacobi (Mexico); C. Gentile (New York, NY); Geo. G. Rockwood (New York, NY); Theo. G. Dimmers (New York, NY); John G. Hill (Brooklyn, NY); Sarony (New York, NY); others.]

L28 "The Lambertype in Cincinnati." ANTHONY'S PHOTOGRAPHIC BULLETIN 7, no. 10 (Oct. 1876): 308. [Letter signed by J. Landy and six other photographers, praising the Lambertype process.]

L29 Lambert, Leon. "Correspondence." ANTHONY'S PHOTOGRAPHIC BULLETIN 7, no. 10 (Oct. 1876): 317-320. [Long letter from Lambert, describing his intention to protect his copyright, other matters.]

L30 Lambert. "Wilson on the Lambert's Process." ANTHONY'S PHOTOGRAPHIC BULLETIN 7, no. 12 (Dec. 1876): 369-374. [Letter from Lambert, attacking Edward Wilson (of the "Philadelphia Photographer," for his response to the Lambertype processes, being supported by E. & H. T. Anthony Co.]

L31 Lambert. "Wilson vs. Carbon & Co." ANTHONY'S PHOTOGRAPHIC BULLETIN 8, no. 1 (Jan. 1877): 17-19. [Another letter from Lambert attacking Edward L. Wilson.]

L32 Lambert. "Infraction of Patents." ANTHONY'S PHOTOGRAPHIC BULLETIN 8, no. 1 (Jan. 1877): 20-21.

L33 Lambert. "Dr. Vogel and Lambertype, Etc." ST. LOUIS PRACTICAL PHOTOGRAPHER 1, no. 1 (Jan. 1877): 17-19. [Lambert defends his carbon printing process against Dr. Vogel, etc.]

L34 Lambert. "Lambert and Wilson." ANTHONY'S PHOTOGRAPHIC BULLETIN 9, no. 1 (Jan. 1878): 20-26. [Lambert attacks Edward L. Wilson and the "Philadelphia Photographer" on issues around carbon printing.]

L35 Lambert. "The Philosophy of Figures in Process Mongering." ANTHONY'S PHOTOGRAPHIC BULLETIN 9, no. 6 (June 1878): 188-191.

L36 Lambert. "Doctor Ott on the Lambert Patents," [and] "E. Z. Webster & Carbon." ANTHONY'S PHOTOGRAPHIC BULLETIN 8, no. 3 (Mar. 1877): 81-84, 85-86. [Lambert attacking Dr. Ott, who was travelling in USA to promote A. Braun's carbon process, a rival to Lambert's own. Lambert then attacks an article on carbon by E. Z. Webster, which had appeared in the "Phila. Photo."]

L37 De Silva, A. M. "Autotype." ANTHONY'S PHOTOGRAPHIC BULLETIN 8, no. 3 (Mar. 1877): 84-85. [E. Z. Webster, in "Phila. Photo." attacked Lambert's carbon process, is here in turn challenged.]

L38 Sawyer, J. R. "Hints on the Lambert Process." ANTHONY'S PHOTOGRAPHIC BULLETIN 8, no. 3 (Mar. 1877): 89-91. [From a circular by J. R. Sawyer, of the Autotype Co., London.]

L39 Lambert. "Comparative Cost of Production and Marketable Value of Chromotype and Silver Prints." ANTHONY'S PHOTOGRAPHIC BULLETIN 9, no. 4 (Apr. 1878): 98-101.

L40 Lambert. "Why 17 Years? Why Not Patent It? Why Not Give Formulas, etc.?" ANTHONY'S PHOTOGRAPHIC BULLETIN 9, no. 5 (May 1878): 153-154. [Lambert discussing his "Lightning" negative process.]

L41 Lambert. "Wilson's Thunder vs. Lambert's Lightning." ANTHONY'S PHOTOGRAPHIC BULLETIN 9, no. 7 (July 1878): 219-220. [Lambert and Edward L. Wilson, "Philadelphia Photographer."]

L42 Lambert. "Wilsonian Integrity." ANTHONY'S PHOTOGRAPHIC BULLETIN 9, no. 8 (Aug. 1878): 241-245. [Sarcastic attacks (again) on Edward L. Wilson, ed. "Philadelphia Photographer"]

L43 Lambert. "A Mystery Unveiled." ANTHONY'S PHOTOGRAPHIC BULLETIN 9, no. 8 (Aug. 1878): 255. [More attacks on Edward L. Wilson.]

L44 Anthony, E. & H. T. "The End of the Heated Term." ANTHONY'S PHOTOGRAPHIC BULLETIN 9, no. 9 (Sept. 1878): 286-287. [Anthony states that the controversy between Lambert and Wilson would end. "For our part all discussion of the character alluded to must end."]

L45 "The 'Artotype.'" PHILADELPHIA PHOTOGRAPHER 15, no. 179 (Nov. 1878): 344. [Wilson claims that this is Obernetter's printing process, being promoted by the Artotype Co. of New York, NY., organizing and selling shares of stock.]

L46 "The Artotype." ANTHONY'S PHOTOGRAPHIC BULLETIN 9, no. 11 (Nov. 1878): 342-343. [Mentions that Bierstadt (New York, NY), Muhrman (Cincinnati, OH) and Lilienthal (New Orleans, LA), licensed to use the process.]

L47 "The Artotype." ANTHONY'S PHOTOGRAPHIC BULLETIN 9, no. 12 (Dec. 1878): 379. [Praise for the process by Ch. Wager Hull and others.]

L48 Artotype Company. "The Artotype Problem." ANTHONY'S PHOTOGRAPHIC BULLETIN 10, no. 2 (Feb. 1879): 54-59.

L49 Lambert. "Bachrach vs. Lambert." ANTHONY'S PHOTOGRAPHIC BULLETIN 10, no. 3 (Mar. 1879): 81-83.

L50 "The Artotype Squabble." ANTHONY'S PHOTOGRAPHIC BULLETIN 10, no. 3 (Mar. 1879): 85. [E. L. Wilson and Lambert, again.]

L51 "Photo-Collographic Printing - The 'Artotype Process.'" ANTHONY'S PHOTOGRAPHIC BULLETIN 10, no. 7 (July 1879): 203-204. [From "London Photographic News." Describes history of development and use of Lambert's Artotype Process in Europe and USA.]

L52 "Obituary: Theodore S. Lambert." ANTHONY'S PHOTOGRAPHIC BULLETIN 19, no. 7 (Apr. 14, 1888): 220. [Born at Nicolet, Quebec in 1843. Graduated Nicolet College, then went to England at age 20, and afterwards traveled widely. Holds patents on many photographic processes, particularly the Lambertype carbon process. Nephew of Napoleon Sarony. Died Mar. 31, 1888 in New York City.]

LAMSON STUDIO. [LAMSON, J. H.?]
L53 Bangs, Ella Matthews. "An Historic Mansion." NEW ENGLAND MAGAZINE 27, no. 6 (Feb. 1903): 695-713. 12 b & w. [Wadsworth-Longfellow House, Portland, Maine. Portrait of Longfellow by J. H. Lamson (1878); views, interiors by the Lamson Studio, taken in 1902.]

LAMY, M. E.
L54 Lamy, M. E. "Photography at Vienna." ANTHONY'S PHOTOGRAPHIC BULLETIN 5, no. 1 (Jan. 1874): 15-16. [Letter from Lamy, "Exhibition Photographer" at the Vienna Exhibition of 1873. Lamy describes his own efforts, mentions others who exhibited there —E. & H. E. Anthony Co.; A. Braun; Obernetter (Munich); Albert (Munich); Luckhardt (Vienna); W. Burger (Vienna), "stereos of the North Pole;" Compte Roydeville (Paris).]

LAND, W. J. (COLUMBUS, GA)
L55 "Editor's Table." PHILADELPHIA PHOTOGRAPHER 6, no. 62 (Feb. 1869): 64. [Views near Columbus, GA.]

LANDON, S. C. (NEW MILFORD, CT)
L56 "Processes which have been proved. - The Processes of S. C. Landon, of New Milford, Conn." AMERICAN JOURNAL OF PHOTOGRAPHY AND THE ALLIED ARTS & SCIENCES n. s. vol. 6, no. 12 (Dec. 15, 1863): 287.

LANDY, JAMES see also SOMERS, F. M.

LANDY, JAMES M. (1838-1897) (USA)
BOOKS
L57 Joblin, Maurice & Co. *Cincinnati Past and Present; or Its Industrial History, as Exhibited in the Life-Labors of Its Leading Men.* Photographically Illustrated by James Landy. Cincinnati: M. Joblin & Co., 1872. 431 pp. 127 l. of plates. 127 b & w. [Original photographic portraits by James Landy, each with a biographical sketch. (Its claimed, in "Phila Photo" (Feb 1873): 63, that Landy made 65,000 prints for this work.]

L58 Shakespeare, William. *Shakespeare's Seven Ages;* Illustrated with Photographs from Life, by J. Landy. Cincinnati: R. Clark & Co., 1876. 10 l. of plates. 7 b & w. [Photomechanical reproductions, from negatives by J. Landy.]

PERIODICALS
L59 "Arch over Vine Street, Cincinnati, Ohio, Erected in Honor of the Fourth of July, 1865. - From a Photograph by Landy." FRANK LESLIE'S ILLUSTRATED NEWSPAPER 20, no. 513 (July 29, 1865): 300. 1 illus. [View.]

L60 "Editor's Table: Another Genre Photograph." PHILADELPHIA PHOTOGRAPHER 3, no. 29 (May 1866): 159. ["From Mr. J. Landy, Cincinnati, OH, we have received a very nice picture of a young sportsman with his dog and rifle, surrounded with the fruits of the chase in the way of game. The picture is very good, and we are glad to see Mr. Landy turning his attention to such work. We believe that therein lies the future of our glorious art, and we hope to hear of many more efforts in that direction."]

L61 "Editor's Table." PHILADELPHIA PHOTOGRAPHER 5, no. 56 (Aug. 1868): 279. [Genre hunting & fishing "cabinets" from J. Landy.]

L62 Portrait. Woodcut engraving, credited "From a Photograph by James Landy." HARPER'S WEEKLY 13, (1869) ["Jesse R. and Hannah Grant, Father and Mother of the President." 13:638 (Mar. 20, 1869): 180.]

L63 "Our Picture." PHILADELPHIA PHOTOGRAPHER 8, no. 92 (Aug. 1871): 275-276. 1 b & w. 1 illus. ["The Last of the Queue," (portrait of an old-fashioned man), plus woodcut of studio layout.]

L64 Landy, J. "Landy's Method of Marginal Printing." PHILADELPHIA PHOTOGRAPHER 9, no. 99 (Mar. 1872): 68.

L65 "Landy's Pets." PHOTOGRAPHIC TIMES 2, no. 19 (July 1872): 104. [Description of twelve portraits of babies, 11 x 14", sold by Landy, for $1.50, to other photographic galleries, for them to display in their waiting rooms.]

L66 "Our Picture." PHILADELPHIA PHOTOGRAPHER 9, no. 104 (Aug. 1872): 300-301. 1 b & w. [Twelve baby photos mounted on one plate.]

L67 "Editor's Table - Medals Awarded at the Cincinnati Exhibition." PHILADELPHIA PHOTOGRAPHER 9, no. 107 (Nov. 1872): 400. [J. Landy, 1st prize for portraits. Ch. Waldack, 2nd prize silver premium for landscape and architecture.]

L68 "Editor's Table." PHILADELPHIA PHOTOGRAPHER 10, no. 110 (Feb. 1873): 63. [J. Landy completed an order for 65,000 cabinet prints for a work entitled "Cincinnati Past and Present."]

L69 "Editor's Table." PHILADELPHIA PHOTOGRAPHER 10, no. 110 (Feb. 1873): 63. [J. Landy completed an order for 65,000 cabinet prints for a work entitled "Cincinnati Past and Present."]

L70 Portrait. Woodcut engraving, credited "Photographed by Landy, of Cincinnati." FRANK LESLIE'S ILLUSTRATED NEWSPAPER 38, (1874) ["Mrs. Caroline S. Brooks, artist." 38:968 (Apr. 18, 1874): 92.] "Buy Landy's Expressive Pets." ANTHONY'S PHOTOGRAPHIC BULLETIN 5, no. 6 (June 1874): 226. [28 cartes-de-visite of babies, on one sheet, for sale.]

L71 "Matters of the Month: American Novelties." PHOTOGRAPHIC TIMES 4, no. 44 (Aug. 1874): 127-128. [Excerpts from German publication praising a series by Landy, "Landy's Crying Babies".]

L72 Portrait. Woodcut engraving, credited "From a Photograph by Landy, Cincinnati, Ohio." FRANK LESLIE'S ILLUSTRATED NEWSPAPER 42, (1876) ["Hon. Alfonso Taft, Sec. of War." 42:1069 (Mar. 25, 1876): 40. "Rutherford B. Hayes, Pres. candidate." 42:1083 (July 1, 1876): 265.]

L73 "Landy's Seven Ages of Man." PHILADELPHIA PHOTOGRAPHER 13, no. 150 (June 1876): 188-189. [Description of a series of genre scenes based on the Shakespeare poem.]

L74 "'The Seven Ages.'" ANTHONY'S PHOTOGRAPHIC BULLETIN 7, no. 7 (July 1876): 210-211. [From "Cincinnati Enquirer." Landy's 20" x 24" picture series based on Shakespeare's "Seven Ages."]

L75 "Editor's Table: 'Shakespeare's Seven Ages of Man.'" PHILADELPHIA PHOTOGRAPHER 13, no. 153 (Sept. 1876): 288. [Review of a book of original prints, created by J. Landy, sold for $5.00.]

L76 "Matters of the Month." PHOTOGRAPHIC TIMES 7, no. 76 (Apr. 1877): 78. [Cabinet portrait of President Hayes.]

L77 "Editor's Table: "Bulldozing." PHILADELPHIA PHOTOGRAPHER 14, no. 162 (June 1877): 191. [A comic genre, with babies, by Landy (Cincinnati, OH), described.]

L78 "Our Picture." PHILADELPHIA PHOTOGRAPHER 15, no. 171 (Mar. 1878): frontispiece, 86-87. 1 b & w. 2 illus. [Female genre portrait. Illustrations show Landy's skylight, portrait set-up.]

L79 "Our Picture." PHILADELPHIA PHOTOGRAPHER 16, no. 185 (May 1879): frontispiece, 156. 1 b & w. [Studio portrait.]

L80 "Our Illustration." ANTHONY'S PHOTOGRAPHIC BULLETIN 18, no. 18 (Sept. 24, 1887): frontispiece, 562. 1 b & w. [Genre scene, "Man, Know Thy Destiny," by J. Landy, Cincinnati.]

L81 "Editorial Notes." PHOTOGRAPHIC TIMES 18, no. 343 (Apr. 13, 1888): 172. [Note in general praise of Landy visiting the editor on his first vacation in years.]

L82 "Our Editorial Table." PHOTOGRAPHIC TIMES 18, no. 363 (Aug. 31, 1888): 420. [Note that Landy making copies of his prize picture "Hiawatha" available. Discussion of other examples of Landy's prize winning photos during the past few years. Landy's advertisement for the photo is found on page xv of the advertising section in the same issue. 10" x 19" print mounted on 20" x 24" card, selling for $10.00.]

L83 Chandler, Charles F. "The 'Hiawatha' Pictures." ANTHONY'S PHOTOGRAPHIC BULLETIN 19, no. 17 (Sept. 8, 1888): 513-514. [Commentary on James Landy winning the Blair Cup at the P. A. of A. Convention in Minneapolis for the best genre illustrations of Longfellow's poem, "Hiawatha." Further note, p. 514, that Landy recently celebrated his 25th wedding anniversary with a party.]

L84 "Notes and News." PHOTOGRAPHIC TIMES 18, no. 373 (Nov. 9, 1888): 538. [Landy awarded several medals at Cincinnati Centennial Exhibition.]

L85 "Editor's Table: "The Daguerreotype Art"." WILSON'S PHOTOGRAPHIC MAGAZINE 33, no. 471 (Mar. 1896): 144. [Note that an interview with James Landy published in a recent number of the "Cincinnati Commercial Gazette".]

L86 "Editor's Table." WILSON'S PHOTOGRAPHIC MAGAZINE 34, no. 483 (Mar. 1897): 144. [The "Cincinnati Commercial Tribune" of Feb. 14, 1897 presented, as a special feature, a group picture of 96 men conspicuous in the history of Cincinnati. Portraits by Landy.]

L87 "Editor's Table: A Strange Coincidence." WILSON'S PHOTOGRAPHIC MAGAZINE 34, no. 487 (July 1897): 335. [Anecdote told by Landy, about a discussion with an insurance man about a fire being started by sun through a magnifying glass, then going to demonstrate how it could happen, only to find that a fire was actually starting in the same manner in his gallery.]

L88 "On the Ground Glass." WILSON'S PHOTOGRAPHIC MAGAZINE 34, no. 492 (Dec. 1897): 530. [Note of the death of James Landy, of Cincinnati.]

L89 "James Landy." WILSON'S PHOTOGRAPHIC MAGAZINE 34, no. 492 (Dec. 1897): 556-558. [Died Nov. 18th, 1897. Born New York City in 1838. Was a photographer for 47 years. Apprenticed with Silas A. Holmes in 1850, a few years later in charge of the operating rooms of the Meade Brothers. Then quit to make series of 14" x 17" views of points of interest along the Hudson River, Niagara Falls, and at Washington, DC. In 1863 he established his studio in Cincinnati, where he worked until his death. In addition to his normal studio portraiture, Landy specialized in costume portraits and genre studies, which won him many awards and honors over the years. President of the Photographers' Association of America in 1885.]

L90 "To the Memory of James Landy." WILSON'S PHOTOGRAPHIC MAGAZINE 35, no. 494 (Feb. 1898): 57. [Letters from Leon Van Loo, C. M. Hayes, S. E. Wayland. Reports of an obituary in the "Cincinnati Commercial Tribune" on Nov. 19th, 1897.]

L91 "Notes." WILSON'S PHOTOGRAPHIC MAGAZINE 35, no. 495 (Mar. 1898): 143. [F. M. Somers, formerly of Memphis, Tenn., has purchased the establishment, negatives, and goodwill of the business of his old tutor and friend, the late James Landy of Cincinnati... Also issued "a neat little Catalogue of Celebrities photographed by Landy," which lists over 500 portraits of people of prominence from 1863 to date.]

LANE, H. M. [?]
L92 "View of Rio de Janeiro, the Capital of Brazil, ...with Portraits of the Emperor and Empress, Street Characters, etc." HARPER'S WEEKLY 9, no. 460 (Oct. 21, 1865): 664-665, 666. 11 illus. ["For the interesting views and portraits... we are indebted to H. M. Lane, whose long residence in Brazil has made him familiar with the customs of the people." Eight street portraits, two portraits of royalty, view.]

LANE'S ART GALLERY. (CHATTANOOGA, TN)
L93 Portrait. Woodcut engraving, credited "From a Photograph by Lane's Art Gallery, Chattanooga, Tenn. FRANK LESLIE'S ILLUSTRATED NEWSPAPER 41, (1875) ["Hon. David M. Key, US Senator from TN." 41:1043 (Sept. 25, 1875): 37.]

LANG. [?]
L94 Sherwood, M. E. W. "Some Society Tableaux." COSMOPOLITAN 24, no. 3 (Jan. 1898): 235-242. 10 b & w. [Women dressed as "Egypt," "England," etc., posed and photographed in formal tableaux, in conjunction with activities associated with the New York Centennial of 1876. "Mr. Daniel Huntington promised assistance in arranging the tableaux, Mr. Lang gave his services and his studio,

while Mr. Bierstadt lent us his stuffed wild animals, his splendid properties and the most thoughtful cooperation.]

LANG, JOHN.
L95 Lang, John. "Description of Improvements in the Stereoscopic Camera." PHOTOGRAPHIC AND FINE ART JOURNAL 10, no. 5 (May 1857): 145-147. 8 illus. [From "J. of Photo. Soc."]

LANGDON, S. L. [?].
L96 "View of General Butler's Dutch Gap Canal before the Explosion of the Bulk-Head." HARPER'S WEEKLY 9, no. 421 (Jan. 21, 1865): 33, 38. 1 illus. [Negro troops digging. "...from a photographic view, for which we are indebted to Captain S. L. Langdon, First United States Artillery."]

LANGENHEIM, WILLIAM & FREDERICK LANGENHEIM.
[The Langenheim brothers opened a daguerreotype studio in Philadelphia in 1842. In addition to the regular portrait studio, the Langenheims were pioneers in introducing the calotype into the USA through purchasing Talbot's USA patent in 1849, and in developing stereo photographs (the American Stereoscopic Co.) and lantern slides. William died in 1874 and Frederick sold the business to Caspar Briggs, then died in 1879.]

BOOKS
[There is an album of approximately 150 early photographic prints (portraits and stereo views) by the Langenheim Brothers in the Robya Scrapbook, at the Missouri Historical Society. The Library of Congress has forty-nine sheets of copy negatives. The Negative series number for this group is LC USZ62-4961 - 5008, 5011, 5015.]

L97 *Panoramic View of Niagara Falls. Taken from the Clifton House, Canada Side. From a Daguerreotype.* On Stone by A. Vandricourt. New York: 1845.[Tinted lithograph, 11 7/8" x 28 3/8".]

L98 *Views in North America, Taken from Nature July, 1850, by the Patent Talbotype process, by W. and F. Langenheim. 216 Chestnut Street, Philadelphia and 247 Broadway, New York.* [101 views mounted in a scrapbook, at the Missouri Historical Society. Series I, "Pennsylvania," Series II, "—-," Series III, "Washington, DC," Series IV, "Niagara Falls".]

L99 *Catalogue of Langenheim's New and Superior Style Colored Photographic Magic Lantern Pictures,* and for the Dissolving View & Stereopticon Apparatus, carefully selected from the best pictures of the old and new masters for educational, private and public exhibitions. Also, a Catalogue of Langenheim's Stereoscopic Pictures on Glass and Paper, and Microscopic Photographs of a superior quality. Made and Sold by the "American Stereoscopic Company," W. Langenheim, General Agent. Philadelphia: E. Ketterlinus, Printer, 1861. 36 pp. [Xerox copies of this catalog offered for sale by the National Stereoscopic Association in 1870s.]

PERIODICALS
L100 Hunt, Robert. "On the Applications of Science to the Fine and Useful Arts: Improvements in Photography - Hyalotype, etc." ATHENAEUM (BOSTON) 13, (Apr. 1, 1851): 106-107.

L101 Hunt, Robert. "On the Applications of Science to the Fine and Useful Arts: Improvements in Photography - Hyalotype, etc." ART JOURNAL (Apr. 1851): 106-107.

L102 Hunt, Robert. "On the Application of Science to the Fine and Useful Arts: Improvements in Photography. - Hyalotype, etc." DAGUERREAN JOURNAL 1, no. 11 (Apr. 15, 1851): 328-330. [From

"London Art Journal." Actually a detailed discussion of the Langenheim Brothers' works.]

L103 "Hyalotypes." DAGUERREAN JOURNAL 2, no. 6 (Aug. 1, 1851): 180-181.

L104 "Photography vs. The Printing Press." AMERICAN JOURNAL OF PHOTOGRAPHY AND THE ALLIED ARTS & SCIENCES n. s. vol. 7, no. 7 (Oct. 1, 1864): 151-152. [From "Phila. Ledger." With increased costs and scarcity of paper due to the war, many newspapers need some solutions to problem. Suggestion to try microphotography. Mentions "Mr. Langenheim,...has succeeded in impressing the whole of the Lord's prayer upon a photographic print scarcely larger than the head of a pin."]

L105 Hunt, Richard. "Who Invented the Magic Lantern Pictures?" ANTHONY'S PHOTOGRAPHIC BULLETIN 5, no. 4 (Apr. 1874): 147. [From "London Art. J. (Apr. 1874)."]

L106 "Editor's Table: Valuable Instruments for Sale." PHILADELPHIA PHOTOGRAPHER 12, no. 138 (June 1875): 192, plus unnumbered p. in adv. section. [F. D. Langenheim, 1018 Wood St., Philadelphia, PA offering microscopic lenses, etc. from the late firm of W. & F. Langenheim, sold by F. D. Langenheim.]

L107 "W. & F. Langenheim - Photographers." PENNSYLVANIA ARTS AND SCIENCES 2, no. 1 (Spring 1937): 24-29, 58-59. 5 b & w. 3 illus.

L108 Russack, Richard. "Langenheims see Double Double." GRAPHIC ANTIQUARIAN 4, no. 1 (Oct. 1976): 18-20. 3 b & w. 2 illus.

L109 Porter, Allan. "Friedrich & Willam Langenheim." CAMERA (LUCERNE) 55, no. 12 (Dec. 1976): 14-23. 8 b & w. [Letter from F. Langenheim to H. H. Snelling reprinted.]

L110 Brey, William "The Langenheims of Philadelphia." STEREO WORLD 6, no. 1 (Mar. - Apr. 1979): 4-20, plus cover. 5 b & w. 6 illus. [Thoroughly researched, extremely detailed account of the lives and professional careers of the Langenheim brothers. Ernst Wilhelm Friedreich Langenheim born Feb. 23, 1807 in Brunswick, Germany. Studied law at the University of Gottingen, but immigrated to America in 1834. Headed, with a band of Irish and German immigrants, for Southwestern Texas, where they founded a colony near San Antonio. In 1835 he fought with Sam Houston's Texas Army to retake San Antonio from Mexican troops. Left the Alamo five days before it was invested by Santa Annas' troops, but captured and imprisoned for eleven months. Released in 1837, he went to New Orleans, where he joined the regular U. S. Army, then engaged in a war with the Seminole Indians. Served three years, then discharged. He then went to Philadelphia and accidently met his brother Frederick, born May 5, 1809 in Brunswick, who had immigrated to the USA in 1840. Frederick had been working as a newspaperman for the German language *Alte und Neue Welt*, but the brothers formed a partnership and opened a daguerreotype studio. The partnership remained active until the death of William in 1874, followed by the death of Frederick in 1879.]

L111 Finkel, Kenneth. "Langenheim Daguerreotype." HISTORY OF PHOTOGRAPHY 4, no. 4 (Oct. 1980): 336. 1 b & w. [Daguerreotype of Pennsylvania Militia occupying the Girard Bank, Philadelphia, PA, in 1844.]

L112 Layne, George. "The Langenheims and the Talbotype (Calotype)." PHOTOGRAPHICA 12, no. 9 (Nov. 1980): 7-8. 3 b & w. 2 illus.

L113 Layne, George S. "The Kirkbride - Langenheim Collaboration: Early Use of Photography in Psychiatric Treatment in Philadelphia." PENNSYLVANIA MAGAZINE OF HISTORY AND BIOGRAPHY 105, no. 2 (Apr. 1981): 182-202. 2 b & w. 3 illus. [Dr. Thomas Story Kirkpatrick collaborated with the Langenheim Brothers to use the magic lantern for "moral treatment" of patients.]

L114 Hanson, David A. "Early Photolithographic Stereographs in America: William and Frederick Langenheim and A. A. Turner." HISTORY OF PHOTOGRAPHY 9, no. 2 (Apr. - June 1985): 131-140. 10 b & w. 5 illus. [Discusses production and sale of photolithographic stereo cards by the Langenheim Brothers and by Austin A. Turner for the publisher D. Appleton.]

L115 Kilgo, Dolores. "The Robyn Collection of Langenheim Calotypes." GATEWAY HERITAGE: QUARTERLY JOURNAL OF THE MISSOURI HISTORICAL SOCIETY 6, no. 2 (Fall 1985): 28-38. 12 b & w.

L116 Layne, George S. "The Langenheims of Philadelphia." HISTORY OF PHOTOGRAPHY 11, no. 1 (Jan. - Mar. 1987): 39-52. 15 b & w. 1 illus. [Discussion of the Langenheim Brother's careers in Philadelphia, PA, with an emphasis on their work with Dr. Thomas Story Kirkbridge at the Pennsylvania Hospital for the Insane.]

L117 Lawson, Ellen NicKenzie. "Fathers of Modern Photography: The Brothers Langenheim. PENNSYLVANIA HERITAGE 13, no. 4 (Fall 1987): 16-23. 12 b & w. 2 illus.

LANGENHEIM, FREDERICK see also LANGENHEIM, WILLIAM & FREDERICK LANGENHEIM.

LANGENHEIM, FREDERICK. (1809-1879) (GERMANY, USA)
L118 "Personal & Fine Art Intelligence." PHOTOGRAPHIC AND FINE ART JOURNAL 7, no. 10 (Oct. 1854): 320. [Praise for Langenheim's stereos. Letter from Langenheim.]

L119 "Personal & Art Intelligence." PHOTOGRAPHIC AND FINE ART JOURNAL 9, no. 5 (May 1856): 159. [Letter from Langenheim describing his experiences with Balsam of Fir for binding lantern slides in 1846-47.]

L120 Langenheim, Frederick. "Correspondence." ANTHONY'S PHOTOGRAPHIC BULLETIN 5, no. 5 (May 1874): 194. [Letter correcting information in earlier article.]

L121 "Editor's Table." PHILADELPHIA PHOTOGRAPHER 16, no. 182 (Feb. 1879): 63. ["Mr. W. [sic. Frederick ?] Langenheim, one of our old fathers of photography died in this city, Jan. 10th, 1879. Only a year or two ago his brother and partner died."]

L122 "Editor's Table - Obituary." PHILADELPHIA PHOTOGRAPHER 16, no. 183 (Mar. 1879): 94-95.

LANGENHEIM, WILLIAM see also LANGENHEIM, WILLIAM & FREDERICK LANGENHEIM.

LANGENHEIM, WILLIAM. (1807-1874) (GERMANY, USA)
L123 "Society Notes." PHILADELPHIA PHOTOGRAPHER 11, no. 126 (June 1874): 185. [Obituary notice, with some history, in the monthly meeting minutes of the Phila. Photo. Soc. Died May 4, at age 68.] "Editor's Table - Obituary Notice." PHILADELPHIA PHOTOGRAPHER 11, no. 126 (June 1874): 190-191.

LANGFIER LTD.
L124 "A Notable Scottish Studio." WILSON'S PHOTOGRAPHIC MAGAZINE 35, no. 504 (Dec. 1898): 547-550. 8 b & w. 1 illus. [8 portraits, 1 view of studio interior of the Langfier Brothers Studio in Glasgow.]

L125 Wilson, Edward L. "Langfier-Portraitist." WILSON'S PHOTOGRAPHIC MAGAZINE 38, no. 536 (Aug. 1901): 313-314, plus 7 unnumbered leaves before p. 313, plus frontispiece. 23 b & w. [A. Langfier of New York, NY, was a member of a large photographic family in Britain. The British firm was founded by the father almost fifty years before, Langfier, Ltd., with sons and brother, with two studios in London, as well as others in Birmingham, Glasgow, Dublin and Belfast. (Apparently just opened a New York Studio).]

L126 "News and Notes: The Napoleon of Photography." WILSON'S PHOTOGRAPHIC MAGAZINE 38, no. 538 (Oct. 1901): 415. [Note about Louis Langfier, of London.]

LANGTON, ROBERT see also BEECHEY, ST. VINCENT.

LANGTON, ROBERT. (MANCHESTER, ENGLAND)
L127 "New Application of Photography - Daguerreotypes on Wood." HUMPHREY'S JOURNAL 5, no. 19 (Jan. 15, 1854): 296. [From "Civil Engineer and Architect's Journal." R. Langton (Manchester, England) developed a process for directly transferring photos to box-wood blocks.]

LANJARROIS.
L128 Lanjarrois. "Photography on Collodion." HUMPHREY'S JOURNAL OF PHOTOGRAPHY, AND THE ALLIED ARTS AND SCIENCES 14, no. 12 (Oct. 15, 1862): 131-134. [From "Moniteur de la Photographie."]

LANNEAU, C. H.
L129 Lanneau, C. H. "The Sky Light." PHOTOGRAPHIC AND FINE ART JOURNAL 9, no. 1 (Jan. 1856): 26. [Lanneau from Greenville, SC.]

LAPOURAILLE.
L130 Lapouraille. "Photogenic Dyeing." MAGAZINE OF SCIENCE AND SCHOOL OF ARTS 2, no. 93 (Jan. 9, 1841): 324. [From "Inventor's Advocate."]

LARKIN, J. E.
L131 Hand-Book of Poems: Selected. Elmira, NY: Wheeler & Watts, 1868. 16 pp. [Collection of poems, accompanied by advertisements for J. E. Larkin, photographer]

LAROCHE, SYLVESTER see also TALBOT, WILLIAM H. F.

LAROCHE, SYLVESTER. [H. SYLVESTER] (1809-1886) (CANADA, GREAT BRITAIN)
[Born in Canada, of French descent, in 1809. He emigrated to Britain, and worked as an artist in pastels. In 1845 he learned daguerreotypy, then the calotype process. He refused to pay a fee to Talbot, and Talbot sued him for years. Worked with Frederick Scott Archer on developing the wet-collodion process, and used it himself in the 1850s. Opened a studio in London in 1853. The Laroche-Talbot lawsuit finally settled in 1854, with mixed results, but Talbot finally released his copyright hold on photography. In 1857 Laroche

photographed Queen Victoria, and on her commission, made a series of portraits of the Shakespearean actor Charles Kean. In 1864 Laroche helped Oliver Sarony open a studio in Birmingham. His son had a studio in Llandudno, Wales. Died in Birmingham in 1886.]

L132 Portrait. Woodcut engraving credited "From a photograph by Laroche, Oxford St." ILLUSTRATED LONDON NEWS 29, (1856) ["Prince of Leiningen." 29:* (Dec. 6, 1856): 566.]

L133 Portrait. Woodcut engraving, credited "From a Photograph by Larouche." ILLUSTRATED NEWS OF THE WORLD AND DRAWING ROOM PORTRAIT GALLERY OF EMINENT PERSONAGES 1, (1858) ["The Late Mr. John Pritt Harley as 'Lancelot Gobbo,' in the 'Merchant of Venice')." 1:31 (Sept. 4, 1858): 145.]

LAROCHE, FRANK. (1853-1934) (USA)
L134 Monroe, Robert D. "Frank LaRoche: Washington's 'Other' Indian Photographer." NORTHWEST PHOTOGRAPHY 4, no. 8 (Sept. 1981): 4-5. 4 b & w. 1 illus.

LATHAM. (MATLOCK, ENGLAND)
L135 "Note." ART JOURNAL (Mar. 1867): 95. [Note of views of cathedrals, views of wild flowers, a fox, birds nest & eggs, marine objects, etc.]

LATTING, R. (SYRACUSE, NY)
L136 *Batchelor's Pictorial Business Directory of the City of Utica 1874-75. Containing the Advertisements of the Business Men in Our Prosperous City.* Photographic Views of the Business Houses. Utica, NY: Curtis & Childs, 1874. n. p. 22 b & w. [Business directory with 22 mounted photographs tipped in, by Prof. R. Latting, "...formerly of Syracuse, N. Y. ...having a practical experience of over 25 years."]

LAUDY, LOUIS H.
L137 Laudy, Louis H. "The Ferro-Photograph." HUMPHREY'S JOURNAL OF PHOTOGRAPHY, AND THE ALLIED ARTS AND SCIENCES 18, no. 19 (Feb. 1, 1867): 199-300.

L138 "The Centennial of Chemistry." ANTHONY'S PHOTOGRAPHIC BULLETIN 6, no. 1 (Jan. 1875): 22. [From "J. of Applied Chemistry." L. H. Laudy, of Columbia College School of Mines, made 72 portraits of leading chemists and views of interesting sites around Northumberland, PA.]

L139 Laudy, L. H. "The Magic Lantern and Its Applications." PHOTOGRAPHIC TIMES 15, no. 223 (Dec. 25, 1885): 713-714. [Substance of lecture delivered before the Photographic Section of American Institute.]

L140 Laudy, L. H., Ph. D. "The Magic Lantern and its Applications." ANTHONY'S PHOTOGRAPHIC BULLETIN 17, no. 1 (Jan. 9, 1886): 8-12.

L141 Laudy, L. H. "The Discovery of the Daguerreotype Process." PHOTOGRAPHIC TIMES 19, no. 390 (Mar. 8, 1889): 121-122. [Paper read before the Society of Amateur Photographers of New York.]

L142 Laudy, L. H., Ph.D. "The Discovery of the Daguerreotype Process." ANTHONY'S PHOTOGRAPHIC BULLETIN 20, no. 5 (Mar. 9, 1889): 142-144. [Brief survey of early history of photography. Read before the Society of Amateur Photographers of New York.]

LAURENT, J. (GREAT BRITAIN, SPAIN)
L143 "The Royal Museum at Madrid." ART JOURNAL (Aug. 1866): 244. [164 photos of the art collection in the Royal Museum of Madrid, taken by J. Laurent, distributed in England by Messrs. Marion & Co.]

L144 Portraits. Woodcut engravings credited "From a photograph by M. J. Laurent, Paris and Madrid." ILLUSTRATED LONDON NEWS 63, (1873) ["Senor Castelar." 63:1775 (Sept. 6, 1873): 225.]

LAUTERHAUSEN, MAX.
L145 "To Correspondents: Max Lauterhausen." HUMPHREY'S JOURNAL OF PHOTOGRAPHY, AND THE ALLIED ARTS AND SCIENCES 17, no. 15 (Dec. 1, 1865): 239. ["The card-pictures representing Peasantry from Oldenburg, Germany carry us into another world, so diverse are the costumes from anything on this side the Atlantic.]

LAVIS, JOSEPH.
L146 Lavis, Jos. "Photolithography. Various Methods of Obtaining an Image on Stone." HUMPHREY'S JOURNAL OF PHOTOGRAPHY, AND THE ALLIED ARTS AND SCIENCES 15, no. 11 (Oct. 1, 1863): 172-173. [From "Photo. News."]

LAW, WILLIAM.
L147 Law, Wm. "Filtering Gelatinous Liquids." HUMPHREY'S JOURNAL OF PHOTOGRAPHY, AND THE ALLIED ARTS AND SCIENCES 9, no. 17 (Jan. 1, 1858): 272. [From "J. of London Photo. Soc."]

L148 Law, Wm., Rev. "A Few Stray Notes From Memoranda of Photographic Difficulties." HUMPHREY'S JOURNAL OF PHOTOGRAPHY, AND THE ALLIED ARTS AND SCIENCES 10, no. 2 (May 15, 1858): 24-25. [Read to Birmingham Photo. Soc.]

L149 Law, Wm. "Dry Collodion Processes." HUMPHREY'S JOURNAL OF PHOTOGRAPHY, AND THE ALLIED ARTS AND SCIENCES 13, no. 14 (Nov. 15, 1861): 223. [From "Photo. News."]

L150 "Portraiture by Gas Light." ANTHONY'S PHOTOGRAPHIC BULLETIN 10, no. 7 (July 1879): 212-214. [From "London Photographic News." Law (Newcastle-on-Tyne).]

LAWRENCE & GORSELINE. (NEWBURGH, NY)
L151 "Neutral Tint." "Newburgh, New York." BALLOU'S PICTORIAL DRAWING-ROOM COMPANION [GLEASON'S] 13, no. 326 (Sept. 19, 1857): 184-185. 6 illus. ["I made the acquaintance also of Messrs. Lawrence & Gorseline, daguerreotypists, who rendered me very valuable assistance in furnishing pictures of several localities which my limited time would not allow me to sketch. In company with Mr. Lawrence, I crossed to Fishkill and sat down to make a sketch."]

LAWRENCE & HOUSEWORTH see also HART, ALFRED A.; HOUSEWORTH; WEED, C. L.

LAWRENCE & HOUSEWORTH. (SAN FRANCISCO, CA)
BOOKS
L152 Lawrence, George S. and Thomas Houseworth. *Gems of California Scenery: Catalogue of Views.* "3rd edition." San Francisco, CA: Lawrence & Houseworth, 1866.

L153 Palmquist, Peter E. *Lawrence & Houseworth/Thomas Houseworth & Company: A Unique View of the West, 1860 - 1866.* Columbus, OH: National Stereoscopic Association, 1981. 150 pp. 73 b & w. 39 illus.

PERIODICALS
L154 Palmquist, Peter E. "Revised Listing of Sacramento City during the Great Flood of 1862." STEREO WORLD 8, no. 2 (May-June 1981): 17-18. 2 b & w. [Additional listing of views by Lawrence & Houseworth and the Vance Gallery.]

L155 Palmquist, Peter E. "Sacramento City (California) During the Flood of 1862." STEREO WORLD 7, no. 6 (Jan.-Feb. 1981): 12-15. 4 b & w. 2 illus. [Stereo views by Lawrence & Houseworth; Charles L. Weed, for Lawrence & Houseworth. Includes a checklist of thirty views.]

LAWRENCE & LAWRENCE. (CAPETOWN, SOUTH AFRICA)

L156 "Tribes of the Shire and Zambesi Rivers." ILLUSTRATED LONDON NEWS 45, no. 1287 (Nov. 12, 1864): 493-494. 2 illus. ["...a set of photographic portraits, taken by Messrs. Lawrence, of Capetown, representing a number of the men, women, and children of the Manganja and Ajawa tribes."]

LAWRENCE, DAVID.

L157 "Landing of the Cargo of Slaves Captured on Board the American Bark Williams by the U.S. Steamer Wyandotte - Disembarkation at Key West. - Photographed by David Lawrence." FRANK LESLIE'S ILLUSTRATED NEWSPAPER 10, no. 239 (June 23, 1860): 65-66, 69. 2 illus. [Long view of the bark tied to the wharf, view of "accommodations of the negroes captured from slavers by United States cruisers," on p. 69.]

LAWRENCE, DAVID. [?]

L158 "The Africans of the Slave Bark 'Wildfire'." HARPER'S WEEKLY 4, no. 179 (June 2, 1860): 344-345. 5 illus. [Negro slaves aboard ship, portraits of slaves, the Barracoon at Key West. "From Daguerreotypes." See "FLIN" (June 23, 1860): 65-66, for source of my attribution.]

LAWRENCE, GEORGE S. see also LAWRENCE & HOUSEWORTH.

LAWRENCE, JOHN.

L159 Lawrence, John. "Photography Applied to Miniature Painting on Ivory." PHILADELPHIA PHOTOGRAPHER 1, no. 2 (Feb. 1864): 30-31.

LAWRENCE, MARTIN M. see also HARRISON, GABRIEL.

LAWRENCE, MARTIN M. (b. 1808) (USA)

L160 Burchard, Rev. S. D. "Martin M. Lawrence and the Daguerrean Art." PHOTOGRAPHIC ART JOURNAL 1, no. 2 (Feb. 1851): frontispiece, 103-106. 1 b & w. [Portrait. Lawrence has an artistic nature. A hard worker, he experimented so much in the laboratory studying the process that he became seriously ill. (Probably mercury poisoning). Then turned to portrait taking and succeeded. A student of light, Lawrence constructed one of the first skylights. Good at group portraits, and made exceptionally large "mammoth" daguerreotypes. One such, a portrait of General James Watson is praised here. At this time he is 43 years old, 9 years as an "artist."]

L161 "The Daguerrean Journal: Elopement in high life - several eminent Daguerreotypists interested." DAGUERREAN JOURNAL 3, no. 3 (Dec. 15, 1851): 81-82. [Lawrence's allegorical portraits "Past, Present, and Future" stolen from his gallery. Gurney also lost some daguerreotypes.]

L162 "Gossip." PHOTOGRAPHIC ART JOURNAL 3, no. 2 (Feb. 1852): 130. ["Those Crystal Palace prize pictures of Mr. Lawrence have safely arrived from London and may now be seen at his rooms."]

L163 Portrait. Woodcut engraving credited "From a photograph by Lawrence, of Broadway, New York City." ILLUSTRATED LONDON NEWS 21, (1852) ["Daniel Webster." 21:589 (Nov. 13, 1852): 408. (dag.)]

L164 "Gossip." PHOTOGRAPHIC ART JOURNAL 3, no. 3 (Mar. 1852): 196. ["Mr. Lawrence is preparing to take daguerreotypes on plates 13x17 inches in size. When completed they will be the largest in the world."]

L165 "Gossip." PHOTOGRAPHIC ART JOURNAL 5, no. 3 (Mar. 1853): 193. [Notice that Lawrence and Brady both opened their new daguerrean halls on Monday, March 14.]

L166 "New Daguerreotype Establishments." HUMPHREY'S JOURNAL 4, no. 24 (Apr. 1, 1853): 378. [Describes opening of new galleries by Brady and by Lawrence.]

L167 "M. M. Lawrence's New Heliographics Establishment, 381 Broadway." HUMPHREY'S JOURNAL 5, no. 1 (Apr. 15, 1853): 10-11. [Description of Lawrence's gallery.]

L168 "Our Illustration: Portrait of Dr. Eliphalet Nott, President of Union College." PHOTOGRAPHIC AND FINE ART JOURNAL 8, no. 8 (Aug. 1855): 253. 1 b & w. [Original photographic print, bound in.]

L169 Portrait. Woodcut engraving credited "From a photograph by Lawrence." ILLUSTRATED LONDON NEWS 28, (1856) ["Francis Pettit Smith, inventor." 28:8 (Apr. 26, 1856): 428.]

L170 "John Brown, Now under Sentence of death for treason and murder, at Charlestown, Va. - From a Photograph Taken One Year Ago by Martin M. Lawrence, 381 Broadway." FRANK LESLIE'S ILLUSTRATED NEWSPAPER 8, no. 207 (Nov. 19, 1859): 383. 1 illus.

L171 Portrait. Woodcut engraving, credited "From a Photograph by Lawrence." HARPER'S WEEKLY 5, (1861) ["Rev. Dr. Murray." 5:217 (Feb. 23, 1861): 117.]

LAWSON, HENRY.

L172 Lawson, Henry, M.D. "Scientific Summary: Quarterly Retrospect: Photography." POPULAR SCIENCE REVIEW 1, no. 2-5 (Jan. - Oct. 1862): 265-267, 400-401, 532-534,. [(Jan.) Mentions Joubert's enamel photography; Mr. Malone's discussion of the composition of the photographic image; G. Whartson Simpson; Mr. Crookes; and Dr. Draper. (Apr.) Mentions controversy at the International Exhibition; Mr. Claudet; Mr. England; Sir John Herschel; Mr. Crookes; Emerson J. Reynolds. (July) Mentions F. S. Archer; Mayall; Hansen (Copenhagen); Ghemar Brothers; Oehme & Jamrath (Berlin); W. T. Mabley; Adolphe Martin.]

L173 Lawson, Henry, M.D. "Scientific Summary: Quarterly Retrospect: Photography." POPULAR SCIENCE REVIEW 2, no. 5-8 (Oct. 1862 - July 1863): 125-128, 290-293, 440-443, 574-577. [(Oct.) Discusses a group portrait of the British Association, a combination print made from separate portraits by Alfred Brothers of Manchester. Discusses fading prints at the International Exhibition. Mentions work of Warner; James Mudd; Vernon Heath; Sidebotham; D. Campbell; R. M. Gordon; T. R. Williams; A. W. Bennett; G. Wharton Simpson. Mentions John Spiller's experiments in recovering silver. (Jan.) Mentions Vernon Heath's portrait of Prince Albert; Mr. Annan's

reproductions of paintings issued for the Glasgow Art-Union; Dr. H. Diamond; Malone's lecture on photochemistry; technical matters, etc. (Apr.) Lists winners of the prizes offered by the Council of the Photographic Society: Claudet, F. Bedford, Colonel Stuart Wortley, Viscountess Harwarden, H. P. Robinson and Thurston Thompson. Bayard, Duboscq and Poitevin received medals from French Emperor. Awards and prizes to Poitevin, Davanne, Girard, Garnier, Salomon, Pouncey, Fargier. Meynier, M. Ponton mentioned. A. F. Eden's microphotography discussed. (July) Chemical matters discussed. W. Deane and Mr. Spiller photographing solar eclipses. Confused results of chemical experiments at high altitudes in balloons by Mr. Glaisher, C. Piazzi Smyth and Mr. Negretti.]

L174 Lawson, Henry, M.D. "Scientific Summary: Quarterly Retrospect: Photography." POPULAR SCIENCE REVIEW 3, no. 9-12 (Oct. 1863 - July 1864): 128-132, 276-280, 412-417, 551-556. [(Oct.) H. F. Talbot's experiments in photoengraving; C. Piazzi Smyth's photos from the Peak of Teneriffe; Negretti & Zambra's balloon photos; Marquier's photolithographs; Henry Swan's stereoscopic experiments; T. L. Phipson; Carey Lea's blueprints; Beyrich's ceramic photos, etc. all reported at the British Association Meeting. (Jan.) "The Watt Photographs": discovery of the photos in Samuel Boulton's estate, presumably made by Mr. James Watt in 1780s and 1790s. Sutton's lenses. Microphotography. Joubert's "burnt-in" photos on glass, etc. (Apr.) Reports on photographic engraving, Carbon printing, etc. More discussion of the Boulton "Watt Photographs" and the controversy around them. Chemical matters, lenses discussed. (July) The Boulton photographs completely discredited. Joseph Swan's carbon process; Mr. Claudet introducing Mr. Willeme's photosculpture to England, the process discussed, illustrated with two engravings. "The Chementi Pictures"(stereoscopic works from the 17th century).]

L175 Lawson, Henry, M.D. "Scientific Summary: Quarterly Retrospect: Photography." POPULAR SCIENCE REVIEW 4, no. 13-17 (Oct. 1864 - Oct. 1865): 130-134, 258-263, 392-395, 530-534, 674-677. [(Oct.) Royal Society Exhibition (H. P. Robinson, Alfred Harmon, Swan, Col. Sir Henry James, Toovey, Osborne, Lady Hawarden, Annan mentioned); Solar camera; Dr. R. L. Maddox's magnesium light; W. H. Davies on carbon process; C. Piazzi Smyth, etc. (Jan.) Chemical and technical matters. (Apr.) Dublin International Exhibition (medals awarded to H. P. Robinson, James Mudd, Thomas Annan, John Smith, J. Ramsay, L'Amy, Samuel Highley and the Pantoscopic Co,)."Photographing from Dean Eyes." Walter Woodbury's views of Japan; copyright; chemical matters. (July) Photographic Exhibit, London: Faulkner, V. Blanchard, H. P. Robinson praised, others mentioned. The Aniline Process; the Eburneum Process; camera stands; Simpsontype, etc. (Oct.) Exhibitors at the Dublin International Exhibition listed; North London Photographic Association Exhibition mentioned: Rejlander, V. Blanchard, H. P. Robinson, Aldis, G. W. Simpson, etc.]

L176 Lawson, Henry, M.D. "Photography and Some of Its Applications." POPULAR SCIENCE REVIEW 4, no. 17 (Oct. 1865): 622-633. 1 illus.

L177 Lawson, Henry, M.D. "Scientific Summary: Quarterly Retrospect: Photography." POPULAR SCIENCE REVIEW 5, no. 18-21 (Jan. - Oct. 1866): 123-128, 254-258, 382-386, 512. [Argument over whether Talbot or Mungo Ponton discovered bichromated gelatin's insolubility after some exposure to light has caused a stir in the scientific journals. Chemical and technical matters discussed. A supplement to Prof. Hitchcock's 'Geology of New England' illustrated by photographs from nature, recently published in Massachusetts. Astronomical photography, etc. (Apr.) More of the Talbot/Ponton

controversy. Photography in Colours (hand colored negatives); chemical and technical matters; Carey Lea's paper on perspective discussed, etc. (July) Proper fixing of prints for permanency; "Opaltypes"; report on A. H. Wall's article against "composition photography" that display clashing perspectives. (Oct.) Commentary on the issue of whether photography could be art: mentions Claudet's 1853 paper, "Upon Photography in an Artistic View, and Its Relation to the Arts." Mentions R. W. Buss, John Leighton, Sir William Newton, Sir Charles Eastlake, A. H. Wall and the argument of selective focus, then attacks Claudet's more recent paper. Discusses chemical matters.]

L178 Lawson, Henry, M.D. "Scientific Summary: Quarterly Retrospect: Photography." POPULAR SCIENCE REVIEW 6, no. 22-25 (Jan. - Oct. 1867): 106-110, 227-229, 339-344, 479-483. [(Jan.) Woodbury's Printing Process; J. Traill Taylor's lenses; belittling of claims of the Frenchman Chambray to have perfected color photography; Claudet's process; London Photographic Society medals; Swan's Carbon process, etc. (Apr.) Pouncy, Carey Lea, Davanne, A. H. Wall mentioned. Dallmeyer's new lenses; O. G. Rejlander's photographs of brass rubbings. (July) Paris Exhibition; Duc de Luynes Prize awarded to Poitevin; Major Russell's dry collodion process discussed; Carey Lea on the latent image, etc. (Oct.) Photolithography by G. Morvan (USA); Prof. Falkland on artificial light; Carey Lea, W. H. Harrison and Mungo Ponton controversy on latent image. British winners of awards at Paris Exhibition: Bedford, England, Mudd, Thurston, Thompson and Robinson, others mentioned. Photography at the British Association Meeting.]

L179 Lawson, Henry, M.D. "Scientific Summary: Quarterly Retrospect: Photography." POPULAR SCIENCE REVIEW 7, no. 26-29 (Jan. - Oct. 1868): 109-113, 223-227, 334-337, 447-450. [(Jan.) London Photographic Society Exhibition. M. Salomon of Paris praised. O. G. Rejlander, Cherrill, Frank Howard, Dumore,Ayling, Bedford, Faulkner, H. P. Robinson mentioned. Duc de Luyne's Prize awarded to Poitevin, Pouncy angered. An award at the Paris Exhibition for lenses was refused by the recipient (Ross), Dr. Diamond involved. Note that Osaka, Japan is reported to have 40 native photographers. Thomas Sutton on cameras, etc. (Apr.) London Photographic Society reported to be in a bad way financially. Philip Crellin's cartes-de-visite of prominent men praised. Chemical, technical matters. (July) Photographing of the eclipse by Major Tennant, Capt. Brandreth and non-coms of the Royal Engineers planned. Chemical and technical matters. A Mr. McLachlan's discoveries downplayed. (Oct.) Kinescope discussed. Technical matters.]

L180 Lawson, Henry, M.D. "Scientific Summary: Quarterly Retrospect: Photography." POPULAR SCIENCE REVIEW 8, no. 30-33 (Jan. - Oct. 1869): 100-102, 209-212, 323-325, 440. [(Jan.) Chemical and technical matters. (Apr.) "R. H. Bow, C.E. of Edinburgh recently applying the theodolite to ascertain the truth of art as displayed in certain well known pictures." Technical and chemical matters. (July) Chemical matters. (Oct.) "Owing to the pressure of our space the photographic summary is unavoidably 'crushed out' of the number."]

L181 Lawson, Henry, M.D. "Scientific Summary: Quarterly Retrospect: Photography." POPULAR SCIENCE REVIEW 9, no. 34-37 (Jan. - July 1870): 102-104, 215-217, 326-327. [(Jan.) Artificial light for enlargements; eclipse of the sun photographed; F. Maxwell Lyte's alkaline dry process; portable camera for dry plates invented by Walter Cook. (Apr.) "The Possibility of obtaining Heliochromes." C. Piazzi Smyth's lecture, "A Poor Man's Photography," published. Photo-engraving. Colonel Stuart Wortley's "moonlight photographs" discussed, the technique described. (July) Combination printing. "The

Illustrated Photographer" which began in 1869 failed. Niépce de St. Victor died on April 7. Chemical matters.]

L182 Lawson, Henry, M.D. "Scientific Summary: Quarterly Retrospect: Photography." POPULAR SCIENCE REVIEW 10, no. 39 (Apr. 1871): 220-222. [Brief note of death of Rev. J. B. Reade, F.R.S., on December 12, 1870. Chemical matters.]

LAWTON, J. (d. 1874) (GREAT BRITAIN, CEYLON)
L183 "Statue of Sir Henry Ward in Ceylon." ILLUSTRATED LONDON NEWS 53, no. 1510 (Nov. 7, 1868): 448-449. 1 illus. ["...after a photograph taken at the monument by J. Lawton, photographic artist, of Kandy." Unveiling the statue.]

L184 "The Natives of Ceylon." ILLUSTRATED LONDON NEWS 58, no. 1602 (July 9, 1870): 29. 2 illus. ["Two groups of figures...Kandyan Chiefs and High-Caste Ladies of Kandy...from the photographs taken by Mr. J. Lawton, at the levée of his Royal Highness the Duke of Edinburgh, at Kandy on April 13th."]

LAWYER, J. H.
L185 Lawyer, J. H. "The Economy of Toning." AMERICAN JOURNAL OF PHOTOGRAPHY AND THE ALLIED ARTS & SCIENCES n. s. vol. 6, no. 4 (Aug. 15, 1863): 94. [Lawyer from New York.]

LAY, JESSIE.
L186 "The 'Challenger's' Visit to New Guinea." ILLUSTRATED LONDON NEWS 66, no. 1871 (June 19, 1875): 577, 580, 580-591. 3 illus. ["The scientific surveying voyage of H.M.S. Challenger over the principal oceans of the globe has been frequently described and illustrated by Engravings in our Journal. We are indebted to Mr. John James Wild for the photographs and accompanying letter." (It seems highly probably from the visual grammar of many of these other illustrations that they were also engraved from photographs - but not frequently credited.) (See "Nature" (Nov. 11, 1875): 25-26, for attribution of artist.)]

L187 Lay, Jessie. "Letters to the Editor: Photography in the 'Challenger.'" NATURE 13, no. 315 (Nov. 11, 1875): 25-26. [Letter from J. Lay, the photographer aboard the "H.M.S. Challenger", about the value of dry plates under difficult conditions. The "Challenger" was on an extended scientific cruise in the South Pacific.]

LAYTON & BARNE. (ROCKFORD, IL)
L188 Portrait. Woodcut engraving, credited "From a Photograph." FRANK LESLIE'S ILLUSTRATED NEWSPAPER 14, (1862) ["Lieut.-Col. E. F. W. Ellis." 14:350 (June 21, 1862): 180.]

LAZELLE & MCMULLEN.
L189 "Fires at Petersburg, Virginia - Ruins of the Colored Baptist Church on Harrison Street." HARPER'S WEEKLY 10, no. 490 (May 19, 1866): 317. 1 illus. ["Photographed by Lazelle & M'Mullen, Petersburg, Va."]

LE BARON DES GRANGES.
L190 "Photographic Views of Greece." ART JOURNAL (Nov. 1868): 257. [35 views on sale at Messr. Colnaghi's.]

LE GRAY, GUSTAVE. (1820-1882) (FRANCE)
[Born at Villiers-le-Bel in 1820. Studied painting with Picot, and in 1845, with Delaroche. Roger Fenton, Henri Le Secq, and Charles Nègre were also studying under Delaroche at this time. Exhibited in Paris Salons in 1848 and 1853. Daguerreotyped with Arago in 1847. Opened a photography studio in Paris in 1848. In 1851 he perfected a dry waxed-paper process which was excellent for landscape views.

In 1851 he became a member of the Société Héliographique. Commissioned by the Society of Historical Monuments to photograph in Touraine and Aquitaine. Worked with O. Mestral. Photographed the forest at Fontainebleau. His four photographic manuals were popular and translated into English in the early 1850s. In 1854 he became a founder-member of the Société française de Photographie. He was considered a master craftsman and he taught photography or advised Léon de Laborde, the Delesserts, Adrien Tournachon, Nègre, Maxime Du Camp, Henri Le Secq and others. Photographed seascapes and painted in Normandy in 1856. In 1857 photographed the French Army at the Camp de Châlons. In 1859, abandoning an unhappy marriage, he left France. Photographed in Palermo in 1860, then moved on to Egypt. Taught drawing and design at the Ecole Polytechnique in Cairo from 1865 on and photographed in Egypt in 1860s. Died in Cairo in 1882.]

BOOKS
L191 Le Gray, Gustave. *A Practical Treatise on Photography*, Upon Paper and Glass, by Gustav LeGray. Translated from the French by Thomas Cousins, Lecturer in Natural Philosophy and Practical Photographer. London: T. & R. Willats, opticians, 1850. 25 pp.

L192 Le Gray, Gustave. *Photographic Manipulation. The Waxed Paper Process, of Gustave Le Gray,* Translated from the French. With a supplement by James How on his modification of the process. London: George Knight & Sons, opticians, 1853. 23 pp., supplement of 11 pp.

L193 Le Gray, Gustave. *Plain Directions for Obtaining Photographic Pictures;* Part I by J. H. Croucher, Part II by Gustave Le Gray. Philadelphia: A. Hart, 1853. 224 pp. illus. [(1860), Philadelphia: H. C. Baird. Reprinted (1973), Arno Press.]

L194 Peterich, Gerda. *The Calotype in France and Its Use in Architectural Documentation; A Study of the Development of the Calotype Photographic Process with Special Consideration of the Contribution made by Blanquart-Evrard and Gustave Le Gray.* Rochester, NY: University of Rochester, 1956. viii, 144 l. pp. [M.A. thesis, University of Rochester. Photocopy of typescript, GEH Collection.]

L195 Ramstedt, N. W. *The Photographs of Gustave Le Gray.* Ann Arbor, Mich.: Dissertations Abstracts International Order no. 78-7016, 1978. 319 pp. [Ph.D. dissertation, Univ. of Calif., Santa Barbara, 1977.]

L196 Janis, Eugenia Parry. *The Photography of Gustave Le Gray.* Chicago: The Art Institute of Chicago and the University of Chicago Press, 1987. 184 pp. b & w. 120 illus.

L197 Baldwin, Gordon. *Gustave Le Gray.* J. Paul Getty Museum, 1988. 1 sheet folded into 8 pages pp. 5 b & w. [Exhibition catalog: J. Paul Getty Museum, May 3-Aug. 28, 1988. Illustrations are photographs by Gustave Le Gray.]

PERIODICALS
L198 De [sic Le] Gray, Gustave. "Of the Actual State of Photography and the Perfection to which It has been Brought." PHOTOGRAPHIC ART JOURNAL 2, no. 3 (Sept. 1851): 156-158. [Trans from "La Lumiére."]

L199 La Gray [sic Le Gray]. "A New Method of Preparing Negative Photographic Paper." HUMPHREY'S JOURNAL 4, no. 2 (May 1, 1852): 21-22. [From "Moniteur Industriel."]

L200 Le Gray, Gustave. "Photography on Paper and Glass." HUMPHREY'S JOURNAL 4, no. 3-9 (May 15 - Aug. 15, 1852): 33-36, 49-52, 65-68, 81-83, 97-100, 113-116, 129-130.

L201 Le Gray, Gustave. "New Process For Obtaining Positive Proofs on Paper with a Very Varied Coloring." PHOTOGRAPHIC ART JOURNAL 3, no. 6 (June 1852): 346-348. [From "La Lumiére."]

L202 Le Gray, Gustave. "On Photography on Paper and Glass." PHOTOGRAPHIC ART JOURNAL 4, no. 2-6 (Aug. - Dec. 1852): 106-113, 163-169, 241-248, 277-287, 354-359.

L203 Le Gray. "On the Camera and Lenses." HUMPHREY'S JOURNAL 4, no. 11 (Sept. 15, 1852): 161-163.

L204 Le Gray. "Remarks on Portrait Taking and the Copying of Daguerreotypes and Oil Paintings." HUMPHREY'S JOURNAL 4, no. 11 (Sept. 15, 1852): 173-174.

L205 Le Gray. "New Photographic Process." HUMPHREY'S JOURNAL 4, no. 16 (Dec. 1, 1852): 241-243.

L206 Le Gray. "Process for Producing Photographs on Paper." HUMPHREY'S JOURNAL 4, no. 18 (Jan. 1, 1853): 286.

L207 G. C. "Le Gray and the Collodion Process." NOTES & QUERIES 7, no. 167 (Jan. 8, 1853): 47-48.

L208 Le Gray. "Albumen on Glass." HUMPHREY'S JOURNAL 5, no. 2-3 (May 1 - 15, 1853): 38-40. [Source not credited.]

L209 "Photography: Le Gray and the Photographic Process. - Originator of the Collodion Process, etc." HUMPHREY'S JOURNAL 5, no. 8 (Aug. 1, 1853): 113, 116-117, 118. [From "Notes and Queries." Exchange of letters from G. C., H. W. D.[iamond], Thomas D. Eaton, F. Horne, W. Brown, and F. Scott Archer, about priority claims to using collodion.]

L210 "Our Library Table." ATHENAEUM no. 1422 (Jan. 27, 1855): 113. [Bk. rev.: "The Collodion Process," by Thomas H. Hennah (Knight); "The Waxed-Paper Process," by Gustave Le Gray (Knight); "Practical Photography on Glass and Paper," by C. A. Long (Bland & Long).]

L211 Archer, Fanny G. "Le Gray & the Discovery of Collodion." PHOTOGRAPHIC AND FINE ART JOURNAL 11, no. 2 (Feb. 1858): 59. [Wife of the photographer Fred S. Archer. From the "J. of the Photographic Society."]

L212 Le Gray, Gustave. "A New Method of Toning Positive Prints." PHOTOGRAPHIC AND FINE ART JOURNAL 12, no. 1 (Jan. 1859): 18-19. illus. [From "Photo. Notes," in turn from "J. of Soc. Helio. Fran."]

L213 Le Gray. "A New Method of Toning Positive Proofs." HUMPHREY'S JOURNAL OF PHOTOGRAPHY, AND THE ALLIED ARTS AND SCIENCES 10, no. 22 (Mar. 15, 1859): 348-350. [From "Bulletin of the French Photo. Soc."]

L214 "New Toning Processes of M. Bayard and M. Le Gray." AMERICAN JOURNAL OF PHOTOGRAPHY AND THE ALLIED ARTS AND SCIENCES n. s. vol. 1, no. 21 (Apr. 1, 1859): 336-338. [From "Bulletin of the French Photo. Soc."]

L215 "Le Gray's Toning Process." AMERICAN JOURNAL OF PHOTOGRAPHY AND THE ALLIED ARTS AND SCIENCES n. s. vol. 1, no. 23 (May 1, 1859): 366-367.

L216 Portrait. Woodcut engraving credited "From a photograph by Gustav LeGray." ILLUSTRATED LONDON NEWS 35, (1859) ["Marshal Regnault de Saint Jean D'Angely." 35:* (July 2, 1859): 5.]

L217 "Talk of the Studio." PHOTOGRAPHIC NEWS 4, no. 114 (Nov. 9, 1860): 336. [Note that Le Gray broke a leg while photographing in Syria.]

L218 Marbot, Bernard. "Souvenirs photographiques du camp de Châlons en 1857 par Gustave Le Gray: album Montebello." BULLETIN DE LA BIBLIOTHEQUE NATIONALE 3, no. 3 (Sept. 1978): 136-141. 6 b & w. 1 illus.

L219 Cava, Paul. "Early Landscapes by Gustave Le Gray." HISTORY OF PHOTOGRAPHY 2, no. 4 (Oct. 1978): 274. 1 b & w.

L220 "Apropos: Le Camp de Chalons: A report on an exhibition in the Bibliotheque National in Paris: Photographic memories of the military camp at Chalons." CAMERA (LUCERNE) 58, no. 2 (Feb. 1979): 39-40. 2 b & w. [Ex. rev.: 'Le Camp at Chalons,' Bibliotheque National, Paris, France. An exhibition in memory of the collector Georges Sirot (1898-1977) who rediscovered this album of photographs.]

L221 Ramstedt, Nils. "An Album of Seascapes by Gustave Le Gray." HISTORY OF PHOTOGRAPHY 4, no. 2 (Apr. 1980): 121-137. 24 b & w. ["Vistas del Mar" album by Le Gray, ca. 1857-1859]

LE GROS, ADOLPHE.
L222 "Coloring Daguerreotypes." PHOTOGRAPHICA 12, no. 2 (Feb. 1980): 7. [Translated article from 1856 "Encyclopedie de la Photographie" by Adolphe Le Gros.]

LE JEUNE. (PARIS, FRANCE)
L223 Portrait. Woodcut engraving credited "From a photograph by LeJeune." ILLUSTRATED LONDON NEWS 58, (1870) ["Marshal Bazaine, French Army." 58:* (Aug. 27, 1870): 208.]

L224 1 engraving (Portrait of Peter Donahue). CALIFORNIA MAIL BAG 1, no. 4 (Oct.-Nov. 1871): frontispiece. 1 illus. [A photograph by Le Jeune, (Paris) accompanies this biography.]

L225 Portrait. Woodcut engraving, credited "From a Photograph by Le Jeune, Paris. FRANK LESLIE'S ILLUSTRATED NEWSPAPER 41, (1875) ["Hon. Alexander H. Rice, of MA.]

L226 Portrait. Woodcut engraving credited "From a photograph by LeJeune." ILLUSTRATED LONDON NEWS 74, (1879) ["Lady Ela Russell." 74:2074 (Mar. 15, 1879): 241.]

LE MERLE, A. E. (1835-1872) (USA)
L227 "Obituary - A. E. Le Merle." PHILADELPHIA PHOTOGRAPHER 9, no. 104 (Aug. 1872): 297. [A. E. Le Merle died July 3, 1872, aged 37 years. Learned photography from I. B. Webster in 1859-60. Worked for Brady, Golden, Gardner, and in other galleries in Washington, DC. Then assisted Dr. Curtis in his microscopic operations. Accompanied the Eclipse Expedition to Des Moines, IA. Examiner of the photo-lithographic drawings for the Patent Office. Always suffered ill-health and died young.]

LE MESURIER, A. A. [?]

L228 "Volunteer Camp in India." ILLUSTRATED LONDON NEWS 66, no. 1854 (Feb. 20, 1875): 157. 2 illus. [Outdoor group portrait and view of men on rifle range. "We are indebted to Major A. A. Le Mesurier, H.M. 14th Reg., Inspector and Adjutant of the East Indian Rifle Volunteers, for a set of photographs."]

LE PIERRE, MADAME.

L229 Le Pierre, Madame. *The Art of Painting Photographs in Water Colors.* New York: Crawford & Willis, 1865. 23 pp. illus.

LE PLONGEON, ALICE D.

L230 Le Plongeon, Alice D. "A Few Hints on Printing." PHOTOGRAPHIC TIMES 12, no. 143 (Nov. 1882): 427-428. [Alice was the wife of the archeologist Dr. Le Plongeon. Apparently she printed the photos that they both took.]

L231 Le Plongeon, Alice D. "An Example of Patience for Photographers." PHOTOGRAPHIC TIMES 14, no. 162 (June 1884): 302-304. [Describes her and her husband's experiences as archaeologists in the Yucatan, at Uxmal.]

L232 Le Plongeon, Alice D. "Collodion vs. Gelatine." PHOTOGRAPHIC TIMES 18, no. 377 (Dec. 7, 1888): 581-582. [Le Plongeon, wife of an archaeologist who worked in Central America, describes their experiences working with collodion processes, then later with gelatine processes.]

LE PLONGEON, AUGUSTUS.

L233 "Matters of the Month." PHOTOGRAPHIC TIMES 7, no. 73 (Jan. 1877): 5. ["Dr. Augustus Le Plongeon, archeologist, author of "The Manual de Fotografia" and various scientific works on surgery, medicine and chemistry, is now in the interior of Mexico, where he has been for a year or more exploring for Indian antiquities, in company with his wife."]

L234 "Note, Letter." PHOTOGRAPHIC TIMES 8, no. 88 (Apr. 1878): 89. [Dr. Augustus Le Plongeon, the celebrated archaeologist, who is now exploring the ruins of British Honduras has sent us... photos of ruins... stereoscopic work.]

L235 "Note." PHOTOGRAPHIC TIMES 8, no. 94 (Oct. 1878): 232. [Dr. Le Plongeon, scientist and archaeologist, author of the best handbook of photography in the Spanish language, entitled "Manual de Fotografia," awaits us."]

L236 "Letter from Dr. Le Plongeon." PHOTOGRAPHIC TIMES 9, no. 100 (Apr. 1879): 77-79. [Describing taking views in Belize, British Honduras.]

L237 "Our Editorial Table." PHOTOGRAPHIC TIMES 12, no. 133 (Jan. 1882): 7. [Bk. rev.: "Vestiges of the Mayas," by Dr. Aug. Le Plongeon. This book has no photograph but Le Plongeon wrote a Spanish edition photography manual, and took photos during his ten years in the Yucatan.]

L238 Le Plongeon, Aug., M.D. "Dry Plates in Yucatan." PHOTOGRAPHIC TIMES 12, no. 137 (May 1882): 143-144.

L239 Le Plongeon, Augustus, M.D. "Photography Not An Art." PHOTOGRAPHIC TIMES 15, no. 206 (Aug. 28, 1885): 495. [Argues that it is an art form.]

L240 Brinton, Dr. D. G. "Photography in Chicago." PHOTOGRAPHIC TIMES 15, no. 222 (Dec. 18, l885): 705. [Excerpt from the "American Antiquarian." Report of talk with Dr. & Mrs. Le Plongeon about their investigations into Mayan civilization in Central America.]

L241 "General Notes." PHOTOGRAPHIC TIMES 16, no. 269 (Nov. 12, 1886): 589. [Notes that Mrs. Le Plongeon giving a lantern slide lecture of her and her husband's archeological investigations in the Yucatan at the Cooper Union on Dec. 4th.]

LE SECQ, HENRI. [JEAN-LOUIS HENRI LE SECQ DES TOUR-NELLES] (1818-1882) (FRANCE)

[Born in Paris in 1818, the son of the chief clerk, Préfecture de la Seine. Studied painting with Pradier, then with Granger. In 1840 studied under Delaroche. Throughout his life Le Secq exhibited his paintings of genre scenes, religious themes, and still lifes in the Paris Salons. In 1848-49 he studied photography with Gustave Le Gray. Made calotypes of French cathedrals in Reims, Strasbourg, Amiens, and Chartres. From 1851 through 1853 he photographed views in Amiens, then in Paris. In 1851 he photographed the regions of Champagne, Lorraine and Alsace for the Historical Monuments Commission. Contributed photographs to Blanquard-Evrard's *Paris Photographique* in 1851. Photographed in the Montmiral forest and completed his series of photographs of cathedrals. About 1856 Le Secq made a group of beautiful and extraordinary still lifes, then abandoned photography. Continued to make etchings, drawings, paintings, and amassed a large collection of medieval ironwork. In the 1870s he published several portfolios of photolithographs of his 1850s views in *Fragments d'Architecture et Sculpture de la Cathédral de Chartres,* (Paris, ca. 1879) and *Monographie de la Cathédral de Reims,* (Paris, 1879). Died in Paris in 1882.]

L242 "Pictures from the Collection." IMAGE 6, no. 6 (June 1957): 142-143. 2 b & w.

L243 Janis, Eugenia Parry. "The Man on the Tower of Notre Dame: New Light on Henri Le Secq." IMAGE 19, no. 4 (Dec. 1976): 13-25. 14 b & w. 8 illus.

L244 "Biographical Notes on a Number of Photographers Published by Blanquart-Evrard." CAMERA (LUCERNE) 57, no. 12 (Dec. 1978): 32, 41-42. [Benecke, Claine, DuCamp, Fortier, Greene, Le Secq, Loydreau, Marville, Regnault, Robert, Salzmann, Stewart, Sutton, and Tenison.]

L245 Buerger, Janet E. "Le Secq's 'Monuments' and the Chartres Cathedral Portfolio." IMAGE 23, no. 1 (June 1980): 1-5. 10 b & w.

L246 Rombout, Melissa K. "Conscience of the Ruins." VIEWS: THE JOURNAL OF PHOTOGRAPHY IN NEW ENGLAND 9, no. 2 (Winter 1988): 13. 3 b & w. [Ex. rev.: "Henri Le Seq: Early French Photographer," Torf Gallery, Boston, MA. Sept. 1 - Nov. 1, 1987.]

LEA, MATHEW CAREY. (1823-1897) (USA)

[Mathew Carey Lea was born in Philadelphia in August, 1823, into a family of "great prominence and considerable wealth." He was the grandson of Mathew Carey, founder of the *Pennsylvania Evening Herald*, and a publishing firm which published many works of American literature. Mathew's father, Isaac Lea, published over 275 papers on science and nature in his lifetime. Mathew and his younger brother, Henry Charles Lea, both grew up to be distinguished scholars and scientists. At age eighteen Mathew published his first scientific paper, "On the First or Southern Coal Field of Pennsylvania," in 1841. He also studied law, and was admitted into practice in 1847, but soon abandoned it to travel for relief from a chronic illness which plagued him all of his life. Blinded in one eye in a laboratory accident in late 1840s. Married in 1852. His *Manual of Photography* became a

standard reference text after its publication in 1868. Lea contributed many papers to the photographic journals throughout the 1870s, and his work on the allotropic forms of silver won him an election to the National Academy of Sciences. He died on Mar. 15, 1897, at Chestnut Hill, PA.]

BOOKS

L247 Lea, Mathew Carey. *Newman's Manual of Harmonious Coloring, As Applied to Photographs, Together with Valuable Papers on Lighting and Posing the Sitter;* Edited with a Preliminary Chapter on Obtaining Harmonious Negatives, and with Notes, by M. Carey Lea. Philadelphia: Benerman & Wilson, 1866. 148 pp. illus.

L248 Lea, Mathew Carey. *A Manual of Photography*. Philadelphia: Benerman & Wilson, 1868. viii, 336 pp. illus. [2nd ed., rev. and enlarged (1871) 439 p.]

PERIODICALS

L249 Lea, M. Carey. "Photolithography with Silver Soap." PHILADELPHIA PHOTOGRAPHER 1, no. 2 (Feb. 1864): 31-32. [M. Carey Lea from Philadelphia, PA; published articles of a technical nature in almost every issue throughout the early years of this journal.]

L250 Lea, M. Carey. "Photography Abroad." PHILADELPHIA PHOTOGRAPHER 1, no. 5 (May 1864): 67. [This became a regular feature of the magazine, published frequently; it is an abstract of the processes, etc. published in several European journals.]

L251 Lea, M. Carey. "On the Dew of Iodine for Detecting Hyposulphite of Soda, and for Reducing Overprinted Positives." AMERICAN JOURNAL OF PHOTOGRAPHY AND THE ALLIED ARTS & SCIENCES n. s. vol. 7, no. 1 (July 1, 1864): 6-7. [From "Phila. Photo."]

L252 Lea, M. Carey. "Photographic Notes on Various Subjects. On Relief in Landscape Photography. On the Development of Plates in the Field." BRITISH JOURNAL OF PHOTOGRAPHY 11, no. 237 (Nov. 18, 1864): 459. [Lea is from Philadelphia, PA.]

L253 Lea, M. Carey. "Photographic Notes on Various Subjects: The Wothlytype Process." BRITISH JOURNAL OF PHOTOGRAPHY 11, no. 239 (Dec. 2, 1864): 483-484.

L254 Lea, M. Carey. "Photographic Notes on Various Subjects: Effect of Erroneous Lighting on Portraits. On the Importance of Securing the Best Effects of Light on a Landscape." BRITISH JOURNAL OF PHOTOGRAPHY 11, no. 240 (Dec. 9, 1864): 499-500.

L255 Lea, M. Carey. "Photographic Notes on Various Subjects: Photography and Engraving." BRITISH JOURNAL OF PHOTOGRAPHY 12, no. 244 (Jan. 6, 1865): 3.

L256 Lea, M. Carey. "Some Remarks on Focussing." BRITISH JOURNAL OF PHOTOGRAPHY 12, no. 245 (Jan. 13, 1865): 14-15. [Mentions Moran photographing in the White Mountains "last summer."]

L257 Lea, M. Carey. "Some Remarks on Focussing." AMERICAN JOURNAL OF PHOTOGRAPHY AND THE ALLIED ARTS & SCIENCES n. s. vol. 7, no. 14 (Jan. 15, 1865): 325-330.

L258 Lea, M. Carey. "Photogalvanography." AMERICAN JOURNAL OF PHOTOGRAPHY AND THE ALLIED ARTS & SCIENCES n. s. vol. 7, no. 15 (Feb. 1, 1865): 352-357.

L259 Lea, M. Carey. "Photogalvanography." BRITISH JOURNAL OF PHOTOGRAPHY 12, no. 249 (Feb. 10, 1865): 70-71.

L260 Lea, M. Carey. "On the Production of Scarlet Negatives." AMERICAN JOURNAL OF PHOTOGRAPHY AND THE ALLIED ARTS & SCIENCES n. s. vol. 7, no. 16 (Feb. 15, 1865): 377-381.

L261 Lea, M. Carey. "Miscellaneous Photographic Hints." AMERICAN JOURNAL OF PHOTOGRAPHY AND THE ALLIED ARTS & SCIENCES n. s. vol. 7, no. 17 (Mar. 1, 1865): 393-396. 1 illus.

L262 Lea, M. Carey. "On Reflections from the Second Surface of the Negative." AMERICAN JOURNAL OF PHOTOGRAPHY AND THE ALLIED ARTS & SCIENCES n. s. vol. 7, no. 18 (Mar. 15, 1865): 421-427. 1 illus.

L263 Lea, M. Carey. "Carbon Proofs by Direct Printing." AMERICAN JOURNAL OF PHOTOGRAPHY AND THE ALLIED ARTS & SCIENCES n. s. vol. 7, no. 19 (Apr. 1, 1865): 449-452.

L264 Lea, M. Carey. "On the Action of Light upon Iodide of Silver." AMERICAN JOURNAL OF PHOTOGRAPHY AND THE ALLIED ARTS & SCIENCES n. s. vol. 7, no. 21 (May 1, 1865): 481-491.

L265 "The New Method of Intensifying." AMERICAN JOURNAL OF PHOTOGRAPHY AND THE ALLIED ARTS & SCIENCES n. s. vol. 7, no. 22 (May 15, 1865): 507-511. [From "Photo. News." Experiments with M. Carey Lea's process.]

L266 "Some of the Good Things discovered by M. Carey Lea, Esq." HUMPHREY'S JOURNAL OF PHOTOGRAPHY, AND THE ALLIED ARTS AND SCIENCES 17, no. 2 (May 15, 1865): 19-25. [Excerpts reprinted from previously published articles.]

L267 Lea, M. Carey. "Photographing Foliage." AMERICAN JOURNAL OF PHOTOGRAPHY AND THE ALLIED ARTS & SCIENCES n. s. vol. 8, no. 4 (Aug. 15, 1865): 83-85.

L268 Lea, M. Carey. "Further Remarks on the Production of Scarlet Negatives." AMERICAN JOURNAL OF PHOTOGRAPHY AND THE ALLIED ARTS & SCIENCES n. s. vol. 8, no. 4 (Aug. 15, 1865): 88-91.

L269 Lea, M. Carey. "The Nature of the Latent Image." AMERICAN JOURNAL OF PHOTOGRAPHY AND THE ALLIED ARTS & SCIENCES n. s. vol. 8, no. 5 (Sept. 1, 1865): 114-116.

L270 "Carey Lea's Developer." HUMPHREY'S JOURNAL OF PHOTOGRAPHY, AND THE ALLIED ARTS AND SCIENCES 17, no. 9 (Sept. 1, 1865): 133-134. [From "Br. J. of Photo."]

L271 "M. Carey Lea's Developer." AMERICAN JOURNAL OF PHOTOGRAPHY AND THE ALLIED ARTS & SCIENCES n. s. vol. 8, no. 6 (Sept. 15, 1865): 140-141.

L272 Lea, M. Carey. "Remarks on the Negative Bath." HUMPHREY'S JOURNAL OF PHOTOGRAPHY, AND THE ALLIED ARTS AND SCIENCES 17, no. 10 (Sept. 15, 1865): 148-150.

L273 Lea, M. Carey. "Remarks on Gold Toning Baths." HUMPHREY'S JOURNAL OF PHOTOGRAPHY, AND THE ALLIED ARTS AND SCIENCES 17, no. 11 (Oct. 1, 1865): 163-165. [Note on p. 158 that M. Carey Lea would become a regular contributor to "HJ."]

L274 Lea, M. Carey. "On Development as to its Influence on Portraiture." HUMPHREY'S JOURNAL OF PHOTOGRAPHY, AND

THE ALLIED ARTS AND SCIENCES 17, no. 12 (Oct. 15, 1865): 182-184.

L275 Lea, M. Carey. "Iron Gelatine Developer." HUMPHREY'S JOURNAL OF PHOTOGRAPHY, AND THE ALLIED ARTS AND SCIENCES 17, no. 13 (Nov. 1, 1865): 199-200.

L276 Lea, M. Carey. "Portraiture by Magnesium Light." PHILADELPHIA PHOTOGRAPHER 3, no. 26 (Feb. 1866): 53.

L277 Lea, M. Carey. "On Photographic Perspective." PHILADELPHIA PHOTOGRAPHER 3, no. 27-28 (Mar. - Apr. 1866): 65-70, 131-136. 16 illus.

L278 "Honor to Whom Honor is Due." HUMPHREY'S JOURNAL OF PHOTOGRAPHY, AND THE ALLIED ARTS AND SCIENCES 17, no. 23 (Apr. 1, 1866): 367. [G. Wharton Simpson, editor of "Photographic News" given an Honorary degree of M.A. and M. Carey Lea received Honorary degree of M.D. from the Geneva College, Geneva, NY.]

L279 "Bibliography." HUMPHREY'S JOURNAL OF PHOTOGRAPHY, AND THE ALLIED ARTS AND SCIENCES 17, no. 24 (Apr. 15, 1866): 374-377. [Bk. rev.: "Newman's Manual of Harmonious Coloring, as Applied to Photographs. Together with valuable Papers on Lighting and Posing the Sitter." Edited, by M. Carey Lea. Jabez Hughes' article "About Light and about Lighting the Sitter, and about the Room in which he is Lighted." reprinted.]

L280 Lea, M. Carey. "Printing by Development." HUMPHREY'S JOURNAL OF PHOTOGRAPHY, AND THE ALLIED ARTS AND SCIENCES 18, no. 1 (May 1, 1866): 13. [From "Br. J. of Photo."]

L281 Lea, M. Carey. "A Theory of Photography." HUMPHREY'S JOURNAL OF PHOTOGRAPHY, AND THE ALLIED ARTS AND SCIENCES 18, no. 5 (July 1, 1866): 75-78. [From "Br. J. of Photo."]

L282 Lea, M. Carey. "On the Detection of Iodine." HUMPHREY'S JOURNAL OF PHOTOGRAPHY, AND THE ALLIED ARTS AND SCIENCES 18, no. 8 (Aug. 15, 1866): 122-123. [From "Silliman's J."]

L283 Lea, M. Carey. "Production of Images by Pressure." HUMPHREY'S JOURNAL OF PHOTOGRAPHY, AND THE ALLIED ARTS AND SCIENCES 18, no. 9 (Sept. 1, 1866): 140-141. [From "Br. J. of Photo."]

L284 Lea, M. Carey. "Cleaning the Fingers." HUMPHREY'S JOURNAL OF PHOTOGRAPHY, AND THE ALLIED ARTS AND SCIENCES 18, no. 10 (Sept. 15, 1866): 154-155. [From "Br. J. of Photo."]

L285 Lea, M. Carey. "Photographic Hints." HUMPHREY'S JOURNAL OF PHOTOGRAPHY, AND THE ALLIED ARTS AND SCIENCES 18, no. 11 (Oct. 1, 1866): 169-170. [From "Br. J. of Photo."]

L286 Lea, M. Carey. "An Examination into the Circumstances under which Silver is found in the Whites of Albumen Prints." HUMPHREY'S JOURNAL OF PHOTOGRAPHY, AND THE ALLIED ARTS AND SCIENCES 18, no. 12-13 (Oct. 15 - Nov. 1, 1866): 184-186. [From "Br. J. of Photo."]

L287 Lea, M. Carey. "On the Mode of Testing the Permanency of Photographic Prints." HUMPHREY'S JOURNAL OF PHOTOGRAPHY, AND THE ALLIED ARTS AND SCIENCES 18, no. 14 (Nov. 15, 1866): 215-216. [From "Br. J. of Photo."]

L288 Lea, M. Carey. "Remarks upon the Action of Cyanide of Potassium on Photographic Impressions." HUMPHREY'S JOURNAL OF PHOTOGRAPHY, AND THE ALLIED ARTS AND SCIENCES 18, no. 14 (Nov. 15, 1866): 221-222. [From "Br. J. of Photo."]

L289 Lea, M. Carey. "Testing Collodion." HUMPHREY'S JOURNAL OF PHOTOGRAPHY, AND THE ALLIED ARTS AND SCIENCES 18, no. 15 (Dec. 1, 1866): 233-235. [From "Br. J. of Photo."]

L290 Lea, M. Carey. "Silver in the Whites of Albumen Prints." HUMPHREY'S JOURNAL OF PHOTOGRAPHY, AND THE ALLIED ARTS AND SCIENCES 18, no. 16 (Dec. 15, 1866): 253-254. [From "Photo. News."]

L291 Lea, M. Carey. "On the Nature of the Influence of Tannin." HUMPHREY'S JOURNAL OF PHOTOGRAPHY, AND THE ALLIED ARTS AND SCIENCES 18, no. 16 (Dec. 15, 1866): 255-256. [From "Br. J. of Photo."]

L292 Lea, M. Carey. "Some Remarks on the Precipitation of Silver." HUMPHREY'S JOURNAL OF PHOTOGRAPHY, AND THE ALLIED ARTS AND SCIENCES 18, no. 18 (Jan. 15 1867): 278-279. [From "Br. J. of Photo."]

L293 Lea, M. Carey. "On Focussing Surfaces." HUMPHREY'S JOURNAL OF PHOTOGRAPHY, AND THE ALLIED ARTS AND SCIENCES 18, no. 19 (Feb. 1, 1867): 296-299. [From "Br. J. of Photo.]

L294 Lea, M. Carey. "Spiller vs. Lea: Silver in the Whites of Albumenized Prints." HUMPHREY'S JOURNAL OF PHOTOGRAPHY, AND THE ALLIED ARTS AND SCIENCES 18, no. 19 (Feb. 1, 1867): 300-301.

L295 Lea, M. Carey. "Miscellaneous Photographic Hints." HUMPHREY'S JOURNAL OF PHOTOGRAPHY, AND THE ALLIED ARTS AND SCIENCES 18, no. 20 (Feb. 15, 1867): 310-313. [From "Br. J. of Photo."]

L296 Lea, M. Carey. "Proof that Pure Iodide of Silver is always Sensitive to Light." HUMPHREY'S JOURNAL OF PHOTOGRAPHY, AND THE ALLIED ARTS AND SCIENCES 18, no. 21-23 (Mar. 1 - Apr. 1, 1867): 333-334, 345-347, 361-362.

L297 Lea, M. Carey. "On the Action of Iodine and of Alkaline Iodides upon the Latent Image." HUMPHREY'S JOURNAL OF PHOTOGRAPHY, AND THE ALLIED ARTS AND SCIENCES 18, no. 24 (Apr. 15, 1867): 376-378. [From "Br. J. of Photo."]

L298 Lea, M. Carey. "Pressure Images." HUMPHREY'S JOURNAL OF PHOTOGRAPHY, AND THE ALLIED ARTS AND SCIENCES 19, no. 1 (May 1, 1867): 7-9. [From "Br. J. of Photo."]

L299 Lea, M. Carey. "Improvement in the Detection of Iodine when Present in Combination with a Base." HUMPHREY'S JOURNAL OF PHOTOGRAPHY, AND THE ALLIED ARTS AND SCIENCES 19, no. 2 (May 15, 1867): 24-25. [From "Br. J. of Photo."]

L300 Lea, M. Carey. "The Glycerine Process." HUMPHREY'S JOURNAL OF PHOTOGRAPHY, AND THE ALLIED ARTS AND SCIENCES 19, no. 3-4 (June 1 - June 15, 1867): 38-40, 56-57.

L301 Lea, M. Carey. "On the Latent Image." HUMPHREY'S JOURNAL OF PHOTOGRAPHY, AND THE ALLIED ARTS AND SCIENCES 19, no. 5-6 (July 1 - July 15, 1867): 70-71, 87-88. [From "Br. J. of Photo."]

L302 Lea, M. Carey. "Photographic Summary." PHILADELPHIA PHOTOGRAPHER 4, no. 43 (July 1867): 221-222. [Note about landscape photos in Germany, mentions Adam-Salomon's portraiture.]

L303 Lea, M. Carey. "On the Nature of the Latent Image." HUMPHREY'S JOURNAL OF PHOTOGRAPHY, AND THE ALLIED ARTS AND SCIENCES 19, no. 7 (Aug. 1, 1867): 103-106. [From "Br. J. of Photo."]

L304 Lea, M. Carey. "Some Remarks on the Photographic Action of Light and its Relation to Collodions." HUMPHREY'S JOURNAL OF PHOTOGRAPHY, AND THE ALLIED ARTS AND SCIENCES 19, no. 8 (Aug. 15, 1867): 122-125. [From "Br. J. of Photo."]

L305 Lea, M. Carey. "Another Word on Photographic Varnishes." HUMPHREY'S JOURNAL OF PHOTOGRAPHY, AND THE ALLIED ARTS AND SCIENCES 19, no. 9 (Sept. 1, 1867): 133-134. [From "Br. J. of Photo."]

L306 Lea, M. Carey. "Photographic Varnishes." HUMPHREY'S JOURNAL OF PHOTOGRAPHY, AND THE ALLIED ARTS AND SCIENCES 19, no. 10 (Sept. 15, 1867): 149-153.

L307 Lea, M. Carey. "Some Remarks on Pressure Frames." HUMPHREY'S JOURNAL OF PHOTOGRAPHY, AND THE ALLIED ARTS AND SCIENCES 19, no. 14-15 (Nov. 15 - Dec. 1, 1867): 215-217, 227-229. [From "Br. J. of Photo."]

L308 Lea, M. Carey. "On a New Test for Hyposulphites." HUMPHREY'S JOURNAL OF PHOTOGRAPHY, AND THE ALLIED ARTS AND SCIENCES 19, no. 16 (Dec. 15, 1867): 249-251. [From "Am. J. of Science."]

L309 Lea, M. Carey. "Portraiture." BRITISH JOURNAL PHOTOGRAPHIC ALMANAC 1868 (1868): 80-81.

L310 Lea, M. Carey. "Photographic Remarks." HUMPHREY'S JOURNAL OF PHOTOGRAPHY, AND THE ALLIED ARTS AND SCIENCES 19, no. 17 (Jan. 1, 1868): 267-268. [From "Br. J. of Photo." Varnishing cold. Pyrogallic acid, Landscape Lenses.]

L311 Lea, M. Carey. "Variable Perceptions of Distance." HUMPHREY'S JOURNAL OF PHOTOGRAPHY, AND THE ALLIED ARTS AND SCIENCES 19, no. 18 (Jan. 15, 1868): 277-279. [From "Br. J. of Photo."]

L312 Lea, M. Carey. "Portrait Figures with Natural Landscapes." PHILADELPHIA PHOTOGRAPHER 5, no. 50 (Feb. 1868): 44. [Technical advice on how to produce a combination print.]

L313 Lea, M. Carey. "Portraiture." HUMPHREY'S JOURNAL OF PHOTOGRAPHY, AND THE ALLIED ARTS AND SCIENCES 19, no. 20 (Feb. 15, 1868): 315-317. [From "Br. J. of Photo. Almanac."]

L314 Lea, M. Carey. "On the Causes of Fading of Silver Prints." HUMPHREY'S JOURNAL OF PHOTOGRAPHY, AND THE ALLIED ARTS AND SCIENCES 19, no. 21 (Mar. 1, 1868): 328-330. [From "Br. J. of Photo."]

L315 Lea, M. Carey. "Sensibility of Pure Iodide of Silver." HUMPHREY'S JOURNAL OF PHOTOGRAPHY, AND THE ALLIED ARTS AND SCIENCES 19, no. 22 (Mar. 15, 1868): 348-350. [From "Br. J. of Photo."]

L316 Lea, M. Carey. "On the Influence of Iodide and Bromide in Collodion." HUMPHREY'S JOURNAL OF PHOTOGRAPHY, AND THE ALLIED ARTS AND SCIENCES 19, no. 23 (Apr. 1, 1868): 365-367.

L317 Lea, M. Carey. "On the Latent Image." HUMPHREY'S JOURNAL OF PHOTOGRAPHY, AND THE ALLIED ARTS AND SCIENCES 20, no. 1 (May 1, 1868): 12-13. [From "Br. J. of Photo."]

L318 Lea, M. Carey. "The Alkaline Developer." HUMPHREY'S JOURNAL OF PHOTOGRAPHY, AND THE ALLIED ARTS AND SCIENCES. 20, no. 2 (May 15, 1868): 24-26. [From "Br. J. of Photo."]

L319 Lea, M. Carey. "Researches on the Latent Image." HUMPHREY'S JOURNAL OF PHOTOGRAPHY, AND THE ALLIED ARTS AND SCIENCES. 20, no. 4-5 (June 15 - July 1, 1868): 58-59, 73-74. [From "Br. J. of Photo."]

L320 Lea, M. Carey. "Coffee and Glycerine Processes." HUMPHREY'S JOURNAL OF PHOTOGRAPHY, AND THE ALLIED ARTS AND SCIENCES. 20, no. 6-7 (July 15 - Aug. 1, 1868): 89-90, 102-104. [From "Br. J. of Photo."]

L321 Lea, M. Carey. "A New Substance Capable of Developing the Latent Image." HUMPHREY'S JOURNAL OF PHOTOGRAPHY, AND THE ALLIED ARTS AND SCIENCES. 20, no. 8 (Aug. 15, 1868): 120-121. [From "Br. J. of Photo."]

L322 Lea, M. Carey. "Theoretical Views on the Action of Light upon Bromide and Iodide of Silver." HUMPHREY'S JOURNAL OF PHOTOGRAPHY, AND THE ALLIED ARTS AND SCIENCES. 20, no. 9 (Sept. 1, 1868): 129-133. [From "Br. J. of Photo."]

L323 Lea, M. Carey. "Albumen." HUMPHREY'S JOURNAL OF PHOTOGRAPHY, AND THE ALLIED ARTS AND SCIENCES. 20, no. 10 (Sept. 15, 1868): 145-148. [From "Br. J. of Photo."]

L324 Lea, M. Carey. "A Theory of Photography." HUMPHREY'S JOURNAL OF PHOTOGRAPHY, AND THE ALLIED ARTS AND SCIENCES. 20, no. 11 (Oct. 1, 1868): 163-166. [From "Br. J. of Photo."]

L325 Lea, M. Carey. "On the Spontaneous Resensitizing of Iodide and Silver." HUMPHREY'S JOURNAL OF PHOTOGRAPHY, AND THE ALLIED ARTS AND SCIENCES. 20, no. 12 (Oct. 15, 1868): 183-186. [From "Br. J. of Photo."]

L326 Lea, M. Carey. "Communications on Photography." HUMPHREY'S JOURNAL OF PHOTOGRAPHY, AND THE ALLIED ARTS AND SCIENCES. 20, no. 13 (Nov. 1, 1868): 201-202. [From "Photo. News."]

L327 Lea, M. Carey. "Dry Plates as Sensitive as Wet." HUMPHREY'S JOURNAL OF PHOTOGRAPHY, AND THE ALLIED ARTS AND SCIENCES. 20, no. 18 (Feb. 15, 1869): 282-283. [From "Br. J. of Photo."]

L328 Lea, M. Carey. "Blurring." HUMPHREY'S JOURNAL OF PHOTOGRAPHY, AND THE ALLIED ARTS AND SCIENCES. 20, no. 19 (Mar. 15, 1869): 292-293. [From "Br. J. of Photo."]

L329 Lea, M. Carey. "Fused Nitrate of Silver for the Negative Bath." HUMPHREY'S JOURNAL OF PHOTOGRAPHY, AND THE ALLIED ARTS AND SCIENCES. 20, no. 20 (Apr. 15, 1869): 314. [From "Br. J. of Photo. Almanac.]

L330 Lea, M. Carey. "Over-Developed Negatives." HUMPHREY'S JOURNAL OF PHOTOGRAPHY, AND THE ALLIED ARTS AND SCIENCES. 20, no. 22 (June 15, 1869): 342-343. [From "Br. J. of Photo."]

L331 "Mr. M. Carey Lea." ANTHONY'S PHOTOGRAPHIC BULLETIN 6, no. 7 (July 1875): 200-203. [From "Br J of Photo." Mr. M. Carey Lea born in Philadelphia in 1823, to a family of "easy circumstances." Developed an interest in photographic chemistry, languages, etc. Began contributing papers to the "British Journal of Photography" in Oct., 1864, and soon succeeded Coleman Sellars as their American correspondent. Has written many papers, of a technical nature, contributing important advances in chloro-bromide processes, which speeded up exposure times. Wrote a "Manual of Photography."]

L332 Lea, M. Carey. "Fading of Silver Prints." BRITISH JOURNAL PHOTOGRAPHIC ALMANAC 1876 (1876): 38-40.

L333 Lea, M. Carey. "Dr. Vogel's Color Theory." ANTHONY'S PHOTOGRAPHIC BULLETIN 7, no. 7 (July 1876): 207-208. [From "Br. J. of Photo." Vogel, Waterhouse, and Lea arguing over color theory.]

L334 Lea, M. Carey. "Emulsion Work." BRITISH JOURNAL PHOTOGRAPHIC ALMANAC 1878 (1878): 44.

L335 "Personal Paragraphs." WILSON'S PHOTOGRAPHIC MAGAZINE 34, no. 486 (June 1897): 270. [Died Mar. 15. "As one of the few American scientists interested in photography and its advancement, his death is an event to be deplored by all."]

L336 "Obituary: M. Carey Lea (April, 1897)." BRITISH JOURNAL PHOTOGRAPHIC ALMANAC 1898 (1898): 640-642. [Lea wrote extensively to "Silliman's Journal," the "Journal of the Franklin Institute", "BJP" and a host of other journals in 1860s, 1870s.]

LEAKE, J. C., JR. (GREAT BRITAIN)
L337 Leake. "Portable Tent." HUMPHREY'S JOURNAL OF PHOTOGRAPHY, AND THE ALLIED ARTS AND SCIENCES. 11, no. 7 (Aug. 1, 1859): 104. [Read to South London Photo. Soc.]

L338 Leake, Jr. "Practical Hints upon Positive Printing." HUMPHREY'S JOURNAL OF PHOTOGRAPHY, AND THE ALLIED ARTS AND SCIENCES. 11, no. 16 (Dec. 15, 1859): 245-248. [From "Liverpool Photo. J."]

L339 Leake, J. C., Jr. "About Lighting the Sitter and Soft Pictures." BRITISH JOURNAL OF PHOTOGRAPHY 12, no. 263 (May 19, 1865): 258-260.

L340 Leake, J. C. "Photographing Interiors." HUMPHREY'S JOURNAL OF PHOTOGRAPHY, AND THE ALLIED ARTS AND SCIENCES. 20, no. 5 (July 1, 1868): 70-71. [From "Illustrated Photographer.]

LEFEVRE, BELFIELD.
L341 Lefevre, Belfield. "Improvements in the Daguerreotype; - A Method of Transferring the Daguerreian Image to Paper." HUMPHREY'S JOURNAL 9, no. 13 (Nov. 1, 1857): 196-198. [From "Photo. Notes." Letter from Lefevre, which incidentally comments on his arguments with Daguerre, advocacy of Niépce in the 1840s, with notes by Mr. Sutton.]

L342 Lefevre, Belfield. "On the Theory of the Daguerreotype." HUMPHREY'S JOURNAL OF PHOTOGRAPHY, AND THE ALLIED ARTS AND SCIENCES 10, no: 18 (Jan. 15, 1859): 274-281. [From "Photo. Notes."]

LEFEVRE, G. SHAW.
L343 "Reviews." ART JOURNAL (Apr. 1856): 128. [Brief review of "Photographic Views of Sebastopol, Taken Immediately after the Retreat of Russians, Sept. 8, 1855. By G. Shaw Lefevre. Published by J. Hogarth, London." Lefevre was an amateur who published, at his own expense, a series of 12 views, the proceeds of the sale going to benefit the "Nightingale Fund".]

LEGGE, W. A. & CO. (QUEBEC, CANADA)
L344 "The Great Fire at Quebec - View of the Ruins." HARPER'S WEEKLY 10, no. 514 (Nov. 3, 1866): 692. 1 illus. ["Photographed by W. A. Legge & Co., Quebec."]

L345 "The Great Fire at Quebec: View from the Marine Hospital." ILLUSTRATED LONDON NEWS 49, no. 1398 (Nov. 10, 1866): 448-449. 1 illus. ["...from a photograph by Messrs. W. A. Legge & Co., of Quebec."]

LEGOUVE, E. (FRANCE)
L346 Legouve, E. "A Photographic Album." PHOTOGRAPHIC TIMES 4, no. 40-41 (Apr. - May 1874): 54-56, 68-70. [Reflections on the nature of photography's uses. Translated from the French. Legouve is identified as being a member of the French Academy.]

LEIGHTON, JOHN. (GREAT BRITAIN)
L347 Leighton, John. "On Photography as a Means or an End." HUMPHREY'S JOURNAL 5, no. 7 (July 15, 1853): 99-100. [From "J. of Photo. Soc."]

L348 Leighton, John. "Binocular Photographs." PHOTOGRAPHIC AND FINE ART JOURNAL 7, no. 9 (Sept. 1854): 271. [From "J. of Photo. Soc."]

L349 Leighton, John. "Binocular Photography." PHOTOGRAPHIC AND FINE ART JOURNAL 7, no. 9 (Sept. 1854): 284. [From "J. of Photo. Soc."]

LEISENRING, J. B.
L350 Portrait. Woodcut engraving, credited "From a Photograph by J. B. Leisenring." HARPER'S WEEKLY 9, (1865) ["Miss Mary Harris, murdered." 9:427 (Mar. 4, 1865): 140. (Reprinted p. 476, 9:448 (July 29, 1865) as her trial began).]

LEITNER, G. W. [?]
L351 "Natives of Dardistan and Kafiristan, Central Asia." ILLUSTRATED LONDON NEWS 65, no. 1831 (Sept. 26, 1874): 297. 6 illus. [Dr. G. W. Leitner, Principal of the Government College of Lahore... has collected... photographs of native people, articles of dress, furniture, tools and weapons, etc., etc.; illustrative of the ethnography of the Central Asiatic highlands. Published books on the topic.]

LEMENGER, H. V. (GREAT BRITAIN)
L352 Payne, Rev. Robert. *Historical Sketch of Rickmansworth and the Surrounding Parishes.* London; Aylesbury: Printed by Watson & Hazell, 1870. vi, 127 pp. 8 b & w. [Original photographs by H. V. Lemenger, of Bushby, England.]

L353 Payne, Rev. Robert. *Moor Park, with a Biographical Sketch of Its Principal Proprietors*. London: Longmans, Green & Co., 1870. n. p. 8 b & w. [Albumen prints, by H. V. Lemenager, of Bushey, England.

LEMER, LERUE. (HARRISBURGH, PA)
L354 Portrait. Woodcut engraving, credited "From a Photograph by Lerue Lemer, Harrisburgh, PA." FRANK LESLIE'S ILLUSTRATED NEWSPAPER 39, (1875) ["Hon. William A. Wallace, U.S. Sen. from PA." 39:1012 (Feb. 20, 1875): 397.]

L355 Portrait. Woodcut engraving, credited "From a Photograph by Le Rue Lemer." FRANK LESLIE'S ILLUSTRATED NEWSPAPER 47, (1879) ["Henry M. Hoyt, Gov. of PA." 47:1219 (Feb. 8, 1879): 417.]

LEMERCIER & CO. (PARIS, FRANCE)
L356 "Photographic Pictures on Stone for Lithographic Printing." PRACTICAL MECHANIC'S JOURNAL 7, no. 83 (Feb. 1855): 252. [Discussion of the process of Lemercier & Co., Paris.]

LENTHALL, H. (LONDON, ENGLAND)
L357 Portrait. Woodcut engraving credited "From a photograph by H. Lenthall, of Regent St." ILLUSTRATED LONDON NEWS (1868) ["Right Rev. Dr. Magee." (Oct. 24, 1868): 401.]

L358 Portrait. Woodcut engraving credited "From a photograph by H. Lenthall." ILLUSTRATED LONDON NEWS 61, (1872) ["Sir Donald MacLeod." 61:1736 (Dec. 14, 1872): 565.]

L359 Portraits. Woodcut engravings credited "From a photograph by H. Lenthall, Regent St." ILLUSTRATED LONDON NEWS 62, (1873) ["Late Prof. Sedgwick." 62:1745 (Feb. 8, 1873): 133. "Late Baron Channell." 62:1750 (Mar. 15, 1873): 249.]

L360 Portrait. Woodcut engraving credited "From a photograph by H. Lenthall." ILLUSTRATED LONDON NEWS 67, (1875) ["Late Commodore Goodenough, C.B." 67:1883 (Sept. 11, 1875): 244.]

LEON & LEVY. (PARIS, FRANCE)
L361 "Editor's Table." PHILADELPHIA PHOTOGRAPHER 9, no. 104 (Aug. 1872): 304. [Stereographs from Leon & Levy (Paris, France).]

LEREBOURS, NICOLAS-MARIE-PAYMAL. (1807-1873) (FRANCE)
[Born on Feb. 15, 1807 in Neuilly. Took over his father's shop in 1839, which supplied daguerreotype materials. In 1839 he commissioned the painter Horace Vernet, his nephew Bouton, and Frédérick Goupil Fesquet to the Middle East to make daguerreotype views. They met Pierre Gustave Joly de Lotbinière by chance on the trip, and all together sailed up the Nile, making the first daguerreotypes of Egypt. In 1840 Lerebours published *Paris et ses environs reproduits par le daguerreotype* and began publishing *Excursions Daguerriannes: Les vues et les monuments les remarquables du globe*, a book of engraved views based on a collection of daguerreotypes from around the world. By 1841 Lerebours and M. A. Gaudin had made many daguerreotype portraits. Lerebours' book *Derniers perfectionnements apportés au daguerréotype* published in 1841 and *Traité de photographie* in 1842. Partnership with Secretan in 1846. Published works of photoengraving and experiments with photomicrography in 1850s. Honors, awards. Died on July 24, 1873 in Neuilly.]

BOOKS
L362 Lerebours, N. P. *A Treatise on Photography: Containing the Latest Discoveries and Improvements appertaining to the Daguerreotype*. Translated by J. Egerton. London: Longman, Brown, Green & Longmans, 1843. 216 pp. 1 l. of plates. [Frontispiece contains 13 illus. Reprinted (1973) Arno Press.]

PERIODICALS
L363 "Gravure de la presente livraison. Vue de Saint-Jean-l'Acre. - Mode de calque du Daguerreotype." L'ARTISTE ser. 2 vol. 6, (1840): 256. 1 illus. [Includes a tipped-in engraving of a view of St. Jean du Acre, in Syria, taken from a daguerreotype and published by Lerebours.]

L364 "Our Library Table: A Treatise on Photography. By N. P. Lerebours. Translated by J. Egerton. Longren & Co." ATHENAEUM no. 834 (Oct. 21, 1843): 946.

L365 Lerebours, N. P. Translated by J. Egerton, with a preface, notes, and alterations by H. H. Snelling. "A Treatise on Photography." PHOTOGRAPHIC ART JOURNAL 1-2, no. 3-6, 1 (Mar. - July 1851): (vol. 1) 146-168, 212-221, 269-277, 341-357 (vol. 2) 17-29. illus.

L366 Lerebours, N. P. "Plate, Paper, or Glass?" PHOTOGRAPHIC ART JOURNAL 4, no. 1 (July 1852): 32-34. [Trans. from "La Lumiére."]

L367 Lerebours, N. P. "Photographic Re-Union." PHOTOGRAPHIC ART JOURNAL 4, no. 2 (Aug. 1852): 89-90. [Trans. from "Le Lumiére."]

LESAGE, A. (DUBLIN, IRELAND)
L368 "Editor's Table." PHILADELPHIA PHOTOGRAPHER 6, no. 72 (Dec. 1869): 426. [Cartes received.]

LESURE, M. A. (ORANGE, MA)
L369 "Busy Work." ANTHONY'S PHOTOGRAPHIC BULLETIN 2, no. 11 (Nov. 1871): 368. [Lesure (Orange, MA) made 239 plates of tintypes of three dozen each (or 8,604 pictures) on one day in May 1867 with Mr. Quint in Manchester, NH. In Rochester, VT in 1868, in a 9' x 21' car, made 84 plates of three dozen each, which his wife finished, in one day.]

LEVY & BACHRACH. (USA)
L370 Levy, Louis E. and David Bachrach, Jr. "Photo-Relief Painting." ANTHONY'S PHOTOGRAPHIC BULLETIN 6, no. 4 (Apr. 1875): 117-118. [Includes text of patent of Levy & Bachrach (Baltimore) on this process.]

LEVY & COHEN. (USA)
L371 "Editor's Table: Views in and around Richmond." PHILADELPHIA PHOTOGRAPHER 2, no. 21 (Sept. 1865): 154. [Levy & Cohen photographed the destruction of Richmond, VA, immediately after Federal occupation.]

L372 "Our Picture: The Burnt District of Richmond, Va." PHILADELPHIA PHOTOGRAPHER 2, no. 22 (Oct. 1865): frontispiece, 170. 1 b & w.

L373 "Obituary Notice - Death of Mr. Levy of Levy & Cohen." PHILADELPHIA PHOTOGRAPHER 2, no. 23 (Nov. 1865): 187. [Died of heart attack.]

L374 "Specialties." PHILADELPHIA PHOTOGRAPHER 2, no. 23 (Nov. 1865): 187. [Offering "Views of the Rebel Capitol" negatives for sale as firm dissolved due to death of S. Levy.]

LEVY, J. & CO. (PARIS, FRANCE)
L375 *Classified Catalogue of Majic Lantern Slides and Transparencies for the Stereoscope, Manufactured by Messers. J. Levy & Co., Paris,*

(Late Ferrier & Soulier). Translated and Published by their American Trade Agents, Benerman & Wilson, Photographic Publishers, 124 North Seventh Street, Philadelphia. Philadelphia: Benerman & Wison, 1876. 88 pp. [Inside title page dated 1875.]

LEVY, LOUIS E. see also LEVY & BACHRACH.

LEVY, LOUIS E. (MILWAUKEE, WI)
L376 "An Experiment with a Dallmeyer Lens." ANTHONY'S PHOTOGRAPHIC BULLETIN 4, no. 1 (Jan. 1873): 26. [Outdoor photographer from Milwaukee.]

LEWIS & MALLORY. (BRIDGEPORT, CT)
L377 "Ruins of 'Iranistan,' Bridgeport, Ct., Late the Residence of P. T. Barnum. From a Daguerreotype by Lewis & Mallory, of Bridgeport." FRANK LESLIE'S ILLUSTRATED NEWSPAPER 5, no. 109 (Jan. 2, 1858): 69. 1 illus. [View.]

LEWIS & TUCK. (LONDON, ENGLAND)
L378 Portrait. Woodcut engraving, credited to "From a Photograph by Lewis & Tuck." ILLUSTRATED LONDON NEWS 60, (1872) ["Late Earl of Lonsdale." 60:1697 (Mar. 16, 1872): 261.]

LEWIS, B. A.
L379 "New York City.- The Four-Horse Wagon-Load of Meat Contributed by the Abatoir, Communipaw, N. J., for the Thanksgiving Dinner of the Children of the Howard Mission and Home for Little Wanderers. - From a Photograph by B. A. Lewis." FRANK LESLIE'S ILLUSTRATED NEWSPAPER 33, no. 847 (Dec. 23, 1871): 237. 1 illus.

LEWIS, RICHARD A. (1820-1891) (USA)
L380 Portrait. Woodcut engraving, credited "From a Photograph by R. A. Lewis." HARPER'S WEEKLY 9, (1865) ["Late Rev. Newton Heston." 9:449 (Aug. 5, 1865): 481.]

L381 Portrait. Woodcut engraving, credited "From a Photograph by Richard A. Lewis." FRANK LESLIE'S ILLUSTRATED NEWSPAPER 21, (1866) ["Late Elijah F. Purdy." 21:540 (Feb. 3, 1866): 305.]

L382 Portraits. Woodcut engravings, credited "From a Photograph by R. A. Lewis." FRANK LESLIE'S ILLUSTRATED NEWSPAPER 22, (1866) ["Robert D. Holmes, Freemason." 22:561 (June 30, 1866): 229. "Judge Albert Cardozo." 22:566 (Aug. 4, 1866): 308.]

L383 Portraits. Woodcut engravings, credited "From a Photograph by R. A. Lewis." FRANK LESLIE'S ILLUSTRATED NEWSPAPER 23, (1866) ["The late Isaac O. Barker." 23:574 (Sept. 29, 1866): 21.]

L384 Portrait. Woodcut engraving, credited "From a Photograph by Lewis, New York." FRANK LESLIE'S ILLUSTRATED NEWSPAPER 24, (1867) ["The late Ex-Gov. John A. King, of NY." 24:617 (July 27, 1867): 293.]

L385 Portrait. Woodcut engraving, credited "From a Photograph by Richard A. Lewis., 158 Chatham St., New York, NY." HARPER'S WEEKLY 11, (1867) ["Late John Alsop King." 11:552 (July 27, 1867): 477.]

L386 "Editor's Table." HUMPHREY'S JOURNAL OF PHOTOGRAPHY, AND THE ALLIED ARTS AND SCIENCES. 20, no. 8 (Aug. 15, 1868): 128. [From "The Freemason." "We are also under many obligations to R. A. Lewis, No. 160 Chatham St. NY for photographs of distinguished Masons for our album."]

L387 Portrait. Woodcut engraving, credited "From a Photograph by Lewis." FRANK LESLIE'S ILLUSTRATED NEWSPAPER 30, (1870) ["The late Robert D. Holmes." 30:757 (Apr. 2, 1870): 37.]

L388 "Note." PHOTOGRAPHIC TIMES 2, no. 22 (Oct. 1872): 145. ["R. A. Louis, the old veteran of Chatham St. (26 years) has opened an additional studio at No. 887 Broadway, N.Y."]

L389 Portrait. Woodcut engraving, credited "From a Photograph by Lewis." FRANK LESLIE'S ILLUSTRATED NEWSPAPER 35, (1872) ["Mr. Louis Schnabel, Superintendent of the Hebrew Industrial School." 35:889 (Oct. 12, 1872): 93.]

L390 "Matters of the Month." PHOTOGRAPHIC TIMES 10, no. 116 (Aug. 1880): 177. [Portrait of General W. S. Hancock, Democratic nominee for President.]

L391 "Obituary: Richard A. Lewis." PHOTOGRAPHIC TIMES 21, no. 524 (Oct. 2, 1891): 486-487. [Lewis had a New York, NY studio for many years, very popular in mid-60s, took hundreds of thousands of negatives in his career. Died Sept. 23, 1891.]

LEWIS, THOMAS. (USA)
L392 Nelson, Charles A. *Waltham, Past and Present; And Its Industries. With an Historical Sketch of Watertown from Its Settlement in 1630 to the Incorporation of Waltham, January 15, 1738,... 55 Photographic Illustrations.* Cambridge, MA: T. Lewis, Landscape Photographer, 1879. 152 pp. 55 b & w. [Photomechanical prints, from photos by Thomas Lewis.]

LEWIS, W. & W. H. LEWIS.
L393 "Lewis' Buff Wheel. - Jenny Lind Table." DAGUERREAN JOURNAL 2, no. 1 (May 15, 1851): 14-15. 2 illus. [Apparatus manufactured by W. & W. H. Lewis.]

LEWIS, WILLIAM. (1791-1879) (GREAT BRITAIN, USA)
L394 "Obituary." ANTHONY'S PHOTOGRAPHIC BULLETIN 10, no. 11 (Nov. 1879): 344. [William Lewis, born in Pontipool, Wales, Sept. 5, 1791, moved to England as an infant. Learned the trade of house carpenter and ship joiner. In 1831 left England for USA. Worked as carpenter until he set up his own business in 1836. In 1839 Lewis, with his eldest son, began to make photographic apparatus for Wolcott & Johnson and others. Worked faithfully on this task for forty years.]

LIBBEY, E. P. (1829-1895) (USA)
L395 "In Memoriam: E. P. Libby." WILSON'S PHOTOGRAPHIC MAGAZINE 33, no. 471 (Mar. 1896): 124. [Of Keokuk, IA, died Dec. 27, 1895, aged 66 years. Entered photography as a business in 1857, under Mr. Lovell of Dubuque, IA. Travelled, established a gallery in Keokuk in 1866.]

LIBOIS, A.
L396 Libois, A. "Printing by Development." AMERICAN JOURNAL OF PHOTOGRAPHY AND THE ALLIED ARTS & SCIENCES. n. s. vol. 8, no. 5 (Sept. 1, 1865): 97-100. [From "Bulletin Belge de la Photographie."]

LIDDIARD.
L397 "Waverly Abbey." ILLUSTRATED LONDON NEWS 33, no. 950 (Dec. 18, 1858): 566. 2 illus. [Views. "From photographs by Mr. Liddiard, of Farnham."]

LIEBERT, ALPHONSE J. (1827-1914) (FRANCE)
[Born in 1827. Became an officer in the French Navy. Resigned in 1848, to follow his interest in photography. In 1851 he moved to San

Francisco, CA, and opened a studio. Returned to Paris and opened a studio in 1863. Practiced the tintype and wrote the book *La Photographie en Amérique*, (Paris, 1864). In 1871 he photographed the ruins and aftermath of the Commune and Siege of Paris, published in the album *Les Ruines de Paris et ses Environs*, 1872. In 1876 publishes *La Photographie au charbon mise à portée de tous*,.... In 1879 he opened the first studio equipped with an electric light, for exposures. Through 1880s and 1890s made various technical improvements. Died in Paris in July, 1914.]

L398 Liebert, A. "Photography upon Painter's Canvas." HUMPHREY'S JOURNAL OF PHOTOGRAPHY, AND THE ALLIED ARTS AND SCIENCES. 16, no. 12 (Oct. 15, 1864): 187-188. [From "Le Moniteur de la Photographie."]

L399 Liebert, A. "Photography upon Painter's Canvas." AMERICAN JOURNAL OF PHOTOGRAPHY AND THE ALLIED ARTS & SCIENCES. n. s. vol. 7, no. 14 (Jan. 15, 1865): 323-325. [From "Moniteur."]

L400 Lacan, Ernest. "Photography in France." PHILADELPHIA PHOTOGRAPHER 11, no. 126 (June 1874): 176-179. [Description of Liebert's studio, mention of his book "Photography in America," etc.]

L401 "Note." ANTHONY'S PHOTOGRAPHIC BULLETIN 7, no. 9 (Sept. 1876): 265. [From "London Photo. News." Liebert (Paris) had a baby, made photos to send with the baptismal announcement.]

L402 Stebbing, E. "Liebert's Studio." ANTHONY'S PHOTOGRAPHIC BULLETIN 7, no. 9 (Sept. 1876): 266. [From "Br. J. of Photo."]

L403 Stebbing, Prof. E. "French Correspondence - A Visit to Mons. Liebert's Photographic Establishment." PHILADELPHIA PHOTOGRAPHER 13, no. 153 (Sept. 1876): 269-272.

L404 Liebert, A. "On Posing." BRITISH JOURNAL PHOTOGRAPHIC ALMANAC 1878 (1878): 154-155.

L405 Liebert, A. "On Posing." ANTHONY'S PHOTOGRAPHIC BULLETIN 9, no. 2 (Feb. 1878): 48. [From "Br J of Photo."]

L406 Liebert, A. "On Posing." PHOTOGRAPHIC TIMES 8, no. 89 (May 1878): 101-102. [Extracted from "Br J of Photo. Almanac."]

L407 "Photography By Electric Light." PHOTOGRAPHIC TIMES 12, no. 135 (Mar. 1882): 74-76. 1 illus. [From, "La Nature." Report on Liebert's exhibition at the Electrical Exposition in Paris, discussed, his history given.]

L408 Taylor, J. Traill. "Editorial Mirror." PHOTOGRAPHIC TIMES 15, no. 218 (Nov. 20, 1885): 647. [General notes on a discussion with Liebert.]

L409 "Photographic Notes from Abroad." PHOTOGRAPHIC TIMES 16, no. 249 (June 25, 1886): 337. [Note that Liebert in Paris is making small photos in one corner of a card which then can be signed and verified by authorities as a valid identity card.]

LIEBREICH. [?]
L410 Dowse, Thomas Stretch, M.D. *Syphilis of the Brain and Spinal Cord; Showing the Part Which this Agent Plays in the Production of Paralysis, Epilepsy, Headache, Neuralgia, Hysteria, Hypochondriasis, and Other Mental and Nervous Derangements.* New York: G. P.

Putnam's Sons, 1879. 144 pp. illus. [Illustrated with three tipped-in woodburytypes of patients, etc. and microscopic sketches. "My thanks are due to Dr. Liebreich and Dr. Long Fox for permission to use their valuable plates."]

LIEBICH, K. A. (CLEVELAND, OH)
L411 "Ohio. - New City Hall, on the Corner of Superior and Wood Streets, Cleveland. - Photographed by K. A. Liebich." FRANK LESLIE'S ILLUSTRATED NEWSPAPER 45, no. 1146 (Sept. 15, 1877): 29. 1 illus.

L412 "Photography by Electric Light." PHOTOGRAPHIC TIMES 12, no. 137 (May 1882): 165. [Liebich took photo of statue of Perry at Monumental Park, Cleveland by electric light.]

LIESEGANG, JOHANN PAUL EDUARD. (1838-1895) (GERMANY)
BOOKS
L413 Liesegang, Paul E. *A Manual of the Carbon Process of Permanent Photography and Its Use in Making Enlargements, &c.* by Paul E. Liesegang; Translated from the Sixth (Revised) German Edition by R. B. Marston. London: Sampson Low, Marston, Searle & Rivington, 1878. vii, 146 pp. 1 l. of plates. [Illustrated with a carbon print.]

PERIODICALS
L414 Liesegang, Paul. "Positive Printing Without Silver." AMERICAN JOURNAL OF PHOTOGRAPHY AND THE ALLIED ARTS & SCIENCES. n. s. vol. 6, no. 18 (Mar. 15, 1864): 416-420. [From "Le Moniteur de la Photographie."]

L415 "Communications from the Laboratory of Dr. Liesegang, Elberfeld." HUMPHREY'S JOURNAL OF PHOTOGRAPHY, AND THE ALLIED ARTS AND SCIENCES. 17, no. 13 (Nov. 1, 1865): 196-198.

L416 Liesegang, Dr. "A New Method of Etching Photographs upon Glass." HUMPHREY'S JOURNAL OF PHOTOGRAPHY, AND THE ALLIED ARTS AND SCIENCES. 20, no. 14 (Nov. 15, 1868): 211-212.

L417 Liesegang, Dr. E. "Photography in Germany." PHILADELPHIA PHOTOGRAPHER 6, no. 64 (Apr. 1869): 114-115.

L418 Liesegang, P. E., Ph.D. "On the Preparation of the Nitrate Bath." BRITISH JOURNAL PHOTOGRAPHIC ALMANAC 1875 (1875): 51-52.

L419 Liesegang, Dr. E. "Panoramic Photography." PHILADELPHIA PHOTOGRAPHER 12, no. 134 (Feb. 1875): 38-39. [Liesegang describes making a panoramic camera: Discusses earlier panoramic cameras, mentions the work of Ad. Braun, Mr. Schultz (Dorpat, Russia) and Schoenscheidt (Cologne).]

L420 "Our Editorial Table." PHOTOGRAPHIC TIMES 11, no. 130 (Oct. 1881): 383-384. [Bk. rev.: "Handbuch der photographischen Verfahren mit Silberverbindungen," by Dr. Paul E. Liesegang.]

L421 Wilson, Edward L. "Dr. Johann Paul Eduard Liesegang." WILSON'S PHOTOGRAPHIC MAGAZINE 33, no. 479 (Nov. 1896): 487-488. [Born Elberfield, Ger. June 26, 1838. Studied Berlin Giessen, Jena. Entered photography at fourteen, published a guide at sixteen. Into manufacturing photographic papers. Founded, in 1860, the "Photographische Archiv," followed shortly by "Le Moniteur de la Photographie". In 1887 magazine "Amateur Photograph" (In Germany.), other magazines.]

LILIENTHAL, THEODORE. (1832-1894) (GERMANY, USA)
[Theodore Lilienthal was born in Prussia in 1832. He immigrated to New Orleans in early 1850s and worked as a daguerrean and photographer in New Orleans, LA from at least 1857 until his death in 1894, either alone or in several partnerships. Julius and Louis Lilienthal, who were probably his brothers, also lived and worked as photographers in New Orleans during this time. Theodore was a cannoneer in the Washington Artillery, Confederate Army, in 1862, but photographed successfully under the Union occupation of New Orleans in 1864-1865. After the war he began to exhibit broadly and he won awards for his views and landscapes at the annual New Orleans Grand Fairs during the 1860s and the Paris Universal Exhibition in 1867.]

BOOKS
L422 Lilienthal, Theodore. *Series of Views of New Orleans and Vicinity.* s. l. [New Orleans?]: s. n. [Lilienthal?], 18—. 1 pp. 11 l. of plates. 11 b & w. [Original photographs.]

PERIODICALS
L423 Portrait. Woodcut engraving, credited "From a Photograph by Lilienthal." HARPER'S WEEKLY 8, (1864) ["Hon. Michael Hahn, Gov. of LA." 8:378 (Mar. 26, 1864): 205.]

L424 Portraits. Woodcut engravings, credited "Photographed by Lilienthal." FRANK LESLIE'S ILLUSTRATED NEWSPAPER 18, (1864) ["Hon. Michael Hahn, Gov.-elect of LA." 18:444 (Apr. 2, 1864): 21.]

L425 "Escape of Lieut.-Col. Flory, 46th Indiana Vols., and Capt. Loring, U. S. N., from Captivity in Texas. - From a Photograph by Lilienthal, N. O." FRANK LESLIE'S ILLUSTRATED NEWSPAPER 19, no. 478 (Jan. 28, 1865): 287. 1 illus. [Double portraits of the men, dressed in rags in front of a live oak tree, as if they were travelling during their escape. Either altered by the engraver, posed in the studio, or posed outdoors by the photographer.]

L426 Portrait. Woodcut engraving, credited "From a Photograph by Lilienthal, 131 Poydras St., New Orleans, LA." HARPER'S WEEKLY 9, (1865) ["Maj.-Gen. Edward R. S. Canby." 9:433 (Apr. 15, 1865): 225.]

L427 Portrait. Woodcut engraving, credited "From a Photograph by Lilienthal, New Orleans." HARPER'S WEEKLY 10, (1866) ["Mississippi Mission Conference of the Methodist Episcopal Church (group portrait)." 10:479 (Mar. 3, 1866): 132. "The Southern Methodist Bishops" 10:495 (June 23, 1866): 388.]

L428 "The 'Abraham Lincoln' School for Freedmen, New Orleans, Louisiana." HARPER'S WEEKLY 10, no. 486 (Apr. 21, 1866): 241. 1 illus. ["Photographed by Lilienthal, New Orleans." Social documentation.]

L429 "Louisiana. - The Southern States Agricultural and Industrial Exhibition at the Fair Grounds, New Orleans. - From Photographs by T. Lilienthal." FRANK LESLIE'S ILLUSTRATED NEWSPAPER 42, no. 1068 (Mar. 18, 1876): 29. 9 illus. [Seven views, two portraits.]

L430 "Louisiana State Exposition." ANTHONY'S PHOTOGRAPHIC BULLETIN 10, no. 4 (Apr. 1879): 117. [From "Cincinnati Trade List (March 6, 1879)." Lilienthal (New Orleans, LA) exhibitor at the exposition.]

L431 "Editor's Table: Death of Theodore Lilienthal." WILSON'S PHOTOGRAPHIC MAGAZINE. 32, no. 457 (Jan. 1895): 46. ["Born Prussia, 62 years old. Resident in New Orleans forty-one years, during all of which time he was engaged in the photographic business."]

L432 Collins, Kathleen. "The Late General Hood's Family." HISTORY OF PHOTOGRAPHY 8, no. 2 (Apr. - June 1984): 99-102. 1 b & w. 3 illus. [Lilienthal, a photographer in New Orleans, LA, in the 1870's, issued a cabinet card of the "Late Gen'l Hood's Family" to raise funds for the destitute survivors. (Hood, his wife and a daughter died of Yellow Fever in 1879.)]

LILLIBRIDGE, C. H. (CHICAGO, IL)
[C. H. Lillibridge was listed in Chicago business directories from 1854 through 1871, with a studio at various addresses on Lake Street during this time.]

L433 "The 'Pile' of Prisoners Guilty of Obtruding on the Sidewalks, Arrested in the Streets of Chicago, on the Night of June 18. Photographed by C. H. Lillibridge, Chicago." FRANK LESLIE'S ILLUSTRATED NEWSPAPER 4, no. 84 (July 11, 1857): 92. 1 illus. [View, with figures.]

L434 "The Greatest Fire that Ever Occurred at Chicago, a Number of Lives Lost, and Eight Hundred Thousand Dollars Worth of Property Destroyed. - From a Photograph by Lillibridge." FRANK LESLIE'S ILLUSTRATED NEWSPAPER 4, no. 100 (Oct. 31, 1857): 352. 1 illus. [View, with crowd.]

L435 "View of the City of Chicago, South of Water Street and East of State Street," and "Michigan Avenue, On the Lake Front of the City of Chicago, Illinois. From a Photograph taken for 'Frank Leslie's Illustrated Newspaper,' by C. H. Lillibridge, of Chicago." FRANK LESLIE'S ILLUSTRATED NEWSPAPER 5, no. 112 (Jan. 23, 1858): 120-121. 2 illus. [Views.]

LINDE, AUGUSTE. (GOTHA, GERMANY?)
L436 "Photographic Monstrosities." HUMPHREY'S JOURNAL OF PHOTOGRAPHY, AND THE ALLIED ARTS AND SCIENCES. 20, no. 25 (Sept. 15, 1869): 397. [Auguste Linde, of Gotha, created photographic caricatures by using convex mirrors, etc.]

LINDLEY & WARREN.
L437 *Surat, Broach and Other Old Cities of Goojerat, Photographed by Lindley and Warren. With Notes by T. C. Hope.* Bombay: Oriental Press, 1868. n. p. 20 b & w. [Albumen prints. Printed captions.]

LINDSLY, H. R. (AUBURN, NY)
L438 "New York. - Obsequies of the Late William H. Seward at Auburn. - From Sketches by Joseph Becker and Photographs by H. R. Lindsly, of Auburn." FRANK LESLIE'S ILLUSTRATED NEWSPAPER 35, no. 892 (Nov. 2, 1872): 124. 6 illus. [Funeral.]

LINGO, E. A.
L439 "Newly Fitted Galleries." ANTHONY'S PHOTOGRAPHIC BULLETIN 6, no. 8 (Aug. 1875): 253. [From "Uniontown Standard."]

LINN, R. M. (d. 1872) (USA)
BOOKS
L440 Linn, R. M. *Linn's Landscape Photography.* Lookout Mountain, TN: R. M. Linn, 1872. 62 pp. [Published posthumously.]

PERIODICALS
L441 "Linn's Landscape Photography." PHILADELPHIA PHOTOGRAPHER 9, no. 103 (July 1872): 268-269. [Praise for Linn's book, published after his death. States it is 62 pages long.]

LIPTON, W. H.

L442 Lipton, W. H. "Anatomy, Phrenology, and Physiognomy, And Their Relations to Photography." PHILADELPHIA PHOTOGRAPHER 14, no. 158,160 (Feb., Apr. 1877): 53-54, 103-104. 3 illus.

LIVERNOIS, JULES B. (1830-1865) (CANADA)

L443 "View of the City, the Citadel, and the Harbor of Quebec. The Capitol and Present Seat of Government of the British Province of the Canadas, North America. - From a Photograph by J. B. Livernois, of Quebec." FRANK LESLIE'S ILLUSTRATED NEWSPAPER 10, no. 248 (Aug. 25, 1860): 210-211. 1 illus. [View.]

L444 "The Wars of the Last Century - Battle Monument Just Erected at Ste. Foye, Near Quebec, Canada. - From a Photograph by Livernois." FRANK LESLIE'S ILLUSTRATED NEWSPAPER 17, no. 436 (Feb. 6, 1864): 317. 1 illus.

LLEWELYN, J. D. see also MASKELYNE.

LLEWELYN, JOHN DILLWYN. (1810-1887) (GREAT BRITAIN)

[Born John Dillwyn, the eldest son of Lewis Dillwyn and Mary Llewelyn. When he came of age he assumed the name of Llewelyn and took over the family estates. Educated by tutors, and at Oxford. Married Emma Thomasina Talbot, a first cousin to William H. Fox Talbot. A Fellow of the Linnaean Society and the Royal Society. Llewelyn, along with a group of similarly interested friends - including Richard Calvert Jones, began to experiment with photography upon Talbot's announcement in 1839. Llewelyn also tried the daguerreotype and other processes and developed the oxymel dry collodion process. Most of Llewelyn's photographs were taken in South Wales, and included family portraits and landscape views. A member of the Photographic Exchange Club, the Amateur Photographic Association, and the Photographic Society. His interest in photography seemed to fade after the 1850s, although he remained a member of the Photographic Society into the 1860s.]

BOOKS

L445 *Dillwyn Llewelyn. A Fox Talbot Centenary Special Exhibition.* Lacock, Wiltshire, England.: Fox Talbot Museum. The National Trust, 1977. 18 pp. 6 b & w. [Forward by R.E. Lassam.]

L446 Morris, Richard. *John Dillwyn Llewelyn 1810 - 1882: The First Photographer in Wales.* Welsh Arts Council, 1980. n. p. b & w. [Exhibition catalog.]

L447 Kraus, Hans P. and Larry J. Schaaf. *Sun Pictures: Llewelyn, Maskelyne, Talbot, a Family Circle;* Catalogue Two. New York: Hans P. Kraus, Jr. Fine Photographs, 1986. 79 pp. illus. [W. H. Fox Talbot; John Dillwyn Llewelyn; Nevil Story-Maskelyne.]

PERIODICALS

L448 Llewellyn, J. D. "Calotype Process." HUMPHREY'S JOURNAL 6, no. 4-5 (June 1 - June 15, 1854): 62-63, 74-76. [From "J. of the London Photo. Soc."]

L449 "Fine Arts: Exhibition of the Photographic Society." ILLUSTRATED LONDON NEWS 26, no. 725, 727-728, 736 (Jan. 27, Feb. 10 - Feb. 17, Apr. 14, 1855): 95, 140-141, 164-166, 349. 3 illus. [The second notice (Feb. 10) is actually a reproduction of Lake Price's genre study "Genevra," with brief comment. The third notice (Feb. 17) contains a reproduction of Roger Fenton's landscape "Valley of the Wharfe," as well as a discussion of the exhibition. The last notice (Apr. 14) has a landscape by Llewellyn.]

L450 Llewelyn, J. D. "The Oxmel Process." PHOTOGRAPHIC AND FINE ART JOURNAL 9, no. 11 (Nov. 1856): 340-341. [From "J. of Photo. Soc., London."]

L451 Llewelyn, J. D. "On a Modification of the Oxymel Process." HUMPHREY'S JOURNAL OF PHOTOGRAPHY, AND THE ALLIED ARTS AND SCIENCES. 10, no. 12 (Oct. 15, 1858): 190-192. [From "J. of London Photo. Soc."]

L452 Morris, Richard. "John Dillwyn Llewelyn (1810-1887)." HISTORY OF PHOTOGRAPHY 1, no. 3 (July 1977): 221-233. 11 b & w.

LLOYD, F. H.

L453 *Photographs amoung the Dolamite Mountains. Photographed by W. D. Howard and F. H. Lloyd.* s. l.: s. n., 1865. n. p. 24 b & w. [Original photographs. Printed title page.]

LLOYD, JAMES. (DURBAN, SOUTH AFRICA)

L454 "The Zulu War in South Africa." ILLUSTRATED LONDON NEWS 74, no. 2069 (Feb. 8, 1879): 137. 2 illus. ["Our illustrations...are supplied by Mr. James Lloyd, an artist and photographer of Durban, in Natal, who accompanied the Commissioners." One view is probably from a photo, one from a sketch.]

L455 "The Zulu War. Garrison of Fort Pearson on the Lower Tugela, at Gatling Gun Practice - From a Photograph by Mr. J. Lloyd, of Durban, Natal." ILLUSTRATED LONDON NEWS 74, no. 2073 (Mar. 8, 1879): 213. 1 illus.

L456 "The Zulu War: Colonel Pearson's Column Crossing the Tugela. - From a Photograph by Mr. J. Lloyd, of Durban, Natal." ILLUSTRATED LONDON NEWS. 74, no. 2073 (Mar. 8, 1879): 220-221. 1 illus.

LLOYD, JAMES. [?]

L457 "The Zulu War: Durban Mounted Volunteers Under the Late Captain W. Shepstone, Setting Out For the Front. - From a Photograph taken on November 30." ILLUSTRATED LONDON NEWS 74, no. 2071 (Feb. 22, 1879): 176. 1 illus.

L458 "Zulu Dandies, Showing the Modes of Wearing the Hair." ILLUSTRATED LONDON NEWS. 74, no. 2086 (June 7, 1879): *. 4 illus. [4 portraits, from photographs taken "...of Zulu Chiefs who have visited Natal, and who were photographed there."]

LLOYDS, ALFRED. (LIVERPOOL, ENGLAND)

L459 "Bust of the Late General Sir Henry Havelock." ILLUSTRATED NEWS OF THE WORLD AND DRAWING ROOM PORTRAIT GALLERY OF EMINENT PERSONAGES 1, no. 15 (May 15, 1858): 229. 1 illus. ["After a Photograph by Alfred Lloyds, Liverpool."]

LOCH.

L460 Taylor, Philip Meadow and James Fergusson. *Architecture of Beejapoor.* London: John Murray, 1866. n. p. b & w. [Original photos by Col. T. Biggs and Maj. Loch.]

LOCK & WHITFIELD. (LONDON, ENGLAND)
BOOKS

L461 Cooper, Thompson. *Men of Mark; A Gallery of Contemporary Portraits, Photographed from Life by Lock and Whitfield,* with brief biographical notices by Thompson Cooper. London: Sampson Low, Marston, Searle, & Rivington, 1876-1883. 7 vol. in 4. 252 b & w. [Woodburytype prints.]

PERIODICALS

L462 Portrait. Woodcut engraving credited "From a photograph by Lock & Whitfield, Regent St." ILLUSTRATED LONDON NEWS 36, (1860) ["Right Rev. J. C. Wigram." 36:* (Apr. 14, 1860): 357.]

L463 "Note." ART JOURNAL (Sept. 1866): 289. [Messrs. Lock & Whitfield taking a portrait of the future Empress of Russia (taken in Sweden).]

L464 Portrait. Woodcut engraving credited "From a photograph by Lock & Whitfield." ILLUSTRATED LONDON NEWS 61, (1872) ["Sheriff White." 61:1731 (Nov. 9, 1872): 440.]

L465 Portrait. Woodcut engraving credited "From a photograph by Lock & Whitfield." ILLUSTRATED LONDON NEWS 63, (1873) ["Late Mr. Fitzball." 63:1784 (Nov. 8, 1873): 445.]

L466 Portrait. Woodcut engraving credited "From a photograph by Lock & Whitfield." ILLUSTRATED LONDON NEWS 64, (1874) ["General Shute, M.P." 64:1815 (June 6, 1874): 536.]

L467 Portrait. Woodcut engraving credited "From a photograph by Lock & Whitfield." ILLUSTRATED LONDON NEWS 66, (1875) ["E. Stanhope, M.P." 66:1853 (Feb. 13, 1875): 144.]

L468 Portrait. Woodcut engraving credited "From a photograph by Lock & Whitfield." ILLUSTRATED LONDON NEWS 69, (1876) ["Late Mr. Mortimer Collins, novelist." 69:1935 (Aug. 26, 1876): 205.]

L469 Portrait. Woodcut engraving credited "From a photograph by Lock & Whitfield." ILLUSTRATED LONDON NEWS 70, (1877) ["Late Earl of Shrewsbury." 70:1976 (May 26, 1877): 493.]

L470 1 b & w ("Mlle. Belocca.") as frontispiece. BRITISH JOURNAL PHOTOGRAPHIC ALMANAC 1878 (1878): frontispiece. 1 b & w. [Woodburytype portrait, from photograph by Lock & Whitfield.]

L471 Portrait. Woodcut engraving credited "From a photograph by Lock & Whitfield." ILLUSTRATED LONDON NEWS 72, (1878) ["Viscount Sandon, M.P." 72:2032 (June 8, 1878): 525. [From "Men of Mark," text by Thompson Cooper, London: Sampson, Low, Marston, Searle, and Rivington.]]

L472 "Figaro Programme." HISTORY OF PHOTOGRAPHY 3, no. 2 (Apr. 1978): frontispiece. 1 illus. [Woodburytype portrait by Lock & Whitfield used on a theatre program, July 27, 1874.]

LOCK, S. R.
L473 Lock, S. R. "Colored Photographs." PHOTOGRAPHIC AND FINE ART JOURNAL 8, no. 4 (Apr. 1855): 111. [From "J. of Photo. Soc., London." Hand coloring.]

LOCKE & ROBBINS.
L474 "The Soldiers Monument at Plymouth, Massachusetts." HARPER'S WEEKLY 13, no. 660 (Aug. 21, 1869): 532. 1 illus. ["Phot. by Locke & Robbins."]

LOCKWOOD.
L475 Portrait. Woodcut engraving, credited "From a Photograph by Lockwood." NEW YORK ILLUSTRATED NEWS 8, (1863) ["Maj.-Gen. John E. Wool." 8:193 (July 11, 1863): 172.]

LOCKWOOD, E. N. [MRS.] (RIPON, WI)
L476 Lockwood, Mrs. E. N. "Does It Pay to Attend the N. P. A. Meetings? What a Lady Photographer Thinks." PHILADELPHIA PHOTOGRAPHER 9, no. 106 (Oct. 1872): 337-338. [Mrs. Lockwood was from Ripon, WI.]

L477 Lockwood, Mrs. E. N. "The National Photographic Association as a Means of Instruction." PHILADELPHIA PHOTOGRAPHER 10, no. 113 (May 1873): 134-135.

L478 Lockwood, Mrs. E. N. "Photographic Mutual Life Insurance." PHILADELPHIA PHOTOGRAPHER 10, no. 115 (July 1873): 194-195.

L479 Lockwood, Mrs. E. N. "Fifth Annual Meeting and Exhibit of the National Photographic Association of the U.S., held in Buffalo, N.Y., beginning July 5, 1873: Shall We Be Insured?" PHILADELPHIA PHOTOGRAPHER 10, no. 117 (Sept. 1873): 353-354.

L480 Lockwood, Mrs. E. N. "A Photographic Washing Machine." ANTHONY'S PHOTOGRAPHIC BULLETIN 5, no. 4 (Apr. 1874): 153-154.

L481 "Editor's Table: Pictures Received." PHILADELPHIA PHOTOGRAPHER 14, no. 166 (Oct. 1877): 320. [H. R. Farr (Prairie du Chien, WI); Frank French (Pecatonica, IL); Mrs. E. N. Lockwood (Ripon, WI); J. B. Marshall (Gold Hill, NB); J. E. Beebee (Chicago).]

L482 "General Notes: Lockwood's Divorce." PHOTOGRAPHIC TIMES 13, no. 147 (Mar. 1883): 107. [Note that Mrs. E. N. Lockwood announcing that she was divorcing her husband of twenty-five years, William M. Lockwood, and continuing her photographic business in Ripon, Wis. Divorce was so unusual that the editor seemed nonplussed, but congratulated her anyway.]

L483 Lockwood, Mrs. E. N. "Yesterday and To-Day; Or, Justice to All." PHOTOGRAPHIC TIMES 16, no. 252 (July 16, 1886): 377-378. [Read at the St. Louis Convention of the Photographers' Assoc. of America. "The past five years has marked the most radical change in the manipulation and formulas for making negatives, of any like period since photography was first invented."]

L484 Lockwood, Mrs. E. N. "Yesterday and Today, or, Justice to All." ANTHONY'S PHOTOGRAPHIC BULLETIN 17, no. 19 (Oct. 9, 1886): 592-593. [Presented at the P. P. A. Convention.]

L485 Lockwood, Mrs. E. N. "How to Make 'Egyptian Photographs.'" PHOTOGRAPHIC MOSAICS:1889 25, (1889): 79. [A variant of the cabinet style of studio portrait, popular in Wisconsin at least.]

LOEFFLER, J. (TOMPKINSVILLE, NY)
L486 Seely, Charles A. "Editorial Department." AMERICAN JOURNAL OF PHOTOGRAPHY AND THE ALLIED ARTS & SCIENCES. n. s. vol. 6, no. 12 (Dec. 15, 1863): 287-288. [Mr. Loefler, of Staten Island, presented prints made with a particular formula.]

L487 Seely, Charles A. "Editorial Department." AMERICAN JOURNAL OF PHOTOGRAPHY AND THE ALLIED ARTS & SCIENCES. n. s. vol. 8, no. 9 (Nov. 1, 1865): 215-216. [High praise for J. Loeffler's landscape views. Loeffler from Tompkinsville, Staten Island.]

L488 Anthony, E. & H. T. & Co. "The Chromotype. Our Illustration." ANTHONY'S PHOTOGRAPHIC BULLETIN 8, no. 7 (July 1877): 193-194. [Loeffler won first prize in Lambert chromotype (carbon) printing contest. Loeffler from Tompkinsville, Staten Island, NY. (Print, originally tipped-in, missing from this copy.)]

L489 "Editor's Table." PHILADELPHIA PHOTOGRAPHER 14, no. 165 (Sept. 1877): 288. [J. Loeffler, Tompkinsville (Staten Island, NY) sent prints.]

L490 "Our Picture." PHILADELPHIA PHOTOGRAPHER 14, no. 168 (Dec. 1877): frontispiece, 353-355. 1 b & w. [Genre portrait "The Fisherman's Daughter," by J. Loeffler (Tompkinsville, Staten Island, NY). Includes letter from Loeffler.]

L491 "The Studios of New York. VIII." PHOTOGRAPHIC TIMES 22, no. 560 (June 10, 1892): 303-304. [Loeffler had studio in Tompkinsville, Staten Island for 30 years.]

LOESCHER.
L492 "Art in the Continental States: Germany. - Munich." ART JOURNAL (July 1, 1849): 208. [Praise for Loescher's portraits.]

LOESCHER & PETSCH. (BERLIN, GERMANY)
L493 "Editor's Table: Fine German Photographs." PHILADELPHIA PHOTOGRAPHER 2, no. 20 (Aug. 1865): 138.

L494 "More About Skylights." PHILADELPHIA PHOTOGRAPHER 3, no. 31 (July 1866): frontispiece, 207-211. 1 b & w. 1 illus. [Genre scene of three peasants, plus diagram of skylight. Also note "Our Picture" on page 218.]

L495 "Berlin Pictures." PHILADELPHIA PHOTOGRAPHER 3, no. 36 (Dec. 1866): 366-367.

L496 "Our Picture." PHILADELPHIA PHOTOGRAPHER 4, no. 47 (Nov. 1867): frontispiece, 366. 1 b & w. [Studio portrait.]

L497 "Editor's Table." PHILADELPHIA PHOTOGRAPHER 4, no. 48 (Dec. 1867): 402. ['Berlin Photographs.']

L498 "The New Atelier of Loescher and Petsch, in Berlin - Parts 1-2." PHILADELPHIA PHOTOGRAPHER 7, no. 75-76 (Mar. - Apr. 1870): 88-90, 117-120.

L499 "Our Picture." PHILADELPHIA PHOTOGRAPHER 7, no. 77 (May 1870): frontispiece, 177. 1 b & w. [Studio portrait.]

L500 "Our Picture." PHILADELPHIA PHOTOGRAPHER 7, no. 82 (Oct. 1870): frontispiece, 338-339. 48 b & w. [Forty-eight postage stamp sized genre pictures on one page.]

L501 Vogel, Dr. H. "German Correspondence." PHILADELPHIA PHOTOGRAPHER 8, no. 88 (Apr. 1871): 110-112. [Loescher and Petsch's stereos...the Victoria card, Medallion pictures.]

L502 "Our Picture." PHILADELPHIA PHOTOGRAPHER 17, no. 204 (Dec. 1880): frontispiece, 386. 1 b & w. [Genre, "A Fickle Shadow."]

L503 "Human Documents: Prince Bismark." MCCLURE'S MAGAZINE 4, no. 6 (May 1895): 486, 525-536. 19 b & w. 4 illus. [Portfolio of portraits of Bismark. Photos by Karl Hahn (Munich); A. Brockmann (Strausburg); Loescher & Petsch (Berlin); A. Braun & Co. (Paris); M. Ziesler or Fiesler (Berlin); Jul. Braatz (Berlin); Pitartz (Kissingen); Strumper & Co. (Hamburg).]

L504 1 b & w (Prince Bismark). CENTURY MAGAZINE 56, no. 6 (Oct. 1898): 824. 1 b & w.

LOMBARDI see CALDESI & LOMBARDI.

LOMBARDI, A. (BRIGHTON, ENGLAND)
L505 Portrait. Woodcut engraving credited "From a photograph by Lombardi." ILLUSTRATED LONDON NEWS 64, (1874) ["Mr. W. H. Smith, M.P." 64:1806 (Apr. 4, 1874): 325.]

L506 Lombardi, A. "A Note on Lighting the Sitter." BRITISH JOURNAL PHOTOGRAPHIC ALMANAC 1876 (1876): 139-140.

L507 Portrait. Woodcut engraving credited "From a photograph by Lombardi, Pall Mall East." ILLUSTRATED LONDON NEWS 72, (1878) ["Late Mr. Wykeham Martin, M.P." 72:2033 (June 15, 1878): 548.]

LONDON PANTASCOPIC CO.
L508 "The Explosion of a Gunpowder magazine at Erith." ILLUSTRATED LONDON NEWS 45, no. 1282 - 1283 (Oct. 15, 1864): 376-377. 3 illus.

LONDON PHOTOGRAPHIC CO. (BAYSWATER, ENGLAND)
L509 Portrait. Woodcut engraving credited "From a photograph by London Photographic Co., Norfolk Terrace, Bayswater." ILLUSTRATED LONDON NEWS 75, (1879) ["Sub-Asst. Commissary Dalton, V.C." 75:2112 (Dec. 6, 1879): 529.]

LONDON STEREOSCOPIC CO. see also ENGLAND, WILLIAM; POCOCK, EDWARD.

LONDON STEREOSCOPIC CO.
BOOKS
L510 *The ABC of Photography; with additions, including recent improvements in the art.* "9th ed." London: London Stereoscopic Co., 1858. 60 pp. [2nd to 5th ed. (1856); 14th ed. (1861); 25 editions by 1890.]

L511 London Stereoscopic & Photographic Co. *The Thames from Wallingford to Kew.* London: London Stereoscopic & Photographic Co., 1868. [77 pp.] 153 b & w. [Original photos, album, no text. Marshall Collection.]

L512 London Stereoscopic and Photographic Co. *Photographs of London.* London: London Stereoscopic & Photographic Co., 187- ? n. p. 24 l. of plates. 24 b & w. [Original photos.]

L513 London Stereoscopic and Photographic Co. *Prose Masterpieces from Modern Essayists: Comprising Twelve Unabridged Essays, by Irving [et al.]; with Twelve Portraits in Permanent Photography.* London: Bickers, 1886. 395 pp. 12 l. of plates. 12 b & w. [Woodburytype prints, from photos by Elliott & Fry, Frear, and the London Stereoscopic Co.]

L514 London Stereoscopic and Photographic Co. *Midland Railway, England: London Terminus and Midland Grand Hotel; Photographed and Printed by the London Stereoscopic and Photographic Company.* London: London Stereoscopic & Photographic Co., 1891 ? 50 pp. 20 l. of plates. b & w. illus. [Carbon and photomezzotype prints.]

L515 London Stereoscopic & Photographic Co. *A Voyage with the Mails between Brisbane-London, Australia and Great Britain: A Memento by an Amateur Photographer with 103 Original Photographs.* London: London Stereoscopic and Photographic Co., [1911]. 58 pp. 103 b & w.

PERIODICALS
L516 "1 engraving (Lord Mayor announcing the Peace, at the Mansion House)." ILLUSTRATED LONDON NEWS 28, no. 793 (Apr. 12,

1856): 381. 1 illus. ["From a photograph by the London Stereoscopic Company."]

L517 "Note." ART JOURNAL (Oct. 1856): 323. [Mention of colored views of "The Winters Tale" by Mr. Charles Keane (actor).]

L518 Portrait. Woodcut engraving credited "From a photograph by London Stereoscopic Co." ILLUSTRATED LONDON NEWS 31, (1857) ["Rev. C. H. Spurgeon." 31:* (Oct. 17, 1857): 400.]

L519 "London Stereoscopic Company." ART JOURNAL (Dec. 1857): 358.

L520 "Note." ART JOURNAL (Mar. 1858): 95. [Views of Ireland.]

L521 Portraits. Woodcut engravings credited "From a photograph by London Stereoscopic Co." ILLUSTRATED LONDON NEWS 36, (1860) ["Captain Harrison." 36:* (Feb. 4, 1860): 116.]

L522 "Note." ART JOURNAL (Feb. 1860): 63. [London Stereoscopic Company issued stereos on the Hospital for Consumption.]

L523 "Fine Arts: Photographs of American Scenery." ILLUSTRATED LONDON NEWS 36, no. 1036 (June 16, 1860): 589.

L524 "America in the Stereoscope." ART JOURNAL (July 1860): 221. [Review of stereos of American scenery, probably taken by William England.]

L525 "Critical Notes: America in the Stereoscope, a series of one hundred views of the most choice and interesting portions of American scenery [by London Stereo Co.]" PHOTOGRAPHIC NEWS 4, no. 104 (Aug. 31, 1860): 208-209.

L526 "The Falls of Niagara." ILLUSTRATED LONDON NEWS 37, no. 1047 (Aug. 25, 1860): 189-190. 2 illus. ["From a photograph by the Stereoscopic Company."]

L527 "America In the Stereoscope, A series of One Hundred Views of the Most Choice and Interesting Portions of American Scenery." AMERICAN JOURNAL OF PHOTOGRAPHY AND THE ALLIED ARTS & SCIENCES. n. s. vol. 3, no. 11 (Nov. 1, 1860): 168-170. [From "Photo. News." By the London Stereoscopic Co.]

L528 "Reviews: American Scenery. Published by the London Stereoscopic Co." JOURNAL OF THE PHOTOGRAPHIC SOCIETY OF LONDON 7, no. 108 (Apr. 15, 1861): 167-169. [Nearly three column review and an excerpt (two columns) from the "Times." (Unusually extensive review, for the time.)]

L529 "Our Weekly Gossip." ATHENAEUM no. 1780 (Dec. 7, 1861): 768. [Views of Paris offered by the London Stereoscopic Co. Note on p. 809 states they were taken by W. England.]

L530 "Stereographs: Instantaneous Views of Paris, London Stereoscopic Company." BRITISH JOURNAL OF PHOTOGRAPHY 8, no. 155 (Dec. 2, 1861): 424.

L531 Portrait. Woodcut engraving credited "From a photograph by London Stereoscopic Co." ILLUSTRATED LONDON NEWS 41, (1862) ["Right Hon. W. A. Rose, Lord Mayor of London." 41:* (Nov. 15, 1862): 520.]

L532 "Note." ART JOURNAL (Jan. 1862): 30. [Views of Paris.]

L533 "Opening of the International Exhibition: Earl Granville Presenting the Address to the Duke of Cambridge." ILLUSTRATED LONDON NEWS 40, no. 1143 (May 10, 1862): 463. 1 illus.

L534 "The International Exhibition: View from the Orchestra on Opening Day." ILLUSTRATED LONDON NEWS 40, no. 1144 (May 17, 1862): 515. 1 illus.

L535 "The International Exhibition: The Western Dome and Transcript." ILLUSTRATED LONDON NEWS 40, no. 1145 (May 24, 1862): 539. 1 illus.

L536 "Useful Facts, Receipts, Etc.: The Photographic Contract at the Exhibition." AMERICAN JOURNAL OF PHOTOGRAPHY AND THE ALLIED ARTS & SCIENCES. n. s. vol. 5, no. 1 (July 1, 1862): 13. [From "London Times." The London Stereoscopic Co. acquired contract to photograph the London International Exhibition of 1862.]

L537 "Note." ART JOURNAL (Aug. 1862): 178. [Protesting London Stereo Co.'s monopoly at the Exhibition.]

L538 "Photographic Views of the International Exhibition." JOURNAL OF THE PHOTOGRAPHIC SOCIETY OF LONDON 8, no. 124 (Aug. 15, 1862): 104-105. [Lists 88 views.]

L539 "The International Exhibition." ILLUSTRATED LONDON NEWS 41, no. 1159-1174 (Aug. 16 - Nov. 15, 1862): 192, 217, 249, 272, 317, 320, 349, 352, 411, 480, 489, 501, 532, 536-537. 20 illus. ["From a Photograph by the London Stereoscopic Company." Views of the exhibition and of certain displays within the exhibition. There were scores of illustrations, of which twenty are credited from photographs.]

L540 "The Stereographs of the Stereoscopic Company." ART JOURNAL (Nov. 1862): 223.

L541 Portrait. Woodcut engraving credited "From a photograph by London Stereoscopic Co." ILLUSTRATED LONDON NEWS 43, (1863) ["Right Hon. William Lawrence, Mayor of London." 43:* (Nov. 7, 1863): 457.]

L542 "Photographs of the Sculpture of the Great Exhibition." ART JOURNAL (Apr. 1863): 68.

L543 "The Sandringham Series of Photographs." JOURNAL OF THE PHOTOGRAPHIC SOCIETY OF LONDON 8, no. 134 (June 15, 1863): 306-307.

L544 "Fine Arts." ILLUSTRATED LONDON NEWS 43, no. 1212 (July 11, 1863): 54. [Review of two series of views of the Prince of Wales' Norfolk castle.]

L545 "Note." ART JOURNAL (Feb. 1864): 58. [Hand-colored views of Venice.]

L546 "Miscellaneous: Cast from Shakespeare's Face." AMERICAN JOURNAL OF PHOTOGRAPHY AND THE ALLIED ARTS & SCIENCES. n. s. vol. 7, no. 2 (July 15, 1864): 40-41.

L547 Portrait. Woodcut engraving credited "From a photograph by London Stereoscopic Co." ILLUSTRATED LONDON NEWS 47, (1865) ["The Chinese Giant, Chang, with his wife and attendant dwarf." 47:* (Sept. 30, 1865): 304.]

L548 "Note." ART JOURNAL (Aug. 1865): 258. [Stereos of Dublin International Exhibition, by London Stereo Co.]

L549 "Note." ART JOURNAL (Aug. 1865): 254. [Scenery of Ireland, by London Stereo Co. 100 views.]

L550 Portrait. Woodcut engraving credited "From a photograph by London Stereoscopic Co." ILLUSTRATED LONDON NEWS 53, (1868) ["Right Hon. James Clark Lawrence, Mayor of London." 53:* (Nov. 7, 1868): 453.]

L551 "Stereoscopic Views and Photographs: 'Grip,' the Raven of Barnaby Rudge." ANTHONY'S PHOTOGRAPHIC BULLETIN 1, no. 8 (Sept. 1870): 165. [A pet of Charles Dickens. Sold at auction to George Nottage, of the London Stereoscopic Co., for a price of $700. Excerpts from the newspapers on this event: photos sold by Anthony Co.]

L552 Portraits. Woodcut engravings credited "From a photograph by London Stereoscopic Co." ILLUSTRATED LONDON NEWS 58, (1871) ["W. Monsell, M.P., Postmaster General." 58:1636 (Feb. 11, 1871): 145.]

L553 "Note." ART JOURNAL (May 1871): 147. [Stereos of the French Emperor.]

L554 "The Ex-Emperor in England. - Portrait of Napoleon III, From a Photograph Just Taken at Chinelhurst by the London Stereoscopic and Photographic Company." FRANK LESLIE'S ILLUSTRATED NEWSPAPER 32, no. 817 (May 27, 1871): 173. 1 illus. [Studio portrait.]

L555 "Note." ART JOURNAL (Nov. 1871): 274. [Series of photos of the sculptures at the International Exhibition.]

L556 Portrait. Woodcut engravings, credited to "From a Photograph by London Stereoscopic Co." ILLUSTRATED LONDON NEWS 60, (1872) ["Late Sir Francis Crossley." 60:1689 (Jan. 20, 1872): 57.]

L557 Portrait. Woodcut engraving, credited "From a Photograph by the London Stereoscopic and Photographic Co." FRANK LESLIE'S ILLUSTRATED NEWSPAPER 36, (1873) ["George MacDonnell, Bank of England forger." 36:916 (Apr. 19, 1873): 97.]

L558 Portraits. Woodcut engravings credited "From a photograph by London Stereoscopic Co." ILLUSTRATED LONDON NEWS 64, (1874) ["Late Mr. Winterbotham, M.P." 64:1795 (Jan. 17, 1874): 48. "Right Hon. W. E. Gladstone, M.P." 64:1798 (Feb. 7, 1874): 125. "Late Rev. Dr. Binney.: 64:1801 (Feb. 28, 1874): 209. "New Cabinet Members: Lord Cairns, Lord Carnarvon, Lord Salisbury, Mr. Gathorne Hardy, Sir Stafford Northcote, Duke of Richmond, Lord John Manners, Ward Hunt." 64:1808 (Apr. 18, 1874): 364-365. "Mr. Macdonald, M.P." 64:1816 (June 13, 1874): 552.]

L559 Portraits. Woodcut engravings credited "From a photograph by London Stereoscopic Co." ILLUSTRATED LONDON NEWS 65, (1874) ["Mr. Puleston, member of Parliament." 65:1823 (Aug. 1, 1874): 105. "Late J. H. Foley, R.A." 65:1879 (Sept. 12, 1874): 249. "The Supposed Nana Sahib." 65:1841 (Dec. 5, 1874): 537.]

L560 Portraits. Woodcut engravings credited "From a photograph by London Stereoscopic Co." ILLUSTRATED LONDON NEWS 66, (1875) ["Marquis of Hartington, Spencer Cavendish." 66:1852 (Feb. 6, 1875): 93. "Late Sir W. Sterndale Bennett." 66:1853 (Feb. 13, 1875): 152. "Sir H. S. Keating." 66:1854 (Feb. 20, 1875): 181. "Right Hon. Sir Alexander Cockburn, Bart. Lord Chief Justice of England." 66:1859 (Mar. 27, 1875): n.p. following p. 300. "Mr. C. Harrison, M.P." 66:1859 (Mar. 27, 1875): 301. "Late Comte de Jarnac."

66:1860 (Apr. 3, 1875): 321. "Mr. Henry Bessemer." 66:1861 (Apr. 10, 1875): 336. "Bishop J. W. Colenso." 66:1866 (May 15, 1875): following p. 468.]

L561 Portrait. Woodcut engraving credited "From a photograph by London Stereoscopic Co." ILLUSTRATED LONDON NEWS 67, (1875)

L562 Portraits. Woodcut engravings credited "From a photograph by London Stereoscopic Co." ILLUSTRATED LONDON NEWS 67, (1875) ["Mr. Samuel Plimsoll, M.P." 67:1878 (Aug. 7, 1875): 136. "Late Mr. Justice Honyman." 67:1886 (Oct. 2, 1875): 333. "Late Rev. W. Brock, D.D." 67:1894 (Nov. 27, 1875): 537.]

L563 "The Cospatrick Disaster: The Supervisors." ILLUSTRATED LONDON NEWS 66, no. 1849 (Jan. 16, 1875): 45, 61. 1 illus. [Portraits of the three survivors - Cotter, MacDonald, and Lewis - of the ship that burned at sea.]

L564 Portrait. Woodcut engraving, credited "From a Photograph by the London Stereoscopic Co." FRANK LESLIE'S ILLUSTRATED NEWSPAPER 42, (1876) ["Mlle. Blanche Rosavella, Prima Donna." 42:1080 (June 10, 1876): 229.]

L565 Portraits. Woodcut engravings credited "From a photograph by London Stereoscopic Co." ILLUSTRATED LONDON NEWS 68, (1876) ["Late Ferdinand Freiligrath, German poet." 68:1914 (Apr. 1, 1876): 325. "Late Mr. Henry Kingsley." 68:1923 (June 3, 1876): 545.]

L566 Portraits. Woodcut engravings credited "From a photograph by London Stereoscope Co." ILLUSTRATED LONDON NEWS 69, (1876) ["Duke of Marlborough." 69:1944 (Oct. 28, 1876): 404. "Late Duke of Saldanha." 69:1949 (Dec. 2, 1876): 533. "Marquis of Salisbury." 69:1950 (Dec. 9, 1876): 549. "Late Mr. Edmund Horsman, M.P." 69:1953 (Dec. 16, 1876): 581.]

L567 Portraits. Woodcut engravings credited "From a photograph by London Stereoscopic Co." ILLUSTRATED LONDON NEWS 70, (1877) ["Late Mr. John Oxenford." 70:1965 (Mar. 10, 1877): 229. "Late Mr. Andrew Halliday." 70:1971 (Apr. 21, 1877): 373. "Rev. Canon Thorold, Bishop of Rochester." 70:1976 (May 26, 1877): 493. "Late Sir M. Digby Wyatt, architect." 70:1977 (June 2, 1877): 517.]

L568 Portraits. Woodcut engravings credited "From a photograph by London Stereoscopic Co." ILLUSTRATED LONDON NEWS 71, (1877) ["J. B. Burgess, A.R.A." 71:1983 (July 14, 1877): 37. "P. R. Morris, A.R.A." 71:1983 (July 14, 1877): 37. "Late Hon. George W. Hunt." 71:1987 (Aug. 11, 1877): following p. 140. "Mr. Alderman Owen, Sheriff Nottage, Sheriff Staples, of London." 71:2000 (Nov. 10, 1877): 444.]

L569 Portraits. Woodcut engravings credited "From a photograph by London Stereoscopic Co." ILLUSTRATED LONDON NEWS 72, (1878) ["Late Sir George Gilbert Scott, R.A." 72:2024 (Apr. 13, 1878): 341. "Col. F. A. Stanley, new Sec. of War." 72:2025 (Apr. 20, 1878): 356. "Mr. W. T. Charley, M.P." 72:2026 (Apr. 27, 1878): 397.]

L570 Portraits. Woodcut engravings credited "From a photograph by London Stereoscopic Co." ILLUSTRATED LONDON NEWS 73, (1878) ["Late Cardinal Paul Cullen." 73:2053 (Nov. 2, 1878): 421. "Late Mr. Alfred Wigan." 73:2061 (Dec. 14, 1878): 565.]

L571 Portraits. Woodcut engravings credited "From a photograph by London Stereoscopic Co." ILLUSTRATED LONDON NEWS 72, (1878) ["Late Sir George Gilbert Scott, R.A." 72:2024 (Apr. 13, 1878):

341. "Col. F. A. Stanley, new Sec. of War." 72:2025 (Apr. 20, 1878): 356. "Mr. W. T. Charley, M.P." 72:2026 (Apr. 27, 1878): 397.]

L572 Portraits. Woodcut engravings credited "From a photograph by London Stereoscopic Co." ILLUSTRATED LONDON NEWS 73, (1878) ["Late Cardinal Paul Cullen." 73:2053 (Nov. 2, 1878): 421. "Late Mr. Alfred Wigan." 73:2061 (Dec. 14, 1878): 565.]

L573 Portrait. Woodcut engraving, credited "From a Photograph by London Stereoscopic Co." FRANK LESLIE'S ILLUSTRATED NEWSPAPER 47, (1878) ["H. R. H. Princess Louise and Marchioness of Lorne." 47:1210 (Dec. 7, 1878): n. p. (Supplement)]

L574 Portraits. Woodcut engravings credited "From a photograph by London Stereoscopic Co." ILLUSTRATED LONDON NEWS 74, (1879) ["Late Mr. E. M. Ward, R.A." 74:2068 (Feb. 1, 1879): 104. "Late General Peel." 74:2073 (Mar. 8, 1879): 224. "Madame Adelina as Aida." 74:2084 (May 24, 1879): 492.]

L575 Portraits. Woodcut engravings credited "From a photograph by London Stereoscopic Co." ILLUSTRATED LONDON NEWS 75, (1879) ["Sir Francis Wyatt Truscott, Lord Mayor of London. Sheriff E. K. Bayley, London." 75:2109 (Nov. 15, 1879): 449. "Late Sergeant Cox." 75:2112 (Dec. 6, 1879): 529. "Late Michael Chevalier." 75:2113 (Dec. 13, 1879): 553.]

L576 Portraits. Woodcut engravings credited "From a photograph by London Stereoscopic Co." ILLUSTRATED LONDON NEWS 74, (1879) ["Late Mr. E. M. Ward, R.A." 74:2068 (Feb. 1, 1879): 104. "Late General Peel." 74:2073 (Mar. 8, 1879): 224. "Madame Adelina as Aida." 74:2084 (May 24, 1879): 492.]

L577 Spear, Benjamin. "Papal Indulgence." HISTORY OF PHOTOGRAPHY 5, no. 2 (Apr. 1981): 169-170. 1 b & w. [London Stereoscopic Co's. carte-de-visite of Pope Leo XIII, with the pope's essay "Ars Photographica."]

L578 Ryder, Richard C. "Personalities in Perspective: Henry M. Stanley." STEREO WORLD 8, no. 3 (July - Aug. 1981): 17, 27. 1 b & w. [Stereo portrait by London Stereoscopic Co,, in 1872.]

L579 "Catalogue of Binocular Pictures of the London Stereoscopic Company, 1856" PHOTOGRAPHIC COLLECTOR 3, no. 2 (Autumn 1982): 217-225. 14 b & w. 1 illus. [Facsimile reprint of 1856 catalog.]

LONG, CHARLES A. (GREAT BRITAIN)
[Charles Long was a member of a London firm of opticians.]

BOOKS
L580 Long, Charles A. *Practical Photography, On Glass and Paper; A Manual Containing Simple Directions for the Production of Portraits, Views, &c., By The Agency of Light, Including the Collodion, Albumen, Calotype, Waxed Paper, and Positive Paper Processes.* London: Bland & Long, opticians, 1854. 48 pp. [2nd ed. (1856), "...to which is added a Paper on the Method of taking Stereoscopic Pictures." 76 pp., 18 illus.; 4th ed. (1859) 77 pp.]

L581 Long, Charles A. *The Dry Collodion Process.* London: Bland & Long, 1857. 26 pp. 5 illus. [2nd. ed. (1857) New York: H. H. Snelling. 24 pp.; 3rd ed. (1858).]

PERIODICALS
L582 Long, Charles A. "Extracts from Foreign Publications: The Waxed Paper Process. - Gravelly Skies and Woolly Negatives."

HUMPHREY'S JOURNAL 8, no. 18 (Jan. 15, 1857): 273-275. [From "Photo. Notes."]

L583 Long, Charles A. "Extracts from Foreign Publications: On some Modifications of the Paper Processes." HUMPHREY'S JOURNAL 8, no. 21-22 (Mar. 1 - Mar. 15, 1857): 334-336, 339-343. [Part 1 (Issue no. 22 missing, not indexed).]

LONG, ENOCH see also HISTORY: USA: MO (Van Ravenswaay)

LONG, ENOCH. (1823-1898) (USA)
[Born in Hopkinton, NH, in 1823. Brother of Horatio H. Long. Studied with Robert Cornelius. Began photographing in 1842. The brothers opened a gallery in Augusta, GA, then moved to St. Louis, MO in 1846. They ran that gallery until Horatio's death in 1851, then Enoch continued there until 1865. Then he operated galleries in Alton, Galena and finally in Quincy, IL for many years, where he specialized in making solar prints (enlargements) for the profession. Author of two manuals *Crayon Portraits on Solar Enlargements,* and *Pastel Portraits on Solar Enlargements.* Died on Jan. 3, 1898.]

BOOKS
L584 Long, Enoch. *Crayon Portraits on Solar Enlargements.* Quincy, IL [?]: E. Long [?], n. d., n. p.

L585 Long, Enoch. *Pastel Portraits on Solar Enlargements.* Quincy, IL [?]: E. Long [?], n. d., n. p.

PERIODICALS
L586 Portrait. Woodcut engraving, credited "From a Photograph by E. Long, St. Louis. FRANK LESLIE'S ILLUSTRATED NEWSPAPER 12, (1861) ["Col. Francis P. Blair, Jun., of MO." 12:293 (June 29, 1861): 102.]

L587 Long, E. "How to Idle Profitably." PHOTOGRAPHIC MOSAICS: 1889 25, (1889): 80. [Study Burnett's "Essays on Art," Long's "Crayon Instructor," etc. while waiting for customers.]

L588 "Correspondence: The 'Old Timers.'" PHOTOGRAPHIC TIMES 19, no. 403 (June 7, 1889): 286. [Letter from E. Long, who has worked as a photographer since 1847, suggests that the names and histories of "old-timers" be published at the next P. A. of A. Convention.]

L589 Long, E. "Are We Advancing?" PHOTOGRAPHIC MOSAICS: 1892 28, (1892): 208-210. [Long from Quincy, IL.]

L590 "Editor's Table: Which Is The Older?" WILSON'S PHOTOGRAPHIC MAGAZINE 32, no. 468 (Dec. 1895): 575. [Long from Quincy, IL, writes that he has been in photography for "53 years last June," wonders if there was anyone else who had been working longer.]

L591 Long, E. "Cloud Negatives." PHOTOGRAPHIC MOSAICS: 1897 33, (1897): 140-141.

L592 "Editorial Notes." PHOTOGRAPHIC TIMES 30, no. 2 (Feb. 1898): 81. ["Dec. 10, writes Mr. E. Long, of Quincy, IL, is my 74th birthday, and it was fifty-five years ago last July that I commenced Daguerreotyping."]

L593 "Personal Photographs." WILSON'S PHOTOGRAPHIC MAGAZINE 35, no. 494 (Feb. 1898): 88-89. [Died Jan. 3, 1898. Began as a daguerreotypist in 1842. For many years he had successfully managed a growing business, making enlargements for

the trade. Worked in Quincy, IL. Author of two manuals "Crayon Portraits on Solar Enlargements", and "Pastel Portraits on Solar Enlargements." Active member at old N. P. A.]

LONG, HORATIO H. (d. 1851) (USA)
[Born in Hopkinton, NH. Brother of Enoch Long. Together studied photography with Robert Cornelius. Opened a gallery in Augusta, GA ca. 1842, then moved to St. Louis, MO in 1846. Horatio died in 1851.]

L594 "Obituary." PHOTOGRAPHIC ART JOURNAL 2, no. 4 (Oct. 1851): 254-255. [Obituary notice for H. H. Long (St. Louis, MO), brother of E. Long, with statements of regret by Fitzgibbon, etc.]

L595 "Editorial." DAGUERREAN JOURNAL 2, no. 10 (Oct. 1, 1851): 305. [Note of death of H. H. Long, while visiting his home town of Hopkinton, NH. Partner with his brother in St. Louis, MO.]

L596 Fitzgibbon, J. H. "A Just Tribute to H. H. Long." DAGUERREAN JOURNAL 2, no. 12 (Nov. 1, 1851): 371-372.

LONGWELL, J.
L597 Longwell, J. "Surface - Finishing Photographs." HUMPHREY'S JOURNAL OF PHOTOGRAPHY, AND THE ALLIED ARTS AND SCIENCES 13, no. 22 (Mar. 15, 1862): 341-342.

LOOMAS, J. H. [sic LOOMIS?]
L598 Loomas, J. H. "Progress of the Art." ST. LOUIS PRACTICAL PHOTOGRAPHER 1, no. 1 (Jan. 1877): 7.

LOOMIS, G. H.
L599 Portrait. Woodcut engraving, credited "From a Photograph by G. H. Loomis, Boston." HARPER'S WEEKLY 5, (1861) ["Maj.-Gen. Benjamin F. Butler, U.S.A." Republished on p. 577, Sept. 14, 1861.]

L600 "Editor's Table." PHILADELPHIA PHOTOGRAPHER 4, no. 41 (May 1867): 160. [Mentioned as losing $200 to fight the stamp tax.]

L601 Portrait. Woodcut engraving, credited "From a Photograph by G. H. Loomis." HARPER'S WEEKLY 13, (1869) ["P. S. Gilmore." 13:651 (June 19, 1869): 385.]

L602 Portrait. Woodcut engraving, credited "From a Photograph by G. H. Loomis." FRANK LESLIE'S ILLUSTRATED NEWSPAPER 28, (1869) ["Patrick P. Gilmore; Eben Tourjek, of the Boston Peace Conference." 28:717 (June 26, 1869): 229.]

L603 "Still Another Change." ANTHONY'S PHOTOGRAPHIC BULLETIN 5, no. 3 (Mar. 1874): 120. [Loomis (Boston) retiring, sold his business to D. K. Prescott.]

L604 Loomis, G. H. "Rallying Words." PHILADELPHIA PHOTOGRAPHER 11, no. 127 (July 1874): 196-197. [Support for the N.P.A.]

L605 Loomis, G. H. "Paragraphic Pencillings." ANTHONY'S PHOTOGRAPHIC BULLETIN 5, no. 2, 4-5 (Feb., Apr. - May 1874): 70-71, 148, 177-179. [(Feb.) Photographic Societies. (Apr.) Title is "Studies," and the author discusses the stereo portraits of Fritz Luckhardt and D. W. Butterfield's (Boston) views of NH scenery. (May) Photographic societies, advertising.]

L606 Loomis, G. H. "Business on the Brain." ANTHONY'S PHOTOGRAPHIC BULLETIN 5, no. 6 (June 1874): 218. [Poem.]

L607 Loomis, G. H. "Hereafter." ANTHONY'S PHOTOGRAPHIC BULLETIN 5, no. 8 (Aug. 1874): 292. [Poem by Loomis (East Cambridge, MA).]

L608 Loomis, G. H. "Away From Home." ANTHONY'S PHOTOGRAPHIC BULLETIN 6, no. 9 (Sept. 1875): 273-276. [Describes his vacation trip to White Mountains in New Hampshire, ride up the cog railroad on Mt. Washington, etc. Mentions F. G. Weller, "one of the best stereoscopic delineators in the country."]

L609 Loomis, G. H. "Here's To Your Health." ANTHONY'S PHOTOGRAPHIC BULLETIN 6, no. 11 (Nov. 1875): 337-338.

L610 Loomis, G. H. "Paragraphic Pencillings." ANTHONY'S PHOTOGRAPHIC BULLETIN 6, no. 12 (Dec. 1875): 366-367.

L611 Loomis, G. H. "Paragraphic Pencilling." ANTHONY'S PHOTOGRAPHIC BULLETIN 7, no. 2-11 (Feb. - Nov. 1876): 49-50,81-83, 113-114, 305-307, 337-338. [(Feb.) Insurance and rents.- Are photographers Justly rated? (Mar.) Photographic Ghosts. (Apr.) Evenings with the stereopticon. (From notes, Loomis was ill during the summer of 1876, did not write.) (Oct.) N.P.A. Convention, etc. (Nov.) The Lambertype.]

L612 Loomis, G. H. "'Don't Care' People." ANTHONY'S PHOTOGRAPHIC BULLETIN 7, no. 5 (May 1876): 151-152.

L613 Loomis, G. H. "Nothing to Do." ANTHONY'S PHOTOGRAPHIC BULLETIN 7, no. 10 (Oct. 1876): 304.

L614 Loomis, G. H. "Recollections." ANTHONY'S PHOTOGRAPHIC BULLETIN 9, no. 2-4 (Feb. - Apr. 1878): 49-50, 84-85, 115.

L615 Loomis, G. H. "The Detective in Dixie." ANTHONY'S PHOTOGRAPHIC BULLETIN 17, no. 6 (Mar. 27, 1886): 167. [Letter from Loomis describing his experiences using the small "detective" hand camera while on a trip to Florida. He mentions the Shiras Brothers, from Pennsylvania, making "creditable" landscape views.]

L616 Loomis, G. H. "A Veteran Calls to Boston." ANTHONY'S PHOTOGRAPHIC BULLETIN 20, no. 14 (July 27, 1889): 437-438. [Letter from G. H. Loomis, mentioning his role in the first photographic convention in Boston in 1860s, recommending an active turnout for the forthcoming P. A. of A. annual meeting to be held in Boston.]

LORAIN, LORENZO. (1831-1882) (USA)
L617 Muller, Alan Clark. "Lorenzo Lorain: Pioneer Photographer of the Northwest." AMERICAN WEST 9, no. 2 (Mar. 1972): 20-26. 9 b & w. [Lieut. Lorenzo stationed in the Pacific Northwest from 1856-1861. Experimented with outdoor photography, documented army life, Indians, scenery.]

LORD, THOMAS C.
L618 Lord, Thomas C. "Scraps from Yorkshire." BRITISH JOURNAL PHOTOGRAPHIC ALMANAC 1879 (1879): 118-120.

LORENT, JACOB AUGUST. (1813-1884) (USA, GERMANY)
L619 Waller, Dr. Franz. "Jacob August Lorent, a Forgotten German Travelling Photographer." PHOTOGRAPHIC COLLECTOR 3, no. 1 (Spring 1982): 21-40. 18 b & w. 1 illus. [Lorent born on Dec. 12, 1813 in Charleston, SC. Family emigrated at age four to Mannheim, Germany. Studied at nearby University of Heidelberg, then travelled throughout Europe and the Ear East in 1840s. Published Egypten, Syrien, Mesopotamien und Armenien, (Mannheim: Verlag Tobias Löffler, 1845). Sometime in the early 1850s, he learned photography

and, inheriting wealth, could afford to travel and photograph at will. 1850s, large photos of Venice, then based in Venice, travelled throughout Italy, Spain, North Africa (1858). Returned to Mannheim in 1858, but continued travelling. Egypt 1859/60. Published *Egypten, Alhambra, Tlemsen, Algier*, (Mannheim: Buchdruck von Heinrich Hogrefe, 1861) and *Jersulem und seine Umgebung*, text by Dr. G. Rosen. (Mannheim, 1861). Exhibited widely, received many awards for his architectural views in 1860s. 1863 to Rome, then Palestine in 1864. 1865 travelled throughout Southern Italy. Mid 60's to 1870 photographed the Roman and Gothic architectural remains in Southern Germany, and published three hundred and fifteen of these photographs in four volumes between 1865 and 1870. At age 60 in 1873 he left Mannheim, moved to Meran in the Alps, where he died on July 9, 1894.]

L620 Waller, Franz V. "Jacob August Lorent. Part Two: His Travels In Algera and Egypt 1858 - 1860." PHOTOGRAPHIC COLLECTOR 5, no. 2 (1984): 186-196. 12 b & w. 1 illus. [233 waxed paper negatives, 95 positives on albumen paper of Lorent's work in Algeria and Egypt located in 1984.]

LORRIE, WILLIAM O.
L621 Lorrie, William O., A.M. *Prize Essay on the Stereoscope.* London: London Stereoscopic Co., 1856. 69 pp. 4 l. of plates. [The London Stereoscopic Co. offered a prize of 20 guineas for the best essay on the stereoscope. Judged by Sir David Brewster. Mr. Lorrie, Mathematical Master at Madras College, St. Andrews, was the winner from fourteen entries.]

LOTHIAN, PETER.
L622 Lothian, Peter. "On Printing Photographs on Prepared Painters Canvas and Similar Surfaces." HUMPHREY'S JOURNAL OF PHOTOGRAPHY, AND THE ALLIED ARTS AND SCIENCES 20, no. 22 (June 15, 1869): 339-342.

LOUD.
L623 Portraits. Woodcut engravings, credited "Photographed by Loud, 182 Bowery." FRANK LESLIE'S ILLUSTRATED NEWSPAPER 10, (1860) ["The late Gustavus A. Rate." 10:248 (Aug. 25, 1860): 222.]

L624 Portrait. Woodcut engraving, credited "From a Photograph by Loud." HARPER'S WEEKLY 9, (1865) ["Elisha Kingsland, New York, NY Fire Dept." 9:451 (Aug. 19, 1865): ***.]

LOVE, J. W.
L625 "Editor's Table." PHILADELPHIA PHOTOGRAPHER 4, no. 38 (Feb. 1867): 64. [Stereos from J. W. Love (Portage City, WI).]

LOVEJOY & FOSTER. (CHICAGO, IL)
L626 Portrait. Woodcut engraving, credited "Photographed by Lovejoy & Foster, of Chicago." FRANK LESLIE'S ILLUSTRATED NEWSPAPER 38, (1874) ["Mr. Algernon C. F. Sartoris." 38:975 (June 6, 1874): 197.]

L627 "Chicago, Ill. - Bookseller's Row, State Street, South from Washington Street. - Photographed by Lovejoy & Foster." FRANK LESLIE'S ILLUSTRATED NEWSPAPER 38, no. 976 (June 13, 1874): 220. 1 illus. [Urban view.]

LOVEJOY, EDWARD see also LOVEJOY & FOSTER.

LOVEJOY, EDWARD.
L628 "General Grant Taking a Drive Through South Park. - From a Photograph by E. Lovejoy." FRANK LESLIE'S ILLUSTRATED NEWSPAPER 49, no. 1261 (Nov. 29, 1879): 217. 1 illus. [Outdoor

scene, with carriage crossing a small bridge in a park in Chicago, IL, with people walking, etc.]

LOVEJOY, HENRY C. (TRENTON, NJ)
L629 Portrait. Woodcut engraving, credited "Photographed by Lovejoy, of Trenton, NJ." FRANK LESLIE'S ILLUSTRATED NEWSPAPER 38, (1874) ["Hugh F. MacDermott." 38:977 (June 20, 1874): 236.]

L630 Portraits. Woodcut engravings credited "From a photograph by H. C. Lovejoy, Trenton, N. J." FRANK LESLIE'S ILLUSTRATED NEWSPAPER 43, (1877) ["Hon. John MacPherson, Sen. of NJ." 43:1116 (Feb. 17, 1877): 397.]

LOVELL, JOHN L. (AMHERST, MA)
BOOKS
L631 Hitchcock, Edward. *Ichnology of New England: A Report on the Sandstone of the Connecticut Valley,* Especially Its Fossil Footmarks; made to the Government of the Commonwealth of Massachusetts. Boston: William White, 1858. xii, 220 pp. 60 l. of plates. illus. [Many of the plates are described as "Ambrotype sketch of slab no." such and such. They are lithographs, possibly from photographs.]

L632 United States Naval Academy, Annapolis. *Autographs and Photographs, Graduating Class 1861: U.S. Naval Academy;* J. L. Lovell, Photographer. s. l. [Amherst, MA ?]: Lovell, 1861. n. p. 48 l. of plates. b & w. [Original photos.]

L633 Hitchcock, Edward. *Supplement to the Ichnology of New England; A Report to the Government of Massachusetts in 1863.* Boston: Wright & Potter, 1865. x, 96 pp. 20 l. of plates. b & w. [Original photos, tipped-in, on seven plates. "The Photographs are executed by J. L. Lovell, of Amherst, who has attained a high degree of efficiency in this department of photography."]

PERIODICALS
L634 "Photography and Its Applications." HUMPHREY'S JOURNAL 8, no. 17 (Jan. 1, 1857): Additional section; 8. [Letter from J. L. Lovell (Amherst, MA); plus description of several of his photographs.]

L635 "J. L. Lovell." HUMPHREY'S JOURNAL OF PHOTOGRAPHY, AND THE ALLIED ARTS AND SCIENCES 20, no. 18 (Feb. 15, 1869): 287. [Note that Lovell, "one of the oldest photographers in the country." visited the editor, showed him mezzotints.]

L636 Portrait. Woodcut engraving, credited "From a Photograph by J. L. Lovell." FRANK LESLIE'S ILLUSTRATED NEWSPAPER 48, (1879) ["W. S. Clark, Pres. of the Woodruff Expedition." 48:1242 (July 19, 1879): 337.]

L637 Todd, Prof. David P. "Forty-Six Years Under the Skylight." AMERICAN ANNUAL OF PHOTOGRAPHY AND PHOTOGRAPHIC TIMES ALMANAC FOR 1896 (1896): 28-33. 1 b & w. 4 illus. [Lovell from Amherst, MA, worked as daguerreotypist in Ware, VT in 1849, then 3 years in Brattleboro, 1854 to Boston to study photography with Whipple & Black, worked in a variety of situations, in 1882 chief photographer for the Lick Observatory expedition to observe the transit of Venus, manufactured dry-plate. Lick Observatory trips to Japan 1887, Africa 1889-90. Worked for a number of colleges in N.E.]

L638 Lovell, J. L. "An All-Around Developer." PHOTOGRAPHIC MOSAICS: 1897 33, (1897): 196-198. 1 b & w. [Studio portrait. "An Every-Day Subject."]

L639 "On the Ground Glass." WILSON'S PHOTOGRAPHIC MAGAZINE 34, no. 492 (Dec. 1897): 530. [Announcement of golden wedding anniversary of Mr. and Mrs. J. L. Lovell. Brief biography of Lovell. Began as a daguerreotypist in 1849 at Ware, MA. Associated with Whipple & Black in 1850s, "afterward undertook much important astronomical and geological photographic work for the illustration of certain publications of the Massachusetts and national governments. "... one of the pioneers in the manufacture of dry plates."]

LOW, PETER.
L640 Low, Peter. "A Few Experiences in the Studio." PHOTOGRAPHIC TIMES 7, no. 80 (Aug. 1877): 178-179. [Read before the Edinburgh Photographic Society.]

LOWE.
L641 Lowe. "Heliographic Engraving." AMERICAN JOURNAL OF PHOTOGRAPHY AND THE ALLIED ARTS & SCIENCES n. s. vol. 7, no. 20 (Apr. 15, 1865): 478-479. [Read before the Fr. Photo. Soc.]

LOYDREAU, EDOUARD. (1820-1905) (FRANCE)
L642 "Biographical Notes on a Number of Photographers Published by Blanquart-Evrard." CAMERA (LUCERNE) 57, no. 12 (Dec. 1978): 32, 41-42. [Benecke, Claine, DuCamp, Fortier, Greene, Le Secq, Loydreau, Marville, Regnault, Robert, Salzmann, Stewart, Sutton, and Tenison. Loydreau was a physician and the mayor of Chagny, a small town near Chalon-sur-Saône. Interested in archeology and in photography. His landscapes and views of rural life were published in *Études photographiques*. A collection of his archeological photographs, taken around 1860, is held at Autun.]

LUCAS & TUCK. (LONDON, ENGLAND)
L643 Portrait. Woodcut engraving credited "From a photograph by Lucas & Tuck, Haymarket." ILLUSTRATED LONDON NEWS 74, (1879) ["Late Joseph Nash, artist." 74:2064 (Jan. 4, 1879): 21.]

LUCAS BROTHERS.
L644 "A 'Batallion Twenty' of the West Middlesex Rifle Volunteers." ILLUSTRATED LONDON NEWS 43, no. 1224/1225 (Oct. 3, 1863): 345-346. 1 illus. ["...from a photograph by Messrs. Lucas Brothers, of St. John's Wood Road."]

LUCAS, ARTHUR.
L645 Kinloch, Alexander. *Large Game Shooting in Thibet and the North West,*...Illustrated by Photographs taken by Arthur Lucas of Wigmore Street. London: Harrison & Sons, 1869. 68 pp. 12 l. of plates. 12 b & w. [Original photos, of mounted herds of game animals.]

LUCE.
L646 "Exterior View of Fort Moultrie, on Sullivan's Island, in the Harbor of Charleston, S. C., as It Appeared Previous to the Evacuation." and "View of the Ramparts of Fort Moultrie, Charleston Harbour, S. C. - From a photograph by Luce, Esq." FRANK LESLIE'S ILLUSTRATED NEWSPAPER 11, no. 267 (Jan. 5, 1861): 104. 2 illus. [Two views, structures, troops.]

LUCKHARDT, FRITZ. (1843-1894) (GERMANY, AUSTRIA)
[Born on March 17 in Kassel. Worked in a soap factory in Hannover. Learned photography in the early 1860s. Opened his first studio in Vienna in 1867. From 1869 to 1890 he worked for the journal *Photographische Correspondenz*. From 1871 to 1894 he was the Secretary of the Photographische Gesellschaft, the Vienna Photographic Society. In 1877 he became the Photographer to the Court of Austria. Died Nov. 19, 1894 in Vienna.]

L647 Luckhardt, Fritz. "The Background." ANTHONY'S PHOTOGRAPHIC BULLETIN 2, no. 10 (Oct. 1871): 317-318. [From "London Photo. News."]

L648 Portrait. Woodcut engraving, credited "From a Photograph by Luckhardt, Vienna." FRANK LESLIE'S ILLUSTRATED NEWSPAPER 35, (1872) ["Anton Rubinstien, pianist." 35:888 (Oct. 5, 1872): 60.]

L649 Portraits. Woodcut engravings credited "From a photograph by Fritz Luckhardt." ILLUSTRATED LONDON NEWS 62, (1873) ["Baron Schwarz-Senborn." 62:1754 (Apr. 12, 1873): 336.]

L650 "Our Picture." PHILADELPHIA PHOTOGRAPHER 10, no. 114 (June 1873): frontispiece, 187-188. 1 b & w. [Portrait.]

L651 Portraits. Woodcut engravings credited "From a photograph by Fritz Luckhardt." ILLUSTRATED LONDON NEWS 63, (1873) ["Mr. Philip Cunliffe Owen." 63:1784 (Nov. 8, 1873): 445.]

L652 "Our Picture." PHILADELPHIA PHOTOGRAPHER 11, no. 121 (Jan. 1874): frontispiece, 2. 1 b & w. [Studio portrait.]

L653 Wilson, Edward L. "Views Abroad and Across. Pt. 6." PHILADELPHIA PHOTOGRAPHER 11, no. 126 (June 1874): 170-174. 2 illus. [Wilson visited many studios in extended visit to Europe. Luckhardt's studio in Vienna, Austria. The illustrations are two diagrams of Luckhardt's studio.]

L654 "Editor's Table: Obituary." WILSON'S PHOTOGRAPHIC MAGAZINE. 32, no. 457 (Jan. 1895): 44. [Died Nov. 29th. Vienna.]

L655 Wilson, Edward L. "Fritz Luckhardt." WILSON'S PHOTOGRAPHIC MAGAZINE. 32, no. 459 (Mar. 1895): 113-115. 1 illus. [Born Cassel, Germany. Briefly to England, then to Vienna. In 1867 began his career as a photographer. In 1871 Secretary of the Photographic Society of Vienna.]

LUKENBACH, W. S.
L656 Lukenbach, W. S. "Lukenbach's Sensitizing Apparatus." HUMPHREY'S JOURNAL OF PHOTOGRAPHY, AND THE ALLIED ARTS AND SCIENCES 20, no. 25 (Sept. 15, 1869): 389-390.

LUKS. (VIENNA, AUSTRIA)
L657 Portrait. Woodcut engraving credited "From a photograph by Luks." ILLUSTRATED LONDON NEWS 75, (1879) ["Archduchess Christina of Austria." 75:2111 (Nov. 29, 1879): 496.]

LUMPKIN, E. S.
L658 "Virginia. - The Terrible Calamity at the State Capitol. City of Richmond, Virginia, Wednesday, April 27, 1870 - Exterior View of the Building -Bringing Out the Wounded, the Dying and the Dead. - From a Photograph by E. S. Lumpkin." FRANK LESLIE'S ILLUSTRATED NEWSPAPER 30, no. 763 (May 14, 1870): 129. 1 illus.

LUPLAN & WULFF.
L659 "The Fire at Chicago." ILLUSTRATED LONDON NEWS 59, no. 1679 (Nov. 18, 1871): 471-473. 5 illus. ["...were drawn from the photographs taken by Messrs. Luplan & Wulff a few days after the conflagration."]

LYMAN, J. B.
L660 Lyman, J. B. "The Stereoscope." PHILADELPHIA PHOTOGRAPHER 7, no. 84 (Dec. 1870): 402-404. 1 illus.

LYNCH.

L661 Lynch. "Fourth Annual Meeting and Exhibition of the N. P. A. in St. Louis, Mo., May 1872: Photography in Texas." PHILADELPHIA PHOTOGRAPHER 9, no. 102 (June 1872): 213-215.

LYNCH, JOHN ROY. (1847-1939) (USA)

[In 1847 John Roy Lynch was born into slavery in Louisiana. After emancipation he attended night school, and worked as a photographer's assistant, then as a photographer. Then he went into politics and was elected to the House of Representatives from Mississippi in the 1870s. Died in 1939.]

BOOKS

L662 Lynch, John Roy. *Reminiscences of an Active Life; the autobiography of John Roy Lynch.* Edited and with an introduction by John Hope Franklin. Chicago: University of Chicago Press, 1970. xlii, 520 pp. illus. ["In the Photography Business," on pp. 39-43.]

PERIODICALS

L663 "Matters of the Month." PHOTOGRAPHIC TIMES 12, no. 137 (May 1882): 181-182. ["Mr. Lynch, the colored Member of Congress, was employed at seventeen as a water boy in a photographic gallery in Natchez... After two years he took charge of a gallery as a practical photographer and managed it for several years... Since 1869, that is to say, since he was twenty-one years old - he has been actively engaged in politics... started as a slave, learned to read at age 13, etc."]

LYON, E. D., CAPTAIN. (GREAT BRITAIN, INDIA)

BOOKS

L664 Lyon, E. D. *Note to Accompany a Series of Photographs... to Illustrate the Ancient Architecture of Southern India.* [Edited by J. Fergusson.] s. l., s. n., 1870. n. p.

PERIODICALS

L665 "Place of Death and Burial of Lord Elgin." ILLUSTRATED LONDON NEWS 44, no. 1242 (Jan. 23, 1864): 80. 2 illus. ["...from photographs taken by Mr. G. D. Lyon." Dhurumsalla, India.]

L666 "Captain Lyon in India." ANTHONY'S PHOTOGRAPHIC BULLETIN 1, no. 10 (Nov. 1870): 189-191. [Description of the work of Capt. Lyon amid the temples of Southern India.]

L667 "Editor's Table." PHILADELPHIA PHOTOGRAPHER 7, no. 84 (Dec. 1870): 428. [526 photos (11" x 14") of the ancient architecture of Southern India by Capt. Lyon. Published by Marion & Co., London.]

L668 "Captain Lyon in India - (Concluded)." ANTHONY'S PHOTOGRAPHIC BULLETIN 2, no. 3 (Mar. 1871): 65-68.

LYSAGHT, J. D., LIEUT. (GREAT BRITAIN, INDIA)

L669 Lysaght, J. D., Lieut. "Notes on Gelatino - Bromide, with a New Method of Development." BRITISH JOURNAL PHOTOGRAPHIC ALMANAC 1877 (1877): 90-93. [Lysaght was in the 102nd Royal Madras Fusiliers.]

L670 Lysaght, Lieut. J. D. "Gelatino - Bromide at Home and Abroad." BRITISH JOURNAL PHOTOGRAPHIC ALMANAC 1878 (1878): 93-95. [Lysaght in Royal Madras Fusiliers. "My first experience with gelatine plates out of England was at Gibraltar, where I happened to be quartered during the early part of last year." (Feb. to June)]

L671 Lysaght, Lieut. J. D. "A New Method of Preparing Gelatine Emulsion and Pellicle." BRITISH JOURNAL PHOTOGRAPHIC ALMANAC 1879 (1879): 58-59.

LYTE, FARNHAM MAXWELL. (1828-1906) (GREAT BRITAIN)

[Born in England in 1828. About 1853 ill health forced him to live in the south of France for many years. Worked with dry collodion and honey collodion processes. In early 1850s he practiced double printing of cloud negatives into the burned out skies of his landscapes. A founding member of the Société français de Photographie. Published many technical papers in the journals, exhibited throughout 1850s and 1860s. Apparently stopped photographing about 1870. Died in 1906.]

L672 Lyte, F. Maxwell. "On Collodion, Positive Paper, &c." PHOTOGRAPHIC AND FINE ART JOURNAL 7, no. 8 (Aug. 1854): 243-244. [From "J. of Photo. Soc."]

L673 Lyte, F. Maxwell. "On Collodion, Positive Paper, Etc." HUMPHREY'S JOURNAL 6, no. 8 (Aug. 1, 1854): 123-125.

L674 Lyte, F. Maxwell. "Mr. Lyte on the Collodion Process." HUMPHREY'S JOURNAL 6, no. 23 (Mar. 15, 1855): 375-376.

L675 Lyte, F. Maxwell. "Extracts From Foreign Publications: On a New Method of Printing." HUMPHREY'S JOURNAL 7, no. 23 (Apr. 1, 1856): 367-368. [From "J. of Photo. Soc., London."]

L676 Lyte, F. Maxwell. "Mr. Maxwell Lytes' New Process of Printing." HUMPHREY'S JOURNAL 8, no. 7 (Aug. 1, 1856): 110-112.

L677 Lyte, F. Maxwell. "On a Process of Coloring Positives." HUMPHREY'S JOURNAL OF PHOTOGRAPHY, AND THE ALLIED ARTS AND SCIENCES 10, no. 20 (Feb. 15, 1859): 313-315. [From "J. of Photo. Soc., London."]

L678 "Maxwell Lyte's Gold Toning Formula." HUMPHREY'S JOURNAL OF PHOTOGRAPHY, AND THE ALLIED ARTS AND SCIENCES 11, no. 3 (June 1, 1859): 46-47. [From "Liverpool Ph. J."]

L679 Lyte, F. Maxwell. "Remedy for the Browning of Prints." HUMPHREY'S JOURNAL OF PHOTOGRAPHY, AND THE ALLIED ARTS AND SCIENCES 11, no. 19 (Feb. 1, 1860): 304.

L680 Lyte, Maxwell. "On Photographic Printing." HUMPHREY'S JOURNAL OF PHOTOGRAPHY, AND THE ALLIED ARTS AND SCIENCES 13, no. 2 (May 15, 1861): 27-29. [From "Br. J. of Photo."]

L681 Lyte, F. Maxwell, M.A., F.C.S. "On Some of the Difficulties which present themselves in the Practice of Photography and the Means of Avoiding Them." AMERICAN JOURNAL OF PHOTOGRAPHY AND THE ALLIED ARTS & SCIENCES n. s. vol. 5, no. 11 (Dec. 1, 1862): 242-248. [From "Photo. News."]

L682 "Modification of the Collodio-Albumen Process." HUMPHREY'S JOURNAL OF PHOTOGRAPHY, AND THE ALLIED ARTS AND SCIENCES 19, no. 8 (Aug. 15, 1867): 117-119. [Read to French Photographic Society.]

L683 "Obituary of the Year: F. Maxwell Lyte (Mar. 4, 1906)" BRITISH JOURNAL PHOTOGRAPHIC ALMANAC 1907 (1907): 625. [F. Maxwell Lyte only connected with photography from 1854 to 1870. Invented "honey process," published in "Notes and Queries" in June 17, 1854. A chemical engineer, an Associate of the Institution of Civil Engineers and an honorary member of the Royal Photographic Society.]

MAC, MACK, MC, M' [ALL INTERFILED]

MCADAM, J. P.
M1 McAdam, J. P. "On Glass Transparencies." HUMPHREY'S JOURNAL OF PHOTOGRAPHY, AND THE ALLIED ARTS AND SCIENCES 12, no. 2 (May 15, 1860): 31-32. [From "Br. J. of Photo."]

MCALLISTER.
M2 Sellers, Coleman. "Foreign Correspondence." BRITISH JOURNAL OF PHOTOGRAPHY 10, no. 196 (Aug. 15, 1863): 336. [Sellers discusses the carte-de-viste of the Negro slave Gordon, published by McAllister in New Orleans, LA. Mentions Moran's photos of military hospital at Chestnut Hill, etc.]

MCANDREW, JOHN. (GREAT BRITAIN, SPAIN)
M3 McAndrew, John (Seville, Spain) "On Accessories in Landscape." BRITISH JOURNAL PHOTOGRAPHIC ALMANAC 1878 (1878): 165-168.

MACANDREWS.
M4 Portrait. Woodcut engraving credited "From a photograph by MacAndrews." ILLUSTRATED LONDON NEWS 36, (1860) ["Madame Enderssohn." 36:* (Jan. 21, 1860): 61.]

M5 Portrait. Woodcut engraving credited "From a photograph by MacAndrews." ILLUSTRATED LONDON NEWS 40, (1862) ["Mdlle. Trebelli, musician." 40:* (June 28, 1862): 654.]

MACBRIDE. (ALLEGHENY, PA)
M6 Portrait. Woodcut engraving, credited "From a Photograph by MacBride, Allegheny, Pa. FRANK LESLIE'S ILLUSTRATED NEWSPAPER 32, (1871) [L. C. Butter, "the Boy Preacher." 32:830 (Aug. 26, 1871): 397.]

MCBRIDE, HENRY. (1831-1884) (USA)
M7 "Note." PHOTOGRAPHIC TIMES 15, no. 172 (Jan. 2, 1885): 10. [Note that "Henry McBride, formerly a well-known photographer in Albany, NY." died 27th Dec. 1884 at age 53.]

MCCABE, M. D.
M8 "Political War in Arkansas. - The Baxter-Brooks Imbroglio.- The Capitol Building at Little Rock Defended by the Troops of Pseudo-Governor Brooks. - From a Photograph by M. D. McCabe." FRANK LESLIE'S ILLUSTRATED NEWSPAPER 38, no. 970 (May 2, 1874): 117. 1 illus. [View, with buildings, troops in the street, probably enhanced by the engraver.]

MCCARTEE. (NINGPO, CHINA)
M9 "American vs. English Chemicals." HUMPHREY'S JOURNAL OF PHOTOGRAPHY, AND THE ALLIED ARTS AND SCIENCES 12, no. 6 (July 15, 1860): 81. [A Dr. McCartee, of Ningpo, China wrote a letter to E. Anthony praising his photographic chemicals.]

MCCLEES & GERMON.
M10 "The Burd Monument. Daguerreotyped by McClees and Germon: Crystalotyped by Whipple." PHOTOGRAPHIC AND FINE ART JOURNAL 7, no. 6 (June 1854): frontispiece, 190. 1 b & w. [Original photograph, tipped-in.]

MCCLEES, JAMES E. see also MCCLEES & GERMON; VANNERSON, JAMES.

MCCLEES, JAMES EARLE. (1821-1887) (USA)
BOOKS
M11 McClees, James E. *Elements of Photography; Being a Brief Detail of the Principles upon which the Different Styles of Heliographic Pictures are Produced.* Philadelphia: J. E. M'Clees, 1855. 32 pp.

M12 M'Clees, James E. *M'Clees' Gallery of Photographic Portraits of the Senators, Representatives and Delegates of the Thirty-fifth Congress, photographed and published by M'Clees & Beck.* Washington, DC: M'Clees & Beck, 1861 [?]. vi, 6 pp. l. of plates. 312 b & w. [312 salt paper prints forming the book's leaves. Julian Vannerson named on p. 3 as an assistant in making the photographs.]

PERIODICALS
M13 "The Fairmount Waterworks." PHOTOGRAPHIC AND FINE ART JOURNAL 8, no. 6 (June 1855): frontispiece, 189-190. 1 b & w. [Original photographic print, tipped-in.]

M14 "Hon. James A. Pearce, U. S. Senator, Md." BALLOU'S PICTORIAL DRAWING-ROOM COMPANION [GLEASON'S] 16, no. 409 (Apr. 23, 1859): 257. 1 illus.

M15 Portraits. Woodcut engravings, credited "Photographed by M'Lees, [sic McClees] of Washington, D. C." FRANK LESLIE'S ILLUSTRATED NEWSPAPER 12, (1861) ["Col. Corcoran, 69th Regiment of N.Y.S.M." 12:291 (June 15, 1861): 74. "Andrew Gregg Curtin, Gov. of PA." 12:295 (July 13, 1861): 134.]

M16 Portraits. Woodcut engravings, credited "From a Photograph by James E. McClees, Philadelphia." HARPER'S WEEKLY 6, (1862) ["Brig.-Gen. Silas Casey, U.S.A." 6:288 (July 5, 1862):421. "Brig.-Gen. George A. McCall." 6:290 (July 19, 1862): 449. "Brig.-Gen. Fitz-John Porter." 6:290 (July 19, 1862): 449.]

M17 Portrait. Woodcut engraving, credited "From a Photograph by James E. McClees." HARPER'S WEEKLY 7, (1863) ["Maj.-Gen. John F. Reynolds." 7:342 (July 18, 1863): 453.]

M18 Portrait. Woodcut engraving, credited "From a Photograph by James E. McClees." NEW YORK ILLUSTRATED NEWS 8, (1863) ["Maj.-Gen. John F. Reynolds." 8:194 (July 18, 1863): 192.]

M19 Portrait. Woodcut engraving, credited "From a Photograph by M'Clees." FRANK LESLIE'S ILLUSTRATED NEWSPAPER 28, (1869) ["Hon. Andrew G. Curtin, US Minister to Russia." 28:709 (May 1, 1869): 101.]

M20 "Obituary: James E. McClees." PHOTOGRAPHIC TIMES 17, no. 297 (May 27, 1887): 273. ["Died last week at his home in Philadelphia in the 67th year of his age. McClees was the first after Langenheim and Whipple to make paper photos in this country."]

M21 "Obituary." PHILADELPHIA PHOTOGRAPHER 24, no. 300 (June 18, 1887): 373-374. [James E. McClees born in Chester County, PA, in 1821. Moved to Philadelphia at age eight. First experiences in daguerreotypy occurred in 1844, with M. Simons, Philadelphia. Formed a partnership with W. L. Germon in 1846, McClees & Germon, which lasted for eight years. In 1854 McClees travelled to Boston to study paper printing with James W. Black. McClees travelled to Europe in 1855 and returned with Leonard Fauderbeck, who painted the first life-sized photographs in oil made in the USA. From 1855 to 1867 McClees operated a gallery in several locations in Philadelphia, then sold out to William Bell, one of his employees. McClees left photography, became an art dealer, and became one of

the best collectors and dealers in paintings in the USA. He continued this profession until his death.]

M22 "Northlights: James E. McClees: A Brief Biography." NORTHLIGHT (JOURNAL OF THE PHOTOGRAPHIC HISTORICAL SOCIETY OF AMERICA) 3, no. 3 (Summer 1976): 15. [Reprinted from "Philadelphia Photographer" (1887).]

M23 Glenn, James R. "The 'Curious Gallery': The Indian Photographs of the McClees Studio in Washington, 1857 - 1858." HISTORY OF PHOTOGRAPHY 5, no. 3 (July 1981): 249-262. 13 b & w. [James E. McClees, of Philadelphia, opened a branch studio in Washington, DC in October 1857. There were over ninety delegates from thirteen Indian tribes in Washington in 1857-58. Julian Vannerson and Samuel A. Cohner probably took approximately sixty portraits for the McClees studio, although these images were later attributed to Antonio Zeno Shindler, who had acquired the photographs in the early 1860s.]

MCCORKINDALE, HUGH. (QUEBEC, CANADA)
M24 "Editor's Table." PHILADELPHIA PHOTOGRAPHER 4, no. 47 (Nov. 1867): 368. [Stereo views of Quebec by Hugh McCorkindale, 39 St. John Street, Quebec, Canada.]

MCCORMAC, W. J. (CLARKSVILLE, TN)
M25 "Great Floods in Tennessee." ILLUSTRATED LONDON NEWS 69, no. 1814 (May 30, 1874): 511, 513. 4 illus. ["We are indebted to Dr. D. F. Wright, of that town, and to his neighbor, Mr. MacCormac, the skillful photographer, for the four views."]

M26 "Tennessee. - Monument Erected, October 24th, to the Memory of Governor Blount, at Clarksville. - From a Photograph by W. J. McCormac, Clarksville." FRANK LESLIE'S ILLUSTRATED NEWSPAPER 45, no. 1156 (Nov. 24, 1877): 197. 1 illus. [View.]

MCCORMICK, CHARLES S.
M27 McCormick, Charles S. "Working a South Light." PHILADELPHIA PHOTOGRAPHER 10, no. 111 (Mar. 1873): 70. [McCormick in Philadelphia, PA.]

MACCOSH, JOHN. (1805-1885) (GREAT BRITAIN, INDIA, BURMA)
BOOKS
M28 Russell-Jones, Peter. "John MacCosh: Photographer of the 2nd Sikh 1848-9 and the 2nd Burma War 1852-3," on pp. *-* in: The Army in India: 1850 - 1914. A Photographic Record. Foreword by Field-Marshal Sir Gerald Templer. Introduction by Field-Marshal Sir Claude Auchinleck. London: Hutchinson of London, published in association with the National Army Museum, 1968. n. p. b & w. illus. [John MacCosh born Mar. 5, 1805. Entered the Bengal Establishment in 1831 as an Assistant Surgeon. Served on the South East Frontier against the Kols in 1832-33. Contracted fever, while on sick leave his ship was wrecked. In 1843-44 on another campaign in India. Probably learned photography around 1844-1845. When the 2nd Sikh War broke out in 1848, he served again as a field surgeon, this time also photographing his fellow officers, making small calotype portraits. In 1852, during the 2nd Burma War MacCosh served with the 5th Battery Bengal Artillery. By this point he had improved his photography and he made a number of larger calotype views and battle aftermath views as well as portraits. Approximately 310 photos remain, approximately 50 views and the remainder portraits of officers, their wives and families, servants, troops and natives. Died Jan. 16, 1885.]

PERIODICALS
M29 McKenzie, Ray. "'The Laboratory of Mankind': John McCosh and the Beginnings of Photography in British India." HISTORY OF PHOTOGRAPHY 11, no. 2 (Apr. - June 1987): 109-118. 10 b & w. [John McCosh began his career as an assistant surgeon of the Bengal Medical Establishment in 1831. He was interested in ethnography and topography. Wrote several volumes of travelogues by 1837. Returned to Edinburgh in early 1840s to study medicine, back to serve with the 31st Bengal Native Infantry in 1843. Began to photograph around 1844. Worked through 1850s. Served in, and photographed, the 2nd Sikh war in 1848-49, and in the Burma conflict. Retired from the army and left India in 1857, and apparently gave up photography about the same time.]

MCCLURE, JAMES.
M30 Hamilton, John R. New Brunswick and Its Scenery; A Tourist's and Angler's Guide to the Province of New Brunswick. St. John, N. B.: J. & A. McMillan, 1874. n. p. 10 b & w. [Eight original photos by James McClure, two original photos by James Notman.]

MCCULLOCH, CAPT. (GREAT BRITAIN)
M31 The History of the Yorkshire Fine Art and Industrial Exhibition, York; Opened July 24th, 1866 - Closed October 31st, 1866. Compiled from the York Herald. York: s. n., 1867 ? 406 pp. 23 b & w. [Original photographs by Capt. McCulloch.]

MCDONALD, J. M., SERGEANT see also ROYAL ENGINEERS.

MCDONALD, J. M., SERGEANT. (ROYAL ORDNANCE SURVEY)
BOOKS
M32 Photographic Views of Netley Abbey: 12 views of Netley Abbey preceded by an introductory letter and a plan of Netley Abbey photozincographed at the Ordnance Survey Office, Southampton, Director Col. Sir Henry James, R.E., F.R.S. Southampton: Ordnance Survey, 1864. n. p. 12 l. of plates. [Photographs by Sergeant J. McDonald.]

M33 Wilson, Captain Charles William. Ordnance Survey of Jerusalem. Published by Authority of the Lords Commissioners of Her Majesty's Treasury. London: H. M. Stationary Office, G. E. Eyre and W. Spottisewoode, Printers, 1865. 3 vol. pp. 81 b & w. [Text vol., atlas vol., and a volume of photographs. Photograph volume contains iv pp., followed by 43 sheets of photographs, each sheet usually containing 2 photographs. Most are by Sgt. J. McDonald of the Royal Engineers. A few by P. Bergheim.]

M34 Wilson, Captain Charles William and H. S. Palmer, R.E. Ordnance Survey of the Peninsula of Sinai. London: H. M. Stationary Office, G. E. Eyre and W. Spottiswoode, Printers, 1869. 5 vol. pp. 300 b & w. 20 plates in vol. 1 illus. [Published in 3 parts. Part I. Account of the Survey (with Illustrations), Part II. Maps, Plans, and Sections; Part III. Photographic Views (In 3 Vols.) Vol. 1, Suez to Mount Sinai (Jebel Musá). Vol. 2 Wády Feirán and Mount Serbál. Vol. 3., Sinaitic and Egyptian Inscriptions. "The non-commissioned officers selected were Colour-Serjeant (now Serjeant-Major) McDonald, R.E., who had previously been employed on the Survey of Jerusalem, and who is not only a skillful surveyor but also a most excellent photographer, as the 300 photographic views taken by him in the Peninsula of Sinai amply testify." p. 2.]

M35 James, Colonel Sir Henry. Notes on the Great Pyramids of Egypt, and the Cubits Used in Its Design. Southampton: Privately printed., 1869. 13 pp. 6 l. of plates. 6 b & w. [Photographs by Sergeant J. McDonald.]

PERIODICALS

M36 Fort, Paul. "Ordinance Survey work in the Middle East during the 1860s." PHOTOGRAPHIC COLLECTOR 2, no. 2 (Summer 1981): 58-67. 9 b & w. [Ordinance Survey of the Peninsula of Sinai, 1868. The British Royal Engineers party provided detailed written and pictorial accounts of the history, geography, topography, ethnography, geology, botany, zoology, etymology and orthography of the Sinai Peninsula. The chief photographer was Colour-Sergeant McDonald, R.E. 3 volumes of "Ordinance Survey of the Peninsula of Sinai," by Captains C. W. Wilson and H. S. Palmer. Southampton: Ordinance Survey Office, 1869, were published. The article includes nine stereo slides from the Survey, an account of its history, and lists of the photographs in the volumes. It also includes a list of other photographs taken around Jerusalem - possibly during an earlier survey in 1864 by Captain C. W. Wilson and Colour-Sergeant McDonald.]

MCDONALD, JOSEPH N. (d. 1894) (ALBANY, NY)

M37 Portrait. Woodcut engraving, credited "From a Photograph by McDonald, of Albany." FRANK LESLIE'S ILLUSTRATED NEWSPAPER 46, (1878) ["Hon. Samuel Hand, NY." 46:1189 (July 13, 1878): 320.

M38 "Notes and News: Joseph N. McDonald." PHOTOGRAPHIC TIMES 25, no. 675 (Aug. 24, 1894): 134. [Brief notice of McDonald's death. Photographed in Albany in early 1860's. Then McDonald & Sterry, later sold supplies.]

MCDONELL, DONALD. (BUFFALO, NY)

M39 "McDonell." DAGUERREAN JOURNAL 1, no. 11 (Apr. 15, 1851): 339. [From "Buffalo [NY] Commercial Advertiser." General description of his practice.]

M40 "Daguerreotypes in Buffalo." DAGUERREAN JOURNAL 2, no. 5 (July 15, 1851): 144. [From "Buffalo [NY] Express."]

M41 "Gossip." PHOTOGRAPHIC ART JOURNAL 2, no. 2 (Aug. 1851): 127. [From Buffalo, NY newspaper.]

M42 "Gossip." PHOTOGRAPHIC ART JOURNAL 4, no. 1 (July 1852): 67. ["Mr. McDonell presented the State Society with a full plate daguerreotype of the city of Buffalo."]

M43 "Reply to 'Justice.'" PHOTOGRAPHIC AND FINE ART JOURNAL 7, no. 5 (May 1854): 159-160. [McDonell was from Buffalo, NY.]

M44 "Personal and Fine Art Intelligence: McDonell's New Daguerrean Rooms." PHOTOGRAPHIC AND FINE ART JOURNAL 8, no. 2 (Feb. 1, 1855): 64. [From "Buffalo Courier."]

MACFARLANE, DONALD HORNE. (d. 1904) (GREAT BRITAIN, INDIA)

M45 Ricketts, Jane. "D. H. MacFarlane: A New Name in Indian Photography." PHOTOGRAPHIC COLLECTOR 3, no. 1 (Spring 1982): 86-90. 6 b & w. [Donald MacFarlane, an East India Merchant and amateur photographer in India from the 1860s until 1863, when he returned to England. Continued photography as a hobby and was a member of the Royal Photographic Society.]

MCINTIRE, C. A. (d. 1891) (USA)

M46 "Notes and News: Dead in His Tent." PHOTOGRAPHIC TIMES 21, no. 493 (Feb. 27, 1891): 107. ["Selma, Ala., Feb. 13 - A woman calling for her pictures today found photographer C. A. McIntire dead on the floor of his tent, used as a gallery, where he had probably died two days ago in great agony, from the effects of morphine. He was

looked upon as a queer character and was somewhat demented at times from the morphine habit."]

MCINTIRE, HENRY M. (1856-1880) (USA)

M47 "Obituary: Henry M. McIntire, M.E." PHILADELPHIA PHOTOGRAPHER 17, no. 198 (June 1880): 166-167. [Born in Easton, Pa. on Aug. 7th, 1856. Attended Lafayette College and obtained a degree in mechanical engineering. Worked briefly for Thomas Edison, then in the Vulcan Steel Works in Carondelet, MO. Published a number of articles on photographic chemistry in the "Philadelphia Photographer." during 1878-79. Accidentally drowned on April 26th, 1880.]

MCINTIRE, STERLING C.

[Sterling C. and G. A. McIntire advertised as dentists in Tallahassee, FL in 1844. In Nov. 1844, Sterling advertised as daguerreotypist. Worked in Florida until 1850, then went to New York, NY in 1850. Then to San Francisco, where he made a panoramic view of the city in 1851.]

M48 "Panorama of San Francisco and the Gold Diggings." DAGUERREAN JOURNAL 2, no. 4 (July 1, 1851): 115-116. [Five half-plate daguerreotypes forming a panorama of San Francisco. Article quotes excerpts from the "San Francisco [CA] Journal of Commerce" and the "Alta Californian."]

MACINTOSH.

M49 "The Fourth Presbyterian Church, Trenton, N. J. Rev. Richard H. Richardson, Pastor. - From a Photograph by MacIntosh." FRANK LESLIE'S ILLUSTRATED NEWSPAPER 28, no. 715 (June 12, 1869): 204. 2 illus. [View. Portrait.]

MACINTOSH, H. P. (NEWBURYPORT, MA)

M50 "Editor's Table." PHILADELPHIA PHOTOGRAPHER 6, no. 66 (June 1869): 203. [Stereos: birth place of Wm. L. Garrison, residence of John G. Whittier, death house of Rev. Geo. Whitfield.]

MCINTOSH, REUBIN M. (1823-) (USA)

M51 "Railroad Disaster Near Northfield, Vermont." HARPER'S WEEKLY 12, no. 575 (Jan. 4, 1868): 4. 1 illus. ["Photographed by R. M. MacIntosh."]

MCINTYRE, ALEXANDER C. (BROCKVILLE, NY)

M52 "The Inauguration of Jefferson Davis as President of the Provisional Government of the New Southern Confederacy of America." ILLUSTRATED LONDON NEWS 38, no. 1080 (Mar. 23, 1861): 267. 1 illus. ["From a photograph by A. C. M'Intyre, of Montgomery, an Illustration of the ceremony of Mr. Davis's inauguration."]

M53 "Amaus Artem." "Thousand Island Photograph Studio." ANTHONY'S PHOTOGRAPHIC BULLETIN 5, no. 4 (Apr. 1874): 145-146. [From "Brockville Recorder."]

M54 "A Ruffed Grouse on Her Nest." ANTHONY'S PHOTOGRAPHIC BULLETIN 7, no. 3 (Mar. 1876): 94. [A. C. McIntyre & Co. of Brockville and Alexandria Bay, NY, first to photograph a ruffed grouse sitting on her nest.]

M55 "Our Illustration." ANTHONY'S PHOTOGRAPHIC BULLETIN 17, no. 7 (Apr. 10, 1886): frontispiece, 215. [Views of Thousand Islands. Photo not bound in this copy.]

M56 "Another Veteran." ANTHONY'S PHOTOGRAPHIC BULLETIN 20, no. 12 (June 22, 1889): 373-374. [Letter from A. C. McIntyre claiming to have used an Anthony camera in 1855 to make 16" x 20"

views of the Thousand Islands, St. Lawrence River, Ontario on dry plates made by the albumen and honey process - the first such published in Europe.]

MACKAY, JAMES.
M57 MacKay, James. "A Few Remarks on Backgrounds." PHOTOGRAPHIC TIMES 1, no. 1 (Jan. 1871): 5-6. [Read at meeting of the Edinburgh Photo Soc.]

MACKENZIE, GEORGE.
M58 "1 engraving (Pipers, etc., of the Royal Renfrewshire Militia)." ILLUSTRATED LONDON NEWS 29, no. 812 (July 26, 1856): 106. 1 illus. ["From a photograph, ably executed by Mr. George MacKenzie, of Paisley."]

MACKENZIE, R. SHELTON, DR.
M59 MacKenzie, Dr. R. Shelton. "Photography." PHILADELPHIA PHOTOGRAPHER 1, no. 1 (Jan. 1864): 1-7. [Survey of the history of the medium from beginnings to 1850s. Daguerre, Talbot, Boulton, Wedgwood, Niépce, Claudet, Draper, Archer mentioned.]

M60 "Photography in the Past Year." PHOTOGRAPHIC NEWS 8, no. 278 (Jan. 1, 1864): 2-4.

MCKERNON, P. H.
M61 Portrait. Woodcut engraving, credited "From a Photograph by P. H. McKernon." FRANK LESLIE'S ILLUSTRATED NEWSPAPER 33, (1871) ["Hon. James B. McKean, Supreme Court of UT." 33:844 (Dec. 2, 1871): 188.]

MACKINTOSH. (KELSO, SCOTLAND)
M62 Portrait. Woodcut engraving credited "From a photograph by Mackintosh, Kelso." ILLUSTRATED LONDON NEWS 75, (1879) ["Late Lieut. Scott Douglas." 75:2097 (Aug. 23, 1879): 176.]

MCLACHLAN, LACHLAN. (d. 1891) (GREAT BRITAIN)
M63 "1 engraving (The Art-Treasures Exhibition Building, Manchester: End View)." ILLUSTRATED LONDON NEWS 30, no. 856 (May 2, 1857): 406. 1 illus. ["From a photograph by McLachlan, Manchester."]

M64 MacLachlan, L. "Extracts from Foreign Publications: The Positive Collodion Process." HUMPHREY'S JOURNAL 9, no. 3 (June 1, 1857): 34-38. [Manchester Photo. Soc.]

M65 McLachlan, Lachlan. "On the Lighting and Management of Light in Photographic Galleries." BRITISH JOURNAL OF PHOTOGRAPHY 9, no. 168 (June 16, 1862): 227-228.

M66 McLachlan, Lachlan. "On the Lighting and Management of Light in Photographic Galleries." AMERICAN JOURNAL OF PHOTOGRAPHY AND THE ALLIED ARTS & SCIENCES n. s. vol. 5, no. 2 (July 15, 1862): 25-29. [Read to Manchester Photo. Soc.]

M67 McLachlan, Lachlan. "On the Ventilating and Warming of Photographic Galleries." BRITISH JOURNAL OF PHOTOGRAPHY 9, no. 170 (July 15, 1862): 274-275.

M68 McLachlan, Lachlan. "National Photographic Portrait Gallery." BRITISH JOURNAL OF PHOTOGRAPHY 10, no. 196 (Aug. 15, 1863): 333. [McLachlan, a photographer, advocates building a nationwide program.]

M69 G. "National Photographic Portrait Museum." BRITISH JOURNAL OF PHOTOGRAPHY 10, no. 199 (Oct. 1, 1863): 380. [Editorial support for McLachlan's idea.]

M70 "Miscellanea: Art and Photographic Grouping." BRITISH JOURNAL OF PHOTOGRAPHY 12, no. 267 (June 16, 1865): 321. [From "Manchester Examiner and Times." McLachlan (Manchester) creating a composite group portrait of the Central Executive Committee of the Relief Fund, chaired by Lord Derby. McLachlan hired "the talented young artist F. J. Shields," to do the preliminary groupings to achieve a more natural and artistic effect.]

M71 Portrait. Woodcut engraving credited "From a photograph by Lachlan McLachlan." ILLUSTRATED LONDON NEWS 62, (1873) ["Late Prince Frederick William of Hesse Darmstadt." 62:1764 (June 21, 1873): 592.]

M72 Ambler, John. "Reminiscences of a Photographic Visit to Germany." ANTHONY'S PHOTOGRAPHIC BULLETIN 10, no. 4-5 (Apr.-May 1879): 105-107, 146-148. [From "London Photo. News." Ambler accompanied Mr. McLachlan in 1873 to photograph members of the British and German Royal families.]

MCLEAN & CO.
M73 "Note." ART JOURNAL (May 1861): 159. [McLean & Co., long famous for the production of engravings has taken up publishing photos, in particular cartes-de-visite.]

MCLEISH, W. (d. 1900) (GREAT BRITAIN)
M74 "Obituary of the Year: W. McLeish." BRITISH JOURNAL PHOTOGRAPHIC ALMANAC 1901 (1901): 672. [Native of Perthshire, went to Darlington about forty years ago. Changed occupation from gardener to photographer, first at Darlington, then at Northgate, where he photographed until the end. In early 1880s became famous for his photograph, "A Misty Morning on the Wear," which had some 2000 to 3000 copies printed which "have gone all over the world."]

MCMATH, JAMES. (PORT BURWELL, CANADA)
M75 McMath, James. "Collodion Pictures." HUMPHREY'S JOURNAL OF PHOTOGRAPHY, AND THE ALLIED ARTS AND SCIENCES 11, no. 14 (Nov. 15, 1859): 216. [McMath from Port Burwell, C. W.]

M76 McMath, Jas. "New Background." HUMPHREY'S JOURNAL OF PHOTOGRAPHY, AND THE ALLIED ARTS AND SCIENCES 12, no. 4 (June 15, 1860): 52-53.

MCMICHAEL, HEZEKIAH. (1844-1907) (CANADA, USA)
M77 "General Notes." PHOTOGRAPHIC TIMES 16, no. 263 (Oct. 1, 1886): 516. [Note that McMichael of Buffalo received a silver medal in Toronto.]

M78 McMichael, H. "Albumen Paper." PHOTOGRAPHIC TIMES 16, no. 275 (Dec. 24, 1886): 665.

M79 "Our Illustration." ANTHONY'S PHOTOGRAPHIC BULLETIN 18, no. 1 (Jan. 8, 1887): frontispiece, 21. 1 b & w. [Photograph, "a child study," not bound into this issue.]

M80 "Our Illustration." ANTHONY'S PHOTOGRAPHIC BULLETIN 18, no. 19 (Oct. 8, 1887): frontispiece, 604. 10 images on one plate b & w. [Composite print of the portraits that H. McMichael displayed at the P. A. of A.'s convention in Chicago; they won several prizes.]

M81 McMichael, H. "Art in Photography." PHOTOGRAPHIC MOSAICS:1888 24, (1888): 111-112. [From Buffalo, NY]

M82 McMichael, H. "Musings by the Way." AMERICAN ANNUAL OF PHOTOGRAPHY & PHOTOGRAPHIC TIMES ALMANAC FOR 1888 (1888): 144-145. [McMichael from Buffalo, NY.]

M83 "McMichael's Latest Prize." ANTHONY'S PHOTOGRAPHIC BULLETIN 19, no. 5 (Mar. 10, 1888): 152. [Note that H. McMichael of New York won award at the exhibition of the Photographic Society of India in Calcutta.]

M84 "Our Editorial Table." PHOTOGRAPHIC TIMES 18, no. 338 (Mar. 9, 1888): 120. [Photos by McMichael highly praised.]

M85 "Death of an Honored Woman." ANTHONY'S PHOTOGRAPHIC BULLETIN 19, no. 14 (July 28, 1888): 444. [Note of the death of the wife of Hezekiah McMichael, of Buffalo, N.Y., on July 17, 1888.]

M86 "King Lear on the Heath." PHOTOGRAPHIC TIMES 19, no. 403 (June 7, 1889): 279. 1 b & w. [Genre portrait. "The Storm."]

M87 "Childhood." PHOTOGRAPHIC TIMES 19, no. 409 (July 19, 1889): frontispiece, 351. 1 b & w. [Genre portrait.]

M88 "H. McMichael." PHOTOGRAPHIC TIMES 19, no. 411 (Aug. 2, 1889): frontispiece, 375. 1 b & w. [Born Norfolk County, Ontario in 1844. On farm until 21, then became a photographer in Hamilton, other Canadian towns. In 1871 to Buffalo, N.Y.; joined P.A. of A. in 1884, rose in ranks, became President of the Association. Self-Portrait.]

M89 "President McMichael's Address - Boston Convention." ANTHONY'S PHOTOGRAPHIC BULLETIN 20, no. 16 (Aug. 24, 1889): 493-495.

M90 "Our Illustration." ANTHONY'S PHOTOGRAPHIC BULLETIN 20, no. 22 (Nov. 23, 1889): frontispiece, 697. 1 b & w. [Portrait by H. McMichael. Photo not bound in this copy.]

M91 McMichael, H. "Correspondence: The Daguerre Monument." PHOTOGRAPHIC TIMES 19, no. 430 (Dec. 13, 1889): *. [Letter describing the options and costs quoted by the sculptor, J. Scott Hartley, for the monument to be commissioned by the Photographers' Assoc. of America.]

M92 McMichael, H. "The Daguerre Monument." ANTHONY'S PHOTOGRAPHIC BULLETIN 20, no. 23 (Dec. 14, 1889): 730. [Report that J. Scott Hartley selected to design the Daguerre monument.]

M93 McMichael, H. Chairman of the Daguerre General Committee. "To Daguerre." PHOTOGRAPHIC TIMES 20, no. 458 (June 27, 1890): 305. [Stating that the Daguerre monument will be unveiled on Aug. 12 in front of the Smithsonian Institute in Washington.]

M94 McMichael, H. "Report of the Daguerre Memorial Committee." PHOTOGRAPHIC TIMES 20, no. 466 (Aug. 22, 1890): 417-418. [McMichael, Chairmen of the Committee, gives a report complaining about the lack of response from the photographic community, detailing the committee's efforts.]

M95 "Notes and News." PHOTOGRAPHIC TIMES 21, no. 498 (Apr. 3, 1891): 165. [McMichael, professional photographer of Buffalo, N.Y. won a silver metal in the genre class at the Liverpool International Photographic Exhibition. Brief excerpts from Buffalo and Liverpool newspapers.]

M96 1 photo (Portrait of Bishop John H. Vincent). PHOTOGRAPHIC TIMES 22, no. 549 (Mar. 25, 1892): frontispiece, 153. 1 b & w. [Note on p. 153. Bishop Vincent, Chancellor of the Chautauqua University, patron of the Chautauqua School of Photography.]

M97 "A Picture of a Bride." WILSON'S PHOTOGRAPHIC MAGAZINE 32, no. 457 (Jan. 1895): 5-6. 1 b & w. ["McMichael, Buffalo, N.Y."]

M98 Wilson, Edward L. "A Tribute to 'Trilby.'" WILSON'S PHOTOGRAPHIC MAGAZINE 32, no. 460 (Apr. 1895): 148-151. 4 b & w. [2 posed portraits of "Trilby," the fictionalized character of George Du Maurier's novel of the same name which was, in turn, based on some legends associated with the statue of the Venus de Milo.]

MCMURRAY, R. K. & CO. (BALTIMORE, MD)
M99 "Monument in Monument Square, Baltimore, Md., Erected in Commemoration of the Soldiers Who Fell in the Battle of North Point," and "Monument Erected on the Site of the Battlefield of North Point, Md., by the First Mechanical Volunteers, Md. - From a Photo. by R. K. M'Murray." FRANK LESLIE'S ILLUSTRATED NEWSPAPER 25, no. 625 (Sept. 21, 1867): 5. 2 illus. [Views.]

M100 "Laying the Cornerstone of the New City Hall at Baltimore, Maryland." HARPER'S WEEKLY 11, no. 567 (Nov. 9, 1867): 709, 710. 1 illus. ["Photographed by R. K. McMurray & Co."]

MACNAB, A.
M101 Macnab, A. "On Printing, Toning, and Fixing Photographic Prints." HUMPHREY'S JOURNAL OF PHOTOGRAPHY, AND THE ALLIED ARTS AND SCIENCES 12, no. 18 (Jan. 15, 1861): 286-288. [From "Br. J. of Photo."]

M102 "The Principle of the Diorama Applied to Photographic Pictures." AMERICAN JOURNAL OF PHOTOGRAPHY AND THE ALLIED ARTS & SCIENCES n. s. vol. 4, no. 16 (Jan. 15, 1862): 377-378. [From "Glasgow Daily Herald." Describes efforts of "Dr. Taylor, seconded in his labors by Mr. McNab, photographer, West Nile Street, who printed and prepared some of the plates."]

MCNULTA see HISTORY: USA: 1861-1865. (1895)

MACOMBIE & WRIGHT.
M103 "Cotton Bales Lying at the Bombay Terminus of the Great Indian Peninsula Railway." ILLUSTRATED LONDON NEWS 41, no. 1160 (Aug. 23, 1862): 197, 218. 1 illus. ["...from MaCombie & Wright, of Bombay."]

MCPHERSON & JOHNSON see MCPHERSON, WILLIAM D.

MCPHERSON & OLIVER.
M104 "A Typical Negro." HARPER'S WEEKLY 7, no. 340 (July 4, 1863): 429-430. 3 illus. [Sketches drawn from photos taken by M'Pherson & Oliver in New Orleans during its occupation by Federal troops. Photos depict an escaped negro slave, seated in rags with his back badly scarred from whippings and then in a U.S. army uniform. The man, named Gordon, had escaped into the Union lines at Baton Rouge, LA, where he entered the Union army. M'Pherson & Roberts made cartes-de-visite of these photos, which were distributed as anti-slavery propaganda during the war.]

MACPHERSON, ROBERT. (1811-1872) (GREAT BRITAIN, ITALY)

[Born in Forfarshire County, Scotland in 1811. Studied medicine at Edinburgh University between 1831 and 1835. Began to paint. Moved to Rome in 1840, became a landscape painter and an art dealer. Learned photography in 1851. From 1850s through 1870s he made many 16" x 20" views of Rome. Worked with a photolithographic process and patented it in 1853. He demonstrated this photolithographic technique to the Société français de Photography and the Scottish Photographic Association in 1856. The Architectural Photographic Association in London exhibited around 400 of his prints in 1862. In 1863 he published over three hundred photographs of sculptures in the Vatican. As a dealer he bought Michelangelo's "Entombment of Christ" for a small sum in 1846, sold it to the National Gallery in London in 1868. Died in Rome in 1872.

BOOKS

M105 *MacPherson's Photographs, Rome. 1st August, 1863.* London: 1863. 1 l. [List of 305 views available from MacPherson's studio in Rome.]

M106 Macpherson, Robert. *Vatican Sculptures, Selected and Arranged in the Order in Which They are Found in the Galleries,* briefly explained by Robert Macpherson, Rome. London: Chapman & Hall, 1863. n. p. [2nd ed. (1873) Rome: E. Calzone.]

M107 MacPherson, Robert. *Rome.* Rome: MacPherson, n. d. [ca. 1871 ?]. n. p. 42 b & w. [Album of views of Rome. BMFA Collection.]

M108 Becchetti, Piero and Carlo Pietrangelli. *Robert Macpherson. Un inglese fotografo a Roma.* Rome: Edizioni Quasar, 1987. 213 pp. 200 b & w. illus. ["L'aspetto di Roma al tempo di Pio IX," by Carlo Pietrangeli on pp. 5-19; "Bibliografia," on pp. 20-21; "Robert Macpherson fotografo," by Piero Becchetti on pp. 23-39; "Bibliografia," on pp. 40-41; "Tavole," on pp. 53-201.]

PERIODICALS

M109 "A Process for Obtaining Lithographs by the Photographic Process." HUMPHREY'S JOURNAL 7, no. 15 (Dec. 1, 1855): 247. [From "London Pharmaceutical Journal, Nov." Process used by Robert MacPherson in Rome.]

M110 Ramsey, Professor. "Scientific and Useful: Obtaining Lithographs by the Photographic Process." FRANK LESLIE'S NEW YORK JOURNAL n. s. 3, no. 2 (Feb. 1856): 127. ["Professor Ramsey describes the process by which Mr. Robert MacPherson, of Rome, had succeeded in obtaining beautiful photo-lithographs, specimens of which have been hung up in the Photographic Exhibition in Buchanan Street."]

M111 MacPherson. "Photo-Lithography." HUMPHREY'S JOURNAL 8, no. 24 (Apr. 15, 1857): 374-378. [From "Photo. Notes."

M112 "Statue of 'America,' From the Model Executed by Crawford for the Dome of the National Capitol. Photographed by MacPherson, of Rome." FRANK LESLIE'S ILLUSTRATED NEWSPAPER 5, no. 106 (Dec. 12, 1857): 17.

M113 "Roman Photographs." ART JOURNAL (July 1859): 226.

M114 "Our Weekly Gossip." ATHENAEUM no. 1815 (Aug. 9, 1862): 181. [MacPherson's views of Rome on exhibit at No. 9, Conduit St., London.]

M115 "Exhibitions: MacPherson's Views of Rome, and Sculptures of the Vatican." BRITISH JOURNAL OF PHOTOGRAPHY 9, no. 172 (Aug. 15, 1862): 315. [Exhibit at No. 9 Conduit St., Regent St.]

M116 "Note." JOURNAL OF THE PHOTOGRAPHIC SOCIETY OF LONDON 8, no. 124 (Aug. 15, 1862): 118. [Opened an Exhibition of Photographs at 9 Conduit Street.]

M117 "Photolithography." BRITISH JOURNAL OF PHOTOGRAPHY 9, no. 173 (Sept. 1, 1862): 323. [Description of MacPherson's process, clear from the article that MacPherson was visiting London during the time of his exhibition.]

M118 "Note." ART JOURNAL (Nov. 1862): 227. [Views of Rome.]

M119 Markham, G., M.D. "Macpherson's Process of Photolithography." BRITISH JOURNAL OF PHOTOGRAPHY 19, * (Dec. 13, 1872): 589-590.

M120 "Robert MacPherson: Italian Photographs." CREATIVE CAMERA 199, (July 1981): 138-139. 2 b & w.

M121 "MacPherson's Photographs: Rome." PHOTOGRAPHIC COLLECTOR 2, no. 3 (Autumn 1981): 94-97. 2 b & w. [Facsimile reprint of MacPherson's price list of his Roman views, listing 191 images. 2 photos have been included in the magazine.]

M122 McKenzie, Ray. "The Cradle and Grave of Empires: Robert MacPherson and the Photography of Nineteenth Century Rome." PHOTOGRAPHIC COLLECTOR 4, no. 2 (Autumn 1984): 215-232. 17 b & w. 6 illus.

M123 "MacPherson's Photographs: Rome. 1st August 1863." PHOTOGRAPHIC COLLECTOR 4, no. 2 (Autumn 1984): 233-234. 1 b & w. [Facsimile of MacPherson's catalog of views numbered from 192 to 305. Continues an earlier list published in the "Photographic Collector" 2:3.]

M124 Munsterberg, Marjorie. "A Biographical Sketch of Robert MacPherson." ART BULLETIN 68, no. 1 (Mar. 1986): 142-153. 7 b & w. 1 illus.

MCPHERSON, WILLIAM D. see also MCPHERSON & OLIVER.

MCPHERSON, WILLIAM D. (ca. 1833-1867) (USA)

[Born ca. 1833 in Boston, MA. Worked as a photographer and ambrotypist in Concord, NH in 1862. To Baton Rouge, LA in 1863, where he worked with a Mr. Oliver, taking carte-de-visite views of the city. In 1865 McPherson & Oliver studio in New Orleans. Died on Oct. 9, 1867 in New Orleans, of Yellow Fever.]

M125 "Editor's Table." PHILADELPHIA PHOTOGRAPHER 4, no. 47 (Nov. 1867): 367. [The photographers McPherson and Johnson in New Orleans, LA, died of the Yellow Fever.]

MCRARY, F. B. [MCRARY & BRANSON] (USA)

M126 "Photographers Old and New: McRary & Branson." WILSON'S PHOTOGRAPHIC MAGAZINE. 32, no. 462 (June 1895): 268-269. 2 illus. [Partners working in Knoxville, Tenn. F. B. Mcrary, worked in tent in Cumberland Gap in 1876. Junior partner Lloyd Branson born in 1853, a printer. Firm established 1878.]

M

J. S. M. (AKRON, OH)
M127 J. S. M. "The Influence of Art." PHOTOGRAPHIC AND FINE ART JOURNAL 8, no. 5 (May 1855): 146. [J. S. M., a daguerrean artist from Akron, OH.]

MABLEY, W. T.
M128 Mabley, W. T. "On Photographic Printing upon Paper." HUMPHREY'S JOURNAL OF PHOTOGRAPHY, AND THE ALLIED ARTS AND SCIENCES 12, no. 4-5 (June 15-July 15, 1860): 61-64, 77-79, 91-92. [From "Br. J. of Photo."]

MADDISON, A.
M129 Maddison, A. "Weak Printing Baths and Nitrate of Soda." HUMPHREY'S JOURNAL OF PHOTOGRAPHY, AND THE ALLIED ARTS AND SCIENCES 15, no. 23 (Apr. 1, 1864): 367.

MADDOX, RICHARD LEACH. (1816-1902) (GREAT BRITAIN)
M130 Maddox, R. L., M.D. "Experiments with Arsenite of Soda." HUMPHREY'S JOURNAL OF PHOTOGRAPHY, AND THE ALLIED ARTS AND SCIENCES 11, no. 18 (Jan. 15, 1860): 281-282. [From "Liverpool Photo. J."]

M131 Maddox, Dr. R. L. "Experiments with Albumen on Glass." AMERICAN JOURNAL OF PHOTOGRAPHY AND THE ALLIED ARTS & SCIENCES n. s. vol. 4, no. 11 (Nov. 1, 1861): 246-249.

M132 "Photo-Micrographs, Executed by Dr. R. L. Maddox." BRITISH JOURNAL OF PHOTOGRAPHY 9, no. 173 (Sept. 1, 1862): 330-331.

M133 Maddox, R. L., M.D. "On the Delineation of Microscopic Objects by Photography." BRITISH JOURNAL OF PHOTOGRAPHY 9, no. 175 (Oct. 1, 1862): 362-364.

M134 Maddox, R. L., M.D. "The Magnesium Light Applied to Photo-Microphotography." AMERICAN JOURNAL OF PHOTOGRAPHY AND THE ALLIED ARTS & SCIENCES n. s. vol. 7, no. 3 (Aug. 1, 1864): 49-52. [From "Br. J. of Photo."]

M135 "Our Editorial Table: Photomicrographs, by Dr. Maddox." BRITISH JOURNAL OF PHOTOGRAPHY 12, no. 264 (May 26, 1865): 279-280.

M136 "Home and Foreign News Epitomized." PHOTOGRAPHIC TIMES 10, no. 117 (Sept. 1880): 199. [Issue of two claimants for the invention of the gelatino-bromide emulsion process (wet-collodion) Dr. R. L. Maddox's claim challenged by Mr. John Burgess. J. Traill Taylor states that Maddox has undisputed claim.]

M137 "A Worthy Cause." PHOTOGRAPHIC TIMES 21, no. 532 (Nov. 27, 1891): 585-586. 1 illus. [Attempt to raise money for R. L. Maddox, inventor of gelatine-dry plate process, now fallen on hard times. "..this being the twenty-first year of the gelatine-dry plate process."]

M138 "Editorial Comment: Aid for Dr. R. L. Maddox." AMERICAN AMATEUR PHOTOGRAPHER 3, no. 12 (Dec. 1891): 481-482. [Maddox, originator of the Gelatine Bromide Process, now old, ill, in financial difficulties. Call for aid.]

M139 Maddox, Richard Leach. "The Maddox Fund." PHOTOGRAPHIC TIMES 21, no. 533 (Dec. 4, 1891): 603-604. [Includes section on "How Dr. Maddox Discovered the Gelatino-Bromide Process," reprinted from W. Jerome Harrison's "A History of Photography".]

M140 "The Maddox Testimonial." PHOTOGRAPHIC TIMES 21, no. 534 (Dec. 11, 1891): 615-616. [Includes letter from Andrew Pringle, the honorary secretary of the Maddox Testimonial Fund Committee, a letter from John Carbutt which contains an extract from a report of the Franklin Institute to Maddox in 1889, etc.]

M141 "The Maddox Fund." PHOTOGRAPHIC TIMES 22, no. 538 (Jan. 8, 1892): 17. [List of subscribers.]

M142 "The Fathers of Photography IX - Dr. R. L. Maddox." PHOTOGRAPHIC TIMES 25, no. 669 (July 13, 1894): 21. 1 illus. [Worked out a Gelatino-Bromide process in 1871.]

M143 Maddox, R. L., M.D., Hon. Fell, R.M.S. "An Attempt to Photograph a Specimen of a Brittle Star." AMERICAN ANNUAL OF PHOTOGRAPHY AND PHOTOGRAPHIC TIMES ALMANAC FOR 1897 (1897): 142-148. 3 b & w. 2 illus. [Starfish.]

M144 "Letter." PHOTOGRAPHIC TIMES 34, no. 8 (Aug. 1902): 370. [Letter from Maddox to the editor, published posthumously.]

M145 "Obituary of the Year: Richard Leach Maddox, M.D." BRITISH JOURNAL PHOTOGRAPHIC ALMANAC 1903 (1903): 681-688. [Died May 11. Maddox contributed articles to the "BJP" and the "BJPA" for over forty years. Born in 1816. Lived for many years in Constantinople, where he practiced as a doctor and raised a family. Back and forth to England. In 1875 he practiced in Ajaccio, Corsica and in Italy. Returned to England in 1880s, retired to Southampton. An appendix is attached to this biography, with a reprise of Maddox's photographic activities and an important article reprinted. "An Experiment with Gelatino-Bromide," first published in the "BJP" on Sept. 8, 1871.]

M146 Maddox, Richard Leach. "The Invention of the Dry Plate." IMAGE 3, no. 9 (Dec. 1954): 60-61. [Reprint from "Br J of Photo." September 8, 1871, of Maddox' article outlining invention of dry plate. Article includes letters from BJP following up the invention.]

MALONE, THOMAS A. (GREAT BRITAIN)
M147 Malone, T. A. "Photography on Glass." ATHENAEUM no. 1179 (June 1, 1850): 589. [Letter on details of process.]

M148 Malone. "Monthly Notes: Photography on Glass." PRACTICAL MECHANIC'S JOURNAL 3, no. 28 (July 1850): 94-95. [Discusses a Mr. Malone's efforts, reprinted from his letter to the "Athenaeum."]

M149 Malone, T. A. "Photography on Paper and on Glass." ART JOURNAL (Aug. 1850): 261. [Talbot, Blanquart-Evrard mentioned.]

M150 Malone, T. A. "Photography on Paper and Glass." PHOTOGRAPHIC ART JOURNAL 1, no. 1 (Jan. 1851): 44-46. [From "London Art. J."]

M151 Malone, Thomas A. "Lectures on Photography, Delivered in the Royal Institutions of Great Britain." PHOTOGRAPHIC AND FINE ART JOURNAL 9-10, no. 12; 1, 3 (Dec. 1856 - Jan., Mar. 1857): (Vol. 9) 371-372; (Vol. 10) 19-20, 91-92.

M152 Malone, Thomas A., F.C.S. "On the Application of Light and Electricity to the Production of Engravings - Photogalvanography." PHOTOGRAPHIC AND FINE ART JOURNAL 10, no. 6 (June 1857):

182-184. [From "Liverpool Photo. J." Includes a survey of the history of experiments from 1813 on.]

M153 Malone. "The Stereoscope." PHOTOGRAPHIC AND FINE ART JOURNAL 10, no. 7 (July 1857): 204-205. [From "Liverpool Photo. J."]

M154 Malone, T. A. "Positive Copies by the Electric Light." BRITISH JOURNAL OF PHOTOGRAPHY 8, no. 134 (Jan. 15, 1861): 36-37.

M155 Malone, T. A. "Positive Copies by the Electric Light." HUMPHREY'S JOURNAL OF PHOTOGRAPHY, AND THE ALLIED ARTS AND SCIENCES 12, no. 22 (Mar. 15, 1861): 348-349. [From "Br. J. of Photo."]

M156 Malone, T. A. "On the Nature of the Photographic Image Formed in Printing and Toning." AMERICAN JOURNAL OF PHOTOGRAPHY AND THE ALLIED ARTS & SCIENCES n. s. vol. 4, no. 13 (Dec. 1, 1861): 300-304. [Read before Am. Photo. Soc.]

MALTBIE, S. W. (USA)
M157 "Editorial Department." AMERICAN JOURNAL OF PHOTOGRAPHY, AND THE ALLIED ARTS AND SCIENCES n. s. vol. 9, no. 10 (May. 1, 1867): 232. [Promises to carry on in Seely's footsteps.]

M158 Maltbie, S. W. "Editorial Department." AMERICAN JOURNAL OF PHOTOGRAPHY, AND THE ALLIED ARTS AND SCIENCES n. s. vol. 9, no. 11 (May 15, 1867): 254-256. [Includes a description of a trip around New York, NY "with a New York photographer," photographing in the dawn light, etc. Nice description of a photographic session.]

M159 Maltbie, S. W. "Editorial Department." AMERICAN JOURNAL OF PHOTOGRAPHY, AND THE ALLIED ARTS AND SCIENCES n. s. vol. 9, no. 12 (June 1, 1867): 278-280. [General comments of activities since Maltbie took over the journal. Promise to publish carbon prints made by Frank Rowell, of Boston, from negatives taken by C., D. Fredericks & Co., of New York, NY as illustrations in a future issue.]

MANCHESTER BROTHERS & ANGELL. (PROVIDENCE, RI)
M160 Portrait. Woodcut engraving, credited "From a Photograph by Manchester Brothers & Angell." HARPER'S WEEKLY 9, (1865) ["Late Francis Wayland, D.D." 9:462 (Nov. 4, 1865): 693.]

MANCHESTER BROTHERS. (PROVIDENCE, RI)
[Henry Manchester studied daguerreotypy with John Plumbe, Jr. in Boston, MA, then moved to Newport, RI and opened what may have been Rhode Island's first daguerreotype studio. Later he moved to Providence, where he worked for Samuel Masury. He then spent a year in Pennsylvania before returning to Providence in 1843 and opening a studio in partnership with his brother Edwin. The firm, configured differently from time to time 197Manchester & Brother, Manchester & Chapin (Joshua Chapin), Manchester Bros. & Angell (Daniel Angell), and Manchester Brothers, (with Edwin's son George)— lasted from 1843 until 1895, when Edwin retired at age seventy-five.]

M161 Portrait. Woodcut engraving, credited "From a Photograph by Manchester Brothers." HARPER'S WEEKLY 13, (1869) ["Miss Ida Lewis, the Heroine of Newport." (Rescued two sailors from drowning in a storm.) 13:657 (July 31, 1869): 481.]

MANCHESTER, EDWIN H. see MANCHESTER BROTHERS.

MANCHESTER, HENRY N. see MANCHESTER BROTHERS.

MANDY, JAMES. (GREAT BRITAIN, INDIA)
M162 "Proclamation of the Queen's Rule in India - The Illuminations." ILLUSTRATED LONDON NEWS 34, no. 953 (Jan. 1, 1859): 17-18. 2 illus. [Views of crowds, illuminated buildings. One view in Calcutta, taken by James Mandy. One view, in Bombay, photographed by H. Hinton.]

MANDY, S. D. (SOUTH AFRICA)
M163 "The Grey Hospital, King William's Town, British Kaffraria." ILLUSTRATED LONDON NEWS 45, no. 1275 (Aug. 27, 1864): 213-214. 1 illus. [See p. 585 for credit to S. D. Mandy.]

M164 "The Witch Doctors of South Africa." ILLUSTRATED LONDON NEWS 45, no. 1266 (Dec. 10, 1864): 584-585. 1 illus. ["We are indebted for the photograph from which we have engraved our portrait of a Kaffir witch doctor, to Mr. S. D. Mandy, who supplied us with a view of the Grey Hospital and Medical College, in British Kaffraria, published in this journal a few months ago."]

MANN, E.
M165 Mann, E. "The Oxymel Process." HUMPHREY'S JOURNAL OF PHOTOGRAPHY, AND THE ALLIED ARTS AND SCIENCES 9, no. 24 (Apr. 15, 1858): 380-382. [From "Liverpool Photo. J."]

MANN, J. H.
M166 Stephens, Frederic George. *A History of Gibraltar and Its Sieges; With Photographic Illustrations by J. H. Mann and Map.* London: Provost & Co., 1870. n. p. 16 b & w. [Original photos by J. H. Mann. "Presentation Edition," sixteen photos and map. "Library Edition," four photos and map.]

MANOURY. (PARIS, FRANCE)
M167 Portrait. Woodcut engraving credited "From a photograph by Manoury." ILLUSTRATED LONDON NEWS 66, (1875) ["Late Edgar Quinet, French Historian." 66:1861 (Apr. 10, 1875): 345.]

MANSELL, THOMAS LUKIS. (1809-1879) (GREAT BRITAIN)
[Born 1809, the eldest son of Rear Admiral Sir Thomas Mansell and Catherine Lukis. Studied medicine at Trinity College, Dublin. Dr. Mansel was a jurat of the Royal Court, the governing body of Guernsey, and a consulting physician. He began to make calotypes in 1852. A friend of Dr. Hugh Diamond, he contributed regularly to *Notes and Queries* in the mid 1850s. Member of the Photographic Society. Developed a syrupted-collodion process in 1855. Also interested in meteorology and a member of the Guernsey Horticultural Society. He died in Guernsey in 1879.]

M168 Mansell, T. L., A.B., M.D. "Miscellania: Photographic Paper." ATHENAEUM no. 1323 (Mar. 5, 1853): 298. [Letter from Mansell describing his process.]

M169 Mansell, T. L., A.B., M.D. "The Calotype on the Seashore." NOTES AND QUERIES 9, no. 224 (Feb. 11, 1854): 134-135.

M170 Mansell, T. L., A.B., M.D. "The Calotype on the Seashore." PHOTOGRAPHIC AND FINE ART JOURNAL 7, no. 5 (May 1854): 153-154. [From "Notes & Queries."]

M171 "Review: Photography in the Isle of Sark." JOURNAL OF THE PHOTOGRAPHIC SOCIETY OF LONDON 7, no. 114 (Oct. 15, 1861): 287.

MANSELL, W. A. & CO. (LONDON, ENGLAND)

M172 "Our Picture." PHILADELPHIA PHOTOGRAPHER 11, no. 132 (Dec. 1874): frontispiece, 366-368. 1 b & w. 4 illus. [Cathedral interior. One photo and four etchings.]

M173 "Our Picture." PHILADELPHIA PHOTOGRAPHER 12, no. 137 (May 1875): frontispiece, 137-139. 1 b & w. 2 illus. [Landscape, plus two etchings.]

MANSFIELD, EPHRIAM SHIRLEY. (ST. LOUIS, MO)

M174 1 engraving ("Joseph W. Thornton Shooting Mr. Charles at St. Louis.") on p. 40: FRANK LESLIE'S ILLUSTRATED NEWSPAPER 8, no. 185 (June 18, 1859): 40. 1 illus. [This is an artist's sketch depicting the shooting of a man, on a sidewalk in front of some shops. The shooting is depicted as happening immediately in front of a photographer's outside display case. The photographer's name was Mansfield and his prices were $.50 per photo. The event depicted by the artist may have been drawn from verbal descriptions of the site, from the artist's imagination, or from an uncredited photograph sent into the magazine. There was, however, an Ephriam Shirley Mansfield working in St. Louis in 1859.]

MANSFIELD, GEORGE.

M175 Mansfield, George. "Landscape Photography." BRITISH JOURNAL PHOTOGRAPHIC ALMANAC 1877 (1877): 141-143.

M176 Mansfield, George. "Landscape Photography." PHOTOGRAPHIC TIMES 7, no. 75 (Mar. 1877): 59-61. [From "Br J of Photo. Almanac."]

M177 Mansfield, George. "Hints for Beginners." BRITISH JOURNAL PHOTOGRAPHIC ALMANAC 1878 (1878): 81-83.

MANSFIELD, SERENO see BEERS & MANSFIELD.

MANVILLE, C. R.

M178 "Dakota. - Sketches of Frontier Civilization - A Sunday Scene in Deadwood City. - From a Photograph by C. R. Manville." FRANK LESLIE'S ILLUSTRATED NEWSPAPER 45, no. 1145 (Sept. 8, 1877): 12. 1 illus. [Close-up view of tent city, with people.]

MARC, B.

M179 Marc, B. "Instantaneous Photography." BRITISH JOURNAL OF PHOTOGRAPHY 8, no. 146 (July 15, 1861): 250-252. [Commentary on the activity and interest in this topic, rather than a technical article.]

MARCEY, LORENZO J.

M180 Marcy, Lorenzo J. *The Sciopticon Manual: Explaining Marcy's New Magic Lantern and Light, including Magic Lantern Optics, Experiments, Photographing and Coloring Slides, Etc.* Philadelphia: Sherman & Co., printers, 1871. 140 pp. illus. [6th ed. (1877) Philadelphia: J. A. Moore xii, 200 p. 7th ed. (1885) Philadelphia: W. F. Fell, xii, 224 pp.]

MARCHANT, G. & G. FANNON. (WELLINGTON, NEW ZEALAND)

M181 "Town of Wanganui, New Zealand." ILLUSTRATED LONDON NEWS 54, no. 1534 (Apr. 17, 1869): 404. 1 illus. ["We have received the view of Wanganui, now engraved, from Messrs. G. Marchant and G. Fannon, of the Crown Lands Office, Wellington."]

MARECHAL & DU MOTAY.

M182 Marechal, M. and Tessie Du Motay. "On Vitrified Photographs." AMERICAN JOURNAL OF PHOTOGRAPHY AND THE ALLIED ARTS & SCIENCES n. s. vol. 8, no. 5 (Sept. 1, 1865): 101-103. [From "Comptes Rendus."]

MARES, EDERICK H. (DUBLIN, IRELAND)

M183 Mares, Frederick H. *Photographs of the Giant's Causeway and North; with Descriptive Letterpress.* Glasgow: Andrew Duthie, 186-? 29 l. 12 b & w. [Original photos by F. H. Mares.]

M184 *Photographic Gems of Irish Scenery:* With Descriptive Letterpress. Photographs by J. Hudson and F. H. Mares. Glasgow: Andrew Duthie, c. 1867. 52 pp. 12 l. of plates. 12 b & w. [Original photos. Eight by J. Hudson and four by F. H. Mares.]

M185 Mares, Frederick H. *Castles and Abbeys in Ireland;* with Descriptive Letterpress. Frederick H. Mares, Photographer. Glasgow: Andrew Duthie, 1867. n. p. 12 b & w. [Original photos by F. H. Mares.]

M186 Mares, Frederick H. *Photographs of Co. Wicklow;* with Descriptive Letterpress. Frederick H. Mares, Photographer. Glasgow: Andrew Duthie, 1867. 39 l. 12 b & w. [Original photos by F. H. Mares.]

M187 Mares, Frederick H. *Photographs of Dublin;* with Descriptive Letterpress. Frederick H. Mares, Photographer. Glasgow: Andrew Duthie, 1867. 29 l. 12 b & w. [Original photos by F. H. Mares.]

M188 Mares, Frederick H. *Sunny Memories of Ireland's Scenic Beauties: Killarney;* Photographically Illustrated by Frederick H. Mares. Dublin: Browne & Nolan, 1867. n. p. 15 b & w. [Original photos, interleaved with descriptive notices.]

M189 Mares, Frederick H. *Sunny Memories of Ireland's Scenic Beauties: Wicklow;* Photographically Illustrated by Frederick H. Mares. Dublin: Mares, 1867. 18 l. l. of plates. 15 b & w.

MAREY, ETIENNE see also MUYBRIDGE, EADWEARD.

MAREY, ETIENNE JULES. (1830-1904) (FRANCE)

[Born March 5, 1830 in Beaune. Studied medicine in Paris, and wrote his doctoral dissertation on the circulation of blood. In 1868 he began to study human movement. In 1869 he was made the professor of Natural History at the Collège de France in Paris, in 1872 elected a member of the Academy of Medicine, and, in 1876, made a member of the Academy of Sciences. In 1870s he began to seek graphic means of representing human motion, and, during the 1880s-1890s, used photography for this purpose. Died in Paris on May 16, 1904. The major portion of the Etienne Marey references will be placed in volume 2 (1880-1919) of this work.]

BOOKS

M190 Marey, E. J. *Animal Mechanism. A Treatise on Terrestrial and Aerial Locomotion... With One Hundred and Seventeen Illustrations, Drawn and Engraved under the Direction of the Author.* "2nd Edition" London: Henry S. King & Co., 1873. 283 pp. 117 illus.

PERIODICALS

M191 "Royal Institution Lectures: Human Locomotion - Locomotion of the Horse - Aerial Locomotion - Aerial and Aquatic Locomotion." ILLUSTRATED LONDON NEWS 66, no. 1855-1858 (Feb. 27 - March 20, 1875): 210, 230, 254, 278. ["Prof. A. H. Garrod began a course of four lectures on Animal Locomotion on Tuesday last. The notations of all these movements and their varieties, the results of numerous elaborate experiments with Marey's apparatus, were exhibited."]

MARGEDANT, CAPT. see USA: 1861-1865. (1897)

MARIAN, H. J.

M192 Marian, H. J. "Let us have More Amateurs." AMERICAN JOURNAL OF PHOTOGRAPHY AND THE ALLIED ARTS & SCIENCES n. s. vol. 7, no. 12 (Dec. 15, 1864): 285. ["Photography as an amusement should be encouraged among the American people, and those having leisure should apply themselves to the advancement of the art, as well as themselves."]

M193 Marian, H. J. "On Taking a Group." AMERICAN JOURNAL OF PHOTOGRAPHY AND THE ALLIED ARTS & SCIENCES n. s. vol. 7, no. 13 (Jan. 1, 1865): 306-307. [Anecdote.]

MARINE, J. J.

M194 Marine, J. J., Dr. "Fulminate of Silver." HUMPHREY'S JOURNAL OF PHOTOGRAPHY, AND THE ALLIED ARTS AND SCIENCES 10, no. 9 (Sept. 1, 1858): 139-140.

MARION, A. & SON.　(LONDON, ENGLAND)

M195 [A. Marion established a studio in Paris in 1853. In addition to making portraits and views, the company specialized in making and selling photographic paper and would eventually build and operate paper manufacturing factories in both France and England. In 1857 the firm opened a branch gallery in London, which specialized in the new carte-de-visite format. Frank Bishop and, after 1907, Gerald Bishop manage the London studio. The son, L. A. Marion, managed the Paris factory. In 1869 the firm purchased from Mayall the right to publish his portraits of the Royal Family, for 35,000 pounds. A. Marion died in 1917.]

PERIODICALS

M196 "Gallery of Photographic Art." BRITISH JOURNAL OF PHOTOGRAPHY 12, no. 266 (June 9, 1865): 304. [A. Marion, Son & Co., establishing a gallery, next to their establishment, "...devoted to the exhibition of photographic reproductions of the works of several great artists."]

M197 "Note." ART JOURNAL (July 1865): 226-227. ["Mssrs. Marion & Son, Soho Square, issued the day after 'the Derby' a photo of the Grand Stand, (with crowd) 8" x 6" "...few photos have been produced that show more emphatically the power of the art."]

M198 Portrait. Woodcut engraving credited "From a photograph by A. Marion & Son." ILLUSTRATED LONDON NEWS 46, (1865) ["Crown Prince Nicholas, of Russia." 46:* (May 6, 1865): 441.]

M199 "Fine Arts. New Photograph of the Princess of Wales." ILLUSTRATED LONDON NEWS 72, no. 2016 (Feb. 16, 1878): 150.

MARIOT, EMANUEL.　(GRAZ, AUSTRIA)

M200 Volkmer, Lt.- Col. Ottomar. "Heliogravure and Galvanography." AMERICAN ANNUAL OF PHOTOGRAPHY & PHOTOGRAPHIC TIMES ALMANAC FOR 1888 (1888): 179-185. [Emanuel Mariot, of Graz, Austria commissioned to generate heliogravure maps of the Austria-Hungarian Monarchy for the Imperial Military Geographical Institute of Vienna in early 1870's. The Institute published major map-making projects during 1870s and 1880s.]

MARJOLLET, NICOLAS BRIANCON. (ca. 1803-1890) (FRANCE, USA)

M201 "Notes and News." PHOTOGRAPHIC TIMES 20, no. 456 (June 13, 1890): 287. ["Nicolas Briancon Marjollet, one of the oldest photographers in New York, died last week in the 87th year of his age... born Paris, there became a wine merchant... in 1853 obtained employment in the gallery of Fredericks & Gurney. Remained with Mr.

Fredericks until his death, he was a great favorite in that gallery for many years."]

MARK OUTE see MASON, GEORGE.

MARKILLIE, JOHN.　(HUDSON, OH)

M202 Markillie, John. "Toning with Gold and Chloride of Lime." AMERICAN JOURNAL OF PHOTOGRAPHY AND THE ALLIED ARTS & SCIENCES n. s. vol. 6, no. 2 (July 15, 1863): 36-37.

M203 Markillie, J. "Lime in the Toning Bath." AMERICAN JOURNAL OF PHOTOGRAPHY AND THE ALLIED ARTS & SCIENCES n. s. vol. 7, no. 20 (Apr. 15, 1865): 474. [Markillie from "Hudson, OH."]

MARKS, HARVEY R. (1821-1902) (BALTIMORE, MD)

M204 "Japanese Sailors." ILLUSTRATED NEWS (NY) 1, no. 4 (Jan. 22, 1853): 57. 3 illus. ["From Daguerreotypes by H. R. Marks, Baltimore, MD." Eighteen portraits presented here in three groups, of stranded Japanese sailors delivered to San Francisco by an American ship, where the photographer R. H. Marks took their portraits aboard the "U.S.R. Polk." Claimed to be the first portraits of Japanese, made sometime in 1851.]

M205 Portrait. Woodcut engraving, credited "From a Photograph by H. R. Marks. FRANK LESLIE'S ILLUSTRATED NEWSPAPER 49, (1879) ["Oran M. Roberts, Gov. of TX." 49:1250 (Sept. 13, 1879): 21.]

MARSH BROTHERS.　(GREAT BRITAIN)
BOOKS

M206 *Thames Scenery. Oxford to London.* Oxford: Marsh Brothers, 1870. n. p. 20 b & w. [Album.]

PERIODICALS

M207 Pritchard, H. Baden. "Instantaneous Photography." MAGAZINE OF ART 5, (1882): 70-73. 5 illus. [5 woodcuts, from photos by the Marsh Brothers (3); and W. Mayland (2).]

MARSH, W. P.　(BOGNOR, ENGLAND)

M208 Portrait. Woodcut engraving credited "From a photograph by W. P. Marsh." ILLUSTRATED LONDON NEWS 75, (1879) ["Mary Wheatland, saved thirteen from drowning." 75:2111 (Nov. 29, 1879): 516.]

MARSHALL, AUGUSTUS. (d. 1916) (BOSTON, MA)

M209 Marshall. "American versus French Cotton." HUMPHREY'S JOURNAL OF PHOTOGRAPHY, AND THE ALLIED ARTS AND SCIENCES 14, no. 15 (Dec. 1, 1862): 191. [Letter from "...Mr. Marshall, well known in Boston and vicinity as the chief operator in Ormsbee's celebrated gallery."]

M210 Marshall, A. "Washing Apparatus." HUMPHREY'S JOURNAL OF PHOTOGRAPHY, AND THE ALLIED ARTS AND SCIENCES 16, no. 2 (May 15, 1864): 27.

M211 Marshall, A. "Making Solar Prints by Development." PHILADELPHIA PHOTOGRAPHER 2, no. 14 (Feb. 1865): 28.

M212 "Letter." PHILADELPHIA PHOTOGRAPHER 2, no. 16 (Apr. 1865): 60-61. [Letter to editor on how Marshall makes double pictures.]

M213 Portrait. Woodcut engraving, credited "From a Photograph by Marshall, of Boston." FRANK LESLIE'S ILLUSTRATED NEWSPAPER 25, (1868) ["Master Daniel Boone (a child)." 25:640 (Jan. 4, 1868): 252.]

M214 Portrait. Woodcut engraving, credited "From a Photograph by Augustus Marshall." HARPER'S WEEKLY 13, (1869) ["Rev. Frederick D. Huntington, Bishop of New York, NY." 13:642 (Apr. 17, 1869): 244.]

M215 "Editor's Table." PHILADELPHIA PHOTOGRAPHER 7, no. 79 (July 1870): 270-272. [Shaw Patent; A. Marshall (Boston, MA); Suddard & Fennemore (Philadelphia, PA) and W. L. Germon (Philadelphia, PA) won Photo-Crayon prize medals; J. F. Ryder's portrait of Dr. H. Vogel; Kilburn Bros.; Prof. Henry Morton; F. H. Houston (Pittsfield, MA) damaged by hail and rain; others mentioned.]

M216 Gaffield, Thomas. "Editor's Table: Letter." PHILADELPHIA PHOTOGRAPHER 9, no. 106 (Oct. 1872): 367. [Letter from Gaffield, describing the trip to England that he and A. Marshall took together. Mentions meeting G. W. Simpson, who praised Marshall's work.]

M217 Marshall, A. "Improving the Lighting of a Studio." BRITISH JOURNAL PHOTOGRAPHIC ALMANAC 1874 (1874): 152.

M218 "Our Picture." PHILADELPHIA PHOTOGRAPHER 11, no. 122 (Feb. 1874): frontispiece, 47-48. 1 b & w. [Studio portrait.]

M219 Marshall, A. "Why do Photographers make so much Better Work than Formerly?" BRITISH JOURNAL PHOTOGRAPHIC ALMANAC 1875 (1875): 116-117.

M220 Marshall, A. "A Convenient Plate-Holder." BRITISH JOURNAL PHOTOGRAPHIC ALMANAC 1876 (1876): 119.

M221 Portrait. Woodcut engraving, credited "From a Photograph by Marshall." FRANK LESLIE'S ILLUSTRATED NEWSPAPER 47, (1879) ["Myron W. Whitney." 47:1222 (Mar. 1, 1879): 476.]

M222 Marshall, A. G. "That Wonderful Dansac-Chassagne Discovery." WILSON'S PHOTOGRAPHIC MAGAZINE 35, no. 493 (Jan. 1898): 12. [Satiric commentary on the French color controversy.]

MARSHALL, F. A. S. (PETERBOROUGH, ENGLAND)
[Marshall established a reputation for his views of Churches, etc. His book Photography;... was a reprint of a paper read before the Associated Architectural and Archaeological Societies of the Dioceses of Northants, Lincoln, Leicester and Cambridge on May 24, 1855.]

BOOKS
M223 Marshall, F. A. S. Photography; the Importance of its Application in Preserving Pictorial Records of the National Amusements of History and Art; with Appendix Containing a Description of the Talbotype Process as adopted and practiced by the Author during the last Seven Years. London: Hering & Remington, 1855. 30 pp.

PERIODICALS
M224 Marshall, F. A. S. "Photography." ATHENAEUM no. 1263 (Jan. 10, 1852): 55. [Letter, with Marshall's formulas.]

MARSHALL, WILLARD. (GUELPH, ONTARIO)
M225 "Editor's Table." PHILADELPHIA PHOTOGRAPHER 6, no. 65 (May 1869): 169. [Cabinets noted.]

MARSTON, C. A.
M226 Portrait. Woodcut engraving, credited "From a Photograph by C. A. Marston. FRANK LESLIE'S ILLUSTRATED NEWSPAPER 48, (1879) ["Hon. John H. Kenkead, Gov. of NV." 48:1229 (Apr. 19, 1879): 109.]

MARSTON, CHARLES L. (1826-1895) (USA)
M227 "Bangor, Maine. - Passenger Train of the Maine Central Railroad Breaking Through a Bridge on Entering the City, August 9th - Scene of the Accident. Photographed by C. L. Marston." FRANK LESLIE'S ILLUSTRATED NEWSPAPER 32, no. 830 (Aug. 26, 1871): 404. 1 illus. [Wreck.]

MARTENS, EIDRICH VON. (1809-1875) (GERMANY, FRANCE)
[Martens was born in Germany, but he was practicing in Paris, with an established reputation, as an engraver of city views and panoramic scenes, when photography was invented. He engraved several plates from daguerreotypes for Lerebour's Excursions daguerriennes. He invented a panoramic camera in 1845, and himself made daguerreotypes, paper and albumen negatives throughout the 1850s. Made panoramic views of the Swiss Alps, and was highly regarded by the photographic community.]

M228 "The Lure of Wide Pictures." IMAGE 3, no. 4 (Apr. 1954): 28-29. 1 b & w. [Friedrich von Martens (1) 1846; designed first panoramic camera.]

MARTIN, ADOLPHE ALEXANDRE. (1824-1896) (FRANCE)
[Born in France in 1824. Studied with Foucault. Professor of Physics at the Collège Sainte-Barbe, Paris. In 1850s and 1860s he experimented with various direct positive printing processes, and developed optical improvements for astronomical photography. Died on May 3, 1896 at Courseulles-sur-Mer.]

M229 "Minor Topics of the Month: Photography." ART JOURNAL (Sept. 1852): 291. [Reprinting his process from "Comptes Rendus."]

M230 Martin, A. "Photolithography. - New Process with Silver Soap. (Quaglio's Process.)" HUMPHREY'S JOURNAL OF PHOTOGRAPHY, AND THE ALLIED ARTS AND SCIENCES 15, no. 15 (Dec. 1, 1863): 225-228. [From "Photographisches Archiv."]

M231 Portrait. Woodcut engraving credited "From a photograph by Alexander Martin, Rue Neuve, Paris." ILLUSTRATED LONDON NEWS (1869) ["Alphonse de Lamartine, Fr. poet." (Mar. 13, 1869): 256.]

MARTIN, F. C.
M232 "Indiana. - New Court House of Marion County at Indianapolis. - From a Photograph by F. C. Martin." FRANK LESLIE'S ILLUSTRATED NEWSPAPER 47, no. 1215 (Jan. 11, 1879): 348. 1 illus. [View.]

MARTIN, H. T.
M233 Towler, John. "Porcelain Picture. - Simpsontype: As Prepared by H. T. Martin, Esq." HUMPHREY'S JOURNAL OF PHOTOGRAPHY, AND THE ALLIED ARTS AND SCIENCES 17, no. 8 (Aug. 15, 1865): 113-116. [Martin described as an amateur.]

MARTIN, JAMES. (GREAT BRITAIN)
BOOKS
M234 Martin, James. The Photographic Art: Its Theory and Practice; including Its Chemistry and Optics. Originally compiled by M. Sparling. Revised and corrected by James Martin. "Orr's Circle of the Sciences, Volume 7." London: R. Griffin & Co., 1860. 204 pp.

PERIODICALS
M235 Martin, James. "Producing Combination Pictures." PHOTOGRAPHIC TIMES 7, no. 81 (Sept. 1877): 199-200. [From "Photographic News."]

MARTIN, JAMES E. (1824-) (USA) see also HISTORY: USA: MN: 19TH C. (Woolworth).

MARTINEAU. (CHILE)
M236 "The Valparaiso and Santiago Railway." ILLUSTRATED LONDON NEWS 28, no. 778 (Jan. 5, 1856): 17. 2 illus. ["The accompanying views are from photographs taken by Mr. Martineau, one of the "engineers of the line."]

M237 "The Valparaiso and Santiago Railroad, Chili." FRANK LESLIE'S ILLUSTRATED NEWSPAPER 1, no. 9 (Feb. 9, 1856): 141. 2 illus. [Views. "The accompanying Views are from photographs taken by Mr. Martineau, one of the engineers of the line."]

MARTINEZ, J. (ASPINWALL, PANAMA)
M238 "Explosion at Aspinwall -Ruins of the Panama Railroad Company's Warehouse - The Wharf and the 'European' on Fire." HARPER'S WEEKLY 10, no. 488 (May 5, 1866): 285. 2 illus. ["Photographed immediately after the explosion by J. Martinez, Aspinwall."]

M239 "The Panama Railroad Freight Depot at Aspinwall, after the Explosion. - From a Photograph by J. Martinez, Aspenwall." FRANK LESLIE'S ILLUSTRATED NEWSPAPER 22, no. 554 (May 12, 1866): 113. 3 illus. [Views, before and after. Ruins.]

MARVILLE, CHARLES. (1816-1879) (FRANCE)
[Born on July 18, 1816 in Paris. He became a lithographer and an illustrator. Began to make photographs around 1851. Marville was a friend of Blanquart-Evrard, who published many of his photographs, in *Album photographique de l'artiste et de l'amateur*(1851), *Mélanges photographiques* (1852), *Etudes photographiques* (1853), Variétés photographiques (1853), *L'Art religiex, série architecture et sculpture* (1854), *Musée photographique* (1854), *Etudes et paysages* (1855), and *Bords du Rhin* (1854). Traveled to Algeria, and then, in 1852-53 throughout France and Germany. In 1853 he photographed along the Rhine and in Picardy. In 1854 he opened a studio in Paris. In 1854 he photographed the church of Baccharah, in 1855 he was in Laon, in 1856 he photographed Notre-Dame, in Paris. In the mid-1850s Marville began to work with wet-collodion. Throughout the late 1850s he photographed the Bois de Boulogne, views of Old Paris. This work appeared in an album *Album du Bois de Boulogne* of sixty prints. Marville moved his studio to a new address in 1861. Photographed in Milan and Torino in 1861-62. In 1862 he was made the photographer to the Imperial Museum at the Louvre and of the City of Paris. Continued to have studios throughout the 1860s. Photographed ruins of the Commune in 1871. Died in 1879.]

M240 "Biographical Notes on a Number of Photographers Published by Blanquart-Evrard." CAMERA (LUCERNE) 57, no. 12 (Dec. 1978): 32, 41-42. [Benecke, Claine, DuCamp, Fortier, Greene, Le Secq, Loydreau, Marville, Regnault, Robert, Salzmann, Stewart, Sutton, and Tenison.]

M241 Hungerford, Constance Cain. "Charles Marville, Popular Illustrator: The Origins of a Photographic Sensibility." HISTORY OF PHOTOGRAPHY 9, no. 3 (July - Sept. 1985): 227-246. 7 b & w. 6 illus.

MASCHER, JOHN F. (PHILADELPHIA, PA)
M242 "Stereoscope Cases." HUMPHREY'S JOURNAL 4, no. 15 (Nov. 15, 1852): 239. [J. F. Mascher, Philadelphia, PA, secured a patent on stereo daguerreotype cases.]

M243 "Mascher's Stereoscope." HUMPHREY'S JOURNAL 5, no. 5 (June 15, 1853): 76. 1 illus. [Engraving of the apparatus.]

M244 "Report on J. F. Mascher's Stereoscope." PHOTOGRAPHIC AND FINE ART JOURNAL 8, no. 4 (Apr. 1855): 123-124. 3 illus. [Two discussions of this apparatus, from the "J. of the Franklin Institute" and from "Silliman's J."]

M245 "Stereoscopic Medallion." HUMPHREY'S JOURNAL 7, no. 1 (May 1, 1855): 12. 1 illus. [Stereoscopic medallion invented by S. F. Mascher (Philadelphia, PA).]

M246 Mascher, J. F. "Daguerreotypes Without a Camera." PHOTOGRAPHIC AND FINE ART JOURNAL 8, no. 5 (May 1855): 144-146.

M247 Mascher, J. F. "A Disclaimer." PHOTOGRAPHIC AND FINE ART JOURNAL 8, no. 8 (Aug. 1855): 237.

M248 "Monthly Notes: Stereoscopic Daguerreotypes." PRACTICAL MECHANIC'S JOURNAL 8, no. 89 (Aug. 1855): 115-116. [Mentions Mascher, of Philadelphia.]

M249 Mascher, J. F. "On Taking Daguerreotypes without a Camera." HUMPHREY'S JOURNAL 7, no. 9 (Sept. 1, 1855): 139-141.

M250 "Mascher's Book Stereoscope." HUMPHREY'S JOURNAL 7, no. 22 (Mar. 15, 1856): 345-347. 1 illus.

M251 "Mascher's Book Stereoscope." PHOTOGRAPHIC AND FINE ART JOURNAL 9, no. 4 (Apr. 1856): 115-116. 1 illus.

M252 Mascher, John F. "Whole Lens Stereoscope." HUMPHREY'S JOURNAL OF PHOTOGRAPHY, AND THE ALLIED ARTS AND SCIENCES 10, no. 5 (July 1, 1858): 67-68. [Claims priority of invention over Claudet.]

M253 Mascher, John F. "The Stereoscope." AMERICAN JOURNAL OF PHOTOGRAPHY AND THE ALLIED ARTS AND SCIENCES n. s. vol. 1, no. 4 (July 15, 1858): 58-60.

M254 Brey, William. "John F. Mascher's Stereoscopic Cases." STEREO WORLD 5, no. 1 (Mar. - Apr. 1978): 14-19. 7 illus.

MASER, JOHN W.
M255 "Flood at Rochester, N. Y. - Street Views, Looking West from East End of Main Street Bridge and View of the Genesee River, Looking Over the Andrews Street Bridge. - From Photographs by J. W. Maser." FRANK LESLIE'S ILLUSTRATED NEWSPAPER 20, no. 498 (Apr. 15, 1865): 61. 2 illus. [Views.]

MASKELYNE.
M256 Maskelyne, Professor, J. D. Llewellyn, F.R.S., T. F. Hardwich and E. Hadow. "Papers on Photography read before the Last Session of the British Association: Abstract of Report on the Present State of Our Knowledge Regarding the Photographic Image." AMERICAN JOURNAL OF PHOTOGRAPHY AND THE ALLIED ARTS & SCIENCES n. s. vol. 2, no. 11 (Nov. 1, 1859): 170-172.

MASON & CO. (LONDON, ENGLAND)
M257 "Fine-Art Gossip." ATHENAEUM no. 1679 (Dec. 31, 1859): 893. [Discussion of Mason & Co.'s series "Photographic Portrait Gallery of Eminent Lawyers," and mention of their series "Church of England Portrait Gallery."]

M258 Portrait. Woodcut engraving credited "From a photograph by Mason & Co." ILLUSTRATED LONDON NEWS 51, (1867) ["Right Rev. G. A. Selwyn, D.D." 51:* (Dec. 14, 1867): 653.]

M259 "Note." ART JOURNAL (Aug. 1868): 162. [Mason & Co. photo of Bishops attending conference at Lambeth Palace.]

M260 Portraits. Woodcut engravings credited "From a photograph by Mason & Co." ILLUSTRATED LONDON NEWS 53, (1868) ["Very Rev. Dr. Milman." 53:* (Oct. 10, 1868): 340. "Right Rev. Dr. Tait." 53:* (Dec. 12, 1868): 573.]

M261 Portraits. Woodcut engravings credited "From a photograph by Mason & Co., Old Bond Street, London." ILLUSTRATED LONDON NEWS 55, (1869) ["Earl Spencer, K.G., Lord Lieutenant of Ireland." 55:* (Jan. 30, 1869): 117. "Right Rev. Dr. Jackson, Bishop of London." 55:* (Jan. 30, 1869): 137.]

M262 Portrait. Woodcut engraving credited "From a photograph by Mason & Co." ILLUSTRATED LONDON NEWS 56, (1870) ["Right Rev. Dr. Fraser." 56:* (Apr. 2, 1870): 349.]

M263 Portraits. Woodcut engravings, credited to "From a Photograph by Mason & Co." ILLUSTRATED LONDON NEWS 60, (1872) ["Prof. Richard Owen, F.R.S." 60:1691 (Feb. 3, 1872): 117. "Late Very Rev. James A. Jeremie." 60:1712 (June 29, 1872): 625.]

M264 Portrait. Woodcut engraving credited "From a photograph by Mason." ILLUSTRATED LONDON NEWS 62, (1873) ["Late W. C. MacReady." 62:1757 (May 3, 1873): 421.]

M265 Portrait. Woodcut engraving credited "From a photograph by Mason." ILLUSTRATED LONDON NEWS 63, (1873) ["Right Rev. E. H. Browne." 63:1172 (Aug. 16, 1873): 153.]

M266 Portrait. Woodcut engraving credited "From a photograph by Mason & Co." ILLUSTRATED LONDON NEWS 64, (1874) ["Late Sir. Archdale Wilson." 64:1813 (May 23, 1874): 493. Studios in London and Norwich]

M267 Portrait. Woodcut engraving credited "From a photograph by Mason & Co." ILLUSTRATED LONDON NEWS 67, (1875) ["Late Bishop Thirlwall." 67:1878 (Aug. 7, 1875): 137.]

MASON, GEORGE ["MARK OUTE"]. (GREAT BRITAIN)
M268 Mark Oute. "Photography - The Fashion." BRITISH JOURNAL PHOTOGRAPHIC ALMANAC 1874 (1874): 91-92. [Comic-dramatic poem.]

M269 Mark Oute. "Impressions. - My Album." BRITISH JOURNAL PHOTOGRAPHIC ALMANAC 1876 (1876): 172. [Poem.]

M270 Mark Oute. "Ferrotypes." BRITISH JOURNAL PHOTOGRAPHIC ALMANAC 1877 (1877): 144-146.

M271 Mark Oute. "'Genius Does What It Must.'" BRITISH JOURNAL PHOTOGRAPHIC ALMANAC 1878 (1878): 169-171. [Poem.]

M272 Mark Oute. "The Silent Witness. A Prison Dialogue." BRITISH JOURNAL PHOTOGRAPHIC ALMANAC 1879 (1879): 136-137. [Narrative poem.]

M273 "The Editorial Table." PHOTOGRAPHIC TIMES 21, no. 490 (Feb. 6, 1891): 71-72. [[Bk rev: "Pictures in Black and White; or

M274 Photographers Photographed" by George Mason ("Mark Oute"). Twenty eight poems about British photographers, appeared originally in "Brit. J. of Photo."]

MASON, K. R. (USA)
M275 New York (State). Constitutional Convention, 1867-1868. *Photographs of the Officers and Members of the Constitutional Convention of the State of New York, 1867.* Albany, NY: Jeffers & McDonald, 1867 ? n. p. 181 b & w. [181 Cartes-de-visite by K. R. Mason. NYPL Collection.]

MASON, OSCAR G. (ca. 1830-1921) (USA)
BOOKS

M276 Dalton, John Call. *Topographical Anatomy of the Brain.* Philadelphia: Lea Brothers & Co., 1885. 3 vol. 56, 107, 175 pp. 48 l. of plates. [Forty-eight heliotype prints. Photographer of O. G. Mason, of Bellevue Hospital, New York, NY]

PERIODICALS

M277 "Review of the Tenth Regiment of Massachusetts Volunteers, at Hampton Park, Springfield, Mass." NEW YORK ILLUSTRATED NEWS 4, no. 93 (Aug. 12, 1861): 229, 234. 1 illus. [Troops drilling. "Photographed by Oscar G. Mason, Springfield, MA."]

M278 "A Few Words in Regard to Lighting Operating Rooms, For Portraiture." AMERICAN JOURNAL OF PHOTOGRAPHY AND THE ALLIED ARTS & SCIENCES n. s. vol. 6, no. 6 (Sept. 15, 1863): 129-132. ["Mr. O. G. Mason, late of Springfield, Mass., now a resident of this city, is the author of the valuable article." p. 168.]

M279 Mason, Oscar G. "Copying." AMERICAN JOURNAL OF PHOTOGRAPHY AND THE ALLIED ARTS & SCIENCES n. s. vol. 7, no. 6 (Sept. 15, 1864): 138-141.

M280 Mason, O. G. "Removal of Developer Stains." AMERICAN JOURNAL OF PHOTOGRAPHY AND THE ALLIED ARTS & SCIENCES n. s. vol. 9, no. 1 (Sept. 1, 1866): 10-11.

M281 Mason, Oscar G. "A Case of Poisoning by Cyanide of Potassium." AMERICAN JOURNAL OF PHOTOGRAPHY AND THE ALLIED ARTS & SCIENCES n. s. vol. 9, no. 2 (Sept. 15, 1866): 43-44.

M282 Mason, O. G. "Correspondence." ANTHONY'S PHOTOGRAPHIC BULLETIN 2, no. 9 (Sept. 1871): 295. [Mason at Bellevue Hospital, New York, NY.]

M283 Mason, O. G. "The Uses of Potash for Cleaning Plates." PHILADELPHIA PHOTOGRAPHER 8, no. 94 (Oct. 1871): 325. [Mason works at Bellevue Hospital, New York, NY.]

M284 Mason, O. G. "An Error and Its Remedy." PHILADELPHIA PHOTOGRAPHER 11, no. 121 (Jan. 1874): 7-8. [Describes problems in copying a huge map for a railroad company.]

M285 "Report of the Photographic Section of the American Institute." ANTHONY'S PHOTOGRAPHIC BULLETIN 10, no. 4 (Apr. 1879): 124-125. [Mason describes his activities photographing patients at Bellevue Hospital to the meeting.]

M286 "Photography at Bellevue Hospital." PHILADELPHIA PHOTOGRAPHER 17, no. 199 (July 1880): 200-201. [Prof. Oscar G. Mason, medical photographer.]

M287 Mason, O. G. "Photographing Submerged Objects." AMERICAN ANNUAL OF PHOTOGRAPHY AND PHOTOGRAPHIC

TIMES ALMANAC FOR 1887 (1887): 157-159. 2 illus. [Mason worked at Bellevue Hospital, New York, NY, in the 1870s. Article is about photographing pathological specimens, submerged in preserving fluids.]

M288 Mason, O. G. "A Voyage to the Moon." ANTHONY'S PHOTOGRAPHIC BULLETIN 18, no. 10 (May 28, 1887): 303-307. [Read before the Photographic Section of the American Institute. Mason was an astronomer.]

M289 "Our Editorial Table." PHOTOGRAPHIC TIMES 18, no. 354 (June 29, 1888): 311. [Flash-light portrait of invalid with nurses taken at Bellevue Hospital.]

M290 "Notes and News: O. G. Mason." PHOTOGRAPHIC TIMES 20, no. 482 (Dec. 12, 1890): 618. [Note that Mason, of the Bellevue Hospital, N.Y., received a lengthy notice in the "N.Y. Sun" on Dec. 7, 1890. Comment that he likes the work, works for very little money because if the position were to be better paid it would "become political" and he would lose it.]

M291 "The Studios of New York. VII." PHOTOGRAPHIC TIMES 22, no. 558 (May 27, 1892): 276-277. [Mason, a photographer at Bellevue Hospital.]

MASON, R. H. (GREAT BRITAIN)
M292 Mason, R. H. *Norfolk Photographically Illustrated*. Norwich, London: R. H. Mason, 1865. 16 pp. 78 l. of plates. 78 b & w. [Original photographs, by R. H. Mason.]

MASSON. (CONSTANTINOPLE, TURKEY)
M293 "Card-Picture of the Sultan Abdul-Aziz." HUMPHREY'S JOURNAL OF PHOTOGRAPHY, AND THE ALLIED ARTS AND SCIENCES 15, no. 10 (Sept. 15, 1863): 160. [Note that a petition of 25,000 signatures presented to the Sultan Abdul-Aziz of Constantinople to have his portrait taken. The sultan has given his consent. "Mr. Masson, of Constantinople, is the favored photographer; to him is secured the sole right of selling this card for the space of five years."]

MASTERTON, JOHN M.
M294 Masterton, J. M. "A New Rapid Dry Process." AMERICAN JOURNAL OF PHOTOGRAPHY AND THE ALLIED ARTS & SCIENCES n. s. vol. 4, no. 24 (May 15, 1862): 561. [Masterton from Bronxville, NY.]

MASURY & SILSBEE. (BOSTON, MA)
M295 Farnham, Rev. Luther. "Boston Pulpit. No. 1 - No. 22." GLEASON'S PICTORIAL DRAWING-ROOM COMPANION 5, no. 1-22 (July 2, 1853-Nov. 26, 1853): 12, 28, 44, 60, 76, 92, 108, 124, 140, 156, 172, 188, 204, 220, 236, 252, 268, 284, 300, 316, 332, 348. 44 illus. [Series of biographies of Boston ministers, each accompanied by a portrait and a view of their church. Seven credited "From a daguerreotype by Southworth & Hawes." Six credited "From a daguerreotype by Whipple." Two credited "From a daguerreotype by Masury & Silsbee."]

M296 "Edward Everett." PHOTOGRAPHIC ART JOURNAL 6, no. 5 (Nov. 1853): frontispiece, 301-303. 1 b & w. [Portrait of Edward Everett.]

M297 "The Anthony Prize Pitcher." PHOTOGRAPHIC AND FINE ART JOURNAL 7, no. 1 (Jan. 1854): 6-11. [Letter describing their "process" on p. 11.]

M298 "Dr. Jerome V. C. Smith." GLEASON'S PICTORIAL DRAWING-ROOM COMPANION 6, no. 4 (Jan. 28, 1854): 64. ["From a daguerreotype by Masury & Silsbee." Smith had just been elected mayor of Boston.]

M299 "'The Artist.'" PHOTOGRAPHIC AND FINE ART JOURNAL 7, no. 8 (Aug. 1854): frontispiece, 250-251. 1 b & w. [Original photograph, tipped-in. The portrait is of Pope, the portrait painter, in his studio. Another brief note on p. 256.]

M300 "Portrait of Forrest." BALLOU'S PICTORIAL DRAWING-ROOM COMPANION [GLEASON'S] 8, no. 1 (Jan. 6, 1855): 11. ["We have received from Messers. Masury & Silsbee, daguerreotypists, No. 229 1/2 Washington Street, a beautiful photographic portrait of the distinguished American tragedian,..." [This is the first statement about a photograph - not daguerreotype - in this magazine.]

M301 "Lucius M. Sargent." BALLOU'S PICTORIAL DRAWING-ROOM COMPANION [GLEASON'S] 8, no. 12 (Mar. 24, 1855): 188. 1 illus. ["...from a Photograph by Masury & Silsbee."]

M302 "Hon. Nathan Hale." BALLOU'S PICTORIAL DRAWING-ROOM COMPANION [GLEASON'S] 8, no. 14 (Apr. 7, 1855): 220. 1 illus. ["From a Photograph by Masury & Silsbee."]

M303 "John Godfrey Saxe, the Comic Poet and Lecturer." BALLOU'S PICTORIAL DRAWING-ROOM COMPANION [GLEASON'S] 8, no. 17 (Apr. 28, 1855): 268. 1 illus. ["...from a Photograph by Masury & Silsbee."]

M304 "Freeman Hunt, Esq." BALLOU'S PICTORIAL DRAWING-ROOM COMPANION [GLEASON'S] 8, no. 21 (May 26, 1855): 332. 1 illus. ["From a Photograph by Masury & Silsbee."]

M305 "Edwin Forrest, the Tragedian." BALLOU'S PICTORIAL DRAWING-ROOM COMPANION [GLEASON'S] 8, no. 24 (June 16, 1855): 380. 1 illus. ["From a photograph by Masury & Silsbee."]

M306 "The Child of the Seventh Regiment." BALLOU'S PICTORIAL DRAWING-ROOM COMPANION [GLEASON'S] 9, no. 9 (Sept. 1, 1855): 140. 1 illus. [A young girl chosen as a mascot by the 7th NY Volunteers. "...from a daguerreotype by Masury & Silsbee."]

M307 "Hon. Robert Charles Winthrop." BALLOU'S PICTORIAL DRAWING-ROOM COMPANION [GLEASON'S] 9, no. 15 (Oct. 13, 1855): 236. 1 illus. ["From a photograph by Masury & Silsbee." Additional note praising their work on p. 237.]

M308 "The Chippewa Indians." BALLOU'S PICTORIAL DRAWING-ROOM COMPANION [GLEASON'S] 10, no. 237 (Jan. 19, 1856): 33. 1 illus. ["From a photograph by Masury & Silsbee." Group portrait of six Chippewa Indian chieftains visiting Boston.]

M309 Portraits. Woodcut engravings, credited "From a Photograph by Masury & Silsbee." BALLOU'S PICTORIAL DRAWING-ROOM COMPANION [GLEASON'S] 10, (1856) ["Rev. Henry Ward Beecher." 10:238 (Jan. 26, 1856): 60. John G. Gilbert." 10:241 (Feb. 10, 1856): 108. "Hon. Edward Everett." 10:246 (Mar. 22, 1856): 177. "Moses Kimball." 10:247 (Mar. 29, 1856): 204.]

MASURY, SILSBEE & CASE. (BOSTON, MA)
M310 Portraits. Woodcut engravings, credited "From a Photograph by Masury, Silsbee & Case." BALLOU'S PICTORIAL DRAWING-ROOM COMPANION [GLEASON'S] 10, (1856)

["Thomas Buchanan Read." 10:249 (Apr. 12, 1856): 225. "Major Thomas Harrison." 10:249 (Apr. 12, 1856): 236. "James Oakes, Esq." 10:252 (May 3, 1856): 284. " Mrs. Julia Bennett Barrow." 10:253 (May 10, 1856): 300. "Thomas Blanchard, The Inventor." 10:254 (May 17, 1856): 316. "Commodore Francis H. Gregory, U.S.N." 10:259 (June 21, 1856): 396.]

M311 "Portraits. Woodcut engravings, credited "From a Photograph by Masury, Silsby & Case." BALLOU'S PICTORIAL DRAWING-ROOM COMPANION [GLEASON'S] 11, (1856) ["Daniel J. Coburn, Chief of Police, Boston." 11:262 (July 12, 1856): 28. "Winslow Lewis, M.D." 11:263 (July 19, 1856): 44. "Signorina Felicita Vestvali." 11:268 (Aug. 23, 1856): 113. "Hon. Peleg Chandler, Esq." 11:270 (Sept. 6, 1856): 156. "Eugene Pierre Godard, the aeronaut." 11:271 (Sept. 13, 1856): 172. "Hon. Otis P. Lord." 11:273 (Sept. 27, 1856): 204. "Alexander Dumas." 11:274 (Oct. 4, 1856): 220. [Credited to Masury, Silsbee & Case, but I suspect that they imported the image from France.] "Henry Willard, Esq." 11:275 (Oct. 11, 1856): 236. "Late Seth Cheney, artist." 11:281 (Nov. 22, 1856): 332. "William W. Clapp, Jr., editor of the 'Saturday Evening Gazette.'" 11:282 (Nov. 29, 1856): 348. "Wyzeman Marshall, tragedian." 11:283 (Dec. 6, 1856): 364. "Col. James M. Thompson." 11:284 (Dec. 13, 1856): 380. "John Neal." 11:285 (Dec. 20, 1856): 396. "George Vandenhoff." 11:286 (Dec. 27, 1856): 412.]

M312 Portraits. Woodcut engravings, credited "From a Photography by Masury, Silsbee & Case." BALLOU'S PICTORIAL DRAWING-ROOM COMPANION [GLEASON'S] 12, (1857) ["William H. (Sedley) Smith." 12:289 (Jan. 17, 1857): 44. "E. Smith Jr., Chief of Boston, MA, Fire Department." 12:292 (Jan. 24, 1857): 60. "Adam W. Thaxter, Jr." 12:197 (Feb. 28, 1857): 140. "Francis A. Durivage, assoc. ed. "Ballou's Pictorial" 12:300 (Mar. 21, 1857): 188. "Lieut. George H. Preble, U.S.N." 12:303 (Apr. 11, 1857): 236. "Rev. Samuel M. Worcester, D.D." 12:304 (Apr. 18, 1857): 252. Adjutant-General Ebenezer W. Stone." 12:307 (May 9, 1857): 300. "James William Wallack, Jr." 12:308 (May 16, 1857): 316. "Col. John T. Hear." 12:310 (May 30, 1857): 348. "Edwin Booth, Tragedian." 12:313 (June 20, 1857): 398.]

M313 "Messrs. Masury, Silsbee & Case." BALLOU'S PICTORIAL DRAWING-ROOM COMPANION [GLEASON'S] 12, no. 301 (Mar. 28, 1857): 205. [Note praising the gallery, briefly describing their operations.]

M314 Portraits. Woodcut engravings, credited "From a Photograph by Masury, Silsbee & Case." BALLOU'S PICTORIAL DRAWING-ROOM COMPANION [GLEASON'S] 13, (1857) ["Dr. Isaac I. Hayes, Arctic Explorer." 13:316 (July 11, 1857): 28. "Nathaniel Parker Willis, Esq." 13:320 (Aug. 8, 1857): 92. "Hon. George Lunt." 13:322 (Aug. 22, 1857): 124. "John Homans, M.D." 13:323 (Aug. 29, 1857): 140. "Colonel Thomas C. Amoey." 13:329 (Oct. 10: 236. "Rembrandt Peale, the artist." 13:330 (Oct. 17, 1857): 241.]

MASURY, SAMUEL see also MASURY & SILSBEE; MASURY, SILSBEE & CASE.

MASURY, SAMUEL. (1820-1874) (USA)
[Born in Salem, MA in 1820. Learned the daguerreotype process from John Plumbe in Boston in 1842, then practiced in the New England area. Active in Providence, RI in the mid-1840s, in partnership with Samuel Hartshorn. Sold gallery to the Manchester Brothers and moved to Boston, MA in 1850. Partnered with George M. Silsbee from 1852 to 1854, then with Silsbee and J. G. Case until 1857, when the partnership dissolved. Ran his own studio in Boston from 1858 to 1860. Visited Paris in 1855, where he studied photography with the

Bisson Frères, where he probably learned paper processes. One of the first to offer paper prints, rather than daguerreotypes, and thus his portraits appeared frequently in the illustrated journals in the late 1850s. By 1966 he was offering photographic specialities, such as photomontaged portraits, but at age fifty-one he left photography and went into the sewing machine business. Five years later he died of tuberculosis.]

M315 "Hon. Aaron V. Brown, Postmaster-General of the United States." BALLOU'S PICTORIAL DRAWING-ROOM COMPANION [GLEASON'S] 14, no. 21 (May 22, 1858): 321. 1 illus. ["...from a very fine photograph taken by Mr. S. Masury, of this city who has recently established himself in a fine galley, No. 289 Washington Street, Boston, MA."]

M316 "Smutty Bear, a Chief of the Sioux." BALLOU'S PICTORIAL DRAWING-ROOM COMPANION [GLEASON'S] 14, no. 22 (May 29, 1858): 337. 1 illus. ["The accompanying portrait of an Indian chief of distinction, who lately paid a visit to President Buchanan, was drawn... from an excellent photograph by Mr. S. Masury." Sioux Indian.]

M317 "Photographic Art." BALLOU'S PICTORIAL DRAWING-ROOM COMPANION [GLEASON'S] 15, no. 6 (Aug. 7, 1858): 93. [Praise for Mr. Masury.]

M318 Portraits. Woodcut engravings, credited "From a Photograph by Masury." BALLOU'S PICTORIAL DRAWING-ROOM COMPANION [GLEASON'S] 16, (1859) ["Charles Hale, Speaker of the House, MA State Legislature." 16: 396 (Jan. 22, 1859): 49. "Charles A. Barry, Artist." 16:401 (Feb. 26, 1859): 136. "Nahum Capen, Postmaster of Boston, MA." 16:402 (Mar. 5, 1859): 145. "Fletcher Webster, Surveyor of Boston, MA." 16:404 (Mar. 19, 1859): 177.]

M319 "Tennyson's 'Adeline.'" BALLOU'S PICTORIAL DRAWING-ROOM COMPANION [GLEASON'S] 16, no. 396 (Jan. 22, 1859): 59. ["Another exquisite photograph, by S. Masury, from a crayon drawing, by C. A. Barry, of this city, is for sale."]

M320 "Samuel Masury, Daguerreotypist and Photographic Artist." BALLOU'S PICTORIAL DRAWING-ROOM COMPANION [GLEASON'S] 16, no. 405 (Mar. 26, 1859): 205. 1 illus. [Portrait and brief biography. Masury was born in Salem, MA in 1820. Attended public schools there until age seventeen, then became a clerk in a store. Had mechanical aptitudes, and soon took up carriage making. In 1842 he studied the daguerreotype process with John Plumbe in Boston and then practiced "...in most of the principle cities in New England..." for the next seventeen years. "Four of five years since." Masury was almost killed in an explosion that occurred while he was experimenting with photographic processes. He went to France in 1855 and studied with the Bisson Brothers. (As Masury was an early practitioner of paper photographic processes in the United States, he probably learned photography in France.) In 1859 he opened a gallery at 289 Washington Street, Boston, MA.]

M321 "Paul Murphey, American Chess Champion " BALLOU'S PICTORIAL DRAWING-ROOM COMPANION [GLEASON'S] 17, no. 419 (July 2, 1859): 1. 1 illus.

M322 Portrait. Woodcut engraving, credited "From a Photograph by Masury, of Boston." FRANK LESLIE'S ILLUSTRATED NEWSPAPER 9, (1860) ["John C. Heenan, the American pugilist." 9:223 (Mar. 10, 1860): 238.]

M323 Portraits. Woodcut engravings, credited "Photographed by S. Masury, Boston." FRANK LESLIE'S ILLUSTRATED NEWSPAPER 10, (1860) ["Madame Inez Fabbri, Prima Donna.' 10:259 (Nov. 10, 1860): 387.]

MATHER, JOHN AKED. (1829-1915) (GREAT BRITAIN, USA)
BOOKS
M324 Giddens, Paul Henry. *Early Days of Oil: A Pictorial History of the Beginnings of the Industry in Pennsylvania.* Princeton: Princeton Univ. Press, 1948. vii, 149 pp. illus. [Primarily photos by John A. Mather taken in and near Titusville, PA. The negatives now in the Mather Collection, the Drake Museum, Titusville.]

PERIODICALS
M325 "Photographs Received." PHILADELPHIA PHOTOGRAPHER 3, no. 26 (Feb. 1866): 64. [Mather from Titusville, PA. Stereos of oil wells, etc. in the Titusville region. "Mr. Mather's first attempts."]

M326 Miller, Ernest C. and T. K. Stratton. "Photographer to Oildom." AMERICAN HERITAGE 17, no. 6 (Oct. 1966): 38-45. 8 b & w. [Short biography of John Mather, photographer to the Titusville, Pa. oil boom in the 1860s. Born in Lancashire, England in 1829. Trained as a paper maker. To U.S. in 1856, became a photographer. Working in Painesville, Ohio in 1860, heard about the Titusville Oil Strike and boom. Moved there, opened a studio and stayed nearly 50 years. 1892 flood and fire ruined 16,000 glass negatives. Died Aug. 23, 1915, penniless.]

M327 Miller, Ernest C. and T. K. Stratton. "Oildom's Photographic Historian." WESTERN PENNSYLVANIA HISTORICAL MAGAZINE 55, no. 1 (Jan. 1972): 1-54. 39 b & w. 4 illus. [Biography of John Mather.]

MATHER, JOHN AKED. [?]
M328 "Oil Springs at Tarr Farm, Oil Creek, Pennsylvania." ILLUSTRATED LONDON NEWS 41, no. 1159 (Nov. 8, 1862): 488. 1 illus. ["Mr. Alexander S. Macrae, petroleum oil broker of Liverpool has furnished us with a photographic view."]

MATHESON, HENRY. (GREAT BRITAIN)
M329 Matheson, Henry. *Practical Advice to Amateur Photographers: On the Direct Negative versus Strengthening Positives.* London: James How, 1863. 36 pp. illus. ["Principle Operator for eight years in the Photographic Department, Crystal Palace, Sydenham."]

MATHEWS, A. (LISBON, AZ)
M330 "Editor's Table." PHILADELPHIA PHOTOGRAPHER 6, no. 71 (Nov. 1869): 386-388. [Prof. Henry Morton; A. Matthews (Lisbon, AR) taking up photography as a profession at age 71; J. M. Elliott (Columbus, OH); E. Harvey (Minneapolis, MN) died July 18, 1869; John Dunmore (J. W. Black) just returned from Arctic regions; J. C. Browne; Wellington Watson (Detroit, MI); William B. Holmes (New York, NY); Wm. Kurtz; H. Noss (New Brighton, PA); others mentioned.]

MATHIEU, P. F.
BOOKS
M331 Mathieu, P. F. *Auto-photographie. Oder: Anweisung, ohne Anwendung des Daguerreotypes, vermittelst des lichts Zeichnungen, Lithographien, Kupferstiche u. wieder zu erzeugen. Aus dem Französischen.* Liepzig: Gottfried Basse, 1847. 13 pp.

M332 Mathieu, P. F. *Auto-Photography; or, the Mode of Reproducing by Light Drawings, Lithographs, &c., without employing the Daguerreotype.* by M. P. F. Mathieu. Translated by J. McMeadows. s. l. [London ?]: s. n., 1848. n. p. [13 p.?] [Includes a memoir on the calotype by Blanquart-Evrard, which is copied from Talbot, according to the reviewer in the Feb. 10, 1849 "Athenaeum."]

M333 Mathieu, P. F. *Auto-Photographie, ou méthode de reproduction par la lumière des dessins, lithographies, gravures, etc. sans l'emploi du Daguerreotype.* "6th ed." [Paris?]: s. n., 1850. n. p.

PERIODICALS
M334 "Our Literary Table: Auto-Photography; or the Mode of Reproducing by Light Drawings, Lithographs, &c., without employing the Daguerreotype, by M. P. F. Mathieu, translated by J. McMeadows." ATHENAEUM no. 1111 (Feb. 10, 1849): 141. [Mentioned with disapproval, trans. from French.]

MATHIOT, GEORGE. (USA)
M335 Mathiot, George. "Photographic Engraving." HUMPHREY'S JOURNAL 6, no. 21 (Feb. 15, 1855): 337-338. [Mathiot working for the U.S. Coast Survey Office, Washington, DC.]

M336 Mathiot, George. "Report of the Supt. of the United States Coast Survey for 1854." HUMPHREY'S JOURNAL 7, no. 12 (Oct. 15, 1855): 189-192. [Discussion of Geo. Mathiot's work in photo engraving maps, etc., with his report.]

M337 Mathiot, George. "Actino-Engraving." HUMPHREY'S JOURNAL 7, no. 14 (Nov. 15, 1855): 217-218. [Letter from Mathiot, elucidating some point of his process.]

M338 Mathiot, George. "Actio-Engraving. No. 1." HUMPHREY'S JOURNAL 7, no. 20 (Feb. 15, 1856): 313-315. [Survey of experiments in color, potential of the medium. etc.]

M339 Mathiot, George. "Actino-Engraving. No. 2." HUMPHREY'S JOURNAL 8, no. 3 (June 1, 1856): 33-35.

M340 Mathiot, George. "Actino-Engraving. No. 3." HUMPHREY'S JOURNAL 8, no. 12 (Oct. 15, 1856): 177-179. [Written for "Humphrey's Journal." Part 3 (at least) of this article is generalized aesthetic commentary - not technical. Mathiot is described as being in the U. S. Coast Survey Office, with the function of reproducing maps, on pp. 181 of the same issue.]

M341 Mathiot, Geo. "Micro-Photography." HUMPHREY'S JOURNAL OF PHOTOGRAPHY, AND THE ALLIED ARTS AND SCIENCES 9, no. 24 (Apr. 15, 1858): 369-370. [Letter from Mr. Mathiot, U. S. Coast Survey Office.]

M342 Mathiot, George. "The Capability of Photography. The Past, Present and Future." PHILADELPHIA PHOTOGRAPHER 5, no. 50 (Feb. 1868): 44-47. [Discusses the technical limitations of the medium.]

M343 Mathiot, Geo. "The Conception of Photography." HUMPHREY'S JOURNAL OF PHOTOGRAPHY, AND THE ALLIED ARTS AND SCIENCES 10, no. 1 (May 1, 1858): 5-7.

M344 Mathiot, Geo. "The Elements for a Successful Negative." HUMPHREY'S JOURNAL OF PHOTOGRAPHY, AND THE ALLIED ARTS AND SCIENCES 10, no. 2 (May 15, 1858): 17-19.

M345 Mathiot, Geo. "Compounding Formulae. - The Weights and Measures." HUMPHREY'S JOURNAL OF PHOTOGRAPHY, AND THE ALLIED ARTS AND SCIENCES 10, no. 3 (June 1, 1858): 33-36.

M346 Mathiot, Geo. "The Importance of Chemical Science to Photographers." HUMPHREY'S JOURNAL OF PHOTOGRAPHY, AND THE ALLIED ARTS AND SCIENCES 10, no. 4 (June 15, 1858): 51-53.

M347 Mathiot, Geo. "The Nitrate Bath." HUMPHREY'S JOURNAL OF PHOTOGRAPHY, AND THE ALLIED ARTS AND SCIENCES 10, no. 6-10 (July 15 - Sept. 15, 1858): 81-83, 97-99, 113-115, 129-131, 147-150.

M348 Mathiot, George. "The Elements for a Successful Negative." LIVERPOOL & MANCHESTER PHOTOGRAPHIC JOURNAL [BRITISH JOURNAL OF PHOTOGRAPHY] n. s. 2, no. 15 (Aug. 1, 1858): 189-191. [From "Humphrey's Journal."]

M349 Mathiot, Geo. "The Chemical Nomenclature." HUMPHREY'S JOURNAL OF PHOTOGRAPHY, AND THE ALLIED ARTS AND SCIENCES 10, no. 12-24 (Oct. 15, 1858-Apr. 15, 1859): 177-179, 209-211, 257-259, 369-371.

M350 Mathiot, Geo. "The Fading of Paper Photographs-Washing the Prints." HUMPHREY'S JOURNAL OF PHOTOGRAPHY, AND THE ALLIED ARTS AND SCIENCES 11, no. 1-3 (May 1-June 1, 1859): 1-3, 17-18, 34-35.

M351 Mathiot, Geo. "A New and Beautiful Stereoscopic Arrangement." HUMPHREY'S JOURNAL OF PHOTOGRAPHY, AND THE ALLIED ARTS AND SCIENCES 11, no. 17 (Jan. 1, 1860): 257-259.

MATTHYS, A., S.J. (BELGIUM)
M352 Matthys, A. "Glazing of Photographs by means of Collodion." HUMPHREY'S JOURNAL OF PHOTOGRAPHY, AND THE ALLIED ARTS AND SCIENCES 16, no. 4 (June 15, 1864): 54-55. [From "Bulletin Belge de la Photographie."]

M353 Matthys, A., S.J. of Antwerp. "On the Glazing of Photographic Prints by Means of Collodion." AMERICAN JOURNAL OF PHOTOGRAPHY AND THE ALLIED ARTS & SCIENCES n. s. vol. 7, no. 6 (Sept. 15, 1864): 121-122. [From "Photo. Notes."]

MAUDE, NEVILLE.
M354 Maude, Neville. "Stereo Photography. Its Inception, Rise and Fall." BRITISH JOURNAL OF PHOTOGRAPHY ANNUAL 1878 (1878): 140-149. 24 illus.

MAUGMAM.
M355 Maugmam, Dr. "Toning with Salts of Platinum." HUMPHREY'S JOURNAL OF PHOTOGRAPHY, AND THE ALLIED ARTS AND SCIENCES 16, no. 2 (May 15, 1864): 27-28. [From "Photo. News." "About two years ago, whilst making some experiments with a lady on the subject of toning photographs, it struck me."]

MAULL & CO. (LONDON, ENGLAND)
M356 Portraits. Woodcut engravings credited "From a photograph by Maull & Co. of Piccadilly." ILLUSTRATED LONDON NEWS 48, (1866) ["John Gibson, R.A." 48:* (Feb. 17, 1866): 161. "Dr. Conolly." 48:* (Mar. 31, 1866): 317. ["by Messrs. Maull & Co., (late Maull & Polyblank), of Piccadilly and Cheapside."]

M357 Portraits. Woodcut engravings credited "From a photograph by Maull & Co., Cheapside, England." ILLUSTRATED LONDON NEWS 49, (1866) ["Right Hon. Thomas Gabriel, Lord Mayor of London." 49:* (Nov. 10, 1866): 457.]

M358 Portraits. Woodcut engravings credited "From a photograph by Maull & Co., Cheapside, England." ILLUSTRATED LONDON NEWS 51, (1866) ["Right Hon. W. F. Allen." 51:* (Nov. 9, 1867): 517. "Earl of Rosse." 51:* (Nov. 16, 1867): 536.]

M359 Portrait. Woodcut engraving credited "From a photograph by Maull & Co." ILLUSTRATED LONDON NEWS 52, (1868) ["Ward Hunt, M.P." 52:* (Mar. 21, 1868): 280.]

M360 Portraits. Woodcut engravings credited "From a photograph by Maull & Co." ILLUSTRATED LONDON NEWS 53, (1868) ["Sir James Brooke, Rajah of Sarawak." 53:* (July 4, 1868): 17. "Mr. Samuel Lover." 53:* (Aug. 1, 1868): 105.]

M361 Portraits. Woodcut engravings credited "From a photograph by Maull & Co." ILLUSTRATED LONDON NEWS 55, (1869) ["Maj.-Gen. Sir Edward Sabine." 55:* (Oct. 9, 1869): 353. "Alderman Robert Besley." 55:* (Nov. 6, 1869): 461.]

M362 Portraits. Woodcut engravings credited "From a photograph by Maull & Co. of Piccadilly." ILLUSTRATED LONDON NEWS 58, (1870) ["Capt. Hugh Burgoyne, V.C." 58:* (Sept. 24, 1870): 312. "Lieut.-Col. Pemberton." 58:* (Oct. 1, 1870): 336.]

M363 Portraits. Woodcut engravings credited "From a photograph by Maull & Co." ILLUSTRATED LONDON NEWS 58, (1871) ["The late Dean Alford." 58:1634 (Jan. 28, 1871): 97. "The claimant to the Sir Roger Tichborne title." 58:1657 (July 1, 1871): 641.]

M364 Portraits. Woodcut engravings, credited to "From a Photograph by Maull & Co." ILLUSTRATED LONDON NEWS 59, (1871) ["Late Mr. George Grote." 59:1658-1659 (July 8, 1871): 13. "Sir Francis Pettit Smith." 59:1668 (Sept. 9, 1871): 241. "Late Sir F. G. Moon, Bart." 59:1676 (Oct. 28, 1871): 401. "Sills J. Gibbons, Lord Mayor of London." 59:1678 (Nov. 11, 1871): 457. "W. W. Gull, M.D." 59:1865 (Dec. 23, 1871): 612.]

M365 Portraits. Woodcut engravings, credited to "From a Photograph by Maull & Co." ILLUSTRATED LONDON NEWS 60, (1872) ["Wm. C. T. Dobson, R.A." 60:1688 (Jan. 13, 1872): 29. "Late Earl of Ellenborough" 60:1688 (Jan. 13, 1872): 37. "Late Mr. Pease" 60:1694 (Feb. 24, 1872): 181. "Late Rev. W. Ellis" 60:1712 (June 29, 1872): 625.]

M366 Portraits. Woodcut engravings credited "From a photograph by Maull & Co." ILLUSTRATED LONDON NEWS 61, (1872) ["Baron Hammer, of Flint." 61:1726 (Oct. 5, 1872): 340. "Sir W. Gomm, K.C.B." 61:1730 (Nov. 2, 1872): 414.]

M367 Portraits. Woodcut engravings credited "From a photograph by Maull & Co." ILLUSTRATED LONDON NEWS 62, (1873) ["Late Dr. Lushington." 62:1744 (Feb. 1, 1873): 96. "Late Hon. and Rev. Baptist Noel." 62:1744 (Feb. 1, 1873): 104.]

M368 Portraits. Woodcut engravings credited "From a photograph by Maull & Co." ILLUSTRATED LONDON NEWS 63, (1873) ["Sir Samuel and Lady Baker." 63:1780 (Oct. 11, 1873): 345. "Late Mrs. Alfred Gratty." 63:1781 (Oct. 18, 1873): 369. "Alderman Whetham." 63:1785 (Nov. 15, 1873): 454.]

M369 Portraits. Woodcut engravings credited "From a photograph by Maull & Co." ILLUSTRATED LONDON NEWS 64, (1874) ["Late Prof. Agassiz." 64:1793 (Jan. 3, 1874): 4. "Late Mr. Oke." 64:1796 (Jan. 24, 1874): 80. "Lieut. Lord Gifford, V.C." 64:1808 (Apr. 18, 1874): 373.]

M370 Portraits. Woodcut engravings credited "From a photograph by Maull & Co., Piccadilly, England." ILLUSTRATED LONDON NEWS 65, (1874) ["Late Sir W. Fairbairn, Bart." 65:1827 (Aug. 29, 1874): 205. "Late Bishop Sumner." 65:1828 (Sept. 5, 1874): 229. "Late Dr. Beatson." 65:1828 (Sept. 5, 1874): 229. "Late Duke of Leinster." 65:1834 (Oct. 17, 1874): 369. "Alderman Stone, Lord Mayor of London." 65:1837 (Nov.7, 1874): 433. "Alderman and Sheriff Ellis." 65:1837 (Nov. 7, 1874): 433. "Sheriff Shaw." 65:1837 (Nov. 7, 1874): 433. "Late Sir Wm. Jardine." 65:1846 (Dec. 26, 1874): 609.]

M371 Portraits. Woodcut engravings credited "From a photograph by Maull & Co., Piccadilly, Eng." ILLUSTRATED LONDON NEWS 66, (1875) ["Late Col. Milward, C.B." 66:1849 (Jan. 16, 1875): 57. "Late Sir Samuel Bignold." 66:1850 (Jan. 23, 1875): 85. "Lieut. R. H. Archer, Lieut. Wyatt Rawson, on H.M.S. "Discovery." 66:1869 (June 5, 1875): 528.]

M372 Portraits. Woodcut engravings credited "From a photograph Maull & Co." ILLUSTRATED LONDON NEWS 67, (1875) ["W. J. R. Cotton, Mayor of London." 67:1891 (Nov. 6, 1875): 452. "Sheriff Breffit, London." 67:1892 (Nov. 13, 1875): 476.]

M373 Portraits. Woodcut engravings credited "From a photograph by Maull & Co." ILLUSTRATED LONDON NEWS 68, (1876) ["Late Sir Balwin Walker, K.C.B." 68:1909 (Feb. 26, 1876): 196. "Late General Sir H. Taylor, G.C.B." 68:1911 (Mar. 11, 1876): 253. "Late Dr. H. Gauntlett." 68:1911 (Mar. 11, 1876): 253. "Late Col. A. Strange." 68:1914 (Apr. 1, 1876): 316.]

M374 Portraits. Woodcut engravings credited "From a photograph by Maull & Co." ILLUSTRATED LONDON NEWS 69, (1876) ["Late Earl of Lonsdale." 69:1936 (Sept. 2, 1876): 213. "Hon. T. F. Fremantle, M.P." 69:1941 (Oct. 7, 1876): 341. "Mr. Justice Hawkins." 69:1947 (Nov. 18, 1876): 476. "Baron Airey." 69:1948 (Nov. 25, 1876): 500. "Mr. George Moore." 69:1949 (Dec. 2, 1876): 533.]

M375 Portraits. Woodcut engravings credited "From a photograph by Maull & Co." ILLUSTRATED LONDON NEWS 70, (1877) ["Rev. Ed. R. Johnson, Bishop of Calcutta." 70:1956 (Jan. 6, 1877): 21. "Mr. John Torr, M.P." 70:1961 (Feb. 10, 1877): 121. "Late Sir Hardman Earle." 70:1962 (Feb. 17, 1877): 156. "Late Sir Edward Belcher." 70:1968 (Mar. 31, 1877): 300. "Field Marshall Sir Charles Yorke." 70:1979 (June 16, 1877): 565.]

M376 Portraits. Woodcut engravings credited "From a photograph by Maull & Co." ILLUSTRATED LONDON NEWS 72, (1878) ["Hon. Wilbraham Egerton, M.P." 72:2012 (Jan. 19, 1878): 53. "Lord Lyons." 72:2029 (May 18, 1878): 452.]

M377 Portraits. Woodcut engravings credited "From a photograph by Maull & Co." ILLUSTRATED LONDON NEWS 73, (1878) ["Late Bishop MacKenzie." 73:2052 (Oct. 26, 1878): 400. "Sheriff Bevan, London." 73:2054 (Nov. 9, 1878): 441. "Sheriff Burt, London." 73:2054 (Nov. 9, 1878): 441.]

MAULL & FOX. (LONDON, ENGLAND)

M378 Portrait. Woodcut engraving credited "From a photograph by Maull & Fox." ILLUSTRATED LONDON NEWS 74, (1879) ["Lady Georgiana Churchill." 74:2074 (Mar. 15, 1879): 241.]

M379 Portrait. Woodcut engraving credited "From a photograph by Maull & Fox." ILLUSTRATED LONDON NEWS 75, (1879) ["Lieut. Reginald C. Hart." 75:2101 (Sept. 20, 1879): 265. Studios in Piccadilly and Cheapside, Eng.]

MAULL & POLYBLANK. (LONDON, ENGLAND)
BOOKS
M380 Maull & Polyblank. *Photographic Portraits of Living Celebrities; Executed by Maull & Polyblank; With biographical Notices by E. Walford.* London: Maull & Polyblank, W. Kent & Co., 1859. 86 pp. 40 b & w. [A "photographic portrait serial," typical of several such issued during the 1850s and 1860s. Individual portraits, each with a letterpress biography, etc., were issued in series, then often bound or reissued as a bound volume. Forty numbers of this work were issued in monthly installments of one portrait with biographical texts, from May 1856 to Oct. 1859. In 1859 the set was cumulated into a volume.]

PERIODICALS
M381 Portraits. Woodcut engravings credited "From a photograph by Maull & Polyblank." ILLUSTRATED LONDON NEWS 29, (1856) ["William Yarrell, F.R.S." 29:* (Sept. 13, 1856): 275. "Rear Admiral Sir John Ross." 29:* (Sept. 13, 1856): 275.]

M382 [Review.] ATHENAEUM no. 1596 (May 29, 1858): 694. [Compares "Photographic Portraits of Living Celebrities," with biographical notices by C. Watford, M.A., published by Maull & Polyblank with "The National Gallery of Photographic Portraits," with notices by Herbert Fry, photos by Herbert Watkins.]

M383 Portraits. Woodcut engravings credited "From a photograph by Maull & Polyblank." ILLUSTRATED LONDON NEWS 33, (1858) ["Robert Brown, Keeper of Botany in British Museum." 33:* (July 10, 1858): 29. "Count de Montalembert." 33:* (Nov. 27, 1858): 507.]

M384 Portraits. Woodcut engravings credited "From a photograph by Maull & Polyblank." ILLUSTRATED LONDON NEWS 34, (1859) ["J. W. Bazalgette, C.E." 34:* (Mar. 12, 1859): 253. "Dr. Beddome, Mayor of Romsey." 34:* (Apr. 16, 1859): 385.]

M385 Portraits. Woodcut engravings credited "From a photograph by Maull & Polyblank." ILLUSTRATED LONDON NEWS 36, (1860) ["Lord MacCaulay." 36:* (Jan. 7, 1860): 13. "Dr. Todd." 36:* (Feb. 18, 1860): 145. "Albert Smith." 36:* (June 2, 1860): 516. "Capt. Vine Hall, of the 'Great Eastern.'" 36:* (June 9, 1860): 561.]

M386 Portraits. Woodcut engravings credited "From a photograph by Maull & Polyblank." ILLUSTRATED LONDON NEWS 37, (1860) ["Duke of Richmond, K.C." 37:* (Nov. 3, 1860): 410. "Earl of Dundonald." 37:* (Nov. 17, 1860): 471. "Sir John Bowring." 37:* (Dec. 1, 1860): 506. "Earl of Aberdeen." 37:* (Dec. 29, 1860): 635.]

M387 Portraits. Woodcut engravings credited "From a photograph by Maull & Polyblank." ILLUSTRATED LONDON NEWS 38, (1861) ["Dr. Baly, F.R.S." 38:* (Feb. 9, 1861): 111. "Rev. T. S. Henslow." 38:* (June 22, 1861): 583.]

M388 Portrait. Woodcut engraving credited "From a photograph by Maull & Polyblank." ILLUSTRATED LONDON NEWS 39, (1861) ["Prof. Quekett, F.R.S." 39:* (Aug. 31, 1861): 227.]

M389 Portraits. Woodcut engravings credited "From a photograph by Maull & Polyblank." ILLUSTRATED LONDON NEWS 40, (1862) ["The Duke of Devonshire." 40:* (Jan. 18, 1862): 73. "Rev. Thomas Hartwell Horne." 40:* (Feb. 22, 1862): 190.]

M390 "Note." ART JOURNAL (Apr. 1864): 123. [A series of 50 cartes of British artists issued.]

M391 Portrait. Woodcut engraving credited "From a photograph by Maull & Polyblank." ILLUSTRATED LONDON NEWS 46, (1864) ["Dr. W. B. Baikie, African Traveller." 46:* (Jan. 23, 1865): 88.]

M392 Portraits. Woodcut engravings credited "From a photograph by Maull & Polyblank." ILLUSTRATED LONDON NEWS 47, (1865) ["Wingrove Cooke." 47:* (July 15, 1865): 49. "Professor Lindley, botanist." 47:* (Dec. 9, 1865): 553.]

M393 Portraits. Woodcut engravings credited "From a photograph by Maull & Polyblank." ILLUSTRATED LONDON NEWS 54, (1869) ["Admiral Sir James Gordon." 54:* (Feb. 13, 1869): 165. "Field Marshall Lord Gough." 54:* (Mar. 20, 1869): 293.]

MAUNIER, V. G. (FRANCE, EGYPT)
[Photographer from Paris, commissioned to photograph Egyptian antiquities in 1852. Some prints published by Blanquart-Evrard in 1854-55. He remained in Egypt, where he traded in Egyptian antiquities for twenty years. An amateur archeologist, he assisted Mariette in his excavations at Luxor. In 1863 he became an administrator for a wealthy Egyptian landowner, became rich himself, retired to France, and donated much of his collections to the Louvre.]

M394 "Photography in Egypt." HUMPHREY'S JOURNAL 4, no. 6 (July 1, 1852): 90. [From "La Lumiére." The French artist M. Mauniers, has been employed by Abbas Pacha to photograph Egyptian antiquities.]

MAWDSLEY, PETER. (GREAT BRITAIN)
M395 Mawdsley, P. "Glass Transparencies." AMERICAN JOURNAL OF PHOTOGRAPHY AND THE ALLIED ARTS & SCIENCES n. s. vol. 6, no. 19 (Apr. 1, 1864): 448-452. [Read before Liverpool Amateur Photo. Assoc.]

M396 Mawdsley, Peter. "A New and Simple Method of Working in the Field." PHOTOGRAPHIC TIMES 7, no. 74 (Feb. 1877): 30-31. [Communication to the Photographic Society of Great Britain.]

MAWSON & SWAN. (GREAT BRITAIN)
BOOKS
M397 The Collodio-Bromide Process and Its Various Modifications. Newcastle-on-the Tyne: Mawson & Swan, 1872. 14 pp.

PERIODICALS
M398 "Note." ART JOURNAL (Dec. 1865): 381. [Of Newcastle-on-Tyne, England. Examples of their carbon process discussed.]

M399 Taylor, Prof. "Carbon Prints." HUMPHREY'S JOURNAL OF PHOTOGRAPHY, AND THE ALLIED ARTS AND SCIENCES 18, no. 20 (Feb. 15, 1867): 306-307.

MAWSON, JOHN see also MAWSON & SWAN.

MAWSON, JOHN. (d. 1867) (GREAT BRITAIN)
M400 Mawson, John. Photographic Formulae relative to the Collodion, Calotype, and other Processes. Newcastle-on-Tyne: J. Mawson, 1856. n. p. [Mawson was killed in a nitroglycerin explosion in 1867.]

MAXWELL, D. C. (LYNCHBURG, VA)
M401 "Photographic Ware." HUMPHREY'S JOURNAL OF PHOTOGRAPHY, AND THE ALLIED ARTS AND SCIENCES 20, no. 7 (Aug. 1, 1868): 112. [Anecdote from D. C. Maxwell, "well-known

stock dealer and operator, (who) bought out a gallery." in Lynchburg, VA in 1861.]

MAY, CHARLES. (GREAT BRITAIN)
M402 Photographic Views of the Churches, Mansions and Country Seats in the Diocese of Oxford, with short descriptive letterpress by Charles May, artist photographer and member of the Bucks Architectural and Archeological Society, etc. Oxford, London: J. H. & J. Parker, 1866. n. p. many b & w. [First issued in parts, each part containing four original photographs. At least twenty-three parts were issued.]

MAY, WILLIAM. (GREAT BRITAIN)
[William May apparently specialized in photographic views of subjects in the West Country of England in the mid 1860s.]

M403 "Earl of Mount Edgcumbe placing the Memorial Stone of the Devonport, Stonehouse, and Cornwall Hospital." ILLUSTRATED LONDON NEWS 41, no. 1152 (July 5, 1862): 4, 22. 1 illus. ["...from a photograph by Mr. W. May, of St. Aubyn Street, Davenport."]

MAYALL & MAYALL. (GREAT BRITAIN)
M404 Portraits. Woodcut engravings credited "From a photograph by Mayall & Mayall." ILLUSTRATED LONDON NEWS 44, (1864) ["Charles Mathews, actor." 44:* (Jan. 23, 1864): 81. "Mr. Wachtel, opera singer." 44:* (May 21, 1864): 501.]

M405 Portraits. Woodcut engravings credited "From a photograph by Mayall & Mayall." ILLUSTRATED LONDON NEWS 46, (1865) ["Field Marshall Viscount Combermere." 46:* (Mar. 4, 1865): 213. "Hungarian General Kmety." 46:* (June 3, 1865): 520.]

M406 Portrait. Woodcut engraving credited "From a photograph by Mayall & Mayall." ILLUSTRATED LONDON NEWS 47, (1865) ["Right Hon. Benjamin Samuel Phillips." 47:* (Nov. 11, 1865): 456.]

M407 Portrait. Woodcut engraving credited "From a photograph by Mayall & Mayall." ILLUSTRATED LONDON NEWS 55, (1869) ["Edward G. S. Stanley, Earl of Derby." 55:* (Oct. 30, 1869): 429.]

MAYALL, JOHN JABEZ EDWIN. (1810-1901) (USA, GREAT BRITAIN)
[Born in 1810. The family name had at some time been Meal. It is unclear whether he was born in England or the USA, but he was in Philadelphia in the early 1840s, where he learned the daguerreotype process from Professor Hans Martin Boyé at the University of Pennsylvania. Also friendly with Dr. Paul Beck Goddard. In 1845 he joined Samuel Van Loan in a studio in Philadelphia. Van Loan was from Manchester, England. Mayall seems to have become the sole owner by 1846, when he sold the studio to Marcus A. Root and left for or returned to England in June, 1846. Worked for Antoine Claudet until 1847, then opened the American Daguerreotype Institution in London, using the name "Professor Highschool," and with Cornelius Jabez Hughes as his assistant. Throughout 1840s Mayall produced groups of allegorical genre daguerreotypes, such as a group of ten plates on the theme of the Lord's Prayer (1845) or illustrative of Thomas Campbell's poem "The Soldier's Dream," (1848), or on other topics. Exhibited some of these among the seventy-two daguerreotypes he displayed at the Crystal Palace Exhibition in 1851. This exhibition made Mayall's reputation, and he was considered one of the best studio photographers from that time forward. Mayall had been invited by Prince Albert to photograph the Royal Family in 1851 and thereafter "distinguished persons of every rank and service availed themselves of the photographer's services." During this period Mayall contributed several articles about his processes and practices to the

new American photographic journals, an activity that has to be regarded as generous in the context of professional practice of the day, the distance involved, and Mayall's flourishing reputation. Mayall began using the wet collodion process soon after it was invented in 1851. He began patenting improvements in processes and techniques throughout his career. In 1853 he patented a vignetting device and, in 1855, the ivorytype process, a method of printing on artificial ivory. Mayall was an active figure in the new Photographic Society, contributing papers and talks, and an active figure in securing a trust for Frederick Scott Archer's children after his early death. Mayall became a Photographic Society Council Member in 1875 and continued his membership through the 1880s. Mayall furnished hundreds of portraits to the *Illustrated London News* and to *Frank Leslie's Illustrated Newspaper.* throughout the 1850s and 1860s. In 1858 a weekly *Illustrated News of the World & Drawing Room Portrait Gallery of Eminent Personages* attempted to compete with the popular and predominant *ILN.* The *INW&DRPGEP* was trying to survive as an more elegant, upper-class journal than the *ILN,* and during the next year the magazine published about forty fine steel engravings drawn from Mayall's portraits, promoting these engravings as a major feature of its own editorial style. However the magazine failed, and its goods were sold at auction. Many of Mayall's portraits "on loan" to the magazine were purchased by another photographer at this auction, who then began to sell copies under his own name. Mayall had to sue to get his photographs back. In 1860 Mayall collected fourteen of the portraits of Queen Victoria and the Royal Family which he had made, and published them as a set of cartes de visite in a *Royal Album.* His cartes-de-visite of the royal family sold in the thousands - one claim was that 100,000 cartes were sold in the 1860s. In 1863 Mayall was "commanded" to photograph the wedding of the Prince and Princess of Wales, and these photographs were also widely published. In 1864 Mayall issued other sets of photographic series - "Celebrities of the London Stage," and "New Series of Photographic Portraits of Eminent and Illustrious Persons." Mayall used electric lights in his studios in the 1860s, in 1865 he was using solar cameras to produce enlarged portraits, and in 1870 he purchased a special lens which enabled the studio to make 24" x 24" group portraits. In other words, his studio was always on the cutting edge of the photographic portrait technology of the day. Mayall turned his London studio over to his son Edwin in 1864, and then he opened another studio in Brighton, Sussex, which he ran with his younger son, John, Jr., until 1877. He was elected Mayor of Brighton from 1877-78. Died in London in 1901. Two other sons, Joe Parkin Mayall and John, Jr. were also involved in the family business at certain times and operated on their own at other times.]

BOOKS

M408 Tallis, John. *Tallis's History and Description of the Crystal Palace, and the Exhibition of the World's Industry in 1851.* Illustrated by Beautiful Steel Engravings, from Original Drawings and Daguerreotypes by Beard, Mayall, etc. London: John Tallis & Co., 1852. 3 vol. pp. 15 illus. [Engravings, four credited from daguerreotypes by Mayall, eight from daguerreotypes by Beard.]

M409 *History and Description of the Crystal Palace and the Exhibition of the World's Industry in 1851.* London: John Tallis, 1852. 48 as bound pp. 15 illus. [Engravings, four credited from daguerreotypes by Mayall, eight from daguerreotypes by Beard. (This is probably a fascicle of the larger work.)]

M410 Mayall, John E. *The Royal Album. Portraits of the Royal Family of England, Photographed from Life.* London: Marion & Co., 1860. n. p. 14 b & w. [Cartes-de-visit. Printed title page and contents page.]

M411 *Mayall's Celebrities of the London Stage.* London: Mavor & Son, 1864. n. p. b & w.

M412 *Mayall's New Series of Photographic Portraits of Eminent and Illustrious Persons.* London: Mavor & Son, 1864. n. p.

PERIODICALS

M413 Mayall, J. E. "Fine Arts: Crayon Daguerreotypes." ATHENAEUM no. 1197 (Oct. 5, 1850): 1048-1049. [Letter from Mayall describing process.]

M414 "Monthly Notes: Crayon Daguerreotypes." PRACTICAL MECHANIC'S JOURNAL 3, no. 32 (Nov. 1850): 191. [Excerpt from Mayall's letter, published in the "Athenaeum."]

M415 Mayall, J. E. "Crayon Daguerreotypes." DAGUERREAN JOURNAL 1, no. 2 (Nov. 15, 1850): 46. [Letter. Gives technical information on this process in order to bypass attempts to patent it. Mayall does not believe in patenting "...anything in connection with so interesting a discovery." (This probably taken from the "Athenaeum.")]

M416 "Fine Art Gossip." ATHENAEUM no. 1203 (Nov. 16, 1850): 1193-1194. [Mention of two specimens of the 'Crayon Daguerreotypes' of Mayall.]

M417 "Fine Art Gossip." ATHENAEUM no. 1206 (Dec. 7, 1850): 1286. [Review of a 'devotional subject' by Mayall - discusses it favorably in comparison to PreRaphaelite paintings.]

M418 "Photography on Glass." ATHENAEUM no. 1220 (Mar. 15, 1851): 304-305. [Commentary, plus a letter from Mayall. Further note no. 1221, (March 22, 1851): 330, that Mayall insists that M. Martens of Paris was discoverer of egg albumen process.]

M419 Mayall, J. E. "Photography on Glass." DAGUERREAN JOURNAL 1, no. 10 (Apr. 1, 1851): 314-315. [Letter from Mayall, describing his procedures.]

M420 Mayall, J. E. "Photography-Glazing the Positive Proof." ATHENAEUM no. 1225 (Apr. 19, 1851): 434.

M421 Mayall, J. E. "Enamelled Daguerreotypes." ATHENAEUM no. 1234 (June 21, 1851): 664.

M422 "Enamelled Daguerreotype." DAGUERREAN JOURNAL 2, no. 4 (July 1, 1851): 111.

M423 "Letter." DAGUERREAN JOURNAL 2, no. 4 (July 1, 1851): 118-121. [Letter from Mayall, describing his processes "for paper."]

M424 Mayall, J. E. "Photography: Glazing the Positive Proof." DAGUERREAN JOURNAL 2, no. 4 (July 1, 1851): 122. [From the "Athenaeum," forwarded by Mayall.]

M425 Portrait. Woodcut engraving credited "From a photograph by J. E. Mayall." ILLUSTRATED LONDON NEWS 19, (1851) ["Mr. A. C. Hobbs, picking a lock." 19:* (Aug. 2, 1851): 141. (dag.)]

M426 "Fine Arts Gossip." ATHENAEUM no. 1249 (Oct. 4, 1851): 1051. [Note about Mayall's photographing the Crystal Palace with daguerreotypes and his intent to produce calotype copies.]

M427 "Gossip." PHOTOGRAPHIC ART JOURNAL 2, no. 5 (Nov. 1851): 315-316. [From "London Morning Chronicle" and "Athenaeum."]

M428 "Fine Art Gossip." DAGUERREAN JOURNAL 2, no. 12 (Nov. 1, 1851): 378. [From "London Athenaeum."]

M429 "Photograph Publications: Myall's [sic Mayall's] Daguerreotypes." HUMPHREY'S JOURNAL 4, no. 1 (Apr. 15, 1852): 8. [From "The Athenaeum."]

M430 "J. E. Mayall's Daguerreotypes." HUMPHREY'S JOURNAL 4, no. 2 (May 1, 1852): 23-24. [From "The Athenaeum."]

M431 "Gossip." PHOTOGRAPHIC ART JOURNAL 4, no. 2 (Aug. 1852): 128. [Note: that Mayall has succeeded in making photos full size to life.]

M432 "Fine-Art Gossip." ATHENAEUM no. 1295 (Aug. 21, 1852): 900. [Mayall took an outdoor group portrait of the Kew Committee of the Council of the British Association, while they were observing a balloon ascension.]

M433 "Scientific Balloon Ascent from Vauxhall Gardens." ILLUSTRATED LONDON NEWS 21, no. 571 (Sept. 4, 1852): 192. ["From a Daguerreotype by Mayall." (Actually a group portrait of the four members, in the balloon basket - which may have been taken in the studio.)]

M434 "Mayall's Daguerreotype of the Balloon Ascent of the Council of the British Association." HUMPHREY'S JOURNAL 4, no. 12 (Oct. 1, 1852): 184. [From "The Athenaeum."]

M435 "One of the London Sights." HUMPHREY'S JOURNAL 4, no. 12 (Oct. 1, 1852): 183. [From "Liverpool Mail." Praise for Mayall's Gallery.] "Gossip." PHOTOGRAPHIC ART JOURNAL 4, no. 5 (Nov. 1852): 323-324. [Excerpts from "Liverpool Mail" and the "Athenaeum."]

M436 Portrait. Woodcut engraving credited "From a photograph by J. E. Mayall." ILLUSTRATED LONDON NEWS 21, (1852) ["Gideon A. Mantell, L.L.D., F.R.S." 21:* (Dec. 4, 1852): 501. (dag.)]

M437 Portrait. Woodcut engraving credited "From a photograph by Mayall." ILLUSTRATED LONDON NEWS 22, (1853) ["Dr. Pereira." 22:* (Jan. 29, 1853): 77. (dag.)]

M438 "A Convenient Process for Photographs upon Paper and Glass." HUMPHREY'S JOURNAL 4, no. 20 (Feb. 1, 1853): 315-320. [Letter from Mayall, defending himself from earlier comments in the "HJ," includes his formulae and practices.]

M439 Mayall, J. E. "Collodion." HUMPHREY'S JOURNAL 4, no. 21 (Feb. 15, 1853): 335. [Additional information, received after the first paper was published.]

M440 "Daguerreotype Movements: Mayall of London." HUMPHREY'S JOURNAL 4, no. 22 (Mar. 1, 1853): 352. [From the "London Morning Chronicle."]

M441 "Recent Patents: Crayon Daguerreotypes. J. E. Mayall, London - Patent dated Jan. 25, 1853." PRACTICAL MECHANIC'S JOURNAL 6, no. 62 (May 1853): 45. 1 illus. [Patent for a spinning disk, placed between the camera and the sitter, designed to soften portions of the photographic image. Device illustrated.]

M442 "Portrait of Richard Cobden, Esq., M. P." HUMPHREY'S JOURNAL 5, no. 2/3 (May 1 - 15, 1853): 40. [Not credited, but a review of this print, probably from the "Athenaeum," with a note that Mayall had sent a copy to the editor.]

M443 "Fine-Art Gossip." ATHENAEUM no. 1335 (May 28, 1853): 657. [Mayall's device for smoothing out contrast in portraiture sittings discussed.]

M444 Portraits. Woodcut engravings credited "From a photograph by Mayall." ILLUSTRATED LONDON NEWS 23, (1853) ["Arthur Napoleon, the young Portuguese pianist." 23:* (July 16, 1853): 29. (dag.) "Mr. Bransby Cooper, F.R.S." 23:* (Aug. 27, 1853): 165. (photo) "Mr. T. P. Cooke, as 'William' in 'Black-Eyed Susan.'" 23:* (Oct. 15, 1853): 320. (photo) "Mr. Albert Smith." 23:* (Dec. 10, 1853): 493. (photo)]

M445 "Mayall's Crayon Daguerreotype Portraits." ART JOURNAL (Oct. 1853): 267.

M446 "Daguerreotype Movements." HUMPHREY'S JOURNAL 5, no. 19 (Jan. 15, 1854): 303. [From "Athenaeum."]

M447 Portraits. Woodcut engravings credited "From a photograph by Mayall." ILLUSTRATED LONDON NEWS 24, (1854) ["Sir John Bowring, Gov. of Hong Kong." 24:* (Feb. 18, 1854): 152. (dag.) "Vice-Admiral Sir Charles Napier." 24:* (Mar. 11, 1854): 208. (dag.) "Rear-Admiral Corry." 24:* (Mar. 25, 1854): 273. (dag.) "Earl of Lucan." 24:* (May 13, 1854): 429. (dag.)]

M448 "Note." ATHENAEUM no. 1395 (July 22, 1854): 913. [Brief note of the equipment necessary for Mayall to make life sized portraits. Article mentions that Mayall had an exhibition at the Polytechnic Institute.]

M449 "Improvements in Photography." CHAMBERS'S JOURNAL OF POPULAR LITERATURE Ser. 3, vol. 2, no. 35 (Sept. 2, 1854): 160. [From the "London Times." Mayall displayed "the largest and smallest photographs ever produced. (a full life-sized portrait and a reduced copy of the front page of the "Times") to the Polytechnic Institute.]

M450 Portraits. Woodcut engravings credited "From a photograph by Mayall." ILLUSTRATED LONDON NEWS 25, (1854) ["Edward L. Davenport." 25:* (Sept. 2, 1854): 208. (dag.) "J. B. Gough." 25:* (Sept. 2, 1854): 208. (dag.) "Henry Russell." 25:* (Sept. 9, 1854): 232. (dag.)]

M451 "Note." ATHENAEUM no. 1420 (Jan. 13, 1855): 55. [Mayall delivering a lecture on albumen on glass stereo views to the Photographic Society.]

M452 Portraits. Woodcut engravings credited "From a photograph by Mayall." ILLUSTRATED LONDON NEWS 26, (1855) ["Mr. Love, as 'Mr. Tranquilius Calm' in 'The London Season.'" 26:8 (Jan. 27, 1855): 84. (dag.) "Joseph Hume, M.P." 26:* (Mar. 3, 1855): 196. (photo) "Mr. Roebuck, M.P." 26:* (May 19, 1855): 480. (photo)]

M453 "Note." ATHENAEUM no. 1424 (Feb. 10, 1855): 177. [Mayall working with a process to secure enlarged collodion copies from the daguerreotypes.]

M454 "Letter." ATHENAEUM no. 1424 (Feb. 10, 1855): 240. [Letter from Mr. Thornton, disputing Mayall's priority to the collodion process. Mayall's reply is printed in the March 3, 1855 issue on p. 272.]

M455 "London Photographic Society: Ordinary Meeting, Jan. 4th, 1855." PHOTOGRAPHIC AND FINE ART JOURNAL 8, no. 3 (Mar. 1855): 87-89. [Consists primarily of J. E. Mayall's paper, "Albumen Process on Glass."]

M456 Mayall, J. E. "Albumen Process on Glass." HUMPHREY'S JOURNAL 6, no. 24 (Apr. 1, 1855): 377-381. [From "J. of Photo. Soc., London."]

M457 Mayall, J. E. "Dry Collodion." PHOTOGRAPHIC AND FINE ART JOURNAL 8, no. 7 (July 1855): 217. [From "J. of Photo. Soc., London."]

M458 Portraits. Woodcut engravings credited "From a photograph by Mayall." ILLUSTRATED LONDON NEWS 27, (1855) ["W. Farren." 27:* (July 28, 1855): 100. (dag.) "Dr. Arthur H. Hassall." 27:* (Aug. 11, 1855): 173. (dag.) "Mr. Hinks, Gov.-General of the Windward Islands." 27:* (Oct. 6, 1855): 413. (photo) "Vicount Canning, Gov.-General of India." 27:* (Dec. 1, 1855): 649. (photo) "Brandreth Gibbs." 27:* (Dec. 22, 1855): 725. (dag.)]

M459 "Personal and Art Intelligence." PHOTOGRAPHIC AND FINE ART JOURNAL 8, no. 8 (Aug. 1855): 256. [Excerpt from "a London paper," describing an exhibition of portraits and views of Mayall's gallery, London.]

M460 "The Adjourned Discussion on Mr. Mayall's Papers." PHOTOGRAPHY AND FINE ART JOURNAL 8, no. 11 (Nov. 1855): 334-335. [From "J. of Photo. Soc., London."]

M461 Portraits. Woodcut engravings credited "From a photograph by Mayall." ILLUSTRATED LONDON NEWS 28, (1856) ["Sir General Sir Colin Campbell." 28:8 (Jan. 5, 1856): 9. "Private John Penn, 11th Lancers." 28:8 (Jan. 26, 1856): 92. "George P. Bidder, C.E." 28:* (Mar. 15, 1856): 268. ("from a Daguerreotype") "Hon. G. M. Dallas, American Minister." 28:* (Apr. 5, 1856): 348. "Mr. Guthrie, F.R.S." 28:8 (May 10, 1856): 500.]

M462 Portraits. Woodcut engravings credited "From a photograph by Mayall." ILLUSTRATED LONDON NEWS 29, (1856) ["Mr. & Mrs. Barney Williams, Adelphi Theater." 29:* (July 26, 1856): 91. "Maj.-Gen. Windham, C.B." 29:* (Aug. 9, 1856): 139. "Mr. Buchanan, Pres. of U.S.A." 29:* (Nov. 29, 1856): 554.]

M463 "Improvements in Photography." ILLUSTRATED LONDON NEWS 30, no. 841 (Jan. 24, 1857): 61. [Note that Mayall's "...substitution of paper for the metallic plate used in the old Daguerreotype." is an improvement.]

M464 "Mayall's New Photographic Material." PHOTOGRAPHIC AND FINE ART JOURNAL 10, no. 2 (Feb. 1857): 50.

M465 "Mayall's Worn Photographs noted." ART JOURNAL (Feb. 1857): 66.

M466 "Mayall's Ivory Photographs." PHOTOGRAPHIC AND FINE ART JOURNAL 10, no. 3 (Mar. 1857): 72.

M467 Portraits. Woodcut engravings credited "From a photograph by Mayall." ILLUSTRATED LONDON NEWS 30, (1857) ["Sir A. Ramsay, M.P." 30:* (Apr. 25, 1857): 386. "Lord Lincoln, M.P." 30:* (Apr. 25, 1857): 386. "Mr. Robson, as 'Daddy Hardacre' at the Olympic Theatre." 30:* (Apr. 25, 1857): 395. "Right Hon. John E. Denison, Speaker of the House of Commons." 30:* (May 16, 1857): 455. "New Parliament: Viscount Ingestre, Wm. Roupell, Wm. Coningham, Sir Brook Wm. Bridges, Maj.-Gen. Sir John M. F. Smith, Acton Ayrton, Alex. Beresford-Hope, Robert Hanbury, Arthur Mills, Wm. Cox, Maj.-Gen. Sir Wm. Codrington." 30:* (May 16, 1857): 478-479. "New Parliament: Lord John Manners, Maj.-Gen. Windham, Lieut.-Col. W. H. Sykes, James Wyld." 30:* (May 23, 1857): 499. "Grand Duke Constantine of Russia." 30:* (June 6, 1857): 535. (photo)]

M468 Portraits. Woodcut engravings, credited "Ambrotyped by Mayall." FRANK LESLIE'S ILLUSTRATED NEWSPAPER 4, (1857) ["Douglas Jerrold." 4:83 (July 4, 1857): 77.]

M469 Portraits. Woodcut engravings credited "From a photograph by Mayall." ILLUSTRATED LONDON NEWS 31, (1857) ["Mr. Benjamin Webster as 'George Darville." 31:* (Aug. 1, 1857): 117. "The Prince of Oude, and Suite." 31:* (Aug. 1, 1857): 121. "Sims Reeves." 31:* (Aug. 1, 1857): 128. "Lord Mayor Elect Rt. Hon. Sir Robert Walter, M.P." 31:* (Nov. 7, 1857): 456. "Siamese Ambassadors." 31:* (Dec. 5, 1857): 561.]

M470 "Our Programme." ILLUSTRATED NEWS OF THE WORLD AND DRAWING ROOM PORTRAIT GALLERY OF EMINENT PERSONAGES 1, no. 1-48 (Feb. 6, 1858 - Jan. 1, 1859): 1-432. 40 illus. [Journal subtitle: "From Photographs in Her Majesty's Private Collections and From the Studios of the Most Celebrated Photographers in the Kingdom, Engraved on Steel by D. J. Pound. With Memoirs by the Most Able Authors." This weekly magazine was very similar to the "Illustrated London News" in its lavish use of woodcuts. It also periodically issued a series of "Portraits of Distinguished Persons" in steel engravings from photographs, the majority taken by Mayall. There were apparently 40 issued in the first year. At least 12 were offered free as special supplements to subscribers; the entire series was apparently also available as a separately bound "gift book." A "Notice" appeared in the "Illustrated London News" each week listing the names of the sitters and announcing the forthcoming issue, crediting both the sitter and the photographer.]

M471 Portraits. Woodcut engravings, credited "Photographed by Mayall. FRANK LESLIE'S ILLUSTRATED NEWSPAPER 5, (1858) ["I. K. Brunel, Chief Constructor of the Steam Ship 'Leviathan.'" 5:115 (Feb. 13, 1858): 172.]

M472 Portraits. Woodcut engravings credited "From a photograph by Mayall." ILLUSTRATED LONDON NEWS 32, (1858) ["Earl of Mulgrave." 32:8 (Feb. 20, 1858): 200. "New Ministry: Lord Stanley, Sir. F. Kelly, Sir F. Thesiger, Earl Malmesbury, Sir J. Pakington." 32:* (Mar. 13, 1858): 260. ["From photographs by Mayall and Watkins."] "Mr. Harley as 'Tony Lumpkin.'" 32:* (Mar. 27, 1858): 321. "Henry T. Hope." 32:* (Apr. 3, 1858): 352. "I. K. Brunel, F.R.S." 32:* (Apr. 3, 1858): 352. "Scott Russell." 32:* (Apr. 3, 1858): 352. "Parliamentary Portraits: Serjeant John A. Kinglake, George H. Vansittart." 32:* (June 5, 1858): 561. "Mrs. Charles Young, actress." 32:* (June 12, 1858): 589.]

M473 Portrait. Woodcut engraving, credited "From a Photograph by Mayall, of London." FRANK LESLIE'S ILLUSTRATED NEWSPAPER 6, (1858) ["Mdlle. Maria Piccolomini." 6:152 (Oct. 30, 1858): 335.]

M474 Portraits. Woodcut engravings, credited "From a Photograph by Mayall." ILLUSTRATED NEWS OF THE WORLD AND DRAWING ROOM PORTRAIT GALLERY OF EMINENT PERSONAGES 1, (1858) ["Tom Taylor, Esq." 1:11 (Apr. 17, 1858): 172. "Benjamin Scott, Esq. Chamberlain of London." 1:42 (Nov. 20, 1858): 332. "Alderman Thomas Quested Finnis." 1:42 (Nov. 20, 1858): 333.]

M475 Portraits. Woodcut engravings credited "From a photograph by Mayall." ILLUSTRATED LONDON NEWS 33, (1858) ["Lord Berners." 33:* (July 24, 1858): 74. "Philip W. Martin, M.P., John Townsend, M.P., Richard Davey. M.P." (3 portraits) 33:* (July 24, 1858): 94. "Mdlle. Humler, violinist." 33:* (July 31, 1858): 102. "Alderman David W. Wire." 33:* (Nov. 6, 1858): 427. "Henri Wieniawski, violinist." 33:* (Nov. 20, 1858): 479. "Prince of Wales in uniform." 33:* (Dec. 11, 1858): 543.]

M476 "The Photographic Portrait of the Prince of Wales." ILLUSTRATED NEWS OF THE WORLD AND DRAWING ROOM PORTRAIT GALLERY OF EMINENT PERSONAGES 1, no. 42 (Nov. 20, 1858): 327. [Note that Prince of Wales went to Mayall for a portrait to be used in the "National Portrait Gallery," published by this magazine.]

M477 Portraits. Woodcut engravings credited "From a photograph by Mayall." ILLUSTRATED LONDON NEWS 34, (1859) ["Mr. Balfe, composer." 34:* (Jan. 1, 1859): 5. "Neapolitan Exiles: Il Duca C. Caballeno, Baron Carlo Poerio, Silvio Spaventa, Cesare Braico, Avvocata Pica." 34:* (Apr. 30, 1859): 425. "Mdlle. Lotti, Royal Italian Opera" 34:* (May 7, 1859): 456. "Charles R. Leslie, R.A." 34:* (May 28, 1859): 509.]

M478 Mayall, J. E. "A New Collodion for Field Work." HUMPHREY'S JOURNAL OF PHOTOGRAPHY, AND THE ALLIED ARTS AND SCIENCES 11, no. 4 (June 15, 1859): 57-60. [From "Liverpool Photo. J."]

M479 Portraits. Woodcut engravings credited "From a photograph by Mayall." ILLUSTRATED LONDON NEWS 35, (1859) ["Jacob Bell." 35:* (July 2, 1859): 4. "Charles Kean." 35:* (Aug. 6, 1859): 131. "Frank Stone, Esq., A.R.A." 35:* (Dec. 10, 1859): 546. "Miss Clara St. Casse, actress." 35:* (Dec. 24, 1859): 626.]

M480 Portraits. Woodcut engravings credited "From a photograph by Mayall." ILLUSTRATED LONDON NEWS 36, (1860) ["Right Hon. Matthew Talbot Baines." 36:* (Feb. 4, 1860): 101. "Mdlle. Csillag, Royal Italian Opera." 36:* (May 26, 1860): 509.]

M481 Portrait. Woodcut engraving, credited "From a Photograph by Mayall, of London." FRANK LESLIE'S ILLUSTRATED NEWSPAPER 9, (1860) ["J. O. Lever, Director of steamship line." 9:225 (Mar. 24, 1860): 267.]

M482 "The Great Contest for the Championship - America Against England - Sayers as He Appears in the Ring - From a Photograph by Mayall, of London, taken Expressly for this Paper." FRANK LESLIE'S ILLUSTRATED NEWSPAPER 9, no. 225 (Mar. 24, 1860): 263. 1 illus. [Engraving from a photo actually taken in the studio, showing camera, photos, etc., in the background.]

M483 "John C. Heenan, the 'Benicia Boy,' From a Photograph. Now in Training in England to Contest with Tom Sayers, the Present Champion of England, for the Champions Belt." FRANK LESLIE'S ILLUSTRATED NEWSPAPER 9, no. 228 (Apr. 14, 1860): 311. 1 illus. [Portrait taken in same studio as that published on p. 263, in Mar. 24 issue.]

M484 "Editorial Note." BRITISH JOURNAL OF PHOTOGRAPHY. 7, no. 119 (June 1, 1860): 157. [Mention that Mayall was asked to photograph Queen Victoria and Prince Albert on May 17th. Brief description of the work.]

M485 "Note." ART JOURNAL (July 1860): 222. [Mayall to take photographs of the Royal family.]

M486 Portrait. Woodcut engraving, credited "From a Photograph by Mayall, of London." FRANK LESLIE'S ILLUSTRATED NEWSPAPER 10, (1860) ["Albert Edward, Prince of Wales." 10:245 (Aug. 4, 1860): 168-169.]

M487 "Our Weekly Gossip." ATHENAEUM no. 1712 (Aug. 18, 1860): 230. [Note that Mayall has put together the series of fourteen portraits that he has taken from time to time of the Royal Family into a "Royal Album."]

M488 "Talk in the Studio: Photography at the Palace." PHOTOGRAPHIC NEWS 4, no. 104 (Aug. 31, 1860): 215. [Note about a Royal Album of fourteen photos of English royalty taken by Mayall. Reprinted from the "Athenaeum."]

M489 "Note." AMERICAN JOURNAL OF PHOTOGRAPHY AND THE ALLIED ARTS & SCIENCES n. s. vol. 3, no. 8 (Sept. 15, 1860): 123-124. [Portraits of the British Royal Family by Mayall discussed.]

M490 "Photographs of Royalty." HUMPHREY'S JOURNAL OF PHOTOGRAPHY, AND THE ALLIED ARTS AND SCIENCES 12, no. 10 (Sept. 15, 1860): 146-147. [J. E. Mayall, Esq., of No. 224 Regent St., London, one of the most eminent Photographers in England, has just published a series of portraits of the Royal family."]

M491 Portraits. Woodcut engravings credited "From a photograph by Mayall." ILLUSTRATED LONDON NEWS 37, (1860) ["Z. C. Pearson, Mayor of Hull." 37:* (Sept. 15, 1860): 262. "Right Hon. W. Cubitt, M.P." 37:* (Nov. 10, 1860): 435.]

M492 "Note." JOURNAL OF THE PHOTOGRAPHIC SOCIETY OF LONDON 7, no. 105 (Jan. 15, 1861): 76. [Note that Mayall's small photographic portraits of the Royal Family have sold considerably more than 100,000 copies.]

M493 Portrait. Woodcut engraving credited "From a photograph by Mayall." ILLUSTRATED LONDON NEWS 38, (1861) ["Lord Campbell." 38:* (June 29, 1861): 611.]

M494 "The Earl of Derby, A photograph by J. E. Mayall, published by Marion & Co., London." ART JOURNAL (July 1861): 192. [Reviewed.]

M495 Portraits. Woodcut engravings credited "From a photograph by Mayall." ILLUSTRATED LONDON NEWS 39, (1861) ["Lord Westbury (Sir Richard Bethell)." 39:* (July 6, 1861): 13. "Albert, Prince Consort." 39:* (Dec. 28, 1861): 663.]

M496 "Our Weekly Gossip." ATHENAEUM no. 1758 (July 6, 1861): 21. [Mayall portraits mentioned.]

M497 Portraits. Woodcut engravings credited "From a photograph by Mayall." ILLUSTRATED LONDON NEWS 40, (1862) ["Mr. Mark Lemon." 40:* (Jan. 11, 1862): 52. "Wm. Lowndes Yancy, Confederate Commissioner." 40:* (Jan. 25, 1862): 95. "Dr. Hawtrey, Provost of Eton College." 40:* (Feb. 22, 1862): 202. "Rev. Andrew Reed, D.D." 40:* (Mar. 8, 1862): 255.]

M498 "Our Weekly Gossip." ATHENAEUM no. 1791, 1802 (Feb. 22, May 10, 1862): 262, 634. [Mr. Tallis, of the "Illustrated News of the World," went bankrupt April 1861. He was holding a number of Mayall's portraits for publication. These were sold, as was Tallis's other assets, at auction. The purchaser issued copies of the prints under his

own name. Mayall sued, and won his case. More information on p. 634.]

M499 "Photographic Piracy." AMERICAN JOURNAL OF PHOTOGRAPHY AND THE ALLIED ARTS & SCIENCES n. s. vol. 4, no. 21 (Apr. 1, 1862): 490-492. [From "Photo. News." Trial of Mayall vs. Higby. Higby had acquired several of Mayall's portraits, was issuing them as his own.]

M500 "Note." ART JOURNAL (Apr. 1862): 110. [Carte-de-visite portraits of Royal Family.]

M501 "Copyright in Photographs." AMERICAN JOURNAL OF PHOTOGRAPHY AND THE ALLIED ARTS & SCIENCES n. s. vol. 5, no. 1 (July 1, 1862): 10-11. [From "The Athenaeum."]

M502 Portrait. Woodcut engraving credited "From a photograph by Mayall." ILLUSTRATED LONDON NEWS 41, (1862) ["Archbishop of Armagh." 42:* (Aug. 2, 1862): 128.]

M503 "Useful Facts, Receipts, Etc.: The American Fashion in London." AMERICAN JOURNAL OF PHOTOGRAPHY AND THE ALLIED ARTS & SCIENCES n. s. vol. 5, no. 7 (Oct. 1, 1862): 165. [Mayall (of London) threw a very large party for his employees.]

M504 "The Circassian Envoys to England." ILLUSTRATED LONDON NEWS 41, no. 1171 (Oct. 25, 1862): 432. 1 illus. [Studio portrait. "From a photograph by Mayall."]

M505 Portrait. Woodcut engraving credited "From a photograph by Mayall." ILLUSTRATED LONDON NEWS 42, (1863) ["Daniel Whittle Harvey, Esq." 42:* (Mar. 7, 1863): 253.]

M506 Portraits. Woodcut engravings, credited "From a Photograph by Mayall, of London." FRANK LESLIE'S ILLUSTRATED NEWSPAPER 16, (1863) ["Albert Edward, Prince of Wales, and Alexandra of Denmark, Princess of Wales - Photographed from life." 16:393 (Apr. 11, 1863): 33. "The Princess Alexandra of Denmark and Her Bridesmaids." 16:394 (Apr. 18, 1863): 49.]

M507 "Fine Arts." ILLUSTRATED LONDON NEWS 43, no. 1216 (Aug. 8, 1863): 146. ["...series of carte-de-visite photographs of the Royal family... at Windsor Castle by Mr. Mayall."]

M508 Portrait. Woodcut engraving credited "From a photograph by Mayall." ILLUSTRATED LONDON NEWS 43, (1863) ["Right Hon. & Most Rev. Richard C. Trench." 43:* (Nov. 21, 1863): 513.]

M509 "'Mayall's New Series of Photographic Portraits of Eminent and Illustrious Persons: Part 1,' and 'Mayall's Celebrities of the London Stage: Part 1,' published by Mavor and Son, Soho Square." ART JOURNAL (May 1864): 156. [Reviewed.]

M510 "Garibaldi and the Photographer." HUMPHREY'S JOURNAL OF PHOTOGRAPHY, AND THE ALLIED ARTS AND SCIENCES 16, no. 2 (May 15, 1864): 29. [Garibaldi hounded by photographers during his trip to England, asking for his portrait. Finally he chose Mayall.]

M511 "Note." ART JOURNAL (July 1865): 225-226. [Photography at the Dublin exhibition. Mentions that Mayall is using the solar camera process for enlargements.]

M512 Mayall, J. E. "On the Construction of a Photographic Glass Room." BRITISH JOURNAL OF PHOTOGRAPHY 12, no. 293 (Dec. 15, 1865): 632-633. 1 illus.

M513 Portraits. Woodcut engravings, credited "From a Photograph by Mayall, London. FRANK LESLIE'S ILLUSTRATED NEWSPAPER 22, (1866) ["George Peabody, American banker." 22:561 (June 30, 1866): 225.]

M514 Portraits. Woodcut engravings credited "From a photograph by Mayall, of Regent St." ILLUSTRATED LONDON NEWS 50, (1867) ["Staff Commander H. A. Moriarty, R.N." 50:* (Jan. 12, 1867): 41. "Right Rev. Dr. Milman, Bishop of Calcutta." 50:* (Mar. 30, 1867): 313. "Sir James Emerson-Tennent." 50:* (Mar. 27, 1867): 317.]

M515 "Note." ART JOURNAL (Oct. 1868): 226. [Two life-sized portraits of Disraeli and Prince of Wales by Mayall. One full-column of text is devoted to the work of Mayall's studio.]

M516 "Note." ART JOURNAL (Oct. 1868): 227. [Three carte-de-visite portraits of Lt. Warren, R.E., of the Palestine Exhibition Fund, were made by Mayall and were on sale for the benefit of the fund.]

M517 "Note." ART JOURNAL (Apr. 1870): 127. [Note of a "gigantic lens" purchased by Mayall making possible 24" x 24" group portraits.]

M518 "Destructive Outrage in Mayall's Studio, and Suicide." ANTHONY'S PHOTOGRAPHIC BULLETIN 3, no. 1 (Jan. 1872): 415-416. [From "London Photo. News." Henry Newman, employee for twenty years, went mad, destroyed buses and backdrops, then drank cyanide of potassium.]

M519 Portraits. Woodcut engravings credited "From a photograph by Mayall." ILLUSTRATED LONDON NEWS 62, (1873) ["Sir J. Cordy Burrows." 62:1748 (Mar. 1, 1873): 192. "Late Viscount Ossington." 62:1752 (Mar. 29, 1873): 297. "Late General Fox." 62:1756 (Apr. 26, 1873): 393. "Late Earl of Zetland." 62:1759 (May 17, 1873): 469. Studios in London and Brighton, Eng.]

M520 Portrait. Woodcut engraving credited "From a photograph by Mayall." ILLUSTRATED LONDON NEWS 63, (1873) ["Late Sir Henry Holland, Bart." 63:1783 (Nov. 1, 1873): 421.]

M521 Portraits. Woodcut engravings credited "From a photograph by Mayall." ILLUSTRATED LONDON NEWS 64, (1874) ["B. Disraeli." 64:1808 (Apr. 18, 1874): 364. "Late Capt. Blake, R.N." 64:1809 (Apr. 25, 1874): 384.]

M522 Portrait. Woodcut engraving credited "From a photograph by Mayall." ILLUSTRATED LONDON NEWS 67, (1875) ["Late Sir Ch. Wheatstone, F.R.S." 67:1891 (Nov. 6, 1875): 461.]

M523 Portrait. Woodcut engraving credited "From a photograph by Mayall." ILLUSTRATED LONDON NEWS 68, (1876) ["Late Mr. Wynn Ellis." 68:1902 (Jan. 8, 1876): 37.]

M524 Portrait. Woodcut engraving credited "From a photograph by Mayall." ILLUSTRATED LONDON NEWS 70, (1877) ["Bishop of Truro." 70:1956 (Jan. 6, 1877): 21. Studio on Kings Road, Brighton, Eng.]

M525 "Successful Photographers." ANTHONY'S PHOTOGRAPHIC BULLETIN 8, no. 12 (Dec. 1877): 367. [From "London Photographic

News." Mayall elected Mayor of Brighton, England. Also mentions that Alderman Nottage had been elected a sheriff (in London?)]

M526 Portrait. Woodcut engraving credited "From a photograph by Mayall." ILLUSTRATED LONDON NEWS 74, (1879) ["Late Very Rev. Dr. Hugh McNeile." 74:2070 (Feb. 15, 1879): 145.]

M527 "Obituary: J. J. E. Mayall." BRITISH JOURNAL PHOTOGRAPHIC ALMANAC, AND PHOTOGRAPHER'S DAILY COMPANION, 1902 (1902): 693. [Died at age 91. Began in 1840s. When the carte-de-visite craze was at its highest, Mayall was extraordinarily popular, etc.]

M528 "The Coronation." IMAGE 2, no. 5 (May 1953): 25. 2 b & w. [1 b & w by Mayall, 1 b & w by unknown. Photographs of the British royal family, 1860-1900.]

M529 Reynolds, Léonie L. and Arthur T. Gill. "The Mayall Story." HISTORY OF PHOTOGRAPHY 9, no. 2 (Apr. - June 1985): 89-107. 8 b & w. 5 illus. [Discussion of Mayall family's role in early photography in United States and Great Britain during the 1840s to the end of the century. Includes list of Mayall Studios and dates, a Mayall family tree, and "Notes" on pp. 105-106.]

M530 Schaaf, Larry J. "Mayall's Life-Size Portrait of George Peabody." HISTORY OF PHOTOGRAPHY 9, no. 4 (Oct. - Dec. 1985): 279-288. 2 b & w. 7 illus. [Mayall's portrait, enlarged to life size through a solar enlargement and overpainted by A. Arnoult, made in 1866. References on p. 287-288.]

M531 Reynolds, Léonie and Arthur T. Gill. "The Mayall Story - A Postscript." HISTORY OF PHOTOGRAPHY 11, no. 1 (Jan. - Mar. 1987): 77-80. 3 b & w. [Additional information on events and people associated with J. J. E. Mayall and John Mayall, Jr. Brief biography of Herbert Rose Barraud, who ran his own studio in London from 1883 to 1893, then managed Mayall & Co.'s Piccadilly studio.]

MAYALL, JOHN, JR. (1842-1891) (GREAT BRITAIN) see also MAYALL, JOHN JABEZ EDWIN.

MAYALL, JOHN, JR.
M532 Mayall, John, Jr. "Antiquity of the Lens." PHOTOGRAPHIC TIMES 16, no. 263 (Oct. 1, 1886): 515-516. [Excerpts from a lecture by John Mayall, Jr. discussing lenses found in Assyria, Greece, etc.]

MAYALL, JOSEPH PARKIN see also MAYALL, JOHN JABEZ EDWIN.

MAYALL, JOSEPH PARKIN. (1839-1906) (GREAT BRITAIN)
[Joe Meal, later Joseph Parkin Mayall, was the second son of John Jabez Edwin Mayall. Worked with his father and independently. He went to Australia and opened a photographic studio there from 1872 to 1875, but then apparently returned to England.]

M533 Stephens, Frederick George. *Artists at Home*: Photographed by J. P. Mayall, and Reproduced in Facsimile by Photo-Engraving on Copper Plates, Edited, with Biographical Notices and Descriptions by F. G. Stephens. New York: Appleton, 1884. 95 pp. 25 b & w. [Photogravures.]

MAYBIN, JOSEPH A. (WILMINGTON, DE)
M534 Williams, John M. "Joseph A. Maybin and two Steamboat Wrecks." HISTORY OF PHOTOGRAPHY 8, no. 1 (Jan. - Mar. 1984): 49-52. 4 b & w. [Maybin stereoview maker in Wilmington, DE, from mid-1860s to 1880s. Views of wrecks taken 1885.]

MAYER & MAYER. (PARIS, FRANCE)
M535 Portrait. Woodcut engraving credited "From a Daguerreotype by the Brothers Mayer." ILLUSTRATED LONDON NEWS 25, (1854) ["Viscount Chewton." 25:* (Dec. 2, 1854): 564.]

M536 Portrait. Woodcut engraving, credited "From a Photograph by Mayer Brothers." ILLUSTRATED NEWS OF THE WORLD AND DRAWING ROOM PORTRAIT GALLERY OF EMINENT PERSONAGES 1, (1858) ["Mademoiselle Rachel, French actress." 1:5 (Mar. 6, 1858): 72.]

M537 Portrait. Woodcut engraving credited "From a photograph by Miall [sic Mayer] Frères." ILLUSTRATED LONDON NEWS 33, (1858) ["Prince Imperial of France (child)." 33:* (Aug. 28, 1858): 210.]

MAYER & PIERSON. (PARIS, FRANCE)
[The Mayer brothers, Léopold Ernest and Louis Frédéric, opened a portrait studio in Paris in 1841. By 1844 Pierre Louis Pierson was also operating a studio in Paris. Both studios were active in producing hand-colored daguerreotypes. In 1847 the Mayers began a journal *Le Daguerréotype*, which was unsuccessful. In 1853 the Mayers photographed Napoleon III, and were named Photographer to the Emperor. In 1855 Mayer Frères et Pierson formed a partnership, and, in 1856, photographed the baptism of the Prince Imperial in Notre-Dame. In 1859 Pierson developed a carte-de-visite camera. Pierson photographed the Royal Family and Court at Fontainebleau. In 1861 Louis Frédéric separated from the firm and opened his own studio in Paris. Mayer, Pierson & Munier opened a branch in Brussels. In 1862 the firm became involved in a lawsuit with Quinet, the ruling establishing that, in France, a photograph was legally a work of art and so had copyright protection. In 1862 Léopold Ernest Mayer and Pierson became photographers to the Emperor and the Monarchy of Wurtemberg, the Queen of the Netherlands, and the King of Sweden. They assembled a collection of almost 1200 portraits of celebrities. They published *La Photographie Considérée comme Art et Industrie - Histoire de sa Découverte, ses Progrès, ses Applications, son Avenir*, Paris: Hachette, 1862. Leopold Ernest Mayer died around 1865 and Pierson was the sole owner of the Maison Mayer Frères. In the 1860s a son of Louis Frédéric Mayer operated several studios in Paris, as did a François Pierson. In 1874 Pierre Louise Pierson sold his studio to his son-in-law Gaston Braun, but continued to work there. He helped take on the management of the Braun company with Gaston, when Gaston's father Adolph Braun died in 1877. Pierre Louise died in 1913.]

M538 Portrait. Woodcut engraving credited "From a photograph by Mayer & Pierson, of Paris." ILLUSTRATED LONDON NEWS 27, (1855) ["Compte de Persigny, French Ambassador." 27:* (Nov. 17, 1855): 577.]

M539 Portrait. Woodcut engraving credited "From a photograph by Mayer & Pierson, of Paris." ILLUSTRATED LONDON NEWS 28, (1855) ["Group portrait, Peace Plenipotentiaries." 28:* (Apr. 26, 1856): 417.]

M540 "Note." JOURNAL OF THE PHOTOGRAPHIC SOCIETY OF LONDON 3, no. 43 (June 21, 1856): 73. ["M. M. Mayer & Pierson have been permitted to photograph the portraits of the Plenipotentiaries at the Congress of Paris, a collection which they have published."]

M541 "Correspondence: Foreign Science; Paris, 21 Nov. 1860." PHOTOGRAPHIC NEWS 4, no. 116 (Nov. 23, 1860): 354-355. [Notes about fashion of life-sized portraits, mentions Mayer & Pierson, Count Aguado.]

M542 Portrait. Woodcut engraving credited "From a photograph by Mayer & Pierson, of Paris." ILLUSTRATED LONDON NEWS 37, (1861) ["M. Fould, Finance Minister in France." 37:* (Nov. 30, 1861): 543.]

M543 Portrait. Woodcut engraving credited "From a photograph by Mayer & Pierson, of Paris." ILLUSTRATED LONDON NEWS 43, (1863) ["M. Billault, French Minister of State." 43:* (Oct. 31, 1863): 440.]

MAYER, LÉOPOLD ERNEST (1817-ca. 1865) (FRANCE) see MAYER & MAYER; MAYER & PIERSON.

MAYER, LOUIS FRÉDÉRIC see MAYER & MAYER; MAYER & PIERSON.

MAYNARD, RICHARD & HANNAH HATHERLY MAYNARD. (CANADA)
M544 Mattison, David. "Richard Maynard: Photographer of Victoria, B.C." HISTORY OF PHOTOGRAPHY 9, no. 2 (Apr.-June 1985): 109-129. 22 b & w. 1 illus. [Maynard and his wife Hannah Hatherly Maynard moved from Ontario to British Columbia in 1862, after photographing there in 1859. Photographed through 1890s. Indians, settlers, railroad views, etc. Notes on pp. 128-129.]

M545 Mattison, David. "The Maynards: A Victoria Photographic Couple." PHOTOGRAPHIC CANADIANA 11, no. 5 (Mar. - Apr. 1986): 2-4. 4 illus.

MAYNARD, HANNAH HATHERLY. see also MAYNARD, RICHARD & HANNAH HATHERLY MAYNARD.

MAYNARD, HANNAH HATHERLY. (1834-1918) (GREAT BRITAIN, CANADA)
M546 Wilks, Claire Weissman. *The Magic Box: The Eccentric Genius of Hannah Maynard.* Toronto: Exile Editions, 1980. 149 pp. b & w. illus. [Hannah Hatherly was born in Cornwall in 1834. She married Richard Maynard in 1852, then they emigrated to Canada in 1834. She had four children, then learned photography - probably from R. & H. O'Hara in Bowmanville, Canada West. The family moved to Victoria, British Columbia, in 1862. Richard worked as a bootmaker and prospected for gold. Hannah opened "Mrs. R. Maynard's Photographic Gallery" in 1862. Richard learned photography from his wife and made landscapes and mining town scenes in British Columbia and in Alaska. Hannah also made outdoor views in addition to the traditional studio portraits. In the 1880s she began experimenting with collaging, multiple printing, and montaging with her portraits and produced many original and interesting works. Richard died in 1907. Hannah retired in 1912 and died in 1918.]

M547 Schwartz, Joan M. "Exchange." PHOTO COMMUNIQUE 1, no. 6 (Jan. - Feb. 1980): 6. [Letter correcting statements about Hannah Maynard made in "Rediscovery: Women in Photography" in Sept./Oct. 1979 issue of "Photo Communique."]

MAYNARD, RICHARD see also MAYNARD, HANNAH.

MAYNARD, RICHARD. (1832-1907) (CANADA)
M548 Mattison, David. "A Fair Wind Blowing: Richard Maynard's Tours on HMS Boxer 1873-1874." PHOTOGRAPHIC CANADIANA 12, no. 4 (Jan.-Feb. 1987): 2-5. 7 illus. [Maynard photographed several Indian villages while touring Pacific Northwest coastline on a Royal Navy boat, taking both stereo and large-format views.]

MEAD. [MRS.]
M549 2 photos (Views of the Iron Block, a building in Chicago). CHICAGO MAGAZINE 1, no. 3 (May 1857): two unnumbered leaves before p. 197. [Two woodcuts credited "Amb. by Mrs. Mead."]

MEADE BROTHERS (NEW YORK, NY)
M550 "Note." DAGUERREAN JOURNAL 1, no. 1 (Nov. 1, 1850): Cover, 17. 1 illus. [Note that engraving of Daguerre on the front cover was taken from a daguerreotype by the Meade Brothers, engraved by N. Orr.]

M551 "Our Daguerreotypes." DAGUERREAN JOURNAL 1, no. 3 (Dec. 2, 1850): 83. [Meade Brothers, formerly of Albany, NY, opened a gallery in New York, NY.]

M552 "Anderson, The Wizard of the North, and his Son." ILLUSTRATED AMERICAN NEWS 1, no. 15 (Sept. 13, 1851): 113-114. 1 illus. [Theatrical performer. "From a Daguerreotype by Meade & Brothers."]

M553 Portrait. Woodcut engraving. GLEASON'S PICTORIAL DRAWING-ROOM COMPANION 1, (1851) ["General Narciso Lopez." 1:22 (Sept. 27, 1851): 352. Note on p. 381.]

M554 "Letter." DAGUERREAN JOURNAL 3, no. 1 (Nov. 15, 1851): 19. [Letter from the Meade Brothers stating that some daguerreotypes exhibited by Mr. Wilmarth at the American Institute Fair were taken by the Meade Brothers.]

M555 "Gossip." PHOTOGRAPHIC ART JOURNAL 3, no. 4 (Apr. 1852): 260. ["We called upon the Meade Brothers to look at two very fine specimens of double whole size pictures of Mrs. Forrest and Mad. Lola Montez."]

M556 "The Brothers Meade and the Daguerrean Art." PHOTOGRAPHIC ART JOURNAL 3, no. 5 (May 1852): 293-295. 1 illus. [Woodcut portrait of the pair. Began as daguerreotypists in Albany, NY in 1842. Travelled throughout upper New York State in 40's, had rooms at Buffalo, Saratoga Springs, and Albany, which they sold when they moved to New York, NY. In 1846 sent views of Niagara Falls to monarchs in Europe, which gained them much publicity and praise. Henry Meade visited Europe in 1847-48. Charles went over a year later, where he took daguerreotypes of Daguerre and views of France, etc. Sent 24 frames to the British World's Fair in 1851, four of them being allegorical genre tableau compositions. In 1852 had ten assistants in their gallery and 1000 pictures in their files.]

M557 "The Brothers Meade." GLEASON'S PICTORIAL DRAWING-ROOM COMPANION 2, no. 24 (June 12, 1852): 377. 1 illus. [Brief biography: Began photography in 1842 in room in Downs's Building, Albany, NY. 1842-43, traveled around towns, with permanent establishments in Buffalo, NY, and Saratoga Springs, NY. Moved to 233 Broadway, New York, NY, ca. 1850. Henry Meade to Europe 1847-1848, then Charles R. in 1848. Charles took views, and portrait of Daguerre at that time. In 1846, views of Niagara Falls, NY, in elegant frames sent to the King of France and the Emperor of Russia. Twenty four daguerreotypes in Worlds Fair, London, four of which were allegorical genre portrait representations of Europe, Asia, Africa and America. Have ten assistants, 1000 pictures in their collection. See also p. 365: "Contents of our next number: A capital likeness of the Brothers Meade, daguerreotypists, Broadway, New York - to whom we are often indebted for accurate likenesses, etc."]

M558 Portraits. Woodcut engravings, credited "From a Daguerreotype by the Meade Brothers." ILLUSTRATED NEWS (NY)

1, (1853) ["Robert Hiller." 1:4 (Jan. 22, 1853): 60. "Misses Fox, the original Rappers." 1:5 (Jan. 29, 1853): 80.]

M559 "Meade Brothers, New York." GLEASON'S PICTORIAL DRAWING-ROOM COMPANION 4, no. 5 (Jan. 29, 1853): 77. [Brief note: "...the well known and enterprising daguerreotyping firm,... have been elected members of the "Société Libres des Beaux Arts" of Paris."]

M560 "Our Daguerrean Galleries - no. 1. The Meade Gallery, New York." PHOTOGRAPHIC ART JOURNAL 5, no. 2 (Feb. 1853): frontispiece, 99-100. 1 illus. [Etching of the waiting room at the Meade Brothers Gallery. The brief statement includes a listing of some of the notable daguerreotypes displayed in the gallery collection, ranging from portraits of statesmen to views of California, etc. It seems clear that not all of these were actually taken by the Meade Brothers.]

M561 "Daguerreotype Galleries of Meade Brothers." GLEASON'S PICTORIAL DRAWING-ROOM COMPANION 4, no. 6 (Feb. 5, 1853): 96. 1 illus. [Description of the gallery in New York, and of the collection of portraits of notables. The engraving is an interior of the waiting room.]

M562 Portrait. Woodcut engraving credited "From a photograph by Meade Brothers, New York." ILLUSTRATED LONDON NEWS 22, (1853) ["General Pierce, New President of U.S.A." 22:613 (Mar. 19, 1853): 209. (dag.)]

M563 "The United States Expedition to Japan." ILLUSTRATED LONDON NEWS 22, no. 620 (May 7, 1853): 344. 2 illus. [Illustration of the Frigate "Mississippi, U.S.N." Portrait of Commodore Matthew C. Perry. "From a daguerreotype by Meade Brothers, NY."]

M564 "'Billy Bowlegs' and Suite." ILLUSTRATED LONDON NEWS 22, no. 622 (May 21, 1853): 395-396. 1 illus. [Seminole Indian party at New York. - "From a Daguerreotype by Meade Brothers, NY."]

M565 "Gossip. " PHOTOGRAPHIC ART JOURNAL 6, no. 1 (July 1853): 65. [Series of daguerreotypes, taken by the Messrs. Meade, illustrative of Shakespeare's "Seven Ages." Henry W. Meade returned from Europe. b & w.]

M566 "Gossip." PHOTOGRAPHIC ART JOURNAL 6, no. 5 (Nov. 1853): 323. [Meade Brothers awarded a gold medal at the American Institute Fair. Elected honorary members of the Academy of Science in France.]

M567 "Proposed Elevated Railroad Terrace for Broadway, New York." GLEASON'S PICTORIAL DRAWING-ROOM COMPANION 6, no. 13 (Apr. 1, 1854): 200-201. 1 illus. [The engraving depicting a proposed elevated railway, drawn with the then current buildings on Broadway as background. The Meade Brothers gallery figures in the sketch.]

M568 Meade Brothers. "Communications: Colors for the Daguerreotype." PHOTOGRAPHIC AND FINE ART JOURNAL 7, no. 10 (Oct. 1854): 311. [Apparently an attack on the methods of John Werge, who had worked for them until Aug. 1854. See Nov. issue, p. 346.]

M569 Meade Brothers. "Daguerreotype Colors." PHOTOGRAPHIC AND FINE ART JOURNAL 7, no. 12 (Dec. 1854): 381. [Another sharp letter in the exchange between J. Werge and the Meade Brothers.]

M570 "Our Dramatic Gallery: William Rufus Blake." FRANK LESLIE'S NEW YORK JOURNAL n. s. 1, no. 1 (Jan. 1855): 44. 1 illus. ["From a Daguerreotype, by Meade, Brothers."]

M571 "Bayard Taylor." BALLOU'S PICTORIAL DRAWING-ROOM COMPANION [GLEASON'S] 8, no. 3 (Jan. 20, 1855): 44. 1 illus. ["...from a daguerreotype by Meade Brothers, of New York."]

M572 "1 photo (Portrait of Daguerre)." PHOTOGRAPHIC AND FINE ART JOURNAL 8, no. 2 (Feb. 1855): frontispiece. 1 b & w. [Portrait of Daguerre from a daguerreotype by the Meade Brothers, crystalotyped by Whipple.]

M573 "Our Dramatic Gallery: Miss Julia Dean." FRANK LESLIE'S NEW YORK JOURNAL n. s. 1, no. 2 (Feb. 1855): 101. 1 illus. ["From a Daguerreotype, by Meade, Brothers."]

M574 "M'lle Dolores Nau." BALLOU'S PICTORIAL DRAWING-ROOM COMPANION [GLEASON'S] 8, no. 19 (May 12, 1855): 300. 1 illus. [Actress. "...from a daguerreotype taken by Messr. Mead [sic. Meade] Brothers of New York."]

M575 "Messrs. Meade Brothers." BALLOU'S PICTORIAL DRAWING-ROOM COMPANION [GLEASON'S] 9, no. 9 (Sept. 1, 1855): 141. ["...just returned from Paris, bringing with him a splendid assortment of photographic pictures taken by himself. Among them is a set taken by Mr. Meade expressly for our Pictorial, including portraits of Madame Rachel, the great French, and Signora Ristori, the distinguished Italian tragediennes, likenesses of other eminent persons, views of noteworthy monuments, interiors, and works of art, which we will present from time to time to our patrons."]

M576 "Mademoiselle Rachel as Phedre." BALLOU'S PICTORIAL DRAWING-ROOM COMPANION [GLEASON'S] 9, no. 12 (Sept. 22, 1855): 177. 1 illus. ["...from a daguerreotype by Meade Brothers, of New York." An actress, in costume, declaiming.]

M577 "Our Illustrations: Photographed by Meade Brothers. Notre Dame, Paris. Cirque de L'Imperatice, Paris." PHOTOGRAPHIC AND FINE ART JOURNAL 8, no. 10 (Oct. 1855): frontispiece, unnumbered p. before p. 309, 317-318. 2 b & w. [Two original photos tipped-into the issue. Views taken by Charles Meade, on his trip to Paris.]

M578 Portraits. Woodcut engravings, credited "From a Photograph by Meade Brothers." BALLOU'S PICTORIAL DRAWING-ROOM COMPANION [GLEASON'S] 10, (1856) ["Charles Anderson Dana." 10:240 (Feb. 9, 1856): 92. "The Sisters Fox, the Original Spirit Rappers." 10:258 (June 14, 1856): 380.]

M579 "Messrs. Meade of New York." BALLOU'S PICTORIAL DRAWING-ROOM COMPANION [GLEASON'S] 10, no. 247 (Mar. 29, 1856): 205. ["...have lately discovered a process for taking daguerreotypes on silk, and so fixing them that washing does not injure the pictures in the least."]

M580 "1 photo (Palais de l'Industrie - Exterior View)." PHOTOGRAPHIC AND FINE ART JOURNAL 9, no. 4 (Apr. 1856): frontispiece. 1 b & w. [Original photographic print, tipped-in. View in Paris, taken by Charles Meade during his visit.]

M581 "William T. Porter, editor of the 'Spirit of the Times.'" BALLOU'S PICTORIAL DRAWING-ROOM COMPANION [GLEASON'S] 11, no. 267 (Aug. 16, 1856): 108. 1 illus.

M582 "Henry T. Herbert." BALLOU'S PICTORIAL DRAWING-ROOM COMPANION [GLEASON'S] 11, no. 268 (Aug. 23, 1856): 124. 1 illus.

M583 "The New Washington Monument, in Union Park, New York." BALLOU'S PICTORIAL DRAWING-ROOM COMPANION [GLEASON'S] 11, no. 269 (Aug. 30, 1856): 129. ["...after the daguerreotype taken expressly for us by those excellent artists, Meade Brothers, of New York... equestrian statue by H. K. Browne."]

M584 Portraits. Woodcut engravings, credited "From a Photograph by Meade Brothers." BALLOU'S PICTORIAL DRAWING-ROOM COMPANION [GLEASON'S] 12, (1857) ["James R. Anderson, actor." 12:293 (Jan. 31, 1857): 76. "John Van Buren." 12:294 (Feb. 7, 1857): 92.]

M585 Portraits. Woodcut engravings, credited "From an Ambrotype by Meade Brothers." FRANK LESLIE'S ILLUSTRATED NEWSPAPER 3, (1857) ["John J. Eckel, murder witness." 3:63 (Feb. 21, 1857): 192. "George Vail Snodgrass." 3:63 (Feb. 21, 1857): 192. "Miss Augusta Cunningham." 3:63 (Feb. 21, 1857): 192. "Miss Helen Cunningham." 3:63 (Feb. 21, 1857): 192. "Mrs. Cunningham, as she appears in court." 3:75 (May 16, 1857): 368. "John J. Eckel, defendant; Rev. Uriah Marvine, witness; Mrs. Farrell, witness.(Three portraits, of participants in the Burdell murder trial)." 3:75 (May 16, 1857): 376.]

M586 "Meade Brothers, New York." BALLOU'S PICTORIAL DRAWING-ROOM COMPANION [GLEASON'S] 12, no. 297 (Feb. 28, 1857): 141. ["In the studio of these accomplished daguerreotype and photographic artists, the Hon. Caleb Lyon, of Lyonsdale, lately threw off some very pretty verses, inspired by their pictures, which are now going the rounds of the newspaper press."]

M587 "Charlestown (Mass.) City Guard, in front of the City Hall, New York, Reviewed by the Mayor. - From a Photograph Taken in a Snow Storm by the Meade Brothers." FRANK LESLIE'S ILLUSTRATED NEWSPAPER 3, no. 68 (Mar. 28, 1857): 264. 1 illus. [View, with group.]

M588 "The Albany Burgesses Corps, as They Appeared in the City Hall Park, on the Way to Attend the Inauguration of Mr. Buchanan, Photographed by Meade Brothers." FRANK LESLIE'S ILLUSTRATED NEWSPAPER 3, no. 69 (Apr. 4, 1857): 280. 1 illus. [Outdoor group portrait.]

M589 "Trial of Mrs. Cunningham for Murder." HARPER'S WEEKLY 1, no. 19 (May 9, 1857): 301-302. 3 illus. [Two portraits from photographs by the Meade Brothers; sketch of the opening of the trial.]

M590 "The Nicaraguan Leaders." HARPER'S WEEKLY 1, no. 21 (May 23, 1857): 332-333. 4 illus. [Four portraits, three of which (Gen. William Walker, Capt. Farnum, General Wheat) are credited to the Meade Brothers.]

M591 "The U. S. Steam Frigate Niagara, W. L. Hudson, Commander, Leaving the Harbor of New York to Assist in Laying Down the Inter-Oceanic Telegraph Cable. From a Photograph by Meade Brothers." FRANK LESLIE'S ILLUSTRATED NEWSPAPER 3, no. 73 (May 2, 1857): 336-337. 3 illus. [View of ship under sail. Two portraits, of Capt. Wm. L. Hudson, Commander of the 'Niagara,' and Jabez C. Rich, Marine Corps.]

M592 "General Walker's Filibustering Expedition." ILLUSTRATED LONDON NEWS 30, no. 864 (June 20, 1857): 593-594. 3 illus.

[American attempted to invade Nicaragua, with about 250 soldiers. Report on the failure of that effort, illustrated with views and a portrait of Walker, taken from a photograph by the Meade Brothers, New York.]

M593 Portraits. Woodcut engravings, credited "Photographed by Meade Brothers." FRANK LESLIE'S ILLUSTRATED NEWSPAPER 4, (1857) ["Andrew Jackson, Jr." 4:95 (Sept. 26, 1857): 257.]

M594 "The Appearance of the 'Central America,' Capt. Wm. L. Herndon, U.S.N., Commander, the Last Time She Left the Port of New York. Photographed by Meade Brothers." FRANK LESLIE'S ILLUSTRATED NEWSPAPER 4, no. 96 (Oct. 3, 1857): 280. 1 illus. [Boat, under steam.]

M595 Portraits. Woodcut engravings, credited "Photographed by Meade Brothers. FRANK LESLIE'S ILLUSTRATED NEWSPAPER 4, (1857) ["Signora Erminie Frezzolini, singer." 4:97 (Oct. 10, 1857): 297. "John Tice; Alexander Grant; George W. Dawson, shipwreck survivors; Capt. Hiram Bury, of the brig 'Marine.' (Four portraits). 4:98 (Oct. 17, 1857): 320.]

M596 "The Kane and Hartstein Medals." FRANK LESLIE'S ILLUSTRATED NEWSPAPER 5, no. 110 (Jan. 9, 1858): 92-93. 4 illus. [Photographs of each side of two gold medals struck by the State of NY for the Arctic explorers.]

M597 "Editorial Brevities: The Meade Brothers." FRANK LESLIE'S ILLUSTRATED NEWSPAPER 5, no. 127 (May 8, 1858): 363. [A brief poem, "The Priests of the Sun," by Wm. Ross Wallace.]

M598 Portraits. Woodcut engravings, credited "Photographed by Meade Brothers." FRANK LESLIE'S ILLUSTRATED NEWSPAPER 5, (1858) ["The late H. W. Herbert." 5:130 (May 29, 1858): 413.]

M599 Portraits. Woodcut engravings, credited "Photographed by Meade Brothers." FRANK LESLIE'S ILLUSTRATED NEWSPAPER 6, (1858) ["Gen. Jose A. Paez, of Venezuela." 5:133 (June 19, 1858): 36.]

M600 Portraits. Woodcut engravings, credited "From a Photograph by Meade Brothers." FRANK LESLIE'S ILLUSTRATED NEWSPAPER 6, (1858) ["Wm. E. Everett, Chief Engineer, U.S. Navy." 6:144 (Sept. 4, 1858): 210. "Mr. Woodhouse, civil engineer aboard the 'Niagara.'" 6:144 (Sept. 4, 1858): 211.]

M601 1 engraving ("Ball, Black & Co.'s Jewellery Store, Corner of Broadway and Murray Street, New York, As It appeared on the Evening of the Telegraphic Jubilee, Sept. 1, 1858.") on p. 235 in: FRANK LESLIE'S ILLUSTRATED NEWSPAPER 6, no. 145 (Sept. 11, 1858): 235. 1 illus. [Note on p. 248 (Sept. 18th issue) crediting photos of the Herndon medals and the store of Mssrs. Ball, Black, and Co. to Meade Brothers. Figures added by the engraver.]

M602 "Steam Fire Engine of the Hibernia Company of Philadelphia. - Photographed by the Meade Brothers." FRANK LESLIE'S ILLUSTRATED NEWSPAPER 7, no. 157 (Dec. 4, 1858): 9. 1 illus.

M603 Portraits. Woodcut engravings, credited "From a Photograph by Meade Brothers." FRANK LESLIE'S ILLUSTRATED NEWSPAPER 7, (1859) ["The Emperor Faustin I, of Hayti." 7:167 (Feb. 12, 1859): 159. "The Empress of Hayti." 7:167 (Feb. 12, 1859): 159. "The late John Richards." 7:167 (Feb. 12, 1859): 166. "Mr. J. Dyott, actor, in costume." 7:169 (Feb. 26, 1859): 195. "Mr. F. Bangs, actor, in costume." 7:169 (Feb. 26, 1859): 195. "Rev. S. R. Brown, 1st

American missionary to Japan." 7:169 (Feb. 26, 1859): 203. "Mr. Joseph Jefferson, actor, in costume." 7:170 (Mar. 5, 1859): 218.]

M604 "The Great Celebration of the Order of Odd Fellows, New York, Apr. 26, 1859." FRANK LESLIE'S ILLUSTRATED NEWSPAPER 7, no. 179 (May 7, 1859): 358-360. 13 illus. [Three sketches of a parade, ten portraits of Odd Fellows dignitaries - 6 by the Meade Bothers, 2 by Loud, 1 by Brady.]

M605 Portrait. Woodcut engraving, credited "From a Photograph by Meade Brothers." FRANK LESLIE'S ILLUSTRATED NEWSPAPER 8, (1859) ["Judge J. H. Welsh." 8:193 (Aug. 13, 1859): 170.]

M606 "Daguerreotype Galleries of the Meade Brothers." HISTORY OF PHOTOGRAPHY 1, no. 4 (Oct. 1977): 348. 1 illus. [Excerpt from "Gleason's Drawing-Room Companion" (Feb. 5, 1853).]

MEADE, CHARLES R. see also MEADE BROTHERS.

MEADE, CHARLES RICHARD. (1826-1858) (USA)

M607 "Letter." PHOTOGRAPHIC ART JOURNAL 5, no. 3 (Mar. 1853): 185. [On the bad effects of mercury vapors. Mentions a solution proposed by a Mr. Meeks, "an Operator from Rio de Janeiro."]

M608 Meade, Charles R. "The Art in London and Paris." PHOTOGRAPHIC AND FINE ART JOURNAL 7, no. 12 (Dec. 1854): 380. [Charles Meade's letter describes his week long visit to London, where he met Claudet, Kilburn, and Mayall. Then his experiences at the Mayer Brothers studio. He also speaks of learning the paper processes "from another gentleman" along with individuals from Calcutta, Lisbon, Rio de Janeiro, Constantinople, England, Cuba, and France. Describes work of the Bisson Fréres and of Thompson.]

M609 "Charles R. Meade." HUMPHREY'S JOURNAL OF PHOTOGRAPHY, AND THE ALLIED ARTS AND SCIENCES 9, no. 22 (Mar. 15, 1858): 352. [Brief note of Meade's death, "died at St. Augustine, Florida, on Tuesday March 2, of consumption, aged 31 years, 11 months and 9 days."]

M610 "Personal & Art Intelligence." PHOTOGRAPHIC AND FINE ART JOURNAL 11, no. 4 (Apr. 1858): 128. [C. R. Meade (New York, NY) died of consumption on Mar. 2, 1858, in Augustine, FL; aged 31 years, 11 months, 9 days.]

M611 Hallenbeck, J. H. "Photographs on Silk and Satin. - Nothing New." HUMPHREY'S JOURNAL OF PHOTOGRAPHY, AND THE ALLIED ARTS AND SCIENCES 18, no. 5 (July 1, 1866): 75. ["Having seen a number of formulae in foreign journals for making the satin and silk photographs, and knowing that the first ones were made by our lamented townsman the late Charles R. Meade, Esq., (over ten years ago,) I thought I would send in the original formula."]

M612 Bott, Rita Ellen. "Charles R. Meade and his Daguerre Pictures." HISTORY OF PHOTOGRAPHY 8, no. 1 (Jan.- Mar. 1984): 33-40. 1 b & w. 6 illus.

MEADE, HENRY see also MEADE BROTHERS.

MEADE, HENRY WILLIAM MATHEW. (1823-1865) (GREAT BRITAIN, USA)

M613 "Gossip." PHOTOGRAPHIC ART JOURNAL 5, no. 1 (Jan. 1853): 64. [Note that Henry Meade is leaving for Europe with the American contribution to Daguerre's monument.]

M614 Meade, Henry W. "Gossip: Letter." PHOTOGRAPHIC ART JOURNAL 6, no. 1 (July 1853): 63-65. [Letter from Meade describing his visit to Europe. Mentions Claudet, Kilburn, and Beard in England, Thompson in Paris, the popularity of stereos abroad, his visit to the Daguerre monument, Niépce de St. Victor, Ernest Lacan, etc.]

M615 Portraits. Woodcut engravings, credited "Photographed by H. W. Meade." FRANK LESLIE'S ILLUSTRATED NEWSPAPER 11, (1861) ["The late Lola Montez." 11:271 (Feb. 2, 1861): 165.]

M616 "Henry William Mathew Meade." NEW YORK ILLUSTRATED NEWS 3, no. 67 (Feb. 16, 1861): 236. 2 illus. [Portrait and biography of Meade. View of interior of the Meade Brothers Photographic Gallery, 233 Broadway, New York, NY. Born in England in 1823, to USA in 1833. Began photography in Albany, NY "twenty years ago." Lost his brother in 1858, but retained the name "Meade Brothers." Occupied Broadway address "for eleven years." James Landy chief photographer for the gallery.]

M617 "Suicide of a Photographer." HUMPHREY'S JOURNAL OF PHOTOGRAPHY, AND THE ALLIED ARTS AND SCIENCES 16, no. 19 (Feb. 1, 1865): 304. ["Mr. H. W. M. Meade, of the firm of Meade Brothers, 233 Broadway, committed suicide by taking laudanum, on Thursday night, Jan. 25th, at Tammany Hotel in the city."]

MEAGHER, P.

M618 Meagher, P. "On the Breaking of Negatives." HUMPHREY'S JOURNAL OF PHOTOGRAPHY, AND THE ALLIED ARTS AND SCIENCES 19, no. 15 (Dec. 1, 1867): 236. [Read to South London Photo. Soc.]

MEDRINGTON. (BATH, ENGLAND)

M619 Portrait. Woodcut engraving credited "From a photograph by Medrington." ILLUSTRATED LONDON NEWS 75, (1879) ["Field Marshall Sir W. Rowan, G.C.B." 75:2104 (Oct. 11, 1879): 337.]

MEICKE, F.

M620 Meicke, F. "On the Amount of Silver absorbed in Sensitizing Paper." AMERICAN JOURNAL OF PHOTOGRAPHY, AND THE ALLIED ARTS AND SCIENCES n. s. vol. 9, no. 10 (May. 1, 1867): 213-214. [From "Photographische Mittheilungen."]

MEIGS, MONTGOMERY.

M621 Fairman, Charles E. "An Old Albumen Print." AMERICAN ANNUAL OF PHOTOGRAPHY, 1911 (1911): 97-98, 100. 1 b & w. [Author discusses the activity of Capt. Montgomery C. Meigs, U.S. Engineers, in the 1850s, during the construction of the Capitol buildings in Washington, DC. Mentions John Wood as the official photographer. Quotes a letter from Meigs to C. Sellers, claiming that Meigs himself took photos as well.]

MEINERTH, CARL. (1825-1892) (GERMANY, USA)

M622 Meinerth, C. "Stereoscopic Vision without an Instrument." HUMPHREY'S JOURNAL OF PHOTOGRAPHY, AND THE ALLIED ARTS AND SCIENCES 13, no. 18 (Jan. 15, 1862): 273-276. [Working in Portsmouth, NH.]

M623 Meinerth, C. "Dry Processes." HUMPHREY'S JOURNAL OF PHOTOGRAPHY, AND THE ALLIED ARTS AND SCIENCES 13, no. 21 (Mar. 1, 1862): 334-335.

M624 Meinerth, Carl. "An Experience with the Old Hypo-Bath." AMERICAN JOURNAL OF PHOTOGRAPHY AND THE ALLIED ARTS & SCIENCES n. s. vol. 5, no. 15 (Feb. 1, 1863): 348-350. [Meinerth from Portsmouth.]

M625 Meinerth, Carl. "Curious Results from an old Hypo Bath." HUMPHREY'S JOURNAL OF PHOTOGRAPHY, AND THE ALLIED ARTS AND SCIENCES 14, no. 22 (Mar. 15, 1863): 301-302.

M626 Meinerth, Carl. "Mottling in the Negative after Varnish." AMERICAN JOURNAL OF PHOTOGRAPHY AND THE ALLIED ARTS & SCIENCES n. s. vol. 6, no. 6 (Sept. 15, 1863): 141-143. [Working in Portsmouth, NH.]

M627 Meinerth, Carl. "Nitrate of Ammonia." HUMPHREY'S JOURNAL OF PHOTOGRAPHY, AND THE ALLIED ARTS AND SCIENCES 15, no. 11 (Oct. 1, 1863): 167-169.

M628 C. M. "Photographic Terms of Common Occurrence, and Maxims, Popularly Explained." AMERICAN JOURNAL OF PHOTOGRAPHY AND THE ALLIED ARTS & SCIENCES n. s. vol. 6, no. 8 (Oct. 15, 1863): 188-190. [(The attribution to Meinerth is written in the border of this copy.)]

M629 Meinerth, Carl. "Blistering of Albumen Paper." AMERICAN JOURNAL OF PHOTOGRAPHY AND THE ALLIED ARTS & SCIENCES n. s. vol. 6, no. 18 (Mar. 15, 1864): 431. [Working in Portsmouth, NH.]

M630 "Major Correspondence: Carl Meinerth to C. J. B., of Ohio." AMERICAN JOURNAL OF PHOTOGRAPHY AND THE ALLIED ARTS & SCIENCES n. s. vol. 7, no. 3 (Aug. 1, 1864): 61-63. [On blistering.]

M631 "Editor's Table: 'Our Josie.'" PHILADELPHIA PHOTOGRAPHER 2, no. 16 (Apr. 1865): 65. [Two views of a little girl, from Carl Meinurth, [sic] of Portsmouth, NH.]

M632 Meinerth, Carl. "Mezzo-Tintos." HUMPHREY'S JOURNAL OF PHOTOGRAPHY, AND THE ALLIED ARTS AND SCIENCES 19, no. 5 (July 1, 1867): 73. [Working in Newburyport, MA.]

M633 Meinerth, Carl. "Mezzo-Tinto Photographs. (Meinerth's Patent.)" HUMPHREY'S JOURNAL OF PHOTOGRAPHY, AND THE ALLIED ARTS AND SCIENCES 19, no. 6 (July 15, 1867): 93-94.

M634 "Meinerth Mezzo-Tintos." HUMPHREY'S JOURNAL OF PHOTOGRAPHY, AND THE ALLIED ARTS AND SCIENCES 19, no. 8 (Aug. 15, 1867): 128.

M635 Meinerth, C. "Mezzo-Tintos." HUMPHREY'S JOURNAL OF PHOTOGRAPHY, AND THE ALLIED ARTS AND SCIENCES 19, no. 10 (Sept. 15, 1867): 153-154. ["After you have allowed Mr. Ryder's letter to appear you will not deny me the common privilege of replying in self defense."]

M636 Meinerth, Carl. "Mezzo-Tintos Again." HUMPHREY'S JOURNAL OF PHOTOGRAPHY, AND THE ALLIED ARTS AND SCIENCES 19, no. 12 (Oct. 15, 1867): 184. [Response to Ryder's second letter. Editor states he would not publish more on this issue.]

M637 Meinerth, C. "Aqueous Varnish." HUMPHREY'S JOURNAL OF PHOTOGRAPHY, AND THE ALLIED ARTS AND SCIENCES 19, no. 20 (Feb. 15, 1868): 320.

M638 "Meinerth's Mezzotint." HUMPHREY'S JOURNAL OF PHOTOGRAPHY, AND THE ALLIED ARTS AND SCIENCES 20, no. 13 (Nov. 1, 1868): 204. [Lists several photographers who purchased at $25.00 each the rights to use the process. Attacks J. Ryder for challenging the process seller previously, etc.]

M639 Meinerth, Carl. "'Sealing up' Pictures." HUMPHREY'S JOURNAL OF PHOTOGRAPHY, AND THE ALLIED ARTS AND SCIENCES 20, no. 26 (Oct. 15, 1869): 404.

M640 Darrah, William C. "Carl Meinerth, Photographer." THE PHOTOGRAPHIC COLLECTOR 1, no. 4 (Winter 1980/81): 6-9. 4 b & w. 2 illus. [Carl Meinerth was born in Bohenier, Germany on Dec. 29, 1825. Emigrated from Germany during the political unrest following the 1848 revolution, and settled in Portsmouth, NH in 1853. An accomplished pianist and violinist, he offered music instruction, and opened a daguerreotype gallery in 1855. In 1864 he briefly formed a partnership with R. E. Mosely in Newburyport, MA. An ardent collector of animal specimins, shells, minerals, etc., he filled his gallery with specimens and made many stereo still lifes of his stuffed birds, butterflys, and shells. In 1867 Meinerth patented a "mezzotinto" printing process, which allowed for softened image. He then sold hundreds of licenses to the use of this process, as was the practice then. This caused some controversy in the field. Meinerth was a Mason. Three of his sons also practiced photography. George E. worked with his father at Newburyport, MA. Charles and John operated as Meinerth Brothers in Cohoes, NY in the 1870s. Carl gave up his studio in 1880, but practiced at home until 1890. Died on May 13, 1892.]

MEJIA, E. A. or H. A. (TX)
M641 "The Collodio-Albumen Process." HUMPHREY'S JOURNAL OF PHOTOGRAPHY, AND THE ALLIED ARTS AND SCIENCES 11, no. 24 (Apr. 15, 1860): 370-371. ["I have for some time past been employed in taking views,... glass transparencies for the stereoscope." (Identified as being from Texas, but city not given.)]

M642 Mejia, E. A. "An American Amateur in France." HUMPHREY'S JOURNAL OF PHOTOGRAPHY, AND THE ALLIED ARTS AND SCIENCES 13, no. 3 (June 1, 1861): 36-38. ["I enclose a few prints of some views taken in France,... I took some passable negatives of the Pyrenees both in France and Spain... a small collection, about thirty in all, stereoscopic size. ...in the course of a few weeks I am going to Mexico... a new country stereoscopically." (At some point Mejia was identified as being from Texas)]

MELENDER. (CHICAGO, IL)
M643 "The Primer's Progress 'Out West.'- A Spelling Match. - From a Photograph by Melender, Chicago." FRANK LESLIE'S ILLUSTRATED NEWSPAPER 41, no. 1059 (Jan. 15, 1876): 308, . 1 illus. [Group portrait, of a class participating in a spelling bee. Strongly composed, almost a genre scene.]

MELHUISH, ARTHUR JAMES. (d. 1895) (GREAT BRITAIN, NEW ZEALAND)
M644 Melhuish, A. J. "The Patent Metal Camera." BRITISH JOURNAL OF PHOTOGRAPHY 7, no. 109-110 (Jan. 1, 1860): 5-6.

M645 Melhuish, A. J. "Photographic Printing." HUMPHREY'S JOURNAL OF PHOTOGRAPHY, AND THE ALLIED ARTS AND SCIENCES 11, no. 18 (Jan. 15, 1860): 276-278. [From "Liverpool Photo. J."]

M646 "Melhuish's Metal Camera." PHOTOGRAPHIC AND FINE ART JOURNAL 13, no. 3 (Mar. 1860): 80-81. [From "London Photo. News."]

M647 "Melhuishs' Metal Camera." PHOTOGRAPHIC AND FINE ART JOURNAL 13, no. 4 (Apr. 1860): 101. [From "Photo. Notes."]

M648 "City of Dunedin, Otago, New Zealand." ILLUSTRATED LONDON NEWS 50, no. 1420 (Apr. 6, 1867): 332-333, 342. 2 illus. ["Our panoramic view is copied from a fine photograph, or series of photographs, taken by Mr. Melhuish, formerly of Bath, who emigrated some time ago from this country to Dunedin, where he practices the business of a photographic artist."]

M649 Portrait. Woodcut engraving credited "From a photograph by A. J. Melhuish." ILLUSTRATED LONDON NEWS 55, (1869) ["Sir Henry Ellis." 55:* (Feb. 6, 1869): 141.]

M650 Portrait. Woodcut engraving, credited to "From a Photograph by A. J. Melhuish." ILLUSTRATED LONDON NEWS 60, (1872) ["H. W. B. Brand, Speaker of the House of Commons." 60:1693 (Feb. 17, 1872): 152. Working in York Place, Portman Square, Eng.]

M651 Henisch, B. A. and H. K. Henisch. "A. J. Melhuish and the Shah." HISTORY OF PHOTOGRAPHY 4, no. 4 (Oct. 1980): 309-312. 3 b & w. [Wealthy amateur photographer Shah Nasser-ed-Dini in England.]

MELLONI.
M652 H. "Daguerreotype." AMERICAN REPERTORY OF ARTS, SCIENCES AND MANUFACTURES 2, no. 4 (Nov. 1840): 262. [A letter from Melloni to Arago, translated from "Annals de Chemie et de Physique."]

MELVILLE, RONALD LESLIE. (1835-1906) (GREAT BRITAIN)
M653 Smaills, Helen. "A Gentleman's Exercise: Ronald Leslie Melville, 11th Earl of Leven, and the Amateur Photographic Association." PHOTOGRAPHIC COLLECTOR 3, no. 3 (Winter 1982): 262-293. 29 b & w. 2 illus. [19 b & w by Melville, 10 b & w others.]

MELVILLE-CLARKE, CAPT.
M654 Clarke, Capt. Melville. *From Simla through Ladac and Cashmere. by Capt. Melville Clarke. 1861.* Calcutta: Savielle & Cranenburgh, 1862. n. p. 37 b & w. *[Original photographs, with title page.]*

MEMES, J. S.
M655 Memes, J. S. *The Photogenic Drawing.* London: Smith & Elder, 1839. n. p.

MENZEN, JOSEPH. (d. 1889) (USA)
M656 "Notes and News." PHOTOGRAPHIC TIMES 19, no. 383 (Jan. 18, 1889): 32. [Very brief note: "Menzen, an experienced operator and careful retoucher, of the old school, died Jan. 18th."]

MERCHANT, W. H. (LAWRENCEVILLE, PA)
M657 "A Substitute for Wing's Patent Plate-Holder." AMERICAN JOURNAL OF PHOTOGRAPHY AND THE ALLIED ARTS & SCIENCES n. s. vol. 8, no. 12 (Dec. 15, 1865): 280.

MERLIN, HENRY BEAUFOY. (1830-1873) (GREAT BRITAIN, AUSTRALIA)
BOOKS
M658 Holtermann, Bernard Otto. *Gold and Silver; an Album of Hill End and Gulgong Photography from the Holtermann Collection,* edited by Keast Burke. Melbourne: Heinemann, 1973. 265 pp. b & w. illus. [H. B. Merlin and Charles Baylies documented the mining activities and settling of Australia for B. O. Holtermann.]

PERIODICALS
M659 "Australia's Holtermann Collection of Wet Plate Negatives." IMAGE 4, no. 3 (Mar. 1955): 22-23. 2 b & w. [Merlin photographed

gold mining towns, etc. in Australia in 1860s, 1870s, then photographed the growth of New South Wales and Victoria, under the patronage of Bernard Otto Holtermann. When he died in 1873, his assistant Charles Bayliss continued the project.]

MERRELL, JAS. O.
M660 "Voices from the Craft." PHILADELPHIA PHOTOGRAPHER 15, no. 179 (Nov. 1878): 335-337. [Jas. O. Merrell from Rutland, VT.]

MERRICK. (BRIGHTON, ENGLAND).
M661 Portrait. Woodcut engraving, credited to "From a Photograph by Merrick." ILLUSTRATED LONDON NEWS 59, (1871) ["George Jessel, Solicitor General." 59:1679 (Nov. 18, 1871): 484.]

MERRITT, JOHN D. (1832-1895) (USA)
M662 "In Memoriam: John D. Merritt." WILSON'S PHOTOGRAPHIC MAGAZINE 33, no. 471 (Mar. 1896): 125-126. 1 illus. [Learned daguerreotyping at Poughkeepsie, NY at age 15. Kept a gallery there for several years, then to Fishkill Landing. Then worked for galleries in Cincinnati, Charleston, Saratoga, Baltimore and elsewhere. Opened a studio in Washington, DC fourteen years ago. Died at age 63.]

MERRITT, T. L.
M663 Merritt, T. L. "Stereography." PHOTOGRAPHIC AND FINE ART JOURNAL 11, no. 11 (Nov. 1858): 342. [From "Liverpool & Manchester Photo. J." Letter in response to errors in previous article by Ross.]

MERRITT, THOMAS A.
M664 Portrait. Woodcut engraving, credited "From a Photograph by Thomas A. Merritt." FRANK LESLIE'S ILLUSTRATED NEWSPAPER 20, (1865) ["Lieut.-Col. Benj. D. Pritchard, 4th MI Cavalry." 20:505 (June 3, 1865): 173.]

MERZ, HENRY. (NEW YORK, NY)
M665 "Editor's Table." PHILADELPHIA PHOTOGRAPHER 6, no. 63 (Mar. 1869): 94. [A number of composition photos noted "Ben-Akibi", "Evening Prayer", "The Little Emigrants", etc.]

MESSER & BLAKE.
M666 "Soldier's Monument at Lewiston, Maine." HARPER'S WEEKLY 12, no. 591 (Apr. 25, 1868): 268. 1 illus. ["Photographed by Messer & Blake."]

M667 "The Soldier's Monument at Lewiston, Maine. - From a Photograph by Messer & Blake." FRANK LESLIE'S ILLUSTRATED NEWSPAPER 26, no. 659 (May 16, 1868): 140. 1 illus. [View, with figures.]

MESTRE, ESTEBAN. (CUBA)
M668 Portrait. Woodcut engraving, credited "From a Photograph by Esteban Mestre." FRANK LESLIE'S ILLUSTRATED NEWSPAPER 47, (1878) ["Don Francisco Montaos." 47:1213 (Dec. 28, 1878): 288.]

MESTRE, N. & CO. (HAVANA, CUBA)
M669 Portrait. Woodcut engraving, credited "From a Photograph by N. Mestre & Co., Havana, Cuba." FRANK LESLIE'S ILLUSTRATED NEWSPAPER 21, (1866) ["The Count of Pozes Dulces, editor of "El Siglo," Havana, Cuba. 21:541 (Feb. 10, 1866): 324.]

METCALF, WILLIAM H. (USA, JAPAN)
M670 Metcalf, William H. "How Amateur Photographers Are Made." PHOTOGRAPHIC TIMES 11, no. 123 (Mar. 1881): 93-94. [Raises

question of why there seems to be so many fewer amateurs proportionally in U.S. than in England.]

M671 Metcalf, William H. "Gelatine Emulsion." PHOTOGRAPHIC TIMES 11, no. 125 (May 1881): 191-193.

M672 Metcalf, W. H. "Photographing in Japan." AMERICAN ANNUAL OF PHOTOGRAPHY & PHOTOGRAPHIC TIMES ALMANAC FOR 1888 (1888): 195-197. [Metcalf apparently photographed as an amateur in Japan. "...ten to a dozen years ago." Mentions that these were 300 native professionals in Tokyo then. Metcalf from Milwaukee.]

METTETAL, A. M. (BLANCO, TX)
M673 Mettetal, A. M. "Filterings From the Fraternity: A Voice from Texas." PHILADELPHIA PHOTOGRAPHER 12, no. 138 (June 1875): 164-165. [A. M. Mettetal's address was Box 17, Blanco, TX.]

METZGER, C. GIS. BATT.
M674 Metzger, C. Gis. Batt. "Instantaneous Photography." HUMPHREY'S JOURNAL OF PHOTOGRAPHY, AND THE ALLIED ARTS AND SCIENCES 19, no. 8 (Aug. 15, 1867): 128. [From "Camera Obscura."]

MEUMEIER.
M675 "Submarine Photography." ANTHONY'S PHOTOGRAPHIC BULLETIN 4, no. 8 (Aug. 1873): 242-243. [From "N.Y. Times" at Berlin Geographical Society, Dr. Meumeier exhibited a device for photographing underwater. . .]

MEVIUS, G. A.
M676 "Druidical Remains Near Rennes, Brittany." ILLUSTRATED LONDON NEWS 53, no. 1505/1506 (Oct. 10, 1868): 361. 2 illus. [Dolmens. "Mr. G. A. Mevius, of that city [Rennes], for two photographs."]

MEYER & PIERRON. (PARIS, FRANCE)
M677 Portrait. Woodcut engraving, credited "From a Photograph by Meyer & Pierron HARPER'S WEEKLY 3, (1859) ["Marshal MacMahon, Duke of Magenta." 3:133 (July 16, 1859): 449.]

MEYER, C. EUGENE.
M678 "Our Picture." PHILADELPHIA PHOTOGRAPHER 1, no. 12 (Dec. 1864): frontispiece, 191. 1 b & w. ["View near Fairmont Waterworks, Philadelphia, PA." Meyer was an amateur photographer. Prints for the magazine made by R. Newell.]

MEYNIER.
M679 Harrison, W. Jerome. "The Chemistry of Fixing: Sulphocyanide of Ammonium Used by Meynier for Fixing." PHOTOGRAPHIC TIMES 20, no. 483 (Dec. 19, 1890): 632-633. [Meynier (1863), Abney (1885), R. E. Liesegang (1890).]

MIARLERLT-BECKNELL, A. M. (ST. JOHN THE BAPTIST, LA)
M680 "Photographing on Copper Plates." HUMPHREY'S JOURNAL OF PHOTOGRAPHY, AND THE ALLIED ARTS AND SCIENCES 19, no. 15 (Dec. 1, 1867): 232. [From "Cosmos."]

MICHAELIS, OTHO E. (d. 1890) (GERMANY, USA)
M681 "Obituary: Major Otho E. Michaelis, U.S.A." PHOTOGRAPHIC TIMES 20, no. 453 (May 23, 1890): 244. [Born Germany, to U.S.A. Joined NY National Guard in 1863; transferred to U.S. Army 1863, in the Signal Corps; remained a career officer, rose from lieut. to major. Studied photography with Charles Ehrmann; used it in experiments in the Signal Corps. Died May 1, 1890.]

MICKLETHWAITE FAMILY. (GREAT BRITAIN, CANADA)
M682 Tessier, Guy. "The photographic saga of the Micklethwaite family." THE ARCHIVIST (PUBLIC ARCHIVES OF CANADA) 13, no. 2 (Mar.-Apr. 1986): 9. 1 b & w. [William Barton Micklethwaite born in Ireland, became a portrait photographer there in 1850s, immigrated to Canada in 1870s. His son Frank, born in 1849 in England, also learned photography in Ireland, then moved to Toronto, Canada in 1875, where he joined his father. Frank took outside views, landscapes, architectural and commercial photographs. Successful. Died 1925. His son Fred and his grandson John continued the business.]

MIELL, J. W.
M683 "Inauguration of a Memorial Statue to the Late Lord Herbert of Lea." ILLUSTRATED LONDON NEWS 43, no. 1212 (July 11, 1863): 37, 43. 1 illus. ["...from a photograph by J. W. Miell, of Salisbury."]

MILES. (LEXINGTON, KY)
M684 Portrait. Woodcut engraving, credited "From a Photograph by Miles, of Lexington, Ky." FRANK LESLIE'S ILLUSTRATED NEWSPAPER 35, (1873) ["The late Lieut. Matthew F. Maury." 35:908 (Feb. 22, 1873): 381.]

MILES, J. A.
M685 Miles, J. A. "The Glass Calotype." HUMPHREY'S JOURNAL OF PHOTOGRAPHY, AND THE ALLIED ARTS AND SCIENCES 10, no. 14 (Nov. 15, 1858): 221-222. [From "J. of London Photo. Soc."]

MILEY, MICHAEL. (1841-1918) (USA)
BOOKS
M686 Fishwick, Marshall. *General Lee's Photographer, the Life and Work of Michael Miley.* Richmond, Va.: Published for the Virginia Historical Society by the Univ. of N. Carolina Press, 1954. xii, 94 pp. illus.

M687 Warren, Mary Elizabeth. *Michael Miley: American Photographer and Pioneer in Color.* Forward by Pamela Hemmenway Simpson. Lexington, VA: Washington and Lee University, 1980. 45 pp. illus.

PERIODICALS
M688 "Lexington, Va. - Scene in the College Grounds on the Morning of the Funeral - The Procession Leaving the Chapel of Washington & Lee College. - From a Photograph by Miley, Lexington, Va." FRANK LESLIE'S ILLUSTRATED NEWSPAPER 31, no. 788 (Nov. 5, 1870): 125. 1 illus. [View of Robert E. Lee's funeral.]

M689 2 photos (Portraits of Confederate General Robert E. Lee, taken in 1865 and 1867). CENTURY MAGAZINE 63, no. 6 (Apr. 1902): 924, 928. 2 b & w.

M690 Fishwick, Marshall W. "Michael Miley: Southern Artist in the Brown Decades." AMERICAN QUARTERLY 3, no. 3 (Fall 1951): 221. 231 b & w.

MILLARD, THOMAS. (d. 1882) (GREAT BRITAIN)
M691 Portrait. Woodcut engraving credited "From a photograph by Thomas Millard, Lower Sackville St., Dublin." ILLUSTRATED LONDON NEWS 42, (1863) ["Field Marshall Lord Seaton." 42:* (May 2, 1863): 472.]

MILLER & MCMURRAY.
M692 "Logan House, Headquarters of Gen. Sheridan, at Winchester, Va. - Photographed by Miller & McMurray." FRANK LESLIE'S

ILLUSTRATED NEWSPAPER 19, no. 490 (Feb. 18, 1865): 349. 1 illus. [View, with figures.]

MILLER. (VIENNA, AUSTRIA)

M693 Portraits. Woodcut engravings credited "From a photograph by Miller, of Vienna." ILLUSTRATED LONDON NEWS 26, (1855) ["M. Drouyn de Lhuys." 26:* (May 19, 1855): 477. (photo) "Ali Pacha, Turkish Minister of Foreign Affairs." 26:* (June 9, 1855): 585.]

M694 Portrait. Woodcut engraving credited "From a photograph by Miller, of Vienna." ILLUSTRATED LONDON NEWS 27, (1855) ["Baron Prokesch von Osten." 27:* (Oct. 13, 1855): 429.]

MILLER, C. (BURLINGTON, VT.)

M695 Hitchcock, Edward. *Report on the Geological Survey of the State of Vermont:* Descriptive, Theoretical, Economical and Scenographical; by Edward Hitchcock, LL.D., Albert D. Hager, A.M., Edward Hitchcock, Jr., M.D., Charles H. Hitchcock, A.M. In Two Volumes. Published Under the Authority of the State Legislature, by Albert D. Hager, Proctorsville, Vt. Claremont Manufacturing Co., Claremont, N. H., printer 1861. 2 vol. 998 pp. 38 l. of plates. 365 illus. [Maps, woodcuts, and lithographic plates. Lithographic plates by Ferd. Meyer & Co., N. Y., from photographs and prints by various artists. Sketches by A. L. Rawson, Miss Hattie E. Read, J. R. Rathbun. Views from photos by C. Miller, Burlington, VT (13); C. L. Howe, Brattleboro, VT (1); and A. F. Styles, Burlington, VT (3).]

MILLER, JAMES SIDNEY. (NASHUA, NH)

M696 "Niagara Engine Co., No. 5, Nashua, N.H." BALLOU'S PICTORIAL DRAWING-ROOM COMPANION [GLEASON'S] 12, no. 313 (June 20, 1857): 393. 2 illus. [View of Niagara Engine Company in the street; portrait of F. Muroe, Chief Engineer of the Fire Department, "...from ambrotypes by Mr. J. S. Miller, of Nashua, NH."]

MILLER, M.

M697 Lifson, Ben. "Who Is This Man?" VILLAGE VOICE 26, no. 37 (Sept. 9-15, 1981): 80. 1 b & w. [Ex. rev.: "M. Miller." Prakapas Gallery, New York, NY. Review of exhibit of portraits by M. Miller who worked as a photographer in Hong Kong ca. 1861-64.]

MILLER, MAURICE N. (1838-1888) (USA)

M698 Miller, Maurice N., M.D. "Theory and Practice of Photo-Micrography." PHOTOGRAPHIC TIMES 15, no. 191 (May 15, 1885): 262-265. [Delivered before Photographic Section of the American Institute, N.Y.C., May 5, 1885. Miller was the Instructor in Biology in the University Medical College, New York.]

M699 Mason, O. G. "Maurice N. Miller, M.D." PHOTOGRAPHIC TIMES 18, no. 380 (Dec. 28, 1888): 633-634. [Obituary. Died Dec. 8th. Born 1838. Worked as doctor in Philadelphia, in the Civil War, in New York, NY. Entered the physiological laboratory of Univ. of City of NY. under Prof. J. W. S. Arnold, then teacher of microscopy. Used photography in histology and pathology.]

M700 "Obituary: Maurice N. Miller." ANTHONY'S PHOTOGRAPHIC BULLETIN 20, no. 1 (Jan. 12, 1889): 27. [Miller born at Keene, NH in 1838. Studied at Leeland Academy. Learned photography with Howe of Brattleboro, Vt. Then studied medicine and graduated at Philadelphia as M.D. at age 21. Served as a surgeon to a Pennsylvania regiment during Civil War. Came to New York where he assisted Prof. J. W. Arnold at the physiological laboratory at the University of the City of New York. Instructor in microscopy at Loomis Laboratory. Wrote articles on technical topics. Died Dec. 8, 1888.]

MILLER, S. (POTTSVILLE, PA)

M701 Miller, S. Rev. "Photography as an Accomplishment." and "My first Experiments in Sun-printing." HUMPHREY'S JOURNAL OF PHOTOGRAPHY, AND THE ALLIED ARTS AND SCIENCES 14, no. 20 (Feb. 15, 1863): 262-264. [Describes his first experiments in 1839.]

M702 Miller, S., Rev. "The New Gold Toning Bath." HUMPHREY'S JOURNAL OF PHOTOGRAPHY, AND THE ALLIED ARTS AND SCIENCES 14, no. 21 (Mar. 1, 1863): 273-274.

M703 Miller, S., Rev. "A New Copying Frame." HUMPHREY'S JOURNAL OF PHOTOGRAPHY, AND THE ALLIED ARTS AND SCIENCES 14, no. 22 (Mar. 15, 1863): 291-293.

M704 Miller, S. Rev. "The New Gold Toning Bath. - No. 2." HUMPHREY'S JOURNAL OF PHOTOGRAPHY, AND THE ALLIED ARTS AND SCIENCES 14, no. 23 (Apr. 1, 1863): 314-316.

M705 Miller, S., Rev. "The Carlotype." HUMPHREY'S JOURNAL OF PHOTOGRAPHY, AND THE ALLIED ARTS AND SCIENCES 15, no. 1 (May 1, 1863): 7-9.

M706 Miller, S., Rev. "The Double Printing Process." HUMPHREY'S JOURNAL OF PHOTOGRAPHY, AND THE ALLIED ARTS AND SCIENCES 15, no. 2 (May 15, 1863): 28-29.

M707 Miller, S. "Acknowledgment. Vote of Thanks. - Society for the Diffusion of Useful Knowledge in the Photographic Arts." HUMPHREY'S JOURNAL OF PHOTOGRAPHY, AND THE ALLIED ARTS AND SCIENCES 15, no. 18 (Jan. 15, 1864): 279-281. [Letter from Miller (Pottsville, PA), reply from the editor.]

M708 Miller, S., Rev. "Iodizing the Negative Bath." HUMPHREY'S JOURNAL OF PHOTOGRAPHY, AND THE ALLIED ARTS AND SCIENCES 16, no. 2 (May 15, 1864): 25-26.

M709 Miller, S., Rev. "Developing Process." HUMPHREY'S JOURNAL OF PHOTOGRAPHY, AND THE ALLIED ARTS AND SCIENCES 16, no. 18 (Jan. 15, 1865): 282-284.

M710 Miller, S., Rev. "A Character." HUMPHREY'S JOURNAL OF PHOTOGRAPHY, AND THE ALLIED ARTS AND SCIENCES 16, no. 19 (Feb. 1, 1865): 295-297.

MILLER, WILLIAM.

M711 Miller, Wm. "Fixing the Skylight - Solar Camera." HUMPHREY'S JOURNAL OF PHOTOGRAPHY, AND THE ALLIED ARTS AND SCIENCES 15, no. 2 (May 15, 1863): 31. [Letter from Miller, reply from Towler.]

MILLHOLLAND, JAMES A. (READING, PA)

M712 Sellers, Coleman. "A Day with 'An Engineer.'" PHILADELPHIA PHOTOGRAPHER 2, no. 21 (Sept. 1865): 139-140. [Millholland, of Reading, PA, an engineer and amateur photographer.]

MILLIGAN BROTHERS.

M713 "Statue of the Late Prince Consort at Sydney, New South Wales." ILLUSTRATED LONDON NEWS 49, no. 1384 (Aug. 11, 1866): 148. 1 illus. ["...from a photograph by Messrs. Milligan Brothers, Sydney, represented the scene at the moment when the statue was uncovered.]

MILLS, J. C. (PENN YAN, NY)

M714 "Note." PHOTOGRAPHIC TIMES 2, no. 13 (Jan. 1872): 26. [Some very elegant specimens of his work noted.]

M715 "Pictures." ANTHONY'S PHOTOGRAPHIC BULLETIN 4, no. 9 (Sept. 1873): 274. [Describes a stereo by Dr. Mills of a group of a woman, her son, and a fish that had attracted attention in the local newspapers.]

M716 "Matters of the Month." PHOTOGRAPHIC TIMES 10, no. 112 (Apr. 1880): 82. [Fire destroyed Mills' gallery. $1000 loss. Will start up again.]

MILLS, S. P. (SAN FRANCISCO, CA)
M717 "Note." ANTHONY'S PHOTOGRAPHIC BULLETIN 7, no. 11 (Nov. 1876): 333. [S. P. Mills (San Francisco, CA) introduces Boudoir mount portraits.]

MILNE, R. (HAMILTON, CANADA)
M718 Portrait. Woodcut engraving credited "From a photograph by Milne." ILLUSTRATED LONDON NEWS 28, (1856) ["Sir Allan MacNab, Prime Minister of Canada." 28:* (Jan. 12, 1856): 44.]

M719 Portraits. Woodcut engravings, credited "From an Photograph by Milne." FRANK LESLIE'S ILLUSTRATED NEWSPAPER 1, (1856) ["Sir Allen McNab, Prime Minister of Canada." 1:10 (Feb. 16, 1856): 156.]

M720 "Monument to Major General Sir Isaac Brock, K.B., on Queenston Heights, Upper Canada, Inaugurated 13th October Last." ILLUSTRATED LONDON NEWS 35, no. 1004 (Nov. 26, 1859): 506-508. 1 illus. ["...from a photograph taken by Mr. R. Milne, of Hamilton, Canada West."]

M721 "The Prince of Wales' Progress. - King Street, Hamilton, Canada West." HARPER'S WEEKLY 4, no. 194 (Sept. 15, 1860): 587-588. 1 illus. ["Photographed by R. Milne, of Hamilton."]

M722 "The Fenian Excitement - Appearance of James Street, Hamilton, C.W." HARPER'S WEEKLY 10, no. 483 (Mar. 31, 1866): 205. 1 illus. ["Photographed by R. Milne, Hamilton, C.W."]

MILSTEAD, JOHN M. (BENTON, NY)
M723 Milstead, John M. "Ferrotype Formulae." ANTHONY'S PHOTOGRAPHIC BULLETIN 3, no. 11 (Nov. 1872): 742. [Milstead from Benton, KY.]

MILTENBERGER, THOMAS. (BELLEFONTAINE, OH)
M724 Miltenberger, Thomas. "Saltpetre is Explosive." HUMPHREY'S JOURNAL OF PHOTOGRAPHY, AND THE ALLIED ARTS AND SCIENCES 10, no. 2 (May 15, 1858): 20.

MINNIS & COWELL. (RICHMOND, VA)
M725 Portrait. Woodcut engraving credited "From a photograph by Minnis & Cowell, of Richmond, Va." ILLUSTRATED LONDON NEWS 44, (1864) ["General Robert E. Lee, Commander-in-Chief, Confederate Army." 44:1262 (June 4, 1864): 533.]

M726 Portrait. Woodcut engraving credited "From a Photograph by Minnis & Cowell, of Richmond." HARPER'S WEEKLY 8, (1864) ["The Rebel Gen. Robert E. Lee." 8:392(July 2, 1864): 417.]

MINNIS, GEORGE W. (RICHMOND, VA)
M727 "Note." PHOTOGRAPHIC AND FINE ART JOURNAL 11, no. 2 (Feb. 1858): 63. [Note that Minnis runs two galleries, extract from a Petersburg, VA paper.]

M728 Portrait. Woodcut engraving, credited "From a Photograph by Minnis, of Richmond." HARPER'S WEEKLY 9, (1865) ["Gen. John C. Breckinridge, Rebel Sec. of War." 9:425 (Feb. 18, 1865): 109.]

MITCHELL, D. F. (ca. 1843-1928) (USA)
M729 Hooper, Bruce. "Stoneman Lake: One of Arizona's Early Tourist Attractions Stereographed by D. F. Mitchell and W. H. Williscraft, c. 1875-1883." STEREO WORLD 12, no. 4 (Sept.-Oct. 1985): 37-40, 47. 9 b & w. 1 illus. [Stoneman Lake, in Northern Arizona, is about sixty-five miles northeast of Prescott, AZ. W. H. Williscraft owned a boot and shoe repair shop in Prescott, and he also owned and operated the Capitol Art Gallery from 1875 to 1877. In 1876 he hired an assistant, who was probably D. F. Mitchell, who had come from San Francisco, CA. Mitchell took over the gallery in late 1877. Williscraft apparently turned to raising and selling cattle and working as a butcher. Mitchell formed a partnership with Erwin Baer from 1883 to 1886. In the 1880s and 1890s Mitchell became an insurance and real estate agent, then died in Prescott in 1928, at age 85. Article includes a list of photographers working in Prescott, AZ from 1874 to 1886.]

MITCHELL, REUBEN.
M730 Mitchell, Reuben. "Photographic Landscapes, Artistic and Mechanical." BRITISH JOURNAL PHOTOGRAPHIC ALMANAC 1877 (1877): 119-121.

M731 Mitchell, Reuben. "Printing Clouds into Landscapes without Masks." BRITISH JOURNAL PHOTOGRAPHIC ALMANAC 1879 (1879): 124-125.

MITCHELL, THOMAS. (GREAT BRITAIN)
BOOKS
M732 Nares, Captain George Strong. *Narrative of a Voyage to the Polar Sea During 1875-76 in H. M. Ships 'Alert' and 'Discovery';* With Notes on the Natural History, edited by H. W. Fellden. London: Sampson Low, Marston, Searle & Rivington, 1878. 2 vol. (vol. 1, 395 pp.; vol. 2, 362 pp.) 6 b & w. illus. [Six Woodburytypes, and watercolors by Thomas Mitchell and George White. Seven full-page engravings from photographs, thirty-seven woodcuts, maps.]

PERIODICALS
M733 Bell, Michael. "Thomas Mitchell, Photographer and Artist in the High Arctic 1875-76." IMAGE 15, no. 3 (Sept. 1972): 12-21. 8 b & w. [British Arctic Expedition of 1875-76 had Thomas Mitchell serving as the photographer. A checklist of photographs taken by T. Mitchell and G. White on the Expedition is on pp. 18-21.]

MITRA, BABU REJENDRA LALL. (1822-1891) (INDIA)
M734 Thomas, G. "Babu Rejendra Lall Mitra." HISTORY OF PHOTOGRAPHY 8, no. 3 (July-Sept. 1984): 223-226. 4 b & w. 1 illus. [Indian amateur, ffl. 1850s-1880s.]

MOELLER. (AUCKLAND, N ZEALAND)
M735 "The Hot Springs of New Zealand." ILLUSTRATED LONDON NEWS 65, no. 1839 (Nov. 21, 1874): 479, 480. 2 illus. ["A book of New Zealand, by J. Ernest Tinne, illustrated with photographs by Mr. Munday, of Wellington and Mr. Moeller, of Auckland,...published last year. A set of Mr. Moeller's photographs has been supplied to us, with...a narrative...by Sir Donald MacLean."]

MOENS, W. J. C. (GREAT BRITAIN)
M736 Moens, W. J. C. "Notes of a Photographic Yacht Voyage in the Mediterranean." BRITISH JOURNAL OF PHOTOGRAPHY 7, no. 131-132 (Dec. 1 - Dec. 15, 1860): 351, 369-370.

M737 Moens, W. J. C. "Notes of a Photographic Yacht Voyage in the Mediterranean." BRITISH JOURNAL OF PHOTOGRAPHY 8, no. 133, 135 (Jan. 1, Feb. 1, 1861): 13-14, 47-48.

M738 "A Photographer Among Brigands." BRITISH JOURNAL OF PHOTOGRAPHY 12, no. 269 (June 30, 1865): 342-343. [Mr. W. J. C. Moens, a member of the North London Photographic Assoc., with Mr. Muray Aynslie, and their wives, kidnapped in Italy. Still being held captive at time of this article.]

M739 "Brigandage and Photography." HUMPHREY'S JOURNAL OF PHOTOGRAPHY, AND THE ALLIED ARTS AND SCIENCES 17, no. 6 (July 15, 1865): 88-90. [From "Photo. News." Moens, an English amateur photographer visiting Italy was kidnapped, eventually ransomed.]

M740 "Miscellanea: Mr. Moens among the Brigands." BRITISH JOURNAL OF PHOTOGRAPHY. 12, no. 273 (July 28, 1865): 396. [Mrs. Moens, apparently released, writes letter discussing her difficulties in ransoming her husband.]

M741 "Miscellanea: The Neapolitan Brigands." BRITISH JOURNAL OF PHOTOGRAPHY 12, no. 279 (Sept. 8, 1865): 467. [Mr. Moens, who had been kidnapped, was finally released, arrives safely in Naples.]

M742 "The Perils of Photography. - Mr. Moens' Case." AMERICAN JOURNAL OF PHOTOGRAPHY AND THE ALLIED ARTS & SCIENCES n. s. vol. 8, no. 9 (Nov. 1, 1865) [From "Br. J. of Photo." Moens was an English amateur photographer who was kidnapped by banditti while in Italy. Finally, after some time, he was ransomed and released.]

MOFFAT, J0HN. (1819-1894) (GREAT BRITAIN)
M743 Portrait. Woodcut engraving credited "From a photograph by J. Moffat, Prince St., Edinburgh." ILLUSTRATED LONDON NEWS 66, (1875) ["Alexander Russell." 66:1870 (June 12, 1875): 552.]

M744 Portrait. Woodcut engraving credited "From a photograph by J. Moffat, Edinburgh." ILLUSTRATED LONDON NEWS 69, (1876) ["Sir James Falshaw, Bart." 69:1937 (Sept. 9, 1876): 253.]

MOGO see BURR & MOGO.

MOIGNO, F., ABBE.
M745 Moigno, L'Abbe F. "Primitive Times of Heliography." PHOTOGRAPHIC ART JOURNAL 3, no. 3 (Mar. 1852): 152-154. [Reprinted from "La Lumiére." Wedgewood, Davy discussed.]

M746 Moigno, Abbe. "The Stereoscope." PHOTOGRAPHIC ART JOURNAL 5, no. 3 (Mar. 1853): 137-140. [From "Cosmos."]

M747 "Fine-Art Gossip." ATHENAEUM no. 1671 (Nov. 5, 1859): 605. [Note that the Abbe Moigno exhibited, at Aberdeen, a collection of photographs in charcoal and metallic powder. Dr. Lyon Playfair, South Kensington, also producing this sort of print.]

MOIRA & HAIGH. (LONDON, ENGLAND)
M748 "Note." ART JOURNAL (Aug. 1863): 166. [About works & history of Moira & Haigh.]

M749 Portrait. Woodcut engraving credited "From a photograph by Moira & Haigh, Lower Seymour St., London." ILLUSTRATED LONDON NEWS 51, (1867) ["W. H. Weiss." 51:* (Nov. 9, 1867): 513.]

M750 "Note." ART JOURNAL (Aug. 1868): 162. [Photos of statue of Lord Herbert of Lea, by Moira & Haigh.]

M751 Portrait. Woodcut engraving credited "From a photograph by Moira & Haigh." ILLUSTRATED LONDON NEWS 53, (1868) ["John Barnham Carslake, champion rifleman." 53:* (Aug. 1, 1868): 109.]

M752 Portrait. Woodcut engraving, credited to "From a Photograph by Moira & Haigh." ILLUSTRATED LONDON NEWS 60, (1872) ["Lumb Stocks, R.A." 60:1688 (Jan. 13, 1872): 29.]

MONCKHOVEN, DÉSIRÉ VAN. (1834-1882) (BELGIUM)
[Born in Ghent in 1834. A good "all-round" man of science. Wrote many articles on photography, contributing ideas on a solar enlarging apparatus, the means of manufacturing carbon tissues and gelatin dry plates, other chemical improvements. Died in 1882.]

BOOKS
M753 Monckhoven, Désiré van. *Photography on Collodion.* New York: H. H. Snelling, 1856. 54 pp.

M754 Monckhoven, Désiré van. *A Popular Treatise on Photography. Also a Description of, and Remarks on, the Stereoscope and Photographic Optics, etc., etc.* Translated by W. H. Thornthwaite, Ph.D., F.C.S. Illustrated with Many Woodcuts. London: Virtue Brothers & Co., 1863. 137 [2nd ed. (1867).]

M755 Monckhoven, Désiré van. *Photographic Optics; including the Description of Lenses and Enlarging Apparatus.* London: R. Hardwicke, 1868. 259 pp. 5 l. of plates. 87 illus.

PERIODICALS
M756 "Van Monckhoven's New Waxed-Paper Process." HUMPHREY'S JOURNAL 9, no. 7 (Aug. 1, 1857): 109-110. [From "Photo. Notes."]

M757 Monckhoven, Van. "The Cuprammonium Process." HUMPHREY'S JOURNAL OF PHOTOGRAPHY, AND THE ALLIED ARTS AND SCIENCES 11, no. 19 (Feb. 1, 1860): 292-294.

M758 Monckhoven, M. D. Van. "On the Dark-room and the Photographic Laboratory." HUMPHREY'S JOURNAL OF PHOTOGRAPHY, AND THE ALLIED ARTS AND SCIENCES 14, no. 9 (Sept. 1, 1862): 90-91. [From "Traite Populaire."]

M759 Van Monckhoven, Dr. D. "Theory of the Photographic Process." AMERICAN JOURNAL OF PHOTOGRAPHY AND THE ALLIED ARTS & SCIENCES n. s. vol. 5, no. 18 (Mar. 15, 1863): 415-422. [Read to London Photo. Soc.]

M760 Monckhoven, Van, M. D. "Construction of Glass-Houses." BRITISH JOURNAL OF PHOTOGRAPHY 10, no. 194-196 (July 15 - Aug. 15, 1863): 287-289, 304-305, 327. 8 illus.

M761 Monckhoven, Van, Dr. "On the Nature of Colored Glass for the Operating Room." HUMPHREY'S JOURNAL OF PHOTOGRAPHY, AND THE ALLIED ARTS AND SCIENCES 16, no. 1 (May 1, 1864): 5-6. [From "La Moniteur de la Photographie."]

M762 Monckhoven, D. Van. "On the Proper Carbon Tissues for Solar Camera Enlargements." BRITISH JOURNAL PHOTOGRAPHIC ALMANAC 1878 (1878): 106-107.

M763 Taylor, J. Traill. "General Notes." PHOTOGRAPHIC TIMES 12, no. 142 (Oct. 1882): 389-390. [Van Monckhoven died Sept. 25th, on his 48th birthday. Scientist, chemist, author in Ghent, Belgium.]

M764 Vidal, Leon. "Obituary: Dr. Van Monckhoven." PHILADELPHIA PHOTOGRAPHER 19, no. 228 (Dec. 1882): 354-356. [(From the "Moniteur," Oct. 16, 1882.) Dr. Monckhoven born in 1834, died on Sept. 25, 1882. A scientist, he made a fortune manufacturing gelatin dry plates. Latterly active in studying physical astronomy, sending papers to the French Academy of Sciences. Died at age 48, of a heart attack.]

MONGER, A. P.

M765 McCarthy, Justin. "The Story of Gladstone's Life." OUTLOOK 55, no. 14 (Apr. 3, 1897): 891-909. 15 b & w. 6 illus. [8 views of London buildings, etc. by A.P. Monger. Portraits taken in 1850's, 1860's by Maull & Fox, H.J. Whitlock, Mackintosh & Co. and others.]

MONKHOUSE, WILLIAM.

M766 Morrell, W. Wilberforce. *The History and Antiquities of Selby in West Riding with Notices of... Brayton.* Selby, London: Whittaker & Co., 1867. n. p. 8 b & w. [Original photographs, by William Monkhouse, of York.]

M767 *Masterpieces of Italian Art. ...26 Photographs from Drawings and Engravings of the Most Celebrated Painters of Italy from the 13th to the 16th Centuries.* London: Bell & Daldy, 1868. n. p. 26 b & w. [Original photographs.]

MONNICKENDAM, N. A. (1836-1902) (GREAT BRITAIN)

M768 "Obituary of the Year: N. A. Monnickendam." BRITISH JOURNAL PHOTOGRAPHIC ALMANAC 1903 (1903): 680. [Died at age 66, "a very able producer of photographic enlargements in black & white, color, etc."]

MONROE.

M769 "Pennsylvania. - Residence of the Late Bayard Taylor, Kennett Square, Chester County. - From a Photograph by Monroe." FRANK LESLIE'S ILLUSTRATED NEWSPAPER 47, no. 1216 (Jan. 18, 1879): 368. 1 illus. [View.]

MONSON, EDWARD.

M770 Monson, Edward. "Modification of the Daguerreotype." PHOTOGRAPHIC AND FINE ART JOURNAL 9, no. 2 (Feb. 1856): 50. [From "Journal of Photographic Society, London."]

M771 Monson, Edward. "Modification of the Daguerreotype." HUMPHREY'S JOURNAL 7, no. 19 (Feb. 1, 1856): 306. [From "J. of Photo. Soc., London." Monson from Birmingham, England. His letter protests the almost complete abandonment of articles on the daguerreotype in the photo journals for articles on the collodion, calotype, and other processes.]

MONTABONE, LUIGI. (d. 1877) (ITALY)

M772 Portrait. Woodcut engraving credited "From a photograph by Montabone, Turin." ILLUSTRATED LONDON NEWS 72, (1878) ["Late King Victor Emmanuel, Italy." 72:2012 (Jan. 19, 1878): 49.]

MOORE BROTHERS. (SPRINGFIELD, MA)

M773 "Note." ANTHONY'S PHOTOGRAPHIC BULLETIN 5, no. 2 (Feb. 1874): 87. [From "Worcester [MA] West Chronicle." Moore Brothers at Springfield, MA.]

M774 "The Colombia College Boat-Crew, Winners of the Inter-Collegiate Race on Lake Saratoga, July 18th. - From Photographs by Sarony, New York; Kimball, Concord, N. H., and Moore Brothers, Springfield, Mass." FRANK LESLIE'S ILLUSTRATED NEWSPAPER 38, no. 983 (Aug. 1, 1874): 321, 326-327, 328-329. 2 illus. [Group portrait of the crew, individual portraits of which must have been copied from different photographs by the engraver, since three separate photographers are credited for the one image. The second image is an artist's sketch.]

MOORE.

M775 "The American Photographical Society: Thirty-Fifth Meeting." AMERICAN JOURNAL OF PHOTOGRAPHY AND THE ALLIED ARTS & SCIENCES n. s. vol. 4, no. 18 (Feb. 15, 1862): 428. [The Rev. Dr. Moore, ex-Pres. of Columbia College, described his early interest in photography - from seeing French work at the London World's Fair of 1851. Visited Paris, studied with M. Chevalier. When returned to New York, NY "...the only photographic amateur in the city."]

MOORE, A.

M776 "The Ex-King of Delhi." ILLUSTRATED NEWS OF THE WORLD AND DRAWING ROOM PORTRAIT GALLERY OF EMINENT PERSONAGES 1, no. 7 (Mar. 20, 1858): 101. ["From a Photograph by Mr. A Moore."]

MOORE, ALBERT. (USA)

M777 "Editor's Table." PHILADELPHIA PHOTOGRAPHER 6, no. 68 (Aug. 1869): 284. [Albert Moore, solar printer; E. L. Brand (Chicago, IL); A. F. Clough (Oxford, NH); Kilburn Bros.; Wm. Kurtz occupied his new studios in New York, NY; Wm. Notman (Montreal, Quebec); others mentioned.]

MOORE, GEORGE W.

M778 "Massachusetts. - View of the Recent Disaster on the Vermont and Massachusetts Railroad. - From a Photograph by George W. Moore, Boston." FRANK LESLIE'S ILLUSTRATED NEWSPAPER 30, no. 771 (July 9, 1870): 268. 1 illus. [Train fell through a covered bridge.]

MOORE, HENRY P. (1833-1911) (USA)

BOOKS

M779 "Mr. Cooley of Beaufort and Mr. Moore of Concord: A Portfolio: Two of hundreds of unsung artists, these photographers captured South Carolina long before the Federals," on pp. 86-111 in: *The Guns of '62; Volume Two of the Image of War: 1861 - 1865,* edited by William C. Davis. Garden City, NY: Doubleday & Co., Inc., 1982. 464 pp. 23 b & w. [Twenty-three photographs by Moore, on pp. 100-111. Moore, from Concord, NH, photographed the activities of the 3rd New Hampshire Regiment, while they occupied Hilton Head, SC in 1862-63.]

PERIODICALS

M780 Sellers, Coleman. "Foreign Correspondence." BRITISH JOURNAL OF PHOTOGRAPHY 11, no. 239 (Dec. 2, 1864): 489-490. ["...the most remarkable collection of views I have seen for a long time. There are forty of them in all, and represent all the interesting 'surroundings' of Hilton Head, South Carolina,...views on shipboard...camp life in the South, etc," taken by H. P. Moore, Concord, N. H.]

M781 "Editor's Table - Views in Dixie." PHILADELPHIA PHOTOGRAPHER 2, no. 16 (Apr. 1865): 65. [Lists a number of photos of former slaves, made in NC and GA.]

M782 "Our Picture - 'Gwine to de Field.'" PHILADELPHIA PHOTOGRAPHER 2, no. 21 (Sept. 1865): 152-153. [Photo of former

slaves made in 1862 on Edisto Island, SC, at the plantation of James Hopkinson.

MOORE, J. W. (BELLEFONTE, PA)

M783 Moore, J. W. "Correspondence." PHILADELPHIA PHOTOGRAPHER 4, no. 41 (May 1867): 153. [Moore from Bellefonte, Center Co., PA.]

MOORE, NELSON AUGUSTUS & ROSWELL A. MOORE. (HARTFORD, CT)

BOOKS

M784 Hillard, Rev. Elias Brewster. *The Last Men of the Revolution.* A Photograph of each from Life, together with views of their homes printed in colors. Accompanied by brief biographical sketches of the men. Hartford, CT: N. A. & R. A. Moore, 1864. 64 pp. 6 b & w. 6 illus. [Republished (1968) Barre Publishers. With a new introduction by Archibald MacLeish, ed. by Wendell A. Garrett. Six albumen portraits, six colored lithographs of their residences. (Photographs have been tentatively credited to the author, but the publishers were well established photographers, and are more probably the makers of the images.)]

PERIODICALS

M785 "Colt's Armory after the Fire." HARPER'S WEEKLY 8, no. 374 (Feb. 27, 1864): 132, 134. 2 illus. ["From a Photograph by N. A. and R. A. Moore, Hartford." Burned buildings.]

MOORE, NELSON AUGUSTUS. (1824-1902) (USA) see MOORE, N. A. & R. A. MOORE.

MOORE, ROSEWELL A. see MOORE, N. A. & R. A. MOORE.

MORA see also COONLEY.

MORA, JOSÉ MARIA. (b. 1849) (CUBA, USA)

BOOKS

M786 Mora, José M. *Illustrated Catalogue of Photographer's Negatives.* New York: Mora, c. 1879. 30 l. of plates. 2430 b & w. [Thirty plates, each with eighty-one portraits. Album, NYPL collection.]

PERIODICALS

M787 Portrait. Woodcut engraving, credited "From a Photograph by Mora." FRANK LESLIE'S ILLUSTRATED NEWSPAPER 36, (1873) ["William J. Florence, the actor." 35:912 (Mar. 22, 1873): 21.]

M788 Portrait. Woodcut engraving, credited "From a Photograph by Mora. FRANK LESLIE'S ILLUSTRATED NEWSPAPER 37, (1873) ["Gen. Benarbe Verona, Cuba." 37:947 (Nov. 22, 1873): 184.]

M789 Portraits. Woodcut engravings, credited "Photographed by Mora." FRANK LESLIE'S ILLUSTRATED NEWSPAPER 39, (1874) ["Mlle. Marie Heilbron, Prima Donna." 39:994 (Oct. 17, 1874): 93. "Mlle. Albani, the great Prima Donna." 39:999 (Nov. 21, 1874): 165.]

M790 "Matters of the Month: Mora." PHOTOGRAPHIC TIMES 5, no. 53 (May 1875): 111. ["We have just received some beautiful photos from Mora, of actors, actresses, and "notables." Mr. Mora is an artist of the "first water."]

M791 Portraits. Woodcut engravings, credited "From a Photograph by Mora, New York City. FRANK LESLIE'S ILLUSTRATED NEWSPAPER 41, (1875) ["Ygnacio Cervantes, pianist." 41:1047 (Oct. 23, 1875): 104. "Mlle. Theresa Titiens." 41:1048 (Oct. 30, 1875): 124.]

M792 Portraits. Woodcut engravings, credited "From a Photograph by Mora." FRANK LESLIE'S ILLUSTRATED NEWSPAPER 42, (1876) ["The Empress Theresa, of Brazil." 42:1075 (May 6, 1876): 137. "William A. Wheeler, Vice.-Pres. candidate." 42:1083 (July 1, 1876): 265. "The late William T. Garner, owner of the yacht 'Mohawk.'" 42:1088 (Aug. 5, 1876): 361. "Don Carlos de Bourbon." 42:1090 (Aug. 19, 1875): 397.]

M793 "Mora's Centennial Album: Raffles for Belles on 'the Avenue.'" PHOTOGRAPHIC TIMES 6, no. 67 (July 1876): 149-150. [Album raffled, proceeds to the Ladies' Centennial Union.]

M794 Hough, E. K. "Mora." PHILADELPHIA PHOTOGRAPHER 15, no. 176 (Aug. 1878): 248-249. [Description of Mora's New York, NY Gallery and its operation.]

M795 "Mora's Gallery." PHOTOGRAPHIC TIMES 8, no. 94 (Oct. 1878): 217-218. [Mr. H. C. Terrington in charge of the reception room, J. J. Montgomery does the darkroom work, A. H. Atwood in charge of the printing department. Worked in New York, NY.]

M796 "Our Picture." PHILADELPHIA PHOTOGRAPHER 16, no. 186 (June 1879): frontispiece, 187. 1 b & w. [Portrait.]

M797 Portraits. Woodcut engravings, credited "From a Photograph by Mora." FRANK LESLIE'S ILLUSTRATED NEWSPAPER 47, (1878) ["Marie Roze-Mapleson, Prima Donna." 47:1203 (Oct. 19, 1878): 117. "Mme. Elizabeth von Stamwitz as 'Messalina.' 47:1205 (Nov. 2, 1878): 149. "Col. Henry G. Mapleson." 47:1208 (Nov. 23, 1878): 207. "Signor Capanani as 'Jose' in 'Carmen.'" 47:1209 (Nov. 30, 1878): 221. "John Gilbert, actor." (3 portraits) 47:1211 (Dec. 14, 1878): 252. "Ole Bull, violinist." 47:1212 (Dec. 21, 1878): 268.]

M798 Portraits. Woodcut engravings, credited "From a Photograph by Mora." FRANK LESLIE'S ILLUSTRATED NEWSPAPER 48, (1879) ["James Orton Woodruff." 48:1226 (Mar. 29, 1879): 53. "Group portrait of four children, "Italian slaves rescued by the Soc. for the Prevention of Cruelty to Children." 48:1226 (Mar. 29, 1879): 53. "Edward Payson Weston, 2nd American winner of the Astley Belt." 48:1240 (July 5, 1879): 293.]

M799 Portraits. Woodcut engravings credited "From a photograph by Mora." ILLUSTRATED LONDON NEWS 75, (1879) ["Madame Roze (Mapleson), actress." 75:2093 (July 26, 1879): 96. Worked on Broadway, New York, NY.]

M800 Portraits. Woodcut engravings, credited "From a Photograph by Mora." FRANK LESLIE'S ILLUSTRATED NEWSPAPER 49, (1879) ["Mlle. Angele as 'Pedro." 49:1258 (Nov. 8, 1879): 157. "Mlle. Paola Marie as 'La Perichole' and Signor Capoul as 'Pequillo." 49:1258 (Nov. 8, 1879): 157. "Miss Emma Thursby, singer." 49:1264 (Dec. 20, 1879): 281. "Signor Galassi as 'Amonastro.'" 49:1265 (Dec. 27, 1879): 304.]

M801 Race, W. H. "Mora's Mounting Room." PHOTOGRAPHIC TIMES 12, no. 135 (Mar. 1882): 77. [Race is described as "Mounter Mora's Studio."]

M802 "Mac." "Photo-Scraps." PHOTOGRAPHIC TIMES 23, no. 593 (Jan. 27, 1893): 40-41. [Notes about discussions with the studio photographer Mora and with Montgomery, his "right-hand man both in sky-light and dark-room." Mora apparently closed his studio and Montgomery became a travelling salesman for "seed plates."]

M803 Fouquier, Henri. "Bernhardt and Coquelin." HARPER'S MONTHLY MAGAZINE 102, no. 607 (Dec. 1900): 63-72. 6 b & w. 2 illus. [Illustrated with photographs and drawings by F. L. Mora.]

MORA, R. (NEW YORK, NY)
M804 Portrait. Woodcut engraving credited "From a photograph by R. Mora." ILLUSTRATED LONDON NEWS 68, (1876) ["Mdlle. Titiens, Opera singer." 68:1921 (May 20, 1876): 484. Broadway, NY.]

MORA, W. M.
M805 Mora, W. M. "Background Matters." PHOTOGRAPHIC TIMES 11, no. 125 (May 1881): 187-188.

MORAN, JOHN see also BORDA & FASSITT & GRAFF.

MORAN, JOHN. (1831-1903) (USA)
[Born in England. Arrived in USA in 1844. Painter, and brother of the famous landscape painter Thomas Moran. Early advocate of the fine art potential in photography. Made many stereographs, landscapes and city views in Philadelphia, PA, and in the surrounding countryside. Partner with Kindler in 1859 [?] Storey in 1864. Went with Commodore T. O. Selfridge to the Isthmus of Darien (Panama) in 1871 and to Tasmania and South Africa in 1874 with the United States astronomical team observing the transit of Venus. Member of the Philadelphia Photographic Society. His landscapes published in the first years of the *Philadelphia Photographer*.]

BOOKS
M806 Artists' Fund Annual. 1868. *A Collection of Twenty Photographs from Original Designs, by Members of the Artists' Fund Society of Philadelphia*. Philadelphia: Artists' Fund Society, 1868. n. p. 20 b & w. [Original photographs by John Moran. NYPL Collection.]

M807 Moran, John. *A Collection of Photographic Views in Philadelphia and Its Vicinity, 1870*. Philadelphia: John Moran, 1870. n. p. 78 b & w. [Original photographs, in an album created by Moran, now in the collections of the Philadelphia Library Company.]

PERIODICALS
M808 Portrait. Woodcut engraving, credited "From a Photograph by John Moran, of Philadelphia." HARPER'S WEEKLY 6, (1862) ["Brig.-Gen. Winfield Scott Hancock." 6:282 (May 24, 1862): 333.]

M809 "Our Picture." PHILADELPHIA PHOTOGRAPHER 1, no. 4 (Apr. 1864): frontispiece, 62. 1 b & w. [Landscape.]

M810 "Editor's Table: Springtime." PHILADELPHIA PHOTOGRAPHER 1, no. 6 (June 1864): 96. [Description of a photo of a man plowing, by John Moran.]

M811 "Our Picture." PHILADELPHIA PHOTOGRAPHER 1, no. 8 (Aug. 1864): frontispiece, 126. 1 b & w. [View, with horses, of a farmer's field - titled "Noonday Rest."]

M812 "Our Picture." PHILADELPHIA PHOTOGRAPHER 1, no. 9 (Sept. 1864): frontispiece, 142-143. 1 b & w. [Landscape view, Indian Ladder Bluff, Delaware Water Gap.]

M813 Moran, John. "The Relation of Photography to the Fine Arts." PHILADELPHIA PHOTOGRAPHER 2, no. 15 (Mar. 1865): 33-35. [Read before the Philadelphia Photographic Society, February 1865.]

M814 "Note." PHOTOGRAPHIC WORLD 1, no. 7 (July 1871): 221. [Mr. John Moran, photographer to the Darien Expedition, has returned with some fine and interesting negatives.]

M815 "Our Picture." PHILADELPHIA PHOTOGRAPHER 9, no. 100 (Apr. 1872): 124-125. 1 b & w. [Landscape.]

M816 Maack, Dr. G. A. "The Secret of the Strait." HARPER'S NEW MONTHLY MAGAZINE 47, no. 282 (Nov. 1873): 801-820. 16 illus. [Discusses Selfridge's 1873 expedition to the Isthmus of Darien [Panama]. No credits given for the illustrations, but they are from photographs taken by both Timothy O'Sullivan and John Moran, who were on this expedition.]

M817 Moran, John. "The Transit of Venus, at Hobart Town, Tasmania." PHILADELPHIA PHOTOGRAPHER 12, no. 136, 138, 141. (Apr., Jun., Sept. 1875): 112-115, 183-186, 261-264. 2 illus. [John Moran, Chief Photographer, William Churchill and Walter B. Devereaux, assistants.]

M818 Moran, John. "Thoughts on Art, Nature, and Photography." PHILADELPHIA PHOTOGRAPHER 12, no. 138 (June 1875): 179-181.

M819 Moran, John. "Reflections on Art." PHILADELPHIA PHOTOGRAPHER 12, no. 142 (Oct. 1875): 294-295.

M820 Benson, Francis M. "The Moran Family." QUARTERLY ILLUSTRATOR 1, no. 2 (1893): *.

M821 Norton, Russell. "O'Sullivan Portrait found to be Moran." STEREO WORLD 3, no. 2 (May - June 1976): 11. 1 b & w. [Portrait of the photographer at Pinogana, during the 1871 expedition to the Isthmus of Darien, must be of John Moran, not Timothy O'Sullivan, as previously thought.]

M822 Reilly, Bernard F., Jr. "The Early Work of John Moran, Landscape Photographer." AMERICAN ART JOURNAL 2, no. 1 (Jan. 1979): 65-75. 7 b & w. 2 illus.

MORAND, AUGUSTUS & CO. see MORAND, AUGUSTUS.

MORAND, AUGUSTUS H. (USA, BRAZIL, USA)
[See below for early history. Opened gallery in New York, NY in 1846. Worked in St. Louis, MO in 1847. In 1851 Morand was elected President of the New York State Daguerreian Association. Gallery at 132 Chatham St, New York, NY from 1858-1859. Moved to Brooklyn, NY, around 1860.]

M823 Kidder, Rev. J. P. "Augustus Morand and the Daguerrean Art." PHOTOGRAPHIC ART JOURNAL 1, no. 4 (Apr. 1851): frontispiece, 237-239. 1 illus. [Portrait. (Lithograph by D'Avignon.) Morand began daguerreotypy in 1840, actively experimenting to find the means of reducing exposure times. From 1841 to 1847 he used a blue glass between the sitter and the skylight to more effectively balance the color spectrum for the daguerreotype process. Ill health led him to take a trip to Brazil in 1842, where for six months he daguerreotyped the emperor Don Pedro II, the members of his family and court, as well as copying paintings in the Royal Gallery and making views of San Cristovan and surrounding scenery. He returned to New York in 1843, still ill. Then he toured the Southern states, travelling along the Mississippi, Missouri, and Ohio rivers before setting up a gallery in New York City.]

M824 "Hon. Towsend Harris, American Minister to Japan - From a Painting by Bogle in the Hall of the N.Y. City Board of Education. - Photographed by A. Morand." FRANK LESLIE'S ILLUSTRATED NEWSPAPER 10, no. 240 (June 30, 1860): 96. 1 illus.

M825 Portrait. Woodcut engraving, credited "From a Photograph by A. Morand & Co., Brooklyn, N. Y." NEW YORK ILLUSTRATED NEWS 4, (1861) ["Commodore Stringham." 4:98 (Sept. 16, 1861): 317.]

M826 Portraits. Woodcut engravings, credited "Photographed by Morand, Brooklyn." FRANK LESLIE'S ILLUSTRATED NEWSPAPER 12, (1861) ["Commodore Silas H. Stringham, U.S.N." 12:305 (Sept. 21, 1861): 301.]

M827 Portrait. Woodcut engraving, credited "From a Photograph by Morand & Co., of Brooklyn, NY." HARPER'S WEEKLY 5, (1861) ["Lieut. Braine, U.S.N." 5:252 (Oct. 26, 1861): 673.]

MORANTES, P. (ATHENS, GREECE)
M828 Portrait. Woodcut engraving credited "From a photograph by P. Morantes." ILLUSTRATED LONDON NEWS 72, (1878) ["Late Mr. C. C. Ogle, "Times" correspondent." 72:2024 (Apr. 13, 1878): 329.]

MORGAN, CHARLES. (LEESBURGH, VA)
M829 Portraits. Woodcut engravings, credited "Photographed by Charles Morgan, Leesburgh, Va." FRANK LESLIE'S ILLUSTRATED NEWSPAPER 11, (1861) ["John Janney, Pres. of the VA Convention." 11:278 (Mar. 23, 1861): 285.]

MORGENEIER, J. W.
M830 Morgeneier, J. W. "Fifth Annual Meeting and Exhibit of the National Photographic Association of the U.S., held in Buffalo, N.Y., beginning July 5, 1873: Retouching Negatives." PHILADELPHIA PHOTOGRAPHER 10, no. 117 (Sept. 1873): 450-451.

MORGENEIER, ROBERT M.
M831 Morgeneier, Robt. M. "Fifth Annual Meeting and Exhibit of the National Photographic Association of the U.S., held in Buffalo, N.Y., beginning July 5, 1873: Ideas on Negative Retouching." PHILADELPHIA PHOTOGRAPHER 10, no. 117 (Sept. 1873): 451.

MORRIS & CO.
M832 "The Tarradale Viaduct of the Melbourne and Sandhurst Railway." ILLUSTRATED LONDON NEWS 45, no. 1273 (Aug. 13, 1864): 161-162. 1 illus. ["...from a photograph by Messrs. Morris & Co., of Elizabeth St., Melbourne."]

MORRISON, J. W. C. (PORTLAND, ME)
M833 Portrait. Woodcut engraving, credited "From a Daguerreotype by Morrison, Portland, ME." BALLOU'S PICTORIAL DRAWING-ROOM COMPANION [GLEASON'S] 13, (1857) ["John White Chickering, D.D." 13:335 (Nov. 21, 1857): 332.]

MORRISON, R. see also HARRISON, C. C.

MORRISON, RICHARD. (1836-1888) (GREAT BRITAIN, USA)
M834 1 photo (Landscape view) tipped-in before the regular frontispiece photograph. PHILADELPHIA PHOTOGRAPHER 9, no. 105 (Sept. 1872): n. p. 1 b & w. ["Specimen Picture made with Morrison's Stereo Lens. Made by R. Morrison, Scoville Manufacturing Co."]

M835 Morrison, R. "Lenses - Difference between those of Large and Small Angle." PHOTOGRAPHIC TIMES 5, no. 57 (Sept. 1875): 213.

M836 Taylor, J. Traill. "The Studios of America. No. 7. Morrison's Lens Factory." PHOTOGRAPHIC TIMES 13, no. 150 (June 1883): 246-248.

M837 "Richard Morrison." PHOTOGRAPHIC TIMES 18, no. 377 (Dec. 7, 1888): 578-579. 1 illus. [Obituary. Morrison an expert lensmaker. Born in Glouchester, England in 1836. Came to America, began work for manufacturers of telescope and microscope objectives. Worked up in business. Started his own company.]

MORRISON, ROBERT. (GREAT BRITAIN, CHINA)
M838 "Note." JOURNAL OF THE PHOTOGRAPHIC SOCIETY OF LONDON 5, no. 75 (Dec. 21, 1858): 104. ["Messrs. Murray & Heath have forwarded us...a well executed photo by Robert Morrison, Esq., attache to H. B. M. mission to China and represents the imperial commissioners Keveiliang & Havashana dressed in their mandarin's costume, and sitting at a table."]

M839 "Photography in China." PHOTOGRAPHIC NEWS 1, no. 19 (Jan. 14, 1859): 221. [Mr. R. Morrison, attached to Lord Elgin's embassy in China...obtained a number of photographic negatives.]

MORROW, J. H. (NEW YORK, NY)
M840 "Microscopic Photographs." HUMPHREY'S JOURNAL OF PHOTOGRAPHY, AND THE ALLIED ARTS AND SCIENCES 16, no. 16 (Dec. 15, 1864): 255. [Tiny portraits, set in jewelry. "Mr. J. H. Morrow, of No. 14 John Street in this city, is engaged exclusively in making microscopic photographs and offers...to give instruction in the art."]

M841 Morrow, J. H. "Microphotography." PHILADELPHIA PHOTOGRAPHER 3, no. 33 (Sept. 1866): 273-278. [Description of the photographic activities at the Army Medical Museum. Author identified on p. 323.]

M842 "Note." PHILADELPHIA PHOTOGRAPHER 10, no. 115 (July 1873): 199. [Brief comic note about "J. H. Morrow, the microscopic photographer of New York," in Texas, trading mustangs - one of which ran away.]

MORROW, STANLEY J. (1843-1921) (USA)
[Born on May 3, 1843 in Richmond Co., OH. Joined the 7th Infantry, Wisconsin Volunteers during the Civil War. Opened a gallery in Yankton, Dakota Territory in 1867. Photographed throughout upper Missouri River region, Dakota Territory in 1870s. Photographed General Crooks' campaigns against the Sioux and Cheyenne in 1876-1877. Moved to Geneva, FL in 1882. Photographed for the South Florida Railroad. Moved to Atlanta, GA in 1888, opened a studio. Also sold deodorizers and disinfectants, and worked as a travel agent. Many of his negatives lost in a fire about 1889. Died Dec. 10, 1921 in Dallas, TX.]

BOOKS
M843 Hurt, Wesley J. and William E. Lass. *Frontier Photographer: Stanley J. Morrow's Dakota Years.* Vermillion, SD and Lincoln, NB: University of South Dakota Press and University of Nebraska Press, 1956. 134 pp. illus.

M844 Hedren, Paul L. *With Crook in the Black Hills: The Photographic Legacy of Stanley Morrow.* Boulder, CO: s. n., 1985. vi, 90 pp. b & w. illus. [Morrow photographing in the Black Hills, SD in 1876 and afterwards.]

PERIODICALS
M845 "Dakota Territory. - An Expedition Consisting of Two Hundred Men and Forty-Seven Wagons Leaving Yankton for the Black Hills on Tuesday, March 7th. - From a Photograph by S. J. Morrow." FRANK LESLIE'S ILLUSTRATED NEWSPAPER 42, no. 1069 (Mar. 25, 1876): 49. 1 illus. [Street scene.]

M846 Lass, William E. "Stanley J. Morrow." EYE TO EYE no. 8 (1956): **.

M847 "Sitting Bull Collection." SOUTH DAKOTA HISTORY 5, no. 3 (1975): 245-265. 24 b & w. [Reproduces the Sitting Bull Collection at SD State Historical Society. 24 portraits of Sitting Bull and his family, daily life at Fort Randall. Copyrighted by the firm of Baily, Dix and Mead in 1882. Photos possibly by Stanley J. Morrow. Photos reproduced with their identifying captions.]

M848 Duncan, Robert G. "The Sioux War of 1876. Part 3: The Army Victorious." PHOTOGRAPHIC HISTORIAN 6, no. 4 (Winter 1985 - 1986): 10-23. 15 b & w. [13 stereo views by S. J. Morrow and a portrait of Morrow.]

MORSE & PEASELEE. (NASHVILLE, TN)
M849 Portrait. Woodcut engraving, credited "From a Photograph by Morse & Peaselee, of Nashville." HARPER'S WEEKLY 8, (1864) ["Brig.-Gen. W. S. Smith." 8:376 (Mar. 12, 1864): 165.]

MORSE. (NASHVILLE, TN)
M850 Portraits. Woodcut engravings, credited "From a Photograph by Morse, Nashville, Tenn." HARPER'S WEEKLY 8, (1864) ["Late Brig.-Gen. Charles H. Harker." 8:398 (Aug. 13, 1864): 525. "Brig.-Gen. A. S. Williams." 8:398 (Aug. 13, 1864): 525. "Maj.-Gen. George Crook." 8:407 (Oct. 15, 1864):661.]

MORSE, A. S. (HUNTSVILLE, AL)
M851 Portrait. Woodcut engraving, credited "From a Photograph by A. S. Morse, of Huntsville, AL." HARPER'S WEEKLY 8, (1864) ["'Fighting Johnny' Logan." 8:392 (July 2, 1864): 421.]

MORSE, G. D. (SAN FRANCISCO, CA)
M852 "Photography." CALIFORNIA MAIL BAG 1, no. 4 (Oct.-Nov. 1871): xxii. ["Photography is a science which is daily becoming more perfectly understood. The master of this, the finest of the fine arts in San Francisco is undoubtedly Morse, whose lifelike representations of the familiar faces of our loved ones recalls in absence their living selves."]

M853 "Note." PHOTOGRAPHIC TIMES 2, no. 22 (Oct. 1872): 154. [Work received from Morse, in Stockton, CA.]

M854 "Editor's Table." PHILADELPHIA PHOTOGRAPHER 14, no. 162 (June 1877): 191-192. [G. D. Morse (San Francisco, CA) creating new Boudoir pictures.]

MORSE, SAMUEL FINLEY BREESE. (1791-1872) (USA)
[Born in Charlestown, MA on April 27, 1791. Studied at Phillips Academy, Andover, MA, and at Yale from 1805 to 1810, where he experimented with chemistry. In 1811 went to England, studied painting under Benjamin West. Returned to America, but not financially successful as a painter. In 1815 he invented a water pump for firemen. Began to experiment with electricity and galvanism, while continuing to paint. Settled in New York, NY in 1823. In 1825 he was an organizer of the National Academy of Design in New York, and became its first president from 1826 to 1845. From 1829 to 1832 he travelled in Italy and France, and lived in Paris. Returned to New York City in 1832, where he thought of the idea of a telegraph. From 1835 he was the professor of drawing and history of the arts at New York University, where he also continued to experiment and improve on his telegraph. In 1839, while on a visit to Paris to promote interest in the telegraph, he met Daguerre and was shown daguerreotypes before the public demonstration of the process. Returning to New York in April, he experimented with the daguerreotype, successful on

September 28, 1839. Made one of the earliest portraits. In 1840 Morse and John William Draper opened a rooftop studio at the university, where they made portraits and taught the process through 1841. Shortly thereafter Morse gave up photography as a profession, but his interest in the medium continued throughout his lifetime - for example, he judged the Anthony Prize Competition in 1853. In 1844 his long-delayed telegraph system was completed between Baltimore and Washington, DC, and his code was put into use. Telegraph lines quickly stretched across the civilized world. In 1866 the first transatlantic cable was successfully laid, linking Europe and the United States. By this time the telegraph was considered one of the keystone inventions of the modern era, and Morse was universally lionized and showered with awards and honors. He died on April 2, 1872, in Poughkeepsie, NY.]

BOOKS
M855 Reid, James D. The Telegraph in America. Its Founders, Promoters, and Noted Men. New York: Derby Brothers, 1879. xiii, 846 pp. 18 l. of plates. illus.

M856 Kloss, William. Samuel F. B. Morse. "Library of American Art Series." New York: Abrams, in cooperation with the National Museum of American Art, Smithsonian Institution., 1988. n. p. 118 illus. [56 color plates.]

PERIODICALS
M857 Page, Professor. "Electro-Telegraphy: Progress and Practibility of Sea and River Lines of Communication." DAGUERREAN JOURNAL 1, no. 4 (Jan. 1, 1851): 103-106. [Background information of S. F. B. Morse.]

M858 "Reward of Merit." DAGUERREAN JOURNAL 1, no. 11 (Apr. 15, 1851): 337. [Describes gold snuff box given to Morse by King of Prussia.]

M859 "The American Electric Telegraph in Prussia." DAGUERREAN JOURNAL 1, no. 12 (May 1, 1851): 372-374. [Exchange of letters between Prussian government and S. F. B. Morse. Reprinted from "NY Observer."]

M860 Morse, Samuel F. B. "Correspondence." DAGUERREAN JOURNAL 2, no. 1 (May 15, 1851): 20-21. [Letter from Morse arguing that Levi L. Hill should be dissuaded from patenting his process. Morse's bitterness was based, in all probability, in the troubles he was experiencing in having his rights to the telegraph accepted in Europe at the time.]

M861 "The American Electric Telegraph." DAGUERREAN JOURNAL 2, no. 2 (June 1, 1851): 42-43. [From "NY Observer."]

M862 "Gold Snuff-Box Presented to Prof. Morse - Prof. Samuel F. B. Morse." GLEASON'S PICTORIAL DRAWING-ROOM COMPANION 1, no. 16 (Aug. 16, 1851): 249. 2 illus. [Brief biographical sketch, focused on invention of the telegraph.]

M863 "The Atlantic Telegraph." ILLUSTRATED NEWS (NY) 2, no. 34 (Aug. 20, 1853): 78-79, 88. 1 illus. [Group portrait and brief biographies of ten individuals associated with the invention and commercial development of the telegraph. Includes biography of Morse.]

M864 "Samuel F. B. Morse." BALLOU'S PICTORIAL DRAWING-ROOM COMPANION [GLEASON'S] 8, no. 6 (Feb. 10, 1855): 92. 1 illus. [Brief biography stressing his early career as a painter

and his invention of the telegraph. His efforts in photography are not mentioned. The portrait isn't credited.]

M865 Morse, Samuel F. B. "Who Made the First Daguerreotype in this Country?" PHOTOGRAPHIC AND FINE ART JOURNAL 8, no. 9 (Sept. 1855): 280. [Letter from Morse describing his experiments in 1839.]

M866 Wynne, James. "Samuel F. B. Morse." HARPER'S MONTHLY 24, no. 140 (Jan. 1862): 224-232. [Anecdotes about Morse, focused on his invention of the telegraph.]

M867 "S. F. B. Morse, L.L.D." HARPER'S WEEKLY 10, no. 504 (Aug. 25, 1866): 531-532. 1 illus. [Biography. Portrait by Brady.]

M868 "The Banquet to Professor S. F. B. Morse, at Delmonico's Hotel, New York, Dec. 29th." FRANK LESLIE'S ILLUSTRATED NEWSPAPER 27, no. 694 (Jan. 16, 1869): 284. 1 illus. [Portrait by M. B. Brady.]

M869 C. "Salad for the Photographer - The Introduction of Photography into America." PHILADELPHIA PHOTOGRAPHER 7, no. 81 (Sept. 1870): 330-331.

M870 "The Morse Statue." FRANK LESLIE'S ILLUSTRATED NEWSPAPER 32, no. 821 (June 24, 1871): 237. 1 illus. [View of statue of Prof. Morse, by Pickett, erected in Central Park, New York, NY.]

M871 "Note." PHOTOGRAPHIC TIMES 1, no. 7 (July 1871): 105. ["Prof. Morse has presented the College (Vassar) at Poughkeepsie with the first daguerreotypes produced in this country."]

M872 "Proceedings of the National Photographic Association Meeting in Philadelphia, 1871." PHILADELPHIA PHOTOGRAPHER 8, no. 91 (July 1871): 237. [On p. 237 of the report of the proceedings A. Bogardus, President of the N.P.A. moved a resolution to honor S. F. B. Morse, followed by a statement by A. S. Southworth recalling his early memory of Morse in New York, NY in 1830s.]

M873 "New York City. - The Morse Celebration at the Academy of Music, June 10th. - Professor Morse Manipulating His Signature to the Message Telegraphed by Miss Sadie E. Cornwell." and "Festival at Central Park on the Unveiling of the Statue of Professor S. F. B. Morse." FRANK LESLIE'S ILLUSTRATED NEWSPAPER 32, no. 822 (July 1, 1871): 249, 257. 2 illus. [Sketches of crowd at ceremonies.]

M874 "Editor's Table." PHILADELPHIA PHOTOGRAPHER 8, no. 92 (Aug. 1871): 280. [Receipt of a letter from Prof. S. F. B. Morse, wherein he says: "I take down with me today, on my way to Boston, the remains of the first photographic instrument ever made and used in this country; and I shall deposit them with my friend Mr. A. Bogardus."]

M875 "Editor's Table: Prof. Morse's First Camera." PHILADELPHIA PHOTOGRAPHER 8, no. 94 (Oct. 1871): 343. [Letter of Samuel Morse about first camera in USA mentioned again.]

M876 Anthony, H. T. "A Visit From Professor Morse." ANTHONY'S PHOTOGRAPHIC BULLETIN 2, no. 10 (Oct. 1871): 333.

M877 "Our Picture." PHILADELPHIA PHOTOGRAPHER 9, no. 97 (Jan. 1872): 1-4. 1 b & w. illus. [Biography of Morse. His letters quoted. Portrait of Morse by A. Bogardus.]

M878 "The Father of Telegraphy." FRANK LESLIE'S ILLUSTRATED NEWSPAPER 34, no. 864 (Apr. 20, 1872): 81, 85-86. 4 illus. [Obituary. Portrait by Bogardus, sketch of Morse lying in state at his

funeral, views of medals awarded to Morse. Appended article "Souvenirs of Morse," on p. 86, with six sketches of his telegraph machines.]

M879 "Professor Morse." PHILADELPHIA PHOTOGRAPHER 9, no. 101 (May 1872): 130. [Obituary notice, details of funeral.]

M880 "The Late Professor Morse." ILLUSTRATED LONDON NEWS 60, no. 1704 (May 4, 1872): 428. 1 illus. [Brief biography. Portrait by H. Claudet.]

M881 Lossing, Benson J. "Professor Morse and the Telegraph." CENTURY MAGAZINE (SCRIBNER'S MONTHLY) 5, no. 5 (Mar. 1873): 579-589. 6 illus. [Illustrations include a "fac-simile of the first daguerreotype of the face made in America" on p. 584. With an account of Morse's early experiments with photography on pp. 584-585.]

M882 Pope, Franklin Leonard. "The American Inventors of the Telegraph: With Special References to the Services of Alfred Vail." CENTURY MAGAZINE 35, no. 6 (Apr. 1888): 924-944. 24 illus. [Has information on Samuel Finley Breese Morse.]

M883 Morse, Edward L. "Samuel F.B. Morse, The Painter." SCRIBNER'S MAGAZINE 51, no. 3 (Mar. 1912): 346-359. 13 illus. ["Illustrations from paintings by Morse."]

M884 Nibbleink, Don D. "Samuel F. B. Morse." AMERICAN ANNUAL OF PHOTOGRAPHY 1949 (1949): 38-45. 9 illus.

MORTON, HENRY (b. 1836) (USA)
M885 Morton, Henry. "Prof. Morton's Lecture on Light." PHILADELPHIA PHOTOGRAPHER 2, no. 18 (June 1865): 101-106. [Lecture at the Franklin Institute.]

M886 Morton, Prof. "Sunlight and Moonlight." PHILADELPHIA PHOTOGRAPHER 5, no. 55 (July 1868): 231-233. 1 illus.

M887 Morton, Prof. Henry. "The Solar Eclipse and Some of Its Teachings." PHILADELPHIA PHOTOGRAPHER 6, no. 63 (Mar. 1869): 81-84. [Discussion of scientific information obtainable from photos.]

M888 Morton, Prof. "The Eclipse Expedition. Prof. Morton's Official Report." PHILADELPHIA PHOTOGRAPHER 6, no. 69 (Sept. 1869): 305-309.

M889 Morton, Henry. "A Lecture on Florescent Light." PHILADELPHIA PHOTOGRAPHER 9, no. 108 (Dec. 1872): 429-437. 7 illus.

M890 "Biographical Notice of President Henry Morton, Ph.D., Of the Stevens Institute of Technology." WILSON'S PHOTOGRAPHIC MAGAZINE 29, no. 423 (Aug. 6, 1892): 449-456. 7 illus. [Henry Morton was the son of the Rev. Henry J. Morton. Both father and son contributed articles to the "Phila. Photo." magazine. The son was born in New York City on Dec. 11, 1836. During the 1870s he prepared and delivered a series of popular lectures on "Light," "Chemistry," etc. at the Philadelphia Academy of Music, the Franklin Institute, and elsewhere which were important both in popularizing science to the lay audience and as revolutionary uses of the magic lantern for education.]

MORTON, HENRY J., REV. (USA)

M891 Morton, Rev. H. J., D.D. "Photography in the Fields." PHILADELPHIA PHOTOGRAPHER 1, no. 5 (May 1864): 65-67.

M892 Morton, H. J., D.D. "Contemporary Press: Photography in the Fields." BRITISH JOURNAL OF PHOTOGRAPHY 11, no. 218 (July 8, 1864): 236-237. [From "Philadelphia Photographer."]

M893 Morton, Rev. H. J., D.D. "Photography Indoors." PHILADELPHIA PHOTOGRAPHER 1, no. 7 (July 1864): 104-106.

M894 Morton, Rev. H. J., D.D. "Photography as a Moral Agent." PHILADELPHIA PHOTOGRAPHER 1, no. 8 (Aug. 1864): 116-118.

M895 Morton, Rev. H. J., D.D. "The Poetry of Photography." PHILADELPHIA PHOTOGRAPHER 1, no. 11 (Nov. 1864): 161-163.

M896 Morton, H. J. "Struck by a Water-Spout." BRITISH JOURNAL OF PHOTOGRAPHY 11, no. 242 (Dec. 23, 1864): 529-530. [Morton, from Philadelphia, PA, muses on a woodcut of a waterspout, from "Illustrated London News."]

M897 Morton, Rev. H. J., D.D. "Photography as an Authority." PHILADELPHIA PHOTOGRAPHER 1, no. 12 (Dec. 1864): 180-183.

M898 Morton, Rev. H. J., D.D. "The Trials of the Photographer." PHILADELPHIA PHOTOGRAPHER 2, no. 15 (Mar. 1865): 36-38.

M899 Morton, H. J., D.D. "Photography in Colours." BRITISH JOURNAL OF PHOTOGRAPHY 12, no. 263 (May 19, 1865): 262-263.

M900 Morton, H. J., D.D. "A Photographic Trip Across the Allegheny Mountains." BRITISH JOURNAL OF PHOTOGRAPHY 12, no. 275 (Aug. 11, 1865): 417-418. [Description of his participation on a railroad excursion for artists and photographers.]

M901 Morton, Rev. H. J., D.D. "Broad Lights and Shadows in Photography." PHILADELPHIA PHOTOGRAPHER 2, no. 22 (Oct. 1865): 167.

M902 Morton, Rev. H. J., D.D. "The Magnesium Light." PHILADELPHIA PHOTOGRAPHER 3, no. 25 (Jan. 1866): 7-8.

M903 Morton, Rev. H. J., D.D. "The Sister Arts." PHILADELPHIA PHOTOGRAPHER 3, no. 27 (Mar. 1866): 71-73. [Claiming that there should not be any conflict between photography and painting.]

M904 Morton, Henry J. "Photography on the Hudson." BRITISH JOURNAL OF PHOTOGRAPHY 13, no. 304 (Mar. 2, 1866): 104-105.

M905 Morton, Henry J. and H. Morton. "The Future of Photography." BRITISH JOURNAL OF PHOTOGRAPHY 13, no. 323 (July 13, 1866): 329-331.

M906 Morton, Rev. H. J., D.D. "The Clouds." PHILADELPHIA PHOTOGRAPHER 4, no. 37 (Jan. 1867): 11-13.

M907 Morton, Rev. H. J., D.D. "East Florida and Photography. Pts. 1 - 3." PHILADELPHIA PHOTOGRAPHER 4, no. 42, 44, 48 (June, Aug., Dec. 1867): 174-177, 257-259, 384-386.

M908 Morton, Rev. H. J., D.D. "Of Natural and Unnatural in Art." PHILADELPHIA PHOTOGRAPHER 4, no. 46 (Oct. 1867): 340-342.

MORVAN.

M909 "M. Morvan's Patent Photolithographic Process." AMERICAN JOURNAL OF PHOTOGRAPHY AND THE ALLIED ARTS & SCIENCES n. s. vol. 6, no. 11 (Dec. 1, 1863): 255-256. [From "Br. J. of Photo."]

M910 Morvan. "New Photolithographic Process." HUMPHREY'S JOURNAL OF PHOTOGRAPHY, AND THE ALLIED ARTS AND SCIENCES 15, no. 16 (Dec. 15, 1863): 253-254. [From the "Cosmos."]

MOSELY, R. E. (NEWBURYPORT, MA)

M911 "Hannah F. Gould, the Actress." FRANK LESLIE'S ILLUSTRATED NEWSPAPER 21, no. 524 (Oct. 14, 1865): 60. 2 illus. [Portrait and a view of her house, both credited "From a Photograph by R. E. Mosely, Newburyport, MA."]

MOSER.

M912 Moser. "On the Formation of the Daguerrean Image." DAGUERREAN JOURNAL 1, no. 4 (Jan. 1, 1851): 97-102. [From Lerebour's "Treatise on Photography." On Mr. Moser's theory, other early experimenters.]

MOSES & PIFFET. (NEW ORLEANS, LA)

M913 "Water Battery at Fort Morgan, in Mobile Bay, Alabama. - Part of Our Fleet Lying Off Shore. - From a Photograph by Moses & Piffet, N. O." FRANK LESLIE'S ILLUSTRATED NEWSPAPER 19, no. 478 (Nov. 26, 1864): 148. 1 illus. [View.]

M914 Portrait. Woodcut engraving, credited "From a Photograph by Moses & Piffet." HARPER'S WEEKLY 9, (1865) ["Gov. James M. Wells, of LA." 9:463 (Nov. 11, 1865): 717.]

MOSES, A. & G. MOSES. (QUINCY, IL)

M915 "Editor's Table." PHILADELPHIA PHOTOGRAPHER 4, no. 40 (Apr. 1867): 128. [Cartes from A. & G. Moses (Quincy, IL).]

MOSES. (NEW ORLEANS, LA)

M916 "Retouched Negatives." HUMPHREY'S JOURNAL OF PHOTOGRAPHY, AND THE ALLIED ARTS AND SCIENCES 20, no. 22 (June 15, 1869): 344-345. [Discussion of a controversy that ensued when Mr. Moses, of New Orleans, was awarded the prize "to the best plain photograph" at the Louisiana State Fair. - the other photographers objecting because his negative was "worked-up" even though he made a straight-print from it. Excerpts from letters by E. H. Tyler, etc.]

MOSES, BERNARD. (1832-1899) (BAVARIA, USA)

[Son of Samuel Moses, brother to Edward R., Gustave A. and Louis Moses. Born Nov. 22, 1832 in Bavaria. Died Sept. 24, 1899 in New Orleans, LA. Jeweler in New Orleans in 1850. By late 1850s was a partner with his brother Gustave in an ambrotype and photograph gallery. Capt., 21st La. Infantry during the Civil War, 1861 to 1864. 1866 reopened ambrotype studio in New Orleans, through 1870s at least.]

MOSES, EDWARD R. (ca. 1833-1905) (BAVARIA, USA)

[Son of Samuel Moses. Died Jan. 16, 1905 in New Orleans, LA. Daguerrean from 1857. 2nd Lieut., 1st Div. La. Militia during the Civil War. 1867 in business with father (S. Moses & Son.) through 1870.]

MOSES, GUSTAV A. (ca. 1836-1915) (BAVARIA, USA) see also MOSES & PIFFET.

[Son of Samuel Moses. Began daguerreotyping in New Orleans 1854. Partner with brother Bernard (B. & G. Moses) from 1857 to 1861. 1st Lieut. in 21st La. Infantry during the Civil War. Partner with E. A. Piffit in 1864. B. & G. Moses again 1867 to 1869.]

MOSES, LOUIS. (USA)

[Son of Samuel Moses. Ran an ambrotype gallery in New Orleans from ca. 1857. Private, 4th Regt. European Brig. La. Militia during Civil War. In 1867 partner with A. Constant in New Orleans.]

MOSES, SAMUEL WOLFGANG. (1798-1885) (BAVARIA, USA)

[Born Dec. 17, 1798 in Bavaria. Died July 12, 1885, in New Orleans, LA. Father of Bernard, Edward R., Gustave A. and Louis, all photographers in New Orleans, LA ca. 1850s - 1870s. Samuel trained as a chemist. Opened a daguerreotype studio in New Orleans in 1850. S. Moses & Son studios in New Orleans until at least 1870. Private in the 11th La. Infantry in 1861.]

MOSHER, CHARLES D. (1829-1897) (USA)

M917 Mosher, C. D. "Artistic Photography. Why Should We Not Excel?" PHILADELPHIA PHOTOGRAPHER 11, no. 127 (July 1874): 209-210.

M918 "American Photographs." ANTHONY'S PHOTOGRAPHIC BULLETIN 5, no. 8 (Aug. 1874): 284-285. [From "London Photo. News." An American lady attended a course of class lectures with Prof. Huxley in England. In repayment, she commissioned C. D. Mosher (Chicago, IL) to prepare an album of portraits of distinguished men and women of America, for a gift to Huxley. Article then goes on to compare the work of several British and American photographers.]

M919 Mosher, C. D. "Voices from the Craft." PHILADELPHIA PHOTOGRAPHER 13, no. 146 (Feb. 1876): 45.

M920 Mosher, C. D. "Photography and Biography and the Photographic College." PHILADELPHIA PHOTOGRAPHER 17, no. 204 (Dec. 1880): 364-366. [Advocates the use of photographic portraits for historical research.]

M921 Mosher, C. D. "Save Your Silver and Gold." PHOTOGRAPHIC TIMES 19, no. 428 (Nov. 29, 1889): 588-589. [Brief biography of Mosher on p. 588 under "Editorial Notes." "Mr. Mosher is a photographer of ability, with forty years experience... He has one of the largest galleries in Chicago, at which a permanent exhibition of historic photographs numbering over two thousand, may be seen..."]

M922 Viskochil, Larry A. "Chicago's Bicentennial Photographer: Charles D. Mosher" CHICAGO HISTORY n. s. 5, no. 2 (Summer 1976): 95-105. 7 illus. [Mosher flourished ca. 1870-1897. Took thousands of portraits of Chicago, IL, notables. Born on a New York farm on Feb. 10, 1829. Apprenticed to a cabinet maker at 16, turned to photography at 20. Learned from his uncle, Nathanial Smith. Moved to Chicago in 1863. Burned out in 1871. Flourished through the 1870s. 1890 sold studio, retired, but remained active. Died June 7, 1897.]

MOSS, JOHN CALVIN. (1828-1892) (USA)

M923 "Notes and News: John Calvin Moss." PHOTOGRAPHIC TIMES 22, no. 552 (Apr. 15, 1892): 201. [Born in Pennsylvania. Died Apr. 8, 1892, aged 65 years. "Early perfected his own wash-out gelatine process to prepare blocks for the printing press. He was practically the pioneer of photo-engraving in America." Started several companies - most successful the Moss Engraving Co.]

M924 "Obituary: John Calvin Moss." WILSON'S PHOTOGRAPHIC MAGAZINE 29, no. 417 (May 7, 1892): 268-270. 1 illus. [Moss was born in Washington Co., Pa. in 1828. Was working as a journeyman printer in 1858 when he began experimenting with various processes of etching on zinc and lithographic stone. In 1867 he succeeded in making good relief plates for typographic printing. Formed various printing companies throughout the 1870s, finally establishing the Moss Engraving Co. in 1880, which became the largest engraving company in the world. Died in April 1892.]

MOTES, COLOMBUS N. (1837-1919) (USA)

M925 Motes, C. N. "Correspondence." ANTHONY'S PHOTOGRAPHIC BULLETIN 7, no. 9 (Sept. 1876): 288. [Letters from C. N. Motes (Atlanta, GA) on Lambert's processes.]

M926 "What an Atlanta Artist is Doing." ANTHONY'S PHOTOGRAPHIC BULLETIN 7, no. 10 (Oct. 1876): 291-292. [From "Atlanta (GA) Constitution."]

M927 "Matters of the Month." PHOTOGRAPHIC TIMES 12, no. 133 (Jan. 1882): 28. [From the "Atlanta Constitution." Promotional piece for C. N. Motes' photograph gallery.]

M928 Taylor, J. Traill. "The Studios of America. No. 5. Mote's Gallery and Carbon Printing Atelier, Atlanta, Ga." PHOTOGRAPHIC TIMES 13, no. 148 (Apr. 1883): 151-154.

M929 Motes, C. N. "I Work For It." PHOTOGRAPHIC MOSAICS: 1897 33, (1897): 171-175. 1 b & w. [Studio Portrait. "A Georgia Beauty."]

M930 "Obituary: Columbus N. Motes." ATLANTA JOURNAL (Apr. 9, 1919): n. p.

MOTTU, P. A. & WEGNER. (AMSTERDAM, HOLLAND)

M931 "Our Picture." PHILADELPHIA PHOTOGRAPHER 11, no. 125 (May 1874): frontispiece, 142. 1 b & w. 1 illus. [Editor of Holland's only photo magazine. Pres. Photo Society of Amsterdam.]

MOTTU, P. A.

M932 "Editor's Table." PHILADELPHIA PHOTOGRAPHER 10, no. 114 (June 1873): 192. [P. A. Mottu (Amsterdam, Holland) sent portraits. Mottu also editor of "De Navorscher," a photographic magazine.]

MOUHOT. (NICE, FRANCE)

M933 "San Remo, Italy, the Winter Residence of the Empress of Russia." ILLUSTRATED LONDON NEWS 66, no. 1850 (Jan. 23, 1875): 85. 1 illus.

MOULD, N. (BARABOO, WI)

M934 "Editor's Table." PHILADELPHIA PHOTOGRAPHER 6, no. 65 (May 1869): 169. [Views of Devils Lake, WI, noted.]

MOULTHROP & WILLIAMS. (NEW HAVEN, CT)

M935 Portrait. Woodcut engraving, credited "From a Photograph by Moulthrop & Williams, New Haven, CT." NEW YORK ILLUSTRATED NEWS 4, (1861) ["Brig.-Gen. D. Tyler." 4:92 (Aug. 5, 1861): 224.]

MOULTHROP, MAJOR. (1805-1890) (USA)

M936 "Gossip." PHOTOGRAPHIC ART JOURNAL 3, no. 4 (Apr. 1852): 260.

M937 Portrait. Woodcut engraving, credited "From a Photograph by Moulethrop, New Haven." FRANK LESLIE'S ILLUSTRATED

NEWSPAPER 9, (1860) ['The late Judge Ingersoll." 9:222 (Mar. 3, 1860): 222.]

M938 Portrait. Woodcut engraving, credited "From a Photograph by Moulthrop, New Haven, CT." FRANK LESLIE'S ILLUSTRATED NEWSPAPER 21, (1866) ['Dr. Eliphalet Nott, Union College." 21:543 (Feb. 24, 1866): 364.]

M939 Portrait. Woodcut engraving, credited "From a Photograph by Moulthrop." FRANK LESLIE'S ILLUSTRATED NEWSPAPER 40, (1875) ["Hon. Charles P. Ingersoll, of CT." 40:1018 (Apr. 10, 1875): 83.]

M940 Shurtleff, R. M. "Major Moulthrop." PHOTOGRAPHIC TIMES 20, no. 443 (Mar. 14, 1890): 126. [Died Feb. 28, aged 85 years. Lived many years in New Haven, CT. Calls forth brief biographies of other "pioneers of photography" by Shurtleff.]

MOULTON, HENRY DE WITT see also GARDENER, ALEXANDER.

MOULTON, HENRY DE WITT. (1828-1893) (USA)
BOOKS
M941 Moulton, H. D. W. Negative and Positive Processes on Glass and Paper. New York: J. P. Prall, 1857. 16 pp.

M942 Gardener, Alexander, ed. Rays of Sunlight from South America. Photographed by Alexander Gardener. Washington, DC: Philip & Solomons, 1865. iv, 140 pp. 70 b & w. [Photographic negatives by H. Moulton, positive prints by A. Gardener. Photographs of Chile and Peru.]

PERIODICALS
M943 "Our Illustrations." PHOTOGRAPHIC AND FINE ART JOURNAL 10, no. 9 (Sept. 1857): frontispiece, 281. 1 b & w. [Original photographic print, tipped-in. "Portrait of Madame Ponisi," from a negative by H. D. W. Moulton, prints by H. H. Snelling. (Print not in this copy.)]

M944 Moulton, H. D. W. "Correspondence." ANTHONY'S PHOTOGRAPHIC BULLETIN 6, no. 2 (Feb. 1875): 61-62. [Moulton describes making full-length life-sized portrait while working for Gurney. Mr. Partridge, then working for Brady, saw the work and made another life-sized group portrait of Brady with two friends, which was 3 inches shorter than Moulton's print. Both destroyed with the burning of the NY Crystal Palace (so made ca. 1852).]

M945 McElroy, Keith. "Henry De Witt Moulton: Rays of Sunlight from South America." HISTORY OF PHOTOGRAPHY 8, no. 1 (Jan.-Mar. 1984): 7-21. 11 b & w. 4 illus. [Negatives by Moulton published by Alexander Gardener, who made the positives for the album "Rays of Sunlight from South America," in 1865.]

MOULTON, HENRY. [?]
M946 "The Chincha (Guano) Islands, Peru." ILLUSTRATED LONDON NEWS 42, no. 1189 (Feb. 21, 1863): 197, 200-201. 7 illus. [Views, diggings, men at work. "...from photographs in the possession of Messrs. Rucker, Offor and Co. will convey a good idea of how the guano is shipped." (Not credited but highly probable that these photos are by Henry Moulton.)]

M947 "Spanish Outrage in Peru. The Chincha Islands" FRANK LESLIE'S ILLUSTRATED NEWSPAPER 18, no. 453 (June 4, 1864): 173-144. 2 illus. [The illustrations to this article depict guano harvesting on the Guano Islands. Moulton took this sort of photograph about this time, which were later published by A. Gardener.]

MOULTON, J. C. (FITCHBURG, MA)
M948 "Voices from the Craft." PHILADELPHIA PHOTOGRAPHER 5, no. 56 (Aug. 1868): 274. [Letter from Moulton.]

M949 Edgerly, Joseph G. "Fitchburg, Massachusetts." NEW ENGLAND MAGAZINE 12, no. 3 (May 1895): 321-337. 28 b & w. 3 illus. ["Illustrated from photographs by J. C. Moulton." Views.]

MOWREY, FRANK. (RUTLAND, VT)
M950 "A Disordered Bath." AMERICAN JOURNAL OF PHOTOGRAPHY AND THE ALLIED ARTS & SCIENCES n. s. vol. 6, no. 18 (Mar. 15, 1864): 430-431.

MOXHAM, EGBERT.
M951 Moxham, Egbert. "Taupenot's Process." HUMPHREY'S JOURNAL OF PHOTOGRAPHY, AND THE ALLIED ARTS AND SCIENCES 10, no. 15 (Dec. 1, 1858): 226-228.

MOYRTON.
M952 Portrait. Woodcut engraving, credited "From a Photograph by Moyrton." FRANK LESLIE'S ILLUSTRATED NEWSPAPER 37, (1873) ["Miss Loula Wilkerson, heroine of the Memphis Yellow Fever epidemic." 37:948 (Nov. 29, 1873): 205. "A. E. Frankland, a hero of the Memphis Yellow Fever epidemic." 37:948 (Nov. 29, 1873): 205.]

MUDD, JAMES. (1821-1906) (GREAT BRITAIN)
[James Mudd was born in Halifax, Yprkshire in 1821. James and Robert Mudd opened a pattern designing business in Manchester in 1847. James began photographing as an amateur in the early 1850s and joined the Manchester Photographic Society in 1855 when it formed. He and Joseph Sidebotham collaborate to improve on a waxed-paper process. In 1857 James and Robert open a photography studio in Manchester in addition to their other business. In 1858 James moves to Bowdon, Cheshire. He exhibits photographs at the National Art Treasures Exhibition in Manchester in 1857, at the Photographic Society of Scotland exhibition in 1859, at the London Photographic Society exhibition in 1860, and widely thereafter through the 1860s —winning awards and medals. Robert leaves the photographic business around 1860 and James S. Platt becomes Mudd's partner until 1864. Mudd becomes known for his landscapes and industrial views, particularly his portraits of locomotives. In 1873 his son joins the firm. James Mudd began drawing and painting in the 1880s. George Grundy began working in his studio then, and takes it over in 1903. Mudd dies in Bowdon around 1906.]

BOOKS
M953 Mudd, James. The Collodio-Albumen Process; Hints on Composition; and other Papers. London: Thomas Piper, Photographic News Office, 1866. 78 pp. [2nd ed. (1868).]

M954 Gray, Priscilla Marie. James Mudd, Early Manchester Photographer. Riverside: Priscilla Marie Gray, 1982. 111 pp. 35 b & w. [M. A. Thesis, Univ. of CA., Riverside. Xerox copy, GEH Collection. Chronology, Bibliography.]

PERIODICALS
M955 Mudd, Jas. "Manchester Photographic Society." LIVERPOOL & MANCHESTER PHOTOGRAPHIC JOURNAL [BRITISH JOURNAL OF PHOTOGRAPHY] n. s. 2, no. 4 (Feb. 15, 1858): 43-46. [Paper by Jas. Mudd, "The Artistic Arrangement of Photographic Landscapes."]

M956 "Manchester Photographic Society." PHOTOGRAPHIC AND FINE ART JOURNAL 11, no. 4 (Apr. 1858): 117-119. [Paper by J. Mudd, "The Artistic Arrangement of Photographic Landscapes."]

M957 "Photographic Society of Scotland." BRITISH JOURNAL OF PHOTOGRAPHY 7, no. 113 (Mar. 1, 1860): 66-67. [Report includes excerpts from James Mudd's paper "On the Collodio-Albumen Process."]

M958 Mudd, James. "A Photographer's Dream." BRITISH JOURNAL OF PHOTOGRAPHY 12, no. 259 (Apr. 21, 1865): 202-205.

M959 "Figures in Landscapes." AMERICAN JOURNAL OF PHOTOGRAPHY, AND THE ALLIED ARTS AND SCIENCES n. s. vol. 9, no. 10 (May. 1, 1867): 228-229. [No source given, but British. Mentions "Illustrated London News" and quotes from Mr. Mudd's essay on "Composition in Photography."]

M960 Mudd, James. "On 'Touching' Landscape Negatives." COMMERCIAL PHOTOGRAPHIC NEWS 1, no. 4 (Oct. 1872): 5-6. [From "Photo News."]

M961 Milligan, H. "James Mudd: A 19th Century Industrial Photographer." PHOTOGRAPHIC JOURNAL 114, no. 11 (Nov. 1974): 544-547. 5 b & w. [Mudd gave up textile designing, took up photography in 1854. Photographed machinery, industrial views, landscapes, and portraits.]

MUELLER, J. (COUNCIL BLUFFS, IA)
M962 Mueller, J. "Salad for the Photographer." PHILADELPHIA PHOTOGRAPHER 3, no. 26 (Feb. 1866): 61-62. [Mueller (Council Bluffs, IA) offers practical suggestions, anecdotes, etc.]

M963 "Editor's Table." PHILADELPHIA PHOTOGRAPHER 3, no. 27 (Mar. 1866): 95. [J. Mueller 'Council Bluffs, IA) completely burned out.]

MUELLER, JOSEPH. (MAGNOKETA, WI)
M964 Mueller, Joseph. "Vignettes, Etc., Again." AMERICAN JOURNAL OF PHOTOGRAPHY AND THE ALLIED ARTS & SCIENCES n. s. vol. 5, no. 23 (June 1, 1863): 535-536. [Letter from Mueller, addressed Magnoketa, WI. Mueller states "...remember, I am a Dutchman, and am not used enough to this language."]

MULLEN, JAMES see also CARPENTER & MULLEN.

MULLEN, JAMES. (LEXINGTON, KY)
M965 "Editor's Table." PHILADELPHIA PHOTOGRAPHER 2, no. 21 (Sept. 1865): 153. [Three 11" x 14" landscape views of KY mentioned.]

M966 "Editor's Table." PHILADELPHIA PHOTOGRAPHER 5, no. 49 (Jan. 1868): 33. [Photos received.]

M967 Mullen, James. "To Make a Small Figure on a Large Plate." PHILADELPHIA PHOTOGRAPHER 10, no. 116 (Aug. 1873): 235.

M968 Mullen, James. "Fifth Annual Meeting and Exhibit of the National Photographic Association of the U.S., held in Buffalo, N.Y., beginning July 5, 1873: Landscape Photography." PHILADELPHIA PHOTOGRAPHER 10, no. 117 (Sept. 1873): 445-446.

M969 Portrait. Woodcut engraving, credited "From a Photograph by Mullen, Lexington, Ky. FRANK LESLIE'S ILLUSTRATED NEWSPAPER 42, (1876) ["Hon. James B. Beck, Sen.-elect from KY." 42:1070 (Apr. 1, 1876): 57.]

M970 Portrait. Woodcut engraving, credited to "From a Photograph by J. Mullen, Lexington, Kentucky." FRANK LESLIE'S ILLUSTRATED NEWSPAPER 46, (1878) ["Hon. William Goodloe, US Minister to Belgium." 46:1182 (May 25, 1878): 205.]

M971 "Editor's Table." WILSON'S PHOTOGRAPHIC MAGAZINE 34, no. 491 (Nov. 1897): 528. [Photo of "Dr. C. E. Mooney, a Kentucky character.]

MULLER, C. J. (PATNA, EAST INDIES)
M972 Muller, C. J. "New Photographic Process." ATHENAEUM no. 1256 (Nov. 22, 1851): 1234.

M973 "Photography on Paper." DAGUERREAN JOURNAL 3, no. 3 (Dec. 15, 1851): 84-85. [We must state that this process originated in Central India, where Mr. Muller resides.]

M974 "Monthly Notes: Muller's Photographic Process." PRACTICAL MECHANIC'S JOURNAL 4, no. 46 (Jan. 1852): 239. ["Mr. C. J. Muller of Patna, in the East Indies, has just added another chapter to the history of photography in the form of a new process resembling the catalissotype of Dr. Woods."]

MULLETT, MARY B.
M975 Mullett, Mary B. "The Daguerreotype (short fiction)." SCRIBNER'S MAGAZINE 41, no. 3 (Mar. 1907): 365-370. [Author uses a daguerreotype as a device to recall memories.]

MULNIER, FERDINAND. (PARIS, FRANCE)
M976 Portrait. Woodcut engraving credited "From a photograph by Ferdinand Mulnier." ILLUSTRATED LONDON NEWS 66, (1875) ["M. Buffet, French Premier." 66:1859 (Mar. 27, 1875): 288.]

MULOCK, B. (BRAZIL)
M977 "The Bahia Railway, Brazil." ILLUSTRATED LONDON NEWS 37, no. 1055 (Oct. 20, 1860): 382. 2 illus. [Views. "The photographs were taken by Mr. B. Mulock, the artist specially engaged by the contractor for taking views of the works." View of Rio de Janeiro on p. 370 mentioned.]

M978 "Rio de Janeiro." ILLUSTRATED LONDON NEWS 37, no. 1055 (Oct. 20, 1860): 370. 1 illus. ["...from a photograph taken from the Castle Hill."]

MULVEY, O. (MADISON, IN)
M979 Mulvey, O. "Stereoscopic Vision without a Stereoscope." HUMPHREY'S JOURNAL OF PHOTOGRAPHY, AND THE ALLIED ARTS AND SCIENCES 13, no. 21 (Mar. 1, 1862): 322-325. 1 illus.

MUMLER, WILLIAM H. (1832-1884) (USA)
BOOKS
M980 Gerry, Elbridge Thomas. *Argument of Mr. Elbridge T. Gerry, of Council for the People, Before Justice Dowling, on the Preliminary Examination of Wm. H. Mumler, Charged with Obtaining Money by Pretended "Spirit" Photographs;* reported by Andrew Devine. New York: Baker, Voorhis, 1869. 55 pp.

PERIODICALS
M981 R. A. S. "Entrements: About Some Photographic Ghost Stories." BRITISH JOURNAL OF PHOTOGRAPHY 10, no. 181 (Jan. 1, 1863): 14-16.

M982 "The Spirit Photographs." AMERICAN JOURNAL OF PHOTOGRAPHY AND THE ALLIED ARTS & SCIENCES n. s. vol. 5, no. 14 (Jan. 15, 1863): 329-330.

M983 "Spirit Photographs: A New and Interesting Development." JOURNAL OF THE PHOTOGRAPHIC SOCIETY OF LONDON 8, no. 129, 132, 135 (Jan. 15, Apr. 15, July 15, 1863): 215-216, 268-269, 324-325. [Mumler from Boston, MA.]

M984 Boyle, C. B. "Photographing Spirits." HUMPHREY'S JOURNAL OF PHOTOGRAPHY, AND THE ALLIED ARTS AND SCIENCES 20, no. 20 (Apr. 15, 1869): 307-308.

M985 "Editor's Table." PHILADELPHIA PHOTOGRAPHER 6, no. 65 (May 1869): 167-170. [Henry Morton; T. C. Matthewson (Tremont, IL); A. S. Southworth; Kilburn Bros.; Mumler; John A. Scholten (St. Louis, MO); H. Vogel; S. A. L. Hardinge (Brooklyn, NY); Willard Marshall (Guelph, Ontario); H. B. Hillyer (Austin, TX); Andrew Khrone (Bogardus Gallery); Joseph Voyle (Tuscaloosa, AL); M. Mould (Baraboo, WI); Thomas Fury (NY); Well G. Singhi (Bainbridge, NY); Cramer & Gross (St. Louis, MO); E. S. M. Haines (Albany, NY); J. H. Fitzgibbon (St. Louis, MO); S. R. Shear (Ossian, IA); others mentioned.]

M986 "Spiritual Photography." FRANK LESLIE'S ILLUSTRATED NEWSPAPER 28, no. 710 (May 8, 1869): 119, 120. 1 illus. [View of William Mumler's trial, report.]

M987 "Spiritual Photography." HARPER'S WEEKLY 13, no. 645 (May 8, 1869): 289. 9 illus. [Seven engravings from photos by Mumler purported to contain images of ghosts. Two portraits by Rockwood demonstrating how transparent figures could be created, plus an article about the images, court action against Mumler.]

M988 "Spirit Photographs." HUMPHREY'S JOURNAL OF PHOTOGRAPHY, AND THE ALLIED ARTS AND SCIENCES 20, no. 21 (May 15, 1869): 327-329. [Report of the trial. Mumler was acquitted.]

M989 Hull, C. Wager. "New York Correspondence." PHILADELPHIA PHOTOGRAPHER 6, no. 66 (June 1869): 199-203. Illus. with etchings of photos in question. illus. [Column this month devoted to the trial of Wm. H. Mumler, proclaimed "spirit photographer".]

M990 "Corry O'lanus." "More About Spirit Photographs." HUMPHREY'S JOURNAL OF PHOTOGRAPHY, AND THE ALLIED ARTS AND SCIENCES 20, no. 22 (June 15, 1869): 345-347. [From the "Brooklyn Eagle." Comic commentary.]

M991 "Note." PHOTOGRAPHIC TIMES 14, no. 162 (June 1884): 304. [Mumler died in Boston on 16th May 1884. Born in Boston in 1832. An inventor, treasurer of the Photo-Electrotype Company, which published photos using an early photoengraving process. "The deceased at one time gained considerable notoriety in connection with spirit photographs.]

M992 Taylor, J. Traill. "General Notes." PHOTOGRAPHIC TIMES 14, no. 163 (July 1884): 347-348. [Death of Mumler has led the editor to wonder how he accomplished the spirit photographs.]

M993 Henisch, Heinz, K. "Frontispiece: Mumler's Spirit Photography." HISTORY OF PHOTOGRAPHY 2, no. 2 (Apr. 1978): 100. 4 illus.

M994 Dobran, John. "The Spirits of Mumler." NORTHLIGHT (JOURNAL OF THE PHOTOGRAPHIC HISTORICAL SOCIETY OF AMERICA) 5, no. 2-3 (Summer - Fall 1978):(Part 1) 4-7, *-*. 16 b & w. 3 illus. [This is a two part article, but part II is missing, therefore not indicated here.]

MUNBY, ARTHUR.
M995 Hiley, Michael. *Victorian Working Women: Portraits from Life.* Boston: David R. Godine, 1979. 144 pp. 159 b & w.

MUNBY, ARTHUR [?]
M996 Plummer, John. "A Real Social Evil." ONCE A WEEK 11, no. 271 (Aug. 27, 1864): 278-280. 1 illus. [Illustration is of "Mining Women in Male Attire - From a Photograph." Social documentary, protesting women working as miners underground.]

MUNDY, DANIEL LOUIS. (CHRISTCHURCH, NEW ZEALAND)
BOOKS
M997 Knight, Hardwick. *Princes Street by Gaslight: The Photography of Daniel L. Mundy.* Dunedin: John McIndoe, 1976. 48 pp. 60 b & w. [Photographs of New Zealand in the 1860s by D. L. Mundy.]

PERIODICALS
M998 "The Canterbury Museum, New Zealand." ILLUSTRATED LONDON NEWS 52, no. 1468 (Feb. 8, 1868): 144. 2 illus. [Museum exterior, interior, with skeletons of prehistoric birds. "Mr. D. L. Mundy, of Christchurch, executed a series of photographs of them for the Canterbury Government."]

M999 "The Continuing Value of Photography: A New Zealand View." HISTORY OF PHOTOGRAPHY 1, no. 1 (Jan. 1977): 9-15. 7 b & w. [Street scenes taken in Dunedin, New Zealand in early 1860s.]

MUNDY, LORENZO CHARLES. (1839-1886) (USA)
BOOKS
M1000 Forest Hill Cemetery (Utica, NY). *Rules and Regulations and Catalogue of Lot Holders; Preceded by a Historical Notice of Forest Hill Cemetery.* Utica, NY: Curtiss & Childs, 1872. 69 pp. 10 l. of plates. 10 b & w. illus. [Photos credited to Mundy or Mundy & Rowell, Utica, NY. One interior and one view credited to L. R. Williams.]

PERIODICALS
M1001 Mundy, L. C. "Fifth Annual Meeting and Exhibit of the National Photographic Association of the U.S., held in Buffalo, N.Y., beginning July 5, 1873: Concerning the Negative Bath." PHILADELPHIA PHOTOGRAPHER 10, no. 117 (Sept. 1873): 327-328.

M1002 Baker, W. J. "Obituary: L. C. Mundy." PHOTOGRAPHIC TIMES 17, no. 280 (Jan. 28, 1887): 42-43. [From "Philadelphia Photographer." ("W. J. B." here credited to be W. J. Baker of Buffalo.) Mundy orphaned at age eight. Apprenticed to L. B. Williams, eventually opened his own gallery. Died in Dec. 1886 in Utica, NY.]

MUNROE, R. (ALLEGHENY CITY, PA)
M1003 "Personal & Art Intelligence: Munroe's Skylight Ambrotype Gallery." PHOTOGRAPHIC AND FINE ART JOURNAL 9, no. 12 (Dec. 1856): 383. [From "Pittsburgh Dispatch." Munroe at Allegheny City, PA.]

MUNSON, JAMES E.
M1004 Munson, James E. *The Complete Photographer.* New York: Robert H. Johnson & Co., 1867. n. p.

MURRAY & HEATH. (GREAT BRITAIN)
BOOKS
M1005 Murray & Heath. *A Catalogue of Photographic Apparatus, Processes, Etc.* London: Murray & Heath, 1859. n. p.

PERIODICALS
M1006 "Minor Topics of the Month: Natural Clouds - Photography." ART JOURNAL (Dec. 1856): 355.

M1007 "Note." ART JOURNAL (Jan. 1861): 30. [Murray & Heath's photographs: views of Endsleigh in Devonshire, stereo views of Royal Palaces mentioned. Stereo views by Soulier also sold by Murray & Heath.]

MURRAY, JOHN. (1809-1898) (GREAT BRITAIN, INDIA)

[Born in 1809, the son of a farmer in Blackhouse, County Aberdeen. Obtained a medical degree in 1832 and entered the medical service of the Army of the East India Company. Became Medical Officer in charge of the Medical School at Agra in 1849, and sometime thereafter he learned photography. In 1857 thirty-five of his views from wax paper negatives were exhibited in London, followed in 1858 with a publication *Photographic Views in Agra and Its Vicinity*, and a portfolio *Picturesque Views in the Northwestern Provinces of India* in 1859. From 1867 to 1871 he was the Inspector General of Hospitals on the northwest provinces of India. Retired in 1871, returned to London, and became the President of the Epidemiological Society of London. Died in Sheringham in 1898.]

BOOKS
M1008 Murray, John. *Photographic Views of Agra and Its Vicinity.* London: J. Hogarth, 1858. n. p. b & w

M1009 Murray, John. *Picturesque Views in the Northwestern Provinces.* London: J. Hogarth, 1859. n. p. 22 b & w. [Portfolio.]

PERIODICALS
M1010 "Photographs of Indian Cities." ART JOURNAL (Dec. 1857): 386.

MURRAY, ROBERT.

M1011 "Fine-Art Gossip." ATHENAEUM no. 1597 (June 5, 1858): 727. [All previous photographs of Egypt "go down" before the large and finely-wrought views published by Robert Murray, late chief engineer to the Viceroy of Egypt (Hogarth), for whom...Mr. Bonomi, has written a Catalogue.]

M1012 "Our Weekly Gossip." ATHENAEUM no. 1815 (Aug. 9, 1862): 182. ["Mr. Hogarth has published nine photographic views, taken in Normandy, by Mr. Robert Murray, an artist well known by his Egyptian views."]

M1013 Murray, Robert, C.E. "A Few Hints to Amateur Landscape Photographers." PHOTOGRAPHIC TIMES 10, no. 113 (May 1880): 102-106. [Communicated to the Edinburgh Photographic Society. From "Br J of Photo."]

M1014 Murray, R. "Transparencies." PHOTOGRAPHIC TIMES 16, no. 249 (June 25, 1886): 343-344. ["A communication to the Edinburgh Photographic Society".]

MURRY, HENRY & MRS. HENRY MURRY. (LONDON, ENGLAND)

M1015 "Note." ART JOURNAL (Nov. 1862): 227. [Notice of opening gallery at 91 Regent Street.]

MUSGRAVE, EDWIN.

M1016 Musgrave, Edwin. "On Positive Printing." AMERICAN JOURNAL OF PHOTOGRAPHY AND THE ALLIED ARTS & SCIENCES n. s. vol. 4, no. 13 (Dec. 1, 1861): 289-291. [Read before Edinburgh Photo. Soc.]

M1017 Musgrave, Edwin. "The Wet Collodion Process, 1858 and 1865." AMERICAN JOURNAL OF PHOTOGRAPHY AND THE ALLIED ARTS & SCIENCES n. s. vol. 8, no. 13-14 (Jan. 1 - Jan 15, 1866): 304-309, 319-320. [Read before Edinburgh Photo. Soc. From "Br. J. of Photo." "Concluded from p. 309" (Missing issue no. 13). Discussion of the changes and improvements in the process during the period.]

M1018 Musgrave, Edwin. "Failures in the Wet Tannin Process." AMERICAN JOURNAL OF PHOTOGRAPHY AND THE ALLIED ARTS & SCIENCES n. s. vol. 8, no. 19 (Apr. 1, 1866): 433-438. [Read before "Edinburgh Photo. Soc."]

MUSKOOR-OOD-DOWLAH.

M1019 "The Grand Durbar at Lucknow." ILLUSTRATED LONDON NEWS 52, no. 1472 (Mar. 7, 1868): 228-229, 232, 238. 2 illus. ["This Engraving is made from a drawing by Mr. R. Clint, assisted by a photograph taken by Muskoor-ood-dowlah, of Lucknow."]

MUYBRIDGE, EADWEARD J. (1830-1904) (GREAT BRITAIN, USA)

[Born Edward James Muggeridge on April 9, 1830 at Kingston-on-Thames, Surrey. In 1850 he went to California, where he worked in the book trade. By 1856 he had a bookstore and distribution business in San Francisco. He left his brother in charge of the business during a visit back to England. One tale has it that during the trip home he fell off of a stagecoach while crossing Texas and hurt his head. In any case he remained in England for several years longer than intended because of medical problems, then returned to California in 1867. On his return he was described as changed, having somehow become both an accomplished photographer and somewhat eccentric. Now believing himself to be descended from ancient Welsh royalty, he changed his name to Eadweard Muybridge, and began working as a landscape photographer in the Yosemite Valley and elsewhere on the Western Coast of North America.

He worked first with Silas Selleck in San Francisco, then moved to the Nahl Gallery, then, in 1871, he went to the Houseworth Gallery, then associates himself with Bradley & Rulofson. In 1868 he photographed along the Pacific Coast up into Alaska with the costal survey team under General Halleck. His stunning photographs throughout the 1860s and 1870s established an international reputation. In 1871 Muybridge began to experiment to find some means to photograph a horse in motion, an activity funded by Ex-Governor Leland Stanford, who, so legend has it, placed a bet of $25,000 that a galloping horse would have all four legs off the ground at once and who wished to prove his argument. Muybridge's first attempts were not successful and they were interrupted by the press of other work and other events in his life.

In 1873 Muybridge documented the Modoc Indian war, making stereo views of the participants of that savage little conflict. Muybridge married Flora Stone, a beautiful young woman who was about half his age, in 1871. His photographic trips were often arduous and took months to complete. In 1874 Muybridge returned from a photographic trip to find that his wife had given birth to a child fathered by another man. Muybridge sent his wife away to another city and thereafter provided support for her and the child; but he also hunted the other man until he found him in a saloon in a California mining town, where he shot him dead. While this reads like a scene right out of a Hollywood Western, in fact the rule of law was strong in California; and it was only Muybridge's international reputation as an artist, his friends in high places, and a very persuasive lawyer which kept him from being hung for murder. After his acquittal it seemed prudent to show a low profile for a while and Muybridge accepted a commission from the Pacific Mail Steamship Company to photograph in Panama and Guatemala. This work kept him out of San Francisco for a year or

so, and resulted in another collection of magnificent views.

In 1877 Muybridge returned to California and to his experiments to photograph a galloping horse, and this time he was successful; creating some revolutions in visual understanding, initiating a complex of investigations into the visual portrayal of movement, which in turn led the way to the development of many major new technologies and industries, and, incidentally, winning Governor Stanford's bet for him. Muybridge almost stopped making landscape photographs after 1877, instead he concentrated on developing his researches in motion studies, first working on these studies in Palo Alto, CA, then moving to the University of Pennsylvania in Philadelphia in the early 1880s, where he worked with the painter Thomas Eakins and others on an extensive program of recording many aspects of motion in men and in many animals.

By the early 1880s Muybridge's reputation, already high in photographic and art circles for his landscapes, mushroomed into a general international fame as the results of his motion studies became known. In 1889 Muybridge retired to England. He died there at Kingston on May 8, 1904.]

BOOKS

M1020 Hittell, John S. *Yosemite: Its Wonders and Beauties,... Illustrated with Twenty Photographic Views and a Map.* San Francisco: H. H. Bancroft & Co., 1868. 59 pp. 20 b & w. [Twenty photos by Muybridge, under the pseudonym "Helios."]

M1021 Muybridge, Eadweard. *Catalogue of Photographic Views, Illustrating the Yosemite, Mammoth Trees, Geyser Springs, and Other Remarkable and Interesting Scenery of the Far West.* San Francisco: Bradley & Rulofson, 1873. 53 pp.

M1022 Muybridge, Eadweard. *The Pacific Coast of Central America and Mexico; the Isthmus of Panama; Guatemala; and the Cultivation and Shipment of Coffee. A Series of Photographs Executed for the Pacific Mail Steamship Company by Muybridge.* San Francisco: s. n. [Pacific Mail Steamship Co.?] 1876, n. p. 144 l. of plates. 144 mounted photographs in album. Five sets published, two sets destroyed. illus.]

M1023 Muybridge, Eadweard. *Panorama of San Francisco from California Street Hill.* San Francisco: Muybridge, 1877. [12 mounted photographs.]

M1024 Muybridge, Eadweard. *Panoramic View of San Francisco, Calif.* San Francisco: T. C. Russell, 1877 ? n. p. 13 b & w. [Panoramic view, consisting of thirteen photographs, taken in 1877. NYPL Collection. GEH Collection.]

M1025 Muybridge, Eadweard. *The Attitudes of Animals in Motion: a Series of Photographs Illustrating the Consecutive Positions Assumed by Animals In Performing Various Movements; Executed at Palo Alto, California in 1878 and 1879.* San Francisco: s. n., 1881. 170 pp. [Approximately 200 collotype plates.]

M1026 Stillman, J. D. B. for Leland Stanford. *The Horse In Motion as Shown by Instantaneous Photography, With a Study on Animal Mechanics Founded on Anatomy and the Revelations of the Camera, In Which is Demonstrated the Theory of Quadrupedal Locomotion.* Boston: J. R. Osgood & Company, 1882. 127 pp. illus.

M1027 Muybridge, Eadweard. Text by Dr. H. Allen. *Animal Locomotion. An Electro-Photographic Investigation of Consecutive Phases of Animal Movements. Commenced 1872 - Completed 1885.* Philadelphia, New York: Published under the auspices of the University of Pennsylvania, Philadelphia, the plates printed by the Photo-Gravure Company, New York, 1887. 11 vol. 781 collotype plates. b & w.

M1028 Marks, W. D., H. Allen, and F. X. Dercum. *Animal Locomotion: The Muybridge Work at the University of Pennsylvania. The Method and the Result. Printed for the University.* Philadelphia: J. B. Lippincott Company, 1888. 106 pp. 80 illus. [Reprinted 1973, Arno Press.]

M1029 Muybridge, Eadweard. *The Science of Animal Locomotion (Zoepraxography)... Executed and Published under Auspices of the University of Pennsylvania.* Philadelphia, London: E. Muybridge, 1891. 24 pp.

M1030 Beard, William Holbrook. *Action in Art.* New York: Cassell Publishing Co., 1893. xii, 349 pp. 220 illus. [Treatise on art in general. Beard discusses Muybridge's photographs, Anschutz's photographs. "With over two hundred and twenty illustrations from the original drawings by the author".]

M1031 Muybridge, Eadweard. *Descriptive Zoepraxography; or, The Science of Animal Locomotion made Popular,... a series of lectures... World's Columbian Exposition in Zoepraxological Hall, 1893.* Philadelphia; Chicago: University of Pennsylvania; Lakeside Press, 1893. n. p. 50 illus.

M1032 Muybridge, Eadweard. *Animals in Motion: An Electrophotographic Investigation of Consecutive Phases of Animal Progressive Movements.* London: Chapman and Hall, 1899. 272 pp. illus. [5th impression. (1925), 264 pp.]

M1033 Lankester, Sir E. R. "The Problem of the Galloping Horse," on pp. 52-84 in: *Science From The Easy Chair.* Methuen, 1911-1913. n. p.

M1034 Muybridge, Eadweard. *The Human Figure in Motion; an Electrophotographic Investigation of Consecutive Phases of Muscular Actions.* London: Chapman & Hall, 1913. n. p. l. of plates.

M1035 Finney, W. E. St. Lawrence. *Eadweard James Muybridge. A famous Kingstonian, Scientist, Inventor, Benefactor.* Reproduced from 'The Concentric' the Journal of the Rotary Club of Kingston-upon Thames. Summer 1931. 5 pp.

M1036 Muybridge, Eadweard. Introduction by Robert Taft. *The Human Figure in Motion.* New York: Dover Pub., 1955. 195 plates.

M1037 Brown, Lewis S., Editor. *Animals in Motion.* New York: Dover Pub., 1957. 74 pp. 183 plates.

M1038 MacDonnell, Kevin. *Eadweard Muybridge: The Man Who Invented the Moving Picture.* Boston; London: Little, Brown and Co.; Weidenfeld & Nicolson, 1972. 158 pp. 132 b & w.

M1039 Mozley, Anita Ventura, introduction, catalogue and notes on the work; essays by Robert Bartlett Haas and Francois Forster-Hahn. *Eadweard Muybridge: The Stanford Years, 1872 - 1882.* Stanford, CA: Stanford University Museum of Art, 1972. 136 pp. 128 b & w. [Exhibition catalog. (Oct. 7 - Dec. 4, 1972)]

M1040 Hendricks, Gordon. *Eadweard Muybridge: The Father of the Motion Picture.* New York; London: Grossman Publishers; Secker & Warburg, 1975. 271 pp. 199 b & w.

M1041 Hass, Robert Bartlett. *Muybridge: Man in Motion.* Berkeley, Los Angeles, London: University of California Press, 1976. 207 pp. 156 b & w.

M1042 Muybridge, Eadweard. Introduction by Anita Ventura Mosley. *Muybridge's Complete Human and Animal Locomotion.* New York: Dover, 1979. 3 vol. 781 b & w.

M1043 Gilardi, Ando. *Muybridge il magnifico voyeur.* Milan: Mazzotta, 1980. 131 pp. illus.

M1044 Munoz, Luis Lujan. *Fotografias de Eduardo Santiago Muybridge en Guatemala (1875)* Guatemala: Cenaltex, Ministerio de Educacion, 1984. n. p.

M1045 *Eadweard Muybridge, Animal Locomotion: Images from the Philadelphia Years.* Albany, NY: SUNY-Albany, University Art Gallery, 1985. 26 pp. 5 b & w. [Essays by Robert J. Phelan and Thomas Fels.]

M1046 Burns, E. Bradford. *Eadweard Muybridge in Guatemala 1875: The Photographer as Social Recorder.* Berkeley: University of California Press, 1986. viii, 136 pp. 85 b & w.

PERIODICALS
M1047 "Helios", San Francisco. "A New Sky Shade." PHILADELPHIA PHOTOGRAPHER 6, no. 65 (May 1869): 142-144, illus. with sketches. ["Helios" was Muybridge.]

M1048 "Our Picture." PHILADELPHIA PHOTOGRAPHER 6, no. 71 (Nov. 1869): frontispiece, 373-375. 1 b & w. [Landscape.]

M1049 Simpson, G. Wharton. "Notes In and Out of the Studio." PHILADELPHIA PHOTOGRAPHER 9, no. 100 (Apr. 1872): 118-120. [American Stereographs - Muybridge views discussed on pp. 119-120.]

M1050 "Pictures from the Lava Beds." HARPER'S WEEKLY 17, no. 860 (June 21, 1873): 533. 5 illus. [Modoc Indian War. "From Photographs by Muybridge, furnished by the courtesy of Bradley & Rulofson, San Francisco." (See Peter Palmquist, "Imagemakers of the Modoc War," "Journal of California Anthropology" 4:2 (Winter 1977)]

M1051 "Note." PHILADELPHIA PHOTOGRAPHER 10, no. 115 (July 1873): 201. [Brief note that J. C. [sic] Muybridge has recently issued a new and magnificent series of Yosemite views, 100 16" x 20" size, 100 medium size and 700 stereos.]

M1052 Vogel, Dr. H. "German Correspondence." PHILADELPHIA PHOTOGRAPHER 11, no. 122 (Feb. 1874): 53. [Muybridge landscapes, Kilburn stereos mentioned favorably by Vogel in his monthly column.]

M1053 "Talk in the Studio: A Horse Photographed at Full Speed." PHOTOGRAPHIC NEWS 21, no. 994 (Sept. 21, 1877): 455-456. [Quote from "Daily Alta California."]

M1054 "Set at Rest - The True Action of a Horse in Trotting Determined." ANTHONY'S PHOTOGRAPHIC BULLETIN 9, no. 7 (July 1878): 216-217. [From "Exchange."]

M1055 "The Horse in Motion." ANTHONY'S PHOTOGRAPHIC BULLETIN 9, no. 8 (Aug. 1878): 254. [Anthony Co. announcing receipt of Muybridge's photos of horses in motion... "There can be no doubt about the genuineness of these pictures."]

M1056 Rulofson, Wm. H. "The California Horse - Electric Feat." PHILADELPHIA PHOTOGRAPHER 15, no. 176 (Aug. 1878): 247. [Letter from Rulofson scoffing and condemning the efforts of Muybridge - although Muybridge's name is never mentioned.]

M1057 "Matters of the Month: Photographing a Race Horse." PHOTOGRAPHIC TIMES 8, no. 92 (Aug. 1878): 169-170. [From the "San Francisco Bulletin," June 14.]

M1058 "Automatic Electro-Photography: The Horse in Motion." PHOTOGRAPHIC TIMES 8, no. 92 (Aug. 1878): 176-178. [Extracted from "Resources of California."]

M1059 "Note." ANTHONY'S PHOTOGRAPHIC BULLETIN 9, no. 9 (Sept. 1878): 281. ["We have received...pictures...of the action of a horse running."]

M1060 "Correspondence." ANTHONY'S PHOTOGRAPHIC BULLETIN 9, no. 9 (Sept. 1878): 288. [Letter from Muybridge praising Dallmeyer lenses, which he states enabled him to make his motion study photos. He also states that he had used Dallmeyer lenses "...within the Arctic Circle and under the Equator, at an elevation of 10,000 feet and beneath the waters of our Bay."]

M1061 "California. - Scenes on the North Pacific Coast Railroad. - From the Bay of San Francisco to the Redwood Forest. - From Photographs by Muybridge." FRANK LESLIE'S ILLUSTRATED NEWSPAPER 47, no. 1208 (Nov. 23, 1878): 200-201. 6 illus. [Views, with train..]

M1062 "The Actual Movements of Horses." ANTHONY'S PHOTOGRAPHIC BULLETIN 10, no. 1 (Jan. 1879): 8-9. [From "NY Times," in turn from "San Francisco Call, Dec. 15."]

M1063 "The Horse in Motion." PHILADELPHIA PHOTOGRAPHER 16, no. 181 (Jan. 1879): 22-23.

M1064 Duhousset. "Varietes-Reproduction instantanee des allures du Cheval, au moyen de l'electricite applique a la photographie." L'ILLUSTRATION 73, no. 1874 (Jan. 25, 1879): 58-59. 11 illus.

M1065 Muybridge, E. J. "Photographing Animals in Action." PHILADELPHIA PHOTOGRAPHER 16, no. 183 (Mar. 1879): 71.

M1066 "Note." L'ILLUSTRATION 73, no. 1886 (Apr. 19, 1879): n.p. [Offer to subscribers of a zoetrope of the horse-running sketches of Muybridge for 15 francs, by the magazine.]

M1067 Rogers, Fairman. "The Zoetrope: Action of Animals in Motion -The Muybridge Photographs of Horses- The Instrument as a Factor in Art Studies." ART INTERCHANGE 3, no. 1 (July 1879): 2-3.

M1068 "Letter." PHOTOGRAPHIC TIMES 9, no. 103 (July 1879): 153-154. [Letter to the Scoville Manufacturing Co. praising a camera used in his motion studies printed under title "Fast-horses and well-made apparatus."]

M1069 "Photographing Men in Motion: Instantaneous Pictures of Athletic Exercises." PHOTOGRAPHIC TIMES 9, no. 106 (Oct. 1879): 227-228. [Reprinted from the "San Francisco Chronical."]

M1070 "Matters of the Month: A Running Dog Photographed." PHOTOGRAPHIC TIMES 10, no. 110 (Feb. 1880): 34-35. [Greyhounds photographed by Muybridge, at Stanford's mansion in Menlo Park, Cal. Article also offers a reprise of Muybridge's

experiments with the horse "Occident". "Some two or three years ago."]

M1071 Pettit, H. D. "The Zoetrope Useless to Artists: The Art of Depicting Motion -Is the Zoetrope Useless as an Adjunct to Pictorial Art?- Action Pictorially Considered." ART INTERCHANGE 5, no. 1 (July 7, 1880): 2.

M1072 Taylor, J. Traill. "General Notes." PHOTOGRAPHIC TIMES 12, no. 133 (Jan. 1882): 5. [Muybridge sailed to Europe in August, well-received. Recently entertained at the studio of the artist Meissonier in Paris, meeting a large number of artists and others.]

M1073 "General Notes: Photographing Rowers." PHOTOGRAPHIC TIMES 12, no. 137 (May 1882): 165. [Mr. R. A. Procter suggests in "Knowledge" magazine that Muybridge be hired to photograph the rowing when at Cambridge and Oxford. (I don't think it was ever attempted.)]

M1074 "Muybridge's Photographs." PHOTOGRAPHIC TIMES 12, no. 138 (June 1882): 223. [Note that Muybridge invited to exhibit his photos at the Liverpool Art Club, and soon sailing for America.]

M1075 Waring, George E. "The Horse in Motion. " CENTURY MAGAZINE 24, no. 3 (July 1882): 381-388. 44 illus. [Illustrated with sketches after Muybridge's photographs.]

M1076 Muybridge, Eadweard. "The Attitudes of Animals in Motion." PHOTOGRAPHIC TIMES 12, no. 139 (July 1882): 237-244. [Lecture delivered before the Society of Arts, London.]

M1077 "General Notes." PHOTOGRAPHIC TIMES 12, no. 139 (July 1882): 255. [Muybridge returned from his trip to France and England, plans to engage in a series of lectures in USA on instantaneous photography.]

M1078 "General Notes." PHOTOGRAPHIC TIMES 12, no. 143 (Nov. 1882): 423-424. [Muybridge, returned from his tour of Europe, preparing course of lectures in the U.S. Already lectured before Massachusetts Institute of Technology and the Turf Club of New York. Zoetrope demonstrated.]

M1079 Taylor, J. Traill. "The Zoetrope." PHOTOGRAPHIC TIMES 12, no. 144 (Dec. 1882): 458-459. [Description of the device invented by Milton Bradley similar to that used by Muybridge to present his motion studies.]

M1080 Taylor, J. Traill. "Exposing." PHOTOGRAPHIC TIMES 12, no. 144 (Dec. 1882): 460. [Muybridge used the term "exposer" rather than "shutter" in his recent lecture. Taylor comments on this, concludes that its a more accurate term.]

M1081 "Commercial Matters of the Month: The Muybridge Pictures." PHOTOGRAPHIC TIMES 12, no. 144 (Dec. 1882): 491-492. ["The pictures Mr. Muybridge displayed and his lectures created a furor throughout Great Britain and Continental Europe for which there is no parallel in the history of photography." Includes excerpts from statements from American and European newspapers.]

M1082 Simpson, W. G. "The Paces of the Horse in Art." MAGAZINE OF ART 6, (1883): 198-203. 8 illus. [Discussion of the impact of Muybridge's and Marey's animal locomotion studies on painters and engravers.]

M1083 Armstrong, Walter. "Movement in the Plastic Arts." ART JOURNAL (1883): 17-19, 89-92, 329-331. illus. [Discusses the impact on the visual arts of Muybridge's motion studies.]

M1084 "Photographing the Motion of Birds and Quadrupeds." PHOTOGRAPHIC TIMES 15, no. 205 (Aug. 21, 1885): 483. [From "Philadelphia [PA] Public Ledger" of Aug. 12, 1885. Long report of Muybridge's intentions to photograph in the Zoological Garden.]

M1085 "The Flight of Birds." PHOTOGRAPHIC TIMES 15, no. 206 (Aug. 28, 1885): 501. [From the "Philadelphia [PA] Ledger."]

M1086 Horgan, S. H. "Two Hundred and Eighty-Eight Negatives in Six Seconds." PHOTOGRAPHIC TIMES 15, no. 221 (Dec. 11, l885): 687-688.

M1087 "Editorial Notes." ANTHONY'S PHOTOGRAPHIC BULLETIN 17, no. 19 (Oct. 9, 1886): 580. [Brief note that Muybridge had photographed lions, and that the work was recently displayed at the Philadelphia Academy of Sciences by Dr. Leidy.]

M1088 Williams, Talcott. "Animal Locomotion in the Muybridge Photographs." CENTURY MAGAZINE (SCRIBNER'S MONTHLY) 34, no. 3 (July 1887): 356-368. 8 b & w. 4 illus. [Photo sequences taken from Muybridge's "Animal Locomotion."]

M1089 "Editorial Notes." ANTHONY'S PHOTOGRAPHIC BULLETIN 18, no. 22 (Nov. 26, 1887): 676. [Note that Muybridge claims that a recent statement about his photograph of a rainbow was incorrect; that he had made such photos in 1868. A second note mentions that his book on animal locomotion was at press.]

M1090 "Note." AMERICAN JOURNAL OF PHOTOGRAPHY 8, no. 12 (Dec. 1887): 224. [Reprint from the "San Francisco Evening Bulletin" (Feb 12, 1868) discussing the Yosemite Valley views of "Helios."]

M1091 "Animal Locomotion." ART AMATEUR 18, no. 4 (Mar. 1888): 85. [Studies at Univ. of Pa. discussed.]

M1092 "Notes and News: Animals in Motion." PHOTOGRAPHIC TIMES 18, no. 340 (Mar. 23, 1888): 141. [Muybridge lectured to the Union League Club on March 9th. Used a zoepraxiscope.]

M1093 "Notes and News: Something New." PHOTOGRAPHIC TIMES 18, no. 353 (June 22, 1888): 296. [From "N.Y. World." Eadweard Muybridge visited Thomas Edison, suggested combining the multiple images with Edison's phonograph to produce "Edwin Booth as "Hamlet," Lillian Russell in some of her songs, etc. This scheme met with the approval of Mr. Edison and he intended to perfect it at his leisure.]

M1094 Woodbury, Walter E. "The Photography of Animals and Animal Motion." AMERICAN ANNUAL OF PHOTOGRAPHY AND PHOTOGRAPHIC TIMES ALMANAC FOR 1894 (1894): 237-239. 5 illus. [Brief mention of Muybridge, Anschultz, and Marcy.]

M1095 "The Representation of Action in Photography." PHOTOGRAPHIC TIMES 24, no. 650 (Mar. 2, 1894): 130-133. 1 b & w. 7 illus. [Bk rev: "Action in Art," by William H. Beard. N.Y.: Cassell Publishing Co. Excerpts from the general treatise of aesthetics. Beard discusses Muybridge's photographs in his book.]

M1096 "Photography and Artists." PHOTOGRAPHIC TIMES 24, no. 662 (May 25, 1894): 321. [Commentary about photography revealing new positions of galloping horses.]

M1097 Jenkins, Francis. "Animated Pictures." PHOTOGRAPHIC TIMES 30, no. 7 (July 1898): 289-297. 5 b & w. 10 illus. [Discusses the work of Marey, Muybridge, and Jenkins.]

M1098 Gurtner, H. "Etiénne Jules Marey and Edward Muybridge, Pioneers in Motion Analysis." CIBA SYMPOSIA 4, no. 5-6 (Aug. - Sept. 1942): 1356-1359. 3 b & w. 3 illus.

M1099 Gibson, H. L. "The Muybridge Pictures of Motion." MEDICAL RADIOGRAPHY AND PHOTOGRAPHY. 26, no. 1 (1950): 18-24.

M1100 Newhall, Beaumont. "The George E. Nitzsche Collection of Muybridge Relics." MEDICAL RADIOGRAPHY AND PHOTOGRAPHY 26, no. 1 (1950): 24-26.

M1101 "The Horse in Gallop." IMAGE 1, no. 4 (Apr. 1952): 3. [In 1862, a Lieutenant in the French Army, L. Wachter, wrote a book "Apercus Equestres," that contained drawn illustrations of a horse's movements that were then considered incorrect, but it was later born out by Muybridge's experiments.]

M1102 Newhall, Beaumont. "Muybridge and the First Motion Picture: THe Horse in the History of the Movies." IMAGE 5, no. 1 (Jan. 1956): 4-11. 3 b & w. 3 illus.

M1103 Scharf, Aaron. "Painting, Photography, and the Image of Movement." BURLINGTON MAGAZINE 104, no. 710 (May 1962): 186-195. 18 illus. [Discusses the work of Muybridge, and that of E. Marey.]

M1104 Homer, William I. "Letters: Concerning Muybridge, Marey, and Seurat." BURLINGTON MAGAZINE 104, no. 714 (Sept. 1962): 391-393. 1 b & w. 1 illus.

M1105 Homer, William I., with John Talbot. "Eakins, Muybridge and the Motion Picture Process." ART QUARTERLY 26, (1963): 194-216. 16 illus.

M1106 Hood, Mary V. Jessup and Robert Bartlett Haas. "Eadweard Muybridge's Yosemite Valley Photographs 1867-1872." CALIFORNIA HISTORICAL QUARTERLY 42, no. 1 (Mar. 1963): 5-26. 16 b & w.

M1107 Hendricks, Gordon. "A May Morning in the Park." BULLETIN OF THE PHILADELPHIA MUSEUM OF ART 60, no. 285 (Spring 1965): 48-64. 16 illus. [Discusses the influences of Muybridge's motion studies on Thomas Eakins' painting "A May Morning in the Park."]

M1108 Graham, Dan. "Muybridge Moments: From Here to There?" ARTS MAGAZINE 41, no. 4 (Feb. 1967): 23-24. 1 b & w.

M1109 Witthoft, Brucia. "'Tonio Kroger' and Muybridge's 'Animals in Motion'." MODERN LANGUAGE REVIEW 62, no. 3 (July 1967): 459-461.

M1110 Hamilton, Harlan. "'Les Allures du Cheval': Eadweard James Muybridge's Contribution to the Motion Picture." FILM COMMENT 5, no. 3 (Fall 1969): 16-35. 1 b & w. 10 illus. [Contains an extensive four-page bibliography. Primary emphasis on Muybridge's contributions to motion studies.]

M1111 Pajunen, Timo Tauno. "Eadweard Muybridge." CAMERA (LUCERNE) 52, no. 1-2 (Jan. - Feb. 1973): 33-44, 41-43. 8 b & w.

M1112 Frampton, Hollis. "Eadweard Muybridge: Fragments of a Tesseract." ARTFORUM 11, no. 7 (Mar. 1973): 43-52. 30 illus.

M1113 Bell, Geoffrey. "The First Picture Show." CALIFORNIA HISTORICAL QUARTERLY 54, no. 2 (Summer 1975): 125-138. 9 illus. [Describes Leland Stanford's and Eadweard Muybridge's experimental work from 1878 to 1880. Contains bibliography.]

M1114 Palmquist, Peter E. "Imagemakers of the Modoc War: Louis Heller and Eadweard Muybridge." JOURNAL OF CALIFORNIA ANTHROPOLOGY 4, no. 2 (Winter 1977): 206-241. 25 b & w. 4 illus. [Includes a summary of events of the Modoc War in 1872-73, biographies of L. H. Heller and E. J. Muybridge, a discussion of the photographic coverage of the conflict, a catalogue and notes on the Modoc War photographs, and a portfolio of photographs and five full-page spreads -from "Harper's Weekly"- of articles illustrated with engravings taken from these photographs. Comments on how the photographs were altered in the magazine, and how they were misattributed.]

M1115 "Portfolios on View." G. RAY HAWKINS GALLERY PHOTO BULLETIN 1, no. 1 (Jan. 1978): 2. [Portfolio notice: "Yosemite Photographs 1872 by Eadweard Muybridge," printed by the Chicago Albumen Works. 10 prints, Edition 300, $1,500.00.]

M1116 Falconer, Paul A. "Muybridge's Window to the Past: A Wet-Plate View of San Francisco in 1877." CALIFORNIA HISTORY 57, no. 2 (Summer 1978): 130-157. 19 b & w. 5 illus.

M1117 Fischer, Hal. "Eadweard Muybridge." ARTWEEK 9, no. 28 (Aug. 26, 1978): 11-12. 1 b & w. [Ex. rev.: Stephen Wirtz Gallery, San Francisco.]

M1118 Kantor, J. R. K. "From the University of California Archives - Muybridge Views of Berkeley in 1874." CALIFORNIA HISTORY 57, no. 4 (Winter 1978 - 1979): 376-381. 7 b & w.

MUYBRIDGE, EADWEARD. [?].
M1119 Wells, Harry L. "The Massacre of the Peace Commissioners." COSMOPOLITAN 11, no. 6 (Oct. 1891): 723-731. 13 illus. [Engravings from photographs. A history of the Modoc Indians.]

MYERS.
M1120 Portrait. Woodcut engraving, credited "From a Photograph by Myers." FRANK LESLIE'S ILLUSTRATED NEWSPAPER 47, (1879) ["The late John Vassar, missionary." 47: 1214 (Jan. 4, 1879): 305.]

MYERS, CARL. (MOHAWK, NY)
M1121 Myers, Carl. "Distortion in Photographic Prints." PHILADELPHIA PHOTOGRAPHER 13, no. 147 (Mar. 1876): 86-87. [Myers, from Mohawk, NY, discussions types of distortions caused by different lenses.]

N

R. N.

N1 R. N. "Photography Afloat." HUMPHREY'S JOURNAL OF PHOTOGRAPHY, AND THE ALLIED ARTS AND SCIENCES 20, no. 8 (Aug. 15, 1868): 115-118. [From "Br. J. of Photo." "As I have now practiced for a year on board ship, and have found the monotony of long sea voyages greatly enlivened by this amusement...."]

NADAR. [GASPARD-FÉLIX TOURNACHON] (1820-1910) (FRANCE)

[Born on April 6, 1820 in Paris. In the 1830s he studied medicine, worked in a bookshop, wrote essays and satiric commentaries for the many small newspapers and literary journals of the day. He was called Tournadar or Nadar, for his biting satire. In 1839 he founded the periodical *Le Livre d'Ore*. Worked in the theatre. Nadar played an active role in the literary and political ferment which ran through the creative mileau of Paris at this time. In 1842 he joined *Le Commerce*. In 1848 he signed a five year contract with *Le Charivari*, founded the *Revue Comique*, and published caricatures in the *Journal pour Rire*. In 1854 he published the huge lithograph "Le Panthéon Nadar," which brought him fame. That same year he began to study photography with Camille d'Arnaud, and while still actively writing and publishing, opened a photography studio. His studio quickly became a center of the Paris intelligentsia and beau-monde and his portraits were recognized then, as they are now, as having an extraordinary quality. In 1856 he founded *Le Petit Journal pour Rire* and wrote *Quand j'etais étudiant*, (Paris: Michel Lévy, 1856). He became a member of the Société française de Photographie. In 1857 he experimented with electric lighting, and later opened the *Salon of electric photography*. In 1858 Nadar combined his passion for ballooning with photography when he took the first aerial photograph from his balloon *Le Géant*. Throughout the 1860s and 1870s he wrote several books on ballooning and other topics - *A Terre et en l'Air*, *Mémoires du Géant*, (Paris: E. Dentu, 1863), *Le Droit au Vol*, (Paris: Cassell, 1865), *Les Ballons en 1870...*, (Paris: Chatelain, 1870), *Le Guide de l'Aéronaute*, (Paris, 1870). In 1860 he opened several branch studios in Paris and in Marseilles. In 1861 he photographed the sewers and catacombs of Paris. In 1870 he organized the carrier-pigeon and microphotography system to deliver messages out of the besieged city. His son Paul became the director of the family business by 1874, and the head of the firm by 1886. A fourth studio is opened in Marseille in 1896. Throughout this Nadar continued to author books of satire and commentary. In 1900 his autobiography *Quand j'etais photographe*, (Paris, Flammarion) was published. In 1911 he published *Charles Baudelaire Intime*, (Paris: Ed. Blaizot). Died March 21, 1910.]

BOOKS

N2 *Nadar*. Vol. 1 *Photographies*; Vol. 2 *Dessins et écrits*. Prefaces and commentaries by Jean-François Bory, Philippe Néagu, and Jean-Jacques Poulet-Allamagny. Paris: A. Hubschmid, 1979. 2 vol. illus.

PERIODICALS

N3 Portrait. Woodcut engraving credited "From a photograph by Nadar." ILLUSTRATED LONDON NEWS 36, (1860) ["Philarete Chasles." 36:* (Apr. 14, 1860): 361.]

N4 Lacan, Ernest. "Foreign Correspondence." BRITISH JOURNAL OF PHOTOGRAPHY 8, no. 136 (Feb. 15, 1861): 76. [Lacan describes an experiment "(to apply) the electric light to photography " in Nadar's new studio.]

N5 "Useful Facts, Receipts, Etc.: The Japanese Ambassadors." AMERICAN JOURNAL OF PHOTOGRAPHY AND THE ALLIED ARTS & SCIENCES n. s. vol. 5, no. 9 (Nov. 1, 1862): 210. [Japanese ambassadors visiting Nadar's studio in Paris. One of the Japanese drew a portrait of Nadar, who in turn drew his.]

N6 "Nadar's Giant Balloon at Paris." ILLUSTRATED LONDON NEWS 43, no. 1226 (Oct. 10, 1863): 376-377. 1 illus.

N7 "Mr. Nadar, a celebrated Parisian photographer has distinguished himself as an aeronaut..." JOURNAL OF THE PHOTOGRAPHIC SOCIETY OF LONDON 8, no. 138 (Oct. 15, 1863): 383. [Description of Nadar's balloon "Le Geant," with an extract from "Br. J. of Photo." on page 384 on same subject.]

N8 "The Giant Balloon." FRANK LESLIE'S ILLUSTRATED NEWSPAPER 17, no. 423 (Nov. 7, 1863): 100. 1 illus. [The balloon, "Le Geant." Illustration is of the balloon in flight.]

N9 "The French Balloon 'Le Geant' Sweeping Along the Earth Near Nienburg - The Balloon Caught in a Forest." HARPER'S WEEKLY 7, no. 362 (Dec. 5, 1863): 773-774. 2 illus. [2 engravings of Nadar's balloon Le Geant being dragged along the ground and destroyed. Dramatic drawings.]

N10 "The Car of Nadar's Balloon at the Crystal Palace." ILLUSTRATED LONDON NEWS 43, no. 1235 (Dec. 12, 1863): 585-586. 1 illus.

N11 "The Catacombs of Paris." HARPER'S WEEKLY 9, no. 468 (Dec. 16, 1865): 788. 2 illus. ["...recently illuminated by the electric light, that M. Nadar might obtain the photographs from which our engravings are taken."]

N12 Houssaye, Arsène. "Personnalités Contemporaines: Nadar." L'ARTISTE ser. ? vol. 1, no. 1 (Jan. 15, 1866): 37-38.

N13 Vogel, Dr. H. "Paris Correspondence." PHILADELPHIA PHOTOGRAPHER 4, no. 41 (May 1867): 152-153.

N14 Portrait. Woodcut engraving credited "From a photograph by Nadar." ILLUSTRATED LONDON NEWS 55, (1869) ["Berlioz, musical composer." 55:* (Apr. 3, 1869): 345.]

N15 "The Balloon and Pigeon Posts." CHAMBERS'S JOURNAL OF POPULAR LITERATURE, SCIENCE, AND ART Ser. 4, no. 375-376 (Mar. 4 - Mar. 11, 1871): 129-134, 154. ["Such was the state of affairs when Nadar, the well-known photographer and aeronaut, turned his attention towards inaugurating a system of balloons..." (p. 129). "...it was decided that an arrangement should be made with M. Dagron, the eminent photographer...to undertake the photographic reduction of the messages." (p. 154).]

N16 Darcel, Alfred. "Les Musèes les arts et les artistes: Pendant la Commune. Part 6." GAZETTE DES BEAUX-ARTS ser. 2 vol. 5, (May 1, 1872): 398-418. [Includes a letter from Nadar, plus commentary, on pp. 408-409.]

N17 Lacan, Ernest. "Photography in France." PHILADELPHIA PHOTOGRAPHER 11, no. 122 (Feb. 1874): 43-46.

N18 Lacan, Ernest. "Note." PHILADELPHIA PHOTOGRAPHER 11, no. 126 (June 1874): 179. [Lacan's column states that "a few days ago" Nadar was planning to take photographs from his balloon.]

N19 1 engraving (Victor Hugo) as frontispiece. HARPER'S MONTHLY 64, no. 381 (Feb. 1882): 322. 1 illus. ["After a photograph by Nadar."]

N20 "Notes and News." PHOTOGRAPHIC TIMES 21, no. 503 (May 8, 1891): 224. [Nadar of Paris announces an illustrated monthly photographic review, the first number of which will shortly appear. It is to be entitled "Paris Photographe."]

N21 1 engraving (George Sand.). CENTURY MAGAZINE 47, no. 3 (Jan. 1894): 456. 1 illus. ["...Photographed by Nadar."]

N22 Bernhardt, Sara. "The Art of Making Up." COSMOPOLITAN 20, no. 5 (Mar. 1896): 530-532. 6 b & w. [Portraits of the actress credited "Reutlinger, Paris" (2); "Nadar, Paris" (3); and "Falk, Sydney" (1).]

N23 16 photos on one plate ("Actors at the Comedie-Française"). WILSON'S PHOTOGRAPHIC MAGAZINE 33, no. 473 (May 1896): unnumbered leaf following p. 240. 16 b & w.

N24 20 photos on one plate ("Poses de Fantaisie") WILSON'S PHOTOGRAPHIC MAGAZINE 33, no. 475 (July 1896): unnumbered leaf following p. 304. 20 b & w. [Brief note on p. 325]

N25 "Nécrologie: Félix Tournachon." LA CHRONIQUE DES ARTS ET DE LA CURIOSITE 1910, no. 13 (Mar. 26, 1910): 102.

N26 "Nécrologie." L'ART ET LES ARTISTS 11, no. 61 (1910): 92.

N27 "Pioneers of the Camera." ART DIGEST 6, (Dec. 15, 1931): 6. [Ex. Rev.: "Atget and Nadar," Julian Levy Gallery, New York, NY.]

N28 Four or more photos, on pp. 4-5 in: MINOTAURE no. 3/4 (1933) [This copy damaged, accurate count not possible.]

N29 San Lazzaro, G. di. "I Nadar." EMPORIUM 81, no. 484 (Apr. 1935): 232-239. 7 b & w.

N30 Bisson, George. "La Leçon de Nadar." LE POINT no. 23 (1942): 36-45. 7 b & w. 1 illus.

N31 Kinzer, H. M. "Nadar père et fils." POPULAR PHOTOGRAPHY 29, no. 5 (Nov. 1951): 81-93, 126. 18 b & w.

N32 "An 1886 Photo Interview." IMAGE 2, no. 6 (Sept. 1953): 36-37. 7 b & w.

N33 Grimmer, G. "Essais Nadariens. I. Vers le cinquantenaire de Nadar." LE VIEUX PAPIER 21, no. 170 (Jan. 1955): 111-123. 5 illus.

N34 Grimmer, G. "Essais Nadariens. II. La famille Tournachon." LE VIEUX PAPIER 21, no. 172 (July 1955): 157-165. 5 illus.

N35 Schneider, Pierre. "The Many-Sided Nadar." ART NEWS ANNUAL 1956 25, (1956): 56-72. 9 b & w. 22 illus.

N36 Grimmer, G. "Essais Nadariens. III. Nadar Ecrivain." LE VIEUX PAPIER 21, no. 174 (Jan. 1956): 225-234. 5 illus.

N37 Schneider, P. "Nadar au Zénith." PREUVES 77, no. 1 (1957): 20-27.

N38 Schwarz, Heinrich. "Daumier, Gill and Nadar." GAZETTE DES BEAUX-ARTS ser. 6 vol. 49, no. 1057 (Feb. 1957): 89-106. 12 b & w. 5 illus.

N39 Schneider, Pierre. "Nadar. Photograph, Luftschiffer und Tausendsassa." DER MONAT 9, no. 107 (Aug. 1957): 76-83. 5 b & w. 1 illus.

N40 Maincent, Paul. "Catalogue de l'oeuvre éditée de Nadar." LE VIEUX PAPIER 22, no. 182 (Jan. 1958): 19-26.

N41 "Pictures from the Collection - Eastman meets Nadar - March 1890." IMAGE 7, no. 7 (Sept. 1958): 164-165.

N42 Veronesi, G. "Nadar." FERRANIA 14, no. 10 (1960): 12-17.

N43 Braive, Michel-François and Emmanuel Sougez. "Nadar." CAMERA (LUCERNE) 39, no. 12 (Dec. 1960): 11-37. 21 b & w.

N44 Racanicchi, Piero. "Felix Nadar." POPULAR PHOTOGRAPHY ITALIANA no. 57 (Mar. 1962): 41-48. 26 b & w.

N45 Detaille, Albert. "Nadar marseillais." LES CONFÉRENCES DE L'INSTITUT HISTORIQUE DE PROVINCE (MARSEILLE) 42, no. 4 (1964): 166-167.

N46 Prinet, Jean. "Nadar 1820-1910." BULLETIN DE LA SOCIETÉ DES AMIS DU MUSÉE DE DIJON (1964-1966): 74-79.

N47 Braive, Michel-François. "Nadar aéronaute." CONNAISSANCE DU MONDE n. s., no. 77 (1965): 22-30.

N48 Detaille, Albert. "Nadar à Marseille." MARSEILLE ser. 3, no. 60 (1965): 37-40.

N49 Hemmerdinger, Bertraud. "Nadar et Jules Verne." BELFAGOR 20, no. 1 (1965): 102-107.

N50 Adhémar, Jean. "Notes et Documents: Sur Nadar à propos de l'exposition de la Bibliothéque Nationale." NOUVELLES DE L'ESTAMPE 1965, no. 7 (July 1965): 227-230.

N51 Kunstler, Charles. "Nadar et les Catacombes." GAZETTE DES BEAUX-ARTS ser. 6 vol. 66, (July - Aug. 1965): 91-96. 4 b & w.

N52 Detaille, Albert. "Jules Verne et Nadar." MARSEILLE ser. 3, no. 67 (1967): 35-38.

N53 Scharf, Aaron. "Album - Who was Nadar?" CREATIVE CAMERA no. 41 (Nov. 1967): 288-289. illus.

N54 Richardson, Joanna. "Nadar: a Portrait." HISTORY TODAY 24, no. 10 (Oct. 1974): 710-715. 3 b & w. 4 illus.

N55 Kozloff, Max. "Nadar and the Republic of Mind." ARTFORUM 15, no. 1 (Sept. 1976): 28-39. 11 b & w. 1 illus.

N56 Nadar, trans. by Thomas Repensek. "My Life as a Photographer." OCTOBER no. 5 (Summer 1978): 6-28. 4 b & w.

N57 Krauss, Rosalind. "Tracing Nadar." OCTOBER no. 5 (Summer 1978): 29-47. 6 b & w. 1 illus. [4 b & w by Nadar, 2 by others.]

N58 Jammes, André. "Duchenne de Boulogne, La Grimace Provoquée et Nadar." GAZETTE DES BEAUX-ARTS ser. 7 vol. 92, no. 1319 (Dec. 1978): 215-219. 8 b & w.

N59 Reynes, Geneviève. "Chevreul Intervievré par Nadar, Premier Document Audiovisuel (1886)." GAZETTE DES BEAUX-ARTS ser. 7

vol. 98, no. 1354 (Nov. 1981): 155-184. 60 b & w. 1 illus. [Article contains the text of this 1886 interview between Michel-Eugene Chevreul and Nadar, on photography, ballooning, and color theory.]

N60 Keller, Ulrich. "Nadar as Portraitist. A Photographic Career Between Art and Industry." GAZETTE DES BEAUX-ARTS (Apr. 1986): 133-156. 27 b & w. 2 illus. [Same issue contains "Propositions pour une thématique des portraits photographiques par Nadar," by Jean Adémar, on pp. 157-162 and "Quelques photographies commentées," on pp. 163-178, with an additional eighty-one portraits.]

N61 Sharf, Aaron. "Who was Nadar?" CREATIVE CAMERA (Nov. 1987): 289.

NADAR JEUNE. [TOURNACHON, ADRIEN] (1825-1903) (FRANCE)

[Born in Paris on Aug. 25, 1825, the illegitimate younger brother of Félix Tournachon (Nadar). His brother encouraged him to learn photography with Gustave Le Gray in 1854. Adrien worked with Jules Lefort, then with J.- P. Johannes, then by himself. Adrien was considered skilled but careless by his peers and apparently found difficulties in coping with his older brother's reputation. The brothers worked together occasionally, but tended not to get along, and in 1857 Félix finally brought a lawsuit against Adrien to force him to stop using the pseudonym "Nadar jeune." Adrien became a member of the Société française de Photographie in 1855. Photographed the mime Charles Debureau in 1854, made some pathological photographs for Dr. Duchenne de Boulogne, photographed prize animals at agricultural fairs in 1856 and 1860, and street carnival performers in 1861. In 1860s Adrien gambled heavily, lost his studio. Apparently he continued this sort of life for the next twenty years. In 1880 he went mad, and was confined to the Galignani Foundation at Neuilly in 1889. In 1902 he went on a rampage and was turned out of the institution. When he was found three days later he had to be hospitalized. He died in Paris in 1903.]

N62 "Note." JOURNAL OF THE PHOTOGRAPHIC SOCIETY OF LONDON 3, no. 43 (June 21, 1856): 73. ["The prize animals of the Agriculture Show at Paris...all taken by photography (M. Adrien Tournachon is the artist chosen)..."]

N63 Portrait. Woodcut engraving credited "From a photograph by Nadar, Jun." ILLUSTRATED LONDON NEWS 43, (1863) ["Horace Vernet." 43:* (Jan. 31, 1863): 125. Paris, FR.]

NADAR, PAUL [PAUL TOURNACHON]. (1856-1939) (FRANCE)

[Born Feb. 8, 1856 in Paris. Son of Félix Tournachon (Nadar). In 1874 he took over the management of the Nadar studio in Paris. Additional references about Paul Nadar will be located in volume two of this work.]

N64 "Hypo". "Interviewing by Photography." PHOTOGRAPHIC TIMES 16, no. 263 (Oct. 1, 1886): 520. [Discusses photo interview of Prof. Chevreul by Paul Nadar in the Sept. 5, 1886 issue of "Le Journal Illustre".]

N65 "Views Abroad and Across." WILSON'S PHOTOGRAPHIC MAGAZINE 37, no. 524 (Aug. 1900): 353-357. 26 b & w. [Second half of article devoted to "what Parisian photographers are doing..." Includes 26 postage stamp sized portraits, selected by Nadar Fils, himself, as representative of the work of the studio.]

N66 "An 1886 Photo Interview." IMAGE 2, no. 6 (Sept. 1953): 36-37. 7 b & w. [Interview with French scientist Marie Eugene Chevreul. Photos by Paul Nadar, interview conducted by Nadar.]

NAPIAS, H. (FRANCE)

[Dr. H. Napias was the Medical Adviser to the French Photographic Benevolent Society.]

N67 Napias, Dr. H. *Sanitary Hints to Photographers.* London: Piper & Carter, 1874, n. p. [Papers from "Moniteur de la Photographie," translated and published in "Photographic News."]

NASMYTH, JAMES. (1808-1890) (GREAT BRITAIN)
BOOKS
N68 Nasmyth, James and James Carpenter. *The Moon: considered as a Planet, a World, and a Satellite. With twenty-four illustrative plates of lunar objects, phenomena, and scenery* London: John Murray, 1874. n. p. 71 illus. [46 wood engravings, 2 lithographs, 1 chromolithograph, 4 autotypes, 13 Woodburytypes, and 5 photogravure plates were used to illustrate yhis work. Another ed. (1885) New York: Scribner & Welford, contains 24 Woodburytype illus.]

PERIODICALS
N69 Crosswhite, Terry. "Photographer of a Model Moon. James Nasmyth 1808 - 1890." NORTHLIGHT [TEMPE, AZ] no. 7 (Nov. 1977): 10-12. [James Nasmyth was born in 1808 in Edinburgh, the son of Alexander Nasmyth, a noted portrait and landscape painter. Displayed a mechanical genius, began to work in an iron foundry at age 13, was constructing models for steam engines by age 17, and built a six-passenger steam carriage at 19. Opened his own workshop at age 23, patenting several inventions, including a steam hammer. Also interested in astronomy. One of Nasmyth's steam hammers was used in the construction of the "Great Eastern" and Nasmyth met and befriended F. H. Wenham there. Nasmyth retired in 1856 at age 48, and turned his attention to astronomy. In 1874 Nasmyth and James Carpenter published the book "The Moon" which was illustrated with photographs of the moon and of a very precise model of the moon created from photographs.]

NATTERER. (VIENNA, AUSTRIA)
[Josef and Johann Natterer were brothers, both born in Vienna. In the 1840s they became part of a group of researchers, artists, and amateurs interested in daguerreotypy in Vienna, along with Carl Schuh, Andreas von Ettingshausen, Joseph Petzval, and others. Their experiments helped find faster chemicals, and sped up exposure times. In 1852 Joseph announced a formula for fixative made from cyanide of potassium. Joseph, a naturalist and traveller, died in Khartoom in 1862. Johann, a doctor, and a municipal councillor in Vienna in 1861 and 1869, retired from medicine in 1874 and died in Vienna in 1900.]

N70 "Daguerreotypes without Mercury." HUMPHREY'S JOURNAL 4, no. 15 (Nov. 15, 1852): 238. [From "Scientific American."]

NATTERER, JOHANN. (1821-1900) see NATTERER.

NATTERER, JOSEF. (1819-1862) see NATTERER.

NAUDIN, ADOLPH. (LONDON, ENGLAND)
N71 "Our Editorial Table: Naudin's Portfolio, edited by Hamilton Hume." BRITISH JOURNAL OF PHOTOGRAPHY 11, no. 238 (Nov. 25, 1864): 475. [Naudin (124 Brompton Rd, London) proposes to

publish a monthly portfolio illustrated with original photographs. Portraits of celebrities and houses.]

NAVEY. (LEEDS, ENGLAND)

N72 Portrait. Woodcut engraving credited "From a photograph by Navey, of Leeds." ILLUSTRATED LONDON NEWS 34, (1859) ["George S. Beecroft, M.P." 34:* (Feb. 19, 1859): 189.]

NAYA, CARLO. (1816-1882) (ITALY)

[Born at Tronzano di Vercelli in Italy in 1816. Studied law at the University of Pisa, then traveled throughout Europe, Asia and Africa. In 1839 he purchased some daguerreotype equipment while visiting Paris. Returned to Italy permanently in 1857, opened a optical instrument shop and photographic studio in Venice. From 1857 to 1868 he works with Carlo Ponti, who published his photographs. In 1866 Ponti published his views, *Ricordi di Venezia*. In 1867 he began to systematically document the restoration of the Scrovegni Chapel at Padua. Business break with Ponti in 1868. Died in Venice in 1882. The studio is run by a succession of individuals through the 1890s.]

BOOKS

N73 Zannier, Italo. *Venice, The Naya Collection.* Foreword by Alberto Moravia. Venice: O. Bôhm, Publishers, 1981. 151 pp. 100 b & w. illus. [Zannier's essay, "Carlo Naya and a Photographic Collection," on pp. 15-32, offers an extensive discussion of the early history of photography in Venice, a thorough survey of Naya's career, and an estimation of Naya's role in this history.]

PERIODICALS

N74 Buerger, Janet E. "Carlo Naya: Venetian Photographer. The Archaeology of Photography." IMAGE 26, no. 1 (Mar. 1983): 1-18. 29 b & w. [Article documents exhibition: "Naya's Italy," IMP/GEH, Rochester, NY, March 11 - May 29, 1983.]

NEFF, L. S. (BELLEVILLE, IL)

N75 "Neff's Advertising Cards." ANTHONY'S PHOTOGRAPHIC BULLETIN 3, no. 1 (Jan. 1872): 423. [Neff from Belleville, IL.]

NEFF, PETER, JR. (1827-1903) (USA)

N76 Seely, Charles A. "Editorial Department." AMERICAN JOURNAL OF PHOTOGRAPHY AND THE ALLIED ARTS & SCIENCES n. s. vol. 5, no. 9 (Nov. 1, 1862): 216. [Discusses the flourishing condition of the melainotype in the USA and attributes this to the hard work of its practitioner, Peter Neff, Jr.]

N77 [Advertisement.] "Melainotype Plate Manufactory of Peter Neff, Jr." AMERICAN JOURNAL OF PHOTOGRAPHY AND THE ALLIED ARTS & SCIENCES n. s. vol. 5, no. 12 (Dec. 15, 1862): unpaged leaves i-ii, followed p.288. 1 illus. [Woodcut of Neff's factory in Gambier, OH, with advertising copy on p. ii.]

NEGRE, CHARLES. (1820-1880) (FRANCE)

[Born on May 9, 1820 in Grasse, Provence. Studied art under Sébastien Pezetti, then in Paris in 1839, under Paul Delaroche. Negre would later study under Michel Drolling and Dominique Ingres. His paintings, exhibited each year in the Paris Salons from 1843 to 1853, drew a measure of critical praise and several gold medals. He began to make daguerreotypes in 1844. In 1847 he registered a formula for shortening exposures for the daguerreotype. Began working with the calotype in 1849. Photographed Chartres, market scenes, and street scenes in 1851. In 1852 he became the professor of drawing at the Ecole Supérieure de Commerce de Paris. Began an extensive documentation of more than 200 photographs of the monuments in the Midi, in the south of France. Only part of these published in *Midi de la France.* (Paris: Goupil & Vibert, 1854). In 1854 worked with

Niépce de Saint Victor's photogravure process. Commissioned by the government in 1855 to document Chartres Cathedral and its sculptures. Photographed and reproduced the work of Horace Vernet in 1857. In 1858 photographed artworks in the Louvre, and, in 1859, photographed the Imperial Asylum for disabled workmen in Vincennes. Moved to Nice in 1861 for his health, where, in 1863, he opened a studio. He also taught drawing at the Lycée Impérial. Published *De la gravure héliographique, son utilité, son origine, son application à l'étude de l'histoire des arts et des sciences naturelles.* (Nice: V. E. Gauthier, 1867), and *Monographie de la Cathédral de Chartres.* (Paris: Lassus, 1867). In 1871 he made sixty-four photogravure reproductions of L. Vigne's photographic views of the Dead Sea, for the book *Voyage d'exploration à la Mer Morte, à Petra et sur la rive gauche du Jourdain,* by the Duc de Luynes. (Paris: Arthur Bertrand, 1871-1875). Died on Jan. 16, 1880 in Grasse.]

BOOKS

N78 Borcoman, James. *Charles Negre. 1820-1880* Ottawa: National Gallery of Canada, 1976. 262 pp. 203 b & w.

N79 *The Painter as Photographer: David Octavius Hill, Auguste Salzmann, Charles Negre:* Works from the National Gallery of Canada, introduction by James Borcoman. Vancouver, B.C.: Vancouver Art Gallery, 1978. 8 pp. 8 l. of plates. b & w. [Exhibition: Vancouver Art Gallery, Dec. 9, 1978-Jan. 14, 1979.]

PERIODICALS

N80 "M. Negre's Process of Photo-Engraving." AMERICAN JOURNAL OF PHOTOGRAPHY, AND THE ALLIED ARTS AND SCIENCES n. s. vol. 9, no. 10 (May. 1, 1867): 216-217. [From "Photo. News."]

N81 Jammes, André. "Charles Nègre. Photographe (1820-1880)." VIEUX PAPIER 23, no. 204 (July 1963): 347-355. 3 b & w.

N82 Heilbrun, Françoise. "Charles Nègre, et la photographie d'architecture." MONUMENTS HISTORIQUES (PARIS) no. 110 (1980): 19-22. 2 b & w.

N83 Bléry, Ginette. "Charles Nègre: Un peintre passionné de photographe." PHOTO CINÉ REVUE (June 1980): 310-315. 7 b & w.

N84 "Tresor: le fonds Charles Nègre: le créateur de l'instantané (1851) nous donne la nostalgie du 'Midi' disparu." PHOTO (PARIS) no. 156 (Sept. 1980): 54-59, 91, 95. 8 b & w.

N85 Lesco, Diane. "'Il faut être de son temps': Charles Nègre as Painter-Photographer in Mid-Nineteenth-Century France." ARTS MAGAZINE 56, no. 1 (Sept. 1981): 131-135. 3 b & w. 10 illus.

NEGRETTI & ZAMBRA. (LONDON, ENGLAND)

[Henry Negretti was born in Como, Italy in 1818. He became a merchant, maker of scientific instruments and photographic equipment, and photographer of portraits and landscape views. Joseph Zambra was born in 1822. In 1850 they formed a partnership. The company constructed and sold optical and photographic equipment, and published stereo views and cartes-de-visite. The company made the optical and meteorological instruments for the Royal Observatory at Greenwich and for the Admiralty. In 1853 they became the official photographers of the Crystal Palace Company, at Sydenham, and opened a second studio there. Published and sold the work of Walter B. Woodbury from Java and the Far East. Published Delamotte's views of the Crystal Palace. Financed Francis Frith's voyages to Egypt and the Near East in the 1850s, and published stereo views and larger prints of this work. In 1863 Negretti photographed

from a balloon over Sydenham. Negretti died on September 28, 1879.]

BOOKS

N86 Negretti & Zambra. *A Catalogue of Photographic Apparatus, manufactured and made by Negretti & Zambra.* London: Negretti & Zambra, 1859. n. p.

N87 Negretti & Zambra. *A Descriptive Catalogue of Stereoscopes and Stereoscopic Views, manufactured and published by Negretti & Zambra.* London: Negretti & Zambra, 1859. n. p.

N88 Westfield, Thomas Clark. *The Japanese, Their Manners and Customs, with an Account of the General Characteristics of the Country, Its Manufactures and Natural Productions.* London: Photographic News Office, 1861. 53 pp. 6 l. of plates. 6 b & w. [Stereoscopic views by Negretti & Zambra.]

N89 Negretti & Zambra. *Practical Photography on Glass and Paper.* Part II: Containing Clear Directions for the Practice of Various Dry Processes on Glass and Paper; the Manufacture of Collodion, &c; Enlarging Processes; Permanent Printing Processes, &c. London: Negretti & Zambra, 1864. viii, 72 pp.

PERIODICALS

N90 "The Horticultural Fete at the Crystal Palace." ILLUSTRATED LONDON NEWS 26, no. 746 (June 9, 1855): 548-549, 582. 3 illus. [Views, interior - "From a photograph by Negretti & Zambra."]

N91 "Note." JOURNAL OF THE PHOTOGRAPHIC SOCIETY OF LONDON 3, no. 43 (June 21, 1856): 73. ["...succeeded in taking stereoscopic views of the ceremony of the inauguration by the Queen of the Peace trophy and Scutari monument at the Crystal Palace."]

N92 "The Great Handel Festival at the Crystal Palace." ILLUSTRATED LONDON NEWS 30, no. 865 (June 27, 1857): 630-631, 640. 1 illus. ["From a Photograph by Negretti & Zambra." Additional illus., probably from a photo, of a large drum used at the festival, on p. 627.]

N93 "Note." ART JOURNAL (Nov. 1858): 347. [Stereo slides of day and night effects produced by Negretti & Zambra, London, Eng.]

N94 "Note." ART JOURNAL (Apr. 1859): 126. [Note about use of photographic dissolving views.]

N95 "Critical Notices - Photographs from the Philippine Islands. London: Negretti & Zambra." PHOTOGRAPHIC NEWS 3, no. 61 (Nov. 4, 1859): 99-100.

N96 "Critical Notices: Stereograms from China - Stereoscopic views of China from Negatives taken by the Wet Collodion Process by Messrs. H. Negretti and Zambra. Published by Negretti & Zambra." PHOTOGRAPHIC NEWS 3, no. 62-63 (Nov. 11 - Nov. 18, 1859): 110-112, 124-126.

N97 "Critical Notices: The Bijou Stereoscope. By Negretti & Zambra." PHOTOGRAPHIC NEWS 3, no. 67 (Dec. 16, 1859): 174.

N98 "The Taal Volcano in the Philippine Islands." ILLUSTRATED LONDON NEWS 36, no. 1015 (Feb. 4, 1860): 109. 1 illus. ["Some time since Messrs. Negretti & Zambra, with an amount of enterprise for which they deserve the thanks of the public, dispatched a representative of their firm to China and Japan..." (This was Walter Woodbury.)]

N99 Portrait. Woodcut engraving credited "From a photograph by "Talk in the Studio: Photographs from Japan." PHOTOGRAPHIC NEWS 4, no. 109 (Oct. 5, 1860): 276. ["A case of rare and curious photos of the scenery of this interesting country, and illustrative of the manners & customs ... executed by a special artist sent out by ... firm of Negretti and Zambra, expected by the Peninsular & Oriental Company's steam ship 'Ceylon' which will arrive at Southhampton on Wedn." From the "Times."]

N100 Negretti & Zambra." ILLUSTRATED LONDON NEWS 37, (1860) ["Harry Smith Parkes, C.B." 37:* (Dec. 22, 1860): 587.]

N101 "Syphon Barometers." ATHENAEUM no. 1732 (Jan. 5, 1861): 20-21. [Letter from H. Negretti, brief comment by Robert FitzRoy.]

N102 "Domestic Life in China." ILLUSTRATED LONDON NEWS 38, no. 1069 (Jan. 12, 1861): 43-44. 6 illus. ["From Photographs taken by Negretti & Zambra."]

N103 "Stereographs: Scenes and Scenery in Java. - Negretti & Zambra, London." BRITISH JOURNAL OF PHOTOGRAPHY 8, no. 139 (Apr. 1, 1861): 127-128. [Note on p. 156 states these stereos to be taken by W. Woodbury.]

N104 "The Albumen Process of M. Ferrier, as Practiced by Mr. Negretti." BRITISH JOURNAL OF PHOTOGRAPHY 8, no. 140 (Apr. 15, 1861): 143-144.

N105 "Reviews: Stereoviews of Java." JOURNAL OF THE PHOTOGRAPHIC SOCIETY OF LONDON 7, no. 108 (Apr. 15, 1861): 166-167. [2 column review.]

N106 "Albumen Process." BRITISH JOURNAL OF PHOTOGRAPHY 8, no. 142 (May 15, 1861): 178. [Editor defends Negretti against attack from Lacan, on claim of using Ferrier's process.]

N107 Negretti, H. "Correspondence: Mr. Negretti's Reply." BRITISH JOURNAL OF PHOTOGRAPHY 8, no. 142 (May 15, 1861): 193. [Letter replying to Lacan's statement that he was unjustly using Ferrier's name.]

N108 "The Albumen Process of M. Ferrier. As practiced by Mr. Negretti." HUMPHREY'S JOURNAL OF PHOTOGRAPHY, AND THE ALLIED ARTS AND SCIENCES 13, no. 3 (June 1, 1861): 39-43. [From "Br. J. of Photo."]

N109 "M. Blondin at the Crystal Palace." ILLUSTRATED LONDON NEWS 38, no. 1092 (June 8, 1861): 519, 537. 1 illus. [Acrobat, with his rope, etc.]

N110 Portrait. Woodcut engraving credited "From a photograph by Negretti & Zambra." ILLUSTRATED LONDON NEWS 38, (1861) ["Mr. George S. Morrison, G.B. council in Japan." 38:* (Oct. 26, 1861): 427. ("photo taken some months ago in Japan by Messrs. Negretti & Zambra.")]

N111 "Note." ART JOURNAL (Nov. 1861): 351. [Negretti and Zambra's stereoscopic views and stereoscopes of China and Japan etc.]

N112 "Our Editorial Table: Photographs of the Crystal Palace." BRITISH JOURNAL OF PHOTOGRAPHY 12, no. 256 (Mar. 31, 1865): 166. [Photos of interiors, etc., taken by Mr. Collings, manager of the N & Z photographic department at the Crystal Palace.]

N113 "Note." ART JOURNAL (June 1871): 170. [A series of colored stereos.]

N114 Portrait. Woodcut engraving credited "From a photograph by Negretti & Zambra." ILLUSTRATED LONDON NEWS 74, (1879) ["Dr. W. F. Carver, American Champion Rifle Shot (and showman)." 74:2082 (May 10, 1879): 449.]

NEGRETTI, HENRY see also NEGRETTI & ZAMBRA.

NEGRETTI, HENRY. (1818-1879) (ITALY, GREAT BRITAIN)
N115 Negretti. "On the Albumen Process." PHOTOGRAPHIC AND FINE ART JOURNAL 8, no. 6 (June 1855): 161-164. [From "J. of Photo. Soc., London."]

N116 Negretti. "On the Albumen Process." HUMPHREY'S JOURNAL 7, no. 3-4 (June 1 - June 15, 1855): 40-42, 62-64. [From "J. of Photo. Soc., London."]

N117 Negretti, H. "Correspondence: Photographic Balloon Trip." BRITISH JOURNAL OF PHOTOGRAPHY 10, no. 192 (June 15, 1863): 261.

N118 "Photographers Aloft." JOURNAL OF THE PHOTOGRAPHIC SOCIETY OF LONDON 8, no. 134 (June 15, 1863): 306. [Up in balloon "Mammoth". From June 6, 1863 "London Review."]

N119 "Aerial Photography." AMERICAN JOURNAL OF PHOTOGRAPHY AND THE ALLIED ARTS & SCIENCES n. s. vol. 6, no. 1 (July 1, 1863): 11-12. [From "London Telegraph." H. Negretti ascended with Mr. Coxwell near Sydenham, Eng. Took photos.]

N120 "Waifs and Strays: Aerial Photography." BRITISH JOURNAL OF PHOTOGRAPHY 10, no. 194 (July 15, 1863): 295. [Excerpt from "Daily Telegraph," by Negretti, describing his experiences.]

N121 "Photographers Aloft." AMERICAN JOURNAL OF PHOTOGRAPHY AND THE ALLIED ARTS & SCIENCES n. s. vol. 6, no. 14 (Jan. 15, 1864): 315-317. [From "London Review." Negretti went on balloon ascension with Mr. Coxwell, aboard the "Mammoth" at Sydenham.]

N122 "A Trip for the Purposes of Photographic Observation in a Balloon." BRITISH JOURNAL OF PHOTOGRAPHY 11, no. 220 (July 22, 1864): 255. [Negretti, of Negretti & Zambra, attempted "last year" to photograph from a balloon. Failed. Tried again this year. With "Mr. Collings, manager of the Messrs. Negretti & Zambra's photographic department at the Crystal Palace" as assistant. Partially successful this time.]

N123 "The Late Mr. Henry Negretti." ANTHONY'S PHOTOGRAPHIC BULLETIN 10, no. 11 (Nov. 1879): 326-327. [From "Br. J. of Photo." Negretti, of Negretti & Zambra, born at Como, Italy in 1818. Came to Great Britain in 1830 at age twelve. Since 1851 the firm has been a leader in producing optical instruments and improved photographic apparatus. Established portrait studies at the Crystal Palace and elsewhere. "...conceived the idea of publishing a series of photographic views of far Eastern countries..." W. B. Woodbury remained for several years in Japan, China, and other portions of Eastern Asia...active citizen both for Great Britain and Italy, defended Pelizzoni, incorrectly accused of a murder, etc.]

N124 Negretti, P. A. "Henry Negretti—Gentleman and Photographic Pioneer." PHOTOGRAPHIC COLLECTOR 5, no. 1 (1985): 96-105.

4 b & w. 14 illus. [His partner, Joseph Warren Zambra, was born in 1822.]

NEILL, A. C. B. see BIGGS, T., COL.

NEILSON, W.
N125 Neilson, W. "Hints on Posing for Beginners." BRITISH JOURNAL PHOTOGRAPHIC ALMANAC 1873 (1873): 64-67.

N126 Neilson, W. "Scene in a Glasshouse. Reported by W. Neilson." BRITISH JOURNAL PHOTOGRAPHIC ALMANAC 1874 (1874): 146-149. [Dialogue play between an artist and a photographer.]

N127 Neilson, W. "A Curtained Glass House." BRITISH JOURNAL PHOTOGRAPHIC ALMANAC 1875 (1875): 76-77.

N128 Neilson, W. "Foreign Make-Up: Science and Art." PHOTOGRAPHIC TIMES 5, no. 54 (June 1875): 131-132. [Paper communicated to the Edinburgh Photographic Society on art-criticism.]

N129 Neilson, W. "Dust in the Dark Room." BRITISH JOURNAL PHOTOGRAPHIC ALMANAC 1876 (1876): 149-150. [Play. Dialogue between "Young Photographer" and "Old Photographer."]

N130 Neilson, W. "Photographic Faults in Mountain Scenery." BRITISH JOURNAL PHOTOGRAPHIC ALMANAC 1877 (1877): 162. [Play, dialogue between "Artist" and "Photographer."]

N131 Neilson, W. "A Want in Photographic Portraiture." BRITISH JOURNAL PHOTOGRAPHIC ALMANAC 1878 (1878): 173-175.

N132 Neilson, W. "Art in Landscapes." BRITISH JOURNAL PHOTOGRAPHIC ALMANAC 1879 (1879): 109-112.

NELSON, ALFRED.
N133 Nelson, Alfred. "On a New Dry Collodion Process." HUMPHREY'S JOURNAL OF PHOTOGRAPHY, AND THE ALLIED ARTS AND SCIENCES 11, no. 12 (Oct. 15, 1859): 180-182. [From "Proceedings of the Royal Dublin Society.]

NELSON, E. H., JR.
N134 "View of the Famous Levee of New Orleans, the Capitol of Louisiana, which commencing 43 Miles below Passes through the City, forming its chief Business Depot, and extends 143 Miles Above, on the Banks of the Mississippi. - Photographed by E. H. Nelson, Jun., N. O." FRANK LESLIE'S ILLUSTRATED NEWSPAPER 9, no. 228 (Apr. 14, 1860): 306, 316. 1 illus. [Double-page, panoramic view, with steamboats. Printed to be removed for display, with pp. 307-315 inserted between.]

N135 "New Orleans - Views of the Crescent City - the Famous Levee - Public Buildings, &c." FRANK LESLIE'S ILLUSTRATED NEWSPAPER 9, no. 229 (Apr. 21, 1860): 330, 332. 2 illus. [Views of cotton presses, steamboats, etc.]

NEVILLE, GEORGE.
N136 Neville, Geo. "The Dry Collodion Process." HUMPHREY'S JOURNAL OF PHOTOGRAPHY, AND THE ALLIED ARTS AND SCIENCES 10, no. 20 (Feb. 15, 1859): 317-319. [From "London Photo. J."]

NEW YORK OPTICAL WORKS.
N137 "New York Optical Works." HUMPHREY'S JOURNAL OF PHOTOGRAPHY, AND THE ALLIED ARTS AND SCIENCES 20, no.

19 (Mar. 15, 1869): 300. [In effect an endorsement for the Globe Lenses manufactured by this company. States that the successful amateur H. J. Newton was delighted with them.]

NEWCOMBE, CHARLES THOMAS. (LONDON, ENGLAND)

N138 "Miscellanea: Exhibition of Photographs." BRITISH JOURNAL OF PHOTOGRAPHY 12, no. 270 (July 7, 1865): 358. [C. T. Newcombe, of Fenchurch St. and Regent St., opened his new Fenchurch St. Gallery with an exhibition of some 300 landscape views of British scenery.]

NEWELL.

N139 "The Submarine Electric Telegraph Cable from England To Belgium." ILLUSTRATED LONDON NEWS 22, no. 621 (May 14, 1853): 364-365. 6 illus. [Six views of making, laying out cable. One image taken at the Newell & Co. manufacturing plant at Sunderland, is from a photograph. The others are from sketches. "...the workmen are represented pausing for an instant (whilst the scene is being calotyped by Mr. Newell in their work of coiling the cable...")]

NEWELL, HENRY see also NEWELL, ROBERT.

NEWELL, HENRY. (d. 1897) (USA)

N140 "Personal Paragraphs." WILSON'S PHOTOGRAPHIC MAGAZINE 35, no. 494 (Feb. 1898): 89. [Henry Newell of firm of Robert Newell & Sons, landscape and commercial photographers, Philadelphia, died Dec. 28, 1897. His father Robert died scarcely twelve months ago.]

NEWELL, ROBERT & SON. see NEWELL, ROBERT.

NEWELL, ROBERT. (d. 1897) (PHILADELPHIA, PA)

[Worked in Philadelphia as a framemaker before 1856. Exhibited portraits at the Institute of American Manufacturers. Made city views, stereographs.]

BOOKS

N141 Philadelphia. Great Central Fair for the U. S. Sanitary Commission, 1864. Memorial of the Great Central Fair for the U. S. Sanitary Commission, held at Philadelphia, June, 1864, by Charles J. Stille. Philadelphia: United States Sanitary Commission, 1864. 211 pp. 3 b & w. [Original photographs by R. Newell.]

PERIODICALS

N142 "Art Intelligence." CHICAGO MAGAZINE 1, no. 3 (May 15, 1857): 268. [Report on a secret patent submitted by Mr. Robert Newell, of Philadelphia, PA, which was supposed to rival the daguerreotype in detail and be in colors. Article mentions Levi Hill's earlier claims, speculates on the validity of Newell's claims.]

N143 "Our Picture." PHILADELPHIA PHOTOGRAPHER 1, no. 10 (Oct. 1864): frontispiece, 157-159. 1 b & w. [Great Central Sanitary Fair interior view.]

N144 "Editor's Table: Mr. Newell's Photographic Wagon." PHILADELPHIA PHOTOGRAPHER 2, no. 21 (Sept. 1865): 153.

N145 "Editor's Table." PHILADELPHIA PHOTOGRAPHER 2, no. 23 (Nov. 1865): 187. [Photographs received from R. Newell, 724 Arch Street, Philadelphia, PA.]

N146 "Editor's Table." PHILADELPHIA PHOTOGRAPHER 2, no. 24 (Dec. 1865): 206-207. [Fire engine photos and ambulance photo mentioned.]

N147 "Editor's Table." PHILADELPHIA PHOTOGRAPHER 3, no. 30 (June 1866): 191. [Panoramic views of Philadelphia, PA, by R. Newell from State House steeple.]

N148 "Seaside Manipulation." PHILADELPHIA PHOTOGRAPHER 3, no. 34 (Oct. 1866): 313-314.

N149 "Stereoscopic Pictures." PHILADELPHIA PHOTOGRAPHER 3, no. 34 (Oct. 1866): 300-302. [Carpenter & Mullen (KY scenery); John Carbutt (Chicago, IL, scenery); R. Newell (Cape Island bathers).]

N150 "Editor's Table." PHILADELPHIA PHOTOGRAPHER 4, no. 48 (Dec. 1867): 403. [Seven 8" x 10" architectural views of houses in Philadelphia, PA.]

N151 "Editor's Table." PHILADELPHIA PHOTOGRAPHER 9, no. 105 (Sept. 1872): 336. [R. Newell & Son (626 Arch St., Philadelphia, PA) made what "was probably one of the largest orders ever given to illustrate a book..." to illustrate the annual report of the Inspectors of the Eastern Penitentiary of PA. Views, interiors, etc.]

N152 "Independence Hall." PHILADELPHIA PHOTOGRAPHER 9, no. 107 (Nov. 1872): 399. [R. Newell & Son made a 14 " x 18" negative of Independence Hall, Philadelphia, PA.]

N153 Wilson, Edward L. "Photographing Interiors." WILSON'S PHOTOGRAPHIC MAGAZINE. 32, no. 459 (Mar. 1895): 105-109. 3 b & w.

N154 Wilson, Edward L. "Photographers, Old and New: R. Newell & Son." WILSON'S PHOTOGRAPHIC MAGAZINE. 32, no. 459 (Mar. 1895): 115-117. [Robert Newell began portrait business in Philadelphia in 1855, and worked there until 1864. Then began out-door photography and commercial photography. His son Henry eventually became partner.]

N155 "Obituary: Mr. Robert Newell." WILSON'S PHOTOGRAPHIC MAGAZINE 34, no. 483 (Mar. 1897): 12-13. [Died Feb. 2nd, 1897. Began as a portrait photographer in 1855. In 1865 took up outdoor and commercial photography exclusively. See the March 1895 "W. P. M." for more information.]

N156 "The Washington Monument at Philadelphia." WILSON'S PHOTOGRAPHIC MAGAZINE 34, no. 490 (Oct. 1897): 455-456. 1 b & w.

NEWMAN, J. HUBERT. (SYDNEY, N. S. WALES)

N157 Portrait. Woodcut engraving credited "From a photograph by J. Hubert Newman." ILLUSTRATED LONDON NEWS 67, (1875) ["Sir Julius Vogel, Prime Minister of New Zealand." 67:1873 (July 3, 1875): 5.]

NEWMAN, JAMES.

N158 Newman, James. The Principles and Practice of Harmonious Colouring, in Oil, Water, and Photographic Colours; Especially as Applied to Photographs on Paper, Glass and Silver-plate, by an Artist-Photographer. London: J. Newman, 1863. xii, 112 pp. [10th ed. (1874) 128 p.]

N159 Newman, James. Newman's Manual of Harmonious Coloring, as applied to Photographs, together with Valuable Papers on Lighting and Posing the Sitter, by James Newman, Edited with a preliminary chapter on obtaining harmonious negatives, and with notes, by M. Carey Lea. Philadelphia: Benerman & Wilson, 1866. 148 pp. illus.

NEWTON, C. T. [?]

N160 Newton, C. T. *Travels and Discoveries in the Levant*. London: Day & Son, 1865. 2 vol. 12 b & w. [Original photographs.]

NEWTON, HENRY J. (1823-1895) (USA)

N161 Newton, H. J. "The Benzoin Process." AMERICAN JOURNAL OF PHOTOGRAPHY AND THE ALLIED ARTS & SCIENCES n. s. vol. 6, no. 16 (Feb. 15, 1864): 373-377. [Read to Am. Photo. Soc.]

N162 Newton, H. J. "Wax Paper Negatives." PHILADELPHIA PHOTOGRAPHER 1, no. 6 (June 1864): 90-91. [H. J. Newton from New York, NY.]

N163 "Our Photograph. - Mr. H. J. Newton's Paraffine Process." AMERICAN JOURNAL OF PHOTOGRAPHY AND THE ALLIED ARTS & SCIENCES n. s. vol. 7, no. 24 (June 15, 1865): 564-566, plus frontispiece. 1 b & w. [Original photograph tipped-in. Landscape view, in Central Park, New York, NY. Negative by H. J. Newton. Prints made by J. W. Campbell, 575 Broadway.]

N164 Newton, H. J. "A New Printing Solution." AMERICAN JOURNAL OF PHOTOGRAPHY, AND THE ALLIED ARTS AND SCIENCES n. s. vol. 9, no. 4 (Oct. 15, 1866): 87-88.

N165 Newton, H. J. "Newton's Improved Paper Negative Process." HUMPHREY'S JOURNAL OF PHOTOGRAPHY, AND THE ALLIED ARTS AND SCIENCES 19, no. 2 (May 15, 1867): 19-22. [Read to Am. Photo. Soc.]

N166 Newton, H. J. "How to Prevent Sensitized Paper from Turning Brown, etc." HUMPHREY'S JOURNAL OF PHOTOGRAPHY, AND THE ALLIED ARTS AND SCIENCES 19, no. 7 (Aug. 1, 1867): 108-110. [Read to Am. Photo. Soc.]

N167 "Acetate of Lead in the Printing Bath." HUMPHREY'S JOURNAL OF PHOTOGRAPHY, AND THE ALLIED ARTS AND SCIENCES 20, no. 5 (July 1, 1868): 77-78. [Shown to Phila. Photo. Soc.]

N168 "McLachlan's Discovery. Opinion of Mr. Newton - He Differs from the English Journals - The Alkaline Bath Recommended." HUMPHREY'S JOURNAL OF PHOTOGRAPHY, AND THE ALLIED ARTS AND SCIENCES 20, no. 15 (Dec. 1, 1868): 228-230. [This is apparently an abstract of a report given by Mr. Newton to the Photographic Section of the American Institute, although not directly credited. McLachlan's process is a developing bath.]

N169 "Newton's Dry Processes." HUMPHREY'S JOURNAL OF PHOTOGRAPHY, AND THE ALLIED ARTS AND SCIENCES 20, no. 16 (Dec. 15, 1868): 243-246. [From "Silver Sunbeam (6th ed.)" The Tea Process and the Opium-Tannin Process.]

N170 "Newton's Toning Bath." PHILADELPHIA PHOTOGRAPHER 6, no. 69 (Sept. 1869): 316. [Noted "some exquisite stereographs of scenery along the Pennsylvania Central Railroad."]

N171 "Our Picture." PHILADELPHIA PHOTOGRAPHER 7, no. 76 (Apr. 1870): frontispiece, 139-140. 1 b & w. [Landscape of Central Park, New York, NY. Newton an amateur from NY.]

N172 Anthony, H. T. "Tea as a Preservative." ANTHONY'S PHOTOGRAPHIC BULLETIN 3, no. 2 (Feb. 1872): 441-442. [Letter from H. T. Anthony, explaining H. J. Newton's (New York, NY) process, to the "Br. J. of Photo.," then republished in the "APB."]

N173 Newton, H. J. "Green Glass in the Camera." PHOTOGRAPHIC TIMES 4, no. 37 (Jan. 1874): 3-4. [Letter from H. J. Newton to W. J. Baker, explaining his experiments with placing green glass in the camera to decrease exposure time.]

N174 Newton, Henry J. "A Quick Method of Freeing Prints from Hyposulphite of Soda." PHOTOGRAPHIC TIMES 4, no. 43 (July 1874): 106-108. [Reprinted from Aug. 1871 "NY Times," reprinted at reader's requests.]

N175 Newton, H. J. "A Rapid Dry-Plate Process." PHOTOGRAPHIC TIMES 4, no. 46-47 (Oct. - Nov. 1874): 155-158, 169-170. [Read before the Photographic Section of the American Institute.]

N176 Newton, H. J. "A Rapid Dry-Plate Process (Part 2)." PHOTOGRAPHIC TIMES 4, no. 47 (Nov. 1874): 169-170.

N177 Newton, H. J. "How to Make Emulsion." PHOTOGRAPHIC TIMES 5, no. 56 (Aug. 1875): 186-188.

N178 Newton, Henry J. "More About Emulsions." PHOTOGRAPHIC TIMES 5, no. 60 (Dec. 1875): 282-285.

N179 Newton, H. J. "Chloride of Gold in Emulsions." BRITISH JOURNAL PHOTOGRAPHIC ALMANAC 1876 (1876): 166-167.

N180 "Note." PHOTOGRAPHIC TIMES 6, no. 67 (July 1876): 155. ["Mr. H. J. Newton, the well-known amateur photographer, has been prevailed upon to send to the Centennial some photographs (portraits and views) from dry-plate negatives."]

N181 "Mr. Newton's Reply to Mr. Lea." PHOTOGRAPHIC TIMES 6, no. 68 (Aug. 1876): 175-178. [One in a series of exchanges charging plagiarism over a process.]

N182 "Newton's Emulsion." PHOTOGRAPHIC TIMES 6, no. 68 (Aug. 1876): 171-172.

N183 "Note." PHOTOGRAPHIC WORLD 6, no. 70 (Oct. 1876): 231-232. [Note that Newton's photos, views and portraits, at the Fair of the American Institute.]

N184 Newton, H. J. "Alkaline Developer for Newton's Emulsion." PHOTOGRAPHIC TIMES 7, no. 76 (Apr. 1877): 74-75. [Newton Pres. of the Photographic Section of the American Institute. Expert at wet-collodion.]

N185 Newton, H. J. "Emulsion Manipulations." PHOTOGRAPHIC TIMES 7, no. 80 (Aug. 1877): 170-171.

N186 Miller, M. N., M.D. PHOTOGRAPHIC TIMES 7, no. 80 (Aug. 1877): 182-183. [Dr. Miller, an amateur, defends H. J. Newton against criticism of his emulsion process.]

N187 Taylor, J. Traill. "Shooting Yachts On the Wing." PHOTOGRAPHIC TIMES 11, no. 127 (July 1881): 237-238. [Describes activities of Henry J. Newton and himself photographing boats in Long Island Sound in July.]

N188 "Our Illustration." ANTHONY'S PHOTOGRAPHIC BULLETIN 17, no. 3 (Feb. 13, 1886): 69, plus frontispiece. 1 b & w. [Photos of sailboats in the International Boat Race, taken by Mr. Newton.]

N189 Newton, Henry J. "Wet and Dry Processes Contrasted." ANTHONY'S PHOTOGRAPHIC BULLETIN 20, no. 2 (Jan. 26, 1889): 51-53. [Read before the New York Camera Club.]

N190 Newton, Henry J. "Early Days of Amateur Photography." ANTHONY'S PHOTOGRAPHIC BULLETIN 20, no. 5 (Mar. 9, 1889): 147-148. [Read before the Society of Amateur Photographers of New York.]

N191 "Our Illustration." ANTHONY'S PHOTOGRAPHIC BULLETIN 20, no. 11 (June 8, 1889): 344, plus frontispiece. 1 b & w. [Animal study. Photo not bound in this copy.]

N192 "Brighton Beach During the Bathing Hours, As Seen From the Iron Pier - Photo by H. J. Newton, Amateur." FRANK LESLIE'S ILLUSTRATED NEWSPAPER 71, no. 1826 (Sept. 13, 1890): 101. 1 b & w. [View of crowd of bathers.]

N193 Newton, Henry J. "How I Make Lantern-Slides." PHOTOGRAPHIC TIMES 23, no. 600 (Mar. 17, 1893): 138-140.

N194 1 photo ("Mullins") as frontispiece. PHOTOGRAPHIC TIMES 23, no. 622 (Aug. 18, 1893): 445, plus frontispiece. 1 b & w. ["...the veteran photographer from New York..." Note on p. 445.]

N195 Newton, Henry J. "Correspondence: Spirit Photography." PHOTOGRAPHIC TIMES 24, no. 665 (June 15, 1894): 381.

N196 "Editor's Table: Obituary." WILSON'S PHOTOGRAPHIC MAGAZINE 33, no. 469 (Jan. 1896): 46. [Amateur in New York City, "an experimenter and contributor to "Wilson's Magazine". Killed by a streetcar - nearly 70 years of age.]

NEWTON, R. L. (BEATRICE, NB)

N197 "Nebraska. - Sheep Shearing Festival of the Southern Nebraska Wool-Growing Association at Beatrice, May 2d. - From a Photograph by R. L. Newton, Beatrice." FRANK LESLIE'S ILLUSTRATED NEWSPAPER 44, no. 1133 (June 16, 1877): 245. 1 illus. [Crowd, close-up, active. Unusually good photographer, or photograph assisted by the engraver.]

NEWTON, W. E. & F. NEWTON. (LONDON, ENGLAND)

N198 C. G. "A New Stereoscope." PHOTOGRAPHIC AND FINE ART JOURNAL 8, no. 10 (Oct. 1855): 302-303. [W. E. & F. Newton, London.]

NEWTON, WILLIAM JOHN, SIR. (1785-1869) (GREAT BRITAIN)
BOOKS

N199 Zillman, Linda Goforth. *Sir William Newton. Miniature Painter and Photographer 1785 - 1869.* "History of Photography Monograph Series Special Issue No. 2." Tempe, AZ: Arizona State University, School of Art, 1986. 158 pp. 23 illus. [Newton born in London in 1785, into a family of artists and architects. Trained as an engraver at the Royal Academy Schools. Was an active and successful miniature painter during 1820s-1830s. 1833 Charter Member of the Graphic Society. 1837 Miniature painter-in-ordinary to new Queen Victoria, Knighted. During the 1840s he was well connected in political and artistic circles. In 1847 began to experiment with the calotype process, and was associated with the Calotype Club. An active amateur during the 1850s's, while continuing to exhibit miniatures. Vice President of Photographic Society of London from 1853. Made a group of photographic studies of "Burnham Beeches" ca. 1853-54. Retired from the Society in 1858, but continued interest. Died Jan. 22, 1869.]

PERIODICALS

N200 Newton, William J. "Upon Photography in an Artistic View and in Its Relation to the Arts." JOURNAL OF THE PHOTOGRAPHIC SOCIETY 1, no. 1 (July 1853): 6-7.

N201 Newton, William J. "Replies to Queries addressed to Sir W. J. Newton." PHOTOGRAPHIC ART JOURNAL 6, no. 2 (Aug. 1853): 130. [From "Journal of the Photographic Society." Letters from Newton, Herbert Shelley, and "Ignoramus."]

N202 Newton, W. J. "Sir W. J. Newton's Printing Process." PHOTOGRAPHIC AND FINE ART JOURNAL 8, no. 12 (Dec. 1855): 376-377. [From "J. of Photo. Soc., London."]

N203 Newton, W. J. "Sir W. J. Newton's Printing Process." HUMPHREY'S JOURNAL 7, no. 15 (Dec. 1, 1855): 245-246. [From "J. of Photo. Soc., London." Comment by Wm. Ross on the process on p. 246.]

N204 Newton, W. J. "Sir W. J. Newton's Printing Process." HUMPHREY'S JOURNAL 7, no. 18 (Jan. 15, 1856): 295-296. [From "J. of Photo. Soc., London."]

N205 Newton, W. J. "Sir W. J. Newton's Printing Process." PHOTOGRAPHIC AND FINE ART JOURNAL 9, no. 2 (Feb. 1856): 46-47. [From "Journal of Photographic Society, London."]

N206 Newton, W. J. "Sir W. J. Newton's Printing Process." PHOTOGRAPHIC AND FINE ART JOURNAL 9, no. 4 (Apr. 1856): 112. [From "J. of Photo. Soc., London."]

N207 Newton, W. J. "Sir W. J. Newton's Printing Process." HUMPHREY'S JOURNAL 7, no. 23 (Apr. 1, 1856): 373-374.

N208 "Sir W. J. Newton on Printing by Daguerreotype." PHOTOGRAPHIC AND FINE ART JOURNAL 9, no. 5 (May 1856): 148-149. [From "J. of Photo. Soc., London."]

N209 Newton, W. J. "Sir W. J. Newton on Printing by Development." HUMPHREY'S JOURNAL 8, no. 4 (June 15, 1856): 49-50. [From "J. of Photo. Soc., London."]

N210 Newton, W. J. "Inventor of the Paper Process." HUMPHREY'S JOURNAL 8, no. 23 (Apr. 1, 1857): Additional section; 7-8. [From "J. of Photo. Soc., London." Newton protests statement that Blanquart-Evrard invented paper process. Mentions Talbot (1839) Cundall (1844), his own work in 1848, etc.]

N211 Newton, Sir W. J. "Negative Printing Process." PHOTOGRAPHIC AND FINE ART JOURNAL 10, no. 6 (June 1857): 185. [From "J. of Photo. Soc., London."]

N212 Newton, Sir W. J. "On the Arrangement of the Sitter in Portraiture." PHOTOGRAPHIC AND FINE ART JOURNAL 10, no. 7 (July 1857): 213-214. [From "J. of Photo. Soc., London."]

N213 "Arrangement of the Sitter in Portraiture." HUMPHREY'S JOURNAL 9, no. 10 (Sept. 15, 1857): 160. [Quotes from Sir William Newton, but source not given.]

N214 Newton, William J. "Is Photography a Fine Art?" AMERICAN JOURNAL OF PHOTOGRAPHY AND THE ALLIED ARTS & SCIENCES n. s. vol. 4, no. 17 (Feb. 1, 1862): 400. [From "Photo. J." Not a "fine" art but a "scientific" art.]

N215 Seiberling, Grace. "Newton's 'Burnham Beeches' and early British photographs of trees." HISTORY OF PHOTOGRAPHY 13, no. 1 (Jan. - Mar. 1989): 49-64. 8 b & w. 5 illus. [Three photos by W. J. Newton, one by Lady Augusta Mostyn, two by John Percy, two by W. J. Thoms. The other illustrations are engravings or etchings of trees. About British amateur photographers in 1850s.]

NEYT, A. L.
N216 Neyt, A. L. "Microscopic Photography." BRITISH JOURNAL OF PHOTOGRAPHY 9, no. 163 (Apr. 1, 1862): 127-128.

N217 "The Micrographic Album of M. A. L. Neyt." BRITISH JOURNAL OF PHOTOGRAPHY 9, no. 167 (June 2, 1862): 207-208. [From "Bulletin Belge de la Photographie."]

NICE, JOHN F. (1837-1924) (USA)
N218 "Editor's Table." PHILADELPHIA PHOTOGRAPHER 3, no. 32 (Aug. 1866): 255. [Building new gallery in Williamsport, PA.]

NICHOL, JOHN.
N219 Nichol, J. "On the Preparation of Transparencies for the Magic Lantern by means of the Camera and Wet Collodion." AMERICAN JOURNAL OF PHOTOGRAPHY AND THE ALLIED ARTS & SCIENCES n. s. vol. 5, no. 18 (Mar. 15, 1863): 409-413.

N220 Nichol, J. "On the Use of Methylated Spirit in Photography." AMERICAN JOURNAL OF PHOTOGRAPHY AND THE ALLIED ARTS & SCIENCES n. s. vol. 7, no. 8 (Oct. 15, 1864): 169-172. [From "Br. J. of Photo."]

N221 Nicol, J. "On the Preparation of Dry Plates in Daylight." AMERICAN JOURNAL OF PHOTOGRAPHY AND THE ALLIED ARTS & SCIENCES n. s. vol. 8, no. 8 (Oct. 15, 1865): 169-171. [From "Br. J. of Photo."]

N222 Nichol, Johm Ph.D. "Notes from the North." ANTHONY'S PHOTOGRAPHIC BULLETIN 4, no. 7 (July 1873): 199-201. [From "British J. of Photography." Much of the article is about several explosions during public lantern-slide lectures taking place in Scotland.]

N223 Nichol, John, Ph.D. "Recording Public Events." BRITISH JOURNAL PHOTOGRAPHIC ALMANAC 1874 (1874): 88.

N224 Nichol, John. "The Camera In the Garden." PHOTOGRAPHIC TIMES 7, no. 81 (Sept. 1877): 201-203. [From "Br J of Photo."]

N225 Nichol, John. "Topics of the Times: Photographing Flowers." PHOTOGRAPHIC TIMES 7, no. 81 (Sept. 1877): 207. [From "Br J of Photo."]

N226 Nichol, John, Ph.D. "A Plea for the Higher Education of Photographers." BRITISH JOURNAL PHOTOGRAPHIC ALMANAC 1878 (1878): 178-179.

N227 Nichol, John, PH.D. "On Increasing the Sensitiveness of an Ordinary Emulsion." ANTHONY'S PHOTOGRAPHIC BULLETIN 9, no. 10 (Oct. 1878): 311-312. [From "Br. J. of Photo." Nichol took landscapes.]

N228 Nichol, John. "A Hand - Screen in the Studio." BRITISH JOURNAL PHOTOGRAPHIC ALMANAC 1879 (1879): 148-150.

N229 Nicol, John Ph.D. "Seasonable Advice." PHOTOGRAPHIC TIMES 9, no. 103 (July 1879): 156-158. [Discusses working practices of British landscape photographers. From the "Br. J. of Photo."]

N230 Nichol, John, Ph.D. "Notes From The North." ANTHONY'S PHOTOGRAPHIC BULLETIN 10, no. 8 (Aug. 1879): 236-237. [From "Br. J. of Photo."]

N231 Nichol, John, Ph.D. "Intensity." ANTHONY'S PHOTOGRAPHIC BULLETIN 10, no. 10 (Oct. 1879): 309-311. [From "Br. J. of Photo."]

N232 Nichol, John, Ph.D. "The Vagaries of Gelatine." ANTHONY'S PHOTOGRAPHIC BULLETIN 10, no. 11 (Nov. 1879): 322-323. [From "Br. J. of Photo."]

N233 Nichol, John. "Report on the Progress of Photography During the Year Ending July 31st, 1887." PHOTOGRAPHIC TIMES 17, no. 309 (Aug. 19, 1887): 418-421. [Read at the Chicago Convention of the P. A. of A.]

N234 Nichol, John. "Which Is the Older?" and "Who of Our Readers Is Veteran Enough to Take Up This Challenge?" WILSON'S PHOTOGRAPHIC MAGAZINE 33, no. 470 (Feb. 1896): 81-83. 1 illus. [Nichol responds to question, claims to have become involved with photography on May 9, 1841. Made first successful portrait (with Dr. Murray) on May 23rd. Then worked with Rev. Low. To Edinburgh in 1842, learned Calotype process, photos of Forfar (NY) on Apr. 25, 1842. Continued interest in the field, as an amateur.]

N235 Nichol, Dr. John. "Quick Photography Afield." OUTING 29, no. 6 (Mar. 1897): 523-528. 6 b & w. [Outdoor photography for the sports hobbyist.]

N236 Nichol, John, Ph.D. "Seasonable Advice." PHOTOGRAPHIC TIMES 9, no. 103 (July 1879): 156-158. [From "Br J of Photo."]

N237 Nichol, Dr. John. "A Plea For the National Recognition of Photography." PHOTOGRAPHIC TIMES 23, no. 621 (Aug. 11, 1893): 437-438. [Read before the World's Congress of Photography.]

N238 Nichol, Dr. John. "The Past, the Present and the Future." CAMERA NOTES 5, no. 1 (July 1901): 5-10. 2 b & w. [Two photos by Hill & Adamson.]

NICHOLAS & CURTHS.
N239 Marshall, William Elliot. *A Phrenologist amongst the Todas; or, A Study of a Primitive Tribe in South India.* London: Longmans, Green, 1873. xx, 271 pp. 13 b & w. [Same work published with slightly variant titles. Autotype plates of portraits and views, several credited to Bourne & Shepherd (Simla) and Nicholas & Curths.]

NICHOLAS, W. A. (AUSTRALIA)
N240 "Note." PHOTOGRAPHIC TIMES 6, no. 61 (Jan. 1876): 14. [Note that Nicholas uses matches for local intensification.]

NICHOLLS, A.
N241 Nicholls, A. "A New Method of Combination Printing." BRITISH JOURNAL PHOTOGRAPHIC ALMANAC 1874 (1874): 121-122.

NICHOLLS, JAMES. (GREAT BRITAIN)
BOOKS
N242 Nicholls, James. *Microscopic Photography: Its Art and Mystery. The Principles of the Art Disclosed, and its Practice Clearly Explained.* London: F. J. Cox, optician, 1860. 30 pp. 4 illus.

PERIODICALS
N243 "New Books." BRITISH JOURNAL OF PHOTOGRAPHY 8, no. 141 (May 1, 1861): 174. [Bk. rev.:"Microscopic Photography: Its Art and Mystery....by James Nicholls.]

NICOLS & CO.
N244 Furneaux, J. H., editor. *Glimpses of India; A Grand Photographic History of the Land of Antiquity, the Vast Empire of the East. With 500...camera views...with full historical text.* London: International Art Co., 1896. 544 pp. 500 b & w. [Photographic illustrations by Bourne & Shepherd, Lala Deen Dayal, Nicols & Co, Barton, Son & Co., and B. D. Dadaboy.]

NICHOLS. (FULTON, NY)
N245 "Gossip" PHOTOGRAPHIC ART JOURNAL 3, no. 4 (Apr. 1852): 260.

NICHOLS, A. C.
N246 Nichols, A. C. "Varnish Troubles." HUMPHREY'S JOURNAL OF PHOTOGRAPHY, AND THE ALLIED ARTS AND SCIENCES 14, no. 20 (Feb. 15, 1863): 266-267.

NICHOLS, H. R.
N247 Nichols, H. R. "The Carbon Process for the Camera." AMERICAN JOURNAL OF PHOTOGRAPHY AND THE ALLIED ARTS & SCIENCES n. s. vol. 6, no. 24 (June 15, 1864): 572. [From "Photo. News."]

N248 Nichols, H. R. "New Carbon Process-Mounting." HUMPHREY'S JOURNAL OF PHOTOGRAPHY, AND THE ALLIED ARTS AND SCIENCES 16, no. 5 (July 1, 1864): 71-72. [From "Photo. News."]

NICHOLS, SHELDON K. (HARTFORD, CT)
N249 "Notes: Curious and Interesting." WILSON'S PHOTOGRAPHIC MAGAZINE 38, no. 537 (Sept. 1901): 376. [Reprint of an advertisement by the daguerreotypist S. K. Nichols in the May 28, l853 "Connecticut Courant".]

NICHOLS, WILLIAM. (GREAT BRITAIN)
N250 Houfe, S. "A Household Preserved: William Nichols, Bailiff and Photographer." COUNTRY LIFE 159, no. 4117 (May 27, 1976): 1430-1431. 10 b & w. [Album of photos of a household in Essex, England, taken in 1860s.]

NICHOLSON, ALEXANDER. (GREAT BRITAIN)
N251 Nicholson, A. "Notes of a Photographic Trip to Derbyshire." BRITISH JOURNAL OF PHOTOGRAPHY 10, no. 201, 204 (Nov. 2 - Dec. 15, 1863): 426-427, 488-489.

N252 Nicholson, Alexander. "Where To Go With the Camera: Jottings of a Trip to Bettws-y-Coed, North Wales." BRITISH JOURNAL OF PHOTOGRAPHY 12, no. 265 (June 2, 1865): 289-290.

NICHOLSON, JAMES. (BASTROP, TX)
N253 Nicholson, James. "Wrinkles and Dodges." PHILADELPHIA PHOTOGRAPHER 9, no. 105 (Sept. 1872): 317. [James Nicholson (Bastrop, TX) puts a silver dollar in the fixing bath to help clear out the sulphur.]

NICHOLSON, W. (VENTOR AND SHANKLIN, ENGLAND)
N254 Portrait. Woodcut engraving credited "From a photograph by W. Nicholson." ILLUSTRATED LONDON NEWS 71, (1877) ["Lady Flora Hastings, Duchess of Norfolk." 71:2002 (Nov. 24, 1877): 505.]

NICKERSON, G. H. (PROVINCETOWN, MA)
N255 "The Fleet of Ice-Bound Fishing Vessels off Provincetown, Cape Cod, Mass. - From Photographs by G. H. Nickerson, and Sketches by E. R. Morse." FRANK LESLIE'S ILLUSTRATED NEWSPAPER 40, no. 1015 (Mar. 13, 1875): 8-9, 11. 1 illus. [View.]

NIÉPCE, JOSEPH NICÉPHORE. (1765-1833) (FRANCE)
[Born on March 7, 1765 at Chalon-sur-Saône, to a landed family. In 1794 Niépce, a lieutenant in the French army during the Italian campaign, contacted typhus in Nice, and retired to St. Roch. In early 1800s he experimented with various inventions, creating an internal combustion engine in 1806. From 1813 to 1816, interested in lithography, attempted to fix the image created by a camera obscura. He continued to experiment, attempting bitumen of Judea in 1817, and successfully produced and fixed a photographic image in 1822. Through 1820s attempted to find some method of creating a gravure image on glass or metal. Began to correspond with Daguerre in 1826, and continued to work on his heliographic process through the 1820s. In 1829 he and Daguerre signed a ten year contract to collaborate —Niepce to work on fixing the images, Daguerre to perfect the camera obscura. Died on July 5, 1833.].

N256 "Fine Arts: The New Art." LITERARY GAZETTE, AND JOURNAL OF THE BELLES LETTRES no. 1154 (Mar. 2, 1839): 137-139. [Includes a letter from Francis Bauer discussing Nicéphore Niépce's role in the discovery of photography, with Niépce's paper "Heliographie," and an excerpt from "Le Qoutidienne." Brief mention on p. 171 (Mar. 16) that Niépce's heliogravures were displayed at the Graphic Society's third meeting of the year. (W. Lake Price was at this meeting.)]

N257 "Our Weekly Gossip." ATHENAEUM no. 593 (Mar. 9, 1839): 187. [Commentary upon Mr. Bauer's letter to the "Literary Gazette" claiming priority of discovery of photography for Niépce.]

N258 "Faits divers." LE NATIONAL DE 1834 (PARIS) (July 7, 1839): 1-2. [Briefly discusses an exhibition of work by Daguerre and Niépce at the Chamber of Deputies, Paris.]

N259 "Heliography." MAGAZINE OF SCIENCE, AND SCHOOL OF ARTS 1, no. 27 (Oct. 5, 1839): 215-216. [Mentions Talbot, Daguerre, then describes the process of M. J. N. Neipce (sic Niépce)," the account of whose process ia as follows, given in Mr. Niépce's own words..."]

N260 "Early History and Process of Photogenic Drawing from 1814 to 1829." DAGUERREAN JOURNAL 1, no. 3 (Dec. 2, 1850): 81-83. [Actually a summary of Nicéphore Niépce's efforts.]

N261 Chevreul. "Considerations on Photography in an Abstract Point of View." HUMPHREY'S JOURNAL 6, no. 14 (Nov. 1, 1854): 213-216. [From "Comptes Rendus," by way of "J. of Photo. Soc., London." Actually a summation of the approaches of Nicéphore Niépce, Niepce de Saint Victor, and his own experiments conducted in the 1830's.]

N262 Lacan, Ernest; trans. by W. Grigg. "Joseph Nicéphore Niépce." PHOTOGRAPHIC AND FINE ART JOURNAL 10, no. 2 (Feb. 1857): 42-44. [From Lacan's "Photographic Sketches" in "La Lumiére."]

N263 "The Oldest Existing Photographs." HUMPHREY'S JOURNAL OF PHOTOGRAPHY, AND THE ALLIED ARTS AND SCIENCES 14, no. 9 (Sept. 1, 1862): 92-93. [From "Photo. News."]

N264 "The Oldest Existing Photographs." AMERICAN JOURNAL OF PHOTOGRAPHY AND THE ALLIED ARTS & SCIENCES n. s. vol. 5, no. 6 (Sept. 15, 1862): 129-130. [Joseph Ellis, of Brighton, England, displayed work of Nicéphore Niépce, taken in 1827 during a visit to England by Niepce.]

N265 "Sketches of Eminent Photographers: Joseph Nicéphore Niépce." BRITISH JOURNAL OF PHOTOGRAPHY 11, no. 235, 238, 242 (Nov. 4, Nov. 25, Dec. 23, 1864): 438, 474, 530-531.

N266 "Sketches of Eminent Photographers; Joseph Nicéphore Niépce." BRITISH JOURNAL OF PHOTOGRAPHY 12, no. 244, 247, 251, 254, 257, 262 (Jan. 6, Jan. 27, Feb. 24, Mar. 17, Apr. 7, May 12, 1865): 5-6, 44-45, 98-100, 136-137, 177-179, 245. [Includes letters by Niépce.]

N267 "The Invention of Photography." CASSELL'S MAGAZINE 2, (1867): 415-416. [Discusses Daguerre and Niépce. Quotes Niépce's letters, written in 1816.]

N268 "Editor's Table: Monument to M. Joseph Nicéphore Niépce." PHILADELPHIA PHOTOGRAPHER 15, no. 177 (Sept. 1878): 287. [City of Chalon-sur-Saône, France, attempting to build monument to M. Niépce.]

N269 Pritchard, H. Baden. "A Fragment of History: Bought at the Sale of Effects of the Late J. J. Bennett, F.R.S." PHOTOGRAPHIC TIMES 14, no. 161 (May 1884): 238-241. [Describes Nicéphore Niépce's first photography experiments, reprints Niepce's autograph memoir on his invention, all acquired by the author in auction. He traces the path of these materials.]

N270 "Joseph Nicéphore Niépce." PHOTOGRAPHIC TIMES 19, no. 400 (May 17, 1889): 241-243. 1 illus. [Biography. Excerpts from an exchange of letters between Niépce and Daguerre.]

N271 "Les éloges de la photographie par des hommes célébres." and "l'Invention de la photographie." L'INTERMÉDIAIRE DES CHERCHERS ET DES CURIEUX 26, no. 591, 593, 597, 599 (Aug. 20, Sept. 10, Oct. 20, Nov. 10, 1892): 165-166, 245-246, 435-436, 505-507. [A laudatory poem about Daguerre, written by Pope Leo XIII, draws forth a series of comments by several authors, upon the roles of Daguerre and N. Niépce in the discovery of photography.]

N272 "A Photo-engraving in 1826." PHOTOGRAM 12, no. 135 (Mar. 1905): 82. [Excerpted from "The Inland Printer." Quotes Isidore Niepce's statement about his father's work in the 1820s.]

N273 "The Fathers of Photography. II. Joseph Nicéphore Niépce." PHOTOGRAPHIC TIMES 23, no. 632 (Oct. 27, 1893): 611-612. 1 illus.

N274 Gross, M. "Niépce and Daguerre." PHOTO ERA 41, no. 12 (Dec. 1918): 283-285.

N275 Epstean, Edward. "Nicéphore Niépce." PHOTO -ENGRAVERS BULLETIN (Aug. 1934): 12-31.

N276 Gernsheim, Helmut and Alison Gernsheim. "Re-discovery of the World's First Photograph." IMAGE 1, no. 6 (Sept. 1952): 1-2. 1 b & w.

N277 Houdin, Maurice. "Polémiques d'hier ou d'aujourd'hui: Niépce ou Daguerre?" BULLETIN DE LA SOCIÉTÉ HISTORIQUE ET ARCHÉLOGIQUE DE NOGENT-SUR-MARNE ET DU CANTON DE NOGENT 16, no. 6 (1966): 111-116.

N278 Gernsheim, Helmut. "The 150th Anniversary of Photography." HISTORY OF PHOTOGRAPHY 1, no. 1 (Jan. 1977): 3-8. 3 b & w. 1 illus. [Discussion of Niépce's first photographic image, made in 1826.]

N279 Eder, J. M. Professor Dr. "Camera: Then, 'The first photograph on glass by Joseph Nicéphore Niépce with light-sensitive asphalt one hundred years ago.'" CAMERA (LUCERNE) 57, no. 3 (Mar. 1978): 43. [Reprint from first year no. 3 (Sept. 1922) CAMERA.]

N280 "Nicéphore Niépce in England." HISTORY OF PHOTOGRAPHY 7, no. 1 (Jan. 1983): 43-50. 4 illus. [Niépce visited England in 1827-1828.]

NIEPCE DE ST. VICTOR see also CAMPBELL, JAMES.

NIÉPCE DE SAINT VICTOR, CLAUDE MARIE FRANÇOIS. (1805-1870) (FRANCE)
[Born on July 25, 1805 at Saint-Cyr. Cousin to Joseph Nicéphore Niépce. Trained for a military career, and by 1842 he was a lieutenant in the 1st Regiment of Dragoons. Began chemical experiments, and he was transferred to Paris, where he continued experimenting throughout 1840s. Worked on albumen, photography on glass, other techniques. In 1849 he was transferred to the Republican Guard, and made a Chevalier of the Legion of Honor for his research. Throughout 1850s and 1860s experiments with color processes, photogravure processes, and studies of the action of light. Died in 1870.]

BOOKS
N281 Niépce de Saint Victor, Claude. Photographic Researches: Photography upon Glass, Heliochromy, Heliographic Engravings, etc. Various Notes and Processes. Followed by Consideration by M. E. Chevreul, with a Biographical Preface and Notes by M. E. Lacan. Paris: Alexis Gaudin, 1855. 168 [English language edition.]

PERIODICALS
N282 "Pictures on Plate-Glass, Ivory, and Wood." DAGUERREAN JOURNAL 1, no. 2 (Nov. 15, 1850): 58. [Progress in use of albumen to photograph the sun and moon.]

N283 Niépce [de Saint Victor]. "Iodine and its Action." DAGUERREAN JOURNAL 1, no. 6 (Feb. 1, 1851): 174-176. [No source given.]

N284 "The Heliochromotype of M. Niépce de St. Victor." PHOTOGRAPHIC ART JOURNAL 2, no. 1 (July 1851): 32-37. [From "La Lumiére, Trans. by Edward Anthony."]

N285 "M. Niépce de St. Victor, and His Discovery." PHOTOGRAPHIC ART JOURNAL 2, no. 2 (Aug. 1851): 95-99. [From "La Lumiére."]

N286 Humphrey, S. D. "Editorial." DAGUERREAN JOURNAL 2, no. 6 (Aug. 1, 1851): 177-178. [Commentary on the color processes of L. L. Hill and of Niepce de Saint Victor.]

N287 Chevreul, M. E. "Review of the Reproduction by M. Niepce de St. Victor, of Engraved Images, Designed or Painted." PHOTOGRAPHIC ART JOURNAL 3-4, no. 5-6, 2 (May - Aug. 1852): (vol 3) 272-275, 367-371; (vol 4) 104-106.

N288 Humphrey, S. D. "Editorial: On M. Niepce's success in obtaining Colors from Nature." HUMPHREY'S JOURNAL 4, no. 10 (Sept. 1, 1852): 154-155.

N289 "Mr. Niepce's Second Memoir to the French Academy on Heliochrome." HUMPHREY'S JOURNAL 4, no. 11-12 (Sept. 15 - Oct. 1, 1852): 170-171, 180-183.

N290 "M. Niepce's New Discovery." HUMPHREY'S JOURNAL 4, no. 12 (Oct. 1, 1852): 189-190. [From "Cosmos." Discusses Niepce de St. Victor, Regnault and Blanquart-Evrard.]

N291 "Colored Photogenic Pictures." HUMPHREY'S JOURNAL 4, no. 13 (Oct. 15, 1852): 206-207. [E. Becquerel's process described.]

N292 "Scientific Gossip: Photography, the Fixation of Colors." ATHENAEUM no. 1308 (Nov. 20, 1852): 1273. [Niépce de St. Victor's Nov. 8 report to the French Academy of Sciences abstracted, translated.]

N293 "Daguerreotype Pictures with the Natural Colors of the Objects Represented." ART JOURNAL (Jan. 1853): 33-34.

N294 "The Heliochromatype of M. Niépce de St. Victor. 3rd Memoir; n Heliochromie." PHOTOGRAPHIC ART JOURNAL 5, no. 2 (Feb. 1853): 110-112. [From "La Lumiére."]

N295 Niepce de St. Victor. "New Process for Copying Engravings and Drawings." PHOTOGRAPHIC ART JOURNAL 6, no. 4 (Oct. 1853): 230-231. [From "J. of Photo. Soc."]

N296 Niépce de St. Victor. "On Heliographic Engraving on Steel Plates." PHOTOGRAPHIC ART JOURNAL 6, no. 5 (Nov. 1853): 316-318. [From "J. of Photo. Soc."]

N297 "Heliographic Engraving on Steel Plates." PHOTOGRAPHIC AND FINE ART JOURNAL 7, no. 3 (Mar. 1854): 76-77. [From "La Lumiére."]

N298 Niépce de Saint Victor. "Memoir on Heliographic Engraving on Steel and on Glass." PHOTOGRAPHIC AND FINE ART JOURNAL 8, no. 1 (Jan. 1855): 6-8. [From "La Lumiére."]

N299 "Works of M. Niépce de St. Victor, - Bibliographical." HUMPHREY'S JOURNAL 7, no. 5 (July 1, 1855): 88. [Announcement of forthcoming publication "Scientific Researches of M. Niépce de St. Victor..."]

N300 Niépce de St. Victor. "Heliographic Engraving, Obtained Directly in the Camera, Etc." PHOTOGRAPHIC AND FINE ART JOURNAL 8, no. 12 (Dec. 1855): 380-381. ["From a new memoir..."]

N301 "Reviews: Photographic Researches." HUMPHREY'S JOURNAL 7, no. 16 (Dec. 15, 1855): 263-264. [Bk. Rev. "Photographic Researches;... by Niépce de St. Victor. (Paris: Alexis Gaudin & Brother, 1855. 138 pp.)]

N302 Niépce de St. Victor. "Traite Pratique de Gravure Heliographique sur Acier et sur Verre." PHOTOGRAPHIC AND FINE ART JOURNAL 9, no. 11 (Nov. 1856): 345-347.

N303 Hunt, Robert. "Niépce de Saint Victor's Discovery of New and Remarkable Photographic Phenomena." ART JOURNAL (Jan. 1858): 15-16.

N304 Niépce de St. Victor. "On Some New and Remarkable Experiments in Photography." HUMPHREY'S JOURNAL OF PHOTOGRAPHY, AND THE ALLIED ARTS AND SCIENCES 9, no. 18 (Jan. 15, 1858): 273-275.

N305 "Our Weekly Gossip." ATHENAEUM no. 1586 (Mar. 20, 1858): 372. [Mentions Niépce de St. Victor's experiments. Discusses Capt. Ibbetson's claim that he had "printed a book by the sun, containing botanical specimens, titled "Le Premier Livre imprime par le Soleil..." in 1830s.]

N306 "Heliographic Researches by M. Niépce de Saint Victor." ART JOURNAL (Feb. 1859): 50.

N307 "Photographic." COSMOPOLITAN ART JOURNAL 3, no. 2 (Mar. 1859): 88. [Brief note about Niépce de Saint Victor's chemical experiments and their usefulness to artists.]

N308 Bouilhon, Ed. & A. Sauvage. "Review of Niépce de St. Victor's Experiments." PHOTOGRAPHIC AND FINE ART JOURNAL 12, no. 2 (July 1859): 60-61. [From "Photo. Notes."]

N309 Laborde, L'Abbe. "On M. Niépce de St. Victor's Researches on Light." AMERICAN JOURNAL OF PHOTOGRAPHY AND THE ALLIED ARTS & SCIENCES n. s. vol. 2, no. 9 (Oct. 1, 1859): 132-135. [From "Bulletin de la Société Photographique."]

N310 Laborde, L'Abbe. "On M. Niépce de St. Victor's Researches on Light." HUMPHREY'S JOURNAL OF PHOTOGRAPHY, AND THE ALLIED ARTS AND SCIENCES 11, no. 12 (Oct. 15, 1859): 183-186. [From "Bulletin de la Société Photographique."]

N311 "Niépce de Saint Victor." ART JOURNAL (Jan. 1860): 29. [Note on Saint Victor's researches.]

N312 Claudet, A. "Production of Natural Colours by Photography." ART JOURNAL (Jan. 1867): 4-6.

N313 "Obituary." ANTHONY'S PHOTOGRAPHIC BULLETIN 1, no. 7 (Aug. 1870): 143-144. [Note of death.]

N314 "The Late Niépce de St. Victor." PHILADELPHIA PHOTOGRAPHER 7, no. 80 (Aug. 1870): 274.

N315 "The Fathers of Photography. VII. Niépce de Saint-Victor." PHOTOGRAPHIC TIMES 24, no. 664 (June 8, 1894): 357. 1 illus.

NIXON, H. J. (GREAT BRITAIN, INDIA)
N316 *Album of Views in His Highness the Nizam's Dominions.* Photographed by H. J. Nixon, Secunderbad, Dekkan. London: Stereoscopic & Photographic Co., 1865. n. p. 14 b & w. [Original photographs. This may be an album.]

NOBLE, JAMES. (DEPOSIT, NY)
N317 "Note." PHOTOGRAPHIC TIMES 2, no. 13 (Jan. 1872): 26. [Burnt out.]

NOE & LEE.
N318 1 photo (Group portrait of General Grant and his party about to descend into the Bonanza silver mine, Virginia City, Nevada, in Oct. 1879.). CENTURY MAGAZINE 53, no. 6 (Apr. 1897): 822. 1 b & w.

NORMAN, HENRY C. (1850-1913) (USA)
N319 "Editor's Table." PHILADELPHIA PHOTOGRAPHER 14, no. 165 (Sept. 1877): 287. [H. C. Norman (Natchez, MS) opened gallery.]

NORMAND, ALFRED-NICOLAS. (1822-1909) (FRANCE)

[Born on June 1, 1822 in Paris, the son of the architect Louis Eleonor Normand. Trained as an artist and architect. Took his first photographs in 1846. Won the Grand Prix de Rome, lived and studied in Rome from 1847 to 1851. Met Flachéron and Maxime DuCamp, travelling with Gustave Flaubert. During 1851-1852 he made 130 calotypes of Rome, Pompeii, Palermo, Athens, and Constantinople. Returned to Paris in 1852, where he is first an inspector for the Ville de Paris, then an auditor of the Conseil Général des Bâtiments Civils, then higher posts in the administration. Apparently he stopped photographing about 1855 as he focused on his active career as an architect and administrator for the French government, building and restoring monuments and public buildings. Travelled to Moscow in 1890, where he left a collection of drawings and photographs. Took up photography again in 1885 to photograph his family, etc. until about 1895. Died in Paris on March 2, 1909.]

N320 Daux, Georges. "l'Athénes antique en 1851: photographies d'Alfred Normand." BULLETIN DE CORRESPONDANCE HELLÉNIQUE 80, no. 2 (1956): 619-624, plus 13 plates. 13 b & w.

N321 Christ, Yvan. "Le calotypiste Alfred-Nicholas Normand." PHOTO-CINÉ-REVUE (June 1978): 340. 2 b & w.

N322 Badger, Gerry. "Notes on a Photograph by Alfred-Nicolas Normand." PHOTOGRAPHIC COLLECTOR 3, no. 3 (Winter 1982): 294-296. 1 b & w. [Normand, a French architect, made calotypes in Rome and Greece in the early 1850s.]

NORRIS, HILL.

N323 Norris, Hill. "On Dry Collodion Processes." HUMPHREY'S JOURNAL OF PHOTOGRAPHY, AND THE ALLIED ARTS AND SCIENCES 10, no. 23 (Apr. 1, 1859): 360-363. [From "Liverpool Photo. J."]

NORTH & OSWALD. (TOLEDO, OH)

N324 "Note." PHOTOGRAPHIC TIMES 6, no. 66 (June 1876): 135. [Opened studio, St. Claire St., Toledo, OH.]

N325 "A Photographic Palace." ANTHONY'S PHOTOGRAPHIC BULLETIN 7, no. 6 (June 1876): 182-183. [From "Toledo [OH] Blade."]

N326 "Ohio. - Reception by President and Mrs. Hayes at their Private Residence in Fremont, September 14th. - From a Photograph by North & Oswald, of Toledo." FRANK LESLIE'S ILLUSTRATED NEWSPAPER 45, no. 1149 (Oct. 6, 1877): 76. 1 illus. [View, with crowd.]

NORTH, ALLEN C. see also NORTH & OSWALD.

NORTH, ALLEN C. (d. 1882) (USA)

N327 "Matters of the Month: Suicide of a Photographer." PHOTOGRAPHIC TIMES 12, no. 141 (Sept. 1882): 382. [North in Toledo, OH nearly twenty years, coming there from Cleveland. About 40 and unmarried. Depressed and ill, committed suicide.]

NORTH, WALTER CRANE. (1831-1891) (USA)

N328 "Editor's Table." PHILADELPHIA PHOTOGRAPHER 3, no. 34 (Oct. 1866): 322. [Walter C. North (Utica, NY) sent negatives of portraits.]

N329 "Our Picture - Study for Lighting." PHILADELPHIA PHOTOGRAPHER 3, no. 36 (Dec. 1866): frontispiece, 387-389. 2 b & w. [Studio portrait; two views on one page. Utica, NY studio.]

N330 "Our Picture." PHILADELPHIA PHOTOGRAPHER 8, no. 86 (Feb. 1871): frontispiece, 63. 1 b & w. [Portrait of lady.]

N331 "Our Picture." PHILADELPHIA PHOTOGRAPHER 11, no. 124 (Apr. 1874): frontispiece, 125-126. 1 b & w. [Studio Portrait.]

N332 "Where to Advertise." ANTHONY'S PHOTOGRAPHIC BULLETIN 5, no. 4 (Apr. 1874): 137. [Note from North (Utica, NY) that he had successfully sold his gallery.]

N333 "A Photographic School of Instruction." PHILADELPHIA PHOTOGRAPHER 11, no. 132 (Dec. 1874): 354-355. [Walter C. North disposed of his gallery in Utica, NY, travelled to Columbus, OH, formed a partnership with William R. Limpert, offered to train photographers on the techniques and practices of professional photography. Includes a letter from J. F. Rank & Co. (Van Wert, OH).]

N334 "Our Picture." PHILADELPHIA PHOTOGRAPHER 14, no. 157 (Jan. 1877): frontispiece, 29-30. 1 b & w. [Studio portrait.]

N335 North, Walter C. "A Photographer's Experience." ST. LOUIS PRACTICAL PHOTOGRAPHER 1, no. 1 (Jan. 1877): 5-7. [North describes his first experience with a daguerreotype, seeing one made by an amateur in Wilber, NY in the fall of 1840 while he was in school. Eight years later, North began in the profession in Rondout, NY.]

N336 "Our Picture." PHILADELPHIA PHOTOGRAPHER 17, no. 198 (June 1880): 165-166, plus frontispiece. 1 b & w. [Genre scene: 3 children with toys in front of a painted apple tree, titled "Under the Apple Blossoms." North from Utica, NY.]

N337 "Obituary: Walter Crane North." PHOTOGRAPHIC TIMES 21, no. 525 (Oct. 9, 1891): 497-498. [Born in Rondout, Ulster County, NY, on Oct. 31, 1831. Began daguerreotypy about 1850 in Rondout for his uncle William C. North. Then to Cleveland, then to Mansfield, Ohio. Returned to Cleveland, bought out his uncle, then sold sewing machines, then back to photography throughout 1860s-1870s. He had a reputation as a retoucher. Member of the National Photographers' Association of America.]

NOSS, HENRY. (1837-1925) (USA)

N338 Noss, H. "Intense Negatives." HUMPHREY'S JOURNAL OF PHOTOGRAPHY, AND THE ALLIED ARTS AND SCIENCES 19, no. 21 (Mar. 1, 1868): 335.

N339 "Editor's Table." PHILADELPHIA PHOTOGRAPHER 6, no. 63 (Mar. 1869): 96. [Stereos of snow views noted.]

N340 "Editor's Table." PHILADELPHIA PHOTOGRAPHER 6, no. 69 (Sept. 1869): 324. [Stereo views of Beaver Valley scenery, from dry-plate negatives, noted. Noss from New Brighton, PA.]

NOTMAN & FRASER. (CANADA)

BOOKS

N341 Notman & Fraser. *Portraits of the Members of the Legislative Assembly, Province of Ontario.* Toronto: Notman & Fraser, 1873. n. p. 86 b & w.

PERIODICALS

N342 "Editor's Table." PHILADELPHIA PHOTOGRAPHER 7, no. 76 (Apr. 1870): 143. [Notes of a number of cabinet photos. Frazer mentioned as a retoucher of skill.]

N343 Bruce, Josiah. "Our Profession." PHOTOGRAPHIC WORLD 1, no. 3-4 (Mar. - Apr. 1871): 88-89, 114-116. [Paper read before the

Photographic Society of Toronto by Josiah Bruce, operator with Messrs. Notman & Fraser.]

N344 Portrait. Woodcut engraving credited "From a photograph by Notman & Fraser." ILLUSTRATED LONDON NEWS 65, (1874) ["Rev. W. Morley Punshon, Pres. of the Wesleyan Conference." 65:1824 (Aug. 8, 1874): 137. Studios in Toronto and Montreal.]

N345 Portrait. Woodcut engraving credited "From a photograph by Notman & Fraser." ILLUSTRATED LONDON NEWS 71, (1877) ["Sir W. B. Richards, Chief Justice of Canada." 71:1997 (Oct. 20, 1877): 380.]

NOTMAN, CHARLES F. (1870-1955) (CANADA)
[William Notman's youngest son. Born in Montreal in 1870. Began to photograph in the Boston branch of the Notman studios in 1888. Joined the staff of the Montreal studio in 1891. Junior partner in 1894. Sole owner of the business in 1913. Sold the studio in 1935. Died in 1955.]

N346 Notman, C. F. *Notman's Handbook of Toronto.* Toronto: Murray Printing Co., 1894. 32 pp. illus.

NOTMAN, JAMES. (1849-1932) (CANADA)
[Brother to William Notman. Born in Glasgow, came to Montreal in 1859. Worked in the Ottawa studio in 1870. Opened a new branch in 1872, until 1877, when the studio burned down. Moved to Boston in 1877 and worked at the Notman studios there. Retired to Nova Scotia in 1895, died in 1932.]

N347 Notman, J. "New Negative Process." PHOTOGRAPHIC AND FINE ART JOURNAL 11, no. 4 (Apr. 1858): 106. [Letter from J. Notman, Montreal.]

N348 E. "Correspondence: A Reply to Mr. Falk." PHOTOGRAPHIC TIMES 15, no. 215 (Oct. 30, 1885): 620. ["Priority in photographing theatrical groups and scenes with the electric light belongs to Mr. James Notman, Boston. May 1881 Harvard College performance of 'Oedipus'."]

N349 Cooke, George Willis. "Dr. Holmes at Fourscore." NEW ENGLAND MAGAZINE 1, no. 2 (Oct. 1889): 114-123. 4 b & w. 2 illus. [I portrait of O. W. Holmes credited to Notman Photo Co.; 1 view of his Cambridge, Mass. house credited to Wilfred A. French; others not credited.]

NOTMAN, JOHN SLOAN. (1830-1879) (CANADA, USA)
[Brother of William Notman. Worked for him in Montreal studio in 1859, then opened a studio in Boston, MA in 1867. Returned to the Toronto studio in 1869. Hit by a train in 1879 and died.]

N350 "Editor's Table." PHILADELPHIA PHOTOGRAPHER 4, no. 41 (May 1867): 160. [A new room at 174 Tremont Street, Boston, MA of Messrs. John S. Notman & Co.]

N351 Notman, John S. "Cabinet Portraits." HUMPHREY'S JOURNAL OF PHOTOGRAPHY, AND THE ALLIED ARTS AND SCIENCES 19, no. 7 (Aug. 1, 1867): 107-108. [Extracts from a pamphlet, "Things You Ought To Know," issued by John S. Notman, of Boston. Advice to sitters.]

N352 Portrait. Woodcut engraving, credited "From a Photograph by James Notman, Boston, MA." HARPER'S WEEKLY 11, (1867) ["Rev. Newman Hall." 11:569 (Nov. 23, 1867): 741.]

N353 Portrait. Woodcut engraving, credited "From a Photograph by John S. Nutman [sic Notman] & Co." FRANK LESLIE'S ILLUSTRATED NEWSPAPER 28, (1869) ["Rev. George H. Hepwoth, of Boston." 28:716 (June 19, 1869): 220.]

N354 "Note." PHOTOGRAPHIC TIMES 9, no. 107 (Nov. 1879): 260. [John S. Notman, the brother of William and a photographer for many years at Montreal and for a time in Boston, was killed by a train.]

N355 1 engraving (Frederick Law Olmsted) CENTURY MAGAZINE 46, no. 6 (Oct. 1893): 802. 1 illus. [From a photo by J. Notman, Boston.]

N356 "The Ancient and Honorable Artillery Company of Massachusetts, Fanueil Hall, Boston. From a photograph by the Notman Photographic Co., Boston." HARPER'S WEEKLY 40, no. 2066 (July 25, 1896): 725, 727. 1 b & w. [Large group portrait, made from composite negatives.]

N357 1 photo (Oliver Wendell Holmes). WORLD'S WORK 4, no. 6 (Oct. 1902): 2589. 1 b & w.

N358 1 photo (late Prof. William James, of Harvard). WORLD'S WORK 20, no. 6 (Oct. 1910): 13455.

NOTMAN, WILLIAM & SON see NOTMAN, WILLIAM.

NOTMAN, WILLIAM. (1826-1891) (GREAT BRITAIN, CANADA)
[Born in 1826 in Paisley, Scotland. Learned the daguerreotype in Glasgow. Emigrated to Canada in 1856, and opened a studio in Montreal. He made excellent portraits and many fine views of Canada. His genre portraits of fur trappers, hunters, snow scenes brought him acclaim. Opened a studio in Ottawa with W. J. Topley in 1862. His younger brother emigrated from Scotland in 1865 and joined the business, then opened his own gallery at St. Jean in 1871. His three sons, William McFarlane, Jr., George, and Charles would all become photographers, involved in the family business, which continued to expand, with studios in Toronto and Halifax in 1871, and, after 1872 as the Notman Photographic Company, in Boston, MA, Newport, RI, Albany, NY and New York City. William Notman, Sr. died in Montreal in 1891. The family business would continue into the twentieth century, until finally sold in the 1930s.]

BOOKS
N359 Notman, William. *Photographic Selections,* by William Notman. Volume 1. Foreword by the Rt. Hon. Viscount Monck. Montreal: W. Notman, publisher, John Lovell, printer, 1863. n. p. b & w.

N360 Way, Charles Jones. *North American Scenery, being Selections from Charles Jones Way's Studies, 1863-64.* Montreal: W. Notman, 1864. 2 pp. 12 l. of plates. 12 b & w.

N361 Notman, William. *Notman's Photographic Selections,* Second Series. Montreal: W. Notman, publisher, John Lovell, printer, 1865. viii pp. 48 l. of plates. 48 b & w.

N362 Taylor, Fennings. *Portraits of British Americans.* By W. Notman...with Biographical Sketches by Fennings Taylor. Montreal: W. Notman, 1865-1868. 3 vol. in 4 pp. 84 b & w. [Original issued in eighteen parts.]

N363 Notman, William. *Sports, Pastimes and Pursuits of Canada.* Montreal: William Notman, 1866. n. p. 20 b & w. [Albumen prints. Printed titles.]

N364 Small, Henry Beaumont. *The Canadian Handbook and Tourist's Guide; Giving a Description of Canadian Lake and River Scenery and Places of Historical Interest, with the Best Spots for Fishing and Shooting,* by H. B. Small. Photographs by W. Notman. Montreal: M. Longmoore & Co., 1867. 196 pp. 9 b & w. [Original photos.]

N365 Vennor, Henry G., F.G.S. *Our Birds of Prey, or the Eagles, Hawks, and Owls of Canada.* With 30 photographic illustrations by William Notman. Montreal: Dawson Brothers, 1876. viii, 156 pp. 30 l. of plates. 30 b & w. [Original photos, of stuffed birds, taken at the Notman Studios, Montreal.]

N366 Notman & Son. *Royal Society of Canada, 1891.* Montreal: Notman & Son, 1891. n. p. b & w.

N367 *Camera Mosaics. A Portfolio of National Photography.* Introduction written by Mural Halstead, under the art direction of Harry C. Jones, text by Hjalmar H. Boyesen et al. Published Weekly by Harry C. Jones, 92-94 5th Ave, N. Y. New York: Harry C. Jones, 1894. n. p. b & w. illus. [20 parts in a volume. pt. 1 Mar. 31, 1894 - Vol. 1 pt. 20 Sept. 1, 1894. Nearly eighty photographers were published in this series. Wm. Jackson was the largest single contributor with forty-four 11 x 14 photos reproduced. William Notman had thirty-six photos printed. Most of the other contributors averaged around six to eight photos.]

N368 *Historic Montreal; Canada's Metropolis.* Toronto: W. G. MacFarlane, n. d. n. p.

N369 *Notman & Son. *Through Mountains and Canyons; The Canadian Rockies.* Toronto: W. G. MacFarlane, n. d. [ca. 1901-09] n. p. illus.

N370 *Notman & Son. *Photography; Things You Ought to Know.* Montreal: Notman & Son, L. Perrault, printers., n. d. n. p. b & w. [Sitters guide. [?]]

N371 *48 Specially Selected Views in the Canadian Rockies on the Line of the Canadian Pacific Railway.* Montreal: Valentine & Sons, 1907. 48 b & w. [Cover title: "Wonderland of Canada, the Rocky Mountains."]

N372 *Quebec.* "Notman's Photographic Series, VI." Montreal: W. Notman, 1908. n. p. illus.

N373 Notman, William. *Portrait of a Period; a Collection of Notman Photographs, 1856 to 1915.* Edited by J. Russell Harper and Stanley Triggs. With an Introduction by Edgar Andrew Collard. Montreal: McGill University Press, 1967. lv pp., 174 l. of plates, 174 b & w. 40 illus.

N374 Triggs, Stanley G. *William Notman: The Stamp of a Studio.* Toronto: Art Gallery of Ontario and McCord Museum, Toronto, 1985. 173 pp. b & w. illus. ["William Notman in Scotland," pp. 15-22; "William Notman in Montreal," pp. 23-52; "Benjamin Baltzly on the North Thompson River," pp. 53-68; "William McFarlane Notman: 'The Son'," pp. 69-98; "William Haggerty: Eastern Landscapes," pp. 99-114; "William Notman and his Staff Photographers," pp. 115-140; "The Art Department," pp. 141-161; "Epilogue," pp. 162; "Appendix: Biographies of the Montreal Studio Photographers," pp. 163-168; "Notes," 169-173. This thoroughly researched effort

discusses the many photographers who together made up the Notman Studio, including G. Arless; B. Baltzly; M. Baum; J. Bennett; D. Bourdon; J. Bruce; T. Campbell; C. O. Coulombe; R. Dandurand; W. Haggerty; A. J. Houde; S. Jarvis; H. McCorkindale; C. F. Notman; G. R. W. Notman; G. S. Notman; J. Notman; J. S. Notman; W. Notman; W. McF. Notman; J. Query; P. A. Query; W. G. Query; R. Summerhayes; W. Topley; E. R. Turner; W. Webb.]

PERIODICALS

N375 "Note." PHOTOGRAPHIC AND FINE ART JOURNAL 11, no. 2 (Feb. 1858): 63. ["This gentleman has sent us a very good positive portrait..."]

N376 "Volunteer Force, Montreal, Canada." ILLUSTRATED LONDON NEWS 36, no. 1021 (Mar. 10, 1860): 241. 1 illus. [Group portrait.]

N377 "The Prince of Wales Laying the Last Stone of and Inaugurating the Victoria Tubular Bridge of Canada," "The Last Stone of the Great Victoria Tubular Bridge...," "The House of the Hon. John Rose,...," "Landing of the Prince of Wales Under the Triumphal Arch..., - From a Photograph by Notman." FRANK LESLIE'S ILLUSTRATED NEWSPAPER 10, no. 250 (Sept. 1, 1860): 239, 242, 246. 4 illus. [Views, with crowds.]

N378 "Critical Notices: Stereoscopic Views of Canada, W. Notman, Montreal." PHOTOGRAPHIC NEWS 4, no. 110 (Oct. 12, 1860): 283-284.

N379 Portraits. Woodcut engravings, credited "Photographed by Notman." FRANK LESLIE'S ILLUSTRATED NEWSPAPER 10, (1860) ["James Hodges, engineer." 10:251 (Sept. 15, 1860): 255. "Hon. James Rose, Chief of the Bureau of Public Works, Canada." 10:257 (Oct. 27, 1860): 363. "The chairmen of the Committee on the Reception of the Prince of Wales at Montreal (Five portraits)." 10:259 (Nov. 10, 1860): 395.]

N380 "Note." PHOTOGRAPHIC NEWS 4, no. 111 (Oct. 19, 1860): 299. ["Talk in the Studio": Canadian Photographs - We learn from Messrs. Notman whose stereographs of Canada we noticed last week, that a set of their photographs was presented to H.R.H. the Prince of Wales, by the Provincial Govt. of Canada. The set composed 55 sheets imperial 28 1/2 x 20; on which were mounted 10 photos 22 x 18, 20 photos 12 x 10, and 315 stereo views - all of Canada.]

N381 "Note." ART JOURNAL (Nov. 1860): 351. [Stereoscopic views of Canada, by Notman, mentioned.]

N382 "Great Inundation at Montreal, Canada." ILLUSTRATED LONDON NEWS 38, no. 1088 (May 11, 1861): 431-432. 1 illus. ["...from a photograph by Notman, of Montreal."]

N383 "Case of Photographic Views in Canada Presented to the Prince of Wales." ILLUSTRATED LONDON NEWS 38, no. 1095 (June 22, 1861): 596-597. 1 illus. [Three folios, of about 600 photographs, of Canadian landscapes made by Notman for the Canadian government, to present to the Prince of Wales during his visit there.]

N384 Portrait. Woodcut engraving credited "From a photograph by Notman, of Montreal." ILLUSTRATED LONDON NEWS 41, (1862) ["Bishops of the Five Dioceses of the United Church of England and Ireland in Canada." 41:* (Nov. 29, 1862): 576.]

N385 "Note." ART JOURNAL (Feb. 1864): 58. [Photos by Notman mentioned.]

N386 "Editor's Table: Canadian Photographs." PHILADELPHIA PHOTOGRAPHER 1, no. 12 (Dec. 1864): 192. ["...elegant cartes-de-visite from Mr. Nottman [sic], Montreal, Canada..."]

N387 "Note." ART JOURNAL (Mar. 1865): 95. [Cartes-de-visite by Notman.]

N388 "Outdoor Photographs Taken Indoors." PHILADELPHIA PHOTOGRAPHER 3, no. 29 (May 1866): frontispiece, 129-131. 1 b & w. [The photo is a genre scene of two hunters. The illustration demonstrates the studio lighting, mock scenery, etc.]

N389 "Our Picture - The Two Sisters." PHILADELPHIA PHOTOGRAPHER 3, no. 32 (Aug. 1866): frontispiece, 252. 1 b & w.

N390 "Editor's Table." PHILADELPHIA PHOTOGRAPHER 3, no. 32 (Aug. 1866): 255. [Received from William Notman a pamphlet showing the merits of his salons, illustrated by a photograph of his building.]

N391 "Further Remarks on Lights and Lighting." PHILADELPHIA PHOTOGRAPHER 3, no. 32 (Aug. 1866): 229-232. 3 illus. [Description of the studio and skylights of Notman's Studio.]

N392 "Moose Hunting in Canada." PHILADELPHIA PHOTOGRAPHER 3, no. 32 (Aug. 1866): 235-236. [Description of seven genre pictures of moose hunters.]

N393 Notman, William. "Salad for the Photographer: The New Size." PHILADELPHIA PHOTOGRAPHER 3, no. 32 (Aug. 1866): 253. [Notman discusses the merits of the new size for photos.]

N394 "Editor's Table." PHILADELPHIA PHOTOGRAPHER 3, no. 33 (Sept. 1866): 288. [Notman's collodion process published.]

N395 Notman, William. "Notman's Negatives and Prints." HUMPHREY'S JOURNAL OF PHOTOGRAPHY, AND THE ALLIED ARTS AND SCIENCES 18, no. 9 (Sept. 1, 1866): 133-135. [Praise for the Notman photograph which appeared as the frontispiece of "Philadelphia Photographer." no. 32. Notman's formulas copied from there and the magazine praised. (rare that "PP" would receive praise.)]

N396 "View of the City and Harbor of Quebec from Montmorency River." HARPER'S WEEKLY 10, no. 514 (Nov. 3, 1866): 692. 1 illus. ["Photographed by Notman, Montreal."]

N397 "Our Picture: Cabinet Portrait." PHILADELPHIA PHOTOGRAPHER 4, no. 37 (Jan. 1867): frontispiece, 31. 1 b & w.

N398 "Viscount Monck, Governor-General of Canada." ILLUSTRATED LONDON NEWS 50, no. 1412 (Feb. 9, 1867): 141. 1 illus. ["The Portrait is from a photograph by Mr. W. Notham, of Montreal, published in the series "Portraits of British Americans," with biographical memoirs, edited by Mr. Fennings Taylor..."]

N399 "Composition Photographs." PHILADELPHIA PHOTOGRAPHER 4, no. 39 (Mar. 1867): 79-80.

N400 "Editor's Table." PHILADELPHIA PHOTOGRAPHER 4, no. 42 (June 1867): 194. [Cabinet portraits of the famous Ristori and her family.]

N401 "Editor's Table." PHILADELPHIA PHOTOGRAPHER 4, no. 43 (July 1867): 234. [A cabinet photo representing boating scenes by the sea-side.]

N402 Wilson, Edward L. "Editorial Correspondence." PHILADELPHIA PHOTOGRAPHER 4, no. 46 (Oct. 1867): 305-308. [Wilson describes a visit to J. H. Kent at Brockport, NH, and to Notman in Montreal, Canada.]

N403 "Our Picture." PHILADELPHIA PHOTOGRAPHER 4, no. 48 (Dec. 1867): frontispiece, 398-399. 1 b & w. [Genre scene of a lady ice skating.]

N404 "Winter Sports in Canada." ILLUSTRATED LONDON NEWS 52, no. 1464 (Jan. 11, 1868): 28, 42. 2 illus. ["...are taken from a set of well-executed photographs, sent to us, a twelvemonth ago, by Mr. W. Notman, photographic artist, of Montreal." Tableaux of moose hunters in camp.]

N405 "Editor's Table: A Rival to Salomon." PHILADELPHIA PHOTOGRAPHER 5, no. 51 (Mar. 1868): 99-100. [Also a note on p. 100, stating that Notman had opened a branch studio in Ottawa.]

N406 "Our Picture." PHILADELPHIA PHOTOGRAPHER 5, no. 52 (Apr. 1868): frontispiece, 133. 1 b & w. [Genre, "Discussing a Sketch."]

N407 Portrait. Woodcut engraving, credited "From a Photograph by William Notman, of Ottawa." HARPER'S WEEKLY 12, (1868) ["The late Thomas D'Arcy McGee." 12:591 (Apr. 25, 1868): 260.]

N408 "Our Picture." PHILADELPHIA PHOTOGRAPHER 5, no. 59 (Nov. 1868): frontispiece, 410. 1 b & w. [Genre scene of fur trappers.]

N409 "Editor's Table." PHILADELPHIA PHOTOGRAPHER 6, no. 68 (Aug. 1869): 284. [12" x 15", 8" x 10" views of Niagara Falls, NY, in winter noted.]

N410 Portrait. Woodcut engraving, credited "From a Photograph by Notman." HARPER'S WEEKLY 13, (1869) ["Prince Arthur, of England." 13:577 (Sept. 11, 1869): 577.]

N411 "Our Picture." PHILADELPHIA PHOTOGRAPHER 6, no. 70 (Oct. 1869): frontispiece, 352. 1 b & w. [Portrait.]

N412 "Editor's Table." PHILADELPHIA PHOTOGRAPHER 7, no. 74 (Feb. 1870): 64. [Note about receipt of a snow scene from Notman.]

N413 Portrait. Woodcut engraving credited "From a photograph by Notman, of Montreal." ILLUSTRATED LONDON NEWS 56, (1870) ["Prince Arthur in Canada." 56:* (Mar. 12, 1870): 269.]

N414 "Editor's Table." PHILADELPHIA PHOTOGRAPHER 7, no. 77 (May 1870): 183. [Note of his composition picture, titled "The Skating Carnival," containing picture of M. R. H. Prince Arthur.]

N415 "Our Picture." PHILADELPHIA PHOTOGRAPHER 7, no. 84 (Dec. 1870): 428, plus unnumbered leaf. [Composite print, "Skating Carnival."]

N416 "Photography in the Canadas." ANTHONY'S PHOTOGRAPHIC BULLETIN 2, no. 2 (Feb. 1871): 57. [From "Montreal Daily Witness." Note that Prince Arthur and Queen Elizabeth keep requesting Notman's prints, after Arthur's visit.]

N417 "The Halifax International Four-Oared Boat-Race, August 31st. - View from the Club House of the Royal Halifax Yacht Club - Ready to Start, and Waiting for the Gun. - From a Photograph by W. Notman." FRANK LESLIE'S ILLUSTRATED NEWSPAPER 33, no. 833 (Sept. 16, 1871): 5. 1 illus. [View, with crowds.]

N418 "The Halifax International Four-Oared Boat-Race, August 31st. - View from the Club House of the Royal Halifax Yacht Club - Ready to Start, and Waiting for the Gun. - From a Photograph by W. Notman." FRANK LESLIE'S ILLUSTRATED NEWSPAPER 33, no. 833 (Sept. 16, 1871): 5. 1 illus. [View, with crowds.]

N419 "Mr. W. Notman on the Superiority of our Collodions and other Manufactures." ANTHONY'S PHOTOGRAPHIC BULLETIN 3, no. 12 (Dec. 1872): 781-782. [Letter from Notman, praising Anthony's products.]

N420 Portraits. Woodcut engravings credited "From a photograph by William Notman." ILLUSTRATED LONDON NEWS 63, (1873) ["Col. J. C. MacNeill, V.C." 63:1788 (Dec. 6, 1873): 541.]

N421 Portrait. Woodcut engraving, credited "Photographed by Notman, of Toronto." FRANK LESLIE'S ILLUSTRATED NEWSPAPER 38, (1874) ["Sir Lamston Lorraine, Commander of the British warship "Niobe." 38:970 (May 2, 1874): 117.]

N422 Portrait. Woodcut engraving, credited "From a Photograph by Notman, Montreal." FRANK LESLIE'S ILLUSTRATED NEWSPAPER 40, (1875) ["Prof. O. C. Marsh." 40:1029 (June 19, 1875): 240.]

N423 "Lightning in Canada." ANTHONY'S PHOTOGRAPHIC BULLETIN 9, no. 8 (Aug. 1878): 245-246. [Lambert's Lightning process used by Wm. Notman.]

N424 "Canada. - The Twelfth of July in Montreal - Scenes and Incidents of the Anniversary of the Battle of the Boyne. - From Photographs by W. Notman and Sketches by Geo. R. Halm." FRANK LESLIE'S ILLUSTRATED NEWSPAPER 46, no. 1192 (Aug. 3, 1878): 369. 6 illus. [Portraits, crowds, etc.]

N425 Portrait. Woodcut engraving, credited "From a Photograph by Notman." FRANK LESLIE'S ILLUSTRATED NEWSPAPER 47, (1879) ["John Walter, proprietor of the 'London Times.'" 47:1215 (Jan. 11, 1879): 329.]

N426 "Canada. - Opening of the Dominion Parliament. - Arrival of the Marquis of Lorne and Princess Louise at the Parliament Building, Ottawa. - From a Photograph by W. Notman, and a Sketch by Our Special Artist." FRANK LESLIE'S ILLUSTRATED NEWSPAPER 47, no. 1222 (Mar. 1, 1879): 469. 1 illus. [View, with crowds.]

N427 "New York. - Annual Encampment of the Grand Army of the Republic, at Albany. - From Sketches by H. A. Ogden, and Photographs by Notman." FRANK LESLIE'S ILLUSTRATED NEWSPAPER 48, no. 1240 (July 5, 1879): 300. 2 illus. [Parades.]

N428 Portrait. Woodcut engraving, credited "From a Photograph by Notman, Boston. FRANK LESLIE'S ILLUSTRATED NEWSPAPER 49, (1879) ["Harry Etherington, W. Cann, and C. Terronts, the Professional Bicycle Team visiting the USA." 49:1263 (Dec. 13, 1879): 265.]

N429 "An Older Customer Than Mr. Rockwood." ANTHONY'S PHOTOGRAPHIC BULLETIN 20, no. 9 (May 11, 1889): 286. [Letter from Notman claiming to have first purchased materials from Anthony Co. in 1856.]

N430 1 engraving (View of mountains, "The Three Sisters, Canmore.") HARPER'S MONTHLY 81, no. 486 (Nov. 1890): 812. 1 illus. [Engraving, from a photograph credited "William Notman & Son, Montreal."]

N431 "Glimpses of Montreal in Winter. From Photos Furnished by Notman, 215 Madison Ave., New York." FRANK LESLIE'S ILLUSTRATED NEWSPAPER 72, no. 1850 (Feb. 28, 1891): 68. 2 b & w. 2 illus.

N432 "Notes and News." PHOTOGRAPHIC TIMES 21, no. 533 (Dec. 4, 1891): 609. [Brief note that William Notman died Wednesday, Nov. 25th.]

N433 "The Late William Notman." PHOTOGRAPHIC TIMES 21, no. 534 (Dec. 11, 1891): 616. [Reprint of obituary from the "Montreal Witness." Born Paisley, Scotland Mar. 8, 1826. Came to Montreal in 1856. Had been an amateur photographer, decided to make it his profession. Flourished, later opened two branches in Boston, one in New York, one in Halifax and a second studio in Montreal. Died Nov. 25th 1891.]

N434 "Obituary: William Notman." ANTHONY'S PHOTOGRAPHIC BULLETIN 22, no. 23 (Dec. 12, 1891): 728-729. [Born Paisley, Scotland, Mar. 8, 1826. Came to Montreal in 1856, worked in the dry goods business. An amateur photographer, he decided to become a professional. Became one of the best and best known. At his death his firm had two branches in Boston, one in New York, NY, one in Halifax, one in Montreal in addition to the parent gallery. Died Nov. 25, 1891.]

N435 Betts, Lillian W. "Quebec: The Crowded City." OUTLOOK 67, no. 9 (Mar. 2, 1901): 521-529. 7 b & w. ["Illustrated with photographs by William Notman."]

N436 1 photo (James Ford Rhodes). WORLD'S WORK 4, no. 3 (July 1902): 2317. 1 b & w.

N437 Roberts, E. S. "Notman's" AMERICAN PHOTOGRAPHY 37, no. 10 (Oct. 1943): 36-37. 8 b & w.

N438 Newhall, Beaumont. "William Notman 1826 - 1891." IMAGE 4, no. 8 (Nov. 1955): 57-59. 3 b & w.

N439 "Canada Exposed: The Look of the Young Nation." AMERICAN HERITAGE 18, no. 4 (June 1967): 20-25. 13 b & w. [From "Portrait of a Period: A Collection of Notman Photographs," Russell Harper, ed. McGill Un. Press, 1967.]

N440 Bunnell, Peter C. "A Portrait of Us Today - And Tomorrow." APERTURE 13, no. 4 (1968): 48-51. 4 b & w.

N441 Wilsher, Ann. "Notman's Notables." HISTORY OF PHOTOGRAPHY 4, no. 4 (Oct. 1980): 344. 1 b & w. [A composite montage of Abraham Lincoln and the general staff of the Federal Army, ca. 1863.]

N442 Schwartz, Joan M. "Another Side of William Notman." HISTORY OF PHOTOGRAPHY 10, no. 1 (Jan. - Mar. 1986): 63-60. 2 b & w. 4 illus. [Commercial record photographs of a coal stove, taken in 1860s.]

N443 Polito, Ron. "Studio and Style." VIEWS: THE JOURNAL OF PHOTOGRAPHY IN NEW ENGLAND. 7, no. 4 (Summer 1986): 18.

3 b & w. [Bk. rev.:"William Notman: The Stamp of a Studio," by Stanley Triggs.]

N444 Bara, Jana. "Through the Frosty Lens: William Notman and his Studio Props, 1861 - 1876." HISTORY OF PHOTOGRAPHY 12, no. 1 (Jan. - Mar. 1988): 23-30. 8 b & w. 2 illus.

NOTMAN, WILLIAM. [?]
N445 Browne, G. Waldo. "Pastimes of the Canadian People." NEW ENGLAND MAGAZINE 32, no. 1 (Mar. 1905): 2-11. 10 b & w. [Photos not credited, but at least two are composites (toboggan sledding) by Notman. Skating, etc.]

NOTMAN, WILLIAM MCFARLANE. (1857-1913) (CANADA) see NOTMAN, WILLIAM.

[William McFarlane was the eldest son of William Notman. Born on November 1, 1857, made a partner in the studio in 1882, inherited the business in 1891. Died on May 1, 1913.]

NOTT, J.
N446 "Society of Arts - Jan. 21." ATHENAEUM no. 953 (Jan. 31, 1846): 125. ["On the theory of Photographic Action, illustrating the connection between the Photographic Agent and Electricity," by J. Nott described and discussed.]

NOTTAGE, WILLIAM. (d. 1885) (GREAT BRITAIN)
N447 "Topics of the Times." PHOTOGRAPHIC TIMES 7, no. 82 (Nov. 1877): 253. ["William Nottage of London, was recently inaugurated as a sheriff of London...managed the photography at the London World's Fair. We congratulate him on his prospect of being sooner or later the lord mayor of the City of London."]

NOVERRE, W. L. see WYMANN,C. & CO.

NOWELL, FRANK A. (CHARLESTON, SC)
N448 Taylor, J. Traill. "The Studios of America. No. 13. Frank A. Nowell's Gallery, Charleston, S. C." PHOTOGRAPHIC TIMES 13, no. 156 (Dec. 1883): 635-636. [The gallery in business for about twenty years, previously owned by G. N. Barnard. Nowell succeeded Barnard in the gallery, "about four years since."]

NUTTER, THOMAS S.
N449 Nutter, Thomas S. *Instructions for Intensifying Negatives.* Logan, OH: Republican News, Book & Job Print, 1879. 36 pp.

NYE, WILLIS A. see BATES & NYE.

O

OAKES, S. H. ASHLEY.
O1 Oakes, S. H. Ashley. "Combination Printing for the Stereoscope." ANTHONY'S PHOTOGRAPHIC BULLETIN 9, no. 4-5 (Apr. - May 1878): 118-120, 149-151. [From "London Photographic News." Oakes', an amateur, paper read before the Manchester Photographic Society.]

O2 Oakes, S. H. Ashley. "How to Make a Cheap Stereoscopic Copying Apparatus Suitable for Combination Printing." BRITISH JOURNAL PHOTOGRAPHIC ALMANAC 1879 (1879): 140-142. 3 illus.

OAKLEY, RICHARD BANNER. (GREAT BRITAIN, INDIA)
BOOKS
O3 *The Pagoda of Hallibeed (State of Mysore),* illustrated by fifty-six photographic views by R. B. Oakley. London: T. McLean, 1859. n. p. 56 b & w. [Original photographs, from calotype negatives.]

PERIODICALS
O4 "Hindoo Idols." ILLUSTRATED LONDON NEWS 32, no. 923 (June 19, 1858): 620. 2 illus. ["...from a series of photographs which were taken by Mr. R. B. Oakley, at the Temple of Hallibeed, in the north-west of Mysore, in the beginning of last year, which are now being published by Mr. MacLean, of the Haymarket.]

OBERNETTER, JOHANN BAPTIST see also ALBERT.

OBERNETTER, JOHANN BAPTIST. (1840-1887) (GERMANY)
[Born May 31, 1840 in Munich. Studied chemistry and physics at Leipzig and Heidelberg. Studied photography under Professor Kayser. Worked for Joseph Albert in Munich in 1860, then opened his own studio. Worked on various chemical processes in plate making and in photogravure, throughout 1860s to 1880s. Expert in phototypy. Died Apr. 12, 1887 in Munich.]

O5 "Editor's Scientific Record: Photographic Printing." HARPER'S MONTHLY 40, no. 237 (Feb. 1870): 468. [Brief discussion of the Albertype photolithographic process, "...announced by Obernetter, of Munich."]

O6 "Editor's Scientific Record: Photographic Printing." HARPER'S MONTHLY 40, no. 237 (Feb. 1870): 468. [Brief discussion of the Albertype photolithographic process, "...announced by Obernetter, of Munich."]

O7 "Editor's Scientific Record: Albertype Printing." HARPER'S MONTHLY 41, no. 214 (June 1870): 151. [Discussion of the process.]

O8 "New Photo-Mechanical Printing Process." ANTHONY'S PHOTOGRAPHIC BULLETIN 1, no. 7 (Aug. 1870): 137-138. [Obernetter's process. From "London Photographic News."]

O9 "Our Picture." PHILADELPHIA PHOTOGRAPHER 9, no. 103 (July 1872): 270. 1 b & w. [Photolithograph.]

O10 "Obituary: J. B. Obernetter." PHOTOGRAPHIC TIMES 17, no. 295 (May 13, 1887): 249. [Died Apr. 14th in Munich in the 47th year of his age. "...in the foremost rank of photographic experimentalist."]

O11 "Obituary: J. B. Obernetter." ANTHONY'S PHOTOGRAPHIC BULLETIN 18, no. 10 (May 28, 1887): 309. [Obernetter, an inventor and investigator, died Apr. 13, 1887, in Munich. Born May 31, 1840 in Munich. Worked for Joseph Albert in 1860, as a chemist, inventor.]

O12 "Our Illustration." ANTHONY'S PHOTOGRAPHIC BULLETIN 19, no. 12 (June 23, 1888): 372, plus frontispiece. 1 b & w. [J. B. Obernetter, of Munich, presents his photogravure work. Photo not bound in this copy.]

O'BRIEN, MARCUS A.
O13 "The Broadway Bulletin." ANTHONY'S PHOTOGRAPHIC BULLETIN 2, no. 11 (Nov. 1871): 367. [O'Brien, from New York, NY, opening a gallery in Hamilton, MO.]

OCA, LOPEZ & CO.
O14 Portrait. Woodcut engraving, credited "From a Photograph by Oca, Lopez & Co. FRANK LESLIE'S ILLUSTRATED NEWSPAPER 46, (1878) ["General Martinez Campos, of Cuba." 46:1188 (July 6, 1878): 309.]

O'CONNOR, J. J. & CO. (NEWARK, OH)
O15 Portrait. Woodcut engraving, credited "From a Photograph by J. J. O'Connor & Co., Newark, OH." FRANK LESLIE'S ILLUSTRATED NEWSPAPER 35, (1872) ["James Roosevelt Bayley, Archbishop." 35:886 (Sept. 21, 1872): 29.]

OGDEN.
O16 "The Boiler Explosion at Dean, in Rossendale." ILLUSTRATED LONDON NEWS 32, no. 924 (June 26, 1858): 644. 2 illus. ["From Photographs by Mr. Ogden."]

OGIER, E. P. (JERSEY, GREAT BRITAIN)
O17 "Glimpses of the Moon." ANTHONY'S PHOTOGRAPHIC BULLETIN 2, no. 4 (Apr. 1871): 128. [Stereo views of the Moon.]

O18 Ogier, E. P. "Lunar Photography." PHILADELPHIA PHOTOGRAPHER 8, no. 95 (Nov. 1871): 354-358. 2 illus. [Ogier describes his practice of making landscape views by moonlight.]

OGLE & EDGE. (PRESTON, GREAT BRITAIN)
BOOKS
O19 Payn, James. *Furness Abbey and Its Neighborhood.* London; Hamilton: Simpkin, Marshall & Co.; Hamilton, Adams & Co., 1862? 60 pp. 7 l. of plates. 7 b & w. [Original photos, by Thomas Ogle & Edge.]

PERIODICALS
O20 "Note." ART JOURNAL (June 1858): 191. [Messrs. Ogle & Edge's photographic views for the stereoscope sold by Negretti & Zambra in Cornhill.]

O21 "Note." ART JOURNAL (Dec. 1858): 374. [Stereo views of Northern Lakes.]

O22 "Critical Notices: Stereoscopic views in the north of England and in Wales. By Messrs. Ogle and Edge, Preston." PHOTOGRAPHIC NEWS 1, no. 24 (Feb. 18, 1859): 281.

OGLE, THOMAS.
BOOKS
O23 Scott, Sir Walter. *The Lady of the Lake.* London: A. W. Bennett, 1863. v, 215 pp. 13 l. of plates. 13 b & w. [One original photo by G. W. Wilson and thirteen views by T. Ogle.]

O24 Wordsworth, William. *Our English Lakes, Mountains and Waterfalls, as seen by William Wordsworth. Illustrated with Thirteen*

Photographs of Stereoscope Size by Thomas Ogle. London: Alfred W. Bennett, 1864. xi, 192 pp. 13 l. of plates. 13 b & w. 1 illus. [Poems. Original photographs. 2nd ed. (1867); 3rd ed. (1868); 4th ed. (1870).]

O25 Wordsworth, William. *Our English Lakes, Mountains, and Waterfalls, as seen by William Wordsworth.* "4th Edition." London: Provost & Co., 1870. n. p. 8 b & w. [Albumen prints, by Thomas Ogle. These prints differ in number and in content from those in the 1st edition (1864).]

PERIODICALS
O26 "Stereographs: English Lake and Other Scenery, by Thomas Ogle, Preston." BRITISH JOURNAL OF PHOTOGRAPHY 7, no. 127 (Oct. 1, 1860): 285-286.

O27 "Stereographs: Fountains Abbey, and the Beauties of Derbyshire, by Thomas Ogle, Preston." BRITISH JOURNAL OF PHOTOGRAPHY 8, no. 136 (Feb. 15, 1861): 65-66.

O28 "Stereographs: Views in Derbyshire, Yorkshire, &c. Photographed by Thomas Ogle." BRITISH JOURNAL OF PHOTOGRAPHY 8, no. 156 (Dec. 16, 1861): 439.

O29 "Photography Applied to Book Illustration." BRITISH JOURNAL OF PHOTOGRAPHY 10, no. 195 (Aug. 1, 1863): 309. [Discussion of Scott's "Lady of the Lake", published by A. W. Bennett, photos by Thomas Ogle, and the Howitt's "The Wye", with photos by Bedford and Sedgfield.]

O30 "Books Illustrated by Photographs." PHILADELPHIA PHOTOGRAPHER 3, no. 25 (Jan. 1866): 32. [Bk. rev.: "Our English Lakes, Mountains and Waterfalls," as seen by William Wordsworth. London: A. W. Bennett. Thirteen photos of stereoscope size by Thomas Ogle.]

OGLESBY, SAMUEL. (PRESTON, ENGLAND)
O31 Portrait. Woodcut engraving credited "From a photograph by Samuel Oglesby, Fishergate" Preston." ILLUSTRATED LONDON NEWS 41, (1862) ["Robert Townley Parker, Esq." 41:* (Sept. 13, 1862): 285.]

OLD FOGY.
O32 "Old Fogy." "On 'Rembrandt Effects'." PHILADELPHIA PHOTOGRAPHER 7, no. 80 (Aug. 1870): 288-289.

OLDFIELD, WILLIAM. (GREAT BRITAIN)
O33 "News." HUMPHREY'S JOURNAL OF PHOTOGRAPHY, AND THE ALLIED ARTS AND SCIENCES 16, no. 10 (Sept. 15, 1864): 160. ["The London 'Times' records a serious accident to a photographer, named Wm. Oldfield, by a fall from Hunstanton Cliffs....fell sixty-five feet, his recovery is doubtful."]

OLDROYD, O. H. (COLUMBUS, OH)
O34 "An Interesting Picture." AMERICAN JOURNAL OF PHOTOGRAPHY, AND THE ALLIED ARTS AND SCIENCES n. s. vol. 9, no. 4 (Oct. 15, 1866): 93. [O. H. Oldroyd (Columbus, OH) just published "a collection of photographs and autographs on a large handsome sheet", which he calls "The Might of the Republic." 100 cartes de visite (Pres. Lincoln, etc.) reduced.]

OLIVER see MCPHERSON & OLIVER.

OLIVER, HENRY.
O35 "Photographing on Concave Surfaces." HUMPHREY'S JOURNAL OF PHOTOGRAPHY, AND THE ALLIED ARTS AND SCIENCES 12, no. 5 (July 1, 1860): 65. [Process used for making photo brooches, etc.]

OLLEY.
O36 *The Wonders of the Microscope Photographically revealed by Olley's Patent Micro-Photographic Reflecting Process.* London: W. Kent & Co., 1860. n. p. 36 b & w. [Original prints, by Fisher.]

OLSEN, CHRISTEN.
O37 "Louisiana. - View of the Levee at Shreveport. - From a Photograph by Christen Olsen." FRANK LESLIE'S ILLUSTRATED NEWSPAPER 35, no. 900 (Dec. 28, 1872): 260. 1 illus. [Men loading paddlewheel boat, etc.]

O38 "The Scourge of Yellow Fever. Scenes in Shreveport, La. - From Photographs and Sketches by Christen Olsen." FRANK LESLIE'S ILLUSTRATED NEWSPAPER 37, no. 940 (Oct. 4, 1873): 57-58. 4 illus. [Views, scenes.]

OMMEGANCK, C.
O39 Ommeganck, C. "On a Case of Photographic Insensitiveness" AMERICAN JOURNAL OF PHOTOGRAPHY AND THE ALLIED ARTS & SCIENCES n. s. vol. 6, no. 20 [sic 21] (May 1, 1864): 497-498. [From "Bulletin Belge."]

O40 Ommeganck. "Alkaline Salt of Silver for Rapid Printing of Positives." HUMPHREY'S JOURNAL OF PHOTOGRAPHY, AND THE ALLIED ARTS AND SCIENCES 18, no. 9 (Sept. 1, 1866): 142. [From "Bulletin Belge de la Photographie."]

O'NEIL, HUGH & JOHN O'NEIL.
O41 "Note." ANTHONY'S PHOTOGRAPHIC BULLETIN 10, no. 9 (Sept. 1879): 270. [Note that the brothers Hugh and John O'Neil, both very experienced, forming a partnership.]

O'NEIL, HUGH see also FREDERICKS, CHARLES.

O'NEIL, HUGH. (USA)
O42 Simons, M. P. "Our Illustrations." PHOTOGRAPHIC AND FINE ART JOURNAL 10, no. 7 (July 1857): frontispiece, 217. 1 b & w. [Original photographic print, tipped-in. Portrait of George Dabbs, well-known, well-liked, salesman of photographic goods, from a negative by Hugh O'Neil of Washington, DC. (Print not in this copy.)]

O43 "Our Illustrations." PHOTOGRAPHIC AND FINE ART JOURNAL 10, no. 8 (Aug. 1857): frontispiece, 237. 1 b & w. [Original photographic print, tipped-in. Portrait of the painter John R. Johnston, from a negative by Hugh O'Neil. (Print not in this copy.)]

O44 "Alba." PHOTOGRAPHIC TIMES 5, no. 51 (Mar. 1875): 50. [Letters praising the Alba plates from Hugh O'Neil (of C. D. Fredericks & Co.), D. D. Crossin (operator for S. Flach, 3rd Ave.) and F. Ulrich (Bowery).]

O45 Anthony, E. & H. T. & Co. "The Nonpareil Plates." ANTHONY'S PHOTOGRAPHIC BULLETIN 7, no. 2 (Feb. 1876): 51. ["...for illustrating our new Spanish work on photography, "El Rayo Solar," we engaged Mr. Hugh O'Neil of the well-known firm of C. D. Fredericks & Co. to prepare them for us..."]

O46 "Our Illustration." ANTHONY'S PHOTOGRAPHIC BULLETIN 18, no. 13 (July 9, 1887): frontispiece, 411. 1 b & w. [Children's portrait by Hugh O'Neil of Union Square, New York City.]

O'NEIL, JOHN. (NEW YORK, NY)

O47 "The Atalanta's Champion Six - The Victors in the New York and Harvard Boat Race, on the Connecticut River, July 19th. - From a Photograph by O'Neil." FRANK LESLIE'S ILLUSTRATED NEWSPAPER 32, no. 828 (Aug. 12, 1871) 1 illus. [Group portrait of sculling crew.]

O48 "The International Boat-Race. - The Crew of the 'Atalanta' Practicing on the Passaic River" and " The American Amateur Champions - From a Photograph by J. O'Neil." FRANK LESLIE'S ILLUSTRATED NEWSPAPER 34, no. 865 (Apr. 27, 1872): 109. 6 illus. [One view of rowers in their scull, with five portraits.]

O49 Portrait. Woodcut engraving, credited "From a Photograph by O'Neil." FRANK LESLIE'S ILLUSTRATED NEWSPAPER 34, (1872) ["The Very Rev. Father Thomas Burke." 34:870 (June 1, 1872): 188.]

O50 Portrait. Woodcut engraving, credited "Photographed by O'Neil, of New York." FRANK LESLIE'S ILLUSTRATED NEWSPAPER 38, (1874) ["Hon. John P. Jones, Sen. from NV." 38:974 (May 30, 1874): 181.]

O'NEIL, ROBERT. (WASHINGTON, DC)

O51 "An Excursion on the Baltimore and Ohio Railroad." THE CRAYON 5, no. 7 (July 1858): 210. [From the "Evening Post." [?] "Besides these [artists], were the photographers consisting of the amateurs G. W. Dobbin and son, and W. E. Bartlett, of Baltimore, Charles Guillou, of Philadelphia; and Robert O'Neil, a professional photographer, from Washington...."]

O52 "Domestic Art Items and Gossip." COSMOPOLITAN ART JOURNAL 2, no. 4 (Sept. 1858): 207. [Describes an excursion organized for artists and photographers on the Baltimore and Ohio Railroad. "The train consists of...a car expressly fitted up for photographic purposes....The rest of the party...including...the following gentlemen...Messrs. G. W. Dobbin, Charles Gillou, William E. Bartlett and Robert O'Neil, photographers. More than one hundred excellent photographic views were taken by the several operators, who had four sets of approved apparatus of their own in full play." (See also the June 1859 "Harper's New Monthly Magazine."]

OPPENHEIM, F. A.

O53 "Notes for Traveling Photographers." HUMPHREY'S JOURNAL 5, no. 4 (June 1, 1853): 62-64. [From "La Lumiere." "Having returned some months since from a journey in Spain, whence I brought back photographs..."]

O54 Oppenheim, F. A. "Notes for Traveling Photographers." PHOTOGRAPHIC ART JOURNAL 6, no. 3 (Sept. 1853): 177-180. ["From "J. of Photo Soc.".]

ORANGE.

O55 Orange. "The Manipulation of the Albumen Process." HUMPHREY'S JOURNAL OF PHOTOGRAPHY, AND THE ALLIED ARTS AND SCIENCES 10, no. 6 (July 15, 1858): 91-92. [From "Liverpool Photo. J.]

ORDONEZ, CASTRO RAFAEL. (SPAIN)

O56 Palmquist, Peter. "Don Rafael's Tree." HISTORY OF PHOTOGRAPHY 6 , no. 1 (Jan. 1982): 15-19. 4 b & w. [Rafael Ordonez Castro, photographer of the Spanish Navy's Pacific Squadron, landed in California in 1863, travelled inland to the Redwood Forest and took photos, subsequently reproduced in several American books.]

ORDWAY, J. MERRILL. (NEWBURYPORT, MA)

O57 "Photographs Received." PHILADELPHIA PHOTOGRAPHER 3, no. 26 (Feb. 1866): 64. [Ordway from Newburyport, MA. View of the "Prince House," Newburyport.]

ORMSBEE, MARCUS. (BOSTON, MA)

[Marcus Ormsbee was listed in Boston business directories as a "photographer" in 1843, but he then moved to Portland, ME and opened a studio there in 1844. He continued operating that studio until 1847. In 1847 he formed a partnership with George M. Silsbee and announced that, in addition to the normal portraits, they were "prepared to take views of cities, villages, houses, to copy Portraits, etc." Employeed Frank M. Danielson, who would then open his own studio in 1848. Ormsbee sold his Portland studio in November 1850 to George M. Howe and left for Boston, MA. Silsbee later joined him there briefly in 1851, then Ormsbee ran his own studio from 1852 until 1863. Ormsbee was an early advocate of paper photography, advertising early that he could take Talbotypes, and actively competing in this area with John Whipple by 1854. In 1862 Ormsbee bought Holden's Gallery in New York City and subsequently left Boston. In 1867 he patented a Multiplying Camera Box, which was later the cause of a slight flurry of controversy.]

O58 "Humphrey's Journal: A Daguerreotype Curiosity." HUMPHREY'S JOURNAL 4, no. 1 (Apr. 15, 1852): 11. [A mammoth-sized group portrait by Ormsbee (Boston, MA), described.]

O59 Portrait. Woodcut engraving, credited "From a Daguerreotype by Ormsbee." BALLOU'S PICTORIAL DRAWING-ROOM COMPANION [GLEASON'S] 12, (1857) 1 illus. ["John Townsend Trowbridge." 12:305 (Apr. 25, 1857): 268.]

O60 "A Boston Gallery on Broadway." HUMPHREY'S JOURNAL OF PHOTOGRAPHY, AND THE ALLIED ARTS AND SCIENCES 14, no. 5 (July 1, 1862): 32. [Ormsbee, of Boston, bought out Holden's Gallery - formerly Morand's - at 411 Broadway, New York, NY.]

O61 "Boston vs. New York." HUMPHREY'S JOURNAL OF PHOTOGRAPHY, AND THE ALLIED ARTS AND SCIENCES 14, no. 8 (Aug. 15, 1862): 78-79. [Describes Ormsbee's activities in his new studio in New York, NY.]

O62 "Ormsbee's Patent Improved Multiplying Camera Box." HUMPHREY'S JOURNAL OF PHOTOGRAPHY, AND THE ALLIED ARTS AND SCIENCES 18, no. 19 (Feb. 1, 1867): 303.

O63 "Ormsbee's Multiplying Camera Box." HUMPHREY'S JOURNAL OF PHOTOGRAPHY, AND THE ALLIED ARTS AND SCIENCES 19, no. 21 (Mar. 1, 1868): 333.

O64 "The War of the Camera-Boxes. Semmendinger vs. Ormsbee - Semmendinger claims Priority of Invention and of Patent - Interesting from Semmendinger." HUMPHREY'S JOURNAL OF PHOTOGRAPHY, AND THE ALLIED ARTS AND SCIENCES 19, no. 22 (Mar. 15, 1868): 345-346.

ORMSBY, ELON DELAMORE. (d. 1895) (USA)

O65 "Voices from the Craft." PHILADELPHIA PHOTOGRAPHER 15, no. 179 (Nov. 1878): 335-337. [E. D. Ormsby from Oakland, CA.]

O66 "Our Picture." PHILADELPHIA PHOTOGRAPHER 16, no. 189 (Sept. 1879): frontispiece, 257-258. 1 b & w. [Studio portrait.]

ORR, CHARLIE E. (SANDWICH, IL)

O67 Orr, Charlie E. "Post-Mortem Photography." PHILADELPHIA PHOTOGRAPHER 10, no. 115 (July 1873): 200-201. [Orr in Sandwich, IL.]

O68 "Editor's Table." PHILADELPHIA PHOTOGRAPHER 14, no. 166 (Oct. 1877): 320. [C. E. Orr (Sandwich, IL) praised.]

ORVIS, JAMES R.

O69 Orvis, James R. "Correspondence." ANTHONY'S PHOTOGRAPHIC BULLETIN 3, no. 2 (Feb. 1872): 461-462. [Orvis from Fayette, IO.]

OSBORN & DURBEC. (CHARLESTON, SC)

O70 "Tom, the Blind Negro Boy Pianist." FRANK LESLIE'S ILLUSTRATED NEWSPAPER 9, no. 222 (Mar. 3, 1860): 211-212. 1 illus. ["Photograph by Osborn & Durbec, Charleston, SC."]

OSBORN. (RICHMOND, VA)

O71 Davis, J. A. "The Richmond Galleries: Answer to 'An Amateur.'" PHOTOGRAPHIC AND FINE ART JOURNAL 9, no. 9 (Sept. 1856): 285-286. [The author gives a brief biography of Osborn. Born Springfield, MA. Went into fancy goods business, then learned photography around 1850. Worked in North and South, then settled in Richmond, VA. Describes his gallery.]

OSBORNE, H. P.

O72 "Lehigh University, South Bethlehem, Pa." HARPER'S WEEKLY 11, no. 567 (Nov. 9, 1867): 709. 1 illus. ["Photographed by H. P. Osborne."]

OSBORNE, JOHN WALTER. (GREAT BRITAIN, AUSTRALIA, USA)

O73 "The Photo-Lithographic Process of Mr. John Walter Osborne, of Melbourne." BRITISH JOURNAL OF PHOTOGRAPHY 8, no. 143 (June 1, 1861): 198-199.

O74 "Photo-Lithography." AMERICAN JOURNAL OF PHOTOGRAPHY AND THE ALLIED ARTS & SCIENCES n. s. vol. 4, no. 4 (July 15, 1861): 78-81. [From "Melbourne Argus (Mar. 12, 1861)." J. W. Osborne's experiments.]

O75 Osborne, J. W., of Melbourne. "Details of a Photolithographic Process, as Adopted by the Government of Victoria, for the Publication of Maps." AMERICAN JOURNAL OF PHOTOGRAPHY AND THE ALLIED ARTS & SCIENCES n. s. vol. 5, no. 10 (Nov. 15, 1862): 221-229. [Read before the British Association.]

O76 "Photolithography in Australia." HUMPHREY'S JOURNAL OF PHOTOGRAPHY, AND THE ALLIED ARTS AND SCIENCES 14, no. 15 (Dec. 1, 1862): 184-185. [From "Moniteur de la Photographie." Osborne's process.]

O77 "Clarification." AMERICAN JOURNAL OF PHOTOGRAPHY AND THE ALLIED ARTS & SCIENCES n. s. vol. 5, no. 11 (Dec. 1, 1862): 250-252. [From "Br. J. of Photo." Additional information on J. W. Osborne's discussion of photolithography as practiced in Australia.]

O78 Osborne, J. W. "On Some of the Difficulties Connected with the Practice of Photolithography." AMERICAN JOURNAL OF PHOTOGRAPHY AND THE ALLIED ARTS & SCIENCES n. s. vol. 5, no. 12 (Dec. 15, 1862): 267-273. [From "Photo. News."]

O79 Osborne, J. W. "On the Appearance of Relief in Negative Plates." AMERICAN JOURNAL OF PHOTOGRAPHY AND THE ALLIED ARTS & SCIENCES n. s. vol. 7, no. 2 (July 15, 1864): 30-31. [From "Br. J. of Photo."]

O80 "The American Photographical Society." AMERICAN JOURNAL OF PHOTOGRAPHY AND THE ALLIED ARTS & SCIENCES n. s. vol. 7, no. 9 (Nov. 1, 1864): 211-213. [Special Meeting: To hear a lecture by John W. Osborne, of London, who :...undoubtedly ranks first among photolithographers." Additional note on p. 216.]

O81 "Photography." HUMPHREY'S JOURNAL OF PHOTOGRAPHY, AND THE ALLIED ARTS AND SCIENCES 16, no. 12 (Oct. 15, 1864): 190. [Note that J. W. Osborne's photolithographic process being displayed in New York, NY by S. T. Hooper, "Mr. Osborne's assignee."]

O82 Osborn, J. W. "On A Practical Photolithographic Process and Its Applications." BRITISH JOURNAL OF PHOTOGRAPHY 12, no. 272 (July 21, 1865): 379-382. [From "Jour. of Franklin Institute, Phil." Extensive discussion of his own career, development of photolithographic printing office in Australia, etc. This is accompanying with excerpts from the discussion following the presentation of this paper to the Franklin Institute, on pp. 382-383.]

O83 Towler, Prof. "Visit to New York Continued." HUMPHREY'S JOURNAL OF PHOTOGRAPHY, AND THE ALLIED ARTS AND SCIENCES 18, no. 18 (Jan. 15, 1867): 273-275. [Towler describes his "visit to the photographic establishment of Mr. Osborne, formerly of Cork, then of Australia, lately of Berlin, and now at the corner of Tenth Street and Third Avenue, South Brooklyn. Osborne specialist in photo-lithographs.]

OSBORN, W. B.

O84 Osborn. "Photographic 'Dodges.'" HUMPHREY'S JOURNAL OF PHOTOGRAPHY, AND THE ALLIED ARTS AND SCIENCES 10, no. 19 (Feb. 1, 1859): 300-304. [Read to Birmingham Photo. Soc.]

O85 "Birmingham Photographic Society." BRITISH JOURNAL OF PHOTOGRAPHY 7, no. 114 (Mar. 15, 1860): 87. [Includes lecture "On the Serio-Comic Aspects of Photography," by W. B. Osborn.]

O'SHAUGHNESSY, WILLIAM BRICKE. (1809-1889) (GREAT BRITAIN, INDIA)

O86 Thomas, G. "O'Shaughnessy's Experiments in Colour Photography." HISTORY OF PHOTOGRAPHY 10, no. 2 (Apr.-June 1986): 169-170. [O'Shaughnessy experimenting with color daguerreotypes at the Medical College, Calcutta in 1830s, exhibited results in August 1839, then went on to other issues.]

OSLER, WILLIAM F. (PHILADELPHIA, PA)

O87 "Editor's Table." PHILADELPHIA PHOTOGRAPHER 6, no. 62 (Feb. 1869): 63.

O88 Osler, William F. "Impression of Form and Expression." PHOTOGRAPHIC TIMES 7, no. 79 (July 1877): 151-152.

OSTHEIM, O. VON.

O89 Turner, Harriet. "Vignette: Lebanese Villagers." HISTORY OF PHOTOGRAPHY 11, no. 2 (Apr. - June 1987): 171. 1 b & w. [Group costume portrait, taken by Osteim ca. 1865. Ostheim thought to be an Austrian cavalry officer who visited the Near East in 1850s and who may have settled in the Levant after 1860.]

O'SULLIVAN, TIMOTHY H. (1840-1882) (USA)

[Timothy O'Sullivan probably was born in New York City around 1840. By his mid-teens, O'Sullivan was working in Brady's New York

gallery. When Brady followed the Union Army to Manassas, with other spectators, to watch the first Battle of Bull Run, O'Sullivan may have been the operator who went along to take the photographs. A statement published in *Harper's Monthly Magazine* in September, 1869 implies that O'Sullivan was at that battle. "The battle of Bull Run would have been photographed close-up but for the fact that a shell from one of the rebel field-pieces took away the photographer's camera...." (p. 465). O'Sullivan certainly went on to become one of the most active and successful photographers of the Civil War. From December 1861 to May 1862 he was with the staff of Brigader-General Egbert Viele, during General Thomas W. Sheridan's campaign against South Carolina to secure bases for a naval blockade of the Confederacy. O"Sullivan photographed near Beaufort and Port Royal, on the islands off the Carolina coast, and around Fort Walker and Fort Pulaski, Georgia.

In May 1862 O'Sullivan was honorably discharged at Hilton Head, South Carolina, after compiled a successful photographic record of that campaign. During July and August 1862 O'Sullivan followed General John Pope's invasion into Virginia and he photographed military bridges, railroad depots, supply camps, and scenes around Manassas and Culpeper. He photographed the sites of skirmishes and battles at Warrington, Sulpher Springs, and Cedar Mountain. The second union defeat at the second Battle of Bull Run ended Pope's campaign. Timothy O'Sullivan seems to have left Brady when Alexander Gardner quit, and O'Sullivan's photograph began to appear under the Gardner gallery name afterwards, In May 1863 he photographed the Union troops deployed before Fredericksburg, and in July he accompanied Alexander Gardner and James Gibson to Gettysburg, and photographed the aftermath of that battle. In 1863 O'Sullivan also photographed the Confederate batteries at Charleston, South Carolina and Fort Sumter, and had his camera knocked over twice by cannon shelling.

In 1864 O'Sullivan covered the opening of General Grant's Spring campaign against Lee in Northern Virginia. He photographed the aftermath of the battle at Spotsylvania in May and the campaign at Massaponax Church and the North Anna River, the siege of Petersburg, operations against Fort Fisher in North Carolina in December 1864. He photographed the end of the conflict at Appomattox Court House in April 1865, then made views of Petersburg, Fort Stedman, and other captured sites in April and May. Gardner published his two volume album *Photographic Sketchbook of the War* in 1866, and forty-four of the one hundred photographs in the work are credited to O'Sullivan.

O'Sullivan joined the U. S. Geological Explorations West of the 40th Parallel, led by Clarence King, in 1867. O'Sullivan would continue as an expeditionary photographer for over ten years, where he came to be known as a brave, resourceful, and valuable companion to have on these arduous ventures. On the King expeditions from 1867-70 O'Sullivan photographed the mines in Virginia City, Nevada, the desert at Carson Sink, and the Rocky Mountains. In 1870 O'Sullivan joined the Selfridge expedition to the Isthmus of Darien (Panama) to locate a route for a canal. In 1871 he joined the Wheeler expedition which sailed down the Colorado River. In 1873-74 he joined Lieut. George Wheeler's expedition to Arizona, where he photographed Navahos, Apaches, and Pueblo Indian tribesmen and documented the Canyon de Chelley area. In 1875 he returned to Washington, DC, to print negatives for the Army Corps of Engineers. In November 1880 he obtained the post of Chief Photographer in the Office of the Supervising Architect in the Treasury Department. His letters of recommendation for this post were many and effusive, indicative of the high esteem he commanded among his peers. But he held the post only until March 1881, then resigned for illness. Died on Staten Island on Jan. 14, 1882.]

BOOKS

O90 Gardner, Alexander. *Gardner's Photographic Sketch-Book of the War.* Washington, DC: Philip & Solomon's, 1866. 2 vol. in 1 pp. 100 b & w. [Forty-four of the one hundred photographs in this work are credited to O'Sullivan.]

O91 King, Clarence. *The Three Lakes: Marian, Lall, Jan, and How They Were Named.* New York: Published by the author., 1870. viii pp. 12 b & w. [Frontispiece portrait by A. J. Russell and 11 albumen photographs by Timothy O'Sullivan, with two poems and two letters. Photographs primarily taken during King's U. S. Geological Survey of the 40th Parallel.]

O92 Wheeler, Capt. George M. *Preliminary Report of Exploration on Nevada and Arizona.* Washington, DC: Government Printing Office, 1872. n. p. [Wheeler's reports contains special volumes, with O'Sullivan photographs. 42 Cong. 2 Sess., Sen. Exec. Doc. 65]

O93 Selfridge, Thomas Oliver. *Reports of Explorations and Surveys to Ascertain the Practicability of a Ship Canal Between the Atlantic and Pacific Oceans by Way of the Isthmus of Darien.* Washington, DC: Government Printing Office, 1874. 268 pp. illus. [Lithographic illustrations taken from O'Sullivan photographs.]

O94 United States Army. Corps of Engineers. *Photographs showing Landscapes, Geological and other Features, of Portions of the Western Territory of the United States, Obtained in Connection with Geographical and Geological Explorations and Surveys West of the 100th Meridian. Seasons of 1871, 1872, 1873. 1st Lieut. George M. Wheeler, Corps of Engineers, U. S. Army.* Washington, DC: Government Printing Office, 1874. ii, 100 pp. 50 b & w. [50 plates, 35 from photographs by Timothy H. O'Sullivan for 1871 and 1873 and 15 from photographs by William Bell for 1872. Atlas volume for the 6 volume "Report upon Geographical and Geological Explorations and Surveys West of the One Hundredth Meridian," published in volumes from 1875 to 1879.]

O95 King, Clarence. *First Annual Report of the United States Geological Survey, to the Hon. Carl Schurz, Secretary of the Interior.* Washington, DC: Government Printing Office, 1880. n. p. [Illustrated by engravings adapted from O'Sullivan photographs.]

O96 *Catalogue and Index of the Hayden, King, and Wheeler Surveys, U.S. Geological Survey.* "Bulletin 222" Washington, DC: Government Printing Office, 1904. n. p. [Illustrated by engravings adapted from O'Sullivan photographs.]

O97 Horan, James D. *Timothy O'Sullivan: America's Forgotten Photographer. The Life and Work of the Brilliant Photographer Whose Camera Recorded the American Scene from the Battlefields of the Civil War to the Frontiers of the West.* Garden City, NY: Doubleday & Co., Inc., 1966. 334 pp. b & w. illus.

O98 Newhall, Beaumont and Nancy Newhall, with an appreciation by Ansel Adams. *T. H. O'Sullivan: Photographer.* Rochester, NY: The George Eastman House, in collaboration with the Amon Carter Museum of Western Art, 1966. 48 pp. 40 b & w. 1 illus.

O99 Wilson, Richard Brian. *American Vision and Landscape: The Western Images of Clarence King and Timothy O'Sullivan.* Albuquerque: Univ. of New Mexico Press, 1979. 376 pp. b & w. illus.

O100 Snyder, Joel. *American Frontiers, the Photographs of Timothy H. O'Sullivan 1867 - 1874.* Millerton, NY: Aperture, 1981. 120 pp. b & w.

O101 Dingus, Rick. *The Photographic Artifacts of Timothy O'Sullivan.* Albuquerque, NM: University of New Mexico Press, 1982. xvii, 158 pp. b & w. illus.

O102 *Wheeler's Photographic Survey of the American West, 1871 - 1873* New York: Dover Publications, 1983. [Facsimile reprint of the album of fifty photographs by O'Sullivan and by William Bell, published by Wheeler to supplement his seven volume report of the surveys.]

PERIODICALS

O103 "The War in Virginia - Lieutenant-General Grant in a Council of War at Massaponax Church. - From a Photograph by Gardner." FRANK LESLIE'S ILLUSTRATED NEWSPAPER 18, no. 459 (July 16, 1864): 257, 263. 1 illus. [This is the well-known image by Timothy O'Sullivan, here credited to Gardner. "...The public calls for action, and our battle scenes cannot be painted in the stereotyped fashion of European art,...Our illustrated papers have opened a new path, and its influence is felt in Europe....The scenery is given truthfully, the moving masses of men, the steady progress of the shot and shell of the great guns, with the cloud of the volley of small arms, the rising dust, all are now given. Formerly a few officers made a battle, now we see armies contending, and can recognize the spot....The sketch which we give of General Grant at Massaponax Church deserves to live in history...In these careless hats, these scarce military dresses, devoid of all but the faintest show of rank, are the true heroes of the republic."]

O104 Sampson, John. "Photographs from the High Rockies." HARPER'S NEW MONTHLY MAGAZINE 39, no. 232 (Sept. 1869): 465-475. 13 illus. [O'Sullivan is not named in the text and his photographs are not credited, but the wood engravings are taken from his photographs of the Clarence King surveys of 1867 and 1868. O'Sullivan's Civil War experience is mentioned, some anecdotes given.]

O105 "Isthmus of Darien, Central America. - Arrival of the Telegraph Corps of the United States Canal-Surveying Expedition at the Mouth of the Sucuriti River, Pacific Side." FRANK LESLIE'S ILLUSTRATED NEWSPAPER 30, no. 766 (June 4, 1870): 181, 186-187. 1 illus. [Group portrait of the team, in the jungle, with equipment. "It is taken from a photograph by Mr. Sullivan, [sic O'Sullivan] the official photographer to the expedition."]

O106 Maack, Dr. G. A. "The Secret of the Strait." HARPER'S NEW MONTHLY MAGAZINE 47, no. 282 (Nov. 1873): 801-820. 16 illus. [Discusses Selfridge's 1873 expedition to the Isthmus of Darien [Panama]. No credits given for the illustrations, but they are from photographs taken by both O'Sullivan and Moran, who were on this expedition.]

O107 Rideing, William H. "The Wheeler Expedition in Southern Colorado." HARPER'S MONTHLY 52, no. 312 (May 1876): 793-807. 15 illus. [Views, people on the 1875 Wheeler expedition, some probably from photographs. Rideing's detachment did not have a photographer along, but good background material.]

O108 Rideing, William H. "A Trail in the Far Southwest." HARPER'S MONTHLY 53, no. 313 (June 1876): 15-24. 7 illus. ["The writer's thanks are due to Mr. Clark (topographer of Lieut. Morrison's expedition into Arizona and New Mexico.) and Mr. W. H. Holmes for the valuable assistance he received from them in illustrating the article." These are engravings, some of which may have been freely translated from O'Sullivan's photos, otherwise background material.]

O109 "The Fire in the Patent-Office—Photographed by T. H. O'Sullivan." HARPER'S WEEKLY 21, no. 1085 (Oct. 13, 1877): 808-810. 2 illus.

O110 "Matters of the Month." PHOTOGRAPHIC TIMES 10, no. 120 (Dec. 1880): 276-277. ["Mr. T. H. O'Sullivan, whose celebrity as landscape photographer, is second to none in this country, has been appointed Photographer-in-Chief of the United States Treasury Department..."]

O111 "Deceased." ANTHONY'S PHOTOGRAPHIC BULLETIN 13, no. 1 (Jan. 1882): 29.

O112 Baumhofer, Hermine M. "T. H. O'Sullivan." IMAGE 2, no. 4 (Apr. 1953): 20-21. 3 b & w.

O113 Doty, Robert. "Gift of Jackson and O'Sullivan Photographs." IMAGE 11, no. 5 (1962): 21-22. [Harvard Univ., Dept. of Geological Sciences gives 364 photographs to the George Eastman House. 140 prints by W. H. Jackson, 134 prints by T. O'Sullivan.]

O114 Ray, Frederick. "A 'Moving Picture' of a Council of War." CIVIL WAR TIMES ILLUSTRATED 1, no. 2 (May 1962): 14-16. 3 b & w. 1 illus. [Describes three photos taken by Timothy O'Sullivan of a Union War Council with Generals Grant and Meade, held May 21, 1864 at the Massaponax Baptist Church near Fredericksburg, VA.]

O115 Vestal, David. "Frontier Photographers: O'Sullivan and Jackson." TRAVEL & CAMERA 32, no. 6 (June 1969): 48-52, +. illus.

O116 Norton, Russell. "O'Sullivan Portrait found to be Moran." STEREO WORLD 3, no. 2 (May - June 1976): 11. 1 b & w. [Portrait of the photographer at Pinogana, during the 1871 expedition to the Isthmus of Darien, must be of John Moran, not Timothy O'Sullivan, as previously thought.]

O117 Frassanito, William A. "Comment." STEREO WORLD 3, no. 3 (July - Aug. 1976): 18-19. [Letter from Frassanito stating that if the misattributed O'Sullivan portrait is Moran, then another image of a photographer taken during the Civil War, which he had tentatively identified as O'Sullivan, may in fact be the only portrait of that artist extant.]

O118 Gilbert, George. "'Forgotten' Photographer Honored with Mountain." PHOTOGRAPHICA 11, no. 4 (Apr. 1979): 15. [Mountain in Utah named after O'Sullivan.]

O119 "Landmark Event for O'Sullivan." AFTERIMAGE 7, no. 5 (Dec. 1979): 2. [Mountain named after O'Sullivan after efforts made by Arthur Whitehead.]

O120 McDarrah, Fred. "Voice Centerfold: Photo." VILLIAGE VOICE 25, no. 38 (Sept. 17 - 23, 1980): 57. [Ex. rev.: "The Wheeler Album," Daniel Wolf Gallery, New York, NY. Exhibition of album made from photographs taken by Timothy O'Sullivan and William Bell on Wheeler Survey through the American southwest in 1872.]

O121 Brey, William. "O'Sullivan's Indians: The Wheeler Expeditions - 1871 through 1874." STEREO WORLD 11, no. 3 (July - Aug. 1984): 14-21. 11 b & w. 2 illus. [Description and listing of a presentation set of fifty stereo views taken during the Wheeler Surveys of 1871-1874.]

O'SULLIVAN, TIMOTHY [?]
BOOKS
O122 Hague, James Duncan. *Mining Industry*, by James Duncan Hague; with Geological Contributions by Clarence King. Washington, DC: Government Printing Office, 1870. xii, 667 pp. 37, atlas of 14 l. of plates. ["Geological Exploration of the Fortieth Parallel. Report Vol. 3." "Professional Papers of the Engineer Department of the U. S. Army. No. 18." Original photo, attributed to Timothy O'Sullivan.]

PERIODICALS
O123 Manning, William C. "Ancient Pueblos of New Mexico and Arizona." HARPER'S MONTHLY 51, no. 303 (Aug. 1875): 327-336. 8 illus. [Engravings, from photos. Moqui, Navaho, Apache, Zuni Indians. Not credited, probably O'Sullivan or Hillers.]

O124 "Ancient America." HARPER'S WEEKLY 20, no. 993 (Jan. 8, 1876): 33. 6 illus. [Brief discussion of the Wheeler and Hayden Surveys, illustrated with five engravings, probably from photos, some probably by O'Sullivan. Navaho Indians, Canyon de Chelle ruins, etc.]

O125 Rideing, William H. "The Wheeler Survey in Nevada." HARPER'S MONTHLY 55, no. 325 (June 1877): 65-76. 11 illus. [Engravings, some may be from photos. However a photographer is not listed among the organization of this party. Background.]

OTIS, C. & CO.
O126 "Scene of the Terrible Boiler Explosion at the State Fair, Indianapolis, Indiana." HARPER'S WEEKLY 13, no. 669 (Oct. 23, 1869): 684. 1 illus. ["Photographed by C. Otis & Co.]

OTT, ADOLPHE.
O127 "Report of the Photographic Section of the American Institute." ANTHONY'S PHOTOGRAPHIC BULLETIN 7, no. 7 (July 1876): 222-223. [Report by Dr. Adolphe Ott contains a brief survey of the exploration of photo-mechanical printing, and a summary of current practices, primarily in Germany.]

O128 "Photo-Stereotyping (Photo-engraving). A Substitute for Wood Engraving." PHILADELPHIA PHOTOGRAPHER 14, no. 162 (June 1877): 163-165. [Paper read by Dr. Adolph Ott, to the Polytechnic Ass. of New York, NY in April, 1877.]

OTTÉ, JOACHIM.
BOOKS
O129 Otté, Joachim, F.G.S. *Landscape Photography; Or a Complete and Easy Description of the Manipulations and Apparatus Necessary for the Production of Landscape Pictures, Geological Sections, etc., by the Calotype, Wet Collodion, Collodio-Albumen, Gelatine, and Wax Paper Processes; by the Assistance of which an Amateur may at once Commence the Practice of the Art.* "New Edition" London: Robert Hardwicke, 1858. xvi, 76 pp. 1 l. of plates. 1 b & w.

PERIODICALS
O130 "Review." LIVERPOOL & MANCHESTER PHOTOGRAPHIC JOURNAL [BRITISH JOURNAL OF PHOTOGRAPHY n. s. 2, no. 17 (Sept. 1, 1858): 216-217. [Bk. rev.: "Landscape Photography;..." by Joachim Otte.]

O131 "Our Library Table." ATHENAEUM no. 1612 (Sept. 18, 1858): 361. [Bk. rev.: "Landscape Photography," by Joachim Otte. (Hardwicke).]

OTTEWILL, THOMAS.
O132 Van Hasbroeck, Paul Henry. "Thomas Ottewill's Collapsible Camera of 1853." PHOTOGRAPHIC COLLECTOR 2, no. 3 (Autumn 1981): 70-73. 9 illus.

OTTINGER see SAVAGE & OTTINGER.

OUR OWN PIONEER.
O133 "Where to Go with the Camera Round About the Cornish Coast, by 'Our Own Pioneer.'" BRITISH JOURNAL OF PHOTOGRAPHY 9, no. 166-169 (May 15 - July 1, 1862): 192-193, 210-212, 234, 256-257.

O134 "Where to Go with the Camera. Round Launceston, by 'Our Own Pioneer.'" BRITISH JOURNAL OF PHOTOGRAPHY 9, no. 170 (July 15, 1862): 275-276.

O135 "Where to Go with the Camera. Round Exeter, by Our Own Pioneer." BRITISH JOURNAL OF PHOTOGRAPHY 9, no. 171-172 (Aug. 1-Aug. 15, 1862): 292-293, 312-313.

O136 "Where to Go with the Camera. Exeter - the Taw and Torridge, by 'Our Own Pioneer.'" BRITISH JOURNAL OF PHOTOGRAPHY 9, no. 173, 175 (Sept. 1, Oct. 1, 1862): 333, 370-371.

OUTE, MARK see MASON, GEORGE.

OVERTON, J. S. (CROWLE, ENGLAND)
O137 "Critical Notices: Stereograms of the Birth-place, etc. of John Wesley. By J. S. Overton, Crowle." PHOTOGRAPHIC NEWS 3, no. 61 (Nov. 4, 1859): 100.

OWEN, GEORGE.
O138 Owen, Geo. "Vignette Glasses." HUMPHREY'S JOURNAL OF PHOTOGRAPHY, AND THE ALLIED ARTS AND SCIENCES 13, no. 10 (Sept. 15, 1861): 150. [From "Photo. News."]

OWEN, HENRY.
O139 "Fine Art Gossip." ATHENAEUM no. 1103 (Dec. 16, 1848): 1271. [Note that a portfolio of Calotypes by Mr. Owen...foliage, etc. was presented at the first meeting of the season of the Graphic Society.]

OWEN, HUGH
O140 *Great Exhibition of the Works of Industry of All Nations. Reports by the Juries on the Subjects in the 30 Classes into which the Exhibition was Divided.* London: Spicer Brothers, 1852. 4 vol. 154 b & w. 1 illus. [Special illustrated ed., 115 copies. One lithograph and 154 calotype prints of interiors, displays, etc. of the exhibition. Hugh Owen and G. Ferrier were the photographers, the prints were made by Nikolaas Henneman. Photography is discussed in Class 10, pp. 243-246, 274-279.]

OWEN, J. & E. OWEN.
O141 "The Newtown and Machynlleth Railway, North Wales." ILLUSTRATED LONDON NEWS 42, no. 1185 (Jan. 24, 1863): 108. 2 illus. ["...from a photograph by Messrs. J. and E. Owen, of Newtown."]

P

D. P.
P1 D. P. "Ocular Stereoscopy." ONCE A WEEK 4, no. 92 (Mar. 30, 1861): 371-373. 7 illus.

J. P. (NEW ZEALAND)
P2 J. P. "Photographic Experiences in New Zealand." ANTHONY'S PHOTOGRAPHIC BULLETIN 10, no. 8 (Aug. 1879): 230-231. [From "Br J of Photo." Jovial anecdotes, not very specific in detail, about his experiences photographing "in the bush."]

R. H. P. (GREAT BRITAIN)
P3 R. H. P. "Photography in Relation to Art." BRITISH JOURNAL OF PHOTOGRAPHY 12, no. 269 (June 30, 1865): 341.

PAAGE, A. (BOWLING GREEN, KY)
P4 Paage, A. "The Natural Colors." AMERICAN JOURNAL OF PHOTOGRAPHY AND THE ALLIED ARTS & SCIENCES n. s. vol. 7, no. 14 (Jan. 15, 1865): 331. [A. Paage (Bowling Green, KY) did some experimenting with colors, wrote a note describing them.]

P5 "Photographs in Natural Colors." PHILADELPHIA PHOTOGRAPHER 4, no. 44 (Aug. 1867): 245. [A. Paage (Bowling Green, KY) reported to be working with a color process.]

PACH BROTHERS. (NEW YORK, NY)
[Gustavus, Gotthelf, and Oscar Pach were the Pach brothers. There are several colorful legends around the start of their business. In 1866 or 1867 Gustavus, then twenty years old, and his younger brother Gotthelf, were called upon to photograph General Ulysses S. Grant, who was being visited by George W. Childs and Anthony Drexel at Long Branch, NJ. Impressed by their talent and energy, Grant collected $500 from each of his financier friends and turned it over to the Pach's to finance their opening their own business. They opened a studio in Long Branch, then moved to 100 Bowery in New York. In 1869 the Pach Studio moved to 858 Broadway, where they photographed Grant, now the new President, in their Broadway gallery. The Pach studio obtained the commission to photograph all the jewels at Tiffany's from the late 1860s until 1890, when the company hired its own photographer. The Pachs opened many branch studios in college towns and specialized in taking portraits for class albums. They also helped the New York City Police Department set up its Rogue's Gallery. The Pach Studio provides a good example of the evolutions in commercial photography during the latter half of the 19th century. In spite of a devastating fire in 1895 which destroyed many of the negatives cumulated over thirty years, by 1897 the main studio on Broadway covered "the ground space of more than six ordinary buildings," and had a full time staff of thirty-five employees. There were also more than a dozen branch studios set up along the East Coast to take college portraits. In addition to the portrait trade the "field work covered by this enterprising house extends over the whole range of professional photography." The Pach Studio became known for its portraits of actors, politicians, and other celebrities, ceremonial groups, flashlight portraits, interiors, and architectural views. By the 1890s the studio provided many photographs for the florishing illustrated press. Over the years many famous men and women had their portraits taken in the Pach studios. In 1910 the studio moved to 570 5th Ave., where it stayed well into the 1930s.]

BOOKS
P6 Pach, Alfred. *Portraits of Our Presidents*. New York: Hastings House, 1943. 68 pp. 31 b & w.

P7 *The Story of the Pach Collection*. New York: Pach Brothers, Photographers, 5 East 57th St., n. d. [ca. 1947?]. 6 pp. 32 b & w. 1 illus. [The portraits are of the thirty-two presidents of the United States, photographs from Grant on, and reproduction photographs of paintings of earlier individuals. (This was apparently a special exhibition, organized and shown at the Library of Congress, NY Public Library, etc.]

PERIODICALS
P8 "Matters of the Month: Pach's Prison Pictures." PHOTOGRAPHIC TIMES 5, no. 49 (Jan. 1875): 8. [Stereos of Sing Sing, West Point, prisoners at work, cadets drilling, etc.]

P9 "Awards of the American Institute (List of Medals and Awards)." PHOTOGRAPHIC TIMES 8, no. 96 (Dec. 1878): 279. [Kurtz, Fredericks, Howell, Rockwood, Jordan, Dinner, Gubelman, Pach, Schwind & Krueger, etc. mentioned.]

P10 "Class Photographs and Photographers." PHOTOGRAPHIC TIMES 8, no. 86 (Feb. 1878): 34-35. [Notman, Pach, Warren, mentioned.]

P11 "Note." PHILADELPHIA PHOTOGRAPHER 16, no. 190 (Oct. 1879): 313. [Note that Mr. Wells, formerly the "operator" or "positionist" at the Bogardus Studio, has moved to the Pach Brothers.]

P12 Ehrmann, Charles. "The Photographic Exhibit at the American Institute Fair." PHOTOGRAPHIC TIMES 15, no. 219 (Nov. 27, 1885): 662-663. [Pach Brothers, Fredericks, Gutekunst, De Yong, C. H. Heimburg, Rockwood, Howe, Parkinson, Prof. Willis, etc.]

P13 "The Intercollegiate Championship Games at Berkeley Oval, May 31st - The Start for the "Hundred Yard Run." Photos by Pach." FRANK LESLIE'S ILLUSTRATED NEWSPAPER 70, no. 1813 (June 14, 1890): 396. 2 illus. [Portrait of runner, taken outdoors, start of the race.]

P14 "Notes and News." PHOTOGRAPHIC TIMES 21, no. 489 (Jan. 30, 1891): 58-59. [Pach's flash-light photo of "the group assembled at the dinner to the Comte de Paris" discussed.]

P15 "Two Prominent Democratic Governors - From a Photo by Pach." FRANK LESLIE'S ILLUSTRATED NEWSPAPER 73, no. 1886 (Nov. 21, 1891): 251. 1 b & w. [Informal portrait, seated outdoors.]

P16 "The Famous 'Meininger' Company at the Thalia Theatre, New York-Character-Sketches from their Representation of 'Julius Caesar' - From Photos by Pach." FRANK LESLIE'S ILLUSTRATED NEWSPAPER 73, no. 1891 (Dec. 12, 1891): 326, 333. 3 b & w. 3 illus. [Sketches from photos.]

P17 "The Studios of New York. Part 5." PHOTOGRAPHIC TIMES 22, no. 554 (Apr. 29, 1892): 222-223. [Pach Brothers Studio, the Moreno Studio, Charles E. Davis & E. Starr's Studio.]

P18 1 photo (Hon. Grover Cleveland, Democratic nominee for President). FRANK LESLIE'S ILLUSTRATED NEWSPAPER 75, no. 1920 (June 30, 1892): cover. 1 b & w.

P19 "The Yale Crew, Winners of the Recent Yale-Harvard Race on the Thames - Photographed by the Pach Brothers." FRANK LESLIE'S ILLUSTRATED NEWSPAPER 75, no. 1922 (July 14, 1892): 53. 2 b & w.

P20 1 photo ("A Baby Profile"). PHOTOGRAPHIC TIMES 23, no. 590 (Jan. 6, 1893): frontispiece, 1. 1 b & w. [Note on p. 1. The poem "A Baby Profile," by Leila R. Ramsdell also on p. 1.]

P21 1 photo (Portrait, President Cleveland). PHOTOGRAPHIC TIMES 23, no. 601 (Mar. 24, 1893): frontispiece, 147. 1 b & w. [Note on p. 147.]

P22 1 photo (Portrait, "H.R.H. the Infanta Princess Eulalia of Spain."). PHOTOGRAPHIC TIMES 23, no. 617 (July 14, 1893): frontispiece, 357. 1 b & w. [Note on p. 357.]

P23 Greenough, J. B. "The Latin Play at Harvard." NEW ENGLAND MAGAZINE 10, no. 4 (June 1894): 491-509. 19 b & w. ["Illustrated from photographs by Pach Brothers." Actors, stage sets.]

P24 "Editor's Table: Destruction of the Pach Studio." WILSON'S PHOTOGRAPHIC MAGAZINE 32, no. 459 (Mar. 1895): 143. [Pach Studio burned, total loss, 30 years of negatives, etc.]

P25 "The Studio and Work of Messrs. Pach Bros." WILSON'S PHOTOGRAPHIC MAGAZINE 34, no. 487 (July 1897): 305-310. 3 b & w. 6 illus.

P26 Waring, George E., Jr. "Education at West Point." OUTLOOK 59, no. 14 (Aug. 6, 1898): 825-837. 10 b & w. [Cadets drilling, etc. Photos credited to Pach Brothers, New York (4); S.R. Stoddard (4).]

P27 "Troubles of Our Own." WILSON'S PHOTOGRAPHIC MAGAZINE 35, no. 500 (Aug. 1898): 357. 1 b & w. [Posed portrait (humorous) of W. C. Farrand, the operator, Mr. E. L. Mix, the printer, and Mr. Hammer, the dark-room man, at Pach Brothers Studio in New York, conferring over a problem photograph.]

P28 "The Photographers and the Schools." WILSON'S PHOTOGRAPHIC MAGAZINE 37, no. 521 (May 1900): 214-215. 3 b & w. [Article is about photographing grade-school classrooms, while they are in session. Illustrated with views by the Pach Brothers, taken in the schools of New York City, for the Educational exhibition at the Paris Exhibition. The Pach Brothers, "one of several local photographers illustrated with this task..." made more than 100 negatives.]

P29 1 photo ("The Presidential Candidates: William Jennings Bryan"). COLLIER'S WEEKLY 26, no. 4 (Nov. 3, 1900): 14.

P30 Camp, Walter. "Sports of the Amateur." COLLIER'S WEEKLY 27, no. 15 (July 13, 1901): 21-22. 11 b & w. [Racing sculls.]

P31 1 photo ("West Point's Centennial"). COLLIER'S WEEKLY 29, no. 12 (June 21, 1902): cover.

P32 "The Graduating Classes of Yale, Columbia and Princeton." COLLIER'S WEEKLY 29, no. 13 (June 28, 1902): 10. 3 b & w.

P33 Keys, C. M. "As Many Railroad Methods as Railroad Kings." WORLD'S WORK 10, no. 5 (Sept. 1905): 6652-6659. 6 b & w.

P34 1 photo (W. M. Ivins, Republican candidate for Mayor of New York, NY.) WORLD'S WORK 11, no. 2 (Dec. 1905): 6911.

P35 1 photo (Miss Alice Roosevelt.) OUTLOOK 82, no. 8 (Feb. 24, 1906): 434. 1 b & w.

P36 1 photo (Politician James R. Garfield.) OUTLOOK 82, no. 12 (Mar. 24, 1906): 676. 1 b & w.

P37 1 photo (Nathaniel S. Shaler, educator.) WORLD'S WORK 12, no. 2 (June 1906): 7583.

P38 1 photo (The Late Carl Schurz.) WORLD'S WORK 12, no. 3 (July 1906): 7697.

P39 1 photo (Railroad Financier J. J. Hill.) OUTLOOK 87, no. 8 (Oct. 26, 1907): 390. 1 b & w.

P40 1 photo (Howard Taft and Family.) WORLD'S WORK 16, no. 4 (Aug. 1908): 10500.

P41 2 photos (Bishop David Greer, Frederich T. Gales, Pres. General Education Board.) WORLD'S WORK 16, no. 5 (Sept. 1908): 10618-10622.

P42 1 photo (George Wickersham, Attorney General.) WORLD'S WORK 17, no. 6 (Apr. 1909): 11399.

P43 1 photo (Otto Bannard, Mayoral candidate, New York, NY.) WORLD'S WORK 19, no. 1 (Nov. 1909): 12182.

P44 Casson, Herbert N. "The Birth of the Telephone." WORLD'S WORK 19, no. 5 (Mar. 1910): 12669-12683. 19 b & w. [Views of telephone employees at work, equipment, etc. One grouping of posed scenes of the telephone in action - in a resturant, a Pullman car, etc., is credited to the Pach Brothers.]

P45 1 photo (Dr. Ambram Jacobi, pediatrician.) WORLD'S WORK 20, no. 2 (June 1910): 12981.

P46 2 photos (Mayor Gaynor, Pres. McKinley, V. P. Roosevelt, etc.) WORLD'S WORK 20, no. 3 (July 1910): cover, 13135. ["Notice of omission of credit for these photos appears on p. 13356 of the Sept. 1910 'World's Work.'"]

P47 1 photo (Major-General Leonard Wood, U.S.A.) WORLD'S WORK 20, no. 5 (Sept. 1910): 13332.

P48 1 photo (Bernard Baker, conservationist.) WORLD'S WORK 20, no. 6 (Oct. 1910): 13458.

P49 2 photos (Henry Stimson, Republican, John Dix, Democrat.) WORLD'S WORK 21, no. 1 (Nov. 1910): 13580, 13581.

P50 1 photo (The Hon. James Bryce, British Ambassador.) WORLD'S WORK 30, no. 2 (June 1915): 131.

P51 2 photos (William G. McAdoo, Sect. of Treasury, Paul Warburg, Financier.) WORLD'S WORK 30, no. 3 (July 1915): 256, 257.

P52 "Pachs Vobiscum." THE NEW YORKER (Jan. 28, 1933): 9.

PACH, ALEXANDER. (EASTON, PA)
P53 Pach, Alex. L. "Points from My Practice." PHOTOGRAPHIC MOSAICS: 1892 28, (1892): 263-264. [Pach from Easton, PA.]

PACH, GUSTAVUS W. (1845-1904) (USA)
BOOKS
P54 Schenck, J. H. *Album of Long Branch; A Series of Photographic Views, with Letterpress Sketches.* New York: John F. Trow, 1868. n. p. 76 b & w. [Original prints, views of scenery, etc., by G. Pach.]

PERIODICALS

P55 "Note." PHOTOGRAPHIC TIMES 6, no. 66 (June 1876): 134. ["Mr. G. W. Pach, the justly celebrated view photographer, has taken views of school buildings and New Jersey interiors and exteriors."]

P56 Portrait. Woodcut engraving, credited "From a Photograph by G. W. Pach." FRANK LESLIE'S ILLUSTRATED NEWSPAPER 47, (1878) ["The late J. H. Raymond, Pres. of Vassar College." 47:1197 (Sept. 7, 1878): 13.]

P57 "Note." ANTHONY'S PHOTOGRAPHIC BULLETIN 10, no. 1 (Jan. 1879): 16. ["Mr. G. W. Pach,...secured the contract for supplying the photographic portion of the "Herald" Polar Expedition,..."]

P58 "The Cabinet and Mrs. Hayes Photographed." ANTHONY'S PHOTOGRAPHIC BULLETIN 10, no. 3 (Mar. 1879): 78. [Note that Pach has taken the first photograph of the Cabinet in session, and portraits of the President's wife.]

P59 Lathrop, George Parsons. "The Literary Movement in New York." HARPER'S MONTHLY 73, no. 438 (Nov. 1886): 813-833. 16 illus. [Portraits of eminent authors, engraved from photographs. Photos by Mora; Pach; Vail Brothers; Zimmerman; Sarony; Barraud; Kurtz; Rockwood.]

P60 "Editor's Table." WILSON'S PHOTOGRAPHIC MAGAZINE 38, no. 530 (Feb. 1901): 72. [Note that several of Pach's photos stolen or lost and National P.A. of A. convention offers a reward for their return.]

P61 "Obituary Notice." PHOTOGRAPHIC TIMES 36, no. 11 (Nov. 1904): 504-505. 1 illus.

P62 McMahon, T. J. "G. W. Pach: Stereographer of Monmouth County's Resorts." STEREO WORLD 1, no. 5 (Nov.-Dec. 1974): 3, 13. 1 b & w. [G. W. Pach worked the Monmouth County, NJ, shore area from about 1870 to 1884.]

PAGE, CHARLES GRAFTON. (1812-1868) (USA)

P63 "Miscellanea: 'Mode of Colouring Daguerreotype Pictures,' by C. G. Page, Prof. Chem. Columbia College, U.S.A." ATHENAEUM no. 907 (Mar. 15, 1845): 277. [From "Silliman's Journal."]

P64 "Curiosities in Daguerreotypes." HUMPHREY'S JOURNAL 4, no. 19 (Jan. 15, 1853): 292. [C. G. Page (New York, NY) offered to photograph certain categories of individuals for free -100 years old, etc...]

PAGLIANO, LEONIDA. (MILAN, ITALY)

P65 Portrait. Woodcut engraving credited "From a photograph by L. Pagliano." ILLUSTRATED LONDON NEWS 72, (1878) ["Queen Margherita, of Italy." 72:2013 (Jan. 26, 1878): 80.]

PAINE.

P66 Portrait. Woodcut engraving credited "From a photograph by Paine." ILLUSTRATED LONDON NEWS 27, (1855) ["Mr. Rogers, aged 92." 27:* (Dec. 29, 1855): 768.]

PALESTINE EXPLORATION FUND see also PHILLIPS, H.

[Corporal (later Sergeant) Phillips was the major photographer during the 1st (Nov. 1865-May 1866) and 2nd (1867) surveys of the Palestine Exploration Fund.]

PALESTINE EXPLORATION FUND.

P67 "The Exploration of Palestine." ART JOURNAL (Feb. 1868): 28-29. [Notice (one of several similar reports) about the activities of the Palestine Exploration Fund which was geographical, geological, etc. Survey party under direction of Lt. Anderson.]

P68 Stanley, A. P. "Palestine Exploration." GOOD WORDS 9, no. 3 (Mar. 1868): 173-176. 2 illus. ["Illustrations from Photographs." Views, taken by the Palestine Exploration Fund.]

P69 "Photographs of Palestine Taken for the Exploration Fund." ART JOURNAL (Apr. 1868): 79. [Survey party under command of Captain Wilson, R.E. 343 photos. First group consists of 164 photos, taken by Corp. H. Phillips, of the Royal Engineers, on the first expedition., Nov. 1865 to May 1866. Second group contains 179 photos, taken by Serg. H. Phillips, in 1867.]

P70 "The Underground Survey of Jerusalem." ILLUSTRATED LONDON NEWS 54, no. 1535 (Apr. 24, 1869): 423-426. 8 illus. [Lieut. Charles Warren, R.E., Sergeant Birtles, and others spending several years working for the Palestine Exploration Fund. Illustrators are from sketches.]

P71 "Explorations of Jerusalem." HARPER'S WEEKLY 13, no. 647 (May 22, 1869): 821-822, 824. 5 illus. [From sketches. Not credited but from "ILN."]

P72 Guernsey, A. H. "The Hebrew Exodus." HARPER'S MONTHLY 45, no. 265 (June 1872): 35-46. 12 illus. [Excerpted from "The Desert of the Exodus: Journeys on Foot in the Wilderness of the Forty Year's Wanderings, taken in Connection with the Ordinance Survey of Sinai and the Palestine Exploration Fund," by E. H. Palmer. (Harper & Brothers) 1872. Engravings, some possibly from photographs.]

P73 Nassau, William E. "Treasures on Glass and Celluloid: Conservation Work on the Photographic Archives of the Palestine Exploration Fund." PALESTINE EXPLORATION QUARTERLY 110, (July - Dec. 1978): 131-133. [Additional information in "Notes and News," on pp. 73-74.]

P74 Collins, Lydia. "Nineteenth Century Photographs in the Palestine Exploration Fund Collection." PALESTINE EXPLORATION QUARTERLY 113, (Jan. - June 1981): 63-66.

P75 Merrill, Selah. "List of Photographic Views, taken expressly for the American Palestine Exploration Society, during a Reconnaissance East of the Jordan, in the Autumn of 1875." PALESTINE EXPLORATION SOCIETY STATEMENT 4, (Jan. 1877): 101-103.

PALMER. (LONDON, ENGLAND)

P76 Portrait. Woodcut engraving credited "From a photograph by Palmer, Ramsgate." ILLUSTRATED LONDON NEWS 74, (1879) ["Lady Blanche Conyngham." 74:2074 (Mar. 15, 1879): 241.]

PALMER. (TORONTO, CANADA)

P77 Portraits. Woodcut engravings, credited "Photographed by Palmer, Toronto." FRANK LESLIE'S ILLUSTRATED NEWSPAPER 10, (1860) ["Sir. Edmund W. Head, Gov.-Gen. of Canada." 10:248 (Aug. 25, 1860): 207.]

PALMER, C. A. (NEWBURGH, NY)

P78 Palmer, C. A. "The Glycerine Process." HUMPHREY'S JOURNAL OF PHOTOGRAPHY, AND THE ALLIED ARTS AND SCIENCES 13, no. 14 (Nov. 15, 1861): 211-212. [Views of Trenton Falls, NJ, by an amateur using Coleman Seller's glycerine process.]

P79 Palmer, C. A. "The Ammonio-Nitrate Process." HUMPHREY'S JOURNAL OF PHOTOGRAPHY, AND THE ALLIED ARTS AND SCIENCES 13, no. 19 (Feb. 1, 1862) [Palmer made stereos.]

P80 Seely, Charles A. "Editorial Department." AMERICAN JOURNAL OF PHOTOGRAPHY AND THE ALLIED ARTS & SCIENCES n. s. vol. 8, no. 8 (Oct. 15, 1865): 192. ["Mr. Charles A. Palmer, of Newburgh, N. Y., has sent us a collection of very excellent stereo-views...of the Hudson River....he is prepared to exchange with photographers in any part of the country.]

P81 "Editor's Table." PHILADELPHIA PHOTOGRAPHER 3, no. 25 (Jan. 1866): 31. [Stereo view of Walkell, Hathaway's Glen, etc., from C. A. Palmer, of Newburgh, NY.]

P82 "Washington's Head-Quarters at Newburg." HARPER'S WEEKLY 11, no. 531 (Mar. 2, 1867): 132. 1 illus. ["Photographed by C. A. Palmer, Newburg." Building, with monument.]

PALMER, H. E. (PLYMOUTH, ENGLAND)
P83 Palmer, H. E. "Correspondence: Life-Size Photographs of Canvas." BRITISH JOURNAL OF PHOTOGRAPHY 10, no. 183 (Feb. 2, 1863): 65-66. [Palmer (Plymouth, England) projected an image of a daguerreotype on to canvas, then painted from that - "years ago."]

PALMER, H. J. (d. 1896) (GREAT BRITAIN)
P84 Palmer, Rev. H. J. "The Gelatine - Beer Process." BRITISH JOURNAL PHOTOGRAPHIC ALMANAC 1877 (1877): 86-89.

P85 Palmer, Rev. H. J., M.A., Oxon. "Some Novelties in Gelatine." BRITISH JOURNAL PHOTOGRAPHIC ALMANAC 1878 (1878): 97-100.

P86 Palmer, Rev. H. J., MA. "A Demonstration of the Preparation and Development of Palmer Films." ANTHONY'S PHOTOGRAPHIC BULLETIN 9, no. 5 (May 1878): 148-149. [From "London Photographic News."]

P87 Palmer, Rev. H. J., MA. "A Further Improvement in the Gelatine Process." ANTHONY'S PHOTOGRAPHIC BULLETIN 9, no. 5 (May 1878): 137-138. [From "London Photographic News." Paper read before Liverpool Photo. Assoc.]

P88 Harmer, H. J. "A Resume of the Gelatine Process." ANTHONY'S PHOTOGRAPHIC BULLETIN 9, no. 6 (June 1878): 172-174. [From "Br J of Photo."]

P89 Palmer, Rev. H. J., M.A. "A New Cure for Blurring." ANTHONY'S PHOTOGRAPHIC BULLETIN 9, no. 12 (Dec. 1878): 367. [From "London Photo. News." Paper read to the Liverpool Amateur Photo. Soc.]

P90 Palmer, Rev. H. J., M.A. "Gelatine Films." BRITISH JOURNAL PHOTOGRAPHIC ALMANAC 1879 (1879): 63-64.

PALMER, J. A. (SAVANNAH, GA)
P91 "Editor's Table." PHILADELPHIA PHOTOGRAPHER 6, no. 62 (Feb. 1869): 64. [Note of a series of views of "Bonaventure" cemetery in Savannah, GA.]

PALMER, J. E. (DEVON, ENGLAND)
P92 "Printing Positives with a Twenty Grain Solution - An Organic Silver Bath." AMERICAN JOURNAL OF PHOTOGRAPHY AND THE ALLIED ARTS & SCIENCES n. s. vol. 8, no. 11 (Dec. 1, 1865): 244-247. [From "Br. J. of Photo."]

P93 "Gelatine in the Printing Bath." AMERICAN JOURNAL OF PHOTOGRAPHY AND THE ALLIED ARTS & SCIENCES n. s. vol. 8, no. 12 (Dec. 15, 1865): 277-279. [From "Photo. News." "The examples first forwarded us by J. E. Palmer,...experiments we have made, in conjunction with Mr. H. P. Robinson, confirm the position in a remarkable degree..."]

PALMER, J. LINTON. (GREAT BRITAIN)
P94 "Easter Island." ILLUSTRATED LONDON NEWS 54, no. 1530 (Mar. 20, 1869): 296-297. 1 illus. ["Mr. J. Linton Palmer, surgeon to Her Majesty's ship "Topaze," has favored us with some photographs and sketches taken by him last November, when that vessel paid a visit to Easter Island..."]

PALMER, O. D.
P95 Portraits. Woodcut engravings, credited "Photographed by O. D. Palmer." FRANK LESLIE'S ILLUSTRATED NEWSPAPER 10, (1860) ["Uncle Ben Fleming, and the Old Lantern; Officers of the Wayne Guards, Erie, Pa. (group portrait)." 10:253 (Sept. 29, 1860): 299.]

PAPILLON, JOHN ASHTON. (1838-1891) (GREAT BRITAIN, CHINA)
P96 Falconer, John. "John Ashton Papillon: An Amateur Photographer in China 1858-60." PHOTOGRAPHIC COLLECTOR 3, no. 3 (Winter 1982): 346-362. 21 b & w.

PARADISE & COOK. (NEW YORK, NY)
P97 "Paradise Lost." HUMPHREY'S JOURNAL OF PHOTOGRAPHY, AND THE ALLIED ARTS AND SCIENCES 20, no. 22 (June 15, 1869): 348. [Paradise and Cook, of Broadway. Partnership broken up when Cook left, then when he failed to receive promised income for his interest, brought the business under an auction.]

PARCIC, DRAGUTIN. (1832-1902) (CROATIA)
P98 Grcevic, Nada. "Sun Pictures by Dragutin Parcic: Early Scientific Calotypes in Croatia." HISTORY OF PHOTOGRAPHY 2, no. 3 (July 1978): 248. 2 b & w. [Flea, solar eclipse, ca. 1860.]

PARIS, JAMES. (OMRO, WI)
P99 Paris, James. "Look Out For Him." PHILADELPHIA PHOTOGRAPHER 10, no. 109 (Jan. 1873): 9. [Letter from J. Paris warning of someone named George Allen, who claimed to have worked for J. F. Ryder, going around stealing.]

PARK, ALBERT GALLATIN. (b. 1824) (USA)
P100 Burgess, N. G. "Albert G. Park" PHOTOGRAPHIC AND FINE ART JOURNAL 9, no. 2 (Feb. 1856): frontispiece, 59. 1 b & w. [Original photographic print tipped-in. Self portrait. Albert G. Park born Aug. 10, 1824 at Newark, NJ. Learned the daguerreotype process in 1844 or '45 from Barnes, in Mobile, AL. Worked in Alabama, then in New Jersey, then back to Montgomery, AL. Then went to work for George S. Cook in Charleston, SC. Then worked for a year for Brady in New York, NY before returning to Charleston. Studied photography and the ambrotype process with Rhen in Philadelphia. Specialized in ambrotype, working in 1856 for F. H. Clark & Co.]

PARK, C. VOSS. (CLIFTON, ENGLAND)
P101 Portrait. Woodcut engraving credited "From a photograph by C. Voss Park." ILLUSTRATED LONDON NEWS 73, (1878) ["Late Prof. Harkness, F.R.S." 73:2052 (Oct. 26, 1878): 400.]

PARK, CHARLES A. (1832-1895) (USA)
P102 "Editor's Table: Obituary." WILSON'S PHOTOGRAPHIC MAGAZINE 32, no. 459 (Mar. 1895): 141. [Born Elyria, OH.

Apprenticed with J. F. Ryder in Elyria in 1840s. Later moved to Cleveland, rejoined Ryder there, then to Norwalk.]

P103 "Notes: Lieut. Col. C. A. Park." PHOTOGRAPHIC TIMES 26, no. 4 (Apr. 1895): 250. [Obituary note. Park learned daguerreotyping from brother-in-law James F. Ryder in Cleveland. Volunteered in Civil War, rose to rank of Lieut. Col., took up photography after war. Worked in Elyria, IL, then Norwalk.]

PARKER. (OXFORD, ENGLAND)
P104 "Note." ART JOURNAL (July 1870): 227. ['Mr. Parker, of Oxford, has exhibited in the German Gallery, New Bond Street, a series of photos of Rome ... not less than 2000 ...']

PARKER, JOHN HENRY. (1806-1884) (GREAT BRITAIN, ITALY)
["John Henry Parker, C.B., was a distinguished antiquary, who employed photography largely to secure a record of the work done under his direction in Rome."]

P105 Parker, John Henry, C.B. *A Selection of Historical Photographs of Rome and Italy: Illustrative of the Historical Construction of Walls.* London: Edward Stanford, 187- ? n. p. 28 l. of plates. [Original photos. Apparently part of a multi-volume set. Statement on back cover attributes the photos to Parker. These are archeological studies.]

P106 Parker, John Henry, C.B. *The Archaeology of Rome.* Oxford; London: James Parker & Co.; John Murray, 1874-1876. 12 parts in 8 vol. pp. 311 b & w. [Plates, except for some photos of plans, are photogravures by Dujardin, Paris, from photographs by Colamedici, F. Lais, Sidoli, Simelli, Spina, Smeaton, etc. Pt. 1. 122 p., 30 plates; Pt. 2 191 p., 19 plates; Pt. 3 92 p., 52 plates; Pt. 5 64 p., 30 plates; Pt. 6 116 p., 15 plates; Pt. 7 68 p., 36 plates; Pt. 8 122 p., 19 plates, maps; Pt. 9 48 p., 20 plates; Pt. 10 92 p., 19 plates; Pt. 11 180 p., 20 plates; Pt. 12 200 p., 41 plates.]

P107 Parker, John Henry. *Historical Photographs: a Catalogue of 3,300 Photographs of Antiquities in Rome and Italy. With Explanatory Prefaces to each subject, the dates, and a General Index.* London: Parker & Co., 1879. 485 pp.

P108 Brizzi, Bruno. *Roma cento anni fa nelle fotografie della Raccolta Parker.* Rome: s. n., 1977. 262 pp. 208 b & w. [Images from Parker's 1879 "Archaeology of Rome."]

P109 Fototeca Unione; Accademia americana a Roma; Unione internazionale degli istituti di archeologia, storia e storia dell'arte in Roma. *Fotografia archeologica, 1864-1914:* Rome: De Luca, 1979. 104 pp. illus. [Exhibition: Accademia Americana a Roma, Feb. 5 - Feb 26, 1979, curated by Karin Bull-Simonsen Einaudi. Bibliography, pp. 98-100.]

P110 Keller, Judith and Kenneth A. Breisch. *A Victorian View of Ancient Rome: the Parker Collection of Historical Photographs in the Kelsey Museum of Archaeology....with a foreword by Maragaret Cool Root.* Ann Arbor, MI: Kelsey Museum of Archaeology, University of Michigan, 1980. 32 pp. 6 l. of plates. illus. [Exhibition: Kelsey Museum of Archeology, Sept. 27-Dec. 14, 1980.]

PARKER, JOHN HENRY. [?]
P111 *Photographic Illustrations to accompany the Architectural History of Canterbury Cathedral by the Rev. R. Willis, selected and arranged by John Henry Parker.* Oxford: James Parker & Co., 1867. n. p. 26 b & w. [Original photographs.]

P112 *Illustrations of the Architectural Antiquities of the City of Wells, prepared under the direction of John Henry Parker, F.S.A.* London: James Parker & Co., 1866. n. p. 32 b & w. [Albumen prints.]

PARKER, JOSEPH C. (1827-1920) (USA)
BOOKS
P113 *Catalogue of Southern California Views, Published by Parker, San Diego, Cal.* San Diego, CA: Parker, n. d. [ca. 1873?]. 2 pp. [Broadside, listing stereo views.]

PERIODICALS
P114 Hooper, Bruce H. "Vignette: Joseph C. Parker in Northern Arizona." HISTORY OF PHOTOGRAPHY 11, no. 2 (Apr. - June 1987): 158. 1 b & w. [Studio portrait of two Mohave Indian women, taken ca. 1880. Parker operated a gallery in Pekin, IL, from 1862 to 1872. Then moved to San Francisco, CA, where he worked for J. P. Spooner, then opened a gallery in San Diego with his brother Francis A. Parker in 1873. Parker & Parker gallery in Yuma , AZ, in 1874. From 1877 to 1880 ran a gallery in Los Angeles, CA. Travelled through AZ in 1889, taking views. Sold out in 1892.]

PARKER, R. M.
P115 Parker, R. M. "Photography by Artificial Light." HUMPHREY'S JOURNAL OF PHOTOGRAPHY, AND THE ALLIED ARTS AND SCIENCES 10, no. 1 (May 1, 1858): 15-16. [From "Photo. Notes."]

PARKER, THOMAS L. (INDIANAPOLIS, IN)
P116 "Indiana. - Scenes and Incidents of the Funeral Services over the Remains of the Late U. S. Senator Oliver P. Morton, in Indianapolis, November 5th. - From Photographs by T. L. Parker." FRANK LESLIE'S ILLUSTRATED NEWSPAPER 45, no. 1156 (Nov. 24, 1877): 193. 3 illus. [Views, with crowds.]

PARKER, W. B.
P117 Parker, W. B. "Glass Rooms, and Lighting the Sitter." BRITISH JOURNAL OF PHOTOGRAPHY 10, no. 204 (Dec. 15, 1863): 482-483. 2 illus.

P118 "Glass Rooms, and Lighting the Sitter." AMERICAN JOURNAL OF PHOTOGRAPHY AND THE ALLIED ARTS & SCIENCES n. s. vol. 6, no. 14 (Jan. 15, 1864): 313-315. [From "Photo. News."]

PARKINSON. (DIEPPE, FRANCE)
P119 "Lime Toning Baths." AMERICAN JOURNAL OF PHOTOGRAPHY AND THE ALLIED ARTS & SCIENCES n. s. vol. 6, no. 3 (Aug. 1, 1863): 66-68. [From "Photo. News." "On our way to Paris we called at the establishment of Mr. Parkinson, of Dieppe, an English artist settled in France."]

PARLOR GALLERY.
P120 Seely, Charles A. "Notes."* AMERICAN JOURNAL OF PHOTOGRAPHY AND THE ALLIED ARTS & SCIENCES n. s. vol. 3, no. 3 (July 1, 1860): 48. [Praise for new gallery titled "The Parlor Gallery." Location, owner, etc. not given.]

PARR, RICHARD.
P121 Parr, Richard. "Notes on Rapid Dry Films and Gelatino Bromide." BRITISH JOURNAL PHOTOGRAPHIC ALMANAC 1878 (1878): 105-106.

P122 Parr, Richard. "How to Build a Cheap and Efficient Studio." BRITISH JOURNAL PHOTOGRAPHIC ALMANAC 1879 (1879): 104-107. 2 illus.

P123 Parr, Richard. "A Home - Made Portable Camera and Instantaneous Shutter." BRITISH JOURNAL PHOTOGRAPHIC ALMANAC 1879 (1879): 160-163.

PARRY, JOHN. (d. 1866) (GREAT BRITAIN)
P124 Parry, John. "On the Action of the Aceto-Nitrate Bath in the Collodio-Albumen Process." HUMPHREY'S JOURNAL OF PHOTOGRAPHY, AND THE ALLIED ARTS AND SCIENCES 12, no. 12 (Oct. 15, 1860): 178-179.

P125 Parry, John. "On a Modification of the Collodio-Albumen Process." HUMPHREY'S JOURNAL OF PHOTOGRAPHY, AND THE ALLIED ARTS AND SCIENCES 12, no. 14 (Nov. 15, 1860): 217. [From "Br. J. of Photo."]

P126 Parry, John. "On Panoramic Photography." BRITISH JOURNAL OF PHOTOGRAPHY 9, no. 171 (Aug. 1, 1862): 286-287. 2 illus.

P127 "Panoramic Photography." BRITISH JOURNAL OF PHOTOGRAPHY 9, no. 172 (Aug. 15, 1862): 303. [Commentary on landscapes taken by John Parry, of the Manchester Photo. Soc.]

PARRY, SILVESTER. (PRESTON, ENGLAND)
P128 Parry, Silvester. "On the Production of Natural Fore and Backgrounds in the Studio." BRITISH JOURNAL PHOTOGRAPHIC ALMANAC 1869 (1869): 115-117.

P129 Parry, Silvester. "The Ridge Roof Not the Best Form of Studio." BRITISH JOURNAL PHOTOGRAPHIC ALMANAC 1879 (1879): 112-114.

PARSONS, SIMEON H. (ST. JOHNS, NEWFOUNDLAND)
BOOKS
P130 Prowse, Daniel Woodley. A History of Newfoundland, from the English, Colonial, and Foreign Records. With numerous illustrations and maps. London: Eyre & Spottiswoode, 1896. n. p. illus. [2nd ed., revised and corrected. This edition contains illustrations taken from Parsons' photographs.]

PERIODICALS
P131 "Voices from the Craft." PHILADELPHIA PHOTOGRAPHER 15, no. 179 (Nov. 1878): 335-337. [Simeon H. Parsons from St. Johns, Canada.]

P132 "Newfoundland. - The Steamship 'Arizona,' as She Appeared on Her Arrival at St. Johns, After Her Collision with an Iceberg, November 7th. - From a Photograph by S. H. Parsons." FRANK LESLIE'S ILLUSTRATED NEWSPAPER 49, no. 1263 (Dec. 13, 1879): 261. 1 illus. [Bow of the ship, with men working on the damage.]

P133 "News and Notes." WILSON'S PHOTOGRAPHIC MAGAZINE 34, no. 485 (May 1897): 207. [With his son Will, Parsons has worked in St. Johns, Newfoundland for years. Parson's furnished portraits and views to illustrate the second edition of Prowse's "History of Newfoundland," London: Eyre & Spottiswoode.]

P134 "Views Abroad and Across." WILSON'S PHOTOGRAPHIC MAGAZINE 37, no. 524 (Aug. 1900): 353-357. 10 b & w. [Includes quotes from a letter by Parsons. Photos of Caribou and fishing in landscapes.] @BULLET = PARTRIDGE, A. C. (WHEELING, VA)

P135 "Gallery for Sale." HUMPHREY'S JOURNAL OF PHOTOGRAPHY, AND THE ALLIED ARTS AND SCIENCES 17, no. 22 (Mar. 15, 1866): 352.

PATCH, G.
P136 "Seaside Chapel of the Reformed Church, Long Branch, N. J. - From a Photograph by G. Patch." FRANK LESLIE'S ILLUSTRATED NEWSPAPER 29, no. 730 (Sept. 25, 1869): 21. 1 illus. [View.]

PATERSON.
P137 Paterson, Dr. "On the Dry Collodion Process." HUMPHREY'S JOURNAL OF PHOTOGRAPHY, AND THE ALLIED ARTS AND SCIENCES 11, no. 23 (Apr. 1, 1860): 364-365. [Read to Photo. Soc. of Scotland. "London Photo. J."]

PATERSON, ROBERT.
P138 Paterson, Robert, M.D. Manx Antiquities. Remarks on the Antiquarian Remains of the Isle of Man. Cupar-Fife, Scotland: St. Andrews University Magazine Press, 1863. 42 pp. 12 b & w. [10 original photos, 2 photomechanical reproductions.]

PATRICK, JOHN. (1830-1923) (GREAT BRITAIN)
P139 Portrait. Woodcut engraving credited "From a photograph by J. Patrick, Kirkaldy." ILLUSTRATED LONDON NEWS 70, (1877) ["Peter Graham, A.R.A." 70:1962 (Feb. 17, 1877): 157.]

P140 Patrick, John. "The Carlyles in Scotland." CENTURY MAGAZINE 57, no. 3 (Jan. 1899): 321-330. 8 b & w. [Photos or drawings from photos by John Patrick. Many were taken in the 1870s. Included portraits of Thomas Carlyle.]

PATTERSON. (GLASGOW, SCOTLAND)
P141 "Topics of the Month: Daguerreotype Casts." ART UNION (ART JOURNAL) (Jan. 1846): 18. [Report that Dr. Patterson, of Glasgow, has developed a method of creating moulds from daguerreotypes.]

PATTERSON, HUGH. (PLYMOUTH, ENGLAND)
P142 Portrait. Woodcut engraving credited "From a photograph by Hugh Patterson, taken about ten years ago." ILLUSTRATED LONDON NEWS 48, (1866) ["J. B. Martin, Captain of the ship "London." 48:* (Feb. 3, 1866): 104.]

PATTERSON, R. S.
P143 Romer, Grant B. "Letters from an Itinerant Daguerreotypist of Western New York." IMAGE 27, no. 1 (Mar. 1984): 12-20. 5 b & w. 1 illus. [Illustrated with five anonymous daguerreotypes and one detail illustration of R. S. Patterson letter.]

PATTIAM. (CHICAGO, IL)
P144 "Heck Hall, Evanston, Illinois." HARPER'S WEEKLY 11, no. 550 (July 13, 1867): 436. 1 illus. ["Photographed by Pattiam, Chicago, IL."]

PAUL, AUBREY, SIR.
P145 Portrait. Woodcut engraving, credited "From a Photograph by Sir Aubrey Paul, Bart." FRANK LESLIE'S ILLUSTRATED NEWSPAPER 34, (1872) ["The English Amateur Rowing Champions. (Four portraits)." 34:869 (May 5, 1872): 173.]

PAXSON & BROTHER. (NEW YORK, NY)
P146 D. "Taking a Peep at the Sun." HUMPHREY'S JOURNAL OF PHOTOGRAPHY, AND THE ALLIED ARTS AND SCIENCES 20, no. 24 (Aug. 15, 1869): 377-378. ["On the other side of the way, directly opposite my room, are located the Messrs. Paxson & Brother, the well-known solar printers...." Comic story about an Irish porter being frightened by the huge solar cameras on the roof of the Paxson & Brother establishment.]

PAXTON, CHARLES. (ca. 1841-1880) (USA)

P147 "Obituary." PHILADELPHIA PHOTOGRAPHER 17, no. 202 (Oct. 1880): 310. [Charles Paxton died on July 6, 1880, in his thirty-ninth year, after twenty years of untiring labor, which undermined his health and left him feeble. A pioneer and specialist in solar printing, working in Chicago, IL, and New York, NY. His business in New York continued by his brother Isaiah Paxton.]

PAYN, JAMES.

P148 Payn, James. *Furness Abbey and Its Neighborhood*. London: Simpkin, Marshall & Co., Adams & Co., 1865. n. p. 13 b & w. [Original photographs. Other editions have different numbers of illustrations.]

PEABODY, E. N. [?]

P149 Robinson, John. *Ferns in Their Homes and Ours*. Salem, MA: S. E. Cassino, 1878. xvi, 178 pp. 22 b & w. [Original photos. Frontispiece photo by E. N. Peabody.]

PEALE see HAAS & PEALE.

PEALE, FRANKLIN.

P150 Peale, Franklin. "Description of a Process for the Reduction of Silver from its Solutions." AMERICAN JOURNAL OF PHOTOGRAPHY AND THE ALLIED ARTS & SCIENCES n. s. vol. 4, no. 20 (Mar. 15, 1862): 472.

PEALE, HOWARD. (1830-1864) (USA)

P151 Sellers, Coleman. "Foreign Correspondence." BRITISH JOURNAL OF PHOTOGRAPHY 11, no. 221 (July 29, 1864): 274. [Notes death, by drowning, of Howard Peale, "leading operator" for Frederick Gutekunst.]

P152 "In Memoriam." PHILADELPHIA PHOTOGRAPHER 1, no. 9 (Sept. 1864): 139-141. [Notice of accidental death by drowning also on page 127 "Editors Table" of the Aug. 1864 "Philadelphia Photographer." Howard Peale began photography at age sixteen, in 1846, by assisting his father James Peale, a daguerreotypist in Philadelphia, PA. When Howard was eighteen, he joined Henry Custin at Niagara Falls, NY, and travelled throughout the upper New York state, taking portraits. Then worked as an operator for T. P. & D. C. Collins, of Philadelphia - where he made his first large pictures. Toured the Shenandoah Valley region with Mr. Collins, returning with "precious trophies of art of that region." Then worked for Samuel Root, in New York, NY, and later J. E. McClees in Philadelphia. Peale had worked for F. Gutekunst for five or six years, when he drowned in June 1864, while saving several companions in an overturned boat.]

PEALE, REMBRANDT.

P153 Peale, Rembrandt. "Notes and Queries: The Physiognotrace." THE CRAYON 4, no. 10 (Oct. 1857): 307-308. 1 illus.

PEALE, TITIAN RAMSAY. (1800-1885) (USA)

BOOKS

P154 Drury, Clifford Merrill, ed. *Diary of Titian Ramsay Peale*. Los Angeles: Glen Dawson, 1957. n. p.

P155 Poesch, Jessie. *Titian Ramsay Peale, 1799 - 1885, and His Journals of the Wilkes Expedition*. Philadelphia: The American Philosophical Society, 1961. n. p.

P156 Haifley, Julia Ann Link. *Capital Images: The Photography of Titian Ramsay Peale, 1855 - 1885*. Washington, DC: George Washington University, 1976. 117 l. pp. [M.A. Thesis, George Washington University, 1976. Xerox copy, George Eastman House Collection.]

PERIODICALS

P157 "Government Photography." PHILADELPHIA PHOTOGRAPHER 3, no. 31 (July 1866): 214-215. [Report of Federal government's use of photography. Army Medical Museum: William Bell. Treasury Department: L. E. Walker. Chief Examiner of Patent Office, Titian R. Peale (an amateur). Extensive library.]

P158 "Obituary." PHILADELPHIA PHOTOGRAPHER 22, no. 256 (Apr. 1885): 125. [Titian R. Peale died on Mar. 13, 1885, in Philadelphia, PA, in the 86th year of his age. The last surviving son of the artist Charles Wilson Peale, he accompanied Wilk's Exploring Expedition, and on his return was appointed examiner in the Patent Office, where he remained many years. He was one of the earliest amateur photographers in the USA, and used his influence in the government to introduce photography in several of the departments and particularly in the expeditions to the far West. His leisure hours at Washington were often spent at Rock Creek and other picturesque spots around the city, and during the war the camps and military movements were favorite subjects for his camera.]

P159 "Meetings of Societies: Philadelphia Photographic Society." PHOTOGRAPHIC TIMES 15, no. 187 (Apr. 17, 1885): 206. [Note of death, brief commentary in Society report. Peale, one of the earliest amateur photographers, and Examiner in the Patent Office, Washington, DC. "...he was enabled to use his influence in introducing photography in several departments of the government, particularly in early expeditions to the Far West." Active member of the first Photographic Exchange Club.]

P160 Peale, Albert Charles. "Titian R. Peale, 1800 - 1885." BULLETIN OF THE PHILOSOPHICAL SOCIETY OF WASHINGTON 14, (Dec. 1905): 317-326.

P161 Boyle, John, Jr. "Titian Ramsay Peale (1800 - 1885), Explorer, Naturalist, Artist, Patent Examiner." JOURNAL OF THE PATENT OFFICE SOCIETY 17, (Dec. 1935): 941-947.

PEARCE, CHARLES E.

P162 Pearce, Charles E. "Children from a Photographic Point of View." BRITISH JOURNAL PHOTOGRAPHIC ALMANAC 1869 (1869): 91-93.

PEARSALL.

P163 "The Pearsall Model Camera." ANTHONY'S PHOTOGRAPHIC BULLETIN 5, no. 1 (Jan. 1874): 31-32. 2 illus.

PEARSALL, ALVA A. (1839-1893) (USA)

P164 "Editor's Table." PHILADELPHIA PHOTOGRAPHER 8, no. 95 (Nov. 1871): 375. ["Alva A. Pearsall, who has the general supervision of Brady's Gallery, Broadway and 10th St., New York, NY...is assisted by John Montgomery, who manipulates the darkroom..."]

P165 Pearsall, A. A. "Instantaneous Portraiture." PHILADELPHIA PHOTOGRAPHER 8, no. 96 (Dec. 1871): 385-386.

P166 "Note." PHOTOGRAPHIC TIMES 2, no. 22 (Oct. 1872): 152-153. ["New gallery erected by A. A. Pearsall, the photographer, who for so many years was the chief artist at Brady's in N. Y...."]

P167 "Another Photographic Art Gallery in Brooklyn." ANTHONY'S PHOTOGRAPHIC BULLETIN 3, no. 11 (Nov. 1872): 753. [Alva A. Pearsall, brother of Frank E., opened a second gallery in Brooklyn, NY.]

P168 Pearsall, Alva. "Fifth Annual Meeting and Exhibit of the National Photographic Association of the U.S., held in Buffalo, N.Y., beginning July 5, 1873: Photographic Associations." PHILADELPHIA PHOTOGRAPHER 10, no. 117 (Sept. 1873): 363-365.

P169 Portrait. Woodcut engraving, credited "Photographed by Alva Pearsall." FRANK LESLIE'S ILLUSTRATED NEWSPAPER 37, (1874) ["Rev. T. DeWitt Talmage, Pastor, New Brooklyn Tabernacle." 37:962 (Mar. 7, 1874): 428.]

P170 Portrait. Woodcut engraving, credited "Photographed by Alva Pearsall." FRANK LESLIE'S ILLUSTRATED NEWSPAPER 39, (1874) ["Frank Moulton, witness in the Beecher-Tilton case." 38:984 (Aug. 8, 1874): 344.]

P171 "Our Picture." PHILADELPHIA PHOTOGRAPHER 12, no. 134 (Feb. 1875): frontispiece, 34-36. 1 b & w. [Portrait.]

P172 Pearsall, Alva. "Photographic Rights Again." PHILADELPHIA PHOTOGRAPHER 13, no. 146 (Feb. 1876): 44-45.

P173 "Alva Pearsall." ANTHONY'S PHOTOGRAPHIC BULLETIN 7, no. 7 (July 1876): 213. [From "Brooklyn Daily Eagle." Pearsall praised both as a photographer and a "crayon artist."]

P174 Portrait. Woodcut engraving, credited "From a Photograph by Pearsall." FRANK LESLIE'S ILLUSTRATED NEWSPAPER 43, (1876) ["E. F. Farrington, engineer." 43:1094 (Sept. 16, 1876): 28.]

P175 "Forgery Revealed Through the Photographic Art." ANTHONY'S PHOTOGRAPHIC BULLETIN 10, no. 9 (Sept. 1879): 283-284. [From "Brooklyn Eagle." Alva Pearsall able to prove photographically that a note in a court case was altered.]

P176 "Matters of the Month." PHOTOGRAPHIC TIMES 11, no. 131 (Nov. 1881): 433. [Reception at Pearsall's studio.]

P177 "Notes and News: Alva A. Pearsall." PHOTOGRAPHIC TIMES 23, no. 597 (Feb. 24, 1893): 101. [Obituary note. Pearsall, photographer of Brooklyn, Born New York, NY in 1839. Began photography in Williamsburgh. Sixteen years ago opened a studio on Fulton Street, Brooklyn. In 1860 he went to the West Indies and South America for five years.]

PEARSALL, FRANK E. (BROOKLYN, NY)
P178 "Our Picture." PHILADELPHIA PHOTOGRAPHER 9, no. 99 (Mar. 1872): 93-95. 1 b & w. [Portrait.]

P179 "Mr. Frank Pearsall's New Gallery." ANTHONY'S PHOTOGRAPHIC BULLETIN 3, no. 9 (Sept. 1872): 670-672. [Extensive description of Pearsall's lavish new gallery in Brooklyn, NY.]

P180 Hull, Charles Wager. "A New Gallery." PHILADELPHIA PHOTOGRAPHER 9, no. 105 (Sept. 1872): 328. [Additional note on p. 335.]

P181 "Pearsall's Gallery." PHOTOGRAPHIC TIMES 2, no. 21 (Sept. 1872): 130. [Notice of opening of new gallery, reception "Pearsall's assistant Mr. Forbes..."]

P182 "A Canard." ANTHONY'S PHOTOGRAPHIC BULLETIN 3, no. 11 (Nov. 1872): 753. [Letters from E. & H. T. Anthony & Co., Frank E. Pearsall, and his employee T. G. Dorland, stating that the Anthony's have no business interest in the Pearsall gallery.]

P183 "Brooklyn Photographic Art Association." ANTHONY'S PHOTOGRAPHIC BULLETIN 4, no. 3 (Mar. 1873): 85-88. [Includes a paper, "The Proper Method of Development as Applied to Photography," by Frank E. Pearsall, that is livelier and more interesting than the usual technical paper on processes.]

P184 Pearsall, Frank E. "The Proper Method of Development as Applied to Photography." PHILADELPHIA PHOTOGRAPHER 10, no. 112 (Apr. 1873): 103-105. [Read before the Brooklyn [NY] Photo. Assoc.]

P185 Pearsall, F. E. "Fifth Annual Meeting and Exhibit of the National Photographic Association of the U.S., held in Buffalo, N.Y., beginning July 5, 1873: A New Train of Thought." PHILADELPHIA PHOTOGRAPHER 10, no. 117 (Sept. 1873): 340-345.

P186 "Our Picture." PHILADELPHIA PHOTOGRAPHER 10, no. 117 (Sept. 1873): frontispiece, 467-468. 1 b & w. 1 illus. [Portrait, plus woodcut of studio.]

P187 "Satisfaction in Likeness." ANTHONY'S PHOTOGRAPHIC BULLETIN 6, no. 11 (Nov. 1875): 331-333. [From "New York Times" and "New York Tribune." A Brooklyn photographer gave 17 portrait sittings to a young woman, who claimed them unsatisfactory - law suit resulted. Photographer not named.]

P188 "Seventeen Sittings." PHILADELPHIA PHOTOGRAPHER 12, no. 143 (Nov. 1875): 348. [A couple sat seventeen times for Pearsall, stayed unsatisfied and refused to pay, Pearsall sued, the thing got into the newspapers, etc.]

P189 "Pearsall vs. Schenck" ANTHONY'S PHOTOGRAPHIC BULLETIN 6, no. 12 (Dec. 1875): 355-357. [From "Brooklyn Daily Eagle" and "NY Times." Pearsall won his suit against the individual who demanded 17 sittings without being satisfied.]

P190 "Shall a Photographer be Paid for His Work?" PHILADELPHIA PHOTOGRAPHER 12, no. 144 (Dec. 1875): 357-358. [Pearsall won, collected $24.]

P191 Pearsall, Frank E. "What are Photographic Rights?" PHILADELPHIA PHOTOGRAPHER 12, no. 144 (Dec. 1875): 362-364.

P192 Pearsall, Frank E. "Improved Negative Retouching." ANTHONY'S PHOTOGRAPHIC BULLETIN 8, no. 10 (Oct. 1877): 316.

P193 Pearsall, F. E. "The Pearsall Vignetting Attachment." ANTHONY'S PHOTOGRAPHIC BULLETIN 9, no. 10 (Oct. 1878): 304.

PEARSALL, THOMAS J.
P194 Pearsall, Thomas J., F.C.S., &c. "Photographic History. - How Men Missed the Way to Photographic Discoveries." BRITISH JOURNAL PHOTOGRAPHIC ALMANAC 1875 (1875): 136-140.

P195 Pearsall, Thomas J., F.C.S., &c. "The Climate of Britain and Photographic Art." BRITISH JOURNAL PHOTOGRAPHIC ALMANAC 1879 (1879): 116-118.

PEARSON, GEORGE C.
P196 "The Great Fire at Chicago." ILLUSTRATED LONDON NEWS 52, no. 1471 (Feb. 29, 1868): 200-201. 2 illus. ["We have engraved

two photographs, taken by Mr. George C. Pearson, showing the aspect of the ruins in Lake-street."]

PEARSON, JAMES R. (1843-1896) (USA)
P197 "The Late James R. Pearson." PHOTOGRAPHIC TIMES 28, no. 12 (Dec. 1896): 589. [Photographed in Allegheny from the 1860s.]

PEASE, BENJAMIN FRANKLIN. (1822-1888) (USA, PERU)
P198 McElroy, Keith. "Benjamin Franklin Pease: An American Photographer in Lima, Peru." HISTORY OF PHOTOGRAPHY 3, no. 3 (July 1979): 195-200. 7 b & w. 11 illus.

PEASE, NATHAN W. (1836-1918) (USA)
P199 "Stereoscopic Views and Photographs." ANTHONY'S PHOTOGRAPHIC BULLETIN 1, no. 8 (Sept. 1870): 165. [Note of 150 views of New Hampshire, from N. W. Pease available, some listed.]

P200 "Editor's Table: Panoramic Photography." WILSON'S PHOTOGRAPHIC MAGAZINE 34, no. 487 (July 1897): 334. [Letter from N. W. Pease stating, in response to Franklin Nims' article on "Panoramic Photography" in Feb. issue, that J. W. Black had made panoramic photos 34 to 38 years ago - thus preceding other claims.]

P201 Walker, Ray. "N. W. Pease: Granite State Photographer." STEREO WORLD 1, no. 5 (Nov. - Dec. 1974): 4. 1 b & w. [Born in Cornish, ME on June 4, 1836. Established a photographic business in North Conway, NH in 1858. Took portraits, landscapes, and stereo views of North Conway and White Mountain scenery. Died Sept. 29, 1918.]

PECK BROTHERS. (USA)
P202 "An Unknown Suicide in New Haven, Conn. - Photographed by the Peck Brothers." FRANK LESLIE'S ILLUSTRATED NEWSPAPER 22, no. 570 (Sept. 1, 1866): 384. 1 illus. [Postmortem portrait. One of a series on missing persons, published by the magazine throughout the early 1860s.]

P203 "The Yale School of Fine Arts at New Haven, Conn. - From a Photograph by Peck Bros., N. H." FRANK LESLIE'S ILLUSTRATED NEWSPAPER 24, no. 615 (July 13, 1867): 261. 1 illus. [View.]

PEIN, JOHN HENRY. (HOBOKEN, NJ)
P204 "Photographing on Vases, etc." HUMPHREY'S JOURNAL OF PHOTOGRAPHY, AND THE ALLIED ARTS AND SCIENCES 11, no. 15 (Dec. 1, 1859): 226-228.

PELL, R. L.
P205 "Light. Remarks made before the Photographical Society." AMERICAN JOURNAL OF PHOTOGRAPHY AND THE ALLIED ARTS & SCIENCES n. s. vol. 2, no. 20-21 (Mar. 15, Apr. 1, 1860): 312-320, 330-331.

PELLEGRINO.
P206 Pellegrino. "Winter Wanderings, No. IX." ANTHONY'S PHOTOGRAPHIC BULLETIN 10, no. 9 (Sept. 1879): 260-261. [From "Br J of Photo." Pellegrino discusses photographing the Cimitero Maggiore, in Milano, Italy.]

PENNY, GEORGE S.
P207 Penny, George S. "The Calotype Process." HUMPHREY'S JOURNAL 7, no. 14 (Nov. 15, 1855): 229-230. ["Liverpool Photo. Soc. J."]

P208 Penny, G. S. "Pigment Printing Applied to Botanical Specimens, &c." BRITISH JOURNAL PHOTOGRAPHIC ALMANAC 1873 (1873): 74-76.

P209 Penny, G. S. "The Photographic Eye in Landscape Work." BRITISH JOURNAL PHOTOGRAPHIC ALMANAC 1875 (1875): 121-122.

P210 Penny, G. S. "Pigment Printing. - Improvement in Tissues." BRITISH JOURNAL PHOTOGRAPHIC ALMANAC 1876 (1876): 90-91.

P211 Penny, G. S. "Gelatino - Bromide Negatives." BRITISH JOURNAL PHOTOGRAPHIC ALMANAC 1879 (1879): 61-62.

PEPLOW & BALCH.
P212 Portrait. Woodcut engraving, credited "From a Photograph by Peplow & Balch. FRANK LESLIE'S ILLUSTRATED NEWSPAPER 16, (1863) ["Maj.-Gen. James McPherson, USA." 16:408 (July 25, 1863): 289.]

PEPPER, J. H. (LONDON, ENGLAND)
[Professor J. H. Pepper was a popular lecturer on science, long connected with the Polytechnic Institution, London.]

P213 Pepper, J. H. "Photography," on pp. 138-148 in: *The Boys' Play-book of Science*. London: Routledge, 1860. 440 pp. [New edition, revised by T. C. Hepworth. (1881), "Photography," on pp. 141-160.]

PERCIVAL, JOHN P. (1831-1891) (GREAT BRITAIN, USA)
P214 "News and Notes." PHOTOGRAPHIC TIMES 21, no. 491 (Feb. 13, 1891): 82. [British born, soldiered in India, to USA at age 25, worked in Waltham, MA, tried to start a studio in New York, NY, failed, committed suicide.]

PERCY, JOHN & JOHN SPILLER.
P215 "The New Mill." HISTORY OF PHOTOGRAPHY 10, no. 4 (Oct.-Dec. 1986): 326. 1 b & w. [View, taken by John Percy (1817-1889) and John Spiller, near Lynton, North Devon, England, in 1856.]

PERCY, JOHN see PERCY, JOHN & JOHN SPILLER.

[John Percy was born on Mar. 23, 1817 in Nottingham. Studied medicine in Paris and at Edinburgh, where he received an M.D. degree in 1838. Turned to the study of ores, wrote papers, and lectured at the Metropolitan School of Science, London in 1851. Became interested in photography and began experimenting around 1844. Worked with George Shaw or John Spiller. Apparently gave up photography around 1860. Collected prints and watercolors. Died in 1899.]

PERGER, F. E. (EMS, GERMANY)
P216 Portrait. Woodcut engraving credited "From a photograph by F. E. Perger." ILLUSTRATED LONDON NEWS 66, (1875) ["Sir George Elliott, Bart., M.P." 66:1866 (May 15, 1875): 465.]

PERIPATETIC PHOTOGRAPHER.
P217 A Peripatetic Photographer. "Extracts From Notes on Passing Events." ANTHONY'S PHOTOGRAPHIC BULLETIN 7, no. 7 (July 1876): 205. [From "Br. J. of Photo."]

PERKINS, GEORGE. (DENISON, TX)

P218 "Matters of the Month." PHOTOGRAPHIC TIMES 7, no. 82 (Oct. 1877): 218. [Letter from Perkins praising Scoville's Lenses, written on Aug. 27, 1977 from Denison, Texas.]

PERKINS, HENRY S.

P219 Perkins, Henry S. "On Photographic Colouring." BRITISH JOURNAL PHOTOGRAPHIC ALMANAC 1874 (1874): 152-155.

PERKINS, J. W. (d. 1898) (USA)

P220 "Editor's Table." WILSON'S PHOTOGRAPHIC MAGAZINE 35, no. 495 (Mar. 1898): 142. [Died Feb. 4, 1898, in Kirkwood, GA. Opened a studio and stock business in Augusta, GA before the Civil War, as a partner of Tucker & Perkins. Then moved to Atlanta. His son, W. R. Perkins, is in business as a photographer in Covington, GA.]

PERKINS, PALMER LANFIELD. (1824-1900) (USA)

P221 "Thomas Wildey - Founder of Odd Fellows." HARPER'S WEEKLY 9, no. 458 (Oct. 7, 1865): 628, 637, 638. 2 illus. [Portrait and monument. "Photographed by P. L. Perkins, Baltimore."]

PERROT DE CHAMEUX, L.

P222 Perrot de Chameux, L. "Rapid Collodion." AMERICAN JOURNAL OF PHOTOGRAPHY AND THE ALLIED ARTS & SCIENCES n. s. vol. 7, no. 7 (Oct. 1, 1864): 158-159. [From "Le Moniteur."]

PERRY & BOLAN. (DENVER, CO)

P223 Portrait. Woodcut engraving, credited "Photographed by Perry & Bohn [sic Bolan?], of Denver." FRANK LESLIE'S ILLUSTRATED NEWSPAPER 37, (1874) ["Mrs. Ann Eliza Young, 19th wife of Brigham Young." 37:957 (Jan. 31, 1874): 349.]

P224 Portrait. Woodcut engraving, credited "From a Photograph by Perry & Bolan, Denver, CO." FRANK LESLIE'S ILLUSTRATED NEWSPAPER 40, (1875) ["Hon. Jerome B. Chaffee." 40:1018 (Apr. 10, 1875): 76.]

P225 Portrait. Woodcut engraving, credited "From a Photograph by Perry & Bolan, Denver, Col." FRANK LESLIE'S ILLUSTRATED NEWSPAPER 43, (1876) ["Jerome R. Chaffee, of CO." 43:1109 (Dec. 30, 1876): 285.]

PERRY see COOK.

PERRY. (MELBOURNE, AUSTRALIA)

P226 "Photographing Colors, and Forgery." ANTHONY'S PHOTOGRAPHIC BULLETIN 5, no. 6 (June 1874): 214. [From "London Photo. News," in turn from "Melbourne Argus." Mr. Perry, of Melbourne, Australia, claims to be able to provide color photos of bank notes.]

PERRY, E. A.

P227 "Virginia. - The Lewis Brooks Museum at the University of Virginia, in Charlottesville. - From a Photograph by E. A. Perry." FRANK LESLIE'S ILLUSTRATED NEWSPAPER 46, no. 1172 (Mar. 16, 1878): 29. 1 illus. [View.]

PERRY, E. H. (d. 1887) (USA)

P228 "General Notes." PHOTOGRAPHIC TIMES 17, no. 320 (Nov. 4, 1887): 552. [E. H. Perry was a photographer in Lancaster, NY., near Buffalo, in 1857. Moved to Kalamazoo, MI, about 1867, then spent last ten years in Battle Creek, MI. Died there Oct. 19th.]

PERRY, WILLIAM, SGT.- MAJ.

P229 Perry, Sgt.- Maj. William. "Experiences in Out-Door Photography." ANTHONY'S PHOTOGRAPHIC BULLETIN 5, no. 5 (May 1874): 175-177. [From "London Photo. News."]

PETERS, OTIS T. (ca. 1809-1861) (USA)

P230 Seely, Charles. "Editorial Miscellany." AMERICAN JOURNAL OF PHOTOGRAPHY AND THE ALLIED ARTS & SCIENCES n. s. vol. 3, no. 18 (Feb. 15, 1861): 288. [Obituary. Otis T. Peters died Jan. 10, 1861, aged 52 years. Specialized in stereoscope portraits, with a gallery at 394 Broadway, New York, NY, previous to 1856, when he retired from photography. Made stereo daguerreotypes. Manufactured hoop skirts at time of death.]

PETERSEN, P.

P231 Hershkowitz, Robert. "P. Petersen's Norsk-Artelleri Material." PHOTOGRAPHIC COLLECTOR 2, no. 1 (Spring 1981): 30-33. 4 b & w. [Illustrated catalog of arms, ordinance and assorted military vehicles published in 1865, presumably Norwegian. Photographs include tableau vivants of military figures demonstrating the equipment.]

PETERSON. (COPENHAGEN, DENMARK)

P232 Portrait. Woodcut engraving credited "From a photograph by Peterson." ILLUSTRATED LONDON NEWS 62, (1873) ["Late R. W. Thomson." 62:1752 (Mar. 29, 1873): 297.]

PETIOT-GROFFIER, FORTUNE-JOSEPH. (1788-1855) (FRANCE)

P233 "Obituary." HUMPHREY'S JOURNAL 7, no. 3 (June 1, 1855): 52. [Note of Petiot-Groffier's death, from "Bulletin of Fr. Photo. Soc." Friend of Baldus, photographed in the Auvergne together in 1854. "...an ardent and zealous practitioner of our art..." Ex-deputy (under the monarchy) for nearly ten years... Founder-member of the Société française de Photographie.]

PETIT, PIERRE. (1832-1909) (FRANCE)

[Born in Aups in 1832. Learned daguerreotypy in 1849, worked for Disdéri in 1855. Moved to the Trinquart Studio in 1858. In 1860 the partnership opened a second studio in Baden, then a branch in Marseille in 1861. Partnership dissolved in 1861 and by 1862 Petit operated his own, very successful, studio in Paris. Petit had taken a series of portraits of the French episcopacy in late 1850s and made other portrait series for the *Galerie des Hommes du Jour* in the 1860s. In 1862 he wrote *Simples conseils, manuel indispensable aux gens du monde*. In 1863 he founded a weekly newspaper *Les Veillées chrétienne*, which strengthened his ties with the clergy, and by 1865 he had made 25,000 portraits of clergymen. He photographed Paris during the Commune and Siege in 1871. Reproduced artworks in the collections of the Musée Dupuytren in the 1870s. Photographed the stages of construction of the Statue of Liberty from 1871 to 1886. Turned the studio over to his son in 1908. Died in February, 1909.]

BOOKS

P234 Gamgee, Joseph Sampson. *History of a Successful Case of Amputation at the Hip-Joint. (the limb 48 inches in circumfrence, 99 pounds weight)....*With four photographs, by Sarony and Pierre-Petit. London: Churchill & Sons, 1865. xiii, 33 pp. 4 b & w. illus.

P235 Buerger, Janet. *Pierre Petit: Photographer.* Rochester, NY: International Museum of Photography at George Eastman House, 1980. 21 pp. 23 illus. [Introduction, plus an annotated checklist for this exhibition.]

PERIODICALS

P236 Portrait. Woodcut engraving credited "From a photograph by Pierre Petit, of Paris." ILLUSTRATED LONDON NEWS 43, (1863) ['Eugene Delacroix.' 43:* (Aug. 29, 1863): 208.]

P237 Portrait. Woodcut engraving credited "From a photograph by Pierre Petit, of Paris." ILLUSTRATED LONDON NEWS 47, (1865) ['M. Dupin, French Judge and Senator.' 47:* (Dec. 9, 1865): 565.]

P238 Portrait. Woodcut engraving credited "From a photograph by Pierre Petit, of Paris." ILLUSTRATED LONDON NEWS 48, (1866) ['M. Michel Chevalier.' 48:* (Jan. 27, 1866): 88.]

P239 "Editor's Table." PHILADELPHIA PHOTOGRAPHER 3, no. 29 (May 1866): 158. [Pierre Petit will have the monopoly of picture making in building at Paris Universal Exhibition of 1867. Cost 60,000 francs.]

P240 Portraits. Woodcut engravings credited "From a photograph by Pierre Petit, of Paris." ILLUSTRATED LONDON NEWS 50, (1867) ['Ingres.' 50:* (Feb. 23, 1867): 177. "Victor Cousin." 50:* (Mar. 2, 1867): 209.]

P241 Portrait. Woodcut engraving credited "From a photograph by Pierre Petit, of Paris." ILLUSTRATED LONDON NEWS 53, (1868) ['M. Berryer, French statesman.' 53:* (Dec. 5, 1868): 549.]

P242 Ferte, Rene de la. "Chronique." L'ARTISTE no. (Sept. 1871): 392. [Mentions that Pierre Petit is assembling a file of photos of the Parisian Communards.]

P243 Portrait. Woodcut engraving credited "From a photograph by Pierre Petit." ILLUSTRATED LONDON NEWS 69, (1876) ['Late Signor Tamburini.' 69:1949 (Dec. 2, 1876): 533.]

P244 Portrait. Woodcut engraving credited "From a photograph by Pierre Petit." ILLUSTRATED LONDON NEWS 70, (1877) ['Jules Simon.' 70:1957 (Jan. 13, 1877): 28.]

P245 1 engraving (Hector Berlioz). CENTURY MAGAZINE 47, no. 2 (Dec. 1893): 304. 1 illus. ["...Photographed by Pierre Petit, Paris."]

PETRI, PHILIPP. (1800-1868) (GERMANY)

P246 Hoerner, Ludwig. "Photohistorica Gottingensis: Part Two: Philipp Petri (1800-1887) [sic 1800-1868]." HISTORY OF PHOTOGRAPHY 6, no. 1 (Jan. 1982): 65-75. 15 b & w. 1 illus. [Early daguerreotypist in Gottingen, Germany.]

PETSCH, MAXIMILIAN M. see also LOESCHER & PETSCH.

PETSCH, MAXIMILIAN M. (BERLIN, GERMANY)

P247 Petsch, M. and Dr. Vogel. "On Posing and Lighting the Figure: Being a Few Hints on the Art of Photography." BRITISH JOURNAL OF PHOTOGRAPHY 11, no. 232, 236 (Oct. 14, Nov. 11, 1864): 401-402, 450-451. 1 illus. [From "Photographische Mittkeilungen"]

P248 Petsch and Hermann Vogel. "Photographic Portraiture. - On Lighting and Pose." HUMPHREY'S JOURNAL OF PHOTOGRAPHY, AND THE ALLIED ARTS AND SCIENCES 16, no. 22 (Mar. 15, 1865): 346-348. [From "Le Moniteur de la Photographie."]

P249 Vogel, Dr. H. "On Posing and Lighting the Sitter. Illustrated with Four Views by Petsch." PHILADELPHIA PHOTOGRAPHER 2, no. 18 (June 1865): 87-93. 4 b & w.

P250 Petsch, Max. "On the Influence of Individuality in Portrait Photography." ANTHONY'S PHOTOGRAPHIC BULLETIN 2, no. 2 (Feb. 1871): 44-46. [Translated from "Photographische Mittheilungen," taken from "London Photo. News."]

P251 Petsch, Max. "Children's Pictures." PHILADELPHIA PHOTOGRAPHER 9, no. 99 (Mar. 1872): 66-68. [From "Mittheilungen."]

P252 Petsch, Max. "Photographing Children." ANTHONY'S PHOTOGRAPHIC BULLETIN 3, no. 3 (Mar. 1872): 475-477. [From "London Photo. News," again from "Photographische Mittheilungen."]

P253 Vogel, Dr. H. "German Correspondence." PHILADELPHIA PHOTOGRAPHER 10, no. 110 (Feb. 1873): 58-60. [Photography of the past year and of the future - cry for a new style - Mr. Petsch resigns from photography - what photography has accomplished and its limits.]

PETSCHLER, H. & CO. (MANCHESTER, ENGLAND.)

P254 "Stereographs: Ferns, in their own haunts. Photographed by H. Petschler, Manchester." BRITISH JOURNAL OF PHOTOGRAPHY 10, no. 199 (Oct. 1, 1863): 390.

P255 "Our Editorial Table: Photographs by Messrs. H. Petschler & Co., Manchester." BRITISH JOURNAL OF PHOTOGRAPHY 11, no. 242 (Dec. 23, 1864): 532.

P256 "Our Editorial Table: Stereographs by H. Petschler, Manchester." BRITISH JOURNAL OF PHOTOGRAPHY 12, no. 293 (Dec. 15, 1865): 633.

PETSCHLER, H.

P257 Petschler, H. "Collodion-Albumen Process." HUMPHREY'S JOURNAL OF PHOTOGRAPHY, AND THE ALLIED ARTS AND SCIENCES 16, no. 22 (Mar. 15, 1865): 348-349. [From "Photographisches Archiv."]

PETTITT, ALFRED. (GREAT BRITAIN)

P258 "Critical Notices: Stereographs of the English Lake District by A. Pettitt." PHOTOGRAPHIC NEWS 4, no. 94 (June 22, 1860): 88-89. [200 stereos reviewed.]

P259 "Note." ART JOURNAL (Aug. 1865): 258. [A. Pettitt setting up studio in the English Lakes district, Keswick.]

PETZVAL see also PRETSCH, PAUL.

PETZVAL, JOSEPH. (1850-1891) (AUSTRIA)

P260 "Obituary: Dr. Joseph Petzval." PHOTOGRAPHIC TIMES 21, no. 528 (Oct. 30, 1891): 534. [Died on Sept. 19, 1891, in the 86th year of his age. Professor at the University of Vienna, Member of the Academy of Sciences at Vienna. Petzval was a mathematician and an optician. He designed the first lenses suitable for portraiture, which were later made and sold by Voightlander.]

PHELPS & POMEROY.

P261 Portrait. Woodcut engraving, credited "From a Photograph by Phelps & Pomeroy. FRANK LESLIE'S ILLUSTRATED NEWSPAPER 34, (1872) ["Noah Porter, D.D.' 34:878 (July 27, 1872): 317.]

PHILBURN, ANTHONY.
P262 Philburn, Anthony. "A Gallery with a South Light." BRITISH JOURNAL PHOTOGRAPHIC ALMANAC 1879 (1879): 173-174. 1 illus.

PHILLIPS & WARREN. (PHILADELPHIA, PA)
P263 Ryder, Richard C. "The Grand International Rowing Regatta." STEREO WORLD 7, no. 3 (July - Aug. 1980): 16-18. 4 b & w. [Sculling races in Philadelphia in 1876. Stereo views by Phillips & Warren, Philadelphia, PA.]

PHILLIPS, H. see also PALESTINE EXPLORATION FUND.

PHILLIPS, H., CORP. (GREAT BRITAIN, PALESTINE)
P264 "Photographs of Palestine Taken for the Exploration Fund." ART JOURNAL (Apr. 1868): 79. [Survey party under command of Captain Wilson, R.E. 343 photos. The first group consists of 164 photos taken by Corp. H. Phillips of the Royal Engineers on the first expedition., Nov. 1865 to May 1866. The second group contains 179 photos taken by Serg. H. Phillips in 1867.]

PHILLIPS, H. C. see BROADBENT & PHILLIPS.

PHILLIPS, J. (GREAT BRITAIN)
P265 Phillips, J. "My Tent." BRITISH JOURNAL PHOTOGRAPHIC ALMANAC 1877 (1877): 182-183. 1 illus.

P266 Phillips, J. "Photographic Topography." BRITISH JOURNAL PHOTOGRAPHIC ALMANAC 1878 (1878): 176-177.

PHILLIPS, J. H. (KIRKWOOD, MO) see TAYLOR, J. T. (June 1884)

PHILLIPS, JOHN.
P267 *Rivers, Mountains and Sea-Coast of Yorkshire.* Oxford: s. n., 1854. n. p. 36 b & w. illus. [Original photos, by John Phillips. Extra-illustrated version, ordinary edition contained engravings.]

PHILLIPS, MORETON. (KENSINGTON, ENGLAND)
P268 Portrait. Woodcut engraving credited "From a photograph by Moreton Phillips, of High Row, Kensington." ILLUSTRATED LONDON NEWS 49, (1866) ["Mr. C. Davis, Queen's Huntsman." 49:* (Nov. 17, 1866): 488. [Phillips was Mr. Davis' nephew.]

PHILPOTTS, J. R. (NEWNHAM, ENGLAND)
P269 "Our Editorial Table: Pictures by J. R. Philpotts, Newnham." BRITISH JOURNAL OF PHOTOGRAPHY 12, no. 288 (Nov. 10, 1865): 574.

PHIPSON, T. L.
P270 Phipson, T. L., Dr., F.C.S. "On Sulphocyanide of Ammonium." HUMPHREY'S JOURNAL OF PHOTOGRAPHY, AND THE ALLIED ARTS AND SCIENCES 20, no. 11 (Oct. 1, 1868): 170-172.

PHOTO-ENGRAVING CO. (NEW YORK, NY)
P271 "Our Illustration." ANTHONY'S PHOTOGRAPHIC BULLETIN 9, no. 6 (June 1878): frontispiece, 177. 1 illus. [Woodcut engraving, by the Photo-Engraving Co., New York, NY.]

PHOTO-GALVANO-GRAPHIC CO.
P272 "Fine Arts. Galvano - Photography. - Photographic Art-Treasures. Part IV." ILLUSTRATED LONDON NEWS 30, no. 865 (June 27, 1857): 641. [Bk. rev.: "Photographic Art Treasures. Part IV," Photo-galvano-graphic Co. Photolithographic plates of photos by R. F. Barnes, Lake-Price mentioned.]

PHOTOGRAPHIC TOURIST.
P273 "The Photographic Tourist: A Stroll on the Banks of the Thames." PHOTOGRAPHIC NEWS 4, no. 101-102 (Aug. 10 - Aug. 17, 1860): 176-177, 187-188. [This article may have never been completed.]

P274 "The Photographic Tourist: A Photographic Visit to the Isle of Wight in 1860." PHOTOGRAPHIC NEWS 4, no. 119 (Dec. 14, 1860): 389-390.

PIARD, VICTOR.
P275 "Our Illustrations." PHOTOGRAPHIC AND FINE ART JOURNAL 10, no. 12 (Dec. 1857): frontispiece, 376. 1 b & w. [Original photographic print, tipped-in. Self portrait by Victor Piard, worked as principal operator for Anthony, Edwards & Co. and Anthony, Clark & Co. since early 1840's. Accompanied E. Anthony to Washington, DC in 1842, assisted in taking portraits of members of Congress. Then went into grocery business but soon returned to profession, working in the gallery of C. D. Fredericks.]

PICKERILL, FRANK & BROTHER.
P276 "City of Dubuque, Iowa." BALLOU'S PICTORIAL DRAWING-ROOM COMPANION [GLEASON'S] 13, no. 332 (Oct. 31, 1857): 280-281. 4 illus. ["...from very beautiful daguerreotypes, taken by Messrs. Frank Pickerill & Brother, superior artists and residents of Dubuque."]

PICKERILL, FRANK M. (SHENANDOAH, IA)
P277 "Frank M. Pickerill's Dry Albumen Process." ANTHONY'S PHOTOGRAPHIC BULLETIN 6, no. 1 (Jan. 1875): 19.

P278 Pickerill, Frank M. "Correspondence: Some Western Dry-Plates and How to Develop Them." PHOTOGRAPHIC TIMES 18, no. 374 (Nov. 16, 1888): 549-550.

PICKERING & STERN.
P279 "Scene of the Fatal Explosion at Birmingham." ILLUSTRATED LONDON NEWS 35, no. 997 (Oct. 8, 1859): 354. 1 illus. ["From a photograph by Pickering & Stern, Moor Street, Birmingham."]

PIERCE, EDWARD W. (GALENA, IL)
P280 "The Grant Family at Home. - Photographed by E. W. Pierce, of Galena, Ill., Expressly for Frank Leslie's Illustrated Newspaper, From the Original Picture in the Possession of General Grant." FRANK LESLIE'S ILLUSTRATED NEWSPAPER 27, no. 686 (Nov. 21, 1868): 145. 1 illus. [Outdoor group portrait.]

P281 Portrait. Woodcut engraving, credited "Photographed by E. W. Pierce." FRANK LESLIE'S ILLUSTRATED NEWSPAPER 38, (1874) ["Miss Nellie Grant at the age of thirteen." 38:975 (June 6, 1874): 204.]

PIERCY, F. (LONDON, ENGLAND)
P282 Piercy, F. *A Crucial Test in Cases of Disputed Identity: The Features of Arthur Orton and Roger Tichborne compared.* London: F. Piercy, Memorial Painter, 1874. 8 pp. 5 illus. [Piercy compares daguerreotypes and recent photographs in a situation of disputed identity.]

PIERRE, PETIT. [?] (BERLIN, GERMANY)
P283 "Miscellanea - Berlin." ATHENAEUM no. 642 (Feb. 15, 1840): 140. ["...optician Petit Pierre has taken three views with the Daguerreotype, which have brought the problem as to the possibility of imparting colour to the photogenic pictures almost to a solution."]

PIERSON & BRAUN. (PARIS, FRANCE)

P284 "Photography in France." PHILADELPHIA PHOTOGRAPHER 11, no. 124 (Apr. 1874): 109-111. [Son of Adolphe Braun, in partnership with Pierson.]

P285 Portrait. Woodcut engraving, credited "From a Photograph by S. Pierson & Braun, Paris, France." FRANK LESLIE'S ILLUSTRATED NEWSPAPER 40, (1875) ["General Raphael Quesada." 40:1032 (July 10, 1875): 321.]

P286 Portrait. Woodcut engraving credited "From a photograph by Pierson & Braun." ILLUSTRATED LONDON NEWS 69, (1876) ["Wilhelm H. Wagner." 69:1935 (Aug. 26, 1876): 196.]

PIERSON, PIERRE LOUIS see MAYER & PIERSON; PIERSON & BRAUN.

PIFFET, EUGENE A. see MOSES & PIFFET.

PIGOU, DR. see also BIGGS, T., COL.

PIGOU, W. H. (d. ca. 1860?) (GREAT BRITAIN?, INDIA)

[W. H. Pigou was in the Bombay Army Medical Service in the 1850s. He became a corresponding member of the Photographic Society of Bombay in 1854. Appointed by the Bombay Government to record Muslim architecture in Bijapur and Ahmedbad after the Indian Mutiny of 1857, replacing Colonel T. Biggs, who had held the job since 1855. Pigou died while photographing these sites, and was succeeded by A. C. Neill, of Mysore. A book of this work was published in 1866, therefore Pigou died sometime between 1858 and early 1860s.]

P287 Taylor, Philip Meadows and James Fergusson. *Architecture in Dharwar and Mysore. Photographed by the Late Dr. Pigou, Bombay Medical Service, A. C. B. Neill, Esq. and Colonel Biggs, Late of the Royal Artillery.* With an Historical and Descriptive Memoir by Colonel Meadows Taylor and Architectural Notes by James Fergusson. London: John Murray, 1866. n. p. 98 b & w. [Original photographs, sixty taken by Dr. Pigou, the remainder by Capt. T. Biggs, and A. C. B. Neill.]

PIKE, NICHOLAS, COL. (b. 1816) (USA)

P288 Pike, Nicholas, Col. "John Stock's Plate-Box." AMERICAN JOURNAL OF PHOTOGRAPHY AND THE ALLIED ARTS & SCIENCES n. s. vol. 4, no. 12 (Nov. 15, 1861): 281-283. 2 illus. [Photographic apparatus manufactured by John Stock & Co., New York, NY. "...perfectly adapted for field purposes." "Having for many years worked the dry process, I have..."]

P289 Pike, Nicolas, Col. "The Acari in the Nitrate of Silver Bath used for Photographic Purposes." AMERICAN JOURNAL OF PHOTOGRAPHY AND THE ALLIED ARTS & SCIENCES n. s. vol. 5, no. 10 (Nov. 15, 1862): 235-236. [Read before Am. Photo. Soc. Pike from Brooklyn, NY.]

P290 Pike, Col. "Bath for Toning Albumenized Prints." HUMPHREY'S JOURNAL OF PHOTOGRAPHY, AND THE ALLIED ARTS AND SCIENCES 14, no. 14 (Nov. 15, 1862): 168-169.

P291 "Nicholas Pike." AMERICAN JOURNAL OF PHOTOGRAPHY AND THE ALLIED ARTS & SCIENCES n. s. vol. 5, no. 13 (Jan. 1, 1863): 310-311. 1 b & w. [Portrait of Col. Nicholas Pike (Not in this issue), with brief biography. Pike, an amateur from Brooklyn, NY. Born in Newburyport, MA on Jan. 22, 1816. Came to New York, NY in early 1840's, became a successful merchant so that he could retire and pursue his interests in studying birds, insects and marine life. Collector. U. S. Consul to Oporto (Portugal) for six years. Took up photography to help pursue these interests. Vice President of American Photographical Society.]

P292 Pike, N., Col. "The Micrograph." HUMPHREY'S JOURNAL OF PHOTOGRAPHY, AND THE ALLIED ARTS AND SCIENCES 15, no. 12 (Oct. 15, 1863): 181-183.

P293 Pike, Nicholas, Col. "The Micrograph." AMERICAN JOURNAL OF PHOTOGRAPHY AND THE ALLIED ARTS & SCIENCES n. s. vol. 6, no. 9 (Nov. 1, 1863): 204-206.

P294 "Col. Nicholas Pike." HUMPHREY'S JOURNAL OF PHOTOGRAPHY, AND THE ALLIED ARTS AND SCIENCES 19, no. 21 (Mar. 1, 1868): 334. [In answer to queries about what had become of Col. Pike. "...an amateur photographer...a frequent contributor to our pages,...an active member and officer of the late American Photographical Society....The Col. took a great disgust to photography; considered it played out; his efforts in its behalf were not appreciated, so he got an appointment as U. S. Consul to Mauritius, Isle of France....taken an interest in Botany,..."]

PINE, LEIGHTON.

P295 "Pine's Bromide Collodion." HUMPHREY'S JOURNAL OF PHOTOGRAPHY, AND THE ALLIED ARTS AND SCIENCES 18, no. 3 (June 1, 1866): 45.

P296 "Pine's Toning Process." HUMPHREY'S JOURNAL OF PHOTOGRAPHY, AND THE ALLIED ARTS AND SCIENCES 18, no. 4 (June 15, 1866): 56-57.

P297 Pine, Leighton. "Weak Silver Baths." HUMPHREY'S JOURNAL OF PHOTOGRAPHY, AND THE ALLIED ARTS AND SCIENCES 18, no. 5 (July 1, 1866): 71-72.

P298 Laudy, L. C. "Pine's Albumen Process." HUMPHREY'S JOURNAL OF PHOTOGRAPHY, AND THE ALLIED ARTS AND SCIENCES 18, no. 7 (Aug. 1, 1866): 106-107.

P299 Pine, Leighton. "Washing and Fixing Prints." HUMPHREY'S JOURNAL OF PHOTOGRAPHY, AND THE ALLIED ARTS AND SCIENCES 18, no. 7 (Aug. 1, 1866): 104-106.

P300 Pine, Leighton. "Solar Printing Process upon Iodide and Bromide of Silver." HUMPHREY'S JOURNAL OF PHOTOGRAPHY, AND THE ALLIED ARTS AND SCIENCES 18, no. 8 (Aug. 15, 1866): 118-119.

P301 Pine, Leighton. "Alcohol vs. Albumen." HUMPHREY'S JOURNAL OF PHOTOGRAPHY, AND THE ALLIED ARTS AND SCIENCES 18, no. 9 (Sept. 1, 1866): 138.

P302 Pine, Leighton. "Pine's Albumen Process." HUMPHREY'S JOURNAL OF PHOTOGRAPHY, AND THE ALLIED ARTS AND SCIENCES 18, no. 9 (Sept. 1, 1866): 141-142.

P303 Pine, Leighton. "Pine's Negative and Positive Varnish." HUMPHREY'S JOURNAL OF PHOTOGRAPHY, AND THE ALLIED ARTS AND SCIENCES 18, no. 10 (Sept. 15, 1866): 155-156.

P304 Pine, Leighton. "Blue Frosting for Sky-Lights." HUMPHREY'S JOURNAL OF PHOTOGRAPHY, AND THE ALLIED ARTS AND SCIENCES 18, no. 11 (Oct. 1, 1866): 170-171.

P305 Pine, Leighton. "Plain Paper Process." HUMPHREY'S JOURNAL OF PHOTOGRAPHY, AND THE ALLIED ARTS AND SCIENCES 18, no. 15 (Dec. 1, 1866): 232-233.

P306 Pine, Leighton. "Treatment of Negative Baths." HUMPHREY'S JOURNAL OF PHOTOGRAPHY, AND THE ALLIED ARTS AND SCIENCES 18, no. 16 (Dec. 15, 1866): 248-250.

P307 Pine, Leighton. "Nitro-Glucose for Enlarged Prints." HUMPHREY'S JOURNAL OF PHOTOGRAPHY, AND THE ALLIED ARTS AND SCIENCES 18, no. 17 (Jan. 1, 1867): 264-265.

P308 Pine, Leighton. "Nitro-Glucose." HUMPHREY'S JOURNAL OF PHOTOGRAPHY, AND THE ALLIED ARTS AND SCIENCES 18, no. 18 (Jan. 15, 1867): 279-281.

P309 Pine, Leighton. "Pine's Substitute for an Opal Printing-Frame." HUMPHREY'S JOURNAL OF PHOTOGRAPHY, AND THE ALLIED ARTS AND SCIENCES 18, no. 18 (Jan. 15, 1867): 285-286. 1 illus.

P310 Pine, Leighton. "New Toning Bath." HUMPHREY'S JOURNAL OF PHOTOGRAPHY, AND THE ALLIED ARTS AND SCIENCES 18, no. 20 (Feb. 15, 1867): 316.

P311 Pine, Leighton. "The New Intensifier." HUMPHREY'S JOURNAL OF PHOTOGRAPHY, AND THE ALLIED ARTS AND SCIENCES 18, no. 23 (Apr. 1, 1867): 359.

PIOT, EUGENE. (1812-1890) (FRANCE)
[Born in 1812, lived in Paris. He was a scholar, art collector and constant traveller. A close friend of Théophile Gautier, with whom he went to Spain. Founded the journal Le Cabinet de l'amateur et de l'antiquaire, first published from 1842 to 1846 and then from 1861 to 1864. In 1851 he published the series L'Italie monumentale, illustrated with original prints of his own views of archeological ruins. Photographs the Acropolis in Greece in 1851. Produced albums on Sicily and Athens in 1853. Photographed in the south of France 1855 to 1859. Exhibited several times in the 1850s, then seems to have left photography. In 1859 he set up the Académie des Inscriptions, then later the Piot Foundation, which published works on archeology and funded archeological activities. Died in Paris in 1890. Edmond Bonnaffe wrote Eugène Piot, (Paris: E. Charavay, 1890). A second biography Eugène Piot, by Maurice Tournex, (Paris: Lahure) was published in 1908.]

P312 Wey, Francis. "A Few Remarks upon the Journal 'La Lumiére.'" PHOTOGRAPHIC ART JOURNAL 3, no. 3 (Mar. 1852): 169-173. [Actually a review of two works: "New Manual of Photography," by E. De Valincourt and "Monumental Italy," by Eugene Piot. Trans. from "La Lumiére."]

P313 Humphrey, S. D. "Editorial: Actinography as a Correction of Careless Artists' Pencils." HUMPHREY'S JOURNAL 6, no. 18 (Jan. 1, 1855): 289-290. [Commentary on Piot's "Monumental Italy."]

PIPER, DIXON. (IPSWITCH, ENGLAND)
P314 "Life-Boat Demonstration at Ipswich." ILLUSTRATED LONDON NEWS 40, no. 1149 (June 14, 1862): 610. 1 illus. ["...represents the life-boat in the act of being launched, and is taken from a photograph by Mr. Dixon Piper, of Ipswich."]

P315 "Antiquarian Researches at Helmingham, Suffolk." ILLUSTRATED LONDON NEWS 45, no. 1266 (July 2, 1864): 3-4. 2 illus. ["An amateur artist - the Rev. T. K. Tucker, Rector of Pittaugh - has made some very interesting drawings of 'The Wilderness' and its

contents; and some admirable photographs have been executed by Mr. Piper, of Ipswich." View of church, excavations.]

PIPER, H. (GATESHEAD, ENGLAND)
P316 "Our Editorial Table: Pictures by Mr. H. Piper, Gateshead." BRITISH JOURNAL OF PHOTOGRAPHY 11, no. 236 (Nov. 11, 1864): 453.

PIPER, J. D.
P317 "Norman Tower, Bury St. Edmunds - By J. D. Piper. - In the Photographic Exhibition." ILLUSTRATED LONDON NEWS 36, no. 1021 (Mar. 10, 1860): 228, 236. 1 illus.

PIPER, STEPHEN. (MANCHESTER, NH)
P318 Portrait. Woodcut engraving, credited "Photographed by Stephen Piper, of Manchester, NH." FRANK LESLIE'S ILLUSTRATED NEWSPAPER 38, (1874) ["Col. Arthur Macarther Eastman." 38:980 (July 11, 1874): 284.]

PIQUEPÉ, P.
BOOKS
P319 Piquepé, P. Practical Treatise on Enameling and Retouching in Photography. London: Piper & Carter, 1876. 76 pp.

PERIODICALS
P320 Piquepé, P. "A New Application of the 'Eclairages á la Façon de Rembrandt.'" BRITISH JOURNAL PHOTOGRAPHIC ALMANAC 1876 (1876): 137-138.

P321 Piquepé, P. "On Collodion." BRITISH JOURNAL PHOTOGRAPHIC ALMANAC 1877 (1877): 106-108.

P322 Piquepé, P. "On the Suppression of Negative Retouching." BRITISH JOURNAL PHOTOGRAPHIC ALMANAC 1878 (1878): 158-161.

PITTS, G. A. (ST.JOHNS, CANADA)
P323 "Damaged Bows of the Steam-Ship "Arizona," from Contact with an Iceberg, St. Johns, Newfoundland." ILLUSTRATED LONDON NEWS. 75, no. 2111 (Nov. 29, 1879): 512. 1 illus.

PLACE. (FRANCE, EGYPT)
P324 "French Researchers at Nineveh." HUMPHREY'S JOURNAL 4, no. 12 (Oct. 1, 1852): 183-184. [M. Place, Consul of France at Mossul, excavating ruins of Nineveh..."M. Place has taken copies of his discoveries by means of the photographic process..."]

PLACE, J. M. (ST. PETERSBURG, PA)
P325 Waldsmith, John. "The Centennial Oil Wells." STEREO WORLD 3, no. 3 (July - Aug. 1976): 12. 2 b & w. [Stereos of displays at the Centennial Exposition in Philadelphia in 1876, published by J. M. Place, of St. Petersburg, PA.]

PLACET, PAUL EMILE.
P326 "Another Engraving Process." BRITISH JOURNAL OF PHOTOGRAPHY 12, no. 277 (Aug. 25, 1865): 438-439. [Process of Paul Emile Placet, a civil engineer in Paris.]

P327 Placet, Paul Emile. "Improvements in Photo-Engraving." ANTHONY'S PHOTOGRAPHIC BULLETIN 7, no. 7 (July 1876): 193-196. [From "London Photo. News."]

PLATT, ALVORD C. (1828-1884) (USA)

P328 "A. C. Platt's Printing Frame." AMERICAN JOURNAL OF PHOTOGRAPHY AND THE ALLIED ARTS & SCIENCES n. s. vol. 8, no. 9 (Nov. 1, 1865): 209-210. [Platt exhibited in New York, NY.]

P329 "The Guardian Angel." HUMPHREY'S JOURNAL OF PHOTOGRAPHY, AND THE ALLIED ARTS AND SCIENCES 18, no. 8 (Aug. 15, 1866): 125-126. [A. C. Platt, of Oberlin, Ohio, made up a composite photograph consisting of an angel (the dead mother) descending to the sofa containing four orphan children. Platt took many views of the children, then applied the portrait of the mother, then the entire ensemble was overpainted "by one of our best artists" who added the angel's figure, etc., in oils. This "most beautiful work of art" was on exhibition at the rooms of Messrs. Willard & Co., 634 Broadway. Article includes a letter from Platt describing his efforts.]

P330 "Editor's Table." PHILADELPHIA PHOTOGRAPHER 3, no. 34 (Oct. 1866): 322. [Note: genre picture of four children on sofa, mother hovering above as angel. On exhibit at office of W. Ward & Co., Broadway, New York, NY. Platt from Oberlin, OH.]

PLATT, HENRY C. (1850-1895) (USA)

P331 Platt, Harry. "Rapid Instantaneous Work." PHOTOGRAPHIC TIMES 14, no. 162 (June 1884): 290-291. [Describes the activities of his firm, the Platt Brothers, taking instantaneous photographs of the two noted bicyclists, Smith and Robertson, riding their cycles down the long marble steps of the east front of the U.S. Capitol building.]

P332 Platt, Harry. "Photographing the Bicyclist in the Daring Act of Riding Down the Steps of the Capital." PHOTOGRAPHIC TIMES 14, no. 165 (Sept. 1884): 485-486. [Platt's earlier article received such attention that he wrote thus fuller account of the events.]

P333 Platt, Harry. "Picture Makeup." AMERICAN ANNUAL OF PHOTOGRAPHY AND PHOTOGRAPHIC TIMES ALMANAC FOR 1891 (1891): 189-191, plus unnumbered leaf after p. 72. 1 b & w. [Photo is of children playing in a boat. Platt from Nantucket, MA.]

P334 Platt, Harry. "Eels and Fishes." PHOTOGRAPHIC TIMES 22, no. 565 (July 15, 1892): 365-366. [Reflections on looking at landscape photographs.]

P335 "Editor's Table." WILSON'S PHOTOGRAPHIC MAGAZINE 32, no. 460 (Apr. 1895): 192. ["Died, at Nantucket, MA, on Mar. 9th, Henry C. Platt, late of Augusta, GA, photographer, aged 44 years, 7 months, and 9 days."]

P336 "Notes: Harry Platt." PHOTOGRAPHIC TIMES 26, no. 5 (May 1895): 314-315. 1 b & w. [Obituary. Born in Augusta, GA. Opened a studio in Norfolk, VA, in 1877. Later moved to Washington, DC.]

PLATZ, MAX. (1850-1894) (GERMANY, USA)

P337 "Notes and News: As to Nude Photography." PHOTOGRAPHIC TIMES 18, no. 375 (Nov. 23, 1888): 560. [From "Chicago News." Max Platz, a photographer in Chicago for twenty years, discounts the stories published in popular papers that society women occasionally request portraits in the nude. Never happened in his experience.]

P338 "Notes and News: Why the Subject of a Photograph Couldn't Look Pleasant." PHOTOGRAPHIC TIMES 20, no. 451 (May 9, 1890): 227-228. [From "Chicago [IL] Mail." Anecdote about difficulty with a female sitter.]

P339 1 photo ("Miss Marie Tempest"). PHOTOGRAPHIC TIMES 23, no. 631 (Oct. 20, 1893): 595.

P340 "Notes and News: Max Platz." PHOTOGRAPHIC TIMES 24, no. 652 (Mar. 16, 1894): 175. [Brief biography, obituary notice. Born near Berlin, began to photograph in Chicago, IL, in 1867, asst. to his brother-in-law H. Rocher. 1881 business by himself. Did a great deal of theatrical photography.]

PLE, CHARLOT.

P341 "Photographs in Natural Colors." HUMPHREY'S JOURNAL OF PHOTOGRAPHY, AND THE ALLIED ARTS AND SCIENCES 15, no. 15 (Dec. 1, 1863): 230-231. [From "Photo. News." Mr. Charlot Ple's experiments described.]

PLUMBE, JOHN, JR. see also HISTORY: USA: MO (Van Ravenswaay)

PLUMBE, JOHN, JR. (1809-1857) (GREAT BRITAIN, USA)

[Born in Wales in 1809. His family came to the USA while John was a child, probably settling in Baltimore, MD. He became a naturalized citizen. Plumbe worked as an assistant on a railroad survey across the Allegheny Mountains in Pennsyvania in 1831 and 1832, then he was appointed superindendent and manager of the first railroad in Virginia and North Carolina. In 1836 he moved to the Wisconsin Territory and purchased a tract of land near what is now Dubuque, IA. In 1837 Plumbe joined a group of speculators, known as the Louisiana Company, to purchase land on the Mississippi River and develop the town of Sinipee as the jump-off location for a transcontinental railroad. In 1838 Plumbe received an appropriation from the U. S. Congress to survey a transcontential railroad route, but flooding and disease wiped out Sinipee and lost Plumbe his economic base. He took up photography when the funds ran out. Opened a gallery in Boston in 1841, which he sold in 1846. Financed other galleries in Baltimore, New York, Philadelphia, Lexington, KY, Washington, DC, and elsewhere during the 1840s. In 1846 he published the *National Plumbeotype Gallery* and the *Plumbeian*. The *Plumbeotype Gallery* was a series of lithographic portraits drawn after daguerreotypes. Plumbe, who had financed many galleries to help him raise money for his larger speculations, left the photographic field by 1849, and headed for the California goldfields. Throughout the early 1850s he again attempted to promote the transcontential railroad, again without success. In 1856 he moved to Dubuque, IA, where he sold real estate. He committed suicide in Dubuque in May, 1857.]

P342 Plumbe, John. *Sketches of Iowa and Wisconsin, Taken during a Residence of Three Years in Those Territories.* St. Louis: Chambers, Harris & Knapp, 1834. xvii, 103 pp. illus. [facsimile reprint (1948) Iowa City: State Historical Society of Iowa. Pt. 1 (Iowa) only, 2nd part never published.]

PERIODICALS

P343 "Plumbe's Daguerrian Gallery." NEW YORK ILLUSTRATED ANNUAL (1847): 128. [Brief comment and praise for Plumbe's "Gallery of Fine Arts."]

P344 1 engraving (Washington Irving) on p. 577. HARPER'S MONTHLY 2, no. 11 (Apr. 1851): 577. 1 illus. ["From a Daguerreotype by Plumbe."]

P345 "Melancholy Suicide." THE DUBUQUE DAILY EXPRESS AND HERALD (DUBUQUE, IA) (May 30, 1857): n. p.

P346 "Death of a Distinguished Photographic Artist." HUMPHREY'S JOURNAL 9, no. 7 (Aug. 1, 1857): 112. [Committed suicide in

Dubuque, IA. Had establishments in New York, NY, Philadelphia, PA, Baltimore, MD, Boston, MA, and Albany, NY for years; but had lost most of his money at his death.]

P347 "Portraits of Irving." COSMOPOLITAN ART JOURNAL 4, no. 2 (June 1860): 76. [From "NY Home Journal." A listing of ten portraits, both paintings and daguerreotypes, which were made of Washington Irving before his death. One was a daguerreotype taken by Plumbe in 1849. Nagel then used that as a source for his painting. The painting was, in turn, photographed by Brady, who displayed their work in his gallery. In June 1851 Irving also sat for the artist Martin, who may have been a daguerreotypist.]

P348 King, John. "John Plumbe, Originator of the Pacific Railroad." ANNALS OF IOWA 3rd Series, vol. 6, no. 4 (Jan. 1904): 288-296. 1 illus. [Includes portrait of Plumbe.]

P349 Taft, Robert. "John Plumbe, America's First Nationally Known Photographer." AMERICAN PHOTOGRAPHY 30, no. 1 (Jan. 1936): 1-2, 4-6, 8, 10, 12. 6 illus.

P350 Bloch, Don. "John Plumbe, Prime Precursor of a Railroad to the Pacific." THE DENVER WESTERNERS BRAND BOOK 21, (1966): 257-281. 3 illus.

P351 Fern, Alan and Milton Kaplan. "John Plumbe, Jr. and the First Architectural Photographs of the Nation's Capitol." QUARTERLY JOURNAL OF THE LIBRARY OF CONGRESS 31, no. 1 (Jan. 1974): 2-20. 9 b & w. 4 illus.

P352 Krainik, Cliff. "Photographer with a Vision: John Plumbe, Jr." NORTHLIGHT (JOURNAL OF THE PHOTOGRAPHIC HISTORICAL SOCIETY OF AMERICA) 1, no. 2 (Summer 1974): 3-5. 2 illus.

PLUMIER, VICTOR. (PARIS, FRANCE)
[Victor Plumier was a well-respected portrait photographer in Paris, where he operated a studio from at least 1845 to 1866, when his studio was taken over by Klary. Plumier made daguerreotype views of the crowds and ceremony surrounding the baptism celebration of the prince imperial in 1856. His brother Alphonse also was a professional photographer, who practiced in Belgium.]

P353 Portrait. Woodcut engraving, credited "From a Daguerreotype by Plumbier, [sic Plumier] Paris." ILLUSTRATED NEWS (NY) 1, (1853) ["Mr. John Banvard, artist." 1:6 (Feb. 5, 1853): 96.]

P354 Portrait. Woodcut engraving credited "From a photograph by Victor Plumier." ILLUSTRATED LONDON NEWS 25, (1854) ["Lieut.-General Sir John Fox Burgoyne." 25:* (Nov. 25, 1854): 540. (dag.)]

POCOCK, EDWARD. (GREAT BRITAIN)
P355 "The Camera at the War." ANTHONY'S PHOTOGRAPHIC BULLETIN 8, no. 7 (July 1877): 207-208. [From "London Photo. News." Brief summation of use of photography in war zones, commenting how little has appeared. Mentions Crimea, China, Abyssinia, the Franco-Prussian War. Suggests that the Warnerke roll film, now available, will be valuable to war correspondents, etc. Mentions that Pocock, of the London Stereoscopic Company, has been dispatched to the current conflict in North Africa, with a roll-film camera.]

P356 Pocock, Edward, Artist for the London Stereoscopic Company. "Photography at the War." ANTHONY'S PHOTOGRAPHIC BULLETIN 8, no. 7-10 (July, Sept. Oct. 1877): 219, 270-271, 309-310.

[From "Br J of Photo." (July) Letter, from Pocock, at Pera, Turkey, describing his camera and equipment. (Sept.) Meets British amateur photographer (not named) living in Pera. Detained by police while photographing. Then mugged, but escapes. (Oct.) Recovered his cameras from officials, then went to Stamboul. Potock made sketches when he was unable, by circumstances, to photograph.]

P357 "Matters of the Month." PHOTOGRAPHIC TIMES 7, no. 81 (Sept. 1877): 208. ["Mr. Edward Pocock, the photographer for the London Stereoscopic Company," ... describes his experiences near the "seat of the war" [In Turkey?] in the "Br J of Photo."]

POEY, ANDRES. (HAVANA, CUBA)
P358 "Photographic Effects of Lightning." HUMPHREY'S JOURNAL 9, no. 9 (Sept. 1, 1857): 144. [From "The Athenaeum." Paper read by Andreas Poey, Director of the Meteorological Observatory at Havana, Cuba to the British Meteorological Society. Describes events of image formation by lightning from 1786 to 1850's.]

P359 "Lightning Prints." CHAMBERS'S JOURNAL OF POPULAR LITERATURE 36, no. 409 (Nov. 2, 1861): 275-278. [Discusses Andrès Poey's historical research into photographic images created by lightning flashes. Poey was the director of the meterological observatory in Cuba.]

POITEVIN, LOUIS-ALPHONSE. (1819-1882) (FRANCE)
[Born at Conflans-sur-Anille in 1819. Graduated from the Ecole Centrale des Arts et Manufactures, worked as a civil engineer. Became interested in photography in 1840, and his experiments with the medium and on photomechanical processes made him one of the leading authorities during the 19th century. He developed a photolithography method which saw use in publishing, and developed practical carbon printing techniques in the 1850s. In 1865 he developed a process for color photography. His books *Traité de l'impression photographique sans sels d'argent, contenant l'histoire, la théorie et la pratique des méthodes et procédés de l'impression au charbon, de l'hélioplastie*, (Paris: Leiber, 1862), and *Traité des impressions photographiques, suivi d'appendices par M. Léon Vidal*, (Paris: Gauthier-Villars, 1883) were standards in this area. Poitevin travelled widely for his work, but died back in Conflans on March 4, 1882.]

P360 "Photographic Engraving." PHOTOGRAPHIC AND FINE ART JOURNAL 10, no. 3 (Mar. 1857): 71. [From "Liverpool Photo J." Brief summary of Poitevin's process.]

P361 "M. Poitevin's Process of Photo-Lithography." HUMPHREY'S JOURNAL 9, no. 12 (Oct. 15, 1857): 177-180. [From "Photo. Notes."]

P362 "Photographic Engraving." PHOTOGRAPHIC AND FINE ART JOURNAL 11, no. 11 (Nov. 1858): 338-339. [Text of patent specification for Poitevin's process.]

P363 Poitevin. "Positive Printing without Salts of Silver." HUMPHREY'S JOURNAL OF PHOTOGRAPHY, AND THE ALLIED ARTS AND SCIENCES 11, no. 9 (Sept. 1, 1859): 140-141.

P364 Poitevin. "The Last New Carbon Printing Process Devised." AMERICAN JOURNAL OF PHOTOGRAPHY AND THE ALLIED ARTS & SCIENCES n. s. vol. 4, no. 6 (Aug. 15, 1861): 132-134. [From "Br. J. of Photo."]

P365 Poitevin. "The last New Carbon Printing Process devised." HUMPHREY'S JOURNAL OF PHOTOGRAPHY, AND THE ALLIED

ARTS AND SCIENCES 13, no. 9 (Sept. 1, 1861): 133-135. [From "Br. J. of Photo."]

P366 Lacan, Ernest. "Carbon Printing Process." AMERICAN JOURNAL OF PHOTOGRAPHY AND THE ALLIED ARTS & SCIENCES n. s. vol. 5, no. 1 (July 1, 1862): 20-21. [From "Br. J. of Photo." Poitevin's

P367 Poitevin, A. "Photography upon Gelatine." AMERICAN JOURNAL OF PHOTOGRAPHY AND THE ALLIED ARTS & SCIENCES n. s. vol. 5, no. 13 (Jan. 1, 1863): 298-300. [Read to Marseilles Photo. Soc. "Traite de l'Impression Photographic sans l'argent" discussed.]

P368 Poitevin, A. "Historical Facts Relative to Photolithography." BRITISH JOURNAL OF PHOTOGRAPHY 10, no. 185 (Mar. 2, 1863): 95-96.

P369 Poitevin, A. "Process of direct Carbon Printing on Paper." HUMPHREY'S JOURNAL OF PHOTOGRAPHY, AND THE ALLIED ARTS AND SCIENCES 14, no. 24 (Apr. 15, 1863): 327-328. [From "Moniteur de la Photographie."]

P370 Van Monckhoven, Dr. "M. Poitevin's New Dry Process." AMERICAN JOURNAL OF PHOTOGRAPHY AND THE ALLIED ARTS & SCIENCES n. s. vol. 6, no. 17 (Mar. 1, 1864): 398-400. [From "Bulletin Belge."]

P371 Poitevin. "Helioplastic Ornaments." AMERICAN JOURNAL OF PHOTOGRAPHY AND THE ALLIED ARTS & SCIENCES n. s. vol. 6, no. 24 (June 15, 1864): 571-572. [Read to Fr. Photo. Soc.]

P372 "The Origin of Carbon Printing." AMERICAN JOURNAL OF PHOTOGRAPHY AND THE ALLIED ARTS & SCIENCES n. s. vol. 8, no. 1 (July 1, 1865): 5-6. [From "Photo. News." Additional note on p. 23, arguing for primacy of Poitevin over Pouncy for the invention of carbon Printing.]

P373 Lacan, Ernest. "A New Chromatype Process." AMERICAN JOURNAL OF PHOTOGRAPHY AND THE ALLIED ARTS & SCIENCES n. s. vol. 8, no. 7 (Oct. 1, 1865): 152-154. [From "Photo. News."]

P374 Anthony, John, M.D. "Poitevin's Carbon and Enamel Process." AMERICAN JOURNAL OF PHOTOGRAPHY AND THE ALLIED ARTS & SCIENCES n. s. vol. 8, no. 10 (Nov. 15, 1865): 223-226. [From "Photo. News."]

P375 Poitevin. "Production of Photographic Colors on Paper." HUMPHREY'S JOURNAL OF PHOTOGRAPHY, AND THE ALLIED ARTS AND SCIENCES 17, no. 20 (Feb. 15, 1866): 309-311. [From "La Lumière."]

P376 "Photographs in Natural Colors. - Successful Experiment." AMERICAN JOURNAL OF PHOTOGRAPHY AND THE ALLIED ARTS & SCIENCES n. s. vol. 8, no. 17 (Mar. 1, 1866): 385-388. [From "Photo. News." I think the article is by Charles Seeley, the editor.]

P377 "Photographs in Natural Colors. - Successful Experiment." HUMPHREY'S JOURNAL OF PHOTOGRAPHY, AND THE ALLIED ARTS AND SCIENCES 17, no. 22 (Mar. 15, 1866): 345-347. [From "Photo. News." Poitevin's experiments discussed.]

P378 Poitevin, L. A. "On the Simultaneous Action of Light and Oxygenated Salts upon the Violet Subchloride of Silver, and its Application to the Production by Photography of Natural Colors on Paper." AMERICAN JOURNAL OF PHOTOGRAPHY AND THE ALLIED ARTS & SCIENCES n. s. vol. 8, no. 19 (Apr. 1, 1866): 438-441. [From "Comptes Rendus, (Dec. 18, 1865)."]

P379 "Nature and Science: Photographing in Colors." CENTURY MAGAZINE (SCRIBNER'S MONTHLY) 8, no. 2 (June 1874): 252. [Brief comment on Poitevin's experiments.]

P380 Stebbing, Prof. E. "A French Photographic Savant." ANTHONY'S PHOTOGRAPHIC BULLETIN 10, no. 10 (Oct. 1879): 305-307. [L. A. Poitevan born in Conflans, France in 1819. Studied at Ecolé Central, Paris, leaving in 1843, with diploma of civil engineer. Many chemical and physical experiments through 1840s, 1850s, 1860s.]

P381 "The Fathers of Photography. VIII. Louis Alphonse Poitevin." PHOTOGRAPHIC TIMES 24, no. 667 (June 29, 1894): 405. 1 illus.

POLE.
P382 Pole, Professor. "Photography for Travellers and Tourists." BRITISH JOURNAL OF PHOTOGRAPHY 9, no. 170 (July 15, 1862): 276-277.

P383 Pole, Prof., F. R. S. "Photography for Travellers and Tourists." HUMPHREY'S JOURNAL OF PHOTOGRAPHY, AND THE ALLIED ARTS AND SCIENCES 14, no. 10, 12 (Sept. 15, Oct. 15, 1862): 109-111, 140-142. [From "Mcmillan's Magazine."]

POLEHAMPTON, ARTHUR. (GREAT BRITAIN, INDIA)
P384 "Ancient Buildings, Beejapoor." ILLUSTRATED LONDON NEWS 59, no. 1661 (July 22, 1871): 67, 72. 2 illus. ["We are indebted to the Rev. Arthur Polehampton, Chaplain in her Majesty's Indian Service, lately at Poonah, but now at Rajkote, Kittyway, for several photographs..."]

P385 "Tomb of Mohammed Adil Chah, Beejapoor, India." ILLUSTRATED LONDON NEWS 59, no. 1664 (Aug. 12, 1871): 145. 1 illus.

POLLITT, J. (GREAT BRITAIN)
P386 Pollitt, J. "Hints to Dry - Plate Workers." BRITISH JOURNAL PHOTOGRAPHIC ALMANAC 1876 (1876): 109-112.

P387 Pollitt, J. "Hints to Dry-plate Workers." ANTHONY'S PHOTOGRAPHIC BULLETIN 7, no. 3 (Mar. 1876): 84-86. [From "Br. J. of Photo. Almanac." Contains statement about ease of use of the wet-collodion vs. various dry processes.]

P388 Pollitt, J. "On Enlarged Negatives." BRITISH JOURNAL PHOTOGRAPHIC ALMANAC 1877 (1877): 109-111.

P389 Pollitt, J. "Remarks on Photographic Apparatus." BRITISH JOURNAL PHOTOGRAPHIC ALMANAC 1879 (1879): 142-146.

P390 Pollitt, J. S. "The Influence of Photography on Popular Taste and the Graphic Arts." PHOTOGRAPHIC TIMES 15, no. 198 (July 3, 1885): 358-359. [Presented to the Hyde Amateur Photographic Society.]

POLLOCK, G. H. & W. E. POLLOCK. (NEW YORK, NY)
P391 "Editor's Table." PHILADELPHIA PHOTOGRAPHER 4, no. 47 (Nov. 1867): 368. [Stereoscopic groups (genre studies) from Messrs. G. H. & W. E. Pollock, 95 Liberty Street, NY. Titles are " The burial of

the bird," "Going to a party," "Deceiving Grandma," etc. Note of further stereos received on page 404, Dec. 1867.]

POLLOCK, HENRY. (1826-1889) (GREAT BRITAIN)
[Henry Pollock was the eleventh child in the first family of Baron Jonathan Frederick Pollock, Lord Chief Baron of the Exchequer, and the half brother of Arthur Julius Pollock, also a photographer. Sir Jonathan Pollock was an amateur photographer, the second president of the Photographic Society and a member of the Photographic Society Club. Henry Pollock was born in 1826. He attended Trinity College, Cambridge. He was an active experimenter in photographic processes and wrote articles for the journals throughout the 1850s. Interested in landscape photography. Member of the Photographic Society and the Photographic Society Club.]

P392 "Directions for Obtaining Positive Photographs upon Albumenized Paper." PHOTOGRAPHIC ART JOURNAL 6, no. 4 (Oct. 1853): 210-211. [From "J. of Photo. Soc."]

P393 Pollock, Henry. "Process for Keeping Collodion Plates." PHOTOGRAPHIC AND FINE ART JOURNAL 9, no. 4 (Apr. 1856): 117. [From "J. of Photo. Soc., London."]

P394 Pollock, Henry. "Process for Keeping Collodion Plates." HUMPHREY'S JOURNAL 7, no. 23 (Apr. 1, 1856): 368-369. [From "J. of Photo. Soc., London."]

POND, C. L. (BUFFALO, NY)
P395 Palmquist, Peter. "C. L. Pond: A Stereoscopic Gadabout Visits Yosemite." STEREO WORLD 10, no. 6 (Jan.-Feb. 1984): 18-20. 6 b & w. [C. L. Pond of Buffalo, NY, was an active photographer from 1861 to 1881 and a stereo publisher from 1869 to 1878. Photographed in Yosemite in 1871, but all the stereo views reproduced here include him posing with the camera, etc.]

PONTING, THOMAS CADBY. (GREAT BRITAIN)
BOOKS
P396 Ponting, T. Cadby. *Photographic Difficulties: How to surmount them. Instantaneous Pictures: How to obtain them.* London; Bristol: Bland & Co.; T. C. Ponting, Collodion Manufacturer, Chemist to the Queen, 1862. 124 pp.

PERIODICALS
P397 Ponting, Thos. C. "Yellow Glass for the Developing-room." HUMPHREY'S JOURNAL OF PHOTOGRAPHY, AND THE ALLIED ARTS AND SCIENCES 10, no. 12 (Oct. 15, 1858): 192. [From "J. of the London Photo. Soc.]

PONTON, MUNGO. (1802-1880) (GREAT BRITAIN)
P398 Ponton, Mungo. "New Photographic Paper, in which the use of any Salt of Silver is dispensed with." MAGAZINE OF SCIENCE, AND SCHOOL OF ARTS 1, no. 14 (July 6, 1839): 109. [From "Edin. New Phil. Jour."]

P399 Ponton, Mungo. "Paper for Photographic Drawing." DAGUERREAN JOURNAL 2, no. 8 (Sept. 1, 1851): 225-226. [Source not given.]

P400 Ponton, M. "Notice of a Cheap and Simple Method of Preparing Paper for Photographic Drawings, In Which the Use of Any Salt of Silver is Dispensed With." BRITISH JOURNAL OF PHOTOGRAPHY 11, no. 232 (Oct. 14, 1864): 400-401.

P401 Ponton, M. "A Cheap and Simple Method of Preparing Paper for Photographic Drawings, Salts of Silver being dispensed with."

AMERICAN JOURNAL OF PHOTOGRAPHY AND THE ALLIED ARTS & SCIENCES n. s. vol. 7, no. 10 (Nov. 15, 1864): 224-226. [From "Transactions of the Scottish Society of Arts, for 1830." Additional notes on Ponton on pp.239-240.]

P402 "Home and Foreign News Epitomized." PHOTOGRAPHIC TIMES 10, no. 118 (Oct. 1880): 225. ["The death of Mr. Mungo Ponton on the 3rd ultimately is announced. For many years he had resided in Clifton, England..." "... discovery of the photographic properties of bichromate of potash."]

P403 "Forgotten Pioneers: I. Mungo Ponton (1802-1880)." IMAGE 1, no. 3 (Mar. 1952): 3-4. [Scottish experimenter. Used potassium bichromate instead of silver salts to make paper light sensitive in 1839.]

POOLE, SAMUEL. (TEIGNMOUTH, ENGLAND)
P404 "Destruction of a Part of the South Devon Railway." ILLUSTRATED LONDON NEWS 35, no. 1005 (Dec. 3, 1859): 531. 1 illus. ["...from a photograph taken by Samuel Poole, of the Devon Photographic Institute, Teignmouth."]

POOLEY, CHARLES. (GREAT BRITAIN)
P405 Pooley, Charles. *On Engraving Collodion Photographs by means of Fluoric Acid Gas.* London, Cirencester: Hamilton, Adams & Co., E. Bailey, 1856. 12 pp. [Reprint of a paper read before the British Association in August, 1856.]

PORKE, JOHN.
P406 "Critical Notices: "Fancies on the Photograph. A Poem in three parts," by John Porke. London: Longman & Co." PHOTOGRAPHIC NEWS 8, no. 285 (Feb. 19, 1864): 87. [Poetry.]

PORTA, GIAMBATTISTA see PREHISTORY.

PORTER & WINTER. (CINCINNATI, OH)
P407 Portrait. Woodcut engraving, credited "From a Photograph by Porter & Winter, Cincinnati." FRANK LESLIE'S ILLUSTRATED NEWSPAPER 35, (1872) ["The late Samuel N. Pike." 35:900 (Dec. 28, 1872): 253.]

PORTER, J. (PERTH, ENGLAND)
P408 Portrait. Woodcut engraving credited "From a photograph by J. Porter." ILLUSTRATED LONDON NEWS 64, (1874) ["Lance Sergeant MacGraw, V.C." 64:1808 (Apr. 18, 1874): 373.]

PORTER, WILLIAM F. (d. 1864) (USA)
P409 "The Photographer of Lookout Mountain." FRANK LESLIE'S ILLUSTRATED NEWSPAPER 18, no. 448 (Apr. 30, 1864): 92. 2 illus. [Two sketches, one of the tent and outfit of Wm. F. Porter, a photographer who had set up operations on Lookout Mountain, TN; the second a view of him falling to his death off the mountain while arranging a portrait setting.]

P410 "Waifs and Strays: The Photographer of Lookout Mountain." BRITISH JOURNAL OF PHOTOGRAPHY 11, no. 214 (May 16, 1864): 177. [From "Frank Leslie's Illustrated Newspaper." "Not long after the battle of Lookout Mountain one of our artists...visited the spot...amused to find...on the summit...the tent of a travelling photographer...(a view shown with) the sketch showing the sad close of the career of the photographer, Mr. Wm. F. Porter, who, while placing a lady and gentleman, lost his foothold and fell down the precipice, a distance of some 200 feet."]

PORTER, WILLIAM S. see also FONTAYNE, CHARLES.

PORTER, WILLIAM SOUTHGATE. (1822-1889) (USA)
[Active in Philadelphia, then to Cincinnati, OH in 1848. Partner with Charles Fontayne.]

P411 F. H. S. "Porter's New Photographic Gallery." PHOTOGRAPHIC AND FINE ART JOURNAL 11, no. 4 (Apr. 1858): 123-124. [Porter's (Cincinnati, OH) gallery described in detail.]

P412 "Nicolas Longworth, Esq., of Cincinnati, and the Vineyards of Ohio." HARPER'S WEEKLY 2, no. 82 (July 24, 1858): 472-474. 5 illus. [Photographic portrait of Mr. Longworth "by Porter, of Cincinnati." Scenes of wine making, vineyards, etc., from sketches.]

P413 Portrait. Woodcut engraving, credited "From a Photograph by Porter, Cincinnati." FRANK LESLIE'S ILLUSTRATED NEWSPAPER 15, (1863) ["Gen. S. G. Burbridge." 15:385 (Feb. 14, 1863): 321.]

POTTER, JUDD C. (1825-1880) (USA)
P414 Potter, J. C. "'Fumination' a Success." AMERICAN JOURNAL OF PHOTOGRAPHY AND THE ALLIED ARTS & SCIENCES n. s. vol. 5, no. 20 (Apr. 20, 1863): 477-478. [J. C. Potter from Elyria, OH.]

P415 Potter, J. C. "The Fuming Process a Success." AMERICAN JOURNAL OF PHOTOGRAPHY AND THE ALLIED ARTS & SCIENCES n. s. vol. 5, no. 21 (May 1, 1863): 498-499.

P416 Potter, J. C. "The Fuming Process - Intense Negatives." AMERICAN JOURNAL OF PHOTOGRAPHY AND THE ALLIED ARTS & SCIENCES n. s. vol. 6, no. 2 (July 15, 1863): 35-36.

P417 Potter, J. C. "Fifth Annual Meeting and Exhibit of the National Photographic Association of the U. S., held in Buffalo, N. Y., beginning July 5, 1873: What I Know about Outdoor Work." PHILADELPHIA PHOTOGRAPHER 10, no. 117 (Sept. 1873): 441-442.

P418 "Obituary - J. C. Potter." PHILADELPHIA PHOTOGRAPHER 17, no. 198 (June 1880): 168. [J. C. Potter born in Sheffield Township, Lorrain County, on Aug. 4th, 1825. Raised in Amherst and learned daguerreotypy there. Worked as an itinerant for a while, then located permanently in Elyria, OH, in 1857. Several years ago, his health failing, he closed his gallery and moved to Montana. However, that proved useless and he returned to Elyria, where he died on Apr. 29th, 1880, of lung disease.]

POTTINGER, C. R. (CHELTENHAM, ENGLAND)
P419 Portrait. Woodcut engraving credited "From a photograph by C. R. Pottinger." ILLUSTRATED LONDON NEWS 65, (1874) ["Late Mr. Sydney Dobell." 65:1832 (Oct. 3, 1874): 321.]

POULTON, S. E. (LONDON, ENGLAND)
P420 "Critical Notices: Stereographic Views of Chatsworth. By Mr. Poulton." PHOTOGRAPHIC NEWS 1, no. 25 (Feb. 25, 1859): 292.

P421 Portrait. Woodcut engraving credited "From a photograph by Poulton, New Kent Road." ILLUSTRATED LONDON NEWS 50, (1867) ["Sir A. Alison." 50:* (June 15, 1867): 605.]

POUNCY, JOHN. (1820-1894) (GREAT BRITAIN)
[Born in 1820, he had a studio in Dorchester, Dorset. Published an album of photolithographs in 1857. Patented his carbon printing process in 1858. Won part of the Duc de Luynes Award with his process in 1859. Continued to improve his processes through the 1860s, but by they 1880s they were supplanted by other, better techniques. Died in England in 1894.]

BOOKS
P422 Pouncy, John. *Dorsetshire Photographically Illustrated; The Detail and Touch of Nature Faithfully Reproduced by a New Process on Stone, by Which Views are Rendered Truthful, Artistic, and Durable.* London; Dorchester: Bland & Long; John Pouncy, Photographic Institution, 1857. 2 vol. 79 b & w. [Photolithographs. Landscape views, heavily retouched, from negatives by John Pouncy.]

PERIODICALS
P423 "Photographic Printing." PHOTOGRAPHIC AND FINE ART JOURNAL 11, no. 11 (Nov. 1858): 326-327. [From "Photo. Notes." J. Pouncy's process.]

P424 "Pouncey's Carbon Process." PHOTOGRAPHIC AND FINE ART JOURNAL 11, no. 12 (Dec. 1858): 364-366, 370-371. [From "Photo. Notes." Letters from John Pouncy, C. G. H. Kinnear.]

P425 "Mr. Pouncy's Process of Photographic Carbon: Printing." AMERICAN JOURNAL OF PHOTOGRAPHY AND THE ALLIED ARTS & SCIENCES n. s. vol. 1, no. 17 (Feb. 1, 1859): 268-270. [From "Photo. Notes."]

P426 Blair, William, et. al. "The Carbon Process: Mr. Pouncy's Carbon Process. Improvement." PHOTOGRAPHIC AND FINE ART JOURNAL 12, no. 1 (June 1859): 26-28. [From "Photo. Notes."]

P427 Pouncy, J. "Pouncy's Carbon Process." PHOTOGRAPHIC AND FINE ART JOURNAL 13, no. 2 (Feb. 1860): 45. [From "Photo. Notes."]

P428 "Photographs in Printing Ink." BRITISH JOURNAL OF PHOTOGRAPHY 10, no. 196 (Aug. 15, 1863): 321. [The process of John Pouncy (Dorchester, Eng.) discussed.]

P429 "Mr. Pouncy's New Patent Process for Permanent Printing (Specification.)" AMERICAN JOURNAL OF PHOTOGRAPHY AND THE ALLIED ARTS & SCIENCES n. s. vol. 6, no. 5 (Sept. 1, 1863): 100-102. [From "Photo. News."]

P430 "Carbon Printing." HUMPHREY'S JOURNAL OF PHOTOGRAPHY, AND THE ALLIED ARTS AND SCIENCES 15, no. 13 (Nov. 1, 1863): 193-197. [From "Photo. Notes." Pouncy's process described.]

P431 H. D. "Permanent Printing Process." AMERICAN JOURNAL OF PHOTOGRAPHY AND THE ALLIED ARTS & SCIENCES n. s. vol. 6, no. 21 [sic 22] (May 15, 1864): 518-520. [From "Photo. News." Pouncy's process discussed. (Dorchester, Eng.)]

P432 Pouncy, John. "Pouncy's Carbon Process. - Further Improvements." AMERICAN JOURNAL OF PHOTOGRAPHY AND THE ALLIED ARTS & SCIENCES n. s. vol. 7, no. 16 (Feb. 15, 1865): 366-367. [From "Br. J. of Photo."]

P433 "Printing from Negatives in Ink." HUMPHREY'S JOURNAL OF PHOTOGRAPHY, AND THE ALLIED ARTS AND SCIENCES 17, no. 8 (Aug. 15, 1865): 120. [John Pouncy's process discussed.]

P434 "Photographic Printing in Oil Colour." ART JOURNAL (May 1868): 93. [Mr. Pouncy.]

P435 "Scientific Results of the Month." ILLUSTRATED LONDON NEWS 56, no. 1597 (June 4, 1870): 587. ["Mr. Pouncy, of Dorchester, has been illustrating his process (of carbon photographs) at King's College."]

POWEL, SAMUEL, JR. (d. 1885) (USA)

P436 "Photographic Societies: Philadelphia Photographic Society." PHOTOGRAPHIC TIMES 15, no. 187 (Apr. 17, 1885): 206. [Notice of death, brief information in the Society report. "Powel, formerly of Philadelphia, more recently of Newport, RI., died Mar. 5, 1885. Took up photography in 1856 to assist him in matters of scientific research, continued to practice as an amateur until failing health forced him to lay it aside, a few years ago...the photographic enlargements of lepidoptera used in illustrating Baron D'Osensacker's volume on that subject... made photographs to illustrate Mr. W. G. Binney's book on Snails...photographed unusual fishes, fossil remains of the...Saurian found in New Jersey described by Dr. Ludy. He also assisted Dr. Weir Mitchell in photographing the heads of snakes..."]

POWELSON.

P437 Portrait. Woodcut engraving, credited "From a Photograph by Powelson." FRANK LESLIE'S ILLUSTRATED NEWSPAPER 46, (1878) ["The Shoe-Wak-Can-Mette [sculling] Crew, GB." 46:1190 (July 20, 1878): 340.]

PRANG & CO. (BOSTON, MA)

P438 "Chromo-lithography." PHILADELPHIA PHOTOGRAPHER 3, no. 32 (Aug. 1866): 233-234. [Prang & Co. (Boston, MA) discussed.]

P439 "Photography An Aid to Painting and Chromo-Lithography: Prang's Chromo of Mr. Hill's Yosemite Valley." PHILADELPHIA PHOTOGRAPHER 7, no. 78 (June 1870): 193-194. [Thomas Hill's use of photos in his painting.]

P440 "An Era of Art - And Its Closing." WILSON'S PHOTOGRAPHIC MAGAZINE 37, no. 517 (Jan. 1900): 7-9. [Notice that Louis Prang, of Boston, closing, selling his collection brings forth a recollection from Wilson about Prang's importance as an art educator, producer of chromolithographs of art for the popular market.]

P441 Wilson, Edward L. "A Portrait of Louis Prang." WILSON'S PHOTOGRAPHIC MAGAZINE 37, no. 518 (Feb. 1900): 69-71. 1 b & w. [Portrait by Ritz Art Studio, Boston. Affectionate memoir of Prang.]

PRATT, DEWITT C. (AURORA, IL)

P442 "History of Aurora." CHICAGO MAGAZINE 1, no. 3 (May 15, 1857): 245-254. 9 illus. ["...we insert nine views of the town....in the next number we will insert six more....The splendid Ambrotypes from which these illustrations were designed were taken by Mr. Pratt of Aurora (IL)."]

P443 "Aurora Illustrated." CHICAGO MAGAZINE 1, no. 4 (June 1857): 323-325. 3 illus.

PRATT, D. L.

P444 "Portrait of D. Saunders, mayor of Lawrence, Mass., O. A. Burredge, fireman, and Miss Olive Bridges, escapee." FRANK LESLIE'S ILLUSTRATED NEWSPAPER 9, no. 217 (Jan. 28, 1860): 136-137, 144. 3 illus. ["Photos. by D. L. Pratt, Lawrence, MA." Portraits from photos. Collapse of the Pemberton Mills, Lawrence, MA. This disaster received extensive visual coverage, over several issues of the "FLIN", but the majority of the images, of views, etc., are from sketches.]

PRATT, W. T.

P445 Pratt, W. T. "New Action of Light." HUMPHREY'S JOURNAL OF PHOTOGRAPHY, AND THE ALLIED ARTS AND SCIENCES 9, no. 23 (Apr. 1, 1858): 367. [From "London Photo. Soc. J."]

PRATT, WILLIAM A. (b. 1818) (GREAT BRITAIN, USA)

[Born in England in 1818. To the USA in 1832. Opened a daguerreotype gallery in Richmond, VA in 1856. Patented a technique for coloring daguerreotypes in 1846. Trip to Europe in 1851. Built a Gothic Revival style studio in Richmond in 1853-54. Superintendent of Buildings and Grounds of the University of Virginia in 1858.]

P446 "Note." PHOTOGRAPHIC ART JOURNAL 2, no. 3 (Sept. 1851): 190. ["Mr. William A. Pratt of Richmond, Va., has returned from his European tour with improved health and innumerable fine things for his gallery..."]

P447 A. "Daguerreotypes." PHOTOGRAPHIC ART JOURNAL 2, no. 4 (Oct. 1851): 235-236. 1 illus. [Includes an etching of the storefront of Pratt's gallery. The article is in the form of a letter from Pratt.]

P448 Pratt, William A. "Mr. Pratt's Gallery at Richmond, VA - Coloring Daguerreotypes." PHOTOGRAPHIC ART JOURNAL 2, no. 4 (Oct. 1851): 235-236. 1 illus. [Letter from Pratt, engraving of a front view of his gallery.]

PRESCOTT & WHITE. (HARTFORD, CT)

P449 "A New Gallery for an Old Firm." ANTHONY'S PHOTOGRAPHIC BULLETIN 3, no. 5 (May 1872): 551. [Prescott & White (Hartford, CT).]

P450 Portrait. Woodcut engraving, credited "From a Photograph by Prescott & White, Hartford, Conn. FRANK LESLIE'S ILLUSTRATED NEWSPAPER 36, (1873) ["Hon. Marshall Jewell, US Minister to Russia." 36:924 (June 14, 1873): 224.]

PRESCOTT, D. K.

P451 "Fall of the City Bindery of O. D. Case & Co., Hartford, Ct." HARPER'S WEEKLY 10, no. 490 (May 19, 1866): 317. 1 illus. ["Photographed by Prescott, Hartford, Ct."]

P452 "Correspondence." ANTHONY'S PHOTOGRAPHIC BULLETIN 3, no. 8 (Aug. 1872): 642. [Prescott from Hartford, CT.]

PRESTIDGE.

P453 "Note." ANTHONY'S PHOTOGRAPHIC BULLETIN 3, no. 1 (Jan. 1872): 431. [Mr. Prestidge (Fort Alkinson, [KA?]) burned out, restarted.]

PRESTON, N. A.

P454 "Freshets in the West - Great Jam of Logs at Chippewa Falls Boom, Wisconsin." HARPER'S WEEKLY 13, no. 649 (June 5, 1869): 360. 1 illus. ["Photographed by N. A. Preston."]

PRESTON, R.

BOOKS

P455 Staunton, H. *Shakespeare's Comedy of 'Much Ado About Nothing.' Photolithographed from the Original of 1600.* London: Day & Son, 1864. n. p. illus.

PERIODICALS

P456 "Our Editorial Table: Shakespeare's Comedy of 'Much Ado About Nothing,' Photolithographed from the Original of 1600." BRITISH JOURNAL OF PHOTOGRAPHY 11, no. 233 (Oct. 21, 1864): 413. ["...the manipulative processes were conducted by R. Preston, who was formerly engaged at the Ordinance Survey establishment at Southampton,...executed the principal portion of the transfer for "The Domesday Book," about to be engaged by Day & Son, publishers."]

PRETSCH, PAUL.

P457 Pretsch, Paul. "On Photo-Galvanography; Or Engraving by Light and Electricity." JOURNAL OF THE SOCIETY OF ARTS [EDINBURGH] 4, no. 179 (Apr. 25, 1856): 385-389.

P458 "The Photo-Galvanographic Process of Engraving." PHOTOGRAPHIC AND FINE ART JOURNAL 9, no. 6 (June 1856): 187-188. [Discussion of Paul Pretsch's (Imperial Austrian Printing Office, Vienna) experiments.]

P459 "Gleanings and Items: The Photo-Galvanographic Process of Engraving." THE CRAYON 3, no. 8 (Aug. 1856): 250-251. [About Paul Pretsch (Austria). From the "London Prac. Mech. Journal" (Apr. 1856).]

P460 Pretsch, Paul. "Photogalvanography; or, Engraving by Light and Electricity." PHOTOGRAPHIC AND FINE ART JOURNAL 9, no. 8 (Aug. 1856): 244-247.

P461 Pretsch, Paul. "Photo-galvanography, or Engraving by Light and Electricity." HUMPHREY'S JOURNAL 8, no. 8-9 (Aug. 15 - Sept. 1, 1856): 124-128, 140-142. [From "J. of Photo. Soc., London."]

P462 "The New Photo-Galvonographic Process." ILLUSTRATED LONDON NEWS 30, no. 839 (Jan. 30, 1857): 23. [Pretsch's process discussed.]

P463 Hunt, Robert. "Pretsch's Process on Photog-Galvanography." PHOTOGRAPHIC AND FINE ART JOURNAL 11, no. 3 (Mar. 1858): 73-74.

P464 "Professor Petzval's New Lens. Explained by Himself in a letter to Mr. Paul Pretsch." PHOTOGRAPHIC AND FINE ART JOURNAL 11, no. 7 (July 1858): 198-203. [From "Photo. Notes." Exchange of letters between Voightlander and Paul Pretsch on priority of new lens. Other articles precede and follow this issue on this subject throughout the year.]

P465 "Blackheath Photographic Society." LIVERPOOL & MANCHESTER PHOTOGRAPHIC JOURNAL [BRITISH JOURNAL OF PHOTOGRAPHY] n. s. 2, no. 21 (Nov. 1, 1858): 264-269. [Long paper, "On Two Main Points in Photography," by Paul Pretsch, describing his new lenses.]

P466 "Voightlander versus Petzval." PHOTOGRAPHIC AND FINE ART JOURNAL 11, no. 12 (Dec. 1858): 353-560. [From "Photo. Notes." Long exchanges between Voightlander and Petzval and others on lens issue.]

P467 "Blackheath Photographic Society." BRITISH JOURNAL OF PHOTOGRAPHY. 7, no. 121 (July 2, 1860): 196-197. [Paper by Paul Pretsch, "Photographic Pictures Reproduced by Ordinary Letterpress Surface Printing."]

P468 Pretsch, Paul. "Photographic Pictures Reproduced by Ordinary Letterpress Surface Printing." HUMPHREY'S JOURNAL OF PHOTOGRAPHY, AND THE ALLIED ARTS AND SCIENCES 12, no. 8 (Aug. 15, 1860): 122-123. [Read to Blackheath Photo. Soc.]

P469 "Photographic Engraving of Blocks, To Be Printed with Ordinary Letterpress. The Invention of Mr. Paul Pretsch." BRITISH JOURNAL OF PHOTOGRAPHY 7, no. 131 (Dec. 1, 1860): 347. 1 illus. [Photo by Francis Bedford, of Dorer Castle, reproduced by Pretsch's engraving process.]

PREVOST, VICTOR. (1820-1881) (FRANCE, USA)

[Born in La Rochelle, France in 1820. Studied art with Paul Delaroche in Paris, during the same period that Roger Fenton and Gustave Le Gray were students there. Visited Rome in 1843. Left for the United States in 1848, where he worked as a topographical painter in San Francisco, then moved to New York, where from 1848 to 1851 he painted and made many calotype views. Returned to Paris in 1853 and learned the waxed paper process from Le Gray, photographed the Forest of Compiègne, views of Poerrefonds, and architecture in Soissons. Returned to New York in 1853 and opened a photographic gallery there with his friend P. C. Duchochois. Made large calotypes, but could not compete with large galleries and the studio was closed in 1854. Hired by Charles D. Fredericks 1850s. In 1857 he taught painting and drawing at a private school, continuing to teach at several schools until his death, but apparently continued to photograph, producing views in Central Park in 1862 and views of the American Museum of Natural History under construction in the 1870s. Died in April, 1881.]

BOOKS

P470 Prevost, Victor. Central Park in 1862; by special permission of the Commissioners. New York: Prevost ?, c. 1862. n. p. 31 b & w. [Album of thirty-one photos, many signed by V. Prevost. NYPL Collection.]

P471 Photographic Album of the American Museum of Natural History, Central Park. New York: G. L. Feuardent, ca. 187- ? n. p. 18 b & w. [Eighteen original photos by V. Prevost, of the Museum under construction in 1870s.]

P472 Scandlin, W. I. Victor Prevost, Photographer, Artist, Chemist. A New Chapter in the Early History of Photography in this Country. Illustrated Lecture. Delivered before the Photographers' Association of America, 21st Annual Convention, Detroit, Mich., August 6, 1901. New York: Press of the Evening Post Job Print, 1901. 8 pp. ["Reprinted from Official Stenographic Report of Proceedings in 'Anthony's Photographic Bulletin.'"]

PERIODICALS

P473 Prevost, Victor. "Photographic Query." PHOTOGRAPHIC AND FINE ART JOURNAL 7, no. 9 (Sept. 1854): 286-287. [Letter from Prevost explaining the waxed paper process, in response from a query from the editor.]

P474 "The American Photographical Society: Fifty-Second Meeting - The Wax Paper Process." AMERICAN JOURNAL OF PHOTOGRAPHY AND THE ALLIED ARTS & SCIENCES n. s. vol. 6, no. 13 (Jan. 1, 1864): 305-306. [Prevost described "his manner of working with the wax process."]

P475 "Editor's Table: A Find." WILSON'S PHOTOGRAPHIC MAGAZINE 35, no. 499 (July 1898): 335. [Mr. W. I. Scandlin, editor of "Anthony's Photographic Bulletin," has unearthed a remarkable collection of large paper negatives made by V. Prevost, of New York City, in 1852-56. 15" x 19" and 10 1/2" x 13 1/2". Includes views of the New York Crystal Palace Exhibition of 1853, views of New York, NY, views of Europe.]

P476 "An Exhibition of Historical Negatives." WILSON'S PHOTOGRAPHIC MAGAZINE 38, no. 532 (Apr. 1901): 139. [Prevost's views of New York City, taken in 1851 to 1857, shown to the New York Genealogical and Biographic Society by W. I. Scandlin, editor of "Anthony's Photographic Bulletin," who obtained them from John Rosch, of White Plains, NY in 1853. Prevost and P. C. Duchochois partners in a New York, NY studio.]

P477 Scandlin, W. I. "Victor Prevost, Photographer, Artist, Chemist—A New Chapter in the Early History of Photography in This Country." WILSON'S PHOTOGRAPHIC MAGAZINE 38, no. 537 (Sept. 1901): 333-336. [Includes excerpts from letters, etc.]

P478 Scanlin, W. I. "Victor Provost, Photographer, Artist, Chemist." PHOTO ERA 7, no. 4 (Oct. 1901): 126-128, 130-131. [Born at La Rochelle, France, in 1820. Died in New York, NY, in April 1881. Came to New York, NY in 1848, won awards at the NY Crystal Palace exhibition, returned to France in 1853, then back to New York, NY. Worked for C. D. Fredericks until 1857. Then taught drawing, painting, and physics at Mme. H. D. Chegaray's Institute for Young Ladies. In 1869 became the Principal for several schools, until 1878. Then taught at the Institute at Tivoli-on-the-Hudson, until his death.]

P479 "Victor Prevost, Early New York Photographer." IMAGE 3, no. 1 (Jan. 1954): 3-4. 1 b & w.

P480 Duncan, R. Bruce. "I, Victor Prevost." GRAPHIC ANTIQUARIAN 4, no. 1 (Fall 1976): 5-11. 9 b & w.

PRICE, ANDREW. (NAPA, CA)
P481 "Our Picture." PHILADELPHIA PHOTOGRAPHER 15, no. 177 (Sept. 1878): frontispiece, 258-260. 1 b & w. [Andrew Price (Napa, CA). Tableau with stuffed animals, and a "sleeping man," titled "The Hunter's Dream."]

PRICE, WILLIAM LAKE. (1810-1896) (GREAT BRITAIN)
[Born in 1810. Trained as a painter in watercolors, he exhibited regularly at the Royal Academy between 1828 and 1832 and the Old Water Colour Society from 1828 to 1852. Painted primarily landscapes and architectural views. Began to make photographs around 1854. He joined the Photographic Society in London and displayed historical genre photographs at their exhibitions. Many of these tableaus are composite prints, made up of several negatives. His work received high praise, and he lectured and wrote about his approach. Collaborated in publishing *Photographic Art Treasures* in 1857 and wrote his manual in 1858. Published a series of articles on composition and chiaroscuro in 1860. Claimed that he was retiring from photography in 1862, and auctioned off his cameras and equipment at high prices. After a hiatus, he apparently continued to contribute articles, lecture, etc. through the 1880s. Died in 1896.]

BOOKS
P482 Price, William Lake. *Interiors and Exteriors in Venice: Lithographs by Joseph Nash from the Original Drawings.* London: T. McLean, 1843. n. p. illus.

P483 Price, [William] Lake. *A Manual of Photographic Manipulation, Treating of the Practice of the Art and Its Various Applications to Nature.* London: John Churchill & Sons, 1858. x, 256 pp. 58 illus. [2nd ed. (1868) viii, 304 pp., 74 illus.; reprinted (1973), Arno Press.]

P484 *Portraits of Eminent British Artists.* London: Lloyd Brothers, & Co., 1858. n. p. 12 l. of plates. 12 b & w. [Original photographs, with descriptive texts.]

P485 *Catalogue of the Remaining Works of the Late Lake Price, and some of the Remaining Works of Louis Falero, Deceased, and an Assemblage of Drawings and Pictures from Private Collections and Different Sources.* London: Christie, Manson & Woods, Apr. 12, 1897. 12 pp. [74 lots auctioned, engravings and photographs, drawings and pictures.]

PERIODICALS
P486 "Fine Arts: Exhibition of the Photographic Society." ILLUSTRATED LONDON NEWS 26, no. 725, 727-728, 736 (Jan. 27, Feb. 10 - Feb. 17, Apr. 14, 1855): 95, 140-141, 164-166, 349. 3 illus. [The second notice (Feb. 10) is actually a reproduction of Lake Price's genre study "Genevra," with brief comment. The third notice (Feb. 17) contains a reproduction of Roger Fenton's landscape "Valley of the Wharfe," as well as a discussion of the exhibition. The last notice (Apr. 14) has a landscape by Llewellyn.]

P487 "Fine Arts: Ginevra, the Baron's Return, and the Court Sideboard." ATHENAEUM no. 1432 (Apr. 7, 1855): 409. [Review of the photographs, issued by Graves.]

P488 "Photographic Society: 'The Monk,' by Mr. Lake-Price." ILLUSTRATED LONDON NEWS 28, no. 790 (Mar. 22, 1856): 309-310. 1 illus.

P489 "New Publications: 'Don Quixote in his Study,' by L. Price." ATHENAEUM no. 1529 (Feb. 14, 1857): 218. [Published by the Photo-galvanographic Co. Reviewed as poorly printed.]

P490 "Fine-Art Gossip." ATHENAEUM no. 1604 (July 24, 1858): 115. ["Some admirable photographic portraits by Mr. Lake Price, of 'Eminent British Artists,' have just been published by Mr. Lloyd..."]

P491 "Review." ART JOURNAL (Aug. 1858): 255-256. ["Portraits of Eminent British Artists," Photographed by Lake Price. Published by Lloyd Brothers, & Co., London.]

P492 Portrait. Woodcut engraving credited "From a photograph by Lake Price." ILLUSTRATED LONDON NEWS 33, (1858) ["Prince of Wales." 33:* (Nov. 13, 1858): 451. [Lithograph by R. J. Lane & J. H. Lynch from Lake Price's photo.]]

P493 "Our Literary Table." ATHENAEUM no. 1600 (June 26, 1858): 818-819. [Bk. Rev.: "A Manual of Photographic Manipulation," by Lake Price. (Churchill).]

P494 "Fine-Art Gossip." ATHENAEUM no. 1604 (July 24, 1858): 115. ["Some admirable photographic portraits by Mr. Lake Price, of 'Eminent British Artists,' have just been published by Mr. Lloyd..."]

P495 "Reviews. A Manual of Photographic Manipulation, by Lake Price." LIVERPOOL & MANCHESTER PHOTOGRAPHIC JOURNAL [BRITISH JOURNAL OF PHOTOGRAPHY] n. s. 2, no. 13 (July 1, 1858): 167-168.

P496 "Lake Price's Photography." AMERICAN JOURNAL OF PHOTOGRAPHY AND THE ALLIED ARTS AND SCIENCES n. s. vol. 1, no. 10 (Oct. 15, 1858): 147-149. [Excerpt from book.]

P497 "Fine Arts: His Royal Highness Albert, Prince of Wales." ILLUSTRATED LONDON NEWS 33, no. 942 (Oct. 23, 1858): 389. [Review of print, issued by Mitchell.]

P498 Price, William Lake. "An Outline of History." AMERICAN JOURNAL OF PHOTOGRAPHY AND THE ALLIED ARTS AND SCIENCES n. s. vol. 1, no. 11 (Nov. 1, 1858): 165-167. [From "Price's Photography."]

P499 Portrait. Woodcut engraving credited "From a photograph by Lake Price." ILLUSTRATED LONDON NEWS 35, (1859) ["Grand Duke Constantine of Russia and Suite, on the deck of the "General Admiral." 35:* (Sept. 10, 1859): 239. ["It was photographed from the

life by Mr. Lake Price, who has been honored with various commissions by his Imperial Highness."]]

P500 "Note." ART JOURNAL (Oct. 1859): 319. ["Osborne House - Mr. Lake Price is stated to have received a commission from her Majesty to execute a series of photographic views of the principle apartments of Osborne House, with their contents."]

P501 Lake Price, Wm. "Composition and Chiaroscuro. Parts 1 - 15." PHOTOGRAPHIC NEWS 3-4, no. 76-90 (Feb. 17 - May 25, 1860): 281-282, 293-294, 305-307, 317-319, 332-334, 343-344, 355-357, 367-368, 384-386, 391-392, 406-407; 6-7, 18-20, 30-31, 37-38. [Illus. with etchings taken from paintings.]

P502 Lake Price, William. "A Photographer's Contribution to the Volunteers Movement." PHOTOGRAPHIC NEWS 5, no. 149 (July 12, 1861): 332. [Paragraph stating that he wore uniform so as not to be bothered by hangers-on. [I think.].]

P503 "Entremets: Photography at Sales by Auction." BRITISH JOURNAL OF PHOTOGRAPHY 9, no. 170 (July 15, 1862): 278-279. [Lake Price's apparatus, negatives, etc. sold at auction.]

P504 "Note." JOURNAL OF THE PHOTOGRAPHIC SOCIETY OF LONDON 8, no. 124 (Aug. 15, 1862): 117. ["The Proceeds of the Sale by Auction of Mr. Lake Price's Photographic Effects Amounted, it is said, to nearly 800 pounds. Most of the lots fetched high prices, some we believe, more than they cost when new. As it is also stated that many of the articles were 'put in' it is probable that purchasers, as well as lots, were sold." Rumor states that Mr. Price had another equipment of photographic apparatus ordered at the time of this sale.!"]

P505 Lake Price. "Photographic Practice." HUMPHREY'S JOURNAL OF PHOTOGRAPHY, AND THE ALLIED ARTS AND SCIENCES 20, no. 11-12 (Oct. 1 - Oct. 15, 1868): 166-168, 177-179.

P506 Lake Price. "The Nitrate Bath." HUMPHREY'S JOURNAL OF PHOTOGRAPHY, AND THE ALLIED ARTS AND SCIENCES 20, no. 22 (June 15, 1869): 350-351. [No source given.]

P507 Lake Price. "On Subjects for the Camera." BRITISH JOURNAL PHOTOGRAPHIC ALMANAC 1870 (1870): 139.

P508 "Landscape Photography." PHOTOGRAPHIC TIMES 8, no. 90 (June 1878): 125-129. [This is the second installment of a serialized article on landscape photography, written by an unnamed author. This section contains many quotes from William Lake Price.]

P509 Lake Price, William. "Art Culture in Photography." AMERICAN JOURNAL OF PHOTOGRAPHY 10, no. 12 (Dec. 1889): 17-20. ["Paper read by Mr. Lake Price, on Thursday, Nov. 8; London Camera Club."]

P510 "Superior Interior." HISTORY OF PHOTOGRAPHY 10, no. 4 (Oct. - Dec. 1986): 316. 1 b & w. [View of an interior, with a mother and child, taken by Lake Price, ca. 1855.]

PRIDGEON, W. R. (LYNN REGIS, ENGLAND)
P511 Portrait. Woodcut engraving, credited to "From a Photograph by W. R. Pridgeon." ILLUSTRATED LONDON NEWS 59, (1871) ["John Lowe, M.D." 59:1685 (Dec. 23, 1871): 612.]

PRIMM, WILSON.
P512 Primm, Wilson. "Fourth Annual Meeting and Exhibition of the N.P.A. in St. Louis, Mo., May 1872: Address." PHILADELPHIA PHOTOGRAPHER 9, no. 102 (June 1872): 188-190.

PRINCE, GEORGE. (1848-) (USA)
P513 Taylor, J. Traill. "Home and Foreign News Epitomized." PHOTOGRAPHIC TIMES 11, no. 124 (Apr. 1881): 132. [Note that George Prince, after working for fourteen years with the Treasury Department, has been made the Chief Photographer.]

PRINCEPT, VALENTINE CAMERON. (GREAT BRITAIN, INDIA)
BOOKS
P514 Princept, Valentine Cameron. *Imperial India - An Artist's Journal.* London: Chapman & Hall, 1879. n. p. illus. [Princept, an artist, toured India in the early 1870s. His book is illustrated with engravings taken from photographs. Some were made by Princept, some by others, Bourne & Shepherd, etc. (1979). Facsimile ed. Delhi: Mittal Publications. (With the title "Glimpses of Imperial India.")]

PERIODICALS
P515 Princep, Val, R.A. "The Influence of Photography on Art." PHOTOGRAPHIC TIMES 30, no. 9 (Sept. 1898): 420-422. [From "Journal of the Camera Club."]

PRINGLE, ANDREW. (b. 1850) (GREAT BRITAIN)
BOOKS
P516 Burton, Willam K. and Andrew Pringle. *The Processes of Pure Photography.* New York: Scoville & Adams Co., 1889. 200, ix pp. illus.

P517 Pringle, Andrew. *Lantern-Slides by Photographic Methods.* New York: Scoville & Adams Co., 1890. 71 pp. illus.

P518 Pringle, Andrew. *The Optical Lantern, for Instruction and Amusement.* New York: Scoville & Adams Co., 106 pp. illus.

P519 Pringle, Andrew. *Practical Photo-micrography: By the Latest Methods.* New York: Scoville & Adams Co., 1890. 183, ix pp. illus.

PERIODICALS
P520 Pringle, Andrew. "Tourist Photography." PHOTOGRAPHIC TIMES 16, no. 248-249, 252-256 (June 18 - June 25, July 16 - Aug. 13, 1886): 321-322, 335-336, 371-372, 386-387, 395-396, 409-410, 419-421.

P521 Pringle, Andrew. "Daylight Engagement." PHOTOGRAPHIC TIMES 16, no. 259 (Sept. 3, 1886): 471-473. [Read at 1st Photographic Convention in Great Britain.]

P522 Pringle, Andrew. "Daylight Enlargement." ANTHONY'S PHOTOGRAPHIC BULLETIN 17, no. 19 (Oct. 9, 1886): 581-583. [Read at the English Photographic Convention at Derby.]

P523 Pringle, Andrew. "Minor Matters in Development." PHOTOGRAPHIC TIMES 17, no. 282 (Feb. 11, 1887): 76-78. [From "Br J of Photo. Almanac."]

P524 Pringle, Andrew. "Figures In Landscape Photography." PHOTOGRAPHIC TIMES 18, no. 336 (Feb. 24, 1888): 88-90. [Article by Pringle called forth to explain something quoted by Robinson in his articles on landscape in the Dec. 2, 1887 issue of "Photo Times."]

P525 "Andrew Pringle." PHOTOGRAPHIC TIMES 18, no. 364 (Sept. 7, 1888): frontispiece, 421-422. 1 b & w. [Portrait of Pringle by W.

Crooke. Biographical sketch. Born July 8, 1850 in England. Studied at Harrow, Trinity and Standhurst. Served in cavalry regiment. Took up photography in 1874 or 1875. Travelled broadly around the world. Popular lecturer with lantern slides. Contributed articles to many photographic journals. Pres. of Photographic Convention of Great Britain for 1889.]

P526 Pringle, Andrew. "Thoughts On Our Art." PHOTOGRAPHIC TIMES 19, no. 383, 388 (Jan. 18, Feb. 22, 1889): 27-28, 91-92.

P527 Pringle, Andrew. "The Art Side of Photography: A Reply to Mr. Stillman." PHOTOGRAPHIC TIMES 19, no. 396 (Apr. 19, 1889): 193-195.

P528 Pringle. "The English Convention: President Pringle's Address." ANTHONY'S PHOTOGRAPHIC BULLETIN 20, no. 20-21 (Oct. 26 - Nov. 9, 1889): 630-633, 662-664.

P529 Pringle, Andrew. "A Reminiscence of Development." AMERICAN ANNUAL OF PHOTOGRAPHY AND PHOTOGRAPHIC TIMES ALMANAC FOR 1890 (1890): 176-178. [Landscape photographer.]

P530 Pringle, Andrew. "The Record of Photo-Micrography." PHOTOGRAPHIC TIMES 20, no. 464 (Aug. 8, 1890): 389-393. [Read before the Photographic Convention of the United Kingdom of Great Britain. Survey of the history of photomicrography.]

P531 Pringle, Andrew. "Lantern-Slides In Colors." PHOTOGRAPHIC TIMES 21, no. 535 (Dec. 18, 1891): 648-649. 1 illus.

P532 "Andrew Pringle." PHOTOGRAPHIC TIMES 22, no. 554 (Apr. 29, 1892): 223-224. 1 illus. [Born in Edinburgh in 1850. Attended public schools, then went to Cambridge. Briefly in a cavalry regiment. Began to photograph about 1875. "...worked every process of pure photography and done an enormous amount of microscopical photography. I have over 3,700 negatives of bacteria, not to mention other medical subjects...photos of bacteria and pathological specimens adorn many books and are used in lectures..." Author of "Practical Photo-Micrography," "The Optical Lantern," "Lantern-Slides by Photographic Methods," and, with Prof. W. K. Burton, "The Processes of Pure Photography."]

P533 Pringle, Andrew. "Hand Cameras." AMERICAN ANNUAL OF PHOTOGRAPHY AND PHOTOGRAPHIC TIMES ALMANAC FOR 1893 (1893): 88-91.

PRINGLE, W. I.
P534 Melrose Abbey. In Twelve Photographic Views by W. I. Pringle. London: Marion & Co., 1870. n. p. 13 b & w. [Albumen prints and a photographic title page. Descriptive texts for each photograph.]

PRITCHARD, COL. [?]
P535 "Photographs of Abyssinia." ART JOURNAL (Jan. 1869): 10. [Photos taken by the 10th Company, Royal Engineers, under Colonel Pritchard, R.E.]

PRITCHARD, HENRY BADEN. (1841-1884) (GREAT BRITAIN)
[Henry Baden Pritchard was the third son of Andrew Pritchard, a pioneer in using the microscope and author of History of Infusoria. Henry "conducted the Photographic Department in the Royal Arsenal, Woolich for several years." He was the editor of the Photographic News in the 1880s. He wrote several popular novels in addition to his works on photography.]

BOOKS

P536 Pritchard, Henry Baden. The Applications of Photography to Military Purposes - From the Journal of the Royal United Service Institution, Lecture June 4, 1869. London: the Journal, 1869 18 pp. illus. [Vol. 13.]

P537 Pritchard, Henry Baden. Tramps in the Tyrol. London: Tinsley Brothers, 1874. xii, 267 pp. [Travel guide.]

P538 Pritchard, Henry Baden. George Vanbrugh's Mistake. London: Sampson Low, Marston, Searle & Rivington, ca. 1880. 3 vol. [Novel.]

P539 Pritchard, Henry Baden. Beauty Spots of the Continent. With illustrations by John Procter and R. P. Leitch. London: Tinsley Brothers, 1875. 320 pp. illus.

P540 Eder, Josef Maria. Edited by H. Baden Pritchard. Modern Dry Plates: or, Emulsion Photography. New York: E. & H. T. Anthony, 1881, viii, 138 pp.

P541 Pritchard, H. Baden. The Photographic Studios of Europe. London; New York: Piper & Carter; E. & H. T. Anthony & Co., 1882. 279 pp. 40 illus. [Describes studios of professional photographers in Great Britain and Europe: Francis Bedford; Wm. England; W. & D. Downey; Payne Jennings; Autotype Works; A. & G. Taylor; Elliott & Fry; Walter Woodbury; Hills & Saunders; Capt. Abney; Valentine Blanchard; Woolwich Arsenal; Robert Faulkner; Van der Weyde; Platinotype Co.; Alexander Bassano; Dr. Huggins; Window & Grove; Woodbury Permanent Printing Co.; William Mayland; Leon Warnerke; Millbank Prison; Pentonville Penitentiary; H. P. Robinson; Mayall; Jazeb Hughes; Kew Observatory; Robert Slingsby; Sarony; P. Maitland Laws; Brown, Barnes & Bell; Lafosse; J. W. Swan; W. Harvey Barton; W. H. Midwinter; Russell & Sons; John Fergus Studio; Marshall Wane; James Valentine & Sons; T. & R. Annan; (all Great Britain); Adam-Salomon; Maison Le Jeune; Joliot; Benque et Cie; Nadar; Liebert; Paris Prefecture de la Police; (all France); J. C. Schaarwachter (Berlin); Th. Prumm (Berlin); Fritz Luckardt (Vienna); J. M. Eder (Vienna); Winter Brothers (Vienna); Atlier Adele (Vienna); Lowy (Vienna); Victor Angerer (Vienna); Koller (Pesth); Josef Albert (Munich); J. Obernetter (Munich); Geruzet (Brussels). 2nd ed. (1883) 303 pp. Reprinted (1973) Arno Press.]

P542 Pritchard, Henry Baden. About Photography and Photographers. A Series of Essays for the Studio and Study, To which is added European Rambles with a Camera. "Scoville Photographic Series, No. 14." New York: Scoville Mfg. Co., 1883. 220 pp. 17 illus. [Reprinted (1973) Arno Press. British ed. "...Continental Rambles..." London: Piper & Carter, 1883.]

P543 Pritchard, Henry Baden. A Trip to the Great Sahara with a Camera. By a Cockney. Being an Account of a Month's Winter Holiday, with Diary of Journey and Statement of Expenses. London: Piper & Carter, 1884. n. p.

P544 Pritchard, Henry Baden. Les ateliers photographiques de l'Europe, ...traduit de l'anglaise sur la 2e edition par Charles Baye. Paris: Gauthier-Villars, 1885. xi, 322 pp. illus.

P545 Pritchard, Henry Baden. Dangerfield. London: Tinsley Brothers, 1878. 3 vols. [Novel.]

PERIODICALS
P546 Pritchard, H. Baden. "The Woodbury Process in France." PHILADELPHIA PHOTOGRAPHER 7, no. 76 (Apr. 1870): 137-139.

[Extracts from a letter by H. Baden Pritchard in the "Photographic Journal."]

P547 Pritchard, H. Baden. "Experiences of Carbon Printing." ANTHONY'S PHOTOGRAPHIC BULLETIN 3, no. 5 (May 1872): 548-550. [From "London Photo. News."]

P548 "The 'Infant School' at Woolwich Arsenal, as seen by the Czar." ILLUSTRATED LONDON NEWS 64, no. 1818 (June 27, 1874): 601, 602. 1 illus.

P549 Pritchard, H. Baden. "The Warnerke Film." ANTHONY'S PHOTOGRAPHIC BULLETIN 7, no. 9 (Sept. 1876): 282. [From "London Photo. News." Pritchard from War Department (Woolwich, England). He describes using a roll-film camera in the Tyrol. (An earlier article, which didn't give Pritchard's name, was also published on the topic.]

P550 Pritchard, H. Baden, F.C.S. "Photography from a Holiday-Makers Point of View." PHOTOGRAPHIC TIMES 7, no. 76 (Apr. 1877): 75-77. [Read before the Photographic Society of Great Britain.]

P551 Pritchard, H. Baden, F.C.S. "Photography from a Holiday-Maker's Point of View." ANTHONY'S PHOTOGRAPHIC BULLETIN 8, no. 6 (June 1877): 179-181. [From "Br. J. of Photo."]

P552 "Our Editorial Table." PHOTOGRAPHIC TIMES 12, no. 139 (July 1882): 237. [Bk. rev.: "The Photographic Studios of Europe," by H. Baden Pritchard. Pritchard visited between 60 and 70 professional studios all over Europe. Described those in "Photographic News." Collected into a volume.]

P553 Taylor, J. Traill. "General Notes." PHOTOGRAPHIC TIMES 14, no. 162 (June 1884): 285. [H. Baden Pritchard, of the "Photographic News" died suddenly May 11th. Worked in photographic department of the Woolwich Arsenal, assisted on "Photo. News." until 1880, then took the magazine over at G. W. Simpson's death. Wrote novels and books "A Trip to Sahara with the Camera, by a Cockney," "Photography and Photographers," "Photographic Studies in Europe."]

P554 "Obituary: Henry Baden Pritchard." PHILADELPHIA PHOTOGRAPHER 21, no. 247 (July 1884): 193-194. [H. B. Pritchard born in Nov. 1841, died on May 11, 1884. At age twenty he entered the Royal Arsenal at Woolwich, England, and there remained until his death, as Chief Director of the Photographic Department. Member of many photographic, art, and benevolent societies. Editor of the "Photographic News."]

PRITCHARD, S. BADEN.
P555 Pritchard, S. Baden. "Photography as an aid to Science." NATURE 6, (May 23, 1872): 62-63.

PROCTOR, G. K. (SALEM, MA)
P556 "Proctor's Patent: Photographing at Night." HUMPHREY'S JOURNAL OF PHOTOGRAPHY, AND THE ALLIED ARTS AND SCIENCES 20, no. 19 (Mar. 15, 1869): 200-201. [Involved constructing an oval room to reflect magnesium light rays evenly.]

PROSCH, GEORGE W.
[Active New York, NY 1840-41, Canada 1842-43, New York, NY 1846, Newark, NJ 1850-55.]

P557 Morgan, Evelyn Clark. "The First Camera Victim in America." PHOTO ERA 4, no. 1 (Jan. 1900): 12-15, plus portrait. 1 b & w. [Portrait of Charles E. West, claimed to be the first portrait taken by George W. Prosch, an associate of Morse.]

PROTHEROE, T.
P558 Protheroe, T. "On Backgrounds." BRITISH JOURNAL PHOTOGRAPHIC ALMANAC 1876 (1876): 152.

PROUT, VICTOR ALBERT.
BOOKS
P559 Prout, Victor A. *The Interior of the Abbey of Westminster.* London: Colnaghi, 1860. n. p. pp. 23 mounted prints. b & w.

P560 *The Thames from London to Oxford in Forty Photographs.* London: Virtue & Co., 1862. n. p. 40 b & w. [1st series. Twenty photos, 2nd series. Twenty photos. These portfolios were long thought to be the work of Roger Fenton, later discovered to be the photographs of Victor Prout.]

P561 Prout, Victor A. *Mar Lodge, August 1863. A Series of Photographs illustrating the Visit of Their Royal Highnesses the Prince and Princess of Wales to Mar Lodge, the Seat of the Right Hon. the Earl and Countess of Fife, during the Braemer Gathering of 1863.* London: [published at 15 Baker Street], 1864. n. p. 70 b & w. [Albumen prints.]

PERIODICALS
P562 "'The Poet's Corner.' - By Victor Prout. - In the Photographic Exhibition." ILLUSTRATED LONDON NEWS 36, no. 1018 (Feb. 25, 1860): 189. 1 illus.

P563 "Critical Notices: Stereoscopic Views of the Interior of Westminster Abbey by V. A. Prout." PHOTOGRAPHIC NEWS 4, no. 97 (July 13, 1860): 127.

PUGH, J. A. (1833-1887) (USA)
P564 "Georgia. - Laying the Corner-Stone of a Confederate Monument, on Mulberry and Second streets, Macon, April 26th. - From a Photograph by Pugh, Macon." FRANK LESLIE'S ILLUSTRATED NEWSPAPER 46, no. 1182 (May 25, 1878): 205. 1 illus. [Outdoor view, with crowd.]

P565 "Obituary: J. A. Pugh." PHOTOGRAPHIC TIMES 17, no. 281 (Feb. 4, 1887): 60. [Died at his Gallery on Macon, GA, on Jan. 22, in the 54th year of his age. Born in North Carolina in l833. Moved to Macon about 1850 from NC, worked as a factory boy. At odd hours he learned photography from R. L. Wood, then the only photographer in Macon. Pugh then set up a gallery, owned by Wood, later bought him out before the war. 1867 Pugh took a trip to Europe, wrote a book of this experience, then moved into a new gallery.]

PULMAN & CO. (NEW ZEALAND)
P566 Main, William. "Maoris in Focus." HISTORY OF PHOTOGRAPHY 2, no. 4 (Oct. 1978): 355-358. 5 b & w.

PULLMAN, E. J.
P567 Pullman, E. J. "Requisites to Success in Photography." PHILADELPHIA PHOTOGRAPHER 10, no. 112 (Apr. 1873): 100-101. [Read before the Photo. Assoc. of the District of Columbia.]

P568 Portrait. Woodcut engraving, credited "From a Photograph by Pullman." FRANK LESLIE'S ILLUSTRATED NEWSPAPER 49, (1879) ["The late Major Thomas T. Thornburgh, U.S.A." 49:1257 (Nov. 1, 1879): 144.]

PUMPHREY BROTHERS
BOOKS
P569 *English Cathedrals, with Photographic Illustrations.* Birmingham: Pumphrey Brothers, 1872. n. p. 219 b & w. [Frontispiece. 218 composite photographs, each consisting of 9 tiny views. Short texts. Made from a booklet series published by the Pumphrey Brothers.]

PERIODICALS
P570 "Our Editorial Table: Photographs by Messrs. Pumphrey Brothers, Birmingham." BRITISH JOURNAL OF PHOTOGRAPHY 11, no. 242 (Dec. 23, 1864): 532.

PUMPHREY, ALFRED.
P571 Pumphrey, A. "Improvements in Lime Lights and Lantern Apparatus." BRITISH JOURNAL PHOTOGRAPHIC ALMANAC 1873 (1873): 90-93. 3 illus.

P572 Pumphrey, Alfred. "Photometery, or the Measurement of Light." BRITISH JOURNAL PHOTOGRAPHIC ALMANAC 1874 (1874): 78-80. 1 illus. @BULLET = PUMPHREY, WILLIAM. [?]

P573 Pumphrey, William. *Photographic Illustrations of the Antiquities of York and Its Environs.* Osbaldwick, England: W. Pumphrey, 1852/53. n. p. 60 b & w. [Published in ten parts, each part with six calotype prints. 200 copies.]

PYNE, GEORGE.
P574 "A Rudimentary and Practical Treatise on Perspective by George Pyne, Artist." PHOTOGRAPHIC AND FINE ART JOURNAL 7, no. 1-4 (Jan. - Apr. 1854): 19-27, 53-60, 84-86, 124-126.

PYNE, J. B., JR.
P575 Portrait. Woodcut engraving credited "From a photograph by J. B. Pyne, Jr." ILLUSTRATED LONDON NEWS 58, (1870) ["Mr. J. B. Pyne, landscape painter." 58:* (Aug. 20, 1870): 193.]

PYWELL, WILLIAM REDISH (1843-1886) see GARDNER, ALEXANDER.

[William Redish Pywell was born on June 9, 1843, a twin, in Washington, DC. He apparently worked for Mathew Brady during the first part of the Civil War, but left Brady when Gardner left. Pywell photographed in Alexandria, VA in 1862 and 1863, at the Big Black River Station and at Vicksburgh, MS in 1864, and in Washington, DC, working for Gardner, in 1865. In 1867-68 he was in Houston, TX, photographing for C. N. Bean, who ran the Houston City Photographic Gallery. By 1869 he had married and returned to Washington, DC, where he apparently worked again for Gardner. In 1874 he was the assistant photographer on the Transit of Venus Expedition to Campbelltown, Australia. In the early 1880s he owned the Excelsior Photographic Studio in Ruston, LA. Died on Aug. 7, 1886.]

Q

QUAGLIO. (VIENNA, AUSTRIA)
Q1 Liesegang, P. "Photolithography." AMERICAN JOURNAL OF PHOTOGRAPHY AND THE ALLIED ARTS & SCIENCES n. s. vol. 6, no. 8 (Oct. 15, 1863): 174-175. [From "Le Moniteur de la Photo." Discusses Quaglio's (Vienna) process.]

QUEEN, JAMES. (1821-1886) (USA)
Q2 Cochran, Carl M. "James Queen, Philadelphia Lithographer." PENNSYLVANIA MAGAZINE OF HISTORY AND BIOGRAPHY 82, no. 2 (Apr. 1958): 138-175. 4 illus. [James F. Queen (1821-1886). Lithographer from Civil War on - used chromolithography, photolithography at the end of his career.]

QUESNAY, M. C.
Q3 "Photographic Portraits with Borders." ANTHONY'S PHOTOGRAPHIC BULLETIN 7, no. 8 (Aug. 1876): 250. [From "Scientific American." Quesnay from Lille, France.]

QUICK, HOAG & CO.
Q4 Portrait. Woodcut engraving, credited "From a Photograph by Hoag Quick & Co." HARPER'S WEEKLY 12, (1868) ["Mr. George F. Sands, Pres. of the National Base-Ball Association." 12:594 (May 16, 1868): 305.]

QUIDDE, C. (d. 1886) (GERMANY)
Q5 "Obituary." PHOTOGRAPHIC TIMES 17, no. 279 (Jan. 21, 1887): 31. [During Franco-Prussian War attached to photographic staff of 3rd Prussian Army Corps. Secretary of the Berlin Photographic Society for years. Died Dec. 5th, 1886.]

QUIMBY & CO. (CHARLESTON, SC)
Q6 Portraits. Woodcut engravings, credited "Photographed by Quimby & Co., Charleston, S. C." FRANK LESLIE'S ILLUSTRATED NEWSPAPER 11, (1861) ["Judge Magrath, of Charleston, SC." 11:270 (Jan. 26, 1861): 149. "Paul H. Hayne, poet, aide-de-camp to the Governor of SC." 11:271 (Feb. 2, 1861): 168. "Hon. Edmund Ruffin, of VA." 11:211 (Feb. 2, 1861): 172. "Dr. Gibbes, Surg.-Gen. of the Army of South Carolina." 11:211 (Feb. 2, 1861): 172. "Government Officials of the "Palmetto Republic" (SC): John Cunningham, Brig.-Gen. of the Army, SC.; A. C. Garlington, Sect. of Interior; D. F. Jameson, Sect. of War. (Three portraits)." 11:272 (Feb. 9, 1861): 184. "Col. Rhett, editor, the 'Charleston Mercury.'" 11:274 (Feb. 23, 1861): 209. "Benjamin Mordecai, of SC." 11:274 (Feb. 23, 1861): 220. "Gen. P. T. G. Beauregard, of SC." 11:282 (Apr. 20, 1861): 341.]

Q7 Portrait. Woodcut engraving, credited "From a Photograph by Quimby & Co., Charleston." HARPER'S WEEKLY 12, (1868) ["Gen. R. K. Scott, Gov. of SC." 12:613 (Sept. 26, 1868): 621.]

QUINBY, C. J.
Q8 "Note." PHOTOGRAPHIC AND FINE ART JOURNAL 11, no. 2 (Feb. 1858): 64. [Specimens sent us...]

R

R.

R1 R. "Notes on a Tour to the Wye." PHOTOGRAPHIC NEWS 3, no. 65 (Dec. 2, 1859): 151-152.

RADCLIFFE, J. DUDLEY. (GREAT BRITAIN)

R2 Radcliffe, J. Dudley. "How to Dry a Gelatino - Bromide Negative Quickly." BRITISH JOURNAL PHOTOGRAPHIC ALMANAC 1878 (1878): 104-105.

R3 Radcliffe, J. Dudley. "Hints at Working the Gelatino - Bromide Process." BRITISH JOURNAL PHOTOGRAPHIC ALMANAC 1879 (1879): 62-63.

RAE, W. (GRAAF REINET, SOUTH AFRICA)

R4 "The South African Diamond Fields." ILLUSTRATED LONDON NEWS 60, no. 1699 (Mar. 30, 1872): 320, 321. 2 illus. [2 panoramic views.]

RAGAN & WINANS.

R5 "The Kansas City Bridge, Missouri." HARPER'S WEEKLY 13, no. 658 (Aug. 7, 1869): 497. 1 illus. ["Photographed by Ragan & Winans, Kansas City, MO."]

RAIFE.

R6 "Miscellanea: Improvement in Daguerreotype." ATHENAEUM no. 671 (Sept. 5, 1840): 703. [M. Raife recommends "...a substitute for silver plates,...the employment of silvered paper."]

RAIN, JOHN G. (OMAHA, NB)

R7 "Processes Which Have Been Proved. - No. 2. Formula for Printing and Toning, by John G. Rain, Omaha, Douglass Co., N. T." AMERICAN JOURNAL OF PHOTOGRAPHY AND THE ALLIED ARTS & SCIENCES n. s. vol. 6, no. 13 (Jan. 1, 1864): 308-309.

RAINE, JOSEPH.

R8 Raine, Joseph. "A Few Hints on Landscape Photography." BRITISH JOURNAL PHOTOGRAPHIC ALMANAC 1873 (1873): 116.

R9 Raine, Joseph. "On Strategy." BRITISH JOURNAL PHOTOGRAPHIC ALMANAC 1874 (1874): 81-83.

RAMSDEN, J. W. (LEEDS, ENGLAND)

R10 Ramsden, J. W. "On Developing." AMERICAN JOURNAL OF PHOTOGRAPHY AND THE ALLIED ARTS & SCIENCES n. s. vol. 8, no. 8 (Oct. 15, 1865): 171-175. [Ramsden tells an anecdote of when he was photographing Mr. Ruskin at Bolton Abbey "...seven or eight years ago..."]

R11 Portrait. Woodcut engraving credited "From a photograph by J. Ramsden." ILLUSTRATED LONDON NEWS 52, (1868) ["J. B. Waring, Chief Commissioner, Leeds Art Exhibition." 52:* (June 27, 1868): 633.]

RAMSEY.

R12 Ramsey, Prof. "Proceedings of Scientific Societies: British Association for the Advancement of Science: Glasgow, September 1855. Section B. - Chemical Science. Prof. Ramsey. - On a Process for Obtaining Lithographs by Photographic Process." PRACTICAL MECHANIC'S JOURNAL 8, no. 92 (Nov. 1855): 186.

RAND, CHARLES S. [?] (CHILI)

R13 "Ruins of the Church of the Compania, at Santiago, Chili, after the Conflagration." HARPER'S WEEKLY 8, no. 370 (Jan. 30, 1864): 65, 71. 3 illus. ["...from photographs kindly sent us by Charles S. Rand, Esq. Secretary of the Legation."]

RANDLE, WILLIAM G. (USA)

R14 Randle, William G. "A Diary of the Travels of William G. Randle, Daguerreotypist of Henry County, Tennessee, 1852." TENNESSEE HISTORICAL MAGAZINE 9, no. 3 (Oct. 1925, issued May 1928): 195-208.

RANGEL, B. (GREAT BRITAIN)

R15 Portrait. Woodcut engraving, credited to "From a Photograph by B. Rangel, Regent St., London and Pennenmawe, North Wales." ILLUSTRATED LONDON NEWS 59, (1871) ["Sir James Paget, Bart., F.R.S." 59:1674 (Oct. 14, 1871): 369.]

RANGER, W. B. (GENEVA, NY)

R16 Ranger, W. B. "Solar Camera Work." HUMPHREY'S JOURNAL OF PHOTOGRAPHY, AND THE ALLIED ARTS AND SCIENCES 17, no. 23 (Apr. 1, 1866): 363-364.

RANGER, WARD V.

R17 "College of Fine Arts of the Syracuse University." ANTHONY'S PHOTOGRAPHIC BULLETIN 5, no. 2 (Feb. 1874): 90. [Mr. Ward V. Ranger, appointed to Professorship of photography at Syracuse Univ.]

RAU, WILLIAM & GEORGE RAU.

R18 "Editor's Table: New Photographic Galleries in Philadelphia." PHILADELPHIA PHOTOGRAPHER 15, no. 170 (Feb. 1878): 63-64. [Mssrs. George and William Rau at 922 Girard Ave., Philadelphia, PA, just occupied their newly refitted studio. C. W. Hearn opened studio at 9th and Arch Sts. with partner Morand (the operator); A. K. P. Trask opened studio on Chestnut St.]

RAU, WILLIAM HERMAN. (1855-1920) (USA)

BOOKS

R19 Parrott, Caryl S. *A Descriptive Reading on California, Yosemite Valley, and the Big Trees. Illustrated by Fifty Lantern Slides.* Philadelphia: William H. Rau, 1889.

R20 Rau, William H. *Illustrated Catalogue: Lantern Slides and Photographs.* Philadelphia: William H. Rau, 1894.

PERIODICALS

R21 Wilson, Edward L. "Matters of the Month." PHOTOGRAPHIC TIMES 11, no. 127 (July 1881): 256-257. [Note that William H. Rau, late of Philadelphia, now with William H. Jackson in Denver, CO.]

R22 Rau, William H. "Experience with Gelatin Films Abroad and at Home." PHOTOGRAPHIC TIMES 16, no. 267-269 (Oct. 29 - Nov. 12, 1886): 568-569, 581-582, 591-592. [Rau visited Italy in Spring 1886. Egypt in 1882. Arrived Antwerp May 19th, then took trains and boats through Europe to Italy, photographing as he travelled. Described his experiences to the Photographic Society of Philadelphia.]

R23 Rau, William H. "Experience with Gelatin Films Abroad and at Home." ANTHONY'S PHOTOGRAPHIC BULLETIN 17, no. 21-22 (Nov. 13 - Nov. 27, 1886): 652-654, 687-690. [Read before the Photographic Society of Philadelphia.]

R24 Rau, William H. "The American Film Paper - Directions for Working It." ANTHONY'S PHOTOGRAPHIC BULLETIN 17, no. 21 (Nov. 13, 1886): 657-660. [Read before the Amateur Photographers of New York.]

R25 Rau, William H. "Directions for Working the American Film Paper." PHOTOGRAPHIC TIMES 16, no. 273-274 (Dec. 10 - Dec. 17, 1886): 642-643, 651-652.

R26 Rau, William H. "A Journey Through Arabia Petra with the Camera." AMERICAN JOURNAL OF PHOTOGRAPHY 8, no. 6-8 (June - Aug. 1887): 94-96, 118-121, 137-140.

R27 "Pictures Received." AMERICAN JOURNAL OF PHOTOGRAPHY 8, no. 11 (Nov. 1887): 201. [Photographs from William H. Rau, Philadelphia.]

R28 Rau, William H. "On Development." AMERICAN JOURNAL OF PHOTOGRAPHY 8, no. 12 (Dec. 1887): 206-207.

R29 Rau, W. H. "The Reproduction of Negatives." ANTHONY'S PHOTOGRAPHIC BULLETIN 19, no. 13 (July 14, 1888): 397-399. [Read before the Photographic Society of Philadelphia.]

R30 "Editorial Notes." PHOTOGRAPHIC TIMES 18, no. 360 (Aug. 10, 1888): 377. [The editor mentions recent visits from "several men prominent in photographic circles. Rau is described as follows. "Mr. William H. Rau, of Philadelphia, who will be remembered as the photographer who accompanied Dr. Edward L. Wilson on his Oriental tour, giving him able assistance in much of the actual photographing in Petra and elsewhere."]

R31 Rau, William H. "Lantern-Shades." AMERICAN ANNUAL OF PHOTOGRAPHY AND PHOTOGRAPHIC TIMES ALMANAC FOR 1889 (1889): 188-189.

R32 "The Editorial Table." PHOTOGRAPHIC TIMES 20, no. 479 (Nov. 21, 1890): 583. ["William H. Rau, of 1324 Chestnut Street, Philadelphia, sends his announcement and list of lecture sets of lantern slides with descriptive readings."]

R33 "Notes and News: To Visit Mexico." PHOTOGRAPHIC TIMES 21, no. 505 (May 22, 1891): 250. [Note that "John L. Stoddard, who finished his twelfth lecture season, proposed... a trip to Mexico... The party, consisting of Mr. Stoddard, Mr. North [manager for Stoddard] and Mr. Rau, the photographer, started from Chicago."]

R34 "Notes and News: An Improved Photographic Car." PHOTOGRAPHIC TIMES 21, no. 514 (July 24, 1891): 376. [Note that Ray is making "on a most elaborate scale, a photographic survey of their great system [Pennsylvania Railroad Company] and that the Railway built him a special 'photographic car' for the task. From 'Philadelphia Public Ledger.'"]

R35 "On the Beach at Atlantic City - From a Photo by William H. Rau, Philadelphia." FRANK LESLIE'S ILLUSTRATED NEWSPAPER 73, no. 1875 (Aug. 29, 1891): 53. 1 b & w. [Full page view of crowd on the beach.]

R36 "A Photographic Car." PHOTOGRAPHIC TIMES 21, no. 525 (Oct. 9, 1891): 506-507. [The Pennsylvania Railroad Company fitted out a car especially for photographic work, plus an immerse panoramic landscape camera, 4 ft. by 1 l/2 ft. in dimension. Mentions that the photographer is William H. Rau, and that he was official photographer of the Government Expedition of the Transit of Venus in 1874 and 1875.]

R37 "The Editorial Table." PHOTOGRAPHIC TIMES 21, no. 534 (Dec. 11, 1891): 623. [Note about two panoramic views of the Pennsylvania R. R. taken by William Rau.]

R38 Rau, William H. "My Summer Experience." AMERICAN ANNUAL OF PHOTOGRAPHY AND PHOTOGRAPHIC TIMES ALMANAC FOR 1892 (1892): 185. [Article is about Rau's solution resolving melting orthochromatic plates.]

R39 Adams, John Coleman. "What A Great City Might Be — A Lesson From the White City." NEW ENGLAND MAGAZINE 14, no. 1 (Mar. 1896): 3-13. 20 b & w. [Chicago Exposition, 1896. "Illustrated from photos. by William H. Rau."]

R40 "Uncle Sam's Great Outfitting Establishment: The Busy Schuylkill Arsenal at Philadelphia ..." LESLIE'S WEEKLY 87, no. 2242 (Sept. 1, 1898): 164, 175. 5 b & w. ["Photographed by Rau."]

R41 "New York's Reception to the Victorious Fleet from Santiago Harbor." LESLIE'S WEEKLY 87, no. 2243 (Sept. 8, 1898): Cover, 185. 6 b & w. [Naval vessels.]

R42 "Editor's Table: The Spanish-American War." WILSON'S PHOTOGRAPHIC MAGAZINE 35, no. 504 (Dec. 1898): 567. ["Rau...announces a very complete series of lantern-slides covering the Spanish-American War."]

R43 1 photo ("Launch of the Russian Battleship 'Retvizan.'") COLLIER'S WEEKLY 26, no. 6 (Nov. 10, 1900): Cover. [Battleship built, launched in USA.]

R44 Lynch, George. "'I Wish They Would Come Out!'" COLLIER'S WEEKLY 29, no. 7 (May 17, 1902): 7. 1 b & w. [Short narrative about events during Spanish-American War associated with Rear-Admiral William T. Sampson. Rau's photo is a portrait of Sampson.]

R45 2 photos ("Launch of the Largest American Ship"). COLLIER'S WEEKLY 29, no. 15 (July 12, 1902): 8.

R46 1 photo (Fireman shovelling coal in a locomotive). WORLD'S WORK 4, no. 4 (Aug. 1902): 2358.

R47 Nixon, Lewis. "The End of the Steam Age. Is the Next Step to be Ocean Vessels and War-Ships with Gas-Producers?" COSMOPOLITAN 38, no. 2 (Dec. 1904): 169-176. 9 b & w. [Battleships, etc. Photos credited to W. H. Rau and Waldon Fawcett.]

R48 Rau, William H. "Photographing a World's Fair." PHOTOGRAPHIC TIMES 37, no. 12 (Dec. 1905): 539-545. 7 b & w.

R49 Davis, Hartley. "The Coal Trust, the Labor Trust, and the People Who Pay." EVERYBODY'S MAGAZINE 14, no. 4 (Apr. 1906): 434-444. 7 b & w. 2 illus. [Photos of miners, miners' homes, coal-breakers, etc. in Pennsylvania, credited to "Rau, Philadelphia." 2 studio portraits by F. Gutekunst, Phila.]

R50 Davis, Hartley. "The Coal Trust, the Labor Trust, and the People Who Pay. II." EVERYBODY'S MAGAZINE 14, no. 5 (May 1906): 640-649. 3 b & w. 2 illus. [Rau (1); Steffen (2).]

R51 Howland, Harold J. "A Costly Triumph." OUTLOOK 85, no. 4 (Jan. 25, 1907): 192-210. 19 b & w. ["Illustrated by the J. Horace McFarland Co. and William H. Rau. Capitol building of Pennsylvania. Exteriors, interiors. 7 b & w copyrighted to S. C. Huston, 4 b & w copyrighted to Wm. H. Rau.]

R52 Rau, William H. "How I Photograph Railroad-Scenery." PHOTO-ERA 37, no. 6 (June 1916): 261-266. 4 b & w. 10 illus.

[Illustrations include scenes of Rau photographing along the lines of the Pennsylvania R. R. and the Lehigh Valley R. R.]

R53 "Obituary: W. H. Rau (Nov. 19, 1920)." BRITISH JOURNAL PHOTOGRAPHIC ALMANAC 1922 (1922): 300-301. [Rau, born in Philadelphia in 1855, of Swiss parentage. At 19 was one of the photographic staff on the U. S. Transit of Venus expedition. Later went with Edward L. Wilson through Egypt, Palestine and Arabia. Used gelatine dry plates on this trip. In 1885 established himself as a technical and commercial photographer in Philadelphia, and was successful. Official photographer for several exhibitions in USA and worked for railroads.]

R54 "Lehigh University acquires, restores old RR photographs." PHOTOGRAPHICA 11, no. 6 (June - July 1979): 3. 1 illus. [Ex. rev.: 'Lehigh Valley Railroad,' Ralph Wilson Gallery, Lehigh, NJ.]

R55 Brey, William. "William H. Rau's Photographic Experiences in the East." STEREO WORLD 11, no. 2 (May - June 1984): 4-11. 4 b & w. 3 illus. [Article describes E. L. Wilson's trip to the Near East in 1881-82, accompanied by William H. Rau. Also a biographical summary of Rau. Rau born Jan. 19, 1855, in Philadelphia, PA. Interested in photography from age 16, at 19 he accompanied the United States Expedition to the South Seas, as John Moran's assistant to photograph the 1874 transit of Venus. Then photographed the Rockies and the Yellowstone Park area. Worked for the Centennial Photographic Co. (Edward L Wilson) in 1876, and accompanied Wilson to the Near East in 1881-82. Published stereo views and lantern slides throughout 1890s. Official photographer to the Lehigh Valley Railroad in 1895, making about two hundred mammoth-plate and panoramic views. Official photographer to the St. Louis Exposition in 1904, and the Lewis and Clark Exposition in Portland, OR in 1905. Documented the dedication ceremonies of the new Pennsylvania State House in 1906. Married to Louise Bell, daughter of William Bell, and herself a photographer. Died November 19, 1920, in Philadelphia.]

R56 Brey, William. "On the Rails with William Rau." PHOTOGRAPHICA 17, no. 2 (Sept. 1988): 3-5. 4 illus. [Illustrations are views of Rau photographing along the line of the Pennsylvania R. R. in 1890s.]

RAVELL, C. H. (b. ca. 1834) (USA)
R57 "Grace Church, Lyons, Wayne County, N. Y. Rev. William H. Williams, Pastor." FRANK LESLIE'S ILLUSTRATED NEWSPAPER 28, no. 727 (Sept. 4, 1869): 389. 2 illus. [View. Portrait.]

RAVEN, JOSEPH.
R58 Raven, Joseph. "The Photographer of the Future, Imitative or Creative." BRITISH JOURNAL PHOTOGRAPHIC ALMANAC 1873 (1873): 143-144.

RAVEN, T. MELVILLE.
R59 Raven, T. Melville. "Account of a Photographic Tour From Jersey to the Pyrenees." PHOTOGRAPHIC AND FINE ART JOURNAL 11, no. 5 (May 1858): 155-157. [From "Photo. Notes."]

R60 Raven, T. Melville. "Account of a Photographic Tour from Jersey to the Pyrenees." HUMPHREY'S JOURNAL OF PHOTOGRAPHY, AND THE ALLIED ARTS AND SCIENCES 10, no. 4 (June 15, 1858): 55-60. [From "Photo. Notes."]

R61 Raven, Rev. T. M. "Pau and the Pyrenees, with a Slight Sketch of a Photographic Tour Made to Them Through the West of France." JOURNAL OF THE PHOTOGRAPHIC SOCIETY OF LONDON 5, no. 75-77 (Dec. 21, 1858 - Jan. 21, 1859): 104-108, 131-132, 155-157.

R62 Raven, T. M. "Photographic Impressions on Paper." HUMPHREY'S JOURNAL OF PHOTOGRAPHY, AND THE ALLIED ARTS AND SCIENCES 11, no. 15 (Dec. 1, 1859): 237-238. [From "Photo. J."]

RAWSON.
R63 Portrait. Woodcut engraving, credited "From a Photograph by Rawson." FRANK LESLIE'S ILLUSTRATED NEWSPAPER 47, (1879) ["Rev. Dr. William Ives Budington." 47:1216 (Jan. 18, 1879): 368.]

RAWSON, D. W. S. (d. 1869) (USA)
R64 "Editor's Table." PHILADELPHIA PHOTOGRAPHER 6, no. 70 (Oct. 1869): 356. [Note of death of Rawson on 24th August. Worked in Peru, IL.]

R65 "Viewer Feature: Rawson's 'Stereopticon.'" STEREO WORLD 7, no. 1 (Mar. - Apr. 1980): 23. 1 illus. [Reprint of an advertisement for a stereo viewer patented by D. W. S. Rawson (Peru, IL), in 1867.]

READ & ROBINSON.
R66 "The Putnam Phalanx at the Tomb of General Putnam, Brooklyn, Connecticut, June 19, 1860." HARPER'S WEEKLY 4, no. 186 (July 21, 1860): 460-461. 1 illus. ["Photographed by Read & Robinson." Group portrait of a social/military organization.]

READ, W. J.
R67 "Letter." ART JOURNAL (Jan. 1852): 22. [Letter on use of proto-sulphate of iron.]

R68 Read, W. J., Rev. "On the Optics of Photography." HUMPHREY'S JOURNAL OF PHOTOGRAPHY, AND THE ALLIED ARTS AND SCIENCES 10, no. 4 (June 15, 1858): 61-63.

R69 Read, Rev. W. J., F.R.A.S. "On the Optic of Photography." PHOTOGRAPHIC AND FINE ART JOURNAL 11, no. 7 (July 1858): 218. [From the "Liverpool Photographic Journal."]

READE, JOSEPH BANCROFT. (1801-1870) (GREAT BRITAIN)
R70 Reade, J. B. "Rev. J. B. Reade, On Mr. H. Fox Talbot's Claim to the Priority of Discovery in the Use of Gallic Acid in Photography." PHOTOGRAPHIC AND FINE ART JOURNAL 7, no. 9 (Sept. 1854): 268-269. [From "J. of Photo. Soc." Reade describes his experiments in 1830s.]

R71 "Photography: History of Photographic Discovery." HUMPHREY'S JOURNAL 6, no. 9 (Aug. 15, 1854): 129-130, 133-134. [Letter from Rev. J. B. Reade, describing his experiments in 1830's here reprinted from "Notes and Queries." Another letter from "a well-known amateur" describing his early experiences on pp. 133-134.]

R72 Reade, Rev. J. B. "Mr. H. Fox Talbot's Claim to the Priority of Discovery of the Use of Gallic Acid in Photography." HUMPHREY'S JOURNAL 6, no. 9 (Aug. 15, 1854): 140-142. [From "J. of Photo. Soc., London." Also the article "On Preparing Paper and Printing Positive Photographs" on pp. 142-143 describes the "photogenic drawing" process.]

R73 "The Early History of Photography." BRITISH JOURNAL OF PHOTOGRAPHY 9, no. 161 (Mar. 1, 1862): 79-80. [Exchange of letters between Rev. J. B. Reade, Lyndon Smith, and George Shadbolt (Editor of BJP).]

R74 "The Late Rev. J. B. Reade, F.R.S." ANTHONY'S PHOTOGRAPHIC BULLETIN 2, no. 4 (Apr. 1871): 104-105. [Reade was President of the Royal Microscopical Society, V.P. of the London Photographic Society. Born at Leeds, Yorkshire on Apr. 5, 1801. Early experimenter, exhibited photos before the Royal Society in 1839, but hadn't discovered the latent image (Talbot's discovery). An ardent microscopist. From "Br J of Photo."]

R75 Wood, Rupert Derek. "J. B. Reade, F.R.S. and the Early History of Photography." ANNALS OF SCIENCE 27, no. 1 (Mar. 1971): 13-83. 3 illus.

R76 Gill, A. T. "'Call Back Yesterday...'" PHOTOGRAPHIC JOURNAL 113, no. 5 (May 1973): 251. 1 illus.

READING, J. T. (SAVANNAH, GA)
R77 "Meeting of Citizens at Johnson Square, Savannah, April 22, 1865." HARPER'S WEEKLY 9, no. 438 (May 20, 1865): 317. 1 illus. ["Photographed by Reading & Co., Savannah."]

REEF, J. B.
R78 "Andrew Johnson's Tailor-Shop in Greenville, Tennessee." HARPER'S WEEKLY 9, no. 459 (Oct. 14, 1865): 641. 1 illus. ["Photographed by J. B. Reef."]

REES, C. R. & CO. (RICHMOND, VA)
R79 "The Rebel Colonel John S. Mosbey - Photographed by Rees, Richmond, Va." HARPER'S WEEKLY 9, no. 421 (Jan. 21, 1865): 43, 45. 1 illus. [Studio portrait.]

R80 Portrait. Woodcut engraving, credited "From a Photograph by C. R. Rees & Co., Richmond, Va." FRANK LESLIE'S ILLUSTRATED NEWSPAPER 27, (1868) ["The late Henry Reeves Pollard." 27:689 (Dec. 12, 1868): 197.]

R81 Portrait. Woodcut engraving, credited "From a Photograph by C. R. Rees & Co., Richmond." HARPER'S WEEKLY 12, (1868) ["H. Rives Pollard, assassinated Nov. 24, 1868." 12:624 (Dec. 12, 1868): 788.]

R82 Portrait. Woodcut engraving, credited "From a Photograph by C. R. Rees & Co." FRANK LESLIE'S ILLUSTRATED NEWSPAPER 28, (1869) [Hon. Gilbert C. Walker, Gov.-elect of VA." 28:721 (July 24, 1869): 293.]

R83 Portrait. Woodcut engraving, credited "From a Photograph by C. R. Rees & Co." HARPER'S WEEKLY 13, (1869) ["Gov. Gilbert C. Walker of VA." 13:656 (July 24, 1869): 476.]

R84 "The Great Flood at Richmond, VA. - From Sketches by Our Special Artist, and from a Photograph by Rees & Co." FRANK LESLIE'S ILLUSTRATED NEWSPAPER 31, no. 786 (Oct. 22, 1870): 89. 7 illus. [The photo is of a wrecked house.]

R85 "Richmond, Va. - Serious Fire at the Spotswood Hotel, on Christmas Night - Instantaneous View of the Throng Around the Ruins, Taken Immediately after the Disaster, by C. R. Rees & Co., Photographers, Richmond." FRANK LESLIE'S ILLUSTRATED NEWSPAPER 31, no. 798 (Jan. 14, 1871): 293. 1 illus. [Ruins.]

R86 Portrait. Woodcut engraving, credited "Photographed by E. Rees & Co., of Richmond, VA." FRANK LESLIE'S ILLUSTRATED NEWSPAPER 38, (1874) ["Hon. Robert Withers, Sen. from VA." 38:964 (Mar. 21, 1874): 28.]

REES, DAVID. (LONDON, ENGLAND)
["...fifteen years photographic miniature printer to the chief London photographers."]

R87 Rees, David. *The Art of Photographic Coloring, in Easy Progressive Lessons. Illustrated with Colored Photographic Portraits showing the working of each process, from the Tinted Carte-de-Visite to the Life-Size or Portraits.* London: D. Rees, 1868. 26 pp. [Includes two colored cartes.]

REESE & CO. (USA)
R88 *Daguerreotype Directory; or Reese & Co's German System of Photography and Picture Making.* New York: Olive & Brother, Steam Job Printers, 1854. 36 pp.

REEVE, LOVELL AUGUSTUS. (1814-1865) (GREAT BRITAIN)
BOOKS
R89 Jephson, John Mounteney, B.A., F.S.A. *Narrative of A Walking Tour In Brittany,...Accompanied by Notes of a Photographic Expedition, by Lovell Reeve, F.L.S.* London: Lovell Reeve, 1859. xvi, 352 pp. 1 b & w. 1 illus. ["...with Map by Arrowsmith, and Stereoscopic Frontispiece." (A box of 90 or 91 stereographs as originally sold with the 1859 version of the book) 2nd ed. (1866) London: A. W. Bennett, has 90 l. of plates.]

PERIODICALS
R90 "Our Weekly Gossip." ATHENAEUM no. 1611 (Sept. 11, 1858): 331. ["...a party consisting of Rev. J. M. Jephson, Mr. Lovell Reeve, and a photographic staff...(traveled through Brittany) will bring home about a hundred stereoscopic pictures...to produce a book illustrated with photographic drawings..."]

R91 "Editorial." LIVERPOOL & MANCHESTER PHOTOGRAPHIC JOURNAL [BRITISH JOURNAL OF PHOTOGRAPHY] n. s. 2, no. 19 (Oct. 1, 1858): 237. [Note that L. Reeve, Rev. J. M. Jephsen "...and a photographic staff..." touring Brittany, to make stereos for a book.]

R92 "Critical Notices: The Stereoscopic Cabinet. Published by Lovell Reeve, Henrietta Street." PHOTOGRAPHIC NEWS 3, no. 63 (Nov. 18, 1859): 126. [Proposed monthly publication containing three stereo prints. The first set includes a view of a church by R. Howlett, statues from the British Museum by R. Fenton and a view from the deck of the "Maraquita" by Capt. Henry, on his voyage to Iceland.]

R93 "Useful Facts, Receipts, Etc.: Photo-zincographs for Reproduction." AMERICAN JOURNAL OF PHOTOGRAPHY AND THE ALLIED ARTS & SCIENCES n. s. vol. 5, no. 7 (Oct. 1, 1862): 164-165. [From "The Athenaeum." Lovell Reeve created a photo-zincographic facsimile of Shakespeare's "Sonnets."]

R94 Stark, Amy E. "Lovell Augustus Reeve (1864 - 1865): Publisher and Patron of the Stereograph." HISTORY OF PHOTOGRAPHY 5, no. 1 (Jan. 1981): 3-15. 8 b & w. 5 illus. [Publisher of first stereographically illustrated book and first magazine illustrated with stereo views. Published four books, two serial publications, and three sets of stereo views in England in the 1850s. Photographic illustrations are by Roger Fenton and Ernest Edwards.]

R95 Joseph, Steven F., and Amy Stark. "Correspondence: Lovell Reeve." HISTORY OF PHOTOGRAPHY 6, no. 2 (Apr. 1982): 179-181. [Response to article HOP 5:1 (Jan. 1981) and Ms. Stark's reply. Includes further lists of photographically illustrated books. Further comment on Lovell Reeve by Ann Wilsher on p. 182.]

REEVES. (BOSTON, MA)
R96 "Editor's Table." PHILADELPHIA PHOTOGRAPHER 14, no. 168 (Dec. 1877): 384. [A "Mr. Reeves of Boston, MA" claiming to be a photographic printer seeking work is actually a petty thief, according to G. M. Carlisle of Providence, RI.]

REEVES, T. S.
R97 Reeves, T. "Binocular Photographs." PHOTOGRAPHIC AND FINE ART JOURNAL 7, no. 11 (Nov. 1854): 324. [From "J. of Photo. Soc."]

R98 Reeves, T. S. "Lime in the Toning Bath." AMERICAN JOURNAL OF PHOTOGRAPHY AND THE ALLIED ARTS & SCIENCES n. s. vol. 7, no. 18 (Mar. 15, 1865): 427-428. [From "Photo. Notes."]

REGNAULT, HENRI-VICTOR. (1810-1878) (FRANCE)
[Born July 21, 1810 at Aix-la-Chapelle. His father, a captain in the French Army, died during Napoleon's invasion of Russia in 1812. In 1830 Henri-Victor entered the Ecole Polytechnique, where he was successful, and was appointed tutor in chemistry there in 1836, then Professor in 1840. In 1841 he became professor in physics at the Collège de France. Began experimenting with photography. In 1847 studied photography with Blanquart-Evrard. A founder-member of the Société Héliographique in 1851. From 1852 to 1871 he was the director at the Manufacture de Sèvres. In 1853-1854 Blanquart-Evrard published his photographs in *Etudes et Paysages*. Founder-member and first President of the Société française de Photographie, from 1855 until he resigned in 1868. His laboratory at Sèvres, with his experiments, notes, and instruments, destroyed by fire in 1870. Gave up his professorship in 1872. Died on Jan. 19, 1878 in Paris.]

BOOKS
R99 Jammes, André. "Victor Regnault, Calotypist," on pp. 78-82 in: *One Hundred Years of Photographic History. Essays in Honor of Beaumont Newhall.* Edited by Van Deren Coke. Albuquerque, NM: University of New Mexico Press, 1975. 180 pp. 7 b & w.

PERIODICALS
R100 "Burnt-in Pictures on Glass or Porcelain." AMERICAN JOURNAL OF PHOTOGRAPHY AND THE ALLIED ARTS & SCIENCES n. s. vol. 8, no. 3 (Aug. 1, 1865): 63-64. [From "Br. J. of Photo."]

R101 "Obituaries - MM. Becquerel and Regnault." ANTHONY'S PHOTOGRAPHIC BULLETIN 9, no. 3 (Mar. 1878): 68. [From "Br J of Photo." Regnault died on 19th inst. (Jan. or Feb.), in Auteuil, at age 68. Engineer-in-Chief of Mines. Prof. of Physics at College of France, Prof. of Chemistry at Ecole Polytechnique, member French Academie des Sciences, etc. Director of the Manufactory of Sevres, President of Photographic Society of France. Son Henri Regnault a celebrated painter.]

R102 "Biographical Notes on a Number of Photographers Published by Blanquart-Evrard." CAMERA (LUCERNE) 57, no. 12 (Dec. 1978): 32, 41-42. [Benecke, Claine, DuCamp, Fortier, Greene, Le Secq, Loydreau, Marville, Regnault, Robert, Salzmann, Stewart, Sutton, and Tenison.]

REHN, ISAAC A. (PHILADELPHIA, PA)
[Painter in Philadelphia from 1845 to 1848. Learned daguerreotypy in 1849 and worked as a photographer at least through the 1860s. Held an interest in the Cutter patent on the ambrotype. Displayed ambrotypes at the Fair of the Franklin Institute in 1855. Worked as a lithographer from late 1850s, awarded a $50,000 contract in 1860 to reproduce Patent Office drawings.]

R103 "Note." AMERICAN JOURNAL OF PHOTOGRAPHY AND THE ALLIED ARTS AND SCIENCES n. s. vol. 1, no. 8 (Sept. 15, 1858): 130. [Collection of "photo-lithographs" noted.]

REICHARD & LINDNER. (BERLIN, GERMANY)
R104 Portrait. Woodcut engraving credited "From a photograph by Reichard & Lindner." ILLUSTRATED LONDON NEWS 71, (1877) ["Late Field Marshall Count von Wrangel." 71:2002 (Nov. 24, 1877): 492.] Portraits. Woodcut engravings credited "From a photograph by Reichard & Lindner." ILLUSTRATED LONDON NEWS 74, (1879) ["Duke and Dutchess of Connaugh, and the Prince and Princess Frederick Charles of Prussia." 74:2074 (Mar. 15, 1879): 240, following p. 258.]

REID, CHARLES. (1837-1929) (GREAT BRITAIN)
R105 1 photo ("Harvest in Scotland"). PHOTOGRAPHIC TIMES 23, no. 626 (Sept. l5, 1893): 515. [Brief comment about the photo on p. 523. Reid lives at Wishaw, Scotland.]

R106 1 photo ("Crossing the River"). PHOTOGRAPHIC TIMES 23, no. 630 (Oct. 13, 1893): 579. [Fox hounds on a hunt.]

R107 1 photo ("Mother and Daughter"). PHOTOGRAPHIC TIMES 23, no. 632 (Oct. 27, 1893): 612. [Mare and colt.]

R108 "Charles Reid and His Work." PHOTOGRAPHIC TIMES 27, no. 5 (Nov. 1895): 272-275. 4 b & w. 1 illus. [Born in rural Scotland. Always loved animals, wanted to draw them as a child when he was a cowherd. Saw his first daguerreotype in 1853, while apprenticed to a shoemaker, when an itinerant photographer visited his town. By 1864 he owned a small camera and persisted in photographing, although that activity was apparently thought to be foolish by his fellows. Became something of a specialist in rural views, animals in their natural settings.]

REID, E. L. (WAXAHACHIE, TX)
R109 "Note." PHOTOGRAPHIC TIMES 8, no. 87 (Mar. 1878): 63. [Mr. E. L. Reid is one of the leading photographers of Waxahachie, Texas.]

REID, JOHN. (1835-1911) (USA)
R110 "Our Picture - Passaic Falls, NJ." PHILADELPHIA PHOTOGRAPHER 3, no. 26 (Feb. 1866): frontispiece, 60. 1 b & w. [Landscape.]

R111 Portrait. Woodcut engraving, credited "From a Photograph by J. Reid, Patterson, N. J." FRANK LESLIE'S ILLUSTRATED NEWSPAPER 33, (1871) illus. ["The late Alice Augusta Bowlsby." 33:833 (Sept. 16, 1871): 1.]

R112 "Our Picture." PHOTOGRAPHIC TIMES 2, no. 20 (Aug. 1872): frontispiece, 114-115. 1 b & w. [Landscape.]

R113 "Passaic Falls," Mr. Reid's Formula." PHOTOGRAPHIC TIMES 2, no. 21 (Sept. 1872): 132-133. [His collodion formula that was used for the landscape photo printed in the Aug. issue.]

R114 "Note." PHOTOGRAPHIC TIMES 2, no. 22 (Oct. 1872): 198. [Perhaps the finest display of outdoor work that was ever made at any American exhibition is now at the fair of the American Institute open in this city... made by Mr. John Reid, Paterson, N.J. - architectural, animal, and landscape."]

REILLY, JOHN JAMES see also SOULE, JOHN PAYSON. (Palmquist).

REILLY, JOHN JAMES. (1838-1894) (GREAT BRITAIN, USA)
BOOKS
R115 Hickman, Paul Addison. *John James Reilly, 1838-1894: Photographic Views of American Scenery*. Albuquerque, NM: University of New Mexico, 1987. 541 l. b & w. [Ph.D. Dissertation, University of New Mexico, (Dec. 1987). Bibliography on l. 420-451.]

PERIODICALS
R116 "Note." PHOTOGRAPHER'S FRIEND 2, no. 1 (Jan. 1872): 29. [Mention and listings of photos taken on a trip through the picturesque California scenery. Published by Reilly & Spooner. Reilly is the photographer.]

R117 Reilly, J. J. "Outdoor Work on the Pacific Coast." PHILADELPHIA PHOTOGRAPHER 11, no. 127 (July 1874): 211-212. [Eight years ago Reilly worked at Niagara Falls, NY. Two years ago he was making views in the Yosemite Valley, CA. Has been photographing up and down the Pacific coast.]

R118 "Our Picture." PHILADELPHIA PHOTOGRAPHER 14, no. 158 (Feb. 1877): frontispiece, 57. 1 b & w. [View of Yosemite Falls, by J. J. Reilly (Stockton, CA).]

R119 Hickman, Paul and Peter Palmquist. "J. J. Reilly, Photographer and Manufacturer of All Kinds of Stereoscopic Views." STEREO WORLD 11, no. 5 (Nov. - Dec. 1984): 4-19, plus back cover. 22 b & w. 2 illus. [First in a four part series, this well-researched, extraordinarily detailed account contains a chronological biography of Reilly's life and career, extensive checklists of the various stereoview series which he photographed and published, informed background historical information, and an excellent account of the interactions of Reilly and his contemporaries within the period. Reilly was born in Glasgow, Scotland in 1838. To USA in 1856. By 1863 working as a photographer in Niagara County, NY, when he enlisted in the Union cavalry. In 1864 discharged with a disability from an accident. From 1865 to 1870 worked as a photographer and publisher of stereo views at Niagara Falls, NY. To California in 1870. Actively worked in Yosemite Valley area, the California coast, San Francisco, etc. through 1870s. 1879 to 1886 operated a gallery in Marysville, CA. 1886 abandoned his second wife and his life's work, moved to San Francisco. Worked for a variety of unsuccessful jobs for other studios. In 1894 committed suicide. Many of his negatives published by other photographers.]

R120 Hickman, Paul and Peter Palmquist. "J. J. Reilly, Photographer and Manufacturer of All Kinds of Stereoscopic Views. Part II - Yosemite." STEREO WORLD 11, no. 6 (Jan. - Feb. 1985): 8-23, 39, plus back cover. 25 b & w.

R121 Hickman, Paul and Peter Palmquist. "J. J. Reilly, Photographer and Manufacturer of All Kinds of Stereoscopic Views. Part III - Views of American Scenery." STEREO WORLD 12, no. 3 (July - Aug. 1985): 4-23. 24 b & w.

R122 Hickman, Paul and Peter Palmquist. "J. J. Reilly, Photographer and Manufacturer of All Kinds of Stereoscopic Views. Part IV - Hard Economic Realities." STEREO WORLD 12, no. 4 (Sept. - Oct. 1985): 4-19. 27 b & w. 1 illus.

REINHOLD, JOHN HENRY. (CINCINNATI, OH)
R123 Reinhold, J. H. "Process Peddlers." HUMPHREY'S JOURNAL OF PHOTOGRAPHY, AND THE ALLIED ARTS AND SCIENCES 19, no. 19 (Feb. 1, 1868): 296-297. [Letter from Reinhold describing a "process peddlar" who attempted to cheat him.]

REJLANDER, OSCAR GUSTAV. (1813-1875) (SWEDEN, GREAT BRITAIN)
[Born in Sweden in 1813. Studied painting and sculpture at the Rome Academy. Settled in England in 1840 and became a portrait painter. In 1846 moved to Wolverhampton. Decided in 1852 to learn photography to aid him in his painting. Opened a professional photographic studio in Wolverhampton in 1855. By 1857 he is making posed genre scenes and complex composite prints. In 1857 his "Two Ways of Life" made his reputation as a creative photographer. Made composite genre studies throughout the 1860s. Apparently Rejlander was the sort of man filled with intelligence, humor, generosity, and bonhomie, who was extraordinarily well-liked and respected by his peers, and around whom stories and anecdotes clustered. He taught both Lewis Carroll and Julia Margaret Cameron. Died in London in 1875.]

BOOKS
R124 Darwin, Charles. *The Expression of the Emotions in Man and Animals*. London.: John Murray., 1872. vi, 374 pp. 7 b & w. 21 illus. ["With Photographic and Other Illustrations." Photographs by O.G. Rejlander, Duchenne de Boulogue, Kindermann and Dr. Wallach. First successful use of Ernest Edwards collotype printing process.]

R125 Darwin, Charles. *Der Ausdrück der Gemuthsbewegungen bei dem Menschen und dem Thieren,...Aus dem Englischen Übersetzt von J. Victor Carus*. Stuttgart: E. Schweitzerbart'sche Verlagshandlung, 1884. 330 pp.

R126 Jones, Edgar Yoxall. *Father of Art Photography: O. G. Rejlander 1813-1875*. Greenwich, CT; London: New York Graphic Society, Ltd.; David & Charles, Ltd., 1973. 112 pp. 80 b & w.

R127 *The Tennyson Album: A Biography in Original Photographs*. By Andrew Wheatcroft, with an introduction by Sir John Betjeman. London; Boston: Routledge & Kegan Paul, Ltd.; Henly & Co., 1980. 160 pp. illus. [Photographs by J. M. Cameron and O. G. Rejlander.]

R128 Spencer, Stephanie. *O. G. Rejlander: Photography as Art*. Ann Arbor, MI: UMI Research Press, 1985. 132 pp.

PERIODICALS
R129 Portrait. Woodcut engraving credited "From a collodion by O. G. Rejlander, Wolverhampton." ILLUSTRATED LONDON NEWS 28, (1856) ["Dhurleep Sing." 28:785 (Feb. 16, 1856): *.]

R130 "Fine-Art Gossip." ATHENAEUM no. 1526 (Jan. 24, 1857): 120. [Brief notices of "Photographic Art Treasures, Part 2," with comment that Roger Fenton has become a partner in the Photo-Galvanographic Co. Praise for O. G. Rejlander's photographs.]

R131 "Fine-Art Gossip." ATHENAEUM no. 1539 (Apr. 25, 1857): 538-539. [Mentions, praises Claudet and Rejlander. Work to be displayed at the Manchester Art Treasures Exhibition.]

R132 "Fine-Arts: New Publications: 'Two Ways of Life,' Photographed by Rejlander." ATHENAEUM no. 1551 (July 18, 1857): 914.

R133 "Practical Hints on Matters Connected with Photography." HUMPHREY'S JOURNAL 9, no. 9 (Sept. 1, 1857): 138-140. [Report of comments by Rejlander, given at a meeting of the Birmingham Photographic Society. Probably from "Photo. Notes."]

R134 Rejlander, O. G. "London Photographic Society." LIVERPOOL & MANCHESTER PHOTOGRAPHIC JOURNAL [BRITISH JOURNAL OF PHOTOGRAPHY] n. s. 2, no. 8 (Apr. 15, 1858): 92-98. [Major paper by O. G. Rejlander "On Photographic Composition."]

R135 Rejlander, O. G. "On Photographic Composition: With a Description of 'Two Ways of Life.'" JOURNAL OF THE PHOTOGRAPHIC SOCIETY OF LONDON 4, no. 65 (Apr. 21, 1858): 191-197.

R136 Rejlander, O. G. "London Photographic Society." PHOTOGRAPHIC AND FINE ART JOURNAL 11, no. 6 (June 1858): 173-178. [From "Liverpool Photographic Journal". Rejlander's paper "On Photographic Composition."]

R137 "Editorial." LIVERPOOL & MANCHESTER PHOTOGRAPHIC JOURNAL [BRITISH JOURNAL OF PHOTOGRAPHY] n. s. 2, no. 17 (Sept. 1, 1858): 210. [Comments on Rejlander's photos - "The Scripture Reader."]

R138 "Editorial." LIVERPOOL & MANCHESTER PHOTOGRAPHIC JOURNAL [BRITISH JOURNAL OF PHOTOGRAPHY] n. s. 2, no. 19 (Oct. 1, 1858): 236. [Excerpt from a letter by Rejlander, describing an event while photographing outdoors, where a bull charged his tripod.]

R139 "Fine-Art Gossip." ATHENAEUM no. 1617 (Oct. 23, 1858): 526-527. [Mentions Fox Talbot's successes in photoengraving. Discusses O. G. Rejlander's "inventive figure photography."]

R140 "Correspondence: Exhibition of the Photographic Society." PHOTOGRAPHIC NEWS 2, no. 27 (Mar. 11, 1859): 8-9. [Letter, signed "An Ex-Member of the Council," discusses the work of O. G. Rejlander and H. P. Robinson.]

R141 Rejlander, O. G. "Caution relative to the Care of Negatives." HUMPHREY'S JOURNAL OF PHOTOGRAPHY, AND THE ALLIED ARTS AND SCIENCES 10, no. 22 (Mar. 15, 1859): 342. [From "Liverpool Photo. J."]

R142 "Fine-Art Gossip." ATHENAEUM no. 1658 (Aug. 6, 1859): 182. [Description and praise for O. G. Rejlander's photograph "The Wayfarer."]

R143 "Photographic Contributions to Art." BRITISH JOURNAL OF PHOTOGRAPHY 7, no. 123 (Aug. 1, 1860): 216. [Rejlander's "Head of St. John the Baptist" discussed.]

R144 "Talk in the Studio: Two Ways of Life." PHOTOGRAPHIC NEWS 4, no. 105 (Sept. 7, 1860): 227. [Note that negatives to "Two Ways of Life" damaged, so that further prints are now an impossibility. The few original prints remaining are in the hands of the London Stereo Co.]

R145 "Photographic Contributions to Art." BRITISH JOURNAL OF PHOTOGRAPHY 7, no. 126 (Sept. 15, 1860): 264. [Review of photos "Coming Events Cast their Shadows Before," "Have a Tune, Miss?", "The Disciple."]

R146 "Note about Rejlander's "Head of John the Baptist."" PHOTOGRAPHIC NEWS 4, no. 109 (Oct. 5, 1860): 276.

R147 "Talk in the Studios: Photography For Caricature." PHOTOGRAPHIC NEWS 4, no. 112 (Oct. 26, 1860): 312. [Note about Rejlander's cartoon.]

R148 Wall, A. H. "An Hour with Rejlander: Parts 1 - 2." PHOTOGRAPHIC NEWS 4, no. 112-113 (Oct. 26 - Nov. 2, 1860): 302-303, 314-315.

R149 "Note." PHOTOGRAPHIC NEWS 4, no. 115 (Nov. 16, 1860): 348. [Rejlander was induced to give a paper "The Camera of Horrors" at next meeting of Birmingham Photo Soc. Mentions this the first time since paper read before Photo. Soc. of London a few years ago.]

R150 Rejlander, O. G. "The Camera of Horrors; or Failures in the Wet Process." BRITISH JOURNAL OF PHOTOGRAPHY 8, no. 134 (Jan. 15, 1861): 29-30.

R151 Rejlander, O. J. "The Camera of Horrors: or Failures in the Wet Process." HUMPHREY'S JOURNAL OF PHOTOGRAPHY, AND THE ALLIED ARTS AND SCIENCES 12, no. 22 (Mar. 15, 1861): 349-352. [Read to Birmingham Photo. Soc. From "Br. J. of Photo."]

R152 "A Tribute of Affection." BRITISH JOURNAL OF PHOTOGRAPHY 9, no. 158 (Jan. 15, 1862): 19-20. [O. G. Rejlander intending to create an allegorical photo as a tribute to the memory of the late Prince Albert.]

R153 "Note." ART JOURNAL (Apr. 1862): 110. [A lithographed portrait of the Prince Concert from photo of O. G. Rejlander. Recently published by Wood at Edinburgh.]

R154 "New Publications: Portrait of H.R.H. the late Prince Consort; James Wood, Edinburgh." BRITISH JOURNAL OF PHOTOGRAPHY 9, no. 163 (Apr. 1, 1862): 138. [Lithographic portrait of Prince Albert, from a photo taken by O. G. Rejlander.]

R155 "Fine-Art Gossip." ATHENAEUM no. 1800 (Apr. 26, 1862): 568. ["Mr. James Wood, of Edinburgh, has published a good lithographic portrait of the Prince Consort, drawn by G. Schacher from a photograph by O. G. Rejlander."]

R156 "Our Weekly Gossip." ATHENAEUM no. 1826 (Oct. 25, 1862): 531. [Rejlander created a genre scene, titled "Vision of Aspromonte," containing a model representing Garibaldi. The critic was angered by this and took Rejlander to task.]

R157 Rejlander, O. G. "An Apology for Art-Photography." BRITISH JOURNAL OF PHOTOGRAPHY 10, no. 184 (Feb. 16, 1863): 76-78. [Read before South London Photo. Soc., Feb. 12, 1863. The report of the meeting of that society, on p. 81 gives additional information about Rejlander and his paper.]

R158 "Mr. O. G. Rejlander's Glass Room, &c." BRITISH JOURNAL OF PHOTOGRAPHY 10, no. 185 (Mar. 2, 1863): 96-97. 1 illus.

R159 Harvey, T. W. "Correspondence: Fine Art and Photography." BRITISH JOURNAL OF PHOTOGRAPHY 10, no. 190 (May 15, 1863): 219-220. [Harvey, a painter, who held a photo show at Edinburgh, was supposed to have made some comment then construed to be disparaging of Rejlander's work. His letter here to Rejlander is to set the record straight, likes Rejlander's work best, just doesn't feel that photo will ever match painting in that arena.]

R160 "Photographic Pictures and Illustrations." BRITISH JOURNAL OF PHOTOGRAPHY 8, no. 137 (Sept. 15, 1863): 359-361. [Rejlander's photographs discussed.]

R161 Rejlander, Oscar. "An Appeal to Photographers." BRITISH JOURNAL OF PHOTOGRAPHY 11, no. 221 (July 29, 1864): 266.

[Letter from Rejlander, asking for photographers to band together to discover a cure for problems caused by working with wet collodion in hot weather.]

R162 Rejlander, O. G. "On Medals, Exhibitions, etc." BRITISH JOURNAL OF PHOTOGRAPHY 11, no. 227 (Sept. 9, 1864): 341.

R163 Rejlander, O. G. "Rejlander in Type." BRITISH JOURNAL OF PHOTOGRAPHY 12, no. 279 (Sept. 8, 1865): 462. [Protesting medals given at the North London Photo. Assoc. Exhibition.]

R164 Rejlander, Oscar G. "Correspondence: An Explanation by Mr. Rejlander." BRITISH JOURNAL OF PHOTOGRAPHY 12, no. 289 (Nov. 17, 1865): 588-589. [Letter from Rejlander, denying an article excerpted from the German "Photographische Mittheilungen," stating he was quitting photography.]

R165 Rejlander, O. G. "Photography as the Handmaid of Art to Artists." BRITISH JOURNAL PHOTOGRAPHIC ALMANAC 1866 (1866): 92-94.

R166 "Salad for the Photographer." PHILADELPHIA PHOTOGRAPHER 3, no. 26 (Feb. 1866): 61. [Mr. Rejlander read paper "On the Uses of Photography to Artists" at Associated Arts Institute. Reported from the "News."]

R167 "Coquetry. From a conversation with O. G. Rejlander." BRITISH JOURNAL PHOTOGRAPHIC ALMANAC 1867 (1867): 61-62.

R168 "The Photographs of Rejlander." ART JOURNAL (Jan. 1868): 15.

R169 "Portraiture Out of Doors." PHILADELPHIA PHOTOGRAPHER 5, no. 57 (Sept. 1868): 336-337. 1 illus. [Article is about devising a portable screen and shade system - using as an example, the system that Rejlander uses. [Reprint from "Br. Journal of Photo."]

R170 "Note." ART JOURNAL (Dec. 1869): 382. [Mentions the Annual Exhibit of Photo Society. Foremost exhibitors Robinson & Cherrill, Rejlander, Colonel Stuart Wortley [clouds & moonlight] Capt. Lyon [temples in India]. Notice, on same page, mentioning that Rejlander produced a portrait of Gustave Doré.]

R171 Rejlander, O. G. "Addressed to an Art-Critic." BRITISH JOURNAL PHOTOGRAPHIC ALMANAC 1870 (1870): 148.

R172 Simpson, G. Wharton. "Notes In and Out of the Studio." PHILADELPHIA PHOTOGRAPHER 7, no. 73 (Jan. 1870): 22. [Note on a series of pictures exhibited by Rejlander, "How to recover a lost negative when you have a print thereof."]

R173 Rejlander, O. G. "The Photographic Press." BRITISH JOURNAL PHOTOGRAPHIC ALMANAC 1871 (1871): 113-114.

R174 Portraits. Woodcut engravings credited "From a photograph by O. G. Rejlander." ILLUSTRATED LONDON NEWS 58, (1871) ["The late Alexander Munro." 58:1634 (Jan. 28, 1871): 96.]

R175 Portrait. Woodcut engraving, credited to "From a Photograph by O. G. Rejlander." ILLUSTRATED LONDON NEWS 59, (1871) ["Late Sir T. D. Acland." 59:1663 (Aug. 5, 1871): 116. Albert Mansions, Victoria St., London.]

R176 Rejlander, O. G. "Hints Concerning The Photographing of Criminals." BRITISH JOURNAL PHOTOGRAPHIC ALMANAC 1872 (1872): 116-117.

R177 Rejlander, O. G. "On Photographing Horses." BRITISH JOURNAL PHOTOGRAPHIC ALMANAC 1873 (1873): 115.

R178 Rejlander, O. G. "Art Backgrounds versus Artificial Backgrounds." BRITISH JOURNAL PHOTOGRAPHIC ALMANAC 1874 (1874): 145-146.

R179 "Rejlander Memorial Fund." ANTHONY'S PHOTOGRAPHIC BULLETIN 6, no. 7 (July 1875): 215. [From "Br J of Photo."]

R180 Rejlander, Oscar G. "Our Foreign Make Up: Mottos for Photographers." PHOTOGRAPHIC TIMES 5, no. 56 (Aug. 1875): 198-199. [From "Photographic News." Mrs. Rejlander found these sayings in her late husband's papers.]

R181 Draper, E. "The Late O. G. Rejlander." BRITISH JOURNAL OF PHOTOGRAPHY 22, no. 769 (Aug. 29, 1875): 45-56. 1 illus. [Obituary, with portrait.]

R182 "Matters of the Month." PHOTOGRAPHIC TIMES 7, no. 81 (Sept. 1877): 208. ["The memory of Mr. O.G. Rejlander, the eminent photographer, is to be perpetuated by a suitable gravestone, which is being executed at the instance of some of his friends.]

R183 A. F. S. "A Reminiscence of the Late O. G. Rejlander." BRITISH JOURNAL PHOTOGRAPHIC ALMANAC, AND PHOTOGRAPHER'S DAILY COMPANION, 1881 (1881): 198-200.

R184 Wall, A. H. "Rejlander's Photographic Art Studies. - Their Teachings and Suggestions. Chapters I - X." PHOTOGRAPHIC NEWS 30-31, no. 1456-1478, 1485-1513 (July 30 - Dec. 31, 1886, Feb. 18 - Sept. 2, 1887): (1886) 483-484, 548-459, 563-565, 618-620, 652-653, 771-772, 834-836 (1887) 101-102, 362-364, 546-548. 32 b & w. 1 illus.

R185 Wall, A. H. "Rejlander's Photographic Studies: Their Teachings and Suggestions." PHOTOGRAPHIC TIMES 16-17, no. 257-287 (Aug. 20, 1886 - Mar. 18, 1887): (vol. 16) 435-437, 505-508, 532-533, 555-556, 567-568, 580-581, 672-673, (vol. 17) 72-73, 121, 131-132. [From "Photographic News". Chapter I. Introductory. Chapter II. Two Ways of Life. Chapter III. Pose and Expression. 4 b & w. Chapter IV. Studies and Stories. 2 b & w. Chapter V. Studies and Stories. 2 b & w. Chapter V. Studies and Stories." 2 b & w. Chapter VI. Photographing Children. 3 b & w. Chapter VII. Allegorical Figures and Studies from Pictures. 2 b & w. Chapter VIII. Domestic and Fancy Subjects. 1 b & w. Chapter VIII. (Conclusion). 2 b & w.]

R186 Emerson, P. H. "Our English Letter: O. G. Rejlander." AMERICAN AMATEUR PHOTOGRAPHER 2, no. 2 (Feb. 1890): 72-75.

R187 "Notes and News." PHOTOGRAPHIC TIMES 20, no. 445 (Mar. 28, 1890): 155. ["The Widow of Rejlander, the famous English photographer of years ago, has prepared some albums, containing 72 prints, from his negatives, of whole-plate size, to be sold at $26.00. Her address is 2 Waverly Villas, Bruce Grove, Tottenham."]

R188 "Notes and News: Artistic Photography." PHOTOGRAPHIC TIMES 21, no. 517 (Aug. 14, 1891): 411. [Discusses Rejlander and J. M. Cameron as "earliest workers...attempting to treat figures artistically by photographing..." From "Magazine of Art" Aug. 1891.]

R189 "Notes and News: Mrs. Rejlander." PHOTOGRAPHIC TIMES 24, no. 665 (June 15, 1894): 382. 1 b & w. [Appeal for aid for Rejlander's widow. Includes a portrait of Rejlander and his wife.]

R190 "Note." PHOTOGRAPHIC TIMES 29, no. 2 (Feb. 1897): 84. [Quote from Rejlander. "In all picture compositions the thought should take first place, and all else be regarded as the language which is to give it expression".]

R191 White, Minor. "Oscar Rejlander and the Model." IMAGE 3, no. 4 (Apr. 1954): 26-28. 3 b & w.

R192 MacDonnell, Kevin. "Homage a Madame Wharton." PHOTOGRAPHY (LONDON) 16, no. 10 (Oct. 1961): 20-22. 4 illus. [Four illustrations of nudes taken by Rejlander for his 1857 photograph 'Two Ways of Life.']

R193 Scharf, Aaron. "Album." CREATIVE CAMERA no. 48 (June 1968): 206-207. ["Charles Darwin's, 'The Expression of the Emotions in May and Animals.'"]

R194 Rejlander, Oscar G. "Photography As the Handmaid of Art." IMAGE 14, no. 1 (Jan. 1971): 12-13. 1 b & w. [Facsimile reprint of pp. 92-94 from the "Br. J. of Photo. Almanac and Photographers Daily Companion, 1866."]

R195 Fuller, John C. "O. G. Rejlander: From Philistine to Forerunner." EXPOSURE 14, no. 4 (Dec. 1976): 32-36. 3 b & w. [Three of Rejlander's photos examined in relation to Victorian painting tradition and Charles Dickens' novel "Hard Times."]

R196 "Cuthbert Bede and O. G. Rejlander." HISTORY OF PHOTOGRAPHY 1, no. 3 (July 1977): 213-214. 3 illus.

R197 Jay, Bill. "Charles Darwin, Photography and Everything Else." BRITISH JOURNAL OF PHOTOGRAPHY 127, no. 45 (Nov. 7, 1980): 1116-1118. [Darwin and his relationship to photography, particularly his use of photographs for his book 'The Expression of the Emotions in Man and Animals.']

R198 "Art and Photography: Two Studies by O. G. Rejlander." HISTORY OF PHOTOGRAPHY 9, no. 1 (Jan. - Mar. 1985): 47-52. 2 b & w. 2 illus.

R199 Fielding, A. G. "Rejlander in Wolverhampton. His Sponsorship by William Parke." HISTORY OF PHOTOGRAPHY 11, no. 1 (Jan. - Mar. 1987): 15-22. 1 b & w. 9 illus.

R200 "Vignette: Polka Tot." HISTORY OF PHOTOGRAPHY 11, no. 4 (Oct. - Dec. 1987): 328. 1 illus. [O. G. Rejlander's portrait of a crying baby, known as "Ginx's Baby," inspired the songwriter J. C. Drane to write a polka with that name. The illustration is of the cover of the sheet music, with a lithograph from the photograph. Ca. 1860s.]

REJLANDER, OSCAR J. [?]
R201 "A Norseman." "Shellac Varnish for Photographers." HUMPHREY'S JOURNAL OF PHOTOGRAPHY, AND THE ALLIED ARTS AND SCIENCES 18, no. 24 (Apr. 15, 1867): 379-380. [From "Photo. News." "It vexes one to see a useful suggestion, tumbled into the limbo...It has vexed me so much that, for the first time, though an old photographer, I shake off my indolent repugnance, and ask you to put me in your 'News.'" "I have varnished ten thousand card plates with it, and all my larger sizes, including some hundreds of 8 by 10, and not a few larger, up to 24 by 18...." (signed A. Norseman, which may be a pseudonym for O. J. Rejlander.)]

REMELÉ, PHILIPP. (d. 1883)
R202 Remelé. "Note on the Employment of Iron Developers." HUMPHREY'S JOURNAL OF PHOTOGRAPHY, AND THE ALLIED ARTS AND SCIENCES 18, no. 22 (Mar. 15, 1867): 342-343. [From "Bulletin Belge de la Photographie."]

R203 Remelé, Philipp. "A Photographer's Experience in the Libyan Desert." ANTHONY'S PHOTOGRAPHIC BULLETIN 6, no. 5 (May 1875): 138-140. [From "Br J of Photo." Trip with a Mr. Rohlf, who wished to have photographic portraits of the natives, and a Prof. Zittel, who was a geologist. Remelé made views in Farafrah and Dachel and vicinity. Also made portraits in Dachel.]

R204 "Topics of the Times." PHOTOGRAPHIC TIMES 7, no. 79 (July 1877): 159. [From "Mittheilungen." Expedition to Morocco which started from Germany in April arrived safely in Tangiers, where Herr Remelé has been taking views and groups of natives...before setting out for the interior.]

REMICK, H. (PORTSMOUTH, NH)
R205 Remick, H. "Ignorant Criticisms." HUMPHREY'S JOURNAL OF PHOTOGRAPHY, AND THE ALLIED ARTS AND SCIENCES 15, no. 5 (July 1, 1863): 70-71. [Protesting abuses of loaning portrait proofs to the customer to take home for decision making.]

RENARD.
R206 1 photo (Emperor William of Germany visiting his naval ship "Luchs" before it sailed to China). COLLIER'S WEEKLY 25, no. 23 (Sept. 8, 1900): 18. ["Photographed by Renard, Kiel."]

RENARD, FRANÇOIS-AUGUSTE. (PARIS, FRANCE)
R207 "Gossip." PHOTOGRAPHIC ART JOURNAL 3, no. 2 (Feb. 1852): 125-126. [Long discourse on improvements in the medium in face of adverse criticisms, etc., ends with fulsome praise of the paper photos of Renard, Paris.]

REUBEN, LEVI.
R208 Reuben, Levi, M.D. "The Stereoscope. A New Philosophical Pleasure." PHOTOGRAPHIC AND FINE ART JOURNAL 12, no. 1 (June 1859): 1-3. [From "Life Illustrated."]

REUTLINGER, CHARLES. (1816-) (GERMANY, FRANCE)
[Karl Reutlinger born on Feb. 25, 1816 in Karlsruhe. On Aug. 27, 1825 his brother Emile-Auguste also was born in Karlsruhe. Karl learned daguerreotypy from Friedreich Brandseph in Stuttgart, and worked there from 1840-49. In 1850 he moved to Paris, changed his name to Charles, and opened a major studio. In 1864 Charles began long-term project to make cabinet portraits of political figures, scientists, academics, etc., which he expanded to include personalities in the theatre and the arts in 1870s, producing *Catalogue de Personnalities* in 1873 and *Foyers et Coulisses* in 1875. In 1880 Emile-Auguste, who had travelled and worked in the United States, and South America, took over the Reutlinger Studio in Paris from Charles. Emile's son Léopold took over from him in 1890, and relatives continued the studio into the 1930s. Emile died at Baden in 1907.]

R209 Portrait. Woodcut engraving credited "From a photograph by Reut, [sic. Reutlinger] of Paris." ILLUSTRATED LONDON NEWS 43, (1863) ["General Pezet, President of Peru." 43:* (Aug. 15, 1863): 169.]

R210 Portrait. Woodcut engraving credited "From a photograph by Reutlinger." ILLUSTRATED LONDON NEWS 51, (1867) ["Mdlle. Christine Nilsson." 51:* (Aug. 3, 1867): 112.]

R211 "Editor's Table." PHILADELPHIA PHOTOGRAPHER 4, no. 45 (Sept. 1867): 304. [Portraits.]

R212 "Editor's Table." PHILADELPHIA PHOTOGRAPHER 4, no. 47 (Nov. 1867): 367. [Cabinet portraits received from Charles Reutlinger, 21 Boulevard Montmarte and 112 Rue Richelieu, Paris.]

R213 North, Walter C. "Paris Correspondence." PHILADELPHIA PHOTOGRAPHER 4, no. 48 (Dec. 1867): 389-391. [Describes visit to Reutlinger and to Adam-Salomon, both in Paris.]

R214 "Our Picture." PHILADELPHIA PHOTOGRAPHER 6, no. 61 (Jan. 1869): frontispiece, 30-31. 1 b & w. [Portrait.]

R215 "The Reutlinger Studio. Parts 1-2." PHILADELPHIA PHOTOGRAPHER 6, no. 64, 68 (Apr., Aug. 1869): 115-116, 258-260. 1 illus.

R216 "Prize Photographs." ANTHONY'S PHOTOGRAPHIC BULLETIN 1, no. 1 (Feb. 1870): 3. [Announcement of exhibition of photos by Charles Reutlinger, of Paris, at the Anthony Store in New York, NY.]

R217 Portrait. Woodcut engraving credited "From a photograph by Reutlinger, of Paris." ILLUSTRATED LONDON NEWS 58, (1870) ["M. Prevost-Paradol, French Ambassador to U.S." 58:* (Aug. 6, 1870): 145.]

R218 Portraits. Woodcut engravings credited "From a photograph by Reutlinger." ILLUSTRATED LONDON NEWS 63, (1873) ["Late Dr. Nelation." 63:1778 (Sept. 27, 1873): 293. "Duc de Broglie." 63:1786 (Nov. 22, 1873): 489.]

R219 "Another Photographic Novelty." ANTHONY'S PHOTOGRAPHIC BULLETIN 4, no. 12 (Dec. 1873): 361. [From "Photo. News." Glazed cameo portraits.]

R220 Lacan, Ernest. "Photography in France." PHILADELPHIA PHOTOGRAPHER 11, no. 121 (Jan. 1874): 4-6, plus 1 etching of studio. 1 illus.

R221 Portrait. Woodcut engraving credited "From a photograph by Reutlinger." ILLUSTRATED LONDON NEWS 64, (1874) ["Late M. Michelet, French historian." 64:1801 (Feb. 28, 1874): 201.]

R222 Portraits. Woodcut engravings credited "From a photograph by C. Reutlinger, Boulevard Montmarte, Paris." ILLUSTRATED LONDON NEWS 72, (1878) ["Dufaure, Prime Minister of France." 72:2010 (Jan. 5, 1878): 4. "Late François V. Raspail." 72:2012 (Jan. 19, 1878): 65.]

R223 Portrait. Woodcut engraving credited "From a photograph by Reutlinger." ILLUSTRATED LONDON NEWS 73, (1878) ["Late Mr. John Penn, Engineer." 73:2049 (Oct. 5, 1878): 325.]

R224 Portraits. Woodcut engravings credited "From a photograph by Reutlinger." ILLUSTRATED LONDON NEWS 74, (1879) ["Mdlle. Sarah Bernhardt, Mdlle. Jeanne Samary, Mdlle. Sophie Croizette, three of the principal actresses of the Comedie Française." 74:2086 (June 7, 1879): 529. "M. Delaunay, M. Got, M. Mounet-Sully, actors of the Comedie Française." 74:2088 (June 21, 1879): 580.]

R225 Portrait. Woodcut engraving credited "From a photograph by Reutlinger." ILLUSTRATED LONDON NEWS 75, (1879) ["M. Coquelin, of the Comédie Française." 75:2090 (July 5, 1879): 21.]

REUTLINGER, EMILE AUGUSTE (1825-1907) see REUTLINGER, CHARLES.

REVELEY, HENRY W.
R226 Reveley, Henry W. "Photography." JOURNAL OF THE SOCIETY OF ARTS (LONDON) 1, no. 16 (Mar. 11, 1853): 189-190. [Response to Claudet's letter in Feb. 1853 issue.]

REYNAUD, E.
R227 Reynaud, E. "Wet Collodion Process." HUMPHREY'S JOURNAL OF PHOTOGRAPHY, AND THE ALLIED ARTS AND SCIENCES 14, no. 21 (Mar. 1, 1863): 281-284. [From "Moniteur de la Photographie."]

REYNOLDS, G. L. (USA)
R228 Reynolds, G. L. *The Photographer's Guide, being a Complete Revelation of All the Mysteries Connected with the Daguerreotype...* Penn Yan, NY: Rodney L. Adams, printer, 1850. n. p. [No extant copies known.]

REYNOLDS, J. EMERSON. (1844-1920) (GREAT BRITAIN)
R229 Reynolds, J. Emerson., F.R.G.S. "Tannin, and Its Impurities." AMERICAN JOURNAL OF PHOTOGRAPHY AND THE ALLIED ARTS & SCIENCES n. s. vol. 7, no. 13 (Jan. 1, 1865): 289-293. [From "Br. J. of Photo."]

R230 Reynolds, Emerson J. "Heliochromy." BRITISH JOURNAL OF PHOTOGRAPHY 12, no. 292 (Dec. 8, 1865): 616.

R231 Reynolds, J. Emerson, M.D. "Magic Lantern Arrangements." HUMPHREY'S JOURNAL OF PHOTOGRAPHY, AND THE ALLIED ARTS AND SCIENCES 18, no. 22 (Mar. 15, 1867): 350. [From "Br. J. of Photo."]

R232 "Obituary: J. Emerson Reynolds (Feb. 22, 1920)." BRITISH JOURNAL PHOTOGRAPHIC ALMANAC 1921 (1921): 314. [Born in 1844. Contributed many technical articles to the "BJP" until about 1865. Edited the "BJPA" in 1863, 1864. Appointed Professor of Chemistry at Royal College of Surgeons, Ireland and seems to have dropped photography.]

RHODES, W. E. (d. 1877) (USA)
R233 "Note." PHILADELPHIA PHOTOGRAPHER 14, no. 158 (Feb. 1877): 42. [Excerpt from "Philadelphia Ledger," Jan. 23, that W. E. Rhodes (Quincy, IL) was murdered by robbers on Jan. 22.]

RHODES, WILLIAM H. (ca. 1835-1885) (USA)
R234 "Editor's Table: Another New Gallery." PHILADELPHIA PHOTOGRAPHER 3, no. 29 (May 1866): 159. [Rhodes opens a new gallery in Philadelphia, PA.]

R235 "Editor's Table." PHILADELPHIA PHOTOGRAPHER 4, no. 40 (Apr. 1867): 127. [Rhoads (Philadelphia, PA) made photo titled "The Fruits of a Tin Wedding."]

R236 Rhodes, William H. "Correspondence: The Alum-Silver Bath." ANTHONY'S PHOTOGRAPHIC BULLETIN 2, no. 10 (Oct. 1871): 337. [Rhodes from Philadelphia, PA.]

R237 "Editor's Table." PHILADELPHIA PHOTOGRAPHER 14, no. 166 (Oct. 1877): 320. [Wm. H. Rhodes (Philadelphia, PA) opens a gallery.]

R238 "Obituary: William H. Rhoads." PHOTOGRAPHIC TIMES 15, no. 182 (Mar. 13, 1885): 129. [Died Feb. 3, 1885 at "about fifty years

of age." Photographer in Philadelphia. Member of the National Photographic Assoc. and its Secretary in 1872. Ill health made him close gallery and go to Florida. Died in Florida.]

R239 "Obituary: William H. Rhodes." PHILADELPHIA PHOTOGRAPHER 22, no. 255 (Mar. 1885): 80. [Rhodes, of Philadelphia, died in Florida on Feb. 3, 1885. Though only about fifty years of age, he was one of the earliest photographers in Philadelphia, and one of the best. National Photographer's Assoc. member and Local Secretary in 1872. Ill health forced him to close his business and move to Florida - but the move was not successful.]

RICE BROTHERS. (WASHINGTON, DC)
R240 Portrait. Woodcut engraving, credited "Photographed by Rice, of Washington, DC." FRANK LESLIE'S ILLUSTRATED NEWSPAPER 38, (1874) ["Mr. S. J. Kimball, chief of the life-saving service." 38:967 (Apr. 11, 1874): 76.]

R241 "Residence of Senator Stewart, of Nevada, at Washington, D. C. Photographed by Rice Brothers." FRANK LESLIE'S ILLUSTRATED NEWSPAPER 38, no. 973 (May 23, 1874): 172. 1 illus. [View.]

R242 Portrait. Woodcut engravings, credited "From a Photograph by Rice Brothers, Washington, DC." FRANK LESLIE'S ILLUSTRATED NEWSPAPER 35, (1872) ["Hon. John Young Brown, from KY." 39:1014 (Mar. 6, 1875): 421.]

R243 Portrait. Woodcut engraving, credited "From a Photograph by Rice Brothers, Washington, D. C. FRANK LESLIE'S ILLUSTRATED NEWSPAPER 40, (1875) ["Hon. John C. New, US Treasurer." 40:1040 (Sept. 4, 1875): 441.]

R244 "Washington, D. C. - The Arraignment of General W. W. Belknap, Late Secretary of War, at the Police Court, on March 8th." and " The Arrest of General W. W. Belknap, at his Residence, 2022 G Street, N. W. - From a Photograph by Rice Bros., and Sketches by Our Special Artist." FRANK LESLIE'S ILLUSTRATED NEWSPAPER 42, no. 1069 (Mar. 25, 1876): 40-41. 2 illus. [Interior, with crowd. View.]

R245 Portrait. Woodcut engraving, credited "From a Photograph by Rice Brothers, Washington, D. C." FRANK LESLIE'S ILLUSTRATED NEWSPAPER 42, (1876) ["Hon. Albert N. Wyman, US Treasurer." 42:1088 (Aug. 5, 1876): 365.]

R246 Portrait. Woodcut engraving, credited "From a Photograph by Rice Brothers, Washington, D. C. FRANK LESLIE'S ILLUSTRATED NEWSPAPER 46, (1878) ["M. Leon Chottreau, Agent from France." 46:1187 (June 29, 1878): 296.]

R247 Portrait. Woodcut engraving, credited "From a Photograph by Rice." FRANK LESLIE'S ILLUSTRATED NEWSPAPER 49, (1879) ["General Edward Hatch, Col. 9th US Cavalry." 49:1265 (Dec. 27, 1879): 301.]

RICHARDS & BETTS. (PHILADELPHIA, PA)
R248 "Old Mill on the Brandywine." PHOTOGRAPHIC AND FINE ART JOURNAL 7, no. 10 (Oct. 1854): frontispiece, 316. 1 b & w. [Original photograph, tipped-in.]

R249 F. D. B. R. "Steinhausen's 'Hero and Leander.'" PHOTOGRAPHIC AND FINE ART JOURNAL 8, no. 4 (Apr. 1855): frontispiece, 122-123. 1 b & w. [Original print containing a view of a statuary group by the sculptor Charles Steinhausen, taken by Richards & Betts. There is commentary about the artwork -(not the photograph) on pp. 122-123.]

RICHARDS, FREDERICK D. see also RICHARDS & BETTS.

RICHARDS, FREDERICK DEBOURG. (1822-1903) (USA)
[Worked as a landscape painter in New York, NY in 1844-45. Moved to Philadelphia and became a daguerreotypist in 1848. Exhibited daguerreotypes at the Institute of American Manufactures, Philadelphia from 1848 to 1856 as well as in New York, NY and Washington, DC. Worked with early paper processes in the 1850s. Made landscape views of Pennsylvania in 1850s. Travelled through Europe in 1855, wrote a book on his experiences there. Partner with John Betts from 1854 to 1857. Photographed President-elect Abraham Lincoln in front of Independence Hall in February 1861. Visited Paris in 1868. Went on to become a prominent landscape and marine artist, working in etchings, watercolors, and oils.]

BOOKS
R250 Richards, F. D. B. *Random Sketches, or What I Saw in Europe: From the Portfolio of an Artist.* Philadelphia: G. Collins, 1857. 344 pp. [Richards published some of those written sketches in the "P & FAJ." The book is described as photographically illustrated.]

R251 Richards, Frederick DeBourg. *Pictorial Views of Houses and Places in Germantown in 1859.* Philadelphia: Richards [?], ca. 1859. n. p. 20 b & w. [Twenty salt paper prints by Richards in an album in the collections of the Philadelphia Library Company. A similar album is held by the Germantown Historical Society. They were probably compiled by John Fanning Watson, who commissioned Richards to take the photographs.]

PERIODICALS
R252 Daguerre, Jr. "Letter." HUMPHREY'S JOURNAL 4, no. 15 (Nov. 15, 1852): 235. [Letter praising Richards (Philadelphia, PA) for winning awards at the Franklin Institute Fair.]

R253 "Richards' Stereoscopes." HUMPHREY'S JOURNAL 4, no. 16 (Dec. 1, 1852): 253. [Praise for F. D. B. Richards (Philadelphia, PA), "who is one of the most extensive manufacturers in the country."]

R254 Richards, F. D. B. "Fair of the Franklin Institute." PHOTOGRAPHIC ART JOURNAL 6, no. 6 (Dec. 1853): 381-382. [Richards won silver medal, his letter is replying to charges of favoritism.]

R255 Richards, F. D. B. "Notes of a Trip to Europe. No. 1." PHOTOGRAPHIC AND FINE ART JOURNAL 8, no. 11 (Nov. 1855): 349-350.

R256 Richards, F. D. B. "Notes of a Trip to Europe." PHOTOGRAPHIC AND FINE ART JOURNAL 9, no. 1-11 (Jan. - Nov. 1856): 22-23, 84-85, 120, 175-176, 242, 283-284, 341-342. [Describes his experiences in travelling through England and Continental Europe. Richards knew and met other photographers, but primarily it is an account of his own experiences.]

R257 "President Lincoln Hoisting the American Flag with Thirty-Four Stars Upon Independence Hall, Philadelphia, February 22, 1861." HARPER'S WEEKLY 5, no. 219 (Mar. 9, 1861): 145. 1 illus. ["From Photographs by F. D. Richards, Philadelphia."]

R258 Portrait. Woodcut engraving, credited "From a Photograph by F. D. B. Richards." HARPER'S WEEKLY 9, (1865) ["John H. Rock, Colored Counselor." 9:426 (Feb. 25, 1865): 124.]

R259 "Three Famous Singers: From Daguerreotypes by Richards of Philadelphia. I. Jenny Lind, II. Catherine Hayes, III. Adelia Patti."

CENTURY MAGAZINE 67, no. 5 (Mar. 1904): 671-674. 3 b & w. [Portfolio.]

RICHARDS, W. A.
R260 "Rhode Island. - Dedication of the Roger William Monument at Providence, Oct. 16. - From a Photo. by W. A. Richards." FRANK LESLIE'S ILLUSTRATED NEWSPAPER 45, no. 1154 (Nov. 10, 1877): 161. 1 illus. [View, with crowds.]

RICHARDSON, BENJAMIN P. (1834-1925) (USA)
R261 Richardson, Benjamin P. "Home Portraiture." AMERICAN ANNUAL OF PHOTOGRAPHY AND PHOTOGRAPHIC TIMES ALMANAC FOR 1891 (1891): 255-258. 2 illus.

R262 "Sarony's Cameraman." IMAGE 1, no. 6 (Sept. 1952): 3-4. 1 b & w.

RICHARDSON, VILLROY L. (LIMA, PERU)
R263 "The Earthquake at Arequipa, Peru." ILLUSTRATED LONDON NEWS 53, no. 1509 (Oct. 31, 1868): 416-417, 420, 433. 5 illus. ["We have been favored by the Secretary of State for the Foreign Department with a set of photographers sent by the British Consul in Lima, of the city of Arequipa...executed by Mr. Richardson, of the Calle de Espaderos in Lima..."]

R264 "Peruvian Expedition Hall at Lima." ILLUSTRATED LONDON NEWS 61, no. 1726 (Oct. 5, 1872): 340. 1 illus.

R265 McElroy, Keith. "Montage or Reportage?" HISTORY OF PHOTOGRAPHY 3, no. 3 (July 1979): 252. 1 b & w. 1 illus. [The use of photomontage for political caricature in Peru in 1872.]

RICHEBOURG, PIERRE-AMBROSE. (1810-) (FRANCE)
[Richebourg studied with the optician Vincent Chevalier in 1839, and together they made daguerreotype plates and lenses in the early 1840s. Richebourg studied with Daguerre and made his equipment. Chevalier and Richebourg also created several microscopic daguerreotypes at that time. Richebourg opened a studio in Paris in 1841. Published *Nouveau manuel complémentaire por l'usage pratique du daguerreotype* in 1843. Made portraits and views through 1840s and taught the process. In 1853 he published *Nouveau manuel de photographie sur collodion.* In 1856 he photographed the reception of Queen Victoria at the Hôtel de Ville de Paris, then the infant Prince Imperial of France, the Universal Agricultural Exposition in Paris, festivals in Cherbourg in 1858, and a broad range of other activities. In 1859 he exhibited two hundred photographs taken in and around St. Petersburg, and illustrated the publication *Trésors d'art de la Russie ancienne et moderne,* text by Théophile Gautier. (Paris: Gide, 1859. 60 b & w.) By 1864 he credits himself as photographer to the crown, photographer to the Hôtel de Ville in Paris, and photographer to the Ministry of Fine Arts. Made mug shots and evidence photographs for the Paris police in the 1860s. Probably died in the middle 1870s.]

R266 "1 engraving (The Imperial Prince in His Cradle)." ILLUSTRATED LONDON NEWS 28, no. 794 (Apr. 19, 1856): 408. 1 illus. ["From a photograph taken at the Tuileries, by M. Richebourg."]

R267 "3 engravings (Hungarian shepherds)." ILLUSTRATED LONDON NEWS 28, no. 808 (June 28, 1856): 709. 3 illus. ["From a photograph by M. Richebourg." Three costume portraits of Hungarian shepherds, taken at the Universal Agricultural Exhibition in Paris, in 1856.]

RICHMOND, W. D.
R268 Richmond, W. D. "The Simplicity of Collodio - Bromide." BRITISH JOURNAL PHOTOGRAPHIC ALMANAC 1879 (1879): 53-55. [Richmond states he has been working with collodio-bromide since 1861, with the Fothergill process. "Though working at photography only occasionally..."]

RICKEY & CARROL. (CINCINNATI, OH)
R269 Portrait. Woodcut engraving, credited "From aPhotograph by Rickey & Carrol." NEW YORK ILLUSTRATED NEWS 9, (1863) ["Brig.-Gen. W. H. Lytle." 9:210 (Nov. 6, 1863): 21.]

RIDDLE. (MACON, GA)
R270 Portrait. Woodcut engraving, credited "From a Photograph by Riddle, of Macon, GA." HARPER'S WEEKLY 11, (1867) ["J. Clarke Swayze." 11:523 (Jan. 5, 1867): 13.]

RIDEAU. (CHREBOURG, FRANCE)
R271 Portrait. Woodcut engraving credited "From a photograph by Maison Rideau, Cherbourg, France." ILLUSTRATED LONDON NEWS 45, (1864) ["David Herbert Llewellyn, Surgeon of 'C.S.S. Alabama.'" 45:* (July 9, 1864): 41.]

RILEY. (RICHMOND, ENGLAND)
R272 Portrait. Woodcut engraving credited "From a photograph by Riley, of Richmond." ILLUSTRATED LONDON NEWS 56, (1870) ["Matthew Greadhead, Centenarian." 56:* (June 11, 1870): 608.]

RIMNER, RICHARD.
R273 "Miscellanea: Photography on Wood." ATHENAEUM no. 1228 (May 10, 1851): 509. [Letter from Richard Rimner, describing his experiences with photographing on wood.]

RINEHART, ALFRED EVANS. (USA)
R274 "Our Pictures." WILSON'S PHOTOGRAPHIC MAGAZINE 32, no. 458 (Feb. 1895): 72-73, plus unnumbered leaf tipped in. 1 b & w.

R275 "Photographers, Old and New: A. E. Rinehart." WILSON'S PHOTOGRAPHIC MAGAZINE 32, no. 458 (Feb. 1895): 65. [Rinehart of Denver, CO. About 40. Studied photography at LaFayette, IN. Moved to Denver in 1874, worked for Charles Bohm. In 1880 formed a brief partnership with W. H. Jackson, Rinehart retaining the portrait department, after it dissolved.]

RINK, HINRICH JOHANNES.
R276 *Greenland;* photographs of Eskimos and scenes of Greenland, by H. J. Rink and others(?) s. l.: s. n., c. 1866. n. p. 17 b & w. [Album, NYPL collection.]

R277 Rink, Hinrich Johannes. *Illustrations to "Eskimoiske Eventyr og Sagr."* Copenhagen: s. n., 1866. n. p. 1 l. of plates. [One composite photo, made from forty-one faces. NYPL collection.]

RINTOUL, ALEXANDER NELSON. (GREAT BRITAIN)
R278 Rintoul, A. N. *A Guide to Painting Photographic Portraits, Draperies, Backgrounds, &c., in Water-Colours,* With Concise Instructions for tinting Paper, Glass, and Daguerreotype Pictures...With Coloured Diagrams. London: J. Barnard, 1855. 44 pp. illus. [4th ed. (n. d.) 74 p., 4 l. of plates.]

RITCHIE, J. H.
R279 "The Tannin Process." AMERICAN JOURNAL OF PHOTOGRAPHY, AND THE ALLIED ARTS AND SCIENCES n. s. vol.

9, no. 3 (Oct. 1, 1866): 50-55. [Read to West Kent Natural History, Microscopic, and Photographic Society.]

RITTER & MOLKENTELLER. (BOMBAY & POONAH, INDIA)

R280 Portrait. Woodcut engraving credited "From a photograph by Ritter & Molkenteller." ILLUSTRATED LONDON NEWS 67, (1875) ["Sir T. Madhava Rao, K.C.S.I." 67:1900 (Dec. 25, 1875): 633.]

RITTON, EDWARD D. (1823-1892) (USA)

R281 "Notes and News." PHOTOGRAPHIC TIMES 23, no. 590 (Jan. 6, 1893): 9. [Brief note from "Hartford Courant" that Ritton, who had "learned the Daguerreotype process when it was new fifty years ago," died in Danbury, Fri., Dec. 9th (1892) at age 69.]

RITZ see BOGARDUS, ABRAHAM.

ROBBIN, G.

R282 Robbin, G. "Photography on Wood." HUMPHREY'S JOURNAL OF PHOTOGRAPHY, AND THE ALLIED ARTS AND SCIENCES 9, no. 20 (Feb. 15, 1858): 308. [From "Photo. Notes."]

ROBBINS, C. R. (BIRMINGHAM, ENGLAND)

R283 Portrait. Woodcut engraving credited "From a photograph by C. R. Robbins, New Street, Birmingham." ILLUSTRATED LONDON NEWS 34, (1859) ["Joseph Sturge." 34:* (June 18, 1859): 580.]

ROBBINS, FRANK. (b. 1846) (USA)

R284 Robbins, Frank. "Dark Tent - On Packing Plates For Field Work." PHILADELPHIA PHOTOGRAPHER 12, no. 137 (May 1875): 140-141. 2 illus. [Robbins claims to have been making views for past 5 years - photographed in the Adirondack Mountains in 1871.]

ROBBINS, G. W.

R285 Robbins, G. W. "Spontaneous Combustion of Gun Cotton." AMERICAN JOURNAL OF PHOTOGRAPHY AND THE ALLIED ARTS AND SCIENCES n. s. vol. 2, no. 16 (Jan. 15, 1860): 254. [Robbins describes an explosion "in his room." His letter has for its address, "Mississippi River."]

ROBERT, LOUIS-REMY. (1810-1882) (FRANCE)

[Born in Paris in 1810. In 1832 he succeeded his father as director of painting on glass at the Sèvres porcelain factory in 1848. Learned photography from Victor Régnault in late 1840s. In 1853 he photographed Versailles, and Blanquart-Evrard would publish some of these in Souvenirs de Versailles. Joined the Société française de Photography in 1855. From 1855 to 1872 he taught photographic chemistry at the Ecole des Ponts et Chaussées. Succeeded Régnault as administer of the Sèvres factory in 1871 and held the position until 1879. Photographed Sévres and its surroundings, Saint-Cloud, Versailles, and in Brittany. Died in Sèvres in 1882.]

R286 "Biographical Notes on a Number of Photographers Published by Blanquart-Evrard." CAMERA (LUCERNE) 57, no. 12 (Dec. 1978): 32, 41-42. [Benecke, Claine, DuCamp, Fortier, Greene, Le Secq, Loydreau, Marville, Regnault, Robert, Salzmann, Stewart, Sutton, and Tenison.]

ROBERTS, G. P. (CANADA)

R287 "Proposed Union of the British North-American Provinces." ILLUSTRATED LONDON NEWS 45, no. 1287 (Nov. 12, 1864): 496. 4 illus. [View of the Province Building, Prince Edward Island, by Mr. G. P. Roberts, of St. John, New Brunswick. Three portraits of members of Canadian government by Ellisson & Co., Quebec.]

ROBERTS, MARTYN J.

R288 "Progress of Science: On the Cause of the Production of Daguerreotype Pictures." AMERICAN REPERTORY OF ARTS, SCIENCES AND MANUFACTURES 3, no. 5 (June 1841): 364-365. [From the "London Philosophical Magazine and Journal."]

ROBERTSON, A.

R289 Robertson, A. "The Stereotrope." HUMPHREY'S JOURNAL OF PHOTOGRAPHY, AND THE ALLIED ARTS AND SCIENCES 12, no. 24 (Apr. 15, 1861): 384. [From "Photo. Notes." A device with a revolving wheel, containing magic lantern slides is revolved in front of a magic lantern projector - producing the effect of movement.]

ROBERTSON, CHARLES (NASHVILLE, TN)

R290 Robertson, Chas. "A Rapid Process for Enlarging Photographs." AMERICAN JOURNAL OF PHOTOGRAPHY AND THE ALLIED ARTS & SCIENCES n. s. vol. 5, no. 4 (Aug. 15, 1862): 87-88. [Robertson describes himself as an amateur, letter written from Nashville, TN on Aug. 7, 1862.]

ROBERTSON, JAMES. (ca. 1813-1885) (GREAT BRITAIN, CRIMEA, TURKEY)

[An engraver and designer of medals, Robertson was the superintendent and chief engraver for the Imperial Mint in Constantinople in 1851. Apparently he had learned photography by this time. Robertson, sometimes accompanied by Felice Beato, who later become his brother-in-law, photographed views in Constantinople, Malta, Egypt, and Greece during the early 1850s. In 1854 Constantinople became a staging area for Allied troops going to the Crimea, and Robertson and Beato sketched and photographed these activities. In September, 1855 they arrived in the Crimea and photographed the Allied armies in that war zone, taking portraits, group portraits, and views around Sebastopol. Robertson's Crimean photographs were exhibited in London in 1856. Some of these views may have been made by Beato. In May, 1857 the Indian Mutiny broke out, and British troop activities to regain control of the country went on for two years. Given the careless manner for attributing authorship of actual negatives in the nineteenth century, it is difficult to be certain if a photographic credit of "Robertson & Beato" means that Robertson actually made the photograph or that he was even in the area or simply a business partner. Robertson may have gone to India to photograph the Mutiny and the Siege of Lucknow, or he may have been the business partner for Beato, who clearly was in India. Nevertheless photographs of scenes in India or people of India which were signed "Robertson & Beato" or "Robertson, Beato & Co." were published. These views were distributed by Shephard, in Simla. In 1860 photographs of India, credited "Shephard & Robertson" were distributed. Beato followed the British troops into China in 1860, but Robertson apparently returned to or stayed in Constantinople, where he lived until at least 1881.]

BOOKS

R291 Robertson, James. Souvenirs de Constantinople - Erinnerung an Constantinople - Remembrances of Constantinople. Trieste: Section Litteraire - Artistique du Lloyd Autrichien, n. d. n. p. 28 l. of plates. [Twenty-eight engravings, by various artists. Twenty-one of the prints state "Nach Photographie von Robertson."]

R292 Robertson, James. Album of Photographs of Athens, Constantinople and the Crimea. s. l.: s. n., 185- ? n. p. 45 b & w. [Album, GEH Collection.]

R293 Robertson, James. Album of Photographs of Athens, Constantinople and Sebastopol. s. l.: s. n., 185- ? n. p. 52 b & w. [Album, GEH Collection.]

R294 Robertson, James. *Grecian Antiquities.* Photographed by James Robertson, Esq., Chief Engraver to the Imperial Mint, Constantinople, published at the Photographic Establishment, Pera of Constantinople. Constantinople: Imperial Mint, 185-? n. p. 60 b & w. [Album. Royal Copenhagen Library.]

R295 Robertson, James. *Photographic Views of Constantinople.* London: Joseph Cundall, 1853. n. p. 20 b & w. [Original prints.]

R296 Robertson, James, Esq. *Photographic Views of Antiquities of Athens, Egina, Corinth, etc.* London: Joseph Cundall, at the Photographic Institute, 1854. n. p. 53 b & w. [Original photos. Album, Marshall Collection.]

R297 Thornbury, Walter. *Turkish Life and Character.* London: Smith, Elder, & Co., 1860. 2 vol. 8 l. of plates. illus. [Illustrated with woodcut engravings, many taken from noncredited photographs, some of which have been proven to be by Robertson.]

R298 Gautier, Théopile. *Constantinople of To-Day.* Translated from the French by Robert Howe Gould. London: David Bougue, 1854. 368 pp. 7 l. of plates. [This edition of this book was illustrated with engravings taken from photographs by Robertson.]

PERIODICALS

R299 Robertson, James, Esq. "Photographic Views of Constantinople." ATHENAEUM no. 1365 (Dec. 24, 1853): 1559. [Reviewed.]

R300 "Fine Arts: New Publications." ATHENAEUM no. 1365 (Dec. 24, 1853): 1559. [Review: "Photographic Views of Constantinople," by James Robertson, Esq. Cundall. 20 views.]

R301 "A Bashi-Bozouk. - From a Drawing by James Robertson, Esq., of Constantinople." ILLUSTRATED LONDON NEWS 24, no. 686 (June 3, 1854): 517. 1 illus. [Turkish soldier.]

R302 "The Allied Troops in Turkey." ILLUSTRATED LONDON NEWS 25, no. 693 (July 15, 1854): 45-46. 2 illus. ["H.B.M. Foot Guards encamped at Scutari." "British Infantry on the line encamped at Scutari." "From a Daguerreotype by Mr. Robertson, of Constantinople," on p. 45.]

R303 "Historical Summary of the Russian War: From Its Commencement to the Present Time." ILLUSTRATED LONDON NEWS 25, no. 705 (Sept. 30, 1854): 317-332. 14 illus. [Entire issue devoted to the topic. Fourteen illustrations of land and sea forces, portraits, troops, etc. Includes two group portraits of British soldiers, "Encampment of the Rifle Brigade, at Constantinople," "Encampment of the Grenadier Guards, at Constantinople," both credited "From a Daguerreotype by J. Robertson," on p. 320.]

R304 "Omar Pacha in the Crimea." ILLUSTRATED LONDON NEWS 25, no. 717 (Dec. 16, 1854): 597-598. 1 illus. ["From a Photograph by Mr. Robertson, of Constantinople."]

R305 "The Earthquake at Constantinople." ILLUSTRATED LONDON NEWS 26, no. 733 (Mar. 24, 1855): 284. 1 illus. ["Bridge at Broussa. - From a Sketch by James Robertson, of Constantinople."]

R306 "The Late Colonel Yea." ILLUSTRATED LONDON NEWS 27, no. 754 (July 28, 1855): 112. 1 illus. ["From a Photograph by Robertson, of Constantinople."]

R307 "Note." ATHENAEUM no. 1469 (Dec. 22, 1855): 1500. [Brief note of exhibition of Robertson's Crimean photos at Mr. Kilburn's Gallery.]

R308 "A Bashi-Bazouk. - From a Drawing by James Robertson, Esq., of Constantinople." FRANK LESLIE'S ILLUSTRATED NEWSPAPER 1, no. 7 (Jan. 26, 1856): 109. 1 illus.

R309 Hunt, Robert. "Photographic Exhibitions." ART JOURNAL (Feb. 1856): 49-50. [Mentions Fenton's exhibition of Crimean War photos at Pall Mall (reviewed in Oct. 1855 issue of "Art Journal"); Robertson's views of Crimea at Kilburn's, on Regent Street; the third exhibition of the Photographic Society.]

R310 "Photographic Pictures of Sebastopol." ART JOURNAL (Feb. 1856): 62. [Crimean War.]

R311 "Interior of the Redan, From a Photograph by Robertson." ILLUSTRATED LONDON NEWS 28, no. 789 (Mar. 15, 1856): 265-266. 1 illus.

R312 "Balaclavia." ILLUSTRATED LONDON NEWS 28, no. 792 (Apr. 5, 1856): 368. 1 illus. [View of the city.]

R313 "Photographic Gossip." JOURNAL OF THE PHOTOGRAPHIC SOCIETY OF LONDON 3, no. 43 (June 21, 1856): 73. ["Mr. Robertson, the superintendent of the Imperial Mint at Constantinople, has sent up an intelligent photographer to the Crimea, and he is now engaged in fixing, as far as possible, every remarkable spot on paper - 'Times,' June 18." (Is this Beato?)]

R314 R. M. G. "The Walls of Constantinople." ILLUSTRATED LONDON NEWS 29, no. 829 (Nov. 8, 1856): 463, 465. 1 illus. ["The Seven Towers, Constantinople. - From a photograph by Robertson."]

R315 "Critical Notices: The Panorama of Lucknow in the Photographic Exhibition." PHOTOGRAPHIC NEWS 1, no. 24 (Feb. 18, 1859): 280.

R316 "A Work by Mr. Walter Thornbury, to be entitled "Turkish Life and Character" is announced as in preparation, which is to be illustrated with photographs." PHOTOGRAPHIC NEWS 4, no. 105 (Sept. 7, 1860): 227.

R317 Santeul, Claude de, vicomte. "Le premier reportage photographique de guerre, 1854 - 55." PHOTO-ILLUSTRATION (PARIS) no. 6 (1934): 3-8, 24. 23 b & w. 1 illus. [Photographs of the Crimean War by James Robertson and Robert Fenton discussed.]

R318 Chappell, Walter. "Camera Vision at Lucknow 1857 - 1858, Robertson, Beato & Co." IMAGE 7, no. 2 (Feb. 1958): 36-40. 8 b & w.

R319 Henisch, B. A. and H. K. Henisch. "Robertson of Constantinople." IMAGE 17, no. 3 (Sept. 1974): 1-11. 7 b & w.

R320 Henisch, B. A. and Heinz K. Henisch. "Souvenir de Constantinople." HISTORY OF PHOTOGRAPHY 4, no. 3 (July 1980): 205-206. 1 b & w.

R321 Henisch, B. A. and H. K. Henisch. "James Robertson of Constantinople." HISTORY OF PHOTOGRAPHY 8, no. 4 (Oct. - Dec. 1984): 299-313. 3 b & w. 11 illus. [Robertson's views of Constantinople, number of books of engravings generated from his photographs.]

R322 Borda, A. V. "James Robertson in Malta." HISTORY OF PHOTOGRAPHY 10, no. 4 (Oct. - Dec. 1986): 302. 1 b & w. [View of Malta harbor, taken by Robertson ca. 1858.]

ROBERTSON, JAMES. [?]
R323 "Viscount Stratford-de-Redcliffe, G.C.B., Ambassador...to the Ottoman Porte." ILLUSTRATED LONDON NEWS 23, no. 646 (Sept. 24, 1853): 275-276. 1 illus. ["Portrait...from a Photograph taken at Constantinople." [Robertson?]]

R324 "The Sultan's New Palace, at Dolmabaghdsche, on the Bosphorus." ILLUSTRATED LONDON NEWS 23, no. 648 (Oct. 8, 1853): 297-298. 1 illus. ["Engraving made after a photograph..." [Robertson?]]

R325 "A Turkish Scribe." ILLUSTRATED LONDON NEWS 23, no. 654 (Nov. 19, 1853): 417. 1 illus. ["From a Photograph taken in Constantinople." Group Costume portrait. [Robertson?]]

R326 "Turkish Soldiers and Tartar Children at Eupatoria." ILLUSTRATED LONDON NEWS 26, no. 730 (Mar. 3, 1855): 209-210. 5 illus. ["We have to thank a Correspondent at Eupatoria for the accompanying groups, photographed at Eupatoria during the month of January..." Group portraits.]

ROBERTSON, WILLIAM. (1818-1882) (GREAT BRITAIN, CRIMEA)
R327 Lawson, Julie. "Dr. John Kirk and Dr. William Robertson: Photographers in the Crimea." HISTORY OF PHOTOGRAPHY 12, no. 3 (July - Sept. 1988): 227-241. 21 b & w. [Dr. John Kirk (1832-1922) was a Scottish physician, and an ardent amateur photographer. Dr. William Robertson (1818-1882) was a Scottish physician. Both took calotypes of military facilities and personnel at Renkioi, in the Crimea, during the Crimean War.]

ROBIE, H. B.
R328 Portrait. Woodcut engraving, credited "From a Photograph by H. B. Robie. FRANK LESLIE'S ILLUSTRATED NEWSPAPER 40, (1875) ["Hon. Robert H. Tewksbury, Mayor of Lawrence, MA." 40:1036 (Aug. 7, 1875): 384.]

ROBINSON & CHERRILL see also ROBINSON, HENRY PEACH.

ROBINSON & CHERRILL. (GREAT BRITAIN)
BOOKS
R329 Robinson, Henry P. and Cherrell. *Portraits and Pictures Produced by Photography and Art.* Tunbridge Wells: Robinson & Cherrill, 1874 [?]. 24 pp. ["Distributed by the authors to customers and friends."]

PERIODICALS
R330 "Messrs. Robinson & Cherrill's New Studio." COMMERCIAL PHOTOGRAPHIC NEWS 1, no. 4 (Oct. 1872): 7-8.

R331 "Secret Process-Mongers in America. - Queer Revelations." ANTHONY'S PHOTOGRAPHIC BULLETIN 5, no. 4 (Apr. 1874): 149-150. [From "Br. J. of Photo." Complicated situation where a W. T. Watson, of Hull, sold the rights to a photo-enamelling process to H. P. Robinson & Cherrill for two guineas. Robinson & Cherrill then formed a partnership with a "keen American businessman, who offered the process for sale for $5000 in America. Everyone confounded.]

R332 Robinson & Cherrill. "The Secret Enamel Process." ANTHONY'S PHOTOGRAPHIC BULLETIN 5, no. 6 (June 1874): 213-214. [From "Br. J. of Photo." Letter from Robinson & Cherrill in response to the earlier article.]

R333 Watson, W. T. "The Enamel Scandal." ANTHONY'S PHOTOGRAPHIC BULLETIN 5, no. 8 (Aug. 1874): 273-274. [From "Br. J. of Photo." Letter from Watson, stating his side of the case in the Robinson & Cherrill issue.]

ROBINSON & SEEBAUM. (USA)
R334 "The Armory of the Dayton Light Guard, Company K, First Regiment Ohio Volunteers, with the Body of Dr. Henry F. Koehne, Regimental Surgeon, Lying in State, March 8, 1858." and "The Late Henry F. Koehne - From a Photograph by Robinson & Seebohm." FRANK LESLIE'S ILLUSTRATED NEWSPAPER 5, no. 122 (Apr. 3, 1858): 284. 2 illus. [Interior, with figures. Portrait.]

ROBINSON & SONS. (DUBLIN, IRE).
R335 Portrait. Woodcut engraving credited "From a photograph by Robinson & Sons, Grafton St., Dublin." ILLUSTRATED LONDON NEWS 75, (1879) ["Major W. Knox Leet, V.C." 75:2107 (Nov. 1, 1879): 417.]

ROBINSON & THOMPSON. (LIVERPOOL, ENGLAND)
R336 Portrait. Woodcut engraving credited "From a photograph by Robinson & Thompson." ILLUSTRATED LONDON NEWS 67, (1875) ["Mr. Carl Rosa, Director of English Opera." 67:1887 (Oct. 9, 1875): 357.]

ROBINSON, C. J.
R337 Robinson, C. J. "Light in Picture Galleries." PHOTOGRAPHIC ART JOURNAL 3, no. 1 (Jan. 1852): 61-62. [From the "London Art Journal."]

ROBINSON, CHARLES. [MRS.]
R338 "'Free State Prisoners' Taken at their Camp, near Lecompton, Kansas Territory. Drawn by Wallen, from a Daguerreotype taken by Mrs. Charles Robinson." FRANK LESLIE'S ILLUSTRATED NEWSPAPER 2, no. 43 (Oct. 4, 1856): 257, 258. 1 illus. [Group portrait, taken outdoors. "Our picture cannot fail to interest. Art has combined in its varied magical demonstrations to bring from the far distant regions of Kansas a bit of life as it was presented in the open day. We have reflected at our firesides the men as they appeared in their natural attitudes, in their every-day costumes, surrounded with their literal associations. If we could have looked in upon the real scene, we could have obtained no better idea of what was before the eye than our picture presents."]

ROBINSON, CHARLES. [MRS.] [?]
R339 "United States Troops as They Appeared In Camp Guarding the Free State Prisoners, Near Lecompton, Kansas Territory. From a Daguerreotype Furnished Expressly for This Paper." FRANK LESLIE'S ILLUSTRATED NEWSPAPER 2, no. 43 (Oct. 4, 1856): 264-265. 1 illus. [View, with figures. Many probably added by the engraver.]

ROBINSON, G. C. (HAVERHILL, MA)
R340 "Editor's Table." PHILADELPHIA PHOTOGRAPHER 6, no. 62 (Feb. 1869): 64. ["Clouded vignettes."]

ROBINSON, HENRY PEACH see also ROBINSON & CHERRILL.

ROBINSON, HENRY PEACH. (1830-1901)
["Henry Peach Robinson, professional photographer, of Tunbridge Wells, formerly of Leamington, is known everywhere as a man who has put more art into his pictures than perhaps any living photographer."

Born on July 9, 1830 in Ludlow, Shropshire - "a sleepy town... quite fifty years behind the rest of the world." Ludlow also was the country home of several wealthy and cultured families, and so had a measure of "culture" unusual for a rural English village in the 1840s. Robinson's father was a schoolmaster and his mother was interested in the arts. His formal eduction ended at age thirteen, but he read and studied art - "I could draw long before I could write, and could now sketch fairly well from nature, and give a good idea of a likeness in pencil." Robinson had an eager and inquiring nature, a bright mind and a degree of talent. He tried all of the forms of artistic expression available to him - he studied literature, botany, geology, architecture, and antiquities, the harp, painting and sketching. Robinson apprenticed to a bookseller and printer, but for eight years Robinson studied almost daily in his spare time under the informal guidance of a Mr. Penwarne, a wealthy, reclusive gentleman who had studied art at the Royal Academy in the early 1800s, and who let Robinson use his library and taught him etching, the lathe, drawing, fishing, and the manners of society. Robinson also received instruction and encouragement from the young landscape painter William Gill. While still a teenager, he wrote articles "little sketches," -articles on local history for the local paper and some items which were published in the *Illustrated London News*. Photography was virtually unknown to him until about 1850, then he was shown the daguerreotype process by a travelling photographer. In 1851 Robinson moved to London to work as an assistant to a London book dealer and continued to pursue his interest in the arts and in literature. An exhibition of Pre-Raphaelite paintings in 1852 was an important influence on him, and he also had a painting accepted in the Royal Academy exhibition that year. Robinson also became more interested in photography from reading the first issues of the *Journal of the Photographic Society* in 1853. He painted, sketched and photographed in his spare time, trying the calotype and then the wet collodion. In 1854, when he was 24 years old, Robinson moved to Leamington, where he met Dr. Hugh Diamond. Dr. Diamond encouraged Robinson's interest in photography. Dr. Diamond held a weekly soiree attended by many of the advanced amateurs of the day and these meetings were important for Robinson. Robinson did not wish to enter a trade and he did not have the independent means to further his interest in painting. Dr. Diamond suggested that he become a professional photographer. Robinson set up his studio in 1857, and almost immediately began to produce "theatrical subjects," such as "Mr. Werner as Richelieu," In 1857 Robinson saw Oscar G. Rejlander's allegorical genre study, "Two Ways of Life" at the Manchester Art Treasures Exhibition. Before the end of the year Robinson had produces his "Juliet with the Poison." At the same time Robinson was producing the standard professional studio portraits and albums of landscape views, but, while the work was beginning to gather praise, he was struggling very hard financially. In 1858 Robinson tried unsuccessfully to sell his studio. He also took the separate negatives that constitute the material for his composite print "Fading Away." He worked for two months to achieve a good print of this technically difficult work, but when it was presented to the public Robinson began to gather a reputation as one of the leading young photographers of the day a photographer with a rare creative and artistic bent. The print also enjoyed a large popular response when it was exhibited at the Crystal Palace in 1858. And Robinson met and befriended the sculptor Alexander Munro, the painter Henry Moore, and others in the Pre-Raphaelite movement that held the artistic avant-guard position in England at that time. Robinson also married in 1858. Then in 1859 the craze for the carte-de-visite caught on in England and made Robinson's business solvent and financially secure. From that point on Robinson attempted to produce at least one "artistic" photograph each year. Only one print a year doesn't sound absurd when one understands that these composite genre scenes had to be carefully thought out in advance, and models found and costumed and posed to fit into carefully arranged portions of the final composition, then photographed, and then the six to ten negatives had to be carefully printed one at a time overlaid into one final photographic print -a process that could take months of careful work. In 1860 a critic would write "It was reserved for Mr. Robinson... to add poetry and a high degree of sentiment to the results obtained by means of the camera..." and in 1861 another would state, "Mr. Robinson deserves the best thanks of photographers for so successfully raising photography above the mechanical, and showing that, in the hands of a true artist, it can be made to produce admirable pictures..." In 1862 Robinson produced his most ambitious effort along these lines, creating a 15" x 40" genre scene with about a dozen figures titled "Bringing Home the May." In addition to his photography he had embarked upon a sustained effort to promote creative photography through his writing, both in many articles and in several influential books, published over the next few decades. By the late 1860s Robinson was widely considered to be a leading, if not the leading photographer of his generation. Edward Wilson stated in 1869, "Mr. Robinson stands almost alone, especially in the old world, as being at once the champion and practical exponent of the art-claims of photography..."

Robinson continued to work and write into the 1890s, always considered a leading figure in the field. He was a member of the Photographic Society from 1857 on, and held a seat on its council from 1869 to 1887, when he was elected Vice-President. He remained as Vice-President until 1891, when he resigned during the conflicts then afflicting that organization. During the 90s, even while troubled by age and illness, he continued to remain active in judging shows and even exhibiting. He died on Feb. 21, 1901 in Tunbridge Wells.]

BOOKS

R341 *Warwickshire Illustrated: A History of Some of the Most Remarkable Places in the County of Warwick.* Illustrated by a choice series of Photographic Views, taken by the Collodio-Albumen Process, by Henry Peach Robinson. Leamington: H. P. Robinson, 1858. n. p. 9 b & w. [Original photographs.]

R342 Robinson, H. P. *Pictorial Effect in Photography: Being Hints on Composition and Chiaroscuro for Photographers. To which is Added a Chapter on Combination Printing.* London: Piper & Carter, 1869. 199 pp. illus. [The first edition was printed on toned paper, and copiously illustrated by the carbon photo-relief and phototype processes, silver printinting, etchings, and wood engravings. There were many later, cheaper editions. (1879) 162 pp. 2nd ed. "Photographic Handy-Books, no. 3." (1881) 162 pp., etc. Reprinted (1971), Pawlet, Vt.: Helios Press. With a new introduction by Robert Sobieszek on pp. v-viii.]

R343 Robinson, H. P. & Captain W. De W. Abney. *The Art and Practice of Silver Printing.* "Scovill's Photographic Series No. 2" London; New York: Piper & Carter; Scovill Manufacturing. Co., 1881. 128 pp. 32 illus. [3rd ed. (1888); reprinted (1973), Arno Press.]

R344 Robinson, H. P. *Pictorial Effect in Photography.* "American Edition" Philadelphia: Edward L. Wilson, 1881. 184 pp. [4th ed. New York: Scovill & Adams, (1897). 158 pp. "Scovill's Photographic Series, No. 30."]

R345 Robinson, H. P. *Picture-Making by Photography.* "Scoville's Photographic Series No. 16." London; New York: Piper & Carter; Scoville Manufacturing Co., 1884. 128 pp. 4 l. of plates. illus. [5th ed. (1897) 33 illus.; reprinted (1973), Arno Press.]

R346 Robinson, H. P. *De l'Effet artistique en Photographie.* ...Traduction de la 2e edition anglaise par Hector Colard. Paris: Gauthier-Villars & Fils, 1885. 170 pp.

R347 Robinson, H. P. *The Studio, and What to Do In It.* "Scoville's Photographic Series No. 18" London; New York: Piper & Carter; Scoville Manufacturing Co., 1885. 143 pp. [London, (1891). 29 illus.; reprinted (1973), Arno Press.]

R348 Robinson, H. P. *Das Glashaus and was darin geschieht...* Autorisirte deutsche Ausgabe. Mit Abbildungen. Düsseldorf: s. n., 1886. 130 pp. illus.

R349 Robinson, H. P. *La Photographie en plein air,* ...Traduit de l'anglais par Hector Colard. Paris: Gauthier-Villars & Fils, 1886. n. p. 2 b & w. [2nd ed. (1889).]

R350 Robinson, Henry P. *L'Atelier du Photographe,* ...Traduit par Hector Colard. Paris: Gauthier-Villars & Fils., 1888. 146 pp.

R351 Robinson, H. P. *Letter on Landscape Photography.* "Scoville's Photographic Series, No. 17" New York: Scoville Manufacturing Co., 1888. 94 pp. 10 b & w. [Originally published in "Photographic Times" in 1887. Reprinted (1973), Arno Press.]

R352 Pringle, Andrew. With Photographs by H. P. Robinson. *H. P. Robinson.* "Sun Artists, No. 1" London: Kegan Paul & Co., 1890. n. p. [Series edited by William A. Boord.]

R353 Robinson, H. P. *Art Photography in Short Chapters.* "Amateur Photographer's Library, no. 4" London: Hazell, Watson & Viney, Ltd., 1890. 60 pp. illus.

R354 Robinson, H. P. *Photography as a Business.* "Practical Photographer Series No. 3" Bradford, England: Percy Lund & Co., 1890. 86 pp. [Reprint of Chapters contributed to the "Practical Photographer".]

R355 Robinson, H. P. *Picture-Making in the Studio by Photography. With Supplementary Chapters on the Business of Portrait Photography and Individuality in Photography.* "Scoville & Adams Series No. 42" New York: Scoville & Adams Co., 1892. 61 pp.

R356 Robinson, H. P. *Elements of a Pictorial Photograph.* New York: Anthony & Scoville ?, 1897. 167 pp. 38 b & w. [Bradford, England: P. Lund & Co., (1896). Reprinted (1973), Arno Press.]

R357 Robinson, H. P. *Les elements d'une photographie artistique,...* Traduit par Hector Colard. Paris: Gauthier-Villers & Fils, 1898. 135 pp. illus.

R358 Robinson, H. P. *Catalogue of Pictorial Photographs by the Late H. P. Robinson.* Redhill, Surrey: Ralph W. Robinson, 1901. 16 pp.

R359 Harris, David R. *H. P. Robinson's "Pictorial Effect in Photography."* Albuquerque, NM: 1981. [M.A. Thesis, University of New Mexico, 1981.]

R360 Blackwell, Basil. *Henry Peach Robinson, Master of Photographic Art, 1830 - 1901.* Oxford: n. p. 1988. 200 pp. b & w. illus.

R361 Harker, Margaret F. *Henry Peach Robinson: Master of Photographic Art, 1830 - 1901.* Oxford, NY: B. Blackwell, 1988. viii, 119 pp. 80 l. of plates. [Bibliography on pp. 115-117.]

PERIODICALS

R362 Robinson, Henry P. "The Simplicity of the Collodio-Albumen Process." JOURNAL OF THE PHOTOGRAPHIC SOCIETY OF LONDON 3, no. 54 (May 21, 1857): 286-287.

R363 Robinson, Henry P. "The Simplicity of the Collodio-Albumen Process." PHOTOGRAPHIC AND FINE ART JOURNAL 10, no. 7 (July 1857): 216-217. [From "J. of Photo. Soc., London."]

R364 Robinson, Henry P. "The Simplicity of the Collodio-Albumen Process." HUMPHREY'S JOURNAL 9, no. 7 (Aug. 1, 1857): 103-104. [From "J. of Photo. Soc., London."]

R365 Robinson, Henry P. "The Collodio-Albumen Process." PHOTOGRAPHIC AND FINE ART JOURNAL 10, no. 10 (Oct. 1857): 307. [From "J. of Photo. Soc., London." Robinson gives his address at 15 Upper Parade, Leaminton, England.]

R366 "Fine Arts." ATHENAEUM no. 1597 (June 5, 1858): 725. [Bk. rev.: "Warwickshire Illustrated: a History of some of the most Remarkable Places in the County of Warwick." Illustrated by a choice Series of Photographic Views, taken by the Collodio-Albumen Process, by Henry Peach Robinson (Leamington, Robinson).]

R367 Robinson, Henry P. "Photography, Artistic and Scientific." JOURNAL OF THE PHOTOGRAPHIC SOCIETY OF LONDON 5, no. 69 (Aug. 21, 1858): 14-15.

R368 "Editorial." LIVERPOOL & MANCHESTER PHOTOGRAPHIC JOURNAL [BRITISH JOURNAL OF PHOTOGRAPHY] n. s. 2, no. 19 (Oct. 1, 1858): 237. [Commentary on Robinson's "Little Red Riding Hood" and "Fading Away."]

R369 Robinson, Henry P. "Photography, Artistic and Scientific." JOURNAL OF THE PHOTOGRAPHIC SOCIETY OF LONDON 5, no. 71 (Oct. 21, 1858): 47-48.

R370 "Note." LIVERPOOL & MANCHESTER PHOTOGRAPHIC JOURNAL [BRITISH JOURNAL OF PHOTOGRAPHY] n. s. 2, no. 21 (Nov. 1 - Nov. 15, 1858): 262, 264. [Comment upon a composite group portrait print from eight individual portrait negatives, identified on p. 274, to be by Robinson.]

R371 "Fading Away." HARPER'S WEEKLY 2, no. 99 (Nov. 20, 1858): 740-741. 1 illus. [Full page reproduction of H. P. Robinson's composite print, "Fading Away," with brief commentary praising its artistic qualities.]

R372 Robinson, Henry P. "Photography, Artistic and Scientific." HUMPHREY'S JOURNAL OF PHOTOGRAPHY, AND THE ALLIED ARTS AND SCIENCES 10, no. 15 (Dec. 1, 1858): 231-235. [From "London Photo. J."]

R373 "Correspondence: Exhibition of the Photographic Society." PHOTOGRAPHIC NEWS 2, no. 27 (Mar. 11, 1859): 8-9. [Letter, signed "An Ex-Member of the Council," discusses the work of O. G. Rejlander and H. P. Robinson.]

R374 Robinson, Henry P. "New Portable Tent and Perambulation." JOURNAL OF THE PHOTOGRAPHIC SOCIETY OF LONDON 5, no. 83 (Apr. 21, 1859): 266.

R375 Robinson, Henry P. "On Printing Photographic Pictures from Several Negatives." PHOTOGRAPHIC AND FINE ART JOURNAL 13,

no. 4 (Apr. 1860): 113-114. [From "Br. J. of Photo." Read before Photo. Soc. of Scotland, Mar. 13, 1860.]

R376 Robinson, H. P. "On Printing Photographic Pictures from Several Negatives." BRITISH JOURNAL OF PHOTOGRAPHY 7, no. 115 (Apr. 2, 1860): 94-95.

R377 "Editorial Note." BRITISH JOURNAL OF PHOTOGRAPHY. 7, no. 121 (July 2, 1860): 187-188. [Editor offers lengthy commentary on a controversy developed between H. P. Robinson and A. H. Wall on the creative value of composite photographs.]

R378 Robinson, H. P. "Composition NOT Patchwork." BRITISH JOURNAL OF PHOTOGRAPHY. 7, no. 121 (July 2, 1860): 189-190.

R379 "Critical Notices: "The Holiday in the Woods," by H. P. Robinson." PHOTOGRAPHIC NEWS 4, no. 117 (Nov. 30, 1860): 366-367. [Review of a composite photograph.]

R380 "Photographic Contributions to Art." BRITISH JOURNAL OF PHOTOGRAPHY 7, no. 131 (Dec. 1, 1860): 346. [Robinson's "Holiday in the Wood" reviewed.]

R381 Robinson, Henry P. "Review: 'A Holiday in the Wood,' photographed from Nature." JOURNAL OF THE PHOTOGRAPHIC SOCIETY OF LONDON 7, no. 104 (Dec. 15, 1860): 72-73.

R382 "A Holiday in the Wood,' Photograph from Nature by Henry Peach Robinson." ILLUSTRATED LONDON NEWS 38, no. 1079 (Mar. 16, 1861): 239, 248. 1 illus.

R383 "Photographic Contribution to Art. 'The Lady of Shalotte.'" BRITISH JOURNAL OF PHOTOGRAPHY 8, no. 152 (Oct. 15, 1861): 355-356.

R384 Robinson, Henry P. "Review: 'The Lady of Shalotte.'" JOURNAL OF THE PHOTOGRAPHIC SOCIETY OF LONDON 7, no. 114 (Oct. 15, 1861): 286-287.

R385 "Note." JOURNAL OF THE PHOTOGRAPHIC SOCIETY OF LONDON 7, no. 119 (Mar. 15, 1862): 21. ["Mr. H. P. Robinson of Leamington, who at the late anniversary was elected on the Council of the Society, received hon. mention for his contributions to the recent exhibition of photos at Brussels..."]

R386 "Royal Cornwall Polytechnic Society. 'Bringing Home the May,' etc." BRITISH JOURNAL OF PHOTOGRAPHY 9, no. 177 (Nov. 1, 1862): 414.

R387 "Note." JOURNAL OF THE PHOTOGRAPHIC SOCIETY OF LONDON 8, no. 129 (Jan. 15, 1863): 217. [Note that Robinson's "Lady of Shalotte," "Top of the Hill" and "Early Spring" received prizes at the Exhibition of the Cornwall Polytechnic Society.]

R388 "On Composition Photographs." JOURNAL OF THE PHOTOGRAPHIC SOCIETY OF LONDON 8, no. 130 (Feb. 16, 1863): 234-235. [From "Daily News."]

R389 Robinson, Henry P. "Review: 'Bringing Home the May,' photographed from nature, and printed in several negatives." JOURNAL OF THE PHOTOGRAPHIC SOCIETY OF LONDON 8, no. 130 (Feb. 16, 1863): 235-236.

R390 "'Bringing Home the May,' By H. P. Robinson." ILLUSTRATED LONDON NEWS 42, no. 1190-1191 (Feb. 28, 1863): 217. 1 illus.

R391 "Correspondence: Art-Photography." BRITISH JOURNAL OF PHOTOGRAPHY 10, no. 185 (Mar. 2, 1863): 112. [Letter from Robinson, attacking Sutton for claiming that his and Rejlander's composite prints were not artistic.]

R392 "Note." JOURNAL OF THE PHOTOGRAPHIC SOCIETY OF LONDON 8, no. 138 (Oct. 15, 1863): 383. [Mr. Robinson has... just completed his large composition picture for next years Exhibition 24" x 16", the subject is "Autumn"...]

R393 "Photographic Contribution to Art." BRITISH JOURNAL OF PHOTOGRAPHY 10, no. 200 (Oct. 15, 1863): 400. [Editorial praise for Robinson's "Bringing Home the May," etc.]

R394 Robinson, Henry P. "Review: 'Autumn: a Landscape and Figures,' Photographed from nature in several negatives." JOURNAL OF THE PHOTOGRAPHIC SOCIETY OF LONDON 8, no. 140 (Dec. 15, 1863): 427-428.

R395 "Note." JOURNAL OF THE PHOTOGRAPHIC SOCIETY OF LONDON 8, no. 141 (Jan. 15, 1864): 462. [The council has directed that the print to be distributed to Members for the present year - Mr. Robinson's "Bringing Home the May..."]

R396 Robinson, H. P. "The Changes in Photography During the Last Few Years." BRITISH JOURNAL OF PHOTOGRAPHY 11, no. 207 (Feb. 1, 1864): 39.

R397 Robinson, H. P. "The Poets and Photography." PHOTOGRAPHIC NEWS 8, no. 283 (Feb. 5, 1864): 62-63. [Miscellaneous quotes drawn from classic literature.]

R398 Robinson, H. P. "On the Selection of a Subject, and its Management." HUMPHREY'S JOURNAL OF PHOTOGRAPHY, AND THE ALLIED ARTS AND SCIENCES 17, no. 9, 12 (Sept. 1 - Oct. 15, 1865): 140-141, 186-189. [From "Photo. News."]

R399 Robinson, H. P. "The Glass Room and its Contents." HUMPHREY'S JOURNAL OF PHOTOGRAPHY, AND THE ALLIED ARTS AND SCIENCES 18, no. 1 (May 1, 1866): 9-12. [Read to Photo. Soc. of Scotland.]

R400 Towler, Prof. "Art Photographs." HUMPHREY'S JOURNAL OF PHOTOGRAPHY, AND THE ALLIED ARTS AND SCIENCES 18, no. 16 (Dec. 15, 1866): 247. [Review of H. P. Robinson's photos, "Mountain Dew Girl, or the Maid of Killarney," and "Waiting for the Boat."]

R401 Robinson, H. P. "The Use of Light." HUMPHREY'S JOURNAL OF PHOTOGRAPHY, AND THE ALLIED ARTS AND SCIENCES 18, no. 22 (Mar. 15, 1867): 340-342. [From "Photo. News Almanac."]

R402 "Note." ART JOURNAL (Dec. 1867): 275. [Note about a photograph, "Sleep - a Study from Nature," by H. P. Robinson.]

R403 Robinson, H. P. "Wet Collodion without Water." HUMPHREY'S JOURNAL OF PHOTOGRAPHY, AND THE ALLIED ARTS AND SCIENCES 20, no. 14 (Nov. 15, 1868): 219-220. [From "Photo. News."]

R404 "Minor Topics of the Month: 'Over the Sea.'" ART JOURNAL (Aug. 1869): 291. [Mentions that the Mssrs. Marion issuing a photo by Robinson & Cherrill.]

R405 "Our Picture - Mr. Robinson's Method of Working." PHILADELPHIA PHOTOGRAPHER 6, no. 68 (Aug. 1869): frontispiece, 253-257. 1 b & w. [Studio genre scene.]

R406 "Editor's Table." PHILADELPHIA PHOTOGRAPHER 6, no. 70 (Oct. 1869): 356. [Composite print "Over the Sea" noted.]

R407 "Editor's Table." PHILADELPHIA PHOTOGRAPHER 6, no. 71 (Nov. 1869): 387. [Note that "Pictorial Effect in Photography" is listed as available.]

R408 "Reviews: Pictorial Effect in Photography." ART JOURNAL (Nov. 1869): 355-356. [Book review: "Pictorial Effect in Photography," by H. P. Robinson.]

R409 "Pictorial Effect in Photography." PHILADELPHIA PHOTOGRAPHER 7, no. 73 (Jan. 1870): 14-15. [Book review.]

R410 "Editor's Table." PHILADELPHIA PHOTOGRAPHER 7, no. 73 (Jan. 1870): 27. ["Mr. H. P. Robinson's 'Gull' picture, a copy of which was on exhibition in Boston, in June, has been exciting English photographers for months, and discussed at great length in the journals. Every way in the world has been guessed at as to how it was done, and yet nobody knows - but Mr. Robinson."]

R411 A. F. H. "Rapid Sea-Views and Moonlight Pictures." ANTHONY'S PHOTOGRAPHIC BULLETIN 1, no. 9 (Oct. 1870): 174-176. [From "London Photographic News." Article about moonlight views by Robinson & Cherrill and Mr. Ogier. Additional commentary on the subject by H. T. Anthony on pp. 175-176 and another excerpt, "Photographs by Moonlight," from "LPN," on p. 176.]

R412 "Editor's Table." PHILADELPHIA PHOTOGRAPHER 7, no. 83 (Nov. 1870): 400. [Composite seascape by Robinson, "The First Hour of Night," described and discussed.]

R413 "Our Picture." PHILADELPHIA PHOTOGRAPHER 8, no. 85 (Jan. 1871): frontispiece, 28. 1 b & w. [Genre. "Returning from the Well."]

R414 "Note." PHOTOGRAPHIC WORLD 1, no. 4 (Apr. 1871): 125. [Robinson & Cherrill obtained gold medal and silver medal at Bengal Exhibition. This makes 27 medals Robinson has won.]

R415 "Note." PHOTOGRAPHIC WORLD 1, no. 12 (Dec. 1871): 380. [Robinson entered picture "The Bridesmaid" at Exhibition of Royal Cornwall Polytechnic Soc. under pseudonym Ralph Ludlow - won gold medal anyway.]

R416 "Editor's Table: Waiting at the Style." PHILADELPHIA PHOTOGRAPHER 10, no. 114 (June 1873): 192. [Robinson & Cherrill (Tunbridge Wells, England) created a combination picture "Waiting at the Style."]

R417 "Our Picture." PHILADELPHIA PHOTOGRAPHER 11, no. 123 (Mar. 1874): frontispiece, 90-93. 1 b & w. [Composition 'Preparing Spring Flowers for Market' by Robinson & Cherrill.]

R418 "Detail of Watson's Enamel Process." PHILADELPHIA PHOTOGRAPHER 11, no. 131 (Nov. 1874): 322-323. [Includes a letter from Robinson & Cherrill, praising the process.]

R419 Robinson, H. P. "Our Foreign Make-Up: Softness and Gradation." PHOTOGRAPHIC TIMES 5, no. 51 (Mar. 1875): 60-61. [From the "Year-Book."]

R420 Robinson, H. P. "Permanency and Fading." PHOTOGRAPHIC TIMES 6, no. 65 (May 1876): 110-111. [Reprint from "Photo. News."]

R421 "The Tables Turned." PHILADELPHIA PHOTOGRAPHER 14, no. 163 (July 1877): 218-223. [Long article, with exchange of letters between H. P. Robinson, J. MacBeth (painter), and Robert McNair over issue of MacBeth copying one of Robinson's photographs in a painting without credit or payment.]

R422 Portrait. Woodcut engraving credited "From a photograph by Henry Peach Robinson, Tunbridge Wells, Eng." ILLUSTRATED LONDON NEWS 74, (1879) ["Lieut. E. H. Dyson, killed in Zulu War." 74:2073 (Mar. 8, 1879): 216.]

R423 Robinson, Henry P. "Pyramidal Forms!" PHILADELPHIA PHOTOGRAPHER 16, no. 190 (Oct. 1879): 293-294. [Extracts from Robinson's "Pictorial Effect in Photog."]

R424 Robinson, Henry P. "'The Blind Fiddler' as a Study." PHILADELPHIA PHOTOGRAPHER 16, no. 191 (Nov. 1879): 330-332. 1 illus. [Reprint from Chapter XV of Robinson's "Pictorial Effect in Photog," "Variety & Repetition."]

R425 "Mr. Robinson on Accessories." PHILADELPHIA PHOTOGRAPHER 16, no. 192 (Dec. 1879): 358-359. [Reprinted from Robinson's "Pictorial Effect in Photography."]

R426 "Note: Pictorial Effect in Photography: A Cheap Edition." PHILADELPHIA PHOTOGRAPHER 17, no. 203 (Nov. 1880): 325. [Bk. Rev.: "Pictorial Effect in Photography," by H. P. Robinson.]

R427 "Our Editorial Table." PHOTOGRAPHIC TIMES 11, no. 121 (Jan. 1881): 9-10. [Bk rev: "Pictorial Effect in Photography," by H. P. Robinson.]

R428 "Our Editorial Table." PHOTOGRAPHIC TIMES 11, no. 132 (Dec. 1881): 441-442. [Bk. rev.: The Art and Practice of Silver Printing," by H. P. Robinson and Capt. Abney.]

R429 "Our Editorial Table." PHOTOGRAPHIC TIMES 14, no. 161 (May 1884): 269-271. [Book rev.: "Picture-Making by Photography," by Henry P. Robinson.]

R430 Robinson, Henry P. "Hints on Posing and the Management of the Sitter. Chapter 1 - The Head." PHOTOGRAPHIC TIMES 14, no. 167 (Nov. 1884): 590-592. 2 illus. [From "Photographic News."]

R431 Robinson, H. P. "Hints on Posing and Management of the Sitter. Chapter 2 - The Head Vignette." PHOTOGRAPHIC TIMES 14, no. 168 (Dec. 5, 1884): 633-636. 2 illus.

R432 Robinson, H. P. "Hints on Posing and Management of the Sitter. Chapter 3 - The Three Quarter Length - Men." PHOTOGRAPHIC TIMES 14, no. 171 (Dec. 26, 1884): 704-705. 1 illus.

R433 Robinson, Henry P. "Hints on Posing and the Management of the Sitter: Full-Length Figures." PHOTOGRAPHIC TIMES 15, no. 173 (Jan. 9, 1885): 18-19. [From "Photographic News."]

R434 Robinson, Henry P. "Hints on Posing and the Management of the Sitter. Groups." PHOTOGRAPHIC TIMES 15, no. 174 (Jan. 16, 1885): 30-31. 5 illus. [From "Photographic News."]

R435 Robinson, Henry P. "Hints on Posing and the Management of the Sitter. Children." PHOTOGRAPHIC TIMES 15, no. 175 (Jan. 23, 1885): 42-43. [From "Photographic News."]

R436 Robinson, Henry P. "Hints on Posing and the Management of the Sitter. Outdoor Groups." PHOTOGRAPHIC TIMES 15, no. 176 (Jan. 30, 1885): 54-55. 3 illus. [From "Photographic News."]

R437 Robinson, Henry P. "Hints on Posing and the Management of the Sitter. Expression in Portraiture." PHOTOGRAPHIC TIMES 15, no. 177 (Feb. 6, 1885): 66-68. [From "Photographic News."]

R438 Robinson, Henry P. "Hints on Posing and the Management of the Sitter. Three-Quarters Length - Ladies." PHOTOGRAPHIC TIMES 15, no. 178 (Feb. 13, 1885): 77-78. 2 illus.

R439 "Our Editorial Table: 'Hope Deferred.'" PHOTOGRAPHIC TIMES 15, no. 196 (June 19, 1885): 333. [Genre picture by Robinson described.]

R440 "Our Editorial Table." PHOTOGRAPHIC TIMES 15, no. 197 (June 26, 1885): 344-345. [Bk. rev.: "The Studio, and What To Do In It," by H. P. Robinson.]

R441 "Our Editorial Table." PHOTOGRAPHIC TIMES 15, no. 216 (Nov. 6, 1885): 625. [Bk. rev.: ~ The Art and Practice of Silver Printing," 2nd. ed. by H. P. Robinson and Capt. Abney.]

R442 Robinson, H. P. "Stray Thoughts Concerning Photography. No. I." PHOTOGRAPHIC TIMES 16, no. 242 (May 7, 1886): 244-245.

R443 Robinson, H. P. "Stray Thoughts Concerning Photography. No. II." PHOTOGRAPHIC TIMES 16, no. 252 (July 16, 1886): 373-374.

R444 Robinson, H. P. "Stray Thoughts Concerning Photography. No. III." PHOTOGRAPHIC TIMES 16, no. 258 (Aug. 27, 1886): 444-446.

R445 Robinson, H. P. "Success." ANTHONY'S PHOTOGRAPHIC BULLETIN 17, no. 18 (Sept. 25, 1886): 559-561. [Read at the English Convention at Derby.]

R446 Robinson, H. P. "Success." PHOTOGRAPHIC TIMES 16, no. 259 (Sept. 3, 1886): 469-471. [Read at 1st Photographic Convention in Great Britain.]

R447 Robinson, Henry P. "Things To See To in Landscape Photography - Address to a Beginner." AMERICAN ANNUAL OF PHOTOGRAPHY AND PHOTOGRAPHIC TIMES ALMANAC FOR 1887 (1887): 44-46.

R448 Robinson, H. P. "Letters on Landscape, Addressed to an American Friend - No. 1." PHOTOGRAPHIC TIMES 17, no. 300 (June 17, 1887): 310-312. 1 illus.

R449 Robinson, H. P. "Letters on Landscape, Addressed to An American Friend - No. 2." PHOTOGRAPHIC TIMES 17, no. 303 (July 8, 1887): 345-347.

R450 Robinson, H. P. "Letters on Landscape; Addressed to an American Friend - No. 3." PHOTOGRAPHIC TIMES 17, no. 307 (Aug. 5, 1887): 394-396.

R451 "Henry Peach Robinson." PHOTOGRAPHIC TIMES 17, no. 307 (Aug. 5, 1887): 391-392, plus frontispiece. 1 illus. [Portrait of Robinson. Born Ludlow, England in 1830. Began photographing in 1852. In 1857 established a studio in Leamington. Began making creative photos in 1858. Retired from professional photography 1875-1878.]

R452 Robinson, Henry P. "Letters on Landscape; Addressed to an American Friend - No. 4." PHOTOGRAPHIC TIMES 17, no. 311 (Sept. 2, 1887): 441-442.

R453 Robinson, H. P. "Correspondence: Portrait of H. P. Robinson." PHOTOGRAPHIC TIMES 17, no. 311 (Sept. 2, 1887): 449. [Letter from Robinson praising the quality of the photo-gravure of his portrait in earlier issue.]

R454 Robinson, Henry P. "Letters on Landscape; Addressed to an American Friend - No. 4.[sic]" PHOTOGRAPHIC TIMES 17, no. 312 (Sept. 9, 1887): 454-455.

R455 Robinson, H. P. "Letters on Landscape; Addressed to an American Friend - No. 5." PHOTOGRAPHIC TIMES 17, no. 314 (Sept. 23, 1887): 492-494. 2 illus.

R456 Robinson, Henry P. "Letters on Landscape: Addressed to an American Friend - No. 6." PHOTOGRAPHIC TIMES 17, no. 319 (Oct. 28, 1887): 538-540.

R457 Robinson, H. P. "Letters on Landscape; Addressed to an American Friend - No. 7." PHOTOGRAPHIC TIMES 17, no. 324 (Dec. 2, 1887): 600-601. 1 illus.

R458 Robinson, Henry P. "Letters on Landscape; Addressed to an American Friend - No. 8." PHOTOGRAPHIC TIMES 17, no. 327 (Dec. 23, 1887): 641-643. 4 illus.

R459 Robinson, Henry P. "Letters on Landscape; Addressed to An American Friend - No. 9." PHOTOGRAPHIC TIMES 17, no. 328 (Dec. 30, 1887): 665-668.

R460 Robinson, H. P. "Figure, Landscape, and Combination Printing." AMERICAN ANNUAL OF PHOTOGRAPHY & PHOTOGRAPHIC TIMES ALMANAC FOR 1888 (1888): 81-82.

R461 "Our Editorial Table." PHOTOGRAPHIC TIMES 18, no. 370 (Oct. 19, 1888): 504. [Book Review: "Letters on Landscape Photography" by H. P. Robinson. New York: Scoville Mfg. Co., 1888.]

R462 l photo ("From Dawn to Sunset"). PHOTOGRAPHIC TIMES 18, no. 379 (Dec. 21, 1888): frontispiece, before p. 601.

R463 Robinson, H. P. "So Natural!" AMERICAN ANNUAL OF PHOTOGRAPHY AND PHOTOGRAPHIC TIMES ALMANAC FOR 1889 (1889): 54-57.

R464 Robinson, Henry P. "Correspondence: Extracts from a Letter from H. P. Robinson Concerning 'Twelve Photographic Studies'." PHOTOGRAPHIC TIMES 19, no. 386 (Feb. 8, 1889): 72-73.

R465 "'Ophelia.'" PHOTOGRAPHIC TIMES 19, no. 387 (Feb. 15, 1889): 77, plus frontispiece. 1 b & w. [Genre portrait.]

R466 Robinson, Henry P. "Art in Photography." PHOTOGRAPHIC TIMES 19, no. 397 (Apr. 26, 1889): 207-208.

R467 "Our Editorial Table: Pictorial Effect in Photography." PHOTOGRAPHIC TIMES 19, no. 397 (Apr. 26, 1889): 213-214. [Book rev.: "Pictorial Effect in Photography" by H. P. Robinson.]

R468 Robinson, H. P. "Winter Photography for the Artist." ART JOURNAL (Jan. 1890): 1-6. 5 b & w. [Photos by: J. Gale, W. W. Abney, F. Hopps, E. Spencer, H. B. Lemere.]

R469 Pringle, Andrew. "H. P. Robinson." SUN ARTISTS 1, no. 2 (Jan. 1890): 11-16, plus 4 unnumbered l. 4 b & w.

R470 Tarbell, John H. "A Visit to H. P. Robinson at Tunbridge Wells, England." PHOTOGRAPHIC TIMES 20, no. 433 (Jan. 3, 1890): 7-8.

R471 "Editorial Comment: H. P. Robinson's Pictures at the Boston Camera Club." AMERICAN AMATEUR PHOTOGRAPHER 2, no. 6 (June 1890): 232.

R472 1 photo ('The Keeper's Donkey'). PHOTOGRAPHIC TIMES 20, no. 464 (Aug. 8, 1890): 384, plus unnumbered leaf following p. 384. 1 b & w. [Note on p. 384, describing a new printing method used to reproduce Robinson's photo.]

R473 "Notes and News." PHOTOGRAPHIC TIMES 20, no. 469 (Sept. 12, 1890): 461. [Note that 64 prints by Robinson are on exhibition at the new quarters of the Society of Amateur Photographers of New York.]

R474 "Notes and News: The Chicago Camera Club." PHOTOGRAPHIC TIMES 20, no. 479 (Nov. 21, 1890): 580. [Note that the Chicago Camera Club will exhibit H. P. Robinson's photographs, loaned by the Boston Camera Club.]

R475 "The New York Camera Club's Exhibition." PHOTOGRAPHIC TIMES 21, no. 491 (Feb. 13, 1891): 76. [Two person show: H. P. Robinson and John E. Dumont.]

R476 Robinson, H. P. "The Use and Abuse of Models." AMERICAN ANNUAL OF PHOTOGRAPHY AND PHOTOGRAPHIC TIMES ALMANAC FOR 1892 (1892): 144-146.

R477 Robinson, Henry P. "If You Want To Make Pictures." PHOTOGRAPHIC MOSAICS:1892 28, (1892): 125-127.

R478 Robinson, H. P. "Where Are We Now?" PHOTOGRAPHIC TIMES 22, no. 546 (Mar. 4, 1892): 120-121. [Summary of professional photography in 1892 in Great Britain.]

R479 Robinson, Henry P. "Picture-Making in the Studio. Part 1." PHOTOGRAPHIC TIMES 22, no. 551 (Apr. 8, 1892): 184-186. 1 illus.

R480 Robinson, Henry P. "Picture Making in the Studio. Part 2." PHOTOGRAPHIC TIMES 22, no. 556 (May 13, 1892): 252-253.

R481 Robinson, Henry P. "Paradoxes of Art, Science, and Photography. Part 1." PHOTOGRAPHIC TIMES 22, no. 562 (June 24, 1892): 331-332.

R482 Robinson, Henry P. "Paradoxes of Art, Science, and Photography. Part 2." PHOTOGRAPHIC TIMES 22, no. 563 (July 1, 1892): 339-341.

R483 Robinson, Henry P. "Individuality in Photography." PHOTOGRAPHIC TIMES 22, no. 572 (Sept. 2, 1892): 452-454. [Read before the Photographic Convention of the United Kingdom.]

R484 Robinson, Henry P. "Picture Making in the Studio. Part 3." PHOTOGRAPHIC TIMES 22, no. 573 (Sept. 9, 1892): 457-459.

R485 Robinson, Henry P. "Picture-Making in the Studio. Part 4." PHOTOGRAPHIC TIMES 22, no. 575 (Sept. 23, 1892): 481-483.

R486 Robinson, Henry P. "Correspondence." PHOTOGRAPHIC TIMES 22, no. 577 (Oct. 7, 1892): 513-514. [Letter protesting a change of the name of the photo in the Sept. 9th issue of "Photographic Times." The substitution of "Elaine" for "Medora" somehow "is to upset much that I have been trying to teach for years..."]

R487 "The Editorial Table." PHOTOGRAPHIC TIMES 23, no. 595 (Feb. 10, 1893): 76. [Bk. rev.: "Picture-Making in the Studio," by H. P. Robinson.]

R488 "Distinguished Photographers of To-Day. IV - H. P. Robinson." PHOTOGRAPHIC TIMES 24, no. 655 (Apr. 6, 1894): 213-216, plus frontispiece. 4 b & w. 1 illus.

R489 Robinson, H. P. "Our Aims and End." PHOTOGRAPHIC TIMES 25, no. 684 (Oct. 26, 1894): 274-276. [Read at the Photographic Salon Oct.3, 1894.]

R490 Robinson, H. P. "Expression in Landscape." AMERICAN ANNUAL OF PHOTOGRAPHY AND PHOTOGRAPHIC TIMES ALMANAC FOR 1895 (1895): 168-173. 1 b & w.

R491 Robinson, H. P. "The Sky." PHOTOGRAPHIC TIMES 26, no. 2 (Feb. 1895): 65-68. 6 b & w.

R492 Wilson, Edward L. "Our Pictures." WILSON'S PHOTOGRAPHIC MAGAZINE 32, no. 459 (Mar. 1895): 111-112, plus frontispiece. 2 b & w. [Genre, "The Rising Lark" as frontispiece. A carte-de-visite by Robinson given to Wilson in 1864 also printed on p. 112.]

R493 "Our Pictures." WILSON'S PHOTOGRAPHIC MAGAZINE 32, no. 460 (Apr. 1895): 166-167, plus unnumbered leaf after p. 152. [Photogravure of composite landscape, "Storm Clearing Off."]

R494 Robinson, H. P. "Dame Nature." PHOTOGRAPHIC TIMES 26, no. 5 (May 1895): 307. [From "Camera & Lantern Review."]

R495 Wilson, Edward L. "On the Ground-Glass: The Evolution of a Photographer." WILSON'S PHOTOGRAPHIC MAGAZINE 32, no. 462 (June 1895): 241-242. [This issue of the monthly column contains comments on H. P. Robinson as well as excerpts of his quotes.]

R496 Robinson, H.P. "Foregrounds." PHOTOGRAPHIC TIMES 27, no. 1 (July 1895): 1-3. 6 b & w.

R497 1 b & w ("A September Morning") as frontispiece. NEW ENGLAND MAGAZINE 13, no. 1 (Sept. 1895): 2. 1 b & w.

R498 Robinson, Henry P. "On The Ground Glass." WILSON'S PHOTOGRAPHIC MAGAZINE 32, no. 468 (Dec. 1895): 532. [Extract of Robinson's article "The Man Who Never Reads," from the "Photographic News."]

R499 Robinson, H. P. "The Sea." AMERICAN ANNUAL OF PHOTOGRAPHY AND PHOTOGRAPHIC TIMES ALMANAC FOR 1896 (1896): 180-186. 6 b & w.

R500 Robinson, H. P. "Models." PHOTOGRAPHIC TIMES 28, no. 3 (Mar. 1896): 113-118. 8 b & w.

R501 Robinson, H. P. "Aim High." PHOTOGRAPHIC TIMES 28, no. 9 (Sept. 1896): 425-426.

R502 "Editorial Notes." PHOTOGRAPHIC TIMES 28, no. 9 (Sept. 1896): 428-432. [Text of presidential speech before the Royal Photographic Society's annual meeting, which is a summation of the position of photography at the time.]

R503 Robinson, Henry P. "Pictorial Photography and Portraiture." WILSON'S PHOTOGRAPHIC MAGAZINE 33, no. 477 (Sept. 1896): 390-392. [Excerpts from lecture given by Robinson at the British Photographic Convention at Leeds.]

R504 Robinson, Henry P. "Digressions. The Picturesque and the Beautiful." PHOTOGRAPHIC TIMES 29, no. 1 (Jan. 1897): 41-43. [From "British Journal of Photography".]

R505 Robinson, H. P. "Autobiographical Sketches. Chapter I - VII." PHOTOGRAPHIC TIMES 29-30, no. 2, 3, 7, 9, 11; 2, 3 (Feb., Mar., July, Sept., Nov. 1897; Feb., Mar. 1898): (Vol. 29) 65-69, 113-117, 305-309, 401-404, 497-501 (Vol. 30) 49-54, 104-107. 17 b & w.

R506 "Editorial Notes." PHOTOGRAPHIC TIMES 29, no. 5 (May 1897): 244, 255. 1 illus. [Portrait, quotes by Robinson.]

R507 "Notes." PHOTOGRAPHIC TIMES 29, no. 12 (Dec. 1897): 590. [Brief excerpt from a letter by H. P. Robinson describing an event where his younger son saves himself and his wife during a boating accident.]

R508 Robinson, Henry P. "Picture-Making Places." AMERICAN ANNUAL OF PHOTOGRAPHY & PHOTOGRAPHIC TIMES ALMANAC FOR 1898 (1898): 35-43.

R509 Robinson, H. P. "An Old Photograph." AMERICAN ANNUAL OF PHOTOGRAPHY AND PHOTOGRAPHIC TIMES ALMANAC FOR 1899 (1899): 101-102, 104-106. [Reminiscences of Robinson's early career, mentioning events and people with whom he associated.]

R510 Robinson, H. P. "Is Photography Among the Fine Arts? A Symposium. 4." MAGAZINE OF ART 23, no. 6 (May 1899): 253-256. 2 b & w. [Photos by Robinson.]

R511 Lund, Percy. "London Letter." PHOTO ERA 6, no. 4 (Apr. 1901): 356-358. 1 illus. [Portrait of H. P. Robinson by Ralph W. Robinson. Obituary.]

R512 Wilson, Edward L. "Obituary: Henry Peach Robinson." WILSON'S PHOTOGRAPHIC MAGAZINE 38, no. 532 (Apr. 1901): 150. [Died Feb. 21, 1901.]

R513 Swift, W. B. "H. P. Robinson." PHOTOGRAPHIC TIMES 33, no. 5 (May 1901): 193-195. 7 illus. [Portraits of Robinson, views of his studio, house and important places.]

R514 "Editorial Notes: Death of H. P. Robinson." PHOTOGRAPHIC TIMES 33, no. 5 (May 1901): 225-230. 5 b & w. [Obituary reprinted from "Photography".]

R515 Cummings, Thomas Harrison. "H. P. Robinson, A Biographical Note." PHOTO ERA 7, no. 1 (July 1901): 1-5. 4 b & w.

R516 "Obituary of the Year: H. P. Robinson." BRITISH JOURNAL PHOTOGRAPHIC ALMANAC 1902 (1902): 691-693. [Robinson died Feb. 21, 1901. Became amateur photographer in 1852 at age 22. Subsequently went into a studio at Leamington professionally in 1857. Began long series of combination or composition pictures which brought him fame. Retired about 1890, but wrote and photographed profusely. Many awards, possibly more than 100 medals from exhibitions between 1860 to 1890. Successful professional author and exhibitor.]

R517 Gill, A. T. "Bringing Home the May." PHOTOGRAPHIC JOURNAL 114, no. 5 (May 1974): 215-217. 10 b & w.

R518 "The Henry Peach Robinson Portfolio." PHOTOGRAPHIC JOURNAL 115, no. 11 (Nov. 1975): 526-529. 8 b & w.

R519 "Bringing Home the May: H. P. Robinson." APERTURE no. 79 (1977): 32-43. 10 b & w. [Illustrations are of the composite photograph "Bringing Home the May" and the nine separate parts that were collaged together to make the final print.]

R520 Taylor, John. "Henry Peach Robinson and Victorian Theory." HISTORY OF PHOTOGRAPHY 3, no. 4 (Oct. 1979): 295-303. 2 b & w. 2 illus.

ROBINSON, JAMES V. (d. 1902) (GREAT BRITAIN)
R521 "Obituary of the Year: J. V. Robinson." BRITISH JOURNAL PHOTOGRAPHIC ALMANAC 1903 (1903): 681. [Native of Spalding, Lincolnshire, went to Dublin over forty years ago. Pharmaceutical work, then became a photographer. With Thomas Millard, one of the pioneer photographers in Ireland. Improved cameras, shutters, etc. Once built camera which could take photos 5'6" x 3'2". Founder of Photo. Soc. of Ireland, member of Royal Dublin Soc., etc.]

R522 Greenhill, Gillian B. "The Death of Chatterton, or Photography and the Law." HISTORY OF PHOTOGRAPHY 5, no. 3 (July 1981): 199-205. 1 b & w. 2 illus. [Article is about the Irish photographer James Robinson's 1859 stereograph re-enacting Henry Wallis' painting "The Death of Chatterton" and the ensuing injunction trial against Robinson.]

ROBINSON, S. M. (USA)
R523 Robinson, S. M. "The Cause of Pinholes in Negatives not the Bath Solution." PHILADELPHIA PHOTOGRAPHER 8, no. 90 (June 1871): 188-189. [S. M. Robinson in charge of Frederick Gutekunst's Gallery darkroom in 1870. He mentions J. W. Black, Wm Bell, etc. in this article.]

R524 "Note." PHOTOGRAPHIC TIMES 1, no. 7 (July 1871): 104. [Note that S. M. Robinson, who had worked for several years for Gutekunst "as a first class operator" has left photography and engaged with the Scovill Manufacturing Company (Photo supplies & equip.).]

R525 "Voices from the Craft." PHILADELPHIA PHOTOGRAPHER 15, no. 179 (Nov. 1878): 335-337. [S. M. Robinson from Pittsburgh, PA.]

ROCHAS, AIME. (FRANCE)
R526 Perez, Nissan. "Aime Perez: Daguerreotypist." IMAGE 22, no. 2 (June 1979): 11-14. 2 b & w. [Conjectural discussion of Rochas, who is credited by Maxime De Camp with having made plates 1, 9 and 52 in the 1852 album "Egypte, Nubie, Palestine et Syrie."]

ROCHE, THOMAS C. (d. 1895) (USA)

[Very little is known about the life and career of Thomas C. Roche, even though he is one of the important American photographers of the 19th century. He was described in the *Photographic History of the Civil War* as "...an indefatigable worker in the armies' train..." He worked for E. & H. T. Anthony & Co. as the war was starting. He went over to the Brady studio and then was with Gardner, perhaps as a consultant on the carte-de-visite printing arrangements in effect between the Anthony Co. and the Brady Studio. He was soon photographing under General Meigs in the Quartermaster Corps, and may have worked under or with Capt. Andrew J. Russell later in the war. He photographed the battle of Dutch Gap Canal while under cannon-fire, and made powerful portraits of dead Confederate soldiers in the trenches at Petersburg after it fell to the Union forces in April 1865. The Anthony Co. printed these and others of Roches' photographs, and, after the war, Roche continued to work for the Anthonys. An acknowledged expert in the gelatin dry-plate process, and considered as one of the premier landscape photographers, Roche travelled over much of the United States in the 1870s and early 1880s, making views for the Anthony Co. In 1870 he travelled over the completed Union Pacific Rail Road to California and made views along the line and in the Yosemite Valley. In 1874 he toured the South, photographing through Georgia, South Carolina, and Florida. In 1875 he was in Tennessee. It was claimed that he made over 15,000 negatives throughout this decade. Roche's articles and photographs were published in *Anthony's Photographic Bulletin* and elsewhere, and in 1883 Roche co-authored, with Henry T. Anthony, the guide *How to Make Photographs: A Manual for Amateurs*.]

BOOKS

R527 Roche, Thomas C., Edited by H. T. Anthony. *How to Make Photographs: A Manual for Amateurs.* "Anthony's Series No. 12" New York: Anthony Manufacturing Co., 1883. ix, 91 pp. 2 b & w. illus. [Two original photos. Revised, updated (through 1904).]

PERIODICALS

R528 "Caution to Photographers." HUMPHREY'S JOURNAL OF PHOTOGRAPHY, AND THE ALLIED ARTS AND SCIENCES 20, no. 21 (May 15, 1869): 334. [Note that a pair of single view lenses, stereos stolen from T. C. Roche, 591 Broadway.]

R529 "Stereoscopic Views of the Cleveland Rink." ANTHONY'S PHOTOGRAPHIC BULLETIN 1, no. 8 (Sept. 1870): 165-166. [Interior views of the National Photographic Assoc. exhibition of 1870 in the Cleveland Rink taken by T. C. Roche, available for sale.]

R530 "Yosemite." ANTHONY'S PHOTOGRAPHIC BULLETIN 1, no. 11 (Dec. 1870): 220-222, 233. [Description of Yosemite Valley, apparently written to draw tourists; doesn't mention any photography. On p. 233, under "Stereoscopic Views," is a listing of views taken by Roche (Anthony Co. photographer) along the line of the Union Pacific R.R. and in Yosemite Valley.]

R531 Roche, T. C. "Correspondence: Going To The Yo Semite." ANTHONY'S PHOTOGRAPHIC BULLETIN 2, no. 5 (May 1871): 157-158.

R532 Roche, Thomas C. "Correspondence: Yosemite Valley." ANTHONY'S PHOTOGRAPHIC BULLETIN 2, no. 8 (Aug. 1871): 268-270. [Letter from Roche, describing his activities at Yosemite. "A Mr. Garrett, of Wilmington, DL, photographing here....A Mr. Pond, from Buffalo, NY here..." Excerpt quoted from the May 28 "San Francisco [CA] Daily Californian."]

R533 "Apropos of Mr. Roche." ANTHONY'S PHOTOGRAPHIC BULLETIN 2, no. 9 (Sept. 1871): 303. [Note that Roche has returned safely from his trip to Yosemite.]

R534 Towler, Prof. J., M.D. "Practical Landscape Photography." PHILADELPHIA PHOTOGRAPHER 8, no. 95 (Nov. 1871): 352-354. [Discussion of Roche's Yosemite, CA, views, with a description of his processes and working methods.]

R535 "Merry Christmas and Happy New Year." ANTHONY'S PHOTOGRAPHIC BULLETIN 2, no. 12 (Dec. 1871): 373. 1 illus. ["In presenting the complements of the season to our 5000 readers,...by means of a modified photo-relief process...design produced directly from a negative on stone or metal, without the use of a graver. Our Mr. T. C. Roche, and John C. Firmbach are the originators of the process,...now being commercially tested by Messrs. McLoughlin Bros., New York, NY."]

R536 "Mr. J. M. Hutchings on the Yo-Semite Valley." ANTHONY'S PHOTOGRAPHIC BULLETIN 3, no. 1 (Jan. 1872): 422-423. [From "Boston Daily Advertiser." "Mr. Hutchings, the lecturer, gave a series of lectures on the Yosemite Valley, accompanied with photographic views," at Tremont Temple, Boston...The photographs, which were the work of the Messrs. Anthony of New York "(ie. T. C. Roche.")]

R537 Roche, T. C. "Landscape and Architectural Photography." ANTHONY'S PHOTOGRAPHIC BULLETIN 4, no. 9 (Sept. 1873): 260-262.

R538 Roche, T. C. "Fifth Annual Meeting and Exhibit of the National Photographic Association of the U. S., held in Buffalo, N. Y., beginning July 5, 1873: Landscape & Architectural Photography." PHILADELPHIA PHOTOGRAPHER 10, no. 117 (Sept. 1873): 346-352.

R539 Roche, T. C. "Roche's Rapid Dry Plates." ANTHONY'S PHOTOGRAPHIC BULLETIN 4, no. 11 (Nov. 1873): 323.

R540 Roche, T. C. "Process for Printing on Wood or Canvas." ANTHONY'S PHOTOGRAPHIC BULLETIN 4, no. 12 (Dec. 1873): 362.

R541 Roche, T. C. "Photographing Below Zero." BRITISH JOURNAL PHOTOGRAPHIC ALMANAC 1874 (1874): 88-89.

R542 "Stereoscopic and 4-4 Views." ANTHONY'S PHOTOGRAPHIC BULLETIN 5, no. 6 (June 1874): 226. ["Our Mr. Roche has just returned from a Southern tour...views of Charleston, Savannah, Jacksonville, Mandarin, Magnolia, Green Cove Springs, Tocoi, St. Augustin, Palatka, the Ocklawaha River, Silver Springs and Okehumkee..."]

R543 "The Illustration." BRITISH JOURNAL PHOTOGRAPHIC ALMANAC 1875 (1875): frontispiece, plus p. i. 1 b & w. [Original photograph, tipped-in. Landscape view of Yosemite.]

R544 Roche, T. C. "Correspondence." ANTHONY'S PHOTOGRAPHIC BULLETIN 6, no. 6 (June 1875): 188-189. [Letter from Roche, who is in Tennessee, making views at Lookout Mountain and vicinity.]

R545 Roche, T. C. "Roche on Bromide Emulsions." ANTHONY'S PHOTOGRAPHIC BULLETIN 6, no. 12 (Dec. 1875): 369. ["To the Photo. Section of the American Institute.]

R546 Loomis, G. H. "Dry Plate Photography." ANTHONY'S PHOTOGRAPHIC BULLETIN 8, no. 11 (Nov. 1877): 341-342. ["A score of years since we began to hear about it; a little later we began to read about it, and now and then to see about it;...at last has been achieved in the development and perfection the dry plate process..." Mentions Roche's contributions.]

R547 "Report of the Photographic Section of the American Institute." ANTHONY'S PHOTOGRAPHIC BULLETIN 8, no. 11 (Nov. 1877): 346-347. [T. C. Roche displayed prints made from his dry plate process, led to discussion.]

R548 "The Picture." ANTHONY'S PHOTOGRAPHIC BULLETIN 10, no. 1 (Jan. 1879): frontispiece, 32. 1 b & w. [In 1879, "Anthony's" began tipping-in an original photographic print as frontispiece. The first photo was a landscape view of Yosemite Valley, by T. C. Roche. (Missing from this issue.)]

R549 Roche, T. C. "A Card." ANTHONY'S PHOTOGRAPHIC BULLETIN 10, no. 5 (May 1879): 151. [Roche praises the Artotype Process.]

R550 Roche, T. C. "To Amateurs and Others." ANTHONY'S PHOTOGRAPHIC BULLETIN 10, no. 8 (Aug. 1879): 251. ["The substitution of dry sensitive plates for general outdoor photography in place of the silver bath is now a recognized fact, the old, cumbersome method...has become obsolete."]

R551 Roche, T. C. "Out-Door Traps." ANTHONY'S PHOTOGRAPHIC BULLETIN 10, no. 9 (Sept. 1879): 280.

R552 Roche, T. C. "Alkaline Development Without Bromide." ANTHONY'S PHOTOGRAPHIC BULLETIN 10, no. 9 (Sept. 1879): 282.

R553 Roche, T. C. "How to Dispense with Water in Field Work." ANTHONY'S PHOTOGRAPHIC BULLETIN 10, no. 12 (Dec. 1879): 377.

R554 Taylor, J. Traill. "Home and Foreign News." PHOTOGRAPHIC TIMES 11, no. 125 (May 1881): 183. [Notice that Roche had obtained a USA patent on argentic gelatino-bromide paper in 1881, drawing forth sarcastic commentary from Taylor, who claimed that the process was already known and used in Britain.]

R555 Taylor, J. Traill. "Home and Foreign News." PHOTOGRAPHIC TIMES 11, no. 126 (June 1881): 212. [Further commentary on Roche's patent, apology for misunderstanding U.S. patent system by the British author.]

R556 Russell, A. J. "Photographic Reminiscences of the Late War." ANTHONY'S PHOTOGRAPHIC BULLETIN 13, no. 7 (July 1882): 212-213. 1 illus. [Anecdote about T. C. Roche at the Petersburg battle.]

R557 "Our Editorial Table: Instantaneous Views of New York." PHOTOGRAPHIC TIMES 15, no. 196 (June 19, 1885): 333. [Description of full-plate instantaneous views of New York taken on Decoration Day by Mr. Roche for E. & T. H. Anthony.]

R558 "Our Illustration." ANTHONY'S PHOTOGRAPHIC BULLETIN 17, no. 11 (June 12, 1886): 329, plus frontispiece. 1 b & w. [Trotting horses in Central Park, by T. C. Roche, taken with dry plate. Photo not bound in this copy.]

R559 "Views Caught with the Drop Shutter." ANTHONY'S PHOTOGRAPHIC BULLETIN 17, no. 22 (Nov. 27, 1886): 704. [Letter from Roche describing his visit to the Electric Light Photo Printing Company in Chicago.]

R560 "Notes and News." PHOTOGRAPHIC TIMES 20, no. 474 (Oct. 17, 1890): 522. [Note that T. C. Roche gave a demonstration of the carbon process at a meeting of the Society of Amateur Photographers on Oct. 14.]

R561 "Obituary." WILSON'S PHOTOGRAPHIC MAGAZINE 32, no. 468 (Dec. 1895): 571. [Began as amateur in 1858, started working for Anthony & Co. in 1862. "During the Civil War, Mr. Roche went to the front under Gen. Meigs as a photographer, and after his service was ended he made a series of some 15,000 negatives covering every section of the United States..."]

ROCHE, THOMAS C. [?]
R562 "Our Illustration." ANTHONY'S PHOTOGRAPHIC BULLETIN 10, no. 6 (June 1879): frontispiece, 189. 1 b & w. [Original photograph, view of Broadway, NY. Only credit, "Negative made with Anthony's Emulsion," where typically the artist is credited. Roche was an Anthony employee at this time, and known to have been taking views of New York, NY. Probably by Roche.]

R563 "Our Illustration." ANTHONY'S PHOTOGRAPHIC BULLETIN 10, no. 8 (Aug. 1879): frontispiece, 255. 1 b & w. [Original photo. "Elevated Railroad, Chatham Square, NY." Not credited, probably by T. C. Roche.]

ROCHER, HENRY. (b. 1824) (GERMANY, USA)
R564 "Editor's Table: Views of Chicago in Ruins." PHILADELPHIA PHOTOGRAPHER 8, no. 96 (Dec. 1871): 407.

R565 "Our Picture." PHILADELPHIA PHOTOGRAPHER 9, no. 98 (Feb. 1872): 33-36. 1 b & w. [Full length portrait, plus floor plans for the studio.]

R566 Loomis, G. H. "Gallery Biographic. No. 6. Henry Rocher." ANTHONY'S PHOTOGRAPHIC BULLETIN 6, no. 5 (May 1875): 147-148. [Born near Berlin, Germany on Nov. 19, 1824. Father a merchant and Rocher apprenticed for six years in the grocery trade, then worked as a book-keeper in Dresden. In 1851 took up the daguerreotype. Came to New York in 1842, where he worked in a variety of trades. Finally in 1862 began photographing again, this time in Chicago, IL. Burned out with the Chicago fire. Began again.]

R567 "Our Picture." PHILADELPHIA PHOTOGRAPHER 12, no. 139 (July 1875): frontispiece, 193-194. 1 b & w. [Studio Portrait. Rocher in Chicago, IL.]

R568 Whitney, E. T. "Photography, Art, Excellence." PHILADELPHIA PHOTOGRAPHER 12, no. 140 (Aug. 1875): 243-245. [Description of Rocher's work. Rocher was from Chicago, IL.]

R569 "Our Picture." PHILADELPHIA PHOTOGRAPHER 12, no. 142 (Oct. 1875): frontispiece, 289-292. 1 b & w. [Studio portrait in "promenade" style awarded the gold medal for Promenade Prize Photo 1875, which was sponsored by "Phila. Photog."]

R570 "Rocher's Exhibit." PHILADELPHIA PHOTOGRAPHER 13, no. 151 (July 1876): 220-221.

R571 "Our Picture." PHILADELPHIA PHOTOGRAPHER 14, no. 162 (June 1877): frontispiece, 175-176. 1 b & w. [Studio portrait by Henry Rocher (Chicago, IL).]

R572 "Editor's Table." PHILADELPHIA PHOTOGRAPHER 15, no. 180 (Dec. 1878): 383. [Henry Rocher opened a new gallery in Chicago, IL.]

R573 Portrait. Woodcut engraving, credited "From a Photograph by H. Rocher, Chicago." FRANK LESLIE'S ILLUSTRATED NEWSPAPER 47, (1878) ["George S. Darling." 47:1213 (Dec. 28, 1878): 288.]

R574 "Photographic Society of Great Britain." ANTHONY'S PHOTOGRAPHIC BULLETIN 10, no. 11 (Nov. 1879): 345-346. [Mention of the annual exhibition, discussion of the work of H. Rocher, from Chicago, IL, who exhibited in the show.]

R575 "Our Illustration." ANTHONY'S PHOTOGRAPHIC BULLETIN 10, no. 11 (Nov. 1879): frontispiece, 352. 1 b & w. [Original photo. Studio portrait.]

ROCKLAND.
R576 "The Late Charles L. Elliott." HARPER'S WEEKLY 12, no. 611 (Sept. 12, 1868): 589. 2 illus. [Includes portrait and a view of Elliott's coffin on display at the Academy of Design, New York, NY.]

ROCKROTH, GEORGE H. (1843-1920) (USA) see also HISTORY:USA:AZ:19TH C. (Hooper).

ROCKWOOD, CHARLES T.
R577 Portrait. Woodcut engraving, credited "From a Photograph by Charles T. Rockwood." FRANK LESLIE'S ILLUSTRATED NEWSPAPER 27, (1869) ["The late James T. Brady." 27:700 (Feb. 27, 1869): 373.]

ROCKWOOD, ELIHU R.
R578 "Another Solar Printer for the Trade." ANTHONY'S PHOTOGRAPHIC BULLETIN 8, no. 3 (Mar. 1877): 95. ["Mr. Elihu R. Rockwood, for the past seventeen years with his brother, Mr. Geo. G. Rockwood (17 Union Square, NY), has organized an establishment for solar printing..."]

ROCKWOOD, GEORGE GARDNER. (1832-1911) (USA)
BOOKS
R579 Walker, James Perkins. Book of Raphael's Madonnas. New York: Levitt & Allen, 1860. 104 pp. 13 l. of plates. 14 b & w. [Original photos by G. G. Rockwood, from Raphael's paintings. Another edition, (1874).]

R580 Potter, Edward Tuckerman. The Capitals of the Banker Screen in the First Reformed Dutch Church, Schenectady, N. Y.; Designed by Edward T. Potter, Architect of the Church. New York: George G. Rockwood, 1864. n. p. 12 b & w.

R581 Rockwood, George G. The Classic Grounds of American Authors. Irving. Photographed and Published by Geo. G. Rockwood. New York: George G. Rockwood, 1864. 7 l. 5 b & w. ["For the explanatory text, the publisher is indebted to the Rev. Ed. Guilbert." Photographic views around Tarrytown, NY, of scenes associated with Washington Irving.]

R582 New York (City). Central Park Commission. Annual Report. New York: Bryant, 1866-1870 (vols. 9-13). [The annual reports from 1865 to 1869 contain thirty-seven mounted photographs, probably all by George G. Rockwood. (NYPL Collection.) In the one volume I've seen, the 11th annual report (1868), the tipped-in photos consist of small,

charming, vignettes showing children at play, people using the park structures etc.]

R583 Guilbert, Edmund. The Home of Washington Irving, Illustrated. New York: D. Appleton & Co., 1867. 9 l. 6 b & w. [Mounted photographs.]

R584 Mitchell, Donald Grant. Pictures of Edgewood; In a Series of Photographs, by Rockwood, and Illustrative Text, By the Author of "My Farm of Edgewood." New York: C. Scribner & Co., 1869. 62 pp. 10 b & w. [300 copies. Mounted photographs.]

R585 New York (City). Park Department. Annual Report of the New York (City) Board of Commissioners of the Department of Public Parks. New York: Bryant, 1871. 427 pp. 5 b & w. illus. [Original prints in volume 1, (1870/71) by George G. Rockwood. NYPL collection. Continues: The Report of the Board of Commissioners of the Central Park. Includes lithographs, etchings, engravings as well. Photoengravings, etc.]

R586 New York (City). Public Works Department. Annual Report nos. 2-3. New York: 1872-73. illus. [1872 vol. has 7 original photos by G. G. Rockwood. 1873 vol. has 3 heliotypes by Rockwood. NYPL collection.]

R587 ...The Humor and Pathos of Charles Dickens. "Quarterly Series, No. 1." New York: George G. Rockwood, 1885-86. 54 pp.

R588 Rockwood, George G. The Book of Beauty. New York: George G. Rockwood, c. 1895. n. p. illus. [Booklet, issued by the Rockwood studio, with advice to sitters on what to wear and how to comport themselves at a photographer's studio—with emphasis on the Rockwood Studio.]

PERIODICALS
R589 "Rockwood's Photographic Van or Travelling Car." PHILADELPHIA PHOTOGRAPHER 2, no. 20 (Aug. 1865): 130-132.

R590 "Burning of the New York Academy of Music on the Night of May 21, 1866." HARPER'S WEEKLY 10, no. 493 (June 9, 1866): 360. 1 illus. ["Photographed by Rockwood & Co., New York." (I suspect that the photograph of the building was taken earlier and that the engraver added the fire and firefighters).]

R591 "The Memorial Church to Washington Irving at Tarrytown, on the Hudson, and Classic Views in the Vicinity." HARPER'S WEEKLY 10, no. 502 (Aug. 11, 1866): 508. 6 illus. ["The photographs from which these sketches were made were taken by G. G. Rockwood, 839 Broadway, N.Y."]

R592 "International Suspension Bridge, two miles below Niagara Falls - Railroad Bridge across the Genesee River at Portage, N.Y." HARPER'S WEEKLY 10, no. 515 (Nov. 10, 1866): 712. 2 illus. ["Photographed by Rockwood & Co."]

R593 "'The Charity Patient.'" HARPER'S WEEKLY 10, no. 519 (Dec. 8, 1866): 769. 1 illus. ["Photographed by Rockwood & Co., New York." Statuary group by Mr. Rogers.]

R594 Portraits. Woodcut engravings, credited "From a Photograph by George G. Rockwood." HARPER'S WEEKLY 10, (1866) ["Cyrus W. Field." 10:518 (Dec. 1, 1866): 757. "Edwin Hubbell Chapin, D.D." 10:519 (Dec. 8, 1866): 773.]

R595 Portrait. Woodcut engraving, credited "From a Photograph by George G. Rockwood." HARPER'S WEEKLY 11, (1867) ["Henry A. Neely, D.D." 11:527 (Feb. 2, 1867): 69. "N. P. Willis." 11:528 (Feb. 9, 1867): 81. "H. Bergh, Pres. of SPCA." 11:530 (Feb. 23, 1867): 121. "American Artists: Daniel Huntington, Eastman Johnson, Charles Elliott, F. O. C. Darley (4 portraits)." 11:540 (May 4, 1867): 273. "New Uniform of the 22nd Regiment, N.Y.S.M. (group portrait of men in uniform)." 11:545 (June 8, 1867): 356. "Frederick E. Church, N.A." 11:545 (June 8, 1867): 364. "American Artists: George Inness, John F. Kensett, S. R. Gifford (3 portraits)." 11:550 (July 13, 1867): 433. "Late Charles King, LL.D." 11:564 (Oct. 19, 1867): 660. "A. W. Bradford." 11:569 (Nov. 23, 1867): 749.]

R596 "Equestrian Statue of Washington, Union Square, New York." HARPER'S WEEKLY 11, no. 531 (Mar. 2, 1867): 129. 1 illus.

R597 "The Leow Bridge Across Broadway, at Fulton Street, and the New Herald Building." HARPER'S WEEKLY 11, no. 545 (June 8, 1867): 360. 1 illus. ["Photographed by Rockwood, 839 Broadway."]

R598 "Statuette by Conkey." HARPER'S WEEKLY 11, no. 550 (July 13, 1867): 436. 1 illus. ["Photographed by Rockwood, 839 Broadway."]

R599 "Scenes on Board Admiral Farragut's Flag-Ship, the 'Franklin,' New York Harbor, June 29, 1867." HARPER'S WEEKLY 11, no. 551 (July 20, 1867): 449, 456-457. 6 illus. ["Photographed by Rockwood, 839 Broadway." Crew, etc.]

R600 "The Fast Trotter 'Ethan Allen'." HARPER'S WEEKLY 11, no. 553 (Aug. 3, 1867): 485. 1 illus. ["Photographed by Rockwood." Horse and surrey.]

R601 "Puck on His War-Horse." HARPER'S WEEKLY 11, no. 556 (Aug. 24, 1867): 533. 1 illus. ["Photographed by Rockwood." Statue by Edward Kuntze.]

R602 "The Round Tower at Newport." HARPER'S WEEKLY 11, no. 556 (Aug. 24, 1867): 540, 541. 1 illus. ["Photographed by Rockwood."]

R603 "The Terrace in Central Park, Looking Toward the Mall." HARPER'S WEEKLY 11, no. 559 (Sept. 14, 1867): 588. 1 illus. ["Photographed by Rockwood."]

R604 "The Terrace at Central Park, Viewed from the Lake." HARPER'S WEEKLY 11, no. 563 (Oct. 12, 1867): 645. 1 illus. ["Photographed by Rockwood."]

R605 "Harlem River Bridges." HARPER'S WEEKLY 11, no. 567 (Nov. 9, 1867): 708. 21 illus. ["Photographed by Rockwood."]

R606 "The Worth Monument, New York City." HARPER'S WEEKLY 11, no. 569 (Nov. 23, 1867): 748. 1 illus. ["Photographed by Rockwood."]

R607 "Pike's New Opera House, Corner of 23rd Street and 8th Avenue, New York." HARPER'S WEEKLY 12, no. 578 (Jan. 25, 1868): 60. 1 illus.

R608 Portrait. Woodcut engraving, credited "From a Photograph by George G. Rockwood." HARPER'S WEEKLY 12, (1868) ["William M. Evarts, of NY." 12:590 (Apr. 18, 1868): 244. "R. W. Hubbard, N.A." 12:595 (May 23, 1868): 324. "J. Q. A. Ward, N.A." 12:595 (May 23, 1868): 324. "Late Emanuel Leutze, the artist." 12:606 (Aug. 8, 1868): 509.]

R609 "The Tigress of Central Park." HARPER'S WEEKLY 12, no. 591 (Apr. 25, 1868): 257. 1 illus. ["Photographed by Rockwood." "The Tigress" is a statue by Cain in Central Park, New York, NY.]

R610 "New Tammany Hall, East Fourteenth Street, New York City." HARPER'S WEEKLY 12, no. 602 (July 11, 1868): 433, 456-457, 458. 2 illus. ["Photographed by Rockwood, 839 Broadway." Includes a double-page spread "'Interior of Tammany Hall,' From Photographs by Rockwood and Sketches by Theodore R. Davis."]

R611 "Union League Club-House, New York." HARPER'S WEEKLY 12, no. 611 (Sept. 12, 1868): 605. 1 illus. ["Photographed by Rockwood."]

R612 "The Good Samaritan - Group by Quincy Ward." HARPER'S WEEKLY 12, no. 613 (Sept. 26, 1868): 620. 1 illus. ["Photographed by Rockwood." Statuary.]

R613 "Monumental Statue Erected to the Memory of Major-General John Sedgwick by the Sixth Corps." HARPER'S WEEKLY 12, no. 617 (Oct. 24, 1868): 684. 1 illus. ["Photographed by Rockwood."]

R614 "The Hebrew Temple Emanu-El, Corner of Fifth Avenue and Forty-Third Street, New York City." HARPER'S WEEKLY 12, no. 620 (Nov. 14, 1868): 729. 1 illus. ["Photographed by Rockwood."]

R615 "Houdin's Statue of Washington." HARPER'S WEEKLY 12, no. 623 (Dec. 5, 1868): 772. 1 illus. ["Photographed by Rockwood."]

R616 "The Hoosac Tunnel." HARPER'S WEEKLY 12, no. 623 (Dec. 5, 1868): 781. 3 illus. [Two photographs of the entrance to Hoosac Tunnel credited to "Rockwood, 839 Broadway" and a sketch of underground drilling by George G. Rockwood.]

R617 Portraits. Woodcut engravings, credited "From a Photograph by George G. Rockwood." HARPER'S WEEKLY 13, (1869) ["James T. Brady, lawyer." 13:635 (Feb. 27, 1869): 141. James Harper 13:642 (Apr. 17, 1869): 241. "Gen. P. H. Jones, Postmaster." 13:646 (May 15, 1869): 316. "Dr. M. W. Jacobus." 13:650 (June 12, 1869): 372. "Dr. P. H. Fowler." 13:650 (June 12, 1869): 372. "Hon. H. T. Blow, U.S. Minister to Brazil." 13:658 (Aug. 7, 1869): 497. "Rev. John Lanahan." 13:677 (Dec. 18, 1869): 813.]

R618 "Booth's New Theatre, Twenty-Third Street and Sixth Avenue, New York." HARPER'S WEEKLY 13, no. 628 (Jan. 9, 1869): 21, 29. 1 illus. ["Photographed by Rockwood."]

R619 Portrait. Woodcut engraving, credited "From a Photograph by George G. Rockwood." FRANK LESLIE'S ILLUSTRATED NEWSPAPER 27, (1869) ["The late Sheppard A. Mount, N.A." 27:692 (Jan. 2, 1869): 253. "The late William A. Mount, N.A." 27:692 (Jan. 2, 1869): 253.]

R620 "View of the Public Institutions of Charity and Correction on Blackwell's Island, East River, New York." HARPER'S WEEKLY 13, no. 632 (Feb. 6, 1869): 91, 92. 9 illus. ["Photographed by Rockwood." Views of buildings and inmates.]

R621 Portrait. Woodcut engraving, credited "From a Photograph by Rockwood." FRANK LESLIE'S ILLUSTRATED NEWSPAPER 28, (1869) ["The late James Harper." 28:707 (Apr. 17, 1869): 65.]

R622 "'The Soldier of the Seventh Regiment'. Statue Designed for Central Park, by J. Q. A. Ward." HARPER'S WEEKLY 13, no. 658 (Aug. 7, 1869): 500. 1 illus. ["Photographed by Rockwood."]

R623 "Mr. A. T. Stewart's New Residence, Corner of Fifth Avenue and Thirty-Fourth Street, New York City." HARPER'S WEEKLY 13, no. 659 (Aug. 14, 1869): 521. 1 illus. ["Photographed by Rockwood."]

R624 "Central Park." HUMPHREY'S JOURNAL OF PHOTOGRAPHY, AND THE ALLIED ARTS AND SCIENCES 20, no. 24 (Aug. 15, 1869): 381. ["We are indebted to" the Board of Commissioners of the Central Park "for a copy of their Twelfth Annual Report, illustrated with thirteen handsome photographs by Rockwood,..."]

R625 "The Eclipse." HARPER'S WEEKLY 13, no. 660 (Aug. 21, 1869): 531. 4 illus. [Solar eclipse as seen in New York. 4 views "from photographs furnished by Rockwood, of this city."]

R626 "The New Hudson River Railroad Depot, Hudson Street, New York City." HARPER'S WEEKLY 13, no. 665 (Sept. 25, 1869): 620. 1 illus. ["Photographed by Rockwood."]

R627 "View of Shippan Point, Opposite Stamford, Connecticut - Shippan Point, Johnson and Miller's Auction Sale, Sept. 21, 1869 - Shippan Point, Visitors Inspecting Property Preliminary to the Sale of Sept. 21, 1869." HARPER'S WEEKLY 13, no. 667 (Oct. 9, 1869): 644. 3 illus. ["Photographed by Rockwood." 3 views, crowds, etc.]

R628 "Excavating for the Foundation of the New York City Post-Office Building." HARPER'S WEEKLY 13, no. 669 (Oct. 23, 1869): 678. 1 illus. ["Photographed by Rockwood."]

R629 "The Young Men's Christian Association's New Building, Fourth Avenue and Twenty-Third Street, New York City." HARPER'S WEEKLY 13, no. 669 (Oct. 23, 1869): 685. 1 illus. ["Photographed by Rockwood."]

R630 Portrait. Woodcut engraving, credited "From a Photograph by Rockwood." FRANK LESLIE'S ILLUSTRATED NEWSPAPER 29, (1869) ["Joseph R. Tooker, New York, NY." 29:732 (Oct. 9, 1869): 68. "The late Maj.-Gen. John E. Wool, U.S.A." 29:739 (Nov. 27, 1869): 173.]

R631 "Mowing with the Camel in the New York Central Park." HARPER'S WEEKLY 13, no. 672 (Nov. 13, 1869): 724. 1 illus. ["Photographed by Rockwood."]

R632 "What can be done by Rockwood's Photo-Engraving Process." ANTHONY'S PHOTOGRAPHIC BULLETIN 4, no. 3 (Mar. 1873): 80.

R633 "A Card." ANTHONY'S PHOTOGRAPHIC BULLETIN 4, no. 4 (Apr. 1873): 118. [Note from Rockwood advising those interested in his photo-engraving process.]

R634 Portrait. Woodcut engraving, credited "From a Photograph by Rockwood, 839 Broadway." FRANK LESLIE'S ILLUSTRATED NEWSPAPER 36, (1873) ["Capt. James A. Williams, of the "Atlantic," shipwrecked." 36:916 (Apr. 19, 1873): 89.]

R635 Portrait. Woodcut engraving, credited "Photographed by Rockwood." FRANK LESLIE'S ILLUSTRATED NEWSPAPER 37, (1874) ["Chief-Justice Morrison E. Waite." 37:958 (Feb. 7, 1874): 364.]

R636 Portrait. Woodcut engraving, credited "From a Photograph by Rockwood, New York City." FRANK LESLIE'S ILLUSTRATED

NEWSPAPER 41, (1875) ["Rev. J. H. Hobart Brown, Fond-du-Lac. WI." 41:1051 (Nov. 20, 1875): 169.]

R637 "Note." ANTHONY'S PHOTOGRAPHIC BULLETIN 10, no. 11 (Nov. 1879): 352. ["The indefatigable Rockwood has embarked in the Platinum enlarging business with his usual push and enterprise...."]

R638 "Rockwood's Photographic Annual: A Cur-Sory View of Art." ANTHONY'S PHOTOGRAPHIC BULLETIN 10, no. 12 (Dec. 1879): 2 unpaged l. following p. 368. [A sketched narrative sequence of cartoons, in 12 panels, depicting the problems a professional photographer has photographing a pet dog. This was apparently an item distributed by the Rockwood studio for publicity.]

R639 Portrait. Woodcut engraving, credited "From a Photograph by George G. Rockwood." HARPER'S WEEKLY 9, (1865) [The late Valentine Mott, M.D., L.L.D." 9:438 (May 20, 1865): 317.]

R640 "The Camera and the Printing Press." ANTHONY'S PHOTOGRAPHIC BULLETIN 5, no. 4 (Apr. 1874): frontispiece, 134. 1 b & w. [(Portrait.) Specimen-print by the Rockwood Photo-Engraving Process, 839 Broadway, NY.]

R641 "Rockwood's New Process of Photo-Lithography." ANTHONY'S PHOTOGRAPHIC BULLETIN 5, no. 6 (June 1874): 2 unnumbered pp. as frontispiece, 216. 2 illus. [Photolithographic copies of etchings.]

R642 Rockwood, George G. "Posing." PHOTOGRAPHIC TIMES 15, no. 219 (Nov. 27, 1885): 667. [Read before the Society of Amateur Photographers of New York.]

R643 Rockwood, George G. "Amateur Photography: Composite Portraits." ART AMATEUR 17, no. 1 (June 1887): 13. 1 b & w.

R644 Rockwood, George G. "Composite Photographs." ANTHONY'S PHOTOGRAPHIC BULLETIN 18, no. 11 (June 11, 1887): 335-337. [From "The Art Amateur".]

R645 Rockwood, George G. "Amateur Photography: Portrait Lighting." ART AMATEUR 17, no. 2 (July 1887): 39.

R646 Rockwood, George C. "Portrait Lighting." ANTHONY'S PHOTOGRAPHIC BULLETIN 18, no. 14 (July 23, 1887): 437-438. [From "The Art Amateur".]

R647 Rockwood, George G. "Amateur Photography: Hints on Landscape Photography, etc." ART AMATEUR 17, no. 3 (Aug. 1887): 58.

R648 Rockwood, George G. "Amateur Photography: Printing, etc." ART AMATEUR 17, no. 4 (Sept. 1887): 80.

R649 Rockwood, George G. "Photography Without a Camera." ANTHONY'S PHOTOGRAPHIC BULLETIN 18, no. 17 (Sept. 10, 1887): 526. [From "The Art Amateur".]

R650 Rockwood, George G. "Amateur Photography: Toning and Fixing, etc." ART AMATEUR 17, no. 5 (Oct. 1887): 100.

R651 Rockwood, George G. "Hints on Landscape Photography." ANTHONY'S PHOTOGRAPHIC BULLETIN 18, no. 19 (Oct. 8, 1887): 595-596. [From "The Art Amateur".]

R652 Rockwood, George G. "Amateur Photography: The Collodion Process -Notes and Formulas." ART AMATEUR 17, no. 6 (Nov. 1887): 125.

R653 Rockwood, George G. "Photography in Natural Colors." ANTHONY'S PHOTOGRAPHIC BULLETIN 18, no. 21 (Nov. 12, 1887): 656-657. [From "N.Y. Tribune."]

R654 "Our Illustration." ANTHONY'S PHOTOGRAPHIC BULLETIN 18, no. 21 (Nov. 12, 1887): 662, plus frontispiece. 1 b & w. [Portrait, taken by magnesium light. A long description of Rockwood's experiments with magnesium light appears in the report of the Soc. of Amateur Photographers of New York, pp. 665, this issue.]

R655 Rockwood, George G. "Toning and Fixing." ANTHONY'S PHOTOGRAPHIC BULLETIN 18, no. 22 (Nov. 26, 1887): 681-682.

R656 Rockwood, George G. "Amateur Photography: Dr. Piffard's Flash." ART AMATEUR 18, no. 1 (Dec. 1887): 12.

R657 Rockwood, George G. "Amateur Photography: Artificial Light in Photography - Night Photography - Mrs. Langtry's Doctored Photographs, etc." ART AMATEUR 18, no. 2 (Jan. 1888): 45.

R658 "Our Illustration." ANTHONY'S PHOTOGRAPHIC BULLETIN 19, no. 1 (Jan. 14, 1888): 24, plus frontispiece. 1 b & w. [Portrait by G. Rockwood. Not bound in this volume.]

R659 Rockwood, George G. "Amateur Photography: The Transferrotype - Photographs of the Moon - Proposed Change of Name, etc." ART AMATEUR 18, no. 3 (Feb. 1888): 70. [Proposal made to change the name of the Amateur Photographers of New York to the New York Camera Club.]

R660 Rockwood, George G. "Brain Pictures: A Photo-Physiological Discovery- Is the Brain a Recording Camera? A Frozen Slice from the Cranium of a Dead Scientist Reveals Wonderful Things." ANTHONY'S PHOTOGRAPHIC BULLETIN 19, no. 3 (Feb. 11, 1888): 76-79.

R661 Rockwood, George G. "Amateur Photography: The Flash Light - Post Mortem Photography - Landscape Photography, etc. " ART AMATEUR 18, no. 4 (Mar. 1888): 101.

R662 Rockwood, George G. "Amateur Photography: Experiments with the Flash, etc." ART AMATEUR 18, no. 5 (Apr. 1888): 118.

R663 Rockwood, George G. "Amateur Photography: The Second Annual Joint Exhibit of Amateur Photographers - Night Photography - Fogging - Clear Images, etc." ART AMATEUR 18, no. 6 (May 1888): 148.

R664 "Our Illustration." ANTHONY'S PHOTOGRAPHIC BULLETIN 19, no. 15 (Aug. 11, 1888): 465, plus frontispiece. 1 b & w. [Portrait of his granddaughter by George G. Rockwood. Photo not bound in this copy.]

R665 "Notes and News: Photography at Association Hall." PHOTOGRAPHIC TIMES 18, no. 372 (Nov. 2, 1888): 524. [Report on 3rd in a series of practical talks by George Rockwood.]

R666 "Views Caught with the Drop Shutter." ANTHONY'S PHOTOGRAPHIC BULLETIN 19, no. 21 (Nov. 10, 1888): 672. [Note that George Rockwood gave a lecture at the New York Young Men's Christian Assoc.]

R667 "Our Illustration." ANTHONY'S PHOTOGRAPHIC BULLETIN 20, no. 5 (Mar. 9, 1889): 149, plus frontispiece. 1 b & w. [Portrait of an actress by George G. Rockwood. Photo not bound in this copy.]

R668 "Our Publishers' Oldest Customer." ANTHONY'S PHOTOGRAPHIC BULLETIN 20, no. 8 (Apr. 27, 1889): 250-251. 2 b & w. [Brief commentary on how George G. Rockwood became a photographer. Rockwood, originally a reporter for the Troy, NY "Daily Times," appeared at Anthony's store in April 1859, with the intention to open a gallery on Broadway. Includes two portraits of Rockwood, one taken in the 1850s, one in 1889.]

R669 "Our Illustration." ANTHONY'S PHOTOGRAPHIC BULLETIN 20, no. 19 (Oct. 12, 1889): 599, plus frontispiece. 1 b & w. [Child portrait. Photo not bound in this copy.]

R670 Boyesen, Hjalmar Hjorth. "Columbia College." COSMOPOLITAN 8, no. 3 (Jan. 1890): 265-275. 20 b & w. ["Illustrated from photographs taken for the 'Cosmopolitan' by Rockwood." Buildings, portraits of faculty, classrooms, etc.]

R671 "Notes and News: The First Carte-de-Visite." PHOTOGRAPHIC TIMES 20, no. 447 (Apr. 11, 1890): 179. [Rockwood tells an anecdote of how Baron Rothschild visited his studio, returned a week later "...with a little picture" and asking for similar portraits... so the first carte-de-visite was made in this country."]

R672 "Notes and News." PHOTOGRAPHIC TIMES 21, no. 493 (Feb. 27, 1891): 107. [Rockwood moved from Union Square to Broadway.]

R673 "Notes and News." PHOTOGRAPHIC TIMES 21, no. 499 (Apr. 10, 1891): 177. [Rockwood opened his new gallery at 1440 Broadway, New York City.]

R674 "The Studios of New York: No. 3." PHOTOGRAPHIC TIMES 22, no. 548 (Mar. 18, 1892): 144-146. [Discusses Frederick's studio and George Rockwood's studio. Rockwood's operator for 33 years was Dan Murphy.]

R675 "Notes and News." PHOTOGRAPHIC TIMES 23, no. 598 (Mar. 3, 1893): 118. [Note that Rockwood, now past 60, wants to sell his Union Square Gallery while retaining the management of the Uptown Broadway Studio.]

R676 1 photo ("The Youngest Member of the Times Staff") as frontispiece. PHOTOGRAPHIC TIMES 23, no. 600 (Mar. 17, 1893): 135, plus frontispiece. 1 b & w. [Rockwood's portrait is of Wilson Irving Adams, grandson of W. I. Adams and son of W. I. L. Adams.]

R677 "Diogenes." PHOTOGRAPHIC TIMES 23, no. 625 (Sept. 8, 1893): 500. [Genre study of Diogenes, posed by the actor Nelson Wheatcroft; with brief commentary and brief quotes from Rockwood.]

R678 "Baby Ruth Photographed. A Perplexed Photographer." PHOTOGRAPHIC TIMES 23, no. 640 (Dec. 22, 1893): 765. [Ruth Cleveland, daughter of President Cleveland and the first baby in the White House, was the focus of intense popular interest. Mrs. Cleveland wanted photos but not to have them distributed commercially. A friend took the child to Rockwood, a well-known professional photographer, thus tricking him into photographing Baby Ruth without knowing who she was.]

R679 "Rockwood's Electrograph." PHOTOGRAPHIC TIMES 25, no. 680 (Sept. 28, 1894): 204-205. 1 b & w.

R680 Rockwood, George G. "Come, Let Us Have Fair Play. "Collodion or Gelatine - Which?" WILSON'S PHOTOGRAPHIC MAGAZINE. 32, no. 458 (Feb. 1895): 90-91. [Letter from Rockwood protesting claims made about one process versus another.]

R681 "Editorial Notes: Letter." PHOTOGRAPHIC TIMES 26, no. 6 (June l895): 369. 1 b & w. [Letter from Rockwood in turn quoting a letter from Ella Wheeler Wilcox, an author referring to her work "Maurine," which was to be used by the Photographers' Association of America as the work to be illustrated in their genre competition.]

R682 Rockwood, George G. "Concerning: "Maurine" and Ella Wheeler Wilcox." WILSON'S PHOTOGRAPHIC MAGAZINE. 32, no. 462 (June 1895): 266-267. 1 b & w. [Rockwood's note includes a portrait and a brief letter from Ms. Wilcox describing how she came to write the poem "Maurine". This poem had been chosen as the poem to illustrate for the annual prize awarded by the Photographer's Association of America.]

R683 DeKoven, Mrs. Reginald. "Bicycling for Women." COSMOPOLITAN 19, no. 4 (Aug. 1895): 386-394. 8 b & w. [Women's dress for bicycling; one photo credited "Taken for 'The Cosmopolitan' by Rockwood, New York."]

R684 Rockwood, George G. "A Bas-Relief Process." WILSON'S PHOTOGRAPHIC MAGAZINE 34, no. 484 (Apr. 1897): 179-180. 2 illus.

R685 Rockwood, George G. "The Single-Slant Light." WILSON'S PHOTOGRAPHIC MAGAZINE 34, no. 485 (May 1897): 227-228. [Article about his skylight arrangement, illus. with 2 diagrams. There are three portraits by Rockwood elsewhere in the issue.]

R686 "A Disputed Bas-Relief Process." WILSON'S PHOTOGRAPHIC MAGAZINE 34, no. 485 (May 1897): 229-230. [A process demonstrated by George Rockwood on p. 170 of Apr. 1897 issue apparently unintentionally infringed on a patent held by H. C. Fairchild.]

R687 "On the Ground-Glass." WILSON'S PHOTOGRAPHIC MAGAZINE 34, no. 487 (July 1897): 290-291. [Notes about bas-relief process being practiced by the George G. Rockwood Studio. See also "N.Y. Herald" May 30, 1897.]

R688 Rockwood, George G. "The Vandyke Style in Portraiture." WILSON'S PHOTOGRAPHIC MAGAZINE 34, no. 488 (Aug. 1897): 340-341.

R689 "The Artists and the Photographer." WILSON'S PHOTOGRAPHIC MAGAZINE 34, no. 491 (Nov. 1897): 525-526. [Rockwood photographed over 150 artworks - paintings, sculptures, miniatures, etc. by American artists, displayed them at the Dept. of Fine Arts at the American Institute Fair.]

R690 Rockwood, George G. "The Best Side of the Face." WILSON'S PHOTOGRAPHIC MAGAZINE 35, no. 496 (Apr. 1898): 171-173. 8 b & w. [From an interview in "Leslie's Weekly."]

R691 "Editor's Table: School of Photography." WILSON'S PHOTOGRAPHIC MAGAZINE 37, no. 525 (Sept. 1900): 432. [Notice that George Rockwood, after numerous requests, intends to give a series of lectures on the practical side of photography. "Mr. Rockwood is, we believe, the first business expert to do this."]

R692 1 b & w (President Theodore Roosevelt) on p. 276. CENTURY MAGAZINE 63, no. 2 (Dec. 1901): 276. 1 b & w.

R693 1 photo (John B. McDonald, builder of N.Y. subway). WORLD'S WORK 5, no. 2 (Dec. l902): 2835.

R694 1 photo (Lieut. Robert E. Peary). WORLD'S WORK 9, no. 1 (Nov. 1904): 5443.

R695 1 photo (Joseph H. Choate, Am. Delegation to Hague Conference). WORLD'S WORK 14, no. 3 (July 1907): 9047.

R696 1 b & w (Author Richard Watson Gilder) on p. 622. CENTURY MAGAZINE 79, no. 4 (Feb. 1910): 622. 1 b & w.

R697 Rockwood, George G. "The Influence of the Old Masters." WILSON'S PHOTOGRAPHIC MAGAZINE 48, no. 650 (Feb. 1911): 91-92.

R698 "George Gardner Rockwood." WILSON'S PHOTOGRAPHIC MAGAZINE 48, no. 656 (Aug. 1911): 382. [Obituary. Born in Troy, NY, in 1832. Studied there and, later, received a Ph.D from Columbia University. Began his photographic career in St. Louis , MO in 1853, and was one of the first to make cartes-de-visite in the USA. Came to New York, NY in 1857 and opened a studio at Broadway and 13th St., in partnership with his brother. Later moved the studio to Union Square and 15th Street. His portraits were well-regarded, and many celebrities sat for him. Rockwood had a fine reputation, which peaked in the the 1880s. Rockwood lectured and wrote about photography for many years, and his articles appeared in the "Philadelphia Photographer" and elsewhere. When he was younger he had been a singer of note, a tenor in the Plymouth Church Choir, Brooklyn. Later he was director of music for a church in New York City. He died in his country home in Lakeville, CT on July 12, 1911, in his 80th year.]

R699 "Beach's Pneumatic Underground Railway." STEREO WORLD 1, no. 4 (Sept. - Oct. 1974): 14. 2 b & w. [Two views, "Photographed at night by artificial light, Rockwood & Co., No. 839 Broadway." Around 1870.]

RODGER, THOMAS. (1833-1883) (GREAT BRITAIN)

R700 Rodger, Thomas. "The Collodion Process." PHOTOGRAPHIC AND FINE ART JOURNAL 10, no. 6-7 (June - July 1857): 189-190, 212-213. [From "J. of Photo. Soc., London."]

R701 Rodger, Thomas, of St. Andrews. "The Collodion Process." HUMPHREY'S JOURNAL 9, no. 7 (Aug. 1, 1857): 105-108. [From "J. of Photo. Soc., London."]

R702 "Fine-Art Gossip." ATHENAEUM no. 1655 (July 16, 1859): 88-89. ["Mr. T. Rodger, of St. Andrews, has commenced a work called 'Fife Calotypes,' a serial, which will comprise many places famous in song and story..."]

R703 Portrait. Woodcut engraving credited "From a photograph by T. Rodgers. [sic Roger], St. Andrews." ILLUSTRATED LONDON NEWS 47, (1865) ["Prof. Aytoun, Edinburgh." 47:* (Aug. 19, 1865): 161.]

R704 Cook, H. "An Artist of the Camera." SCOTS MAGAZINE 106, (Jan. 1877): 382-292.

R705 Portrait. Woodcut engraving credited "From a photograph by T. Rodger, St. Andrews." ILLUSTRATED LONDON NEWS 70, (1877) ["Earl of Haddington." 70:1961 (Feb. 10, 1877): 121.]

R706 Portrait. Woodcut engraving credited "From a photograph by T. Rodger, St. Andrews." ILLUSTRATED LONDON NEWS 75, (1879) ["Late John T. Delane." 75:2113 (Dec. 13, 1879): 548.]

R707 Smith, Graham. "James David Forbes and Thomas Rodger." SCOTTISH PHOTOGRAPHY BULLETIN (Autumn 1987): 14-19, back cover. 5 b & w. 1 illus. [One portrait of Thomas Rodger and Dr. George Berwick (1851). Three portraits by Thomas Rodger. One by Dr. John Adamson. A painted portrait of J. D. Forbes by Sir John Watson-Gordon. J. D. Forbes, the Professor of Natural Philosophy at Edinburgh University 1830s-1850s, was "...a well-informed and sometimes critical observer during the first three decades of the history of photography..." Thomas Rodger established a photo studio in St. Andrews in 1849.]

RODGER, WILLIAM. (MONTROSE, SCOTLAND)
R708 "Stereographs: Picturesque Scenery in the Vales of Tweed, Ettrick, and Yarrow, photographed by W. Rodger, Montrose." BRITISH JOURNAL OF PHOTOGRAPHY 7, no. 121 (July 2, 1860): 194.

R709 "Stereographs: Picturesque Scenery of the Highlands of Perthshire, by William Rodger, Montrose." BRITISH JOURNAL OF PHOTOGRAPHY 7, no. 131 (Dec. 1, 1860): 348.

RODGERS, H. J. (HARTFORT, CT)
BOOKS
R710 Rodgers, H. J. *Twenty-Three Years Under a Skylight; or, Life and Experiences of a Photographer.* "The People's Guide to Photography." Hartford, CT: American Publishing Co., 1872. 236 pp. 96 illus. [A manual for commercial studio portraiture. Reprinted (1973), Arno Press.]

PERIODICALS
R711 Rodgers, H. J. "Blisters. - Their Cause and Prevention." ANTHONY'S PHOTOGRAPHIC BULLETIN 5, no. 12 (Dec. 1874): 405-406. [Rodgers from Hartford, CT.]

R712 Rodgers, H. J. "Photographic Wrongs." PHILADELPHIA PHOTOGRAPHER 12, no. 139 (July 1875): 206-207.

RODGERS, H. J. [?] (HARTFORD, CT)
R713 Rogers, [sic Rodgers?] H. J. "Fifth Annual Meeting and Exhibit of the National Photographic Association of the U. S., held in Buffalo, N. Y., beginning July 5, 1873: Printing, Toning, etc." PHILADELPHIA PHOTOGRAPHER 10, no. 117 (Sept. 1873): 383-384.

R714 Rogers, [sic Rodgers?] H. J. "Small Things, or How to Profit Financially." ST. LOUIS PRACTICAL PHOTOGRAPHER" 11, no. (Jan. 1877): 21-22.

RODRIGUEZ, JOSE JULIO.
R715 Rodriguez, Jose Julio. "Photographic Process: Giving Half Tones." PHILADELPHIA PHOTOGRAPHER 14, no. 167 (Nov. 1877): 327-329, 364-365. [Presented to the Belgian Assoc. of Photography, translated for the "P.P." See Wenderoth's refutation on pp. 356-357.]

ROE, SYLVESTER. (FLUSHING, NY)
R716 Roe, Sylvester. "Blisters - Browning of Paper." AMERICAN JOURNAL OF PHOTOGRAPHY, AND THE ALLIED ARTS AND SCIENCES n. s. vol. 9, no. 6 (Nov. 15, 1866): 130.

ROEGELS & LA ROUCHE. (LAREDO, TX)
R717 "Texas. - The War-Cloud on the Mexican Frontier - The American and Mexican Towns of Laredo, on the Opposite Banks of the Rio Grande. - From Photographs by Roegels & La Rouche, Laredo,

Texas." FRANK LESLIE'S ILLUSTRATED NEWSPAPER 44, no. 1128 (May 12, 1877): 172. 2 illus. [Views.]

ROESCH, C. (ST. PETERSBURG, RUSSIA)
R718 Portrait. Woodcut engraving credited "From a photograph by C. Roesch." ILLUSTRATED LONDON NEWS 75, (1879) ["Lord Augustus Loftus, Gov. of N.S. Wales." 75:2114 (Dec. 20, 1879): 584.]

ROESLER, AUGUSTUS. (SWEDEN)
R719 "Editor's Table." PHILADELPHIA PHOTOGRAPHER 13, no. 151 (July 1876): 223. [Panoramic view of Stockholm, 8" x 36", from Mr. Augustus Roesler.]

ROETTGER.
R720 "H. Roettger's New Patent Parallatic Solar Camera." AMERICAN JOURNAL OF PHOTOGRAPHY AND THE ALLIED ARTS & SCIENCES n. s. vol. 7, no. 23 (June 1, 1865): 538-539.

R721 "Roettger's New Patent Parallactic Solar Camera." PHILADELPHIA PHOTOGRAPHER 2, no. 19 (July 1865): 106-107. 2 illus.

R722 "Roettger's New Patent Parallactic Solar Camera." AMERICAN JOURNAL OF PHOTOGRAPHY AND THE ALLIED ARTS & SCIENCES n. s. vol. 8, no. 4 (Aug. 15, 1865): 87-88. 2 illus.

R723 "Enlarging Photographs. - Roettger's new Patent Parallactic Solar Camera." HUMPHREY'S JOURNAL OF PHOTOGRAPHY, AND THE ALLIED ARTS AND SCIENCES 17, no. 8 (Aug. 15, 1865): 116-117. 2 illus.

ROGER, VICTOR.
R724 "Personal & Art Intelligence." PHOTOGRAPHIC AND FINE ART JOURNAL 9, no. 3 (Mar. 1856): 96. [Mr. Delarue, the photographer Victor Roger, and others arrested for making and selling pornographic photos in Paris.]

ROGERS. (NORFOLK, ENGLAND)
R725 Portraits. Woodcut engravings credited "From a photograph by Rogers, of Norfolk." ILLUSTRATED LONDON NEWS 32, (1858) ["Parliamentary Portraits: Viscount Bury, Henry Wm. Schneider." 32:* (June 5, 1858): 561.]

ROGERS, CLEMENT. (ST. LEONARDS-ON-SEA, ENGLAND)
R726 Portrait. Woodcut engraving credited "From a photograph by Clement Rogers." ILLUSTRATED LONDON NEWS 72, (1878) ["Late Rev. Dr. J. B. Mozley." 72:2014 (Feb. 2, 1878): 108.]

ROGERS, EDWARD D. (HAMILTON, OH)
R727 "Our Picture." PHILADELPHIA PHOTOGRAPHER 16, no. 188 (Aug. 1879): frontispiece, 240. 1 b & w. [Portrait.]

ROGERS, H. F. (d. 1865) (USA)
R728 "Editor's Table." PHILADELPHIA PHOTOGRAPHER 2, no. 24 (Dec. 1865): 207. [Rogers, a photographer in Hamilton, OH, was murdered by his room-mate David O'Connor.]

ROGERS, HENRY G. (NAPLES, ITALY)
R729 Rogers, Henry G. "Collodion Emulsion." BRITISH JOURNAL PHOTOGRAPHIC ALMANAC 1878 (1878): 62-63.

R730 Rogers, H. G. "A Reminiscence." AMERICAN ANNUAL OF PHOTOGRAPHY AND PHOTOGRAPHIC TIMES ALMANAC FOR 1896 (1896): 218, 220, 222-223. [Recalls meeting with Walter B.

Woodbury in the 1870s in Italy; discusses that meeting, and his own action of photographing the interior of the Milan Cathedral, etc.]

ROGERS, JOHN. (PITTSBURGH, PA)
R731 "Personal & Art Intelligence: A Model Daguerrean Establishment." PHOTOGRAPHIC AND FINE ART JOURNAL 9, no. 12 (Dec. 1856): 383. [From "Pittsburgh (PA) Evening Chronicle."]

R732 "Personal & Art Intelligence: Roger's Daguerrean and Ambrotype Gallery." PHOTOGRAPHIC AND FINE ART JOURNAL 10, no. 2 (Feb. 1857): 64. [From "Pittsburgh (PA) Daily Union."]

R733 "The Railroad Depot at Pittsburgh, Pennsylvania, on the Site of Fort Daquesne." HARPER'S WEEKLY 2, no. 101 (Dec. 4, 1858): 773. 1 illus. ["Photographed by John Rogers."]

ROGERS, JOSEPH A.
R734 Rogers, Joseph A. "Letter from Prof. Rogers on Emulsions." PHOTOGRAPHIC TIMES 5, no. 60 (Dec. 1875): 289-290.

ROGERS, S. G. & T. W. ROGERS. (CARMICHAELS, PA)
R735 "Our Picture - Oil Well, Carmichaels, PA." PHILADELPHIA PHOTOGRAPHER 3, no. 28 (Apr. 1866): frontispiece, 125. 1 b & w.

ROGERS, T. (GREAT BRITAIN)
R736 "Fine-Art Gossip." ATHENAEUM no. 1655 (July 16, 1859): 88-89. ["Mr. T. Rogers, of St. Andrews, has commenced a work called 'Fife Calotypes,' a serial, which will comprise many places famous in song and story..."]

ROGERS, WILLIAM B.
R737 Rogers, William B., Prof. "Experiments and Conclusions on Binocular Vision." AMERICAN JOURNAL OF PHOTOGRAPHY AND THE ALLIED ARTS & SCIENCES n. s. vol. 3, no. 12 (Nov. 15, 1860): 177-179. [From "Photo. Notes."]

R738 Rogers, William B. Prof. "Experiments and Conclusions on Binocular Vision." HUMPHREY'S JOURNAL OF PHOTOGRAPHY, AND THE ALLIED ARTS AND SCIENCES 12, no. 13 (Nov. 1, 1860): 205-207. [From "Br. J. of Photo."]

ROHRER, H. (CINCINNATI, OH)
R739 Rohrer, H. "A New Toning Process." AMERICAN JOURNAL OF PHOTOGRAPHY AND THE ALLIED ARTS & SCIENCES n. s. vol. 7, no. 20 (Apr. 15, 1865): 477-478.

ROLFE. (LONDON, ENGLAND)
R740 "Note." ART JOURNAL (Mar. 1864): 91. ["Mr. Rolfe, landscape painter & photographer of the Haymarket, has painted & photographed some views in order to supply the vigor of tone, definition of form, and the artistic distribution of lights and darks considered necessary to pictorial compositions."]

ROLLASON.
R741 "Enamelling Photographs." AMERICAN JOURNAL OF PHOTOGRAPHY AND THE ALLIED ARTS & SCIENCES n. s. vol. 7, no. 15 (Feb. 1, 1865): 344-345. [From "Br. J. of Photo."]

ROME. (CALCUTTA, INDIA)
R742 "Photographs of Lord and Lady Canning, Walter Bourne, M.D., Hon. Sec. of Bengal Photographic Society, Calcutta." JOURNAL OF THE PHOTOGRAPHIC SOCIETY OF LONDON 8, no. 135 (July 15, 1863): 334-335. [Controversy: photos of Lord & Lady Canning were made by Mr. Rome of Calcutta, then copyrighted by Mr. Hering,

photographer to the Queen (in London?) without his permission. Henry Hering's reply in Aug. issue.]

ROOD, O. N. (1831-1907) (GREAT BRITAIN)
R743 Rood, Professor O. N. "On the Practical Application of Photography to the Microscope." BRITISH JOURNAL OF PHOTOGRAPHY 8, no. 153 (Nov. 1, 1861): 378-380. 3 illus. [Rood from Troy, NY. From "Silliman's Journal."]

R744 Rood, Professor O. N. "Some Reasons Why Photographic Portraits Should Not Be Coloured." BRITISH JOURNAL OF PHOTOGRAPHY 10, no. 188 (Apr. 15, 1863): 161-162.

R745 Rood, O. N. "On the Use of Stereographs in Painting." BRITISH JOURNAL OF PHOTOGRAPHY 10, no. 190 (May 15, 1863): 205-206. [Discusses causes for reluctance of the painters to take advantage of stereographs.]

ROOT, MARCUS A. & SAMUEL ROOT.
BOOKS
R746 Cary, Samuel Fenton, ed. *American Temperance Magazine and Sons of Temperance Offering.* New York: R. Van Dion, 1851. 420 pp. 9 illus. [Eight steel engravings of portraits (stereotyped by Vincent L. Dill), from daguerreotypes, two of which are by Root, one by Whitehurst. One wood engraving, of the Temperance building, by N. Orr. Originally appeared monthly, but this is a cumulated volume.]

PERIODICALS
R747 "Note." DAGUERREAN JOURNAL 1, no. 1 (Nov. 1, 1850): 17. [Brady and Root both taken daguerreotypes of the actress Jenny Lind. The Root Brothers, of Phila., recently opened a gallery in New York, NY. A daguerreotype of the Calhoun temple and statue. Meade Brothers portrait of Daguerre.]

R748 "Genesee Falls - Rochester." ILLUSTRATED AMERICAN NEWS 1, no. 19 (Oct. 11, 1851): 149. 1 illus. ["The view of the Upper Falls of the Genesee, Rochester, NY is from a daguerreotype view taken by Messrs. Root of New York."]

ROOT, MARCUS A. see also BRADY, MATHEW B.

ROOT, MARCUS AURELIUS. (1808-1888) (USA)
[Born in Granville, OH in 1808. Studied painting with Thomas Sully, taught penmanship and wrote several manuals on the topic in the early 1840s. Learned the daguerreotype from Robert Cornelius and began daguerreotyping in early 1840s. Partner with David C. Collins 1844-45. Purchased John J. E. Mayall's studio in 1846. Exhibited at the Institute of American Manufactures, Philadelphia, PA from 1844 to 1854. Opened galleries with partnerships in Mobile, AL, New Orleans, LA, St. Louis, MO, and Philadelphia, PA. In 1849 he opened a gallery on Broadway, New York, NY in partnership with his brother Samuel. Partnership lasted until 1857. In 1853 opened a gallery in Washington, DC in 1852, managed by John Clark. In a railroad accident which disabled him and he began to write. Wrote extensively on various aspects of photography, including its history and aesthetics. Authored *The Camera and the Pencil* in 1864. Died in Philadelphia in 1888. (See below.)]

BOOKS
R749 Root, Marcus Aurelius. *Philosophical Theory and Practice of Penmanship... In Three Parts... Each Part in Four Books.* Philadelphia: A. W. Harrison, 1842. 7 parts.

R750 Root, Marcus Aurelius. *Prospectus of the System of Penmanship, Taught at the Writing-Rooms, South-West Corner of Arch and Eighth Streets, Philadelphia.* Philadelphia: M. A. Root, 1842. 20 pp.

R751 Arthur, T. S. *Sketches of Life and Character.* Philadelphia: Bradley, 1850. 402 pp. illus. [Contains an 8 page sketch, "The Daguerreotypist," which is based on Root's Philadelphia studio, apparently first published in "Godey's Lady's Book, 1849."]

R752 Root, Marcus Aurelius. *The Camera and the Pencil; Or the Heliographic Art,...Its Theory and Practice...Together With Its History In the United States and Europe...Illustrated With Fine Engravings On Steel and on Wood.* Philadelphia; New York: M. A. Root; D. Appleton, 1864. 456 pp. illus.

PERIODICALS

R753 Arthur, T. S. "The Daguerreotypist." GODEY'S LADY'S BOOK (May 1849): *-*. 1 illus. [Five page article, with anecdote about a farmer fearful of having his portrait taken. Illustrated with a full-page engraving of the event.]

R754 "Gossip: Letter." PHOTOGRAPHIC ART JOURNAL 1, no. 2 (Feb. 1851): 128. [Letter from M. A. Root discussing his being the NY agent for Whipple's patented 'Crayon Daguerreotype' process.]

R755 Root, M. A. "The Various Uses of the Daguerrean Art." PHOTOGRAPHIC ART JOURNAL 4, no. 6 (Dec. 1852): 360-362. ["Extract from a manuscript soon to be published."]

R756 "Editorial Notices." HUMPHREY'S JOURNAL 4, no. 18 (Jan. 1, 1853): 280. [Note that M. A. Root (Philadelphia, PA) "about to open an establishment in Washington...".]

R757 Root, M. A. "Some Thoughts on the Fitting Up of Daguerrean Rooms: Extract from a Manuscript Volume Soon to Be Published." PHOTOGRAPHIC ART JOURNAL 5, no. 6 (June 1853): 361-364.

R758 Root, M. A. "The Fine Arts." PHOTOGRAPHIC ART JOURNAL 6, no. 1 (July 1853): 51-53. [Extract from a manuscript volume, soon to be published.]

R759 Root, M. A. "Qualifications of a First-Class Daguerreotypist." PHOTOGRAPHIC ART JOURNAL 6, no. 2 (Aug. 1853): 112-115.

R760 Root, M. A. "Moral Requisites of the Eminent Daguerrean Artist." PHOTOGRAPHIC ART JOURNAL 6, no. 3 (Sept. 1853): 187-190.

R761 Root, M. A. "The Sun Beams. [sic Sunbeam]" PHOTOGRAPHIC ART JOURNAL 6, no. 4-5 (Oct. - Nov. 1853): 250-253, 309-313.

R762 Root, M. A. "The Sunbeam." PHOTOGRAPHIC ART JOURNAL 6, no. 5 (Nov. 1853): 309-313.

R763 Root, Marcus A. "The Various Uses of the Daguerrean Art." PHOTOGRAPHIC ART JOURNAL 6, no. 6 (Dec. 1853): 360-363.

R764 Root, M. A. "Harmony of Colors." PHOTOGRAPHIC AND FINE ART JOURNAL 7, no. 1-2 (Jan. - Feb. 1854): 29-31, 61-62. 1 illus.

R765 "The Poetry of Daguerreotyping." PHOTOGRAPHIC AND FINE ART JOURNAL 7, no. 2 (Feb. 1854): 51-52. [Poem entitled "Fifty-three and Fifth-four" by Mr. Root of New York.]

R766 Root, M. A. "Harmony of Colors." PHOTOGRAPHIC AND FINE ART JOURNAL 7, no. 2 (Feb. 1854): 61-62.

R767 "Sitting for a Daguerreotype." ARTHUR'S HOME MAGAZINE (PHILADELPHIA) 3, no. 3 (Mar. 1854): frontispiece, 173-174. 1 illus. [Image of a corpulent farmer sitting for a portrait in Mr. Root's studio on Chestnut Street, Philadelphia, PA, accompanying an anecdote of how he then became frightened by the camera and left before the portrait could be taken. (This seems to have been reprinted from the May 1849 issue of "Godey's Lady's Book.")]

R768 Root, M. A. "Communication." PHOTOGRAPHIC AND FINE ART JOURNAL 7, no. 6 (June 1854): 175-176. [Letter, attacking cheap operators.]

R769 M. A. R. "Collodion Process - Ambrotype." PHOTOGRAPHIC AND FINE ART JOURNAL 8, no. 7 (July 1855): 220-221.

R770 M. A. R. "Heliography - Daguerreotypes - Photography - Ambrotype and Heliocharts." PHOTOGRAPHIC AND FINE ART JOURNAL 8, no. 8 (Aug. 1855): 244-245.

R771 Root, Marcus A. "Heliography." PHOTOGRAPHIC AND FINE ART JOURNAL 8, no. 9 (Sept. 1855): 277-278. [Impact of photography, mentioning the "Illus. London News," etc.]

R772 Root, Marcus A. "Heliography." PHOTOGRAPHIC AND FINE ART JOURNAL 8, no. 10 (Oct. 1855): 298-299.

R773 "Personal & Art Intelligence." PHOTOGRAPHIC AND FINE ART JOURNAL 9, no. 6 (June 1856): 190-192. [Exchange of letters between M. A. Root and H. H. Snelling over Root's failure to provide the mss. for a promised book.]

R774 "Tinted Ambrotypes." HUMPHREY'S JOURNAL 8, no. 7 (Aug. 1, 1856): 97-98. [M. A. Root (Philadelphia, PA) and J. B. Hall (of J. Gurney's Gallery, New York, NY) hand tinted ambrotypes.]

R775 "Photographic Patents: Patent for the application of Coloring substances, or matter, to Photographic Impressions." HUMPHREY'S JOURNAL 8, no. 7 (Aug. 1, 1856): 99-100. [Patent given to Giles Langdell and Marcus A. Root.]

R776 Root, M. A. "Daguerreotype and Its Destiny." PHOTOGRAPHIC AND FINE ART JOURNAL 10, no. 6 (June 1857): 164-165.

R777 Root, M. A. "Heliography - Its Wonders and Its Rapid Progress." PHOTOGRAPHIC AND FINE ART JOURNAL 10, no. 6 (June 1857): 171-172.

R778 Root, M. A. "Heliography No. 2. - Its Elevating and Refining Influences." PHOTOGRAPHIC AND FINE ART JOURNAL 10, no. 7 (July 1857): 214.

R779 Root, M. A. "Heliography and Its Professors. The Magnetic Telegraph and Steam Locomotive With Their Uses." PHOTOGRAPHIC AND FINE ART JOURNAL 10, no. 8 (Aug. 1857): 246.

R780 Root, M. A. "Heliography - Expression, Posture, Etc." PHOTOGRAPHIC AND FINE ART JOURNAL 10, no. 9 (Sept. 1857): 283.

R781 Root, Marcus A. "Importance of Cultivation to the Heliographer." PHOTOGRAPHIC AND FINE ART JOURNAL 10, no. 10 (Oct. 1857): 305.

R782 Root, Marcus A. "The Painter vs. the Photographer." PHOTOGRAPHIC AND FINE ART JOURNAL 11, no. 5 (May 1858): 154-155.

R783 Root, M. A. "Small Matters." PHOTOGRAPHIC AND FINE ART JOURNAL 11, no. 6 (June 1858): 179-180.

R784 Root, Marcus A. "Heliography; Its powerful agency in, and its great importance to, the development of human civilization and refinement." PHOTOGRAPHIC AND FINE ART JOURNAL 11, no. 7 (July 1858): 217-218.

R785 Root, Marcus A. "Heliography vs. Painting." PHOTOGRAPHIC AND FINE ART JOURNAL 11, no. 8 (Aug. 1858): 242-243.

R786 Root, M. A. "Some Items, Relating to the Process of Sitting for a Heliographic Portrait." PHOTOGRAPHIC AND FINE ART JOURNAL 11, no. 9 (Sept. 1858): 264.

R787 Root, Marcus A. "The Daguerreotype." PHOTOGRAPHIC AND FINE ART JOURNAL 11, no. 12 (Dec. 1858): 371-372.

R788 Root, Marcus A. "Our Philadelphia Editor's Table. Requisites of a Heliographer." PHOTOGRAPHIC AND FINE ART JOURNAL 12, no. 2 (July 1859): 56-58.

R789 Root, M. A. "The Painter vs. the Photographer." PHOTOGRAPHIC NEWS 3, no. 68 (Dec. 23, 1859): 190-191. [Letter.]

R790 Root, M. A. "Our Philadelphia Editor's Table; Stereoscopic Views." PHOTOGRAPHIC AND FINE ART JOURNAL 13, no. 1 (Jan. 1860): 30-31.

R791 Root, M. A. "Heliographic School." PHOTOGRAPHIC AND FINE ART JOURNAL 13, no. 4 (Apr. 1860): 111-112. [Suggestion to establish a school of photography.]

R792 Root, M. A. "A Heliographic School - Its Importance." PHOTOGRAPHIC AND FINE ART JOURNAL 13, no. 5 (May 1860): 140.

R793 Root, M. A. "Heliographic School." AMERICAN JOURNAL OF PHOTOGRAPHY AND THE ALLIED ARTS AND SCIENCES n. s. vol. 2, no. 24 (May 15, 1860): 376-378. [Advocating starting a school.]

R794 Root, M. A. "A Heliographic School - Its Importance." AMERICAN JOURNAL OF PHOTOGRAPHY AND THE ALLIED ARTS & SCIENCES n. s. vol. 3, no. 1 (June 1, 1860): 11-14.

R795 Root, M. A. "Heliographic Schools." HUMPHREY'S JOURNAL OF PHOTOGRAPHY, AND THE ALLIED ARTS AND SCIENCES 12, no. 3 (June 1, 1860): 33-35.

R796 "Heliographic Schools." HUMPHREY'S JOURNAL OF PHOTOGRAPHY, AND THE ALLIED ARTS AND SCIENCES 12, no. 4 (June 15, 1860): 49-52. [Very long editorial (for the time) on the topic of establishing a school, raised in M. A. Root's earlier article.]

R797 Root, M. A. "The Heliographic School." AMERICAN JOURNAL OF PHOTOGRAPHY AND THE ALLIED ARTS & SCIENCES n. s. vol. 3, no. 3 (July 1, 1860): 33-35. [From "Photo. Notes."]

R798 Root, M. A. "The Heliographic School." AMERICAN JOURNAL OF PHOTOGRAPHY AND THE ALLIED ARTS & SCIENCES n. s. vol. 3, no. 3 (July 1, 1860): 41-42.

R799 Root, M. A. "Heliographic Schools." HUMPHREY'S JOURNAL OF PHOTOGRAPHY, AND THE ALLIED ARTS AND SCIENCES 12, no. 5 (July 1, 1860): 68-71.

R800 Root, M. A. "Uses of Heliography." AMERICAN JOURNAL OF PHOTOGRAPHY AND THE ALLIED ARTS & SCIENCES n. s. vol. 3, no. 4 (July 15, 1860): 59-60.

R801 Root, M. A. "A Photography College." PHOTOGRAPHIC AND FINE ART JOURNAL 13, no. 8 (Aug. 1860): 219.

R802 Root, M. A. "Daguerreotypes Looking Up." AMERICAN JOURNAL OF PHOTOGRAPHY AND THE ALLIED ARTS & SCIENCES n. s. vol. 3, no. 5 (Aug. 1, 1860): 73-75.

R803 Root, M. A. "Photography in Schools." AMERICAN JOURNAL OF PHOTOGRAPHY AND THE ALLIED ARTS & SCIENCES n. s. vol. 3, no. 6 (Aug. 15, 1860): 93-95.

R804 Root, M. A. "Heliography in our Military Schools." HUMPHREY'S JOURNAL OF PHOTOGRAPHY, AND THE ALLIED ARTS AND SCIENCES 12, no. 9 (Sept. 1, 1860): 134-135.

R805 "Fortunes and Misfortunes of an Artist." THE SCIENTIFIC AMERICAN (Feb. 8, 1862): 87. [Extended discussion about M. A. Root reopening a Broadway gallery in New York City, after an absence from the profession for five years, due to the length of time necessary to recover from a serious accident which he received in a train accident.]

R806 Root, M. A. "A Plea for Heliography." PHILADELPHIA PHOTOGRAPHER 1, no. 2 (Feb. 1864): 19-21.

R807 "Editor's Table: The Camera and the Pencil." PHILADELPHIA PHOTOGRAPHER 1, no. 6 (June 1864): 96. [Bk. rev.: "The Camera and the Pencil," by M. A. Root, of Philadelphia, PA.]

R808 Simmons, M. P. "New Publication." AMERICAN JOURNAL OF PHOTOGRAPHY AND THE ALLIED ARTS & SCIENCES n. s. vol. 6, no. 23 (June 1, 1864): 547. [Brief, signed review of M. A. Root's, "The Camera and the Pencil, or the Heliographic Art."]

R809 Root, M. A. "'The Camera and the Pencil' and 'Lights and Shadows in a Picture - Their Use and Value.'" PHILADELPHIA PHOTOGRAPHER 1, no. 7 (July 1864): 108-110. [Excerpted from Root's book.]

R810 Root, M. A. "Landscape Photography." PHILADELPHIA PHOTOGRAPHER 1, no. 9 (Sept. 1864): 137-139. [Abstract from Vol. II of "The Camera & the Pencil."]

R811 Root, M. A. "Gun-Cotton and Collodion. Their Discovery and History." PHILADELPHIA PHOTOGRAPHER 8, no. 93 (Sept. 1871): 286-288. [From advance sheets of Root's book, "The Camera and the Pencil." Quotes a letter by Josiah Curtis, Surgeon, U.S. Army, who invented collodion in 1846. Describes early photographic experimenters, F. Langenheim (1848); F. S. Archer (1852).]

R812 Root, Marcus Arelius. "The Magic Lantern, Its History and Uses for Educational and Other Purposes." MAGIC LANTERN 1, no. 2 (Oct. 1874): 11-?

R813 Root, M. A. "The Photographic Art, in the Great International Exposition." PHILADELPHIA PHOTOGRAPHER 12, no. 144 (Dec. 1875): 373-376. [Suggestions for photographers for the forthcoming exhibition.]

R814 "Obituary: Marcus A Root." PHOTOGRAPHIC TIMES 18, no. 344 (Apr. 20, 1888): 195. [Died in Philadelphia, PA, on Apr. 12, in the 80th year of his age. Believed to be the first white man born in Licking County, Ohio. In 1838 he established himself in Philadelphia as a teacher of writing, originator of the Root system of writing. Well known as a daguerreotypist. Won seven prizes at the 1851 London's World's Fair, etc.]

R815 "Obituary." PHILADELPHIA PHOTOGRAPHER 25, no. 321 (May 5, 1888): 284-285. [Marcus Root, of Philadelphia, PA, was one of the first daguerreotypists in America. He had studios in Philadelphia, New York, St. Louis, Boston, and Washington, his New York place being considered the handsomest in the country. An eventful life. In June, 1856, he invested $40,000 in a hotel that burned to the ground a few days later. Injured in a railroad accident the same year, so seriously that he could not sit up for five months. Root paid $600 for the choice of seats when Jenny Lind first sang in Philadelphia. In 1863 he began publication of his book, "The Camera and the Pencil." The first part was printed and sold, and the second part at the press when it burned down. Mr. Root was the first man to introduce the ambrotype. At the 1876 Centennial he exhibited a collection of prominent people, taken by the daguerreotype, which he afterwards presented to the Historical Society. Three years ago he fell, attempting to get off a street car, breaking three bones. He never recovered from these injuries, and died at age 80. His brother, Samuel Root, has been a photographer in Dubuque, IA, for many years.]

R816 Hart, Charles Henry, introduction and notes. "Life Portraits of Henry Clay." MCCLURE'S MAGAZINE 9, no. 5 (Sept. 1897): 910, 939-948. 2 b & w. 7 illus. [Paintings, etc. Includes a daguerreotype portrait taken by Marcus A. Root in 1848, and an unknown portrait, taken about 1845. (Possibly by Brady.) Information on the photographers and the sittings in the captions.]

R817 Gale, David M. and Charlotte Gale. "A Study and Catalog of 19th Century Photographic Tokens. Part 1. Marcus Aurelius Root and the American Daguerreotype." PHOTOGRAPHIC HISTORIAN 6, no. 2 (Summer 1985): 14-30. 3 b & w. 9 illus. [Article discusses work of M. A. Root on pp. 14-21, followed by a checklist of more than 60 tokens issued by American photographic galleries during the 19th century.]

ROOT, SAMUEL & J. W. THOMPSON. (NEW YORK, NY)
R818 "Note." PHOTOGRAPHIC ART JOURNAL 2, no. 6 (Dec. 1851): 377. [S. Root and J. W. Thompson formed a co-partnership.]

ROOT, SAMUEL. (1819-1889) (USA)
[Samuel Root born in Granville, OH in 1819, the younger brother of Marcus A. Root. Learned daguerreotypy from his brother and opened a gallery in partnership with him in New York, NY in 1849, then purchased the gallery from him in 1851.. Went into co-partnership with J. W. Thompson in 1851. Moved to Dubuque, IA about 1856, worked there until 1882. Died in Rochester, NY in 1889.]

R819 "Editorial Notices." HUMPHREY'S JOURNAL 4, no. 18 (Jan. 1, 1853): 280. ["Medals stolen from his door..."]

R820 "Loss of Prize Medals." HUMPHREY'S JOURNAL 4, no. 19 (Jan. 15, 1853): 302. [More extensive account of the theft of S. Root's prize medals.]

R821 "The Anthony Prize Pitcher." PHOTOGRAPHIC AND FINE ART JOURNAL 7, no. 1 (Jan. 1854): 6-11. [Letter describing Root's process on p. 10.]

R822 "Note." PHOTOGRAPHIC WORLD 1, no. 6 (June 1871): 192. [Mentions several "retouched heads" of veteran photographer S. Root of Dubuque, Iowa.]

R823 "Note." PHOTOGRAPHIC TIMES 10, no. 118 (Oct. 1880): 225. [Excerpt from the "Dubuque Daily Times" article discussing Samuel Root's success in breeding quails in captivity (apparently popularly supposed to be impossible).]

R824 "Matters of the Month." PHOTOGRAPHIC TIMES 12, no. 139 (July 1882): 277. [Pictures, by S. Root, of four inch hailstones from a storm that swept that part of Iowa. The Dubuque photo galleries - S. Root, Mr. Billbrough, and Mr. Morheiser - all damaged.]

R825 "Obituary: Samuel Root." PHOTOGRAPHIC TIMES 19, no. 393 (Mar. 29, 1889): 158-159. [Samuel Root, born in Ohio. Learned photography in Philadelphia, PA. Came to New York, NY and worked there until 1855. "Also conducted a gallery" in Dubuque, Iowa. Retired two or three years ago. Died in Rochester, NY, on March 11, 1889.]

ROPE. (d. 1864) (USA)
R826 "A Sad Accident." HUMPHREY'S JOURNAL OF PHOTOGRAPHY, AND THE ALLIED ARTS AND SCIENCES 16, no. 1 (May 1, 1864): 14. ["We have to record the death of a young photographer by the name of Rope, who for some time has been established on the summit of Mount Lookout, near Chattanooga, taking views with considerable success. One day last week...he fell...and was killed instantly."]

RORKE, JOHN. (DUNGANNON, IRELAND)
["author of a Treatise on the Use of the Globes; and formerly for many years English and Science Master in the Royal School of Dungannon."]

R827 Rorke, John. *Fancies on the Photograph: a Poem in Three Parts.* Part I, The Triumph of Light; Part II, The New Temple of Fame; Part III, The Mysterious Photograph, a Dream. London: Longmans & Co., 1864. 137 pp.

ROSE see BLESSING & ROSE.

ROSE, PHILIP H. (1848-1926) (USA)
R828 "Exquisite Carbons." ANTHONY'S PHOTOGRAPHIC BULLETIN 10, no. 8 (Aug. 1879): 256. [Rose from Galveston, TX.]

R829 "A New Photographic Studio." PHOTOGRAPHIC TIMES 16, no. 243 (May14, 1886): 260-261. [Announcement that P. H. Rose, late of Galveston, TX, moving to Providence, RI.]

ROSE, R. H. (NEWARK, NJ)
R830 "Boiler Explosion at Newark, New Jersey - the Ruins." HARPER'S WEEKLY 11, no. 564 (Oct. 19, 1867): 660. 1 illus. ["Photographed by R. H. Rose, Newark."]

R831 Baird, Donald. "American's First Dinosaur in Stereo, c. 1876." STEREO WORLD 7, no. 4 (Sept. - Oct. 1980): 12. 1 b & w.

ROSENECKER, PAUL.

R832 "Fire in a Photographic Gallery." AMERICAN JOURNAL OF PHOTOGRAPHY AND THE ALLIED ARTS & SCIENCES n. s. vol. 9, no. 1 (Sept. 1, 1866): 9-10. [Paul Rosenecker's gallery, No. 51 3rd Ave., New York, NY burned out.]

ROSS & PRINGLE.

R833 "A Visit to Ross & Pringle." ANTHONY'S PHOTOGRAPHIC BULLETIN 2, no. 11 (Nov. 1871): 354-355. [From "Br. J. of Photo." Ross & Pringle, Photographers to the Queen. At Edinburgh (?) introduced the curved "Salomon" background in 1864. Studio prop of boat on water, very popular. Children's swings, balconies, ships riggings, other props used as well.]

ROSS & THOMSON. (EDINBURGH, SCOTLAND)

["Ross & Thompson were professional photographers in Edinburgh as early as 1847. For several years after 1849 they practiced Niépce's [de St. Victor] albumen process with great success."]

R834 Ross, James. *Plain Answers to Common Questions regarding Photography.* Edinburgh: Ross & Thomson, 1853. 16 pp. [Pamphlet with suggestions for their customers.]

R835 Thomson, John. *The Process of Heliochromy; or, Printing in Colors by Light.* Edinburgh; Liverpool: James Wood; H. Greenwood, 1855. n. p.

ROSS, COLONEL. (GREAT BRITAIN, INDIA)

R836 "Tiger-Hunting in India." ILLUSTRATED LONDON NEWS 56, no. 1587 (Apr. 2, 1870): 351-352. 1 illus. ["Colonel Ross, commanding the 24th (Second Warwickshire) Regiment of Foot, is the amateur photographer..."]

ROSS, A. C. (ZANESVILLE, OH)

R837 Ross, A. C. "Daguerreotype Economy." HUMPHREY'S JOURNAL 6, no. 19 (Jan. 15, 1855): 311. [Letter from Ross (Zanesville, OH) praising "Humphrey's Journal." Ross mentions he's been in the business for about six years.]

R838 Ross, A. C. "A Portable Tent." AMERICAN JOURNAL OF PHOTOGRAPHY AND THE ALLIED ARTS AND SCIENCES n. s. vol. 1, no. 12 (Nov. 15, 1858): 179-180. 1 illus.

ROSS, ANDREW. (1798-1859) (GREAT BRITAIN)

R839 "The Late Mr. Andrew Ross." AMERICAN JOURNAL OF PHOTOGRAPHY AND THE ALLIED ARTS & SCIENCES n. s. vol. 2, no. 14 (Dec. 15, 1859): 211-215. [From "Photo. J." Ross, of Scots parentage, born in London in 1798. Detailed obituary. Ross constructed devices and lenses for astronomical instruments, telescopes, etc.]

ROSS, HORATIO, CAPT. (1801-1886) (GREAT BRITAIN)

R840 Stein, Donna. "Horatio Ross Presentation Album." HISTORY OF PHOTOGRAPHY 11, no. 4 (Oct. - Dec. 1987): 307-319. 11 b & w. [Born Rossie Castle, Forfarshire, on Sept. 5, 1801. Served in the 14th Light Dragoons from 1819 to 1826. Member of Parliament from 1831 to 1834. An ardent sportsman and amateur photographer. Worked with daguerreotypes as early as 1847, and calotypes after 1849. A founder-member of the Photographic Society of Scotland. This album of photos taken ca. 1858.]

ROSS, JAMES see also ROSS & THOMSON.

ROSS, JAMES. (d. 1878) (GREAT BRITAIN)

R841 Ross, James. "The Albumen Process." PHOTOGRAPHIC AND FINE ART JOURNAL 10, no. 4 (Apr. 1857): 101-102. [From "Liverpool Photo. J."]

R842 Ross, James. "On Taking and Printing Stereoscopic Pictures." HUMPHREY'S JOURNAL 9, no. 9 (Sept. 1, 1857): 142-143. [From "Photo. Notes." Paper read to Photo. Soc. of Scotland.]

R843 Ross, James. "On Stereoscopic Photography." PHOTOGRAPHIC AND FINE ART JOURNAL 10, no. 10 (Oct. 1857): 299-300. [From "J. of Photo. Soc., London."]

R844 "Our Editorial Table: Photographs of Children, by Mr. Ross, of Edinburgh." BRITISH JOURNAL OF PHOTOGRAPHY 11, no. 229 (Sept. 23, 1864): 370. [Ross, formerly of Ross & Thomson, Edinburgh.]

R845 Pringle, Thomas. "How to Photograph Children: Mr. Ross in His Studio." BRITISH JOURNAL OF PHOTOGRAPHY 11, no. 231 (Oct. 7, 1864): 390.

R846 Ross, James. "Photography a Fine Art." BRITISH JOURNAL OF PHOTOGRAPHY 11, no. 234 (Oct. 28, 1864): 423.

R847 "Our Editorial Table: Views of the Crystal Palace." BRITISH JOURNAL OF PHOTOGRAPHY 12, no. 262 (May 12, 1865): 250.

R848 "Note." ART JOURNAL (Dec. 1865): 381. [Work mentioned, received a medal at Dublin International Exhibition.]

R849 Pringle. "How to Photograph Children. - The Practice of Mr. Ross, Edinburgh." BRITISH JOURNAL PHOTOGRAPHIC ALMANAC 1866 (1866): 90-92.

R850 Ross, James. "Studios." BRITISH JOURNAL PHOTOGRAPHIC ALMANAC 1872 (1872): 102-104.

R851 Ross, James. "One Word of Advice." BRITISH JOURNAL PHOTOGRAPHIC ALMANAC 1875 (1875): 126-127.

R852 Ross, James. "Letter to a Friend." BRITISH JOURNAL PHOTOGRAPHIC ALMANAC 1877 (1877): 166-168.

R853 Ross, James. "Where Are We?" AMERICAN AMATEUR PHOTOGRAPHER 11, no. 8 (Aug. 1899): 324, 326-327. [General commentary on the state of the art, which this author felt was in bad shape.]

ROSS, WILLIAM. (NEW YORK, NY)

R854 Ross. [?] "Landscape Camera." DAGUERREAN JOURNAL 2, no. 7-8 (Aug. 15 - Sept. 1, 1851): 204-206, 229-231. [From the "American Artisan"(?).]

R855 Ross, William. "Panoramic Camera for Paper: New Frame of M. Relandin." HUMPHREY'S JOURNAL 7, no. 7 (Aug. 1, 1855): 105-106.

R856 Ross. "Dark Tent for Landscapes." DAGUERREAN JOURNAL 2, no. 8 (Sept. 1, 1851): 231-233. [From "American Artisan."]

R857 Ross, William. "On Apportioning the Aperture for a Landscape Lens of any Focal Length." HUMPHREY'S JOURNAL 6, no. 17 (Dec. 15, 1854): 278. [Written for "Humphrey's Journal."]

R858 Ross, William. "Views." HUMPHREY'S JOURNAL 6, no. 19 (Jan. 15, 1855): 305-309. [Practical advice on taking interior, exterior views.]

R859 Ross, William. "Humbugs. - On the Use of Silvered Plate Glass Reflectors for Actinic Purposes." HUMPHREY'S JOURNAL 6, no. 20 (Feb. 1, 1855): 323-324.

R860 Ross, William. "Hints on the Various Types: Notes on Talbotype Manipulation." HUMPHREY'S JOURNAL 6, no. 22 (Mar. 1, 1855): 356-359. 1 illus.

R861 Ross, William. "On the Probability of Producing Actino-Polychrome Pictures." HUMPHREY'S JOURNAL 6, no. 22 (Mar. 1, 1855): 345-349. [From "J. of Photo. Soc., London." Wm. Ross identified as Architect, 112 Chambers St., NY.]

R862 Ross, William. "Notes on Lenses." HUMPHREY'S JOURNAL 6, no. 24 (Apr. 1, 1855): 384.

R863 Ross, William. "Claims of Originality. - Le Gray vs. Archer - Morse and Draper vs. Daguerre - Hill vs. Becquerel - Wattles vs. Talbot." HUMPHREY'S JOURNAL 7, no. 14 (Nov. 15, 1855): 222-223.

R864 Ross, William. "Stereography." PHOTOGRAPHIC AND FINE ART JOURNAL 11, no. 10 (Oct. 1858): 316-317. [From "Photo. J." Ross from New York, NY.]

R865 Ross, William. "Stereography." LIVERPOOL & MANCHESTER PHOTOGRAPHIC JOURNAL [BRITISH JOURNAL OF PHOTOGRAPHY] n. s. 2, no. 19 (Oct. 1, 1858): 242-244. [Ross from New York, NY, published earlier articles in L & MPJ on this topic.]

R866 Ross, William. "The New Petzval Lens." LIVERPOOL & MANCHESTER PHOTOGRAPHIC JOURNAL [BRITISH JOURNAL OF PHOTOGRAPHY] n. s. 2, no. 22 (Nov. 15, 1858): 287-288.

R867 "Ross' Panoramic Lens." HUMPHREY'S JOURNAL OF PHOTOGRAPHY, AND THE ALLIED ARTS AND SCIENCES 14, no. 5 (July 1, 1862): 24-25. [Includes a letter from Ross.]

R868 "Improvements in the Manufacture of Lenses for Photographic and Other Purposes." HUMPHREY'S JOURNAL OF PHOTOGRAPHY, AND THE ALLIED ARTS AND SCIENCES 19, no. 12 (Oct. 15, 1867): 189-190. [Ross's lenses.]

ROUCH, W. W. (d. 1871) (GREAT BRITAIN)
R869 "Mentone." ILLUSTRATED LONDON NEWS 54, no. 1522 (Jan. 23, 1869): 96. 2 illus. ["...from some admirable photographs taken in the present season by Mr. Rouch, of the Strand who has sent them to us." Mentone is a town in Monaco.]

ROUSSELET, LOUIS. (FRANCE, INDIA)
BOOKS
R870 Rousselet, Louis. India and its Native Princes. - Travels in Central India and in the Presidency of Bombay and Bengal. London: Chapman & Hall, 1875. n. p. b & w. illus.

PERIODICALS
R871 Sharma, Brij Bhushan. "Artists and Photography; Some Indian Encounters." HISTORY OF PHOTOGRAPHY 12, no. 3 (July - Sept. 1988): 247-258. 10 illus. [Louis Rousselet, Valentine Cameron Princep, other European artists travelled in India in 1860s, 1870s. Some, like Rousselet, photographed there, and some of these photos

were later used to illustrate books. Engravings of views, after photos. Eight by Louis Rousselet, one by Prinsep, one by Bourne & Shepherd.]

ROUTLEDGE, ROBERT. (GREAT BRITAIN)
R872 "Photography," on pp. 446-458 in: Discoveries and Inventions of the Nineteenth Century, by Robert Routledge, B.Sc. London: George Routledge & Sons, 1877. 594 pp.

ROWE, W.
R873 Rowe, W. "A New Design for a Photographic Glass House." BRITISH JOURNAL OF PHOTOGRAPHY 11, no. 231 (Oct. 7, 1864): 386-387. 2 illus.

ROWELL, FRANK. (1832-1889) (USA)
[Rowell was an ornamental painter before he became a professional daguerreotypist in Boston, MA in 1859. In 1863 he joined R. A. Miller and that partnership lasted until 1865. Rowell then opened a studio at 25 Winter St., Boston. Edward L. Allen joined him in a partnership in 1874. Rowell died in 1889.]

R874 "American Carbon Prints." PHILADELPHIA PHOTOGRAPHER 4, no. 39 (Mar. 1867): 81-82. [Frank Rowell (Boston, MA) experimented successfully to make some of earliest carbon prints in USA. Article also includes a letter from Rowell.]

R875 "Editor's Table: Rowell's Porcelain Pictures." PHILADELPHIA PHOTOGRAPHER 4, no. 39 (Mar. 1867): 96.

R876 "Editor's Table: Mr. Rowell's Carbon Process." PHILADELPHIA PHOTOGRAPHER 4, no. 40 (Apr. 1867): 127.

R877 Wilson, Edward L. "Carbon Printing." PHILADELPHIA PHOTOGRAPHER 4, no. 41 (May 1867): 129-134.

R878 Rowell. "Directions for using Rowell's Tissue." AMERICAN JOURNAL OF PHOTOGRAPHY, AND THE ALLIED ARTS AND SCIENCES n. s. vol. 9, no. 12 (June 1, 1867): 257-263.

R879 "Obituary: Frank Rowell." BOSTON EVENING TRANSCRIPT (May 10, 1900): 9.

ROWLAND, D. (FRANKFORT, KY)
R880 "The Birthplace of Gen. Frank P. Blair. - From a Photograph by D. Rowland, Frankfort, Ky." FRANK LESLIE'S ILLUSTRATED NEWSPAPER 27, no. 683 (Oct. 31, 1868): 108. 1 illus. [View.]

ROWLAND, JOHN ALEXANDER
BOOKS
R881 Rowland, John. Photographic Manipulation; The Calotype and Collodion Processes. London: Rowland, 1855. 12 pp.

PERIODICALS
R882 Rowland, John Alexander. "The Object of Improvement in Panoramic Cameras." HUMPHREY'S JOURNAL OF PHOTOGRAPHY, AND THE ALLIED ARTS AND SCIENCES 18, no. 6 (July 15, 1866): 94.

ROWSELL, CHARLES L. (GREAT BRITAIN, CHILI)
R883 Rowsell, Charles L. "Photography at Valparaiso." JOURNAL OF THE PHOTOGRAPHIC SOCIETY OF LONDON 7, no. 103 (Nov. 15, 1860): 39-42.

R884 C. L. R. "Foreign Correspondence." BRITISH JOURNAL OF PHOTOGRAPHY 8, no. 136 (Feb. 15, 1861): 76-77. [Letter from C. L. R., with address, "The Far South" describes his experiences while

photographing the railway line between Quillota and Llai Llai, in (apparently) South America.]

R885 "The Indians of Peru and Bolivia." ILLUSTRATED LONDON NEWS 45, no. 1295 (Dec. 31, 1864): 672-673. 1 illus. ["The Portraits...were sent by Mr. C. L. Rowsell, photographer, of Valparaiso." Group portrait of Peruvian Indians.]

R886 "War Between Spain and Chili." ILLUSTRATED LONDON NEWS 47, no. 1344 (Nov. 25, 1865): 504, 519. 2 illus. [View of Port of Valparaiso, Plaza in Valparaiso, Chili..."taken by our correspondent, Mr. C. L. Rowsell, photographic artist, a resident at Valparaiso for twelve years past; the view of the harbour and bay was taken with Johnson's pantoscopic camera."]

ROYAL ENGINEERS.
R887 "Boiler Explosion in Chatham Dockyard." ILLUSTRATED LONDON NEWS 49, no. 1389 (Sept. 15, 1866): 261. 2 illus. ["...photographs taken by the staff of the Royal Engineers at Chatam; and we have to thank Colonel Symons, R. E. for permission to use them."]

R888 "The Malta Theatre." ILLUSTRATED LONDON NEWS 62, no. 1763 (June 14, 1873): 561, 562. 1 illus. ["We have to thank two officers of the Royal Engineers for the photographs..."]

R889 Fort, Paul. "Ordinance Survey work in the Middle East during the 1860s." PHOTOGRAPHIC COLLECTOR 2, no. 2 (Summer 1981): 58-67. 9 b & w. [Ordinance Survey of the Peninsula of Sinai, 1868. British Royal Engineers party provided detailed written and pictorial accounts of the history, geography topography, ethnography, geology, botany, zoology of the Sinai Peninsula. Team, of which the chief photographer was Colour-Sergeant McDonald, R.E. 3 volumes "Ordinance Survey of the Peninsula of Sinai," by Captains C. W. Wilson and H. S. Palmer. Southampton: Ordinance Survey Office, 1869 were published. The article includes 9 stereo slides from the Survey, an account of its history, and lists of the photographs in the volumes. It also includes a list of other photographs taken around Jerusalem - possibly during an earlier survey in 1864 by Captain C. W. Wilson and Colour-Sergeant McDonald.]

R890 Falconer, John. "Photography and the Royal Engineers." PHOTOGRAPHIC COLLECTOR 2, no. 3 (Autumn 1981): 33-64. 37 b & w. [Royal Engineers, Great Britain, formed photographic units as early as 1850s, documented activities throughout the British Empire - Canada, India, Near East, Far East, etc. through 1880s.]

ROYAL ORDNANCE SURVEY
R891 James, Colonel Sir Henry. *Plans and Photographs of Stonehenge, and of Turusachan in the Island of Lewis; with Notes relating to the Druids and Sketches of Cromlechs in Ireland.* Southampton: Ordnance Survey, 1867. iv, 20 pp. 8 l. of plates. 8 b & w. 9 illus.

ROYER. (CAIRO, EGYPT)
R892 "Discovery of the Source of the Nile." ILLUSTRATED LONDON NEWS 43, no. 1211 (July 4, 1863): 5, 8-9, 17, 20-23. 12 illus. [Captain Speke's expedition. Photos of native bearers, the British explorers, views, etc. Some illustrations from sketches, some from photos. Group portraits of bearers credited to "Royer photo - Caire, Egypt." Portraits of Europeans by Williams and by Mayall."]

ROYLE, VERNON. (PATERSON, NJ)
BOOKS
R893 *Chips from Royle's Machines,* (3rd. ed.) Paterson, NJ: John Royle & Sons, 1897. 80 pp. 26 b & w. [An advertising booklet issued by

producer of tools and machinery for photo-engravers, includes 26 half-tone engravings of pastoral scenes in the vicinity from photos by the amateur Vernon Royle.]

R894 "Editor's Table." PHILADELPHIA PHOTOGRAPHER 6, no. 62 (Feb. 1869): 64. [Six stereos of Passaic Falls noted.]

R895 1 photo ("Fruit"). PHOTOGRAPHIC TIMES 24, no. 654 (Mar. 30, 1894): frontispiece, 195. 1 b & w. [Royle was an amateur.]

R896 "Actinic." "Old Times and New." WILSON'S PHOTOGRAPHIC MAGAZINE 33, no. 472 (Apr. 1896): 161-166. 4 b & w. [Description of difficulties associated with photographing outdoors in the days of wet-collodion. Illustrated with photographs by Vernon Royle, of Paterson, NJ.]

R897 "Pictorial "Chips" From a Royle Router." WILSON'S PHOTOGRAPHIC MAGAZINE 34, no. 491 (Nov. 1897): 499-500. 3 b & w. [Bk. rev.: *Chips from Royle's Machines,* (3rd. ed.) of an advertising booklet issued by John Royle & Sons, Paterson, N.J. (producer of tools and machinery for photo-engravers). 80pp., includes 26 half-tone engravings of pastoral scenes in the vicinity from photos by the amateur Vernon Royle.]

R898 Heathcote, Charles. "A Glimpse of American Amateur Photography in the Sixties." PENROSE'S PICTORIAL ANNUAL 1905-1906 (1906): 145-147. 3 b & w.

RUFF.
R899 New York Steam Engine Company. *Descriptions and Photographs of Machinist's and R. R. Repair Shop Tools manufactured by the N. Y. Steam Engine Company.* New York: Printed by Powers, Mcgowan & Slipper, 1874. n. p. 100 b & w. [Specifications accompanied with photographic or woodcut illustrations. About 100 photographs by Ruff, of Newark, NJ.]

RUFF, WILHEIM see HISTORY: POLAND: 19TH C.

RULOFSON, WILLIAM HERMAN see also BRADLEY & RULOFSON.

RULOFSON, WILLIAM HERMAN. (1826-1878) (USA)
R900 Rulofson, W. H. "The New Size in California." PHILADELPHIA PHOTOGRAPHER 7, no. 84 (Dec. 1870): 407.

R901 Loomis, G. H. "Gallery Biographic. No. 1 - William H. Rulofson." ANTHONY'S PHOTOGRAPHIC BULLETIN 5, no. 11 (Nov. 1874): 357-359. [William H. Rulofson began learning photography with L. H. Hale & Co. in Boston at about age sixteen - when J. W. Black was the boss buffer at the same place. Later travelled around and daguerreotyped in the Eastern States, the Canadas, then to England, Ireland and Wales, then to the Azores and the Western Islands, Mexico, and the Southern States. Then, around 1848, he briefly worked in Newfoundland, before going to California, going by way of (and apparently daguerreotyping) Rio de Janeiro, Patagonia, and Valparaiso. Settled in San Francisco, where, in 1863, he became the managing partner of Bradley & Rulofson. Elected President of the National Photographic Association in 1874.]

R902 "Our Picture." PHILADELPHIA PHOTOGRAPHER 12, no. 133 (Jan. 1875): 9-10. 1 b & w. [Biography & portrait of Rulofson, Pres. of N.P.A. Additional note in: "Editor's Table" p. 30, discusses portrait of King Kalakaua of Hawaiian Islands by Bradley & Rulofson. Rulofson was born in Maine in Sept. 1826. Orphaned at an early age. Took up

daguerreotyping while in his teens and travelled in Europe, America, and the South Sea islands. Shipwrecked in 1846, found and landed in Liverpool, England destitute. But travelled again, with a camera. In 1848 left Newfoundland for California around the South American continent - taking daguerreotypes along the way. Located his studio in Sonora in 1850. Moved to San Francisco, CA, in 1863 and formed partnership with H. W. Bradley. Rulofson elected second President of the National Photographic Association.]

R903 "Lively Times Among the Photographers. Official Corruption Rebuked." ANTHONY'S PHOTOGRAPHIC BULLETIN 6, no. 9 (Sept. 1875): 278-280. [Letter by Rulofson to the Photo. Soc. of the Pacific, protesting the use of the Society name in professional advertising.]

R904 "Address from President Rulofson." PHILADELPHIA PHOTOGRAPHER 13, no. 145 (Jan. 1876): 1-2.

R905 Rulofson, William H. "Retouching Negatives." PHILADELPHIA PHOTOGRAPHER 13, no. 145 (Jan. 1876): 8-11. [Read at the Nov. meeting of the Photographic Art Society of the Pacific.]

R906 "'Men of Mark.'" ANTHONY'S PHOTOGRAPHIC BULLETIN 7, no. 6 (June 1876): 180. [Description of 101 prominent people, combined to make a cabinet card.]

R907 "A Visitor." ANTHONY'S PHOTOGRAPHIC BULLETIN 7, no. 9 (Sept. 1876): 287.

R908 "William H. Rulofson's Fatal Fall." ANTHONY'S PHOTOGRAPHIC BULLETIN 9, no. 11 (Nov. 1878): 344. [Obituary from the "San Francisco Alta".]

R909 Spooner, J. Pitcher. "A Tribute to W. H. Rulofson." PHILADELPHIA PHOTOGRAPHER 15, no. 180 (Dec. 1878): 353-354. [Report of Wm H. Rulofson's death, caused by a fall while inspecting his skylight.]

R910 "Obituary." PHILADELPHIA PHOTOGRAPHER 15, no. 180 (Dec. 1878): 370-372. [Letters of condolence, etc. from around the country. Rulofson was the President of the National Photographic Assoc. when he died.]

R911 "Obituary." PHOTOGRAPHIC TIMES 8, no. 96 (Dec. 1878): 266.

R912 Haas, Robert Bartlett. "William Herman Rulofson: Pioneer Daguerreotypist and Photographic Educator. Part 1." CALIFORNIA HISTORICAL QUARTERLY 34, no. 4 (Dec. 1955): 288-300. 1 b & w. 1 illus. [Early life in New Brunswick 1826-1849, early career in photography, immigration to Sonoma, then move to San Francisco in 1863.]

R913 Haas, Robert Bartlett. "William Herman Rulofson: Pioneer Daguerreotypist and Photographic Educator. Part 2." CALIFORNIA HISTORICAL QUARTERLY 35, no. 1 (Mar. 1956): 47-58. 1 b & w. 1 illus. [Career and accidental death in 1878.]

RUMSEY, H. D.

R914 Harris, Maria Welch. *United States Girls Across the Atlantic; by Maria Welch Harris. H. D. Rumsey, Photographer.* Homer, NY: s. n., 1876. 204 pp. 35 l. of plates. 6 b & w. illus. [Narrative of a tour through Europe. The thirty-five leaves of plates are actually thirty-five sheets of photographic paper, each one containing three to six images (similar to an album) of the landscapes artwork and interesting events

discussed in the narrative. These images are from noncredited vernacular or topographic photographs, from sketches, from paintings or whatever. Its actually a charming and clever use of the reproducability of the medium. The title page is a collage of portraits of the author and her daughter, the ship they sailed on, texts and borders. H. D. Rumsey must have made the collations - not the original photographs.]

RUNKEL. (NEW YORK, NY)
R915 "Note." AMERICAN JOURNAL OF PHOTOGRAPHY AND THE ALLIED ARTS AND SCIENCES n. s. vol. 1, no. 8 (Sept. 15, 1858): 130.

RUSKIN, JOHN. (1819-1900) (GREAT BRITAIN)
BOOKS
R916 Constantini, Paolo and Italo Zannier. *I Dagherrotipi della Collezione Ruskin.* Venice: Arsenale Editrice, 1986. 130 pp. illus. [The 19th century British art critic John Ruskin collected daguerreotypes for his work. This collection is now held at the Ruskin Galleries at Bembridge School, in the Isle of Wight. Catalog, photos, and essays on Ruskin. (In Italian.)]

PERIODICALS
R917 "Mr. Ruskin and Photography." AMERICAN JOURNAL OF PHOTOGRAPHY AND THE ALLIED ARTS & SCIENCES n. s. vol. 8, no. 3 (Aug. 1, 1865): 55-57. [From "Photo. News."]

R918 "Obituary: John Ruskin." WILSON'S PHOTOGRAPHIC MAGAZINE 37, no. 518 (Feb. 1900): 94. [Brief obituary. Died Jan. 20, 1900 at age 80.]

RUSSELL, ANDREW JOSEPH. (1830-1902) (USA)
[Andrew Russell grew up in Nunda, NY. He displayed artistic abilities and taught penmanship in the Nunda public schools, then left for New York City to open a painting studio. He learned photography in New York, and used it for preliminary sketches for his paintings. He displayed paintings based on photographs during the early 1860s.
In 1862 Russell enlisted in the 141st New York Volunteers, then he was assigned to the U. S. Military Railroad Construction Corps, under General Haupt. Russell documented the bridge building activities, railroad construction techniques, camps and supplies of the corps. He also photographed troops, battlefields, and combat aftermath scenes. His work provided some of the most coherent documentation of the war, and some of the most beautiful photographs of the new technologies of transportation. Russell photographed at Marye's Heights during the battle of Fredricksburg, at Petersburg, Alexandria, and the fall of Richmond.
After the war Russell was hired by the Union Pacific Rail Road to document the construction along the line of track as the road was built across the country. Russell led a crew of photographers, among them S. J. Sedgewick, J. P. Silvis, and O. C. Smith, from 1867 to 1869, which again created an extraordinary group of documents of a major event in American history. Ironically, his photograph of "The Joining of the Rails" at Promontory Point, Utah was misattributed to C. R. Savage for years.
Russell joined the King Survey in the Bear River Area in Utah in 1869, then he photographed in California, then he returned to New York City in 1870. The joining of the rails had been well-covered in the illustrated press, as both the *Illustrated London News* and *Frank Leslie's Illustrated Newspaper* had used a number of Russell's photographs. But *Frank Leslie's* continued to publish Russell's photographs of the Union Pacific Rail Road throughout 1869 and 1870, publishing a series titled "Across the Continent."
At some point in the early 1870s Russell was hired as a full-time staff photographer by *Frank Leslie's Illustrated Newspaper.* Photographs

credited to "Our Staff Photographer" and others specifically credited to him began to appear in the magazine from 1870 on. In 1875 Russell was identified in an article as "Photographer-in-Chief to *Frank Leslie's Illustrated Newspaper. Leslie's* and other illustrated magazines had placed photographers on their staffs before this, but these individuals were used for the most part as technicians to photomechanically translate artist's sketches onto woodblocks for more rapid and accurate transcriptions of the engravings. The illustrated magazines also had for years commissioned photographers to perform special assignments, but A. J. Russell was the first or at least one of the first photographers hired on a full-time basis by a magazine to work as a photojournalist.

Russell returned to the West at least once after 1869 and he may have photographed there more often. At the end of 1873 and in early 1874 *Leslie's* published several of Russell's photographs taken in Utah and New Mexico. While these may have been taken in 1869 and published four years later, this was not a usual practice of the time and the photographs include specifically named individuals - which would make a four year delay seem improbable. Further, Russell published an article describing a western photographic expedition in the January 1874 issue of *Anthony's Photographic Bulletin*. Unfortunately, this was written in what was considered a high literary style and contained absolutely no specific information about when or where this expedition occurred. Even more puzzling and frustrating is the fact that, although more was promised, no further article seems to have been published. Nevertheless, it would have been unusual to publish such an article four years after the actual event.

Russell certainly returned to the West one other time. On April 10th, 1877 Mr. and Mrs. Frank Leslie, accompanied by several artists, photographers, writers, and functionaries from the magazine, set out on a highly publicized trip by special train to cross the continent to California. The party returned to New York in June, but the three month journey furnished materials for a series of weekly articles in the *Weekly* that ran from July 1877 to May 1878. The unnamed photographer on this trip would almost certainly have been Russell, and many of the 174 illustrations published in these articles were drawn directly or indirectly from his photographs. Some of these were republished in Mrs. Frank Leslie's book about this event, also published in 1877.

Russell photographed a wide variety of subjects for *Leslie's*, providing photographs for what today would be called "news" articles and "feature" stories. Many of these photographs are exceptionally interesting images, displaying a sense of form, action, and presence which is unusual for the photography of the period. And, from the manner in which Russell worked, his job was not so very different than that of a typical photojournalist today. In a letter describing one working day, Russell tells how he left New York City for Bridgeport, Connecticut by train at 8:05 A.M. on April 15, 1876. Four minutes after arriving there he had made two views of the hotels and the depot and was on the return train which had been scheduled to leave at that time. He went 110 miles in five hours and submitted a proof to the editorial office by 1:00 P.M. of the same day. Issues of competency, speed, and distance are an aspect of a photojournalist's life today, and this type of tale is often repeated in today's photojournalist literature. Russell was an active and valued member of the *Leslie's* staff for many years, perhaps until 1891, the year he retired to Brooklyn, where he died in 1902.]

BOOKS

[During the Civil War Capt. Andrew J. Russell, 141st New York Volunteers, was assigned to General Herman Haupt's Military Railroad Construction Corps to photographically document that organization's activities. Several large albums of photographs created by Russell and his staff were produced during or immediately after the war. Sets known to still exist include the "United States Military Railroad Photographic Album," held at the Virginia Historical Society, Richmond, Va. (136 prints); the Buberger/Gladstone/Neikrug album; the Manies album, 116 prints (reproduced in the Dover book), and the "General Haupt Album," in the Prints and Photographs Division at the Library of Congress.]

R919 *The Great West Illustrated in a Series of Photographic Views Across the Continent: taken along the line of the Union Pacific Railroad, West from Omaha, Nebraska.* New York: Union Pacific Railroad Co., 1869. 12 pp. 50 l. of plates. 50 b & w. [50 albumen photographs by A. J. Russell.]

R920 *Union Pacific R. R. Views. Photographs by A. J. Russell.* Boston: A. Mudge & Son, c. 187- ? n. p. 25 b & w. [Twenty-five mounted photos, in an album, probably bound by the collector.]

R921 Hayden, F. V. *Sun Pictures of Rocky Mountain Scenery,* With a description of geographical and geological features and some account of the resources of the great West, containing thirty photographic views along the line of the Union Pacific Railroad, from Omaha to Sacramento. New York: Julius Bien, 1870. 150 pp. 30 b & w.

R922 *Catalogue of Stereoscopic Views of Scenery in all parts of the Rocky Mountains between Omaha and Sacramento;* Taken by the Photographic Corps of the U.P.R.R. of which Prof. Sedgwick was a member, for Union Pacific Railroad, at a cost of over $10,000. 1000 Different Stereoscopic Views. Newtown, NY: Prof. S. J. Sedgwick, 1873. n. p.

R923 *Announcement of Prof. S. J. Sedgewick's Illustrated Course of Lectures and Catalogue of Stereoscopic Views of Scenery of All Parts of the Rocky and Sierra Nevada Mountains between Omaha and San Francisco.* Newtown, NY: Prof. S. J. Sedgwick, 1879. n. p.

R924 Combs, Barry B. Introduction by J. S. Holliday. *Westward to Promontory;* Building the Union Pacific across the Plains and Mountains, a Pictorial Documentary. Palo Alto, CA; New York: American West Publishing Co. with the Oakland Museum; Garland Books, 1969. 30 pp. 49 b & w. 3 illus.

R925 Russell, Andrew J. With a preface by Joe Buberger and Mathew Isenberg. *Russell's Civil War Photographs;* 116 Historic Prints by Andrew J. Russell. New York: Dover Publications, Inc., 1982. 124 pp. 116 b & w.

R926 Walther, Susan Danly. *The Landscape Photographs of Alexander Gardner and Andrew Joseph Russell.* (Ph.D. Dissertation, Brown University, 1983.) Ann Arbor, MI: University Microfilms, 1984. 231 pp. 95 b & w. [Bibliography on pp. 160-182.]

R927 Fels, Thomas W. *Destruction and Destiny: The Photographs of A. J. Russell; Directing American Energy in War and Peace, 1862 - 1869.* Pittsfield, MA: The Berkshire Museum, 1987. 32 pp. b & w. [Travelling exhibition. Seventy-six images in the show.]

R928 Danley, Susan. "Andrew Joseph Russell's 'The Great West Illustrated,'" on pp. 93-94 in: *The Railroad in American Art: Representations of Technological Change,* edited by Susan Danley and Leo Marx. Cambridge, MA: *, 1988. * pp. b & w. illus.

PERIODICALS

R929 "Captain Russell and the Mormons." HUMPHREY'S JOURNAL OF PHOTOGRAPHY, AND THE ALLIED ARTS AND SCIENCES 20, no. 20 (Apr. 15, 1869): 320. ["A few days since we had the pleasure of meeting with Captain A. J. Russell, whose beautiful prints of views

in Utah called forth the admiration of the Photographic Section of the American Institute. Captain Russell is very indignant at the remarks of a writer in our Philadelphia contemporary, who called some of the subjects in the pictures alluded to "ugly-featured, ill-shapen specimens of the gentler sex." Captain R. considers this a gratuitous insult to his patrons....He is one of our oldest subscribers, and wished us to give the public his opinion of the article in question.']

R930 "Windmill at Laramie, Wyoming Territory, for Supplying the Locomotives of the Union Pacific Railroad with Water. - From a Photograph by A. J. Russell." FRANK LESLIE'S ILLUSTRATED NEWSPAPER 28, no. 710 (May 8, 1869): 125. 1 illus. [View.]

R931 "The Completion of the Union Pacific Rail Road - Dr. Durant and Gov. Stanford Driving the Last Spike, Connecting the Union Pacific and Central Pacific Rail Roads, at Promontory Point, Utah, at Five Minutes Past 3 P.M., New York Time, May 10th, 1869," "Rail Road - the Scene at Promontory Point Before Driving the Last Spikes - The Rev. Dr. Todd, of Massachusetts, Invoking the Divine Blessing on the Enterprise, May 10th, 1869," The Completion of the Pacific Rail Road, the Ceremony at Promontory Point, Utah, May 10th, 1869. - The Locomotives Jupiter of the Central Line, and 119, of the Union Line, Meeting at the Junction, After the Driving of the Last Spike. - From a Photograph by A. J. Russell." FRANK LESLIE'S ILLUSTRATED NEWSPAPER 28, no. 714 (June 5, 1869): 177, 183, 184-185. 3 illus. [Views. "The engravings we give are the faithful reproduction of the scenes prominently associated with the completion of the road. They are strict copies of photographs taken expressly for Frank Leslie's Illustrated Newspaper at Promontory Point on that eventful 10th of May, and we can imagine no pictures more interesting to the civilized world."]

R932 "The Union Pacific Railway in America." ILLUSTRATED LONDON NEWS 55, no. 1552 (Aug. 14, 1869): 160-161. 3 illus. [One sketch, two views..."from photographs by Captain Russell, artist to the Union Pacific Railway."]

R933 "The Union Pacific Railway in America." ILLUSTRATED LONDON NEWS 55, no. 1556 (Sept. 11, 1869): 265. 3 illus. ["Our Illustration is taken from a photograph by Captain Russell...who is about to publish under the auspices of the company, an extensive album of large photographs, with descriptive letter press, to be...named 'The Great West.'"]

R934 "The National Grand Lodge of Odd Fellows Holding a Meeting in Echo Canyon, on the Pacific Railway. - From a Photograph by A. J. Russell." FRANK LESLIE'S ILLUSTRATED NEWSPAPER 29, no. 732 (Oct. 9, 1869): 61. 1 illus. [View, with crowd.]

R935 "Dale Creek Bridge, on the Union Pacific Railroad of America." ILLUSTRATED LONDON NEWS 55, no. 1568 (Nov. 27, 1869): 537. 1 illus.

R936 "Across the Continent. - The Eagle's Nest, Red Butte Station, on the Line of the Union Pacific Railroad." and "...- Monument Rock, Echo Canyon, One Thousand Miles West of Omaha. - From a Photograph by A. J. Russell." FRANK LESLIE'S ILLUSTRATED NEWSPAPER 29, no. 753 (Mar. 5, 1870): 417, 420. 2 illus. [Views.]

R937 "Across the Continent. - The Hanging Rock at Echo Canyon, on the Line of the Union Pacific Railroad. - From a Photograph by A. J. Russell." FRANK LESLIE'S ILLUSTRATED NEWSPAPER 29, no. 754 (Mar. 12, 1870): 436. 1 illus. [View.]

R938 "Across the Continent. - Valley of the Weber, From the Witches' Rock. Near the Pacific Railroad. - From a Photograph by A. J. Russell." FRANK LESLIE'S ILLUSTRATED NEWSPAPER 30, no. 755 (Mar. 19, 1870): 12. 1 illus. [View.]

R939 "Across the Continent. - Bitter Creek Valley, - Construction Camp of the Pacific Railroad in the Foreground." and " Citadel Rock, Green River, Pacific Railroad-Bridge in the Foreground - From a Photograph by A. J. Russell." FRANK LESLIE'S ILLUSTRATED NEWSPAPER 30, no. 756 (Mar. 26, 1870): 28. 2 illus. [Views.]

R940 Russell, A. J. "On the Mountains with the Tripod and Camera." ANTHONY'S PHOTOGRAPHIC BULLETIN 1, no. 3, 7 (Apr., Aug. 1870): 33-35, 128-130. [Additional note on p. 165 (Sept.) that Russell's U.P.R.R. views were for sale.]

R941 "Across the Continent. - The Giant's Club, a Water Formation on Green River, Near the Line of the Pacific Railroad - From a Photograph by A. J. Russell." FRANK LESLIE'S ILLUSTRATED NEWSPAPER 30, no. 757 (Apr. 2, 1870): 44. 1 illus. [View.]

R942 "The Sick Indian Girl. - An Incident of the Plains. - From a Photograph by A. J. Russell." FRANK LESLIE'S ILLUSTRATED NEWSPAPER 30, no. 761 (Apr. 30, 1870): 97, 99. 1 illus. [Double portrait, in the outdoors. The image is accompanied with an anecdote, apparently by Russell, stating that the girl believed that his taking her portrait cured her of her temporary illness.]

R943 Russell, A. J. "Correspondence: A New Outdoor Camera Box." ANTHONY'S PHOTOGRAPHIC BULLETIN 1, no. 6 (July 1870): 117-118. [Diagram of camera on p. 117.]

R944 "New York. - Horace Greeley at Home. - Views of the Chappaqua Farm and Its Surroundings. - From Sketches by A. Berghaus and Photographs by A. J. Russell." FRANK LESLIE'S ILLUSTRATED NEWSPAPER 34, no. 870 (June 1, 1872): 184-185. 9 illus. [Views, with Greeley at home and in a rural environment.]

R945 "New York. - Horace Greeley at Home. - Outdoor and Interior Views at Chappaqua. - From Sketches by A. Berghaus and Photographs by A. J. Russell." FRANK LESLIE'S ILLUSTRATED NEWSPAPER 34, no. 871 (June 8, 1872): 200-201. 10 illus. [Views, with Greeley at home and in a rural environment. Livestock, etc.]

R946 "The World's Peace Jubilee. - Interior View of the Great Coliseum Building in Boston, at the Opening of the Exercises, Monday, June 17th, 1872. - From Sketches by Joseph Becker, and Photographs by A. J. Russell." FRANK LESLIE'S ILLUSTRATED NEWSPAPER 34, no. 874 (June 29, 1872): 245, 248-249. 1 illus. [Interior of huge hall, filled with a large crowd.]

R947 "New Jersey. - The Monmouth Park Races - The Celebrated Horse "Harry Bassett," and His Owner, Colonel M'Daniels." and "...The Celebrated Horse "Longfellow," and His Owner, Mr. John Harper. - From a Photograph by A. J. Russell." FRANK LESLIE'S ILLUSTRATED NEWSPAPER 34, no. 876 (July 13, 1872): 281. 2 illus. [Racehorses.]

R948 "New Jersey. - The Principal Entrance to the Monmouth Park Race Course. - From a Photograph by A. J. Russell." FRANK LESLIE'S ILLUSTRATED NEWSPAPER 34, no. 876 (July 13, 1872): 285. 1 illus. [View, with figures.]

R949 "Utah. - A Group of Squaws of the Snake Tribe of Indians Playing Cards. - From a Photograph by A. J. Russell." FRANK LESLIE'S

ILLUSTRATED NEWSPAPER 35, no. 906 (Feb. 8, 1873): 345, 351. 1 illus. [Outdoor group portrait. Informal, close-up. This photo accompanies a signed (rare) article by Thomas W. Knox, which is essentially a generalized, derogatory, description of the Indian's practices and habits.]

R950 Russell, Andrew J. "Whoa January!" ANTHONY'S PHOTOGRAPHIC BULLETIN 5, no. 1 (Jan. 1874): 3-4. [Russell describes his expeditions by pack mule into the mountains. Article was to be continued, but nothing else was published in 1874.]

R951 "Charles Sumner in His Study." FRANK LESLIE'S ILLUSTRATED NEWSPAPER 38, no. 965 (Mar. 28, 1874): 37. 1 illus. [This portrait was reprinted in the magazine on the occasion of the death of Sumner. This time no credit was given to the photographer, who was Andrew Russell. See "FLIN" (Oct. 19, 1872).]

R952 "Herding Cattle in New Mexico. - Photographed by Captain Russell." FRANK LESLIE'S ILLUSTRATED NEWSPAPER 38, no. 985 (Aug. 15, 1874): 363, 365. 1 illus. [Full-page engraving, view of cowboys, horses, cattle in a roundup near a makeshift corral belonging to Wilson, Waddington & Co., at Fort Bascom, on the Canadian River, near Ute Creek, NM.]

R953 "Wood Merchant of Santa Fe, New Mexico. - Photographed by A. J. Russell." FRANK LESLIE'S ILLUSTRATED NEWSPAPER 39, no. 989 (Sept. 12, 1874): 12. 1 illus. [Two men outside, in Santa Fe, NM, with a burro loaded with wood, and a baby burro. (The last two references are confusing. There was a R. W. Russell working in Sante Fe, NM who became partners with the photographer Ben Wittick in 1880. And, given the frequency of typographical errors printed at the time, these works may have been misattributed to A. J. Russell. On the other hand A. J. Russell was clearly very well known to the *Leslie's* in 1874.)]

R954 "New Jersey. - Meeting of the Evangelical Alliance at Sea Grove, Cape May - The Afternoon Session at the Pavilion, Friday, August 27th. - From a Photograph by Captain A. J. Russell." FRANK LESLIE'S ILLUSTRATED NEWSPAPER 41, no. 1042 (Sept. 18, 1875): 21. 2 illus. [View. Interior, with crowd.]

R955 "Matters of the Month." PHOTOGRAPHIC TIMES 5, no. 60 (Dec. 1875): 296. [Captain Russell, photographer in chief to "Frank Leslie's Illustrated Newspaper," is now making views of Philadelphia and vicinity for the above publication... "]

R956 "Success Cameras." ANTHONY'S PHOTOGRAPHIC BULLETIN 7, no. 1 (Jan. 1876): 25. ["...our Centennial Pocket Camera, already in use by Capt. A. J. Russell, Mr. G. P. B. Hoyt and others..."]

R957 "Society Gossip: Photographic Society of Philadelphia, Meeting of Dec. 2, 1875." PHILADELPHIA PHOTOGRAPHER 13, no. 145 (Jan. 1876): 29. ["Colonel A. J. Russell of N. Y., who has been making a series of views of Philadelphia on dry plates...talked before Society." [Gives his process].]

R958 "Letter." PHOTOGRAPHIC TIMES 6, no. 64 (Apr. 1876): 76. [Letter, "Sirs: I have been using your pocket camera 4 x 5 size, find it first class in every way ...I recommend it to all parties for outdoor work." Dated New York, Feb. 24, 1876.]

R959 Russell, A. J. "Triumph of Anthony's Bromide Emulsion. Rapid Transit! Sharp Work." ANTHONY'S PHOTOGRAPHIC BULLETIN 7, no. 5 (May 1876): 129. [Letter from A. J. Russell. Left New York, NY for Bridgeport, by train, at 8:05 A.M., Apr. 15, 1876. Four minutes

after arrival, he had taken two views of the hotels and depot and on the return train." "...110 miles in five hours from starting, and a proof in the office by one o'clock of the same day. Hurrah for dry plate photography..."]

R960 Russell, A. J. "Matters of the Month." PHOTOGRAPHIC TIMES 7, no. 73 (Jan. 1877): 5. [Letter from Russell praising Morrison's lenses. Dated Nov. 1, 1876, signed A. J. Russell, Photographer, Frank Leslie's. 537 Pearl Street, NY.]

R961 Russell, A. J. "Photographic Reminiscences of the Late War." ANTHONY'S PHOTOGRAPHIC BULLETIN 13, no. 7 (July 1882): 212-213. 1 illus. [Anecdote about T. C. Roche at the Petersburg battle, told by A. J. Russell, who was also there.]

R962 Parker, Alice Lee. "Photographs and Negatives." QUARTERLY JOURNAL OF THE LIBRARY OF CONGRESS 13, no. 1 (Nov. 1955): 54. [Album of 138 photographs, taken by A. J. Russell, or under his direction, of the Union Military railroads during the Civil war, once in the possession of General Haupt, now added to the Library.]

R963 Pattison, William D. "Westward by Rail with Professor Sedgwick. A Lantern Journey of 1873." HISTORICAL SOCIETY OF SOUTHERN CALIFORNIA QUARTERLY 42, no. 4 (Dec. 1960): 335-349. 6 b & w. 4 illus. [In the Early 1870s, Stephen Sedgwick delivered popular public lecture series on the Union Pacific R.R., illustrated with lantern slides. Sedgwick claimed to have joined A. J. Russell's photographic team documenting the U. P. R. R. in 1869-1870, along with O. C. Smith and J. P. Silvis, which produced approximately 600 stereos in the "Union Pacific Railroad Stereoscopic Views" series as well as other photos. Sedgwick published several catalogs of these view series as part of his lecture practice.]

R964 Pattison, William D. "The Pacific Railroad Rediscovered." GEOGRAPHICAL REVIEW 52, (Jan. 1962): 25-36. 7 b & w. 1 illus. [Pattison discusses Russell's role in photographing the construction of the U. P. R. R. and his activities at the ceremony of driving the last spike at Promontory Point, Utah.]

R965 Weinstein, Robert and Roger Olmsted. "Epic on Glass." AMERICAN WEST 4, no. 1 (Feb. 1967): 10-23. 13 b & w. [Views of Union Pacific R.R. taken in 1968-1969. Plates from the archives of the American Geographical Society.]

R966 Pattison, William D. "Collector's Choice: The Photographs of A. J. Russell." AMERICAN WEST 6, no. 3 (May 1969): 20-33. 6 b & w.

R967 Coke, Van Deren. "A. J. Russell: Workin' on the railroad." AFTERIMAGE (Feb. 1976): 13-14. 2 b & w. [Bk. rev.: Makin' Tracks, by Lynne Rhodes Mayer and Kenneth E. Vose Praeger.]

R968 Gladstone, William. "Captain Andrew J. Russell: First Army Photographer." PHOTOGRAPHICA 10, no. 2 (Feb. 1978): 7-9. 4 illus. [Illustrations are copies of military records. Article describes A. J. Russell's military career in detail. Enlisted for service in the 141st New York Volunteers on August 19, 1862 at Elmira, NY. Entered service in September and assigned to duty in Washington, DC. Through December his unit was based north of the Potomac River as part of the defenses of the city, then his unit was deployed south to Belle Plains, VA. Then placed on Detached Service to Alexandria, VA, by Special Order 19, which classified him as "Government Artist." General Haupt had just been assigned to the post of Chief of Construction and Transportation Corps of the U. S. Military Railroad, and Russell was transferred into the Construction Corps. Haupt used Russell's photographs to explicate several of Haupt's new tools and

techniques used to restore damaged railroads and bridges. Instructions, illustrated with Russell's photographs were distributed to Departmental Officers as instructional aids. In addition to these works, several bound albums were created, which were presented to various dignitaries. From 1862 to 1864 Russell, a servant, and a laborer documented the Construction Corps activities, and also "...used some of his time painting cars and engines." However Russell did have the assistance of E. G. Fowx for one three month period. Capt. Russell was honorably discharged on Sept. 9, 1865.]

R970 Cooney, Charles F. "Andrew J. Russell: The Union Army's Forgotten Photographer." CIVIL WAR TIMES ILLUSTRATED 21, no. 4 (Apr. 1982): 32-35.

R971 Rich, Nancy. "Politics and the Picturesque: A. J. Russell's Great West Illustrated." VIEWS 10, no. 4 - 11, no. 1 (Summer - Fall 1989): 4-6, 24. 3 b & w. 1 illus. [Discussion of Russell's "The Great West Illustrated."]

RUSSELL, ANDREW J. [?]
BOOKS
R972 Haupt, Herman. *Photographs Illustrative of Operations in Construction and Transportation as Used to Facilitate the Movements of Armies of the Rappahannock, of Virginia, and of the Potomac, including Experiments Made to Determine the Most Practical and Expeditious Modes to be Resorted to in the Construction, Destruction and Reconstruction of Roads and Bridges.* Boston: Wright & Potter, 1863. 27 l. pp. 87 l. of plates.

R973 Leslie, Frank, Mrs. *California: A Pleasure Trip from Gotham to the Golden Gate (April, May, June, 1877)* New York; London: G. W. Carleton & Co; Samson Low & Son., 1877. xiv, 286 pp. 48 illus. [Illustrated with woodcuts, some of which may be from A. J. Russell photos. Reprinted (1972) Nieuwkoop, Neth: B. DeGraaf, with bibliography and introduction by Madeleine B. Stern.]

PERIODICALS
R974 "Massachusetts. - The Peabody Funeral - Depositing the Remains of the Late George Peabody in the Peabody Tomb, Harmony Grove, at Peabody, Formerly South Danvers. - From a Photograph by Our Special Artist." FRANK LESLIE'S ILLUSTRATED NEWSPAPER 29, no. 752 (Feb. 26, 1870): 393, 401-402. 1 illus. [Outdoor crowd at funeral, credited to a photo, but unusually active, close-up composition - so either the image was enhanced by the engraver or it was the work of an unusual photographer. A. J. Russell may have been working for the magazine by this time.]

R975 "New York State - The Oneida Community of Free Lovers - Out-Door Life of the Members - A Bag-Bee, with Portraits from Photographs, of the Prominent Members." FRANK LESLIE'S ILLUSTRATED NEWSPAPER 30, no. 759 (Apr. 16, 1870): 77. 1 illus. [Group sitting outdoors, sewing.]

R976 "On the Plains. - Indian Women and Children, at their Toilets. - From a Photograph by Our Special Photographer." FRANK LESLIE'S ILLUSTRATED NEWSPAPER 30, no. 768 (June 18, 1870): 209, 211. 1 illus. [Outdoor group portrait. Informal grouping, closer stance give an immediacy to the image not often found in the group portraits of this time.]

R977 "Our Summer Resorts - Bathing in the Surf at Long Branch. - From Instantaneous Pictures taken by Our Own Photographer." FRANK LESLIE'S ILLUSTRATED NEWSPAPER 30, no. 773 (July 23, 1870): 297. 1 illus. [Crowd of swimmers at a beach. Close-up and active, this image probably assisted by the engraver.]

R978 "Washington, D. C. - Hon. Charles Sumner in His Study. At His Residence. Corner of H and Fifteenth Streets. - From a View Taken by Our Own Photographer." FRANK LESLIE'S ILLUSTRATED NEWSPAPER 32, no. 812 (Apr. 22, 1871): 89, 91. 1 illus. [Full-page engraving of an informal portrait, taken in Sumner's study.]

R979 "The Orange Riot." FRANK LESLIE'S ILLUSTRATED NEWSPAPER 32, no. 826 (July 29, 1871): 327, 328-329, 332, 333. 6 illus. [Riot in New York, NY between Irish Catholics and Protestants, with U.S. militia called in. Over forty people killed. "Our Illustrations: The artists and photographers of *Frank Leslie's* were promptly on the line of action...These reliable tracings are Historic Art in her every-day robes." Two and possibly three of these sketches came from photos.]

R980 "The Explosion on the Staten Island Ferry-Boat "Westfield" - State of the Ruins and Location of the Exploded Boiler after the Disaster. - View Taken by Our Own Photographer." FRANK LESLIE'S ILLUSTRATED NEWSPAPER 32, no. 829 (Aug. 19, 1871): 384, 389. 5 illus. [Disaster aftermath. Three of the images derived from photos.]

R981 "New York City. - Our Wandering Minstrels - A Street Scene From an Instantaneous Photograph by Our Own Photographer." FRANK LESLIE'S ILLUSTRATED NEWSPAPER 33, no. 843 (Nov. 25, 1871): 165. 1 illus. [Street portraits.]

R982 "President Grant Preparing His Veto Message in the Cabinet Room of the White House. - From Photographs and Sketches by Our Special Artist." FRANK LESLIE'S ILLUSTRATED NEWSPAPER 38, no. 971 (May 9, 1874): 129. 1 illus. [Portrait of Grant, in his study.]

R983 "New York City. - The Five Points House of Industry. - The Children's Playing-Hour. An Instantaneous View, by Our Own Photographer." FRANK LESLIE'S ILLUSTRATED NEWSPAPER 39, no. 1001 (Dec. 5, 1874): 201. 1 illus. [Outdoor close up portrait of a group of young children playing on the steps in front of a building. Social documentary.]

R984 "New York to Philadelphia. - The Route to the Centennial. - Scenes Along the Pennsylvania Railroad." FRANK LESLIE'S ILLUSTRATED NEWSPAPER 42, no. 1072-1073 (Apr. 15, Apr. 22, 1876): 101, 109. 7 illus. [These views of towns along the route of the railroad in NJ and PA are not credited; but it seems from the visual grammar that they are from photographic sources. Its known that A. J. Russell photographed for the "FLIN" in Philadelphia in late 1875, probably in anticipation of the magazine's needs in reporting on the forthcoming Centennial exhibition. This may be a typical example of the way in which his work was used as source material for later engravings, without credit to the photographer.]

R985 "Philadelphia, Pa. - The Centennial Exposition. - The Wilson Sewing Machine Company, of Chicago. - From Sketches and Photographs by Our Special Artists." FRANK LESLIE'S ILLUSTRATED NEWSPAPER 42, no. 1086 (July 22, 1876): 329. 3 illus. [Views, interiors, displays.]

R986 "Philadelphia, Pa. - The Centennial Exposition. - The Champion Mowing and Reaping Machine Trials. - From Sketches and Photographs by Our Special Artists." FRANK LESLIE'S ILLUSTRATED NEWSPAPER 42, no. 1086 (July 22, 1876): 321. 3 illus. [Views, displays.]

R987 "Philadelphia, Pa. - The Centennial Exposition. - The Cazade, Crooks & Reynaud's Exhibit of Foreign Wines,... - From Sketches and Photographs by Our Special Artists." FRANK LESLIE'S ILLUSTRATED

NEWSPAPER 42, no. 1087 (July 29, 1876): 341. 3 illus. [Views, displays.]

R988 "Philadelphia, Pa. - The Centennial Exposition. - Exhibit of Greenfield & Strauss, Confectioners,.... - From Sketches and Photographs by Our Special Artists." FRANK LESLIE'S ILLUSTRATED NEWSPAPER 42, no. 1087 (July 29, 1876): 348. 1 illus. [View, displays.]

R989 "Across the Continent. Frank Leslie en Route to the Pacific Coast - The Start at the Forty-Second Street Depot...New York to Niagara...From Omaha to Fremont and the Platte River Valley...Scenes and Incidents on the Central Pacific RR in Traversing the Great American Desert in Nevada... Episodes of Western RR Life...Virginia City, Nevada...San Francisco... etc." FRANK LESLIE'S ILLUSTRATED NEWSPAPER 44, no. 1126, 1136-1182 (Apr. 28, July 7, 1877 - May 25, 1878): [vol. 44] 140-141, 297, 301-302, 304, 321-322, 344-346, 356-357, 369, 370-371, 404-405, 406, 417, 420-422, 437-438, [vol. 45] 5, 9, 17, 21, 23, 37-38, 53, 54, 70-71, 72-73, 85-86, 101-102, 117-118, 134, 137-138, 160-162, 173-174, 189-190, 205-206, 226, 228, 241-242, 257-258, 273-275, 305, 321, 337, 343, 353, 355, 373, 389-390, 405, 421, 445-446, [vol. 46] 5-6, 9, 21-22, 37, 39, 61-62, 77-78, 93-94, 96-97, 109-110, 125-126, 128-129, 132, 134, 141, 143, 165-166, 181-182, 197, 198-199. 174 illus. ["On Tuesday evening, April 10th,... Mr. and Mrs. Frank Leslie, who were about starting on a trip to California and the Pacific Coast. Mr. Leslie was accompanied by several artists, photographers and literary ladies and gentlemen connected with his publishing house, and it is his intention to visit every locality of special note on the route, with a view to illustrating the grand highway between the Atlantic and Pacific Oceans on a scale never heretofore attempted....a party of twelve..." The party returned to New York, NY on June 7th. This series began to be printed in the July 7, 1877 issue, and appeared almost every week thereafter until the end. Each article contained from one to five illustrations, of scenes, events and persons along the way, most of which were taken from artist's sketches, but many were clearly from photographs or assisted by photographs. The photographers were not named, although, on occasion, their activities were described - e.g. " Twenty minutes are given to us to revel in this one long look....While the train stops, and the photographer runs hither and thither with his tripod, we wander along the track....The brakeman shouts to us, and the photographer, shouldering his camera, runs past us down the track and scrambles up on the car again." (Apr. 27, 1878): 126. It is probable that A. J. Russell was one of the photographers.]

R990 "Massachusetts. - An American Poet's Home - Henry W. Longfellow in His Study, in the Old Washington Headquarters Building, Cambridge. From a Photograph Taken Exclusively for Frank Leslie's Illustrated Newspaper." FRANK LESLIE'S ILLUSTRATED NEWSPAPER 45, no. 1154 (Nov. 10, 1877): 157. 1 illus. [Portrait, in natural setting.]

R991 "California. - Grand Court of the Palace Hotel, San Francisco. - From a Photograph by Our Own Photographer." FRANK LESLIE'S ILLUSTRATED NEWSPAPER 46, no. 1187 (June 29, 1878): 281. 1 illus. [Interior view.]

RUSSELL, C. see also HARDWICH, THOMAS. (1864)

RUSSELL, C., MAJOR. (1820-1887) (GREAT BRITAIN)
BOOKS
R992 Russell, Major C. *The Tannin Process.* Illustrated. London; Liverpool: J. W. Davies; Henry Greenwood, 1861. iv, 80 pp. illus. [2nd. ed. (1863) London: J. W. Davies, 135 pp. (1865) Appendix and

index. 50 pp., published separately and with the 2nd issue. 3rd ed. (1865), London: R. Hardwicke.]

R993 Russell, C. *Le procede au tannin,*...traduit de l'anglaise par Aimé Girard. "2nd ed." Paris: Gauthier-Villars, 1864. 177 pp. illus.

R994 Roth, Karl de. *Major Russell's Tannin-Verfahren:* Ausführliche Anleitung, mit geringen Kosten sehr empfindliche trockene Platten und transparente Photographien von wundervoller Tonabstufung zu erzielen. Nach Major Russell's Tannin-Prozess bearbeitet und mit den neuesten Erfahrungen bereichert. "2nd ed." Leipzig: O. Spamer, 1866. xii, 47 pp. illus.

R995 Russell, Major C. *The Photographic Society and its Organ.* London: Privately printed, Diprose & Bateman, 1866. 24 pp. [Pamphlet about problems with the Photographic Society and its Journal.]

PERIODICALS
R996 "Major Russell's Dry Collodion Process." AMERICAN JOURNAL OF PHOTOGRAPHY AND THE ALLIED ARTS & SCIENCES n. s. vol. 3, no. 21 (Apr. 1, 1861): 328-330. [From "Photo. Notes."]

R997 "The new Tannin Dry Process." HUMPHREY'S JOURNAL OF PHOTOGRAPHY, AND THE ALLIED ARTS AND SCIENCES 12, no. 24 (Apr. 15, 1861): 377-380. [From "Photo. Notes."]

R998 Russel [sic Russell], Major. "The Tannin Process." AMERICAN JOURNAL OF PHOTOGRAPHY AND THE ALLIED ARTS & SCIENCES n. s. vol. 3, no. 23 (May 1, 1861): 353-356. [From Photo. News."]

R999 Russell, Major. "The Tannin Process. - Some Improvements in the Manipulations." HUMPHREY'S JOURNAL OF PHOTOGRAPHY, AND THE ALLIED ARTS AND SCIENCES 13, no. 3 (June 1, 1861): 46-47. [From "Br. J. of Photo."]

R1000 Russell, Major. "The Tannin Process." HUMPHREY'S JOURNAL OF PHOTOGRAPHY, AND THE ALLIED ARTS AND SCIENCES 13, no. 14, 16 (Nov. 15, Dec. 15, 1861): 220-223, 246-248.

R1001 Russell, Major. "On Highly-Sensitized Dry Plates." AMERICAN JOURNAL OF PHOTOGRAPHY AND THE ALLIED ARTS & SCIENCES n. s. vol. 5, no. 21 (May 1, 1863): 484-487. [From "Br. J. of Photo."]

R1002 Russell, C. "On the Tendency of Bromide of Silver to Cause Fogging." AMERICAN JOURNAL OF PHOTOGRAPHY AND THE ALLIED ARTS & SCIENCES n. s. vol. 7, no. 2 (July 15, 1864): 25-29. [Read before Liverpool Amateur Photo. Assoc.]

R1003 Towler, Prof. "The Tannin Process. - Bibliography." HUMPHREY'S JOURNAL OF PHOTOGRAPHY, AND THE ALLIED ARTS AND SCIENCES 17, no. 16-17 (Dec. 15, 1865 - Jan. 1, 1866): 241-246, 262-264. [Extensive, rather critical review of Major C. Russell's "Appendix to the second edition of the Tannin Process."]

R1004 Russell, C. "Notes, by Major Russell." AMERICAN JOURNAL OF PHOTOGRAPHY AND THE ALLIED ARTS & SCIENCES n. s. vol. 8, no. 17 (Mar. 1, 1866): 392-396. [From "Photo. Notes."]

R1005 Russell, Major. "Notes of Experiments." HUMPHREY'S JOURNAL OF PHOTOGRAPHY, AND THE ALLIED ARTS AND SCIENCES 18, no. 2 (May 15, 1866): 28-30. [From "Photo Notes."]

R1006 Russell, Major. "Silver in Dry Films." HUMPHREY'S JOURNAL OF PHOTOGRAPHY, AND THE ALLIED ARTS AND SCIENCES 18, no. 10 (Sept. 15, 1866): 158. [From "Photo. Notes."]

R1007 Russell, C. "Weak and Strong Negative Baths." HUMPHREY'S JOURNAL OF PHOTOGRAPHY, AND THE ALLIED ARTS AND SCIENCES 18, no. 23 (Apr. 1, 1867): 364-365. [From "Photo. Notes."]

R1008 Russell, C., Major. "Removing Hyposulphites." and "Spots on Negatives." HUMPHREY'S JOURNAL OF PHOTOGRAPHY, AND THE ALLIED ARTS AND SCIENCES 19, no. 3 (June 1, 1867): 41-42, 43. [From "Photo. Notes."]

R1009 Russell, Major. "Notes of Experiments." HUMPHREY'S JOURNAL OF PHOTOGRAPHY, AND THE ALLIED ARTS AND SCIENCES 19, no. 11 (Oct. 1, 1867): 168-169. [From "Photo. Notes."]

R1010 Russell, Major. "Notes of Experiments." HUMPHREY'S JOURNAL OF PHOTOGRAPHY, AND THE ALLIED ARTS AND SCIENCES 19, no. 15 (Dec. 1, 1867): 236-237. [From "Photo. Notes."]

R1011 Russell, Major. "Blurring." HUMPHREY'S JOURNAL OF PHOTOGRAPHY, AND THE ALLIED ARTS AND SCIENCES 20, no. 9 (Sept. 1, 1868): 143-144. [From "Illustrated Photo."]

R1012 "The Fathers of Photography: V. Major C. Russell." PHOTOGRAPHIC TIMES 24, no. 659 (May 4, 1894): 277-279. [Born in Essex, England in 1820. Family name was Bramfill, but legally changed to Russell to meet the terms of a will. He took up photography in 1856, and began experimenting with the tannin process. During the 1860s he perfected a dry collodion process, and made other chemical improvements. Seems to have stopped experimenting in photography at the end of the decade. Died on May 16, 1887.]

RUSSELL, JAMES & SONS. (CHICHESTER, ENGLAND)

R1013 Portrait. Woodcut engraving, credited to "From a Photograph by James Russell & Sons." ILLUSTRATED LONDON NEWS 59, (1871) ["Earl of Dalkeith." 59:1665 (Aug. 19, 1871): 169.]

R1014 Portraits. Woodcut engravings credited "From a photograph by James Russell & Sons." ILLUSTRATED LONDON NEWS 63, (1873) ["Rev. J. R. Woodford." 63:1774 (Aug. 30, 1873): 205. "Late E. T. Parris." 63:1789 (Dec. 13, 1873): 564.]

R1015 Portrait. Woodcut engraving credited "From a photograph by James Russell & Sons." ILLUSTRATED LONDON NEWS 67, (1875) ["Late Dean Hook." 67:1891 (Nov. 6, 1875): 461.]

R1016 Portrait. Woodcut engraving credited "From a photograph by Russell & Sons." ILLUSTRATED LONDON NEWS 71, (1877) ["Duke of Norfolk." 71:2002 (Nov. 24, 1877): 505.]

R1017 1 photo ("In Caesar's Palace") as frontispiece. EVERYBODY'S MAGAZINE 2, no. 10 (June 1900): 504. 1 b & w. [Genre scene.]

R1018 "Correspondence: The German Emperor Poses for an English Photographer; Photographing the Empress of Germany." PHOTOGRAPHIC TIMES 21, no. 508 [sic 509] (June 19, 1891): 300-301. [Anecdotes of photographic session from "N.Y. World".]

R1019 "Notes and News: Photographing Royalty." PHOTOGRAPHIC TIMES 29, no. 8 (Aug. 1897): 396-397. [From Feb. 1897 "Winsor Magazine."]

R1020 1 photo (King Henry VII in royal coach). COLLIER'S WEEKLY 29, no. 22 (Aug. 30, 1902): 6.

R1021 Mark's Jeannette. "The Pedlar's Window." OUTLOOK 87, no. 4 (Sept. 28, 1907): 203-208. 3 b & w. ["With Photographs Specially Taken for this Article by Russell, Royal Photographer." Views of buildings in Lambeth, England.]

RUSSELL, J. (ST. THOMAS, WEST INDIES)

R1022 Russell, J. "Correspondence." ANTHONY'S PHOTOGRAPHIC BULLETIN 2, no. 12 (Dec. 1871): 398-399. [J. Russell, from St. Thomas, West Indies, describes a technique he had for reusing old fixer.]

RUSSELL, LORENZO HENRY.

R1023 "A Photographic Jack-of-all-Trades." PHOTOGRAPHIC TIMES 9, no. 102 (June 1879): 139. [Note about Russell, prof. of music and singing, miniature painter, phrenologist, taxidermist, mesmerist and photographer.]

RUSSELL, MURRAY.

R1024 Russell, Murray. "My Studio. Operator No. V." ANTHONY'S PHOTOGRAPHIC BULLETIN 8, no. 9 (Sept. 1877): 266-267. [From "Br. J. of Photo." Anecdotes about "an operator" in Mr. Russell's studio. May be fictional.]

RUTHERFORD, J. C.

R1025 Rutherford, J. C. "The New Toning Process." HUMPHREY'S JOURNAL OF PHOTOGRAPHY, AND THE ALLIED ARTS AND SCIENCES 12, no. 9 (Sept. 1, 1860): 132.

RUTHERFORD, LEWIS MORRIS. (1816-1892) (USA)

BOOKS

R1026 Proctor, Richard A. *The Moon: Her Motions, Aspect, Scenery, and Physical Condition.* London: Longmans, Green & Co., 1873. n. p. 3 b & w. [Albumen prints, of the moon, negatives taken by L. M. Rutherford, enlarged by Alfred Brothers.]

PERIODICALS

R1027 "How the Eclipse was taken by the Astronomers." AMERICAN JOURNAL OF PHOTOGRAPHY AND THE ALLIED ARTS & SCIENCES n. s. vol. 3, no. 5 (Aug. 1, 1860): 71-73. [Rutherford's Observatory, New York, NY. Rutherford and Prof. Hackley, Columbia College. From "NY Daily Tribune" (July 19).]

R1028 "The American Photographical Society: Thirty-fourth Meeting." AMERICAN JOURNAL OF PHOTOGRAPHY AND THE ALLIED ARTS & SCIENCES n. s. vol. 4, no. 16-17 (Jan. 15 - Feb. 1, 1862): 381, 400-402. [Rutherford describes his early attempts to photograph the moon in 1857/58 and his current experiments. Dr. Henry Draper described his work in constructing 16" telescope.]

R1029 "Lewis M. Rutherford, Esq. Vice-President of the Photographical Society. (Illustrated by a Photograph.)" AMERICAN JOURNAL OF PHOTOGRAPHY AND THE ALLIED ARTS & SCIENCES n. s. vol. 4, no. 24 (May 15, 1862): 567. 1 b & w. [Portrait made by C. D. Fredericks & Co. Operator was Hugh O'Neil, the printer W. J. Kuhns. Little biographical info. - Rutherford "especially eminent in the photographic world for his valuable contributions to celestial photography." (Photo missing from this issue.)]

R1030 Rutherford, Lewis M. "Astronomical Photography." AMERICAN JOURNAL OF SCIENCE 39, (1865): 304-309.

R1031 "Astronomical Photography." HUMPHREY'S JOURNAL OF PHOTOGRAPHY, AND THE ALLIED ARTS AND SCIENCES 17, no. 4 (June 15, 1865): 54-55. [L. M. Rutherford presented a photographic picture of the moon, nearly two feet in diameter, to the American Photographical Society.]

R1032 Rutherford, Lewis M. "Contemporary Press: Astronomical Photography." BRITISH JOURNAL OF PHOTOGRAPHY 12, no. 269 (June 30, 1865): 343-344. [From "Am. J. of Science and Arts."]

R1033 "Contemporary Press: Photographing the Moon." BRITISH JOURNAL OF PHOTOGRAPHY 12, no. 281 (Sept. 21, 1865): 490. [From "Scientific American." Work of Lewis M. Rutherford discussed.]

R1034 "Photographing the Moon." AMERICAN JOURNAL OF PHOTOGRAPHY AND THE ALLIED ARTS & SCIENCES n. s. vol. 8, no. 8 (Oct. 15, 1865): 184-186. [From "Scientific American."]

R1035 "Rutherford's Photograph of the Moon." PHILADELPHIA PHOTOGRAPHER 3, no. 26 (Feb. 1866): 36-39. [Extended quotes from a paper contributed to the "Am. J. of Science" describing his experiments since 1857/58. Rutherford from New York, NY.]

R1036 Vogel, Hermann. "Astronomical Photography in America." PHOTOGRAPHIC NEWS *, no. 646-647 (Jan. 20 - Jan. 27, 1871): 31-32, 39-40. [From "Photographische Mittheilungen." Rutherford, an American amateur, working ca. 1869, mentioned.]

R1037 Mann, Robert J. "Mr. Lewis Rutherford's Photographs of the Sun and Fixed Stars." PHOTOGRAPHIC NEWS 15, no. 668 (June 23, 1871): 294-295.

R1038 Rutherford, Lewis M. "Paper on Astronomical Photography." ANTHONY'S PHOTOGRAPHIC BULLETIN 7, no. 3 (Mar. 1876): 67-74.

R1039 Mason, O. G. "In Memoriam: Lewis Morris Rutherford." PHOTOGRAPHIC TIMES 22, no. 561 (June 17, 1892): frontispiece, 313-315. 1 illus. [Lewis Morris Rutherford was born on Nov. 25, 1816, in Morrisania, NY, into a wealthy and socially prominent family. He graduated from Williams College in 1834, at age eighteen. He had studied chemistry and physics at Williams, and had demonstrated a keen ability to build or adapt technical apparatus to his investigations. He rebuilt an old telescope at college and began his life-long interest in astronomy at that time. After Williams, he studied law, then practiced it in New York City. He married Miss Margaret Stuyvesant Chanler, and merged two considerable fortunes. They went to Europe in 1849 and spent several years there, where Lewis studied optics with Professor Amici in Italy. After returning to New York, Rutherford constructed one of the finest and best equipped private astronomical observatories in the country at his home. He built telescopes, perfected devices to better study solar spectra, and did pioneering work in solar spectroscopy, publishing his papers in the *American Journal of Science*. After serving for years as the first Vice-President of the American Photographical Society, he was elected its President in 1867. The organization became the Photographical Section of the American Institute under his leadership. Rutherford died on May 30, 1892, at his country home in New Jersey. His equipment and research was presented to Columbia College after his death.]

R1040 Warner, Deborah Jean. "Lewis M. Rutherford: Pioneer Astronomical Photographer and Spectroscopist." TECHNOLOGY AND CULTURE 12, no. 2 (Apr. 1971): 190-216. 1 b & w. 3 illus. [During 3rd quarter of 19th century, Rutherford produced several instruments needed by those two sciences. Designed reflecting and refracting telescopes especially for photographic work.]

RYAN, DAVID J. (b. 1837) (USA)
R1041 "An Elegant Establishment." ANTHONY'S PHOTOGRAPHIC BULLETIN 4, no. 12 (Dec. 1873): 364. [From the "Exchange." Perhaps Washington, DC.]

RYDER, JAMES FITZALLEN. (1826-1904) (USA)
[Born in 1826 and grew up in Tompkins County, NY, near Ithaca. He worked for three years as a printer's apprentice, but met a Professor Brightly in 1847 and learned the most rudimentary introduction to daguerreotypy from him. Ryder then went to Cleveland, OH in 1850, where he studied with Charles E. Johnson, whom he had met passing through Ithaca. Ryder then worked as an itinerant photographer throughout southwestern New York state, through Pennsyvania, and into Ohio, learning his trade. In the mid-1850s Ryder settled in Cleveland, OH; taking over Charles E. Johnson's studio there. Ryder kept up-to-date by bringing innovations such as the ambrotype, stereo views, the hallotype, and hand-colored portraits to Cleveland. Ryder claimed to have introduced negative retouching to America in 1868 by importing a skilled retoucher from Germany. By the end of the decade Ryder was one of the leading photographers in Ohio. He became active in the fight against Cutting's bromide patent in the 1860s and was an important figure in the early National Photographers' Association. He helped plan and host their second, very successful, national convention and exhibition, held in Cleveland in 1870. Ryder began to lecture and write articles in the journals, establishing a national reputation. He built an elaborate new studio in Cleveland in 1872. After the N. P. A. disbanded, Ryder became the first President of the Photographers Association of America in 1880, and was instrumental in persuading the photographic community to erect a statue of Daguerre in Washington, DC. Ryder published his autobiography in 1902. He died in Cleveland on June 2, 1904.]

BOOKS
R1042 Ryder, James F. *Voightlander and I: In Pursuit of Shadow Catching. A Story of Fifty-Two Years Companionship with a Camera.* Cleveland: Cleveland Printing and Publishing Co., 1902. 251 pp. 116 illus. [Reprinted (1973), Arno Press.]

PERIODICALS
R1043 "The Celebration of Perry's Victory at Put-In Bay, Lake Erie, Sept. 10." FRANK LESLIE'S ILLUSTRATED NEWSPAPER 6, no. 150 (Oct. 16, 1858) 3 illus. [Views: steamers at anchor in the Bay, crowds, etc., all credited "From a Photograph by J. F. Ryder, Cleveland, OH."]

R1044 "The Perry Celebration at Cleveland." HARPER'S WEEKLY 4, no. 193 (Sept. 8, 1860): 565, 568-570. 12 illus. ["Photographed by Ryder, of Cleveland, Ohio." Portrait of sculptor William Walcutt; portraits of four survivors of the Battle of Lake Erie; view of the public square in Cleveland; view of the statue to Comm. Perry. Sketches.]

R1045 "Statue Erected in Olive Park, In Honor of Commodore Oliver Hazard Perry, the Hero of Lake Erie,... at Cleveland, Ohio, September 10, 1860. - From a Photograph by J. F. Ryder." FRANK LESLIE'S ILLUSTRATED NEWSPAPER 10, no. 251 (Sept. 15, 1860): 262-263. 7 illus. [View. Six portraits of celebrities associated with the inauguration of the Perry Monument, in Cleveland, OH.]

R1046 Portraits. Woodcut engravings, credited "Photographed by J. F. Ryder, Cincinnati, Oh." FRANK LESLIE'S ILLUSTRATED

NEWSPAPER 11, (1861) ["S. F. Chase, Sec. of Treasury." 11:280 (Apr. 6, 1861): 312.]

R1047 Portrait. Woodcut engraving, credited "From a Photograph by James F. Ryder, of Cleveland." HARPER'S WEEKLY 6, (1862) ["Brig.-Gen. Garfield." 6:271 (Mar. 8, 1862): 157.]

R1048 Portrait. Woodcut engraving, credited "From a Photograph." FRANK LESLIE'S ILLUSTRATED NEWSPAPER 13, (1862) ["Maj.-Gen. J. A. Garfield." 13:329 (Mar. 15, 1862): 268.]

R1049 "Editor's Table: Burglary." PHILADELPHIA PHOTOGRAPHER 2, no. 16 (Apr. 1865): 66. [Ryder's studio burglarized. Additional note on page 121 in July 1865 "Philadelphia Photographer."]

R1050 Ryder, J. F. "Meinerth's Patent - How I was Sold." HUMPHREY'S JOURNAL OF PHOTOGRAPHY, AND THE ALLIED ARTS AND SCIENCES 19, no. 8 (Aug. 15, 1867): 120-121. [Rueful letter from J. F. Ryder, who paid $25.00 for the license to practice Meinerth's patent, which Ryder found out was something that he himself had tried and discarded eight years earlier as being impracticable. (Ryder would later be vilified by the publisher, Ladd, who supported Meinerth's patent.]

R1051 "Voices from the Craft." PHILADELPHIA PHOTOGRAPHER 4, no. 45 (Sept. 1867): 300. [Letter from Ryder.]

R1052 "The 'Mezzo-Tintos' Again - Second Letter from Mr. Ryder." HUMPHREY'S JOURNAL OF PHOTOGRAPHY, AND THE ALLIED ARTS AND SCIENCES 19, no. 11 (Oct. 1, 1867): 173-174.

R1053 "Editor's Table: Composite Skating Pictures." PHILADELPHIA PHOTOGRAPHER 5, no. 52 (Apr. 1868): 134.

R1054 "The Bromide Patent Case. Our Expose of the Treasurer's Account - 'The Galled Jade Winces' - Ryder to the Rescue! Who is Ryder?" HUMPHREY'S JOURNAL OF PHOTOGRAPHY, AND THE ALLIED ARTS AND SCIENCES 20, no. 12 (Oct. 15, 1868): 179-181. [Further attack on the Bromide defense fund, which is also an attack on Col. Wilson and the "Philadelphia Photographer." Attacks Ryder as well.]

R1055 "Our Picture." PHILADELPHIA PHOTOGRAPHER 7, no. 75 (Mar. 1870): frontispiece, 92-93. 1 b & w. [Double self-portrait.]

R1056 "Still Another Art Palace." ANTHONY'S PHOTOGRAPHIC BULLETIN 3, no. 9 (Sept. 1872): 672-673. [Ryder's (Cleveland, OH) new gallery.]

R1057 "Editor's Table - Mr. Ryder's New Studio." PHILADELPHIA PHOTOGRAPHER 9, no. 105 (Sept. 1872): 334-335.

R1058 "Note of "Mr. Ryder's New Gallery in Cleveland."" PHOTOGRAPHIC TIMES 2, no. 21 (Sept. 1872): 139. [$20,000 spent on fitting up a magnificent art gallery.]

R1059 "Mr. J. F. Ryder's New Rooms." COMMERCIAL PHOTOGRAPHIC NEWS 1, no. 4 (Oct. 1872): 8-9.

R1060 "A Lofty One for Mr. Ryder." ANTHONY'S PHOTOGRAPHIC BULLETIN 4, no. 1 (Jan. 1873): 23. [From the "Cleveland (OH) Leader." Praise for newly refurbished gallery.]

R1061 "Editor's Table." PHILADELPHIA PHOTOGRAPHER 12, no. 136 (Apr. 1875): 128. [Photos, view of his gallery, with its windows blown out by an explosion.]

R1062 "Editor's Table." PHILADELPHIA PHOTOGRAPHER 12, no. 139 (July 1875): 224. [Description of J. F. Ryder's (Cleveland, OH) studio.]

R1063 Portrait. Woodcut engraving, credited "From a Photograph by Ryder, Cleveland, Ohio." FRANK LESLIE'S ILLUSTRATED NEWSPAPER 41, (1875) ["Rev. Dr. William E. McLaren." 41:1051 (Nov. 20, 1875): 169.]

R1064 "Eyelashes for Cameras." PHILADELPHIA PHOTOGRAPHER 13, no. 149 (May 1876): 148-149. [Ryder invented a gadget.]

R1065 "Letter." PHOTOGRAPHIC TIMES 6, no. 67 (July 1876): 160. [Letter from Ryder on a technical device, "eye-lashes for cameras."]

R1066 Portrait. Woodcut engraving, credited "From a Photograph by Ryder, Cleveland, Ohio." FRANK LESLIE'S ILLUSTRATED NEWSPAPER 45, no. 1146 (Sept. 15, 1877): 29. 1 illus.

R1067 Portrait. Woodcut engraving, credited "From a Photograph by Ryder." FRANK LESLIE'S ILLUSTRATED NEWSPAPER 49, (1879) ["Col. John Hay, Asst.-Sec. of State." 49:1264 (Dec. 20, 1879): 273.]

R1068 "A Call from President Ryder." PHILADELPHIA PHOTOGRAPHER 17, no. 198 (June 1880): 186-187. [Announcement of Chicago, IL, convention, first meeting of Photographers' Association of America.]

R1069 "Matters of the Month." PHOTOGRAPHIC TIMES 10, no. 116 (Aug. 1880): 179. [Visit, his portraits of General Garfield selling well, his Presidency of the P. A. of A. mentioned.]

R1070 Ryder, J. F. "On the Business Management of Photography." PHOTOGRAPHIC TIMES 14, no. 164 (Aug. 1884): 407-410. [Paper read before the P. A. of A.]

R1071 Ryder, J. F. "How to See." PHOTOGRAPHIC TIMES 15, no. 201 (July 24, 1885): 416-417.

R1072 Bellsmith, P. R. "Correspondence: A Correction - Mr. Ryder's Photographs." PHOTOGRAPHIC TIMES 15, no. 208 (Sept. 11, 1885): 526. ["I wish to correct a statement... W. J. White has charge of Mr. Ryder's out-door work, and is not the portraitist, while I have full and sole charge of the operating room, and do all portrait work."]

R1073 "Commercial Intelligence: The Drummer's Latest Yarn." PHOTOGRAPHIC TIMES 15, no. 209 (Sept. 18, 1885): 541. [Advertisement for an oleograph reproduction of a genre painting with the same name by the artist A. M. Willard, apparently manufactured and sold by J. F. Ryder.]

R1074 "General Notes." PHOTOGRAPHIC TIMES 16, no. 240 (Apr. 23, 1886): 215. [Excerpts reprinted from a biography of J. F. Ryder published in the April issue of the inaugural issue of "Journal of Science and Art." Anecdote about Ryder introducing negative retouching in USA in 1869.]

R1075 "General Notes." PHOTOGRAPHIC TIMES 16, no. 272 (Dec. 3, 1886): 625. [Note that Ryder one of three Americans to receive an award at an exhibition from the Convention of German Photographers at Braunschweig.]

R1076 "Editorial Notes." ANTHONY'S PHOTOGRAPHIC BULLETIN 17, no. 23 (Dec. 11, 1886): 707. [Note that Ryder won a cup for photos submitted to an exhibition in Braunschweig, Germany.]

R1077 "A Reminiscence." AMERICAN ANNUAL OF PHOTOGRAPHY AND PHOTOGRAPHIC TIMES ALMANAC FOR 1887 (1887): 144-146. [Narrative of events leading to Ryder photographing a dead boy in 1848.]

R1078 Ryder, J. F. "Correspondence: Plush and Gold." PHOTOGRAPHIC TIMES 17, no. 278 (Jan. 14, 1887): 21-22. [Ryder defends his practice of elegant frames for his prints in the annual P.P.A. convention exhibition, apparently in response to what he felt was criticisms directed towards him.]

R1079 Ryder, James F. "Killed by Overdose." PHOTOGRAPHIC TIMES 17, no. 311 (Sept. 2, 1887): 445-446. [Negatives, prints, etc., destroyed by chemicals mixed to strongly.]

R1080 Ryder, J. F. "Killed by Over-Dosing." ANTHONY'S PHOTOGRAPHIC BULLETIN 18, no. 17 (Sept. 10, 1887): 519-520. [About developers.]

R1081 Ryder, J. F. "An Argument in Favor of Association." ANTHONY'S PHOTOGRAPHIC BULLETIN 18, no. 19 (Oct. 8, 1887): 588.

R1082 Ryder, J. F. "Old Friend, Keep Young." AMERICAN ANNUAL OF PHOTOGRAPHY & PHOTOGRAPHIC TIMES ALMANAC FOR 1888 (1888): 234-235.

R1083 "Notes and News: J. F. Ryder." PHOTOGRAPHIC TIMES 18, no. 339 (Mar. 16, 1888): 129-130. 1 illus. [Engraved portrait of Ryder. Brief biography began taking daguerreotypes in Cleveland in 1850. Moved his gallery in 1872 from the Merchant's Bank to 239 Superior Street. From "Cleveland Sun."]

R1084 Ryder, J. F. "Correspondence: Some 'Business Methods.'" PHOTOGRAPHIC TIMES 18, no. 361 (Aug. 17, 1888): 394. [J. F. Ryder sends in two letters addressed to him from professional photographers asking him to make prints of his portraits so that they may display them as their own work.]

R1085 Conly, Mrs. "A Cook-Book, A Famous Photographer, and a Boston Housewife." ANTHONY'S PHOTOGRAPHIC BULLETIN 20, no. 3 (Feb. 9, 1889): 94. [J. F. Ryder issued a cookbook as an advertising device; sent a copy to his friend and former assistant Conly (of Boston) and Conly's wife wrote some letters to Ryder in response to the gift: letters published here.]

R1086 "Mr. J. F. Ryder's Address of Welcome at Boston." ANTHONY'S PHOTOGRAPHIC BULLETIN 20, no. 16 (Aug. 24, 1889): 490-491. [Annual P. A. of A. convention]

R1087 Ryder, J. F. "Correspondence: The Daguerre Memorial Design: A Criticism." PHOTOGRAPHIC TIMES 20, no. 439 (Feb. 14, 1890): 79. [Ryder, who originated the movement to build the Daguerre monument, criticizes the design.]

R1088 "The Garfield Memorial." FRANK LESLIE'S ILLUSTRATED NEWSPAPER 70, no. 1813 (June 14, 1890): 396, 398, 402. 1 b & w. 3 illus. [Statue of General Garfield in Cleveland, crowds at ceremony. "Photos by J. F. Ryder."]

R1089 "Notes and News: A Photographer of National Fame." PHOTOGRAPHIC TIMES 20, no. 458 (June 27, 1890): 312. [From "Frank Leslie's Weekly." Brief biography, etc.]

R1090 Ryder, J. F. "On Negative Retouching." AMERICAN ANNUAL OF PHOTOGRAPHY AND PHOTOGRAPHIC TIMES ALMANAC FOR 1892 (1892): 101-102.

R1091 Ryder, J. F. "Business Methods." PHOTOGRAPHIC MOSAICS:1892 28, (1892): 207-208.

R1092 1 photo ("Little Sweetheart"). PHOTOGRAPHIC TIMES 22, no. 544 (Feb. 19, 1892): frontispiece, 89. 1 b & w.

R1093 "James F. Ryder." PHOTOGRAPHIC TIMES 22, no. 544 (Feb. 19, 1892): 89-90. 1 illus. [Born Ithaca, NY, Apr. 25, 1826. Apprenticed to Robert Watson in 1847-48. Worked as itinerant daguerreotypist several years. Opened gallery in Elyria, Ohio. Then to Cleveland, worked for Charles E. Johnson, daguerreotypist. Later took over the gallery, owned Cleveland Studio for 40 years.]

R1094 Ryder, J. F. "Conscientious Photography." AMERICAN ANNUAL OF PHOTOGRAPHY AND PHOTOGRAPHIC TIMES ALMANAC FOR 1893 (1893): 111-112.

R1095 "Notes and News." PHOTOGRAPHIC TIMES 23, no. 590 (Jan. 6, 1893): 9. [Brief note: "Mrs. Susie Ryder Brennan, the only child of Mr. James F. Ryder, of Cleveland, recently died in that city."]

R1096 Ryder, J. F. "'Hands Off.'" AMERICAN ANNUAL OF PHOTOGRAPHY AND PHOTOGRAPHIC TIMES ALMANAC FOR 1894 (1894): 222-223. [Ryder's suggestions on how to deal with nervous sitters.]

R1097 Ryder, James F. "Scheme for Lighting." AMERICAN ANNUAL OF PHOTOGRAPHY AND PHOTOGRAPHIC TIMES ALMANAC FOR 1895 (1895): 196-197. 1 illus.

R1098 "Our Pictures." WILSON'S PHOTOGRAPHIC MAGAZINE 32, no. 462 (June 1895): frontispiece, 280. 1 b & w. [J. F. Ryder, Cleveland, OH. Photo is a portrait of the actor Charles Couldock.]

R1099 "Editor's Table: Warning to the Craft." WILSON'S PHOTOGRAPHIC MAGAZINE 33, no. 472 (Apr. 1896): 192. [An operator advertising for employment claimed to have been "head operator for J. F. Ryder of Cleveland, Ohio for the past year." Ryder wrote a letter protesting. During the 12 years Ryder in business he had had 4 operators, the 4th for 11 years and head operator past 6. Advertiser worked 3 weeks as retoucher, discharged as unsatisfactory.]

R1100 16 photos on one panel ("A Variety of Studies"). WILSON'S PHOTOGRAPHIC MAGAZINE 33, no. 479 (Nov. 1896): unnumbered leaf following p. 496. 16 b & w. [Portraits by: 4 by W. M. Morrison (Chicago, IL); 4 by B. J. Falk (New York, NY); 1 by R. H. Furman (San Diego, CA); 2 by S. L. Stein (Milwaukee, WI); 3 by J. F. Ryder (Cleveland, OH). Brief note on pp. 519-520.]

R1101 1 photo (Studio Portrait). WILSON'S PHOTOGRAPHIC MAGAZINE 33, no. 480 (Dec. 1896): unnumbered leaf, before p. 529. [Note on p. 564.]

R1102 Ryder, James F. "As I Focused Along." PHOTOGRAPHIC MOSAICS:1897 33, (1897): 157-161. 1 b & w. [Costume portrait. "Easter Thoughts."]

R1103 "Editor's Table." WILSON'S PHOTOGRAPHIC MAGAZINE 35, no. 497 (May 1898): 240. [Note that James F. Ryder of Cleveland, OH, has recovered from a serious illness. John H. Ryder died in Jan. at age 64. P. S. Ryder, of Syracuse, NY, another brother of James, has also been seriously ill.]

R1104 "Editor's Table: Character Pictures." WILSON'S PHOTOGRAPHIC MAGAZINE 35, no. 503 (Nov. 1898): 528. [Several costume portraits, genre. Additional note on same page mentions a portrait of Admiral Sampson, complimented by the sitter in a letter, which was run in a recent issue of the "Cleveland Plain Dealer."]

R1105 "Notes and News: A Card." PHOTOGRAPHIC TIMES 31, no. 4 (Apr. l899): 202. 1 b & w. ["...a catchy little business card devised by Mr. Ryder, the well-known Cleveland photographer." Genre of little girl calling on the telephone.]

R1106 "An Interview with James F. Ryder." WILSON'S PHOTOGRAPHIC MAGAZINE 37, no. 519 (Mar. 1900): 103-104.

R1107 Ryder, James F. "In Natural Colors." WILSON'S PHOTOGRAPHIC MAGAZINE 37, no. 524 (Aug. 1900): 358-360. [Ryder tells of his experience of being hoodwinked by L. L. Hill, who had purportedly discovered a color process, in the early 1850s. From "Voightlander and I," a work in preparation.]

R1108 Ryder, James F. "A Reminiscence: My First Pupil." WILSON'S PHOTOGRAPHIC MAGAZINE 37, no. 528 (Dec. 1900): 539-540. 1 b & w. [Anecdote occurring in the 1860s.]

R1109 Ryder, J. F. "The Advent of Negative Retouching in America—How to do it." WILSON'S PHOTOGRAPHIC MAGAZINE 38, no. 532 (Apr. 1901): 134-136. 1 b & w. [Ryder claims that negative retouching imported into USA from Germany in 1868. Ryder hired Karl Leutgib of the Munich Academy, brought him to the US.]

R1110 Ryder, James F. "Photographing A Railroad." AMERICAN ANNUAL OF PHOTOGRAPHY AND PHOTOGRAPHIC TIMES-BULLETIN ALMANAC FOR 1904 (1904): 144-146. [Anecdotes of Ryder photographing the Atlantic and Great Western Railway on 1862. "Overflow from the book 'Voightlander and I in pursuit of Shadow Catching' by James F. Ryder."]

R1111 "Obituary." PHOTOGRAPHIC TIMES 36, no. 7 (July 1904): 311.

R1112 Waldsmith, John. "James F. Ryder." NORTHLIGHT (JOURNAL OF THE PHOTOGRAPHIC HISTORICAL SOCIETY OF AMERICA) 3, no. 2 (Spring 1976): 4-7. 4 b & w. 1 illus.

R1113 Waldsmith, John. "Ryder Revisited." NORTHLIGHT (JOURNAL OF THE PHOTOGRAPHIC HISTORICAL SOCIETY OF AMERICA) 3, no. 4 (Fall 1976): 2. [Additional notes about Ryder, including the mention that Charles Fontayne, formerly of Fontayne & Porter in Cincinnatti, may have worked for Ryder in 1856.]

RYE.
R1114 "Rye's Photo-Mechanical Printing Process." ANTHONY'S PHOTOGRAPHIC BULLETIN 3, no. 2 (Feb. 1872): 447-448. [From "Br. J. of Photo."]

RYLEY, J.
R1115 Ryley, J. "On Photogalvanography" HUMPHREY'S JOURNAL OF PHOTOGRAPHY, AND THE ALLIED ARTS AND SCIENCES 9, no. 22 (Mar. 15, 1858): 351.

S

A. S.

S1 A. S. "An Artist in Trouble. - Help Wanted. - Pinholes and Varnish." AMERICAN JOURNAL OF PHOTOGRAPHY AND THE ALLIED ARTS & SCIENCES n. s. vol. 6, no. 5 (Sept. 1, 1863): 116-119.

R. A. S.

S2 R. A. S. "The Magic Lantern." AMERICAN JOURNAL OF PHOTOGRAPHY AND THE ALLIED ARTS & SCIENCES n. s. vol. 6, no. 13 (Jan. 1, 1864): 301-308. [From "Br. J. of Photo," in turn from the London Review."]

SABATIER-BLOT, JEAN-BAPTISTE. (1801-1881) (FRANCE)

[Born Jan. 31, 1801 in Lassur. Studied for the priesthood but quit, then turned to drawing. From 1831 on he exhibited in the Paris Salons. Interested in the daguerreotype at its inception, studied with Daguerre in 1841, then they became friends. Takes portraits, including one of Daguerre in 1844. Opened a studio in Paris in 1844, where he works as a photographer until he retired in 1870. Made cartes-de-visite from 1857 on. Sabatier-Blot made several technical improvements during this time. Died in Paris in 1881.]

S3 Sabatier, Dr. "Transparent Positives upon Collodion." HUMPHREY'S JOURNAL OF PHOTOGRAPHY, AND THE ALLIED ARTS AND SCIENCES 12, no. 19 (Feb. 1, 1861): 295-296. [From "Photo. Notes."]

SACCHI, L. (MILAN, ITALY)

S4 "A Recent Visit to the Field of Solferino." ILLUSTRATED LONDON NEWS 36, no. 1018 (Feb. 25, 1860): 176. 1 illus. ["Solferino, Nov. 1859 - From a Photograph by L. Sacchi, Milan."]

SACHÉ

S5 Portrait. Woodcut engraving credited "From a photograph by Saché." ILLUSTRATED LONDON NEWS 68, (1876) ["Maj. Gen. the Hon. Sir Henry Ramsay, Commissioner of Kumaon, India." 68:1913 (Mar. 25, 1876): 305.]

SACHSE, JULIUS FRIEDRICH. (1842-1919) (USA)
BOOKS

S6 Sachse, Julius Friedrich. *Philadelphia's Share in the Development of Photography.* Philadelphia: Franklin Institute, 1893. 17 pp. illus. [Lecture read before the Franklin Institute of Phila. on Dec. 16, 1892. Printed in the Apr. 1893 "Journal," also reprinted and issued as a separate pamphlet.]

S7 Sachse, Julius Friedrich. *A Photographic Ramble in the Millbach Valley (Lebanon County, Penna.).* Philadelphia: Ferris, 1896. 15 pp. b & w. [Reprinted from American Journal of Photography (Sept. 1896).]

S8 Sachse, Julius Friedrich. *The Wayside Inns on the Lancaster Roadside Between Philadelphia and Lancaster.* Lancaster, Pa.: Press of the New Era Printing Co., 1912. 2 vol. pp. b & w.

PERIODICALS

S9 "Notes and News: Photographing the Growth of a Plant." PHOTOGRAPHIC TIMES 18, no. 372 (Nov. 2, 1888): 524. [Sequence of flash exposures of the night-blooming cereus flower by Julius Sache reported.]

S10 Sachse, Julius E. "Artist vs. Photographer." AMERICAN ANNUAL OF PHOTOGRAPHY AND PHOTOGRAPHIC TIMES ALMANAC FOR 1893 (1893): 245-247.

SAHLER, EUGENE.

S11 Sahler, Eugene. "Researches for Accelerative Substances." HUMPHREY'S JOURNAL OF PHOTOGRAPHY, AND THE ALLIED ARTS AND SCIENCES 14, no. 9 (Sept. 1, 1862): 91-93. [From "Photo News," in turn from "Revue Photographique." Sahler described as an amateur.]

S12 Sahler. "Instantaneous Photography." PHOTOGRAPHIC TIMES 7, no. 79 (July 1877): 152-153. [From "Photographic News," in turn taken from "Bulletin de la Société Française." Formulas for working quickly.]

SAINT-AMANT, PIERRE CHARLES FOURNIER DE. (1808-1872) (FRANCE) [?]
BOOKS

S13 Saint-Amant, M. de, Envoyé du Gouvernment Française, en 1851-1852. *Voyages en Californie et dans l'Orégon.* Paris: Libraire L. Maison, 1854. 652 pp. illus. [The chapter on gold mining in California is extensively illustrated with wood-cuts of miners at work, many of them credited to be from daguerreotypes. Unfortunately, the photographer is not credited.]

PERIODICALS

S14 "Photographs from California." ILLUSTRATED LONDON NEWS 22, no. 605 (Jan. 29, 1853): 69. 3 illus. [California gold miners, "...accompanying Photographs of the California Diggings, from a work now preparing for publication by M. Saint-Amant, the distinguished chess-player, who has lately returned from a visit to Oregon and California, undertaken by order of the French Government." Not clear if these photos were actually taken by Saint-Amant, or whether he acquired them from someone else.]

SAINT CROIX.

S15 "Varieties: Daguerreotype Exhibitions." LITERARY GAZETTE, AND JOURNAL OF THE BELLES LETTRES no. 1186 (Oct. 12, 1839): 653-654. [Description of daguerreotypes, taken in London, exhibited at the Adelaide Gallery by Mr. St. Croix. Note that Mr. Cooper giving three lectures a week at the Polytechnicon.]

SAINT-VICTOR, PAUL DE.

S16 Saint-Victor, Paul de. "La Photochromie." L'ARTISTE (1876): 281-285.

SALMON & GARNIER.

S17 Salmon and Garnier. "Process of Photographic Engraving." HUMPHREY'S JOURNAL 7, no. 15 (Dec. 1, 1855): 240-242. [From "Bulletin de la Société Française de Photo.," through "J. of Photo. Soc., London."]

S18 Salmon & Garnier. "Process of Photographic Engraving." PHOTOGRAPHIC AND FINE ART JOURNAL 8, no. 12 (Dec. 1855): 355-356. [From "Bull. de la Soc. Française de Photographie."]

SALMON. (GREAT BRITAIN)

S19 "New Stereoscope." PHOTOGRAPHIC AND FINE ART JOURNAL 11, no. 5 (May 1858): 148. [Salmon (London) brought out a new form of stereoscope.]

S20 "Waltham Abbey Restored." ILLUSTRATED LONDON NEWS 36, no. 1031 (May 19, 1860): 488. 2 illus. ["From a photograph by Mr. Salmon, of Cheshunt."]

SALTER & JUDD. (INDIANAPOLIS, IN)

S21 "Scene of the Recent Fire at Indianapolis, Indiana - Photographed by Salter & Judd." FRANK LESLIE'S ILLUSTRATED NEWSPAPER 38, no. 968 (Apr. 18, 1874): 92. 1 illus. [Ruins]

S22 "Indiana. - The Chamber of Commerce of Indianapolis. - From a Photograph by Salter & Judd, Indianapolis." FRANK LESLIE'S ILLUSTRATED NEWSPAPER 41, no. 1043 (Sept. 25, 1875): 45. 1 illus. [View.]

SALTER, W. H.

S23 "Indiana. - Meeting of the R. W. Grand Lodge of the United States I. O. O. F. in Indianapolis - The Procession Passing Through Washington Street on the Way to the Odd Fellow's Temple. - From Sketches by J. R. Beale, and Photographs by Salter." FRANK LESLIE'S ILLUSTRATED NEWSPAPER 41, no. 1045 (Oct. 9, 1875): 69. 1 illus. [View, with crowds.]

S24 Portrait. Woodcut engraving, credited "From a Photograph by W. H. Salter, Indianapolis." FRANK LESLIE'S ILLUSTRATED NEWSPAPER 43, (1876) ["James D. Williams, Gov. of Indiana." 43:1101 (Nov. 4, 1876): 137.]

SALVIN, OSBERT. (HONDURAS)

S25 "The Ruins of Copan." ILLUSTRATED LONDON NEWS 44, no. 1241 (Jan. 16, 1864): 68. 4 illus. ["...from a series of photographic views of the ruins of Copan, Central America, taken by Mr. Osbert Salvin, and recently published by Messrs. Smith & Beck, of Cornhill."]

S26 "Note." ART JOURNAL (May 1864): 155. [Ruins of Copan, Honduras series of stereo views taken by Osbert Salvin recently published by Messrs. Smith, Beck, & Co.]

SALZMANN, AUGUSTE. (1824-1872) (FRANCE, JERUSALEM)

[Born in Ribeauvillé, Haut-Rhin in 1824, of an Alsatian family of painters. Learned painting from his brother Henri-Gustave. Auguste Salzmann exhibited religious and allegorical paintings at the Paris Salon in the late 1840s. Interested in archeology, he went to Jerusalem in 1853. With an assistant, Charles Durheim, he made about two hundred calotype negatives of the monuments in Jerusalem. In 1854 Blanquart-Evrard published *Jérusalem, époques judaïque, romaine, chrétienne, arabe. Explorations photographiques par A. Salzmann.* A revised version of this work was published under the title: *Jérusalem, étude et reproduction photographique des monuments de la ville saint depuis l'époque judaïque jusqu' à nous jours, par Auguste Salzmann, chargé par le Ministère de l'Instruction publique d'une mission scientifique en Orient.* (Paris: Gide & J. Baudry, 1856. 174 b & w). Salzmann continued to excavate archeological sites, working in Rhodes from 1858 to 1867, where he discovered the necropolis at Camiros. His photographs of that work were published in *Nécropole de Camiros, journal des fouilles exécutées dans cette nécropole pendant les années 1858 à 1865.* (Paris: Detaille, 1875. illustrated with sixty photogravures). Salzmann returned to Jerusalem with the archeologist Louis de Saulcy in 1863 and made more photographs there. Salzmann died in Paris in 1872.]

BOOKS

S27 *The Painter as Photographer: David Octavius Hill, Auguste Salzmann, Charles Negre:* Works from the National Gallery of Canada, introduction by James Borcoman. Vancouver, B. C.: Vancouver Art Gallery, 1978. 8 pp. 8 l. of plates. b & w. [Exhibition: Vancouver Art Gallery, Dec. 9, 1978 - Jan. 14, 1979.

PERIODICALS

S28 Sobieszek, Robert A. "Aug. Salzmann, Phot." IMAGE 14, no. 5-6 (Dec. 1971): 24-26. 4 b & w. [Born in Ribeauville, Haut Rhin, Apr. 15, 1824. Studied painting, exhibited at Salons in 1847, 1849, 1950. By 1854 photographing architecture in Jerusalem. Published book.]

S29 "Biographical Notes on a Number of Photographers Published by Blanquart-Evrard." CAMERA (LUCERNE) 57, no. 12 (Dec. 1978): 32, 41-42. [Benecke, Claine, DuCamp, Fortier, Greene, Le Secq, Loydreau, Marville, Regnault, Robert, Salzmann, Stewart, Sutton, and Tenison.]

S30 Solomon-Godeau, Abigail. "A Photographer in Jerusalem, 1855: Auguste Salzmann and His Times." OCTOBER no. 18 (Fall 1981): 90-107. 7 b & w.

S31 Phillips, Christopher. "To the Editor." OCTOBER no. 19 (Winter 1981): 120-121. [Letter responding to article published in issue no. 18.]

SAMPSON, H. (SOUTHPORT, ENGLAND.)

S32 "Our Editorial Table: Stereographs, by H. Sampson, Southport." BRITISH JOURNAL OF PHOTOGRAPHY 12, no. 248 (Feb. 3, 1865): 61.

SANBORN, NATHANIEL C. (1830-1886) (USA)

S33 "The Statue of 'Victory,' Presented by Dr. J. C. Ayer to the City of Lowell, Mass., Dedicated July 4th, 1867 - From a Photograph by Sanborn, of Lowell." FRANK LESLIE'S ILLUSTRATED NEWSPAPER 24, no. 616 (July 20, 1867): 277. 1 illus. [View.]

S34 "Obituary: Nathaniel C. Sanborn." PHOTOGRAPHIC TIMES 16, no. 265 (Oct. 15, 1886): 543. [Sanborn died Oct. 3, 1886 at age 56 in Lowell, Ma. Made portraits, but concentrated on the chemical aspects of the medium. Made early dry-plates, taught amateurs. Also served on the City Council, ran for Mayor in 1879, etc.]

SANCIER, MAURICE.

S35 "Note." AMERICAN JOURNAL OF PHOTOGRAPHY AND THE ALLIED ARTS AND SCIENCES n. s. vol. 1, no. 9 (Oct. 1, 1858): 146. [Noted that Sancier displays a fine collection of photograph views from dry collodion. The first in the field.]

SANDERS.

S36 Sanders. "Micellanea: Reminiscences of a Daguerreotypist." BRITISH JOURNAL OF PHOTOGRAPHY 12, no. 269 (June 30, 1865): 345. [From "American J. of Photo."]

SANDERS, J. MILTON. (NEW YORK, NY)

S37 Sanders, J. Milton, L.L.D. "A New and Beautiful Picture." AMERICAN JOURNAL OF PHOTOGRAPHY AND THE ALLIED ARTS AND SCIENCES n. s. vol. 1, no. 10 (Oct. 15, 1858): 154-156. [New method of coloring pictures, named by author the Durotype.]

S38 Sanders, J. Milton, Dr. "The Dry Plate." AMERICAN JOURNAL OF PHOTOGRAPHY AND THE ALLIED ARTS & SCIENCES n. s. vol. 3, no. 2 (June 15, 1860): 18-20. [Sanders from Madison, CT. Read before the Am. Photo. Society in June, 1860.]

S39 Sanders, J. Milton, Prof. "The Xantho-Collodion." AMERICAN JOURNAL OF PHOTOGRAPHY AND THE ALLIED ARTS & SCIENCES n. s. vol. 3, no. 4 (July 15, 1860): 60-62. [Read before Am. Photo. Soc.]

S40 Sanders, J. Milton, L.L.D. "More About Collodion." AMERICAN JOURNAL OF PHOTOGRAPHY AND THE ALLIED ARTS & SCIENCES n. s. vol. 3, no. 6 (Aug. 15, 1860): 89-91.

S41 Sanders, J. Milton, L.L.D. "About Toning Baths." AMERICAN JOURNAL OF PHOTOGRAPHY AND THE ALLIED ARTS & SCIENCES n. s. vol. 5, no. 1 (July 1, 1862): 14-17.

S42 Sanders, J. Milton, M.D., L.L.D. "About Dry Plates." AMERICAN JOURNAL OF PHOTOGRAPHY AND THE ALLIED ARTS & SCIENCES n. s. vol. 5, no. 24 (June 15, 1863): 561-562.

S43 Sanders, J. Milton, L.L.D. "About Collodion, Etc." AMERICAN JOURNAL OF PHOTOGRAPHY AND THE ALLIED ARTS & SCIENCES n. s. vol. 5, no. 23 (June 1, 1863): 536-538. [Sanders' letter addressed St. Domingo, W. I.]

S44 Sanders, J. Milton, Prof. "Collodion." AMERICAN JOURNAL OF PHOTOGRAPHY AND THE ALLIED ARTS & SCIENCES n. s. vol. 7, no. 17 (Mar. 1, 1865): 401-404.

SANG, JOHN.
S45 "Topics of the Week: Stereoscopic Pictures from Flat Surfaces." ILLUSTRATED NEWS OF THE WORLD AND DRAWING ROOM PORTRAIT GALLERY OF EMINENT PERSONAGES 1, no. 39 (Oct. 30, 1858): 279. [From the "London Times." Mr. John Sang's improvements discussed.]

SARGEANT, JOHNATHAN DICKINSON. (1822-) (USA)
S46 "Our Picture." PHILADELPHIA PHOTOGRAPHER 1, no. 11 (Nov. 1864): frontispiece, 173-175. 1 b & w. [Landscape. Camp Pool, on the Nipissiquit. Prints for the magazine by F. Gutekunst.]

S47 "Our Picture - The Grand Falls on the Nipissiquit, a Salmon River of the Province of New Brunswick." PHILADELPHIA PHOTOGRAPHER 2, no. 19 (July 1865): frontispiece, 121. 1 b & w.

SARONY & CO. (SCARBOROUGH, ENGLAND) see SARONY, NAPOLEON.

SARONY, NAPOLEON. (1821-1896) (CANADA, GREAT BRITAIN, USA)
[Born Quebec, Canada in 1821. Moved to New York, NY in 1831. Worked for Henry Robinson and Nathaniel Currier as a lithographer. Entered partnership Sarony, Major & Knapp as makers and sellers of lithographic illustrations. Listed as a daguerreotypist in Yonkers, NY in 1857-58. Retired from lithography in 1858, travelled to England. Returned to New York, NY in 1864, opened a photography gallery, where he worked until 1896.]

BOOKS
S48 Montgomery, James Eglinton. *Our Admiral's Flag Abroad. The Cruise of Admiral D. G. Farrigut, Commanding the European Squadron in 1867-68, in the Flag-Ship Franklin.* New York: G. P. Putnam, 1869. xvi, 464 pp. 21 l. of plates. 1 b & w. 39 illus. [Tipped-in photographic portrait, by Sarony. Engravings and vignettes, many from photographs, artist credited, but photographers (topographic views) in Europe, etc. not credited.]

S49 Irving, Washington. *Rip van Winkle; A Legend of the Kaatskill Mountains.* New York: Putnam, Henry L. Hinton, 1870. 32 pp. 4 b & w. illus. [Carbon prints, by Napoleon Sarony, of the actor Joseph Jefferson in this role.]

PERIODICALS
S50 "Improvements in Vignetting Portraits." AMERICAN JOURNAL OF PHOTOGRAPHY AND THE ALLIED ARTS & SCIENCES n. s. vol. 7, no. 15 (Feb. 1, 1865): 351-352. [From "Br. J. of Photo." Napoleon Sarony at Birmingham, England in 1860s.]

S51 "New Patents: Specifications of Patent Obtained by Napoleon Sarony, Birmingham. Sealed December 2, 1864, dated June 9, 1864, and entitled 'Improvements in the Production and Treatment of Photographs.'" BRITISH JOURNAL OF PHOTOGRAPHY 12, no. 260 (Apr. 28, 1865): 222.

S52 "Note." ART JOURNAL (May 1866): 159. [Mr. N. Sarony, a Canadian by birth, of Italian descent, is one of best photographers. Works in Birmingham (England). Taking photos of actresses (Menkin). Uses the "rest" invented by his brother, of Scarborough.]

S53 "A New Era in Photography." HUMPHREY'S JOURNAL OF PHOTOGRAPHY, AND THE ALLIED ARTS AND SCIENCES 18, no. 9 (Sept. 1, 1866): 143. ["...rooms of Mr. N. Sarony at No. 543 Broadway... delighted in the specimens of posing in pictures which he exhibited to us."]

S54 Seely, Charles A. "Editorial Department." AMERICAN JOURNAL OF PHOTOGRAPHY AND THE ALLIED ARTS & SCIENCES n. s. vol. 9, no. 2 (Sept. 15, 1866): 48. [Praise for Sarony's Photographic Studies.]

S55 "Editor's Table: Sarony's Universal Rest and Posing Apparatus." PHILADELPHIA PHOTOGRAPHER 3, no. 34 (Oct. 1866): 321-322.

S56 "Photographic Society of Philadelphia. Meeting of Dec. 5, 1866." PHILADELPHIA PHOTOGRAPHER 4, no. 37 (Jan. 1867): 27-28. [Discussion of Sarony's studies. V. Blanchard mentioned.]

S57 "Sarony's Studies and Drawings." PHILADELPHIA PHOTOGRAPHER 4, no. 38 (Feb. 1867): 46-47.

S58 "An Hour with Mr. Sarony - Our Picture." PHILADELPHIA PHOTOGRAPHER 4, no. 39 (Mar. 1867): frontispiece, 82-84. 4 b & w. [Four portrait studies, on one page.]

S59 "The Sarony Photography Company." HUMPHREY'S JOURNAL OF PHOTOGRAPHY, AND THE ALLIED ARTS AND SCIENCES 19, no. 12 (Oct. 15, 1867): 191. [The Sarony Photography Company, with new partners George W. Carleton and J. C. Darby have bought out Klauser's Gallery, No. 630 Broadway, New York, NY.]

S60 Hull, C. Wager. "The 'Lights' and Formula of Fredericks and Sarony." PHILADELPHIA PHOTOGRAPHER 5, no. 58 (Oct. 1868): 353-355. [Describes working methods of Sarony's studio, Richardson mentioned as Sarony's operator, Mr. Campbell is his partner.]

S61 Portrait. Woodcut engraving, credited "From a Photograph by Napoleon Sarony & Co." HARPER'S WEEKLY 13, (1869) ["Hon. John Jay, Minister to Austria." 13:644 (May 1, 1869): 273.]

S62 Portrait. Woodcut portrait, credited "From a Photograph by Sarony." FRANK LESLIE'S ILLUSTRATED NEWSPAPER 31, (1870) ["James J. Kelso, Supt. of Police, New York, NY." 31:788 (Nov. 5, 1870): 124.]

S63 "Photo-Crayon Process of Sarony & Co." ART JOURNAL (Feb. 1871): 61.

S64 Portrait. Woodcut engraving, credited "From a Photograph by Sarony." FRANK LESLIE'S ILLUSTRATED NEWSPAPER 33, (1872) ["J. T. Raymond, actor." 33:849 (Jan. 6, 1872): 268.]

S65 "Novelties: Cabinet Pictures." ANTHONY'S PHOTOGRAPHIC BULLETIN 3, no. 3 (Mar. 1872): 500. [Portraits of Miss Jenny Lee, Rozelle, Dr. Hall, Stephen Tyng, Jr., and Buffalo Bill, among others, for sale.]

S66 Portrait. Woodcut engraving credited "From a photograph by Sarony." ILLUSTRATED LONDON NEWS 61, (1872) ["Horace Greeley." 61:1736 (Dec. 14, 1872): 565.]

S67 Portrait. Woodcut engraving, credited "From a Photograph by Sarony." FRANK LESLIE'S ILLUSTRATED NEWSPAPER 35, (1872) ["The late Edwin Forrest." 35:900 (Dec. 28, 1872): 253.]

S68 Sarony, Napoleon. "The Portrait." BRITISH JOURNAL PHOTOGRAPHIC ALMANAC 1873 (1873): frontispiece, plus p. i. 1 b & w. [Original photograph, tipped-in. Full length studio portrait.]

S69 Portrait. Woodcut engraving, credited "From a Photograph by Sarony." FRANK LESLIE'S ILLUSTRATED NEWSPAPER 35, (1873) ["Hon. John A. Dix, Gov. of NY." 35:903 (Jan. 18, 1873): 297.]

S70 Portrait. Woodcut engraving, credited "From a Photograph by Sarony." FRANK LESLIE'S ILLUSTRATED NEWSPAPER 37, (1873) [Miss Anna E. Dickinson, lecturer." 37:940 (Oct. 4, 1873): 61.]

S71 "Producing Large Negatives." ANTHONY'S PHOTOGRAPHIC BULLETIN 4, no. 12 (Dec. 1873): 354-355. ["An important branch of Mr. Sarony's business at Scarborough consists in reproducing pictures on a large scale for art publishers." From "Photo. News."]

S72 Portrait. Woodcut engraving credited "From a photograph by Sarony." ILLUSTRATED LONDON NEWS 64, (1874) ["E. Jenkins." 64:1810 (May 2, 1874): 416.]

S73 Portraits. Woodcut engravings, credited "Photographed by Sarony." FRANK LESLIE'S ILLUSTRATED NEWSPAPER 38, (1874) ["Joseph Strauss, Pres. of the Alsace-Lorraine Society." 38:964 (Mar. 21, 1874): 28. "Richard P. Morgan, railroad reformer." 38:969 (Apr. 25, 1874): 108. "Edmund C. Stedman, banker and poet." 38:973 (May 23, 1874): 173.]

S74 "The Colombia College Boat-Crew, Winners of the Inter-Collegiate Race on Lake Saratoga, July 18th. - From Photographs by Sarony, New York; Kimball, Concord, N. H., and Moore Brothers, Springfield, Mass." FRANK LESLIE'S ILLUSTRATED NEWSPAPER 38, no. 983 (Aug. 1, 1874): 321, 326-327, 328-329. 2 illus. [Group portrait of the crew, individual portraits of which must have been copied from different photographs by the engraver, since three separate photographers are credited for the one image. The second image is an artist's sketch.]

S75 Portraits. Woodcut engravings, credited "Photographed by Sarony." FRANK LESLIE'S ILLUSTRATED NEWSPAPER 39, (1874) ["Miss Charlotte Cusman, actress." 39:996 (Oct. 31, 1874): 124. "Hon. Thomas I. James, Postmaster, New York, NY." 39:1004 (Dec. 26, 1874): 268.]

S76 Loomis, G. H. "Gallery Biographic. No. 3. Sarony." ANTHONY'S PHOTOGRAPHIC BULLETIN 6, no. 1 (Jan. 1875): 26-27. [Born in Quebec, Canada in 1821. To New York, NY in 1831. Apprenticed as a lithographer, then as a caricaturist, then as lithographer for N. Currier,

then started his own firm Sarony, Major & Knapp. After 15 years retired, took a trip to Europe, took up photography and returned to New York.]

S77 Portrait. Woodcut engraving, credited "From a Photograph by Sarony." FRANK LESLIE'S ILLUSTRATED NEWSPAPER 39, (1875) ["Miss Susannah Evans, temperance lecturer." 39:1006 (Jan. 9, 1875): 300.]

S78 Portrait. Woodcut engraving, credited "From a Photograph by Sarony." FRANK LESLIE'S ILLUSTRATED NEWSPAPER 40, (1875) ["The late S. R. Wells." 40:1025 (May 22, 1875): 177.]

S79 "Sarony's Dramatic Tableaus." ANTHONY'S PHOTOGRAPHIC BULLETIN 6, no. 6 (June 1875): 187. [From "NY Tribune." "Sarony is doing what no one has ever done for his predecessors. He has begun to illustrate the plays of the time with copious photographic reproductions of characters, scenes, and tableaus."]

S80 Portrait. Woodcut engraving, credited "From a Photograph by Sarony." FRANK LESLIE'S ILLUSTRATED NEWSPAPER 40, (1875) ["Hon. Daniel Chamberlain, Gov. of SC." 40:1033 (July 17, 1875): 337.]

S81 Portrait. Woodcut engraving, credited "From a Photograph by Sarony." FRANK LESLIE'S ILLUSTRATED NEWSPAPER 41, (1876) ["The late Charlotte Cushman." 41:1066 (Mar. 4, 1876): 420.]

S82 Portraits. Woodcut engravings, credited "From a Photograph by Sarony." FRANK LESLIE'S ILLUSTRATED NEWSPAPER 43, (1876) ["Samuel J. Tilden, Gov. of NY." 43:1102 (Nov. 11, 1876): 156. "Hon. Daaniel H. Chamberlain, of SC." 43:1107 (Dec. 16, 1876): 253.]

S83 "Matters of the Month: Sarony's New Gallery." PHOTOGRAPHIC TIMES 7, no. 78 (June 1877): 126-127. [From "New York Graphic."]

S84 "Ten Pins." ANTHONY'S PHOTOGRAPHIC BULLETIN 8, no. 10 (Oct. 1877): 308. [Employees of Sarony's studio and E. & H. T. Anthony's company met in a bowling contest.]

S85 "Sarony vs. Anthony." ANTHONY'S PHOTOGRAPHIC BULLETIN 8, no. 11 (Nov. 1877): 348. [Another bowling contest between the employees. Anthony company won again.]

S86 Portrait. Woodcut engraving, credited "From a Photograph by Sarony." FRANK LESLIE'S ILLUSTRATED NEWSPAPER 46, (1878) ["Col. S. W. Burt, Port of New York, NY." 46:1192 (Aug. 3, 1878): 377.]

S87 Portraits. Woodcut engravings, credited "From a Photograph by Sarony." FRANK LESLIE'S ILLUSTRATED NEWSPAPER 47, (1878) ["Miss Ada Cavendish as 'Mercy Merrick.'in 'The New Magdalen.'" 47:1200 (Sept. 28, 1878): 61. "Miss Geneveve Ward as 'Queen Elizabeth' in 'Henry VIII.'" 47:1204 (Oct. 26, 1878): 132. "Hon. Edward Cooper, Mayor of New York, NY." 47:1208 (Nov. 23, 1878): 193. "Madame Etelka Gerter-Gardini, Prima Donna." 47:1209 (Nov. 30, 1878): 213. "August Wilhelmj, violinist." 47:1210 (Dec. 7, 1878): 236. "Madame Modjeska, actress." 47:1210 (Dec. 7, 1878): 236. "Minnie Hauk, the American Prima Donna." 47:1211 (Dec. 14, 1878): 245.]

S88 "Doubting Castle." and "President Hayes and the Lightning Process. ANTHONY'S PHOTOGRAPHIC BULLETIN 9, no. 10 (Oct. 1878): 320. [Sarony's use of Lambert's "Lightning Process" mentioned.]

S89 D. C. P. "Artistic Photography." ANTHONY'S PHOTOGRAPHIC BULLETIN 9, no. 11 (Nov. 1878): 332. [Pirated portrait by Sarony brings praise to a Parisian photographer.]

S90 "The Picture." ANTHONY'S PHOTOGRAPHIC BULLETIN 10, no. 2 (Feb. 1879): frontispiece, 53. 1 b & w. ["Little Nora," by Sarony.]

S91 Portraits. Woodcut engravings, credited "From a Photograph by Sarony." FRANK LESLIE'S ILLUSTRATED NEWSPAPER 47, (1879) ["Ex-Judge Josiah Sutherland." 47:1218 (Feb. 1, 1879): 401. "Mrs. Anna Granger Dow." 47:1222 (Mar. 1, 1879): 476.]

S92 Portraits. Woodcut engravings, credited "From a Photograph by Sarony." FRANK LESLIE'S ILLUSTRATED NEWSPAPER 48, (1879) ["Charles Rowell, competitive walker." 48:1226 (Mar. 29, 1879): 49. "Hon. Andrew D. White, US Minister to Germany." 48:1229 (Apr. 19, 1879): 101. "The late Maj.-Gen. John A. Dix." 48:1232 (May 10, 1879): 149.]

S93 Portraits. Woodcut engravings, credited "From a Photograph by Sarony." FRANK LESLIE'S ILLUSTRATED NEWSPAPER 49, (1879) ["Rev. Thomas S. Starkey, of NJ." 49:1260 (Nov. 22, 1879): 212. "Right Rev. Horatio Potter." 49:1262 (Dec. 6, 1879): 249.]

S94 1 engraving (Henry Wadsworth Longfellow). HARPER'S MONTHLY 65, no. 385 (June 1882): unnumbered l. before p. 123. 1 illus. ["From a photograph by Sarony."]

S95 "Wedding Bells." PHOTOGRAPHIC TIMES 15, no. 221 (Dec. 11, 1885): 692. [From "NY Tribune." Extensive report on the wedding of Napoleon Sarony's daughter to Giuseppe Bonano at City Hall.]

S96 "Our Illustration." ANTHONY'S PHOTOGRAPHIC BULLETIN 17, no. 15 (Aug. 14, 1886): frontispiece, 471. 1 b & w. [Note states that several pictures of actresses, from the studio of Sarony, New York, NY, are used to illustrate this issue.]

S97 "Our Illustration." ANTHONY'S PHOTOGRAPHIC BULLETIN 18, no. 14 (July 23, 1887): frontispiece, 438. 1 b & w. [Costume study of the actress Ada Rehan by Sarony.]

S98 "Our Illustration." ANTHONY'S PHOTOGRAPHIC BULLETIN 19, no. 5 (Mar. 10, 1888): frontispiece, 148. 1 b & w. [Portrait by Sarony of New York. Photo not bound in this copy.]

S99 "Notes and News: Photographing an Old Soldier." PHOTOGRAPHIC TIMES 18, no. 341 (Mar. 30, 1888): 152. [From "Toledo Commercial." "On his 68th birthday, General Sherman was captured by Lieut. Gurney, of Sarony's Photographic establishment and was ... "taken" in twenty different positions."]

S100 1 photo (Portrait of General William T. Sherman). NEW ENGLAND MAGAZINE 2, no. 6 (Aug. 1890): 660. 1 b & w.

S101 "Scenes from the Play of "Dr. Bill" at the Garden Theatre - From Photos by Sarony." FRANK LESLIE'S ILLUSTRATED NEWSPAPER 71, no. 1841 (Dec. 27, 1890): 391, 398. 5 b & w. 5 illus. [One view of the play on stage, montage of vignetted portraits of ten of the actors. Sketches, from photos.]

S102 "Edwin Booth's Retirement from the Stage. Sketches of the Great Actor in Some of His Principal Roles from Photos by N. Sarony and Sketches." FRANK LESLIE'S ILLUSTRATED NEWSPAPER 72, no. 1858 (Apr. 25, 1891): 202. 4 b & w. 5 illus.

S103 "Notes and News: Sarony Sues Wilson Barrett." PHOTOGRAPHIC TIMES 21, no. 502 (May 1, 1891): 212. [Sarony sues actor for non-payment for photos.]

S104 1 photo (Actress Ada Rehan in "The Prayer"). PHOTOGRAPHIC TIMES 21, no. 520 (Sept. 4, 1891): frontispiece, 437. 1 b & w. [Note "Ada Rehan" on p. 437.]

S105 "Notes and News: Actors Before the Camera." PHOTOGRAPHIC TIMES 21, no. 525 (Oct. 9, 1891): 505-506. [Anecdote about a commercial photographic session by Sarony. From "NY Commercial Advertiser."]

S106 Portrait. Credited, "From a Photograph by Sarony." FRANK LESLIE'S ILLUSTRATED NEWSPAPER 73, (1892) ["Walt Whitman." 73:1895 (Jan. 9, 1892): 403.]

S107 "The Studios of New York: 2." PHOTOGRAPHIC TIMES 22, no. 546 (Mar. 4, 1892): 122-123. [Discusses Napoleon Sarony and Kurtz.]

S108 "Our Gallery of Players: XLVII. Rose Coghlan as Jocelyn." ILLUSTRATED AMERICAN 11, no. 118 (May 21, 1892): 6, 32. 1 b & w.

S109 "Our Gallery of Players. XLIX. Edwin Booth." ILLUSTRATED AMERICAN 11, no. 120 (June 4, 1892): 110, 132. 1 b & w.

S110 1 engraving (Nikola Testa). CENTURY MAGAZINE 47, no. 4 (Feb. 1894): 585. 1 illus. ["From a photograph by Sarony."]

S111 1 engraving (Matthew Arnold). CENTURY MAGAZINE 47, no. 6 (Apr. 1894): 802. 1 illus. ["Photographed by Sarony."]

S112 Carr, Lyell. With original illustrations by Napoleon Sarony. "A Dream Painter." QUARTERLY ILLUSTRATOR 2, no. 8 (Oct. - Dec. 1894): 372-376. [Sarony's sketches.]

S113 Sarony, Napoleon. "Private Character of Artist's Models." AMERICAN ANNUAL OF PHOTOGRAPHY AND PHOTOGRAPHIC TIMES ALMANAC FOR 1895 (1895): 106-109. 1 b & w.

S114 Willets, Gilson. "The Art of Not Posing - An Interview with Napoleon Sarony." AMERICAN ANNUAL OF PHOTOGRAPHY AND PHOTOGRAPHIC TIMES ALMANAC FOR 1896 (1896): 188-194. 9 b & w.

S115 "Obituary: Napoleon Sarony." AMERICAN JOURNAL OF PHOTOGRAPHY 17, no. 204 (Dec. 1896): 575.

S116 "Editor's Table: Napoleon Sarony Deceased." WILSON'S PHOTOGRAPHIC MAGAZINE 33, no. 480 (Dec. 1896): 576. [Brief note that Sarony died on Nov. 8th.]

S117 Willets, Gilson. "Bernhardt, the Camera, and Some Anecdotes (An Interview with Napoleon Sarony)." AMERICAN ANNUAL OF PHOTOGRAPHY AND PHOTOGRAPHIC TIMES ALMANAC FOR 1897 (1897): 84-91. 6 b & w. 1 illus.

S118 "Napoleon Sarony." PHOTOGRAPHIC TIMES 29, no. 1 (Jan. 1897): 51-52. 1 b & w. 1 illus.

S119 "Sarony." WILSON'S PHOTOGRAPHIC MAGAZINE 34, no. 482 (Feb. 1897): frontispiece, 65-68. 1 b & w. 3 illus. [Died Nov. 8, 1896. Born Quebec, Canada in 1821. Moved to New York, NY at

age 10. Father died shortly thereafter and Sarony apprenticed to a lithographer for six years. 1848 founded lithographic firm of Sarony, Major & Knapp. Successful but later went to Europe for 3 or 6 years with his younger brother Oliver. Began a photo studio in Birmingham, (ca. 1856) his brother Oliver started a studio in Scarborough. Oliver died in Scarborough a year or two ago, after a most successful career. Napoleon Sarony returned to New York just after the Civil War, began running a series of successful galleries, 630 Broadway, then to 680 Broadway, then to the Union Square Gallery." In 1876 he was recognized as the leading photographer of the western world. Negatives of celebrities alone numbered over 40,000. Also drew. In 1895 a series of his studies "Sarony's Sketch-Book," were issued in portfolio form, very successful. Opened a new gallery on 5th Ave. in 1896. His son Otto Sarony, now carries on the business left by his father. Illustrated with 3 portraits of Sarony.]

S120 Cooper, W. A. "A Few Words About Sarony." WILSON'S PHOTOGRAPHIC MAGAZINE 34, no. 482 (Feb. 1897): 68-69. 1 illus.

S121 "Sarony: As Seen By His Contemporaries." WILSON'S PHOTOGRAPHIC MAGAZINE 34, no. 482 (Feb. 1897): 69-75. 2 b & w. 2 illus. [Quotes by Benj. J. Falk, C. C. Langill, George G. Rockwood; Edward Moran; Thomas Nast; excerpts from "NY Tribune," "NY Journal."]

S122 "Personal Paragraphs: Napoleon Sarony." WILSON'S PHOTOGRAPHIC MAGAZINE 34, no. 486 (June 1897): 270-271. [At a recent meeting of the Photographers' Copyright League a note praising Sarony read into the minutes. Reprinted here.]

S123 Willets, Gilson. "Photography's Most Famous Chair: Sarony relates anecdotes of the Chair of Two Hundred Thousand Sitters." AMERICAN ANNUAL OF PHOTOGRAPHY AND PHOTOGRAPHIC TIMES ALMANAC FOR 1899 (1899): 56-62. 19 b & w. [Portraits of actors, other celebrities.]

S124 "Without Prejudice." "Some Plays and Their Actors." COSMOPOLITAN 26, no. 5 (Mar. 1899): 4 unnumbered leaves after p. 584. 10 b & w. [Portraits of actresses. Photos by J. Schloss; Fowler; Byron; Sarony; White; Thors.]

S125 Shufeldt, Dr. R. W. "A Souvenir of Napoleon Sarony." PHOTOGRAPHIC TIMES 34, no. 2 (Feb. 1902): 64-66. 1 illus. [Drawing by Sarony.]

S126 "The Stage as a Career for Women." COLLIER'S WEEKLY 29, no. 2 (Apr. 12, 1902): 11. 12 b & w. [Portraits of actresses. Photos by: Burr McIntosh (4), Sarony (6), Sands & Brady (1), Morrison, Chicago (1).]

S127 "The Players." EVERYBODY'S MAGAZINE 21, no. 6 (Dec. 1909): 822-831. 9 b & w. [Actors, actresses. Photos by Sarony (2); Frank C. Bangs (1); Walinger (1); White (2); Mishkin Studio (1); Moffett Studio (1); Hall (1).]

S128 Roberts, Mary Fanton. "Outdoor Drama a Part of National Progress: Granville Barker's Production in New York Stadium of the Greatest War Play Ever Written." CRAFTSMAN 28, no. 5 (Aug. 1915): 430-441, 524. 6 b & w. [Barker's production of the play, "The Trojan Women." Photographs credited "By Permission of Granville Barker," but two at least contain Sarony's signature in the image.]

S129 Averell, Thomas W. "Personalities in Perspective: William Cullen Bryant." STEREO WORLD 7, no. 5 (Nov. - Dec. 1980): 27, 36. [Stereo portrait by Sarony, 1873.]

S130 Allen, William. "Legal Tests of Photography-as-Art: Sarony and Others." HISTORY OF PHOTOGRAPHY 10, no. 3 (July - Sept. 1986): 221-228. 4 b & w. 2 illus. [The Burrow-Giles Lithographic Co. made an unauthorized copy of Napoleon Sarony's portrait of Oscar Wilde. Sarony sued. Case reached the Supreme Court in 1883, decided for Sarony in 1884. In 1889 Louis Robira, of New Orleans attempted to avoid a tax by claiming he followed a mechanical, not creative trade. Lost his case.]

SARONY, NAPOLEON. [?]
S131 Booth's Theatre: Behind the Scenes; Illustrated. New York: Henry L. Hinton, 1870. 16 pp. 1 b & w. 7 illus. [From "Appleton's Journal." Wood engravings illustrating interiors and activities of the theatre. The portrait is an original photograph, not identified, but N. Sarony's advertisement appears prominently on the back cover.]

SARONY, OLIVER FRANÇOIS (1820-1879) (CANADA, GREAT BRITAIN)
S132 "Carrick's Photographic Pictures." ART JOURNAL (Oct. 1854): 314. [Note that Mr. Carrick paints over photographs by Sarony.]

S133 Portrait. Woodcut engraving credited "From a photograph by Sarony." ILLUSTRATED LONDON NEWS 30, (1857) ["Lord Hennicker, M.P." 30:* (May 16, 1857): 479.]

S134 "The American Ivorytype." AMERICAN JOURNAL OF PHOTOGRAPHY AND THE ALLIED ARTS & SCIENCES n. s. vol. 7, no. 1 (July 1, 1864): 11-12. [From Root's "Camera and the Pencil." Root states this process discovered by Wenderoth (Philadelphia). Seely claims that it was first practiced by Oliver Sarony.]

S135 "Editor's Table: Sarony's Universal Rest and Posing Apparatus." PHILADELPHIA PHOTOGRAPHER 3, no. 34 (Oct. 1866): 321-322.

S136 Towler, Prof. "Sarony's Patent Universal Rest." HUMPHREY'S JOURNAL OF PHOTOGRAPHY, AND THE ALLIED ARTS AND SCIENCES 18, no. 16 (Dec. 15, 1866): 243-244.

S137 "Sarony's Richmond Drawings and Crayon Heads." BRITISH JOURNAL PHOTOGRAPHIC ALMANAC 1869 (1869): 142.

S138 "Sarony & Co.'s Enlargements." ANTHONY'S PHOTOGRAPHIC BULLETIN 2, no. 1 (Jan. 1871): 4-5. [From "Br J of Photo."]

S139 "Photo-Crayon Process of Sarony & Co." ART JOURNAL (Feb. 1871): 61.

S140 "The Scarborough Annual Dinner." ANTHONY'S PHOTOGRAPHIC BULLETIN 3, no. 1 (Jan. 1872): 407-411. [From "Scarborough Gazette."]

S141 "Visit of Mr. O. Sarony to the United States." ANTHONY'S PHOTOGRAPHIC BULLETIN 3, no. 4 (Apr. 1872): 530.

S142 "Producing Large Negatives." ANTHONY'S PHOTOGRAPHIC BULLETIN 4, no. 12 (Dec. 1873): 354-355. ["An important branch of Mr. Sarony's business at Scarborough consists in reproducing pictures on a large scale for art publishers." From "Photo. News."]

S143 Portrait. Woodcut engraving credited "From a photograph by Sarony." ILLUSTRATED LONDON NEWS 72, (1878) ["Mr. Russell Gurney, M.P." 72:2034 (June 22, 1878): 589.]

S144 "Recent Improvements in Carbon Printing." ANTHONY'S PHOTOGRAPHIC BULLETIN 9, no. 8 (Aug. 1878): 225-226. [From "Br J of Photo." J. R. Johnson and Sarony of Scarborough, England partnered to perfect improvements in carbon printing processes.]

S145 "Obituary: O. Sarony." ANTHONY'S PHOTOGRAPHIC BULLETIN 10, no. 9 (Sept. 1879): 287. [O. Sarony, of Scarborough, England, was the brother of N. Sarony of New York, NY. His studio had 98 rooms, employed 110 people, worth an estimated $150,000.]

SARONY, OTTO. (d. 1903) (USA)
S146 Willets, Gilson. "Facial Expressions in Photographs—An Interview with Otto Sarony." PHOTOGRAPHIC TIMES 29, no. 11 (Nov. 1897): 505-507. 10 b & w. [Includes portraits of the actress Minnie M. Fiske, displaying specific emotions.]

S147 "Obituary." PHOTOGRAPHIC TIMES 35, no. 10 (Oct. 1903): 452.

SATTERLEE, EDWARD.
S148 Satterlee, Edward. "Is Photography a Fine Art?" PHILADELPHIA PHOTOGRAPHER 6, no. 70 (Oct. 1869): 326-328.

SAUNDERS, W. (GREAT BRITAIN, CHINA)
S149 "Attack Upon and Capture of Ningpo." ILLUSTRATED LONDON NEWS 41, no. 1157 (Aug. 2, 1862): 117, 120-121, 138. 5 illus. ["The capture of Ningpo, in May last,... Through the courtesy of Mr. M'Arthur, Paymaster of the Royal Navy, and of Mr. Saunders, photographer, of Shanghai, we are enabled to give ...several Engravings in connection with this gallant feat of arms." Three views are from sketches and two, on p. 120, are from photographs.]

S150 "Sketches from Shanghai." ILLUSTRATED LONDON NEWS 43, no. 1219 (Aug. 29, 1863): 224. 2 illus.

S151 "Ministers of State, Japan - Yokohama, Japan." ILLUSTRATED LONDON NEWS 43, no. 1221 (Sept. 12, 1863): 256, 262. 3 illus. ["...from a series of photographs taken by Mr. W. Saunders, of Shanghai, in last November."]

S152 "Native Tea Gardens - Shanghai." NEW YORK ILLUSTRATED NEWS 8, no. 204 (Sept. 26, 1863): 338-339. 1 illus. ["...from a photograph by Mr. W. Saunders, an English resident there."]

S153 "The Taeping Rebellion in China." ILLUSTRATED LONDON NEWS 44, no. 1249 (Mar. 12, 1864): 261, 264-265. 8 illus. ["...a series of eight photographic views; "illustrative of the capture of the Chinese town of Soo-Chow by the Imperialist troops, under Major Gordon... by Mr. W. Saunders, of Shanghai."]

S154 "A Shanghai Street Cab." ILLUSTRATED LONDON NEWS 69, no. 1944 (Oct. 28, 1876): 411, 416. 1 illus.

S155 "Chinese Itinerant Barbers." ILLUSTRATED LONDON NEWS 69, no. 1949 (Dec. 2, 1876): 529, 530. 1 illus.

S156 Wilsher, Ann. "Saunders in Yokohoma." HISTORY OF PHOTOGRAPHY 5, no. 2 (Apr. 1981): 117-118. 3 illus. [European photographer working in China until 1885. Engravings from his photographs reproduced in Sept. 12, 1863 "Illustrated London News." Studio in Shanghai from early 1860s.]

SAVAGE & OTTINGER. (SALT LAKE CITY, UT)
[The partnership of Charles Roscoe Savage and George Martin Ottinger was formed in Salt Lake City, Utah in 1862. It lasted until about 1870, when it was amiably dissolved as Ottinger resumed his former career as a painter.]

S157 "Lime and Gold Toning Bath." HUMPHREY'S JOURNAL OF PHOTOGRAPHY, AND THE ALLIED ARTS AND SCIENCES 16, no. 3 (June 1, 1864): 45. [Excerpt from letter from Savage & Ottinger (Salt Lake City, UT), with comment by Towler.]

S158 "Editor's Table." PHILADELPHIA PHOTOGRAPHER 3, no. 26 (Feb. 1866): Following page 66. ["Mormon views and portraits from Savage & Ottinger, Salt Lake City." Five-section panorama of Salt Lake City, UT, and others.]

S159 "Editor's Table." PHILADELPHIA PHOTOGRAPHER 3, no. 30 (June 1866): 191. [Savage coming East to secure supplies, having immense wagon built to travel home in.]

S160 "The City and the Valley of the Great Salt Lake, Utah - Brigham Young and the Twelve Apostles of the Mormon Church." HARPER'S WEEKLY 10, no. 503 (Aug. 18, 1866): 520-521. 23 illus. ["From Photographs by Savage & Ottinger, Salt Lake City." 1 panoramic view, 6 scenes and 16 portraits.]

S161 "The Overland Pony Express." HARPER'S WEEKLY 11, no. 566 (Nov. 2, 1867): 693, 694. 6 illus. ["...for the original photographs of these several engravings to Messrs. Savage & Ottinger, photographers, of Salt Lake City, Utah." Portraits of the Ute and Snake Indians, several views, copy of a painting by George M. Ottinger.]

S162 "'The Niagara of the West' - Great Shoshone Falls - Photographed by Savage & Ottinger, Salt Lake City." HARPER'S WEEKLY 13, no. 642 (Apr. 17, 1869): 244, 248. 1 illus.

S163 "Completion of the Pacific Railroad - Meeting of Locomotives of the Union and Central Pacific Lines: The Engineers Shake Hands - Photographed by Savage & Ottinger, Salt Lake City." HARPER'S WEEKLY 13, no. 649 (June 5, 1869): 356. 1 illus. [Photos credited to Savage & Ottinger, later research indicates that some were taken by A. J. Russell.]

S164 Ryder, Richard C. "Personalities in Perspective: Brigham Young." STEREO WORLD 7, no. 1 (Mar. - Apr. 1980): 18, 28. [Stereo portrait by Savage & Ottinger.]

SAVAGE, A. J. (VINCENNES, IN)
S165 Savage, A. J. "The Solar Camera." HUMPHREY'S JOURNAL OF PHOTOGRAPHY, AND THE ALLIED ARTS AND SCIENCES 17, no. 19 (Feb. 1, 1866): 299.

S166 Savage, A. J. "Salad for the Photographer." PHILADELPHIA PHOTOGRAPHER 3, no. 29 (May 1866): 157. [Letter from A. J. Savage (Vincennes, IN) discussing the gelatine developer.]

SAVAGE, CHARLES R. see also SAVAGE & OTTINGER.

SAVAGE, CHARLES ROSCOE. (1832-1909) (GREAT BRITAIN, USA)
BOOKS
[Charles R. Savage was born on Aug. 16, 1832 in Southampton, England. A Morman, Savage emigrated to the USA in 1858. Worked in New York City for the photographer Elder Stenhouse. Left for Nebraska in 1859, then opened a studio in Council Bluffs, IA in 1860.

Then moved to Salt Lake City, UT, formed a partnership with Marsena Cannon, and opened a studio, called the Pioneer Art Gallery. Cannon left the partnership around 1861 and the firm of Savage & Ottinger was founded in 1862. Charles W. Carter worked for the studio. In 1869 Savage photographed the joining of the rails of the Union Pacific Railroad and the Central Pacific Railroad at Promentory Point, UT - as did A. J. Russell, Alfred A. Hart, and others. In 1870 Savage accompanied the Mormon leader Brigham Young on a photographic trip through the Zion Canyon area. The partnership of Savage & Ottinger dissolved in 1870 and Savage continued the successful studio alone. The photographers James Fennemore and George E. Anderson worked for Savage in the 1870s. Savage toured England in 1879. In 1883 his studio was destroyed by fire, then rebuilt. His sons George L., Roscoe E., and Ralph all worked in the studio and took over it's management in 1906, when Charles retired. Charles Savage died in Salt Lake City in 1909.]

S167 *Collection of Twelve Original Photographs of Utah Scenes.* Salt Lake City: Savage, 187- ? n. p. 12 b & w. [12 photos on original mounts, laid in original cloth portfolio. Title may be binder's title.]

S168 Crofutt, George A. *Crofutt's New Overland Tourist and Pacific Coast Guide,* Containing a Condensed and Authentic Description of Over One Thousand Two Hundred Cities, Towns, Villages, Stations, Government Fort and Camps, Mountains, Lakes, Rivers, Sulphur, Soda and Hot Springs, Scenery, Watering Places, and Summer Resorts;... While passing Over the Union, Central and Southern Pacific Railroads,... From Sunrise to Sunset, and Part the Way Back Again;... Vol. 1 - 1878-9. Chicago: The Overland Publishing Co., 1878. 322 pp. illus. ["...illustrated with nearly 100 beautiful engravings, most of which were photographed, designed, drawn, and expressly engraved for the author of this work...engraved by R. S. Bross, of New York, and C. W. Chandler, of Ravenswood, Illinois,...The photographs were by Savage, of Salt Lake City, and Watkins and Houseworth, of San Francisco. All these artists, we take pleasure in recommending."]

S169 Savage, C. R. *Views of Utah and Tourist's Guide Containing a Description of the Views and General Information for the Traveller, Resident and Public General...authentic sources by C. R. Savage.* Salt Lake City: Savage, 1887. 30 pp. 16 b & w. [Folder with 16 plates and 30 pp. of descriptive text.]

S170 *Salt Lake City and Vicinity.* Salt Lake City: C. R. Savage, 12 Main St., 1895. n. p. ["This little work comprises an album of views...with letterpress descriptions."]

PERIODICALS
S171 "Brigham Young - Brigham Young's Residence." ILLUSTRATED LONDON NEWS 39, no. 1117 (Nov. 16, 1861): 503. 2 illus. ["The View and Portrait are from photographs taken recently by C. R. Savage, late of Southampton, and were brought from Salt Lake City by a gentleman who spent several days there early in September."]

S172 Savage, C. R. "Plain Photographs." HUMPHREY'S JOURNAL OF PHOTOGRAPHY, AND THE ALLIED ARTS AND SCIENCES 15, no. 22 (Mar. 15, 1864): 343. [Letter from Savage, reply from Towler.]

S173 "The Art Among the Mormons." HUMPHREY'S JOURNAL OF PHOTOGRAPHY, AND THE ALLIED ARTS AND SCIENCES 16, no. 18 (Jan. 15, 1865): 286-287. [Praise for card pictures sent in by C. R. Savage, Salt Lake City, UT.]

S174 "To Correspondents. - C. R. Savage." HUMPHREY'S JOURNAL OF PHOTOGRAPHY, AND THE ALLIED ARTS AND SCIENCES 16,
no. 22 (Mar. 15, 1865): 351-352. [Letter from C. R. Savage, reply from Towler.]

S175 "To Correspondents: C. R. Savage." HUMPHREY'S JOURNAL OF PHOTOGRAPHY, AND THE ALLIED ARTS AND SCIENCES 17, no. 6 (July 15, 1865): 95. [Letter from Savage, with a formula for collodion. Savage also sent a panoramic view of Salt Lake City, UT.]

S176 "Editor's Table - Salt Lake City." PHILADELPHIA PHOTOGRAPHER 2, no. 21 (Sept. 1865): 154. [Two views of Salt Lake City, UT, mentioned.]

S177 "Editor's Table." PHILADELPHIA PHOTOGRAPHER 2, no. 24 (Dec. 1865): 207. [Panoramic view of Great Salt Lake City, UT, received.]

S178 "To Correspondents: C. R. Savage." HUMPHREY'S JOURNAL OF PHOTOGRAPHY, AND THE ALLIED ARTS AND SCIENCES 17, no. 15 (Dec. 1, 1865): 239. ["We are greatly pleased with your panoramic view of Salt Lake City."]

S179 "Editor's Table." PHILADELPHIA PHOTOGRAPHER 4, no. 37 (Jan. 1867): 32. [Note that Savage has arrived home safely in Salt Lake City, UT, from his eastern journey.]

S180 "To Correspondents: C. R. Savage." HUMPHREY'S JOURNAL OF PHOTOGRAPHY, AND THE ALLIED ARTS AND SCIENCES 18, no. 22 (Mar. 15, 1867): 351-352.

S181 Savage, C. R. "A Photographic Tour of Nearly 9000 Miles." PHILADELPHIA PHOTOGRAPHER 4, no. 45-46 (Sept. - Oct. 1867): 287-289, 313-316.

S182 Savage, C. R. "Voices from the Craft." PHILADELPHIA PHOTOGRAPHER 4, no. 47 (Nov. 1867): 352. [Letter from C. R. Savage, describing some of the difficulties in portraiture.]

S183 "Editor's Table." PHILADELPHIA PHOTOGRAPHER 7, no. 78 (June 1870): 222-224. [J. W. Ryder; Wm. Bell (Philadelphia, PA); C. M. Van Orsdell's Gallery (Wilmington, NC), struck by lightning; E. V. Seutter (Jackson, MS); C. R. Savage (Salt Lake City, UT); Bushby & Hart (Lynn, MA); J. Lee Knight (Topeka, KS); J. Inglis (Montreal); E. Long & Co. (Quincy, IL); A. F. Clough (Warren, NH); others mentioned.]

S184 "The Mormons and their Religion." CENTURY MAGAZINE (SCRIBNER'S MONTHLY) 3, no. 4 (Feb. 1872): 396-408. 17 illus. [Article illustrated with woodcut views of Salt Lake City and portraits of leading Mormons. Not credited, but evidence strongly suggests many were taken from C. R. Savage's photos.]

S185 "The Snow Blockade." FRANK LESLIE'S ILLUSTRATED NEWSPAPER 34, no. 861 (Mar. 30, 1872): 45. 3 illus. [Trains blocked by heavy snowfalls in UT. One sketch by Savage, "A Passenger Train on the Union Pacific Railroad in a Snow Drift." Two from photographs by Savage. "Digging Out a Train on the Laramie Plains,..." and "Attacking a Drift with a Snow-Plow."]

S186 "Southern Utah. - Baptism of Qui-Tuss, Chief of the Shebit Tribe of Indians, Together with One Hundred and Thirty of the Same Tribe, at St. George. - Photographed by C. R. Savage." FRANK LESLIE'S ILLUSTRATED NEWSPAPER 40, no. 1025 (May 22, 1875): 169, 171. 1 illus. [Outdoor scene with crowd, baptism in a river.]

S187 "Needle Palm, or Yucca Brevifolia - Also Specimens of the Barrel Cactus (Cereus Le Contei) Found in the Deserts of Arizona. - Photographed by C. R. Savage." FRANK LESLIE'S ILLUSTRATED NEWSPAPER 41, no. 1047 (Oct. 23, 1875): 101, 103. 1 illus. [View.]

S188 "Editor's Table." PHILADELPHIA PHOTOGRAPHER 12, no. 144 (Dec. 1875): 383-384. [C. C. Giers (Nashville, TN); C. R. Savage; W. D. Lockwood (Ripon, WI); E. H. Train (Helena, MT); L. G. Bigelow (Detroit, MI); Alfred Freeman (Dallas, TX); Frank Jewell (Hyde Park, PA); E. A. Scholfield (Mystic River, CT); J. Pitcher Spooner; others mentioned.]

S189 "Editor's Table." PHILADELPHIA PHOTOGRAPHER 13, no. 154 (Oct. 1876): 320. ["...a series of magnificent views on the Pacific Railroad."]

S190 Portraits. Woodcut engravings credited "From a photograph by Savage, Salt Lake City." FRANK LESLIE'S ILLUSTRATED NEWSPAPER 44, (1877) ["Brigham Young." 44:1155 (June 30, 1877): 281.]

S191 Portrait. Woodcut engraving, Credited "From a Photograph by C. R. Savage, Salt Lake City." FRANK LESLIE'S ILLUSTRATED NEWSPAPER 45, (1878) ["John Taylor, Pres. of the Mormon Twelve Apostles." 45:1163 (Jan. 12, 1878): 329.]

S192 "Editor's Table." PHILADELPHIA PHOTOGRAPHER 15, no. 176 (Aug. 1878): 255. [Note from C. R. Savage, describing a fast and effective collodion process.]

S193 "Our Editorial Table." PHOTOGRAPHIC TIMES 18, no. 373 (Nov. 9, 1888): 540. [Note that Savage publishing a little publication entitled "The Busy Bee," an organ of home industry - matters of photographic interest, some political information and a useful receipt."]

S194 2 photos (Henry M. Stanley and his wife). PHOTOGRAPHIC TIMES 21, no. 514 (July 24, 1891): frontispiece, 365. 2 b & w. [Portraits by C. R. Savage, Salt Lake City, of the "great explorer and his wife, on their way across the American continent."]

S195 Savage, C. R. "How to be Successful as a Photographer." PHOTOGRAPHIC TIMES 21, no. 536 (Dec. 25, 1891): 668. [From the "Juvenile Instructor" in Salt Lake City.]

S196 "The New Mormon Temple." ILLUSTRATED AMERICAN 11, no. 119 (May 28, 1892): 66-67. 2 b & w. [View, statue.]

S197 "Notes and News: Nocturnal Photography." PHOTOGRAPHIC TIMES 24, no. 650 (Mar. 2, 1894): 143. [Brief note that C. R. Savage has been making nocturnal photos by burning celluloid, rather than magnesium.]

S198 Bullington, Neal R. "Timpanogos: The National Parks Mini-Cave." STEREO WORLD 4, no. 5 (Nov. - Dec. 1977): 6-7. 3 b & w. [Two b & w by C. R. Savage, 1 b & w by unknown.]

SAVAGE, CHARLES R. [?]
S199 "Brigham Young." and "Echo Canyon." FRANK LESLIE'S ILLUSTRATED NEWSPAPER 22, no. 565 (July 28, 1866): 292-293. 6 illus. [Article on Brigham Young, accompanied with a portrait, plus views of buildings in Salt Lake City, UT, and other scenery in Utah. None credited, but possibly by C. R. Savage?]

SAVAGE, J.
S200 Savage, J. "Photography." MAGAZINE OF SCIENCE AND SCHOOL OF ARTS 3, no. 135 (Oct. 30, 1841): 248. [Letter. "...of the following method of preparing a photographic paper, that gives the shades in their proper places."]

SAVAGE, WILLIAM. (GREAT BRITAIN)
BOOKS
S201 Humbert, Rev. Lewis Macnaughton. *Memorials of the Hospital of St. Cross and Alms House of Noble Poverty;* Illustrated with Thirteen Photographs by W. Savage and Numerous Woodcuts. Winchester: William Savage, Photographic Publisher, 1868. 96 pp. 13 b & w. 16 illus. [Thirteen original photos by William Savage, sixteen woodcuts.]

S202 Savage, William. *The Birthplace, Home, Churches, and Other Places Connected with the Author of the "Christian Year,"* Illustrated in thirty-two photographs by W. Savage: with Memoir and notes by the Rev. J. Frowen Moor, Jun. M.A. London; Winchester: J. Parker & Co.; W. Savage, 1868. n. p. 32 b & w.

S203 Savage, William. *...A Guide to the Ancient City of Winchester,... To Which Is Added a Guide to the Hospital of Saint Cross and Alms-House of Noble Poverty, by the Rev. L. M. Humbert... also a Guide to Hursley, the Home of Keble... by the Rev. J. Frewen Moor...and Reminiscences of Winchester; a Series of Poems by Christopher Wood.* "8th ed." Winchester: W. Savage, 1869. 118 pp. illus. [—-9th ed. 1875—-12th ed. 1884]

S204 Savage, William. *A Guide to the Cathedral and College, of the Ancient City of Winchester.* "10th ed." Winchester: W. Savage, 1877. 42 pp. illus.

PERIODICALS
S205 "Note." ART JOURNAL (Sept. 1866): 290. [A memorial tracing the path of the reverend poet John Keble from his birthplace in Fairford to his grave in Hursley is in preparation by Mr. Savage of Winchester.]

SAVORY.
S206 Portrait. Woodcut engraving credited "From a photograph by Savory." ILLUSTRATED LONDON NEWS 31, (1857) ["Gen. Nicholson, Commander of troops at Delhi." 31:* (Oct. 31, 1857): 425.]

SAWYER & BIRD. (NORWICH and YARMOUTH, ENGLAND)
S207 Portrait. Woodcut engraving credited "From a photograph by Sawyer & Bird." ILLUSTRATED LONDON NEWS 75, (1879) ["Brig.-Gen. Dunham Massy." 75:2104 (Oct. 11, 1879): 329.]

SAWYER, D. H. see FRENCH & SAWYER.

SAWYER, J. R. (d. 1889) (GREAT BRITAIN)
BOOKS
S208 Sawyer, J. R. *The Autotype Process; Being a Practical Manual of Instruction in the Art of Printing in Permanent Pigments.* "6th ed., rev." London: Autotype Co., 1877. ix, 110 pp. 1 b & w. illus.

PERIODICALS
S209 Sawyer, J. R. "Lichtdrück in Germany." BRITISH JOURNAL PHOTOGRAPHIC ALMANAC 1873 (1873): 70-74. [In 1869, Sawyer made photos of details of Norwich Cathedral for the Dean of Norwich, to illustrate a work written by the Dean. Sawyer went to Germany to see if he could have "Lichtdrück" photoengravings made for the book. Met inventor Gemoser, describes his process, etc.]

S210 Sawyer, J. R. "A Day with a Collographic Printer." BRITISH JOURNAL PHOTOGRAPHIC ALMANAC 1874 (1874): 58-62. [Sawyer describes his visit to the Autotype works at Ealing Dean, England. Describes their process and techniques.]

S211 Sawyer, J. R. "Photography in Permanent Pigments, with Recent Improvements in Autotype Transfer." ANTHONY'S PHOTOGRAPHIC BULLETIN 6, no. 6-7 (June - July 1875): 162-164, 195-198. [From "British Journal of Photography."]

S212 Sawyer, J. R. "The Simplicity of the Autotype Process of Permanent Printing." BRITISH JOURNAL PHOTOGRAPHIC ALMANAC 1876 (1876): 64-65.

S213 Sawyer, J. R. "Difficulties in Permanent Printing." BRITISH JOURNAL PHOTOGRAPHIC ALMANAC 1877 (1877): 111-112.

S214 Sawyer, J. R. "Converging Perpendiculars in Architectural Photographs." BRITISH JOURNAL PHOTOGRAPHIC ALMANAC 1878 (1878): 168-169.

SAXTON, JOSEPH. (1799-1873) (USA)
BOOKS
S215 Henry, Joseph. "Biographical Memoir of Joseph Saxton," on p. 291, vol. 1, in: *Biographical Memoirs, National Academy of Sciences* Washington, DC: The Academy, 1877.

S216 "Joseph Saxton," on p. 998, vol. 4, in: *Encyclopedia of Philadelphia* Harrisburg, PA: s. n., 1933.

S217 Frazier, Arthur H. *Joseph Saxton and His Contributions to the Medal Ruling and Photographic Arts.* "Smithsonian Studies in History and Technology, No. 32." Washington, DC: Smithsonian Institute Press, 1975. iii, 17 pp. illus.

PERIODICALS
S218 Rung, Albert M. "Joseph Saxton: Pennsylvania Inventor and Pioneer Photographer." PENNSYLVANIA HISTORY 7, no. 3 (July 1940): 153-158. [Employed in United States Mint in Philadelphia. When he read about Daguerre's invention in Oct. 1839, he made a daguerreotype from the window of the Mint on Oct. 16, 1839. Born Mar. 22, 1799 in Huntington, PA. At age 18 moved to Philadelphia, employed by a jeweler, then became an engraver. He perfected and invented a number of mechanical devices, clocks, cartridges, electromagnetic machines, etc. Elected to the Franklin Institute. Travelled to England, became acquainted with Michael Faraday and other scientists. In 1837 returned to Philadelphia and took the office of constructor and curator of the standard weighing apparatus at the U.S. Mint. Partially paralyzed about 15 years before his death, which occurred on Oct. 26, 1873.]

S219 Frazier, Arthur H. "Joseph Saxton's First Sojourn at Philadelphia, 1818-1831, and His Contributions to the Independence Hall Clock." SMITHSONIAN JOURNAL OF HISTORY 3, no. 2 (Summer 1968): 45-76. 17 illus. [Article's content precedes Saxton's work with the daguerreotype, but it provides substantial background information on Saxton. Notes on pp. 72-73, 76.]

SAYCE & BOLTON.
S220 Sayce, B. J. and W. B. Bolton. "Photography Without a Nitrate of Silver Bath." AMERICAN JOURNAL OF PHOTOGRAPHY AND THE ALLIED ARTS & SCIENCES n. s. vol. 7, no. 8 (Oct. 15, 1864): 181-183. [From "Br. J. of Photo."]

SAYCE, B. J. (1837-1895) (GREAT BRITAIN)
S221 Sayce, B. J. "On the Use of Bromised Collodion." AMERICAN JOURNAL OF PHOTOGRAPHY AND THE ALLIED ARTS & SCIENCES n. s. vol. 6, no. 6 (Sept. 15, 1863): 121-124. [From "Br. J. of Photo." Sayce states that G. W. Wilson uses this process in his landscape work.]

S222 Sayce, B. J. "Photography Without a Nitrate of Silver Bath. Wet and Dry Negative Processes with Collodio-Bromide of Silver." HUMPHREY'S JOURNAL OF PHOTOGRAPHY, AND THE ALLIED ARTS AND SCIENCES 17, no. 7 (Aug. 1, 1865): 105-108. [From "Photo. News."]

S223 "B. J. Sayce." PHOTOGRAPHIC TIMES 24, no. 663 (June 1, 1894): 343. 1 illus. [Born on Apr. 13, 1837. Began to study photography in 1853. Elected Honorary Secretary of the Liverpool Photographic Association in 1864-65 and became the organization's President in 1888. Experimented with collodio-bromide of silver in the 1860s.]

SAYLOR, B. FRANK. (b. 1838) (USA)
S224 Saylor, B. Frank. "Poser and Posing." PHOTOGRAPHIC WORLD 1, no. 3 (Mar. 1871): 85-86. [Read before Feb. meeting of Pa. Photo. Assoc.]

SAYLOR, CHARLES A. (READING, PA)
S225 "Editor's Table." PHILADELPHIA PHOTOGRAPHER 3, no. 32 (Aug. 1866): 255. [Charles A. Saylor, Reading, PA, building new gallery.]

SCHAARWACHTER, JULIUS. (1821-1891) (GERMANY, NETHERLANDS)
S226 "Our Picture." PHILADELPHIA PHOTOGRAPHER 12, no. 138 (June 1875): frontispiece, 161-162. 1 b & w. [Studio portrait.]

SCHAEFER, ADOLPH. (NETHERLANDS, DUTCH INDIES)
S227 Moeshart, Herman J. "Daguerreotypes by Adolph Schaefer." HISTORY OF PHOTOGRAPHY 9, no. 3 (July - Sept. 1985): 24-28. 8 b & w. [German daguerreotypist in the Hague in 1843, sent to the Dutch Indies to record Javanese art and archeological works in middle 1840s.]

SCHAEFHAEUTL.
S228 Schaefhaeutl, Dr. "On a New Method of Photogenic Drawing." ATHENAEUM (Oct. 3, 1840 *not 1840*): 772-773.

SCHAUER, GUSTAV. (GERMANY)
S229 Neite, Werner. "G. Schauer: Photograph und Kunst-Verleger in Berlin, 1851-1864." HISTORY OF PHOTOGRAPHY 1, no. 4 (Oct. 1977): 291-296. 6 illus.

SCHEIER, T. M. (NASHVILLE, TN)
S230 "A Good Chance." HUMPHREY'S JOURNAL OF PHOTOGRAPHY, AND THE ALLIED ARTS AND SCIENCES 18, no. 8 (Aug. 15, 1866): 123. [Wants to sell his gallery or take on a partner.]

SCHEMBOCHE, MICHELE. (TURIN and FLORENCE, ITALY)
S231 Badeau, W. H. "Foreign Correspondence." ANTHONY'S PHOTOGRAPHIC BULLETIN 1, no. 6 (July 1870): 116. [Describes his visit to the studios of Schemboche and H. Le Lieure (of Turin, Italy?).]

S232 Portrait. Woodcut engraving, credited to "From a Photograph by M. Schemboche." ILLUSTRATED LONDON NEWS 60, (1872) ["Mdlle. Albani, Royal Italian Opera." 60:1704 (May 4, 1872): 441.]

SCHIEFFELIN, HENRY H. (ca. 1782-1865) (USA)
S233 Seely, Charles A. "Editorial Department: Obituary." AMERICAN JOURNAL OF PHOTOGRAPHY AND THE ALLIED ARTS & SCIENCES n. s. vol. 8, no. 8 (Oct. 15, 1865): 192. ["Henry H. Schieffelin died Oct. 14, in the 83rd year of his age. ...a very ardent amateur in photography, and for several years held the office of Vice-President of the Photographical Society."]

SCHILLER, J. A.
S234 "Dakota. - Destruction of the Town of Gayville by Fire, on the Morning of August 18th. - From a Photograph by J. A. Schiller." FRANK LESLIE'S ILLUSTRATED NEWSPAPER 45, no. 1146 (Sept. 15, 1877): 28. 1 illus. [View of destruction.]

SCHNEIDAU, JOHN FREDERICK VON. (1812-1859) (SWEDEN, USA)
S235 "Note." PHOTOGRAPHIC ART JOURNAL 6, no. 1 (July 1853): 63. [On using yellow cambric in darkroom. Von Schneidau from Chicago, IL.]

S236 Duncan, R. Bruce. "Polycarp Von Schneidau: Chicago Daguerrian Artist." CHICAGO PHOTOGRAPHIC COLLECTORS NEWSLETTER 1, no. 1 (Mar. 1971): [unpaged, 3 pages]. [John Carl Frederick Polycarpus Von Schneidau was born in Stockholm, Sweden in 1812, a descendant of the noble house of Rix. He married a Jewish woman and left Sweden for America. First lived at Pine Lake, WI, then moved to Chicago, IL in 1844. Worked as a civil engineer, then as a surveyor for the proposed Chicago & Galena Railroad. Went to New York in 1848 to learn daguerreotypy, apparently from Mathew Brady. Opened a studio in Chicago in 1849. In 1850 he persuaded the reluctant Swedish singer Jenny Lind to sit for Brady. By 1851 Von Schneidau was practicing successfully in Chicago, and amassing property. In 1854 Abraham Lincoln and George Scheider, editor of the "Illinois Staats Zeitung," sat for a portrait, which is the second earliest known portrait of Lincoln. From 1852 Von Schneidau also acted as the Scandinavian Council in Chicago and was active in the local Swedish Church. His wife died in 1855, and he himself became ill. Returned to Europe for medical help, but proved futile. In 1859, a paralytic invalid, he returned to Chicago, where he died.]

SCHOEFFT, O. (CAIRO, EGYPT)
S237 Portrait. Woodcut engraving credited "From a photograph by O. Schoefft." ILLUSTRATED LONDON NEWS 75, (1879) ["Mohammed Tewfik, Khedive of Egypt." 74:2095 (Aug. 9, 1879): 124.]

SCHOLFIELD, EVERETT A. (1843-1930) (USA)
S238 "Our Picture." PHILADELPHIA PHOTOGRAPHER 17, no. 195 (Mar. 1880): 65-66, plus frontispiece. 1 b & w. [Vignette portrait. Scholfield from Mystic River, CT.]

S239 Parker, William E. "The Perseverant Vision of Everett A. Scholfield: An Early Photographer of New England and the Regionalist Tradition." ATLANTA ART WORKERS COALITION NEWSPAPER 3, no. 3 (May - June 1979): 4, 7-8.

S240 Peterson, William. "Rescued: A part of American history." NORTHLIGHT (JOURNAL OF THE PHOTOGRAPHIC HISTORICAL SOCIETY OF AMERICA) 5, no. 4 (Winter 1978/79): 4-9. 6 b & w. 6 illus. [Everett A. Scholfield was born in Lowell, MA in 1843. His father, Edwin A., moved the family to Westerly, RI around 1853, and opened a photographic studio there from about 1859. Everett probably learned photography from his father. He enlisted in the Union Army, but was discharged in 1862. He became an itinerant photographer for a time, then settled in Mystic, CT in 1865. His photographic career there ran until 1913. He worked independantly or with various partners throughout, including Scholfild & Holmes (1865-1866), Scholfield & Angell (1869-1870), Scholfield Brothers, with his brother Addison A. (1875-1881), and Scholfield & Tingley (1886-1894). He also worked briefly in Putnam, CT in 1872, 1873, and 1876. In 1871 and in 1877 he visited Christiansted, St. Croix, in the Danish West Indies. He apparently retired around 1913, then died in 1930. He made many views of the businesses and houses of Mystic, CT.]

S241 "The Mystic Vision of Everett Scholfield: A Connecticut photographer's record of life in a shipbuilding town." AMERICAN HERITAGE 31, no. 2 (Feb. - Mar. 1980): 24-33. 11 b & w. [Born Lowell, MA, in 1843. Learned photography from his father. Settled in Mystic, CT in 1865. Worked there until 1894, then set up a studio in New London. Died 1930. Views, portraits.]

SCHOLIM. (ST. LOUIS, MO)
S242 Portrait. Woodcut engraving, credited "From a Photograph by Scholim, St. Louis." FRANK LESLIE'S ILLUSTRATED NEWSPAPER 24, (1867) ["Kit Carson." 24:603 (Apr. 20, 1867): 65.]

SCHOLTEN, JOHN A. see also HISTORY: USA: MO (Van Ravenswaay)

SCHOLTEN, JOHN A. (1829-1886) (GERMANY, USA)
S243 "Editor's Table." PHILADELPHIA PHOTOGRAPHER 6, no. 65 (May 1869): 168. [Cabinets mentioned.]

S244 "Our Picture." PHILADELPHIA PHOTOGRAPHER 8, no. 89 (May 1871): frontispiece, 157-159. 2 b & w. 2 illus. [2 children's portraits "card" size, 2 woodcuts of studio.]

S245 "Our Picture." PHOTOGRAPHIC WORLD 1, no. 6 (June 1871): 184-185. 2 b & w. [2 'cartes' on one page.]

S246 "Here and There." PHILADELPHIA PHOTOGRAPHER 9, no. 106 (Oct. 1872): 366. [Excerpt from "St. Louis [MO] Democrat." Joking references to John Scholten as an ardent fisherman. Noted on the same page that Scholten's photos were reproduced in Sept. issue of the "Photographic World."]

S247 "[Biography of John Scholten.]" CENTRAL MAGAZINE (ST. LOUIS, MO) (1874): *. 1 illus. [Portrait. (I've not seen this reference.)]

S248 Portrait. Woodcut engraving, credited "Photographed by Scholten." FRANK LESLIE'S ILLUSTRATED NEWSPAPER 38, (1874) ["Miss Phoebe Couzins, attorney-at-law, St. Louis, MO." 38:972 (May 16, 1874): 156.]

S249 "Monument Erected in the Memory of General Nathaniel Lyon, at St. Louis, Mo. - Photographed by Scholten." FRANK LESLIE'S ILLUSTRATED NEWSPAPER 39, no. 994 (Oct. 17, 1874): 92. 1 illus. [View.]

S250 "Matters of the Month." PHOTOGRAPHIC TIMES 5, no. 51 (Mar. 1875): 66. [Scholten's new gallery favorably described in local newspapers.]

S251 "Note." PHOTOGRAPHIC TIMES 9, no. 98 (Feb. 1879): 40-41. [Scholten's "picture place," the leading photographer in St. Louis, destroyed by fire.]

S252 "Note." PHOTOGRAPHIC TIMES 9, no. 99 (Mar. 1879): 57-58. [The fire-damaged building collapsed after repairs had been almost completed.]

S253 "Tea Party." ANTHONY'S PHOTOGRAPHIC BULLETIN 10, no. 5 (May 1879): 152. [Announcement of newly opened gallery in St. Louis, MO.]

S254 "Obituary: John A. Scholten." PHOTOGRAPHIC TIMES 16, no. 235 (Mar. 19, 1886): 159-160. [John A. Scholten born at Rees, Prussia in 1829, lived there until age 14. His parents then emigrated to Hermann, MO. At age 17 John moved to St. Louis. Worked at a dry goods store, then in 1857 became a photographer. Became successful in St. Louis, stayed there until his death on Mar. 7, 1886.]

S255 "Obituary: John A. Scholten." PHILADELPHIA PHOTOGRAPHER 23, no. 270 (Mar. 20, 1886): 189-190. [Scholten died on May 7, 1886, in St. Louis, MO, in the 58th year of his age. Born at Rees, a Prussian town on the Rhine. His parents emigrated to Missouri when he was 14. Scholten first worked in a dry goods store in St. Louis, but then became a professional photographer in 1857. In 1874 established a large gallery on 10th and Olive Street. Gallery destroyed by fire in 1878, but rebuilt. First to introduce the carte-de-visit to St. Louis. Keen supporter of the National Photographers' Assoc. from its beginnings.]

S256 "Obituary: John A. Scholten." ANTHONY'S PHOTOGRAPHIC BULLETIN 17, no. 6 (Mar. 27, 1886): 180. [John A. Scholten born in Rees, in Rhenish Prussia, Oct. 18, 1829. At 14, he and family emigrated to USA and settled in Missouri. At 18, Scholten moved to St. Louis, entered the dry goods business. In 1857 became a photographer and did well. Died Mar. 7, 1886.]

SCHOLTEN, JOHN A. [?]
S257 "The Grand Duke Alexis and General Custer as They Appeared After Returning from the Buffalo Hunt. - From a Photograph by Scholter [sic Scholten ?]." FRANK LESLIE'S ILLUSTRATED NEWSPAPER 33, no. 856 (Feb. 24, 1872): 369, 371. 1 illus. [Outdoor portrait.]

S258 Portrait. Woodcut engraving, credited "From a Photograph by J. A. Schotten, [sic Scholten?] St. Louis." FRANK LESLIE'S ILLUSTRATED NEWSPAPER 12, (1861) ["Brig.-Gen. Franz Siegel, of Missouri." 12:302 (Aug. 31, 1861): 252.]

SCHOONMAKER & BURGESS.
S259 Portrait. Woodcut engraving, credited "From a Photograph by Schoonmaker & Burgess." FRANK LESLIE'S ILLUSTRATED NEWSPAPER 40, (1875) ["A. P. Sprague, author." 40:1025 (May 22, 1875): 176.]

SCHOONMAKER, C. C. (TROY, NY)
S260 "Ruins of the Great Fire at Troy, New York, May 10, 1862." HARPER'S WEEKLY 6, no. 282 (May 24, 1862): 333. 1 illus. ["Photographed by Schoonmaker, of Troy."]

S261 "Terrible Conflagration at Troy, N. Y., Saturday May 10 - Nearly Seven Hundred Houses Burned, Many Lives Lost, and Three Millions of Property Destroyed. - Photographed by C. C. Schoonmaker, of Troy." FRANK LESLIE'S ILLUSTRATED NEWSPAPER 13, no. 346-347 (May 31, 1862): 117. 1 illus. [Full-page engraving of ruins.]

S262 "Letter." PHILADELPHIA PHOTOGRAPHER 6, no. 72 (Dec. 1869): 428. [Letter from Schoonmaker discussing his being sued by the Wing & Co. plate-holder patent holders.]

S263 "The Stamp Nuisance." HUMPHREY'S JOURNAL OF PHOTOGRAPHY, AND THE ALLIED ARTS AND SCIENCES 17, no. 18 (Jan. 15, 1866): 281.

S264 "A Good Chance." HUMPHREY'S JOURNAL OF PHOTOGRAPHY, AND THE ALLIED ARTS AND SCIENCES 17, no. 24 (Apr. 15, 1866): 384. ["Schoonmaker's celebrated gallery in Troy is for sale."]

SCHREIBER & SON. (PHILADELPHIA, PA)
BOOKS
S265 American Jersey Cattle Club. *Herd Register of the American Jersey Cattle Club.* New York: American Jersey Cattle Club, 1871-1876. 4 vol. n. p. l. of plates. b & w. [Four volumes per year from 1871 to 1937. Illustrated with original photographs, most of the early images by Schreiber & Son, Philadelphia.]

PERIODICALS
S266 "The New Railroad Bridge Across the Susquehanna, From Havre de Grace to Perryville, Md. - From a Photograph by Schreiber & Son, Philadelphia." FRANK LESLIE'S ILLUSTRATED NEWSPAPER 23, no. 586 (Dec. 22, 1866): 217. 1 illus. [View.]

S267 "The Philadelphia and Baltimore Railroad Bridge Across the Susquehanna, Connecting Perryville with Havre de Grace." HARPER'S WEEKLY 10, no. 521 (Dec. 22, 1866): 807, 808. 1 illus. ["Photographed by Schreiber & Son, Philadelphia."]

S268 "Four Famous Trotters." HARPER'S WEEKLY 13, no. 667 (Oct. 9, 1869): 652-653. 4 illus. ["Photographed by Schreiber & Son, 818 Arch St., Philadelphia."]

S269 "Our Picture - The Last Load." PHILADELPHIA PHOTOGRAPHER 9, no. 105 (Sept. 1872): 332-334. 1 b & w. [Photo of hay wagon.]

S270 "Our Picture." PHILADELPHIA PHOTOGRAPHER 10, no. 110 (Feb. 1873): frontispiece, 61. 3 b & w. [Animals.]

SCHREIBER, GEORGE FRANCIS. (1803-1892) (GERMANY, USA)
S271 Schreiber, G. "Porcelain Pictures." PHILADELPHIA PHOTOGRAPHER 8, no. 90 (June 1871): 188.

S272 "Editorial Notes." PHOTOGRAPHIC TIMES 19, no. 385 (Feb. 1, 1889): 52-53. [Mr. Schreiber an early associate of the Langenheim Brothers, one of the first to make photographs in this country.]

S273 "Obituary: George Francis Schreiber." PHOTOGRAPHIC TIMES 22, no. 539 (Jan. 15, 1892): 26-27. [Schreiber born Frankfurt-am-Main on Jan. 10, 1803. Came to USA in 1834. Took daguerreotypes for William & Frederick Langenheim. One of the first photographers to work with paper negatives (Calotypes). Worked in Philadelphia, PA, for fifty years. By 1871 the Schreiber studio included at least six family members. Includes an article from the "Philadelphia [PA] Evening Telegraph."]

S274 "Obituary." WILSON'S PHOTOGRAPHIC MAGAZINE 29, no. 410 (Jan. 16, 1892): 63. [George Francis Schreiber born at Frankfort-am-Main on Jan. 10, 1803, died in Philadelphia on Jan. 3, 1892. Schreiber came to USA in 1834, founded the paper, "Die Alte und Neue Welt." Then became a daguerreotypist and flourished. Made a large sectional camera, and made a view of Niagara Falls which won many medals and praise from Queen Victoria. In 1848 he heard that glass was used for a negative in Europe and quickly

experimented to produce the same effect, first called "Talbotypes on glass." Then he produced the "Hyalotype," from which were produced the first stereopticon views. "...for fifty years a prominent photographer of Philadelphia, and who, with his four or five sons, has been for many years well known as a photographer of fine cattle and noted horses. His "Studies from Nature" rank among the finest ever produced by the photographer's art. His sons continue to do the largest "animal" photograph business in the world."]

S275 Ehrmann, Charles. "George Francis Schreiber: A Reminiscence." PHOTOGRAPHIC TIMES 22, no. 540 (Jan. 22, 1892): 40-41. [Experimented with Talbotypes in 1843, worked for Wm. & Fr. Langenheim. Ehrmann's remarks then turn to a brief survey of the history of individuals who perfected various photographic processes in the 1840s, 1850s.]

S276 Maisch, Frederick D. and Charles Ehrmann. "Correspondence: George Francis Schreiber." PHOTOGRAPHIC TIMES 22, no. 541 (Jan. 29, 1892): 57-58. [Maisch's letter, responding to earlier obituary, challenges some early history - basing his information of M. A. Root's book "The Camera and the Pencil." Elicits a reply from Ehrmann, claiming Root in error with certain facts on the early history of photography in USA.]

SCHROEDER, G. (DUBLIN, IRE)
S277 Portrait. Woodcut engraving credited "From a photograph by G. Schroeder." ILLUSTRATED LONDON NEWS 75, (1879) ["Late Dr. Ambrose Kelly." 75:2103 (Oct. 4, 1879): 304.]

SCHUBERT & CO.
S278 Portrait. Woodcut engraving, credited "From a Photograph by Schubert & Co. FRANK LESLIE'S ILLUSTRATED NEWSPAPER 41, (1875) ["Dr. Hans von Bulow." 41:1049 (Nov. 6, 1875): 137.]

SCHUBERT, FRANCIS.
BOOKS
S279 Schubert, F. Hints on Photographic Portraiture. London: s. n., 1854. n. p.

PERIODICALS
S280 Schubert, Francis. "Position of Sitters." HUMPHREY'S JOURNAL 6, no. 8 (Aug. 1, 1854): 127-128. [From "Art of Photography, London."]

SCHULL & RUE. (RICHMOND, KY)
S281 Portrait. Woodcut engraving, credited "From a Photograph by Schull & Rue, Richmond, Ky. FRANK LESLIE'S ILLUSTRATED NEWSPAPER 41, (1875) ["Hon. James McCreary, Gov. of KY." 41:1043 (Sept. 25, 1875): 37.]

SCHULTZE, JOHANN HEINRICH. (b. 1687)
S282 Ehrmann, Charles. "The Columbus of Photography." AMERICAN ANNUAL OF PHOTOGRAPHY AND PHOTOGRAPHIC TIMES ALMANAC FOR 1894 (1894): 28-32. 1 illus. [Discoverer of the action of light on chemical substances in 1720's.]

SCHUMACHER, FRANK G. (LOS ANGELES, CA)
S283 "Our Pictures." WILSON'S PHOTOGRAPHIC MAGAZINE 32, no. 462 (June 1895): 281, plus unnumbered leaf after p. 272. 12 b & w. ["F. G. Schumacher, Los Angeles." Panel of 12 "California Maidens" reproduced on one page.]

S284 "Photographers, Old and New." WILSON'S PHOTOGRAPHIC MAGAZINE. 32, no. 463 (July 1895): 313-314. 1 illus. [Began in Los Angeles in Wolfenstein's studio, then worked for Bradley & Rulofson

in San Francisco under D. B. Taylor for seven years. In 1883 opened his own studio on Los Angeles.]

S285 "The Old Year and the New Year." WILSON'S PHOTOGRAPHIC MAGAZINE 33, no. 469 (Jan. 1896): 17. 2 b & w. ["Schumacher, Los Angeles, Calif". Brief note commenting on two photos of a baby girl crying and smiling - titled "The Old Year and "The New Year" - presented as seasons greetings.]

S286 "Our Pictures." WILSON'S PHOTOGRAPHIC MAGAZINE 33, no. 469 (Jan. 1896): 39-40, plus frontispiece. 1 b & w. ["Schumacher, Los Angeles". 1 studio portrait "The Daughter of the Pacific".]

S287 "Photographic Studies by Schumacker." WILSON'S PHOTOGRAPHIC MAGAZINE 34, no. 481 (Jan. 1897): 42-43. [Bk rev.: "Series III. Pictorial lessons in Portraiture. Forty-eight artistic studies by F. G. Schumacher, Los Angeles." N.Y.: Edward L. Wilson, 1897. (Pictorial lessons I and II were by B. J. Falk).]

S288 "Editor's Table: California Visitors." WILSON'S PHOTOGRAPHIC MAGAZINE 35, no. 501 (Sept. 1898): 431. [F. G. Schumacher, Los Angeles, and Otto H. Boye, San Francisco, visited Wilson in NY. Boye, formerly with Schumacher, now with Mr. Habernicht.]

S289 "Editor's Table: Honor's for American Photographers." WILSON'S PHOTOGRAPHIC MAGAZINE 37, no. 525 (Sept. 1900): 432. [W. N. Brenner (Cincinnati), Frank G. Schumacher (Los Angeles) and Baker's Art Gallery (Columbus) honored at Paris Exhibition and at Dr. Eder's Imperial Royal School of Graphic Arts in Vienna.]

S290 "Everyday Portraiture." WILSON'S PHOTOGRAPHIC MAGAZINE 38, no. 538 (Oct. 1901): 4 leaves following p. 392, plus frontispiece. 9 b & w. [Portfolio, no texts beyond captions.]

SCHURCH, WILLIAM H.
S291 Wright, Hendrick Bradley. Historical Sketches of Plymouth, Luzerne Co., Penna.; ...with Twenty-five Photographs of Some of the Early Settlers and Present Residents of the Town of Plymouth, Old Landmarks, Family Residences, and Places of Special Note. Philadelphia: T. B. Peterson & Brothers, 1873. 419 pp. 25 b & w. [Original photos by Wm. H. Schurch.]

SCHWENDLER, C. (DRESDEN, GERMANY)
S292 Portrait. Woodcut engraving credited "From a photograph by C. Schwendler." ILLUSTRATED LONDON NEWS 36, (1860) ["W. C. T. Dobson." 36:* (Feb. 25, 1860): 180.]

SCHWIER, KARL. (1842-) (GERMANY)
S293 Schwier, K. "Photography at the Castle of the Wartburg in Eisenach." ANTHONY'S PHOTOGRAPHIC BULLETIN 4, no. 2 (Feb. 1873): 40-42. [From the "Photographische Mittheilungen."]

S294 "Editorial Notes." PHOTOGRAPHIC TIMES 31, no. 9 (Sept. l899): 433-434. [Biographical notes "contributed by our German correspondent." Schwier photographed the Franco-Prussian War, worked as photographer, editor, etc.]

SCIUTTO, J. B. (GENOA, ITALY)
S295 Portrait. Woodcut engraving credited "From a photograph by J. B. Sciutto." ILLUSTRATED LONDON NEWS 70, (1877) ["Late Mr. Cowden Clarke." 70:1968 (Mar. 31, 1877): 292.]

SCOLIK, CHARLES. (1854-1928) (AUSTRIA)

S296 "Our Editorial Table." PHOTOGRAPHIC TIMES 19, no. 395 (Apr. 12, 1889): 190. ["Received a collection of landscape and portrait studies, printed in platinotype."]

S297 "Charles Scolik." PHOTOGRAPHIC TIMES 19, no. 398 (May 3, 1889): 215-216. 1 b & w. [Biography: Editor of "Photographische Rundschau," the organ of the Vienna Amateur Photographic Club. Born Vienna, Mar. 16, 1854. At 13 apprenticed to photographer Carl Wrabetz, then worked at various establishments in Austria and Hungary. In 1873 traveled through Hungary making photos, on commission, of national costumes. Worked again in Vienna, superintending Kroh's Gallery. Also experimenting and writing. Honorary Member of Vienna Amateur Photographic Club. Worked with platinum prints, etc. The photo is a portrait of Scolik.]

S298 "Editorial Notes." PHOTOGRAPHIC TIMES 22, no. 568 (Aug. 5, 1892): 400. ["Emperor Francis Joseph, of Austria, has conferred on our good friend and contributor Chas. Scolik of Vienna, the title of photographer to the Imperial and Royal Court."]

S299 1 photo ("A Viennese Maiden"). PHOTOGRAPHIC TIMES 23, no. 633 (Nov. 3, 1893): 625. [Brief note on p. 634.]

S300 1 photo ("From the Dry Process to the Wet"). PHOTOGRAPHIC TIMES 23, no. 639 (Dec. 15, 1893): 737. [Genre, a monk pauses from reading to drink a glass of wine.]

S301 "Editors Table." WILSON'S PHOTOGRAPHIC MAGAZINE 34, no. 486 (June 1897): 287. [Portfolio of half-tone engravings from Scolik's photographs. These pictures show its varieties of vignettes with fancy borders. Published in Halle, A.S. Germany: Wilhelm Knapp, 1897.]

SCOTELLARI, D.

S302 Scotellari, D. "New Method of Lighting the Studio." PHILADELPHIA PHOTOGRAPHER 14, no. 157 (Jan. 1877): 13-14. [From the "Moniteur de la Photographie," Nov. 16th.]

S303 Scotellari. "Photographic News." PHILADELPHIA PHOTOGRAPHER 15, no. 171 (Mar. 1878): 93-94. [Letter on artistic lighting (of portraits).]

S304 Scotellari, D. "Artistic Lighting and the Genre Called Rembrandt." PHOTOGRAPHIC TIMES 8, no. 86 (Feb. 1878): 28-29. [From "Photographic News."]

SCOTT, ALEXANDER DE COURCY.

S305 Scott, Alexander De Courcy. *On Photo-zincography and Other Photographic Processes Employed at the Ordnance Survey Office, Southampton,* by Captain A. De C. Scott; under the Direction of Colonel Sir Henry James. Published by permission of the Secretary of War. London: Longman, Green, Longman, Roberts & Green, 1862. vi, 16 pp. 12 l. of plates. 12 illus. [Plates demonstrate photo-zincography and photolithography processes. 2nd ed. (1863), with 15 plates.]

SCOTT, ALLEN N., CAPT. (GREAT BRITAIN, INDIA)
BOOKS
S306 Weld, Charles Richard, ed. *Sketches in India, taken at Hyderabad and Secunderabad, in the Madras Presidency.* London: Lovell Reeve, 1862. n. p. 100 b & w. [Stereographs by Capt. Allan N. Scott, Madras Artillery.]

PERIODICALS
S307 Weld, Mr. "Photography in India." JOURNAL OF THE PHOTOGRAPHIC SOCIETY OF LONDON 8, no. 125 (Sept. 15, 1862): 128-132. [Capt. Scott was in the Madras Artillery. 100 views around Hyderabad, the military encampment at Secunderabad, tombs at Golconda, etc.]

S308 "Photographic Illustrations of India." BRITISH JOURNAL OF PHOTOGRAPHY 9, no. 177 (Nov. 1, 1862): 411. [100 Photos by Capt. A. N. Scott.]

S309 "Photographic Illustrations of India." AMERICAN JOURNAL OF PHOTOGRAPHY AND THE ALLIED ARTS & SCIENCES n. s. vol. 5, no. 11 (Dec. 1, 1862): 255-256 . [From "Br. J. of Photo." 100 half-stereo views, taken by Capt. A. N. Scott, mounted in an album, with letterpress description of each plate, by Charles Weld.]

S310 "Dancing Beggars of Southern India." ILLUSTRATED LONDON NEWS 43, no. 1234 (Dec. 5, 1863): 577-578. 1 illus. ["...partly taken from a photograph by Captain Allan Scott, of the Madras Artillery."]

S311 Macleod, Norman, D.D. "Peeps at the Far East." GOOD WORDS 10, no. 1-12 (Jan. - Dec. 1869): 22-31, 94-107, 178-188, 249-264, 324-337, 407-417, 550-562, 640-650, 689-699, 776-783, 855-863. 40 illus. ["Illustrations from Photographs." Some views credited to Bourne and Shephard. Photos of Indian types are credited, on p. 640: "I am indebted to the kindness of Colonel Allen Scott, of the Madras Army, for the photographs from which those illustrations are engraved." (These are similar to photos in "People of India").]

S312 "Stereographs. Illustration of East Indian Scenery, by Capt. A. N. Scott, Madras Artillery." BRITISH JOURNAL OF PHOTOGRAPHY 7, no. 123 (Aug. 1, 1860): 223-224.

SCOTT, J. G.
S313 "First Reformed Church, New Brunswick, N. J., Rev. Richard H. Steele, D.D., Pastor. - From a Photograph by J. G. Scott." FRANK LESLIE'S ILLUSTRATED NEWSPAPER 28, no. 703 (Mar. 20, 1869): 13. 2 illus. [View. Portrait.]

SCOTT, J. M. (VINCENNES, IN)
S314 "Eclipse of the Sun." HUMPHREY'S JOURNAL OF PHOTOGRAPHY, AND THE ALLIED ARTS AND SCIENCES 20, no. 26 (Oct. 15, 1869): 412. ["...beautiful stereographs of the recent eclipse."]

SCOTT, J. T.
S315 Scott, J. T. "How to Get Forty-Two Cartes Out of a Sheet of Paper." BRITISH JOURNAL PHOTOGRAPHIC ALMANAC 1877 (1877): 123-124. 1 illus.

SCOTT, JAMES W.
S316 Scott, James W. "Correspondence." DAGUERREAN JOURNAL 1, no. 6 (Feb. 1, 1851): 180-181. [Letter about rivalry between operators, etc.]

SCOVILLE MANUFACTURING CO.
S317 "Obituary: Samuel W. Hall." PHOTOGRAPHIC TIMES 7, no. 76 (Apr. 1877): 88-89. [President of Scoville Manufacturing Co.]

S318 "Commercial Intelligence: A Mill with a History." PHOTOGRAPHIC TIMES 14, no. 164 (Aug. 1884): 459-461. [History of the Scoville Manufacturing Co.]

SCOVILLE, JAMES M. L. (1789-1857) (USA)

S319 "Death of J. M. L. Scoville, Esq." PHOTOGRAPHIC AND FINE ART JOURNAL 10, no. 6 (June 1857): 172-174. [From "Waterbury [CT] American." Obituary, history of this eminent photographic manufacturer.]

SCOVILLE, WILLIAM H. (1796-1854) (USA)

S320 "Death of William H. Scoville." HUMPHREY'S JOURNAL 6, no. 2 (May 1, 1854): 25, 29-30. [Announcement of death, obituary printed from the "Waterbury American." Scoville head of the Scoville Manufacturing Co.]

SCRIPTURE, GEORGE H. (PETERBOROUGH, NH)

S321 "Monadnock Mountain Scenery." HUMPHREY'S JOURNAL OF PHOTOGRAPHY, AND THE ALLIED ARTS AND SCIENCES 18, no. 15 (Dec. 1, 1866): 240. [Praise for stereo views by George H. Scripture, of Peterborough, NH.]

SCWARZ, H.

S322 Schwarz, H., Prof. "On a New Method for the Production of Glass Positives." AMERICAN JOURNAL OF PHOTOGRAPHY, AND THE ALLIED ARTS AND SCIENCES n. s. vol. 9, no. 6 (Nov. 15, 1866): 133-135. [From "Photo. News."]

SEAGER, D. W.

S323 "Photography Comes to America." IMAGE 1, no. 1 (Jan. 1952): 2. 1 illus. [Autograph letter of D. W. Seager, claiming to have taken a daguerreotype on Sept. 16, 1839, which he feels to have been the first made in the USA. Seager may have been born in England. Later went to Mexico as an advisor to the government on their national economy.]

SEAVER, CHARLES, JR.

[Daguerreotypist, photographer, operated a gallery in Boston, MA from 1854 to 1864. Stereo views published by Charles Pollock, Boston. Travelled throughout New England, the South and the West from 1865 to 1875.]

S324 "Rev. John Pierpont." BALLOU'S PICTORIAL DRAWING-ROOM COMPANION [GLEASON'S] 11, no. 264 (July 26, 1856): 60. 1 illus.

SEAVEY, L. W.

S325 Seavey, L. W. "Suggestions on the Use of Backgrounds." ST. LOUIS PRACTICAL PHOTOGRAPHER 1, no. 1 (Jan. 1877): 19-20. 2 illus.

SECCHI, FATHER.

S326 Secchi, Father. "Lunar Photography." PHOTOGRAPHIC AND FINE ART JOURNAL 10, no. 4 (Apr. 1857): 106. [From "Liverpool Photo. J.," quoting "Cosmos."]

S327 Secchi, Father. "Extracts from Foreign Publications: Lunar Photography." HUMPHREY'S JOURNAL 8, no. 23 (Apr. 1, 1857): 354. [From "Cosmos."]

SEDGFIELD, WILLIAM RUSSELL. (1826-1902) (GREAT BRITAIN)

BOOKS

S328 Sedgfield, Russell. *Photographic Delineations of the Scenery, Architecture and Antiquities of Great Britain and Ireland,... Part 1. Highley.* by Russell Sedgfield. London: s. n. [Samuel Highley?], 1854. n. p. 35 b & w. [First published in six parts, each part containing five to six original prints; with title page.]

S329 Howitt, William and Mary Howitt. *Ruined Abbeys and Castles of Great Britain,... The Photographic Illustrating by Bedford, Sedgfield, Wilson, Fenton and Others.* London: Alfred W. Bennett, 1862. viii, 228 pp. 27 b & w. illus.

S330 Howitt, William. *The Ruined Abbeys of Yorkshire:* Extracted from "The Ruined Abbeys and Castles of Great Britain." With Photographic Illustrations by Sedgfield and Ogle. London: Alfred W. Bennett, 1863. 71 pp. 6 b & w.

S331 Howitt, William and Mary Howitt. *The Wye. Its Ruined Abbeys and Castles;* the Photographic Illustrations by Bedford and Sedgfield. London: A. W. Bennett, 1863. 75 pp. 5 b & w. [Original photos by Russell Sedgfield. Extracted from "The Ruined Abbeys and Castles of Great Britain."]

S332 Unger, Franz Joseph Andrews. *Ideal Views of the Primitive World: In Its Geological and Palaenontological Phases,* by Dr. F. Unger, of Vienna, edited by Samuel Highley, F.G.S., F.C.C.,... Illustrated by Seventeen Photographic Plates from Drawings by J. Kuwasseg. London: Taylor & Francis, 1863. 8 pp. 17 l. of plates. b & w. [Photographs of sketches, recreating earlier times, except for the frontispiece, which is a photo of a model of "extinct animals" by B. Waterhouse Hawkins. Russell Sedgfield is the photographer (In "Editor's Preface"). This book was reviewed in Oct. 1, 1860 "Br. J. of Photo." Perhaps there is an earlier, foreign edition?]

S333 Howitt, William *Ruined Abbeys and Castles of Great Britain and Ireland,* 2nd series. The Photographic Illustrations by Thompson, Sedgfield, Ogle and Hemphill. London: Alfred W. Bennett, 1864. viii, 224 pp. b & w. [Approximately 30 original photographs.]

S334 Howitt, William *The Ruined Castles of North Wales,...* With Photographic Illustrations by Bedford, Sedgfield and Ambrose. London: Alfred W. Bennett, 1864. 76 pp. 7 b & w. illus. [Original photographs.]

S335 Howitt, William *Yorkshire: Its Abbeys and Castles,...* Illustrated with Photographs by Sedgfield and Ogle. London: Alfred W. Bennett, 1865. n. p. b & w.

S336 *The Thames Illustrated by Photographs. From Richmond to Cliefden.* Russell Sedgfield, Photographer. "Series I" London: A. Marion, Son & Co., 1866. 30 pp. 13 l. of plates. 13 b & w. [Original photos.]

S337 *The Thames Illustrated by Photographs. Cookham to Whitchurch.* Russell Sedgfield, Photographer. "Series II" London: A. Marion, Son & Co., 1867. 35 pp. 15 l. of plates. 15 b & w. [Original prints.]

S338 *The Thames Illustrated by Photographs. Whitchurch to Oxford.* Russell Sedgfield, Photographer. "Series III" London: A. Marion, Son & Co., 1868. 28 pp. 15 l. of plates. 15 b & w. [Original prints.]

S339 Davies, Samuel J. *Dover.* With Photographic Illustrations by Russell Sedgfield. London: Provost & Co., successors to A. W. Bennett, 1869. 48 pp. 12 l. of plates. 12 b & w. [Original photographs, by Russell Sedgfield.]

S340 Ware, James Redding. *The Isle of Wight;* The Photographic Illustrations by Russell Sedgfield and Frank M. Good. London: Provost, Successor to A. W. Bennett, 1869. 182 pp. 16 l. of plates. 21 b & w. [Sixteen original photos by Russell Sedgfield, four by Frank M. Good,

one after a painting. A "Library Edition" was also published, containing only fifteen original prints. 2nd ed. (1872), with twenty-four prints.]

S341 Scott, Sir Walter. *The Lord of the Isles*. London: Provost & Co., 1871. 186 pp. 9 b & w. [Original photos, three by S. Thompson. six by R. Sedgfield.]

S342 Scott, Sir Walter. *The Lay of the Last Minstrel*. With Photographic Illustrations by Russell Sedgfield. London: Provost & Co., 1872. vi, 138 pp. 6 l. of plates. 6 b & w. [Albumen prints, by Russell Sedgfield.]

S343 Pitcairn, Robert. *Harrow*, by R. Pitcairn. With Eight Photographs by Russell Sedgfield. "Our Public Schools." London: Provost & Co., ca. 1872. n. p. 8 b & w. [Original photos.]

PERIODICALS
S344 "New Publications: Photographic Delineations of the Scenery, Architecture and Antiquities of Great Britain and Ireland." ATHENAEUM no. 1419 (Jan. 6, 1855): 22. [Book review: "Photographic Delineations of the Scenery, Architecture and Antiquities of Great Britain and Ireland. Part 1. Highley," By Russell Sedgfield.]

S345 Sedgfield, W. Russell. "Albuminized Paper." HUMPHREY'S JOURNAL 7, no. 21 (Mar. 1, 1856): 338-339. [From "J. of Photo. Soc., London."]

S346 "Critical notices: Stereographic pictures - English & Welsh Scenery. Illus. by Wm. Russell Sedgfield." PHOTOGRAPHIC NEWS 1, no. 15 (Dec. 17, 1858): 173-174.

S347 "Our Weekly Gossip." ATHENAEUM no. 1638 (Mar. 19, 1859): 390. [Praise for Sedgfield's stereo views.]

S348 "Sedgfield's Stereographs of English and Welsh Scenery." ART JOURNAL (Apr. 1859): 126.

S349 "Stereoscopic Interiors." PHOTOGRAPHIC AND FINE ART JOURNAL 12, no. 2 (July 1859): 33-34. [From "Photo. Notes." Includes letter from Sedgfield, describing his techniques.]

S350 Sedgfield, W. R. "Micro-Photography." PHOTOGRAPHIC AND FINE ART JOURNAL 12, no. 2 (July 1859): 41. [From "Photo. Notes."]

S351 Sedgfield, R. "On Taking Interiors." HUMPHREY'S JOURNAL OF PHOTOGRAPHY, AND THE ALLIED ARTS AND SCIENCES 11, no. 10 (Sept. 15, 1859): 150-151. [From "Liverpool Photo. J."]

S352 "Critical Notices: Sedgfield's English Scenery." PHOTOGRAPHIC NEWS 4, no. 110 (Oct. 12, 1860): 284.

S353 "Stereographs: Canterbury, Rochester, and the Watering Places on the South and South-East Coasts, by W. Russell Sedgfield." BRITISH JOURNAL OF PHOTOGRAPHY 7, no. 129 (Nov. 1, 1860): 317.

S354 Sedgfield, Russell. "India-Rubber for Mounting - Distilled Water." HUMPHREY'S JOURNAL OF PHOTOGRAPHY, AND THE ALLIED ARTS AND SCIENCES 20, no. 1 (May 1, 1868): 9-10.

S355 "Literature." ILLUSTRATED LONDON NEWS 54, no. 1530 (Mar. 20, 1869): 295. [Bk. rev.: "The Isle of Wight," by J. Redding Ware. The Photographic Illustrations by Russell Sedgfield and Frank M. Good. (London: Provost & Co., 1869.)]

S356 Sedgfield, Russell. "Concerning Sloppy Photographers." PHOTOGRAPHIC TIMES 6, no. 72 (Dec. 1876): 280. [From the "Br J of Photo."]

S357 Sedgfield, Russell. "Concerning the Iron Developer." BRITISH JOURNAL PHOTOGRAPHIC ALMANAC 1879 (1879): 108-109.

S358 Knight, Hardwicke. "Russell Sedgfield: The Complete Photographer." HISTORY OF PHOTOGRAPHY 1, no. 4 (Oct. 1977): 301-312. 23 b & w. 1 illus. [Russell Sedgfield was born into a wealthy, landed family in Wiltshire. At age sixteen he applied to W. H. F. Talbot for a licence to practice the calotype process as an amateur. By age eighteen he had learned both engraving and photography. He continued to pursue photography for the rest of his life. By 1854 Sedgfield had moved to North London, where Samuel Highley held an exhibition of his photographs and published his *Photographic Delineations of the Scenery, Architecture and Antiquities of Great Britain and Ireland*. Married, moved to Hempstead, and set up a studio. Moved to Kingston-upon-Thames in 1864. Firm of Sedgfield & Eliot listed in 1867, but Sedgfield listed alone from 1869 on. Associated with the Norwich Photographic Society, and an acquaintance of Dr. Hugh W. Diamond. Sedgfield's landscape views drew critical recognition in the 1850s, 1860s and 1870s. He continued to practice as a professional portrait photographer until after 1890. He died in 1902.]

SEDGEWICK, STEVEN J. see also RUSSELL, ANDREW J.

SEDGEWICK, STEVEN JAMES.
S359 Sedgewick, S. J., A.M. "Great Salt Lake." ANTHONY'S PHOTOGRAPHIC BULLETIN 1, no. 4 (May 1870): 56. ["The pleasant months spent in company of the camera through this region will long be remembered."]

S360 "Reed's Rock, Black Hills. - Photographed by S. J. Sedgewick." FRANK LESLIE'S ILLUSTRATED NEWSPAPER 39, no. 989 (Sept. 12, 1874): 12. 1 illus. [View, in Dakota Territory. (SD)]

SEDGEWICK, STEVEN JAMES. [?]
S361 "Lookout Peak, Black Hills." FRANK LESLIE'S ILLUSTRATED NEWSPAPER 39, no. 990 (Sept. 19, 1874): 27, 28. 1 illus. [View. Not credited, but probably from the same source as the image published the previous week - either S. J. Sedgewick or Southworth & Co.]

SEDGWICK, H. M. [MACKEY'S STUDIO]
S362 Sedgwick, H. M. "Elimination of Hypo Soda from Photographic Prints." PHOTOGRAPHIC TIMES 5, no. 57 (Sept. 1875): 213.

SEEBOHM, LOUIS. (OH)
S363 Seebohm, Louis. "Saltpetre-not Explosive!" HUMPHREY'S JOURNAL OF PHOTOGRAPHY, AND THE ALLIED ARTS AND SCIENCES 10, no. 6 (July 15, 1858): 84.

S364 "Strength of Bath." HUMPHREY'S JOURNAL OF PHOTOGRAPHY, AND THE ALLIED ARTS AND SCIENCES 15, no. 15 (Dec. 1, 1863): 234.

S365 "A Veteran Subscriber." HUMPHREY'S JOURNAL OF PHOTOGRAPHY, AND THE ALLIED ARTS AND SCIENCES 16, no. 14 (Nov. 15, 1864): 224. ["I have quit photography at present, but you may continue to send the Journal... I have been a subscriber for over ten years."]

SEELEY, EDWARD.

S366 Seeley, Ed. "A 'Reason Why' Acid Toning is Objectionable." HUMPHREY'S JOURNAL OF PHOTOGRAPHY, AND THE ALLIED ARTS AND SCIENCES 18, no. 6 (July 15, 1866): 87-88. [From "Photo. News."]

SEELY, CHARLES A.
BOOKS

S367 *The Ambrotype Manual,* selected from the Works of Charles A. Seely, A.M., Editor of the "American Journal of Photography." New York: Seely & Garabanati, 1857. 46 pp.

S368 *The Ambrotype Manual,* selected from the Works of Charles A. Seely, A.M., Editor of the "American Journal of Photography." Liverpool: John Atkinson, 1858. 46 pp. [1st English edition. Pamphlet.]

S369 Seely, Charles A. *The Ambrotype, a Practical Treatise on the Art of Producing Collodion Positives.* "2d. ed." New York: Seely & Garbanati, 1858. 48 pp. [Contains, on 33 seperately numbered pages, "Seely & Garbanati, Catalogue of Apparatus, Materials and Pure Chemicals, Manufactured Expressly for the Photographic Art."]

S370 *A Description of Some Improvements in the Processes and Apparatus Designed for the Use of Photographers, with Illustrations and Confirmative Testimony* New York: Seely & Garabanati, 1859. 24 pp.

PERIODICALS

S371 Seely, Charles A., A.M. "A Manual of Photography - Theoretical and Practical." PHOTOGRAPHIC AND FINE ART JOURNAL 8, no. 6-12 (June - Dec. 1855): 187-189, 217-218, 237-238, 285, 347-348.

S372 Seely, Charles A., A.M. "On the Manipulation of Positives." LIVERPOOL & MANCHESTER PHOTOGRAPHIC JOURNAL [BRITISH JOURNAL OF PHOTOGRAPHY] n. s. 2, no. 4 (Feb. 15, 1858): 49-51. [From "The Ambrotype," by Ch. A. Seely.]

S373 Seely, Charles A. "The Stereoscope." AMERICAN JOURNAL OF PHOTOGRAPHY AND THE ALLIED ARTS AND SCIENCES n. s. vol. 1, no. 9 (Oct. 1, 1858): 141-142.

S374 "Reviews." LIVERPOOL & MANCHESTER PHOTOGRAPHIC JOURNAL [BRITISH JOURNAL OF PHOTOGRAPHY] n. s. 2, no. 20 (Oct. 15, 1858): 257. [Bk. rev.: "The Ambrotype Manual," by C. A. Seely.]

S375 Seely, Charles A. "Photography and Printers Ink - Photo-Wood-Engraving." AMERICAN JOURNAL OF PHOTOGRAPHY AND THE ALLIED ARTS & SCIENCES n. s. vol. 1, no. 20 (Mar. 15, 1859): 312-314. [Discusses current practice, mentions experiments of Charles B. Boyle, of Albany, NY.]

S376 Seely, Charles A. "The Stereoscope." AMERICAN JOURNAL OF PHOTOGRAPHY AND THE ALLIED ARTS AND SCIENCES n. s. vol. 2, no. 8 (Sept. 15, 1859): 118-121.

S377 Seely, Charles. "Instantaneous Photographs." AMERICAN JOURNAL OF PHOTOGRAPHY 2, no. 13 (Dec. 1, 1859): 207-208.

S378 S. "Photography without Light." AMERICAN JOURNAL OF PHOTOGRAPHY AND THE ALLIED ARTS & SCIENCES n. s. vol. 4, no. 4 (July 15, 1861): 89-90.

S379 S. "Gun Cotton." AMERICAN JOURNAL OF PHOTOGRAPHY AND THE ALLIED ARTS & SCIENCES n. s. vol. 4, no. 4 (July 15, 1861): 91-92.

S380 S. "Testing Collodion and the Bath." AMERICAN JOURNAL OF PHOTOGRAPHY AND THE ALLIED ARTS & SCIENCES n. s. vol. 4, no. 6 (Aug. 15, 1861): 141-142.

S381 [Ladd, Joseph H.] "Is Photography a Mechanic Art?" HUMPHREY'S JOURNAL OF PHOTOGRAPHY, AND THE ALLIED ARTS AND SCIENCES 13, no. 10 (Sept. 15, 1861): 160. [This is actually an attack on Charles Seely by the editor of "HJ." He begins by stating that Seely indignantly informed the Am. Photo. Soc. of the British decision to place Photography with Machinery in the London World's Fair, then goes on to sarcastically attack Seely's position.]

S382 "The Daguerreotype - Its present Position." HUMPHREY'S JOURNAL OF PHOTOGRAPHY, AND THE ALLIED ARTS AND SCIENCES 13, no. 17 (Jan. 1, 1862): 260-261.

S383 Seely, Charles A. "How to Make the Nitrate Bath." AMERICAN JOURNAL OF PHOTOGRAPHY AND THE ALLIED ARTS & SCIENCES n. s. vol. 5, no. 9 (Nov. 1, 1862): 213-215.

S384 Seely, Charles A. "How to Enlarge Photographs." AMERICAN JOURNAL OF PHOTOGRAPHY AND THE ALLIED ARTS & SCIENCES n. s. vol. 6, no. 15 (Feb. 1, 1864): 357-358.

S385 Seely, Charles A. "A New Silvering Process." AMERICAN JOURNAL OF PHOTOGRAPHY AND THE ALLIED ARTS & SCIENCES n. s. vol. 6, no. 16 (Feb. 15, 1864): 382-383.

S386 Seely, Charles A. "Editorial Department." AMERICAN JOURNAL OF PHOTOGRAPHY AND THE ALLIED ARTS & SCIENCES n. s. vol. 6, no. 20 [sic 21] (May 1, 1864): 504. [Note that Seely "is again the sole proprietor of the photographic interests at 244 Canal St. Our late respected associate (Boltwood) has for a long time felt that more of his services were due the country. At a sacrifice of some pecuniary interests, he has therefore accepted an important position under the Sanitary Commission... will be in New Orleans."]

S387 Seely, Charles A. "A New Method of Rectifying the Nitrate-Bath." AMERICAN JOURNAL OF PHOTOGRAPHY AND THE ALLIED ARTS & SCIENCES n. s. vol. 6, no. 24 (June 15, 1864): 570-571.

S388 "The Ectograph. [Patented by William Campbell, Jersey City, N. J.]." AMERICAN JOURNAL OF PHOTOGRAPHY AND THE ALLIED ARTS & SCIENCES n. s. vol. 7, no. 2 (July 15, 1864): 35-36. [From Root's "Camera and Pencil." Seely claims that he perfected the process in 1855.]

S389 Seely, Charles A. "Editorial Department." AMERICAN JOURNAL OF PHOTOGRAPHY AND THE ALLIED ARTS & SCIENCES n. s. vol. 7, no. 18 (Mar. 15, 1865): 431-432. ["The Card Photograph is, without doubt, the most reasonable and popular style of portrait yet invented."]

S390 Seely, Charles A. "The Opalotype." AMERICAN JOURNAL OF PHOTOGRAPHY AND THE ALLIED ARTS & SCIENCES n. s. vol. 7, no. 20 (Apr. 15, 1865): 475-476.

S391 Seely, Charles A. "The Modifications of the Ivorytype." AMERICAN JOURNAL OF PHOTOGRAPHY AND THE ALLIED ARTS & SCIENCES n. s. vol. 7, no. 20 (Apr. 15, 1865): 476-477.

S392 Seely, Charles A. "To Prevent Sensitized Paper from Turning Brown in the Dark." AMERICAN JOURNAL OF PHOTOGRAPHY AND THE ALLIED ARTS & SCIENCES n. s. vol. 7, no. 24 (June 15, 1865): 567-568.

S393 Seely, Charles A. "The Caoutchoucotype." AMERICAN JOURNAL OF PHOTOGRAPHY AND THE ALLIED ARTS & SCIENCES n. s. vol. 7, no. 24 (June 15, 1865): 570-571.

S394 Seely, Charles A. "Carelessness. - How to get Intense Negatives." AMERICAN JOURNAL OF PHOTOGRAPHY AND THE ALLIED ARTS & SCIENCES n. s. vol. 8, no. 7 (Oct. 1, 1865): 161-162.

S395 Seely, Charles A. "A Substitute for the ordinary Nitrate Bath." AMERICAN JOURNAL OF PHOTOGRAPHY AND THE ALLIED ARTS & SCIENCES n. s. vol. 9, no. 2 (Sept. 15, 1866): 41-43. [Read before Am. Photo. Soc.]

S396 "Photographic Theories. - The Action of Light on Iodide of Silver, &c. (An abstract of remarks made by Prof. Seely at the Photographical Society October 8th.)." AMERICAN JOURNAL OF PHOTOGRAPHY, AND THE ALLIED ARTS AND SCIENCES n. s. vol. 9, no. 4 (Oct. 15, 1866): 89-92.

S397 Seely, Charles A. "The Bromide Patent. Explanatory and Personal." AMERICAN JOURNAL OF PHOTOGRAPHY, AND THE ALLIED ARTS AND SCIENCES n. s. vol. 9, no. 6 (Nov. 15, 1866): 135-138. [Gives history of the struggle against the patent and his role, as editor of the "Am. J. of Photography," in that struggle. States how it seems impossible to keep opposing the patent at this time, as so many others have made accommodations with the patentee.]

S398 Seely, Charles A. "Editorial Department, Valedictory." AMERICAN JOURNAL OF PHOTOGRAPHY, AND THE ALLIED ARTS AND SCIENCES n. s. vol. 9, no. 10 (May. 1, 1867): 230-232. ["The present writing is the last of my service as editor of this Journal; today closes a long episode in my life... I have selected and published fourteen volumes, comprising nearly ten thousand pages. ...as a correspondent and contributor I hope still to be in communication with the photographic public."]

S399 Seely, Charles A. "Oilography." AMERICAN JOURNAL OF PHOTOGRAPHY, AND THE ALLIED ARTS AND SCIENCES n. s. vol. 9, no. 11 (May. 15, 1867): 251-252.

S400 Seely, Charles A. "Photographic Mysteries." AMERICAN JOURNAL OF PHOTOGRAPHY, AND THE ALLIED ARTS AND SCIENCES n. s. vol. 9, no. 12 (June 1, 1867): 274-275.

S401 "American Photographical Society: Charles Seely vs. 'Practical' Photographers and 'Humphrey's Journal.'" PHOTOGRAPHICA 12, no. 2 (Feb. 1980): 8. [Excerpted minutes of meeting of the American Photographical Society, New York.]

SEGAR, WILLIAM.
S402 Segar, William. "Screens. - Backgrounds." HUMPHREY'S JOURNAL OF PHOTOGRAPHY, AND THE ALLIED ARTS AND SCIENCES 15, no. 20 (Feb. 15, 1864): 317-318. [Segar's letter and Towler's reply.]

SELBY, T. J. (CORINTH, MS)
S403 Portrait. Woodcut engraving, credited "From a Photograph by T. J. Selby, of Corinth, MS." HARPER'S WEEKLY 9, (1865) ["Rebel Gen. N. B. Forrest." 9:425 (Feb. 18, 1865): 109.]

SELKIRK, J. H. & J. SELKIRK.
S404 "Daguerreotype Movements." HUMPHREY'S JOURNAL 5, no. 19 (Jan. 15, 1854): 303. [Selkirks from Matagorda, TX., had daguerreotypes of oldest settlers.]

SELLACK, C. S.
S405 Sellack, C. S., PhD. "On Stellar Photography." PHILADELPHIA PHOTOGRAPHER 10, no. 116 (Aug. 1873): 228-232.

SELLECK, SILAS W. (SAN FRANCISCO, CA)
S406 "Note. "Mr. Silas W. Selleck is perhaps the oldest devotee of the art in San Francisco... now engaged in taking photos of the members of the Pioneer Assoc. ...books of 50 each (900 members). Rooms 163 Day St., near Montgomery."" PHOTOGRAPHIC AND FINE ART JOURNAL 11, no. 3 (Mar. 1858): 96. [From "Fireman's Journal, Calif."]

S407 "A California Photographic Painting." PHOTOGRAPHIC AND FINE ART JOURNAL 11, no. 5 (May 1858): 160. [The photographer Silas Selleck made a portrait of a boy and his dog. The portrait painter, Mr. Shaw, then overpainted the photograph. The landscape painter, Mr. T. A. Ayres, then painted in a landscape background. This composite effort was then displayed at Thomas Young's store in New York, NY.]

S408 Portrait. Woodcut engraving, credited "From a Photograph by Silleck (sic Selleck), San Francisco." FRANK LESLIE'S ILLUSTRATED NEWSPAPER 41, (1875) ["Andrew J. Bryant, Mayor-elect of San Francisco, CA." 41:1049 (Nov. 6, 1875): 141.]

S409 Palmquist, Peter E. "Black & White." HISTORY OF PHOTOGRAPHY 5 , no. 4 (Oct. 1981): frontispiece. 2 b & w. [Photographs of Billy Birch, member of the San Francisco [CA] Minstrels; one in black-face and one without makeup, taken in 1870s.]

SELLERS, COLEMAN. (1827-1907) (USA)
S410 Sellers, Coleman. "Wet Collodion without Water." HUMPHREY'S JOURNAL OF PHOTOGRAPHY, AND THE ALLIED ARTS AND SCIENCES 12, no. 21 (Mar. 1, 1861): 322-323.

S411 "A New Contributor." HUMPHREY'S JOURNAL OF PHOTOGRAPHY, AND THE ALLIED ARTS AND SCIENCES 12, no. 21 (Mar. 1, 1861): 324-325. [Includes an excerpt from a letter by Sellers. "Since the introduction of Photography into our office we find it to our advantage to make not only large prints, but an immense number of stereoscopic pictures for circulation." "They are views of different pieces of machinery manufactured at the extensive establishment of Messrs. Wm. Sellers & Co., whose works are celebrated the world over. The Prince of Wales honored their establishment with a visit on his recent sojourn in the Quaker City."]

S412 Sellers, Coleman. "Stereographs on Glass." HUMPHREY'S JOURNAL OF PHOTOGRAPHY, AND THE ALLIED ARTS AND SCIENCES 12, no. 23 (Apr. 1, 1861): 353-355. 1 illus.

S413 Sellers, Coleman. "Stereographs on Glass. (Reply to Mr. Towler's article.)" HUMPHREY'S JOURNAL OF PHOTOGRAPHY, AND THE ALLIED ARTS AND SCIENCES 13, no. 2 (May 15, 1861): 17-18.

S414 Sellers, Coleman. "On Photographic Printing." HUMPHREY'S JOURNAL OF PHOTOGRAPHY, AND THE ALLIED ARTS AND SCIENCES 13, no. 3-4 (June 1 - June 15, 1861): 33-36, 49-51.

S415 Sellers, Coleman. "Gun-Cotton for Collodion." HUMPHREY'S JOURNAL OF PHOTOGRAPHY, AND THE ALLIED ARTS AND SCIENCES 13, no. 5 (July 1, 1861): 65-68.

S416 Sellers, Coleman. "The Explosion of a Collodion Bottle." AMERICAN JOURNAL OF PHOTOGRAPHY AND THE ALLIED ARTS & SCIENCES n. s. vol. 4, no. 3 (July 1, 1861): 60-61.

S417 Sellers, Coleman. "Wet Collodion without Water." AMERICAN JOURNAL OF PHOTOGRAPHY AND THE ALLIED ARTS & SCIENCES n. s. vol. 4, no. 6 (Aug. 15, 1861): 138.

S418 Sellers, Coleman. "Wet Collodion on the Mountains." HUMPHREY'S JOURNAL OF PHOTOGRAPHY, AND THE ALLIED ARTS AND SCIENCES 13, no. 9-10 (Sept. 1-Sept 15, 1861): 129-131, 145-147. [Describes a photographic trip. He stayed with Reubens Peale and met E. Borda. Sellers describes Borda and his darkroom, etc.]

S419 "Choice Specimens." HUMPHREY'S JOURNAL OF PHOTOGRAPHY, AND THE ALLIED ARTS AND SCIENCES 13, no. 10 (Sept. 15, 1861): 160. [Note praising Coleman Sellers' photos of views of machinery.]

S420 Sellers, Coleman. "Photography and the Fine Arts." AMERICAN JOURNAL OF PHOTOGRAPHY AND THE ALLIED ARTS & SCIENCES n. s. vol. 4, no. 8 (Sept. 15, 1861): 181-184. [Unclear if this was reprinted from BJP, without credit.]

S421 Sellers, Coleman. "Photography and the Fine Arts." JOURNAL OF THE PHOTOGRAPHIC SOCIETY OF LONDON 7, no. 114 (Oct. 15, 1861): 288-289. [From "Am. J. of Photo."]

S422 Sellers, Coleman. "Protosulphate of Iron." AMERICAN JOURNAL OF PHOTOGRAPHY AND THE ALLIED ARTS & SCIENCES n. s. vol. 4, no. 11 (Nov. 1, 1861): 258-259.

S423 Seely, Charles A. "Editorial Miscellany." AMERICAN JOURNAL OF PHOTOGRAPHY AND THE ALLIED ARTS & SCIENCES n. s. vol. 4, no. 11 (Nov. 1, 1861): 264. ["We have had the pleasure of examining a fine collection of views of machinery, made by our esteemed correspondent Coleman Sellers... machinery used in the working of iron."]

S424 Sellers, Coleman. "Exchanges of Photographs." AMERICAN JOURNAL OF PHOTOGRAPHY AND THE ALLIED ARTS & SCIENCES n. s. vol. 4, no. 12 (Nov. 15, 1861): 283-285. 1 illus. [Additional editorial note on p. 288.]

S425 Sellers, Coleman. "Focussing with a Compound Microscope." HUMPHREY'S JOURNAL OF PHOTOGRAPHY, AND THE ALLIED ARTS AND SCIENCES 13, no. 15 (Dec. 1, 1861): 225-226.

S426 Sellers, Coleman. "Wet and Dry Collodion." AMERICAN JOURNAL OF PHOTOGRAPHY AND THE ALLIED ARTS & SCIENCES n. s. vol. 4, no. 15 (Jan. 1, 1862): 353-355.

S427 Sellers, Coleman. "Clearing a Silver Bath." HUMPHREY'S JOURNAL OF PHOTOGRAPHY, AND THE ALLIED ARTS AND SCIENCES 13, no. 17 (Jan. 1, 1862): 257-258.

S428 Sellers, Coleman. "Clearing a Silver Bath." BRITISH JOURNAL OF PHOTOGRAPHY 9, no. 159 (Feb. 1, 1862): 44. [From "Humphrey's Journal."]

S429 Sellers, Coleman. "Photographic Secrets." HUMPHREY'S JOURNAL OF PHOTOGRAPHY, AND THE ALLIED ARTS AND SCIENCES 13, no. 19 (Feb. 1, 1862): 289-291.

S430 Sellers, Coleman. "A Letter From Mr. Sellers." AMERICAN JOURNAL OF PHOTOGRAPHY AND THE ALLIED ARTS & SCIENCES n. s. vol. 4, no. 18 (Feb. 15, 1862): 420-421. [Letter praising notion of an international exchange club, warning everyone to write legible addresses. Mentions Franklin Peale's process. Borda's work discussed.]

S431 Sellers, Coleman. "Stereoscopic Vision without an Instrument." HUMPHREY'S JOURNAL OF PHOTOGRAPHY, AND THE ALLIED ARTS AND SCIENCES 13, no. 20 (Feb. 15, 1862): 307-310.

S432 Sellers, Coleman. "Humidus Trembleth - The Gathering Hosts Under the Banner of Siccus Appalleth Him." AMERICAN JOURNAL OF PHOTOGRAPHY AND THE ALLIED ARTS & SCIENCES n. s. vol. 4, no. 20 (Mar. 15, 1862): 473-474. [Friendly exchange of opinions between E. Borda and C. Sellers on best process for landscape photography.]

S433 Seely, Charles A. "Editorial Miscellany." AMERICAN JOURNAL OF PHOTOGRAPHY AND THE ALLIED ARTS & SCIENCES n. s. vol. 4, no. 24 (May 15, 1862): 568. ["A few days since Siccus and Humidus (C. Sellers and E. Borda), each fully equipped with his favorite appliances, had a spirited tilt at each other near High Bridge, on the Harlem River. The rivals came out covered with glory; we have seen some of the trophies."]

S434 Sellers, Coleman. "Letter from Coleman Sellers, Esq." HUMPHREY'S JOURNAL OF PHOTOGRAPHY, AND THE ALLIED ARTS AND SCIENCES 14, no. 5 (July 1, 1862): 26-29. [Describes visit to Springfield, MA., photographing there, etc.]

S435 Sellers, Coleman. "The Great Photographic Duello." AMERICAN JOURNAL OF PHOTOGRAPHY AND THE ALLIED ARTS & SCIENCES n. s. vol. 5, no. 1 (July 1, 1862): 18-19. [Seller's describes visiting New York, NY, and the photographic "contest" which he and Mr. Thompson (Secretary of the Am. Photo. Soc.) participated in, assisted by Anthony.]

S436 Sellers, Coleman. "Humidus Dried Up." AMERICAN JOURNAL OF PHOTOGRAPHY AND THE ALLIED ARTS & SCIENCES n. s. vol. 5, no. 4 (Aug. 15, 1862): 82-84. [Sellers describes his experience using Tannin dry plates.]

S437 Sellers, Coleman. "The Phantasmascope." BRITISH JOURNAL OF PHOTOGRAPHY 9, no. 175 (Oct. 1, 1862): 366-367. 3 illus. [Device for viewing stereoscopic pictures of moving objects, invented and patented by Sellers.]

S438 Sellers, Coleman. "Short Focus Lenses." HUMPHREY'S JOURNAL OF PHOTOGRAPHY, AND THE ALLIED ARTS AND SCIENCES 14, no. 14 (Nov. 15, 1862): 166-168.

S439 Sellers, Coleman. "Short Focus Lenses." AMERICAN JOURNAL OF PHOTOGRAPHY AND THE ALLIED ARTS & SCIENCES n. s. vol. 5, no. 9 (Nov. 1, 1862): 211-213.

S440 Sellers, Coleman. "Secret Formulae." AMERICAN JOURNAL OF PHOTOGRAPHY AND THE ALLIED ARTS & SCIENCES n. s. vol. 5, no. 17 (Mar. 1, 1863): 397-400. [Read before Phila. Photo. Soc.]

S441 Sellers, Coleman. "On Secret Formulae." BRITISH JOURNAL OF PHOTOGRAPHY 10, no. 187 (Apr. 1, 1863): 144-145. [Read before the Photo. Soc. of Phila., Feb. 4, 1863.]

S442 Sellers, Coleman. "Letters to an Engineer, On Photography, as applied to his Profession." PHILADELPHIA PHOTOGRAPHER 1-2, no. 1-4, 6, 9-10, 12, 13, 16, 18 (Jan.-Apr., June, Sept.-Oct., Dec. 1864; Jan., Apr., June 1865): (1864) 7-10, 25-29, 33-35, 51-54, 87-89, 129-131, 148-150, 178-180; (1865) 6-7, 49-50, 96-97.

S443 Sellers, Coleman. "Correction." PHILADELPHIA PHOTOGRAPHER 1, no. 3 (Mar. 1864): 43. [Correcting misstatements about lenses.]

S444 Sellers, Coleman. "Photography at the Pennsylvania Hospital for the Insane, Philadelphia." BRITISH JOURNAL OF PHOTOGRAPHY 12, no. 267 (June 16, 1865): 317-318. [Use of magic lantern slide shows at mental institution for therapeutic purposes, by Dr. Kirkbride and his assistant Dr. Lee. These began in 1843, began using photographic slides, made by the Langenheim Brothers, about 1856. Kirkbride's son became a successful amateur photographer, his work used.]

S445 Sellers, Coleman. "A Brief History of Photography in the Magic Lantern." PHILADELPHIA PHOTOGRAPHER 2, no. 19 (July 1865): 119-120. [Sellers' paper, actually about work of Dr. Thomas S. Kirkbride, of the Pennsylvania Insane Asylum, who created magic lantern shows for display to the inmates, (using slides created by the Langenheim Brothers) was reported in the monthly "Photographic Society of Philadelphia Minutes of the Meeting."]

S446 "The Stereo-Phantasmascope." BRITISH JOURNAL OF PHOTOGRAPHY 12, no. 280 (Sept. 15, 1865): 473. 1 illus. [Device for achieving the appearance of motion with, stereo viewers and a wheel of images, invented by Coleman Sellers "some years ago."]

S447 Sellers, Coleman. "Lecture on Photography." PHILADELPHIA PHOTOGRAPHER 3, no. 26-36 (Feb. - Dec. 1866): 49-52, 78-80, 99-104, 139-144, 179-182, 202-205, 268-273, 348-349, 373-376. 8 illus. [Technical article. Delivered at Franklin Institute.]

S448 "A New Photograph Album - Photographing on Wood, etc." PHILADELPHIA PHOTOGRAPHER 4, no. 45 (Sept. 1867): 275-277. [Letter from Sellers.]

S449 "Correspondence: A Criticism." ANTHONY'S PHOTOGRAPHIC BULLETIN 17, no. 6 (Mar. 27, 1886): 177. [Letter from Coleman Sellers (he claims the first letter in many years) protesting certain alterations in perspective in a photogravure landscape by Ernest Edwards, published in an earlier issue. Edwards' reply also printed.]

S450 Sellers, Coleman. "How to Attach a Camera to the Tripod." ANTHONY'S PHOTOGRAPHIC BULLETIN 18, no. 20 (Oct. 22, 1887): 618.

S451 Sellers, Coleman, M. Inst. C.E., Prof. of Mechanics, Franklin Institute, Phila. "Some Practical Notes." ANTHONY'S PHOTOGRAPHIC BULLETIN 19, no. 3 (Feb. 11, 1888): 72-73.

S452 Sellers, Coleman. "Mounting Prints." ANTHONY'S PHOTOGRAPHIC BULLETIN 19, no. 7 (Apr. 14, 1888): 219. [Letter suggesting a procedure to mount prints "I will try again when I am again on my feet."]

S453 Sellers, Coleman. "Fuming Paper." ANTHONY'S PHOTOGRAPHIC BULLETIN 20, no. 13 (July 13, 1889): 399. [Actually a discussion of early practitioners of dry plate photography in 1850s-1860s. Mentions Cole, S. Fisher Corlies, J. C. Browne.]

S454 Sellers, Coleman, E.D. "Thoughts Suggested by a Summer's Use of Celluloid Films." AMERICAN ANNUAL OF PHOTOGRAPHY AND PHOTOGRAPHIC TIMES ALMANAC FOR 1890 (1890): 237-241.

S455 Sellers, Coleman, E.D. "Photography at Home and Abroad, 1886 and 1891." PHOTOGRAPHIC MOSAICS: 1892 28, (1892): 137-144. [Sellers from Philadelphia.]

S456 Morton, Henry, M.D. "Coleman Sellers, E.D., Sc.D. A Biographical Sketch." CASSIER'S MAGAZINE: ENGINEERING ILLUSTRATED 24, no. 4 (Aug. 1903): 352-362. 6 illus. [Grew up in Philadelphia. Entered the Academy of Anthony Bolmar at West Chester, PA in 1838, at age eleven. Interested in "natural philosophy" from an early age, studied physics, chemistry, botany, and mineralogy. Graduated at age seventeen, then turned to farming, where he developed tools and techniques to aid his efforts. At nineteen, in 1846, he began to work in the Globe Rolling Mill in Cincinnati, OH, owned by his older brothers, working as a mechanical draftsman and designer. Began to conduct informal teaching on the sciences with interested friends and acquaintances. By 1850 Sellers was the superintendent and manager of the Globe Rolling Mills, which was at that time building locomotives for the Panama Railroad. Worked for several years as a locomotive designer and tool designer in various companies, then joined William Sellers & Co. in Philadelphia, where he worked as chief engineer for over thirty years, designing hydraulic machinery, cranes, elevator, pumps, forging machines, bridges, and other equipment. Took out many patents. In 1873 Sellers became a partner in the company.
In 1858 he decided to use photography to illustrate the company's products, and after suffering some disappointments with the work of commercial operators, learned the process himself. Set up a darkroom at the drafting office of the firm and devised special equipment to photograph the products. Later turned to photography as a hobby as well, and made both portraits and landscapes. Developed a variety of helpful devices.
In 1861 and 1862 he served as the American correspondent for the "British J. of Photo." (His columns provide excellent information about the state of photographic activity in the USA during the Civil War.) Sellers frequently wrote for American journals as well. Founder-member of the Philadelphia Photographic Society and of the Amateur Exchange Club. In 1861 patented the kinematoscope, a device to present groups of stereos so as to present the illusion of motion. Lectured on photography to the Franklin Institute in 1873. Loved to do sleight-of-hand and magician's tricks, and entertained wounded soldiers during the Civil War for the Sanitary Commission. From 1884 to 1887 he served on a commission appointed by the University of Pennsylvania to investigate the phenomena of modern spiritualism. Good teacher, and active in support of the Franklin Institute, serving as vice-president for years and president for five terms. Charter member, president of the American Society of Mechanical Engineers, member of many other professional organizations. Visited Europe in 1884 and in 1886. Retired in 1886, and became a consulting engineer, then offered a Chair of Engineering Practice at Stevens Institute of Technology at Hoboken, NJ. From 1889 through 1895 he led the engineering team involved in the constructions of the Niagara Falls Power Company, overcoming a variety of technical problems and design issues. Sellers was simply a man who could develop an extraordinary range of solutions to practical problems. Still alive in 1903.]

S457 Sellers, Charles Coleman. "Coleman Sellers." IMAGE 7, no. 10 (Dec. 1958): 233-235. 2 b & w. 1 illus. [Amateur photographer who invented the Kinematoscope, 1861. Born in Philadelphia, PA, on Jan. 28, 1877. Professional engraver. Flourished as amateur photographer in late 1850s. Died Dec. 28, 1907.]

SELLSTEDT, L. G.

S458 Sellstedt, L. G. "Fifth Annual Meeting and Exhibit of the National Photographic Association of the U.S., held in Buffalo, N.Y., beginning July 5, 1873: Art & Its Relations to the Photographic Art." PHILADELPHIA PHOTOGRAPHER 10, no. 117 (Sept. 1873): 366-369.

SELVATICO, P.

S459 Selvatico, P. "La Photographic dans l'Enseignement du Dessin." L'ARTISTE (1875): 424-426.

SELWYN, A. R. C.

S460 Gordon, Daniel M. "Victoria to Winnipeg via the Peace River Pass." GOOD WORDS 21, no. 2-4 (Feb. - May 1880): 116-123, 158-164, 305-310. 3 illus. [Report on exploration through Western Canada. 2 woodcut illustrations, of Peace River landscapes, are credited "From a photograph by A. R. C. Selwyn."]

SENTER, E. P.

S461 "Torture and Homicide in an American State Prison." HARPER'S WEEKLY 2, no. 103 (Dec. 18, 1858): 808-810. 9 illus. [Eight sketches of punitive devices, one view of the state prison at Auburn, NY, from a photograph by E. P. Senter. Social documentary.]

SEQUIER, LE BARON.

S462 Johnson, Walter A. "Photography's Great Moments." GRAPHIC ANTIQUARIAN 4, no. 1 (Oct. 1976): 14-15. 1 illus. [Portable photographic equipment perfected by Mr. Le Baron Sequier, from "Les Arts Chimiques," 1840.]

SERGEANT, J. D. (PHILADELPHIA, PA)

S463 "Our Picture." PHILADELPHIA PHOTOGRAPHER 1, no. 11 (Nov. 1864): 173-175, plus frontispiece. 1 b & w. [Landscape.]

S464 "Our Picture - The Grand Falls on the Nipissiguit, a Salmon River of the Province of New Brunswick." PHILADELPHIA PHOTOGRAPHER 2, no. 19 (July 1865): 121.

SEUTER, E. VON. (JACKSON, MS)

S465 "Editor's Table." PHILADELPHIA PHOTOGRAPHER 12, no. 137 (May 1875): 159. [E. Von Seuter (Jackson, MS) taking photos of the legislature.]

SEWARD, H. WATSON. (d. 1871) (UTICA, NY)

S466 "Editor's Table." PHILADELPHIA PHOTOGRAPHER 6, no. 69 (Sept. 1869): 324. [Some views and photographs of machinery.]

SEYMOUR, R. A.

S467 Seymour, R. A. "Entremets: In Search of an Operator." BRITISH JOURNAL OF PHOTOGRAPHY 9, no. 157-159 (Jan. 1 - Feb. 1, 1862): 13-14, 30-31, 49-50.

SHADBOLT, GEORGE. (1830-1901) (GREAT BRITAIN)

S468 Shadbolt, George. "On the Photographic Delineation of Microscopic Objects by Artificial Illumination." PHOTOGRAPHIC ART JOURNAL 5, no. 6 (June 1853): 367-370. [From "Q. J. of Microscopical Science."]

S469 Shadbolt, George. "On the Photographic Delineation of Microscopic Objects by Artificial Illumination." HUMPHREY'S JOURNAL 5, no. 20 (Feb. 1, 1854): 315-319. [From "Q. J. of Microscopic Science."]

S470 Shadbolt, George. "Some Observations upon Photographic Printing." PHOTOGRAPHIC AND FINE ART JOURNAL 9, no. 1 (Jan. 1856): 17-19. [From "J. of Photo. Soc., London."]

S471 Shadbolt, George. "Extracts from Foreign Publications - Further Observations on "Positive Printing" with Details of a New Toning Process." HUMPHREY'S JOURNAL 9, no. 1 (May 1, 1857): 5-9.

S472 Shadbolt, Geo. "On Focussing the Camera." HUMPHREY'S JOURNAL OF PHOTOGRAPHY, AND THE ALLIED ARTS AND SCIENCES 10, no. 14 (Nov. 15, 1858): 213-215. [From "Liverpool Photo. J."]

S473 Shadbolt, George. "On Suggestions for the Improvement of Landscape Photography, with Hints for the Enlargement of Negatives." LIVERPOOL & MANCHESTER PHOTOGRAPHIC JOURNAL [BRITISH JOURNAL OF PHOTOGRAPHY] n. s. 2, no. 23-24 (Dec. 1 - Dec. 15, 1858): 296-299, 317-318. [Read before the Historical Society of Lancashire and Cheshire.]

S474 Shadbolt, George. "The Solar Camera." AMERICAN JOURNAL OF PHOTOGRAPHY AND THE ALLIED ARTS & SCIENCES n. s. vol. 2, no. 11 (Nov. 1, 1859): 164-168.

S475 Shadbolt, George. "The Photographer's Tripod." BRITISH JOURNAL OF PHOTOGRAPHY 7, no. 127 (Oct. 1, 1860): 281-282. 2 illus.

S476 Shadbolt, Geo. "Some Remarks on Mounting Stereographs." HUMPHREY'S JOURNAL OF PHOTOGRAPHY, AND THE ALLIED ARTS AND SCIENCES 13, no. 6 (July 15, 1861): 93-94. [From "Br. J. of Photo."]

S477 Shadbolt, George. "On the Choice of a Dry Process." BRITISH JOURNAL OF PHOTOGRAPHY 8, no. 152 (Oct. 15, 1861): 357-359.

S478 Shadbolt, George. "On the Choice of a Dry Process." AMERICAN JOURNAL OF PHOTOGRAPHY AND THE ALLIED ARTS & SCIENCES n. s. vol. 4, no. 12 (Nov. 15, 1861): 269-275.

S479 Shadbolt, George. "On Washing Positive Proofs." AMERICAN JOURNAL OF PHOTOGRAPHY AND THE ALLIED ARTS & SCIENCES n. s. vol. 4, no. 16 (Jan. 15, 1862): 373-377.

S480 Shadbolt, George. "On Open Air Portraiture." BRITISH JOURNAL OF PHOTOGRAPHY 10, no. 191 (June 1, 1863): 224-225.

S481 Shadbolt, Geo. "Mounting Photographs." HUMPHREY'S JOURNAL OF PHOTOGRAPHY, AND THE ALLIED ARTS AND SCIENCES 15, no. 10 (Sept. 15, 1863): 152-153. [From "Br. J. of Photo."]

S482 "Presentation to Mr. Shadbolt." BRITISH JOURNAL OF PHOTOGRAPHY 12, no. 270 (July 7, 1865): 350. [Silver epergne given to Shadbolt to honor his services to the photographic community, after his retirement to look after his business.]

S483 "George Shadbolt." BRITISH JOURNAL PHOTOGRAPHY ALMANAC & PHOTOGRAPHER'S DAILY COMPANION, 1902 (1902): 688-689. [Obituary. Shadbolt editor of the "British Journal of Photography" from 1857 to 1864, then "the growth of his private business necessitated his retirement from photography and its journalism." A founder of the Photographic Society of London, now the Royal Photographic Society. Wrote about lenses,

microphotography, open-air portraiture. His son, C. V. S. Shadbolt, interested in balloon photography; accidentally killed.]

SHAHAN & BEGMATS.
S484 *A History of the Emperors of Delhi in the Mughal Family, with 56 Photographs by Shahan and Begmats;* compiled by Munshi Bulaqi Dass, son of the late Rai Juggan Lal, Assistant Private Secretary in the British Government Agency, Delhi, and a grandson of Rai Sona Mull, Risalder in the Nizam's States, Hyderabad, Deccan. Delhi: s. n., n. d. [ca. 1870]. n. p. 56 b & w.

SHAKESPEAR.
S485 "The Photographic Tourist: A Photographic Trip to Bassar by Major Shakespear, B.A." PHOTOGRAPHIC NEWS 4, no. 99-100 (July 27-Aug. 3, 1860): 149-150, 162-164.

SHARP, T.
S486 "Photography on Wood." HUMPHREY'S JOURNAL OF PHOTOGRAPHY, AND THE ALLIED ARTS AND SCIENCES 9, no. 17 (Jan. 1, 1858): 261-262. [From "Photo. Notes." T. Sharp's process.]

SHARPE & MELVILLE.
S487 Portrait. Woodcut engraving credited "From a photograph by Sharpe & Melville." ILLUSTRATED LONDON NEWS 27, (1855) ["Major-General Windham, C.E." 27:* (Oct. 6, 1855): 401.]

S488 Portrait. Woodcut engraving credited "From a photograph by Sharpe & Melville." ILLUSTRATED LONDON NEWS 30, (1857) ["Right Rev. Dr. Bickersteth." 30:* (Jan. 17, 1857): 43.]

SHAW. (SCHENECTADY, NY)
S489 Portraits. Woodcut engravings, credited "Photographed by Shaw, of Schenectady, N. Y." FRANK LESLIE'S ILLUSTRATED NEWSPAPER 11, (1861) ["Nicholas Veeder, one hundred year old, Revolutionary war veteran." (Outdoor portrait)." 11:279 (Mar. 30, 1861): 300.]

SHAW, C. A.
S490 Shaw, C. A. "On the Use of Photographs as Art Studies." PHOTOGRAPHIC WORLD 1, no. 12 (Dec. 1871): 367-369.

SHAW, GEORGE. (1818-1904) (GREAT BRITAIN)
BOOKS
S491 Shaw, George. *Photographic Studies.* Birmingham, London: Joseph Cundall, 1853. n. p. 8 b & w. [Original calotype prints. Shaw was the Professor of Chemistry at Queen's College.]

PERIODICALS
S492 "Fine Arts: New Publications." ATHENAEUM no. 1365 (Dec. 24, 1853): 1559. [Reviews of George Shaw's "Photographic Studies nos. I and II," (Cundall) and Hugh Owen's "Photographic Pictures," Parts I and II (Cundall).]

S493 "Mr. George Shaw." PHOTOGRAPHIC COLLECTOR 1, no. 2 (Autumn 1980): 36-39. 1 b & w. [George Shaw was Professor of Chemistry at Queen's College, Birmingham in the 1850s. Self-portrait daguerreotype. Article includes an obituary from the "Birmingham Daily Post," 15 Aug. 1904, letters.]

SHAW, GEORGE. [?]
S494 "Scientific and Literary: Royal Institution Mar. 14.: 'On Some Photographic Phenomena,' by Mr. Shaw." ATHENAEUM no. 909 (Mar. 29, 1845): 312-313.

SHAW, NICKERSON & GARRETT. (LOUISVILLE, KY)
S495 "Camp Boone - The Kentucky State Guard's First Encampment, on the Fair Grounds, Louisville, Ky., August 23, 1860. - Photographed by Shaw, Nickerson & Garrett, Louisville, Ky." FRANK LESLIE'S ILLUSTRATED NEWSPAPER 10, no. 254 (Oct. 6, 1860): 315. 1 illus. [View, with figures.]

SHAW, WILLIAM. (d. 1895) (USA)
S496 Portrait. Woodcut engraving, credited "From a Photograph by William Shaw, Chicago." FRANK LESLIE'S ILLUSTRATED NEWSPAPER 32, (1871) ["Rev. Charles E. Cheney." 32:818 (June 3, 1871): 189.]

S497 "Chicago, Ill. - The Opening of the New Canal - Inauguration of the Deep Cut Which Establishes a Back Current from Lake Michigan to the Mississippi River. - From a Photograph by Shaw." FRANK LESLIE'S ILLUSTRATED NEWSPAPER 32, no. 830 (Aug. 26, 1871): 400 . 1 illus. [View, with figures.]

S498 "The Heart of Chicago in Ruins. - Panoramic View of the Burnt District, Looking Eastward Toward the Lake. - From Sketches by Joseph Becker, and Photographs by Wm. Shaw." FRANK LESLIE'S ILLUSTRATED NEWSPAPER 33, no. 839 (Oct. 28, 1871): n. p., tipped-in. 1 illus. [Ruins.]

S499 "Exterior View of the Cincinnati Soup-House at Chicago. - Photographed by Shaw." FRANK LESLIE'S ILLUSTRATED NEWSPAPER 33, no. 843 (Nov. 25, 1871): 161. 1 illus. [View.]

S500 "Chicago. - The Court-House Bell. - From a Photograph by Shaw." FRANK LESLIE'S ILLUSTRATED NEWSPAPER 33, no. 843 (Nov. 25, 1871): 172. 1 illus.

S501 "Chicago. - The Clark Street Bridge Over the Chicago River, the First Bridge Rebuilt Since the Great Fire. - From a Photograph by Shaw." FRANK LESLIE'S ILLUSTRATED NEWSPAPER 33, no. 855 (Feb. 17, 1872): 357. 1 illus. [View.]

S502 "Laying of the Corner-Stone of the New Custom House and Post Office, June 24th. - From Photographs by William Shaw, and Sketches by Joseph B. Beale." FRANK LESLIE'S ILLUSTRATED NEWSPAPER 38, no. 980 (July 11, 1874): 280-281. 1 illus. [Building views, with crowds.]

S503 "The New Hall of Trade and Chamber of Commerce, Washington Street, Chicago.- From a Photograph by W. Shaw, Chicago."" FRANK LESLIE'S ILLUSTRATED NEWSPAPER 21, no. 522 (Sept. 30, 1865): 29. 1 illus.

S504 "Chicago As It Is." FRANK LESLIE'S ILLUSTRATED NEWSPAPER 33, no. 841 (Nov. 11, 1871): 136, 140-141. 8 illus. [Ruins after the fire. Five credited "From a Photograph by William Shaw," Three credited "From a Sketch by Joseph Becker."]

S505 "Editor's Table: Obituary." WILSON'S PHOTOGRAPHIC MAGAZINE 33, no. 469 (Jan. 1896): 46. [Born in NY, to Chicago, IL, began taking ambrotypes. Photographed the Chicago fire, invested in orange grove in Florida, lost his money, returned to photography in Chicago again, tried oranges again, failed again, opened a studio in Atlanta, GA, with his sons.]

S506 Ostendorf, Lloyd. "An Original Lincoln Photograph Uncovered." LINCOLN HERALD 68, no. 3 (Fall 1966): 130-134. 1 b & w. [Photo probably made in Chicago, IL, in 1860, by William Shaw.]

SHEAFFER, S. G.

S507 Sheaffer, S. G. "How to Take Children's Pictures." HUMPHREY'S JOURNAL OF PHOTOGRAPHY, AND THE ALLIED ARTS AND SCIENCES 15, no. 18 (Jan. 15, 1864): 283-284. [Sheaffer's letter and Towler's reply.]

SHEAR, S. R. (OSSIAN, IA)

S508 "Letter." PHILADELPHIA PHOTOGRAPHER 6, no. 65 (May 1869): 170. [Letter describing in detail his photograph wagon.]

SHELDON.

S509 "Reception of Crimean Soldiers in Kingston, Canada West. - From a Photograph by Sheldon." FRANK LESLIE'S ILLUSTRATED NEWSPAPER 2, no. 35 (Aug. 9, 1856): 137. 1 illus. [View, with figures.]

SHEPHERD & CO.

S510 *Shepherd & Co.'s "Universal" Guide to Photography*, by a Practical Photographer. "3rd ed." London: E. Marlborough & Co., Shepherd & Co., 1860. n. p.

SHEPHERD, CHARLES see also BOURNE & SHEPHERD.

SHEPHERD, CHARLES.

S511 Cole, Henry Hardy, Lieut. *The Architecture of Ancient Delhi; Especially the Buildings around the Kuth Minar.* London: Arundel Society, 1872. n. p. 25 b & w. [Woodburytypes and Autotypes, from negatives by Shepherd.]

SHERIDAN, JAMES PETER. (d. 1861) (GREAT BRITAIN, ARGENTINA)

S512 "Obituary." BRITISH JOURNAL OF PHOTOGRAPHY 8, no. 139 (Apr. 1, 1861): 135. ["Obituary - Suddenly, at his residence, the Estanci de los Sajoues, Buenos Ayres, James Peter Sheridan, Esq., formerly a member of the Liverpool Photographic Society, and an ardent photographer in the waxed-paper process."]

SHERLOCK, W.

S513 "Fine-Art Gossip." ATHENAEUM no. 1315 (Jan. 8, 1853): 56. [Includes a letter from W. Sherlock correcting the typographic error in the Society of Fine Arts Exhibition checklist stating that his photo was taken by a Mr. Sandford, which was repeated in the Jan. 1, 1853 "Athenaeum" review of the exhibition.]

SHERMAN, T. P.

S514 "The Des Moines Cavalry Company Leaving Des Moines (Iowa) for the War." HARPER'S WEEKLY 5, no. 247 (Sept. 21, 1861): 604. 1 illus. ["Photographed by T. P. Sherman."]

SHERMAN, WILLIAM H. (1821-1898) (USA)

S515 Sherman, W. H. "How to Recover Silver and Gold." AMERICAN JOURNAL OF PHOTOGRAPHY AND THE ALLIED ARTS & SCIENCES n. s. vol. 7, no. 14 (Jan. 15, 1865): 322-323.

S516 Sherman, W. H. "On Intensifying Negatives." AMERICAN JOURNAL OF PHOTOGRAPHY AND THE ALLIED ARTS & SCIENCES n. s. vol. 7, no. 18 (Mar. 15, 1865): 409-410.

S517 Sherman, W. H. "Fifth Annual Meeting and Exhibit of the National Photographic Association of the U.S., held in Buffalo, N.Y., beginning July 5, 1873: Printing, Toning and Finishing." PHILADELPHIA PHOTOGRAPHER 10, no. 117 (Sept. 1873): 377-382.

S518 Sherman, W. H. "Fuming Paper." BRITISH JOURNAL PHOTOGRAPHIC ALMANAC 1875 (1875): 47-49. 1 illus. [Sherman from Milwaukee, WI.]

S519 Sherman, William H. "A New Way of Treating an Old Bath." BRITISH JOURNAL PHOTOGRAPHIC ALMANAC 1876 (1876): 68-69.

S520 Sherman, W. H. "Restoring Exposed Plates." BRITISH JOURNAL PHOTOGRAPHIC ALMANAC 1877 (1877): 112-113.

S521 Sherman, W. H. "Dust." BRITISH JOURNAL PHOTOGRAPHIC ALMANAC 1878 (1878): 191-193.

S522 Sherman, W. H. "Ferrous Oxalate Redeveloper." BRITISH JOURNAL PHOTOGRAPHIC ALMANAC 1879 (1879): 70-71.

S523 Sherman, W. H. "The Rise and Fall of the Daguerreotype." PHOTOGRAPHIC TIMES 20, no. 484 (Dec. 26, 1890): 650-651. [Sherman was a working daguerreotypist. This article primarily a general discussion of the process, and a discussion of its strengths and weaknesses.]

S524 Sherman, W. H. "The Rise and Fall of the Daguerreotype. (As Seen by a Country "Operator"). Parts 1-8." PHOTOGRAPHIC TIMES 21, no. 489, 495, 500, 504, 520, 522, 527, 535 (Jan. 30, Mar. 13, Apr. 17, May 15, Sept. 4, Sept. 18, Oct. 23, Dec. 18, 1891): 52-53, 125-127, 183-185, 231-233, 442-443, 466-467, 525-526, 641-642. 1 illus.

S525 Sherman, W. H. "A Plea for Simplicity in Position." PHOTOGRAPHIC TIMES 21, no. 512 (July 10, 1891): 340-341. [Sherman, apparently a professional, argues for traditional values against "... the mannerism of the New York school of photographic art."]

S526 Sherman, W. H. "The Past and Future of the Albumen Print." AMERICAN ANNUAL OF PHOTOGRAPHY AND PHOTOGRAPHIC TIMES ALMANAC FOR 1892 (1892): 23-25. [General commentary of albumen prints, reports on the preservation quality of photos taken in the 1860s.]

S527 Sherman, W. H. "The Lowest Round of the Ladder." PHOTOGRAPHIC TIMES 22, no. 537 (Jan. 1, 1892): 4-5. [Article about professional portraiture.]

S528 "William H. Sherman." WILSON'S PHOTOGRAPHIC MAGAZINE 35, no. 502 (Oct. 1898): 458-459. [Died Sept. 7, 1898 at age 77. Born Lunenberg, VA in 1821. Located in Milwaukee, WI in 1860. Entered business at Grie, PA in 1855, associated in the business of Hugo von Broich.]

SHERWOOD, C. C. (PEEKSKILL, NY)

S529 "Editor's Table." PHILADELPHIA PHOTOGRAPHER 6, no. 69 (Sept. 1869): 324. [Specimen of portrait work noted.]

S530 "St. Paul's M. E. Church, Peekskill, N. Y. Rev. Milton S. Terry, Pastor. - From a Photograph by G. C. Sherwood." FRANK LESLIE'S ILLUSTRATED NEWSPAPER 28, no. 712 (May 22, 1869): 149. 2 illus. [View. Portrait.]

SHERWOOD, J. D. [?]

S531 "Queen Isabella II of Spain - Pantheon of Royal Vault of the Escorial, Spain." HARPER'S WEEKLY 11, no. 561 (Sept. 28, 1867): 613. 2 illus. [Portrait of Isabella is a standard studio portrait. Interior

credited as "...Mr. J. D. Sherwood, who furnished the original photograph from which our engraving is made."]

SHEW, M. (PHILADELPHIA, PA)
S532 "Magnifying Daguerreotype Case." HUMPHREY'S JOURNAL 7, no. 10 (Sept. 15, 1855): 160. 1 illus. [Case developed by M. Shew, a dealer in Philadelphia, PA, with a magnifying glass.]

SHEW, WILLIAM. (1820-1903) (USA)
BOOKS
S533 Soulbe, Frank, John H. Gilhon, M.D. and James Nisbet. *The Annals of San Francisco; Containing a Summary of the History of... California, and a Complete History of... Its Great City. To Which is added, Biographical Memoirs of Some Prominent Citizens. ...Illustrated with One Hundred and Fifty Fine Engravings.* New York "D. Appleton & Co." 1855. 824 pp. [Illustrated with woodcuts drawn from daguerreotypes by William Shew.]

PERIODICALS
S534 "Humphrey's Journal." HUMPHREY'S JOURNAL 4, no. 3 (May 15, 1852): 44. [Views of San Francisco, CA, taken by Wm. Shew, formerly of Boston, MA.]

S535 "Photography." THE PIONEER, OR CALIFORNIA MONTHLY MAGAZINE 2, (1854): 34-40.

S536 Froebe, Th. W. "Photography in San Francisco and Honolulu." BRITISH JOURNAL OF PHOTOGRAPHY 10, no. 196 (Aug. 15, 1863): 329-330. [From "Photographisches Archiv." The author, a German, discusses a process learned from William Shew, "while we were both staying in San Francisco five years since...", then describes using the process in the Sandwich Islands.]

S537 Froebe, Th. W. "Photography in San Francisco and Honolulu." HUMPHREY'S JOURNAL OF PHOTOGRAPHY, AND THE ALLIED ARTS AND SCIENCES 15, no. 9 (Sept. 1, 1863): 134-136. [From "Photographisches Archiv." "Whilst I was in San Francisco, five years ago, such pictures (on canvas) were made by Mr. Wm. Shew in the following manner:...." "...in the Sandwich Islands (in Honolulu) where I practiced as a photographer." (during 1850's).]

S538 1 engraving (Portrait of Thomas H. Selby). CALIFORNIA MAIL BAG 1, no. 5 (Dec. 1871): frontispiece. 1 illus. [From a photograph by William Shew, accompanying a biography of the sitter.]

S539 Lange, O. V. "A Portrait Photographer for More than Half a Century in San Francisco." CAMERA CRAFT 5, no. 3 (July 1902): 100-107. 9 b & w. [Three of the illustrations are self portraits of Shew at different ages. This article was written by a friend of Shew's, while he was still alive. "William Shew came to San Francisco by way of the Isthmus of Panama in 1850, bringing with him a small photographic gallery mounted on wheels..." Born on a farm near Watertown, Jefferson Co., NY. Shew taught in country schools when a young man. He read about the newly invented daguerreotype process in the *New York Observer*. Brother to Jacob, Myron and Trueman Shew, all of whom studied daguerreotypy from S. F. B. Morse in 1841, all of whom worked as photographers. They began daguerreotyping in Watertown, then moved to Ogdensburg, NY, where they put up the first skylight gallery and drew most of their patronage from the English army officers stationed at Prescott, on the Canadian side of the St. Lawrence River. The Shews soon moved to Rochester, NY, then to Geneva, NY. Not being very successful at any of these towns, the family then moved to New York, NY, where they formed the firm of L. P. Hayden & Co. at 1 Park Place. In 1841 John Plumbe hired the brothers to superintend three of his galleries located in different cities.

William Shew went to Boston, Trueman Shew went to Philadelphia, and Jacob Shew, who subsequently would also open a gallery in San Francisco, went to Baltimore. William opened his own gallery in Boston in 1845, where he manufactured and sold daguerreotype cases and materials in addition to taking portraits. Although the business went well William moved to San Francisco, CA in 1850, bringing a portable gallery on wheels with him. He took his portable gallery around the mining camps and gold fields, but based himself in San Francisco. He was burned out of several locations, but he continued and prospered. Over the years Shew taught many individuals photography. He operated his gallery in San Francisco until his death in 1903.]

S540 Calmenson, Wendy Cunkle. "Likenesses Taken In the Most Approved Style: William Shew, Pioneer Daguerreotypist." CALIFORNIA HISTORICAL QUARTERLY 56, no. 1 (Spring 1977): 2-19. 16 b & w. 1 illus.

SHINDLER, ANTONIO Z. see also MCCLEES, JAMES E.

SHINDLER, ANTONIO ZENO. (1823-1899) (AUSTRIA, USA)
[Antonio Zeno Shindler was born in the area which is now Bulgaria. He apparently fled to France as a child and lived with a Dr. Shindler and adopted his name. He studied art in France. Emigrated to the USA and was working in Philadelphia by the 1850s. In 1867 he moved to Washington, DC and opened a photographic gallery, which he maintained until the early 1870s. Shindler acquired the Washington studio of James E. McClees which had closed in 1863, and he also probably acquired that studio's negatives at the same time. Many of the portraits of Indians later credited to Shindler were taken earlier by the McClees studio. From 1871 to 1876 Shindler lived in New York and Philadelphia. He returned to Washington in 1876 as the artist for the U. S. National Museum. He died in Washington on Aug. 8, 1899.]

S541 *Photographic Portraits of North American Indians in the Gallery of the Smithsonian Institution.* "Smithsonian Miscellaneous Publications, vol. 14, art. 7, pub. 216" Washington, DC: Smithsonian Institution Press, 1867. [sic 1869] 42 pp. [List of 301 photographs in this collection. Photographs either credited to "Shindler, photo, Washington," or "Copied by Shindler, Washington, 1869." Dates of copyright statement read 1867 to 1869, although the publication is dated 1867.]

SHIPLER, A. J.
S542 Shipler, A. J. "My Practice: Improved Methods of Working - A Tank for Washing Parts." PHILADELPHIA PHOTOGRAPHER 14, no. 161 (May 1877): 142-143.

SHOEMAKER, W. L. (PHOENIXVILLE, PA)
S543 Shoemaker, W. L. "Cleaning the Daguerreotype." PHILADELPHIA PHOTOGRAPHER 14, no. 164 (Aug. 1877): 233.

S544 Shoemaker, W. L. "Preparing Photographs for Reproduction by the Half-tone Process." PHOTOGRAPHIC MOSAICS:1892 28, (1892): 242-244, plus unnumbered leaf. 1 b & w. [Shoemaker from Phoenixville, Pa.]

SHORT, JOHN GOLDEN. (ca. 1830-) (GREAT BRITAIN)
S545 Phillips, C. J. *The New Forest Handbook.* Lyndhurst, England: 1876. 106 pp. b & w.

SHRIVE, DAVID. (USA)
S546 "Shrive's Patent Portable Heliotropic Solar Camera." HUMPHREY'S JOURNAL OF PHOTOGRAPHY, AND THE ALLIED

ARTS AND SCIENCES 16, no. 15 (Dec. 1, 1864): 239. [Shrive's camera being reissued by John H. Simmons, of Philadelphia, PA.]

S547 "Shive's Patent Solar Camera." PHILADELPHIA PHOTOGRAPHER 2, no. 14 (Feb. 1865): 22-23. 2 illus.

S548 Shive, David. "More Facts about the Solar Camera." HUMPHREY'S JOURNAL OF PHOTOGRAPHY, AND THE ALLIED ARTS AND SCIENCES 17, no. 12 (Oct. 15, 1865): 189-190.

S549 Shrive, David. "Correspondence: Another Reply to Mr. Lochman." PHOTOGRAPHIC TIMES 21, no. 493 (Feb. 27, 1891): 105. [Shrive states that he met a daguerreotypist in 1859 who claimed to have been cured of consumption by working in a dark room.]

SIDEBOTHAM, JOSEPH. (1824-1885) (GREAT BRITAIN)
S550 "Extracts from Foreign Publications - Manchester Photographic Society." HUMPHREY'S JOURNAL 9, no. 2 (May 15, 1857): 26-30. [Paper on Collodio-Albumen process by Mr. Sidebotham.]

S551 Sidebotham, Joseph. "On Some of the Causes of Distortion in Photographic Portraits." BRITISH JOURNAL OF PHOTOGRAPHY 8, no. 138 (Mar. 15, 1861): 102-103. 1 illus.

S552 Sidebotham, Joseph. "On Printing Transparencies for the Stereoscope and Magic Lantern." AMERICAN JOURNAL OF PHOTOGRAPHY AND THE ALLIED ARTS & SCIENCES n. s. vol. 7, no. 13 (Jan. 1, 1865): 302-305. [Read to Photo. Section of the Literary and Philosophical Society of Manchester.]

S553 Sidebotham, J. "On Certain Phenomena Connected with the Perspective and Measurement of Photographic Pictures." BRITISH JOURNAL OF PHOTOGRAPHY 12, no. 249 (Feb. 10, 1865): 69-70. ["...matters connected with landscape photography."]

S554 Milligan, H. "Joseph Sidebotham: A Victorian Amateur Photographer." PHOTOGRAPHIC JOURNAL 118, no. 2 (Mar. - Apr. 1978): 82-87. 6 b & w.

SILLIMAN, B., JR.
S555 Silliman, B., Jr. and Wm. Henry Goode. "A Daguerreotype Experiment by Galvanic Light." DAGUERREAN JOURNAL 1, no. 5 (Jan. 15, 1851): 139-140. [From "Silliman's Journal."]

S556 Silliman, B., Jr. "Daguerreotypes by Galvanic Light." DAGUERREAN JOURNAL 1, no. 11 (Apr. 15, 1851): 333-334. [From "Silliman's Journal," 1851.]

SILSBEE, CASE & CO.
S557 "M'lle. Louise Lamoureaux, the Celebrated Danseuse." BALLOU'S PICTORIAL DRAWING-ROOM COMPANION [GLEASON'S] 14, no. 3 (Jan. 16, 1858): 33. 1 illus. ["...from a photograph by Silsbee, Case, & Co., of this city."]

S558 "The Ravel Brothers." BALLOU'S PICTORIAL DRAWING-ROOM COMPANION [GLEASON'S] 14, no. 8 (Feb. 20, 1858): 113. 1 illus. [Actors. "...from a fine photograph by Silsbee, Case & Co."]

S559 "William E. Burton, Esq., Comedian." BALLOU'S PICTORIAL DRAWING-ROOM COMPANION [GLEASON'S] 15, no. 23 (Dec. 4, 1858): 353. 1 illus. ["...from a photograph by Silsbee, Case & Co."]

S560 "Franklin Haven, Esq." BALLOU'S PICTORIAL DRAWING-ROOM COMPANION [GLEASON'S] 15, no. 24 (Dec.

11, 1858): 369. 1 illus. [This article, which is a biography of a businessman, begins with a discussion of the phenomenon of the growth of illustrated biography in magazines, and of photography's role in this phenomenon. The portrait is by Silsbee, Case & Co.]

S561 "The Useful and Beautiful Arts." BALLOU'S PICTORIAL DRAWING-ROOM COMPANION [GLEASON'S] 15, no. 24 (Dec. 11, 1858): 381. [Praise for the gallery of Silsbee, Case & Co. and a description of their promotional brochure, "A Glance of the Progress and Position of the Useful and Beautiful Arts," which describes the studio.]

S562 Portraits. Woodcut engravings, credited "From a Photograph by Silsbee, Case & Co." BALLOU'S PICTORIAL DRAWING-ROOM COMPANION [GLEASON'S] 16, (1859) 3 illus. ["M. Wight, the Artist." 16:410 (Apr. 30, 1859): 285. "The late Col. Samuel Jaques." 16:411 (May 7, 1859): 289. "Madame Laborde, the Prima Donna." 16:418 (June 25, 1859): 401.]

S563 "Capt. Robert B. Forbes." BALLOU'S PICTORIAL DRAWING-ROOM COMPANION [GLEASON'S] 17, no. 426 (Aug. 20, 1859): 113. 1 illus. "William Evans Burton, the Comedian." FRANK LESLIE'S ILLUSTRATED NEWSPAPER 9, no. 221 (Feb. 25, 1860): 202. 4 illus. [Four costume portraits of the late actor. One credited to Silsbee, Case & Co., Boston, two credited to J. Gurney, one credited "from Weston's Photograph."]

S564 Portrait. Woodcut engraving, credited "From a Photograph by Silsbee, Case & Co." FRANK LESLIE'S ILLUSTRATED NEWSPAPER 9, (1860) ["Oliver Wendall Holmes." 9:225 (Mar. 24, 1860): 258.]

S565 "Longfellow." FRANK LESLIE'S ILLUSTRATED NEWSPAPER 10, no. 245 (Aug. 4, 1860): 166. 2 illus. [Portrait, view of Longfellow's seashore residence at Nahant, MA. Both credited to Silsbee, Case & Co.]

S566 Portrait. Woodcut engraving, credited "From a Photograph by Silsbee, Case & Co." FRANK LESLIE'S ILLUSTRATED NEWSPAPER 10, (1860) ["The late Rev. Theodore Parker of Boston." 10:237 (June 9, 1860): 40.]

S567 Portraits. Woodcut engravings, credited "Photographed by Silsbee, Case & Co., Boston." FRANK LESLIE'S ILLUSTRATED NEWSPAPER 10, (1860) ["The late Rembrandt Peale, artist." 10:256 (Oct. 20, 1860): 339.]

S568 Portrait. Woodcut engraving, credited "From a Photograph by Silsbee, Case & Co." FRANK LESLIE'S ILLUSTRATED NEWSPAPER 12, (1861) ["Maj.-Gen. B. F. Butler, USA." 12:287 (May 17, 1861): 5.]

SILSBEE, GEORGE M. see also MASURY & SILSBEE; MASURY, SILSBEE & CASE; SILSBEE, CASE & CO.

SILSBEE, GEORGE M. (1816-1866) (USA)
[George M. Silsbee was born in Maine in 1816. He formed a photographic partnership with Marcus Ormsbee in Portland, ME in 1847 which lasted until 1849. Silsbee opened his own studio in Portland in 1849, but then moved to Boston, MA where he briefly rejoined Ormsbee. In 1852 Silsbee joined Samuel Masury to form Masury & Silsbee, a firm which lasted until 1854. J. G. Case (1808-1880) joined the firm in 1855. Masury left in 1858 and the partnership of Silsbee, Case & Co. worked in Boston until 1863. Silsbee left the firm in 1863, with the intention of becoming an artist, but his mental health deteriorated and he died of "mania" in a lunatic asylum in 1866.]

BOOKS

S569 Warren, John Collins. *Remarks on Some Fossil Impressions in the Sandstone Rocks of the Connecticut River*. Boston: Ticknor & Fields, 1854. 56 pp. 1 b & w. [One salt paper print. The second American book illustrated with a photograph.]

PERIODICALS

S570 Masury, S. "Obituary." HUMPHREY'S JOURNAL OF PHOTOGRAPHY, AND THE ALLIED ARTS AND SCIENCES 17, no. 23 (Apr. 1, 1866): 365. [Expression of regret at death of George M. Silsbee, offered by S. Masury, President of the New England Photo. Soc.]

S571 "Obituary." PHILADELPHIA PHOTOGRAPHER 3, no. 29 (May 1866): 153. [Letter from S. Masury, Pres. of the New England Photographic Society, expressing regret at the death of George M. Silsbee, "one of our oldest and most estimable members."]

SILVER & WATERMAN.

S572 "New York City. - Terrible Explosion of a Load of Torpedoes in Beekman Street. - From a Photograph by Silver & Waterman." FRANK LESLIE'S ILLUSTRATED NEWSPAPER 33, no. 835 (Sept. 30, 1871): 45. 1 illus. [Ruins.]

SILVIS, J. B.

S573 "Note." ANTHONY'S PHOTOGRAPHIC BULLETIN 6, no. 2 (Feb. 1875): 53. [From "Papillon Times." "J. B. Silvis - he who meanders up and down the U.P. in his palatial photograph car, seeking the shadows of us poor terrestrial mortals,..."]

SILVY, CAMILLE. (b. 1835) (FRANCE, GREAT BRITAIN)

[A diplomat who began a new career as a commercial photographer and opened a studio in Paris around 1858, then moved to London and opened a studio there in 1859, where he makes portraits of high society members and the like. Member of the Société française de Photographie in 1858. In addition to portraits, Silvy also photographed buildings and landscapes, animals, views with figures, reproductions of art, etc. In 1860s he promoted the idea of making photographic copies of rare manuscripts. Made many carte-de-visite portraits, including one series titled "Les Beautés d'Angleterre." Exhibited through the 1860s. His studio employed forty people in 1869, when he sold it and retired to his family chateau in France. Reopened a studio in Paris after the Franco-Prussian War, then returned to England as a Consul.]

BOOKS

S574 *Orleans House Fete Champetre Album*. London: Camille Silvy, 1864. 14 12 b & w. [Original photographs. Printed title page and contents page. "Album photographed and published for the benefit of the Société Française de Bienfaisance by Camille Silvy."]

PERIODICALS

S575 "Classification of Photography." BRITISH JOURNAL OF PHOTOGRAPHY 8, no. 151 (Oct. 1, 1861): 335-336. [Silvy sent a letter disclaiming that photography was an art, editorial reply here.]

S576 "Fire at M. Silvy's." BRITISH JOURNAL OF PHOTOGRAPHY 9, no. 176 (Oct. 15, 1862): 395. [Silvy's studio at Bayswater, burned with great loss.]

S577 Portrait. Woodcut engraving credited "From a photograph by Silvy, Porchester Terrace, Bayswater." ILLUSTRATED LONDON NEWS 51, (1867) ["Sir Thomas Troubridge, C.B." 51:* (Oct. 19, 1867): 420.]

S578 Garner, Phillipe. "Silvy Portrait: Arrested Motion." HISTORY OF PHOTOGRAPHY 2, no. 1 (Jan. 1978): ii. 1 b & w.

SIMMONS & CO.

S579 "A Good Chance." HUMPHREY'S JOURNAL OF PHOTOGRAPHY, AND THE ALLIED ARTS AND SCIENCES 18, no. 2 (May 15, 1866): 26. [Simmons & Co., No. 390 Bowery wish to sell their solar printing operation, focus their energies on manufacturing solar cameras.]

SIMONS, MONTGOMERY P. (1816-1877) (USA)

[Partner with Collins in 1845 in Philadelphia. Daguerreotype case manufacturer from 1843 to 1847. Exhibited daguerreotypes at the Institute of American Manufacture from 1845 to 1848. Worked in Richmond, VA from 1851 to 1857. Authored several manuals.]

BOOKS

S580 Simons, Montgomery P. *Plain Instructions for Colouring Photographs in Water Colours and India Ink: with a Palette of Flesh Tints, and Notes of Explanation*. Philadelphia: T. K. & F. G. Collins, 1857. 42 pp. 1 l. of plates. illus. [2nd ed. (1857) variant subtitle: "...Embracing Full Directions for Colouring Photographs, Engravings, Lithographs, Etc., by the Grecian Process." 61 pp.]

S581 Simons, M. P. *Photography in a Nut Shell, or, The Experience of an Artist in Photography, on Paper, Glass and Silver, with Illustrations*. Philadelphia: King & Baird, 1858. x, 107 pp. 2 illus.

S582 Simons, M. P. *The Secrets of Ivorytyping Revealed, or, Every Photographer His Own Artist*. Philadelphia: J. B. Lippincott & Co., 1860. 57 pp.

PERIODICALS

S583 "Gossip." PHOTOGRAPHIC ART JOURNAL 4, no. 5 (Nov. 1852): 319-322. [Exchange of letters between M. P. Simons, of Philadelphia, PA, excoriating the "cheap" $.50 operators and Moulson, defending himself.]

S584 "Gossip." PHOTOGRAPHIC ART JOURNAL 5, no. 1 (Jan. 1853): 66-67. [Reprint of an essay, 'A short dissertation on the daguerrean art,' plus 'An anecdote of Henry Clay,' from a Richmond, VA, paper reprinted. Article by M. P. Simons who took "My Likeness of Mr. Clay, which has elicited so many comments from the Press."]

S585 "A Scene at Simons' Daguerrean Rooms, Richmond, Va." PHOTOGRAPHIC ART JOURNAL 6, no. 1 (July 1853): 33-34. [Anecdote.]

S586 Simons, M. P. "Mr. Peter Slumpkins." PHOTOGRAPHIC AND FINE ART JOURNAL 10, no. 4 (Apr. 1857): 123-124. [Comic parody of a fictitious daguerrean artist's biography, written by a real practitioner.]

S587 Simons, M. P. "Negatives Not to be Sold." AMERICAN JOURNAL OF PHOTOGRAPHY AND THE ALLIED ARTS & SCIENCES n. s. vol. 7, no. 10 (Nov. 15, 1864): 232-234.

S588 Simons, M. P. "A Name Wanted." AMERICAN JOURNAL OF PHOTOGRAPHY AND THE ALLIED ARTS & SCIENCES n. s. vol. 7, no. 19 (Apr. 1, 1865): 448-449.

S589 Simons, M. P. "An Easy and Cheap Method for Removing the Silver from used Developing Solution." AMERICAN JOURNAL OF PHOTOGRAPHY AND THE ALLIED ARTS & SCIENCES n. s. vol. 7, no. 20 (Apr. 15, 1865): 471-472.

S590 Simons, M. P. "The Old Homestead." AMERICAN JOURNAL OF PHOTOGRAPHY AND THE ALLIED ARTS & SCIENCES n. s. vol. 8, no. 9 (Nov. 1, 1865): 210-211.

S591 Simons, M. P. "A Few Remarks on Focussing Glasses." AMERICAN JOURNAL OF PHOTOGRAPHY AND THE ALLIED ARTS & SCIENCES n. s. vol. 8, no. 11 (Dec. 1, 1865): 258-259.

S592 "Photographing at the Natural Bridge, Va." ANTHONY'S PHOTOGRAPHIC BULLETIN 1, no. 11 (Dec. 1870): 211-213.

S593 Simons, M. P. "On the Fading and Turning Yellow of the Photograph." ANTHONY'S PHOTOGRAPHIC BULLETIN 2, no. 5 (May 1871): 132-133.

S594 Simons, M. P. "An Exquisite Picture." ANTHONY'S PHOTOGRAPHIC BULLETIN 2, no. 6 (June 1871): 179. [Anecdote of photographing a baby in "the early days of daguerreotyping."]

S595 Simons, M. P. "On Pencilling Negatives.- The Best Kind of Varnish for the Purpose, Etc." ANTHONY'S PHOTOGRAPHIC BULLETIN 2, no. 9 (Sept. 1871): 297-298.

S596 Simons, M. P. "What Shall We Do with Our Old Camera Tubes?" ANTHONY'S PHOTOGRAPHIC BULLETIN 2, no. 10 (Oct. 1871): 329-330.

S597 Simons, M. P. "Correspondence." ANTHONY'S PHOTOGRAPHIC BULLETIN 2, no. 11 (Nov. 1871): 368-369. [Simons (Philadelphia, PA), about printing. Mentions John R. Clemons' experiments.]

S598 Simons, M. P. "A Plea for the Little Stereoscope and the Stereoscope Portrait." ANTHONY'S PHOTOGRAPHIC BULLETIN 3, no. 3 (Mar. 1872): 469-470.

S599 Simons, M. P. "On Working Up Negatives." ANTHONY'S PHOTOGRAPHIC BULLETIN 3, no. 5 (May 1872): 550-551.

S600 Simons, M. P. "College for Teaching Photography." ANTHONY'S PHOTOGRAPHIC BULLETIN 3, no. 6 (June 1872): 568-569.

S601 Simons, M. P. "Bubbles." ANTHONY'S PHOTOGRAPHIC BULLETIN 3, no. 9 (Sept. 1872): 669.

S602 Simons, M. P. "Expression." ANTHONY'S PHOTOGRAPHIC BULLETIN 4, no. 1 (Jan. 1873): 5. [Advice for portrait photographers.]

S603 Simons, M. P. "A Few Thoughts Suggested on Looking Over My Photographic Album." ANTHONY'S PHOTOGRAPHIC BULLETIN 4, no. 4 (Apr. 1873): 113-115.

S604 Simons, M. P. "On Choice of Paper for Views." ANTHONY'S PHOTOGRAPHIC BULLETIN 4, no. 5 (May 1873): 150. [Simons recommends pick paper for stereo views - likes the warm tone.]

S605 Simons, M. P. "The Confession of a Photographer. How He Obtained a Likeness Under False Pretenses." ANTHONY'S PHOTOGRAPHIC BULLETIN 4, no. 10 (Oct. 1873): 294-296. ["Founded on fact." Anecdote about a daguerreotypist finally achieving a portrait from a reluctant sitter.]

S606 Simons, M. P. "Anecdote of Mr. Clay." ANTHONY'S PHOTOGRAPHIC BULLETIN 5, no. 4 (Apr. 1874): 147-148. [Anecdotes of Henry Clay, sitting for a daguerreotype.]

S607 Simons, M. P. "Correspondence." ANTHONY'S PHOTOGRAPHIC BULLETIN 5, no. 5 (May 1874): 193-194. [Letter commenting on postcards.]

S608 Simons, M. P. "The Early Days of Daguerreotyping." ANTHONY'S PHOTOGRAPHIC BULLETIN 5, no. 9 (Sept. 1874): 309-311. [Early photography in Philadelphia. Mentions Cornelius, Langenheim Brothers, himself.]

S609 Simons, M. P. "Irish Wit." ANTHONY'S PHOTOGRAPHIC BULLETIN 5, no. 12 (Dec. 1874): 409. [Poem.]

S610 Simons, M. P. "Correspondence." ANTHONY'S PHOTOGRAPHIC BULLETIN 6, no. 5 (May 1875): 159-160.

S611 Simons, M. P. "A Few Words on Cleaning the Daguerreotype." ANTHONY'S PHOTOGRAPHIC BULLETIN 6, no. 10 (Oct. 1875): 300.

S612 "Obituary." ANTHONY'S PHOTOGRAPHIC BULLETIN 8, no. 3 (Mar. 1877): 93. [Simons died Feb. 28th, in the 61st year of his age, in Philadelphia."...one of the oldest photographers in America... contributor to "Anthony's Photo. Bulletin... a staunch republican."]

SIMONS, M. P. [MRS.]
S613 "Photography." ANTHONY'S PHOTOGRAPHIC BULLETIN 8, no. 8 (Aug. 1877): 240. [Note that Mrs. M. P. Simons resuming the business of her late husband, in Philadelphia, PA.]

SIMPSON.
S614 Cole, Henry Hardy. *Illustrations of Buildings near Muttra and Agra; Showing the Mixed Hindu-Mahomedan Style of Upper India.* London: India Office, 1873. n. p. 42 b & w. [Original photos by Rev. Mr. Simpson, Chaplain of Muttra.]

SIMPSON, GEORGE WHARTON. (1825-1880) (GREAT BRITAIN)
[George Wharton Simpson was the editor and proprietor of the *Photographic News* for twenty years before his death in 1880. "He was well-known in literary and artistic circles, and was the founder of the since extinct Solar Club, a club established for social purposes, but formed almost entirely of photographers." He introduced and improved the collodio-chloride process and experimented with color photography.]

BOOKS
S615 Simpson, George Wharton. *The Photographic Teacher: Or, What to do in Photography, and How to do It: a Clear and Concise Compendium of the Collodion Process.* London: H. Squire & Co., 1858. vii, 64 pp. [6th ed. (1859).]

S616 Simpson, George Wharton. *On the Production of Photographs in Pigments: containing Historical Notes on Carbon Printing and Practical Details of Swan's Patent Carbon Process.* London: T. Piper, 1867. 103 pp. 1 b & w.

PERIODICALS
S617 "Reviews." LIVERPOOL & MANCHESTER PHOTOGRAPHIC JOURNAL [BRITISH JOURNAL OF PHOTOGRAPHY] n. s. 2, no. 20 (Oct. 15, 1858): 256-257. [Bk. rev.: "The Photographic Teacher,"... by G. Wharton Simpson.]

S618 Simpson, G. W. "The Positive Collodion Process." HUMPHREY'S JOURNAL OF PHOTOGRAPHY, AND THE ALLIED

ARTS AND SCIENCES 11, no. 18-20 (Jan. 15-Feb. 15, 1860): 278-280, 299-301, 311-314. [From "Br. J. of Photo."]

S619 "Alabastrine Photographs." PHOTOGRAPHIC AND FINE ART JOURNAL 13, no. 2 (Feb. 1860): 42-44. [From "Photo. Notes."]

S620 Simpson, G. Wharton. "The Positive Collodion Process, with Some Remarks on the Alabastrine Process." PHOTOGRAPHIC AND FINE ART JOURNAL 13, no. 3 (Mar. 1860): 66-68, 78-79. [From "Photo. News."]

S621 Simpson, G. Wharton. "Developing without Free Nitrate of Silver." BRITISH JOURNAL OF PHOTOGRAPHY 8, no. 153 (Nov. 1, 1861): 376. [Mentions process used by Mr. Mudd and his assistant Mr. Wardley.]

S622 Simpson, G. Wharton. "On Mounting Photographs." BRITISH JOURNAL OF PHOTOGRAPHY 8, no. 155 (Dec. 2, 1861): 420-422.

S623 Simpson, G. Wharton. "On Mounting Photographs." HUMPHREY'S JOURNAL OF PHOTOGRAPHY, AND THE ALLIED ARTS AND SCIENCES 13, no. 16 (Dec. 15, 1861): 252-254. [From "Photo. News."]

S624 Simpson, G. Wharton. "On Mounting Photographs." HUMPHREY'S JOURNAL OF PHOTOGRAPHY, AND THE ALLIED ARTS AND SCIENCES 13, no. 17 (Jan. 1, 1862): 264-268. [Conclusion of article.]

S625 Simpson, G. Wharton. "On Mounting Photographs." AMERICAN JOURNAL OF PHOTOGRAPHY AND THE ALLIED ARTS & SCIENCES n. s. vol. 4, no. 15-16 (Jan. 1 - Jan. 15, 1862): 337-340, 364-367. [Read to South London Photo. Soc.]

S626 Simpson, G. Wharton. "Instantaneous Dry Plates." AMERICAN JOURNAL OF PHOTOGRAPHY AND THE ALLIED ARTS & SCIENCES n. s. vol. 4, no. 22 (Apr. 15, 1862): 520-522. [From "Photo. Notes."]

S627 Simpson, G. Wharton. "Practical Notes on the New Fixing Agents." HUMPHREY'S JOURNAL OF PHOTOGRAPHY, AND THE ALLIED ARTS AND SCIENCES 15, no. 6 (July 15, 1863): 86-92. [From "Photo. News."]

S628 Simpson, G. Wharton. "Experiments in Uranium Printing." AMERICAN JOURNAL OF PHOTOGRAPHY AND THE ALLIED ARTS & SCIENCES n. s. vol. 7, no. 13 (Jan. 1, 1865): 295-301. [Read before South London Photo. Soc.]

S629 Simpson, G. W. "On a New Method of Printing and the Preparation and Use of Collodio-Chloride of Silver." BRITISH JOURNAL OF PHOTOGRAPHY 12, no. 254 (Mar. 17, 1865): 137-138.

S630 Simpson, G. Wharton. "Collodio-Chloride of Silver in Printing." AMERICAN JOURNAL OF PHOTOGRAPHY AND THE ALLIED ARTS & SCIENCES n. s. vol. 7, no. 20 (Apr. 15, 1865): 465-471. [Read before London Photo. Soc. Simpson, H. P. Robinson, V. Blanchard and Mr. Cooper all tried this method.]

S631 Simpson, G. W. "Collodio-Chloride of Silver for Printing on Paper or Glass." AMERICAN JOURNAL OF PHOTOGRAPHY AND THE ALLIED ARTS & SCIENCES n. s. vol. 8, no. 2 (July 15, 1865): 42-46. [From "Photo. News."]

S632 "Honor to Whom Honor is Due." HUMPHREY'S JOURNAL OF PHOTOGRAPHY, AND THE ALLIED ARTS AND SCIENCES 17, no. 23 (Apr. 1, 1866): 367. [G. Wharton Simpson, editor of "Photographic News" given an Honorary degree of M.A. and M. Carey Lea received Honorary degree of M.D. from the Geneva College, Geneva, NY.]

S633 Simpson, G. Wharton. "Practical Notes on Various Photographic Subjects." PHILADELPHIA PHOTOGRAPHER 6, no. 61-72 (Jan. - Dec. 1868): 7-11, 40-43, 69-74, 99-102, 138-142, 188-192, 241-244, 273-275, 296-299, 337-342, 362-366, 417-418.

S634 Simpson, G. Wharton. "The Preparation and Selection of Collodion." HUMPHREY'S JOURNAL OF PHOTOGRAPHY, AND THE ALLIED ARTS AND SCIENCES 19, no. 21-22 (Mar. 1-Mar. 15, 1868): 326-328, 347-348.

S635 Simpson, G. Wharton. "Practical Notes on Various Photographic Subjects." PHILADELPHIA PHOTOGRAPHER 5, no. 51-60 (Mar. - Dec. 1868): 67-69, 120-122, 167-169, 202-204, 219-221, 262-265, 317-319, 348-351, 400-403, 432-434.

S636 Simpson, G. Wharton. "The Nitrate Bath." HUMPHREY'S JOURNAL OF PHOTOGRAPHY, AND THE ALLIED ARTS AND SCIENCES 19, no. 23 (Apr. 1, 1868): 361-364. [From "Photo. News Almanac."]

S637 Simpson, G. Wharton. "India-Rubber for Mounting and Transfers." HUMPHREY'S JOURNAL OF PHOTOGRAPHY, AND THE ALLIED ARTS AND SCIENCES 19, no. 24 (Apr. 15, 1868): 383-384.

S638 Simpson, G. Wharton. "Printing with Collodio-Chloride of Silver on Paper and Opal Glass." HUMPHREY'S JOURNAL OF PHOTOGRAPHY, AND THE ALLIED ARTS AND SCIENCES 20, no. 1 (May 1, 1868): 10-12.

S639 Simpson, G. Wharton. "Sel Clement, or Preservative Nitrate of Silver." HUMPHREY'S JOURNAL OF PHOTOGRAPHY, AND THE ALLIED ARTS AND SCIENCES 20, no. 2 (May 15, 1868): 26-30. [From "Photo. News."]

S640 Simpson, G. Wharton, M.A., F.S.A. "Notes In and Out of the Studio." PHILADELPHIA PHOTOGRAPHER 7, no. 73 (Jan. - Dec. 1870): 20-22, 59-62, 85-88, 122-126, 165-168, 210-212, 264-266, 301-303, 318-322, 359-363, 389-392, 416-418. [(Jan.) Valentine Blanchard's Studio is gutted by fire. London Photo Society Exhibition, Idealism in Portraiture. Rejlander.]

S641 Simpson, G. Wharton. "On Heliotypy as a Means of reproducing Works of Art." ART PICTORIAL AND INDUSTRIAL 1, no. 4 (Oct. 1870): 73-76.

S642 Simpson, G. Wharton. "Notes In and Out of the Studio." PHILADELPHIA PHOTOGRAPHER 8, no. 85-96 (Jan. - Dec. 1871): 23-26, 57-59, 81-82, 141-142, 178-180, 243-245, 276-277, 305-306, 360-361. [(Jan.) The English Exhibition, p. 23. Adam-Solomon's system of lighting and his alcove background, pp. 24-25. V. Blanchard mentioned. (Mar.) Rembrandt effects. (Apr.) Training, cameo vignettes. (June) Obituary for J. R. Williams. (Aug.) Lighting. etc.]

S643 Simpson, G. Wharton. "Notes In and Out of the Studio - The War and Photography." PHOTOGRAPHIC WORLD 1, no. 4 (Apr. 1871): 104-105. [Notes on the Franco-Prussian War's effects on

portrait studios in Paris - Reutlinger, Adam-Solomon, Goupil & Co., etc. mentioned.]

S644 Simpson, G. Wharton, M.A., F.S.A. "Notes In and Out of the Studio." PHILADELPHIA PHOTOGRAPHER 10, no. 109-113 (Jan. - June 1873): 22-23, 60-61, 123-124, 188-189. [Technical.]

S645 Simpson, G. Wharton. "Notes In and Out of the Studio." PHILADELPHIA PHOTOGRAPHER 11, no. 121-132 (Jan. - Dec. 1874): 14-16, 58-59, 93-94, 111-113, 143-144, 182-183, 209, 251-253, 283-285.

S646 Simpson, G. Wharton. "Notes from the News." PHOTOGRAPHIC TIMES 4, no. 41 (June 1874): 84-85. ["Gelatin Instead of Collodion—Gelatino-Bromide of Silver Process," etc. Commentary on generally unsuccessful experiments with replacing collodion by gelatin, etc. [I think this from "Photographic News."].]

S647 Simpson, G. Wharton. "Photography Abroad." PHOTOGRAPHIC TIMES 5, no. 49 (Jan. 1875): 12-14. [Letter from Simpson about the French process "Lambertypie," worked by Mr. Liebert. Process involves drawing with a pencil to alter the image. Mentions Bedford, Robinson, and England working in similar fashion in 1860s.]

S648 "The Late George Wharton Simpson." PHILADELPHIA PHOTOGRAPHER 17, no. 195 (Mar. 1880): 66-67. [Died Jan. 15th, 1880, at the age of fifty-five. Editor of the "Photographic News" for almost twenty years.]

S649 "The Death of G. Wharton Simpson." PHOTOGRAPHIC TIMES 10, no. 111 (Mar. 1880): 51-52. [From "Br J of Photo." Died Jan. 15, 1880. Began public life as editor of "Darlington and Stockton Times." Resigned, ill health. Some time abroad, "returned to England, engaged himself in photography, practicing the art professionally for several years." Editor, then owner of "Photographic News" for nearly twelve years. Vice President of both Photographic Society of Great Britain and South London Photographic Society, promoter of the Solar Club, other organizations.]

SIMPSON, SAMUEL F. (MISSISSIPPI RIVER)
S650 Simpson, Samuel F. "Daguerreotyping on the Mississippi." PHOTOGRAPHIC AND FINE ART JOURNAL 8, no. 8 (Aug. 1855): 252-253. [Simpson ran floating galleries down the Mississippi River.]

SIMPSON, W., REV. (GREAT BRITAIN, INDIA)
S651 Illustrations of Buildings near Muttra and Agra; showing the Mixed Hindu - Mohamedan Style of Upper India. London: India Office, 1873. n. p. 42 b & w. [Original photographs, by Rev. W. Simpson.]

SIMS. (WESTBOURNE GROVE, ENGLAND)
S652 "St. James Church, Gerrard's-Cross, Bucks." ILLUSTRATED LONDON NEWS 35, no. 996 (Oct. 1, 1859): 314. 1 illus. ["From a Photograph by Mr. Sims, Westbourne Grove."]

SINCLAIR, A. (ST. PAUL, MN)
S653 Sinclair, A. "The Bromide Patent. - Permanent Toning Bath." AMERICAN JOURNAL OF PHOTOGRAPHY, AND THE ALLIED ARTS AND SCIENCES n. s. vol. 9, no. 3 (Oct. 1, 1866): 68-69.

SINCLAIR, AUDREY.
S654 Sinclair, Audrey. "Stray Observations on the Aesthetics of Portraiture." BRITISH JOURNAL PHOTOGRAPHIC ALMANAC 1871 (1871): 126-129.

SINGER, SIGMUND.
S655 Singer, Sigmund. "Milwaukee Correspondence." PHILADELPHIA PHOTOGRAPHER 13, no. 155 (Nov. 1876): 339-341.

SINGH, SAWAI RAM, II. (1833-1880) (INDIA)
BOOKS
S656 Kumar, Asok. The Photographer Prince, Maharaja Sawai Ram Singh II. Jaipur: Kumar Publishing, 1984. n. p. [Brochure for an exhibition held in 1984 at Jaipur.]

PERIODICALS
S657 Thomas, G. "Maharaja Sawai Ram Singh II of Jaipur, Photographer-Prince." HISTORY OF PHOTOGRAPHY 10, no. 3 (July - Sept. 1986): 181-191. 14 b & w. 1 illus. [Two photos by T. Murray, twelve by Singh. Portraits, views. Some 2000 glass negatives exist, taken by Singh ca. 1860 - 1880.]

SINGHI, WELL G. (USA)
S658 "Editor's Table." PHILADELPHIA PHOTOGRAPHER 6, no. 65 (May 1869): 169. [Snow view of old church and trees noted. Bainbridge, NY.]

S659 "Matters of the Month: A Card." PHOTOGRAPHIC TIMES 4, no. 41 (June 1874): 89. [Note from Well G. Singhi thanking firemen, etc. for trying to save his gallery, claims that he will reopen again.]

S660 "Matters of the Month." PHOTOGRAPHIC TIMES 5, no. 49 (Jan. 1875): 8. [Wishes to sell his gallery.]

S661 "Editor's Table. " PHILADELPHIA PHOTOGRAPHER 14, no. 159 (Mar. 1877): 96. [Praise for comic advertising card by Mr. Well G. Singhi.]

S662 "Note." PHOTOGRAPHIC TIMES 8, no. 96 (Dec. 1878): 278. [Extract from "Binghamton [NY] Republican," Sept. 14, 1878 discussing a genre photo of a newsboy used to illustrate the "Practical Photo." magazine in December.]

S663 "Note." ANTHONY'S PHOTOGRAPHIC BULLETIN 10, no. 10 (Oct. 1879): 319-320. [Comment on a photo by Singhi (Binghamton, NY).]

S664 "Note." PHOTOGRAPHIC TIMES 9, no. 108 (Dec. 1879): 282. [Panel photo noted.]

S665 "View Caught with the Drop Shutter." ANTHONY'S PHOTOGRAPHIC BULLETIN 17, no. 14 (July 24, 1886): 448. [Note that Singhi, of Bridgeport, CT., met with an accident a year past, still suffering the effects, sold his studio to E. C. Betts.]

SISSON, J. LAWSON. (GREAT BRITAIN)
S666 Sisson, Rev. J. Lawson. The Turpentine Waxed-paper Process Described and Illustrated. To which is added Notes upon the Wax Paper and other Processes. London: A. Marion & Co., 1858. 57 pp. 2 illus. [Two pair of stereographs mounted in the work as illustrations.]

SISSONS, N. E. (ALBANY, NY)
S667 "Note." DAGUERREAN JOURNAL 1, no. 12 (May 1, 1851): 370. [N. E. Sissons (Albany, NY) was the "practical Daguerrean artist" who furnished the journal with the largest number of subscribers, thus winning a camera.]

SITTLER, GEORGE W. (1847-1887) (USA)

S668 Craig, John S. "Photographer: Almost Unknown." NORTHLIGHT (JOURNAL OF THE PHOTOGRAPHIC HISTORICAL SOCIETY OF AMERICA) 3, no. 1 (Winter 1975/76): 10-11. 4 b & w. [George W. Sittler was born in Illinois in 1847. He apprenticed to the photographer Dr. George Hannaman in 1866 in Shelby County, IL. In 1868 he purcased the gallery, then took a partner, A. R. Launey, in 1872. Sold the gallery to Launey in 1881 and went to Ft. Scott, KN. Then moved to Springfield, MO, where he bought William S. Johnson's gallery in January, 1882. He was a member of the Photographic Association of America. He died of an accident on Sept. 22, 1887. The four photographs are stereo illustrations of the exterior and interior of his gallery.]

SKAIFE, THOMAS. (GREAT BRITAIN)

[Thomas Skaife perfected a camera which enabled him to take small, about two inches in diameter, photographs with an exposure time of about one-tenth of a second. This camera was shaped like a pistol and hand-held. Skaife was reported to have once been arrested for attempting to "shoot" Queen Victoria as she was taking a drive near Winsor.]

BOOKS

S669 Skaife, Thomas. *Report of a Short Lecture on the Pistolgraph and its Chromo-Crystal Productions.* By T. Skaife, at the Royal Pavilion, Brighton, November 17, 1859. London: J. Hogarth, 1859. 10 pp.

S670 Skaife, Thomas. *Instantaneous Photography, Mathematical and Popular, including Practical Instructions on the Manipulation of the Pistolgraph according to the mode practiced by the Inventor and most successful of his pupils...*London: J. Hogarth, 1860. 36 pp. 9 illus. [2nd. ed. (1863)]

PERIODICALS

S671 "Blackheath Photographic Society." LIVERPOOL & MANCHESTER PHOTOGRAPHIC JOURNAL [BRITISH JOURNAL OF PHOTOGRAPHY] n. s. 2, no. 12 (June 15, 1858): 152. [Paper by T. Skaife, "Nautical Photography," on his instantaneous stereo views of ships, etc.]

S672 "Photographic Curiosities." LIVERPOOL & MANCHESTER PHOTOGRAPHIC JOURNAL [BRITISH JOURNAL OF PHOTOGRAPHY] n. s. 2, no. 16 (Aug. 15, 1858): 204-205. [From the "London Times." Letters from Skaife, describing his experiences photographing exploding shells at artillery practice at Woolwich.]

S673 Skaife, Thomas. "Photographic Curiosities." PHOTOGRAPHIC AND FINE ART JOURNAL 11, no. 9 (Sept. 1858): 277-278. [Letters from Skaife to the "London Times," on July 14 and Aug. 5, his photographing a cannon shell in flight during experimental firings at the Woolwich mortar battery.]

S674 "Editorial." LIVERPOOL & MANCHESTER PHOTOGRAPHIC JOURNAL [BRITISH JOURNAL OF PHOTOGRAPHY] n. s. 2, no. 17 (Sept. 1, 1858): 209. [Commentary on Skaife's photos of exploding shells.]

S675 "Instantaneous Photography." PHOTOGRAPHIC AND FINE ART JOURNAL 11, no. 10 (Oct. 1858): 312-313. [Skaife (Blackheath, England), photographed cannon shell in flight. Discussion of his techniques, etc.]

S676 "Photographic Curiosities." HUMPHREY'S JOURNAL OF PHOTOGRAPHY, AND THE ALLIED ARTS AND SCIENCES 10, no. 11 (Oct. 1, 1858): 165-168. [From "London Times." Skaife's stereophotographs of mortar battery firings discussed.]

S677 "Editorial." LIVERPOOL & MANCHESTER PHOTOGRAPHIC JOURNAL [BRITISH JOURNAL OF PHOTOGRAPHY] n. s. 2, no. 19 (Oct. 1, 1858): 235. [Description of camera, with special shutters, used by Skaife to photograph military shells in flight.]

S678 "Description of Mr. Skaife's Apparatus. - Amusing Incident." HUMPHREY'S JOURNAL OF PHOTOGRAPHY, AND THE ALLIED ARTS AND SCIENCES 10, no. 16 (Dec. 15, 1858): 252-255. [From "Liverpool Photo. J."]

S679 Skaife, Thomas. "Mortar Phantoms." HUMPHREY'S JOURNAL OF PHOTOGRAPHY, AND THE ALLIED ARTS AND SCIENCES 10, no. 20 (Feb. 15, 1859): 310. [From "J. of Photo. Soc., London."]

S680 "Instantaneous Photography." HUMPHREY'S JOURNAL OF PHOTOGRAPHY, AND THE ALLIED ARTS AND SCIENCES 11, no. 7 (Aug. 1, 1859): 110. [From "Liverpool Photo. J."]

S681 Skaife, Thomas. "Instantaneous Photography." HUMPHREY'S JOURNAL OF PHOTOGRAPHY, AND THE ALLIED ARTS AND SCIENCES 11, no. 12 (Oct. 15, 1859): 188-191. [From "Photo. J."]

S682 Skaife, Thomas. "On the Pistolgraph." BRITISH JOURNAL OF PHOTOGRAPHY 7, no. 132 (Dec. 15, 1860): 368.

S683 Skaife, T. "On the Pistolgraph." HUMPHREY'S JOURNAL OF PHOTOGRAPHY, AND THE ALLIED ARTS AND SCIENCES 12, no. 18 (Jan. 15, 1861): 288.

S684 Skaife, T. "On Enlarging from Micro-Photographs." BRITISH JOURNAL OF PHOTOGRAPHY 8, no. 141 (May 1, 1861): 160.

S685 Skaife, T. "On Enlarging from Micro-Photographs." HUMPHREY'S JOURNAL OF PHOTOGRAPHY, AND THE ALLIED ARTS AND SCIENCES 13, no. 4 (June 15, 1861): 59-61. [From "Br. J. of Photo."]

S686 Skaiee. [sic Skaife] "The Pistolgraph." AMERICAN JOURNAL OF PHOTOGRAPHY AND THE ALLIED ARTS & SCIENCES n. s. vol. 6, no. 24 (June 15, 1864): 553-555. [From "Br. J. of Photo."]

S687 "Editor's Table: Instantaneous Photography by Artificial Light." PHILADELPHIA PHOTOGRAPHER 3, no. 35 (Nov. 1866): 358.

S688 "The Pistolgraph." IMAGE 2, no. 3 (Mar. 1953): 14. 1 illus. [Invented by Thomas Skaife, London, 1859: "miniature" camera. Collection George Eastman House.]

S689 Schaaf, Larry. "Thomas Skaife's Pistolgraph and the Rise of Modern Photography in the Nineteenth Century." PHOTOGRAPHIC COLLECTOR 4, no. 1 (Spring l983): 27-39. 6 b & w. 11 illus. [Thomas Skaife perfected a miniature camera capable of arresting motion, ca. 1859.]

SKEEN & CO.

S690 Morton, Rosalie Slaughter. "The City of the Sacred Bo-Tree: Marvelous Ruins Unearthed in Ceylon." CENTURY MAGAZINE 73, no. 6 (Apr. 1907): 946-954. 11 b & w. ["From photographs by Skeen & Co., Colombo, Ceylon."]

SKEEN, L. H. & CO. [?]
S691 "Kandyan Chiefs." FRANK LESLIE'S ILLUSTRATED NEWSPAPER 22, no. 570 (Sept. 1, 1866): 381. 1 illus. [This group portrait of these inhabitants of Ceylon is not credited, but I think it is from a photograph by L. H. Skeen & Co.]

SKEEN, WILLIAM LOUIS HENRY. (d. 1903) (CEYLON)
BOOKS
S692 Skeen, W. *The Knuckles and other Poems.* Colombo, Ceylon: W. L. H. Skeen and Co., 1868. 181 pp. 7 b & w. [Original photos, of the Knuckles, a coffee plantation area in Ceylon.]

PERIODICALS
S693 "Prince Alfred in Ceylon." ILLUSTRATED LONDON NEWS 56, no. 1598 (June 11, 1870): 613-614. 2 illus. ["...a series of photographs taken by Mr. W. H. Skeen, of Colombo, Ceylon."]

S694 "Railway Bridge Destroyed by Floods in Ceylon." ILLUSTRATED LONDON NEWS 61, no. 1732 (Nov. 16, 1872): 460. 1 illus.

SKEOLAN, P. P. (HARROGATE, ENGLAND)
S695 Portrait. Woodcut engraving, credited to "From a Photograph by P. P. Skeolan." ILLUSTRATED LONDON NEWS 59, (1871) ["Rev. John H. James, D.D." 59:1665 (Aug. 19, 1871): 157.]

SKUTT, ALLAN K. (1834-1895) (USA)
S696 "In Memoriam: Allan K. Skutt." WILSON'S PHOTOGRAPHIC MAGAZINE 33, no. 471 (Mar. 1896): 124-125. 1 illus. [Died Dec. 17, 1895 in the 61st year of his age. Began about 35 years ago in Hudson, MI, worked as negative retoucher for James F. Ryder in Cleveland. 18 years ago to Jamestown, NY, died there.]

SLACKE & BARTON. (ZANESVILLE, OH)
S697 "Frightful Railroad Accident at Zanesville, Ohio. - From a Photograph by Slacke & Barton, Zanesville." FRANK LESLIE'S ILLUSTRATED NEWSPAPER 23, no. 586 (Dec. 22, 1866): 209. 1 illus. [View.]

SLADEN, EDWARD S. [?]
S698 "The Mengoon Bell." ILLUSTRATED LONDON NEWS 48, no. 1368 (Apr. 28, 1866): 416. 1 illus. ["...from a photograph obligingly forwarded to us by Captain Edward S. Sladen, British Agent at the Court of Mandalay."]

SLANEY, JOHN M. (PHILADELPHIA, PA)
S699 "Editor's Table." PHILADELPHIA PHOTOGRAPHER 2, no. 23 (Nov. 1865): 187. [Portraits received.]

S700 "Commodore Truxton's Grave. - From a Photograph by Slaney." FRANK LESLIE'S ILLUSTRATED NEWSPAPER 22, no. 567 (Aug. 11, 1866): 332. 1 illus.

SLATTEN, GEORGE. (JOHNSTOWN, PA)
S701 Portraits. Woodcut engravings, credited "From a Photograph by George Slatten, Johnstown, PA." FRANK LESLIE'S ILLUSTRATED NEWSPAPER 23, (1866) ["Miss Letitia Cannon." 23:575 (Oct. 6, 1866): 44.]

SLEE BROTHERS. (POUGHKEEPSIE, NY)
S702 "Ice-Boat Expedition from Poughkeepsie to Albany. - From Photographs by the Slee Brothers, Poughkeepsie." FRANK LESLIE'S ILLUSTRATED NEWSPAPER 21, no. 546 (Mar. 17, 1866): 412. 2 illus. [Views of the crafts on the ice-covered river.]

S703 "The Vassar Female College, at Poughkeepsie, N. Y." FRANK LESLIE'S ILLUSTRATED NEWSPAPER 23, no. 581 (Nov. 17, 1866): 140. 4 illus. [Three views of the College, one portrait of its President, Matthew Vassar. Only one view is credited to the Slee Brothers, but the others are probably also by them as well.]

S704 Portrait. Woodcut engraving, credited "From a Photograph by Slee Brothers, Poughkeepsie, NY." HARPER'S WEEKLY 12, (1868) ["Capt. Louis M. Hamilton." 12:625 (Dec. 19, 1868): 804.]

S705 Portrait. Woodcut engraving, credited "From a Photograph by Slee Brothers, Poughkeepsie." FRANK LESLIE'S ILLUSTRATED NEWSPAPER 27, (1868) ["The late Capt. M'Lane Hamilton, killed in the battle of the Washita." 27:691 (Dec. 26, 1868): 229.]

S706 "Winter Sports - Ice Boats on the Hudson." HARPER'S WEEKLY 13, no. 629 (Jan. 16, 1869): 33. 1 illus. ["Photographed by Slee Brothers."]

S707 "The Hamilton Monument, Evergreen Cemetery, Williamsburgh, L. I. - From a Photograph by Slee Brothers." FRANK LESLIE'S ILLUSTRATED NEWSPAPER 29, no. 739 (Nov. 27, 1869): 181. 1 illus. [View.]

S708 "Editor's Table: Fire." PHILADELPHIA PHOTOGRAPHER 14, no. 164 (Aug. 1877): 256. [Slee Bros. (Poughkeepsie, NY) destroyed by fire.]

SLIGHT, GEORGE H.
S709 Slight, George H. "Concerning Art-Photography." BRITISH JOURNAL OF PHOTOGRAPHY 12, no. 275 (Aug. 11, 1865): 413-414.

S710 Slight, George H. "Artful Dodging." BRITISH JOURNAL PHOTOGRAPHIC ALMANAC 1878 (1878): 161-163.

SLINGSBY, R.
S711 Slingsby, R. "A Few Notes on Portraiture." BRITISH JOURNAL PHOTOGRAPHIC ALMANAC 1873 (1873): 124-125.

S712 Slingsby, R. "On Background Effects." BRITISH JOURNAL PHOTOGRAPHIC ALMANAC 1876 (1876): 87.

S713 Slingsby, R. "Where Is It? Or a Place for Your Dark Slides." BRITISH JOURNAL PHOTOGRAPHIC ALMANAC 1878 (1878): 156-157. [Slingsby a professional portrait photographer. Discussing developing an orderly routine.]

SLINN & CO. (COLUMBO, CEYLON)
S714 "The Lighthouse at Colombo, Ceylon." ILLUSTRATED LONDON NEWS 45, no. 1278 (Sept. 17, 1864): 280, 285. 1 illus. ["...from a photograph by Messrs. Slinn and Co., of Columbo, Ceylon."]

S715 "The Custom-House and Inner Harbour, Colombo." ILLUSTRATED LONDON NEWS 45, no. 1280 (Oct. 1, 1864): 337. 1 illus. ["...from a photograph by Messrs. Slinn & Co., of that town."]

SMALLCOMBE, J. C. (LONDON, ENGLAND)
S716 Portrait. Woodcut engraving credited "From a photograph by J. C. Smallcombe, Baker St." ILLUSTRATED LONDON NEWS 69, (1876) ["Sir James Ingham." 69:1932 (Aug. 5, 1876): 133.]

SMEATON. (QUEBEC, CANADA)
S717 Portrait. Woodcut engraving, credited "From a Photograph by Smeaton." FRANK LESLIE'S ILLUSTRATED NEWSPAPER 20, (1865)

["The late Sir E. P. Tache, of the Canadian Parliament." 20:518 (Sept. 2, 1865): 372.]

S718 "Views at Quebec." FRANK LESLIE'S ILLUSTRATED NEWSPAPER 20, no. 519 (Sept. 9, 1865): 396, 397. 2 illus. [Views. "Old St. John's Gate, Quebec," and "The New Jail at Quebec - From Photographs by Smeaton."]

S719 "Gold Mining on the Gilbert River, Canada. - From Photographs by Smeaton, of Quebec." FRANK LESLIE'S ILLUSTRATED NEWSPAPER 22, no. 566 (Aug. 4, 1866): 309. 7 illus. [Miners, sites, a gold nugget, etc.]

SMEE, ALFRED.
S720 "Fine Arts: Photogenic Drawing." LITERARY GAZETTE, AND JOURNAL OF THE BELLES LETTRES no. 1165 (May 18, 1839): 314-316. [Detailed technical discussion of calotype process.]

SMILEY. (KNOXVILLE, TN)
S721 Portrait. Woodcut engraving, credited "From a Photograph by Smiley, of Knoxville, TN." HARPER'S WEEKLY 5, (1861) ["William G. Brownlow, of TN." 5:231 (June 1, 1861): 341.]

SMILLIE, THOMAS WILLIAM. (1843-1917) (USA)
S722 Portrait. Woodcut engraving, credited "From a Photograph by T. W. Smillie." FRANK LESLIE'S ILLUSTRATED NEWSPAPER 46, (1878) ["The late Joseph Henry, Sec. of Smithsonian Inst." 46:1183 (June 1, 1878): 213.]

SMITH, BECK & BECK see also BECK.

SMITH, BECK & BECK. (GREAT BRITAIN)
BOOKS
S723 Description and Price of the Achromatic Stereoscope, Invented and Manufactured by Smith, Beck & Beck. To which is added "A Familiar Explanation of the Phenomena Produced by the Stereoscope." London: Smith, Beck & Beck. 6, Coleman Street, December, 1858. 8 pp. illus.

S724 Description of the Acromatic Table Stereoscope, and of the Patent Achromatic Mirror Stereoscope, invented and manufactured by Smith, Beck & Beck. London: Dare & Co., Printers, November, 1862. 10 pp. illus.

PERIODICALS
S725 "Illustrated Description of Messrs. Smith, Beck, and Beck's Patent Achromatic Mirror Stereoscope." BRITISH JOURNAL OF PHOTOGRAPHY 7, no. 109 (Jan. 1, 1860): 6. 1 illus.

S726 "Fine Arts: Stereoscopes." ILLUSTRATED LONDON NEWS 36, no. 1011 (Jan. 7, 1860): 11. [Messrs. Smith, Beck & Beck, London announces improvements in the achromatic stereoscope.]

S727 "The Patent Mirror Stereoscope." HUMPHREY'S JOURNAL OF PHOTOGRAPHY, AND THE ALLIED ARTS AND SCIENCES 11, no. 17 (Jan. 1, 1860): 268-269. [From "Liverpool Photo. J." "Smith, Beck and Beck, opticians in London, are about to bring out a new form of stereoscope."]

S728 "The Achromatic Mirror Stereoscope." ART JOURNAL (May 1860): 158.

S729 "The Achromatic Mirror Stereoscope." PHOTOGRAPHIC AND FINE ART JOURNAL 13, no. 6 (June 1860): 161. [From "London Art J."]

S730 "Smith, Beck & Beck Catalogue, July 1860." PHOTOGRAPHIC COLLECTOR 4, no. 3 (Winter 1983): 332-335. [Facsimile reproduction of British stereoscope manufacturing catalog, July 1860. Features A Chromatic Table Stereoscope, but also lists some views for sale, particularly "Photographs of the Moon, by Warren De la Rue."]

SMITH & MOTES. (ATLANTA, GA)
S731 "Smith & Motes: Display in Atlanta." ANTHONY'S PHOTOGRAPHIC BULLETIN 4, no. 12 (Dec. 1873): 358. [From the "Atlantic [GA] Daily Herald."]

S732 Portrait. Woodcut engraving, credited "From a Photograph by Smith & Motes, Atlanta, GA." FRANK LESLIE'S ILLUSTRATED NEWSPAPER 40, (1875) ["Gen. John B. Gordon, Sen. from GA." 40:1017 (Mar. 27, 1875): 44.]

S733 Portrait. Woodcut engraving, credited "From a Photograph by Smith & Motes, Atlanta, Ga." FRANK LESLIE'S ILLUSTRATED NEWSPAPER 40, (1875) ["R. H. Hill, Cong. from GA." 40:1033 (July 17, 1875): 337.]

S734 "Newly Fitted Galleries." ANTHONY'S PHOTOGRAPHIC BULLETIN 6, no. 8 (Aug. 1875): 253. [From "Atlanta [GA] Constitution."]

SMITH, A. E.
S735 "Views of the Seat of War in New Zealand." ILLUSTRATED LONDON NEWS 44, no. 1239 (Jan. 2, 1864): 5. 3 illus. ["...from photographs recently taken by Mr. A. E. Smith, in the Waikato district, seat of the war in New Zealand."]

SMITH, A. FORD.
S736 Smith, A. Ford. "Printing from Ferns, or Leaves of Plants So Arranged as to Produce Designs, Mottoes, or Scriptural Texts, &c." BRITISH JOURNAL PHOTOGRAPHIC ALMANAC 1878 (1878): 69-70.

SMITH, ANGUS. (d. 1884) (GREAT BRITAIN)
S737 Harrison, W. Jerome. "The Chemistry of Fixing." PHOTOGRAPHIC TIMES 21, no. 487 (Jan. 16, 1891): 28-29. [Reprint of May 8, 1866 paper to Photo. Society of Scotland by Dr. Angus Smith, F. W. Hart's 1864 paper to the "BJP" reprinted.]

SMITH, B.
S738 "The Cricket-Match between Madras and Calcutta: The Madras Eleven." ILLUSTRATED LONDON NEWS 44, no. 1249 (Mar. 12, 1864): 249. 1 illus. ["...from a photograph taken by Mr. B. Smith, of Madras Cricket team."]

SMITH, BUCHANAN.
S739 Smith, Buchanan. "Lighting the Sitter." HUMPHREY'S JOURNAL OF PHOTOGRAPHY, AND THE ALLIED ARTS AND SCIENCES 14, no. 15 (Dec. 1, 1862): 186-187. [From "Photo. News."]

SMITH, D. E. (ONEIDA COMMUNITY, NY)
S740 "Matters of the Month." PHOTOGRAPHIC TIMES 5, no. 56 (Aug. 1875): 191. [Specimens of portraiture and landscapes.]

SMITH, D. G. (DETROIT, MI)
S741 "Note." PHOTOGRAPHIC TIMES 14, no. 165 (Sept. 1884): 485. ["Mr. D. G. Smith will open a new gallery... Mr. L. G. Bigelow will attend to posing and lighting." "Mr. Smith was a knight of the camera twenty years ago, and now having 'many shekels' made in the provision business, returns to his old love..." From the "Detroit Correspondence."]

SMITH, EDWARD.
S742 "The Crimean Monument in the Abbey Cemetery, Bath." ILLUSTRATED NEWS OF THE WORLD AND DRAWING ROOM PORTRAIT GALLERY OF EMINENT PERSONAGES 1, no. 40 (Nov. 6, 1858): 292. 1 illus. ["After a photograph by Edward Smith, of Bath."]

SMITH, F.
S743 "Laying the Foundation Stone of an Additional Building for the General Hospital at Bath." ILLUSTRATED LONDON NEWS 34, no. 980 (June 25, 1859): 605. 1 illus. ["From a photograph by E. Smith, Bath."]

SMITH, F. M. BELL.
S744 Smith, F. M. Bell. "Composition Pictures." ANTHONY'S PHOTOGRAPHIC BULLETIN 5, no. 9 (Sept. 1874): 305-306. [Smith from Hamilton.]

SMITH, G. S. (BROWNSVILLE, TX)
S745 "Pontoon Bridge Across the Rio Grande - Detachment of United States Troops Crossing to Mexico." HARPER'S WEEKLY 11, no. 523 (Jan. 5, 1867): 12. 1 illus. ["Photographed by G. S. Smith, Brownsville, TX." General Sedgwick briefly entered Mexico at Brownsville to Matamoras, to fend off the Mexican Escobedo.]

SMITH, GEORGE.
S746 Smith, George. "On the Permanence of Carbon Prints." BRITISH JOURNAL PHOTOGRAPHIC ALMANAC 1879 (1879): 82-83.

SMITH, HAMILTON L. (1818-1903) (USA)
[Hamilton L. Smith was born on Nov. 5, 1818 in New London, CT. Educated at the Union School in New London, and at Yale. Graduated from Yale University in 1839. He had constructed a telescope at Yale and began studying nebulae. Made daguerreotypes in Cleveland, OH in 1840. Published articles in *Silliman's Magazine, American Journal of Microscopy,* and others, and served as editor for the *Annuals of Science* from 1842 to 1844. In 1849 he held the Chair of Natural Philosophy and Astronomy at Kenyon College, Gambier, OH. Invented and patented the tintype in 1856. Moved to Geneva, NY in 1867, and was Professor of Chemistry at Hobart College from 1867 until his retirement in 1900. Served as its Acting President in 1883-1884. Died in Yonkers, NY in 1903.]

BOOKS
S747 "Hamilton L. Smith," on p. 466 of vol. 12 in: *National Cyclopedia of American Biography.*

S748 "Hamilton L. Smith," on p. 1142 of vol. 1 in: *Who Was Who in America.*

PERIODICALS
S749 Smith, Hamilton L. "Photographic Patents: Patent for the use of Japanned surfaces previously prepared upon Iron or other metallic or mineral sheets or plates in the Collodion Process, called Melainotypes." HUMPHREY'S JOURNAL 8, no. 7 (Aug. 1, 1856): 98-99. [Patent letter by Hamilton L. Smith.]

SMITH, J. EDWARDS.
S750 Smith, J. Edwards. "Correspondence: The Alum-Silver Bath." ANTHONY'S PHOTOGRAPHIC BULLETIN 2, no. 10 (Oct. 1871): 336-337. [Smith from (Painesville?).]

SMITH, JAMES H.
S751 "Photographers, Old and New: James H. Smith." WILSON'S PHOTOGRAPHIC MAGAZINE. 32, no. 461 (May 1895): 214-215, plus unnumbered leaf after p. 214. 1 b & w. 1 illus. [Smith began photographing in 1866 in Belleville, IL, became involved in selling photographic goods, eventually became wealthy inventing and manufacturing specialties in apparatus and supplies in Chicago. Continued, on occasion, to photograph - in this case as an amateur.]

S752 "Our Pictures." WILSON'S PHOTOGRAPHIC MAGAZINE 32, no. 461 (May 1895): 235, plus one leaf after p. 214. 1 b & w. [Original photograph, tipped-in. Landscape.]

SMITH, JOHN. (GREAT BRITAIN, AUSTRALIA)
S753 Macmillan, David S. and Keast Burke. "John Smith: A Pioneer of Photography in Australia." IMAGE 7, no. 8 (Oct. 1958): 185-188. 3 b & w. [Born Petercutter, Scotland. Graduated college in 1843, to Sydney, Australia in 1852 as a professor in chemistry. Took up photography.]

SMITH, JOHN SHAW. (1811-1873) (GREAT BRITAIN)
S754 Adam, Hans Christian. "John Shaw Smith (1811-1873)." FOTOGRAFIE (GÖTTINGEN) no. 17/18 (1982): 94-99. 10 b & w. [Irish calotypist who photographed in the Mediterranean area in 1850-1852.]

SMITH, JOSHUA. (CHICAGO, IL)
S755 "Matters of the Month." PHOTOGRAPHIC TIMES 10, no. 118 (Oct. 1880): 231. [Cabinet photos "Good Night," and "Good Morning", of many babies crying and laughing respectively.]

S756 "Meetings of Societies: Chicago Photographic Association." PHOTOGRAPHIC TIMES 11, no. 124 (Apr. 1881): 145-153. [Unusually long and detailed report of a meeting of this association on the impacts of the gelatine dry-plate process on commercial photographers. Brought forth reminiscences by the Society's President, Alfred Hall, (a photographer for thirty-three years); P. B. Green (a Chicago pioneer in the use of dry plates); A. Hesler; Joshua Smith; George N. Barnard (from Rochester, NY); and others.]

S757 Taylor, J. Traill. "Home and Foreign News." PHOTOGRAPHIC TIMES 11, no. 127 (July 1881): 245. [Describes several of Smith's photos of children, for which he was well-known.]

S758 Smith, Joshua. "Developing Gelatine Negatives." PHOTOGRAPHIC TIMES 11, no. 129 (Sept. 1881): 367-368.

S759 Smith, Joshua. "An Improved Method of Preparing Gelatine-Bromide Dry Plates." PHOTOGRAPHIC TIMES 12, no. 133 (Jan. 1882): 17-21. [Communication to the Chicago Photographic Association.]

S760 Smith, Joshua. "Observations and Comparisons." PHOTOGRAPHIC TIMES 17, no. 311-312 (Sept. 2 - Sept. 9, 1887): 448-449, 460-462. [Presented at the Chicago Convention. Compares and contrasts professions in Germany, France, and England with USA.]

S761 Smith, Joshua. "Observations and Comparisons." ANTHONY'S PHOTOGRAPHIC BULLETIN 18, no. 17 (Sept. 10, 1887): 521-523. [Read before the Chicago Convention of the P. A. of A.]

SMITH, L. R. (BRANTFORD, CANADA)
S762 "Execution of Over and Moore for the Murder of Lancelot Adams, on the 14th of April Last." FRANK LESLIE'S ILLUSTRATED NEWSPAPER 8, no. 186 (June 25, 1859): 60. 3 illus. [Portraits of the accused murderers. Credited to "L. R. Smith, of Brantford, C. W."]

SMITH, M.
S763 "Art in Our City." ANTHONY'S PHOTOGRAPHIC BULLETIN 9, no. 12 (Dec. 1878): 376. [From "Poughkeepsie, NY Courier." M. Smith from Atlanta, GA (formerly Smith & Motes) moved to Poughkeepsie, purchased gallery of Merritt & Myers. John D. Merritt staying on as well.]

SMITH, MILTON & CO. (ISLINGTON, ENGLAND)
S764 Portrait. Woodcut engraving credited "From a photograph by Milton Smith & Co., Upper Terrace, Islington" ILLUSTRATED LONDON NEWS 75, (1879) ["Rev. J. Bayley." 75:2096 (Aug. 16, 1879): 157]

SMITH, O. C.
S765 Smith, O. C. "Naming and Numbering Views." BRITISH JOURNAL PHOTOGRAPHIC ALMANAC 1876 (1876): 171-172.

SMITH, PETER.
S766 Smith, Peter. "Re-Discoveries in Photography." BRITISH JOURNAL OF PHOTOGRAPHY 8, no. 145 (July 1, 1861): 236.

SMITH, R. (GREAT BRITAIN)
S767 Smith, R. (Blackford). "Anatomy of the Physical Structure of the Universe. VI. - Light." PRACTICAL MECHANIC'S JOURNAL 1, no. 9-10 (Dec. 1848 - Jan. 1849): 201-203, 222. [This general survey includes a brief history of the early experiments in photography. Mentions Daguerre, Talbot, Wedgewood, Niépce, Fizeau, Brewster, Herschel, Dr. Woods, others.]

SMITH, R. (GREAT BRITAIN)
S768 "Scientific: Societies: Society of Arts - Feb. 2." ATHENAEUM no. 1322 (Feb 26, 1853): 262-263. [Brief summation of R. Smith's paper, "On Chromatic Photo-Printing, being a mode of Printing textile fabrics by the chemical action of Light."]

SMITH, R. D. O. (HARTFORD, CT)
S769 Smith, R. D. O. "First Stereoscope in Connecticut." PHOTOGRAPHIC TIMES 26, no. 5 (May 1895): 271-272. 2 illus. [Smith learned daguerreotypy from Major Moulthrop in New Haven, CT, in the early 1850s. Then he bought a gallery in Hartford, CT; and he ran the gallery there for "a year or two." The chemicals damaged his health and he quit the profession, however his interest in photography continued unabated. When he was at Hartford, he made stereoscopic daguerreotype portraits in 1/8 size.]

S770 Smith, R. D. O. "How to Manage Some Troublesome Interiors." AMERICAN ANNUAL OF PHOTOGRAPHY AND PHOTOGRAPHIC TIMES ALMANAC FOR 1897 (1897): 137-141. 5 b & w. 2 illus. [Industrial photographer, discusses solutions to difficult problems.]

S771 Smith, R. D. O. "A Little Election Day Experience." PHOTOGRAPHIC TIMES 29, no. 10 (Oct. 1897): 457-459. 3 illus.

S772 Smith, R. D. O. "The Occult in Photography." PHOTOGRAPHIC TIMES 30, no. 8 (Aug. 1898): 349-350.

S773 Smith, R. D. O. "Photographing Machinery." AMERICAN ANNUAL OF PHOTOGRAPHY AND PHOTOGRAPHIC TIMES ALMANAC FOR 1900 (1900): 127-129. 2 b & w.

SMITH, S. P. (KANKAKEE CITY, IL)
S774 Smith, S. P. "Negatives Without Fixing." AMERICAN JOURNAL OF PHOTOGRAPHY AND THE ALLIED ARTS & SCIENCES n. s. vol. 6, no. 20 [sic 21] (May 1, 1864): 502.

SMITH, SAMUEL. (1802-1892) (GREAT BRITAIN)
[Born at Tydd St. Giles, Ely Island, Cambridgeshire, England in 1802. Son of a farmer. In the 1830s he worked as a mechanic and timber merchant, and either made or inherited enough money to retire by 1847. Enthusiastic collector of stamps, shells, botanical specimens, etc. Began to photograph in 1852 and made over 100 calotype views of Wisbech and surroundings with equipment that he built himself. Photographed into the early 1860s. In 1860 he became the director of the Wisbech Gas Light & Coke Company. During the latter years he was a partial invalid, but seems to have spent time sorting, organizing and preparing objects for display at the town museum. He died on July 18, 1892.]

S775 Coe, Brian and Michael Millward. *Samuel Smith Calotype Photographer.* s. l. [Wisbech?] : s. n. [Wisbech & Fenland Museum?], n. d. [ca. 1974?]. 8 pp. 5 b & w. [Exhibition catalog, no site or date given. The introductory essay "The Photography of Samuel Smith," is cosigned by Michael Milleard, Wisbech & Fenland Museum, and Brian Coe, Kodak Museum.]

S776 Coe, Brian and Michàel Millward. *Victorian Townscape; the Work of Samuel Smith.* London: Ward Lock Ltd., 1974. 120 pp. 84 b & w. [Photographed Wisbech, in Cambridgeshire, England from 1852 to 1862, using the calotype process, often with his friend Thomas Craddock.]

SMITH, SYDNEY. (GREAT BRITAIN)
S777 R. A. S. "How to Produce Life-size Photographs." AMERICAN JOURNAL OF PHOTOGRAPHY AND THE ALLIED ARTS & SCIENCES n. s. vol. 7, no. 5 (Sept. 1, 1864): 97-104. [From "Art Journal." Describes Sydney Smith's method. Gives history of solar enlargements in Great Britain from Mr. Wenham (1853), Atkinson, etc.]

SMITH, THEOPHILUS. (GREAT BRITAIN)
BOOKS
S778 Smith, Theophilus. *Wharencliffe, Wortley, and the Valley of the Don. Photographically illustrated by Theophilus Smith.* London: A. W. Bennett, 1864. viii, 52 pp. 16 b & w. [16 albumen prints by Smith, landscape views of Scotland.]

S779 Smith, Theophilus. *Sheffield and Its Neighborhood. Photographically Illustrated.* London: A. W. Bennett, 1865. viii, 132 pp. 16 b & w. [16 albumen prints by Smith.]

PERIODICALS
S780 "Books Illustrated by Photographs." PHILADELPHIA PHOTOGRAPHER 3, no. 25 (Jan. 1866): 32. [Bk. rev.: "Sheffield and its Neighborhood," by Theophilus Smith. Illustrated with 16 original photographs. London: A. W. Bennett.]

SMITH, W. LYNDON. (d. 1865) (GREAT BRITAIN)
S781 Smith, Lyndon. "Albumen Process." HUMPHREY'S JOURNAL 8, no. 2 (May 15, 1856): 25-27. [From "Liverpool Photo. J."]

S782 Smith, W. Lyndon. "On the Choice of Subject in Photography, and the Adaptation of Different Processes." JOURNAL OF THE PHOTOGRAPHIC SOCIETY OF LONDON 5, no. 72 (Nov. 6, 1858): 68-69.

S783 Smith, W. Lyndon. "On the Choice of Subject in Photography, etc." HUMPHREY'S JOURNAL OF PHOTOGRAPHY, AND THE ALLIED ARTS AND SCIENCES 10, no. 17 (Jan. 1, 1859): 270-272. [From "London Photo. J."]

S784 Smith, Lyndon. "Fading of Alabastrine Positives." PHOTOGRAPHIC AND FINE ART JOURNAL 13, no. 1 (Jan. 1860): 3. [From "Photo. Notes."]

S785 Smith, Lyndon. "Plain Paper Printing." HUMPHREY'S JOURNAL OF PHOTOGRAPHY, AND THE ALLIED ARTS AND SCIENCES 13, no. 14 (Nov. 15, 1861): 218-219. [From "Photo. News."]

S786 Smith, Lyndon. "Photography a Fine Art." AMERICAN JOURNAL OF PHOTOGRAPHY AND THE ALLIED ARTS & SCIENCES n. s. vol. 4, no. 14 (Dec. 15, 1861): 326-328. [From "Photo. Notes."]

S787 "Obituary - Melancholy Death of Mr. Lyndon Smith." BRITISH JOURNAL OF PHOTOGRAPHY 12, no. 247 (Jan. 27, 1865): 38. [Died of drowning, while trying to rescue someone else. About 30 years old, an amateur who had won the first medal awarded by the Photo. Soc. of Scotland.]

SMITH, WASHINGTON GEORGE. (1825-1893) (USA)

S788 [Coffin, Robert Barry.] *The Home of Cooper and the Haunts of Leatherstocking,* by Barry Gray. New York: Russell Brothers, 1872. 38 pp. 7 l. of plates. 6 b & w. illus. [Original photos, landscape views, etc. Also engravings, one of which, (a portrait of J. Fennemore Cooper) is credited "From a Daguerreotype by Brady, Sept. 1850." GEH Collection copy attributes photos to Washington George Smith.]

S789 *Descriptive Catalogue of Stereoscopic Views. Photographed and Published by W. G. Smith, Portrait and Landscape Photographer, Cooperstown, N. Y. Cooper Views a Speciality.* Cooperstown, NY: The Republican and Democrat Office, n. d. 32 pp.

SMITH, WILLIAM HENRY. (HAVERSTOCK HILL, ENGLAND)

S790 "Photography on Wood." BRITISH JOURNAL OF PHOTOGRAPHY 12, no. 279 (Sept. 8, 1865): 462. [Wm. Henry Smith (Haverstock Hill, England); forming the Art Decorative and Photographic Co.]

SMYTH, CHARLES PIAZZI. (1819-1900) (GREAT BRITAIN, EGYPT)

[Born on Jan. 3, 1819 in Naples, of British parents. From 1835 to 1845 Smyth assisted Sir John Hershel at the Cape of Good Hope Observatory. Began to make calotypes and corresponded with W. H. Fox Talbot and Robert Hunt. In 1845 he was named Astronomer Royal of Scotland, a post he held until 1887. In 1856 he led an expedition to Teneriffe for astronomic experiments and to photograph the islands. His book describing this trip, published in 1858, was illustrated with stereographs. To Russia in the early 1860s. In 1864 Smyth and his wife went to Egypt and photographed the Great Pyramid, and made magnesium flash powder exposures inside the pyramids interior chambers. Smyth lectured broadly and published several books about these experiences, even though his thesis was considered dubious in scientific circles. "Our readers need scarcely be reminded that Professor Smyth is the principal supporter of the theory which states that the Great Pyramid was built under divine inspiration as a permanent record of weights and measures, etc." Smyth retired in 1887, but continued to pursue his independent scientific expeditions. Died on Feb. 21, 1900 at Clova, near Ripon, Yorkshire.]

BOOKS

S791 Smyth, Charles Piazzi. *Astronomical Experiment on the Peak of Teneriffe.* London: Printed by Taylor & Francis, 1858. iv, 604 pp. 2 b & w. 9 illus. [From "Philosophical Transactions" 1858, pt. 2.]

S792 Smyth, C. Piazzi. *Teneriffe, An Astronomer's Experiment: or Specialties of a Residence above the Clouds.* Illustrated with Photo-Stereographs. London: Lovell Reeve, 1858. xvi, 452 pp. 20 b & w. [20 stereographs, taken by Smyth.]

S793 Smyth, Charles Piazzi. *Our Inheritance in the Great Pyramid,...* with Photograph, Map, and Plates. London: Alexander Strahan & Co., 1864. xvi, 400 pp. 19 b & w. [Frontispiece photo by Francis Bedford.]

S794 Smyth, C. Piazzi. *Life and Work at the Great Pyramid During the Months of January, February, March and April, A. D. 1865...with a Discussion of the Facts Ascertained.* Edinburgh: Edmonston & Douglas, 1867. 3 vol. pp. 38 l. of plates. illus.

S795 Smyth, C. Piazzi. *A Poor Man's Photography at the Great Pyramid in the year 1865, compared with that of the Ordinance Survey Establishment, subsidized by London Wealth, and under the orders of Colonel Sir Henry James, R.E., F.R.S. (Director General of the Survey), at the same place four years afterwards. A Discourse delivered before the Edinburgh Photographic Society on December 1, 1869.* London: Henry Greenwood, 1870. 24 pp.

S796 Smyth, C. Piazzi. *Madeira Spectroscopic: Being a revision of 21 places in the Red Half of the Solar Visible Spectrum with a Rutherfurd Diffraction Grating, at Madeira... during the Summer of 1881.* Edinburgh: W. & A. K. Johnston, 1882. x, 32 pp. 18 l. of plates.

PERIODICALS

S797 "Free Revolver Stand." PHOTOGRAPHIC AND FINE ART JOURNAL 10, no. 8 (Aug. 1857): 253. [From "J. of Photo. Soc." P. Smyth developed a revolving camera stand.]

S798 Smyth, Piazzi. "Photography in Teneriffe." PHOTOGRAPHIC AND FINE ART JOURNAL 10, no. 11 (Nov. 1857): 348. [From the "Literary Gazette." Author not given, but it's Piazzi Smyth.]

S799 "Photography in Teneriffe." HUMPHREY'S JOURNAL OF PHOTOGRAPHY, AND THE ALLIED ARTS AND SCIENCES 9, no. 17 (Jan. 1, 1858): 260-261. [From "Edinburgh Literary Gazette.]

S800 "Scientific: Societies: Royal Institution: March 5." ATHENAEUM no. 1587 (Mar. 27, 1858): 406. [Summary of C. Piazzi Smyth's paper, "On the Astronomical Experiment at Teneriffe in 1856," describing his trip to South Africa to observe stars and photograph from a mountain top, where altitude made sky clearer.]

S801 Photography as Employed for the Illustration of Books. ART JOURNAL (Feb. 1861): 48. [Talbot's "Pencil of Nature," Prof. Piazzi Smyth's "Work on Teneriffe, "Ramble in Brittany" "Stereoscopic Magazine," "Sunshine in the Country" by Mr. Grundy.]

S802 Smyth, C. Piazzi. "Vistas In the Russian Church." GOOD WORDS 3, no. 8-9 (Aug. - Sept. 1862): 455-462, 528-534. 3 illus. [Two engravings of church door panels and a view of the Cathedral of St. Sophia at Novgorod, probably from photographs.]

S803 Smyth, C. Piazzi. "Experiments with the Trophy Telescope of the First Exhibition." GOOD WORDS 4, no. 2 (Feb. 1863): 125-132. 4 illus. [Background.]

S804 Smyth, C. Piazzi. "Interesting Electrical Phenomenon." BRITISH JOURNAL OF PHOTOGRAPHY 11, no. 222 (Aug. 5, 1864): 278.

S805 Smyth, C. Piazzi. "Interesting Electrical Phenomenon." AMERICAN JOURNAL OF PHOTOGRAPHY AND THE ALLIED

ARTS & SCIENCES n. s. vol. 7, no. 5 (Sept. 1, 1864): 116-117. [From "Br. J. of Photo."]

S806 "Photographing the Pyramids by Magnesium Light." HUMPHREY'S JOURNAL OF PHOTOGRAPHY, AND THE ALLIED ARTS AND SCIENCES 17, no. 5 (July 1, 1865): 70. [Excerpts from Smyth's letter describing these activities. No source given.]

S807 Smyth, C. Piazzi. "The Great Pyramid, and Egyptian Life of 4,000 Years Ago." GOOD WORDS 8, no. 6-7 (June - July 1867): 378-387, 444-453. 8 illus. [Illustrations from photographs. From the author's recent book, "Life and Work at the Great Pyramid," 3 vol. Edmonston & Douglas, Edinburgh.]

S808 Smyth, C. Piazzi. "The Great Pyramid, and Egyptian Life of 4,000 Years Ago. Second Paper." GOOD WORDS 8, no. 7 (July 1867): 444-453. 4 illus. [Illustrations from photographs.]

S809 Wilson, Edward L. "Photography In and About the Great Pyramid." PHILADELPHIA PHOTOGRAPHER 4, no. 46 (Oct. 1867): 321-323. [Description of twenty glass negatives taken in Egypt, by C. P. Smyth.]

S810 Smyth, C. PIAZZI. "Ordinary Photographics, From an Astronomer's Point of View." BRITISH JOURNAL PHOTOGRAPHIC ALMANAC 1873 (1873): 54-57.

S811 Smyth, C. Piazzi. "Optical Helps to 'Rapido-Manie.'" BRITISH JOURNAL PHOTOGRAPHIC ALMANAC 1874 (1874): 43-47.

S812 "Editor's Table." PHILADELPHIA PHOTOGRAPHER 11, no. 131 (Nov. 1874): 351. [Pamphlets from C. Piazzi Smyth, describing his work at the Great Pyramid, Egypt, his controversies with the Royal Society, and other matters.]

S813 Smyth, C. Piazzi. "A Mono-Stereoscope." BRITISH JOURNAL PHOTOGRAPHIC ALMANAC 1875 (1875): 39-41.

S814 Smyth, Piazzi. "On Small Negatives." BRITISH JOURNAL PHOTOGRAPHIC ALMANAC 1876 (1876): 36-38.

S815 Smyth, Piazzi. "The Art-Science, and Its Means of Realization." BRITISH JOURNAL PHOTOGRAPHIC ALMANAC 1877 (1877): 36-41.

S816 Smyth, Piazzi. "Photography as Both a High and Low Helper." BRITISH JOURNAL PHOTOGRAPHIC ALMANAC 1878 (1878): 40-43.

S817 Smyth, Piazzi. "The Art - Science and the Sun - Distance." BRITISH JOURNAL PHOTOGRAPHIC ALMANAC 1879 (1879): 32-37.

S818 Smyth, C. Piazzi. "Preparations." PHOTOGRAPHIC MOSAICS: 1890 26, (1890): 51-56. [Late astronomer Royal of Scotland.]

S819 Smyth, C. Piazzi. "Photography not of the Human Eye, in a Particular Branch of High Science." PHOTOGRAPHIC MOSAICS: 1891 27, (1891): 113-117.

S820 Nicol, Dr. John. "Cloud-Forms That Have Been." WILSON'S PHOTOGRAPHIC MAGAZINE 33, no. 473 (May 1896): 215-218. 4 b & w. [Review of Prof. C. Piazzi Smyth's studies of cloud formations. Mentions that Smyth has produced 3 volumes, each containing about 150 studies in 1892, 1893, 1894. Corrections on p. 288 next issue.]

S821 "Editor's Table: Obituary." WILSON'S PHOTOGRAPHIC MAGAZINE 37, no. 520 (Apr. 1900): 190. [Smith, Astronomer Royal of Scotland, died in London in March. Photographer, known to Wilson since mid-1860's, views of Egypt, etc.]

S822 "Obituary of the Year: Professor Piazzi Smyth." BRITISH JOURNAL PHOTOGRAPHIC ALMANAC 1901 (1901): 670. ["Late Astronomer Royal of Scotland, began his astronomical career at the Cape of Good Hope sixty-five years ago. In 1859 visited Russian observatories. In 1888 he returned to Ripon, where he devoted himself to spectroscopy and the study of cloud forms. Frequently contributed articles to the 'BJP' and the 'BJPA.'"]

S823 Schaaf, Larry. "Charles Piazzi Smyth's 1865 Conquest of the Great Pyramid." HISTORY OF PHOTOGRAPHY 3, no. 4 (Oct. 1979): 331-354. 8 b & w. 19 illus.

S824 Schaaf, Larry. "Piazzi Smyth at Teneriffe: Part I. The Exposition and the Resulting Book." HISTORY OF PHOTOGRAPHY 4, no. 4 (Oct. 1980): 289-307. 15 b & w. 11 illus. [Piazzi Smyth went to Canary Islands 1856 to set up an astronomical observatory. "Teneriffe, an Astronomer's Experiment," unpublished, with photographs 1858.]

S825 Schaaf, Larry. "Piazzi Smyth at Teneriffe: Part 2, Photography and the Disciples of Constable and Harding." HISTORY OF PHOTOGRAPHY 5, no. 1 (Jan. 1981): 27-50. 17 b & w. 9 illus.

S826 Henisch, B. A. and H. K. Henisch. "Correspondence: Melhuish and 'Teneriffe'." HISTORY OF PHOTOGRAPHY 5, no. 1 (Jan. 1981): 83. [This is a follow-up to an article by the same authors "A. J. Melhuish and the Shah" in "History of Photography" 4:3 (Oct. 1980), pp. 309-317.]

S827 Schaaf, Larry. "Charles Piazzi Smyth, Photography, and the Disciples of Constable & Harding." PHOTOGRAPHIC COLLECTOR 4, no. 3 (Winter 1983): 314-331. 13 b & w. 10 illus. [Smyth, who was Scotland's Astronomer Royal, began taking photos at the Cape of Good Hope in 1839-1840, photographed in Egypt in the 1860s, etc.]

S828 Schaaf, Larry J. "Charles Piazzi Smyth's 1865 Photographs of the Great Pyramid." IMAGE 27, no. 4 (Dec. 1984): 24-32. 6 b & w. 2 illus.

SNELL, WILLIAM.
S829 Snell, William. "Conditions of Success." PHOTOGRAPHIC TIMES 4, no. 37 (Jan. 1874): 6-7. [Advice to commercial photographers for successful business management.]

SNELLING & FISHER.
S830 "Snelling & Fisher's Quick Working Camera Box." and "Harrison's New Buffing Wheel." PHOTOGRAPHIC ART JOURNAL 1, no. 3 (Mar. 1851): 177-179. 1 illus.

SNELLING, HENRY HUNT. (1817-1897) (USA)
BOOKS
S831 Snelling, Henry Hunt. *The History and Practice of the Art of Photography; Or, The Production of Pictures Through the Agency of Light; Containing all the Instructions Necessary for the Complete Practice of the Daguerrian and Photogenic Art, both on Metallic Plates and on Paper.* New York : G. P. Putnam, 1849. vii, 139 pp. illus. [4th ed., corrected and rev. NY: Putnam, (1853). 2 vol. Facsimile Reprint (1970) Hastings-on-Hudson, NY: Morgan & Morgan. With a new introduction by Beaumont Newhall.]

S832 Snelling, Henry Hunt. *A Dictionary of the Photographic Art; Forming a Complete Encyclopedia of All the Terms, Receipts, Processes, Apparatus and Materials in the Art; Together with a List of Articles of Every Description Employed in Its Practice.* New York: G. P. Putnam, 1853. 235 pp. illus. [1854 ed., reprinted (1973), Arno Press.]

S833 Snelling, Henry Hunt. *A Guide to the Whole Art of Photography, including the Daguerreotype, Ambrotype, Melainotype, Photography on Glass, Albumen, Paper, Etc., and Comprising Tables exhibiting the Expenses to be Incurred in Establishing a Photographic Gallery.* New York: H. H. Snelling, 1858. 80 pp.

S834 Snelling, Henry Hunt. *Memoirs of a Life, 1817 - 1897* [Manuscript. E. W. Ayer Collection, the Newberry Library, Chicago. 3 vol.]

S835 *Sunlight Sketches; or, The Photographic Textbook.* New York: H. H. Snelling, 1858, 64 pp.

PERIODICALS
S836 Snelling, H. H. "The Art of Photography." PHOTOGRAPHIC ART JOURNAL 1, no. 1 (Jan. 1851): 1-3.

S837 Snelling, H. H. "The Difficulties of the Art." PHOTOGRAPHIC ART JOURNAL 1, no. 1-2 (Jan. - Feb. 1851): 31-36, 91-95.

S838 Snelling, H. H. "Photographic Re-Unions." PHOTOGRAPHIC ART JOURNAL 1, no. 2-3, 5 (Feb. - Mar., May 1851): 107-110, 139-141, 266-268 . [Call for the organization of a professional society.]

S839 Snelling, H. H. "On Taking Daguerreotypes in the Natural Colors." PHOTOGRAPHIC ART JOURNAL 1, no. 4 (Apr. 1851): 208-211.

S840 "Photographs in Natural Colours." ATHENAEUM no. 1242 (Aug. 16, 1851): 881.

S841 Snelling, H. H. "The Difficulties of the Art." PHOTOGRAPHIC ART JOURNAL 2, no. 4 (Oct. 1851): 232-234.

S842 [Snelling, Henry H.] "Gossip." PHOTOGRAPHIC ART JOURNAL 4, no. 6 (Dec. 1852): 381-384. [Survey of events, discoveries during the past year; mention of the active use of paper processes in France and England; praise for John A. Whipple's Crystalotype process; Prevost's experiments in photolithography; L. L. Hill's discoveries with colored daguerreotypes; list of more Anthony Prize competitors, Anthony Prize contest announcement.]

S843 Snelling, H. H. "On Coloring Daguerreotypes." PHOTOGRAPHIC ART JOURNAL 5, no. 1 (Jan. 1853): 60-61. [From "The Art of Photography" by H. H. Snelling, 4th Ed., just published.]

S844 Snelling, H. H. "From 'A Dictionary of the Photographic Art.'" PHOTOGRAPHIC ART JOURNAL 5, no. 5 (May 1853): 305-309. 8 illus.

S845 Snelling, H. H. "A Dictionary of the Photographic Art." PHOTOGRAPHIC AND FINE ART JOURNAL 13, no. 3-8 (Mar. - Aug. 1860): 83-84, 108-111, 177-179, 187-188, 228-232 . illus.

S846 Snelling, H. H. "On the Fading of Photographic Prints." AMERICAN JOURNAL OF PHOTOGRAPHY AND THE ALLIED ARTS & SCIENCES n. s. vol. 3, no. 20 (Mar. 15, 1861): 312-318. [Read before Am. Photo. Soc.]

S847 Snelling, H. H. "Practical Details of the Photographic Printing Press." AMERICAN JOURNAL OF PHOTOGRAPHY AND THE ALLIED ARTS & SCIENCES n. s. vol. 3, no. 22 (Apr. 15, 1861): 337-342. [Technical, on processes.]

S848 Snelling, H. H. "Instantaneous Camera Box." AMERICAN JOURNAL OF PHOTOGRAPHY AND THE ALLIED ARTS & SCIENCES n. s. vol. 4, no. 13 (Dec. 1, 1861): 310-311. [Sutton's description of a camera box published in Oct. 1 "Photo. News," leads Snelling to describe a similar apparatus he designed in 1850 for a daguerreotype camera.]

S849 Davie, D. D. T. "Meeting an Old Friend." HUMPHREY'S JOURNAL OF PHOTOGRAPHY, AND THE ALLIED ARTS AND SCIENCES 20, no. 24 (Aug. 15, 1869): 379. [Davie tells of how Snelling, the editor of the "Photographic and Fine Art Journal," had been forced to sell due to lack of support and that he had not done any editorial work in photography since. Davie suggests that he return to editing, perhaps for "Humphrey's Journal."]

S850 Snelling, H. H. "Letter from H. H. Snelling, Esq." HUMPHREY'S JOURNAL OF PHOTOGRAPHY, AND THE ALLIED ARTS AND SCIENCES 20, no. 25 (Sept. 15, 1869): 395. ["I regret that Friend Davie has,... reopened an old sore which I hoped would never again stare me in the face."]

S851 Snelling, H. H. "Doctor Photo." PHILADELPHIA PHOTOGRAPHER 8, no. 92 (Aug. 1871): 270-272. [Snelling reminiscences about a toothache he had in 1855, and gives the formula he worked out to alleviate the pain.]

S852 Snelling, H. H. "Photographic Printing on Oil Surfaces." PHILADELPHIA PHOTOGRAPHER 8, no. 93 (Sept. 1871): 281-282.

S853 Snelling, H. H. "Past and Present." PHILADELPHIA PHOTOGRAPHER 8, no. 94 (Oct. 1871): 337-338. [Quotes from his own essay in the May 1854 "Photo. & Fine Art J." where he compared the relative merits of the daguerreotype and the nascent paper processes, then reflects on the changes of the past two decades.]

S854 Snelling, H. H. "The Present." PHILADELPHIA PHOTOGRAPHER 8, no. 95 (Nov. 1871): 370-371.

S855 Snelling, H. H. "The Journal Pictures." PHILADELPHIA PHOTOGRAPHER 8, no. 96 (Dec. 1871): 384-385. [Criticism of original photographs that were published in the "Phila. Photo." and the "Photo. World" during 1871.]

S856 Snelling, H. H. "Photographic Prints For Books." PHILADELPHIA PHOTOGRAPHER 9, no. 97 (Jan. 1872): 11-12.

S857 Snelling, H. H. "Mutual Benefit Association." PHILADELPHIA PHOTOGRAPHER 9, no. 98 (Feb. 1872): 37.

S858 Snelling, H. H. "'Retouching Negatives.'" PHILADELPHIA PHOTOGRAPHER 9, no. 99 (Mar. 1872): 71-72.

S859 Snelling, H. H. "The Wants of Photography." PHILADELPHIA PHOTOGRAPHER 9, no. 100 (Apr. 1872): 101-103.

S860 "A Testimonial to H. H. Snelling, Esq." PHILADELPHIA PHOTOGRAPHER 9, no. 100 (Apr. 1872): 123-124. [Testimonial to Snelling's contributions, signed by Samuel Holmes, Ed. Anthony, A. Bogardus and Ed. L. Wilson.]

S861 "A Testimonial to H. H. Snelling, Esq.""
ANTHONY'S PHOTOGRAPHIC BULLETIN 3, no. 5 (May 1872): 560. [Letter, signed by S. Holmes, E. Anthony, A. Bogardus, and E. L. Wilson, asking the photographic community to send funds to assist H. H. Snelling.]

S862 Snelling, H. H. "Criticism and Photography." PHILADELPHIA PHOTOGRAPHER 9, no. 101 (May 1872): 135.

S863 Snelling, H. H. "Fourth Annual Meeting and Exhibition of the N. P. A. in St. Louis, Mo., May 1872: Looking Higher." PHILADELPHIA PHOTOGRAPHER 9, no. 102 (June 1872): 208-209.

S864 Snelling, H. H. "Photographic Instruction." PHILADELPHIA PHOTOGRAPHER 9, no. 103 (July 1872): 246-248.

S865 Snelling, H. H. "To Touch or Not to Touch; That's the Question." PHILADELPHIA PHOTOGRAPHER 9, no. 104 (Aug. 1872): 299-300.

S866 Snelling, H. H. "On the Recovery of Silver from Waste Solutions." PHILADELPHIA PHOTOGRAPHER 9, no. 105-106 (Sept. - Oct. 1872): 324-325, 359-360.

S867 Snelling, H. H. "A Touching Subject." PHILADELPHIA PHOTOGRAPHER 9, no. 107 (Nov. 1872): 380-381. [Retouching.]

S868 Snelling, H. H. "The Same Subject Continued." PHILADELPHIA PHOTOGRAPHER 9, no. 108 (Dec. 1872): 406-407. [Retouching.]

S869 Snelling, H. H. "Yet Another Touch." PHILADELPHIA PHOTOGRAPHER 10, no. 109 (Jan. 1873): 6-8.

S870 Snelling, H. H. "The Untruthfulness of Photography." PHILADELPHIA PHOTOGRAPHER 10, no. 110 (Feb. 1873): 37-38.

S871 Snelling, H. H. "Explanatory - The Beautiful in Photography." PHILADELPHIA PHOTOGRAPHER 10, no. 116 (Aug. 1873): 239-241.

S872 Snelling, H. H. "Fifth Annual Meeting and Exhibit of the National Photographic Association of the U.S., held in Buffalo, N.Y., beginning July 5, 1873: Beauty & Photography." PHILADELPHIA PHOTOGRAPHER 10, no. 117 (Sept. 1873): 388-393.

S873 Snelling, H. H. "Thoughts: On the Relation of Discoveries and Inventors to Photographers." PHOTOGRAPHIC TIMES 5, no. 50 (Feb. 1875): 41-43.

S874 Snelling, H. H. "Looking Back; Or, The Olden Days of Photography." ANTHONY'S PHOTOGRAPHIC BULLETIN 19, no. 9-10, 12, 14, 18, 21 (May 12 - May 26, June 23, July 28, Sept. 22, Nov. 10, 1888): 263-265, 295-298, 368-370, 433-438, 559-563, 650-654. [History of early photography in USA. Anecdotes, etc. Mentions Dr. Gourand introducing photo to USA; the Lewises; Brady; Thompson; Whipple, etc.]

S875 "Notes about Photographers - Death of Henry Hunt Snelling." PHOTOGRAPHIC TIMES 29, no. 9 (Sept. 1897): 447. [Obituary. Died June 24th, 1897 in St. Louis. Born at the Military Post at Plattsburgh, NY in 1817. Went to Georgetown College. Employed in the chemical department of the E. & T. H. Anthony Company in the 1850s, during which time he published "The Photographic and Fine Arts Journal." "About this time he became blind, but his interest in

photography and editorial work still continued, and his contributions to photographic literature were quite voluminous."]

S876 Olmstead, A. J. "Snelling - Father of Photographic Journalism." THE CAMERA 47, no. 12 (Dec. 1933): 391-394. [After father's death while Snelling was a teenager, the family moved to Detroit, MI. He married there in 1837, then moved to New York City. Met the Anthony Brothers while they were still practicing photographers, and when they set up their photographic stock business, Snelling became their general sales manager. In 1851 Snelling began publishing the "Photographic Art Journal," while still working twelve hour day for the Anthonys. In early 1850s worked with collodion processes, invented an enlarging camera, published several books. Plagued by ill health, overwork, and "nervous disorders," Retired, under doctor's orders, and sold the "PAJ" to Seeley. Rested three years, then worked for Internal Revenue Department. Later farmed, edited a local town paper, etc. By 1887 he was blind.]

S877 Kahan, Robert S., Larry J. Schaaf and Roy L. Flukinger. "Plagiarism in the "First" American Book About Photography." PAPERS OF THE BIBLIOGRAPHIC SOCIETY OF AMERICA 67, no. 3 (1973): 283-304. 3 illus. [Henry Hunt Snelling's "The History and Practice of the Art of Photography", published in 1849 is claimed to have been largely plagiarized from George Thomas Fisher Jr.'s "Photogenic Manipulation: Containing the Theory and Plain Instructions in the Art of Photography," published in London in 1843.]

SNELLING, H. H. [?]
S878 "Knowledge of the Art." PHOTOGRAPHIC ART JOURNAL 1, no. 1 (Jan. 1851): 49-50.

S879 "Our Photographic Illustrations. II." PHOTOGRAPHIC AND FINE ART JOURNAL 13, no. 4 (Apr. 1860): Unnumbered page before p. 114; 116. 1 b & w. [Original photographic print, tipped-in. "A Group from life representing our printers at one of their noon-day amusements when they play at a game they call Jeffing..." No artist identified, may be the editor, H. H. Snelling.]

SNYDER & TRIMBLE.
S880 "Indiana. - Silver Maple-Tree Growing from the Tower of the Greensburg Court House. - From a Photograph by Snyder & Trimble." FRANK LESLIE'S ILLUSTRATED NEWSPAPER 47, no. 1222 (Mar. 1, 1879): 476. 1 illus. [View.]

SOLEIL, JEAN BAPTISTE FRANÇOIS. (1798-1878) (FRANCE)
S881 "Early Attempts to Improve the Daguerreotype: Two Plates in the Franklin Institute by J. F. Soleil and the Breton Freres." IMAGE 19, no. 1 (Mar. 1976): 7-12.

SOLOMON, JOSEPH. (1803-1890) (GREAT BRITAIN)
[A well-known dealer of photographic apparatus in London.]

BOOKS
S882 Solomon, Joseph. *Photographic Wrinkles, Remedies and Recipes. Catalogue for Photographic Apparatus.* London: J. Solomon, 1861. 37 pp.

S883 Solomon, J. *Photography in Three Lessons: a Book for Beginners.* London: J. Solomon, photographic apparatus, etc., 1863. 16 pp.

S884 Solomon, J. *Photography in Four Lessons: a Book for Beginners and Advanced Students.* Comprising the Best Methods of Producing Large Pictures from Small Ones. London: J. Solomon, 1874. 40 pp.

S885 Solomon, J. *Vitrified Photographs on Enamel. The Powder and Fiber Processes.* London: J. Solomon, 1874. 15 pp.

S886 Solomon, J. *Photography in Six Lessons: including Transfer Pictures and Enlargements.* London: J. Solomon, 1879. n. p.

PERIODICALS

S887 "The Magnesium Light Applied to Photography." ART JOURNAL (Apr. 1868): 76. [Solomon of Red Lion Square, optician.]

S888 Solomon, J. "Printing in Dark Weather." BRITISH JOURNAL PHOTOGRAPHIC ALMANAC 1878 (1878): 92-93.

S889 Solomon, J. "Recollections of Early Days in Photography. " PHOTOGRAPHIC TIMES 17, no. 299-305 (June 10 - July 22, 1887): 304-305, 309, 314-315, 339-340, 351-352, 363-364, 374-375. [Solomon was "late of Red Lion Square, London, England." Early history of invention Daguerre, Claudet, Beard, Talbot. Brief statement about Solomon on p. 309 in "General Notes," claiming that "...he is probably the oldest man now living who is connected with photography. Born in 1803, he now in his 84th year... recalls the personal experiences of his youth, when photography was born." Began in London in 1840. Mentions Frederick Yorke, photographer on the Cape of Good Hope in 1850s, among others, on pp. 363-364. Describes his experiences from 1840s through 1860s.]

SOMERS, F. M. see LANDY, JAMES.

SOMMER, GIORGIO. (1834-1914) (GERMANY, ITALY)
[Born in Frankfurt, Germany in 1834, to a prosperous family. Began to take photographs in the early 1850s, photographing in Switzerland. Moved to Naples and, by 1857, set up a studio there. Photographed in Switzerland and Austria, the Opera at Naples, views in Italy. In 1860 he forms a partnership with Edmundo Behlès, which lasts until 1872. In 1861 photographed the fort at Gaeta, the military camps there, etc. Photographed in Pompeii in 1863, Capri in 1865. Published an album of views, *Voyage en Sicile*, in 1869. In 1873 opened a new studio in Naples and published a catalog *Photographies d'Italie et de Malte*. Photographed Palermo in 1880. Died in Naples in 1914.]

BOOKS

S890 Weinberg, Adam D. *The Photographs of Giorgio Sommer.* Rochester, NY: Visual Studies Workshop, 1981. 56 pp. 24 b & w. [Exhibition catalog; Visual Studies Workshop, Rochester, NY., Nov. 20, 1981-Jan. 17, 1892. 141 prints in exhibition.]

PERIODICALS

S891 "1 photo (Landscape View of Naples)." PHILADELPHIA PHOTOGRAPHER 11, no. 129 (Sept. 1874): frontispiece. 1 b & w. [The regular column "Our Picture" missing from this issue.]

SONREL, A. (BOSTON, MA)
S892 Portrait. Woodcut engraving, credited "From a Photograph by A. Sonrel, of Boston." HARPER'S WEEKLY 10, (1866) ["Professor Agassiz." 10:486 (Apr. 21, 1866): 244.]

S893 Portrait. Woodcut engraving, credited "From a Photograph by Sonrel." HARPER'S WEEKLY 11, (1867) ["Dr. Oliver Wendell Holmes, the Poet." 11:558 (Sept. 7, 1867): 565.]

S894 Portrait. Woodcut engraving, credited "From a Photograph by A. Sonrel, of Boston" FRANK LESLIE'S ILLUSTRATED NEWSPAPER 28, (1869) ["Hon. E. R. Hoar, Pres. Grant's Cabinet." 278:705 (Apr. 3, 1869): 40.]

SOTHEN, SGT. VON.
S895 "Blown Up With Powder." ANTHONY'S PHOTOGRAPHIC BULLETIN 9, no. 8 (Aug. 1878): 247-249. [From "New York Times." A Sergt. von Sothen, under direction of Gen. Abbott, photographed a ship blown up by torpedoes at the Willett's Point Works (Army yard?) near Fort Schuyler, NY. Von Sothen's enlistment expired and he went to work for the Photo-Lithographic Co., New York, NY.]

SOUDER.
S896 "The Steamship 'Florida,' the U.S. Vessel Recently Searched on the High Seas by the Spanish Cruiser. - From a Photograph by Souder." FRANK LESLIE'S ILLUSTRATED NEWSPAPER 33, no. 854 (Feb. 10, 1872): 341. 1 illus.

SOULE PHOTOGRAPH CO. see SOULE, JOHN P.

SOULE, JOHN PAYSON. (1827-1904) (USA)
[John P. Soule came to Boston, MA in 1857 as a print seller, in partnership with John Roger. He became a professional photographer in 1859, and began to produce and market stereo views in 1866. He ran the Soule Photographic Co., a large firm producing prints of art work, portraits, scenery, etc., in Boston until 1883, when he sold the firm to his brother William, who had worked there since the mid 1870s. John then left Boston until 1886, when he returned to become a real estate broker, in partnership with Charles Kendall. John Soule moved to Seattle, WA in 1899, where he died of an apoplectic stroke in 1904.]

BOOKS

S897 *Views in the White Mountain Region of New Hampshire. Photographed from Nature, and Published by John P. Soule, 199 Washington Street, Boston.* Boston: Smith & Foster, Printers, n. d. 8 pp.

S898 *Catalogue of Stereographic Views, Published by John P. Soule, 199 Washington Street, Boston, Mass.* Boston: Cawell & Mollins, Printers, 1868. 28 pp. [Lists about 900 views.]

S899 Kneeland, Samuel, with original photographic illustrations by John P. Soule. *The Wonders of the Yosemite Valley and of California.* Boston: Alexander Moore, 1871. 71 pp. 10 b & w. [Original prints, tipped-in. By John P. Soule.]

PERIODICALS

S900 "Boston As It Was. - Photographed by John P. Soule, of Boston." FRANK LESLIE'S ILLUSTRATED NEWSPAPER 35, no. 896 (Nov. 30, 1872): 193. 7 illus. [Views of Boston, MA, before the fire.]

S901 "The Second Boston Fire. - The Burning of the Globe Theatre, in Washington Street. - From Sketches by E. R. Morse, and Photos. by Soule." FRANK LESLIE'S ILLUSTRATED NEWSPAPER 36, no. 924 (June 14, 1873): 213, 218-219, 221. 3 illus. [Views, map.]

S902 "Obituary: John P. Soule." BOSTON EVENING TRANSCRIPT (Nov. 28, 1904): n. p.

S903 Palmquist, Peter E. "Soule's California Stereographs." STEREO WORLD 8, no. 1 (Mar. - Apr. 1981): 4-10. 11 b & w. [Soule born in Phillips, ME on Oct. 19, 1828. Founded and ran the Soule Photograph Co. in Boston, MA, in the early 1860s, which he ran until he sold it to his brother William Stinson Soule in 1882. In 1870 John Soule published an extensive series of over 260 titles of California views. Palmquist concludes that these negatives were probably taken by John James Reilly. Article includes a checklist of these stereographs.

(Additional titles to this checklist included in the May/June 1981 issue, on pp. 17-18.)]

S904 Ryder, Richard C. "The Night Portland Burned." STEREO WORLD 9, no. 3 (July - Aug. 1982): 4-14. 17 b & w. 2 illus. [Portland, ME burned in July 1866. John Soule came up from Boston and took twenty-five views on July 12-14. In September he took additional views.]

S905 Palmquist, Peter E. "Frontispiece: The Cat's Meow." HISTORY OF PHOTOGRAPHY 12, no. 3 (July - Sept. 1988): frontispiece. 2 b & w. [Stereo cards, of kittens playing with a camera, taken by John P. Soule, Boston, MA, in 1871.]

SOULE, WILLIAM STINSON. (1836-1908) (USA)
[Born on Aug. 28, 1836 in Turner, ME. William S. was the brother of the Boston photographer John P. Soule. William was listed as a photographer in the Civil War, and he was wounded in action in 1861. In 1865 he opened a studio in Chambersburg, PA. The studio burned down in 1866 or 1867 and William moved to Ft. Dodge, KS, where he worked as clerk in a store. He then began to take photographs of the Plains Indian tribes in the area. In 1868 William moved to Ft. Sill and Camp Supply (then in the Indian Territory) and continued to make portraits and views amoung the tribes in the area. In 1874 or 1875 William moved to Boston, MA to work with his brother at the Soule Photographic Co. William bought the company from his brother in 1882. The business stayed active at least through the 1890s, publishing thousands of reproductions of works of art. William S. Soule died in 1908.]

BOOKS
S906 Soule Photograph Co., Boston. *Catalogue of Photographs of American Architecture.* Boston: Soule Photograph Co., 1885. n. p.

S907 Soule Photograph Co., Boston. *Catalogue of Photographic Reproductions of Works of Art*, ed. by W. B. Everett and W. S. Soule. Boston: Soule Photograph Co., 1887. 205 pp. [The 3rd ed. (Jan. 1887) lists 10,053 items. Supplements were published to the 1900s.]

S908 Soule Photograph Co., Boston. *Illustrated Catalogue; Soule Photograph Co., Boston.* Boston: Soule Photograph Co., 1890 ? 38 pp. illus. [3700 photos listed, with minute reproductions of the images,]

S909 Soule Photograph Co., Boston. *Catalogue of Photographic Reproductions of Works of Art. Vol. 2.* Boston: Soule Photograph Co., ca. 1900. n. p. [Lists items 10,054 through 15,597.]

S910 Nye, Wilbur Sturtevant. *Plains Indian Raiders, the Final Phases of Warfare from the Arkansas to the Red River, with Original Photographs by William S. Soule.* Norman, Okla.: University of Oklahoma Press, 1968. 418 pp. b & w.

S911 Belous, Russell E. and Robert A. Weinstein. *Will Soule: Indian Photographer at Fort Sill, Oklahoma 1869 - 74.* Los Angeles: The Ward Richie Press, 1969. 120 pp. b & w. illus. [Includes chapter, "The American Images: The Image Fixed," which contains a brief survey of photographers of American Indians.]

PERIODICALS
S912 "The Scalped Hunter - Photographed by William S. Soule." in: " The Indian War." HARPER'S WEEKLY 13, no. 629 (Jan. 16, 1869): 41, 42. 3 illus. [One engraving from Soule's photo, two engravings from sketches by Theo R. David. Includes a letter (signed A. B. C.), on p. 42, describing the incident that led to Soule's photograph.]

S913 Chatfield-Taylor, H. C. "Cordova, the City of Memories." COSMOPOLITAN 21, no. 4 (Aug. 1896): 362-371. 12 b & w. [2 photos credited to Soule Photo Co., Boston.]

S914 Weinstein, Robert A. and Russell E. Belous. "Indian Portraits: Fort Sill, 1869." AMERICAN WEST 3, no. 1 (Winter 1966): 50-63, inside back cover. 15 b & w. [Photos taken at Fort Sill, OK, in 1869.]

SOULIER, CHARLES see also FERRIER & SOULIER.

SOULIER, CHARLES. (1840-1875) (FRANCE)
[Associate of A. Clouzard in Paris in 1854, then proprietor of the studio in 1859. His panoramic views of Paris were highly praised in 1855. In 1859 Soulier, Ferrier and Bérardy followed the French army into Italy during the Franco-Austrian War, photographing the departure of troops for Magenta, camp scenes, etc. Partner with Claude-Marie Ferrier & Fils until 1864. Published *Catalogue général des épreuves stéréoscopiques sur verre de Ferrier père-fils et Soulier.* (Paris: H. Plon, 1864). In 1864 Léon & Levy take over the studio. Soulier operated on his own after 1864. Made landscapes, urban views, etc. in Paris and elsewhere in Europe, sold both glass stereos and prints through Antonin. Made the series "Vues instantanées de Paris" in 1865. In 1869 he photographed a climbing trip up Mont-Blanc. In 1871 he photographed the Commune, the Communards, the ruins of the Siege.]

S915 "Stereoscopic Views of the Royal Palaces." ART JOURNAL (Jan. 1861): 30. [Mr. Soulier has executed a series of glass stereo views of royal palaces of England for the firm of Murray & Heath.]

SOUTHWELL & SOUTHWELL. (LONDON, ENGLAND)
S916 Portraits. Woodcut engravings credited "From a photograph by Southwell & Southwell, Baker St." ILLUSTRATED LONDON NEWS 48, (1866) ["H.R.H. Princess Mary of Cambridge." 48:* (June 16, 1866): 592. "H.R.H. Prince Teck." 48:* (June 16, 1866): 593.]

S917 "A Novelty in Portraiture." AMERICAN JOURNAL OF PHOTOGRAPHY AND THE ALLIED ARTS & SCIENCES n. s. vol. 9, no. 1 (Sept. 1, 1866): 1-3. [From "Photo. News."]

SOUTHWELL. (BRIGHTON, ENGLAND)
S918 "Lithography An Auxiliary to Photographic Portraiture." ART JOURNAL (Aug. 1866): 250. [Process patented by Mr. Southwell, of Brighton.]

SOUTHWELL, FREDERICK. (d. 1883) (GREAT BRITAIN)
S919 Portrait. Woodcut engraving, credited to "From a Photograph by Southwell, Baker St." ILLUSTRATED LONDON NEWS 59, (1871) ["Late Sir Joshua Walmsley." 59:1681 (Dec. 2, 1871): 532.]

SOUTHWORTH & CO.
S920 "North American Hotel, Summit of the Sierra Nevada Mountains. - Photographed by Southworth & Co." FRANK LESLIE'S ILLUSTRATED NEWSPAPER 39, no. 989 (Sept. 12, 1874): 12. 1 illus. [View in the Black Hills, Dakota Terr. (SD) A second, similar, image is credited to S. J. Sedgewick. (May be that Sedgewick was marketing his work through Southworth?)]

SOUTHWORTH & HAWES see also HAWES, J.; SOUTHWORTH, A. S.

SOUTHWORTH, ALBERT SANDS & JOSIAH HAWES.
BOOKS
S921 Stokes, I. N. Phelps. *The Hawes - Stokes Collection of American Daguerreotypes by Albert Sands Southworth and Josiah Johnson*

Hawes. New York: Metropolitan Museum of Art, 1939. 21 pp. 24 b & w. [Exhibition: Nov. 4 - Dec. 7, 1939.]

S922 Moore, C. L. *Two Partners in Boston: The Careers and Daguerrian Artistry of Albert Southworth and Josiah Hawes.* Ann Arbor, MI: University Microfilms, 1975. xviii, 635 l. pp. [Ph.D. dissertation, Univ. of Michigan, 1975. Bibliography l. 408-421. Dissertation Abstracts International Order No. 76-11674.]

S923 Sobieszek, Robert A. and Odette M. Appel. With research assistance by Charles R. Moore. *The Spirit of Fact: The Daguerreotypes of Southworth and Hawes, 1843 - 1862.* Boston: David R. Godine, with the International Museum of Photography at George Eastman House, 1976. xvi, 164 pp. 147 b & w. [Republished (1980) by Dover Publishers, NY, with the title "The Daguerreotypes of Southworth and Hawes."]

S924 Ackley, Clifford. *"The Spirit of Fact" The Daguerreotypes of Southworth & Hawes 1843 - 1862: A loan exhibition organized by the International Museum of Photography at the George Eastman House, Rochester. Illustrated checklist.* Boston: Museum of Fine Arts, Boston, 1977. 16 pp. 8 b & w. [Exhibition: Jan. 19 - Mar. 20, 1977.]

S925 Isenburg, Matthew R. "Southworth and Hawes: The Artists," on pp. 74-78 and Appollo, Ken. "Southworth and Hawes: The Studio Collection," on pp. 79-90 in: *The Daguerreotype: A Sesquicentennial Celebration,* edited by John Wood. Iowa City: University of Iowa Press, 1989.

PERIODICALS

S926 Portrait. Woodcut engraving from a daguerreotype by Southworth & Hawes. GLEASON'S PICTORIAL DRAWING-ROOM COMPANION 1, (1851) ["Gov. George S. Boutwell." 1:7 (June 14, 1851): 100. (Note on p. 125 credits Southworth & Hawes.) "Gen. John E. Wool." 1:9 (June 28, 1851): 137. "Chief Justice Shaw." 1:20 (Sept. 13, 1851): 320.]

S927 Portrait. Woodcut engraving, credited "From a Daguerreotype by Southworth & Hawes." GLEASON'S PICTORIAL DRAWING-ROOM COMPANION 2, (1852) ["Col. N. A. Thompson." 2:6 (Feb. 7, 1852): 88.]

S928 "The Stereoscope." GLEASON'S PICTORIAL DRAWING-ROOM COMPANION 4, no. 2 (Jan. 8, 1853): 29. [Brief announcement of improvements in the stereoscope available at the Southworth & Hawes gallery.]

S929 "Mayor and Aldermen of Boston." GLEASON'S PICTORIAL DRAWING-ROOM COMPANION 4, no. 9 (Feb. 26, 1853): 136, 143. 1 illus. ["...we are indebted to those excellent daguerrean artists, Messers. Southworth & Hawes... to whom the gentlemen kindly sat." Nine portraits engraved from daguerreotypes.]

S930 Farnham, Rev. Luther. "Boston Pulpit. No. 1 - No. 22." GLEASON'S PICTORIAL DRAWING-ROOM COMPANION 5, no. 1-22 (July 2, 1853 - Nov. 26, 1853): 12, 28, 44, 60, 76, 92, 108, 124, 140, 156, 172, 188, 204, 220, 236, 252, 268, 284, 300, 316, 332, 348. 44 illus. [Series of biographies of Boston ministers, each accompanied by a portrait and a view of their church. Seven credited "From a daguerreotype by Southworth & Hawes." Six credited "From a daguerreotype by Whipple." Two credited "From a daguerreotype by Masury & Silsbee."]

S931 "Daguerreotype." GLEASON'S PICTORIAL DRAWING-ROOM COMPANION 6, no. 8 (Feb. 25, 1854): 125.

["DAGUERREOTYPES- We were struck with admiration,... while on a visit to the extensive and unsurpassed daguerrean establishment of Southworth & Hawes, No. 5 1/2 Tremont Row."]

S932 "Men of the Times: Donald McKay." BALLOU'S PICTORIAL DRAWING-ROOM COMPANION [GLEASON'S] 8, no. 1 (Jan. 6, 1855): 12. 1 illus. ["... engraved from an accurate daguerreotype by Southworth & Hawes."]

S933 "Isaac Adams, Inventor of the Adams Power Press." BALLOU'S PICTORIAL DRAWING-ROOM COMPANION [GLEASON'S] 8, no. 8 (Feb. 24, 1855): 124. 1 illus. ["...from a daguerreotype by Messers. Southworth & Hawes, who also furnished us with the heads of Colonel Adams and Donald McKay, published in preceding numbers." (Uncredited portrait of an Alvin, not Colonel, Adams on p. 108.)]

S934 "Charles Gordon Greene: Editor of the 'Boston Post.'" BALLOU'S PICTORIAL DRAWING-ROOM COMPANION [GLEASON'S] 8, no. 11 (Mar. 17, 1855): 172. 1 illus. ["...from an admirable daguerreotype by Southworth & Hawes."]

S935 Portrait. Woodcut engraving, not credited, but from a Southworth & Hawes daguerreotype. BALLOU'S PICTORIAL DRAWING-ROOM COMPANION [GLEASON'S] 10, (1856) ["Laura Bridgman, pupil at the Perkins Institute for the Blind." 10:251 (Apr. 26, 1856): 268.]

S936 "Photography." BALLOU'S PICTORIAL DRAWING-ROOM COMPANION [GLEASON'S] 11, no. 262 (July 12, 1856): 29. ["We have seen some beautiful specimens of a new style of photographic pictures, invented and patented by Messrs. Southworth & Hawes, of this city. They have a delicacy and softness surpassing that of the finest mezzotint engravings or crayon drawings, and resemble, in some respects, monochromatic pictures in oil. The effect is remarkably fine."]

S937 "Photographic Ware: Southworth & Hawes." HUMPHREY'S JOURNAL 9, no. 1 (May 1, 1857): Additional section; 7. [Praise for their daguerreotypes and photographs.]

S938 "Statue of Major-Gen. Jos. Warren, by Henry Dexter, Sculptor,... From a Photograph by Southworth & Hawes." FRANK LESLIE'S ILLUSTRATED NEWSPAPER 4, no. 81 (June 20, 1857): 36. 1 illus.

S939 Portraits. Woodcut engravings, credited "Photographed by Southworth & Hawes." FRANK LESLIE'S ILLUSTRATED NEWSPAPER 4, (1857) ["Henry Dexter, sculptor." 4:81 (June 20, 1857): 44.]

S940 "Statue of General Warren." BALLOU'S PICTORIAL DRAWING-ROOM COMPANION [GLEASON'S] 13, no. 316 (July 11, 1857): 17. 1 illus. ["...from an admirable photograph by Messrs. Southworth & Hawes, Tremont Row."]

S941 Portrait. Woodcut engraving, credited "From a Daguerreotype by Southworth & Hawes." BALLOU'S PICTORIAL DRAWING-ROOM COMPANION [GLEASON'S] 13, (1857) ["Hon. Robert I. Burbank." 13:328 (Oct. 23, 1857): 220.]

S942 White, Minor. "Pictures from the Collection." IMAGE 5, no. 1 (Jan. 1956): 20-21. 1 b & w. [Portrait of Ralph Waldo Emerson by Southworth & Hawes.]

S943 "Index to Resources: Southworth and Hawes Collection of Daguerreotypes." IMAGE 6, no. 5 (May 1957): 120-121. 6 b & w. [Continuing series on George Eastman House Collections. American

daguerreotypes: unknown (3); Southworth & Hawes (3). 486 daguerreotypes at GEH, 1434 items of correspondence, etc. in S & H collection.]

S944 Newhall, Beaumont. "Critic's Choice: 'More living than the memory of the man': Daguerreotype by Southworth & Hawes." POPULAR PHOTOGRAPHY 55, no. 5 (Nov. 1964): 152-153, 176. 1 illus.

S945 Sobieszek, Robert A. "Albert Sands Southworth and Josiah Johnson Hawes: Introductory Comments. The Daguerreotypes of Southworth and Hawes, 1843 - 1861." CAMERA (LUCERNE) 55, no. 12 (Dec. 1976): 4-13, 34-37. 8 b & w. [Excerpts from "The Spirit of Fact," by Sobieszek et al on pp. 34-37.]

SOUTHWORTH, ALBERT SANDS. (1811-1894) (USA)

[Born on March 12, 1811 at West Fairlee, VT. Studied at Bradford Academy and at Phillips Academy, Andover. In 1839 he opened a drugstore in Cabotville, MA, but after hearing François Gourand lecture on the daguerreotype in Boston in 1840, he attempted to set up a studio in Cabotville with his friend Joseph Pernell. Unsuccessful, moved to Boston in 1841, opened a new studio there. In 1843 Josiah Hawes joins him, later married his sister Nancy. The firm of Southworth & Hawes become one of the best daguerreotype studios in America, displaying extraordinary facility and quality in their many fine portraits. In 1849 Southworth left Boston to seek gold in California, but was unsuccessful. Photographed briefly in California, but returned to Boston in 1851 and the partnership reformed. Through 1850s Southworth patents a number of improvements in the daguerreotype, in cameras, and various technical procedures. The partnership dissolved in 1861-62, and both continued to operate separate studios in Boston for many years. Hawes ran his studio quietly and also made many beautiful views of Boston architecture and sights. Southworth was more active in the community of professional photographers, writing, attending professional meetings and lecturing throughout the 1870s. Active in the National Photographic Association. He was also a leading figure in several complicated patent actions which caused much consternation throughout the photographic community in the 1860s and 1870s. He died in Charlestown, MA on March 3, 1894.]

BOOKS
S946 United States Courts. Circuit Court. 2nd Circuit. New York, Southern District... *In Equity*; Proofs on the Part of the Defendants. Boston: Tolman & White, 1877. n. p. 7 b & w. [Original photos, are of the defendants' exhibits in Simon Wing et al (including A. S. Southworth) vs. Edward Anthony, on the invention of the 'multi-frame' daguerreotype frame in the 1840's. NYPL collection.]

PERIODICALS
S947 "The Multiplying Camera Patent Case. Simon Wing vs. Charles F. Richardson." HUMPHREY'S JOURNAL OF PHOTOGRAPHY, AND THE ALLIED ARTS AND SCIENCES 17, no. 6 (July 15, 1865): 91. [S. Wing and A. S. Southwood suing Richardson.]

S948 Southworth, Albert S. "To Clean Glass for Collodion and Silvering." PHILADELPHIA PHOTOGRAPHER 8, no. 92 (Aug. 1871): 264.

S949 Southworth, A. S. "An Address to the National Photographic Assoc. at the U.S. Delivered at Cleveland, Ohio, June 1870 by Albert S. Southworth." PHILADELPHIA PHOTOGRAPHER 8, no. 94 (Oct. 1871): 315-323. [Includes reminiscences of early photography in Boston and Southworth's observations on the growth of the medium.]

S950 Southworth, Albert S. "An Address to the National Photographic Association of the United States." ANTHONY'S PHOTOGRAPHIC BULLETIN 2, no. 11 (Nov. 1871): 343-351. [Includes early history of photography in USA, his own beginnings, etc.]

S951 Southworth, A. S. "Fourth Annual Meeting and Exhibition of the N.P.A. in St. Louis, Mo., May 1872: An Address." PHILADELPHIA PHOTOGRAPHER 9, no. 102 (June 1872): 178-180.

S952 "An Address by Albert S. Southworth: Proceedings at the N.P.A. of the U.S. (4th Annual Convention, May 1872, St. Louis)." ANTHONY'S PHOTOGRAPHIC BULLETIN 3, no. 9 (Sept. 1872): 677-689.

S953 Southworth, Albert S. "Fifth Annual Meeting and Exhibit of the National Photographic Association of the U.S., held in Buffalo, N.Y., beginning July 5, 1873: Comments." PHILADELPHIA PHOTOGRAPHER 10, no. 117 (Sept. 1873): 277-287.

S954 Southworth, Albert S. "Fifth Annual Meeting and Exhibit of the National Photographic Association of the U.S., held in Buffalo, N.Y., beginning July 5, 1873: The Use of the Camera." PHILADELPHIA PHOTOGRAPHER 10, no. 117 (Sept. 1873): 433-440.

S955 "Letter." PHILADELPHIA PHOTOGRAPHER 11, no. 132 (Dec. 1874): 384. [Letter from Southworth stating that if the annual N.P.A. meeting was held in Boston, MA, those attending would not be brought to court in relation to the Wing & Southworth patent.]

S956 "Photography and Truth." PHILADELPHIA PHOTOGRAPHER 13, no. 155 (Nov. 1876): 323. [About photos used in law courts, discusses A. S. Southworth's description of some activities along this line.]

S957 Ritz, Ernest R. "Society Gossip: Boston Photographic Society." PHILADELPHIA PHOTOGRAPHER 14, no. 162 (June 1877): 179-180. [Extracts from a speech given by Albert S. Southworth to the Boston Photographic Society on May 4, 1877.]

S958 "What a Father in Photography Thinks." PHILADELPHIA PHOTOGRAPHER 16, no. 190 (Oct. 1879): 300-301. [Letter from Southworth about reorganization of Nat. Photo. Assoc.]

S959 Southworth, G.[sic A.] S. "A Miniature - What Does It Express?" PHOTOGRAPHIC TIMES 29, no. 10 (Oct. 1897): 47?

S960 Southworth, A. S. "Photography, Painting and Sculpture." PHOTOGRAPHIC TIMES 29, no. 11 (Nov. 1897): 510-511.

S961 Jarvis, E. P. "After M. Daguerre." NEW BOSTON REVIEW 2, no. 2 (Fall 1976): 10-11. 2 b & w. [Ex. rev.: 'Southworth & Hawes,' Museum of Fine Arts, Boston.]

S962 "World record price set at Christies' auction." NEWSLETTER OF THE FRIENDS OF PHOTOGRAPHY 3, no. 6 (June 1980): 2. [Southworth daguerreotype sells for $36,000.]

S963 Allen, William. "The Spirit of Fact in Court: Southworth's Testimony in Marcy v. Barnes and Bacon v. Williams." HISTORY OF PHOTOGRAPHY 6, no. 4 (Oct. 1982): 327-332. 1 b & w. 2 illus. [Southworth testified in a law case on the issue of a forged signature.]

SPAHN, EMIL H. (1836-1885) (GERMANY, USA)
S964 "Note." PHOTOGRAPHIC TIMES 15, no. 218 (Nov. 20, 1885): 656. ["Emil H. Spahn, a well-known photographer in Newark... missing since Nov. 6th. Born Blenheim in l837.]

S965 "Obituary: Emil Spahn, of Newark, N. J." PHOTOGRAPHIC TIMES 15, no. 220 (Dec. 4, l885): 678. [Born 1836 at Blenheim, in the Grand Dutchy of Hesse Darmstadt. To U.S. in 1860. Joined Union army and fought in Civil War. Became a photographer in Newark after the war. Had owned a prosperous and well-paying gallery but sold it and went into the insurance business, where he met with little success. Found drowned in November 1888.]

SPARHAWK, LUTHER T.
S966 Sparhawk, L. T. "Correspondence." ANTHONY'S PHOTOGRAPHIC BULLETIN 3, no. 1 (Jan. 1872): 430. [Sparhawk from West Randolph, VT.]

SPARK.
S967 Portrait. Woodcut engraving, credited "From a Photograph by Spark." FRANK LESLIE'S ILLUSTRATED NEWSPAPER 34, (1872) ["Hon. Joel Parker, Labor reform candidate." 34:859 (Mar. 16, 1872): 1.]

SPARLING, WILLIAM MARCUS. (d. 1860) (GREAT BRITAIN)
BOOKS
S968 Sparling, W. *Theory and Practice of the Photographic Art; Including its Chemistry and Optics, with Minute Instructions in the Practical Manipulation of the Various Processes, Drawn from the Author's Daily Practice, Assistant to Mr. Fenton, Honorary Secretary to the Photographic Society.* London: Houlston & Stoneman, 1856. 219 pp. 123 illus. ["Orr's Circle of Sciences." 2nd ed. (1859) London, Glasgow: R. Griffin & Co., 230 pp. Revised and corrected to the present date by James Martin. Reprinted (1973), Arno Press.]

PERIODICALS
S969 "Obituary." BRITISH JOURNAL OF PHOTOGRAPHY. 7, no. 117 (May 1, 1860): 137. [Brief note that "Mr. M. Sparling, late assistant to R. Fenton, Esq., in the Crimea..." died in Liverpool on Apr. 20th.]

SPENCE, CHARLES. (LERWICK, GREAT BRITAIN)
S970 Portrait. Woodcut engraving credited "From a photograph by Charles Spence." ILLUSTRATED LONDON NEWS 68, (1876) ["Rev. Dr. Ingram, aged 100 years." 68:1918 (Apr. 29, 1876): 421.]

SPENCER see also BISCHOFF & SPENCER.

SPENCER, E. C.
S971 "South America. - The Hurricane of May 27th - 31st - A View of Valparaiso, Chili, June 1st. - From a Photograph by E. C. Spencer." FRANK LESLIE'S ILLUSTRATED NEWSPAPER 46, no. 1193 (Aug. 10, 1878): 385. 1 illus. [Aftermath.]

SPENCER, F. M.
S972 Spencer, F. M. "Some Rambling Thoughts on Lighting." PHILADELPHIA PHOTOGRAPHER 13, no. 155 (Nov. 1876): 348.

S973 Spencer, F. M. "Scattered Thoughts. (First - Sixth Pagers)." PHILADELPHIA PHOTOGRAPHER 14, no. 158-168 (Feb. - Dec. 1877): 46-47, 106-107, 144-146, 197-198, 294-295, 365-367.

S974 Spencer, F. M. "Theory and Practice." PHILADELPHIA PHOTOGRAPHER 14, no. 160 (Apr. 1877): 106-107.

S975 "Scattered Thoughts. (Seventh - Ninth Papers)." PHILADELPHIA PHOTOGRAPHER 15, no. 169-180 (Jan. - Dec. 1878): 46-48, 102-104, 310-313.

SPENCER, JOHN A.
BOOKS
S976 Wyatt, Matthew Digby. *Notices of Sculpture in Ivory, Consisting of a Lecture on the History, Methods, and Chief Productions of the Art; Delivered at the First Annual General Meeting of the Arundel Society, on the 29th June, 1855,...and a catalogue of Specimens of Ancient Ivory. Carvings in Various Collections... with Nine Photographic Illustrations by J. A. Spencer.* London: The Arundel Society, 1856. 54 pp. 9 b & w. [Original photos.]

PERIODICALS
S977 Spencer, John A. "What is 'Life Size?'" BRITISH JOURNAL PHOTOGRAPHIC ALMANAC 1874 (1874): 143-145.

S978 Spencer, John A. "Carbon Printing." BRITISH JOURNAL PHOTOGRAPHIC ALMANAC 1878 (1878): 107-108.

SPENCER, THOMAS N. (1815-1897) (USA)
S979 "Obituary: Mr. Thomas N. Spencer." WILSON'S PHOTOGRAPHIC MAGAZINE 34, no. 483 (Mar. 1897): 126. [Died at Circleville, OH, on Jan. 25th, aged 82 years. Actively engaged in his business until Sept. 1896, when Mr. G. Edwin Thornton succeeded him.]

SPILLER, JOHN. (1833-1921) (GREAT BRITAIN)
S980 Spiller, John. "Photography in Its Applications to Military Purposes." JOURNAL OF THE PHOTOGRAPHIC SOCIETY OF LONDON 8, no. 140 (Dec. 15, 1863): 410-413. [History of British Army's use of photography.]

S981 Spiller, John. "Silver in the Whites of Fixed Albumenized Prints." AMERICAN JOURNAL OF PHOTOGRAPHY AND THE ALLIED ARTS & SCIENCES n. s. vol. 6, no. 20 (Apr. 15, 1864): 463-464. [From "Photo. News." Spiller was in the Chemical Dept., Royal Arsenal.]

S982 Spiller, John, F.C.S. "Restoration of Injured Negatives." AMERICAN JOURNAL OF PHOTOGRAPHY AND THE ALLIED ARTS & SCIENCES n. s. vol. 7, no. 5 (Sept. 1, 1864): 108-109.

S983 Spiller, John, F.C.S. "Recovery of Nitrate of Silver from Paper Ashes." HUMPHREY'S JOURNAL OF PHOTOGRAPHY, AND THE ALLIED ARTS AND SCIENCES 18, no. 13 (Nov. 1, 1866): 208. [From "Photo. News."]

S984 Harrison, W. Jerome. "The Chemistry of Fixing." PHOTOGRAPHIC TIMES 20, no. 480 (Nov. 28, 1890): 587-589. [John Spiller (1862).]

SPOONER, D. B. & H. B. SPOONER. (SPRINGFIELD, MA)
S985 "Photographic Patent: Coloring Ambrotypes." HUMPHREY'S JOURNAL 8, no. 9 (Sept. 1, 1856): 129-130. [Patent letter from D. B. and H. B. Spooner (Springfield, MA) for coloring ambrotypes.]

SPOONER, JOHN PITCHER. (1845-1917) (USA)
S986 Spooner, J. Pitcher. "Photographic Advertising." PHILADELPHIA PHOTOGRAPHER 11, no. 121 (Jan. 1874): 14.

S987 Spooner, J. P. "California Correspondence." PHILADELPHIA PHOTOGRAPHER 13, no. 148 (Apr. 1876): 105-106.

S988 Spooner, J. P. "Dollars and Cents." PHILADELPHIA PHOTOGRAPHER 15, no. 171 (Mar. 1878): 75-76.[Spooner of Stockton, CA.]

S989 Spooner, J. Pitcher. "The Robe as Photographer." PHILADELPHIA PHOTOGRAPHER 15, no. 174 (June 1878): 168. [J. Pitcher Spooner (Stockton, CA) argues against cliche of using robes as props in studio portraits.]

S990 Spooner, J. Pitcher. "'Only a Photographer.'" PHOTOGRAPHIC MOSAICS: 1888 24, (1888): 54-55.

S991 Spooner, J. Pitcher. "Permanent Photograph-ers." PHOTOGRAPHIC MOSAICS: 1889 25, (1889): 80-81.

S992 Spooner, J. Pitcher. "Accelerator for Photographers." PHOTOGRAPHIC TIMES 19, no. 431 (Dec. 20, 1889): 636. [Spooner who, "Nearly 25 years the writer has given this art..." recommends an annual vacation as a health measure.]

S993 Spooner, J. Pitcher. "Prices for 1890" PHOTOGRAPHIC MOSAICS: 1890 26, (1890): 86-87.

S994 Spooner, J. Pitcher. "Artistic, Scientific, and Business Standpoints of Photography." PHOTOGRAPHIC MOSAICS: 1891 27, (1891): 206-208. [Spooner of Stockton, CA.]

S995 "Notes and News." PHOTOGRAPHIC TIMES 21, no. 517 (Aug. 14, 1891): 408. [Note that Spooner, "the veteran photographer of Stockton, Cal." on a trip to the Sierras.]

S996 Spooner, J. Pitcher. "Scientific, Theoretical and Practical Photography." PHOTOGRAPHIC MOSAICS: 1892 28, (1892): 245-246.

S997 Spooner, J. P. "Correspondence: Spirit Photography." PHOTOGRAPHIC TIMES 25, no. 673 (Aug. 10, 1894): *. [Letter about fraudulent practice in San Francisco a few years ago.]

S998 Spooner, J. Pitcher. ""Next!"" PHOTOGRAPHIC MOSAICS: 1897 33, (1897): 251-255. 1 b & w. [Costume portrait. "Dolce Far Niente."]

S999 "Editor's Table: Pacific Coast." WILSON'S PHOTOGRAPHIC MAGAZINE 37, no. 523 (July 1900): 335. [Brief note that Spooner, of Stockton, Calif., forced to retire by poor health. His business taken over by E. J. McCullagh.]

SPOONER, JOHN.
S1000 Spooner, John. "Improved Album." HUMPHREY'S JOURNAL OF PHOTOGRAPHY, AND THE ALLIED ARTS AND SCIENCES 19, no. 7 (Aug. 1, 1867): 106.

SPOUT, R. J.
S1001 Spout, R. J. "Securing Clouds in Landscapes." AMERICAN JOURNAL OF PHOTOGRAPHY AND THE ALLIED ARTS & SCIENCES n. s. vol. 6, no. 17 (Mar. 1, 1864): 397-398. [From "Photo. News."]

SPRINGFIELD, ADAM.
S1002 Springfield, Adam. "Salad for the Photographer: Photographing a Corpse." PHILADELPHIA PHOTOGRAPHER 5, no. 57 (Sept. 1868): 341-342. [Springfield (Rochester, NY) gives advice on proper manner to make post-mortem portraits.]

SPROAT, R. J.
BOOKS
S1003 Payn, James. *The Lakes in Sunshine; Being Photographic and Other Pictures of the Lake District of Westmoreland and North Lancaster;* with Descriptive Letterpress by James Payn. London: Simpkin, Marshall, 1868. 105 pp. 14 l. of plates. 14 b & w. [Original photos. Several editions, slightly different. Photographers for some editions were John Garnett and R. J. Sproat.]

PERIODICALS
S1004 Sproat, R. J. "Securing Clouds in Landscapes." PHOTOGRAPHIC NEWS 8, no. 278 (Jan. 1, 1864): 5.

SPURR, REGINALD.
S1005 "New Bridge at Huddersfield." ILLUSTRATED LONDON NEWS 64, no. 1815 (June 6, 1874): 541. 1 illus.

SQUIER, EPHRAIM GEORGE. (1821-1888) (USA, PERU)
[E. G. Squier was born in Bethlehem, NY on July 17, 1821. He earned M.A. and civil engineering degrees and gained a reputation as an archeologist and a traveller in the 1840s and 1850s. Served the USA in a diplomatic capacity in Central America in the 1840s, later wrote the book *Nicaragua*. Published many articles and books on archeological sites in the Mississippi Valley and in New York State, and on Central and South America. (A partial listing of these is printed below.) Many of his earlier published articles are illustrated, but probably not from photographs. For examples of these writings, see: "Ancient Peru - Its People and Its Monuments," *Harper's New Monthly Magazine* (June 1853); "Visit to the Silver Mines of Central America," *Harper's New Monthly Magazine* (May 1856).
In the early 1860s Squier was appointed to serve on an international commission to settle disputes between Peru and the USA. He arrived in Peru in 1863, spent six months on the commission and several years in archeological exploration. He apparently learned photography in Peru in the 1860s, and made photographs there and elsewhere. The subsequent articles which he wrote on these explorations were illustrated with woodcuts, but this time often drawn from photographic sources. See "Among the Andes of Peru and Bolivia." *Harper's New Monthly Magazine* (Apr. - Aug. 1868), and others.
Squire became the editor of *Frank Leslie's Illustrated Newspaper* in the 1860s, while he and his wife lived with Frank Leslie in Leslie's mansion in New York City. In the 1870s Ephraim Squier was institutionalized in a mental hospital, and he died in 1888. His wife, who had also edited several of Frank Leslie's magazines, later became Mrs. Frank Leslie, and took over Leslie's publishing empire at his death.]

BOOKS
S1006 Squire, Ephraim George and E. H. Davis. *Ancient Monuments of the Mississippi Valley.* New York: Barlett & Welford, 1848. xxxix, 306 pp. 4 l. of plates.

S1007 Squier, Ephraim George. *Nicaragua, Its People, Scenery, Monuments and the Proposed Interoceanic Canal.* New York: D. Appleton & Co., 1851. 2 vol. in one. illus.

S1008 Squier, Ephraim George. *Peru, Incidents of Travel and Exploration in the Land of the Incas.* New York: Harper Brothers, 1877. 599 pp. 225 illus. [Woodcut illustrations, some from photographs. The text of this book contains references to Squires' use of photography on his explorations.]

S1009 Squier, Ephraim George. *Adventures on the Mosquito Shore.* New York: Belford, Clarke, 1888. 366 pp. illus. [First issued as *Waikna*,

or, *Adventures on the Mosquito Shore*, by Samuel A. Bard. [pseud.] in 1855.]

PERIODICALS

S1010 Squire, E. G. "Indigenous Animals of the Andes, the Llama, Alpaca, Huanaco and Vicuna." FRANK LESLIE'S ILLUSTRATED NEWSPAPER 23, no. 579 (Nov. 3, 1866): 109. 3 illus. [Artist's sketches of these animals - not from photographs. Rare signed article. Squire was learning photography and making photographs during his trip to Peru, but not here. Later, Squire would become an editor of this magazine.]

S1011 "Cyclopean Walls of the Palace of Inca Rocca, Cuzco, Peru." FRANK LESLIE'S ILLUSTRATED NEWSPAPER 23, no. 581 (Nov. 17, 1866): 140-141. 1 illus. [View, with figure. "...from a photograph by Honorable E. G. Squier, late Commissioner of the United States in Peru, and forms one of the illustrations of his forthcoming work on that country."]

S1012 "View Among the Ancient Ruins of Mansiche, or Grand Chimu, Peru." FRANK LESLIE'S ILLUSTRATED NEWSPAPER 25, no. 650 (Mar. 14, 1868): 405, 406. 1 illus. [View, with figure. "Mr. E. G. Squier, in his lecture before the Travellers' Club, a few evenings ago..."]

S1013 "Explorations in Peru." FRANK LESLIE'S ILLUSTRATED NEWSPAPER 26, no. 651 (Mar 21, 1868): 10-11. [Long (for the time) detailed description of Squier's lecture on his explorations in Peru, from a talk given to the Travellers' Club, on Feb. 20th.]

S1014 Hull, C. Wager. "New York Correspondence." PHILADELPHIA PHOTOGRAPHER 5, no. 54 (June 1868): 195-199. [(June) Report of the May meeting of the Photographic Section of the American Institute, featuring a talk by E. G. Squier, "the celebrated traveller, whose works on travel in Central and South America have rendered his name a household word."]

S1015 Squier, E. G. "Tongues from Tombs: or, The Stories that Graves Tell." FRANK LESLIE'S ILLUSTRATED NEWSPAPER 28, no. 703-721 (Mar. 20 - July 24, 1869): 5-6, 21-22, 205-206, 221-222, 236-238, 269-270, 285-286, 300-302. many illus. [This series by Squier deals with archeology, and was illustrated with many small woodcuts of pots, shards, etc. Each article was on a different subject. No. 1 (Mar. 20): "The Mounds of the United States." No. 2 (Mar. 27): "A Plain Man's Tomb in Peru." No. 3 (June 12): "The Agricultural Laborers and the Princes of Chimu." No. 4: (June 19) "Grand Chimu and New Granada." No. 5: "Central America." No. 6: (July 10) "Central America and Yucatan." No. 7: (July 17) "Mexico." No. 8: (July 24) "The Egyptians."]

S1016 Squier, Ephraim George. "The Great South American Earthquakes of 1868." HARPER'S MONTHLY 38, no. 227 (Apr. 1869): 603-623. 13 illus. [At least some of the views of the mountains in Peru were probably taken by Squier. "I had just exposed a plate in my photographic camera, [in Dec. 1863] and was timing the exposure, when my attention was arrested by a sound from the southward,... the movement was not very severe, although sufficiently great to ruin my photographic negative, which I preserve as probably the only example of photographing an earthquake."]

S1017 McElroy, Keith. "Ephraim George Squier: Photography and the Illustration of Peruvian Antiquities." HISTORY OF PHOTOGRAPHY 10, no. 2 (Apr. - June 1986): 99-129. 18 b & w. 23 illus. [Squier's book "Peru, Incidents of Travel and Exploration in the Land of the Incas," (1877), illustrated with engravings made from photographs. Notes on pp. 127-129.]

SQUIER, EPHRAIM GEORGE. [?]

S1018 Squier, E. G. "The Great South American Earthquakes of 1868." HARPER'S MONTHLY 38, no. 227 (Apr. 1869): 603-623. 13 illus. [Views of the aftermath. Some may be from photographs. (E. G. Squire, V. Richardson, and R. Villaalba all in the area, all photographing during this time.)]

STACEY, GEORGE. (NEW YORK, NY)

S1019 "View of the Capitol, Showing the Present State of the Dome - Taken during the Inauguration of Lincoln, Monday, March 4, 1861." and "Inauguration of the Sixteenth President of the United States - Scene in Front of the Capitol at Washington, D. C. - Abraham Lincoln, President-Elect, Reading His Inaugural Address, Previous to Receiving the Oath of Office from Chief Justice Taney, March 4th, 1861. - Photographed by Stacey." FRANK LESLIE'S ILLUSTRATED NEWSPAPER 11, no. 277 (Mar. 16, 1861): 261, 264-265. 2 illus. [Views, with crowds.]

S1020 "Gun-Yard, Shot and Shell at Fortress Monroe. - John Tyler's Residence, Hampton, Virginia. - Chesapeake Female College." HARPER'S WEEKLY 5, no. 235 (June 29, 1861): 406. 410. 7 illus. [Views around Fort Monroe, etc. Two from sketches, five "...from photographs by Stacey."]

S1021 Portrait. Woodcut engraving, credited "From a Photograph by Stacey." NEW YORK ILLUSTRATED NEWS 8, (1863) ["Thomas C. Acton, Chief of Police, New York, NY." 8:197 (Aug. 8, 1863): 229.]

STADTFELD, MAURICE.

S1022 Stadtfeld, Maurice. *National Academy of Design. Photographs of the New Building;* with an introductory essay by P. B. Wight, Architect. Maurice Stadtfeld, Photographer. No. 711 Broadway, N.Y. New York: S. P. Avery, 1866. 12 pp. 15 l. of plates. 15 b & w.

STAFFORD, CHARLES.

S1023 "Letter." PHILADELPHIA PHOTOGRAPHER 6, no. 72 (Dec. 1869): 424. [Letter in "Voices From the Craft" on swindler.]

STANFIELD, T. H. M. (GREAT BRITAIN)

S1024 Stanfield, T. H. M. *Photographic Manipulation; being a Manual of Practical Photography for Amateurs.* Torquay: T. H. M. Stanfield, 1866. 30 pp.

STANLEY, J. H. S. (HOUSTON, TX)

S1025 "Gossip: Letter." PHOTOGRAPHIC ART JOURNAL 3, no. 3 (Mar. 1852): 196. [Letter from J. H. S. Stanley of Houston, TX, praising the magazine.]

S1026 "Gossip." PHOTOGRAPHIC ART JOURNAL 4, no. 1 (July 1852): 68. [Extract from the Houston, Tex. "Morning Star."]

STANLEY, W. F. (LONDON, ENGLAND)

S1027 Stanley, W. F. *Photography Made Easy: a Manual for Beginners. Containing Full Instructions for taking Portraits and Views by either Positive or Negative Processes; with Illustrated Description of the Apparatus, and Directions for Preparing the Various Solutions Used.* London: W. F. Stanley, optician, 1871. 32 pp. [7th ed. (1880) 41 pp.]

S1028 Stanley, W. F. *Dry Plate Photography, a supplement to the above.* London: W. F. Stanley, optician, 1881. 8 pp.

STANTON & BUTLER.

S1029 "The Baltimore Regatta." HARPER'S WEEKLY 10, no. 497 (July 7, 1866): 417-418. 2 illus. [Boats, crowds. "Photographed by Stanton & Butler."]

S1030 Portrait. Woodcut engraving, credited "From a Photograph by Stanton & Butler." FRANK LESLIE'S ILLUSTRATED NEWSPAPER 35, (1873) ["Maj.-Gen. Winfield Scott Hancock, U.S.A." 35:904 (Jan. 25, 1873): 324.]

STAPLEY, L. A.
S1031 "Bengal Military Normal School at Sanawur." ILLUSTRATED LONDON NEWS 43, no. 1231 (Nov. 14, 1863): 497. 1 illus. ["...from a photograph taken by Mr. L. A. Stapley."]

STARBIRD.
S1032 Portraits. Woodcut engravings, credited "Photographed by Starbird." FRANK LESLIE'S ILLUSTRATED NEWSPAPER 11, (1861) ["Hon. Lot M. Morrill, Sen. from ME." 11:274 (Feb. 23, 1861): 220.]

STAREE & BANTON.
S1033 "The Old State and County Court House at Zanesville, Ohio, Recently Demolished. - Photographed by Staree & Banton." FRANK LESLIE'S ILLUSTRATED NEWSPAPER 39, no. 995 (Oct. 24, 1874): 108. 1 illus. [View, with figures.]

STARK, ROBERT. (WOODSTOCK, CANADA)
S1034 Stark, Robert. "M. Carey Lea's Collo-Developer." HUMPHREY'S JOURNAL OF PHOTOGRAPHY, AND THE ALLIED ARTS AND SCIENCES 18, no. 11 (Oct. 1, 1866): 168-169.

S1035 Stark, Robert. "Improved Dark Tent." HUMPHREY'S JOURNAL OF PHOTOGRAPHY, AND THE ALLIED ARTS AND SCIENCES 18, no. 12 (Oct. 15, 1866): 189-191. [Stark from Woodstock, Canada West.]

S1036 Stark, Robert. "Letter From Canada." HUMPHREY'S JOURNAL OF PHOTOGRAPHY, AND THE ALLIED ARTS AND SCIENCES 18, no. 13 (Nov. 1, 1866): 199-200.

S1037 "Editor's Table." PHILADELPHIA PHOTOGRAPHER 4, no. 38 (Feb. 1867): 64. [Views by Robert Stark (Woodstock, C. W.)]

S1038 Stark, Robert. "The Prospects of Photographers Desiring to Emigrate." BRITISH JOURNAL PHOTOGRAPHIC ALMANAC 1872 (1872): 127-129. [Describes conditions, availability of supplies, etc. in Canada.]

STARKE, W. G.
S1039 Badeau, W. H. "From Across the Water." ANTHONY'S PHOTOGRAPHIC BULLETIN 4, no. 12 (Dec. 1873): 368-371. [Discusses the Photographic Society of Great Britain's annual exhibition, mentions among others, the work of W. G. Starke (Zanesville, OH).]

STATHAM, F. F. (d. 1884) (GREAT BRITAIN)
S1040 Taylor, J. Traill. "General Notes." PHOTOGRAPHIC TIMES 14, no. 161 (May 1884): 223. [Note of unexpected death of the Rev. F. F. Statham, President of the South London Photographic Society, on 22nd March. Statham had been president of the society since its formation 25 years ago. "...the death of the society will not improbably soon follow that of its president."]

STEBBINS, A. B. (CORRY, PA)
S1041 "The City of Corry, Pennsylvania. - From a Photograph by A. B. Stebbins, Corry, Penn." FRANK LESLIE'S ILLUSTRATED NEWSPAPER 24, no. 604 (Apr. 27, 1867): 88-89. 6 illus. [Four views of the town. a portrait of its mayor, a view of an Indian skull found there. Only one view credited to the photographer. but probably all of the images were from him.]

STEIN, SIMON L. (1854-1922) (USA)
S1042 "Photographers, Old and New: S. L. Stein." WILSON'S PHOTOGRAPHIC MAGAZINE 32, no. 460 (Apr. 1895): frontispiece, 156-158. 1 b & w. 1 illus. [Began photography in 1872 at Ludington, MI, then to Milwaukee, WI and Chicago, IL.]

S1043 "Our Pictures." WILSON'S PHOTOGRAPHIC MAGAZINE 32, no. 460 (Apr. 1895): frontispiece, 166-167. 1 b & w. [Original studio portrait, tipped in.]

S1044 Wilson, Edward L. "To Julius and Sidney Stein." WILSON'S PHOTOGRAPHIC MAGAZINE 32, no. 468 (Dec. 1895): 557-558, plus unnumbered leaf following p. 576. 3 b & w. [Article [in the form of a fictional letter to Stein's sons] praising Mr. Stein's photographic efforts. Stein worked in Chicago, IL, and Milwaukee, WI. Won the Photographers' Assoc. of Am. annual genre-poetry illustration contest. Published a "title souvenir" titled "Portraits and Portraiture" in 1895. The photos are two studio portraits of Stein's sons Julius and Sidney and a posed genre study titled "Intermission."]

S1045 16 photos on one plate ("Sixteen Well-Springs of Pleasure"). WILSON'S PHOTOGRAPHIC MAGAZINE 33, no. 472 (Apr. 1896): unnumbered leaf following p. 176. 16 b & w. ["Stein, Milwaukee." Studio portraits of children in costumes. Brief note on pp. 179-180 in "Our Pictures."]

S1046 16 photos on one plate (Celeron Prize Studies:). WILSON'S PHOTOGRAPHIC MAGAZINE 33, no. 476 (Aug. 1896): unnumbered page following p. 368. 16 b & w. ["Stein, Milwaukee, Wis." Portraits of children. Note on pp. 382-383.]

S1047 16 photos on one panel ("A Variety of Studies"). WILSON'S PHOTOGRAPHIC MAGAZINE 33, no. 479 (Nov. 1896): unnumbered leaf following p. 496. 16 b & w. [Portraits by: W. M. Morrison, Chicago, IL (4); B. J. Falk, NY, (4); R.H. Furman, San Diego, CA (1); S. L. Stein, Milwaukee, WI (2); J. F. Ryder, Cleveland, OH (3). Brief note on pp. 519-520.]

S1048 "The New Studio of S. L. Stein." WILSON'S PHOTOGRAPHIC MAGAZINE 34, no. 484 (Apr. 1897): 161-166. 1 b & w. 9 illus. [One studio portrait, seven illustrations of the rooms of the Stein Studio. See the Apr. 1895 issue for biographical information.]

STEIN, SIEGMUND THEODORE. (1834-1891) (FRANKFURT, GERMANY)
S1049 "Photographing the Human Voice." ANTHONY'S PHOTOGRAPHIC BULLETIN 8, no. 8 (Aug. 1877): 228-229. [From "London Photo. News."]

S1050 "Obituary: Dr. Siegmund Theodore Stein." PHOTOGRAPHIC TIMES 21, no. 528 (Oct. 30, 1891): 534. [Died in Frankfurt on Sept. 27, 1891 at age 57. A practicing physician, who studied the sciences auxiliary to medicine. Became an excellent photographer. With Drs. Koch and Gerlach, he contributed much to bacteriology, in which photography was a great aid. Contributed many articles to the photographic journals, and his book "Das Licht, im Dieuth der Wissenschaftlichen," in two volumes, became a standard in this discipline.]

STEINHEL & ROBEL. (MUNICH, GERMANY)
S1051 "Foreign Correspondence." ATHENAEUM no. 597 (Apr. 6, 1839): 259. [Note on excitement generated by Daguerre's discovery, mentions Prof. Steinhel & Robel in Munich.]

STEINHEIL.

S1052 Towler, Prof. "Steinheil's Periscopic Lens." HUMPHREY'S JOURNAL OF PHOTOGRAPHY, AND THE ALLIED ARTS AND SCIENCES 17, no. 19 (Feb. 1, 1866): 289-291. 2 illus.

S1053 Wright, Nelson. "Steinheil's Periscopic Lens." HUMPHREY'S JOURNAL OF PHOTOGRAPHY, AND THE ALLIED ARTS AND SCIENCES 17, no. 20 (Feb. 15, 1866): 315-316.

S1054 Sommer, A. "Steinheil's Periscopic Lens." HUMPHREY'S JOURNAL OF PHOTOGRAPHY, AND THE ALLIED ARTS AND SCIENCES 17, no. 22 (Mar. 15, 1866): 343.

S1055 Drummond, A. J. "Steinheil vs. Zentmeyer." HUMPHREY'S JOURNAL OF PHOTOGRAPHY, AND THE ALLIED ARTS AND SCIENCES 19, no. 12 (Oct. 15, 1867): 185-187.

S1056 Drummond, A. J. "Steinheil vs. Zentmeyer. Another Letter from Mr. Drummond." HUMPHREY'S JOURNAL OF PHOTOGRAPHY, AND THE ALLIED ARTS AND SCIENCES 19, no. 22 (Mar. 15, 1868): 343-345.

STEINHEIL, CARL AUGUST VON. (1801-1870) (GERMANY)

S1057 Gernsheim, Helmut and Alison Gernsheim. "The First Photograph Taken in Germany." IMAGE 9, no. 1 (Mar. 1960): 38-43. 4 b & w. 2 illus. [Discusses Carl August von Steinheil (1801-1870) and Franz von Kobell (1803-1874); their experiments in 1839.]

STENNING, J. C.

S1058 Stenning, J. C. "Short Holidays in Sussex." BRITISH JOURNAL PHOTOGRAPHIC ALMANAC 1877 (1877): 150-152.

S1059 Stenning, J. C. "Photographic Work in Connection with Architecture." PHOTOGRAPHIC TIMES 16, no. 261-262 (Sept. 17 - Sept. 24, 1886): 499, 508-509. ['A communication to the Architectural Assoc'.]

STEPHENS, JOHN LLOYD. (1805-1852)

S1060 Stephens, John Lloyd. *Incidents of Travel in Yucatan,...* Illustrated by 120 Engravings. London: John Murray, 1843. 2 vol. pp. 65 l. of plates. 120 illus. ["The descriptions are accompanied by full illustrations from Daguerreotype views and drawings taken on the spot by Mr. Catherwood..." The daguerreotypes were taken by Dr. Stephens and Dr. Cabot. Reprinted facsimile (ca. 1962) Univ. of Oklahoma Press.]

STERRY, E. S.

S1061 "Note." ANTHONY'S PHOTOGRAPHIC BULLETIN 10, no. 5 (May 1879): 160. [E. S. Sterry now associated with Mr. McDonald in Albany, as well as being the proprietor of the galleries in Saratoga and Cohoes, NY.]

STEVENS, C. N.

S1062 Stevens, C. N. "How to Build a Photographic Car." PHILADELPHIA PHOTOGRAPHER 8, no. 90 (June 1871): 169. 1 illus. [Stevens (Prophettstown, IL) gives directions for constructing a mobile gallery.]

STEVENS, HENRY. (d. 1886) (USA, GREAT BRITAIN)

S1063 Stevens, Henry. *Photo-Bibliography; of a Word on Printed Card Catalogues of Old, Rare, Beautiful, and Costly Books, and How to Make Them on a Co-operative System. And Two Words on the Establishment of a Central Bibliographical Bureau or Clearing House for Librarians.* London: Privately printed, 1878. 49 pp. l. of plates. [Read at the Conference of Librarians, October, 1877. Proposal to photograph the title pages of books, reproduce them as electrotype portraits of the books, keep copies of these at a central clearing-house for sale and distribution to librarians and others. (Stevens was an American who acted as London agent for American book-buyers. Died in 1886.)]

STEVENS, R. P.

S1064 Stevens, R. P., M.D. "The Pre-Adamite Light." AMERICAN JOURNAL OF PHOTOGRAPHY AND THE ALLIED ARTS & SCIENCES n. s. vol. 3, no. 6 (Aug. 15, 1860): 91-93.

STEVENSON, DAVID.

S1065 Stevenson, David. "Gelatine Combined with Iron." HUMPHREY'S JOURNAL OF PHOTOGRAPHY, AND THE ALLIED ARTS AND SCIENCES 19, no. 10 (Sept. 15, 1867): 155-158. [From "Br. J. of Photo."]

STEWART, E. J. (CLARKSVILLE, MO)

S1066 Stewart, E. J. "Photography Afloat." ANTHONY'S PHOTOGRAPHIC BULLETIN 7, no. 1 (Jan. 1876): 27. [Stewart from Clarksville, MO. "...the latest news of photograph and ferrotype boats doing business on the rivers "Out West." Col. Henry Gibson, after death of brother Stephen (Feb. last), partnered with Helm to form Helm & Gibson. L. F. Wetzel; Brickey Brothers (St. Louis, MO); Mason; H. W. Spenser; Denison; J. Whiteman; J. P. Doremus; others.]

STEWART, I. D., LIEUT.-COLONEL. (GREAT BRITAIN, INDIA)

S1067 "Indian Rebel, Zahoor-Ool-Hoosein, Recently Captured." ILLUSTRATED LONDON NEWS 41, no. 1177 (Dec. 6, 1862): 592. 1 illus. ["...from a photograph taken at Poona by Lieutenant-Colonel I.D. Stewart, of the Bombay Army."]

STEWART, JOHN.

[John Stewart was a Brother-in-law of Sir John Herschel. An amateur photographer, who lived in Pau for several years from 1847 and made landscape views in the Pyrénées, often with Maxwell Lyte and J. J. Heilmann as photographic companions. His views of the Pyrénées exhibited at the Society of Arts in London in December 1852. His photographs published by Blanquart-Evrard in *Souvenirs des Pyrénées, 1852-53* in 1853. Member of the Société française de Photographie in 1855. Photographed at Versailles in 1857. Exhibited in France and England during the 1850s. Knew and worked with Victor Régnault and other French savants. J. J. Heilmann, in Pau, also printed and published his waxed paper negatives. Died in 1887.]

S1068 Herschel, J. F. W., and John Stewart. "Photographic Landscapes on Paper." ATHENAEUM no. 1311 (Dec. 11, 1852): 1363-1364. [Letter from Herschel, discussing his brother-in-law's landscapes. Stewart lived in Pau, Switzerland. A letter from Stewart, describing his experiences, also included.]

S1069 "Photographic Landscapes on Paper." HUMPHREY'S JOURNAL 4, no. 19 (Jan. 15, 1853): 293-296. [From the "Athenaeum." Letter from J. F. W. Herschel introducing a letter from John Stewart, describing his practices taking landscape views in Switzerland.]

S1070 Stewart, John. "New Photographic Process." ATHENAEUM no. 1341 (July 9, 1853): 831. [Letter from John Stewart describing a new photographic copying process, accompanying an introductory letter from his brother-in-law, J. F. W. Herschel. This drew a letter from W. E. Kilburn on p. 864 of July 16 issue, claiming that Mr. Keilmann had discovered the same process years ago. Stewart replies on p. 921 in the July 30 issue.]

S1071 "New Photographic Process." HUMPHREY'S JOURNAL 5, no. 7 (July 15, 1853): 109-110. [From the "Athenaeum." A second set of letters by J. F. W. Herschel and his brother-in-law John Stewart. Stewart's explains his process.]

S1072 Kilburn, W. E. "Editorials." HUMPHREY'S JOURNAL 5, no. 8 (Aug. 1, 1853): 121. [From the "Athenaeum." Letter from Kilburn in response of a statement by Mr. Stewart, published earlier. This evokes a letter from Stewart in turn, which is published on pp. 137-138 of "Humphrey's."]

S1073 Stewart, John. "Photographic Pantograph." PHOTOGRAPHIC ART JOURNAL 6, no. 5 (Nov. 1853): 303-305. 1 illus. [From "J. of Photo. Soc." Letter from Stewart, in Pau, Switzerland, accompanied by a note from J. F. W. Herschel, his brother-in-law.]

S1074 Stewart, John. "Mr. Stewart on the Paper Process." PHOTOGRAPHIC AND FINE ART JOURNAL 7, no. 9 (Sept. 1854): 261-263. [From "J. of the Photo. Soc."]

S1075 Stewart, John. "Paper Process." HUMPHREY'S JOURNAL 6, no. 10 (Sept. 1, 1854): 145-151. [From "J. of the Photo. Soc., London."]

S1076 "Biographical Notes on a Number of Photographers Published by Blanquart-Evrard." CAMERA (LUCERNE) 57, no. 12 (Dec. 1978): 32, 41-42. [Benecke, Claine, DuCamp, Fortier, Greene, Le Secq, Loydreau, Marville, Regnault, Robert, Salzmann, Stewart, Sutton, and Tenison.]

STIFF, C. W. [B. F. JONES GALLERY] (SALEM, MA)
S1077 "Pictures." ANTHONY'S PHOTOGRAPHIC BULLETIN 2, no. 3 (Mar. 1871): 93.

STILLMAN, WILLIAM JAMES. (1828-1901) (USA, GREAT BRITAIN, USA)
BOOKS
S1078 Stillman, William James. *Photographic Studies by W. J. Stillman. Part I. The Forest. Adirondac Woods.* Boston: J. W. Black, 1860. n. p. 12 b & w. [Album, with original photographs, printed by J. W. Black. Private Collection.]

S1079 Stillman, William James. *The Acropolis of Athens; Illustrated Picturesquely and Architecturally in Photography.* London: F. S. Ellis, 1870. x, 25 l. of plates. 26 b & w. [Autotypes, by Stillman. Photograph mounted on the title page. Descriptive letterpress mounted at the foot of the plates.]

S1080 Stillman, William J. *The Amateur's Photographic Guide Book: Being a Complete Résumé of the Most Useful Dry and Wet Collodion Processes.* London: C. D. Smith & Co., Opticians, 1874. 92 pp. illus.

S1081 Stillman, William J. *The Cretan Insurrection of 1866-7-8.* New York: H. Holt & Co., 1874. xi, 203 pp.

S1082 [Stillman, W. J.] *Every Man His Own Photographer.* Liverpool: Liverpool Dry Plate Company, 1875. n. p. ["This little book was written as a guide of the collodion emulsion dry plates prepared by Mr. Peter Mawdsley. It did not bear the author's name, ...Mr. Stillman kindly informed us he was responsible for it." W. J. Harrison "Anthony's Photo. Bulletin," (July 9, 1887): 395.]

S1083 Stillman, William James, editor. *Poetic Localities of Cambridge.* Illustrated with Heliotypes from Nature. Boston: James R. Osgood & Co., 1876. ii, 42 pp. 11 b & w. [Eleven collotypes by Stillman, with texts by Oliver Wendell Holmes, James Russell Lowell, and Longfellow.]

S1084 Stillman, William J. *Herzegovina and the Late Uprising; the Causes of the Latter.* London: Longmans, Green & Co., 1877. iv, 186 pp.

S1085 Stillman, William J. *Report of W. J. Stillman on the Cesnola Collection.* New York: Thompson & Moreau, 1885. 33 pp. [Coin collection.]

S1086 Stillman, William James. *On the Track of Ulysses. Together with an Excurion in Quest of the So-called Venus of Melos. Two Studies in Archaeology, made during a Cruise among the Greek Islands.* Boston, New York: Houghton, Mifflin & Co., 1887. 106 pp. illus. [First published in the "Century Magazine."]

S1087 Cole, Timothy. *Old Italian Masters,* engraved by Timothy Cole. With Historical Notes by W. J. Stillman, and Brief Comments by the Engraver. New York, London: The Century Co., T. Fisher Unwin, 1892. xxi, 282 pp. 66 l. of plates.

S1088 Lowell, James Russell. *A Few of Lowell's Letters.* By W. J. Stillman. New York: The Atlantic, 1892. 13 pp. [Offprint from "The Atlantic" (Dec. 1892): 744-757.]

S1089 Stillman, William J., ed. *Venus & Apollo in Painting and Sculpture.* London: Bliss, Sands & Co., 1897. xviii, 170 pp. 40 l. of plates.

S1090 Stillman, William J. *The Union of Italy, 1815 - 1895.* Cambridge: University Press, 1898. x, 412 pp. ["Cambridge Historical Series." (1912) new, revised ed.]

S1091 Stillman, William J. *Billy and Hans, a True History.* London: Bliss Sands & Co., 1897. xxi, 61 pp. [First published in "Century Magazine" (Feb. 1897). Children's book, about squirrels.]

S1092 Stillman, William J. *Little Bertha.* London: Grant Richards, 1898. 110 pp. [Children's book, about squirrels.]

S1093 Stillman, William James. *The Old Rome and the New and Other Studies.* New York: Houghton, Mifflin & Co., 1898. 296 pp.

S1094 Stillman, William J. *Francesco Crispi. Insurgent, Exile, Revolutionist and Statesman.* London, Boston: G. Richards, Houghton, Mifflin & Co., 1899. 287 pp.

S1095 Stillman, William James. *The Autobiography of a Journalist.* London, Boston: G. Richards, Houghton, Mifflin & Co., 1901. 2 vol.

S1096 Stillman, William J. "The Opinions of John Ruskin on Various Artists. The Decay of Art," in "Appendix" in: *Landscape Painting and Modern Dutch Artists,* by E. B. Greenshields. New York: The Baker & Taylor Co., 1906. xvii, 229 pp. 45 l. of plates.

S1097 Stillman, William J. *Billy and Hans, My Squirrel Friends; A True History.* Portland, ME: Thomas B. Moser, 1914. xxii, 47 pp. [950 copies.]

S1098 Stillman, William J. *American Consul in a Cretan War; Revised Edition of the The Cretan Insurrection of 1866-7-8.* With introduction and notes by George Georgiades Arnakis. Austin, TX: Center for Neo-Hellenic Studies, 1966. 146 pp. illus.

S1099 Stillman, William J. *The Coinage of the Greeks*. Chicago: Obol International, 1975. 16 pp. illus. [Reprinted from "Century Magazine" (Mar. 1887): 788-799.]

S1100 Stillman, William J. *Articles and Despatches [sic] from Crete*. Edited with an introduction by George Georgiades Arnakis. Austin, TX: Center for Neo-Hellenic Studies, 1976. 138 pp.

S1101 Ehrenkranz, Anne, with Colin Eisler, Linda S. Ferber, and André Jammes. *Poetic Localities: Photographs of Adirondacks. Cambridge. Crete. Italy. Athens. William J. Stillman*. Biographical Essay and Catalogue Notes by Anne Ehrenkranz. Dedication by André Jammes. Essays by Colin Eisler and Linda S. Ferber. New York: Aperture Press, in association with the International Center for Photography, 1988. 127 pp. 66 b & w. 21 illus. [Includes checklist for the exhibition, at the International Center for Photography, New York, NY.]

PERIODICALS

S1102 Stillman, William James. "Photography." THE CRAYON 1, (Mar. 14, 1855): 170. [Stillman was a founding co-editor, with John Durand, of "The Crayon" from 1855 to 1856.]

S1103 Stillman, W. J. "The Nature and Use of Beauty." THE CRAYON 3, no. 1-7 (Jan. 1856 - July 1856): 1-4, 33-36, 65-67, 97-99, 129-132, 161-162, 193-195.

S1104 W. J. S. [Stillman] "Country Correspondence - Adirondac Woods, Sept. 13th." THE CRAYON 6, no. 10 (Oct. 1859): 321-322. [Discussion of aesthetics, no mention of photography - but written during the period Stillman was photographing.]

S1105 "Art: Forest Photographs." ATLANTIC MONTHLY 5, no. 27 (Jan. 1860): 109. ["We call the attention of our readers to a series of twelve photographic views of forest and lake scenery published by Mr. J. W. Black, Boston, from negatives taken by Mr. Stillman in the Adirondack country."]

S1106 "Roman Antiquities at Kisamos, Island of Crete." ILLUSTRATED LONDON NEWS 49, no. 1388 (Sept. 8, 1866): 233, 238. 3 illus. ["We have been favored by Mr. M. [sic W.] Stillman, the United States Consul at Canea, in Crete, with photographs of two statues... and a view of the town itself."]

S1107 Stillman, W. J. "Masks for Double Printing." BRITISH JOURNAL PHOTOGRAPHIC ALMANAC 1872 (1872): 100-101.

S1108 Stillman, W. J. "Artistic Photography." BRITISH JOURNAL PHOTOGRAPHIC ALMANAC 1872 (1872): 106-110.

S1109 Stillman, W. J. "Suggestion for a Photographic Education." ANTHONY'S PHOTOGRAPHIC BULLETIN 3, no. 4 (Apr. 1872): 511-512. [From "Br. J. of Photo." Response to an earlier editorial on the subject.]

S1110 Stillman, W. J. "A Photographic Field Day." PHOTOGRAPHIC TIMES 2, no. 20 (Aug. 1872): 122-124. [An American photographer in England. Reprinted from "The Nation."]

S1111 Stillman, W. J. "Timing for Dry Plates." ANTHONY'S PHOTOGRAPHIC BULLETIN 3, no. 12 (Dec. 1872): 767-769. [From "London Photo. News."]

S1112 Stillman, W. J., M.A. "Locomotive Photography." BRITISH JOURNAL PHOTOGRAPHIC ALMANAC 1873 (1873): 135-138. 2 illus. [Talking about photographers who travel, not railroad engines.

Illustrations are portable developing boxes. Stillman's equipment made for him by Mr. Solomon, of Red Lion Square, London.]

S1113 Stillman, W. J., M.A. "Certain Peculiarities in Emulsions." BRITISH JOURNAL PHOTOGRAPHIC ALMANAC 1874 (1874): 107-112.

S1114 "A New Dry Process." ANTHONY'S PHOTOGRAPHIC BULLETIN 5, no. 10 (Oct. 1874): 326-328.

S1115 Stillman, W. J. "Washed Emulsions." BRITISH JOURNAL PHOTOGRAPHIC ALMANAC 1875 (1875): 59-61.

S1116 Stillman, W. J. "Our London Letter." PHILADELPHIA PHOTOGRAPHER 12, no. 135-137, 139-141 (Mar. - May, July - Sept. 1875): 65-69, 106-107, 132-134, 202-204, 233-236, 271-274. [Crisis of Photo. Soc. of London. Stillman himself apparently elected to head the Royal Photo. Soc.]

S1117 "The Chloro-bromide Emulsion." ANTHONY'S PHOTOGRAPHIC BULLETIN 6, no. 8 (Aug. 1875): 233-235.

S1118 "Editor's Table." PHILADELPHIA PHOTOGRAPHER 12, no. 140 (Aug. 1875): 256. ["...beautiful 'bits' of English landscape scenery from his emulsion negatives."]

S1119 Stillman, W. J. "Advice to Amateurs Travelling." BRITISH JOURNAL PHOTOGRAPHIC ALMANAC 1879 (1879): 79-82. [Stillman writing from Florence, Italy. Describes his photographic apparatus and procedures.]

S1120 Stillman, W. J. "Photography and Art." PHOTOGRAPHIC TIMES 15, no. 172 (Jan. 2, 1885): 1-2.

S1121 Stillman, W. J. "Instantaneous Photography." PHOTOGRAPHIC TIMES 15, no. 174 (Jan. 16, 1885): 26.

S1122 Stillman, W. J. "Experimenting." PHOTOGRAPHIC TIMES 15, no. 175 (Jan. 23, 1885): 37-38.

S1123 Stillman, W. J. "Film Negatives." PHOTOGRAPHIC TIMES 15, no. 178 (Feb. 13, 1885): 74-75.

S1124 Stillman, W. J. "Photography for Amateurs. Nos. 1 - 4." PHOTOGRAPHIC TIMES 15, no. 181-182, 185-186 (Mar. 6 - Mar. 13, Apr. 3 - Apr. 10, 1885): 114-115, 125-126, 166-167, 182-183.

S1125 Stillman, W. J. "Notes: Complimentary Dinner." PHOTOGRAPHIC TIMES 15, no. 189 (May 1, 1885): 200. [W. J. Stillman, about to leave this country for Europe. "...was entertained at Delmonico's by friends and acquaintances from the Society of Amateur Photographers of New York and others. Sailed the following day on the 'Adriatic'."]

S1126 Stillman, W. J. "Orthographic Reproduction." PHOTOGRAPHIC TIMES 15, no. 203 (Aug. 7, 1885): 452-453.

S1127 Stillman, W. J. "Hints on Out-of-Door Photography." PHOTOGRAPHIC TIMES 15, no. 210 (Sept. 25, 1885): 546-547.

S1128 "Correspondence: How to Focus." PHOTOGRAPHIC TIMES 15, no. 211 (Oct. 2, 1885): 568-569.

S1129 Stillman, W. J. "General Hints for Field Photography." PHOTOGRAPHIC TIMES 16, no. 224 (Jan. 1, 1886): 3-5.

S1130 Stillman, W. J. "Paper Negatives." PHOTOGRAPHIC TIMES 16, no. 229 (Feb. 5, 1886): 81-82. [Includes reminiscences of his travels in the East, Albania, etc.]

S1131 Stillman, W. J. "The Art in It. I - III." PHOTOGRAPHIC TIMES 16, no. 235-237 (Mar. 19 - Apr. 2, 1886): 156-157, 165-166, 177-178.

S1132 Stillman, W. J. "Mounting Photographs." PHOTOGRAPHIC TIMES 16, no. 244 (May 21, 1886): 273-274.

S1133 Stillman, W. J. "Photography and Art: A Reply to 'Charlotte Adams' in the 'Philadelphia Photographer'." PHOTOGRAPHIC TIMES 16, no. 260 (Sept. 10, 1886): 479-480.

S1134 Stillman, W. J. "Pictorial Photography." AMERICAN ANNUAL OF PHOTOGRAPHY AND PHOTOGRAPHIC TIMES ALMANAC FOR 1887 (1887): 149-152.

S1135 Stillman, W. J. "Spirit Photography." PHOTOGRAPHIC TIMES 17, no. 278-281 (Jan. 14 - Feb. 4, 1887): 18-19, 33-34, 44-45, 62-63. [Apparently a fictional short story.]

S1136 "W. J. Stillman." PHOTOGRAPHIC TIMES 17, no. 312 (Sept. 9, 1887): frontispiece, 451-453. 1 illus. [Portrait drawing of Stillman. Biography. Born at Schenectady, NY, in 1828. Graduated Union College. Practiced landscape painting 1840s - 1850s. Moved back and forth between Europe and USA, studying with Ruskin and others. Learned photography at Black & Whipple Studio in Boston in 1857. Back in Rome practiced and experimented with photography while a correspondent for the "London Times." Associate editor "Photographic Times" 1883 - 1885 signed his articles "S." at that time.]

S1137 Stillman, W. J. "John Manson: A Studio Story." PHOTOGRAPHIC TIMES 17-18, no. 312-373 (Sept. 9, 1887 - Nov. 9, 1888): (vol. 17) 458-459, 467-469, 480-483, 494-497, 504-506, 516-517, 528-529, 541-543, 552-554, 566-568, 579-580, 590-592, 602-603, 619-620, 629-631, 650-652. (vol. 18) 6-8, 17-18, 29-30, 42-43, 53-54, 66-67, 77-78, 90-91, 101-102, 124-125, 137-138, 148-149, 162-163, 174-176, 186-187, 196-198, 233-235, 244-246, 257-258, 267-270, 282-283, 294-295, 318-319, 363-365, 379-381, 389-391, 400-402, 416-418, 425-429, 438-440, 451-455, 461-463, 473-475, 485-487, 498-499, 508-510, 521-523, 534-538. [This is a fictional story about an artist living in Rome. While it is a romance, in which the protagonist woos and eventually marries a young lady, there are extended discussions revolving around matters of art, aesthetics, and photography occurring within the narrative. As was typical of the time, this story appeared in segments of three or four pages each in nearly every weekly issue of the "Photographic Times" during the years 1887 and 1888.]

S1138 Stillman, W. J. "Correspondence: Infant Design." PHOTOGRAPHIC TIMES 17, no. 317 (Oct. 14, 1887): 520. [Republication of a letter by Stillman, first published in "The Nation: Oct. 6, asking for examples of children's drawings for a serious and somewhat elaborate study into this subject."]

S1139 Stillman, W. J. "Cameras for Tourist's Work." PHOTOGRAPHIC TIMES 17, no. 318 (Oct. 21, 1887): 523-524.

S1140 Stillman, W. J. "Detective Cameras." AMERICAN ANNUAL OF PHOTOGRAPHY & PHOTOGRAPHIC TIMES ALMANAC FOR 1888 (1888): 87-90. [Survey of the small hand cameras available, discusses the possible uses of this format.]

S1141 "Notes and News: W. J. Stillman." PHOTOGRAPHIC TIMES 18, no. 333 (Feb. 3, 1888): 57. [Brief biography in response to query to "NY Post" generated by an article on Ruskin by Stillman in "Century" magazine. Some additional information, not found in the Sept. 9, 1887 "Photo Times" article.]

S1142 Stillman, W. J. "Photography at Sea." PHOTOGRAPHIC TIMES 18, no. 338 (Mar. 9, 1888): 109-111. 1 b & w. [Stillman writes of his experience on his latest trip from New York to Europe, from Rome, Jan. 1888. Previous note indicates that Stillman was in New York, NY in 1887.]

S1143 "Our Editorial Table." PHOTOGRAPHIC TIMES 18, no. 351 (June 8, 1888): 275. ["Mr. Stillman has sent us some prints made with his detective camera, of Italian peasants about Rome. They show just such people as we have pictured in our imaginations, after reading his descriptions of Carlo and the other Italian characters who appears in "John Manson."]

S1144 Stillman, W. J. "Retouching Negatives." PHOTOGRAPHIC TIMES 18, no. 356 (July 13, 1888): 325-326.

S1145 Stillman, W. J. "Editorial Notes: Art Education." PHOTOGRAPHIC TIMES 18, no. 367 (Sept. 28, 1888): 458. [From the Sept. 1888 issue of "Century."]

S1146 Stillman, W. J. "Correspondence: A Suggested Roll-Holder Vest Camera." PHOTOGRAPHIC TIMES 18, no. 370 (Oct. 19, 1888): 501. 2 illus. [Diagrams.]

S1147 "Instantaneous Studies." PHOTOGRAPHIC TIMES 18, no. 379 (Dec. 21, 1888): 618, plus unnumbered leaf following p. 618. [Six "Instantaneous Studies in Italy" on one plate.]

S1148 Stillman, W. J. "More Haste Less Speed." PHOTOGRAPHIC TIMES 18, no. 379 (Dec. 21, 1888): 618-620.

S1149 Stillman, W. J. "Trifles Light as Air." PHOTOGRAPHIC TIMES 19, no. 382 (Jan. 11, 1889): 16-18. [Anecdotes from Stillman's experiences with amateurs.]

S1150 Stillman, W. J. "The Art Side of Photography." PHOTOGRAPHIC TIMES 19, no. 391 (Mar. 15, 1889): 129-130.

S1151 Stillman, W. J. "The Art Side of Photography." PHOTOGRAPHIC TIMES 19, no. 398 (May 3, 1889): 217-220.

S1152 Stillman, W. J. "The Aesthetic Side of Photography." PHOTOGRAPHIC TIMES 19, no. 401 (May 24, 1889): 256-257.

S1153 Stillman, W. J. "Correspondence: Colored Positive Paper for Photography." PHOTOGRAPHIC TIMES 19, no. 403 (June 7, 1889): 285.

S1154 Stillman, W. J. "The Art in Photography." PHOTOGRAPHIC TIMES 19, no. 405 (June 21, 1889): 306-309.

S1155 Stillman, W. J. "The Art in Photography." PHOTOGRAPHIC TIMES 19, no. 406 (June 28, 1889): 316-318.

S1156 Stillman, W. J. "Film Photography." PHOTOGRAPHIC TIMES 19, no. 431 (Dec. 20, 1889): 632, plus unnumbered leaf after p. 632. 1 b & w. [Photography on the plastic film base. Stillman shot several rolls of film on a trip through Europe, reports this experience. A full

page photo of the Facade of the Duomo of Florence, Italy, is also included.]

S1157 Stillman, W. J. "Architectural Photography." AMERICAN ANNUAL OF PHOTOGRAPHY AND PHOTOGRAPHIC TIMES ALMANAC FOR 1890 (1890): 113-119.

S1158 Stillman, W. J. "Art and Photography." PHOTOGRAPHIC TIMES 20, no. 433 (Jan. 3, 1890): 4-7.

S1159 "Doorway of the Duomo of Florence, Italy." PHOTOGRAPHIC TIMES 20, no. 446 (Apr. 4, 1890): frontispiece, 159. 1 b & w.

S1160 "W. J. Stillman." PHOTOGRAPHIC TIMES 20, no. 453 (May 23, 1890): frontispiece, 243. 1 b & w. [Stillman lives in Rome, "occupied at Rome and Greece as Eastern correspondent of the "London Times." Landscape painter, pupil of Turner, disciple and friend of Ruskin. Amateur photographer, contributor of papers on the Art Side of Photography to "Photographic Times." See also "P.T." Sept. 9, 1887. The illustration is a portrait of Stillman by Charles Ehrmann.]

S1161 Stillman, W. J. "The Lighting in Photographic Studios." PHOTOGRAPHIC TIMES 20, no. 456 (June 13, 1890): 281-282. [Still attacking Mr. Edwards-Ficken.]

S1162 "A Scene in the Tyrolese Alps." PHOTOGRAPHIC TIMES 20, no. 471 (Sept. 26, 1890): frontispiece, 477. 1 illus. [Reproduction of a painting of the Alps by the painter and critic Stillman. "...in the green stages of my development I wrote a great deal of rubbish for which I hope to atone before I die."]

S1163 Stillman, W. J. "Retrospect." AMERICAN ANNUAL OF PHOTOGRAPHY AND PHOTOGRAPHIC TIMES ALMANAC FOR 1891 (1891): 156-161. [Autobiographic reminiscences of more than 50 years experiences with photography. Painter, studied with James Black in Boston in 1850's. Photographed plants, animals in Florida. Gave up photography for a while, then years later, after appointed to the consulate in Crete, bought amateur equipment, photographed extensively in Crete for four years. Then to London, joined the Photographic Field Club, then became too busy as a journalist, politician, author, etc.]

S1164 Stillman, W. J. "The Philosophy of Development." PHOTOGRAPHIC TIMES 21, no. 497 (Mar. 27, 1891): 145-147. [Discussion of aesthetic principles, general issues loosely based on concepts of developing negatives.]

S1165 Stillman, W. J. "A Photographers Dream." PHOTOGRAPHIC TIMES 21, no. 497-499 (Mar. 27 - Apr. 10, 1891): 151-152, 163-164, 175-176. [Humorous story involving the devil and a photographer, revolving around the issue of "naturalistic photography" raised by P. H. Emerson and in discussion within the field.]

S1166 Stillman, W. J. "The Old Rome and the New." PHOTOGRAPHIC TIMES 21, no. 511 (July 3, 1891): 323-324. [From the July "Atlantic." Essay about Rome, doesn't mention photography at all, but Stillman is reported to have published photos that he took in Rome.]

S1167 Stillman, W. J. "A Cool Retreat." PHOTOGRAPHIC TIMES 21, no. 535 (Dec. 18, 1891): 631-633. 2 b & w. 1 illus. [Anecdotes about his experiences photographing in Italy.]

S1168 Stillman, W. J. "Lighting the Head." AMERICAN ANNUAL OF PHOTOGRAPHY AND PHOTOGRAPHIC TIMES ALMANAC FOR 1892 (1892): 108-111.

S1169 Stillman, W. J. "A Ghostly Sitter. A Photographic Story." PHOTOGRAPHIC TIMES 22, no. 543 (Feb. 12, 1892): 84-85. [Story is set in the 1850's.]

S1170 Stillman, W. J. "Imponderable Elements." PHOTOGRAPHIC TIMES 23, no. 608 (May 12, 1893): 244-245. [Argument that most discoveries in photography achieved by amateurs who constantly experiment, rather than by professionals or even chemists.]

S1171 Stillman, William J. "The Philosopher's Camp: Emerson, Agassiz, Lowell and Others in the Adirondacks." CENTURY MAGAZINE 46, no. 8 (Aug. 1893): 598-606.

S1172 "Editor's Table: W. J. Stillman." WILSON'S PHOTOGRAPHIC MAGAZINE 38, no. 536 (Aug. 1901): 328. [Note of Stillman's death in England in early July, with a very brief precis of his career, his connection with Wilson's magazines in the 1870s and the London "Times" from 1875 to 1896.]

S1173 "Obituary of the Year: W. J. Stillman." BRITISH JOURNAL PHOTOGRAPHIC ALMANAC 1902 (1902): 693-695. [Stillman died at his Surrey home on July 6, 1901, at the age of 74. Frequent exhibitor at Pall Mall Exhibitions (RPS). 1869 series of photographs of ruined temples, etc. in Athens. Born in NY in 1828. Studied painting, visited England in 1850, made friends with Ruskin, Millais and Rossetti. Dossuth's 1851 tour in America for Hungarian freedom inspired Stillman to attempt to help that cause. Confusions and frustrations, and Stillman went back to the USA and resumed painting. Began The Crayon, met Longfellow, Lowell, Emerson, Bierstadt, etc. In 1861 appointed U. S. Consul at Rome, then later to Crete. Forced to leave by the Turks because of his support for the Cretan independence movement, and moved to Athens in 1868, where he made photographs. Then moved to England and in 1875 worked as a correspondent for the London Times, covering the Herzegovinian insurrection and subsequent campaigns. To Albania and Montenegro, Athens and Rome in 1880s. Retired from journalism in 1898, at age 70, to Surrey. Published his memoir The Autobiography of a Journalist, shortly before his death in 1901.]

S1174 Lindquist-Cock, Elizabeth. "Stillman, Ruskin and Rossetti: The Struggle Between Nature and Art." HISTORY OF PHOTOGRAPHY 3, no. 1 (Jan. 1979): 1-14. 13 b & w. [8 photos by Stillman, 5 by Julia M. Cameron.]

STOCK, JOHN.
S1175 "John Stock's Patent Improved Adjustable Ambrotype Frames." HUMPHREY'S JOURNAL OF PHOTOGRAPHY, AND THE ALLIED ARTS AND SCIENCES 10, no. 7 (Aug. 1, 1858): 99. 1 illus.

STODDARD, J. H. (ANSONIA, CT)
S1176 Anthony, H. T. "Photography in Ansonia." ANTHONY'S PHOTOGRAPHIC BULLETIN 3, no. 10 (Oct. 1872): 706. [Stoddard from Ansonia, CT.]

STODDARD, SENECA RAY. (1843-1917) (USA)
BOOKS
S1177 Stoddard, Seneca Ray. Adirondacks: Illustrated. Glens Falls, NY: Stoddard, 1874. n. p. illus.

S1178 Catalogue of Stereographs of New York Scenery. Glens Falls, NY: S. R. Stoddard, 1877. 11 pp. [Lists about 1600 views.]

S1179 Stoddard, Seneca Ray. *Lake George: A Book of Today.* Glens Falls, NY: Stoddard, 1892. n. p. b. & w.

S1180 Stoddard, Seneca Ray. *Lake George and Lake Champlain: A Book of Today.* Glens Falls, NY: Stoddard, 1913. n. p. b & w.

S1181 Stoddard, Seneca Ray. *Old Times in the Adirondacks: the Narrative of a Trip into the Wilderness in 1873,* by Seneca Ray Stoddard, Edited, with a biographical sketch, by Maitland C. De Sormo. Saranac Lake, NY: Adirondack Yesteryears, 1971. 152 pp. b & w. illus.

S1182 Sormo, Maitland C. De. *Seneca Ray Stoddard: Versatile Camera-Artist.* Saranac Lake, NY: Adirondack Yesteryears, 1972. n. p. b & w.

S1183 Crowley, William. *Seneca Ray Stoddard: Adirondack Illustrator.* Blue Mountain Lake, NY: Adirondack Museum, 1982. n. p. b. & w.

PERIODICALS
S1184 "Our Picture." PHILADELPHIA PHOTOGRAPHER 13, no. 147 (Mar. 1876): frontispiece, 94-95. 1 b & w. ["Promenade' landscape.]

S1185 "Lunar Effects." PHILADELPHIA PHOTOGRAPHER 12, no. 134 (Feb. 1875): 46-47. ["Night" Stereo Views.]

S1186 "Our Picture." PHILADELPHIA PHOTOGRAPHER 14, no. 161 (May 1877): frontispiece, 129-130. 1 b & w. [View of lake "In the Adirondacks."]

S1187 Stoddard, S. R. "Landscape and Architectural Photography." PHILADELPHIA PHOTOGRAPHER 14, no. 161 (May 1877): 146-148.

S1188 "Editor's Table." PHILADELPHIA PHOTOGRAPHER 14, no. 164 (Aug. 1877): 256. [Mentions Stoddard's annuals, "The Adirondacks," and "Lake George."]

S1189 "Our Picture." PHILADELPHIA PHOTOGRAPHER 15, no. 173 (May 1878): frontispiece, 153-154. 1 b & w. [Landscape view.]

S1190 "Pleasant Valley." PHOTOGRAPHIC TIMES 19, no. 385 (Feb. 1, 1889): frontispiece, 5. 1 b & w. [A montage of landscape views and "ornamental accessories" [flowers, texts, borders] of Pleasant Valley, NY. S. R. Stoddard was a "well-known Adirondack photographer."]

S1191 "Our Editorial Table." PHOTOGRAPHIC TIMES 19, no. 386 (Feb. 8, 1889): 76. [Series of 8x10" Adirondack photographs.]

S1192 "The Editorial Table." PHOTOGRAPHIC TIMES 19, no. 403 (June 7, 1889): 290. [Flash-light view of the Washington Memorial Arch mentioned.]

S1193 "Notes and News: 'Flash' Light Photography Out-of-Doors." PHOTOGRAPHIC TIMES 19, no. 425 (Nov. 8, 1889): 559-560. 1 illus. [Report on Stoddard's flash-light photo of the Washington Arch. Engraving from the photo.]

S1194 "Notes and News: Liberty Photographed." PHOTOGRAPHIC TIMES 19, no. 427 (Nov. 22, 1889): 582. [Report on a "flash-light" photograph of the Statue of Liberty taken by Stoddard, from "N.Y. World."]

S1195 "Notes and News: Poetical Correspondence." PHOTOGRAPHIC TIMES 19, no. 432 (Dec. 27, 1889): 655. [Reprints two humorous poems sent between photographer S. R. Stoddard and Wallace Bruce, U.S. Council at Edinburgh, Scotland.]

S1196 Stoddard, Solomon R. "Photographing Bats." AMERICAN ANNUAL OF PHOTOGRAPHY AND PHOTOGRAPHIC TIMES ALMANAC FOR 1890 (1890): 53-56, plus unnumbered leaf after p. 56. 1 b & w. [Anecdotes of his experiences.]

S1197 "Notes and News." PHOTOGRAPHIC TIMES 20, no. 438 (Feb. 7, 1890): 72. [Received a "flash-light" picture of "Liberty Enlightening the World."]

S1198 "Notes and News: S. R. Stoddard's Latest Flash-Light Attempt." PHOTOGRAPHIC TIMES 20, no. 484 (Dec. 26, 1890): 653-654. [Stoddard tried to photograph the "N.Y. World" building after dark. Describes the problems that occurred.]

S1199 "Notes and News." PHOTOGRAPHIC TIMES 22, no. 546 (Mar. 4, 1892): 125. ["S. R. Stoddard, the famous Adirondack artist, lectured on the Adirondack Wilderness before the Legislature of New York, under the auspices of the Forest Commission,... Feb. 25th... exhibited about 200 stereoscopic views of the picturesque region."]

S1200 1 vignette ("S. R. Stoddard and His Work"). PHOTOGRAPHIC TIMES 23, no. 640 (Dec. 22, 1893): 763. [Consists of a portrait and about 53 dime-sized, overlapping circular photos by Stoddard.]

S1201 Fuller, John C. "The Collective Vision and Beyond - Seneca Ray Stoddard's Photography." HISTORY OF PHOTOGRAPHY 11, no. 3 (July - Sept. 1987): 217-227. 9 b & w. 1 illus. [Stoddard's work in the eastern Adirondacks discussed. Stoddard photographed in the late 1860s-1870s with the wet-collodion process, though most of his known works are stereographs or dry plates. His use of magnesium flash in the 1880s-1890s, particularly to photograph the Statue of Liberty, discussed.]

STOLTE, EDWARD H. see BUCHTEL & STOLTE.

STONE, JOHN BENJAMIN, SIR. (1838-1914) (GREAT BRITAIN)
[Born on Feb. 9, 1838 at Aston, near Birmingham. Joins his father's glass manufacturing company, Faundry & Stone, in Birmingham. Wealthy by the 1860s, Stone was active in founding or aiding many philanthropic and cultural associations. In 1869 he became a municipal councillor of Birmingham. He was the Mayor of Sutton Coldfield from 1886 to 1890. In 1892 he was knighted for his activities in the Conservative Party. Member of Parliament from 1895-1910. He died in 1914. Although apparently he was photographing as early as 1870, Stone's major contribution to photography occurred in 1880s and later. Other references about Stone will be located in volume two of this work.]

BOOKS
S1202 Stone, John Benjamin, Sir. *A History of Lichfield Cathedral.* London: Longmans, Green, Reader & Dyer, 1870. 120 pp. 5 b & w. [Original photos.]

S1203 Stone, John Benjamin, Sir. *A Tour with Cook through Spain.* London: Sampson Low, Son & Marston, 1873. n. p. 4 b & w. [Autotype views.]

S1204 Stone, John Benjamin, Sir. *Sir Benjamin Stone's Picture Records of National Life and History;* Reproduced from the Collection of

Photographs made by Sir Benjamin Stone. London: Cassell, 1906. 2 vol. b & w. illus.

S1205 *Customs & Faces: Photographs, by Sir Benjamin Stone, 1838 - 1914*, text by Bill Jay. London; New York: Academy Editions; St. Martin's Press, 1972. 96 pp. b & w. illus.

S1206 Stone, John Benjamin, Sir. *Sir Benjamin Stone, Photographer.* London: Arts Council of Great Britain, 1974. 4 pp. 8 l. of plates. 8 b & w.

PERIODICALS
S1207 "The Month: Science and Arts: Pictures for Posterity." CHAMBERS'S JOURNAL 75, no. 1 (Jan. 1, 1898): 61-62. [Announcement of the formation of the National Photographic Record Association, under Sir John B. Stone.]

S1208 "Making A King." COLLIER'S WEEKLY 26, no. 21 (Feb. 23, 1901): 3. 2 b & w. [Ceremony of proclaiming Edward VII King of England upon the death of Queen Victoria.]

S1209 Parker, George F. "History by Camera: With Examples of Photographic Records From the Exhibit to be Made in the Louisiana Purchase Exposition of the Work of Sir Benjamin Stone." CENTURY MAGAZINE 68, no. 1 (May 1904): 136-145. 6 b & w. 1 illus.

S1210 "Mention of Sir John Benjamin Stone's photos at St. Louis Exhibit." PHOTOGRAPHIC TIMES 36, no. 8 (Aug. 1904): 375.

S1211 Blumenfeld, Ralph D. "The Story of the Coronation." OUTLOOK 98, no. 12 (July 22, 1911): 616-624. 6 b & w. [1 photo credited to Sir Benjamin Stone, 2 photos Underwood & Underwood.]

S1212 "Sir Benjamin Stone." CREATIVE CAMERA no. 119 (May 1974): 150-159. 11 b & w.

S1213 Wilsher, Ann. "Rural Record." HISTORY OF PHOTOGRAPHY 5 , no. 4 (Oct. 1981): 338. 2illus. [Cartoon satirizing British amateur photographers, 1901. Article briefly tells about Sir Benjamin Stone's founding of the National Photographic Record Association to collect photographs of vanishing customs, etc.]

STONE, N. L.
S1214 Portrait. Woodcut engraving, credited "From a Photograph by N. L. Stone." FRANK LESLIE'S ILLUSTRATED NEWSPAPER 46, (1878) ["Gen. E. A. Merritt, New York, NY." 46:1192 (Aug. 3, 1878): 377.]

STONEHOUSE, W.
S1215 "Destruction of the Victoria Iron and Cement Works, at Wreckhills." ILLUSTRATED LONDON NEWS 32, no. 914 (Apr. 24, 1858): 415-416. 2 illus. [Ruins "from photographs by Mr. W. Stonehouse, of Whitby."]

STORR, J. H.
S1216 Storr, J. H. "An Amateur's Gelatino - Bromide Process." BRITISH JOURNAL PHOTOGRAPHIC ALMANAC 1879 (1879): 64-65.

STORTZ, P. C. (LIVERPOOL, ENGLAND)
S1217 Portrait. Woodcut engraving credited "From a photograph by P. C. Stortz, of Liverpool." ILLUSTRATED LONDON NEWS 37, (1860) ["Ricciotti, youngest son of General Garibaldi." 37:* (July 21, 1860): 50.]

S1218 "Fire at a Photographic Gallery, Liverpool." BRITISH JOURNAL OF PHOTOGRAPHY 10, no. 187 (Apr. 1, 1863): 151.

STORY-MASKELYNE, M. H. NEVIL. (1823-1911) (GREAT BRITAIN)
BOOKS
S1219 Kraus, Hans P. and Larry J. Schaaf. *Sun Pictures: Llewelyn, Maskelyne, Talbot, a Family Circle;* Catalogue Two. New York: Hans P. Kraus, Jr. Fine Photographs, 1986. 79 pp. illus. [W. H. Fox Talbot; John Dillwyn Llewelyn; Nevil Story-Maskelyne.]

PERIODICALS
S1220 Lassam, Robert E. "Nevil Story-Maskelyne, 1823-1911." HISTORY OF PHOTOGRAPHY 4, no. 2 (Apr. 1980): 85-93. 12 b & w.

S1221 Allison, David. "Nevil Story-Maskelyne: Photographer." PHOTOGRAPHIC COLLECTOR 2, no. 2 (Summer 1981): 16-36. 29 b & w. [Born Besset Down, Wiltshire on Sept. 3, 1823. Died there May 20, 1911. Interested in science, made photogenic drawings in 1839, worked with calotype processes and variants through 1840s, collodion through the 1850s. Apparently stopped in late 1850s devoting himself to building up the mineralogy collection at Oxford and to his marriage.]

S1222 Fort, Paul. "Nevil Story-Maskelyne: A Daguerreotype Portrait." PHOTOGRAPHIC COLLECTOR 2, no. 3 (Autumn 1981): 90-91. 2 b & w.

STOTHARD, THOMAS.
S1223 Defoe, Daniel. *The Life and Adventures of Robinson Crusoe,* by Daniel Defoe; With a Memoir by the Author and Twelve Illustrations in Permanent Photography by T. Stothard, R. A. London: Bickers, 1881. xix, 378 pp. 12 l. of plates. 12 b & w. [Original photos of paintings or engravings.]

STOUT, JOHN V. (EASTON, PA)
S1224 "Note." ANTHONY'S PHOTOGRAPHIC BULLETIN 8, no. 10 (Oct. 1877): 292. [From "Easton [PA] Free Press." John V. Stout opening gallery, assisted by William A. Hodges, who worked formerly for A. Bogardus (New York, NY).]

STRACHAN. (ARBROATH, SCOTLAND)
S1225 Portrait. Woodcut engraving credited "From a photograph by Strachan." ILLUSTRATED LONDON NEWS 52, (1868) ["Rev. Patrick Bell, Ll.D." 52:* (Mar. 7, 1868): 225.]

STRAUSS STUDIO see STRAUSS, JULIUS CAESAR.

STRAUSS, FRANCIS.
S1226 Strauss, Francis. "Working a South Light." PHILADELPHIA PHOTOGRAPHER 10, no. 109 (Jan. 1873): 10-11. 2 illus. [Strauss from York, PA.]

STRAUSS, JULIUS CAESAR. (1857-1924) (USA)
S1227 "Our Illustration." ANTHONY'S PHOTOGRAPHIC BULLETIN 20, no. 21 (Nov. 9, 1889): frontispiece, 665. 1 b & w. [Genre with children, by Strauss of St. Louis. Photo not bound in this copy.]

S1228 1 photo (Genre "Christmas Morning"). PHOTOGRAPHIC TIMES 22, no. 587 (Dec. 16, 1892): unnumbered leaf after p. 640. 1 b & w. [Editorial note on p. 680 Dec. 30 issue states that the photo actually made by F. W. Guerin of St. Louis, mislabeled.]

S1229 Dunwoody, H. H. C., U.S.A. "The Progress of Science: The St. Louis Tornado." COSMOPOLITAN 21, no. 4 (Aug. 1896): 440-444. 5 b & w. 5 illus. [Views of St. Louis tornado aftermath by J. C. Strauss.]

S1230 Strauss, J. C. "The New Studio of J. C. Strauss." WILSON'S PHOTOGRAPHIC MAGAZINE 34, no. 488 (Aug. 1897): frontispiece, 353-360. 11 b & w. 13 illus. [10 portraits. 13 views of rooms in the studio.]

S1231 "The Strauss Studio Destroyed by Fire." WILSON'S PHOTOGRAPHIC MAGAZINE 37, no. 519 (Mar. 1900): 127-129.

S1232 "The Strauss Studio, After the Fire." WILSON'S PHOTOGRAPHIC MAGAZINE 37, no. 520 (Apr. 1900): 176. 2 illus. [2 views of the destroyed studio. Includes brief biography. Began in a tin-type gallery in Cleveland at age 12. Then worked in St. Louis and, in 1876, in Chicago. Then 1877 back to St. Louis 1880 opened studio in partnership with Ed Guerin. Guerin retired after a few weeks. Strauss went on alone to build successful studio.]

S1233 "Editor's Table." WILSON'S PHOTOGRAPHIC MAGAZINE 37, no. 528 (Dec. 1900): 552. [Note that the Strauss Studio, recently destroyed by fire, rebuilding. Excerpt from "St. Louis Mirror."]

S1234 "At the Strauss Studio." WILSON'S PHOTOGRAPHIC MAGAZINE 38, no. 529 (Jan. 1901): 28-30. [Extracted from the "St. Louis Mirror." An imaginary conversation at the Strauss Studio.]

S1235 Strauss, J. C. "Photographic Portraiture as an Art." WILSON'S PHOTOGRAPHIC MAGAZINE 38, no. 535 (July 1901): 233-234. [From "The Art Review," St. Louis, Mo.]

S1236 Wilson, Edward L. "The New Strauss Studio." WILSON'S PHOTOGRAPHIC MAGAZINE 38, no. 535 (July 1901): 249-255. 15 illus.

S1237 Strauss, J. C. "Photography at the St. Louis World's Fair." WILSON'S PHOTOGRAPHIC MAGAZINE 38, no. 536 (Aug. 1901): 314. [Excerpts from letter from Strauss proposing that a photographic pavilion be opened at the forthcoming St. Louis World's Fair, asking for support from the photographic community.]

S1238 "Reproducing Famous Paintings by Photography." WILSON'S PHOTOGRAPHIC MAGAZINE 38, no. 538 (Oct. 1901): 409-410. [Excerpts from "St. Louis Republic".]

S1239 Reedy, WIlliam Marion. "'My Friend Strauss': With Some Particulars About Lyric Portraits." WILSON'S PHOTOGRAPHIC MAGAZINE 38, no. 540 (Dec. 1901): 458-459. [Reprinted from the "St. Louis Mirror".]

S1240 5 photos facing p. 225, plus 1 photo as frontispiece. PHOTOGRAPHIC TIMES 34, no. 5 (May 1902)

S1241 De Koven, Mrs. Reginald. "Western Society and Its Leaders." EVERYBODY'S MAGAZINE 10, no. 2 (Feb. 1904): 196-205. 13 b & w. [Article about prominent women in the social set in the U.S. Illustrated with studio portraits, two credited to Strauss.]

S1242 "Portraits of Old Masters." PHOTOGRAM 12, no. 139 (July 1905): 130, 151, 166, '86. 4 b & w. [From the series of "Portraits of the Old Masters," by J. C. Strauss. From "The Photo Era." The series consists of portraits of photographers dressed up to resemble portraits made by old master painters. Photos appeared in the May through July issues of the "Photogram."]

S1243 White, William Allan. "Folk: The Story of a Little Leaven in a Great Commonwealth." MCCLURE'S MAGAZINE 26, no. 2 (Dec. 1905): 114-132. 12 b & w. ["Illustrated with Portraits and Photographs." Electorial campaign for governor of Missouri, Joseph W. Folk. Four portraits credited to Strauss, two portraits credited to Murillo, several views of houses, scenes of political meetings, campaigns.]

S1244 1 photo (Judge William Sanborn). WORLD'S WORK 19, no. 3 (Jan. 1910): 12413.

S1245 Wright, Bonnie. "Julius Strauss and the Art of Photography." MISSOURI HISTORICAL REVIEW 73, no. 4 (July 1979): 451-462. 7 b & w. [Strauss internationally known at turn of the century. Fell from popularity in the teens. Discusses his attempts to have an exhibition of creative photography at the St. Louis World's Fair in 1903, the opposition of Alfred Stieglitz.]

STRIEGLER, RUDOLPH. (d. 1876) (DENMARK)
S1246 Portrait. Woodcut engraving credited "From a photograph by Rudolph Striegler, of Copenhagen." ILLUSTRATED LONDON NEWS 41, (1862) ["Her Royal Highness Princess Alexandria." 41:* (Nov. 8, 1862): 493.]

STROUD, WILLIAM. (NORRISTOWN, PA)
S1247 Portraits. Woodcut engravings, credited "Photographed by Wm. Stroud, Norristown, Pa." FRANK LESLIE'S ILLUSTRATED NEWSPAPER 11, (1861) ["Lieut. Slemmer, U.S.A.; Mrs. Slemmer (Two portraits)." 11:273 (Feb. 16, 1861): 208.]

S1248 "Soldiers' and Sailors' Monument at Norristown, Penn." HARPER'S WEEKLY 13, no. 669 (Oct. 23, 1869): 684. 1 illus. ["Photographed by William Stroud."]

STRUDWICK, WILLIAM. (GREAT BRITAIN)
BOOKS
S1249 Strudwick, William. The Art of Photographic Etching. London: the author, 1860. 12 pp. [Pamphlet.]

PERIODICALS
S1250 "The House in Which Pope Was Born." ILLUSTRATED LONDON NEWS 61, no. 1735 (Dec. 7, 1872): 532. 1 illus.

STUART, F. G. O.
S1251 Stuart, F. G. O. The Albert Memorial, London: A National Monument Erected by Public Subscription, in Memory of the Prince Consort, from Designs by Sir Gilbert G. Scott. Photographed and Published by F. G. O. Stuart. London: F. G. O. Stuart, 18—. 1 p. 29 l. of plates. [Original photographs.]

STUART, JOHN. (1831-1907) (GREAT BRITAIN)
S1252 Stuart, J. "Printing and Toning of Albumenized Prints." AMERICAN JOURNAL OF PHOTOGRAPHY AND THE ALLIED ARTS & SCIENCES n. s. vol. 3, no. 14 (Dec. 15, 1860): 212-216. [From "Br. J. of Photo." Stuart in the City of Glasgow and West of Scotland Photo. Soc.]

S1253 Stuart, J. "Printing and Toning of Albumenized Prints." HUMPHREY'S JOURNAL OF PHOTOGRAPHY, AND THE ALLIED ARTS AND SCIENCES 12, no. 16-17 (Dec. 15, 1860 - Jan. 1, 1861): 250-252, 265-267. [From "Br. J. of Photo."]

S1254 Stuart, John. "Improvements on the Solar Camera." HUMPHREY'S JOURNAL OF PHOTOGRAPHY, AND THE ALLIED

ARTS AND SCIENCES 15, no. 16 (Dec. 15, 1863): 251-253. [Read to the Glasgow Photo. Soc.]

S1255 Stuart, J. "On the Production of Large Paper Negatives." ANTHONY'S PHOTOGRAPHIC BULLETIN 2, no. 12 (Dec. 1871): 390-391. [From "Br. J. of Photo." Stuart regrets that the old calotype and waxed-paper processes have been so completely superceded by wet-collodion for large-scale landscape views.]

S1256 "A Helensburgh Studio." ANTHONY'S PHOTOGRAPHIC BULLETIN 2, no. 12 (Dec. 1871): 384-386. [From "Br. J. of Photo." Stuart in Glasgow.]

S1257 Stuart, John. "The Photographing of Children." BRITISH JOURNAL PHOTOGRAPHIC ALMANAC 1873 (1873): 120-123.

S1258 Stuart, J. "Photographing Interiors." BRITISH JOURNAL PHOTOGRAPHIC ALMANAC 1875 (1875): 64-66.

S1259 Stuart, John. "Silver Printing." PHOTOGRAPHIC TIMES 15, no. 221 (Dec. 11, l885): 688-689. [A communication to the Glasgow Photographic Association.]

S1260 Stuart, John. "A Professional to Professionals." PHOTOGRAPHIC TIMES 24, no. 657 (Apr. 20, l894): 251-252. [Abstract from President's Address to Glasgow and West of Scotland Photographic Assoc, from Photographic News. General exhortation to go out and persevere in the face of the difficult economic conditions.]

S1261 Stuart, John. "The Progress of Photography." WILSON'S PHOTOGRAPHIC MAGAZINE 35, no. 501 (Sept. 1898): 389-395. [Extracted from "Presidential Address at the British Convention at Glasgow, July 4th."]

S1262 "Obituary of the Year: John Stuart (July 13, 1907)." BRITISH JOURNAL PHOTOGRAPHIC ALMANAC 1908 (1908): 555-556. [Born 1831 in Glasgow. Opened a studio in Buchanan St., Glasgow more than fifty years ago. Elected to Town Council in 1865, member for seventeen years. Provost in 1877, for seven years. Fellow of Royal Photo. Society, supporter of the Photographic Convention.]

STUART-WORTLEY, COL see WORTLEY, STUART.

STUBBS, LIEUT. [?]
S1263 J. S. "Capture of a Slaver." ILLUSTRATED LONDON NEWS 30, no. 864 (June 20, 1857): 595-596. 5 illus. ["I send you some photographs, that I took a few days ago, of these ill-treated African youths... a photograph of the little craft that bore them across the great Atlantic: these being illustrative proofs of the fearful reality that the African slave trade still exists in all its unabated horrors." "J. S., Kingston, Jamaica, May 11, 1857." (This may be a Lieut. Stubbs, R. N. of H. M. Brig. "Arab.")]

STUBER BROTHERS. (ST. LOUIS, MO)
S1264 "Notes and News." PHOTOGRAPHIC TIMES 20, no. 437 (Jan. 31, 1890): 55. [Gallery burned down.]

STUBER, FRANK L. (b. 1846) (USA)
S1265 "Editor's Table." PHILADELPHIA PHOTOGRAPHER 6, no. 69 (Sept. 1869): 324. [Number of 8" x 10" portraits noted.]

S1266 Stuber, F. L. "Correspondence." ANTHONY'S PHOTOGRAPHIC BULLETIN 1, no. 3 (Apr. 1870): 47-48. [Stuber, of

Bethlehem, Pa. His letter is a report on his experiences with the Dallmar lenses.]

S1267 "More Pictures." ANTHONY'S PHOTOGRAPHIC BULLETIN 1, no. 4 (May 1870): 59. [Pictures received from F. L. Stuber (Bethlehem, PA); S. A. Thomas; H. A. Prichard (Rutland, VT.)]

S1268 "Our Illustration." PHOTOGRAPHER'S FRIEND 2, no. 1 (Jan. 1872): frontispiece, 17. 1 b & w. [Genre portrait.]

S1269 Zeigenfuss, C. O. "Sketches of Prominent Photographers No. 7: Frank L. Stuber." PHOTOGRAPHER'S FRIEND 2, no. 1 (Jan. 1872): 17-18. 1 illus. [Born on a farm near Bethlehem, Pa. Oct. 13, 1846. Apprenticed for his father, a carpenter, then worked as a newsboy in Bethlehem for four years. Then learned photography and found a job in a Philadelphia gallery. Then worked at Whitaker's Gallery in Philadelphia. In 1866 opened his own gallery in South Bethlehem. Studied hard, made composite genre studies in the manner of Notman.]

S1270 "The Prize Pictures." PHOTOGRAPHER'S FRIEND 2, no. 2 (Apr. 1872): 39. [Formula, working procedures of Stuber.]

STUBER, M. (ca. 1843-1884) (USA)
S1271 Gatchel, W. D. "Death of an Old Photographer." PHOTOGRAPHIC TIMES 14, no. 157 (Jan. 1884): 45. [Died Jan. 9, 1884 at age 41. Had been a photographer for 25 years in Louisville, KY.]

STURROCK, JOHN, JR.
S1272 Sturrock, John, Jr. "Honey-Albumen Process." HUMPHREY'S JOURNAL OF PHOTOGRAPHY, AND THE ALLIED ARTS AND SCIENCES 10, no. 15 (Dec. 1, 1858): 239-240. [From "J. of Photo. Soc., London."]

STURZA-SCHEIANU, CONSTANTIN. (1797-1877) (ROMANIA)
S1273 Costinescu, Peter. "Constantin Sturza-Scheianu, Romanian Calotypist." HISTORY OF PHOTOGRAPHY 11, no. 3 (July - Sept. 1987): 247-254. 7 b & w. 2 illus. [High Chancellor Constantin Sturza-Scheianu was Romania's first amateur photographer. Seven of his calotypes, taken in 1852, have survived.]

STYLES, ADIN FRENCH. (1832-1910) (USA)
[Styles was a photographer working in Burlington and Middlebury, VT. Went to Florida for his health in 1866. Made Florida views. Bought orange grove and gave up photography ca. 1871.]

BOOKS
S1274 Hitchcock, Edward. Report on the Geological Survey of the State of Vermont: Burlington, VT: Daily Times Office Printer, 1857. n. p. illus. [Lithographic plates, from photographs by A. F. Styles.]

S1275 Hitchcock, Edward. Report on the Geological Survey of the State of Vermont: Descriptive, Theoretical, Economical and Scenographical; by Edward Hitchcock, LL.D., Albert D. Hager, A.M., Edward Hitchcock, Jr., M.D., Charles H. Hitchcock, A.M. In Two Volumes. Published Under the Authority of the State Legislature, by Albert D. Hager, Proctorsville, Vt. Claremont Manufacturing Co., Claremont, N. H., printer 1861. 2 vol. 998 pp. 38 l. of plates. 365 illus. [Maps, woodcuts, and lithographic plates. Lithographic plates by Ferd. Meyer & Co., N. Y., from photographs and prints by various artists. Sketches by A. L. Rawson, Miss Hattie E. Read, J. R. Rathbun. Views from photos by C. Miller, Burlington, VT (13); C. L. Howe, Brattleboro, VT (1); and A. F. Styles, Burlington, VT (3).]

PERIODICALS

S1276 "Pictures on Some Ancient Dry Plates." ANTHONY'S PHOTOGRAPHIC BULLETIN 17, no. 20 (Oct. 23, 1886): 619. [20 years before, Styles visited Florida, from Vermont, took photos but only developed them recently.]

S1277 Waldsmith, John. "The Search for an Enigma: A. F. Styles." NORTHLIGHT (JOURNAL OF THE PHOTOGRAPHIC HISTORICAL SOCIETY OF AMERICA) 6, no. 3-4 (Fall-Winter 1979/80): 4-10. 5 b & w. 4 illus. [A. F. Styles was born Adin French Stiles on Aug. 30, 1832 in Jericho, VT. He began photographing in the early 1860s, working in a partnership with his brother Adoniram J. Stiles and G. B. Davis. He worked out of Montpelier, VT, Burlington, VT, and St. Albans, VT in the mid-1860s. William Henry Jackson worked as a colorist for Styles in his Vermont Gallery of Art studio in Burlington in 1865 and 1866. In 1866 Styles decided to sell his studios and become a full-time maker of stereo views of Green Mountain area scenery, and from 1864 to 1869 he produced over 800 views from all parts of Vermont. In 1867 he travelled to Florida for his health and did a large business photographing around the Jacksonville and St. Augustine area in the winters. By 1870 he moved to Florida, and although he may have taken photographs as late as 1875, he bought a large tract of orange groves, and gave up photography. He died of chronic nephritus on Dec. 13, 1910 in South Jacksonville, FL.]

SUDDARDS & FENNEMORE. (PHILADELPHIA, PA)

S1278 Croughton, George. "Vignette Portraits; How to Light and How to Print Them." PHOTOGRAPHIC WORLD 1, no. 5 (May 1871): frontispiece, 133-134. 4 b & w. ["Our Picture" on pg. 156-157, 2 portrait views, 1 vignette, 1 3/4 view on one page.]

S1279 "Note." ANTHONY'S PHOTOGRAPHIC BULLETIN 4, no. 11 (Nov. 1873): 323. [Note about new establishment at 820 Arch St., Philadelphia.]

S1280 "International Baseball. Boston and Philadelphia Champions." FRANK LESLIE'S ILLUSTRATED NEWSPAPER 38, no. 982 (July 25, 1874): 317. 2 illus. [Group portrait of the Boston, MA, baseball team, by J. W. Black. Group portrait of the Philadelphia, PA, baseball team, by Suddards & Fennimore.]

SUGG.

S1281 "Shark Caught Off Exmouth." ILLUSTRATED LONDON NEWS 39, no. 1115 (Nov. 2, 1861): 461. 1 illus. [From a photograph by Mr. Sugg, of Exmouth.]

SURREY PHOTOGRAPHIC CO. (GUILDFORD, ENGLAND)

S1282 Portrait. Woodcut engraving credited "From a photograph by Surrey Photographic Co., at Guildford." ILLUSTRATED LONDON NEWS 49, (1866) ["Sir William Bovill." 49:* (Dec. 15, 1866): 569.]

S1283 "Railway Accident near Guilford." ILLUSTRATED LONDON NEWS 63, no. 1777 (Sept. 20, 1873): 273. 2 illus.

S1284 Portrait. Woodcut engraving credited "From a photograph by Surrey Photographic Co." ILLUSTRATED LONDON NEWS 71, (1877) ["Lord Justice A. Thesiger." 71:2001 (Nov. 17, 1877): 481.]

SUSCIPI, LORENZO. (b. 1802) (ITALY)

S1285 Portraits. Woodcut engravings credited "From a photograph by Suscipi." ILLUSTRATED LONDON NEWS 75, (1879) ["Col. C. M. MacGregor." 75:2101 (Sept. 20, 1879): 265. "Late John Blackwood, publisher." 75:2109 (Nov. 15, 1879): 461.]

S1286 Wilsher, Ann and Benjamin Spear. "An Artist's Advertisement: The Memoirs of James E. Freeman." HISTORY OF PHOTOGRAPHY 10, no. 1 (Jan. - Mar. 1986): 15-17. 1 b & w. 2 illus. [Book of memoirs of the artist, Freeman, published in Rome in 1877, illustrated with photographic copies of his paintings and a portrait, all taken by Lorenzo Suscipi.]

SUTCLIFFE, FRANK MEADOW. (1853-1941) (GREAT BRITAIN)

[Born at Headingly, Leeds in 1853. His father was an artist and photographer. Frank began to photograph in 1871. He worked for Francis Frith, then, in 1875, he opened a portrait studio in Whitby, on the Yorkshire coast. In his spare time he began to walk around Whitby, photographing people and scenes, landscapes, and attempting to develop an unmannered, natural style of photography. Sutcliffe later became an important figure in the British creative photography movement at the end of the century, and more references about him will appear in the second volume of this reference work.]

BOOKS

S1287 Hiley, Michael. *Frank Sutcliffe: Photographer of Whitby.* London: Gordon Fraser, 1974. 224 pp. b & w. illus.

S1288 Shaw, Bill Eglon, compiler. *Frank Meadow Sutcliffe, Hon. F.R.P.S.: Whitby and Its People as seen by one of the Founders of the Naturalistic Movement in Photography. A Selection of His Work.* Whitby, England: Sutcliffe Gallery, 1974. 63 pp. b & w.

S1289 *Frank Meadow Sutcliffe.* "Aperture History of Photography Series, No. 13." Millerton, NY: Aperture, 1979. 93 pp. b & w. [Essay by Michael Hiley.]

S1290 Shaw, Bill Eglon, compiler. *Frank Meadow Sutcliffe, Hon. F.R.P.S.: Whitby and Its People as seen by one of the Founders of the Naturalistic Photography Movement in Photography: A Second Selection of His Work.* Whitby, England: Sutcliffe Gallery, 1982. 63 pp. b & w.

PERIODICALS

S1291 Sutcliffe, Frank M. "Practical Odds and Ends." BRITISH JOURNAL PHOTOGRAPHIC ALMANAC 1876 (1876): 154-156. 1 illus.

S1292 Sutcliffe, Frank M. "'Where Am I to Look.'" BRITISH JOURNAL PHOTOGRAPHIC ALMANAC 1877 (1877): 159-160.

S1293 Sutcliffe, Frank M. "A New Vignette." BRITISH JOURNAL PHOTOGRAPHIC ALMANAC 1878 (1878): 133-134.

S1294 Sutcliffe, Frank M. "Cheap Portraiture in Times of Yore." BRITISH JOURNAL PHOTOGRAPHIC ALMANAC 1878 (1878): 172.

S1295 Sutcliffe, Frank M. "A Hint on Copying Old Oil Pictures." BRITISH JOURNAL PHOTOGRAPHIC ALMANAC 1879 (1879): 131. 1 illus.

S1296 "Our Illustration." AMERICAN AMATEUR PHOTOGRAPHER 2, no. 5 (May 1890): 162-163. 1 b & w. [Genre, "Under the Capstan."]

S1297 Bisland, Elizabeth. "London Charities." COSMOPOLITAN 11, no. 3 (July 1891): 259-269. 13 b & w. [Article illustrated with portraits of London street people. The last photo, although not credited, is by Sutcliffe.]

S1298 Sutcliffe, F. M. "How to Look at Photographs." PHOTOGRAPHIC TIMES 22, no. 574 (Sept. 16, 1892): 477-479. [Read before the Photographic Convention of the United Kingdom.]

S1299 Sutcliffe, Frank M. "Breadth and Sharpness in Portraiture." PHOTOGRAPHIC TIMES 28, no. 10 (Oct. 1896): 489-490.

S1300 Sutcliffe, F. M. "The Studio Light." WILSON'S PHOTOGRAPHIC MAGAZINE 34, no. 481 (Jan. 1897): 40-42. [Extracted from "Photography."]

S1301 Sutcliffe, F. M. "Selection." WILSON'S PHOTOGRAPHIC MAGAZINE 34, no. 487 (July 1897): 327-329. [From "Photography."]

S1302 Sutcliffe, Frank M. "'Process' from the Photographic Point of View." PENROSE'S PICTORIAL ANNUAL 1898 (1898): 22-24.

S1303 Sutcliffe, Frank M. "Portraiture Under a Cloud." WILSON'S PHOTOGRAPHIC MAGAZINE 35, no. 503 (Nov. 1898): 502-504. [From "The Practical Photographer."]

S1304 Sutcliffe, Frank M. "On Likeness Taking." WILSON'S PHOTOGRAPHIC MAGAZINE 38, no. 534 (June 1901): 196-197. [From "Amateur Photographer".]

S1305 Sutcliffe, F. M. "On Figure Photography (With Illustrations by the Author)." CAMERA NOTES 5, no. 1 (July 1901): 13-18. 5 b & w.

S1306 Sutcliffe, F. M. "What R. L. Stevenson Thought of His Portrait." PHOTOGRAPHIC TIMES 36, no. 8 (Aug. 1904): 360-361. [Reprinted from "Amateur Photographer."]

S1307 Sutcliffe, Frank M. "The Camera in the Country." AMATEUR PHOTOGRAPHER & PHOTOGRAPHIC NEWS 49, no. 1267 (Jan. 12, 1909): 38-39.

S1308 Sutcliffe, Frank M. "A Note on Exposure." AMATEUR PHOTOGRAPHER & PHOTOGRAPHIC NEWS 55, no. 1438 (Apr. 22, 1912): 415. 1 b & w.

S1309 Sutcliffe, Frank M. "The Fine Etcher." PENROSE'S PICTORIAL ANNUAL 1912-1913 (1913): 17-20. 3 illus.

SUTCLIFFE, W. H.

S1310 "Auckland, New Zealand." ILLUSTRATED LONDON NEWS 36, no. 1031 (May 19, 1860): 472-473. 2 illus. ["From a photograph by W. H. Sutcliffe."]

SUTLIFF, M. K.

S1311 Sutliff, M. K. "To prevent Paper from turning Red." HUMPHREY'S JOURNAL OF PHOTOGRAPHY, AND THE ALLIED ARTS AND SCIENCES 15, no. 7 (Aug. 1, 1863): 108-109. [Letter from Sutliff (Ohio), reply by Towler.]

S1312 Sutliff, M. K. "Cure of Salt Rheum by Photographic Chemicals." HUMPHREY'S JOURNAL OF PHOTOGRAPHY, AND THE ALLIED ARTS AND SCIENCES 16, no. 10 (Sept. 15, 1864): 150-151.

S1313 Sutliff, M. K. "A New Developer." HUMPHREY'S JOURNAL OF PHOTOGRAPHY, AND THE ALLIED ARTS AND SCIENCES 20, no. 20 (Apr. 15, 1869): 312.

S1314 Sutliff, M. K. "To make a Porcelain Picture from an Ambrotype." HUMPHREY'S JOURNAL OF PHOTOGRAPHY, AND THE ALLIED ARTS AND SCIENCES 20, no. 22 (June 15, 1869): 347.

SUTPHEN, DAVID. (1810-1884) (USA)

S1315 Sutphen, D. "Why Prints Fade." AMERICAN JOURNAL OF PHOTOGRAPHY AND THE ALLIED ARTS & SCIENCES n. s. vol. 8, no. 13 (Jan. 1, 1866): 309-310. [Sutphen from Mt. Morris, NY.]

SUTTERLY, J. K.

S1316 Portrait. Woodcut engraving, credited "From a Photograph by J. K. Sutterly. FRANK LESLIE'S ILLUSTRATED NEWSPAPER 39, (1875) ["J. D. Lee, leader of the Mormon massacre of 140 Gentile emigrants." 39:1006 (Jan. 9, 1875): 300.]

SUTTON. (HORNELLSVILLE, NY ?)

S1317 "Sutton's New Gallery." ANTHONY'S PHOTOGRAPHIC BULLETIN 4, no. 12 (Dec. 1873): 364-365. [From the "Extract."]

SUTTON & BROTHER. (DETROIT, MI)

S1318 "Daguerreotype Movements." HUMPHREY'S JOURNAL 6, no. 16 (Dec. 1, 1854): 255-256. [Excerpts from Detroit, MI, newspapers describing Sutton & Brother's paper views of Detroit, views of the Saut Canal Company's works.]

SUTTON, EDWIN. (LONDON, ENGLAND)

S1319 Portrait. Woodcut engraving credited "From a photograph by Edwin Sutton, Regent St., London." ILLUSTRATED LONDON NEWS 51, (1867) ["General Sir Robert Napier." 51:* (Sept. 28, 1867): 349.]

SUTTON, FREDERICK WILLIAM. (GREAT BRITAIN, JAPAN)

S1320 "A Visit to the Tycoon of Japan." ILLUSTRATED LONDON NEWS 50, no. 1440 (Aug. 10, 1867): 144-146. 4 illus. [Three sketches, one engraving of a portrait, of Stots Bashi, the new tycoon of Japan, from a photograph. "We have been favored by Mr. Frederick William Sutton, chief engineer to "H.M.S. Serpent," with two photographs of the Tycoon, which Mr. Sutton was permitted to take on the occasion of the late visit of the British Legation to Osaca."]

SUTTON, G. H. E.

S1321 Sutton, G. H. E. "On the Probabilities of the Permanency of Silver Prints." BRITISH JOURNAL PHOTOGRAPHIC ALMANAC 1879 (1879): 122-124.

SUTTON, MOSES. (d. 1874) (USA)

S1322 "Obituary." ANTHONY'S PHOTOGRAPHIC BULLETIN 5, no. 2 (Feb. 1874): 90. [Note that Sutton (Detroit, MI) died in New York, NY, on his way to Florida.]

SUTTON, THOMAS. (1819-1875) (GREAT BRITAIN)

[Born in 1819 at Kensington, Took a B. A. degree at Caius College, Cambridge, in 1846. Commenced to work as a photographer in Jersey in 1847. Went to Italy in 1851, photographed in Florence. Met Flacheron in Rome and took lessons from him. Also met McPherson. Back in Jersey in 1855, he formed a partnership with Blanquart-Evrard and ran the Establishment for Permanent Positive Printing at St. Brelade's Bay for the next two years. In 1856 began publication of "Photographic Notes," which he wrote and edited until its merger with the "Pictorial Photographer" in 1865. Published several manuals and, in 1858, compiled the first dictionary of photography, *Sutton's Dictionary of Photography*. In 1850s and 1860s he developed several improvements in lenses and cameras, working with a panoramic lens. Briefly held the post of Lecturer on Photography in King's College, London in 1861, but resigned. Moved to Redon, in Brittany, in 1865, where he acted as Foreign Correspondent for the *British Journal of Photography*. Sutton stayed in Redon until a few months before his death in 1875. Died at Pwllheli, North Wales.]

BOOKS

S1323 *Souvenirs de Jersey.* Jersey: Thomas Sutton & Blanquart-Evrard, 1854. n. p. 18 b & w. [Original photos.]

S1324 Sutton, Thomas, B.A. *The Calotype Process: A Handbook to Photography on Paper.* London: J. Cundall & S. Low, 1855. viii, 91 pp. 1 b & w. illus. [2nd ed. (1856), Sampson Low, Son & Co., 93 pp.]

S1325 Sutton, Thomas. *The Calotype Process; a Handbook to Photography on Paper.* New York: H. H. Snelling, 1858. 64 pp.

S1326 Sutton, Thomas. *A New Method of Printing Positive Photographs, by which Permanent and Artistic Results may be Uniformly obtained.* Jersey: T. Sutton, 1855. 32 pp.

S1327 Sutton, Thomas. *Directions for Using Hollingworth's Thin Photographic Paper in the Positive and Negative Processes.* St. Brelade's, Jersey: Sutton & Blanquart-Evrard, 1856. 12 pp.

S1328 Sutton, Thomas. *Practical Hints on Photography.* St. Brelade's, Jersey: T. Sutton, 1856. n. p. b & w. [Apparently was sold with a choice of either one specimen photograph or two specimen photographs.]

S1329 Sutton, Thomas, B.A. *A Treatise of the Positive Collodion Process.* London: Bland & Long, Opticians, 1857. 75 pp. illus.

S1330 Sutton, Thomas. *A Directory of Photography. The Chemical Articles of A. B. C., by John Worden. Illustrated with diagrams.* London: Sampson Low, Son & Co., 1858. vii, 423 pp. illus. [2nd, enlarged ed. (1867), with George Dawson, 480 pp.]

S1331 Sutton, Thomas. "Photography," on pp. 689-716 of Vol.II, in: Muspratt, Dr. S. *Chemistry, Theoretical, Practical, and Analytical; as applied and relating to the Arts and Manufactures.* Glasgow: W. Mackenzie, 1860. 2 vol. pp.

S1332 Sutton, Thomas. *The Collodion Processes, Wet and Dry.* London: Sampson Low, 1862. 149 pp. [2nd ed. (1864).]

S1333 Sutton, Thomas. *Photography in Printing Ink: being a description of the process recently patented by John Pouncy, of Dorchester.* London: Sampson Low, Son & Co., 1863. 63 pp. illus.

S1334 Sutton, Thomas. *A Treatise on Positive Printing.* London: Lambray, Tibbits & Co., 1863. n. p. [2nd ed. (1864), London: Sampson Low.]

S1335 Sutton, Thomas. *A Description of Certain Instantaneous Dry Collodion Processes, and also of a New Set of Apparatus for Preparing Dry Plates. Illustrated.* London: Sampson Low, Son & Co., 1864. 92 pp. illus.

S1336 Sutton, Thomas, B.A. and George Dawson, M.A. *A Dictionary of Photography. Illustrated with Numerous Diagrams.* London: Sampson Low, Son & Co., 1867. iv, 390 pp. illus. [Revised version of 1st edition, 1858.]

S1337 Sutton, Thomas. *Description of a New Instantaneous Wet Collodion Process; together with a Method of Preparing Rapid Dry Plates.* London: J. W. Green, 1869. 47 pp. 3 illus.

S1338 Sutton, Thomas. *Procédé alcalin,* ou nouvelle mannière d'obtenir des placques instantanées aux collodions humide et sec, par Th. Sutton, traduit par Romain Talbot. Paris: librairie centrale de photographie, 1870. 18 pp.

S1339 Sutton, Thomas. *Practical Details of a New Wet Collodion Process.* London: H. Greenwood, 1873. n. p.

S1340 Gernsheim, Helmut. "Cuthbert Bede (The Rev. Edward Bradley, 1827 - 1889), Robert Hunt F.R.S. (1807 - 1887), and Thomas Sutton (1819 - 1875)," on pp. 60-67 in: *One Hundred Years of Photographic History. Essays in Honor of Beaumont Newhall.* Edited by Van Deren Coke. Albuquerque, NM: University of New Mexico Press, 1975. 180 pp.

PERIODICALS

S1341 "Paper Vs. Collodion." HUMPHREY'S JOURNAL 6, no. 16 (Dec. 1, 1854): 247-248, 253-254. [From "J. of Photo. Soc., London." Sutton describes his past experiences copying artwork at the Vatican in Rome in 1852, in Florence, at work on a series "Souvenirs de Jersey" to be published by Blanquart-Evrard, etc.]

S1342 Sutton, Thomas. "Paper vs. Collodion." PHOTOGRAPHIC AND FINE ART JOURNAL 8, no. 1-2 (Jan. - Feb. 1855): 28-29, 59-60. [From "Photo. J." Corrections to article by author in following issue.] Sutton, Thomas. "From Foreign Journals: Gold versus Old Hypo." HUMPHREY'S JOURNAL 7, no. 2 (May 15, 1855): 29-32. [From "J. of Photo. Soc., London."]

S1343 Sutton, Thomas. "The Albumen Process on Glass." PHOTOGRAPHIC AND FINE ART JOURNAL 8, no. 6 (June 1855): 168. [From "J. of Photo. Soc., London."]

S1344 "Reviews." ATHENAEUM no. 1446 (July 14, 1855): 811. [Bk. Rev.: "The Calotype Process: A Handbook to Photography on Paper," by Thomas Sutton, B.A. (Cundall)]

S1345 Sutton, Thomas, B.A. "The Calotype Process, - A Hand Book to Photography on Paper." PHOTOGRAPHIC AND FINE ART JOURNAL 8, no. 10, 12 (Oct., Dec. 1855): 310-317, 370-376.

S1346 "Monthly Notes: Sutton's System of Printing Photographic Positives." PRACTICAL MECHANIC'S JOURNAL 8, no. 91 (Oct. 1855): 164. [Thomas Sutton of St. Brelade's Bay, Jersey.]

S1347 Sutton, Thomas. "On Positive Printing, Etc." HUMPHREY'S JOURNAL 7, no. 23 (Apr. 1, 1856): 369-371. [From "J. of Photo. Soc., London."]

S1348 "Sutton's Calotype Process. - The Negative Process." HUMPHREY'S JOURNAL OF PHOTOGRAPHY, AND THE ALLIED ARTS AND SCIENCES 10, no. 8-12 (Aug. 15 - Oct. 15, 1858): 125-128, 158-160, 173-176, 186-188.

S1349 "Log of a Photo-Yachting Excursion to the Coast of Brittany." PHOTOGRAPHIC AND FINE ART JOURNAL 11, no. 9 (Sept. 1858): 259-263. [From "Photo. Notes."]

S1350 "Our Library Table." ATHENAEUM no. 1614 (Oct. 2, 1858): 420. [Bk. rev.: "A Dictionary of Photography," by Thomas Sutton, B.A. (Low & Co.).]

S1351 Sutton, Thomas. "Photography Upon Wood." AMERICAN JOURNAL OF PHOTOGRAPHY AND THE ALLIED ARTS & SCIENCES n. s. vol. 1, no. 18 (Feb. 15, 1859): 289. [From "Photo. Notes."]

S1352 Sutton, T. "Stereoscopy." PHOTOGRAPHIC AND FINE ART JOURNAL 12, no. 1 (June 1859): 16-17. [From "Photo. Notes."]

S1353 Sutton, Thomas. "Advice to Beginners - the Printing Process." AMERICAN JOURNAL OF PHOTOGRAPHY AND THE ALLIED ARTS & SCIENCES n. s. vol. 2, no. 3-4 (July 1 - July 15, 1859): 44-48, 54-55. [From "Photo. Notes."]

S1354 Sutton, Thomas. "Advice to Beginners. Out-Door Photography - Stereoscopy." PHOTOGRAPHIC AND FINE ART JOURNAL 12, no. 2 (July 1859): 36-41. [From "Photo. Notes."]

S1355 Sutton, Thomas. "Mounting Stereoscopic Pictures." AMERICAN JOURNAL OF PHOTOGRAPHY AND THE ALLIED ARTS & SCIENCES n. s. vol. 2, no. 7 (Sept. 1, 1859): 102-105.

S1356 Sutton, Thomas. "Instantaneous Photography." HUMPHREY'S JOURNAL OF PHOTOGRAPHY, AND THE ALLIED ARTS AND SCIENCES 11, no. 10 (Sept. 15, 1859): 156-158. [From "Photo. Notes."]

S1357 Sutton, Thomas. "Artistic Positive Printing." AMERICAN JOURNAL OF PHOTOGRAPHY AND THE ALLIED ARTS AND SCIENCES n. s. vol. 2, no. 9 (Oct. 1, 1859): 136-144.

S1358 Sutton, Thomas. "Papers on Photography Read before the Last Session of the British Association: On a New Photographic Lens." AMERICAN JOURNAL OF PHOTOGRAPHY AND THE ALLIED ARTS & SCIENCES n. s. vol. 2, no. 11 (Nov. 1, 1859): 168-170.

S1359 "Panoramic Photography." PHOTOGRAPHIC AND FINE ART JOURNAL 13, no. 2 (Feb. 1860): 37-39. [From "Photo. Notes."]

S1360 Sutton, Thomas. "Artistic Positive Printing." PHOTOGRAPHIC AND FINE ART JOURNAL 13, no. 2 (Feb. 1860): 33-35. [From "Photo. Notes."]

S1361 Sutton, Thomas. "Artistic Positive Printing." AMERICAN JOURNAL OF PHOTOGRAPHY AND THE ALLIED ARTS & SCIENCES n. s. vol. 2, no. 17 (Feb. 1, 1860): 257-262. [From "Photo. Notes."]

S1362 Sutton, Thomas. "Difficulties in the Negative Collodion Process." AMERICAN JOURNAL OF PHOTOGRAPHY AND THE ALLIED ARTS & SCIENCES n. s. vol. 2, no. 18 (Feb. 15, 1860): 281-284. [From "Photo. Notes."]

S1363 Sutton, Thomas. "Artistic Positive Printing." PHOTOGRAPHIC AND FINE ART JOURNAL 13, no. 3 (Mar. 1860): 85-87. [From "Photo. News."]

S1364 [Sutton, Thomas.] "Difficulties in the Negative Collodion Process." HUMPHREY'S JOURNAL OF PHOTOGRAPHY, AND THE ALLIED ARTS AND SCIENCES 11, no. 21 (Mar. 1, 1860): 325-327. [From "Photo. Notes."]

S1365 "Panoramic Camera Lens." PHOTOGRAPHIC AND FINE ART JOURNAL 13, no. 3 (Mar. 1860): 69. [From "Photo. News."]

S1366 "Description of the Panoramic Lens. (Invented and patented by the Editor of this Journal.)" PHOTOGRAPHIC AND FINE ART JOURNAL 13, no. 4 (Apr. 1860): 97-98. [From "Photo. Notes." The lens must have been invented by Th. Sutton.]

S1367 "Photographic Optics." PHOTOGRAPHIC AND FINE ART JOURNAL 13, no. 4 (Apr. 1860): 104-107. [Not credited, but from "Photo. Notes."]

S1368 Sutton, Thomas. "Theory of the Panoramic Lens." PHOTOGRAPHIC AND FINE ART JOURNAL 13, no. 4 (Apr. 1860): 107-108. [From "Photo. Notes."]

S1369 Sutton, Thomas. "Panoramic Photography." PHOTOGRAPHIC AND FINE ART JOURNAL 13, no. 4 (Apr. 1860): 98-101. [From "Photo. Notes."]

S1370 Sutton, Thomas "On Panoramic and Plane Perspective." BRITISH JOURNAL OF PHOTOGRAPHY 7, no. 116 (Apr. 16, 1860): 109.

S1371 "Panoramic Lens." PHOTOGRAPHIC AND FINE ART JOURNAL 13, no. 6 (June 1860): 170-172. [From "Photo. Notes."]

S1372 Sutton, Thomas. "Printing and Toning." AMERICAN JOURNAL OF PHOTOGRAPHY AND THE ALLIED ARTS & SCIENCES n. s. vol. 3, no. 2 (June 15, 1860): 22-26. [From "Photo Notes."]

S1373 "Our Weekly Gossip." ATHENAEUM no. 1732, 1738 (Jan. 5, Feb. 16, 1861): 21, 232. [Sutton publishing a "Photographic Quarterly Review." Sutton replacing Hardwich as Lecturer on Photography at King's College.]

S1374 Sutton, T. "The Stereographic Camera." HUMPHREY'S JOURNAL OF PHOTOGRAPHY, AND THE ALLIED ARTS AND SCIENCES 12, no. 24 (Apr. 15, 1861): 374-377. [From "Photo. Notes."]

S1375 "On the Manufacture of Collodion. (As taught by Mr. Sutton to the Students of King's College." AMERICAN JOURNAL OF PHOTOGRAPHY AND THE ALLIED ARTS & SCIENCES n. s. vol. 4, no. 2 (June 15, 1861): 31-37. [From "Photo. Notes."]

S1376 Sutton, Thomas. "On the Panoramic Lens." AMERICAN JOURNAL OF PHOTOGRAPHY AND THE ALLIED ARTS & SCIENCES n. s. vol. 4, no. 9 (Oct. 1, 1861): 211-213. [Read before the British Assoc., Sept. 5.]

S1377 "Resignation of Mr. Sutton." JOURNAL OF THE PHOTOGRAPHIC SOCIETY OF LONDON 7, no. 114 (Oct. 15, 1861): 296. [From Kings College. Taken from "Photo Notes."]

S1378 "Sutton's Panoramic Lens." HUMPHREY'S JOURNAL OF PHOTOGRAPHY, AND THE ALLIED ARTS AND SCIENCES 13, no. 14 (Nov. 15, 1861): 209-210.

S1379 Sutton, Thomas. "Instantaneous Photography." AMERICAN JOURNAL OF PHOTOGRAPHY AND THE ALLIED ARTS & SCIENCES n. s. vol. 4, no. 16 (Jan. 15, 1862): 367-372. [From "Photo. Notes." Unlike many such articles, this contains more than formulae - describes practice and practitioners - G. W. Wilson (Aberdeen); W. England (London); Anthony (New York, NY).]

S1380 "The Panoramic Lens." ILLUSTRATED LONDON NEWS 40, no. 1128 (Jan. 25, 1862): 90, 96. 3 illus. [Two views of St. Brelade's Bay, Jersey, from photographs taken by Mr. Horace Harral, with Sutton's patent panoramic lens.]

S1381 Sutton, Thomas. "Rapid Dry Processes." AMERICAN JOURNAL OF PHOTOGRAPHY AND THE ALLIED ARTS & SCIENCES n. s. vol. 4, no. 19 (Mar. 1, 1862): 441-447. [From "Photo. Notes."]

S1382 Sutton, Thomas. "Rapid Dry Collodion. - And Dr. Draper's Process." AMERICAN JOURNAL OF PHOTOGRAPHY AND THE ALLIED ARTS & SCIENCES n. s. vol. 4, no. 23 (May 1, 1862): 533-535. [From "Photo. Notes."]

S1383 Sutton, Thomas. "Instantaneous Dry Process." AMERICAN JOURNAL OF PHOTOGRAPHY AND THE ALLIED ARTS & SCIENCES n. s. vol. 4, no. 24 (May 15, 1862): 553-555. [From "Photo. Notes."]

S1384 Russel, Major. "Mr. Sutton's Rapid Dry Process." AMERICAN JOURNAL OF PHOTOGRAPHY AND THE ALLIED ARTS & SCIENCES n. s. vol. 5, no. 11 (Dec. 1, 1862): 341-342. [From "Photo. News."]

S1385 Sutton, Thomas, B.A. "On Panoramic Photography." BRITISH JOURNAL OF PHOTOGRAPHY 9, no. 179 (Dec. 1, 1862): 451-452.

S1386 "Our Literary Table." ATHENAEUM no. 1834 (Dec. 20, 1862): 805. [Bk. Rev.: "The Collodion Process, Wet and Dry," by Thomas Sutton, B.A. (Low & Co.)]

S1387 Sutton, Thomas. "On Some of the Uses and Abuses of Photography." JOURNAL OF THE PHOTOGRAPHIC SOCIETY OF LONDON 8, no. 129 (Jan. 15, 1863): 202-206. [Read before the Photo. Soc. of Scotland, Jan. 13, 1863.]

S1388 Wall, Alfred H. "Thomas Sutton, B.A. on Art Photography." JOURNAL OF THE PHOTOGRAPHIC SOCIETY OF LONDON 8, no. 130-131 (Feb. 16 - Mar. 16, 1863): 232-234, 244-245.

S1389 Wall, Alfred H. "Thomas Sutton, B.A., On Art - Photography." BRITISH JOURNAL OF PHOTOGRAPHY 10, no. 184 (Feb. 16, 1863): 73-74. [Read before South London Photo. Soc., Feb. 12, 1863.]

S1390 Sutton, Thomas. "On Rapid Day Collodion Processes." BRITISH JOURNAL OF PHOTOGRAPHY 10, no. 204 (Dec. 15, 1863): 484-485.

S1391 Sutton, Thomas, B. A. "On The Action of Light upon the Salts of Silver." AMERICAN JOURNAL OF PHOTOGRAPHY AND THE ALLIED ARTS & SCIENCES n. s. vol. 6, no. 15 (Feb. 1, 1864): 353-356. [From "Photo. Notes."]

S1392 Sutton, T., B.A. "New Wet Collodion Process." HUMPHREY'S JOURNAL OF PHOTOGRAPHY, AND THE ALLIED ARTS AND SCIENCES 15, no. 24 (Apr. 15, 1864): 376-380. [From "Photo. Notes."]

S1393 Sutton, Thomas. "New Wet Collodion Process." AMERICAN JOURNAL OF PHOTOGRAPHY AND THE ALLIED ARTS & SCIENCES n. s. vol. 6, no. 20 (Apr. 15, 1864): 457-462. [From "Photo. Notes."]

S1394 Sutton, Thomas. "Alkaline Development for Wet Plates." AMERICAN JOURNAL OF PHOTOGRAPHY AND THE ALLIED ARTS & SCIENCES n. s. vol. 6, no. 21 [sic 22] (May 15, 1864): 521-525. [From "Photo. Notes."]

S1395 Sutton, Thomas. "On the Glass Room and Portrait Camera." BRITISH JOURNAL OF PHOTOGRAPHY 12, no. 254 (Mar. 17, 1865): 141-142.

S1396 Sutton, Thomas. "The Eburneum and the Opalotype Process: Development vs. Direct Printing." AMERICAN JOURNAL OF PHOTOGRAPHY AND THE ALLIED ARTS & SCIENCES n. s. vol. 8, no. 1-2 (July 1 - July 15, 1865): 16-21, 25-27.

S1397 Sutton, Thomas. "The Alkaline Developer - Time of Exposure Reduced to One Half - Dry Plates as Sensitive as the Wet." AMERICAN JOURNAL OF PHOTOGRAPHY AND THE ALLIED ARTS & SCIENCES n. s. vol. 8, no. 12 (Dec. 15, 1865): 269-272. [From "Photo. Notes."]

S1398 Sutton, Thomas. "Almond Oil Paper - Alkaline Developer, &c." AMERICAN JOURNAL OF PHOTOGRAPHY AND THE ALLIED ARTS & SCIENCES n. s. vol. 8, no. 16 (Feb. 15, 1866): 361-365. [From "Photo. Notes."]

S1399 Sutton, Thomas, R.A. "Sketch of the History of Photographic Lenses." ART JOURNAL (May 1866): 143-144.

S1400 Sutton, T. "Reminiscences of an Old Photographer." BRITISH JOURNAL OF PHOTOGRAPHY 14, no. 382 (Aug. 30, 1867): 413-414. [Sutton recalls having his portrait taken by Claudet at the Adelaide Gallery in early 1840s. He bought a daguerreotype outfit while a student at Cambridge, but work and marriage kept him too busy and he put it away. Around 1851 he saw some calotype views at St. Helier's in Jersey. Studied the process with a Mr. Laverty, then visited Italy, where he photographed in Florence and along the route to Rome. Met Flacheron and McPherson in Rome. Met Blanquart-Evrard, later became his partner in a photographic printing plant. Published and edited "Photo. Notes."]

S1401 Sutton, Thomas. "An Account of a New Photographic Dry Process." ANTHONY'S PHOTOGRAPHIC BULLETIN 2, no. 11 (Nov. 1871): 356-357. [From "Br. J. of Photo."]

S1402 Sutton, Thomas. "Instantaneous Landscape Photography." BRITISH JOURNAL PHOTOGRAPHIC ALMANAC 1872 (1872): 51-52.

S1403 Sutton, Thomas. "How to Warm the Feet, during Winter, in the Studio." ANTHONY'S PHOTOGRAPHIC BULLETIN 3, no. 2 (Feb. 1872): 448-449. [From "Br. J. of Photo."]

S1404 "Correspondence of Mr. Sutton." ANTHONY'S PHOTOGRAPHIC BULLETIN 4, no. 7 (July 1873): 193-196. [From "Br J of Photo." Letter about glass transparencies for stereos. Sutton begins the letter with a discussion about a van filled with stereo slides and viewers that travelled throughout rural France and charged an admission fee.]

S1405 Sutton, Thomas, B.A. "Wet, Dry, and Moist Films." ANTHONY'S PHOTOGRAPHIC BULLETIN 4, no. 7 (July 1873): 202-203. [From "Br J of Photo."]

S1406 Sutton, Thomas, B.A. "A Simple Developing-Stand." BRITISH JOURNAL PHOTOGRAPHIC ALMANAC 1874 (1874): 158-159.

S1407 "Editor's Table." PHILADELPHIA PHOTOGRAPHER 12, no. 137 (May 1875): 158. [Brief note that Thomas Sutton, editor of "Photographic Notes," died in March.]

S1408 Harrison, W. Jerome. "The Toning of Photographs Considered Chemically, Historically, and Generally. Chapter 8. Investigations of Sutton, and of Davanne and Girard Into Toning Processes." PHOTOGRAPHIC TIMES 21, no. 506 (May 29, 1891): 257-259.

[Discusses the processes of Thomas Sutton (1859), Davanne & Girard (1863).]

S1409 "Biographical Notes on a Number of Photographers Published by Blanquart-Evrard." CAMERA (LUCERNE) 57, no. 12 (Dec. 1978): 32, 41-42. [Benecke, Claine, DuCamp, Fortier, Greene, Le Secq, Loydreau, Marville, Regnault, Robert, Salzmann, Stewart, Sutton, and Tenison. Thomas Sutton, an English photographer who lived in Jersey from 1850, introduced to paper processes by Count Flacheron in Rome in 1852. Continued to work the process. Blanquart-Evrard and Sutton formed a partnership in mid 1850s to make positive prints. Sutton launched the journal "Photographic Notes" in 1856, compiled a dictionary of photography in 1858, invented a reflex camera in 1861. Published many articles in the photographic press.]

S1410 Sexton, Sean. "Thomas Sutton's Panoramic Camera and Outfit." PHOTOGRAPHIC COLLECTOR 2, no. 3 (Autumn 1981): 6-13. 7 illus. [Built in 1859.]

SVOBODA, ALEXANDER.
BOOKS
S1411 Svoboda, Alexander. *The Seven Churches of Asia; with Twenty Full-Page Photographs, Taken on the Spot, Historical Notes, and Itinerary,* by Alexander Svoboda; With an Introduction by H. B. Tristram. London: Sampson Low, Son & Marston, 1869. viii, 76 pp. 20 b & w. [Original photos.]

PERIODICALS
S1412 "Photographs from the Seven Churches of Asia." ART JOURNAL (Feb. 1868): 29. [50 photos on exhibit at the Arundel Society. Svoboda a Member of Acad. of Venice, an artist, and an amateur photographer.]

SWAN, GEORGE HENRY. (1833-1913) (GREAT BRITAIN, NEW ZEALAND)
S1413 "Wellington, New Zealand." ILLUSTRATED LONDON NEWS 34, no. 968 (Apr. 9, 1859): 348, 357. 1 illus. ["From a photograph by Mr. Swan."]

SWAN, HENRY.
S1414 "The Casket Miniature in Relief." HUMPHREY'S JOURNAL OF PHOTOGRAPHY, AND THE ALLIED ARTS AND SCIENCES 18, no. 3 (June 1, 1866): 41-42. [From "Photo. News."]

S1415 Swan, Henry. "The Casket Miniature in Relief. On Printing, Coloring, and Mounting the Transparencies." HUMPHREY'S JOURNAL OF PHOTOGRAPHY, AND THE ALLIED ARTS AND SCIENCES 18, no. 4 (June 15, 1866): 54-56. [From "Photo. News."]

SWAN, JOSEPH WILSON, SIR. (1828-1914) (GREAT BRITAIN)
[Born Oct. 31, 1828 at Sunderland. Studied pharmacology at Durham University. Became an assistant to John Mawson, a manufacturer of photographic products at Newcastle-upon-Tyne. Later became Mawson's partner, in 1860, and brother-in-law. Worked with collodion in 1850s, invented an incandescent electric lamp in 1860, and perfects Poitevin's carbon printing process in 1864. Mawson killed in a nitroglycerine explosion in 1867. Swan began to manufacture "Swan's" gelatin plates in 1867. Continued experimenting, improving his discoveries in electricity and photography through 1880s. Many honors and awards. Died at Overhill, Warlingham, Surrey in 1914.]

S1416 Swan, J. W. "One of the Causes of Pin-holes in Negatives." HUMPHREY'S JOURNAL OF PHOTOGRAPHY, AND THE ALLIED

ARTS AND SCIENCES 15, no. 14 (Nov. 15, 1863): 224. [From "Photo. News."]

S1417 "A New Carbon Process." AMERICAN JOURNAL OF PHOTOGRAPHY AND THE ALLIED ARTS & SCIENCES n. s. vol. 6, no. 19 (Apr. 1, 1864): 433-436. [From "Photo. News." Describes J. W. Swan's process. Swan from Newcastle-on-Tyne, England. Mentions Pouncy's work as well.]

S1418 "Examination of Mr. Swan's Carbon Prints." AMERICAN JOURNAL OF PHOTOGRAPHY AND THE ALLIED ARTS & SCIENCES n. s. vol. 6, no. 20 (Apr. 15, 1864): 464-468. [From "Br. J. of Photo."]

S1419 Swan, Joseph W. "A New Carbon Process." BRITISH JOURNAL OF PHOTOGRAPHY 11, no. 212 (Apr. 15, 1864): 128-130.

S1420 "Mr. Swan's New Carbon Process." AMERICAN JOURNAL OF PHOTOGRAPHY AND THE ALLIED ARTS & SCIENCES n. s. vol. 6, no. 21 [sic 22] (May 15, 1864): 505-511. [From "Photo. News."]

S1421 Dawson, George. "Swan's Carbon Process." BRITISH JOURNAL OF PHOTOGRAPHY 11, no. 214 (May 16, 1864): 164-165.

S1422 "Mr. Swan's New Carbon Process." HUMPHREY'S JOURNAL OF PHOTOGRAPHY, AND THE ALLIED ARTS AND SCIENCES 16, no. 2 (May 15, 1864): 17-18.

S1423 Sutton, Thomas. "Mr. Swan's Carbon Printing Process." AMERICAN JOURNAL OF PHOTOGRAPHY AND THE ALLIED ARTS & SCIENCES n. s. vol. 6, no. 23 (June 1, 1864): 538-540. [From "Photo. Notes."]

S1424 [Towler, John.] "Swans New Carbon Process. - No. 2." HUMPHREY'S JOURNAL OF PHOTOGRAPHY, AND THE ALLIED ARTS AND SCIENCES 16, no. 5 (July 1, 1864): 65-69.

S1425 Swan. "Transferring Negatives." AMERICAN JOURNAL OF PHOTOGRAPHY AND THE ALLIED ARTS & SCIENCES n. s. vol. 7, no. 1 (July 1, 1864): 18-19. [From "Photo. News."]

S1426 "A New System of Printing." HUMPHREY'S JOURNAL OF PHOTOGRAPHY, AND THE ALLIED ARTS AND SCIENCES 16, no. 14 (Nov. 15, 1864): 218-221. [From "Photo. News." Swan's process described.]

S1427 "A New System of Printing." AMERICAN JOURNAL OF PHOTOGRAPHY AND THE ALLIED ARTS & SCIENCES n. s. vol. 7, no. 10 (Nov. 15, 1864): 226-230. [Swan's process. From "Photo. News."]

S1428 "Home: Mr. Swan's Claims versus Mr. Woodbury's." BRITISH JOURNAL OF PHOTOGRAPHY 12, no. 261-263 (May 5 - May 19, 1865): 238-239, 254-255, 271. [Includes letters by Walter B. Woodbury and Joseph S. Swan.]

S1429 Swan, Joseph W. "Collodio-Chloride on Opal Glass." AMERICAN JOURNAL OF PHOTOGRAPHY AND THE ALLIED ARTS & SCIENCES n. s. vol. 7, no. 22 (May 15, 1865): 523-525. [From "Photo. News."]

S1430 Swan, Joseph W. "Precipitation of Collodio-Chloride of Silver." AMERICAN JOURNAL OF PHOTOGRAPHY AND THE ALLIED

ARTS & SCIENCES n. s. vol. 8, no. 4 (Aug. 15, 1865): 93-95. [From "Photo. News."]

S1431 "Photo-gelatine Prints." HUMPHREY'S JOURNAL OF PHOTOGRAPHY, AND THE ALLIED ARTS AND SCIENCES 17, no. 18 (Jan. 15, 1866): 278-279.

S1432 Towler, Prof. "Photo-Mezzotint Photography." HUMPHREY'S JOURNAL OF PHOTOGRAPHY, AND THE ALLIED ARTS AND SCIENCES 17, no. 22 (Mar. 15, 1866): 337-340. [Joseph H. Swan's process discussed.]

S1433 Swan, Joseph W. "Photo-Mezzotint, Photo-Engraving, Photo-Lithography. Extract from the English Patent Specifications." AMERICAN JOURNAL OF PHOTOGRAPHY AND THE ALLIED ARTS & SCIENCES n. s. vol. 8, no. 20 (Apr. 15, 1866): 469-476.

S1434 Swan, J. W. "On a Photographic Actinometer." HUMPHREY'S JOURNAL OF PHOTOGRAPHY, AND THE ALLIED ARTS AND SCIENCES 17, no. 24 (Apr. 15, 1866): 379-381. [Read to North London Photo. Assoc.]

S1435 "Working of Mr. Swan's Carbon Process." HUMPHREY'S JOURNAL OF PHOTOGRAPHY, AND THE ALLIED ARTS AND SCIENCES 18, no. 1 (May 1, 1866): 7-8. [From "Photo. News."]

S1436 "Swan's Carbon Pictures." PHILADELPHIA PHOTOGRAPHER 3, no. 35 (Nov. 1866): 334-337.

S1437 Swan, Joseph W. "Practical Details of Carbon Printing." AMERICAN JOURNAL OF PHOTOGRAPHY, AND THE ALLIED ARTS AND SCIENCES n. s. vol. 9, no. 8 (Mar. 1, 1867): 172-176. [From "Photo. News."]

S1438 Lewis, Joseph. "Carbon Printing." HUMPHREY'S JOURNAL OF PHOTOGRAPHY, AND THE ALLIED ARTS AND SCIENCES 19, no. 11 (Oct. 1, 1867): 166-167. [Describes the carbon printing works of Mr. Swan, at Newcastle.]

S1439 "Mr. Swan's New Patent." HUMPHREY'S JOURNAL OF PHOTOGRAPHY, AND THE ALLIED ARTS AND SCIENCES 19, no. 14 (Nov. 15, 1867): 218-219. [From "Br. J. of Photo."]

S1440 "Carbon Prints." HUMPHREY'S JOURNAL OF PHOTOGRAPHY, AND THE ALLIED ARTS AND SCIENCES 19, no. 17 (Jan. 1, 1868): 259-260. [From "New York World."]

S1441 "Swan's Carbon Process." ART JOURNAL (Mar. 1868): 56-57.

S1442 "Swan's Carbon Process." HUMPHREY'S JOURNAL OF PHOTOGRAPHY, AND THE ALLIED ARTS AND SCIENCES 20, no. 4 (June 15, 1868): 54. [From "Photo. News."]

S1443 "Status of the Swan Carbon Patents in the U.S." PHILADELPHIA PHOTOGRAPHER 15, no. 173-174 (May - June 1878): 134-135, 179-180. [Swan's copyrights expired - his process available.]

SWANTON.
S1444 "Information Wanted - The Mysterious Murder in New York." FRANK LESLIE'S ILLUSTRATED NEWSPAPER 19, no. 475 (Nov. 5, 1864): 112. 1 illus. [Portrait of a decapitated head, published with a request for information.]

SWATRIDGE, T. S.
S1445 Swatridge, T. S. "A Few Words about Glass Positives." AMERICAN JOURNAL OF PHOTOGRAPHY AND THE ALLIED ARTS & SCIENCES n. s. vol. 4, no. 13 (Dec. 1, 1861): 304-306.

SWEENY, THOMAS T. (CLEVELAND, OH)
S1446 "Inauguration of the Monument Dedicated to the Fallen Heroes of Erie County, at Girard, Pennsylvania, November 1, 1865." HARPER'S WEEKLY 9, no. 465 (Nov. 25, 1865): 737. 1 illus. ["Photographed by Thomas Sweeny, Cleveland, Ohio."]

S1447 "Our Picture." PHOTOGRAPHIC WORLD 1, no. 9 (Sept. 1871): frontispiece, 286. 1 b & w. [Landscape.]

S1448 "Note." PHOTOGRAPHIC TIMES 2, no. 16 (Apr. 1872): 56. [Mentions stereo views of Chicago, IL, ruins.]

S1449 "Ohio. - Schooner Yacht 'Oeoresta.'- From a Photograph by Thomas T. Sweeny." FRANK LESLIE'S ILLUSTRATED NEWSPAPER 47, no. 1216 (Jan. 18, 1879): 360. 1 illus.

SWEET, G. O. (GIBSON, PA)
S1450 "Editor's Table." PHILADELPHIA PHOTOGRAPHER 5, no. 56 (Aug. 1868): 280. [Whole-sized picture of Cascade Falls on N.Y & Erie R.R.]

SYKES, D. H. (GREAT BRITAIN, INDIA)
S1451 Burgess, James. The Temple of Amaranth. Bombay: Sykes & Dwyer, 1868. 1 pp. 8 l. of plates. Burgess, James. The Temples of Satranjaga. Bombay: Sykes & Dwyer [?], 1868. n. p. 45 b & w. [Albumen prints.]

S1452 Burgess, James. Rock-Temples of Elephanta or Gharapuri; With Photographic Illustrations by D. H. Sykes. Bombay: D. H. Sykes & Co. [etc.], 1871. 40 pp. 30 b & w.

PERIODICALS
S1453 "Rock Inscribed with the Edicts of an Emperor, in Kathiawad, Western India." ILLUSTRATED LONDON NEWS 60, no. 1689 (Jan. 20, 1872): 60, 63. 1 illus. ["...from one of the photographs of another series by Mr. Sykes, of Bombay."]

SYKES, JAMES BENNETT. (USA)
S1454 Sykes, James Bennett. "Correspondence." DAGUERREAN JOURNAL 1, no. 8 (Mar. 1, 1851): 244. [Letter from Sykes, commenting about the field.]

S1455 Sykes, Jas. B. "How to Polish the Artists." AMERICAN JOURNAL OF PHOTOGRAPHY AND THE ALLIED ARTS & SCIENCES n. s. vol. 8, no. 19 (Apr. 1, 1866): 444. [Sykes of Clinton, NY.]

SYMONDS & CO.
S1456 "The New British Cup Yacht "Shamrock II" and Her Owner." COLLIER'S WEEKLY 27, no. 12 (June 22, 1901): 10, 21. 5 b & w. ["Shamrock" Photographs Copyright 1901 by Symonds & Co., Portsmouth."]

SYMONDS, HENRY. (PORTSMITH, ENGLAND)
S1457 Portrait. Woodcut engraving credited "From a photograph by Symonds." ILLUSTRATED LONDON NEWS 74, (1879) ["Lieut. Griffith, killed." 74:2073 (Mar. 8, 1879): 216.]

S1458 Symonds, Henry. Official Photographer of the British Navy. "The Perils of Marine Photography." COSMOPOLITAN MAGAZINE 42, no. 6 (Apr. 1907): 629-635. 7 b & w. [Ships at sea, etc.]

SZATHMARI see DE SZATHMARI, CAROL POPP.

T

D. T.
T1 D. T. "Photography." ART JOURNAL (1852): 159. [Letter from "D. T.," describing his process.]

T2 D. T. "Notes of a Photographic Tour in the Holy Land. Nos. XI-XV." BRITISH JOURNAL OF PHOTOGRAPHY 7, no. 109-116 (Jan. 1 - Apr. 16, 1860): 8-9, 23-24, 50-51, 83, 114-115. [Extensive article, carried over from vol 6. (1859).]

T3 D. T. "Notes of a Photographic Tour in the Holy Land." HUMPHREY'S JOURNAL OF PHOTOGRAPHY, AND THE ALLIED ARTS AND SCIENCES 11, no. 21-24 (Mar. 1 - Apr. 15, 1860): 336, 367-368, 383-384.

TABER, CHARLES & CO. (NEW BEDFORD, MA)
T4 Ambrotype Copies of Fine Engravings. Manufactured by Charles Taber & Co., New Bedford, Mass. New Bedford, MA: Daily Evening Standard Steam Printing House, 1860. 9 pp.

TABER, ISAIAH WEST. (1830-1912) (USA)
[I. W. Taber worked for Bradley & Rulofson in San Franscisco, CA from 1864 to 1871. In 1871 he opened his own studio, which quickly became one of the major studios of the city, and which remained in operation until 1905. Taber also published and distributed the work of other photographers, (For example, he acquired Carleton E. Watkin's negatives in 1881.) sold photographic supplies, and, in the early 1880s he manufactured dry plates. In 1880 he toured the Sandwich Islands (Hawaii.) Taber died in 1912.]

BOOKS
T5 Finck, Henry T. The Pacific Coast Scenic Tour: From Southern California to Alaska. The Canadian Pacific Railway. Yellowstone Park and The Grand Canyon,...with illustrations. New York: Charles Scribner's Sons, 1890. 309 pp. 20 b & w. ["Most of the illustrations in this volume are by courteous permission reproduced from photographs in the excellent collection of Messrs. Taber, San Francisco, Haynes, Yellowstone Park, B. C. Towne & Macalpin & Lamb, Portland, and Pierce & Blanchard, Los Angeles."]

PERIODICALS
T6 Advertisement "Unequaled Photographic Gallery." CALIFORNIA MAIL BAG 1, no. 2 (July 1871): advertising section, p. xxxii. ["I. W. Taber, for seven years the head operator at Bradley & Rulofson's, has taken the spacious establishment of Nahl Brothers, No. 12 Montgomery Street."]

T7 1 photo (Portrait of an unidentified military officer). CALIFORNIA MAIL BAG 1, no. 4 (Oct. - Nov. 1871): unpaged leaf before p. 65. 1 b & w. [An original photographic print tipped-into the magazine, probably as an advertising strategy for the new I. W. Taber Gallery. The sitter is not identified, although probably known to the magazine's audience.]

T8 1 engraving (Portrait of Taber ?). CALIFORNIA MAIL BAG 1, no. 6 (Jan. - Feb. 1872): unpaged leaf following p. 112. 1 illus. [Advertisement for the opening of the I. W. Taber Art and Photographic Gallery. Contains an unidentified portrait, which may be of Taber.]

T9 "A New Size - the Promenade Photograph." PHILADELPHIA PHOTOGRAPHER 12, no. 133 (Jan. 1875): 2.

T10 "Our Picture." PHILADELPHIA PHOTOGRAPHER 12, no. 135 (Mar. 1875): frontispiece, 83-85. 1 b & w. [1 studio portrait in promenade style.]

T11 "Our Picture." PHILADELPHIA PHOTOGRAPHER 12, no. 136 (Apr. 1875): frontispiece, 125-127. 1 b & w. [Studio portrait in 'promenade' style.]

T12 Taber, I. W. "Enterprise in Photography." PHILADELPHIA PHOTOGRAPHER 12, no. 138 (June 1875): 162-164. 2 illus.

T13 "Matters of the Month: Pictures Received." PHOTOGRAPHIC TIMES 5, no. 55 (July 1875): 171. [Promenade cards from Mr. I. W. Taber, operator for G. D. Morse, San Francisco, CA. "They are works of art."]

T14 "Our Picture." PHILADELPHIA PHOTOGRAPHER 12, no. 143 (Nov. 1875): frontispiece, 339-341. 1 b & w. [Studio portrait in promenade style.]

T15 Taber, I. W. "The Promenade Picture - the Inventor's Ideas Concerning It." PHILADELPHIA PHOTOGRAPHER 12, no. 144 (Dec. 1875): 377.

T16 "Editor's Table." PHILADELPHIA PHOTOGRAPHER 13, no. 145 (Jan. 1876): 31. [I. W. Taber and Thomas H. Boyd have bought the Yosemite Art Gallery in San Francisco, CA.]

T17 "Photography and the Telephone." ANTHONY'S PHOTOGRAPHIC BULLETIN 9, no. 4 (Apr. 1878): 117. [I. W. Taber (San Francisco, CA) "connected his photographic establishment, by means of the telephone, with the various hotels of that city."]

T18 "Note." PHOTOGRAPHIC TIMES 8, no. 94 (Oct. 1878): 232. [Note that has elegant new gallery.]

T19 Portrait. Woodcut engraving, credited "From a Photograph by I. W. Faber. [sic Taber]" FRANK LESLIE'S ILLUSTRATED NEWSPAPER 49, (1879) ["Gen. Ulysses S. Grant, in San Francisco." 49:1255 (Oct. 18, 1879): 97.]

T20 "Display of Floral Tributes in the General's Parlor at the Palace Hotel." and "View of the Parlor and Dining-Room Occupied by General Grant at the Palace Hotel. - From Photographs by I. W. Faber. [sic Taber]" FRANK LESLIE'S ILLUSTRATED NEWSPAPER 49, no. 1255 (Oct. 18, 1879): 109. 2 illus. [Interiors, with figures.]

T21 "Matters of the Month." PHOTOGRAPHIC TIMES 10, no. 103 (Jan. 1880): 10-11. ["a package of pictures in cabinet and boudoir sizes, containing portraits of General and Mrs. Grant... on their tour around the world."]

T22 "Matters of the Month." PHOTOGRAPHIC TIMES 10, no. 116 (Aug. 1880): 178. [Taber returned to San Francisco returned from six weeks trip to Sandwich Islands, with Dr. Merritt on the yacht "Casco." Photographed the Hawaiian King while there.]

T23 "Matters of the Month." PHOTOGRAPHIC TIMES 10, no. 120 (Dec. 1880): 276. [Mr. I. W. Taber... has favored us with a 14" x 17" photo of the interior of his reception room.]

T24 Wilson, Edward L. "Matters of the Month." PHOTOGRAPHIC TIMES 11, no. 123 (Mar. 1881): 104. [Discusses Taber's visit to the Sandwich Islands, where he met and photographed King Kalakaua.

Then King Kalakaua visited San Francisco and sat for Taber in his studio.]

T25 Taylor, J. Traill. "Our Editorial Table: Portraits by I. W. Taber, San Francisco." PHOTOGRAPHIC TIMES 11, no. 126 (June 1881): 217. [Portraits of King Kalakua of the Sandwich Islands, others described.]

T26 Taber, I. W. "The Superiority of Californian Photography." PHOTOGRAPHIC TIMES 11, no. 127 (July 1881): 250-251. [Taber claimed that the even climate of San Francisco makes it possible to make better portraits there.]

T27 "Matters of the Month." PHOTOGRAPHIC TIMES 11, no. 130 (Oct. 1881): 402. [Note that Taber returned to San Francisco, CA, from his New York visit. Mentions that he "has purchased the well known Watkins collection of negatives of the Yosemite Valley and the Pacific Coast and will continue publication of the photographs there from."]

T28 "Matters of the Month." PHOTOGRAPHIC TIMES 11, no. 132 (Dec. 1881): 462. [Mention of a circular issued by Taber promoting his View Department.]

T29 "General Notes." PHOTOGRAPHIC TIMES 16, no. 265 (Oct. 15, 1886): 542. [Mention of visit from I. W. Taber, of San Francisco. Mentions recent illness, fact that he has stopped manufacturing dry plates for sale.]

T30 Fitch, George H. "A Night in Chinatown." COSMOPOLITAN 2, no. 6 (Feb. 1887): 349-358. 2 b & w. 3 illus. [San Francisco's Chinatown. Photos credited, "(From a photography by Taber.)" and engravings are probably from photos.]

T31 Roberts, Edward. "A Santa Barbara Holiday." HARPER'S MONTHLY 75, no. 450 (Nov. 1887): 813-835. 13 illus. ["Drawn... from Photographs by Rea and Taber." California views.]

T32 "The United States Cruiser "Charleston," Flag Ship of the Pacific Coast Squadron - Photo by Taber, San Francisco." FRANK LESLIE'S ILLUSTRATED NEWSPAPER 70, no. 1811 (May 31, 1890): 353. 1 b & w.

T33 "The Launching of the United States Cruiser "Monterey" at the Union Iron Works, San Francisco, Apr. 28th. Photo by Taber." FRANK LESLIE'S ILLUSTRATED NEWSPAPER 72, no. 1862 (May 23, 1891): 266, 272. 1 b & w.

T34 "The Tunnel Through One of the Big Wellingtonias of the Tuolumne Big-Tree Grove, California - From a Picture by I. W. Taber." FRANK LESLIE'S ILLUSTRATED NEWSPAPER 72, no. 1872 (Aug. 1, 1891): 442, 446. 1 b & w. [Full page photo of cart driving through a redwood tree.]

T35 "California - The Yosemite Falls, with a Descent of Two Thousand Five Hundred and Fifty Feet - From a Photo by Taber, San Francisco." FRANK LESLIE'S ILLUSTRATED NEWSPAPER 73, no. 1881 (Oct. 3, 1891): 137, 139. 1 b & w.

T36 "Glacier Point Rock, Yosemite Valley, California: Elevation 3,201 feet - Photo by Taber." FRANK LESLIE'S ILLUSTRATED NEWSPAPER 73, no. 1886 (Nov. 7, 1891): 227. 1 b & w.

T37 Andrews, E. Benjamin. "A History of the Last Quarter Century in the United States: Home Agitations and Foreign Problems." SCRIBNER'S MAGAZINE 18, no. 4 (Oct. 1895): 477-500. 2 illus. [Part of a series, this article contains a report on "The Chinese Question,"

and is illustrated by at least nine drawings made "after photographs by Taber" of Chinatown residents in San Francisco, parades, etc.]

T38 "Editor's Table." WILSON'S PHOTOGRAPHIC MAGAZINE 33, no. 472 (Apr. 1896): 191. [I. W. Taber and his brother F. A. Taber of San Francisco producing a "Base-relief photograph." Sent example.]

T39 "Personal Paragraphs: Taber." WILSON'S PHOTOGRAPHIC MAGAZINE 34, no. 486 (June 1897): 272. ["Taber, the well-known photographer of San Francisco, has opened a bas-relief portrait studio in London."]

T40 "Obituary: Isaiah West Taber." SAN FRANCISCO CALL (Feb. 23, 1912): 4, col 2. ["...died of heart failure at noon yesterday. Born at Fairhaven, Mass., August 17, 1830. In 1845 he made a voyage on a whaling vessel to the Pacific coast and Bering sea, returning to Massachusetts in 1848. In 1849 he joined a party organized for gold hunting that arrived in San Francisco in February... In April he went to the Marquesas Islands in the South Seas and returned with a cargo of hogs that sold at a large profit. He engaged in mining along the American River for the next two years and turned his attention to ranching in 1852. His photographic career began in 1854, when he went east to study the art. He returned to San Francisco in 1864, and in 1872 set up business for himself... The views of Pacific coast scenery made by Taber were an important factor in attracting tourists,... in recognition of this fact... he was appointed a Yosemite Valley commissioner in 1888. He was awarded the photographic concession at the Mid-winter Fair in 1893. In 1897 he photographed the pageant at the diamont jubilee celebration of Queen Victoria in London,... Taber's large collection was destroyed by fire in 1906, 80 tons of portrait negatives and 20 tons of view negatives being spoiled."]

T41 "Isaiah West Taber, 1830 - 1912." IMAGE 3, no. 3 (Mar. 1954): 19-20. 2 b & w. [Taber was a native of New Bedford, MA, who went to California to search for gold in Feb. 1850. Mined for three years, then returned to New England in 1854. He then learned photography and returned to California in 1864. He became the chief operator in the Bradley & Rulofson Photograph Gallery in San Francisco. In 1871 he established his own gallery in the city. Known for having collected many views of California during his career. In 1897 Taber photographed the Diamond Jubilee celebration of Queen Victoria in London, then photographed King Edward VIII. His huge collection of negatives and prints was destroyed in the 1906 earthquake and fire. From *The Bay of San Francisco - a History*, 1982, II, 93-94, and "San Francisco Call" (Feb. 23, 1912).]

T42 McCauley, Elizabeth Anne. "Taber and Company's Chinatown Photographs: A Study in Prejudice and its Manifestations." BULLETIN OF THE UNIVERSITY OF NEW MEXICO ART MUSEUM no. 13 (1980-1981): 9-17.

T43 Palmquist, Peter E. "Menagerie en Collage." HISTORY OF PHOTOGRAPHY 4, no. 3 (July 1980): 242. 1 b & w. 1 illus. [A set of pictorial souvenir portfolios generated by I. W. Taber for the San Francisco [CA] Midwinter Fair of 1894. "The Monarch Souvenir of Sunset City and Sunset Scenes being Views of California's Midwinter Fair and Famous Scenes of the Golden State" by I. W. Taber, 15 vols., San Francisco: H. S. Crocker Co., 1894.]

TAFT, PRESTON WILLIAM. (1827-) (USA)

T44 "Photos Burned Out." HUMPHREY'S JOURNAL OF PHOTOGRAPHY, AND THE ALLIED ARTS AND SCIENCES 20, no. 8 (Aug. 15, 1868): 126. ["At a recent fire in Bellows Falls, Vt., J. W. F. Blanchard's room was badly damaged. The photograph saloon of P.

W. Taft, an old settler in the village, being mounted on wheels was soon drawn out of danger."]

TAGERSPACHER. (GMUNDEN, GERMANY)

T45 Portrait. Woodcut engraving credited "From a photograph by Tagerspacher." ILLUSTRATED LONDON NEWS 68, (1876) ["King George V. of Hanover." 68:1923 (June 3, 1876): 541.]

TAIT, WILLIAM J.

T46 Portrait. Woodcut engraving, credited "From a Photograph by William A. Tait." NEW YORK ILLUSTRATED NEWS 8, (1863) ["Theophilus Calicot, at Albany, NY." 8:184 (May 9, 1863): 28.]

TALBOT, WILLIAM HENRY FOX. (1800-1877) (GREAT BRITAIN)

[Born in Dorset, England in 1800 to a landed family. Educated at Harrow and Trinity College, Cambridge and early evidenced a skill as a scholar and scientist. By 1822 he had published papers in mathematical journals and by the 1830s he had a reputation as a etymologist of note. He studied physics, botany, Egyptology, and a host of other interests, contributing fifty memoirs to various scientific periodicals between 1822 and 1872. He used a camera lucida on trips to Italy in 1823-24 and again in 1833. Elected to the Royal Society in 1831. Stood for Parliament in 1833-34. He began to study light and methods of chemically fixing images in the early 1830s, began working with citrate of silver in 1834. By 1835 he had worked out a process of photogenic drawing, then he developed the idea of a photographic negative, from which many positive prints could be made. In January, 1839 Daguerre announced but did not describe his process, and Talbot presented his own system to the Royal Society in February. It was later seen that the two processes had significant differences. Talbot perfected the concept of chemically enhancing a latent image in 1840. In 1841 he secured a patent for his improved calotype process, which he defended aggressively. Throughout the 1840s and 1850s Talbot continued to seek better means of turning his discoveries into more practical technologies - attempting to make the images more permanent, faster, finer-grained in order to compete commercially with the daguerreotype. He opened a studio in London in 1846 and a small factory for printing photographs, managed by his assistant Nicolaas Henneman, to print multiple copies for illustrated books, notably *The Pencil of Nature* in 1844 and *Sun Pictures of Scotland,* in 1845.

Talbot devised an instaneous process in 1851 and a photoglyptic engraving process in 1852. His patent expired in 1853 and the courts did not extend the negative/positive concept to cover photographs made with wet-collodion or other techniques. Talbot worked on photogravure in 1858 and photoglyptography on steel in 1861. By 1971 his interests were engaged in astronomy. Talbot was elected to the Royal Photographic Society in 1873. He died at Laycock Abbey, Wiltshire in 1877.]

BOOKS

T47 Talbot, William H. F. *Legendary Tales, In Verse and Prose.* Collected by Henry F. Talbot. London: s. n., 1830.

T48 Talbot, William H. F. *Hermes; Or, Classical and Antiquarian Researches.* London: self-published ?, 1838-39. No. I, II (paged contin.)

T49 Talbot, William H. F. *The Antiquity of the Book of Genesis, Illustrated by some New Arguments.* London: s. n., 1839.

T50 Talbot, H. F., Esq. *The Process of Calotype Photogenic Drawing, Communicated to the Royal Society, June 10th, 1841.* London: J. L.

Cox & Sons, 1841. 4 pp. [Reprinted on pp. 75-78 in: "On Photography," edited by Beaumont Newhall.]

T51 Talbot, H. F., Esq. *A Brief Description of the Photogenic Drawings Exhibited at the Meeting of the British Association at Birmingham in August, 1839.* s. l. [London ?]: s. n. [self-published ?], 1839. 4 pp. [Describes 93 photographs.]

T52 Talbot, William H. F. *Some Account of the Art of Photogenic Drawing, or the Process by Which Natural Objects May be Made to Delineate Themselves Without the Art of the Artist's Pencil.* London: Richard & John E. Taylor, 1839. 13 pp. ["Read before the Royal Society, Jan. 31, 1839."]

T53 Walter, John Jr. *Record of the Death Bed of C. M. W.* Reading: The Talbotype Establishment, 1844. n. p. 1 illus. [A pamphlet written by John Walter Jr. in memory of his sister, Catherine M. Walter. Published at the Talbotype establishment in Reading in 1844. Contains one calotype of a statue of the deceased, taken by Nicholas Henneman, for a frontispiece.]

T54 Talbot, H. Fox, Esq. F.R.S., &c, &c, &c. *The Pencil of Nature.* London: Longman, Brown, Green & Longmans, 1844-1846. 80 pp. 24 l. of plates. 24 b & w. ["Juvat ire jugis qua nulla priorium castaliam molli devertitur orbita Clivo." Twenty-four calotypes, issued in six fascicles.]

T55 Talbot, H. Fox, Esq., F.R.S. *Sun Pictures in Scotland.* Reading: The Talbotype Establishment, 1845. 2 pp. 18 l. of plates. 23 b & w. ["Juvat ire jugis qua nulla priorum castaliam molli devertitur orbita clivo." Album, containing twenty-three original calotypes, printed at the Talbotype establishment in Reading.]

T56 *The Talbotype Applied to Hieroglyphics.* Reading: The Talbotype Establishment, 1846. n. p. 3 l. of plates. 3 illus. [Three calotype prints, of drawings of Egyptian hieroglyphics.]

T57 Talbot, H. Fox. *English Etymologies.* London: J. Murray, 1847. 492 pp.

T58 Stirling, William. *Annals of the Artists of Spain - Talbotype Illustrations to the Annals of the Artists of Spain.* London: Ollivier, 1848 (for volumes 1-3). xii pp. 62 l. of plates. 66 b & w. [66 calotypes of prints and drawings, etc. This was an added plate volume to the three volume work, with "only 25 preferred copies" made. Calotypes actually made by Talbot's assistant, Nicholaas Henneman. "Illustrations executed under the supervision of William Sterling by Nicolaas Henneman."]

T59 Coleridge, Samuel Taylor. "2nd division - photography," on pp. in: *Encyclopedia Metropolitana* London: John Joseph Griffin & Co., 1851.

T60 Boulongne, A. *Photographie et gravure héliographique:* histoire et exposé des divers procédés employés dans cet art depuis Joseph Niépce et Daguerre justqu'a nos jours. Paris: Lerebours & Secretan, 1854. 60 pp. [From "Moniteur universal, Dec. 11, 12, 13, 1853 and Jan. 11, 13, and 23, 1854." Articles are about Daguerre, Niépce, Talbot, Bayard, and Blanquart-Évrard.]

T61 Belloc, Auguste. *Les quatres branches de la photographie.* Traité complet théorique et pratique des procédés de Daguerre, Talbot, Niépce de Saint-Victor et Archer. Précédé des Annuals de la photographie et suivre d'éléments de chemie et d'optique appliqués

à cet art. Paris: Belloc, 1855. 476 pp. 2 b & w. [2nd ed., 1858. slight title change.]

T62 Talbot, William H. F. *Inscription of the Tiglath Pileser,* ...as translated by F. Talbot London: 1857.

T63 Tissandier, Gaston. *A History and Handbook of Photography;* Translated from the French of Gaston Tissandier. Edited by John Thomson. Second and revised edition, with an Appendix by the late H. Fox-Talbot. London: Samson Low, Marston, Low & Searle, 1878. 400 pp. 20 l. of plates. 60 illus. [The second edition contains an appendix with an autobiographical statement by William H. F. Talbot, as well as biographies of other early British photographers. Illustrated with sixty woodcuts and twenty full-page engravings, etc. by various processes.]

T64 Colson, René, ed. *Memoires originaux des créateurs de la photographie: Nicéphore Niépce, Daguerre, Bayard, Talbot, Niépce de Saint-Victor, Poitevin;* Annotés et commentés par R. Colson. Paris: Gauthier-Villars, 1898. 226 pp. [I. Notice sur Talbot, pp. 79-83. II. Lettres de Talbot au sujet de son premier papier, pp. 84-90. III. Lettres de Talbot an sujet du developpement de l'image latente, p. 91-93. IV. Brevet de Talbot au sujet de la photographie sur papier calotype, pp. 94-100. IV. Lettres de Talbot du sujet d'instantanes obtenus avec l'albumine sur verre, pp. 101-103. VI. Note et Brevet de Talbot sur la gravure photographique, pp. 104-114.]

T65 Albertotti, Giuseppe. *Disegni Foto-genici Communicati da Fox Talbot a G. B. Amici (1840-41) e Correspondenza Amiciana.* Roma: Typografia delle Scienze, 1926. 11 pp. ["Estratta dagli Alti della Societa Italiana di Optalmoglia Congresso 1925," Roma 27-30 Ottobre.]

T66 *Centenary of Photography. Exhibition of prints made by Henry Fox Talbot between 1834-1846 together with early cameras used by him.* London: Elliot & Fry's Gallery, 1934. 4 pp. [Exhibition: November 1934.]

T67 *The Father of Modern Photography. An Account of the Life of W. H. Fox Talbot;* Together with a catalogue of the Kodak Exhibition prepared in his memory on the occasion of the Festival of Britain. s. l. [London ?]: s. n. [Kodak, Ltd. ?], [1951 ?]. 20 pp.

T68 *W. H. Fox Talbot Commemoration.* Reading: Reading Camera Club, 1951. 8 pp. [Festival of Britain, 1951, Reading Camera Club Programme. 9th June, 1951.]

T69 Talbot, Matilda. Foreword by Lord Methuen. *My Life and Lacock Abbey.* London: Allen & Unwin, Ltd., 1956. 261 pp. 11 illus.

T70 Thomas, D. B., B.Sc., Ph.D. *The First Negatives;* An account of the discovery and early use of the negative-positive photographic process. "A Science Museum Monograph." London: Her Majesty's Stationery Office, 1964. 42 pp. 34 illus.

T71 Booth, Arthur Harold. *William Henry Fox Talbot, Father of Photography.* "Creators of the Modern World" London: Arthur Barker, Ltd., 1964. 119 pp. illus.

T72 Newhall, Beaumont. *Latent Image: the Discovery of Photography.* New York: Doubleday & Co., Anchor Books, 1967. * pp. b & w. illus.

T73 Raskin, Naum Mikhailovich. *Zhozef Nisefor Neps, Lui Zhak Mande Dagerr, Vil'iam Genri Foks Talbot.* "Nauchnobiograficheskaia servia" Leningrad: Nauka, Leningradskop otd-nie, 1967. 188 pp.

T74 Talbot, William Henry Fox. Introduction by Beaumont Newhall. *The Pencil of Nature: A Facsimile of the 1844-45 edition.* New York: Da Capo Press, 1968. 140 pp. 24 b & w.

T75 Jammes, André. *William H. Fox Talbot.* "Bibliothek der Photographie, No. 2." Lucerne: C. J. Bucher Verlag, 1972. n. p. b & w. illus. [English language ed. (1973). New York: Macmillan.]

T76 Jammes, Andre. *William H. Fox Talbot: Inventor of the Negative-Positive Process.* "Photography: Men and Movements, 2." New York: Macmillan Publishing Co., Inc., 1972. 96 pp. 69 b & w.

T77 *The Art of Photogenic Drawing.* "Fox Talbot Museum Information leaflet, 1." Lacock, England: Fox Talbot Museum, n. d. [ca. 1975]. 8 pp. 2 b & w.

T78 Wood, Rupert Derek. *The Calotype Patent Lawsuit of Talbot v. Laroche 1854.* A contribution to the history of photography to welcome the opening of the Talbot Museum at Lacock. Bromley, Kent, England.: R. D. Wood, 1975. 34 pp. 2 illus.

T79 *An Illustrated Guide: Fox Talbot Museum, Lacock.* London: National Trust, 1976. 16 pp. 20 illus.

T80 *Sun Pictures: the Work of William Henry Fox Talbot, 1800 - 1877.* London: Science Museum, Fox Talbot Museum and Kodak Ltd., 1976. 42, 12 pp. b & w. illus. [Special issue of "Camera" (Lucerne) magazine issued as a catalog for the exhibition.]

T81 Hannavy, John. *Fox Talbot: An illustrated life of William Henry Fox Talbot, 'Father of Modern Photography' 1800-1877.* "Lifelines, 38" Aylesbury, England: Shire Publications, Ltd., 1976. 48 pp. 25 illus.

T82 Arnold, H. J. P. *William Henry Fox Talbot: Pioneer of Photography and Man of Science.* London: Hutchinson Benham, 1977. 382 pp. 108 illus.

T83 Lassam, Robert and Michael Seaborne. *[William Henry Fox Talbot Centenary Exhibition].* Lacock, England: Fox Talbot Museum, 1977. 36 pp. 23 illus. [Exhibition: Aug.-Oct. 1977. Exhibition was of Talbot's scientific researches other than photography, designed to complement another exhibition held concurrently with the Science Museum, London.]

T84 Buckland, Gail. *Fox Talbot and the Invention of Photography.* New York: Camera/Graphic Press, 1978. 268 pp. 190 b & w. [(1980) Boston: David R. Godine, 216 pp., 127 b & w. 16 color.]

T85 Zannier, Italo. *Henry Fox Talbot:* la raccolta della Biblioteca Estense di Modena, presentazione di Italo Zannier. Milano: Editphoto, 1978. 23 pp. b & w. [Supplement to "Fotografia Italiana" No. 237 (May 1978).]

T86 Lassam, Robert. Foreword by Sir Cecil Beaton. *Fox Talbot: Photographer.* Salisbury, England; Kent, OH: Compton Press Ltd., in association with the Dovecote Press; Kent State Univ. Press, 1979. 96 pp. 84 illus.

T87 Ward, John and Sara Stevenson. *Printed Light: The Scientific Art of William Henry Fox Talbot and David Octavius Hill, with Robert Adamson.* Edinburgh: Scottish National Portrait Gallery, 1986. 174 pp.

T88 Kraus, Hans. P., Jr. & Larry J. Schaaf. *Sun Pictures: The Harold White Collection of Works by William Henry Fox Talbot; Catalogue*

Three. New York: Hans P. Kraus, Jr., Fine Photographs, Meriden-Stinehour Press, 1987. 115 pp. b & w. illus.

T89 Kraus, Hans P. and Larry J. Schaaf. *Sun Pictures: Llewelyn, Maskelyne, Talbot, a Family Circle;* Catalogue Two. New York: Hans P. Kraus, Jr. Fine Photographs, 1986. 79 pp. illus. [W. H. Fox Talbot; John Dillwyn Llewelyn; Nevil Story-Maskelyne.]

T90 Schaaf, Larry J. *H. Fox Talbot's The Pencil of Nature, Anniversary Facsimile.* Introductory Volume. Historical Sketch. Notes on the Plates. Census. New York: Hans P. Kraus, Jr. Inc., 1989. 7 vol.

PERIODICALS

T91 "Our Weekly Gossip." ATHENAEUM no. 588 (Feb. 2, 1839): 96. [Discussion of Arago's announcement of Daguerre's discovery to the Academie des Sciences and discussion of Daguerre's images and of the interest aroused in Paris is printed in the "Foreign Correspondence." Talbot's claim to prior discovery reprinted in same issue, comparing Daguerre's & Talbot's processes.]

T92 "Fine Arts: The New Art." LITERARY GAZETTE, AND JOURNAL OF THE BELLES LETTRES no. 1150 (Feb. 2, 1839): 72-75. [Includes a letter from Talbot claiming priority, an account of Daguerre's invention, and report from the Royal Institution and from the Royal Society.]

T93 Talbot, Henry Fox, Esq., F.R.S. "Photogenic Drawing: Some Account of the Art of Photogenic Drawing, or the Process by which Natural Objects may be made to delineate themselves without the aid of the artist's Pencil." ATHENAEUM no. 589 (Feb. 9, 1839): 114-117.

T94 "Fine Arts: Photogenic Drawing." LITERARY GAZETTE, AND JOURNAL OF THE BELLES LETTRES no. 1151 (Feb. 9, 1839): 90.

T95 Talbot, H. Fox, Esq., F.R.S. "Scientific and Literary: Royal Society Feb. 21. An Account of the Processes employed in Photogenic Drawing in a letter to S. H. Christie, Esq., Sec. R. S." ATHENAEUM no. 591 (Feb. 23, 1839): 156.

T96 "New Discovery-Engraving, and Burnet's Cartoons." BLACKWOOD'S EDINBURGH MAGAZINE 45, no. 281 (Mar. 1839): 382-391. [Letter from Talbot on pp. 385-387 "...an account of the French Discovery." on pp. 387-391."]

T97 Talbot, H. F., Esq. "XXXVII: Some Account of the Art of Photogenic Drawing." LONDON, EDINBURGH AND DUBLIN PHILOSOPHICAL MAGAZINE AND JOURNAL OF SCIENCE Ser. 3, vol. 14, no. 87 (Mar. 1839): 196-208.

T98 Talbot, H. F., Esq. "XXXVIII: An account of the processes employed in Photogenic Drawing, in a letter to Samuel H. Christie, Esq., Sec. R.S., from H. Talbot, Esq., F.R.S." LONDON, EDINBURGH AND DUBLIN PHILOSOPHICAL MAGAZINE AND JOURNAL OF SCIENCE Ser. 3, vol. 14, no. 87 (Mar. 1839): 209-211. [Read before Royal Soc. Feb. 21, 1839]

T99 "Fine Arts: Photogenic Drawing." LITERARY GAZETTE, AND JOURNAL OF THE BELLES LETTRES no. 1157 (Mar. 23, 1839): 187. [Discusses the process of "J. F. Havell" and Mr. Willmore, which is essentially a resist printing technique. (Next issue contains a letter from "Wm. Havell"). This article gives rise to a controversy with Talbot about priority.]

T100 "Painting by the Action of Light." CHAMBERS'S EDINBURGH JOURNAL 8, no. 374 (Mar. 30, 1839): 77-78.

T101 "Fine Arts: The Photogenic Art." LITERARY GAZETTE, AND JOURNAL OF THE BELLES LETTRES no. 1158 (Mar. 30, 1839): 202-204. [Arago defends Daguerre's claim against that of Talbot. Letter from Talbot. Letter from Biot. Letter from Wm. Havell.]

T102 "IX. - Daguerre - Photogenic Drawings." FOREIGN QUARTERLY REVIEW (LONDON) 23, no. 45 (Apr. 1839): 213-218. [Both Daguerre and Talbot discussed.]

T103 "Photogenic Drawings. Part 1 - Part 4." MAGAZINE OF SCIENCE AND SCHOOL OF ARTS. 1, no. 1, 4 - 5, 8 (Apr. 1, Apr. 27, May 1, May 25, 1839): 18-20, 25-27, 33-35, 59-60. 6 illus. [Facsimiles of photogenic drawings.]

T104 Talbot, Henry Fox, Esq. "Scientific and Literary: Royal Society Mar. 21. 4. Notes respecting a new kind of Sensitive Paper." ATHENAEUM no. 597 (Apr. 6, 1839): 260.

T105 "Fine Arts: The Photogenic Art." LITERARY GAZETTE, AND JOURNAL OF THE BELLES LETTRES no. 1159 (Apr. 6, 1839): 215. [Letter from J. T. Wilmore, defending his claims against those of Talbot.]

T106 Talbot, H. F., Esq. "The Pencil of Nature: A New Discovery." CORSAIR: A GAZETTE OF LITERATURE, ART, DRAMATIC CRITICISM, FASHION & NOVELTY 1, no. 5 (Apr. 13, 1839): 71. [Extracts of W. H. F. Talbot's letter on Daguerre's discovery, from the "Literary Gazette and Journal of the Belles Lettres." Very early mention of photography in an American journal.]

T107 "Fine Arts: Photogenic Art." LITERARY GAZETTE, AND JOURNAL OF THE BELLES LETTRES no. 1160 (Apr. 13, 1839): 235-236. [Letter from Talbot. Letter from C. Toogood Downing. Letter from Wm. Havell.]

T108 "The New Art - Photography. Part 1 - Part 4." MIRROR OF LITERATURE, AMUSEMENT, AND INSTRUCTION 33, no. 946 - 947, 949 - 950 (Apr. 27 - May 25, 1839): 262-263, 281-283, 317-318, 333-335.

T109 Talbot, W. F. "Remarks on M. Daguerre's Photogenic Process." REPORT OF THE NINTH MEETING OF THE BRITISH ASSOCIATION FOR THE ADVANCEMENT OF SCIENCE. PART 2. NOTICES AND ABSTRACTS OF COMMUNICATIONS (Aug. 1839): 3-5.

T110 "Report of the 9th Meeting of the British Association for the Advancement of Science." ATHENAEUM no. 618 (Aug. 31, 1839): 643-644. [Talbot remarks on Daguerre's process.]

T111 "Mr. Talbot's Remarks on the Daguerreotype." MAGAZINE OF SCIENCE AND SCHOOL OF ARTS 1, no. 23 (Sept. 1839): 182-184. [Read before the British Association, Aug. 26, 1839.]

T112 "Fine Arts: Photogenic Drawings." LITERARY GAZETTE, AND JOURNAL OF THE BELLES LETTRES no. 1217 (May 16, 1840): 315-316.

T113 Talbot, H. F. "Fine Arts: Calotype (Photogenic) Drawing." LITERARY GAZETTE, AND JOURNAL OF THE BELLES LETTRES no. 1258 (Feb. 27, 1841): 139-140. [Letter describing the discovery of the latent image.]

T114 "Our Weekly Gossip." ATHENAEUM no. 711 (June 12, 1841): 461. [Note on Talbot's discovery of the latent image.]

T115 "Fine Arts: Calotype (Photogenic) Drawings." LITERARY GAZETTE, AND JOURNAL OF THE BELLES LETTRES no. 1273 (June 12, 1841): 379. [Abstract from Talbot's paper "On Calotype" read before the Royal Society, June 10, 1841.]

T116 Talbot, H. F., Esq. "XVII: Intelligence and Miscellaneous Articles: Two Letters on Calotype Photogenic Drawing. From H. F. Talbot, Esq., F.R.S. to the editor." LONDON, EDINBURGH AND DUBLIN PHILOSOPHICAL MAGAZINE AND JOURNAL OF SCIENCE Ser. 3, vol. 19, no. 121 (July 1841): 88-92.

T117 Talbot, H. F. "Fine Arts: Photography." LITERARY GAZETTE, AND JOURNAL OF THE BELLES LETTRES no. 1277 (July 10, 1841): 445. [Letter stating activity of German experimenters.]

T118 Talbot, H. F., Esq. "Scientific and Literary: Royal Society 5. An Account of Some Recent Improvements in Photography." ATHENAEUM no. 716 (July 17, 1841): 540-541.

T119 "Calotype Pictures." MAGAZINE OF SCIENCE AND SCHOOL OF ARTS 3, no. 18 (July 31, 1841): 139-141. [Reprint of Talbot's paper read before the Royal Society.]

T120 Talbot, H. F., Esq., F.R.S. "XXVI. Proceedings of the Royal Society. 5. An account of some Recent Improvements in Photography." LONDON, EDINBURGH AND DUBLIN PHILOSOPHICAL MAGAZINE AND JOURNAL OF SCIENCE ser. 3, vol. 19, no. 122 (Aug. 1841): 164-168.

T121 "Miscellaneous: Foreign. Calotype." AMERICAN REPERATORY OF ARTS, SCIENCES AND MANUFACTURES 4, no. 1 (Aug. 1841): 47-48. [From the "Athenaeum." Describes Talbot's paper on the calotype (and the latent image) read to the Royal Society on June 10, 1841.]

T122 "Calotypes." LITERARY GAZETTE, AND JOURNAL OF THE BELLES LETTRES no. 1312 (Mar. 12, 1842): 184. [Note that Collen was working with Talbotypes to make portraits.]

T123 "Things of the Day. No. III. Photography." BLACKWOOD'S EDINBURGH MAGAZINE 51, no. 318 (Apr. 1842): 517-518. ["A new exhibition has just appeared in London, and with the advantage of a new title; a Mr. Fox Talbot has applied himself to making it effective for taking likenesses,..." Includes a statement from the "Morning Post," then concludes, "...the likenesses which have been produced by the former system [daguerreotype] are so absolutely fearful, that we have but little hope of ever seeing anything tolerable from any machine."]

T124 Talbot, H. F., Esq. "LVIII. On the Iodide of Mercury." LONDON, EDINBURGH AND DUBLIN PHILOSOPHICAL MAGAZINE AND JOURNAL OF SCIENCE ser. 3, vol. 21, no. 139 (Nov. 1842): 336-337. [Claiming priority.]

T125 "Photogenic Drawing or Drawing by the Agency of Light." EDINBURGH REVIEW 76, no. 154 (Jan. 1843): 309-344. [Extended state of the art paper based on a review of four books - one of them Talbot's "Some Account of the art of photogenic drawing."]

T126 "Note: 'We have just heard of a curious & interesting practical application of a recent scientific discovery... - The Chinese treaty was copied by the Photographic process of Mr. Fox Talbot, and the copy, so made, for the sake of securing perfect accuracy, is now deposited amongst the State Papers.'" ATHENAEUM no. 794 (Jan. 14, 1843): 39.

T127 Talbot, H. F., Esq. "XV. On the coloured rings produced by Iodine on Silver, with remarks on the history of photography." LONDON, EDINBURGH AND DUBLIN PHILOSOPHICAL MAGAZINE AND JOURNAL OF SCIENCE ser. 3, vol. 22, no. 143 (Feb. 1843): 94-97. [Talbot claiming priority.]

T128 Talbot, H.F., Esq. "VIII. On the Iodide of Mercury." LONDON, EDINBURGH AND DUBLIN PHILOSOPHICAL MAGAZINE AND JOURNAL OF SCIENCE ser. 3, vol. 22, no. 145 (Apr. 1843): 297-298. [Further arguments on priority on defense from Hunt.]

T129 "The Pencil of Nature. No. I." LITERARY GAZETTE, AND JOURNAL OF THE BELLES LETTRES 28, no. 1432 (June 29, 1844): 410.

T130 "The Pencil of Nature." SPECTATOR no. 838 (July 20, 1844): 685.

T131 "The Pencil of Nature. No. 1." ART-UNION 6, no. 69 (Aug. 1844): 223.

T132 "The Pencil of Nature." LITTELL'S LIVING AGE no. 18 (Sept. 14, 1844): 337. [Bk. rev.: "The Pencil of Nature," by W. H. F. Talbot. From the "Spectator."]

T133 "The Pencil of Nature. No. II" LITERARY GAZETTE, AND JOURNAL OF THE BELLES LETTRES no. 1463 (Feb. 1, 1845): 73.

T134 "'The Pencil of Nature,' by Henry Fox Talbot, F.R.S. Parts I and II. Longman & Co." ATHENAEUM no. 904 (Feb. 22, 1845): 202-203.

T135 "The Pencil of Nature. No. 2." ART UNION 7, no. 78 (Mar. 1845): 84.

T136 "The Pencil of Nature. No. III." LITERARY GAZETTE, AND JOURNAL OF THE BELLES LETTRES no. 1481 (June 7, 1845): 365.

T137 "The Pencil of Nature. No. IV." LITERARY GAZETTE, AND JOURNAL OF THE BELLES LETTRES no. 1488 (July 26, 1845): 500.

T138 "Fine Arts: 'The Pencil of Nature,' by Henry Fox Talbot, Esq, F.R.S. Part III. Longman & Co." ATHENAEUM no. 920 (June 14, 1845): 592-593. [Brief note on p. 771 (Aug. 2, 1845) that part IV had been issued. "...a wonderful illustration of modern necromancy."]

T139 "The Pencil of Nature. No. 3." ART UNION 7, no. 85 (Sept. 1845): 296.

T140 "The Pencil of Nature. No. 4." ART UNION 7, no. 86 (Oct. 1845): 325.

T141 "The Pencil of Nature. No. V." LITERARY GAZETTE, AND JOURNAL OF THE BELLES LETTRES no. 1512 (Jan. 10, 1846): 38-39.

T142 "The Pencil of Nature. No. VI." LITERARY GAZETTE, AND JOURNAL OF THE BELLES-LETTRES no. 1529 (May 9, 1846): 433.

T143 "The Talbotype - Sun Pictures." ART UNION 8, no. 91 (June 1846): frontispiece, 143-144. 1 b & w. [Calotype tipped-in to this issue of the magazine. With a description of the process. (Photograph missing from this issue.)]

T144 "The Application of the Talbotype." ART UNION 8, no. 92 (July 1846): 195.

T145 "The Talbotype: Sun Pictures." LITTELL'S LIVING AGE 10, (July - Sept. 1846): 213-216. [Reprint of article in the "Art Union."]

T146 "Fine Arts - New Publications: "The Pencil of Nature," by H. Fox Talbot, F.R.S. No. 6." ATHENAEUM no. 985 (Sept. 12, 1846): 939.

T147 "Reviews of New Books: 'English Etymologies,' by H. Fox Talbot, Esq." LITERARY GAZETTE, AND JOURNAL OF THE BELLES LETTRES no. 1566 (Jan. 23, 1847): 57-58. [Book review: "English Etymologies," by H. Fox Talbot.]

T148 "Mr. Fox Talbot's English Etymologies. [In Continuation]" LITERARY GAZETTE, AND JOURNAL OF THE BELLES LETTRES no. 1567 (Jan. 30, 1847): 87-89.

T149 "Mr. Talbot's English Etymologies. [Concluded]" LITERARY GAZETTE, AND JOURNAL OF THE BELLES LETTRES no. 1568 (Feb. 6, 1847): 109-111.

T150 "English Etymologies, by H. Fox Talbot." ATHENAEUM no. 1027 (July 3, 1847): 693-695. [Book review.]

T151 "Seventeenth Meeting of the British Association for the Advancement of Science." ATHENAEUM no. 1028 (July 10, 1847): 739-750. [Dr. Carpenter read a paper "On the Application of Photography to Copying Microscopic Objects," on p. 744. Wm H. F. Talbot formally protested a paper published by Blanquart-Evrard in the "Comptes Rendus," claiming that the work was pirated from his own publications, on p. 744.]

T152 "Note." ATHENAEUM no. 1028 (July 10, 1847): 744. [Talbot, at the seventeenth meeting of the British Assoc. for the Advancement of Science, "...rose to protest what he claimed was an act of scientific piracy" by Blanquard-Evrard's paper published at the Acad. of Science, Paris]

T153 Brewster, Sir David. [?] "Photography." NORTH BRITISH REVIEW 7, no. 14 (Aug. 1847 (American Edition.)): 248-269. [Extended state of the art paper based loosely on a review of eight books on photography. One of them is Talbot's "Pencil of Nature."]

T154 "Minor Topics of the Month: Photographic Club." ART-UNION 10, no. 118 (Apr. 1848): 130-131. [Mentions amateurs club formed, mentions Cundall, Owen and makes in indirect illusion to Talbot's refusal to release his patent rights.]

T155 "Annals of the Artists of Spain." ART UNION 10, no. 122 (Aug. 1848): 240. [Review of book, fails to mention any Talbotype illustrations.]

T156 Malone, T. A. "Photography on Paper and on Glass." ART JOURNAL (Aug. 1, 1850): 261. [Mentions Talbot, Daguerre, Hunt, Baron Gros, Blanquart-Evrard, Niépce de Saint-Victor, Cundall and Wheatstone.]

T157 "The Patent of Mr. Fox Talbot." ART JOURNAL (Aug. 1, 1850): 261-262. [Abstract of pamphlet for 'improvements in photography' use of porcelain plates.]

T158 Talbot, William H. F. "Mr. Fox Talbot's Late Improvements in Photography." PHOTOGRAPHIC ART JOURNAL 1, no. 1 (Jan. 1851): 51-52.

T159 Talbot, H. F. "Photogenic Drawing." DAGUERREAN JOURNAL 1, no. 5 (Jan. 15, 1851): 129-138. [From "London Philosophical J. of Science."]

T160 Whitlock, N. "Photographic Drawing Made Easy; A Plain and Practical Introduction to Drawing and Writing by the Action of Light." PHOTOGRAPHIC ART JOURNAL 1, no. 2 (Feb. 1851): 96-101. [Includes synthesis of Talbot's and Herschel's discoveries.]

T161 "Mr. Fox Talbot's Patents in England." PHOTOGRAPHIC ART JOURNAL 1, no. 5 (May 1851): 300-304.

T162 Talbot, H. F. "On the Coloured Rings Produced by Iodine on Silver, with Remarks on the History of Photography." DAGUERREAN JOURNAL 1, no. 12 (May 1, 1851): 357-359. [Dated Dec. 21, 1842. Source not given.]

T163 "Instantaneous Photogenic Images." ATHENAEUM no. 1235 (June 28, 1851): 688.

T164 "Instantaneous Photographic Impressions on Paper." ART JOURNAL (Aug. 1, 1851): 217-218.

T165 "Daguerreotypes by Electric Light." DAGUERREAN JOURNAL 2, no. 6 (Aug. 1, 1851): 178.

T166 Talbot, H. F. "On the production of instantaneous photographic images." ATHENAEUM no. 1258 (Dec. 6, 1851): 1286-1287.

T167 "Photography." ART JOURNAL (Jan. 1852): 23. [Abridged reprint of Talbot's instantaneous method. Plus commentary on other processes.]

T168 Talbot, H.F., Esq. "On the production of instantaneous photographic images." LONDON, EDINBURGH AND DUBLIN PHILOSOPHICAL MAGAZINE AND JOURNAL OF SCIENCE Ser. 4, vol. 3, no. 15 (Jan. 1852): 73-77. [From "Athenaeum." Dec. 6, 1851.]

T169 "Photography." ATHENAEUM no. 1262 (Jan. 3, 1852): 22-23. [Letters from Thomas Woods, Talbot, Robert Hunt, Mr. Thomas Spencer dispute priority to various technical discoveries.]

T170 "Photography." ART JOURNAL (Feb. 1852): 65. [Discusses Talbot's "Amphitype" process, attacks his patents, mentions Archer, Fry.]

T171 Woods, Thomas, M.D. and H. F. Talbot. "Catalysotype and Amphitype." PHOTOGRAPHIC ART JOURNAL 3, no. 4 (Apr. 1852): 242-246. [From "Athenaeum." Exchange of letters between Dr. Woods and Wm. H. F. Talbot about priority of discoveries in 1840s. Followed by two supplementary responding articles, one from the "London Art Journal" and the other, by Robert Ellis, from "La Lumiére."]

T172 Talbot, H. F. "On the Production of Instantaneous Photographic Images." HUMPHREY'S JOURNAL 4, no. 1 (Apr. 15, 1852): 1-4. [From "Foreign Journal."]

T173 "Fox Talbot's Patents - Amphitype Pictures on Glass - Archer's Collodion Process." HUMPHREY'S JOURNAL 4, no. 1 (Apr. 15, 1852): 13-15. [Excerpts from "London Art Journal."]

T174 "Nouvelles du Jour et Photographie." COSMOS 1, no. 7 (June 13, 1852): 143-153. [Section IV, pp. 149-153 is an article responding to Hunt's article on patents in the "Art Journal" giving French version.]

T175 "Photography and Its Patents." PHOTOGRAPHIC ART JOURNAL 4, no. 1 (July 1852): 41-45. [From "London Art-Journal."]

T176 "Photography and Its Patents." HUMPHREY'S JOURNAL 4, no. 6 (July 1, 1852): 84-88. b & w. [Excerpted from the "London Art Journal." A review of Talbot's copyright patents, arguments for canceling them, etc.]

T177 "Whitlock's Application of Photography to the Purposes of Drawing." HUMPHREY'S JOURNAL 4, no. 8 (Aug. 1, 1852): 125-126. [Description of Talbot's photogenic process of 1834.]

T178 "Full text of Lord Eastlake's letter & Talbot's reply printed in 'Photographie.'" COSMOS 1, no. 18 (Aug. 29, 1852): 420-421. [Translated into French, Talbot renouncing copyright.]

T179 "Resignation of the Photographic Patents." ART JOURNAL (Sept. 1, 1852): 270-271. [Exchange of letters between C. L. Eastlake and H. Fox Talbot. Talbot gives up most of his copyright.]

T180 "Chemical Gleanings: Mr. Talbot's Patent." HUMPHREY'S JOURNAL 4, no. 11 (Sept. 15, 1852): 175. ["Talbot has thrown up his patent in England."]

T181 "Reservations made by Mr. Talbot in throwing up his Patent, with remarks upon it." HUMPHREY'S JOURNAL 4, no. 13 (Oct. 15, 1852): 197.

T182 "Talbot and His Process." HUMPHREY'S JOURNAL 4, no. 16 (Dec. 1, 1852): 251-252.

T183 "Photographie: La Chambre noire du voyageur. Lettre de M. Fox Talbot." COSMOS 21, no. 33 (Dec. 11, 1852): 52-54.

T184 "Talbot's Patent in England." HUMPHREY'S JOURNAL 4, no. 22 (Mar. 1, 1853): 350-351. [Letter from Lord Rosse and C. L. Eastlake to Talbot. Talbot's letter of reply, stating his withdrawing of copyright claims.]

T185 Talbot, William H. F. "Gossip." PHOTOGRAPHIC ART JOURNAL 5, no. 4 (Apr. 1853): 252-253. [Exchange of Letters between Talbot and C. F. Eastlake, on the photographic patent right, first printed in the "London Times", August l3, 1852.]

T186 "Photogenic Drawing." HUMPHREY'S JOURNAL 4, no. 24 (Apr. 1, 1853): 381-383. [Includes quotes and excerpts from Talbot's publications in the 1830's.]

T187 Talbot, H. F. "Photographic Engraving." ATHENAEUM no. 1328 (Apr. 9, 1853): 450-451. [Talbot announcing his discoveries in photographic engraving.]

T188 Hunt, Robert. "The Calotype." HUMPHREY'S JOURNAL 5, no. 1 (Apr. 15, 1853): 1-6. [From "Hunt's Photography."]

T189 Talbot, H. F. "Photographic Engraving." ATHENAEUM no. 1329 (Apr. 16, 1853): 481-482. [Additional note on photographic engraving.] Talbot, H. F. "Photographic Engraving." ATHENAEUM no. 1331 (Apr. 30, 1853): 532-533. [Long report on process.]

T190 Talbot, W. F. "Photographic Engraving." HUMPHREY'S JOURNAL 5, no. 2/3 (May 1 - May 15, 1853): 34-36. [From the "Athenaeum."]

T191 "Engraving Photographs on Steel." ILLUSTRATED LONDON NEWS 22, no. 620 (May 7, 1853): 359. [Brief note of Talbot's announcement of his discovery of a photoengraving process.]

T192 "Photographie." COSMOS 2, (May 8, 1853): 560-568. [Paper from Talbot to M. Biot presented at the Academie, Paris reprinted, then several pages of commentary upon Talbot's claims to priority.]

T193 Talbot, H. F. "Photographic Engraving." HUMPHREY'S JOURNAL 5, no. 4 (June 1, 1853): 49-52. [From the "Athenaeum," no. 1331.]

T194 "Fine-Art Gossip." ATHENAEUM no. 1337 (June 11, 1853): 711. ["Specimens of prints taken from plates engraved directly by the sun."]

T195 Talbot, William H. F. "Photographic Engraving." PHOTOGRAPHIC ART JOURNAL 6, no. 1 (July 1853): 54-56. [From "J. of Photo Soc."]

T196 "Daguerreotype on Porcelain." HUMPHREY'S JOURNAL 5, no. 12 (Oct. 1, 1853): 187-189. [From "Hunt's Manual of Photography."]

T197 NOTES AND QUERIES no. 222-274 (Jan. 28, 1854 - Jan. 27, 1855) [Letters, comments, and news notes about the issues around Talbot's patent restrictions, the challenges to that copyright, Rev. Reade's claims to priority, the Talbot/Laroche trial, and Talbot's final release of the patent appear in this journal throughout 1854 to 1855. See: no. 222 (Jan 28, 1854): 83; no. 240 (June 3, 1854): 524-525, 526; no. 243 (June 24, 1854): 598-599; no. 244 (July 1, 1854): 15; no. 245 (July 8, 1854): 34-36; no. 255 (Sept. 16, 1854): 230-231; no. 270 (Dec. 30, 1854): 528-530; no. 271 (Jan. 6, 1855): 16; no. 274 (Jan. 27, 1855): 71. "We are glad to hear that the questio vexata which has so long agitated the photographic world, is at length at rest."]

T198 "The Photographic Patents." ART JOURNAL (Aug. 1, 1854): 236-238.

T199 Humphrey, S. D. "Editorial, Talbot's Patent." HUMPHREY'S JOURNAL 6, no. 9 (Aug. 15, 1854): 137. [Argument against Talbot's patent.]

T200 "The Photographic Patents." PHOTOGRAPHIC AND FINE ART JOURNAL 7, no. 9 (Sept. 1854): 277-278. [Listing of inventions, Talbot's claims, and various challenges -from 1802 to the present- in England.]

T201 "The Photographic Patents." HUMPHREY'S JOURNAL 6, no. 10 (Sept. 1, 1854): 155-159. [From "London Art Journal." Includes a survey of early discoveries from Wedgewood, Niépce, Herschel, Talbot, etc.]

T202 "Mr. Fox Talbot's Patents." HUMPHREY'S JOURNAL 6, no. 11 (Sept. 15, 1854): 162-165, 168. [From "Notes and Queries." Court depositions from Sir David Brewster and Sir John F. W. Herschell that Talbot was inventor of photography, other letters around the various lawsuits.]

T203 "Photographic Society: Extraordinary Meeting - Thursday, July 6, 1854." HUMPHREY'S JOURNAL 6, no. 11 (Sept. 15, 1854): 172-173. [From "J. of Photo. Soc., London." Minutes of the meeting, including a resolution adopted by the Society to send to Talbot protesting his holding and renewing his copyright.]

T204 Newton, Wm. J. "Talbot's Patent." HUMPHREY'S JOURNAL 6, no. 13 (Oct. 15, 1854): 193-194. [From "J. of Photo. Soc., London." Additional letter on the subject on p. 206.]

T205 "Photographie." COSMOS 3, (Dec. 5, 1854): 653-654. [Report and commentary on article in "Art Journal" discussing Talbot's defense of his copyright against Laroche.]

T206 "Photography." JOURNAL OF THE SOCIETY OF ARTS (EDINBURGH) 3, no. 110 (Dec. 29, 1854): 100-101. [Report of Talbot/Laroche trial.]

T207 "Photographie." COSMOS 6 , (Jan. 5, 1855): 17-18. [Report of Talbot-Laroche trial, with some transcript of the decision.]

T208 "The Talbot Patent." PHOTOGRAPHIC AND FINE ART JOURNAL 8, no. 2 (Feb. 1855): 37-38. [Test of lawsuit between Talbot and Laroche, from "London Times."]

T209 "Law Reports in Patents: Photography - Talbot v. Laroche - Infringement." PRACTICAL MECHANIC'S JOURNAL 7, no. 83 (Feb. 1855): 261-262. [Includes a summation of early discoveries.]

T210 "The Photographic Patent Right: Talbot v. Laroche." ART JOURNAL (Feb. 1, 1855): 49-54. [Detailed transcript of the trial.]

T211 "The Photographic Patent Right: Talbot vs. Laroche." PHOTOGRAPHIC AND FINE ART JOURNAL 8, no. 4 (Apr. 1855): 101-110. [From "London Art J."]

T212 Thornthwaite, W. H. "Correspondence: Talbot v. Laroche." ART JOURNAL (Apr. 1, 1855): 127. [Letter from W.H. Thornthwaite, hon. sec. of the Defense Fund.]

T213 "Fox Talbot v. Laroche." PHOTOGRAPHIC AND FINE ART JOURNAL 8, no. 8 (Aug. 1855): 234. [From "J. of Photo. Soc., London."]

T214 Newton, W. J. "Inventor of the Paper Process." PHOTOGRAPHIC AND FINE ART JOURNAL 10, no. 3 (Mar. 1857): 95. [From "J. of Photo. Soc., London." Newton's letter restates Talbot's priority over Blanquart-Évrard.]

T215 "Specifications of Mr. Fox Talbot's Calotype Patent." PHOTOGRAPHIC AND FINE ART JOURNAL 10, no. 7 (July 1857): 208-210. [From "Liverpool Photo. J."]

T216 "The Calotype or Talbotype." PHOTOGRAPHIC AND FINE ART JOURNAL 10, no. 10 (Oct. 1857): 311-314. [From "Liverpool Photo. J." Apparently the introduction to Talbot's "Pencil of Nature" is repeated here.]

T217 Talbot, H. F. "The History of Photography. The Calotype or Talbotype. Parts 1 - 2." HUMPHREY'S JOURNAL 9, no. 13-14 (Nov. 1 - Nov. 15, 1857): 193-195, 209-211. [Extended quotes from the introduction to the "Pencil of Nature," reprinted from the "Liverpool Photo. J."]

T218 "History of Photography. - Photographic Engraving." PHOTOGRAPHIC AND FINE ART JOURNAL 10, no. 12 (Dec. 1857): 356-357. [From "Liverpool Art J.," in turn reprinting Apr. 1853 letter to "Athenaeum."]

T219 M. "Amateur's Column." LIVERPOOL & MANCHESTER PHOTOGRAPHIC JOURNAL [BRITISH JOURNAL OF PHOTOGRAPHY] n. s. 2, no. 2 (Jan. 15, 1858): 23-24. [Describes printing the photos for Talbot's "Pencil of Nature," etc. Henneman mentioned.]

T220 "The 'Pencil of Nature' Process of Mr. Fox Talbot." PHOTOGRAPHIC AND FINE ART JOURNAL 11, no. 2-3 (Feb. - Mar. 1858): 54-55, 94. [From the "Liverpool Photographic J."]

T221 "Mr. Fox Talbot's new discovery: photoglyptic engraving." PHOTOGRAPHIC NEWS 1 , no. 3 (Sept. 24, 1858): 25-26.

T222 "Description of Mr. Fox Talbot's new process of photoglyptic engraving." PHOTOGRAPHIC NEWS 1, no. 7 (Oct. 22, 1858): 73-75. [Historical sketch of photoglyptic engraving p. 75.]

T223 "Photoglyptic Engraving." JOURNAL OF THE SOCIETY OF ARTS (EDINBURGH) 6, no. 310 (Oct. 29, 1858): 697-698.

T224 "Photo-Glyphic Engraving. New Process of William H. Fox Talbot, Esq., of Lacock Abbey, Wiltshire." PHOTOGRAPHIC AND FINE ART JOURNAL 11, no. 11 (Nov. 1858): 333-336. [Text of the patent application.]

T225 "Specifications of Mr. Fox Talbot's New Process of Photoglypic Engraving." LIVERPOOL & MANCHESTER PHOTOGRAPHIC JOURNAL [BRITISH JOURNAL OF PHOTOGRAPHY] n. s. 2, no. 21 (Nov. 1, 1858): 269-271. [Additional commentary on p. 262.]

T226 "Specification of the Patent Granted to William Henry Fox Talbot... for Improvements to the Art of Engraving." JOURNAL OF THE PHOTOGRAPHIC SOCIETY OF LONDON 5, no. 72 (Nov. 6, 1858): 58-61.

T227 "Specification of Mr. Fox Talbot's New Process of Photoglyphic Engraving." AMERICAN JOURNAL OF PHOTOGRAPHY AND THE ALLIED ARTS AND SCIENCES n. s. vol. 1, no. 13 (Dec. 1, 1858): 200-206. [Verbatim report.]

T228 "Editorial Melange: Photographic Engraving." BALLOU'S PICTORIAL DRAWING-ROOM COMPANION [GLEASON'S] 16, no. 395 (Jan. 15, 1859): 47. ["Photographic Engraving - Mr. Fox Talbot, inventor of the well known 'paper process' of photography, has just been inventing a new process of engraving by light on plates of copper, steel, or zinc."]

T229 R. H. [Hunt, Robert?]. "Photographic Engraving." ART JOURNAL (Feb. 1859): 46.

T230 Hunt, Robert. "Photoglyphic Engraving." ART JOURNAL (Feb. 1, 1859): 46. [Reprint of Talbot's process, with commentary.]

T231 "1 photo (Photoglyptic engraving)." PHOTOGRAPHIC NEWS 3, no. 54 (Sept. 16, 1859): frontispiece, 13-14. 1 b & w. [Commentary, history of the discovery of the photoglyptic engraving technique on pp. 13-14.]

T232 Mathiot, Geo. "Mr. Talbot's recent Patent for Improvement in Photoglyptic Engraving, not Original." HUMPHREY'S JOURNAL OF PHOTOGRAPHY, AND THE ALLIED ARTS AND SCIENCES 11, no. 15 (Dec. 1, 1859): 225-226.

T233 "Photographic Engraving: Letter from A Member of the Photographic Society." PHOTOGRAPHIC NEWS 3, no. 70 (Jan. 6, 1860): 210-211. [Letter attacking a Mr. Beatty, defending Talbot.]

T234 Photography as Employed for the Illustration of Books. ART JOURNAL (Feb. 1861): 48. [Talbot's "Pencil of Nature," Prof. Piazzi Smyth's "Work on Teneriffe, "Ramble in Brittany" "Stereoscopic Magazine," "Sunshine in the Country" by Mr. Grundy.]

T235 "Waifs and Strays." BRITISH JOURNAL OF PHOTOGRAPHY 10, no. 188 (Apr. 15, 1863): 173. [Talbot awarded honorary DD.L. degree from Edinburgh University. Text of Prof. Muirhead's award speech presented in this issue of this regular column of news, etc.]

T236 "A Reward for Photographic Discovery." AMERICAN JOURNAL OF PHOTOGRAPHY AND THE ALLIED ARTS & SCIENCES n. s. vol. 5, no. 23 (June 1, 1863): 534-535. [From "Edinburgh Scotsman." Talbot awarded a Ph.D. at Edinburgh University on Apr. 1, 1863. Award speech, by Prof. Muirhead, reprinted here.]

T237 "Letters." JOURNAL OF THE PHOTOGRAPHIC SOCIETY OF LONDON. 8, no. 141 (Jan. 15, 1864): 430-431. [Two letters by Talbot about a photograph of a breakfast table that Talbot took in 1841 or 1842, in response to query.]

T238 "The First Use of Bromine in Photography." BRITISH JOURNAL OF PHOTOGRAPHY 11, no. 212 (Apr. 15, 1864): 127-128. [Letters from Talbot and Biot.]

T239 "Sketches of Eminent Photographers: William Henry Fox Talbot." BRITISH JOURNAL OF PHOTOGRAPHY. 11, no. 217, 219, 222, 224, 227, 233 (July 1, July 15, Aug. 5, Aug. 19, Sept. 9, Oct. 21, 1864): 220-221, 242-243, 278-279, 303, 340-341, 412-413. 1 illus. [Portrait.]

T240 "Ancient Photography. Part 1." PHILADELPHIA PHOTOGRAPHER 3, no. 32 (Aug. 1866): 248-250. [Extracts from Talbot's articles on Daguerre.]

T241 Heath, Vernon. "Correspondence: Mr. Fox Talbot and the Bichromate process." PHOTOGRAPHIC NEWS 21, no. 968 (Mar. 23, 1877): 142. [Letter.]

T242 "Photography In and Out of the Studio: Honor from Abroad to Fox Talbot." PHOTOGRAPHIC NEWS 21, no. 975 (May 11, 1877): 217. [Note: Verein fur Gliverbefleiss, Berlin elects Talbot Honorary member.]

T243 "The Discoverer of Talbotype." PHOTOGRAPHIC NEWS 21, no. 995 (Sept. 28, 1877): 459. [Obituary reprinted from "The Times."]

T244 "William Henry Fox Talbot. F.R.S." PHOTOGRAPHIC NEWS 21, no. 995 (Sept. 28, 1877): 462-463. [Obituary.]

T245 "Obituary: William Henry Fox Talbot." ANTHONY'S PHOTOGRAPHIC BULLETIN 8, no. 10 (Oct. 1877): 308. [Brief note that Talbot died.]

T246 "Obituary: William Henry Fox Talbot." PHILADELPHIA PHOTOGRAPHER 14, no. 166 (Oct. 1877): 311. [Note that W. H. F. Talbot died, with brief summary of his life.]

T247 "The Late W. H. Fox Talbot." PHOTOGRAPHIC NEWS 21, no. 996 (Oct. 5, 1877): 471-472. [Obituary notices from "The Athenaeum" and from the "Standard."]

T248 Lacan, Ernest. "French Correspondence: Fox Talbot." PHOTOGRAPHIC NEWS 21, no. 997 (Oct. 12, 1877): 487. [Testimonial note by Lacan.]

T249 "Fox Talbot." NATURE 16, no. 416 (Oct. 18, 1877): 523-525.

T250 "The Late H. Fox Talbot." PHOTOGRAPHIC NEWS 21, no. 999 (Oct. 26, 1877): 507-509. [Obituary notice from "Nature."]

T251 "The Late W. H. Fox Talbot." PHILADELPHIA PHOTOGRAPHER 14, no. 167 (Nov. 1877): 321-325. [From "Br J of Photo.," Sept. 28." Obituary. Brief additional note by E. L. Wilson on p.352, in "Editor's Table."]

T252 "William Henry Fox Talbot, F.R.S." PHOTOGRAPHIC TIMES 7, no. 83 (Nov. 1877): 246-248. [Obituary. Reprinted from the "Photographic News."]

T253 "The Discoverer of the Talbotype." PHOTOGRAPHIC TIMES 7, no. 83 (Nov. 1877): 248-250. [Reprinted from "The Times."]

T254 "Obituary: William H. Fox Talbot, F.R.S." ART JOURNAL (Dec. 1877): 367.

T255 Wenderoth, F. A. "Honor To Whom Honor is Due." PHILADELPHIA PHOTOGRAPHER 14, no. 168 (Dec. 1877): 356-357. [Wenderoth states that a photographic halftone process claimed by J. J. Rodriquez, of the Belgian Photographic Assoc. (see p.327) actually published by W. H. Fox Talbot 25 years earlier in 1852.]

T256 Cull, Richard., F.S.A. "A Biographical Notice of the Late William Henry Fox Talbot, F.R.S." TRANSACTIONS OF THE SOCIETY OF BIBLICAL ARCHAEOLOGY. 6, (1878): 543-559. [Read before the Society Apr. 2, 1878. This article contains a bibliography of over fifty references to Talbot's articles and notes on his language and biblical studies, published between 1856 and 1878.]

T257 Taylor, J. Traill. "Home and Foreign News Epitomized." PHOTOGRAPHIC TIMES 11, no. 124 (Apr. 1881): 129-130. [Taylor uses the occasion of the publishing of a portrait of Talbot in the "Photographic News" to reminisce on his meeting in 1862 and eventual friendship with Talbot.]

T258 Taylor, J. Traill. "Editorial Mirror." PHOTOGRAPHIC TIMES 15, no. 216 (Nov. 6, 1885): 623. [Mentions Wm. H. F. Talbot's "Pencil of Nature," claims to own a copy. Quotes Talbot. Discusses calotype paper negatives, new paper negatives being experimented with at this time.]

T259 Harrison, W. Jerome. "The Chemistry of Fixing." PHOTOGRAPHIC TIMES 20, no. 471 (Sept. 26, 1890): 481-402. [Talbot.]

T260 Sherman, W. H. "Photographers, Don't Forget the Founder of Your Art." PHOTOGRAPHIC MOSAICS: 1891 27, (1891): 250-252.

T261 Harrison, W. Jerome. "The Toning of Photographs Considered Chemically, Historically, and Generally. Chapter 2. Talbot and Hunt on the Toning of Paper Prints." PHOTOGRAPHIC TIMES 21, no. 499 (Apr. 10, 1891): 171-173. [Discusses processes of Talbot and Hunt.]

T262 Lang, William, Jr., F.C.S. "Early Talbotypes and Where to Find Them." AMERICAN ANNUAL OF PHOTOGRAPHY AND PHOTOGRAPHIC TIMES ALMANAC FOR 1892 (1892): 73-74. [Mentions that Talbot furnished talbotypes to the July 1846 issue of the "Art Union Monthly Journal."]

T263 "An Old Instantaneous Albumen Process." WILSON'S PHOTOGRAPHIC MAGAZINE 35, no. 499 (July 1898): 317-318. [Details of Talbot's 1851 process, reprinted from "Photography."]

T264 Brown, George. "Enquiry into the Early History of Photography - A Sketch of the Life of W. H. Fox Talbot Specially in Reference to Photography." PHOTOGRAPHIC TIMES 32, no. 7-9 (July - Sept. 1900): 297-302, 355-360, 400-403. illus.

T265 Epstean, Edward. "William Henry Fox Talbot." PHOTO-ENGRAVERS BULLETIN 23, no. 11 (June 1934): 14-37. [Contains a bibliography.]

T266 "The Fox Talbot Centenary: Commemoration at Lacock Abbey." PHOTOGRAPHIC JOURNAL 74, no. 8 (Aug. 1934): 427. 1 b & w.

T267 Clark-Maxwell, Prebendary W. G. "The Personality of Fox Talbot." PHOTOGRAPHIC JOURNAL 74, no. 8 (Aug. 1934): 428-430. 2 b & w.

T268 Lambert, Herbert. "Fox Talbot's Photographic Inventions." PHOTOGRAPHIC JOURNAL 74, no. 8 (Aug. 1934): 430-432. 2 b & w.

T269 Bull, A. J., M.Sc., F. Inst. P., F.R.P.S. "Fox Talbot's Photoglyphic Engraving." PHOTOGRAPHIC JOURNAL 74, no. 8 (Aug. 1934): 432-433, 435.

T270 Bull, A. J. and H. Mills Cartwright. "Fox Talbot's Pioneer Work in Photo-Engraving." PHOTOGRAPHIC JOURNAL 77, no. 5 (May 1937): 307-313. 13 b & w.

T271 Talbot, Miss. M. T. "The Life and Personality of Fox Talbot." JOURNAL OF THE ROYAL SOCIETY OF ARTS 87, no. 4517 (June 23, 1939): 826-830. 3 b & w. [This essay also published in "Photographic Journal" (Sept. 1939).]

T272 Talbot, Miss M. T. "The Live and Personality of Fox Talbot." PHOTOGRAPHIC JOURNAL 79, no. 9 (Sept. 1939): 546-549. 2 b & w.

T273 Johnston, J. Dudley. "Sidelight on Fox Talbot." PHOTOGRAPHIC JOURNAL 81, no. 1 (Jan. 1941): 24-26.

T274 Johnston, J. Dudley, Hon. F.R.P.S. "William Henry Fox Talbot, F.R.S.: Materials Towards a Biography." PHOTOGRAPHIC JOURNAL 87, no. 1 (Jan. 1947): 3-13. 7 illus.

T275 White, Harold. "William Henry Fox Talbot, The First Miniaturist." PHOTOGRAPHIC JOURNAL 89, no. 11 (Nov. 1949): 247-251. 3 b & w. 2 illus.

T276 "A Talbot Letter." IMAGE 1, no. 2 (Feb. 1952): 3.

T277 "Index to Resources: William Henry Fox Talbot." IMAGE 7, no. 1 (Jan. 1958): 20-21. 1 b & w. 4 illus. [Talbot's cameras.]

T278 "Index to Resources: Publications - William H. Fox Talbot." IMAGE 7, no. 2 (Feb. 1958): 44-45. 3 illus. [Continuing series on George Eastman House Collection; documents pertaining to William Henry Fox Talbot.]

T279 "Index to Resources: Photographs by Fox Talbot." IMAGE 7, no. 3 (Mar. 1958): 68-69. 9 b & w. [Continuing series on George Eastman House Collection; photographs by Talbot.]

T280 "Index to Resources: Henry Fox Talbot." IMAGE 7, no. 4 (Apr. 1958): 94-95. 8 b & w. [Photographs by William Henry Fox Talbot.]

T281 Newhall, Beaumont. "Editorial: Prophetic Pioneer." IMAGE 8, no. 2 (June 1959): 58-59. [Introduction to the issue, devoted to W. H. F. Talbot.]

T282 Newhall, Beaumont. "William Henry Fox Talbot, 1800 - 1877." IMAGE 8, no. 2 (June 1959): 60-75. 4 b & w. 6 illus.

T283 Newhall, Beaumont. "Notes on the Publication of 'The Pencil of Nature'." IMAGE 8, no. 2 (June 1959): 75-105. 24 b & w. [History of the 'Pencil of Nature.' on pp. 75-76, then photographic reproduction of the entire book.]

T284 Gernsheim, Helmut. "Talbot's and Herschel's Photographic Experiments in 1839." IMAGE 8, no. 3 (Sept. 1959): 132-137. 2 b & w. [Talbot (2), plus exchange of letters.]

T285 Ostroff, Eugene. "Restoration of Photographs by Neutron Activation." SCIENCE 154, no. 3745 (Oct. 7, 1966): 119-123. 3 b & w. 3 illus. [Discussion of restoring several faded photographs by Talbot.]

T286 Ostroff, Eugene. "Talbot's Earliest Extant Print, June 20, 1935, Rediscovered." PHOTOGRAPHIC SCIENCE AND ENGINEERING 10, no. 6 (Nov. - Dec. 1966): 350-354. 1 b & w. 6 illus.

T287 Caminos, Ricardo A. "The Talbotype Applied to Hieroglyphics." JOURNAL OF EGYPTIAN ARCHEOLOGY 52, (Dec. 1966): 65-70. 3 illus.

T288 Thomas, David. "The Pencil of Nature." MUSEUMS JOURNAL 69, no. 2 (Sept. 1969): 78-79. [Bk. rev.: 'The Pencil of Nature,' by William Henry Fox Talbot. With an introduction by Beaumont Newhall.]

T289 Wood, Rupert Derek. "The Involvement of Sir John Herschel in the Photographic Patent Case, Talbot v. Henderson, 1854." ANNALS OF SCIENCE 27, no. 3 (Sept. 1971): 239-264. 3 illus.

T290 Gill, A. T. "Call Back Yesterday: William H. Fox Talbot." PHOTOGRAPHIC JOURNAL 112, no. 11 (Nov. 1972): 352-354. 2 illus. [Talbot's first experiments with silver nitrate solutions discussed.]

T291 Gill, A. T. "Call Back Yesterday: Photogenic Drawing." PHOTOGRAPHIC JOURNAL 113, no. 1 (Jan. 1973): 25, 47-48. 2 illus. [Early experiments, with small wooden pinhole cameras, Talbot's lecture to the Royal Society in 1839.]

T292 Baldwin, C. R. "In Search of 'Sun Pictures.'" ARTFORUM 12, no. 5 (Jan. 1974): 54-56. 5 b & w. [Ex. rev.: 'William H. F. Talbot,' Scott Elliot Gallery, NY.]

T293 Gill, A. T. "Call Back Yesterday: Calotype." PHOTOGRAPHIC JOURNAL 114, no. 6 (June 1974): 308-309. 3 b & w. [Talbot's development of the calotype process in 1840, discovery of the latent image.]

T294 Gill, A. T. "Call Back Yesterday: Calotype Part 2." PHOTOGRAPHIC JOURNAL 114, no. 9 (Sept. 1974): 466-467. 4 b & w. [Talbot's improvements with the calotype process from 1841 to ca. 1845.]

T295 Gill, A. T. "Call Back Yesterday: The Reading Establishment." PHOTOGRAPHIC JOURNAL 114, no. 12 (Dec. 1974): 610-611. 2 illus. [Discussion of the calotype printing plant that Talbot set up in Reading, England, then placed under Nicholas Henneman's direction.]

T296 Gill, A. T. "Call Back Yesterday: A Fox Talbot Museum at Lacock." PHOTOGRAPHIC JOURNAL 115, no. 1 (Jan. 1975): 30-31. 3 illus.

T297 Gill, A. T. "Call Back Yesterday: 'The Pencil of Nature' by H. Fox Talbot, F.R.S." PHOTOGRAPHIC JOURNAL 115, no. 2 (Feb. 1975): 81, 83. 4 illus. [Discussion of the printing history of 'The Pencil of Nature.']

T298 Gill, A. T. "Call Back Yesterday: The Sun Pictures Themselves." PHOTOGRAPHIC JOURNAL 115, no. 4 (Apr. 1975): 180-181. 2 illus. [Discussion of the prints in "The Pencil of Nature."]

T299 Gill, A. T. "Call Back Yesterday: Calotype Correspondence." PHOTOGRAPHIC JOURNAL 115, no. 6 (June 1975): 284-285. 3 illus.

T300 Lassam, Robert. "Fox Talbot: New Horizons." PHOTOGRAPHIC JOURNAL 115, no. 7 (July 1975): 300-302. 4 illus.

T301 Gill, A. T. "Call Back Yesterday: Portraits of Fox Talbot." PHOTOGRAPHIC JOURNAL 115, no. 7 (July 1975): 303-305. 5 b & w.

T302 Adam, Hans Christian. "Fox Talbot pre-1840 Photos found in Goettingen, West Germany." PHOTOGRAPHICA 7, no. 7 (Aug. - Sept. 1975): 1, 5. 5 b & w. [Some of Talbot's early calotypes found in the Niedersaechsische Staats und Universitatsbibliothek, Goettingen, West Germany.]

T303 Gill, A. T. "Call Back Yesterday: Record of C. M. W." PHOTOGRAPHIC JOURNAL 115, no. 10 (Oct. 1975): 490-491. 2 illus. [Talbot's photograph of the marble portrait bust of Catherine Walber, used in the privately published memorial booklet, "Record of the Deathbed of C. M. W.", published before the "Pencil of Nature."]

T304 "The Fox Talbot Museum, Lacock." ARTS REVIEW 28, no. 4 (Feb. 20, 1976) 2 illus. [Describes newly opened Fox Talbot Museum.]

T305 Gill, A. T. "Call Back Yesterday: More Sun Pictures." PHOTOGRAPHIC JOURNAL 116, no. 3 (May - June 1976): 170-171. 4 b & w. [Describes "Sun Pictures of Scotland," published by Talbot in 1845.]

T306 "Sun Pictures: The Work of William Henry Fox Talbot 1800 - 1877." CAMERA (LUCERNE) 55, no. 9 (Sept. 1976): 1-42. 41 b & w. 5 illus. [Special issue. "William H. F. Talbot. The Unseen, Unknown, Artistic Merits of an Inventor," by Allan Porter, on p. 1; "The Invention of Photography with Paper Negatives and Paper Positives with Physical Development by Talbot," by Josef Maria Eder, on pp. 2-4; "Talbot's Life and Work," on p. 4; "Fox Talbot, a Brief Biography," by R. E. Lassam, on p. 21; "'Sun Pictures' Modern Preparation," by Brian Coe, on pp. 22-23; "The Fox Talbot Collection, National Science Museum," by John Ward, on pp. 23-24; "Note," by Dr. Karl Steinorth, on p. 24; "List of Illustrations," on p. 41; "Fox Talbot - Bibliography," on p. 41.]

T307 Coe, Brian W. "Sun Pictures: Printing Talbot's Calotype Negatives." HISTORY OF PHOTOGRAPHY 1, no. 3 (July 1977): 175-182. 3 b & w. 7 illus.

T308 Winter, G. "Fox Talbot, The Overlooked Genius: Centenary Exhibitions at Lacock and in London." COUNTRY LIFE 162, no. 4185 (Sept. 15, 1977): 674-675. 6 b & w.

T309 Lassam, Robert. "William Henry Fox Talbot." HISTORY OF PHOTOGRAPHY 1, no. 4 (Oct. 1977): frontispiece. 1 illus. [Watercolor of Talbot, printed in 1803 when Talbot was three years old.]

T310 Lassam, Robert. "The Fox Talbot Museum." HISTORY OF PHOTOGRAPHY 1, no. 4 (Oct. 1977): 297-300. 6 illus.

T311 Ward, J. P. "The Fox Talbot Collection at the Science Museum." HISTORY OF PHOTOGRAPHY 1, no. 4 (Oct. 1977): 275-287. 10 b & w. 2 illus.

T312 Gill, Arthur. "Fox Talbot's Photoglyptic Engraving Process." HISTORY OF PHOTOGRAPHY 2, no. 2 (Apr. 1978): 134. 1 b & w. [Illus. by A. Claudet.]

T313 White, H. "W. H. Fox Talbot and Photo-Engraving." PHOTOGRAPHIC JOURNAL 118, no. 4 (July - Aug. 1978): 163. 2 illus.

T314 Buckland, Gail. "Another Fox Talbot." EXPOSURE 16, no. 3 (Fall 1978): 30-37. 11 b & w.

T315 Buckland, Gail. "William Henry Fox Talbot: The True Inventor of Photography." AMERICAN PHOTOGRAPHER 2, no. 1 (Jan. 1979): 42-49. 11 b & w. 1 illus.

T316 Schaaf, Larry J. "The First Photographically Printed and Illustrated Book." THE PAPERS OF THE BIBLIOGRAPHIC SOCIETY OF AMERICA 73, (Second Quarter, 1979): 209-224.

T317 Schaaf, Larry. "Herschel, Talbot and Photography: Spring 1831 and Spring 1839." HISTORY OF PHOTOGRAPHY 4, no. 3 (July 1980): 181-204. 6 b & w. 13 illus. [Discussion and reproduction of early correspondence between Talbot and Herschel on "photographic" matters.]

T318 Gosser, H. Mark. "Further Notes on Herschel and Talbot: the term 'Photography'." HISTORY OF PHOTOGRAPHY 5, no. 3 (July 1981): 269.

T319 Schaaf, Larry. "Further Notes on Herschel and Talbot: the term 'Photography': Correspondence." HISTORY OF PHOTOGRAPHY 5, no. 3 (July 1981): 269-270.

T320 Keeler, Nancy B. "Illustrating the 'Reports by the Juries' of the Great Exhibition of 185l; Talbot, Henneman, and their Failed Commission." HISTORY OF PHOTOGRAPHY 6, no. 3 (July 1982): 257-272. 8 b & w. 6 illus.

T321 Lanyon, Andrew. "The First Cornish Photographs?" HISTORY OF PHOTOGRAPHY 8, no. 4 (Oct. - Dec. 1984): 333-336. 4 b & w. [Calotypes by William H. Fox Talbot and Robert Hunt in early 1840s.]

T322 Tooming, Peeter. "Original Talbot Photographs in Estonia." HISTORY OF PHOTOGRAPHY 9, no. 2 (Apr. - June 1985): 162-167. 12 b & w. 3 illus.

T323 Harley, Joanna Lingren. "Talbot's Plan for a Photographic Expedition to Kenilworth." HISTORY OF PHOTOGRAPHY 12, no. 3 (July - Sept. 1988): 223-225.

T324 Kraus, Hans P., Jr. "The Beginnings of Photographic Book Illustration." BOOKMAN'S WEEKLY 82, no. 18 (Oct. 31, 1988): 1657-1664. 2 b & w. 2 illus. [Discusses Talbot's "The Pencil of Nature" in detail, mentions other early works.]

TALFOR.
T325 "The Yachting Season of 1871. - The New Yacht 'Wanderer,' Built for Mr. Lorillard, of the New York Yacht Club. - From a Photograph by Talfor." FRANK LESLIE'S ILLUSTRATED NEWSPAPER 32, no. 812 (Apr. 22, 1871): 92. 1 illus.

TALLMAN, CHARLES W. (b. 1833) (USA)
T326 "Prize Print Hints." PHILADELPHIA PHOTOGRAPHER 15, no. 171 (Mar. 1878): 65-68. [Competitor in the "Phila. Photo." Gold Medal Prize, describing his working methods, etc.]

TANNER, HENRY CHARLES BASKERVILLE, LIEUT. see HOUGHTON & TANNER.

TANNER, ROBERT.
T327 "Tanner's Wet Paper Process." PHOTOGRAPHIC AND FINE ART JOURNAL 10, no. 11 (Nov. 1857): 345-346. [From "Liverpool Photo. J." Tanner's modifications to Talbot's calotype patent, reused by Blanquart-Evrard, led to controversy of priority.]

T328 "Tanner's Wet-Paper Process." HUMPHREY'S JOURNAL 9, no. 14 (Nov. 15, 1857): 220-221. [From "Liverpool Photo. J." Robert Tanner, living on the Continent when Talbot's process appeared, was successful at adapting the process to German and French papers. Later taught the process to Blanquart-Evrard, who apparently claimed it to be his own invention. This process faster then Talbot's, allowing for portraiture.]

TATUM.
T329 "Tatum's Patent Oil-Ground Photographs." HUMPHREY'S JOURNAL OF PHOTOGRAPHY, AND THE ALLIED ARTS AND SCIENCES 17, no. 19 (Feb. 1, 1866): 303-304. ["A process by which any likeness may be taken on canvas of all sizes, either from a Daguerreotype, Ambrotype, or Photograph; or from life itself."]

TAUNT, HENRY WILLIAM. (1842-1922) (GREAT BRITAIN)
T330 Taunt, Henry William. *A New Map of the River Thames from Oxford to London.* Illustrated with Eighty Photographs. "2nd ed., corr." Oxford: Taunt & Co., 1873. vi, 79 pp. 24 l. of plates. 80 b & w. [Original photos.]

T331 Taunt, Henry William. *A New Map of the River Thames from Thames Head to London.* Oxford: Taunt & Co., 1873. 216 pp. 100 b & w. [2nd ed. (1886) 220 p. 100 Woodburytypes tipped-in to illustrate the maps.]

T332 Graham, M. *Henry Taunt of Oxford: A Victorian Photographer.* Oxford, England: Oxford Illustrated Press, 1973. 78 pp. 120 b & w.

T333 Brown, Bryan, ed. *The England of Henry Taunt, Victorian Photographer; His Thames, His Oxford, His Home Counties and Travels, His Portraits, Times and Ephemera.* London: Routledge & Kegan Paul, 1973. xviii, 142 pp. 226 b & w.

TAYLOR & BROWN see also WENDEROTH, TAYLOR & BROWN.

TAYLOR & BROWN. (PHILADELPHIA, PA)
T334 "Philadelphia. - Opening of the New Masonic Temple, N. E. Corner of Broad and Filbert Streets. - Photographed by Taylor & Brown, Philadelphia." FRANK LESLIE'S ILLUSTRATED NEWSPAPER 37, no. 940 (Oct. 4, 1873): 49. 1 illus. [View.]

T335 Portrait. Woodcut engraving, credited "From a Photograph by Taylor & Brown, Philadelphia. FRANK LESLIE'S ILLUSTRATED NEWSPAPER 41, (1876) ["Mrs. E. D. Gillespie, Pres. of the Women's Centennial Executive Committee." 41:1064 (Feb. 19, 1875): 381.]

T336 Portrait. Woodcut engraving, credited "From a Photograph by Taylor & Brown, Philadelphia. FRANK LESLIE'S ILLUSTRATED NEWSPAPER 40, (1875) ["The late Horace Binney." 40:1040 (Sept. 4, 1875): 448.]

T337 Portrait. Woodcut engraving, credited "From a Photograph by Taylor & Brown, Philadelphia. FRANK LESLIE'S ILLUSTRATED NEWSPAPER 41, (1875) ["Hon. Cyrus L. Pershing, of PA." 41:1045 (Oct. 9, 1875): 76. "Hon. Victor E. Piglett, of PA." 41:1045 (Oct. 9, 1875): 76.]

T338 Portrait. Woodcut engraving, credited "From a Photograph by Taylor & Brown." FRANK LESLIE'S ILLUSTRATED NEWSPAPER 41, (1875) ["Sir George Ferguson Bowen, Gov. of Australia." 41:1053 (Dec. 4, 1875): 201.]

TAYLOR & HUNTINGTON.
T339 Ryder, Richard C. "Personalities in Perspective: Nelson A. Miles." STEREO WORLD 9, no. 4 (Sept. - Oct. 1982): 27, 29. 1 b & w. [Stereo portrait of General Miles, by Taylor & Huntington.]

TAYLOR.
T340 Portrait. Woodcut engraving credited "From a photograph by Taylor." ILLUSTRATED LONDON NEWS 23, (1853) ["Lieut. Gurney Cresswell, R.N." 23:* (Nov. 5, 1853): 389. (photo)]

T341 Taylor. "The Dry Process in Scotland." HUMPHREY'S JOURNAL OF PHOTOGRAPHY, AND THE ALLIED ARTS AND SCIENCES 14, no. 4 (June 15, 1862): 5-8. [Read to Edinburgh Photo. Soc.]

T342 "A Travelling Outfit." ANTHONY'S PHOTOGRAPHIC BULLETIN 6, no. 4 (Apr. 1875): 106. [From "Br. J. of Photo."]

TAYLOR, A. & G. TAYLOR. (LONDON, ENGLAND)
T343 "Metropolitan Photographic Industries: The Victoria and Forest Lodge Works." ANTHONY'S PHOTOGRAPHIC BULLETIN 7, no. 11 (Nov. 1876): 342-345. [From "Br. J. of Photo." A. & G. Taylor, Photographers to the Queen, with galleries in London and at Forest Lodge.]

T344 "Old World Gleanings." PHOTOGRAPHIC TIMES 14, no. 166 (Oct. 1884): 535. [A & G. Taylor, London and elsewhere, were summoned to court for making use of the Royal Arms in their business, unlawfully representing themselves as photographers to the Queen.]

T345 "Old World Gleanings." PHOTOGRAPHIC TIMES 14, no. 167 (Nov. 1884): 587. [A. & G. Taylor, brought to judgement for illegally representing themselves as photographers to the Queen, agreed to remove the Royal Arms, etc., and paid a fine.]

TAYLOR, A. A. E., REV.
T346 Taylor, Rev. A. A. E. "The Photographer's Study of Character." PHILADELPHIA PHOTOGRAPHER 1, no. 10 (Oct. 1864): 150-151.

T347 Taylor, Rev. A. A. E. "Expression." PHILADELPHIA PHOTOGRAPHER 2, no. 14 (Feb. 1865): 23-25.

T348 Taylor, Rev. A. A. E. "Thoroughness." PHILADELPHIA PHOTOGRAPHER 2, no. 21 (Sept. 1865): 142-143.

T349 Taylor, Rev. A. A. E. "Photographic Views of the Inner Man." PHILADELPHIA PHOTOGRAPHER 3, no. 29 (May 1866): 136-139.

T350 Taylor, Rev. A. A. E. "Taking the Baby." PHILADELPHIA PHOTOGRAPHER 4, no. 38 (Feb. 1867): 41-44. [Humorous article on difficulties in taking baby portraits.]

TAYLOR, ALFRED SWAINE. (1801-1880) (GREAT BRITAIN)
[Alfred S. Taylor was the Lecturer on Chemistry in Guy's Hospital, London.]

BOOKS
T351 Taylor, Alfred S. *On the Art of Photogenic Drawing.* London: Jeffery, 1840. 37 pp.

PERIODICALS
T352 "Our Weekly Gossip." ATHENAEUM no. 670 (Aug. 29, 1840): 684. [Note on publication of pamphlet by Alfred S. Taylor about calotype processes.]

T353 White, Stephen. "Alfred Swaine Taylor - A Little Known Photographic Pioneer." HISTORY OF PHOTOGRAPHY 11, no. 3 (July - Sept. 1987): 229-235. 5 b & w. [A. S. Taylor was a professor of medical jurisprudence in the Royal College of Surgeons in the 1830s and a trained chemist who lectured in chemistry at Guy's Hospital, London, from 1832 to 1870. He also edited the "London Medical Gazette" from 1844 to 1851, and authored several books, articles, etc. From April 1839 until August 1841 Taylor experimented with Talbot's photogenic process, when he then published a thirty-seven page pamphlet, "On the Art of Photogenic Drawing."]

TAYLOR, ARTHUR. (GREAT BRITAIN, FRANCE)
T354 Taylor, Arthur. "Shellac Printing Process." HUMPHREY'S JOURNAL OF PHOTOGRAPHY, AND THE ALLIED ARTS AND SCIENCES 18, no. 5 (July 1, 1866): 78-80. [From "Photo. News."]

T355 Taylor, Arthur. "Photographic Printing by the Shellac Process." AMERICAN JOURNAL OF PHOTOGRAPHY, AND THE ALLIED ARTS AND SCIENCES n. s. vol. 9, no. 3-4 (Oct. 1 - Oct. 15, 1866): 63-65, 73-74. [Taylor living in Marseilles, France in August, 1866.]

T356 Taylor, Arthur. "Printing by the Shellac Process." AMERICAN JOURNAL OF PHOTOGRAPHY, AND THE ALLIED ARTS AND SCIENCES n. s. vol. 9, no. 8 (Mar. 1, 1867): 181-183. [From "Photo. News Yearbook."]

TAYLOR, BENJAMIN J. (PHILADELPHIA, PA)
T357 "Taylor's Method of Photographing Engravers' Blocks." PHILADELPHIA PHOTOGRAPHER 4, no. 44 (Aug. 1867): 244-245. [Benjamin F. Taylor (Philadelphia, PA) patented the process described here.]

TAYLOR, CHARLES.
T358 Taylor, Charles. "A Suggestion to Portraitists." HUMPHREY'S JOURNAL OF PHOTOGRAPHY, AND THE ALLIED ARTS AND SCIENCES 18, no. 18 (Jan. 15, 1867): 283. [From "Photo. News."]

TAYLOR, D. B. [BRADLEY & RULOFSON]
T359 "Editor's Table." PHILADELPHIA PHOTOGRAPHER 13, no. 145 (Jan. 1876): 32. [Letter from D. B. Taylor, operator for Bradley & Rulofson (San Francisco, CA), stating that someone was illegally using his name, touring the East and trying to sell a fake process.]

TAYLOR, F. C., CAPT. (GREAT BRITAIN, INDIA)
T360 "Oodeypore, Rajpootana." ILLUSTRATED LONDON NEWS 52, no. 1471 (Feb. 29, 1868): 208. 2 illus. ["A few months ago we published two Engravings of the scenery and architectural monuments of Oedeypore, an ancient city in the Rajpoot States, in the interior of Upper India. They were made from the photographs ... by Captain F. C. Taylor, of the Madras Staff corps, holding the office of Executive Engineer in the province of Meywar. Two Engravings published in this Number."]

T361 "Temple of Juggonath, at Oodeypore." ILLUSTRATED LONDON NEWS 53, no. 1505/1506 (Oct. 10, 1868): 345, 350. 1 illus. ["Several Illustrations of the scenery and architectural antiquities of Oodeypore, the city of Rajpootana, in Upper India, and the capital of the native State of Meywar... have appeared in this Journal. They were all... from photographs taken by Captain F. C. Taylor, of the Madras Staff Corps, holding the office of Executive Engineer in Meywar."]

TAYLOR, HENRY. (GREAT BRITAIN)
BOOKS
T362 Taylor, Henry. *Photographic Memoranda.* Part I. Goldalming, Surrey; London: H. Taylor; Henry Hering, 1856. n. p. b & w. [Landscape views, etc.]

PERIODICALS
T363 "Reviews: Photographic Memoranda. Part 1." ART JOURNAL (Dec. 1856): 383-384. [Bk. rev.: "Photographic Memoranda, Part 1," by Henry Taylor. London: Henry Hering.]

TAYLOR, J.
T364 Portrait. Woodcut engraving, credited "From a Photograph by J. Taylor." FRANK LESLIE'S ILLUSTRATED NEWSPAPER 46, (1878) ["The late Rev. John Dowling, D.D." 46:1191 (July 27, 1878): 349.]

TAYLOR, J. TRAILL. (1827-1895) (GREAT BRITAIN, USA, GREAT BRITAIN)
[Born on Jan. 23, 1827 at Kirkwell, in the Orkney Islands, Scotland. Worked as a practical watchmaker and optician in Edinburgh in the early 1840's and was attracted to the daguerreotype. Helped found the Edinburgh Photographic Society. A chemist and photographer, Taylor contributed many articles to the photographic journals and became the editor of the *British Journal of Photography* in 1864. In 1879 he resigned from the *BJP* with the intention of "practicing photography as a business" but soon quit as it was not congenial to his character. Then came to the USA, where from 1880 to 1885 he edited the *Photographic Times* magazine. Visited Florida ca. 1881-1882 and wrote about photographing there in 1882. Purchased land and a citrus farm in Florida. Apparently returned to England about 1885, and resumed the editorship of the *British Journal of Photography.* In 1895 he was stricken with typhoid dysentery and died there.]

T365 Taylor, J. T. "Discoveries and Re-discoveries in Photography." HUMPHREY'S JOURNAL OF PHOTOGRAPHY, AND THE ALLIED ARTS AND SCIENCES 10, no. 21 (Mar. 1, 1859): 328-333. [From "London Photo. J." Read to the London Photo. Soc., Jan. 11, 1859. J. Traill Taylor.]

T366 Taylor, J. Traill. "Photographic Society of Scotland. Report of the Lens Committee." PHOTOGRAPHIC AND FINE ART JOURNAL 13, no. 2 (Feb. 1860): 35-36. [From "Photo. News."]

T367 Taylor, J. T. "On Silver and some of its Salts." HUMPHREY'S JOURNAL OF PHOTOGRAPHY, AND THE ALLIED ARTS AND

SCIENCES 12, no. 20-21 (Feb. 15 - Mar. 1, 1861): 317-320, 327-330. [Read to Photo. Soc. of Scotland. From "Br. J. of Photo."]

T368 Taylor, J. T. "On the Construction and Application of the Magic Lantern." BRITISH JOURNAL OF PHOTOGRAPHY 8, no. 144 (June 15, 1861): 218-220.

T369 Taylor, J. T. "On the Construction and Applications of the Magic Lantern." AMERICAN JOURNAL OF PHOTOGRAPHY AND THE ALLIED ARTS & SCIENCES n. s. vol. 4, no. 6 (Aug. 15 - Sept. 1, 1861): 127-130, 147-150. [Read to Edinburgh Photo. Soc.]

T370 Taylor, J. T. "Photolithography & Photographic Engraving." BRITISH JOURNAL OF PHOTOGRAPHY 10, no. 185 (Mar. 2, 1863): 94-95. Taylor, J. T. "Popular Notes on Photographic Lenses." BRITISH JOURNAL OF PHOTOGRAPHY 10, no. 187 (Apr. 1, 1863): 139-140. 2 illus. [Pt. 1 - On Portrait Lenses.]

T371 Taylor, J. T. "How and When Nitrate of Soda Came to Be Employed in the Printing Bath." AMERICAN JOURNAL OF PHOTOGRAPHY AND THE ALLIED ARTS & SCIENCES n. s. vol. 6, no. 19 (Apr. 1, 1864): 447-448. [From "Br. J. of Photo."]

T372 Taylor, J. T. "The Alabastrine Process." AMERICAN JOURNAL OF PHOTOGRAPHY AND THE ALLIED ARTS & SCIENCES n. s. vol. 6, no. 19 (Apr. 1, 1864): 452-454. [From "Br. J. of Photo."]

T373 Taylor, J. T. "Photographic Lenses." AMERICAN JOURNAL OF PHOTOGRAPHY AND THE ALLIED ARTS & SCIENCES n. s. vol. 6, no. 21 [sic 22] (May 15, 1864): 513-518. [Read to Photo. Soc. of Scotland.]

T374 Taylor, J. T. "Positive Printing on Albumenised Paper." AMERICAN JOURNAL OF PHOTOGRAPHY AND THE ALLIED ARTS & SCIENCES n. s. vol. 7, no. 2 (July 15, 1864): 31-34. [From "Br. J. of Photo."]

T375 Taylor, J. Traill. "Engraving With a Sunbeam. Woodbury's Relief-Printing." POPULAR SCIENCE REVIEW 5, no. 19 (Apr. 1866): 145-152. 2 b & w. [Illustrated with two Woodburytypes on two pages before p. 145.]

T376 Taylor, J. T. "Photographic Cyclopedia." HUMPHREY'S JOURNAL OF PHOTOGRAPHY, AND THE ALLIED ARTS AND SCIENCES 20, no. 1-19 (May 1, 1868 - Mar. 15, 1869): 14-16, 30-32, 44-46, 59-61, 75-77, 92-94, 124-126, 139-141, 156-157, 173-174, 189-190, 205-206, 223-224, 238-239, 254-255, 271-272, 284-285, 301.

T377 Taylor, J. T. "Photographic Poisons and their Antidotes." HUMPHREY'S JOURNAL OF PHOTOGRAPHY, AND THE ALLIED ARTS AND SCIENCES 20, no. 21 (May 15, 1869): 324-327. [Source not given.]

T378 Taylor, J. Traill. "Photographic Optics and Lenses." BRITISH JOURNAL PHOTOGRAPHIC ALMANAC 1870 (1870): 21-56. 26 illus.

T379 Taylor, J. Traill. "Photographic Enlargements. And the Various Methods by Which They May Be Produced." BRITISH JOURNAL PHOTOGRAPHIC ALMANAC 1870 (1870): 56-73. 12 illus.

T380 Taylor, J. Traill. "A Series of Lessons or Short Progressive Essays on Photography: Intended to form a manual of practice or text book of photography, embracing such improvements as have been

published up to 1873." BRITISH JOURNAL PHOTOGRAPHIC ALMANAC 1873 (1873): 21-54.

T381 Taylor, J. Traill. "Cameras - Ancient and Modern: Their Construction, Peculiarities and Uses." BRITISH JOURNAL PHOTOGRAPHIC ALMANAC 1874 (1874): 23-43. 32 illus.

T382 Taylor, J. Traill. "A Photograph in Natural Colours." POPULAR SCIENCE REVIEW 13, no. 50 (Jan. 1874): 41-49.

T383 Taylor, J. Traill. "Discursive Chapters on the Cognates of Photographic Optics." BRITISH JOURNAL PHOTOGRAPHIC ALMANAC 1875 (1875): 28-39. 1 illus.

T384 Taylor, J. Traill. "Recent Discoveries in Photography." POPULAR SCIENCE REVIEW 14, no. 57 (Oct. 1875): 395-402.

T385 Newton, Henry J. "More About Emulsions." PHOTOGRAPHIC TIMES 5, no. 60 (Dec. 1875): 282-285. [Refutation of Taylor's criticism of Newton's process.]

T386 Taylor, J. Traill. "Phototypography, Photo-lithography, and Photo - Engraving." BRITISH JOURNAL PHOTOGRAPHIC ALMANAC 1876 (1876): 23-31. 1 illus.

T387 Taylor, J. Traill. "The Optics of Instantaneous Landscape Photography." BRITISH JOURNAL PHOTOGRAPHIC ALMANAC 1876 (1876): 31-33.

T388 Taylor, J. Traill. "Epitome of Progress during 1875." BRITISH JOURNAL PHOTOGRAPHIC ALMANAC 1876 (1876): 179-196.

T389 Taylor, J. Traill. "On the Optics of the Magic Lantern." BRITISH JOURNAL PHOTOGRAPHIC ALMANAC 1877 (1877): 23-35. 8 illus.

T390 Taylor, J. Traill. "Epitome of Progress During 1876." BRITISH JOURNAL PHOTOGRAPHIC ALMANAC 1877 (1877): 191-200.

T391 Taylor, J. Traill. "Epitome of Progress During 1877." BRITISH JOURNAL PHOTOGRAPHIC ALMANAC 1878 (1878): 196-207.

T392 Taylor, J. Traill. "Epitome of Progress During 1878." BRITISH JOURNAL PHOTOGRAPHIC ALMANAC 1879 (1879): 180-202.

T393 Taylor, J. Traill. "The Rise and Progress of Collodion Emulsion Photography." BRITISH JOURNAL PHOTOGRAPHIC ALMANAC 1879 (1879): 23-32.

T394 "Mr. J. Traill Taylor." ANTHONY'S PHOTOGRAPHIC BULLETIN 10, no. 1 (Jan. 1879): 23. [Note that Taylor resigning as Editor of the "Br. J. of Photo." changing his status from that of a quasi-amateur to that of a practitioner of the art as a business.]

T395 "Mr. J. Traill Taylor" (and) "The 'Taylor' Testimonial and Dinner." ANTHONY'S PHOTOGRAPHIC BULLETIN 10, no. 2 (Feb. 1879): 39, 40-41. [Note that J. Traill Taylor has arrived in USA, intends to begin a business here. Report of a testimonial dinner held for him before he left England.]

T396 Taylor, J. Traill. "How to Produce Lantern Transparencies." PHOTOGRAPHIC TIMES 10, no. 113-114 (May - June 1880): 100-102, 127-129.

T397 "Matters of the Month." PHOTOGRAPHIC TIMES 10, no. 119 (Nov. 1880): 254-255. [From the "Br. J. of Photo." "From a

communication just received we learn that the conducting of a 'club portrait' business being quite uncongenial to his tastes and previous habits of life, a deed of separation from his partners,... was signed."]

T398 Taylor, J. Traill. "Shortening the Exposures In the Camera." PHOTOGRAPHIC TIMES 11, no. 121 (Jan. 1881): 2-4. [This article of technical suggestions is also revealing that the limitations and dimensions of the processes and lenses imposed on studio portrait photographers. Author tells an anecdote about a complicated series of maneuvers that Antoine Claudet once went through to get a sharp portrait under difficult circumstances.]

T399 Taylor, J. Traill. "Photographic Lenses - Their Nature, Construction and Use." PHOTOGRAPHIC TIMES 11, no. 122-129 (Feb. - Sept. 1881): 44-45, 83-85, 128-129, 180-181, 208-210, 238-240, 262-264, 354-355. 1 b & w, 5 illus. [Chap. III. [sic 2] Portrait Combinations. Chap. IV. - Spherical Abstraction and Achromatism of Lenses. Chap. V. Landscape Lenses - The Nature and Cure of Distortion. Chap. VI. - Rectilinear and Group Lenses. Chap. VII. - The Equivalent Focus of a Lens. Chap. VIII. - The"Orthoscopic" and "Globe" Combinations. Chap. IX. - Lenses for Large Portraits.]

T400 Taylor, J. Traill. "Home and Foreign News." PHOTOGRAPHIC TIMES 11, no. 127 (July 1881): 245. [Brief note that Dr. Henry Draper in America has been photographing. Dr. William Huggins in England also.]

T401 Taylor, J. Traill. "Home and Foreign News." PHOTOGRAPHIC TIMES 11, no. 128 (Aug. 1881): 268. [Quotes the stockdealer John J. Atkinson, of Liverpool, saying that business is very bad in England right now, with bankruptcies, price cutting, etc.]

T402 Taylor, J. Traill. "Home and Foreign News." PHOTOGRAPHIC TIMES 11, no. 128 (Aug. 1881): 270. [Taylor discusses another photographic outing to photograph sailing ships - this time in the Boston Harbor, on board Mr. Ernst Edward's small steam yacht "Picl." Edwards was the chief of the Heliotype Printing co. and an amateur photographer.]

T403 "Our Editorial Table: 'The Photographic Amateur.'" PHOTOGRAPHIC TIMES 11, no. 129 (Sept. 1881): 357-359. [Bk. rev.: "The Photographic Amateur," by J. Traill Taylor.]

T404 Taylor, J. Traill. "Expedients for Equalizing the Exposure in the Camera." PHOTOGRAPHIC TIMES 11, no. 130 (Oct. 1881): 377-379. [Discussion of difficulties encountered when doing landscape photography.]

T405 Taylor, J. Traill. "Photography in Twenty-four Lessons." PHOTOGRAPHIC TIMES 11, no. 131 (Nov. 1881): 405. [J. B. Gardner, recently advocated that any new amateurs wishing to learn photography shall learn the wet-collodion process. Taylor disagrees, feels that the future is in dry plates.]

T406 Taylor, J. Traill. "The Waterbury Lens." PHOTOGRAPHIC TIMES 11, no. 131 (Nov. 1881): 405-406. 1 illus.

T407 "A Few Opinions of the Press and of Eminent Men Respecting the 'Photographic Amateur.'" PHOTOGRAPHIC TIMES 11, no. 132 (Dec. 1881): 463-464. [Bk. rev.: "Photographic Amateur," by J. Traill Taylor. Reprints from reviews in the "British Journal of Photography," and "Philadelphia Photographer," as well as letters by well respected photographers.]

T408 Taylor, J. Traill. "The Art of Seeing Stereographic Pictures Without a Stereoscope." PHOTOGRAPHIC TIMES 12, no. 133 (Jan. 1882): 2-3.

T409 Taylor, J. Traill. "The Optical Requirements for Photographing on a Scale of Nature." PHOTOGRAPHIC TIMES 12, no. 133 (Jan. 1882): 3-4.

T410 Taylor, J. Traill. "In Florida With a Camera." PHOTOGRAPHIC TIMES 12, no. 133-134 (Jan. - Feb. 1882): 4-5, 34-35.

T411 "Matters of the Month: "The Photographic Amateur," By J. Traill Taylor - Opinions of the Press." PHOTOGRAPHIC TIMES 12, no. 134 (Feb. 1882): 60-61. [Reviews reprinted from "Scientific American," "Journal of the Society of Arts," "Chicago Druggist," "Chicago Picture and Art Furniture Trade Journal."]

T412 Taylor, J. Traill. "General Notes." PHOTOGRAPHIC TIMES 12, no. 135 (Mar. 1882): 69-70. [Notice that the Photographic Society of Great Britain is going to attempt to get camera, manufacturers to standardize screws, mounts, etc.]

T413 "Matters of the Month." PHOTOGRAPHIC TIMES 12, no. 135 (Mar. 1882): 89-90. [Reviews of the book "The Photographic Amateur," reprinted from "Boston Journal of Chemistry," "New York Carpenter and Builder," "National Scientific Journal."]

T414 Taylor, J. Traill. "Photography with the Microscope." PHOTOGRAPHIC TIMES 12, no. 138 (June 1882): 185-186.

T415 "Press Opinions." PHOTOGRAPHIC TIMES 12, no. 138 (June 1882): 227. [Bk. rev.: "The Photographic Amateur," by J. Traill Taylor reprinted from "American Architect and Building News."]

T416 Taylor, J. Traill. "Notes on a Visit to Great Britain. - 1." PHOTOGRAPHIC TIMES 12, no. 139 (July 1882): 229-232. [Taylor sailed on the "Ethiopia" from New York to England. On board he met by accident the painter John Moran, who had with him many of W. H. Jackson's photos. The two had travelled all over the Rocky Mountains and the Yellowstone Region together. Taylor photographed at sea. Landed first in Scotland, describes activities and events there.]

T417 Taylor, J. Traill. "American vs. English Lenses." PHOTOGRAPHIC TIMES 12, no. 139 (July 1882): 256-258. [Lecture delivered before the London Photographic Club. (See note p. 337 of crediting error.)]

T418 Taylor, J. Traill. "General Notes." PHOTOGRAPHIC TIMES 12, no. 141 (Sept. 1882): 348-351. [Discusses Mr. Motes, Atlanta, Ga.; Cecil V. Shadbolt's balloon pictures, Mr. Schleier's photos by electric light (Nashville, Tenn.); John A. Scholten (St. Louis, Mo.) returns from his trip to Europe, and other items.]

T419 Taylor, J. Traill. "Photographing Groups on the Stoop." PHOTOGRAPHIC TIMES 12, no. 142 (Oct. 1882): 385-386.

T420 Taylor, J. Traill. "For the Beginner: "Doctoring Imperfect Negatives and Printing in Skies and Clouds." PHOTOGRAPHIC TIMES 12, no. 143 (Nov. 1882): 424-425.

T421 Taylor, J. Traill. "General Notes." PHOTOGRAPHIC TIMES 12, no. 144 (Dec. 1882): 460-462. [Alva Pearsall won medal for photos at the American Institute Fair, G. L. Wilson gave an illustrated lecture on his trip to Egypt at Association Hall, Germantown, Muybridge's motion studies have prompted Charles Barnard, N.Y., to do similar

instantaneous studies of a violinist playing his instrument as well as other musicians at work, actors, etc.]

T422 Taylor, J. Traill. "Photographing on Wood." PHOTOGRAPHIC TIMES 13-14, no. 155-158 (Nov. 1883 - Feb. 1884): (vol. 13) 569-570, 633-635; (vol. 14) 2-4, 57-59.

T423 Taylor, J. Traill. "Dioramic Effects by Photography." PHOTOGRAPHIC TIMES 14, no. 158 (Feb. 1884): 55-57. [Discusses the work of Dr. Taylor, of Glasgow, on "the application of photography to the production of dioramic effects."]

T424 Taylor, J. Traill. "How to Enamel Prints." PHOTOGRAPHIC TIMES 14, no. 159 (Mar. 1884): 109-111.

T425 Taylor, J. Traill. "Artificial Atmosphere and Its Uses." PHOTOGRAPHIC TIMES 14, no. 160 (Apr. 1884): 171-172.

T426 Taylor, J. Traill. "Effects Obtained by Landscape Lens of Various Foci." PHOTOGRAPHIC TIMES 14, no. 161 (May 1884): 219-220.

T427 Taylor, J. Traill. "Cyanide Poisoning." PHOTOGRAPHIC TIMES 14, no. 162 (June 1884): 284-285. [Includes a letter from J. H. Phillips (Kirkwood, MO), a photographer of 20 years, now paralyzed - thinks it was caused by cyanide poisoning.]

T428 "Subordinating Objects While Being Photographed." PHOTOGRAPHIC TIMES 14, no. 162 (June 1884): 292-294. [Article published in the "Br. J. of Photo." in response to J. T. Taylor's article "Artificial Atmosphere," in Apr. 1884 issue of "Photo. Times." Author not credited.]

T429 Taylor, J. Traill. "Portraiture Without a Glass Room." PHOTOGRAPHIC TIMES 14, no. 164 (Aug. 1884): 399-400.

T430 Taylor, J. Traill. "Report on Photographic Progress." PHOTOGRAPHIC TIMES 14, no. 164 (Aug. 1884): 400-403. [Survey of recent events, dominated by technical discussion, but containing information about other issues as well.]

T431 Taylor, J. Traill. "General Notes." PHOTOGRAPHIC TIMES 14, no. 165 (Sept. 1884): 472. [Article about advocating bayonet lens mounts and interchangeable lenses. "An experienced traveller, Mr. Andrew Pringle, who has been round the world with a camera, suggests the advantages."]

T432 Taylor, J. Traill. "Ambrotypes." PHOTOGRAPHIC TIMES 14, no. 165 (Sept. 1884): 469-471.

T433 Taylor, J. Traill. "Wide-Angle Landscapes." PHOTOGRAPHIC TIMES 14, no. 166 (Oct. 1884): 524-525. [Discussion of panoramic landscapes.]

T434 Taylor, J. Traill. "General Notes." PHOTOGRAPHIC TIMES 14, no. 168 (Dec. 5, 1884): 629-630. [Editorial commentary on the question of "The Ethics of Photography." Raises issue of retouching, relation of photographic verity (or realism) to truth. "...realism is not necessarily truth, by which we mean that a photography may be strictly an accurate representation of nature, yet not only fail to convey a truthful idea but one the very perverse."]

T435 Taylor, J. Traill. "How We Photographed a Ghost." PHOTOGRAPHIC TIMES 15, no. 172 (Jan. 2, 1885): 4-5.

T436 Taylor, J. Traill. "Making Transparencies by Camera and Artificial Light." PHOTOGRAPHIC TIMES 15, no. 177 (Feb. 6, 1885): 61-62.

T437 Taylor, J. Traill [?]. "The Principles and Practice of Mounting Stereographs." PHOTOGRAPHIC TIMES 15, no. 178 (Feb. 13, 1885): 73-74. [Letter from N. E. Maxon (amateur of Hopedale, Mass.) led to this article, which contains both practical and theoretical suggestions.]

T438 Taylor, J. Traill. "Large Portraits." PHOTOGRAPHIC TIMES 15, no. 182 (Mar. 13, 1885): 125. [Author admonishes professional portrait galleries to counteract low prices for cabinet photos by making large portraits.]

T439 Taylor, J. Traill. "Nocturnal Photography." PHOTOGRAPHIC TIMES 15, no. 184 (Mar. 27, 1885): 151-152.

T440 Taylor, J. Traill. "Vignetting." PHOTOGRAPHIC TIMES 15, no. 189 (May 1, 1885): 229-230.

T441 Taylor, J. Traill. "Photographing Yachts in a Storm." PHOTOGRAPHIC TIMES 15, no. 196 (June 19, 1885): 329-330.

T442 Taylor, J. Traill. "Tin-Types and Ambrotypes Redivivus." PHOTOGRAPHIC TIMES 15, no. 198 (July 3, 1885): 357-358. [Statement "...that several photographers, disgusted at the low prices which almost everywhere now prevail, have resolved to add the ferrotype to their business."]

T443 Taylor, J. Traill. "Unfrequented Paths for New York Artists." PHOTOGRAPHIC TIMES 15, no. 206 (Aug. 28, 1885): 493-494.

T444 Taylor, J. Traill. "Backgrounds." PHOTOGRAPHIC TIMES 15, no. 207 (Sept. 4, 1885): 505-506.

T445 Taylor, J. Traill. "Panoramic Views." PHOTOGRAPHIC TIMES 15, no. 208 (Sept. 11, 1885): 517-518.

T446 Taylor, J. Traill. "The Photo-Crayon as a Means of Revivifying Business." PHOTOGRAPHIC TIMES 15, no. 209 (Sept. 18, 1885): 531-532. [Lecture before the Convention of the Photographic Association of Canada.]

T447 Taylor, J. Traill. "Seeing Natural Scenery with Photographic Effect." PHOTOGRAPHIC TIMES 15, no. 212 (Oct. 9, 1885): 573-574.

T448 Taylor, J. Traill. "Editorial Mirror." PHOTOGRAPHIC TIMES 15, no. 217 (Nov. 13, 1885): 635-636. [Taylor touring England. Mentions people and places: amateur Mr. Hyslop's photos of Cunard ship collision; Glasgow photographer John Urie perfecting printing by lamplight; John Stuart of Glasgow and his large business of photographing ships, steam engines, engineering projects, etc.]

T449 Taylor, J. Traill. "Panoramic Photography." PHOTOGRAPHIC TIMES 15, no. 218 (Nov. 20, 1885): 650-651.

T450 Taylor, J. Traill. "Photographic Engraving." PHOTOGRAPHIC TIMES 15, no. 220 (Dec. 4, 1885): 673-674.

T451 Taylor, J. Traill. "Notes From Abroad." PHOTOGRAPHIC TIMES 15, no. 222 (Dec. 18, 1885): 698-699.

T452 Taylor, J. Traill. "Paper Negatives." PHOTOGRAPHIC TIMES 16, no. 224 (Jan. 1, 1886): 7-9. ["A communication to the South London Photographic Society."]

T453 Taylor, J. Traill. "Report of the Progress of Photography in Great Britain." PHOTOGRAPHIC TIMES 16, no. 250 (July 2, 1886): 353-355. [Read at the St. Louis Convention of the Photographers' Assoc. of America.]

T454 Taylor, J. Traill. "Report on the Progress of Photography in Great Britain." ANTHONY'S PHOTOGRAPHIC BULLETIN 17, no. 13 (July 10, 1886): 398-400. [Read at the St. Louis Convention of the P. A. of A.]

T455 Taylor, J. Traill. "On Focusing Sailing Ships and Other Moving Objects." PHOTOGRAPHIC TIMES 16, no. 259 (Sept. 3, 1886): 468-469. [Read at first Photographic Convention in Great Britain.]

T456 Taylor, J. Traill. "On Focusing Sailing Ships and Other Moving Objects." ANTHONY'S PHOTOGRAPHIC BULLETIN 17, no. 18 (Sept. 25, 1886): 562-564. [Read at the English Convention at Derby.]

T457 Taylor, J. Traill. "Photographic Lenses." ANTHONY'S PHOTOGRAPHIC BULLETIN 18, no. 5 (Mar. 12, 1887): 151-153. [Communication to the Society of Arts, London.]

T458 Taylor, J. Traill. "Transatlantic Gossip." PHOTOGRAPHIC TIMES 17, no. 301 (June 24, 1887): 323-324.

T459 Taylor, J. Traill. "Instantaneous Nocturnal Photography - A Novelty Which Is Not New." PHOTOGRAPHIC TIMES 17, no. 322 (Nov. 18, 1887): 574-575.

T460 Taylor, J. Traill. "Correspondence. A New Magnesium Flashing Light." PHOTOGRAPHIC TIMES 18, no. 332 (Jan. 27, 1888): 43-44.

T461 Taylor, J. Traill. "Ethics of Photography and Photographers." PHOTOGRAPHIC TIMES 20, no. 457-458 (June 20 - June 27, 1890): 296-297, 309-311. [A communication to the London and Provincial Photographic Association.]

T462 Taylor, J. Traill. "Fuzziness and Naturalism." AMERICAN ANNUAL OF PHOTOGRAPHY AND PHOTOGRAPHIC TIMES ALMANAC FOR 1891 (1891): 240-241.

T463 Taylor, J. Traill. "Combination Negatives." PHOTOGRAPHIC TIMES 22, no. 583 (Nov. 18, 1892): 588-589.

T464 "Obituary." WILSON'S PHOTOGRAPHIC MAGAZINE 32, no. 468 (Dec. 1895): 570-571. [Born Kirkwall, in Orkney Islands about 65 years ago. Working as a practical watchmaker and optician in Edinburgh in the early 1840's attracted to the daguerreotype. Helped found the Edinburgh Photographic Society. 1864 took over editorship of the "British Journal of Photography," 1890's except for 5 years (1880 - 1885) when he edited the "Photographic Times" of New York.]

TAYLOR, JOHN WILSON (d. 1918) see BACON & TAYLOR.

TAYLOR, JOHN.
T465 Taylor, John, M.D. "Dioramic Effects Produced on Photographic Pictures." AMERICAN JOURNAL OF PHOTOGRAPHY AND THE ALLIED ARTS & SCIENCES n. s. vol. 5, no. 14 (Jan. 15, 1863): 313-320. [From "Br. J. of Photo." Read to Glasgow Photo. Assoc.]

T466 Taylor, John. "Dioramic Effects produced on Photographic Pictures." HUMPHREY'S JOURNAL OF PHOTOGRAPHY, AND THE ALLIED ARTS AND SCIENCES 14, no. 18-19 (Jan. 15 - Feb. 1, 1863): 236-238, 247-250. [Read to Glasgow Photo. Meeting.]

TAYLOR, R. (CHATHAM, ENGLAND)
T467 "New Drinking-Fountain and Parochial Schools, Chatham." ILLUSTRATED LONDON NEWS 44, no. 1244 (Feb. 6, 1864): 129. 1 illus. ["...from a photograph by Mr. R. Taylor, of Chatham."]

TAYLOR, W. C. see also WENDEROTH, TAYLOR & BROWN.

TAYLOR, W. C.
T468 "Taylor to the Rescue." HUMPHREY'S JOURNAL OF PHOTOGRAPHY, AND THE ALLIED ARTS AND SCIENCES 20, no. 26 (Oct. 15, 1869): 406-407. [Satiric commentary on a letter from Taylor to the editor, protesting his attacks on E. L. Wilson. The editor (Ladd?) does not print Taylor's letter, just attacks it.]

TAYLOR, WILLIAM CURTIS. (USA)
[Worked in Philadelphia, PA. Partner with Samuel Broadbent from 1875 to 1879.]

T469 Taylor, William Curtis. "Art and Mechanism." PHILADELPHIA PHOTOGRAPHER 12, no. 144 (Dec. 1875): 353-356.

TEASDALE, WASHINGTON. (1839-1902) (GREAT BRITAIN)
T470 "Obituary of the Year: Washington Teasdale." BRITISH JOURNAL PHOTOGRAPHIC ALMANAC 1904 (1904): 676-677. [Died Sept. 1902, aged 73. From Yorkshire. Independently wealthy. Ran avid follower of scientific subjects. Amateur enthusiast in astronomy and photography. Fellow of the Microscopical Society, the Royal Astronomical Society, etc.]

TENISON, E. K. (GREAT BRITAIN, SPAIN)
T471 "Biographical Notes on a Number of Photographers Published by Blanquart-Evrard." CAMERA (LUCERNE) 57, no. 12 (Dec. 1978): 32, 41-42. [Benecke, Claine, DuCamp, Fortier, Greene, Le Secq, Loydreau, Marville, Regnault, Robert, Salzmann, Stewart, Sutton, and Tenison. Tenison was described as a 'well-known English amateur.' He published an album of photographs of Spain in 1854. Created a very long panorama of Toledo in 1855.]

TENNEY, CHARLES ADNA. (1847-1917) (USA)
T472 Sterling, David N. "Charles Tenney: Minnesota Photographer." STEREO WORLD 3, no. 2 (May - June 1976): 22. 1 b & w. [Charles Adna Tenney born on June 6, 1847 in Hanover, NH. Learned photography in Chicago in 1869, and moved to Winona, MN in 1871, and set up a studio, Hoard & Tenny. In 1879, it became Elmer & Tenny. Tenny considered to be the photographer. Through 1880s taking Minnesota and Wisconsin scenery. In 1892 Charles left Winona for Minneapolis, then to Creston OH, where he died in 1917.]

TERRY. (USA, PERU, USA)
T473 "Daguerreotype Movements." HUMPHREY'S JOURNAL 4, no. 16 (Dec. 1, 1852): 255. [Terry, crossed the Isthmus of Panama in 1848 to reach Lima, Peru, where he opened a gallery. Returned after four years to New York City.]

TERRY, S. J.
T474 "Confederate Cemetery, Franklin, Tennessee." HARPER'S WEEKLY 10, no. 516 (Nov. 17, 1866): 721. 1 illus. ["Photographed by S. J. Terry."]

TERRY, WILLIAM A. (BRISTOL, CT)
T475 Terry, Wm. A. "The Reddening of the Printing Bath. - The Fuming Process. - Toning. - New Strengthening Process." AMERICAN JOURNAL OF PHOTOGRAPHY AND THE ALLIED ARTS & SCIENCES n. s. vol. 6, no. 3 (Aug. 1, 1863): 63-65.

T476 Terry, Wm. A. "Chloride of Lime Toning; How to Succeed With It." AMERICAN JOURNAL OF PHOTOGRAPHY AND THE ALLIED ARTS & SCIENCES n. s. vol. 6, no. 15 (Feb. 1, 1864): 338-342.

T477 Terry, William A. "Experiments on the Nitrate Bath, Blistering of Prints." AMERICAN JOURNAL OF PHOTOGRAPHY AND THE ALLIED ARTS & SCIENCES n. s. vol. 6, no. 18 (Mar. 15, 1864): 423-426.

T478 Terry, William A. "Experiments on the Developer - Substitutes for the Bromides." AMERICAN JOURNAL OF PHOTOGRAPHY AND THE ALLIED ARTS & SCIENCES n. s. vol. 8, no. 15 (Feb. 1, 1866): 337-342.

T479 Terry, Wm.A. "Quick Working. - Developers, &c." AMERICAN JOURNAL OF PHOTOGRAPHY AND THE ALLIED ARTS & SCIENCES n. s. vol. 8, no. 16 (Feb. 15, 1866): 378-383.

T480 Terry, William. "Lime Toning." HUMPHREY'S JOURNAL OF PHOTOGRAPHY, AND THE ALLIED ARTS AND SCIENCES 20, no. 17-18 (Jan. 15 - Feb. 15, 1869): 257-258, 273-274.

T481 Terry, Wm. A. "How to Save the Silver." AMERICAN JOURNAL OF PHOTOGRAPHY, AND THE ALLIED ARTS AND SCIENCES n. s. vol. 9, no. 11 (May. 15, 1867): 247-248.

T482 Terry, W. A. "On the Manufacture of Collodion." AMERICAN JOURNAL OF PHOTOGRAPHY, AND THE ALLIED ARTS AND SCIENCES n. s. vol. 9, no. 12 (June 1, 1867): 263-265.

T483 Terry, William A. "Collodio-Chloride." HUMPHREY'S JOURNAL OF PHOTOGRAPHY, AND THE ALLIED ARTS AND SCIENCES 19, no. 24 (Apr. 15, 1868): 372-375. [Note on p. 379. "Mr. Terry is one of the best practical writers on the art in this country; in fact he is the only regular operator who writes to any extent."]

TESCH.
T484 Portrait. Woodcut engraving, credited "From a Photograph by Tesch." FRANK LESLIE'S ILLUSTRATED NEWSPAPER 28, (1869) ["Carl Zerbahn, Conductor of Symphony at Boston Peace Jubilee." 28:717 (June 26, 1869): 229.]

TESCH, HENRY. (d. 1875) (GREAT BRITAIN)
T485 Tesch, Henry. "Art and Photography." PHOTOGRAPHER'S FRIEND 2, no. 1 (Jan. 1872): 21-22. [From "Br J of Photo."]

TESSIE DU MOTAY, C. M. & C. R. MARECHAL.
T486 Tessie du Motay, C. M. and C. R. Marechal. "Improvements in Photo-Lithographic Transfers." HUMPHREY'S JOURNAL OF PHOTOGRAPHY, AND THE ALLIED ARTS AND SCIENCES 18, no. 2 (May 15, 1866): 24-25. [From "Photo. News."]

TEWKSBURY, J. R. (b. 1831) (USA)
T487 "Do Magic Lantern Exhibitions Pay?" PHILADELPHIA PHOTOGRAPHER 9, no. 106 (Oct. 1872): 360-361. 1 illus. [Article includes a facsimile of a printed poster from J. R. Tewksbury, Photographer, Farmington, Iowa, listing the contents of his show. (Its clear, from the subjects, that he used slides made by other photographers.)]

THACKERAY, WILLIAM M. (1811-1863) (GREAT BRITAIN)
T488 "Thackeray as Novelist and Photographer." JOURNAL OF THE PHOTOGRAPHIC SOCIETY OF LONDON 7, no. 102 (Oct. 15, 1860): 15-17. [Compares Thackeray's naturalism with photo. Excerpted from "Westerminster Review."]

T489 "Art, Literature and Photography." PHOTOGRAPHIC NEWS 4, no. 112 (Oct. 26, 1860): 305-306. [From "Thackeray as Novelist and Photographer" in the "Westminster Review."]

T490 "'Thackeray as Novelist and Photographer.'" AMERICAN JOURNAL OF PHOTOGRAPHY AND THE ALLIED ARTS & SCIENCES n. s. vol. 3, no. 12 (Nov. 15, 1860): 183-185. [Discussion of an article with the same title published in the "Westminster Review" in Oct. 1860. Reference is to Thackeray's ability to write detailed, descriptive prose.]

T491 "Art, Literature, and Photography." AMERICAN JOURNAL OF PHOTOGRAPHY AND THE ALLIED ARTS & SCIENCES n. s. vol. 4, no. 1 (June 1, 1861): 4-6. [From "Thackeray as Novelist and Photographer," in the "Westminster Review."]

THIELE, HUGO A. (DRESDEN, GERMANY)
T492 Portrait. Woodcut engraving, credited "From a Photograph by Hugo Thiele, Dresden." FRANK LESLIE'S ILLUSTRATED NEWSPAPER 36, (1873) ["The late Albert I. Sumner, lost on the "Atlantic." 36:918 (May 3, 1873): 121.]

THOMAS, ALEXANDER S. see BALL & THOMAS.

THOMAS, G. L. (COLUMBUS CITY, IA)
T493 "Bad Case of Poisoning." HUMPHREY'S JOURNAL OF PHOTOGRAPHY, AND THE ALLIED ARTS AND SCIENCES 16, no. 23 (Apr. 1, 1865): 357-359. [Partially paralyzed, through chemicals.]

T494 Thomas, G. L. "Poisoning by Cyanide." HUMPHREY'S JOURNAL OF PHOTOGRAPHY, AND THE ALLIED ARTS AND SCIENCES 18, no. 1 (May 1, 1866): 5-6. ["I am nearly recovered from the effect of the poison."]

THOMAS, J. J. (MT. CARMEL, IL)
T495 "Matter of the Month." PHOTOGRAPHIC TIMES 7, no. 80 (Aug. 1877): 180. [Stereo views "Ruins of Mt. Caramel."]

THOMAS, JOHN. (1838-1905)
BOOKS
T496 Woollen, Hilary and Alistair Crawford. *John Thomas, Photographer, 1838 - 1905.* Llandysul, Wales: Gomer Press, 1977. 81 pp. b & w. illus. [John Thomas was born in Glan-rhyd, Cellan in Cardiganshire, Wales, on Apr. 14, 1838, the son of a laborer. Studied at the village school, then apprenticed as a draper. Went to Liverpool in 1853, where he worked in a Drapery Trading House for ten years. The worked as a salesman in a shop selling writing materials and photographic portraits of famous personalities. Thomas acquired a camera in 1863 with the idea of photographing prominent Welsh ministers. Learned photography at the Harry Emmens gallery in Liverpool. Set up his own studio in Liverpool in 1867, which he named the Cambrian Gallery. Thomas was interested in Wales, he wrote for Welsh journals, and his gallery became a focal point for Welshmen. He photographed celebrities, costume portraits, views, landscapes, and the like. He died in Liverpool in 1905.]

PERIODICALS
T497 Jones, Emyr Wyn. "John Thomas, Cambrian Gallery: Ei Atgofion a'i Deithidiau." JOURNAL OF THE MERIONETH HISTORICAL AND RECORD SOCIETY 4, no. 3 (1963): 242-273.

T498 Jones, Emyr Wyn. "John Thomas of the Cambrian Gallery." JOURNAL OF THE NATIONAL LIBRARY OF WALES 11, no. 4 (Winter 1956): 385-*.

T499 Jones, E. W. "John Thomas of the Cambrian Gallery, 1838 - 1905." CREATIVE CAMERA no. 143 (May 1976): 148, 156-163. 8 b & w.

THOMAS, RICHARD WHEELER. (d. 1881) (GREAT BRITAIN)

[Richard W. Thomas, F.C.S., was a chemist and dealer in photographic apparatus, with a shop in Pall Mall, London. Perhaps the first to make photographic collodion for public sale.]

BOOKS

T500 Thomas, Richard Wheeler. *Enlarged Paper of Instructions for the use of "his preparation of Collodion: 'Xylo-Iodide of Silver'"* London: R. W. Thomas, 1856. n. p.

T501 Thomas, Richard Wheeler. *Pamphlet containing Five Papers on the Negative, etc.* London: R. W. Wheeler, 1863. n. p. [Revised ed. (1865)]

T502 Thomas, Richard Wheeler. *The Modern Practice of Photography.* Introductory Sketch and Five Chapters. London: Harrison, 1866. 67 pp. [New ed. (1868) and (1873). 94 pp. ["Very popular text-book in its day. ...thirty thousand copies disposed of (by 1873)."]

T503 Thomas, Richard W. *The Modern Practice of Photography.* Philadelphia: H. C. Baird, 1868. 72 pp.

PERIODICALS

T504 Thomas, Richard W. "Photography in Rome." ART JOURNAL 14, (May 1852): 159-160. [Thomas photographed in Rome for four months, gives his formulae. Mentions Mr. Robinson, Prince Giron des Anglonnes, Signor Caneva, M. Constant and M. Flacheron.]

T505 Thomas, Richard W. "Photography in Rome." PHOTOGRAPHIC ART JOURNAL 3, no. 6 (June 1852): 377-380. [From "London Art Journal."]

T506 Thomas, Richard Wheeler. "Cleaning the Plate." AMERICAN JOURNAL OF PHOTOGRAPHY AND THE ALLIED ARTS & SCIENCES n. s. vol. 3, no. 6 (Aug. 15, 1860): 87-89. [From "Photo. J."]

T507 Thomas, R. W., Esq. "How to Print From the Negative." AMERICAN JOURNAL OF PHOTOGRAPHY AND THE ALLIED ARTS & SCIENCES n. s. vol. 3, no. 14 (Dec. 15, 1860): 209-212. [London Photo. Soc.]

T508 Thomas, R. W. "How to Varnish the Negative." HUMPHREY'S JOURNAL OF PHOTOGRAPHY, AND THE ALLIED ARTS AND SCIENCES 12, no. 19 (Feb. 1, 1861): 297-300. [From "Br. J. of Photo."]

T509 Thomas, R. W. "How to Prevent Stains and Streaks in the Collodion Negative." AMERICAN JOURNAL OF PHOTOGRAPHY AND THE ALLIED ARTS & SCIENCES n. s. vol. 4, no. 3 (July 1, 1861): 54-60. [Read to London Photo. Soc.]

T510 Thomas, R. W. "How to Prevent Stains and Streaks in the Collodion Negative." HUMPHREY'S JOURNAL OF PHOTOGRAPHY, AND THE ALLIED ARTS AND SCIENCES 13, no. 6-7 (July 15 - Aug. 1, 1861): 84-87, 99-101. [From "Br. J. of Photo."]

T511 Thomas, R. W., F.C.S. "Dried Egg Albumen." BRITISH JOURNAL PHOTOGRAPHIC ALMANAC 1875 (1875): 117-118.

T512 Taylor, J. Traill. "Home and Foreign News." PHOTOGRAPHIC TIMES 11, no. 128 (Aug. 1881): 269. [Died in 1881, aged 58 - Well-known photographic chemist, one of first to make photographic collodion as an article of commerce.]

THOMAS, S. A. (1823-1894) (USA)

T513 "The Studios of New York. 1. S. A. Thomas." PHOTOGRAPHIC TIMES 22, no. 544 (Feb. 19, 1892): 94-95. [Specialist in child portraits.]

T514 "Editorial Notes: Obituary Notice." PHOTOGRAPHIC TIMES 25, no. 671 (July 27, 1894): 60. [Started gallery 1853 in New York, NY, died July 8th at age 71. Specialized in children's portraits.]

THOMPSON & DAVIS. (BROOKLYN, NY)

T515 "J. O'Brien, Aged 102 Years." GLEASON'S PICTORIAL DRAWING-ROOM COMPANION 5, no. 16 (Oct. 15, 1853): 248. 1 illus. ["The engraving from a daguerreotype by Thompson & Davis, Brooklyn."]

THOMPSON.

T516 "Africa. - The Diamond Diggings of South Africa. - View of Colesburg Kopje, Looking South. - From a Photograph by Thompson." FRANK LESLIE'S ILLUSTRATED NEWSPAPER 34, no. 883 (Aug. 31, 1872): 397. 1 illus. [View of open pit mine, with miners at work.]

THOMPSON, CHARLES THURSTON. (1816-1868) (GREAT BRITAIN)

BOOKS

T517 Robinson, Sir John Charles. *The Art Wealth of England.* A series of photographs, representing fifty of the most remarkable works of art contributed on loan for the special exhibition at the South Kensington Museum, 1862. London: Colnaghi, Scott, & Co., 1862. 26 pp. 50 b & w. [50 albumen photographs by C. Thurston Thompson.]

T518 Murray, Andrew. *The Book of the Royal Horticultural Society 1862-63.* London: Bradley & Evans, 1863. n. p. 12 b & w. illus. [Original photographs, by C. Thurston Thompson as well as other illustrations.]

T519 Turner, Joseph Mallord William. *Photographs of Turner's "Liber Studiorum."* London: Cundall, Downes & Co., 1863. n. p. 71 l. of plates. 71 b & w. [Photographs, by Thurston Thompson, of J. M. W. Turner's art.]

T520 *The Cathedral of Santiago de Compostella in Spain;* Showing Especially the Sculpture of the Portico de la Gloria by Mestre Mateo. A Series of 20 Photographs Recently Taken by the Late Mr. Thurston Thompson. London: Bell & Daldy, for the Arundel Society, 1868. n. p. 20 b & w. [Original photos.]

T521 *The Sculptured Ornament of the Monastery of Batalha in Portugal;* 20 Photographs by the Late Mr. Thurston Thompson, with a Descriptive Account of the Building. London: Bell & Daldy, for the Arundel Society, 1868. n. p. 20 b & w. [Original photos.]

PERIODICALS

T522 "Fine Arts: Photographs of Turner's 'Liber Studiorum.'" ILLUSTRATED LONDON NEWS 42, no. 1182 (Jan. 3, 1863): 24-25. [Review of Thurson Thompson's photographs of Turner's 'Libert Studiorum;' published by Cundall, Downes & Co.]

T523 "Photographs of Turner's 'Liber Studiorum.'" ILLUSTRATED LONDON NEWS 45, no. 1278 (Sept. 17, 1864): 284. 1 illus. [71

plates of J. W. M. Turner's artworks, photos taken by Thurston Thompson, published by Cundall & Downes.]

T524 "Waxing Photographs." AMERICAN JOURNAL OF PHOTOGRAPHY AND THE ALLIED ARTS & SCIENCES n. s. vol. 7, no. 11 (Dec. 1, 1864): 247-249. [From "Photo. News." "Mr. Thurston Thompson, the skillful photographer to South Kensington Museum."]

T525 "Batalha, In Portugal." ILLUSTRATED LONDON NEWS 51, no. 1446 (Sept. 21, 1867): 312, 317. 1 illus. ["...part of a series lately executed for the Department of Science and Art, South Kensington."]

THOMPSON, E. C. (WASHINGTON, DC)
T526 "Personal & Art Intelligence." PHOTOGRAPHIC AND FINE ART JOURNAL 7, no. 1 (Jan. 1854): 32. ["Mr. E. C. Thompson, of Washington City, has acquired the paper process with a view to its practice in that way."]

THOMPSON, F.
T527 "Main Drainage at the Metropolis." ILLUSTRATED LONDON NEWS 35, no. 990 (Aug. 27, 1859): 203. 1 illus. ["...from a photograph by Mr. F. Thompson." Sewers under construction.]

THOMPSON, FREDERICK F. (1836-1899) (USA)
T528 Thompson. "Mr. Thompson's Method of Preparing Tannin Plates." AMERICAN JOURNAL OF PHOTOGRAPHY AND THE ALLIED ARTS & SCIENCES n. s. vol. 4, no. 24 (May 15, 1862): 566. 1 illus. [Sec. Thompson (of Am. Photo. Soc.) "preparing plates for a trip into Pennsylvania," described process.]

T529 "Minor Correspondence." AMERICAN JOURNAL OF PHOTOGRAPHY AND THE ALLIED ARTS & SCIENCES n. s. vol. 5, no. 3 (Aug. 1, 1862): 72. ["...a very amusing note from Secretary (Captain) Thompson,..." describing his experience while in camp in Virginia. "...war and photography, like the dandy's flies and butter, cannot with propriety and success be served in the same dish."]

T530 Thompson, F. F., Capt. "A New Process - The Milk and Sugar Process." AMERICAN JOURNAL OF PHOTOGRAPHY AND THE ALLIED ARTS & SCIENCES n. s. vol. 5, no. 6 (Sept. 15, 1862): 135-137. [Thompson, was the Secretary of the American Photographical Society, an officer in the Union Army (on leave) and apparently a broker on Wall St. Had a sense of humor. Note on p. 168 with some corrections.]

T531 Thompson, F. F. "Two Weeks on the Road, by a Straggling Amateur." AMERICAN JOURNAL OF PHOTOGRAPHY AND THE ALLIED ARTS & SCIENCES n. s. vol. 5, no. 6-7 (Sept. 15-Oct. 1, 1862): 137-141, 155-159. [Description of a photographic trip into New Jersey and Pennsylvania where he ran into a forest fire. Describes his problems at inns, etc. Author identified on p. 161.]

T532 Thompson, F. F. "Daddy Long Legs' Memories, by a Straggling Amateur." AMERICAN JOURNAL OF PHOTOGRAPHY AND THE ALLIED ARTS & SCIENCES n. s. vol. 5, no. 8 (Oct. 15, 1862): 184-187.

T533 Thompson, F. F., Capt. "The Golden Virtues of 'Brass.'" AMERICAN JOURNAL OF PHOTOGRAPHY AND THE ALLIED ARTS & SCIENCES n. s. vol. 5, no. 8 (Oct. 15, 1862): 189-190. [Read before "Am. Photo. Soc.," Oct. 13, 1862]

T534 Thompson, F. F. "Scraps from the Rural Districts," by a Straggling Amateur." AMERICAN JOURNAL OF PHOTOGRAPHY AND THE ALLIED ARTS & SCIENCES n. s. vol. 5, no. 10 (Nov. 15, 1862): 217-221. [Describes photo trip to Seneca Lake, NY and Watkins Glenn, NY.]

T535 [Thompson, F. F.] "In Search of Ideas, by the Straggling Amateur." AMERICAN JOURNAL OF PHOTOGRAPHY AND THE ALLIED ARTS & SCIENCES n. s. vol. 5, no. 20 (Apr. 20, 1863): 467-469.

T536 "The Amateur Photographic Print." HUMPHREY'S JOURNAL OF PHOTOGRAPHY, AND THE ALLIED ARTS AND SCIENCES 15, no. 10 (Sept. 15, 1863): 158. [Note that "F. F. Thompson, an amateur photographer of some celebrity in this city, has commenced the publication of a Photographic Journal under the same name." 2 pages of a letter sheet. Includes the "prospectus."]

T537 Thompson, F. F. "Daddy Long-Leg's visit to Skaneateles, by a Straggling Amateur." AMERICAN JOURNAL OF PHOTOGRAPHY AND THE ALLIED ARTS & SCIENCES n. s. vol. 6, no. 7 (Oct. 1, 1863): 164-166. [Trip to Skaneateles, NY described. Praise for the studio of Finely & Sons in Canandaigua, NY. A note on p. 168 indicates that Thompson had been ill for some time, but now recovered.]

T538 Thompson, F. F. "Brass-Toned." HUMPHREY'S JOURNAL OF PHOTOGRAPHY, AND THE ALLIED ARTS AND SCIENCES 15, no. 11 (Oct. 1, 1863): 169-170. [From "Amat. Photo. Print." A toning process for stereo cards.]

T539 Thompson, F. F. "'Sold' for Three Dollars." HUMPHREY'S JOURNAL OF PHOTOGRAPHY, AND THE ALLIED ARTS AND SCIENCES 15, no. 11 (Oct. 1, 1863): 170. [From "Photo. Print." Thompson's describing a process seller's pamphlet, which is a repetition of already known information.]

T540 [Thompson, F. F.] "A Word about Toning, by Prof. C. F. Himes. Moses, the First Amateur on Record. The Amateur Photographic Exchange Club. Gutta-Percha Stoppers, by S. Fisher Corlies, Esq." and "Oh! Gully!, by a Straggling Amateur." HUMPHREY'S JOURNAL OF PHOTOGRAPHY, AND THE ALLIED ARTS AND SCIENCES 15, no. 12 (Oct. 15, 1863): 184-187. ["We copy the four following articles from "The Amateur Photographic Print" (which was a small publication written, edited and printed by F. F. Thompson) and the final piece was a letter, from a "Straggling Amateur" (Who was Thompson). The letter describes Thompson's photographic trip to area near Naples, NY.]

T541 "An Amateur Catastrophe, by a Straggling Amateur." AMERICAN JOURNAL OF PHOTOGRAPHY AND THE ALLIED ARTS & SCIENCES n. s. vol. 6, no. 8 (Oct. 15, 1863): 186-188. [Trip to Canandaigua Lake, fell and broke his camera.]

T542 Thompson, F. F. "Photography and I Are Out." PHOTOGRAPHIC TIMES 21, no. 519 (Aug. 28, 1891): 435. [Humorous anecdotes of trials of amateur photographer.]

THOMPSON, H. I. B.
T543 Thompson, H. I. B. "Astro - Photography." HUMPHREY'S JOURNAL OF PHOTOGRAPHY, AND THE ALLIED ARTS AND SCIENCES 9, no. 24 (Apr. 15, 1858): 383-384.

THOMPSON, J. A.
T544 "Dr. J. A. Thompson's Photograph Cabinet." AMERICAN JOURNAL OF PHOTOGRAPHY AND THE ALLIED ARTS & SCIENCES n. s. vol. 7, no. 1 (July 1, 1864): 22. 1 illus. ["Cards" attached to tape and rolled up to a window for viewing in a wooden cabinet.]

THOMPSON, J. S. & J. TOMFORD.
T545 "The Negro Insurrection in Jamaica." ILLUSTRATED LONDON NEWS 47, no. 1344 (Nov. 25, 1865): 508-509, 512, 518-519. 5 illus. ["Our illustrations consist of a general view of Morant Bay; a view of Port Morant, with the ruined Courthouse from a sketch by Mr. Cyprian Bridge, R.N.; and a view of the Hordley Estate, taken by Messrs. J. S. Thompson and J. Tomford, photographers at Falmouth, Jamaica."]

THOMPSON, J. S.
T546 "The Santo Domingo Expedition. - Arrival of the 'Tennessee' at Charleston, S. C. - Group on Deck Including the Commission and Ship's Officers. - From a Photograph by J. S. Thompson." FRANK LESLIE'S ILLUSTRATED NEWSPAPER 32, no. 811 (Apr. 15, 1871): 69. 1 illus.

THOMPSON, S. J. (ALBANY, NY)
T547 Thompson, S. J. "Developing Negatives." HUMPHREY'S JOURNAL OF PHOTOGRAPHY, AND THE ALLIED ARTS AND SCIENCES 10, no. 21 (Mar. 1, 1859): 325.

T548 Portraits. Woodcut engravings, credited "Photographed by S. J. Thompson, Albany." FRANK LESLIE'S ILLUSTRATED NEWSPAPER 11, (1861) ["Hon. Ira Harris, Sen. from NY." 11:278 (Mar. 23, 1861): 288.]

T549 Portrait. Woodcut engraving, credited "From a Photograph by S. J. Thompson." HARPER'S WEEKLY 5, (1861) ["Corporal Francis E. Brownell, Ellsworth Zouaves." 5:232 (June 8, 1861): 357.]

T550 Thompson, S. J. "Mounting Photographs - S. J. Thompson's Plan." AMERICAN JOURNAL OF PHOTOGRAPHY AND THE ALLIED ARTS & SCIENCES n. s. vol. 6, no. 10 (Nov. 15, 1863): 237-238.

THOMPSON, STEPHEN. (GREAT BRITAIN)
BOOKS
T551 Thompson, Stephen. *Places and Scenes of Historical Interest in England and Scotland.* London: A. W. Bennett, 1862. n. p. 50 b & w. [Albumen prints.]

T552 Waring, John Barley. *Masterpieces of Industrial Art & Sculpture at the International Exhibition, 1862,* Selected and Described by J. B. Waring. London: Day & Son, 1863. 3 vol. 301 l. of plates. b & w. illus. ["Chromolithographed... from photographs supplied by the London Photographic and Stereoscopic Company, taken exclusively for this work by Stephen Thompson."]

T553 Howitt, William. *The Ruined Abbeys of the Border;* Extracted from "The Ruined Abbeys and Castles of Great Britain." With Photographic Illustrations by G. W. Wilson and Stephen Thompson. London: Alfred W. Bennett, 1865. 70 pp. 6 b & w.

T554 *Scotland; Her Songs and Scenery as Sung by Her Bards, and Seen in the Camera.* London: A. W. Bennett, 1868. n. p. 14 b & w. illus. [Original photos by Stephen Thompson and P. Ewing.]

T555 Thompson, Stephen. *Swiss Scenery.* London: A. W. Bennett, 1868. n. p. 31 b & w. illus. [Original photos.]

T556 Thompson, Stephen, ed. *Venice and the Poets,* with Photographic Illustrations. Edited and illustrated by Stephen Thompson, author of *Swiss Scenery.* London: Provost & Co., 1870. 48 pp. 10 b & w. illus. [Original photos, by S. Thompson. Poems by Wordsworth, Byron, Browning.]

T557 Scott, Sir Walter. *The Lord of the Isles.* London: Provost & Co., 1871. n. p. 9 b & w. [Albumen prints, six by Russell Sedgfield, three by Stephen Thompson.]

T558 *British Museum Collections.* Photographed by Stephen Thompson. With a Comprehensive Catalogue of the Objects Depicted and an Introduction by Charles Harrison. "London" W. A. Mansell & Co.: 1872, liii, 122. approximately 900 b & w. [This work is made up of seven parts, the total illustrated with approximately nine hundred original photographs.]

T559 *The Works of Velasquez. Being a Reproduction of Seventeen Scarce and Fine Prints in the British Museum,* selected and described by G. W. Reid. Photographed by Stephen Thompson. London: Bell & Daldy, 1872. n. p. 17 b & w. [Original photographs.]

T560 Smith, George. *Assyrian Discoveries; An Account of Exploration and Discoveries on the Site of Nineveh, During 1873 and 1874.* London; New York: Sampson Low, Marston, Low & Searle; Scribner, Armstrong, 1875. xviii, 461 pp. 4 b & w. 25 illus. [Woodburytypes by Stephen Thompson, of paintings, sculpture and inscriptions.]

T561 Thompson, Stephen. *Studies from Nature.* London: Sampson Low, Marston, Low & Searle, 1875. 21 l. 20 l. of plates. 20 b & w. [Woodburytype prints.]

T562 Thompson, Stephen. *Old English Homes: a Summer's Sketch-Book,* ...the Illustrations by the Author. London: Sampson Low, Marston, Low & Searle, 1876. viii, 215 pp. 24 l. of plates. 24 b & w. [NYPL collection copy, Woodburytypes, with 22 original photos.]

PERIODICALS
T563 Thompson, S. "How to prevent the Collodion Film cracking." HUMPHREY'S JOURNAL OF PHOTOGRAPHY, AND THE ALLIED ARTS AND SCIENCES 13, no. 3 (June 1, 1861): 45-46. [From "Br. J. of Photo."]

T564 Thompson, S. "Photography One of the Fine Arts." BRITISH JOURNAL OF PHOTOGRAPHY 8, no. 145 (July 1, 1861): 234-235.

T565 Thompson, S. "Photography Applied to Pictorial Decoration." BRITISH JOURNAL OF PHOTOGRAPHY 8, no. 147 (Aug. 1, 1861): 267-268.

T566 "Recent Publications: Series of Cabinet-sized Photographs, taken by S. Thompson, Including the Waverly Photographs, Places of Historical Interest in England and Scotland, Reproductions, &c." BRITISH JOURNAL OF PHOTOGRAPHY 8, no. 154 (Nov. 15, 1861): 408-409.

T567 Thompson, S. "On Portraits and Portraiture." BRITISH JOURNAL OF PHOTOGRAPHY 9, no. 158 (Jan. 15, 1862): 21-22.

T568 "The Waverly series of Cabinet Photographs, Places and Scenes of Historical Interest in England and Scotland, by S. Thompson, Published by A. W. Bennett, London." ART JOURNAL 1, (Mar. 1862): 96. [Reviewed.]

T569 Thompson, Stephen. "The Commercial Aspects of Photography." BRITISH JOURNAL OF PHOTOGRAPHY 9, no. 177 (Nov. 1, 1862): 406-407.

T570 "'The Faithful Shepherdess,' photographed by Stephen Thompson. (London)." BRITISH JOURNAL OF PHOTOGRAPHY 10, no. 1898 (May 1, 1863): 190. [A sculpture, by Miss S. D. Durant.]

T571 "Note." ART JOURNAL (Feb. 1864): 58. [Photos of Balmoral Castle taken by S. Thompson, published by Victor Delarue.]

T572 Thompson, Stephen. "Photography Amongst the Alpine Passes of Switzerland and Italy." BRITISH JOURNAL OF PHOTOGRAPHY 11, no. 239-240 (Dec. 2 - Dec. 9, 1864): 485, 502.

T573 "The British Museum Photographs," NATURE 6, (Sept. 26, 1872): 430. [Book review: "Photographs from the Collections of the British Museum. Taken by S. Thompson. 1st Series. (London: W. A. Mansell & Co.).]

THOMPSON, W. C. (NEWBURYPORT, MA)
T574 "Editor's Table." PHILADELPHIA PHOTOGRAPHER 6, no. 68 (Aug. 1869): 284. [Stereos mentioned briefly.]

THOMPSON, W. N. (BARNSBURG, ENGLAND)
T575 "Burning of the Alexandria Palace." ILLUSTRATED LONDON NEWS 62, no. 1764 (June 21, 1873): 593-594. 3 illus. ["...two views taken by a photographer (Mr. W. N. Thompson, of Roman Road, Barnsburg), which show the palace."]

THOMPSON, WILLIAM.
T576 Thompson, William. "On Taking Photographic Images Under Water." JOURNAL OF THE SOCIETY OF ARTS (LONDON) 4, no. 181 (May 9, 1856): 425-426.

THOMSON, J. (LIVERPOOL, ENGLAND)
T577 A Short Description of the Photographs of the Atlantic Telegraph Cable Machinery taken on board the Steamship 'Great Eastern.' Liverpool: J. Thomson, 1867. n. p. 11 b & w. [Original photographs, with printed captions.]

THOMSON, JOHN [of ROSS & THOMSON, EDINBURGH] see also ROSS & THOMSON.

THOMSON, JOHN [of ROSS & THOMSON, EDINBURGH] [?]
T578 Thomson, John. The Progress of Heliochromy; or, Printing in Colors by Light. Edinburgh; Liverpool: Wood; H. Greenwood, 1855. n. p.

T579 Bede, Cuthbert (Edward Bradley). The Visitors' Handbook to Rosslyn and Hawthornden. Edinburgh: R. Grant & Son, n. d. [1862 ?]. 64 pp. 9 b & w. [9 tipped-in photos, credited to "John Thomson, Rosslyn."

THOMSON, JOHN. (1837-1921) (GREAT BRITAIN, CHINA, GREAT BRITAIN)
[Born in Edinburgh, Scotland in 1837. Studied chemistry at Edinburgh University, then, in 1865, he left for the Far East where he spent a decade, travelling and photographing in Malaysia, Indochina, Cambodia and China. Published many books from this work. Returned to England in 1875, where he made the photographs used to illustrate the pioneering survey Street Life in London, by Adolph Smith. Official Photographer to Queen Victoria in 1881. In 1886 he was appointed professor of photography to the Royal Geographic Society, London - having been a member since 1866. Official Photographer to King George V in 1910. Died in 1921.]

BOOKS
T580 Thomson, John. The Antiquities of Cambodia. A Series of Photographs taken on the Spot, with Letterpress Description by John Thomson, F.R.G.S., F.E.S.L. Edinburgh: Edmonston & Douglas, 1867. 72 pp. 16 b & w. [Original photographs.]

T581 Thomson, John. Notes on Cambodia and Its Races. 1867. [Library Cat. of the Royal Geographical Cat.]

T582 Beach, Rev. William R. Visit of His Royal Highness the Duke of Edinburgh... to Hongkong in 1869. Compiled from the local journals, and other sources by The Rev. William R. Beach. Illustrated by a portrait of His Royal Highness taken in Hongkong, and by photographs of local scenes, and incidents of the Prince's visit. Hongkong; London: Printed by Noronha & Sons; Smith, Elder & Co., 1869. n. p. 6 b & w. [Portrait and five photographs by John Thomson.]

T583 Thomson, John. Views of the North River. Hong Kong: Noronha & Sons, Printers, 1870. 8 pp. 14 l. of plates. 14 b & w. [14 albumen prints of the north branch of the Pearl River in China.]

T584 Thomson, John. Illustrations of China and Its People; A Series of Two Hundred Photographs, with Letterpress Descriptive of the Places and People Represented. London: Sampson Low, Marston, Low & Searle, 1874. 4 vol. 200 b & w. [Autotype prints.]

T585 Thomson, John. The Straits of Malacca, Indo-China and China: Or, Ten Years Travels, Adventures and Residence Abroad, Illustrated with upwards of Sixty Wood Engravings by J. D. Cooper from the Author's Own Sketches and Photographs. London: Sampson Low, Marston, Low & Searle, 1875. xv, 54 pp. illus.

T586 Le Bon, Charles Davillier. Spain. Illustrated by Gustave Doré, Translated by John Thomson. London: Sampson Low, Marston, Low & Searle, 1876. 512 pp.

T587 Thomson, John. The Land and the People of China; A Short Account of the Geography, History and Government of China and Its People. With Map and Illustrations. London: Society for Promoting Christian Knowledge, 1876. iv, 288 pp. b & w. illus.

T588 Tissandier, Gaston. A History and Handbook of Photography; Translated from the French of Gaston Tissandier. Edited by John Thomson, F.R.G.S. London: Samson Low, Marston, Low & Searle, 1876. xvi, 326 pp. 1 l. of plates. illus. [2nd, revised ed. (1878).]

T589 Thomson, John. Text by Adolphe Smith. Street Life in London. With Permanent Photographic Illustrations Taken from Life Expressly for This Publication. London: Sampson Low, Marston, Searle & Rivington, 1877-1878. vi, 142 pp. 36 b & w. [Thirty-six Woodburytypes. Issued in twelve parts. Reprinted. (1969) New York: Blom, 142p.]

T590 Thomson, John. Dix ans de voyage dans la Chine et l'Indo-Chine. Ouvrage traduit de l'anglais par MM. A. Talandier et H. Vattemare et illustré de... gravure sur bois. Paris: Hachette, 1877. 492 pp. illus.

T591 Thomson, John. L'Indo-Chine et la Chine; récits de voyages. ...abrégés par H. Vattemare. "Bibliothèque des écoles et des familles." Paris: Hachette, 1879. 192 pp. illus. [2nd ed. (1885) 3rd ed. (1888)]

T592 Thomson, John. Through Cyprus with the Camera; In the Autumn of 1878; ...with Sixty Permanent Photographs. London: Sampson Low, Marston, Searle & Rivington, 1879. 2 vol. 60 b & w.

T593 Davis, Charles. A Description of the Works of Art Forming the Collection of Alfred de Rothschild. The Photographs by John Thomson. Compiled by C. Davis. London: s. n., 1884. 2 vol. b & w.

T594 Thomson, John. *China: The Land and Its People: Early Photographs by John Thomson.* Hong Kong: John Warner Publications, 1977. 160 pp. 143 b & w. [Annotated selection of photos from Thompson's 1873 "Illustration's of China and Its People."]

T595 Thomson, John. *Through China with a Camera.* With nearly 100 Illustrations. Westminster: A. Constable & Co., 1899. 284 pp. illus. [2nd ed. London, New York: Harper & Brothers, 1899. 269 pp.]

T596 White, Stephen. Preface by Robert A. Sobieszek. *John Thomson: A Window to the Orient.* New York: Thames & Hudson, 1986. 200 pp. 173 b & w.

PERIODICALS

T597 "Mons. Blondin Crossing the Niagara River on a Rope. - From a Stereoscopic View, Taken Especially for this Paper by J. Thomson." FRANK LESLIE'S ILLUSTRATED NEWSPAPER 8, no. 189 (July 16, 1859): 97. 1 illus.

T598 "The King of Siam - Amazons of the King of the Siam's Guard." ILLUSTRATED LONDON NEWS 48, no. 1366 - 1367 (Apr. 21, 1866): 385. 2 illus. ["...from photographs by Mr. John Thomson, of Singapore."]

T599 Thomson, J. "Practical Photography in Tropical Regions." HUMPHREY'S JOURNAL OF PHOTOGRAPHY, AND THE ALLIED ARTS AND SCIENCES 18, no. 16 (Dec. 15, 1866): 254-255. [From "Br. J. of Photo."]

T600 "Bangkok, the Capital of Siam." ILLUSTRATED LONDON NEWS 50, no. 1428 (May 25, 1867): 512, 514. ["Our Illustrations are engraved from photographs taken by Mr. John Thomson, late of Singapore." Includes view of the King's state barge and a view of the city."]

T601 "The Ruined Temples of Cambodia." ILLUSTRATED LONDON NEWS 52, no. 1467 (Feb. 1, 1868): 105, 118. 2 illus. ["...the ruined temples... have been visited more recently by Mr. J. Thomson."]

T602 "Prince Alfred at Hong-Kong." ILLUSTRATED LONDON NEWS 56, no. 1578 (Jan. 29, 1870): 111-112. 2 illus. ["We have engraved two Illustrations, from photographs by Mr. J. Thomson, of the scenes at Hong-Kong when his Royal Highness arrived there."]

T603 Thomson, J., F.R.G.S. "A Pocket Camera." BRITISH JOURNAL PHOTOGRAPHIC ALMANAC 1874 (1874): 156-158. 1 illus.

T604 Thomson, J., F.R.G.S. "Proverbial Photographic Philosophy." BRITISH JOURNAL PHOTOGRAPHIC ALMANAC 1875 (1875): 128-129.

T605 "New Books: Illustrated Books of Travel." ILLUSTRATED LONDON NEWS 66, no. 1849 (Jan. 16, 1875): 66. [Bk. rev.: "The Straits of Malacca, Indo-China, and China," by J. Thomson (Sampson Low, Marston, Low, and Searle). Illus. with 60 or 70 woodcuts. ("China and its People reviewed in the ILN 'some months ago.'")]

T606 "Mountain Views in Cyprus." ILLUSTRATED LONDON NEWS 73, no. 2054 (Nov. 9, 1878): 432, 434. 2 illus. ["Mr. J. Thomson, a photographic artist, who has lately visited Cyprus to obtain views of its scenery." Quotes from Thomson's letter describing his experiences.]

T607 "Pictures Received: Portrait of R. L. Maddox, M.D." PHOTOGRAPHIC TIMES 14, no. 164 (Aug. 1884): 431. [Describes a cabinet portrait of R. L. Maddox, inventor of the gelatine-emulsion process, issued by John Thomson, of Grosvenor Square, London.]

T608 1 photo (Chinese minister Li Hung Chang, in 1872). MCCLURE'S MAGAZINE 7, no. 5 (Oct. 1896): 428. 1 b & w. [Thompson's portrait in an article on the Chinese minister, which is also illustrated with other, later, non-credited portraits.]

T609 Doty, Robert. "Street Life in London: A review of an early use of photography in social documentation." IMAGE 6, no. 10 (Dec. 1957): 240-245. 5 b & w.

T610 "The First Photojournalist: John Thomson." CREATIVE CAMERA no. 43 (Jan. 1968): 22-25. 6 b & w.

T611 "Proverbial Photographic Philosophy." IMAGE 14, no. 2 (Mar. 1971): 12-13. 1 b & w. [An article reprinted from pp. 125-126 of "The British Journal Photographic Almanac, 1875." A photograph from "Illustrations of China and Its People" also reproduced.]

T612 Warner, John. "John Thomson: Compassionate Photographer." ARTS OF ASIA 6, no. 3 (May - June 1976): 42-53. 15 b & w.

T613 Westerbeck, Colin, Jr. "John Thomson: Victorian adventurer and innovator of candid street photography." AMERICAN PHOTOGRAPHER 1, no. 4 (Sept. 1978): 66-72. 6 b & w.

T614 Lehr, Janet. "John Thomson (1837-1921)." HISTORY OF PHOTOGRAPHY 4, no. 1 (Jan. 1980): 67-71. 9 b & w. [Discussion of Thomson's photographic work in China in the 1860s.]

T615 Gernsheim, Helmut and Janet Lehr. "Correspondence." HISTORY OF PHOTOGRAPHY 4, no. 4 (Oct. 1980): 343. [Letters from Gernsheim and Lehr correct biographical and professional speculations made by Lehr in "History of Photography" 4:1 (January 1980).]

T616 Cowan, Aileen Gibson. "John Thomson on Cyprus." PHOTOGRAPHIC COLLECTOR 5, no. 3 (1985): 309-319. 11 b & w. [Thomson photographed Cyprus in 1878.]

THOMSON, JOHN. [?]
T617 "West Front of the Cathedral of Famagusta, Cyprus." ILLUSTRATED LONDON NEWS 73, no. 2055 (Nov. 16, 1878): 453. 1 illus. ["...from a photograph." (Thomson was in Cyprus at this time and had contributed work to the "ILN." See p. 432 of the Nov. 9, 1878 issue.]

THORN, HARRY.
T618 "In King Arthur's Land: A Week's Study of Cornish Life." GOOD WORDS 8, no. 1 (Jan. 1867): 61-71. 5 illus. ["The illustrations to this paper are from photographs by Mr. Harry Thorn, Bude Harbour." Views.]

THORNE, GEORGE W.
T619 *Catalogue and Price List of Photograph Albums and Photographs.* New York: G. W. Thorne, 1866. 23 pp. [Lists about 900 views.]

THORNTON, MARY A. (MRS.) (PERRYSBURG, OH)
T620 Thornton, Mrs. Mary A. "Photographic Refrigerator." ANTHONY'S PHOTOGRAPHIC BULLETIN 2, no. 9 (Sept. 1871): 295-296. ["Being a practical artist, I have used this box four years." Thornton from Perrysburg, Wood Co., OH.]

THORNTHWAITE, WILLIAM HENRY. (LONDON, ENGLAND)

[Of the firm Horne & Thornthwaite, Chemists and Dealers in Photographic Apparatus, London.]

BOOKS

T621 Thornthwaite, W. H. *Photographic Manipulation; Containing Simple and Practical Details of the Most Improved Processes of Photogenic Drawing the Daguerreotype and Calotype.* "2nd ed." London: E. Palmer, 1843. vii, 48 pp. 1 illus.

T622 Thornthwaite, W. H. *A Guide to Photography; including Photogenic Drawing, Calotype, Daguerreotype, Crysotype, Anthotype, Energiatype, Cyanotype, Ferrotype, Tithonotype, and Thermography.* London: Horne, Thornthwaite & Wood, 1845. 57 pp. 1 l. of plates. illus. [The plate contains ten woodcut illustrations. First printing of this often republished work.]

T623 Thornthwaite, W. H. *A Guide to Photography; Containing Simple and Concise Directions for Obtaining Views, Portraits, etc., by the Chemical Agency of Light, including the Most Recent and Improved Processes for the Production of Collodion Positives and Negatives.* London: Simpkin, Marshall & Co., 1855. 73 pp. [many editions throughout 1850s, etc.]

T624 Thornthwaite, W. H. *A Guide to Photography: Containing a Concise History of the Science and its Connection with Optics; together with simple and practical details for the production of Pictures by the Chemical Action of Light upon Prepared Surfaces of Paper, Glass, and Silvered Plates, including Photogenic Drawing, Talbotype or Calotype, Daguerreotype, and the Improved Processes for Obtaining Views, Portraits, etc., with Prepared Collodion and Albumen.* "3rd ed." London: R. R. Pond, 1851. 71 pp. 47 illus. [Two or three editions issued annually and sold by Horne & Thornthwaite, dealers in photographic apparatus and supplies, London, and Simpkin, Marshall & Co., publishers. 10th ed. (1856) New York: S. D. Humphrey, 88 pp.; 17th ed. (1860) 75 pp., 43 illus.]

PERIODICALS

T625 "Our Library Table: 'Guide to Photography,' by W. H. Thornthwaite." ATHENAEUM no. 921 (June 21, 1845): 609.

T626 Thornthwaite, W. H. "On Photography." HUMPHREY'S JOURNAL 8, no. 3-8 (June 1 - Aug. 15, 1856): 35-44, 51-60, 67-77, 84-88, 88-92, 92-104, 105-110, 114-122. 45 illus. [Includes chapters: "On the Calotype Process," by F. Horne on pp. 88-92, "The Collodio-Albumen Process," by W. Ackland on pp. 105-110.]

THORP, F. (WASHINGTON, DC)

T627 Thorp, F. "Buckeye Correspondence From the Backwoods." PHOTOGRAPHIC WORLD 1, no. 6 (June 1871): 173-175. [Is photography a fine art? Can it elevate the public taste?]

T628 Portrait. Woodcut engraving, credited "From a Photograph by Thorp." FRANK LESLIE'S ILLUSTRATED NEWSPAPER 34, (1872) ["Hon. David Davis, Labor reform party candidate." 34:859 (Mar. 16, 1872): 1. "Sen. Lyman Trumball." 34:866 (May 4, 1872): 124.]

T629 Thorp, F. "On Critics." PHILADELPHIA PHOTOGRAPHER 9, no. 100 (Apr. 1872): 109-111.

T630 Portrait. Woodcut engraving, credited "From a Photograph by Thorpe [sic Thorp], Washington, D. C. FRANK LESLIE'S ILLUSTRATED NEWSPAPER 36, (1873) ["The late Chief-Justice S. F. Chase." 36:921 (May 24, 1873): 165.]

T631 Portrait. Woodcut engraving, credited "From a Photograph by F. Thorpe, [sic Thorp] Artist, Washington, D. C." FRANK LESLIE'S ILLUSTRATED NEWSPAPER 41, (1875) ["Hon. Thomas W. Perry, of MI." 41:1054 (Dec. 11, 1875): 217.]

T632 Portrait. Woodcut engraving, credited "From a Photograph by F. Thorpe, [sic Thorp] Artist, Washington, D. C." FRANK LESLIE'S ILLUSTRATED NEWSPAPER 47, (1879) ["The late Hon. Caleb Cushing." 47:1216 (Jan. 18, 1879): 368.]

T633 Thorp, F. "Fourth Annual Meeting and Exhibition of the N.P.A. in St. Louis, Mo., May 1872: Things Beautiful & Otherwise." PHILADELPHIA PHOTOGRAPHER 9, no. 102 (June 1872): 210-212.

T634 Thorp, F. "A Reply to Mr. Snelling." PHILADELPHIA PHOTOGRAPHER 9, no. 105 (Sept. 1872): 312-314. [Response to Snelling's article in the Aug. issue, defining the role and values of photography.]

T635 Portrait. Woodcut engraving, credited "From a Photograph by Thorp, of Washington." FRANK LESLIE'S ILLUSTRATED NEWSPAPER 35, (1873) ["Hon. Ward Hunt, judge." 35:906 (Feb. 8, 1873): 357.]

T636 Portraits. Woodcut engravings, credited "Photographed by F. Thorp, of Washington, DC." FRANK LESLIE'S ILLUSTRATED NEWSPAPER 37, (1874) ["Hon. Caleb Cushing, Minister to Spain." 37:956 (Jan. 24, 1874): 325. "Hon. Matthew Hale Carpenter, Sen. from WI." 37:960 (Feb. 21, 1874): 396.]

T637 Portraits. Woodcut engravings, credited "Photographed by F. Thorp, of Washington, DC." FRANK LESLIE'S ILLUSTRATED NEWSPAPER 38, (1874) ["Gen. R. H. Bristow, Sec. of Treasury." 38:977 (June 20, 1874): 229. "Hon. George C. Gorham, Sec. of U. S. Senate." 38:980 (July 11, 1874): 284.]

THORPE, T. B. [?]

T638 Thorpe, T. B. "Webster, Clay, Calhoun, and Jackson. How They sat for Their Daguerreotypes." HARPER'S MONTHLY 38, no. 228 (May 1869): 787-789. [Detailed and well written accounts of the portrait sessions of these men, all taking place between 1845 and 1850. The implication is that the author was the photographer, although that is never actually stated.]

THRUPP, R. W. (BIRMINGHAM, ENGLAND)

BOOKS

T639 *The Royal Visit to Wolverhampton.* Wolverhampton, England: E. Roden, 1867. 81 pp. 5 l. of plates. [Original photos by R. W. Thrupp and a portrait of Queen Victoria attributed to Messrs. Downey.]

PERIODICALS

T640 Portrait. Woodcut engraving reedited "From a photograph by R. W. Thrupp, of Birmingham." ILLUSTRATED LONDON NEWS 55, (1869) ["Mr. Josiah Mason, founder of Erdington Almshouses." 55:* (Sept. 11, 1869): 248.]

T641 Portraits. Woodcut engravings credited "From a photograph by R. W. Thrupp, New Street, Birmingham." ILLUSTRATED LONDON NEWS 66, (1875) ["Sampson Lloyd, M.P." 66:1859 (Mar. 27, 1875): 301. "Samuel C. Allsopp, M.P." 66:1866 (May 15, 1875): 465.]

T642 Portraits. Woodcut engravings credited "From a photograph by R. W. Thrupp." ILLUSTRATED LONDON NEWS 69, (1876) ["J. Chamberlain, M.P." 69:1928 (July 15, 1876): 69. "Late Mr. George Dawson." 69:1953 (Dec. 16, 1876): 581.]

THURBER, CALVIN. (WARREN, RI)
T643 Thurber, Calvin. "The Study of Art Necessary to the Photographer." AMERICAN JOURNAL OF PHOTOGRAPHY AND THE ALLIED ARTS & SCIENCES n. s. vol. 7, no. 21 (May 1, 1865): 491-493.

T644 Thurber, Calvin. "The Mission of Photography." AMERICAN JOURNAL OF PHOTOGRAPHY AND THE ALLIED ARTS & SCIENCES n. s. vol. 7, no. 22 (May 15, 1865): 512-515.

THURLOW, JAMES THOMAS. (1831-1878) (GREAT BRITAIN, USA)
T645 "Pictures Received." ANTHONY'S PHOTOGRAPHIC BULLETIN 6, no. 7 (July 1875): 224. [Thurlow, formerly of Peoria, IL, in Colorado taking views in the vicinity of Manitou and Pike's Peak.]

T646 Young, Alan. "James Thurlow: Colorado's Overlooked Photographer." STEREO WORLD 10, no. 6 (Jan. - Feb. 1984): 4-13, 38. 13 b & w. 1 illus. [Thurlow born near Bedford, England on Nov. 13, 1831. Immigrated to USA at age 17, were he began to work as a clerk in Peoria, IL. Learned photography there at Francis Burrows' Mammoth Fine Art Gallery. By 1860 he was working as a photographer. In 1874 moved to Manitou, CO, where he began to make stereo views in addition to his regular portrait trade. Died of pneumonia in 1878. His 250 negatives were bought by Charles Weitful, who was a major producer of stereoview from his own negatives as well as those by Thurlow, Ben Hawkins, and William Chamberlain. Article discusses Weitful as well. Thurlow's studio sold to Mrs. Galbreaith, Manatou's first woman photographer. A checklist of approximately 220 of James Thurlow's stereographs is in the article.]

TILFORD, W. H. (ST. LOUIS, MO)
T647 "Our Illustrations." PHOTOGRAPHIC AND FINE ART JOURNAL 10, no. 11 (Nov. 1857): frontispiece, 343. 1 b & w. [Original photographic print, tipped-in. Portrait of "Master George Marsh, juvenile comedian." negatives by W. H. Tilford, prints by H. H. Snelling.]

T648 "Matters of the Month." PHOTOGRAPHIC TIMES 4, no. 40 (Apr. 1874): 57. [Mentions visit of W. H. Tilford, of St. Louis, who has retired from the profession, but dropped by to say hello.]

T649 "Condition of W. H. Tilford." ANTHONY'S PHOTOGRAPHIC BULLETIN 9, no. 12 (Dec. 1878): 376. [Tilford (St. Louis, MO) very ill.]

TILLEY.
T650 "Tilley's Method of Printing in Backgrounds." ANTHONY'S PHOTOGRAPHIC BULLETIN 6, no. 10 (Oct. 1875): 308-310. [From "Br J of Photo." Combination printing for portrait studios.]

T651 "Pictorial Backgrounds to Portraits." ANTHONY'S PHOTOGRAPHIC BULLETIN 6, no. 12 (Dec. 1875): 353-355.

TILLMAN, SAMUEL D.
T652 Tillman, Samuel D., A.M. "A New Nomenclature for the Imponderables." AMERICAN JOURNAL OF PHOTOGRAPHY AND THE ALLIED ARTS & SCIENCES n. s. vol. 2, no. 4 (July 15, 1859): 49-51. [Read before the Photographical Society, June 11th. "Light is not matter."]

T653 Tillman, S. D., Esq. "A New Method of Counterfeiting." AMERICAN JOURNAL OF PHOTOGRAPHY AND THE ALLIED ARTS & SCIENCES n. s. vol. 2, no. 16 (Jan. 15, 1860): 241-242. [Read before Am. Photographical Soc.]

T654 Tillman, S. D., Esq. "The Photo-Lithographic Process." AMERICAN JOURNAL OF PHOTOGRAPHY AND THE ALLIED ARTS & SCIENCES n. s. vol. 2, no. 16 (Jan. 15, 1860): 248-250.

T655 Tillman, S. D., Esq. "The Harmonic Hypothesis." AMERICAN JOURNAL OF PHOTOGRAPHY AND THE ALLIED ARTS & SCIENCES n. s. vol. 3, no. 1 (June 1, 1860): 1-4.

T656 Tillman, Samuel D. "The Eclipse and Corona of 1860." AMERICAN JOURNAL OF PHOTOGRAPHY AND THE ALLIED ARTS & SCIENCES n. s. vol. 3, no. 21 (Apr. 1, 1861): 324-326.

T657 Tillman, S. D. "New Sources of Artificial Light." AMERICAN JOURNAL OF PHOTOGRAPHY AND THE ALLIED ARTS & SCIENCES n. s. vol. 4, no. 2-3 (June 15 - July 1, 1861): 44-45, 63-64. [Read before Am. Photo. Soc. Coal oil, oil, etc.]

T658 Tillman, Samuel D. "Heliochromy." AMERICAN JOURNAL OF PHOTOGRAPHY AND THE ALLIED ARTS & SCIENCES n. s. vol. 5, no. 21 (May 1, 1863): 496-498. [Read to Am. Photo. Soc.]

TIMBS, JOHN.
T659 Timbs, John. "Photography and the Stereoscope," on pp. 313-324 in: Stories of Inventors and Discoverers. London: Kent & Co., 1860.

TIPTON & MYERS. (GETTYSBURG, PA)
T660 "The Gettysburg Monument, Dedicated July 1, 1869 - Photo by Tipton and Myers, Gettysburg." HARPER'S WEEKLY 13, no. 655 (July 17, 1869): 456, 457. 5 illus. [1 engraving from photo, 4 engravings from sketches.]

TIPTON, WILLIAM H. (1850-1929) (USA)
BOOKS
T661 Catalogue of Photographic Views of the Battlefield of Gettysburg. Gettysburg, PA: W. H. Tipton, 1894. 23 pp. [Lists over 1600 views. 1st Tipton catalog in 1873, the second in 1876.]

PERIODICALS
T662 Tipton, W. H. "'Roughing It;' Or, A Week's Ramble with Camera and Tripod." PHILADELPHIA PHOTOGRAPHER 14, no. 167-168 (Nov. - Dec. 1877): 341-343, 362-364. [Tipton (Gettysburg, PA) describes his tour through MD, VA, and PA. Tipton's views of sites of Civil War battlefields described in "Editor's Table," on p. 351.]

T663 Tipton, W. H. "A Trio of Suggestions." PHILADELPHIA PHOTOGRAPHER 14, no. 168 (Dec. 1877): 368-369. [Advice to gallery owners.]

TISSANDIER, GASTON. (1835-1899) (FRANCE)
BOOKS
T664 Tissandier, Gaston. A History and Handbook of Photography. Translated from the French. Edited by J. Thomson, F.R.G.S. London: Sampson Low & Co., 1875. xvi, 326 pp.

T665 Tissandier, Gaston. A History and Handbook of Photography. Translated from the French of Gaston Tissandier. Edited by John Thomson, F.R.G.S. Second and revised edition, with an Appendix by the late H. Fox-Talbot. London: Samson Low, Marston, Low & Searle, 1878. 400 pp. 20 l. of plates. 60 illus. [The second edition contains an appendix with an autobiographical statement by William H. F. Talbot, as well as biographies of other early British photographers. Illustrated with sixty woodcuts and twenty full-page engravings, etc. by various processes.]

PERIODICALS

T666 "The Fatal Balloon Ascent in France." ILLUSTRATED LONDON NEWS 66, no. 1864 (May 1, 1875): 405, 421. 5 illus. [Gaston Tissandier and two others attempted a high altitude balloon flight, lost consciousness due to lack of oxygen, Tissandier only one to survive.]

T667 "New Books." ILLUSTRATED LONDON NEWS 67, no. 1900 (Dec. 25, 1875): 627. [Bk. rev.: "A History and Handbook of Photography," translated from the French of Gaston Tissandier, edited by J. Thomson, F.R.G.S. (Sampson Low & Co.).]

T668 "A History and Handbook of Photography: by Gaston Tissandier." PHOTOGRAPHIC TIMES 6, no. 64-72 (Apr. - Dec. 1876): 78-79, 99-101, 122-126, 150-154, 172-173, 193-197, 220-224, 242-244, 269-273. [Survey of the prehistory and early history of photography up to the 1870s.]

T669 "History and Handbook of Photography. A New Book." PHOTOGRAPHIC TIMES 7, no. 75 (Mar. 1877): 49-50. [Announcement of publication in America of an English language version of Tissandier's book.]

T670 "A New Handbook." PHILADELPHIA PHOTOGRAPHER 14, no. 161 (May 1877): 157. [Book review: "History and Handbook of Photography," by Gaston Tissandier, trans. by J. Thompson. [Am. ed. Scoville Mfg. Co.] Has almost 70 illustrations and a photographic portrait tipped in. The photograph is by L. S. Washburn, (Louisville, KY), first published in Oct. 1872 "Phila. Photo."]

T671 "Our New Book." PHOTOGRAPHIC TIMES 7, no. 77 (May 1877): 97-99. [Bk rev: "A History and Handbook of Photography," by Gaston Tissandier. Includes reviews from "New York [NY] Daily Tribune" (Apr. 13, 1877) and "Rochester [NY] Sunday Morning Herald."]

T672 Tissandier, Gaston. "Photography and Art." PHOTOGRAPHIC TIMES 7, no. 77 (May 1877): 102-104. [Excerpts from "A History and Handbook of Photography," by Gaston Tissandier.]

T673 "Bibliography." ANTHONY'S PHOTOGRAPHIC BULLETIN 17, no. 21 (Nov. 13, 1886): 670. [Bk. rev.: "La Photographie en Baloon," by Gaston Tissandier.]

T674 Tissandier, Gaston. "How Photographic Dry Plates Are Made." ANTHONY'S PHOTOGRAPHIC BULLETIN 17, no. 4-5 (Feb. 27 - Mar. 13, 1886): 121-123, 148-149. 1 illus. [From "La Nature."]

TITTERMAN. (ELY, ENGLAND)

T675 "Autographs of the Sun." AMERICAN JOURNAL OF PHOTOGRAPHY AND THE ALLIED ARTS & SCIENCES n. s. vol. 5, no. 11 (Dec. 1, 1862): 249-250. [From "Photo. News." Mr. Titterton, of Ely (Eng.), took photos of the sun.]

TOD, A. G. (CHELTENHAM, ENGLAND)

T676 Portrait. Woodcut engraving credited "From a photograph by A. G. Tod." ILLUSTRATED LONDON NEWS 64, (1874) ["Rev. Dr. Jex Blake, Headmaster of Rugby." 64:1807 (Apr. 11, 1874): 353.]

TODD, JOHN A. (SACRAMENTO, CA)

T677 "Editor's Table." PHILADELPHIA PHOTOGRAPHER 6, no. 69 (Sept. 1869): 324.

T678 "Our Picture." PHILADELPHIA PHOTOGRAPHER 12, no. 141 (Sept. 1875): frontispiece, 276-277. 1 b & w. [Photo of the California State Capitol.]

T679 "The Promenade Portrait." ANTHONY'S PHOTOGRAPHIC BULLETIN 7, no. 1 (Jan. 1876): 15-16. [From "Br. J. of Photo." Todd, formerly of Sacramento, CA, visiting England.]

T680 Todd, John A. "Prize Print Hints." PHILADELPHIA PHOTOGRAPHER 15, no. 172 (Apr. 1878): 100-101. [Competitor in the "Phila. Photo." Gold Medal Prize, describing his working methods, etc.]

T681 "Our Picture." PHILADELPHIA PHOTOGRAPHER 15, no. 175 (July 1878): frontispiece, 212-213. 1 b & w. [Studio portrait by John A. Todd of Sacramento, CA.]

TOMBOEKEN, H. (CHICAGO, IL)

T682 Tomboeken, H. "Formic Acid - The Iron Process, &c." AMERICAN JOURNAL OF PHOTOGRAPHY AND THE ALLIED ARTS & SCIENCES n. s. vol. 6, no. 2 (July 15, 1863): 45.

TOMLINSON, CHARLES. (LONDON, ENGLAND)

T683 "Photography," on pp. 393-405 of vol. 3 in: *Cyclopedia of Useful Arts and Manufactures,* edited by Charles Tomlinson. London: Virtue & Co, 1854. 4 vol. illus. [New edition, rewritten (1866), "Photography," on pp. 291-303 of vol. 4.]

TOMLINSON, WILLIAM see also CUTTING, JAMES A.

TOMLINSON, WILLIAM A. (1819-ca. 1862) (USA)

[Born in Connecticut in 1819. Worked in New Haven, CT in 1845, Poughkeepsie, NY in 1846, Troy, NY from 1847 to 1852. Member of the NY State Daguerreian Assoc., member of committee which investigated L. L. Hill's claims to a color daguerreotype process in 1851. Broadway gallery, New York, NY from 1857 to 1862. Held the Cutting patent in the late 1850s and was prosecuting the photographic community to hold to the patent. Died around 1862.]

T684 "Note." AMERICAN JOURNAL OF PHOTOGRAPHY AND THE ALLIED ARTS AND SCIENCES n. s. vol. 2, no. 3 (July 1, 1859): 48. ["While we are writing, our neighbor Tomlinson (447 Broadway) and the firemen are endeavoring to extinguish a fire which originated in his gallery." Tomlinson held the Cutting patent and was suing Fredericks, etc.]

TOMPKINS, J. H.

T685 Tompkins, J. H. "Stereoscopic Views - Case of Poisoning." PHOTOGRAPHIC AND FINE ART JOURNAL 11, no. 3 (Mar. 1858): 94-95. [Letter from Tompkins (Buffalo, NY).]

TOMPSON, W. D., CAPT.

T686 "Nova Scotia Goldfields: The Horizontal Formation of Auriferous Quartz at Laidlaw's Farm, Nova Scotia." ILLUSTRATED LONDON NEWS 41, no. 1177 (Dec. 6, 1862): 619, 620. 2 illus. ["...from photographs obligingly furnished by Captain W. D. Tompson, of the 17th Regiment."]

TONKIN, J. C. (ST. MARY'S ISLAND, GREAT BRITAIN)

T687 "Scene of the Wreck of the Steamship 'Schiller' on the Retarriere Ledges, near Bishop's Rock, Scilly Islands. - From a Photograph by J. C. Tonkin, St. Mary's Island." FRANK LESLIE'S ILLUSTRATED NEWSPAPER 40, no. 1026 (May 29, 1875): 187, 188, 193. 3 illus. [Views of the ocean, and of the Scilly Islands.]

TOOKER, T. D. (ca. 1833-) (USA)

T688 Tooker, T. D. "Yellow Prints." HUMPHREY'S JOURNAL OF PHOTOGRAPHY, AND THE ALLIED ARTS AND SCIENCES 16, no. 13 (Nov. 1, 1864): 208. [Tooker from Newark, NJ.]

T689 Tooker, T. D. "The Tannin Process." HUMPHREY'S JOURNAL OF PHOTOGRAPHY, AND THE ALLIED ARTS AND SCIENCES 17, no. 10 (Sept. 15, 1865): 151-152. [Views of the High Bridge, etc. Note on p. 158 explains views were taken along the Genesee River between Portage Falls and Mount Morris (NY).]

TOOVEY, WILLIAM. (BRUSSELLS, BELGIUM)
T690 "Toovey's Patent Photolithographic Process." AMERICAN JOURNAL OF PHOTOGRAPHY AND THE ALLIED ARTS & SCIENCES n. s. vol. 7, no. 8 (Oct. 15, 1864): 179-180. [William Toovey, of Brussells, won award for best photolithograph at Photo Soc. exhibition, London.]

T691 Towler, Prof. "Litho-Photography." HUMPHREY'S JOURNAL OF PHOTOGRAPHY, AND THE ALLIED ARTS AND SCIENCES 18, no. 5 (July 1, 1866): 69-70. [Toovey's litho-photographic process discussed.]

TOPLEY FAMILY.
T692 Rodger, Andrew. "The Topley family and photography." THE ARCHIVIST (PUBLIC ARCHIVES OF CANADA) 13, no. 2 (Mar. - Apr.1986): 18-19. 2 b & w. [Topley Family, from Ottawa, worked for several generations. Anna Delia Topley, mother, worked the daguerreotype in 1850s; her sons William James, John G., and Horatio Nelson, worked as tintypists, for William Notman's Studio in 1860s, and for themselves. Then Horatio worked for Dept. of Interior, Geological Survey until retired in 1908. John G. (1950-1923) worked for Notman, then opened his own studio in Ottawa. William James (1845-1930) worked for Notman in Ottawa, then bought him out in 1872, but continued using the name until 1875. Ran that, then other studios until 1918. Studios taken over by their sons, William DeCourcy, etc.]

TORBERT, J. R.
T693 "Grace M. E. Church, Wilmington, Del." FRANK LESLIE'S ILLUSTRATED NEWSPAPER 28, no. 728 (Sept. 11, 1869): 412. 1 illus. [View.]

TOULOUSE.
T694 Toulouse. "On Transferring Collodion Negatives to Waxed Paper." HUMPHREY'S JOURNAL OF PHOTOGRAPHY, AND THE ALLIED ARTS AND SCIENCES 12, no. 7 (Aug. 1, 1860): 110-111. [From "Cosmos."]

TOURNACHON, ADRIEN. see NADAR JEUNE.

TOURNACHON, GASPARD-FÉLIX see NADAR.

TOURNIER, HENRY see FURNE & H. TOURNIER.

TOWLER, JOHN. (1811-1886) (USA)
BOOKS
T695 Towler, John, M.D. *The Silver Sunbeam; A Practical and Theoretical Text-book, on Sun Drawing and Photographic Printing.* New York; Liverpool: Joseph H. Ladd; J. Atkinson, 1864. viii, 351 pp. b & w. illus. [Facsimile reprint. (1969) Hastings on Hudson, NY: Morgan & Morgan. With a new introduction by Beaumont Newhall.]

T696 Towler, J. *The Porcelain Picture.* New York: J. H. Ladd ?, 1865. 47 pp. b & w. illus.

T697 Towler, John. *Dry Plate Photography;* or, The Tannin Process, Made Simple and Practical for Operators and Amateurs. New York: J. H. Ladd, 1865. 97 pp. illus.

T698 Towler, John. *The Negative and the Print;* or, The Photographer's Guide, In the Gallery and In the Field, Being a Text-book for the Operator and Amateur. New York: J. H. Ladd, 1866. xi, 150 pp. illus.

T699 Towler, John. *El rayo solar:* tratado teorico y pratico de fotografia. New York: D. Appleton, 1876. xiv, 439 pp. 2 l. of plates. b & w. illus. [Spanish translation "The Silver Sunbeam." A Ferrotype portrait as frontispiece.]

PERIODICALS
T700 Towler, J. "New Toning Process." HUMPHREY'S JOURNAL OF PHOTOGRAPHY, AND THE ALLIED ARTS AND SCIENCES 12, no. 3 (June 1, 1860): 35.

T701 Towler, J. "Stereographs on Glass." HUMPHREY'S JOURNAL OF PHOTOGRAPHY, AND THE ALLIED ARTS AND SCIENCES 12, no. 24 (Apr. 15, 1861): 370.

T702 Towler, J. "The Stereograph and the Stereoscope." HUMPHREY'S JOURNAL OF PHOTOGRAPHY, AND THE ALLIED ARTS AND SCIENCES 14, no. 5-24 (July 1, 1862 - Apr. 15, 1863): 18-20, 34-38, 52-55, 72-76, 102-105, 114-117, 134-137, 147-150, 198-200, 230-231, 297-300, 305-308, 324-327. [This series began as a technical discussion, but in March, 1863 (pp. 297-300), the author abruptly stated that it was "...now high time to descend from the pinnacle of science to rusticate awhile - to browse on the mountain escarpment." and then proceeded to tell anecdotes about photographic field trips to Seneca Lake and elsewhere. Towler mentions that he has a laboratory at the Geneva Medical College.]

T703 Towler, J. "A Short Lesson in Photography." HUMPHREY'S JOURNAL OF PHOTOGRAPHY, AND THE ALLIED ARTS AND SCIENCES 14, no. 6-24 (July 15, 1862 - Apr. 15, 1863): 33-34, 49-51, 69-70, 86-88, 97-100, 121-123, 137-140, 145-147, 164-166, 179-182, 212-215, 245-247, 274-277.

T704 Towler, J. "State Medical Association. - Albany, Feb. 3, 1863." HUMPHREY'S JOURNAL OF PHOTOGRAPHY, AND THE ALLIED ARTS AND SCIENCES 14, no. 21 (Mar. 1, 1863): 277-278. [The editor, J. Towler, a doctor, discusses the meeting and describes how photographs were being used by the surgeons, etc. to illustrate their reports. Then Towler narrates an anecdote about making some photographs for a court action, then being approached by a boy who had been helping him, to improve a faded copy of a daguerreotype portrait of a girl who had died.]

T705 Towler, J. "Photographic Quackery." HUMPHREY'S JOURNAL OF PHOTOGRAPHY, AND THE ALLIED ARTS AND SCIENCES 14, no. 21 (Mar. 1, 1863): 278-281.

T706 [Towler, J.] "Questions - Answers - Reasons." HUMPHREY'S JOURNAL OF PHOTOGRAPHY, AND THE ALLIED ARTS AND SCIENCES 15, no. 6 (July 15, 1863): 92-94. [21 riddles and answers by Towler. Not photographic.]

T707 [Towler, J.] "By what means can the art of Photography become a Science?" HUMPHREY'S JOURNAL OF PHOTOGRAPHY, AND THE ALLIED ARTS AND SCIENCES 15, no. 7 (Aug. 1, 1863): 97-101.

T708 Towler, J. "The Editor's Visit to the City." HUMPHREY'S JOURNAL OF PHOTOGRAPHY, AND THE ALLIED ARTS AND SCIENCES 15, no. 8 (Aug. 15, 1863): 113-114.

T709 [Towler, J.] "Improvements in the Tannin Process." HUMPHREY'S JOURNAL OF PHOTOGRAPHY, AND THE ALLIED ARTS AND SCIENCES 15, no. 14 (Nov. 15, 1863): 209-213.

T710 Towler, J. "Imperfections in Collodion Negatives and Positives, and their Remedies." HUMPHREY'S JOURNAL OF PHOTOGRAPHY, AND THE ALLIED ARTS AND SCIENCES 15, no. 14 (Nov. 15, 1863): 213-215. [From Towler's "Silver Sunbeam," not yet published.]

T711 Towler, John. "Photographic Engraving." HUMPHREY'S JOURNAL OF PHOTOGRAPHY, AND THE ALLIED ARTS AND SCIENCES 15, no. 15 (Dec. 1, 1863): 235-237. [Extract from Towler's "Silver Sunbeam," not yet published. Summary of the history of experiments in the field. Nicéphore Niépce, Dr. Donne, Fitzeau mentioned.]

T712 "The Silver Sunbeam." HUMPHREY'S JOURNAL OF PHOTOGRAPHY, AND THE ALLIED ARTS AND SCIENCES 15, no. 16 (Dec. 15, 1863): 255-256. [Announcement that the long awaited book, "The Silver Sunbeam," by the editor of "Humphrey's Journal," now finally off the press.]

T713 Miller, S. "The Silver Sunbeam." HUMPHREY'S JOURNAL OF PHOTOGRAPHY, AND THE ALLIED ARTS AND SCIENCES 15, no. 17 (Jan. 1, 1864): 265-266. [Book rev.: "The Silver Sunbeam," by J. Towler.]

T714 [Towler, J.] "A Short Lesson in Photography." HUMPHREY'S JOURNAL OF PHOTOGRAPHY, AND THE ALLIED ARTS AND SCIENCES 15, no. 1-24 (May 1, 1863 - Apr. 15, 1864): 49-54, 81-84, 114-118, 129-134, 161-164, 177-180, 241-245, 257-260, 273-277, 305-309, 353-356, 368-372.

T715 [Towler, J.] "The Glass-House." HUMPHREY'S JOURNAL OF PHOTOGRAPHY, AND THE ALLIED ARTS AND SCIENCES 15, no. 2 (May 15, 1863): 17-20.

T716 [Towler, John.] "Photography as a Detector of Crime." HUMPHREY'S JOURNAL OF PHOTOGRAPHY, AND THE ALLIED ARTS AND SCIENCES 15, no. 19 (Feb. 1, 1864): 288-292. [Actually a description of some early blood analysis experiments to test whether the blood belonged to the victim.]

T717 "Critical Notices: "The Silver Sunbeam: A Practical and Theoretical Text-book, on Sun Drawing and Photographic Printing," By J. Towler, M.D. New York: J.H. Ladd; and Liverpool: J. Atkinson." PHOTOGRAPHIC NEWS 8, no. 285 (Feb. 19, 1864): 86-87.

T718 [Towler, John.] "Short lesson in Photography." HUMPHREY'S JOURNAL OF PHOTOGRAPHY, AND THE ALLIED ARTS AND SCIENCES 16, no. 1-24 (May 1, 1864 - Apr. 15, 1865): 1-4, 19-22, 33-37, 49-53, 81-85, 97-100, 113-117, 129-133, 144-148, 164-167, 198-201. [Continuation of Towler's series.]

T719 "The Silver Sunbeam; A Practical and Theoretical Text Book of Sun-Drawing, &c. &c." HUMPHREY'S JOURNAL OF PHOTOGRAPHY, AND THE ALLIED ARTS AND SCIENCES 16, no. 3 (June 1, 1864): 39-44. [Bk. rev.: "The Silver Sunbeam," by John Towler. Extensive, for the period, reviews of the work, from the "Br.

J. of Photo." or "Photo. News," and "Photo. Notes." along with responses to several criticisms, by Towler.]

T720 [Towler, John.] "Aesthetics of Photography. Being Short Lessons in Photography. - No. 30-36." HUMPHREY'S JOURNAL OF PHOTOGRAPHY, AND THE ALLIED ARTS AND SCIENCES 16, no. 6-13 (July 15 - Nov. 1, 1864): 81-85, 97-100, 113-117, 129-133, 144-148, 164-167, 198-201.

T721 Towler, Professor. "Photography a branch of Education in Schools and Colleges." HUMPHREY'S JOURNAL OF PHOTOGRAPHY, AND THE ALLIED ARTS AND SCIENCES 16, no. 12 (Oct. 15, 1864): 177.

T722 Towler, John. "Negatives in the Eye. - Ghosts!" HUMPHREY'S JOURNAL OF PHOTOGRAPHY, AND THE ALLIED ARTS AND SCIENCES 16, no. 12 (Oct. 15, 1864): 177-181. 1 illus. [Towler, a surgeon, conducted experiments to ascertain color and visual retention. An addenda to this article published on p. 243.]

T723 Towler, Prof. "Die or Stamp for cutting out Card Pictures." HUMPHREY'S JOURNAL OF PHOTOGRAPHY, AND THE ALLIED ARTS AND SCIENCES 16, no. 12 (Oct. 15, 1864): 182-183.

T724 Towler, Prof. "Photographic Review of European Discoveries during the last few Months." HUMPHREY'S JOURNAL OF PHOTOGRAPHY, AND THE ALLIED ARTS AND SCIENCES 16, no. 14, 16 (Nov. 15, Dec. 15, 1864): 209-213, 243-244.

T725 Towler, Prof. "How to Varnish the Edges of a Negative." HUMPHREY'S JOURNAL OF PHOTOGRAPHY, AND THE ALLIED ARTS AND SCIENCES 16, no. 14 (Nov. 15, 1864): 217-218.

T726 Towler, Prof. "Lake Scenery." HUMPHREY'S JOURNAL OF PHOTOGRAPHY, AND THE ALLIED ARTS AND SCIENCES 16, no. 15 (Dec. 1, 1864): 225-229. [Towler discusses a photo trip to Cayuga Lake, NY.]

T727 Towler, Prof. "Proposed Modification or Change in the Plateholder." HUMPHREY'S JOURNAL OF PHOTOGRAPHY, AND THE ALLIED ARTS AND SCIENCES 16, no. 16 (Dec. 15, 1864): 241-243. 1 illus.

T728 Towler, Prof. "Printing on Opal Glass." HUMPHREY'S JOURNAL OF PHOTOGRAPHY, AND THE ALLIED ARTS AND SCIENCES 16, no. 17-20 (Jan. 1 - Feb. 15, 1865): 261-263, 277-279, 308-311.

T729 Towler, Prof. "Card Pictures Representing the Same Person in Two Different Positions on the same Card." HUMPHREY'S JOURNAL OF PHOTOGRAPHY, AND THE ALLIED ARTS AND SCIENCES 16, no. 18 (Jan. 15, 1865): 273-276.

T730 Towler, Prof. "Clean Hands." HUMPHREY'S JOURNAL OF PHOTOGRAPHY, AND THE ALLIED ARTS AND SCIENCES 16, no. 20 (Feb. 15, 1865): 305-308. [Literally an article on how to protect your hands against chemicals.]

T731 Towler, Prof. "Enamel Process." HUMPHREY'S JOURNAL OF PHOTOGRAPHY, AND THE ALLIED ARTS AND SCIENCES 16, no. 20-21 (Feb. 15 - Mar. 1, 1865): 311-312, 322-324.

T732 Towler, Prof. "How to Take Tow Card-Pictures with a Single Lens endowed with Stereoscopic Effect." HUMPHREY'S JOURNAL OF

PHOTOGRAPHY, AND THE ALLIED ARTS AND SCIENCES 16, no. 21 (Mar. 1, 1865): 321-322.

T733 Towler, Prof. "The Stereograph in Court." HUMPHREY'S JOURNAL OF PHOTOGRAPHY, AND THE ALLIED ARTS AND SCIENCES 16, no. 22 (Mar. 15, 1865): 337-339. [Towler made fourteen stereoviews of a site for evidence in a law court.]

T734 Towler, Prof. "Our Portable Tent, or Photographic Light Chamber, For Coating Plates with Collodion, Developing, Fixing, and Washing the Image in the Field." HUMPHREY'S JOURNAL OF PHOTOGRAPHY, AND THE ALLIED ARTS AND SCIENCES 16, no. 23 (Apr. 1, 1865): 353-355.

T735 Towler, John. "To Correspondents." HUMPHREY'S JOURNAL OF PHOTOGRAPHY 16, no. 23 (Apr. 1, 1865): 368.

T736 Towler, Prof. "Stereoscopic Negatives, Dark Tents, and Other Matters." BRITISH JOURNAL OF PHOTOGRAPHY 12, no. 257 (Apr. 7, 1865): 179-180. [From Towler's article in the "American Photographic Almanac."]

T737 Towler, Prof. "The Triple Salt in the Wothlytype." HUMPHREY'S JOURNAL OF PHOTOGRAPHY, AND THE ALLIED ARTS AND SCIENCES 16, no. 24 (Apr. 15, 1865): 369-370.

T738 Towler, Prof. "Asclepias Cornuti-Milk Weed." HUMPHREY'S JOURNAL OF PHOTOGRAPHY, AND THE ALLIED ARTS AND SCIENCES 16, no. 24 (Apr. 15, 1865): 376-378.

T739 [Towler, John.] "Troubles of an Amateur." HUMPHREY'S JOURNAL OF PHOTOGRAPHY, AND THE ALLIED ARTS AND SCIENCES 17, no. 1 (May 1, 1865): 9-12. [Anecdotes.]

T740 Towler, Prof. "Print Clamps-Spring-Clamp Plateholder." HUMPHREY'S JOURNAL OF PHOTOGRAPHY, AND THE ALLIED ARTS AND SCIENCES 17, no. 2 (May 15, 1865): 17-18. 1 illus.

T741 Towler, Prof. "A Practical Photographer's Processes." HUMPHREY'S JOURNAL OF PHOTOGRAPHY, AND THE ALLIED ARTS AND SCIENCES 17, no. 3 (June 1, 1865): 33-36. ["...a friend, the head of a laboratory of one of our best galleries in the city."]

T742 Towler, Prof. "Aniline Process Printing." HUMPHREY'S JOURNAL OF PHOTOGRAPHY, AND THE ALLIED ARTS AND SCIENCES 17, no. 3 (June 1, 1865): 36-37.

T743 Towler, Prof. "The Panoramic Stereograph." HUMPHREY'S JOURNAL OF PHOTOGRAPHY, AND THE ALLIED ARTS AND SCIENCES 17, no. 4 (June 15, 1865): 49-50. 1 illus.

T744 Towler, Prof. "Collodio-chloride of Silver." HUMPHREY'S JOURNAL OF PHOTOGRAPHY, AND THE ALLIED ARTS AND SCIENCES 17, no. 5 (July 1, 1865): 65-70.

T745 Towler, Dr. "Contemporary Press: Aesthetics of Photography." BRITISH JOURNAL OF PHOTOGRAPHY 12, no. 270 (July 7, 1865): 357-358. [From Dr. Towler, editor of "Humphrey's Journal."]

T746 Towler, Prof. "Experience Derived from Experiments with the Tannin Process." HUMPHREY'S JOURNAL OF PHOTOGRAPHY, AND THE ALLIED ARTS AND SCIENCES 17, no. 7 (Aug. 1, 1865): 108-110.

T747 Towler, Prof. "The Porcelain Picture." HUMPHREY'S JOURNAL OF PHOTOGRAPHY, AND THE ALLIED ARTS AND SCIENCES 17, no. 9 (Sept. 1, 1865): 132-133.

T748 Towler, J., M.D. "Contemporary Press: Landscape Photography." BRITISH JOURNAL OF PHOTOGRAPHY 12, no. 279 (Sept. 8, 1865): 465. [From "Humphrey's Journal."]

T749 Towler, Prof. "Taughannoc Falls." HUMPHREY'S JOURNAL OF PHOTOGRAPHY, AND THE ALLIED ARTS AND SCIENCES 17, no. 10 (Sept. 15, 1865): 145-148. [Report on photographic trip.]

T750 Towler, John. "How to produce a Clean Picture on Porcelain." HUMPHREY'S JOURNAL OF PHOTOGRAPHY, AND THE ALLIED ARTS AND SCIENCES 17, no. 11 (Oct. 1, 1865): 161-163.

T751 Towler, John. "Glyco-protosulphate of Iron." HUMPHREY'S JOURNAL OF PHOTOGRAPHY, AND THE ALLIED ARTS AND SCIENCES 17, no. 11 (Oct. 1, 1865): 166-168.

T752 Towler, Prof. "Specs, Flashes of Lightning, Islands, Lakes &c., on the Negative Film During Development." HUMPHREY'S JOURNAL OF PHOTOGRAPHY, AND THE ALLIED ARTS AND SCIENCES 17, no. 11 (Oct. 1, 1865): 171-173.

T753 Towler, Prof. "Various Modes of Washing Prints." HUMPHREY'S JOURNAL OF PHOTOGRAPHY, AND THE ALLIED ARTS AND SCIENCES 17, no. 12 (Oct. 15, 1865): 177-181.

T754 Towler, Prof. "How to Take Photographs by Magnesium Light." HUMPHREY'S JOURNAL OF PHOTOGRAPHY, AND THE ALLIED ARTS AND SCIENCES 17, no. 15 (Dec. 1, 1865): 228-231. 1 illus.

T755 Towler, Prof. "America of America. (An Article for New Year's Day.)" HUMPHREY'S JOURNAL OF PHOTOGRAPHY, AND THE ALLIED ARTS AND SCIENCES 17, no. 17 (Jan. 1, 1866): 257-262.

T756 Towler, Prof. "To Adjust a pair of Compound Lenses to one and the same Focus without changing the Curvature of the Lenses." HUMPHREY'S JOURNAL OF PHOTOGRAPHY, AND THE ALLIED ARTS AND SCIENCES 17, no. 17 (Jan. 1, 1866): 266-268.

T757 Towler, Prof. "Collo-Sulphate of Iron." HUMPHREY'S JOURNAL OF PHOTOGRAPHY, AND THE ALLIED ARTS AND SCIENCES 17, no. 18 (Jan. 15, 1866): 273-275. [Includes Nelson K. Cherrill's modification. Clericus' modification. H. Cooper, Jr.'s modification.]

T758 Towler, Prof. "Inventions; Improvements." and "New Apparatus." HUMPHREY'S JOURNAL OF PHOTOGRAPHY, AND THE ALLIED ARTS AND SCIENCES 17, no. 18 (Jan. 15, 1866): 275-278. 1 illus. [Print Cutter, Porcelain or Opal Printing Frames, Drying Racks, etc.]

T759 Towler, Prof. "Photographic Printing Paper." HUMPHREY'S JOURNAL OF PHOTOGRAPHY, AND THE ALLIED ARTS AND SCIENCES 17, no. 19 (Feb. 1, 1866): 292-295.

T760 Towler, Prof. "The Serpents of Pharaoh." HUMPHREY'S JOURNAL OF PHOTOGRAPHY, AND THE ALLIED ARTS AND SCIENCES 17, no. 19 (Feb. 1, 1866): 295. ["The Serpents of Pharaoh consist of a small pyramid of tinfoil filled with a yellowish-white powder," which when ignited forms the "tail of a snake" which grows until the powder is exhausted.]

T761 "Bibliography." HUMPHREY'S JOURNAL OF PHOTOGRAPHY, AND THE ALLIED ARTS AND SCIENCES 17, no. 20 (Feb. 15, 1866): 316-317. [From "Photo. News." Bk. rev: "Dry Plate Photography; or the Tannin Process made Simple and Practicable for Operators and Amateurs," by John Towler, M.D."]

T762 Towler, Prof. "How to Prepare Opal Plates for Contact Printing." HUMPHREY'S JOURNAL OF PHOTOGRAPHY, AND THE ALLIED ARTS AND SCIENCES 17, no. 22 (Mar. 15, 1866): 340-341.

T763 Towler, Prof. "Arrangement for Measuring Drops of any Given Fluid." HUMPHREY'S JOURNAL OF PHOTOGRAPHY, AND THE ALLIED ARTS AND SCIENCES 17, no. 22 (Mar. 15, 1866): 342-343. 1 illus.

T764 Brown, J. J. (Falley Seminary). "Bibliography." HUMPHREY'S JOURNAL OF PHOTOGRAPHY, AND THE ALLIED ARTS AND SCIENCES 17, no. 22 (Mar. 15, 1866): 344-345. [Bk. rev: "Dry Plate Photography." by John Towler.]

T765 Towler, Prof. "How to Analyze Collodion." HUMPHREY'S JOURNAL OF PHOTOGRAPHY, AND THE ALLIED ARTS AND SCIENCES 17, no. 24 (Apr. 15, 1866): 369-373.

T766 Towler, Prof. "The Stereograph as applied to Statuary, etc." HUMPHREY'S JOURNAL OF PHOTOGRAPHY, AND THE ALLIED ARTS AND SCIENCES 18, no. 1 (May 1, 1866): 1-5. 1 illus.

T767 Towler, Prof. "Chloride of Calcium." HUMPHREY'S JOURNAL OF PHOTOGRAPHY, AND THE ALLIED ARTS AND SCIENCES 18, no. 2 (May 15, 1866): 17-19.

T768 Towler, Prof. "Double Salts." HUMPHREY'S JOURNAL OF PHOTOGRAPHY, AND THE ALLIED ARTS AND SCIENCES 18, no. 3 (June 1, 1866): 33-36.

T769 Towler, Prof. "Magic Photographs." HUMPHREY'S JOURNAL OF PHOTOGRAPHY, AND THE ALLIED ARTS AND SCIENCES 18, no. 3 (June 1, 1866): 36-38.

T770 Towler, Prof. "Transparent Negative Holders." HUMPHREY'S JOURNAL OF PHOTOGRAPHY, AND THE ALLIED ARTS AND SCIENCES 18, no. 3 (June 1, 1866): 39-40.

T771 Towler, Prof. "Nitro-Glycerine." HUMPHREY'S JOURNAL OF PHOTOGRAPHY, AND THE ALLIED ARTS AND SCIENCES 18, no. 3 (June 1, 1866): 42.

T772 Towler, Prof. "Dry Plate Photography." HUMPHREY'S JOURNAL OF PHOTOGRAPHY, AND THE ALLIED ARTS AND SCIENCES 18, no. 4 (June 15, 1866): 49-52.

T773 Towler, Prof. "Automaton Pentagraph." HUMPHREY'S JOURNAL OF PHOTOGRAPHY, AND THE ALLIED ARTS AND SCIENCES 18, no. 5 (July 1, 1866): 65-67.

T774 Towler, Prof. "The Negative. - How to Make It." HUMPHREY'S JOURNAL OF PHOTOGRAPHY, AND THE ALLIED ARTS AND SCIENCES 18, no. 6-7 (July 15 - Aug. 1, 1866): 81-86, 97-102.

T775 Towler, Prof. "The Negative for the Copying and Solar Camera." HUMPHREY'S JOURNAL OF PHOTOGRAPHY, AND THE ALLIED ARTS AND SCIENCES 18, no. 8 (Aug. 15, 1866): 113-116.

T776 Squier, E. George. "Photographic Books." HUMPHREY'S JOURNAL OF PHOTOGRAPHY, AND THE ALLIED ARTS AND SCIENCES 18, no. 8 (Aug. 15, 1866): 128. ["Frank Leslie's Illustrated Newspaper,' edited by Hon. E. Geo. Squier, formerly U. S. Minister to Peru and a successful amateur, gives the titles of some of Prof. Towler's books and says:..." (review follows).]

T777 Towler, Prof. "Pinholes in Negatives." HUMPHREY'S JOURNAL OF PHOTOGRAPHY, AND THE ALLIED ARTS AND SCIENCES 18, no. 9 (Sept. 1, 1866): 133.

T778 Towler, Prof. "The Print." HUMPHREY'S JOURNAL OF PHOTOGRAPHY, AND THE ALLIED ARTS AND SCIENCES 18, no. 9,13 (Sept. 1, Oct. 15, 1866): 129-132, 177-181.

T779 Towler, Prof. "Landscape Photography." HUMPHREY'S JOURNAL OF PHOTOGRAPHY, AND THE ALLIED ARTS AND SCIENCES 18, no. 10 (Sept. 15, 1866): 145-149. ["The present Summer has again drawn us into glens and ravines, upon cliffs and dangerous precipices; the trip has increased our experience... our readers shall have the benefit of the conclusions... we selected the Wet Process for the photographic campaign."]

T780 Towler, Prof. "President Johnson and his Suite." HUMPHREY'S JOURNAL OF PHOTOGRAPHY, AND THE ALLIED ARTS AND SCIENCES 18, no. 10 (Sept. 15, 1866): 150-151. ["The morning after our return home from the photographic tour,... all was bustle and excitement; President Johnson and his suite were expected at nine o'clock." Towler then describes his successful efforts to take a stereo of the party at the train station.]

T781 "A New Work on Photography." HUMPHREY'S JOURNAL OF PHOTOGRAPHY, AND THE ALLIED ARTS AND SCIENCES 18, no. 10 (Sept. 15, 1866): 156. [Prepublication announcement, description of John Towler's new book, "The Negative and the Print; or the Photographer's Guide in the Gallery and in the Field, being a Text-Book for the Operator and Amateur."]

T782 Towler, Prof. "Flashes of Lightning, Thunderbolts, etc., on the Negative Film." HUMPHREY'S JOURNAL OF PHOTOGRAPHY, AND THE ALLIED ARTS AND SCIENCES 18, no. 11 (Oct. 1, 1866): 161-164.

T783 Towler, Prof. "Letter-Photograph." HUMPHREY'S JOURNAL OF PHOTOGRAPHY, AND THE ALLIED ARTS AND SCIENCES 18, no. 11 (Oct. 1, 1866): 164-166.

T784 Towler, J. "American Photographical Society." HUMPHREY'S JOURNAL OF PHOTOGRAPHY, AND THE ALLIED ARTS AND SCIENCES 18, no. 12 (Oct. 15, 1866): 181-184. [Includes text of Towler's address on "Gordon's Modified Fothergill Progress," read to the American Photographical Society, Oct. 8, 1866.]

T785 Towler, Prof. "Experiments with a Dry Plate. Prepared after Gordon's Modified Fothergill Process." HUMPHREY'S JOURNAL OF PHOTOGRAPHY, AND THE ALLIED ARTS AND SCIENCES 18, no. 13 (Nov. 1, 1866): 193-194.

T786 Towler, Prof. "Tanno-Albumen Process." HUMPHREY'S JOURNAL OF PHOTOGRAPHY, AND THE ALLIED ARTS AND SCIENCES 18, no. 14 (Nov. 15, 1866): 209-212.

T787 Towler, Prof. "Gordon's Modified Fothergill Process." HUMPHREY'S JOURNAL OF PHOTOGRAPHY, AND THE ALLIED ARTS AND SCIENCES 18, no. 14 (Nov. 15, 1866): 212-213.

T788 Towler, Prof. "What to Do when a Negative has been Intensified too Much." HUMPHREY'S JOURNAL OF PHOTOGRAPHY, AND THE ALLIED ARTS AND SCIENCES 18, no. 15 (Dec. 1, 1866): 230-232.

T789 Towler, Prof. "The Opal Printing Frames on the Retired List." HUMPHREY'S JOURNAL OF PHOTOGRAPHY, AND THE ALLIED ARTS AND SCIENCES 18, no. 16 (Dec. 15, 1866): 245-247. 1 illus.

T790 Towler, Prof. "Annual Address - Time and Eternity." HUMPHREY'S JOURNAL OF PHOTOGRAPHY, AND THE ALLIED ARTS AND SCIENCES 18, no. 17 (Jan. 1, 1867): 257-264. [Happy New Year - New Developer for Negatives - Willard & Co's Lenses - Scoville Mfg. Co. - Sarony's Photo Studies - American Optical Co. - etc.]

T791 Towler, Prof. "The Non-Coincidence of the Focal Distance of the Stereogram and of each of its Components." HUMPHREY'S JOURNAL OF PHOTOGRAPHY, AND THE ALLIED ARTS AND SCIENCES 18, no. 19 (Feb. 1, 1867): 289-291. 1 illus.

T792 Towler, Prof. "Nitro-Gelatine Developer." HUMPHREY'S JOURNAL OF PHOTOGRAPHY, AND THE ALLIED ARTS AND SCIENCES 18, no. 19 (Feb. 1, 1867): 291-292. [Read to the Am. Photo. Soc.]

T793 Towler, Prof. "Opal Printing-Frame." HUMPHREY'S JOURNAL OF PHOTOGRAPHY, AND THE ALLIED ARTS AND SCIENCES 18, no. 20 (Feb. 15, 1867): 305-306.

T794 "Music." HUMPHREY'S JOURNAL OF PHOTOGRAPHY, AND THE ALLIED ARTS AND SCIENCES 18, no. 20 (Feb. 15, 1867): 318. [The publisher Joseph Ladd reprints several articles written in praise of the daughter of John Towler of Hobart and Geneva Medical Colleges, Geneva, NY. The daughter was fifteen and studying music at the Conservatory at Liepsic. Towler was the editor of "Humphrey's Journal" at this time.]

T795 Towler, Prof. "Equalization of Focus During Exposure." HUMPHREY'S JOURNAL OF PHOTOGRAPHY, AND THE ALLIED ARTS AND SCIENCES 18, no. 21 (Mar. 1, 1867): 321-326. 2 illus.

T796 Towler, Prof. "To Photograph Manuscripts, Drawings, etc." HUMPHREY'S JOURNAL OF PHOTOGRAPHY, AND THE ALLIED ARTS AND SCIENCES 18, no. 22 (Mar. 15, 1867): 337-338.

T797 Towler, Prof. "Advice Gratis." HUMPHREY'S JOURNAL OF PHOTOGRAPHY, AND THE ALLIED ARTS AND SCIENCES 18, no. 22 (Mar. 15, 1867): 339-340.

T798 Towler, Prof. "Cabinet Pictures." HUMPHREY'S JOURNAL OF PHOTOGRAPHY, AND THE ALLIED ARTS AND SCIENCES 18, no. 23 (Apr. 1, 1867): 353-356.

T799 Towler, Prof. "Photographic Varnish, for Negatives, Ferrotypes, etc." HUMPHREY'S JOURNAL OF PHOTOGRAPHY, AND THE ALLIED ARTS AND SCIENCES 18, no. 24 (Apr. 15, 1867): 369.

T800 Towler, Prof. "The Eye." HUMPHREY'S JOURNAL OF PHOTOGRAPHY, AND THE ALLIED ARTS AND SCIENCES 19, no. 1 (May 1, 1867): 1-6.

T801 Towler, Prof. "Paper Negatives." HUMPHREY'S JOURNAL OF PHOTOGRAPHY, AND THE ALLIED ARTS AND SCIENCES 19, no. 2 (May 15, 1867): 17-19.

T802 Towler, Prof. "Vertical and Horizontal Swing-Back Cameras." HUMPHREY'S JOURNAL OF PHOTOGRAPHY, AND THE ALLIED ARTS AND SCIENCES 19, no. 2 (May 15, 1867): 22-24.

T803 Towler, Prof. "Developers." HUMPHREY'S JOURNAL OF PHOTOGRAPHY, AND THE ALLIED ARTS AND SCIENCES 19, no. 3 (June 1, 1867): 33-38.

T804 Towler, Prof. "Dry Plate Photography." HUMPHREY'S JOURNAL OF PHOTOGRAPHY, AND THE ALLIED ARTS AND SCIENCES 19, no. 4 (June 15, 1867): 49-51.

T805 Towler, Prof. "Photographic Patents to be Applied for." HUMPHREY'S JOURNAL OF PHOTOGRAPHY, AND THE ALLIED ARTS AND SCIENCES 19, no. 4 (June 15, 1867): 51-53. [Comic essay.]

T806 Towler, Prof. "Chapter of Recipes for Photographers and Photographers' Wives." HUMPHREY'S JOURNAL OF PHOTOGRAPHY, AND THE ALLIED ARTS AND SCIENCES 19, no. 4 (June 15, 1867): 53-55. [Comic essay.]

T807 Towler, Prof. "Dry Process." HUMPHREY'S JOURNAL OF PHOTOGRAPHY, AND THE ALLIED ARTS AND SCIENCES 19, no. 5 (July 1, 1867): 65-69.

T808 Towler, Prof. "The Morphine Dry Process." HUMPHREY'S JOURNAL OF PHOTOGRAPHY, AND THE ALLIED ARTS AND SCIENCES 19, no. 6 (July 15, 1867): 81-84.

T809 Towler, Prof. "Intensifiers." HUMPHREY'S JOURNAL OF PHOTOGRAPHY, AND THE ALLIED ARTS AND SCIENCES 19, no. 7 (Aug. 1, 1867): 97-101.

T810 Towler, Prof. "Solar Camera Printing, etc." HUMPHREY'S JOURNAL OF PHOTOGRAPHY, AND THE ALLIED ARTS AND SCIENCES 19, no. 8 (Aug. 15, 1867): 113-117.

T811 Towler, Prof. "Words from the Camp." HUMPHREY'S JOURNAL OF PHOTOGRAPHY, AND THE ALLIED ARTS AND SCIENCES 19, no. 9 (Sept. 1, 1867): 129-133. ["Camp Towler, Freer's Glen, Aug. 16, 1867" Towler's summer photographic expedition.]

T812 Towler, Prof. "Photographic Residues." HUMPHREY'S JOURNAL OF PHOTOGRAPHY, AND THE ALLIED ARTS AND SCIENCES 19, no. 10 (Sept. 15, 1867): 145-149.

T813 Towler, Prof. "Glen McClure, or Masonic Glen." HUMPHREY'S JOURNAL OF PHOTOGRAPHY, AND THE ALLIED ARTS AND SCIENCES 19, no. 11 (Oct. 1, 1867): 161-165. [Discusses the work of Gates and Burrill (of Ithica, NY) who he met during his summer outing.]

T814 Towler, Prof. "Catalogue of the U.S.A. Medical Museum. Prepared under the Direction of the Surgeon General, United States Army." HUMPHREY'S JOURNAL OF PHOTOGRAPHY, AND THE ALLIED ARTS AND SCIENCES 19, no. 14 (Nov. 15, 1867): 209-211. ["We are glad to find that our beloved art has been called in to render service,... many specimens of cutaneous disease,... in the microscopical department... negatives prepared by Asst. Surgeon Edward Curtis, U.S.A., on plates seven inches square."]

T815 Towler, Prof. "Lenses and Light." HUMPHREY'S JOURNAL OF PHOTOGRAPHY, AND THE ALLIED ARTS AND SCIENCES 19, no. 16 (Dec. 15, 1867): 241-242.

T816 Towler, John. "Lenses and Light." HUMPHREY'S JOURNAL OF PHOTOGRAPHY, AND THE ALLIED ARTS AND SCIENCES 19, no. 17 (Jan. 1, 1868): 257-259.

T817 Towler, Prof. "Toning and Fixing Prints." HUMPHREY'S JOURNAL OF PHOTOGRAPHY, AND THE ALLIED ARTS AND SCIENCES 19, no. 18 (Jan. 15, 1868): 274-277.

T818 Towler, John, Prof., M.D. "The Negative by the Dry Process." HUMPHREY'S JOURNAL OF PHOTOGRAPHY, AND THE ALLIED ARTS AND SCIENCES 19, no. 18, 20 (Jan. 15, Feb. 15, 1868): 294-295, 310-312.

T819 Towler, John, Prof., M.D. "To Prepare Transparent Positives." HUMPHREY'S JOURNAL OF PHOTOGRAPHY, AND THE ALLIED ARTS AND SCIENCES 19, no. 21-22 (Mar. 1 - Mar. 15, 1868): 324-326, 341-342.

T820 Towler, Prof. John., M.D. "Catechism of Photography." PHILADELPHIA PHOTOGRAPHER 5, no. 51-53 (Mar. - May 1868): 69-71,122-124, 158-161. [History and technology combined with a curious metaphorical slant.]

T821 Towler, John, Prof., M.D. "To Prepare Transparent Stereographs." HUMPHREY'S JOURNAL OF PHOTOGRAPHY, AND THE ALLIED ARTS AND SCIENCES 19, no. 23 (Apr. 1, 1868): 356-357.

T822 Towler, John, Prof., M.D. "The Nitrate of Silver Bath, its Preparation, Troubles and Renovation." HUMPHREY'S JOURNAL OF PHOTOGRAPHY, AND THE ALLIED ARTS AND SCIENCES 19, no. 24 (Apr. 15, 1868): 377-379.

T823 Towler, John, Prof., M.D. "The Nitrate of Silver Bath, its Preparation, Troubles and Renovation." HUMPHREY'S JOURNAL OF PHOTOGRAPHY, AND THE ALLIED ARTS AND SCIENCES 20, no. 1 (May 1, 1868): 4-6.

T824 Towler, John, Prof., M.D. "To Make the Actinic Focus and Luminous Focus Coincident." HUMPHREY'S JOURNAL OF PHOTOGRAPHY, AND THE ALLIED ARTS AND SCIENCES 20, no. 2 (May 15, 1868): 22-23.

T825 Towler, John, Prof., M.D. "To Prepare Opal or Porcelain Pictures." HUMPHREY'S JOURNAL OF PHOTOGRAPHY, AND THE ALLIED ARTS AND SCIENCES 20, no. 3,5 (June 1, July 1, 1868): 35-37, 68-69.

T826 Towler, John, Prof., M.D. "How to Make the Print." HUMPHREY'S JOURNAL OF PHOTOGRAPHY, AND THE ALLIED ARTS AND SCIENCES 20, no. 6-8 (July 15 - Aug. 15, 1868): 81-83, 99-100, 113-115.

T827 "Professor Towler's Developing Tent." PHILADELPHIA PHOTOGRAPHER 5, no. 56 (Aug. 1868): 254-255. 1 illus. [Sketch, description of a portable dark room that Prof. Towler used on a trip to Niagara Falls "a few months ago."]

T828 Towler, Professor, M.D. "Photograph of the Moon." PHILADELPHIA PHOTOGRAPHER 5, no. 60 (Dec. 1868): 421-422.

T829 Towler, Prof. John. "The Exhibition and Meetings of the National Photographic Association: The Lectures - Concentration of Ways and Means." PHILADELPHIA PHOTOGRAPHER 6, no. 67 (July 1869): 222-234. [First annual meeting held in Horticultural Hall, Boston, MA.]

T830 Towler, John. "Alabastine Positives." HUMPHREY'S JOURNAL OF PHOTOGRAPHY, AND THE ALLIED ARTS AND SCIENCES 20, no. 23 (July 15, 1869): 364-365.

T831 Towler, John. "The Non-Actinic Room - Developing." HUMPHREY'S JOURNAL OF PHOTOGRAPHY, AND THE ALLIED ARTS AND SCIENCES 20, no. 25 (Sept. 15, 1869): 385-387.

T832 Towler, Prof. J., M.D. "How to Get Clouds in the Photograph." PHILADELPHIA PHOTOGRAPHER 6, no. 70 (Oct. 1869): 329.

T833 Towler, Prof. J., M.D. "The Stereograph." PHILADELPHIA PHOTOGRAPHER 8, no. 93-94 (Sept. - Oct. 1871): 283-286, 325-328. 2 illus.

T834 Towler, Prof. "Fourth Annual Meeting and Exhibition of the N. P. A. in St. Louis, Mo., May 1872: Albertype." PHILADELPHIA PHOTOGRAPHER 9, no. 102 (June 1872): 205-207.

T835 Towler, J. "Photography on the Ocean." PHILADELPHIA PHOTOGRAPHER 9, no. 105 (Sept. 1872): 314-315. [Prof. Towler, with several students, taking a trip to Europe. These are his commentaries on the journey.]

T836 Towler, Prof. J., M.D. "Photography in Europe." PHILADELPHIA PHOTOGRAPHER 9, no. 108 (Dec. 1872): 410-411.

TOWLER, J. [?]
T837 "How to take an Ambrotype." HUMPHREY'S JOURNAL OF PHOTOGRAPHY, AND THE ALLIED ARTS AND SCIENCES 15, no. 10 (Sept. 15, 1863): 149-151. [Long poem, describing the technique of creating an ambrotype.]

TOWSON see HUNT, ROBERT.

TRACY.
T838 "Portraits of Planet, Daniel Boone, and Congaree, Horses Entered in the Great Four Mile Race,... on the Fashion Racecourse, Long Island - From a Photograph by Tracy." FRANK LESLIE'S ILLUSTRATED NEWSPAPER 10, no. 253 (Sept. 29, 1860): 295. 4 illus. [Horses.]

TRAER, REEVES.
T839 Traer, Reeves, M.R.C.S. "On the Photographic Delineation of Microscopic Objects." HUMPHREY'S JOURNAL OF PHOTOGRAPHY, AND THE ALLIED ARTS AND SCIENCES 10, no. 16 (Dec. 15, 1858): 243-250. [Read to London Photo. Soc. From "Liverpool Photo. J."]

TRAILL, JOHN.
T840 "The Waxed-Paper Progress." AMERICAN JOURNAL OF PHOTOGRAPHY AND THE ALLIED ARTS & SCIENCES n. s. vol. 4, no. 5 (Aug. 1, 1861): 97-99. [Read to Edinburgh Photo. Soc.]

T841 Traill, John. "Notes of a Photographic Trip to the Orkney Islands." BRITISH JOURNAL OF PHOTOGRAPHY 8, no. 147 (Aug. 1, 1861): 269.

TRAIN, E. H. (1831-1899) (USA)
T842 "Commendable Enterprise." PHILADELPHIA PHOTOGRAPHER 10, no. 110 (Feb. 1873): 43. [E. H. Train (Helena, MT) praised.]

T843 "Editor's Table." PHILADELPHIA PHOTOGRAPHER 12, no. 144 (Dec. 1875): 383-384. [C. C. Giers (Nashville, TN); C. R. Savage;

W. D. Lockwood (Ripon, WI); E. H. Train (Helena, MT); L. G. Bigelow (Detroit, MI); Alfred Freeman (Dallas, TX); Frank Jewell (Hyde Park, PA); E. A. Scholfield (Mystic River, CT); J. Pitcher Spooner; others mentioned.]

T844 Train, E. H. of Montana. "The Negative Bath and Its Treatment." ST. LOUIS PRACTICAL PHOTOGRAPHER 1, no. 1 (Jan. 1877): 20-21.

T845 Train, E. H. "What I Know About Photography." PHILADELPHIA PHOTOGRAPHER 15, no. 179 (Nov. 1878): 333-335. [Mr. Train was from MT. Describes his processes, techniques.]

TRAQUAIR, WILLIAM.
T846 Traquair, William. "The Position of Photography as a Fine Art." BRITISH JOURNAL OF PHOTOGRAPHY 10, no. 181-185 (Jan. 1 - Mar. 2, 1863): 11-13, 34-35, 50-51, 78-79, 100-101. 2 illus.

TRASK, ALBION K. P. (1830-1900) (USA)
BOOKS
T847 Trask, A. K. P. Trask's Practical Ferrotyper. Philadelphia: Benerman & Wilson, 1872. 80 pp. 1 b & w. illus. [Original Ferrotype as frontispiece. Reprinted (1973), Arno Press.]

PERIODICALS
T848 Trask, A. K. P. "On the Model Skylight." PHILADELPHIA PHOTOGRAPHER 8, no. 92 (Aug. 1871): 268-270. 2 illus.

T849 "Our Picture." PHOTOGRAPHIC TIMES 2, no. 17 (May 1872): frontispiece, 65-67. 1 b & w. [Photo by Trask is a genre scene called "The Little Newsboy." An excerpt from the "Philadelphia Enquirer" also printed.]

T850 "Our Picture." PHILADELPHIA PHOTOGRAPHER 10, no. 120 (Dec. 1873): frontispiece, 576. 1 b & w. [Trask of Trask & Bacon, Phila. PA.]

T851 "Editor's Table: Obituary." WILSON'S PHOTOGRAPHIC MAGAZINE 37, no. 528 (Dec. 1900): 551-552. [Born Bangor, ME in 1830. Learned daguerreotyping just before the Civil War. Served in the war, afterwards moved to Philadelphia opened a studio in 1865. Early exponent of the ferrotype. 1872 published "The Practical Ferrotyper." Retired 1891. Died 1900.]

TRASK, E. K. (PHILADELPHIA, PA)
T852 "Editor's Table." PHILADELPHIA PHOTOGRAPHER 6, no. 69 (Sept. 1869): 323-324. [David Bendann; E. K. Trask (Philadelphia, PA); Schreiber & Son (Philadelphia, PA); baseball game between employees of Jordan & Co., photographers, and the Scoville Mfg. Co.; employees of J. Gurney & Son and E. & H. T. Anthony had a sculling race; Wellington Watson; W. E. Bowman; J. R. Gorgas (Madison, IN); H. B. Hillyer (Austin, TX); H. W. Seward (Utica, NY); others mentioned.]

TRESIZE, J. Q. A. (1827-1881) (USA)
T853 Tresize, J. Q. A. "American Photographic Tent." BRITISH JOURNAL OF PHOTOGRAPHY 8, no. 143 (June 1, 1861): 204. 1 illus. [Tresize from Zanesville, OH.]

T854 "The Lincoln Monument at Springfield, Illinois, Dedicated Thursday, October 15th. - Photographed by J. Q. A. Tresize." FRANK LESLIE'S ILLUSTRATED NEWSPAPER 39, no. 996 (Oct. 31, 1874): 124. 1 illus. [View, with crowds.]

T855 "Views on the Muskingham." HUMPHREY'S JOURNAL OF PHOTOGRAPHY, AND THE ALLIED ARTS AND SCIENCES 17, no. 11 (Oct. 1, 1865): 176. [Praise for his views on the Muskingham River, Ohio and his views of the home and tomb of Abraham Lincoln.]

T856 "Editor's Table." PHILADELPHIA PHOTOGRAPHER 2, no. 23 (Nov. 1865): 167. ["From J. Q. A. Tresize, Zanesville, OH, we have a fine view of tomb of A. Lincoln, late residence in Springfield and several views of the beautifully wild surroundings of Zanesville."]

T857 Tresize, J. Q. A. "Stereographs and How to Make Them." PHILADELPHIA PHOTOGRAPHER 4, no. 48 (Dec. 1867): 375-382.

T858 "Photograph Gallery for Sale." ANTHONY'S PHOTOGRAPHIC BULLETIN 7, no. 2 (Feb. 1876): 53. [Tresize (Springfield, IL) selling gallery, for reasons of health.]

TRESSLER BROTHERS. (FORT SCOTT, KY)
T859 "Kansas. - Scene of the Bender Murders near Cherryville, Labette County. - From a Photograph by Tressler Bros." FRANK LESLIE'S ILLUSTRATED NEWSPAPER 36, no. 923 (June 7, 1873): 209. 1 illus. [Outdoor view. Digging up bodies.]

T860 "Wisconsin. - A United States Steamer Hauling Out Snags on the Wisconsin River. - From a Photograph by Tussler [sic Tressler?] Bros., Fort Scott, Kan." FRANK LESLIE'S ILLUSTRATED NEWSPAPER 45, no. 1165 (Jan. 26, 1878): 361. 1 illus.

T861 "Kansas. - The Insane Asylum at Ossawatomie. - From a Photograph by Tressler Brothers, Fort Scott." FRANK LESLIE'S ILLUSTRATED NEWSPAPER 49, no. 1255 (Oct. 18, 1879): 114. 1 illus. [View.]

TRIPE, LINNAEUS, CAPT. (1822-1902) (GREAT BRITAIN, INDIA, BURMA)
[Born in Davenport, England in 1822. Listed under the Twelfth Regiment Native Infantry, at Bangalore, in 1839. Made Captain in 1856. Appointed photographer to the British Mission at the court of Ava, Burma in 1855. Made over 120 views in about five weeks. Published in Bangalore in 1857 for the Madras Photographic Society. The Madras Presidency appointed Tripe official photographer in 1856. Six volumes, containing over one hundred photographs, of the urban areas (Madura, Tanjore and Trivady, Poodoocottah, Ryakotta, Seringham, and Trichinopy) in the Madras Presidency were published. The position of official photographer was eliminated around 1860. Tripe continued his military career, promoted to Major in 1861, to Colonel in 1870, and retired as Honorary Major General in 1875. Returned to Davenport, where he died in 1902.]

BOOKS
T862 Tripe, Captain L. Photographic Views in Madura. By Captain L. Tripe, Government Photographer, Madras Presidency. With Descriptive Notes by Martin Norman and Rev. W. Tracy. s. l.: s. n., 1858. 12 b & w. [A title leaf and a leaf of notes, with original photographs.]

T863 Tripe, Captain L. Photographic Views of Poodoocottah. By Captain L. Tripe, Government Photographer, Madras Presidency. s. l.: s. n., 1858. 12 b & w. [A title leaf and a leaf of notes, with original photographs.]

T864 Tripe, Captain L. Photographic Views of Rayakottah. By Captain L. Tripe, Government Photographer, Madras Presidency. With Descriptive Notes by Boswell. s. l.: s. n., 1858. 12 b & w. [A title leaf and a leaf of notes, with original photographs.]

T865 Tripe, Captain L. *Photographic Views of Tanjore & Trivady.* By Captain L. Tripe, Government Photographer, Madras Presidency. With Descriptive Notes by Rev. G. U. Pope. s. l.: s. n., 1858. 12 b & w. [A title leaf and a leaf of notes, with original photographs.]

T866 Tripe, Captain L. *Stereographs of Madura,* taken by Capt. L. Tripe, Government Photographer, Madras Presidency. s. l. [Madras]: s. n. [Madras Presidency], 1858. 4 pp. 70 b & w. [Seventy stereographs and a four page printed list, "Descriptive notes by the Rev. W. Tracy."]

T867 Tripe, Captain L. *Stereographs of Trichinopoly, Tanjore and Other Places in Their Neighborhood,* taken by Capt. L. Tripe, Government Photographer, Madras Presidency. London: J. Hogarth, 1858. n. p. b & w.

T868 *Photographs of the Elliot Marbles and Other Subjects in the Central Museum, Madras.* Madras: Madras Presidency, 1859. n. p. 75 b & w. [Original photographs.]

T869 Dewan, Janet and Maia-Mari Sutnik. *Linneaus Tripe: Photographer of British India, 1854-1870.* Toronto: Art Gallery of Ontario, 1986. 39 pp. [Exhibition catalog. (Nov. 1986 - Jan. 1987)]

PERIODICALS
T870 Thomas, G. "Linnaeus Tripe in Madras Presidency." HISTORY OF PHOTOGRAPHY 5, no. 4 (Oct. 1981): 329-337. 9 b & w. 1 illus. [Article about Tripe, photographer to the government of Madras between 1857 and 1860.]

T871 Dewan, Janet. "Linnaeus Tripe's Photographs: Notes toward an Index." HISTORY OF PHOTOGRAPHY 8, no. 1 (Jan. - Mar. 1984): 23-32. 7 b & w. 2 illus. [Worked in India, Burma during the 1850s.]

T872 Dewan, Janet. "Linnaeus Tripe: Critical Assessments and Other Notes." PHOTOGRAPHIC COLLECTOR 5, no. 1 (1985): 47-65. 17 b & w. 1 illus. [Tripe remained in the Indian Army in India and Burma from 1839 until 1873. Photographed in India in 1850s.]

T873 Dewan, Janet. "'Near Tomghoo Burmah': Linnaeus Tripe's Later Photographs." PHOTOGRAPHIC COLLECTOR 5, no. 3 (1985): 271-277. 5 b & w. 1 illus. [Tripe, a career officer in the 12th Regiment Madras Native Infantry, was Government Photographer in the government of India's Mission to Ava (Burma) in 1855 and to the Madras Presidency from 1856-1860. Returned to England, 1860-1862. From 1869-1872 Tripe's regiment was stationed in Burma again and he made more photographs there.]

T874 Thomas, G. "The Elliot Marbles." HISTORY OF PHOTOGRAPHY 9, no. 2 (Apr. - June 1985): 149-153. 7 b & w. [An album of views of sculptures from India, taken by Capt. Linnaeus Tripe in 1859. The "Elliot Marbles" came to England in 1860.]

TRISTRAM, HENRY BAKER, F.R.S.
T875 *Pathways of Palestine, A Descriptive Tour Through the Holy Land;* Illustrated with Forty-four Permanent Photographs. "1st series." London: Sampson Low, Marston, Searle & Rivington, 1881. 133 pp. 44 b & w.

TROTTER, A.
T876 Trotter, A. "Portable Photographic Apparatus." ANTHONY'S PHOTOGRAPHIC BULLETIN 8, no. 8 (Aug. 1877): 249-250. 1 illus. [From "London Photo. News."]

TROTTER, H.
T877 Forsyth, Sir T. D., K.C.S.I., C.B. *Report of a Mission to Yarkund in 1873,* under command of Sir T. D. Forsyth, K.C.S.I., C.B., Bengal Civil Service, with historical and geographical information regarding the possessions of the Ameer of Yarkund. Calcutta: Foreign Department Press, 1875. 573 pp. 102 b & w. [Eighty-six photographs by Capt. E. F. Chapman, sixteen photographs by Capt. H. Trotter.]

TROXELL, W. L. (ST. LOUIS, MO)
T878 Portrait. Woodcut engraving, credited "From a Photograph." FRANK LESLIE'S ILLUSTRATED NEWSPAPER 14, (1862) ["Col. Everett Peabody, killed." 14:348 (June 7, 1862): 150.]

TRUCHELOT. (PARIS, FRANCE)
T879 Portrait. Woodcut engraving credited "From a photograph by Truchelot." ILLUSTRATED LONDON NEWS 73, (1878) ["Late Louis Garnier-Pagès." 73:2055 (Nov. 16, 1878): 456.]

TRUEFITTS. (EDINBURGH, SCOTLAND)
T880 "Dreadful Railway Accident." ILLUSTRATED LONDON NEWS 37, no. 1041 (July 21, 1860): 70. 1 illus. ["From a Photograph by Truefitts, Edinburgh." Accident at Granton, near Edinburgh.]

TRUMANS, H. C. (WASHINGTON, IA)
T881 Trumans, H. C. "The Toning Bath." AMERICAN JOURNAL OF PHOTOGRAPHY AND THE ALLIED ARTS & SCIENCES n. s. vol. 8, no. 15 (Feb. 1, 1866): 349-350.

TRUMBULL, A. E. (UPPER SANDUSKY, OH)
T882 "Editor's Table." PHILADELPHIA PHOTOGRAPHER 5, no. 56 (Aug. 1868): 280. [Stereo views.]

TUCKER see DICKENSON & TUCKER.

TUCKER & PERKINS. (AUGUSTA, GA)
T883 "Note." PHOTOGRAPHIC AND FINE ART JOURNAL 11, no. 2 (Feb. 1858): 63. [Extract from "Augusta Dispatch."]

TUCKER, I. (AUGUSTA, GA)
T884 "Note." HUMPHREY'S JOURNAL 5, no. 1 (Apr. 15, 1853): 16. [Tucker & Perkins, Augusta, GA, dissolved. Mr. Tucker going on alone.]

TUELY, N. C.
T885 Tuely, N. C. "Waxed Paper." HUMPHREY'S JOURNAL OF PHOTOGRAPHY, AND THE ALLIED ARTS AND SCIENCES 11, no. 15 (Dec. 1, 1859): 231-232. [From "Photo. J."]

TULLEY, JAMES SYRUS.
T886 Tulley, James Syrus. "How to Glaze Your Photographs." BRITISH JOURNAL PHOTOGRAPHIC ALMANAC 1875 (1875): 135-136.

TUMINELLO, LUDOVICO. (1824-1907) (ITALY)
T887 Boerio, Lina Fiore. "Lodovico Tuminello fotografo romano." PALATINO 12, no. 3 (Aug./Sept. 1968): 282-293. 18 b & w. [Views of Rome, Italy, taken ca. 1860-1880.]

TUNNY, JAMES GOOD. (d. 1887) (GREAT BRITAIN)
T888 "The Zulus of Natal." ILLUSTRATED LONDON NEWS 30, no. 865 (June 27, 1857): 626. 1 illus. [Portrait of a young Zulu male, from a photograph by Tunny, of Edinburgh. The Zulu accompanied an Englishman to Edinburgh, where the photograph was apparently taken, then he went back to South Africa.]

T889 Tunny. "The Vitro-Heliographic Process applied to Portraiture and the Decorative Arts." HUMPHREY'S JOURNAL OF

PHOTOGRAPHY, AND THE ALLIED ARTS AND SCIENCES 9, no. 18 (Jan. 15, 1858): 283-288. [From "Photo. Notes."]

T890 Tunny. "On a new method of Decolorizing the Albumen Silver Bath." HUMPHREY'S JOURNAL OF PHOTOGRAPHY, AND THE ALLIED ARTS AND SCIENCES 12, no. 19 (Feb. 1, 1861): 296-297. [From "Br. J. of Photo."]

T891 Tunny, J. G. "Enamelled Photographs." BRITISH JOURNAL OF PHOTOGRAPHY 11, no. 228 (Sept. 16, 1864): 350-351.

T892 Tunny, James G. "A Printing-Frame for Opal Pictures." AMERICAN JOURNAL OF PHOTOGRAPHY AND THE ALLIED ARTS & SCIENCES n. s. vol. 7, no. 21 (May 1, 1865): 497-498. [From "Br. J. of Photo."]

T893 Tunny, James G. "Instantaneous Photography." BRITISH JOURNAL OF PHOTOGRAPHY 12, no. 264 (May 26, 1865): 273-274.

T894 Tunny, James G. "New Collodion Printing Process, Applicable to Vitreous, Enamelled, and Other Surfaces." AMERICAN JOURNAL OF PHOTOGRAPHY AND THE ALLIED ARTS & SCIENCES n. s. vol. 7, no. 23 (June 1, 1865): 527-532. [Read to Photo. Soc. of Scotland.]

T895 Tunny, James G. "Artificial Ivory and Other Printing Surfaces." AMERICAN JOURNAL OF PHOTOGRAPHY AND THE ALLIED ARTS & SCIENCES n. s. vol. 7, no. 24 (June 15, 1865): 559-562. [Read to Edinburgh Photo. Soc.]

T896 "The Preparation and Mounting of Enamelled Cartes de Visite." BRITISH JOURNAL OF PHOTOGRAPHY 12, no. 270 (July 7, 1865): 355. [Work of Mr. Tunny (Edinburgh).]

T897 "The Preparation and Mounting of Enamelled Cartes de Visite." AMERICAN JOURNAL OF PHOTOGRAPHY AND THE ALLIED ARTS & SCIENCES n. s. vol. 8, no. 3 (Aug. 1, 1865): 70-72. [From "Br. J. of Photo."]

T898 "Note." PHOTOGRAPHIC TIMES 8, no. 88 (Apr. 1878): 89. ["Mr. J. G. Tunny, the leading photographer in Edinburgh, Scotland, has..."]

T899 Tunny, J. G. "Mounting and Mounting Materials" BRITISH JOURNAL PHOTOGRAPHIC ALMANAC 1874 (1874): 105.

T900 "General Notes." PHOTOGRAPHIC TIMES 13, no. 148 (Apr. 1883): 154. ["...the veteran Scottish photographer... on a holiday tour of the United States."]

T901 Tunny, James G. "Vitrified Enamels." BRITISH JOURNAL PHOTOGRAPHIC ALMANAC 1873 (1873): 69-70.

T902 "General Notes." PHOTOGRAPHIC TIMES 17, no. 319 (Oct. 28, 1887): 538. [Announcement of death of British photographer James Tunny on Sept. 24th. Well-known, widely travelled. In USA less than a year ago.]

TURK, M.

T903 Turk, M. Dr. "Letter from Dr. Turk." HUMPHREY'S JOURNAL OF PHOTOGRAPHY, AND THE ALLIED ARTS AND SCIENCES 17, no. 1 (May 1, 1865): 12-13. ["Being a recent refugee from Galveston, Texas, where during the war I have learned and practiced the ambrotype business, besides my profession (homeopathic physician) was anxious to inform myself the progress of the science and art during the long years we were blockaded and cut off from the civilized world."]

TURNER, A. WELLESLEY.
T904 Turner, A. Wellesley. "Carbon Printing." ANTHONY'S PHOTOGRAPHIC BULLETIN 8, no. 4, 6 (Apr., June 1877): 97-102, 161-163. [From "London Photo. News."]

TURNER, AUSTIN A. see also CUTTING & TURNER.

TURNER, AUSTIN AUGUSTUS. (ca. 1831-1866) (USA)
BOOKS
T905 *Villas on the Hudson. A Collection of Photo-Lithographs of Thirty-one Country Residences.* New York: D. Appleton & Co., 1860. 3 pp. 32 l. of plates. illus. [Photolithographs by A. A. Turner.]

T906 Turner, Austin A. *Views on the Hudson. A Collection of Photo-Lithographs of Thirty-one Country Residences.* New York: D. Appleton & Co., 1860. vi pp. 31 l. of plates. 31 b & w. 21 illus. [Thirty-one photolithographic views, twenty-one lithographic ground plans.]

T907 Brion, Gustave. *Illustrations to 'Les Misérables,' of Victor Hugo;* Scenes and Characters Photographed by A. A. Turner, after the Original Designs of G. Brion. New York; Paris: Carleton; Pagnerre, 1863. 59 pp. 26 l. of plates. 26 b & w.

T908 *Washington Irving. Mr. Bryant's Address on his Life and Genius.* Addresses by Everett, Bancroft, Longfellow, Felton, Aspinwall, King, Francis, Greene. Mr. Allibone's Sketch of His Life and Work. With Eight Photographs. New York: G. P. Putnam, 1860. 113 pp. 8 b & w. illus. [Salt paper prints?, View of Irving's home 'Sunnyside' and 'Burial Place.' "From a large photograph by A. A. Turner." Portraits, from paintings, daguerreotypes, (* credited to Plumbe), etc.]

T909 Düsseldorf Gallery. New York. *Gems from the Düsseldorf Gallery; Photographed from the Original Pictures by A. A. Turner, and Reproduced (For the First Time) under the Supervision of B. Frodsham.* New York: Appleton & Co., 1863. 107 l. pp. 52 l. of plates. 52 b & w. illus. [Original photos.]

T910 Young, William. *Lights and Shadows of New York Picture Galleries.* Forty Photographs by A. A. Turner. Selected and described by William Young. New York; London: D. Appleton & Co.; Sampson Low & Co., 1864. vi pp. 40 l. of plates. 40 b & w. [Forty albumen prints of reproductions of oil paintings, by Austin A. Turner.]

PERIODICALS
T911 "Personal and Art Intelligence." PHOTOGRAPHIC AND FINE ART JOURNAL 8, no. 5 (May 1855): frontispiece, 160. 1 b & w. [A. A. Turner, who's self-portrait is the original photographic print bound into this issue, learned photographic process from Whipple in Boston, but continued his own experiments since then.]

T912 "Our Illustrations. I. Sleepy Hollow Church, at Irvington, on the Hudson." PHOTOGRAPHIC AND FINE ART JOURNAL 13, no. 7 (July 1860): Frontispiece, 211. 1 b & w. [Original photographic print, tipped-in.]

T913 Portrait. Woodcut engraving, credited "From a Photograph by Turner." NEW YORK ILLUSTRATED NEWS 8, (1863) ["Henry Ward Beecher." 8:187 (May 30, 1863): 76.]

T914 "James H. Hackett." HARPER'S WEEKLY 16, no. 786 (Jan. 20, 1872): 53. 1 illus.

BY ARTIST OR AUTHOR
TURNER, BENJAMIN BRACKNELL.

BY ARTIST OR AUTHOR
TYTLER, ROBERT CHRISTOPHER & HARRIET CHRISTINA TYTLER.

T915 Hanson, David A. "A. A. Turner, American Photolithographer." HISTORY OF PHOTOGRAPHY 10, no. 3 (July - Sept. 1986): 193-211. 17 b & w. 4 illus. [Born Abijah Austin Turner ca. 1831, in NC. Family resettled in Bath, ME. By 1852, Turner was working as an operator in B. F. Cambell's Boston, MA, gallery. Worked for Marcus Ormsbee in Boston, then to New York, NY, where he worked for Brady, Gurney, and others. In early 1850s Turner learned early photolithographic processes and techniques. In 1856 James A. Cutting and Turner opened a gallery in Boston - the Boston Gallery of Art. Turner moved back to New York, NY in 1860 and began business there as a photolithographer. He printed stereo views for D. Appleton & Co, and made prints for books and magazines, including "P & FA J" and "Humphrey's J." (Listed as a lithographer in New York, NY directories from 1860 to 1864, then listed as a photographer from 1864-65. With Dr. William Dutton as assistant, Turner took views of the fortifications of Washington, DC soon after the first Battle of Bull Run in 1861.) Moved to New Orleans in 1864 and formed a partnership with Samuel Anderson. (Anderson & Turner) Then opened his New Orleans Photographic Co. in 1865. Later partner Warren M. Cohen. Died Sept. 29, 1866 in New Orleans, LA.]

TURNER, BENJAMIN BRACKNELL.
T916 *Bredicot and Crowle, Worcestershire, photographed by Benjamin Bracknell Turner, 1850 - 61.* s. l.: s. n., 1861 [?]. n. p. 36 b & w. [Thirty-six albumen prints and a photographic title page.]

TURNER, J. (GEELONG, AUSTRALIA)
T917 "Prince Alfred at Geelong." ILLUSTRATED LONDON NEWS 52, no. 1471 (Feb. 29, 1868): 204, 214. 1 illus. ["...for which we have to thank Mr. J. Turner, photographic artist, of Moorabool St., Geelong."]

TURNER, J. C. (CHEAPSIDE, BARNSBURY & ISLINGTON)
T918 Portrait. Woodcut engraving credited "From a photograph by J. C. Turner." ILLUSTRATED LONDON NEWS 67, (1875) ["Rev. Gervase Smith, M.A." 67:1879 (Aug. 14, 1875): 161.]

TURNER, JOHN. (LEEDS, ENGLAND)
T919 "*[Train wreck]" ILLUSTRATED LONDON NEWS 57, no. 1601 (July 2, 1870): 13, 18. 1 illus. ["Our Engraving... is made from a sketch taken by Mr. John Turner, photographer, of Leeds, one of the passengers in the excursion-train." (Example of the ILN's movement away form photos of events, this is not from a photograph but from a sketch.)]

TUTTLE & PRATT. (ST. PAUL, MN)
T920 "Miss Gardner and Her Fearful Adventure." BALLOU'S PICTORIAL DRAWING-ROOM COMPANION [GLEASON'S] 13, no. 322 (Aug. 22, 1857): 113. 5 illus. [Portrait of Miss Gardner, who was captured by Sioux Indians, then ransomed, from a photo by Messrs. Tuttle & Pratt "who have a large daguerreotype and ambrotype gallery at the corner of 3rd and Cedar Streets, St. Paul, Minnesota." Portrait surrounded by sketches depicting the capture, captivity and ransom.]

T921 "St. Paul, Minnesota." BALLOU'S PICTORIAL DRAWING-ROOM COMPANION [GLEASON'S] 13, no. 329 (Oct. 10, 1857): 232-233. 5 illus. ["...a number of very fine daguerreotypes taken by Messrs. Tuttle and Pratt, whose daguerreotype and ambrotype gallery enjoys a high and deserved reputation." One large general view of St. Paul from a bluff across the river (with an operator and camera in the foreground) and four buildings.]

TUTTLE, MOSES C. (ca. 1831 -) see TUTTLE & PRATT.

[Moses C. Tuttle was born in ME ca. 1831. He operated an ambrotype and daguerreotype gallery in St. Paul, MN from about 1856 on, at first in the partnership of Tuttle & Pratt, then on his own.]

TUTTLE, W. N. (SANTA BARBARA, CA)
T922 Waldsmith, John. "Sarver's Mammoth Grape Vine." STEREO WORLD 3, no. 3 (July - Aug. 1976): 11. 2 b & w. [Stereo views of a huge grape vine, taken by W. N. Tuttle, of Santa Barbara, CA, in the 1870s.]

TWEEDY, W. G.
T923 Tweedy, W. G. "Clean Hands and Clean Pictures." AMERICAN JOURNAL OF PHOTOGRAPHY AND THE ALLIED ARTS & SCIENCES n. s. vol. 7, no. 15 (Feb. 1, 1865): 348-350. [From "Photo. News."]

TWYMAN, C. (RAMSGATE, ENGLAND)
T924 "Double Printing for Portraits." AMERICAN JOURNAL OF PHOTOGRAPHY AND THE ALLIED ARTS & SCIENCES n. s. vol. 7, no. 9 (Nov. 1, 1864): 203-204. [From "Photo. News."]

TWYMAN, J. C. (RAMSGATE, ENGLAND)
T925 Portrait. Woodcut engraving credited "From a photograph by J. C. Twyman, Ramsgate." ILLUSTRATED LONDON NEWS 46, (1865) ["Sir Moses Montefiore, Bart." 46:* (Feb. 18, 1865): 153.]

TYNDALL, JOHN.
T926 Tyndall, John. *Lectures on Light, Delivered in the United States in 1872-73.* New York: D. Appleton & Co., 1873. 194 pp. illus.

TYSON & PERRY. (CHARLOTTESVILLE, VA)
T927 "How It's Done in Virginia." ANTHONY'S PHOTOGRAPHIC BULLETIN 4, no. 9 (Sept. 1873): 269. [From the "Charlottesville Weekly Chronicle."]

TYSON BROTHERS. (GETTYSBURG, PA)
T928 "Editor's Table: Views of the Battle-Field of Gettysburg, Pa." PHILADELPHIA PHOTOGRAPHER 1, no. 10 (Oct. 1864): 159-160. [Description of stereo views.]

TYTLER, ROBERT CHRISTOPHER & HARRIET CHRISTINA TYTLER.
T929 Thomas, G. "Indian Mutiny Veterans: The Tytlers." HISTORY OF PHOTOGRAPHY 9, no. 4 (Oct. - Dec. 1985): 267-273. 9 b & w. [Robert Tytler and his wife, documented the sites associated with the Indian Mutiny, making calotypes around 1858.]

U

UBBAS ALLI, DAROGHA.
U1 Sharma, Brij Bhusham. "Darogha Ubbas Alli: an unknown 19th Century Indian Photographer." HISTORY OF PHOTOGRAPHY 7, no. 1 (Jan. 1983): 63-68. 5 b & w. 1 illus. [Published "The Lucknow Album: ...Fifty Photographic Views of Lucknow..." in 1874.]

UHLMAN, RUDOLPH. (1828-1898) (GERMANY, USA)
U2 "Obituary: Rudolph Uhlman." WILSON'S PHOTOGRAPHIC MAGAZINE 35, no. 497 (May 1898): 233. [Born at Chemnitz, Saxony, came to U.S. as young man. 1859 on gold rush to Pike's Peak. In 1861 he began photographing in St. Paul, Mo., worked there for forty years. Died. March 23rd, 1898.]

ULKE, HENRY & BROTHER. (WASHINGTON, DC)
U3 Portrait. Woodcut engraving, credited "From a Photograph by Henry Ulke & Brother." FRANK LESLIE'S ILLUSTRATED NEWSPAPER 33, (1871) ["Rear-Admiral James Alden, U.S.N." 33:844 (Dec. 2, 1871): 181.]

U4 Portraits. Woodcut engravings, credited "From a Photograph by Henry Ulke & Bro., Washington, D. C." FRANK LESLIE'S ILLUSTRATED NEWSPAPER 36, (1873) ["Gen. Albert J. Myer, Chief of the Signal Service Bureau and Government Weather Reporter." 36:935 (Aug. 30, 1873): 389.]

U5 Portrait. Woodcut engraving, credited "From a Photograph by Henry Ulke & Brother, Washington, D. C." FRANK LESLIE'S ILLUSTRATED NEWSPAPER 37, (1873) ["Alexander R. Shepherd, Gov. of DC." 37: 941 (Oct. 11, 1873): 81.]

U6 Portrait. Woodcut engraving, credited "From a Photograph by Ulke." FRANK LESLIE'S ILLUSTRATED NEWSPAPER 43, (1876) ["Gen. J. A. Sutter, CA pioneer." 43:1095 (Sept. 23, 1876): 44.]

ULKE, HENRY (1821-1910) (USA) see ULKE, HENRY & BROTHER.

ULKE, JULIUS (ca. 1833-1910) (USA) see ULKE, HENRY & BROTHER.

UNDERWOOD, JOHN H.
U7 "Printing and Toning." HUMPHREY'S JOURNAL OF PHOTOGRAPHY, AND THE ALLIED ARTS AND SCIENCES 14, no. 5 (July 1, 1862): 31-32. [From "Photo. News."]

UNSWORTH, RICHARD H.
U8 Unsworth, Richard H. "A Photographic Trip to Fountains Abbey, Yorkshire." BRITISH JOURNAL OF PHOTOGRAPHY 11, no. 224 (Aug. 19, 1864): 305-306.

U9 Unsworth, Richard H. "Photographic Rambles; or, Where to Go with the Camera." BRITISH JOURNAL OF PHOTOGRAPHY 11, no. 239 (Dec. 2, 1864): 485-487.

UNTERBERGER, FRANZ.
U10 Sommergruber, W., B. A. and H. K. Henisch. "Three by Four." HISTORY OF PHOTOGRAPHY 5, no. 3 (July 1981): frontispiece. 1 b & w. [Commentary about an Austrian carte-de-visite that contains three montaged portraits of European rulers, made ca. 1871.]

UPSON & SIMPSON. (BUFFALO, NY)
U11 "Editor's Table." PHILADELPHIA PHOTOGRAPHER 5, no. 54 (June 1868): 215. [Group of cabinets.]

UPSON, J. T. (c. 1829-1870) (USA)
U12 "Editor's Table." PHILADELPHIA PHOTOGRAPHER 7, no. 81 (Sept. 1870): 336. [Upson, of Upton & Simpson, Buffalo, NY, died of consumption at age 41.]

UPTON, BENJAMIN F. see also HISTORY: USA: MN: 19TH C. (Woolworth).

URDA, ANTONIO. (MATANZAS, CUBA)
U13 Portrait. Woodcut engraving, credited "From a Photograph by Antonio Urda, Matanzas." FRANK LESLIE'S ILLUSTRATED NEWSPAPER 37, (1873) [Gen. Juan Nepomuceno Burriel, Cuba." 37:950 (Dec. 13, 1873): 225.]

URIE, JOHN. (GLASGOW, SCOTLAND)
BOOKS
U14 Urie, John. *Reminiscences of Eighty Years,* Paisley, Scotland: Gardner, 1908. n. p.

PERIODICALS
U15 "Monthly Notes: Photography in the Provinces." PRACTICAL MECHANIC'S JOURNAL 5, no. 57 (Dec. 1852): 216. [Praise for the work of Mr. Urie, of Glasgow, and his efforts with the "collodionized glass process" and using photography in wood engraving.]

U16 "Photographic Pictures in Relief." PRACTICAL MECHANIC'S JOURNAL 7, no. 74 (May 1854): 28. [Work by Urie.]

U17 Urie, J. "Pictures from Life. From the Scrap Book of a Photographer" BRITISH JOURNAL OF PHOTOGRAPHY 24, no. 909-910 (Oct. 5 - Oct. 12, 1877): 474-475, 486-487. [Urie's talk began with a summation of early photographers practicing in Scotland, then he described his own career, then ended with anecdotes from his many years as a practicing photographer. The first daguerreotypes shown in Glasgow were displayed at the Zoological Gardens. Then a Mr. Picken at the Andersonian Institute presented work. Then William Gardner, Bernard, Young, White, and Miss Descerne. Urie describes sitting outdoors in the hot sun for a quarter hour to have his portrait taken. Mentions Dr. Paterson, an amateur. Mr. Kibble, who made a 4 ft. x 3 ft. glass positive of Gourock Bay. The Mactear Brothers. In Edinburgh there was Ross & Thomson. Papowitz. Howie. The Englishman Bernard, who made a fortune by claiming to be making colored daguerreotypes, who was later proven to be a fraud. Exposed, he returned to London and became a manager of a boot and shoe factory. Mr. Young, who advertised his work as Young and Sun. (Not Son.) White. Hughes. McNab in Glasgow. Taylor. Annan. The German painter Bibo, who made excellent glass positives. The Frenchmen Mr. Descerne, and the Maguee Brothers, who were burned out, moved to London, where one starved to death while painting a historical painting. Mr. Greatrex, a religious zealot who forged banknotes. Praise for the stockdealer John Spenser, who trained and advised many young photographers.
Urie had been a wood engraver who had copied daguerreotypes to woodblocks. He tried, with less success than more, to daguerreotype directly onto a treated woodblock, then engrave it by hand. Developed a more successful process with the introduction of collodion. Advised to himself become a portrait photographer, and he did so. He was burned in a collodion explosion, but his studio flourished. The explorer Dr. Livingstone had his portraits taken by Urie, then learned photography to use on his expeditions, but died before returning. Urie tells many anecdotes about his operators, customers, etc.]

U18 Taylor, J. Traill. "Two Hundred Prints an Hour by Gas-Light." PHOTOGRAPHIC TIMES 15, no. 219 (Nov. 27, 1885): 661.

V

VACQUERIE, AUGUSTE (1819-1895) see HUGO, CHARLES-VIC-TOR.

VAIL, E. (PARIS, FRANCE)
V1 Vial, E., of Paris. "On a Method of Instantaneous Engraving on Metal." AMERICAN JOURNAL OF PHOTOGRAPHY AND THE ALLIED ARTS & SCIENCES n. s. vol. 6, no. 23 (June 1, 1864): 529-538. [From "Photo. Notes."]

VAIL, J. H. (d. 1853) (NEW BRUNSWICK, NJ)
V2 "Editorials." HUMPHREY'S JOURNAL 5, no. 10 (Sept. 1, 1853): 154. [Note of death of J. H. Vail (New Brunswick, NJ).]

VAIL, JAMES GARDNER. (1842-1929) (USA)
V3 Vail, R. W. G. "The Photographer of the 'Elegant and Salubrious Village'." IMAGE 6, no. 9 (Nov. 1957): 204-207. 5 b & w. [Biography and career of a commercial photographer in Geneva, NY, from the 1860s to 1880s. Born Apr. 19, 1842 in Romulus, NY. Learned to make ambrotypes in 1862, then opened a studio in Geneva. Worked there until he closed his business in 1880.]

VALENTINE & HIGGENS. (USA)
V4 "Fearful Accident on the Michigan Southern Railroad, on the 27th June, 1859. - From a Photograph by Valentine & Higgens." FRANK LESLIE'S ILLUSTRATED NEWSPAPER 8, no. 189 (July 16, 1859): 108. 1 illus. [Wrecked train.]

VALENTINE, GEORGE D. see also VALENTINE, JAMES & SONS.

VALENTINE, GEORGE D.* (d. 1890) (GREAT BRITAIN)
V5 "Obituary." PHOTOGRAPHY 2, no. 76 (Apr. 24, 1890): 261.*

VALENTINE, JAMES & SONS. (DUNDEE, SCOTLAND)
BOOKS
V6 Photographic View Album of North Wales Scenery; Views Selected from Valentine & Sons' Photographs of North Wales. Dundee: Valentine & Sons., 189- ? 28 pp. illus. [GEH Collection.]

V7 St. Andrews. Fife: W. C. Henderson & Son, 189- ? 16 pp. 16 b & w. illus. [GEH Collection.]

V8 Catalogue of Photographic Publications: Contains 28,000 Views of the Finest Scenery in England, Scotland, Wales, Norway, Spain, Morocco, etc.: Lantern Slide Dept., Season 1890-91. Dundee: Valentine & Sons., 1890 ? 26 pp.

PERIODICALS
V9 "Our Picture." PHILADELPHIA PHOTOGRAPHER 17, no. 197 (May 1880): frontispiece, 133-134. 1 b & w. [Landscape.]

V10 "At Messrs. Valentine and Sons, Dundee." PHOTOGRAPHIC NEWS 35, no. 1732 (Nov. 13, 1891): 778.*

V11 1 photo ("A Scottish Crofter's Home). PHOTOGRAPHIC TIMES 23, no. 627 (Sept. 22, 1893): 531.

V12 Colvin, Sidney, editor. "The Letters of Robert Louis Stevenson." SCRIBNER'S MAGAZINE 25, no. 1 (Jan. 1899): 29-49. 8 illus. ["Illustrations drawn from copyright photograph by Valentine & Sons, Dundee." Views of Scottish scenery, buildings.]

V13 Sobieszek, Robert A. "Messrs. James Valentine and Sons, Dundee." IMAGE 14, no. 2 (Mar. 1971): 6-8. 4 b & w. [James Valentine founded Scotland's second largest photographic establishment in 1880, then died the same year. His sons were W. D. and George D. Valentine. Firm specialized in views, printing as many as 3000 a day by 1882. By 1906 the firm was also producing many postcards. George D. was a founding vice-president of the Dundee and East of Scotland Photographic Association in 1880. George D. later moved to Parnell, New Zealand, for his health. W. D. was apparently the chief executive of the family business. The firm also employed other photographers, so individual attribution of images is impossible.]

V14 Sobieszek, Robert A. "A Further Note on Messrs. James Valentine and Sons, Dundee." IMAGE 14, no. 3 (June 1971): 18. 1 b & w. 1 illus.

V15 Spear, Benjamin. "Frontispiece: The Lady is for Turning." HISTORY OF PHOTOGRAPHY 12, no. 4 (Oct. - Dec. 1988): frontispiece. 1 b & w. [View of a huge water pump, used in the mines at Laxey, Isle of Man. Taken by Valentine & Sons, ca. 1855.]

VALENTINE, JAMES see also VALENTINE, JAMES & SONS.

VALENTINE, JAMES. (1815-1880) (GREAT BRITAIN)
BOOKS
V16 Handbook to the Cathedral Church of Ely: With Some Account of the Monastic Buildings. "7th Edition" Ely: T. A. Hills & Sons, 1867. n. p. 6 b & w. [This was the first of these editions to be illustrated with original photographs, taken by James Valentine.] Scottish Scenery. James Valentine, 1871. n. p. 47 b & w. [Album, Boston Museum of Fine Arts Collection.]

PERIODICALS
V17 "Our Editorial Table." BRITISH JOURNAL OF PHOTOGRAPHY 11, no. 223 (Aug. 12, 1864): 295. [Praise for scenic views.]

V18 Valentine, James. "A Substitute for a Dark Room in Field Operations." BRITISH JOURNAL PHOTOGRAPHIC ALMANAC 1867 (1867): 100-101.

V19 Valentine, James. "On the Protection of Negatives." BRITISH JOURNAL PHOTOGRAPHIC ALMANAC 1876 (1876): 126.

V20 "The Tay Bridge, Near Dundee." ILLUSTRATED LONDON NEWS 71, no. 2003 (Dec. 1, 1877): 529, 530. 2 illus. ["Our Illustrations are from the photographs in Valentine's 'Views of Scottish Scenery.'"]

V21 "Warming the Studio." ANTHONY'S PHOTOGRAPHIC BULLETIN 9, no. 7 (July 1878): 209-211. 1 illus. [From "Br J of Photo." Describes James Valentine's studio in Dundee, warmed by Mr. Keith's invention.]

V22 MacLeod, Fiona. "From the Hebrid Isles." HARPER'S MONTHLY 92, no. 547 (Dec. 1895): 45-60. 10 b & w. [Short story, illustrated with landscape views, credited either "from a photograph by" or "drawn from a photograph by..." James Valentine & Sons, Dundee (6); G. W. Wilson & Co., Aberdeen (4).]

VALENTINE, JOHN see also VALENTINE, JAMES & SONS.

VALENTINE, JOHN. (GREAT BRITAIN, USA)
V23 Valentine, John. "Dry Plates in California: An Echo from the Far West." BRITISH JOURNAL OF PHOTOGRAPHY 11, no. 227 (Sept.

9, 1864): 346-347. [Letter from John Valentine, who a year before, had been at "a well-known photographic establishment at Dundee." Then moved to California for his health, worked his way around the Horn on a boat, taking six months, arriving March 12th. Exposing tannin dry plates in San Francisco, CA.]

VALENTINE, W. D. see VALENTINE, JAMES & SONS.

VALLEAU, GEORGE W. (d. 1877) (USA)
V24 "Editor's Table: Obituary." PHILADELPHIA PHOTOGRAPHER 14, no. 161 (May 1877): 160. [Note that George W. Valleau (Colusa, CA) died on March 22, of heart disease.]

VALLEE, LOUIS PARENT. (QUEBEC, CANADA)
V25 "Canada. - Scene of the Destructive Conflagration in the St. Louis Suburb of Quebec, May 30th - The Sufferers Encamping on the Cricket-Field. - Photographed by L. P. Vallee, Quebec." FRANK LESLIE'S ILLUSTRATED NEWSPAPER 42, no. 1081 (June 17, 1876): 244. 1 illus. [View, with figures.]

VAN AKEN, E. M. (LOWVILLE, NY)
V26 "Editor's Table." PHILADELPHIA PHOTOGRAPHER 4, no. 38 (Feb. 1867): 64. [Views by E. M. Van Aken and his student G. W. Carter, both of Lowville, NY. Van Aken's genre portrait, "The Old Sexton" mentioned on the same page.]

V27 Van Aken, E. M. "Correspondence." ANTHONY'S PHOTOGRAPHIC BULLETIN 2, no. 10 (Oct. 1871): 337. [Van Aken (Lowville, NY) praising Rembrandt Collodion. Additional note on p. 339.]

V28 "Note." PHOTOGRAPHIC TIMES 2, no. 22 (Oct. 1872): 154. [Work received, including photos of one-day old chickens.]

V29 Van Aken, E. M. "How to Produce Fine Cloud Effects, With Stump and Crayon Chalk." PHOTOGRAPHIC MOSAICS: 1888 24, (1888): 53. [In Elmira, NY.]

VAN BUREN.
V30 "The Rogues' Gallery." AMERICAN JOURNAL OF PHOTOGRAPHY AND THE ALLIED ARTS AND SCIENCES n. s. vol. 2, no. 5 (Aug. 1, 1859): 75-77. [New York, NY Police Dept. collection of ambrotypes. Been in operation for over a year, 450 photos.]

VAN DEUSEN.
V31 Palmquist, Peter E. "Van Deusen's Photocryptogram." HISTORY OF PHOTOGRAPHY 6, no. 2 (Apr. 1982): 117-118. 1 b & w. 2 illus. [A rebus used in advertising for the firm of Van Deusen's Gallery, Indianapolis, 1871.]

VAN GESTEL, J. THEODORE. [?]
V32 Van Gestel, J. Theodore. "Among the Dyaks." COSMOPOLITAN 26, no. 4 (Feb. 1899): 425-432. b & w. [Description of his journey in Borneo in 1879. Illustrated with heavily overpainted photographs of natives, etc., which may have been taken by the author at that time. "The Sultan of Koeti, whose picture I brought away, furnished me..."]

VAN GIESON, RANSFORD E.
V33 Van Gieson, Ransford E. *The Application of Photography to Medical Science, Including a Process for Photographing the Microscopic Field.* New York: Thomas Holman, Book and Job Printer, 1860. 16 pp. 1 b & w. [Tipped-in photograph.]

VAN LOAN, SAMUEL P. (GREAT BRITAIN, USA)
[Samuel Van Loan was born in England and apparently learned and practiced photography there in the early 1840s. Moved to USA and was active in Philadelphia, PA from 1844 to 1854. Sold his gallery to J. Shew in 1851.]

V34 "Lady Anna Isabella Byron." FRANK LESLIE'S ILLUSTRATED NEWSPAPER 29, no. 731 (Oct. 2, 1869): 45. 1 illus. [Portrait. Woodcut engraving, credited "From a Daguerreotype by S. F. Van Loan, in London, 1842."]

VAN LOO, LEON. (1841-1906) (BELGIUM, USA)
V35 Portrait. Woodcut engraving, credited "From a Photograph by Leon Van Loo." HARPER'S WEEKLY 13, (1869) ["Gov. R. B. Hayes, of OH." 13:671 (Nov. 6, 1869): 705.]

V36 "Mr. Van Loo's Opening." ANTHONY'S PHOTOGRAPHIC BULLETIN 3, no. 1 (Jan. 1872): 426. [From "Cincinnati Commercial."]

V37 Portrait. Woodcut engraving, credited "From a Photograph by Van Loo." FRANK LESLIE'S ILLUSTRATED NEWSPAPER 36, (1873) ["Deacon Richard Smith, Cincinnati, OH." 36:920 (May 17, 1873): 153.]

V38 "Our Picture." PHILADELPHIA PHOTOGRAPHER 15, no. 178 (Oct. 1878): frontispiece, 313-315. 1 b & w. [Leon Van Loo (Cincinnati, OH) produced a composition "genre" titled, "An Evening at Home," consisting of individually posed people: children playing with blocks, father reading, older girl playing piano, etc. Pictures then combined to seem as if they were all together in a living room. Letter from Van Loo describes how the picture was created.]

V39 Van Loo, Leon. "Art Talk By A Veteran Photographer." WILSON'S PHOTOGRAPHIC MAGAZINE 32, no. 458 (Feb. 1895): 65-72. 2 illus. [Lecture at the Cincinnati Camera Club, Dec. 10, 1894. Article includes a biography of Van Loo. Began photographing at college in Ghent, Belgium in 1853 under Charles Waldack. To Cincinnati in 1857 to join Waldack, who had moved there in 1854. 1858-1860 taught photo in midwest. 1861-1886 worked as studio photographer in Cincinnati. Retired 1886.]

VAN LOO, WILLIAM F. [VAN LOO & TROST] (TOLEDO, OH)
V40 "A Taking Combination Picture." WILSON'S PHOTOGRAPHIC MAGAZINE 32, no. 464 (Aug. 1895): 360-361. 1 b & w. [Commercial studio, combined several portraits of a child or children, rephotographs them with decorative floral borders, etc.]

V41 Wilson, Edward L. "The Van Loo Studio at Toledo." WILSON'S PHOTOGRAPHIC MAGAZINE 38, no. 539 (Nov. 1901): 433, plus 1 leaf before 433. 5 illus.

VAN MONCKHOVEN see MONCKHOVEN.

VAN RIPER, J. A.
V42 "A Gallery In a Fix." ANTHONY'S PHOTOGRAPHIC BULLETIN 3, no. 3 (Mar. 1872): 495. [Comments about a gallery on a boat, stuck in ice. Puns based on developing.]

VAN STAVOREN, J. H. (NASHVILLE, TN)
V43 "Van Stavoren's Mammoth Solar Camera 'Jupiter,' Nashville, Tenn." FRANK LESLIE'S ILLUSTRATED NEWSPAPER 25, no. 636 (Dec. 7, 1867): 188. 1 illus. [View of the solar camera on a roof, with three men. Brief description.]

V44 Knight, J. Lee. "Correspondence." ANTHONY'S PHOTOGRAPHIC BULLETIN 2, no. 9 (Sept. 1871): 298-299. [Knight recalls that J. H. Van Stavoren, now of Nashville, TN, but then making daguerreotypes in Northern Indiana (in 1852 or '53) used a revolving wheel of wood strips to achieve a background of neutral tint - similar to something patented in 1871.]

VANCE, GEORGE I. (WINONA, MN)

V45 Sterling, David N. "The Long Winter: The Great Snow Blockade of 1880 and 1881." STEREO WORLD 5, no. 6 (Jan. - Feb. 1979): 4-10. 10 views b & w. 1 illus. [Six views of snow-blocked trains on the Chicago & Northwestern R. R. in Minnesota in 1881, taken by George I. Vance for Elmer & Tenney (Winona, MN). One woodcut from "Harper's Weekly" (Apr. 30, 1881) from this series. Two views by McKecknie & Oswald (Toledo, OH). View by Trost (Toledo, OH). One view by an unidentified maker. George I. Vance began working for the photographer S. T. Wiggins in Winona, MN in 1873. Soon he went to work for Hoard & Tenney (later Elmer & Tenney. Vance took thirty-four views of the terrible snows in March, 1881 and thirty-one in April. The firm of Elmer & Terry is reported to have sold over 25,000 copies of these blizzard views by 1883.]

VANCE, ROBERT H. (1825-1876) (USA)

[Worked in California during the gold rush. Made over 300 daguerreotype views of the mining camps and scenery, which he exhibited in New York, NY in 1851, then auctioned. Purchased by J. H. Fitzgibbon, but subsequently lost. Vance owned a gallery in San Francisco from 1854 to 1861. Also had galleries in Sacramento and Marysville, CA. Hired Carleton E. Watkins to run his San Jose gallery, and Charles L. Weed worked for him at San Jose and later at Sacramento. Sold his San Francisco gallery to Charles L. Weed in 1861. Left CA in 1865. Died in New York in 1876.]

BOOKS

V46 Catalogue of Daguerreotype Panoramic Views in California by R. H. Vance on Exhibition at No. 349 Broadway. New York: Baker, Godwin & Co., Printers, 1851. 8 pp.

V47 Coulter, Edith M. and Jeanne Van Nostrand. A Camera in the Gold Rush... A Series of Photographs of Pacific Coast Towns, Camps and Mining Operations of Pioneer Days. "Book Club of Calif., San Francisco Keepsake Series no. 10" San Francisco: Book Club of Calif, 1946. n. p. 12 b & w. [600 copies.]

PERIODICALS

V48 "Note." PHOTOGRAPHIC ART JOURNAL 2, no. 3 (Sept. 1851): 189. [Note that "Mr. Vance of San Francisco is preparing some 300 California views for exhibition, of which we will speak hereafter."]

V49 "Gossip: Mr. Vance's California Views." PHOTOGRAPHIC ART JOURNAL 2, no. 4 (Oct. 1851): 252-253. [Review of exhibit at corner of Leonard Street and Broadway, over Mr. Whitehurst's Gallery....]

V50 "Note." DAGUERREAN JOURNAL 2, no. 10 (Oct. 1, 1851): 308. ["Mr. Vance, recently returned from California, exhibiting his views."]

V51 "California Daguerreotyped." ILLUSTRATED AMERICAN NEWS 1, no. 20 (Oct. 18, 1851): 155. [Note that R. H. Vance, just returned from the California gold fields, was displaying 300 daguerreotype views at 349 Broadway, New York, NY, over Whitehurst's Gallery.]

V52 "California Daguerreotyped." ILLUSTRATED AMERICAN NEWS 1, no. 21 (Oct. 25, 1851): 164. 1 illus. [Exhibition of Vance daguerreotype views of CA described. The illustration is titled "Mining Scene in the Street of Placerville."]

V53 "Daguerreotype Panoramic Views in California." DAGUERREAN JOURNAL 2, no. 12 (Nov. 1, 1851): 371. [Review of 300 views of California goldfields, etc., displayed in New York, NY.]

V54 "California Mining - The Long Tom." ILLUSTRATED AMERICAN NEWS 1, no. 23 (Nov. 8, 1851): 184. 1 illus. ["the present illustration is taken from a daguerreotype by Mr. Vance,..."]

V55 "Gossip." PHOTOGRAPHIC ART JOURNAL 5, no. 2 (Feb. 1853): 126-129. [Discussion, plus a descriptive list of 131 daguerreotypes of activities and views in California. Offered for sale for $1,500.]

V56 "Gossip." PHOTOGRAPHIC ART JOURNAL 5, no. 2 (Feb. 1853): 130. [Notice from the "Placer Times (Calif.) that Vance has recovered from the San Francisco fire.]

V57 "Gossip." PHOTOGRAPHIC ART JOURNAL 5, no. 3 (Mar. 1853): 190-191. [Excerpt from Sacramento (Calif.) paper praising Vance's work.]

V58 "Editorial Items." HUMPHREY'S JOURNAL 5, no. 2/3 (May 1-15, 1853): 41. [Announcement of forthcoming auction of 300 California views. Refers to advertisement [not bound in this issue]. Further note on p. 57 announces the postponement of the auction and names the artist.]

V59 "Note." PHOTOGRAPHIC ART JOURNAL 6, no. 1 (July 1853): 53. ["The celebrated California views of Mr. Vance are to be sold at auction on 20th of July at auction rooms of Bangs, Brothers & Co., N.Y."]

V60 "Editorials." HUMPHREY'S JOURNAL 5, no. 7 (July 15, 1853): 105. [J. H. Fitzgibbon (St. Louis, MO) has purchased all 300 of Vance's California views.]

V61 "Gossip." PHOTOGRAPHIC ART JOURNAL 6, no. 2 (Aug. 1853): 129. ["Fitzgibbon, of St. Louis, has become the purchaser of Vance's superb collection of California views."]

V62 "View down Sacramento St., San Francisco, Showing the Excitement in the Street. - From a Daguerreotype ny R. H. Vance." FRANK LESLIE'S ILLUSTRATED NEWSPAPER 2, no. 29 (June 28, 1856): 41. 1 illus. [This illustration one of several, the others from sketches, in an article about a vigilante riot and lynching.]

V63 "View of Fort Vigilance, San Francisco, Cal. - From an Ambrotype by Vance." FRANK LESLIE'S ILLUSTRATED NEWSPAPER 2, no. 35 (Aug. 9, 1856): 137. 1 illus. [View of buildings.]

V64 "Scenes in the Last Grand Parade and Review of the Vigilance Committee, San Francisco. - From Daguerreotypes by Vance. " FRANK LESLIE'S ILLUSTRATED NEWSPAPER 2, no. 43 (Oct. 4, 1856): 264-265. 2 illus. [Street scenes, with crowd.]

V65 "Abduction of Mr. Vance - Extraordinary Outrage." SAN FRANCISCO ALTA (Sept. 16, 1857): 1, col. 3. [Bizarre story. Vance owned some land and was having a dispute with some settlers over the property. A gang of men, disguised and wielding guns, broke into his gallery at night after Vance had gone to bed and kidnapped him - with dramatic scuffles, shots, escapes, and the like. His assistant roused the community and chased after the band, which got away. However Vance later escaped from his captors, wrapped his nightshirt (his only garment) around his feet, and, naked, walked back to town. "Of

further particulars we are not advised. The whole affair is a most extraordinary one."]

V66 "A New Feature in Photography." PHOTOGRAPHIC AND FINE ART JOURNAL 11, no. 5 (May 1858): 160. [Vance, with a gallery in San Francisco, opens another gallery in Sacramento.]

V67 "Personal and Art Intelligence." PHOTOGRAPHIC AND FINE ART JOURNAL 12, no. 1 (June 1859): 32. [From "San Francisco [CA] Daily Times." Description of New Gallery.]

V68 "Vance's Daguerrian Gallery." DAILY SCIENTIFIC PRESS 1, no. 18 (Sept. 7, 1860): 130. 1 illus. [Woodcut view of the exterior of the Vance gallery. Brief description of the interior.]

V69 "Brevities." DAILY ALTA CALIFORNIA (July 17, 1876): 1, col. 2. ["R. H. Vance, formerly a photographer here, died in New York recently."]

V70 "Gold Rush Photographer." IMAGE 1, no. 9 (Dec. 1952): 3. 1 b & w. Duncan, R. Bruce. "Gold Rush Photographer." THE GRAPHIC ANTIQUARIAN 2, no. 2 (Winter 1971): 14-19.

V71 Palmquist, Peter E. "Robert H. Vance: First Photographer of California Indians?" JOURNAL OF CALIFORNIA ANTHROPOLOGY 5, no. 1 (Summer 1978): 113-114. 1 b & w. [Illustration is a portrait of Vance, who listed several portraits of Indians in his "Catalogue of Daguerreotype Panoramic Views in California," a sales catalog produced in 1851. These views, later sold to John Fitzgibbon, in St. Louis, subsequently disappeared.]

V72 Palmquist, Peter. "Chinese Custom." HISTORY OF PHOTOGRAPHY 3, no. 1 (Jan. 1979): 32. 1 illus. [Advertisement in Chinese-language newspaper published in San Francisco, CA, in July 1856.]

V73 Palmquist, Peter E. "Western Photographers, II: Robert Vance: Pioneer in Western Landscape Photography." AMERICAN WEST 18, no. 5 (Sept. - Oct. 1981): 22-27. 5 b & w. 3 illus. [Vance operated galleries in San Francisco, California, Nevada and Hong Kong.]

VANDERBIE, L. (PLATTEVILLE, WI)
V74 Vanderbie, L. "The South Light." AMERICAN JOURNAL OF PHOTOGRAPHY AND THE ALLIED ARTS & SCIENCES n. s. vol. 8, no. 6 (Sept. 15, 1865): 134-135.

VANDERWEYDE, HENRY. (GREAT BRITAIN)
[The family name of Henry, J. J., and P. H. was published at random as Van der Weyde, Vander Weyde, or Vanderweyde throughout their lifetimes.]

V75 "Vander Weyde's Process of 'Applying Tints to Photographs.'" PHILADELPHIA PHOTOGRAPHER 9, no. 101 (May 1872): 145.

V76 "Mezzotint Effects, or "Atmospheric Stipples." ANTHONY'S PHOTOGRAPHIC BULLETIN 3, no. 10 (Oct. 1872): 693-696. [From "London Photo. News."]

V77 "The Vanderweyde System of Lighting Studios." ANTHONY'S PHOTOGRAPHIC BULLETIN 6, no. 10 (Oct. 1875): 295-297. 3 illus. [From "Br J of Photo."]

V78 "The Van Der Weyde Studio." PHILADELPHIA PHOTOGRAPHER 12, no. 144 (Dec. 1875): 358. [Van Der Weyde studio in England.]

V79 Vanderweyde, Henry. "The Proper Judges of Art-Progress in Photography." BRITISH JOURNAL PHOTOGRAPHIC ALMANAC 1876 (1876): 108-109.

V80 "Photographing at Night." PHOTOGRAPHIC TIMES 7, no. 79 (July 1877): 147-148. [From "Manufacturer and Builder." Van der Weyde experimenting with magnesium, hydro-oxygen light, electric light, sulphur and other products.]

V81 "Photographic News." PHILADELPHIA PHOTOGRAPHER 15, no. 170 (Feb. 1878): 60. [From "Br. J. of Photo." Description of Mr. Van der Weyde's nocturnal photos, taken with an electric light.]

V82 "Portraits by the Electric Light." ANTHONY'S PHOTOGRAPHIC BULLETIN 9, no. 2 (Feb. 1878): 40-41. [From "London Photographic News."]

V83 "Our Illustration." ANTHONY'S PHOTOGRAPHIC BULLETIN 17, no. 17 (Sept. 11, 1886): 531, frontispiece. [Portrait of actress, Miss Mary Anderson. [From description p. 531, not bound into this copy].]

V84 Van de Weyde, H. "The Pictorial Modification of Photographic Perspective." PHOTOGRAPHIC TIMES 23, no. 610 (May 26, 1893): 272-275. [Read before the Society of Arts, London.]

V85 1 photo ("Theodore Roosevelt, as Asst. Sec. of the Navy") SCRIBNER'S MAGAZINE 66, no. 5 (Nov. 1919): 514.

VANDERWEYDE, JOHN J. (USA, URUGUAY)
V86 Vanderweyde, John J. "'Black your Boots and Take Your Picture for Sixpence.'" AMERICAN JOURNAL OF PHOTOGRAPHY AND THE ALLIED ARTS AND SCIENCES n. s. vol. 2, no. 13 (Dec. 1, 1859): 203-204. [Complaints on cheap business practices.]

V87 Vanderweyde, John J. "An Operator's Dilemma." AMERICAN JOURNAL OF PHOTOGRAPHY AND THE ALLIED ARTS AND SCIENCES n. s. vol. 2, no. 18 (Feb. 15, 1860): 274-275. [Commentary about fires.]

V88 Vanderweyde, John J. "Photography and the Drama." AMERICAN JOURNAL OF PHOTOGRAPHY AND THE ALLIED ARTS AND SCIENCES n. s. vol. 2, no. 21 (Apr. 1, 1860): 321-322.

V89 Vanderweyde, John J. "Photographic Artists." AMERICAN JOURNAL OF PHOTOGRAPHY AND THE ALLIED ARTS AND SCIENCES n. s. vol. 2, no. 22 (Apr. 15, 1860): 337-339.

V90 Vander Weyde, J. J. "A Few Words on Photographic Copying." AMERICAN JOURNAL OF PHOTOGRAPHY AND THE ALLIED ARTS & SCIENCES n. s. vol. 3, no. 2 (June 15, 1860): 17-18. [Vanderweyde gives the Root Gallery, Phila. as his address.]

V91 Vanderweyde, J. J., Montevideo, S. A. "A Voice from South America." PHILADELPHIA PHOTOGRAPHER 10, no. 116 (Aug. 1873): 237-238.

V92 J. J. V. W. "On the Silver Bath and other Topics." ANTHONY'S PHOTOGRAPHIC BULLETIN 7, no. 3 (Mar. 1876): 65-66. [J. J. V. W. from Montevideo, S. A. (Uruguay).]

V93 "Note." ANTHONY'S PHOTOGRAPHIC BULLETIN 7, no. 8 (Aug. 1876): 245. ["...welcoming back among us Mr. J. J. Vanderweyde, who is making a flying visit to the Centennial and comes via England. Mr. V. has for the last fifteen years been established in South America, and is unquestionably the leading photographer in his

part of the world, where his vast establishment is known under the name of Bate & Co."]

VANDERWEYDE, P. H. (NETHERLANDS, USA)

V94 Vanderweyde, P. H., M.D. "On the Method of Enlarging Photographic and Other Pictures." AMERICAN JOURNAL OF PHOTOGRAPHY AND THE ALLIED ARTS & SCIENCES n. s. vol. 1, no. 4-7 (July 15, - Sept 1, 1858): 49-51, 67-69, 89-93, 102-103. [Prehistory of cameras, enlarging, etc.]

V95 Vander Weyde, P. H., M.D. "On the Actinic Power of the Colors." HUMPHREY'S JOURNAL OF PHOTOGRAPHY, AND THE ALLIED ARTS AND SCIENCES 10, no. 8-9 (Aug. 15 - Sept. 1, 1858): 115-117, 138-139. 3 illus. [The series was to be continued, but apparently never was.]

V96 Vander Weyde, P. H., M.D. "History of the Camera." HUMPHREY'S JOURNAL OF PHOTOGRAPHY, AND THE ALLIED ARTS AND SCIENCES 10, no. 8 (Aug. 15, 1858): 118-120. 1 illus.

V97 Vanderweyde, P. C. [sic. H], M.D. "Electricity and Photography." AMERICAN JOURNAL OF PHOTOGRAPHY AND THE ALLIED ARTS & SCIENCES n. s. vol. 1, no. 10 (Oct. 15, 1858): 149-151.

V98 Van der Weyde, P. H., M.D. "Focusing Glass. - Stereoscopic Camera." HUMPHREY'S JOURNAL OF PHOTOGRAPHY, AND THE ALLIED ARTS AND SCIENCES 11, no. 3 (June 1, 1859): 35-36.

V99 "Van." "The Photographer as He Is and as He Should Be." AMERICAN JOURNAL OF PHOTOGRAPHY AND THE ALLIED ARTS & SCIENCES n. s. vol. 2, no. 15 (Jan. 1, 1860): 228-229.

V100 "Van." "Our Artists." AMERICAN JOURNAL OF PHOTOGRAPHY AND THE ALLIED ARTS & SCIENCES n. s. vol. 2, no. 15 (Jan 1, 1860): 236-237.

V101 "Van." "Advice to Beginners, or Photography Made Easy." AMERICAN JOURNAL OF PHOTOGRAPHY AND THE ALLIED ARTS & SCIENCES n. s. vol. 2, no. 17 (Feb. 1, 1860): 262-263.

V102 "Van." "Hard Cider Developer." AMERICAN JOURNAL OF PHOTOGRAPHY AND THE ALLIED ARTS & SCIENCES n. s. vol. 2, no. 18 (Feb. 15, 1860): 284. [Describes, in playful mood, his decision to develop an ambrotype in apple cider, steeped overnight with rusty nails. Success.]

V103 Vander Weyde, P. H., M.D. "Photography as a Detective." HUMPHREY'S JOURNAL OF PHOTOGRAPHY, AND THE ALLIED ARTS AND SCIENCES 16, no. 23 (Apr. 1, 1865): 367. [The author, the Professor of Industrial Science, Girard College, Philadelphia, PA, describes the physical conditions necessary for a dead person's eye to retain an image on the retina and concludes they make it impossible for the phenomena to occur.]

V104 Van der Weyde, P. H., M.D. "Colored Daguerreotypes by the reversed action of light." AMERICAN JOURNAL OF PHOTOGRAPHY, AND THE ALLIED ARTS AND SCIENCES n. s. vol. 9, no. 12 (June 1, 1867): 268-270. ["Twenty-eight years ago...I resided in Holland...I was soon one of the first amateur daguerreotypists of that part of the world,..." Van der Weyde then tells how he took a daguerreotype of a Gothic stone tower which was overexposed and which solarized (turning the sky blue). He later gold toned the daguerreotype which turned the tower grey (which was its natural color) - thus through a series of accidents he achieved a daguerreotype "in natural colors."]

V105 Van der Weyde, P. H., M.D. "Photography in Girard College, Philadelphia." HUMPHREY'S JOURNAL OF PHOTOGRAPHY, AND THE ALLIED ARTS AND SCIENCES 19, no. 18-21 (Jan. 15 - Mar. 1, 1868): 292-293, 307-309, 323-324. [Vanderweyde given the chair of Industrial Sciences at Girard College in 1864; taught photography. "The operations in this branch were very successful, pupils taking many good pictures...a kind of amusement to them, a relaxation between the hours of mental study; however, later it was supplied by base ball playing, when the photographic department was abandoned by want of pecuniary support, and the base ball mania penetrated and raged fearfully behind the walls of Girard College...." The article then becomes a detailed discussion of the way photography was treated at the college, internal bickering, etc. This article ended before being finished.]

V106 "New Contributor." HUMPHREY'S JOURNAL OF PHOTOGRAPHY, AND THE ALLIED ARTS AND SCIENCES 19, no. 19 (Feb. 1, 1868): 298. [P. H. Van der Weyde, late Professor of Industrial Science at Girard College, Philadelphia, and now of New York Dental College. Was written for "HJ" and for "Am. J. of Photo." Practiced photography since 1842. He taught his son who went to South America, practiced photography very successfully - making a hundred dollars a day.]

V107 Vander Weyde, Prof. "Practical Novelties in Photography." HUMPHREY'S JOURNAL OF PHOTOGRAPHY, AND THE ALLIED ARTS AND SCIENCES 19, no. 22 (Mar. 15, 1868): 339-340. [Cause of White Spots in Card Pictures. New Iron and Copper Developer. Honey in Collodion, etc.]

V108 Van der Weyde, P. H., M.D. "New Silver Compound for Printing, more Sensitive than Chloride." HUMPHREY'S JOURNAL OF PHOTOGRAPHY, AND THE ALLIED ARTS AND SCIENCES 19, no. 22 (Mar. 15, 1868): 340-341.

V109 Van der Weyde, Prof., M.D. "The Meniscus War." HUMPHREY'S JOURNAL OF PHOTOGRAPHY, AND THE ALLIED ARTS AND SCIENCES 19, no. 23 (Apr. 1, 1868): 353-356.

V110 Van der Weyde, Prof., M.D. "The Meniscus War." HUMPHREY'S JOURNAL OF PHOTOGRAPHY, AND THE ALLIED ARTS AND SCIENCES 20, no. 1 (May 1, 1868): 1-3.

V111 Van der Weyde, Prof., M.D. "On the Theory of Lenses." HUMPHREY'S JOURNAL OF PHOTOGRAPHY, AND THE ALLIED ARTS AND SCIENCES 20, no. 1 (May 1, 1868): 17-19, 33-35, 64-66, 97-98.

V112 Van der Weyde, Prof., M.D. "The Summer Campaign." HUMPHREY'S JOURNAL OF PHOTOGRAPHY, AND THE ALLIED ARTS AND SCIENCES 20, no. 2 (May 15, 1868): 20-21. [Planning for summer landscape sessions.]

VANDYKE & BROWN. (LIVERPOOL, ENGLAND)

V113 "A Handsome Studio." HUMPHREY'S JOURNAL OF PHOTOGRAPHY, AND THE ALLIED ARTS AND SCIENCES 20, no. 10 (Sept. 15, 1868): 152. [From "Liverpool Daily Courier." Description of new studio opened by Vandyke & Brown in Liverpool.]

V114 Portrait. Woodcut engraving credited "From a photograph by Vandyke & Brown." ILLUSTRATED LONDON NEWS 66, (1875) ["Lieut. Wm. H. May,"H.M.S. Alert." 66:1869 (June 5, 1875): 528.]

VANDYKE, A. (d. 1892) (GREAT BRITAIN) see VANDYKE & BROWN.

VANNERSON, JULIAN see also WHITEHURST, JESSE H.

VANNERSON, JULIAN. (1853-1864) (USA)

V115 Brainard, Charles H. "Biographical Sketches of U. S. Senators. No. 1." GLEASON'S PICTORIAL DRAWING-ROOM COMPANION 4, no. 6 (Feb. 5, 1853): 84, 88-89, 93. 18 illus. ["We commence this week a series of likenesses of the senators of the United States... All of these gentlemen have favored us with sittings, and our artist, Mr. J. Vannerson, at Whitehurst's Gallery, Washington, has been remarkably successful in the matter of likenesses." (p. 93.) Double-page spread of eighteen portraits engraved from Vannerson's daguerreotypes.]

V116 Brainard, Charles H. "Biographical Sketches of U. S. Senators. No. 2." GLEASON'S PICTORIAL DRAWING-ROOM COMPANION 4, no. 8 (Feb. 19, 1853): 116, 120-121, 125. 18 illus. ["Let the reader remember that the honorable gentlemen sat especially for these likenesses, and as the greatest care has been taken by the artists, they are very perfect in the resemblance."]

V117 Brainard, Charles H. "Biographical Sketches of U. S. Senators. No. 3." GLEASON'S PICTORIAL DRAWING-ROOM COMPANION 4, no. 10 (Mar. 5, 1853): 148, 152-153, 157. 18 illus. ["...the honorable gentlemen sat expressly for them to our artist, at Whitehurst's Gallery, Washington..."]

V118 "Putnam's Monthly Portraits: The Author of 'Swallow Beach' (Hon. John P. Kennedy)." PUTNAM'S MONTHLY 4, no. 21 (Sept. 1854): frontispiece. 1 illus. ["Daguerreotype by Vannerson." Engraved by H. B. Hall.]

V119 Weinstein, Robert. "Silent Witnesses." G. RAY HAWKINS GALLERY PHOTO BULLETIN 1, no. 4 (Apr. 1978): 1-8. 8 b & w. [Exhibition review: "Documents of a Heritage: Portraits of the North American Indians," G. Ray Hawkins Gallery, Los Angeles. Exhibition also includes Adam Clark Vroman and Edward Curtis.]

V120 Glenn, James R. "The 'Curious Gallery': The Indian Photographs of the McClees Studio in Washington, 1857-1858." HISTORY OF PHOTOGRAPHY 5, no. 3 (July 1981): 249-262. 13 b & w. [Either Julian Vannerson, the manager of James McClee's Portrait Studio in Washington, DC, or Samuel A. Cohner are the probable authors of the 1858 portraits of visiting American Indians.]

V121 "North Gallery: Julius [sic] Vannerson." G. RAY HAWKINS GALLERY PHOTO BULLETIN 3, no. 2 (May 1980): 7. [Exhibition review: "Julius Vannerson," G. Ray Hawkins Gallery, Los Angeles, CA.]

VANNERSON, JULIAN. [?]

V122 C. M. "Transatlantic Sketches. - Interview of Indians with the 'Great Father.'" ILLUSTRATED LONDON NEWS 32, no. 903 (Feb. 13, 1858): 156-158. 4 illus. [Meeting of delegations of the Ponca, Pawnee and Potowattamie Indians with U.S. President in the White House. Illustrated with two views of the meeting, from sketches, and two portraits of two warriors, from uncredited photographs.]

V123 "Indian Warriors." BALLOU'S PICTORIAL DRAWING-ROOM COMPANION [GLEASON'S] 15, no. 23 (Dec. 4, 1858): 364. 2 illus. [Portraits of Pawnee Indians Scalla-Na-Sharo (Only Chief) and Qu-U-Aek (Buffalo Bull), taken in Washington, DC. "...last winter with others of their tribe on business with the government." (J. Vannerson ?)]

VANWEIKE, ROLAND see CHUTE, R. J.

VARLEY BROTHERS. (CHELSEA, ENGLAND)

V124 Portrait. Woodcut engraving credited "From a photograph by Varley Brothers, Oakley St., Chelsea." ILLUSTRATED LONDON NEWS 63, (1873) ["Late Mr. Cornelius Varley." 63:1782 (Oct. 25, 1873): 389.]

VENNOR, G. W. (CHARLESTON, MA)

V125 "The Harvard Monument." HARPER'S WEEKLY 13, no. 644 (May 1, 1869): 284. 1 illus. ["Photographed by G. W. Vennor, Charleston, Massachusetts."]

VERDOT, P. (CHATEAUROUX, INDIA)

V126 Portrait. Woodcut engraving credited "From a photograph by P. Verdot." ILLUSTRATED LONDON NEWS 68, (1876) ["Late Madame Dudevant (George Sand)." 68:1926 (June 24, 1876): 613.]

VERITY, ALFRED.

V127 Verity, Alfred. "Development by the Fumes of Ammonia." AMERICAN JOURNAL OF PHOTOGRAPHY AND THE ALLIED ARTS & SCIENCES n. s. vol. 5, no. 16 (Feb. 15, 1863): 368-373. [Read to Manchester Photo. Soc.]

VERNEY, GEORGE H., CAPT. (GREAT BRITAIN)

V128 Verney, Capt. George H. "Useful Photographic Hints for Amateurs." BRITISH JOURNAL PHOTOGRAPHIC ALMANAC 1879 (1879): 99-100.

V129 Verney, Capt. George. "The Utilizing of Amateur's Negatives." BRITISH JOURNAL PHOTOGRAPHIC ALMANAC 1877 (1877): 66-67. ["...I have some fifty 10 x 12 plates,...embracing views of Claremont Palace, Melrose, Dryburgh, Roslin, Dunkeld, Holy Island, Netley Abbey, etc...."]

V130 Verney, Capt. George. "The Amateur as a Professional." BRITISH JOURNAL PHOTOGRAPHIC ALMANAC 1877 (1877): 146-148.

VERNIER, JR.

V131 Vernier, Jr. "Photography on Paper. - Quick Process." HUMPHREY'S JOURNAL OF PHOTOGRAPHY, AND THE ALLIED ARTS AND SCIENCES 11, no. 3 (June 1, 1859): 39-41. [From "La Lumière."]

VERVEGA, RICHARD.

V132 Vervega, Richard. "Pinholes and Fog - Cyanide of Potassium in the Bath." HUMPHREY'S JOURNAL OF PHOTOGRAPHY, AND THE ALLIED ARTS AND SCIENCES 20, no. 19 (Mar. 15, 1869): 303. [From "Br. J. of Photo. Almanac."]

VIANELLI BROTHERS. (ITALY)

V133 Portrait. Woodcut engraving credited "From a photograph by Vianelli." ILLUSTRATED LONDON NEWS 70, (1877) ["Marcus Stone, A.R.A." 70:1962 (Feb. 17, 1877): 157.]

V134 1 b & w (Margaret of Savoy, Queen of Italy) on p. 337. CENTURY MAGAZINE 23, no. 3 (Jan. 1882): 337. 1illus. ["From Photograph from Life, by Fratelli Vianelli, Venice."]

VICK, W. (IPSWICH, ENGLAND)

V135 Portrait. Woodcut engraving credited "From a photograph by W. Vick." ILLUSTRATED LONDON NEWS 67, (1875) ["Late Mr. J. P. Cobbold, M.P." 67:1900 (Dec. 25, 1875): 629.]

VICKERS, H. T.

V136 Vickers, H. T., B.A. "On Instantaneous Photography." HUMPHREY'S JOURNAL OF PHOTOGRAPHY, AND THE ALLIED ARTS AND SCIENCES 11, no. 14 (Nov. 15, 1859): 220-222. [From "London Photo. J."]

VIDAL, LEON. (1833-1906) (FRANCE)

[Born in Marseille. Writer and journalist. Experimented with carbon printing processes and chromolithography in Marseille during the 1860s. Founded a photographic society there in 1863. From 1870 to 1906 he published and edited the *Moniteur de la Photographie*. In 1875 he moved to Paris, where, in 1877, he invented a process for photographing in natural colors. Through 1880s to his death, on August 5, 1906, he continued to produce innovations in techniques and processes, be active as an author and publisher, and member of societies and organizations.]

V137 Vidal, Leon. "On the Negative Image and the Relative Effects Produced." BRITISH JOURNAL PHOTOGRAPHIC ALMANAC 1878 (1878): 157-158.

V138 Vidal, Leon. "What Advantage Is to Be Derived from Heliochromic Proofs, Such as Those of M. Ducos du Hauron?" BRITISH JOURNAL PHOTOGRAPHIC ALMANAC 1879 (1879): 73-74.

V139 Vidal, Leon. "Congress of the Provincial Learned Societies at the Sorbonne." ANTHONY'S PHOTOGRAPHIC BULLETIN 10, no. 6 (June 1879): 178-180. [From "London Photographic News." Vidal reports on his new phototype process.]

V140 "Production of Phototype Plates for the Printing-press." ANTHONY'S PHOTOGRAPHIC BULLETIN 10, no. 11 (Nov. 1879): 343. [From "Moniteur de la Photographie." Describes Leon Vidal's process.]

V141 Vidal, Leon. "Retouching and Varnishing of the 'Lichtdruck.'" PHOTOGRAPHIC TIMES 10, no. 110 (Feb. 1880): 29-31. [From Leon Vidal's "Traite Pratique de Phototypie."]

V142 Vidal, Leon. "French Correspondence." PHILADELPHIA PHOTOGRAPHER 17, no. 196 (Apr. 1880): 154-158. [Report on Apr. 2 meeting of French Photographic Society. Argument if photography is an art debated. Guillaume, a sculptor and director of the School of F. A., etc. says yes; but much opposition. Adam-Solomon mentioned.]

V143 Vidal, Leon. "French Correspondence." PHOTOGRAPHIC TIMES 15, no. 199 (July 10, 1885): 379-380. [From "Photographic News."]

V144 Vidal, Leon. "Practical Notes on the Use of the Detective Camera." PHOTOGRAPHIC TIMES 15, no. 217 (Nov. 13, 1885): 640-641. [From "Bulletin de l'Association Belge."]

V145 Vidal, Leon. "Photozincography for Line Work." PHOTOGRAPHIC TIMES 17, no. 297 (May 27, 1887): 282. [From "Moniteur de la Photographie."]

V146 Vidal, Leon. "Polychromatic Lantern Slides from Uncolored Photographs." PHOTOGRAPHIC TIMES 22, no. 583 (Nov. 18, 1892): 590-591. [Actually a survey of experiments in this area, from Vidal's point of view. Vidal is claiming priority in certain of these experiments. From "Photographic News."]

V147 Vidal, Leon. "The Question of Color Photography Again and Forever." PHOTOGRAPHIC TIMES 23, no. 590 (Jan. 6, 1893): 6-7.

V148 Vidal, Leon. "Present and Future Possibilities of Photography." PHOTOGRAPHIC TIMES 23, no. 638 (Dec. 8, 1893): 708-711. [Read at the World Congress of Photographers.]

V149 "Obituary of the Year: Leon Vidal (Aug. 5, 1906)." BRITISH JOURNAL PHOTOGRAPHIC ALMANAC 1907 (1907): 626. [Vidal's parents were proprietors of the saltworks at Port de Bouc, near Marseilles. Educated as an engineer at the Lycee, St. Louis, and at the Sorbonne. Met Poitevin, edited his works. Edited "Moniteur de la Photographie" from 1879 on. Many experiments in photomechanical reproduction processes, and later color processes. Chevalier of the Legion of Honor, Officer of Public Instruction, Professor at the Schools of Decorative ARts at Paris and Limoges. Active in societies, etc.]

VIENNOT, LEON. (WV)

V150 Viennot, Leon. "The New Toning Bath." HUMPHREY'S JOURNAL OF PHOTOGRAPHY, AND THE ALLIED ARTS AND SCIENCES 19, no. 8 (Aug. 15, 1867): 122.

VILES, EDWARD. (d. 1892) (GREAT BRITAIN)

V151 Viles, Edward. "White Marble Cylinders for the Lime Light." BRITISH JOURNAL PHOTOGRAPHIC ALMANAC 1875 (1875): 116

V152 Viles, Edward. "Away-From-Home Photography." ANTHONY'S PHOTOGRAPHIC BULLETIN 6, no. 1 (Jan. 1875): 9-12. [From "London Photo. News."]

V153 Viles, Edward. "Photographing Dark Interiors." BRITISH JOURNAL PHOTOGRAPHIC ALMANAC 1876 (1876): 91-94.

V154 Viles, Edward. "The Solar Microscope: Its Value and Its Inconveniences." BRITISH JOURNAL PHOTOGRAPHIC ALMANAC 1878 (1878): 124-129. 1 illus.

VILLAALBA, RICARDO & CO. (TACANA, PERU)

V155 "View of the Ruins of the City of Arica, Peru, Three Days after the Earthquake. - From a Photograph by Ricardo Villalba & Co., Tacana, Peru." FRANK LESLIE'S ILLUSTRATED NEWSPAPER 27, no. 684 (Nov. 7, 1868): 121. 1 illus. [View.]

V156 "Earthquake in South America - The U. S. Steamer Waterbee, Peruvian War Steamer America, and British Bark Charvasilla, Stranded on the Coast, Near Arica, Peru. - From a Photograph by R. Villalba & Co." FRANK LESLIE'S ILLUSTRATED NEWSPAPER 27, no. 686 (Nov. 21, 1868): 156. 1 illus. [View of stranded ships, with figures.]

VILLAALBA, RICARDO & CO. [?]

V157 "The Cathedral of Arequipa, a City Destroyed by the Earthquake in Peru." ILLUSTRATED LONDON NEWS 53, no. 1505/1506 (Oct. 10, 1868): 333, 352. 1 illus. ["...from a photograph..." (V. Richardson, E. G. Squire, and R. Villaalba all in the area and all photographing during this time.)]

V158 "The late Earthquake in South America." ILLUSTRATED LONDON NEWS 53, no. 1508 (Oct. 24, 1868): 396-397, 405. 4 illus. ["Several Illustrations of the scenes of destruction in the towns of Arequipa and Africa are engraved from photographs taken soon after the disaster..." (V. Richardson, E. G. Squire, and R. Villaalba all in the area and all photographing during this time.)]

V159 "The Earthquake in South America - The Plaza Mayor of Arequipa - The Encampment of the Inhabitants Amid the Ruins."

FRANK LESLIE'S ILLUSTRATED NEWSPAPER 27, no. 687 (Nov. 28, 1868): 172. 1 illus. [View. "...our picture is from a photograph taken very soon after the occurrence of the calamity..." (V. Richardson, E. G. Squire, and R. Villaalba all in this area and all photographing during this time.)]

VIVIAN, COMLEY.
V160 Portrait. Woodcut engraving credited "From a photograph by Comley Vivian." ILLUSTRATED LONDON NEWS 75, (1879) ["Sheriff Woolloton, London." 75:2109 (Nov. 15, 1879): 449.]

VOGEL, HERMANN WILHELM. (1834-1898) (GERMANY)
BOOKS
V161 Vogel, Dr. Hermann. *Handbook of the Practice and Art of Photography...* Revised and Corrected by the Author, and Especially Adapted for the United States. Translated from the German by Edward Moelling. Philadelphia: Benerman & Wilson, 1871. 332 pp. 125 illus. [Includes the chapter "The Art of Photography or Photographic Aesthetics" on pp. 232-314.]

V162 Vogel, Dr. Hermann. *The Chemistry of Light and Photography in their Application to Art, Science, and Industry.* "International Scientific Series, vol. XV." London: H. S. King, 1875. 288 pp. 6 l. of plates. 94 illus. [4th ed. (1884) London: Kegan, Paul & Co.]

PERIODICALS
V163 Vogel. "Preparation of Iodide of Cadmium." HUMPHREY'S JOURNAL OF PHOTOGRAPHY, AND THE ALLIED ARTS AND SCIENCES 16, no. 1 (May 1, 1864): 12. [From "Polytechnisches Centralblatt."]

V164 Vogel, H. "Influence of Iodide of Silver on the Silver Bath." AMERICAN JOURNAL OF PHOTOGRAPHY AND THE ALLIED ARTS & SCIENCES n. s. vol. 7, no. 8 (Oct. 15, 1864): 172-173. [From "Photo. Notes."]

V165 Vogel, Hermann, Dr. "Photolithography." HUMPHREY'S JOURNAL OF PHOTOGRAPHY, AND THE ALLIED ARTS AND SCIENCES 16, no. 12 (Oct. 15, 1864): 185-187.

V166 Vogel, Herman, Dr. "New Photographic Chemical Experiments." AMERICAN JOURNAL OF PHOTOGRAPHY AND THE ALLIED ARTS & SCIENCES n. s. vol. 7, no. 23 (June 1, 1865): 542-547. [From "Photo. News."]

V167 Seely, Charles A. "Vogel's Experiments. Great Improvements in our Art to be Expected." AMERICAN JOURNAL OF PHOTOGRAPHY AND THE ALLIED ARTS & SCIENCES n. s. vol. 7, no. 23 (June 1, 1865): 547-549.

V168 Vogel, Hermann. "On Gelatino-Iron Developers." HUMPHREY'S JOURNAL OF PHOTOGRAPHY, AND THE ALLIED ARTS AND SCIENCES 17, no. 21 (Mar. 1, 1866): 334-335.

V169 Vogel, H., Dr. "Experiments with the Pantoscope Lens." HUMPHREY'S JOURNAL OF PHOTOGRAPHY, AND THE ALLIED ARTS AND SCIENCES 18, no. 2 (May 15, 1866): 27-28. [From "Photographische Mittheilungen."]

V170 Vogel, Dr. H. "On the Neutralization of the Acid Silver Bath with Carbon of Lime or Chalk." HUMPHREY'S JOURNAL OF PHOTOGRAPHY, AND THE ALLIED ARTS AND SCIENCES 18, no. 3 (June 1, 1866): 46-47. [From "Photo. News."]

V171 Vogel, Dr. H. "Photographic Novelties in Germany - Photography and War. Berlin September 29, 1866." PHILADELPHIA PHOTOGRAPHER 3, no. 35 (Nov. 1866): 345.

V172 Vogel, Dr. H. "Paris Correspondence." PHILADELPHIA PHOTOGRAPHER 4, no. 41 (May 1867): 152-153. [Vogel to be judge of Paris International Exhibition.]

V173 Vogel, Dr. H. "German Correspondence." PHILADELPHIA PHOTOGRAPHER 4, no. 45-48 (Sept. - Dec. 1867): 296-299, 327-329, 360-363, 391-393.

V174 Vogel, Dr. H. "German Correspondence." PHILADELPHIA PHOTOGRAPHER 5, no. 55-56 (July - Aug. 1868): 239-240, 267-269.

V175 Vogel, H. Dr. "The Photographic Expedition to Aden, Arabia, to Photograph the Solar Eclipse." PHILADELPHIA PHOTOGRAPHER 5, no. 58, 60 (Oct., Dec. 1868): 364-367, 434-438.

V176 Vogel, Hermann, Dr. "Photographing the Eclipse." HUMPHREY'S JOURNAL OF PHOTOGRAPHY, AND THE ALLIED ARTS AND SCIENCES 20, no. 13 (Nov. 1, 1868): 196-197.

V177 Vogel, Prof. H. "German Correspondence." PHILADELPHIA PHOTOGRAPHER. 6, no. 62 - 72 (Feb. - Dec. 1869): 45-47, 85-88, 157-160, 246-248, 302-304, 343-345, 375-377, 419-422.

V178 "Photographing the Great Eclipse of 1868, at Aden." FRANK LESLIE'S ILLUSTRATED NEWSPAPER 28, no. 706 (Apr. 10, 1869): 60-61. 7 illus. [Five views of the eclipse, two views of the North German Expedition at work, in Aden, Arabia. Report excerpted from Dr. Vogel's description of the expedition.]

V179 Vogel, Dr. H. "Photography and Truth." PHILADELPHIA PHOTOGRAPHER 6, no. 68 (Aug. 1869): 262-264.

V180 Vogel, Dr. H. "German Correspondence." PHILADELPHIA PHOTOGRAPHER 7, no. 73-84 (Jan. - Dec. 1870): 22-24, 48-51, 83-85, 129-132, 163-164, 253-256, 369-371, 418-420. [(Feb.) On the influence of distance in portraiture illus. (Apr.) Effect of distance and wide angle in landscape and portrait photography, genre pictures. No column in the June issue, due to Vogel's trip to U.S. for National Photography Association Meeting.]

V181 Vogel, Dr. H. "German Correspondence." PHILADELPHIA PHOTOGRAPHER 7, no. 76 (Apr. 1870): 129-132. [Effect of distance and wide angle in landscape and portrait photography, genre pictures.]

V182 "The Cleveland Convention." ANTHONY'S PHOTOGRAPHIC BULLETIN 1, no. 5 (June 1870): 76-78. [Includes the text of the speech given by Dr. Herman Vogel at the Photographic Convention at Cleveland in June 1870.]

V183 "Dr. Vogel." PHILADELPHIA PHOTOGRAPHER 7, no. 80 (Aug. 1870): 274-276.

V184 "Dr. Vogel's Farewell to America." PHILADELPHIA PHOTOGRAPHER 7, no. 81 (Sept. 1870): 322. [Description of Vogel's triumphant tour of the USA.]

V185 Vogel, Dr. "Photography in America." PHOTOGRAPHIC WORLD 1, no. 1 (Jan. 1871): 4-5. [State of the art report on photography in Philadelphia.]

V186 Vogel, Dr. H. "German Correspondence." PHILADELPHIA PHOTOGRAPHER 8, no. 85-95 (Jan. - Nov. 1871): 21-23, 51-54, 82-85, 110-112, 145-148, 242-243, 273-275, 306-310, 330-332, 362-364. [(Jan.) Dry plates on the German Polar Expedition - American pictures in Berlin- Eclipse Expedition. (Feb.) The Total Eclipse in Italy. (Mar.) Art and photography in Italy - Steinhall's new lens - Albert's lichtdruck - Bierstadt's pictures of the Yosemite Valley. (Apr.) Loescher and Petsch's stereos... The Victoria card, Medallion pictures. (May) Technical. (July) Technical. (Aug.) Technical, mentions use of magic lantern slides for educational purposes in the USA as opposed to Germany, where they were used in side shows. (Sept.) Technical - Photography and the war. (Oct.) Landscape photo. - cameo medallion pictures - the photographer to his patrons. (Nov.) Technical.]

V187 Vogel, Dr. H. "The Total Eclipse in Italy." PHILADELPHIA PHOTOGRAPHER 8, no. 86 (Feb. 1871): 51-54.

V188 Vogel, Dr. H. "A Very Simple Dark Tent." ANTHONY'S PHOTOGRAPHIC BULLETIN 3, no. 3 (Mar. 1872): 477-479. 2 illus. illus. [From "London Photo. News," again from "Photographisches Mittielungen." Vogel describes his portable developing apparatus, which he used during his "recent journey through the Carpathians." He credits Kilburn, of Littleton, NH with the initial idea. The "APB" editor appends a note that "Capt. A. J. Russell, during the late war, and also while in the employ of the Union Pacific R.R., constructed and used a box very similar...his was, probably, the first..."]

V189 Vogel, H. "Fourth Annual Meeting and Exhibition of the N. P. A. in St. Louis, Mo., May 1872: Progress in Germany." PHILADELPHIA PHOTOGRAPHER 9, no. 102 (June 1872): 174-175.

V190 Vogel, H. "German Correspondence." PHILADELPHIA PHOTOGRAPHER 9, no. 106 (Oct. 1872): 361-363. [Report of a photo-excursion by Vogel into the Carpathian Mountains.]

V191 Vogel, Dr. H. "German Correspondence." PHILADELPHIA PHOTOGRAPHER 10, no. 109-114 (Jan. - June 1873): 24-26, 58-60, 93-95, 124-125, 154-155, 172-175. [(Jan.) Review of Anderson's "Skylight & Darkroom" - Vienna exhibition Bldg. - Congress of German photographers, etc. (Feb.) Photography of the past year and of the future - cry for a new style - Mr. Petsch resigns photography - what photography has accomplished and its limits. (Mar.) Technical. (Apr.) The Vienna exhibition. (May) Technical. (June) Gossip - Panoramic views, etc.

V192 "Our Picture." PHILADELPHIA PHOTOGRAPHER 10, no. 109 (Jan. 1873): frontispiece, 28-31. 1 illus. [Biographical statement, plus a portrait of Vogel. Vogel born on March 26, 1834, in Dobrilitsch, Germany, near Berlin. Father was a grocer and Hermann was apprenticed to this trade. At age twenty he was permitted to enter a college, where he excelled and won a scholarship to the Berlin Polytechnic Institute. Specialized in chemistry and by 1861 was publishing papers on the topic. In 1862 he learned photography from Loescher of the Berlin photographic firm of Loescher & Petsch. Goettingen University awarded him a doctorate in 1863. One of the founding members of a Berlin photographic society and editor of it's journal, the "Photographisches Mittheilungen." Active experimenter, writer from that date. Contributed almost monthly to the "Philadelphia Photographer" from 1865 on. Member of the jury of the Paris Exposition in 1868. Accompanied the solar eclipse expedition to Aden in 1868, where he became ill in Egypt with a debilitating disease that impaired his health thereafter. Accompanied another eclipse expedition to Sicily ca. 1870. Wrote "A Handbook to Photography."

Visited extensively in the USA several times, attending N. P. A. conferences and exhibitions, etc.]

V193 Vogel. "Photography in Berlin." PHOTOGRAPHIC TIMES 4, no. 45 (Sept. 1874): 142-143. [Excerpts from Vogel's "Photographische Mittielungen".]

V194 Vogel, Dr. Herman. "German Correspondence - Landscape Photography." PHILADELPHIA PHOTOGRAPHER 11, no. 130 (Oct. 1874): 308-311. [Vogel compares and contrasts German and English landscapists.]

V195 Vogel, Prof. H. "Photography Abroad: Landscape Photography." PHOTOGRAPHIC TIMES 5, no. 49 (Jan. 1875): 15. [From "Photographische Notizen." Discusses his technique of travelling and photographing with glass plates. Worked in the Carpathian Mountains two or three years ago.]

V196 Vogel, Prof. H. "Photography Abroad: Several New Experiences in the Negative Process." PHOTOGRAPHIC TIMES 5, no. 50 (Feb. 1875): 32-34. [From "Photographische Notizen."]

V197 Vogel, Dr. H. "Letter from Dr. Vogel." PHILADELPHIA PHOTOGRAPHER 12, no. 137 (May 1875): 129-132. [Vogel journeyed through Egypt to join the English Eclipse Expedition in India. Describing his trip.]

V198 Vogel, H. "The English Eclipse Expedition." PHILADELPHIA PHOTOGRAPHER 12, no. 139 (July 1875): 195-198. [Fever, other problems, caused the expedition to fail in its attempt to photograph the eclipse in India at Camorta, an island north of Sumatra.]

V199 "Dr. Hermann Vogel." ANTHONY'S PHOTOGRAPHIC BULLETIN 7, no. 8 (Aug. 1876): 244-245. [From "Daily Morning Call" (San Francisco). Report of Vogel's reception in San Francisco.]

V200 "Dr. Vogel in San Francisco." PHILADELPHIA PHOTOGRAPHER 13, no. 153 (Sept. 1876): 264-266. [Abstracts of Vogel's lecture at the Academy of Science on pp. 265-266.]

V201 Vogel, H. "German Correspondence." PHILADELPHIA PHOTOGRAPHER 16, no. 185 (May 1879): 140-143. [Commentary on Muybridge's instantaneous pictures on p. 141.]

V202 Vogel, Dr. H. "German Correspondence: English Photography." PHILADELPHIA PHOTOGRAPHER 17, no. 202 (Oct. 1880): 311-313. [Mentions Mayland, Robinson, Van der Weyde.]

V203 Vogel, Dr. "Sunlight in Landscapes." PHOTOGRAPHIC TIMES 15, no. 209 (Sept. 18, 1885): 536-537. [From "Photographische Notizen."]

V204 Vogel, H. W. "Photography in Germany." PHOTOGRAPHIC TIMES 16, no. 233 (Mar. 5, 1886): 133-135.

V205 Vogel, H. W. "Photography in Germany." PHOTOGRAPHIC TIMES 16, no. 236 (Mar. 26, 1886): 167-169. [Describes series of studies of portraits with varying lighting, etc. —conducted by Loescher & Petsch, Berlin a few year ago.]

V206 Vogel, Dr. H. W. "Letter from Germany." ANTHONY'S PHOTOGRAPHIC BULLETIN 17, no. 10-23 (May 22 - Dec. 11, 1886): 299-302, 388-391, 453-456, 458-550, 645-648, 708-711. [(Aug. 14) Discusses, among other issues, amateurs and the

photographic bicycle, landscape photography, Obernetter's photogravures and Loescher's portraits.]

V207 Vogel, Dr. H. W. "Letter from Germany." ANTHONY'S PHOTOGRAPHIC BULLETIN 18, no. 1-24 (Jan. 8 - Dec. 24, 1887): 4-6, 69-71, 133-135, 197-199, 261-264, 326-329, 387-390, 453-456, 612-616, 677-679, 740-743. [(Oct. 22) The Russian Solar Eclipse. 1 b & w.]

V208 Vogel, Dr. H. W. "Letter from Germany." ANTHONY'S PHOTOGRAPHIC BULLETIN 19, no. 2-24 (Jan. 28 - Dec. 22, 1888): 36-38, 99-102, 166-169, 260-263, 324-326, 422-425, 485-487, 547-550, 582-585, 645-647, 740-743.

V209 Vogel, Dr. H. W. "Letter from Germany." ANTHONY'S PHOTOGRAPHIC BULLETIN 20, no. 2-24 (Jan. 26 - Dec. 28, 1889): 37-39, 101-103, 166-169, 229-233, 259-262, 356-358, 420-424, 484-487, 551-554, 740-743.

V210 "Our Illustration." ANTHONY'S PHOTOGRAPHIC BULLETIN 20, no. 7 (Apr. 13, 1889): frontispiece, 217. 1 b & w. [Photo not bound in this copy.]

V211 "Obituary." PHOTOGRAPHIC JOURNAL 23, no. 5 (Jan. 1899): 113-114. [Obituary, with a detailed bibliography of published writings.]

V212 "Notes and News: Dr. H. W. Vogel." PHOTOGRAPHIC TIMES 31, no. 2 (Feb. l899): 104. [Obituary, taken from the "Br J of Photo."]

V213 "Obituary of the Year: Dr. H. W. Vogel (Dec. 19, 1898)." BRITISH JOURNAL PHOTOGRAPHIC ALMANAC 1900 (1900): 641. [Studied chemistry, physics and mineralogy under Prof. Rammelsberg and Done in 1850s. Took up photography. Founded the Photographische Verein in Berlin in 1863 and the Verein zur Forderung der Photographie in 1869 of which he was the President until his death. 1864 began "Photographische Mittheilungen" and served as editor. Helped found the Imperial Technical High School of Photography at Berlin. Many other activities and honors.]

VOIGHTLANDER, FREDERICK WILLIAM VON see also PRETSCH, PAUL.

VOIGTLANDER, FREDERICK WILLIAM VON, BARON. (1812-1878) (AUSTRIA)
V214 "A Monster Portrait Lens." HUMPHREY'S JOURNAL 9, no. 13 (Nov. 1, 1857): 208. [Voightlander manufacturing a 5" aperture lens, to cover 15" x 12" plates.]

V215 "The Ten Thousandth Voightlander Camera." AMERICAN JOURNAL OF PHOTOGRAPHY AND THE ALLIED ARTS & SCIENCES n. s. vol. 4, no. 24 (May 15, 1862): 556.

V216 E. X. "Frederick William von Voightlander." BRITISH JOURNAL OF PHOTOGRAPHY 12, no. 294 (Dec. 22, 1865): 648-649.

V217 "Frederick William von Voightlander." AMERICAN JOURNAL OF PHOTOGRAPHY AND THE ALLIED ARTS & SCIENCES n. s. vol. 8, no. 16 (Feb. 15, 1866): 369-374. [From "Photographische Correspondez." Extended, for the day, biography.]

V218 F. X. M. "Frederick William von Voightlander." HUMPHREY'S JOURNAL OF PHOTOGRAPHY, AND THE ALLIED ARTS AND SCIENCES 17, no. 20 (Feb. 15, 1866): 311-315. [From

"Photographische Correspondenz." Through biography, history of the camera manufacturer.]

V219 "Frederick William von Voigtlander." PHILADELPHIA PHOTOGRAPHER 3, no. 29 (May 1866): 151-152. [F. Voightlander born in Vienna in 1812. Learned lensmaking from his father and studied at the Imperial Polytechnic Institution. Travelled in Europe, then joined the family business in 1835. Met Prof. Petzval in 1840, with him constructed the first combination portrait lens for the camera. By 1866 the Voightlander company had manufactured 18,000 lenses. Also made opera and field glasses.]

V220 "Baron Frederick von Voightlander - Biographical Sketch." PHILADELPHIA PHOTOGRAPHER 11, no. 130 (Oct. 1874): 4 page sketch and etched portrait following page 320. [Born in Vienna in 1812.]

VON HERFORD, WILHELM see HERFORD, WILHELM VON.

VON SCHNEIDAU, JOHN F. see SCHNEIDAU, JOHN F. VON.

VON SEUTER, E. see SEUTER, E. VON.

VON SOTHEN, SGT. see SOTHEN, SGT.

VON STEINHEIL, CARL A. see STEINHEIL, CARL A. VON.

VOX see HALLENBACK, JOHN H.

VOYLE, JOSEPH. (TUSCALOOSA, AL)
V221 Voyle, Joseph. "Salad for the Photographer." PHILADELPHIA PHOTOGRAPHER 4, no. 38 (Feb. 1867): 59. [Letter from Jos. Voyle (Tuscaloosa, AL).]

V222 "Editor's Table." PHILADELPHIA PHOTOGRAPHER 6, no. 65 (May 1869): 169. [Prints noted.]

VOYTOT.
V223 Voytot. "Glass Operating Rooms." AMERICAN JOURNAL OF PHOTOGRAPHY AND THE ALLIED ARTS & SCIENCES n. s.

W

A. J. W.
W1 A. J. W. "Changes in Photographic Fashions." BRITISH JOURNAL PHOTOGRAPHIC ALMANAC 1874 (1874): 84-86.

A. W. W.
W2 A. W. W. "Photography in the Parlor." AMERICAN JOURNAL OF PHOTOGRAPHY AND THE ALLIED ARTS AND SCIENCES n. s. vol. 2, no. 24 (May 15, 1860): 375-376. [Discusses the potential benefits of photography for amateurs.]

C. W.
W3 C. W. "The Charms of Photography." AMERICAN JOURNAL OF PHOTOGRAPHY AND THE ALLIED ARTS & SCIENCES n. s. vol. 4, no. 22 (Apr. 15, 1862): 524-525. [C. W. from New York, NY.]

J. S. W.
W4 J. S. W. "Art Hints for Photographers." HUMPHREY'S JOURNAL OF PHOTOGRAPHY, AND THE ALLIED ARTS AND SCIENCES 17, no. 8 (Aug. 15, 1865): 121-123. [From "Photo. News."]

N. R. W.
W5 N. R. W. "Expression." PHOTOGRAPHER'S FRIEND 2, no. 1 (Jan. 1872): 8-9.

S. A. W.
W6 "A Great Mystery. Is It the 'Spirits'? Eight Baths and Fourteen Collodions do not Exorcise Them!" AMERICAN JOURNAL OF PHOTOGRAPHY AND THE ALLIED ARTS & SCIENCES. n. s. vol. 6, no. 15 (Feb. 1, 1864): 347-348. [Problems with bath. "The writer of the above is a lady..."]

W. H. W.
W7 W. H. W. "Deeds of Photography." PHOTOGRAPHIC TIMES 7, no. 77 (May 1877): 106. [From "Br J of Photo." Discusses manifold uses of photography.]

WAGENTREIBER.
W8 "Effects of the Cyclone at Calcutta." ILLUSTRATED LONDON NEWS 45, no. 1289 (Nov. 26, 1864): 544. 2 illus. ["...engraved from the photographs taken on the spot by Mr. Wagentreiber."]

WAGNER, OTTO. (ca. 1854-1888) (GERMANY, USA)
W9 "Editorial Notes." PHOTOGRAPHIC TIMES 18, no. 343 (Apr. 13, 1888): 172. [Died Apr. 2, 1888 at age 54. Originally a lithographer, then took up photography in USA, made money, returned to Germany, then later came back to the USA.]

WAITE, S. H. (HARTFORD, CT)
W10 Portrait. Woodcut engraving, credited "From a Photograph by S. H. Waite, of Hartford." HARPER'S WEEKLY 10, (1866) ["Albert L. Starkweather, the matricide." 10:479 (Mar. 3, 1866): 129.]

WAITZ, R. (BOSTON, MA)
W11 "Voices from the Craft." PHILADELPHIA PHOTOGRAPHER 5, no. 56 (Aug. 1868): 273. [Letter from R. Waitz.]

WAKE, ARTHUR J.
W12 Wake, Arthur J. "On Posing." BRITISH JOURNAL PHOTOGRAPHIC ALMANAC 1872 (1872): 104-106. 2 illus.

WAKE, JOSEPH. (d. 1883) (GREAT BRITAIN)
W13 Wake, J. "The Retouching of Negatives." ANTHONY'S PHOTOGRAPHIC BULLETIN 4, no. 2 (Feb. 1873): 45-46. [A Communication from the Manchester Society. From the "Br J of Photo." Discusses the old photographer's prejudice to the practice of retouching.]

W14 Wake, Joseph. "The Art of Painting Upon the Photographic Image." PHOTOGRAPHIC TIMES 7, no. 82-84 (Oct. - Dec. 1877): 222-224, 252-255, 277-280. [From "Br J of Photo."]

WAKELY, GEORGE D.
W15 Wakely, Geo. D. "Toning and Fixing. - Stereoscopic Views." HUMPHREY'S JOURNAL OF PHOTOGRAPHY, AND THE ALLIED ARTS AND SCIENCES 14, no. 21 (Mar. 1, 1863): 287-288. [Implication that Wakely in from Canada.]

W16 Seely, Charles A. "Editorial Department." AMERICAN JOURNAL OF PHOTOGRAPHY AND THE ALLIED ARTS & SCIENCES n. s. vol. 7, no. 14 (Jan. 15, 1865): 336. ["Mr. G. D. Wakely, formerly of this city, has recently returned from the gold regions of Colorado, and has brought a fine collection of views....illustrative of gold mining,...also landscapes 'Twin Lakes' and 'Garden of the Gods.'"]

WALDACK, CHARLES. (BELGIUM, USA)
BOOKS
W17 Waldack, Charles and Peter Neff. *Treatise of Photography on Collodion; Embracing Full Directions for Compounding the Chemicals.* Cincinnati, OH: Moore, Wilstach, Keys & Co., 1857. 127 pp. [2nd ed. (1857) xi, 141 pp. [Includes on pp. 126-141, "Addenda from the first edition of the Melainotype manual."]

W18 Waldack, Charles. *Treatise on Photography.* Cincinnati, OH: Central Printing Office, 1860. 271 pp. ["An entirely new work, instead of a third edition."]

W19 Waldack, Charles. *The Card Photograph;* An Appendix to the Third Edition of a "Treatise on Photography." Cincinnati, OH: H. Watkin, 1862. 32 pp.

PERIODICALS
W20 Waldack, Chas. "Imperfections in the Collodion Film." AMERICAN JOURNAL OF PHOTOGRAPHY AND THE ALLIED ARTS & SCIENCES n. s. vol. 3, no. 4 (July 15, 1860): 55. [Read before Am. Photo. Soc.]

W21 Waldack, Charles. "Printing, Toning, Fixing, and Mounting." AMERICAN JOURNAL OF PHOTOGRAPHY AND THE ALLIED ARTS & SCIENCES n. s. vol. 5, no. 3 (Aug. 1, 1862): 59-63. [From Waldack's book, "The Card Photograph."]

W22 "Off for Europe." HUMPHREY'S JOURNAL OF PHOTOGRAPHY, AND THE ALLIED ARTS AND SCIENCES 14, no. 7 (Aug. 1, 1862): 64. [Ch. Waldack and John Carbutt visiting Europe, sailing on the "Great Eastern."]

W23 Waldack, Charles. "The Chloride of Calcium Box." HUMPHREY'S JOURNAL OF PHOTOGRAPHY, AND THE ALLIED ARTS AND SCIENCES 14, no. 13 (Nov. 1, 1862): 150-151.

W24 Waldack, Charles. "Iodo-Nitrate of Silver. - Pin-holes caused by it." and "What's in a Name?" HUMPHREY'S JOURNAL OF PHOTOGRAPHY, AND THE ALLIED ARTS AND SCIENCES 14, no. 14 (Nov. 15, 1862): 174-176. ["Waldack...is now in Belgium spending

a few months....His gallery in Cincinnati is still being carried on by an able practitioner of the art...."]

W25 Waldack, Charles. "Albumen Glass Process." HUMPHREY'S JOURNAL OF PHOTOGRAPHY, AND THE ALLIED ARTS AND SCIENCES 14, no. 20 (Feb. 15, 1863): 264-266. [Writing from Ghent, Belgium.]

W26 Waldack, Chas. "Pinholes in Negatives." HUMPHREY'S JOURNAL OF PHOTOGRAPHY, AND THE ALLIED ARTS AND SCIENCES 15, no. 1 (May 1, 1863): 5-7.

W27 Waldack, Chas. "Preparations employed in the Collodion Process for Positives." HUMPHREY'S JOURNAL OF PHOTOGRAPHY, AND THE ALLIED ARTS AND SCIENCES 15, no. 2 (May 15, 1863): 22-24.

W28 Seely, Charles A. "Editorial Department." AMERICAN JOURNAL OF PHOTOGRAPHY AND THE ALLIED ARTS & SCIENCES n. s. vol. 6, no. 5 (Sept. 1, 1863): 119. ["Our correspondent, Charles Waldack, just returned from Europe by the Great Eastern...seems well recuperated in health and hopes...It seems probable that he will make his permanent home in New York."]

W29 Waldack, Chas. "Rational Systems of Washing Prints." HUMPHREY'S JOURNAL OF PHOTOGRAPHY, AND THE ALLIED ARTS AND SCIENCES 15, no. 9 (Sept. 1, 1863): 138-140. [Note on p. 142 that Waldack returned from his visit to Europe.]

W30 Waldack, Charles. "Enlarged Positives on Canvas." HUMPHREY'S JOURNAL OF PHOTOGRAPHY, AND THE ALLIED ARTS AND SCIENCES 16, no. 3 (June 1, 1864): 37-39. [From "Bulletin Belge de la Photographie."]

W31 Waldack, Chas. "Enlarged Positives on Canvas." AMERICAN JOURNAL OF PHOTOGRAPHY AND THE ALLIED ARTS & SCIENCES n. s. vol. 7, no. 1 (July 1, 1864): 7-10. [From "Bulletin Belge."]

W32 Waldack, Charles. "Ammonia Fumes in Printing." AMERICAN JOURNAL OF PHOTOGRAPHY AND THE ALLIED ARTS & SCIENCES n. s. vol. 7, no. 20 (Apr. 15, 1865): 463-464.

W33 Waldack, Charles. "Ammonia Fumes in Printing." HUMPHREY'S JOURNAL OF PHOTOGRAPHY, AND THE ALLIED ARTS AND SCIENCES 17, no. 4 (June 15, 1865): 58-59. [From "Photo. News."]

W34 Waldack, Charles. "Photography in the Mammoth Cave by Magnesium Light." PHILADELPHIA PHOTOGRAPHER 3, no. 32 (Aug. 1866): 241-244.

W35 Waldack, Charles. "Photographing in the Mammoth Cave." PHILADELPHIA PHOTOGRAPHER 3, no. 36 (Dec. 1866): 359-363.

W36 Waldack. "Photography in the Mammoth Cave." BRITISH JOURNAL OF PHOTOGRAPHY 13, no. 344 (Dec. 7, 1866): 584-585. [Waldack (Cincinnati, OH) photographed the Mammoth Cave, KY with magnesium light. This is a letter by Waldack, forwarded to the "BJP" by Edward L. Wilson.]

W37 "Editor's Table." PHILADELPHIA PHOTOGRAPHER 5, no. 49 (Jan. 1868): 33. [Two 11" x 14" views of a suspension bridge.]

W38 Waldack, Charles. "On the Treatment of the Silver Printing Bath." BRITISH JOURNAL PHOTOGRAPHIC ALMANAC 1874 (1874): 127-128.

W39 Waldack, Charles. "Belgian Correspondence." PHILADELPHIA PHOTOGRAPHER 11, no. 132 (Dec. 1874): 375-378.

W40 Taylor, J. Triall. "Home and Foreign News." PHOTOGRAPHIC TIMES 11, no. 128 (Aug. 1881): 269. [Quotes letter from Waldack, visiting his birthplace in Ghent, Belgium. Mentions his friend, Monckhoven, "busy making emulsion plates." Describes how he and Monckhoven studied together in school, learned daguerreotypy, etc. Mentions the accident to the boat "Belgenland" (that apparently injured him on his trip over to Europe. Waldack worked in Cincinnati, OH.)]

WALERY. (PARIS, FRANCE)
W41 Portrait. Woodcut engraving, credited "From a Photograph by Walery." FRANK LESLIE'S ILLUSTRATED NEWSPAPER 48, (1879) ["M. Menier, of French Assembly." 48:1237 (June 14, 1879): 255.]

W42 Portrait. Woodcut engraving credited "From a photograph by Walery, Rue de Loudres, Paris." ILLUSTRATED LONDON NEWS 75, (1879) ["Late Mr. Lionel Lawson." 75:2105 (Oct. 18, 1879): 361.]

WALKER & WALKER. (LONDON, ENGLAND)
W43 Portrait. Woodcut engraving, credited "From a Photograph by Walker & Walker, London." FRANK LESLIE'S ILLUSTRATED NEWSPAPER 21, (1865) ["The Last of the Temples - the Late Lord Palmerson." 21:531 (Dec. 5, 1865): 164.]

WALKER, A. B. (IOWA CITY, IA)
W44 Portraits. Woodcut engravings, credited "Photographed by A. B. Walker, Iowa City." FRANK LESLIE'S ILLUSTRATED NEWSPAPER 12, (1861) ["Hon. Samuel J. Kirkwood, Gov. of IA." 12:307 (Oct. 5, 1861): 326.]

WALKER, CHARLES VINCENT. (1812-1882)
BOOKS
W45 Walker, Charles V. *Manipulations électrotypiques, ou traite de galvanoplasie* ...Tr. de l'anglais sur la 18e éd. "3. ed." Paris: Méquignon-Marvis, 1849. 153 pp. illus.

PERIODICALS
W46 Walker, Charles V. "Electrotype Manipulations." PHOTOGRAPHIC ART JOURNAL 2, no. 1, 3 (July, Sept. 1851): 52-59, 178-186. [Continued from Vol. 1, p. 376.]

WALKER, DAVID.
W47 Walker, David, M.D., F.R.G.S., F.L.S. "Days and Nights in Greenland." GOOD WORDS 3, no. 2 (Feb. 1862): 69-78. 4 illus. [Woodcuts of the terrain, eskimos, etc. "from a photograph by the Author."]

WALKER, DELTENRE. (BRUSSELS, BELGIUM)
W48 "Another Permanent Printing Process." AMERICAN JOURNAL OF PHOTOGRAPHY AND THE ALLIED ARTS & SCIENCES n. s. vol. 7, no. 17 (Mar. 1, 1865): 397-398. [From "Photo. News." Deltenre Walker, of Brussels.]

WALKER, E. S.
W49 "Military Execution at Camp Chase." HARPER'S WEEKLY 9, no. 456 (Sept. 23, 1865): 593. 2 illus. [Portraits of two murderers, subsequently hung.]

WALKER, JAMES.

W50 Walker, James. "Brilliant Prints in Winter." BRITISH JOURNAL PHOTOGRAPHIC ALMANAC 1876 (1876): 148-149.

WALKER, LEWIS E. (1826-) (USA)

W51 "L. E. Walker, Warsaw's Picture Man." HISTORICAL WYOMING (WYOMING COUNTY HISTORICAL SOCIETY, NY) (Oct. 1963): 11-14. 1 b & w. [Discusses the career of Lewis E. Walker, born in Warsaw, NY on May 15, 1826. Walker taught district schools in Vermont and Ohio. In 1854 he returned to Warsaw and went into the book and stationary business, which he ran for nearly fifty years, until at least 1901. He carried an extensive stock of stereoscopic cards during that time. He held the rights to make and sell photographs of Chatauqua for several years, and he issued many stereo views of the Watkins Glen, Gennessee Falls, and the Wyoming Valley, NY area. These were identified as "Published by L. E. Walker, Warsaw, NY." A note by Frank Salisbury, photographer in Warsaw from 1896 to 1918, published in vol. 17, p. 59, clarifies the situation. "Mr. Walker was not a 'picture' man in the sense of a photographer. He was associated with Mr. C. W. Buell, one of the best oldtime wet plate photographers of that period of picture taking. He was equally as good as Brady of Civil War fame. In connection with his stereoscopic work, Buell operated a studio in the rear of the third story of the Walker block where a north light furnished the necessary light for portrait taking." L. E. Walker died on Dec. 31, 1916, at age ninety-one.]

WALKER, LEWIS EMORY. (1825-1880) (USA)

W52 "Our Illustrations." PHOTOGRAPHIC AND FINE ART JOURNAL 10, no. 6 (June 1857): frontispiece, 185-186. 1 b & w. [Original photographic print, tipped-in. View of "Old Columbia College, from a negative by L. E. Walker." (Print not in this copy.)]

W53 "Our Illustrations." PHOTOGRAPHIC AND FINE ART JOURNAL 10, no. 8 (Aug. 1857): unnumbered page, 238-239. 1 b & w. [Original photographic print, tipped-in. View of the statue "Egeria," by J. H. Foley. Negative by L. E. Walker. (Print not in this copy.)]

W54 "Our Illustrations." PHOTOGRAPHIC AND FINE ART JOURNAL 10, no. 9 (Sept. 1857): unnumbered page, 281. 1 b & w. [Original photographic print, tipped-in. "View in Broadway, Looking North from the NY Hospital," negative by L. E. Walker, print by H. H. Snelling. (Print not in this copy.)]

W55 "Our Illustration." PHOTOGRAPHIC AND FINE ART JOURNAL 10, no. 10 (Oct. 1857): unnumbered page, 318. 1 b & w. [Original photographic print, tipped-in. A fancy portrait from life, "Margaret," negatives by L. E. Walker, prints by H. H. Snelling.]

W56 Walker, L. E. "Photography at the Capitol." PHILADELPHIA PHOTOGRAPHER 3, no. 30 (June 1866): 170-171. [Walker, Photographer to the Treasury Department. Description of the process involved in taking a photo of a mural in the dome of the Capitol Building.]

W57 "Government Photography." PHILADELPHIA PHOTOGRAPHER 3, no. 31 (July 1866): 214-215. [Report on the Federal government's use of photography. Army Medical Museum: William Bell. Treasury Department: L. E. Walker. Chief Examiner of Patent Office: Titian R. Peale (an amateur). Extensive library.]

W58 "Editor's Table." PHILADELPHIA PHOTOGRAPHER 3, no. 35 (Nov. 1866): 358. [Note that views of Washington, DC, by L. E. Walker and by William Bell received by the editor.]

W59 "Interior of the Dome of the Capitol at Washington." HARPER'S WEEKLY 10, no. 520 (Dec. 15, 1866): 785. 1 illus. ["Photographed by L. E. Walker."]

W60 "The Stable of the White House." HARPER'S WEEKLY 13, no. 642 (Apr. 17, 1869): 245. 1 illus. ["Photographed by L. E. Walker."]

W61 "The Young Men's Christian Association Building, Washington, D. C." HARPER'S WEEKLY 13, no. 645 (May 8, 1869): 301. 1 illus. ["Photographed by L. E. Walker, Washington."]

W62 "Washington, D. C. - Explosion of the Magazine in the Government Arsenal, July 22d. - From a Sketch by E. L. [sic L. E.] Walker, Photographic Artist." FRANK LESLIE'S ILLUSTRATED NEWSPAPER 32, no. 828 (Aug. 12, 1871): 361. 1 illu . [Sketch of explosion.]

W63 "Official Architecture.-Importance of the Photographic Branch." ANTHONY'S PHOTOGRAPHIC BULLETIN 7, no. 1 (Jan. 1876): 13-14. [From "NY Times." Walker in charge of the Supervising Architect's Office (Treasury Dept.) since June 1857. During the Civil War Walker made photographs of Engineer's maps.]

W64 "Obituary - Lewis E. Walker." PHILADELPHIA PHOTOGRAPHER 17, no. 204 (Dec. 1880): 366-367. [Lewis E. Walker was a native of Greenwich, Hampshire County, MA. Attracted to daguerreotypy as a young man and taught school for several years to raise the money to learn the process and buy equipment. Then worked as an itinerant, travelling widely around the country. In 1856, at age thirty-three, he took charge of the ambrotyping in Matthew Brady's New York gallery, worked there for a year, then moved to Frederick's Gallery. However, the position of Chief Photographer of the Treasury Department, in Washington, D. C. was offered him. Walker accepted this position and worked there for twenty-three years, until his death on Oct. 21, 1880, at age fifty-seven.]

W65 "Obituary; Died, October 21st, 1880. Aged Fifty-seven Years." PHOTOGRAPHIC TIMES 10, no. 120 (Dec. 1880): 271. [Walker, head photographer in the office of the Supervising Architect, Treasury Department, Washington, DC. In 1856 took charge of ambrotyping department at Brady's Gallery, New York, NY (At age 33). Then moved to Frederick's, then offered the position of govt. photographer. Obituary claims he was only 47 years old. Title claims 57.]

WALKER, LEWIS E. [?]

W66 United States. Treasury Department. *Annual Report of the Supervising Architecture of the Treasury Department for the Year 1869.* Washington, DC: Government Printing Office, 1869. 32 pp. 6 l. of plates. 6 b & w. [Photos of drawings of buildings owned by Govt.]

WALKER, SAMUEL A. (LONDON, ENGLAND)

W67 Portrait. Woodcut engraving credited "From a photograph by Samuel A. Walker." ILLUSTRATED LONDON NEWS 52, (1868) ["Lord Wensleydale." 52:* (Mar. 14, 1868): 265.]

W68 Portraits. Woodcut engravings credited "From a photograph by Samuel A. Walker." ILLUSTRATED LONDON NEWS 55, (1869) ["Right Rev. Dr. Wordsworth, Bishop of Lincoln." 55:* (Feb. 13, 1869): 161. "Earl Granville." 55:* (May 1, 1869): 436.]

W69 Portrait. Woodcut engraving credited "From a photograph by Samuel A. Walker." ILLUSTRATED LONDON NEWS 56, (1869) ["Right Rev. Henry Phillpots." 56:* (Sept. 25, 1869): 300.]

W70 Portrait. Woodcut engraving credited "From a photograph by Samuel A. Walker." ILLUSTRATED LONDON NEWS 57, (1870) ["Right Rev. Richard Dunford, D.D." 57:* (May 14, 1870): 505.]

W71 Portrait. Woodcut engraving credited "From a photograph by Samuel Walker, of Margaret St., Cavendish Square." ILLUSTRATED LONDON NEWS 58, (1870) ["Earl of Clarendon, K.G." 58:* (July 9, 1870): 41.]

W72 Portraits. Woodcut engravings credited "From a photograph by S. Walker, Margaret St., Cavendish Square." ILLUSTRATED LONDON NEWS 58, (1871) ["The late Sir John Herschel." 58:1652 (May 27, 1871): 513.]

W73 Portraits. Woodcut engraving, credited to "From a Photograph by Samuel Walker." ILLUSTRATED LONDON NEWS 60, (1872) ["Late Earl of Mayo." 60:1694 (Feb. 24, 1872): 185.]

W74 Portrait. Woodcut engraving credited "From a photograph by S. A. Walker." ILLUSTRATED LONDON NEWS 63, (1873) ["Late Lord Westbury." 63:1770 (Aug. 2, 1873): 105.]

W75 Portraits. Woodcut engravings credited "From a photograph by S. A. Walker, Margaret St., Cavadish Sq." ILLUSTRATED LONDON NEWS 72, (1878) ["Late Dutchess of Argyll." 72:2032 (June 8, 1878): 533. "Right Rev. W. D. MacLaglan, Bishop of Lichfield." 72:2035 (June 29, 1878): 613.]

W76 Portraits. Woodcut engravings credited "From a photograph by S. A. Walker." ILLUSTRATED LONDON NEWS 72, (1878) ["Late Dutchess of Argyll." 72:2032 (June 8, 1878): 533. "Right Rev. W. D. MacLaglan, Bishop of Lichfield." 72:2035 (June 29, 1878): 613.]

W77 Portrait. Woodcut engraving credited "From a photograph by S. A. Walker." ILLUSTRATED LONDON NEWS 74, (1879) ["Rev. Joseph B. Lightfoot, Bishop of Durham." 74:2072 (Mar. 1, 1879): 201.]

W78 1 engraving (William E. Gladstone). HARPER'S MONTHLY 64, no. 383 (Apr. 1882): 741. 1 illus. ["From a photograph taken by Samuel A. Walker, at his studio, 220 Regent St., London."]

WALKER, SAMUEL LEON. (1802-1874) (USA)
W79 "Neutral Tint." "Poughkeepsie, New York." BALLOU'S PICTORIAL DRAWING-ROOM COMPANION [GLEASON'S] 13, no. 323 (Aug. 29, 1857): 136-138. 6 illus. [The artist/author, "Neutral Tint," traveled around the country, presenting his work to "Ballou's Pictorial" in the form of chatty letters illustrated with detailed sketches of the houses and views of the town he was visiting. In this article, he depicts S. L. Walker's Daguerreotype Studio in a view of the main street of Poughkeepsie, mentions that Walker arranged for him to visit Samuel F. B. Morse, and states, "At the hotel I met Mr. Walker, who brought me the daguerreotypes from which most of my views are drawn..." The article also includes some anecdotes about Morse. It seems highly probable, from the visual grammar of this artist's engravings, that he worked from photographs in his other reports as well.]

W80 Walker, S. L. "Salutatory." THE INTELLIGENCER (POUGHKEEPSIE, NY) 1, no. 1 (Dec. 1872): 1. [Walker owned and edited this newspaper. (I don't know how long the paper lasted.)]

W81 "Editor's Table - Obituary Notice." PHILADELPHIA PHOTOGRAPHER 11, no. 126 (June 1874): 190. [Died April 25 in his 72nd year, in Poughkeepsie, NY. "...one of the first disciples of Daguerre in this country, and attained great success in the days when the daguerreotype was at the height of its popularity." Well liked.]

W82 Reynolds, Helen Wilkinson. "Daguerreotypes and Photographs." YEARBOOK OF THE DUTCHESS HISTORICAL SOCIETY 16, (1931): 34-38.

W83 Sobieszek, Robert A. "Historical Profile: Samuel Leon Walker, Poughkeepsie Daguerreotypist. An eccentric 'marked man,' whose daguerreotypes express a compelling spiritualism." AMERICAN PHOTOGRAPHER 9, no. 3 (Sept. 1982): 80-85. 12 b & w. [Walker was born in New Salem, MA in 1802. He was a writer, newspaper editor, daguerreotypist, photographer, photographic teacher, and a religious spiritualist. There is a claim that Walker was an assistant to Samuel F. B. Morse in 1830s. May have stopped photographing between 1854 and early 1860s, due to health. Reopened a gallery in Poughkeepsie in May 1864. Died in 1874.]

WALKER, W. & SONS. (LONDON, ENGLAND)
W84 Portrait. Woodcut engraving credited "From a photograph by Walker & Sons, Margaret St., Cavendish Sq., London." ILLUSTRATED LONDON NEWS 51, (1867) ["Michael Faraday." 51:* (Sept. 14, 1867): 280. (see p. 314.)]

WALL, ALFRED H. (d. 1906) (GREAT BRITAIN)
BOOKS
W85 Wall, Alfred H. *A Manual of Artistic Colouring as Applied to Photographs. A Practical Guide to Artists and Photographers, Containing Clear, Simple, and Complete Instructions for Colouring Photographs on Glass, Paper, Ivory, and Canvas, with Crayon, Powder, Oil, or Water Colours. With Chapters on the Proper Lighting, Posing and Artistic Treatment Generally of Photographic Portraits; and on Colouring Photographic Landscapes.* London: T. Piper, Photographic News Office, 1861. vi, 226 pp. [Reprinted (1973), Arno Press.]

W86 Wall, Alfred H. *Fifty Years of a Good Queen's Reign. A Book for the Royal Jubilee of 1886 - 1887.* London: Ward & Downey, 1886. xiv, 344 pp. illus.

W87 Wall, Alfred H. *Artistic Landscape Photography; A Series of Chapters on the Practical and Theoretical Principles of Pictorial Composition.* New York; London: The Anthony & Scovile Co.; Percy Lund & Co., 1896. 172 pp. 32 illus. [(1973) Reprinted by Arno Press.]

W88 Wall, Alfred H. *Bookshelves and Books; Giving instructions for the planning and making of bookshelves, for the collections, classifying, indexing, arranging and cataloguing of books.* "Useful-Arts and Handicrafts Series, No. 42" London: Dawbarn & Ward, Ltd., 1902. 24 pp. [Series editor, H. Snowden Ward.]

PERIODICALS
W89 Wall, Alfred A. "Letters to a Young Photographer." HUMPHREY'S JOURNAL OF PHOTOGRAPHY, AND THE ALLIED ARTS AND SCIENCES 10, no. 22-24 (Mar. 15 - Apr. 15, 1859): 341-342, 363-367, 375-379. [From "Liverpool Photo. J." Chatty, but essentially a manual of suggestions of how to learn photography.]

W90 Wall, Alfred A. "Letters to a Young Photographer." HUMPHREY'S JOURNAL OF PHOTOGRAPHY, AND THE ALLIED ARTS AND SCIENCES 11, no. 1-24 (May 1, 1859 - Feb. 1, 1860): 7-12, 23-25, 41-43, 74-77, 89-91, 107-110, 121-123, 137-139, 153-156, 167-170, 186-188, 199-202, 217-220, 233-236, 250-253, 265-268, 282-285, 298-299. [From "Liverpool Photo. J."]

W91 Wall, Alfred H. "Practical Instructions on Coloring Photographs." HUMPHREY'S JOURNAL OF PHOTOGRAPHY, AND THE ALLIED ARTS AND SCIENCES 11, no. 3-24 (June 1 - Dec. 15, 1859): 45-46, 60-63, 73-74, 91-94, 111-112, 141-144, 175-176, 206-208.

W92 Wall, A. H., Esq. "Photography as One of the Fine Arts." PHOTOGRAPHIC NEWS 3, no. 69 (Dec. 30, 1859): 193-195. [Read before the S. London Photographic Society.]

W93 Wall, Alfred H. "Practical Observations Upon Photographs in their Relation to Art." BRITISH JOURNAL OF PHOTOGRAPHY 7, no. 109 (Jan. 1, 1860): 3-5.

W94 Wall, Alfred H. "Practical Instructions on Colouring Photographs." BRITISH JOURNAL OF PHOTOGRAPHY 7, no. 109-132 (Jan. 1 - Dec. 15, 1860): 14-15, 29, 42-43, 56-57, 70, 88-89, 104, 121, 137, 153-154, 168, 183, 210-211, 227-228, 244,276-277, 291-292, 305-306, 320-321, 338-339, 356-357, 376-377. [Extensive article, carried over from vol. 6 (1859).]

W95 Wall, Alfred H. "Practical Instructions for Coloring Photographs." HUMPHREY'S JOURNAL OF PHOTOGRAPHY, AND THE ALLIED ARTS AND SCIENCES 11, no. 17-24 (Jan. 1 - Apr. 15, 1860): 270-272, 302-303, 319-320, 327-328, 350-352, 366-367, 380-382.

W96 Wall, Alfred H. "Practical Observations on Photographs in their Relation to Art." AMERICAN JOURNAL OF PHOTOGRAPHY AND THE ALLIED ARTS AND SCIENCES n. s. vol. 2, no. 17 (Feb. 1, 1860): 267-270. [Extracted from the "Photog. Journal."]

W97 Wall, Alfred H. "Our Photographic Pic-Nic, and How We Fared." BRITISH JOURNAL OF PHOTOGRAPHY 7, no. 116 (Apr. 16, 1860): 113-114.

W98 Wall, Alfred H. "The 'Liverpool Albion' on Photography and the Fine Arts." BRITISH JOURNAL OF PHOTOGRAPHY. 7, no. 117 (May 1, 1860): 133-134. [Wall responding to a critical review on photography in a British newspaper.]

W99 Wall, Alfred H. "Practical Instructions on Coloring Photographs." HUMPHREY'S JOURNAL OF PHOTOGRAPHY, AND THE ALLIED ARTS AND SCIENCES 12, no. 1-24 (May 1, 1860 - Apr. 15, 1861): 15-16, 46-48, 79-80, 118-121, 136-138, 152-153, 169-170, 180-183, 199-200, 223-224, 226-228, 246-249, 259-261, 275-277, 289-293, 307-309, 336, 368, 372-374.

W100 Wall, Alfred H. "'Composition' vs. 'Patchwork.'" BRITISH JOURNAL OF PHOTOGRAPHY. 7, no. 120 (June 15, 1860): 176.

W101 Wall, Alfred H. "The 'Liverpool Albion' on Photography and the Fine Arts." PHOTOGRAPHIC AND FINE ART JOURNAL 13, no. 7 (July 1860): 194-195. [From the "Br J of Photo."]

W102 "Editorial Note." BRITISH JOURNAL OF PHOTOGRAPHY 7, no. 121 (July 2, 1860): 187-188. [Editor offers lengthy commentary on a controversy developed between H. P. Robinson and A. H. Wall on the creative value of composite photographs.]

W103 Wall, Alfred H. "'Composition' versus 'Patchwork.'" BRITISH JOURNAL OF PHOTOGRAPHY. 7, no. 121 (July 2, 1860): 190-191.

W104 Wall, A. H. "Meetings of Societies - South London Photographic Society. First Out-of-Door Meeting." BRITISH JOURNAL OF PHOTOGRAPHY 7, no. 123 (Aug. 1, 1860): 226-227. [Wall describes, in a letter format, as Secretary of the S. London Photo

Society, his experiences during a rain-tormented photographic outing.]

W105 Wall, A. H. "From a Photographer's Common Place Book. Parts 1-16." PHOTOGRAPHIC NEWS 4, no. 103-120 (Aug. 24 - Dec. 21, 1860): 197-199, 207-208, 217-219, 230-231, 244-245, 254-256, 266-267, 280, 292, 302-303, 314-316, 327-328, 363-364, 375-376, 386-387, 398-399.

W106 Wall, A. H. "Photographic Exhibitions and Art Progress." PHOTOGRAPHIC NEWS 4, no. 111 (Oct. 19, 1860): 293.

W107 Wall, A. H. "Photography as Imitative Art." PHOTOGRAPHIC NEWS 4, no. 114 (Nov. 9, 1860): 327-328.

W108 Wall, Alfred H. "A Few Words About the Managers, Exhibitors, and Critics, of Our Photographic Exhibitions." BRITISH JOURNAL OF PHOTOGRAPHY 7, no. 132 (Dec. 15, 1860): 363-365.

W109 Wall, Alfred H. "Hints on 'Keeping' - in Composition Photography." PHOTOGRAPHIC NEWS 4, no. 121 (Dec. 28, 1860): 411-412. [Read before the South London Photographic Society Dec. 20, 1860.]

W110 Wall, Alfred H. "A Few Hints on Composition and Keeping." BRITISH JOURNAL OF PHOTOGRAPHY 8, no. 133 (Jan. 1, 1861): 8-9. [Discusses Fry.]

W111 Wall, Alfred, H. "Practical Instructions on Coloring Photographs." BRITISH JOURNAL OF PHOTOGRAPHY 8, no. 133-142 (Jan. 1 - May 15, 1861): 18-19, 75-76, 95-96, 115-116, 153, 172-173, 190-191.

W112 Wall, Alfred H. "An Appeal to Practical Photographers." BRITISH JOURNAL OF PHOTOGRAPHY 8, no. 138-139 (Mar. 15 - Apr. 1, 1861): 101-102, 126-127.

W113 Wall, Alfred H. "Practical Instructions on Coloring Photographs." HUMPHREY'S JOURNAL OF PHOTOGRAPHY, AND THE ALLIED ARTS AND SCIENCES 13, no. 1-6 (May 1 - July 15, 1861): 1-4, 18-20, 52-53, 68-71, 81-83. [From "Br. J. of Photo."]

W114 Wall, A. H. "Sharpness - What Is It?" BRITISH JOURNAL OF PHOTOGRAPHY 8, no. 143 (June 1, 1861): 201-202.

W115 Wall, Alfred H. "Another 'Half Brick.'" BRITISH JOURNAL OF PHOTOGRAPHY 8, no. 145 (July 1, 1861): 235. [Wall's response to an editorial comment in the June 15 issue. The editor's reply also published on p. 235.]

W116 Wall, A. H. "The Technology of Art as Applied to Photography." PHOTOGRAPHIC NEWS 5, no. 148-149 (July 5 - July 12, 1861): 313-314, 324-325. [Dictionary of art definitions.]

W117 Wall, A. H. "Sharpness - What is it?" HUMPHREY'S JOURNAL OF PHOTOGRAPHY, AND THE ALLIED ARTS AND SCIENCES 13, no. 6-7 (July 15 - Aug. 1, 1861): 94-96, 103-107. [From "Br. J. of Photo."]

W118 Wall, Alfred H. "An Artist's Letters to a Young Photographer." BRITISH JOURNAL OF PHOTOGRAPHY 8, no. 148-155 (Aug. 15 - Dec. 2, 1861): 292-293, 310-311, 329-330, 343-344, 367-368, 387-388, 410-411, 426-427.

W119 Wall, A. H. "An Artist's Letters to a Young Photographer: On Landscape." HUMPHREY'S JOURNAL OF PHOTOGRAPHY, AND THE ALLIED ARTS AND SCIENCES 13, no. 11-24 (Oct. 1, 1861 - Apr. 15, 1862): 171-173, 197-201, 213-216, 235-238, 268-271, 313-316, 342-347, 374-378.

W120 Wall, A. H. "Correspondence: Award of Medals at Exhibitions and Elsewhere." BRITISH JOURNAL OF PHOTOGRAPHY 9, no. 157 (Jan. 1, 1862): 17.

W121 Wall, Alfred H. "An Artist's Letters to a Young Photographer: On Landscape." BRITISH JOURNAL OF PHOTOGRAPHY 9, no. 157-172 (Jan. 1 - Aug. 15, 1862): 11-12, 29-30, 47-48, 68-70, 90, 131-132, 212-213, 253-255, 314-315.

W122 Wall, Alfred H. "On Photographic Reproductions." BRITISH JOURNAL OF PHOTOGRAPHY 9, no. 164 (Apr. 15, 1862): 145-146.

W123 Wall, Alfred H. "An Artist's Letters to a Young Photographer." HUMPHREY'S JOURNAL OF PHOTOGRAPHY, AND THE ALLIED ARTS AND SCIENCES 14, no. 4 (June 15, 1862): 8-12.

W124 Wall, A. H. "A Chat about Glass Houses." AMERICAN JOURNAL OF PHOTOGRAPHY AND THE ALLIED ARTS & SCIENCES n. s. vol. 5, no. 8 (Oct. 15, 1862): 176-181. 1 illus. [From "Br. J. of Photo."]

W125 Wall, A. H. "A Chat about Lighting the Model." AMERICAN JOURNAL OF PHOTOGRAPHY AND THE ALLIED ARTS & SCIENCES n. s. vol. 5, no. 9 (Nov. 1, 1862): 203-208. [From "Br. J. of Photo."]

W126 Wall, A. H. "Bits of Chat: A Chat Over a Bundle of Cartes-de-Visite." BRITISH JOURNAL OF PHOTOGRAPHY 9, no. 177 (Nov. 1, 1862): 411-413.

W127 Wall, A. H. "Bits of Chat: Backgrounds: - Their Abuse, Their Use, Their Principles, and the Modes of Painting Them." BRITISH JOURNAL OF PHOTOGRAPHY 9, no. 179 (Dec. 1, 1862): 449-450.

W128 Wall, A. H. "Bits of Chat: Backgrounds: their abuse, their use, their principles, and the modes of painting them." BRITISH JOURNAL OF PHOTOGRAPHY 10, no. 189 (May 1, 1863): 188-189.

W129 Wall, Alfred H. "Bits of Chat: A Chat over a Certain Packet of Letters." BRITISH JOURNAL OF PHOTOGRAPHY 10, no. 193 (July 1, 1863): 270-271.

W130 Wall, Alfred H. "In Search of Truth." BRITISH JOURNAL OF PHOTOGRAPHY 10, no. 194 (July 15, 1863): 285-286.

W131 Wall, Alfred H. "Entremets: The Awkward Model." BRITISH JOURNAL OF PHOTOGRAPHY 10, no. 195 (Aug. 1, 1863): 310.

W132 A. H. W. "The Awkward Model." AMERICAN JOURNAL OF PHOTOGRAPHY AND THE ALLIED ARTS & SCIENCES n. s. vol. 6, no. 4 (Aug. 15, 1863): 90-91. [From "Br. J."]

W133 Wall, Alfred H. "Bits of Chat: A Bit about Solar Camera Enlargements." BRITISH JOURNAL OF PHOTOGRAPHY 10, no. 196 (Aug. 15, 1863): 331-332.

W134 Wall, Alfred H. "Bits of Chat: A Bit About Honesty and the Best Policy." BRITISH JOURNAL OF PHOTOGRAPHY 10, no. 199 (Oct. 1, 1863): 388-389.

W135 Wall, Alfred H. "'Composition' Photography: Its Aspects, Advantages, and Disadvantages." BRITISH JOURNAL OF PHOTOGRAPHY 10, no. 200 (Oct. 15, 1863): 403-404.

W136 Wall, Alfred H. "A Few Thoughts About Photographic Societies." BRITISH JOURNAL OF PHOTOGRAPHY 10, no. 200 (Oct. 15, 1863): 407-409.

W137 Wall, Alfred H. "Glass Rooms." BRITISH JOURNAL OF PHOTOGRAPHY 10, no. 204 (Dec. 15, 1863): 483-484.

W138 Wall, Alfred H. "'Composition' Photography - Searching for a Subject." BRITISH JOURNAL OF PHOTOGRAPHY 11, no. 205 (Jan. 1, 1864): 8-9.

W139 Wall, A. H. "Bits of Chat: A Bit about a Certain Discussion, and of Sundry Comments Made Thereon." BRITISH JOURNAL OF PHOTOGRAPHY 11, no. 207 (Feb. 1, 1864): 43-44.

W140 Wall, Alfred H. "Practical Hints on Artistic Portraiture." BRITISH JOURNAL OF PHOTOGRAPHY 11, no. 208, 213, 216, 222 (Feb. 15, May 2, June 15, Aug. 5, 1864): 61-62, 149-151, 204-205, 282-283. 16 illus.

W141 Wall, A. H. "On a Photographic Provident Society." BRITISH JOURNAL OF PHOTOGRAPHY 11, no. 210 (Mar. 15, 1864): 95-96.

W142 "Critical Notices: "The Art Student. Nos. 1 and 2." London: Hall, Smart & Allen." PHOTOGRAPHIC NEWS 8, no. 289 (Mar. 18, 1864): 136-137. [New illustrated monthly magazine of the fine and industrial arts ... edited by A. H. Wall.]

W143 Wall, A. H. "On a Photographic Provident Society." PHOTOGRAPHIC NEWS 8, no. 290 (Mar. 24, 1864): 150-151. [Read before a meeting of the South London Photo. Soc. Mar. 10, 1864.]

W144 Wall, A. H. "Why Photographers Should Study Art and Nature." BRITISH JOURNAL OF PHOTOGRAPHY 11, no. 236 (Nov. 11, 1864): 449-450.

W145 Wall, A. H. "A Few Thoughts About Photographic Art Progress." BRITISH JOURNAL OF PHOTOGRAPHY 12, no. 267 (June 16, 1865): 313-314. [Read to South London Photo. Soc. June 8, 1865.]

W146 Wall, A. H. "A Few Thoughts About Photographic Art Progress." PHOTOGRAPHIC NEWS 9, no. 353 (June 16, 1865): 282-283.

W147 Wall, A. H. "On Colouring Photographic Slides for the Magic Lantern." BRITISH JOURNAL OF PHOTOGRAPHY 12, no. 269, 273 (June 30, July 28, 1865): 340-341, 391-392.

W148 Wall, A. H. "On Colouring Landscape Transparencies for the Magic Lantern." BRITISH JOURNAL OF PHOTOGRAPHY 12, no. 270 (July 7, 1865): 354-355.

W149 Wall, A. H. "Correspondence: Some Supplementary and Explanatory Remarks." BRITISH JOURNAL OF PHOTOGRAPHY 12, no. 270 (July 7, 1865): 361. [Wall defending his paper read before South London Photo. Soc. which had drawn commentary.]

W150 Wall, A. H. "Excellence Versus Cheapness - An Appeal to Photographic Portraitists." BRITISH JOURNAL OF PHOTOGRAPHY 12, no. 274 (Aug. 4, 1865): 402-403.

W151 Wall, A. H. "Practical Art Hints." BRITISH JOURNAL OF PHOTOGRAPHY 12, no. 277-290 (Aug. 25 - Nov. 24, 1865): 439-440, 462-464, 487, 511, 557-559, 594-595.

W152 Wall, Alfred H. "Backgrounds and Accessories." AMERICAN JOURNAL OF PHOTOGRAPHY AND THE ALLIED ARTS & SCIENCES n. s. vol. 8, no. 10 (Nov. 15, 1865): 217-222. [From "Br. J. of Photo."]

W153 Wall, A. H. "On Tinting Photographs in Water Colours." BRITISH JOURNAL PHOTOGRAPHIC ALMANAC 1867 (1867): 60-61.

W154 Wall, A. H. "On Tinting Photographs in Water Colors." HUMPHREY'S JOURNAL OF PHOTOGRAPHY, AND THE ALLIED ARTS AND SCIENCES 18, no. 22 (Mar. 15, 1867): 343-345. [From "Br. J. Photo. Almanac."]

W155 Wall, A. H. "What Art-Study Should be to the Photographer." BRITISH JOURNAL PHOTOGRAPHIC ALMANAC 1868 (1868): 82.

W156 Wall, A. H. "Photographic Portraiture: Parts 1 - 4." PHOTOGRAPHIC TIMES 6-7, no. 70-73 (Oct. 1876 - Jan. 1877): (1876) 229-231, 244-247, 267-269, (1877) 2-4. [From the "Br. J. of Photo." Part 1. Some Lessons from Vandyke. Part 2. Some Lessons from Sir Joshua Reynolds. Part 3. Some Lessons from Sir Thomas Lawrence. Part 4. Some Lessons from Leslie.]

W157 Wall, A. H. "A Few of the Less Known Good Deeds of Photography." ANTHONY'S PHOTOGRAPHIC BULLETIN 8, no. 2 (Feb. 1877): 53-54. [From "Br. J. of Photo." Effects of photography on graphic illustration in the mass magazines.]

W158 "Editor's Table." WILSON'S PHOTOGRAPHIC MAGAZINE 32, no. 462 (June 1895): 286. [Wall, amateur photographer, was librarian of the Shakespeare Memorial Library, and editor of Shakepeare's works.]

W159 Wall, Alfred H. "Pictorial Photography: Its Past Progress and Present Position: A Last Century History." WILSON'S PHOTOGRAPHIC MAGAZINE 38, no. 534 (June 1901): 204-207. [Discusses Arago, Talbot.]

W160 "Obituary of the Year: A. H. Wall (June 24, 1906)." BRITISH JOURNAL PHOTOGRAPHIC ALMANAC 1907 (1907): 625. [Born in London. Unsympathetic step-father, ran away from home and joined one of the early Daguerreotypists. Then "went on" as a super in the company of the great Macready. In 1850 with a partner in Cheapside, London began a business as miniature painters and Daguerreotypists. Assisted a photographer working near the Great Exhibition in 1851, later opened a studio in the Strand. Failed. Married in 1852, toured as a portrait painter, using the name R. A. Seymour. That story published in the "Photographic News" in 1861. Wife died, Wall went back to the stage. Edited "The Illustrated Photographer" for Hazell, Watson & Viney from 1868 to 1870. Regularly contributed articles to "BJP" and elsewhere. Founded the old South London Photographic Society, a founder, member of the Solar Club. The later years of his life were spent as Curator of the Shakespeare Memorial Library at Stratford-on-Avon.]

WALL, WILLIAM COVENTRY. (1810-1880) (GREAT BRITAIN, USA)

W161 "William Coventry Wall," on pp. 212-213, following, in: Donaldson, Mary Katherine. *Composition in Early Landscapes of the Ohio River Valley: Backgrounds and Components.* Pittsburgh:

University of Pittsburgh, 1971. [Ph.D. Dissertation, University of Pittsburgh, 1971. William C. Wall was born in Oxford, England in 1810. Family moved to Mount Pleasant, PA, by 1825. Wall maintained an Ambrotype and Photographic Gallery in his Wall's Picture Gallery in Pittsburgh, PA, from at least 1856 to 1859. Also a painter.]

WALLACE, ELLERSLIE, JR. (1819-1885) (USA)

W162 "Rebel Cruelty - Our Starved Soldiers." HARPER'S WEEKLY 8, no. 390 (June 18, 1864): 385, 386. 2 illus. ["From Photographs taken at United States General Hospital, Annapolis, Maryland, under charge of Dr. Z. Vanderkieft....Dr. Ellerslie Wallace, in sending the photographs, writes..." (It may be that these photographs were actually taken by David Bachrach.)]

W163 Wallace, Ellerslie, Jr. "The Packing of Photographic Apparatus for Travel." BRITISH JOURNAL PHOTOGRAPHIC ALMANAC 1877 (1877): 117-118.

W164 B. C. J. "An Evening with the Lantern." PHILADELPHIA PHOTOGRAPHER 14, no. 162 (June 1877): 174-175. [Describes exhibition of Ellerslie Wallace's lantern slide views of England, at the Philadelphia Photo. Soc.]

W165 Wallace, Ellerslie, Jr. "An Adventure in Drying Plates." BRITISH JOURNAL PHOTOGRAPHIC ALMANAC 1879 (1879): 138-139.

W166 Wallace, Ellerslie. "The Fading of Transparent Positives." BRITISH JOURNAL PHOTOGRAPHIC ALMANAC 1878 (1878): 67-68.

W167 Wallace, Ellerslie. "Silver Printing on Albumenized Paper." ANTHONY'S PHOTOGRAPHIC BULLETIN 18, no. 3-4 (Feb. 12 - Feb. 26, 1887): 79-80, 111-113. [Read before the Photographic Society of Philadelphia.]

W168 Wallace, Ellerslie. "Composite Photography." AMERICAN JOURNAL OF PHOTOGRAPHY 8, no. 12 (Dec. 1887): 211-213. [Read before the Photo. Soc. of Phila., Dec. 8, 1887.]

W169 Wallace, Ellerslie. "Composite Photography." ANTHONY'S PHOTOGRAPHIC BULLETIN 19, no. 1 (Jan. 14, 1888): 15-17. [Read before the Photographic Society of Philadelphia. Attack on the validity of composite photography.]

W170 Wallace, Ellerslie. "Amateur Photography." OUTING 13, no. 6 (Mar. 1889): 515-517.

W171 Wallace, Ellerslie. "Amateur Photography." OUTING 14, no. 1 (Apr. 1889): 28-30.

W172 Wallace, Ellerslie. "Amateur Photography." OUTING 14, no. 2 (May 1889): 98-102. 4 b & w.

W173 Wallace, Ellerslie. "Photographic False Doctrines." AMERICAN ANNUAL OF PHOTOGRAPHY AND PHOTOGRAPHIC TIMES ALMANAC FOR 1891 (1891): 138-139.

W174 Wallace, Ellerslie. "Landscape Photography." OUTING 17, no. 6 (Mar. 1891): 467-471. 3 b & w. [3 views of cottages in England, apparently by Wallace.]

W175 Wallace, Ellerslie. "Photographic Dark Rooms." OUTING 18, no. 2 (May 1891): 105-107.

W176 Wallace, Ellerslie. "Photographing Foliage." OUTING 18, no. 4 (July 1891): 305-308. 4 b & w.

W177 Wallace, Ellerslie. "Photographing in the White Mountains." OUTING 18, no. 5 (Aug. 1891): 389-392. 3 b & w.

W178 Wallace, Ellerslie. "Photography - Orthochromatic Films and Plates." OUTING 19, no. 2 (Nov. 1891): 116-117.

W179 Wallace, Ellerslie. "Artistic Composition in Out-Door Photography." AMERICAN ANNUAL OF PHOTOGRAPHY AND PHOTOGRAPHIC TIMES ALMANAC FOR 1892 (1892): 56-59, plus 3 leaves between pp. 54-55. 3 b & w.

W180 Wallace, Ellerslie. "Quick Exposure Versus Pictorial Effect." PHOTOGRAPHIC MOSAICS: 1892 28, (1892): 183-185. [Wallace from Philadelphia.]

W181 Wallace, Ellerslie. "Photographing Disasters." AMERICAN ANNUAL OF PHOTOGRAPHY AND PHOTOGRAPHIC TIMES ALMANAC FOR 1893 (1893): 34-36. [Advice about photographing accidents.]

W182 Wallace, Ellerslie. "Artists As Photographic Judges." AMERICAN ANNUAL OF PHOTOGRAPHY AND PHOTOGRAPHIC TIMES ALMANAC FOR 1894 (1894): 58.

W183 Wallace, Ellerslie. "Photograph the Right Things." PHOTOGRAPHIC TIMES 29, no. 4 (Apr. 1897): 169-171.

W184 Wallace, Ellerslie. "Preparing Negatives for Slide Making." PHOTOGRAPHIC TIMES 29, no. 11 (Nov. 1897): 501-502.

WALLACE, G. W.
W185 "Our Advance Column." PHILADELPHIA PHOTOGRAPHER 13, no. 147 (Mar. 1876): 71-72. [Formulae, working procedures.]

WALLERY. (COUNT OSTRAGOG) (d. 1890) (FRANCE)
W186 Lacan, E. "A Photographic Fairy Palace." ANTHONY'S PHOTOGRAPHIC BULLETIN 4, no. 3 (Mar. 1873): 78-79. [From "Photo News." M. Wallerie, [sic Wallery ?] well known as a skillful photographer in Marseilles, "opening a luxurious studio in Paris." (N.B. Wallery later opened a studio in London as well.]

W187 "Securing Short Exposures." ANTHONY'S PHOTOGRAPHIC BULLETIN 5, no. 4 (Apr. 1874): 137-139. [From "London Photo. News." Includes description of the operation of Wallerie's (Marseilles) gallery. J. R. Johnson, B. J. Edwards, Melchion, Gage also mentioned.]

WALLICH, G. C., DR. (KENSINGTON, ENGLAND)
BOOKS
W188 *Eminent Men of the Day: Scientific Series.* London: John van Voorst, 1870. n. p. 16 b & w. [Original photographs. Portraits, taken by G. C. Wallich, M.D. Printed biographies under each photograph. Printed title page and foreword.]

PERIODICALS
W189 "Note." ART JOURNAL (June 1867): 158. [About the photographic portraits of Dr. Wallich.]

W190 Portrait. Woodcut engraving, credited to "From a Photograph by Dr. Wallich, Trevor House, Warwick Gardens, Kensington." ILLUSTRATED LONDON NEWS 60, (1872) ["Prof. Tyndall, Ll.D., F.R.S." 60:1687 (Jan. 6, 1872): 9.]

W191 Portrait. Woodcut engraving credited "From a photograph by Dr. Wallich." ILLUSTRATED LONDON NEWS 66, (1875) ["Archdeacon John Sinclair." 66:1870 (June 12, 1875): 552.]

WALLIS. (GREAT BRITAIN)
W192 Wallis. "Mr. Wallis's Lecture on Elementary Art." AMERICAN JOURNAL OF PHOTOGRAPHY AND THE ALLIED ARTS & SCIENCES n. s. vol. 8, no. 18 (Mar. 15, 1866): 409-413. [From "Photo. News." Mr. Wallis, Chief of the Art Department at South Kensington Museum, delivered an address on Elementary Art as Relating to Photography, to the members of the South London Photographic Society.]

WALLIS, OSCAR J. (d. 1865) (GERMANY, USA)
W193 Wallis, Oscar J. "Only Practically Valuable Method to Increase the Intensity of a Weak Negative." PHOTOGRAPHIC AND FINE ART JOURNAL 9, no. 1 (Jan. 1856): 26-27. [Wallis from Cincinnati, OH.]

W194 Wallis, O. J. "Notes on the Production of Life-Size Photographs of any Dimension." PHOTOGRAPHIC AND FINE ART JOURNAL 9, no. 4, 7-8 (Apr., July - Aug. 1856): 118, 203-204, 253-254. 4 illus.

W195 Wallis, Oscar J. "Photography in Germany." PHOTOGRAPHIC AND FINE ART JOURNAL 11, no. 9 (Sept. 1858): 258-259.

W196 Wallis, Oscar J. "Method of Printing and Toning the Photographs of 'Kaulbach's Goethe Gallery.'" AMERICAN JOURNAL OF PHOTOGRAPHY AND THE ALLIED ARTS & SCIENCES n. s. vol. 4, no. 12 (Nov. 15, 1861): 277-279. [Includes a letter from Wallis, from Chicago, IL.]

W197 Seely, Charles A. "Editorial Department." AMERICAN JOURNAL OF PHOTOGRAPHY AND THE ALLIED ARTS & SCIENCES n. s. vol. 8, no. 2 (July 15, 1865): 47. [Oscar J. Wallis, late of Chicago, travelled to Germany "hopeful for a speedy restoration of his health...But he had barely the strength to reach his father's house in Germany, and there he died...a man of very refined taste, and an enthusiastic photographer...."]

WALMSLEY, HUGH MULLENEUX.
BOOKS
W198 Walmsley, Hugh Mulleneux. *The Chasseur D'Afrique, and Other Tales.* London: Chapman & Hall, 1864. 293 pp. 3 l. of plates. 3 b & w. [This is a work of fiction, "...So far as we are aware, Colonel Walmsley is the first who has attempted the arduous task of illustrating a work of the imagination by means of the camera..." ["Br. J. of Photo." (Nov. 25, 1864): 475.] These are simple tableaux, posed by models of scenes depicted in the narrative.]

PERIODICALS
W199 "Our Editorial Table: The Chasseur D'Afrique and Other Tales, by Hugh Mulleneux Walmsley." BRITISH JOURNAL OF PHOTOGRAPHY 11, no. 238 (Nov. 25, 1864): 475.

WALSH, C. F. (GREAT BRITAIN, JAPAN)
W200 "Scenes on the New Railway in Japan between Osaka and Kobe." ILLUSTRATED LONDON NEWS 69, no. 1936 (Sept. 2, 1876): 221. 7 illus.

WALSH, PHILLIP. (N ZEALAND)
W201 "Scenes in New Zealand: Town of Shortland, at the Thames Gold-Fields - Bay in the Island of Kawau - Bay of Islands." ILLUSTRATED LONDON NEWS 55, no. 1558 (Sept. 25, 1869): 300, 304-305. 3 illus. ["...a View of the Bay of Islands to Mr. Philip Walsh of Russell...other photographs, from correspondents at Wellington..."]

WALTER, J.

W202 Walter, J. "Instantaneous Portraits and the Management of Sitters." PHOTOGRAPHIC NEWS 3, no. 68 (Dec. 23, 1859): 189-190. [Letter from Walter, a professional photographer, stating his point of view in response to an earlier comment by Fennessy.]

WALZL, JOHN HENRY (1833-) see WALZL, RICHARD.

WALZL, RICHARD EDMUND. (1843-1899) (AUSTRIA, USA)

[Richard Walzl was the son of John Walzl, a respected manufacturer of gold and silver ware from Stein, Austria, and the younger brother of John Henry Walzl. The Walzl family immigrated to the USA in the early 1850s. John Henry trained in Austria, and worked as a jeweller for Tiffany's in New York. In 1854 he formed a partnership with Beeckman Cooke in Baltimore, MD, to form the daguerreotype studio of Cooke & Walzl. Six months later Walzl bought the business, and became a principle supplier of daguerreotype and later photographic supplies to the South. After 1868 he became heavily engaged in real estate, developing the town of Waverly, MD and rebuilding Chancellorsville, VA and colonizing it with German immigrants in the early 1870s. Richard was born on Oct. 14, 1843, in Stein, Austria, and came to Baltimore, MD in 1852. He studied at Professor Knapp's Institute for two years, then apprenticed as a photographer. After four years he opened his own studio in Hartford County, MD, then moved to Baltimore in 1862. Five years later he opened a larger studio. Richard edited and published *Photographic Rays of Light*, "...a popular photographic magazine," and *The Photographer's Friend*. He died in Baltimore on May 10, 1899.]

BOOKS

W203 Walzl, Richard. *The Photographic Art of Today:* Dedicated to the Friends and Patrons at the Palace of Photography. Baltimore: Palace of Photography, c. 1879. 84 pp. 1 l. of plates. illus.

PERIODICALS

W204 "J. H. Walzl's 'Photographic Journal.'" HUMPHREY'S JOURNAL OF PHOTOGRAPHY, AND THE ALLIED ARTS AND SCIENCES 17, no. 23 (Apr. 1, 1866): 367. [Sort of a notice about "a new number...of our irrepressible friend Walzl's...heb-domadal, which contains twenty pages of matter..."]

W205 "Removal and Expansion." ANTHONY'S PHOTOGRAPHIC BULLETIN 3, no. 4 (Apr. 1872): 526. [Walzl (Baltimore, MD) moved to larger gallery.]

W206 "Origin and Progress of the National Photographic Emporium April 1862 - April 1872." COMMERCIAL PHOTOGRAPHIC NEWS 1, no. 2 (Apr. 1872): 1-6. [Sketch of Walzl's career, who was the publisher of both the "Commercial Photographic News" and "The Photographer's Friend." Walzl assisted in galleries in Richmond, Va. and Baltimore from the age of 12. Opened his own gallery in Baltimore in 1862 at age 16. Prospered. Added a stock room (i.e. sold photographic supplies as well.) Prospered. Eventually published several house organs in the early 1870s, which lasted several years.]

W207 "Our New Establishment: What the Press Says About It." COMMERCIAL PHOTOGRAPHIC NEWS 1, no. 3 (July 1872): 7-9.

W208 "Our Illustration." PHOTOGRAPHER'S FRIEND 2, no. 4 (Oct. 1872): frontispiece, 108-109. 1 b & w. [Portrait, made by James S. Cummings, operator of the Richard Walzl Gallery, 46 N. Charles St., Baltimore.]

W209 Portrait. Woodcut engraving, credited "From a Photograph by Walze [sic Walzl], Baltimore." FRANK LESLIE'S ILLUSTRATED NEWSPAPER 43, (1876) ["Gen. Wade Hampton." 43:1106 (Dec. 9, 1876): 237.]

W210 "Note." PHOTOGRAPHIC TIMES 8, no. 91 (July 1878): 158. [Noted as good photographer.]

W211 "Matters of the Month." PHOTOGRAPHIC TIMES 10, no. 103 (Jan. 1880): 10. [Mr. R. Walzl, Baltimore, celebrated the twentieth anniversary of his photographic career by publishing and presenting to his patrons a very neat little brochure of 84 pages, entitled "The Photographic Art."]

W212 "Our Editorial Table." PHOTOGRAPHIC TIMES 11, no. 125 (May 1881): 186-187. [Bk. rev.: "The Photographic Art of To-day," A brochure describing the Walzl Studio in Baltimore.]

W213 Taylor, J. Traill. "The Studios of America. No. 3. Walzl's Gallery, Baltimore, Md." PHOTOGRAPHIC TIMES 13, no. 147 (Mar. 1883): 102-104.

W214 "News and Notes: The Late Richard Walzl." PHOTOGRAPHIC TIMES 31, no. 8 (Aug. 1899): 399. [Walzl started a studio in Baltimore in 1862. Then went into selling photographic supplies. In the 1870s he published and edited "The Commercial Photographic News," "The Photographer's Friend," and several other publications.]

WANE, MARSHALL. (1833-1903) (GREAT BRITAIN)

W215 Wane, Marshall. "Renovating Old Negative Baths." BRITISH JOURNAL PHOTOGRAPHIC ALMANAC 1876 (1876): 83-84. 1 illus.

W216 "Obituary of the Year: Marshall Wane." BRITISH JOURNAL PHOTOGRAPHIC ALMANAC 1905 (1905): 648-649. [Died Dec. 14, 1903. Born in 1833, first began to photograph in 1852 as an amateur. In 1854 practiced in Knutsford as a professional. In 1858 built a studio at Douglas, Isle of Man, where he remained 23 years. 1879 went to Edinburgh, worked at studio there until 1902. Then to Glasgow, opened a studio, now run by his two sons. H. P. Wane and Charles Marshall Wane.]

WARD, A. T. (d. 1903) (GREAT BRITAIN)

W217 "Obituary of the Year: A. T. Ward." BRITISH JOURNAL PHOTOGRAPHIC ALMANAC 1904 (1904): 679. [A. T. Ward carried on a large photographic business in Brixton, Battersea and Chelsea, from 1864 on. Died of cancer on Sept. 19, 1903.]

WARDLEY, G.

W218 Wardley, G. "Glass Transparencies." AMERICAN JOURNAL OF PHOTOGRAPHY AND THE ALLIED ARTS & SCIENCES n. s. vol. 8, no. 1 (July 1, 1865): 1-4. [Read to Photo. Section of the Literary and Philosophical Soc. of Manchester.]

WARNER, ASEL M. (d. 1886) (USA)

W219 "Obituary: A. M. Warner." ANTHONY'S PHOTOGRAPHIC BULLETIN 19, no. 3 (Feb. 11, 1888): 85. [Note of death of A. M. Warner, "one of the veteran photographers of Quincy, IL." No biographical information given. (Worked in Quincy from 1873 until his death in 1886.)]

WARNER, W. HARDING. (LONDON, ENGLAND)

[Warner was "an excellent professional photographer, good alike at portraits and landscapes. Formerly of Ross."]

BOOKS

W220 Warner, W. Harding. *Simple Rules for the Mounting and Touching of Photo Pictures, specially designed for Amateurs.* London, Liverpool: Philip, Son & Nephew, 1876. n. p.

PERIODICALS

W221 "Critical Notices: Stereograms of English Scenery and Interiors. By W. H. Warner, London." PHOTOGRAPHIC NEWS 1, no. 23 (Feb. 11, 1859): 268-269.

W222 Warner, W. H. "On the Fading of Photographs." AMERICAN JOURNAL OF PHOTOGRAPHY, AND THE ALLIED ARTS AND SCIENCES n. s. vol. 9, no. 12 (June 1, 1867): 272-274. [From "Br. J. of Photo."]

W223 Warner, W. H. "Gelatine Combined with Iron." HUMPHREY'S JOURNAL OF PHOTOGRAPHY, AND THE ALLIED ARTS AND SCIENCES 19, no. 12 (Oct. 15, 1867): 179-180. [From "Br. J. of Photo."]

W224 Warner, W. Harding. "How I spent My Season, The Difficulties I Met With, and How They Were Overcome." BRITISH JOURNAL PHOTOGRAPHIC ALMANAC 1875 (1875): 133-135.

W225 Warner, W. Harding. "A New Application for Photography." BRITISH JOURNAL PHOTOGRAPHIC ALMANAC 1878 (1878): 177. [From Duffield, Derby.]

WARNERKE, LEON. (d. 1900) (HUNGARY, GREAT BRITAIN)

W226 "Dry Plates Without Glass." ANTHONY'S PHOTOGRAPHIC BULLETIN 6, no. 9 (Sept. 1875): 276-278. [From "London Photographic News." Leon Warnerke (Austria) worked out a technique for applying dry collodion to paper backing.]

W227 Warnerke, Leon. "Dialyzed Collodion Emulsion." BRITISH JOURNAL PHOTOGRAPHIC ALMANAC 1876 (1876): 145-146. 1 illus.

W228 "The Rationale of Cloudy Skies in Photographs." ANTHONY'S PHOTOGRAPHIC BULLETIN 8, no. 1 (Jan. 1877): 8-9. [From "Br. J. of Photo." Mr. Warnerke advocates placing clouds into prints. Moncure Conway mentioned.]

W229 Warnerke, Leon. "Photographs in Natural Colors Produced by the Improved Process of L. Lumiere, After Prof. Lippman's Interference Method." PHOTOGRAPHIC TIMES 23, no. 637 (Dec. 1, 1893): 696-697. ["London Camera Club"]

W230 "Obituary of the Year: Leon Warnerke." BRITISH JOURNAL PHOTOGRAPHIC ALMANAC 1901 (1901): 672-674. [Born in Hungary, settled in England "about 30 years ago," being, by profession, a civil engineer. Interested in photography and in 1875 presented paper "Paper versus Glass," to the old South London Photographic Society. Very active lecturer, author from then on, mostly technical matters. Investigated educational institutions in Europe later.]

WARR, W. & H. S. WARR.

W231 "Fine Arts: New Publications: 'A Photograph, containing One Hundred and Four Portraits of Eminent Actors and Actresses,' Arranged and published by W. and H. S. Warr." ATHENAEUM no. 1532 (Mar. 7, 1857): 314.

WARREN, GEORGE C.

W232 Warren, G. C. "Hints on the Production of Clouds." BRITISH JOURNAL PHOTOGRAPHIC ALMANAC 1866 (1866): 90.

W233 Warren, George C. "Photographing on Canvas." HUMPHREY'S JOURNAL OF PHOTOGRAPHY, AND THE ALLIED ARTS AND SCIENCES 20, no. 19 (Mar. 15, 1869): 302. [From "Br. J. of Photo. Almanac."]

WARREN, GEORGE K. see also HISTORY: USA: MA: 19TH & 20TH C. (Rodgers, P. H.)

WARREN, GEORGE KENDALL. (1824-1884) (USA)

[George K. Warren was born in Nashua, NH. He practiced photography in Lowell, MA in 1851. Moved into Boston in 1870. He also opened a second studio in 1873 near his home in Cambridgeport, MA.]

BOOKS

W234 United States Military Academy. *Class Album for 1868.* Boston: Warren, n. d. [1868]. n. p. 123 b & w. [123 photographs, all by Warren. Nineteen officers, sixty-six cadets, and thirty-eight scenes.]

W235 *Harvard College, Class of 1871.* Yearbook. Boston: Warren, 1871. n. p. 207 b & w. [207 portraits of faculty and students.]

W236 Drake, Samuel Adams. *Historic Fields and Mansions of Middlesex.* Boston: James R. Osgood, 1874. 442 pp. 18 b & w. 2 illus. [Twenty collotype reproductions, eighteen from photographs by Warren (Cambridge, MA); Wilkinson (Medford, MA), etc.]

PERIODICALS

W237 "Gossip." PHOTOGRAPHIC ART JOURNAL 3, no. 2 (Feb. 1852): 130. ["We have very fine Daguerreotypes taken by Mr. Warren of Lowell, Mass."]

W238 1 photo (Portrait of Harriet Beecher Stow). PHOTOGRAPHIC ART JOURNAL 6, no. 2 (Aug. 1853): frontispiece. 1 b & w. [Actual crystalotype tipped in. No credit is given for photographer. Noted on page 149 of the Sept. issue that photo is by Whipple from a daguerreotype by G. W. Warren.]

W239 "The Anthony Prize Pitcher." PHOTOGRAPHIC AND FINE ART JOURNAL 7, no. 1 (Jan. 1854): 6-11. [Letter briefly describing Warren's process on page 9.]

W240 Portrait. Woodcut engraving, credited "From a Photograph by G. K. Warren." HARPER'S WEEKLY 10, no. 504 (Aug. 25, 1866): 540. 1 illus. [Six portraits of the Harvard sculling crew." 10:504 (Aug. 24, 1866): 540.]

W241 Portrait. Woodcut engraving, credited "From a Photograph by Warren." FRANK LESLIE'S ILLUSTRATED NEWSPAPER 29, (1869) ["Prof. J. Dwight Whitney, Pres. of the Am. Philological Assoc." 29:729 (Sept. 18, 1869): 5.]

W242 "New York. - Monument to the Memory of the Late Admiral Farragut in Woodlawn Cemetery, Westchester County. - From a Photograph by Warren." FRANK LESLIE'S ILLUSTRATED NEWSPAPER 35, no. 887 (Sept. 28, 1872): 45. 1 illus.

W243 Portrait. Woodcut engraving, credited "Photographed by Warren, of Boston." FRANK LESLIE'S ILLUSTRATED NEWSPAPER 38, (1874) ["Wendell Phillips." 38:981 (July 18, 1874): 293.]

W244 Portrait. Woodcut engraving, credited "From a Photograph by Warren, of Boston." FRANK LESLIE'S ILLUSTRATED NEWSPAPER 42, (1876) ["Hon. Richard H. Dana, Jr., US Minister to England." 42:1069 (Mar. 25, 1876): 41.]

W245 "Warren's Photographic Studio." ANTHONY'S PHOTOGRAPHIC BULLETIN 8, no. 3 (Mar. 1877): 86. [From "NY Trade Journal."]

W246 Portrait. Woodcut engraving, credited "From a Photograph by Warren, of Boston. FRANK LESLIE'S ILLUSTRATED NEWSPAPER 46, (1878) ["The late Charles Hodge, D.D., LL.D." 46:1188 (July 6, 1878): 309.]

W247 Portrait. Woodcut engraving, credited "From a Photograph by Warren." FRANK LESLIE'S ILLUSTRATED NEWSPAPER 47, (1878) ["Hon. Thomas Talbot, Gov. of MA." 47:1208 (Nov. 23, 1878): 208.]

W248 Portrait. Woodcut engraving credited "From a photograph by Warren, Washington St., Boston." ILLUSTRATED LONDON NEWS 74, (1879) ["Late Mr. Wm. Lloyd Garrison." 74:2086 (June 7, 1879): 537.]

W249 1 engraving (Charles Sumner). COSMOPOLITAN 4, no. 2 (Oct. 1887): 143. 1 illus. ["From a photograph by Warren, Boston."]

WARREN, H. F.
W250 1 photo (General Grant). CENTURY MAGAZINE 53, no. 1 (Nov. 1896): 21. 1 b & w. ["Photograph taken in the field at City Point, Va., by F. H. Warren, March 15, 1865..."]

WARRINGTON, E. F. (d. 1870) (USA)
W251 "Editor's Table." PHILADELPHIA PHOTOGRAPHER 7, no. 77 (May 1870): 182-184 . [Wm. Notman (Montreal); M. Carey Lea; Dr. Woodward; Toronto Photo Soc.; S. W. Sawyer (Bangor, ME), burned out; R. Emery (Plymouth, OH), burned out; M. Moses (Trenton, NJ), burned out; A. E. Alden; F. W. Hardy (Bangor, ME); E. H. Alley (Toledo, OH); W. R. Gill (Lancaster, PA); E. F. Warrington (Philadelphia, PA), died Apr. 22; A. Bogardus; J. A. Schoelton; others mentioned.]

WASHBURN, L. S. (LOUISVILLE, KY)
W252 "Our Picture." PHILADELPHIA PHOTOGRAPHER 9, no. 106 (Oct. 1872): 356-357. 1 b & w.

WASHBURN, WILLIAM WATSON. (ca. 1827-1903) (USA)
[Born ca. 1827 in Peterboro, NH. Brother and partner of Lorenzo S. Washburn (ca. 1822-1907). Operating as a daguerreotype artist in New York, NY in 1849. In November 1849 opened the New York Daguerrean Establishment in New Orleans, LA. Continued as photographer in New Orleans through 1870s. Died in New Orleans on Nov. 15, 1903.]

W253 Portraits. Woodcut engravings, credited "From a Photograph by Washburn." FRANK LESLIE'S ILLUSTRATED NEWSPAPER 33, (1872) ["Hon. George W. Carter, of LA." 33:854 (Feb. 10, 1872): 337. "Hon. Henry C. Warmoth, Gov. of LA." 33:854 (Feb. 10, 1872): 337.]

W254 "Editor's Table." PHILADELPHIA PHOTOGRAPHER 14, no. 162 (June 1877): 192. [W. W. Washburn opened a new gallery in New Orleans, LA.]

W255 "Editor's Table: News." PHILADELPHIA PHOTOGRAPHER 15, no. 171 (Mar. 1878): 95. [W. W. Washburn (New Orleans, LA) praised in "N. O. Commercial." 35 years in photography.]

WASHAM, WILLIAM. (GREAT BRITAIN, GIBRALTAR)
W256 Washam, William. "Development of Gelatino - Bromide Emulsion Plates in Hot Climates." BRITISH JOURNAL PHOTOGRAPHIC ALMANAC 1878 (1878): 100-101.

WASHINGTON, AUGUSTUS. (1820-) (USA, LIBERIA)
BOOKS
W257 "Washington, Augustus," on pp. 6-7 in: Black Photographers, 1840 - 1940. An Illustrated Bio-Bibliography, by Deborah Willis-Thomas. New York: Garland Publishing Co., 1985. [Lists thirteen references from newspapers and books.]

PERIODICALS
W258 White, David O. "Augustus Washington, Black Daguerreotypist of Hartford." CONNECTICUT HISTORICAL SOCIETY BULLETIN. 39, no. 1 (Jan. 1974): 14-19. 1 illus. [Born Trenton, NJ, in early 1820s. Determined to get an education. Studied at the Oneida Institute in Whitestown, NY. Taught in the Public School in Brooklyn, then entered Kimball Union Academy in New Hampshire. Studied daguerreotyping to earn an income. Moved to Hartford, CT in 1844, where he taught in one of the city's Negro schools. Opened a gallery in 1847, left the city in 1848, then returned and ran a gallery there from 1850 to 1854. Washington left for Liberia in 1854, and he took a daguerrean outfit with him. He then operated a studio in Liberia for several years.]

WATERHOUSE, J. (CALCUTTA, INDIA)
BOOKS
W259 Sikandar Begam, Nawab of Bhopal. A Pilgrimage to Mecca,... Translated and edited by Mrs. Willoughby-Osborne... London: W. H. Allen, 1870. 240 pp. 13 b & w. [Autotypes by F. Fitzjames and Capt. Waterhouse.]

W260 Waterhouse, Lieut. J., R.A. Report of the Cartographic Applications of Photography. s. l. [Calcutta ?]: s. n., 1870. 240 pp. [Lieut., later Colonel, Waterhouse was in charge of the photographic department of the Indian Survey at Calcutta for many years. By 1887 he was the Assistant Surveyor-General of India. In 1870 he toured many photo-printing and photoengraving establishments in Europe and wrote this report.]

W261 Waterhouse, J. Report on the Cartographic Applications of Photography as used in the Topographical Departments of the Principal States in Central Europe, with Notes on the European and Indian Surveys. s. l. [Calcutta ?]: s. n., 1870. n. p.

W262 Fergusson, James. Tree and Serpent Worship; Or, Illustrations of Mythology and Art in India in the First and Fourth Centuries after Christ. From the Sculptures of the Buddhist Topes at Sanchi and Amravati. "2nd ed., revised and re-written." London: India Museum, William H. Allen & Co., 1873. 274 pp. 97 l. of plates. b & w illus. [In the "Preface" to the first edition, reprinted here, Fergusson discusses the importance of the photographs to this project, mentions that Mr. Griggs, the photographer attached to the [India?] Museum, London, responsible for the detailed views and that views of certain monuments on site were taken by Lieut. Waterhouse, R.A. (Indian Army). Original prints, mixed with lithographs and engravings.]

W263 Waterhouse, Capt. J. Report on the Operations connected with the observation of the Total Solar Eclipse of April 6th, 1875, at Camorta in the Nicobar Islands. Calcutta: Office of the Superintendent of Government Printing, 1875. n. p. 7 b & w. [Views of the equipment used on the expedition, etc.]

W264 Waterhouse, J. The Application of Photography to the Reproduction of Maps and Plans, by the Photo-Mechanical and Other Processes. s. l.: s. n., 1878. n. p.

W265 Waterhouse, Lieut. J., R.A. *The Application of Photography to the Reproduction of Maps and Plans*. Calcutta: s. n., 1878. n. p. [Reprint of a paper read before the Asiatic Society of Bengal.]

PERIODICALS

W266 Waterhouse, J. "A New Photo-Mechanical Printing Process." ANTHONY'S PHOTOGRAPHIC BULLETIN 3, no. 2 (Feb. 1872): 442-444. [From "Br. J. of Photo."]

W267 Waterhouse, Captain. "A New Photo-Mechanical Printing Method." ANTHONY'S PHOTOGRAPHIC BULLETIN 3, no. 3 (Mar. 1872): 472-473. [From "Photo. News." Waterhouse was the Assistant Surveyor-General of India.]

W268 Waterhouse, Capt. J. "Captain Waterhouse's Photo-Collographic Process." ANTHONY'S PHOTOGRAPHIC BULLETIN 3, no. 9 (Sept. 1872): 667. [From "London Photo. News."]

W269 Waterhouse, Captain. "Photography Abroad: Prints with Iron Salts." PHOTOGRAPHIC TIMES 5, no. 49 (Jan. 1875): 11-12. [From the "Archiv." Cyanotype process.]

W270 Waterhouse, J., Capt., B.S.C. "Coloured Films." BRITISH JOURNAL PHOTOGRAPHIC ALMANAC 1876 (1876): 72-77. [Discusses J. W. Draper (1840s); J. M. Sanders (1860); William Blair (1870); Carey Lea; H. Cooper, Dr. Vogel; Ducos du Hauron; his own work.]

W271 "Photographic Engraving in Half-Tones." ANTHONY'S PHOTOGRAPHIC BULLETIN 9, no. 9 (Sept. 1878): 280-281. [From "Br J of Photo." Capt. J. Waterhouse, B.S.C., Asst. Surveyor-General of India, describes his process.]

W272 "Scientific Research under Difficulties." ANTHONY'S PHOTOGRAPHIC BULLETIN 7, no. 6 (June 1876): 183-184. [From "London Photo. News." Capt. Waterhouse (Calcutta, India) experiences difficulties with heat, humidity, weather, etc.]

W273 Waterhouse, Capt. J. Assistant Surveyor-General of India. "The Ferriscyanide of Lead Intensifier." BRITISH JOURNAL PHOTOGRAPHIC ALMANAC 1877 (1877): 67-69.

W274 Waterhouse, Capt. J., B.S.C. "On the Preparation of Drawings for Photographic Reproduction." BRITISH JOURNAL PHOTOGRAPHIC ALMANAC 1878 (1878): 155-156.

W275 Waterhouse, Capt. J. "Platinum Printing." BRITISH JOURNAL PHOTOGRAPHIC ALMANAC 1879 (1879): 78.

W276 Waterhouse, Major J., B.S.C. "Photo-Lithography and Photo-Zincography." PHOTOGRAPHIC TIMES 12-13, no. 141-156 (Sept. 1882 - Dec. 1883): (vol. 12) 354-363, 398-404, 438-445, 467-472; (vol. 13) 29-32, 75-79, 122-127, 160-165, 210-214, 255-259, 326-330, 479-485, 529-536, 644-650. [Waterhouse was the Asst. Surveyor-General of India.]

W277 Waterhouse, Col. J., B.S.C. "The Bye-Ways of Photography." AMERICAN ANNUAL OF PHOTOGRAPHY AND PHOTOGRAPHIC TIMES ALMANAC FOR 1891 (1891): 42-45.

W278 Waterhouse, Major-General J. "The Teachings of the Daguerreotype. Part 1 - 2." WILSON'S PHOTOGRAPHIC MAGAZINE 37, no. 517-518 (Jan. - Feb. 1900): 34-40, 80-88. [Second J. Trail Taylor Memorial Lecture, read before the Royal

Photographic Society, Nov. 1, 1899. Survey of scientific discoveries in early history. Discusses Talbot, J. W. Draper.]

WATERS, W. R. (DOVER, ENGLAND)
W279 Portrait. Woodcut engraving credited "From a photograph by W. R. Waters." ILLUSTRATED LONDON NEWS 68, (1876) ["Henry Gastineau." 68:1906 (Feb. 5, 1876): 133.]

WATKIN.
W280 Watkin. "Dry Plate Difficulties." HUMPHREY'S JOURNAL OF PHOTOGRAPHY, AND THE ALLIED ARTS AND SCIENCES 13, no. 13 (Nov. 1, 1862): 201-202. [From "Br. J. of Photo."]

WATKINS & HAIGH.
W281 Portrait. Woodcut engraving credited "From a photograph by Herbert Watkins & Haigh, 213 Regent St." ILLUSTRATED LONDON NEWS 63, (1873) ["Sergeant Menzies." 63:1769 (Jul. 26, 1873): 85.]

W282 Portrait. Woodcut engraving credited "From a photograph by Watkins & Haigh." ILLUSTRATED LONDON NEWS 64, (1874) ["Late Mr. Owen Jones." 64:1811 (May 9, 1874): 445.]

WATKINS, ALFRED.
W283 Watkins, Alfred. "Hints for Intending Beginners." BRITISH JOURNAL PHOTOGRAPHIC ALMANAC 1876 (1876): 150-152. ["I have only practiced photography one year,...."]

WATKINS, CARLETON EUGENE. (1829-1916) (USA)
[Born in Oneonta, NY in 1829. Went to California in 1851 or 1852, learned photography at Robert Vance's daguerreotype studio in San Francisco in 1854. By 1861 he had his own studio, but he specialized in views and travelled throughout California. Made his first trip to Yosemite in 1861, and returned many times in the 1860s. In 1867 he photographed the Oregon and Columbia River region. Opened the Yosemite Art Gallery in 1867. Exhibited in the Paris International Exhibition of 1867. Commissioned to photograph the estate of Thurlow Lodge in Menlo Park from 1872 to 1874, Watkins produced a large body of work on this subject. Bankrupt in 1874, his galley and negatives were taken over by I. W. Taber, who printed them throughout the 1870s and 1880s. Watkins continued to photograph into the 1890s, but age and ill health slowed him down. His studio and its contents destroyed in the San Francisco earthquake of 1906. He died in 1916.]

BOOKS

W284 Haller, Douglas M. "'Yosemite Landscape Showing Mount Watkins and Mirror Lake,' 1861, by Carleton E. Watkins, San Francisco," in: *Four Pioneer Photographers in California: Carleton E. Watkins, Arnold Genthe, Charles C. Pierce, Minor White*. San Francisco, CA: California Historical Society, 1986. 4 pp. 4 l. of plates. [Portfolio of four photographs, one by each photographer named, from the photographic collections of the Society. Texts are biographical and critical essays about each photographer in the portfolio.]

W285 Watkins, Carleton E. *Yo-Semite Valley: Photographic Views of the Falls and Valley of Yo-Semite in Mariposa County, California*. San Francisco, CA: Bartling & Kimball, 1863 [1866?]. n. p. 65 l. of plates. 65 b & w. [Album, of original photographs, bound by the publisher. Syracuse Univ. Library.]

W286 California. Geological Survey. *The Yosemite Book; A Description of the Yosemite Valley and the Adjacent Region of the Sierra Nevada, and the Big Trees of California*. New York: Julius Bien, 1868. 116 pp. 28 b & w. [Twenty-four photos by Watkins, four by W. Harris. Edition of 250 copies. NYPL Collection, GEH Collection.]

W287 Whitney, Josiah Dwight, State Geologist. *Geological Survey of California. The Yosemite Book. A Description of the Yosemite Valley and the Adjacent Region of the Sierra Nevada, and of the Big Trees of California. Illustrated by Maps and Photographs.* New York: Julius Bien, 1868. 116 pp. 28 l. of plates. 28 b & w. [Twenty-eight photographs, four by W. Harris, the remainder by Carleton E. Watkins. Photographic edition limited to 250 copies.]

W288 *The Valley of the Grisly Bear.* London: Sampson Low & Marston, 1870. n. p. 100 plus b & w. [Album containing original photographs by Albert Bierstadt and Carleton E. Watkins. (Its unclear from the citation whether this a published album or a compilation.]

W289 Crofutt, George A. *Crofutt's New Overland Tourist and Pacific Coast Guide, Containing a Condensed and Authentic Description of Over One Thousand Two Hundred Cities, Towns, Villages, Stations, Government Fort and Camps, Mountains, Lakes, Rivers, Sulpher, Soda and Hot Springs, Scenery, Watering Places, and Summer Resorts;...While passing Over the Union, Central and Southern Pacific Railroads,... From Sunrise to Sunset, and Part the Way Back Again;... Vol. 1 - 1878-9.* Chicago: The Overland Publishing Co., 1878. 322 pp. illus. ["...illustrated with nearly 100 beautiful engravings, most of which were photographed, designed, drawn, and expressly engraved for the author of this work....engraved by R. S. Bross, of New York, and C. W. Chandler, of Ravenswood, Illinois,...The photographs were by Savage, of Salt Lake City, and Watkins and Houseworth, of San Francisco. All these artists, we take pleasure in recommending."]

W290 Bentley, William R. *Bentley's Handbook of the Pacific Coast; Containing a Complete List of the Prominent Seaside and Mountain Resorts, Mineral Springs, Lakes, Mountains, Valleys, Forests, and Other Places and Objects of Interest on the Pacific Coast.* Oakland: Pacific Press, 1884. n. p. 31 b & w. [Original photographs by C. E. Watkins.]

W291 *The Hearst Collection of Photographs by Carleton E. Watkins, Pioneer Pacific Coast Photographer.* Berkeley, CA: University of California, 1956. 8 pp. [Exhibition checklist, Apr. 1956.]

W292 Johnson, J. W. *The Early Pacific Coast Photographs of Carleton E. Watkins.* "Water Resources Center Archive Series, Report No. 8" Berkeley, CA: University of California, Water Resources Center, 1960. 64 pp. b & w.

W293 Alinder, James, ed. Essays by David Featherstone and Russ Anderson. *Carleton E. Watkins: Photographs of the Columbia River and Oregon.* Carmel, CA: Friends of Photography, in association with the Weston Gallery, Carmel, 1979. 136 pp. 51 b & w. 8 illus.

W294 Sexton, Nanette. *Carleton E. Watkins: Pioneer California Photographer.* Cambridge, MA: Harvard University, 1982. n. p. illus. [Ph.D. Dissertation, Harvard University, 1982]

W295 Fels, Thomas Weston. *Carleton Watkins: Photographer - Yosemite and Mariposa Views from the Collection of the Park-McCullough House, North Bennington, Vermont.* Williamstown, MA: Sterling and Francine Clark Art Institute, 1983. 42 pp. 14 b & w. [Introduction by Rafael Fernandez.]

W296 *Carleton E. Watkins: Photographer of the American West.* Fort Worth, TX: Amon Carter Museum, 1983. 1 l. pp. 6 b & w. [Illustrated guide to the exhibition, first displayed at the Amon Carter Museum, Fort Worth, TX, then travelled. One sheet, folded into 16 sections, with a biographical essay, a chronology, and six reproductions of Watkins' views.]

W297 Palmquist, Peter E. *Carleton E. Watkins: Photographer of the American West.* Albuquerque, NM: University of New Mexico Press, 1983. 235 pp. 113 b & w. 68 illus. [With a foreword by Martha A. Sandweiss.]

W298 Dimock, George. *Exploiting the View: Photographs of Yosemite & Mariposa by Carleton Watkins.* North Bennington, VT: Park-McCullough House, 1984. 32 pp. 8 b & w. [Exhibition: July 8 - Sept. 28, 1984]

W299 *Carleton E. Watkins. Photographs 1861 - 1874.* Essay by Peter E. Palmquist. San Francisco, CA: Fraenkel Gallery, in association with Bedford Arts, Publishers, 1989. 222 pp. 110 b & w.

PERIODICALS

W300 "Views in the Yosemite Valley." PHILADELPHIA PHOTOGRAPHER 3, no. 28 (Apr. 1866): 106-107. [Review of Watkins' photographs.]

W301 "California Photographs." HUMPHREY'S JOURNAL OF PHOTOGRAPHY, AND THE ALLIED ARTS AND SCIENCES 18, no. 2 (May 15, 1866): 21. [Review of an album of twenty prints 17"x22", of the Yo Semite Valley and elsewhere.]

W302 Morton, Rev. H. J., D.D. "Yosemite Valley." PHILADELPHIA PHOTOGRAPHER 3, no. 36 (Dec. 1866): 376-379. [Description of the views.]

W303 "The Valley of the Grisly Bear." ART JOURNAL (Aug. 1870): 252. [Yosemite Valley photos described, then mentioned again on page 291 in September 1, 1970 "Art Journal" as giving credence to Albert Bierstadt's paintings.]

W304 Advertisement "Stereoscopic Views: Watkin's Photographic Gallery." on p. xxviii of the advertising section. CALIFORNIA MAIL BAG 1, no. 3 (Aug. 1871): advertising section, p. xxviii.

W305 "The Four Modoc Indians Executed at Fort Klamath, Oregon, Friday, October 3d. - From Photographs by C. F. Watkins." FRANK LESLIE'S ILLUSTRATED NEWSPAPER 37, no. 942 (Oct. 18, 1873): 96. 4 illus. [These are actually republications of the portraits of Captain Jack, etc. published earlier.]

W306 "Editorial Table - Watkins' Stereos." PHILADELPHIA PHOTOGRAPHER 11, no. 123 (Mar. 1874): 96.

W307 "The Eucalyptus, or Fever Tree. Photographed by C. E. Watkins, San Francisco." FRANK LESLIE'S ILLUSTRATED NEWSPAPER 38, no. 969 (Apr. 25, 1874): 108. 1 illus. [Tree in a yard, before a house.]

W308 "Nevada. - The Source of Our Silver Wealth - Panoramic View of Virginia City, Showing the Great Bonanza Mines on the Comstock Load, Including the Consolidated Virginia, the California, the Ophir, the Gould & Curry, the Hale & Norcross, the Savage, Etc. - From Photographs by Watkins, of San Francisco, Cal." FRANK LESLIE'S ILLUSTRATED NEWSPAPER 45, no. 1170 (Mar. 2, 1878): n. p. [4 l. foldout.]. 1 illus. ["Supplement Gratis with No. 1,170 of "Frank Leslie's Illustrated Newspaper." (In this copy, bound into the August issue.) This is a large, four page foldout, with a view of Virginia City, NV.]

W309 Turrill, Charles B. "An Early California Photographer: C. E. Watkins." NEWS NOTES OF CALIFORNIA LIBRARIES 13, no. 1 (Jan. 1918): 29-37.

W310 Anderson, Ralph H. "Carleton E. Watkins." YOSEMITE NATURE NOTES 32, no. 4 (1953): *.

W311 Giffen, Helen S. "Carleton E. Watkins, California's Expeditionary Photographer." EYE TO EYE no. 6 (Sept. 1954): 26-32.

W312 Kearful, Jerome. "Carleton E. Watkins: Pioneer California Photographer." WESTWAYS 47, no. 5 (May 1955): 26-27. 5 b & w.

W313 Parker, Alice Lee. "Photographs and Negatives." QUARTERLY JOURNAL OF THE LIBRARY OF CONGRESS 13, no. 1 (Nov. 1955): 54-55. [Thirty-three photographs by Watkins, of the Yosemite Valley, in the collections.]

W314 Hemmingsson, Per. "Carleton E. Watkins - Natur-fotograf; Storformat." FOTOGRAFISK ARSBOK 1969 (1969): 54-60. 5 b & w.

W315 Wollenberg, Charles. "Reviews: Pictorial Resources: Carleton E. Watkins Photographs." CALIFORNIA HISTORICAL QUARTERLY 53, no. 1 (Spring 1974): 83-86. 4 b & w. [Ex. Note: "Carleton E. Watkins," Focus Gallery, San Francisco, CA.]

W316 Millard, Charles W. "An American Landscape." PRINT COLLECTORS NEWSLETTER 7, no. 2 (May - June 1976): 47-48. 1 b & w.

W317 Hickman, Paul Addison. "Carleton E. Watkins, 1829 - 1916." NORTHLIGHT (ARIZONA STATE UNIVERSITY) no. 1 (Jan. 1977): 1-41.

W318 Hill, Eric. "Carleton E. Watkins." STEREO WORLD 4, no. 1 (Mar. - Apr. 1977): 4-5. 3 b & w.

W319 Doherty, Amy S. "Carleton E. Watkins, Photographer: 1829-1916." THE COURIER: SYRACUSE UNIVERSITY LIBRARY ASSOCIATES 15, no. 4 (1978): 3-20, plus cover. 5 b & w. [Thorough description of Watkins' career and practices, as well as a general background of events that led to his making an album of sixty-five photographs of views in Yosemite, published in 1865, now in the collections of the Syracuse University research library. The article also contains a description and plate list of the album.]

W320 Weinstein, Robert A. "North from Panama, Went to the Orient, The Pacific Mail Steamship Company, As Photographed by Carleton E. Watkins." CALIFORNIA HISTORY 57, no. 1 (Spring 1978): 46-57. 9 b & w. 1 illus.

W321 "Special Issue: Carleton E. Watkins." CALIFORNIA HISTORY 57, no. 3 (Fall 1978): 210-270. 50 b & w. 14 illus. ["Carleton E. Watkins, Pioneer Photographer" pp. 210-216; "Watkins and the Historical Record," by Richard Rudisill, pp. 216-219; "Before Yosemite Art Gallery: Watkin's Early Career," by Pauline Brenbeaux, pp. 220-229; "The Maripose Views" pp. 230-235; "The Yosemite Views," pp. 236-241; "Watkin's Style and Technique in the Early Photographs," by Nanette Sexton, pp. 242-251; "Watkins - the Photographer as Publisher," by Peter E. Palmquist pp. 252-257; "After 1875: Watkin's Mature Years," pp. 258-263; "A Watkins Chronology," pp. 264-265; "Watkin's Photographs in the California Historical Society Library," by Laverne Mau Dickee, pp. 266-267; "Notes" pp. 268-270.]

W322 Lifson, Ben. "Photography: Notes for a Historical Fantasy." VILLAGE VOICE (Oct. 23, 1978): 112.

W323 Coplans, John. "C. E. Watkins at Yosemite." ART IN AMERICA 66, no. 6 (Nov. - Dec. 1978): 100-108. 7 b & w.

W324 Lifson, Ben. "Photography: Tales without Morals. III. The Ambiguous Apotheosis of Carleton E. Watkins." VILLAGE VOICE (May 21, 1979): 101. [Discussion of sale of two albums of Watkins' views by the Swann Galleries on May 10th.]

W325 "News Notes: Watkins Albums Sell For Record Price." AFTERIMAGE 7, no. 3 (Oct. 1979): 21.

W326 Schiffman, Amy M. "Gallery: Carleton E. Watkins." AMERICAN PHOTOGRAPHER 3, no. 4 (Oct. 1979): 74. 1 b & w. [Ex. notice: Fraenkel Gallery and Simon Lowinsky Gallery, San Francisco, CA.]

W327 Murray, Joan. "Carleton Watkins, New Discoveries." ARTWEEK 11, no. 8 (Mar. 1, 1980): 13. 1 b & w. [Fifteen Watkins photos taken in 1861 found by Peter Palmquist in Bancroft Library.]

W328 Palmquist, Peter E. "What Price Success? The Life and Photography of Carleton E. Watkins." AMERICAN WEST 17, no. 4 (July - Aug. 1980): frontispiece, 14-29, 66-67. 22 b & w.

W329 Palmquist, Peter E. "Carleton E. Watkins: A Checklist of Surviving Photographically Illustrated Books and Albums." THE PHOTOGRAPHIC COLLECTOR 2, no. 1 (Spring 1981): 4-12. 6 b & w. 1 illus.

W330 Palmquist, Peter E. "Carleton E. Watkin's oldest surviving landscape photograph." HISTORY OF PHOTOGRAPHY 5, no. 3 (July 1981): 223-224. 1 b & w. [Two-part panorama, taken ca. Aug. 1858]

W331 Palmquist, Peter E. "Taber Reprints of Watkin's Mammoth Plates." THE PHOTOGRAPHIC COLLECTOR 3, no. 2 (Summer 1982): 12-20. 5 b & w.

W332 Palmquist, Peter E. "Carleton E. Watkins at Work (A Pictorial Inventory of Equipment and Landscape Technique used by Watkins in the American West, 1854 - 1900)." HISTORY OF PHOTOGRAPHY 6, no. 4 (Oct. 1982): 291-325. 32 b & w. 6 illus.

W333 Sandweiss, Martha A. "To Look On, To Analyze, To Explain Matters to Myself." JOURNAL OF AMERICAN CULTURE 5, no. 4 (Winter 1982): *. [Explores the parallels between the work of a photographer and the historian. Includes an extended discussion of the Carleton Watkins photograph "Wreck of the Viscata."]

W334 Palmquist, Peter E. "Watkins's New Series Stereographs, Part I." THE PHOTOGRAPHIC COLLECTOR 3, no. 4 (Winter 1982/1983): 10-20. 9 b & w. 1 illus.

W335 Street, Richard Steven. "A Kern County Diary: The Forgotten Photographs of Carleton E. Watkins, 1881 - 1888." CALIFORNIA HISTORY 61, no. 4 (Winter 1983): 243-263. 26 b & w.

W336 Palmquist, Peter E. "Views to Order. Carleton Watkins: Life and Art." PORTFOLIO: THE MAGAZINE OF THE FINE ARTS (Mar. - Apr. 1983): 84-91. 11 b & w.

W337 Palmquist, Peter E. "Watkins' E-Series: The Columbia River Gorge and Yellowstone." STEREO WORLD 10, no. 1 (Mar. - Apr. 1983): 4-14. 18 b & w. [Brief summation of Watkins' forth trip to the northwest in 1883-1884. Checklist of Watkins' E-Series Stereographs: Oregon, Idaho (?) and Yellowstone, 1884-85. (43 views listed).]

W338 Palmquist, Peter E. "Watkins's New Series Stereographs, Part II." THE PHOTOGRAPHIC COLLECTOR 4, no. 1 (Spring 1983): 28-39. 18 b & w.

W339 Haller, Douglas M. "CHS Collection Represented in Watkins' Photography Exhibit." CALIFORNIA HISTORICAL COURIER 35, no. 2 (Apr. 1983): 10-11. 7 b & w. [Discusses the fourteen photographs from the California Historical Society's collections in the Watkins' exhibit, organized by the Amon Carter Museum.]

W340 Haller, Douglas M. "An Addition and Amplification." CALIFORNIA HISTORICAL COURIER 35, no. 3 (June 1983): 2. 1 b & w. [Discusses a Watkins' portrait, now correctly identified as an Japanese Ambassador, Tomomi Iwakura, visiting San Francisco in 1872.]

W341 Palmquist, Peter E. "Watkins's New Series Stereographs, Part III." THE PHOTOGRAPHIC COLLECTOR 4, no. 2 (Summer 1983): 18-27. 16 b & w.

W342 Palmquist, Peter E. "'Second to None' Carleton Watkins, Photographer of the American West." THE MUSEUM OF CALIFORNIA JOURNAL 7, no. 3 (Nov. - Dec. 1983): 4-7, plus cover. 6 b & w.

W343 Hickman, Paul Addison. "Carleton E. Watkins and His Modern Interpreters." AFTERIMAGE 11, (Dec. 1983): 6-7. * b & w.

W344 Solomon-Godeau, Abigail. "Books in Review: REviewing the View: Carleton E. Watkins Redux." PRINT COLLECTOR'S NEWSLETTER 15, no. 2 (May - June 1984): 70-74. 4 b & w. [Review of several books on Watkins.]

W345 Fletcher, Stephen J. "Watkins' Stereographs." CALIFORNIA HISTORICAL COURIER 38, no. 5 (Dec. 1986 - Jan. 1987): 6-7. 3 b & w. [Fifty-nine Watkins' stereos added to the California Historical Society Collection. Essay discusses the collection and the additions.]

W346 Palmquist, Peter E. "'It Is As Hot As H—-' Carleton E. Watkins's Photographic Excursion Through Southern Arizona, 1880." JOURNAL OF ARIZONA HISTORY 28, no. 4 (Winter 1987): 353-372. 17 b & w. 1 illus. [In 1880 Watkins photographed along the line of the Southern Pacific R. R. in southern California and Arizona.]

W347 Palmquist, Peter E. "Chapter 1: Oneonta, New York 1829-1851," and "Chapter 2: California, 1851-1854." THE PHOTOGRAPHIC HISTORIAN 8, no. 4 (Winter 1987/88): 1-10, 17-26. 12 illus. [First and second chapters in C. E. Watkin's biography, The first part offers details his family background, and his childhood years until he left for California at age 21 in 1851. Part two describes his early years in California.]

WATKINS, CHARLES. (LONDON, ENGLAND)
W348 Portrait. Woodcut engraving, credited to "From a Photograph by Charles Watkins, Chancery Lane, London." ILLUSTRATED LONDON NEWS 60, (1872) ["Late Charles Lever." 60:1710 (June 15, 1872): 581.]

W349 Portrait. Woodcut engraving credited "From a photograph by Charles Watkins." ILLUSTRATED LONDON NEWS 61, (1872) ["Late Richard Lane, A.R.A." 61:1735 (Dec. 7, 1872): 548.]

W350 Portrait. Woodcut engraving credited "From a photograph by Charles Watkins." ILLUSTRATED LONDON NEWS 65, (1874) ["Late Mr. Tom Hood." 65:1840 (Nov. 28, 1874): 521.]

W351 Portrait. Woodcut engraving credited "From a photograph by Charles Watkins, 34 Parliament St., Westminster." ILLUSTRATED LONDON NEWS 66, (1875) ["Mr. Justice Field." 66:1854 (Feb. 20, 1875): 181.]

W352 Portraits. Woodcut engravings credited "From a photograph by Charles Watkins." ILLUSTRATED LONDON NEWS 68, (1876) ["Late Canon Conway." 68:1914 (Apr. 1, 1876): 325. "Mr. Edwin Long, A.R.A." 68:1919 (May 6, 1876): 437. "Late Mr. Thornbury." 68:1926 (June 24, 1876): 613.]

W353 Portrait. Woodcut engraving credited "From a photograph by Charles Watkins." ILLUSTRATED LONDON NEWS 69, (1876) ["Late Mr. Noble, sculptor." 69:1928 (July 8, 1876): 37.]

W354 Portraits. Woodcut engravings credited "From a photograph by Charles Watkins." ILLUSTRATED LONDON NEWS 70, (1877) ["Late Sir Augustus Clifford." 70:1963 (Feb. 24, 1877): 181. "Kuo-Ta-Jen and Liu-Ta-Jen, Chinese Ministers to London." 70:1963 (Feb. 24, 1877): 185.]

W355 Portrait. Woodcut engraving credited "From a photograph by Charles Watkins, Ludgate Hill." ILLUSTRATED LONDON NEWS 72, (1878) ["Late Mr. Thomas Wright, F.S.A." 72:2011 (Jan. 12, 1878): 41.]

W356 Portrait. Woodcut engraving credited "From a photograph by Charles Watkins." ILLUSTRATED LONDON NEWS 73, (1878) ["Late Charles Mathews." 73:2036 (July 6, 1878): 4.]

W357 Portrait. Woodcut engraving credited "From a photograph by Watkins." ILLUSTRATED LONDON NEWS 74, (1879) ["Late Charles Baxter." 74:2067 (Jan. 25, 1879): 72.]

W358 Portrait. Woodcut engraving credited "From a photograph by Charles Watkins, Torraino Ave., Camden Rd." ILLUSTRATED LONDON NEWS 75, (1879) ["Late Mr. C. Landseer, R.A." 75:2094 (Aug. 2, 1879): 109.]

WATKINS, HERBERT. (LONDON, ENGLAND)
BOOKS
W359 *The National Gallery of Photographic Portraits*, by Herbert Watkins, with notices by Herbert Fry. London: H. Watkins, 1857-1858. n. p. b & w. [A "photographic portrait serial," typical of several such issued during the 1850s and 1860s. Individual portraits, each with a letterpress biography, etc., issued in series of usually four or five individuals at a time, then often bound or reissued as a bound volume. Begun late in 1857, apparently only ten issues were published.]

PERIODICALS
W360 "Fine-Art Gossip." ATHENAEUM no. 1543 (May 23, 1857): 668. [Note that Herbert Fry and Herbert Watkins have commenced a 'National Gallery of Photographic Portraits.' Apparently, with commentary by Mr. Fry; Watkins was a photographer.]

W361 Portrait. Woodcut engraving credited "From a photograph by Herbert Watkins." ILLUSTRATED LONDON NEWS 31, (1857) ["Mdlle. Victoria Balfe, Royal Italian Opera." 31:* (Aug. 1, 1857): 116.]

W362 Portraits. Woodcut engravings credited "From a photograph by Herbert Watkins." ILLUSTRATED LONDON NEWS 32, (1858) ["Sir Wm. Jolliffe, Sec. to Treasury." 32:* (Mar. 27, 1858): 312. "Miss Amy Sedgwick, actress." 32:* (Apr. 10, 1858): 368. "Earl Stanhope." 32:* (Apr. 17, 1858): 401. "Group portrait, band of the Paris Garde

Nationale." 32:* (May 22, 1858): 508. "Major H. F. Saunders, 70th Regiment." 32:* (June 5, 1858): 552.]

W363 "Fine-Art Gossip." ATHENAEUM no. 1596 (May 29, 1858): 694. [Compares "Photographic Portraits of Living Celebrities," with biographical notices by C. Watford, M.A., published by Maull & Polyblank with "The National Gallery of Photographic Portraits," with notices by Herbert Fry, photos by Herbert Watkins.]

W364 "Statue of Her Majesty in the Vestibule of the Town Hall, Leeds." ILLUSTRATED NEWS OF THE WORLD AND DRAWING ROOM PORTRAIT GALLERY OF EMINENT PERSONAGES 1, no. 34 (Sept. 25, 1858): 193. 1 illus.

W365 Portraits. Woodcut engravings credited "From a photograph by Herbert Watkins." ILLUSTRATED LONDON NEWS 35, (1859) ["Jacques Fosse." 35:* (July 16, 1859): 47. "John Phillip, Esq., R.A." 35:* (Dec. 10, 1859): 543. "Hon. Mr. Justice Crowder." 35:* (Dec. 17, 1859): 586.]

W366 Portraits. Woodcut engravings credited "From a photograph by Herbert Watkins." ILLUSTRATED LONDON NEWS 36, (1860) ["Viscount Palmerston." 36:* (Jan. 21, 1860): 49. "Henry O'Neil." 36:* (Feb. 25, 1860): 180. "Lord Brougham and Vaux." 36:* (May 26, 1860): 489. "Sir Charles Barry." 36:* (June 2, 1860): 513. "Miss Augusta Thomson." 36:* (June 30, 1860): 620.]

W367 Portraits. Woodcut engravings credited "From a photograph by Herbert Watkins." ILLUSTRATED LONDON NEWS 37, (1860) ["Antonio Guiglini, singer." 37:* (July 28, 1860): 74. "Mr. F. W. Bowlby, "Times" correspondent." 37:* (Dec. 29, 1860): 615.]

W368 Portraits. Woodcut engravings credited "From a photograph by Herbert Watkins." ILLUSTRATED LONDON NEWS 38, (1861) ["Michael Faraday." 38:8 (Jan. 12, 1861): 28. "Mrs. Gore, author." 38:* (Feb. 16, 1861): 147.]

W369 Portrait. Woodcut engraving credited "From a photograph by Herbert Watkins." ILLUSTRATED LONDON NEWS 39, (1861) ["Miss Emily Faithful, social reformer." 39:* (Nov. 30, 1861): 538.]

W370 Portrait. Woodcut engraving credited "From a photograph by Herbert Watkins." ILLUSTRATED LONDON NEWS 41, (1862) ["Capt. Williams, prizewinning rifleman." 41:* (Aug. 2, 1862): 129.]

W371 Portraits. Woodcut engravings credited "From a photograph by Herbert Watkins." ILLUSTRATED LONDON NEWS 42, (1863) ["Marquis of Lansdowne.' 42:* (Feb. 14, 1863): 173. "Sir George Cornewall Lewis." 42:* (Apr. 25, 1863): 453.]

W372 Portraits. Woodcut engravings credited "From a photograph by Herbert Watkins." ILLUSTRATED LONDON NEWS 43, (1863) ["Sir Joshua Jebb." 43:* (July 11, 1863): 36. "Sergeant Roberts, 19th Shropshire Rifles." 43:* (July 25, 1863): 89. "Lord Lyndhurst." 43:* (Oct. 24, 1863): 417. (From "Herbert Fry's National Gallery of Photographic Portraits.")]

W373 Portraits. Woodcut engravings credited "From a photograph by Herbert Watkins." ILLUSTRATED LONDON NEWS 45, (1864) ["Frederick Robson." 45:* (Aug. 27, 1864): 208. "Walter Savage Landor." 45:* (Oct. 15, 1864): 385.]

W374 Portraits. Woodcut engravings credited "From a photograph by Herbert Watkins." ILLUSTRATED LONDON NEWS 47, (1865)

["Private Sharman, 4th West York Rifles." 47:* (July 29, 1865): 93. "Judge Haliburton." 47:* (Sept. 9, 1865): 245.]

W375 Portrait. Woodcut engraving credited "From a photograph by Herbert Watkins, of Regent St." ILLUSTRATED LONDON NEWS 49, (1866) ["Angus Cameron, champion rifleman." 49:* (July 28, 1866): 93.]

W376 Portrait. Woodcut engraving credited "From a photograph by Herbert Watkins." ILLUSTRATED LONDON NEWS 51, (1867) ["Sergeant Lane, Winner of the Queen's Prize." 51:* (July 27, 1867): 101.]

W377 Portrait. Woodcut engraving credited "From a photograph by Herbert Watkins." ILLUSTRATED LONDON NEWS 58, (1870) ["Mr. Humphries, 6th Surrey Rifle Volunteers." 58:* (July 30, 1870): 129.]

W378 Portrait. Woodcut engraving credited "From a photograph by Herbert Watkins, Regent St." ILLUSTRATED LONDON NEWS 61, (1872) ["Mr. Michie, Winner Wimbleton shooting contest." 61:1716 (July 27, 1872): 84.]

W379 Portrait. Woodcut engraving credited "From a photograph by Herbert Watkins." ILLUSTRATED LONDON NEWS 65, (1874) ["Late Bryan W. Procter (Barry Cornwall)." 65:1833 (Oct. 10, 1874): 353.]

W380 Portraits. Woodcut engravings credited "From a photograph by Herbert Watkins." ILLUSTRATED LONDON NEWS 66, (1875) ["Prof. George A. McFarren, Prof. of Music." 66:1863 (Apr.)]

W381 Portraits. Woodcut engravings credited "From a photograph by Herbert Watkins, Torriano Ave., Camden Rd." ILLUSTRATED LONDON NEWS 66, (1875) ["Prof. George A. MacFarren, Prof. of Music." 66:1863 (Apr. 24, 1875); 393. "Late Count Brunnow." 66:1864 (May 1, 1875): 417.]

WATKINS, JOHN & CHARLES WATKINS. (LONDON, ENGLAND)

W382 Portraits. Woodcut engravings credited "From a photograph by John & Charles Watkins, Parliament St." ILLUSTRATED LONDON NEWS 38, (1861) ["Charles Francis Adams, U.S. Minister to Great Britain." 38:* (June 15, 1861): 541.]

W383 Portraits. Woodcut engravings credited "From a photograph by John & Charles Watkins, Parliament St." ILLUSTRATED LONDON NEWS 39, (1861) ["John Laird." 39:* (July 27, 1861): 75. "Earl of Eglington And Winton." 39:* (Oct. 19, 1861): 394.]

W384 Portraits. Woodcut engravings credited "From a photograph by John & Charles Watkins." ILLUSTRATED LONDON NEWS 40, (1862) ["Lord Dufferin, Earl of Shelburne, Hon. W. H. B. Portman, Mr. Western Wood." (4 portraits) 40:* (Feb. 15, 1862): 175. "Earl Granville, Sir C. Wentworth Dilke, John Fairbairn, Commissioners of International Exhibition of 1862." 40:* (Mar. 1, 1862): 215. "Mr. F. R. Sanford, Esq." 40:* (Mar. 22, 1862): 282. "Captain Fowke, R.E." 40:* (May 3, 1862): 431. "John G. Grace, Supt. of 1862 International Exhibition." 40:* (May 24, 1862): 535. "Giacomo Meyerbeer." 40:* (May 31, 1862): 550. "Professor Sterndale Bennett." 40:* (May 31, 1862): 551.]

W385 Portraits. Woodcut engravings credited "From a photograph by John & Charles Watkins, Parliament St." ILLUSTRATED LONDON NEWS 41, (1862) ["Lord Portman, Royal Agricultural Soc." 41:* (July 12, 1862): 57. "Archbishop of Canterbury." 41:* (Sept. 20, 1862): 301.]

W386 Portraits. Woodcut engravings, credited "Photographed by John & Charles Watkins." ILLUSTRATED LONDON NEWS 42, (1863) ["Earl of Granard, Earl of Dudley, Mr. Bazley, Mr. Calthorpe (4 portraits)." 42:* (Feb. 14, 1863): 181. "Lieut.-Gen. Sir James Outram, Bart." 42:* (Apr. 4, 1863): 376. "Members of Prince of Wales' Council: Sir C. B. Phipps, Lord Portman, Sir W. J. Alexander, Lieut.-Gen. Knollys, Duke of Newcastle, Sir W. Dunbar (6 portraits)." 42:* (Apr. 11, 1863): 400. "Earl de Gray and Ripon." 42:* (May 9, 1863): 513.]

W387 Portraits. Woodcut engravings, credited "Photographed by John & Charles Watkins." ILLUSTRATED LONDON NEWS 43, (1863) ["William Boxall, Henry Weekes, Frederick Goodall, Henry Le Jeune, Royal Academicians." 43:* (June 25, 1863): 80. "Sir James Plaisted Wilde." 43:* (Sept. 26, 1863): 320. "Robert Porrett Collier, Esq., M.P." 43:* (Oct. 17, 1863): 393. "Sir Roundell Palmer, M.P." 43:* (Oct. 24, 1863): 421. "Hon. Mr. Baron Pigott." 43:* (Oct. 31, 1863): 433.]

W388 Portraits. Woodcut engravings, credited "Photographed by John & Charles Watkins." ILLUSTRATED LONDON NEWS 44, (1864) ["Hon. William Shee." 44:* (Jan. 2, 1864): 12. "Very Rev. Arthur P. Stanley, D.D." 44:* (Jan. 30, 1864): 112. "Marquis of Sligo; Lord Abercromby, Lord Richard Grosvenor, Mr. Göschen (4 portraits)." 44:* (Feb. 13, 1864): 144. "W. Hunt, painter." 44:* (Feb. 20, 1864): 181. "W. Dyce, Esq., R.A." 44:* (Mar. 5, 1864): 224. "Guard of the British Legation of Pekin (group portrait)." 44:* (Mar. 12, 1864): 256. "T. P. Cooke." 44:* (Apr. 16, 1864): 369. "Alaric Alexander Watts." 44:* (May 7, 1864):449. "Right Rev. Dr. Browne." 44:* (May 14, 1864): 477. "Sir Rowland Hill, Sec. of the Post Office." 44:* (May 21, 1864): 496. "Right Rev. Francis Jeune, D.D." 44:* (May 28, 1864): 512.]

W389 Portraits. Woodcut engravings, credited "Photographed by John & Charles Watkins. ILLUSTRATED LONDON NEWS 45, (1864) ["Edward William Watkin, M.P." 45:* (July 23, 1864): 93. "F. Leighton, E. W. Cooke, E. B. Stephens, P. H. Calderon, members of the Royal Academy." 45:* (Aug. 13, 1864): 173. "J. R. McCulloch." 45:* (Nov. 26, 1864): 541. "David Roberts, R.A." 45:* (Dec. 10, 1864): 580. "J. C. Horsley, R.A." 45:* (Dec. 31, 1864): 677.]

W390 Portraits. Woodcut engravings, credited "Photographed by John & Charles Watkins." ILLUSTRATED LONDON NEWS 46, (1865) ["Lord Houghton, Earl of Charlemont, Charles Douglas Richard Hanbury-Tracy, Sir Hedworth Williamson." 46:* (Feb. 18, 1865): 165. "Right Hon. Edward Cardwell, M.P." 46:* (Mar. 18, 1865): 252. "John Hawkshaw, C.E." 46:* (Mar. 18, 1865): 253. "J. G. Dodson, Esq., M.P." 46:* (Mar. 25, 1865): 272. "John F. Lewis, Esq., R.A." 46:* (Mar. 25, 1865): 285. "Most Rev. Dr. Manning." 46:* (June 10, 1865): 557.]

W391 Portraits. Woodcut engravings, credited "Photographed by John & Charles Watkins." ILLUSTRATED LONDON NEWS 47, (1865) ["Right Rev. Dr. Jacobson." 47:* (Sept. 2, 1865): 217. "Judge Justice Lush." 47:* (Nov. 25, 1865): 513. "Professor David Masson." 47:* (Dec. 2, 1865): 537.]

W392 "Note." ART JOURNAL (Dec. 1865): 382. [" The list of Photographic portraits issued by J & C Watkins is really a remarkable 'document'."]

W393 Portraits. Woodcut engravings, credited "Photographed by John & Charles Watkins." ILLUSTRATED LONDON NEWS 48, (1866) ["Mr. E. J. Reed, Chief Constructor of the Navy." 48:* (Jan. 6, 1866): 4. "Marquis of Normanby, Earl of Morley, Lord F. Cavendish, Mr. W. Graham (4 portraits)." 48:* (Feb. 10, 1866): 144. "Thomas Hughes, M.P." 48:* (Feb. 17, 1866): 165. "Sir William Fergusson, Bart., F.R.S."

48:* (Feb. 24, 1866): 176. "Sir Roderick Murchison." 48:* (Mar. 10, 1866): 237. "Right Hom. C. Fortescue, M.P." 48:* (Mar. 17, 1866): 252. "Marie Amelie D'Orleans, Ex-Queen of the French." 48:* (Mar. 31, 1866): 305. "Mr. W. E. Forster, M.P." 48:* (Mar. 31, 1866): 313. "General Sir John Fox Burgoyne, Bart." 48:* (Apr. 28, 1866): 413. "George Edmund Street, A.R.A.; Joseph Durham, A.R.A." 48:* (June 9, 1866): 560.]

W394 Portraits. Woodcut engravings, credited "Photographed by John & Charles Watkins." ILLUSTRATED LONDON NEWS 49, (1866) ["Bridesmaids of Princess Helena (8 portraits)." 49:* (July 14, 1866): 36. "George Richmond, Esq., R.A." 49:* (Sept. 1, 1866): 216. "Marquis of Abercorn" 49:* (Sept. 8, 1866): 233. "Right Hon. Sir Hugh Cairns." 49:* (Oct. 27, 1866): 413. "Sir Frederick Pollock." 49:* (Nov. 3, 1866): 424. "Right Hon. Sir Fitzroy Kelly." 49:* (Nov. 17, 1866): 472. "Sir James Lewis Knight Bruce." 49:* (Nov. 17, 1866): 485. "Sir John Bolt." 49:* (Dec. 29, 1866): 648. "Sir John B. Karslake." 49:* (Dec. 29, 1866): 649.]

W395 Portraits. Woodcut engravings, credited "Photographed by John & Charles Watkins." ILLUSTRATED LONDON NEWS 50, (1867) ["Right Hon. Seymour Fitzgerald." 50:* (Feb. 2, 1867):117. "Sir William Lawrence, Bart., Queens Serjeant-Surgeon." 50:* (Apr. 27, 1867): 424. "Clarkson Stanfield, R.A." 50:* (June 1, 1867): 545. "E. H. Baily, R.A." 50:* (June 8, 1867): 569. "Right Rev. T. L. Claughton, Bishop of Rochester." 50:* (June 15, 1867): 592.]

W396 Portraits. Woodcut engravings, credited "Photographed by John & Charles Watkins." ILLUSTRATED LONDON NEWS 51, (1867) ["Thomas Sidney Cooper, R.A." 51:* (July 6, 1867): 5. "John Henry Robinson." 51:* (Aug. 3, 1867): 116. "Earl Brownlow, Lord Hylton, W. Hart Dyke, Lieut.-Col. Hogg." 51:* (Dec. 7, 1867): 609.]

WATKINS, JOHN. (d. 1875) (GREAT BRITAIN)

W397 Portraits. Woodcut engravings credited "From a photograph by John Watkins." ILLUSTRATED LONDON NEWS 28, (1856) ["Picco, the Sardinian Minstrel." 28:8 (Mar. 15, 1856): 268. "Major-General Sir William Williams, K.C.B." 28:* (June 28, 1856): 697.]

W398 Portraits. Woodcut engravings credited "From a photograph by John Watkins." ILLUSTRATED LONDON NEWS 29, (1856) ["Col. Atwell Lake, C.B." 29:* (Aug. 2, 1856): 126. "Lieut.-Col. Treesdale, C.B." 29:* (Aug. 2, 1856): 126. "Don Victor Herran, Honduras Minister." 29:* (Aug. 30, 1856): 210. "Count de Chreptowitch, Russian Ambassador." 29:* (Oct. 11, 1856): 378. "Very Rev. Dr. Richard C. Trench." 29:* (Nov. 8, 1856): 474. "Right Rev. Dr. Longley." 29:* (Nov. 29, 1856): 539. "Miss E. S. Northcote, blind musician." 29:* (Nov. 29, 1856): 551. "Samuel Warren, Q.C., M.P." 29:* (Dec. 13, 1856): 598.]

W399 Portraits. Woodcut engravings credited "From a photograph by John Watkins." ILLUSTRATED LONDON NEWS 30, (1857) ["Royal Academicians: Gibson, MacDowell, Ross, Roberts, Ward, Frith, Dyce, Knight." 30:* (May 2, 1857): 418. "Associate Members of Royal Academy: Goodall, Pickersgill, Foley, Weekes, Egg, Lane, Hook, Frost." 30:* (May 2, 1857): 419. "W. H. Russell ('Times' war correspondent)." 30:* (May 16, 1857): 475. "New Parliament: Ralph Dutton, Sir Arthur Elton, Donald Nicoli, John Locke." 30:* (May 16, 1857): 478-479. "New Parliament: Patrick McMahon, Sir John V. Shelley, J. G. Dodson, E. G. Salisbury." 30:* (May 23, 1857): 499.]

W400 Portrait. Woodcut engraving credited "From a photograph by John Watkins." ILLUSTRATED LONDON NEWS 31, (1857) ["Sir Wm. Gore Ouseley." 31:* (Nov. 7, 1857): 460.]

W401 Portraits. Woodcut engravings credited "From a photograph by John Watkins." ILLUSTRATED LONDON NEWS 32, (1858) ["The New Ministry: Lord Stanley, Sir F. Kelly, Sir F. Thesiger, Earl Malmesbury, Sir J. Pakington." 32:* (Mar. 13, 1858): 260. ("From photographs by Mayall and Watkins.") "The New Ministry: Earl of Carnavon, Lord Colchester, Sotheron Estcourt." 32:* (Mar. 27, 1858): 312. "Lord George Paget." 32:* (May 8, 1858): 461. "Parliamentary Portraits: Wm. Laslett, Hon. Dudley F. Fortesque, John Laurie, Alderman Wm. T. Copeland." 32:* (June 5, 1858): 561.]

W402 Portraits. Woodcut engravings credited "From a photograph by John Watkins." ILLUSTRATED LONDON NEWS 33, (1858) ["Gen. Perronet Thompson, M.P., John Thomas Norris, M.P." (2 portraits) 33:* (July 24, 1858): 94.]

W403 Portraits. Woodcut engravings credited "From a photograph by John Watkins." ILLUSTRATED LONDON NEWS 34, (1859) ["Lord Ravensworth." 34:* (Feb. 19, 1859): 188. "Hon. F. Lygon, M.P." 34:* (Apr. 2, 1859): 337. "Edwin James, Esq., M.P." 34:* (Apr. 30, 1859): 429. "Duke of Leeds." 34:* (May 21, 1859): 485.]

W404 Portraits. Woodcut engravings credited "From a photograph by John Watkins." ILLUSTRATED LONDON NEWS 35, (1859) ["Lord Fermoy, M.P." 35:* (July 23, 1859): 82. "W. H. Bodkin, judge." 35:* (July 23, 1859): 82. "George H. Whalley, M.P." 35:* (Sept. 10, 1859): 242. "Robert Stephenson, M.P., civil engineer." 35:* (Oct. 22, 1859): 399. "Earl of Elgin, Postmaster-General." 35:* (Dec. 3, 1859): 519. "Sydney Smirke, Esq., B.A." 35:* (Dec. 10, 1859): 543. "Rev. Thomas Dale." 35:* (Dec. 31, 1859): 647.]

W405 Portraits. Woodcut engravings credited "From a photograph by John Watkins." ILLUSTRATED LONDON NEWS 36, (1860) ["Sir William Charles Ross, R.A." 36:* (Feb. 4, 1860): 113. "Right Hon. W. F. Cowper, M.P." 36:* (Feb. 25, 1860): 176. "Sir Rowland Hill, K.C.B., F.R.S." 36:* (Mar. 3, 1860): 201. "James Clarke Hook, R.A." 36:* (Mar. 24, 1860): 276. "J. W. Raynor." 36:* (Apr. 7, 1860): 324. "Sir Charles Lock Eastlake." 36:* (May 12, 1860): 449. "Mohammed Baux, the miniature man of India." 36:* (May 12, 1860): 453.]

W406 Portraits. Woodcut engravings credited "From a photograph by John Watkins." ILLUSTRATED LONDON NEWS 37, (1860) ["Lord Elcho." 37:* (July 7, 1860): 4. "Prince of Wales." 37:* (July 28, 1860): 87. "Hubert Ingram, M.P." 37:* (Oct. 6, 1860): 306. "S. Laing." 37:* (Nov. 10, 1860): 447. "Hon. and Rev. Samuel Waldegrave, D.D." 37:* (Nov. 17, 1860): 458. "Duke of Newcastle, K.G." 37:* (Dec. 22, 1860): 575.]

W407 "Note." ART JOURNAL (Aug. 1860): 253. [Watkins to take portraits of Prince of Wales.]

W408 Portrait. Woodcut engraving, credited "From a Photograph just taken by Watkins, of London." HARPER'S WEEKLY 4, (1860) ["His Royal Highness, the Prince of Wales." 4:191 (Aug. 25, 1860): 529.]

W409 Portraits. Woodcut engravings credited "From a photograph by John Watkins." ILLUSTRATED LONDON NEWS 38, (1861) ["Henry Loch, Esq." 38:* (Jan. 12, 1861): 32. "Sir Edward Colebrook." 38:* (Feb. 16, 1861): 135. "Earl of Sefton." 38:* (Feb. 16, 1861): 135. "George Gilbert Scott, R.A., Paul Falconer Poole, R.A." 38:* (Feb. 23, 1861): 175. "Edward M. Barry, Thomas Faed, Baron Marochetti, Richard Ansdell." (4 portraits) 38:* (Feb. 23, 1861): 178. "Right Rev. Henry Philpott, D.D." 38:* (Apr. 6, 1861): 322. "Right Hon. Sir W. G. Hayter, M.P." 38:* (Apr. 13, 1861): 339. "Hon. A. Dudley Mann, Confederate Commissioner." 38:* (May 4, 1861): 414.]

W410 Portraits. Woodcut engravings credited "From a photograph by John Watkins." ILLUSTRATED LONDON NEWS 38, (1861) ["M. Fechter as 'Hamlet.'" 38:* (May 4, 1861): 410. "Hon. A. Dudley Man, Commissioner of C.S.A." 38:* (May 4, 1861): 414.]

W411 Portraits. Woodcut engravings, credited "Photographed by John Watkins." ILLUSTRATED LONDON NEWS 52, (1868) ["G. B. Airy, Astronomer Royal." 52:* (Jan. 4, 1868): 5. "General Sir H. Storks." 52:* (Jan. 11, 1868): 45. "T. Landseer, A.R.A." 52:* (Feb. 15, 1868): 169. "Sir W. B. Brett, Solicitor-General." 52:* (Mar. 7, 1868): 237. "Justice Hannen, Judge." 52:* (Mar. 14, 1868): 257. "Sir W. Page Wood." 52:* (Mar. 21, 1868): 285. "Major-General Frome, Inspector of Engineers." 52:* (Mar. 28, 1868): 305. "Vice-Chancellor Gifford." 52:* (Apr. 4, 1868): 320. "Daniel Maclise, R.A." 52:* (May 9, 1868): 469. "Joseph Whitworth." 52:* (May 16, 1868): 493. "John Burnet, engraver." 52:* (May 23, 1868): 504.]

W412 Portraits. Woodcut engravings, credited "Photographed by John Watkins, Parliment Street, Winchester." ILLUSTRATED LONDON NEWS 53, (1868) ["Right Rev. Dr. Atlay." 53:* (July 25, 1868): 85. "Richard Baggallay, M.P." 53:* (Oct. 3, 1868): 329.]

W413 "Note." ART JOURNAL (Aug. 1868): 163. [Photo of Longfellow mentioned.]

W414 Portraits. Woodcut engravings, credited "Photographed by John Watkins." ILLUSTRATED LONDON NEWS 54, (1869) ["Sir Charles Mayne." 54:* (Jan. 9, 1869): 45. "Baron Cleasby, Judge." 54:* (Jan. 23, 1869): 93. "H. P. Cowper & A. J. Mundella." 54:* (Feb. 27, 1869): 213. "Earl of Carysfort & Viscount Monck." 54:* (Mar. 6, 1869): 232. "Mr. William Ewart, M.P." 54:* (Mar. 6, 1869): 237. "Lieut.-Col. Henderson, London Chief of Police." 54:* (Mar. 13, 1869): 269. "Vice-Chancellor Sir W. M. James." 54:* (Mar. 27, 1869): 304. "Earl of Clarendon, Duke of Argyll, H. A. Bruce, E. Cardwell." 54:* (May 1, 1869): 436.]

W415 Portraits. Woodcut engravings, credited "Photographed by John Watkins." ILLUSTRATED LONDON NEWS 55, (1869) ["Sir R. D. Hanson, Chief Justice of the Supreme Court, Australia." 55:* (July 31, 1869): 117. "Rev. F. J. Jobson, D.D." 55:* (Aug. 14, 1869): 165. "Right Rev. Dr. Moberly." 55:* (Oct. 30, 1869): 437.]

W416 Portraits. Woodcut engravings, credited "Photographed by John Watkins." ILLUSTRATED LONDON NEWS 56, (1870) ["Marquis of Huntley, Earl of Fingall, Capt. F. Egerton, Sir Charles Dilke (4 portraits)." 56:* (Feb. 19, 1870): 205. "Vicat Cole, A.R.A." 56:* (Feb. 26, 1870): 229. "Right Rev. Dr. MacKenzie." 56:* (Mar. 5, 1870): 253. "Right Hon. Charles G. Lennox, Duke of Richmond." 56:* (Mar. 19, 1870): 297.]

W417 Portraits. Woodcut engravings, credited "Photographed by John Watkins." ILLUSTRATED LONDON NEWS 57, (1870) ["Mr. Alderman Dakin, Mayor of London." 57:* (Nov. 5, 1870): 481. "Vice-Chancellor Sir J. Bacon." 57:* (Nov. 12, 1870): 497. "Patrick MacDowell, R.A." 57:* (Dec. 31, 1870): 681.]

W418 Portraits. Woodcut engravings, credited to "From a Photograph by John Watkins." ILLUSTRATED LONDON NEWS 58, (1871) ["W. E. Frost, R.A." 58:1633 (Jan. 21, 1871): 61. "Marquis of Lorne and H.R.H. the Princess Louise." 58:1642 (Mar. 25, 1871): 290-291. "Eight bridesmaids to the marriage of Princess Louise." 58:1643 (Apr. 1, 1871): 313. "Late J. R. Davison, M.P. Judge Advocate General." 58:1649 (May 6, 1871): 444. "Vice Chancellor Wickens." 58:1649 (May 6, 1871): 457.]

W419 Portrait. Woodcut engraving, credited to "From a Photograph by John Watkins." ILLUSTRATED LONDON NEWS 59, (1871) ["Field-Marshall Sir G. Pollock, G.C.B." 59:1677 (Nov. 4, 1871): 441.]

W420 Portraits. Woodcut engravings, credited to "From a Photograph by John Watkins." ILLUSTRATED LONDON NEWS 60, (1872) ["Earl Delaware, Viscount Powerscourt, Hon. Henry Strutt, Mr. J. J. Colman, movers and seconders in Parliament." 60:1693 (Feb. 17, 1872): 157. "Sir John Gilbert, A.R.A." 60:1697 (Mar. 16, 1872): 257. "Sir Thomas Chambers" 60:1703 (Apr. 27, 1872): 400.]

W421 Portraits. Woodcut engravings credited "From a photograph by John Watkins, Parliament St., Westminster." ILLUSTRATED LONDON NEWS 61, (1872) ["Late Mr. Justice Willes." 61:1727 (Oct. 12, 1872): 353. "Sir Sydney H. Waterlow." 61:1731 (Nov. 9, 1872): 440. "Mr. Justice Denman." 61:1732 (Nov. 16, 1872): 460. "Sir Bartle Frere, F.C.B." 61:1732 (Nov. 16, 1872): 473. "Late Sir John Bowring." 61:1735 (Dec. 7, 1872): 541.]

W422 Portraits. Woodcut engravings credited "From a photograph by John Watkins." ILLUSTRATED LONDON NEWS 62, (1873) ["Late Mr. Graves, M.P." 62:1744 (Feb. 1, 1873): 113. "Lord Clarendon, Hon. Charles G. Lyttleton." 62:1746 (Feb. 15, 1873): 157. "Robert Graves, A.R.A." 62:1750 (Mar. 15, 1873): 249. "Right Hon. Mr. Corry." 62:1751 (Mar. 22, 1873): 280. "Admiral Sir Sydney Dacress." 62:1753 (Apr. 5, 1873): 321. "Late John Stuart Mill." 62:1759 (May 17, 1873): 456. "Late Mr. Charles Lucy." 62:1762 (June 7, 1873): 544. Parliament St., Westminster.]

W423 Portraits. Woodcut engravings credited "From a photograph by John Watkins." ILLUSTRATED LONDON NEWS 63, (1873) ["Late Bishop Wilberforce." 63:1769 (July 26, 1873): 81. "Vice Chancellor Charles Hall." 63:1786 (Nov. 22, 1873): 485.]

W424 Portrait. Woodcut engraving credited "From a photograph by John Watkins." ILLUSTRATED LONDON NEWS 64, (1874) ["Late Sir W. Bodkin." 64:1807 (Apr. 11, 1874): 345.]

W425 Portraits. Woodcut engravings credited "From a photograph by John Watkins." ILLUSTRATED LONDON NEWS 66, (1875) ["Right Hon. John T. Ball, Irish Lord Chancellor." 66:1850 (Jan. 23, 1875): 72. "Mr. Alexander Whitelaw, M.P." 66:1853 (Feb. 13, 1875): 144. "Late Mr. H. W. Pickersgill, R.A." 66:1866 (May 15, 1875): 456.]

W426 Portraits Woodcut engraving credited "From a photograph by John Watkins." ILLUSTRATED LONDON NEWS 71, (1877) ["Late Mr. Samuel Warren." 71:1987 (Aug. 11, 1877): 137.]

W427 Portrait. Woodcut engraving credited "From a photograph by Watkins." ILLUSTRATED LONDON NEWS 74, (1879) ["Late Charles Baxter." 74:2067 (Jan. 25, 1879): 72.]

WATSON, H. W. (USA)
W428 "Matters of the Month: Pictures Received." PHOTOGRAPHIC TIMES 5, no. 55 (July 1875): 171. ["... views of Central Park, Florida scenery by H. W. Watson, NY."]

WATSON, JOHN. (LONDON, ENGLAND)
W429 "Note." JOURNAL OF THE PHOTOGRAPHIC SOCIETY OF LONDON 8, no. 134 (June 15, 1863): 307. [Mr. John Watson, late of Regent St. & Bond St., has been totally deprived of sight during the last 12 months... The 10 years previous he had been engaged in photography... "]

W430 "Note." ART JOURNAL (July 1863): 147. [Fundraising drive for Mr. John Watson, who for some years past was engaged as a photographic artist in Regent Street & Bond Street, who went blind.]

WATSON, WELLINGTON. [GRELLING'S GALLERY] (DETROIT, MI)
W431 "Editor's Table." PHILADELPHIA PHOTOGRAPHER 6, no. 62 (Feb. 1869): 64. [Note of cabinet and carte photos.]

W432 "Editor's Table." PHILADELPHIA PHOTOGRAPHER 6, no. 69 (Sept. 1869): 324. [Several cartes noted.]

WATSON, WILLIAM TINDILL.
W433 Watson, William Tindill. "Photographs on Enamel." BRITISH JOURNAL PHOTOGRAPHIC ALMANAC 1874 (1874): 139.

WATT see BOULTON & WATT.

WATT, ALEXANDER.
W434 Watt, Alexander. "The Advantages of Photography in Painting and Sculpture." PHOTOGRAPHIC NEWS 3, no. 68 (Dec. 23, 1859): 185.

WATTS, WILLIAM LORD.
W435 Watts, William Lord. *Snioland or Iceland, its Jökulls and its Fyalls.* London: Longmans, 1875. n. p. 12 b & w. [Watts, a member of the Alpine Club, revisited Iceland in 1874 with Rev. J. W. Watson, and his "small book is adorned with a dozen good photographs..." ("ILN" (June 26, 1875): 600.)]

WEARN & HIX. (COLUMBIA, SC)
W436 "A New Art Gallery in Columbia." ANTHONY'S PHOTOGRAPHIC BULLETIN 4, no. 3 (Mar. 1873): 76. [From "The South Carolinian. Announcement of a new "Art Gallery" opening in Columbia, SC, by Wearn & Hix. Its unclear if this is a photographic studio or a dealer.]

WEARN, RICHARD. (COLUMBIA, SC)
W437 "Editor's Table." PHILADELPHIA PHOTOGRAPHER 6, no. 64 (Apr. 1869): 136. [Gallery recently destroyed by fire, opening another.]

WEAVER & BACHRACH. (BALTIMORE, MD)
W438 "Grand Celebration of the Independent Order of Odd Fellows, and Dedication of the Monument Erected to the Memory of P. G. Sire, and Thomas Wildey, the Founder of the Order of Odd Fellows in America, at Baltimore, Wednesday, Sept. 20. - From a Photograph by Weaver & Bachrach." FRANK LESLIE'S ILLUSTRATED NEWSPAPER 21, no. 523 (Oct. 7, 1865): 40-41. 1 illus. [Outdoor crowd.]

W439 "Sailing of the Steamer 'Somerset' from Baltimore, Saturday, Sept. 30, for Liverpool. - From a Photograph by Weaver & Bachrach." FRANK LESLIE'S ILLUSTRATED NEWSPAPER 21, no. 526 (Oct. 28, 1865): 85. 1 illus. [Ship sailing.]

W440 "Monument to John McDonough, Erected at Baltimore, Maryland. - From a Photograph by Weaver and Bacharach [sic Bachrach]." FRANK LESLIE'S ILLUSTRATED NEWSPAPER 22, no. 551 (Apr. 21, 1866): 77. 1 illus.

WEAVER, WILLIAM H. (1827-1913) (USA)
[William Weaver was born in Dec., 1827. He died on Oct. 8, 1913. He is listed as owning a gallery at 147 E. Baltimore St. in Baltimore from 1863 to 1886. His son John, born in 1858, also became a photographer and joined his father in 1894-95. Because some of the

earliest violence attending the Civil War broke out in Baltimore in May 1861, causing Federal troops to quickly occupy the city to keep it in the Union, and because William Weaver photographed those troops in camp, he became one of the first photographers to document the war—although he is not now generally credited as a Civil War photographer.]

W441 "View of Fort McHenry, Baltimore. - The Burning of the Bridge at Canton, Maryland, by the Mob." HARPER'S WEEKLY 5, no. 228 (May 11, 1861): 292. 2 illus. ["From photographs by W. H. Weaver of Baltimore." Two views.]

W442 "Raising the Stars and Stripes over the Custom-House at Baltimore, on May 1." HARPER'S WEEKLY 5, no. 229 (May 18, 1861): 316. 1 illus. ["Photographed by W. H. Weaver."]

W443 "Winans Steam Gun." HARPER'S WEEKLY 5, no. 230 (May 25, 1861): 331. 1 illus. ["Photographed by Weaver."]

W444 "Winan's Steam Battery, Invented by Mr. Dickerson." NEW YORK ILLUSTRATED NEWS 4, no. 81 (May 25, 1861): 33, 43. 1 illus. ["Photographed by W. H. Weaver." Steam-operated cannon.]

W445 "The Military Occupation of Baltimore. - Major General Butler's Encampment on Federal Hill." HARPER'S WEEKLY 5, no. 231 (June 1, 1861): 344-345. 1 illus. ["Photographed by Weaver."]

W446 "General Cadwallader's Camp of the United States Volunteers at Locust Point, Opposite Baltimore, Maryland." HARPER'S WEEKLY 5, no. 232 (June 8, 1861): 359. 1 illus. ["Photographed by Weaver."]

W447 "Colonel Morehead's Camp, Near Patterson's Park, Baltimore, Maryland." HARPER'S WEEKLY 5, no. 233 (June 15, 1861): 374. 1 illus. ["Photographed by Weaver."]

W448 "Military Occupation of Monument Square, Baltimore, Md., By United States Artillery, by Order of Major-General Banks." HARPER'S WEEKLY 5, no. 238 (July 20, 1861): 461. 1 illus. ["Photographed by Weaver."]

W449 "The Smallest Vessel Ever Built for Ocean Service." HARPER'S WEEKLY 11, no. 544 (June 1, 1867): 341, 349. 3 illus. ["Photographed by Wm. H. Weaver, Baltimore." View of sailboat, two portraits. Men attempting to sail a 24-foot boat across the Atlantic.]

W450 Kelbaugh, Ross J. "Stereo (?) Panoramas of Baltimore by William H. Weaver." STEREO WORLD 8, no. 5 (Nov. - Dec. 1981): 12-14. 3 b & w. [Views taken in 1873 by William Weaver.]

WEBBER, SAMUEL BLATCHFORD (1819-1905) (GREAT BRITAIN)

W451 "Obituary of the Year: S. B. Webber (Sept. 17, 1905)." BRITISH JOURNAL PHOTOGRAPHIC ALMANAC 1906 (1906): 658. [Died Sept. 17 at Bromley, Kent at age 86. Retired goldsmith. Vice-Pres. of Bromley Camera Club, trustee to the Photographic Convention, etc.]

WEBSTER & BROTHER. (LOUISVILLE, KY)

W452 "Gossip." PHOTOGRAPHIC ART JOURNAL 3, no. 6 (June 1852): 384. [Webster & Brother quoted in "a Louisville paper," expressing anger at Whipple's patenting of the crayon daguerreotype process.]

W453 "Gossip." PHOTOGRAPHIC ART JOURNAL 4, no. 2 (Aug. 1852): 130.

W454 "Communications." PHOTOGRAPHIC ART JOURNAL 6, no. 1 (July 1853): 32-33. [Letter from Webster & Brother on Crystal Palace Exhibition.]

W455 Webster & Brother. "Communications: Skylight." PHOTOGRAPHIC ART JOURNAL 6, no. 4 (Oct. 1853): 246-247.

W456 "Letter." PHOTOGRAPHIC AND FINE ART JOURNAL 7, no. 3 (Mar. 1854): 88. [Letter from Webster & Brother (Louisville, KY).]

W457 Webster & Brother. "Communication." PHOTOGRAPHIC AND FINE ART JOURNAL 7, no. 7 (July 1854): 221.

W458 "Communications." PHOTOGRAPHIC AND FINE ART JOURNAL 8, no. 3 (Mar. 1855): 70-71. [Letter from Webster & Brother.]

W459 Webster & Brother. "Communication." PHOTOGRAPHIC AND FINE ART JOURNAL 8, no. 6 (June 1855): 191. [Letter from Webster.]

W460 Webster & Brother. "Photography in Louisville, KY." PHOTOGRAPHIC AND FINE ART JOURNAL 8, no. 9 (Sept. 1855): 271-272.

W461 Webster & Brother. "From Louisville, KY." PHOTOGRAPHIC AND FINE ART JOURNAL 9, no. 2 (Feb. 1856): 61-62.

W462 Webster & Brother. "Ambrotype vs. Collodiotype." PHOTOGRAPHIC AND FINE ART JOURNAL 9, no. 5 (May 1856): 146.

W463 "View of the Court-House and Jail in Which the Four Negroes were Confined. From a Photograph by Webster & Brother, Louisville." FRANK LESLIE'S ILLUSTRATED NEWSPAPER 4, no. 80 (June 13, 1857): 25. 1 illus. [View, with crowd.]

W464 "Great National Agricultural Fair, Louisville Kentucky." FRANK LESLIE'S ILLUSTRATED NEWSPAPER 4, no. 94 (Sept. 19, 1857): 248-249. 5 illus. [Four views of fairgrounds, with figures. Portrait of M. P. Wilder, Pres. of the Fair.]

W465 "Fifth Exhibition of the United States Agricultural Society." HARPER'S WEEKLY 1, no. 39 (Sept. 26, 1857): 612-613. 3 illus. [Includes a portrait of the President of the Society and two views, the Tent and the Machinery Hall, each credited "From a photograph by Webster & Brother, Louisville." This is the first credited view from a photo in this magazine.]

W466 "Our Illustration." PHOTOGRAPHIC AND FINE ART JOURNAL 10, no. 10 (Oct. 1857): frontispiece, 318. 1 b & w. [Original photographic print, tipped-in. "General William Walker, negatives by Webster Brothers, Louisville, KY. Prints by H. H. Snelling. (Print not in this copy.)]

W467 "Candidates for the Presidency in 1861." FRANK LESLIE'S ILLUSTRATED NEWSPAPER 9, no. 229 (Apr. 21, 1860): 327-328. 8 illus. [Eight portraits, collaged onto one page. Robert Hunter (VA), James Hammond (SC), (portraits by Brady); Andrew Johnson (TN), Howell Cobb (GA), James L. Orr (SC), Jefferson Davis (MS), Robert Toombs (GA), (portraits by Whitehurst); Samuel Houston (TX) (portrait by Webster & Brother, Louisville, KY).]

W468 Portraits. Woodcut engravings, credited "Photographed by Webster & Bros." FRANK LESLIE'S ILLUSTRATED NEWSPAPER 11, (1861) ["Maj. Robert Anderson, U.S.A." 11:271 (Feb. 2, 1861): 161.]

W469 "Raising the Stars and Stripes over the Court House, Louisville, Ky., on Washington's Birthday, 22nd of February, 1861, by Col. J. H. Barney and George D. Prentice, Esq. - Photographed by Webster & Bros. " FRANK LESLIE'S ILLUSTRATED NEWSPAPER 11, no. 277 (Mar. 16, 1861): 260. 1 illus. [View, with crowd.]

W470 Portraits. Woodcut engravings, credited "From a Photograph." FRANK LESLIE'S ILLUSTRATED NEWSPAPER 13, (1862) ["Gen. S. B. Buckner, C.S.A." 13:329 (Mar. 15, 1862): 268. "Brig.-Gen. L. H. Rousseau." 13:335 (Apr. 12, 1862): 356.]

W471 Portraits. Woodcut engravings, credited "From a Photograph by Webster & Bro, Louisville, Ky." FRANK LESLIE'S ILLUSTRATED NEWSPAPER 17, (1863) ["Maj.-Gen. George H. Thomas." 17:425 (Nov. 21, 1863): 140. "Maj.-Gen. Gordon Granger." 17:425 (Nov. 21, 1863): 140.]

WEBSTER, E. L. see WEBSTER & BROTHER.

WEBSTER, E. Z. (NORWICH, CT)
W472 Portrait. Woodcut engraving, credited "From a Photograph by Webster, Norwich, Conn." FRANK LESLIE'S ILLUSTRATED NEWSPAPER 40, (1875) ["Hon. David A. Wells." 40:1032 (July 10, 1875): 321.]

W473 "Connecticut. - Ruins of the Alms-House at Norwich, Destroyed by Fire March 12th. - From a Photograph by E. Z. Webster." FRANK LESLIE'S ILLUSTRATED NEWSPAPER 42, no. 1070 (Apr. 1, 1876): 57. 1 illus. [View.]

W474 Webster, E. Z. "Mr. Webster Strikes Again." PHILADELPHIA PHOTOGRAPHER 15, no. 179 (Nov. 1878): 329-330. [E. Z. Webster (Norwich, CT) attacks the Lambert "lightning" process in one of a number of articles on this controversial issue.]

WEBSTER, FRANCIS. (COPPER FALLS, MI)
W475 Webster, Francis. "A New Washing Apparatus." AMERICAN JOURNAL OF PHOTOGRAPHY AND THE ALLIED ARTS & SCIENCES n. s. vol. 6, no. 18 (Mar. 15, 1864): 429-430.

WEBSTER, G. WATMOUGH. (1843-1919) (GREAT BRITAIN)
W476 Webster, G. Watmough. "Warming the Studio." ANTHONY'S PHOTOGRAPHIC BULLETIN 3, no. 2 (Feb. 1872): 453-454. [From "Br. J. of Photo."]

W477 Webster, G. Watmough. "The Best Method of Enlarging." BRITISH JOURNAL PHOTOGRAPHIC ALMANAC 1876 (1876): 84-86.

W478 Webster, G. Watmough, F.C.S. "Quick Exposures in the Studios." ANTHONY'S PHOTOGRAPHIC BULLETIN 7, no. 10 (Oct. 1876): 289-291. [From "Br. J. of Photo."]

W479 Webster, G. Watmough. "Instantaneous Photography in the Studio." BRITISH JOURNAL PHOTOGRAPHIC ALMANAC 1877 (1877): 129-130.

W480 Webster, G. Watmough. "On Photographing Children." PHOTOGRAPHIC TIMES 7, no. 76 (Apr. 1877): 84-86.

W481 Webster, G. Watmough, F.C.S. "Babies and Studios." ANTHONY'S PHOTOGRAPHIC BULLETIN 9, no. 9 (Sept. 1878): 277-278. [From "Br J of Photo."]

W482 Webster, G. Watmough. "Clean Fingers." BRITISH JOURNAL PHOTOGRAPHIC ALMANAC 1879 (1879): 86-87.

W483 Webster, G. Watmough, F.C.S. "The Dark-Room and Its Lights." PHOTOGRAPHIC TIMES 15, no. 177 (Feb. 6, 1885): 68-69. [From "Br J of Photo. Almanac."]

W484 Webster, G. Watmough. "Photographing Machinery." PHOTOGRAPHIC TIMES 15, no. 180 (Feb. 27, 1885): 103-104. [From "Br J of Photo."]

W485 Webster, G. Watmough. "The Eye in Relation to Photography." PHOTOGRAPHIC TIMES 16, no. 253 (July 23, 1886): 383-384.

W486 "Notes and News: The Studio of Mr. G. Watmough Webster." PHOTOGRAPHIC TIMES 20, no. 464 (Aug. 8, 1890): 396. [From "Br. J. of Photo." Webster, a commercial photographer of Chester, England, was an occasional contributor to the "Photographic Times."]

W487 Webster, G. Watmough. "How I Develop." PHOTOGRAPHIC TIMES 21, no. 535 (Dec. 18, 1891): 643-644.

W488 "A Successful Photographer." PHOTOGRAPHIC TIMES 21, no. 536 (Dec. 25, 1891): 660. [Brief biography. Webster born in Warrington. Studied Liverpool College. Opened studio in Chester. Specialist in children.]

W489 "Obituary: G. Watmough Webster (Mar. 22, 1919." BRITISH JOURNAL PHOTOGRAPHIC ALMANAC 1920 (1920): 338-339. [Died Mar. 22, 1919 at age 76. Professional from early years of wet-collodion. Contributed frequently to "BJP." Studio at Chester, made portraits of Gladstone and visitors to Hawarden Castle. Moved to West Kirby, where he worked until he died. Wrote under his own name and under the pseudonym, "Free Lance."]

WEBSTER, H. (BAYSWATER, ENGLAND)
W490 Portraits. Woodcut engravings, credited "Photographed by H. Webster, of Bayswater." ILLUSTRATED LONDON NEWS 49, (1866) ["Maharajah of Johore." 49:* (Aug. 4, 1866): 124.]

WEBSTER, ISRAEL B. see also WEBSTER & BROTHER.

WEBSTER, ISRAEL B. (b. 1826) (USA)
W491 Portrait. Woodcut engraving, credited "From a Photograph by I. B. Webster." HARPER'S WEEKLY 9, (1865) ["Gen. S. G. Burbridge." 9:420 (Jan. 14, 1865): 28.]

W492 "Voices from the Craft." PHILADELPHIA PHOTOGRAPHER 5, no. 56 (Aug. 1868): 272-273. [Letter.]

W493 Webster, I. B. "Fourth Annual Meeting and Exhibition of the N. P. A. in St. Louis, Mo., May 1872: Manipulation of the Darkroom." PHILADELPHIA PHOTOGRAPHER 9, no. 102 (June 1872): 219.

W494 Webster, I. B. "Photographic Mincemeat." PHILADELPHIA PHOTOGRAPHER 9, no. 104-107 (Aug. - Nov. 1872): 280-282, 323-324, 341-342, 375-376.

W495 Webster, I. B. "Photographic Mincemeat." PHILADELPHIA PHOTOGRAPHER 10, no. 109-120 (Jan. - Dec. 1873): 5-6, 36-37, 72-73, 109-110, 132-133. 200, 495.

W496 Webster. "Fifth Annual Meeting and Exhibit of the National Photographic Association of the U.S., held in Buffalo, N.Y., beginning July 5, 1873: Skylight Construction." PHILADELPHIA PHOTOGRAPHER 10, no. 117 (Sept. 1873): 288-290.

W497 Webster. "Fifth Annual Meeting and Exhibit of the National Photographic Association of the U.S., held in Buffalo, N.Y., beginning July 5, 1873: Manipulation Continued." PHILADELPHIA PHOTOGRAPHER 10, no. 117 (Sept. 1873): 332-335.

W498 Webster, I. B. "A Reminiscence of the Old Daguerreotype Days." ANTHONY'S PHOTOGRAPHIC BULLETIN 5, no. 1 (Jan. 1874): 12. [Anecdote of how Webster tricked a nervous sitter into posing.]

W499 Webster, I. B. "An Enamelling Process." ANTHONY'S PHOTOGRAPHIC BULLETIN 5, no. 10 (Oct. 1874): 344-345.

W500 Loomis, G. H. "Gallery Biographic No. 5: I. B. Webster." ANTHONY'S PHOTOGRAPHIC BULLETIN 6, no. 4 (Apr. 1875): 113-114. [Born May 3, 1826 in Plattsburg, NY. First worked on a farm, then apprenticed to be a tinsmith in New London, CT. His brother had taken lessons in daguerreotyping, learned from him around 1846. He and his brother (E. L. Webster) formed a partnership that lasted until 1866. I. B. Webster remained in Louisville, KY, his brother returned to New England. One of first to take a paper photograph in Louisville, studying the practice with Mr. Turner, then worked for Whipple & Black. In 1861 joined the Union Army as a captain, coming under fire in nineteen engagements. After the war returned to his gallery in Kentucky. Adept musician.]

W501 Webster, I. B. "About Genius." PHILADELPHIA PHOTOGRAPHER 12, no. 136, 138 (Apr., Jun. 1875): 105, 169-170.

W502 Webster, I. B. "Some Things Seen and Felt." PHILADELPHIA PHOTOGRAPHER 14, no. 158-168 (Feb. - Dec. 1877): 43, 105, 143-144, 182-183, 232, 355-356. [Webster (Louisville, KY), on general commentaries, chemistry, etc. The Aug. issue was titled "Some Things Seen and Smelled."]

W503 Webster, I. B. "Correspondence." ANTHONY'S PHOTOGRAPHIC BULLETIN 8, no. 5 (May 1877): 158-159. [Long letter, about carbon printing, etc. Webster from Louisville, KY.]

W504 Webster, I. B. "Reversed Negatives." PHILADELPHIA PHOTOGRAPHER 15, no. 172 (Apr. 1878): 101-102.

W505 Webster, I. B. "Lightning!!" PHILADELPHIA PHOTOGRAPHER 15, no. 174 (June 1878): 161-162. [Against the practice of selling processes.]

WEDDELL. (EDINBURGH, SCOT)

W506 Portraits. Woodcut engravings, credited "Photographed by Weddell, published by Mr. Moffat, Princes St., Edinburgh." ILLUSTRATED LONDON NEWS 50, (1867) ["Alexander Smith, author." 50:* (Feb. 16, 1867): 161.]

WEDGWOOD, THOMAS. (1771-1805) (GREAT BRITAIN)
BOOKS

W507 Davy, Sir Humphrey, edited by J. Davy. "An Account of a Method of Copying Paintings upon Glass, and of Making Profiles by the Agency of Light upon the Nitrate of Silver. Invented by T. Wedgwood, with observations by H. Davy," on pp. 240-245 of Vol. 2 in: *Collected Works of Sir H. Davy*. London: Smith, Elder & Co.,

1839. 2 vol. [This paper first appeared in the "Journal of the Royal Institution," Vol. 1 (1802).]

W508 Meteyard, Eliza. *The Life of Josiah Wedgwood...* with an introductory sketch of the art of pottery in England, by Eliza Meteyard. London: Hurst & Blackett, 1866. 2 vol. (vol. II, xxiv, 643) pp. illus. [Volume two contains a notice on Thomas Wedgwood, an early experimenter with silver solutions.]

W509 Meteyard, Eliza. *A Group of Englishmen (1795-1815)*, being Records of the Younger Wedgwoods and their Friends, embracing the History of the Discovery of Photography and a "Facsimile of the First Photograph." London: Longman, Green & Co., 1871. xxii, 416 pp. illus.

W510 Meteyard, Eliza. *Memorials of Wedgwood;* A Selection of His Fine Art Works in Plaques, Medallions, Figures, and Other Ornamental Objects. London: George Bell & Sons, 1874. n. p. 28 l. of plates. 60 b & w. [Sixty Autotypes on twenty-eight plates, by Cundall.]

W511 Meteyard, Eliza. *Choice Examples of Wedgwood Art.* London: George Bell & Sons, 1879. n. p. 30 b & w. [Autotype prints of ceramics.]

W512 Litchfield, Richard B. *Tom Wedgwood, the First Photographer.* An Account of His Life, His Discovery and His Friendship with Samuel Taylor Coleridge; Including the letters of Coleridge to the Wedgwoods and an examination of the accounts of alleged earlier photographic discoveries. London: Duckworth & Co., 1903. xvi, 271 pp. 10 illus. [Reprinted (1973), Arno Press.]

PERIODICALS
W513 Wedgwood, T., with observations by H. Davy. "A Method of Copying Paintings upon Glass, and making Profiles, by the Agency of Light upon Nitrate of Silver." HUMPHREY'S JOURNAL 9, no. 10 (Sept. 15, 1857): 150-151. [From "J. of Royal Institution of Great Britain, vol., 1802," through "Liverpool Photo. J."]

W514 "Thomas Wedgwood's Contributions to Photography." IMAGE 3, no. 7 (Oct. 1954): 42.

WEED, CHARLES LEANDER. (1824-1903) (USA)
[Born in New York State in 1824. By 1854 Weed was the camera operator for G. W. Watson's daguerreotype studio. In 1858 he managed a studio, Vance & Weed, in Sacramento, CA. Used the wet-collodion process to make views on the American River in 1858. Photographed in the Yosemite Valley in 1850s. Reproduced in *Hutching's California Magazine* in 1859. Weed went to the Far East in 1860 and opened a gallery in Hong Kong, but returned again to California. Travelled to the Hawaiian Islands in 1865. Went back to the East in 1867, produced an album of Mammoth Plate views in 1869. May have accompanied Muybridge to Yosemite in 1872. Worked as a photoengraver in 1880s. Died in Oakland, CA in 1903.]

BOOKS
W515 Hutchings, James Mason. *Scenes of Wonder and Curiosity in California.* New York, San Francisco: A. Roman & Co., 1861, 1871. illus.

W516 Weed, Charles Leander. *Oriental Scenery.* San Francisco: Thomas Houseworth & Co., 1869 [?]. n. p. b & w. [Album of original photographs. Views of Nagasaki, Japan, etc.]

W517 Coyne & Relyea, firm, publishers, Chicago. *Sun Pictures of the Yo Semite Valley, California.* Chicago: Coyne & Relyea, pub., Knight & Leonard, 1874. n. p. 44 b & w. [Original photos, credited to Thomas Houseworth & Co., from negatives taken by C. L. Weed in 1860s then sold to Houseworth in 1870s.]

W518 Hutchings, James Mason. *In the Heart of the Sierras: The Yo Semite Valley, Both Historical and Descriptive, and Scenes by the Way; Big Tree Groves; the High Sierra, with Its Magnificent Scenery, Ancient and Modern Glaciers, and Other Objects of Interest.* Yosemite Valley, CA; Oakland, CA: Old Cabin; Pacific Press Publishing House, 1886. illus. [Engravings, from stereos of Yosemite views by Weed.]

PERIODICALS

W519 "The Yosemite Valley." HARPER'S MONTHLY 32, no. 192 (May 1866): 697-708. 15 illus. ["The illustrations in this article are copied from the correct and beautiful photographs taken in the summer of 1864 by Mr. C. L. Weed, who courteously granted permission to use his pictures for that purpose."]

W520 Hood, Mary V. "Charles L. Weed, Yosemite's First Photographer." YOSEMITE NATURE NOTES 38, no. 6 (1959): *.

W521 Palmquist, Peter E. "California's Peripatetic Photographer, Charles Leander Weed." CALIFORNIA HISTORY 58, no. 3 (Fall 1979): 194-219. 13 b & w. 6 illus.

W522 Palmquist, Peter E. "Yosemite's First Stereo Photographer: Charles Leander Weed (1824-1903)." STEREO WORLD 6, no. 4 (Sept. - Oct. 1979): 4-11. 8 b & w. 3 illus. [Weed working as an operator for George W. Watson in the Sacramento, CA area in 1854. Then became junior partner and manager of Robert H. Vance's Sacramento gallery. In 1858 Weed was taking mining scenes with a wet-collodion outfit, and in June 1859 he photographed Yosemite Valley. He continued making both stereo views and mammoth-plate views, but left Vance and changed to the Lawrence & Housewworth stereopublishing firm in 1864. Travelled to Hawaii in 1865, and for four years from January 1866 he was in the Orient - possibly making views in China and Japan. Article includes a checklist of seventy-eight California Views by Weed, published by Edward Anthony in 1860.]

W523 "Mark Twain in Paradise." AMERICAN HERITAGE 32, no. 6 (Oct. - Nov. 1981): 81-91. 13 b & w. [Photos of Hawaii taken in 1850s and 1860s by Hugo Stangenwald and Charles Leander Weed, with selections from Mark Twain's "Roughing It." Seven images by Weed, five by Stangewald. Views, portraits.]

WEEKS, GEORGE H. (NEW YORK, NY)

W524 Weeks, George H. "Correspondence." ANTHONY'S PHOTOGRAPHIC BULLETIN 3, no. 2 (Feb. 1872): 461. [Weeks (New York, NY) claims to have been awarded Franklin Institute Medals in 1853-54.]

WEINGARTNER. (MOSCOW, RUSSIA)

W525 Portraits. Woodcut engravings, credited "Photographed by Weingartner, of Moscow." ILLUSTRATED LONDON NEWS 28, (1856) ["General Mouravieff." 28:* (May 3, 1856): 484.]

WEITFLE, CHARLES see also THURLOW, JAMES.

WEITFLE, CHARLES. (b. 1836) (GERMANY, USA)

W526 Waldsmith, Thomas. "Charles Weitfle: Colorado Entrepreneur." STEREO WORLD 5, no. 4 (Sept. - Oct. 1978): 4-11, 13. 8 b & w. [Weitfle born in Germany on February 15, 1836. Immigrated to USA at age 13, to apprentice in the harness trade in New Jersey. By 1854 he was interested in photography and when he travelled to Rio de Janeiro, Brazil in 1856 he was making ambrotypes. Returned to Washington, DC in 1860 and operated a gallery there. After the war he moved to Newark and later Dover, NJ. Moved to Central City, CO in 1878. For next five years he travelled around Colorado making views. Bought J. Collier's business in 1878 and purchased collections from Thurlow, W. G. Chamberlain, and Ben E. Hawkins. Moved to Denver in early 1880s. Burned out in 1883 and over 1000 of his own and others negatives lost. After 1884 he seems to have stopped. Nevertheless he had been one of the strongest publishers of stereo views in the area. Includes a checklist of over 450 views.]

WEITFLE, WILLIAM C.

W527 "Pictures Received." ANTHONY'S PHOTOGRAPHIC BULLETIN 9, no. 10 (Oct. 1878): 320. [Stereo views of Central City, CO, Clear Creek Canyon, etc.]

WELCH, D.

W528 Welch, D. "A few Hints on the best means of Obtaining Good Cartes de Visite." HUMPHREY'S JOURNAL OF PHOTOGRAPHY, AND THE ALLIED ARTS AND SCIENCES 17, no. 4 (June 15, 1865): 59-60. [From "Photo. News."]

WELD, JAMES A. (d. 1876) (USA)

W529 "Editor's Table." PHILADELPHIA PHOTOGRAPHER 13, no. 151 (July 1876): 223. [James A. Weld, a photographer at Penn Yan, NY, with two of his three children, died of diphtheria. C. Irwing Page, a photographer for Mr. Weld, continues the business.]

WELDON see BURNITE & WELDON.

WELLER, FRANKLIN G. (1833-1877) (USA)

[Weller began taking stereo views as early as 1861, located in Littleton, NH. The Kilburn Brothers were also located in Littleton, and they were one of the leading stereo view makers in the USA. Weller turned from views to the production of genre scenes, narrative stereo cards, "composition studies," and "allegorical" series. These gained him a fine reputation and a good living. In the 1870s he renamed his business the Littleton View Company, then later sold it and retired. G. H. Aldrich continued to publish Weller's cards until at least 1900.]

W530 "Editor's Table." PHILADELPHIA PHOTOGRAPHER 6, no. 62 (Feb. 1869): 64. [Views of White Mountain scenery.]

W531 Weller, F. G. "Composition Photography." PHOTOGRAPHER'S FRIEND 2, no. 2 (Apr. 1872): 35-37.

W532 "Editor's Drawer." PHOTOGRAPHER'S FRIEND 2, no. 2 (Apr. 1872): 60. [Describes F. G. Weller's (Littleton, N. H.) "composition stereograms" (genre studies).]

W533 Weller, F. G. "Composition Photography." PHOTOGRAPHER'S FRIEND 2, no. 4 (Oct. 1872): 97-100.

W534 "Editor's Table: Allegorical Stereographs." PHILADELPHIA PHOTOGRAPHER 12, no. 137 (May 1875): 159-160. [F. G. Weller (Littleton, NH) makes scenes - "Santa Claus at Home," "Frost Workers," etc.]

W535 "Matters of the Month." PHOTOGRAPHIC TIMES 5, no. 54 (June 1875): 134-135. [Catalog of F.G. Weller's stereographs mentioned. The Allegorical Series featured.]

W536 Loomis, G. H. "Gallery Biographic No. 8: F. G. Weller." ANTHONY'S PHOTOGRAPHIC BULLETIN 6, no. 10 (Oct. 1875): 305-306. [Weller born in Hanover, NH, in 1833. His father was a carriage trimmer by trade and G. H. Loomis apprenticed with him, showing artistic talent. Learned photography in Boston under S. L. Gerry. In 1867 he purchased a half interest from Franklin White —who had a trade established in White Mountain scenery. Weller took photos of Franconia Notch and set up a gallery in Littleton, NH. Specialized in stereo views of New Hampshire.]

W537 "Obituary." PHILADELPHIA PHOTOGRAPHER 15, no. 169 (Jan. 1878): 24. [Died Dec. 8, 1877, aged 45 years. Entered photography in 1868, from a trade in carriage painting. Specialized in life studies, or groups. Studio in Littleton, NH.]

WELLS see BOGARDUS, ABRAHAM.

WELLS & CO. (NEW YORK, NY)
BOOKS
W538 Artotypes. New York: Harroun & Bierstadt, 1880. 29 pp. 29 b & w. [29 artotype plates, enclosed in a morocco case, sold as a souvenir. The images are from negatives by Wells & Co. of the theatrical troupe (which played the drama "Hazel Kirke") posed in various life groups. 1000 edition.]

PERIODICALS
W539 "Our Editorial Table." PHOTOGRAPHIC TIMES 11, no. 121 (Jan. 1881): 10. [Bk. rev: "Artotypes," by Harroun & Bierstadt. "A souvenir of Artotype printing," this work consists of 29 artotype plates from negatives of a theatrical troupe in "various life groups" taken by Wells & Co., New York, NY.]

WELLS, J. D. (NORTHAMPTON, MA)
W540 "Note." HUMPHREY'S JOURNAL 5, no. 1 (Apr. 15, 1853): 16. [J. D. Wells, Northampton, MA, opened branch room Brattleborough, VT, with Mr. Lovell.]

WELLS, J. H. (HARTFORD, CT)
W541 Wells, J. H. ANTHONY'S PHOTOGRAPHIC BULLETIN 7, no. 8 (Aug. 1876): 256. [J. H. Wells with H. J. Rogers, Hartford, CT.]

WELLS, R. L. (d. 1875) (USA)
W542 "Obituary." PHILADELPHIA PHOTOGRAPHER 13, no. 145 (Jan. 1876): 26. [Wells worked in Cleveland, OH. Died of consumption on Dec. 11, 1875. "...an old photographer of this city... and a member of the N. P. A."]

WELLS, S. P. see also CRAMER, GUSTAV.

WELLS, S. P. (ST. LOUIS, MO)
W543 Wells, S. P. "Fifth Annual Meeting and Exhibit of the National Photographic Association of the U.S., held in Buffalo, N.Y., beginning July 5, 1873: To Manipulate with Iron." PHILADELPHIA PHOTOGRAPHER 10, no. 117 (Sept. 1873): 328-331.

W544 "Note." PHOTOGRAPHIC TIMES 17, no. 278 (Jan. 14, 1887): 22. [Brief note that Wells, "the skillful operating artist" in Cramer's Studio in St. Louis, deserves credit for making the silver print portrait which embellishes the "American Annual of Photography and Photographic Times Almanac for 1887."]

WELLS, W. H.
W545 Wells, W. H. "How to Get Forty-Eight Cartes out of a Sheet of Paper." ANTHONY'S PHOTOGRAPHIC BULLETIN 8, no. 11 (Nov. 1877): 344. [From "Br. J. of Photo."]

WELLSTED, W. J. & SON.
W546 "Hull Dock Offices." ILLUSTRATED LONDON NEWS 59, no. 1675 (Oct. 21, 1871): 393. 1 illus.

WENDEROTH, see also DODGE & WENDEROTH.

WENDEROTH, TAYLOR & BROWN.
BOOKS
W547 The Gallery of Arts and Manufactures. Philadelphia: Wenderoth, Taylor & Brown and William Ritter Publisher, 1870. n. p. 57 b & w. [An album of 57 mounted albumen prints of businesses, or manufactured goods, accompanied with advertising text on the borders of each print.]

PERIODICALS
W548 "Specialties." PHILADELPHIA PHOTOGRAPHER 2, no. 15 (Mar. 1865): Following page 48. [Advertisement.]

W549 "Model Skylight." PHILADELPHIA PHOTOGRAPHER 2, no. 24 (Dec. 1865): 192-194. 1 illus.

W550 "Our Pictures - Two Portraits." PHILADELPHIA PHOTOGRAPHER 2, no. 24 (Dec. 1865): frontispiece, 205. 2 b & w. [Two portraits of painter on one page.]

W551 "The Virginia Delegation to the Southern Loyalists' Convention, Held at Philadelphia on Sept. 3rd. From a Photograph by Wenderoth, Taylor & Brown." FRANK LESLIE'S ILLUSTRATED NEWSPAPER 23, no. 575 (Oct. 6, 1866): 36. 1 illus. [Outdoor group portrait.]

W552 "Our Picture - Cabinet Portrait." PHILADELPHIA PHOTOGRAPHER 4, no. 40 (Apr. 1867): frontispiece, 111-113. 1 b & w.

W553 Portrait. Woodcut engraving, credited "From a Photograph by Wenderoth, Taylor & Brown." HARPER'S WEEKLY 13, (1869) ["Adolph E. Borie, Sec. of the Navy." 13:638 (Mar. 20, 1869): 189.]

W554 Portrait. Woodcut engraving, credited "From a Photograph by Wenderoth, Taylor & Brown. FRANK LESLIE'S ILLUSTRATED NEWSPAPER 28, (1869) ["Hon. Adolphe E. Borie, Pres. Grant's Cabinet." 28:705 (Apr. 3, 1869): 41.]

W555 "The New Mercantile Library Building, Philadelphia." HARPER'S WEEKLY 13, no. 659 (Aug. 14, 1869): 513. 1 illus. ["Photographed by Wenderoth, Taylor & Brown, Philadelphia." Interior.]

W556 "The Mercantile Library Association of Philadelphia. - From Photographs by Wenderoth, Taylor & Brown." FRANK LESLIE'S ILLUSTRATED NEWSPAPER 29, no. 737 (Nov. 13, 1869): 148. 2 illus. [Views.]

W557 Portrait. Woodcut engraving, credited "From a Photograph by Wenderoth, Taylor and Brown." FRANK LESLIE'S ILLUSTRATED NEWSPAPER 34, (1872) ["Dr. Joseph Parrish, Supt. of PA Sanitarium for Inebriates." 34:869 (May 25, 1872): 172.]

WENDEROTH, FREDERICK AUGUST. (ca. 1814-1884) (USA)
[A painter in Charleston, SC in the late 1850s, by the second half of the decade he had taken up photography and worked with tintypes, the ivorytype process which he invented, and developed the solar camera -a device for making enlarged prints. Worked for the photographers Broadbent & Co. in the 1860s. Partner in the

Philadelphia firm of Wenderoth, Taylor & Brown from 1866 to 1884. Portraits, landscapes, city views, etc.]

W558 "Asphaltotype." PHOTOGRAPHIC AND FINE ART JOURNAL 9, no. 11 (Nov. 1856): 348-349. [Wenderoth (Charleston, SC) "...taking positive photographs...more than nine months on japanned tin."]

W559 "Our Illustrations." PHOTOGRAPHIC AND FINE ART JOURNAL 10, no. 5 (May 1857): frontispiece, 153. 1 b & w. [Original photographic print, tipped-in. "Portrait of a Negress," by F. A. Wenderoth (Charleston, SC). Print not in this copy.]

W560 "Letter." PHOTOGRAPHIC AND FINE ART JOURNAL 11, no. 2 (Feb. 1858): 64. [Wenderoth the inventer of a solar camera.]

W561 Wenderoth, F. A. "The Ivorytype." PHOTOGRAPHIC AND FINE ART JOURNAL 12, no. 1 (June 1859): 6.

W562 Seely, Charles. "Editorial Department." AMERICAN JOURNAL OF PHOTOGRAPHY AND THE ALLIED ARTS & SCIENCES n. s. vol. 5, no. 14 (Jan. 15, 1863): 335. [Commentary upon British response to some Solar Camera photographs, made by Wenderoth, of Philadelphia, and displayed in London. (A Solar Camera photo is, in effect, an enlargement.)]

W563 "American Photographs, &c." BRITISH JOURNAL OF PHOTOGRAPHY 10, no. 185 (Mar. 2, 1863): 91-92. [Defending earlier statements made about some at Wenderoth's (Philadelphia, PA) solar enlargements.]

W564 Wenderoth, F. A. "On the Relative Merits of Different Lenses, for making out-of-door photographs." PHILADELPHIA PHOTOGRAPHER 1, no. 1 (Jan. 1864): 10-12.

W565 "Our Picture." PHILADELPHIA PHOTOGRAPHER 1, no. 3 (Mar. 1864): frontispiece, 44-45. 1 b & w. [Landscape view. An accompanying letter describes Wenderoth's techniques.]

W566 Wenderoth, F. A. "A Mode to Remove Negative Films from Glass Plates." PHILADELPHIA PHOTOGRAPHER 1, no. 6 (June 1864): 83-85.

W567 "The American Ivorytype." AMERICAN JOURNAL OF PHOTOGRAPHY AND THE ALLIED ARTS & SCIENCES n. s. vol. 7, no. 1 (July 1, 1864): 11-12. [From Root's "Camera and the Pencil." Root states this process discovered by Wenderoth (Philadelphia). Seely claims that it was first practiced by Oliver Sarony.]

W568 "Mr. Wenderoth's Method of Transferring Negatives." HUMPHREY'S JOURNAL OF PHOTOGRAPHY, AND THE ALLIED ARTS AND SCIENCES 16, no. 7 (Aug. 1, 1864): 102-103. [From "Br. J. of Photo."]

W569 Wenderoth, F. A. "Jottings on Various Subjects." BRITISH JOURNAL OF PHOTOGRAPHY 12, no. 278-279 (Sept. 1 - Sept. 8, 1865): 451-452, 460-461. 2 illus. [Wenderoth from Philadelphia. Describes his lighting arrangements. Mentions sending a portrait of General Grant, another of Abraham Lincoln, mentions painting photos, his lenses, etc.]

W570 "American versus English Photographs." BRITISH JOURNAL OF PHOTOGRAPHY 12, no. 280 (Sept. 15, 1865): 471-472. [Detailed analysis of "a large consignment of photographs," received from Mr. Wenderoth, of Philadelphia.]

W571 Wenderoth, F. A. "Letter." PHILADELPHIA PHOTOGRAPHER 2, no. 24 (Dec. 1865): 202-203. [Wenderoth claims that he made porcelain photographs before James W. Black. Philadelphia, PA.]

W572 "Our Picture." PHILADELPHIA PHOTOGRAPHER 3, no. 33 (Sept. 1866): frontispiece, 285-286. 1 b & w. [Still life.]

W573 "A New and Brilliant Picture." ANTHONY'S PHOTOGRAPHIC BULLETIN 2, no. 11 (Nov. 1871): 361. [Wenderoth (Philadelphia, PA) perfected a new style of picture.]

W574 Wenderoth. "Instructions for Making the Argento Picture." ANTHONY'S PHOTOGRAPHIC BULLETIN 3, no. 3 (Mar. 1872): 485-489.

W575 Wenderoth, F. A. "A Few Words About Fading of Carbon Photographs." PHILADELPHIA PHOTOGRAPHER 14, no. 168 (Dec. 1877): 358-359.

WENHAM, FRANCIS HERBERT. (1824-1908) (GREAT BRITAIN, EGYPT)

W576 Wenham, F. H. "On a Method of obtaining Enlarged Positive Impressions from Transparent Collodion or Albumen Negatives, by Means of the Ordinary Photographic Camera." JOURNAL OF THE PHOTOGRAPHIC SOCIETY 1, no. 12 (Dec. 21, 1853): 142-145.

W577 Wenham, F. H. "Balloon Photography." JOURNAL OF THE PHOTOGRAPHIC SOCIETY OF LONDON 8, no. 133 (Apr. 15, 1863): 271-272.

W578 Wenham, F. H. "View Lenses." BRITISH JOURNAL PHOTOGRAPHIC ALMANAC 1875 (1875): 41-43.

W579 Wenham, F. H. "A Photographic Tour - Past and Present." BRITISH JOURNAL OF PHOTOGRAPHY 45, no. 1997 (Aug. 12, 1898): 523-524. [Wenham describes his tour with Francis Frith in Egypt in 1856, describing the heat, the sand, and other problems.]

W580 Jay, Bill. "Up the Nile with Francis Frith. Francis H. Wenham 1824 - 1908." NORTHLIGHT no. 7 (Nov. 1977): 18-24. 1 b & w. [Born in Kensington (now London) in 1824, the son of an army surgeon. Apprenticed to a marine engineering firm at Bristol at age 18. One of the engineers building the steamship, the "Great Eastern." Met and befriended the photographer James Nasmyth while at this task. Wenham attending meetings of the Photographic Society of London since 1853. Wenham built a small, powerful, steam launch in early 1850s, and in 1856 Wenham was introduced to Francis Frith. He and Frith travelled up the Nile River in Egypt on this boat. Frith returned to Egypt two more times. Wenham became the director of the short-lived Panoptican of Science, then returned to engineering and designing engines. Wenham experimented with photography, microscopy, and optics in the 1850s and 1860s. In 1870 became a scientific advisor to the lens manufacturing firm of Ross & Co. Also interested in ballooning. Retired, in 1880s, to Woking, Surry. Died on August 11, 1908.]

WERGE, JOHN. (b. 1825) (LONDON, ENGLAND)

[Werge owned a "...shop, near the British Museum, well stocked with every requisite."]

BOOKS

W581 Hughes, C. Jabez and John Werge. *How to Learn Photography: A Manual for Beginners. Containing the Positive Collodion Process; the Negative Collodion Process; Printing on Albumenized Paper, and Toning by the Alkaline Gold Process; Copying Pictures so as to Enlarge*

or Reduce Them; Life-Sized Portraits; and How to Produce Them by Solar Camera. Dry-Plate Photography; Including the Collodio-Albumen, Fothergill, and Tannin Processes. How to Colour and Mount Photographs. "Waterhouse" and Other Diaphragms in Lenses, and How to Use Them, &c. London; New York: C. Jabez Hughes; John Werge, 1861. n. p.

W582 Werge, J. *How to Produce Opalotypes without Silver.* London: J. Werge, 1875. n. p.

W583 Werge, J. *Pictorial Backgrounds and How to Produce Them; to which is added, How to Produce Opalotypes with Ivory Black.* London: J. Werge and Piper & Carter, 1875. 24 pp. 1 b & w. [Original photograph.]

W584 Werge, John. *The Evolution of Photography. With a Chronological Record of Discoveries, Inventions, Etc., Contributions to Photographic Literature, and Personal Reminiscences Extending over Forty Years.* London: Piper & Carter and J. Werge, 1890. viii, 312 pp. 4 b & w. illus. [Reprinted (1973), Arno Press.]

PERIODICALS
W585 Humphrey, S. D. "Editorial: Colored Daguerreotypes, Etc." HUMPHREY'S JOURNAL 5, no. 14 (Nov. 1, 1853): 217-218. [Reprinting an exchange of letters between John Werge and S. D. Humphrey, first published in the "NY Tribune" about (hand-colored) daguerreotypes and their fading.]

W586 Werge, John. "Coloring Daguerreotypes, Mr. Werge's Reply to the Messrs. Meade." PHOTOGRAPHIC AND FINE ART JOURNAL 7, no. 11 (Nov. 1854): 346-347. [Response to a letter published in Oct. issue. Werge had worked for the Meade Brothers until Aug. 1854, then left them.]

W587 "Celtic Society's Gatherings." ILLUSTRATED NEWS OF THE WORLD AND DRAWING ROOM PORTRAIT GALLERY OF EMINENT PERSONAGES 1, no. 30 (Aug. 28, 1858): 140-141. 2 illus. ["From photographs by John Werge." Portraits of pipers, taken outdoors.]

W588 "The Statue of the Late Rev. Dr. Wardlaw." ILLUSTRATED NEWS OF THE WORLD AND DRAWING ROOM PORTRAIT GALLERY OF EMINENT PERSONAGES 1, no. 32 (Sept. 11, 1858): 173. 1 illus.

W589 Portrait. Woodcut engraving, credited "After a Photograph by John Werge, Glasgow." ILLUSTRATED NEWS OF THE WORLD AND DRAWING ROOM PORTRAIT GALLERY OF EMINENT PERSONAGES 1, (1858) ["Harry Clasper, of Newcastle-on-Tyne. A celebrated rower..." 1:38 (Oct.23, 1858): 269. "Lieut.-Col. Alison, Late Secretary to Lord Clyde." 1:44 (Dec. 4, 1858): 357.]

W590 Werge, J. "How to Take Vignette Negatives in and out of the Camera - Old and New Processes." AMERICAN JOURNAL OF PHOTOGRAPHY AND THE ALLIED ARTS & SCIENCES n. s. vol. 7, no. 17 (Mar. 1, 1865): 389-392. [From "Photo. News."]

W591 "Photographic Impressions: The Hudson, Developed on the Voyage." BRITISH JOURNAL OF PHOTOGRAPHY 12, no. 262, 266 (May 12, June 9, 1865): 248-249, 303-304.

W592 Werge, John. "The Photographer's Alphabet." ANTHONY'S PHOTOGRAPHIC BULLETIN 3, no. 4 (Apr. 1872): 531. [Poem. From "Br. J. Almanac."]

W593 Werge, John. "A String of Old Beads." BRITISH JOURNAL PHOTOGRAPHIC ALMANAC 1873 (1873): 125-127.

W594 Werge, J. "Another String of Old Beads." BRITISH JOURNAL PHOTOGRAPHIC ALMANAC 1874 (1874): 72-73.

W595 Werge, J. "Lights and Lighting." BRITISH JOURNAL PHOTOGRAPHIC ALMANAC 1876 (1876): 97-98.

W596 Werge, J. "Light Comforts." BRITISH JOURNAL PHOTOGRAPHIC ALMANAC 1877 (1877): 118-119. [Dark room lighting.]

W597 Werge, J. "Dry Plate Treatment." BRITISH JOURNAL PHOTOGRAPHIC ALMANAC 1879 (1879): 87-88.

W598 Rowe, Jeremy. "The Oldest Living Daguerreotypist. John Werge 1825-?" NORTHLIGHT no. 7 (Nov. 1977): 69-74. 1 b & w. [Born in 1825, John Werge saw his first daguerreotype in 1839, at age 14. A friend brought a daguerreotype apparatus from Edinburgh after 1845, and tried it without success. Werge then tried, with little success but much persistence, to learn the process for the next few years. In 1849 he decided to become a professional photographer, and apprenticed with George Brown. Worked as an itinerant in England in early 1850s, then sailed to America in 1853. Worked as a colorist for daguerreotypes in the Meade Brothers Studio in New York, NY, then travelled again. By 1854 he went through upper New York State to Niagara Falls, where he colored many of Platt D. Babbit's daguerreotypes and photographed there with Easterly. He also visited and worked in Montreal and Boston, where he learned photography from Whipple. Werge returned to England in 1854, where he worked for Jabez Hughes in Glasgow. Werge took over the studio when Hughes moved to London. Fire in 1860, sent Werge back to New York, where he bought out the Meade Brothers Gallery. He returned to London in 1861, at the outbreak of the Civil War. Began to work in Jabez Hughes' London gallery. Became friends with George Simpson, and contributed articles to the "Photographic News." Elected to the Photographic Society of London in 1866. Published *The Evolution of Photography* in 1890. Retired in 1892. Still alive in 1902.]

WERNER & SON see also WERNER, M. LOUIS.

WERNER & SON. (DUBLIN, IRELAND)
W599 "Notes and News." PHOTOGRAPHIC TIMES 23, no. 609 (May 19, 1893): 265. [Note that Werner & Son of Dublin, have just made what they think is the largest negative yet taken direct from life... 64 x 38 inches.]

WERNER, ALFRED. (DUBLIN, IRELAND)
W600 Werner, A. "Photography In Its Pictorial Aspect." WILSON'S PHOTOGRAPHIC MAGAZINE 35, no. 504 (Dec. 1898): 531-535. [An address delivered before the Photographic Society of Ireland.]

WERNER, M. LOUIS. (1823-1901) (GERMANY, GREAT BRITAIN)
W601 Portraits. Woodcut engravings, credited "Photographed by L. Werner, of Dublin." ILLUSTRATED LONDON NEWS 47, (1865) ["General Sir George Brown." 47:* (Sept. 16, 1865): 257.]

W602 Portraits. Woodcut engravings credited "From a photograph by L. Werner." ILLUSTRATED LONDON NEWS 74, (1879) ["Lieut. Neville Coghill, killed, Lieut. George F. J. Hodson, killed." 74:2072 (Mar. 2, 1879): 193.]

W603 "Obituary of the Year: M. Louis Werner." BRITISH JOURNAL PHOTOGRAPHIC ALMANAC 1903 (1903): 680. [Died in Dublin on Dec. 12, 1901, at age 78. Born in the department of the Upper Rhine, studied art in Strasburg. Admitted to Ecole des Beaux Arts, Paris in 1842. Studied under Delaroche, Horace Vernet, Ingres, etc. Settled in Dublin in 1854 as a portrait painter, then "although he himself did not practice photography as a profession, in 1864 he founded the firm of Werner & Son. Transferred in 1885 to his son Alfred Werner.]

WEST, G. & SON. (GOSPORT, ENGLAND)
W604 Portrait. Woodcut engraving credited "From a photograph by G. West & Son." ILLUSTRATED LONDON NEWS 75, (1879) ["Col. W. P. Collingwood." 75:2113 (Dec. 13, 1879): 553.]

WESTERVELT, J. D. (MUSKEGON, MI)
W605 Portrait. Woodcut engraving, credited "From a Photograph by J. D. Westervelt, Muskegon." FRANK LESLIE'S ILLUSTRATED NEWSPAPER 47, (1878) ["The late Jonathan Walker." and "Walker monument at Muskegon, MI." 47:1198 (Sept. 14, 1878): 29.]

WESTMACOTT, PERCY.
W606 "Soiree of the Mechanics' Institute at the Armstrong Gun Works, Newcastle-on-Tyne." ILLUSTRATED LONDON NEWS 35, no. 994 (Sept. 24, 1859): 306-307. 2 illus. ["From a photograph by Percy Westmacott." Photo is an interior view of a large luncheon, a second view of the factory itself is not credited, but probably also from a photo.]

WESTMANN, O. R. (d. 1887) (GERMANY, USA)
W607 "Obituary: O. R. Westmann." PHOTOGRAPHIC TIMES 17, no. 281 (Feb. 4, 1887): 61. ["O. R. Westmann, for many years a photographer in Joliet, IL, committed suicide Thursday, Jan. 27th, by swallowing a dose of cyanide of potassium. He was a German, and unmarried."]

WESTON.
W608 "William Evans Burton, the Comedian." FRANK LESLIE'S ILLUSTRATED NEWSPAPER 9, no. 221 (Feb. 25, 1860): 202. 4 illus. [Four costume portraits of the late actor. One credited to Silsbee, Case & Co., Boston, two credited to J. Gurney, one credited "from Weston's Photograph."]

WESTON, J. & SON. (DOVERLAND and FOLKESTONE, ENGLAND)
W609 Portrait. Woodcut engraving credited "From a photograph by Weston & Son." ILLUSTRATED LONDON NEWS 69, (1876) ["Late Marquis of Tweeddale." 69:1943 (Oct. 21, 1876): 397.]

W610 Portrait. Woodcut engraving credited "From a photograph by J. Weston & Son." ILLUSTRATED LONDON NEWS 74, (1879) ["Lieut-General Lord Chelmsford." 74:2072 (Mar. 1, 1879): 192.]

WESTON, LAMBERT & SON. (DOVER, ENGLAND)
W611 Portrait. Woodcut engraving credited "From a photograph by Lambert Weston & Son." ILLUSTRATED LONDON NEWS 74, (1879) ["Lieut. Charles Pope, killed." 74:2072 (Mar. 2, 1879): 193.]

W612 1 photo (Late Lord Salisbury). WORLD'S WORK 6, no. 6 (Oct. 1903): 4031. ["Lambert Weston & Son."]

WEY, FRANCIS. (FRANCE)
W613 Wey, Francis. "Of the Influence of Heliography Upon the Fine Arts; Brief Considerations upon the Exhibition of 1851. " PHOTOGRAPHIC ART JOURNAL 2, no. 2-3 (Aug. - Sept. 1851):

105-106, 161-164. [Translated from "La Lumiere." Discusses works by G. Le Gray, the Baron Gros, others.]

W614 Wey, Francis. "Primitive Times of Heliography." DAGUERREAN JOURNAL 3, no. 3 (Dec. 15, 1851): 75-78.

W615 Wey, Francis. "Heliography on Plates." PHOTOGRAPHIC ART JOURNAL 3, no. 1 (Jan. 1852): 41-45.

W616 Wey, Francis. "On the Progress of Photography, and Its Future Prospects." PHOTOGRAPHIC ART JOURNAL 3, no. 4 (Apr. 1852): 212-214. [Trans. from "La Lumiere."]

W617 Wey, Francis. "The Journal 'La Lumiere.'" HUMPHREY'S JOURNAL 4, no. 3 (May 15, 1852): 36-40. [Survey article by Francis Wey, first published in "La Lumiere," is reprinted here, with additional commentary by Humphrey, who refutes the claim that "La Lumiere" was the first photographic magazine. Humphrey claims that his "Daguerrean Journal" proceeded the others. The article includes a review of M. E. De Valincourt's "New Manual of Photography," E. Piot's "Monumental Italy," etc.]

W618 Wey, Francis. "Theory of Portraiture." PHOTOGRAPHIC ART JOURNAL 5, no. 1-2 (Jan. - Feb. 1853): 33-36, 104-109. [From "La Lumiere."]

WEYLER. (PARIS, FRANCE)
W619 Portraits. Woodcut engravings, credited "Photographed by Weyler, of Rue Lafitte, Paris." ILLUSTRATED LONDON NEWS 49, (1866) ["Rev. E. Mahony 'Father Prout.'" 49:* (Aug. 11, 1866): 137.]

WHAITE, L. E.
W620 Whaite, L. E. "On Coloring the Backgrounds of Collodion Positives." HUMPHREY'S JOURNAL OF PHOTOGRAPHY, AND THE ALLIED ARTS AND SCIENCES 9, no. 19 (Feb. 1, 1858): 289-290. [Read to Chorlton Photo. Assoc.]

WHARMBY, H. A.
W621 Wharmby, H. A. "The Morphine Process." HUMPHREY'S JOURNAL OF PHOTOGRAPHY, AND THE ALLIED ARTS AND SCIENCES 19, no. 17 (Jan. 1, 1868): 270-271. [Read to the Liverpool Amat. Photo. Assoc.]

WHEATSTONE, CHARLES see also BREWSTER, DAVID, SIR.

WHEATSTONE, CHARLES. (1802-1875) (GREAT BRITAIN)
BOOKS
W622 Wade, Nicholas J., ed. *Brewster and Wheatstone on Vision.* London: Academic Press, 1983. 358 pp. [Bibliography on pp. 329-339. Introduction, obituaries, thirty-five papers by Brewster and Wheatstone reprinted.]

PERIODICALS
W623 "Professor Wheatstone on the Physiology of Vision." HUMPHREY'S JOURNAL 4, no. 3 (May 15, 1852): 46. [From "Philosophical Magazine."]

W624 "Invention of the Stereoscope." HUMPHREY'S JOURNAL 4, no. 8 (Aug. 1, 1852): 120. [Report of a claim of inventing the stereoscope by Mr. Elliot refuted by Prof. Wheatstone, who had worked with the process in 1830, abstracted from the "Philosophical Magazine."]

W625 "Professor Sir C. Wheatstone." ILLUSTRATED LONDON NEWS 52, no. 1468 (Feb. 8, 1868): 145-146. 1 illus.

W626 Brey, William. "Professor Wheatstone and His Inventions." STEREO WORLD 4, no. 2 (May - June 1977): 4-15. 7 illus. [Thorough, readable account of Wheatstone's life and scientific discoveries.]

W627 Klooswiij, Abram I. "Stereo Viewing Scoop 150 Years Ago." STEREO WORLD 10, no. 4 (Sept. - Oct. 1983): 16-17. 4 illus. [Page from Herbert Mayo's "Outlines of Human Physiology," (1833), which contains an account of Charles Wheatstone's experiments with binocular vision reproduced, with commentary..]

W628 Joseph, Steven F. "Wheatstone's Double Vision." HISTORY OF PHOTOGRAPHY 8, no. 4 (Oct. - Dec. 1984): 329-331. 2 b & w. [Discussion of interactions between Charles Wheatstone, Henry Collen, and Adolphe Quetelet during the early 1840's.]

WHEELER, D. W.
W629 Wheeler, D. W. "Transparent Positives." HUMPHREY'S JOURNAL OF PHOTOGRAPHY, AND THE ALLIED ARTS AND SCIENCES 12, no. 12 (Oct. 15, 1860): 179.

WHEELER, JOHN R. (ST. LOUIS, MO)
W630 Portraits. Woodcut engravings, credited "Photographed by John R. Wheeler, St. Louis." FRANK LESLIE'S ILLUSTRATED NEWSPAPER 12, (1861) ["Brig.-Gen. J. McKinstry, U.S.A." 12:305 (Sept. 21, 1861): 292.]

WHETTEMORE. [sic WHITTEMORE?]
W631 "Daguerreotype Movements." HUMPHREY'S JOURNAL 4, no. 16 (Dec. 1, 1852): 255. [Whettemore, so long known as the South American Daguerreotypist, is now located in this city...much engaged in the Stereoscopic line..."]

WHIPPLE & BLACK.
W632 "Gossip." PHOTOGRAPHIC ART JOURNAL 3, no. 3 (Mar. 1852): 195. [We were shown, a few days since, Mr. Black, three daguerreotypes, by Mr. Whipple of Boston, taken with the aid of the Drummond light at night...]

W633 "Gossip." PHOTOGRAPHIC ART JOURNAL 4, no. 5 (Nov. 1852): 317-318. [Discusses Whipple & Black's paper photographs, which are judged superior to French efforts.]

W634 Whipple, John A. "Communications: Mr. Whipple's Experiments." PHOTOGRAPHIC ART JOURNAL 6, no. 3 (Sept. 1853): 148-149. [Whipple's letter describing his experiments with paper processes, praising J. W. Black's "untiring efforts...for...the past two years..."]

W635 "Personal & Art Intelligence." PHOTOGRAPHIC AND FINE ART JOURNAL 7, no. 1 (Jan. 1854): 32. ["Mr. Whipple is now prepared to teach either the collodion or albumin process, in Boston or New York. Mr. Black, his agent, will be found in Mr. Root's rooms, and is in every way capable of teaching these processes."]

W636 "The Fine Arts: The Crystalotype." PUTNAM'S MONTHLY 5, no. 27 (Mar. 1855): 335. [Bk. rev.: "The work...under the name of "The World of Art and Industry, an Illustrated Record of the Great Exhibition," did our designers, engravers and the publisher so much credit, appears under a new name, which it derives from the addition of a number of fine photographs or crystalotypes, representing some of the fine pieces of sculpture exhibited in the New York Crystal Palace. Those make the work more valuable..."]

W637 "Nathaniel Hawthorne, Author of "Twice Told Tales." BALLOU'S PICTORIAL DRAWING-ROOM COMPANION [GLEASON'S] 9, no. 3 (July 21, 1855): 36. 1 illus. ["From a daguerreotype by Whipple & Black."]

W638 "Oliver Wendell Holmes, the Poet." BALLOU'S PICTORIAL DRAWING-ROOM COMPANION [GLEASON'S] 9, no. 10 (Sept. 8, 1855): 149. 1 illus. ["From a Photograph by Whipple & Black."]

W639 "James Russell Lowell, the Poet." BALLOU'S PICTORIAL DRAWING-ROOM COMPANION [GLEASON'S] 9, no. 11 (Sept. 15, 1855): 172. 1 illus. ["From a daguerreotype by Whipple & Black."]

W640 "Prof. Louis Agassiz." BALLOU'S PICTORIAL DRAWING-ROOM COMPANION [GLEASON'S] 9, no. 17 (Oct. 27, 1855): 268. 1 illus. ["...from a photograph by Whipple & Black."]

W641 "Epes Sargent." BALLOU'S PICTORIAL DRAWING-ROOM COMPANION [GLEASON'S] 9, no. 22 (Dec. 1, 1855): 348. 1 illus. ["...from a photograph by Whipple & Black."]

W642 "William Warren, the Comedian." BALLOU'S PICTORIAL DRAWING-ROOM COMPANION [GLEASON'S] 9, no. 24 (Dec. 15, 1855): 380. 1 illus. ["...from a photograph by Whipple & Black."]

W643 Portraits. Woodcut engraving, credited "From a Photograph by Whipple & Black." BALLOU'S PICTORIAL DRAWING-ROOM COMPANION [GLEASON'S] 10, (1856) ["Alexander H. Rice, Mayor of Boston, MA." 10:236 (Jan. 12, 1856): 17. "Hon. George S. Hillard." 10:237 (Jan. 19, 1856): 44. "Hammat Billings." 10:250 (Apr. 19, 1856): 252.]

W644 "Thomas Comer, of the Boston Theatre." BALLOU'S PICTORIAL DRAWING-ROOM COMPANION [GLEASON'S] 11, no. 265 (Aug. 2, 1856): 76. 1 illus.

W645 "Our Illustrations." PHOTOGRAPHIC AND FINE ART JOURNAL 10, no. 1 (Jan. 1857): frontispiece, 25. 1 b & w. [Original photographic print, copy of the Statue of Flora at the NY Crystal Palace, negatives by Whipple & Black, Boston, MA.]

W646 "Our Illustrations." PHOTOGRAPHIC AND FINE ART JOURNAL 10, no. 3 (Mar. 1857): frontispiece, unnumbered page, 89. 2 b & w. [Two original photographic prints, tipped-in. One a copy of a drawing, the second a view of the Franklin Monument, by Whipple & Black. (Photos not in this issue.)]

W647 Portrait. Woodcut engraving, credited "From a Photograph by Whipple & Black." BALLOU'S PICTORIAL DRAWING-ROOM COMPANION [GLEASON'S] 12, (1857) ["Hon. Charles W. Upham." 12:299 (Mar. 14, 1857): 172.]

W648 "Our Illustrations." PHOTOGRAPHIC AND FINE ART JOURNAL 10, no. 4 (Apr. 1857): frontispiece, 121. 1 b & w. [Original photographic print, tipped-in. Portraits of Mrs. Barry and Miss Taylor, of the Boston Theatre. Negative by Whipple & Black. (Print not in this copy.)]

W649 "Notes." HUMPHREY'S JOURNAL 9, no. 1 (May 1, 1857): 2. [Whipple & Black credited, with others, as leaders in use of paper processes in USA.]

W650 "Photographic Ware: Whipple & Black." HUMPHREY'S JOURNAL 9, no. 1 (May 1, 1857): Additional section; 7-8. [Whipple uses steam to clean plates, and to drive a model sun revolving in front of the building.]

W651 Portraits. Woodcut engravings, credited "Photographed by Whipple & Black." FRANK LESLIE'S ILLUSTRATED NEWSPAPER 4, (1857) ["G. Washington Warren, Pres. of the Bunker Hill Monument Assoc." 4:81 (June 20, 1857): 33. "John T. Heard, Grand Master, Mason." 4:81 (June 20, 1857): 41. "Alexander N. Rice, Mayor of Boston." 4:81 (June 20, 1857): 44. "H. J. Gardner, Gov. of MA." 4:81 (June 20, 1857): 44.]

W652 "Bunker Hill Celebration. The Boston Military, the Seventh Regiment N.Y.S.M., Gov. Gardner and Staff, Mayor Rice and the City Authorities, the Bunker Hill Monument Association, and Invited Guests, Assembling in Front of the State House, Boston, Preparatory to Joining in the Monumental Procession." and "Bunker Hill Celebration. The Grand Encampment of the Knights Templars, the Grand Lodge of the State of Massachusetts and Subordinate Lodges of the State and Other States, Preparing to Form in the Monumental Procession, in the Mall in Front of the Masonic Temple, Boston. Photographed by Whipple & Black." FRANK LESLIE'S ILLUSTRATED NEWSPAPER 4, no. 81 (June 20, 1857): 40. 2 illus. [Views, with crowd.]

W653 Bond, W. C. "Astronomical Photography." PHOTOGRAPHIC AND FINE ART JOURNAL 10, no. 7 (July 1857): 208. [From "Boston [MA] Daily Advertiser."]

W654 Portrait. Woodcut engraving, credited "From a Photograph by Whipple & Black." BALLOU'S PICTORIAL DRAWING-ROOM COMPANION [GLEASON'S] 13, (1857) ["Miss Harriet Hosmer, American Sculptor." 13:337 (Dec. 5, 1857): 353.]

W655 "Our Photographic Illustrations: Residence of the Late General Winchester (Near Cambridge, Mass.)." PHOTOGRAPHIC AND FINE ART JOURNAL 11, no. 1 (Jan. 1858): frontispiece, 9. 1 b & w. [View. Negative by Whipple & Black, positive print by H. H. Snelling.]

W656 "Our Photographic Illustrations: 1. Garden Scene, In Cambridge College Botanical Gardens." PHOTOGRAPHIC AND FINE ART JOURNAL 11, no. 2 (Feb. 1858): frontispiece, 52. 1 b & w.

W657 "Photographs of the Moon." PHOTOGRAPHIC AND FINE ART JOURNAL 11, no. 5 (May 1858): 134-135, 159. [Article about De la Rue, but discusses Whipple & Black's participation in making moon photographs. "The most cordial thanks of Astronomers are due to Mr. Bond, and to the professional amateurs, Messrs. Whipple & Black, by whose preserverance this object has been obtained. Additional commentary on Whipple's role on p. 159.]

W658 "Our Illustrations: II. Morning. Negatives by Whipple & Black; from a Bas-relief by Thorwaldsen." PHOTOGRAPHIC AND FINE ART JOURNAL 11, no. 5 (May 1858): 149, plus tipped-in photo opposite p. 145. 1 b & w.

W659 "Our Illustrations: I. Winter. Negative by Whipple & Black; from a Bas-relief by Thorwaldsen." PHOTOGRAPHIC AND FINE ART JOURNAL 11, no. 6 (June 1858): 191, plus tipped-in photo opposite p. 161. 1 b & w.

W660 "Our Illustrations. II. - Night." PHOTOGRAPHIC AND FINE ART JOURNAL 11, no. 8 (Aug. 1858): 245, plus unnumbered leaf. 1 b & w. [Thorwalden's sculpture "Night," photographed by Whipple & Black.]

W661 "Henry Wadsworth Longfellow." BALLOU'S PICTORIAL DRAWING-ROOM COMPANION [GLEASON'S] 15, no. 392 (Dec. 25, 1858): 401. 1 illus. ["...from one of those beautiful and artistic photographs for which Messrs. Whipple & Black of this city, are so justly celebrated."]

W662 "Joseph Ames, American artist." BALLOU'S PICTORIAL DRAWING-ROOM COMPANION [GLEASON'S] 16, no. 393 (Jan. 1, 1859): 12. 1 illus. [...from a photograph by Whipple & Black."]

W663 "Massachusetts General Hospital." BALLOU'S PICTORIAL DRAWING-ROOM COMPANION [GLEASON'S] 16, no. 397 (Jan. 29, 1859): 73. 1 illus. ["...drawn by Waud,...from a photograph by Whipple & Black."]

W664 "U.S. Marine Hospital, Chelsea, Mass." BALLOU'S PICTORIAL DRAWING-ROOM COMPANION [GLEASON'S] 16, no. 398 (Feb. 5, 1859): 88. 1 illus. ["...from a photograph by Whipple & Black..."]

W665 "Portrait of Longfellow." BALLOU'S PICTORIAL DRAWING-ROOM COMPANION [GLEASON'S] 17, no. 423 (July 30, 1859): 74. 1 illus. ["Mr. Charles H. Brainard,...has just issued a fine lithographic head of the poet Longfellow...after one of Whipple & Black's best photographs...."]

W666 "Powers's Statue of Webster, Just Inaugurated at Boston." HARPER'S WEEKLY 3, no. 144 (Oct. 1, 1859): 628. 1 illus. ["From a photograph by Whipple & Black, of Boston."]

W667 Pierce, Sally. "Whipple and Black: Commercial Photographers in Boston." VIEWS: THE JOURNAL OF PHOTOGRAPHY IN NEW ENGLAND. 9, no. 1 (Fall 1987): 6-11. 10 b & w. 3 illus.

WHIPPLE, JOHN ADAMS. (1822-1891) (USA)

[John A. Whipple was born in Grafton, MA on Sept. 10, 1822. He was mechanically handy as a youth. In 1839 he heard of Daguerre's discovery, and attempted to make a daguerreotype, with mixed success. Moved to Boston in 1840, where, for a while, he manufactured photographic chemicals for sale. He exhibited daguerreotype portraits at the 1841 Massachusetts Charitable Mechanic Association exhibition.

Working with William B. Jones in 1844, Whipple began to experiment with a process which made paper photographs from negatives on glass plates. This would be patented in 1850 as the crystalotype process. Litch & Whipple opened a daguerreotype studio in Boston. Whipple experimented with making daguerreotypes through a microscope in 1846. Patented the crayon daguerreotype process in 1849. At the Harvard College Observatory, Whipple & Jones attempted to take a daguerreotype of the moon in 1849 which failed, then made the first successful daguerreotype of a star in July 1850. Whipple made a successful moon daguerreotype in March 1851, which was the first to show detailed surface structure.

James Wallace Black began to work for Whipple in 1850. Whipple made a group of daguerreotype portraits of the Harvard Class of 1852, the earliest or one of the earliest of such activities.

In 1852 H. H. Snelling, the editor of *Photographic Art Journal*, illustrated issues of his magazine with tipped-in photographic prints, most of the earliest of these were crystalotypes by Whipple, either copied from daguerreotype originals, or made from crystalotype negatives taken by Whipple, his assistant and partner J. W. Black, or others. In 1853, crystalotype prints of the moon were exhibited at the New York Crystal Palace exhibition. In 1854 a crystalotype print of a view of the Hancock House, Boston was used as a frontispiece to the book *Homes of American Statesmen*, the first photographically illustrated book published in the USA. The Whipple & Black partnership was formed in 1854, and it lasts until 1859, then each partner continued to operate separate studios in Boston.

In 1863 Whipple patented an adjustable camera. In 1868 Whipple

took a leadership role in assisting the formation of the National Photographic Association. In addition to the many portraits taken in his gallery, Whipple made views of buildings and ceremonial events in Boston. He photographed until 1874, when he retired from photography, and became a bookseller and publisher of religious works. Whipple died in 1891.]

BOOKS

W668 *Homes of American Statesmen with Anecdotal, Personal and Descriptive Sketches, by Various Writers. Illustrated with Engravings on Wood, from Drawings by Dopler and Daguerreotypes and Facsimiles of Autograph Letters.* New York; London: G. P. Putnam & Co.; Sampson Low, Son & Co., 1854. viii, 469 pp. 1 b & w. 60 illus. [Contains a salt print of the Hancock House, Boston as frontispiece, blindstamped "Whipple's Patent Crystallotype or Sun Picture," 43 wood engravings by Orr and Richardson Cox, 17 autograph letters reproduced by lithography. Very early USA book with original photograph.]

W669 *The Landing of the French Atlantic Cable at Duxbury, Mass., July 1869.* Boston: Alfred Mudge & Son, Printers, 1869. 58 pp. 6 b & w. [6 albumen prints tipped-in.]

W670 Pierce, Sally. With a chronological Annotated Bibliography by William S. Johnson. *Whipple and Black:* Commercial Photographers in Boston: The Boston Athenaeum, 1987. 121 pp. 90 b & w.

PERIODICALS

W671 "Stellar Daguerreotype." DAGUERREAN JOURNAL 1, no. 1 (Nov. 1, 1850): 13. [Daguerreotype of the star Lyra, taken by John Whipple, with W. C. Bond, at the Cambridge observatory.]

W672 "Lunar Daguerreotype." DAGUERREAN JOURNAL 1, no. 1 (Nov. 1, 1850): 14. [Includes a letter from the President of Harvard University, Jared Sparks, congratulating John Whipple and W. C. Bond for their work on daguerreotypes of the moon during 1849.]

W673 Root, Marcus A. "Gossip: Crayon Daguerreotypes." PHOTOGRAPHIC ART JOURNAL 1, no. 2 (Feb. 1851): 128. [Letter from M. A. Root discussing his being the NY agent for Whipple's patented 'Crayon Daguerreotype' process.]

W674 "Our Daguerreotypes." DAGUERREAN JOURNAL 2, no. 3 (June 15, 1851): 83. [Whipple's daguerreotypes of the moon discussed.]

W675 Engraved portrait of John A. Whipple as frontispiece. PHOTOGRAPHIC ART JOURNAL 2, no. 1 (July 1851): frontispiece. 1 b & w.

W676 Grant, M. "John A. Whipple and the Daguerrean Art." PHOTOGRAPHIC ART JOURNAL 2, no. 2 (Aug. 1851): frontispiece, 94-95. 1 illus. [Portrait. Whipple was born at Grafton, MA. 28 years old. At 18 came to Boston, began making chemicals for daguerreotypists, soon began making daguerreotypes himself. Noted for introducing steam driven machinery into his gallery, the Crayon Daguerreotype process, microscopy, crystalotype process (not yet so named), and daguerreotypes of the moon.]

W677 "Gossip." PHOTOGRAPHIC ART JOURNAL 2, no. 2 (Aug. 1851): 95. [Note about British reaction to Whipple's daguerreotype of the moon.]

W678 "Proceedings of Scientific Societies. Meeting of the British Association at Ipswich. Thursday, July 3. Section A. - Mathematical and

Physical Sciences." PRACTICAL MECHANIC'S JOURNAL 4, no. 41 (Aug. 1851): 114-115. ["Daguerreotypes of the moon were shown, taken by Messrs. Whiple (sic. Whipple) and Jones, of Boston, from the image formed in the focus of the great equatorial of the Cambridge (U. S.) Observatory....Mr. Bond exhibited daguerreotypes of the moon..."]

W679 "Lunar Daguerreotypes." DAGUERREAN JOURNAL 2, no. 6 (Aug. 1, 1851): 179.

W680 "Important Experiment. Daguerreotype of the Sun." DAGUERREAN JOURNAL 2, no. 7 (Aug. 15, 1851): 210.

W681 "View of the Ruins of Tremont Temple, Boston." GLEASON'S PICTORIAL DRAWING-ROOM COMPANION 2, no. 16 (Apr. 17, 1852): 256. 1 illus. ["...from a daguerreotype by Whipple."]

W682 Whipple, John Adams. "Preparing Plates by Steam." PHOTOGRAPHIC ART JOURNAL 3, no. 5 (May 1852): 271-272.

W683 "Humphrey's Journal." HUMPHREY'S JOURNAL 4, no. 3 (May 15, 1852): 44. [Calotypes, Crayon daguerreotypes, etc., by Whipple.]

W684 "Gossip." PHOTOGRAPHIC ART JOURNAL 3, no. 6 (June 1852): 383. [Commentary on Whipple's vital role in forwarding the development of paper photography in the United States.]

W685 "Chrystolotype." HUMPHREY'S JOURNAL 4, no. 5 (June 15, 1852): 75-76. [Specimens of Whipple's crystalotypes, with an excerpt from the "Boston [MA] Evening Journal."]

W686 "Gossip." PHOTOGRAPHIC ART JOURNAL 4, no. 1 (July 1852): 62. [Brief discussion of Whipple's role in introducing paper processes in the United States.]

W687 Whipple, John A. "Communications: Microscopic Daguerreotypes." PHOTOGRAPHIC ART JOURNAL 4, no. 4 (Oct. 1852): 227-228.

W688 "Daniel Webster." AMERICAN WHIG REVIEW 16, no. 6 (Dec. 1852): 30-31. 1 illus. [Wood engraving by A. H. Ritchie, from a daguerreotype portrait by John A. Whipple.]

W689 "A New and Important Invention." PHOTOGRAPHIC ART JOURNAL 4, no. 6 (Dec. 1852): 380. [From "N.Y. Tribune." Briefly discusses Whipple's Crystalotype, note that examples could be seen in Root's Gallery of Daguerrean Art, Broadway, New York, NY.]

W690 "Note." HUMPHREY'S JOURNAL 4, no. 17 (Dec. 15, 1852): 269. [Brief note that the Instrument employed by Whipple in taking the daguerreotype of the moon cost $25,000.]

W691 "Whipple's Crystalotypes." HUMPHREY'S JOURNAL 4, no. 17 (Dec. 15, 1852): 269. [Two views of the moon, "taken from the original daguerreotype exhibited at the World's Fair," a view of Daniel Webster's home, and a view of the "Traveller Buildings, Boston."]

W692 Portrait. Woodcut engraving, credited "From a Daguerreotype by Whipple." ILLUSTRATED NEWS (NY) 1, (1853) ["The late Amos Lawrence." 1:4 (Jan. 22, 1853): 60.]

W693 "Gossip." PHOTOGRAPHIC ART JOURNAL 5, no. 3 (Mar. 1853): 187.

W694 "Gossip." PHOTOGRAPHIC ART JOURNAL 5, no. 4 (Apr. 1853): frontispiece, 254-255. 1 b & w. [Note on Whipple's crystalotype process, with an announcement that a joint-stock company was being organized to promote the process, plus an example of the crystalotype (a portrait of E. Anthony), used as a frontispiece.]

W695 "Grand Panoramic View of the East Side of Washington Street, Boston, Mass.,..." GLEASON'S PICTORIAL DRAWING-ROOM COMPANION 4, no. 21 (May 21, 1853): 328-329. 3 illus. [Frontal view of John A. Whipple's gallery is shown.]

W696 "Editorial: Whipple and his Crystolotype." HUMPHREY'S JOURNAL 5, no. 5 (June 15, 1853): 73.

W697 "Gossip: Letter." PHOTOGRAPHIC ART JOURNAL 6, no. 1 (July 1853): frontispiece, 66. 1 b & w. [Whipple's crystalotype of the moon pasted into the issue. The letter by Whipple describes his experience taking the daguerreotype from which Whipple's crystalotype was made.]

W698 Farnham, Rev. Luther. "Boston Pulpit. No. 1 - No. 22." GLEASON'S PICTORIAL DRAWING-ROOM COMPANION 5, no. 1-22 (July 2, 1853 - Nov. 26, 1853): 12, 28, 44, 60, 76, 92, 108, 124, 140, 156, 172, 188, 204, 220, 236, 252, 268, 284, 300, 316, 332, 348. 44 illus. [Series of biographies of Boston ministers, each accompanied by a portrait and a view of their church. Seven credited "From a daguerreotype by Southworth & Hawes." Six credited "From a daguerreotype by Whipple." Two credited "From a daguerreotype by Masury & Silsbee.]

W699 "Editorials." HUMPHREY'S JOURNAL 5, no. 7 (July 15, 1853): 105. [Note that John Whipple decided to sell rights to practice his crystalotype process for $50.00, with a $25.00 training fee.]

W700 Whipple, John A. "Gossip." PHOTOGRAPHIC ART JOURNAL 6, no. 3 (Sept. 1853): frontispiece, 195-196. 1 b & w. [Letter from Whipple describing his illustration, a photomicrograph of the trachea of a silkworm, published in the issue.]

W701 3 or more photographs tipped into: THE AMHERST COLLEGIATE MAGAZINE 1, no. 1 (Oct. 1853). ["Conducted by Students of Amherst College. ...Editors of the Class of '54. Edward Crane, Henry V. Emmons, Wm. W. Fowler, John C. Kimball, George Partridge. Vol. I. Amherst: Published by the Editors." Illustrated with an engraved frontispiece, credited "Ambrotyped by E. W. Cowles." The issue is illustrated with at least three tipped-in crystalotype portraits of young students, probably the editors.]

W702 "Our Illustration." PHOTOGRAPHIC ART JOURNAL 6, no. 4 (Oct. 1853): frontispiece, 247. 1 b & w. [View of the Boston depot of the Fitchburg R.R. described on p. 247.]

W703 "Whipple's Crystalotypes." HUMPHREY'S JOURNAL 5, no. 13 (Oct. 15, 1853): 202. [Excerpt from a letter by Whipple announcing his willingness to teach his process. This same statement then republished on the inside back page of subsequent issues of the journal.]

W704 Crystalotype print of a view of the Perkins Institute for the Blind, South Boston, tipped into the issue. PHOTOGRAPHIC ART JOURNAL 6, no. 6 (Dec. 1853): frontispiece. 1 b & w. [Uncredited, but probable that the print at least is by Whipple.]

W705 "Miss Agnes Robertson, Theatrical Sensation." GLEASON'S PICTORIAL DRAWING-ROOM COMPANION 5, no. 20 (Apr. 1, 1854): 201. 1 illus. [Actress. "Based on daguerreotypes by Whipple and by Meade Bros."]

W706 "Miss Eliza Logan." GLEASON'S PICTORIAL DRAWING-ROOM COMPANION 7, no. 1 (July 8, 1854): 12. 1 illus. [Actress. "...from a daguerreotype by Whipple."]

W707 "Webster. After the Statue by T. Ball. Crystalotyped by Whipple." PHOTOGRAPHIC AND FINE ART JOURNAL 7, no. 11 (Nov. 1854): frontispiece, 346. 1 b & w. [Original photograph, tipped-in.]

W708 "Washington Headquarters - Cambridge, MA." PHOTOGRAPHIC AND FINE ART JOURNAL 8, no. 1 (Jan. 1855): frontispiece, 30-31. 1 b & w. [Original photograph, tipped-in.]

W709 Humphrey, S. D. "Personal and Art Intelligence." PHOTOGRAPHIC AND FINE ART JOURNAL 8, no. 3 (Mar. 1855): 94-95. [Editorial comment on Levi L. Hill controversy, with a letter on the issue by John A. Whipple included.]

W710 "Mrs. John W. Wood." BALLOU'S PICTORIAL DRAWING-ROOM COMPANION [GLEASON'S] 8, no. 15 (Apr. 14, 1855): 236. 1 illus. ["From a photograph by John A. Whipple."]

W711 "Photographs." BALLOU'S PICTORIAL DRAWING-ROOM COMPANION [GLEASON'S] 8, no. 16 (Apr. 21, 1855): 251. ["PHOTOGRAPHS - We are in receipt of some very perfect and elegant specimens of this important and valuable processes of likeness taken from the extensive and well-known establishment of John A. Whipple, No. 96 Washington Street. The more we see of this art, the more it pleases and interests us." (First commentary on photography - not daguerreotypes - in this magazine.)]

W712 "Jonathan Mason Warren, M.D." BALLOU'S PICTORIAL DRAWING-ROOM COMPANION [GLEASON'S] 8, no. 19 (May 12, 1855): 296. 1 illus. ["From a Photograph by John A. Whipple."]

W713 1 photo (Suburban Residence near Boston, MA). PHOTOGRAPHIC AND FINE ART JOURNAL 8, no. 12 (Dec. 1855): frontispiece. 1 b & w. [Original photographic print, tipped-in.]

W714 "Proceedings of the Liverpool Photographic Society: Ninth Monthly Meeting, Nov. 6, 1855." HUMPHREY'S JOURNAL 7, no. 16 (Dec. 15, 1855): 257-259. [From "Liverpool Photo. J." Contains text of a paper by Mr. Bell, "On Whipple's Albumen Process," read to the society.]

W715 Coale, George B. "Whipple's Process." HUMPHREY'S JOURNAL 9, no. 3 (June 1, 1857): 33-34.

W716 Portrait. Woodcut engraving, credited "From a Photograph by Whipple." FRANK LESLIE'S ILLUSTRATED NEWSPAPER 7, (1858) ["William Hickling Prescott." 7:158 (Dec. 11, 1858): 17.]

W717 "Ruins of the Pemberton Mills, at Lawrence, Massachusetts, the Morning After the Fire." HARPER'S WEEKLY 4, no. 160 (Jan. 21, 1860): 33. 1 illus. ["Photograph by Whipple, of Boston."]

W718 Woodcut engraving (View of Abraham Lincoln's house in Springfield, IL.), credited "From a Photograph by John A. Whipple. ILLUSTRATED LONDON NEWS 37, no. 1063 (Dec. 8, 1860): 543.

W719 "The New President of the United States." ILLUSTRATED LONDON NEWS 37, no. 1063 (Dec. 8, 1860): 543-544. 2 illus. [Portrait of Lincoln - from lithograph published by G. W. Nichols, NY. - "The Residence of Abraham Lincoln, at Springfield, Illinois. - From a photograph by J. A. Whipple, of Boston, U.S."]

W720 "Note." AMERICAN JOURNAL OF PHOTOGRAPHY AND THE ALLIED ARTS & SCIENCES n. s. vol. 3, no. 20 (Mar. 15, 1861): 319. ["Mr. Whipple, of Boston, has been making glass negatives five feet by four."]

W721 "The United States War Steamer 'Minnesota,' Flag-Ship of the Blockading Squadron." HARPER'S WEEKLY 5, no. 243 (Aug. 24, 1861): 541. 1 illus. ["Photographed by Whipple, of Boston."]

W722 "Photographing the Comet." AMERICAN JOURNAL OF PHOTOGRAPHY AND THE ALLIED ARTS & SCIENCES n. s. vol. 4, no. 7 (Sept. 1, 1861): 146. [Note that Whipple attempted, and failed, to photograph "the comet."]

W723 "Photographic Olla Podrida: Astro-Photography." BRITISH JOURNAL OF PHOTOGRAPHY 8, no. 149 (Sept. 2, 1861): 313. [Brief note that Whipple, "who so successfully photographed Donati's comet and other heavenly bodies, reports" ...unable to photograph the current comet.]

W724 "Photographic Olla Podrida: Astro-Photography." HUMPHREY'S JOURNAL OF PHOTOGRAPHY, AND THE ALLIED ARTS AND SCIENCES 13, no. 12 (Oct. 15, 1861): 192. [Note that J. A. Whipple reports that he was unable to photograph the comet which appeared in July.]

W725 Portrait. Woodcut engraving, credited "From a Photograph." FRANK LESLIE'S ILLUSTRATED NEWSPAPER 13, (1862) [Capt. Theodorus Bailey, U.S.N." 13: 346-347 (May 31, 1862): 121.]

W726 "Editorial Department." AMERICAN JOURNAL OF PHOTOGRAPHY AND THE ALLIED ARTS & SCIENCES n. s. vol. 5, no. 23 (June 1, 1863): 552. ["The card of Mr. Whipple, in our advertising pages, comes like a voice from antiquity. A daguerreotypist wanted forsooth!..." (Advertising section not in this copy.)]

W727 Portrait. Woodcut engraving, credited "From a Photograph by Whipple." FRANK LESLIE'S ILLUSTRATED NEWSPAPER 16, (1863) ["The late Brig.-Gen. George C. Strong." 16:412 (Aug. 22, 1863): 353.]

W728 "The American Photographical Society: Fifty Second Meeting. - Views at Night." AMERICAN JOURNAL OF PHOTOGRAPHY AND THE ALLIED ARTS & SCIENCES n. s. vol. 6, no. 13 (Jan. 1, 1864): 304-305. [Two views of Ike Fountain in Boston Common, taken at night with the electric light by J. Whipple, presented to the Society. Whipple's memoranda, explaining how the photos were achieved is also printed.]

W729 "Photography In Boston." AMERICAN JOURNAL OF PHOTOGRAPHY AND THE ALLIED ARTS & SCIENCES n. s. vol. 6, no. 14 (Jan. 15, 1864): 321-323. [J. W. Black has "the largest establishment in the city. 40,000 negatives stored. 60 hands, male and female, employed in the establishment. One room is devoted to copying, one to groups, one to ordinary card work. One operator coats the plates, another exposes them, Mr. Black himself attends to the positions, and another assistant develops....Nearly twenty tons of glass (negatives) must be stored away in this single establishment. Mr. Black also has rooms at Cambridge, near his residence." Mr. Whipple maintains his ancient fame, and keeps his old establishment at 96

Washington St....(More info. on Whipple.) Ormsbee and Burnham mentioned. Boston maintains about seventy galleries.]

W730 "Note." PHOTOGRAPHIC NEWS 8, no. 282 (Jan. 29, 1864): 57. [Note that Whipple had made two views of the fountains in the Boston Common at night on Aug. 6, 1863, which he presented to the American Photographical Society in New York.]

W731 Wilson, Edward L. "A Day or Two in Boston." PHILADELPHIA PHOTOGRAPHER 2, no. 14 (Feb. 1865): 27-28. [Note that Whipple was experimenting with magnesium light for flash photographs.]

W732 "Faneuil Hall, Boston." HARPER'S WEEKLY 10, no. 513 (Oct. 27, 1866): 685. 1 illus. ["Photographed by John A. Whipple, Boston."]

W733 "The New Masonic Hall, Boston, Dedicated June 24, 1867." HARPER'S WEEKLY 11, no. 549 (July 6, 1867): 421. 1 illus. ["Photographed by John A. Whipple, 297 Washington St., Boston."]

W734 "Interior of Faneuil Hall, Boston." HARPER'S WEEKLY 11, no. 550 (July 13, 1867): 440. 1 illus. ["Photographed by Whipple,...."]

W735 "Plymouth Rock, As It Now Appears." HARPER'S WEEKLY 11, no. 572 (Dec. 14, 1867): 797. 1 illus. ["Photographed by Whipple, Boston."]

W736 "Stuart's Washington." HARPER'S WEEKLY 12, no. 583 (Feb. 29, 1868): 132. 1 illus. ["Photographed by Whipple, Boston." Painting of George Washington by Gilbert Stuart.]

W737 Portrait. Woodcut engraving, credited "From a Photograph by John A. Whipple." HARPER'S WEEKLY 12, (1868) ["Benjamin R. Curtis, of MA." 12:590 (Apr. 18, 1868): 244.]

W738 Portraits. Woodcut engravings, credited "From a Photograph by John A. Whipple. HARPER'S WEEKLY 13, (1869) ["Hon. William Claflin, Gov. of MA." 13:630 (Jan. 23, 1869): 52. "Harvard Crew: J. S. Fay, Wm. Simmons, Alden Loring, E. O. Lyman, Arthur Burnham (5 portraits)." 13:662 (Sept. 4, 1869): 565. "Charles E. Eliot, Pres. of Harvard University." 13:671 (Nov. 6, 1869): 708.]

W739 "The National Peace Jubilee Building, Boston, Massachusetts." HARPER'S WEEKLY 13, no. 647 (May 22, 1869): 328. 1 illus. ["Photographed by John A. Whipple, 297 Washington Street, Boston." Building under construction.]

W740 "The First Church, Boston, Mass. Rev. Rufus Ellis, Pastor. - From a Photograph by Whipple." FRANK LESLIE'S ILLUSTRATED NEWSPAPER 28, no. 714 (June 5, 1869): 181.

W741 "The Ether Monument, In the Public Garden, Boston, Mass," "The Public Garden, Boston, Mass. - View from the Corner of Charles and Beacon Streets, Looking South," "The Public Garden, Boston, Mass. - View from the Corner of Arlington and Boylston Streets, Looking North - From a Photograph by Whipple." FRANK LESLIE'S ILLUSTRATED NEWSPAPER 28, no. 715 (June 12, 1869): 193, 200-201. 3 illus. [Views, with figures.]

W742 "Grand Coliseum in which the Boston Peace Jubilee is Held." HARPER'S WEEKLY 13, no. 651 (June 19, 1869): 389. 1 illus. ["Photographed by John A. Whipple, 297 Washington St., Boston, Mass."]

W743 "The Peace Jubilee, Boston - Interior of the Grand Coliseum - Photographed by John A. Whipple, 297 Washington Street, Boston."

HARPER'S WEEKLY 13, no. 652 (June 26, 1869): 408-409, 411. 1 illus. [Unusual double page engraving, unusual praise and brief bio. for Whipple in text on p. 411. "...in a view scarcely ever equaled and never surpassed, the possibilities of his act for the perfect presentation of the vast interiors of public buildings." Image of interior of the hall, filled with a large crowd.]

W744 "Cable House, Rouse's Hummock, Duxbury, Massachusetts. - Landing of the French Cable at Duxbury Massachusetts. - Celebration of the Completion of the French Cable at Duxbury, Massachusetts." HARPER'S WEEKLY 13, no. 659 (Aug. 14, 1869): 516. 3 illus. [3 views. "Photographed by John A. Whipple, 297 Washington St., Boston."]

W745 "The Solar Eclipse, August 1, 1869 - Harvard Astronomical Expedition Making Observations at Shelbyville, Kentucky - Photographed by J. A. Whipple." and " Solar Eclipse, Aug. 7, 1869 - Phases of the Eclipse, As Seen at Shelbyville, Kentucky from the Beginning to the Point of Totality - Photographed by J. A. Whipple." HARPER'S WEEKLY 13, no. 661 (Aug. 28, 1869): 545-546. 9 illus. [8 views of the eclipse and a view of the expeditionary party at work.]

W746 "The International Boat-Race - The Harvard Crew." HARPER'S WEEKLY 13, no. 662 (Sept. 4, 1869): 565. 5 illus. ["Photographed by John A. Whipple." 5 portraits.]

W747 "The Coliseum at Boston after the Terrible Gale of September 8." HARPER'S WEEKLY 13, no. 665 (Sept. 25, 1869): 612, 614. 1 illus. ["Photo. by John A. Whipple, Boston."]

W748 "Union Park Unitarian Church, Boston, Mass. Rev. Edward E. Hale, Pastor. - From a Photograph by Whipple." FRANK LESLIE'S ILLUSTRATED NEWSPAPER 29, no. 736 (Nov. 6, 1869): 132. 2 illus. [View. Portrait.]

W749 Portrait. Woodcut engraving, credited "From a Photograph by Whipple." FRANK LESLIE'S ILLUSTRATED NEWSPAPER 33, (1871) ["Hon. William B. Washburn, Gov.-elect of MA." 33:843 (Nov. 25, 1871): 173.]

W750 "Boston - Washington Street, Looking Toward the Old South Church from Summer Street." HARPER'S WEEKLY 16, no. 832 (Dec. 7, 1872): 948. 1 illus. [Boston fire aftermath.]

W751 Portrait. Woodcut engraving, credited "Photographed by Whipple." FRANK LESLIE'S ILLUSTRATED NEWSPAPER 38, (1874) ["Hon. Wm. B. Washburn, Gov. of MA." 38:971 (May 9, 1874): 141.]

W752 Ehrmann, Charles. "Whipple's Crystalotypes - The First Negatives Made on Glass in America." PHOTOGRAPHIC TIMES 15, no. 188 (Apr. 24, 1885): 216-217. [A communication to the Photographic Section of the American Institute. Ehrmann presented this to fill in the gap in Dr. Laudy's previous lecture. Brief history of calotype. Then describes Whipple's process in detail and discusses its impact. Mentions that James E. McClees exhibited in Paris in 1855 a panoramic view of Niagara Falls, composed of five 16" x 20" Whipple Plates.]

W753 "Photographic Section of the American Institute." PHOTOGRAPHIC TIMES 15, no. 188 (Apr. 24, 1885): 218-219. [Additional commentary from members in response to Charles Ehrmann's paper on Whipple's Crystallotype process, published on pp. 216-217.]

W754 Snelling, H. H. "Looking Back; or the Olden Days of Photography." ANTHONY'S PHOTOGRAPHIC BULLETIN 19, no.

9-21 (May 12 - Nov. 10, 1888): 263-265, 295-298, 368-370, 433-438, 559-563, 650-654. [Anecdotal history of photography in the USA from 1830s through 1850s. John Whipple's letter describing his photomicroscope experiences published on pp. 562-563.]

W755 "Recent Deaths: John A. Whipple." BOSTON TRANSCRIPT (Apr. 11, 1891): 9. [Obituary.]

W756 "Obituary: John A. Whipple." PHOTOGRAPHIC TIMES 21, no. 500 (Apr. 17, 1891): 182-183.

W757 Hoffleit, Dorrit. "The First Star Photograph." SKY AND TELESCOPE (July 1950): 207-210. 3 b & w. 2 illus.

W758 Lokuta, Donald P. "Daguerreotype of the Moon." HISTORY OF PHOTOGRAPHY 1, no. 3 (July 1977): 248. 1 b & w. [Daguerreotype taken Aug. 1851.]

W759 Welling, William. "More on the early development of photography in Boston." PHOTOGRAPHICA 12, no. 3 (Mar. 1980): 8-9, plus cover. 1, 1 portrait b & w. [Discusses John A. Whipple's daguerreotypes of the moon and magic lantern slide photographer, James Wallace Black.]

WHITE, EDWIN MANSER. (1848-1912) (USA)
W760 "E. M. White, Keene Photographer." NEWS-LETTER OF THE HISTORICAL SOCIETY OF CHESHIRE COUNTY (NEW HAMPSHIRE) 3, no. 4 (Nov. 1986): 1-2. 2 b & w. [Edwin Manser White was born in Keene, NH on Oct. 29, 1848. By 1871, at age twenty-two, he was employed by J. A. French, of Keene. In 1879 White took over the studio of H. Ollis in Keene and operated the studio until 1904. He made portaits, groups, and photographs of local businesses and manufacturing plants and their products. White died in Keene in 1912.]

WHITE, FRANKLIN. (LANCASTER, NH)
BOOKS
W761 White, Franklin. *Photographic Scrap Book, Containing Views of Mountain Scenery, Views of Boston, New York.* Lancaster, NH: F. White, 1858. n. p. b & w. [Original photographs, tipped-in.]

W762 White, Franklin. *Photographic Scrap Book; Entered in Clerks Office in District Court of New Hampshire, July 1859. "2nd Series"* Lancaster, NH: White, 1859. 11 pp. 45 b & w. [Tiny, approximately 2" x 3", oval prints of views of Quebec and New Hampshire. Five or six original calotype prints tipped-in onto each page. Library of Congress Collection.]

W763 White, Franklin. *Photographic Views from Mount Washington and Vicinity, and the Franconia Range.* Lancaster, NH: F. White, 1859. 2 l. 24 l. of plates. [Calotypes and one albumen print. Cover title: White's Photographic Views of White Mountain Scenery.]

W764 *White's Photographic Views, for 1860, 2nd Series.* Lancaster, NH: White, 1860. n. p. 25 b & w. [Set of 25 half stereos.]

PERIODICALS
W765 Chamberlin, Gary N. "Franklin White: Pioneer Photographer." STEREO WORLD 2, no. 4 (Sept. - Oct. 1975): 1, 20. 1 b & w. [White began photographing in Lancaster, NH in mid 1850s. Brother Luther White, of Montpelier, VT, also a photographer. Franklin White went into partnership with Franklin G. Weller in 1867. Many views of the White Mountains.]

WHITE, FRANKLIN. [?]

W766 "Report of the Photographic Section of the American Institute." ANTHONY'S PHOTOGRAPHIC BULLETIN 8, no. 5 (May 1877): 153. [H. J. Newton, in discussion, stated "Some twenty-five years ago Mr. White, who photographed the White Mountain region, had a method of keeping his plates damp for two or three days..."]

WHITE, HENRY. (1819-1903) (GREAT BRITAIN)

[Henry White was a solicitor in London from 1841. Practiced with his father (White & Son) until the father's death in 1857, then continued alone. He seems to have began to photograph around 1855 and worked until about the end of the decade. He published a series of landscape views in 1856, many from North Wales. Member of the Photographic Society in mid 1850s.]

W767 "Note." ART JOURNAL (Feb. 1857): 65-66. [Note about landscape photos and his success in exhibition.]

WHITE, JOHN. (SALEM, MA)

W768 Portrait. Woodcut engraving, credited "From a Photograph by John White, Salem, Mass." FRANK LESLIE'S ILLUSTRATED NEWSPAPER 36, (1873) ["Miss N. S. Emerson, author." 36:925 (June 21, 1873): 233.]

WHITE, JOHN FORBES. (1831-1904) (GREAT BRITAIN)

W769 White, John Forbes. *16 Modern Prints from Wax-Paper Negatives; Made by J. F. White in 1854 - 57.* Introduced by his daughter, Ina Mary Harrower. s. l.: s. n., 196- ? 18, 35 pp. 16 b & w. [Loose leaf notebook, with letters of Molly Harrower in the pocket, GEH collection.]

W770 *John Forbes White: Miller, Collector, Photographer 1831 - 1904.* "Occasional Publications, 9" Edinburgh: Edinburgh Corporation. Libraries and Museums Committee, 1970. 24 pp. 13 b & w. [With an appreciation by his daughter, Dorothea, Lady Fyfe, and an introduction by C. S. Minto.]

WHITE, LUTHER.

W771 White, Luther. *A Sett of Stereoscopic Views of White Mountain and Other Scenery.* Montpelier, VT: s. n. [White ?], 1859. n. p. [Bound album, with typescript title page, stereo photos mounted on elongated page format in album. LC Collection. See "Anthony's Photo. Bulletin." (May 1877): 153, for statement that a Mr. White was photographing in the White Mountains in the 1850s.]

WHITE, SYDNEY & ERNEST WHITE. (READING, ENGLAND)

W772 Portraits Woodcut engraving credited "From a photograph by Sydney White & Ernest White." ILLUSTRATED LONDON NEWS 72, (1878) ["Mr. George Palmer, M.P." 72:2031 (June 1, 1878): 500.]

WHITE, T. & CO. (GREAT BRITAIN)

W773 Portrait. Woodcut engraving credited "From a photograph by T. White & Co, Princes St., London Rd., S.E." ILLUSTRATED LONDON NEWS 75, (1879) ["Corporal Taylor, champion rifleman." 75:2094 (Aug. 2, 1879): 116.]

WHITE, WALLACE S. (1842-1921) (USA)

W774 "Note." ANTHONY'S PHOTOGRAPHIC BULLETIN 9, no. 6 (June 1878): 192. [From Kalamazoo, MI "Daily Telegraph." New Gallery.]

WHITE, WELLS H. & CO. (DUBUQUE, IA)

W775 "Letter." PHOTOGRAPHIC ART JOURNAL 6, no. 1 (July 1853): 65. [Letter praising Journal.]

WHITEHURST, JESSE H. (1820-1875) (USA)

[Jessie H. Whitehurst was born in Princess Anne County, VA in 1820, the son of Captain Charles Whitehurst. Demonstrated mechanical and artistic talents, and in 1843 visited New York to learn daguerreotypy. Opened a gallery in Charleston, SC in the Fall of 1843, and a larger gallery in Richmond, VA in 1844. Then quickly opened branch galleries in Lynchburg, Petersburg, Baltimore, and New York. Claimed to have produced over 60,000 pictures in the first six years of operations, employing twenty-three assistants. His gallery sent daguerreotype views of Niagara Falls to the Crystal Palace exhibition in 1851. Julian Vannerson worked in Whitehurst's Washington studio in 1853, and Marcellus J. Powere worked there in 1862-63, at which time he photographed the Indian delegations to the Capitol for Whitehurst. Whitehurst died in Baltimore, MD on Sept. 8, 1875.]

BOOKS

W776 Cary, Samuel Fenton, ed. *American Temperance Magazine and Sons of Temperance Offering.* New York: R. Van Dion, 1851. 420 pp. 9 illus. [Eight steel engravings of portraits (stereotyped by Vincent L. Dill), from daguerreotypes, two of which are by Root, one by Whitehurst. One wood engraving, of the Temperance building, by N. Orr. Originally appeared monthly, but this is a cumulated volume.]

W777 "J. H. Whitehurst, of Norfolk, the Virginia Daguerreotypist," on pp. 397-398 in: *Historical and Descriptive Sketches of Norfolk and Vicinity, including Portsmouth and the Adjacent Counties.* by William S. Forest. Philadelphia: Lindsay & Blakiston, 1853. n. p.

PERIODICALS

W778 "Our Daguerreotypes." DAGUERREAN JOURNAL 1, no. 5 (Jan. 15, 1851): 148. [Whitehurst had galleries in Washington, DC, Baltimore, MD, Richmond, Norfolk, Peterburg, and Lynchburg, VA.]

W779 Portrait. Woodcut engraving, credited "Our engraving is a copy from a daguerreotype by Whitehurst of New York." GLEASON'S PICTORIAL DRAWING-ROOM COMPANION 1, (1851) ["Actress Jenny Lind." 1:3 (May 17, 1851): 41.]

W780 "American Poets, No. II. R. H. Stoddard." ILLUSTRATED AMERICAN NEWS 1, no. 12 (Aug. 23, 1851): 93-94. 1 illus. ["The portrait... engraved from an excellent daguerreotype by Whitehurst, in whose establishments in New York, Baltimore, Washington, Richmond and other cities, portraits of nearly every person of eminence are constantly on view."]

W781 "American Poets, No. III. Alice, Phoebe, and Elmina Carey." ILLUSTRATED AMERICAN NEWS 1, no. 14 (Sept. 6, 1851): 105-106. 1 illus. ["From a Daguerreotype by Whitehurst."]

W782 "Laura Addison: The Tragic Queen of the Romantic Drama." ILLUSTRATED AMERICAN NEWS 1, no. 18 (Oct. 4, 1851): 141. 1 illus. ["From a daguerreotype by Whitehurst, 349 Broadway, New York, NY."]

W783 "Angiolona Bosio." ILLUSTRATED AMERICAN NEWS 1, no. 19 (Oct. 11, 1851): 149. 1 illus. [Singer. "From a daguerreotype by Whitehurst."]

W784 "Wyman the Magician." ILLUSTRATED AMERICAN NEWS 1, no. 20 (Oct. 18, 1851): 157. 1 illus. ["From a Daguerreotype by Whitehurst."]

W785 Portrait. Woodcut engraving, credited "From a Daguerreotype by Whitehurst." ILLUSTRATED AMERICAN NEWS 1, no. 22 (1851) ["Dr. Holland." 1:22 (Nov. 1, 1851): 173.]

W786 "Gossip." PHOTOGRAPHIC ART JOURNAL 3, no. 4 (Apr. 1852): 257. ["Mrs. Whitehurst, whose beautiful gallery in N.Y. was nearly ruined by fire and water on Sunday morning, March 28th..."]

W787 Portrait. Woodcut engraving, credited "From a Daguerreotype by Jesse H. Whitehurst." ILLUSTRATED NEWS (NY) 1, (1853) ["Clark Mills, sculptor." 1:5 (Jan. 29, 1853): 72.]

W788 "Extraordinary Ceremony in the Roman Catholic Church of St. Peter's, Baltimore. - From a Daguerreotype by J. H. Whitehurst, of Baltimore." FRANK LESLIE'S ILLUSTRATED NEWSPAPER 1, no. 8 (Feb. 2, 1856): 113. 1 illus. [Interior, with people.]

W789 "Sleighing Scene in Baltimore. From a Daguerreotype by G. H. [sic J. H.] Whitehurst of Baltimore." FRANK LESLIE'S ILLUSTRATED NEWSPAPER 1, no. 8 (Feb. 2, 1856): 120. 1 illus. [Outdoor scene, children sledding.]

W790 "Gilmore House and Battle Monument, Baltimore. (From a Daguerreotype by J. M. Whitehurst.)" FRANK LESLIE'S ILLUSTRATED NEWSPAPER 1, no. 8 (Feb. 2, 1856): 128. 1 illus. [View.]

W791 Portraits. Woodcut engravings, credited "From an Ambrotype by G. H. [sic J. H.] Whitehurst. FRANK LESLIE'S ILLUSTRATED NEWSPAPER 1, (1856) ["Lewis P. W. Balch, D.D." 1:12 (Mar. 1, 1856): 192.]

W792 Portraits. Woodcut engravings, credited "From an Photograph by Whitehurst, of Washington City." FRANK LESLIE'S ILLUSTRATED NEWSPAPER 3, (1857) ["Roger P. Taney, Chief-Justice of US Supreme Court." 3:68 (Mar. 28, 1857): 256. "Howell Cobb, Sec. of Treasury." 3:69 (Apr. 4, 1857): 276. "Gen. Lewis Cass, Sec. of State." 3:72 (Apr. 25, 1857): 320. "Isaac Toucey, Sec. of the Navy." 3:72 (Apr. 25, 1857): 328. "Aaron Brown, Postmaster General." 3:76 (May 23, 1857): 392.]

W793 "Inauguration of Mr. Buchanan as President of the United States." ILLUSTRATED LONDON NEWS 30, no. 851 (Mar. 28, 1857): 295-296. 1 illus. [Outdoor crowd at inauguration ceremony in front of the Capitol. "From a Photograph by Whitchurch, [sic Whitehurst] of Washington."]

W794 Portraits. Woodcut engravings, credited "Photographed by Whitehurst." FRANK LESLIE'S ILLUSTRATED NEWSPAPER 4, (1857) ["Col. John W. Forney, of PA." 4:87 (Aug. 1, 1857): 129. "Horatio King, First-Asst. Postmaster-General." 4:94 (Sept. 19, 1857): 252. "Rev. L. G. Hay. missionary." 4:99 (Oct. 24, 1857): 321. "The late George Washington Parks Custus, adopted son of Geo. Washington." 4:101 (Nov. 7, 1857): 360.]

W795 Portrait. Woodcut engraving, credited "From a Daguerreotype by Whitehurst, Washington, DC." BALLOU'S PICTORIAL DRAWING-ROOM COMPANION [GLEASON'S] 13, (1857) ["Lieut. Matthew F. Maury, U.S.N." 13:327 (Sept. 16, 1857): 193.]

W796 Portrait. Woodcut engraving, credited "From a Photograph by Jesse H. Whitehurst." HARPER'S WEEKLY 1, (1857) ["Hon. Stephen A. Douglas of Illinois." 1:52 (Dec. 26, 1857): 817.]

W797 Portraits. Woodcut engravings, credited "From a Photograph by Jessie H. Whitehurst." HARPER'S WEEKLY 2, (1858) ["Hon. Jefferson Davis, of MS." 2:54 (Jan. 9): 17; "Sen. Brown, of MS." 2:58 (Feb 6): 81; "Hon. James L. Orr, of SC." 2:61 (Feb. 27): 129; "Hon. Henry Wilson, of MA." 2:62 (Mar. 6): 145.]

W798 Portraits. Woodcut engravings, credited "Photographed by Whitehurst." FRANK LESLIE'S ILLUSTRATED NEWSPAPER 5, (1858) ["Hon. James M. Mason, Sen. from VA." 5:122 (Apr. 3, 1858): 273. "Hon. T. L. Harris, from IL." 5:122 (Apr. 3, 1858): 273. "Hon. George Washington Jones, from TN." 5:126 (May 1, 1858): 337.]

W799 Portraits. Woodcut engravings, credited "From a Photograph by Whitehurst, of Washington." FRANK LESLIE'S ILLUSTRATED NEWSPAPER 7, (1859) ["Smith O'Brien." 7:172 (Mar. 19, 1859): 242. "Robert Ould, US Attorney." 7:173 (Mar. 26, 1859): 270.]

W800 "Candidates for the Presidency in 1861." FRANK LESLIE'S ILLUSTRATED NEWSPAPER 9, no. 229 (Apr. 21, 1860): 327-328. 8 illus. [Eight portraits, collaged onto one page. Robert Hunter (VA), James Hammond (SC), (portraits by Brady); Andrew Johnson (TN), Howell Cobb (GA), James L. Orr (SC), Jefferson Davis (MS), Robert Toombs (GA), (portraits by Whitehurst); Samuel Houston (TX) (portrait by Webster & Brother, Louisville, KY).]

W801 Portraits. Woodcut engravings, credited "From a Photograph by Whitehurst, of Washington." FRANK LESLIE'S ILLUSTRATED NEWSPAPER 9, (1860) ["Hon. Stephen A. Douglas." 9:226 (Mar. 31, 1860): 278. "Mr. Stephen A. Douglas." 9:234 (May 26, 1860): 407.]

W802 Portraits. Woodcut engravings, credited "From a Photograph by Jesse H. Whitehurst." NEW YORK ILLUSTRATED NEWS 3, (1861) ["Gov. Hicks, of MD." 3:67 (Feb. 16, 1861): 228. "Hon. Mr. Van Wyck." 3:70 (Mar. 9, 1861): 273.]

W803 Portrait. Woodcut engraving, credited "From photographs by Whitehurst, of Washington, and Hinton, of Montgomery, Alabama." HARPER'S WEEKLY 5, (1861) ["The Cabinet of the Confederate States at Montgomery." 5:231 (June 1, 1861): 340.]

W804 Portrait. Woodcut engraving, credited "From a Photograph Taken Shortly Before His Death by Whitehurst, of Washington." FRANK LESLIE'S ILLUSTRATED NEWSPAPER 12, (1861) ["The late Stephen A. Douglas, of IL." 12:290 (June 8, 1861): 60.]

W805 "Batteries at the Chain Bridge, Washington, D.C." HARPER'S WEEKLY 5, no. 243 (Aug. 24, 1861): 538. 2 illus. ["Photographed by Whitehurst."]

W806 "Obituary." PHILADELPHIA PHOTOGRAPHER 12, no. 142 (Oct. 1875): 300-301. [Born in Virginia "about fifty-five years ago." One of the first to practice photography in the South, as he and a friend opened a gallery in Norfolk, VA, very early. Successful, and within a few years owned half a dozen galleries - in Baltimore, MD, Washington, DC, Richmond, VA, Norfolk, VA, Wilmington, DL and New York, NY. Over the years scores of "artists," who later were to become well-known, worked for Whitehurst. In 1851 the Whitehurst Gallery won an award at the Crystal Palace Exposition for a series of panoramic daguerreotypes of Niagara Falls. Died on Sept. 8, 1875, in Baltimore, MD.]

WHITEMAN, H. W. (PROVIDENCE, RI)

W807 "Photographic Swindlers. - More Quackery." AMERICAN JOURNAL OF PHOTOGRAPHY AND THE ALLIED ARTS & SCIENCES n. s. vol. 6, no. 20 (Apr. 15, 1864): 469-476. [W. Chase (Bucyrus, OH) and Whiteman (Providence, R. I.) offered for sale certain formulas, which are reprinted here and claimed by the editor to be stolen from previously published works.]

WHITFIELD, HENRY.

W808 Whitfield, Henry. "On Some of the Earlier Preservative Processes." BRITISH JOURNAL PHOTOGRAPHIC ALMANAC 1875 (1875): 89-93. [Discusses improvements to types of wet collodion processes designed to keep the collodion active), and dry processes, from 1850s to 1870s. M. Girod; Spiller & Crookes; Pollock; Spiller; Shadbolt; Maxwell Lyte; Llewellyn; Gaudin; King; R. F. Barnes; Abbe* Despratz; Bolton; Phipps; Kennett; Ackland; Mudd; Keene; Pritchard; Petschler & Mann; Hill Norris; Long; Sparling; others mentioned.]

WHITHAM, A.

W809 Whitham, A. "A modified Oxymel Process." HUMPHREY'S JOURNAL OF PHOTOGRAPHY, AND THE ALLIED ARTS AND SCIENCES 10, no. 19 (Feb. 1, 1859): 299-300. [From "Liverpool Photo. J."]

WHITLOCK, BENJAMIN. (LUDLOW, ENGLAND)

W810 "Positive Collodion Pictures Direct on Wood, for Engraving." HUMPHREY'S JOURNAL 9, no. 15 (Dec. 1, 1857): 235-236. [From "Photo. Notes." Process of Benjamin Whitlock, of Ludlow, England.]

WHITLOCK, H. J. (BIRMINGHAM, ENGLAND)

W811 Portraits. Woodcut engravings, credited "Photographed by H. J. Whitlock." ILLUSTRATED LONDON NEWS 22, (1853) ["John Ellis, teacher." 33:* (Apr. 9, 1853): 268.]

W812 Portraits. Woodcut engravings, credited "Photographed by Whitlock, of Birmingham." ILLUSTRATED LONDON NEWS 33, (1858) ["John Bright, M.P." 33:* (Dec. 18, 1858): 579.]

W813 Portraits. Woodcut engravings, credited "Photographed by H. J. Whitlock." ILLUSTRATED LONDON NEWS 55, (1869) ["Right Rev. Dr. Temple." 55:* (Nov. 27, 1869): 529.]

W814 Portraits. Woodcut engravings, credited "Photographed by H. J. Whitlock." ILLUSTRATED LONDON NEWS 56, (1870) ["Mr. Mark Lemon, author." 56:* (June 4, 1870): 573.]

W815 Portrait. Woodcut engraving, credited "From a Photograph by H. J. Whitlock, Birmingham, Eng." ILLUSTRATED LONDON NEWS 58, (1871) ["Sir Julius Benedict." 58:1645 (Apr. 15, 1871): 377.]

W816 Portrait. Woodcut engraving credited "From a photograph by H. J. Whitlock." ILLUSTRATED LONDON NEWS 69, (1876) ["Late Harriet Martineau." 69:1928 (July 15, 1876): 61.]

WHITLOCK, JOSEPH. (GREAT BRITAIN)

W817 "Portrait of a Girl." HISTORY OF PHOTOGRAPHY 3 , no. 4 (Oct. 1979): frontispiece. 1 b & w. [Portrait taken ca. 1848]

WHITLOCK, N. (GREAT BRITAIN)

W818 Whitlock, N. *Manual of Photography*. London: Robins, 1841. n. p.

W819 Whitlock, N. *Photogenic Drawing*. London: Robins, 1843. n. p.

WHITNEY & BECKWITH. (NORWALK, CT)

W820 "Editor's Table: Stereographs Received." PHILADELPHIA PHOTOGRAPHER 4, no. 42 (June 1867): 195.

W821 "Note." ANTHONY'S PHOTOGRAPHIC BULLETIN 1, no. 10 (Nov. 1870): 205-206. [From Norwalk, CT "Gazette." Review of Whitney & Beckwith's work exhibited "at the late Fair."]

WHITNEY & DENNY. (ROCHESTER, NY)

W822 Gossip." PHOTOGRAPHIC ART JOURNAL 4, no. 1 (July 1852): 167.

WHITNEY & ZIMMERMAN. (ST. PAUL, MN)

W823 "St. Anthony Falls Dam, Minnesota." HARPER'S WEEKLY 13, no. 671 (Nov. 6, 1869): 705. 1 illus. ["Photographed by Whitney & Zimmerman, St. Paul, Minnesota."]

W824 "Editor's Table." PHILADELPHIA PHOTOGRAPHER 7, no. 74 (Feb. 1870): 64. [Note of winter views of Minnehaha Falls from Whitney & Zimmerman, and Zimmerman's accident from falling ice.]

WHITNEY, EDWARD T. see also WHITNEY & DENNY.

WHITNEY, EDWARD TOMKINS. (1820-1893) (USA)

[Born in New York, NY in 1820. Worked as a jeweler, then learned photography from M. M. Lawrence in 1844. Moved to Rochester, NY in 1845. Partner with Mercer from 1845 to 1848, then ran his own gallery to 1851. Then partner with Conrad B. Denny from 1852 to 1854. In 1859 moved to Norwalk, CT.]

W825 Whitney, E. T. "Expression." PHOTOGRAPHIC AND FINE ART JOURNAL 7, no. 4 (Apr. 1854): 111.

W826 Whitney, E. T. "On Taking Daguerreotypes of Children." PHOTOGRAPHIC AND FINE ART JOURNAL 8, no. 3 (Mar. 1855): 76.

W827 Portraits. Woodcut engravings, credited "From an Photograph by Whitney, of Rochester." FRANK LESLIE'S ILLUSTRATED NEWSPAPER 1, (1856) ["Seandough, the old Oneida chief." 1:14 (Mar. 15, 1856): 217.]

W828 "Plymouth Church, Rochester, N. Y. - From an Ambrotype by Whitney." FRANK LESLIE'S ILLUSTRATED NEWSPAPER 2, no. 30 (July 5, 1856): 52. 1 illus. [View.]

W829 "The Port of Gennessee, on Lake Ontario, N. Y." FRANK LESLIE'S ILLUSTRATED NEWSPAPER 2, no. 30 (July 5, 1856): 53, 54. 1 illus. [View. "Our beautiful picture...is from an Ambrotype by Whitney of Rochester, and gives a striking and picturesque representation of the Port and contiguous scenery, as they appeared about the middle of April, 1856."]

W830 Whitney, E. T. "Our Illustrations. III. Genesee Falls, with Rochester in the distance and the scene of the Little's murder in the foreground, by E. T. Whitney." PHOTOGRAPHIC AND FINE ART JOURNAL 11, no. 8 (Aug. 1858): frontispiece, 245-246. 1 b & w. [Contains a letter from Whitney, describing the murder and general scenery.]

W831 Whitney, E. T. "Fifth Annual Meeting and Exhibit of the National Photographic Association of the U.S., held in Buffalo, N.Y., beginning July 5, 1873: Treatment of the Sitter." PHILADELPHIA PHOTOGRAPHER 10, no. 117 (Sept. 1873): 320-321.

W832 Whitney, E. T. "Connecticut Correspondence." PHILADELPHIA PHOTOGRAPHER 13, no. 145 (Jan. 1876): 23-24.

W833 "Our Illustration." ANTHONY'S PHOTOGRAPHIC BULLETIN 10, no. 9 (Sept. 1879): frontispiece, 288. 1 b & w. [Original photo. "Rt. Rev. John Williams," by E. T. Whitney (Norwalk, CT).]

W834 Whitney, E. T. "The Second Annual Convention of the Photographers Association of America: Past and Present." PHOTOGRAPHIC TIMES 11, no. 128 (Aug. 1881): 345-348. [Lecture given to the PA of A convention, reported in this special supplement to the "PT." Whitney mingled some of his memories of his own early career with some comments on the early history of photography in the USA and an exhortation to excel. Whitney claimed to have been the first individual to have a large exhibition of daguerreotypes at a [the NY] State Fair, in 1848. He also states that, with the assistance of George N. Barnard and Mr. Davies, he organized the first convention for the promotion of the art in 1848. In 1850 or 1851 he learned photography (not daguerreotypy) from James W, Black and his assistant Dunmore, and that Barnard helped him (with photography) afterward.]

W835 "Reminiscences." PHOTOGRAPHIC TIMES 14, no. 159 (Mar. 1884): 122-124. [Paper read before the Photographic Section of the American Institute. Autobiographical. Whitney claims to have seen his first daguerreotype in 1840, while in Norwalk, CT - taken by Seth Boyden. His cousin Thomas R. Whitney opened a daguerreotype gallery in 1841, with a Mr. Knight, (in New York City?) and E. T. Whitney had an early portrait made there. "In 1844, I, too, left the jewelry business and took instruction from Mr. Lawrence." Moved to Rochester, NY in 1846 and opened a gallery there. Whitney exhibited "sun pictures" at the New York State Fair in Albany in 1848, which he felt were the first so displayed in a state fair. With the assistance of Mr. G. N. Barnard and D. D. T. Davie, he organized "the first convention to promote the art." Went to New York twice a year to learn the latest developments in the art, with unusual access to Gurney's and Brady's galleries. Learned much from "Mr. A. W. Paradise, who was Brady's right hand man for so many years." "After teaching Gurney and Brady in New York, J. W. Black came to Rochester with John Dunmore and taught me photography in 1850..." (This is incorrect, it would have been 1854 or later.) Whitney took up paper photography strongly. In 1859 suffered ill health from the chemicals, sold his gallery in Rochester, and moved to New York City. He opened a gallery at 585 Broadway with his new partner, A. W. Paradise, and a second gallery in Norwalk, CT. "At Brady's request..." Whitney and his operator, Mr. Woodbury, "...went into the field..." during the Civil War. They photographed the site after the battle of Bull Run, at Manassas, then "...spent the winter making views of the fortifications around Washington. Views were taken at Yorktown, Williamsburg, White House, Gaines Hill, Chickahominy, Seven Pines. During the seven days' retreat from before Richmond to Harrison's Landing, photographs were taken of James River from a balloon."]

W836 "Pictures from the Collection: Whitney Studio." IMAGE 7, no. 4 (Apr. 1958): 92-93. 1 b & w. [1 daguerreotype view of Rochester, NY, by Edward Tompkins Whitney, taken ca. 1851-1853.]

WHITNEY, JOEL E. see also EBELL, ADRIAN J.; HISTORY: USA: MN: 19TH C. (Woolworth).

WHITNEY, JOEL EMMONS. (1822-1886) (USA)
[Born in Phillips, ME in 1822. Moved to St. Paul, WI in 1850. Learned the daguerreotype process from Alexander Hesler. Operated a gallery in St. Paul from 1851 to 1871. In 1862 he either photographed the participants in the Sioux Revolt, or published Andrian Ebell's portraits of these individuals. The photographers Andrew Falkenshield and M. C. Tuttle both worked for Whitney. In 1867 Charles A. Zimmerman began to work for Whitney, and, in 1871, Zimmerman took over the studio when Whitney retired. Whitney died in St. Paul in 1886.]

W837 Whitney, J. E. "Letter." PHOTOGRAPHIC ART JOURNAL 5, no. 4 (Apr. 1853): 253.

W838 "The Anthony Prize Pitcher." PHOTOGRAPHIC AND FINE ART JOURNAL 7, no. 1 (Jan. 1854): 6-11. [Letter detailing Whitney's "process" on p. 10.]

W839 Seely, Charles A. "Editorial Miscellany." AMERICAN JOURNAL OF PHOTOGRAPHY AND THE ALLIED ARTS & SCIENCES n. s. vol. 4, no. 22 (Apr. 15, 1862): 528. [Portraits received from J. E. Whitney (St. Paul, MN), two being of Dakota Indians; J. A. Sheriff (Pictou, C. W.) sent in Canadian scenery and portraits; D. T. Lawrence (Newburgh, NY), portrait; F. Mowrey (Rutland, VT), portrait.]

W840 "Photography in the West." HUMPHREY'S JOURNAL OF PHOTOGRAPHY, AND THE ALLIED ARTS AND SCIENCES 14, no. 16 (Dec. 15, 1862): 208. ["...some portraits of Sioux braves and squaws from J. E. Whitney, of St. Paul's, Minn."]

W841 "Portraits of Sioux Indians connected with the Minnesota Massacre. - From Photographs by Whitney, St. Paul, Minnesota." FRANK LESLIE'S ILLUSTRATED NEWSPAPER 15, no. 383 (Jan. 31, 1863): 300. 3 illus. [Portraits of the Indians, "Mah-pe-oke-na-jin, or Cut Nose; Ampetu Tokeca, or Other Day - the good Indian; Little Crow, the leader." (These photographs may have been taken by Adrian Ebell and marketed by Whitney.)]

W842 "Card Pictures." HUMPHREY'S JOURNAL OF PHOTOGRAPHY, AND THE ALLIED ARTS AND SCIENCES 15, no. 21 (Mar. 1, 1864): 336. [Brief note praising card pictures by Whitney, of St. Paul, MN.]

W843 "Photographs Received: Indian Photographs." PHILADELPHIA PHOTOGRAPHER 3, no. 26 (Feb. 1866): 64. ["From Mr. J. E. Whitney, St. Paul, MN, we have received... photographs of Sioux and Chippewa Indians... Among them those demons engaged in the terrible massacre of 1862,..."]

WHITNEY, THOMAS R., COL.
W844 "Note." PHOTOGRAPHIC ART JOURNAL 1, no. 1 (Jan. 1851): 60. ["Our Friend, Col. Whitney, one of our former daguerreotypists, and discoverer of the applications of galvanism to photographic manipulation, is out with his new monthly, the 'Republic'..."]

WHITTEMORE, H.
[Partner to William Hutchings in the Orleans Daguerreian Gallery in 1845. Operated in New Orleans through the 1840s, but apparently also travelled throughout the South into Florida and the West Indies making views. Exhibited over forty views at the American Institute Fair in New York, NY. Travelled to South America in 1852, then returned to New York, NY, where he made stereoscopic daguerreotypes at 373 Broadway. Sold gallery in 1853. Daguerreotyped the artworks at the NY Crystal Palace exhibition to aid the engraver for the illustrated catalog. (Some of these may have been copied in the crystallotype process by John W. Black.)]

W845 "Fair of the American Institute: Daguerreotypes." DAGUERREIAN JOURNAL 2, no. 11 (Oct. 15, 1851): 341-342. ["H. Whittemore has exhibited forty views... has for several years been engaged in taking views in the West Indies and different parts of the country... Havana, Bermuda, Nassau, Trinidad, etc... also New Orleans, Niagara Falls, etc."]

W846 "Editorials." HUMPHREY'S JOURNAL 5, no. 6 (July 1, 1853): 89. [Note that "Whittemore is engaged in the Crystal Palace, Daguerreotyping the various works of art. The object is to aid the Engraver in illustrating the catalogue."]

WHITTOCK, NATHANIEL.

W847 Whitlock, N. *Photogenic Drawing Made Easy. A Manual of Photography.* A Plain and Practical introduction to Drawing and Writing by the Action of Light. Illustrated with Facsimiles of the Various Styles of Photogenic Drawing. London: J. Robins, 1841. 16 pp.

WHITTREDGE, THOMAS WORTHINGTON. (1820-1910) (USA)

W848 "Worthington Whittredge," on pp. 90, 93 in: Donaldson, Mary Katherine. *Composition in Early Landscapes of the Ohio River Valley: Backgrounds and Components.* Pittsburgh: University of Pittsburgh, 1971.[Ph.D. Dissertation, University of Pittsburgh, 1971. Whittredge, a landscape painter, worked as a daguerreotypist in Ohio and Indiana from 1840 to 1843, then returned to painting.]

WILBOUR & BASSETT.

W849 Portrait. Woodcut engraving, credited "Photographed by Wilbour & Bassett." FRANK LESLIE'S ILLUSTRATED NEWSPAPER 38, (1874) ["Capt. O. Ottinger, inventor." 38:969 (Apr. 25, 1874): 108.]

WILCOX see CHAPMAN & WILCOX.

WILCOX, VINCENT MIEGS., COL. (1828-1896) (USA)

W850 Wilson, Edward L. "Another Veteran Gone." WILSON'S PHOTOGRAPHIC MAGAZINE 33, no. 474 (June 1896): 286. [Obituary. Wilcox was president of the E & H. T. Anthony Co. Born Madison, Ct. Oct. 17, 1828. Organized a company of 132nd regiment, Pennsylvania volunteers in Civil War. After war began working at Anthony Co., working there until his death. Died in 1896.]

W851 "Col. V. M. Wilcox." WILSON'S PHOTOGRAPHIC MAGAZINE 33, no. 475 (July 1896): 317-318. [Additional excerpts from correspondence following the death of Wilcox. Letters from Edward Cope, Charles Wilcox and obituary from "Anthony's Bulletin" reprinted.]

WILDE, ISAAC.

W852 Wilde, Isaac. "Combined Carriage and Dark Room." BRITISH JOURNAL PHOTOGRAPHIC ALMANAC 1878 (1878): 145-146.

WILDER, J. W. (CINCINNATI, OH)

W853 Glazer, Walter S. "Cincinnati in 1866: A Panoramic Photograph." CINCINNATI HISTORICAL SOCIETY BULLETIN 25, no. 4 (Oct. 1967): 265-287. 10 b & w. 1 illus. [Seven photographs taken first part of 1866, the reproductions are sections from the photos and a map showing the site lines of the original photographs. Winder was a local commercial photographer.]

WILDER, W. L. (LANCONIA, NH)

W854 Wilder, W. L. "Correspondence." PHILADELPHIA PHOTOGRAPHER 4, no. 41 (May 1867): 154-155. [Letter from Wilder (Lanconia, NH), correcting statements made in the March issue.]

WILEY see BONELL & WILEY.

WILKINSON, JAMES. (CHELSEA ENGLAND)

W855 "New Artificial Light." AMERICAN JOURNAL OF PHOTOGRAPHY AND THE ALLIED ARTS & SCIENCES n. s. vol. 8, no. 10 (Nov. 15, 1865): 238-239. [From "Mechanic's Magazine. Wilkinson burned a mixture of phosphorus and nitrate of potash in his garden at night to take a photo. Firemen responded.]

WILKINSON, W. T. (GREAT BRITAIN, CEYLON)

W856 Wilkinson, W. T. "Landscape Photography." BRITISH JOURNAL PHOTOGRAPHIC ALMANAC 1872 (1872): 85-89.

W857 Wilkinson, W. T. "Photography in the East.- Notes from Ceylon." ANTHONY'S PHOTOGRAPHIC BULLETIN 8, no. 8 (Aug. 1877): 242-244. [From "Br. J. of Photo." Wilkinson apparently just arrived in Ceylon from England, works the carbon process, and mentions visiting a photographer in Aden on his trip out.]

W858 Wilkinson, W. T. "A Bit of Printing Experience." ANTHONY'S PHOTOGRAPHIC BULLETIN 10, no. 8 (Aug. 1879): 249-250. [From "London Photographic News." Wilkinson mentions, "I am now in the Himalayas at one end of the Hill Stations, and at the end of the summer I go down into the Plains,..." and "My experiments in Ceylon..."]

W859 Wilkinson, W. T. "A Collodio-Bromide Process." PHOTOGRAPHIC MOSAICS: 1897 33, (1897): 202-203, 226. 2 b & w. [Landscape views on pp. 202, 226.]

WILLARD & CO.

W860 "American Lenses." HUMPHREY'S JOURNAL OF PHOTOGRAPHY, AND THE ALLIED ARTS AND SCIENCES 17, no. 22 (Mar. 15, 1866): 343-344. [Willard & Co.'s lenses discussed.]

W861 "American Cameras." PHILADELPHIA PHOTOGRAPHER 3, no. 30 (June 1866): 182. [Discusses cameras made by Willard & Co.]

WILLARD, C. T. (ca. 1838-1866) (USA)

W862 "Editor's Table: Sad Death of a Photographer." PHILADELPHIA PHOTOGRAPHER 3, no. 33 (Sept. 1866): 288. [Brother of Mr. O. H. Willard, also a photographer, died from an accidental fall. About 28 years old and worked in Philadelphia, PA.]

WILLARD, OLIVER H. (d. 1876) (USA)

[Worked in Philadelphia, PA, from about 1854 on. Exhibited calotypes at the Institute of American Manufactures in 1854, ambrotypes and daguerreotypes in 1856.]

W863 Portrait. Woodcut engraving, credited "From a Photograph by O. H. Willard." HARPER'S WEEKLY 5, no. 235 (June 29, 1861): 413. 1 illus. ["Lieut. Greble, U.S.A." 5:235 (June 29, 1861): 413.]

W864 Portrait. Woodcut engraving, credited "From a Photograph by O. H. Willard." HARPER'S WEEKLY 7, (1863) ["Hon. John Brough, Gov.-Elect of Ohio." 7:365 (Dec. 26, 1863): 828.]

W865 Willard, O. H. "The Exhibition and Meetings of the National Photographic Association: The Lectures - Lantern Exhibition." PHILADELPHIA PHOTOGRAPHER 6, no. 67 (July 1869): 234. [First annual meeting held in Horticultural Hall, Boston, MA.]

W866 Willard, O. H. "Obituary." PHILADELPHIA PHOTOGRAPHER 13, no. 145 (Jan. 1876): 26. ["O. H. Willard, of this city (Philadelphia, PA), died suddenly on Dec. 19, after a brief illness....one of the pioneers of photography, but retired from the business several years ago; since which he has devoted his attention to the magic lantern."]

WILLARD, O. H. [?]

W867 Portrait. Woodcut engraving, credited "From a Photograph by Willard." FRANK LESLIE'S ILLUSTRATED NEWSPAPER 14, (1862) ["Surgeon-Gen. Hammond." 14:359 (Aug. 16, 1862): 325.]

WILLAT.

W868 "Monthly Notes: Willat's Portable Camera and Linen Prover." PRACTICAL MECHANIC'S JOURNAL 4, no. 48 (Mar. 1852): 285. 2 illus. [Camera, with cloth body for travellers, displayed at the Crystal Palace, discussed, illustrated.]

WILLEME, FRANÇOIS. (1830-1905) (PARIS, FRANCE)

[Born on May 27, 1830 in Sedan. Studied painting and sculpture under Philippoteaux. He began to use photography to aid his sculpture in the 1850s. In 1860 he patented the idea of making twenty-four simultaneous portraits with twenty-four cameras arranged in a circle around the sitter, in order to create a three-dimensional map from which a portrait bust could be constructed. Opened a studio in 1863 to much publicity. Studio closed in 1867, a financial failure. Willème returned to Sedan, where he taught drawing and occasionally made more photo-sculptures. Retired to Roubaix in 1900 and died there on Jan. 29, 1905.]

W869 "Note: Photo-Sculpture." ART JOURNAL (Mar. 1863): 59.

W870 "Contemporary Press: Photo-Sculpture [Art Student.]" BRITISH JOURNAL OF PHOTOGRAPHY 11, no. 210 (Mar. 15, 1864): 97-98. 2 illus.

W871 Carpenter, J. "A New Era in Portraiture." ONCE A WEEK 11, no. 274 (Sept. 24, 1864): 368-371. [Report on Willème's "Photosculpture" experiments.]

W872 "Photo-Sculpture and Chromolithography." HARPER'S WEEKLY 12, no. 620 (Nov. 14, 1868): 727.

W873 Newhall, Beaumont. "Photosculpture." IMAGE 7, no. 5 (May 1958): 100-105. 8 b & w. 4 illus. [Willème perfected a technique for taking 24-50 simultaneous views of a subject from all sides, then constructed a sculptural portrait from the model generated by the pantograph. In 1860 in France, to USA in 1860s. Eventually failed.]

W874 Greenhill, Gillian. "Photo-Sculpture." HISTORY OF PHOTOGRAPHY 4, no. 3 (July 1980): 243-245. 2 illus. [Antoine Claudet sent his carte-de-visite portraits to Willème's sculpture studio in Paris, where they were projected and copied into clay. Complicated apparatus projecting 24 simultaneous views of an individual.]

W875 Sobieszek, Robert A. "Sculpture as the Sum of Its Profiles: François Willème and Photosculpture in France, 1859-1868." ART BULLETIN 62, no. 4 (Dec. 1980): 617-630. 5 b & w. 14 illus.

WILLEMIN, ADOLPH.

W876 Willemin, Ad. "Microscopic Photography." HUMPHREY'S JOURNAL OF PHOTOGRAPHY, AND THE ALLIED ARTS AND SCIENCES 17, no. 11-12 (Oct. 1 - Oct. 15, 1865): 168-171, 184-187. [From "Traité de L'Agrandissement des Epreuves Photographiques,...by Ad. Willemin."]

WILLIAMS & MCDONALD. (DENVER, CO)

W877 "Editor's Table." PHILADELPHIA PHOTOGRAPHER 6, no. 62 (Feb. 1869): 64. [Fifteen stereos of Rocky Mountain scenery noted.]

WILLIAMS see BUNDY & WILLIAMS.

WILLIAMS.

W878 Portrait. Woodcut engraving credited "From a photograph by Williams." ILLUSTRATED LONDON NEWS 68, (1876) ["Late Sir J. T. Coleridge." 68:1909 (Feb. 26, 1876): 213.]

WILLIAMS, F. FISK. (GREAT BRITAIN, INDIA)

BOOKS
W879 Williams, F. F. A Guide to the Indian Photographer. Illustrated. Calcutta: R. C. Lepage & Co., photographic dealer, 1860. 80 pp. illus.

PERIODICALS
W880 "The Destructive Hurricane at Calcutta." ILLUSTRATED LONDON NEWS 45, no. 1288 (Nov. 19, 1864): 502. 1 illus. ["...copied from a photographic view taken by Mr. F. Fisk Williams on the day after the hurricane."]

WILLIAMS, FREDERICK S.

W881 Nottingham: Past and Present. Illustrated by Photographs by Frederick S. Williams. Nottingham: R. Allen & Son, 1875. n. p. 12 b & w. [Albumen prints.]

WILLIAMS, GEORGE F.

W882 Williams, Geo. "William's Revolving Washing Apparatus." HUMPHREY'S JOURNAL OF PHOTOGRAPHY, AND THE ALLIED ARTS AND SCIENCES 16, no. 2 (May 15, 1864): 28-29.

W883 Williams, George F. "Printing on Opal Glass." AMERICAN JOURNAL OF PHOTOGRAPHY AND THE ALLIED ARTS & SCIENCES n. s. vol. 7, no. 14 (Jan. 15, 1865): 313-316. [From "Br. J. of Photo."]

W884 Williams, George F. "Where to Go with the Camera: A Photographic Trip into Wales." BRITISH JOURNAL OF PHOTOGRAPHY 12, no. 261 (May 5, 1865): 235.

WILLIAMS, R. TUDOR.

W885 Williams, R. Tudor. "Hints to Provincial Photographers on Architectural and Landscape Photography." BRITISH JOURNAL PHOTOGRAPHIC ALMANAC 1872 (1872): 126-127.

WILLIAMS, T. R. (1825-1871) (GREAT BRITAIN)

W886 "Our Weekly Gossip." ATHENAEUM no. 1590 (Apr. 17, 1858): 500. [Note: "At the last meeting of the Astronomical Society, a very remarkable Daguerreotype, of the recent eclipse was exhibited, made...by Mr. Williams, of Regent Street." Note: Messrs. Negretti & Zambra [wish to correct the error that] Mr. Frith is [their] photographer...he is a gentleman of independent means, who travels for his own pleasure...Negretti & Zambra fortunate to acquire Frith's Egyptian views..."]

W887 "How a Celebrated English Photographer does His Work." AMERICAN JOURNAL OF PHOTOGRAPHY AND THE ALLIED ARTS & SCIENCES n. s. vol. 6, no. 12 (Dec. 15, 1863): 279-281. [From "Photo. News."]

W888 Simpson, G. Wharton. "Notes In and Out of the Studio." PHILADELPHIA PHOTOGRAPHER 8, no. 90 (June 1871): 178-180. [Preserving sensitive paper - The Photo World - Obituary [T. R. Williams].

W889 Simpson, G. Wharton. "Obituary." PHILADELPHIA PHOTOGRAPHER 8, no. 90 (June 1871): 179-180. [First operator for Claudet in 1840, one of the best early photographers in Great Britain. Perfected a variety of chemical and technical improvements to the daguerreotype process. Made the first "charming subject stereo slides which were at one time such a rage..."]

W890 Portrait. Woodcut engraving credited "From a photograph by T. R. Williams." ILLUSTRATED LONDON NEWS 64, (1874) ["Late Capt. Huyshe." 64:1803 (Mar. 14, 1874): 249.]

W891 Steel, Jonathan. "T. R. Williams: The First Master of the Stereograph: The Stereoscope and Collecting Stereocards." PHOTOGRAPHIC COLLECTOR 3, no. 1 (Spring 1982): 91-101. 19 b & w. 2 illus. [British stereo view maker in 1850s.]

WILLIAMS, T. R. [?]
W892 "Photographic Portraits of the Princess Frederick William of Prussia." LIVERPOOL & MANCHESTER PHOTOGRAPHIC JOURNAL [BRITISH JOURNAL OF PHOTOGRAPHY] n. s. 2, no. 4 (Feb. 15, 1858): 49.

WILLIAMSON, A. (GREAT BRITAIN, INDIA)
W893 "Chota Haziree - the Little Breakfast." ILLUSTRATED LONDON NEWS 33, no. 951 (Dec. 25, 1858): 587, 590. 1 illus. ["From a photograph (taken in India) by A. Williamson." British officer reading, being served a light snack by a native servant.]

WILLIAMSON, CHARLES H. (1826-1874) (GREAT BRITAIN, USA)
W894 Portraits. Woodcut engravings, credited "Photographed by Williamson." FRANK LESLIE'S ILLUSTRATED NEWSPAPER 4, (1857) ["Joseph Wilson, sculptor, deceased." 4:95 (Sept. 26, 1857): 269.]

W895 Portrait. Woodcut engraving, credited "From a Photograph by Charles H. Williamson." HARPER'S WEEKLY 6, (1862) ["Hon. Moses F. Odell." 6:285 (June 14, 1862): 381.]

W896 Portrait. Woodcut engraving, credited "From a Photograph by Charles H. Williamson." HARPER'S WEEKLY 8, (1864) ["Late Hon. Owen Lovejoy." 8:381 (Apr. 16, 1864): 253.]

W897 Portrait. Woodcut engraving, credited "From a Photograph by Charles H. Williamson." HARPER'S WEEKLY 9, (1865) ["Marcus L. Ward, Gov.-Elect of NJ." 9:467 (Dec. 9, 1865): 781.]

W898 "The Otero Murder." HARPER'S WEEKLY 9, no. 468 (Dec. 16, 1865): 797. 3 illus. [2 portraits of murderers; one posed portrait of "Captain Waddy arresting Gonzales." "Photographed by Williamson, Brooklyn, L.I."]

W899 Portraits. Woodcut engravings, credited "From a Photograph by Williamson, Brooklyn, NY." FRANK LESLIE'S ILLUSTRATED NEWSPAPER 22, (1866) ["The late Hon. Moses F. Odell." 22:562 (July 7, 1866): 244. "The late Hon. James Humphrey." 22:562 (July 7, 1866): 244.]

W900 Portraits. Woodcut engravings, credited "From a Photograph by Charles H. Williamson." HARPER'S WEEKLY 10, (1866) ["Types of American Beauty (14 portraits)." 10:473 (Feb. 20, 1866): 91. "Dudley Kavanagh." 10:483 (Mar. 31, 1866): 193. "John Roberts 10:483 (Mar. 31): 193. "'Atlantic' Baseball Club of Brooklyn and 'Athletics' of Philadelphia (group portrait)." 10:514 (Nov. 3, 1866): 697.]

W901 Portrait. Woodcut engraving, credited "From a Photograph by Charles H. Williamson." HARPER'S WEEKLY 12, (1868) ["Dr. Abram N. Littlejohn." 12:624 (Dec. 12, 1868): 797.]

W902 Troxell, B. F., Secretary. "Brooklyn Photographic Art Association." ANTHONY'S PHOTOGRAPHIC BULLETIN 4, no. 11 (Nov. 1873): 331-334. [Dr. Hall, an amateur, was elected president of the Brooklyn Photographic Art Assoc. Dr. Hall related some incidents from his experience in taking pictures of landscapes during the war, then made a statement about the importance of the medium which was excerpted on pp. 331-332. Lecture "The Decline of Art," by C. H. Williamson, also printed.]

W903 "Brooklyn Photo. Art Association." ANTHONY'S PHOTOGRAPHIC BULLETIN 5, no. 11 (Nov. 1874): 384. [Obituary notice, memorial statement on death of Williamson, a Brooklyn photographer.]

W904 "Obituary." PHOTOGRAPHIC TIMES 4, no. 47 (Nov. 1874): 176. [Williamson was born in Scotland in 1826, learned photography in Springfield, MA. Came to Brooklyn, NY in 1851 and opened a daguerreotype gallery. Continued as a professional studio photographer in Brooklyn until his death Oct. 11, 1874.]

WILLIS, GEORGE.
W905 Willis, George. "The Wothltype Process." AMERICAN JOURNAL OF PHOTOGRAPHY AND THE ALLIED ARTS & SCIENCES n. s. vol. 7, no. 15 (Feb. 1, 1865): 346-347. [From "Photo. News."]

W906 "Willis's Aniline Process." AMERICAN JOURNAL OF PHOTOGRAPHY AND THE ALLIED ARTS & SCIENCES n. s. vol. 8, no. 20 (Apr. 15, 1866): 457-462. [From "Br. J. of Photo."]

W907 Willis, George. "Carbon Enlargements on Artists' Canvas without an Enlarged Negative." BRITISH JOURNAL PHOTOGRAPHIC ALMANAC 1878 (1878): 114-115.

W908 Willis, George. "Durable Sensitive Paper." BRITISH JOURNAL PHOTOGRAPHIC ALMANAC 1879 (1879): 83-84.

WILLIS, WILLIAM JR. (1841-1923) (GREAT BRITAIN)
W909 Pietz, Gregory L. "Inventor of the Platinum Printing Process. William Willis, Jr. 1841-1923." NORTHLIGHT no. 7 (Nov. 1977): 42-45. [William Willis Jr was born in 1841. His father was a photographer-inventor of some prominence, the inventor of the aniline process. William, Jr. was an engineer, and worked for a time for Lloydes Bank, in London. Quiet and retiring. Discovered the platinum process, and patented the Platinotype in 1873. Founded the Platinotype Company of London in 1879. Published, with Mr. Clements, *The Platinotype* in 1885. Other technical improvements through the 1880s, 1890s. Died in Kent, in March, 1923.]

WILLISCRAFT, W. H. see also HISTORY: USA: AZ: 19TH C. (Hooper).

WILLISCRAFT, W. H. (PRESCOTT, AZ)
W910 Hooper, Bruce. "Stoneman Lake: One of Arizona's Early Tourist Attractions Stereographed by D. F. Mitchell and W. H. Williscraft, c. 1875-1883." STEREO WORLD 12, no. 4 (Sept.-Oct. 1985): 37-40, 47. 9 b & w. 1 illus. [Stoneman Lake, in Northern Arizona, is about sixty-five miles northeast of Prescott, AZ. W. H. Williscraft owned a boot and shoe repair shop in Prescott, and he also owned and operated the Capitol Art Gallery from 1875 to 1877. In 1876 he hired an assistant, who was probably D. F. Mitchell, who had come from San Francisco, CA. Mitchell took over the gallery in late 1877. Williscraft apparently turned to raising and selling cattle and working as a butcher. Mitchell formed a partnership with Erwin Baer from 1883 to 1886. In the 1880s and 1890s Mitchell became an insurance and real estate agent, then died in Prescott in 1928, at age 85. Article includes a list of photographers working in Prescott, AZ from 1874 to 1886.]

WILLOUGHBY. (FINLAY, OH)
W911 "Personal & Art Intelligence." PHOTOGRAPHIC AND FINE ART JOURNAL 9, no. 5 (May 1856): 159-160. [Letter from Walter C. North introducing the information that a Mr. Willoughby, in Finlay, OH, had developed a (hand-coloring) process.]

WILSON & ADAMS. [EDWARD L. WILSON.]

W912 "Our Picture." PHILADELPHIA PHOTOGRAPHER 14, no. 164 (Aug. 1877): frontispiece, 250-252. 1 b & w. [Portrait of Jotham Shaw, 99 years old.]

WILSON & BEADELL. (LONDON, ENGLAND)

W913 Portraits. Woodcut engravings, credited "Photographed by Wilson & Beadell, of New Bond St., London." ILLUSTRATED LONDON NEWS 49, (1866) ["Sir Thomas Watson, M.D." 49:* (Sept. 15, 1866): 261.]

W914 Portraits. Woodcut engravings, credited to "From a Photograph by Wilson & Beadell, New Bond St." ILLUSTRATED LONDON NEWS 59 , (1871) ["Late Sir Roderick Murchison." 59:1676 (Oct. 28, 1871): 413. "Sir Wm. Jenner, M.D." 59:1685 (Dec. 23, 1871): 612.]

W915 Portrait. Woodcut engraving credited "From a photograph by Wilson & Beadell." ILLUSTRATED LONDON NEWS 61, (1872) ["Dr. W. B. Carpenter, F.R.S." 61:1719 (Aug. 17, 1872): 148.]

WILSON, A. J. (GREAT BRITAIN)

[A. J. Wilson, who wrote for the British journals, occasionally used the pseudonom "Aliquis."]

BOOKS
W916 Wilson, A. J. *Silver Printing: Its Difficulties and Their Remedies.* London: Albion Albumenizing Co., 1873. n. p.

PERIODICALS
W917 Wilson, A. J. "Photography from an Art Point of View." BRITISH JOURNAL PHOTOGRAPHIC ALMANAC 1875 (1875): 142.

WILSON, ALEXANDER. (LEAMINGTON, ENGLAND)

W918 "Note." ART JOURNAL (Dec. 1866): 383. ["Photographic views of Warwickshire." Stereo slides by Mr. Alexander Wilson, of Leamington.]

W919 "Our Picture." PHILADELPHIA PHOTOGRAPHER 8, no. 93 (Sept. 1871): frontispiece, 303-305. 1 b & w. [Kenilworth Castle.]

WILSON, EDWARD LIVINGSTON. (1838-1903) (USA)
BOOKS
W920 Wilson, Edward L. *The American Carbon Manual; or, The Production of Photographic Prints in Permanent Pigments.* New York: Scovill Mfg. Co., 1868. viii, 100 pp. 1 l. of plates. 1 b & w. [Reprinted (1973), Arno Press.]

W921 *Wilson's Lantern Journeys. A Series of Descriptions of Journeys at Home and Abroad for Use with Views in the Magic Lantern or the Stereoscope.* Philadelphia: Benerman & Wilson, 1874-83. 3 vol. [Many editions, with slight title variations, throughout 1880s.]

W922 Wilson, Edward L. *Wilson's Photographics: A Series of Lessons, Accompanied by Notes, on All the Processes which are Needful in the Art of Photography.* Philadelphia: E. L. Wilson, 1881. xv, 376 pp. 2 l. of plates. illus. [Variant editions. Reprinted (1973), by Arno Press.]

W923 Wilson, Edward L. *Wilson's Quarter Century in Photography. A Collection of Hints on Practical Photography which form a Complete Text-Book of the Art.* New York: E. L. Wilson, 1887. xv, 528 pp.

W924 Wilson, Edward L. *Wilson's Cyclopaedic Photography: A Complete Hand-Book of the Terms, Processes, Formulae and Appliances Available in Photography, arranged in Cyclopaedic Form for Ready Reference.* New York: E. L. Wilson, 1894. viii, 480 pp. illus.

PERIODICALS
W925 Wilson, Edward L. "A Day in New York." PHILADELPHIA PHOTOGRAPHER 1, no. 4 (Apr. 1864): 57-58.

W926 Wilson, Edward L. "More Facts about the Solar Camera." HUMPHREY'S JOURNAL OF PHOTOGRAPHY, AND THE ALLIED ARTS AND SCIENCES 17, no. 13 (Nov. 1, 1865): 203. [Letter in response to Shive's earlier article.]

W927 Wilson, Edward L. "Here a Little and There a Little." PHILADELPHIA PHOTOGRAPHER 2, no. 23 (Nov. 1865): 179-181. [Wilson describes his visit to Boston. Black & Case discussed on p. 181. Wilson states that Black was the first photographer to make porcelain photographs in the USA.]

W928 Wilson, Edward L. "Magnesium Light, and How to Photograph with It." PHILADELPHIA PHOTOGRAPHER 3, no. 25 (Jan. 1866): 14-16. [Working with J. C. Browne, Wilson describes his experiments with magnesium flash.]

W929 "Photographing Children." PHILADELPHIA PHOTOGRAPHER 3, no. 31 (July 1866): 196.

W930 "More Piracy." HUMPHREY'S JOURNAL OF PHOTOGRAPHY, AND THE ALLIED ARTS AND SCIENCES 18, no. 6 (July 15, 1866): 91. [Attacking "Phila. Photo." for copying an article from "Photographisches Archiv.," which it credited, which the "P. A." had, so claims Ladd, previously copied from "Humphrey's Journal" without credit.]

W931 "About that Credit." HUMPHREY'S JOURNAL OF PHOTOGRAPHY, AND THE ALLIED ARTS AND SCIENCES 18, no. 8 (Aug. 15, 1866): 123. [Another criticism of the "Philadelphia Photographer."]

W932 "Oldest, Cheapest and Best." HUMPHREY'S JOURNAL OF PHOTOGRAPHY, AND THE ALLIED ARTS AND SCIENCES 19, no. 6 (July 15, 1867): 96. [Angry outburst at "Philadelphia Photographer" for accusing "H.J." of copying articles without credit.]

W933 "Twaddle." HUMPHREY'S JOURNAL OF PHOTOGRAPHY, AND THE ALLIED ARTS AND SCIENCES 19, no. 7 (Aug. 1, 1867): 110. [Attack on "our young friends, W. & H." (Edward L. Wilson, of the "Philadelphia Photographer.")]

W934 "More Unblushing Falsehood." HUMPHREY'S JOURNAL OF PHOTOGRAPHY, AND THE ALLIED ARTS AND SCIENCES 19, no. 8 (Aug. 15, 1867): 127. [Another attack on Ed. L. Wilson, of "Philadelphia Photographer."]

W935 "'Out of Thine Own Mouth Will I Condemn Thee.'" HUMPHREY'S JOURNAL OF PHOTOGRAPHY, AND THE ALLIED ARTS AND SCIENCES 19, no. 10 (Sept. 15, 1867): 155. [Another attack on Ed. L. Wilson.]

W936 "Art Principles Applicable to Photography." PHILADELPHIA PHOTOGRAPHER 4-5, no. 46-60 (Oct. 1867 - Dec. 1868): (1867) 337-338, 371-374, (1868) 7-9, 49-52, 71-73, 111-118, 165-167, 204-206, 226-228, 265-267, 331-332, 367-369, 438-439. [(Feb. 1868) On aerial perspective, discusses the work of Braun, Frith, W. England, and J. M. Cameron.]

W937 "The Bromide Patent. The Treasurer's Account. - Where the Money Went To - A Specimen Brick." HUMPHREY'S JOURNAL OF PHOTOGRAPHY, AND THE ALLIED ARTS AND SCIENCES 20, no.

10 (Sept. 15, 1868): 148-149. [Criticism of the way the monies in the Bromide Defense Fund were expended, which is actually an attack on Edward L. Wilson, the editor of the rival, "Philadelphia Photographer."]

W938 "The Bromide Patent Case. Our Expose of the Treasurer's Account - 'The Galled Jade Winces' - Ryder to the Rescue! Who is Ryder?" HUMPHREY'S JOURNAL OF PHOTOGRAPHY, AND THE ALLIED ARTS AND SCIENCES 20, no. 12 (Oct. 15, 1868): 179-181. [Further attack on the Bromide defense fund, which is also an attack on Col. Wilson and the "Philadelphia Photographer." Attacks Ryder as well.]

W939 "The Anti-Bromide Patent Swindle. Letter from a Philadelphia Photo - Startling Disclosures - The Little Game Exposed - Collusion Charged Between the Parties." HUMPHREY'S JOURNAL OF PHOTOGRAPHY, AND THE ALLIED ARTS AND SCIENCES 20, no. 13 (Nov. 1, 1868): 200-201. [Letter from F. B. H. (Philadelphia, PA) critical of the management of the Bromide Patent fund.]

W940 "The Anti-Bromider's Account. More Wriggling - Sophistry Exposed - A Challenge." HUMPHREY'S JOURNAL OF PHOTOGRAPHY, AND THE ALLIED ARTS AND SCIENCES 20, no. 14 (Nov. 15, 1868): 215. [Attack on Wilson again.]

W941 "A Pathetic Appeal." HUMPHREY'S JOURNAL OF PHOTOGRAPHY, AND THE ALLIED ARTS AND SCIENCES 20, no. 14 (Nov. 15, 1868): 216. [Another attack on E. L. Wilson, editor of the "Philadelphia Photographer." One of many such launched by this editor.]

W942 "The Anti-Bromide Swindle. A Letter from Boston - Indignation of a Photographer." HUMPHREY'S JOURNAL OF PHOTOGRAPHY, AND THE ALLIED ARTS AND SCIENCES 20, no. 14 (Nov. 15, 1868): 221-222. [Letter from T. W. B. (Boston, MA), supporting Ladd's attacks on Ed. L. Wilson, etc.]

W943 "Close of the Year." HUMPHREY'S JOURNAL OF PHOTOGRAPHY, AND THE ALLIED ARTS AND SCIENCES 20, no. 16 (Dec. 15, 1868): 246-247. [Is supposed to be a summation of the activities of "Humphrey's Journal." for the past year, but it turns into an attack on Edward L. Wilson, ed. of "Philadelphia Photographer."]

W944 "More Names." "'Young Friend's' Agency." "Green." HUMPHREY'S JOURNAL OF PHOTOGRAPHY, AND THE ALLIED ARTS AND SCIENCES 20, no. 19 (Mar. 15, 1869): 296, 300, 303. [More sarcastic attacks on Edward L. Wilson.]

W945 "Quack Compounds," "Returned to the Field," "Conceited." HUMPHREY'S JOURNAL OF PHOTOGRAPHY, AND THE ALLIED ARTS AND SCIENCES 20, no. 20 (Apr. 15, 1869): 317, 319. [Actually more attacks on Wilson, of "Philadelphia Photographer."]

W946 "Photographic Rings." and "Thanks." HUMPHREY'S JOURNAL OF PHOTOGRAPHY, AND THE ALLIED ARTS AND SCIENCES 20, no. 24 (Aug. 15, 1869): 381-382. [Another attack of Ed. L. Wilson, this time accusing him of fraud and corruption.]

W947 Wilson, Edward L. "Photographing the Eclipse." PHILADELPHIA PHOTOGRAPHER 6, no. 69 (Sept. 1869): 285-292. [Parties of photographers were stationed all over the country to take views of the solar eclipse. For example, a party including J. C. Browne and W. J. Baker was at Ottumwa, IA; J. W. Black was at Springfield, IL, J. A. Whipple was at Shelbyville, KY., etc.]

W948 "Immaculate Honesty!" and "Photographic Journalistic Dignity." HUMPHREY'S JOURNAL OF PHOTOGRAPHY, AND THE ALLIED ARTS AND SCIENCES 20, no. 25 (Sept. 15, 1869): 394-396. [More attacks on Ed. L. Wilson.]

W949 "Philadelphia vs. New York. - Competition for the Stock Trade." "Lukenbach's Sensitizing Apparatus: Opinion of Edward L. Wilson, Esq., of Philadelphia, on the Subject. 'The Man Who Knows.'" "Taylor to the Rescue." HUMPHREY'S JOURNAL OF PHOTOGRAPHY, AND THE ALLIED ARTS AND SCIENCES 20, no. 26 (Oct. 15, 1869): 405-407. [Again, in reality, attacks on Ed. L. Wilson.]

W950 Wilson, Edward L. "The 'White Hills' When they are 'White'." PHILADELPHIA PHOTOGRAPHER 7, no. 77 (May 1870): 169-171. [Reminiscences of an "outing" into the White Hills of NH.]

W951 Wilson, Edward L. "Art Writings for Photographers." PHILADELPHIA PHOTOGRAPHER 8, no. 88 (Apr. 1871): 102-104. ["Among the works devoted to the aesthetics of photography, they are so far, none that compare for a moment with that of H. Robinson."]

W952 Wilson, Edward L. "Photography in Canada." PHILADELPHIA PHOTOGRAPHER 8, no. 89 (May 1871): 151-152.

W953 "The Libel Suit: The Shaw & Wilcox Co. vs. Edward L. Wilson." PHILADELPHIA PHOTOGRAPHER 9, no. 102-103 (June - July 1872): 232-233, 262-264. [Wilson describes being arrested and jailed on March 1870, as a consequence of a libel suit. Wilson lost the suit in New York - claims he cannot return to the city for fear of arrest. This draws forth a response from the other side, Shaw & Wilcox Co,, in the July issue.]

W954 "Editor's Table: A Word or Two with Our Friends." PHILADELPHIA PHOTOGRAPHER 9, no. 104 (Aug. 1872): 304. [A group, headed by B. French, organized a subscription drive to repay Edward L. Wilson some of the money he lost fighting the Shaw & Wilcox patent claims. A circular from this group, with more details, follows p. 304.]

W955 Wilson, Edward L. "Editorial Correspondence." PHILADELPHIA PHOTOGRAPHER 10, no. 118-120 (Oct. - Dec. 1873): 497-500, 517-518, 550-552. [Part 1: Berlin. Prussia. Part 2: Paris. Part 3: London.]

W956 Wilson, Edward L. "Art Studies for All. Nos. 1-6." PHILADELPHIA PHOTOGRAPHER 10, no. 110-119 (Feb. - Nov. 1873): 40-41, 122, 215-216, 244, 488-489, 538-539.

W957 Wilson, E. "Fifth Annual Meeting and Exhibit of the National Photographic Association of the U.S., held in Buffalo, N.Y., beginning July 5, 1873: How to Manage the Lines." PHILADELPHIA PHOTOGRAPHER 10, no. 117 (Sept. 1873): 400.

W958 Wilson, Edward L. "Editorial Correspondence. Parts 1 - 3." PHILADELPHIA PHOTOGRAPHER 10, no. 118-120 (Oct. - Dec. 1873): 497-500, 517-518, 550-552. [Wilson on trip through Europe, describes the cities he visits. (Oct.) Berlin, Prussia. (Nov.) Paris. (Dec.) London.]

W959 Wilson, Edward L. "Views Abroad and Across." PHILADELPHIA PHOTOGRAPHER 11, no. 121-132 (Jan. - Dec. 1874): 29-31, 33-39, 82-88, 116-124, 146-151, 170-174, 197-202, 225-231, 259-265, 289-298, 328-333, 355-363. [Wilson visited many studios, manufacturers, etc. on an extended visit to Europe. Pt. 1. Leaving NY. In Ireland, Brussels. Pt. 2. Brussels, Rome. Pt. 3. Berlin.

Pt. 4. Vienna. Pt. 5. Exhibitions in Vienna. Pt. 6. Luckhardt's studio (Vienna). Pt. 7. Venice. Pt. 8. Milan, Rome. Pt. 9. Naples. Pt. 10. Adolphe Braun in Dornach, Liebert, Levy, Adam-Salomon, and Reutlinger in Paris. Pt. 11. Paris. Pt. 12. In London, mentions Robinson, Woodbury, Frank M. Good, Mansell & Co. (Egyptian and eastern views), V. Blanchard.]

W960 "Art Studies for All." PHILADELPHIA PHOTOGRAPHER 11, no. 122-124, 128 (Feb. - Apr., Aug. 1874): 42-43, 70-71, 103-104, 236-237. [From a book. Continuation from 1873.]

W961 "Fire! Water!" PHOTOGRAPHIC TIMES 4, no. 41 (May 1874): 67-68. [Commentary on the fire at the bindery of the "Philadelphia Photographer," draws forth a series of puns around the issues of photography, fire and water. The fire briefly noted in previous issue on p. 57.]

W962 "A Valuable Photographic Collection." PHOTOGRAPHIC TIMES 4, no. 43 (July 1874): 104-106. [Extensive (for the time) review of a collection of photos gathered by Edward L. Wilson on a recent European trip and displayed at the offices of the "Philadelphia Photographer." Discusses the work of Adam Salomon (Paris); Robinson & Cherrill (Great Britain); Ch. Reutlinger (Paris) and others.]

W963 "'Promenade' Studies." PHILADELPHIA PHOTOGRAPHER 12, no. 136 (Apr. 1875): 116-118.

W964 Wilson, Edward L. "Art and Chemistry in Photography." PHILADELPHIA PHOTOGRAPHER 13, no. 151 (July 1876): 206-207.

W965 "Dextrine." "Permanent." ANTHONY'S PHOTOGRAPHIC BULLETIN 8, no. 2 (Feb. 1877): 51-52. [Letter attacking Edward L. Wilson, former "permanent" secretary of the National Photographic Association, replaced in the last year by J. H. Fitzgibbon.]

W966 Wilson, Edward L. "Art Culture: The Imagination." PHILADELPHIA PHOTOGRAPHER 14, no. 160 (Apr. 1877): 107-108. [Extracted from Torrey's "Theory of Fine Art."]

W967 Wilson, Edward L. "Editorial Trials." PHILADELPHIA PHOTOGRAPHER 14, no. 162 (June 1877): 172-174. [Wilson describes problems of being an editor - includes a list of times that he experienced certain events, i.e."Threatened to be whipped, 13 times," "Answered the same questions over and over, 2480 times," etc.]

W968 Wilson, Edward L. "Photographic Training of Experts and Specialists." PHILADELPHIA PHOTOGRAPHER 14, no. 164 (Aug. 1877): 225-229.

W969 Wilson, Edward L. "A Vision." PHILADELPHIA PHOTOGRAPHER 14, no. 166 (Oct. 1877): 308-309. [Comic statement by Wilson of him traveling around the country, dunning subscribers for failure to pay - mentions many photographers and dealers by name (in fun).]

W970 Wilson, Edward L. "A Photographic Exploit." PHILADELPHIA PHOTOGRAPHER 14, no. 167 (Nov. 1877): 334-335. [Wilson took three wet collodion portraits, very quickly for a lawyer friend, of the site of a railroad accident, for a trial judgement.]

W971 Anthony, E. & H. T. "Mr. Wilson's Private Circular." ANTHONY'S PHOTOGRAPHIC BULLETIN 9, no. 1 (Jan. 1878): 27-28. [Reprints from a circular, circulated by Wilson, asking for subscriptions to the "Philadelphia Photographer" magazine.]

W972 Wilson, Edward L. "What is Art?" PHILADELPHIA PHOTOGRAPHER 15, no. 169 (Jan. 1878): 12.

W973 Wilson, Edward L. "One Turn Better." PHILADELPHIA PHOTOGRAPHER 15, no. 169 (Jan. 1878): 21-22.

W974 "Our Picture." PHILADELPHIA PHOTOGRAPHER 15, no. 169 (Jan. 1878): frontispiece, 25-26. 1 b & w. [Genre group portrait, "Christmas Gathering in Ye Olden Time."]

W975 Wilson, Edward L. "Photographic Gibberish." PHILADELPHIA PHOTOGRAPHER 15, no. 170 (Feb. 1878): 44-45.

W976 "Our Picture." PHILADELPHIA PHOTOGRAPHER 15, no. 170 (Feb. 1878): frontispiece, 33-34. 1 b & w. [Portrait of John Welsh, of Philadelphia, PA.]

W977 "Our Picture." PHILADELPHIA PHOTOGRAPHER 15, no. 180 (Dec. 1878): frontispiece, 379-380. 1 b & w. [Genre portrait "Over the Hills to the Poor House."]

W978 Wilson, Edward L. "Art in the House. " PHILADELPHIA PHOTOGRAPHER 16, no. 188 (Aug. 1879): 225-227. 1 illus. [Wilson uses review of book "Art in the House" ed. C. C. Perkins, Boston: L. Long & Co., as cause for editorial to upgrade photog.]

W979 Wilson, Edward L. "Sinai and the Wilderness." CENTURY MAGAZINE 36, no. 3 (July 1880): 323-340. 20 illus. [Illustrations drawn by Henry Fenn, after photographs by the author.]

W980 "Matters of the Month." PHOTOGRAPHIC TIMES 10, no. 118 (Oct. 1880): 230. [...an elegant set of views of Dixville Notch, NH., made by himself (Edward L. Wilson) on Newton's Emulsion Dry Plates...during his vacation this summer.]

W981 "Our Picture." PHILADELPHIA PHOTOGRAPHER 17, no. 203 (Nov. 1880): 326-328. 1 b & w. [Original photo, tipped-in. Landscape.]

W982 Wilson, Edward L. "Matters of the Month." PHOTOGRAPHIC TIMES 11, no. 121-127 (Jan. - July 1881): 15-18, 56-58, XXX, 155-157, XXX, 234-235, 256-257. [(Jan.) This column features commercial news, mentions dealers, stockdealers, etc., some photographers. Mentions O. Pierre Havens (Savannah, GA.); E. C. Thompson (to assist at the Astronomical Observatory in Cordova, Argentina); Baker & Record (Saratoga, NY) St. Louis Photographic Association, A. J. W. Copelin (Chicago); Elmer & Tenny (Winona, MN). (Feb.) Mentions stock dealers, etc. Photographers discussed: Blessing & Brother (Galveston, TX) closing gallery; Gardner & Co. (Brooklyn, NY); Frank McNight (Paducah, KY) purchased the Winter Gallery in Cairo, IL.; Mr. Carbutt. (Apr.) Mr. Wm. E. Small (of Edmer & Tenney, Winona, MN) taking views of snowdrifts; O. Pierre Havens (Savannah, GA) fire, but not badly damaged; Frank McNight (Cairo, IL) opening gallery; commercial news. (June) "J.P. Blessing and F. Kuhn joined together to form a studio in Galveston, TX; W. H. Jackson exhibited recently views of scenery in Colorado 11" x 14" and 13" x 16"; Muybridge, (San Francisco, CA) being about to engage in a special field of photography, has consigned to us a member of Dallmeyer and other lenses for sale..." etc. (July) News of dealers, etc. Note that William H. Rau, late of Philadephila, now with W. H. Jackson in Denver, CO. mentions that Jackson now using Carbutt's "Keystone Dry Plates" exclusively.]

W983 Wilson, Edward L. "Timely Topics." PHOTOGRAPHIC TIMES 11, no. 121 (Jan. 1881): 11-12.

W984 Wilson, Edward L. "Timely Topics: After the Plates - Then?" PHOTOGRAPHIC TIMES 11, no. 122 (Feb. 1881): 50-51.

W985 Wilson, Edward L. "Timely Topics: Convention? For What?" PHOTOGRAPHIC TIMES 11, no. 123 (Mar. 1881): 91-93.

W986 Wilson, Edward L. "Timely Topics: The Photographic Society." PHOTOGRAPHIC TIMES 11, no. 124 (Apr. 1881): 137-138.

W987 Wilson, Edward L. "The Structure of Culture." PHOTOGRAPHIC TIMES 11, no. 125 (May 1881): 194-195.

W988 Taylor, J. Traill. "Our Editorial Table." PHOTOGRAPHIC TIMES 11, no. 126 (June 1881): 213-216. [Bk. rev.: "Wilson's Photographics," by Edward L. Wilson. Excerpts from the book reprinted.]

W989 Wilson, Edward L. "Photographers' Faith." PHOTOGRAPHIC TIMES 11, no. 126 (June 1881): 218-219.

W990 Wilson, Edward L. "Timely Topics. Photographic Friction - A New Philosophy." PHOTOGRAPHIC TIMES 11, no. 127 (July 1881): 248-250.

W991 Wilson, Edward L. "Wrestling with Gelatino-Bromide." PHOTOGRAPHIC TIMES 11, no. 128-130 (Aug. - Oct. 1881): 273-275, 365-367, 387-388. [Anecdotes of his experiences photographing in the mountains of New Hampshire.]

W992 Wilson, Edward L. "Wrestling with Gelatino-Bromide. (Continued)." PHOTOGRAPHIC TIMES 11, no. 129 (Sept. 1881): 365-367. [Anecdotes of his photographing of Dixville Notch, NH.]

W993 Wilson, Edward L. "Photographic Progress Among the People." PHOTOGRAPHIC TIMES 11, no. 130 (Oct. 1881): 384-386. [Quotes from an article by Charles Barnard in the Aug. 6, 1881 "Manufacturers' Gazette (Boston, MA)" on photography, then discusses the issues raised.]

W994 Wilson, Edward L. "Wrestling With Gelatino-Bromide. (Continued)." PHOTOGRAPHIC TIMES 11, no. 130 (Oct. 1881): 387-388.

W995 Wilson, Edward L. "Photography - Pro Bono Publico." PHOTOGRAPHIC TIMES 11, no. 131 (Nov. 1881): 423-425.

W996 Wilson, Edward L. "The Low-Price Dodge." PHOTOGRAPHIC TIMES 12, no. 133 (Jan. 1882): 11-12.

W997 Wilson, Edward L. "Dry Plates Adrift." PHOTOGRAPHIC TIMES 12, no. 134 (Feb. 1882): 40-42. [Describing his trip to Europe, and on his way to Egypt.]

W998 Wilson, Edward L. "The Rives Paper Manufactory." PHOTOGRAPHIC TIMES 12, no. 134 (Feb. 1882): 49-51. [Wilson describes his visit to the town of Rives, France site of the manufacturer of the widely used photographic paper.]

W999 "Matters of the Month." PHOTOGRAPHIC TIMES 12, no. 134 (Feb. 1882): 61. ["Edward L. Wilson writes from Cairo, Egypt that he has made over 300 negatives, on Carbutt plates, of the most picturesque objects to be found in the oldest country in the world..."]

W1000 Wilson, Edward L. "Photography in the Orient." PHOTOGRAPHIC TIMES 12, no. 135 (Mar. 1882): 71-73. [Wilson's experiences photographing in Egypt.]

W1001 Wilson, Edward L. "A Little Light on Light." PHOTOGRAPHIC TIMES 12, no. 136 (Apr. 1882): 100-102.

W1002 Wilson, Edward L. "Spring Suggestions." PHOTOGRAPHIC TIMES 12, no. 137 (May 1882): 141-143.

W1003 Wilson, Edward L. "Stick Together." PHOTOGRAPHIC TIMES 12, no. 138 (June 1882): 188-189.

W1004 Wilson, Edward L. "A Drop from the Desert." PHOTOGRAPHIC TIMES 12, no. 138 (June 1882): 196-198. [Describes his experiences in Jerusalem.]

W1005 Wilson, Edward L. "Photography in the Orient." PHOTOGRAPHIC TIMES 12, no. 138 (June 1882): 198-200. [Describes his experiences in Egypt.]

W1006 Wilson, Edward L. "What Young Photographers Should Do." PHOTOGRAPHIC TIMES 12, no. 139 (July 1882): 248-251. [Commentary on state of training education available in U.S. Quotes several educators, scientists. Rev. S. B. Dodd, Coleman Sellers (mechanical engineer and amateur photographer), Prof. R. W. Raymond Horatio Allen.]

W1007 "General Notes." PHOTOGRAPHIC TIMES 12, no. 139 (July 1882): 255. [Wilson returned from his trip to the Near East. Brief description of his route, mention of his photographic materials.]

W1008 Taylor, J. Traill. "A Visit to Philadelphia." PHOTOGRAPHIC TIMES 12, no. 139 (July 1882): 275-276. [Taylor visited Wilson in Philadelphia, back from his trip to Europe and the Near East. Taylor describes Wilson's voyage, his preferred cameras, etc.]

W1009 Wilson, Edward L. "Emulsion Photography Abroad." PHOTOGRAPHIC TIMES 12, no. 139 (July 1882): 244-245. [Wilson visited Paris studios. Mentions A. Liebert, Benayne (who has brothers in Hamburg and Terest who also are photographers), Maison Walery, Nadar - all working with dry plates.]

W1010 Wilson, Edward L. "Some Experience with the Emulsion Plates Not So Pleasant." PHOTOGRAPHIC TIMES 12, no. 141 (Sept. 1882): 351-352.

W1011 Wilson, Edward L. "Photographic Wrecks." PHOTOGRAPHIC TIMES 12, no. 141 (Sept. 1882): 376-378. [Wilson discusses the fact of many photographers overextending themselves and failing.]

W1012 Wilson, Edward L. "Watchman, Tell Us of the Day?" PHOTOGRAPHIC TIMES 12, no. 142 (Oct. 1882): 393-394.

W1013 Wilson, Edward L. "A Day Among the Paris Studios." PHOTOGRAPHIC TIMES 12, no. 142 (Oct. 1882): 409-412. [Interview with Wilson about his experiences in Paris. Bengue, Liebert, Nadar discussed.]

W1014 Wilson, Edward L. "Hyposulphite of Soda in The Ferrous Oxalate Developer." PHOTOGRAPHIC TIMES 12, no. 143 (Nov. 1882): 429-431.

W1015 Wilson, Edward L. "For the Beginner: The Nature and Treatment of the Subject." PHOTOGRAPHIC TIMES 12, no. 144 (Dec. 1882): 462-463.

W1016 "Commercial Matters of the Month." PHOTOGRAPHIC TIMES 12, no. 144 (Dec. 1882): 490-491, 492-493. [Wilson brought home a thousand views of Egypt, the Sinai Peninsula, Arabia Petra, Palestine and Syria. Magic lantern slides have been made and a catalog issued. Further commentary on this activity on pp. 492-493.]

W1017 Wilson, Edward L. "Westerly Wanderings." PHOTOGRAPHIC TIMES 14, no. 157-163 (Jan. - July 1884): 8-11, 70-71, 124-125, 359-360. [Continued from vol. l3, p. 653. (Jan.) Discusses stock dealers, photographic suppliers in Detroit, mentions "Luke Sharp," humorous commentator for "Detroit Free Press." (Feb.) Discusses Cincinnati, OH, photographers. (Mar.) Discusses photographers in Kansas City, MO. (July) Wilson visits Chicago, describes the city, its photographers, photographic stock dealers.]

W1018 Wilson, Edward L. "The Influence of Prices on Health." PHOTOGRAPHIC TIMES 14, no. 160 (Apr. 1884): 183-184.

W1019 Wilson, Edward L. "The Influence of Photography Upon the Public Mind." PHOTOGRAPHIC TIMES 14, no. 161 (May 1884): 228-230. [Discusses the popular journal "Century," its illustrations, and their impacts.]

W1020 Wilson, Edward L. "The Influence of Photography Upon the Scientific Mind." PHOTOGRAPHIC TIMES 14, no. 162 (June 1884): 299-301.

W1021 Wilson, Edward L. "The Influence of Photography Upon the Dear Public." PHOTOGRAPHIC TIMES 14, no. 163 (July 1884): 351-353.

W1022 Wilson, Edward L. "A Day's Photographing with Luke Sharp, of the 'Detroit Free Press.'" PHOTOGRAPHIC TIMES 14, no. 165 (Sept. 1884): 480-483.

W1023 Wilson, E. L. "The Dignity of Photographic Art." PHOTOGRAPHIC TIMES 15, no. 201 (July 24, 1885): 411-412.

W1024 "Notes." PHOTOGRAPHIC TIMES 15, no. 214 (Oct. 23, 1885): 605. [Note that "increased demand for Prof. Edward L. Wilson's services on the lecture stage, together with extractions of his literary work have compelled him recently to give up his retail business. He will, however, continue in his manufacturing for the trade slides from his Egyptian and other foreign negatives, and from those of the Centennial and New Orleans Exposition..."]

W1025 "Notes." PHOTOGRAPHIC TIMES 15, no. 215 (Oct. 30, 1885): 620. [List and description of six lectures to be given by Wilson at the Philadelphia Academy of Music.]

W1026 Wilson, Edward L. "A Photographers Visit to Petra: With an Introduction by Thomas W. Ludlow." CENTURY MAGAZINE 31, no. 1 (Nov. 1885): 3-27. 21 illus. [Illustrations drawn by Harry Fenn, from photographs.]

W1027 "Bibliography." ANTHONY'S PHOTOGRAPHIC BULLETIN 17, no. 18 (Sept. 25, 1886): 575. [Bk. rev.: "Wilson's Lantern Journeys No. 3".]

W1028 "Portraiture at Home." PHOTOGRAPHIC TIMES 16, no. 265 (Oct. 15, 1886): 539-540.

W1029 "Note." PHOTOGRAPHIC TIMES 16, no. 276 (Dec. 31, 1886): 693. [Brief note that Wilson gave a lantern slide lecture "The Finding of the Pharaohs" at Chickering Hall. Comment on Wilson's growing success as a popular lecturer.]

W1030 Wilson, Edward L. "Making Pictures." AMERICAN ANNUAL OF PHOTOGRAPHY AND PHOTOGRAPHIC TIMES ALMANAC FOR 1887 (1887): 162-164.

W1031 Wilson, Edward L. "Finding Pharaoh." CENTURY MAGAZINE 34, no. 1 (May 1887): 3-10. 11 illus. ["Illustrations from Photographs by Emil B. Rugsch Bey and Edward L. Wilson."]

W1032 "Bibliography." ANTHONY'S PHOTOGRAPHIC BULLETIN 18, no. 13 (July 9, 1887): 415. [Bk. rev.: "Wilson's Quarter Century In Photography," by Edward L. Wilson. New York: Edward L. Wilson, 1887. 516 pp.]

W1033 Wilson, Edward L. "The Modern Nile." SCRIBNER'S MAGAZINE 2, no. 3 (Sept. 1887): 259-282. 18 illus. ["...with illustrations from photographs by the author."]

W1034 Wilson, Edward L. "The Sea of Galilee." CENTURY MAGAZINE 35, no. 2 (Dec. 1887): 171-183. 18 illus. [18 views, genre portraits in engraving. "Illustrations drawn by J. D. Woodward, from sketches from nature, and by Otto H. Bacher and Irving R. Wiles, from photographs by the author and Frank M. Good."]

W1035 Wilson, Edward L. "Why Study Art?" AMERICAN ANNUAL OF PHOTOGRAPHY & PHOTOGRAPHIC TIMES ALMANAC FOR 1888 (1888): 117-118.

W1036 Wilson, Edward L. "A Few Hints Backward." PHOTOGRAPHIC MOSAICS: 1888 24, (1888): 2-42. [General commentary on the state of the art, aesthetic advice with quotes from a variety of sources. Enoch Root, Edward Dumore, Miss Ada S. Ballin, J. F. Mostyn Clarke, Norman MacBeth, Andrew Pringle, Hugh Brebner, Edward L. Wilson, William Cook, G. G. Rockwood, G. Brangwin Barnes comments on portraiture. Quotes on landscape photography by Alex M. Riddle, G. G. Rockwood, Xanthus Smith, H. A. H. Daniel, Dr. S. C. Passavant, Wilfred A. French, Lyonel Clarke, W. E. Partridge, and others.]

W1037 Wilson, Edward L. "The Great Pyramid." SCRIBNER'S MAGAZINE 3, no. 1 (Jan. 1888): 41-63. 14 b & w. 8 illus. ["With illustrations from photographs by the author, and from drawings by J. D. Woodward."]

W1038 Wilson, Edward L. "The Advantages of Art Education with Especial Reference to the Value of Burnet's Essays on Art." PHOTOGRAPHIC TIMES 18, no. 341 (Mar. 30, 1888): frontispiece, 145-146. 7 illus. [7 engravings on one plate taken from Burnet's "Essays on Art."]

W1039 Wilson, Edward L. "From Dan to Beersheba." CENTURY MAGAZINE 35, no. 6 (Apr. 1888): 814-833. 25 illus. [Views, costume portraits. "Illustrations by Otto H. Bacher, J. D. Woodward.]

W1040 "Edward Livingstone Wilson." PHOTOGRAPHIC TIMES 18, no. 355 (July 6, 1888): frontispiece, 313-315. 1 b & w. [Portrait by Frederick Kurtz. Biography. Describes Wilson's battles to repeal the bromide patent, his role in the formation of the National Photographic Association, editorship of "Philadelphia Photographer," importance to obtaining a photographic hall at the 1876 Philadelphia Centennial

Exposition, his role in the N. P. A. and later the P. P. of A, trip to Palestine and Egypt, touring lectures, etc.]

W1041 Wilson, Edward L. "The Temples of Egypt." SCRIBNER'S MAGAZINE 4, no. 4 (Oct. 1888): 387-409. 21 illus. ["With...illustrations from drawings...and from photographs by the author..."]

W1042 Robinson, Charles S. "Where Was 'The Place Called Calvary'?" CENTURY MAGAZINE (SCRIBNER'S MONTHLY) 37, no. 1 (Nov. 1888): 98-107. 5 illus. ["Illustrations by J. D. Woodward and Harry Fenn, from photographs by E. L. Wilson. Map by Jacob Wells."]

W1043 "Editorial Notes." PHOTOGRAPHIC TIMES 18, no. 372 (Nov. 2, 1888): 519. [Comment about Wilson photographing two pages of the Codex Aureus, (A.D. 776) in a monastery "on one of his famous oriental journeys...."]

W1044 Wilson, Edward L. "From Sinai to Shechem." CENTURY MAGAZINE 37, no. 2 (Dec. 1888): 193-208. 16 illus. [Illustrations by Kenyon Cox, Harry Fenn, and A. Brennon, from photographs by the author.]

W1045 Wilson, Edward L. "How to Develop - Yourself." AMERICAN ANNUAL OF PHOTOGRAPHY AND PHOTOGRAPHIC TIMES ALMANAC FOR 1889 (1889): 146-147.

W1046 Wilson, Edward L. "Tracing Over Old Lines." PHOTOGRAPHIC MOSAICS: 1889 25, (1889): 9-40. [General commentary on the state of the art. Includes quotes from Andrew Pringle, Enoch Root, David R. Clark, A. J. Treat, W. J. Baker, E. K. Hough, on treating photography creatively. W. T. Gregg, G. Hanmer Croughton, E. Boelte, John Carbutt, G. Cramer, Charles Ehrmann, and others on technical matters. A. C. Campbell on landscape photography.]

W1047 "Editorial Notes." ANTHONY'S PHOTOGRAPHIC BULLETIN 20, no. 2 (Jan. 26, 1889): 36-37. [Summary of Wilson's career as a photographer, editor, first published in the German "Photographisher Almanach fur 1889," reprinted.]

W1048 Wilson, Edward L. "Round About Galilee." CENTURY MAGAZINE 37, no. 3 (Jan. 1889): 413-426. 17 illus. [Illustrations by Harry Fenn, Kenyon Cox, W. Taber, Otto H. Bacher, from photographs by F.M. Good and the author.]

W1049 Wilson, Edward L. "Notes and News: Photographing the Birth-Place of Jesus." PHOTOGRAPHIC TIMES 19, no. 391 (Mar. 15, 1889): 136. [Photographing in Jerusalem. From Jan. 1889 "Century" magazine.]

W1050 Wilson, Edward L. "Round About Jerusalem." CENTURY MAGAZINE 38, no. 1 (May 1889): 42-55. 9 illus.

W1051 Wilson, Edward L. "Three Jewish Kings." CENTURY MAGAZINE 38, no. 6 (Oct. 1889): 863-871. 12 illus.

W1052 Wilson, Edward L. "Dallying With the Developer." AMERICAN ANNUAL OF PHOTOGRAPHY AND PHOTOGRAPHIC TIMES ALMANAC FOR 1890 (1890): 186-187.

W1053 Wilson, Edward L. "The Bicentennial Year." PHOTOGRAPHIC MOSAICS: 1890 26, (1890): 9-50. [General survey of the year.]

W1054 Wilson, Edward L. "Some Wayside Places in Palestine." CENTURY MAGAZINE 39, no. 5 (Mar. 1890): 737-743. 7 illus.

W1055 "The Editorial Table." PHOTOGRAPHIC TIMES 20, no. 480 (Nov. 28, 1890): 596. [Book rev.: "In Scripture Lands: New Views of Sacred Places," by Edward L. Wilson, Ph.D. New York: Charles Scribner's Sons.]

W1056 Wilson, Edward L. "Realism in Photography." AMERICAN ANNUAL OF PHOTOGRAPHY AND PHOTOGRAPHIC TIMES ALMANAC FOR 1891 (1891): 250-251. [Mentions Max Petsch of Berlin of "twenty-five years ago..." Petsch's portraits of children at play in the 1860's went far beyond the stiffly-posed conventional portraits of the time.]

W1057 Wilson, Edward L. "Redeveloping the Year Last Past." PHOTOGRAPHIC MOSAICS: 1891 27, (1891): 9-112.

W1058 Wilson, Edward L. "Mount Washington in Winter." SCRIBNER'S MAGAZINE 9, no. 2 (Feb. 1891): 135-155. 14 illus. ["Illustrations by Victor Pérard."]

W1059 Wilson, Edward L. "The Biography of the Oyster." SCRIBNER'S MAGAZINE 10, no. 4 (Oct. 1891): 469-485. 9 illus. [Oyster harvesters, etc. "Illustrations by Carleton T. Chapman, Charles Broughton, and J. H. Twachtman."]

W1060 Wilson, Edward L. "The Progress of Photography During 1891." PHOTOGRAPHIC MOSAICS: 1892 28, (1892): 9-124.

W1061 Wilson, Edward L. "Art in Portraiture." PHOTOGRAPHIC TIMES 23, no. 605 (Apr. 21, 1893): frontispiece, 199-203. 8 b & w. [From "Photographic Mosaics of 1893." Includes 8 examples of professional portraits by: Chute & Brooks (Montevideo); Oscar Sueck (Carlsruhe); N. Sarony (N.Y.); J. A. Todd (San Francisco); Dr. J. M. Eder (Vienna); C. P. Marshall (Cazenovia, N.Y.); and two by F. W. Guerin (St. Louis).]

W1062 Wilson, Edward L. "Christ in Art." WILSON'S PHOTOGRAPHIC MAGAZINE.32, no. 457 (Jan. 1895): 6-9. 2 b & w. 1 illus. [Photos representing Christ by H. McMichael, Ch. Scolik, etc.]

W1063 Wilson, Edward L. "On the 'Suppression of Girls.'" WILSON'S PHOTOGRAPHIC MAGAZINE.32, no. 457 (Jan. 1895): 12-15. 5 b & w. [Photos of small groups of women by C. O. Towles, (Frostburg, Md.), E. R. Curtiss (Madison, Wis.), H. Randall (Ann Arbor), with a humorous article of commentary by Wilson.]

W1064 Wilson, Edward L. "Atmosphere." WILSON'S PHOTOGRAPHIC MAGAZINE. 32, no. 458 (Feb. 1895): 54-56. 3 b & w. [Landscape photos by W. B. Woodbury, Edward L. Wilson.]

W1065 Wilson, Edward L. "About Getting Grace." WILSON'S PHOTOGRAPHIC MAGAZINE.32, no. 459 (Mar. 1895): 100-105. 3 b & w. [General aesthetic, illustrated with 3 portraits of women. Mentions Berghaim, Holliper, H.P. Robinson by name.]

W1066 Wilson, Edward L. "Studies of the Head." WILSON'S PHOTOGRAPHIC MAGAZINE 32, no. 460 (Apr. 1895): 160-161, plus unnumbered leaf after p. 160. 16 b & w. [A set of 16 portraits (actresses and models) reproduced on one page is compared to the same 16 portraits rearranged. The article briefly discusses the good and bad points of the two arrangements. It is the first situation, that I know of a discussion about the affective relationships of groups of

photos shown together and the power of effective groupings of photographs. The photographer was not named.]

W1067 Wilson, Edward L. "The Apparent Size of Objects." WILSON'S PHOTOGRAPHIC MAGAZINE 32, no. 460 (Apr. 1895): 172-173.

W1068 Wilson, Edward L. "Does Photography Describe?" WILSON'S PHOTOGRAPHIC MAGAZINE.32, no. 461 (May 1895): 198-203. 3 b & w. [2 photos by Edward Wilson, 1 by J. H. Lloyd.]

W1069 Wilson, Edward L. "Wood-Engraving vs. Half-Tone Engraving." WILSON'S PHOTOGRAPHIC MAGAZINE 32, no. 462 (June 1895): 257-260. 4 illus. [Includes two half-tone cuts of views of Syria taken by E. L. Wilson as well as two examples of how the wood engraver translated these illustrations for publication in the "Century Magazine" "some time ago."]

W1070 Wilson, Edward L. "Photographing Animals." WILSON'S PHOTOGRAPHIC MAGAZINE.32, no. 462 (June 1895): 260-265. 9 b & w. [Illus. with photos of domestic animals by E. L. Wilson, Geo. W. Burger, W. E. Tefft, Jr., Albion W. Floyd, F. M. Somers.]

W1071 Wilson, Edward L. "Photography By The River." WILSON'S PHOTOGRAPHIC MAGAZINE.32, no. 463 (July 1895): 305-309. 4 b & w. ["With the adaptation of remarks upon "Rivers" from "Landscape" by Philip Gilbert Hamerton, 3 photos by Edward L. Wilson, 1 photo by Walter B. Woodbury.]

W1072 Wilson, Edward L. "'Composition' and 'Combination.'" WILSON'S PHOTOGRAPHIC MAGAZINE 32, no. 464 (Aug. 1895): 353-357. 5 b & w. [Illustrated with photos by B. J. Falk, M. Herbert Brindle, O'Keefe & Stockdorf (of Leadville, Colo.) and H. Randle. O'Keefe & Stockdorf's work is bizarre combinations - a woman sitting on a moon superimposed over a landscape, a boy riding an eagle, etc.]

W1073 Wilson, Edward L. "Legs." WILSON'S PHOTOGRAPHIC MAGAZINE 32, no. 467 (Nov. 1895): 503-505. 7 illus. [Humorous article about photographing legs, illustrated with examples.]

W1074 Wilson, Edward L. "A Pilgrimage After the Pictorial In Portraiture. Part 3." WILSON'S PHOTOGRAPHIC MAGAZINE 33, no. 469 (Jan. 1896): 17-21. 4 b & w. 2 illus. [In this segment from photographic studies of B. J. Falk, 2 illustrations from painting used to illustrate the theme of the issue.]

W1075 Wilson, Edward L. "The Apex of the Pyramid." WILSON'S PHOTOGRAPHIC MAGAZINE 33, no. 470 (Feb. 1896): 79-81. 5 b & w. 1 illus. [Essay on composition.]

W1076 "The Uses of Photography in Book-Making." WILSON'S PHOTOGRAPHIC MAGAZINE 33, no. 471 (Mar. 1896): 115-119. 2 b & w. 2 illus. [Actually a discussion of photographic reproduction techniques used in Edward L. Wilson's book "In Scripture Lands."]

W1077 1 photo ("Philae, Egypt"). WILSON'S PHOTOGRAPHIC MAGAZINE 33, no. 473 (May 1896): unnumbered leaf following p. 224. [Brief note on p. 230 in "Our Pictures."]

W1078 Wilson, Edward L. "About Feeling and Judgement." WILSON'S PHOTOGRAPHIC MAGAZINE 33, no. 474 (June 1896): 259-265. 5 b & w. 2 illus. [Humorous article on aesthetics. Illus. with photos by Mrs. J. M. Kendall, C. H. Graves, H. Kimball, Edward L. Wilson, and a comic sketch by A. G. Marshall.]

W1079 Wilson, Edward L. "Some Thinking About Thought." WILSON'S PHOTOGRAPHIC MAGAZINE 33, no. 476 (Aug. 1896): 367-369. ["Read by the author at the Convention of the P.A. of A., at Celeron, Wednesday A.M., June 24, 1896.]

W1080 Wilson, Edward L. "Variety In the Treatment of the Subject." WILSON'S PHOTOGRAPHIC MAGAZINE 33, no. 477 (Sept. 1896): 413-415.

W1081 Wilson, Edward L. "A Romance of Ro-Ent-Gen-Ra." WILSON'S PHOTOGRAPHIC MAGAZINE 33, no. 477 (Sept. 1896): 416-418. [Essay apparently sparked by the resemblances of two photos, one of a mummified hand, the second a radiograph (x-ray) of a hand.]

W1082 Wilson, Edward L. "Section 1. The Review of the Year 1896." PHOTOGRAPHIC MOSAICS: 1897 33, (1897): 2-106. [Survey, with these section headings: Associations and Conventions, Pictorial Lessons in Portraiture, Single Slant Light in the Studio, Animated Photography, Portraiture Outside the Studio, Artificial Light in Photography, Pastel and Color Work, Picture-Making Outdoors, Landscape Work as a Diversion, Business Methods, The Reception and Treatment of the Patron, The Photographer's Advertising, An Advertising Booklet, To Whom Does the Negative Belong?, Copyright for Photographs, A Remedy for Hard Times, Wanted - A Revolution, (Developers, etc., Printing Methods, Toning Baths, Papers, etc.), Photographic Literature, Obituary. Excerpts and statements already published in the literature during the year. Section 2 is titled "Original Contributions." Section 3 is titled "Illustrated Articles.]

W1083 Wilson, Edward L. "Getting the advantage of Things Inanimate." PHOTOGRAPHIC MOSAICS: 1897 33, (1897): 220-224.

W1084 Wilson, Edward L. "Editor's Table." WILSON'S PHOTOGRAPHIC MAGAZINE 34, no. 481 (Jan. 1897): 17-22. 10 b & w. [Illus. with photos by F. G. Schumacher (Los Angeles). Includes a statement about Schumacher's photographs by E. K. Hough, as well as Wilson's general commentary.]

W1085 Wilson, Edward L. "A Few Hints on Criticism." WILSON'S PHOTOGRAPHIC MAGAZINE 35, no. 499 (July 1898): 308-314. 13 b & w. [Excerpts of quotes by H. Snowden Ward from "Mosaics, 1891" combined with the unnamed author (Wilson?) to comment upon portraits by Joe L. Douglass (Columbia, Mo.); R. H. Schacht (Boston) and Reutlinger (Paris).]

W1086 Wilson, Edward L. "Letters to Jack - And Things Old and New." WILSON'S PHOTOGRAPHIC MAGAZINE 37, no. 517-523 (Jan. - July 1900): 17-18, 73-75, 122-124, 172-175, 210-212, 248-249, 325-326.

W1087 Wilson, Edward L. et al. "Old vs. New Methods in Portraiture. Part 1." WILSON'S PHOTOGRAPHIC MAGAZINE 37, no. 518 (Feb. 1900): 49-55. [Article includes an overview describing old and new portrait styles, background, etc., then quotes eight professional photographers. A bibliography of articles on the "inception and growth of the 'new' movement in professional portraiture," published in the previously five volumes of the magazine is included. The photographers quoted are M. R. Hemperly (Philadelphia, PA); Donald Roberts (Detroit, MI); E. M. Estabrook (Elizabeth, NJ), F. M. Somers (Cincinnati, OH); J. E. Mock (Rochester, NY); Herbert Randall (New Haven, CT); Louis F. Jansen (Buffalo, NY); and W. C. Farrand (Pach Bros., New York, NY).]

W1088 Wilson, Edward L. et al. "Old vs. New Methods in Portraiture. Part 2." WILSON'S PHOTOGRAPHIC MAGAZINE 37, no. 519 (Mar. 1900): 97-100. [Quotes by Emily Stokes (Boston, MA); Henry H. Pierce (Providence, RI); F. W. Guerin (St. Louis, MO); Clayton Stone Harris (Philadelphia, PA); Frances A. Place (Chicago, IL); Edgar E. Seavy (New Castle, PA); Rogers & Newing (Binghamton, NY); D. Rosser (Pittsburgh, PA); Homeier & Clark (Richmond, VA); Whitney & Son (Cambridgeport, MA); J. Ed Rosch (St. Louis, MO); John H. Kemp (Scranton, PA); Charles P. Marshall (Cazenovia, NY); A. L. Jackson (Tacoma, WA).]

W1089 Wilson, Edward L, et al. "Old vs. New Methods in Portraiture." WILSON'S PHOTOGRAPHIC MAGAZINE 37, no. 520 (Apr. 1900): 145-147. [Statements by: Charles E. Stafford (Chicago, IL); W. W. Cowles (Seneca Falls, NY), Evan D. Evans (Ithaca, NY); Pirie McDonald (Albany, NY).]

W1090 Wilson, Edward L. "Letters to Jack - And Things Old and New." WILSON'S PHOTOGRAPHIC MAGAZINE 37, no. 522 (June 1900): 248-249. [Reminiscences about photography in Boston in the 1860s. Mentions James Black, John Whipple, A. Southworth, the first exhibition of the National Photographic Assoc., held in the Horticulture Hall in 1869.]

W1091 Wilson, Edward L. "American Photography." WILSON'S PHOTOGRAPHIC MAGAZINE 37, no. 523 (July 1900): 289. [Defense of American photography against British criticisms and the arguments of the avant-guard.]

W1092 Wilson, Edward L. "Studio Traditions Out of Doors." WILSON'S PHOTOGRAPHIC MAGAZINE 37, no. 523 (July 1900): 305-306.

W1093 Wilson, Edward L. "Pictures with Figures." WILSON'S PHOTOGRAPHIC MAGAZINE 38, no. 530 (Feb. 1901): 43-44.

W1094 Wilson, Edward L. "Dark Backgrounds and Simplicity." WILSON'S PHOTOGRAPHIC MAGAZINE 38, no. 534 (June 1901): 195-196.

W1095 Wilson, Edward L. "Interior Photography." WILSON'S PHOTOGRAPHIC MAGAZINE 38, no. 535 (July 1901): 270-272.

W1096 Wilson, Edward L. "Under the Skylight." WILSON'S PHOTOGRAPHIC MAGAZINE 38, no. 536 (Aug. 1901): 284-285. [Advice for professional photographers.]

W1097 Wilson, Edward L. "The Making of a Big Business." WILSON'S PHOTOGRAPHIC MAGAZINE 38, no. 536 (Aug. 1901): 289-282.

W1098 Wilson, Edward L. "Professional Photography - Not Portraiture." WILSON'S PHOTOGRAPHIC MAGAZINE 38, no. 536 (Aug. 1901): 293-294. [Discusses possibilities of making a living by photography outside of the portrait studio. Mentions evolution of reporter photographers for illustrated magazines, press photographers, railroad photography (mentions Jackson, Ray and Nims), industrial photography.]

W1099 Wilson, Edward L. "Artistic Photography for Reproduction." WILSON'S PHOTOGRAPHIC MAGAZINE 38, no. 537 (Sept. 1901): 375.

W1100 "Edward L. Wilson." PHOTOGRAPHIC TIMES 35, no. 9 (Sept. 1903): 407. [Died June 23, 1903, at Vineland, NJ. Born at Flemington, NJ, in 1838. Began his work in photography with Frederick Gutekunst in Philadelphia in the early 1860s. Began publishing the "Philadelphia Photographer" in 1864. A founder of the National Photographic Association. Between 1881 and 1893, wrote several books.]

W1101 "Obituary of the Year: Edward L. Wilson." BRITISH JOURNAL PHOTOGRAPHIC ALMANAC 1904 (1904): 674-676. [Detailed biographical information.]

WILSON, EDWARD L. [?]

W1102 "Photography as a Progressive Art." PHILADELPHIA PHOTOGRAPHER 1, no. 9 (Sept. 1864): 131-133.

W1103 "The Wonders of Photography." PHILADELPHIA PHOTOGRAPHER 2, no. 17 (May 1865): 74-75.

W1104 "The Total Depravity and Gymnastics of Inanimate Things Photographic." PHILADELPHIA PHOTOGRAPHER 2, no. 22 (Oct. 1865): 155-157.

WILSON, EDWARD T.

W1105 Wilson, Edward T., M.B. Oxon. "How to Photograph Microscopic Objects." POPULAR SCIENCE REVIEW 6, no. 22 (Jan. 1867): 54-65. 1 illus.

WILSON, FRANCESCA HENRIETTA. [?]

W1106 Wilson, Francesca Henrietta. *Rambles in Northern India with Incidents and Descriptions of Many Scenes of the Mutiny, with Twelve Large Photographic Views.* London: Sampson Low, Marston, Low & Searle, 1876. 87 pp. 12 b & w. [Carbon prints. I am not certain that the author of the book is also the maker of the photographs.]

WILSON, GEORGE WASHINGTON. (1823-1893) (GREAT BRITAIN)

[Born in Aberdeen, Scotland in 1823. From 1843 to 1852 he worked as a landscape painter and miniaturist. Opened a portrait studio in Aberdeen in 1852. In 1859 published a stereo set titled "Scottish Gems." Appointed photographer to the Queen in Scotland in 1860. Throughout 1860s and 1870s he came to be considered one of the leading landscape photographers, making thousands of photographs and publishing many illustrated books and albums. Died in Aberdeen in 1893.]

BOOKS

W1107 Wilson, George Washington. *A Practical Guide to the Collodion Process in Photography.* London: Longmans & Co., 1855. 44 pp. 2 illus.

W1108 *Aberdeen Portraits, No. 1., A Group of Upwards of One Hundred Portraits, By G. W. Wilson, Photographer to Her Magesty.* Aberdeen: A. Brown & Co., [1957] 4 pp. ["Critical Notice," from "Gossip from Aberdeen," in "Banffshire Journal," May 26, 1857. Reprinted and issued as a seperate offprint.]

W1109 Howitt, William & Mary Howitt. *Ruined Abbeys and Castles of Great Britain...* The photographic illustrations by Bedford, Sedgfield, Wilson, Fenton, and others. London : Alfred W. Bennett, 1862. viii, 228 pp. 27 b & w. [Original photos, tipped-in.]

W1110 Scott, Sir Walter. *The Lady of the Lake.* London: A. W. Bennett, 1863. v, 215 pp. 13 l. of plates. 13 b & w. [Original photos by G. W. Wilson and T. Ogle.]

W1111 *Photographs of English and Scottish Scenery. English Cathedrals - York and Durham.* 12 Views by G. W. Wilson. Aberdeen: G. W. Wilson, 1865. 13 l. 12 l. of plates. 12 b & w. [Leaf of descriptive text with each illustration.]

W1112 Howitt, William. *The Ruined Abbeys of the Border:* Extracted from "The Ruined Abbeys and Castles of Great Britain." With Photographic Illustrations by Wilson and Stephen Thompson. London: Alfred W. Bennettt, 1865. 70 pp. 6 b & w.

W1113 *Photographs of English and Scottish Scenery. Balmoral.* 12 Views by G. W. Wilson. Aberdeen: G. W. Wilson , 1866. 14 l. 12 l. of plates. 12 b & w. [Leaf of descriptive text with each illustration.]

W1114 *Photographs of English and Scottish Scenery. Blair-Athole.* 12 Views by G. W. Wilson. Aberdeen: G. W. Wilson , 1866. 14 l. 12 l. of plates. 12 b & w. [Leaf of descriptive text with each illustration.]

W1115 *Photographs of English and Scottish Scenery. Braemer.* 12 Views by G. W. Wilson. Aberdeen: G. W. Wilson, 1866. 14 l. 12 l. of plates. 12 b & w. [Leaf of descriptive text with each illustration.]

W1116 *Photographs of English and Scottish Scenery. Dunkeld.* 12 Views by G. W. Wilson. Aberdeen: G. W. Wilson , 1866. 14 l. 12 l. of plates. 12 b & w. [Leaf of descriptive text with each illustration.]

W1117 *Photographs of English and Scottish Scenery. Gloucester Cathedral.* 12 Views by G. W. Wilson. Aberdeen: G. W. Wilson, 1866. 14 l. 12 l. of plates. 12 b & w. [Leaf of descriptive text with each illustration.]

W1118 *Photographs of English and Scottish Scenery. Trossach and Lake Katrine.* 12 Views by G. W. Wilson. Aberdeen: G. W. Wilson, 1866. 14 l. 12 l. of plates. 12 b & w. [Leaf of descriptive text with each illustration.]

W1119 *Photographs of English and Scottish Scenery. The Caledonian Canal.* 12 Views by G. W. Wilson. London: A. Marion, Son & Co., 1867. 14 l. 12 l. of plates. 12 b & w.

W1120 *Photographs of English and Scottish Scenery. Staffa and Iona.* 12 Views by G. W. Wilson. London: A. Marion, Son & Co., 1867. 14 l. 14 l. of plates. 12 b & w.

W1121 Blake, James. *Jim Blake's Tour from Glonave to London.* Dublin: M. H. Gill, 1867. n. p. 9 b & w. [Original photographs, by G. W. Wilson, of drawings by Erskine Nicol.]

W1122 *Photographs of English and Scottish Scenery. Edinburgh.* 12 Views by G. W. Wilson. London: A. Marion, Son & Co., 1868. 14 l. 12 l. of plates. 12 b & w.

W1123 Victoria, Queen of Great Britain. Helps, Arthur, ed. *Leaves from the Journal of Our Life in the Highlands, from 1848 to 1861. To Which is Prefixed and Added Extracts from the Same Journal giving an account of Earlier Visits to Scotland, and Tours in England and Ireland, and Yachting Excursions.* London: Smith, Elder & Co., 1868. xx, 315 pp. 42 b & w. [Texts are selections from the journals of Queen Victoria, the illustrations were chosen to record places as they looked in the mid-1860s, the views by G. W. Wilson.]

W1124 *List of Stereoscopic, Album, and Cabinet Views by G. W. Wilson, Photographer to the Queen, 24 & 25 Crown Street, Aberdeen.* Boston: Charles Pollock, 1871. 48 pp.

W1125 *Photographs of Scottish Scenery. Souvenir of Sir Walter Scott.* Photographs by G. W. Wilson. Aberdeen: G. W. Wilson, 187-. 6 l. 10 b & w.

W1126 Scott, Sir Walter. *The Lady of the Lake.* "Author's Edition." Edinburgh: Adam & Charles Black, 1871. iv, 353 pp. 6 tipped-in b & w. [Variant editions with 10 to 12 photographs attributed to G. W. Wilson, and wood engravings by Birket Foster and John Gilbert, published from 1863 through 1870s.]

W1127 *List of Stereoscopic, Album, Cabinet, and Imperial Views, by G. W. Wilson, Photographer, 24 Crown Street, Aberdeen.* Aberdeen: Free Press Office, printers, 1873. 60 pp.

W1128 *Catalogue of Imperial, Cabinet, Stereoscopic and Carte-de-Visite Views, etc., etc., by G. W. Wilson & Co.* Aberdeen; Edinburgh: G. W. Wilson & Co.; G. Ferrier, 1877. 72 pp.

W1129 *Photographic View Album of Fraserburgh.* (Photographed and Printed by G. W. Wilson & Co., Ltd., Aberdeen.) Fraserburgh: W. R. Melvin, n. d. [189- ?]. n. p. 14 l. of plates. 14 b & w.

W1130 Wilson, G. W. & Co. *Catalogue of Landscape & Architectural Views in South Africa.* Photographed by G. W. Wilson & Co. Aberdeen: G. W. Wilson & Co., 190- ? 10 pp.

W1131 Taylor, Roger. *George Washington Wilson: Artist and Photographer (1823 - 1893).* Aberdeen: Aberdeen University Press, 1981. 204 pp. b & w. illus.

PERIODICALS

W1132 Wilson, G. W. "General Description of the Collodion Process." HUMPHREY'S JOURNAL 8, no. 1-2 (May 1 - May 15, 1856): 8-16, 27-30.

W1133 Wilson, George N. [sic W.] "On Developing Negatives with Iron." PHOTOGRAPHIC AND FINE ART JOURNAL 11, no. 6 (June 1858): 182-183. [Letter from Wilson (Aberdeen) describing his process.]

W1134 Wilson, Geo. N. [sic W.] "On Developing Negatives with Iron." HUMPHREY'S JOURNAL OF PHOTOGRAPHY, AND THE ALLIED ARTS AND SCIENCES 10, no. 3 (June 1, 1858): 47-48.

W1135 "Notices of Recently Published Stereographs. Scottish Gems." BRITISH JOURNAL OF PHOTOGRAPHY 7, no. 109-110 (Jan. 1 - Jan. 15, 1860): 6-7, 23.

W1136 "Photographs of Scottish Celebrities." PHOTOGRAPHIC NEWS 3, no. 70 (Jan. 6, 1860): 206-207. [Note that Comm. of the Archeological Expedition had photos of portraits of historical Scots taken by Mr. Wilson of Aberdeen... "but as we have never seen any of this gentleman's pictures, we are unable to say...any guarantee of their excellence or otherwise."]

W1137 "Fine-Art Gossip." ATHENAEUM no. 1682 (Jan. 21, 1860): 99. [Description, praise for the photographs of the principle portraits in the Aberdeen Gallery. Note on p. 139 in the next issue credits this work to George W. Wilson.]

W1138 "Critical Notices: Stereograms of Scottish Scenery. By G. W. Wilson, Aberdeen." PHOTOGRAPHIC NEWS 3, no. 73 (Jan. 27, 1860): 246-248. [Very favorable review.]

W1139 "Stereographs: Instantaneous Marine and Street Views, by George Wilson, Aberdeen." BRITISH JOURNAL OF PHOTOGRAPHY 7, no. 128 (Oct. 15, 1860): 303-304.

W1140 "Stereographs: Stonehenge, Cathedral Interiors, &c., by Geo. Wilson, Aberdeen." BRITISH JOURNAL OF PHOTOGRAPHY 8, no. 133 (Jan. 1, 1861): 11-12.

W1141 "Stereographs: Scottish Lake Scenery, Illustrated by George Wilson, Aberdeen." BRITISH JOURNAL OF PHOTOGRAPHY 8, no. 140 (Apr. 15, 1861): 145-146.

W1142 "Stereographs. Scenes in the Hebrides, &c., Photographed by George Wilson, Aberdeen." BRITISH JOURNAL OF PHOTOGRAPHY 8, no. 149 (Sept. 2, 1861): 308-309.

W1143 "Stereographs. An Artist's Gatherings in Cornwall, Devon, and the West of England. Photographed by George Wilson, Aberdeen." BRITISH JOURNAL OF PHOTOGRAPHY 9, no. 158 (Jan. 15, 1862): 24-25.

W1144 "Stereographs: Scenes on the River Thames - Views of Vessels of the Channel Fleet. Illustrations of Scottish Scenery, Photographed by George Wilson, Aberdeen." BRITISH JOURNAL OF PHOTOGRAPHY 9, no. 160 (Feb. 15, 1862): 65-66.

W1145 Wilson, George Washington. "Reviews: A Series of Views taken in the South of England by George Washington Wilson." JOURNAL OF THE PHOTOGRAPHIC SOCIETY OF LONDON 7, no. 118 (Feb. 15, 1862): 372-373.

W1146 "Stereographs: Highland Scenery: Cathedral Illustrations and Scenes on the River Thames. Photographed by George W. Wilson, Aberdeen." BRITISH JOURNAL OF PHOTOGRAPHY 10, no. 183 (Feb. 2, 1863): 52.

W1147 "Album Views. Photographed by Geo. W. Wilson." BRITISH JOURNAL OF PHOTOGRAPHY 10, no. 197 (Sept. 1, 1863): 352-354.

W1148 Sayce, B. J. "On the Use of Bromised Collodion." AMERICAN JOURNAL OF PHOTOGRAPHY AND THE ALLIED ARTS & SCIENCES n. s. vol. 6, no. 6 (Sept. 15, 1863): 121-124. [From "Br. J. of Photo." Sayce states that G. W. Wilson uses this process in his landscape work.]

W1149 "Mr. Wilson's Wet Collodion Process." BRITISH JOURNAL OF PHOTOGRAPHY 11, no. 228 (Sept. 16, 1864): 349.

W1150 Wilson, George Washington. "A Voice from the Hills: Mr. Wilson at Home." BRITISH JOURNAL OF PHOTOGRAPHY 11, no. 228, 230, 231, 233 (Sept. 16, Sept. 30, Oct. 7, Oct. 21, 1864): 352-354, 374-375, 388, 410.

W1151 Wilson, George Washington. "Correspondence: On Camera Stands, Stains, and Fine Art." BRITISH JOURNAL OF PHOTOGRAPHY 11, no. 232 (Oct. 14, 1864): 407.

W1152 "Mr. Wilson's Negative Process." BRITISH JOURNAL OF PHOTOGRAPHY 11, no. 233 (Oct. 21, 1864): 409.

W1153 "Our Editorial Table: Stereographs of the Lake District, by George Washington Wilson." BRITISH JOURNAL OF PHOTOGRAPHY 11, no. 237 (Nov. 18, 1864): 462.

W1154 "Our Editorial Table: Architectural Stereographs, by G. Washington Wilson." BRITISH JOURNAL OF PHOTOGRAPHY 11, no. 240 (Dec. 9, 1864): 503.

W1155 "Our Editorial Table: Stereographs by G. Washington Wilson, Aberdeen." BRITISH JOURNAL OF PHOTOGRAPHY 12, no. 291 (Dec. 1, 1865): 609-610.

W1156 Wilson, George W. "Photography in the Field." BRITISH JOURNAL PHOTOGRAPHIC ALMANAC 1866 (1866): 65-70.

W1157 "Photographic Views." ART JOURNAL (Sept. 1866): 290. [Mr. G. W. Wilson of Aberdeen is very industrious.]

W1158 "Stereographs." PHILADELPHIA PHOTOGRAPHER 4, no. 46 (Oct. 1867): 332-333. [Mentions at length G. W. Wilson. Also mentions Ch. Bierstadt (formerly New Bedford, MA), A. F. Styles (Burlington, VT), H. R. Lindsley, (Auburn, NY).]

W1159 "Voices from the Craft." PHILADELPHIA PHOTOGRAPHER 4, no. 48 (Dec. 1867): 383-384. [Letter from G. W. Wilson on mounting stereo slides.]

W1160 "Editor's Table: Photographs to Illustrate the Queen's Book." PHILADELPHIA PHOTOGRAPHER 5, no. 58 (Oct. 1868): 376. [Mentions twelve cabinet size and forty two smaller views from Wilson. The smaller photos to be used to illustrate "Leaves from the Journal of our Life in the Highlands." [Apparently, a memento album for Queen Victoria.]]

W1161 "Note." ART JOURNAL (Dec. 1868): 286. [Note of a series of "cartes" of scenery of Scotland, by G. W. Wilson, of Aberdeen.]

W1162 Wilson, George Washington. "On Out-Door Photography." PHILADELPHIA PHOTOGRAPHER 6, no. 63 (Mar. 1869): 66-68.

W1163 "Our Picture." PHILADELPHIA PHOTOGRAPHER 6, no. 67 (July 1869): frontispiece, 248-249. 1 b & w. [Landscape.]

W1164 Wilson, George Washington. "On Outdoor Photography." BRITISH JOURNAL PHOTOGRAPHIC ALMANAC 1870 (1870): 117-119.

W1165 "Our Picture." PHOTOGRAPHIC WORLD 1, no. 2 (Feb. 1871): 56-57. 1 b & w. [Landscape.]

W1166 "Our Illustration." PHOTOGRAPHER'S FRIEND 2, no. 2 (Apr. 1872): frontispiece, 47-48. 2 b & w. [Landscape views.]

W1167 "Sketches of Prominent Photographers. No. 8: George Washington Wilson." PHOTOGRAPHER'S FRIEND 2, no. 2 (Apr. 1872): 48-50.

W1168 "Wilson's Landscape Studies." PHILADELPHIA PHOTOGRAPHER 9, no. 101 (May 1872): 137.

W1169 "Wilson's Album of Landscape Studies." PHOTOGRAPHIC TIMES 2, no. 17 (May 1872): 69. [Folding albums of 10 landscape views, each in a green & gold cloth cover, just issued by Benerman & Wilson.]

W1170 "The Camera in the Field." PHOTOGRAPHIC TIMES 4, no. 38 (Feb. 1874): 20-22. [Includes an excerpt "Outdoor Photography," by George Washington Wilson on pp. 21-22, with a description of the

cameras and other equipment that Anthony's had available for landscape photography.]

W1171 "Class in Landscape Photography." PHILADELPHIA PHOTOGRAPHER 11, no. 127 (July 1874): 214-215. [Monthly column, printing hints & formulas of various photographers. In July, discussed the work of G. W. Wilson, (Aberdeen) and John L. Gihon (Montevideo, S.A.).]

W1172 Wilson, George Washington. "Is It Desirable that Photographs Should be Permanent." BRITISH JOURNAL PHOTOGRAPHIC ALMANAC 1875 (1875): 45-46.

W1173 "A Respectable Photographic Establishment." ANTHONY'S PHOTOGRAPHIC BULLETIN 8, no. 1 (Jan. 1877): 7. [From "Br. J. of Photo."]

W1174 Nichol, John, Ph.D. "Notes from the North." ANTHONY'S PHOTOGRAPHIC BULLETIN 8, no. 5 (May 1877): 129-132. [From Br. J. of Photo."]

W1175 Portrait. Woodcut engraving credited "From a photograph by George Washington Wilson." ILLUSTRATED LONDON NEWS 72, (1878) ["Late Dr. R. Carruthers." 72:2033 (June 15, 1878): 557.]

W1176 "George Washington Wilson." PHOTOGRAPHIC TIMES 23, no. 603 (Apr. 7, 1893): 176-177. [From the "Br J of Photo." Obituary. Studied at the Art School, Edinburgh, worked several years as a miniature painter, switched to photography soon after it was invented. Died March, 1893, seventy years of age.]

W1177 Findlay, William. "The First Snapshot Ever Made - Its Story and Something About the Artist." AMERICAN PHOTOGRAPHY 24, no. 6 (June 1930): 298-299. 1 b & w. [Wilson photograph taken in 1856.]

W1178 Newhall, Beaumont. "George Washington Wilson: The Indefatigable Photographist." EYE TO EYE no. 5 (July 1954): 30-34. [Born Alvah, Banffshire, Scotland in 1823. Apprenticed as a joiner but wanted to be an artist. Moved to Aberdeen in 1848, tried to make a living painting portraits. Learned photography in 1852, took portraits. Then began to take landscape views and cityscapes. His street scenes were filled with movement and attracted attention. During the 1860s and 1870s he was considered one of the foremost professional landscape photographers. Business flourished. Died in 1893.]

W1179 Peterich, Gerda. "'G. W. W.'" IMAGE 5, no. 10 (Dec. 1956): 220-229. 9 b & w. [Essay based on 400 prints and 200 stereographs by George Washington Wilson, in the George Eastman House Collection.]

W1180 Badger, Gerry. "Viewed: George Washington Wilson at the Stills Gallery, Edinburgh." BRITISH JOURNAL OF PHOTOGRAPHY *, no. * (Feb. 23, 1979): 175-176.

W1181 Ryder, Richard C. "Wilson's English Cathedrals." STEREO WORLD 8, no. 2 (May - June 1981): 4-15. 19 b & w. 1 illus.

WILSON, J. (LIVERPOOL, ENGLAND)
W1182 "Experiments with the Mackay Gun on Crosby Sands, Liverpool." ILLUSTRATED LONDON NEWS 44, no. 1263 (June 11, 1864): 569. 2 illus. ["...from photographs taken by Mr. J. Wilson, of Castle Street, Liverpool."]

WILSON, J. P. (OLNEY, IL)
W1183 Wilson, J. P. "A Curious Freak of a Negative Bath." AMERICAN JOURNAL OF PHOTOGRAPHY AND THE ALLIED ARTS & SCIENCES n. s. vol. 7, no. 14 (Jan. 15, 1865): 331.

WILSON, JOHN. (NEW YORK, NY)
W1184 Wilson, John. "Fifty Thousand Photographs in an Hour." AMERICAN JOURNAL OF PHOTOGRAPHY AND THE ALLIED ARTS & SCIENCES n. s. vol. 4, no. 5 (Aug. 1, 1861): 118-119.

WILSON, T. (USA)
W1185 Lowe, Dennis E. "Daguerreotypist Daguerreotyped." HISTORY OF PHOTOGRAPHY 1, no. 3 (July 1977): 200. 1 b & w. 1 illus. [Signed portrait of man with camera, dated 1853.]

WILSON, W. H. (GREAT BRITAIN)
W1186 Wilson, W. H. "On the Manipulation of Tannin Plates." AMERICAN JOURNAL OF PHOTOGRAPHY AND THE ALLIED ARTS & SCIENCES n. s. vol. 8, no. 9 (Nov. 1, 1865): 193-197. [Read to Liverpool Photo. Soc.]

WINDER, JOHN W. (CINCINNATI, OH)
BOOKS
W1187 [Strauch, Adolphus] Spring Grove Cemetery: Its History and Improvements, with Observations on Ancient and Modern Places of Sepulture. Cincinnati: R. Clarke, 1869. viii, 199 pp. 29 l. of plates. 29 b & w. [J. W. Winder, photographer, credited on the photos, which are views of the monuments, tombs, etc.]

PERIODICALS
W1188 "Great German Festival - The Turner Hall, Walnut Street, Above 14th, Cincinnati, Ohio. - From a Photograph by J. W. Winder & Co., Cincinnati." FRANK LESLIE'S ILLUSTRATED NEWSPAPER 21, no. 522 (Sept. 30, 1865): 21. 1 illus. [Street scene, with a crowd.]

W1189 "Cincinnati and Covington Suspension Bridge. - From a Photograph by Winder, of Cincinnati." FRANK LESLIE'S ILLUSTRATED NEWSPAPER 24, no. 620 (Aug. 7, 1867): 344. 1 illus. [View.]

W1190 "Destruction of the Ohio Female College, at Columbus Hill, Near Cincinnati, by Fire, April 23. - From a Photograph by J. W. Winder, Cincinnati." FRANK LESLIE'S ILLUSTRATED NEWSPAPER 26, no. 659 (May 16, 1868): 133. 1 illus. [View of ruins, with figures.]

W1191 "Ruins of the Ohio Female College at College Hill, Near Cincinnati, Ohio." HARPER'S WEEKLY 12, no. 594 (May 16, 1868): 317. 1 illus. ["Photographed by J. W. Winder, Cincinnati."]

W1192 "Ohio. - The Fountain Presented to the City of Cincinnati by Messrs. Davidson & Probasco." and "The Cincinnati Public Hospital. - From a Photograph by Winder." FRANK LESLIE'S ILLUSTRATED NEWSPAPER 34, no. 867 (May 11, 1872): 133. 2 illus. [Views.]

WINDOW & BRIDGE. (LONDON, ENGLAND)
W1193 "Diamond Cameo Photographs." AMERICAN JOURNAL OF PHOTOGRAPHY AND THE ALLIED ARTS & SCIENCES n. s. vol. 7, no. 9 (Nov. 1, 1864): 204-206. [From "Photo. News."]

W1194 Portraits. Woodcut engravings, credited "Photographed by Window & Bridge, of Regent St., London." ILLUSTRATED LONDON NEWS 48, (1866) ["The Princess of Wales with the Infant Prince Albert Victor" 48:* (Jan. 6, 1866): 8.]

W1195 "Cabinet Portraits. - A New Impulse for Portraiture." AMERICAN JOURNAL OF PHOTOGRAPHY AND THE ALLIED ARTS & SCIENCES n. s. vol. 9, no. 2 (Sept. 15, 1866): 25-30. [From "Photo. News."]

W1196 Portraits. Woodcut engravings, credited "Photographed by Window & Bridge, of Baker St., London." ILLUSTRATED LONDON NEWS 58, (1870) ["Baron Brunnow, Russian Ambassador to Great Britain" 58:* (July 23, 1870): 89.]

WINDOW & GROVE. (LONDON, ENGLAND)
W1197 Portrait. Woodcut engraving credited "From a photograph by Window & Grove, Baker St." ILLUSTRATED LONDON NEWS 69, (1876) ["Lord Bury." 69:1939 (Sept. 23, 1876): 284.]

W1198 Portrait. Woodcut engraving credited "From a photograph by Window & Grove." ILLUSTRATED LONDON NEWS 75, (1879) ["Late G. H. Damant." 75:2109 (Nov. 15, 1879): 461.]

WINDOW, FREDERICK RICHARD see also WINDOW & BRIDGE.

WINDOW, FREDERICK RICHARD. (d. 1875) (GREAT BRITAIN)
W1199 "Diamond Cameo Photographs." HUMPHREY'S JOURNAL OF PHOTOGRAPHY, AND THE ALLIED ARTS AND SCIENCES 16, no. 13 (Nov. 1, 1864): 205-207. [From "Photo. News."]

W1200 Window, F. R. "Diamond Cameo Portraits." BRITISH JOURNAL OF PHOTOGRAPHY 11, no. 241 (Dec. 16, 1864): 517-518.

W1201 Portrait. Woodcut engraving credited "From a photograph by F. R. Window." ILLUSTRATED LONDON NEWS 63, (1873) ["Sir Garnet Wolseley." 63:1777 (Sept. 20, 1873): 269.]

WINDSOR & CARTER. (LONDON, ENGLAND)
W1202 Portraits. Woodcut engravings, credited "Photographed by Windsor & Carter, of King William St., London." ILLUSTRATED LONDON NEWS 50, (1867) ["Alfred Mellon, musician" 50:* (Apr. 13, 1867): 377.]

WING, SIMON. (WATERVILLE, ME)
W1203 "Fifty Thousand Photographs in an Hour!" AMERICAN JOURNAL OF PHOTOGRAPHY AND THE ALLIED ARTS & SCIENCES n. s. vol. 4, no. 4 (July 15, 1861): 85-86. 1 b & w. [Illustrated with a tiny (about 1/2" x 1 1/2") original photograph of the machine under discussion, tipped-in.]

W1204 "The Wing Patents. United States of America - Circuit Court of the United States - District of Massachusetts - May Term - 1865. Opinion in the Case of Simon Wing vs. Chas. F. Richardson." AMERICAN JOURNAL OF PHOTOGRAPHY AND THE ALLIED ARTS & SCIENCES n. s. vol. 8, no. 12 (Dec. 15, 1865): 272-277.

W1205 "The Sliding Plate-Holder Patent Decision: Simon Wing vs. C. C. Schoonmaker." HUMPHREY'S JOURNAL OF PHOTOGRAPHY, AND THE ALLIED ARTS AND SCIENCES 20, no. 25 (Sept. 15, 1869): 387-388. [This patent not upheld. Some of the history of Simon Wing is given. He went to CA in the winter of 1848-49 and remained there two years, etc.]

WINNER, J. L.
W1206 Winner, J. L. "Salad for the Photographer." PHILADELPHIA PHOTOGRAPHER 3, no. 26 (Feb. 1866): 61-62. [Winner (Shickshinny, PA) discusses his collodion process.]

WIRE, TRAVERS B.
W1207 "A Week with the Camera Among the Kentish Hills." LIVERPOOL & MANCHESTER PHOTOGRAPHIC JOURNAL [BRITISH JOURNAL OF PHOTOGRAPHY] n. s. 2, no. 14-16 (July 15-Aug. 15, 1858): 179-180, 191-192, 202-203. [Mr. Ledger, Mr. Wood, and Mr. Wire, amateurs, photographed in Great Britain.]

W1208 Wire, Travers B. "A Week with the Camera Among the Kentish Hills." PHOTOGRAPHIC AND FINE ART JOURNAL 11, no. 9 (Sept. 1858): 268-273.

WISE & CLARK. (SPRINGFIELD, OH)
W1209 Portrait. Woodcut engraving, credited "Photographed by Wise & Clark, of Springfield, OH." FRANK LESLIE'S ILLUSTRATED NEWSPAPER 37, (1874) ["Mother Stewart, a leader in the Whisky War in Springfield, OH." (Two portraits, one in her "disguise," holding a glass of whiskey.) 37:961 (Feb. 28, 1874): 412.]

WISEMAN, G. T. J. [?]
W1210 "Stereographs: Memento of the Royal Wedding. Published by G. T. J. Wiseman, Southampton." BRITISH JOURNAL OF PHOTOGRAPHY 10, no. 187 (Apr. 1, 1863): 143. [Views of the Royal Yacht and Southampton Docks..."though published by Mr. Wiseman, (a professional photographer in Southampton) have been executed by an amateur, an occasional contributor to our pages."]

WITCOMB, A. S. (BUENOS AYRES, ARGENTINA)
W1211 Witcomb, A. S. "Retouching Varnish." BRITISH JOURNAL PHOTOGRAPHIC ALMANAC 1878 (1878): 137.

WITCOMB, C. J.
W1212 Witcomb, C. J. "Hints on Permanent Chromotype Printing." ANTHONY'S PHOTOGRAPHIC BULLETIN 8, no. 2 (Feb. 1877): 41-42. [From "London Photo. News." Witcomb from Salisbury, England.]

WITHINGTON, E. W. [MRS.] (d. 1877) (USA)
W1213 "Matters of the Month: Of Course." PHOTOGRAPHIC TIMES 4, no. 44 (Aug. 1874): 126. [Mrs. E. W. Withington of Ione City, CA, took views of Silver Lake.]

W1214 Withington, Mrs. E. W. "How a Woman Makes Landscape Photographs." PHILADELPHIA PHOTOGRAPHER 13, no. 156 (Dec. 1876): 357-360.

W1215 "Editor's Table." PHILADELPHIA PHOTOGRAPHER 14, no. 160 (Apr. 1877): 128. [Note of death of Mrs. E. W. Withington (Ione City, CA). Practicing photography about four years. Article on landscape photography in "Mosaics" for 1876.]

W1216 Palmquist, Peter E. "Stereo Artist: Mrs. E. W. Withington, Or, 'How I use my Skirt for a Darktent.'" STEREO WORLD 10, no. 5 (Nov.-Dec. 1983): 20-21, 40. 2 b & w. 1 illus. [Mrs. Withington based in Ione City, CA in the 1870s. Made landscape views. Excerpt from her article in "Philadelphia Photographer" (Dec. 1876) reprinted.]

WITTE, RUDOLPH. (d. 1881) (USA)
W1217 Taylor, J. Traill. "General Notes." PHOTOGRAPHIC TIMES 11, no. 131 (Nov. 1881): 407. [Rudolph Witte (Morrisania) suddenly became insane on Oct. 16, rushed madly around, then took cyanide and died.]

WITTEMANN BROTHERS see also ALBERTYPE COMPANY.

WITTEMANN BROTHERS.

W1218 "Prints and Photographs." QUARTERLY JOURNAL OF THE LIBRARY OF CONGRESS 11, no. 1 (Nov. 1953): 36-37. [Views for postcards and souvenir booklets published by the Albertype Company, originally the Witteman Brothers, from the 1860s to 1950s. Son was Herman L. Witteman.]

WITTICK, BEN. (1845-1903) (USA)

[George Ben Wittick was born on Jan. 1, 1845 in Huntington, PA. He was serving in the U. S. Army in 1861, and was stationed at Ft. Snelling, MN. He opened a photographic studio in Moline, IL in the late 1870s. Then, in 1878 or 1879 Wittick moved to Santa Fe, NM, where he formed a partnership with W. P. Bliss. Then, in 1880 forms a partnership with R. W. Russell. Russell opereated the studio while Whittick travelled to take photographs in the open. Whittick photographed the settlers and the Indian tribes of that area. The partnership moved to Albuquerque, NM in 1881, then dissolved in 1884. Whittick then operated a studio in Gallup, NM from 1884 to 1900. He then moved to Ft. Wingate, AZ, where his son Archie assisted in the photographic business. Ben Wittick died in 1903, but his son continued the business.]

W1219 Packard, Gar and Maggy Packard. *Southwest 1880 with Ben Wittick, Pioneer Photographer of Indian and Frontier Life,* ...Photographs from the Collection in Museum of New Mexico. Santa Fe, NM: Packard Publications, 1970. 47 pp. b & w. illus.

WITTINGEN. (RICHMOND, VA)

W1220 Portraits. Woodcut engravings, credited "From an Ambrotype by Wittingen of Richmond, Va." FRANK LESLIE'S ILLUSTRATED NEWSPAPER 3, (1857) ["Henry A. Wise, Gov. of VA." 3:74 (May 9, 1857): 356.]

WOLCOTT & JOHNSON. (USA, GREAT BRITAIN)

[John Johnson, born in Saco, ME in 1813, trained as a watch-maker. In 1839, when Daguerre's discovery was announced, Johnson was living in New York City, and in a business partnership with Alexander Simon Wolcott, an instrument maker and manufacturer of dental supplies. Together they quickly constructed a camera, and in October 1839, took their first daguerreotype. In May 1840 they patented a lensless camera. William S. Johnson, John's father left for England early in 1840 to market the new camera. Forming a business arrangement with Richard Beard, a studio was opened in 1840. John Johnson and Wlexander Wolcott both soon went to England. Johnson returned to the USA in 1842 and entered the plumbing business with his brother in New York. He also continued to experiment in chemistry and science. He returned to Saco, ME in 1861, helped found the York Institute there, and died there in 1871. Wolcott returned to the USA in 1844, then died soon afterwards.]

W1221 "Editorial." DAGUERREAN JOURNAL 2, no. 2 (June 1, 1851): 51-52. [Note that John Johnson had passed many of A. S. Wolcott's papers and letters on to the editor, S. D. Humphrey, who intends to publish some after editing.]

W1222 Johnson, John. "Daguerreotype." DAGUERREAN JOURNAL 2, no. 2-3 (June 1 - June 15, 1851): 56-57, 73-80. [Extensive history of the firm, by its surviving partner.]

W1223 Ross, William. "Retrospective Criticism: First Application of the Daguerreotype to Taking Portraits." HUMPHREY'S JOURNAL 7, no. 6 (July 15, 1855): 96-98. [Wm. Ross and Humphrey criticize John H. Draper for claiming to be the first to take a portrait, stating that priority should go to Wolcott & Johnson.]

W1224 "Photography in Its Infancy." AMERICAN JOURNAL OF PHOTOGRAPHY AND THE ALLIED ARTS & SCIENCES n. s. vol. 3, no. 8 (Sept. 15, 1860): 119-123. [Letters of Alexander S. Wolcott, John Johnson and William S. Johnson, written in the early 1840's while they were in London reprinted here.]

W1225 "Photography in Its Infancy." AMERICAN JOURNAL OF PHOTOGRAPHY AND THE ALLIED ARTS & SCIENCES n. s. vol. 3, no. 9 (Oct. 1, 1860): 142-143. [More letters, of A. S. Wolcott.]

W1226 Seely, Charles A. "Who Inaugurated Photography As A Business?" AMERICAN JOURNAL OF PHOTOGRAPHY AND THE ALLIED ARTS & SCIENCES n. s. vol. 3, no. 13 (Dec. 1, 1860): 195-197. [Reprint of an article in the "Br. J. of Photo." protesting Wolcott & Johnson's claim to have been the first commercial photographers, along with a letter defending the claim, by Charles Seely.]

W1227 G. "The First Photographic Gallery." AMERICAN JOURNAL OF PHOTOGRAPHY AND THE ALLIED ARTS & SCIENCES n. s. vol. 4, no. 2 (June 15, 1861): 41. [Letter describes a visit to Wolcott & Johnson's room on 2nd St., New York, NY in Feb. 1840. "G." sat for a portrait, taken by Mr. Fitz, "the operator on that occasion" in the presence of Wolcott, Johnson, Johnson's father, S. F. B. Morse and Moses Y. Beach (of "NY Sun.") Portrait took eight minutes in strong light.]

W1228 Johnson, John. "The Bromine Discovery Question. - Letter from John Johnson, of the firm of Wolcott and Johnson." AMERICAN JOURNAL OF PHOTOGRAPHY AND THE ALLIED ARTS & SCIENCES n. s. vol. 6, no. 15 (Feb. 1, 1864): 343-347. [John Johnson's letter addressed from Saco, ME. Letter states the early history of Wolcott & Johnson, who began to daguerreotype in Oct. 1839 and who "opened daguerrean rooms to the public in the city of New York, in March, 1840." Johnson then goes on to describe, in great detail, the move to London and the opening of the studio there in association with Richard Beard, etc. He discusses his activities, those of Wolcott and the activities of his father William Johnson through the mid forties. See also pp. 350-351 and pp. 359-360.]

W1229 Johnson, John. "The Earliest Methods of Lighting." AMERICAN JOURNAL OF PHOTOGRAPHY AND THE ALLIED ARTS & SCIENCES n. s. vol. 6, no. 16 (Feb. 15, 1864): 372-373. [Describes practices put into place in New York, NY gallery in 1840.]

W1230 "Photographic Section of the American Institute." ANTHONY'S PHOTOGRAPHIC BULLETIN 17, no. 10 (May 22, 1886): 310-314. [Minutes of the meeting of May 4, 1886. Includes a report by H. J. Lewis of the contributions of William Lewis and William H. Lewis (son), who made the first camera and daguerreotype equipment for Wolcott & Johnson, who opened the first daguerreotype portrait studio in America. J. Gurney's early career described as well as A. Bogardus' and Alexander Becker's.]

W1231 Rinhart, Floyd and Marion Rinhart. "Wolcott and Johnson: Their Camera and Their Photography." HISTORY OF PHOTOGRAPHY 1, no. 2 (Apr. 1977): 129-134. 3 illus.

W1232 Gill, Arthur T. "Wolcott's Camera in England and the Bromine-Iodine Process." HISTORY OF PHOTOGRAPHY 1, no. 3 (July 1977): 215-220. 4 b & w. 3 illus.

W1233 Odgers, Stephen L. "A Labelled Wolcott Daguerreotype." HISTORY OF PHOTOGRAPHY 2, no. 1 (Jan. 1978): 19-21. 1 b & w. 2 illus.

W1234 Craig, John S. "The Lensless Camera of A. S. Wolcott." NORTHLIGHT (JOURNAL OF THE PHOTOGRAPHIC HISTORICAL SOCIETY OF AMERICA) 3, no. 3 (Summer 1976): 2-6. 7 illus. [First American photographic patent, for a camera developed by A. S. Wolcott, John Johnson, and Henry Fitz, Jr. Camera located at the York Institute, Saco, ME. Article contains excerpts from articles by Johnson, published in "Humphries Daguerreian Journal" (1851).]

WOLCOTT, ALEXANDER SIMON see also **WOLCOTT & JOHNSON.**

WOLCOTT, ALEXANDER SIMON. (d. 1844) (USA)
W1235 Wolcott, A. S. "Mr. A. S. Wolcott's Improvements on the Daguerreotype." AMERICAN REPERTORY OF ARTS, SCIENCES AND MANUFACTURES 1, no. 3 (Apr. 1840): 193-197. [Includes a letter from Wolcott on pp. 194-197, dated Mar. 13, 1840, claiming to have taken a daguerreotype portrait with the aid of a concave mirror in October 1839.]

W1236 "The Daguerreotype." THE FAMILY MAGAZINE *, no. * (ca. May 1840): 462-463. Brief introduction describing Wolcott's improvement, and his letter, first published in the "American Repertory," republished here.]

W1237 Wolcott, A. S. "On the Daguerreotype." AMERICAN REPERTORY OF ARTS, SCIENCES AND MANUFACTURES 2, no. 6 (Jan. 1841): 401-405. 1 illus.

W1238 "Photographic Portraits." LITERARY GAZETTE no. 1261 (Mar. 20, 1841): 188. [Note about an exhibition of portrait-taking by the Wolcott's patent reflecting apparatus of the Polytechnic Institute.]

W1239 "Daguerreotype Portraits." MORNING CHRONICLE (LONDON) (Sept. 12, 1840 [sic 1841?]): 3397. ["We had yesterday the satisfaction of witnessing a new application of the wonderful process of M. Daguerre, at the Medical Hall, near Furnival's Inn, Holborn, by taking portraits from life... The inventor, Mr. Woolcot [sic Wolcott], has, in conjunction with his partner, Mr. Beard, taken the proper steps to obtain a patent..."]

W1240 "Obituary Notice of A. S. Wolcott, Esq." AMERICAN JOURNAL OF PHOTOGRAPHY AND THE ALLIED ARTS & SCIENCES n. s. vol. 4, no. 22 (Apr. 15, 1862): 525-526. [Reprinted from a NY daily newspaper (Nov. 1844).]

W1241 Smith, Frank, Signal Corps Engineering Laboratories. "Alexander S. Wolcott: America's First Photographic Genius." SIGNAL (May - June 1953): 18-20. 5 illus.

WOLFE, J. J. (d. 1892) (USA)
W1242 "Matters of the Month." PHOTOGRAPHIC TIMES 11, no. 131 (Nov. 1881): 434. [Comments from The "Lancaster [OH] Gazette."]

W1243 "Note." PHOTOGRAPHIC TIMES 22, no. 581 (Nov. 4, 1892): 558. [Note of death of J. J. Wolfe, a fine photographer located at Lancaster, Ohio a good number of years, removed to Fort Wayne, Ind. for health. Died there on Oct. 11th.]

WOOD & CO. (BURNLEY, ENGLAND)
W1244 "Royal Butterfly, the Towneley Bull." ILLUSTRATED LONDON NEWS 44, no. 1254 (Apr. 9, 1864): 352. 1 illus. ["...from a photograph by Messrs. Wood & Co., St. James Street, Burnley.]

WOOD, JOHN see also **MEIGS, MOMTGOMERY.**

WOOD, JOHN. (USA)
W1245 *Photographs of the United States Capitol, Etc. Thomas Ustick Walter, architect.* One hundred and sixteen in number, with MS. notes by Mr. Walter. Washington, DC: Walker [?], 1858. n. p. 116 b & w. [Presentation album of original photographs, bound by the author or photographer. In the collection of the Fine Arts Library, Harvard University. A similar album reported to be in the National Archives. ("About 1859,...a Mr John Wood was employed at the Capitol and had a room fitted up for business and made albumen negatives and prints from them, showing the progress made in construction from time to time of the building..." Busey, Samuel C., M.D. "Early History of Daguerreotypy in the City of Washington," on pp. 81-95 in: "Records of the Columbia Historical Society." Vol. 3 (1900).)]

WOOD, JOHN MUIR. (1805-1892) (GREAT BRITAIN)
BOOKS
W1246 Stevenson, Sara, Julia Lawson, and Michael Gray. *The Photography of John Muir Wood 1805-1892.* An Accomplished Amateur. Edinburgh: Scottish National Portrait Gallery, by the Dirk Nishen Publishing Co., 1988. 95 pp. 65 b & w. 24 illus. [Born in Edinburgh in 1805. A musician, trained in Paris in Vienna. Returned to Edinburgh in 1828, set up as a music teacher, then in the family business of piano-making and music publishing. Moved to Glasgow in 1848. Married in 1851. Died in 1892. An amateur photographer, friends with Cundell family, Hugo Owen and others. Became a member of the Glasgow Philosophical Society in 1850. Took calotypes in 1840s-1850s, in Scotland and in Germany, Belgium, and England. Landscapes views, figures, etc.]

PERIODICALS
W1247 Coppens, Jan. "Scottish Calotypists in Belgium." PHOTOGRAPHIC COLLECTOR 5, no. 3 (1985): 320-330. 13 b & w. [Photos by George Muir (1), John Muir Wood (11) W. H. F. Talbot (1), taken in 1840s.]

WOOD, R. O. (SARATOGA SPRINGS, NY)
W1248 "Editor's Table." PHILADELPHIA PHOTOGRAPHER 3, no. 34 (Oct. 1866): 322. [Views by R. O. Wood (Saratoga Springs, NY).]

WOODBURY, WALTER B. see also **NEGRETTI & ZAMBRA; SWAN.**

WOODBURY, WALTER BENTLEY. (1834-1885) (GREAT BRITAIN, USA)
[W. B. Woodbury was born in Manchester in 1834, died (from an overdose of laudanum) at Margate in 1885. Went to Australia in 1852, practiced as a photographer there and in the East Indies until 1863, when he returned to England. A prolific inventor, he perfected the Woodbury Process and many other photoengraving techniques and devices. Early user of the sciopticon.]

BOOKS
W1249 Woodbury, Walter Bentley. *The Scenograph Manual. (With cabinet landscape taken with the instrument.)* London: Sciopticon Co., 1874. n. p. 1 b & w. [The Scenograph was a pocket camera.]

W1250 Woodbury, Walter Bentley, ed. *The Sciopticon Manual, containing Full Directions for using the New Drawing Room Lantern, together with a Variety of Experiments that can be performed with the Same.* Greenhithe: Sciopticon Co., 1875. n. p.

W1251 Woodbury, Walter B., editor. *Treasure Spots of the World. A Selection of the Chief Beauties and Wonders of Nature and Art. Containing Twenty-eight Splendid Photographs.* London: Ward, Lock, and Tyler, 1875. 120 pp. 28 b & w. [Twenty-eight Woodburytypes by Stuart, Good, Woodbury, King, England, Braun, Parret, S. Thompson,

Bierstadt, Naya, Houseworth, Muybridge, J. Thomson, Shepherd. Texts by various authors.]

W1252 Woodbury, Walter B. *Science at Home. A Series of Experiments in Chemistry, Optics, Electricity, Magnetism, &c., Adapted for the Magic Lantern.* London: 188- ? 16 pp. illus. [Reprinted from "The English Mechanic".]

PERIODICALS

W1253 "Group of Indian Fruit from the Island of Java." ILLUSTRATED LONDON NEWS 35, no. 998 (Oct. 15, 1859): 382. 1 illus. [From a Photograph by W. B. Woodbury, Stafford.]

W1254 Negretti & Zambra. "Correspondence: Stereographs of Java." BRITISH JOURNAL OF PHOTOGRAPHY 8, no. 140 (Apr. 15, 1861): 156. [Note from Negretti & Zambra crediting "Mr. Woodbury, of Batavia, Java," for the stereos previously received.]

W1255 Woodbury, Walter. "Woodbury's New Printing Process." BRITISH JOURNAL OF PHOTOGRAPHY 12, no. 254 (Mar. 17, 1865): 134.

W1256 "New Patent: Complete Specifications of Patent Obtained by Walter Bentley Woodbury, Manchester, Filed 23rd March, 1865, and entitled - "An Improved Method of Producing or Obtaining by the Aid of Photography Surfaces in 'Relievo' and 'Intaglio' upon Albuminous, Vitreous, Metallic, or Other Suitable Materials." BRITISH JOURNAL OF PHOTOGRAPHY 12, no. 262 (May 12, 1865): 247-248.

W1257 Woodbury, Walter. "Woodbury's New Printing Process." AMERICAN JOURNAL OF PHOTOGRAPHY AND THE ALLIED ARTS & SCIENCES n. s. vol. 7, no. 22 (May 15, 1865): 515-516. [From "Br. J. of Photo."]

W1258 "New English Patent. Complete Specification of Patent obtained by Walter Bentley Woodbury, Manchester...entitled - An Improved Method of Producing or Obtaining, by the aid of Photography, Surfaces in 'Relieno' and 'Intaglio' upon Albuminous, Vitreous, Metallic, or Other Suitable Materials." AMERICAN JOURNAL OF PHOTOGRAPHY AND THE ALLIED ARTS & SCIENCES n. s. vol. 7, no. 24 (June 15, 1865): 554-556. [From "Br. J. of Photo."]

W1259 Woodbury, Walter. "Woodbury's New Printing Process." AMERICAN JOURNAL OF PHOTOGRAPHY AND THE ALLIED ARTS & SCIENCES n. s. vol. 8, no. 1 (July 1, 1865): 11-12. [From "Photo. Journal."]

W1260 "Printing Photographs from Metal Plates." BRITISH JOURNAL OF PHOTOGRAPHY 12, no. 277 (Aug. 25, 1865): 435-436. [Describes Walter B. Woodbury's experiments.]

W1261 "The New Printing Process - A Day with Mr. Woodbury." BRITISH JOURNAL OF PHOTOGRAPHY 12, no. 285 (Oct. 20, 1865): 535-536.

W1262 Woodbury, Walter. "Photo-Relief Printing." BRITISH JOURNAL OF PHOTOGRAPHY 12, no. 293 (Dec. 15, 1865): 632.

W1263 "Photo-Relief Printing." ART JOURNAL (Feb. 1866): 60-61.

W1264 Woodbury, Walter. "Mr. Walter Woodbury's New Photo-Relief Printing Process." AMERICAN JOURNAL OF PHOTOGRAPHY AND THE ALLIED ARTS & SCIENCES n. s. vol. 8, no. 16 (Feb. 15, 1866): 366-367. [Read to London Photo. Soc.]

W1265 Towler, Prof. "Photo-Relief Printing." HUMPHREY'S JOURNAL OF PHOTOGRAPHY, AND THE ALLIED ARTS AND SCIENCES 17, no. 23 (Apr. 1, 1866): 353-356. [Details of Woodbury's Photo-Relief Printing Process given.]

W1266 Taylor, J. Traill. "Engraving With a Sunbeam. Woodbury's Relief-Printing." POPULAR SCIENCE REVIEW 5, no. 19 (Apr. 1866): 145-152. 2 b & w. [Illustrated with two Woodburytypes on two pages before p. 145.]

W1267 Woodbury, Walter B. "On a Method of Obtaining Imperishable Photographs." BRITISH JOURNAL PHOTOGRAPHIC ALMANAC 1867 (1867): 95-97.

W1268 Woodbury, Walter. "Lantern Transparencies in Carbon." HUMPHREY'S JOURNAL OF PHOTOGRAPHY, AND THE ALLIED ARTS AND SCIENCES 20, no. 3 (June 1, 1868): 48. ["Br. J. of Photo. Almanac."]

W1269 Woodbury, Walter. "Cloud Negatives and Their Use." PHILADELPHIA PHOTOGRAPHER 5, no. 59 (Nov. 1868): 388-389.

W1270 Woodbury, Walter. "How to Transfer a Negative Film." BRITISH JOURNAL PHOTOGRAPHIC ALMANAC 1869 (1869): 76-77.

W1271 Woodbury, Walter. "Improvements in Photo-Press Printing." BRITISH JOURNAL PHOTOGRAPHIC ALMANAC 1870 (1870): 110-111.

W1272 "The Woodbury Photo-Relief Printing Process - Our Picture." PHILADELPHIA PHOTOGRAPHER 7, no. 73 (Jan. 1870): frontispiece, 2-4. 1 b & w.

W1273 Pritchard, H. Baden. "The Woodbury Process in France." PHILADELPHIA PHOTOGRAPHER 7, no. 76 (Apr. 1870): 137-139. [Extracts from a letter by H. Baden Pritchard in the "Photographic Journal."]

W1274 Woodbury, Walter B. "Photo-Engraving. - A New Method." BRITISH JOURNAL PHOTOGRAPHIC ALMANAC 1872 (1872): 40-41.

W1275 Woodbury, Walter B. "Kaleidoscopic Photography." BRITISH JOURNAL PHOTOGRAPHIC ALMANAC 1873 (1873): 149.

W1276 Woodbury, Walter B. "Commercial Photography in Munich." ANTHONY'S PHOTOGRAPHIC BULLETIN 4, no. 1 (Jan. 1873): 7-8. [Mentions Bruckmann, Albert, Haensflengel, From "London Photographic News."]

W1277 Woodbury, Walter B. "A New Photo-Engraving Process." BRITISH JOURNAL PHOTOGRAPHIC ALMANAC 1874 (1874): 106-107.

W1278 Woodbury, Walter B. "Experiences in Producing Negatives in Plumbago." ANTHONY'S PHOTOGRAPHIC BULLETIN 5, no. 7 (July 1874): 241-242. [From "Br. J. of Photo."]

W1279 Woodbury, Walter B. "Further Experiences with the Plumbago Process." ANTHONY'S PHOTOGRAPHIC BULLETIN 5, no. 9 (Sept. 1874): 315-316. [From "Br. J. of Photo."]

W1280 Woodbury, Walter B. "Carbon Lantern Slides." BRITISH JOURNAL PHOTOGRAPHIC ALMANAC 1875 (1875): 67.

W1281 Woodbury, Walter B. "A New System of Restoring Cracked Negatives." BRITISH JOURNAL PHOTOGRAPHIC ALMANAC 1877 (1877): 163.

W1282 Woodbury, Walter B. "Mounting Photographs." ANTHONY'S PHOTOGRAPHIC BULLETIN 8, no. 7 (July 1877): 218-219. [From "Br. J. of Photo."]

W1283 Woodbury, Walter. "Mounting Photographs." PHOTOGRAPHIC TIMES 7, no. 79 (July 1877): 159. [From "Br J of Photo."]

W1284 Woodbury, Walter B. "Negatives Without Glass." BRITISH JOURNAL PHOTOGRAPHIC ALMANAC 1878 (1878): 189.

W1285 Woodbury, Walter B. "Ephemeral Photography." ANTHONY'S PHOTOGRAPHIC BULLETIN 10, no. 6 (June 1879): 192. [From "London Photographic News."]

W1286 Woodbury, W. B. "Balloon Photography." PHOTOGRAPHIC TIMES 12, no. 133 (Jan. 1882): 14-17. [An address to the Aeronautic Society. Discusses his activities, mentions events in Great Britain and France.]

W1287 "Editorial Mirror." PHOTOGRAPHIC TIMES 15, no. 210 (Sept. 25, 1885): 546. [Announcement of sudden death of Walter B. Woodbury, of England. Died of accidental overdose of laudanum.]

W1288 "Walter Bentley Woodbury." PHILADELPHIA PHOTOGRAPHER 22, no. 263 (Nov. 1885): 345-348. [[From "Amateur Photographer"].]

W1289 "A Worthy Life Ended: Walter Bentley Woodbury." PHILADELPHIA PHOTOGRAPHER 22, no. 263 (Nov. 1885): 368-370. 1 illus. [Portrait.]

W1290 "The Fathers of Photography IV. Walter B. Woodbury" PHOTOGRAPHIC TIMES 23, no. 639 (Dec. 15, 1893): 734-735. 1 illus. [Born in Manchester, England on June 26, 1834. Apprenticed in a patent office, then trained as a civil engineer. Sailed to Australia in 1852 to search for gold, but purchased a camera in Melbourne and worked at many things for several years to survive. In 1854 won a prize with his photography, turned to professional photography. In late 1850s also photographed in Java. (His work published in London by Negretti & Zambra.) In 1860 established a firm in Java - Woodbury & Page. Firm still active, but Woodbury returned to England in 1865. Between 1864 and 1884 he filed twenty patents on photographic printing processes, including the Woodburytype. Died on Sept. 5, 1885. His son, Walter E. Woodbury, also became an active photographer.]

W1291 "Early Half-Tone Cuts." PHOTOGRAPHIC TIMES 25, no. 687 (Nov. 16, 1894): 313. [Early (1872) examples of half-tone by Walter B. Woodbury presented by Mr. T. Bolas to the Royal Photographic Society. See "Photographic News" 1883, p. 678 for reproduction.]

W1292 Rogers, H. G. "A Reminiscence." AMERICAN ANNUAL OF PHOTOGRAPHY AND PHOTOGRAPHIC TIMES ALMANAC FOR 1896 (1896): 218, 220, 222-223. [Recalls meeting with Walter B. Woodbury in the 1870's in Italy; discusses that, his own action of photographing the interior of the Milan Cathedral, etc.]

W1293 "Walter B. Woodbury." PROCESS PHOTOGRAM AND ILLUSTRATOR 12, no. 141 (Sept. 1905): 134-135. [Brief survey of Woodbury's career. Born in 1834 in England. To Australia to hunt gold

- took up photography there in early 1850s. Photographed also in Java in 1857, 1858, 1859. Published stereoviews of tropical scenery in late 50s through Negretti and Zambra. Returned to England in 1863. In 1854 invented the Woodburytype printing process. Continued experimenting.]

WOODS.
W1294 Portrait. Woodcut engraving, credited "From a Photograph by Woods." FRANK LESLIE'S ILLUSTRATED NEWSPAPER 37, (1873) ["Gen. Jesus del Sol, Cuba." 37:947 (Nov. 22, 1873): 184.]

WOODS, THOMAS. (GREAT BRITAIN)
W1295 Woods, Thomas, M.D. "Photography." ATHENAEUM no. 1262 (Jan. 3, 1852): 22-23. [Letter from Thomas Woods, claiming certain discoveries in 1844.]

W1296 Woods, Thomas, M.D. "Photography, - Its Rise and Progress." PHOTOGRAPHIC AND FINE ART JOURNAL 8, no. 1-2, 12 (Jan. - Feb., Dec. 1855): 4-6, 38-39, 369-370. [From "Life Illustrated." Survey of early history of the medium. Daguerre, Talbot, et. al.]

WOODWARD, CHARLES WARREN. (1836-1894) (USA)
[Charles W. Woodward was not himself a photographer, but he became a major publisher of stereograph views. He was born in Orange, MA in 1836. He settled in Rochester, NY in 1862 and opened his business, the Fine Art Depot, which sold art supplies and picture frames. He had several business partners throughout his career. Apparently he began publishing and selling stereo views in the 1870s —including E. O. Beaman's Western views in 1874. But by the late 1870s Woodward suffered financial setbacks, and he finished his career working as a manager or salesman for other companies. He died in 1894.]

W1297 *C. W. Woodward, Publisher of Stereoscopic Views. Fine Art Depot, 112 State Street, Rochester, N. Y., June 1876.* Rochester, NY: C. W. Woodward, 1876. 40 pp. [Lists about 3000 views.]

WOODWARD, DAVID ACHESON. (1823-) (USA)
[David A. Woodward, Professor of Fine Arts, was born in Philadelphia, PA on Sept. 16, 1823. His grandfather and father were publishers, the father moving the business and family to Cincinnati, OH when David was a child. David began to draw and paint from an early age. Opened a painting studio in Cincinnati with T. Buchanan Reed. Then moved to Philadelphia and opened a studio there, and continued to study at the Pennsylvania Academy. Located in Baltimore, MD in the fall of 1847. Instructor of Drawing at the Maryland Institute in 1852. Elected Principal and reorganized the school, now named the School of Art and Design, in 1860. In mid 1870s there were twelve faculty and five hundred students. Woodward developed the improved solar camera for making prints, and successfully introduced it into the USA and Europe during the 1850s and 1860s.]

BOOKS
W1298 *The Solar Camera.* s. l.: D. A. Woodward, n. d. 15 pp. [Advertisement for D. A. Woodward's solar enlarging camera, ca. 1860s.]

W1299 *The Solar Camera; Inventor and Distributor; D. A. Woodward.* s. l. [Philadelphia ?]: s. n. [D. A. Woodward], 1877 ? 15 pp. [Brochure advertising the solar camera.]

PERIODICALS
W1300 Seely, Charles A. "Woodward's Solar Camera." AMERICAN JOURNAL OF PHOTOGRAPHY AND THE ALLIED ARTS & SCIENCES n. s. vol. 1, no. 6 (Aug. 15, 1858): 85-87, 90.

W1301 Woodward, D. A. "Woodward's Solar Camera." PHOTOGRAPHIC AND FINE ART JOURNAL 12, no. 1 (June 1859): 30. [Woodward from Baltimore, MD.]

W1302 "Life-Size Portraits." PHOTOGRAPHIC AND FINE ART JOURNAL 13, no. 1 (Jan. 1860): 3-4. [From "'Cosmos' July 22, 1859." Woodward, from USA, demonstrating his solar camera in France.]

W1303 "Mr. Woodward's Solar Camera." PHOTOGRAPHIC AND FINE ART JOURNAL 13, no. 1 (Jan. 1860): 5-8. [From "Photo. Notes." Woodward visiting England.]

W1304 "The End of the Solar Camera Suit." ANTHONY'S PHOTOGRAPHIC BULLETIN 1, no. 2 (Mar. 1870): 25-28. [Text of judgment upholding patent of David A. Woodward.]

W1305 Woodward, David A. "The Solar Camera." ANTHONY'S PHOTOGRAPHIC BULLETIN 1, no. 5 (June 1870): 79-81. [Text of D. A. Woodward's patent on the solar enlarging camera.]

W1306 "The Solar Camera Extension Case." ANTHONY'S PHOTOGRAPHIC BULLETIN 2, no. 4 (Apr. 1871): 98-100. [More particulars on D. A. Woodward's patent extension.]

W1307 Anthony, H. T. "A Card." ANTHONY'S PHOTOGRAPHIC BULLETIN 2, no. 4 (Apr. 1871): 100-101. [Henry Anthony defends himself against what he feels was an unjustified attack on him in the "Phila. Photographer," over an issue concerning the Solar Camera copyright.]

W1308 "Final Decree in Favor of D. A. Woodward." ANTHONY'S PHOTOGRAPHIC BULLETIN 5, no. 6 (June 1874): 200. [Judgement on manufacturing of solar camera.]

W1309 Woodward, D. A. "Artist's Compact Reflecting Solar Camera." ANTHONY'S PHOTOGRAPHIC BULLETIN 8, no. 2 (Feb. 1877): 37.

W1310 Taylor, J. Traill. "The Studios of America. No. 2. D. A. Woodward's Solar Camera Atelier." PHOTOGRAPHIC TIMES 13, no. 146 (Feb. 1883): 56-57.

WOODWARD, JOSEPH JANVIER. (1833-1884) (USA)
BOOKS

W1311 United States Army. Surgeon General's Office. *Circular No. 6, Reports on the Extent and Nature of the Materials Available for the Preparation of a Medical and Surgical History of the Rebellion.* Philadelphia: Printed for the Surgeon General's Office by J. B. Lippincott & Co., 1865. 2 vol. Vol. 1: 166 pp. Vol. 2: 46 photos 46 b & w. 5 illus. [J. J. Woodward probably made some of the negatives for this work.]

W1312 United States Army. Surgeon General's Office. *Report of the Surgeon General of the United States Army, on the Magnesium and Electric Lights, as applied to photomicrography.* By Brevet Lieutenant Colonel J. J. Woodward, Assistant Surgeon, U. S. Army. Washington, DC: (for the War Department), 1870. 12 pp. 39 b & w. [39 photo-micrographs by J. J. Woodward.]

W1313 United States. Surgeon General's Office. *Report to the Surgeon General of the United States Army on the Improved Method of Photographing Histological Preparations by Sunlight,* by J. J. Woodward. Washington, DC: Government Printing Office, 1871. 10 pp. 9 l. of plates. illus.

W1314 Woodward, Joseph Janvier. *On the structure of cancerous tumors and the mode in which adjacent parts are invaded.* "Smithsonian Miscellaneous Collections—266—The Toner Lectures, Lecture 1" Washington, DC: Smithsonian Institution, 1873. iv, 40 pp. 74 b & w. [74 photo-micrographs by J. J. Woodward, Assistant Surgeon, U.S.A.]

PERIODICALS

W1315 Woodward, J. J., Brevet Major. "American Photographical Society." HUMPHREY'S JOURNAL OF PHOTOGRAPHY, AND THE ALLIED ARTS AND SCIENCES 18, no. 14 (Nov. 15, 1866): 216-218. ["Report Continued from last Number." Photo-microscopic pictures by Brevet Major J. J. Woodward, U.S.A., exhibited. Includes an excerpt from "Silliman's Journal," of Woodward's article explaining his activity and process.]

WOODWARD, WILLIAM. (NOTTINGHAM, ENGLAND)
W1316 "Stereograms of English Scenery. By W. Woodward, Nottingham." PHOTOGRAPHIC NEWS 1, no. 21 (Jan. 28, 1859): 245.

W1317 "Critical Notices: Stereograms of Fountain's Abbey, Kirkstall Abbey, & etc. By Mr. W. Woodward, Nottingham." PHOTOGRAPHIC NEWS 3, no. 53 (Sept. 9, 1859): 6-7.

W1318 "Note." ART JOURNAL (Dec. 1859): 378. [Stereoscopic views of Scottish scenery.]

W1319 "Notices of Recently Published Stereographs: Fountains Abbey, W. Woodward, Nottingham." BRITISH JOURNAL OF PHOTOGRAPHY 7, no. 117 (May 1, 1860): 133.

W1320 "Stereographs. Reminiscences of Scottish Scenes, by W. Woodward, of Nottingham." BRITISH JOURNAL OF PHOTOGRAPHY 7, no. 124 - 125 (Aug. 15, Sept. 1, 1860): 240-241, 256-257.

W1321 "Stereographs: Abbeys, Castles, and Cathedrals of Great Britain, Illustrated by W. Woodward, Nottingham." BRITISH JOURNAL OF PHOTOGRAPHY 8, no. 138 (Mar. 15, 1861): 106-107.

W1322 Lowden, Ronald D., Jr. "W. Woodward, Photographic Chemist." STEREO WORLD 2, no. 6 (Jan.-Feb. 1976): 18. 2 b & w. [Views by Woodward, from Nottingham, England, taken in 1859.]

WOOTTON, CHARLES. (TAUNTON, ENGLAND)
W1323 Portrait. Woodcut engraving credited "From a photograph by Charles Wootton." ILLUSTRATED LONDON NEWS 70, (1877) ["Capt. Day, R.N." 70:1956 (Jan. 6, 1877): 21.]

WORDEN, JOHN.
W1324 Worden, John. "On the Coalescence In the Stereoscope of Figures of Unequal Magnitude." PHOTOGRAPHIC AND FINE ART JOURNAL 10, no. 4 (Apr. 1857): 115-116. 2 illus. [From "J. of Photo. Soc., London."]

WORDEN, N. R.
W1325 Worden, N. R. "How to Sit for a Photograph." ANTHONY'S PHOTOGRAPHIC BULLETIN 8, no. 6 (June 1877): 171-172. [From "New Britain [CT] Record." Sarcastic advice.]

WORMALD, E. (LEEDS, ENGLAND)
W1326 "Note." ART JOURNAL (Aug. 1868): 163. [Note about photos of Leeds Exhibition.]

WORRALL, J. H. (GREAT BRITAIN)

W1327 Worrall, J. H. "Printing Stereoscopic Transparencies." PHOTOGRAPHIC AND FINE ART JOURNAL 10, no. 6 (June 1857): 190. [From "J. of Photo. Soc., London." Worrall at Wheatley College, Bacup, England.]

WORTLEY, ARCHIBALD STUART, COL. see also WOTHLY.

WORTLEY, ARCHIBALD STUART, LIEUT-COL. (1832-1890) (GREAT BRITAIN)

BOOKS
W1328 Stuart-Wortley, Col. *Hints on Photography without a Silver Bath.* London: Uranium Dry Plate Co., 1872. n. p. [Pamphlet.]

PERIODICALS
W1329 "Note." JOURNAL OF THE PHOTOGRAPHIC SOCIETY OF LONDON 8, no. 120 (Apr. 15, 1862): 39. ["Who was elected a member at the last meeting of the Photo. Soc., contributes large pictures to the International Exhib. of views of Vesuvius in eruption, views of bay and city of Naples...."]

W1330 Wortley, Stuart, Lieut.-Col. "Hot Development for Tannin Plates." AMERICAN JOURNAL OF PHOTOGRAPHY AND THE ALLIED ARTS & SCIENCES n. s. vol. 5, no. 2 (July 15, 1862): 31-34. [From "Photo. News."]

W1331 "The Distress of the Manufacturing Districts." JOURNAL OF THE PHOTOGRAPHIC SOCIETY OF LONDON 8, no. 127 (Nov. 15, 1862): 170. [Sale of his photos at the Photo. Exhib. to go "to the relief of the Lancashire operatives."]

W1332 Stuart-Wortley, Lt. Col. "On Instantaneous Photography." BRITISH JOURNAL OF PHOTOGRAPHY 10, no. 184 (Feb. 16, 1863): 70.

W1333 "On the Production of Instantaneous Pictures on Large Plates." JOURNAL OF THE PHOTOGRAPHIC SOCIETY OF LONDON 8, no. 130 (Feb. 15, 1863): 221-222.

W1334 Wortley, Stuart. "On the Production of Instantaneous Photographs on Large Plates." AMERICAN JOURNAL OF PHOTOGRAPHY AND THE ALLIED ARTS & SCIENCES n. s. vol. 5, no. 19 (Apr. 1, 1863): 437-439.

W1335 Wortley, Stuart, Lieut.-Col. "On Instantaneous Photography." HUMPHREY'S JOURNAL OF PHOTOGRAPHY, AND THE ALLIED ARTS AND SCIENCES 15, no. 2 (May 15, 1863): 20-22. [From "Br. J. of Photo."]

W1336 Wortley, Stuart, Lieut. Col. "On Photography in Connection With Art." JOURNAL OF THE PHOTOGRAPHIC SOCIETY OF LONDON 8, no. 138 (Oct. 15, 1863): 365-368.

W1337 "Art in Photography." AMERICAN JOURNAL OF PHOTOGRAPHY AND THE ALLIED ARTS & SCIENCES n. s. vol. 6, no. 10 (Nov. 15, 1863): 217-218. [From "Photo. News." Excerpt from Col. Stuart Wortley's paper, read to the Cornwall Polytechnic Society.]

W1338 "A New Step in Photography." AMERICAN JOURNAL OF PHOTOGRAPHY AND THE ALLIED ARTS & SCIENCES n. s. vol. 7, no. 9 (Nov. 1, 1864): 206-211. [From "London Times." The Wothlytype printing process described and extolled for its permanence. Invented by the German, Wothly, but purchased for commercial exploitation in Great Britain by Colonel Stuart Wortley, amateur photographer.]

W1339 "Colonel Stuart Wortley's Photographic Works." ART JOURNAL (Feb. 1871): 51.

W1340 Wortley, H. Stuart. "Colonel Stuart Wortley's Bromo-Chloride Process." ANTHONY'S PHOTOGRAPHIC BULLETIN 2, no. 11 (Nov. 1871): 352-354. [From "Br. J. of Photo."]

W1341 "Col. Stuart Wortley's New Emulsion Process," and "Revolution in the Studio." ANTHONY'S PHOTOGRAPHIC BULLETIN 3, no. 5 (May 1872): 554-558. [From "Photo. News" and "Br. J. of Photo." Detailed reports of a test of Stuart Wortley's "dry process" vs. traditional wet-collodion process. Careful description of the advantages of both.]

W1342 Wortley, H. Stuart. "On the Urano-Bromide Emulsion Process." ANTHONY'S PHOTOGRAPHIC BULLETIN 3, no. 6 (June 1872): 569-571. [From "Br. J. of Photo."]

W1343 Wortley, Col. Stuart. "The Urano-Bromide Emulsion Process." ANTHONY'S PHOTOGRAPHIC BULLETIN 3, no. 9 (Sept. 1872): 661-663. [From "London Photo. News."]

W1344 Wortley, Colonel Stuart. "Hints." BRITISH JOURNAL PHOTOGRAPHIC ALMANAC 1873 (1873): 129.

W1345 Wortley, Colonel Stuart. "Photography in Connection with Astronomy." ANTHONY'S PHOTOGRAPHIC BULLETIN 5, no. 11 (Nov. 1874): 363-364. [From "Br. J. of Photo."]

W1346 Wortley, Colonel Stuart. "Comparative Rapidity." BRITISH JOURNAL PHOTOGRAPHIC ALMANAC 1875 (1875): 113-114.

W1347 Wortley, Colonel Stuart. "Sensitiveness of Film and Quality of Negative." BRITISH JOURNAL PHOTOGRAPHIC ALMANAC 1878 (1878): 148-149.

W1348 Wortley, Col. Stuart. "Are Extra - Sensitive Dry Plates Fit for All Kinds of Work?" BRITISH JOURNAL PHOTOGRAPHIC ALMANAC 1879 (1879): 79.

W1349 Wortley, Col. Stuart. "Notes on Strong Alkaline Developers." ANTHONY'S PHOTOGRAPHIC BULLETIN 10, no. 8 (Aug. 1879): 246. [From "London Photographic News."]

W1350 "Home and Foreign News Epitomized." PHOTOGRAPHIC TIMES 10, no. 118 (Oct. 1880): [Wortley visiting USA during past month, enroute from Australia to England.]

W1351 Wortley, Stuart. "Development." PHOTOGRAPHIC TIMES 11, no. 127-128 (July - Aug. 1881): 246-248, 270-271.

W1352 Wortley, Col. Stuart. "Scientific Development." PHOTOGRAPHIC TIMES 15, no. 201 (July 24, 1885): 406.

W1353 "Notes and News." PHOTOGRAPHIC TIMES 20, no. 455 (June 6, 1890): 276. ["Colonel Stuart-Wortley, a man once well-known in photographic circles, died...St. John's Wood, England, Apr. 30, in the 56th year of his age."]

WOTHLY see also WORTLEY, STUART, COL.

WOTHLY.

W1354 Wothly. "A New Process of Photographic Printing." ART JOURNAL (Nov. 1864): 341.

W1355 "A New Step in Photography." HUMPHREY'S JOURNAL OF PHOTOGRAPHY, AND THE ALLIED ARTS AND SCIENCES 16, no. 13 (Nov. 1, 1864): 202-205. [From "London Times." Wothly's process described.]

W1356 "The Wothlytype Patent. Specifications." AMERICAN JOURNAL OF PHOTOGRAPHY AND THE ALLIED ARTS & SCIENCES n. s. vol. 7, no. 12 (Dec. 15, 1864): 265-268. [From "Photo. News."]

W1357 "Wothlytype Patent. - Specification." HUMPHREY'S JOURNAL OF PHOTOGRAPHY, AND THE ALLIED ARTS AND SCIENCES 16, no. 16 (Dec. 15, 1864): 245-247. [From "Photo. News," with additional comments by Towler.]

W1358 "Photography Applied to Wood Engraving." BRITISH JOURNAL OF PHOTOGRAPHY 12, no. 249 (Feb. 10, 1865): 72. [Wothlytype process.]

W1359 Cooper, H., Jr. "The Wothlytype Process." BRITISH JOURNAL OF PHOTOGRAPHY 12, no. 250 (Feb. 17, 1865): 85-86.

W1360 "The French Specification of the Wothlytype Process." AMERICAN JOURNAL OF PHOTOGRAPHY AND THE ALLIED ARTS & SCIENCES n. s. vol. 7, no. 19 (Apr. 1, 1865): 445-448. [From "Br. J. of Photo."]

W1361 "The 'Wothlytype' Specification in France." HUMPHREY'S JOURNAL OF PHOTOGRAPHY, AND THE ALLIED ARTS AND SCIENCES 17, no. 1 (May 1, 1865): 1-4. [From "Photo. News."]

W1362 "Our Editorial Table: Wothlytype Pictures, by the United Association of Photography." BRITISH JOURNAL OF PHOTOGRAPHY 12, no. 266 (June 9, 1865): 305. [Company, under direction of Lieut.-Col. Wothly, printer is H. Cooper.]

W1363 Wothly, J. "New Printing Process with Urano-Platinum Collodion." HUMPHREY'S JOURNAL OF PHOTOGRAPHY, AND THE ALLIED ARTS AND SCIENCES 18, no. 6 (July 15, 1866): 86-87. [From "Jacobsen's Chem: Tech: Repertorium."]

WRIGHT, C. C. (d. 1887) (USA)
W1364 "Obituary: C. C. Wright." PHOTOGRAPHIC TIMES 17, no. 281 (Feb. 4, 1887): 60-61. [Born 1841, been following the photographic profession since 1868. Formerly in business in Lafayette, Ind., but for four years carried on a large business in Denver, Colo., where he died suddenly on Jan. 27th.]

WRIGHT, CHARLES. (GREAT BRITAIN, INDIA)
W1365 Wright, Charles. A Missionary Album of India and Kaffraria, Photographed, printed and published by Charles Wright. Edinburgh: C. Wright, 1870. n. p. 15 b & w. [Original photographs.]

WRIGHT, JAMES. (d. 1893) (GREAT BRITAIN, USA)
W1366 "Matters of the Month." PHOTOGRAPHIC TIMES 7, no. 73 (Jan. 1877): 6. [Letter from J. Wright about Morrison's lenses. Described as "one of the highest authorities on photography in this country. For several years he was photographer-in-chief for Frank Leslie's publishing house. Inventor of a process for photographing on wood...Englishman.]

W1367 "Obituary." APPLETON'S ANNUAL CYCLOPEDIA & REGISTER OF THE YEAR 1893 (1894): 575. ["Wright, James, photographer, born in England; died in Brooklyn, NY, Feb. 4, 1893. He served the British War Office as a photographer during the Crimean War, and the United States War Department in the same capacity during the Civil War, and in the latter was attached to the headquarters of the Army of the Potomac. After the war he devised a method of photographing on wood, both direct and in enlarged and reduced reproduction, for the benefit of engravers on wood, and he had been employed since in his special work for the principal illustrated periodicals."]

WRIGHT, WILLIAM SAMUEL.
W1368 The Loved Haunts of Cowper; or The Photographic Rembrancer of Olney and Weston. Being Photographs of Buildings and Rural Scenes immortalized by the Poet. Olney: William S. Wright, 1867. n. p. 18 b & w. [Albumen prints.]

WYCKOFF, J. H. (RIPON, WI)
W1369 "Editor's Table." PHILADELPHIA PHOTOGRAPHER 6, no. 65 (May 1869): 169. [Snow scene noted.]

WYKES, EDWARD S. (d. 1863) (USA)
W1370 "Note." PHOTOGRAPHIC AND FINE ART JOURNAL 11, no. 3 (Mar. 1858): 96. [Prints mentioned.]

WYKES, J. W.
W1371 Wykes, J. W. "Lambertype." ST. LOUIS PRACTICAL PHOTOGRAPHER 1, no. 1 (Jan. 1877): 15. [Wykes, a professional photographer, praises the new carbon printing process.]

WYLES, BENJAMIN. (SOUTHPORT, ENGLAND)
BOOKS
W1372 Wyles, Benjamin. Instructions for Beginners in Photography. With a Preface by J. Harris Stone, M.A. London: Scientific Publishing Co., 1886. xii, 117 pp. illus.

PERIODICALS
W1373 Wyles, B. "Natural 'Rocks' in the Studio, and How to Make Them." BRITISH JOURNAL PHOTOGRAPHIC ALMANAC 1871 (1871): 135-136.

WYMANN, C. & CO.
W1374 "Animals Exhibited at the Calcutta Agricultural Show." ILLUSTRATED LONDON NEWS 45, no. 1266 (July 2, 1864): 5-6. 6 illus. ["We have engraved half a dozen of the series of photographs taken by Messrs. C. Wyman & Co., of Mare St., Calcutta." However, see p. 324. "The photographs of the prize animals on that occasion were taken...by an amateur photographer Mr. W. L. Noverre, since appointed Asst. Commissioner of Forests in Central India." (The prints were probably made by Wymann & Co.)]

WYNFIELD, DAVID WILKIE. (1837-1887) (GREAT BRITAIN)
W1375 "An Art-Critic on Photographic Portraiture." PHOTOGRAPHIC NEWS 8, no. 287 (Mar. 4, 1864): 109-110. [Article in "The Reader" on Wynfield's portraits reprinted with dissenting comments. Article is totally reprinted on page 114-115 of same issue.]

W1376 "Photography and Photographers." PHOTOGRAPHIC NEWS 8, no. 287 (Mar. 4, 1864): 114-115. [From "The Reader." Commentary in editorial statement p. 109-110 same issue.]

W1377 Garner, M. A. K. "David Wynfield: Painter and Photographer." APOLLO 97, no. 132 (Feb. 1973): 158-159. 6 b & w. [Portraits of British painters ca. 1870-1880.]

WYNTER, ANDREW. (GREAT BRITAIN)
[Dr. Wynter was a popular essayist, whose articles appeared in the general press.]

BOOKS

W1378 "Photo-Sculpture," on pp. 263-271 in: *Our Social Bees,* by Andrew Wynter. London: Hardwicke, 1869.

W1379 "Application of Photography," in vol. 2 of: *Peeps in the Human Hives,* by Andrew Wynter. London: Chapman & Hall, 1874. 2 vol.

W1380 "Carte-de-Visite and Photographic Pictures," on pp. 239-249 in vol. 1 of: *Fruit between the Leaves,* by Andrew Wynter. London: Chapman & Hall, 1875. 2 vol.

PERIODICALS

W1381 Wynter, A. "Cartes de Visite." ONCE A WEEK 6, (Jan. 25, 1862): 134-137.

W1382 Wynter, Dr. "Cartes de Visite." JOURNAL OF THE PHOTOGRAPHIC SOCIETY OF LONDON 7, no. 118 (Feb. 15, 1862): 375-377.

W1383 Wynter, A. "Cartes de Visite." LIVING AGE 72, no. 929 (Mar. 22, 1862): 673-676. [From "Once a Week."]

W1384 Wynter, Andrew. "Cartes de Visite." GOOD WORDS 10, no. 3 supplement (Mar. 1869): 57-64.

X

X. (TUNBRIDGE WELLS, ENGLAND)

X1 "X." "Notes for Travelling Photographers." HUMPHREY'S JOURNAL 6, no. 15 (Nov. 15, 1854): 233-235. [From "J. of Photo. Soc., London." The unnamed photographer who describes his "photographic excursion around the Isle of Wight," was from Tunbridge Wells, England.]

X2 "X." "Notes for Travelling Photographers." PHOTOGRAPHIC AND FINE ART JOURNAL 7, no. 12 (Dec. 1854): 362-363. [From "J. of Photo. Soc." "X," from Tunbridge Wells, England, describes a trip around the Isle of Wight.]

X3 "X's Process." HUMPHREY'S JOURNAL 6, no. 23 (Mar. 15, 1855): 368. [From "J. of Photo. Soc., London." "X" describes his chemical processes. He is from Tunbridge Wells, England.]

Y

YATES & ORR.
Y1 "North Carolina. - Observance of 'Memorial Day' by the Ladies' Memorial Association of Wilmington. - From a Photograph by Yates & Orr." FRANK LESLIE'S ILLUSTRATED NEWSPAPER 48, no. 1235 (May 31, 1879): 213. 1 illus. [View.]

YATES, C. W.
Y2 Portrait. Woodcut engraving, credited "From a Photograph by C. W. Yates." FRANK LESLIE'S ILLUSTRATED NEWSPAPER 29, (1869) ["Commodore Edwin Higgins, of Cuba." 29:735 (Oct. 30, 1869): 112.]

YERBURY, E. R. (EDINBURGH, SCOTLAND)
Y3 Portrait. Woodcut engraving credited "From a photograph by Yerbury, South Hanover St., Edinburgh." ILLUSTRATED LONDON NEWS 63, (1873) ["Late Rev. Dr. Candlish." 63:1784 (Nov. 8, 1873): 437.]

Y4 Portraits. Woodcut engravings credited "From a photograph by E. R. Yerbury." ILLUSTRATED LONDON NEWS 72, (1878) ["Late Rev. Dr. Duff." 72:2017 (Feb. 23, 1878): 172.]

YORK, FREDERICK. (1823-1903) (GREAT BRITAIN, SOUTH AFRICA, GREAT BRITAIN)
Y5 Portraits. Woodcut engravings, credited "Photographed by York." ILLUSTRATED LONDON NEWS 35, (1859) ["Sir George Grey, K.C.B." 35:* (Dec. 17, 1859): 586.]

Y6 "York's 'Zoological' Camera." ANTHONY'S PHOTOGRAPHIC BULLETIN 4, no. 5 (May 1873): 135-136. [From "Br J of Photo." Description of camera used to photograph the animals at the London Zoological Garden.]

Y7 York, F. "Photography in the Zoological Gardens." ANTHONY'S PHOTOGRAPHIC BULLETIN 4, no. 6 (June 1873): 175-177. [Read before the South London Photographic Society. From "Photo. News."]

Y8 "Our Foreign Make-Up." PHOTOGRAPHIC TIMES 5, no. 57 (Sept. 1875): 219-221. [London Photographic Society - his "experience with the wet-process described.]

Y9 "Editor's Table: South Kensington Museum Photographs." PHILADELPHIA PHOTOGRAPHER 13, no. 152 (Aug. 1876): 255.

Y10 York, F. "Photographic Difficulties." ANTHONY'S PHOTOGRAPHIC BULLETIN 8, no. 6 (June 1877): 164-166. [From "Br. J. of Photo." York took many "views" in London, he describes problems with weather, bystanders, police, traffic, etc.]

Y11 York, Frederick. "Weak versus Strong Developers." BRITISH JOURNAL PHOTOGRAPHIC ALMANAC 1878 (1878): 70-71. [Weak developers work better for interiors, etc.]

Y12 York, Frederick. "John Bull's Experience in America." PHOTOGRAPHIC TIMES 15, no. 184 (Mar. 27, 1885): 154-155. [British, traveled for ten weeks in the Northwest, exposing 370 plates.]

Y13 York, F. "Hints on Taking Panoramas." AMERICAN ANNUAL OF PHOTOGRAPHY AND PHOTOGRAPHIC TIMES ALMANAC FOR 1887 (1887): 227-228.

Y14 "Obituary of the Year: Frederick York." BRITISH JOURNAL PHOTOGRAPHIC ALMANAC 1905 (1905): 649-650. [Died Dec. 17, 1903, aged 80 years. Born at Bridgwater in 1823. Apprenticed to a chemist in 1839. Experimented with photographs. In 1855 went to Cape of Good Hope, for health, learned photography from Mr. Cogan, of Bath, before he left. Made wet-collodion photos under difficulties in South Africa. Imported photographic materials, taught photography. Returned to England in 1861. In 1862 began taking over 1000 stereo, cabinet and larger views of London. His photos of animals at Zoological Garden considered excellent. Then made lantern slides, over 15,000. Member of South London Photographic Society, the Photographic Club, and others.]

YOUNG.
Y15 "Our Illustrations." PHOTOGRAPHIC AND FINE ART JOURNAL 10, no. 6 (June 1857): unnumbered page, 186. 1 b & w. [Original photographic print, tipped-in. View "of Mormon Island, CA, negatives by C. Farrand, from a Daguerreotype by Young." (Print not in this copy.)]

YOUNG [?].
Y16 "Our Illustrations." PHOTOGRAPHIC AND FINE ART JOURNAL 10, no. 7 (July 1857): unnumbered page, 217. 1 b & w. [Original photographic print, tipped-in. "'View of a Gold Mine in California,' negative by Mr. C. Farrand, from a Daguerreotype." In June issue the daguerreotypist of another California view was identified as "Young."]

YOUNG, J. M. (LLANDUDNO, WALES)
Y17 Young, J. M. "Combination Pictures." ANTHONY'S PHOTOGRAPHIC BULLETIN 5, no. 1 (Jan. 1874): 8. [Young from Llandudno, Wales.]

Y18 Young, J. M. "A Modification of the Howard Tent." BRITISH JOURNAL PHOTOGRAPHIC ALMANAC 1877 (1877): 181-182.

Y19 Young, J. M. "A New Studio." BRITISH JOURNAL PHOTOGRAPHIC ALMANAC 1879 (1879): 166. 1 illus.

YOUNG, LEWIS T. (PHILADELPHIA, PA)
Y20 Young, Lewis T. "Experiments with Boldon's Washed Emulsion Process." BRITISH JOURNAL PHOTOGRAPHIC ALMANAC 1875 (1875): 58-59.

YOUNG, R. H. (CANADA)
Y21 "Reception of the Earl of Dufferin, Governor-General of Canada, at Victoria, British Columbia." ILLUSTRATED LONDON NEWS 69, no. 1940 (Sept. 30, 1876): 316. 1 illus. ["...a set of photographs which have been sent to us by Mr. R. H. Young, accountant to the Canadian Pacific Railway..."]

Z

ZEALY, JAMES T. (COLUMBIA, SC)

Z1 "Note." PHOTOGRAPHIC ART JOURNAL 2, no. 6 (Dec. 1851): 376-377. [Extract from "South Carolinian" promising his new gallery.]

Z2 "Gossip." PHOTOGRAPHIC ART JOURNAL 3, no. 4 (Apr. 1852): 257. [Poem titled "To Mr. Zealy, the Distinguished Artist, in return for the present of my husband's daguerreotype" by M. M.]

ZENTMAYER, JOSEPH see also STEINHEIL.

ZENTMEYER, JOSEPH. (1826-1888) (GERMANY, USA)

Z3 Zentmayer, Joseph. "The Zentmayer Lens. Investigation of an Investigation" HUMPHREY'S JOURNAL OF PHOTOGRAPHY, AND THE ALLIED ARTS AND SCIENCES 19, no. 13 (Nov. 1, 1867): 199-202. [Letter protesting earlier article by Drummond. Includes letters from Benjamin French (Boston); Coleman Sellers, etc.]

Z4 Zentmayer, Joseph. "A Lecture on Lenses." ANTHONY'S PHOTOGRAPHIC BULLETIN 7, no. 11-12 (Nov. - Dec. 1876): 321-329, 35

Z5 "Obituary: Joseph Zentmeyer." ANTHONY'S PHOTOGRAPHIC BULLETIN 19, no. 8 (Apr. 28, 1888): 243. [Born Mannheim, Germany Mar. 26, 1826. Learned optics while growing up. To America 1848, worked as a lensmaker for which he gained fame. Lived in Philadelphia, died 1888.]

ZIMMERMAN, CHARLES A. (1844-1909) (FRANCE, USA)

[Charles A. Zimmerman was born in France ca. 1844. He learned photography from his father, also named Charles. By 1866 Charles A. was in St. Paul, MN, working for Joel E. Whitney. In 1871 he took over the Whitney studio. In 1873 he formed a partnership with his brother Edward O. Zimmerman. The Zimmerman Brothers studio operates through the 1890s. Charles died in St. Paul in 1090.]

Z6 "Our Picture." PHILADELPHIA PHOTOGRAPHER 8, no. 88 (Apr. 1871): frontispiece, 125-127. 1 b & w. [Railroad bridge over the St. Croix River.]

Z7 "Wisconsin. - Application of Steam-Power to the Breaking-Out of a Log-Jam on the Chippewa River. - From a Photograph by Charles A. Zimmerman, St. Paul." FRANK LESLIE'S ILLUSTRATED NEWSPAPER 32, no. 823 (July 8, 1871): 276. 1 illus. [View.]

Z8 Zimmerman, C. A. "Fifth Annual Meeting and Exhibit of the National Photographic Association of the U.S., held in Buffalo, N.Y., beginning July 5, 1873: On Landscape Photography." PHILADELPHIA PHOTOGRAPHER 10, no. 117 (Sept. 1873): 447-448.

Z9 Portrait. Woodcut engraving, credited "From a Photograph by Zimmerman, St. Paul. FRANK LESLIE'S ILLUSTRATED NEWSPAPER 42, (1876) ["Brevet Maj.-Gen. Alfred Terry, U.S.A." 42:1089 (Aug. 12, 1876): 373. "The late 2nd Lieut. James G. Sturgis, 7th Cavalry." 42:1089 (Aug. 12, 1876): 373. "The late Asst.-Surgeon George Lord, U.S.A." 42:1089 (Aug. 12, 1876): 373.]

Z10 "Our Illustration." ANTHONY'S PHOTOGRAPHIC BULLETIN 17, no. 6 (Mar. 27, 1886): frontispiece, 176. 1 b & w. [Apparently a winter view of St. Paul, MN, taken by C. A. Zimmerman of Zimmerman Brothers. Photo not bound in this copy.]

Z11 Zimmerman, C. A. "Lighting and Posing." WILSON'S PHOTOGRAPHIC MAGAZINE 34, no. 489 (Sept. 1897): 401-409. [Address delivered before the Convention of the Northwestern Photographer's Association in St. Paul, MN, on Aug. 3-6. "Zimmerman has been prominently identified with photography and art in the Northwest for almost fifty years... "]

Z12 Zimmerman, C. A. "Some Photographic Crises." AMERICAN ANNUAL OF PHOTOGRAPHY 1910 24, (1910): 110-113. [Argument that various technical changes in printing caused problems for the professional photographer, and that the latest, the amateur photographer, will be solved in due course.]

SPECIAL TOPICS

PLEASE REMEMBER THAT IT WAS THE PRACTICE OF THE INDEXER TO PLACE A REFERENCE UNDER AN INDIVIDUAL PHOTOGRAPHER'S NAME WHERE POSSIBLE. THUS THE READER SHOULD ALWAYS CHECK UNDER THE NAME OF AN INDIVIDUAL KNOWN TO HAVE PRACTICED A CERTAIN TYPE OF PHOTOGRAPHY.

ALL TOPIC CLASSIFICATIONS IN THIS WORK ARE ORDERED FIRST BY REFERENCES TO BOOKS, THEN BY PERIODICAL REFERENCES. EACH SPECIAL TOPIC CATEGORY IS DIVIDED IN THE MANNER WHICH SEEMED TO BEST FIT THAT SUBJECT CATEGORY. THE CATAGORIES AND THEIR MANNER OF ORGANIZATION ARE LISTED BELOW.

BIBLIOGRAPHY

ORDERED BY THE DATE OF PUBLICATION.

PREHISTORY

ORDERED BY THE DATE OF PUBLICATION.

HISTORY

GENERAL
RETROSPECTIVE. (1880-1989)

CONTAINS PUBLICATIONS ABOUT THE PERIOD 1839-1879 WHICH WERE PUBLISHED AFTER THE PERIOD. ORDERED BY THE DATE OF PUBLICATION, FROM 1880 TO 1989.

GENERAL
BY YEAR (1839-1879)

CONTAINS PUBLICATIONS ABOUT THE PERIOD 1839-1879 WHICH WERE PUBLISHED DURING THAT TIME. ORDERED BY THE DATE OF PUBLICATION, FROM 1839 TO 1879.

BY COUNTRY

EACH COUNTRY IS, IN TURN, SUBDIVIDED INTO RETROSPECTIVE (1880-1989) AND BY YEAR (1839-1879) CATEGORIES. THE UNITED STATES OF AMERICA SECTION IS ALSO FURTHER DIVIDED BY STATE, WHEN THE FOCUS OF THE INDEXED ARTICLE IS ABOUT PHOTOGRAPHY IN THAT LOCALE.

BY APPARATUS OR EQUIPMENT

APPARATUS

RETROSPECTIVE (1880-1989)
BY YEAR (1839-1879)

EQUIPMENT

RETROSPECTIVE (1880-1989)
BY YEAR (1839-1879)

CAMERAS

RETROSPECTIVE (1880-1989)
BY YEAR (1839-1879)

LENSES

RETROSPECTIVE (1880-1989)
BY YEAR (1839-1879)

SOLAR CAMERAS

RETROSPECTIVE (1880-1989)
BY YEAR (1839-1879)

BY APPLICATION OR USAGE

ASTRONOMICAL PHOTOGRAPHY.

RETROSPECTIVE (1880-1989)
BY YEAR (1839-1879)

COLOR PHOTOGRAPHY

RETROSPECTIVE (1880-1989)
BY YEAR (1839-1879)

EXHIBITIONS

BY COUNTRY, THEN BY YEAR, THEN BY CITY, THEN BY SITE OR ORGANIZATION

MAGIC LANTERN PHOTOGRAPHY

RETROSPECTIVE (1880-1989)
BY YEAR (1839-1879)

MICROPHOTOGRAPHY

RETROSPECTIVE (1880-1989)
BY YEAR (1839-1879)

ORGANIZATIONS AND SOCIETIES

BY COUNTRY, THEN BY TITLE OF ORGANIZATION, THEN BY YEAR

PHOTOJOURNALISM AND MAGAZINES

RETROSPECTIVE (1880-1989)
BY COUNTRY
BY TITLE OF MAGAZINE

PHOTOMECHANICAL REPRODUCTION

RETROSPECTIVE (1880-1989)
BY YEAR (1839-1879)

STEREOSCOPIC PHOTOGRAPHY

RETROSPECTIVE (1880-1989)
BY YEAR (1839-1879)

BIBLIOGRAPHY

BIBLIOGRAPHY: see also PHOTOJOURNALISM AND MAGAZINES.

BIBLIOGRAPHY

[With a few scattered exceptions, this work is limited to English language publications. Nevertheless, I have included references to bibliographical works published in other languages in this section, in the hope that those references will provide some guide to that photographic literature. However, I did not list all of the general histories of photography, the various biographical dictionaries and encyclopedias, or general periodical indexes, because those general works can be accessed elsewhere.]

BOOKS

ST1 Zuchold, Ernst Amadus. *Bibliotheca Photographica. Verzeichniss der auf dem Gebiete der Photographie, sowie der damit verwandten Künste und Wissenschaften seit Erfindung der Daguerreotype bis zu Anfang des Jahres 1860 erschienenen Schriften.* Leipzig: Selbstverlag des Verfassers, 1860. 28 pp. [Listing of German language books, with a few foreign language publications. Facsimile reprint (1977) Ikaros Forlag.]

ST2 E. B de L. *Manuel Bibliographique du Photographe Français; ou Nomenclature des ouvrages publiés en France depuis la découverte du Daguerréotype jusqu'a nos jours.* Paris: Auguste Aubry, 1863. 22 pp. [Lists 172 books and offprints published in France, arranged by date of publication. Facsimile reprint (1982) Éditions Lecointre-Ozanne.]

ST3 [Lehmann-Haupt, Helmut, Bertha M. Frick, and Janet Bogardus]*A Catalogue of the Epstean Collection on the History and Science of Photography and Its Applications Especially to the Graphic Arts.* New York, 1937. n. p. [Revised ed., with an introduction by Beaumont Newhall. Pawlet, VT: Helio, 1972. Classed bibliography, listing 1418 books, mostly of a technical nature.]

ST4 Royal Photographic Society of Great Britain. *Library Catalogue. Authors.* London: The Society, 1939. 48 pp.

ST5 Royal Photographic Society of Great Britain. *Library Catalogue. Supplement to Author Catalogue 1939.* London: The Society, 1952. 42 pp.

ST6 Royal Photographic Society of Great Britain. *Library Catalogue. Second Supplement (1950 - 1952) to Author Catalogue, 1939.* London: The Society, 1953. 28 pp.

ST7 Royal Photographic Society of Great Britain. *Library Catalogue. Part 2 - Subject Catalogue.* London: The Society, 1952. 106 pp.

ST8 Royal Photographic Society of Great Britain. *Library Catalogue. Supplement (1950 - 1952) to Subject Catalogue.* London: The Society, 1953. 44 pp.

ST9 Marshall, Albert E. *Original typed catalogue of his vast collection of photographic books... with a wealth of otherwise unobtainable annotations concerning photographers, processes imployed, etc. etc. Arranged chronologically from 1668 - 1948.* Typscript in a loose-leaf binder, ca. 1950. n. p. [Copy now held at the IMP/GEH.]

ST10 *Photography: A Panoramic History of the Art of Photography as Applied to Book Illustration, from Its Inception up to Date; the Important Collection of the late Albert Marshall of Providence, R. I.... Public auction sale Thursday, Feb. 14, 1952.* New York: Swann Auction Gallery, 1952. 37 pp. [Lists about 150 titles.]

ST11 Schultze, R. S. "Books Illustrated with Original Photographs: Notes on a Collection and Bibliography," on pp. 138-147 in: *Jubiläums Festschrift. Hundert Jahre Photographische Gesellschaft in Wien 1861 - 1961. Beitrage aus Photochemie, Photophysik, Reproduktionstechnik und Geschichte der Photographie.* Vienna: Verlag Dr. Othmar Helwich, 1961.

ST12 Boni, Albert, ed. *Photographic Literature: An International Bibliographic Guide to General and Specialized Literature on Photographic Processes; Techniques; Theory; Chemistry; Physics; Apparatus; Materials & Applications; Industry; History; Biography; Aesthetics.* Hastings-on Hudson, NY: Morgan & Morgan, Inc., 1962. 336 pp. [Subject bibliography, with author index. Strong on technical materials.]

ST13 Schultz, Rolf F. *Victorian Book Illustration with Original Photographs and Early Photomechanical Processes.* London: National Book League, 1962. 14 pp. [Ex. cat.: Oct. 8 - Oct. 13, 1962. About 115 titles listed and described.]

ST14 Carver, George T. and Bernard L. Freemesser. *Literature of Photography: The Essay, Philosophy, Criticism, History. A Partial Bibliography.* Eugene, OR: School of Journalism, University of Oregon, 1966. 50 pp. [Listing of 1420 book and periodical references to 19th and 20th century photographers. Organized by artist or author. The references are incomplete, often no more than the title of a book. Stronger in 20th century citations.]

ST15 Snider, Robert C. *A Catalogue of the Robert C. Snyder Collection of Books on the History of American Photography.* s. l., s. n., 1967. 17 pp. [Short title listing of 235 19th and 20th century titles.]

ST16 Boni, Albert, ed. *Photographic Literature 1960 - 1970: An International Bibliographic Guide to General and Specialized Literature on Photographic Processes; Techniques; Theory; Chemistry; Physics; Apparatus; Materials & Applications; Industry; History; Biography; Aesthetics.* Hastings-on Hudson, NY: Morgan & Morgan, Inc., 1972. 536 pp. [Supplement to the first volume. Subject bibliography, with author index. Strong on technical materials.]

ST17 Neems, Karen Vogel, compiler. *Bibliography of Regional Checklists of Photographers: Predominantly 19th Century.* Sept. 1979. 13 l. [Research paper, compiled at the IMP/GEH, and in their Information File. Arranged by country, and within the USA, by state. Includes references to unpublished works and works in progress at other institutions, etc.]

ST18 Barger, M. Susan, compiler. Preface by Larry Booth. *Bibliography of Photographic Processes in Use Before 1880: The Materials, Processing, and Conservation.* Rochester, NY: Graphic Arts Research Center, Rochester Institute of Technology, 1980. 149 pp. illus. [Classed bibliography of articles and books. "General Works." "Technical Evolution of Processes." "Daguerreotypes." "Paper Negatives and Salted Paper Prints." "Albumen Processes." "Collodion." "Gelatin." "Non-Silver Processes." etc.]

ST19 Goldschmidt, Lucien and Weston J. Naef. *The Truthful Lens: A Survey of the Photographically Illustrated Book, 1844 - 1914.* New York: The Grolier Club, 1980. 241 pp. 172 illus. [Ex. cat.: (The Grolier Club, New York, NY, Dec. 1974 - Jan. 1975, 192 items in the exhibition.) "Foreword," by David Hunter McAlpin, pp. ix-x,

"Tangible Facts, Poetic Interpretation," by Lucien Goldschmidt, pp. 3-7, "From Illusion to Truth and Back Again," by Weston J. Naef, pp. 9-46, "Bibliography," pp. 47-49, "Photographs," pp. 52-180, "Catalogue," pp. 181-230, "Index," pp. 231-241. This is an elegant and scholarly work.]

ST20 Heidtmann, Frank, Hans-Joachim Bresemann and Rolf H. Krauss, ed. *Die deutsche Photoliteratur 1839 - 1978: Eine Bibliographie - German Photographic Literature 1839 - 1978: A Bibliography. Theory - Technology Visual: A Classified bibliography of German-language photographic publications.* Munich: K. G. Saur, 1980. 690 pp. [In German and English. "Index," pp. 597-689.]

ST21 *Library Catalog of the International Museum of Photography at George Eastman House.* Boston: G. K. Hall & Co., 1982. 4 vol. (2302 pp.). ["Introduction," by Gail McClain, pp. iii-iv. This is a photographic reproduction of the author/title and subject catalog cards for those books cataloged in the IMP/GEH library, up to 1981.]

ST22 *Photographica: A Subject Catalog of Books on Photography. Includes Books, Pamphlets and Selected Periodical Articles on Still Photography and Allied Topics. Drawn from the Holdings of the Research Libraries of the New York Public Library Astor, Lenox and Tilden Foundations.* Boston: G. K. Hall & Co., 1984. 380 pp. ["Preface," by Julia Van Haaften, on pp. iii. A subject bibliography ("Accounting and Bookkeeping for Photogravers, Cost" to "Woodburytype.") composed of photographic reproductions of the subject cards drawn from the card catalog of the NYPL.]

ST23 Gernsheim, Helmut. *Incunabula of British Photographic Literature. A bibliography of British photographic literature 1839 - 75 and British books illustrated with original photographs.* London, Berkeley: Scholar Press, 1984. 159 pp. b & w. ["Part I. Bibliography of books published in Great Britian and illustrated with original photography," and "Newspapers, periodicals and magazines illustrated with original photographs," pp. 15-81. "Part II. Bibliography of early British photographic literature 1839 - 1875," pp. 85-127. "Part III. Photographic Journals, almanacs and annuals," "Non-Photographic journals," "Important essays on photography," pp. 131-144. "Appendix: Examples of metaphorical use of the words 'heliography,' 'photograph' and 'daguerreotype,'" "Index to Photographers," "General Index," pp. 147-159. Within each section, this work is arranged chronologically by the date of publication. It is copiously illustrated with reproductions of some of the photographs found within cited works or title pages from cited works. There are 1261 references given, including 638 works in "Part I" and 344 works in "Part II." (I referred to this excellent work for verifications for some citations and drew on it as a source for others, but I did not repeat all of the works cited therein. It should be checked by anyone seeking a more in-depth entry into the British literature of this time, not only because it contains additional references and more detailed information on many citations, but also for the many illustrations.)]

ST24 Sennett, Robert S. *Photography and Photographers to 1900: An Annotated Bibliography.* New York: Garland Publishing Co, 1985. xi, 134 pp. [Lists 409 books. Index on pp. 117-134. This is essentialy a transcription of the 19th century books listed in the shelf-list of the Fine Arts Library of the Harvard University Library. In other words, a listing of those books which have been cataloged into the photography classification of that library. This would not necessarily include books which were placed into other subject classifications in the Harvard Library system.]

ST25 Willis-Thomas, Deborah. *Black Photographers, 1840 - 1940. An Illustrated Bio-Bibliography.* New York: Garland Publishing Co., 1985.

142 pp. illus. ["Part I. Daguerreans, 1840 - 1859," pp. 3-7. "Part II. Daguerreans and Photographers, 1860 - 1899," pp. 9-12. Lists thirty-seven photographers for the period 1840 - 1899. Includes biographical information, collections statements, and bibliographies, which are drawn primarily from local newspapers. Quotes or abstractions of these references are included.]

ST26 Sennett, Robert A. *The Nineteenth-Century Photographic Press: A Study Guide.* New York: Garland Publishing Co., 1987. 97 pp. [A seven page introduction provides a brief overview, followed by a "Bibliography of Citations and Titles." This section lists eighty-eight periodicals, with some dates of publication and editors given. A few titles have a sample of references to published articles given. For example *Anthony's Photographic Bulletin* is described: "A major journal in the history of photography in America. Citations have been selected from vol. 1 (1870) through vol. 4 (1873)." This is followed by a random sampling of twenty-one articles from that journal. An appendix "A Geographical Guide to the Photographic Press," lists the titles by country.]

ST27 Roosens, Laurent and Luc Salu. *History of Photography: A bibliography of books.* London, New York: Mansell, 1989. 446 pp. [Lists "...more than 11,000 books, grouped under some 3000 alphabetically arranged subject headings and subheadings." 19th and 20th century titles in all languages. Author, title, city, publisher, date, pagination given. In many cases a brief descriptive annotation is included. A major effort, but many gaps.]

PERIODICALS

[Throughout most of the nineteenth century, from at least ser. 1, vol 4 (1859), through the early 1900s, the GAZETTE DES BEAUX ARTS published a "Bulletin Bibliographique: Photographie," in each of its annual cumulated issues. In 1859 Photography was "Section VIII," in 1860 it became section X, and then section XI, in the classed bibliography which was first compiled by Paul Chéron, then later, in the 1880s, by Henri Jouin. Most French manuals of photography were listed. A few foreign language volumes were also included. Author, publisher, date, size, pagination, and number of illustrations were given, when known. Books illustrated with original photographs were also listed in the other sections of the bibliography. This is the most complete listing to French language books, pamphlets, and offprints available for this period. From 1897 to 1900 the magazine LA REVUE DE L'ART ANCIEN ET MODERNE also published a column "Ouvrages sur les Beaux-Arts: Photographie," compiled by Paulin Teste.]

ST28 "Recent Photographic Publications." PHOTOGRAPHIC NEWS 4, no. 115 (Nov. 16 1860): 341-342.

ST29 Thompson, S. "Photography in its Application to Book Illustration." BRITISH JOURNAL OF PHOTOGRAPHY 9, no. 161 (Mar. 1, 1862): 88-89. [Primarily a book review for "Ruined Castles and Abbeys of Great Britain," by William and Mary Howitt.]

ST30 Mayer, Heinrich, Dr. "Photography as a Medium of Illustration." HUMPHREY'S JOURNAL OF PHOTOGRAPHY, AND THE ALLIED ARTS AND SCIENCES. 14, no. 22 (Mar. 15, 1863): 293-296. [From "Zeitschrift für Fotografie und Stereoscopie." "The first important work in which photography was applied as a means of illustration instead of copperplate engravings, lithographic prints, and woodcuts was..." Lists and describes approximately a dozen books and articles illustrated with photos or photolithographs.]

ST31 Towler, John, M.D. "The Value and Influence of Photographic Journals." BRITISH JOURNAL PHOTOGRAPHIC ALMANAC 1870 (1870): 149-150.

ST32 Harrison, W. Jerome, F.G.S. "The Literature of Photography." ANTHONY'S PHOTOGRAPHIC BULLETIN 17-18, no. 7-24, 1-15 (Apr. 10, 1886 - Aug. 13, 1887): (vol. 17) 202-204, 296-297, 334-340, 723-726, 744-745. (vol. 18) 8-10, 105-107, 140-141, 168-171, 201-203, 235-237, 270-272, 295-297, 333-335, 361-363, 392-395, 427-430, 458-461. [Listing of "English-printed books, arranged under their author's names." Several hundred books on process and technique, published up through the early 1880s are listed and described. Size, number of pages and illustrations, editions and prices are given. Harrison often included a brief summation of the author's career.]

ST33 Harrison, W. Jerome, F.G.S. "The Literature of Photography." ANTHONY'S PHOTOGRAPHIC BULLETIN 19, no. 2-10 (Jan. 3 - May 26, 1888): 42-44, 73-75, 102-104, 136-138, 169-173, 298-301. [Alphabetical list of "British and Colonial Periodicals Relating to Photography." Cites periodicity, length of publishing run, editorial tenure, size, and price. Occasional commentary about the nature of the publication is also included.]

ST34 Canfield, C. W. "American Bibliography of Photography Class A. - Photographic Journals. 1st Article." PHOTOGRAPHIC TIMES 17, no. 327 (Dec. 23, 1887): 648-649. [Annotated descriptive survey of first American periodicals. Discusses the editorial and publishing history of the "Daguerrean Journal."]

ST35 Canfield, C. W. "American Bibliography of Photography. Class A. -Photographic Journals. 2nd Article." PHOTOGRAPHIC TIMES 18, no. 334 (Feb. 10, 1888): 64-66. ["Photographic Art Journal" 1851-1853 described.]

ST36 Canfield, C. W. "American Bibliography of Photography. 3rd Article." PHOTOGRAPHIC TIMES 18, no. 338 (Mar. 9, 1888): 112. ["Humphrey's Journal of Photography and the Allied Arts," vol. 4 (1852) - vol. 10 (Apr. 1859). Survey of the editorial practice and format. No discussion of the actual articles in the magazine.]

ST37 Canfield, C. W. "American Bibliography of Photography. 4th Article." PHOTOGRAPHIC TIMES 18, no. 351 (June 8, 1888): [General bibliographic description of "Photographic and Fine Art Journal," "American Journal of Photography," and "Seeley's Journal."]

ST38 Canfield, C. W. "American Bibliography of Photography. 5th Article." PHOTOGRAPHIC TIMES 18, no. 359 (Aug. 3, 1888): 362-363. ["Philadelphia Photographer." Vol. 1-3, 1864 - 1865.]

ST39 Canfield, C. W. "Bibliographic Supplement to the Photographic Times, February, 1893." PHOTOGRAPHIC TIMES 23, no. 595, 599, 605, 608 (Feb. 10, Mar. 10, Apr. 21, May 12, 1893): 77-79, 133-134, 213-215, 255-257. 1 illus. [Canfield's 1887 articles are republished here "...corrected, with such additional information as I have since been able to obtain." A short title list of volumes in the "Photographic Times" library is also included.]

ST40 Bolas, Thomas, F.C.S., F.I.C. "Contributions Towards the Bibliography of Photography in Colours." JOURNAL OF THE SOCIETY OF ARTS [EDINBURGH] 45, no. 2318 (Apr. 23, 1897): 531-540. [Annotated bibliographic essay on the history of experiments in color photography, organized chronologically from 1810 to 1897, and then by author within the year. Provides, in effect, a survey of the evolution of color photography throughout the 19th century.]

ST41 Chase, Adelaide. "A Bibliography of Photography." PHOTO ERA 8 and 9, no. 2 following (Feb. 1902 and following): vol. 8: 319-332; 359-362; 399-402; 440-442; 491-494; vol. 9 45-47;

93-96; 141-144; 191-192. [A classed guide to the literature of photography from 1860 to 1901, with subject categories ranging from "Aerial Photography" to "Trick Photography." Lists 407 books, and many periodical references. Technical and creative articles listed.]

ST42 Stenger, Erich. "Aus der Frühgeschichte der Photographie: Die englische photographische Literatur von 1839 bis 1870." DIE PHOTOGRAPHISCHE INDUSTRIE 29, no. 2-3, 8-9 (Jan. 14 - Mar. 4, 1931): 32-35, 56-57, 204, 206, 252, 254.

ST43 Marshall, Albert E. "There Were Giants Then." U.S. CAMERA 1, no. 9 (May 1940): 24-25, 65. 4 b & w. [Discusses the practice of illustrating books with original photographs which was strongest in the 1860s and 1870s. 2 b & w by Francis Frith, 2 b & w by Grundy.]

ST44 Marshall, A. E. "Some Byways in Photographic History." AMERICAN ANNUAL OF PHOTOGRAPHY 1946 (1945): 20-28. 6 b & w. [Discussion of 19th century practice of illustrating books with original photographs. Illustrations are by Francis Frith, Fizeau, James Robertson, Dr. Rankin, P. H. Delamotte & Joseph Cundall, Dr. Percy & John Spiller.]

ST45 Jakovsky, Anatole. "Les Premiers Livres Illustre par la Photographie d'apres Nature." LE VIEUX PAPIER 19, no. 146 (Jan. 1949): 301-305.

ST46 Guillemain, Charles. "Une curieuse et éphémère étape de l'illustration du livre par la photographie colée ou montée dans le texte." LE VIEUX PAPIER 20, no. 160-161 (July, Oct. 1952): 217-223, 289-294. [Annotated list of 64 books illustrated with original photographs. All the books listed are French.]

ST47 "Books Illustrated with Actual Photographic Prints." July 1954. 11 pp. [Internal research paper generated at the International Museum of Photography at George Eastman House. Lists 216 entries.]

ST48 "A Check List of Books on Photography Published in America before the Civil War. Revised August 15, 1958 from list published Feb. 14, 1947." 12 pp. [Internal research paper generated at the International Museum of Photography at George Eastman House. Lists and describes 71 works, including many not held in the IMP/GEH collections at that time. Gives holdings statements for American libraries.]

ST49 Braive, Michel-François. "A Propos du Prix Nadar. Le Photographe Imagier du Livre." JARDIN DES ARTS no. 67 (May 1960): 45-51. 8 illus.

ST50 Adhémar, Jean and André Jammes. "État des Questions sur l'Histoire de la Photographie." BULLETIN DES BIBLIOTHEQUES DE FRANCE 7, no. 7 (July 1962): 345-350.

ST51 Baier, W. "Das Buch - Ein Beitrag zur Geschichte der photographischen Buchillustration im 19. Jahrhundert." BILD UND TON 16, no. 10 (1963): 312-313, 342-345.

ST52 Schultze, R. S. "Scottish Books with Original Photographs." THE BIBLIOTHEK 4, no. 1 (1963): 3-12. [Lists 97 titles.]

ST53 Keim, Jean A. "Histoires de Photographies." CRITIQUE 22, no. 235 (Dec. 1966): 1012-1027. [Bibliographic article on nine books published on aspects of the history of photography during 1964-65.]

ST54 Keim, Jean A. "Les Histoires de la Photographie: Cent Titres pour un Essai de Bibliographie." GAZETTE DES BEAUX-ARTS 77, no. 1225 (Feb. 1971): 117-128.

ST55 Kurutz, Gary F. "California Books Illustrated with Original Photographs." BIBLIO-CAL NOTES: SOUTHERN CALIFORNIA LOCAL HISTORY COUNCIL 7, no. 2 (Summer-Fall 1974): 3-16.

ST56 Van Haaften, Julia. "'Original Sun Pictures.' A Check List of the New York Public Library's Holdings of Early Works Illustrated with Photographs, 1844 - 1900." BULLETIN OF THE NEW YORK PUBLIC LIBRARY 80, no. 3 (Spring 1977): 355-413. [Descriptive bibliography of 465 books and 96 albums in the collections. Includes an index to photographers and main entries. With an introductory essay.]

ST57 Krauss, Rolf H. "Photographs as Early Scientific Book Illustrations." HISTORY OF PHOTOGRAPHY 2, no. 4 (Oct. 1978): 291-314. 26 illus.

ST58 Krauss, Rolf H. "Travel Reports and Photography in Early Photographically Illustrated Books." HISTORY OF PHOTOGRAPHY 3, no. 1 (Jan. 1979): 15-30. * illus.

ST59 Mattison, David, comp. "British Columbia Photographers of the Nineteenth Century: An Annotated, Select Bibliography." BC STUDIES no. 52 (Winter 1981/82): 166-170. [Essay in a special issue "The Past In Focus: Photography & British Columbia, 1858 - 1914."]

ST60 Stark, Amy E. "Dissertations in the History of Photography: An Overview, Bibliography, and Index." EXPOSURE 22, no. 3 (Fall 1984): 31-42. [Lists 165 Ph.D dissertations, with a subject and name index.

ST61 Palmquist, Peter E. "Photographic Archaeology: A Case for Regional Research." CALIFORNIA MUSEUM OF PHOTOGRAPHY BULLETIN 4, no. 1 (1985): 17-29. 7 b & w. 10 illus. [Contains "A Bibliography of Regional Photography" on pp. 25-29 which lists more than 120 published works and unpublished works or works in progress.]

ST62 Layer, Harold A. "The Literature of Stereoscopy: 1853 - 1986." STEREO WORLD 14, no. 1 (Mar. - Apr. 1987): 44-45. [Chronological listing of more than eighty books on stereoscopy.]

PREHISTORY.

PREHISTORY: see also BOLTON; BURN, JOHN S.; DE LANGUE, C.; DE ROTH, K.; PEARSALL, THOMAS J.; PEALE, REMBRANDT; SCHULTZE, J. H.; WEDGWOOD;

PREHISTORY.

BOOKS

ST63 Hooper, W., M.D. *Rational Recreations, in which the Principles of Numbers and Natural Philosophy are clearly and copiously elucidated by a series of easy, entertaining, interesting experiments: amoung which are those commonly performed with the Cards.* London: s. n., 1783. 4 vol. pp. [Vol. II contains descriptions of fixed and portable camera obscura, and of the magic lantern. Vol 4, p. 323 describes the experiment "Writing on Glass by the Rays of the Sun." (Apparently a translation into English of an experiment performed in 1727 by the German physician J. H. Schulze.]

ST64 Hall, Basil. *Forty Etchings, from Sketches made with the Camera Lucida, in North America, in 1827 and 1828,* by Captain Basil Hall. Edinburgh; London: Cadell; Simpkin & Marshall, 1829. 21 pp. 20 l. of plates. 40 illus.

ST65 Society for Promoting Christian Knowledge. *The Wonders of Light and Shadow.* Published under the direction of the Committee of General Literature and Education, appointed by the Society for Promoting Christian Knowledge. London: The Society, 1851. 106 pp. 15 illus. [First history of the prehistory of photography. Reprinted (1973), Arno Press.]

ST66 Galassi, Peter. *Before Photography: Painting and the Invention of Photography.* New York: Museum of Modern Art, distributed by the New York Graphic Society, Boston., 1981. 152 pp. b & w. 120 illus. [Exhibition: The Museum of Modern Art, NY, May 9 - July 5, 1981. Bibliography, pp. 146-149.]

ST67 Schwarz, Heinrich. "An Eighteenth-Century English Poem on the Camera Obscura," on pp. 128-138 in: *One Hundred Years of Photographic History. Essays in Honor of Beaumont Newhall.* Edited by Van Deren Coke. Albuquerque, NM: University of New Mexico Press, 1975. 180 pp. 10 illus. [Unknown author, published in 1747.]

PERIODICALS

ST68 "The Camera Lucida:" GLASGOW MECHANICS' MAGAZINE 1, (1830): 401-403.

ST69 "The Camera Lucida: Invented by Dr. Wollaston: for drawing objects from nature in true perspective, and also for copying, reducing, or enlarging drawings already made." GLASGOW MECHANICS' MAGAZINE 1, (1830): 401-403.

ST70 "The Camera Obscura." MAGAZINE OF SCIENCE, AND SCHOOL OF ARTS 1, no. 1 (Apr. 6, 1839): 1. 1 illus.

ST71 "Portable Camera Obscura." MAGAZINE OF SCIENCE, AND SCHOOL OF ARTS 1, no. 2 (Apr. 13, 1839): 12-13.

ST72 "Panoramas and Cosmoramas." MAGAZINE OF SCIENCE, AND SCHOOL OF ARTS 1, no. 13 (June 29, 1839): 101-102. 1 illus.

ST73 "Wollaston's Camera Lucida, Amici's Ditto, and Alexander's Graphic Mirror." MAGAZINE OF SCIENCE AND SCHOOL OF ARTS 1, no. 43 (Jan. 25, 1840): 337-339. 4 illus.

ST74 "A Simple Camera Lucida." MAGAZINE OF SCIENCE AND SCHOOL OF ARTS 3, no. 130 (Sept. 25, 1841): 204-205. 1 illus. [Sir John Robison, Sec. of the Royal Society of Edinburgh.]

ST75 P., Edward. "Improved Camera Obscura." MAGAZINE OF SCIENCE AND SCHOOL OF ARTS 3, no. 154 (Mar. 12, 1842): 400. 1 illus.

ST76 "The Chemistry of Light in 1817." HUMPHREY'S JOURNAL 9, no. 11 (Oct. 1, 1857): 168.

ST77 "Miscellaneous: Photography Three Hundred Years Ago." PHOTOGRAPHIC NEWS 4, no. 109 (Oct. 5, 1860): 274.

ST78 "The Diorama." AMERICAN JOURNAL OF PHOTOGRAPHY AND THE ALLIED ARTS & SCIENCES n. s. vol. 3, no. 17 (Feb. 1, 1861): 263-265. [From "Bakewell's Great Facts."]

ST79 "Photography Foreshadowed." AMERICAN JOURNAL OF PHOTOGRAPHY AND THE ALLIED ARTS & SCIENCES n. s. vol. 4, no. 10 (Oct. 15, 1861): 227-228. [From "Notes & Queries." About French book, "Giphantia, or a View of What has passed," ...published in London in 1761.]

ST80 "General Notes." PHOTOGRAPHIC TIMES 16, no. 270 (Nov. 19, 1886): 600-601. [Excerpts from an article in the "N.Y. Post" by Prof. Brocklesby, describing examples of natural photographs by lightning, etc.]

ST81 Lang, William Jr., F.C.S. "Porta: His Life and Writings." ANTHONY'S PHOTOGRAPHIC BULLETIN 18, no. 23 (Dec. 10, 1887): 728-729.

ST82 "Correspondence: The History of Photography." PHOTOGRAPHIC TIMES 17, no. 327 (Dec. 23, 1887): 659-660. [Duchochois' letter praises Harrison's book on the history of photography, then suggests that the invention of the camera obscures predates J. B. Porta, whom Harrison had credited with that discovery. Duchochois mentions Leonardo de Vinci and Roger Bacon (1250).]

ST83 "Editorial Notes." PHOTOGRAPHIC TIMES 18, no. 331 (Jan. 20, 1888): 26. [A Philip Hofmeister, of Nordhausen, Germany, a minister, claims to have, in 1833, exposed paper coated with a solution of cochenille in a camera obscura "... but owing to a want of knowledge in chemistry, and without assistance the experiments were interrupted and remained uncompleted."]

ST84 "The Photography of Colors Described One Hundred and Thirty Years Ago." PHOTOGRAPHIC TIMES 21, no. 508 [sic 509] (June 19, 1891): 303-304. [Excerpted from the "Br J of Photo," Narrative of an article published in 1760 in the "Intemediare des Chercheurs et des Curieux".]

ST85 Fourdrigner, Edouard. "The Antiquity of the Lens." PHOTOGRAPHIC TIMES 23, no. 615 (June 30, 1893): 333. [From "Photo Club de Paris." Quotes Confucius, Plutarch, Vitellus, Roger Bacon, others.]

ST86 "The Fathers of Photography 1 - J. H. Schultze." PHOTOGRAPHIC TIMES 23, no. 617 (July 14, 1893): 370, plus unnumbered leaf following p. 370. 1 illus. [Johann Heinrich Schultze born 1687 at Koblitz, Germany. In 1727 he engaged in chemical experiments involving light. The illustration is a portrait from a painting.]

ST87 "Notes and News." PHOTOGRAPHIC TIMES 23, no. 616 (July 7, 1893): 353. [Brief note that a camera obscura was claimed to have been recently found in excavations in the ruined temples of Upper Egypt.]

ST88 "Editorial Notes." PHOTOGRAPHIC TIMES 37, no. 9 (Sept. 1905): 421-422. [Report of claim made by H. Russell Perkins of Newburyport, MA, that his father Dr. Henry C. Perkins made photos on sensitized plates in 1838, before Daguerre's announcement.]

ST89 Gross, M. "Wedgwood to Talbot." PHOTO ERA 41, no. 11 (Nov. 1918): 227-229.

ST90 Schwarz, Heinrich. "Art and Photography: Forerunners and Influences." MAGAZINE OF ART 42, no. 7 (Nov. 1949): 252-257. 6 b & w. 14 illus.

ST91 "Cameras Before Photography." IMAGE 2, no. 3 (Mar. 1953): 11-12. 2 illus.

ST92 Matthews, G. E. and J. I. Crabtree. "The First Use of Hypo." IMAGE 2, no. 5 (May 1953): 26-27. [Brief history of early uses of "hypo" (sodium thiosulfate) from Herschel's discovery 1819, Reade, Talbot. Includes letters about use in photography from 1839.]

ST93 "Index to Resources in the George Eastman House Collection." IMAGE 5, no. 1 (Jan. 1956): 18-19. 4 illus. [Silhouettes, camera obscura, physionotrace, etc.]

ST94 Kingslake, Rudolph. "The Camera Lucida." IMAGE 6, no. 8 (Oct. 1957): 195-197. 5 illus.

ST95 Seymour, Charles, Jr. "Dark Chamber and Light-Filled Room: Vermeer and the Camera Obscura." ART BULLETIN 46, no. 3 (Sept. 1964): 323-339.

ST96 Schwarz, Heinrich. "Vermeer and the Camera Obscura." PANTHEON 24, no. 3 (May - June 1966): 170-182.

ST97 Fink, Daniel A. "Vermeer's Use of the Camera Obscura - A Comparative Study." ART BULLETIN (Feb. 1972): 493-505. 15 illus.

ST98 Condax, Philip L. "Tent Style Camera Obscura." IMAGE 15, no. 3 (Sept. 1972): 8-9, cover. 3 illus. [Jacques-Louis-Vincent Chevalier, father of Daguerre's lensmaker, built a camera obscura and lenses in 1820s.]

ST99 Gill, Arthur T. "The London Diorama." HISTORY OF PHOTOGRAPHY 1, no. 1 (Jan. 1977): 31-36. 7 illus.

ST100 Deutelbaum, Marshall. "'Rounds of Amusement': The Thaumatrope." IMAGE 20, no. 1 (Mar. 1977): 28-29. 1 illus.

ST101 Henius, Bent. "Apropos: Denmark - History of Photography. Discoverer of the Movement of Light." CAMERA (LUCERNE) 56, no. 4 (Apr. 1977): 40-41. 1 illus. [Danish astronomer Ole Romer (1644-1710).]

ST102 Wheelock, Arthur K., Jr. "Constatijn Huygens and Early Attitudes Towards the Camera Obscura." HISTORY OF PHOTOGRAPHY 1, no. 2 (Apr. 1977): 93-103. 5 illus.

ST103 "Camera Obscura Watercolor." HISTORY OF PHOTOGRAPHY 1, no. 2 (Apr. 1977): 104. 2 illus. [Two watercolors made by American artist W. Banton in 1818.]

ST104 Lipson, Stanley H. "Euclid's Optica." STEREO WORLD 5, no. 1 (Mar. - Apr. 1978): 20. [Euclid, Greek mathematician about 300 B.C., wrote the earliest extant work on mathematical optics. Five of his sixty-one propositions in this work deal with binocular vision.]

ST105 Le Pourhiet, Alain. "A Photographic Camera Obscura." HISTORY OF PHOTOGRAPHY 2, no. 3 (July 1978): 186. 1 illus.

ST106 Neite, W. "The Cologne Diorama." HISTORY OF PHOTOGRAPHY 3, no. 2 (Apr. 1979): 105-109. 5 illus. [Diorama opened on Cologne in 1843.]

ST107 Wilsher, Ann and William B. Becker. "Phantasmagoria, A View in Elephanta." HISTORY OF PHOTOGRAPHY 3, no. 3 (July 1979): 210. 1 illus. [A Thomas Rowlandson aquatint of a satirical cartoon of a lantern slide show, issued in 1816.]

ST108 Kissick, Kathleen. "Count Algarotti on the Camera Obscura." HISTORY OF PHOTOGRAPHY 3, no. 3 (July 1979): 193-194. 7 illus. [About Count Algarotti. His chapter on the camera obscura is reproduced from an English translation of his "An Essay on Painting" published in 1764.]

ST109 Le Pourhiet, Alain. "Corrigendum: A Photographic Camera Obscura." HISTORY OF PHOTOGRAPHY 3, no. 3 (July 1979): 283. 1 b & w.

ST110 Harmant, Pierre G. "Paleophotographic Studies: Was photography born in the 18th century?" HISTORY OF PHOTOGRAPHY 4, no. 1 (Jan. 1980): 39-45. 4 illus. [Examination of military and other government documents hold evidence that Nicéphore Niépce and his brother Claude may have been working through "photographic" ideas much earlier than previously assumed.]

ST111 Wilsher, Ann. "Horace Walpole, William Storer and the Accurate Delineator." HISTORY OF PHOTOGRAPHY 4, no. 3 (July 1980): 247-249. [Use of a camera obscura by artist/art observer Horace Walpole, during the second half of the 18th century. Camera made by William Storer.]

ST112 "The Magic Lantern." HISTORY OF PHOTOGRAPHY 5, no. 1 (Jan. 1981): 58. 1 illus. [C. A. P. van Loo's (1719-1795) genre painting, "The Magic Lantern," reproduced.]

ST113 Graver, Nicholas M., communicated by. "Camera Obscura." HISTORY OF PHOTOGRAPHY 6, no. 2 (Apr. 1982): 143-144. 2 illus. [Reprinted from "Cassell's Complete Book of Sports and Pastimes...", 1982.]

ST114 Scott, Peter. "Which Came First, Camera or Photograph: An account of the Camera Obscura Gallery at the National Museum of Photography." PHOTOGRAPHIC COLLECTOR 4, no. 1 (Spring 1982): 90-105. 24 illus.

ST115 Hammond, John H. "Patent No. 1183.29 June 1778: The Royal Accurate Delineator." PHOTOGRAPHIC COLLECTOR 5, no. 2 (1984): 181-185. 5 illus. [British camera obscura.]

ST116 Barnes, John. "Inventing the Camera." PHOTOGRAPHIC COLLECTOR 5, no. 2 (1984): 134-141. 10 illus. [The Thaumatrope, (ca. 1827), Phenakisticope (1832), Zoetrope (1833), Phantasmasscope (1833).

ST117 Marien, Mary Warner. "Toward a New Prehistory of Photography." VIEWS: THE JOURNAL OF PHOTOGRAPHY IN NEW ENGLAND. 6, no. 2 (Special Issue: Winter 1985): 12-16. 7 illus.

ST118 "Use of the Camera Obscura." HISTORY OF PHOTOGRAPHY 11, no. 1 (Jan. - Mar. 1987): 37. [From "The Glasgow Mechanic's Magazine," (Aug. 7, 1824).]

HISTORY: GENERAL

HISTORY: GENERAL: RETROSPECTIVE.
BOOKS

ST119 Harrison, William Jerome. *A History of Photography Written as a Practical Guide and an Introduction to Its Latest Developments,* by William Jerome Harrison. With a Biographical Sketch of the Author, and an Appendix by Dr. Maddox on the Discovery of the Gelatine-Bromide Process. "Scoville's Photographic Series, No. 23." New York: Scovill Manufacturing Co., 1887. 36 pp. [(1888) Bradford, England: Percy Lund & Co.]

ST120 Gernsheim, Helmut and Alison Gernsheim. *A History of Photography from the earliest use of the Camera Obscura in the Eleventh Century up to 1914.* London: Oxford University Press, 1955. 359 pp. b & w. illus. [2nd ed. (1969) NY: McGraw-Hill.]

ST121 Bliven, Floyd Edward. *The Daguerreotype Story.* NY: Vantage Press, 1957. viii, 22 pp. 20 l. of plates.

ST122 Bramsen, Henrik Boe, Marieanne Brons, and Bjorn Ochsner. *Early Photographs of Architecture and Views in Two Copenhagen Libraries.* Copenhagen: Thaning & Appel, 1957. 92 pp. b & w. [Biographies of early travel photographers and topographic view photographers, with checklists of works held in two libraries in Copenhagen.]

ST123 Coke, Van Deren. *The Painter and the Photograph.* Albuquerque, NM: University of New Mexico Press, 1964. 79 pp. New Mexico. University Art Museum. *The Painter and the Photograph;* An exhibition organized by the staff of the Art Gallery, the University of New Mexico, and shown during 1964 and 1965 at the following institutions:... Van Deren Coke, director of the exhibition. Albuquerque, NM: University of New Mexico Press, 1964. 79 pp. b & w. illus.

ST124 Ottawa. National Gallery of Canada. *The Art of Early Photography. L'art de la photographie à ses débuts.* Ottawa: R. Duhamel, 1965. 19 pp. illus.

ST125 Braive, Michel François. *The Era of the Photograph. A Social History.* London: Thames & Hudson, 1966. 367 pp. b & w. illus.

ST126 Lindquist-Cock, Elizabeth. *Photography and Art in the Nineteenth Century.* Exhibition in Conjunction with The Symposium on Photography and Art, Mount Holyoke College. South Hadley, MA: Mount Holyoke College, 1971. 31 pp. 16 b & w. [Exhibition catalog, Mount Holyoke College, Apr. 14 - Apr. 30, 1971. Essay by Elizabeth Lindquist-Cock, on pp. 3-12. "Checklist," on pp. 13-19. 41 prints by 21 photographers.]

ST127 Castle, Peter. *Collecting and Valuing Old Photographs.* London: Garnstone Press, 1973. 168 pp. illus.

ST128 Mathews, Oliver. *Early Photographs and Early Photographers: A Survey in Dictionary Form.* London: Reedminister Publications, 1973. viii, 198 pp. b & w.

ST129 Buckland, Gail. *Reality Recorded, Early Documentary Photography.* Greenwich, CT: New York Graphic Society, 1974. 127 pp. b & w. illus.

ST130 Mathews, Oliver. *The Album of Carte-de-Visite and Cabinet Portrait Photographs 1854 - 1914.* London: Reedminister Publications, 1974. 184 pp. illus.

ST131 Chiarenza, Carl. "Notes on Aesthetic Relationships between Seventeenth-Century Dutch Painting and Nineteenth-Century Photography," on pp. 19-34 in: *One Hundred Years of Photographic History. Essays in Honor of Beaumont Newhall.* Edited by Van Deren Coke. Albuquerque, NM: University of New Mexico Press, 1975. 180 pp. 8 b & w. 4 illus.

ST132 *Photography: the first eighty years* London: P. & D. Colnaghi & Co., Ldt., 1976. 262 pp. b & w. illus. [Ex. cat.: Colnaghi & Co., London, Oct. 27 - Dec. 1, 1976. Text by Valerie Lloyd.]

ST133 Welling, William. *Collector's Guide to Nineteenth Century Photographs.* New York: Macmillan Co., 1976. 204 pp. illus.

ST134 *Niépce to Atget: The First Century of Photography.* Introduction by David Travis. Essays by Marie-Thérèse Jammes and André Jammes. Chicago: Art Institute of Chicago, 1977. 116 pp. 144 b & w.

ST135 Maddow, Ben. Photographs compiled and edited by Constance Sullivan. *Faces: A Narrative History of the Portrait in Photography.* Boston: New York Graphic Society, 1977. 544 pp. 80 b & w.

ST136 Thomas, Alan. *Time in a Frame: Photography and the Nineteenth-Century Mind.* New York: Schocken Books, 1977. 172 pp. 152 l. of plates.

ST137 Buckland, Gail. *First Photographs: People, Places and Phenomena as Captured for the First Time by the Camera.* London; New York: Robert Hale; Macmillan Publishing Co., 1980. 272 pp. 300 b & w. illus.

ST138 Feldvebel, Thomas P. *The Ambrotype, Old and New.* Rochester, NY: Graphic Arts Research Center, 1980. v, 51 pp. illus. [Bibliography pp. 50-51.]

ST139 McCauley, Elizabeth Anne. *Likenesses; Portrait Photography in Europe, 1850 - 1870.* Albuquerque, NM: University of New Mexico Art Museum, 1980. 85 pp. 71 b & w. [Exhibition catalog.]

ST140 Reilly, James M. *The Albumen & Salted Paper Book.* Rochester, NY: Light Impressions Corp., 1980. 133 pp. illus. [Cover title. "The History and Practice of Photographic Printing, 1840-1895."]

ST141 *Touring the World: 19th Century Travel Photographs.* Amarillo, TX: Amarillo Art Center, 1981. [28] pp. 27 b & w. 13 illus. [Exhibition catalog, Amarillo Art Center, Amarillo, TX, Mar. 4 - May 10, 1891, and Huntington Art Gallery, University of Texas, Austin, July 1 - Aug. 9, 1981. "introduction," by David Turner, on p. 3. "Viewing the World," by David Turner, on pp. 5-6. "The Victorian Traveller," by Bill Jay, on pp. 7-9. "The Touring Photographer," by Roy Flukinger on pp. 11-13. "Catalogue of the Exhibition," on pp. 26-28. Sixty-four prints from Egypt, the Near East, Central America, Europe, India and Japan.]

ST142 Crawford, William. *The Keepers of Light: A History and Working Guide to Early Photographic Processes.* Dobbs Ferry, NY: Morgan and Morgan, 1981. 324 pp. illus.

ST143 Darrah, William C. *Cartes de Visite in Nineteenth Century Photography.* Gettysburg, PA: W. C. Darrah, 1981. 221 pp. illus.

ST144 McCulloch, Lou W. *Card Photographs: A Guide to their History and Value.* Exton, PA: Schiffer Pub., 1981. 235 pp. illus.

ST145 Gernsheim, Helmut. *The Origins of Photography.* With 191 illustrations. London: Thames and Hudson, 1982. 280 pp. 191 illus. [This is a revised, third edition of the first part of "The History of Photography," first published in 1955, then republished in 1969. This edition contains a new chapter, "The origins of photography in Italy," by Daniela Palazzoli, on pp. 167-178.]

ST146 Oliphant, Dave & Thomas Zigal. *Perspectives on Photography. Essays on the Work of Du Camp, Daveer, Robinson, Stieglitz, Strand & Smithers at the Humanities Research Center.* Austin, TX: Humanities Research Center, Univ. of TX in Austin., 1982. 180 pp. illus. [Materials in Humanities Research Center, University of TX in Austin.]

ST147 *New World Africans: Nineteenth Century Images of Blacks in South America and the Caribbean.* New York: The New York Public Library, Astor, Lenox and Tilden Foundations, 1985.

ST148 Collins, Kathleen. *The Camera as an Instrument of Persuasion: Studies of 19th-century Propaganda Photography.* University Park, PA: Pennsylvania State University, 1985. [Ph.D. Dissertation, Pennsylvania State University, (May 1985).]

ST149 Fralin, Frances. With an essay by Jane Livingston. *The Indelible Image: Photographs of War - 1846 to the Present.* New York: Harry N. Abrams, Inc., with the Corcoran Gallery of Art, Washington, DC, 1985. 256 pp. 127 b & w.

ST150 Landsell, Avril. *Fashion à la Carte 1860 - 1900: A Study of Fashion through Cartes-de-Visite.* Aylesbury, England: Shire Publications, Ltd., 1985. 96 pp. b & w.

ST151 Bánta, Melissa and Curtis M. Hinsley, with the assistance of Joan Kathryn O'Donnell. *From Site to Sight. Anthropology, Photography, and the Power of Imagery.* A photographic exhibition from the collections of the Peabody Museum of Archaeology and Ethnology and the Department of Anthropology, Harvard University. Cambridge, MA: Peabody Museum Press, distributed by Harvard University Press, 1986. 136 pp. 97 b & w. [Exhibition Catalog, Peabody Museum, Harvard University, opened Sept. 5, 1986, then travelled. Essays include "Photography in the Service of Anthropology," "Basic Photographic Processes," and "Nineteenth-Century Visions of the Exotic: Travel and Expeditionary Photography," etc. "Bibliography," on pp. 128-134.]

ST152 Johnson, R. F. and R. H. Shimshak. *The Power of Light: Daguerreotypes from the Robert Harshorn Shimshak Collection.* San Francisco, CA: Ashenbach Foundation for the Graphic Arts and the Fine Arts Museums of San Francisco, 1986. 48 pp. 28 b & w.

ST153 Lifson, Ben. *"...images that yet/ Fresh images beget..." Photographing Art.* J. Paul Getty Museum, 1987. 1 sheet folded into 8 pages pp. 5 b & w. [Exhibition catalog: J. Paul Getty Museum, Sept. 15 - Nov. 15, 1987. Illustrations are photographs by W. H. F. Talbot; Félix Tenyard; Gustave Le Gray; Clarence Kennedy; Walker Evans.]

ST154 Sobieszek, Robert A. *"This Edifice Is Colossal": 19th-Century Architectural Photography.* Rochester, NY: International Museum of Photography at George Eastman House, 1987. 84 pp. 149 b & w. [Exhibition catalog, International Museum of Photography at George Eastman House, Rochester, NY, Nov. 8, 1986 - Jan. 4, 1987, then travelled. 168 prints listed.]

ST155 Younger, Dan. *Cartes-de-Visite: Precedents and Social Influences.* Riverside, CA: California Museum of Photography, 1987. 24 pp. illus.

ST156 Edwards, Gary. *International Guide to Nineteenth-Century Photographers and Their Works.* Boston: G. K. Hall & Co., 1988. 391 pp.

ST157 Ostroff, Eugene, ed. *Pioneers of Photography; Their Achievements in Science and Technology.* Springfield, VA: Society of Photographic Scientists and Engineers, 1988. 286 pp. [Twenty-six essays on 19th and 20th century pioneers, including the Rev. Levi Hill, and others.]

ST158 Naef, Weston. *Experimental Photography: Discovery & Invention.* J. Paul Getty Museum, 1989. 1 sheet folded into 8 pages 6 b & w. [Exhibition catalog: J. Paul Getty Museum, Jan. 17 - Apr. 2, 1989. Illustrations are photographs by W. H. F. Talbot; Anna Atkins; Hippolyte Bayard; Hill & Adamson.]

ST159 Cameron, John B. and William B. Becker, eds. *Photography's Beginnings: A Visual History Featuring the Collection of William B. Becker.* Introduction by Heinz K. Henish. Rochester, MI: Oakland University, distributed by the University of New Mexico Press, 1989. 176 pp. 115 b & w. 78 color.

ST160 Wood, John, ed. *The Daguerreotype. A Sesquicentennial Celebration.* Iowa City: University of Iowa Press, 1989. 141 pp. 100 l. of plates. illus. ["Silence and Slow Time: An Introduction to the Daguerreotype," by John Wood, pp. 1-29; "Rembrandt Perfected," by Ben Maddow, on pp. 30-42; "The Genius of Photography," by Janet E. Buerger, on pp. 43-59; "Mirror in the Marketplace: American Responses to the Daguerreotype, 1839 - 1851," by Alan Trachtenberg, on pp. 60-73; "Southworth and Hawes: The Artists," by Matthew R. Isenberg, on pp. 74-78; "Southworth and Hawes: The Studio Collection," by Ken Appollo, on pp. 79-90; "Beard and Claudet: A Further Inquiry," by Roy Fluckinger, on pp. 91-96; "Delicate and Complicated Operations: The Scientific Examination of the Daguerreotype," by M. Susan Barger, on pp. 97-109; "Heavy Lightness, Serious Vanity: Modern Daguerreotypy," by Grant B. Romer, on pp. 110-115; "The Illustrations," on pp. 117-135; "Selected Bibliography," on pp. 137-141.]

PERIODICALS

ST161 Platt, S. L. "Memories of the Past." PHILADELPHIA PHOTOGRAPHER 17, no. 193 (Jan. 1880): 23-24. [Early technical history.]

ST162 Ehrmann, Charles. "A Chapter in the History of Photography." PHOTOGRAPHIC TIMES 14, no. 160 (Apr. 1884): 181-182. [Discussion of the technical history of emulsion processes in the 1850s.]

ST163 Ehrmann, Charles. "A Few Remarks on Fixing." PHOTOGRAPHIC TIMES 14, no. 161 (May 1884): 231-233. [Technical, but contains theory and some history of investigations.]

ST164 Ehrmann, Charles. "The Action of Light on Salts of Silver." PHOTOGRAPHIC TIMES 14, no. 162 (June 1884): 294-298.

ST165 Taylor, J. Traill. "Ambrotypes." PHOTOGRAPHIC TIMES 14, no. 165 (Sept. 1884): 469-471.

ST166 Stein, Theo., M.D. "Photographing the Larynx." PHOTOGRAPHIC TIMES 15, no. 187 (Apr. 17, 1885): 202-203. 5

illus. [Survey of investigations of this area of study occurring from 1862 on. Illustrated with line cuts of special cameras constructed for this study. Mentions himself and Prof. Czermack (Paris?), Dr. T. R. French (Brooklyn), L. Brown & E. Behuke (England). From "La Lumiere Electric."]

ST167 Harrison, W. Jerome. "Chapters In the History of Photography." PHOTOGRAPHIC TIMES 16-17, nos. 275 (Dec. 24, 1886 - Aug. 19, 1887): 668-670, 690-691, 7-9, 17-18, 31, 43, 59-60, 71-72, 82-83, 93-94, 107-108, 120, 130-131, 143-144, 155-156, 167-169, 202, 213-214, 225, 248-249, 260-261, 272, 287-2888, 300-301, 313, 335-336, 347-349, 360-361, 372, 385-386, 397-398, 407-408, 422-424. [Prehistory, Daguerre, the Daguerreotype, Fitzeau, Draper and Morse, Claudet,Charles, Matthew Boulton, Wedgewood, Davy, Talbot, etc. through 1880s.]

ST168 "Daguerreotypy." PHOTOGRAPHIC TIMES 19, no. 402 (May 31, 1889): 279-281. 1 illus. [Reprise of early history and process of the daguerreotype. Engraving of an early daguerreotype studio.]

ST169 Champney, J. Wells. "Fifty Years of Photography." HARPER'S NEW MONTHLY MAGAZINE 79, no. 471 (Aug. 1889): 357-366. 1 illus. [Brief survey of photography. Illustration is an engraving of Daguerre, from a daguerreotype taken by the Meade Brothers. Article discusses Talbot, Daguerre, Draper, etc.]

ST170 Adams, W. I. Lincoln. "Notes and News: Fifty Years of Photographic Growth." PHOTOGRAPHIC TIMES 19, no. 413 (Aug. 16, 1889): 416-417. [From the "Boston Globe." Brief survey of the prehistory and early discoveries in photography.]

ST171 "Notes and News." PHOTOGRAPHIC TIMES 19, no. 416 (Sept. 6, 1889): 453-454. [From "Processes of Pure Photography," by W. K. Burton and Andrew Pringle. Brief survey of history of the medium.]

ST172 C. J. "Notes and News: Platinum Toning." PHOTOGRAPHIC TIMES 20, no. 440 (Feb. 21, 1890): 96-97. [From "Photography." Actually a historical survey of toning prints from the 1860s.]

ST173 Bothamley, C. H. "The Latent Photographic Image." PHOTOGRAPHIC TIMES 20, no. 455-456 (June 6 - June 13, 1890): 272-275, 283-286. [Read before the London Camera Club Conference.]

ST174 Harrison, W. Jerome. "The Chemistry of Fixing." PHOTOGRAPHIC TIMES 20, no. 465 - 483 (Aug. 15 - Dec. 19, 1890): 403-404, 470-471, 481-482, 503-505, 540-542, 555-556, 587-589,611-612, 632-633. [Series on the history of chemical discoveries from Wedgewood, Davy, and Niépce up to the 1890s.]

ST175 Sherman, W. H. "The Rise and Fall of the Daguerreotype." PHOTOGRAPHIC TIMES 20, no. 484 (Dec. 26, 1890): 650-651. [Sherman was a working daguerreotypist. This article primarily a general discussion of the process, and a discussion of its strengths and weaknesses.]

ST176 Harrison, W. Jerome. "The Chemistry of Fixing. Why do Photographs Fade?" PHOTOGRAPHIC TIMES 21, no. 485 (Jan. 2, 1891): 4-6. [Serial article. This section is actually a history of technical photography, with reprints of articles and reports from the 1850's, article first published in the Journal of the London Photographic Society Nov. 21, 1855.]

ST177 Harrison, W. Jerome. "The Toning of Photographs Considered Chemically, Historically, and Generally. Chapters 1-10." PHOTOGRAPHIC TIMES 21, no. 498-508 (Apr. 3 - June 12, 1891): 161-162, 171-173, 196-198, 206-208, 217-219, 233-234, 243-244, 257-259, 285-286. [Survey of toning processes and techniques used in the past and present. Names prominent figures, includes formulas, and contains bibliographies of earlier articles. Given the dominant historiography of that time, this series is, in effect, a historical survey. (Ch. 1) Fizeau's 1841 report, translated from the French. (Ch. 2) Talbot, Hunt on toning paper prints. (Ch. 3) T. F. Harwich (1855). (Ch. 4) Harwich, Waterhouse, LeGray. (Ch. 5) Hannaford & Laborde (1859). (Ch. 6) Maxwell Lyte (1859), LeGray, T. Sutton, etc. (Ch. 7) John Heywood (1859), G. Spiller (1863), A. Hughes (1865), etc. (Ch. 8) T. Sutton (1859), Davanne & Girard (1863). (Ch. 9) [Contemporaries, after 1879.] (Ch. 10) W. T. Bovey (1868), N. K. Cherrill (1868), Durand (1876), Heisch (1865), A. Lewis (1879), etc.]

ST178 Pike, Nicolas. "Photography As It Was and Is. Part 1." PHOTOGRAPHIC TIMES 21, no. 503 (May 8, 1891): 226-227. [Brief general survey of technological advances in the medium by Pike, who claims to have invented a dry-plate process in 1856. From the "Scientific American."]

ST179 Ehrmann, Charles. "The Albumen Process. Parts 1 - 4." PHOTOGRAPHIC TIMES 21, no. 506 [sic 507]-510 (June 5 - June 26, 1891): 269-270, 281-283, 293-294, 305-306. [This series is a survey of the inventors and practitioners of albumen processes in photography. Given the historiography of the period this is, in effect, a historical article. Part 1 deals with American practitioners, mentioning Frederick Langenheim and discussing John A. Whipple. Describes Whipple's "celebrated albumen honey process" which was called by Whipple "crystalotypy." Part 2 discusses Niépce, Blanquart-Evrard, J. R. LeMoyne, Groll, Humbolt de Molard, Mayall. Part 3 discusses Mayall, Dr. Maddox, John Craud, Duchoclois, F. Richards, Coale & Shadbolt, et al. Part 4 discusses William Ackland (1856), Fothergill.]

ST180 Harrison, W. Jerome. "The Chemistry of Photography." PHOTOGRAPHIC TIMES 22, no. 539 - 554 (Jan. 22 - Apr. 29, 1892): 27-29, 41-42, 54-56, 72-73, 83-84, 95-96, 108-109, 123-125, 133-135, 146-148, 159-160, 172, 197-199, 214-216, 225-226. [This serialized survey is a history of investigations and discoveries in the chemistry of photography from the early 1800s to the 1890s. Harrison credits individuals, gives their formulas, and cites his sources.]

ST181 "Photography for Beginners: Historial Introduction. Part 1." PHOTOGRAPHIC TIMES 22, no. 543 (Feb. 12, 1892): 80-82. 2 illus. [Brief survey. Daguerre, Niépce, Porta, etc.]

ST182 "History of the Gelatine Process." PHOTOGRAPHIC TIMES 22, no. 546 (Mar. 4, 1892): 118-119. [Brief survey. Niépce de St. Victor, A Poitevin (1851), Alexis Gaudin (1861), B. J. Sayce & W. B. Boldon (1864), Dr. R. L. Maddox (1871), Charles Bennett (1878), Geo. Mansfield (1879), Dr. von Monckhoven (1879).]

ST183 "Panoramic Photography." CHAMBERS'S JOURNAL 70, no. 479 (Mar. 4, 1893): 133-135. [Survey of panoramic photography. Mentions Col. R. W. Stewart, Royal Engineers and W. Gage Tweedy in 1860s; Johnson's Pantascopic camera of 1864, etc.]

ST184 "Senex". "Correspondence." PHOTOGRAPHIC TIMES 24, no. 663 (June 1, 1894): 349. [Letter commenting favorably on the "Fathers of Photography" series, gives a brief summation of early history, mentions H. Bayard.]

ST185 Lochman, Charles L. "The Daguerreotype." PHOTOGRAPHIC TIMES 29, no. 11 (Nov. 1897): 508-509. illus. [Description of the process.]

ST186 "A Plea for Imperfection." WILSON'S PHOTOGRAPHIC MAGAZINE 35, no. 497 (May 1898): 224-225. [From "Amateur Photographer," reprinting an Article first published in the "Illustrated London News," Mar. 19, 1864.]

ST187 Waterhouse, Major-General J. "The Teachings of the Daguerreotype. Part 1 - 2." WILSON'S PHOTOGRAPHIC MAGAZINE 37, no. 517-518 (Jan. - Feb. 1900): 34-40, 80-88. [Second Trail Taylor Memorial Lecture, read before the Royal Photographic Society, Nov. 1, 1899. Survey of scientific discoveries in early history. Discusses Talbot, J. W. Draper.]

ST188 "The Photographer's Position." WILSON'S PHOTOGRAPHIC MAGAZINE 37, no. 520 (Apr. 1900): 151-152. [Discussion of the rise and fall of the professional photographer's status with the general public since photography's invention.]

ST189 "Fugitive Prints." WILSON'S PHOTOGRAPHIC MAGAZINE 37, no. 520 (Apr. 1900): 158-159. [General discussion around question of permanency of prints and the quality of work in 1900 vs. earlier. Brings in commentary on changing role of photography, influx of amateurs, etc.]

ST190 Boyd, John. "Twenty-Five Years Ago." AMERICAN ANNUAL OF PHOTOGRAPHY FOR 1909 (1909): 194, 196, 198-199. [A brief survey of the processes and techniques in use before the development of the dry plate.]

ST191 Salmon, Percy B. "The Earliest Photographs." CASSELL'S MAGAZINE 50, (Sept. 1910): 465-472.

ST192 Wall, E. J., F.C.S., F.R.P.S. "The Daguerreotype Process." AMERICAN PHOTOGRAPHY 17, no. 4 (Apr. 1923): 234-242. illus.

ST193 Howe, M. E. "More about Daguerreotypes." PHOTO ERA 51, no. 9 (Sept. 1923): 146-147.

ST194 Bugeja, Vincent, M.A. "The Origin of Photography - A Retrospect." AMERICAN PHOTOGRAPHY 20, no. 1 (Jan. 1926): 8-13. illus.

ST195 "History of a Carte-de-visite, 1865." PHOTO ERA 66, no. 5 (May 1931): 250-252.

ST196 Newhall, Beaumont. "Photography and the Artist." PARNASSUS 6, no. 5 (Oct. 1934): 24-25, 28-29. 2 b & w. [Photos by Hill & Adamson and O. G. Rejlander.]

ST197 Epstein, Edward and John Tennant. "Daguerreotype in Europe and the United States, 1839-1853." PHOTO-ENGRAVERS BULLETIN 24, no. 4 (Nov. 1934): 262-274.

ST198 Newhall, Beaumont. "Documentary Photography." AMERICAN PHOTOGRAPHY 32, no. 8 (Aug. 1938): 558-562. illus.

ST199 Newhall, Beaumont. "Pictures from a Black Box, the Birth of Photography - A Chronology." U. S. CAMERA 1, no. 3 (Mar. 1939): 16, 72. 2 b & w.

ST200 "A Hundred Years of Photography." NATURE 143, no. 3632 (June 10, 1939): 963-964.

ST201 Bull, A. J., Ph.D., M.Sc., F.R.P.S. "Some Early Photographic Processes." JOURNAL OF THE ROYAL SOCIETY OF ARTS (LONDON) 87, no. 4518 (June 23, 1939): 837-840. 1 illus. [Calotype and Wet Collodion processes explained. This essay also published in "Photographic Journal" (Sept. 1939).]

ST202 Epstean, Edward. "An Epilogue to the Centenary of Photography." PENROSE ANNUAL 1940 42, (1940): 93-98.

ST203 "Centennial of Photography." PENNSYLVANIA ARTS AND SCIENCES 4, no. 1 (Fall 1940): 7, 18-94. [Special issue devoted to "The Centennial of Photography," edited by Frank V. Chambers and John A. Tennant. Includes articles: "The Daguerreotype," "The Negative Positive Idea," "The Photograph on Glass," "A Century of Photographic Lenses," by Everett W. Melson, "Photography and Science," by F. Wager Schlesinger, and others.]

ST204 Newhall, Beaumont. "A Brief History of Photographic Techniques." CIBA SYMPOSIA 4, no. 5-6 (Aug. - Sept. 1942): 1330-1339. 7 illus. Newhall, Beaumont. "The Daguerreotype." ANTIQUES 53, no. 4 (Apr. 1948): 278-280. illus.

ST205 Hammond, Arthur. "Beginnings of Photography." AMERICAN PHOTOGRAPHY 43, no. 10 (Oct. 1949): 644-646. illus.

ST206 Schwarz, Heinrich. "Art and Photography: Forerunners and Influences." MAGAZINE OF ART 42, no. 7 (Nov. 1949): 252-257. 6 b & w. 14 illus.

ST207 Kracauer, Sigfried. "The Photographic Approach." MAGAZINE OF ART 44, no. 3 (Mar. 1951): 107-113. 8 b & w. [Photos by Talbot, Adam-Salomon, A. J. Russell, others.]

ST208 Newhall, Beaumont. "The Story of Tintypes." AMERICAN ANNUAL OF PHOTOGRAPHY 1952 (1952): 158-163. illus.

ST209 "Early Photographic Medical Illustrations." IMAGE 1, no. 4 (Apr. 1952): 2-3. [Brief history of medical photography in the 19th century.]

ST210 "The Boyer Collection." IMAGE 2, no. 7 (Oct. 1953): 41-48. 4 b & w. 8 illus. [Issue devoted to Boyer Collection at the George Eastman House. Article contains sections on Southworth & Hawes, daguerreotypes, calotypes, Hill & Adamson, Boyer's book collection.]

ST211 "The Names of Prints: A Glossary." IMAGE 3, no. 4 (Apr. 1954): 29-30. [First in a series of columns that defines prints according to their supports, light-sensitive materials, and medium of suspension. "Albumen Print to Calotype."]

ST212 "The Names of Prints: A Glossary." IMAGE 3, no. 7 (Oct. 1954): 45-46. [Second column in a continuing series. "Carbon print" to "glue printing."]

ST213 "The Names of Prints: A Glossary." IMAGE 3, no. 9 (Dec. 1954): 62. [Third and last of articles defining print processes. "Greasy ink process" to "Woodburytype."]

ST214 Newhall, Beaumont. "60,000 Eggs a Day." IMAGE 4, no. 4 (Apr. 1955): 25-26. 2 illus. [Describes manufacture and use of albumen paper for photographic prints during the 19th century.]

ST215 Newhall, Beaumont. "Light Sensitivity of Early Photographic Materials." IMAGE 4, no. 4 (Apr. 1955): 31. [Lists, charts, exposure times necessary to several processes.]

ST216 "Photographs from the Johnston Album." IMAGE 4, no. 5 (May 1955): 33-35. 4 b & w. [Eastman House acquires album of 176 original 19th century prints. Hill & Adamson (2), McGlashan (1), J. B. Johnston (1).]

ST217 Newhall, Beaumont. "Plastic Daguerreotype Cases." IMAGE 4, no. 9 (Dec. 1955): 65-67. 3 illus. [On the invention of relief daguerreotype cases, made of plastic, 1853.]

ST218 Newhall, Beaumont. "Photographic Words." IMAGE 5, no. 5 (May 1956): 234-235. [Discussion of the evolution of the term "photography" (From Sir John Herschel) and other terms.]

ST219 "Index to Resources: Daguerreotypes." IMAGE 5, no. 6 (June 1956): 140-141. 7 b & w. 1 illus. [Listing of some of the daguerreotype landscapes in the G. Eastman House collection. S. M. Bemis, M. Clausel, Delemotte & Alary, unknowns.]

ST220 Newhall, Beaumont. "Photographic Words." IMAGE 5, no. 10 (Dec. 1956): 234-235.

ST221 "Index to Resources: American Daguerreotype Apparatus." IMAGE 6, no. 3 (Mar. 1957): 51.

ST222 "Index to Resources: Daguerreotype Cases." IMAGE 6, no. 8 (Oct. 1957): 198-199. 7 illus.

ST223 "Index to Resources: Daguerreotype Cases." IMAGE 6, no. 9 (Nov. 1957): 224-225. 6 illus.

ST224 Doty, Robert. "Aloft ... with balloon and camera." IMAGE 7, no. 9 (Nov. 1958): 195-210. 10 b & w. 7 illus. [History with aerial photography, 19th and 20th centuries.]

ST225 Peterich, Gerda. "Nineteenth Century Architectural Photographs: A Survey of Approaches and Techniques." IMAGE 7, no. 10 (Dec. 1958): 220-232. 13 b & w. [Talbot, Le Secq, C. S. S. Dickins, Marville, J. Valentine, G. W. Wilson, F. Frith, John Shaw Smith, Bisson Freres, Fred H. Evans mentioned.]

ST226 Braive, Michel-Francois. "A Propos du Prix Nadar. Le Photographe Imagier du Livre." JARDIN DES ARTS no. 67 (May 1960): 45-51. 8 illus.

ST227 Jammes, André. "Photographic Incunabula." CAMERA (LUCERNE) 40, no. 12 (Dec. 1961): 24-40. illus.

ST228 Newhall, Beaumont and Robert Doty. "The Value of Photography to the Artist, 1839." IMAGE 11, no. 6 (1962): 2-8. 2 illus. [Contains an annotated bibliography of fourteen references on lithographs, albums and portfolios and illustrated books on the topic of artist's renderings after photographic images.]

ST229 Newhall, Beaumont. "How They Made Daguerreotypes." POPULAR PHOTOGRAPHY 53, no. 1 (July 1963): 58-59, 90-91. 1 b & w. 1 illus.

ST230 "Synoptic Catalogue of the George Eastman House Collection: Abbott - Baldi & Wurthe." IMAGE 14, no. 1 (Jan. 1971): 14-15. 8 b & w. [Partial listing of the photographic holdings at the George Eastman House, Rochester, NY, arranged alphabetically by photographer. Includes 19th and 20th century photographers, gives birth and death dates.]

ST231 "Synoptic Catalogue of the George Eastman House Collection: Baldus - Bell." IMAGE 14, no. 2 (Mar. 1971): 17-18. 9 b & w.

ST232 "Synoptic Catalogue of the George Eastman House Collection: Bemis - Black." IMAGE 14, no. 3 (June 1971): 16-17. 10 b & w.

ST233 "Synoptic Catalogue of the George Eastman House Collection: Blanquart-Evrard - Braun." IMAGE 14, no. 4 (Sept. 1971): 16-17. 9 b & w.

ST234 "Synoptic Catalogue of the George Eastman House Collection: Bridgman - Chiarenza." IMAGE 14, no. 5-6 (Dec. 1971): 32-33. 17 b & w.

ST235 "Synoptic Catalogue of the George Eastman House Collection: Chodziewiez - Cremer." IMAGE 15, no. 1 (Mar. 1972): 29-32. 16 b & w.

ST236 "Synoptic Catalogue of the George Eastman House Collection: Cresley - ." IMAGE 15, no. 2 (July 1972): 28-30. 12 b & w. "Synoptic Catalogue of the George Eastman House Collection: Day - Drury." IMAGE 15, no. 3 (Sept. 1972): 21-26 . 21 b & w.

ST237 "Synoptic Catalogue of the George Eastman House Collection: DuCamp - Ehret." IMAGE 15, no. 4 (Dec. 1972): 30-32. 10 b & w. "Synoptic Catalogue of the George Eastman House Collection: Eisenmann - Fichter." IMAGE 16, no. 1 (Mar. 1973): 28-32. 19 b & w.

ST238 "Synoptic Catalogue of the George Eastman House Collection: Fierlants - Fridrich." IMAGE 16, no. 2 (June 1973): 28-32. 18 b & w.

ST239 "Synoptic Catalogue of the George Eastman House Collection: Friedlander: S. P. Horowitz - Ghemar Freres." IMAGE 16, no. 4 (Dec. 1973): 28-32. 18 b & w.

ST240 "Synoptic Catalogue of the George Eastman House Collection: Giacomelli - Gutekunst." IMAGE 17, no. 2 (June 1974): 28-32. 27 b & w.

ST241 "Synoptic Catalogue of the George Eastman House Collection: Haas - Hilbrandt." IMAGE 17, no. 3 (Sept. 1974): 28-32. 22 b & w. "Synoptic Catalogue of the George Eastman House Collection: Hill & Adamson - Howlett." IMAGE 17, no. 4 (Dec. 1974): 30-32. 9 b & w.

ST242 "Synoptic Catalogue of the George Eastman House Collection: Huard - Keely." IMAGE 18, no. 1 (Mar. 1975): 28-32. 26 b & w.

ST243 "Synoptic Catalogue of the George Eastman House Collection: Keighley - Klein." IMAGE 18, no. 2 (June 1975): 31-32. 9 b & w. "Synoptic Catalogue of the George Eastman House Collection: Klein - Lange." IMAGE 18, no. 4 (Dec. 1975): 30-32. 16 b & w.

ST244 "Synoptic Catalogue of the George Eastman House Collection: Lange, O. V. - Llewlyn." IMAGE 19, no. 1 (Mar. 1976): 28-32. 25 b & w.

ST245 Coke, Van Deren. "Why Putti?" IMAGE 14, no. 3 (June 1971): 2-3. 7 illus. [Use of putti in photographers' advertising on their cards, etc.]

ST246 Newhall, Beaumont. "Documenting the Photo Document." IMAGE 14, no. 3 (June 1971): 4-5. 3 b & w. [Discussion of some of the problems of present-day historians identifying 19th century photographer's work - since they often didn't sign them, often

swapped prints or negatives and sometimes copied the work of others. Cites the case of three photographs by T. O'Sullivan and W. H. Jackson sold and signed by Carleton S. Watkins.]

ST247 "Victorian Illustrated Books." IMAGE 14, no. 5-6 (Dec. 1971): 36-39. 8 b & w. [Portfolio of photographs drawn from illustrated books published ca. 1865-1890 and now in the George Eastman House collections.]

ST248 Sobieszek, Robert A. "The Acquisitions: A Note on Early Photomontage Images." IMAGE 15, no. 4 (Dec. 1972): 19-24. 5 b & w. [Discusses 19th century photomontage, including the work of Francis Bedford, J. M. Cameron, and the Campbell Family album.]

ST249 Porter, Allan. "Photography: An Iconographic, Chronological History: 1839 - 1972." CAMERA (LUCERNE) 51, no. 12 (Dec. 1972): 1 - 112. 80 b & w. [Includes a chronology from prehistory to 1972.]

ST250 Pilling, Arnold R. "Dating Early Photographs by Card Mounts and Other External Evidence: Tentative Suggestions." IMAGE 17, no. 1 (Mar. 1974): 11-16. 6 b & w. 1 illus.

ST251 Jay, Bill, ed. "Facts and Fallacies from Photography's History." NORTHLIGHT no. 6 (1977): 1-39.

ST252 Julia Van Haaften. "'Original Sun Pictures': A Checklist of the New York Public Library's Holdings of Early Work Illustrated with Photographs, 1844 - 1900." BULLETIN OF THE NEW YORK PUBLIC LIBRARY 80, no. 3 (Spring 1977): 355-415. 8 illus.

ST253 Romer, Grant B. "The Daguerreotype in America and England after 1860." HISTORY OF PHOTOGRAPHY 1, no. 3 (July 1977): 201-212. 11 b & w.

ST254 Harmant, Pierre G. "Apropos: Anno Lucis 1839: Anecdotal History of Photography." CAMERA (LUCERNE): 56, no. 5, 8, 10 (May, Aug., Oct. 1977) : 39-43, 37-41, 40-44.

ST255 Coe, Brian, Tom J. Collins and Arthur T. Gill for the Society of Archivists, London. "Recognition of Photographic Processes." HISTORY OF PHOTOGRAPHY 2, no. 1 (Jan. 1978): 34-36.

ST256 Henisch, B. A., and H. K. Henisch. "Thorvaldsen Daguerreotype Cases." HISTORY OF PHOTOGRAPHY 2, no. 2 (Apr. 1978): 135-140. 6 illus.

ST257 Isenberg, Matthew. "Daguerrean vs. Wet-Plate." PHOTOGRAPHICA 10, no. 5 (June 1978): 6-7, 12. 5 illus.

ST258 Buberger, J. "Trump Card." HISTORY OF PHOTOGRAPHY 2, no. 3 (July 1978): 264. 1 b & w. [Comic ambrotype of "gamblers".]

ST259 Wilsher, Ann. "Photography in Literature: The First Seventy Years." HISTORY OF PHOTOGRAPHY 2, no. 3 (July 1978): 223-2324. 7 b & w. 4 illus. [Response to photography in popular literature.]

ST260 Sobieszek, Robert A. "Composite Imagery and the Origins of Photomontage. Part 1: The Naturalistic Strain." ARTFORUM 17, no. 1 (Sept. 1978): 58-65. 16 b & w.

ST261 Sobieszek, Robert A. "Composite Imagery and the Origins of Photomontage. Part 2: The Formalist Strain." ARTFORUM 17, no. 2 (Oct. 1978): 40-45. 10 b & w.

ST262 Krauss, Rolf H. "Photographs as Early Scientific Book Illustrations." HISTORY OF PHOTOGRAPHY 2, no. 4 (Oct. 1978): 291-314. 26 illus.

ST263 Lindquist-Cock, Elizabeth. "Sentiment, Compassion, Straight Record: The Mid-Victorians." THE MASSACHUSETTS REVIEW 19, no. 4 (Winter 1978): 717-728.

ST264 Krauss, Rolf H. "Travel Reports and Photography in Early Photographically Illustrated Books." HISTORY OF PHOTOGRAPHY 3, no. 1 (Jan. 1979): 15-30. 16 b & w. 2 illus. [6 b & w by unknown, 1 b & w by LeComte de Beauvior, 4 b & w by Captain Chapman, 2 b & w by Rockwood, 3 b & w by Henry P. Robinson.]

ST265 Becker, William B. "The American Cliche Verre." HISTORY OF PHOTOGRAPHY 3, no. 1 (Jan. 1979): 71-80. 1 b & w. 13 illus.

ST266 Davis, Keith F. "History in Words and History in Photographs." IMAGE 22, no. 3 (Sept. 1979): 19-26. 6 b & w. [Discussion of 19th century positives, as applied to an unattributed, undated album of photographs of Samoa and Fiji. George Eastman House Collection.]

ST267 Fink, Daniel A. "Positive Processes: Photographs from the Early Nineteenth Century." NINETEENTH CENTURY 5, no. 3 (Autumn 1979): 34-42. 14 b & w. 5 illus. [Discussion of the daguerreotype, ambrotype and tintype processes, with examples.]

ST268 Freitag, Wolfgang M. "Early Uses of Photography in the History of Art." ART JOURNAL 39, no. 2 (Winter 1979/80): 117-123. 8 illus.

ST269 Jacobson, Ken. "Nineteenth Century Exotic Portraiture." PHOTOGRAPHIC COLLECTOR 1, no. 1 (Spring 1980): 28-47. 27 b & w. [Discussion of portraits of third world peoples - South America, India, China, etc. as well as American Indians.]

ST270 Steel, Jonathan. "Collecting Stereos." PHOTOGRAPHIC COLLECTOR 1, no. 1 (Spring 1980): 16-21. 8 b & w. [General commentary, illus. with stereos by G. W. Wilson, J. Valentine, London Stereo Co., Fine Art Photographers Publishing Co., Underwood & Underwood, etc.]

ST271 Eisenstein, Sergei M. "Daguerre's Work." PHOTOGRAPHIC COLLECTOR 1, no. 2 (Autumn 1980): 6-10. 5 b & w. [Memories by Sergei M. Eisenstein, translated from his autobiography, published with illustrations of daguerreotypes.]

ST272 Steel, Jonathan. "Collecting Stereos. Part 2. Historic events through the stereoscope." PHOTOGRAPHIC COLLECTOR 1, no. 2 (Autumn 1980): 16-19. 19 b & w. [Brief survey, illustrated with stereographs of historic events from ca. 1854 to ca. 1905. Illustrated with photos by T. R. Williams, Underwood & Underwood, R. Benecke, James M. Davis, the American and Foreign Scenery Co., etc.]

ST273 Lehr, Janet. "Photographic Processes." PHOTOGRAPHIC COLLECTOR 1, no. 2 (Autumn 1980): 22-27. [Includes a bibliography.]

ST274 "The Album of Photographic Cards." PHOTOGRAPHIC COLLECTOR 1, no. 2 (Autumn 1980): 46-50. 15 b & w. 1 illus. [Cartes-de-visite and cabinet cards, by Elliot & Fry, Russell & Sons, Disderi, Maull & Polybank, Chancellor, Alex Wilson, G. W. Wilson, Bedford, W. Bates, S. Rothwell, Hills & Saunders, Grimmett, H. Pointer.]

ST275 Jay, Bill. "Death in the Darkroom: Part One: Explosions." BRITISH JOURNAL OF PHOTOGRAPHY 127, no. 40 (Oct. 3, 1980): 976-979.

ST276 Jay, Bill. "Death in the Darkroom: Part Two: Poisons." BRITISH JOURNAL OF PHOTOGRAPHY 127, no. 41 (Oct. 10, 1980): 1002-1007.

ST277 Burns, Stanley B. "The Doctors." ARTFORUM 19, no. 3 (Nov. 1980): 71-73. 6 b & w. [Portfolio of photographs of doctors from ca. 1850s to early 1900s.]

ST278 Symmes, Mariln F. and Elizabeth Glassman. "The Curious Medium of Cliche-Verre." ART NEWS 80 , no. 3 (Mar. 1981): 107-111. 7 b & w.

ST279 Jay, Bill. "Ms. Miscellany. Parts 1 - 2." BRITISH JOURNAL OF PHOTOGRAPHY 128, no. 10-11 (Mar. 6 - Mar. 13, 1981): 258-260, 278-280. [Anecdotes about 19th century views on women in photography.]

ST280 Jay, Bill. "Smoking in the Darkroom." BRITISH JOURNAL OF PHOTOGRAPHY 128, no. 14 (Apr. 3, 1981): 360-361. [Discussion about the practice of smoking in the darkroom during the 19th century.]

ST281 Jay, Bill. "'Move a Muscle and I'll Blow Your Brains Out.'" BRITISH JOURNAL OF PHOTOGRAPHY 128, no. 19 (May 8, 1981): 466-469, 482. [Problems and practices of professional portraitists.]

ST282 Steel, Jonathan. "The Stereoscope - and collecting stereocards. Part 3. Nude studies in stereo-daguerreotypes." PHOTOGRAPHIC COLLECTOR 2, no. 1 (Spring 1981): 54-58. 11 b & w. [Possibly French, possibly taken early 1850s.]

ST283 Mauner, George. "The Putto with the Camera; Photography as a Fine Art." HISTORY OF PHOTOGRAPHY 5, no. 3 (July 1981): 185-198. 15 illus. [Discusses the uses of putti on the back of photograph card mounts by professional studios, and in other publications about photography.]

ST284 Jay, Bill. "Keraunography: the Strange Case of Lightning Photography." BRITISH JOURNAL OF PHOTOGRAPHY 128, no. 27 (July 3, 1981): 668-671.

ST285 Verkoren, Luc. "Enamel Photography." PHOTOGRAPHIC COLLECTOR 2, no. 2 (Summer 1981): 76-79. 5 illus. [Enamel photography invented in 1855, used throughout the remainder of the 19th century.]

ST286 Scott, Martin L. "Technology the Enabler." IMAGE 24, no. 2 (Dec. 1981): 4-9.

ST287 Krauss, Rosalind. "Photography's Discursive Spaces: Landscape/View." ART JOURNAL 42, no. 4 (Winter 1982): 311-319. 6 b & w. [Photos by O'Sullivan; A. Salzmann; S. Bourne; E. Atget.]

ST288 "Nineteenth Century Photographs of the World's Cities from the Joseph Armstrong Baird, Jr. Collection. Urbi et Orbi." CALIFORNIA MUSEUM OF PHOTOGRAPHY BULLETIN 2, no. 5 (1983): 1-16. [Portfolio of prints by Achille Quinet, Disderi, Reulbach, R. MacPherson, Carlo Naya, G. Sommer, Laurent, J. Brunner of Winterthur, Constantine, J. Robertson & F. Beato, Leroux, J. P. Sebah, Scowen, Skeen & Co. Friedrich, and others. Afterword, "A Picnic on a Gigantic Scale," by Susan Wladaver-Morgan on p. 16.]

ST289 Senelick, Laurence. "Pepper's Ghost Faces the Camera." HISTORY OF PHOTOGRAPHY 7, no. 1 (Jan. 1983): 69-72. 5 b & w. [Theatrical photographs, with ghostly images (by moving during long exposure) issue as cartes-de-visite, etc. during 1850s, 1860s, etc. Photos by Thiebault (Paris) and C. D. Fredericks (New York), representing a popular theatrical illusion of the time.]

ST290 Hart, Janice. "Photography, Pornography and the Law: The First Fifty Years." PHOTOGRAPHIC COLLECTOR 4, no. 3 (Winter 1983): 287-299. 13 b & w. [Illustrated with nude stereos, work by Rejlander, J. Watson, Southwell Brothers, Lewis Carroll, etc.]

ST291 Palmquist, Peter E. "The Early Panoramists (and Other Mothers of Invention)." DARKROOM PHOTOGRAPHY 6, no. 1 (Jan. - Feb. 1984): 26-32. 11 b & w. 3 illus. [Unusual apparatus to achieve special photographs discussed. Watkins's and Muybridge's views in California; B. O. Holterman's views in Australia; George R. Lawrence's views of the Chicago & Alton Railroad train and his aerial views from kites, etc.]

ST292 Naef, Weston J. "Acquisitions/1984: Photographs." THE J. PAUL GETTY MUSEUM JOURNAL 13, (1985): 215-238. 49 b & w. [Alphabetical list of photographers represented in the collection, followed by a selection of 49 prints from those holdings, which are reproduced, with maker, dates, process, size, accession number, and provenance.]

ST293 Foster, Alasdair. "The Male Nude in Photography." PHOTOGRAPHIC COLLECTOR 5, no. 3 (1985): 331-344. 13 b & w. [Discussion of photographs of the nude male made during the 19th century. Illustrated by H. Bayard, Hill & Adamson, O. G. Rejlander, E. Muybridge, W. von Gloeden, G. von Pluschow, F. H. Day, F. H. Crossley, W. Parrish, Yvonne Gregory, G. P. Lynes.]

ST294 Newhall, Beaumont. "The Case of the Elliptical Wheel and Other Photographic Distortions." IMAGE 28, no. 1 (Mar. 1985): 1-4. 3 b & w. 5 illus.

ST295 Marable, Darwin. "Photography and Human Behavior in the Nineteenth Century." HISTORY OF PHOTOGRAPHY 9, no. 2 (Apr. - June 1985): 141-147. 5 b & w. [Discusses Dr. Hugh W. Diamond, Dr. G. B. Duchenne, Charles Darwin, Jean-Martin Charcot, Francis X. Dorcum, Sir Francis Galton, etc. and their use of photography in the study of human behavior.]

ST296 Naef, Weston J. "Acquisitions/1985: Photographs." THE J. PAUL GETTY MUSEUM JOURNAL 14, (1986): 265-286. 58 b & w. [Alphabetical list of photographers represented in the collection, followed by a selection of 58 prints from those holdings, which are reproduced, with maker, dates, process, size, accession number, and provenance.]

ST297 Cottington, Ian E. "Platinum and Early Photography: Some Aspects of the Evolution of the Platinotype." HISTORY OF PHOTOGRAPHY 10, no. 2 (Apr. - June 1986): 131-139. 8 illus. [From "Platinum Metals Review" vol. 28 (1984). Discussion of the historical development of the use of platinum in photography, featuring William Willis.]

ST298 Phillips, Christopher. "The Body under the Eye of Science." VIEWS: THE JOURNAL OF PHOTOGRAPHY IN NEW ENGLAND. 7, no. 2 (Winter 1986): 18-19. 7 b & w. [Review of three books. "Early Medical Photography in America (1839-1883)," by Dr. Stanley Burns. "Seeing the Insane," by Sander Gilman. "Invention de l'hysterie;

Charcot et l'Iconographie Photographique de la Saltpêtrierè," by Georges Didi-Huberman.]

ST299 Naef, Weston J. "Acquisitions/1986: Photographs." THE J. PAUL GETTY MUSEUM JOURNAL 15, (1987): 222-238. 40 b & w. [Alphabetical list of photographers represented in the collection, followed by a selection of 40 prints from those holdings, which are reproduced, with maker, dates, process, size, accession number, and provenance.]

ST300 Naef, Weston J. "Acquisitions/1987: Photographs." THE J. PAUL GETTY MUSEUM JOURNAL 16, (1988): 187-199. 36 b & w. [Alphabetical list of photographers represented in the collection, followed by a selection of 36 prints from those holdings, which are reproduced, with maker, dates, process, size, accession number, and provenance.]

ST301 Spira, S. F. "A Daguerreotypist's Self-portrait." HISTORY OF PHOTOGRAPHY 12, no. 3 (July - Sept. 1988): 219-222. 1 b & w. 3 illus.

ST302 Yates, Steve. "Ambiguous Space: Tradition and Non-Tradition." TAMARIND PAPERS (1989): 20-27. 7 illus. [Discusses the cliché-verre work of Jean-Baptiste Corot, Paul Huet, Théodore Rousseau, and others.]

ST303 Naef, Weston J. "Photography: Discovery and Invention." THE MAGAZINE ANTIQUES (Jan. 1989): 288-297. 16 b & w.

HISTORY: GENERAL: BY YEAR

1839.
ST304 "On Photogenic Drawing." SATURDAY MAGAZINE 14, no. 435 (Apr. 13, 1839): 138-139.

ST305 "Photogenic Drawing." MAGAZINE OF SCIENCE, AND SCHOOL OF ARTS 1, no. 3, 5 (Apr. 20 - May 4, 1839): 18-20, 27-28, 34-35. 3 illus. [The illustrations, on p. 33, are a woodcut representation of a positive and negative image, plus a diagram of a camera.]

ST306 Francis, G. "Important Applications of Photogenic Drawing." MAGAZINE OF SCIENCE, AND SCHOOL OF ARTS 1, no. 4 (Apr. 27, 1839): 25, 28. 3 illus. [Three "Facsimiles of Photogenic Drawings"..."which were impressed at once on box-wood, and therefore are fit for the graver without any other preparation."]

ST307 "Photogenic Drawing." MAGAZINE OF SCIENCE, AND SCHOOL OF ARTS 1, no. 8 (May 25, 1839): 59-60. [This article, different from the earlier with the same title, contains suggestions for making photos.]

1840.
BOOKS
ST308 Parsey, Arthur. *The Science of Vision; or, Natural Perspective! containing the True Language of the Eye, Necessary in Common Observation, Education, Art and Science; Constituting the basis of the Art of Design, with Practical Methods for Foreshortening and Converging in Every Branch of Art, the New Elliptical or Conic Sections, Laws of Shadows, Universal Vanishing Points, and the New Optical Laws of the Camera Obscura, or Daguerreotype, also, The Physiology of the Human Eye, explaining the Seat of Vision to be the Iris and Not the Retina.* "2nd ed." London: Longman & Co., 1840. xxxvii, 122 pp. 24 l. of plates. illus. [1st and 2nd ed. both published in 1840.]

PERIODICALS
ST309 "On Photogenic Drawing. No. II - III. The Daguerreotype." SATURDAY MAGAZINE 16, no. 490-491 (Feb. 22 - Feb. 29, 1840): 71-72, 79-80.

ST310 "Improvement in the Daguerreotype." AMERICAN REPERTORY OF ARTS, SCIENCES AND MANUFACTURES 1, no. 2 (Mar. 1840): 129- ? [I've not seen this article, only the index.]

ST311 "Rival to the Daguerreotype." AMERICAN REPERTORY OF ARTS, SCIENCES AND MANUFACTURES 1, no. 2 (Mar. 1840): 132-? [I've not seen this article, only the index.]

ST312 "Process of the Daguerreotype." MAGAZINE OF SCIENCE AND SCHOOL OF ARTS 2, no. 55-56 (Apr. 18 - Apr. 25, 1840): 19-20, 25-28. 5 illus. [From Daguerre's English patent, through his agent, Mr. Berry.]

ST313 "Miscellaneous: Anticipated Results from the Daguerreotype." AMERICAN REPERTORY OF ARTS, SCIENCES AND MANUFACTURES 1, no. 4 (May 1840): 304-305. [Speculation about the medium's usefulness to science and the arts. Mentions Daguerre, suggests that Egyptian hieroglyphics can be accurate copied.]

ST314 "The Diorama." MAGAZINE OF SCIENCE AND SCHOOL OF ARTS 2, no. 66 (July 4, 1840): 105-107. 2 illus. [Plans for the diorama in Regent's Park, London.]

1843.
ST315 "Photogenic Drawing, or Drawing by the Agency of Light." EDINBURGH REVIEW 76, no. 154 (Jan. 1843): 309-344. [Review of: I. "History and Practice of Photogenic Drawing, or the ten Principles of the Daguerreotype," By the Inventor, L. J. M. Daguerre, translated by J. S. Memes, Ll.D., London, 1839; 2. "Some Account of the Art of Photogenic Drawing, or the Process by which Natural Objects may be made to delineate themselves without the aid of the Artist's Pencil," by Henry Fox Talbot, Esq, F.R.S. London, l839; 3. "Die Calotypische Portraitirkunst," von Dr. F. A. W. Netto. Quadlingburg and Leipzig, 1842; 4. "Ueber der Process des Sehens und die Wirkung des Lichts auf Alle Korper," von Ludwig Moser, "Poggendorff Annalen der Physik und Chemie," Band LVI., 1842, no. 6.]

ST316 "Photogenic Drawing, or Drawing by the Agency of Light." EDINBURGH REVIEW (AMERICAN EDITION) 76, no. 154 (Jan. 1843): 159-177. [Extended discussion of the field, based on review of books by Daguerre, Talbot, Netto, and Moser.]

1846.
ST317 "Daguerreotypes." LITTELL'S LIVING AGE 9, no. 110 (June 1846): 551-552. ["From the 'Christian Watchman.'"]

1848.
ST318 *Light: Its Nature, Sources, Effects and Applications. Parts I - IV.* London: Society for Promoting Christian Knowledge, London, Under the Direction of the Committee of General Literature and Education, ca. 1848. 300 pp. 1 b & w. [Original photo frontispiece. "This work is perfectly pure and untouched by the pencil..." Part IV "On Applications of Light, including History of Sun Painting, the Daguerreotype, and the Talbottype." Marshall Collection.]

1850.
ST319 "Operating and Preparing the Daguerreotype Plate." DAGUERREIAN JOURNAL 1, no. 1-5 (Nov. 1, 1850 - Jan. 15, 1851): 22-24, 57-58, 87-88, 116-117, 153-154. [Instructions. Pt. 1. Accelerating Buff - Bromine. Pt. 2. Coating the Daguerreotype Plate. Pt. 3. Exposing the Plates in the Camera. Pt. 4. Exposure of the Plate of Mercury. Pt. 5. Washing and Gilding the Daguerreotype Plate.]

ST320 "Chromatype." DAGUERREIAN JOURNAL 1, no. 1 (Nov. 1, 1850): 12. [Brief description of a positive paper process.]

ST321 "Plate Holder." DAGUERREAN JOURNAL 1, no. 2 (Nov. 15, 1850): 47. 1 illus. [Plate Holder patented by Samuel Peck, New Haven, CT.]

ST322 "Operating. Coating the Daguerreotype Plate." DAGUERREIAN JOURNAL 1, no. 2 (Nov. 15, 1850): 57-58.

ST323 "New Way to Obtain Groups." DAGUERREAN JOURNAL 1, no. 3 (Dec. 2, 1850): 91.

1851.
ST324 "Background, Transparent or Invisible." DAGUERREAN JOURNAL 1, no. 4 (Jan. 1, 1851): 111. [From "System of Photography, 1849."]

ST325 "Durability of Daguerreotypes." DAGUERREAN JOURNAL 1, no. 4 (Jan. 1, 1851): 113-114. [A Mr. Ulex, of Hamburg, quoted. Source not given.]

ST326 "History of the Science." PHOTOGRAPHIC ART JOURNAL 1, no. 1 (Jan. 1851): 21-31. [From the "Handbook of Heliography". Prehistory, Niépce, Daguerre, etc.]

ST327 "Practical Photography." PHOTOGRAPHIC ART JOURNAL 1, no. 1 (Jan. - Feb. 1851): 59-60, 111-114. 4 illus. [(Jan.) Buffing the Plate. (Feb.) Galvanizing Plates.]

ST328 "Jenny Lind Head Supporters." DAGUERREAN JOURNAL 1, no. 9 (Mar. 15, 1851): 281. 1 illus.

ST329 "Gossip." PHOTOGRAPHIC ART JOURNAL 1, no. 4 (Apr. 1851): 252-256. 1 illus. [A. Claudet; G. Harrison; W. E. Kilburn's letter on whitening the camera box (from London "Athenaeum"). Silas Selleck (NY) also whitens his camera; H. W. Hayden (Waterbury, CT); George Thomas Fisher writes letter about value of the daguerreotype to modern man; Doak's camera stand; L. L. Hill's circular; H. H. Snelling's book "History & Practice, etc."]

ST330 "Doak's Camera Stand." DAGUERREAN JOURNAL 1, no. 10 (Apr. 1, 1851): 304. 1 illus.

ST331 "Phosphorus and Its Compounds." PHOTOGRAPHIC ART JOURNAL 2, no. 1 (July 1851): 29-31.

ST332 "A System. Preparation of the Plate. - The True Artist." DAGUERREAN JOURNAL 2, no. 7 (Aug. 15, 1851): 214-216. [From "Photographic Researches."]

ST333 "Daguerreotype." DAGUERREAN JOURNAL 3, no. 3 (Dec. 15, 1851): 71-74. [Description of practice of making a daguerreotype.]

1852.
ST334 "Science: Photography. Its Origins, Progress, and Present State." ILLUSTRATED LONDON NEWS 21, no. 571 (July 31, Aug. 28, 1852): 87,176. [Prehistory, beginnings and current practices through 1851, states "to be concluded in our next issue," but in fact, it was not completed until Aug. 28th issue.]

ST335 "Progress in Photography." HUMPHREY'S JOURNAL 4, no. 1 (Apr. 15, 1852): 6-8. [From "London Art Journal."]

ST336 "The Beauties of Heliography." HUMPHREY'S JOURNAL 4, no. 2 (May 1, 1852): 23. ["A foreign writer..."]

ST337 "Chemical Gleanings: How to Take Life-Size Photographs." HUMPHREY'S JOURNAL 4, no. 11 (Sept. 15, 1852): 175.

ST338 "Photographic Pictures on Paper." HUMPHREY'S JOURNAL 4, no. 13 (Oct. 15, 1852): 197-199. [Mentions Niépce de St. Victor, Blanquart-Evrard, C. Brooke and A. Martin (Vienna).]

ST339 "Note Upon the Process of Fixation by M. M. Phol and Oulif." PHOTOGRAPHIC ART JOURNAL 4, no. 5 (Nov. 1852): 297-298.

ST340 "Photography." PHOTOGRAPHIC ART JOURNAL 4, no. 5 (Nov. 1852): 300-308. [From "Cosmos."]

ST341 Cunningham, A. "Life of Edward Bird." PHOTOGRAPHIC ART JOURNAL 4, no. 5 (Nov. 1852): 308-314. [Biography of a painter.]

ST342 "Photography." PHOTOGRAPHIC ART JOURNAL 6, no. 1 (July 1853): 13-19. [From the "Illustrated Magazine of Art."]

1854.
ST343 "On the Application of the Daguerreotype to Paper." HUMPHREY'S JOURNAL 5, no. 22 (Mar. 1, 1854): 347-349. [Letter,

with the author not identified, describing improvements to his process earlier presented to the Royal Society "On the Influence of Iodine in rendering several Argentine Compounds...etc."]

1855
ST344 "Practical Instructions in the Art of Photography." FRANK LESLIE'S NEW YORK JOURNAL n. s. 1-2, no. 1, 3-6; 1 (Jan., Mar. - July 1855): v. 1: 31, 167, 239, 285, 366; v. 2: 61. 28 illus. [Discussion of lenses, chemistry, etc. Author is not credited; probably taken from a current manual, without citing the source, as was this magazine's practice. Series ended abruptly with July issue.]

1856.
BOOKS
ST345 *Sunlight Sketches, or The Photographic Text Book, a Practical Treatise on Photography.* New York: Published for the author by H. H. Snelling, 1856. 64 pp.

PERIODICALS
ST346 "Photography - Its Rise and Progress." PHOTOGRAPHIC AND FINE ART JOURNAL 9, no. 1, 2 (Jan. - Feb. 1856): 1-4, 41-44. [(Jan.) Pt. 4. 1840's in USA, GB. Archer, Fry, J. B. Reade, Talbot, etc. Pt. 5. Daguerre, Niépce, Niépce de St. Victor, Becquerel, etc.]

ST347 "Social Life of Hayti." FRANK LESLIE'S ILLUSTRATED NEWSPAPER 1, no. 12 (Mar. 1, 1856): 188. 3 illus. [Outdoor costume portraits. "Our engravings, which are very truthful daguerreotypes of the subjects represented, present..." (I think this is meant metaphorically, and that they are not really from daguerreotypes.)]

ST348 "Photography and the Elder Arts." JOURNAL OF THE PHOTOGRAPHIC SOCIETY OF LONDON 3, no. 41 (Apr. 21, 1856): 29-32.

ST349 "Photography and the Elder Fine Arts." PHOTOGRAPHIC AND FINE ART JOURNAL 9, no. 5 (May 1856): 147-148. [Author not given.]

ST350 "Miscellaneous: Photographs at any Hour." FRANK LESLIE'S NEW YORK JOURNAL n. s. 3, no. 6 (June 1856): 380. [Brief report of Dr. Lover's demonstration of a gas-light apparatus for taking photographs at a meeting of the Dublin Photographic Society. This same report was published earlier, on p. 180 of this journal.]

ST351 "Daguerreotypes." THE CRAYON 4, no. 2 (Feb. 1857): 64. [Brief note that daguerreotypes can be copied by the electrotype process. From the "Exchange."]

ST352 "The 'Quarterly Review' and Photography." PHOTOGRAPHIC AND FINE ART JOURNAL 10, no. 8 (Aug. 1857): 233-236. [From "Liverpool Photo. J." Response to a critical article.]

ST353 "Ambrotypes." PHOTOGRAPHIC AND FINE ART JOURNAL 10, no. 9 (Sept. 1857): 281-282.

1858.
ST354 "Photography." COSMOPOLITAN ART JOURNAL 2, no. 2-4 (Mar. - Sept. 1858): 107-111, 180-182. [Well-written, general survey of the early history of photography. Author not given.]

ST355 "Hints for the Production of Panoramic Negatives upon Collodion." PHOTOGRAPHIC AND FINE ART JOURNAL 11, no. 6 (June 1858): 164-165. [From "Liverpool Photo. J." Mentions early work of M. Marten.]

ST356 "Photographic Improvements in 1858." PHOTOGRAPHIC AND FINE ART JOURNAL 11, no. 12 (Dec. 1858): 374-378. [From "Photo. Notes."]

1859.
BOOKS
ST357 *A Catechism of Photography; Including Simple Instructions for Performing All the Various Operations Connected with the Art.* Reprinted from the "Photographic News." London: Cassell, Peter, & Galpin., 1859. 104 pp. [2nd ed. (1863).]

PERIODICALS
ST358 "Photographic Apparatus, etc." ART JOURNAL (Jan. 1859): 24.

ST359 "A Half Century of Progress, In Physical Science and Invention." GREAT REPUBLIC MONTHLY 1, no. 1 (Jan. 1859): 49-55. [Photography briefly discussed on p. 54. Mentions Niépce and "Mr. Price's recent work for photographing on wood..."]

ST360 "Photographic Glossary." HUMPHREY'S JOURNAL OF PHOTOGRAPHY, AND THE ALLIED ARTS AND SCIENCES 10 - 11, no. 23-24, 1-21 (Apr. 1, 1859 - Mar. 1, 1860): [vol. 10] 367-368, 382-384; [vol. 11] 5-6, 31-32, 47-48, 79-80, 95-96, 127-128, 159-160, 191-192, 222-224, 239-240, 255-256, 287-288, 318-319, 335. [From "Liverpool Photo. J."]

ST361 "Colours for Photographic Painting." ART JOURNAL (Aug. 1859): 242-243.

ST362 "Photography Considered as a Recreative Agency for the Minds of the Educated." PHOTOGRAPHIC NEWS 3, no. 58 (Oct. 14, 1859): 63.

ST363 "Photography and Medical Science." PHOTOGRAPHIC NEWS 3, no. 61 (Nov. 4, 1859): 97. [Essay is about photos usefulness to physical anthropology - in race classification.]

1860.
ST364 "Night Photography." PHOTOGRAPHIC AND FINE ART JOURNAL 13, no. 1 (Jan. 1860): 9-10. [From "Photo. Notes." Moule still demonstrating in Paris.]

ST365 "Summary of Photographic Improvements for 1859." PHOTOGRAPHIC AND FINE ART JOURNAL 13, no. 3 (Mar. 1860): 77-78.

ST366 "Report of the Collodion Committee." AMERICAN JOURNAL OF PHOTOGRAPHY AND THE ALLIED ARTS & SCIENCES n. s. vol. 2, no. 21 (Apr. 1, 1860): 322-330. [Twelve person committee in the Photo. Society tested Mayall's, Sutton's and Hardwich's collodion. Results.]

ST367 "On the Position Occupied by Photography Amoung the Fine Arts." PHOTOGRAPHIC NEWS 4, no. 94 (June 22, 1860): 85-86. [Page 86 has a table showing the relative placement of photo to other visual arts.]

ST368 "On the Present State of Our Knowledge Regarding the Photographic Image." PHOTOGRAPHIC AND FINE ART JOURNAL 13, no. 8 (Aug. 1860): 223-226. [From the "Report of the Br. Assoc. for Advancement of Science for 1859." Author not given.]

ST369 "Photography a Chameleon." BRITISH JOURNAL OF PHOTOGRAPHY 7, no. 127 (Oct. 1, 1860): 284-285. [Musings on the state of continual change, growth of the medium.]

ST370 "Photography a Chameleon." AMERICAN JOURNAL OF PHOTOGRAPHY AND THE ALLIED ARTS & SCIENCES n. s. vol. 3, no. 13 (Dec. 1, 1860): 193-194. [From "Br. J. of Photo." Sort of a comment on constant growth and improvement in the media.]

1861.
ST371 "On the Dry Processes. (Report of the Experimental Committee of the South London Photographic Society.)" AMERICAN JOURNAL OF PHOTOGRAPHY AND THE ALLIED ARTS & SCIENCES n. s. vol. 3, no. 20 (Mar. 15, 1861): 305-310. [From "Photo. Notes." Sebastian Davis; Bocher; Dr. Schnauss; Petschler; Dr. Norris; Hannaford; Hardwich; Ackland; others mentioned.]

ST372 "The Negative Process." HUMPHREY'S JOURNAL OF PHOTOGRAPHY, AND THE ALLIED ARTS AND SCIENCES 12, no. 22 (Mar. 15, 1861): 337-338. ["There have been so many hundred formulae given for the negative process, all differing somewhat, that the whole fraternity are now bewildered as to which is the best one to adopt...."]

ST373 "Photography and Oil Paintings." AMERICAN JOURNAL OF PHOTOGRAPHY AND THE ALLIED ARTS & SCIENCES n. s. vol. 3, no. 21 (Apr. 1, 1861): 321-324. [From "NY Leader," (Mar. 16). With editorial comment on pp. 323-324.]

ST374 "Reviews of New Books." PRACTICAL MECHANIC'S JOURNAL 2nd ser., 7 (14), no. 165 (Dec. 1861): 243. [Bk. rev.: "Abridgments of Specifications Relating to Photography." Printed by Order of the Commissioners of Patents. London: Eyre & Spottiswoode, 1861. 165 pp.]

ST375 "Photography." AMERICAN JOURNAL OF PHOTOGRAPHY AND THE ALLIED ARTS & SCIENCES n. s. vol. 4, no. 14 (Dec. 15, 1861): 313-316. [From "The Mechanic's Magazine."]

1862.
ST376 "Photography in Its Relation to the Fine Arts." JOURNAL OF THE PHOTOGRAPHIC SOCIETY OF LONDON 7, no. 117 (Jan. 15, 1862): 358-360. [From "London Review."]

ST377 "Enlargement of Photographs." BRITISH JOURNAL OF PHOTOGRAPHY 9, no. 170 (July 15, 1862): 263.

ST378 "Photographic Portraits and Pen-and-Ink Portraits." AMERICAN JOURNAL OF PHOTOGRAPHY AND THE ALLIED ARTS & SCIENCES n. s. vol. 5, no. 11 (Dec. 1, 1862): 248-249. [From "Literary Budget."]

ST379 "Caudle amongst the Photographers." HUMPHREY'S JOURNAL OF PHOTOGRAPHY, AND THE ALLIED ARTS AND SCIENCES 14, no. 16 (Dec. 15, 1862): 200-202. [Sort of a comic narrative.]

1863.
ST380 "Having Your Photograph Taken." AMERICAN JOURNAL OF PHOTOGRAPHY AND THE ALLIED ARTS & SCIENCES n. s. vol. 5, no. 13 (Jan. 1, 1863): 292-293. [From "Saturday Review."]

ST381 "Photographic Review." HUMPHREY'S JOURNAL OF PHOTOGRAPHY, AND THE ALLIED ARTS AND SCIENCES 14, no. 17-20 (Jan. 1 - Feb. 15, 1863): 209-211, 255-229, 241-244, 257-261.

[Includes excerpts of items taken from foreign press, etc., general summations of current activities, chemical experiments, etc. Idea introduced by the new editor, Towler - ran four issues, then seems to have stopped.]

ST382 "Printing Difficulties, by a Photographer's Assistant." HUMPHREY'S JOURNAL OF PHOTOGRAPHY, AND THE ALLIED ARTS AND SCIENCES 14, no. 23 (Apr. 1, 1863): 317-319. [From "Photo. News."]

ST383 "Note." JOURNAL OF THE PHOTOGRAPHIC SOCIETY OF LONDON 8, no. 135 (July 15, 1863): 321. [Untitled extract from the "Athenaeum" savagely attacking pretensions of photographers to an art claim. Also an editorial note on pp. 309-310.]

ST384 "A Few Words on Portraiture." AMERICAN JOURNAL OF PHOTOGRAPHY AND THE ALLIED ARTS & SCIENCES n. s. vol. 6, no. 3 (Aug. 1, 1863): 49-53. [From "Photo. News."]

ST385 "By What Means Can the Art of Photography become a Science?" BRITISH JOURNAL OF PHOTOGRAPHY 10, no. 200 (Oct. 15, 1863): 406-407. [From "Humphrey's Journal." Actually about standardization of formulae, etc.]

ST386 "Talk in the Studio: Photographic Image in a Dead Eye." PHOTOGRAPHIC NEWS 8, no. 282 (Jan. 29, 1864): 59. [Tells story of photographing murdered soldiers in Moscow, discovering their murderers.]

ST387 "Lighting the Sitter." HUMPHREY'S JOURNAL OF PHOTOGRAPHY, AND THE ALLIED ARTS AND SCIENCES 15, no. 20 (Feb. 15, 1864): 310-313. [From "Photo. News."]

ST388 "Critical Notices: "The Universal Text-Book of Photography: or, Manual of the Various Photographic Processes, Instruments, Art Desiderata, etc." Second edition, illustrated and enlarged. London: Lemarc; Leeds: Harvey, Reynolds & Fowler." PHOTOGRAPHIC NEWS 8, no. 285 (Feb. 19, 1864): 86-87.

ST389 "On the Portraiture of Children." HUMPHREY'S JOURNAL OF PHOTOGRAPHY, AND THE ALLIED ARTS AND SCIENCES 16, no. 4 (June 15, 1864): 61-62. [From "Photo. News."]

ST390 "Pinholes in Summer." HUMPHREY'S JOURNAL OF PHOTOGRAPHY, AND THE ALLIED ARTS AND SCIENCES 16, no. 5 (July 1, 1864): 72-75. [From "Photo. News." Mentions T. R. Williams, H. Vogel, S. Fry, S. Miller, etc.]

ST391 "About Smoking and Photography." AMERICAN JOURNAL OF PHOTOGRAPHY AND THE ALLIED ARTS & SCIENCES n. s. vol. 7, no. 4 (Aug. 15, 1864): 75-78. [From "Br. J. of Photo." Comic essay.]

ST392 "Contemporary Press: Aesthetics of Photography." BRITISH JOURNAL OF PHOTOGRAPHY 11, no. 224 (Aug. 19, 1864): 306-307. [From "Humphrey's Journal."]

ST393 "Panoramic Photographs." BRITISH JOURNAL OF PHOTOGRAPHY 11, no. 228 (Sept. 16, 1864): 349-350. [Discuss Martens (1845); Brooman (London)(1857); Holmer (1858); Sutton (1859); Johnson & Harrison (1862). Describes Johnson's work in greater detail.]

ST394 "Concerning Sharpness." AMERICAN JOURNAL OF PHOTOGRAPHY AND THE ALLIED ARTS & SCIENCES n. s. vol. 7, no. 10 (Nov. 15, 1864): 234-236. [From "Br. J. of Photo." Actually an argument on the aesthetics of photography - "atmospheric effect" vs. "want of sharpness."]

ST395 "On the Comparative Permanency of some Photographic Processes." AMERICAN JOURNAL OF PHOTOGRAPHY AND THE ALLIED ARTS & SCIENCES n. s. vol. 7, no. 10-11 (Nov. 15 - Dec 1, 1864): 236-239, 251-252. [From "Br. J. of Photo." Discusses Swan, Pouncey, Wothlytypes, etc.]

1865.
ST396 "Troubles of a Photographer." HUMPHREY'S JOURNAL OF PHOTOGRAPHY, AND THE ALLIED ARTS AND SCIENCES 16, no. 17 (Jan. 1, 1865): 263-267.

1866.
ST397 "Condensed History of Pre-Journalistic Photography." BRITISH JOURNAL PHOTOGRAPHIC ALMANAC 1866 (1866): 102-106. [From "Abridgments of Specification," by the Commissioners of Patents. A Chronological list of photographic developments from Euclid (300 B.C.) to 1852.]

ST398 "To Glaze the Surface of Photographs." HUMPHREY'S JOURNAL OF PHOTOGRAPHY, AND THE ALLIED ARTS AND SCIENCES 17, no. 20 (Feb. 15, 1866): 305-308. [Methods of John Frew (Great Britain); G. H. Richards (Great Britain); F. A. Wenderoth (Great Britain) and others.]

1867.
ST399 "Photography: Its History and Applications." LIVING AGE 92, no. 1182 (Jan. 26, 1867.): 195-218. [Extensive review of 13 books on photography, from the "British Quarterly Review."]

1868.
ST400 "Photographic Cyclopedia." HUMPHREY'S JOURNAL OF PHOTOGRAPHY, AND THE ALLIED ARTS AND SCIENCES 19, no.. 18-24 (Jan. 15 - Apr. 15, 1868): 299-301, 318-319, 367-368. [From "Br. J. Photo. Almanac." Alphabetical list of terms, etc. "Alcohol, Methylated. Alethoscope, Alkaline Development," etc.]

ST401 "Magnified Photographic Pictures." HUMPHREY'S JOURNAL OF PHOTOGRAPHY, AND THE ALLIED ARTS AND SCIENCES 20, no. 5 (July 1, 1868): 74-75. [From "Scientific American." Physical limits to enlarging photos discussed.]

1870.
ST402 "Studies from Nature. Nos. I-III." ART PICTORIAL AND INDUSTRIAL 1, no. 2-3 (Aug. - Sept. 1870, Feb. 1871): 40, 84, 180, plus 3 tipped-in pages. 3 b & w. [Three Heliotype reproductions of photographic views from nature. These were close-ups, all probably taken from the same, unnamed, photographer. Each accompanied with a brief comment.]

1871.
ST403 "Position and Composition. Parts 1-12." PHOTOGRAPHIC WORLD 1, no. 1-12 (Jan. - Dec. 1871): 25, 50-51, 82-84, 123-125, 140-141, 180-182, 217-218, 234-236, 285-286, 302-304, 339-340, 372-373.

ST404 "Table Talk - the Influence of Photographic Journals." PHOTOGRAPHIC WORLD 1, no. 2 (Feb. 1871): 62.

ST405 "The Victoria Card." ANTHONY'S PHOTOGRAPHIC BULLETIN 2, no. 3 (Mar. 1871): 73-74. [From "London Photo. News." Extended discussion of the new size for portraits, its use in GB and abroad, etc., with statement by the editors correcting errors.]

ST406 "Novelties: Bowdish's Perfect Chair." ANTHONY'S PHOTOGRAPHIC BULLETIN 2, no. 11 (Nov. 1871): 371-372. 3 illus. [Sitter's chair, with clamps - adjustable.]

1872.
ST407 "Photographs." PHOTOGRAPHER'S FRIEND 2, no. 1 (Jan. 1872): 19. [From "Appleton's Journal."]

ST408 "An Illustrated Journal." ANTHONY'S PHOTOGRAPHIC BULLETIN 3, no. 2 (Feb. 1872): 436-437. [Editorial explanation why the "APB" has chosen not to try to tip-in photographs. Also mentioned are "the artists whose productions we (G. & T. H. Anthony Co.) have constantly in stock (in the store)."(Thus a listing of the major commercial photographic firms of the day.) New York, NY: Sarony; Gurney; Howell; Brady; Fredericks & Co. Vienna: F. Luckhardt; Kramer; A. F. Czihak; E. Rabending; Dr. Szekely, Adele. Trieste: Sebastianutti. Berlin: Linde; Loescher & Petsch; Dr. Stolze; H. Hirsh, Sophus Williams. London: London Stereo Co.; Elliott & Fry; Marion & Co. St. Petersburg: Bergamasco. Copenhagen: Budtz, Muller & Co.]

ST409 "Useful to Artists by 'Only a Photographer.'" PHOTOGRAPHER'S FRIEND 2, no. 4 (Oct. 1872): 125-126. [From "Photo News."]

ST410 "The Adamantean Plates." ANTHONY'S PHOTOGRAPHIC BULLETIN 3, no. 11 (Nov. 1872): 748. [Brief history of the manufacturers of "japanned iron plates" (tintypes). Peter Neff (Cincinnati, OH); V. M. Griswold; John Dean, of Dean & Emerson.]

1873.
ST411 "Summary of Photographic Progress During 1872." BRITISH JOURNAL PHOTOGRAPHIC ALMANAC 1873 (1873): 151-157.

ST412 "Photography in Winter." ANTHONY'S PHOTOGRAPHIC BULLETIN 4, no. 1 (Jan. 1873): 2-3. [Technical advice, some of it drawn from the "Br J. of Photo."]

ST413 "A New and Powerful Light for Photographic Use." ANTHONY'S PHOTOGRAPHIC BULLETIN 4, no. 8 (Aug. 1873): 238-239. ["...a new electro-magnetic machine which is in action in the vaults below the clock tower at Westminster Palace." From the "Br J of Photo."]

1874.
ST414 "Summary of Photographic Progress during 1873." BRITISH JOURNAL PHOTOGRAPHIC ALMANAC 1874 (1874): 162-176.

ST415 "Habit." PHOTOGRAPHIC TIMES 4, no. 39 (Mar. 1874): 34.

ST416 "Art in Photography." PHOTOGRAPHIC TIMES 4, no. 39 (Mar. 1874): 36-37.

ST417 "Good Enough." PHOTOGRAPHIC TIMES 4, no. 40 (Apr. 1874): 51-52.

ST418 "What Constitutes a Plain Photograph." PHOTOGRAPHIC TIMES 4, no. 40 (Apr. 1874): 52. [Editor's definition of a plain photograph—as opposed to one that is overpainted in oils or pastels, etc. The editor feels that retouching the negative before making a print is a legitimate act.]

ST419 "Superficial Reading." PHOTOGRAPHIC TIMES 4, no. 41 (May 1874): 66.

ST420 "Attention to Business." PHOTOGRAPHIC TIMES 4, no. 41 (June 1874): 82-83.

ST421 "Effects in Cameo Vignettes." ANTHONY'S PHOTOGRAPHIC BULLETIN 5, no. 7 (July 1874): 243-244. [From "Br. J. of Photo." Atkinson (Liverpool); Reutlinger (Paris); Marion & Co. (Paris); C. D. Fredericks (New York, NY), practice this printing technique.]

ST422 "John". "Lessons in Photography." PHOTOGRAPHIC TIMES 4, no. 43-45 (July - Oct. 1874): 99-100, 123-124, 139-141, 158-160. 3 illus. [Fictional dialogue between a pupil and a photographer, who gives lessons on photographic techniques and practices.]

1875.
ST423 "Epitome of Progress during 1874." BRITISH JOURNAL PHOTOGRAPHIC ALMANAC 1875 (1875): 146-170.

ST424 "John." "Lessons in Photography." PHOTOGRAPHIC TIMES 5, no. 49-51 (Jan. - Mar. 1875): 5-7, 28-29, 56-57. 6 illus. [Series of articles set up in a dialogue form between the "Pupil" and the "Photographer." Beginner's advice. First article on the camera. Illustrated with engravings of cameras, etc.]

ST425 "Make Better Work." ANTHONY'S PHOTOGRAPHIC BULLETIN 6, no. 5 (May 1875): 136-138. [Author not given, may be the editor. Read before the Boston Photo. Assoc.]

ST426 "Our Foreign Make-Up: Portraiture." PHOTOGRAPHIC TIMES 5, no. 58 (Oct. 1875): 246-247. [Neither the author or the source of this discussion of the aesthetics of portraiture is given.]

ST427 "Photography and Truth." PHILADELPHIA PHOTOGRAPHER 13, no. 155 (Nov. 1876): 323.

1877.
ST428 "A New Electric Lamp Invented." PHOTOGRAPHIC TIMES 7, no. 74 (Feb. 1877): 39-40. [Paper communicated by M. L. Denayrouse to the French Academy of Sciences. Discusses "...the result of the studies undertaken in my ateliers by Mr. Paul Jobloschkoff, formerly an officer in the Russian engineer corps, upon the question of lighting by electricity.]

ST429 "Photographic Progress." CHAMBERS'S JOURNAL OF POPULAR LITERATURE 54, no. 688 (Mar. 3, 1877): 134-137. [General survey of latest developments.]

ST430 "The Photographing of Sounds Accomplished." ANTHONY'S PHOTOGRAPHIC BULLETIN 8, no. 4 (Apr. 1877): 105-106. [From "London Photo. News." Dr. Vogel, Koening experimenting. Success by Dr. Stein.]

ST431 "Transmitting Photographs by Telegraph." ANTHONY'S PHOTOGRAPHIC BULLETIN 8, no. 5 (May 1877): 149-150. [From "Br. J. of Photo." F. C. Bakewell's theories on the subject explained.]

ST432 "Poser." "About Head-rests and How to Use Them." PHOTOGRAPHIC TIMES 7, no. 78 (June 1877): 122-125.

ST433 "Recent Improvements in Photography." PHOTOGRAPHIC TIMES 7, no. 78 (June 1877): 134-135. [From "Scientific American." Discusses dry-plate processes coming into use. Use of platinum in printing.]

ST434 "Outdoor Photography." PHOTOGRAPHIC TIMES 7, no. 81 (Sept. 1877): 201. [General exhortation to photograph outdoors.]

ST435 "The Photographic Burglar." PHOTOGRAPHIC TIMES 7, no. 82 (Oct. 1877): 224-226. [Satiric commentary on patent claimants.]

ST436 "Pre-Glacial Photography." PHOTOGRAPHIC TIMES 7, no. 82 (Nov. 1877): 242-244. [Satiric commentary on patent claimants.]

ST437 "Photography: Can It Be Classed Among the Fine Arts?" PHOTOGRAPHIC TIMES 7, no. 84 (Dec. 1877): 276-277. [From "Chicago [IL] Saturday Evening Herald."]

1878.
ST438 "Truth, the One Element of Portraiture." ANTHONY'S PHOTOGRAPHIC BULLETIN 9, no. 2 (Feb. 1878): 51. [From "London Photographic News."]

ST439 "Rapid Photography." ANTHONY'S PHOTOGRAPHIC BULLETIN 9, no. 2 (Feb. 1878): 64. [Brief note, with editorial comment. "The great desideratum of years, the one thing lacking in practical photography...improvements in shortening the time of exposure...."]

1879.
ST440 "Large Portraits and the Gelatino-Bromide Process." ANTHONY'S PHOTOGRAPHIC BULLETIN 10, no. 2 (Feb. 1879): 42. [From "Br. J. of Photo."]

ST441 "The Study of Physiognomy." PHILADELPHIA PHOTOGRAPHER 16, no. 187 (July 1879): 199-200. [Etchings.]

HISTORY: BY COUNTRY.

ABYSSINIA: 1868.

ST442 "The Abyssinian War." HARPER'S WEEKLY 12, no. 593 (May 9, 1868): 297-298. 2 illus. ["From Photographs forwarded by the 'New York Herald' Correspondent in Abyssinia." Portraits of Lieut.-Gen. Sir Robert Napier and Staff in camp. etc.]

ST443 "Photographs of Abyssinia." ART JOURNAL (Jan. 1869): 10. [Photos taken by the 10th Company, Royal Engineers, under Colonel Pritchard, R.E.]

AFRICA: 19TH C.

ST444 Bensusan, A. D. *Silver Images: The History of Photography in Africa.* Cape Town, S. Africa: Howard Timmins, 1966. xi, 146 pp. b & w. illus.

ST445 Monti, Nicholas, ed., with introductory text. *Africa Then: Photographs 1840 - 1918.* New York: Alfred A. Knopf, 1987. viii, 175 pp. 87 b & w. [Brief biographies of approximately one hundred and twenty photographers who worked in Africa during this time. Some bibliography. Stronger coverage toward the latter portion of the chronology. Bibliography, pp. 173-175.]

AFRICA: 1852.

ST446 "Photographic Items." HUMPHREY'S JOURNAL 4, no. 10 (Sept. 1, 1852): 158. [From "Art Journal." ...G. Townsend (Exeter), has received from his brother, residing at Abbrokuta, a large town in the interior of Africa, some calotypes...']

AFRICA: 1858.

ST447 "Kroomen." ILLUSTRATED NEWS OF THE WORLD AND DRAWING ROOM PORTRAIT GALLERY OF EMINENT PERSONAGES 1, no. 13 (May 1, 1858): 205. 1 illus. ["After a photograph." Portrait of three Kroomen, a class of men on the western coast of Africa.]

AFRICA: 1877.

ST448 "Mr. H. M. Stanley and Some of His Native Followers. - From Photographs Taken at the Cape." ILLUSTRATED LONDON NEWS 71, no. 2004 (Dec. 8, 1877): 537. 1 illus.

AFRICA: 1879.

ST449 "Cetewayo Photographed." ANTHONY'S PHOTOGRAPHIC BULLETIN 10, no. 11 (Nov. 1879): 329. [From "Br J of Photo," in turn from "Cape Times" (South Africa). Report on photographing the Zulu chieftain Cetewayo, while aboard the steamer "Natal."]

ALBANIA: 19TH C.

ST450 Girard, Gerard. "Notes on Early Photography in Albania." HISTORY OF PHOTOGRAPHY 6, no. 3 (July 1982): 241-256. 24 b & w. 2 illus. [Based on conversations with Albanian photographers: Gege Marubi, Piro Milkani and others. 1980. Research on Pjetro Marubi, ffl. 1864-1890; Kole Idromeno 1860-1939; Kristaq Sotiri 1883-1970; Petro and Sulidhi 1890s, Vani Buda 1920s. Gjon Mili 1898-]

ALGERIA: 1858.

ST451 C. A. "Photography in Algeria. Nos. 1-4." PHOTOGRAPHIC NEWS 1, no. 1, 6, 9-11, 20, 22 (Sept. 10, 1858 - Feb. 4, 1859): 5-7, 63-65, 98-100, 112-113, 123-124, 232-233, 256-257.

ARGENTINA: 1859.

ST452 "The Exchange at Buenos Ayres." HARPER'S WEEKLY 3, no. 116 (Mar. 19, 1859): 188. 1 illus.

ARGENTINA: 1859.

ST453 "The People of Montenegro." BALLOU'S PICTORIAL DRAWING-ROOM COMPANION [GLEASON'S] 16, no. 405 (Mar. 26, 1859): 197. 3 illus. ["...from a series of photographs taken from life..." (Not credited, but taken from "Illus. London News" and much cruder in the recutting of the image).]

ARGENTINA: 1859.

ST454 "Exchange at Buenos Ayres, S. America." BALLOU'S PICTORIAL DRAWING-ROOM COMPANION [GLEASON'S] 16, no. 15 (Apr. 9, 1859): 237. 1 illus. [Group portrait of financiers in the new Exchange building in Buenos Aires. "The interesting group on this page, the various figures of which are all life-like and characteristic, is engraved from a photograph, and forms a very striking picture."]

ARGENTINA: 1873.

ST455 J. J. V., Montevideo, S. A. "A Voice from South America." PHILADELPHIA PHOTOGRAPHER 10, no. 116 (Aug. 1873): 237-238.

AUSTRALIA: 19TH C.

ST456 Cato, Jack. *The Story of the Camera in Australia.* Melbourne: Georgian House, 1955. 187 pp. 193 illus.

ST457 Cannon, Michael. *An Australian Camera, 1851-1914.* Newton Abbott: David & Charles, 1973. 112 pp. b & w. illus.

ST458 Davies, Alan and Peter Stanbury, with assistance from Con Tanre. *The Mechanical Eye in Australia: Photography 1841-1900.* Melbourne: Oxford University Press, 1985. 270 pp. approx. 50 b & w. [Includes portfolio, lists of professional photographers to 1900, amateurs to 1880.]

ST459 Barrie, Sandy. *Queenslanders behind the Camera. Professional Photographers in Queensland, 1849 to 1920.* Alphabetical listing, with dates and addresses. Volume 1. List 2. Queensland, Australia: Sandy Barrie, 1987. 37 pp. 4 b & w. 1 illus. [Volume one of five. The total work lists over 1,800 photographers.]

AUSTRALIA: 1853.

ST460 Chamberlayne, Rev. I., ed. *The Australian Captive; or, An Authentic Narrative of Fifteen Years in the Life of William Jackman. In which, among other adventures, is included a forced residence of a year and a half among the cannibals of Nuyt's Land, on the coast of the Great Australian Bight. Also including, with other appendices, Australia and its gold, from the latest and best authorities. With various Illustrations.* Auburn, NY: Derby & Miller, 1853. 392 pp. illus. ["Note. - The two portraits are Daguerreotypes of the original - the best that could be procured in that part of the far West to which he had removed...Both, however are to be taken with an allowance of ten years in the age of the subject; that being the time between his metamorphosis from savage to civilized life, and the date of the two Daguerreographs." (Actually engravings by N. Orr, probably from daguerreotypes.)]

AUSTRALIA: 1857.

ST461 "Sketches in Southern Australia." ILLUSTRATED LONDON NEWS 30, no. 850 (Mar. 21, 1857): 266. 4 illus. [Two views. Two portraits of natives, from photographs.]

ST462 "Aborigines of South Australia." BALLOU'S PICTORIAL DRAWING-ROOM COMPANION [GLEASON'S] 12, no. 309 (May 23, 1857): 336. 2 illus. [Portraits, "...from recent photographs."]

AUSTRALIA: 1858.
ST463 Haes, Frank. "On Photography in Australia." JOURNAL OF THE PHOTOGRAPHIC SOCIETY OF LONDON 4, no. 64 (Mar. 22, 1858): 179. [Freeman Brothers, Rev. Mr. Kemp mentioned.]

AUSTRALIA: 1862.
ST464 "The Melbourne and Ballarat Railway." ILLUSTRATED LONDON NEWS 41, no. 1158 (Aug. 9, 1862): 157. 1 illus. [View of the Morrabool Viaduct (bridge) from a photo, but photographer not credited.]

AUSTRIA: 19TH C.
ST465 Hubmann, Franz. *The Habsburg Empire; the World of the Austro-Hungarian Monarchy in Original Photographs, 1840-1916.* New York: Library Press, 1972. 320 pp. b & w. illus.

AUSTRIA: 1839.
ST466 "Photogenic Drawing." MIRROR OF LITERATURE, AMUSEMENT, AND INSTRUCTION no. 975 (Nov. 2, 1839): 288. [Mr. Schafhaeutl, of Vienna, displayed photogenic drawings.]

AUSTRIA: 1847.
ST467 Frank, Hans. "'Kino' - Janner 1847 in Wien." HISTORY OF PHOTOGRAPHY 1, no. 4 (Oct. 1977): 289-290. 1 b & w. 2 illus.

AUSTRIA: 1852.
ST468 "Our Weekly Gossip." ATHENAEUM no. 1312 (Dec. 18, 1852): 1396. [Comment upon the Austrian government's established policy of having daguerreotypes made of train wrecks as evidentiary records.]

AUSTRIA: 1853.
ST469 "Application of the Daguerreotype." HUMPHREY'S JOURNAL 4, no. 20 (Feb. 1, 1853): 312. [Austrian government orders that daguerreotypes be taken at the site of train wrecks, etc.]

AUSTRIA: 1857.
ST470 "Death of Mr. Taupenot - Photography in Vienna." HUMPHREY'S JOURNAL 8, no. 17 (Jan. 1, 1857): 261-262. [From "Cosmos" Oct. 19. M. Taupenot, Prof. of physics and inventor of collodio-albumen process, died. Royal Printing Establishment, Vienna. M. Dubois de Nehaut made sixty negatives in three days, of the grand exhibition, processions, crowds, etc. at Vienna, etc.]

AUSTRIA: 1862.
ST471 "Photography in Austria." JOURNAL OF THE PHOTOGRAPHIC SOCIETY OF LONDON 8, no. 128 (Dec. 15, 1862): 193-194. [From "Austrian Official Report."]

AUSTRIA: 1863.
ST472 "Cartes de Visite Extraordinary." HUMPHREY'S JOURNAL OF PHOTOGRAPHY, AND THE ALLIED ARTS AND SCIENCES 15, no. 16 (Dec. 15, 1863): 254. [Rumor that carte portraits of the disinterred remains of Beethoven and Schubert would be made and sold.]

AUSTRIA: 1873.
ST473 Badeau, W. H. "From Across the Water." ANTHONY'S PHOTOGRAPHIC BULLETIN 4, no. 10 (Oct. 1873): 301-302. [Discusses photography in Vienna, site of the International Exhibition. Mentions Gertlinger, discusses Luckhardt.]

AUSTRIA: 1874.
ST474 Wilson, Edward L. "Views Abroad and Across. Pt. 4." PHILADELPHIA PHOTOGRAPHER 11, no. 124 (Apr. 1874): 116-124. [Wilson visited many studios in extended visit to Europe. Vienna.]

BELGIUM: 19TH C.
BOOKS
ST475 Magelhaes, Claude and Laurent Roosens. *De fotokunst in België 1839 - 1940. L'art de la photographie en Belgique 1839 - 1940. Photographic Art in Belgium 1839 - 1940. Die Fotokunst in Belgien 1839 - 1940.* Duerne, Antwerp: Het Sterckshof, Provinciaal Museum voor Kunstambachten, Afdeling foto en film, 1970. 88 pp. 121 l. of plates. illus.

PERIODICALS
ST476 Coremans, P. "Le role de la Belgique dans l'histoire de la photographie." BULLETIN DES MUSÉES ROYAUX D'ART ET D'HISTOIRE ser. 3 vol. 11, no. 1 (Jan./Feb. 1939): 2-8. 4 illus. [D. Van Monckhoven (1834-1882), J. Plateau (1801-1883), L. Gevaert (1868-1935), L. H. Baekeland (b. 1863).]

BELGIUM: 1862.
ST477 Waldack, Charles. "Photography in Europe - Letter from Mr. Waldack." AMERICAN JOURNAL OF PHOTOGRAPHY AND THE ALLIED ARTS & SCIENCES n. s. vol. 5, no. 8 (Oct. 15, 1862): 181-184. [Briefly discusses the London Exhibition, describes events in Brussels, Belgium, talks about his own processes.]

ST478 Waldack, Charles. "Photography in Europe. Letter from Mr. Waldack." AMERICAN JOURNAL OF PHOTOGRAPHY AND THE ALLIED ARTS & SCIENCES n. s. vol. 5, no. 10 (Nov. 15, 1862): 229-233. [Describes activities and practices (mostly chemical) in Europe.]

ST479 Waldack, Charles. "Photography in Europe - Letter from Mr. Waldack." AMERICAN JOURNAL OF PHOTOGRAPHY AND THE ALLIED ARTS & SCIENCES n. s. vol. 5, no. 12 (Dec. 15, 1862): 276-280.

ST480 "Belgian First-Class Railway Carriage, with Smoking Salon Attached. - From a Photograph." FRANK LESLIE'S ILLUSTRATED NEWSPAPER 15, no. 376 (Dec. 15, 1862): 189. 1 illus.

BELGIUM: 1863.
ST481 Waldack, Charles. "Photography in Europe. - Letter from Mr. Waldack." AMERICAN JOURNAL OF PHOTOGRAPHY AND THE ALLIED ARTS & SCIENCES n. s. vol. 5, no. 16 (Feb. 15, 1863): 374-377. [Mostly chemical matters, Waldack writing from Ghent.]

ST482 "Photography in Europe - Letter from Mr. Waldack." AMERICAN JOURNAL OF PHOTOGRAPHY AND THE ALLIED ARTS & SCIENCES n. s. vol. 5, no. 17 (Mar. 1, 1863): 404-407. [Describes visit to Ghemar Fréres (Brussels), who employ thirty people, currently printing thousands of cartes-de-visite of British royalty, etc. Solar camera, lenses. F. Beyrich (Berlin) introduced Caseine paper. Interest in "spirit photography" craze also in Europe, etc.]

BELGIUM: 1864.
ST483 Lea, M. Carey. "Photography in Belgium." PHILADELPHIA PHOTOGRAPHER 1, no. 4 (Apr. 1864): 58-60. [Discussion of matters abstracted from "Bulletin Belge."]

BELGIUM: 1871.
ST484 "Photography in Brussels." ANTHONY'S PHOTOGRAPHIC BULLETIN 3, no. 1 (Jan. 1872): 421. [From "London Photo. News."]

BELGIUM: 1874.
ST485 Wilson, Edward L. "Views Abroad and Across. Pt. 2." PHILADELPHIA PHOTOGRAPHER 11, no. 122 (Feb. 1874): 33-39. [Wilson visited many studios in extended visit to Europe Brussels, Rome.]

ST486 Waldack, Charles. "Belgian Correspondence." PHILADELPHIA PHOTOGRAPHER 11, no. 132 (Dec. 1874): 375-378.

BELGIUM: 1875.
ST487 Waldack, Charles. "Belgium Correspondence." PHILADELPHIA PHOTOGRAPHER 12, no. 136, 139, 142. (Apr., Jul., Oct. 1875): 105-107, 198-200, 301-303.

BELGIUM: 1876.
ST488 Waldack, Charles. "Belgium Correspondence." PHILADELPHIA PHOTOGRAPHER 13, no. 145 (Jan. 1876): 15-17.

BOHEMIA: 19TH C.
ST489 Skopec, Rudolph. "Early Photography in Eastern Europe. Bohemia, Moravia and Slovakia." HISTORY OF PHOTOGRAPHY 2, no. 2 (Apr. 1978): 141-153. 6 b & w. 8 illus.

BRAZIL: 19TH C.
ST490 Ferrez, Gilberto. *Pioneer Photographers of Brazil, 1840-1920.* New York: Center for Inter-American Relations, 1976. 143 pp. b & w.

ST491 Kossoy, Boris. "Nineteenth-Century Brazilian Photography," on pp. 38-48 in: *Windows on Latin America: Understanding Society through Photographs,* edited by Robert M. Levine. Coral Gables, FL: North-South Center, University of Miami, 1987. 142 pp. 9 b & w.

ST492 Vasquez, Pedro. *Brazilian Photography in the nineteenth century.* Rio de Janeiro: Museu de Arte Moderna do Rio de Janerio, 1988. 1 sheet, folded to make 16 pp. 10 b & . [Exhibition curated and text of checklist written by Pedro Vasquez. This exhibition created for display at the Houston Foto Fest in Feb. - Mar. 1988. 81 prints in the show. Photographers are Victor Frond; Militao Augusto de Azevedo; A. Frisch; George Leuzinger; Felipe Augusto Fidanza; Marc Ferrez; Juan Gutierrez; Francisco du Bocage; Jorge Henrique Papf. Ten page essay, two page checklist, one page bibliography.]

BRAZIL: 1863.
ST493 "Photography in Brazil." HUMPHREY'S JOURNAL OF PHOTOGRAPHY, AND THE ALLIED ARTS AND SCIENCES 15, no. 5 (July 1, 1863): 80. [Praise for "the house of Robert Duncan, Rio de Janeiro, dealer in Photographic goods.]

BRAZIL: 1864.
ST494 "Photography in South America." HUMPHREY'S JOURNAL OF PHOTOGRAPHY, AND THE ALLIED ARTS AND SCIENCES 15, no. 17 (Jan. 1, 1864): 272. [Praise for the stockdealer Fales & Duncan, in Rio de Janeiro, Brazil.]

ST495 Kossoy, Boris. "Photographic Miscarriage." HISTORY OF PHOTOGRAPHY 2, no. 2 (Apr. 1978): 154. 1 b & w. [Caricature of commercial photographer by Henrique Fleiuss from "Semana Illustrada", March 13, 1864.]

BRAZIL: 1868.
ST496 E. H. K. "Letter." PHILADELPHIA PHOTOGRAPHER 6, no. 69 (Sept. 1869): 321. ["E. H. K." was a North American photographer travelling and working in Brazil. His letter recounts an anecdote of how, after being driven down to half his normal price by a customer in Brazil who only wanted "half of a full-length portrait", he then took a photo of the man from the waist down.]

BRAZIL: 1869.
ST497 Evans, Thomas C. "A Health Trip to Brazil." HARPER'S MONTHLY 39, no. 232-234 (Sept. - Nov. 1869): 489-504, 625-639, 818-831. 35 illus. [Views, portraits, etc. Engravings, many probably from photographs.]

BRAZIL: 1874.
ST498 Auchincloss, William Stuart. *Ninety Days in the Tropics,* Or, Letters from Brazil. Wilmington, Del.: s. n., 1874. 83 pp. 9 b & w. [Nine tipped-in photographs. Natives, views, etc. One is identified as by Henschel & Benque (Rio de Janerio).]

BRITISH GUIANA: 1866.
ST499 Bennett, George Wheatley. *An Illustrated History of British Guiana;* Compiled from Various Authorities and Illustrated with Photographs. Georgetown, Demerara, British Guiana: Richardson & Co., 1866. x, 265 pp. 44 b & w. [Original photographs, 15 from nature, the remainder from art.]

BURMA: 1853.
ST500 "Photographs from Burmah." ART JOURNAL (Aug. 1853): 207.

BURMA: 1874.
ST501 Conant, S. S. "The Land of the White Elephant." HARPER'S MONTHLY 48, no. 285 (Feb. 1874): 378-389. 9 illus. [Excerpted from "The Land of the White Elephant. Sights and Scenes of Southeastern Asia. A Personal Narrative...," by Frank Vincent, Jr. (Harper & Brothers). Views, costume portraits, etc. Burma, Siam, Cambodia, and China. Engravings, probably from photographs.]

BURMA: 1875.
ST502 "Court Customs in Burmah." ILLUSTRATED LONDON NEWS 67, no. 1874 (July 10, 1875): 37. 2 illus.

CANADA: 19TH C.
See also NOTMAN, WILLIAM (Triggs).

BOOKS
ST503 Greenhill, Ralph. *Early Photography in Canada.* Toronto: Oxford University Press, 1965. 173 pp. b & w.

ST504 Greenhill, Ralph and Andrew Birrell. *Canadian Photography: 1839 - 1920.* Toronto: The Coach House Press, 1979. 184 pp. 104 b & w. ["This book is a substantial revision and expansion of "Early Photography in Canada," by Ralph Greenhill, published by Oxford University Press in 1965."]

ST505 Thomas, Ann. *Fact and Fiction: Canadian Painting and Photography, 1860 - 1900.* Montreal: McCord Museum, 1979. 116 pp. [Exhibition catalog: McCord Museum, Montreal.]

ST506 Koltun, Lilly. *City Blocks, City Spaces. Historical Photographs of Canada's Urban Growth, c. 1850-1900.* Ottawa: National Archives of Canada, 1980. 102 pp. 29 l. of plates. [Exhibition catalog: National Archives of Canada, Ottawa, Apr. 22 - July 8, 1980. Essays. Annotated checklist of 207 photographs. Biographical Notes on thirty-seven

SPECIAL TOPICS
HISTORY: BY COUNTRY: CANADA: 1859.

SPECIAL TOPICS
HISTORY: BY COUNTRY: CANADA: BRITISH COLUMBIA: 19TH C.

photographers on pp. 85 - 102. Illustrations include several panoramas.]

ST507 Koltun, Lilly, ed. *Private Realms of Light. Amateur photography in Canada. 1839 - 1940,* edited by Lilly Koltun. Written by members of the National Photography Collection, Public Archives of Canada. Andrew J. Birrell, Peter Robertson, Lilly Koltun, Andrew C. Rodger, Joan M. Schwartz. Markham, Ontario: Fitzhenry & Whiteside, 1984. 336 pp. b & w. [Based on an exhibition first shown at the Public Archives of Canada, Ottawa, July 14, 1983 - Oct. 23, 1983. Essays include "The Early Years/1839 - 1885," by Andrew J. Birrell on pp. 2 - 15. Biographies on pp. 304 - 328. Bibliography on pp. 329 - 332.]

ST508 Schwartz, Joan M. and Jim Burant. *Aperçu. The Archive looks... Behind the Lines.* Art, Photography and the Pictorial Press. Ottawa: Public Archives of Canada. Documentary Art and Photography Division., 1988. 1 folded sheet, making 6 pp. 2 b & w. 3 illus. [Exhibition handout. Public Archives of Canada, Ottawa, Nov. 7, 1988 - Feb. 3, 1989. Exhibition displaying woodcuts drawn from photographs which were published in the "Illustrated London News," "Canadian Illustrated News," "l'Opinion publique," etc. along with the original photographs which were their source. Brief essay in English and French.]

ST509 Jackson, Christopher E. *With Lens and Brush. Images of the Western Canadian Landscape 1845 - 1890. Objectif et coup de pinceau. Paysages de l'ouest Canadien de 1845 - 1890.* Calgary, Canada: Glenbow-Alberta Institute, 1989. 108 pp. 72 illus. [Exhibition catalog. 159 works by forty-four artists, including the photographers Benjamin Baltzly (1835-1883); W. Hanson Boorne (act. 1885-1890); Oliver B. Buell (1844-1910); Frederick Dally (act. 1860s); George Mercer Dawson (1849-1901); Edouard Deville (1849-1924); Simon Duffin & Co. (ca. 1870s-1880s); Charles Gentile (act. 1865); Alexander Henderson (1831-1913); Humphrey Lloyd Hime (1839-1903); Charles Horetzky (1838-1900); Charles MacMunn (act. 1880s); Richard Maynard (1832-1907); William McFarlane Notman (1857-1913); A. B. Thom (act. 1880s-1890s); Corps of Royal Engineers (1870s).]

ST510 Mobbs, Leslie. *Aperçu. The Archive looks at... One of a Kind.* Ottawa: Public Archives of Canada. Documentary Art and Photography Division., June 1989. 1 folded sheet, making 6 [Exhibition handout. Public Archives of Canada, Ottawa, June 15 - Oct. 22, 1989. Exhibition of daguerreotypes, ambrotypes and tintypes. Brief essay in English and French.]

PERIODICALS
ST511 Davison, J. Robert. "Turning a Blind Eye: The Historians Use of Photographs." BC STUDIES no. 52 (Winter 1981-1982): 16-38. 10 b & w. [Essay in a special issue "The Past In Focus: Photography & British Columbia, 1858 - 1914." Discusses photography's uses to a cultural and social historian.]

ST512 Roger, Andrew. "Religious Archives: Nave gazing." THE ARCHIVIST (PUBLIC ARCHIVES OF CANADA) 12, no. 1 (Jan. - Feb. 1985): 1-2, 20-21. 3 b & w. [Brief discussion of making and uses of photographs of religious structures, events in 19th century Canada. Illus by L. P. Valeé, of Quebec (1870s) and J. G. Parks, Montreal (1870s).]

ST513 Schwartz, Joan M. "The 'Little Wanzer.'" HISTORY OF PHOTOGRAPHY 10, no. 2 (Apr. - June 1986): 141-146. 2 b & w. 4 illus. [Discussion of the use of photography in advertising by the Wanzer sewing machine company of Hamilton, Ontario in the late 1860s and early 1870s.]

ST514 "Photography and the international boundary." THE ARCHIVIST (PUBLIC ARCHIVES OF CANADA) 13, no. 6 (Nov. - Dec. 1986): 6-7. 2 b & w. [Several Canadian/USA boundary survey commissions from 1860s on used photographers. Brief discussion of these efforts by Canadian teams - including Dr. Thomas Milman in 1870s and Edouard Deville's work in 1880s.]

ST515 Schwartz, Joan M. "Ned Hanlan: Portrait of a Sports Hero." HISTORY OF PHOTOGRAPHY 11, no. 2 (Apr. - June 1987): 123-132. 10 b & w. 7 illus. [Cartes-de-visite, other portraits of Edward Hanlan, the champion sculler of Canada during the 1870s. Photos by J. Bruce & Co. (Toronto); W. Williamson (Toronto); D. C. Ferguson; Notman & Sandham (Montreal); the "Canadian Illustrated News," and others. (Reprinted in "The Archivist" 15: 4 (July - Aug. 1988): 7-9.)]

ST516 Schwartz, Joan M. "Studies in Documents. Documenting Disaster: Photography at the Desjardins Canal, 1857." ARCHIVARIA 25, (Winter 1987-88): 147-154. 1 b & w. 5 illus. [Photographs and engravings, after photographs, in the illustrated periodicals and other literature, of a serious train wreck near Hamilton, Canada, on March 12, 1857. R. Milne, D. N. Preston, D. C. Beere known to have photographed or daguerreotyped the site.]

ST517 Carey, Brian. "Daguerreotypes in the National Archives of Canada." HISTORY OF PHOTOGRAPHY 12, no. 1 (Jan. - Mar. 1988): 45-60. 14 b & w. 3 illus. [Seth Park; Thomas Coffin Doane; Wellington A. Chase; Thomas Connon; others mentioned.]

CANADA: 1859.
ST518 "The Victoria Bridge Over the St. Lawrence at Montreal." ILLUSTRATED LONDON NEWS 34, no. 960 (Feb. 19, 1859): 175-177. 3 illus. [Three views, one a hypothetical view of what the bridge would look like when finished, two from photographs taken in June 1858, of the bridge under construction.]

CANADA: 1860.
ST519 "The 'George Stephenson' Locomotive Engine Built at Hamilton, Canada West, for the Great Western Railway of Canada." ILLUSTRATED LONDON NEWS 37, no. 1048 (Sept. 1, 1860): 201-202. 1 illus. [Not credited, but from a photo.]

CANADA: 1871.
ST520 Wilson, Edward L. "Photography in Canada." PHILADELPHIA PHOTOGRAPHER 8, no. 89 (May 1871): 151-152. [William Notman (Montreal); Alexander Henderson (Montreal); J. Inglis; Notman & Frazer (Toronto); Ewing & Co.; W. O'Conner; etc.]

CANADA: 1872 see STARK, ROBERT.

CANADA: 1876.
ST521 Barrow, Richard W. "Canada Correspondence." PHILADELPHIA PHOTOGRAPHER 13, no. 146, 148 (Feb., Apr. 1876): 36-37, 106-107.

ST522 "Correspondence." ANTHONY'S PHOTOGRAPHIC BULLETIN 7, no. 9 (Sept. 1876): 288. [Letter, signed by 13 photographers from Ontario, Canada, praising the Lambert processes. The photographers' names and cities given.]

CANADA: BRITISH COLUMBIA: 19TH C.
BOOKS
ST523 Mattison, David. *Camera Workers: The British Columbia Photographers Directory, 1858 - 1900. Volume 1.* Victoria: Camera Workers Press, 1985. 274 pp. illus.

SPECIAL TOPICS
HISTORY: BY COUNTRY: CANADA: NOVA SCOTIA: 19TH C.

SPECIAL TOPICS
HISTORY: BY COUNTRY: CEYLON: 19TH C.

ST524 Mattison, David. *Eyes of a City: Early Vancouver Photographers, 1868 - 1900.* "Occasional Papers No. 3" Vancouver, B. C.: City of Vancouver Archives, Raincoast Book Distribution, Ltd., 1986. 75 pp. illus. [William McFarlane Notman (1857-1913); S. J. Thompson (1864-1929); Frederick Dally (1838-1914); David Withrow (d. 1905); Francis George Claudet (1837-1906); Joseph Davis (d. 1891); others. A list of studios. Bibliography.]

PERIODICALS

ST525 Schwartz, Joan M. "The Photographic Record of Pre-Confederation British Columbia." ARCHIVARIA 5, (1977-78): 17-43. 27 b & w. 1 illus. [A dozen photographers active in area between 1858 and 1871. Illustrations are photos of gold mining operations, landscapes, buildings, etc. by Charles Gentile (1860s); Frederick Dally (1860s); Benjamin Baltzly (1870s). Stephen Spencer; L. A. Blanc; others mentioned. The essay discusses which subjects the photographers photographed. (Reprinted in "Journal of American Culture" 4: 1 (Spring 1981).]

ST526 Mattison, David. "The Victoria Theatre Photographic Galley (and the Gallery Next Door)." BRITISH COLUMBIA HISTORICAL NEWS 14, no. 2 (Winter 1980): 1-14. 4 illus. [Article traces the history of two photo studios operated in Victoria, B. C. from 1862-1878 by a succession of owners. Illustrations are advertisements.]

ST527 Schwartz, Joan M., ed. "The Past in Focus: Photography & British Columbia, 1858-1914: A Special Issue of BC Studies." BC STUDIES no. 52 (Winter 1981-1982): 5-15. [Introduction to the theme of this special issue.]

ST528 Birrell, Andrew. "Survey Photography in British Columbia, 1858-1900" BC STUDIES no. 52 (Winter 1981-1982): 39-60. 7 b & w. [Essay in a special issue "The Past In Focus: Photography & British Columbia, 1858-1914." Discusses the British Royal Engineers survey party in Canada in 1858 through the early 1860s. Benjamin Baltzly in the 1870s, Charles Hornetzky in 1870s, Otto Julius Klotz, Edouard Deville, J. J. McArthur and W. S. Drewry in 1880s.]

ST529 Thomas, Alan. "Photography of the Indian: Concept and Practice on the Northwest Coast." BC STUDIES no. 52 (Winter 1981-1982): 61-85. 13 b & w. [Essay in a special issue "The Past In Focus: Photography & British Columbia, 1858-1914." Discusses Charles Gentile (1860s); Frederick Dally (1860s); Richard Maynard (1870s-1880s); Edward Dossetter (1880s); Mrs. Hannah Maynard (1880s); B. W. Leeson (1890s); Edward S. Curtis (1900); O. C. Hastings (1890s, 1900s).]

ST530 Blackman, Margaret B. "Copying People: Northwest Coast Native Response to Early Photography." BC STUDIES no. 52 (Winter 1981-1982): 86-112. 12 b & w. [Essay in a special issue "The Past In Focus: Photography & British Columbia, 1858-1914." Discusses the work of Hannah Maynard, EDward Dossetter and others.]

ST531 Schwartz, Joan M. and Lilly Koltun. "A Visual Cliche': Five Views of Yale." BC STUDIES no. 52 (Winter 1981-1982): 113-128. 5 illus. [Essay in a special issue "The Past In Focus: Photography & British Columbia, 1858-1914." Visual representations of Fort Yale, British Columbia discussed.]

ST532 Mattison, David, comp. "British Columbia Photographers of the Nineteenth Century: An Annotated, Select Bibliography." BC STUDIES no. 52 (Winter 1981-1982): 166-170. [Essay in a special issue "The Past In Focus: Photography & British Columbia, 1858-1914." Bibliography of published monographs, periodical articles, catalogs, and unpublished academic dissertations, current to March 1981.]

ST533 Mattison, David. "The World's Panorama Company." HISTORY OF PHOTOGRAPHY 8, no. 1 (Jan. - Mar. 1984): 47-48. 2 illus. [Discusses panoramic views of Victoria, B.C. taken by George Robinson Fardon (1807-1886) ca. 1861 or 1862, and a two photographers (J. A. Miller and unknown) working for a firm, The World's Panorama Company, during the same time.]

ST534 Schwartz, Joan M. "The Gold Rush. Gold in early British Columbia." THE ARCHIVIST (PUBLIC ARCHIVES OF CANADA) 13, no. 1 (Jan. - Feb. 1986): 1-2. 3 b & w. [Photos by Frederick Dally (Victoria, B. C.) of the Caribou gold fields in 1867 - 1868. Other photographers mentioned are Christopher Fulton, Charles Gentile, L. A. Blanc.]

CANADA: NOVA SCOTIA: 19TH C.

ST535 Burant, Jim. "Pre-Confederation Photography in Halifax, Nova Scotia." JOURNAL OF CANADIAN ART HISTORY 4, no. 1 (Spring 1977): 25-44. 10 b & w. [Illustrations by Thomas Coffin Doane (1840s); Daniel J. Smith (1850s); Wellington Chase (1850s); Isaac Parish (1860s). John Clow, Mr. Seager, Halsey & Sadd travelled through in 1840s. William Valentine opened a studio in 1841, worked until his death in 1849. Thomas Coffin Doan, born Barrington, Nova Scotia, in 1814. Artist, learned daguerreotyping in 1842, briefly partnered with Valentine, then spent year in West Indies, then moved to Montreal and established a portrait studio there, became well-known. Moved to Boston, MA in 1866 and returned to portrait painting. Died in New York in 1896. J. Clow also partnered with Valentine, then ran his own studio until about 1848. A. S. Kimball, C. E. Johnson, H. Johnson , Thomas A. Cleverdon, Mrs. Jane Carroll, A. H. Lincoln & Co., Daniel J. Smith, James M. Margeson, T. A. Salteri & Co., Dan Smith, Wellington A. Chase, William D. O'Donnell (b. 1831, in business to at least 1902), A. Oxley, Charles Mitchell, Parish & Co, J. M. Margeson, J. R. P. Fraser, Joseph S. Rogers, Isaac Parish, a branch of the Notman studios, run by A. B. Almon, and others discussed.]

CANADA: QUEBEC: 19TH C.

ST536 Koltun, Lilly. "Pre-Confederation Photography in Toronto." HISTORY OF PHOTOGRAPHY 2, no. 3 (July 1978): 249-263. 14 b & w. 6 illus.

ST537 Cloutier, Nicole "Les disciples de Daguerre a Quebec 1839 - 1855." JOURNAL OF CANADIAN ART HISTORY 5, no. 1 (1980): 33-38. 7 b & w.

ST538 Lotbiniere-Harwood, Susanne. "The Season in Review." ARTMAGAZINE no. 50 (Sept. - Oct. 1980): 59. 1 b & w. [Review of exhibition: "Photographs of 19th Century Quebec," Yajima Gallery, Montreal, Quebec, Canada.]

CANADA: QUEBEC: 1874.

ST539 Hubbard, Benjamin F. *Forests and Clearings. The History of Stanstead County, Province of Quebec,* with Sketches of More than Five Hundred Families. Compiled by B. F. Hubbard...The Whole Revised, Abridged and Published with Additions and Illustrations. Montreal: John Lawrence, printed by Lovell Printing and Publishing Co., 1874. viii, 367 pp. 8 b & w. illus. [Original photos, portraits, one view.]

CEYLON: 19TH C.

ST540 Lawton, S. K. "When was Photography Introduced into the East?" PENROSE'S PICTORIAL ANNUAL 1912-1913 (1913):

132-134. illus. [Christian missionaries to Ceylon at Batticotta Seminary introduced photography, ca. 1840s.]

ST541 Falconer, John. "Nineteenth Century Photography in Ceylon." PHOTOGRAPHIC COLLECTOR 2, no. 2 (Summer 1981): 39-54. [Photographs by Samuel Bourne (1) 1860s; S. Slinn & Co. (1) ca. 1864; W. L. H. Skeen & Co. (b) 1870s, 1880s; Charles T. Scowen (b) ca. 1875-1880; Joseph Lawton (2) 1870-71; Julia M. Cameron (1) ca. 1887; Plate & Co. (1) 1890s.]

CEYLON: 1872.
ST542 "A Ceylon Coffee Plantation." ILLUSTRATED LONDON NEWS 60, no. 1711 (June 22, 1872): 591, 593. 1 illus. ["Our illustration is taken from a photograph..."]

CHILE: 1865.
ST543 "The Attack of Spain on Chile." FRANK LESLIE'S ILLUSTRATED NEWSPAPER 21, no. 535 (Dec. 30, 1865): 228-229. 2 illus. [Views of Valparaiso, Chile. Not credited, but from photographs. Also, in the text, a note stating that the Spanish squadron, which arrived "about two years ago" had a photographer in its complement of men.]

CHINA: 19TH C.
BOOKS
ST544 Goodrich, L. Carrington and Nigel Cameron. *The Face of China as seen by Photographers and Travelers, 1860 - 1912.* Millerton, NY: Aperture, 1978. 160 pp. 104 b & w. 48 illus.

ST545 Worswick, Clark and Jonathan Spence. *Imperial China: Photographs 1850 - 1912.* ...Introduction by Harrison Salisbury. New York: Pennwick Publishing, 1978. 151 pp. b & w. illus.

PERIODICALS
ST546 J. R. "Hong-Kong Photographers." IMAGE 1, no. 7 (Oct. 1952): 3-4. [Condensed reprint from the "Br J of Photo.," 1873.]

CHINA: 1861.
ST547 Lacan, Ernest. "Foreign Correspondence." BRITISH JOURNAL OF PHOTOGRAPHY 8, no. 134 (Jan. 15, 1861): 38. [Lists the photographers among the French military Expeditionary Corps in China. "Antoine Fauchery, official correspondent of the 'Moniteur,' is also attached to the 'Photographic Mission' of Colonel Dupin, Chief of the Topographic Office Expeditionary Corps....at the Tche-fou camp, a M. Legrand, a French photographer from Shanghai,...(thus) there are at least three persons on the theatre of war capable of taking views with the camera, without counting our ambassador, Baron Gros,..."]

CHINA: 1867.
ST548 Towler, Prof. "Japanese, Chinese, Egyptian, etc., Photographs." HUMPHREY'S JOURNAL OF PHOTOGRAPHY, AND THE ALLIED ARTS AND SCIENCES 18, no. 22 (Mar. 15, 1867): 338-339. [Towler invited to see the art collection of Robert H. Pruyn, formerly United States Ambassador to Japan, living in Albany, NY. He describes the Japanese work, textiles, etc. Pruyn's collection also included photographs of Japan and China. "Some of the views from China were as barbarous as those that were taken during our late civil contest between the North and South - they exhibited the mangled corpses of human beings slaughtered in warfare,....." (Perhaps these are photos by Beato?).]

CHINA: 1869.
ST549 "Opening of a New Dock at Singapore." ILLUSTRATED LONDON NEWS 54, no. 1519 (Jan. 2, 1869): 17-18. 1 illus. ["...from a photograph taken on the occasion."]

CHINA: 1872.
ST550 "China. - Launch of a New War Frigate by the Chinese Government at the Arsenal, Shanghai. - From a Photograph by a Chinese Photographer." FRANK LESLIE'S ILLUSTRATED NEWSPAPER 34, no. 880 (Aug. 10, 1872): 348. 1 illus.

CHINA: 1875.
ST551 "How To Produce Photographic Portraits Without a Camera." ANTHONY'S PHOTOGRAPHIC BULLETIN 6, no. 9 (Sept. 1875): 270. [From "London Photo. News." Anecdote from M. C. Kardactz, attached to the British Transit of Venus Expedition to China. Mentions visiting a Chinese portrait studio in Tschifu, South China, which did not have a camera. The proprietor had a stock of portrait negatives which he matched to a customer and sold as his own portrait.]

CHINA: 1878.
ST552 Rapier, Richard Christopher. *Renumerative Railways for New Countries; With Some Account of the First Railway in China.* London, New York: E. & F. N. Spon, 1878. 114 pp. 9 l. of plates. 8 b & w. 8 illus. [Photomechanical prints, from negatives of the first Chinese railroad.]

COLOMBIA: 19TH CENTURY.
ST553 Mejia, German Rodrigo. "Colombian Photographs of the Nineteenth and Early Twentieth Centuries," on pp. 48-61 in: *Windows on Latin America: Understanding Society through Photographs.* edited by Robert M. Levine. Coral Gables, FL: North-South Center, University of Miami, 1987. 142 pp. 14 b & w.

CROATIA: 19TH C.
ST554 Grcevic, Nada "Early Photography in Eastern Europe, Croatia." HISTORY OF PHOTOGRAPHY 1, no. 2 (Apr. 1977): 153-167. 18 b & w.

CUBA: 19TH CENTURY.
ST555 Fernandez, Ramiro A. "Cuba: Fotografia 1860 - 1920, selected Images from the Collection of Ramiro A. Fernandez," on pp. 8-32 in: *Windows on Latin America: Understanding Society through Photographs,* edited by Robert M. Levine. Coral Gables, FL: North-South Center, University of Miami, 1987. 142 pp. 26 b & w.

CUBA: 1853.
ST556 "A Glance at Havana." PUTNAM'S MONTHLY 1, no. 2 (Feb. 1853): 185-193. 7 illus. [Views, engraved. Not credited, but an advertisement on p. 95 (Feb. 5, 1853) "Illustrated News" a description of the issue claims: "A Glance at Havana - Illustrations - From Daguerreotypes." 6 views and a map. All illus. are signed Richardson & Cox, Sc., in the right corner and credited variously in the left corner: Miller, Del., Wells, Coater, Del.]

CUBA: 1855 see also FREDERICKS, CHARLES DEFOREST.

CUBA: 1859.
ST557 J. M. S. [Sanders]. "Letter." AMERICAN JOURNAL OF PHOTOGRAPHY AND THE ALLIED ARTS AND SCIENCES n. s. vol. 1, no. 17 (Feb. 1, 1859): 271-272. [Describing status of photography in Havana, Cuba. Mentions Fredericks as best photographer there, says that he & Wm Winter, S. A. Cohner & Jas. H. Bosell going to open a gallery.]

CZECHOSLOVAKIA: 19TH C.

ST558 *Kouzlo stare fotografie. [The Charm of Old Photographs.]* Brno: Moravske Galerie, 1978. 77 pp. b & w. [Ex. cat.: Moravska Gallery, Brünn, Oct. - Nov., 1978. Summaries in English, Russian and German. Bibliography on pp. 2-3.]

DENMARK: 19TH C.
BOOKS

ST559 Oschsner, Bjorn. *Photographers in and from Denmark up to and including 1920.* Ballerup, Denmark: Bibliotekscentralen Forlag, 1986. 924 pp. [Biographical dictionary.]

PERIODICALS

ST560 Mayer, Robert. "The Thorvaldsen Daguerreotype." HISTORY OF PHOTOGRAPHY 1, no. 1 (Jan. 1977): 85-87. 1 b & w. [Daguerreotype portrait of the Danish sculptor Albert Thorvaldsen.]

ST561 "The Thorvaldsen Daguerreotype: Correspondence From Robert Meyer." HISTORY OF PHOTOGRAPHY 2, no. 1 (Jan. 1978): 85-87. 1 b & w. 3 illus.

DENMARK: 1864.

ST562 "Danish Infantry Soldiers - Photographed from the Life." ILLUSTRATED LONDON NEWS 44, no. 1259 (May 14, 1864): 461, 464. 1 illus.

ST563 "The War in Denmark: Ruins of the Langaa Railway Bridge in Jutland." ILLUSTRATED LONDON NEWS 45, no. 1271 (July 30, 1864): 113-114. 1 illus.

DUTCH INDIES: 19TH C.

ST564 Museum voor Volkenkunde, Rotterdam. *Toekang Potret, 100 Years of Photography in the Dutch Indies, 1839-1939.* Rotterdam: Museum voor Volkenkunde, 1989. 192 pp. 139 b & w. 41 illus. [Essays: "Introduction," by Liane van der Linden. "Photography in aid of science," by Anneke Groeneveld. "Commercial photographers until 1870," by Anneke Groeneveld and Steven Wachlin. "Commercial photography," by Ineke Zweers. "Large scale studios and amateur photography," by Steven Wachlin. "Commercial photographers and photographic studios in the Netherlands East Indies, a survey," by Steven Wachlin. Woodbury & Page; Kurkdjian; Céphas; C. B. Nieuwehhuis; Van Kinsbergen; Tan Tjie Lan; Kleingrothe; others discussed. Texts in Dutch and English. Bibliography.]

EGYPT: 19TH C.
BOOKS

ST565 Baldwin, Gordon. *Procession to the Fallen Gods: Photography in Nineteenth-Century Egypt.* J. Paul Getty Museum, 1987. 1 sheet folded into 8 pages pp. 5 b & w. [Exhibition catalog: J. Paul Getty Museum, Feb. 10 - Apr. 19, 1987. Illustrations are photographs by Henry Cammas; Maxime Du Camp; Felix Tenyard; John B. Greene; Francis Frith.]

ST566 *Splendors of the Nile: Nineteenth-Century Photographs of Egypt.* Detroit: Albert and Peggy de Salle Gallery of Photography. Detroit Institute of Arts, 1989. 20 pp. 11 b & w. 1 illus. [Ex. cat.: Feb. 21 - May 7, 1989. "Foreword," by Christine Swenson, pp. 4-5. "Travellers on the Nile," by William H. Peck, on pp. 5-6. "Heat, Wind, and Sand: The Hazards of a Nineteenth-Century Photographer in Egypt," by Martha Mardirosian, on pp.7-9. 105 photographs by 12 photographers.]

PERIODICALS

ST567 Jammes, André and Marie-Thérèse Jammes. "Egypt in Flaubert's Time: the First Photographers, 1839 - 1860." APERTURE no. 78 (1977): 62-77. 13 b & w. [Illustrations by Louis De Clerque; Maxime Du Camp; Beato; F. Frith; J. B. Greene; Felix Tenyard.]

ST568 Thomas, Ritchie. "Some 19th Century Photographers in Syria, Palestine and Egypt." HISTORY OF PHOTOGRAPHY 3, no. 2 (Apr. 1979): 157-166. 11 b & w. [1 b & w by F. Bonfils, 1 b & w by F. Beato, 1 b & w by J. P. Sebah, 5 b & w by G. Lakegian, 1 b & w by anonymous, 2 b & w by American Colony Photographic Department.]

EGYPT: 1877.

ST569 McClellan, George B. "A Winter on the Nile." CENTURY MAGAZINE (SCRIBNER'S MONTHLY) 13, no. 3-5 (Jan. - Mar. 1877): 368-383, 452-459, 670-677. 15 illus. [Woodcuts, many apparently from photos. Not credited, but the article implies that they were taken by the author or a member of his party.]

ESTONIA: 19TH C.
BOOKS

ST570 Teder, Kaljula. *Eesti fotograafia teerajajaid sada aastat (1840 - 1940) arenguteed.* Tallinn: Eesti Raamat, 1972. 146 pp. 56 l. of plates. [Summaries in English and Russian.]

PERIODICALS

ST571 Teder, K. "Early Photography in Eastern Europe: Estonia." HISTORY OF PHOTOGRAPHY 1, no. 3 (July 1977): 249-268. 17 b & w. 7 illus.

FINLAND: 19TH C.

ST572 Hirn, Sven. "Early Photography in Eastern Europe: Finland." HISTORY OF PHOTOGRAPHY 1, no. 2 (Apr. 1977): 135-152. 22 b & w. 3 illus.

FRANCE: 19TH C.
BOOKS

ST573 Bonney, Mabel Thérèse. *The Second Empire by Louis-Jacques Daguerre and His School,* Exhibition of Daguerreotypes from the Collection of M. Thérèse Bonney. New York: Knoedler Galleries, 193-? 13 pp.

ST574 *French Primitive Photography.* Introduction by Minor White. Commentaries by André Jammes and Robert Sobieszek. New York: Aperture, 1969. 73 b & w. 11 illus. [Also issued as a special issue of "Aperture" 15, no. 1 (Spring 1970), in conjunction with an exhibition first held at the Philadelphia Museum of Art, Nov. 17 - Dec. 28, 1969. 246 items listed in the exhibition.]

ST575 Sobieszek, Robert A. "Photography and the Theory of Realism in the Second Empire: A Reexamination of a Relationship," on pp. 146-159 in: *One Hundred Years of Photographic History. Essays in Honor of Beaumont Newhall.* Edited by Van Deren Coke. Albuquerque, NM: University of New Mexico Press, 1975. 180 pp. 8 b & w.

ST576 *Niépce to Atget. The First Century of Photography From the Collection of André Jammes.* With an essay and catalogue by Marie-Thérèse and André Jammes and an introduction by David Travis. Chicago: The Art Institute of Chicago, 1977. 115 pp. 118 b & w. 3 illus. [Ex. cat.: The Art Institute of Chicago, Nov. 16, 1977 - Jan. 15, 1978. Checklist lists 144 prints.]

ST577 Hough, Richard, organizer. *Mid 19th Century French Photography: Images on Paper.* Edinburgh: The Scottish Photography

Group, Ltd., 1979. 48 pp. 86 b & w. [Exhibition catalog, Stills, the Scottish Photography Group Gallery, Edinburgh, Aug. 15 - Sept. 22, 1979. "Preface," by Richard Hough, on p. 3. "A Historical Background: France in the Second Empire," by Robert Anderson, on pp. 4-5. "Landscape in Amber: Camille Silvy's 'River Scene,'" by Mark Haworth-Booth, on pp. 6-8. "'il faut etre de son temps,'" by Gerry Badger, on pp. 9-10. Portfolio of photographs, on pp. 11-42. "Checklist," of 86 prints on pp. 43-46. "Selected References," on pp. 47.]

ST578 *After Daguerre: Masterworks of French Photography (1848 - 1900) from the Bibliothèque Nationale.* New York: The Metropolitan Museum of Art, New York in association with Berger-Levrault, Paris, 1980. 187 pp. b & w. illus. [Exhibition catalog. Musée du Petit Palais, Paris (Sept. 18 - Nov. 23, 1980); Metropolitan Museum of Art, NY (Dec. 18, 1980 - Feb. 15, 1981). "Preface," by Georges Le Rider, p. 9. "Preface," by Philippe de Montebello, p. 10. "Early Photography in the Collection of the Cabinet des Estampes," by Jean-Pierre Seguin, pp. 11-14. "The Beginnings of Photography as Art in France," by Weston J. Naef, pp. 15-70. "Catalogue," by Bernard Marbot, pp. 71-179. "Selected Bibliography," pp. 180-181.]

ST579 Freund, Gisèle. *Photography & Society.* London, Boston: Gordon Fraser, David R. Godine, 1980. 231 pp. b & w. illus. [Translation from the French.]

ST580 Buerger, Janet. *The Era of the French Calotype.* Rochester, NY: International Museum of Photography at George Eastman House, 1982. 64 pp. 262 illus. [Survey of the times and context of the work. Index to the photographers and bibliography.]

ST581 Jammes, André and Eugenia Parry Janis. *The Art of French Calotype:* With a Critical Dictionary of Photographers, 1845 - 1870. Princeton, NJ: Princeton University Press, 1983. xxvi, 284 pp. b & w. illus. [Bibliography pp. 269-275.]

ST582 Johnson, Brooks. *Nineteenth Century French Photography.* Norfolk, VA: The Chrysler Museum, 1983. 40 pp. b & w. [Ex. cat.: The Chrysler Museum, Apr. 1 - June 19, 1983.]

ST583 Brettell, Richard R. *Paper and Light: The Calotype in France and Great Britain, 1839 - 1870.* Richard R. Brettell, with Roy Fluckinger, Nancy Keeler, and Sydney Mallett Kilgore. Boston: David Godine, 1984. 216 pp. 141 b & w. [Bibliography pp. 207-215.]

ST584 English, Donald E. *Political Uses of Photography in the Third French Republic, 1871 - 1914.* Ann Arbor, MI: UMI Reasearch Press, 1984. xvi, 262 pp. b & w. illus. [Bibliography pp. 247-256.]

ST585 Janis, Eugenia Parry. *The Flowering of Early French Photography, 1840 - 1870.* J. Paul Getty Museum, 1987. 1 sheet folded into 8 pages pp. 5 b & w. [Exhibition catalog: J. Paul Getty Museum, Apr. 28 - June 28, 1987. Illustrations are photographs by Nadar; Eugène Durieu & Eugène Delacroix; Gustave Le Gray; Charles Marville; Adolphe Braun.]

ST586 Buerger, Janet E. *French Daguerreotypes.* Foreword by Walter Clark. Technical Appendix by Alice Swan. Chicago, London: University of Chicago Press, 1989. 256 pp. 268 illus. ["Appendix I: The Sources," pp. 139-149. "Appendix II: French Methods and Materials for Coloring Daguerreotypes," by Alice Swan, pp. 150-163. "Color Plates," pp. 167-175. "Notes," pp. 177-191. "Catalog of Daguerreotypes," pp. 193-242. "Catalog of Books Illustrated with Engravings made from Daguerreotypes," pp.243-250.]

PERIODICALS

ST587 "Daguerre's Photography." PHOTOGRAPHIC TIMES 1, no. 2 (Feb. 1871): 17-18. [The above was published by Galiguani in 1840, and is really an account of the christening of photography.]

ST588 Laudy, L. H. "The Discovery of the Daguerreotype Process." PHOTOGRAPHIC TIMES 19, no. 390 (Mar. 8, 1889): 121-122. [Paper read before the Society of Amateur Photographers of NY.]

ST589 Laudy, L. H., Ph.D. "The Discovery of the Daguerreotype Process." ANTHONY'S PHOTOGRAPHIC BULLETIN 20, no. 5 (Mar. 9, 1889): 142-144. [Brief survey of early history of photography. Read before the Society of Amateur Photographers of NY.]

ST590 "Senex". "Correspondence." PHOTOGRAPHIC TIMES 24, no. 663 (June 1, 1894): 349. [Letter commenting favorably on the "Fathers of Photography" series, gives a brief summation of early history, mentions H. Bayard.]

ST591 Canfield, C. W. "Daguerreotyping in 1840." PHOTOGRAPHIC TIMES 33, no. 1 (Jan. 1901): 26-27. 1 illus. [Discussion of a satirical cartoon engendered by the excitement about the daguerreotype in France in the early 1840s.]

ST592 Sadoul, Georges. "Peinture et photographe." ARTS DE FRANCE no. 19/20 - 21/22 (1948): 5-22, 37-49. 10 b & w. 14 illus. [Cross media influences during 19th and early 20th centuries, with emphasis on activity in France.]

ST593 "The Daguerreotype Craze." IMAGE 2, no. 4 (Apr. 1953): 17. 1 illus. [Lithograph by Theodore Maurisset, caricature of photography, 1839, George Eastman House Collection.]

ST594 Christ, Yvan. "Le Paris de la 'comédie humaine' photographié." JARDIN DES ARTS no. 7 (1955): 417-424. 18 b & w. [Photos of Paris by Charles Marville and others.]

ST595 "Index to Resources." IMAGE 5, no. 2 (Feb. 1956): 40-41. 5 illus. [Second in a series of illustrated articles on items in George Eastman House Collection; brief biographies and/or descriptions of camera lucida, Nicéphore Niépce, L. J. M. Daguerre.]

ST596 "Index to Resources: French Daguerreotypes." IMAGE 5, no. 7 (Sept. 1956): 162-163. 7 b & w. [Continuing series on George Eastman House Collections. French daguerreotypes, views and portraits, 5 unknown, 1 by Baron Gros, 1 by F. Gabaud.]

ST597 "Index to Resources: French Daguerreotypes." IMAGE 5, no. 8 (Oct. 1956): 186-187. 8 b & w. [Continuing series on George Eastman House Collection; French portrait daguerreotypes. Sabatier-Blot (2), E. Thiesson (2), W. Thompson (1), Lerebours (1), unknown (2).]

ST598 "Index to Resources: French Daguerreotype Portraits." IMAGE 5, no. 9 (Nov. 1956): 210-211. 8 b & w. [8 daguerreotype portraits by Legendre, Vaillat, Godquin, unknowns.]

ST599 "Index to Resources: French Daguerreotypes, Daguerreotype Cameras and Equipment." IMAGE 5, no. 10 (Dec. 1956): 236-237. 4 b & w. 2 illus. [Continuing series on George Eastman House Collections, French daguerreotypes and equipment. Unknown (2), Derussy (1), Alphonse Bernoud (1).]

ST600 Doty, Robert. "Daumier and Photography." IMAGE 7, no. 4 (Apr. 1958): 86-91. 1 b & w. 7 illus. [Caricatures of photography by

Honore Daumier; portrait of Daumier by Nadar. List of Daumier lithographs in the George Eastman House Collection.]

ST601 "Index to Resources: Calotypes." IMAGE 7, no. 9 (Nov. 1958): 212-213. [French calotypes by Blanquart-Evrard, Maxime de Camp, Bisson Fréres, Edouard Baldus, Gustave Le Gray, Chzodzkiewicz.]

ST602 Braive, Michel-François. "130 années de photographie. Qu'etait, q'uest devenu le portrait?" JARDIN DES ARTS no. 78 (May 1961): 60-61. 4 b & w. [Adam-Salomon, Nadar, Otto.]

ST603 Scharf, Aaron. "Camile Corot and Landscape Photography." GAZETTE DES BEAUX-ARTS ser. 6 vol. 59, (Feb. 1962): 99-102. 2 b & w. 1 illus.

ST604 Christ, Yvan. "Le temps des crinolines à travers les vues stéréoscopiques." JARDIN DES ARTS no. 91 (June 1962): 22-29. 15 b & w.

ST605 Keim, Jean-A. "Un enthousiasme oublié: Le daguerréotype." REVUE DES DEUX MONDES (Mar. 15, 1965): 399-411.

ST606 Christ, Yvan. "Le portrait photographique de 1839 à 1900." JARDIN DES ARTS no. 131 (Oct. 1965): 34-48. 14 b & w.

ST607 Christ, Yvan. "Les premiers voyageurs photographes." JARDIN DES ARTS no. 152/153 (July - Aug. 1967): 26-37. 19 b & w.

ST608 Sobieszek, Robert A. "The Facsimile Photographs in 'Galerie Contemporaine': A Problem in Cataloguing." IMAGE 15, no. 2 (July 1972): 21-24, 31-32. 5 b & w. [Serial publication of "Galerie contemporaine, litterare, artistique" and "Galerie contemporaine, artistique, nouvelle serie" published in Paris between 1876 and 1884, illustrated with portraits by Adam-Salomon, Bertall, Carjat, Franck, Mulnier, Nadar, Numa Blanc, Pierre Petit and others. Includes a "portrait Index to Galerie Contemporaine" on pp. 31-32.]

ST609 Lemagny, Jean-Claude. "Photographie Française 1840 - 1940. Collection Bibliothèque National, Paris. The Cabinet des Estampes of the Bibliothèque Nationale in Paris." CAMERA (LUCERNE) 53, no. 2 (Feb. 1974): 3-48. 44 b & w. [Special issue. Photos and short biographies on many photographers: Ch. Aubry; Warnod; Malacrida; L. D'Olivier; B. Braquehais; E. Disdéri; J.- B.- H. Durand-Brager; Ch. Marville; E. Baldus; Bisson Fréres; Compte O. Aguado; A. Tournachon; Cremière; Furne, Jr. & E. Tournier; G. Le Gray; C. Silvy; E. Colliau; E. Carjat; Collard; A. S. Adam-Salomon; Nadar; A. Liébert; A. Quinet; C. Famin; and others from a later period.]

ST610 Hauptman, William. "Ingres and Photographic Vision." HISTORY OF PHOTOGRAPHY 1, no. 2 (Apr. 1977): 117-128. 7 b & w. 9 illus. [Seven photographs by 19th century photographers, nine illustrations of paintings by Ingres.]

ST611 Cate, Phillip Dennis. "The 'revolutionary intrigue' among 19th century printmakers; in which the 'agent provocateur' was photography." ART NEWS 77, no. 3 (Mar. 1978): 77-78, 82, 84. 3 illus.

ST612 Buerger, Janet E. "Nineteenth Century French Photography." IMAGE 22, no. 1 (Mar. 1979): 28-32, back cover. 6 b & w. [Discussion of French daguerreotypes and paper images in the Eastman House Cramer Collection. Illustrations by A. S. Adam-Salomon, J. Duboscq-Soleil, Warren Thompson, others.]

ST613 Harmant, Pierre G. "History: Photography as a Word and as a Phenomenon." CAMERA (LUCERNE) 59, no. 1 (Jan. 1980): 36-38. [Discussion of early photography in France. Niépce, Arago, Daguerre. A report by L. Desmarest, written on Feb. 11, 1839 reprinted.]

ST614 Eisenstein, Sergei M. "Daguerre's Work." PHOTOGRAPHIC COLLECTOR 1, no. 2 (Autumn 1980): 6-10. 5 b & w. [Memories by Sergei M. Eisenstein, translated from his autobiography, published with illustrations of daguerreotypes.]

ST615 "Corsair. February 29, 1840." PHOTOGRAPHICA 12, no. 10 (Dec. 1980): 6. [Facsimile reprint of newspaper article on invention of daguerreotype.]

ST616 Graver, Nicholas M. "Early Camera Innovation in the Medical Laboratory." PHOTOGRAPHICA 13, no. 5 (May 1981): 4-6. 10 illus. [Examples of medical photography in "Photographie Médicale " (1893) and "Mechanisme de la Physionomie (1862).]

ST617 Ackley, Clifford S. "After Daguerre: Masterworks of French Photography (1848 - 1900)." PRINT COLLECTOR'S NEWSLETTER 12, no. 2 (May - June 1981): 41-42. 1 b & w. [Review of the exhibition from the Bibliothéque Nationale at the New York Metropolitan Museum of Art.]

ST618 Copjec, Joan. "Flavit et Dissipati Sunt." OCTOBER no. 18 (Fall 1981): 20-40. 5 b & w. 1 illus. [About the photographs of hysterics which appear in the three-volume "Iconographie Photographique de la Salpetriere," published in Paris from 1877 to 1880.]

ST619 Badger, Gerry. "New Light on Paper." PHOTOGRAPHIC COLLECTOR 4, no. 3 (Winter 1983): 350-361. 10 b & w. [[Bk.rev: "The Art of French Calotype," by Andre Jammes and Eugenia Parry Janis.]]

ST620 Michaels, Barbara L. "Vintage Rhône Photography." NEW YORK TIMES (Sun., July 17, 1983): Sect. X, pp. 12, 30. 2 b & w. 2 illus. [Discusses three museums in Rhône Valley, France, and describes holdings - including works by Joseph Nicéphore Niépce, Etiénne-Jules Marey, and the Lumière Family.]

ST621 McCauley, Elizabeth Anne. "Caricature and Photography in Second Empire Paris." ART JOURNAL (Winter 1983): 355-360.

ST622 McCauley, Elizabeth Anne. "Of Entrepreneurs, Opportunists, and Fallen Women: Commercial Photography in Paris, 1848 - 1870." NEW MEXICO STUDIES IN THE FINE ARTS 9, (1984): 16-27.

ST623 Mustardo, Peter J. "Early Impressions of the Daguerreotype from the Notebook of an Anonymous Frenchman: A Translation." HISTORY OF PHOTOGRAPHY 9, no. 1 (Jan.- Mar. 1985): 53-56. 2 illus. [Notebook in the George Eastman House, Rochester, NY.]

ST624 Wilsher, Ann. "Gautier, Piot and the Susse Freres Camera." HISTORY OF PHOTOGRAPHY 9, no. 4 (Oct. - Dec. 1985): 275-278. 2 illus.

ST625 Ligo, Larry L. "Manet's Frontispiece Etchings: His Symbolic Self-Portrait acknowledging the influences of Baudelaire and Photography upon his work." GAZETTE DES BEAUX ARTS no. * (Sept. 1986): 14-21.

ST626 Rice, Shelley. "Parisian Views." VIEWS: THE JOURNAL OF PHOTOGRAPHY IN NEW ENGLAND. 8, no. 1 (Supplement: Fall 1986): 7-13. 10 b & w. [Illustrations by H. Le Secq; Delmaet &

Durandelle; E. Baldus; C. Negre; C. Marville; Houssin; Nadar. Discussion of photography in Paris in the 1850's-1860's.]

ST627 Ligo, Larry L. "The 'Luncheon in the Studio': Manet's reaffirmation of the Influences of Baudelaire and Photography upon his work." ARTS MAGAZINE (Jan. 1987): 46-51.

ST628 McCauley, Elizabeth Anne. "The Amateur Aesthetic: Bayard, Le Secq, and the Victorians." AFTERIMAGE (Oct. 1987): 5-7.

ST629 Ligo, Larry L. "Manet's 'Le Vieux Musicien': An Artistic Manifesto acknowledging the Influences of Baudelaire and Photography upon his Work." GAZETTE DES BEAUX ARTS (Dec. 1987): 232-238.

ST630 Ligo, Larry L. "Baudelaire's 'Mistress Reclining' and 'Young Woman Reclining in Spanish Costume': Manet's Pendant Portraits of His Acknowledged 'Mistresses,' Baudelairian Aesthetics and Photography." ARTS MAGAZINE (Jan. 1988): 76-85. 2 b & w. 17 illus. [Photographs are by Nadar.]

FRANCE: 1839.
See also DAGUERRE, LOUIS J. M.

ST631 D. and Jh. G. "Académie des Sciences. Séance du..." LE NATIONAL DE 1834 (PARIS) (Jan. 7-9, Feb. 4-6, Feb. 19-20, Mar. 18-20, May 27-29, Sept. 23-25, Sept.30-Oct. 2, Oct. 7-9, Oct. 14-16, 1839): 1, 1-2, 1-2, 1-2, 1-2, 1-3, 1-2, 1-2, 1-2. [Running commentary upon Daguerre's announcement, the claims of priority made by Daguerre and Talbot, Niépce's role, an engraving process by Donné, etc.]

ST632 "Our Weekly Gossip." ATHENAEUM no. 620 (Sept. 14, 1839): 708. [Note on the fragile surface of daguerreotypes, M. Dumas developing a varnish to protect.]

ST633 "Fine Arts: The Daguerreotype." LITERARY GAZETTE, AND JOURNAL OF THE BELLES LETTRES no. 1182 (Sept. 14, 1839): 590. [Arago's report of Dumas' experiments with the daguerreotype. Mentions Chevalier; Susse, the picture dealer, displaying and selling daguerreotypes; Giroux' shop, etc.]

ST634 "Our Weekly Gossip." ATHENAEUM no. 631 (Nov. 30, 1839): 908. [Note on French Acad. of Science meeting dealing with aspects of photographic improvements, experiments of Baron Seguier, Gauche, and Abbe Moignat.]

FRANCE: 1841.
ST635 "Des nouveaux procédés. De la photographies." L'ARTISTE ser. 2 vol. 8, no. 16 (1841): 244-245. [Discusses Daguerre, Niépce, Lerebours and Gaudin of France, and Claudet in London.]

FRANCE: 1842.
ST636 "The World of Art: Photography." NEW WORLD (NY) 4, no. 2 (Jan. 8, 1842): 31-32. [Translated "from a French paper." Mentions Arago's summation of Daguerre's still incomplete report on how to speed up images with electric sparks. An artillery officer posed the Guard at the Tuilleries as if in battle and daguerreotyped them, September 15, 1841.]

FRANCE: 1844.
ST637 "f. Photographie." LES BEAUX-ARTS. L'INDUSTRIE 3, no. 2 (1844): 207.

FRANCE: 1845.
ST638 Bobierre, Adolphe. "Chimie appliquee aus arts. Quelques mots sur le Daguerréotype." BULLETIN DE L'AMI DES ARTS 3, no. 6 (1845): 201-204.

ST639 Brisbart-Gobert, E. and Albert de la Fizolière. "Bulletin photographique." BULLETIN DE L'AMI DES ARTS 3, no. 8 (1845): 284-288.

FRANCE: 1848.
ST640 "Funeral of 'the Victims of June.'" ILLUSTRATED LONDON NEWS 13, no. 326 (July 15, 1848): 19-20. 2 illus. ["The Procession and Great Altar, at the Place de la Concorde. - (From a Daguerreotype.)"]

FRANCE: 1851.
ST641 Zeigler, J. "Extracts From 'La Lumiére.'" PHOTOGRAPHIC ART JOURNAL 2, no. 2 (Aug. 1851): 108-111. [From "La Lumiére." Discussed Mr. Mestral, Niépce de St. Victor, etc.]

ST642 Wey, Francis. "Of the Influence of Heliography Upon the Fine Arts." PHOTOGRAPHIC ART JOURNAL 2, no. 2-3 (Aug. - Sept. 1851): 105-108, 161-164. [From "La Lumiere." G. LeGray submitted photos to the jury of the exposition of 1851, which were rejected; Baron Gros used the daguerreotype to study Greek architecture; the exhibition of 1851, etc.]

ST643 Snelling, J. Russell, trans. "Heliographic Society of Paris." PHOTOGRAPHIC ART JOURNAL 2, no. 5 (Nov. 1851): 272-275. [Meeting of Apr. 18, 1851, from "La Lumiere."]

FRANCE: 1852.
ST644 Lerebours, N. P. "Plate, Paper, or Glass?" PHOTOGRAPHIC ART JOURNAL 4, no. 1 (July 1852): 32-34. [Trans. from "La Lumiere."]

ST645 Lerebours, N. P. "Photographic Re-Union." PHOTOGRAPHIC ART JOURNAL 4, no. 2 (Aug. 1852): 89-90. [Trans. from "Le Lumiere."]

ST646 "On Views of Buildings, Landscapes, and Instantaneous Proofs." HUMPHREY'S JOURNAL 4, no. 9 (Aug. 15, 1852): 138-139. [From "La Lumiere." The article describes the personal experiences and practices of a photographer, who was not named in the translation.]

ST647 "Novel Employment of Daguerreotypes in France." HUMPHREY'S JOURNAL 4, no. 9 (Aug. 15, 1852): 143. [Daguerreotypes required of anyone seeking a passport.]

ST648 "Photographic Items: Photography in France." HUMPHREY'S JOURNAL 4, no. 10 (Sept. 1, 1852): 157-158. [From "London Art Journal." Praise of Egyptian , Nubian views in "Daguerrean Excursions," published by Lerebours and Sacretan.]

ST649 "Chemical Gleanings." HUMPHREY'S JOURNAL 4, no. 11 (Sept. 15, 1852): 175. [Lawyers using daguerreotypes to convince a jury in an accident case.]

ST650 "Photographic Items." HUMPHREY'S JOURNAL 4, no. 13 (Oct. 15, 1852): 207. [Notes about activities in France, probably taken from "La Lumiere," but not credited. Lerebours, Baldus, de Monfort, Deville mentioned.]

ST651 "French Plates." HUMPHREY'S JOURNAL 4, no. 15 (Nov. 15, 1852): 239. [From "La Lumiere." Statistics on the business of manufacturing daguerreotype plates in Paris.]

ST652 "Photographic Publications." ART JOURNAL (Dec. 1852): 374. [Mentions the "Photographic Album," "Cosmos," and Du Camp's "Egypte, Nubie,...''']

FRANCE: 1853.
ST653 "Photography." PHOTOGRAPHIC ART JOURNAL 5, no. 3 (Mar. 1853): 140-143. [From "Cosmos." Discussion of photographers photographing the religious and military fete of May 10, 1852, in France. Macaire, Thompson, Baron Gros, Jules Dubosq, mentioned by name.]

ST654 Wornum, R. N. "French Art-Collections and Instruction." PHOTOGRAPHIC ART JOURNAL 5, no. 3 (Mar. 1853): 167-181. [From "London Art. J." (Background. Extensive survey of art education institutions and practices in France.)]

ST655 W. "Our Foreign Correspondent." HUMPHREY'S JOURNAL 4, no. 22 (Mar. 1, 1853): 347-350. [W. travelled to France; describes activities of French photographers, notes the prevalence of paper processes, etc.]

ST656 Wey, Francis. "Photographs and Lithographs. The Album of Ancient and Modern Artists, by Messrs. Mourlleron, Francais, Nanteuil, H. Baron. and Eugene Le Roux." PHOTOGRAPHIC ART JOURNAL 5, no. 4 (Apr. 1853): 195-200. [From "La Lumiere." Extensive review, discussion of the merits of each process.]

ST657 L. K. "The Photographer's Dressing Room." PHOTOGRAPHIC ART JOURNAL 5, no. 4 (Apr. 1853): 216-217. ["From La Lumiére."]

ST658 "Spirit of 'La Lumiere.'" PHOTOGRAPHIC ART JOURNAL 6, no. 6 (Dec. 1853): 325-334. [Excerpts of papers from "La Lumiere." Leon Kraffs, Henri Plaut; Casimir Ouliff; Vt. Lois de Dax, etc.]

FRANCE: 1854.
ST659 "A Few Photographs from the French." PHOTOGRAPHIC AND FINE ART JOURNAL 7, no. 4 (Apr. 1854): 101-103. [Narrative of problems with sitters for portraits.]

ST660 "Note." HUMPHREY'S JOURNAL 6, no. 1 (Apr. 15, 1854): 14-15. [Mentions photos replacing daguerreotypes in Paris. Mayer mentioned as a most popular gallery.]

ST661 Portrait. Woodcut engraving credited, "from a beautifully executed Calotype..." ILLUSTRATED LONDON NEWS 24, (1854) ["Prince Louis-Lucien Bonapart." 24:* (Apr. 22, 1854): 360.]

ST662 Meade, Charles R. "The Art in London and Paris." PHOTOGRAPHIC AND FINE ART JOURNAL 7, no. 12 (Dec. 1854): 380. [Charles Meade's letter describes his week long visit to London, where he met Claudet, Kilburn, and Mayall. Then his experiences at the Mayer Brothers studio. He also speaks of learning the paper processes "from another gentleman" along with individuals from Calcutta, Lisbon, Rio de Janeiro, Constantinople, England, Cuba, and France. Describes work of the Bisson Freres and of Thompson.]

FRANCE: 1855.
ST663 Gaudin, Charles. "Photographic Soiree." PHOTOGRAPHIC AND FINE ART JOURNAL 8, no. 5 (May 1855): 141-143. [From "La Lumiere." A soiree held at Ernest Lacan's house. 25 photographers, artists, etc. there. Benjamin Delessert displayed the views of

Constantinople by J. Robertson; Count Aguado landscapes; Baldus views; Petiot Groffier; G. LeGray; M. Bilordeaux; Bayard; Mr. Tenison (English amateur's panorama of Toledo, Spain); Marville's panorama of Paris; LeSecq; many others.]

ST664 Meade, Charles R. "Communications." PHOTOGRAPHIC AND FINE ART JOURNAL 8, no. 3 (Mar. 1855): 70. [Letter from Meade, at this time visiting Paris. Comments on photoengraving, experiments of Niépce de St. Victor, mentions that "Mr. Neckin, photographist, and assistants, who had been sent by the British Government to make photographs of Sebastopol..." were lost when their ship sank in a storm. Mayer & Pierson, W. Thompson mentioned.]

ST665 "Actinography as a means of Identifying Criminals." HUMPHREY'S JOURNAL 7, no. 2 (May 15, 1855): 32. [From "La Lumiere."]

ST666 Lacan, Ernest. "Photography, and Its Various Applications to the Fine Arts and Sciences." PHOTOGRAPHIC AND FINE ART JOURNAL 8, no. 6-7 (June - July 1855): 170-173, 202-204. [From "La Lumiere," trans. by W. Grigg. Describing the invention of the medium, summary of activities being carried on at the time, with French emphasis.]

ST667 L. "Something about Champagne (With Illustrations from Photographs taken at Pierry.)" ILLUSTRATED LONDON NEWS 27, no. 755 (Aug. 4, 1855): 145-146. 7 illus. [Seven posed portraits of men and women at work bottling champagne - demonstrating the various stages of the process.]

ST668 "The Palace of Industry in Paris." ILLUSTRATED LONDON NEWS 27, no. 756 (Aug. 11, 1855): 169. 2 illus. ["...both illustrations have been engraved from well-executed photographs."]

ST669 Conduche, Ernest. "On a New Application of Photography." PHOTOGRAPHIC AND FINE ART JOURNAL 8, no. 9 (Sept. 1855): 275-276. [From "La Lumiere." Photo for scientific records. Mentions Dr. Unger's collecting "representations of the principal physical revolutions of the globe, with the animals who have existed at the different epochs of its formation..."the Schlagintweit Brothers on the geology of the Alps. Martin's panorama of Mt. Blanc. Baldus' view of Auvergue. Jiffereau in possession of "silver mining in Mexico...," etc.]

FRANCE: 1856.
ST670 "Something about Champagne." FRANK LESLIE'S NEW YORK JOURNAL n. s. 3, no. 2 (Feb. 1856): 116-117, 128. 7 illus. [Images of bottling champagne.]

ST671 "The Imperial Cradle." BALLOU'S PICTORIAL DRAWING-ROOM COMPANION [GLEASON'S] 10, no. 258 (June 14, 1856): 384. 1 illus. ["Cradle of the Young French Imperial Prince...an authentic photographic portrait..."]

ST672 "Photography in Forging." BALLOU'S PICTORIAL DRAWING-ROOM COMPANION [GLEASON'S] 11, no. 280 (Nov. 15, 1856): 309. [From the "Home Journal." Report that Arago states that he could perfectly forge a banknote with photography.]

ST673 "Progress and Extent of the Photographic Art." HUMPHREY'S JOURNAL 7, no. 20 (Feb. 15, 1856): 328. [Note claiming that there are 110 establishments in Paris, 700 photographers, etc.]

ST674 "Photographie: Société Française de Photographie. Seance du 20 Juin 1856." COSMOS (June 1856): 675-681.

FRANCE: 1857.
ST675 Gautier, Théophile. "Exposition photographique." L'ARTISTE ser. 6 vol. 3, no. 13 (Mar. 8, 1857): 193-195.

ST676 Lacan, Ernest. "Revue photographique." LE MONITEUR UNIVERSEL (Dec. 3, 1857): 1325-1326.

FRANCE: 1859.
ST677 "Vol a la photographie." PHOTOGRAPHIC NEWS 1, no. 20 (Jan. 21, 1859): 234. [Comments on cut-throat business practices.]

ST678 J. P. "Photography in Paris." HUMPHREY'S JOURNAL OF PHOTOGRAPHY, AND THE ALLIED ARTS AND SCIENCES 10, no. 22-24 (Mar. 15 - Apr. 15, 1859): 345-347, 357-360, 373-375. [From "Liverpool Photo. J."]

ST679 "Photography in Paris." HUMPHREY'S JOURNAL OF PHOTOGRAPHY, AND THE ALLIED ARTS AND SCIENCES 10, no. 1-24 (May 1 - Dec. 15, 1859): 12-16, 25-27, 69-72, 105-107, 124-127, 170-173. [From "Liverpool Photo. J."]

ST680 J. P. "Photography in Paris." PHOTOGRAPHIC AND FINE ART JOURNAL 12, no. 1 (June 1859): 8-9. [Niépce de St. Victor; Chevreul; Roussin; Bayard; Poitevin; Salmon & Garnier, others mentioned.]

ST681 "Photography at Night." PHOTOGRAPHIC AND FINE ART JOURNAL 12, no. 2 (July 1859): 56. [From "Photo. Notes," again from "La Lumiere." Report of a John Moule, of London, demonstrating photos made at night, in Paris.]

ST682 "Marshall de St. Jean d'Angely." BALLOU'S PICTORIAL DRAWING-ROOM COMPANION [GLEASON'S] 17, no. 424 (Aug. 6, 1859): 81. 1 illus. ["...from a photograph..."]

FRANCE: 1859 - 1860 [FRANCO-AUSTRIAN WAR]
ST683 "Correspondence: Foreign Science: Photography and War!" PHOTOGRAPHIC NEWS 2, no. 39 (June 1, 1859): 150-151. ["La Lumiere" sent "it's own correspondent, M. Berardy," into Italy. M. Gaudin took a series of stereoscopic slides "following the belligerent parties step by step." Ferrier took stereo views of Genoa, Milan, Turin, Piedmont, and Lombardy. Some French Artillery officers were trained in photography. M. Porro (Paris), other photographers mentioned.]

ST684 "Photography in the Camp." PHOTOGRAPHIC NEWS 2, no. 37 (May 20, 1859): 121-122. [Brief note. "...photographic apparatus was sent to the (French) Artillery in garrison, at Versailles, with proper persons to give instruction in the art...(several months since)" "...The scene of their labor is now transferred to the plains of Italy, the Emperor being desirous of possessing pictures of those fields of action in which he so confidently expects to be victorious..."]

ST685 "Photography at the Seat of War." PHOTOGRAPHIC NEWS 2, no. 41 (June 17, 1859): 172. [From "La Lumiere." "Nadar sent for to headquarters for a particular mission..." Note that many of the officers in the conflicts had been photographed. Disdéri mentioned taking portraits on the eve of the fight at Palestra, then afterwards. "A photographer writes to us...describing his photographing at the cemetery at Montebello, with the dead soldiers still lying about. ...As regards photographers, I have only met Disdéri; but I know that they are all along the line..."]

ST686 J. L. "Photography at the Seat of War." PHOTOGRAPHIC NEWS 2, no. 42, 44 (June 24, July 8, 1859): 183-185, 207-209. [Long descriptive letter from a British photographer, touring Switzerland, then diverted into Italy to cover the Franco-Austrian war. Describes

his experiences, including behind the lines, then the battle of Palestro, where he cared for the wounded. Apparently he did not photograph there.]

ST687 Lacan, Ernest. "Foreign Correspondence." BRITISH JOURNAL OF PHOTOGRAPHY 7, no. 122 (July 16, 1860): 212-213. [This issue of this regular column is concerned with the use of photography by military forces, which they were doing, although primarily for mapmaking and surveying. Mentions a Capt. Laussédat, in the Engineer Corps, French Army, the "War Ministry in Brussels in 1856, Mons. Libois, a staff officer." A Mons. Riffaut in France at the same time. That Russian and Sardinian officers had trained with Niépce de Saint Victor, etc.]

ST688 Laussedat, M. A. "Photography and Its Applications. On the Employment of Photography in Surveying and Military Reconnoitering." PHOTOGRAPHIC AND FINE ART JOURNAL 13, no. 8 (Aug. 1860): 226-227. [From "Photo. News," in turn from "The Paris Academy of Science." Capt. Laussedat, apparently in the French military, seems to have been working on this topic since 1851.]

FRANCE: 1860.
ST689 J. P. "Foreign Correspondence." BRITISH JOURNAL OF PHOTOGRAPHY 7, no. 109-118 (Jan. 1 - May 15, 1860): 15, 29-30, 57, 70-71, 89, 104-105, 121-122, 137-138, 154. ["J. P." wrote this column until May 15, 1860, thereafter E. Lacan wrote the column.]

ST690 "Photography in Paris." HUMPHREY'S JOURNAL OF PHOTOGRAPHY, AND THE ALLIED ARTS AND SCIENCES 11, no. 17-24 (Jan. 1-Apr. 15, 1860): 314-316, 348-349, 377-379. [From "Br. J. of Photo."]

ST691 J. B. "Paris Correspondence." PHOTOGRAPHIC AND FINE ART JOURNAL 13, no. 5 (May 1860): 141-142. [Omegauck of Antwerp, photometer, portraits with a 5" diameter Voightlander lens, etc.]

ST692 "Photography in Paris." HUMPHREY'S JOURNAL OF PHOTOGRAPHY, AND THE ALLIED ARTS AND SCIENCES 12, no. 1-24 (May 1, 1860-Apr. 15, 1861): 64, 125-127, 155-157, 213-214, 233-236, 269-272, 279-280, 362-364. [From "Br. J. of Photo."]

ST693 Lacan, Ernest. "Foreign Correspondence." BRITISH JOURNAL OF PHOTOGRAPHY 7, no. 119-132 (June 1 - Dec. 15, 1860): 168-169, 183-184, 199-200, 212-213, 228-229, 244-245, 259-260, 277, 292-293, 306-307, 321-322, 339*, 357, 377-378. ["J. P., from Paris, wrote this column until May 15, 1860. Thereafter E. Lacan wrote the column, and continued to do so for several years. *This issue missing, accurate page count difficult.]

ST694 "Correspondence: Foreign Science (From our Special Correspondent)." PHOTOGRAPHIC NEWS 4, no. 103 (Aug. 24, 1860): 199-201. [Mentions French photographers beginning to take landscapes, compares leading workers in France and England.]

ST695 "Correspondence: Foreign Science." PHOTOGRAPHIC NEWS 4, no. 107 (Sept. 21, 1860): 248-249. [Mentions growth of carte-de-visite use in France, compares with London.]

ST696 Lacan, Ernest. "Foreign Correspondence." BRITISH JOURNAL OF PHOTOGRAPHY 7, no. 125 (Sept. 1, 1860): 259. [Commentary on Baldus receiving an official award for his work documenting the construction of the new Louvre. Mentions other photographers so honored in the past. Niépce de Saint Victor. Blanquart-Evrard, Maxime du Camp, A. Salzmann, Martens, E. Delessert, and Braun.]

FRANCE: 1861.

ST697 Burty, Phillipe. "La photographie en 1861." GAZETTE DES BEAUX-ARTS 1, no. 11 (1861): 241-249.

ST698 Lacan, Ernest. "Foreign Correspondence." BRITISH JOURNAL OF PHOTOGRAPHY 8, no. 133-156 (Jan. 1 - Dec. 16, 1861): 20, 38, 54, 76, 96, 116-117, 153-154, 173-174, 191, 210, 226-227, 244-245, 260, 276-277, 295, 314, 333, 351, 372, 391-392, 413, 432-433, 450-451. [(Jan 15) French Military Expedition to China. (Apr. 15) Disderi training military officers. (May 15) French Photo. Soc. exhibition. (June 15) Printing processes. (July 15) Nièpce de St. Victor. (Aug. 15) Auguste Bisson ascended Mont Blanc. (Sept. 16) French Photo. Soc. exhibition. (Nov. 1) Nièpce de St. Victor, Edouard Delessert. (Nov. 15) Delessert, Auguste Bisson. (Dec. 16) Huge Disdéri exhibition.]

ST699 Seely, Charles. "Editorial Miscellany." AMERICAN JOURNAL OF PHOTOGRAPHY AND THE ALLIED ARTS & SCIENCES n. s. vol. 3, no. 20 (Mar. 15, 1861): 320. ["Louis Napoleon has decided that a movable photographic establishment shall be attached to each regiment in the French army,..."]

ST700 Lacan, Ernest. "Foreign Correspondence." BRITISH JOURNAL OF PHOTOGRAPHY 8, no. 140 (Apr. 15, 1861): 153-154. [Lacan reports that twenty-five officers in the French Army have been studying photography with M. Disdéri, and that preparations to establish either an official photographic organization within the army were either underway or at least under discussion by the Minister of War.]

ST701 "Photography in Paris." HUMPHREY'S JOURNAL OF PHOTOGRAPHY, AND THE ALLIED ARTS AND SCIENCES 13, no. 1-16 (May 1 - Dec. 15, 1861): 14-15, 25-27, 47-48, 78-80, 101-102, 122-124, 150-153, 169-171, 205-207, 248-252. [From "Br. J. of Photo."]

FRANCE: 1862.

ST702 Lacan, Ernest. "Foreign Correspondence." BRITISH JOURNAL OF PHOTOGRAPHY 9, no. 157-180 (Jan. 1 - Dec. 15, 1862): 16-17, 34-35, 52-53, 66, 95, 116, 137, 175, 198, 218-219, 238, 258-259, 279-280, 298, 317-318, 337-338, 357-358, 374-375, 397, 418, 437, 457-458, 474-475.

ST703 "Profits in Photography." HUMPHREY'S JOURNAL OF PHOTOGRAPHY, AND THE ALLIED ARTS AND SCIENCES 13, no. 17 (Jan. 1, 1862): 261-262. [From "Photo. News." Claims that a Parisian studio (probably Nadar) making 48,000 pounds sterling a year.]

ST704 "Photography in Paris." HUMPHREY'S JOURNAL OF PHOTOGRAPHY, AND THE ALLIED ARTS AND SCIENCES 13, no. 21 (Mar. 1, 1862): 332-334. [From "Br. J. of Photo."]

ST705 "Prize for the Discovery of an Instantaneous Dry Collodion Process." HUMPHREY'S JOURNAL OF PHOTOGRAPHY, AND THE ALLIED ARTS AND SCIENCES 14, no. 6 (July 15, 1862): 41-42. [Marseilles Photographic Society offering prize.]

ST706 "Photography in Paris." HUMPHREY'S JOURNAL OF PHOTOGRAPHY, AND THE ALLIED ARTS AND SCIENCES 14, no. 11 (Oct. 1, 1862): 124-126. [From "Photo. News."]

FRANCE: 1863.

ST707 "Echoes of the Week, and the New Year in Paris." ILLUSTRATED LONDON NEWS 42, no. 1182 (Jan. 3, 1863): 10.

[Mentions carte-de-visite craze and mentions Nadar's portrait of Victor Hugo.]

ST708 Lacan, Ernest. "Foreign Correspondence." BRITISH JOURNAL OF PHOTOGRAPHY 10, no. 181-204 (Jan. 1 - Dec. 15, 1863): 19, 41, 62, 107-108, 130, 150, 174, 196-197, 217, 238-239, 257, 276-277, 295-296, 313, 335-336, 354, 374, 394, 415, 434-435, 455-456, 476, 494.

ST709 "Photography in Paris." HUMPHREY'S JOURNAL OF PHOTOGRAPHY, AND THE ALLIED ARTS AND SCIENCES 14, no. 18-24 (Jan. 15 - Apr. 15, 1863): 233-234, 250-252, 284-286, 296-297, 333-334. [The new editor, Towler, began the practice of regularly including news etc. of Paris, usually abstracted from the columns of both the "Br. J. of Photo." and "Photo. News."]

ST710 "Photography in Paris." HUMPHREY'S JOURNAL OF PHOTOGRAPHY, AND THE ALLIED ARTS AND SCIENCES 15, no. 1-24 (May 1, 1863 - Apr. 15, 1864): 14-16, 26-28, 104-106, 174-176, 330-331, 346-349. [News from Paris, abstracted from both the "Br. J. of Photo." and "Photo. News."]

ST711 Waldack, Charles. "Photography in Paris. - Photo-Sculpture - Photo-Engraving - Rapid Dry Plates, Etc." AMERICAN JOURNAL OF PHOTOGRAPHY AND THE ALLIED ARTS & SCIENCES n. s. vol. 5, no. 23 (June 1, 1863): 546-549. [Ernest Lacan; Mr. Willeme (photo-sculptor); De la Blanchere; Livitsky (formerly Thompson's, of New York) discussed.]

ST712 "Miscellaneous: Photography in Paris." AMERICAN JOURNAL OF PHOTOGRAPHY AND THE ALLIED ARTS & SCIENCES n. s. vol. 6, no. 3 (Aug. 1, 1863): 70. [From "Br. J." British visitor claims French very backward.]

ST713 "Toulon." ILLUSTRATED LONDON NEWS 43, no. 1224/1225 (Oct. 3, 1863): 348-349, 350. 1 illus. ["Our Engraving of Toulon is from a photograph by Mr. P. Barry, author of 'The Dockyards and Shipyards of the Kingdom.'" (The author's statement in this volume mentions that he hired an unnamed photographer to illustrate this work.)]

FRANCE: 1864.
BOOKS
ST714 Normandy: its Gothic Architecture and History illustrated by 25 photographs from Buildings in Rouen, Caen, Nantes, Bayeux, and Falaise. London: A. W. Bennett, 1864. 50 pp. 25 b & w. 52 illus. [Original photographs and woodcuts.]

PERIODICALS
ST715 Lacan, Ernest. "Foreign Correspondence." BRITISH JOURNAL OF PHOTOGRAPHY 11, no. 205-243 (Jan. 1 - Dec. 30, 1864): 30-31, 51, 70, 86, 105, 120, 159, 177, 194-195, 212, 224, 250, 262, 273-274, 297, 322, 344-345, 370, 415-416, 440-441, 466, 489, 522.

ST716 "Photography in Paris." HUMPHREY'S JOURNAL OF PHOTOGRAPHY, AND THE ALLIED ARTS AND SCIENCES 16, no. 1-24 (May 1, 1864 - Apr. 15, 1865): 63-64, 158-159, 269-271, 378-379. [Information excerpted from "Photo. News" and "Br. J. of Photo."]

ST717 "Miscellaneous: Romance of a Photograph." AMERICAN JOURNAL OF PHOTOGRAPHY AND THE ALLIED ARTS & SCIENCES n. s. vol. 6, no. 24 (June 15, 1864): 575. [From "Photo. News." Story being published in "several of the Paris journals." Story is that the Dutch interpreter of the Japanese Embassy, "now in Paris," a Frank Bleckman, had been out of touch with his father for many

years. The father was sent a portrait of the Japanese Embassy by a friend and both were reunited.]

ST718 Harrison, W. "Foreign Correspondence." BRITISH JOURNAL OF PHOTOGRAPHY 11, no. 222-243 (Aug. 5 - Dec. 30, 1864): 285, 309-310, 358-359, 405-406, 430, 453-454, 477, 506-507, 534. [About halfway through 1864 W. Harrison began writing the column "Foreign Correspondence" from Paris, sharing the task with Ernest Lacan, who had written it previously. A few columns at this time were unsigned, but were probably by Harrison as well.]

ST719 "Photography Inefficient." AMERICAN JOURNAL OF PHOTOGRAPHY AND THE ALLIED ARTS & SCIENCES n. s. vol. 7, no. 7 (Oct. 1, 1864): 161-162. [From "Mercury." Discusses alterations in color transmission by the photographic processes, and the effects caused in portraiture.]

ST720 "Counterfeiting a Photographic Portrait." AMERICAN JOURNAL OF PHOTOGRAPHY AND THE ALLIED ARTS & SCIENCES n. s. vol. 7, no. 7 (Oct. 1, 1864): 165-166. [From "Revue Photo." Trial. Duroni & Murer portrait of Senator Ricacoli, of Milan. Copied by M. Prevot & Co. The court ruled in favor of Duroni & Murer.]

ST721 "Photographic Night Views." HUMPHREY'S JOURNAL OF PHOTOGRAPHY, AND THE ALLIED ARTS AND SCIENCES 16, no. 12 (Oct. 15, 1864): 183-184. [A letter inquiring about "...night views taken by the French," seen at the Stereopticon display at Irving Hall. Towler replied that they were not actually taken after dark, but in the daylight, then doctored to resemble evening.]

FRANCE: 1865.
ST722 Harrison, W. "Foreign Correspondence." BRITISH JOURNAL OF PHOTOGRAPHY 12, no. 244-280 (Jan. 6 - Sept. 15, 1865): 10, 23, 33-34, 48-49, 79-80, 92, 103,-104, 117-118, 169-170, 182, 209-210, 236-237, 253-254, 383-384, 420-421, 432-433, 455-456, 479-480.

ST723 Fowler, R. J. "Foreign Correspondence." BRITISH JOURNAL OF PHOTOGRAPHY 12, no. 283-295 (Oct. 6 - Dec. 29, 1865): 515, 528, 539-540, 550-551, 562-563, 575-576, 588, 599-600, 610-611, 622-623, 635-636, 659-660.

ST724 "Photography in Paris." HUMPHREY'S JOURNAL OF PHOTOGRAPHY, AND THE ALLIED ARTS AND SCIENCES 17, no. 13 (Nov. 1, 1865): 204-205. [From "Photo. News."]

FRANCE: 1866.
ST725 "Photographs of French Celebrities." AMERICAN JOURNAL OF PHOTOGRAPHY AND THE ALLIED ARTS & SCIENCES n. s. vol. 8, no. 19 (Apr. 1, 1866): 441-443. [From "The Nation." A list of celebrities, with a verbal description of their character as read by the correspondent who "a few years ago, while in Paris, he amused himself by studying the faces of distinguished Frenchmen,...whose photographs were exhibited in the shop windows of the Boulevards...." Reprinted here for "...assistance to those who desire to learn how to describe faces."]

ST726 "Notice to Photographers." HUMPHREY'S JOURNAL OF PHOTOGRAPHY, AND THE ALLIED ARTS AND SCIENCES 18, no. 8 (Aug. 15, 1866): 126-127. [Announcement that the Imperial Commission organizing the International Exposition in Paris in 1867 wishes to create a display of "living vegetable products" and "such plants as cannot be exhibited here, living..." would be represented by "Photography, which seizes its subject almost instantaneously,

alone offers the guaranty of exactness and fidelity which must be looked for in preparing this new diorama...."]

FRANCE: 1867.
ST727 Vogel, Dr. H. "Paris Correspondence." PHILADELPHIA PHOTOGRAPHER 4, no. 41 (May 1867): 152-153. [Vogel to be judge of Paris International Exhibition.]

ST728 "Photographs of Ticket-Holders at the Paris Exhibition." AMERICAN JOURNAL OF PHOTOGRAPHY, AND THE ALLIED ARTS AND SCIENCES n. s. vol. 9, no. 12 (June 1, 1867): 277-278. [From "London Daily Telegraph." The Imperial Commission of the International Exhibition in Paris had required that season ticket holders have a carte de visite portrait, which they should show at the gate. Much complaining, etc.]

ST729 "Messrs. Mason & Hamlin's Parlor Organs on Exhibition at the Paris Exposition - From a Photograph Taken Expressly for this Paper." FRANK LESLIE'S ILLUSTRATED NEWSPAPER 24, no. 623 (Sept. 7, 1867): 389. 1 illus. [Interior, with figures.]

ST730 "Photographic Scraps: Photographic Memorials." HUMPHREY'S JOURNAL OF PHOTOGRAPHY, AND THE ALLIED ARTS AND SCIENCES 19, no. 12 (Oct. 15, 1867): 182-183. [Photos of the clothing worn by Emperor Maximilian when he was shot in Mexico "excited considerable interest in Paris...."]

FRANCE: 1868.
ST731 "Wedding Cards." HUMPHREY'S JOURNAL OF PHOTOGRAPHY, AND THE ALLIED ARTS AND SCIENCES 20, no. 15 (Dec. 1, 1868): 240. [Two portraits, entwined with the symbolic silver cord, etc. sent instead of ordinary engraved name card, in France.]

FRANCE: 1869.
ST732 Grangedor, J. "Les derniers progrös de la photographie." GAZETTE DES BEAUX-ARTS 2, no. 1 (1869): 447-461.

ST733 "The Pantin Tragedy." HARPER'S WEEKLY 13, no. 670 (Oct. 30, 1869): 696-698. 6 illus. [Multiple murder in France. Illustrated with two views from sketches and four views of "the Victims of the Pantin Tragedy" from photographs.]

FRANCE: 1870.
ST734 "Tit for Tat." ANTHONY'S PHOTOGRAPHIC BULLETIN 1, no. 5 (June 1870): 91. [From "Br J of Photo." Article humorously claims that the French underworld has responded to French Police's use of photographs for identification by acquiring copies of photos of French policemen.]

FRANCE: 1870 - 1871. [FRANCO-PRUSSIAN WAR]
BOOKS
ST735 DeLaffoys. *Memoir of the Photographic and Administrative Section of the Service of Dispatching by Carrier Pigeons during the Siege of Paris, 1870-71*, by DeLaffoys, translated by George W. Angers with the assistance of Everett E. Thompson. Springfield, MA: G. W. Angers, c. 1952. 21 pp. illus.

PERIODICALS
ST736 "The French Pigeon Post." FRANK LESLIE'S ILLUSTRATED NEWSPAPER 31, no. 794 (Dec. 17, 1870): 229, 231. 3 illus. [Discussion of the pigeon post system set up during the siege of Paris. Illustrations are of pigeons, etc.]

ST737 "The Balloon and Pigeon Posts." CHAMBERS'S JOURNAL OF POPULAR LITERATURE, SCIENCE, AND ART Ser. 4, no. 375-376 (Mar. 4 - Mar. 11, 1871): 129-134, 154. ["Such was the state of affairs when Nadar, the well-known photographer and aeronaut, turned his attention towards inaugurating a system of balloons..." (p. 129). "...it was decided that an arrangement should be made with M. Dagron, the eminent photographer...to undertake the photographic reduction of the messages." (p. 154).]

ST738 Simpson, G. Wharton. "Notes In and Out of the Studio - The War and Photography." PHOTOGRAPHIC WORLD 1, no. 4 (Apr. 1871): 104-105. [Notes on the Franco-Prussian War's effects on portrait studios in Paris - Reutlinger, Adam-Solomon, Goupil & Co., etc. mentioned.]

ST739 "What Photography Can Accomplish." ANTHONY'S PHOTOGRAPHIC BULLETIN 2, no. 4 (Apr. 1871): 106-107. [From "Br J of Photo." Report on the Pigeon Post and Microphotography system in use in Paris during the siege.]

ST740 "How the 'Times' was Sent to Paris." ANTHONY'S PHOTOGRAPHIC BULLETIN 2, no. 4 (Apr. 1871): 121. [From "London Photo. News." Reducing the "London Times" by microphotography, by the London Stereoscopic and Photographic Co., and then flown to Paris by carrier pigeon, from Bordeaux.]

ST741 "Pigeon Messages." FRANK LESLIE'S ILLUSTRATED NEWSPAPER 32, no. 812 (Apr. 22, 1871): 83. 1 illus. [Note about use of microphotography to reduce newspapers and use of carrier pigeons to carry them into Paris during the Siege of Paris in 1871. An example of a reduced newspaper, furnished to the "FLIN" by E. & H. T. Anthony Co., reproduced.]

ST742 Moore, George. "The London Deputation in Paris." GOOD WORDS 12, no. 6 (June 1871): 403-408. 1 illus. [This report of events in Paris by a member of the London Relief Deputation (delivering food to the besieged city) is illustrated with a woodcut, from a photograph, of the pigeon-post microphotograph used to send the report out of Paris.]

ST743 "Ruins of Paris." ILLUSTRATED LONDON NEWS 58, no. 1656 (June 24, 1871): 605. 1 illus. [Front cover has a sketch of a cameraman busily taking photographs in the midst of firefighters, tumult and destruction of Paris after it was recaptured from the Communards.]

ST744 "The Pictorial Spirit of the Illustrated European Press: Paris. -Photographing the Ruins." FRANK LESLIE'S ILLUSTRATED NEWSPAPER 32, no. 825 (July 22, 1871): 304. 1 illus. [Sketch of a photographer at work, surrounded by firemen fighting a fire. From, I think, the "Illus. London News."]

ST745 Lacan, Ernest. "French Correspondence." ANTHONY'S PHOTOGRAPHIC BULLETIN 2, no. 11 (Nov. 1871): 357-359. [From "London Photo. News." Commandant de Milly, director of the photographic establishment at the Depot de la Guerre (France) was not killed in the war, as reported earlier, but then killed in a riding accident afterwards. De Milly organized the photographic service for the French army. Levy escaped by balloon from Paris, organized the pigeon post operation (microphotographs taken, flown into Paris by carrier pigeon). Dagron "charged with the exclusive performance of the operations..."]

ST746 "Viator." "From Across the Water." ANTHONY'S PHOTOGRAPHIC BULLETIN 2, no. 12 (Dec. 1871): 397. [The British author visits Paris and describes events there after the war and the destruction of the Commune. Mentions de Milly, Dagron, Reutlinger, etc. "A publisher here has told me 'a joke,' to wit: - He has negatives of the Confederate dead, taken after the final engagement before Richmond, and is doing a lively business in selling from them pictures of the killed about the Paris fortifications."]

ST747 "Transalpine Photography." ANTHONY'S PHOTOGRAPHIC BULLETIN 3, no. 4 (Apr. 1872): 509-511. [From "Br. J. of Photo." The unidentified author describes staying in Paris on his way to the Alps, on p. 509: "...there were to be bought a great variety [of photos] purporting to be faithful representations of the events of the siege, such as barricades, executions, streets with dead bodies lying in them and so forth. These ...were fictitious, carefully-arranged tableaux, but terribly natural, and greedily bought by tourist, the greater portion of whom never...questioned the reality of the representation."]

ST748 Morley, James. "The Most Tragic Winter in Modern Times." EVERYBODY'S MAGAZINE 2, no. 8 (Apr. 1900): 351-357. 11 b & w. [Article is about the Siege of Paris, during the Franco-Prussian War in 1870. Unidentified photos are of destroyed buildings, etc. taken during the period.]

ST749 "Pigeons and Microphotography." IMAGE 1, no. 1 (Jan. 1952): 4. [Technique of microphotography worked out by Rene Prudent Dragon during siege of Paris 1870-1871.]

FRANCE: 1872.
ST750 Lacan, Ernest. "French Correspondence." ANTHONY'S PHOTOGRAPHIC BULLETIN 3, no. 3 (Mar. 1872): 481-482. [From "Photo. News." Prof. Merget's process for printing photographs.]

ST751 Towler, J. "Letter from Prof. Towler." PHILADELPHIA PHOTOGRAPHER 9, no. 107 (Nov. 1872): 376-377. [Towler visiting Europe, describes his meetings with Reutlinger and J. Levy & Co. (successor to the house of Ferrier & Soulier), in Paris. Also discusses Delteure, in Brussels.]

FRANCE: 1873.
ST752 "Munificent French Prizes." ANTHONY'S PHOTOGRAPHIC BULLETIN 4, no. 3 (Mar. 1873): 78. [From "Bulletin" of the Fr. Photo Society. The Society for the Encouragement of National Industry offering prizes for improved printing paper, printing block techniques.]

FRANCE: 1874.
ST753 Lacan, Ernest. "Photography in France." PHILADELPHIA PHOTOGRAPHER 11, no. 121-132 (Jan. - Dec. 1874): 4-6, 43-46, 109-111, 139-141, 176-179, 202-204, 239-241, 268-271, 311-313, 335-337, 380-382.

ST754 Lacan, Ernest. "A New Application of Photography." ANTHONY'S PHOTOGRAPHIC BULLETIN 5, no. 4 (Apr. 1874): 155. [From "Photo. News." Paris banking houses keeping photographic portraits of their staffs on file, in case of later need.]

ST755 Napias, Dr. H. "Photography from a Sanitary Point of View." ANTHONY'S PHOTOGRAPHIC BULLETIN 5, no. 9 (Sept. 1874): 311-313. [From "Moniteur de la Photographie." Health issues.]

ST756 Wilson, Edward L. "Views Abroad and Across. Pts. 10-11." PHILADELPHIA PHOTOGRAPHER 11, no. 130-131 (Oct. - Nov. 1874): 289-298, 328-333. [Wilson visited many studios in extended visit to Europe. Adolphe Braun in Dornach, Liebert, Levy, Adam-Salomon, and Reutlinger in Paris.]

FRANCE: 1875.

ST757 Lacan, Ernest. "Photography in France." PHILADELPHIA PHOTOGRAPHER 12, no. 133-144 (Jan. - Dec. 1875): 5-9, 42-44, 69-71, 107-109, 135-137, 176-177, 200-202, 236-238, 269-271.

ST758 Lacan, Ernest. "A Cupboard Full of Spirits." ANTHONY'S PHOTOGRAPHIC BULLETIN 6, no. 7 (July 1875): 213-214. [From "London Photographic News." Spirit Photography in Paris.]

ST759 "Spirituality." ANTHONY'S PHOTOGRAPHIC BULLETIN 6, no. 7 (July 1875): 216-217. [Description of trial of three individuals, the photographer was named Buguet, for fraud, while taking "spirit" photographs in Paris.]

ST760 Stebbing, Prof. "Are They?" PHILADELPHIA PHOTOGRAPHER 12, no. 140 (Aug. 1875): 248-249. [Extract from Prof. Stebbing's letters to the "British Journal of Photography" about growth of huge, opulent photographic studios in Paris.]

FRANCE: 1876.

ST761 Stebbing, Prof. E. "French Correspondence." PHILADELPHIA PHOTOGRAPHER 13, no. 145-156 (Jan. - Dec. 1876): 19-23, 78-80, 91-94, 115-117, 154-156, 179-181, 203-206, 269-272, 366-368.

ST762 Lacan, Ernest. "French Correspondence of the 'London Photo. News.'" ANTHONY'S PHOTOGRAPHIC BULLETIN 7, no. 2 (Feb. 1876): 46-47.

ST763 "Photographic Canvassing." ANTHONY'S PHOTOGRAPHIC BULLETIN 7, no. 3 (Mar. 1876): 80. [From "London Photo. News." M. Darblay, candidate for office in France, using photographs in campaign.]

ST764 "Photographic Ornamentation of Vases, etc." ANTHONY'S PHOTOGRAPHIC BULLETIN 7, no. 4 (Apr. 1876): 109. [From "London Photo. News."]

ST765 An Amateur Photographer. "A Field Day in Paris." ANTHONY'S PHOTOGRAPHIC BULLETIN 7, no. 9 (Sept. 1876): 284-287. [From "London Photo. News." Semi-comic adventures of a British amateur attempting to photograph in Paris, running afoul of officialdom and bureaucracy.]

FRANCE: 1877.

ST766 Stebbing, Prof. E. "French Correspondence." PHILADELPHIA PHOTOGRAPHER 14, no. 157-168 (Jan. - Dec. 1877): 26-28, 100-102, 114-116, 187-189, 214-215, 277-279.

ST767 "Our Foreign Make-Up: Competition of the French Society of Encouragement." PHOTOGRAPHIC TIMES 7, no. 73 (Jan. 1877): 17. [Paris "Moniteur de la Photographie" offers 2000 franc prize for improvements in applications of photography.]

ST768 "Spirit Photographs." FRANK LESLIE'S ILLUSTRATED NEWSPAPER 44, no. 1127 (May 5, 1877): 155, 157. 2 illus. [Portraits, taken in Paris, presented with discussion.]

ST769 "The St. Gothard Railway Tunnel Works." ILLUSTRATED LONDON NEWS 70, no. 1980 (June 23, 1877): 597, 598. 5 illus. ["...from a series of photographs..."]

ST770 "Photography at the Prefecture de Police, at Paris." PHOTOGRAPHIC TIMES 7, no. 80 (Aug. 1877): 173-175. [From "Le Petit Moniteur." Idea of photographic records of criminals proposed in 1854, but not until 1871, under the direction of M. Lombard, was

there a small unit established. Grew from two to eight photographers, doing mug shots and morgue photos.]

ST771 Lacan, Ernest. "French Correspondence." ANTHONY'S PHOTOGRAPHIC BULLETIN 8, no. 9 (Sept. 1877): 282-284. [From "London Photo. News." Public institutions opened to photographers; mentions Terperau (Bordeau); Boivin; chemical matters, etc.]

ST772 "The Late M. Thiers at the Pavillon Henri IV, St. Germain - From a Photograph taken August 30." ILLUSTRATED LONDON NEWS 71, no. 1992 (Sept. 15, 1877): 241. 1 illus.

FRANCE: 1878.

ST773 Stebbing, E. "French Correspondence." PHILADELPHIA PHOTOGRAPHER 15, no. 169-180 (Jan. - Dec. 1878): 81-83, 115-118, 146-147, 279-281, 301-303, 341-344, 377-379.

ST774 "French Items." PHILADELPHIA PHOTOGRAPHER 15, no. 169-180 (Jan. - Dec. 1878): 16-18, 48-50, 87-88, 249-250, 304-306, 380-381. [Excerpts of technical, news items, etc. from French periodicals, etc., translated for the "Phila. Photo."]

ST775 "French Correspondence." ANTHONY'S PHOTOGRAPHIC BULLETIN 9, no. 2 (Feb. 1878): 56-57. [From "London Photographic News." French Photo. Soc., Janssen's discoveries of sun spots, etc.]

ST776 "Mark Oute." "The Big Show." ANTHONY'S PHOTOGRAPHIC BULLETIN 9, no. 9 (Sept. 1878): 278-280. [From "Br J of Photo." Author visits Paris, discusses Klary's (Franck's studio) work with Boissanna's rapid process, then describes the Paris Exhibition, mentioning Notman, Sarony, Weston (San Francisco, CA), Joshua Smith, J. Landy.]

ST777 "An Outrè Development of Photography." ANTHONY'S PHOTOGRAPHIC BULLETIN 9, no. 11 (Nov. 1878): 336. [From "Br J of Photo." Report of cartes being made in France of double portraits or "decapitated" portraits, etc.]

ST778 York, F. "Photographic Experiences in Paris." ANTHONY'S PHOTOGRAPHIC BULLETIN 9, no. 11 (Nov. 1878): 337-340. [From "London Photographic News." York describes his experiences while attempting to photograph in France.]

ST779 "Police Photography: How They Manage the Thing in Paris, With Some Funny Incidents." PHOTOGRAPHIC TIMES 8, no. 96 (Dec. 1878): 272-273.

FRANCE: 1879.

ST780 "Paris Portraiture." ANTHONY'S PHOTOGRAPHIC BULLETIN 10, no. 3 (Mar. 1879): 77-78. [From "London Photo. News." Commentary on French galleries.]

ST781 "'A Wedding Party at the Photographers' - From the Picture by M. Dagnan-Bouveret." ILLUSTRATED LONDON NEWS. 74, no. 2085 (May 31, 1879): 511, double-page spread following p. 524. [Painting, with commentary.]

ST782 Stebbing, E. "Correspondence of the British Journal of Photography." ANTHONY'S PHOTOGRAPHIC BULLETIN 10, no. 8 (Aug. 1879): 252-253. [Stebbing writing from Paris, for the "Br J of Photo."]

ST783 "Meeting of the Chambre Syndicale des Photographie." ANTHONY'S PHOTOGRAPHIC BULLETIN 10, no. 9 (Sept. 1879): 265-266. [From "London Photographic News."]

GERMANY: 19TH.
BOOKS
ST784 Kempe, Fritz. "A Historical Sketch of Photography in Hamburg," on pp. 92-102. *One Hundred Years of Photographic History. Essays in Honor of Beaumont Newhall.* Edited by Van Deren Coke. Albuquerque, NM: University of New Mexico Press, 1975. 180 pp. 18 b & w.

ST785 Sobieszek, Robert A., ed. *The Daguerreotype in Germany: Three Accounts.* "The Sources of Modern Photography." New York: Arno Press, 1979. 16, 124, 81 pp. 35 l. of plates. [Reprints of I. Cephir *Der Daguerreotypen-Kreig in Hamburg.* W. Dost **Daguerreotypie in Berlin 1839 - 1860.** W. Weimar. *Die Daguerreotypie in Hamburg 1839 - 1860.*]

PERIODICALS
ST786 "Surveying By the Aid of Photography." PHOTOGRAPHIC TIMES 15, no. 198 (July 3, 1885): 360-361. [From "Photo. News." The article discusses uses of photography by the German military, for surveying, in 1870-1871.]

ST787 Forster-Hahn, Françoise. "Adolph Menzel's Daguerreotypical Image of Frederick the Great: A Liberal Bourgeois Interpretation of German History." ART BULLETIN 59, no. 2 (June 1977): 242-261. [The term, "Daguerreotypical" seems to refer to the painter's conceptual approach rather than any sort of specific connection with photography.]

ST788 Henisch, H. K. "The Leipziger Stadtanzeiger." HISTORY OF PHOTOGRAPHY 2, no. 3 (July 1978): 273. [Letter about his article, previously published in Jan. 1978 "History of Photography"]

ST789 Wilsher, Ann. "Marriage of Convenience." HISTORY OF PHOTOGRAPHY 5, no. 2 (Apr. 1981): frontispiece. 2 b & w. [Satiric cartes-de-visite montages created to comment on the alliance between Prussia and Austria in 1864.]

GERMANY: 1852.
ST790 "The Magnetic Daguerreotypes from a Few Startling Sketches by a Strolling Artist." PHOTOGRAPHIC ART JOURNAL 3, no. 6 (June 1852): 353-359. [Satirical short story set in Germany. Reprinted from "NY Sunday Courier."]

GERMANY: 1858.
ST791 Wallis, Oscar J. "Photography in Germany." PHOTOGRAPHIC AND FINE ART JOURNAL 11, no. 9 (Sept. 1858): 258-259. [Describes how German professional photographer's practices differ from his US counterpart, but doesn't name any specific photographers.]

GERMANY: 1859.
ST792 "Count Albert de Pourtales: Prussian Minister to France." BALLOU'S PICTORIAL DRAWING-ROOM COMPANION [GLEASON'S] 17, no. 432 (Oct. 1, 1859): 217. 1 illus. ["...from a photograph."]

GERMANY: 1860.
ST793 Lowenstein Gebruder, Frankfurt am Main. *Catalogue of the Celebrated Collection of Works of Art and Vertu, known as "The Vienna Museum," the Property of Messrs. Lowenstein, brothers, of Frankfort-on-the-Main: which will be sold by auction, by Messrs. Christi, Manson & Woods on March 12, 1860, and nine following days (Saturdays and Sundays excepted).* London: W. Clowes & Sons, 1860. 90 pp. 41 l. of plates. [Original photographs, of works of art.]

GERMANY: 1861.
ST794 "Photography in 1861." AMERICAN JOURNAL OF PHOTOGRAPHY AND THE ALLIED ARTS & SCIENCES n. s. vol. 4, no. 12 (Nov. 15, 1861): 286-287. [From "Daily Telegraph." States that the Germans are excelling in detailed architectural views, extols the British to keep up.]

GERMANY: 1862.
ST795 Liesegang, Paul E. "The Art in Germany." HUMPHREY'S JOURNAL OF PHOTOGRAPHY, AND THE ALLIED ARTS AND SCIENCES 13, no. 19 (Feb. 1, 1862): 300-302. [From "Photo. News."]

GERMANY: 1863.
ST796 "Miscellaneous: Photography and Matrimony." AMERICAN JOURNAL OF PHOTOGRAPHY AND THE ALLIED ARTS & SCIENCES n. s. vol. 6, no. 3 (Aug. 1, 1863): 70. [Report that a marriage broker travels on train between Cologne and Hanover, with an album of cartes-de-visite of prospective suitors.]

GERMANY: 1864.
ST797 Lea, M. Carey. "Photography in Germany." PHILADELPHIA PHOTOGRAPHER 1, no. 4 (Apr. 1864): 54-55. [Discussion of materials abstracted from "Photographisches Archiv."]

ST798 "Miscellaneous: Photography and Art." AMERICAN JOURNAL OF PHOTOGRAPHY AND THE ALLIED ARTS & SCIENCES n. s. vol. 7, no. 2 (July 15, 1864): 39-40. [Discusses photographers in Germany who have made photographs of works of art. Albert (Munich); Michels (Düsseldorf); Shauer (Berlin); Berlin Photographic Society (Berlin).]

GERMANY: 1865.
ST799 "Photography in Germany." AMERICAN JOURNAL OF PHOTOGRAPHY AND THE ALLIED ARTS & SCIENCES n. s. vol. 7, no. 21 (May 1, 1865): 501-502. [Technical issues, but Dr. Reissig, Mr. Grüne, Mr. Böhm mentioned by name.]

GERMANY: 1866.
ST800 Vogel, Dr. H. "Photographic Novelties in Germany." PHILADELPHIA PHOTOGRAPHER 3, no. 31-36 (July - Dec. 1866): 205-207, 245-248, 307-310, 345-347. [Describes the impact of the war on Germany. Mentions the work of Henry Graf and Mr. Stiehm, who photographed the sites and activities of the war. (Nov.)]

GERMANY: 1867.
ST801 Lea, M. Carey. "Photographic Summary." PHILADELPHIA PHOTOGRAPHER 4, no. 43 (July 1867): 221-222. [Note about landscape photos in Germany, mentions Adam-Salomon's portraiture.]

ST802 Vogel, Dr. H. "German Correspondence." PHILADELPHIA PHOTOGRAPHER 4, no. 37-48 (Jan. - Dec. 1867): 24-26, 84-86, 115-117, 223-226, 262-264, 296-299, 327-329, 360-363, 391-393.

ST803 Hoelke, H. E. "Landscape Photography in Germany." PHILADELPHIA PHOTOGRAPHER 4, no. 47 (Nov. 1867): 347-348.

GERMANY: 1868.
ST804 "German Photographs." PHILADELPHIA PHOTOGRAPHER 5, no. 49 (Jan. 1868): 15-16. [Dr. Vogel, Loescher & Petsch, H. Graf, E. Milster mentioned.]

ST805 Vogel, Dr. H. "German Correspondence." PHILADELPHIA PHOTOGRAPHER 5, no. 49-60 (Jan. - Dec. 1868): 29-31, 54-56, 91-93, 206-209, 239-240, 267-269.

GERMANY: 1869.

ST806 Vogel, Prof. H. "German Correspondence." PHILADELPHIA PHOTOGRAPHER. 6, no. 61-72 (Jan. - Dec. 1869): 45-47, 85-88, 157-160, 246-248, 302-304, 343-345, 375-377, 419-422.

ST807 Liesegang, Dr. E. "Photography in Germany." PHILADELPHIA PHOTOGRAPHER 6, no. 64 (Apr. 1869): 114-115.

ST808 Walker, L. E. "Photography at the Government Works in Berlin." HUMPHREY'S JOURNAL OF PHOTOGRAPHY, AND THE ALLIED ARTS AND SCIENCES 20, no. 25 (Sept. 15, 1869): 392-393. [Describes practice and formulas, for reproductive copy work.]

GERMANY: 1870.

ST809 Vogel, Dr. H. "German Correspondence." PHILADELPHIA PHOTOGRAPHER 7, no. 73-84 (Jan. - Dec. 1870): 22-24, 48-51, 83-85, 129-132, 163-164, 253-256, 369-371, 418-420. [June issue has no column due to Vogel's trip to USA for National Photography Association Meeting.]

GERMANY: 1871.

ST810 Vogel, Dr. H. "German Correspondence." PHILADELPHIA PHOTOGRAPHER 8, no. 85-96 (Jan. - Dec. 1871): 21-23, 82-85, 110-112, 145-148, 242-243, 273-275, 306-310, 330-332, 362-364. [(Jan.) Dry plates on the German Polar Expedition - American pictures in Berlin-Eclipse Expedition. (Feb.) Art and photo in Italy, Bierstadt's pictures of Yosemite Valley discussed, etc. (Apr.) Loescher & Petsch. (Sept.) Franco-Prussian war., etc.]

ST811 "Viator." "From Across the Water." ANTHONY'S PHOTOGRAPHIC BULLETIN 2, no. 8 (Aug. 1871): 266-268. [Author goes from England to Germany. Loescher & Petsch; Schnaebli, others mentioned.]

GERMANY: 1872.

ST812 Vogel, Dr. H. "German Correspondence." PHILADELPHIA PHOTOGRAPHER 9, no. 97-108 (Jan. - Dec. 1872): 17-19, 57-59, 88-90, 146-147, 264-266, 278-280, 330-331, 361-363, 388-389, 422-423. [(Oct.) Report on a photo excursion by Vogel into the Carpathian Mountains.]

ST813 Vogel, H. "Fourth Annual Meeting and Exhibition of the N. P. A. in St. Louis, Mo., May 1872: Progress in Germany." PHILADELPHIA PHOTOGRAPHER 9, no. 102 (June 1872): 174-175.

ST814 Towler, Prof. J., M.D. "Photography in Europe." PHILADELPHIA PHOTOGRAPHER 9, no. 108 (Dec. 1872): 410-411.

GERMANY: 1873.

ST815 Vogel, Dr. H. "German Correspondence." PHILADELPHIA PHOTOGRAPHER 10, no. 109-116 (Jan. - Aug. 1873): 24-26, 58-60, 93-95, 124-125, 154-155, 172-175, 224-228. [(Jan.) Review of Anderson's "Skylight & Darkroom" - Vienna exhibition Bldg. - Congress of German photographers, etc. (Feb.) Petsch leaves photography. (Apr.) Vienna exhibit. (June) Panoramic views.]

ST816 Woodbury, Walter B. "Commercial Photography in Munich." ANTHONY'S PHOTOGRAPHIC BULLETIN 4, no. 1 (Jan. 1873): 7-8. [Mentions Bruckmann, Albert, Haensflengel, From "London Photographic News."]

GERMANY: 1874.

ST817 Vogel, Dr. H. "German Correspondence." PHILADELPHIA PHOTOGRAPHER 11, no. 121-132 (Jan. - Dec. 1874): 25-29, 50-54, 99-102, 153-155, 179-181, 217-219, 249-251, 266-268, 308-311, 333-335, 378-379. [(Oct.) Vogel compares and contrasts German and English landscapists.]

ST818 Wilson, Edward L. "Views Abroad and Across. Pt. 3." PHILADELPHIA PHOTOGRAPHER 11, no. 123 (Mar. 1874): 82-88. [Wilson visited many studios in extended visit to Europe. Berlin.]

ST819 Vogel. "Photography in Berlin." PHOTOGRAPHIC TIMES 4, no. 45 (Sept. 1874): 142-143. [Excerpts from Vogel's "Photographische Mittheilungen".]

GERMANY: 1875.

ST820 Vogel, Dr. H. "German Correspondence." PHILADELPHIA PHOTOGRAPHER 12, no. 133-144 (Jan. - Dec. 1875): 2-5, 49-51, 85-87, 238-240, 274-276, 303-305, 341-343, 380-382.

ST821 "Matters of the Month: No Accounting for Taste." PHOTOGRAPHIC TIMES 5, no. 54 (June 1875): 160. [From "NY World." Royal Family in Bavaria has interests... King Louis II loves music, Duke Charles into surgery and Dutchess Sophie purported to have eloped with a Bavarian photographer.]

GERMANY: 1876.

ST822 Vogel, Dr. H. "German Correspondence." PHILADELPHIA PHOTOGRAPHER 13, no. 145-156 (Jan. - Dec. 1876): 17-19, 50-52, 76-78, 113-115, 152-154, 177-179, 346-348, 369-371.

ST823 "Foreign Notes and News." ANTHONY'S PHOTOGRAPHIC BULLETIN 7, no. 1 (Jan. 1876): 17-19. [From "Br. J. of Photo." Berlin Photo. Soc.; Richter; Vogel; Marowsky; Schaarwaecher, visited Paris. Describes the major studios there; Belgian Photo. Soc.; Etc.]

GERMANY: 1877.

ST824 Vogel, Dr. H. "German Correspondence." PHILADELPHIA PHOTOGRAPHER 14, no. 157-168 (Jan. - Dec. 1877): 23-26, 66-68, 98-99, 149-151, 185-187, 212-214, 249-250, 309-311, 349-351.

ST825 "Topics of the Times." PHOTOGRAPHIC TIMES 7, no. 79 (July 1877): 160. [Quotes an article in the "Mittheilungen" giving information about the scale of commercial photography in Germany. Approximately 3000 studios, each consuming about 3 pounds of nitrate of silver annually. Other statistics on chemical costs, etc...]

GERMANY: 1878.

ST826 Vogel, Dr. H. "German Correspondence." PHILADELPHIA PHOTOGRAPHER 15, no. 169-180 (Jan. - Dec. 1878): 18-20, 52-53, 113-114, 144-146, 177-179, 210-212, 244-246, 276-279, 299-301, 374-377.

ST827 "Photographer's Assistants Abroad." ANTHONY'S PHOTOGRAPHIC BULLETIN 9, no. 4 (Apr. 1878): 112. [From "London Photographic News." Survey of German pay scales, etc.]

ST828 "Photographs of Offenders." PHOTOGRAPHIC TIMES 8, no. 91 (July 1878): 150-151. [Mug shots used in Germany.]

GERMANY: 1879.

ST829 Vogel, H. "German Correspondence." PHILADELPHIA PHOTOGRAPHER 16, no. 185 (May 1879): 140-143. [Commentary on Muybridge's instantaneous pictures on p. 141.]

ST830 "Our Picture." PHILADELPHIA PHOTOGRAPHER 16, no. 190 (Oct. 1879): 289-290. 1 illus. [Copy of oil painting "The Village Photographer" by Mr. Anton Seitz of Munich, Germany.]

GREAT BRITAIN: 19TH C.
BOOKS

ST831 Gernsheim, Helmut. *Masterpieces of Victorian Photography.* With a foreword by C. H. Gibbs-Smith. London: Phaidon Press, 1951. 107 pp. b & w.

ST832 Fuller, John Charles. *The Photographic Image in England from 1839 - 1865: An Interrelated Study of Photography and Painting showing the Emergence of a New Medium amid Academic and Pre-Raphaelite Art.* Athens, OH: Ohio University, 1968. 170 l. [Ph.D. Dissertation, Ohio University, June 9, 1968. Bibliography on leaves 160 - 170.]

ST833 Maas, Jeremy. "Chapter XIII. The Effects of Photography," on pp. 190-208 in: *Victorian Painters.* New York: Putnam, 1969. 257 pp.

ST834 Thomas, D. B. *The Science Museum Photography Collection.* London: Her Majesty's Stationary Office, 1969. 113 pp. illus. [667 items - cameras, equipment, photographs, etc. - listed and annotated. Includes early work by W. H. F. Talbot and others.]

ST835 Winsor Castle Royal Archives. *Royal Archives at Winsor Castle: Victorian Photographic Collection,* Compiled by Roger Taylor. London: World Microfilm Publications, 197-. 18 pp.

ST836 *'From today painting is dead' The Beginnings of Photography.* London: The Arts Council of Great Britian, 1972. 110 pp. 53 b & w. 9 illus. [Exhibition catalog, Victoria & Albert Museum, London, Mar. 16 - May 14, 1972. Exhibition selected and catalog written by Dr. D. B. Thomas, with the assistance of Gail Buckland. "Fixing the Face," by Tristram Powell, on pp. 9-11. "Photography as Social Documentation," by Asa Briggs, on pp. 13-15. 914 pieces listed in the checklist. Primary emphasis on British photography to about 1880, some works by French photographers also discussed.]

ST837 Howarth-Loomes, B. E. C. *Victorian Photography: An Introduction for Collectors and Connoisseurs.* New York: St. Martin's Press, ca. 1974. 99 pp. b & w. illus.

ST838 *The Real Thing. An Anthology of British Photographs 1840 - 1950.* London: Arts Council of Great Britian, 1975. 124 pp. 80 b & w. 16 illus. [Exhibition catalog, Hayward Gallery, London, Mar. 19 - May 4, 1975, then travelled. "British Photography from Fox Talbot to E. O. Hoppé," by Ian Jeffrey, on pp. 5-24. "Patterns of Naturalism: Hoppé to Hardy," by David Mellor, on pp. 25-35. Portfolio of 80 prints.]

ST839 Borcoman, James. "Notes on the Early Use of Combination Printing," on pp. 16-18 in: *One Hundred Years of Photographic History. Essays in Honor of Beaumont Newhall.* Edited by Van Deren Coke. Albuquerque, NM: University of New Mexico Press, 1975. 180 pp. [Discusses the work of H. P. Robinson, O. G. Rejlander and Hippolyte Bayard.]

ST840 Hannavy, John. *Masters of Victorian Photography.* New York: Holmes & Meier, 1976. 96 pp. b & w.

ST841 Sobieszek, Robert A. *British Masters of the Albumen Print: A Selection of mid-nineteenth century Victorian photography.* Chicago: University of Chicago Press, with the International Museum of Photography at George Eastman House, 1976. vi, 34 pp. 3 l. of plates. [Exhibition: IMP/GEH, 1976. Bibliography, pp. 19-21. Contains three sheets of microfiche containing illustrations of the exhibition.]

ST842 Heyert, Elizabeth. *The Glass House Years: Victorian Portrait Photography 1839 - 1870.* Montclair, NJ: Allanheld & Schram, 1979. viii, 158 pp. b & w. illus. [Bibliography on pp. 143-149.]

ST843 Hannavy, John. *The Victorian Professional Photographer.* Aylesbury, England: Shire Publications, Ltd., 1980. 32 pp. illus.

ST844 Hershkowitz, Robert. *The British Photographer Abroad - The First Thirty Years.* London: Robert Hershkowitz, Ldt., 1980. 95 pp.

ST845 Budge, Adrian. *Early Photography in Leeds: 1839 - 1870.* Leeds, England: Leeds Art Gallery, 1981. n. p. [Exhibition catalog: Temple Newsam House, Leeds, April, 1981.]

ST846 Edwards, Elizabeth and Lynne Williamson. *World on a Glass Plate: Early Anthropological Photographs from the Pitt Rivers Museum, Oxford.* Oxford, England: Pitt Rivers Museum, 1981. 42 pp. 39 b & w.

ST847 Harker, Margaret F. *Victorian and Edwardian Photographs.* London: Charles Letts, 1982. 80 pp. b & w. illus. [Rev. ed.]

ST848 Brettell, Richard R. *Paper and Light: The Calotype in France and Great Britian, 1839 - 1870.* Richard R. Brettell, with Roy Fluckinger, Nancy Keeler, and Sydney Mallett Kilgore. Boston: David R. Godine, 1984. 216 pp. 155 b & w.

ST849 Haworth-Booth, Mark, ed. and introduction. *The Golden Age of British Photography 1839 - 1900.* Photographs from the Victoria and Albert Museum, London, with selections from the Philadelphia Museum of Art, Royal Archives, Windsor Castle, The Royal Photographic Society, Bath, Science Museum, London, Scottish National Portrait Gallery, Edinburgh. New York: Aperture Press, 1984. 191 pp. [Ex. cat.: Victoria and Albert Museum, London, June 6 - Aug. 19, 1984, and travelling. "The Dawning on an Age: Chauncy Hare Townshend: Eyewitness," by Mark Haworth-Booth, on pp. 11-21. "1. The Daguerreotype A New Wonder," on pp. 22-29. "2. The Calotype Era," on pp. 30-31. "The Circle of William Henry Fox Talbot," by Carolyn Bloore, on pp. 32-47. "3. Picturesque Britian and the Industrial Age," on pp. 48-69. "Roger Fenton and the Making of a Photographic Establishment," by Valerie Lloyd, on pp. 70-81. "4. The Grand Tour," on pp. 82-93. "5. High Art Photography in Search of an Ideal," on pp. 94-103. "6. Exploring the Empire," on pp. 104-117. "7. Aristocratic Amateurs," on pp. 118-131. "Julia Margaret Cameron, Christian Pictorialist," by Mike Weaver, on pp. 132-141. "8. Street Life," on pp. 142-151. "The Art of Photography, Fulfilling the Vision," on pp. 152-153. "Peter Henry Emerson, Art and Solitude," by Ian Jeffrey, on pp. 154-169. "James Craig Annan, Brave Days in Glasgow," by William Buchanan, on pp. 170-183. "10. Paul Martin and the Modern Era," on pp. 184-188. "References," on pp. 189.]

ST850 Kraus, Hans P. and Larry J. Schaaf. *Sun Pictures: Early British Photographers on Paper.* Catalogue One. New York: Hans P. Kraus, Jr. Fine Photographs, 1984. 60 pp. illus.

ST851 Maas, Jeremy. *The Victorian Art World in Photographs.* New York: Universe Books, 1984. 224 pp. b & w. illus.

ST852 McCoo, Donald. *Paisley Photographers, 1850 - 1900.* Glasgow: Foulis Archive Press, Glasgow School of Art, 1985. n. p.

ST853 Stamp, Gavin. *The Changing Metropolis: Earliest Photographs of London 1839 - 1879.* Middlesex, England: Penguin Books, Ltd., 1984. 240 pp. 211 b & w. [Photographs, by W. H. F. Talbot, James Hedderly, Charles Thurston Thompson, and others, identified by

photographer. Texts are about the architectural history of the subjects depicted in the views.]

ST854 Bartram, Michael. *The Pre-Raphaelite Camera: Aspects of Victorian Photography.* Boston: Little, Brown & Co., 1985. 200 pp. b & w.

ST855 Fluckinger, Roy. *The Formative Decades: Photography in Great Britian, 1839 - 1920.* Austin: University of Texas Press, 1985. 164 pp. [Materials drawn from the Helmut Gernsheim Collection, Univ. of Texas, Austin.]

ST856 O'Connell, Michael. *Shadows, an Album of the Irish People, 1841 - 1914.* Dublin: The O'Brien Press Ltd., 1985. 132 pp. b & w. [Includes information on W. H. F. Talbot; Leon Gluckmann, who ran a portrait studio in Dublin in the 1840s, etc.]

ST857 *Masterpieces of Photography from the Riddell Collection.* Introduction by Sara Stevenson. Catalogue by Julie Lawson. Edinburgh: Scottish National Portrait Gallery, 1986. 144 pp. 86 b & w. [Exhibition catalog. "Nineteenth-Century Photography: Real Life, Truth and the Pursuit of Art," by Sara Stevenson on pp. 11-33. "Plates," on pp. 35-108, "Catalogue" on pp. 110-144. 72 Works exhibited, by Annan & Sons; James C. Annan; Platt D. Babbit; Francis Bedford; Samuel Bourne; Archibald Burns; William Donaldson Clark (d. 1873); A. L. Coburn; James Crighton; William Eismore & Co.; F. H. Evans; F. Frith; Alexander Henderson (1831-1913); Hill & Adamson; Eugene Clutterbuck Impey (1830-1904); G. Käsebier; Paul Kee; A. O. Knoblauch; Joseph Lawton (d. 1874); F. J. Moulin; A. Noack; John Patrick (1830-1923); Thomas Rodger (1833-1883); Charles T. Scowen; Charles Shepherd & Arthur Robertson; W. L. H. Skeen & Co.; Isaac West Taber (1830-1912); W. H. F. Talbot; James Valentine (1815-1880); G. W. Wilson (1823-1893); Zangaki; Unknowns. Biographical information, included, when known. Although the collection of Peter Fletcher Riddell included Americans and others, its strength is British (Scottish) photographers from 19th century.]

ST858 DiGuilio, Katherine. *Narrative Photography exhibited in Britain 1855 - 1863.* [Ph.D. Thesis, Yale University, 1986.]

ST859 Edge, Sarah. *Our Past - Our Struggle: Images of Women in the Lancashire Coal Mines 1860 - 1880.* Rochedale, England: Rochedale Art Gallery, 1986. 16 pp. [Photographs from the collection of Arthur J. Munby.]

ST860 Murray, Hugh. *Photographs and Photographers of York: The Early Years 1844 - 1879.* York, England: Yorkshire Architectural and York Archaeological Society in association with Sessions of York, 1986. 130 pp. [Chapters for Hill & Adamson; W. H. F. Talbot; William Pumphrey; Roger Fenton; G. W. Wilson; F. Frith; George Fowker Jones; York Photographers; Commercial Photographers in York 1844 - 1879.]

ST861 Pritchard, Michael. *A Directory of London Photographers 1841 - 1908.* Watford, England: Allm Books, 1986. 106 pp. [Lists over 2,500 photographers, with their active dates, business addresses, etc.]

ST862 Seiberling, Grace, with Caroyln Bloore. *Amateurs, Photography, and Mid-Victorian Imagination.* ...in association with the International Museum of Photography at George Eastman House. Chicago, London: University of Chicago Press, 1986. 195 pp. b & w. ["Biographical Appendix," by Carolyn Bloore, on pp. 123-147, contains biographies on: Francis Bedford; W. G. Campbell; Joseph Cundall; Francis E. Currey; Philip H. Delamotte; Hugh W. Diamond;

Thomas D. Eaton; Roger Fenton; Joseph J. Forrester; George Glossop; Robert Howlett; Edward Kater; John D. Llewelyn; Robert W. S. Lutwidge; Mary E. Lynn; Thomas G. Mackinlay; John R. Major, D.D; John R. Major; Thomas L. Mansell; Count de Montizon; Lady Augusta Mostyn; Lady Caroline Nevill; Sir William J. Newton; John Percy; Arthur J. Pollock; Henry A. R. Pollock; William L. Price; Henry P. Robinson; Benjamin B. Turner; H. Gordon Watson; Henry White.]

ST863 Dimond, Frances and Roger Taylor. *Crown and Camera: The Royal Family and Photography, 1842 - 1910.* Catalog of an exhibition in the Queen's Gallery at Buckingham Palace. London: Penguin Books, Ltd., 1987. 223 pp. b & w. [The support that Queen Victoria and Prince Albert gave to photography in 1850s and 1860s is featured in this exhibition.]

ST864 Kraus, Hans P. *Sun Pictures: Catalogue Two: Llewelyn, Maskelyne, Talbot, a family Circle.* New York: Hans P. Kraus, Jr. Inc., 198-. 79 pp. b & w.

ST865 Kraus, Hans P. and Larry J. Schaaf. *Sun Pictures: The Harold White Collection of Historical Photographs from the Circle of Talbot.* Catalogue Four. New York: Hans P. Kraus, Jr. Fine Photographs, 1987. n. p. illus.

PERIODICALS

ST866 "Ancient Photography. Part 1." PHILADELPHIA PHOTOGRAPHER 3, no. 32 (Aug. 1866): 248-250. [Extracts from Talbot's articles on Daguerre.]

ST867 "Ancient Photography." PHILADELPHIA PHOTOGRAPHER 3, no. 33 (Sept. 1866): 281-284. [Daguerre's process from the "Journal of the Franklin Institute."]

ST868 Hull, C. Wager. "New York Correspondence." PHILADELPHIA PHOTOGRAPHER 5, no. 53 (May 1868): 173-177. [Survey of early history of photography in Great Britain.]

ST869 McCarthy, Justin. "The Story of Gladstone's Life." OUTLOOK 56, no. 1 (May 1, 1897): 26-45. 14 b & w. 6 illus. [Illustrated with portraits and views of England and Greece. Photos by London Stereoscopic Co., S. Bregi (Florence); W. & D. Downey, Maull & Fox, F. Frith, etc.]

ST870 Coburn, Alvin Langdon. "The Old Masters of Photography." CENTURY MAGAZINE 90, no. 6 (Oct. 1915): 908-920. 9 b & w. [Coburn organized an exhibition of British 19th century photographers: D. O. Hill, Julia M. Cameron, Dr. Thomas Keith, Lewis Carroll.]

ST871 Wight, G. W. "Early Photographic History in Edinburgh." EDINBURGH JOURNAL OF SCIENCE, TECHNOLOGY AND PHOTOGRAPHIC ART 14, 15, (Jan. 1940 - Jan. 1941): (14) 82-86, 141-148 (15) 32-48, 77-86. [1. Mungo Ponton. 2. W. H. Fox Talbot. 3. D. O. Hill 4. The Photographic Society of Scotland. 5. Edinburgh Photographic Society.]

ST872 Marshall, Albert E. "There Were Giants Then." U. S. CAMERA 1, no. 9 (May 1940): 24-25, 65. 4 b & w. [Frith, Grundy, etc.]

ST873 Dallas, Duncan C. "The Museum of Photography." IMAGE 1, no. 2 (Feb. 1952): 2. [Reprinted from "British Journal Photographic Almanac, 1871."]

ST874 "Amateur Albums." IMAGE 2, no. 2 (Jan.- Feb. 1953): 58. 2 b & w. [Brief notes about two amateur exchange albums from the 1850s, now in the Eastman House Collection.]

ST875 "Index to Resources: English Daguerreotypes: Reproductions of Daguerreotypes." IMAGE 6, no. 10 (Dec. 1957): 248-249. 7 b & w. [Landscape views.]

ST876 "The First Reproduction of a Photograph." IMAGE 11, no. 2 (1962): 7-8. 2 illus. [The Apr. 20, 1839 issue of "The Mirror of Literature, Amusement and Instruction" contained a "facsimile of a Photogenic Drawing."]

ST877 "Victoriana." CAMERA (LUCERNE) 47, no. 12 (Dec. 1968): 3 - 43. 41 b & w. [Special issue on British photography. "Victorian Photography," by Helmut Gernsheim, on pp. 4, 13-14, 23. "Victorian England," by Maureen Martin Turner, on pp. 24, 33. "Lewis Carroll," by O. J. Rothrock, on p. 34. "Biographies," on p. 43. Portfolios by D. O. Hill (11 b & w); W. H. F. Talbot (9 b & W); Lewis Carrol (11 b & w). Photographs by J. M. Cameron; Lyddell Sawyer; F. Myers; F. M. Sutcliffe; J. B. B. Wellington.]

ST878 Jenkins, William. "British Masters of the Albumen Print: A Major New Exhibition at the International Museum of Photography." IMAGE 16, no. 2 (June 1973): 1-7. 7 b & w. [Exhibition covers the years 1850-1880. Illustrations are by Roger Fenton [actually these photos are by Victor Prout], Wm. Lake Price, J. M. Cameron, Francis Frith, Antione F. J. Claudet, The Earl of Caithness, Major F. Gresley.]

ST879 Hannavy, John. "The Rise and Fall of the Victorian Stereoscope." PHOTOGRAPHIC TECHNIQUE 3, no. 1 (1975): 43. illus.

ST880 Becker, William B. "Calotype of Edinburgh." HISTORY OF PHOTOGRAPHY 1, no. 1 (Jan. 1977): 78. 1 b & w. [View of Edinburgh, taken between 1845 and 1850, photographer unknown.]

ST881 Gill, Arthur T. "East Anglia and Early Photography." JOURNAL OF THE ROYAL SOCIETY OF ARTS 125, no. 5250 (May 1977): 317-327. 9 illus.

ST882 McCauley, Elizabeth Anne. "Evasion in Victorian Landscape Photography: The Amateur Photographic Association Album." BULLETIN OF THE UNIVERSITY OF NEW MEXICO ART MUSEUM (1978-1979): 3-13.

ST883 Ford, Colin. "The National Portrait Gallery: 'People in Camera 1838-1914.'" CAMERA (LUCERNE) 58, no. 6 (June 1979): 3-33, 35-50. 39 b & w. 3 illus. [Ex. cat.: 'People in Camera 1839 - 1914,' National Portrait Gallery, London, June 1 - Aug. 12, 1979.]

ST884 Wood, R. Derek. "The Daguerreotype in England: Some Primary Material Relating to Beard's Lawsuits." HISTORY OF PHOTOGRAPHY 3, no. 4 (Oct. 1979): 305-309. 1 illus.

ST885 Mann, Charles W. "Memories." HISTORY OF PHOTOGRAPHY 3, no. 4 (Oct. 1979): 330. 1 illus. [Samuel Carter Hall, founder of the "Art Journal", his wife, the author Anna Maria Hall, and the use of their photographic portraits on their 50th wedding anniversary announcement.]

ST886 Wood, R. Derek. "The Daguerreotype Patent, the British Governor, and the Royal Society." HISTORY OF PHOTOGRAPHY 4, no. 1 (Jan. 1980): 53-59. 3 b & w. 7 illus.

ST887 Haworth-Booth, Mark. "Hoddy and John Munroe in Flaipool in 1847." PHOTOGRAPHIC COLLECTOR 1, no. 1 (Spring 1980): 14-15. 1 b & w. [Daguerreotype of two men fishing, taken outdoors, it is solarized, thereby creating a blue sky.]

ST888 Wilsher, Ann. "Faces of Fame." HISTORY OF PHOTOGRAPHY 4, no. 3 (July 1980): 246. 1 b & w. [A carte-de-visite montage of portraits of the royal family issued in England in the early 1860s.]

ST889 Wood, R. Derek. "Daguerreotype Case Backs: Wharton's Design of 1841." HISTORY OF PHOTOGRAPHY 4, no. 3 (July 1980): 251-252. 1 illus.

ST890 "Photography at Sydenham." PHOTOGRAPHICA 12, no. 8 (Oct. 1980): 14-15. 3 b & w. [Stereo and daguerreotype views of the Crystal Palace after it was reconstructed at Sydenham in 1854.]

ST891 Jay, Bill. "Images in the Eyes of the Dead." BRITISH JOURNAL OF PHOTOGRAPHY 128, no. 5 (Jan. 30, 1981): 124-127, 132, 133. [Discusses the popular 19th c. belief that the last image seen by a dying person remained fixed in the retina for a period of time.]

ST892 Falconer, John. "The Photograph Collection of the Royal Commonwealth Society." PHOTOGRAPHIC COLLECTOR 2, no. 1 (Spring 1981): 34-53. 26 b & w. [Royal Colonial Institute founded 1868 as "a place of meeting for all gentlemen connected with the Colonies and British India." Photograph collection of more than 40,000 prints.]

ST893 Chanan, Noel. "The Daguerreotype in London; An account by two visitors from India." HISTORY OF PHOTOGRAPHY 5, no. 2 (Apr. 1981): 155-156. 1 illus. [An account by two Indian engineers visiting London, printed in 1841, includes comments about the daguerreotype. "Journal of a Residence of Two Years and a Half in Great Britain" by Jehangeer Nowrojee and Hijeebhoy Merwanjer of Bombay. London: Wm. H. Allen & Co.]

ST894 Jay, Bill. "'Whiffley Puncto & Co.'" BRITISH JOURNAL OF PHOTOGRAPHY 128, no. 24 (June 12, 1981): 596-598. [British photographers' custom of using pseudonyms.]

ST895 Steel, Jonathan. "The Stereoscope and Collecting Stereocards: Part 7. Isambard Kingdom Brunel." PHOTOGRAPHIC COLLECTOR 3, no. 2 (Autumn 1982): 206-216. 18 b & w. 4 illus. [Stereoscope images of Brunel's (1806-1859) steamship, "The Leviathan," published by the London Stereoscopic Company.]

ST896 Steel, Jonathan. "The Stereoscope and Collecting Stereocards: Part 8. Oxford University." PHOTOGRAPHIC COLLECTOR 3, no. 3 (Winter 1982): 322-331. 20 b & w. 1 illus. [Views of Oxford University in 19th century. Photos by Hills & Saunders, Roger Fenton, Spiers, J. G. Millas, Wheeler & Day, Henry Taunt, Mary Lichtenberg, S. Thompson, et al.]

ST897 Budge, Adrian. "Yorkshire & Photography—the Early Years." PHOTOGRAPHIC COLLECTOR 4, no. 1 (Spring l983): 10-23. 19 b & w. 2 illus. [Photos by: Leeds Photographic Portrait Gallery, D. O. Hill & R. Adamson, W. H. F. Talbot, J. Bottomley, John Wm. Ramsden, Wm. Pumphrey, R. Fenton, P. H. Delamotte & J. Cundall, Edmund Wormald, Wm. Child & Ed. Wormald.]

ST898 Weaver, Mike. "The Hard and Soft in British Photography." PHOTOGRAPHIC COLLECTOR 4, no. 2 (Autumn 1983): 195-196.

1 b & w. [Commentary on Lady Eastlake, Ruskin, other mid-century responses to photography.]

ST899 Hart, Janice. "The Family Treasure: Productive and Interpretative Aspects of the Mid to Late Victorian Photograph Album." PHOTOGRAPHIC COLLECTOR 5, no. 2 (1984): 164-180. 14 illus.

ST900 Main, William. "Charles Dickens and the Magic Lantern." HISTORY OF PHOTOGRAPHY 8, no. 1 (Jan. - Mar. 1984): 67-72. 19 b & w. [Posed genre scenes illustrating several of Dickens' stories. "Gabriel Grub" reproduced in a series of magic lantern slides.]

ST901 Mann, Charles and Kathleen Collins. "Studio Sample Sheets." HISTORY OF PHOTOGRAPHY 8, no. 3 (July - Sept. 1984): 197-200. 9 b & w. illus. [Advertising method used in USA, Great Britain and elsewhere to sell cartes-de-visite: tiny reproductions pasted to canvas sheet, then rolled up for easy transportation. Article illustrates some from Great Britain, 1860s-1890s.]

ST902 Henggler, Joseph, as told to Lawrence Wolfe. "Stereo Emeralds: A Look at Nineteenth Century Irish Stereo Views." STEREO WORLD 14, no. 1 (Mar. - Apr. 1987): 22-30. 14 b & w. [Views by London Stereoscopic Co.; William England; William Despard Hemphill; Douglas; E. & H. T. Anthony & Co.; G. W. W. Wilson; H. Petschler & Co.; Husdson.]

ST903 Pritchard, Michael. "Commercial Photographers in Nineteenth Century Great Britian." HISTORY OF PHOTOGRAPHY 11, no. 3 (July - Sept. 1987): 213-215. 2 illus. [Graphs, charting percentages of male and female photographers, growth of the profession, etc.]

ST904 Heathcote, Bernard V. and Pauline F Heathcote. "Correspondence: Commercial Photographers in Nineteenth Century Great Britian." HISTORY OF PHOTOGRAPHY 12, no. 1 (Jan. - Mar. 1988): 89. [Letter disputing some facts in M. Pritchard's "Commercial Photographers in Great Britian," HOP (July - Sept. 1987): 213. Discusses Mrs. Ann Cooke, Miss Jane Nina Wigley, who worked in the 1840s. States that 123 photographers have been positively identified working in 1851.]

ST905 Heathcote, Bernard V. and Pauline F. Heathcote. "The Feminine Influence: Aspects of the Role of Women in the Evolution of Photography in the British Isles." HISTORY OF PHOTOGRAPHY 12, no. 3 (July - Sept. 1988): 259-273. 3 b & w. 7 illus. [Discusses Mrs. Ann Cooke (b. 1796); Miss Matilda Hamilton; Miss Jane Nina Wigley (b. ca. 1821); all flourishing before 1855; other women after 1855 mentioned —among them the amateurs Anna Atkins; the Viscountess Hawarden; and J. M. Cameron. Includes a list of women proprietors of commercial photographic studios active from 1841 to 1855.]

ST906 Smith, Roger. "Selling Photography - Aspects of Photographic Patronage in Nineteenth Century Britian." HISTORY OF PHOTOGRAPHY 12, no. 4 (Oct. - Dec. 1988): 317-326. 7 b & w. [Four b&w by Roger Fenton, three b&w by Francis Frith. Discusses photographic exchange clubs, photographic art unions, and lotteries in the mid 1850s.]

GREAT BRITAIN: 1839.
BOOKS
ST907 *Ackermann's Photogenic Drawing Apparatus.* London: Ackermann & Co., 1839. 8 pp. [On sale in Apr. 1839, this is claimed to be the first photographic instruction booklet published.]

PERIODICALS
ST908 "Our Weekly Gossip." ATHENAEUM no. 597 (Apr. 6, 1839): 259. [Report on the interest raised by Talbot's and Daguerre's counterclaims to priority. Discussion of Wm. Havell's experiments based on Talbot's suggestions.]

ST909 Bird, Dr. Golding. "A Treatise on Photogenic Drawing." MIRROR OF LITERATURE, AMUSEMENT AND INSTRUCTION 33, no. 945 (Apr. 1839): 241, 243-244. 1 illus. [Facsimile of a photogenic drawing on pg. 241.]

ST910 "The New Art - Photography." MIRROR OF LITERATURE, AMUSEMENT AND INSTRUCTION 33, no. 946 (Apr. 27, 1839): 262-263.

ST911 "The New Art - Photography." MIRROR OF LITERATURE, AMUSEMENT AND INSTRUCTION 33, no. 947 (May 4, 1839): 281-283.

ST912 H. L. "Miscellanea: Photogenic Drawing." ATHENAEUM no. 602 (May 11, 1839): 358. [Brief note, with formula for preparing photogenic paper. "Considering that any (however trifling) improvement will not be unacceptable to those of your readers who feel an interest in this art, I have been induced to comment..."] "The New Art - Photography." MIRROR OF LITERATURE, AMUSEMENT AND INSTRUCTION 33, no. 949 (May 18, 1839): 317-318.

ST913 "Miscellanea: Photogenic Drawings." ATHENAEUM no. 604 (May 25, 1839): 398. [Robert Mallet communicated to Royal Irish Academy ... property of the light emitted by incandescent coke to blacken photogenic paper...]

ST914 "The New Art - Photography." MIRROR OF LITERATURE, AMUSEMENT AND INSTRUCTION 33, no. 950 (May 25, 1839): 333-335.

ST915 "Miscellanies: Photogenic Drawings." MAGAZINE OF SCIENCE, AND SCHOOL OF ARTS 1, no. 9 (June 1, 1839): 71. [Robert Mallet, at Royal Irish Acad., on incandescent coke. Dr. Fyfe described technique for making photogenic drawings at the Soc. for Encouragement of Useful Arts.]

GREAT BRITAIN: 1840.
ST916 "Our Weekly Gossip." ATHENAEUM no. 650 (Apr. 11, 1840): 294. [Critical comment of Daguerre's patent in England plus note that Claudet & Houghton have received examples from Paris. "The selfish policy of M. Daguerre appears to have all but put a stop to the practical application and improvement of his interesting discovery, by limiting its use to the wealthy..."]

ST917 "Miscellaneous: Galvanic Electrotype and Daguerreotype." AMERICAN REPERTORY OF ARTS, SCIENCES AND MANUFACTURES 1, no. 6 (July 1840): 458. ["Dr. Simon, of Dover, has just succeeded in reversing the image obtained by the Daguerreian process....' From "Dover Chronicle."]

ST918 "The Daguerreotype." ART-UNION no. 23 (Dec. 15, 1840): 187-188. [Letter from "An Amateur," on the process.]

GREAT BRITAIN: 1842.
ST919 "Miscellanea: Improvements in the Process of Photography." ATHENAEUM no. 741 (Jan. 8, 1842): 44. [Note from Prof. Barnard to Prof. Silliman.]

GREAT BRITAIN: 1843.

ST920 "Photogenic Drawing, or Drawing by the Agency of Light." EDINBURGH REVIEW 76, no. 154 (Jan. 1843): 309-344. [Review of:1."History and Practice of Photogenic Drawing, or the ten Principles of the Daguerreotype," By the Inventor, L. J. M. Daguerre, translated by J. S. Memes, Ll.D., London, 1839; 2. "Some Account of the Art of Photogenic Drawing, or the Process by which Natural Objects may be made to delineate themselves without the aid of the Artist's Pencil," by Henry Fox Talbot, Esq, F.R.S. London, l839; 3. "Die Calotypische Portraitirkunst," von Dr. F. A. W. Netto. Quadlingburg and Leipzig, 1842; 4."Ueber der Process des Sehens und die Wirkung des Lichts auf Alle Korper," von Ludwig Moser, Poggendorff Annalen der Physik und Chemie, Band LVI., 1842, no. 6.]

ST921 Illex, M. "Miscellanea: Durability of Photographic Impressions." ATHENAEUM no. 793 (Jan. 28, 1843): 92-93.

GREAT BRITAIN: 1843.

ST922 Carey, Miss Elizabeth Sheridan. "Lines Written on Seeing a Daguerreotype Portrait of a Lady." ILLUSTRATED LONDON NEWS 3, no. 68 (Aug. 19, 1843): 125. 1 illus. [Poem. "Our engraving (of a photographer making a portrait) represents the photographic process of Mr. Beard's establishment, Parliament Street, Westminster."]

GREAT BRITAIN: 1844.

ST923 J. D. "Miscellanea: Photography." ATHENAEUM no. 880 (Sept. 7, 1844): 814. [Letter from J. D. describing an improvement on Mr. Hunt's Energiatype Process.]

ST924 Shaw, George. "On Some Photographic Phenomena." DAGUERREAN JOURNAL 1, no. 10 (Apr. 1, 1851): 289-294. [Dated Nov. 15, 1844. Source not given.]

GREAT BRITAIN: 1845.

ST925 "The Late Professor Daniell." ILLUSTRATED LONDON NEWS 6, no. 151 (Mar. 22, 1845): 185. 1 illus. ["The annexed portrait of the deceased is from a Daguerreotype, taken a few months since..."]

ST926 "Obituary of Eminent Persons, Recently Deceased. Earl Spencer." ILLUSTRATED LONDON NEWS 7, no. 180 (Oct. 11, 1845): 229-230. 1 illus. ["From a Recent Photograph." (This is the first engraving taken from a photograph - not a daguerreotype - that I've seen in this magazine.)]

ST927 Nine engravings (Portraits of members of the "English Exploring Expedition to the Arctic Seas," under Captain John Franklin) on front cover. GLEASON'S PICTORIAL DRAWING-ROOM COMPANION 1, no. 25 (Oct. 18, 1851): 385, 397. 9 illus. [Note on p. 397. "Portraits of the principle officers...which sailed from Greenhithe on May 19, 1845. The originals of these portraits were taken by daguerreotype just previous to the sailing of the expedition...."]

GREAT BRITAIN: 1846.

ST928 "Royal Institution: Professor Faraday's Lecture on Magnetism and Light." ILLUSTRATED LONDON NEWS 8, no. 196 (Jan. 31, 1846): 76. 1 illus. [Engraving shows Faraday lecturing, with a magic lantern, for illustrations.]

ST929 "The Application of the Talbotype." ART UNION (ART JOURNAL) (July 1846): 195. [Suggestions about the potential uses of photography to scientists, explorers, and the like.]

ST930 "The Great Wellington Statue." ILLUSTRATED LONDON NEWS 9, no. 219 (July 11, 1846): 21. 2 illus. [Illustrated with engravings, from drawings. The descriptive captions, however, indicates the credibility bestowed upon the visual accuracy of the photograph. "...a pair of illustrations, representing with Daguerreotypic fidelity the locus in quo this stupendous work has been designed and executed."]

ST931 Winter, Andrew. "The Pencil of Nature." THE PEOPLE'S JOURNAL (Nov. 1846): 288-289. ["it is our intention to say a few words... upon the sun pictures as produced by Daguerre, and by our own countryman, Mr. Fox Talbot." Advice on what to wear and how to prepare for a daguerreotype portrait sitting, and excerpts from Talbot's report to the Royal Society on how to make a Talbotype.]

GREAT BRITAIN: 1847.

ST932 "Photography." ART UNION (ART JOURNAL) (Mar. 1, 1847): 109.

ST933 "Daguerreotype Institution." LITERARY GAZETTE no. 1577 (Apr. 10, 1847): 280-281. [Professor Highschool, of Philadelphia, PA, about to open a daguerreotype establishment in London. Displaying panoramic views of Niagara Falls and genre scenes from "The Lord's Prayer" there. Kilburn's daguerreotypes also praised.]

ST934 "Photography." ART UNION (ART JOURNAL) (June 1, 1847): 23.

ST935 Hunt, Robert. "On the Application of Science to the Fine and Useful Arts: Photography." ART UNION (ART JOURNAL) (Apr. 1, 1848): 130.

ST936 Hunt, Robert. "On the Application of Science to the Fine and Useful Arts: Photography." ART UNION (ART JOURNAL) (May 1, 1848): 133-136.

ST937 Smith, R. (Blackford). "Anatomy of the Physical Structure of the Universe. VI. - Light." PRACTICAL MECHANIC'S JOURNAL 1, no. 9-10 (Dec. 1848 - Jan. 1849): 201-203, 222. [This general survey includes a brief history of the early experiments in photography. Mentions Daguerre, Talbot, Wedgewood, Niépce, Fizeau, Brewster, Herschel, Dr. Woods, others.]

GREAT BRITAIN: 1850.

ST938 Brooke, C. "British Association for the Advancement of Science - Nineteenth Meeting - Birmingham, September 12, 1849. Section B. - Chemistry. 'On an Improvement in the preparation of Photographic Paper.'" PRACTICAL MECHANIC'S JOURNAL 2, no. 23 (Feb. 1850): 261. [Excerpt of his report.]

ST939 "A Centenarian." ILLUSTRATED LONDON NEWS 16, no. 413 (Feb. 16, 1850): 120. 1 illus. [Mr. James Colman, Aged 100. "The accompanying portrait is from a Daguerreotype,...when the old gentleman managed, without difficulty, to mount four flights of stairs, to sit for the process...taken at the expense of a gentleman who has known Colman for six-and-thirty years..."]

ST940 Malone. "Monthly Notes: Photography on Glass." PRACTICAL MECHANIC'S JOURNAL 3, no. 28 (July 1850): 94-95. [Discusses a Mr. Malone's efforts, reprinted from his letter to the "Athenaeum."]

ST941 "Answers to Correspondents." DAGUERREAN JOURNAL 1, no. 3 (Dec. 2, 1850): 91-92. [In answer to a question whether the daguerreotype process was patented in England, the editor printed an excerpt from "The Athenaeum," published in 1849, which, in turn, quoted a letter from Daguerre stating that Miles Berry held copyright in Great Britian.]

GREAT BRITAIN: 1851

ST942 Egerton. "The Daguerreotype Patent in England." PHOTOGRAPHIC ART JOURNAL 1, no. 1 (Jan. 1851): 47-49. [Reprinted from "London Report", Vol. VI, p. 256, N.S. Beard vs. Egerton.]

ST943 "The Pencil of the Sun." LITTELL'S LIVING AGE 28, no. 352 (Feb. 15, 1851): 296-301. [From "Tait's Magazine." Brief survey of history of the medium. Mentions Blanquart-Evrard, Henneman & Malone, Claudet, Kilburn, Hunt, etc. as contemporaries.]

ST944 "Photography in the Palace of Glass." ATHENAEUM no. 1233 (June 14, 1851): 632. [Discussion of the photos on exhibit at the Crystal Palace.]

ST945 Hunt, Robert. "Photography - Recent Improvements." PHOTOGRAPHIC ART JOURNAL 2, no. 2 (Aug. 1851): 111-115. [From "London Art. J."]

ST946 "The Arctic Expedition." DAGUERREAN JOURNAL 2, no. 6 (Aug. 1, 1851): 165-166. [From "London Athenaeum." Background information about the lost expedition of Sir John Franklin. Interesting that it should appear here.]

ST947 H. R. "Correspondence: Photographs on Glass." PRACTICAL MECHANIC'S JOURNAL 4, no. 45 (Dec. 1851): 209-210. [Letter detailing the author's process. "H. R." is from Glasgow. The editor comments on the exciting potential of the new process on p. 210.]

ST948 Portrait. Woodcut engraving credited,"from a Calotype." ILLUSTRATED LONDON NEWS 19, (1851) ["Elie Jean Filleul, Aged 102." 19:* (Dec. 13, 1851): 700.]

GREAT BRITAIN: 1852.

ST949 Robinson, C. J. "Light in Picture Galleries." PHOTOGRAPHIC ART JOURNAL 3, no. 1 (Jan. 1852): 61-62. [From the "London Art Journal." About art galleries, painting and sculpture, etc.]

ST950 "Fine-Art Gossip." ATHENAEUM no. 1283 (May 29, 1852): 610. ["...Mr. Talbot...having offered to abandon his patents provided he is requested to do so by the general voice of the artistic and scientific world..." (to allow the formation of the photographic society.)]

ST951 "Photography - Its Origin, Progress, and Present State." PHOTOGRAPHIC ART JOURNAL 4, no. 3-4 (Sept. - Oct. 1852): 160-163, 238-241. [From the "London Illustrated News."]

ST952 W. "Our Foreign Correspondents." HUMPHREY'S JOURNAL 4, no. 16 (Dec. 1, 1852): 250-251. [Brief survey of activities in London.]

GREAT BRITAIN: 1853.

BOOKS

ST953 Stirling, William (afterwards Sir William Stirling-Maxwell). *The Cloister Life of Emperor Charles V.* "3rd. ed." London: John W. Parker & Son, 1853. xxxii, 342 pp. 18 b & w. [Eighteen albumen photographs, after prints, taken by an unnamed photographer. Only twelve copies of the work included the photographs.]

PERIODICALS

ST954 Newton, William J. "Photography in an Artistic View, 1853." JOURNAL OF THE PHOTOGRAPHIC SOCIETY 1, (1853): 6-7.

ST955 W. "Our Foreign Correspondent." HUMPHREY'S JOURNAL 4, no. 18 (Jan. 1, 1853): 283-285. [Letter describing role and social position of photography in London.]

ST956 "Photography in England." HUMPHREY'S JOURNAL 4, no. 19 (Jan. 15, 1853): 301-302. [Excerpts of review of "The Photographic Album" by Roger Fenton and Philip Delamotte, from "London Art Journal," with additional commentary by the editor.]

ST957 "Photography." HOUSEHOLD WORDS 7, no. 156 (Jan. 1853): 54-61. [Survey of the field.]

ST958 "Helio." "Our Foreign Correspondent." HUMPHREY'S JOURNAL 4, no. 20 (Feb. 1, 1853): 313-315. [Describes work of Kilburn, Mayall, etc.]

ST959 Howard, Frank. "Photography Applied to Fine Artist." JOURNAL OF THE PHOTOGRAPHIC SOCIETY 1, (Mar. 3, 1853): 154-158.

ST960 "Helio." "Our Foreign Correspondent: State of the Daguerreotype Art in London - Photographic Society, etc." HUMPHREY'S JOURNAL 4, no. 23 (Mar. 15, 1853): 364-366. [Describes galleries of Beard; Kilburn; Claudet; Mayall; Sherman & Carbanati. Discusses the formation of the Photographic Society.]

ST961 "Our Weekly Gossip." ATHENAEUM no. 1325 (Mar. 19, 1853): 354. [Comment that England and Switzerland proposing to build up files of portraits of criminals and that Mr. Verneiul in France proposes to put photographs on passports.]

ST962 "Photography." HUMPHREY'S JOURNAL 5, no. 5-17 (June 15 - Dec. 15, 1853): 65-72, 81-88, 97-98, 113-120, 129-136, 145-152, 161-168, 177-184, 193-200, 209-216, 225-232, 241-248, 257-264. [Continuation of letters to the British "Notes and Queries," by many authors, about all sorts of topics. Dr. Hugh Diamond, W. J. Newton, F. S. Archer, E. Kater, Wm. Crookes, George Shadbolt, and others. Most of these brief signed letters are about chemical processes, etc., but some contain information about individual's procedures.]

ST963 Leighton, John. "On Photography as a Means or an End." JOURNAL OF THE PHOTOGRAPHIC SOCIETY 1, (June 21, 1853): 74-75.

ST964 Buss, R. W. "On the Use of Photography to Artists." JOURNAL OF THE PHOTOGRAPHIC SOCIETY 1, (June 21, 1853): 75-78.

ST965 J. C. "Communications: The Present State of Photography in England." PHOTOGRAPHIC ART JOURNAL 6, no. 1 (July 1853): 30-31.

ST966 "Gossip." PHOTOGRAPHIC ART JOURNAL 6, no. 1 (July 1853): 67-68. [From the "Journal of the Photographic Institute." Discussion of Talbot's photoengraving experiments. Mentions W. T. Kingley. Mentions Delamotte. Discusses the April issue of the "Quarterly Journal of Microscopic Science," which has photographic illustrations.]

ST967 "Photographic Notes and Queries." PHOTOGRAPHIC ART JOURNAL 6, no. 1-2 (July - Aug. 1853): 34-42, 91-97. [From "Notes and Queries." Letters from George Shadbolt; W. J. Newton; J. L. Sisson; John Stewart; Weld Taylor and others.]

ST968 "The Aztec Children." ILLUSTRATED LONDON NEWS 23, no. 632 (July 9, 1853): 11-12. 1 illus. ["...The Portraits...are from a Daguerreotype."]

ST969 "Photography." HUMPHREY'S JOURNAL 5, no. 9 (Aug. 15, 1853): 144. [From "London Art Journal." Brief comments on current activities, mentions Stewart (Edinburgh); Ross & Thompson; others.]

ST970 "Meeting of the British Association, at Hull." ILLUSTRATED LONDON NEWS 23, no. 644 (Sept. 17, 1853): 225-227, 239. [Summary of 23rd meeting of the British Association. Robert Hunt, Antoine Claudet presented papers on photography and the daguerreotype; reported on p. 226. Claudet exhibited photographic and stereoscopic portraits (on p. 239). Further letter "The Daguerreotype," by Claudet, published on p. 258 (Sept. 24) correcting error in fact in the earlier report.]

ST971 Tylor, Weld. "Photography: Photographic Portraits of Criminals, Etc." HUMPHREY'S JOURNAL 5, no. 12 (Oct. 1, 1853): 180-181. [From "Notes and Queries."]

ST972 "Partial Destruction of Lismore Bridge." ILLUSTRATED LONDON NEWS 23, no. 655 (Nov. 26, 1853): 447-448. 1 illus. ["From a Photograph taken during the recent floods."]

GREAT BRITAIN: 1854.
BOOKS
ST973 Blackburn, Mrs. J. and J. Wilson. *Illustrations of Scripture, by an Animal Painter, with Notes by a Naturalist.* Edinburgh: Thomas Constable & Co., 1854. n. p. 20 b & w. [Original photographs, of artworks.]

PERIODICALS
ST974 "Photography." HUMPHREY'S JOURNAL 5, no. 20-24 (Feb. 1 - Feb. 15, 1854): 305-312, 321-325, 368-376, 378-380. [Letters reprinted from "Notes and Queries." From W. H. Diamond, Geo. Shadbolt, M. L. Mansell, F. Maxwell Lyte, others.]

ST975 "Busy with the Photograph." HOUSEHOLD WORDS 9, no. 214 (Mar. 1854): 242-245.

ST976 "London Photographic Society." PHOTOGRAPHIC AND FINE ARTS JOURNAL 7, no. 3 (Mar. 1854): 77-81. [Reports on F. H. Wenham's "On the Method of Obtaining Enlarged Positive Impressions fromTransparent Collodian or Albumen Negatives."; George Shadbolt's "On the Production of Enlarged Positive Copies from Negatives of Interior Dimensions."; William Crook's "On the Restoration of Old Collodian."; and W. H. Cooke's "On the Improved Camera. From the "J. of the Photo. Soc."]

ST977 "Photography in Scotland." ART JOURNAL (Apr. 1854): 100. [Formation of a photographic society in Glasgow; exhibition of photographs loaned from London photographers held in Edinburgh.]

ST978 "Obituary: Mr. Francis Arundale, Mr. Charles Barbor, J. Van Eycken." PHOTOGRAPHIC AND FINE ART JOURNAL 7, no. 4 (Apr. 1854): 119-120. [All artists. Arundal sketched, Barber was a teacher of drawing and Van Eycken an allegorical painter.]

ST979 "Progress in Photography." HUMPHREY'S JOURNAL 6, no. 5 (June 15, 1854): 78-79. [From "J. of Photo. Soc." Further information on Mr. Elliott's experiments of photographing aboard ship. Also discussion of photoengraving experiments conducted by Niépce de Saint-Victor and by A. Baldus.]

ST980 "Busy with the Photograph." LITTELL'S LIVING AGE 41, no. 526 (June 17, 1854): 552-555. [From "Household Words."]

ST981 "Monthly Notes: New Discovery in Photography." PRACTICAL MECHANIC'S JOURNAL 7, no. 77 (Aug. 1854): 116. ["One of the most promising improvements...relates to the collodion process..." Mentions Spiller & Crookes experiments. Additional note on p. 138, in Sept. issue.]

ST982 "Photographic Notes and Queries." PHOTOGRAPHIC AND FINE ART JOURNAL 7, no. 6-10 (June - Oct. 1854): 179-182, 207-212, 245-246, 295-298. [From "Notes and Queries."]

ST983 Meade, Charles R. "The Art in London and Paris." PHOTOGRAPHIC AND FINE ART JOURNAL 7, no. 12 (Dec. 1854): 380. [Charles Meade's letter describes his week long visit to London, where he met Claudet, Kilburn, and Mayall. Then his experiences at the Mayer Brothers studio. He also speaks of learning the paper processes "from another gentleman" along with individuals from Calcutta, Lisbon, Rio de Janeiro, Constantinople, England, Cuba, and France. Describes work of the Bisson Freres and of Thompson.]

ST984 "Price's Patent Candle Company - Bromborough Pool Works." ILLUSTRATED LONDON NEWS 25, no. 715 (Dec. 2, 1854): 553-554. 2 illus. [Two illustrations of a large factory, one view is from a sketch, the second and interior is credited from a photograph.]

ST985 "Science in 1854, and Its Applications to the Arts." PHOTOGRAPHIC AND FINE ART JOURNAL 8, no. 2 (Feb. 1855): 33-35. [From "London Art J."]

GREAT BRITAIN: 1854 - 1856. [CRIMEAN WAR] see also DE SZATHMARI, C. P.; FENTON, R.; LANGLOIS, C.; ROBERTSON, J.

GREAT BRITAIN: 1854 - 1856. [CRIMEAN WAR]
BOOKS
ST986 Hannavy, John. *The Camera Goes to War. Photographs of the Crimean War 1854-56.* Edinburgh: The Scottish Arts Council, 1974. 59 pp. 16 b & w. 6 illus. [153 pieces listed in the checklist to the exhibition. Sixteen photographers are listed in the "Biographical Notes," on pp. 57-58. Essay discusses both the photographers who went to the Crimea and those who issued war-related photographs in England.]

PERIODICALS
ST987 "Reporting By Photography." HUMPHREY'S JOURNAL 6, no. 1 (Apr. 15, 1854): 15. [From "J. of the Photo. Soc., London." Letter, from "Z," discussing the British government's plan to send a photographer to the Crimean War.]

ST988 "Photography Applied to the Purposes of War." ART JOURNAL (May 1854): 152-153. [Fenton mentioned.]

ST989 "Photography Applied to the Purposes of War." HUMPHREY'S JOURNAL 6, no. 3 (May 15, 1854): 43-44. [From "London Art Journal." Complaint that the War Department sent an engineering officer and two men to the Crimea with two days training in photography. Mentions unfortunate experience of the "Samarange" in South Seas with similar situation, where man could not make photos, as different from Mr. Elliott aboard the steamer "Hecla," (Capt. Scott) who made photos of Wingo Sound as a trial. Roger Fenton has taken photos of the Baltic Fleet at anchor.]

ST990 "Photography Applied to Purposes of War." and "Photographic Engraving." PHOTOGRAPHIC AND FINE ART JOURNAL 7, no. 7

(July 1854): 212. [From "J. of Photo. Soc." Mr. Elliott photographing on board a ship in the Baltic Fleet; contemplating usefulness of photography in the Crimean War.]

ST991 Jammes, André and M. Th. Jammes. "The First War Photographs." CAMERA (LUCERNE) 43, no. 1 (Jan. 1964): 2-38. 52 b & w. [Crimean war photographs by Roger Fenton, Charles Langlois, James Robertson, et al.]

GREAT BRITAIN: 1855.
ST992 "Photography." HUMPHREY'S JOURNAL 6, no. 19 (Jan. 15, 1855): 297-303. [From "Notes & Queries." Letters by George Shadbolt, John Leachman and others.]

ST993 "Photographic Notes." PHOTOGRAPHIC AND FINE ART JOURNAL 8, no. 3-11 (Mar. - Nov. 1855): 90-93, 135-138, 166-167, 218-220, 247-249, 279-280, 304-305, 322-324, 354-355. [From "Notes and Queries." Letters on technical and creative matters by J. B. Reade, Hugh W. Diamond, F. Maxwell Lyte and others.]

ST994 "Photography." ART JOURNAL (June 1, 1855): 194.

ST995 "The Modern Art of Sun-Painting." PRACTICAL MECHANIC'S JOURNAL 8, no. 88 (July 1855): 75-77. [Discussion of photography's usefulness. Mentions Hooper & Co., coachbuilders, and J. G. Taylor, jewelry merchant, who use photographs of their wares. Mayall and B. J. M. Donne producing a "Photographic Album."]

ST996 "Proceedings of the Liverpool Photographic Society." HUMPHREY'S JOURNAL 7, no. 10 (Sept. 15, 1855): 153-157. [From "J. of Liverpool Photo. Soc."]

ST997 "Her Majesty's Palace at Balmoral - Photographed from the North Side of the Dee." ILLUSTRATED LONDON NEWS 27, no. 765 (Oct. 13, 1855): 436. 1 illus. [Photographer not named. Landscape view.]

ST998 "Photographs from Drawings." ART JOURNAL (Nov. 1, 1855): 307.

ST999 "Pictures on Glass versus Daguerreotypes, etc." HUMPHREY'S JOURNAL 7, no. 13 (Nov. 1, 1855): 207-208. [From "Liverpool Photo. Soc. J."]

ST1000 "Photography - Practical and Theoretical." HUMPHREY'S JOURNAL 7, no. 14 (Nov. 15, 1855): 228-229. [From "J. of Liverpool Photo. Soc." Mentions G. R. Berry, Thomas Sutton, Frank Howard, Sir W. J. Newton, etc.]

ST1001 "Photographic Progress." HUMPHREY'S JOURNAL 7, no. 16 (Dec. 15, 1855): 260-261. [From "Liverpool Photo. J." Summary of contemporary events.]

GREAT BRITAIN: 1856.
BOOKS
ST1002 Robinson, Sir John Charles. Catalogue of the Soulages Collection, being a descriptive inventory of a collection of works of art, formerly in the possession of M. Jules Soulages of Toulouse, now exhibited to the public at the Museum of Ornamental Art, Marlborough House, December 1856. London: Marlborough House, 1856. n. p. 10 b & w. [First exhibition catalog illustrated with original photographs.]

PERIODICALS
ST1003 "English Photography." HUMPHREY'S JOURNAL 7, no. 17 (Jan. 1, 1856): 279. [Review of English photos exhibited at the Paris exhibition in 1855. From the "Liverpool Photo. J.," which translated comments from the "Bulletin de la Société Française." Roger Fenton; Maxwell Lyte; J. D. Llewelyn; Sir Wm. J. Newton; Ross; Thomson; B. B. Turner; Townsend mentioned.]

ST1004 "Photographic Progress." HUMPHREY'S JOURNAL 7, no. 17 (Jan. 1, 1856): 279-280. [From "Liverpool Photo. J."]

ST1005 "Photographic Notes." PHOTOGRAPHIC AND FINE ART JOURNAL 9, no. 1, 5 (Jan., May 1856): 6-8, 156-157. [From "Notes and Queries." Shadbolt, T. L. Merritt, others. Other excerpts from "Notes and Queries" were also published throughout the year, but under separate titles.]

ST1006 "Monthly Notes: The Evanescence of Paper Photographs." PRACTICAL MECHANIC'S JOURNAL 8, no. 95 (Feb. 1856): 234. [Discussion of the report of the photographic committee to investigate fading in photographs. Committee members were Delamotte; Diamond; Hardwich; Malone; Percy; Pollock; Shadbolt.]

ST1007 "Belvedere - Crescent Reformatory." ILLUSTRATED LONDON NEWS 28, no. 787 (Mar. 1, 1856): 228. 3 illus. [Social documentary. Portrait of William Driver, founder. Two portraits - before and after, of young boys in the institution. "City Arabs" - from a photograph."]

ST1008 Portrait. Woodcut engraving, credited "From a Photograph." BALLOU'S PICTORIAL DRAWING-ROOM COMPANION [GLEASON'S] 10, (1856) 1 illus. ["Sir Allan Napier McNabb." 10:246 (Mar. 22, 1856): 188.]

ST1009 "Photographic Items." PHOTOGRAPHIC AND FINE ART JOURNAL 9, no. 8 (Aug. 1856): 254. [From "J. of Photo. Soc., London." Mr. Thompson photographed underwater; Dr. Diamond on photo of mental patients; Maxwell Lyte died.]

ST1010 "Photography and the Elder Fine Arts." JOURNAL OF THE PHOTOGRAPHIC SOCIETY 3, (Apr. 21, 1856): 29-32.

GREAT BRITAIN: 1857.
ST1011 "Notes of the Week: Royal Visit to the Photographic Exhibition." ILLUSTRATED LONDON NEWS 30, no. 839 (Jan. 10, 1857): 3.

ST1012 "Fine-Art Gossip." ATHENAEUM no. 1525 (Jan. 17, 1857): 87. [Manchester Art Treasures Exhibition to display photography, that department under the direction of Philip DelaMotte. Mayall's work with miniature portraits praised.]

ST1013 "Town and Table Talk on Literature, Art, etc. - Photography." ILLUSTRATED LONDON NEWS 30, no. 856 (May 2, 1857): 401. [Brief comment of British photographers.]

ST1014 "Photographic Effects of Lightning." PHOTOGRAPHIC AND FINE ART JOURNAL 10, no. 6 (June 1857): 174-175. [From "Liverpool Photo. J." Report of a talk given by Andres Poey, Director of the Observatory in Havana, on this topic.]

ST1015 Brushfield, T. N. "Application of Photography to Lunacy." PHOTOGRAPHIC AND FINE ART JOURNAL 10, no. 7 (July 1857): 214. [From "J. of Photo. Soc., London."]

ST1016 "The "Fox" Arctic Discovery Vessel set by Lady Franklin in Search of the Missing Expedition." ILLUSTRATED LONDON NEWS 31, no. 869 (July 18, 1857): 77-78. 1 illus. ["From a photograph."]

ST1017 "Application of Photography in the Treatment of Lunacy." HUMPHREY'S JOURNAL 9, no. 8 (Aug. 15, 1857): 124. [From "J. of Photo. Soc., London." T. N. Brushfield, Superintendent of County Lunatic Asylum, Chester, England, comments on possible usefulness of photography. Experiments by Dr. Hugh Diamond in England and work at the State Lunatic Asylum in Utica, NY also mentioned.]

ST1018 "Use of the Magic Lantern for Exhibiting Photographs." HUMPHREY'S JOURNAL 9, no. 12 (Oct. 15, 1857): 190. [From "Photo. Notes." J. F. Dudgeon (Glasgow) describes his experience using lantern slides, made by himself for education.]

GREAT BRITAIN: 1858.

ST1019 "New Applications of Photography." HUMPHREY'S JOURNAL OF PHOTOGRAPHY, AND THE ALLIED ARTS AND SCIENCES 9, no. 18 (Jan. 15, 1858): 276-280. [From "Photo. Notes."]

ST1020 "Photographers." PHOTOGRAPHIC AND FINE ART JOURNAL 11, no. 2 (Feb. 1858): 45-47. [Comic short story. Source, author, not given, but British.]

ST1021 Hislop, W. "Method of Illustrating Lectures or Scientific Papers by Means of Photography." LIVERPOOL & MANCHESTER PHOTOGRAPHIC JOURNAL [BRITISH JOURNAL OF PHOTOGRAPHY] n. s. 2, no. 3 (Feb. 1, 1858): 30.

ST1022 Hepworth. "Chorlton Photographic Association." LIVERPOOL & MANCHESTER PHOTOGRAPHIC JOURNAL [BRITISH JOURNAL OF PHOTOGRAPHY] n. s. 2, no. 3 (Feb. 1, 1858): 33-37. [Report of paper, "An Historical Sketch of the Photographic Art - its present influence and prospective development, applications, and uses," by Mr. Hepworth.]

ST1023 Hislop, W., F.R.A.S. "Method of Illustrating Lectures or Scientific Papers by means of Photography." PHOTOGRAPHIC AND FINE ART JOURNAL 11, no. 4 (Apr. 1858): 121. [Read before the North London Photo. Assoc., Dec 30, 1857.]

ST1024 Brown, J. T. "On the Application of Photography to Art and Art Purposes, but more Particularly to Architecture." PHOTOGRAPHIC AND FINE ART JOURNAL 11, no. 5 (May 1858): 129-134. [From "Liverpool Photo. J." Read to the Birmingham, England Photo. Society.]

ST1025 Haines, C. L. "The Rise and Progress of Photography." PHOTOGRAPHIC AND FINE ART JOURNAL 11, no. 6 (June 1858): 169-172. [From "Photo. Notes." Includes an account of the Prehistory, early history of photography.]

ST1026 Grant, A. G. "A Letter From London." AMERICAN JOURNAL OF PHOTOGRAPHY AND THE ALLIED ARTS & SCIENCES n. s. vol. 1, no. 3, 8 (July 1, Sept. 15, 1858): 40-41, 115-116. [London Photo Society meeting, etc.]

ST1027 Osborn, W. R. "Photography - Its Application to the Present Wants of Society and its Future Prospects." PHOTOGRAPHIC AND FINE ART JOURNAL 11, no. 7 (July 1858): 193-195. [From "Photo. Notes." Read before the Birmingham Photo. Soc.]

ST1028 "Editorial." LIVERPOOL & MANCHESTER PHOTOGRAPHIC JOURNAL [BRITISH JOURNAL OF PHOTOGRAPHY] n. s. 2, no. 14 (July 15, 1858): 171-174. [Long, comic description of an "umbrella tripod" camera invented by a Mr. Hooper (Manchester), to fool curious bystanders.]

ST1029 "The Daguerreotype." HUMPHREY'S JOURNAL OF PHOTOGRAPHY, AND THE ALLIED ARTS AND SCIENCES 10, no. 7 (Aug. 1, 1858): 112. [From "Photo. Notes." Excerpt stating that the daguerreotype possesses many remarkable qualities, would like to see some return to its use for certain situations.]

ST1030 "Birmingham Photographic Society." PHOTOGRAPHIC AND FINE ART JOURNAL 11, no. 8 (Aug. 1858): 236-339. [Paper by Mr. Bourne "The Application of Photography to Business Purposes" read to the Society.]

ST1031 Campbell, Ronald. "Photography for Portraits: A Dialogue Held in an Artist's Studio." ART JOURNAL (Sept. 1858): 273-275.

ST1032 "The Photographer. (Manuscript Photographic Journal.) - No. II." PHOTOGRAPHIC AND FINE ART JOURNAL 11, no. 9 (Sept. 1858): 273-276. [Short informal notes from British photographers. J. T. Taylor, R. L. Jones, G. C. Warren, J. Archer, Geo. Shadbolt, T. Sutton, etc.]

ST1033 S. "Notes for Alpine Photographers." PHOTOGRAPHIC NEWS 1, no. 4, 9 (Oct. 1, Nov. 5, 1858): 38-39, 100-101.

ST1034 "Photography at the Meeting of the British Association for the Advancement of Science." LIVERPOOL & MANCHESTER PHOTOGRAPHIC JOURNAL [BRITISH JOURNAL OF PHOTOGRAPHY] n. s. 2, no. 20 (Oct. 15, 1858): 252-255. [Excerpts from papers: W. Sykes Ward, "The Dry Collodion Process," R. J. Fowler, "On a Process for the Estimation of Actinism," W. Lyndon Smith, "On the Choice of Subject in Photography, and the Adaptation of Different Processes," etc.]

ST1035 "Questionable Subjects for Photography." PHOTOGRAPHIC NEWS 1, no. 6, 12 (Oct. 15, Nov. 26, 1858): 62-63, 135-136. [Author felt that not all genre and humorous scenes depicted in stereos are in good taste.]

ST1036 "Application of Photography to Scientific Purposes." HUMPHREY'S JOURNAL OF PHOTOGRAPHY, AND THE ALLIED ARTS AND SCIENCES 10, no. 13 (Nov. 1, 1858): 196-197. [From "London Photo. J."]

ST1037 Burnett, C. J. "On the Application of Photography to Botanical and other Book Illustration." HUMPHREY'S JOURNAL OF PHOTOGRAPHY, AND THE ALLIED ARTS AND SCIENCES 10, no. 13 (Nov. 1, 1858): 206-208. [From "Liverpool Photo. J."]

ST1038 "Recollections of a Daguerreotype Trip to Europe by Sol Skylight, Esq." AMERICAN JOURNAL OF PHOTOGRAPHY AND THE ALLIED ARTS AND SCIENCES n. s. vol. 1-2, no. 12-24, 2-13 (Nov. 15, 1858 + Dec. 1, 1859): (vol. 1) 187-190, 195-197, 216-218, 229-231, 243-246, 259-262, 275-278, 291-294, 307-310, 323-325, 339-341, 355-358, 371-374 (vol. 2) 17-19, 33-36, 63-64, 71-74, 97-99, 113-116, 129-132, 145-148, 161-163. [Humorous anecdotes, apparently in the form of a novella. The author of this anecdotal, possibly fictional, narrative, claims to have been an American who spent a year or so in England, working as a photographer, then returned to the USA. An index to the volume credits several of the same page numbers to "Sol Skylight" and to T. Sutton, leading to the speculation that the work could have been written by Sutton. I am doubtful.]

ST1039 Portrait. Woodcut engraving, credited "From a Photograph." ILLUSTRATED NEWS OF THE WORLD AND DRAWING ROOM PORTRAIT GALLERY OF EMINENT PERSONAGES 1, (1858) ["The Late Admiral Lord Lyons, G.C.B." 1:44 (Dec. 4, 1858): 357.]

GREAT BRITAIN: 1859.
ST1040 "The London'Times'' Definition of Photography." HUMPHREY'S JOURNAL OF PHOTOGRAPHY, AND THE ALLIED ARTS AND SCIENCES 10, no. 21 (Mar. 1, 1859): 336.

ST1041 Hains. "On the Uses and Abuses of Photography." AMERICAN JOURNAL OF PHOTOGRAPHY AND THE ALLIED ARTS AND SCIENCES n. s. vol. 1, no. 20 (Mar. 15, 1859): 317-321. [From "Photographic News."]

ST1042 Smartt, Charles W. "Photography from a Baloon [sic Balloon]." HUMPHREY'S JOURNAL OF PHOTOGRAPHY, AND THE ALLIED ARTS AND SCIENCES 10, no. 22 (Mar. 15, 1859): 352. [From "Liverpool Photo. J." Mr. Smartt categorically denies that it will ever be possible to take a photograph from a balloon.]

ST1043 "Fine Arts: Photographic Minutiae." ILLUSTRATED LONDON NEWS 34, no. 965 (Mar. 19, 1859): 283. [Mr. Amadio perfected a microphotography technique - leading the author to humorous speculation.]

ST1044 "A Member." "Photography and Art." JOURNAL OF THE PHOTOGRAPHIC SOCIETY OF LONDON 5, no. 85 (May 7, 1859): 285. [Letter, arguing "The brush or chisel is as much a machine as a camera..." and therefor photography is coming to be recognized as capable of being creative.]

ST1045 "Photography in Medical Science." HUMPHREY'S JOURNAL OF PHOTOGRAPHY, AND THE ALLIED ARTS AND SCIENCES 11, no. 2 (May 15, 1859): 32. [From the "Lancet." Author felt there should be more photos dealing with medical situations.]

ST1046 "Letters to a Young Photographer." PHOTOGRAPHIC AND FINE ART JOURNAL 12, no. 1 (June 1859): 9. [From "Photo. J." Apparatus and procedures needed to begin photographing.]

ST1047 "Abuses of Photography." PHOTOGRAPHIC AND FINE ART JOURNAL 12, no. 2 (July 1859): 61-62. [From "Photo. Notes." Pornography, etc.]

ST1048 "The Royal Family of England." BALLOU'S PICTORIAL DRAWING-ROOM COMPANION [GLEASON'S] 17, no. 421 (July 16, 1859): 37. 1 illus. [Group portrait of Royal Family outdoors. "...an English photograph." (Not credited, but from "Illus. London News.")]

ST1049 "Photographing a Lion." AMERICAN JOURNAL OF PHOTOGRAPHY AND THE ALLIED ARTS AND SCIENCES n. s. vol. 2, no. 6 (Aug. 15, 1859): 83-85. [Anecdote by a British photographer describing his act of photographing a lion after he had killed it in Algeria. The lion had killed an Arab laborer. The photographer is not named.]

ST1050 "Photography in Hot Weather." HUMPHREY'S JOURNAL OF PHOTOGRAPHY, AND THE ALLIED ARTS AND SCIENCES 11, no. 8 (Aug. 15, 1859): 118-120. [From "Liverpool Photo. J."]

ST1051 Howitt, Mary. "Sun Pictures. I - IV." ECLECTIC REVIEW n. s. 2 (110), (Sept. - Dec. 1859): 303-310, 381-387, 466-480, 589-597. [Article has nothing to do with photography except as a generating idea. It is a travel piece. "Sun- Pictures, as secured by the photographic art, are amongst the most beautiful and interesting discoveries of the present day. We saw a great number - unproduced, however, on paper - during a late three day's excursion in the country. Perhaps we may be able to secure a few of them through a faithful photography of memory. Let us try...."]

ST1052 "Miscellania: Photographs taken for Government Institutions." ATHENAEUM no. 1665 (Sept. 24, 1859): 410. [Note that an office opening at the South Kensington Museum to sell photographs of works of art, science, etc.]

ST1053 "Out-door Photography - Failures." HUMPHREY'S JOURNAL OF PHOTOGRAPHY, AND THE ALLIED ARTS AND SCIENCES 11, no. 13 (Nov. 1, 1859): 205-206. [From "London Photo. J."]

ST1054 "Photography at the War Department." PHOTOGRAPHIC NEWS 3, no. 62 (Nov. 11, 1859): 110.

ST1055 "Backgrounds, How to Paint and Arrange Them. Parts 1 - 11." PHOTOGRAPHIC NEWS 3, no. 64-77 (Nov. 25, 1859 - Feb. 24, 1860): 133-134, 173, 183, 196, 222, 235, 246, 259, 270-271, 286-287, 298. [Illus. with diagrams.]

ST1056 "The Establishment of a Universal Collection of Engraved and Photographed Portraits." PHOTOGRAPHIC NEWS 3, no. 63 (Nov. 18, 1859): 121-122.

ST1057 "Miscellaneous." PHOTOGRAPHIC NEWS 3, no. 65 (Dec. 2, 1859): 155. [From "All the Year Round." Discourse of new uses of photography. Photos of mental patients, mentions photos replacing miniature painters. Mentions "stereotype mania."]

ST1058 "A Shooting Party in Front of Meggernie Castle, Glenlyon, Scotland. [From a Photograph.]" BALLOU'S PICTORIAL DRAWING-ROOM COMPANION [GLEASON'S] 17, no. 442 (Dec. 10, 1859): 377. 1 illus. [Outdoor group portrait, with horses, dogs, etc. May be Fenton?]

ST1059 "Sam Cowell, the Celebrated Musical Comedian." FRANK LESLIE'S ILLUSTRATED NEWSPAPER 9, no. 210 (Dec. 10, 1859): 27-28. 5 illus. [Five portraits of the British actor in varied costumes. Not credited, but probably from photos.]

ST1060 J. M. "The Unfortunate Photographer." PHOTOGRAPHIC NEWS 3, no. 69 (Dec. 30, 1859): 196-198. [Humorous anecdotes of the trials of a photographer.]

GREAT BRITAIN: 1860.
BOOKS
ST1061 Contencin, James. *Photographic Illustrations of the Architecture and Sculptural Details of Streetly Church, Derbyshire.* Worksop: Robert White, 1860 [?]. n. p. 21 b & w. [Albumen prints.]

ST1062 Falkener, Edward. *Daedalus, or The Causes and Principles of the Excellence of Greek Sculpture.* London: Longman, Green, Longman, & Roberts, 1860. xxiii, 322 pp. 16 l. of plates. 8 b & w. 4 illus. [Eight original photographs, four chromolithographs.]

PERIODICALS
ST1063 "Woman's Noblest Attitude: A Photograph from the Gospel History." GOOD WORDS 1, no. 1-2 (Jan. - Feb. 1860): 33-35, 54-56. ["A Photograph..." is used to refer to a vivid, specific verbal description of a specific event. Other than this metaphoric usage, the article doesn't have anything to do with photography.]

ST1064 Hannaford. "Photographic Jottings." HUMPHREY'S JOURNAL OF PHOTOGRAPHY, AND THE ALLIED ARTS AND SCIENCES 11, no. 17 (Jan. 1, 1860): 262-264. [From "Liverpool Photo. J."]

ST1065 "Instantaneous Photography." PHOTOGRAPHIC AND FINE ART JOURNAL 13, no. 1-3 (Jan. - Mar. 1860): 20-21, 40-42, 57-58. [From "Photo. Notes." Exchange of letters between "R." and an unidentified authority (probably the editor T. Sutton).]

ST1066 "Photography and Crime." PHOTOGRAPHIC NEWS 3, no. 74 (Feb. 3, 1860): 258-259. [Mug shots.]

ST1067 "Birmingham Photographic Society: The Wet Process v. The Dry." BRITISH JOURNAL OF PHOTOGRAPHY 7, no. 109 (Apr. 2, 1860): 103-104. [A friendly challenge led Charles Breese to display and discuss his work with the wet process and Mr. Osborn and Dr. Hill Norris displayed examples of their works and others in the dry processes. In effect, this report became a review. S. Bourne,(of Nottingham) discussed. Woodward (Nottingham) discussed. Seymour, Bright and Applewhaite mentioned.]

ST1068 Statham, Rev. F. F., B.A., F.G.S. "On the Application of Photography to Scientific Pursuits." BRITISH JOURNAL OF PHOTOGRAPHY. 7, no. 119, 121 (June 1, July 2, 1860): 159, 192-193.

ST1069 Donelly, Captain, R. E. "On Photography and Its Application to Military Purposes." BRITISH JOURNAL OF PHOTOGRAPHY. 7, no. 120 (June 15, 1860): 178-179. [Lecture given at the United Services Institution, London, on June 8. Donelly describes the uses of photography made by the British military forces. Mentions Captain Fowke, Royal Engineers, and his development of a portable camera. Showed photos by Corporal Lawson, with Capts. Gordon and James surveying in Asia Minor between Russia and Turkey. Sergeant Church accompanied Col. Stanton to Isthmus of Panama to survey proposed railroad site. Sergeant Mack, at Moscow, accompanying Lord Granville. Views in India, China, (possibly Beato), etc.]

ST1070 Donelly, Capt., R. E. "On Photography and Its Application to Military Purposes." AMERICAN JOURNAL OF PHOTOGRAPHY AND THE ALLIED ARTS & SCIENCES n. s. vol. 3, no. 4 (July 15, 1860): 52-55. [From Br. J. of Photo.]

ST1071 Donelly, Capt., R. E. "On Photography and Its Application to Military Purposes." PHOTOGRAPHIC AND FINE ART JOURNAL 13, no. 8 (Aug. 1860): 213. [From "Br J of Photo." Primarily for surveying, mapmaking, etc. Mentions activities of British military. Capt. Fowke, of Royal Engineers, fitted out most expeditional parties. Corporal Lawson, photographer with Capt. Gordon & James surveying the boundary between Russia and Turkey. Sergeant Church, photographer, accompanied Col. Stanton to survey proposed railway in the Panama-Honduras. Sergeant Mack in Moscow with Lord Granville. Others, not named, in China, India, and Crimea.]

ST1072 "Photographic Notes and Queries: Immoral Photographs." PHOTOGRAPHIC NEWS 4, no. 101 (Aug. 10, 1860): 180.

ST1073 "Government Competition with Photographers." PHOTOGRAPHIC NEWS 4, no. 103 (Aug. 24, 1860): 194. [Editorial against establishment of government photos of museums. "...as we have it on authority so high as that of Mr. Roger Fenton that "he had given up all the higher branches of photography, as he found himself unable to compete with a government department."]

ST1074 "Government in Competition with Professional Photographers." BRITISH JOURNAL OF PHOTOGRAPHY 7, no. 125 (Sept. 1, 1860): 257. [Report of Select Committee on the South Kensington Museum, Robert Fenton protesting.]

ST1075 "Photography of South Kensington Museum." PHOTOGRAPHIC NEWS 4, no. 105-116 (Sept. 7 - Nov. 23, 1860): 224-225, 233, 273-274, 286-287, 323, 345-346, 358-359. [Report of the committee investigating governmental agency asking for the right to photograph museum objects. Editors opposed.]

ST1076 "Editor's Note." BRITISH JOURNAL OF PHOTOGRAPHY 7, no. 128 (Oct. 15, 1860): 295-297. [Further commentary on the controversy surrounding the Report of the Committee of the South Kensington Museum. Signor Caldesi and Roger Fenton opposing government restrictions.]

ST1077 "Knavery." BRITISH JOURNAL OF PHOTOGRAPHY 7, no. 128 (Oct. 15, 1860): 297-298. [Fake Ross lenses being made and sold. A "Professor Kastner" travelling around, cheating photographers.]

ST1078 "Government in Competition with Professional Photographers. No. II." BRITISH JOURNAL OF PHOTOGRAPHY 7, no. 128 (Oct. 15, 1860): 301. [Committee of the South Kensington Museum.]

ST1079 "Notes From the North: By an Edinburgh Correspondent." BRITISH JOURNAL OF PHOTOGRAPHY 7, no. 128 (Oct. 15, 1860): 301-302.

ST1080 Shadbolt, George. "Photographic News from Europe." AMERICAN JOURNAL OF PHOTOGRAPHY AND THE ALLIED ARTS & SCIENCES n. s. vol. 3, no. 9 (Oct. 1, 1860): 136-138. [Letter from Shadbolt, discussing the state of photography in rural England.]

ST1081 "Curious Electric Phenomena." AMERICAN JOURNAL OF PHOTOGRAPHY AND THE ALLIED ARTS & SCIENCES n. s. vol. 3, no. 11 (Nov. 1, 1860): 167-168. [Discusses a "joke" article, first published in the "Photo. J.," about purported photos taken by lightning. General press took up the report as true and circulated it widely.]

ST1082 "Editorial Note." BRITISH JOURNAL OF PHOTOGRAPHY 7, no. 129 (Nov. 1, 1860): 309. [Further commentary on the South Kensington Museum controversy.]

ST1083 Coningham, William, M.P. "Observations in Reply to the Report of the Select Committee on the South Kensington Museum." BRITISH JOURNAL OF PHOTOGRAPHY 7, no. 129 (Nov. 1, 1860): 312-313.

ST1084 "'Great Expectations.'" BRITISH JOURNAL OF PHOTOGRAPHY 7, no. 132 (Dec. 15, 1860): 367-368. [General commentary on British activities.]

GREAT BRITAIN: 1861.
BOOKS
ST1085 Contencin, James. *Photographic Illustrations of the Architecture and Sculptured Details of Steetley Church, Derbyshire.* By James Contencin. With Plans and sections measured and drawn by Theophilus Smith. Worksop: Published by Robert White, 1861. n. p. b & w.

PERIODICALS

ST1086 "Editorial." BRITISH JOURNAL OF PHOTOGRAPHY 8, no. 133 (Jan. 1, 1861): 1-2.

ST1087 "Fine Art Gossip." ATHENAEUM no. 1733 (Jan. 12, 1861): 55. [Praise for O. G. Rejlander's series "Studies from Life." Mansfield's portrait as part 53, Cundall's portrait as part 54 in "Church of England Photographic Gallery." Kilburn's "British Photographic Portrait Gallery, nos. 1 and 2, mentioned.]

ST1088 "Intensifying Processes." AMERICAN JOURNAL OF PHOTOGRAPHY AND THE ALLIED ARTS & SCIENCES n. s. vol. 4, no. 1 (June 1, 1861): 7-12. [From "Photo. Notes." Mentions V. Blanchard, Mr. Warren De La Rue, Mr. Skaife, G. W. Wilson, Maxwell Lyte, Archer, others.]

ST1089 "A Case of Poisoning by Cyanide." AMERICAN JOURNAL OF PHOTOGRAPHY AND THE ALLIED ARTS & SCIENCES n. s. vol. 4, no. 2 (June 15, 1861): 25-27. [From "Photo. News." Detailed discussion of the death of a parlor maid, who committed suicide by swallowing cyanide of potassium.]

ST1090 "Useful Facts, Receipts, &c.: Photography in the Witness Box." AMERICAN JOURNAL OF PHOTOGRAPHY AND THE ALLIED ARTS & SCIENCES n. s. vol. 4, no. 3 (July 1, 1861): 68. [From "Photo. News."]

ST1091 "Useful Facts, Receipts, &c.: Photography and the Art Critics." AMERICAN JOURNAL OF PHOTOGRAPHY AND THE ALLIED ARTS & SCIENCES n. s. vol. 4, no. 3 (July 1, 1861): 69. [From "Athenaeum." Review of a David Robert's painting in Royal Academy exhibition discusses photography.]

ST1092 S. T. "Notes of the Month." BRITISH JOURNAL OF PHOTOGRAPHY 8, no. 145-155 (July 1 - Dec. 2, 1861): 244, 276, 313, 350, 428. [General commentary on activities and events.]

ST1093 "Leaves from the Diary of a Late Enthusiastic Amateur, Edited by Sydney Sunshine." BRITISH JOURNAL OF PHOTOGRAPHY 8, no. 146, 148, 152, 154 (July 15, Aug. 15, Oct. 15, Nov. 15, 1861): 256-257, 285-286, 366-367, 407-408. [Comic narrative.]

ST1094 J. P. M. "Siccus and Humidus." AMERICAN JOURNAL OF PHOTOGRAPHY AND THE ALLIED ARTS & SCIENCES n. s. vol. 4, no. 6 (Aug. 15, 1861): 123-125. [From "Photo. J." Poem about virtues and vices of the wet and dry processes.]

ST1095 "Useful Facts, Receipts, &c.: A Hint to Farce Writers." AMERICAN JOURNAL OF PHOTOGRAPHY AND THE ALLIED ARTS & SCIENCES n. s. vol. 4, no. 6 (Aug. 15, 1861): 135-136. [From "Photo. News." Anecdote about mix-up in negatives leading to domestic confusions...]

ST1096 Seely, Charles A. "Editorial Miscellany." AMERICAN JOURNAL OF PHOTOGRAPHY AND THE ALLIED ARTS & SCIENCES n. s. vol. 4, no. 6 (Aug. 15, 1861): 143-144. [Commentary on the conflict in London on the Photography Section of the 1861 World's Fair being classified in machine tools, etc.]

ST1097 "Photographic Dens and 'Doorsmen.'" AMERICAN JOURNAL OF PHOTOGRAPHY AND THE ALLIED ARTS & SCIENCES n. s. vol. 4, no. 8 (Sept. 15, 1861): 189-191. [From "London Daily Telegraph."]

ST1098 "Our Eye-Witness at St. Helen's." BRITISH JOURNAL OF PHOTOGRAPHY 8, no. 151 (Oct. 1, 1861): 347. [Report of tour throughout mining and industrial region near Manchester, England.]

ST1099 "'The Photographic Nuisance.'" AMERICAN JOURNAL OF PHOTOGRAPHY AND THE ALLIED ARTS & SCIENCES n. s. vol. 4, no. 10 (Oct. 15, 1861): 219-222. [From "Photo. News." Conflicts between photographers and sitters discussed.]

ST1100 "The Photographic Album. Vol. II. (Thirty Nine Pictures.)" JOURNAL OF THE PHOTOGRAPHIC SOCIETY OF LONDON 7, no. 114 (Oct. 15, 1861): 285-286. [39 prints by 39 photographers listed. Dr. Diamond, Bedford, etc.]

ST1101 "Photography in 1861." BRITISH JOURNAL OF PHOTOGRAPHY 8, no. 153 (Nov. 1, 1861): 385. [Excerpt from London "Daily Telegraph," discussing controversy over whether photography is an art form.]

ST1102 "Cartes de Visite." AMERICAN JOURNAL OF PHOTOGRAPHY AND THE ALLIED ARTS & SCIENCES n. s. vol. 4, no. 12 (Nov. 15, 1861): 265-269. [From "Art Journal."]

ST1103 Tomlinson. "On Lighting Figures." AMERICAN JOURNAL OF PHOTOGRAPHY AND THE ALLIED ARTS & SCIENCES n. s. vol. 4, no. 12 (Nov. 15, 1861): 280-281. [From "Photo. News." Paper, by Tomlinson, on "lightning photographs," in response to the work of Professor Poey.]

ST1104 "Photographic Effects of Lightning." HUMPHREY'S JOURNAL OF PHOTOGRAPHY, AND THE ALLIED ARTS AND SCIENCES 13, no. 14 (Nov. 15, 1861): 217-218. [From "The Athenaeum." Report on Tomlinson's paper "On Lighting Figures," read to the British Association.]

ST1105 "Photography at the International Exhibition." BRITISH JOURNAL OF PHOTOGRAPHY 8, no. 155 (Dec. 2, 1861): 415-416. [Editorial commentary about the role of photography as it was then seen in the country, quotes from "Daily Telegraph," etc.]

ST1106 "Our Weekly Gossip." ATHENAEUM no. 1780 (Dec. 7, 1861): 768. [Views by Wm. England published by the London Stereoscopic Co.; the Earl of Caithness, Capt. Kater, and Dr. Diamond appointed to the Committee on Photography for the forthcoming International Exhibition, P. Le Neve Foster is Secretary; W. & M. Howitt's book "Ruined Castles and Abbeys of Great Britian" reviewed.]

GREAT BRITAIN: 1862.

ST1107 "The Past Year" and "In Memoriam." BRITISH JOURNAL OF PHOTOGRAPHY 9, no. 157 (Jan. 1, 1862): 1-2. [Survey of events and memorial statement of death of Prince Albert, a patron of photography.]

ST1108 "Scraps and Fragments." BRITISH JOURNAL OF PHOTOGRAPHY 9, no. 157-180 (Jan. 1 - Dec. 15, 1862): 29, 49, 68, 91, 116, 133, 155-156, 178, 200, 218, 240, 258, 278, 294-295, 320, 336, 357, 374, 396, 420-421, 439, 456-457, 477.

ST1109 S. T. "Notes of the Month." BRITISH JOURNAL OF PHOTOGRAPHY 9, no. 157-180 (Jan. 1 - Dec. 15, 1862): 13, 48, 133, 178, 217, 257, 297, 335, 373, 419, 456.

ST1110 Lawson, Henry, M.D. "Scientific Summary: Quarterly Retrospect: Photography." POPULAR SCIENCE REVIEW 1, no. 2 (Jan.

1862): 265-267. [Mentions Joubert's enamel photography; Mr. Malone's discussion of the composition of the photographic image; G. Wharton Simpson; Mr. Crookes; and Dr. Draper.]

ST1111 "The New Picture Galleries." AMERICAN JOURNAL OF PHOTOGRAPHY AND THE ALLIED ARTS & SCIENCES n. s. vol. 4, no. 16 (Jan. 15, 1862): 361-364. [Sarcastic commentary, from "London Review," of fashionable craze for photography in England.]

ST1112 "Photography vs. Talent." AMERICAN JOURNAL OF PHOTOGRAPHY AND THE ALLIED ARTS & SCIENCES n. s. vol. 4, no. 16 (Jan. 15, 1862): 372-373. [From "Blackwood's Magazine." Excerpt of a (fictional?) dialogue between a painter and a photographer.]

ST1113 "Photographic Aids to Physiognomy." AMERICAN JOURNAL OF PHOTOGRAPHY AND THE ALLIED ARTS & SCIENCES n. s. vol. 4, no. 16 (Jan. 15, 1862): 382-383. [Argument that photographic "truth" in portraits valuable. Mentions Mayall, Dickensen, Silvy and Watkin.]

ST1114 "The Principle of the Diorama Applied to Photographic Pictures." BRITISH JOURNAL OF PHOTOGRAPHY 9, no. 158 (Jan. 15, 1862): 25. [A Dr. Taylor, of Andersonian Univ., Glasgow, with the photographer MacNab has developed a method of coloring glass slides, moving them and projecting them, for entertainment and instruction.]

ST1115 "A Great Bereavement." HUMPHREY'S JOURNAL OF PHOTOGRAPHY, AND THE ALLIED ARTS AND SCIENCES 13, no. 18 (Jan. 15, 1862): 279. [From "Photo. News." Comments on death of Prince Albert.]

ST1116 Wynter, A. "Cartes de Visite." ONCE A WEEK 6, (Jan. 25, 1862): 134-137.

ST1117 "Mr. Punch's Opinions of a New Fashion" and "Playing at Cards." AMERICAN JOURNAL OF PHOTOGRAPHY AND THE ALLIED ARTS & SCIENCES n. s. vol. 4, no. 17 (Feb. 1, 1862): 394-395. [From "Punch," Nov. 2, 1861. Satiric comment on carte-de-visite craze.]

ST1118 "Euclid in the Stereoscope. To the Public." AMERICAN JOURNAL OF PHOTOGRAPHY AND THE ALLIED ARTS & SCIENCES n. s. vol. 4, no. 17 (Feb. 1, 1862): 397-398. [Poem. From "Photo. Notes."]

ST1119 "Photography versus Talent." HUMPHREY'S JOURNAL OF PHOTOGRAPHY, AND THE ALLIED ARTS AND SCIENCES 13, no. 19 (Feb. 1, 1862): 302-303. [From "Blackwood's Magazine." Narrative dialogue.]

ST1120 "Preliminary Coatings for Glass Plates." AMERICAN JOURNAL OF PHOTOGRAPHY AND THE ALLIED ARTS & SCIENCES n. s. vol. 4, no. 18 (Feb. 15, 1862): 409-414. [Describes working processes of Glover; Maj. Russell; Rev. Mr. Laws; Hyslop; Alex. McNab; Hughes; and others.]

ST1121 "The Death of Prince Albert." AMERICAN JOURNAL OF PHOTOGRAPHY AND THE ALLIED ARTS & SCIENCES n. s. vol. 4, no. 18 (Feb. 15, 1862): 416-417. [From "Photo. Journal." Describes the Prince Consort's importance to British photography.]

ST1122 Wynter, Dr. "Cartes de Visite." JOURNAL OF THE PHOTOGRAPHIC SOCIETY OF LONDON 7, no. 118 (Feb. 15, 1862): 375-377. [From "Once a Week."]

ST1123 "Recent Progress of Photographic Art." NORTH BRITISH REVIEW 36, (Feb.- May 1862): 170-203.

ST1124 Thompson, S. "Photography In Its Application to Book Illustration." BRITISH JOURNAL OF PHOTOGRAPHY 9, no. 161 (Mar. 1, 1862): 88-89. [Discusses the Howitt's "Ruined Castles and Abbeys of Great Britain," with photos by Bedford, Sedgfield, Wilson, Fenton, etc.]

ST1125 "Cartes de Visite." HUMPHREY'S JOURNAL OF PHOTOGRAPHY, AND THE ALLIED ARTS AND SCIENCES 13, no. 21 (Mar. 1, 1862): 326-330. [From "Art Journal."]

ST1126 MacTear, Andrew. "On the Successful Application of the Principles of the Diorama to Photographic Pictures." BRITISH JOURNAL OF PHOTOGRAPHY 9, no. 162 (Mar. 15, 1862): 110-111.

ST1127 "My First Photographic Trip to the Country." BRITISH JOURNAL OF PHOTOGRAPHY 9, no. 162, 164 (Mar. 15, Apr. 15 1862): 111, 146-147. ["By a Member of the Edinburgh Photographic Society."]

ST1128 Wynter, A. "Cartes de Visite." LIVING AGE 72, no. 929 (Mar. 22, 1862): 673-676. [From "Once a Week."]

ST1129 Wynter, A., M.D. "Cartes de Visite." AMERICAN JOURNAL OF PHOTOGRAPHY AND THE ALLIED ARTS & SCIENCES n. s. vol. 4, no. 21 (Apr. 1, 1862): 481-486. [From "Once a Week." Extensive discussion of the Carte-de-Visite craze in England.]

ST1130 Lawson, Henry, M.D. "Scientific Summary: Quarterly Retrospect: Photography." POPULAR SCIENCE REVIEW 1, no. 3 (Apr. 1862): 400-401. [Mentions controversy at the International Exhibition; Mr. Claudet; Mr. England; Sir John Herschel; Mr. Crookes; Emerson J. Reynolds.]

ST1131 "Instantaneous Photography." JOURNAL OF THE PHOTOGRAPHIC SOCIETY OF LONDON 8, no. 120 (Apr. 15, 1862): 30-33. [Mentions Dr. Diamond, Maxwell Lyte, G. W. Wilson, Wm. England, V. Blanchard.]

ST1132 "The Carte de Visite." ALL THE YEAR ROUND 7, no. 157 (Apr. 26, 1862): 165-168.

ST1133 "Instantaneous Photography." AMERICAN JOURNAL OF PHOTOGRAPHY AND THE ALLIED ARTS & SCIENCES n. s. vol. 4, no. 24 (May 15, 1862): 561-565. [From "Photo Journal." Survey of practitioners and history of this activity in Great Britain. Wilson; England; Blanchard; Dr. Hill Norris; R. Mudd; others mentioned.]

ST1134 Lawson, Henry, M.D. "Scientific Summary: Quarterly Retrospect: Photography." POPULAR SCIENCE REVIEW 1, no. 4 (July 1862): 532-534. [Mentions F. S. Archer; Mayall; Hansen (Copenhagen); Ghemar Brothers; Oehme & Jamrath (Berlin); W. T. Mabley; Adolphe Martin.]

ST1135 Portrait. Woodcut engraving credited, "from a photograph in the possession of A. M. Dowleans, Esq...." ILLUSTRATED LONDON NEWS 41, (1862) ["Earl Canning." 41:* (July 5, 1862): 1.]

ST1136 "Entremets: Photography at the Royal Dramatic College Fete." and "The 'Powerful' Lecture on Photography, by Professor Toole, T.R.A." BRITISH JOURNAL OF PHOTOGRAPHY 9, no. 171 (Aug. 1, 1862): 295-296. [Everybody having fun - "Prof. Toole" and "Mr. Bedford" mentioned as an important part of the festivities.]

ST1137 "The New Copyright (Works of Art) Act." BRITISH JOURNAL OF PHOTOGRAPHY 9, no. 173 (Sept. 1, 1862): 333-335. [Text of the act.]

ST1138 "Photography as an Industry." JOURNAL OF THE PHOTOGRAPHIC SOCIETY OF LONDON 8, no. 125 (Sept. 15, 1862): 361-363. [From "London Review."]

ST1139 Lawson, Henry, M.D. "Scientific Summary: Quarterly Retrospect: Photography." POPULAR SCIENCE REVIEW 2, no. 5 (Oct. 1862): 125-128. [Discusses a group portrait of the British Association, a combination print made from separate portraits by Alfred Brothers of Manchester. Discusses fading prints at the International Exhibition. Mentions work of Warner; James Mudd; Vernon Heath; Sidebotham; D. Campbell; R. M. Gordon; T. R. Williams; A. W. Bennett; G. Wharton Simpson. Mentions John Spiller's experiments in recovering silver.]

ST1140 "Useful Facts, Receipts, Etc.: A Learned Disquisition on Photography." AMERICAN JOURNAL OF PHOTOGRAPHY AND THE ALLIED ARTS & SCIENCES n. s. vol. 5, no. 7 (Oct. 1, 1862): 166. [A Mr. J. L. Toole, at the Royal Dramatic College, Fancy Fair and Fete at the Crystal Palace, during the operations conducted by him and Mr. Paul Bedford in their photographic hut...delivered (a comic monologue on arcane technical language of photographic operators).]

ST1141 Mure, Andrew. "Observations on the Recent Copyright Act." BRITISH JOURNAL OF PHOTOGRAPHY 9, no. 176 (Oct. 15, 1862): 390-392.

ST1142 "Photography and Forgery." AMERICAN JOURNAL OF PHOTOGRAPHY AND THE ALLIED ARTS & SCIENCES n. s. vol. 5, no. 9 (Nov. 1, 1862): 200-203. [From "Photo. Notes."]

ST1143 "Useful Facts, Receipts, Etc.: The Bride Elect of the Prince of Wales." AMERICAN JOURNAL OF PHOTOGRAPHY AND THE ALLIED ARTS & SCIENCES n. s. vol. 5, no. 9 (Nov. 1, 1862): 208-209. [From "Br. J." Commentary on an article in the "Daily Telegraph."]

ST1144 "Photography and Forgery." HUMPHREY'S JOURNAL OF PHOTOGRAPHY, AND THE ALLIED ARTS AND SCIENCES 14, no. 13 (Nov. 1, 1862): 156-159.

ST1145 "Photography and the Copyright Act." BRITISH JOURNAL OF PHOTOGRAPHY 9, no. 178 (Nov. 15, 1862): 431-432. [From "Daily Telegraph."]

ST1146 "Photography in Disgrace." AMERICAN JOURNAL OF PHOTOGRAPHY AND THE ALLIED ARTS & SCIENCES n. s. vol. 5, no. 11 (Dec. 1, 1862): 256-257. [From "Br. J. of Photo." Reply to commentary in the "Athenaeum" on the London Exhibition, which attacked H. P. Robinson, ignored Osborn's photozincography process, etc.]

ST1147 "The 'Sensation' Cab." AMERICAN JOURNAL OF PHOTOGRAPHY AND THE ALLIED ARTS & SCIENCES n. s. vol. 5, no. 12 (Dec. 15, 1862): 286-287. [From "Br. J. of Photo." Story about a photographer hiring a cab to use as a darkroom - it blocking traffic, problems with the law, etc.]

ST1148 "Cartes de Visite of Celebrities." JOURNAL OF THE PHOTOGRAPHIC SOCIETY OF LONDON 8, no. 128 (Dec. 15, 1862): 188-190.

GREAT BRITAIN: 1863.
BOOKS
ST1149 Barry, Patrick. *Dockyard Economy and Naval Power.* London: Sampson, Low, Son, & Co., 1863. xxiv, 312 pp. 31 b & w. [Original photographs, tipped-in. Barry hired a photographer or photographers to make views of the dockyards, ironworks, etc. There is a two-page "Photographic Preface" but Barry does not identify the photographers.]

PERIODICALS
ST1150 "Photographic Reproduction and Piracy." AMERICAN JOURNAL OF PHOTOGRAPHY AND THE ALLIED ARTS & SCIENCES n. s. vol. 5, no. 13 (Jan. 1, 1863): 289-292. [Powel & Pipere, photographers, copying engravings belonging to Gambert, printseller. Gambert sued. From (London) "Daily Telegraph."]

ST1151 "Notes of the Month." BRITISH JOURNAL OF PHOTOGRAPHY 10, no. 181-204 (Jan. 1 - Dec. 15, 1863): 21, 60, 109, 151, 196, 237, 275, 312, 355, 391, 432, 475. [Column with gossip, news, etc., primarily about British photography and photographic activities.]

ST1152 "Waifs and Strays." BRITISH JOURNAL OF PHOTOGRAPHY 10, no. 181-204 (Jan. 1 - Dec. 15, 1863): 21-22, 40-41, 61-62, 86, 110, 129-130, 152, 173-174, 198, 219, 238, 259, 276, 294-295, 312, 334, 356-357, 374, 393-394, 414, 433-434, 446, 474, 493. [This column which appeared regularly in the "British Journal of Photography", contained news notes, excerpts of articles, and commentary about British and foreign events. At this time the column was filled with information about photographers, etc. - later it became less rich with such information.]

ST1153 Lawson, Henry, M.D. "Scientific Summary: Quarterly Retrospect: Photography." POPULAR SCIENCE REVIEW 2, no. 7 (Jan. 1863): 290-293. [Mentions Vernon Heath's portrait of Prince Albert; Mr. Annan's reproductions of paintings issued for the Glasgow Art-Union; Dr. H. Diamond; Malone's lecture on photochemistry; technical matters, etc.]

ST1154 "Cartes de Visite of Celebrities." AMERICAN JOURNAL OF PHOTOGRAPHY AND THE ALLIED ARTS & SCIENCES n. s. vol. 5, no. 14 (Jan. 15, 1863): 324-328. [From "Saturday Review."]

ST1155 "'The Last of the Photos.'" AMERICAN JOURNAL OF PHOTOGRAPHY AND THE ALLIED ARTS & SCIENCES n. s. vol. 5, no. 14 (Jan. 15, 1863): 328. [From "Br. Journal." Comic poem, ostensibly written at the end of the London International Exhibition.]

ST1156 A. W. "Photographic Portraiture." ONCE A WEEK 8, no. 188 (Jan. 31, 1863): 148.

ST1157 "Photographic Piracy of Engravings." AMERICAN JOURNAL OF PHOTOGRAPHY AND THE ALLIED ARTS & SCIENCES n. s. vol. 5, no. 15 (Feb. 1, 1863): 343-347. [From "Photo. News." Further matters on Gambert v. Hall.]

ST1158 Wright, H. C., M.D. "Photography and the Healing Art." AMERICAN JOURNAL OF PHOTOGRAPHY AND THE ALLIED ARTS & SCIENCES n. s. vol. 5, no. 15 (Feb. 1, 1863): 347-348. [From "Photo. News." The Medical and Chirurgical Society of London adding photos to their study collections for study and research.]

ST1159 "Useful Facts, Receipts, Etc.: Photographic Book Illustration." AMERICAN JOURNAL OF PHOTOGRAPHY AND THE ALLIED ARTS & SCIENCES n. s. vol. 5, no. 15 (Feb. 1, 1863): 351-352. [From "Saturday Review." Discusses the amount of use of photographs to illustrate books. "For a certain class of books they are all but indispensible..." Mentions Prof. Smyth's book on Teneriffe, Fenton's book on the scenery of the Conway, Bennet's new edition of Sir W. Scott's "Lady of the Lake." (With views by J. W. Wilson?).]

ST1160 "Photography in Court." BRITISH JOURNAL OF PHOTOGRAPHY 10, no. 183 (Feb. 2, 1863): 53-55.

ST1161 "Photographic Portraiture." NEW YORK ILLUSTRATED NEWS 7, no. 175 (Mar. 7, 1863): 279. [From "Once a Week." General commentary on growth of studio portraiture since 1840s.]

ST1162 Wall, A. H. "Bits of Chat: The Royal Marriage from a Photographic Point of View." BRITISH JOURNAL OF PHOTOGRAPHY 10, no. 186 (Mar. 16, 1863): 123-124. [Wall describes attempts by photographers to photograph the royal procession from Gravesend to Cheapside. Wall states that Bedford, Downes, Harmon and other photographers were at Gravesend, Blanchard was at the dock, Sydney Smyth was at King William Street (failed to get an image.) England was positioned before the Mansion House, and others were at work as well, documenting the festive events on March 7.]

ST1163 R. A. S. "Photography in Natural Colors." AMERICAN JOURNAL OF PHOTOGRAPHY AND THE ALLIED ARTS & SCIENCES n. s. vol. 5, no. 19 (Apr. 1, 1863): 433-434. [From "Br. J. of Photo." Anecdote about a fraud taking advantage of sitters.]

ST1164 "Photography and Its Critics." AMERICAN JOURNAL OF PHOTOGRAPHY AND THE ALLIED ARTS & SCIENCES n. s. vol. 5, no. 19 (Apr. 1, 1863): 435-436. [From "Br. J. of Photo." Commentary on reviews in "Chamber's Journal" and "All the Year Round."]

ST1165 Lawson, Henry, M.D. "Scientific Summary: Quarterly Retrospect: Photography." POPULAR SCIENCE REVIEW 2, no. 7 (Apr. 1863): 440-443. [Lists winners of the prizes offered by the Council of the Photographic Society: Claudet, F. Bedford, Colonel Stuart Wortley, Viscountess Harwarden, H. P. Robinson and Thurston Thompson. Bayard, Duboscq and Poitevin received medals from French Emperor. Awards and prizes to Poitevin, Davanne, Girard, Garnier, Salmon, Pouncey, Fargier. Meynier, M. Ponton mentioned. A. F. Eden's microphotography discussed.]

ST1166 Wenham, F. H. "Balloon Photography." JOURNAL OF THE PHOTOGRAPHIC SOCIETY OF LONDON 8, no. 132 (Apr. 15, 1863): 271-272.

ST1167 Lawson, Henry, M.D. "Scientific Summary: Quarterly Retrospect: Photography." POPULAR SCIENCE REVIEW 2, no. 8 (July 1863): 574-577. [Chemical matters discussed. W. Deane and Mr. Spiller photographing solar eclipses. Confused results of chemical experiments at high altitudes in balloons by Mr. Glaisher, C. Piazzi Smyth and Mr. Negretti.]

ST1168 "The Influence of Photography." AMERICAN JOURNAL OF PHOTOGRAPHY AND THE ALLIED ARTS & SCIENCES n. s. vol. 6, no. 2 (July 15, 1863): 25-28. [From "Daily Telegraph."]

ST1169 "The King of Greece and the Photographer." BRITISH JOURNAL OF PHOTOGRAPHY 10, no. 195 (Aug. 1, 1863): 311. [Frith, the painter, commissioned to paint a portrait of the future King of Greece, while visiting Great Britain. Frith sought and obtained, with difficulty, permission to have a photographic portrait of the prince made for preliminary studies. Anecdote about the difficulties made by the prince during the sitting. Photographer not named.]

ST1170 Kemp, Geo., M.D., CANTAB. "Fatal Accident in Connection with Photographic Pursuit at Hereford, with Practical Remarks Arising Therefrom." AMERICAN JOURNAL OF PHOTOGRAPHY AND THE ALLIED ARTS & SCIENCES n. s. vol. 6, no. 4 (Aug. 15, 1863): 87-89. [From "Br. J."]

ST1171 "An Attack of Bile." AMERICAN JOURNAL OF PHOTOGRAPHY AND THE ALLIED ARTS & SCIENCES n. s. vol. 6, no. 5 (Sept. 1, 1863): 104-105. [From "Br. J. of Photo." Reply to an attack on photography, published in the "Athenaeum."]

ST1172 "Photographic Pictures and Illustrations." JOURNAL OF THE PHOTOGRAPHIC SOCIETY OF LONDON 8, no. 137 (Sept. 15, 1863): 359-363. [From "London Review." Discusses the varied uses of photography: high art, (Referring to Rejlander's genre scenes.)cartes-de-visite, Swann's casket portraits, views of places and scenery, (London Stereoscopic Co., G. W. Wilson.) illustrations for books, (Clifford, etc.) views of geographical places, physical scenery, and the finest architectural buildings, stereo collections, etc.]

ST1173 "Photography as an Industry." JOURNAL OF THE PHOTOGRAPHIC SOCIETY OF LONDON 8, no. 137 (Sept. 15, 1863): 361-364. [From "London Review." London Stereoscopic Co.; Mayall; Bedford; De la Rue; Bisson Freres; others mentioned.]

ST1174 "St. Aidan's College, Birkenhead." ILLUSTRATED LONDON NEWS 43, no. 1226 (Oct. 10, 1863): 373. 1 illus.

ST1175 "The Disenchantment of the 'Carte-de-Viste.'" BRITISH JOURNAL OF PHOTOGRAPHY 10, no. 200 (Oct. 15, 1863): 409-410. [From "All the Year Round."]

ST1176 Traill, Jeffrey. "Entrements: How We Photograph the Thieves." BRITISH JOURNAL OF PHOTOGRAPHY 10, no. 200 (Oct. 15, 1863): 412-413. [Anecdote about taking mug-shots.]

ST1177 "Photographic Pictures and Illustrations." JOURNAL OF THE PHOTOGRAPHIC SOCIETY OF LONDON 8, no. 138 (Oct. 15, 1863): 359-361. [From the "London Review." Rejlander mentioned. Plus a letter of reply signed 'Cave' published vol. 8 no. 138, Oct. l5, 1863, p. 378.]

ST1178 "Reviews: Books Illustrated by Photographs." JOURNAL OF THE PHOTOGRAPHIC SOCIETY OF LONDON 8, no. 138 (Oct. 15, 1863): 381. ["Lady of the Lake". Sir Walter Scott Photos by Thomas Ogle, "Ruined Abbeys & Castles" William & Mary Howitt. 6 views by Bedford and Sedgfield. Both published by Bennett.]

ST1179 Lawson, Henry, M.D. "Scientific Summary: Quarterly Retrospect: Photography." POPULAR SCIENCE REVIEW 3, no. 9 (Oct. 1863): 128-132. [H. F. Talbot's experiments in photoengraving; C. Piazzi Smyth's photos from the Peak of Teneriffe; Negretti & Zambra's balloon photos; Marquier's photolithographs; Henry Swan's stereoscopic experiments; T. L. Phipson; Carey Lea's blueprints; Beyrich's ceramic photos, etc. all reported at the British Association Meeting.]

ST1180 Davies, W. H. "Applications of Photography to Art Manufactures." BRITISH JOURNAL OF PHOTOGRAPHY 10, no.

201 (Nov. 2, 1863): 425. [Advocating industrial, commercial, advertising photography.]

ST1181 "Miscellaneous: Novel Defense of a Forger - Photography with a New Face." AMERICAN JOURNAL OF PHOTOGRAPHY AND THE ALLIED ARTS & SCIENCES n. s. vol. 6, no. 10 (Nov. 15, 1863): 239. [Argument in British court that law against forgery did not include photography. Report, from "Punch" about strong-arm tactics used by cheap photographic studios.]

ST1182 Davies, W. H. "Applications of Photography to Art Manufacturers." AMERICAN JOURNAL OF PHOTOGRAPHY AND THE ALLIED ARTS & SCIENCES n. s. vol. 6, no. 11 (Dec. 1, 1863): 250-253. [From "Br. J. of Photo.]

ST1183 "Photography as a Criminal Detective." AMERICAN JOURNAL OF PHOTOGRAPHY AND THE ALLIED ARTS & SCIENCES n. s. vol. 6, no. 11 (Dec. 1, 1863): 256-257. [From Br. J. of Photo."]

ST1184 Spiller, John, F.C.S. "Photography In Its Application to Military Purposes." BRITISH JOURNAL OF PHOTOGRAPHY 10, no. 204 (Dec. 15, 1863): 485-487. [Spiller was Asst. Chemist to the War Department. Brief survey of the use of photography by the War Department from about 1855 on.]

ST1185 "Photography as a Detective." HUMPHREY'S JOURNAL OF PHOTOGRAPHY, AND THE ALLIED ARTS AND SCIENCES 15, no. 16 (Dec. 15, 1863): 254. [1500 copies of the portrait of a perpetuator of a bank fraud in Liverpool were circulated, and the felon was captured in Pesth.]

ST1186 "Photography with a New Face." HUMPHREY'S JOURNAL OF PHOTOGRAPHY, AND THE ALLIED ARTS AND SCIENCES 15, no. 16 (Dec. 15, 1863): 256. [From "Punch." Commentary on aggressive behavior of cheap portrait makers in London.]

GREAT BRITAIN: 1864.
BOOKS
ST1187 Burritt, Elihu. *A Walk from London to John O'Groat's*: With Notes by the Way, by Elihu Burritt. Illustrated with Photographic Portraits. London: Sampson Low, Son & Marston, 1864. 420 pp. 5 l. of plates. 5 b & w. [Original photographs.]

ST1188 Christie, Manson & Woods, Ltd. *The Illustrated Catalogue of the Valuable Collection of Pictures and Other Works of Art of the Egyptian, Greek, Roman and Medieval Periods*: Also, a Choice Collection of Coins and Medals of...John Watkins Brett...which will be sold by Auction by Messrs. Christie, Manson & Woods...on Tuesday, April 5, 1864 and...Monday, April 18, 1864...[London]: [W. Clowes], 1864. 146 pp. 44 l. of plates. [Original photographs, copies of works of art.]

ST1189 James, T. *The History and Antiquities of Northamptonshire*. Northampton, London: s. n., 1864. n. p. 10 b & w. [Original photographs.]

PERIODICALS
ST1190 [Salsbury, Lord]. "Photography." QUARTERLY REVIEW 116, (1864): 482-519. [Extensive, intelligent discussion of the field.]

ST1191 Spiller, John. "Photographic Processes Used in the English War Department." AMERICAN JOURNAL OF PHOTOGRAPHY AND THE ALLIED ARTS & SCIENCES n. s. vol. 6, no. 14 (Jan. 15,

1864): 327-330. [Spiller's paper printed elsewhere, but source not credited here.]

ST1192 Lawson, Henry, M.D. "Scientific Summary: Quarterly Retrospect: Photography." POPULAR SCIENCE REVIEW 3, no. 10 (Jan. 1864): 276-280. ["The Watt Photographs": discovery of the photos in Samuel Boulton's estate, presumably made by Mr. James Watt in 1780s and 1790s. Sutton's lenses. Microphotography. Joubert's "burnt-in" photos on glass, etc.]

ST1193 "Lighting the Sitter." AMERICAN JOURNAL OF PHOTOGRAPHY AND THE ALLIED ARTS & SCIENCES n. s. vol. 6, no. 18 (Mar. 15, 1864): 409-414. [From "Photo. News."]

ST1194 "Photographic Image on a Dead Eye." HUMPHREY'S JOURNAL OF PHOTOGRAPHY, AND THE ALLIED ARTS AND SCIENCES 15, no. 22 (Mar. 15, 1864): 349-350. [From "Photo. News." The location of this version of the myth was supposed to have occurred in Russia.]

ST1195 "Photography as an Industry." PHOTOGRAPHIC NEWS 8, no. 290 (Mar. 24, 1864): 153-154. [Actually a comment on the state of the art -Mayall, Claudet, Bisson Freres, Bedford are mentioned. From the "London Review."]

ST1196 Lawson, Henry, M.D. "Scientific Summary: Quarterly Retrospect: Photography." POPULAR SCIENCE REVIEW 3, no. 11 (Apr. 1864): 412-417. [Reports on photographic engraving, Carbon printing, etc. More discussion of the Boulton "Watt Photographs" and the controversy around them. Chemical matters, lenses discussed.]

ST1197 "The Twopenny Piracies." AMERICAN JOURNAL OF PHOTOGRAPHY AND THE ALLIED ARTS & SCIENCES n. s. vol. 6, no. 20 (Apr. 15, 1864): 477-479. [From "Photo. News." Unauthorized recopying of portraits.]

ST1198 Seely, Charles A. "Editorial Department." AMERICAN JOURNAL OF PHOTOGRAPHY AND THE ALLIED ARTS & SCIENCES n. s. vol. 6, no. 23 (June 1, 1864): 551-552. [General commentary on recent excitement about the carbon process in England. Seely feels that this praise for a complicated, tedious process is unwarranted, or at least, misguided.]

ST1199 "Photographs of a Lifetime." HUMPHREY'S JOURNAL OF PHOTOGRAPHY, AND THE ALLIED ARTS AND SCIENCES 16, no. 5 (July 1, 1864): 77. [From "Photo. News."]

ST1200 Lawson, Henry, M.D. "Scientific Summary: Quarterly Retrospect: Photography." POPULAR SCIENCE REVIEW 3, no. 12 (July 1864): 551-556. 2 illus. [The Boulton photographs completely discredited. Joseph Swan's carbon process; Mr. Claudet introducing Mr. Willeme's photosculpture to England, the process discussed, illustrated with engravings. "The Chementi Pictures" (stereoscopic works from the 17th century).]

ST1201 "Adventure of a Traveling Photographer." AMERICAN JOURNAL OF PHOTOGRAPHY AND THE ALLIED ARTS & SCIENCES n. s. vol. 7, no. 2 (July 15, 1864): 30. [From "Br. J. of Photo." A story about "...a patrol of Cossacks, in the neighborhood of Kowno,..." finding "...a wandering disciple of photography..." and drinking his alcohol, his ether and his collodion, then when he broke the poisonous bottle of cyanide of potassium before they could drink that, beating him up.]

ST1202 "The Importance of a Carte de Visite." HUMPHREY'S JOURNAL OF PHOTOGRAPHY, AND THE ALLIED ARTS AND SCIENCES 16, no. 6 (July 15, 1864): 96. [A criminal in England, captured by being identified by a carte de visite.]

ST1203 "On the Uses of the Stereoscope." BRITISH JOURNAL OF PHOTOGRAPHY 11, no. 220 (July 22, 1864): 254-255.

ST1204 "The Functions of Art." AMERICAN JOURNAL OF PHOTOGRAPHY AND THE ALLIED ARTS & SCIENCES n. s. vol. 7, no. 6 (Sept. 15, 1864): 127-128. [From "Intellectual Observer."]

ST1205 "Retouching Negatives." HUMPHREY'S JOURNAL OF PHOTOGRAPHY, AND THE ALLIED ARTS AND SCIENCES 16, no. 10 (Sept. 15, 1864): 151-155. [From "Photo. News."]

ST1206 Lawson, Henry, M.D. "Scientific Summary: Quarterly Retrospect: Photography." POPULAR SCIENCE REVIEW 4, no. 13 (Oct. 1864): 130-134. [Royal Society Exhibition (H. P. Robinson, Alfred Harmon, Swan, Col. Sir Henry James, Toovey, Osborne, Lady Hawarden, Annan mentioned); Solar camera; Dr. R. L. Maddox's magnesium light; W. H. Davies on carbon process; C. Piazzi Smyth, etc.]

ST1207 Bockett, John. "The Holidays of a London Photographer: Mr. Hughes' Establishment at Ryde-Photography in Brighton - The Future of the Art, &c., &c." BRITISH JOURNAL OF PHOTOGRAPHY 11, no. 234 (Oct. 28, 1864): 425.

ST1208 "Photosculpture." BRITISH JOURNAL OF PHOTOGRAPHY 11, no. 243 (Dec. 30, 1864): 539-540. [Commentary on "London Times" article on photosculpture.]

GREAT BRITAIN: 1865.

ST1209 Lawson, Henry, M.D. "Scientific Summary: Quarterly Retrospect: Photography." POPULAR SCIENCE REVIEW 4, no. 14 (Jan. 1865): 258-263. [Chemical and technical matters.]

ST1210 "Punch's Scientific Register." HUMPHREY'S JOURNAL OF PHOTOGRAPHY, AND THE ALLIED ARTS AND SCIENCES 16, no. 18 (Jan. 15, 1865): 286. [From "Punch." Comic, fictional, record of a meeting of the London Photographic Society.]

ST1211 "Photographs on Opal Glass." HUMPHREY'S JOURNAL OF PHOTOGRAPHY, AND THE ALLIED ARTS AND SCIENCES 16, no. 19 (Feb. 1, 1865): 293-295. [From "Photo. News."]

ST1212 Lawson, Henry, M.D. "Scientific Summary: Quarterly Retrospect: Photography." POPULAR SCIENCE REVIEW 4, no. 15 (Apr. 1865): 392-395. [Dublin International Exhibition (medals awarded to H. P. Robinson, James Mudd, Thomas Annan, John Smith, J. Ramsay, L'Amy, Samuel Highley and the Pantoscopic Co,)."Photographing from Dean Eyes." Walter Woodbury's views of Japan; copyright; chemical matters.]

ST1213 "Doubles. - The Latest Photographic Novelty." AMERICAN JOURNAL OF PHOTOGRAPHY AND THE ALLIED ARTS & SCIENCES n. s. vol. 7, no. 20 (Apr. 15, 1865): 457-459. [From "Br. J. of Photo."]

ST1214 Sturrock, Thomas. "Photography an Instrument of Education." BRITISH JOURNAL OF PHOTOGRAPHY 12, no. 263 (May 19, 1865): 265-266.

ST1215 "Where to Go with the Camera. South Wales - Nos. I - III." BRITISH JOURNAL OF PHOTOGRAPHY 12, no. 263, 268, 277 (May 19, June 23, Aug. 25, 1865): 266-267, 331, 443.

ST1216 "Lighting the Sitter." BRITISH JOURNAL OF PHOTOGRAPHY 12, no. 265 (June 2, 1865): 285-286. [Paper read by Mr. Leake, sparks comments from Hughes, Wall, Shadbolt and others.]

ST1217 "Instantaneous Photography." AMERICAN JOURNAL OF PHOTOGRAPHY AND THE ALLIED ARTS & SCIENCES n. s. vol. 7, no. 24 (June 15, 1865): 551-553. [From "Br. J. of Photo." Talbot's photo of a revolving newspaper illuminated with an electric spark described. Mr. Hearder (Plymouth), Mr. Hadow (King's College) mentioned.]

ST1218 Lawson, Henry, M.D. "Scientific Summary: Quarterly Retrospect: Photography." POPULAR SCIENCE REVIEW 4, no. 16 (July 1865): 530-534. 1 illus. [Photographic Exhibit, London: Faulkner, V. Blanchard, H. P. Robinson praised, others mentioned. The Aniline Process; the Eburneum Process; camera stands; Simpsontype, etc.]

ST1219 "Glass Houses, and the Right of Photographers to Erect Them." BRITISH JOURNAL OF PHOTOGRAPHY 12, no. 271 (July 14, 1865): 365.

ST1220 "Photography - Commercial and Artistic." BRITISH JOURNAL OF PHOTOGRAPHY 12, no. 275 (Aug. 11, 1865): 411.

ST1221 "Photographers in the Police Court. Disgraceful Proceedings." BRITISH JOURNAL OF PHOTOGRAPHY 12, no. 275 (Aug. 11, 1865): 418.

ST1222 "Photography and Photolithography at the East India Museum." BRITISH JOURNAL OF PHOTOGRAPHY 12, no. 278 (Sept. 1, 1865): 452-453. [Mentions the "People of India" survey, under Dr. Forbes Watson. Mr. Griggs is staff photographer at the East India Museum, London, making prints for this and other publications.]

ST1223 "Illustrations of the Meeting of the British Association at Birmingham. - Photography by Aid of the Magnesium Light - A Sketch at the Soiree at the Townhall." ILLUSTRATED LONDON NEWS 47, no. 1334 (Sept. 16, 1865): 256-257. 1 illus. [Illustration of lantern slide projections demonstrated.]

ST1224 "Cheap Photography, From an Oriental Point of View." BRITISH JOURNAL OF PHOTOGRAPHY 12, no. 282 (Sept. 29, 1865): 500-501. [Comic (fictional) letter, supposedly written by a Turkish visitor, describing his experiences visiting London.]

ST1225 "Photography." ART JOURNAL (Oct. 1865): 304.

ST1226 Lawson, Henry, M.D. "Scientific Summary: Quarterly Retrospect: Photography." POPULAR SCIENCE REVIEW 4, no. 17 (Oct. 1865): 674-677. [Exhibitors at the Dublin International Exhibition listed; North London Photographic Association Exhibition mentioned: Rejlander, V. Blanchard, H. P. Robinson, Aldis, G. W. Simpson, etc.]

ST1227 "Photographic Piracies." BRITISH JOURNAL OF PHOTOGRAPHY 12, no. 294 (Dec. 22, 1865): 639-640. [Case of Graves vs. Ashford.]

GREAT BRITAIN: 1866.

BOOKS

ST1228 Keble, John. *The Christian Year; Thoughts in Verse for the Sundays and Holy Days Throughout the Year, with Photographic Illustrations*. London: R. E. A. Suttaby, 1866 ? xii, 383 pp. 10 b & w. [Original photos.]

ST1229 Walcott, Mackenzie E. C. *Battle Abbey, with Notices of the Parish Church and Town*. Battle, England: F. W. Ticehurst, 1866. 90 pp. 9 b & w. [Original photos.]

PERIODICALS

ST1230 "Preservation of Framed Photographs and Drawings." AMERICAN JOURNAL OF PHOTOGRAPHY AND THE ALLIED ARTS & SCIENCES n. s. vol. 8, no. 13 (Jan. 1, 1866): 298-299. [From "Athenaeum."]

ST1231 Lawson, Henry, M.D. "Scientific Summary: Quarterly Retrospect: Photography." POPULAR SCIENCE REVIEW 5, no. 18 (Jan. 1866): 123-128. [Argument over whether Talbot or Mungo Ponton discovered bichromated gelatin's insolubility after some exposure to light has caused a stir in the scientific journals. Chemical and technical matters discussed. A supplement to Prof. Hitchcock's 'Geology of New England' illustrated by photographs from nature, recently published in Massachusetts. Astronomical photography, etc.]

ST1232 Lawson, Henry, M.D. "Scientific Summary: Quarterly Retrospect: Photography." POPULAR SCIENCE REVIEW 5, no. 19 (Apr. 1866): 254-258. [More of the Talbot/Ponton controversy. Photography in Colours (hand colored negatives); chemical and technical matters; Carey Lea's paper on perspective discussed, etc.]

ST1233 R. A. "Portraits and Pictures." HUMPHREY'S JOURNAL OF PHOTOGRAPHY, AND THE ALLIED ARTS AND SCIENCES 18, no. 2 (May 15, 1866): 22-23. [From "Photo. News." "The proper place for the horizontal line in a card portrait does not appear to be definitely settled."]

ST1234 Lawson, Henry, M.D. "Scientific Summary: Quarterly Retrospect: Photography." POPULAR SCIENCE REVIEW 5, no. 20 (July 1866): 382-386. [Proper fixing of prints for permanency; "Opaltypes"; report on A. H. Wall's article against "composition photography" that display clashing perspectives.]

ST1235 "The Queen's Picture to Mr. Peabody." HUMPHREY'S JOURNAL OF PHOTOGRAPHY, AND THE ALLIED ARTS AND SCIENCES 18, no. 8 (Aug. 15, 1866): 124-125. [From "London Times." A watercolor, by Mr. Tilt, of Queen Victoria in her robes of state, commissioned to be used for a miniature in enamels to be given to George Peabody, the American philanthropist who did many good deeds in England. Peabody intends to place it in an institution in Danvers, Mass., his native town.]

ST1236 "Cabinet Portraits. - A New Impulse for Portraiture." HUMPHREY'S JOURNAL OF PHOTOGRAPHY, AND THE ALLIED ARTS AND SCIENCES 18, no. 10 (Sept. 15, 1866): 152-153. [From "Photo. News." Window & Bridge (Great Britian?) apparently began using this format first.]

ST1237 "New Style of Photograph." HUMPHREY'S JOURNAL OF PHOTOGRAPHY, AND THE ALLIED ARTS AND SCIENCES 18, no. 10 (Sept. 15, 1866): 159. [From "Br. J. of Photo." Prediction that the cabinet style would replace the carte de visite.]

ST1238 "On Enlarging." AMERICAN JOURNAL OF PHOTOGRAPHY, AND THE ALLIED ARTS AND SCIENCES n. s. vol. 9, no. 3 (Oct. 1, 1866): 59-63. [From "Br. J. of Photo."]

ST1239 J. M. "'Process Peddling.'" AMERICAN JOURNAL OF PHOTOGRAPHY, AND THE ALLIED ARTS AND SCIENCES n. s. vol. 9, no. 3 (Oct. 1, 1866): 66-67. [From "Br. J. of Photo."]

ST1240 "The Queen's Portrait for Mr. Peabody." AMERICAN JOURNAL OF PHOTOGRAPHY, AND THE ALLIED ARTS AND SCIENCES n. s. vol. 9, no. 4 (Oct. 15, 1866): 94-95. ["Photography is, we understand, chiefly employed as the aid in producing the portrait of Her Majesty to be presented to Mr. Peabody." (Source not cited.)]

ST1241 Lawson, Henry, M.D. "Scientific Summary: Quarterly Retrospect: Photography." POPULAR SCIENCE REVIEW 5, no. 21 (Oct. 1866): 512. [Commentary on the issue of whether photography could be art: mentions Claudet's 1853 paper, "Upon Photography in an Artistic View, and Its Relation to the Arts." Mentions R. W. Buss, John Leighton, Sir William Newton, Sir Charles Eastlake, A. H. Wall and the argument of selective focus, then attacks Claudet's more recent paper. Discusses chemical matters.]

ST1242 "Front Light, Tunnels &c." AMERICAN JOURNAL OF PHOTOGRAPHY, AND THE ALLIED ARTS AND SCIENCES n. s. vol. 9, no. 4 (Oct. 15, 1866): 75-81. [From "Photo. News." Long discussion of advantages and disadvantages of certain skylight arrangements for studios - Gives examples of arrangements by H. P. Robinson, O. G. Rejlander, Silvy, T. R. Williams, Samuel Fry, Mr. Hughes, etc.]

ST1243 "Female Photographers." HUMPHREY'S JOURNAL OF PHOTOGRAPHY, AND THE ALLIED ARTS AND SCIENCES 18, no. 12 (Oct. 15, 1866): 192. ["It is stated that a photographic establishment has been opened in England by Mrs. Kemp, under the sanction of the Society for the Employment of Women, with the object of facilitating the entrance of ladies into the profession of photography.]

ST1244 "Cabinet Pictures." AMERICAN JOURNAL OF PHOTOGRAPHY, AND THE ALLIED ARTS AND SCIENCES n. s. vol. 9, no. 6 (Nov. 15, 1866): 117-119. [From "Br. J. of Photo."]

ST1245 "Military Photography." AMERICAN JOURNAL OF PHOTOGRAPHY, AND THE ALLIED ARTS AND SCIENCES n. s. vol. 9, no. 6 (Nov. 15, 1866): 119-126. [From "Br. J. of Photo."]

ST1246 "Statistics of Photography." AMERICAN JOURNAL OF PHOTOGRAPHY, AND THE ALLIED ARTS AND SCIENCES n. s. vol. 9, no. 6 (Nov. 15, 1866): 126-127. [From "British Quarterly Review." Number practicing in England in 1861 (2,534), amount of eggs consumed for albumen, etc.]

ST1247 "Photographs of Celebrated Pictures." ART JOURNAL (Dec. 1866): 362. [Review of "The Gallery of Photographs, a collection of reproductions of celebrated Paintings, Drawings, etc.," published by A. Mansell & Son, Gloucester. Extended discussion of the values of photography for art instruction, etc.]

GREAT BRITAIN: 1867.

BOOKS

ST1248 *Scotland: Her Songs and Scenery*. London: A. W. Bennett, 1867. n. p. b & w. ["It consists of a number of Scottish songs, with photographs of the grand or charming scenes they commemorate." "Art Journal" (Jan. 1868): 19.]

ST1249 *The Women of the Gospels*. With Twelve Photographs. London: Seeley, Jackson, & Halliday, 1867. n. p. 12 b & w. [Photographs of engravings, by various artists.]

ST1250 Corbet, Robert St. John. *The Golden Ripple; or, The Leaflets of Life. An Allegorical Poem*. London: A. W. Bennett, 1867. 37 pp. b & w. [Original photographs.]

ST1251 Gray, Thomas. *Poems and Letters*. London: Printed at the Chiswick Press, 1867. xvi, 415 pp. 4 l. of plates. 4 b & w. [Original photos.]

ST1252 London. South Kensington Museum. *Index to the Collection of Photographs in the National Art Library of the South Kensington Museum, London*. London: Eyre & Spottiswoode, 1867. n. p. [List of over 55,000 items, arranged by subject matter and by photographer, when known.]

ST1253 Nall, John Greaves. *Great Yarmouth and Lowestoft*. Chapters on the Archaeology, Natural History, etc., of the District; A History of the East Coast Herring Fishery; and an Etymological and Comparative Glossary of the Dialect of East Anglia. London: Longmans, Green, Ryder & Dyer, 1867. 770 pp. 107 b & w. illus. [Issued in several versions - one with woodcuts, maps, etc., a second version, of ninety copies, with forty-one photographic prints, and a third version, of twelve copies, with an additional seventy photographs.]

ST1254 Whittier, John Greenleaf. *Snow-Bound, A Winter Idyll*. London: Alfred W. Bennett, 1867. 46 pp. 6 b & w. [Six photographs, five of landscape subjects and a portrait of the author from an engraving after a photograph by J. J. Hawes.]

ST1255 Wright, William Samuel. *The Loved Haunts of Cowper; Or, The Photographic Remembrancer of Olney and Weston; Being Photographs of Buildings and Rural Scenes Immortalized by the Poet*. Olney: Bucks, 1867. 38 pp. 18 b & w. [Original prints, One portrait, ten views, seven copies of paintings or prints. NYPL Collection. GEH Collection.]

PERIODICALS
ST1256 "English Photographs." PHILADELPHIA PHOTOGRAPHER 4, no. 37 (Jan. 1867): 17-18. [Mentions G. W. Wilson, Wm. England, Bedford, J. Mudd, discusses photos by V. Blanchard and H. P. Robinson.]

ST1257 Lawson, Henry, M.D. "Scientific Summary: Quarterly Retrospect: Photography." POPULAR SCIENCE REVIEW 6, no. 22 (Jan. 1867): 106-110. [Woodbury's Printing Process; J. Traill Taylor's lenses; belittling of claims of the Frenchman Chambray to have perfected color photography; Claudet's process; London Photographic Society medals; Swan's Carbon process, etc.]

ST1258 "Prices of Cabinet Portraits." HUMPHREY'S JOURNAL OF PHOTOGRAPHY, AND THE ALLIED ARTS AND SCIENCES 18, no. 20 (Feb. 15, 1867): 319.

ST1259 Atkinson, J. Beavington. "Photographs of National Portraits." ART JOURNAL (Apr. 1867): 105. [964 photos of paintings. "The National Portraits," issued in 10 volumes at price of 62 pounds.]

ST1260 Lawson, Henry, M.D. "Scientific Summary: Quarterly Retrospect: Photography." POPULAR SCIENCE REVIEW 6, no. 23 (Apr. 1867): 227-229. [Pouncy, Carey Lea, Davanne, A. H. Wall mentioned. Dallmeyer's new lenses; O. G. Rejlander's photographs of brass rubbings.]

ST1261 "Photography as an Industry." AMERICAN JOURNAL OF PHOTOGRAPHY, AND THE ALLIED ARTS AND SCIENCES n. s. vol. 9, no. 11 (May. 15, 1867): 250. [From "Photo. News."]

ST1262 "Out-of-Door Portraiture." HUMPHREY'S JOURNAL OF PHOTOGRAPHY, AND THE ALLIED ARTS AND SCIENCES 19, no. 4 (June 15, 1867): 59-61. [From "Photo. Notes."]

ST1263 Lawson, Henry, M.D. "Scientific Summary: Quarterly Retrospect: Photography." POPULAR SCIENCE REVIEW 6, no. 24 (July 1867): 339-344. [Paris Exhibition; Duc de Luynes Prize awarded to Poitevin; Major Russell's dry collodion process discussed; Carey Lea on the latent image, etc.]

ST1264 "Photography as an Industry." HUMPHREY'S JOURNAL OF PHOTOGRAPHY, AND THE ALLIED ARTS AND SCIENCES 19, no. 5 (July 1, 1867): 77. [Extract from Official Catalogue of the British Section of the French Exhibition. In 1861, 2,957 persons engaged as photographic artists.]

ST1265 "Recent Patents in England." HUMPHREY'S JOURNAL OF PHOTOGRAPHY, AND THE ALLIED ARTS AND SCIENCES 19, no. 11 (Oct. 1, 1867): 174-176. ["Obtaining Designs in Relief," by David Winstanley, Jr. "A Magic Camera," by A. Fournet and O. Nadaud. "Medallion Portraits," by Luigi Bernieri.]

ST1266 Lawson, Henry, M.D. "Scientific Summary: Quarterly Retrospect: Photography." POPULAR SCIENCE REVIEW 6, no. 25 (Oct. 1867): 479-483. [Photolithography by G. Moran (USA); Prof. Falkland on artificial light; Carey Lea, W. H. Harrison and Mungo Ponton controversy on latent image. British winners of awards at Paris Exhibition: Bedford, England, Mudd, Thurston, Thompson and Robinson, others mentioned. Photography at the British Association Meeting.]

ST1267 "Photographic Scraps: Photography in Evidence." HUMPHREY'S JOURNAL OF PHOTOGRAPHY, AND THE ALLIED ARTS AND SCIENCES 19, no. 12 (Oct. 15, 1867): 181-182. [George Wm. Gordon convicted as an instigator of riots in Jamaica, through identifying him from a portrait.]

ST1268 "Indecent Photographs." HUMPHREY'S JOURNAL OF PHOTOGRAPHY, AND THE ALLIED ARTS AND SCIENCES 19, no. 15 (Dec. 1, 1867): 234. [Sidney Osborn Fowler, alias Dr. John Galt, sentenced to two years hard labor in England for selling twelve obscene and indecent photographic pictures.]

GREAT BRITAIN: 1868.
BOOKS
ST1269 *The Women of the Old Testament*. With Twelve Photographs. London: Seeley, Jackson, and Halliday, 1868. n. p. 12 b & w. [Photographs of paintings.]

ST1270 Hamerton, Philip Gilbert. *Contemporary French Painters*. An Essay by Philip Gilbert Hamerton, Author of "A Painter's Camp." With Sixteen Photographic Illustrations. London: Seeley, Jackson & Halliday., 1868. x, 66 pp. 16 b & w. [Photographs of paintings.]

ST1271 Kennedy, Alexander W. M. Clark. *The Birds of Berkshire and Buckinghamshire;* A Contribution to the Natural History of the Two Counties. Eton; London: Ingalton & Drake; Simpson, Marshall, 1868. xiv, 232 pp. 4 b & w. [Original photos.]

ST1272 Laxton, W. H. *Dudley; Illustrated by Photographs.* Dudley: W. H. Laxton, 1868. 49 pp. 25 b & w. [Twenty-five original photos, three small oval photos inset in text.]

ST1273 Monkhouse, Cosmo. *Masterpieces of English Art, with Sketches of Some of the Most Celebrated of the Deceased Painters of the English School, from the Time of Hogarth to the Present Day;* London: Bell & Daldy, 1868. 170 pp. 26 b & w.

PERIODICALS
ST1274 Lawson, Henry, M.D. "Scientific Summary: Quarterly Retrospect: Photography." POPULAR SCIENCE REVIEW 7, no. 26 (Jan. 1868): 109-113. [London Photographic Society Exhibition. M. Salomon of Paris praised. O. G. Rejlander, Cherrill, Frank Howard, Dunmore, Ayling, Bedford, Faulkner, H. P. Robinson mentioned. Duc de Luyne's Prize awarded to Poitevin, Pouncy angered. An award at the Paris Exhibition for lenses was refused by the recipient (Ross), Dr. Diamond involved. Note that Osaka, Japan is reported to have 40 native photographers. Thomas Sutton on cameras, etc.]

ST1275 Ralston, W. R. S. "A Gipsies' Christmas Gathering." GOOD WORDS 9, no. 2 (Feb. 1868): 96-101. 7 illus. [7 portraits engraved "from photographs." Example of use of photographs in "physical anthropology."]

ST1276 Lawson, Henry, M.D. "Scientific Summary: Quarterly Retrospect: Photography." POPULAR SCIENCE REVIEW 7, no. 27 (Apr. 1868): 223-227. 1 illus. [London Photographic Society reported to be in a bad way financially. Philip Crellin's cartes-de-visite of prominent men praised. Chemical, technical matters.]

ST1277 Lawson, Henry, M.D. "Scientific Summary: Quarterly Retrospect: Photography." POPULAR SCIENCE REVIEW 7, no. 28 (July 1868): 334-337. [Photographing of the eclipse by Major Tennant, Capt. Brandreth and non-coms of the Royal Engineers planned. Chemical and technical matters. A Mr. McLachlan's discoveries downplayed.]

ST1278 Lawson, Henry, M.D. "Scientific Summary: Quarterly Retrospect: Photography." POPULAR SCIENCE REVIEW 7, no. 29 (Oct. 1868): 447-450. 1 illus. [Kinescope discussed. Technical matters.]

GREAT BRITAIN: 1869.
BOOKS
ST1279 Hamerton, Philip Gilbert. *Painting in France After the Decline of Classicism.* With 14 photographic illustrations. London: Seeley, Jackson & Halliday, 1869. x, 68 pp. 14 b & w.

PERIODICALS
ST1280 "Photographic Wonders." CHAMBERS'S JOURNAL 46, (1869): 585.

ST1281 Lawson, Henry, M.D. "Scientific Summary: Quarterly Retrospect: Photography." POPULAR SCIENCE REVIEW 8, no. 30 (Jan. 1869): 100-102. [Chemical and technical matters.]

ST1282 Wynter, Andrew. "Cartes de Visite." GOOD WORDS 10, no. 3 supplement (Mar. 1869): 57-64.

ST1283 Lawson, Henry, M.D. "Scientific Summary: Quarterly Retrospect: Photography." POPULAR SCIENCE REVIEW 8, no. 31 (Apr. 1869): 209-212. ["R. H. Bow, C.E. of Edinburgh recently applying the theodolite to ascertain...the truth of art as displayed in certain well known pictures..." Technical and chemical matters.]

ST1284 Lawson, Henry, M.D. "Scientific Summary: Quarterly Retrospect: Photography." POPULAR SCIENCE REVIEW 8, no. 32 (July 1869): 323-325. [Chemical matters.]

ST1285 "Note: Messrs. Dickinson of Bond Street have opened an exhibition of 700 photographs; illustrative of London Society in 1854-1855." ART JOURNAL (Aug. 1869): 259.

ST1286 Lawson, Henry, M.D. "Scientific Summary: Quarterly Retrospect: Photography." POPULAR SCIENCE REVIEW 8, no. 33 (Oct. 1869): 440. ["Owing to the pressure of our space,...the photographic summary is unavoidably 'crushed out' of the number."]

ST1287 Portrait. Woodcut engraving, credited "From a Photograph Furnished by E. & H. T. Anthony & Co." FRANK LESLIE'S ILLUSTRATED NEWSPAPER 29, (1869) ["The late Earl of Derby." 29:737 (Nov. 13, 1869): 144.]

GREAT BRITAIN: 1870.
BOOKS
ST1288 Duprez, Louis. *Duprez's Trip Up the Tamar;* Barbican Pier to the Weir Head, Illustrated with Photographs. Plymouth, Eng.: Smith & Perry, 1870 . 54 pp. 7 l. of plates. 7 b & w. 1 illus.

ST1289 Napier, Charles O. Groom, F.G.S., F.A.S.L. *The Book of Nature and the Book of Man, in which Man is Accepted as the Type of Creation - the Microcosm - the Great Pivot on which all Lower Forms of Life Turn,...* With a Preface by the Late Lord Brougham. Illustrated with Photographs and Numerous Woodcuts. London: John Camden Hotten, 1870. vi, 479 pp. 4 b & w. 130 illus. [Photos of birds, nests, shells, etc.]

ST1290 Scott, W. B., ed. *Gems of French Art; A Series of Carbon Photographs.* London: Routledge & Sons, 1870. n. p. b & w.

PERIODICALS
ST1291 Lawson, Henry, M.D. "Scientific Summary: Quarterly Retrospect: Photography." POPULAR SCIENCE REVIEW 9, no. 34 (Jan. 1870): 102-104. [Artificial light for enlargements; eclipse of the sun photographed; F. Maxwell Lyte's alkaline dry process; portable camera for dry plates invented by Walter Cook.]

ST1292 Simpson, G. Wharton, M.A., F.S.A. "Notes In and Out of the Studio." PHILADELPHIA PHOTOGRAPHER 7, no. 73-84 (Jan. - Dec. 1870): 20-22,59-62, 85-88, 122-126, 165-168, 210-212, 264-266, 301-303, 318-322, 359-363, 389-392, 416-418. [(Jan.) Valentine Blanchard's Studio is gutted by fire. London Photo Society Exhibition, Idealism in Portraiture. Rejlander.]

ST1293 Lawson, Henry, M.D. "Scientific Summary: Quarterly Retrospect: Photography." POPULAR SCIENCE REVIEW 9, no. 35 (Apr. 1870): 215-217. ["The Possibility of obtaining Heliochromes." C. Piazzi Smyth's lecture, "A Poor Man's Photography," published. Photo-engraving. Colonel Stuart Wortley's "moonlight photographs" discussed, the technique described.]

ST1294 Portrait. Woodcut engraving, credited "From a photograph." ILLUSTRATED LONDON NEWS 56, (1870) ["Charles Dickens." 56:* (June 18, 1870): 629.]

ST1295 Lawson, Henry, M.D. "Scientific Summary: Quarterly Retrospect: Photography." POPULAR SCIENCE REVIEW 9, no. 36 (July 1870): 326-327. [Combination printing. "The Illustrated Photographer" which began in 1869 failed. Niepce de St. Victor died on April 7. Chemical matters.]

ST1296 "Military Photography." ANTHONY'S PHOTOGRAPHIC BULLETIN 1, no. 10 (Nov. 1870): 191-193. [From "Br J. of Photo." Discusses the Photographic Establishment at Woolwich, a military school of photography at Chatham, a photolithographic department at Southampton (map-making), etc.]

ST1297 "Notes on a Visit to Liverpool." ANTHONY'S PHOTOGRAPHIC BULLETIN 1, no. 11 (Dec. 1870): 213-217. [From "Br J. of Photo." Atkinson; Daniel Jones; Messrs. Chance; Helsby; Vandyke & Brown, etc. mentioned.]

GREAT BRITAIN: 1871.
BOOKS
ST1298 Box, John, editor. *Chronicals of the Castle of Amerloy, with numerous Photographs.* London: Sampson Low, Son & Marston, 1871. n. p. 26 b & w. [Original photographs, tipped-in. Views of the exterior and interior of the castle, facsimiles of handwriting, copies of paintings, etc.]

ST1299 Turner, Godfrey Wordsworth. *Homely Scenes from Great Painters, by Godfrey Wordsworth Turner, with 24 full-page Photographs by the Woodbury process.* London: Cassell, Petter & Galpin, 1871. 126 pp. 24 l. of plates. 24 b & w. [Woodburytypes of Turner's engravings.]

ST1300 Wright, W. H. K. *Duprez's Visitors' Guide to Mount Edgcombe; Descriptive and Historical Sketch by W. H. K. Wright,* Illustrated with Photographs. Plymouth, Eng.: Cove Brothers, 1871. 47 pp. 6 l. of plates. 6 b & w. illus.

PERIODICALS
ST1301 Croughton, George. "A Few Words on Photographic Exhibitions." BRITISH JOURNAL PHOTOGRAPHIC ALMANAC 1871 (1871): 137-138.

ST1302 Croughton, George. "Photography as an Aid to the Artist." ANTHONY'S PHOTOGRAPHIC BULLETIN 2, no. 1 (Jan. 1871): 5-9. [From "London Photographic News." Discusses how artists use photography; cites Mr. Piercy, who uses photography as a ground for his drawings; other instances and values of the medium.]

ST1303 Portraits. Woodcut engravings credited "From a photograph." ILLUSTRATED LONDON NEWS 58, (1871) ["The Late George Wilson." 58:1633 (Jan. 21, 1871): 73.]

ST1304 "Applications of Photography." EDINBURGH REVIEW 130, (Apr. 1871): 338-358.

ST1305 Lawson, Henry, M.D. "Scientific Summary: Quarterly Retrospect: Photography." POPULAR SCIENCE REVIEW 10, no. 39 (Apr. 1871): 220-222. [Brief note of death of Rev. J. B. Reade, F.R.S., on December 12, 1870. Chemical matters.]

ST1306 "Sitting for One's Photograph." ANTHONY'S PHOTOGRAPHIC BULLETIN 2, no. 5 (May 1871): 137-139. [From "Br J of Photo.," again from "The Graphic."]

ST1307 Badeau, W. H. "From Across the Water." ANTHONY'S PHOTOGRAPHIC BULLETIN 2, no. 5 (May 1871): 151-152. [Describes activities in England, particularly Liverpool.]

ST1308 "Viator." [Badeau?] "From Across The Water - No. 1. From Across The Water - No. 2." ANTHONY'S PHOTOGRAPHIC BULLETIN 2, no. 6, 9-12 (June, Sept. - Dec. 1871): 180-184, 293-294, 334-335, 397. [(June) F. M. Good; William England;

Robinson & Cherrill; F. C. Earle; Simpson; Blanchard; Capt. Lyon (of India); others mentioned. (Sept.) Elliott & Fry, William England, others mentioned. (Oct.) London Stereo Co. releasing series on the International Exhibition, from negatives by William England; copyright in Great Britian, etc. (Nov.) British Assoc. of Amateur Photographers; active participation of women amateurs, etc. (Dec.) Visit to Paris, describes events there after the war and commune. Mentions de Milly, Dagron, Reutlinger, etc.]

ST1309 "New Application of Photography." ANTHONY'S PHOTOGRAPHIC BULLETIN 2, no. 10 (Oct. 1871): 314-315. [From "Br. J. of Photo." Photographic enamelled finger plates for doors, etc.]

ST1310 "Compressed Literature." ANTHONY'S PHOTOGRAPHIC BULLETIN 2, no. 10 (Oct. 1871): 320. [From the "Br. J. of Photo." Discussion about microreduction for newspapers, books, etc.]

ST1311 "Photographic Immorality." ANTHONY'S PHOTOGRAPHIC BULLETIN 2, no. 12 (Dec. 1871): 374-375. [From "Br. J. of Photo." About fading in prints, carbon printing processes, etc.]

ST1312 "The French Photographer and the Queen." ANTHONY'S PHOTOGRAPHIC BULLETIN 2, no. 12 (Dec. 1871): 391-392. [From "Br. J. of Photo.," in turn from "Pall Mall Gazette." Story, possibly apocryphal, of a comic confrontation between Queen Victoria and a French photographer.]

GREAT BRITAIN: 1872.
BOOKS
ST1313 Audsley, George Ashdown. *Catalogue Raisonné of the Oriental Exhibition of the Liverpool Art Club:* Held in the Club Rooms, No. 4, Sandon Terrace, Upper Duke Street, December 1872, Edited by George Ashdown Audsley. Liverpool: Liverpool Art Club, 1872. 163 pp. 36 l. of plates. [Original photographs, tipped-in.]

ST1314 Biddle, Clement. *Airdrie, and Other Fugitive Pieces.* s. l. : s. n., 1872. n. p. b & w.

ST1315 Knowles, Edward Hadarezer. *The Castle of Kenilworth; A Handbook for Visitors.* Warwick: H. T. Cooke & Son, 1872. 240 pp. 23 b & w. illus. [Twenty-three original photos; three plans.]

ST1316 Morgan, Octavius. *Some Account of the Ancient Monuments in the Priory Church, Abergavenny.* Newport, England.: Monmouthshire & Carleon Antiquarian Assn., 1872. 87 pp. 13 l. of plates. 13 b & w. [Original photos, of altar tombs.]

PERIODICALS
ST1317 Simpson, G. Wharton. "Notes In and Out of the Studio." PHILADELPHIA PHOTOGRAPHER 9, no. 97-108 (Jan. - Dec. 1872): 19-21, 59-61, 90-92, 118-120, 147-148, 234-236, 266-268, 274-277, 331-332, 363-365, 389-392.

ST1318 Badeau, W. H. "From Across the Water." ANTHONY'S PHOTOGRAPHIC BULLETIN 3, no. 1-12 (Jan. - Dec. 1872): 428-429, 457-459, 497-498, 526, 558-560, 578, 601, 641-642, 673-674, 707, 754, 783-784. [(Jan.) Opening of the anniversary exhibition of the London Photo. Soc.; Robinson & Cherrill; Frank M. Good; F. C. Earle; Blanchard, Rejlander, others mentioned. J. W. Black of Boston showed "The First Snow," which was, with the exception of a portrait of Abraham Bogardus, the only American print in the exhibition. (Feb.) Amateur Photo. Assoc. (London). (Mar.) George Hare's revolving stereoscope. (Apr.) Huge market for cartes-de-visite. (May) Author to Berlin for the Berlin Soc. of Photo. Winterfest. (Jun.) In Leipzig. (Jul.) More about photo. in Germany and Austria.

Comments on G. Wharton Simpson's articles on "Photo. As Art" in "Photo. News." (Aug.) Forthcoming International Exhibition in Vienna asking 30,000 gulden for rights of photographic coverage, etc.; Berlin galleries described, Ernst Milster; Loescher & Petsch. (Sept.) Back in London. Mentions Mayall; W. & D. Downing; Sarony & Co.; Lock & Whitfield; Thomas Edge; O. E. L. Dickinson; G. & R. Lewis; Wm. England; Mansell & Co. (Oct.) London news, R. T. Crawshay offering prizes, Estabrook, of NY, opened his studio. (Nov.) Carbon prints, photographic publishing, etc. (Dec.) T. W. Banks (Little Rock, AR) traveled to London, Europe, praised by author. Sarony; T. Jones Barker; W. & D. Downey; C. R. Pottinger; others mentioned.]

ST1319 "Sitting for a Photograph." PHOTOGRAPHER'S FRIEND 2, no. 1 (Jan. 1872): 24-27. [From "Br J of Photo."]

ST1320 "The Combination Printing-Frame Suit" and "Photography in Court." ANTHONY'S PHOTOGRAPHIC BULLETIN 3, no. 3 (Mar. 1872): 479-480, 482. [From "London Photo. News." B. J. Edwards suing Col. Stuart Wortley from infringing on his printing-frame patent. A further letter from J. T. Taylor on this issue published from "Br. J. of Photo." on p. 482.]

ST1321 "The Education of Photographers." ANTHONY'S PHOTOGRAPHIC BULLETIN 3, no. 4 (Apr. 1872): 503-504. [From "Photo. News." Commentary on lack of system for the proper education of photographers.]

ST1322 "Photographic Society of London. Report of the Council." ANTHONY'S PHOTOGRAPHIC BULLETIN 3, no. 5 (May 1872): 545-546. [From "London Photo. News." General survey of activities in Great Britain during the year.]

ST1323 "Photography and Physical Science." ANTHONY'S PHOTOGRAPHIC BULLETIN 3, no. 7 (July 1872): 607-608. [From "London Photo. News." Rev. Canon Kingsley, Artillery Institute (Woolwich) recommends to "young officers" to learn photography and photograph geological, botanical features of areas they were in...]

ST1324 "British Museum Photography." ANTHONY'S PHOTOGRAPHIC BULLETIN 3, no. 10 (Oct. 1872): 698-701. [From "London Photo. News." British Museum now offering study sets of photographs of nearly 1000 of its objects. 7 parts, each under its curatorial specialist, with a general introduction by Charles Harrison.]

ST1325 "Mr. Crawhay's Prizes for Large Photographs." ANTHONY'S PHOTOGRAPHIC BULLETIN 3, no. 11 (Nov. 1872): 731-732. [From "London Photo. News."]

ST1326 "Destroying a Photographer's Specimen." ANTHONY'S PHOTOGRAPHIC BULLETIN 3, no. 12 (Dec. 1872): 781. [From "London Photo. News." Sitter forcibly removed his portrait from a photographer's display in England. Photograph was Frank Simpson, with a "traveling van."]

GREAT BRITAIN: 1873.
BOOKS
ST1327 My Lady's Cabinet; Decorated with Drawings and Miniatures. London: Sampson Low, Marston, Low & Searle, 1873. 2 l. 24 l. of plates. 24 b & w. [Carbon prints, reproductions of works of art.]

ST1328 Jeboult, Edward. A General Account of West Somerset: Description of the Valley of the Tone, and the History of the Town of Taunton. Taunton: Somerset & Bristol Steam-Press, 1873. n. p. 14 l.

of plates. b & w. [Photomechanical prints. Each plate has smaller photo of typographic views set in, so 6 to 16 views per plate.]

ST1329 [Light, Bianca.] Our American Cousins at Home. By Vera. [Bianca Light]. Illustrated with pen-and-ink sketches by the author, and photographs. London: Sampson Low, Marston, Low & Searle, 1873. ix, 267 pp. 10 l. of plates. b & w. illus. [Original photos.]

ST1330 Mann, H. J. A History of Gibraltar and its Sieges. "2nd ed." London: Provost & Co., 1873. vi, 280 pp. 16 b & w.

ST1331 Page, Mary Ann Reynolds. Memoir of Mrs Mary Reynolds Page. Edited by A. G. Pease. Cambridge, MA: Riverside Press, 1873. vi, 183 pp. 11 l. of plates. 11 b & w. [Journal of Mrs. Page's stay in Sandown, Isle of Wright and Nice, France in 1871-1872. Original photos, tipped-in. Portrait, horses, views. Photos could have been taken by the author, or associates.]

ST1332 Wright, Archdeacon H. P. The Story of the "Domus Dei" of Portsmouth. London: James Parker & Co., 1873. 221 pp. 9 b & w. 16 illus. [Original photos, woodcuts and line engravings.]

PERIODICALS
ST1333 Badeau, W. H. "From Across the Water." ANTHONY'S PHOTOGRAPHIC BULLETIN 4, no. 1-5, 11-12 (Jan. - May, Nov. - Dec. 1873): 27-28, 57-59, 90-92, 124-125, 155-156, 334-335, 368-371. [(Mar.) Mentions the great strike of 60,000 colliers and miners affecting the "great iron king," R. F. Crawshay, an amateur photographer, excerpts from an article "Enlarged Landscape Autotypes," from the "London Times," A. Braun, Sarony, Vander Weyde, etc. (Apr.) Preparations for forthcoming transit of Venus expeditions. (May) Discusses the Photographer's Provident and Benevolent Assoc., "spirit photographs" issued by the Stereoscopic Co.; further preparations for transit of Venus studies, book of mug-shots established by the Keeper of the Criminal Register in Scotland. (Nov.) General commentary on effect of societies and magazines on education of photographers, views about events occurring in London. (Dec.) Discusses the Photographic Society of Great Britain annual exhibition and the Technical Exhibition of the South London Photographic Society. Reviews the PS exhibition, mentions among others, the work of W. G. Starke (Zanesville, OH).]

ST1334 "Imperilled by a Photograph." ANTHONY'S PHOTOGRAPHIC BULLETIN 4, no. 2 (Feb. 1873): 42-44. [From "Chambers Journal" as excerpted in the "Photographic News." Story about an Englishman named Jones visiting Paris who was thought to be a communist because he had a beard. The issue has something to do with a passport photograph in Paris.]

ST1335 Hughes, Jabez. "Photography as an Industrial Occupation for Women." ANTHONY'S PHOTOGRAPHIC BULLETIN 4, no. 6 (June 1873): 162-166. [From "Victoria Magazine."]

ST1336 "On Photographic Patents." ANTHONY'S PHOTOGRAPHIC BULLETIN 4, no. 6 (June 1873): 173-175.

ST1337 Nichol, John, Ph.D. "Notes from the North." ANTHONY'S PHOTOGRAPHIC BULLETIN 4, no. 7 (July 1873): 199-201. [From "Br J. of Photo." Much of the article is about several explosions during public lantern-slide lectures taking place in Scotland.]

GREAT BRITAIN: 1874.
BOOKS
ST1338 Aitken, Cora Kennedy. *Legends and Memories of Scotland.* London: Hodder & Stoughton, 1874. x, 155 pp. 4 l. of plates. 4 b & w. [Poems, illustrated with original photographs.]

ST1339 Heaton, Mary [Mrs. Charles]. *Albert Durer of Nurnberg. The History of His Life, with a Translation of his Letters and Journal, and some account of his Works.* London: Macmillan & Co., 1874 ? n. p. illus. ["With upwards of 30 lithographs, autotypes and woodcuts."]

ST1340 Heaton, Mary [Mrs. Charles.] *Leonardo Da Vinci and His Works; Consisting of a Life of Leonardo Da Vinci;* by Mrs. Charles Heaton,...an Essay on his Scientific and Literary Works, by Charles Christopher Black, M. A., and an Account of His Most important Paintings and Drawings. Illustrated with 20 Permanent Photographs. London, New York: Macmillan & Co., 1874. 302 pp. 20 b & w. ["Illustrations printed by the Woodbury Permanent process."]

ST1341 Ker, David. *On the Road to Khiva,* by David Ker, late Khivan correspondent of the 'Daily Telegraph.' Illustrated with Photographs of the Country and its Inhabitants, and an...official map...London: Henry S. King & Co., 1874. n. p. 7 b & w. [Woodburytype prints. Landscapes, views etc.]

ST1342 Passavant, J. D. *Raphael of Urbino, and His Father Giovanni Santi.* London: Macmillan & Co., c. 1874. n. p. 20 b & w. ["Illustrated by 20 permanent photographs."]

ST1343 Piercy, F. *A Crucial Test Case of Disputed Identity: The Features of Arthur Orton and Roger Tichborne compared.* London: F. Piercy, Memorial Painter, Studio, 12 Pall Mall, 1874. 8 pp. 5 l. of plates. [Pamphlet attempts to show, by comparing the daguerreotype of the missing Roger Tichborne with portraits of Mr. Orton, a claimant to the fortune, that they could not be the same person.]

ST1344 Saxby, Jessie, M.E. *Glamour from Argyllshire.* Inverary: John Rodger, 1874. 54 pp. 8 l. of plates. 8 b & w. [Poems. Original photos, landscape views. Not necessarily topographic, may be by author or an associate.]

PERIODICALS
ST1345 Badeau, Wm. H. "From Across the Water." ANTHONY'S PHOTOGRAPHIC BULLETIN 5, no. 1-12 (Jan. - Dec. 1874): 23-27, 95-97, 130-132, 191-193, 223-225, 256-259, 289-291, 322-324, 385-388, 414-417. [(Jan.) Vienna Exhibition; Technical Exhibition of Great Britain; Art in photography; copyright (Frith vs. the Autotype Co.); British government in photo.; photographing criminals; Austrian photographers honored; Crawshay's prize; etc. (Feb.) Winter doldrums; Autotype Co.; Slosson, from Bogardus's gallery (New York, NY) visiting. Mrs. Cameron gave exhibition of almost 1000 photos at No. 9, Conduit St. (Mar.) Enamels; Henderson; Solomon; Watson (Hull); Mayall; etc. (May) Extensive review of the art education system available to photographers in Britain in 1874 - schools, institutions, museums, etc. (June) London International Exhibition; Berlin Photographic Co.; Vienna Photographic Society. (July) Kurtz; the Transit of Venus Exhibitions; extended paper on "Photography at the World's Exhibition at Vienna, 1873," by Oscar Kramer. (Aug.) Visit to Berlin. Petsch retired, replaced by Hartman; Schaarwaecher; Grasshoff; Luckhardt; Vogel. (Sept.) Dresden. Hermann Krone; Dresden Photo. Soc.; E & O. Brockmann; Hanns Hanfstaengel; etc. (Oct.) Photographic paper manufacture. (Nov.) Discussion of publishers of fine art reproductions. (Dec.) Photo. Soc. Exhibition review.]

ST1346 "Photographic Bas-Relief." ANTHONY'S PHOTOGRAPHIC BULLETIN 5, no. 4 (Apr. 1874): 146.

ST1347 "Mercantile Photography." ANTHONY'S PHOTOGRAPHIC BULLETIN 5, no. 4 (Apr. 1874): 150. [Photographs made of hardware and cutlery, used by salesmen.]

ST1348 "A Few Words About Valuations Interesting to Partners in Photographic Firms." ANTHONY'S PHOTOGRAPHIC BULLETIN 5, no. 6 (June 1874): 199-200. [Text of judge's opinions on this matter.]

ST1349 "Photographic Galleries in Churchyards." ANTHONY'S PHOTOGRAPHIC BULLETIN 5, no. 8 (Aug. 1874): 267. [From "London Daily News." Cartes-de-visite attached to tombstones at Shrewsbury, England.]

ST1350 "Fires at Photographic Establishments." ANTHONY'S PHOTOGRAPHIC BULLETIN 5, no. 11 (Nov. 1874): 373-374. [From "Br. J. of Photo."]

ST1351 Wilson, Edward L. "Views Abroad and Across. Pt. 12." PHILADELPHIA PHOTOGRAPHER 11, no. 132 (Dec. 1874): 355-363. [Wilson visited many studios in extended visit to Europe. In London mentions Robinson, Woodbury, Frank M. Good, Mansell & Co. (Egyptian and eastern views), V. Blanchard.]

ST1352 "A Provincial Photographer." "Technical Education for Photographers." ANTHONY'S PHOTOGRAPHIC BULLETIN 5, no. 7 (July 1874): 232-233. [From "Br. J. of Photo."]

GREAT BRITAIN: 1875.
BOOKS
ST1353 Black, Charles Christopher. *Michael Angelo Buonarotti: Sculptor, Painter, Architect.* London: Macmillan, 1875. xvi, 264 pp. 19 b & w. [Nineteen Woodburytype illustrations of Michelangelo's sculpture, etc. Photographer not named, both A. Braun and Alinari Brothers listed in advertisements at end of book.]

ST1354 Harris, Vernon, Capt. *Dartmoor Prison, Past and Present.* Plymouth: William Brendon & Son, 1875. n. p. 6 b & w. [Albumen prints.]

ST1355 Laird, Egerton K. *Rambles of a Globe Trotter; Through America, South Seas, Australia, India, China, Japan, etc.* London: Chapman & Hall, 1875. 2 vol. vol 1 325 pp., vol. 2 360 pp. 40 b & w. [Woodburytype prints. While presented here with consistent frames, etc. I suspect that these are topographic views acquired from the native photographers of each country, then edited by the publisher.]

PERIODICALS
ST1356 Badeau, W. H. "From Across the Water." ANTHONY'S PHOTOGRAPHIC BULLETIN 6, no. 1-5 (Jan. - May 1875): 29-31, 59-61, 93-95, 122-127, 156-158. [(Jan.) General commentary on events of 1874. (Feb.) Winter. Vogue in Christmas Cards increasing (over past two years.) Stereoscopic viewings at entertainments, etc. G. W. Wilson's landscapes, etc. (Mar.) S. London Photo. Assoc.; Photographers' Benevolent Assoc.; G. W. Wilson; F. York's slides at Transit of Venus; other matters; list of deceased. (Apr.) Tribute to Rejlander, Tennyson's "Idylls of the King" with Cameron's illus. reviewed; Woodburytype discussed, Caldesi mentioned, Valentine Blanchard, Marion & Co. stockdealers, etc. (May)Stereoscopic Co., lantern pictures popular, Friedrich (Prague); Frith's landscapes, exhibitions, Th. Sutton died, etc.]

ST1357 "Photography Abroad: Photographs on Glass." PHOTOGRAPHIC TIMES 5, no. 49 (Jan. 1875): 14-15. [Excerpted from "Photographic News." About glass slides and the stereo stand. Writer discusses how these glass stereo views bring all the distant places into his living room.]

ST1358 A. P. C. "Our London Correspondence." PHOTOGRAPHIC TIMES 5, no. 51-58 (Mar. - Oct. 1875): 51-53, 74-76, 98-99, 125-128, 172-174, 194-197, 210-212, 234-236. [(Mar.) Not much studio work due to weather, discussion over lenses, equipment, patents, etc. Discusses possibility that Mr. Bingham was a co-inventor of the Collodion process, credited to F. Scott Archer. (Apr.) Discusses large number of amateurs in Britain; discusses the Amateur Field Club, South London Photographic Society, Amateur Photographic Society of London. (May) Argues that a process recommended by Prof. Vogel long superseded and rejected in Great Britain. (June) Discusses cameras, etc. Mr. Hare, Mr. W. J. Stillman mentioned. (A death in his family and his own illness interrupted his experiments). Death of Thomas Sutton discussed. (July) Mentions Newton's, Stillman's and Carey Lea's emulsion processes. Describes his own technique for making collodion. (Aug.) Discusses the dry-plate's use by amateurs in England. Carey Lea, Mr. Gordon, a member of the Field Club, uses dry-plates, etc. Mostly chemical discussions. (Sept.) Same. (Oct.) Mostly technical arguments over Mr. Newton's formula.]

ST1359 "Engineering Problems Solved by Photography." ANTHONY'S PHOTOGRAPHIC BULLETIN 6, no. 3 (Mar. 1875): 78-79. [From "London Photo. News." Photographs of a difficult engineering feat were taken, then used to explain details of the operation for others wishing to achieve similar effects.]

ST1360 "Painters and Photography." ANTHONY'S PHOTOGRAPHIC BULLETIN 6, no. 4 (Apr. 1875): 11. [From "Br. J. of Photo." Portrait painters use photographs to work from, etc.]

ST1361 "The Arctic Expedition Officers." ILLUSTRATED LONDON NEWS 66, no. 1868 - 1869 (May 29 - June 5, 1875): 500, 504-506, 528-530. 17 illus. [Capt. Nares and Capt. Stephenson, of the "Alert" and the "Discovery" on a voyage to the Arctic, other officers. Nares' portrait by J. Griffin & Co., (Portsmouth and London); Stephenson's portrait by Jackson and Co., (Southsea); Commander Albert Markham's portrait by Elliott and Fry, Sub-Lieut. G. L. Egerton and Lieut. G. A. Giffard by Elliott & Fry; Rev. Charles Hodson's portrait by Elliott & Fry; Lieut. R. B. Fulford's portrait by Elliott & Fry; Lieut. Wm. H. May's portrait by VanDyke & Brown; Lieut. Wyatt Rawson's portrait by Maull & Co.; Lieut. R. H. Archer's portrait by Maull & Co. Three sketches. This party will have a photographer along - not named here.]

ST1362 "Fresh Fields for Photographic Enterprise." ANTHONY'S PHOTOGRAPHIC BULLETIN 6, no. 8 (Aug. 1875): 236-237. [From "Br J of Photo." Advocating that commercial interests use photography more - promoting what we would now call advertising, commercial and industrial photography.]

ST1363 "Photography and Military Equipments." ANTHONY'S PHOTOGRAPHIC BULLETIN 6, no. 8 (Aug. 1875): 240. [From "London Photographic News." Photos taken of the proper uniform, proper stance of soldiers, then distributed to officers for their use to shape the mode of the deportment of their troops.]

ST1364 "Photography In and Out of the Studio: The Summer and Out-door Photography." ANTHONY'S PHOTOGRAPHIC BULLETIN 6, no. 9 (Sept. 1875): 269-270. [From "London Photographic News."]

ST1365 "Scotticus." "Spirit Photography" ANTHONY'S PHOTOGRAPHIC BULLETIN 6, no. 9 (Sept. 1875): 271-272. [From the "Br J of Photo." Letter about recent articles on spirit photography, scoffing.]

ST1366 "Why The Lady Fainted." ANTHONY'S PHOTOGRAPHIC BULLETIN 6, no. 9 (Sept. 1875): 282. [From "London Photographic News." Woman fainted from holding her breath during preparations for photograph.]

ST1367 "The Arctic Expedition: Greenlanders at Godhaven, Disco Island - English Sailors with the Greenland Girls." ILLUSTRATED LONDON NEWS 67, no. 1884 (Sept. 18, 1875): 277, 283, 284. 2 illus. ["Our present illustrations are from the photographs taken by the photographers of the Arctic Expedition." Weekly reports of this expedition appeared during this period - with many illustrations from sketches and some from photographs. However they were not always credited to source.]

ST1368 "Unmounted Photographs in Commerce." ANTHONY'S PHOTOGRAPHIC BULLETIN 6, no. 10 (Oct. 1875): 292-293. [Growth of sale of unmounted prints to tourists for their albums, etc.]

ST1369 "The Balaclava Banquet." ILLUSTRATED LONDON NEWS 67, no. 1890 (Oct. 30, 1875): 421, 428, 438-439, 442-443. 29 illus. [15 portraits of survivors of the Crimean War.]

ST1370 "News of the Arctic Expedition: Supplement: Arctic Sketches from the 'Pandora.' - Photographing the Wall of Ice in Peel Sound, 72 Deg. 30 Min., N. Lat." ILLUSTRATED LONDON NEWS 67, no. 1890 (Oct. 30, 1875): 433, 434, 436-437, 440-441, 444, 445. 11 illus. ["Sketches are by Mr. de Wilde, aboard the Pandora." One view, on p. 445, shows a photographer at work. Some images seem to have been "assisted" by photographs, others are clearly sketched.]

ST1371 Howard, F. "On the Desirability of Forming Associations of Amateur Photographers." BRITISH JOURNAL PHOTOGRAPHIC ALMANAC 1876 (1876): 130-131.

ST1372 "The Prince of Wales, with the King and Queen of Greece, Being Photographed at Athens." ILLUSTRATED LONDON NEWS 67, no. 1891 (Nov. 6, 1875): 465. 1 illus. [Scene of the group being photographed in a studio.]

GREAT BRITAIN: 1876.
BOOKS
ST1373 Hine, Thomas Chambers. *Nottingham, Its Castle; a Military Fortress, a Royal Palace, a Ducal Mansion, a Blackened Ruin, a Museum and Gallery of Art. With Notes Relating to the Borough of Nottingham,...* London: Hamilton, Adams & Co., 1876. 4 pp. 59 l. of plates. b & w. [Original photographs.]

ST1374 Renwar. *Illustrated Guide for Tourists in Search of Recreation, Health and Information, to the Various Watering Places and Manufacturing Towns in England and the Continent.* "3rd ed." London: Hackett & Rawlinson, 1876-77. viii, 246, 109 pp. 4 l. of plates. 4 b & w. illus.

PERIODICALS
ST1375 Nicol, J. "The Progressive Results of the Last Season." ANTHONY'S PHOTOGRAPHIC BULLETIN 7, no. 3 (Mar. 1876): 76-77. [From "Photo. News."]

ST1376 "Movable Dark Rooms." ANTHONY'S PHOTOGRAPHIC BULLETIN 7, no. 6 (June 1876): 181-182. [From "London Photo.

News." Describes various portable dark rooms rigged up by photographers, including an old prison ran for transporting convicts, now employed at the Woolrich Photographic Establishment.]

ST1377 "Photography at the Patent Office." ANTHONY'S PHOTOGRAPHIC BULLETIN 7, no. 6 (June 1876): 184. [Col. Stuart Wortley, Curator of the Patent Museum, Patent Office, G. B.]

ST1378 "Should Photographers Prepare Their Own Materials?" ANTHONY'S PHOTOGRAPHIC BULLETIN 7, no. 7 (July 1876): 198-201. [From "Br. J. of Photo."]

ST1379 "Instantaneous Photography." ANTHONY'S PHOTOGRAPHIC BULLETIN 7, no. 8 (Aug. 1876): 225-227. [From "Br. J. of Photo." Ross (Edinburgh) mentioned.]

ST1380 Aldridge, R. W. "Obstacles to Photographic Progress." ANTHONY'S PHOTOGRAPHIC BULLETIN 7, no. 8 (Aug. 1876): 230-231. [From "Br. J. of Photo."]

ST1381 L. D. "Odic Force or What?" ANTHONY'S PHOTOGRAPHIC BULLETIN 7, no. 9 (Sept. 1876): 262-265. [From "Br. J. of Photo." Narrative story, possibly fictional, about mysterious events, psychic phenomena around some photos.]

ST1382 "Faulty Photography." ANTHONY'S PHOTOGRAPHIC BULLETIN 7, no. 9 (Sept. 1876): 277-278. [From "London Photo. News." Experience with an inept commercial photographer described.]

ST1383 "Ornamental Entourage to Portraits." ANTHONY'S PHOTOGRAPHIC BULLETIN 7, no. 9 (Sept. 1876): 283-284. [From "London Photo. News."]

ST1384 "News of the Arctic Expedition." ILLUSTRATED LONDON NEWS 69, no. 1945 (Nov. 4, 1876): 442-443, 444-445, 448. 5 illus.

ST1385 "The North Pole Expedition." ILLUSTRATED LONDON NEWS 69, no. 1946 (Nov. 11, 1876): 449, 452-453, 456-457, 460-461, 465, 466-470. 20 illus. [Illustrations "...were supplied by the photographs taken on board the two ships, "H.M.S. Alert" and "H.M.S. Discovery."]

GREAT BRITAIN: 1877.
BOOKS
ST1386 Harrison, W. J., F.G.S. *A Sketch of the Geology of Leicestershire and Rutland.* Sheffield, Eng.: William White, 1877. 67 pp. 12 b & w. [Original photos. Reprinted from "White's History, Gazetteer and Directory of the Counties." The author probably is William Jerome Harrison, an important individual in photography during the latter half of the 19th century. However, these photographs were probably taken by someone else. Harrison himself did not begin to take photographs until 1881.]

ST1387 Sayre, Lewis Albert. *Spinal Disease and Spinal Curvature: Their Treatment by Suspension and the Use of the Plaster of Paris Bandage.* London; Philadelphia: Smith, Elder & Co.; Lippincott, 1877. xii, 124 pp. 21 b & w. [Twenty-one albumen photographs.]

PERIODICALS
ST1388 "Photographic Painting." PRACTICAL MAGAZINE 7, (1877): 271.

ST1389 "The Photographic Records Brought Home By the Arctic Expedition." ANTHONY'S PHOTOGRAPHIC BULLETIN 8, no. 1 (Jan. 1877): 2-3. [From "London Photo. News." Capt. Nare's two-year expedition to the North Pole from England. Capt. Abney and Baden Pritchard trained members of the expedition. Lieut. Chermside, R. E. took photos within the Arctic Circle. (May not have been the same expedition, however.)]

ST1390 "Things Well Said." PHOTOGRAPHIC TIMES 7, no. 77 (May 1877): 108-109. [From "Br J. of Photo Almanac." Excerpted quotes by Vernon Heath, Jabez and Alfred Hughs, F. York.]

ST1391 Nichol, John, Ph.D. "Notes from the North." ANTHONY'S PHOTOGRAPHIC BULLETIN 8, no. 6 (June 1877): 167-169. [From "Br. J. of Photo." Nichol describes his visit to Aberdeen, Scotland. Mentions Mr. Thompson and an unnamed photographer who had only one arm and one leg. (This may be Thompson -it's unclear.) Mentions also Mr. Gray of Fraserburgh, and Truefit of Edinburgh.]

ST1392 "Photography and the Healing Art." ANTHONY'S PHOTOGRAPHIC BULLETIN 8, no. 7 (July 1877): 203-204. [From "London Photo. News."]

ST1393 "Things Well Said." PHOTOGRAPHIC TIMES 7, no. 79 (July 1877): 155. [Excerpt of quotes by John McAndrew, William White, Reuben Mitchell.]

ST1394 "Illustrations of Lace Manufacture." ANTHONY'S PHOTOGRAPHIC BULLETIN 8, no. 8 (Aug. 1877): 254. [From "London Photo. News." Lacemakers found that photographs of lace samples were very helpful for the many women who each made pieces of lace. Then photographically illustrated lace books began to be produced in France, Germany, Great Britain, etc. "La dentelle, histoire, description, fabrication, bibliographie" in Paris. "Spitzen Album" in Vienna. "Ancient Needle-point and Pillow-lace" in London.]

ST1395 "Hot and Cold Dark Rooms." ANTHONY'S PHOTOGRAPHIC BULLETIN 8, no. 8 (Aug. 1877): 255. [From "London Photo. News." Describes difficulties encountered with wet-collodion processes in hot weather, etc.]

ST1396 "Studio Routine - Printer's Room." ANTHONY'S PHOTOGRAPHIC BULLETIN 8, no. 9 (Sept. 1877): 267-269. [From "Br. J. of Photo." Advice on management issues.]

ST1397 "The British Association for the Advancement of Science." ANTHONY'S PHOTOGRAPHIC BULLETIN 8, no. 9 (Sept. 1877): 274-276. [From "London Photo. News." 47th annual meeting of the Association draws forth comment that, in general, the Association has turned away from the close interest in photography that it held in the 1840s - '50s. Then discusses the work of Francis Galton, in Anthropology, who is using photography in an attempt to classify criminal types.]

ST1398 "Photography in Court." ANTHONY'S PHOTOGRAPHIC BULLETIN 8, no. 9 (Sept. 1877): 284-285. [From "Br. J. of Photo." Crookenden vs. Hawke, Crookenden, the photographer, won suite against a client. Louis vs. The London and Northwestern Railway Co. Louis, landscape photographer had equipment damaged.]

GREAT BRITAIN: 1878.
BOOKS
ST1399 *Picture Gallery of Modern Art,* containing 24 permanent Photographs from original Paintings, with biographical Notices of the artists. London: Longmans, Green & Co., 1878. n. p. 24 b & w.

ST1400 Moore, James J. *The Historical Handbook and Guide to Oxford: Embracing a Succinct History of the University and City from the Year 912...* "2nd ed., rev. and enl." Oxford: T. Shrimpton & Son, 1878. viii, 296 pp. 12 b & w. [Original photos; topographic views from unidentified local commercial photographer.]

PERIODICALS
ST1401 "War Preparations and Photography." ANTHONY'S PHOTOGRAPHIC BULLETIN 9, no. 5 (May 1878): 136. [From "London Photo. News." Describes the British Army's photographic arrangements.]

ST1402 "Popular Estimate of a Photographer's Abilities." ANTHONY'S PHOTOGRAPHIC BULLETIN 9, no. 7 (July 1878): 193. [From "London Photographic News." Anecdote about a landscape painters feeling that it would be easy for anyone to take photos.]

ST1403 "A Physiological Hint To Photographers." ANTHONY'S PHOTOGRAPHIC BULLETIN 9, no. 9 (Sept. 1878): 268-269. [From "Br J of Photo," in turn from "Lancet." Suggestions on how to relieve tension and eye strain during long exposures necessary for portrait.]

ST1404 Galton. "Photographic News." PHILADELPHIA PHOTOGRAPHER 15, no. 178 (Oct. 1878): 315-316. [Excerpt from an address on "composite portraiture" read to the Anthropological Institute, London, by Mr. Galton.]

ST1405 "Curious Case - Dust vs. Kent." ANTHONY'S PHOTOGRAPHIC BULLETIN 9, no. 11 (Nov. 1878): 323. [From "Br J of Photo." D. B. James & Co., photographer in dispute with clothing vendor, in same building.]

GREAT BRITAIN: 1879.
BOOKS
ST1406 Clarke, Mary Cowden. *The Girlhood of Shakespeare's Heroines; A Series of Fifteen Tales,* by Mary Cowden Clarke. A New Edition condensed by Her Sister, Sabilla Novello. London: Bickers, 1879. vi, 456 pp. 15 l. of plates. 15 b & w. [Photographic reproductions of other art.]

ST1407 Hine, Thomas Chambers. *Supplement to Nottingham, Its Castle; a Military Fortress, a Royal Palace, a Ducal Mansion, a Blackened Ruin, a Museum and Gallery of Art. With Notes Relating to the Borough of Nottingham,...* London: Hamilton, Adams & Co., 1879. 32 pp. 7 l. of plates. 7 b & w. [Original photos. One, a portrait of the Prince and Princess of Wales, is credited to Turner & Drinkwater.]

ST1408 Pascoe, Charles Eyre. *The Dramatic List; A Record of the Principal Performances of Living Actors and Actresses of the British Stage. With Criticisms from Contemporary Journals.* London: Hardwicke & Bogue, 1879. v, 358 pp. 12 b & w. [Woodburytype prints, actors and actresses.]

PERIODICALS
ST1409 Le Neve Foster, P., M.A. "Technological Examination in Photography at the Society of Arts." BRITISH JOURNAL PHOTOGRAPHIC ALMANAC 1879 (1879): 118.

ST1410 "All in a Carte." ANTHONY'S PHOTOGRAPHIC BULLETIN 10, no. 3 (Mar. 1879): 68-69. [From "London Photo. News." Comic dialogue.]

ST1411 "A Photographic Witness." ANTHONY'S PHOTOGRAPHIC BULLETIN 10, no. 3 (Mar. 1879): 70-72. [From "London Photo.

News." Story, possibly fictional, about a young man's photograph proving the innocence of a man accused of a crime.]

ST1412 "Copyright in Pictures." ANTHONY'S PHOTOGRAPHIC BULLETIN 10, no. 3 (Mar. 1879): 75-77. [From "London Photo. News."]

ST1413 "The Zulu War: Officers of the 24th Regiment Killed at Isandula." ILLUSTRATED LONDON NEWS. 74, no. 2073 (Mar. 8, 1879): 216. 7 illus. [Seven portraits on one page.]

ST1414 "The Zulu War: Officers Killed at Isanhlwana, January 22." ILLUSTRATED LONDON NEWS. 74, no. 2075 (Mar. 22, 1879): 277. 9 illus. [Nine portraits on one page.]

ST1415 "Illustrations of the Zulu War: Officers Killed." ILLUSTRATED LONDON NEWS. 74, no. 2076 (Mar. 29, 1879): 288. 3 illus. [Three portraits on one page.]

ST1416 Clarke, Thomas. "Liverpool Amateur Photographic Association." ANTHONY'S PHOTOGRAPHIC BULLETIN 10, no. 5 (May 1879): 135. [From "Br. J. of Photo." Consists primarily of a report of a speech by the new president Mr. Thomas Clarke, which sums up photographic activity in England for the year.]

ST1417 "Liverpool Associated Societies' Soiree." ANTHONY'S PHOTOGRAPHIC BULLETIN 10, no. 5 (May 1879): 135-136. [From "Br. J. of Photo."]

ST1418 "Royal Institution Lectures: Composite Portraits - Generic Images." ILLUSTRATED LONDON NEWS. 74, no. 2081 (May 3, 1879): 422. [Francis Galton, F.R.S., lectured on the topic.]

ST1419 "Officers Killed in the Zulu War." ILLUSTRATED LONDON NEWS. 74, no. 2084 (May 24, 1879): 489. 3 illus. [Three portraits on one page.]

ST1420 "Officers Killed in the Zulu War." ILLUSTRATED LONDON NEWS. 74, no. 2085 (May 31, 1879): 521. 3 illus. [Three portraits on one page.]

ST1421 "A Photographic Jack-of-All-Trades." PHOTOGRAPHIC TIMES 9, no. 102 (June 1879): 139. [Describes an announcement of a certain Lorenzo Henry Russell, of Manchester, England, who claimed to be a "Professor of Singing and Music, Miniature Painter, Phrenologist, Taxidermist, Mesmerist and Photographer."]

ST1422 "Photographers vs. Painters in the Matter of Copyright." ANTHONY'S PHOTOGRAPHIC BULLETIN 10, no. 7 (July 1879): 200-201. [From "London Photographic News."]

ST1423 "Mass." "Photography as a Business." ANTHONY'S PHOTOGRAPHIC BULLETIN 10, no. 9 (Sept. 1879): 262-264. [From "London Photographic News." Discussion of employee relations, etc.]

ST1424 "Photography and Photographic Equipments in Warfare." ANTHONY'S PHOTOGRAPHIC BULLETIN 10, no. 10 (Oct. 1879): 296-297. [From "London Photo. News." Describes the procedures and outfit of photographers in the British army and then gives a brief survey of the military use of photography from Crimea through Franco-German war of 1870.]

ST1425 "The Zulu War Officers Decorated with Order of the Bath." ILLUSTRATED LONDON NEWS 75, no. 2115 (Dec. 27, 1879): 605. 6 illus. [Six portraits on one page.]

GREECE: 19TH C.
BOOKS
ST1426 *Athens 1839 - 1900: A Photographic Record*. Athens: Benaki Museum, 1985. 213 pp. [Includes "Foreign Photographers in Greece in the Nineteenth Century," by Gary Edwards.]

ST1427 Xanthakis, Alkis X. *History of Greek Photography 1839 - 1960*. Athens: Hellenic Literary and Historical Archives Society, 1988. 248 pp. 173 illus.

GREECE: 1853.
ST1428 Bellot, Thomas., F.R.C.S.E., Surgeon, Royal Navy. "Athens." ILLUSTRATED LONDON NEWS 22, no. 603 (Jan. 15, 1853): 45. 1 illus. ["Athens - From a Recent Calotype." The article is about a hurricane at Athens in Oct. 1852. Unclear if the calotype was taken by the author, or simply an available view.]

GREECE: 1859.
ST1429 "Costumes of Corfu, Ionian Islands." BALLOU'S PICTORIAL DRAWING-ROOM COMPANION [GLEASON'S] 16, no. 406 (Apr. 2, 1859): 224. 1 illus. ["...carefully copied form photographs taken on the spot..." (Probably from "Illus. London News," not credited).]

GREECE: 1861.
ST1430 "Photographing Curious Old Manuscripts of the Bible." AMERICAN JOURNAL OF PHOTOGRAPHY AND THE ALLIED ARTS & SCIENCES n. s. vol. 3, no. 18 (Feb. 15, 1861): 285-287. [M. de Sevastianoff has spent three years in the monasteries at Mount Athos, Greece, taken 4500 negatives of views of convents, pages from manuscripts, etc. From "Photo. News."]

GREECE: 1863.
ST1431 "The Royal Palace at Athens." ILLUSTRATED LONDON NEWS 43, no. 1233 (Nov. 28, 1863): 537. 1 illus.

GREECE: 1866.
ST1432 "Volcanic Eruption at Santorin." HARPER'S WEEKLY 10, no. 484 (Apr. 7, 1866): 217. 2 illus. ["Our American Council at Athens, Mr. Canfield, sends us two photographic views... I send...two photographs of New Kaimini taken by the best photographer here."]

GREECE: 1867.
ST1433 Dyer, Thomas H. *Pompeii Photographed. The Ruins of Pompeii. A Series of Eighteen Photographic Views. With an Account of the Destruction of the City, and a Description of the Most Interesting Remains*. London: Bell & Daldy, 1867. 111 pp. 18 b & w. [18 photographs by unidentified photographers.]

GREECE: 1868.
ST1434 Postlethwaite, Edward. *Letters from Greece*. London: John Camden Hotten, 1868. iv, 95 pp. 3 b & w. [Original photos. Gennadius Library, Athens.]

HUNGARY: 19TH C.
ST1435 Karlovits, Karoly. "Early Photography in Eastern Europe: Hungary." HISTORY OF PHOTOGRAPHY 2, no. 1 (Jan. 1978): 53-74. 31 illus.

HUNGARY: 1851.
ST1436 "Cultivation of Disrespect for the Daguerreotype." DAGUERREAN JOURNAL 3, no. 2 (Dec. 1, 1851): 52-53. [Comment on Louis Kossuth's (of Hungary) refusal to allow daguerreotypists to take his portrait for commercial purposes.]

ICELAND: 1879.
ST1437 Van Gruisen, N. L., Jr. *A Holiday in Iceland*. London: Elliot Stock, 1879. vi, 98 pp. 5 b & w. [Photomechanical prints.]

INDIA: 19TH C.
BOOKS
ST1438 *The Indian Amateur's Photographic Album*. Bombay: Johnson & Henderson, 1856-1858. n. p. pp. 74 b & w. [Published in twenty-five parts of three photos each, from Nov., 1856 to Dec., 1858. Each photo has some descriptive text. Photos by members of the Royal Engineers or the East India Company.]

ST1439 Watson, Dr. John Forbes. *The Textile Manufactures and the Costumes of the People of India*. London: Printed for the India Office by George Edward Eyre and William Spottiswoode, 1866. xxi, 174 pp. 11 l. of plates. 3 illus. [Each of the eleven photographs is a collage of several smaller photographs, totalling fifty-eight portraits - taken by W. Griggs, J. C. A. Dannenberg, Lieut Tanner, Dr. Simpson, Capt. Houghton, W. Johnson, R. H. De Montgomery, Shepherd & Robertson, Lieut. MacDonald, and others. "The foregoing illustrations have been selected from "People of India."]

ST1440 Watson, Dr. John Forbes and Sir John William Kaye, editors. *The People of India*. A Series of Photographic Illustrations of the Races and Tribes of Hindustan, Originally Prepared under the Authority of the Government of India, and Reproduced by Order of the Secretary of State for India in Council. With descriptive letterpress by Col. Meadows Taylor. London: Printed for the India Museum by Wm. Allen & Co., 1868-1875. 8 vol. 468 b & w. [J. C. A. Dannenberg; Lieut. R. H. De Montmorency; Rev. E. Godfrey; Lieut. W. W. Hooper; Maj. Houghton; Capt. H. C. McDonald; J. Mulheran; Capt. Oakes; Rev. G. Richter; Shepherd & Robertson; Dr. B. Simpson; Dr. B. W. Switzer; Capt. H. C. B. Tanner; Capt. C. C. Taylor; and Lieut. J. Waterhouse credited as "known to have been engaged in photographing the different subjects."]

ST1441 Furneaux, J. H., ed. *Glimpses of India. A Grand Photographic History of the Land of Antiquity, the Vast Empire of the East*. With 500 superbly reproduced Camera-Views of her Cities, Temples, Towers, Public Buildings, Fortifications, Tombs, Mosques, Palaces, Waterfalls, Natural Wonders, and Pictures of the Various Types of her People, Also, Supplementary Photographic Views of Burmah, Ceylon, Cashmere and Aden. Philadelphia: Historical Publishing Co., 1895. 544 pp. 500 b & w. ["...prepared by best known firms of photographers in India including Messrs. Bourne & Shepherd, (Calcutta & Bombay) Lala Deen Dayal & Sons, (Secunderabad), Nicholas & Co. (Madras), Barton, Son & Co. (Bangalore), B. D. Dadaboy (Mooltan), etc.]

ST1442 Auchinleck, Field-Marshal Sir Claude, introduction. Foreword by Field-Marshal Sir Gerald Templer. *The Army in India: 1850-1914. A Photographic Record*. London: Hutchinson of London, published in association with the National Army Museum, 1968. 192 pp. b & w. illus. [Includes biographies of John MacCosh (1805-1885) and others.]

ST1443 Desmond, Ray. "Photography in India During the Nineteenth Century," on pp. 5-36 in: *India Office Library & Records Report 1974* London: India Office, 1974. n. p. illus.

ST1444 *The Last Empire: Photography in British India, 1855 - 1911*. Preface by the Earl Mountbatten of Burma; with texts by Clark Worswick and Ainslie Embree. Millerton, NY: Aperture, 1976. 146 pp. b & w.

ST1445 Barr, Pat and Ray Desmond. *Simla, a Hill Station in British India.* 1979.New York: Scribner, 1978. 108 pp. b & w. illus.

ST1446 Thomas, G. *History of Photography - India 1840 - 1980.* Andhra: Pradesh State Akedemi of Photography, 1981. 87 pp. 48 l. of plates.

ST1447 Desmond, Ray. *Victorian India in Focus:* A Selection of Early Photographs from the Collection in the India Office Library and Records. London: Her Majesty's Stationary Office, 1982. 100 pp. b & w.

ST1448 Gutman, Judith Mara. *Through Indian Eyes: 19th and Early 20th Century Photographs from India.* New York: Oxford University Press, International Center of Photography, 1982. 198 pp. b & w. illus.

PERIODICALS
ST1449 Desmond, R. "19th Century Indian Photographers in India." HISTORY OF PHOTOGRAPHY 1, no. 4 (Oct. 1977): 313-317. 5 b & w. [Hurrichand Chintamon, P.C. Mukherji, Shivashanker Narayen, Muccoond Ramchundra, Lala Din Dyal, Ahmut Ali Khan mentioned.]

ST1450 Thomas, G. "The First Four Decades of Photography in India." HISTORY OF PHOTOGRAPHY 3, no. 3 (July 1979): 215-216. 12 b & w. 1 illus. [3 b & w by Capt. L. Tripe, 3 b & w by Capt. E. C. Impey, 2 b & w by Bourne & Shepherd, 1 b & w by Samuel Bourne, 1 b & w by Johnstone and Hoffman, 2 b & w by unknown.]

ST1451 Thomas G. "Photography and the Elphinstone Institution of Bombay." HISTORY OF PHOTOGRAPHY 5, no. 3 (July 1981): 245-247. 3 b & w. [Discussion of provisions made in 1850s to teach photography in the school there. Project tried, failed for some unaccountable reason after a year.]

ST1452 Sharma, Brij Bhushan. "A 'Photographic' Book on the Indian Mutiny." HISTORY OF PHOTOGRAPHY 6, no. 2 (Apr. 1982): 173-177. 4 illus. [The book "Views in Lucknow; from Sketches Made During the Siege" by Major MacBean, N.I., Photographed by J. Hogarth. London: J. Hogarth, 1858. 15 photos of sketches, list of plates, descriptions, letterpress.]

ST1453 Falconer, John. "Ethnographical Photography in India 1850 - 1900." PHOTOGRAPHIC COLLECTOR 5, no. 1 (Spring 1984): 16-46. 34 b & w. [John McCosh (1805-1885); William Johnson & William Henderson; Shepherd & Robertson; John P. Nicholas & Curths; Albert Thomas Watson Penn (1849-1924); Samuel Bourne (1834-1912); Benjamin Simpson; et al. Excellent introductory survey.]

ST1454 Thomas, G. "Indian Courtesans in Cartes-de-Visite." HISTORY OF PHOTOGRAPHY 8, no. 2 (Apr. - June 1984): 83-87. 12 b & w.

ST1455 Thomas, G. "Their Highnesses of India." HISTORY OF PHOTOGRAPHY 10, no. 1 (Jan. - Mar. 1986): 9-13. [Portfolio of portraits of Indian rulers. Photos by Bourne & Shepherd, Wiele & Klein, and unknowns.]

ST1456 Sharma, Brij Bhushan. "Wilsonian Rambles." HISTORY OF PHOTOGRAPHY 10, no. 3 (July - Sept. 1986): 217-220. 3 b & w. 1 illus. [Francesca H. Wilson (British) travelled in India, produced a book, "Rambles in Northern India," London, 1876, illustrated with twelve original photos by an unnamed photographer.]

ST1457 Sharma, Brij Bhushan. "Artists and Photography; Some Indian Encounters." HISTORY OF PHOTOGRAPHY 12, no. 3 (July - Sept.

1988): 247-258. 10 illus. [Louis Rousselet, Valentine Cameron Princep, other European artists travelled in India in 1860s, 1870s. Some, like Rousselet, photographed there, and some of these photos were later used to illustrate books. Engravings of views, after photos. Eight by Louis Rousselet, one by Princep, one by Bourne & Shepherd.]

INDIA: 1857.
ST1458 "The Guicowar of Goojerat." ILLUSTRATED LONDON NEWS 30, no. 853 (Apr. 11, 1857): 346. 1 illus. ["...from a photograph taken a few weeks since at his palace in Baroda..."]

ST1459 "Sketches in Delhi." ILLUSTRATED LONDON NEWS 31, no. 870 (July 25, 1857): 91-92. 2 illus. [One of the views, of a house near the Lahore Gate, is credited from a photograph.]

ST1460 "Views in Delhi." ILLUSTRATED LONDON NEWS 31, no. 872 (Aug. 8, 1857): 136-138. 3 illus. [Three views of architecture, etc. in Delhi - two of which, the Kotub Minar and the Ruined Arch near Kotaub Minar, are credited from photographs.]

ST1461 "The Mutiny in India." FRANK LESLIE'S ILLUSTRATED NEWSPAPER 4, no. 95 (Sept. 26, 1857): 260-261. 5 illus. [Illustrated with views of Indian temples and views, several credited to be from photographs.]

ST1462 "The Kootab Minar. - From a Photograph." FRANK LESLIE'S ILLUSTRATED NEWSPAPER 4, no. 96 (Oct. 3, 1857): 284. 1 illus. [View of temple in India.]

ST1463 "Delhi, the Doomed City." FRANK LESLIE'S ILLUSTRATED NEWSPAPER 4, no. 97 (Oct. 10, 1857): 292-293. 3 illus. [Views, some of them credited to be from photographs.]

ST1464 "The Mutiny in India: Fall of Delhi." ILLUSTRATED LONDON NEWS 31, no. 885 (Oct. 31, 1857): 432-435. 3 illus. [View of Delhi, sketched by Richard Hare, an officer of the Bengal Artillery. "Group of Sepoys at Lucknow - from a photograph." "Koor Sing"-'The Rebel of Arrah' and his attendants," from a photograph. ("As these are group portraits of the "rebels" then must have been taken by an Indian photographer.)]

INDIA: 1858.
ST1465 "Hindoo Servants of Dr. Fayrer." ILLUSTRATED NEWS OF THE WORLD AND DRAWING ROOM PORTRAIT GALLERY OF EMINENT PERSONAGES 1, no. 7 (Mar. 20, 1858): 100. 1 illus. ["From photographs in the possession of Lieut. Anderson, (12th Regt. Bengal Army) taken by a native at Lucknow..."]

ST1466 "Humayoun's Tomb, Delhi." ILLUSTRATED NEWS OF THE WORLD AND DRAWING ROOM PORTRAIT GALLERY OF EMINENT PERSONAGES 1, no. 7 (Mar. 20, 1858): 101. 1 illus. ["(From a Photograph)".]

ST1467 "Wajid Ali Shah, Ex-King of Oude." ILLUSTRATED NEWS OF THE WORLD AND DRAWING ROOM PORTRAIT GALLERY OF EMINENT PERSONAGES 1, no. 18 (June 5, 1858): 276. 1 illus. ["After a photograph by a native of Lucknow."]

ST1468 "Sketches of India." ILLUSTRATED LONDON NEWS 33, no. 932 (Aug. 21, 1858): 179-180. 2 illus. [One view, from a sketch. One costume portrait of Brahmin students, from photograph from the "Photographic Album," of Bombay.]

INDIA: 1859.

ST1469 "Photography in Western India." PHOTOGRAPHIC NEWS 1, no. 23 (Feb. 11, 1859): 265-266.

ST1470 "Bombay and Commissioner Reed's Return." HARPER'S WEEKLY 3, no. 122 (Apr. 30, 1859): 276-278. 5 illus. [Views in Bombay, some portraits from photographs.]

INDIA: 1862.

ST1471 "Correspondence from India." BRITISH JOURNAL OF PHOTOGRAPHY 9, no. 171 (Aug. 1, 1862): 300-301. [Letter from a "Bombay Amateur."]

INDIA: 1863.

ST1472 "A Bombay Amateur." "Correspondence: Photography in India." BRITISH JOURNAL OF PHOTOGRAPHY 10, no. 186 (Mar. 16, 1863): 131-132.

ST1473 "Sholapore Native (Indian) Police in Charge of a Hindoo Rebel." ILLUSTRATED LONDON NEWS 42, no. 1210 (June 27, 1863): 697, 703. 1 illus. ["...from a photograph taken during a halt of the Sholapore native police with their prisoner." (Taken outdoors.)]

ST1474 "Relative Exposure for Various Processes by an Amateur in India." AMERICAN JOURNAL OF PHOTOGRAPHY AND THE ALLIED ARTS & SCIENCES n. s. vol. 6, no. 10 (Nov. 15, 1863): 231-235. [From "Photo. News."]

ST1475 "Miscellaneous: Photography in India." AMERICAN JOURNAL OF PHOTOGRAPHY AND THE ALLIED ARTS & SCIENCES n. s. vol. 6, no. 10 (Nov. 15, 1863): 240. [Report that native Indians being taught photography at the Thomason College at Roorkee.]

ST1476 Warner, W. H. "On Photography in India." BRITISH JOURNAL OF PHOTOGRAPHY 10, no. 202 (Nov. 16, 1863): 444-445.

INDIA: 1864.

ST1477 "Group of the Bengal New Police." ILLUSTRATED LONDON NEWS 44, no. 1239 (Jan. 2, 1864): 4. 1 illus. [From a photograph.]

ST1478 "Laying the First Stone of the Lucknow Memorial - The Burial Ground at Lucknow." ILLUSTRATED LONDON NEWS 44, no. 1249 (Mar. 12, 1864): 257. 2 illus. ["...from photographs..."]

INDIA: 1868.

ST1479 "The Campaign on the Punjaub Frontier: Abbottabad, the Chief Military and Civil Station in Hazarra." ILLUSTRATED LONDON NEWS 53, no. 1507 (Oct. 17, 1868): 384-386, 388. 4 illus. ["Another correspondent has supplied us with photographs of Abbottabad and of the Peshawur battery of mountain guns."]

INDIA: 1869.

ST1480 Alden, Henry M. "The Sacred City of the Hindus." HARPER'S MONTHLY 38, no. 228 (May 1869): 750-768. 10 illus. [Views. Engravings, probably from photographs.]

INDIA: 1870.

ST1481 Willoughby-Osborne, Mrs., ed. *A Pilgrimage to Mecca*, by the Nawak Sikandar Begum of Bhophal, G.C.S.I. Translated from the Original Urdu, and Edited by Mrs. Willoughby-Osborne. Followed by a Historical Sketch of the Reigning Family of Bhophal, by Lt. Col. Willoughby-Osborne, C.B., Political Agent in Bhophal, And an Appendix translated by the Rev. William Wilkinson, Chaplain of

Sehore. London: William H. Allen & Co., 1870. xii, 241 pp. 13 l. of plates. 13 b & w. [Carbon prints.]

ST1482 Constable, A. G. "Bombay and the Parees." HARPER'S MONTHLY 42, no. 247 (Dec. 1870): 66-75. 8 illus. [Costume portraits, views, etc. some probably from photographs.]

INDIA: 1873.

ST1483 Henderson, George and Allan O. Hume. *Lahore to Yarkland; Incidents of the Route and Natural History of the Countries Traversed by the Expedition of 1870*, under T. D. Forsyth, Esq., C.B. London: Lovell Reeve, 1873. n. p. 26 b & w. [Heliotypes, landscapes and figures.]

INDIA: 1874.

ST1484 *The Beauties of Lucknow: Consisting of Twenty-four Selected Photographed Portraits, Cabinet Size, of the Most Celebrated and Popular Living Histrionic Singers, Dancing Girls and Actresses of the Oudh Court and of Lucknow*. Calcutta: Calcutta Central Press, 1874. 4 pp. 24 l. of plates. 24 b & w. [Original photos.]

INDIA: 1875.
BOOKS

ST1485 Wilson, Francesca H. *Rambles in Northern India. With Incidents and Descriptions of Many Scenes of the Mutiny, Including Agra, Delhi, Lucknow, Cawnpore, Allahabad, etc. With Twelve Large Photographic Views*. London: Sampson Low, Marston, Low, & Searle., 1875. 86 pp. 12 b & w. [Original photos. Photographer not named. ("ILN" (Dec. 11, 1875): 575.)]

PERIODICALS

ST1486 "Kashgar and Yarkund: A Guard of Honour at Kashgar - Verandah of the Hall of Audience, Yarkund." ILLUSTRATED LONDON NEWS 66, no. 1849 (Jan. 16, 1875): 64. 2 illus. ["...Sir T. Douglas Forsyth's special mission to the Ameer Yakoob Khan, ruler of Eastern Turkestan...we have been enabled by the sketches of Captain Chapman, R.A., to give many illustrations of the people and places they saw. Two of our present engravings, from photographs, also belong to this series..."]

[His Royal Highness the Prince of Wales made a state tour throughout India and Ceylon during 1875-1876. During this tour the "ILN" published many feature articles, with hundreds of illustrations by "Our Special Artists." Some of these were taken from photographs, or from sketches assisted by photographs - see, for example, "The Maharajah of Benares." (Jan. 22, 1876): 92; "Ghaut at Benares." (Jan. 29, 1876): 113, etc. This series was concluded with a special forty-eight page supplement, "India and the Prince of Wales." (Apr. 1876), which also has non-credited illustrations, some taken from photographs. ILLUSTRATED LONDON NEWS 66-69, (Jan. 1875 - Apr. 1876).]

ST1487 "Visit of the Prince of Wales to India - Special Supplement." ILLUSTRATED LONDON NEWS 67, no. 1893 (Nov. 20, 1875): 513, 516-517, 520. 10 illus. [The course of this state voyage was extensively reported each week in the "ILN." While most of the illustrations were by William Simpson and other artists, many of the portraits of Indian notables published this week and throughout the series are credited as being from photographs.]

INDIA: 1876.
BOOKS

ST1488 Da Cunha, Joseph Gerson. *Notes on the History and Antiquities of Chaul and Bassein*. Bombay: Thacker, Vining, 1876. xvi, 262 pp. 8 l. of plates. [Original photos.]

PERIODICALS
ST1489 "The Nizam of Hyderabad." ILLUSTRATED LONDON NEWS 68, no. 1925 (June 17, 1876): 581. 1 illus. ["...from a photograph of his Highness, for which we are indebted to Mr. Hurrychund Chintamon of 4, Addison Terrace, Kensington, who has supplied us with portraits of several other Indian princes and statesmen."]

INDIA: 1877.
ST1490 McClelland, James. *Journal of a Visit to India and the East; By an Old Traveller.* [James M'Clelland] Glasgow: J. Maclehose, printed for private circulation., 1877. 183 pp. 16 l. of plates. 16 b & w. [Photomechanical reproductions.]

INDIA: 1878.
BOOKS
ST1491 Leitner, Gottlieb William. *The Languages and Races of Dardistan,...with maps by E. G. Ravenstein.* "3rd ed." Lahore: Government Central Book Depot, 1878. 193 pp. 1 b & w. illus. [One original photo, of Leitner with group of Dards. Several engraved portraits credited "From Photographs." (Some of these also appeared in "People of India", engravings from drawings.]

PERIODICALS
ST1492 "British Officers at Peshawur. - From a Photograph." ILLUSTRATED LONDON NEWS 73, no. 2050 (Oct. 12, 1878): 333. 1 illus. [Mounted officers on parade.]

INDIA: 1880.
ST1493 *Nilgiri Sporting Reminiscences,* by an Old Shikarri; With Twenty-Six Photographs. Madras: Higginbotham, 1880. xii, 157 pp. 2 l. of plates. [Preface signed G. A. R. D.]

IRAN: 19TH C.
ST1494 Stein, Donna. "Early Photography in Iran." HISTORY OF PHOTOGRAPHY 7, no. 4 (Oct. - Dec. 1983): 257-291. 38 b & w. [Includes photos by and general history of both European and Iranian photographers.]

ITALY: 19TH C.
BOOKS
ST1495 Becchetti, Piero and others. *Rome in Early Photographs, The Age of Pious IX.* Copenhagen: The Thorvaldsen Museum, 1977. n. p. b & w. illus.

ST1496 Troyer, Nancy Jane Gray. *The Macchiaioli: Effects of Modern Color Theory, Photography, and Japanese Prints on a Group of Italian Painters, 1855 - 1900.* Ann Arbor, MI: University Microfilms, 1978. 291 l. pp. 141 l. of plates. [Ph.D. Thesis, Northwestern University, 1978. Bibliography on leaves 274-291.]

ST1497 Watson, Wendy M. *Images of Italy: Photography in the Nineteenth Century.* South Hadley, MA: Mount Holyoke College Art Museum, 1980. xix, 71 pp. b & w. [Exhibition catalog: Mount Holyoke College Art Museum, Feb. 8 - Mar. 14, 1980.]

PERIODICALS
ST1498 Helsted, Dyveke. "Rome in Early Photographs." HISTORY OF PHOTOGRAPHY 2, no. 4 (Oct. 1978): 335-346. 15 b & w.

ST1499 Sobieszek, Robert A. "Vedute Della Camera: Nineteenth Century Views of Italy." IMAGE 22, no. 1 (Mar. 1979): frontispiece, 1-7. 7 b & w. [Exhibition documentation; 6 b & w by various Italian and non-Italian photographers in 1850s-1890s. George Eastman House collections.]

ST1500 Gladstone, William. "Extraordinary Application of Photography." HISTORY OF PHOTOGRAPHY 3, no. 4 (Oct. 1979): 373-374. [This is an article by an unknown author reprinted from "Harper's Weekly", 25th February, 1865 p. 123. It is about using photographs of murder victim's eyes that supposedly had images of objects seen immediately before death imprinted on them.]

ST1501 Wilsher, Ann. "The Tauchnitz 'Marble Faun'." HISTORY OF PHOTOGRAPHY 4, no. 1 (Jan. 1980): 61-66. 10 b & w. [Brief discussion of 19th century photographically illustrated travel books, and specific discussion of various editions of Hawthorne's "Marble Faun," first published with photographic illustrations in 1860.]

ST1502 "Ferdinando Ongania and the Golden Basilica: A Documentation Programme in 19th-Century Venice." HISTORY OF PHOTOGRAPHY 8, no. 4 (Oct. - Dec. 1984): 315-328. 14 b & w. 4 illus. [Ongania was a publisher & bookseller of Venice during the 1870s, 1880s who produced the 22 volume set, "La Basilica di San Marco in Venezia", which included five illustrated volumes. Oreste Bertani and Carlo Jacobi produced the negatives used to make photoengravings.]

ST1503 Collins, Kathleen. "Photography and Politics in Rome: The Edict of 1861 and the Scandalous Montages of 1861 - 1862." HISTORY OF PHOTOGRAPHY 9, no. 4 (Oct. - Dec. 1985): 295-304. 5 b & w. 2 illus. [References on pp. 303-304.]

ITALY: 1852.
ST1504 Thomas, Richard W. "Photography in Rome." ART JOURNAL (May 1852): 159-160. [Mr. Robinson, Prince Giron des Anglonnes, Signor Caneva, M. Constant and M. Flacheron mentioned. Thomas photographed in Rome for four months, gives his formulae.]

ST1505 Thomas, Richard W. "Photography in Rome." PHOTOGRAPHIC ART JOURNAL 3, no. 6 (June 1852): 377-380. [From "London Art Journal." Robinson; Prince Giron des Anglonnes; Cavena; Constant; Flacheron.]

ST1506 Thomas, Richard W. "Photography in Rome." HUMPHREY'S JOURNAL 4, no. 7 (July 15, 1852): 100-103. [From "London Art Journal."]

ITALY: 1856.
ST1507 "Fine-Art Gossip." ATHENAEUM no. 1481 (Mar. 15, 1856): 336. [Photographers banned from Pompeii, Herculaneum, and the Museum. Disapproval of the policy.]

ITALY: 1858.
ST1508 "Effects of the Late Earthquake in Naples (From Photographs)." ILLUSTRATED LONDON NEWS 32, no. 904 (Feb. 20, 1858): 181. 9 illus. [Views of ruins.]

ST1509 "The Earthquakes at Naples." HARPER'S WEEKLY 2, no. 64 (Mar. 20, 1858): 189. 9 illus. ["From the 'Illustrated London News."' Ruins.]

ITALY: 1861.
ST1510 "Photography in Italy." HUMPHREY'S JOURNAL OF PHOTOGRAPHY, AND THE ALLIED ARTS AND SCIENCES 13, no. 9 (Sept. 1, 1861): 142-143. [From "Br. J. of Photo." "The Italian Government have lately sent an order to England for a complete outfit for a Photographic Department that is to be established under the new auspices...."]

ITALY: 1862.
ST1511 "Photographic Caricatures at Rome." AMERICAN JOURNAL OF PHOTOGRAPHY AND THE ALLIED ARTS & SCIENCES n. s. vol. 4, no. 16 (Jan. 15, 1862): 383-384. [From "Punch." Satirical comment on an edict that no photography in Rome possible without approval of authorities.]

ST1512 "Political Photography." AMERICAN JOURNAL OF PHOTOGRAPHY AND THE ALLIED ARTS & SCIENCES n. s. vol. 5, no. 11 (Dec. 1, 1862): 261. [From "Br. Journal." Man jailed for possessing two microscopic photos of Garibaldi.]

ITALY: 1865.
ST1513 "Miscellanea: The Last 'Burst-Up' of an Oft-Revived Photographic Canard." BRITISH JOURNAL OF PHOTOGRAPHY 12, no. 247 (Jan. 27, 1865) [Murderer's image in victim's eye, from Florence.]

ST1514 "The Dead Eye and Chromo-Photograph Hoaxes." BRITISH JOURNAL OF PHOTOGRAPHY 12, no. 251 (Feb. 24, 1865): 100.

ITALY: 1866.
ST1515 "The Campo Santo at Pisa." ART JOURNAL (Oct. 1866): 319. [25 photos of the works of Benozzo Gizzoli by various artists of Pisa, distributed in England by A. Mensell & Son, Gloucester. Photos mentioned as being excellent.]

ITALY: 1866.
ST1516 "The Coliseum in Rome." HARPER'S WEEKLY 10, no. 510 (Oct. 6, 1866): 628, 630. 1 illus.

ST1517 "Pope Pius and His Cardinals." FRANK LESLIE'S ILLUSTRATED NEWSPAPER 23, no. 586 (Dec. 22, 1866): 221. 1 illus. [Group portrait.]

ITALY: 1869.
BOOKS
ST1518 Mullooly, Joseph. *Saint Clement, Pope and Martyr: And His Basilica in Rome*, by Rev. Joseph Mullooly. Rome: B. Guerra, 1869. lii, 342 pp. 12 l. of plates. 10 b & w. illus. [Original photos, of artworks. 2nd ed. (1873). 447 p., 13 l. of plates.]

PERIODICALS
ST1519 "Historical Photographs." ART JOURNAL (Dec. 1869): 378. [Views of Rome, 1500 in number, useful for art history, etc.]

ITALY: 1871.
ST1520 "The Floods in Rome." ILLUSTRATED LONDON NEWS 58, no. 1632 (Jan. 14, 1871): 47, 48. 1 illus.

ST1521 Abbott, Lyman. "The Eternal City." HARPER'S MONTHLY 44, no. 259 (Dec. 1871): 1-19. 16 illus. [Archeological excavations in Rome. Engravings from noncredited photographs.]

ITALY: 1872.
ST1522 N. S. D. "Alpine Travel." ANTHONY'S PHOTOGRAPHIC BULLETIN 3, no. 4 (Apr. 1872): 504-507. [From "NY Times." Travel article, published with companion article on pp. 509-511.]

ST1523 "Transalpine Photography." ANTHONY'S PHOTOGRAPHIC BULLETIN 3, no. 4 (Apr. 1872): 509-511. [From "Br. J. of Photo." Narrative of a visit through the Italian Alps, describing, in a general manner, the sorts of photographs being taken in the region, and suggesting that good view photographers could profit from the

situation. A companion travel article, "Alpine Travel," by N. S. D., from the "N.Y. Daily Times," was published on pp. 504-507.]

ITALY: 1873.
ST1524 "Editor's Table: Italian Photography." PHILADELPHIA PHOTOGRAPHER 10, no. 114 (June 1873): 192. [Book of criticism of the 2nd National Exhibition of Fine Arts, Milan (1872) was illustrated with original photos, sent to Wilson by Ottavio Baratti. (Not clear that he is the author.)]

ST1525 Browne, Junius Henri. "Sicily and the Sicilians." HARPER'S MONTHLY 47, no. 278 (July 1873): 183-202. 11 illus. [Views, etc. Engravings, some probably from photographs.]

ITALY: 1874.
ST1526 Montagna, A. "Photography in Italy." PHILADELPHIA PHOTOGRAPHER 11, no. 124, 129 (Apr., Sept. 1874): 108-109, 271-273. [Mentions Sobacchi, Marzocchini (Leghorn).]

ST1527 A. J. W. "Photography in Venice." ANTHONY'S PHOTOGRAPHIC BULLETIN 5, no. 7 (July 1874): 230-232. [From "Br. J. of Photo." Naja and S. Bertoja are the two leading photographers in Venice.]

ST1528 Wilson, Edward L. "Views Abroad and Across. Pts. 7-9." PHILADELPHIA PHOTOGRAPHER 11, no. 127-129 (July - Sept. 1874): 197-202, 225-231, 259-265. [Wilson visited many studios in extended visit to Europe. (July) Venice. (Aug.) Milan, Rome. (Sept.) Naples.]

ST1529 Atkinson, John J. "Photographic Enamels." ANTHONY'S PHOTOGRAPHIC BULLETIN 5, no. 8 (Aug. 1874): 286. [From "Br. J. of Photo." Atkinson (Liverpool, Eng.) describes photographs attached to tombstones in Bologna, and elsewhere in Italy. Recommends photographic enamels for permanency.]

ITALY: 1878.
ST1530 "Funeral of the Late Pope Pius IX." ILLUSTRATED LONDON NEWS 72, no. 2017 (Feb. 23, 1878): 180-182. 3 illus. [Includes a post-mortem photographic portrait.]

ITALY: 1879.
ST1531 Issaverdenz, Dr. J. *The Island of San Lazzaro; Or, the Armenian Monastery near Venice.* Venice: Armenian Typography of San Lazzaro, 1879. 30 pp. 20 b & w. [Original photos.]

ST1532 Shedd, Mrs. Julia A. *The Ghiberti Gates. An Account of Lorenzo Ghiberti and the Bronze Doors of the Baptistry at Florence.* Boston: s. n., 1879. n. p. 33 b & w. [Thirty-three full-page heliotypes.]

JAPAN: 19TH C.
BOOKS
ST1533 Worswick, Clark, ed. *Japan: Photographs 1854 - 1905.* Edited and with a historical text by Clark Worswick; with an introduction by Jan Morris. New York: Pennwick/Alfred A. Knopf, 1979. 151 pp. 111 b & w. [Exhibition catalog: Japan House Gallery, New York.]

ST1534 Dower, John W. *A Century of Japanese Photography.* New York: Pantheon Books, 1980. 385 pp. 514 b & w. [Based on a book published in 1971 by the Japan Photographers' Association, with an introduction in English by Dower.]

ST1535 *The Origins of Photography in Japan.* "The Complete History of Japanese Photography, vol. 1." Tokyo: Shogakukan, ca. 1985. 179

pp. b & w. illus. [Title in English and Japanese, with a short essay in English.]

ST1536 Ozawa, Takeshi. *The History of Photography in Japan. From End of Bakumatsu (1860's) to Meiji Period (1910's).* ...an English summary translation with annotations by Kay K. Tateishi. "Nikon Salon Books, vol. 12." Tokyo: Nikkor Club, 1986. 74 l.

ST1537 *A Timely Encounter: Nineteenth-Century Photographs of Japan.* An Exhibition of photographs from the collections of the Peabody Museum of Archaeology and Ethnology and the Wellesley College Museum. Contributors: Melissa Banta, Ellen Handy, Haruko Iwasaki, Bonnell D. Robinson. Volume Editors and Exhibition Curators: Melissa Banta, Susan Taylor. Cambridge, MA: Peabody Museum Press, Wellesley College Museum, 1988. 71 pp. 61 b & w.

PERIODICALS

ST1538 Perl, Jed. "Photography: Japan: Photographs 1854 - 1905." ART IN AMERICA 68, no. 2 (Feb. 1980): 35-37. 6 b & w. [Ex. rev.: "Japan: Photographs 1854-1905," Japan House Gallery, New York, NY.]

ST1539 Worswick, Clark. "The Origins of Japanese Photography." AMERICAN PHOTOGRAPHER 4, no. 6 (June 1980): 36-45. 8 b & w.

ST1540 Welling, William. "Japanese Photographs from Admiral Perry's Day." PHOTOGRAPHICA 13, no. 3 (Mar. 1981): 8-9. 4 b & w. 1 illus. [Photographs in Japan, ca. 1850s to 1869.]

ST1541 Ozawa, Takesi. "The History of Early Photography in Japan." HISTORY OF PHOTOGRAPHY 5 , no. 4 (Oct. 1981): 285-303. 18 b & w. 5 illus. [1839-1879 covered.]

ST1542 Romer, Grant. "'Near the Temple at Yokushen...'" IMAGE 29, no. 2 (Aug. 1986): 1-11. 1 b & w. 10 illus. [Daguerreotype view of American graves in a Japanese cemetery taken between 1855 and 1858, now in the collection of the IMP/GEH, is the earliest extant photographic landscape of Japan. Discussion of possible maker rules out Eliphalet Brown, Jr., of Perry's expedition. The Russian daguerreotypist Aleksandr Fedorovich Mozhaikii, of Admiral Poutiatine's expedition, a likely candidate. Others possible.]

JAPAN: 1858.
ST1543 "The Ladies of Japan in the Stereoscope." PHOTOGRAPHIC NEWS 1, no. 10 (Nov. 12, 1858): 113. [Geisha girls.]

ST1544 "A Cruise in Japanese Waters." BLACKWOOD'S EDINBURGH MAGAZINE (NY) 84-85, no. 518-523 (Dec. 1858 - May 1859): (1858) 635-646 (1859) 49-70, 239-250, 393-412, 532-545. [This article was apparently written by a British naval officer, describing his experiences in Japan. While this is good background information for Japan during the period when Beato was active there, the article also contains an anecdote on p. 55, describing the experience of a Dutch trader who was approached by a Japanese official who had travelled from Edo, a trip of forty days, in order to ask him a single question. The question was how to register the hourly variations of a barometer by means of a photographic apparatus.]

JAPAN:1859.
ST1545 "Photography in Japan: Letter from F. B." JOURNAL OF THE PHOTOGRAPHIC SOCIETY OF LONDON 5, no. 80 (Mar. 5, 1859): 222. [Anecdote taken from series "A cruise in Japanese Waters" in "Blackwood's Mag." Jan, 1859. F. B. may be Felix Beato.]

ST1546 "From Our Own Correspondent" "Through Japan with a Camera. Parts 1 - 21." PHOTOGRAPHIC NEWS 3, no. 57-77 (Oct. 7, 1859 - Feb. 24, 1860): 56-58, 68-70, 80-82, 92-93, 104-105, 116-117, 130-131, 139-140, 150-151, 163-164, 177-178, 188-189, 200-201, 209-210, 225-226, 238-239, 250-251, 262-263, 275, 288-289, 301-302. [Perhaps the photographer was Dutch, as the articles were forwarded through F. Van Hoogen, Bruxelles. Or these may have been written by W. Woodbury, who was then travelling through Japan for Negretti & Zambra.]

JAPAN: 1860.
ST1547 "Talk in the Studio: Photographs from Japan." PHOTOGRAPHIC NEWS 4, no. 109 (Oct. 5, 1860): 276. ["A case of rare and curious photos of the scenery of this interesting country, and illus. of the manners & customs...executed by a special artist sent out by ...firm of Negretti and Zambra, expected by the Peninsular & Oriental Company's steam ship 'Ceylon' which will arrive at Southhampton on Wedn." From the "Times."]

JAPAN: 1862.
ST1548 "Fine-Art Gossip." ATHENAEUM no. 1804 (Mar. 24, 1862): 700. [Mr. Hogarth has on exhibition at the Haymarket photos of Japan, China, Egypt, India, and Australia. The Japanese photos are described as views of Nagasaki and portraits.]

JAPAN: 1866.
ST1549 "Japanese Makers of Cartes-de-Visite." FRANK LESLIE'S ILLUSTRATED NEWSPAPER 23, no. 577 (Oct. 27, 1866): 93. 1 illus. [View of artisans at work, cutting and painting cards. Although the brief article mentions photograph albums, its unclear that these craftsmen are cutting up sheets of photographic portraits into cartes-de-visite or if they are making hand-drawn calling cards.]

JAPAN: 1867.
ST1550 "The Mirror of Photography." IMAGE 4, no. 1 (Jan. 1955): 6. 1 illus. [Japanese book on photography, "The Mirror of Photography," by Yoky Gakujin, 1867, acquired by George Eastman House.]

JAPAN: 1868.
ST1551 "Photography in Japan." HUMPHREY'S JOURNAL OF PHOTOGRAPHY, AND THE ALLIED ARTS AND SCIENCES 19, no. 18 (Jan. 15, 1868): 287. [Note that town of Asaka, Japan, with 300,000 inhabitants has at least forty photographers.]

JAPAN: 1869.
ST1552 "Pictures of the Japanese." HARPER'S NEW MONTHLY MAGAZINE 39, no. 231 (Aug. 1869): 305-322. 24 illus. [The illustrations are etchings from photos & paintings. The statements in this article are chiefly taken from "Our Life in Japan" by R. Mounteney. Japhesin and Edward Pennell Elmurst, officers of the Ninth Regiment of the British Horse Guards. The pictures are from photographs or nature paintings.]

JAPAN: 1871.
ST1553 "The Japanese Mint, Osaka." ILLUSTRATED LONDON NEWS 58, no. 1652 (May 27, 1871): 511, 513. 1 illus. ["...from one of a set of photographs supplied as by the architect, Mr. T. Waters, of Jeddo, official engineer to the Japanese Government."]

JAPAN: 1872.
ST1554 "Editor's Table: Japanese Appreciation of Photography." PHILADELPHIA PHOTOGRAPHER 9, no. 105 (Sept. 1872): 335. [Excerpt from a letter from "Tommy" (K. Nagano), sent to F. Gutekunst in the USA, responding to a Gutekunst photo, apparently sent to Japan.]

JAPAN: 1874.

ST1555 "Sketches in Japan: Scene in Temple Street, Nagasaki." ILLUSTRATED LONDON NEWS 64, no. 1794 (Jan. 10, 1874): 35, 36. 1 illus. [Not credited, but probably taken from a vernacular Japanese photograph.]

ST1556 "Japanese Escort Officers." ILLUSTRATED LONDON NEWS 65, no. 1832 (Oct. 3, 1874): 327-328. 1 illus. [Not credited, but probably from a photograph.]

ST1557 "Japan. - The Great Typhoon of August 21st. - View of the 'Bund' the Day After." FRANK LESLIE'S ILLUSTRATED NEWSPAPER 39, no. 1001 (Dec. 5, 1874): 205. 1 illus. [Damage to the foreign enclave, in Japan. "...from a photograph sent us..."]

JAPAN: 1875.

ST1558 "Education in Japan. The American School at Yokohama." FRANK LESLIE'S ILLUSTRATED NEWSPAPER 40, no. 1039 (Aug. 28, 1875): 425. 2 illus. [Two group portraits of classes of adult Japanese men with their European teachers. Not credited, but from photographs.]

JAPAN: 1878.

ST1559 "Japanese Doing Homage to the Mikado's Photograph." ILLUSTRATED LONDON NEWS 72, no. 2021 (Mar. 23, 1878): 268. 1 illus.

LATIN AMERICA: 19TH C.

ST1560 Hoffenberg, H. L. *Nineteenth Century South America in Photographs.* New York: Dover Publications, Inc., 1982. n. p. b & w. illus.

ST1561 Levine, Robert M., ed. *Windows on Latin America: Understanding Society through Photographs.* Coral Gables, FL: SECOLAS, 1987. 220 pp. [Includes several essays on 19th century Latin American photography by Boris Kossoy, Ramiro Fernandez, Louis Perez, Jr., and Elyn Welsh and a bibliography by Martha Davidson, which lists materials on 19th c. Latin American photography.]

ST1562 Levine, Robert M. *Images of History: Nineteenth and Early Twentieth Century Latin America Photographs as Documents.* Durham, NC, London: Duke University Press, 1989. 216 pp. 225 b & w. illus. ["Bibliography," pp. 199-206.]

LATVIA: 19TH C.

ST1563 Kreichbergs, Janis. "Early Photography in Eastern Europe: Latvia." HISTORY OF PHOTOGRAPHY 1, no. 4 (Oct. 1977): 319-325. 7 b & w. 3 illus.

LITHUANIA: 19TH C.

ST1564 Juodakis, V. "Early Photography in Eastern Europe: Lithuania." HISTORY OF PHOTOGRAPHY 1, no. 3 (July 1977): 235-247. 17 b & w. 1 illus.

ST1565 Garztecki, Julius. "19th Century Photographers in Lithuania." HISTORY OF PHOTOGRAPHY 2, no. 3 (July 1978): 267-268. 1 b & w. 2 illus. [Letter in response to V. Juodakis' article in July 1977 "History of Photography".]

MEXICO: 1863.

ST1566 "General View of Puebla Mexico." HARPER'S WEEKLY 7, no. 338 (June 20, 1863): 397. 1 illus. ["From a Photograph." "...from drawings by French artists..."]

MEXICO: 1866.

ST1567 "Matamoras, Mexico." HARPER'S WEEKLY 10, no. 506 (Sept. 8, 1866): 565. 1 illus. ["From a Photograph."]

MEXICO: 1867.

ST1568 "The Emperor Maximilian." HUMPHREY'S JOURNAL OF PHOTOGRAPHY, AND THE ALLIED ARTS AND SCIENCES 19, no. 6 (July 15, 1867): 95. [This is an angry outburst at the death of Emperor Maximilian of Mexico. "We knew him when a youth of eighteen, the kindest, the brightest, the most noble and most honorable of men.... We cannot help - we must weep!..." (This statement probably from Ladd, the publisher, and not from the editor.)]

MIDDLE EAST: 19TH C.
BOOKS

ST1569 Onne, Eyal. *Photographic Heritage of the Holy Land, 1839 - 1914.* Text and editing by Eyal Onne. Manchester, Eng.: Institute of Advanced Studies, Manchester Polytechnic, 1980. 104 pp. illus.

ST1570 Chevedden, Paul E. *The Photographic Heritage of the Middle East: An Exhibition of Early Photographs of Egypt, Palestine, Syria, Turkey, Greece, and Iran, 1849 - 1893.* Malibu, CA: Undena Publications, 1981. iv, 36 pp. 26 b & w. 2 illus. [Ex. cat.: Department of Special Collections, UCLA Research Library, Los Angeles, CA, Nov. 5, 1981-Feb. 21, 1982. 132 print exhibition. Essay, "The Photographic Heritage of the Middle East," followed by biographical statements and checklists for Maxime Du Camp; Francis Frith; W. Hammerschmidt; Francis Bedford; Antonio Beato; La Maison Bonfils; G. Zangaki; Isabella Lucy Bird Bishop; and Gulmez Frères. Bibliography on pp. 35-36. Published as a fascicle of "Occasional Papers on the Near East (OP 1/3), and corresponds to pp. 67-106 in Volume 1 in "Monographic Journals of the Near East."]

ST1571 Vacsek, Louis and Gail Buckland. *Travelers in Ancient Lands: A Portrait of the Middle East 1839 - 1919.* Boston: New York Graphic Society, ca. 1981. xxi, 202 pp. 265 l. of plates. [Biographies, bibliography.]

ST1572 Gidal, Nachum T. *Eternal Jerusalem, 1840 - 1917.* Jerusalem: Steimatzky, 1985. n. p. b & w.

ST1573 Nir, Yeshayahu. *The Bible and the Image: The History of Photography in the Holy Land, 1839 - 1899.* Philadelphia: University of Pennsylvania Press, 1985. 314 pp. 109 l. of plates. [Bibliography on pp. 281-290.]

ST1574 Museum voor Volkenkunde, Rotterdam. *Images of the Orient, 1860 - 1900.* Rotterdam: Museum voor Volkenkunde, 1986. 96 pp. 75 b & w. [Essays: "Tourism in the Orient," by Anneke Groeneveld. "Conception of the Orient," by Steven Wachlin. "Backgrounds," by Fred Ros. Abdullah Frères; Bonfils; Zangaki; Hammerschmidt; Fiorillo; Beato; and others. Dutch and English texts. Bibliography.]

ST1575 Perez, Nissan, N. *Focus East: Early Photography in the Near East 1839 - 1885.* New York: Harry N. Abrams, in association with the Domino Press, Jerusalem and the Israel Museum, Jerusalem, 1987. 256 pp. 268 b & w. ["Part 1: The Photographic Image of the Near East." "Part II: A to Z of Photographers Working in the Near East," pp. 123-133. "Notes and Bibliography," pp. 238 - 250.]

PERIODICALS

ST1576 Wolff, Anthony. "A New Look at the Old Middle East." THE LAMP *, no. * (Spring 1979): 16-21. 11 b & w.

ST1577 Gavin, Carney E. S. "History's Invisible Treasures: Early Mideastern Photos." JORDAN 5, (Summer 1980): 12-15.

ST1578 Chevedden, Paul E. "Early Photography of the Middle East: Review Article." MELA NOTES 30, (Fall 1983): 23-43.

ST1579 Chevedden, Paul E. "Making Light of Everything: Early Photography of the Middle East and Current Photomania." MIDDLE EAST STUDIES ASSOCIATION BULLETIN 18, (Dec. 1984): 151-174.

NEAR EAST: 1853.
ST1580 "Church of the Holy Sepulchre, Jerusalem." ILLUSTRATED LONDON NEWS 22, no. 615 (Apr. 2, 1853): 249-250. 2 illus. [Two views, one "from 'Views from Palestine, Egypt, Etc." by David Roberts, R.A., the second "from 'Photographs of the Monuments of Egypt, Nubia, and Syria."]

NEAR EAST: 1860.
ST1581 "The War in Morocco." HARPER'S WEEKLY 4, no. 169 (Mar. 24, 1860): 184-185. 2 illus. ["...we give a couple of pictures of Moorish life, from photographs recently taken." Group of men and women on balcony, women indoors.]

NEAR EAST: 1861.
ST1582 "An Execution Photograph." AMERICAN JOURNAL OF PHOTOGRAPHY AND THE ALLIED ARTS & SCIENCES n. s. vol. 3, no. 23 (May 1, 1861): 365-367. [From "Photo. News." Detailed description of a mass execution of Arabs, by guillotine. The country is not named, nor is the photographer. Inference is that the photographer was French and the country in Middle East or North Africa.]

NEAR EAST: 1864.
ST1583 Oscanyan, C. Oscanyan's Oriental Album. New York: C. Oscanyan, 1864. n. p. 24 b & w. ["A New Edition. Bound, in book form, containing... 24 Photographic Portraits of Oriental Men and Women, taken from life in both indoor and outdoor costumes, representing Turkish, Jewish, Armenian, Circassian, Egyptian and Druz nationalities and also scenes from domestic life..." Advertisement in "Frank Leslie's Illus. Newspaper," (Dec. 17, 1864): 194.]

ST1584 Smith, Sir Robert Murdoch and E. A. Porcher. History of the Recent Discoveries at Cyrene; Made During an Expedition to the Cyrenaica in 1860-61, under the Auspices of Her Majesty's Government. London: Day, 1864. n. p. 16 b & w. [Original photos, of sculpture.]

NEAR EAST: 1869.
ST1585 "Reviews: Photographs of the Holy Land." ART JOURNAL (Nov. 1869): 355. [Book review: "Photographs of the Holy Land." Published by A. Mansell, Gloucester. 63 photos.]

NEAR EAST: 1875.
ST1586 Burton, Lady Isabel (Arundell). The Inner life of Syria, Palestine, and the Holy Land, From My Private Journal. ...With map, photographs, and coloured plates. London: Henry S. King & Co., 1875. 2 vols. 376, 340. pp. 2 b & w. illus. [Lord and Lady Burton toured Syria, etc. in Dec. 1869. The photographs are original portraits of Mrs. Burton and of Richard Burton, one each tipped-in as frontispiece to each volume.]

NEW ZEALAND: 19TH C.
BOOKS
ST1587 Turner, John B. Nineteenth Century New Zealand Photographs, Edited by John B. Turner. A Govett-Brewster Art Gallery

Travelling Exhibition. New Plymouth, New Zealand: Govett-Brewster Art Galley, 1970. 83 pp. 94 b & w. [Brief biographies of twenty-two photographers.]

ST1588 Knight, Hardwicke. Photography in New Zealand: A Social and Technical Study. Dunedin: John McIndoe, 1971. 196 pp. illus.

ST1589 Main, William. Maori in Focus. Wellington, New Zealand: Millwood Press, 1976. 121 pp. b & w. illus.

ST1590 Main, William. Auckland through a Victorian Lens. Wellington: Millwood Press, 1977. 177 pp. b & w. illus.

PERIODICALS
ST1591 Knight, Hardwicke. "Composite Portraiture in New Zealand." HISTORY OF PHOTOGRAPHY 5, no. 1 (Jan. 1981): 21-26. 7 b & w. [From 1850 to 1890. Burton Brothers (1), Tait Brothers (2), Thomas E. Price (2), William R. Frost (1), Johnstone, O'Shannessy & Company (1).]

ST1592 Main, William. "Photographic Reportage of the New Zealand Wars." HISTORY OF PHOTOGRAPHY 5, no. 2 (Apr. 1981): 105-116. 14 b & w. 1 illus. [Wars between Maori tribes and white settlers, ca. 1850s to 1870s, is documented by portraits, rather than battle action photographs. Hartley Webster (1); William James Harding (1); George Henry Swan (1); John Kinder (1); Daniel Marders Beere (1); Daniel Louis Mundy (1); James Dacie Wrigglesworth (1); G. Pulman (1); William Temple (2).]

ST1593 Knight, Hardwicke. "Photographers in Colonial New Zealand." HISTORY OF PHOTOGRAPHY 9, no. 3 (July - Sept. 1985): 175-181. 8 b & w. [James Wilson (1857), William Meluish (1857), James Weaver Allen (1861), Daniel L. Mundy (1864), Walter Burton (1867), James de Maus (1867), Thomas M. B. Muir and others.]

NEW ZEALAND: 1862.
ST1594 "Otago, New Zealand." ILLUSTRATED LONDON NEWS 41, no. 1161 (Aug. 30, 1862): 221, 228-229. 2 illus. [Views of gold fields at Tuapeka, Otago, New Zealand and town of Dunedin - from noncredited photos.]

NEW ZEALAND: 1864.
ST1595 "Illustrations of the War in New Zealand." ILLUSTRATED LONDON NEWS 44, no. 1247 (Feb. 27, 1864): 215-216. 3 illus. ["...that of the redoubt from a photograph, both taken on the spot, and forwarded to us by the last New Zealand mail." The view of the redoubt held by the Maoris, then stormed and taken by British forces has a view camera and film-holders displayed in the illustration.]

ST1596 "The Maori Kingdom of New Zealand." ILLUSTRATED LONDON NEWS 45, no. 1266 (July 2, 1864): 3-4. 2 illus. [We have engraved a portrait of Te Wheora and three of his tribe, on board the gun-boat Pioneer, in the Waikako River. Our second illustration is a view of the Tomb of Te Whero Whero, alias Potatan,...a British soldier stood century over the place at the time the photograph was taken."]

NEW ZEALAND: 1869.
ST1597 "Wairarapa, New Zealand." ILLUSTRATED LONDON NEWS 55, no. 1563 (Oct. 23, 1869): 409. 2 illus. ["...from our correspondents at Wellington, taken in the Wairarapa Valley." Landscapes. View of the town of Wellington also published on p. 476, also not credited, but probably from a photo.]

NEW ZEALAND: 1875.
BOOKS
ST1598 Vogel, Julius, Sir, ed. *The Official Handbook of New Zealand: A Collection of Papers by Experienced Colonists On the Colony as a Whole, and On the Several Provinces.* London: Wyman, 1875. 272 pp. 12 b & w. [Photomechanical prints.]

PERIODICALS
ST1599 "New Zealand Parliamentary Portraits." ILLUSTRATED LONDON NEWS 67, no. 1873 (July 3, 1875): 5. 4 illus. ["We give the portraits of three if these respectable Maori Legislators, from photographs which have been lent us by Mr. D. L. Mundy. These were taken by different photographers, but were collected by him during his residence in New Zealand..."]

NORWAY: 1871.
ST1600 "Photography in the North of Europe." ANTHONY'S PHOTOGRAPHIC BULLETIN 2, no. 10 (Oct. 1871): 309-311. [From "Photo. News." Narrative of (I think) an Englishman photographing in Norway. Author not identified.]

PANAMA: 1865.
ST1601 "Launch of the Panama Railroad Company's New Steamer 'Panama,' at Panama, New Grenada, Jan. 28. - From a Photograph." FRANK LESLIE'S ILLUSTRATED NEWSPAPER 19, no. 493 (Mar. 11, 1865): 388. 1 illus.

PERU: 19TH C.
BOOKS
ST1602 McElroy, Douglas Keith. *The History of Photography in Peru in the Nineteenth Century, 1839 - 1876.* Albuquerque, NM: University of New Mexico, 1977. 2 vol. b & w. illus. [Ph.D. thesis, University of New Mexico, 1977.]

ST1603 McElroy, Douglas Keith. *Early Peruvian Photography: a Critical Case Study.* Ann Arbor, MI: UMI Research Press, 1985. 192 pp.

PERIODICALS
ST1604 "Prints and Photographs." QUARTERLY JOURNAL OF THE LIBRARY OF CONGRESS 10, no. 1 (Nov. 1952): 56. [Two albums, "Recuerdos del Peru," dated Oct. 28, 1868, of scenes in Lima, Peru, earthquake aftermath, portraits of a bullfighter, etc., made for presentation to the American Legation.]

ST1605 McElroy, Keith. "The Daguerrean Era in Peru, 1839 - 1859." HISTORY OF PHOTOGRAPHY 3, no. 2 (Apr. 1979): 111-123. 8 b & w. 4 illus.

ST1606 McElroy, Keith. "Photography in Depth." HISTORY OF PHOTOGRAPHY 3, no. 2 (Apr. 1979): 132. 2 illus. [Photographic print of an over-painted battle photograph, taken in Peru ca. 1866.]

ST1607 McElroy, Keith. "La Tapada Limena: The Iconology of the Veiled Woman in 19th-Century Peru." HISTORY OF PHOTOGRAPHY 5, no. 2 (Apr. 1981): 133-149. 27 b & w. 8 illus. [Tapada, or "veiled woman," was a distinctive, often photographed, image of 19th century Peru.]

PERU: 1860.
ST1608 "Photography in Peru." PHOTOGRAPHIC NEWS 4, no. 102 (Aug. 17, 1860): 184. ["...MM. Colpaert and Garreaud, now on a mission in Peru..."]

PERU: 1871.
ST1609 Barlow, E. A., Tarma, Peru. "South American Photography." PHOTOGRAPHIC WORLD 1, no. 9 (Sept. 1871): 263-264.

PERU: 1872.
ST1610 "The Late Revolution in Peru." FRANK LESLIE'S ILLUSTRATED NEWSPAPER 34, no. 884 (Sept. 7, 1872): 413. 8 illus. [Two sketches and six portraits of participants. The portraits are from photographs.]

PHILIPPINES: 1863.
ST1611 "The Earthquake in Manila." ILLUSTRATED LONDON NEWS 43, no. 1221 (Sept. 12, 1863): 263-264. 3 illus. ["I hasten to send you further photographs, which will illustrate the ravages caused by the earthquake..."]

POLAND: 19TH C.
BOOKS
ST1612 *Fotografia Polska: featuring original masterworks from public and private collections in Poland, 1839 - 1945, and a selection of avant-garde photography, film, and video from 1945 to the present.* New York: International Center of Photography, 1979. 49 pp. b & w. illus. [Ex. cat.: ICP, July 26 - Sept. 15, 1979.]

PERIODICALS
ST1613 Garztecki, Juliusz. "Early Photography in Eastern Europe: Poland." HISTORY OF PHOTOGRAPHY 1, no. 1 (Jan. 1977): 39-62. 9 b & w. 7 illus. [First practitioners, Strasz, Beyer, Mieczkowski, Fajans, Greim, Rzewuski, Szweycer, Lewicki, Metejko, Szacinski, Dobrzanski, Okninski, Szubert, Bizanski, and others.]

POLAND: 1862.
ST1614 Schaefer, Friedrich. "On the preparation of Weaving Patterns for the Jacquard-loom, by means of Photography. The invention of Friedrich Schaefer, Civil Engineer, and executed by Wilhelm Ruff, Photographer, Prague." HUMPHREY'S JOURNAL OF PHOTOGRAPHY, AND THE ALLIED ARTS AND SCIENCES 14, no. 13 (Nov. 1, 1862): 152-153. [From "Zeitschrift der Fotografie and Stereoscopie."]

ROMANIA: 19TH C.
ST1615 Savulescu, C. "Early Photography in Eastern Europe: Romania." HISTORY OF PHOTOGRAPHY 1, no. 1 (Jan. 1977): 63-77. 22 b & w. 1 illus. [Carol Popp de Szathmari, Bart, Scheianu, Angerer, Duschek, Patzelt, Maltopl, Manakia and others.]

ROMANIA: 1858.
ST1616 "Wallachian Peasants." BALLOU'S PICTORIAL DRAWING-ROOM COMPANION [GLEASON'S] 15, no. 25 (Dec. 18, 1858): 400. 1 illus. ["Picture of Wallachian Peasants, from a Photograph. To the photographic art we are indebted for the most minute representations of the architecture, features, and costumes of different nations. The engraving on this page, representing a Wallachian peasant and his wife, if from one of these accurate photographs..."]

RUSSIA: 19TH C.
BOOKS
ST1617 Lyons, Marvin, comp. Andrew Wheatcroft, ed. *Russia in Original Photographs, 1860 - 1920.* New York: Scribner, 1977. xii, 212 pp. b & w.

PERIODICALS
ST1618 Parry, Albert. "Russia's Early Photography." EYE TO EYE 1, no. 5 (June 1954): 24-29. [1840s: Alexei Grekov (Moscow); Sergei

Levitsky; Grigori Karelin. 1850s: P. I. Sevastianov; Nikolai Vtorov's ethnological albums, containing photos by Mikhail Tulinov; Pyotr Piatnitsky. 1860s: A. S. Murenko; Ivan Boldyrev. 1870s: G. Krivtsova; Lyubov Poltoratskaya; Raoul. 1880s: Ivan Boldyrev; Ivan Barchevsky; Maria Preobrazhenskaya; Dmitri Mendeleyev; Nikolai Miklukko-Maklai; N. M. Przhevalsky. 1890s: G. Tsybikov. This is a very condensed summation, in English, of information in S. Morozov's "Russkie puteschestvenniki-fotografy," edited by D. I. Shcherbakov. (Moscow: State Publishing House of Geographic Literature, 1953.)]

ST1619 Morozov, S. "Early Photography in Eastern Europe: Russia." HISTORY OF PHOTOGRAPHY 1, no. 4 (Oct. 1977): 327-347. 26 b & w.

ST1620 Mamasakhlisi, A. V. "Early Photography in Georgia." HISTORY OF PHOTOGRAPHY 2, no. 1 (Jan. 1978): 75-84. 14 b & w.

RUSSIA: 1870 see SWEDEN: 1870 (McGovern)

RUSSIA: 1870.
ST1621 Portrait. Woodcut engraving taken at St. Petersburg, published in London by Marion & Co. ILLUSTRATED LONDON NEWS 58, (1870) ["Crown Prince Frederick William of Prussia." 58:* (Aug. 20, 1870): 185.]

RUSSIA: 1872.
ST1622 "Chemaka, Russian Caudasus, the Scene of the Late Earthquake." ILLUSTRATED LONDON NEWS 60, no. 1693 (Feb. 17, 1872): 151, 153. ["...view ...taken by photograph from the steps leading into the Armenian churchyard..."]

RUSSIA: 1876.
ST1623 Portrait. Woodcut engraving credited "From a photograph taken at St. Petersburg." ILLUSTRATED LONDON NEWS 69, (1876) ["Alexander Alexandrovitch, Future Emperor of Russia." 69:1954 (Dec. 23, 1876): 605.]

RUSSIA: 1879.
ST1624 "Photographic News." PHILADELPHIA PHOTOGRAPHER 16, no. 182 (Feb. 1879): 44. ["Mr. Warnecke spent 6 months of last winter in Russia ... stirred them up to organizing a society, which he left flourishing. Portrait photography in Moscow and St. Petersburg is of a high grade."]

SAVOY: 1859.
ST1625 Portraits. Woodcut engravings, credited "From a Photograph." HARPER'S WEEKLY 3, (1859) ["Princess Clotilde Maria Teresa of Savoy." 3:113 (Feb. 26, 1859): 141. "Count Cavour." 3:123 (May 7, 1859): 293. "Bishop Doane." 3:125 (May 21, 1859): 325.]

SERBIA: 19TH C.
ST1626 Debeljkovic, Branibor. "Early Serbian Photography." HISTORY OF PHOTOGRAPHY 3, no. 3 (July 1979): 233-252. 26 b & w. 1 illus. [7 b & w by Anastas Jovanovic, 1 b & w by Anastas Stojanovic, 1 b & w by Musil i Miric, 1 b & w by Ana Feldmann, 1 b & w by Petar Arandjelovic of Nis, 2 b & w by I. V. Groman, 1 b & w by A. Mijovic of Kragujevac, 1 b & w by Mileta Rajkovic of Aleksinac, 3 b & w by Milan Jovanovic of Belgrade, 1 b & w by Lazar Lecter, 1 b & w by Vladimir Gradojevic, 1 b & w by Nikola Zega, 1 b & w by Marko Stojanovic.]

SIAM: 1865.
ST1627 Dubois, Patterson. "Photography in Siam." PHILADELPHIA PHOTOGRAPHER 2, no. 21 (Sept. 1865): 151. [Mentions Director of Royal Siamese Mint, Pra Wisnt Yotamad, as practitioner.]

SIAM: 1866.
ST1628 Portrait. Woodcut engraving, credited "From a photograph." ILLUSTRATED LONDON NEWS 48, (1866) ["The Late King of Siam." 48:* (Mar. 17, 1866): 261.]

SIAM: 1875.
ST1629 "The Two Kings of Siam." ILLUSTRATED LONDON NEWS 66, no. 1852 (Feb. 6, 1875): 133. 3 illus. [Two portraits, a view of a crowd in front of the British Consulate, Bangkok..."from photographs lent us by Mr. E. B. Gould."]

SPAIN: 19TH C.
BOOKS
ST1630 Fontanella, Lee. *Photography in Spain in the Nineteenth Century.* Dallas, TX; San Francisco, CA: Delahunty Gallery; Fraenkel Gallery, 1983. 40 pp. 43 b & w. illus. [Introductory survey, then brief biographical essays on the Beauchy family; the Hon. Frank Charteris; Charles Clifford; José Garcia Ayola; Juan Laurent; Francisco de Leygonier; Pedro Martinez [de] Herbert; Alejandro Massari; Luis Leon Masson; Auguste Muriel; R. P. Napper; and José Spreafico. Includes "Appendix A: Significant Markings and Signatures," and "Appendix B: Survey of Collections with Holdings by Photographers Included in the Accompanying Exhibit."]

ST1631 Fontanella, Lee. "Washington Irving's 'Tales of the Alhambra' and Early Photography in Spain," on pp. 113-126 in: *Romanticism of Washington Irving in the Old and New World,* edited by Stanley Brodwin. New York, Westport, CT, London: Greenwood Press, 1986.

SPAIN: 1856.
ST1632 "1 engraving (The Late Toreador Puceta, the Insurgent of Madrid)." ILLUSTRATED LONDON NEWS 29, no. 814 (Aug. 2, 1856): 119. 1 illus. ["From a photograph."]

SPAIN: 1860.
ST1633 Hardman, Frederick. *The Spanish Campaign in Morocco,* by Frederick Hardman, Special Correspondent of "The Times." Edinburgh, London: William Blackwood & Sons, 1860. n. p. 22 b & w. [Carte-de-visite portraits of military and political figures.]

SPAIN: 1862.
ST1634 "Application of Photography to Sanitary Purposes." HUMPHREY'S JOURNAL OF PHOTOGRAPHY, AND THE ALLIED ARTS AND SCIENCES 15, no. 16 (Dec. 15, 1863): 250. [From "El Propagador de la Fotografie." "At the request of Superior Authority, the photographs of a certain class of females have to be taken; the intention is to form a register of all of them, to which their likeness will be attached.]

SPAIN: 1864.
ST1635 E. N. M. "Photography in Spain." BRITISH JOURNAL OF PHOTOGRAPHY 11, no. 214 (May 16, 1864): 169-170. [Describes photographic opportunities available, from standpoint of a tourist. Photographic journals "El Propagador de la Fotografia," "El Eco de la Fotografia." Few amateurs. Clifford's death suspended publication of "Collection of the Views of Spain."]

SPAIN: 1868.

ST1636 "A Group of Gipsies in Grenada, Spain - From a Photograph from Life." FRANK LESLIE'S ILLUSTRATED NEWSPAPER 27, no. 690 (Dec. 19, 1868): 210. 1 illus. [Outdoor group portrait.]

SPAIN: 1869.

ST1637 "The Plaza at Cadiz, After the Recent Struggle Between the Citizens and the Troops - From a Photograph Taken Immediately After the Battle." FRANK LESLIE'S ILLUSTRATED NEWSPAPER 27, no. 696 (Jan. 30, 1869): 317. 1 illus. [View, with troops.]

SPAIN: 1879.

ST1638 Portrait. Woodcut engraving credited "From a photograph." ILLUSTRATED LONDON NEWS 74, (1879) ["Late Marshall Espartero, Spain." 74:2066 (Jan. 18, 1879): 61.]

SWEDEN: 1870.

ST1639 McGovern, Thomas, Esq. *Recollections of a Short Trip to Sweden and Russia in 1870 by the Narrator and Printer Thomas McGovern.* Dublin: Thomas McGovern, 1874. n. p. 8 b & w. [Albumen prints. Unclear who the maker is.]

SWITZERLAND: 1855.

ST1640 Smyth, Rev. Christopher Charles. "Ascent of Monte Rosa; And of Mont Blanc, Without Guides." ILLUSTRATED LONDON NEWS 27, no. 762 (Sept. 22, 1855): 355-356. 1 illus. [Mountain climbers. "Our party consisted of my brother and myself, a Yorkshire clergyman, and a pupil of his, who is a botanist, and withal a photographer." (Second trip.) "...Rev. C. Hudson, Messrs. Kennedy, Ainslie, Stephenson and G. Joad..."]

ST1641 "The Ascent of Mont Blanc." FRANK LESLIE'S ILLUSTRATED NEWSPAPER 1, no. 19 (Apr. 19, 1856): 291-293. 4 illus. [Views, portrait of a climbing party, probably from a photograph. This seems to be a composite story put together from several European sources. Some of the illustrations may be derived from photographic sources.]

SWITZERLAND: 1863.

ST1642 "Miscellaneous: A Curious Picture Gallery." AMERICAN JOURNAL OF PHOTOGRAPHY AND THE ALLIED ARTS & SCIENCES n. s. vol. 6, no. 13 (Jan. 1, 1864): 311. [From "Notes & Queries." "The 'Revue Geneve' states that the Dept. of Justice and Police to incur the charge of photographing the portraits of persons breaking the laws by mendicancy in cantons where they have no settlement...." (Dated Nov. 15, 1852, but I think this is a typo - should be 1862.)]

SWITZERLAND: 1868.

ST1643 "The Villa Wallis, Lucerne, The Temporary Residence of Queen Victoria in Switzerland." ILLUSTRATED LONDON NEWS 53, no. 1497 (Aug. 15, 1868): 141. 1 illus.

SWITZERLAND: 1874.

ST1644 Berlepsch, Hermann Alexander von. *Rhododendron; Lake and Mountain Scenery of the Swiss Alps,* by G. Closs and O. Froelicher, with text by T. G. Bonney. New York: Stroefer & Kirchner, 1874. 148 pp. 24 l. of plates. 24 b & w. [Original photographs, of oil paintings and sketches.]

THAILAND: 19TH C.

ST1645 Nawigamune, Anake. *Early Photography in Thailand.* Bangkok: s. n., 1987. 190 pp. b & w. [Texts in Thai, with English summary.]

TURKEY: 19TH C.
BOOKS

ST1646 Çizgen, Engin. *Photography in the Ottoman Empire 1839 - 1919.* Istanbul: Kervan Kitapçilik, Basin Sanayii, printer, 1987. 231 pp. 172 b & w. illus. ["Introduction: Factors Influencing Attitudes to Photography," pp. 13-17; "The Early Years," pp. 20-27; "The Development of Photographic Themes," pp. 28-29; "Photographers," pp. 46-54; "Biographies," pp. 54-179; "Publications on Photography in Ottoman Istanbul," pp. 180-187; "Bibliography," pp. 215-219. Includes biographical information, portraits and photographs by photographers living in the area (Abdullah Fréres) and those visiting (Jacob A. Lorent, Francis Frith, etc).]

PERIODICALS

ST1647 Kulturman, Perihan. "Pioneers of Turkish Photography 1858 - 1920." CAMERA (LUCERNE) 45, no. 6 (June 1966): 6-9. 7 b & w. [Abdullah Brothers; Sabah & Joaillier; Nicholas Andriomeno; B. Karcopoulo.]

ST1648 Allen, William. "The Abdul Hamid II Collection." HISTORY OF PHOTOGRAPHY 8, no. 2 (Apr. - June 1984): 119-144. 22 b & w. [The Ottoman Sultan, Abdul Hammid II presented 51 albums of 1,819 photographs to the US government in 1893. Collection now at the Library of Congress. Views, costume portraits, etc., by six photographers. Abdullah Fréres (1292 photos); Phoebus (66 photos); Sébah & Joaillier (60 photos); Ali Riza (60 photos); others.]

TURKEY: 1845.

ST1649 "Smyrna." ILLUSTRATED LONDON NEWS 7, no. 171 (Aug. 9, 1845): 83-84. 1 illus. ["Smyrna. - From a Daguerreotype taken on the Roof of the Governor's House."]

TURKEY: 1854.

ST1650 Gautier, Théophile. *Constantinople Today.* Trans. from the French by Robert Howe Gould...Illus. with engravings from photographic pictures. London: David Bogue, 1854. 368 pp. illus. [Gennadius Lib. Collection.]

TURKEY: 1859.

ST1651 "Interior of a Turkish Cafe." BALLOU'S PICTORIAL DRAWING-ROOM COMPANION [GLEASON'S] 17, no. 431 (Sept. 24, 1859): 200. 1 illus. ["...from a photograph..." Costume portrait of two Turks, smoking. (Probably from "Illus. London News.").]

USA: RETROSPECTIVE
BOOKS

ST1652 Taft, Robert. *Photography and the American Scene - A Social History, 1839 - 1889*. New York: Macmillan Co., 1939. 546 pp. b & w. illus. [Reprint edition (1970). New York: Dover.]

ST1653 Newhall, Beaumont. *The Daguerreotype in America*. New York: Duell, Sloan & Pierce, 1961. 176 pp. 83 b & w. illus. ["Biographies and Notes," on pp. 139-168. "Select Bibliography," on pp. 169-170. 3rd, rev. ed. (1975) New York: Dover Publications Inc., 176 pp., 104 illus.]

ST1654 Ehrlich, George. *Technology and the Artist: A Study of the Interaction of Technological Growth and Nineteenth Century American Pictorial Art*. Ann Arbor, MI: University Microfilms, 1962. iv, 243 l. illus. [Ph.D. Thesis, University of Illinois, 1960. Bibliography, leaves 238-242.]

ST1655 Rinhart, Floyd and Marion Rinhart. *American Daguerreian Art*. New York: C. N. Potter, 1967. ix, 135 pp. b & w. illus. [Bibliography on pp. 133-134.]

ST1656 Rudisill, Richard. *Mirror Image; the Influences of the Daguerreotype on American Society*. Albuquerque, NM: University of New Mexico Press, 1971. ix, 342 pp. 202 b & w. [Reworking of Ph.D dissertation, Univ. of Minnesota, 1967. 592 l. in 2 vol.]

ST1657 Jenkins, Reese V. *Images and Enterprise. Technology and the American Photographic Industry, 1839 - 1925*. Baltimore: Johns Hopkins University Press, 1975. 371 pp. b & w. illus.

ST1658 Jareckie, Stephen B. *American Photography, 1840 - 1900*. Worcester, MA: Worcester Art Museum, ca. 1976. 60 pp. b & w. [Exhibition, June 2 - July 25, 1976.]

ST1659 Lindquist-Cock, Elizabeth. *The Influence of Photography on American Landscape Painting, 1839 - 1880*. "Outstanding Dissertations in the Fine Arts" New York: Garland Publishing, 1977. ix, 205 pp. illus. [Originally presented as Ph.D thesis, New York University, 1967. Bibliography, pp. 181-198.]

ST1660 Pfister, Harold Francis. *Facing the Light: Historic American Portrait Daguerreotypes*. An Exhibition at the National Portrait Gallery, September 22, 1978 - January 15, 1979, by Harold Francis Pfister; foreword by Marvin Sadik; curatorial preface by William F. Stapp. Washington D.C.: Published for the National Portrait Gallery by the Smithsonian Institution Press, 1978. 378 pp. b & w. illus. [Bibliography on pp. 361-374.]

ST1661 Welling, William. *Photography in America; the Formative Years, 1839 - 1900*. New York: Thomas Y. Crowell Co., 1978. 431 pp. b & w. 400 illus. [(1987) Albuquerque, NM: Univ. of New Mexico Press, 428 pp.]

ST1662 Naef, Weston J. "'New Eyes' - Luminism and Photography," on pp. 267-289 in: *American Light: The Luminist Movement, 1850 - 1875; Paintings, Drawings, Photographs*. Edited by John Wilmerding. Essays by Lisa F. Andrus, Linda S. Ferber, Albert Gelpi, David C. Huntington, Weston Naef, Barbara Novak, Earl Powell, Theodore Stebbins, Jr. New York: Harper & Row, for the National Gallery of Art, 1980. 330 pp.

ST1663 Rinhart, Floyd and Marion Rinhart. *The American Daguerreotype*. Athens: University of Georgia Press, 1981. x, 446 pp. b & w. illus. [Biographies on pp. 380-421.]

ST1664 Walther, Susan Danley, ed. *The Railroad in the American Landscape, 1850 - 1950*. Wellesley, MA: Wellesley College Museum, 1981.

ST1665 Burns, Stanley B., M.D., F.A.C.S. *Early Medical Photography in America (1839 - 1883)*. New York: The Burns Archive, 30 E. 60th St., 1983. 136 pp. 150 b & w. 16 illus. [Reprints of articles from the "New York State Journal of Medicine," collected and republished by the author. Seven parts. 1. History of Photographic Processes. 2. Physicians and Early Photography. 3. The Daguerrean Era. 4. Early Wet-Plate Era. 5. Beginnings of Psychiatric Photography. 6. Civil War Medical Photography. 7. American Medical Publications with Photographs. The seventh section contains a brief but thorough introduction to early 19th century illustration methods and processes, plus an extended, annotated bibliography of illustrated books and journals.]

ST1666 Coar, Valencia Hollins. *A Century of Black Photographers, 1840 - 1960*. Providence, RI: Museum of Art, Rhode Island School of Design, 1983. 192 pp. b & w. [Exhibition: Museum of Art, RISD, Mar. 31 - Aug. 26, 1983.]

ST1667 Wolf, Daniel, ed. *The American Space: Meaning in Nineteenth-Century Landscape Photography*. Middletown, CT: Wesleyan University Press, 1983.

ST1668 Hales, Peter B. *Silver Cities: The Photography of American Urbanization, 1839 - 1915*. Philadelphia: Temple University Press, 1984. x, 315 pp. b & w. illus.

ST1669 Willis-Thomas, Deborah. *Black Photographers, 1840 - 1940: An Illustrated Bio-Bibliography*. New York: Garland Press, 1985. xviii, 141 pp. illus.

ST1670 Sufrin, Mark. *Focus on America: Profiles of Nine Photographers*. New York: Charles Scribner's Sons, 1987. 162 pp. 28 b & w. [Chapters on Mathew Brady; William H. Jackson; Edward Curtis; Lewis Hine; Dorothea Lange; Bernice Abbott; Walker Evans; Margaret Bourke-White; W. Eugene Smith. Written either for a popular audience or for young adults.]

ST1671 Phillips, Sandra S. "Chapter 3: Documents of the Personal Landscape," on pp. 59-76 in: *Charmed Places. Hudson River Artists and Their Houses, Studios, and Vistas*, conceived and curated by Sandra Phillips. Compiled and Edited by Sandra S. Phillips and Linda Weintraub. Color Photographs by Len Jenshel. With Essays by James Marston Fitch, Albert Fein, Donelson Hoopes, Sandra S. Phillips, William Rhoads. Anandale-on-Hudson, NY: Edith C. Blum Art Institute, Bard College and the Vassar College Art Gallery, in association with Harry N. Abrams, Inc., 1988. [The author discusses the influences and uses of photography by members of this school of painting during the second half of the 19th century.]

ST1672 *American Daguerreotypes from the Matthew R. Isenburg Collection*. Exhibition and catalogue prepared by Richard S. Field and Robin Jaffee Frank. Introduction by Matthew R. Isenburg. Essay by Alan Trachtenberg. New Haven, CT: Yale University Art Gallery, 1989. 126 pp. 67 illus. [Exhibition held Nov. 10, 1989 - Jan. 3, 1990. Checklist of 146 pieces. Includes a special section of 14 "Portraits by Southworth & Hawes."]

ST1673 Isaacs, Charles, curator. *The Strange and the Sublime: American Photography 1850 - 1920*. Bethlehem, PA: Kemerer Museum of Decorative Arts, 1989. 32 pp. 34 b & w. [Exhibition

catalog. (Sept. 17 - Nov. 22, 1989) Foreword by Sarah J. Wilson, p. 1. Essay by Charles Isaacs and Carol A. Nigro, pp. 3-4.]

ST1674 Palmquist, Peter E., ed. *Camera Fiends & Kodak Girls: 50 Selections By and About Women in Photography, 1840 - 1930.* New York: Midmarch Arts Press, 1989. 272 pp. 14 b & w. 18 illus.

ST1675 Trachtenberg, Alan. *Reading American Photographs: Images as History. Mathew Brady to Walker Evans.* New York: Hill & Wang, 1989. 129 b & w. ["Chapter 1: Illustrious Americans," pp. 21-70; "Chapter 2: Albums of War," pp. 71-118; "Chapter 3: Naming the View," pp. 119-163. Covers the period from 1830s to 1880s. Focus on Mathew Brady, Civil War photographers, O'Sullivan. The last two chapters deal with Hine, Stieglitz and Walker Evans.]

PERIODICALS

ST1676 "Shade." "My First Daguerreotype." AMERICAN JOURNAL OF PHOTOGRAPHY AND THE ALLIED ARTS AND SCIENCES n. s. vol. 1, no. 15 (Jan. 1, 1859): 233-251. [Describes his experiences in the early 1840S.]

ST1677 West, Charles E. "The Daguerreotype." ANTHONY'S PHOTOGRAPHIC BULLETIN. 14, no. 3 (Mar. 1883): 72-73. [From "NY Times." Discussion of the various claims to priority for making the first American portrait. West discusses the activities of Morse and his assistant George W. Prosch, Dr. James R. Chilton, Dr. John W. Draper, A. S. Wolcott.]

ST1678 Snelling, H. H. "Looking Back; Or, The Olden Days of Photography." ANTHONY'S PHOTOGRAPHIC BULLETIN 19, no. 9-10, 12, 14, 18, 21 (May 12 - May 26, June 23, July 28, Sept. 12, Nov. 10, 1888): 263-265, 295-298, 368-370, 433-438, 559-563, 650-654. [History of early photography in USA. Anecdotes, etc. Mentions Dr. Gouraud introducing photo to USA; the Lewises; Brady; Thompson; John Whipple's letter describing his photomicroscope experiences published on 562-563.]

ST1679 Canfield, C. W. "An Early American Notice of the Daguerreotype." PHOTOGRAPHIC TIMES 18, no. 379 (Dec. 21, 1888): 607-609. 2 illus. [Reprint of an article by Prof. E. A. Aikin, M.D. published in the April 1840 "Maryland Medical and Surgical Journal".]

ST1680 Gardner, J. B. "The Daguerreotype Process." ANTHONY'S PHOTOGRAPHIC BULLETIN 20, no. 7 (Apr. 13, 1889): 214-216. [Survey of the early history of photography in the U.S.; mentions Samuel Morse, John Johnson, Draper, Langenheim, Root, Simons, Plumb, Mayall, J. Gurney and others. J. B. Gardner was himself an early daguerreotypist in New York City.]

ST1681 Shrive, David. "Correspondence: Another Reply to Mr. Lochman." PHOTOGRAPHIC TIMES 21, no. 493 (Feb. 27, 1891): 105. [Comment that Shrive met a daguerreotypist in 1859 who claimed to have been cured of consumption by working in a dark room.]

ST1682 Ehrmann, Charles. "Notes on the Address to the Franklin Institute." PHOTOGRAPHIC TIMES 23, no. 610 (May 26, 1893): 278-279. [Ehrmann comments on Julius Saches' address to the Franklin Institute on the early history of photography in Philadelphia, PA. Mentions James McClees, others.]

ST1683 "Carlyle and Emerson On Their Own and Each Other's Daguerreotypes." PHOTOGRAPHIC TIMES 24, no. 644 (Jan. 19, 1894): 38-39, 41. [Quotes exchange of letters between Thomas Carlyle and Ralph Waldo Emerson, discussing an exchange of daguerreotype portraits that each mailed to the other.]

ST1684 "A Bit of Photographic History - An Old Landmark Gone." PHOTOGRAPHIC TIMES 24, no. 667 (June 29, 1894): 415. [Comment that an old gallery building in the Bronx has been torn down, which led to a detailed account of the ten or twelve photographers that had operated out of the building.]

ST1685 "Senex." "Correspondence." PHOTOGRAPHIC TIMES 25, no. 671 (July 27, 1894): 69. [Letter mentioning that the "N. Y. Sun" had an extensive and illustrated article on "New York Fathers of Photography." Claims that the article left out some important figures, mentions by name Thomas Faris, Cornelius Hunt, T. C. Roche, Peter Duchochois, Oscar Mason and Henry J. Newton.]

ST1686 Davis, Mrs. D. T. "The Daguerreotype in America." MCCLURE'S MAGAZINE 8, no. 1 (Nov. 1896): 2-16. 11 b & w. [Discusses S. F. B. Morse; Françoise Gouraud; John W. Draper; Edward E. Hale; M. B. Brady; J. Gurney; Meade Brothers; Southworth & Hawes.]

ST1687 Sachse, Julius F. "The Daguerreotype in America." AMERICAN JOURNAL OF PHOTOGRAPHY 17, no. 204 (Dec. 1896): 552-557. [Discusses claims to the first portrait taken in USA. Cornelius vs. Morse, Draper, Wolcott, etc. Quotes the "New York Sun" (Feb. 10, 1838) and includes a letter from Charles E. West on p. 556.]

ST1688 Hart, Charles Henry, introduction and notes. "Life Portraits of Daniel Webster." MCCLURE'S MAGAZINE 9, no. 1 (May 1897): 619-630. 4 b & w. 9 illus. [Painted portraits of Webster and his wife. Photographs by Richards (Philadelphia, 1846); Southworth & Hawes (Boston, 1850); Ormsby & Silsbee (Boston, 1851); J. W. Black (Boston, 1852?). Brief information on the photographers and the sittings in the captions.]

ST1689 Sachse, Julius F. "Heliography as a Pioneer of Modern Civilization." PHOTOGRAPHIC TIMES 29, no. 10 (Oct. 1897): 468-469. 1 b & w. [From "Eder's Jahrbuch" for 1897. Article illustrated with a daguerreotype, taken about 1847, showing a daguerreotype gallery in a flatboat on the Ohio River.]

ST1690 Lochman, Charles L. "The Daguerreotype." PHOTOGRAPHIC TIMES 29, no. 11 (Nov. 1897): 508-509. [Brief discussion of the daguerreotype process as practiced in the 1840s, 1850s.]

ST1691 "A Word to Photographers and the Trade." WILSON'S PHOTOGRAPHIC MAGAZINE 34, no. 491 (Nov. 1897): 489-490. [Article against the practice of "process-mongering," gives the history of the development of the practice in the USA during the early years of photography.]

ST1692 Hale, Edward Everett. "James Russell Lowell and His Friends Chapter VIII—Lowell as a Public Speaker." OUTLOOK 59, no. 1 (May 7, 1898): 38-55. 8 b & w. 5 illus. [This article includes portraits of notable literary figures taken in 1850s, 1860s by Southworth & Hawes, Bogardus, J. W. Black, and views of Elmwood (Lowell's home) by Pach Brothers, (Cambridge, MA) and Miss C. E. Peabody.]

ST1693 Chittenden, L. E. "An Historical Letter." CAMERA NOTES 2, no. 1 (July 1898): 17-18. [Chittenden relates his experience of his first sitting for a daguerreotype in 1842.]

ST1694 Hale, Edward Everett. "James Russell Lowell and His Friends. XII. Twenty Years of Harvard." OUTLOOK 60, no. 1 (Sept. 3, 1898): 59-71. 10 b & w. [Series, illustrated with drawings, portraits. This issue contains landscape photographs of rural Cambridge, MA. 1 credited to J. Olssen of Cambridge, 1 credited to Mrs. J. M. Thurston, of Cambridge, others non-credited. Also portraits taken in 1850s-1860s.]

ST1695 "Autobiographical Sketch of Mrs. John Drew: With an Introduction by Her Son." SCRIBNER'S MAGAZINE 26 , no. 4 (Oct. 1899): 417-433. 17 illus. [Drew was a well-known actress, her memoir's filled with photos of actors, actresses from 1850s, 1860s. Some credited: Meade Brothers (1), Fredericks (2), Case & Getchel (Boston, MA) (1), etc.]

ST1696 "Autobiographical Sketch of Mrs. John Drew (Second Paper)." SCRIBNER'S MAGAZINE 26, no. 5 (Nov. 1899): 552-569. 20 illus. [Photos by B. J. Falk, W. L. Germon (Philadelphia, PA), Brady, etc.]

ST1697 Martin, Charlotte M., ed. "The Stage Reminiscences of Mrs. Gilbert. Parts I - III." SCRIBNER'S MAGAZINE 29, no. 2-4 (Feb. - Apr. 1901): 167-184, 312-323, 460-471. 19 b & w. [Illustrated with portraits of actors, actresses from ca. 1850s - 1880s. Photos credited are: Gurney (New York, NY), Sarony (New York, NY), Howell (New York, NY), C. D. Fredericks & Co. (New York, NY), E. & H. T. Anthony & Co. (New York, NY), J. F. Ryder (Cleveland, OH), Rockwood (New York, NY), Ritz (Boston, MA), H. G. Smith (Boston, MA), Brady (New York, NY), Rocher, et al.]

ST1698 King, Pauline. "The Charming Daguerreotype." CENTURY MAGAZINE 68, no. 1 (May 1904): 81-82. 1 illus. [Brief reflections on the beautiful qualities of this obsolete process. Leads to the following article, "The Lost Art of the Daguerreotype," by Abraham Bogardus.]

ST1699 Claudy, C. H. "An Old Romance." PHOTOGRAPHIC TIMES 37, no. 9 (Sept. 1905): 401-403. 1 b & w. [Narrative including a letter about an old ambrotype that played a role in a couple meeting in the 1860's, then marrying.]

ST1700 Hill, James J. "Highways of Progress: Second Article. How the Railroads Opened the Northwest." WORLD'S WORK 19, no. 2 (Dec. 1909): 12338-12361. 30 b & w. 9 illus. [Cities, railroads, industry, etc. Includes earlier photos, from 1830s, 1860s, etc.]

ST1701 Taft, Robert. "Old Photographs - A Review of American Photography in the Period 1839 - 1880." KANSAS ACADEMY OF SCIENCE, TRANSACTIONS 36, (Apr. 13-15, 1933): 36-42. 14 b & w. [Abstract of Taft's Presidential Address at the 65th Annual Meeting of the Kansas Academy of Science. Based on Taft's then unpublished book; includes a checklist of 74 slides that Taft presented, including Alexander Gardner's Kansas photos, etc.]

ST1702 Wall, A. J., Jr. "The Story of Photography in America." NEW YORK HISTORICAL SOCIETY QUARTERLY BULLETIN 23, no. 4 (Oct. 1939): 124-130. 5 b & w. 1 illus. [Written in conjunction with the exhibition of the same name, held at the Society from Oct. 1 - Nov. 5, 1939, of materials in their collections. Photos by Victor Prevost; Jeremiah Gurney; Mathew B. Brady; Alexander Gardner; Rabineau (Albany, NY); George Rockwood; J. M. Mora; L. E. Walker; H. H. Lawrence and C. H. Williamson also mentioned.]

ST1703 "American Photographic Periodicals." PENNSYLVANIA ARTS AND SCIENCES 4, no. 1 (Fall 1940): 60-62, 91. [General survey.]

ST1704 Lovejoy, Edward Daland. "Daguerreotypes in America." ESSEX INSTITUTE HISTORICAL COLLECTIONS 81, no. 4 (Apr. 1945): 186-190. 2 illus. [Rather general introduction to early photography in USA.]

ST1705 Newhall, Beaumont. "Portraits for the Millions." MAGAZINE OF ART 41, no. 3 (Mar. 1948): 104-108. 7 b & w. 6 illus.

ST1706 Newhall, Beaumont. "The Daguerreotype." ANTIQUES 53, no. 4 (Apr. 1948): 278-280. 6 b & w. 1 illus. [Images by Fontayne & Porter; Luther H. Hale; Southworth & Hawes; Jame P. Ball; etc.]

ST1707 Newhall, Beaumont. "The Daguerreotype and the Painter." MAGAZINE OF ART 42, no. 7 (Nov. 1949): 249-251. 3 b & w. 7 illus. [Cites examples of portraits painted or engraved from daguerreotypes. Discusses Samuel F. B. Morse; Frederick De Bourge Richards; John A. Whipple; Mathew B. Brady; Southworth & Hawes; John Plumbe; Thomas Farris; and others.]

ST1708 "Rogue's Gallery." IMAGE 1, no. 7 (Oct. 1952): 2. [Early uses of photographs of criminals 1850s (USA) to Alphonse Bertillon's book "Le Photographie Judiciare," Paris, 1890.]

ST1709 "Little Gems." IMAGE 2, no. 3 (Mar. 1953): 12-13. 2 illus. [Postage-stamp sized portraits, vogue of the 1870s and 1880s.]

ST1710 "3-D Daguerreotypes in America." IMAGE 3, no. 1 (Jan. 1954): 1-3. 3 b & w. 2 illus. [Southworth and Hawes (3); images from George Eastman House collection.]

ST1711 Newhall, Beaumont. "The Development of Action Photography." ART IN AMERICA 43, no. 4 (Dec. 1954): 8-21. b & w. [Photographing movement, from 1850s to 1890s.]

ST1712 Angle, Paul. "Chicago Historical Society Displays its Treasures." IMAGE 3, no. 9 (Dec. 1954): 57-60. 6 b & w. ["American Photography: 1845 - 1865." Illustrated by 6 unknown photographers' work.]

ST1713 "Footlight and Skylights: Theatrical Photographs 1860 - 1900." IMAGE 4, no. 7 (Oct. 1955): 52-53. 7 b & w. [Ex. notice, "Footlights and Skylights: Theatrical Photographs 1860-1900," organized from Eastman House Collections, Rochester, NY. 1 b & w by Nadar, 1 b & w by Sarony, 5 unknown.]

ST1714 Marks, Alfred H. "Hawthorne's Daguerreotypist: Scientist, Artist, Reformer." BALL STATE TEACHERS COLLEGE FORUM 3, no. 1 (Spring 1956): 61-74.

ST1715 "Index to Resources - Daguerreotypes." IMAGE 5, no. 6 (June 1956): 140-141. 8 b & w.

ST1716 Newhall, Beaumont. "Ambulatory Galleries." IMAGE 5, no. 9 (Nov. 1956): 202-207. 6 b & w. 1 illus. [Discusses photograph galleries set up in wagons, boats, railroad cars; where the photographer travelled around the country.]

ST1717 Culver, D. Jay. "The Camera Opens Its Eye on America." AMERICAN HERITAGE 8, no. 1 (Dec. 1956): 49-64. 35 b & w. [Portfolio of daguerreotypes taken in America ca. 1840 - ca. 1860.]

ST1718 "Index to Resources: American Daguerreotype Apparatus." IMAGE 6, no. 2 (Feb. 1957): 44-45. 5 illus. [Continuing series on George Eastman House Collection: American daguerreotype apparatus.]

ST1719 "Index to Resources: American Portrait Daguerreotypes." IMAGE 6, no. 4 (Apr. 1957): 94-95. 6 b & w. [Continuing series on George Eastman House Collections. American daguerreotypes: unknown (4), Southworth & Hawes (1), J. H. Whitehurst (1).]

ST1720 "Index to Resources: American Daguerreotypes - City Views and Scenes." IMAGE 6, no. 6 (June 1957): 144-146. 10 b & w.

ST1721 "Index to Resources: American Daguerreotypes - City Views and Scenes." IMAGE 6, no. 7 (Sept. 1957): 172-173. 8 b & w. [1 b & w by J. M. Thompson, 7 unknown.]

ST1722 Newhall, Beaumont. "Ambrotype. A Short and Unsuccessful Career." IMAGE 7, no. 8 (Oct. 1958): 171-177. 6 b & w. 1 illus. [Invented by James A. Cutting, 1854. By 1862 ambrotypes hardly requested.]

ST1723 Coke, Van Deren. "Camera and Canvas." ART IN AMERICA 49, no. 3 (1961): 68-73. 7 b & w. 6 illus. [Cites instances when painters used photographs as source materials, i. e. W. B. Cox painting of R. E. Lee, from a photo by J. Vannerson.]

ST1724 Newhall, Beaumont. "America's First News of Photography." IMAGE 10, no. 3 (1961): 11. [Mentions an article in the "Museum of Foreign Literature, Science and Art" (Philadelphia, PA) in March 1839. Quotes excerpts from the article.]

ST1725 Newhall, Beaumont. "Daguerrian Gallery." ART IN AMERICA 49, no. 4 (July - Aug. 1961): 74-79. 14 illus.

ST1726 Rinhart, Floyd and Marion Rinhart. "Rediscovery: An American Way of Death." ART IN AMERICA 55, no. 5 (Sept. - Oct. 1967): 78-81. 7 b & w. [Discusses use of post-mortem portrait daguerreotypes in America from 1839 to 1860.]

ST1727 Fuller, John C. "Glimpses at Early American Photography." JOURNAL: OSWEGO COUNTY HISTORICAL SOCIETY 33, (1973): 19-25. 3 b & w. 3 illus. [Brief survey of early processes and some key photographers, including the local photographer George N. Barnard.]

ST1728 Stashin, Leo. "Portraits of notable nineteenth-century Americans in daguerreotype." ANTIQUES 103, no. 4 (Apr. 1973): 784-800. 28 b & w. [Portraits, with biographies of the sitter.]

ST1729 Davidson, Carla. "The Mirror with a Memory: American Daguerreotypes." AMERICANA (AMERICAN HERITAGE SOCIETY) 1, no. 7 (July 1973): 16-19. 6 b & w. 1 illus.

ST1730 Lindquist-Cock, Elizabeth. "Frederick Church's 'Stereographic Vision.'" ART IN AMERICA 61, no. 5 (Sept. - Oct. 1973): 70-75.

ST1731 Gromet, Michael. "Cancel Notes." STEREO WORLD 2, no. 6 (Jan. - Feb. 1976): 7. [Stamps used by photographic studios to cancel tax revenue stamps in use during the Civil War. Examples of Whitney & Beckwith (Norwalk, CT); Abraham Bogardus (New York, NY): Black & Case (Boston, MA and Newport, RI.).]

ST1732 Rowles, Brandt. "Risque Stereo Views." STEREO WORLD 2, no. 6 (Jan. - Feb. 1976): 12. 2 b & w. [Climax View Co., New York, NY and others produced views of women undressing, etc.]

ST1733 Millard, Charles E. "An American Landscape." PRINT COLLECTORS NEWSLETTER 7, no. 2 (May - June 1976): 47-48. 1 b & w. [Illustration is a view by Muybridge. Article is a brief, incisive discussion of an American style or vision of landscape, with references to, and descriptions of, the work of certain Western landscape photographers of the 1870s, such as W. H. Jackson; T. O'Sullivan; A. J. Russell; Wm. Bell; E. Muybridge; and C. E. Watkins.]

ST1734 Keyes, Donald S. "The Daguerreotype's Popularity in America." ART JOURNAL 36, no. 2 (Winter 1976/1977): 116-122. 10 b & w.

ST1735 Porter, Allan. Photography and American History." CAMERA (LUCERNE) 55, no. 12 (Dec. 1976): 3, 38-40. [Discusses the first introduction of the news of the daguerreotype into the USA. S. F. B. Morse discussed.]

ST1736 Peters, Marsha and Bernard Mergen. "Doing the Rest: The Uses of Photographs in American Studies." AMERICAN QUARTERLY 29, no. 3 (1977): 280-303. 6 b & w. ["Bibliography Issue."]

ST1737 Lothrop, Eaton S., Jr. "Time Exposure:...Daguerreotypes..," POPULAR PHOTOGRAPHY 80, no. 4 (Apr. 1977): 32, 38, 138, 139. 1 b & w.

ST1738 Weinstein, Robert A. "Cameras at Sea and In Port: West Coast Maritime Photography." AMERICAN WEST 14, no. 3 (May - June 1977): 34-49. 15 b & w. [ca. 1860-1910.]

ST1739 "Harvard University's Peabody Museum Discovers Rare Slave Photographs." PHOTOGRAPHICA 9, no. 5 (June - July 1977): 2-3, plus cover. 5 b & w. [Fifteen daguerreotypes of South Carolina slaves.]

ST1740 "M. R. Isenberg Acquires Capitol Photo Found in Calif." PHOTOGRAPHICA 10, no. 2 (Feb. 1978): 4-6. 4 b & w. [Daguerreotype of U. S. Capitol building, taken in 1846.]

ST1741 Waldsmith, John. "The Cleveland Convention of 1870." STEREO WORLD 5, no. 1 (Mar. - Apr. 1978): 4-5. 3, plus 1 on cover b & w.

ST1742 Sobieszek, Robert A. "An American Century of Photography. 1840 -1940: Selections from the Sipley/3M Collection." CAMERA (LUCERNE) 57, no. 6 (June 1978): 4-29. 26 b & w. [Illustrations by Frederick E. Ives (1856-1937); Wm. & Fr. Langenheim; Samuel Van Loan; W. G. Mason; Robert Cornelius; Isaac A. Rehn; Wm. S. Porter (1822-1889); Fitz. W. Guerin; Joshua J. Hawes; Stephen H. Horgan; John Moran (1832-1903); and others.]

ST1743 Welling, William. "Notable Photographic Fires." PHOTOGRAPHICA 10, no. 7 (Sept. 1978): 8.

ST1744 Kelton, Ruth. "Daguerreotypes: A major exhibition of early photos mirrors the faces of U.S. history." SKY (Oct. 1978): 48-51, 93. 8 b & w. [Ex. rev.: "Facing the Light: Historic American Portrait Daguerreotypes," National Portrait Gallery, Washington, DC.]

ST1745 Wills, Camfield H. and Deirdre Wills. "Union Cases Based on Designs by Bertel Thorvaldsen." HISTORY OF PHOTOGRAPHY 3, no. 1 (Jan. 1979): 93. 1 illus.

ST1746 Murray, Joan. "Face of Our Fathers: The Daguerreotype Captured the Faces and the Spirit of Our Early Heroes." AMERICAN PHOTOGRAPHER 2, no. 3 (Mar. 1979): 66-71.

ST1747 Palmquist, Peter. "Silhouette on Silver." HISTORY OF PHOTOGRAPHY 3, no. 2 (Apr. 1979): 124. 1 b & w. [A

daguerreotype of a silhouette taken at Westfield, MS, by Collins, Aug. 10, 1859.]

ST1748 Wright, Helen. "Machine Portrait." HISTORY OF PHOTOGRAPHY 3, no. 2 (Apr. 1979): 156. 1 b & w. [Daguerreotype of a woman at a loom, ca. 1850.]

ST1749 Romer, Grant B. "The Night Watch." HISTORY OF PHOTOGRAPHY 3, no. 3 (July 1979): 192. 1 b & w. [A rare example of a daguerreotype of a tableau vivant.]

ST1750 Spira, S. F. "Daguerreotypes as a Selling Tool." HISTORY OF PHOTOGRAPHY 3 , no. 4 (Oct. 1979): 378. 6 b & w. [Daguerreotypes of clocks, used by salesmen in a sample case, ca. 1850's.]

ST1751 Palmquist, Peter E. "Timely Likeness." HISTORY OF PHOTOGRAPHY 4, no. 1 (Jan. 1980): 60. 1 illus. [Describes use of photographs on watch cases and dials.]

ST1752 "The Making of the First Nighttime Photos with Magnesium Lighting." PHOTOGRAPHICA 12, no. 1 (Jan. 1980): 11. [Article reprinted from Dec. 1865 "Philadelphia Photographer."]

ST1753 "Daugre-o-types, Dog-gerre-times, Etc." PHOTOGRAPHICA 12, no. 3 (Mar. 1980): 14. 1 illus. [Humorous early references to daguerreotypy in America.]

ST1754 Palmquist, Peter E. "Mr. Popeolay Brings Home a Stereoscope." STEREO WORLD 7, no. 1 (Mar. - Apr. 1980): 16-17. 2 illus. [Reprinting of satiric cartoon on the popularity of stereoscopes, first published in "Harper's New Monthly Magazine," (Oct. 1860): 717-718.]

ST1755 Crossette, Barbara. "Liberty Island Remembers the Old Countries." NEW YORK TIMES (May 23, 1980): III, 14. 1 b & w. [Exhibition review: "Places of Origin: Cities and Towns European Immigrants Left Behind, 1845-1914." Statue of Liberty's American Museum of Immigration, New York, NY.]

ST1756 "Frederick Douglass Daguerreotype." HISTORY OF PHOTOGRAPHY 4, no. 3 (July 1980): 180. 1 b & w. [Daguerreotype of the former slave, Frederick Douglass, taken ca. 1847. Photographer not known.]

ST1757 Gilbert, George. "Of Cherubs, Palettes and Scrolls." PHOTOGRAPHICA 12, no. 7 (Aug. - Sept. 1980): 14-15. 8 illus. [Cherub imagery used as back designs on cartes-de-visite.]

ST1758 Spira, Fred. "Photographs on Early Employment Contracts." HISTORY OF PHOTOGRAPHY 4, no. 4 (Oct. 1980): 308. 1 b & w. 1 illus. [Use of photographs in 1863.]

ST1759 Palmquist, Peter. "Photography As Seen by Caricaturists in "Harper's New Monthly Magazine."" HISTORY OF PHOTOGRAPHY 4, no. 4 (Oct. 1980): 325-328. 10 illus. [Cartoons that spoof photography but also identify its popularity during the 1850s.]

ST1760 Baldwin, Brooke Evans. "The Stereotyped Image of Blacks in American Popular Photography." EXPOSURE 19, no. 2 (1981): 14-24. 12 b & w.

ST1761 Wilsher, Ann. "Christmas Albums and Photographic Cases." HISTORY OF PHOTOGRAPHY 5, no. 1 (Jan. 1981): 20. 1 illus.

[Photograph albums designed to resemble popular literary giftbooks, etc.]

ST1762 Welling, William. "The New York Debut of Scoville Manufacturing and the 'New York Times.'" PHOTOGRAPHICA 13, no. 3 (Mar. 1981): 4-6. 1 b & w. 4 illus.

ST1763 Eltzroth, Elsbeth L. "One Face Reflected." HISTORY OF PHOTOGRAPHY 5, no. 2 (Apr. 1981): 124. 1 b & w. 1 illus. [A doctor's reflections on being photographed while in a small-pox hospital in Atlanta, Ga. in 1863.]

ST1764 "Army Curator Says Image is of a Young Judah Benjamin." PHOTOGRAPHICA 13, no. 6 (June - July 1981): 9. 2 b & w. 1 illus. [Daguerreotype from 1840s identified, with supporting materials.]

ST1765 Peter Palmquist. "Seeing Double." HISTORY OF PHOTOGRAPHY 5, no. 3 (July 1981): 265-267. 3 b & w. [Examples of "doubled portraits", a practice in 1870s of photographing two poses of the same individual in the same setting. Illustrations by I. G. Davidson (1875), Ginter & Cook, and John A. Todd.]

ST1766 Spira, S. F. "Graves and Graven Images." HISTORY OF PHOTOGRAPHY 5, no. 4 (Oct. 1981): 325-328. 3 b & w. 5 illus. [The Mausoleum Daguerreotype Company offered special daguerreotype cases for placing a daguerreotype at a gravesite in 1855.]

ST1767 Day, Diane L. "Lola Montez and Her American Image." HISTORY OF PHOTOGRAPHY 5 , no. 4 (Oct. 1981): 339-353. 14 b & w. 5 illus. [Role that photography played in the publicity of the actress Lola Montez during the 1850s.]

ST1768 Palmquist, Peter E. "Daguerreian Scrimshaw." HISTORY OF PHOTOGRAPHY 6, no. 1 (Jan. 1982): 28. 1 b & w. 1 illus. [Daguerreotype portrait, taken in Richmond, VA in 1855, of a Mason in his fraternal regalia. Areas of the daguerreotype have been overworked by hand with a stylus.]

ST1769 Smith, Graham. "The First American Calotypes?" HISTORY OF PHOTOGRAPHY 6, no. 4 (Oct. 1982): 349-352. 4 b & w. [Album of calotypes found at St. Andrews University Library, Scotland, has penciled annotations by one Alexander Gavan indicating some pictures may have been made in America. Also contains calotypes of or by the circle of David Brewster.]

ST1770 Spira, S. F. "Photograph Marriage Certificates." HISTORY OF PHOTOGRAPHY 7, no. 4 (Oct. - Dec. 1983): 305-309. 4 b & w. 2 illus. [Elaborate marriage certificates made to be framed and displayed on the wall, with provision for carte-de-visite or tintype inserts.]

ST1771 Ruby, Jay. "Post Mortem Portraiture in America." HISTORY OF PHOTOGRAPHY 8, no. 3 (July - Sept. 1984): 201-222. 27 b & w.

ST1772 Mayer, Robert A. "Photographing the American Presidency." IMAGE 27, no. 3 (Sept. 1984): 1-36. 51 b & w.

ST1773 Ostroff, Eugene. "Photography and American History: Photographs as Source Documents." CALIFORNIA MUSEUM OF PHOTOGRAPHY BULLETIN 4, no. 1 (1985): 1-9. 15 b & w. 1 illus.

ST1774 Palmquist, Peter E. "Photographic Archaeology: A Case for Regional Research." CALIFORNIA MUSEUM OF PHOTOGRAPHY BULLETIN 4, no. 1 (1985): 17-29. 7 b & w. 10 illus. [Contains "A Bibliography of Regional Photography" on pp. 25-29 which lists more

than 120 published works and unpublished works or works in progress.]

ST1775 Mayer, Robert A. "Three Stereo Views of Early Presidents." STEREO WORLD 12, no. 1 (Mar. - Apr. 1985): 23-25. 3 b & w. [Three stereo views of crowds, each containing a President of the USA. One is Andrew Johnson, two are of President Grant.]

ST1776 Gale, David M. and Charlotte Gale. "A Study and Catalog of 19th Century Photographic Tokens. Part 1. Marcus Aurelius Root and the American Daguerreotype." PHOTOGRAPHIC HISTORIAN 6, no. 2 (Summer 1985): 14-30. 3 b & w. 9 illus. [Article discusses work of M. A. Root on pp. 14-21, followed by a checklist of more than 60 tokens issued by American photographic galleries during the 19th century.]

ST1777 Duncan, Robert G. "Victorian America in Stereographs. Part 4: Leisure." PHOTOGRAPHIC HISTORIAN 6, no. 2 (Summer 1985): 32-40. 17 b & w.

ST1778 Phillips, Christopher. "Urban Observations." VIEWS: THE JOURNAL OF PHOTOGRAPHY IN NEW ENGLAND. 6, no. 4 (Summer 1985): 16-17. 6 b & w. [Bk. rev.:"Silver Cities: The Photography of American Urbanization, 1839-1915," by Peter Bacon Hales.]

ST1779 "Firemen in Early Photographs." PHOTOGRAPHIC HISTORIAN 6, no. 3 (Autumn 1985): 8-14. 18 b & w. [Ambrotypes, cartes-de-visite, etc.]

ST1780 Gladstone, William. "Meaningful Mixtures." PHOTOGRAPHIC HISTORIAN 6, no. 4 (Winter 1985-1986): 24-26. 9 b & w. [Describes the "mosaic" carte-de-visite, consisting of combined images, drawings, paintings etc. to make a single composite print. Made in U.S. during 1860s.]

ST1781 Yarnall, James L. "John La Farge's 'Portrait of the Painter' and the Use of Photography in His Work." AMERICAN ART JOURNAL 18, no. 1 (1986): 4-19. 7 b & w. 8 illus.

ST1782 Patterson, Norman B. "The Birth of Burlesque in America." STEREO WORLD 12, no. 6 (Jan. - Feb. 1986): 4-20, 39. 22 b & w. [Illustrated with stereos of actors and actresses in the 1860s, by J. Gurney & Sons; Napoleon Sarony; C. W. Woodward; E. & H. T. Anthony & Co.]

ST1783 Fels, Thomas Weston. "Inherence/Inheritance: From Canyon de Chelle to Wall Street." PRINT COLLECTOR'S NEWSLETTER 17, no. 1 (Mar. - Apr. 1986): 1-5. 4 b & w. [Discussion of American landscape photography during 19th century of city views during early 20th century. Photos by T. O'Sullivan, P. Strand, B. Abbott.]

ST1784 "The Fading Photograph." HISTORY OF PHOTOGRAPHY 10, no. 4 (Oct. - Dec. 1986): 325. [Poem. Reprinted from "Harper's Weekly," (Aug. 22, 1863).]

ST1785 Orvell, Miles. "Almost Nature: The Typology of Late Nineteenth Century American Photography." VIEWS: THE JOURNAL OF PHOTOGRAPHY IN NEW ENGLAND. 8, no. 1 (Supplement: Fall 1986): 14-19. 9 b & w. 1 illus. [Illustrations by Southworth & Hawes; Wm. Notman; A. Gardner; T. O'Sullivan; J. Riis; F. H. Day; H. P. Robinson; others.]

ST1786 Yarnall, James L. "New Insights on John LaFarge and Photography." AMERICAN ART JOURNAL 19, no. 2 (1987): 52-79.

6 b & w. 29 illus. [The American painter used photographs as source material for some of his work, during 1850s to 1890s.]

ST1787 Druckery, Timothy. "Traces of Poe." VIEWS: THE JOURNAL OF PHOTOGRAPHY IN NEW ENGLAND. 8, no. 2 (Winter 1987): 21. 4 illus. [Illustrations are daguerreotypes by Masury & Hartshorn (1848) and William Pratt (1849). Article discusses several daguerreotypes taken a few weeks before Poe's death by William Pratt, along with other, earlier works.]

ST1788 Wilsher, Ann. "Vignette: Photo Dentistry." HISTORY OF PHOTOGRAPHY 12, no. 1 (Jan. - Mar. 1988): 36. 2 illus. [Cartes, with photographs. Used by dentists for advertising in USA, ca. 1860s, 1870s.]

ST1789 Spira, S. F. "Frontispiece: Union Mutual Life Insurance Company Daguerreotype." HISTORY OF PHOTOGRAPHY 12, no. 2 (Apr. - June 1988): frontispiece. 1 b & w. [Daguerreotype portrait, ca. 1849, used as employee identification on a business card.]

ST1790 Mann, Charles. "Vignette: Black on White; White on Black." HISTORY OF PHOTOGRAPHY 12, no. 3 (July - Sept. 1988): 226. 1 b & w. [Title page and frontispiece of the book "Chess Problems," by Theophilus A. Thompson. Dubuque, IA: O. A. Brownson, Jr., 1873. The frontispiece was a tipped-in portrait of the author, who was black.]

ST1791 Ventimiglia, Tony. "The May Flower Incident." HISTORY OF PHOTOGRAPHY 12, no. 3 (July - Sept. 1988): 243-246. 1 b & w. 1 illus. [The "May Flower," a passenger boat on the Great Lakes, between Buffalo, NY and Detroit, MI, suffered a shipwreck in 1851. The illustrations are an engraving of the boat and a daguerreotype of the boat after the accident.]

ST1792 Miller, Kathleen L. "The Cabinet Card Photograph: Relic of a Gilded Age." JOURNAL OF THE WEST 28, no. 1 (Jan. 1989): 29-41. 22 b & w.

HISTORY: USA: BY YEAR
USA: 1839.
ST1793 "Self-operating Processes of Fine Art: The Daguerotype [sic]." on pp. 341-343 in: *The Museum of Foreign Literature, Science, and Art.* n. s. 7, (1839): n. p.

ST1794 Daguerre, L. J. M., translated by J. F. Frazer. "The Daguerreotype." JOURNAL OF THE FRANKLIN INSTITUTE n. s. 24, (Nov. 1839): 303-311. illus.

ST1795 "Miscellaneous: The Daguerreotype." NEW YORK OBSERVER (Nov. 3, 1839): 176. 6 illus. [Excerpted from J. S. Memes' translation of Daguerre's manual.]

ST1796 "Inventions, Experiments, Improvements, Artizans, &c.: Rival to the daguerreotype." NILE'S NATIONAL REGISTER (Nov. 9, 1839): 172. ["Leipmann, an artist in Berlin, has invented a machine for obtaining correct copies of oil colored pictures."

USA: 1840.
BOOKS
ST1797 "The Daguerreotype." on pp. 350-367 (vol. II) in : *The Useful Arts,* by Jacob Bigelow. Boston: T. Webb & Co., 1840. 2 vol. [Reprinting of J. S. Memes' translation of Daguerre's manual.]

PERIODICALS
ST1798 Daguerre, L. J. M., translated by J. S. Memes, LL.D. "The Daguerreotype." AMERICAN REPERTORY OF ARTS, SCIENCES

AND MANUFACTURES 1, no. 2 (Mar. 1840): 116-129, 130-132. 23 illus. [Translation of Daguerre's manual, by the editor of this magazine. Mentions that "Dr. Chilton, President Morse and Professor Draper, have fully succeeded in procuring fine specimens of photogenic drawing, by means of this instrument." Also includes "Improvements in the Daguerreotype," on pp. 128 (From "The Athenaeum," mentions Arago, Abbe Moignat, Baron Seguiers, and Talbot); "Observations," on pp. 130-132 (with a table of exposures, drawn up by D. W. Seager, New York, NY); "The Daguerreotype," on p. 132 (a note about the Belgian practitioner, Jobard exhibiting "the first portrait."); and "Rival to the Daguerreotype," p. 132 (about Leipmann's (Berlin) copying process for oil colored pictures, from the "Bury Post").]

ST1799 "The Daguerreotype." THE FAMILY MAGAZINE 7, (1840): 415-423. [From the "American Repertory," in turn from J. S. Memes' translation of Daguerre's manual.]

ST1800 "The Daguerreotype." THE FAMILY MAGAZINE 7, (1840): 462-464. ["In our last number we gave a full description... Mr. A. S. Wolcott, has made important improvements..." Includes a letter from Wolcott, on p. 463. Discusses Arago's report to the French Chamber of Deptuties, on p. 464.]

ST1801 "Chronicle: Daguerreotype." NILES' NATIONAL REGISTER (June 27, 1840): 272. [Aspot on a daguerreotype portrait, under magnification proved to be a fly, which had settled on the sitter's face during the exposure.]

ST1802 "Notices: Daguerreotype." AMERICAN REPERATORY OF ARTS, SCIENCES AND MANUFACTURES 2, no. 2 (Sept. 1840): 112. ["This art keeps pace in improvement with its twin-sister Electrotype. Professors Draper and Morse, and Mr. Wolcott, of this city, are obtaining by their experiments the most gratifying results. The last named gentleman has, within a few days, much increased the excellence of his pictures by a new arrangement of his lights and apparatus. We may venture to promise that he will ere long publish some important facts relating to the speculum."]

USA: 1841.
ST1803 "Notices: Daguerreotype." AMERICAN REPERTORY OF ARTS, SCIENCES AND MANUFACTURES 3, no. 2 (Mar. 1841): 114. [Note about improved sensitivity.]

USA: 1846 - 1848 (MEXICAN WAR).
BOOKS
ST1804 Frost, John. *Pictorial History of Mexico and the Mexican War; ...Embellished with 500 Engravings from Designs by W. Croome and Other Distinguished Artists.* Philadelphia; Boston: Charles Desilver, J. B. Lippincott & Co.; Nichols & Hall, 1871. 640 pp. 500 illus. [Preface: "In embellishing the work, the author has had the advantage of Mr. Croome's invaluable services; and he is indebted to Messrs. Root, Simons, Collins, Butler, Gunn & England, and Van Loan, for daguerreotype portraits of the officers; by which means a degree of authenticity in this department has been obtained, which was out of the question before the invention of this important art."]

ST1805 Sandweiss, Martha A. "Daguerreotypes of the Mexican War," on pp. 44-69 in: *Eyewitness to War: Prints and Daguerreotypes of the Mexican War, 1846-1846*, by Martha A. Sandweiss, Rick Stewart and Ben W. Huseman. Washington, DC: Smithsonian Institution Press, 1989. 368 pp. 180 b & w., 24 color. [The first substantial effort to provide information about this little-known period in American photography. Includes photographs of all known extant daguerreotypes of this event. About 55 of the illustrations are of

daguerreotypes. Includes research into the daguerreotypists known to have been working in Mexico during this period. Discusses Fanny Calderon de la Barca (formerly Frances Irskine Caldwell) in Mexico in 1840; John Lloyd Stephens, in Yucatan in 1841; Richard Carr, in Mexico from 1845-1847. A. J. Halsey, photographed in Mexico City from 1845 through the US occupation, then into the 1860s. J. A. Palmer; Charles J. Betts; L. H. Polock; J. C. Gardiner; A. L. Cosmes de Cosio; George Noessel; Josiah Gregg; J. H. Wm. Smith. But nothing to conclusively determine who took the surviving images.]

PERIODICALS
ST1806 Lowe, Dennis. "Hero of Ceirro Gordo Daguerreotype." HISTORY OF PHOTOGRAPHY 1, no. 1 (Jan. 1977): 16. 1 b & w. [Daguerreotype of Gen. John S. Williams, possibly taken ca. 1848.]

USA: 1849.
ST1807 "An Epitome of American Invention in 1849." PRACTICAL MECHANIC'S JOURNAL 3, no. 35 (Feb. 1851): 249-251. [About American patents in 1849. Mentions F. B. Morse and the telegraph, discusses patents for improvements to the daguerreotype, etc.]

USA: 1850.
ST1808 "The Fine Arts." DAGUERREIAN JOURNAL 1, no. 1 (Nov. 1, 1850): 25. [From the "International Magazine." Author feels that Europe excels over the USA in all the fine arts, with the exception of photography.]

ST1809 "Daguerrean Artists' Register." DAGUERREAN JOURNAL 1, no. 1 (Nov. 1, 1850): unpaged. [List, with addresses of 54 daguerreotypists, printed in the unpaged advertising section in the back of the journal. This list continued and expanded in each issue of the magazine for several years.]

ST1810 "Our Daguerreotypes." DAGUERREIAN JOURNAL 1, no. 2 (Nov. 15, 1850): 50-51. [Clarke, of Boston, MA, Utica, NY, and Syracuse, NY, has opened a gallery in New York, NY. Root, Gurney, Cary, Meade Brothers, Gavit, Harrison & Holmes won awards at the American Institute Fair, NY. Thomas B. Atkins (Brooklyn, NY); N. E. Sisson (Albany, NY); S. J. Thompson (Albany, NY).]

USA: 1851.
ST1811 "Our Daguerreotypes." DAGUERREAN JOURNAL 1, no. 4 (Jan. 1, 1851): 114-115. [Meade Brothers, D. E. Gavit, M. B. Brady, M. M. Lawrence, O. B. Evans (Buffalo, NY) works in the World's Fair of 1851; Mr. Fitzgibbon (St. Louis, MO); Root Brothers (New York, NY and Philadelphia, PA); S. L. Walker (formerly Poughkeepsie, opens gallery in Albany, NY).]

ST1812 "Getting a Likeness." DAGUERREAN JOURNAL 1, no. 4 (Jan. 1, 1851): 120-121. [An anecdote about a difficult sitter, told by a "Mr. Smith, ...while he was taking Daguerreotypes in western New York."]

ST1813 E. "Daguerreotypes." DAGUERREAN JOURNAL 1, no. 5 (Jan. 15, 1851): 155. [From "Portland [ME?] Transcript." General commentary.]

ST1814 "Background." DAGUERREAN JOURNAL 1, no. 6 (Feb. 1, 1851): 176.

ST1815 "Gossip." PHOTOGRAPHIC ART JOURNAL 1, no. 2 (Feb. 1851): 123-128. [Editorial statements about the nature and intent of the "PAJ." Poem "The Baby in the Daguerreotype," by Mrs. Anna L. Snelling. J. A. Whipple; Levi L. Hill; V. Regnault (Paris); John Roach; D. D. T. Davie; C. C. Harrison; others mentioned.]

ST1816 "Our Daguerreotypes." DAGUERREAN JOURNAL 1, no. 8 (Feb. 15, 1851): 211-212. [Clark & Brothers; Root Brothers (microphotographs); Meade and Brother; Lawrence; C. C. Harrison, cameramaker, Scovile Manufacturing Co.]

ST1817 "Our Daguerreotypes." DAGUERREAN JOURNAL 1, no. 8 (Mar. 1, 1851): 243. [Gurney; Thompson; H. McBride, operator for Meade & Brother, about to establish a gallery in Albany, NY; Weston (New York, NY) producing calotypes; A. Morand. T. Antisell, M.D., Finley (Canandaigua, NY) and J. E. Mayall also mentioned on same page.]

ST1818 "The Daguerrean Art - its Origin and Present State." PHOTOGRAPHIC ART JOURNAL 1, no. 3 (Mar. 1851): 136-138. [Extracts from the "Sunday Courier" and from the "American Artisan."]

ST1819 "Gossip." PHOTOGRAPHIC ART JOURNAL 1, no. 3 (Mar. 1851): 187-192. [Levi L. Hill; D. D. T. Davie; Faris & Hawkins (Cincinnati, OH), work compared to that in Italy; Poem "On Seeing a Daguerreotype Portrait," by Mrs. C. H. Putnam; American photographers at England's World's Fair: Lawrence, Brady, Meade Brothers, W. A. Pratt & Co., Root Brothers, Whitehurst; Pratt's medallion pictures; others mentioned.]

ST1820 "Our Daguerreotypes." DAGUERREAN JOURNAL 1, no. 10 (Apr. 1, 1851): 306. [Thompson (Albany, NY); S. L. Walker (Albany and Poughkeepsie, NY); Root; Fitzgibbon (St. Louis, MO); VanLoan & Co. (Philadelphia, PA); R. H. Hill (Kingston, NY).]

ST1821 "Our Daguerreotypes." DAGUERREAN JOURNAL 1, no. 11 (Apr. 15, 1851): 338-339. [Hoyt; Thompson, Walker & Douglas (Albany, NY); R. H. Hill (Kingston, NY); McDonell (Buffalo, NY); Dodge (Augusta, GA).]

ST1822 "Gossip." PHOTOGRAPHIC ART JOURNAL 1, no. 5 (May 1851): 315-320. [Announcement of Anthony's Prize award, to be given for "the most important improvements in the Photographic Art in 1851." Hillotype; Morand; Poem "On Seeing Mr. Anthony's Portrait of Jenny Lind," by Mrs. Anna L. Snelling; J. K. Fisher, moved studio to Broadway; cheap photographers; others mentioned.]

ST1823 "Our Daguerreotypes." DAGUERREAN JOURNAL 2, no. 1 (May 15, 1851): 19. [Gurney had a large print stolen; Johnson & Fellows (Cleveland, OH); Myron Shew (stockdealer in Philadelphia); H. H. Long (St. Louis, MO); Harrison's cameras discussed; L. M. Ives (Boston, MA); P. Haas (New York, NY).]

ST1824 "Our Daguerreotypes." DAGUERREAN JOURNAL 2, no. 2 (June 1, 1851): 52-53. [Butler (painter of "Daguerreotypes in Oil"); E. Long, not H. H. Long of St. Louis, produced portrait of Jenny Lind; L. M. Ives (Boston); N. E. Sissons (Albany, NY); J. D. Wells (Northampton, MA).]

ST1825 "Gossip." PHOTOGRAPHIC ART JOURNAL 1, no. 6 (June 1851): 377-379. [Hillotype, Kingsley's plate bender and plate holder; improvements; Lewis's improved camera; movement to organize a national society; other issues discussed.]

ST1826 "Our Daguerreotypes." DAGUERREAN JOURNAL 2, no. 3 (June 15, 1851): 83. [Whipple (Boston); T. Farris (Cincinnati, OH); E. C. Hawkins.]

ST1827 "Wanderer." "The Peregrinations of a Daguerrean. Nos. 1 - 3." PHOTOGRAPHIC ART JOURNAL 2, no. 1, 5, 6 (July, Nov. - Dec. 1851): 14-17, 270-271, 358-361. [No. 1: Mount Airy, NC, June 18,

1851. No. 2: South, Oct 15, 1851. (T. H. Smiley and Levi Hill mentioned.) No. 3: Buncomb Co., NC, Nov. 1, 1851. Commentary about people and events observed while working a travelling daguerreotype operation throughout North Carolina area.]

ST1828 "Gossip." PHOTOGRAPHIC ART JOURNAL 2, no. 1 (July 1851): 60-64. [Discussion of L. L. Hill and Niepce de St. Victor; article on enamelled daguerreotypes reprinted from May "London Art Journal"; discussion by Sir W. Brewster on whitening of interior of camera; call for a convention of photographic artists in Syracuse, (Mention of Mr. Haas); Brady sails to Europe to visit London World's Fair; Mention that Root (New York, NY) working on Whipple's Crayon Daguerreotype process; J. H. Whitehurst portrait of a child mentioned; Gurney (New York, NY); Cary (Savannah, GA).]

ST1829 "Our Daguerreotypes." DAGUERREAN JOURNAL 2, no. 4 (July 1, 1851): 117-118. [R. Anson (New York, NY); DeWitt C. C. Grenell (New York, NY); Lamartine & Sullivan (boat on the Muskingum River); A. Bogardus; M. B. Brady leaves for Europe, leaving his establishment in charge of George S. Cook, of Charleston, SC; Webster & Brother (Louisville, KY); M. Moulthroup (New Haven, CT); Bostwick & Burgess (Springfield, MA); S. C. McIntire (San Francisco, CA) burned out.]

ST1830 Copway, George. "Kah-Ge-Ga-Gah Bowh's First Daguerreotype." DAGUERREAN JOURNAL 2, no. 5 (July 15, 1851): 153. [From "Copway's American Indian." George Copway, an Ojibwa, the editor, describes his first experience with a daguerreotype "several years ago."]

ST1831 Snelling, H. H. "The Daguerrean Art; Its Present State and Future Prospects." PHOTOGRAPHIC ART JOURNAL 2, no. 2 (Aug. 1851): 99-101. [Lists over 40 American daguerreotypists, mentions L. L. Hill, argues for the creation of a national society, etc.]

ST1832 "Gossip." PHOTOGRAPHIC ART JOURNAL 2, no. 2 (Aug. 1851): 127-128. [Report on meeting held at Brady's Gallery to form a photographic society; L. L. Hill; McDonell and Evans (Buffalo, NY); George P. Hanson (Chicago, IL); George S. Cook (Charleston, SC) taking over C. C. Harrison's Broadway Gallery in New York, NY. Harrison retiring to make cameras; Mayall (London); D. D. T. Davie (Utica, NY); Johnson & Fellows (Cleveland, OH); North (Cleveland, OH); Von Schneidau (Chicago, IL).]

ST1833 "Our Daguerreotypes." DAGUERREAN JOURNAL 2, no. 6 (Aug. 1, 1851): 180. [George S. Cook (Charleston, SC); purchased C. C. Harrison's "picture establishment." Johnson & Fellows (Cleveland, OH); M. M. Lawrence opens summer studio at Newport, RI.; Beckers & Piard; Gurney; Thompson.]

ST1834 "Our Daguerreotypes." DAGUERREAN JOURNAL 2, no. 7 (Aug. 15, 1851): 211-212. [Richards (Philadelphia, PA) taken over rooms of M. P. Simons; J. H. Fitzgibbon (St. Louis, MO); H. H. & E. Long (St. Louis, MO) visiting White Mtns. in NH and VT, taking views; Geer & Benedict (Syracuse, NY); E. Jacobs (New Orleans, LA); Johnson & Fellows; Mr. Irvin (Troy, NY stockdealer); L. White (Springfield, MA).]

ST1835 "Daguerreotype Bee-Hive." DAGUERREAN JOURNAL 2, no. 7 (Aug. 15, 1851): 212-214. [Describes daguerreotype stock dealers. Chapman; Meade & Brother; W. & W. H. Lewis; E. Anthony; Scoville Manufactures, etc.]

ST1836 "Gossip." PHOTOGRAPHIC ART JOURNAL 2, no. 2 (Sept. 1851): 187. [Report of Daguerreotypist's convention at Utica, NY;

Hesler [Galena, IL]; Sutton [Detroit, MI]; Langenheim & McLees; Letillois color process from "La Lumiére;" letters; etc.]

ST1837 "Gossip." PHOTOGRAPHIC ART JOURNAL 2, no. 3 (Sept. 1851): 187-190. [Report of Convention of Daguerreotypists at Utica; letter of complaint about cheap practitioners; letter reprinted from "La Lumiére" announces discovery by Letillior's in color; Hesler of Galena, IL; Mr. Sutton of Detroit, MI; Langenheim & McLees of Philadelphia, PA.; Whitehurst of Baltimore, MD; Partridge of Pittsburgh, PA; Dobyns of New Orleans, LA; Cary & Prentice of Savannah, GA; Earl of Reading, WV; Woodbridge of Columbus, GA; and Vance of San Francisco, CA; article by Ernest Lacan from "La Lumiére" on Heliochrome reprinted; Wm. A. Platt of Richmond, VA, returned from European tour; painting by Mr. Peary, operator to Mr. Cook mentioned; announcement of publication of a "Daguerrean Album."]

ST1838 "Note." PHOTOGRAPHIC ART JOURNAL 2, no. 3 (Sept. 1851): 189. ["We have had among us quite a number of western and southern Daguerreans during the last month: Sutton of Detroit, [MI] Langenheim & McLees of Philadelphia, [PA] Whitehurst of Baltimore, [MD] Partridge of Pittsburgh, [PA] Dobyns of New Orleans, [LA] Cary & Prentice of Savannah, [GA] Earl of Reading, [WV] Woodbridge of Columbus, [GA] Vance of San Francisco, [CA]."]

ST1839 "Our Daguerreotypes." DAGUERREAN JOURNAL 2, no. 8 (Sept. 1, 1851): 243. [Finley (Canandaigua, NY); Osborn & Holt; J. Atkins (Brooklyn, NY); Olmsbee & Silsbee (Boston, MA); C. P. Webster (Nashville, TN); H. E. Insley (New York, NY); Hough & Anthony (Pittsburgh, PA); N. E. Sissons (Albany, NY); Samuel Broadbent (Philadelphia, PA).]

ST1840 "Gossip: Movements of Daguerrean Artists." PHOTOGRAPHIC ART JOURNAL 2, no. 4 (Oct. 1851): 255-256. [Mentioned: Barnes (Mobile, AL); Cook (Charleston, SC); Dobyns; J. H. Fitzgibbon (St. Louis, MO); McDonell (Buffalo, NY est. gallery in Toronto, CAN); Whitney & Denny (Rochester, NY); R. C. Johnson (Hillsville, VA); E. Long & H. H. Long (St. Louis, MO); Moulthrop (New Haven, CT); L. W. Kerr (TN); J. G. Richmond; Dorat (Brooklyn, NY); Knapp (opened new gallery 559 Broadway, New York, NY); Morand (NY); Carey is in Georgia; Zealy (Columbia, SC); Tucker of Leigh, Tucker and Perkins (Augusta, GA).]

ST1841 J. F. "A Hint to Daguerreotypists." PHOTOGRAPHIC ART JOURNAL 2, no. 4 (Oct. 1851): 215. [Argument for daguerreotypists to contribute research to the journals.]

ST1842 "Editorial Notes." DAGUERREAN JOURNAL 2, no. 10 (Oct. 1, 1851): 306-307. [Gurney; E. T. Whitney (Rochester, NY); L. L. Hill; Clarke & Brother (New York, NY) mentioned.]

ST1843 Y. T. S. "Life in the Daguerreotype. No. 1. The Reception Room." DAGUERREAN JOURNAL 2, no. 10 (Oct. 1, 1851): 309-311. [Comic description of confrontations between sitters and studio operators.]

ST1844 "Sunshine." "The Blues." DAGUERREAN JOURNAL 2, no. 10 (Oct. 1, 1851): 312. [Anecdote about daguerreotyping a little old lady, dressed in blue, blue eyes, etc.- all difficult for the medium.]

ST1845 "Editorial Notes." DAGUERREAN JOURNAL 2, no. 11 (Oct. 15, 1851): 338-339. [Note that E. Church, "a veteran," of St. Louis, MO, has sold out to Dobyns, of New Orleans, LA; P. Haas; D. D. Winchester (Columbus, OH); Wm. H. Sherman (Erie, PA).]

ST1846 "Our Daguerreotype." DAGUERREAN JOURNAL 2, no. 12 (Nov. 1, 1851): 370-371. [N. G. Burgess; S. D. Humphrey; Hawkins (Cincinnati, OH) back in business; E. S. Horton (Newburgh); C. H. Gay (New London, CT); Sherwood & Parsons (Auburn, NY); W. & W. H. Lewis (manufacturers); C. C. Harrison, cameramaker; Tomlinson (Troy, NY); Burham & Ellis (Bangor, ME); T. Hayes (New York, NY); James Brown (New York, NY).]

ST1847 English, Dunn T. "Felix O. Darley." PHOTOGRAPHIC ART JOURNAL 2, no. 5 (Nov. 1851): 300-304. [Obituary for the painter Darley. From "Sartain's Union Magazine."]

ST1848 "Gossip." PHOTOGRAPHIC ART JOURNAL 2, no. 5 (Nov. 1851): 313-320. [Report of committee from NY State Dag. Assoc. to investigate claims of Hill; essays from "London Morning Chronical." and the "Athenaeum" on the work of Mayall; letter from Austin T. Earle which is principally a review of exhibition at the Ohio Mechanics Fair, suggestion for establishing an artist's exhibition gallery for the annual distribution of art; letter from M'me Daguerre to Mead Brothers reply of letter of condolence for D's death; mention of 3 paper photos by Renard of Paris, FR; mention of Barnard of Oswego, NY, and Davie of Utica, NY; etc.]

ST1849 Y. T. S. "Communications: Life in the Daguerreotype. No. 2. The Operating Room." DAGUERREAN JOURNAL 2, no. 12 (Nov. 1, 1851): 373.

ST1850 "Daguerreville." DAGUERREAN JOURNAL 3, no. 1 (Nov. 15, 1851): 20. [Daguerreville, NY, home of W. & W. H. Lewis manufacturing firm.]

ST1851 "Daguerrean Artist's Register." DAGUERREAN JOURNAL 3, no. 1 (Nov. 15, 1851): 31-32. [List, with addresses of American daguerrean artists.]

ST1852 "Gossip." PHOTOGRAPHIC ART JOURNAL 2, no. 6 (Dec. 1851): 373-380. [Editorial comments on "PAJ" at close of first year. Improvements in silvering plates. Subscription for erecting a memorial to Daguerre. J. T. Zealey (Columbia, SC); S. Root & J. W. Thompson (New York, NY) formed a partnership; J. H. Whitehurst, other matters discussed.]

ST1853 "Daguerrean Journal." DAGUERREAN JOURNAL 3, no. 2 (Dec. 1, 1851): 49-51. [M. B. Brady, M. M. Lawrence and John A. Whipple received medals at World's Fair, London. M. A. Root separated from partnership with brother and S. Root & J. W. Thompson reformed the partnership. Brinkerhof & Co. (formerly with C. C. Harrison) opened a gallery. E. Elliott (Chester, SC) visited New York, NY. Bartlett (Hartford, CT). C. H. Gay (New London, CT). McClees & Germon (Philadelphia, PA); A. B. Mortley (Utica, NY dealer); R. B. Appleby (Rochester, NY); E. S. Dodge (Augusta, GA); Ennis (Philadelphia, PA). L. L. Hill's letter protesting statement that his color process was fraudulent.]

ST1854 "The Daguerreian Journal." DAGUERREAN JOURNAL 3, no. 3 (Dec. 15, 1851): 81-82. [E. T. Whitney (Rochester, NY); Mr. Denney associated with Whitney; daguerreotypes stolen from Lawrence and from Gurney; N. E. Sisson formed partnership with Mr. Green from California gold fields, in Albany, NY; A. Morand (New York, NY); Meade Brothers.]

USA: 1852.

BOOKS

ST1855 Lanman, Charles. *The Private Life of Daniel Webster*. New York: Harper & Brothers, 1852. 205 pp. 4 illus. [Engravings, made from daguerreotypes.]

PERIODICALS

ST1856 "Development of Nationality in American Art." PHOTOGRAPHIC ART JOURNAL 3, no. 1 (Jan. 1852): 36-41.

ST1857 "Gossip." PHOTOGRAPHIC ART JOURNAL 3, no. 1 (Jan. 1852): 63-68. [Comment on L. L. Hill's supposed invention; Knapp opening gallery on Broadway; Gurney made $120 for one day's work; Morand opens new gallery; Hesler; Meade Brothers raising subscriptions towards a monument for Daguerre; A. T. Earle (Cincinnati, OH) Beckers & Piard; intent of editor to produce a "Daguerrean Album"; A. H. Place, appointed Consul of France to Mosuel takes camera equip. with him to excavations of site of Ninevah.]

ST1858 Portrait. Woodcut engraving. GLEASON'S PICTORIAL DRAWING-ROOM COMPANION 2, (1852) ["Group portrait of the Dodworth Family Coronet Band." 2:3 (Jan. 17, 1852): 41. Clearly from a photograph, though not credited as such.]

ST1859 "Gossip." PHOTOGRAPHIC ART JOURNAL 3, no. 2 (Feb. 1852): 125-132. [Discussion on improvements in the field; letter from George P. Hansen (Chicago, IL); Poem "The Husband's Daguerreotype," by M. M. B.; Hesler (Galena, IL); Electro-Photography by Aubree, Millet & Leborgne (FR); W. J. Read (London); W. A. Allen & Brother opening a gallery on Broadway; Warren (Lowell, MA); Brady in Europe; A. Bogardus (New York, NY); Lawrence; L. L. Hill controversy.]

ST1860 "Gossip." PHOTOGRAPHIC ART JOURNAL 3, no. 3 (Mar. 1852): 189-196. [Argument to raise standards in the profession; L. L. Hill controversy; Hesler; Allen's improved camera stand; travelling saloon wagon; D. D. T. Davie; Johnson (Utica, NY); J. A. Bennet on subscribing to the Daguerre monument fund; Gurney displaying Vance's California views; Whipple & Black views taken at night by Drummond light; Davis & Perry opened rooms in Boston, MA; Brinkerhoff opened rooms on Broadway, New York, NY; Lawrence making 13" x 17" daguerreotypes; J. K. Fisher; J. H. S. Stanley (Houston, TX).]

ST1861 "Daguerreville Manufactory." HUMPHREY'S JOURNAL 4, no. 1 (Apr. 15, 1852): 11-12. [W. & W. H. Lewis manufacturing firm at Daguerreville, NY.]

ST1862 "Gossip." PHOTOGRAPHIC ART JOURNAL 3, no. 4 (Apr. 1852): 253-260. [Promoting photographic association; Daguerre monument for New York, NY proposed; letter from S. N. Carvahlo (Charleston, SC); Zealy (Columbia, SC); D. E. Gavit (New York, NY) burned out; Gurney (New York, NY) fire; Clark (Ithica, NY) burned out; Whitehurst (New York, NY) burned out; G. S. Cook (Charleston, SC) horse ran into studio, causing damage; Allen's Improved Camera Box; Meade Brothers; Moulthrop (New Haven, CT); Nichols (Fulton, NY); the sculptor Brackett praised, etc.]

ST1863 "Movements of the Daguerreotypists." HUMPHREY'S JOURNAL 4, no. 2 (May 1, 1852): 31-32. [Thomas Faris (Cincinnati, OH); J. D. Wells (Northampton, MA); J. D. Randall (Aurora, IN); D. D. T. Davie (Utica, NY) opened another gallery in Syracuse, NY; E. Church (Louisville, KY and St. Louis, MO) working in northern NY; Wm. Perry (Boston, MA); H. Whittemore in South America.]

ST1864 "Gossip." PHOTOGRAPHIC ART JOURNAL 3, no. 5 (May 1852): 317-324. [Subscribe to the Journal; Brady returned from Europe; Philip Morand opened rooms on Broadway (New York, NY); Gabriel Harrison opened gallery in Brooklyn, NY; E. C. Thompson opened gallery in Washington, D.C.; Gurney ill from mercury poisoning; D. D. Davie opened additional rooms in Syracuse, NY; organizing a photo society in England; Ernest Lacan, in "La Lumiére" on the L. L. Hill controversy; C. B. Denny; McDonell (Buffalo, NY); letter from D. D. T. Davie; letter from George N. Barnard.]

ST1865 "Movements of the Daguerreotypists." HUMPHREY'S JOURNAL 4, no. 3 (May 15, 1852): 47-48. [M. B. Brady returned from Europe; J. Gurney recovering from mercury poisoning; D. D. Winchester (Columbus, OH); M. Sutton (Detroit, MI); J. H. Whitehurst (New York, NY); P. Haas (New York, NY); J. E. Martin (Detroit, MI); left the business; Dr. Canfield (PA), Whipple (Boston, MA) and Holt (New York, NY) making calotypes; A. Bogardus (New York, NY); J. C. Heath (Rochester, NY).]

ST1866 Wellmont, Mrs. E. "The Daguerreotype." GLEASON'S PICTORIAL DRAWING-ROOM COMPANION 2, no. 22 (May 29, 1852): 343. [Short story.]

ST1867 "Gossip." PHOTOGRAPHIC ART JOURNAL 3, no. 6 (June 1852): 380-384, plus 2 pages following 384. 2 illus. [Caution against unscrupulous practitioners; commentary on formation of British photographic society; Brady promises to write an account of his trip to Europe; A. Hesler; J. A. Whipple, paper photographs; Allen's "Union Head Rest;" Webster & Brother attacks Whipple for patenting the crayon daguerreotype process; Anthony's prize pitcher award announced; two engravings of the Prize Pitcher following the announcement.]

ST1868 "Movements of the Daguerreotypists." HUMPHREY'S JOURNAL 4, no. 4 (June 1, 1852): 63. [Richards (Philadelphia, PA); Gabriel Harrison opened gallery in Brooklyn, NY; Hawkins (Cincinnati, OH); T. C. Done (Montreal, CAN); Thompson (Paris, FR).]

ST1869 "What the Sunbeam Does." HARPER'S MONTHLY 5, no. 26 (July 1852): 210-212. [Discussion of the physical and chemical attributes of sunshine, for the general audience. Mentions photography on pp. 211-212, stating that, contrary to expectations, too much sunshine is detrimental to the process, and comments upon recent discoveries to that effect in Mexico.]

ST1870 "Gossip." PHOTOGRAPHIC ART JOURNAL 4, no. 1 (July 1852): 62-68. [Improvements in photography; L. L. Hill controversy; Anthony prize announcement; R. B. Appleby (Rochester NY); McDonell (Buffalo, NY); J. H. S. Stanley (Houston, TX); L. L. Hill controversy again.]

ST1871 "Movements of the Daguerreotypists." HUMPHREY'S JOURNAL 4, no. 6 (July 1, 1852): 95. [D. C. Winchester (Columbus, OH); O. B. Evens (Buffalo, NY); Cary (Savannah, GA); H. Whittemore, leaves South America for the USA; Gurney recovered; Southworth in California; C. C. Kelsey (Chicago, IL stockdealer); T. Hayes operating in Gurney's establishment.]

ST1872 "Wanderer." "Peregrinations of a Daguerrean. No. 4." PHOTOGRAPHIC ART JOURNAL 4, no. 2 (Aug. 1852): 101-103. [Mentions Martin (Spartanberg, SC) and Lee (travelling in a wagon). Also describes events and activities of non-photographic nature around Charlotte, NC area.]

ST1873 "Gossip." PHOTOGRAPHIC ART JOURNAL 4, no. 2 (Aug. 1852): 128-132. [General commentary; L. L. Hill controversy; Gurney purchased Whitehurst's New York, NY gallery; J. H. Fitzgibbon, E. Long (St. Louis, MO); Webster & Brother; Richmond & Hawkins taking over Allen's Broadway rooms; French and German lenses; proposed "Photographic Album" failed from lack of contributors; etc.]

ST1874 "Gossip." PHOTOGRAPHIC ART JOURNAL 4, no. 3 (Sept. 1852): 192-196. [NY State Daguerrean Assoc.; letter from E. T. Whitney; letter from A. Hesler; Beckers & Piard; etc.]

ST1875 "Communications." PHOTOGRAPHIC ART JOURNAL 4, no. 4 (Oct. 1852): 222-226. [Letter from "Junius" 140 Chestnut St., Philadelphia, PA, claiming that the state of the art must be uplifted, protesting professional quality, etc.]

ST1876 "Gossip." PHOTOGRAPHIC ART JOURNAL 4, no. 4 (Oct. 1852): 254-260. [Stereo daguerreotypes; cheap operators; text of address by A. Morand to the NY State Daguerrean Assoc.; letter from Marcelia W. Barnes on the Assoc.; list of competitors for Anthony Prize Pitcher; report on the American Institute Fair, New York, NY; Anthony Prize announcement.]

ST1877 "Gossip." PHOTOGRAPHIC ART JOURNAL 4, no. 5 (Nov. 1852): 317-324. [Growth of paper processes (Whipple & Black); Anthony Prizes; Henry Meade to Europe; Davie & Evans (Utica, NY) publishing monthly Scientific Daguerrean;" letters from M. P. Simons and Moulson's; Excerpts from "La Lumiére;" Mayall (London); offer of gold medals to the "best dissertation on the Daguerrean Art as practiced in the United States,...the best original practical treatise on the daguerreotype, and the best article on the value of the photographic art as compared with the fine arts generally;" Anthony Prize announcement.]

ST1878 "Editorial." HUMPHREY'S JOURNAL 4, no. 15 (Nov. 15, 1852): 233-234. [Richards (Philadelphia, PA) won award at Franklin Institute Fair; G. E. Hall (Detroit, MI); Addis (Lancaster, PA).]

ST1879 "Daguerreotype Movements." HUMPHREY'S JOURNAL 4, no. 15 (Nov. 15, 1852): 240. [L'Homdieu (Charleston, SC); Thompson (Albany, NY) has taken James Green (formerly of Sisson & Green) into partnership; Rea (Indianapolis, IN); Hawkins (Cincinnati, OH); Douglass (formerly Albany, NY) moved to St. Louis, MO; Gurney sold old rooms; Lawrence (New York, NY); Cremer (stockdealer in Boston, formerly of Salem, MA); Sutton & Hall (Detroit, MI); Kelsy (Chicago, IL); Dobyns & Co. (St. Louis, MO); Fitzgibbon (St. Louis, MO).]

ST1880 Poore, Benjamin Perley. "Daniel Webster at Home - Webster Funeral Ceremonies." GLEASON'S PICTORIAL DRAWING-ROOM COMPANION 3, no. 21 (Nov. 20, 1852): 327-329. 5 illus. [Drawn illustrations of Webster's funeral, etc. "The fifth and last picture is a copy from a daguerreotype lately taken at Marshfield of Mr. Webster, as he appeared...sitting under his own tree. It is an actual copy from life, and possesses at this time extraordinary interest...." (p. 317) The drawings are by Manning, the daguerreotypist isn't credited.]

ST1881 Humphrey, S. D. "Editorial: Recent Improvements." HUMPHREY'S JOURNAL 4, no. 16 (Dec. 1, 1852): 249. [Mentions H. E. Insley; Douglass (St. Louis, MO); Rea (Indianapolis, IN); Hewitt & Brown (Louisville, KY); Tucker & Perkins (Augusta, GA); Gurney; Lawrence.]

ST1882 "Wounded in the Heart and Pocket." HUMPHREY'S JOURNAL 4, no. 16 (Dec. 1, 1852): 252-253. [From the "Philadelphia [PA] Ledger." A letter, signed "A Victim," complaining about practices of the $.25 to $.75 photographic studios.]

ST1883 "Daguerreotype Movements." HUMPHREY'S JOURNAL 4, no. 16 (Dec. 1, 1852): 255. [Terry (Formerly Lima, Peru) returned to USA; Whipple (Boston, MA); Hawkins (Cincinnati, OH); Whettemore; S. L. Walker (Poughkeepsie, NY); Webster & Brother (formerly Poughkeepsie, now Louisville, KY); N. G. Burgess (New York, NY); Sutton (Detroit, MI).]

ST1884 "Daguerreotype Movements." HUMPHREY'S JOURNAL 4, no. 17 (Dec. 15, 1852): 271-272. [Bailey (Winchester, VA); J. H. & J. Selkirk (Matagora, TX); Douglas (St. Louis, MO); Wellington (Nashville, TN); Davis (Cincinnati, OH); Whitney & Denny (Rochester, NY stockdealers); Mayall (London); Mercer (formerly of Rochester, NY) is dead; North (formerly Boston, MA, now Cleveland, OH); Cooley (Springfield, MA); Wells (Northampton, MA); Brown (Manchester); G. S. Cook (now at Charleston, SC); Wellman (Georgeton, SC); Dr. Barr (Harrisburg, PA) is sick; Brady (New York, NY); Ellis (formerly Providence, RI, now in Lynn, MA); Gurney & Litch; Churchill (Albany, NY); McBride (Albany, NY).]

USA: 1853.

ST1885 "Daguerreotype Movements." HUMPHREY'S JOURNAL 4, no. 18 (Jan. 1, 1853): 287. [H. Meade; W. & W. H. Lewis (manufacturers); M. M. Lawrence; A. Bogardus; S. D. Humphrey; O. H. Cooley; J. M. Clark (formerly 551 Broadway, New York, NY) left the business; Elliott (Chester, SC); Van Schneidau (Chicago, IL); T. M. Easterly (St. Louis, MO); H. S. Brown (Milwaukee, WI); G. J. Goodridge (York, PA); Mather (Marshall, MI); Bailey (Columbia, TN); Babbet (formerly traveller for E. Anthony, now operating a studio in Worcester, MA.)]

ST1886 "Gossip." PHOTOGRAPHIC ART JOURNAL 5, no. 1 (Jan. 1853): 62-68. [Quote from "an English author" on value of the medium to society; G. N. Barnard (Oswego, NY); George P. Hansen (Charlottesville, VA); Robert F. Jones replaces Retzer in Charlottesville, VA; Henry W. Meade leaves for Europe; letter from W. Whetten, Sec. of the NY Crystal Palace, offering space to exhibitors;; letter from J. H. Fitzgibbon suggesting that a national museum for daguerreotypists be established; letters from M. P. Simons (Richmond, VA); W. R. King; Rea (Indianapolis, IN); others mentioned.]

ST1887 "Daguerreotype Movements." HUMPHREY'S JOURNAL 4, no. 19 (Jan. 15, 1853): 303-304. [H. S. & T. K. Dunshee (Toledo, OH); M. M. Lawrence (New York, NY); Lyndal (Columbus, OH); A. Terry; H. Meade; S. L. Walker (Poughkeepsie, NY); Gurney; Richards (Philadelphia, PA); Moulthroup (New Haven, CT); Wells & Brother (New Haven, CT); Powelson; Shew.]

ST1888 Portraits. Woodcut engravings, credited "From a Daguerreotype." ILLUSTRATED NEWS (NY) 1, (1853) ["Harriet Beecher Stowe, author." 1:2 (Jan. 8, 1853): 24. James Fennimore Cooper." 1:3 (Jan. 15, 1853): 44. "Thomas S. Hamblin." 1:4 (Jan. 22, 1853): 60. "William Upham 1:5 (Jan. 29, 1853): 69. "Dr. George A. Gardiner, dentist, fraud." 1:15 (Apr. 9, 1853): 225.]

ST1889 "Birthplace of the President Elect, Hillsboro, N. H." ILLUSTRATED NEWS (NY) 1, no. 3 (Jan. 15, 1853): 44. 1 illus. ["From a Daguerreotype." General Pierce's home.]

ST1890 Portrait. Woodcut engraving credited, "from a Daguerreotype taken in New York." ILLUSTRATED LONDON NEWS 22, (1853) ["Mrs. Harriet Beecher Stowe, Author of "Uncle Tom's Cabin." 22:* (Jan. 15, 1853): 48.]

ST1891 "Gossip." PHOTOGRAPHIC ART JOURNAL 5, no. 2 (Feb. 1853): 125-132. [Praise for A. Hesler; list of Vance's daguerreotype views of California, plus offer for sale; editorial comment that the "FAJ" not affiliated with or influenced by the Anthony company; NY State Daguerrean Assoc. preparing a joint exhibit for the NY Crystal Palace Exhibition; death of American Art Union greeted with satisfaction; C. C. Harrison's cameras praised; Anthony Prize award.]

ST1892 "New York Daguerreotyped." PUTNAM'S MONTHLY 1-2-3, no. 2, 4, 6, 7, 13, 14, 15 (Feb., Apr., June, July, Sept. 1853; Jan., Feb., Mar., 1854): v. 1: 121-136, 353-368, 673-686; v. 2: 1-16, 233-248; v. 3: 11-15, 141-152, 233-248. 91 illus. ["This is...a series...to give a rapid glance at the progress of New York and its architecture....These will be followed by similar papers on Boston, Philadelphia, and other places. These papers are illustrated with engravings from Daguerreotypes, and drawings with one or two exceptions made expressly for this purpose." Part I: "Business Streets, Mercantile Blocks, Stores and Banks," 12 illus, some obviously from daguerreotypes. Part II: "Business Street, etc.," 16 illus. Part III: "The Benevolent Institutions of New York," 4 illus. Part IV: "Educational Institutions of New York," 11 illus. Part V: "New York Church Architecture," 19 illus. Part VI: "Public Buildings of New York," 6 illus. Part VII: "Places of Public Amusement," 6 illus. Part VIII: "Private Residences," 17 illus.]

ST1893 "Daguerreotype Movements." HUMPHREY'S JOURNAL 4, no. 21 (Feb. 15, 1853): 335-336. [Nelson (Pittsburgh, PA); Manchester & Brother (Providence, RI) formed partnership with Mr. Chapin, now Manchester & Chapin; Wells (Northampton, MA); Meade Brothers; Fitzgibbon; Brady; Lawrence, etc.]

ST1894 "Houdon's Statue of Washington." ILLUSTRATED NEWS (NY) 1, no. 9 (Feb. 26, 1853): 129. 1 illus. ["A Correct Copy - From a Daguerreotype."]

ST1895 "Gossip." PHOTOGRAPHIC ART JOURNAL 5, no. 3 (Mar. 1853): 186-194. [Approaching NY World's Fair discussed; L. L. Hill displayed his color process to a Senate committee; letter from R. M. Cole (Peoria, IL); James Campbell's (Dayton, OH) color experiments reported from "Scientific American." Vance (San Francisco, CA); more controversy around L. L. Hill; others mentioned.]

ST1896 "Daguerreotype Movements." HUMPHREY'S JOURNAL 4, no. 22 (Mar. 1, 1853): 352. [Haas (371 Broadway, New York, NY); Whitney & Dewey [sic Denny] (Rochester, NY).]

ST1897 "Daguerreotype Movements." HUMPHREY'S JOURNAL 4, no. 23 (Mar. 15, 1853): 368. [Meade Brothers; Richards (Philadelphia, PA); Kelsy (Chicago, IL); Ennis (Philadelphia, PA) sold out; Dobyns (opens another gallery in Nashville, TN); Bisbee (OH); Whittemore (New York, NY) sold out.]

ST1898 "Gossip." PHOTOGRAPHIC ART JOURNAL 5, no. 4 (Apr. 1853): 250-256. [General comments on state of the art; letter from G. N. Barnard, Sec., NY State Dag. Assoc. announcing forthcoming meeting; Talbot's and C. Eastlake's exchange of letters on Talbot's releasing his copyright; letter from J. E. Whitney; Carvalho's enamelled daguerreotypes mentioned; L. L. Hill again; Whipple's portrait of E. Anthony, announcement of a joint-stock company being formed to promote the crystalotype process; Le Gray; Von Schneidau (Chicago, IL) in Washington, DC to secure a patent on a new style of daguerreotype case; Stevens & Butler (Portland, ME); others mentioned.]

ST1899 "Daguerreotype Movements." HUMPHREY'S JOURNAL 4, no. 24 (Apr. 1, 1853): 383-384. [Lawrence (New York, NY); Brady (New York, NY); Combs (CA); Douglass (St. Louis, MO, travelling to CA); Litch (operator for Gurney, about to open a gallery in England with Mr. Terry (who had been in South America); A. d'Othon Hartmann (from Hayti, opened rooms on Broadway (New York, NY); J. W. Thompson purchased Clark's establishment on Broadway, sold his 50 cent gallery (New York, NY); J. Gurney; Collins (Westfield, MA); Whitney & Denny (Rochester, NY) not Whitney & Dewey as previously reported.]

ST1900 Humphrey, S. D. "Editorial: Photography upon Glass and Paper - Monopolies in the United States." HUMPHREY'S JOURNAL 5, no. 1 (Apr. 15, 1853): 9-10.

ST1901 "Daguerreotype Movements." HUMPHREY'S JOURNAL 5, no. 1 (Apr. 15, 1853): 16. [C. E. Johnson "...long and favorably known as one of the first Daguerreotype operators in America..." has left Cleveland, OH, for CA; Tucker & Perkins (Augusta, GA) dissolved; J. D. Wells (Northampton, MA); Dobyns & Richardson & Moisset about to open a gallery in New York, NY; Richards, Humphrey, Hill, Brady mentioned on p. 15 as well.]

ST1902 "Poetry." PHOTOGRAPHIC ART JOURNAL 5, no. 5 (May 1853): 303-304. [Poems. "Light," by M. W. Barnes and "The Daguerreotype" by Mrs. L. G. Abell.]

ST1903 "Gossip." PHOTOGRAPHIC ART JOURNAL 5, no. 5 (May 1853): 316-320. [General comments on vise of civilization, photography. Letter, from "NY Tribune," calling for the creation of a museum for historic photographs, etc., more on L. L. Hill; A. Bisbee's "The History and Practice of Photography," reviewed; J. C. Gray (Jamestown, NY); Dobyns & Harrington (New Orleans, LA) opening a gallery in New York, NY; E. S. Bachelder (Havana, Cuba) works collodion process; Anthony Prize announced.]

ST1904 "Photography in the United States." PHOTOGRAPHIC ART JOURNAL 5, no. 6 (June 1853): 334-341. [From the "NY Daily Tribune." Early discoveries, L. L. Hill, Bond's daguerreotype of the moon (Whipple not mentioned by name), New York, NY galleries, etc.]

ST1905 "Gossip." PHOTOGRAPHIC ART JOURNAL 5, no. 6 (June 1853): 377-380. [Announcement of intent to illustrate the "PAJ" with crystalotypes; D. D. T. Davie; R. M. Cole (Peoria, IL); Fredericks gone to Paris; aesthetic statement reprinted from "Barry's Lectures;" Romero, on his way to San Francisco with apparatus to take paper pictures; S. Selleck working for Johnson in Calif.; Anthony Prize award announcement.]

ST1906 "Gossip." PHOTOGRAPHIC ART JOURNAL 6, no. 1 (July 1853): 62-66. [Mentions Von Schneidau (Chicago, IL); letter from H. Meade; letter from Wells H. White & Co. (Dubuque, IA); Meade's genre group "The Seven Ages of Man" discussed, Henry Meade's return from Europe mentioned; Gurney; North (Cleveland, OH); Whipple's crystalotype of the moon; Whipple's note that the joint-stock venture not proceeding; Upton's mercury bath discussed; excerpts from the "J. of Photo. Soc."]

ST1907 "Daguerreotype Movements." HUMPHREY'S JOURNAL 5, no. 7 (July 15, 1853): 111. [S. J. Thompson (Albany, NY) opening rooms at Saratoga Springs; R. S. Jones (Charlottesville, VA); Sweeney; Lawrence; Litch; Fellows (Cleveland, OH); Lutton (Detroit, MI); Cooley & Collins (Springfield, MA); Perry working for Gurney; Chase (Boston, MA); Douglass left St. Louis, MO, others listed.]

ST1908 "Inauguration of the Crystal Palace - Prayer by Bishop Wainwright." ILLUSTRATED NEWS (NY) 2, no. 31 (July 30, 1853): **. 1 illus. ["From a Daguerreotype." Actually, the sketch was probably hand drawn, with the portrait of Wainwright from the daguerreotype.]

ST1909 "Daguerreotype Movements." HUMPHREY'S JOURNAL 5, no. 8 (Aug. 1, 1853): 127-128. [Thompson & Stephens (Saratoga Springs, NY) burnt out; N. S. Bennett, who had been attending Whitehurst's Washington Gallery, burned in a steamboat accident on his way to set up a gallery in Saratoga Springs; S. Root (NY); Whittemore (New York, NY); Bisbee (Dayton, OH); others mentioned. (Note on p. 137 corrects the information that Bennett worked for Whitehurst, in fact he had his own gallery in Washington, DC.)]

ST1910 "Gossip." PHOTOGRAPHIC ART JOURNAL 6, no. 2 (Aug. 1853): 127-130. [Fitzgibbon (St. Louis, MO) purchased Vance's California views; Crystalotype portrait of Harriet Beecher Stowe; hand-colored daguerreotypes; NY State Daguerrean Assoc. to meet in Utica; argument for reform; Anthony Prize contest announcement.]

ST1911 "View of Nashville, Tenn." ILLUSTRATED NEWS (NY) 2, no. 32 (Aug. 6, 1853): 51. 1 illus. ["From a Daguerreotype." View of city.]

ST1912 "Inauguration of the New York Exhibition." ILLUSTRATED LONDON NEWS 23, no. 636 (Aug. 6, 1853): 71-72. 1 illus. ["The New York Crystal Palace - From a Photograph." Exterior view, under construction.]

ST1913 "The Inauguration of the New York Exhibition." ILLUSTRATED LONDON NEWS 23, no. 637 (Aug. 13, 1853): 103-104. 1 illus. [Interior, view of opening ceremony. "Inauguration of the New York Crystal Palace - Platform in the North Nave - From a Daguerreotype taken during the prayer offered by Bishop Wainwright."]

ST1914 "Editorials." HUMPHREY'S JOURNAL 5, no. 9 (Aug. 15, 1853): 137. [Notes about N. S. Bennett, Tucker (Augusta, GA); Perkins (Augusta, GA); Alkins (Brooklyn, NY) moving to Cincinnati, OH); etc.]

ST1915 "The Daguerreotype in America." HUMPHREY'S JOURNAL 5, no. 9 (Aug. 15, 1853): 138-139. [Article attacking the cut-price houses, defending better work of more expensive galleries. No author given.]

ST1916 Humphrey, S. D. "Editorials." HUMPHREY'S JOURNAL 5, no. 10 (Sept. 1, 1853): 153-154. [Further commentary on false advertising, other problems facing the community.]

ST1917 "Shakespeare and Stratford-Upon-Avon." GLEASON'S PICTORIAL DRAWING-ROOM COMPANION 5, no. 11 (Sept. 10, 1853): 164-165. 3 illus. [About Shakespeare's home, illustrated with views and interiors. Ends with the comment "Had daguerreotyping been known in Shakespeare's time, we should have an abundant supply of his "counterfeit presentment," even as the present day, when a man can scarcely show a symptom of genius that elevates him above his brethren, that he is not at once a subject for the daguerreotype."]

ST1918 "A Photographic Picture." ILLUSTRATED NEWS (NY) 2, no. 37 (Sept. 10, 1853): 131. 1 illus. [Cartoon, with a photographer attempting to photograph a frightened lady.]

ST1919 "Daguerreotype Movements." HUMPHREY'S JOURNAL 5, no. 11 (Sept. 15, 1853): 174-175. [J. H. Fitzgibbon; J. G. Holcomb (Augusta, ME); A. M. Allen (Pottsville, PA); R. S. Jones (Charlottesville, VA); M. Finley; P. Smith; Hegan (Louisville, KY); Wm. Shew (San Francisco, CA); Kelsey, formerly of Shew's establishment in Philadelphia, PA, now in Rochester, NY, in the room formerly occupied by Mr. Heath; A. Washington (Hartford, CT) offering his gallery for sale; S. D. Humphrey (ed of HJ) now taking daguerreotypes at 546 Broadway (New York, NY); Dr. Merrick (Adrian, MI); Clarkson (Long Island, NY); N. S. Bennett; S. L. Walker (Poughkeepsie, NY); Mr. Bronk, going to St. Louis, MO, to work for Dobyns & Spaulding; E. C. Hawkins (Cincinnati, OH); Masury & Silsbee (Boston, MA); Whipple (Boston, MA).]

ST1920 "Answers to Correspondents: Caution to Daguerreotypists." HUMPHREY'S JOURNAL 5, no. 11 (Sept. 15, 1853): 175. [Warning about an individual fraudulently claiming to have worked as a colorist for J. Gurney.]

ST1921 Portrait. Woodcut engraving, credited "From a Daguerreotype." ILLUSTRATED NEWS (NY) 2, (1853) ["Gen. Joseph Villamil, Minister from Ecuador." 2:38 (Sept. 17, 1853): 149.]

ST1922 "Daguerreotype Movements." HUMPHREY'S JOURNAL 5, no. 12 (Oct. 1, 1853): 190-191. [James Irvin (Troy, NY); Edwin Church, previously with Lawrence, leaving for Memphis, TN to set up a gallery in partnership with Dobyns; G. N. Barnard (Oswego, NY); C. C. Harrison making "extra whole size" lenses; Johnson & Selleck (Sacramento, CA); Meade Brothers; Cutting & Rhenn; J. P. Ball (Cincinnati, OH); Atkins of Brooklyn, NY, did not go to Cincinnati; Hawkins, nephew of E. C. Hawkins; Heath (Rochester, NY); S. Broadbent (Philadelphia, PA); McGowan (in Shew's Rooms, Philadelphia, PA); Babbit (Niagara Falls, NY).]

ST1923 "Gossip." PHOTOGRAPHIC ART JOURNAL 6, no. 4 (Oct. 1853): 254-260. [Letter from John Werge, colorist for the Meade Brothers Gallery, replying to the negative review in the "New York Tribune"; paper photographs by Cutting (at Gurney's gallery); Root; Brown; Aulet (an amateur in Cuba); Peter's stereo views; Henry Meade married; Mr. Mascher (Philadelphia, PA); Anthony's Prize pitcher announcement; Hesler; Whipple; Cook mentioned.]

ST1924 "Daguerreotype Movements." HUMPHREY'S JOURNAL 5, no. 13 (Oct. 15, 1853): 206-207. [Farris (Cincinnati, OH); Haas (New York, NY); L. L. Hill & Co.; S. Van Loan (Philadelphia, PA); Ross; Rea & Bailey (Indianapolis, IN); Bisbee & Robinson (OH); M. Moulthrop (New Haven, CT); A. Washington (Hartford, CT) sold out; Tomlinson (Troy, NY) E. P. Senter (Auburn, NY); H. Meade (New York, NY) married; Sherman (Erie, PA); Wm. H. Butler (New York, NY); S. Root (New York, NY); J. Gurney (New York, NY); etc.]

ST1925 "Daguerreotype Movements." HUMPHREY'S JOURNAL 5, no. 14 (Nov. 1, 1853): 222-223. [J. H. Fitzgibbon; Hesler (Galena, IL); Cary (of Cary & Perkins (Savannah, GA) opened a gallery in New York, NY; R. E. Churchill (Albany, NY); S. J. Thompson purchased Humphrey's establishment in New York, NY; Meade Brothers; John Werge; M. Finley (Canandaigua, NY); E. Church now in Nashville, TN; Yearout in Memphis, TN to open gallery Dobyns & Yearout; Bronk in St. Louis, MO; Haas (New York, NY); E. S. Dodge (Augusta, GA) to retire; H. & E. Jackson (Pittsburgh, PA); W. K. Milles (OH); O. D. More (Detroit, MI); P. H. Benedict; Meade Brothers; F. A. Brown (Manchester, NH); Southworth & Hawes (Boston, MA); Hale (Boston, MA); D. B. Nichols (Detroit, MI); P. Van Schneidau (Chicago, IL).]

ST1926 "Wanderer." "Peregrinations of a Wanderer." PHOTOGRAPHIC ART JOURNAL 6, no. 5 (Nov. 1853): 285-287. [Writing from Montgomery, AL. Mentions J. S. Park's "Skylight Gallery"

in Auburn. McIntire in Montgomery. Freare to West Point for the summer to escape the Yellow Fever.]

ST1927 "Gossip." PHOTOGRAPHIC ART JOURNAL 6, no. 5 (Nov. 1853): 320-324. [Anthony's prizes discussed. "Chicago [IL] Democratic Press" review of the Illinois Mechanic's Fair reprinted - mentions A. Hesler; J. H. Taylor (Springfield); C. C. Kelsey; P. Von Schneidau; W. G. Chamberlain; H. P. Danks; E. G. Stiles; Miss Miller. C. C. Harrison; Meade Brothers mentioned.]

ST1928 "Daguerreotype Movements." HUMPHREY'S JOURNAL 5, no. 15 (Nov. 15, 1853): 238-239. [Richards (Philadelphia, PA); G. W. Squires partnering with Thompson's Gallery, New York, NY); F. A. Brown (Manchester, NH); L. Buel (OH); O. W. Horton (OH); A. R. Cole (Zanesville, OH); J. F. Ryder (OH); E. Long (St. Louis, MO); Mayall; Barnes (Mobile, AL); Webster & Brother (New York, NY); Gibbs (Lynchburg, VA); McClees & Germon (Philadelphia, PA) producing paper prints; O. R. Benton (Buffalo, NY); White (Atlanta, GA) shot dead.]

ST1929 "Editorials." HUMPHREY'S JOURNAL 5, no. 16 (Dec. 1, 1853): 246. [Note that J. Gurney won the E. Anthony Award. Brief mention of other competitors, judges.]

ST1930 Snelling, H. H. "Gossip." PHOTOGRAPHIC ART JOURNAL 6, no. 6 (Dec. 1853): 383-384. [Announcement that the "PAJ" would be illustrated in the future. Gurney and S. Root won the Anthony Prizes. C. C. Harrison mentioned.]

ST1931 "Daguerreotype Patent." HUMPHREY'S JOURNAL 5, no. 16 (Dec. 1, 1853): 266-267. [Long letter, from an unnamed correspondent, protesting attempts to secure patents for every minor improvement in a process or technique.]

ST1932 "Editorial: Daguerreotype Hats." HUMPHREY'S JOURNAL 5, no. 17 (Dec. 15, 1853): 265. [Comic commentary on the practice of the firm of Rafferty & Leask, an "...enterprising firm in this city..."offering a daguerreotype portrait sewn into your hat.]

ST1933 "Daguerreotype Movements." HUMPHREY'S JOURNAL 5, no. 17 (Dec. 15, 1853): 272. [T. L. Ennis, formerly of Philadelphia, PA, now in Cleveland, OH; Rea & Bailey; A. Johnson (Lima, NY) selling out; A. Hesler (Galena, IL); M. Brady (New York, NY); S. Root acquiring views of Jerusalem through purchase; P. Smith (Cincinnati, OH); Fredericks (from Paris) to make paper photographs for Gurney; Hovey makes paper prints for Mr. Root.]

USA:1854.

ST1934 "Daguerreotype Movements." HUMPHREY'S JOURNAL 5, no. 18 (Jan. 1, 1854): 287. [W. H. Sherman (Erie, PA); Grannis (Waterbury, CT); S. Root (New York, NY); Southworth & Hawes; G. N. Warren (Lowell, MA); S. L. Walker (Poughkeepsie, NY); R. E. Churchill (Albany, NY); Jacobs (New Orleans, LA); J. J. Outley (St. Louis, MO); Barnes (Mobile, AL); Webster & Brother (Louisville, KY); E. Long (St. Louis, MO); S. W. Fisher (PA); James Brown (New York, NY); T. H. Benedict (Syracuse, NY); E. Church (Nashville, TN).]

ST1935 "The Anthony Prize Pitcher." PHOTOGRAPHIC AND FINE ART JOURNAL 7, no. 1 (Jan. 1854): 6-11. [List of prize winners plus statement of working practices of the prize winners. 1st prize J. Gurney, 2nd prize S. Root, Hon. Mention: Gabriel H. Harrison, A. Hesler, G. N. Barnard, G. K. Warren, J. Brown.]

ST1936 "Powell's Discovery of the Mississippi." PHOTOGRAPHIC AND FINE ART JOURNAL 7, no. 1 (Jan. 1854): 13-14. [Powell was a painter. From the "NY Times."]

ST1937 "Personal & Art Intelligence." PHOTOGRAPHIC AND FINE ART JOURNAL 7, no. 1 (Jan. 1854): 32-34. [Discussion of new format size increase 8 1/2x11" paper; Geo. Barnard & Nichols form partnership and open establishment in Syracuse; P. H. Benedict of Syracuse mentioned; letter wishing to form professional organization; James Irving opens shop in Troy, NY; J. J. Bardwell forms partnership with J. E. Whitney in St. Paul, Minn. Terr.; M. Farrand of New York, NY mentioned. Mr. C. D. Fredericks returned from Paris to establish in New York, NY with collodion work; work of Gillot of Paris, discussed; Wulff of Paris photos on textile fabrics; E. C. Thompson of Washington, DC working with a paper process; Whipple & Black, of boston, MA, teaching collodion process; Whitehurst of Baltimore, MD also teaching collodion; mentions that Brady has carried first prize at NY Crystal Palace Exposition.]

ST1938 "Report of the Committee on Anthony's Prizes." HUMPHREY'S JOURNAL 5, no. 19 (Jan. 15, 1854): 298. [Committee: S. F. B. Morse, John W. Draper, James Renwick; lists winners, honorable mentions, etc.]

ST1939 "Daguerreotype Movements." HUMPHREY'S JOURNAL 5, no. 19 (Jan. 15, 1854): 301-303. [G. W. Squires bought out Thompson in New York, NY; Masury & Silsbee (Boston, MA); Anson (New York, NY); W. H. Sherman (Erie, PA); H. S. Brown (Milwaukee, WI); Geo. Adams (formerly Worcester, MA) moving West; S. Root (New York, NY); Westcott (Watertown, NY); Elliott (Chester, SC); Dobyns; W. P. Beck (from Troy to Homer, NY); T. Leambach (Salem, NC); O. B. Curtis (Marietta, GA); J. D. Wells (Northampton, CT); J. H. & J. Selkirk (Matagorda, TX); H. E. Insley (New York, NY); E. P. Senter (Auburn, NY); Hesler; J. E. Mayall (London).]

ST1940 "Daguerreotype Movements." HUMPHREY'S JOURNAL 5, no. 20 (Feb. 1, 1854): 320. [Partridge & Brother (Wheeling, VA); G. N. Barnard purchased Clark's studio in Syracuse, NY; Gurney & Fredericks; A. Litch making cameras.]

ST1941 "Personal & Art Intelligence." PHOTOGRAPHIC AND FINE ART JOURNAL 7, no. 2 (Feb. 1854): 63-64. [J. E. Whitney (St. Paul, MN) exhibited at NY Fair; Meade Brothers daguerreotype processing techniques mentioned; letter from B. F. Upton; W. H. DeShong (Memphis, TN), V. Prevost and C. Duchochois & Co. (New York, NY) taking views of the North River; Dobyns & Richardson (New York, NY) at NY Fair; H. W. Bradley (San Francisco, CA) visiting New York, NY: note that "the rumor that Mr. Brady had obtained the gold medal at the World's Fair exhibition in New York, appears to be incorrect. The awards of the Jurors have been published..." NY World's Fair Exhibition awards listed: J. A. Whipple (Boston, MA), Alex. Butler, M. Brady,(Bronze medal, 2nd premium), C. C. Harrison, A. Hesler, M. M. Lawrence, Samuel Root, Henry Plaut (Paris, FR), J. H. Fitzgibbon, Jeremiah Gurney, Harrison & Hill, Meade Brothers, Moissenet, Dobyns & Richardson, W. C. North, O. S. Peters, M. A. Root, J. H. Whitehurst. Further note: "We were in error in stating that a gold medal was awarded to Mr. Brady at the World's Fair in London. There were but two medals awarded for daguerreotypes. These were of bronze and were presented to Mr. Brady and Mr. Lawrence, both of New York city."]

ST1942 "Daguerreotype Movements." HUMPHREY'S JOURNAL 5, no. 21 (Feb. 15, 1854): 335-336. [A. C. Partridge (Wheeling, VA); Hartmann (New York, NY); Dr. Wilde (Savannah, GA); Hutchings (New York, NY) committed suicide; Shaw, of Memphis, dead; Caleb

Hunt (Cleveland, OH); C. North (Cleveland, OH); Mrs. Short (Cleveland, OH); Johnson & Fellows (Cleveland, OH); Bisbee (Dayton, OH); Richards (Philadelphia, PA); J. E. Mayall (London); etc.]

ST1943 "Editorials." HUMPHREY'S JOURNAL 5, no. 22 (Mar. 1, 1854): 345-347. [Notes about Gurney & Fredericks; Hawkins (Cincinnati, OH); letter from L. P. R. (New Orleans, LA) and "Iago" (Cleveland, OH); praising his journal.]

ST1944 "Daguerreotype Movements." HUMPHREY'S JOURNAL 5, no. 22 (Mar. 1, 1854): 352. [James Brown (New York, NY); Whitney & Denny (Rochester, NY); M. A. Root (Philadelphia, PA) about to open a gallery in New York, NY; Whitehurst; Anson; H. Pollock (Baltimore, MD); H. S. Brown (Milwaukee, WI); J. D. Wells (Northampton, NY); A. Gregory; Backers & Piard.]

ST1945 "Personal & Art Intelligence." PHOTOGRAPHIC AND FINE ART JOURNAL 7, no. 3 (Mar. 1854): 96. [Commentary on growing use of paper processes, specifically naming Whipple and Masury & Silsbee in Boston; Brady, Gurney, Root, Haas, Fredericks, Lawrence, and Prevost in New York; McClees and Germon in Philadelphia; Whitehurst in Baltimore; Whitney and Denny in Rochester; Hawkins in Cincinnati; Fitzgibbon in St. Louis and Miller in Akron, OH.]

ST1946 "Daguerreotype Movements." HUMPHREY'S JOURNAL 5, no. 23 (Mar. 15, 1854): 368. [Wm. Shew (San Francisco, CA); H. Meade; C. S. Germon (Canada).]

ST1947 "Daguerreotype Movements." HUMPHREY'S JOURNAL 5, no. 24 (Apr. 1, 1854): 384. [Fellows & Ryder (Cleveland, OH); Richards (Philadelphia, PA); Whipple (Boston, MA).]

ST1948 Branson, Dr. "Soap as a Means of Art." PHOTOGRAPHIC AND FINE ART JOURNAL 7, no. 4 (Apr. 1854): 124.

ST1949 "American Artists and Tourists in Italy." PHOTOGRAPHIC AND FINE ART JOURNAL 7, no. 4 (Apr. 1854): 126-127. [About painters. From the "NY Tribune." Feb. 22, 1854.]

ST1950 "Personal & Art Intelligence." PHOTOGRAPHIC AND FINE ART JOURNAL 7, no. 4 (Apr. 1854): 127-128. [Announcement of publication of "Weekly Photographic Art Journal"; explosion at Masury & Silsbee (Boston, MA); sculptor Thomas D. Jones has allegorical group on display in New York, NY; Mr. W. Schaus wishes to establish a gallery of art; exhibition of National Academy of Design opened Mar. 22; G. N. Barnard reported very ill but recovering; J. W. Thompson intends moving; L.W. Kean now at Blountville, Tenn.; listing of reputable dealers in photographic goods in the West and South-West; L. L. Hills "Photographic Researches & manipulations, including the author's former treatise on daguerreotype"; M. Shaw, Phila pub. mentioned; etc.]

ST1951 "Daguerreotype Movements." HUMPHREY'S JOURNAL 6, no. 1 (Apr. 15, 1854): 15-16. [Olmsbee (Boston, MA); Weeks, formerly with Gurney, to open a gallery in Toledo, OH; Sutton (Detroit, MI); S. L. Walker (Philadelphia, PA); M. B. Brady (New York, NY).]

ST1952 "Daguerreotype Movements." HUMPHREY'S JOURNAL 6, no. 2 (May 1, 1854): 30-31. [M. Sutton (Detroit, MI); T. L. Ennis (Cleveland, OH); Oliver P. Hanks (Cleveland, OH); S. Crowbaugh (Cleveland, OH), W. H. Sherman (Erie, PA); Stephen B. Butts (Buffalo, NY); Yearout (Memphis, TN); E. Jacobs (New Orleans, LA); N. S. Sisson (Albany, NY) closed dag. studio, became a stock dealer.]

ST1953 Jameson, Mrs. "Washington Allston." PHOTOGRAPHIC AND FINE ART JOURNAL 7, no. 5 (May 1854): 140-145. [Biography of the painter Washington Allston.]

ST1954 "Personal & Art Intelligence." PHOTOGRAPHIC AND FINE ART JOURNAL 7, no. 5 (May 1854): 160. [Revolution in daguerreotype business forthcoming, due to ascendancy of paper processes. Whipple; Faris; Hesler; Kelsey; Thayer; Walker (Holyoke, MA); Barnard recovering from illness, Masury was injured in explosion (not Silsbee as previously reported); D. D. T. Davie burned out; Fontayne (Cincinnati, OH) robbed, etc.]

ST1955 "Daguerreotype Movements." HUMPHREY'S JOURNAL 6, no. 4 (June 1, 1854): 63. [A. Bisbee (Dayton, OH); Tilley (Newport, RI); A. Hesler (Galena, IL); C. C. Kelsey (Chicago, IL); J. H. Fitzgibbon; Dobyns; Barnes (Mobile, AL).]

ST1956 "Personal & Art Intelligence." PHOTOGRAPHIC AND FINE ART JOURNAL 7, no. 6 (June 1854): 191-192. [Comments on low prices; McDonnell (Buffalo, NY); Fitzgibbon; F. D. B. Richards; Brinkerhoff (New York, NY); Fredericks; Davie (Utica, NY) ill; Barnard recovered, moved back to Syracuse; Harrison & Hill; Prevost; Bardwell back to Marshall, MI; Glen (Charleston, SC); C. A. Johnson; Meade Brothers slightly damaged by fire; others mentioned.]

ST1957 "The Daguerreotype Material Manufactories." PHOTOGRAPHIC AND FINE ART JOURNAL 7, no. 7 (July 1854): 202-206. 7 illus. [7 woodcut views of activities within daguerreotype case making factory.]

ST1958 "Personal & Fine Art Intelligence." PHOTOGRAPHIC AND FINE ART JOURNAL 7, no. 7 (July 1854): 223-224. [Whipple's crystalotypes; Talbot's calotype patent, held by Langenheim Brothers in USA, being revived;; daguerreotypes of eclipse of the sun by Prevost, Root, Kelsey, C. Barnes (in Mobile, AL). J. E. Joslyn; R. M. Cole (Peoria, IL); T. J. Bailey (Columbus, MS); C. B. Peyroux (New Orleans; LA); Norton & Carden (New York, NY); Hitchings (New York, NY); others mentioned.]

ST1959 "Personal & Fine Art Intelligence." PHOTOGRAPHIC AND FINE ART JOURNAL 7, no. 8 (Aug. 1854): 256. [Franklin White (Brattleboro, VT); NY State Daguerrean Assoc.; letter from V. Prevost correcting a statement printed before; Masury & Silsbee; Gurney; J. C. Gray (Jamestown, NY); Whitney & Denny (Rochester, NY) dissolved partnership, Whitney continuing; Whitehurst (Baltimore, MD); H. E. Insley; Gage left Brady, opened his own gallery on Broadway; others mentioned.]

ST1960 "Daguerreotype Movements." HUMPHREY'S JOURNAL 6, no. 9 (Aug. 15, 1854): 143. [Whipple (Boston, MA); McClees & Germon (Philadelphia, PA); J. H. Fitzgibbon (St. Louis, MO); J. H. S. Stanley (Houston, TX); Bronk (formerly operator at Brady's) is with Winchester, in Columbus, OH; James Cremer; C. A. Johnson, formerly Batavia, NY to Madison, WI; Gurney & Frederick; M. M. Lawrence; Denny, formerly Whitney & Denny (Rochester, NY) leaving the profession for health; H. D. Knight (Batavia, NY).]

ST1961 "Daguerreotype Movements." HUMPHREY'S JOURNAL 6, no. 10 (Sept. 1, 1854): 160. [T. P. Collins (Westfield, NY); C. Meade; Manchester & Chapin (Providence, RI); Tilley (Newport, RI); Elliott (Chester, SC); S. Root; Benedict (Syracuse, NY); P. Haas.]

ST1962 "Personal & Fine Art Intelligence." PHOTOGRAPHIC AND FINE ART JOURNAL 7, no. 9 (Sept. 1854): 287-288. [Talbot patent, in England and in USA, discussed; Langenheim's stereos praised,

mention that he had lost his Philadelphia business, went to Europe, then returned; J. H. Fitzgibbon; Henry Meade; McClees; D. D. T. Davie; others mentioned.]

ST1963 "Daguerreotype Movements." HUMPHREY'S JOURNAL 6, no. 11 (Sept. 15, 1854): 175. [J. E. Whitney (St. Paul, MN); R. B. Appleby (Rochester, NY); John Kelsey (Rochester, NY); Huntoon (Saratoga Springs, NY); Irving (Troy, NY); S. L. Walker (Poughkeepsie, NY) "has probably instructed more young men in the 'mystery and art' of Daguerreotyping than any other person in this country;" T. C. Doane (Montreal, Canada); Willard Ellis Geer, "daguerreotyping on wheels" sent poem.]

ST1964 M. F. "Photography and the Publications Devoted to It." HUMPHREY'S JOURNAL 6, no. 12 (Oct. 1, 1854): 186-187. [Actually a letter protesting the magazines support for paper processes over daguerreotype processes.]

ST1965 "Daguerreotype Movements." HUMPHREY'S JOURNAL 6, no. 12 (Oct. 1, 1854): 192. [Richards (Philadelphia, PA); A. Hesler (Galena, IL); Barnard (Oswego and Syracuse, NY); Brown (Elmira, NY); W. H. Sherman (Erie, NY); J. H. and J. Selkirk (Matagorda, TX).]

ST1966 Humphrey, S. D. "Editorial: A Yankee Sharper "Selling" Messrs. Cutting and Whipple's Processes, in the West." HUMPHREY'S JOURNAL 6, no. 12 (Oct. 1, 1854): 183. [Fraud, illegally teaching the paper processes of Whipple and of Cutting.]

ST1967 "Personal and Fine Art Intelligence." PHOTOGRAPHIC AND FINE ART JOURNAL 7, no. 10 (Oct. 1854): 319-320. [Complaints about apathy in the profession; John Greene's travels and photographing in Egypt; F. Langenheim's stereos; with a letter from Langenheim; T. Harris (Louisville, KY); Benedict (Syracuse, NY); Sutton (Detroit, MI); Whitney (St. Paul, MN); others mentioned.]

ST1968 "Daguerreotype Movements." HUMPHREY'S JOURNAL 6, no. 13 (Oct. 15, 1854): 207. [E. G. Hall (Detroit, MI); Sutton & Brother (MI); H. S. Dunshire (Toledo, OH); A. B. Weeks, formerly with Gurney, now in Ohio; O. W. Horton (Grand Rapids, MI); J. H. Fitzgibbon; T. J. Dobyns sold his interest in St. Louis, Louisville, Nashville and New York establishments; N. E. Sisson (Albany, NY); G. W. Squier (New York, NY) sold out; Cary; Whipple; McCarty; Thompson & Green (Albany, NY) dissolved partnership; J. F. Green (Geneva, NY); etc.]

ST1969 "Personal & Fine Art Intelligence." PHOTOGRAPHIC AND FINE ART JOURNAL 7, no. 11 (Nov. 1854): 351-352. [Richards & Betts (Philadelphia, PA); Turner; Franklin White; Beckers & Piard (New York, NY); J. F. Harrison (Oshkosh, WI); Fitzgibbon; L. L. Hill; E. Long; Brinkerhoff; J. W. Black, taking views in White Mts. of NH; McClees & Germon (Philadelphia, PA); M. M. Lawrence; Johnson (Utica, NY); others mentioned.]

ST1970 "Daguerreotype Movements." HUMPHREY'S JOURNAL 6, no. 15 (Nov. 15, 1854): 239-240. [Myron Shew (Philadelphia stock dealer); E. Codding (IL); G. E. Hall (Detroit, MI) learning the paper process from Whipple (Boston, MA); Tilley (Newport, RI); Whitney (Rochester, NY); Bronk moving again.]

ST1971 "Daguerreotype Movements." HUMPHREY'S JOURNAL 6, no. 16 (Dec. 1, 1854): 255-256. [Moulthroup (New Haven, CT); R. B. Appleby (Rochester stock dealer); I. Tucker (Augusta, GA); Cary & Perkins (Savannah, GA) opened rooms in Macon, GA; Lewis (Bridgeport, CT); E. Ritten (Danbury, CT); Zeley (Columbia, SC); Brady (New York, NY); A. M. Allen (Pottsville, PA); Sutton & Brother (Detroit, MI).]

ST1972 "Justice." "The Trials of a Day; Or, An Artist's Troubles. Scene, a Daguerreotypist's Gallery." PHOTOGRAPHIC AND FINE ART JOURNAL 7, no. 12 (Dec. 1854): 359-362. [Fictional narrative of problems between customers and a daguerreotypist.]

ST1973 "Personal & Fine Art Intelligence." PHOTOGRAPHIC AND FINE ART JOURNAL 7, no. 12 (Dec. 1854): 383-384. [Summary of improvements and events of the year. Niepce de St. Victor, Whipple, Le Gray, Brickerhoff, etc.; Stanley (Houston, TX); Gillou (Philadelphia, PA); Vance (San Francisco, CA); others mentioned.]

USA: 1855.

ST1974 "Daguerreotype Movements." HUMPHREY'S JOURNAL 6, no. 18 (Jan. 1, 1855): 295-296. [R. B. Appleby hired G. W. Squiers to take charge of his operating department, A. taking over stock department full time; J. B. Smith (Rome, NY); A. Litch working for Cooley (Springfield, MA); J. Gurney & C. D. Fredericks taking paper photos; S. Root; Brady; Anson; S. A. Holmes.]

ST1975 "Personal and Art Intelligence." PHOTOGRAPHIC AND FINE ART JOURNAL 8, no. 1 (Jan. 1855): 31-32. [Long commentary on recent depressions, and its effects on the photographic business. McClees & Germon (Philadelphia, PA); Joseph Cundall (London); Fitzgibbon; L. L. Hill; others mentioned.]

ST1976 "Daguerreotype Movements." HUMPHREY'S JOURNAL 6, no. 20 (Feb. 1, 1855): 327-328. [S. J. Thompson (Albany, NY); H. A. Balch (Juliet, IL); A. C. Partridge (Wheeling, VA); James Cremer, stock dealer; Anderson (Newark, NJ); Prosch (Newark, NJ); P. C. Gibbs (Lynchburg, VA); M. Sutton (Detroit, MI).]

ST1977 "Photography in Counterfeiting." PHOTOGRAPHIC AND FINE ART JOURNAL 8, no. 2 (Feb. 1855): 55-56. [From "NY Tribune."]

ST1978 "Personal and Art Intelligence." PHOTOGRAPHIC AND FINE ART JOURNAL 8, no. 2 (Feb. 1855): 63-64. [Editorial comment on immanent developments in photoengraving; Fitzgibbon; Barnaby (Dayton, OH); Fontayne (Cincinnati, OH); Webster & Brothers (Louisville, KY); Miller (Akron, OH); McDonnelll (Buffalo, NY); C. A. Johnson (travelling artist); others mentioned.]

ST1979 Griswold, Dr. C. D. "Effects of Iodine in Consumption: To Daguerreian Operators." HUMPHREY'S JOURNAL 6, no. 21 (Feb. 15, 1855): 239-240. [Questionnaire, by Griswold, to operators to see if iodine vapors were helpful in curing consumption.]

ST1980 F. A. F. "Origin of the Daguerreotype." BALLOU'S PICTORIAL DRAWING-ROOM COMPANION [GLEASON'S] 8, no. 8 (Feb. 24, 1855): 119. [Lyric poem using classical mythology for its imagery, actually has nothing to do with photography.]

ST1981 "Personal and Art Intelligence." PHOTOGRAPHIC AND FINE ART JOURNAL 8, no. 3 (Mar. 1855): 94-96. [Editorial statement on L. L. Hill; J. Whipple; A. Hesler; Whitney; Gurney & Frederick; S. Root; others mentioned.]

ST1982 "Photography." THE CRAYON 1, no. 11 (Mar. 14, 1855): 170. [From "The Artist." Discusses the impacts of photography on illustrative artists, engravers, etc. Its use in France for copying paintings, etc. mentioned. "The camera, it is true, is a most accurate copyist, but it is no substitute for original thought or invention."]

ST1983 "Photography." HUMPHREY'S JOURNAL 6, no. 24 (Apr. 1, 1855): 384. [From "NY Tribune." Comment on increasing use of photography vs. daguerreotypy.]

ST1984 Snelling, H. H. "Personal and Art Intelligence." PHOTOGRAPHIC AND FINE ART JOURNAL 8, no. 4 (Apr. 1855): 126-128. [Commentary on Levi L. Hill's color process; R. M. Cole (Peoria, IL); Parks (Auburn, AL); Frear (Montgomery, AL); Murray & Jacobs (New York, NY); Hesler; M. Penabert (formerly of Gurney & Frederick's) going to work for Fitzgibbon; Masury & Silsbee; James Egan; others mentioned.]

ST1985 "The Inconstant Daguerreotype." HARPER'S MONTHLY 10, no. 60 (May 1855): 820-826. [Fictional short story.]

ST1986 "Fun in Miller's Daguerrean Gallery, by a Loafer." PHOTOGRAPHIC AND FINE ART JOURNAL 8, no. 5 (May 1855): 132-133. [From "the Summit Beacon." Anecdotal tale about country folks confrontations with a studio photographer.]

ST1987 Snelling, H. H. "Personal and Art Intelligence." PHOTOGRAPHIC AND FINE ART JOURNAL 8, no. 5 (May 1855): 159-160. [Editorial stand for professional unity. A. A. Turner; E. Huyler (New York, NY); Whitney (Rochester, NY); Cutting & Rhen (Philadelphia, PA); McClees & Germon (Philadelphia, PA); J. E. Joslin leaving New York, NY to work the paper processes for Hester in Chicago, IL; A. B. Hutchings (New York, NY); S. Root; Meade; others mentioned.]

ST1988 Snelling, H. H. "Personal and Art Intelligence." PHOTOGRAPHIC AND FINE ART JOURNAL 8, no. 6 (June 1855): 191-192. [Editorial comment on present state of the art. Webster & Brother (Louisville, KY); Penabert, now working the paper processes for Fitzgibbon in St. Louis; G. Harrison (Brooklyn, NY); F. D. B. Richards sailed for Europe; Masury also; others mentioned.]

ST1989 "Daguerreotypes." BALLOU'S PICTORIAL DRAWING-ROOM COMPANION [GLEASON'S] 8, no. 25 (June 23, 1855): 387. [Quote from "Mrs. Jameson." (This may be a book.) Comment upon the generally unsatisfactory nature of daguerreotype portraits, felt by the author to be lacking the qualities of the "human mind and brain" - unlike painting.]

ST1990 Snelling, H. H. "Personal and Art Intelligence." PHOTOGRAPHIC AND FINE ART JOURNAL 8, no. 7 (July 1855): 231-232. [Editorial statement favoring the Photo. Exchange Club proposed elsewhere in the issue. Faris (Cincinnati, OH); Barnard & Nichols, postmortem portrait praised; Senter (Auburn); Benedict (Syracuse); Whitney (St. Paul, MN); Hughes (Nashville, TN); Bailey (Columbia); Corey & Pickerill (succeeded W. H. White in Dubuque, IA); others mentioned.]

ST1991 "Personal and Art Intelligence." PHOTOGRAPHIC AND FINE ART JOURNAL 8, no. 8 (Aug. 1855): 255-256. [American Photographic Exchange Club; Letter from Cutting's lawyer to G. N. Barnard, concerning prices for the use of his ambrotype patent; Mayall (London); Webster & Brother (Louisville, KY); Southworth & Hawes (Boston, MA); Lawrence (New York, NY) produced some 2000 portraits for the University in Rochester, NY; Faris (Cincinnati, OH).]

ST1992 "Personal and Art Intelligence." PHOTOGRAPHIC AND FINE ART JOURNAL 8, no. 9 (Sept. 1855): 287. [List of members of the Photographic Exchange Club. Barnaby (Dayton, OH); Hesler (Chicago, IL); Sutton & Brother (Detroit, MI); Vannerson (Washington, DC); M. A. Root (Philadelphia, PA); Webster & Brother (Louisville,

KY); Webster (Cincinnati, OH); J. Werge, moved to Glasgow, Scotland; Charles R. Meade returned from France; Holt (New York, NY); Cook (Charleston, SC); Simons (Richmond, VA).]

ST1993 "Photographic Images Found in the Bodies of Those Struck by Lightning." FRANK LESLIE'S NEW YORK JOURNAL n. s. 2, no. 4 (Oct. 1855): 232. [Brief, unfounded report.]

ST1994 "Personal and Art Intelligence." PHOTOGRAPHIC AND FINE ART JOURNAL 8, no. 10 (Oct. 1855): 319-320. [Discusses Photographic Exchange Club, lists members. Faris; Hawkins; J. J. Woodbridge; Ball's & Bishop's; all of Cincinnati, OH; McDonald & Brother, Evans (Buffalo, NY); Sutton (Detroit, MI); Corey & Pickerell's (Dubuque, IA); J. E. Joslin (Chicago, IL); M. A. Root; Fitzgibbon; A. P. Hart (Elmira, NY); Gillman & Ehrmann; Holmes (New York, NY); S. D. Humphrey.]

ST1995 "Personal & Art Intelligence." PHOTOGRAPHIC AND FINE ART JOURNAL 8, no. 11 (Nov. 1855): 351-352. [Photographic Exchange Club; M. A. Root; premiums awarded at Wisconsin State Fair; Fasset (Chicago, IL).]

ST1996 "Inventors and Discoverers." BALLOU'S PICTORIAL DRAWING-ROOM COMPANION [GLEASON'S] 9, no. 19 (Nov. 10, 1855): 289. 1 illus. [Engravings of the inventors Gutenberg, Watt, Whitney, Samuel Morse, and Daguerre, accompanied by a brief commentary upon their importance to the modern world.]

ST1997 "Personal & Art Intelligence." PHOTOGRAPHIC AND FINE ART JOURNAL 8, no. 12 (Dec. 1855): 383-384. [Commentary on the "P & FAJ." J. A. Whipple; M. P. Simons (Richmond, VA); list of premium winners at the American Institute Fair; Holmes; Minnis (Lynchburg, VA) joined by Turner (New York, NY); Sutton (Detroit, MI); Davie; David Shive (Philadelphia, PA).]

ST1998 "Personal & Art Intelligence." PHOTOGRAPHIC AND FINE ART JOURNAL 9, no. 4 (Apr. 1856): 126-128. [Aesthetics of coloring photos. Brady being sued by Cutting patent holders. Fitzgibbon; Minnis; Jas. T. Zealy; others.]

ST1999 "Personal & Art Intelligence." PHOTOGRAPHIC AND FINE ART JOURNAL 9, no. 12 (Dec. 1856): 380-384. [Photographic exhibitions in London. T. J. Bailey (Columbia, TN); Davie (Utica, NY); James M. Letts; M. Sutton (Detroit, MI); Fitzgibbon robbed; Robert Munroe; A. W. Phipps; R. M. Cargo; Cutting & Turner (Boston, MA); J. Rogers (Pittsburgh, PA); American Institute Fair awards list; others mentioned.]

USA:1856.

ST2000 "Personal and Art Intelligence." PHOTOGRAPHIC AND FINE ART JOURNAL 9, no. 1 (Jan. 1856): 30-32. [Long description of the problems faced by the editor in obtaining the photographic illustrations for the "P & FAJ." John F. Mascher; Webster & Brother; J. F. Ryder; J. Vannerson; Willard & Depew (Columbus, GA); R. A. Vance (San Francisco, CA); A. Hesler; Mechanic's Institute Fair in Louisville, KY; Troxel; F. Langenheim; M. A. Root; White (Montpelier, VT); A. A. Turner; C. Guillou (amateur from Philadelphia, PA); J. H. Fitzgibbon; Knecht & Thompson (Easton, PA); others mentioned.]

ST2001 Portraits. Woodcut engravings, credited "From an Daguerreotype, Taken in Washington, Expressly for This Paper." FRANK LESLIE'S ILLUSTRATED NEWSPAPER 1, (1856) ["Hon. N. P. Banks, Cong." 1:7 (Jan. 26, 1856): 97.]

ST2002 "Personal & Art Intelligence." PHOTOGRAPHIC AND FINE ART JOURNAL 9, no. 2 (Feb. 1856): 63-64. [Commentary on the Cutting patent controversy. Photographic Exchange Club; Levi L. Hill; Wisconsin State Fair awards correction; others mentioned.]

ST2003 "Personal & Art Intelligence." PHOTOGRAPHIC AND FINE ART JOURNAL 9, no. 3 (Mar. 1856): 94-96. [Editor again addresses the constant problem of the theft of his journals in the mail. Commentary about a French review of an article by Mascher. Barnard & Nichols (Syracuse, NY); Sutton; Meade & Brother; Minnis & Tanner (Lynchburg, VA) dissolved partnership, Tanner continuing the business; Paris exhibition; Victor Roger, in Paris, tried for making pornographic photographs, other matters discussed.]

ST2004 "Personal & Art Intelligence." PHOTOGRAPHIC AND FINE ART JOURNAL 9, no. 5 (May 1856): 158-160. [Cutting patent controversy, with a letter from F. Langenheim. F. White, views of NH scenery; Walter C. North (Mansfield, OH); Willoughby's discovery of a color process; J. M. Ford (San Francisco, CA); A. Bisbee; Barnard & Nichols (Syracuse, NY); Lieut. Gilmore at West Point; others mentioned.]

ST2005 "Personal & Art Intelligence." PHOTOGRAPHIC AND FINE ART JOURNAL 9, no. 6 (June 1856): 189-192. [Hallotype (Prof. John Bishop Hall) entered into partnership with J. Gurney to introduce this process; exchange of letters between M. A. Root and H. H. Snelling detailing the failure of Root to provide a book for publication in the "P & FAJ."]

ST2006 "Personal & Art Intelligence." PHOTOGRAPHIC AND FINE ART JOURNAL 9, no. 7 (July 1856): 223-224. [Nicholson & Thompson; W. C. North; D. D. T. Davie; C. Barnes (Mobile, AL); Glosser; Vannerson; others.]

ST2007 "Experiments in Photograph: Mr. Bonaparte Stubbs wishing his Daguerreotype, the Operator being out, his Boy tries his hand." HARPER'S MONTHLY 13, no. 75 (Aug. 1856): 429-430. 16 illus. [Comic drawings of the misadventures occurring during a portrait sitting.]

ST2008 "Arrest of an Ambrotype Swindler." HUMPHREY'S JOURNAL 8, no. 7 (Aug. 1, 1856): Additional section; 7. [Letter from Moore (Painesville, OH) describing how he, Mr. Brokaw (Oberlin, OH) and others were swindled by a Julius Archer, alias J. A. Atkyns; then how he helped arrest him.]

ST2009 "Personal & Art Intelligence." PHOTOGRAPHIC AND FINE ART JOURNAL 9, no. 8 (Aug. 1856): 254-256. [L. L. Hill; M. M. Griswold; J. F. Harrison; E. C. Hawkins (Cincinnati, OH); M. P. Simons; Webster & Brother; others mentioned.]

ST2010 "Personal & Art Intelligence." PHOTOGRAPHIC AND FINE ART JOURNAL 9, no. 9 (Sept. 1856): 286-288. [General commentary on current processes. Promotion of Davie's notion of establishing a national society. C. D. Fredericks opened new gallery. Gurney; Moulton; Brady; Glosser (at S. Root's Gallery); Webster; Fitzgibbon; C. Barns (Mobile, AL); Geo. S. Cook purchased M. A. Root's Philadelphia, PA gallery, working it in the summer; Simmons.]

ST2011 "Charles Gildemeister and G. J. B. Carstensen, architects of the Crystal Palace, New York, NY." BALLOU'S PICTORIAL DRAWING-ROOM COMPANION [GLEASON'S] 11, no. 273 (Sept. 27, 1856): 208. 2 illus.

ST2012 "Art Patronage in America." COSMOPOLITAN ART JOURNAL 1, no. 2 (Oct. 1856): 34-35. [General commentary on the topic, with one paragraph devoted to the influence of photography. "Daguerreotyping, though not regarded as a legitimate child of Art, has done much to advance her cause with the people..."]

ST2013 "Personal & Art Intelligence." PHOTOGRAPHIC AND FINE ART JOURNAL 9, no. 10 (Oct. 1856): 319-320. [Lieut. Gilmore at West Point, Army now using photographers..." scarcely an expedition is sent out for exploration or survey that is not accompanied by its photographers." Letter from T. C. Ball (Cincinnati) protesting printed statement that he was struggling financially. A. A. Turner forming partnership with J. A. Cutting, to open a gallery in Boston; more comment on Cutting patent; American Institute Fair, NY; Massachusetts Charitable Mechanics Assoc. Fair.]

ST2014 "Col. William H. Spooner." BALLOU'S PICTORIAL DRAWING-ROOM COMPANION [GLEASON'S] 11, no. 276 (Oct. 18, 1856): 252. 1 illus.

ST2015 "Sixteenth Size in Union Cases." HUMPHREY'S JOURNAL 8, no. 13 (Nov. 1, 1856): Additional section; 8. [Mentions J. Gurney; Dobyns; M. B. Brady; M. M. Lawrence still ill; J. H. Fitzgibbon; W. W. Granger moved from Palmyra, MO; G. M. Thomas moved from Madison, GA; Samuel Holmes; C. C. Harrison, others mentioned.]

ST2016 "Personal & Art Intelligence." PHOTOGRAPHIC AND FINE ART JOURNAL 9, no. 11 (Nov. 1856): 350-352. [Commentary on processes selling. American Institute Fair. (Exhibitors V. Prevost; Meade Brothers; G. N. Barnard; N. G. Burgess; A. Judson; A. Hesler; S. Root; Hawkins & Faris; J. Gurney; C. D. Fredericks; J. E. McClees; S. A. Holmes; R. A. Lewis; W. A. Tomlinson; Kertson; Hofrauch & Co., Neff; Loud; J. F. Ryder; Charles Ketchum; Bisbee; Mechanic's Fair, (Louisville, KY); Webster & Brother; Webster; J. C. Elrod; Fasset & Cook.]

ST2017 G. B. C. "Remarks upon Photographic Apparatus." HUMPHREY'S JOURNAL 8, no. 15 (Dec. 1, 1856): 225-226. [G. B. C. (Baltimore) suggests that the USA needs more amateur photographers, and that camera makers and dealers could facilitate this by making materials that would be more accessible to amateurs. Discusses Whipple's albumen process as an example.]

ST2018 Portraits. Woodcut engravings, credited "From an Ambrotype Taken Expressly for Our Paper." FRANK LESLIE'S ILLUSTRATED NEWSPAPER 3, (1856) ["Gov. A. H. Reeder, of Kansas." 3:55 (Dec. 15, 1856): 64.]

USA: 1857.
BOOKS
ST2019 Lawrence, Amos. *Extracts from the Diary and Correspondence of the Late Amos Lawrence*; Edited by His Son, William R. Lawrence. Boston: Gould & Lincoln, 1857. xvi, 369 pp. 27 b & w. [Original crystalotypes.]

PERIODICALS
ST2020 "Personal & Art Intelligence." PHOTOGRAPHIC AND FINE ART JOURNAL 10, no. 1 (Jan. 1857): 30-32. [Excuses for late issue. Whipple & Black made 18"x 22" portraits from life; Augustus Wenderoth purchased J. H. Bolles' gallery (Charleston, SC); Sutton (Detroit, MI); Gibbs (Richmond, VA); further information on winners at Ohio State Fair in Cleveland; Mechanics Institute Fair of VA awards (Peter E. Gibbs; J. H. Whitehurst, D. Bendham); Wenderoth; North; Hall & Gurney; Faris & Irwin (late of Cincinnati, purchased Root's New York, NY gallery).]

ST2021 "Trip of the Washington Light Infantry of Charleston, S. C., to the Battle Ground of Cowpens." FRANK LESLIE'S ILLUSTRATED NEWSPAPER 3, no. 59 (Jan. 24, 1857): 121-122. 5 illus. [Not credited to photographs, but two of the group portraits of this military organization closely resemble photographs now attributed to Brady, and the visual grammar of the views of the group encampment at Cowpens strongly suggest a photographic source for the engravings.]

ST2022 "Personal & Art Intelligence." PHOTOGRAPHIC AND FINE ART JOURNAL 10, no. 2 (Feb. 1857): 62-64. [John Bishop Hall and J. Gurney; Cutting & Rehn suing F. Keeler; Brady; G. D. Wakely; A. Wenderoth; Rogers (Pittsburgh, PA); Porter; Faris & Irwin; J. Forrest Gowan (Spartenburg, SC); others mentioned.]

ST2023 "Financier." "Photographic Counterfeiting of Bank Notes." PHOTOGRAPHIC AND FINE ART JOURNAL 10, no. 3 (Mar. 1857): 68-69. [From "Hunt's Merchant's Magazine." Procedures worked out by Mr. Seropyan to prevent counterfeiting. Article includes a letter from John A. Whipple (Boston, MA), stating that it was impossible to copy.]

ST2024 "Personal & Art Intelligence." PHOTOGRAPHIC AND FINE ART JOURNAL 10, no. 3 (Mar. 1857): 96. [Hallotype discussed. J. C. Elrod; J. Carbutt; others mentioned.]

ST2025 "Personal & Art Intelligence." PHOTOGRAPHIC AND FINE ART JOURNAL 10, no. 4 (Apr. 1857): 127-128. [Hallotype. C. A. Seely; Willoughby; F. A. Wenderoth; F. D. B. Richards; others mentioned.]

ST2026 "Personal & Art Intelligence." PHOTOGRAPHIC AND FINE ART JOURNAL 10, no. 5 (May 1857): 159-160. [Attempt to organize a national photographic association. Letts (Dundee, NY); Davie & Francois (Saratoga Springs, NY); M. P. Simons; F. D. B. Richards; A. Bogardus; others mentioned.]

ST2027 "Photographic Ware." HUMPHREY'S JOURNAL 9, no. 1 (May 1, 1857): Additional section; 7-8. [Geo. Mathiot; J. Gurney; Fredericks; Southworth & Hawes; Whipple & Black; J. H. Fitzgibbon.]

ST2028 "Personal & Art Intelligence." PHOTOGRAPHIC AND FINE ART JOURNAL 10, no. 6 (June 1857): 192. [Death of F. Scott Archer; Wenderoth; M. A. Root, recovering from "terrible accident...in bed since Dec. last..."; J. J. Bardwell (MI); McDonald (Fort Wayne, IN); George Adams (Davenport, IO); Fitzgibbon (St. Louis, MO) in the Eastern States exhibiting a photographic diorama of Kansas scenery, and the events which have occurred there recently; J. Gurney travelling in the South and Southwest; Fasset & Cook (Chicago, IL).]

ST2029 "Personal & Art Intelligence." PHOTOGRAPHIC AND FINE ART JOURNAL 10, no. 7 (July 1857): 223-224. [Chiding the photographic community for not responding to call for national society; aid to widow of F. S. Archer; Wm. Stroud; John R. Rose; D. W. T. Moulton; Prof. Hamilton L. Smith, Kenyon College.]

ST2030 "A Railroad Pleasure-Trip to the West." HARPER'S WEEKLY 1, no. 27 (July 4, 1857): 427-430. 15 illus. [Excursion on the Ohio and Mississippi RR between Cincinnati, OH, and St. Louis, MO. Three portraits, obviously from photos. Views of scenery, St. Louis, Cincinnati, etc., some of which may be from photos.]

ST2031 Portraits. Woodcut engravings, credited "From a Photograph." BALLOU'S PICTORIAL DRAWING-ROOM COMPANION [GLEASON'S] 13, (1857) ["Dr. Livingston, the famous

African traveller." 13:316 (July 11, 1857): 20. "Hon. William Willis, Mayor of Portland, ME." 13: 324 (Sept. 5, 1857): 156.]

ST2032 "Personal & Art Intelligence." PHOTOGRAPHIC AND FINE ART JOURNAL 10, no. 8 (Aug. 1857): 255-256. [Editorial decision to stop publishing photos supplied by the "practical photographers" because of difficulties in securing an adequate and timely supply; Stroud; Mahan & Good (Philadelphia, PA); H. D. W. Moulton; A. L. Daniels; F. A. Wenderoth; patents, etc.]

ST2033 "Family Daguerreotypes, found every where." HARPER'S MONTHLY 15, no. 87 (Aug. 1857): 285-286. 16 illus. [Comic portraits of stock portraits, for example "Cousin Fred, who sent this Picture from California to his Mother," is a wild-eyed, dirty miner.]

ST2034 "Boggle's Photograph." HARPER'S WEEKLY 1, no. 35 (Aug. 29, 1857): 557. [Satiric commentary of fashionability of photography.]

ST2035 "Making Light of Photography." PHOTOGRAPHIC AND FINE ART JOURNAL 10, no. 9-12 (Sept. - Dec. 1857): 278-280, 289-292, 321-325, 357-359. [Comic description of the history of photography. Author not given, possibly H. H. Snelling.]

ST2036 "Personal & Art Intelligence." PHOTOGRAPHIC AND FINE ART JOURNAL 10, no. 9 (Sept. 1857): 287-288. [More discussion of problems getting promised negatives from photographers for illustrating the "P & FAJ"; Wm. C. North & Co. (Cleveland, OH); H. H. Richardon; W. N. Gardner, working for C. D. Fredericks; Wood & Brother purchased C. C. Shoonmaker's gallery; others mentioned.]

ST2037 "Photographic Counterfeiting." PHOTOGRAPHIC AND FINE ART JOURNAL 10, no. 10 (Oct. 1857): 307. [Paper read by Prof. B. Silliman, Jr. on topic.]

ST2038 Draper, H. "Copying Bank Notes by Photography." PHOTOGRAPHIC AND FINE ART JOURNAL 10, no. 10 (Oct. 1857): 308. [From "J. of Photo. Soc., London."]

ST2039 "Personal & Art Intelligence." PHOTOGRAPHIC AND FINE ART JOURNAL 10, no. 10 (Oct. 1857): 318-320. [General commentary, discussion of illustrations for the "P & FAJ." Wood's views of the Capitol; Cahill; Barnard, working with a wood engraving process -which is praised by the engraver Orr- sold his Syracuse gallery to Laziere, to concentrate on this process; Gurney; J. C. Gray; A. A. Turner, of Cutting & Turner, nearly blinded by accident; W. N. Faris (Wheeling, VA); C. A. Johnson (Madison, WI) fire; Mr. & Mrs. Fasset (Galena, IL); Davie & Francois (Saratoga, NY); others mentioned.]

ST2040 "Personal & Art Intelligence." PHOTOGRAPHIC AND FINE ART JOURNAL 10, no. 11 (Nov. 1857): 350-352. [Commentary upon impact of photography. The pantograph discussed. Letter from J. W. Black, about varnish; Wenderoth; C. D. Fredericks enlarged his gallery; Lay & Heywood (Boston, MA); J. C. Elrod; Porter (Cincinnati, OH); others mentioned.]

ST2041 "Happy Idea for a Family Photograph." HARPER'S WEEKLY 1, no. 45 (Nov. 7, 1857): 720. 1 illus. [Cartoon, of a couple at a photographer's studio.]

ST2042 Portrait. Woodcut engraving, credited "From a Photograph." HARPER'S WEEKLY 1, (1857) ["Reverend Charles H. Spurgeon, preacher." 1:46 (Nov. 14, 1857): 724.]

ST2043 "Personal & Art Intelligence." PHOTOGRAPHIC AND FINE ART JOURNAL 10, no. 12 (Dec. 1857): 382-384. [Close of volume

statement. List of premium winners at the American Institute Fair; Wenderoth; R. H. Vance; George K. Warren; Davie & Francois (Albany, NY); Benjamin F. Hawkes occupying Whitehurst's Gallery in Baltimore; Whitehurst moved to different location in same city; Hall (of Hallotype process); Faris (New York, NY); others mentioned.]

ST2044 "Bohemian." "Bohemian Walks and Talks: An Hour with the Photographs." HARPER'S WEEKLY 1, no. 52 (Dec. 26, 1857): 819. [Comic essay about the author's experience at a photographer's studio; mentions Brady briefly.]

USA:1858.
ST2045 "Personal & Art Intelligence." PHOTOGRAPHIC AND FINE ART JOURNAL 11, no. 1 (Jan. 1858): 31-32. [Denial of fading in photographs, mentions owning Blanquart-Evrard, Renard, which have held up for years. J. C. Gray (Jamestown, NY); Frank Ford (Ravenna, OH); C. A. Johnson (Madison, WI), burned out.]

ST2046 "Personal & Art Intelligence." PHOTOGRAPHIC AND FINE ART JOURNAL 11, no. 2 (Feb. 1858): 62-64. [Bogardus; Tucker & Perkins (Augusta, GA); Minnis (Petersburgh, VA); Hopkins (Petersburgh, VA); W. Notman (Montreal); C. J. Quimby; F. A. Wenderoth; Charles H. Stokoe (Niagara Falls, NY); William Armstrong (Toronto).]

ST2047 "Personal & Art Intelligence." PHOTOGRAPHIC AND FINE ART JOURNAL 11, no. 3 (Mar. 1858): 95-96. [Frank Ford; E. S. Wykes; Bailey & Orr at the Metropolitan Gallery (Indianapolis, IN); Silas W. Selleck (San Francisco, CA); photographing members of the Pioneer Assoc., to make albums; M. J. Gurney (Natchez, MS); others mentioned.]

ST2048 Portraits. Woodcut engravings, credited "From a Photograph." FRANK LESLIE'S ILLUSTRATED NEWSPAPER 5, (1858) ["Commodore Matthew C. Perry, U. S. N., deceased." 5:119 (Mar. 13, 1858): 225.]

ST2049 C. H. E. "Photography in the West." PHOTOGRAPHIC AND FINE ART JOURNAL 11, no. 4 (Apr. 1858): 107-108. [Farris; Porter; Hawkins, of Cincinnati, OH, are mentioned. Long; Fitzgibbon; T. M. Easterly, all of St. Louis, MO, mentioned.]

ST2050 "Personal & Art Intelligence." PHOTOGRAPHIC AND FINE ART JOURNAL 11, no. 4 (Apr. 1858): 126-128. [Caution against process sellers. Hamilton (Savannah, GA); F. A. Wenderoth; Marshall (Claremont, IL); R. A. Carnden; Robert Benecke; M. B. Brady opens gallery in Washington, DC; S. Remington; B. F. Hawkes (Baltimore, MD); Charles Richard Meade died March 2.]

ST2051 "Personal & Art Intelligence." PHOTOGRAPHIC AND FINE ART JOURNAL 11, no. 5 (May 1858): 158-160. [Role of photography and Fine Art. Meeting of the American Institute. Whipple's moon photographs discussed. Woodward; H. S. Brown; W. W. Shaw, Silas Sellick and T. A. Ayres, combined forces to create a painting, with the figures photographed by Sellick, S. W. Shaw, and Ayres each painting a portion of the canvas; Vance & Co.; others mentioned.]

ST2052 "English and American Photographs." BALLOU'S PICTORIAL DRAWING-ROOM COMPANION [GLEASON'S] 14, no. 22 (May 29, 1858): 347. [From the "Bee." Brief commentary on the superior qualities of American photography, blamed by the author on England's air pollution.]

ST2053 "Gossip." "A Letter from Buffalo." AMERICAN JOURNAL OF PHOTOGRAPHY AND THE ALLIED ARTS AND SCIENCES n. s. vol. 1, no. 2 (June 15, 1858): 26-28. [About the first portrait entry views.]

ST2054 "Personal & Art Intelligence." PHOTOGRAPHIC AND FINE ART JOURNAL 11, no. 6 (June 1858): 190-192. [Photography and Fine Art. Stereoscope. B. M. Breckenridge; Whipple & Black; McPherson (Concord, NH); Gage (St. Johnsbury, VT); Ford (Ravenna, OH); Cutting & Turner (Boston, MA); Faris & Mullen (Cincinnati, OH); others mentioned.]

ST2055 "Gossip." "A Letter from Buffalo." AMERICAN JOURNAL OF PHOTOGRAPHY AND THE ALLIED ARTS AND SCIENCES n. s. vol. 1, no. 3 (July 1, 1858): 41-42. [About swindles.]

ST2056 "Personal & Art Intelligence." PHOTOGRAPHIC AND FINE ART JOURNAL 11, no. 7 (July 1858): 223. [Attack on the growth of the use of ambrotypes in the U. S., mixed with praise of the work of Mr. Judson (Newark, NJ), the only good practitioner of this process. Portraits from Lazier (Syracuse, NY). Portraits from A. Bisbee (Columbus, OH). Views of South American architecture by J. H. Fitzgibbon. Letter from H. S. Brown (Milwaukee, WI). Snelling's new "American Journal of Photography" reviewed. L. H. Bradford; Churton; J. B. Hall (Brooklyn, NY): Vance & Bradley: E. T. Whitney (Rochester, NY) mentioned.]

ST2057 "Gossip." "A Letter from Aurora." AMERICAN JOURNAL OF PHOTOGRAPHY AND THE ALLIED ARTS AND SCIENCES n. s. vol. 1, no. 5 (Aug. 1, 1858): 77-79.

ST2058 "Note." AMERICAN JOURNAL OF PHOTOGRAPHY AND THE ALLIED ARTS AND SCIENCES n. s. vol. 1, no. 5 (Aug. 1, 1858): 82. [In "Editorial Miscellany," note that stereos "are at last coming into vogue with us..." mentions its value as conversation piece, educational potential, etc.]

ST2059 "Gossip." "En Route." AMERICAN JOURNAL OF PHOTOGRAPHY AND THE ALLIED ARTS AND SCIENCES n. s. vol. 1, no. 6 (Aug. 15, 1858): 87-89. [General commentary, humorous.]

ST2060 "Personal & Art Intelligence." PHOTOGRAPHIC AND FINE ART JOURNAL 11, no. 8 (Aug. 1858): 255-256. [Discussion of the relative merits of the daguerreotype, ambrotype and melainotype processes. Discussion of the magazine's practice of providing photographic illustrations and the fact of their fading. Benecke (Brunswick, MO) sent photos of steamboats. Carden's (New York, NY) photos of New Orleans, LA. Others mentioned.]

ST2061 "Gossip." "A Letter from Monmonth." AMERICAN JOURNAL OF PHOTOGRAPHY AND THE ALLIED ARTS AND SCIENCES n. s. vol. 1, no. 7 (Sept. 1, 1858): 103-106. [Discusses average quality of pictures taken in studios in towns and villages around the country. Concluded that they were O. K. technically, less good artistically.]

ST2062 "The Photographic Beauty." COSMOPOLITAN ART JOURNAL 2, no. 4 (Sept. 1858): 201-203. [Fictional short story, based on the premise of a young man falling in love with a portrait he sees while passing Brady's studio on Broadway, in New York, NY.]

ST2063 "Domestic Art Items and Gossip." COSMOPOLITAN ART JOURNAL 2, no. 4 (Sept. 1858): 207. [Describes an excursion organized for artists and photographers on the Baltimore and Ohio Railroad. "The train consists of...a car expressly fitted up for photographic purposes. The rest of the party...including...the following gentlemen...Messrs. G. W. Dobbin, Charles Gillou, William

E. Bartlett and Robert O'Neil, photographers. More than one hundred excellent photographic views were taken by the several operators, who had four sets of approved apparatus of their own in full play." (See also the June 1859 issue of "Harper's New Monthly Magazine.")

ST2064 "Personal & Art Intelligence." PHOTOGRAPHIC AND FINE ART JOURNAL 11, no. 9 (Sept. 1858): 286-288. [Conflicts with other photographic magazines. Esteven Mestre Aulet (Havana, Cuba); T. Farris; John Wood; Sellick's Gallery (San Francisco, CA) mentioned.]

ST2065 "Gossip." "A Letter from Monmoth." AMERICAN JOURNAL OF PHOTOGRAPHY AND THE ALLIED ARTS AND SCIENCES n. s. vol. 1, no. 8 (Sept. 15, 1858): 124-126.

ST2066 "Note." AMERICAN JOURNAL OF PHOTOGRAPHY AND THE ALLIED ARTS AND SCIENCES n. s. vol. 1, no. 8 (Sept. 15, 1858): 130. ["We believe American views will soon be in demand, and that people will be convinced that every branch of photography is as thoroughly understood here as abroad."]

ST2067 "Gossip." "En Route." AMERICAN JOURNAL OF PHOTOGRAPHY AND THE ALLIED ARTS AND SCIENCES n. s. vol. 1, no. 9 (Oct. 1, 1858): 143-144.

ST2068 "Photographic, Daguerreotype, and Ambrotype Stock Dealers." HUMPHREY'S JOURNAL OF PHOTOGRAPHY, AND THE ALLIED ARTS AND SCIENCES 10, no. 11 (Oct. 1, 1858): 164-165. [Description of the stock house of Holmes, Booth & Haydens, of 61 Chamber and 63 Reade Streets, New York, NY.]

ST2069 "Personal & Art Intelligence." PHOTOGRAPHIC AND FINE ART JOURNAL 11, no. 10 (Oct. 1858): 319-320. [Letter from John C. Gray (Jamestown, NY). Long (St. Louis, MO); Tucker & Perkins (Augusta, GA.); J. S. Coonley; Faris; Gurney and Fredericks both mentioned losing prints in the NY Crystal Palace fire. Death of M. J. Gurney (Natchez, MS).]

ST2070 "The Winans Steamship." HARPER'S WEEKLY 2, no. 95 (Oct. 23, 1858): 676-678. 6 illus. [Four views of the steamship under construction, from photographs. One sketch, one plan.]

ST2071 Portraits. Woodcut engravings, credited "From a Photograph." HARPER'S WEEKLY 2, (1858) ["Mademoiselle Piccolomini, musician." 2:96 (Oct. 30, 1858): 689. "Thomas Carlyle." 2:99 (Nov. 20, 1858): 737.]

ST2072 "Gossip." "A Letter from Evansville." AMERICAN JOURNAL OF PHOTOGRAPHY AND THE ALLIED ARTS AND SCIENCES n. s. vol. 1, no. 11 (Nov. 1, 1858): 169-170.

ST2073 "Personal & Art Intelligence." PHOTOGRAPHIC AND FINE ART JOURNAL 11, no. 11 (Nov. 1858): 350-352. [Tomlinson vs. Bogardus on Cutting patent; confusions with the photographers of Albany, NY; Fitzgibbon; Louis Seebohm (Dayton, OH); others mentioned.]

ST2074 "Personal & Art Intelligence." PHOTOGRAPHIC AND FINE ART JOURNAL 11, no. 12 (Dec. 1858): 383-384. [Asking for support for magazine, in form of payment of subscriptions and more written contributions. Cutting patent sustained. Whipple; Cutting; D. D. T. Davie; others mentioned.]

ST2075 "The Paraguay Expedition - The 'Sabine' at Bermuda." HARPER'S WEEKLY 2, no. 102 (Dec. 11, 1858): 792. 2 illus. ["The 'Sabine' at Anchor in Grassy Bay, Bermuda,""The Officers of the

'Sabine' visiting the Fortifications at Bermuda' - From Photographs by Our Artist Correspondent."]

USA:1859.

ST2076 "Gossip." "A Letter from 'Gossip.'" AMERICAN JOURNAL OF PHOTOGRAPHY AND THE ALLIED ARTS AND SCIENCES n. s vol. 1, no. 15 (Jan. 1, 1859): 231-232.

ST2077 "Gossip." "A Letter from 'Gossip.'" AMERICAN JOURNAL OF PHOTOGRAPHY AND THE ALLIED ARTS AND SCIENCES n. s. vol. 1, no. 16 (Jan. 15, 1859): 248-251.

ST2078 "Photographic, Daguerreotype and Ambrotype Stock Dealers: Scoville Manufacturing Company." HUMPHREY'S JOURNAL OF PHOTOGRAPHY, AND THE ALLIED ARTS AND SCIENCES 10, no. 19 (Feb. 1, 1859): 295-298. 2 illus.

ST2079 "Gossip." "A Letter from Jefferson." AMERICAN JOURNAL OF PHOTOGRAPHY AND THE ALLIED ARTS AND SCIENCES n. s. vol. 1, no. 19 (Mar. 1, 1859): 295-297.

ST2080 "Henry Wieniawski, the Celebrated Violinist." BALLOU'S PICTORIAL DRAWING-ROOM COMPANION [GLEASON'S] 16, no. 399 (Feb. 12, 1859): 112. 1 illus. ["...from a photograph recently taken in Europe."]

ST2081 "Our Daguerreian Experiment." HARPER'S WEEKLY 3, no. 115 (Mar. 12, 1859): 170-171. [Comic report of trials while sitting for a portrait.]

ST2082 "Trying, Very." HARPER'S WEEKLY 3, no. 116 (Mar. 19, 1859): 192. 1 illus. [Cartoon, at a photographic studio.]

ST2083 "Gossip." "A Letter from Laporte." AMERICAN JOURNAL OF PHOTOGRAPHY AND THE ALLIED ARTS AND SCIENCES n. s. vol. 1, no. 21 (Apr. 1, 1859): 326-328.

ST2084 "Gossip." "A Letter from Rockford." AMERICAN JOURNAL OF PHOTOGRAPHY AND THE ALLIED ARTS AND SCIENCES n. s. vol. 1, no. 23 (May 1, 1859): 358-359.

ST2085 "The Paraguay Expedition - Reception of the Officers at San Jose." HARPER'S WEEKLY 3, no. 123 (May 7, 1859): 296-298. 4 illus. ["...from photographs and sketches furnished us by our correspondent on board the Paraguay squadron, some interesting pictures of the bloodless encounters..." One view of ships at Rosario credited from a photograph.]

ST2086 "Western Photographer - 'Now, Sir, If You Dare to Move a Muscle...'" FRANK LESLIE'S ILLUSTRATED NEWSPAPER 7, no. 182 (May 28, 1859): 414. 1 illus. [Cartoon, of a camera operator threatening a sitter with a gun to make him sit still.]

ST2087 "Artist's Excursion Over the Baltimore and Ohio Rail Road." HARPER'S MONTHLY 19, no. 109 (June 1859): 1-19. 23 illus. [Illustrations by "Porte Crayon." (D. H. Strother) Report of a special five day excursion by fifty artists on a special train organized by a William Prescott Smith as a publicity device for the B & O R.R. "The train was composed of six cars... the forward compartment of car No. 1 was fitted up for the convenience of the photographers, and occupied by several skillful and zealous amateurs of that wonderful and charming art..." Two of the illustrations include depictions of photographers at work with their tripoded cameras.]

ST2088 "Personal and Art Intelligence." PHOTOGRAPHIC AND FINE ART JOURNAL 12, no. 1 (June 1859): 31-32. [Cutting patent. American Photographical Society formation. Vance (San Francisco, CA); E. M. Aulet (Havana, Cuba); Fassett (Chicago, IL); etc.]

ST2089 "Ye Verdant Young Man Visiteth Ye City." PHOTOGRAPHIC AND FINE ART JOURNAL 12, no. 2 (July 1859): 49. [From "Pittsburgh [PA] Daily Post." Comic tale of an inexperienced youth's comic interactions with some "5-cent" photographers.]

ST2090 "Personal & Art Intelligence." PHOTOGRAPHIC AND FINE ART JOURNAL 12, no. 2 (July 1859): 63-64. [Description of court activities during the trial of Wm. Tomlinson vs. C. D. Fredericks over the Cutting patent. John Carbutt; John Rogers (Pittsburgh, PA); A. Mesler (new gallery in Chicago, IL); W. Bruner, etc.]

ST2091 "The Photographic Art." AMERICAN JOURNAL OF PHOTOGRAPHY AND THE ALLIED ARTS AND SCIENCES n. s. vol. 2, no. 6 (Aug. 15, 1859): 85-87. [Reprinted from the "NY Herald."]

ST2092 "Scenes and Sketches about Pike's Peak - From Photographs by our own Correspondent." FRANK LESLIE'S ILLUSTRATED NEWSPAPER 8, no. 194 (Aug. 20, 1859): 182-183, 186. 8 illus. [Views of Pike's Peak, CO, area, Denver City, etc. Buildings, tents, miners. (In spite of the title, these images do not seem to be derived from photographs.)]

ST2093 "Explosion at the Port Gibson, Mississippi Court-House." HARPER'S WEEKLY 3, no. 140 (Sept. 3, 1859): 572. 1 illus. ["From a photograph."]

ST2094 "Gerrit Smith, of Peterboro. - From an Authentic Photograph Furnished from a Private Source." FRANK LESLIE'S ILLUSTRATED NEWSPAPER 8, no. 208 (Nov. 26, 1859): 399. 1 illus. [Smith with John Brown at Harper's Ferry. The engraved portrait probably taken from a photo, but the head is attached to a body drawn out of scale.]

ST2095 "The Quadruple Execution: Our Portraits." NEW YORK ILLUSTRATED NEWS (Dec. 24, 1859): [first pages missing], 84-85, 88-89, 92-93, 96. 11 illus. ["We present our readers this week a gallery of correct and genuine portraits of parties figuring prominently in the Harper's Ferry excitement, viz: the two sons of Brown...taken from daguerreotypes in possession of the family...Mr. J. M. McKim, Gov. Henry A. Wise of Virginia and Wedell Phillips, Esq...(from photographs.)" Sketches of the execution of John E. Cook and Edwin Coppie, the funeral of John Brown and portraits, from daguerreotypes and photographs. (Damaged issue, I haven't seen the total reference.]

USA: 1860.
ST2096 "Account of an Explosion of Gun Cotton." AMERICAN JOURNAL OF PHOTOGRAPHY AND THE ALLIED ARTS AND SCIENCES n. s. vol. 2, no. 15 (Jan. 1, 1860): 238-239.

ST2097 "List of American Photographic Patents, Issued from Jan. 1, 1858 to May 1, 1859. - English Patents - Stereoscopic Patents." PHOTOGRAPHIC AND FINE ART JOURNAL 13, no. 1 (Jan. 1860): 15-16.

ST2098 "Editorial Matters." PHOTOGRAPHIC AND FINE ART JOURNAL 13, no. 1 (Jan. 1860): 31-32. [Editorial statement about starting again, stating by indirection that no issues were published from July 1859 to Jan. 1860. Fontayne; A. A. Turner; Alex Hesler; John Carbutt, others mentioned.]

ST2099 Portraits. Woodcut engravings, credited "From a Photograph." FRANK LESLIE'S ILLUSTRATED NEWSPAPER 9, (1860) ["Hon. Wm H. Seward, U. S. Senator from NY." 9:214 (Jan. 7, 1860): 81. "Pius IX, Pope of Rome." 9:220 (Feb. 18, 1860): 181. "Miss Harriet Lane, the presiding lady of the White House." 9:226 (Mar. 31, 1860): 279.]

ST2100 "The Building of the Great Victoria Tubular Bridge across the River St.-Lawrence." FRANK LESLIE'S ILLUSTRATED NEWSPAPER 9, no. 215 (Jan. 14, 1860): 108-109. 4 illus. [Four views of the construction, one credited from a photo. The others could also have been taken from photos. Three additional non-credited views published on pp. 72-73, in the Dec. 31, 1859 issue.]

ST2101 "Photography at the Patent Office." AMERICAN JOURNAL OF PHOTOGRAPHY AND THE ALLIED ARTS & SCIENCES n. s. vol. 2, no. 17 (Feb. 1, 1860): 266-267. [From "Scientific American." Plans to use photography to reproduce all the drawings used in patent applications.]

ST2102 "Editorial Matters." PHOTOGRAPHIC AND FINE ART JOURNAL 13, no. 2 (Feb. 1860): 56. [Cutting patent. O. J. Wallis and Brother opening a new gallery in Chicago, IL. Silas Sellick; B. French; others mentioned.]

ST2103 Bruce, John. "Photography Applied to Horticulture." AMERICAN JOURNAL OF PHOTOGRAPHY AND THE ALLIED ARTS & SCIENCES n. s. vol. 2, no. 18 (Feb. 15, 1860): 285-286. [Read to Farmer's Club, of the American Institute, New York, NY. Suggested uses.]

ST2104 "Photography at the United States Patent Office." PHOTOGRAPHIC NEWS 3, no. 76 (Feb. 17, 1860): 284. [Titian R. Peale discussed.]

ST2105 "Progress of Photography in America." PHOTOGRAPHIC NEWS 3, no. 76 (Feb. 17, 1860): 284. [Wm. Campbell; S. D. Tillman; Joseph Dixon mentioned.]

ST2106 Portraits. Woodcut engravings, credited "From a Photograph." HARPER'S WEEKLY 4, (1860) ["Pope Pius the Ninth." 4:164 (Feb. 18, 1860): 108. "Rev. Henry Grattan Guinnes." 4:169 (Mar. 24, 1860): 188. "Hon. John M. Botts, of VA." 4:175 (May 5, 1860): 284. "Hon. Erasmus Brooks, of NY." 4:175 (May 5, 1860): 284. "Hon. Caleb Cushing." 4:176 (May 12, 1860): 300. "Bishops of the Methodist Episcopal Church (6 portraits)." 4:177 (May 19, 1860): 308. "Japanese Noblemen." 4:177 (May 19, 1860): 316. "Capt. John V. Hall, Commander of the 'Great Eastern.'" 4:184 (July 7, 1860): 429. "His Royal Highness Albert Edward, Prince of Wales." (probably by Watkins); 4:197 (Oct. 6, 1860): 625. "Gen. Lamoriciere, Italian General." 4:198 (Oct. 13, 1860): 653. "Charles Dickens, Esq." 4:204 (Nov. 24, 1860): 740.]

ST2107 "The Great Floyd Gun: Its Casting and Hoisting at the Fort Pitt Foundry, Pittsburgh, Pa. - From a Photograph." FRANK LESLIE'S ILLUSTRATED NEWSPAPER 9, no. 221 (Feb. 25, 1860): 195-196. 1 illus.

ST2108 "Editorial Matters." PHOTOGRAPHIC AND FINE ART JOURNAL 13, no. 3 (Mar. 1860): 92. [Reasons given for the manner of illustrating the "P & FAJ." Cutting patent.]

ST2109 "Editorial Matters." PHOTOGRAPHIC AND FINE ART JOURNAL 13, no. 4 (Apr. 1860): 115-116. [Cutting patent, including

a list of contributors to fund. Argument for starting a school. Complaints against the Post Office, assertion that the magazine would continue.]

ST2110 "Portrait of the Unrecognized Man Found Floating in the Bay of New Haven. - From a Photograph taken after the Inquest." FRANK LESLIE'S ILLUSTRATED NEWSPAPER 9, no. 227 (Apr. 7, 1860): 298, 302. 1 illus. ["...we publish the portrait...in the hope that some of his friends recognizing our picture may be able to identify the body."]

ST2111 "Missing Man - Alonso Plum, Lenawee County, Mich." FRANK LESLIE'S ILLUSTRATED NEWSPAPER 9, no. 228 (Apr. 14, 1860): 318. 1 illus. [Portrait, from photo supplied by relatives, in the hope that the missing man's whereabouts could be established. The "FLIN" ran this sort of image on its back page from time to time, during early 1860, as a sort of public service.]

ST2112 "Editorial Matters." PHOTOGRAPHIC AND FINE ART JOURNAL 13, no. 5 (May 1860): 148. [Discusses the American Photographical Society. Magazine "Photograph." (Lancaster, OH) ed. by V. M. Griswold; Fitzgibbon; intention that the "P & FAJ" will, after July, have another publisher.]

ST2113 "Mental Photographs." COSMOPOLITAN ART JOURNAL 4, no. 2 (June 1860): 71. [Poem. "Photograph" used metaphorically.]

ST2114 S. R. D. "Photography in the Country." PHOTOGRAPHIC AND FINE ART JOURNAL 13, no. 6 (June 1860): 176.

ST2115 "Editorial Miscellany." AMERICAN JOURNAL OF PHOTOGRAPHY AND THE ALLIED ARTS & SCIENCES n. s. vol. 3, no. 2 (June 15, 1860): 31-32. [Comment upon Japanese embassy mission to USA, widespread photographing in San Francisco, Washington and New York, and interest by general public.]

ST2116 Seely, Charles A. "Editorial Miscellany." AMERICAN JOURNAL OF PHOTOGRAPHY AND THE ALLIED ARTS & SCIENCES n. s. vol. 3, no. 4 (July 15, 1860): 63-64. [Japanese visitors; Mr. Davie presented 19" x 23" photo of the "Great Eastern" at sea; NY Directory of 1860 lists 120 photographers, Seely claims should list at least ten more; Harthill & Co.'s Guide Books illus. with engravings from photos.]

ST2117 "Editorial Miscellany." AMERICAN JOURNAL OF PHOTOGRAPHY AND THE ALLIED ARTS & SCIENCES n. s. vol. 3, no. 5 (Aug. 1, 1860): 80. [P. C. Duchochois accompanied the Labrador expedition, now returning to the USA, and worked as the photographer. Hayes' Arctic expedition sailed without Mr. Peale. A Mr. Sontag, of the original party will try to take photos.]

ST2118 "Art in the Arctic Regions." PHOTOGRAPHIC NEWS 4, no. 102 (Aug. 17, 1860): 191. ["...the Am. Photo Soc. at its last meeting made arrangements to send a photographer with the expedition of Dr. Hayes, which sailed ... end of June."]

ST2119 Seely, Charles A. "Foreign Correspondence." BRITISH JOURNAL OF PHOTOGRAPHY 7, no. 125 (Sept. 1, 1860): 260.

ST2120 "Art Gossip." COSMOPOLITAN ART JOURNAL 4, no. 3 (Sept. 1860): 127-128. ["Photography threatens to flood the world with the amateur performances, on paper, of the Sun. Stereoscopic "views" are becoming as thick as autumn leaves, and almost as cheap. We may well characterize this era as that of promiscuous production in the way of pictures."]

ST2121 Portraits. Woodcut engravings, credited "From a Daguerreotype in the Possession of R. D. Holmes, Esq." FRANK LESLIE'S ILLUSTRATED NEWSPAPER 10, (1860) ["Edwin Forrest, actor." 10:253 (Sept. 29, 1860): 287.]

ST2122 "Photographic Schools." PHOTOGRAPHIC NEWS 4, no. 109 (Oct. 5, 1860): 265-266. [Editorial for establishing schools, quotes from Root in "Humphrey's Journal."]

ST2123 "Note." AMERICAN JOURNAL OF PHOTOGRAPHY AND THE ALLIED ARTS & SCIENCES n. s. vol. 3, no. 11 (Nov. 1, 1860): 175. [From "Cleveland, OH Plain Dealer." Daguerreotype of Edgar A. Poe recopied by an Ohio photographer, enlarged then overpainted in oils by "Walcutt, the western artist."]

ST2124 "Betrayal of Five-Score Women. - Escape of the Deceiver." AMERICAN JOURNAL OF PHOTOGRAPHY AND THE ALLIED ARTS & SCIENCES n. s. vol. 3, no. 12 (Nov. 15, 1860): 190-191. [A "Mr. Downing," (New York, NY) ran a crooked operation, fled.]

ST2125 "Photography in the United States Coast Survey." HUMPHREY'S JOURNAL OF PHOTOGRAPHY, AND THE ALLIED ARTS AND SCIENCES 12, no. 14 (Nov. 15, 1860): 209-212. [From the "North American Review." Detailed discussion of the introduction of photography (primarily for copying maps) into the U. S. Coast Survey. Introduction by the editor gives the history of this struggle to have the medium accepted.]

ST2126 "Photographic Stock Dealers." HUMPHREY'S JOURNAL OF PHOTOGRAPHY, AND THE ALLIED ARTS AND SCIENCES 12, no. 16 (Dec. 15, 1860): 245-246. [Mentions a "panic," then lists nine major stock dealers by name, with a brief one-paragraph description of each firm's recent activities.]

USA: 1861.

ST2127 Seely, Charles. "Editorial Miscellany." AMERICAN JOURNAL OF PHOTOGRAPHY AND THE ALLIED ARTS & SCIENCES n. s. vol. 3, no. 17 (Feb. 1, 1861): 271-272. ["Card photographs in New York are now the height of fashion." Stereoscope and thaumatrope discussed.]

ST2128 "Cartes de Visite." HUMPHREY'S JOURNAL OF PHOTOGRAPHY, AND THE ALLIED ARTS AND SCIENCES 12, no. 20 (Feb. 15, 1861): 305-306. ["...lately a new feature has developed itself in this country in the call for portraits known as Cartes de Visite, or visiting cards."]

ST2129 "The Photographic Trade." AMERICAN JOURNAL OF PHOTOGRAPHY AND THE ALLIED ARTS & SCIENCES n. s. vol. 3, no. 22-24 (Apr. 15, - May 15, 1861): 349-350, 364-365, 379-380. [Describes several "principal dealers in photographic goods..." First two articles focus on New York, NY. 3rd article describes dealers in Boston, MA and Cincinnati, OH.]

ST2130 Seely, Charles A. "Editorial Miscellany." AMERICAN JOURNAL OF PHOTOGRAPHY AND THE ALLIED ARTS & SCIENCES n. s. vol. 3, no. 22 (Apr. 15, 1861): 351-352. [Harrison's lenses; S. C. Landon (Washington, CT); amateur photography growing; Simon Wing (Waterville, ME) has patented a camera box and shield for stereos, cartes and large views.]

ST2131 J. C. "The Poet Abroad." AMERICAN JOURNAL OF PHOTOGRAPHY AND THE ALLIED ARTS & SCIENCES n. s. vol. 3, no. 23 (May 1, 1861): 363. [J. C. quotes a poem from memory written "about ten years ago...to grace the placard...of one Von

SPECIAL TOPICS
HISTORY: BY COUNTRY: USA: 1861 - 1865 (CIVIL WAR).

SPECIAL TOPICS
HISTORY: BY COUNTRY: USA: 1861 - 1865 (CIVIL WAR).

Schweipenhoven, a Pennsylvania dutchman came to Williamstown, Mass...."]

ST2132 Seely, Charles A. "An Explosion of a Collodion Bottle." AMERICAN JOURNAL OF PHOTOGRAPHY AND THE ALLIED ARTS & SCIENCES n. s. vol. 4, no. 1 (June 1, 1861): 17-19. ["S." is from New York, NY. Graphically describes the event.]

ST2133 Seely, Charles A. "Failure of a New Toning Process." AMERICAN JOURNAL OF PHOTOGRAPHY AND THE ALLIED ARTS & SCIENCES n. s. vol. 4, no. 1 (June 1, 1861): 19.

ST2134 Seely, Charles A. "Ventilate the Dark Room." AMERICAN JOURNAL OF PHOTOGRAPHY AND THE ALLIED ARTS & SCIENCES n. s. vol. 4, no. 1 (June 1, 1861): 20.

ST2135 Seely, Charles A. "Toning and Fixing Albumen Prints." AMERICAN JOURNAL OF PHOTOGRAPHY AND THE ALLIED ARTS & SCIENCES n. s. vol. 4, no. 2 (June 15, 1861): 46-47.

ST2136 "A Photographer's Story." LITTELL'S LIVING AGE 70, no. 902 (Sept. 14, 1861): 675-682. [From "The Ladies' Companion." This is a fictional short story. Not the same as the story with the same title, written by Lucy Hooper in 1868.]

ST2137 "Improvement in Business." HUMPHREY'S JOURNAL OF PHOTOGRAPHY, AND THE ALLIED ARTS AND SCIENCES 13, no. 11 (Oct. 1, 1861): 176.

ST2138 "Photography in America." AMERICAN JOURNAL OF PHOTOGRAPHY AND THE ALLIED ARTS & SCIENCES n. s. vol. 4, no. 11 (Nov. 1, 1861): 255-257. [From "Photo. News." Ambrotypes strong in USA. Cutting (Boston); Meade Brothers (New York, NY); Woodward's solar camera mentioned.]

ST2139 "Editorial Miscellany." HUMPHREY'S JOURNAL OF PHOTOGRAPHY, AND THE ALLIED ARTS AND SCIENCES 13, no. 15 (Dec. 1, 1861): 239-240. [Business good. Peter Neff, Jr.'s Melainotype plates "are all the rage now..." Benj. French & Co. (Boston) lowered prices on Voightlander's and Jamin's lenses. R. A. Lewis gallery on Chatham St., doing large business, in cards at $2.00 per dozen. Great demand for card pictures of distinguished military men, many sold by E. Anthony & Co. L. M. Dornbach making money, but apparently not as photographer.]

USA: 1861 - 1865 (CIVIL WAR).
USA: 1861 - 1865 (CIVIL WAR) see also ANTHONY, E.; BACHRACH, DAVID; BARNARD, G. N.; BARR & YOUNG; BELL, WM. H.; BERGSTRESSER BROTHERS; BERRY; BISHOP, T. B.; BRADY, M. B.; BURNITE & WELDON; CAMPBELL, J. W.; CARR; COOK, G. S.; EDWARDS, J. D.; GARDNER, A.; HAAS & PEALE; HIMES, CHARLES F.; HOUGHTON, G. H.; KEIFER, C. E.; LEVY & COHEN; LILIENTHAL, T.; LUCE; MCCLEES, JAMES; MOORE, H. P; MOSES & PIFFET; O'SULLIVAN, T.; PEALE, T. R.; ROCHE, T. C.; RUSSELL, A. J.; THOMPSON, F. F.; WARREN, H. F.; WEAVER, W. H.; WHITEHURST, JESSE H.; WHITNEY, E. T.; HISTORY: PHOTOJOURNALISM & MAGAZINES (Johnson, 1988);

BOOKS
ST2140 Wister, Sally Butler, "Mrs. C. J. Wister." Walter S. Newhall, a Memoir. Philadelphia: Published for the benefit of the Sanitary Commission, 1864. 140 pp. 13 l. of plates. 1 b & w. illus. [One portrait, of Newhall, who was a young soldier, with copies of his sketches while in camp, etc. He was killed in the war.]

ST2141 New York. (State). Bureau of Military Statistics. Presentation of Flags of New York Volunteer Regiments and Other Organizations: To His Excellency, Governor Fenton, in accordance with the resolution of the Legislature, July 4, 1865; Published under Direction of the Chief of Bureau of Military Record, 1865. State of New York. Albany, NY: Weed, Parsons, 1865. 249 pp. 19 l. of plates. 2 b & w. illus. [1500 copies. Two actual photos tipped-in, one color lithograph of flags, fourteen engravings of portraits, some credited from photos by Anson (1), Brady (6), Fredericks (2) and McLees (1).]

ST2142 Hanson, John Wesley. Historical Sketch of the Old Sixth Regiment of Massachusetts Volunteers, During Its Three Campaigns in 1861, 1862, 1863, and 1864. Containing the History of the Several Companies Previous to 1861, and the Name and Military Record of Each Man Connected with the Regiment During the War. Boston: Lee & Shepard, 1866. 352 pp. 3 l. of plates. 28 b & w. [Three pages of photographic paper bound in, each page having several smaller images printed in. The total consisting of twenty-six portraits (officers of the 6th regiment) and two views (of a monument).]

ST2143 Pollard, Edwin Alfred., trans. Jules Noblom. La cause perdue: histoire de la guerre des Confédérés, d'après des rapports officiels et des documents authentiques, par Edward A. Pollard, editeur du 'Richmond Examiner' pendant la guerre,... traduction française de Jules Noblom. New Orleans: La Renaisaance Louisianaise, 1867. 420 pp. 11 l. of plates. 1 b & w. illus. [Steel engravings of portraits of Confederate leaders and military men, most from photographs but only one credited - to Brady. One original photo, tipped-in, is a copy of a painting of Confederate officers.]

ST2144 Medical and Surgical History of the War of the Rebellion. Washington, DC: Surgeon General's Office, 1870-1888. 6 volumes 40 b & w. illus. [Vol. I is the Surgical Series. Vol. II is the Medical Series, each volume has three parts. All volumes, except the Medical Series, part 3, are illustrated from photographs. Several volumes have tipped-in Woodburytype and heliotype reproductions as well - eg. those written by Otis, George A. (Part II, Vol. II) and Woodward, J. J. (Part II, Vol. I.)]

ST2145 War memories... The War for the Union, 1861 - 1865. Views taken by the U. S. government photographers Mathew B. Brady and Alexander Gardner. Hartford, CT: Taylor & Huntington, 1890. 24 pp. 249 l. of plates. 249 b & w. [249 plates mounted on cards, in five portfolios.]

ST2146 The American Civil War Book and Grant Album: A Portfolio of Half-Tone Reproductions from Rare and Costly Photographs Designed to Perpetuate the Memory of General Ulysses S. Grant: Depicting Scenes and Incidents in Connection with the Civil War;... Boston: William H. Allen, 1894. [202] pp. illus. [Early compilation book, distinguished by large, high quality reproductions.]

ST2147 Williams, Major George F. The Memorial War Book, as Drawn from Historical Records and Personal Narratives of the Men Who Served in the Great Struggle. Illustrated by two thousand magnificent engravings taken by the U. S. Government photographers M. B. Brady and Alexander Gardner, being the only original photographs taken during the war of the rebellion; making a complete panorama of this greatest event in history, including portraits of the leaders and commanders of both the Federal and Confederate armies and navies, giving, for the first time, a complete pictorial representation of the scenes, battles and incidents, the whole forming a fitting memorial of the greatest event of the century, the most momentous of the age. New York: Lovell Brothers Company, 1894. 610 pp. b & w.

SPECIAL TOPICS
HISTORY: BY COUNTRY: USA: 1861 - 1865 (CIVIL WAR).

SPECIAL TOPICS
HISTORY: BY COUNTRY: USA: 1861 - 1865 (CIVIL WAR).

ST2148 United States. War Dept. Library. *List of the Photographs and Photographic Negatives Relating to the War for the Union, now in the War Department Library.* "Subject Catalogue No. 5" Washington, DC: Government Printing Office, 1897. 219 pp.

ST2149 *Original Photographs taken on the Battlefields during the Civil War of the United States, by Mathew B. Brady and Alexander Gardner, Who Operated Under the Authority of the War Department and the Protection of the Secret Service. Rare reproductions from photographs selected from seven thousand original negatives...now the private collection of Edward Bailey Eaton.* Hartford, CT: E. B. Eaton, 1907. 126 pp. b & w. illus.

ST2150 Miller, Francis Trevelyn. *Portrait Life of Lincoln. Life of Abraham Lincoln, the greatest American, told from original photographs taken with his authority during the great crisis through which he led his country. Treasured amoung the 7000 Secret Service war negatives in the Brady - Gardner collection at Springfield, Mass., and in private collections...collected by Edward Bailey Eaton.* Springfield, MA: The Patriot Publishing Co., 1910. 164 pp. illus.

ST2151 Miller, Francis Trevelyn, editor-in-chief; managing editor Robert S. Lanier, text by many special authorities. *The Photographic History of the Civil War in Ten Volumes 1861 - 1865.* New York: The Review of Reviews Co., 1912. 10 volumes pp. illus. [This work includes thousands of photographs, many of which were subsequently lost. It also includes a chapter "Photographing the Civil War" by Henry Wysham Lanier containing information apparently drawn from the reminiscences of several photographers or their acquaintances long after the war was over. This information was accepted uncritically, with little effort made to substantiate or verify the facts; and the work has helped cause confusion about the photographic coverage of the Civil War for several generations of photographic historians. (1957) Facsimile reprint. New York: T. Yoseloff.]

ST2152 Lanier, Henry Wysham. *Photographing the Civil War.* The Review of Reviews Co., ca. 1912. 4 vol. illus. [Substantially the same as "The Photographic History of the Civil War, by Francis T. Miller, editor-in-chief, but with the narrative text omitted and illustrative material rearranged.]

ST2153 Elson, Henry E. *The Civil War Through the Camera: Hundreds of Vivid Photographs, Actually Taken in Civil War Times. Sixteen Reproductions in Color of Famous War Paintings.* New York: McKinlay, Stone & Mackenzie, 1912. n. p. illus. [Early compilation book.]

ST2154 Lossing, Benson J. *A History of the Civil War, 1861 - 1865, and the Causes that Led Up to the Great Conflict. A Chronological summary and record of every engagement...showing the total losses and casualties together with war maps of localities, compiled from the official records of the War department. Illustrated with facsimile photographic reproductions of official war photographs taken at the time by Mathew B. Brady, under the authority of President Lincoln and now in the possession of the War Department, Washington, D. C.* New York: The War Memorial Association, 1912. 512 pp. 737 b & w. illus. [First published in sixteen parts. Facsimile reprint (19—), New York: Fairfax Press. With new cover title: *Mathew Brady's Illustrated History of the Civil War 1861 - 1865.*]

ST2155 Egan, Joseph B. and Arthur W. Desmond, editors. *The Civil War, Its Photographic History... Compiled from Actual Photographs Taken at the Time of Action by Mathew B. Brady and Others.* Wellesley Hills, MA: Character Building Publications, 1914. 2 vols. illus.

ST2156 Lorant, Stefan. *Lincoln: His Life in Photographs.* New York: Duell, Sloan & Pierce, 1941. 160 pp. 92 b & w. [Portraits, many credited to M. B. Brady.]

ST2157 Lorant, Stefan. *Lincoln: A Picture Story of his Life.* New York: Harper & Brother, 1952. 256 pp. b & w. illus. [rev. ed. (1957), 304 pp.; (1970) NY: W. W. Norton Co., Inc.]

ST2158 Milhollen, Hurst D. and Milton Kaplan, picture editors; caption editors Hurst D. Milhollen, Milton Kaplan and Hylen Stuart; author of the text and general editor David Donald. *Divided We Fought: A Pictorial History of the War 1861 - 1865.* New York: The Macmillan Company, 1952. 452 pp. 441 b & w. illus. [Compilation book with unusually thorough picture credit sources on pp. 443-447, making it useful to the photographic historian.]

ST2159 Meredith, Roy, ed. *Mr. Lincoln's General, U. S. Grant: An Illustrated Autobiography.* New York: E. P. Dutton & Co., 1959 [?]. 252 pp. 300 illus. [Text from Grant's "personal Memoirs," with illustrations gathered by the editor.]

ST2160 Milhollen, Hurst D. and D. H. Mugridge. *Civil War Photographs, 1861 - 1865; A Catalog of Copy Negatives Made from Originals Selected from the Mathew B. Brady Collection in the Prints and Photographs Division of the Library of Congress.* Washington, DC: Government Printing Office, for the Reference Department, Library of Congress, 1961. 74 pp. 1 b & w. illus. [Lists 1047 photos, with their maker, and the L of C negative code number. The introduction gives a lucid account of the complex history of the Brady Collection and an overview of the course of the conflict and the limitations on the photographers who chose to record it. The listed photographs are then grouped in an order paralleling the course of the war. The first major battle in the Eastern theatre, the first battle of Bull Run, occurring in July 1861, was not photographed. George N. Barnard did photograph the battlefield, but not until after the Federal forces had occupied the site in March 1862. George N. Barnard & James Gibson and Timothy O'Sullivan also photographed the Manassas and Centreville, VA area in March 1862, after the Confederate troops had retreated from their 1861/62 winter quarters. The Peninsular Campaign, from Yorktown to Fair Oaks, VA then back to Harrison's Landing, ran from May to August 1862. In June George N. Barnard photographed that activity. David B. Woodbury and Alexander Gardner were there in August 1862. John Reekie photographed the area later, in April 1865. Timothy O'Sullivan followed McDowell's army near Manassass in July 1862, then he photographed Pope's campaign near Cedar Mountain, Culpeper Court House, the Rappahannock River, and Manassas Junction. The Battle of Antietam was fought in mid-September. Timothy O'Sullivan was in the area, but Alexander Gardner and James Gibson were able to photograph the actual aftermath. C. O. Bostwick, Silas W. Holmes & David B. Woodbury photographed at Harper's Ferry in October 1862. James F. Gibson, Alexander Gardner and Timothy O'Sullivan were all photographing around Aquia Creek and Falmouth, VA in February and March 1863. Timothy O'Sullivan photographed Meade's army in Virginia near Bealton and Culpeper in August and September 1863. Alexander Gardner was also there in November. James Gardner, James F. Gibson, and Timothy O'Sullivan photographed the Federal troops at their winter quarters at Brandy Station from December 1863 to April 1864. In May and June, 1864 Timothy O'Sullivan and James Gardner followed Grant's Wilderness Campaign. David Knox and Timothy O'Sullivan photographed at the long siege of Petersburg, then O'Sullivan followed Grant's troops to Appomattox Court House in April 1865, to document the site of Lee's surrender. Alexander Gardner and others documented the damage to occupied Richmond, VA in April 1865. George N. Barnard and James Gardner had photographed around Washington, DC in the

SPECIAL TOPICS
HISTORY: BY COUNTRY: USA: 1861 - 1865 (CIVIL WAR).

SPECIAL TOPICS
HISTORY: BY COUNTRY: USA: 1861 - 1865 (CIVIL WAR).

Spring of 1865, and William M. Smith documented the fortifications and troops immediately after the war. When Lincoln's assassins were captured in April, 1865, then executed in July, Alexander Gardner photographed the events. Mathew Brady himself is credited with photographing the Grand Review of the Army of the Potomac in Washington in May 1865.

Timothy O'Sullivan and James F. Gibson were the most active photographers of the coastal war. Gibson photographed along the James River in July 1862. O'Sullivan photographed at Hilton Head and Port Royal, SC in Nov. 1861 and in the Spring of 1862, at Fort Pulaski, GA in April 1862, and at Fort Fisher, NC in January 1865. Samuel A. Cooley and George N. Barnard photographed the recapture of Fort Sumter and Morris Island, near Charlestown, SC in April 1865. Cooley also photographed in reoccupied Florida.

In the West, William R. Pywell photographed in the vicinity of Vicksburg, TN in 1864. George N. Barnard photographed in the Knoxville, TN area, then followed Sherman's army from Atlanta, GA to Savannah, GA in 1864.]

ST2161 Mugridge, Donald H., compiler. *The Civil War in Pictures, 1861 - 1865; a chronological list of selected pictorial works.* Washington, DC: General Reference and Bibliography Division, Library of Congress, 1961. 30 pp. [Annotated bibliography of 85 books or articles, not limited to photography.]

ST2162 Hamilton, Charles and Lloyd Ostendorf. *Lincoln in Photographs; An Album of Every Known Pose.* Norman, OK: University of Oklahoma Press, 1963. x, 400 pp. b & w. illus.

ST2163 Frassanito, William A. *Gettysburg: A Journey in Time.* New York: Charles Scribner's Sons, 1975. 248 pp. illus. [Detailed study and reevaluation of every photograph made at Gettysburg from 1863 to 1866 - approximately 250 images. Includes analysis of the work of the three photographers - Alexander Gardner, Timothy O'Sullivan and James F. Gibson - who were at the site immediately after the battle, followed by Mathew Brady and his crew who photographed the battlefield within a month of the battle, the Tyson Brothers (local photographers) who photographed the site for several years and a few other photographers.]

ST2164 Frassanito, William A. *Antietam: The Photographic Legacy of America's Bloodiest Day.* New York: Charles Scribner's Sons, 1978. 304 pp. illus. [Extensive and detailed research into the photographs of the battle of Antietam. Includes the chapter "The Evolution of Early War Photography" and a chapter "American Cameramen Go to War" which gives the most coherent account of the actual photographers who worked during the early part of the Civil War. Discusses the activities of Timothy O'Sullivan, George N. Barnard, James F. Gibson, John Wood, David B. Woodbury, Alexander Gardner and others. Alexander Gardner and James F. Gibson were the photographers who worked at Antietam.]

ST2165 Snyder, Joel and Doug Munson; foreword by Edward A. Mason, essays by Alan Fern, Joel Snyder, John Cavelti, Doug Munson. *The Documentary Photograph as a Work of Art: American Photographs, 1860 - 1876.* Chicago: The University of Chicago. The David and Alfred Smart Gallery., 1976. 49 pp. 13 b & w. illus. [Exhibition catalog, David and Alfred Smart Gallery, University of Chicago, Oct. 13 - Dec. 12, 1976. Includes: "Documentation, Art, and the Nineteenth-Century Photograph," by Alan Fern on pp. 11-13. "Photographers and Photographs of the Civil War," by Joel Snyder, pp. 17-24, "Photographing the West Sublime," by John Cawelti on pp. 25-30, "The Practice of Wet-Plate Photography," by Doug Munson on pp. 33-38, "Catalog of the Exhibition," on pp. 41-48,

listing 238 items, by thirty-eight photographers, and "Select Bibliography," on p. 49.]

ST2166 Gutman, Richard J. S. and Kelly O. Gutman. *John Wilkes Booth Himself.* Dover, MA: Hired Hand Press, 1979. 88 pp. 45 b & w. [All known portraits of Booth.]

ST2167 Davis, William C., ed. *The Image of War: 1865 - 1869.* ...senior consulting editor Bell L. Wiley; photographic consultants William A. Frassanito, Manuel Kean, Lloyd Ostendorf, Frederic Ray. "A Project of the National Historical Society." Garden City, NY: Doubleday & Company, Inc., 1981-1984. 6 vols. illus. [Vol. 1, *Shadows of the Storm.*; 1981 (464 pp, 650 photos). Vol. 2, *The Guns of '62.*; 1982 (464 pp, 650 photos). Vol. 3, *The Embattled Confederacy.*; 1982 (464 pp. 650 photos). Vol. 4, *Fighting for Time.*; 1983 (464 pp., 650 photos). Vol. 5, *The South Besieged.*; 1983 (461 pp. 650 photos). Vol. 6, *The End of an Era.*; 1984 (496 pp., 650 photos.) Volume 1 contains: "The Photographers of the War: Historians with Cameras and their Journey for Posterity," by Frederick E. Ray on pp. 409-455 and "Photographer of the Confederacy: J. D. Edwards," by Leslie D. Jensen on pp. 344-363. Vol. 4 contains "Following the Armies: A Portfolio: Wherever They Go, the Camera Follows," on pp. 86-133 (81 b & w. Alfred R. Waud; George N. Barnard; James Gardner; William Kunstman (of PA); Barnard & Gibson; Barnard & Bostwick; Brady & Co.; Alexander Gardner; R. M. Linn; Armstead & White (Corinth, MS); Timothy O'Sullivan mentioned.) and "The Camera Craft: A Portfolio. Innovation, Invention and Sometimes Art, Spill from the Lens," on pp. 275-300. (32 b & w. T. O'Sullivan; J. Dowling; Henry P. Moore; George N. Barnard; B. Shunk; R. M. Linn (Gallery Point Lookout, Lookout Mountain, TN) mentioned.) Vol. 5 contains "Partners in Posterity - A Portfolio, Haas & Peale and Their Incomparable Record of Siege in South Carolina." on pp. 153-172. (32 b & w by Haas & Peale.) Vol. 6 contains "Houghton at the Front: A Portfolio. The Little-Known Vermont Photographer G. H. Houghton went to the War in 1862 for an Unforgettable Series," on pp. 122-145. Other volumes have similar portfolios and sections.]

ST2168 Frassanito, William A. *Grant and Lee: The Virginia Campaigns 1864 - 1865.* New York: Charles Scribner's Sons, 1983. 255 pp. illus. [Extensive, thorough investigation of the photography during this period; featuring work by O'Sullivan, Brady and Co., A. J. Russell, T. C. Roche and others.]

ST2169 Davis, William C., ed. *Touched by Fire: A Photographic Portrait of the Civil War.* ...William A. Frassanito, Photographic Consultant. "A Project of the National Historical Society." Boston: Little, Brown and Co., 1985-1986. 2 vols. Vol. 1. (1985. 331 pp.) Vol. 2 (1986. 313 pp.) b & w. illus. [Vol. 1 contains "A Yankee in Dixie: Baton Rouge Photographer A. D. Lytle," by Charles East, on pp. 195-232. 60 b & w.]

ST2170 Roberts, Bobby and Carl Moneyhon. *Portraits of Conflict: A Photographic History of Arkansas in the Civil War.* Fayetteville, AR: The University of Arkansas Press, 1987. 242 pp. 200 b & w. [Many portraits of soldiers. Views. etc., by R. H. White, Thomas W. Bankes, and others.]

ST2171 Witham, George F., compiler. *Catalogue of Civil War Photographers. A Listing of Civil War Photographers' Imprints.* Portland, OR: G. F. Witham, 1988. 58 pp. [A listing of Civil War imprints, arranged by state and city, plus thirty-five "Army Photographers."]

SPECIAL TOPICS
HISTORY: BY COUNTRY: USA: 1861 - 1865 (CIVIL WAR).

SPECIAL TOPICS
HISTORY: BY COUNTRY: USA: 1861 - 1865 (CIVIL WAR).

PERIODICALS

ST2172 Portraits. Woodcut engravings, credited "From a Photograph." HARPER'S WEEKLY 5, (1861) ["Lieut. Slemmer, U.S.A., Commanding Ft. Pickens." 5:217 (Feb 23, 1861): 125. "Lieut. Gilman, U.S.A., at Fort Pickens." 5:217 (Feb. 23, 1861): 125. "Major Anderson's command at Fort Sumter (group portrait, "From a photograph taken in the Fort")." 5:221 (Mar. 23, 1861): 177. "Comm. Dahlgren, U.S.N." 5:225 (Apr. 20, 1861) 244. "Major-Gen. Patterson." 5:238 (July 20, 1861) 461. "Brig.-Gen. Williams." 5:239 (July 27, 1861): 465. "Major-Gen. McClellan." 5:240 (Aug. 3, 1861): 484. "Gen. Ben McCulloch, C.S.A." 5:245 (Sept. 7, 1861): 565. "Brig.-Gen. Rosecrans, U.S.A." 5:246 (Sept. 14, 1861): 580. "Brig.-Gen. Sturgis, U.S.A." 5:250 (Oct. 12, 1861): 641. "General Price, C.S.A." 5:250 (Oct. 12, 1861): 641. "Col. Mulligan." 5:251 (Oct. 19, 1861): 657. "Maj.-Gen. Halleck, U.S.A." 5:257 (Nov. 30, 1861): 753. "Brig.-Gen. T. W. Sherman, U.S.A." 5:257 (Nov. 30, 1861): 764.]

ST2173 Seely, Charles. "Editorial Miscellany." AMERICAN JOURNAL OF PHOTOGRAPHY AND THE ALLIED ARTS & SCIENCES n. s. vol. 3, no. 19 (Mar. 1, 1861): 303-304. [General comments, referring to events of the day (firing on Fort Sumter in SC.) hoping for peace and prosperity.]

ST2174 "Major Anderson Captured. - Another triumph of Gun-Cotton." AMERICAN JOURNAL OF PHOTOGRAPHY AND THE ALLIED ARTS & SCIENCES n. s. vol. 3, no. 19 (Mar. 1, 1861): 298-300. [Exchange of letters between Thomas Faris (363 Broadway, New York, NY); Edward Anthony (New York, NY) and George S. Cook (Charleston, SC). Both Faris and Anthony had asked Major Anderson to sit for a portrait and then asked George Cook to take it for them. The priorities, agreements, etc. became very complicated, and if nothing else, show the complexities of attribution during the Civil War period.]

ST2175 "The State of the Art in the City of New York." HUMPHREY'S JOURNAL OF PHOTOGRAPHY, AND THE ALLIED ARTS AND SCIENCES 12, no. 21 (Mar. 1, 1861): 324. [Recent commercial panic caused difficulties,...change of the Government is near at hand...the kind of pictures most in demand at the large galleries is the Cartes de Visite...."The prospect for the ensuing summer is as good as usual, for whatever may be the condition of the country (and we trust it may yet remain united), there will always be a certain demand for the productions of a photographer's skill."]

ST2176 "Inauguration of President Jefferson Davis of the Southern Confederacy, at Montgomery, Alabama, February 18, 1861." HARPER'S WEEKLY 5, no. 219 (Mar. 9, 1861): 157. 1 illus. ["From a photograph obligingly placed at our disposal..."]

ST2177 "Inauguration of the President and Vice-President of the Southern Confederacy, at Montgomery, Ala., on the Morning of Feb 18." NEW YORK ILLUSTRATED NEWS 3, no. 70 (Mar. 9, 1861): 284, 285. 1 illus. ["From a photograph taken expressly for this paper by a photographer in Montgomery, AL."]

ST2178 "President Lincoln Delivering His Inaugural Address in Front of the Capitol at Washington." ILLUSTRATED LONDON NEWS 38, no. 1081 (Mar. 30, 1861): 299-300. 1 illus. [Crowd in front of the White House.]

ST2179 Seely, Charles A. "Editorial Miscellany." AMERICAN JOURNAL OF PHOTOGRAPHY AND THE ALLIED ARTS & SCIENCES n. s. vol. 3, no. 23 (May 1, 1861): 367-368. ["Since our last, every person and thing displays its warlike front....The dogs of war are slipped and all cry havoc! He who thinks of the arts of peace may hold his tongue, or talk to the winds....We have introduced the painful subject here, not because it is our taste or suitable to a journal of peace, but rather to impress on our readers the fact of our continued existence,..." (This ideology might explain the almost total absence of discussion of the war in the American photographic journals during 1861-1865.)]

ST2180 Seely, Charles A. "Foreign Correspondence." BRITISH JOURNAL OF PHOTOGRAPHY 8, no. 142-156 (May 15 - Dec. 16, 1861): 191-192, 210-211, 227, 245, 277, 295-296, 314, 352, 372, 392, 433, 451. [(May 15) "At the present time nothing is talked about or thought of but our impending civil war..." (June 1) Discusses waiting for the war, A. A. Turner's work in photolithography. (June 15) 100,000 medallion badges created in last Presidential election campaign. (July 1) Reports that New York, NY has 150 galleries. (Aug. 1) C. D. Frederick opens new gallery. (Aug. 15) Photo-sculpture. Thomas Cummings. (Sept. 2) "Several photographers who followed our army to the battle of Bull Run were completely routed. In the inglorious retreat they abandoned and threw away everything which would encumber their flight. Thus, by a narrow chance, did we lose the photographs of a great battle." (Oct. 1) Harrison's lenses, etc. (Nov. 1) Photographic journals, bath vessels, Gurney & Sons awarded a medal by the Prince of Wales. (Dec. 16) Dr. Hays arctic expedition, from Boston July 10th, 1860, just returned. Studied photo., brought home 200 stereo negatives; Wolcott & Johnson's 1842-1843 magic lantern daguerreotypes described.]

ST2181 Seely, Charles A. "Editorial Miscellany." AMERICAN JOURNAL OF PHOTOGRAPHY AND THE ALLIED ARTS & SCIENCES n. s. vol. 4, no. 1 (June 1, 1861): 22-23. ["The twenty-eighth meeting of the Photographical Society was a failure...the meeting disintegrated at an early hour, but its members re-formed in little squads to fight over again the battle of Sumpter, the riot of Baltimore, and even to arrange the jubilee over the final victory, and the execution of the traitor Davis...." Further discussion of the consequences of the new war.]

ST2182 "Balloons in Warfare." AMERICAN JOURNAL OF PHOTOGRAPHY AND THE ALLIED ARTS & SCIENCES n. s. vol. 4, no. 2 (June 15, 1861): 40-41. [From "Scientific American." Suggested the reconnaissance balloons by employed by the Union Army. Seely suggests that photos could also be taken, mentions Black, of Boston and Kuhns of New York as examples.]

ST2183 Seely, Charles A. "Editorial Miscellany." AMERICAN JOURNAL OF PHOTOGRAPHY AND THE ALLIED ARTS & SCIENCES n. s. vol. 4, no. 2 (June 15, 1861): 47-48. 1 b & w. [Describes disruption to Southern photographers caused by the rupture. Supplies not getting through, letters not mailed, etc. "We present a sample of a photograph, on albumen paper, which may be printed by a single person at the rate of fifty thousand an hour... The photograph is an excellent likeness of Col. Ellsworth." (Tipped-in portrait, approximately 1/2 inch square.)]

ST2184 "Bivouac of Rebel Troops at General Bragg's Camp at Warrington, Pensacola." HARPER'S WEEKLY 5, no. 234 (June 22, 1861): 395. 1 illus. ["From a photograph."]

ST2185 "The Privateer 'Savannah,' Jefferson Davis' No. 1, Captured by the United States Brig 'Perry,' As She Appeared Off the Battery, New York." NEW YORK ILLUSTRATED NEWS 4, no. 86 (June 29, 1861): 123, 128. 1 illus. ["From a photograph."]

SPECIAL TOPICS
HISTORY: BY COUNTRY: USA: 1861 - 1865 (CIVIL WAR).

SPECIAL TOPICS
HISTORY: BY COUNTRY: USA: 1861 - 1865 (CIVIL WAR).

ST2186 "American Photographical Society." AMERICAN JOURNAL OF PHOTOGRAPHY AND THE ALLIED ARTS & SCIENCES n. s. vol. 4, no. 3 (July 1, 1861): 65-67. 29th Meeting: A. Plunkett, A. Hoguet elected to Society. Postponed the exhibition, due to the war. Tillman read paper on artificial light. Seely suggested that the Society discuss the application of photography to military purposes. Garbanati, Babcock, Barnard, Kuhns, Tillman joined the discussion. Barnard stated that "photographers now in employ of the government are, one in Treasury, one in the Capitol Extension, one in the Navy Yard and the contract for the Patent Office given to Mr. Rehn, for $50,000." illus.

ST2187 "Camp of Colonel Duryea's Zouaves, Fortress Monroe." NEW YORK ILLUSTRATED NEWS 4, no. 87 (July 6, 1861): 136, 138-139. 1 illus. [Troops drilling. "From a photograph."]

ST2188 Portraits. Woodcut engravings, credited "From a Photograph." NEW YORK ILLUSTRATED NEWS 4, (1861) ["Clarence MacKenzie, Drummer in the 13th Brooklyn Reg." 4:88 (July 13, 1861): 156. "Colonel Siegel, Commanding the U.S. Troops in the Battle near Carthage, MO." 4:90 (July 22, 1861): 181. "Maj.-Gen. McClellan." 4:93 (Aug. 12, 1861): 225. "Brig.-Gen. Nathaniel Lyon." 4:94 (Aug. 19, 1861): 248. " Maj.-Gen. John Charles Fremont." 4:94 (Aug. 19, 1861): 249. "Brig.-Gen. Franz Siegel." 4:95 (Aug. 26, 1861): 257. "Ben McCulloch, Rebel General Commanding the Traitors in Southern Missouri." 4:95 (Aug. 26, 1861): 272. "Maj.-Gen. John E. Wool." 4:96 (Sept. 2, 1861): 273.]

ST2189 "The Eleventh Indiana Regiment of Zouaves, Colonel L. Wallace." HARPER'S WEEKLY 5, no. 238 (July 20, 1861): 452. 5 illus. [2 sketches, 3 views of troops parading, from photographs.]

ST2190 "State of Business." HUMPHREY'S JOURNAL OF PHOTOGRAPHY, AND THE ALLIED ARTS AND SCIENCES 13, no. 7 (Aug. 1, 1861): 112. ["There has been just nothing at all doing, so far as we can learn, for the past fortnight, less even than in any similar space of time during the war.... We saw recently a subscriber from New Orleans; he says that there, business has been first rate...The end of the war looks farther off than it did a month ago. The contest is increasing in bitterness and intensity, and the good time coming is in the dim distance of futurity."]

ST2191 Seely, Charles A. "Editorial Miscellany." AMERICAN JOURNAL OF PHOTOGRAPHY AND THE ALLIED ARTS & SCIENCES n. s. vol. 4, no. 5 (Aug. 1, 1861): 120. ["The irrepressible photographer, like the warhorse, snuffs the battle from afar. We have heard of two photographic parties in the rear of the Federal army, on its advance into Virginia. One of these got so far as the smoke of Bull's Run, and were aiming the never-failing tube at friends and foes alike when with the rest of our grand army they were completely routed and took to their heels, leaving their photographic accoutrements on the ground, which the rebels no doubt pounced upon as trophies of victory. Perhaps they considered the camera an infernal machine. The soldiers live to fight another day, our special friends to make again their photographs. The other party, stopping at Fairfax, were quite successful. We have before us their fine stereo-view of the famed Fairfax Court House. When will photographers have another chance in Virginia?"]

ST2192 "Revival of Business." HUMPHREY'S JOURNAL OF PHOTOGRAPHY, AND THE ALLIED ARTS AND SCIENCES 13, no. 9 (Sept. 1, 1861): 143. ["Things seem to be rapidly settling down to a war standard, and to be adapting themselves to the present state of the country. Already an improvement has been noticed in the various branches of trade,...The Melainotype continues in good demand for

small pictures of our generals and distinguished army officers,...We have been cautioned by some of our Southern subscribers that our Journal had given offence on account of its expression of Union sentiments! What! did the gentlemen expect that we were for disunion? - Not until we have suffered a dozen more Bull Run defeats shall we incline to a dissolution of the Union."]

ST2193 Raphael, George. "A Powerful Spy." AMERICAN JOURNAL OF PHOTOGRAPHY AND THE ALLIED ARTS & SCIENCES n. s. vol. 4, no. 7 (Sept. 1, 1861): 167. [Letter from George Raphael, New York, NY, advocating that the camera obscura, "such is now on exhibition at 59th at Broadway," be adopted for military purposes. Editor doesn't agree.]

ST2194 Seely, Charles A. "Editorial Miscellany." AMERICAN JOURNAL OF PHOTOGRAPHY AND THE ALLIED ARTS & SCIENCES n. s. vol. 4, no. 7 (Sept. 1, 1861): 163. ["Photography seems not to suffer quite so much from the war as most other avocations. Photographers in the neighborhood of military recruiting are even doing better than usual. The photograph has become almost an article of necessity."]

ST2195 "Major-General Fremont, U.S.A., and Staff Inaugurating Camp Benton, at St. Louis, Missouri, Before Starting for Lexington." HARPER'S WEEKLY 5, no. 250 (Oct. 12, 1861): 644, 646. 1 illus. ["From a Photograph."]

ST2196 Seely, Charles A. "Editorial Miscellany." AMERICAN JOURNAL OF PHOTOGRAPHY AND THE ALLIED ARTS & SCIENCES n. s. vol. 4, no. 10 (Oct. 15, 1861): 240. [In the Southern states of the Union, photography...for lack of materials...for lack of patrons, is well nigh a lost art. When the war is ended, by next Spring we trust." "Ten years ago we had here only Daguerreotypists, now not one...What we talk about today was in the practical art almost a novelty, only a year ago-the card photograph." Gurney & Son received a medal from the Prince of Wales. Am. Photo. Soc. meeting.]

ST2197 Portrait. Woodcut engraving, credited "From a Photograph." NEW YORK ILLUSTRATED NEWS 5, (1861) ["Col. Alfred W. Taylor, 4th Reg., NY Volunteers." 5:111 (Dec. 16, 1861): 101.]

ST2198 "Public Park and Fountain in the City of Savannah, Georgia. - From a Photograph." FRANK LESLIE'S ILLUSTRATED NEWSPAPER 13, no. 317 (Dec. 21, 1861): 71. 1 illus. [View.]

ST2199 Towler, John. "New Year's Day, 1862." HUMPHREY'S JOURNAL OF PHOTOGRAPHY, AND THE ALLIED ARTS AND SCIENCES 13, no. 17 (Jan. 1, 1862): 271-272. ["The past year has been a sad one to, alas!...The Photographic art down South has completely died out in consequence of the war. The miserable rebels are shut up like a rat in a hole....The photographic art here at the North is flourishing finely, and we positively hear no complaints of hard times among operators...."]

ST2200 Portraits. Woodcut engravings, credited "From a Photograph." FRANK LESLIE'S ILLUSTRATED NEWSPAPER 13, (1862) ["Maj. Edward W. Serrell." 13:321 (Jan. 18, 1862): 132. "Capt. J. R. Goldsborough, U.S.N." 13:323 (Feb. 1, 1862): 171. "Capt. A. H. Davis, U.S.N." 13:323 (Feb. 1, 1862): 171. "Capt. A. H. Foote, U.S.N." 13:326 (Feb. 22, 1862): 224. "Maj.-Gen. Ulysses S. Grant." 13:329 (Mar. 15, 1862): 261.]

ST2201 "'Monticello,' Virginia, Formerly the Residence of President Jefferson, Owned by Com. U. P. Levy, U.S.N., Lately Confiscated by the Rebels. - From a Photograph." FRANK LESLIES'S ILLUSTRATED

SPECIAL TOPICS
HISTORY: BY COUNTRY: USA: 1861 - 1865 (CIVIL WAR).

SPECIAL TOPICS
HISTORY: BY COUNTRY: USA: 1861 - 1865 (CIVIL WAR).

NEWSPAPER 13, no. 324 (Feb. 8, 1862): 180, 182. 1 illus. [Landscape view, very heavily overworked, and romanticized, by the engraver.]

ST2202 "Photography in the Army." HUMPHREY'S JOURNAL OF PHOTOGRAPHY, AND THE ALLIED ARTS AND SCIENCES 13, no. 20 (Feb. 15, 1862): 319. [Actually a note about the fact that many melainotype and ambrotypes being mailed back and forth between soldiers and their friends and relatives at home.]

ST2203 Portraits. Woodcut engravings, credited "From a Photograph." HARPER'S WEEKLY 6, (1862) ["Flag-Officer Goldsborough." 6:270 (Mar. 1, 1862): 136. "Maj.-Gen. Ulysses S. Grant, U.S.A., the hero of Fort Donelson." 6:271 (Mar. 8, 1862): 145.]

ST2204 "The Capitol at Nashville." HARPER'S WEEKLY 6, no. 271 (Mar. 8, 1862): 153. 1 illus. ["From a Photograph."]

ST2205 "Photographing from Balloons in Military Reconnaissances." AMERICAN JOURNAL OF PHOTOGRAPHY AND THE ALLIED ARTS & SCIENCES n. s. vol. 4, no. 23 (May 1, 1862): 550. [From "Scientific American." The American Photographical Society had several times made the offer to accompany Prof. Lowe on his balloon observation flights to the military. Apparently ignored or refused each time.]

ST2206 "Baton Rouge, Louisiana." FRANK LESLIE'S ILLUSTRATED NEWSPAPER 13, no. 344 (May 24, 1862): 84-85. 4 illus. [These four views of the city, "...taken from the top of the State House," are not credited to be from photos, but they are not credited to any other artist either. The visual grammar indicates a possible photographic source.]

ST2207 Portraits. Woodcut engravings, credited "From a Photograph." FRANK LESLIE'S ILLUSTRATED NEWSPAPER 14, (1862) ["Lieut. Wm. N. Jeffers, U.S.N." 14:349 (June 14, 1862): 173. "Hon. James T. Close, Sen. from VA." 14:349 (June 14, 1862): 173. "Brig.-Gen. G. M. Dodge." 14:351 (June 28, 1862): 205.]

ST2208 "The Steamer 'Planter' and Her Captor." HARPER'S WEEKLY 6, no. 285 (June 14, 1862): 372. 2 illus. [Party of Negroes in Charleston, under Robert Smalls, stole the Confederate gunboat, 'Planter,' from Charleston, SC., fled to Federal lines. Portrait of Smalls, view of the boat "...from photographs sent us by our correspondent at Hilton Head."]

ST2209 "Editorial Department." AMERICAN JOURNAL OF PHOTOGRAPHY AND THE ALLIED ARTS & SCIENCES n. s. vol. 5, no. 1 (July 1, 1862): 24. [Note that "many of the prominent members [of the American Photographical Society] have found it their duty to join the army. The last we heard of Secretary Thompson was that he was in sight of Richmond, and daily getting a nearer view. Drs. J. C. and Henry Draper are serving as surgeons. But when September comes, it is hoped that all strife will be ended..."]

ST2210 "California Joe, of the Berdan Sharpshooters." HARPER'S WEEKLY 6, no. 292 (Aug. 2, 1862): 492. 1 illus. [Portrait, presumably taken in the field, or posed in the studio, of a Union sharpshooter, with his rifle.]

ST2211 Seely, Charles A. "Editorial Department." AMERICAN JOURNAL OF PHOTOGRAPHY AND THE ALLIED ARTS & SCIENCES n. s. vol. 5, no. 4 (Aug. 15, 1862): 95. ["The history of the ornamental arts in America for the past year is very complimentary to Photography. Photography has scarcely felt the shock of the war which

has brought disaster and ruin among its rivals and allies, - some of those rivals are indeed lost arts."]

ST2212 "The Carte de Visite." AMERICAN JOURNAL OF PHOTOGRAPHY AND THE ALLIED ARTS & SCIENCES n. s. vol. 5, no. 5 (Sept. 1, 1862): 113-114. [From "Harper's Magazine." Poem, about a soldier killed in the war, identified by photo.]

ST2213 "Useful Facts, Receipts, Etc.: Photography at the Seat of War." AMERICAN JOURNAL OF PHOTOGRAPHY AND THE ALLIED ARTS & SCIENCES n. s. vol. 5, no. 7 (Oct. 1, 1862): 164. [From "Corr. Tribune, Aug. 20th." "A camp is hardly pitched before one of the omnipresent artists in collodion and amber-bead varnish drives up his two-horse wagon, pitches his canvas-gallery, and unpacks his chemicals...Here,...near Gen. Burnside's headquarters (at Fredericksburg)...are two brothers from Pennsylvania...named Bergstresser. They have followed the army for more than a year...thousands of portraits...[with the] melainotype [process]."]

ST2214 "The Civil War In America: Colonel of the 4th Regiment European Brigade of the Confederate Army." ILLUSTRATED LONDON NEWS 41, no. 1167 (Oct. 4, 1862): 369. 1 illus. ["From a photograph." Posed full-length portrait.]

ST2215 "Battle of Corinth, Oct. 4, 1862. - Appearance of Fort Robinett When Taken by the National Army under General Rosencrans - Two Rebel Generals (Johnson and Rodgers) Lying Dead Among the Killed. - From a Photograph." FRANK LESLIE'S ILLUSTRATED NEWSPAPER 15, no. 372 (Nov. 15, 1862): 116. 1 illus. ["We present...an exact copy of a photograph sent to us by an officer of our Western army, showing the scene which presented itself to our men at Fort Robinett." (Battlefield aftermath view, with piled corpses. This is the only such image from a photograph that I have found, to date, in the "FLIN."]

ST2216 "American Tact for Business." HUMPHREY'S JOURNAL OF PHOTOGRAPHY, AND THE ALLIED ARTS AND SCIENCES 14, no. 14 (Nov. 15, 1862): 169-172. [Long, complicated tale about someone learning photography, acquiring the apparatus in one day in order to make and sell portraits of "the 126th regiment" before it marched off to war. May be fictional, but it accurately portrays the sense of opportunism and energy of the photographers of the period.]

ST2217 Seely, Charles A. "Editorial Department." AMERICAN JOURNAL OF PHOTOGRAPHY AND THE ALLIED ARTS & SCIENCES n. s. vol. 5, no. 13 (Jan. 1, 1863): 312. [War continues, but business flourishing in the North.]

ST2218 Sellers, Coleman. "Foreign Correspondence." BRITISH JOURNAL OF PHOTOGRAPHY 10, no. 182 (Jan. 15, 1863): 41-42. [Sellers discusses Civil War photographers..."pictures published by Messrs. Brady & Co., of the Antietam battlefield, Mr. La Merle, of the Washington Brady's Gallery, says that those pictures were made by Mr. Alexander Gardner, assisted by Mr. Timothy O'Sullivan...The Bull Run and Peninsula pictures, published by Mr. Brady, were taken by Mr. Barnard and Mr. Gibson. It was the former of these gentlemen who took the fine Niagara views published by Anthony...Most of the cabinet-size pictures taken in and around Washington are the work of Messrs. Whitney and Woodbury."]

ST2219 "The New Year!" HUMPHREY'S JOURNAL OF PHOTOGRAPHY, AND THE ALLIED ARTS AND SCIENCES 14, no. 17 (Jan. 1, 1863): 222-233. [Diatribe against "the Rebellion." "We confess we are getting more into the Political than the Photographic vein, but no matter; everything hinges on politics, and Photography,

SPECIAL TOPICS
HISTORY: BY COUNTRY: USA: 1861 - 1865 (CIVIL WAR).

SPECIAL TOPICS
HISTORY: BY COUNTRY: USA: 1861 - 1865 (CIVIL WAR).

like everything else, is affected by the political state of the country....We fear the country is going to ruin, and all branches of trade will suffer from the crash."]

ST2220 Portraits. Woodcut engravings, credited "From a Photograph." HARPER'S WEEKLY 7, (1863) ["The Pirate Raphael Semmes." 7:314 (Jan. 3, 1863): 13. "Union Jim (Negro Jim Williams)." 7:326 (Mar. 28, 1863): 196. "'Unconditional Surrender' Grant." 7:343 (July 25, 1863): 465. "Gen. Judson Kilpatrick." 7:347 (Aug. 22, 1863): 541. "Gen. Gordon Granger." 7:362 (Dec. 5, 1863): 780.]

ST2221 "Fort Hindman, at Arkansas Post, Arkansas." HARPER'S WEEKLY 7, no. 321 (Feb. 21, 1863): 123, 124. 5 illus. ["From Drawings and Photographs Furnished by the Ordnance Department." "...we are indebted to Mr. Stellwagen, of the Bureau of Ordnance at Washington, for the drawings of the attack on Fort Hindman..."]

ST2222 Sellers, Coleman. "Foreign Correspondence." BRITISH JOURNAL OF PHOTOGRAPHY 10, no. 192 (June 15, 1863): 257-258. [Titian R. Peale, an amateur, was offered and took the opportunity to photograph General Hooker's headquarters the day before Hooker broke camp to cross the Rappahannock. Near Fredericksburg, VA.]

ST2223 "The Iron-Clad Gun-Boat 'Cincinnati,' Sunk at Vicksburg." HARPER'S WEEKLY 7, no. 338 (June 20, 1863): 385. 1 illus. ["From a Photograph."]

ST2224 Sellers, Coleman. "Foreign Correspondence." BRITISH JOURNAL OF PHOTOGRAPHY 10, no. 195 (Aug. 1, 1863): 313-314. [Discusses Ruebens Peale, then mentions the activities of Rev. Charles H. Hall, of Washington, DC, an amateur, photographing (in the war zones).]

ST2225 Sellers, Coleman. "Foreign Correspondence." BRITISH JOURNAL OF PHOTOGRAPHY 10, no. 197 (Sept. 1, 1863): 354-355. [Mentions Gutekunst photographing after the battle of Gettysburg. Robert Shriver, amateur, describes the brief Confederate occupation of Cumberland, MD (but didn't take photos); etc.]

ST2226 Seely, Charles A. "Editorial Department." AMERICAN JOURNAL OF PHOTOGRAPHY AND THE ALLIED ARTS & SCIENCES n. s. vol. 6, no. 6 (Sept. 15, 1863): 143. [Describes J. H. Fitzgibbon's leaving Vicksburg, then his blockade, his capture and trip to New York, NY. "Finally with alcohol at twenty-four dollars per gallon, and many other useful things not procurable at any price, and with no money among the people to pay for pictures if he could produce them, he...(left)...There has been little photography in Jeffdom for the past two years. It is only in Charleston and perhaps Richmond that any photographs at all are made. By favor of our British cousins who run the blockade with powder and guns, our friend Cook of Charleston, has still a precarious stock of photographic materials and still makes a business in the shadows of the people....Apropos of our British cousins, perhaps we ought to make an apology for introducing matters somewhat foreign to Photography. The editor of the "British Journal" on occasion of allusions to the rebellion by his American correspondent, administers a hint in the following words. - 'It is no doubt difficult for one in the position of our worthy correspondent to avoid taking part in political matters, though we ignore politics in connection with science.'"]

ST2227 Sellers, Coleman. "Foreign Correspondence." BRITISH JOURNAL OF PHOTOGRAPHY 10, no. 199 (Oct. 1, 1863): 395. [Brief mention that the amateur Prof. Himes did make stereos of the battleground of Gettysburg. Also mentions that the amateur Hemple

who "volunteered for the emergency at the time of Lee's invasion" has returned home, with anecdotes (but didn't take photos).]

ST2228 "Scenes on Board the 'Alabama.' From Photographs." ILLUSTRATED LONDON NEWS 43, no. 1226 (Oct. 10, 1863): 361. 3 illus. [Portraits of Captain and crew of the Confederate war steamer "Alabama." Report of the presence of the ship at Cape Town, Cape of Good Hope, South Africa from the Aug. 20 "Cape Argus." The photos probably taken while it was at Cape Town as well.]

ST2229 "Scenes on Board the Pirate 'Alabama.'" NEW YORK ILLUSTRATED NEWS 9, no. 211 (Nov. 14, 1863): 44-45. 3 illus. [Portraits of Capt. Semmes, 1st Lieut. McIntyre Bell and crew aboard the Confederate ship 'Alabama,' taken at Cape Town, South Africa. From the "ILN"?]

ST2230 "The Army of the Potomac: The Great Depot of Supplies on the Railroad - The Army of the Potomac: The Bridge over Bull Run, Present Appearance." HARPER'S WEEKLY 7, no. 363 (Dec. 12, 1863): 789. 2 illus. ["From a Photograph."]

ST2231 Notes on the Colours of the National Guard; with Some Incidental Passages of the History of the Regiment; Prepared at the Request of the Veterans of the National Guard and Read Before the Association January 12th, 1863. New York: From an Amateur Press for private distribution., 1864. 80 l. 18 b & w. [67 copies printed. Original photos. George Eastman House Collection.]

ST2232 K. H. W. "The Dead Soldier's Children." PHILADELPHIA PHOTOGRAPHER 1, no. 1 (Jan. 1864): 15. [Poem, written in response to an event wherein an unidentified Union soldier was found dead after the battle of Gettysburg with portraits of three children in his hand. These portraits were copied by several photographers, sold commercially in the hopes of finding the children and turning the profits over to them, which was supposedly accomplished.]

ST2233 "An Incident of Gettysburg - The Last Thought of a Dying Father." FRANK LESLIE'S ILLUSTRATED NEWSPAPER 17, no. 431 (Jan. 2, 1864): 235, 236. 1 illus. [Sketch of a dead soldier at Gettysburg, with photographs of his children clutched to his chest.]

ST2234 "The War In Virginia - Soldiers looking at a Show near Culpepper. - From a Sketch by Our Special Artist E. Forbes." FRANK LESLIE'S ILLUSTRATED NEWSPAPER 17, no. 432 (Jan. 9, 1864): 249. [Small group of US soldiers, "in winter camp," looking into a small portable box on a tripod, at some sort of images. Unclear, but it might be a stereo viewer, or a lantern-slide arrangement of some sort.]

ST2235 "The War in South Carolina - Battery of Sullivan's Island. - From a Rebel Photograph." FRANK LESLIE'S ILLUSTRATED NEWSPAPER 17, no. 432 (Jan. 9, 1864): 249. 1 illus. [View, with figures.]

ST2236 "Emancipated Slaves, White and Colored." HARPER'S WEEKLY 8, no. 370 (Jan. 30, 1864): 69, 71. 1 illus. [Social documentary. Group portrait. "A large photograph of the whole group has been taken, and cartes-de-visite of the separate figures. They are for sale at the rooms of the National Freedman's Relief Association, No. 1 Mercer Street, New York..." Negroes in New Orleans.]

ST2237 Heckendorn, D. "Our Art in Rebeldom - The Latest News From Dixie." AMERICAN JOURNAL OF PHOTOGRAPHY AND THE ALLIED ARTS & SCIENCES n. s. vol. 6, no. 20 [sic 21] (May 1, 1864): 502-503. [D. Heckendorn, of New Berlin, PA, spent the winter in Castle Thunder, Richmond. "I visited two of the principal galleries (in

SPECIAL TOPICS
HISTORY: BY COUNTRY: USA: 1861 - 1865 (CIVIL WAR).

SPECIAL TOPICS
HISTORY: BY COUNTRY: USA: 1861 - 1865 (CIVIL WAR).

Richmond) and found them busy. There seemed to be more done in ambrotypes than in photographs...(ambrotypes selling) for twenty dollars. Photographs, for a single copy, fifteen dollars, or four for twenty-five dollars. As I was under guard, I was not permitted to ask any questions, but came to the conclusion that they were short of stock."]

ST2238 "Work Shops - Head-quarters Army of the Potomac." HARPER'S WEEKLY 8, no. 385 (May 14, 1864): 317. 1 illus. [Fixing weapons, tents, in the field. "Our sketch is made from a photograph furnished us by our artist, A. R. Wand, at the Army head-quarters." Wand was an illustrator; doubtful that he took the photograph himself. There are several other camp scenes throughout the 1864 volume that seem to be derived from photos, but which are not credited.]

ST2239 Seely, Charles A. "Editorial Department." AMERICAN JOURNAL OF PHOTOGRAPHY AND THE ALLIED ARTS & SCIENCES n. s. vol. 6, no. 21 [sic 22] (May 15, 1864): 527. ["The news has come again to-day (14th) that Gen. Grant is moving on the enemy's works. This is the cheering news we have had every day for more than a week. We expect to hear it again and again till it shall culminate in the tidings of the glorious and final victory. And what then? We answer as a photographer only....New fields of enterprise! A thousand new photographic establishments are to be opened..."]

ST2240 Portraits. Woodcut engravings, credited "From a photograph." ILLUSTRATED LONDON NEWS 44, (1864) ["General Longstreet, Confederate Army." 44:* (June 11, 1864): 573. "General J. E. B. Stuart, Confederate Army." 44:* (June 18, 1864): 585.]

ST2241 "Union Soldiers as They Appeared on Their Release from the Rebel Prisons. - From Photographs Made by Order of Congress." FRANK LESLIE'S ILLUSTRATED NEWSPAPER 18, no. 455 (June 18, 1864): 193, 199. 8 illus. [Eight portraits of malnourished, ill ex-prisoners]

ST2242 "State of Trade." HUMPHREY'S JOURNAL OF PHOTOGRAPHY, AND THE ALLIED ARTS AND SCIENCES 16, no. 6 (July 15, 1864): 95. [Slow quarter year. Comment upon the war. "We are now in the fourth year of the war, and so much nearer to the end, but when that end will come God only knows!..."]

ST2243 "Liberal Compensation." HUMPHREY'S JOURNAL OF PHOTOGRAPHY, AND THE ALLIED ARTS AND SCIENCES 16, no. 7 (Aug. 1, 1864): 112. ["...prices charged in the loyal Southern States (or rather the restored Southern cities) for vignettes, payable in greenbacks - Ten dollars per dozen...the price in Natchez, July 2nd. Gurney, of Natchez, sends us some excellent specimens of his work."]

ST2244 "The Sixth Corps Embarking at City Point, to Proceed to the Relief of Washington. - From a Photograph." FRANK LESLIE'S ILLUSTRATED NEWSPAPER 18, no. 462 (Aug. 6, 1864): 313. 1 illus. [View. Boats and troops.]

ST2245 "The Lighthouse at Fort Morgan, Mobile Harbor, After the Surrender. - From a Photograph." FRANK LESLIE'S ILLUSTRATED NEWSPAPER 19, no. 475 (Nov. 5, 1864): 97. 1 illus. [View.]

ST2246 "The Wharfs at Nassau, New Providence, with the Blockade-Runner Fanny Discharging Cotton. - From a Photograph." FRANK LESLIE'S ILLUSTRATED NEWSPAPER 19, no. 475 (Nov. 5, 1864): 100. 1 illus. [View.]

ST2247 "Libby Prison, Richmond, Va. - Place of Confinement for U. S. Soldiers Captured by the Rebels. - From a Photograph." FRANK

LESLIE'S ILLUSTRATED NEWSPAPER 19, no. 480 (Dec. 10, 1864): 177. 1 illus. [View. "...from a photograph accidentally picked up by one of our travelling artists."]

ST2248 "A Novel Application of Photography." BRITISH JOURNAL OF PHOTOGRAPHY 12, no. 244 (Jan. 6, 1865): 4. [United States Sanitary Commission using photographs of ill and dying prisoners released from Confederate prisons at Belle Island and Fort Sumter.]

ST2249 Seely, Charles A. "Editorial Department." AMERICAN JOURNAL OF PHOTOGRAPHY AND THE ALLIED ARTS & SCIENCES n. s. vol. 7, no. 20 (Apr. 15, 1865): 479-480. ["Since our last, the insane rebellion which has for four years threatened the permanent prosperity of our country has received its mortal wound....We are in the dawn of a new era of peace and progress. Every friend of humanity must be filled with profound thankfulness. The prospect for photography is perhaps not brighter than for other peaceful arts; all may rejoice in concert. It is, however, the peculiar and personal interests which will provoke the immediate and profound movement in our craft. In a few months the field of our operations will be almost doubled. Every man directly or remotely connected with photography may reasonably anticipate an advantage."]

ST2250 "End of the War." and "The National Bereavement." HUMPHREY'S JOURNAL OF PHOTOGRAPHY, AND THE ALLIED ARTS AND SCIENCES 17, no. 1 (May 1, 1865): 16. ["The Great Rebellion is crushed; the war is virtually over... the delay in filling orders from the 15th to the 25th inst., was owing altogether to the recent loss sustained by the nation. Business was at a complete stand still for days."]

ST2251 Knowles, Charles D. "How it Goes." HUMPHREY'S JOURNAL OF PHOTOGRAPHY, AND THE ALLIED ARTS AND SCIENCES 17, no. 1 (May 1, 1865): 15. ["We are getting letters like this daily: - Richmond, Va., April 29, 1865. ...Please send my Journal hereafter to Weedsport, Cayuga County, New York, for this war is played out, and I expect to soon be at home...Charles D. Knowles, Battery K, 3rd NYV Artillery, 24th Army Corps." "Our brave boys are coming home at last. The war must certainly be over when we get such letters. Hundreds of operators who have been in the army will now be welcomed home...The Photographic profession has been well represented in this war, and many have nobly distinguished themselves."]

ST2252 "Sharp Practice." HUMPHREY'S JOURNAL OF PHOTOGRAPHY, AND THE ALLIED ARTS AND SCIENCES 17, no. 1 (May 1, 1865): 16. ["It is known that Messrs. Gurney took some very fine negatives of scenes in and around the hall where the remains of our late lamented President laid in state in this city. They had uninterrupted possession of the premises for several hours; and no other artist was allowed any similar privileges by the city authorities. This did not please some other photographers in New York, so they sent on a statement of facts in the case to Secretary Stanton, when that official immediately dispatched officers to Gurneys and seized all the above mentioned negatives they could lay their hands upon, and sent them off to Washington. Mr. Gurney followed after, post haste, but whether he succeeded in recovering the negatives we are not informed."]

ST2253 "Our Nation's Woe." PHILADELPHIA PHOTOGRAPHER 2, no. 17 (May 1865): 80. [Obituary notice about assignation of Abraham Lincoln. This is the one of the very few times that events associated with the Civil War are mentioned in this journal.]

SPECIAL TOPICS
HISTORY: BY COUNTRY: USA: 1861 - 1865 (CIVIL WAR).

SPECIAL TOPICS
HISTORY: BY COUNTRY: USA: 1861 - 1865 (CIVIL WAR).

ST2254 Portraits. Woodcut engravings, credited "From a Photograph." FRANK LESLIE'S ILLUSTRATED NEWSPAPER 20, (1865) ["Russian bloodhound 'hero' from Castle Thunder. (Soldier and dog in front of tent.) 20:505 (June 3, 1865): 172. "Rev. Thos. Armitage, pastor, New York, NY" 20:511 (July 15, 1865): 268. "The late John Hutchings, pilot of the first steamer built by John Fitch - from a Daguerreotype." 20:518 (Sept. 2, 1865): 372.]

ST2255 "Rebel Cruelties." HARPER'S WEEKLY 9, no. 442 (June 17, 1865): 379, 380. 7 illus. [Portraits of Union soldiers who were prisoners suffering from exposure, malnutrition, etc. "These illustrations are the exact facsimiles of photographs..." "Chaplain J. J. Greer, from whom we received the photographs..."]

ST2256 "Execution of Captain Wirz at Washington, Friday, Nov. 10." FRANK LESLIE'S ILLUSTRATED NEWSPAPER 21, no. 530 (Nov. 25, 1865): 152. 1 illus. [This sketch of the view of the hanging of Capt. Wirz shows two photographers in the crowd of observers, photographing the event. Probably Alexander Gardner and his crew.]

ST2257 "Marks of Punishment Inflicted Upon a Colored Servant in Richmond, Virginia." HARPER'S WEEKLY 10, no. 500 (July 28, 1866): 477. 1 illus. ["Enclosed I send you a photograph showing in part..."]

ST2258 Shanks, William F. G. "Lookout Mountain, and How We Won It." HARPER'S MONTHLY 37, no. 217 (June 1868): 1-15. 17 illus. [Reminiscences, by the author, of the three months spent by the war correspondents covering the Union Army after it captured Chattanooga, TN. "The 'Bohemian Club,' which had barely managed to exist through the long and tedious siege of Chattanooga, glad of new-found liberty, reinforced themselves with a photographer, and established themselves in 'Camp Harper's Weekly,' which they located on the eastern slope of the mountain... Here they painted and photographed, sketched and scribbled, until in the course of time all that was prominent, or picturesque, or interesting, on or of the mountain and the battle, was preserved on canvas or in a note-book..." An engraving on p. 9 displays an artist sketching and a photographer at work. (The photographer in this group is not named.]

ST2259 "Viator." "From Across the Water." ANTHONY'S PHOTOGRAPHIC BULLETIN 2, no. 12 (Dec. 1871): 397. ["A publisher told me 'a joke,' to wit. He has photographs of the Confederate dead, taken after the final engagement before Richmond, and is doing a lively business in selling from them pictures of the killed at the Paris fortifications."]

ST2260 "The Last Picture of Lincoln." PHOTOGRAPHIC TIMES 9, no. 97 (Jan. 1879): 10-11. [Reprinted from the "Exchange." Anecdote of Lincoln's visit to an unnamed gallery before his death.]

ST2261 "Ghastly Photographic Experiences." PHOTOGRAPHIC TIMES 12, no. 136 (Apr. 1882): 111-114. [From the "Sunday Mercury." Unnamed photographer from Philadelphia recounts his twenty years experiences making portraits of the dead. This narrator recounts how he began by photographing the battle of Antietam, three days after the fight. Then he goes on to describe his experiences at Fredericksburg and Spottsylvania Court House.]

[Century Magazine published a famous series of articles about the Civil War, under the general series title "Battles and Leaders of the Civil War," throughout 1884 to 1888. These articles were written by many authors (most of them former officers on both sides of the conflict), and copiously illustrated with engravings of officers and men, sites of the battles, etc. Many of the illustrations are credited "From a Photograph." Occasionally, the credit includes the photographer: E. Anthony, M. Brady, G. S. Cook, etc., though these are usually portraits. Upon occasion, an actual photo is reproduced, as in "Section of the Encampment of the Army of the Potomac Near White House, Va. (Process Reproduction of a Photograph)," on p. 139, in the May 1885 issue. This series was later expanded and published in a multi-volume publication with the same title. CENTURY MAGAZINE (SCRIBNER'S MONTHLY) 29-35, (Nov. 1884 - Apr. 1888).]

ST2262 "Notes and News." PHOTOGRAPHIC TIMES 20, no. 464 (Aug. 8, 1890): 395. [Quote of a passage by John Russell Young, describing Lincoln's speech at Gettysburg, remembering how most of those present on the platform missed the speech because "The noticeable thing was the anxiety of all on the platform that the photographer should be able to get his picture. I remember we were all very much disappointed at his failure and were more interested in his adventure than in the address."]

ST2263 "Notes and News: The Recent Discovery of Two Portraits of Lincoln and Grant They had Taken Together." PHOTOGRAPHIC TIMES 21, no. 525 (Oct. 9, 1891): 506. [Report on the discovery of a double portrait of Lincoln and Grant, taken in 1864, now owned by the Treasury Department. The photographer of the portraits was not identified.]

ST2264 "Obituary: Gen. Montgomery Cunningham Meiggs." PHOTOGRAPHIC TIMES 22, no. 539 (Jan. 15, 1892): 27. [Note that John Wood and Charles Ehrmann took photos of the construction of the U.S. Capitol building under Captain Meiggs of the Topographical Bureau. First use of photography by the government. Meiggs later Quartermaster General of U.S. Army. (Where, during the Civil War, he had Capt. A. J. Russell and a corps of photographers document the activities of the U.S. Army Corps of Engineers.)]

ST2265 1 photo (Abraham Lincoln). CENTURY MAGAZINE 47, no. 4 (Feb. 1894): 592. 1 b & w. ["From an original, unretouched negative, made in 1864." "Copyright, 1891, by M. P. Rice." (The copyright holder doesn't seem to have taken the photo.)]

ST2266 Porter, General Horace. "Personal Traits of General Grant." MCCLURE'S MAGAZINE 2, no. 6 (May 1894): 506-514. 7 b & w. 1 illus. [Portraits of Grant, his headquarters, and his horses, taken during the Civil War. Credited to Brady, but most not by him. Also a portrait of General Porter, by the Pach Brothers.]

ST2267 "General Grant's Human Documents." MCCLURE'S MAGAZINE 2, no. 6 (May 1894): 520-531. 11 b & w. 2 illus. [This was one in a series of articles, wherein an individual is featured, with a portfolio of portraits taken at different times during his or her lifetime. In this case there are several portraits of Grant taken during the Civil War, and here credited to M. B. Brady, but probably not by him.]

ST2268 Howard, O. O., Major-General, U.S.A. and General Ely S. Parker. "Some Reminiscences of Grant." MCCLURE'S MAGAZINE 2, no. 6 (May 1894): 532-535. 2 b & w. [Two group portraits of Grant and his officers taken in Boston in 1865. Not credited, possibly by J. W. Black?]

ST2269 Byers, S. H. M. "Some Personal Recollections of General Sherman." MCCLURE'S MAGAZINE 3, no. 3 (Aug. 1894): 212-224. 6 b & w. [Six portraits of Sherman, credited to Brady; Mora; and Sarony.]

SPECIAL TOPICS
HISTORY: BY COUNTRY: USA: 1861 - 1865 (CIVIL WAR).

SPECIAL TOPICS
HISTORY: BY COUNTRY: USA: 1861 - 1865 (CIVIL WAR).

ST2270 McClure, Alexander K. "Lincoln as Commander-in-Chief." MCCLURE'S MAGAZINE 4, no. 3 (Feb. 1895): 253-266. 6 b & w. [Portraits of Lincoln and the top Federal generals, credited to Brady.]

ST2271 McClure, Colonel A. K. "The Night of Harrisburg. A Reminiscence of Lincoln's Journey to Washington in 1861." MCCLURE'S MAGAZINE 5, no. 1 (June 1895): 91-96. 2 b & w. [Portrait of Lincoln, taken in 1861 by McNulta in Springfield, IL. Portrait of Mrs. Lincoln by Brady.]

ST2272 Tarbell, Ida M., ed. "Abraham Lincoln." MCCLURE'S MAGAZINE 5-7, no. 6, 1-6, 1-5 (Nov. 1895 - Oct. 1896): (vol. 5) 480-512, (vol. 6) 2-23, 114-136, 209-240, 306-327, 428-448, 526-544, (vol. 7) 57-88, 171-181, 272-281, 401-413. many b & w. many illus. [Serial article on the life of Abraham Lincoln, with scores of illustrations. The captions often contain information about the making of the photographs, as well as their location at that time, in 1895. The Dec. 1895 issue contains letters about "The Earliest Portrait of Lincoln," on pp. 109-112.]

ST2273 Badeau, Adam. "The Mystery of Grant." COSMOPOLITAN 20, no. 5 (Mar. 1896): 483-492. 12 b & w. [Illustrated with portraits of Grant, most of them taken during the Civil War, including an unusual portrait "...from a broken negative made in 1863."]

ST2274 Hay, John. "A Young Hero. Personal Reminiscences of Colonel E. E. Ellsworth." MCCLURE'S MAGAZINE 6, no. 4 (Mar. 1896): 354-361. 6 b & w. 1 illus. [Portraits of officers in Col. Ellsworth's military company. Ellsworth was killed very early in the war. Photos taken in 1860 and 1861 are credited to "...Colonel E. L. Brand of Chicago, a member of Ellsworth's Chicago company, and afterwards in command of it..." (Brand was probably the owner of the photos, not their maker.)]

ST2275 "The Glory of War: After The Battle." COSMOPOLITAN 23, no. 1 (May 1897): 81-87. 12 b & w. [Portfolio of Civil War photographs taken on battlefields, showing the dead. "These photographs were taken by Brady, of Washington, who was frequently at the front, and have been kept unpublished until now." In fact, they are photos by T. O'Sullivan, Alexander Gardner, and others.]

ST2276 Dana, Charles A. "Reminiscences of Men and Events of the Civil War. Illustrated with Portraits from the War Department Collection of Civil War Photographs." MCCLURE'S MAGAZINE 10, no. 1-6 (Nov. 1897 - Apr. 1898): 20-31, 150-164, 253-266, 347-360, 431-442, 561-571. 34 b & w. 6 illus.

ST2277 Greely, General A. W. "The Government Collection of Civil War Photographs." MCCLURE'S MAGAZINE 10, no. 1 (Nov. 1897): 18-19. [Collection of more than 8000 photographs of the Civil war held in the War Department Library. 1000 are from the Corps of Engineers and the Quartermaster's Department, Adjutant-General's Department. 700 Portraits of officers. 50 views of Chattanooga from Capt. Margedant. Includes the Brady Collection of 6000 negatives, for which "the government secured a perfect title to the entire collection in April 1875, at an aggregate expense of nearly $28,000."]

ST2278 Gordon, General John B., of the Confederate Army. "Antietam and Chancellorsville." SCRIBNER'S MAGAZINE 33, no. 6 (June l903): 685-699. 7 b & w. 1 illus. [3 photos (from the wartime period), 4 views of Antietam taken in l903.]

ST2279 Gordon, General John B., of the Confederate Army. "Gettysburg." SCRIBNER'S MAGAZINE 34, no. 1 (July 1903): 2-24. 14 b & w. 2 illus. [Illustrations with three views (from a war-time photograph) probably by A. Gardner; eight portraits of Union and Confederate generals with three views of the battlefield site, taken ca. 1900.]

ST2280 1 group portrait (Pres. Lincoln, Gen. Rosecrans, Robert Pinkerton, ca. 1863). COSMOPOLITAN 38, no. 4 (Feb. 1905): 486. 1 b & w. ["By courtesy of Edward Bass. From a unique photograph found in a farmhouse near Gettysburg, Pa."]

ST2281 Gilder, Richard Watson. "Lincoln the Leader." CENTURY MAGAZINE 77, no. 4 (Feb. 1909): 478-50. 22 illus. [Illustrated with portraits of Lincoln, many of them photographs—several credited to Brady, Hesler, Gardner, etc.]

ST2282 Lanier, Henry Wysham. "Photographing the Civil War." AMERICAN REVIEW OF REVIEWS 43, no. 3 (Mar. 1911): 302-315. 13 b & w. [Includes a portrait of Brady.]

ST2283 Putnam, George Haven. "The Civil War Fifty Years After. A Veteran's Experience as Recalled by Battle Field Pictures." AMERICAN REVIEW OF REVIEWS 43, no. 3 (Mar. 1911): 316-326. 9 b & w. [Putnam was a major in the 176th New York Volunteer Infantry. Photos are not credited to individual photographers.]

ST2284 King, Horatio C. "The Story of the Civil War Told By Photographs." AMERICAN REVIEW OF REVIEWS 44, no. 4 (Oct. 1911): 459-470. 20 b & w. [Summary of "Photographic History of the War." Illustrations are portraits of soldiers.]

ST2285 Sandburg, Carl. "Abraham Lincoln: The War Years." U. S. CAMERA 1, no. 7 (Mar. 1940): 50-55. illus. [From Sandburg's biography of Lincoln, matched to photographs taken from the 1860s.]

ST2286 Vanderbilt, Paul. "Two Photographs of Abraham Lincoln." LIBRARY OF CONGRESS QUARTERLY JOURNAL 10, no. 4 (Aug. 1953): 185-189. 2 b & w. [Discusses an ambrotype by Calvin Jackson, taken in 1858, at Pittsfield, IL, and a photograph by Mathew Brady, taken in Washington, DC, on Feb. 9, 1864. The article includes a summary of other early portraits of Lincoln.]

ST2287 "Prints and Photographs." QUARTERLY JOURNAL OF THE LIBRARY OF CONGRESS 11, no. 1 (Nov. 1953): 36. [Additions to the Civil War Collections. Description of the Mathew Brady Collection. Photos of General Dodge, taken in Cornith, MS in 1863 by G. W. Armstead. Portraits of General Grant from the Ansco Collection, etc.]

ST2288 Bender, Charles. As communicated to R. G. Vail. "Mr. Bender's Sad Story." EYE TO EYE no. 3 (Dec. 1953): 9-12. [Bender describes his activity during the early part of the 20th century, buying thousands of glass-plate negatives that had come from the studios of Brady, Gardner, and others; then scraping off the images to resell the glass.]

ST2289 Lightfoot, Frederick S. "The Stereographic Portrait of Lincoln." IMAGE 6, no. 2 (Feb. 1957): 36-39. 2 b & w.

ST2290 Newhall, Beaumont. "The Photographic History of the Civil War." IMAGE 6, no. 9 (Nov. 1957): 217-220. 3 b & w. [Book Review: "The Photographic History of the Civil War," ed. by Francis Trevelyan Miller. New York: Thomas Yoseloff, 1957. 10 vol.]

ST2291 Ostendorf, Lloyd. "Lincoln in Three Dimensions." LINCOLN HERALD 62, no. 3 (Fall 1860): 109-115. 3 b & w. [33 of the 115 known photos of Lincoln made in stereo discussed.]

SPECIAL TOPICS
HISTORY: BY COUNTRY: USA: 1861 - 1865 (CIVIL WAR).

SPECIAL TOPICS
HISTORY: BY COUNTRY: USA: 1861 - 1865 (CIVIL WAR).

ST2292 Cobb, Josephine. "Notes and Documents: Photographers of the Civil War." MILITARY AFFAIRS 26, no. 3 (Fall 1962): 127-135. [Lists names, cites government records of more than 300 photographers who photographed within military zones during the conflict.]

ST2293 Ray, Frederick. "Rare Photographs of Troops Identified Show Rebel and Yankee Troops in Frederick." CIVIL WAR TIMES ILLUSTRATED 4, no. 1 (Apr. 1965): 22-24. 3 b & w. [Rare (claimed to be only) photograph of Confederate troops on the march in a campaign, taken in Frederick, Md. ca. 1862. Accompanied by two photos of Federal troops which were taken at a later date.]

ST2294 Fern, Alan and Hirst D. Milhollen. "Photographs." QUARTERLY JOURNAL OF THE LIBRARY OF CONGRESS 23, no. 1 (Jan. 1966): 64-65. 1 b & w. [Twelve portraits of Abraham Lincoln received from A. Conger Goodyear bequest. Includes the ambrotype taken by Preston Butler on Aug. 13, 1860, in Springfield, IL, which is discussed in this article.]

ST2295 Ray, Frederick. "Faked Photographs of 'Dead' at Gettysburg." CIVIL WAR TIMES ILLUSTRATED 5, no. 9 (Jan. 1967): 20-21. 4 b & w. [Three stereo views with "corpses" arranged as if killed by the battle, published with an authentic aftermath photograph.]

ST2296 Craig, John S. "Debut: War in 3-D." STEREO WORLD 1, no. 1 (Mar. - Apr. 1974): 2, 4, 10. 2 b & w. [Two views from "Brady's Album Gallery Series." Lists several Civil War photographers, discusses Brady, Gardner, Anthonys, Samuel A. Cooley, Barnard, C. J. Tyson, Ropes & Co., others.]

ST2297 "Faces North and South: A Civil War Portrait Gallery." AMERICAN HISTORY ILLUSTRATED 9, no. 9 (Jan. 1975): 39-41. 10 b & w. [Portraits of Civil War soldiers.]

ST2298 "Civil War Trumpeter." HISTORY OF PHOTOGRAPHY 1, no. 1 (Jan. 1977): 3. 2 b & w. [Image of a musician ca. 1861-62]

ST2299 Holzer, Harold. "The Imagemakers: Portraits of Lincoln in the 1860 Campaign." CHICAGO HISTORY n. s. 7, no. 4 (Winter 1978-1979): 198-207. 3 b & w. 3 illus. [Includes portraits of Lincoln by Samuel M. Fassett, taken in 1859, and by Alexander Hesler, taken in 1860. Discusses lithographs, etc. drawn from those photographs; their use in the presidential campaign.]

ST2300 Ostendorf, Lloyd and Harold Holzer. "Major New Discoveries: Two Hitherto-Unknown, Signed Lincoln Photographs." LINCOLN HERALD 81, no. 2 (Summer 1979): 118-125. 6 b & w.

ST2301 Visochil, Larry A. "Civil War Tintypes: The Common Soldier's 'Instant' Memories." CHICAGO HISTORY n. s. 9, no. 4 (Winter 1980-81): 194-195. 9 b & w.

ST2302 Stapp, William P. "'The Terrible Mementoes': Civil War Photography." CHICAGO HISTORY n. s. 9, no. 4 (Winter 1980-81): 197-211. 11 b & w. [General discussion of photography and photographers during the Civil War.]

ST2303 Collins, Kathleen Fuller. "Civil War Stamp Duty; Photography as a Revenue Source." HISTORY OF PHOTOGRAPHY 4, no. 4 (Oct. 1980): 263-282. 14 b & w. 16 illus. [Between Aug. 1, 1864 and Aug. 1, 1866 photographers were required to affix revenue stamps to photographs, to help finance the Civil War.]

ST2304 Davis, Keith F. "The Chattanooga Album and George N. Barnard." IMAGE 23, no. 2 (Dec. 1980): 20-27. [Album of 45 Civil War photos in George Eastman House Collection.]

ST2305 Terraine, John. "The Camera at War." JOURNAL OF THE ROYAL UNITED SERVICES INSTITUTE FOR DEFENSE STUDIES (GREAT BRITAIN) 125, no. 4 (Dec. 1980): 74-77. 7 b & w. [Discusses distortion, recaptioning of photos by the British press during WWI for propaganda purposes. Also discusses William Frassanito's conclusions in his book about photographic distortions "America's Bloodiest Day: The Battle of Antietam 1862." All photos from WWI.]

ST2306 "Shadows of the Storm: A haunting portfolio of newly discovered Civil War Photographs." AMERICAN HERITAGE 32, no. 4 (June - July 1981): 42-55. 20 b & w. [Portfolio of civil war photographs taken from the forthcoming book "Shadows of the Storm."]

ST2307 "Between the Battles: Far from home and in the face of every kind of privation, the Civil War soldier did his best to re-create the world he left behind him." AMERICAN HERITAGE 33, no. 2 (Feb. - Mar. 1982): 68-79. 20 b & w. [Portfolio of Civil War camp scenes, from the "Guns of '62."]

ST2308 Sauerlender, Philip H. "A Matter of Record, Photography in the Atlas to Accompany the Official Records of the Union and Confederate Armies." HISTORY OF PHOTOGRAPHY 7, no. 2 (Apr. - June 1983): 121-124. 1 b & w. 2 illus. [The Atlas was published 1895 as part of a 128 volume compilation on the Civil War. Briefly discusses Army photographer Royan M. Linn, and George N. Barnard.]

ST2309 Collins, Kathleen. "Shadow and Substance: Sojourner Truth." HISTORY OF PHOTOGRAPHY 7, no. 3 (July - Sept. 1983): 183-205. 16 b & w. 11 illus. [Biography of Sojourner Truth, Negro woman who sold photographic portraits to support her anti-slavery activities. Includes history of the many cartes-de-visite which had been made of her.]

ST2310 Grover, Jan Zita. "The First Living-Room War: The Civil War in the Illustrated Press." AFTERIMAGE 11, no. 7 (Feb. 1984): 8-11. 15 illus. [Analysis of the social impact of the illustrated press on the American citizen's perceptions of the war, with a discussion of the role played by photography.]

ST2311 Collins, Kathleen. "The Massachusetts Hyena." HISTORY OF PHOTOGRAPHY 8, no. 3 (July - Sept. 1984): 227-230. 3 illus. [Union General Butler occupied New Orleans, LA, during the Civil War. Unpopular with the populace, generating caricature cartes-de-visite, etc.]

ST2312 Collins, Kathleen. "The Scourged Back." HISTORY OF PHOTOGRAPHY 9, no. 1 (Jan. - Mar. 1985): 43-45. 1 b & w. 3 illus. [Carte-de-viste portraits of a Negro slave scarred from whippings, taken in occupied New Orleans by McPherson & Oliver in 1863. Distributed as anti-slavery propaganda during the Civil War.]

ST2313 Collins, Kathleen. "Portraits of Slave Children." HISTORY OF PHOTOGRAPHY 9, no. 3 (July - Sept. 1985): 187-210. 29 b & w. 6 illus. [1863-1864, a group of emancipated slave children taken to Philadelphia, PA and New York, NY, photographed as part of a fund raising campaign by M. H. Kimball, J. E. McClees, Charles Paxton, Renowden Studio, J. W. Black, Kellogg Brothers and others.]

ST2314 Gladstone, William. "The Photographers of the Civil War." BOOKMAN'S WEEKLY 76, no. 19 (Nov. 4, 1985): n. p. [2 pages.] [Brief overview. Discusses Capt. William C. Margedant (9th Ohio);

Capt. Albert Campbell (Army of Northern Virginia); Major Jed Hotchkiss (CSA); A. J. Riddle (Macon, GA); 2nd. Lieut Phillip Haas (1st NY); Capt. Andrew J. Russell (Construction Corps); Asst. Surgeon George H. Bixby (Naval Hospital Ship 'Red Rover'); William Bell, E. J. Ward, Lt. Col. Joseph J. Woodward, Maj. Edward Curtis (Army Medical Museum); Alexander Gardner; J. F. Coonley; George N. Barnard; Cressey; Goldrick; E. Meyer; E. T. Whitney; Vreeland & Wearne; Sam. F. Cooley; T. C. Roche; John Wood; others.]

ST2315 Collins, Katheleen. "Photographic Fundraising: Civil War Philanthropy." HISTORY OF PHOTOGRAPHY 11, no. 3 (July - Sept. 1987): 173-187. 8 b & w. 11 illus. [Cartes-de-visite in 1860s used for fundraising to support charitable organizations. Photos by H. C. Phillips; Burnite & Weldon; Bishop & Zimmerman; J. E. McClees; Wendroth, Taylor & Brown; C. J. Tyson; and others.]

ST2316 Collins, Kathleen. "Living Skeletons; Carte-de-visite Propaganda in the American Civil War." HISTORY OF PHOTOGRAPHY 12, no. 2 (Apr. - June 1988): 103-120. 9 b & w. 20 illus. [Includes use of the images in the illustrated press.]

USA:1862.
ST2317 Seely, Charles A. "Editorial Miscellany." AMERICAN JOURNAL OF PHOTOGRAPHY AND THE ALLIED ARTS & SCIENCES n. s. vol. 4, no. 15 (Jan. 1, 1862): 360. [Brief summation of events of 1861-the war, the craze for "card photographs."]

ST2318 Seely, Charles A. "Editorial Miscellany." AMERICAN JOURNAL OF PHOTOGRAPHY AND THE ALLIED ARTS & SCIENCES n. s. vol. 4, no. 16 (Jan. 15, 1862): 384. [Congress not appropriating funds for American photographers' representation at the World's Fair in London in 1862. Photographers otherwise occupied as well. Mr. Kuhns closed his printing business, becoming superintendent of printing division of the Fredericks' Gallery. Wing's Card Camera Box popular.]

ST2319 Seely, Charles A. "Editorial Miscellany." AMERICAN JOURNAL OF PHOTOGRAPHY AND THE ALLIED ARTS & SCIENCES n. s. vol. 4, no. 17 (Feb. 1, 1862): 408. [Proposed photo exchange club between GB and USA. Micro-photograph jewelry appearing in New York, NY, popular.]

ST2320 Warrender, Ann. "My Photographic Album." GOOD WORDS 3, no. 2 (Feb. 1862): 107-112. 1 illus. ["Illustration by T. B. Dalziel (From a Photograph.)"]

ST2321 Sellers, Coleman. "Foreign Correspondence." BRITISH JOURNAL OF PHOTOGRAPHY 9, no. 161-180 (Mar. 1 - Dec. 15, 1862): 95, 117, 137-138, 156-157, 219-220, 238-239, 259-260, 280-281, 298-299, 318-319, 338-339, 375-376, 397-398, 418-419, 437-438, 458-459, 475-476. [With the March 1862 issue Coleman Sellers, a Philadelphia amateur photographer began contributing a regular column to the "BJP." Unlike most such columns, which are most often filled with chemical formulae, etc., Sellers discussed people that he met daily and events that happened around him - thus giving one of the few real informed descriptions of photographic activity in the USA during the Civil War era. The column lasted three years, when Sellers finally stopped writing consistently in mid 1865.]

ST2322 "Miscellaneous Items: Robbing a Daguerreotypist." AMERICAN JOURNAL OF PHOTOGRAPHY AND THE ALLIED ARTS & SCIENCES n. s. vol. 4, no. 19 (Mar. 1, 1862): 454. [A man sat for Mr. Frederick Don at Greenpoint (Brooklyn, NY?) then robbed his office while the photographer was developing the portrait. Caught from his portrait. From "Brooklyn News."]

ST2323 "Minor Correspondence." AMERICAN JOURNAL OF PHOTOGRAPHY AND THE ALLIED ARTS & SCIENCES n. s. vol. 4, no. 21 (Apr. 1, 1862): 502-503. [Letters, unfortunately unattributed, from "the gold regions among the Rocky Mountains," Wisconsin, New Hampshire and Pennsylvania - all claiming that photography is booming.]

ST2324 Seely, Charles A. "Editorial Miscellany." AMERICAN JOURNAL OF PHOTOGRAPHY AND THE ALLIED ARTS & SCIENCES n. s. vol. 4, no. 22 (Apr. 15, 1862): 528. [Portraits received from J. E. Whitney (St. Paul, MN), two being of Dakota Indians; J. A. Sheriff (Pictou, C. W.) sent in Canadian scenery and portraits; D. T. Lawrence (Newburgh, NY), portrait; F. Mowrey (Rutland, VT), portrait.]

ST2325 Seely, Charles A. "Editorial Miscellany." AMERICAN JOURNAL OF PHOTOGRAPHY AND THE ALLIED ARTS & SCIENCES n. s. vol. 4, no. 23 (May 1, 1862): 552. [Dry Process not yet worked out - still too slow for normal use for portrait taking.]

ST2326 "Chauncy Larkin, the Famous Confidence Man." FRANK LESLIE'S ILLUSTRATED NEWSPAPER 13, no. 341 (May 10, 1862): 44. 1 illus. [Portrait, from a photograph, of this individual, with a list of his misdeeds - published at the request of the New York, NY Police Department.]

ST2327 Sellers, Coleman. "Card Pictures in America." HUMPHREY'S JOURNAL OF PHOTOGRAPHY, AND THE ALLIED ARTS AND SCIENCES 14, no. 6 (July 15, 1862): 64. [From "Br. J. of Photo."]

ST2328 "Useful Facts, Receipts, Etc.: A New Application of Photography." AMERICAN JOURNAL OF PHOTOGRAPHY AND THE ALLIED ARTS & SCIENCES n. s. vol. 5, no. 3 (Aug. 1, 1862): 68. [Whit & Yost, publishers of Bibles in Philadelphia, adding pages, perforated to accept thirty-two cartes-de-visite, at the end of their Bibles - for family records.]

ST2329 "The Photographic Art a Blessing to the World - Cartes-de-Visite." AMERICAN JOURNAL OF PHOTOGRAPHY AND THE ALLIED ARTS & SCIENCES n. s. vol. 5, no. 4 (Aug. 15, 1862): 76-78. [From "Scientific American."]

ST2330 "Cases! Cases!" HUMPHREY'S JOURNAL OF PHOTOGRAPHY, AND THE ALLIED ARTS AND SCIENCES 14, no. 10 (Sept. 15, 1862): 112. ["Just now there is an unprecedented demand for Cases of all kinds...none at all in first hands..."]

ST2331 "Cartes de Visite." HUMPHREY'S JOURNAL OF PHOTOGRAPHY, AND THE ALLIED ARTS AND SCIENCES 14, no. 11 (Oct. 1, 1862): 123-124.

ST2332 "Photography in America." AMERICAN JOURNAL OF PHOTOGRAPHY AND THE ALLIED ARTS & SCIENCES n. s. vol. 5, no. 9 (Nov. 1, 1862): 198-200. [From "Photo. News." Editor describes a discussion he had with Prof. Edwin Emerson, American amateur. Describes the prevalence of dry tannin process in use, by amateurs, etc.]

ST2333 Seely, Charles A. "Minor Correspondence." AMERICAN JOURNAL OF PHOTOGRAPHY AND THE ALLIED ARTS & SCIENCES n. s. vol. 5, no. 10 (Nov. 15, 1862): 340. [Reply to a letter from E. E. of NY, who writes in a quandary about his customers taking offense at a stereo card of Roman statuary, which he kept with others in his office for the amusement of his customers.]

ST2334 "Photographic representation of Ghosts! Answer to H. B. King." HUMPHREY'S JOURNAL OF PHOTOGRAPHY, AND THE ALLIED ARTS AND SCIENCES 14, no. 15 (Dec. 1, 1862): 190-191. [Describes possible ways to create "spirit photographs."]

ST2335 "The Tax on Photographers." AMERICAN JOURNAL OF PHOTOGRAPHY AND THE ALLIED ARTS & SCIENCES n. s. vol. 5, no. 11 (Dec. 1, 1862): 257-258. [Letter protesting unjust aspects of the photography stamp tax.]

ST2336 Seely, Charles A. "Editorial Department." AMERICAN JOURNAL OF PHOTOGRAPHY AND THE ALLIED ARTS & SCIENCES n. s. vol. 5, no. 11 (Dec. 1, 1862): 263-264. [Talks about interest in "spirit photos." Is skeptical.]

ST2337 "Professor Silver's Photographic Discoveries." AMERICAN JOURNAL OF PHOTOGRAPHY AND THE ALLIED ARTS & SCIENCES n. s. vol. 5, no. 12 (Dec. 15, 1862): 281-283. [Scathing attack on a "process peddler."]

ST2338 Sellers, Coleman. "Foreign Correspondence." BRITISH JOURNAL OF PHOTOGRAPHY 10, no. 181-204 (Jan. 1 - Dec. 15, 1863): 19-20, 41-42, 62-63, 85-86, 108-109, 130-131, 150-151, 174-175, 197-198, 217-218, 239, 257-259, 277-278, 296-297, 313-314, 336-337, 354-355, 374-375, 394-395, 415-416, 435, 456-457, 476-477, 494-495. [Some of the many issues discussed were civil war photographers, Mumler's spirit photographs, Dr. John Dean's book on nerves, manufacturing albumenized paper, etc.]

ST2339 "Wanted - A Photographer!, by Baron Kahlkopf." HUMPHREY'S JOURNAL OF PHOTOGRAPHY, AND THE ALLIED ARTS AND SCIENCES 14, no. 17 (Jan. 1, 1863): 217-220. [Comic commentary, anecdotal story. "Baron Kahlkopf" is, I think, a fictional name.]

ST2340 "My First Carte de Visite, by An Outsider." AMERICAN JOURNAL OF PHOTOGRAPHY AND THE ALLIED ARTS & SCIENCES n. s. vol. 5, no. 15 (Feb. 1, 1863): 337-343. [Long comic narrative story.]

ST2341 "From Our New Correspondent." AMERICAN JOURNAL OF PHOTOGRAPHY AND THE ALLIED ARTS & SCIENCES n. s. vol. 5, no. 16 (Feb. 15, 1863): 361-363. [A story, couched in the form of a letter to the editor from "Lizzie," describing her difficulties with being photographed.]

ST2342 "Sitting for a Picture." AMERICAN JOURNAL OF PHOTOGRAPHY AND THE ALLIED ARTS & SCIENCES n. s. vol. 5, no. 16 (Feb. 15, 1863): 367-368. [From the "Mercury." Commentary on difficulties of sitting for a professional portrait photographer.]

ST2343 "My First Cartes de Visite, and What Became of Them, by an Outsider." AMERICAN JOURNAL OF PHOTOGRAPHY AND THE ALLIED ARTS & SCIENCES n. s. vol. 5, no. 17 (Mar. 1, 1863): 385-392. [Not credited, comic fictional short story.]

ST2344 "Spring Trade." HUMPHREY'S JOURNAL OF PHOTOGRAPHY, AND THE ALLIED ARTS AND SCIENCES 14, no. 21 (Mar. 1, 1863): 288. [Business booming.]

ST2345 "A Few Cartes-de-Visite." HARPER'S MONTHLY 26, no. 155 (Apr. 1863): 717-718. 2 illus. [Two full-page cartoon drawings of comic characters, presented as on the then current carte-de-visite craze.]

ST2346 [Towler, J.] "Photographic Spirits." HUMPHREY'S JOURNAL OF PHOTOGRAPHY, AND THE ALLIED ARTS AND SCIENCES 14, no. 23 (Apr. 1, 1863): 312-314. [Commentary on the current interest in "spirit photographs."]

ST2347 "Letter from Down East." HUMPHREY'S JOURNAL OF PHOTOGRAPHY, AND THE ALLIED ARTS AND SCIENCES 15, no. 1 (May 1, 1863): 12-13. [Professional from Boston, MA., signed his letter "Plus Ultra." describes practice of giving proofs to customers for decisions and the abuse of that practice.]

ST2348 Register, Seely. "The Spirit Photograph." HARPER'S MONTHLY 27, no. 157 (June 1863): 122-124. [Fictional short story, where a wife, supposedly lost at sea, appears in a photograph, then later returns safely.]

ST2349 Seely, Charles A. "Editorial Department." AMERICAN JOURNAL OF PHOTOGRAPHY AND THE ALLIED ARTS & SCIENCES n. s. vol. 6, no. 2 (July 15, 1863): 47. ["For three days ending with this 15th of July, in New York, law and decency has been almost completely overawed by one of the most brutal mobs which ever disgraced an American city. In this fearful time, of course, photography has stood still; the sun has shone to no good purpose."]

ST2350 "State of Business." HUMPHREY'S JOURNAL OF PHOTOGRAPHY, AND THE ALLIED ARTS AND SCIENCES 15, no. 6 (July 15, 1863): 96. [Slow period for business last three months.]

ST2351 J. S. "Naturalism and Genius." NEW PATH (SOCIETY FOR THE ADVANCEMENT OF TRUTH IN ART) 1, no. 4, 6 (Aug., Oct. 1863): 37-44, 64-70. [The author argues that American painters should produce more natural work, primarily landscapes based on close observation, rather than paintings based on artistic conventions. During this argument, the author discusses the values of photography and suggests that the illustrated magazines have merit, if they accurately portray historical events.]

ST2352 Seely, Charles A. "Editorial Department." AMERICAN JOURNAL OF PHOTOGRAPHY AND THE ALLIED ARTS & SCIENCES n. s. vol. 6, no. 4 (Aug. 15, 1863): 94-96. [Seely attended a popular play where "ghosts" formed the main attraction - Seely describes how the effect was achieved, by using reflections through plate glass. Photography, per se, wasn't involved - but optical principles were used.]

ST2353 "The City of Chicago, United States." ILLUSTRATED LONDON NEWS 43, no. 1218 (Aug. 22, 1863): 203-204. 2 illus. [Not credited, but views from photographs.]

ST2354 "An Interesting Experiment." AMERICAN JOURNAL OF PHOTOGRAPHY AND THE ALLIED ARTS & SCIENCES n. s. vol. 6, no. 7 (Oct. 1, 1863): 166-167. [From "Evansville (IN) Journal." Report that, at the request of individuals who had heard the story of the image of the murderer remaining on the retina of a victim, a Mr. Adams, of Evansville, ambrotyped a murdered man, then enlarged his negative and found therein a portrait. The editor is doubtful.]

ST2355 Seely, Charles A. "Editorial Department." AMERICAN JOURNAL OF PHOTOGRAPHY AND THE ALLIED ARTS & SCIENCES n. s. vol. 6, no. 7 (Oct. 1, 1863): 167-168. ["The grand problem in photographic portraiture for the past twenty years has been how to make a photograph with the shortest exposure of the model...." Essay then goes on to give a brief summary of chemical improvements and argues that more attention should be paid to experiments with light.]

ST2356 B. "Children's Pictures." AMERICAN JOURNAL OF PHOTOGRAPHY AND THE ALLIED ARTS & SCIENCES n. s. vol. 6, no. 9 (Nov. 1, 1863): 200-202. [Comic description of trials and tribulations facing portrait photographers who take portraits of young children.]

ST2357 "Miscellaneous: The Queen and the Yankee." AMERICAN JOURNAL OF PHOTOGRAPHY AND THE ALLIED ARTS & SCIENCES n. s. vol. 6, no. 10 (Nov. 15, 1863): 240-241. [From "Br. J. of Photo." Report on a story, told by Nathaniel Hawthorne, about a "queer, stupid" fellow from America who somehow felt a kinship to Queen Victoria and who went to England to try to see her.]

ST2358 "Prof. Silver's New Five Dollar Processes. - More Humbug Exposed." AMERICAN JOURNAL OF PHOTOGRAPHY AND THE ALLIED ARTS & SCIENCES n. s. vol. 6, no. 12 (Dec. 15, 1863): 281-283.

USA: 1864.
BOOKS
ST2359 *Home Scenes, Or, Lights and Shadows of the Christian Home.* New York: American Tract Society, 1864. 160 pp. 14 b & w. [Original photos, of paintings, engravings, etc. vignetted into the poems, short stories, etc.]

PERIODICALS
ST2360 Sellers, Coleman. "Foreign Correspondence." BRITISH JOURNAL OF PHOTOGRAPHY 11, no. 205 (Jan. 1 - Dec. 30, 1864): 18, 30-31, 52, 86-87, 105-106, 120-121, 159-160, 177-178, 195, 212, 225, 251, 274, 322, 370-371, 393, 416, 441, 466-467, 489-490, 547. [Coleman Sellers, an amateur from Philadelphia, contributed these letters to the "BJP" on a regular basis. Unlike most such reports, Sellers did not spend much time discussing processes and techniques. Rather he reported on events and activities occurring in the USA, particularly in Philadelphia, and, as such, these are a remarkably good source to the history of that time.]

ST2361 "Exposure of Another Villainous Plot." AMERICAN JOURNAL OF PHOTOGRAPHY AND THE ALLIED ARTS & SCIENCES n. s. vol. 6, no. 16 (Feb. 15, 1864): 369. [From "Tribune." Someone collecting photographs of women, to set up the equivalent of a "dating service."]

ST2362 "Girls! don't you do it." HUMPHREY'S JOURNAL OF PHOTOGRAPHY, AND THE ALLIED ARTS AND SCIENCES 15, no. 20 (Feb. 15, 1864): 314-315. [From the "Sun." "The Photographic Union is designed to become a gallery of the portraits of young females,...."]

ST2363 Seely, Charles A. "Editorial Department." AMERICAN JOURNAL OF PHOTOGRAPHY AND THE ALLIED ARTS & SCIENCES n. s. vol. 6, no. 19 (Apr. 1, 1864): 455-456. [Plea for support for the Sanitary Fair (sort of a precursor of the Red Cross, to raise funding for medical services during the Civil War.) by the photographic community.]

ST2364 Seely, Charles A. "Editorial Department." AMERICAN JOURNAL OF PHOTOGRAPHY AND THE ALLIED ARTS & SCIENCES n. s. vol. 6, no. 20 (Apr. 15, 1864): 479. ["During the present week at the Stock Exchange, gold has touched 180; to buy a gold dollar requires one dollar and eighty cents of our old fashioned bank notes, or of our fashionable and precious greenbacks...." Goes on to describe rising cost of materials, taxes, etc.]

ST2365 "Ruins of Colonel Colt's Firearms Factory at Hartford, United States." ILLUSTRATED LONDON NEWS 44, no. 1255 (Apr. 16, 1864): 359-360. 1 illus.

ST2366 Seely, Charles A. "Editorial Department." AMERICAN JOURNAL OF PHOTOGRAPHY AND THE ALLIED ARTS & SCIENCES n. s. vol. 6, no. 20 [sic 21] (May 1, 1864): 503-504. [Report that the Sanitary Commission Fair was successful, raising over one million dollars. Praises Gurney & Sons for opening a photographic gallery at the Fair, the proceeds of which went to the fund. Mentions Philadelphia about to hold a similar Fair, and that the association has already approached the Phila. Photo. Soc.]

ST2367 "Photographing the Eyes of Murdered Persons." HUMPHREY'S JOURNAL OF PHOTOGRAPHY, AND THE ALLIED ARTS AND SCIENCES 16, no. 1 (May 1, 1864): 11-12. [From "San Francisco Bulletin."]

ST2368 "Photographs in Natural Colors at Last! - Instantaneous Pictures in the Gallery! The Great Process Promulgated by the Spirits - Oil of Pinks Forever!" AMERICAN JOURNAL OF PHOTOGRAPHY AND THE ALLIED ARTS & SCIENCES n. s. vol. 6, no. 23 (June 1, 1864): 544-547. [Long, involved satire on fictitious discoveries (with assistance of mediums and spirits, etc.). Unclear to me if this is directed to "process sellers" in general, or if Seely has a particular individual in mind.]

ST2369 "Photographs of a Few Celebrated Artists." AMERICAN JOURNAL OF PHOTOGRAPHY AND THE ALLIED ARTS & SCIENCES n. s. vol. 6, no. 24 (June 15, 1864): 562-564. [General suggestions on qualities needed for good portraits, couched in anecdotal terms. Article signed "42nd St."]

ST2370 "Date your Photographs." AMERICAN JOURNAL OF PHOTOGRAPHY AND THE ALLIED ARTS & SCIENCES n. s. vol. 7, no. 1 (July 1, 1864): 13-14. [From "The Easy Chair" in "Harper's Monthly."]

ST2371 Medhurst, John. "A Delicate Operation in Photography." AMERICAN JOURNAL OF PHOTOGRAPHY AND THE ALLIED ARTS & SCIENCES n. s. vol. 7, no. 1 (July 1, 1864): 20-21. [Grieving father, hoping that some way of creating a better image from a portrait of his dead son can be found.]

ST2372 "Photographic Eminence." AMERICAN JOURNAL OF PHOTOGRAPHY AND THE ALLIED ARTS & SCIENCES n. s. vol. 7, no. 2 (July 15, 1864): 45. [From "Brooklyn Eagle." Commentary on cartes-de-visite phenomenon. Collecting of celebrities, including actors, comedians and patent medicine salesmen. "No pill box is made so small but there is room enough on it for the portrait of the gifted compounder..."]

ST2373 Seely, Charles A. "Editorial Department." AMERICAN JOURNAL OF PHOTOGRAPHY AND THE ALLIED ARTS & SCIENCES n. s. vol. 7, no. 2 (July 15, 1864): 45-46. [Note that photographers raising their prices. Note that the stamp tax on photographs will begin on August 1.]

ST2374 "Photographic Eminence." HUMPHREY'S JOURNAL OF PHOTOGRAPHY, AND THE ALLIED ARTS AND SCIENCES 16, no. 6 (July 15, 1864): 93-94. [Wry commentary upon active use of cartes, etc by actors, comedians, etc. for publicity. "The private supply of cartes de visite is nothing to the deluge of portraits of public characters which are thrown upon the market; piled up by the bushel in the print

stores, offered by the gross at the book stands, and thrust upon our attention everywhere."]

ST2375 "Mechanical Drawing versus Photography." AMERICAN JOURNAL OF PHOTOGRAPHY AND THE ALLIED ARTS & SCIENCES n. s. vol. 7, no. 3 (Aug. 1, 1864): 60-61. [From "American Artisan."]

ST2376 "Photography vs. The Printing Press." AMERICAN JOURNAL OF PHOTOGRAPHY AND THE ALLIED ARTS & SCIENCES n. s. vol. 7, no. 7 (Oct. 1, 1864): 151-152. [From "Phila. Ledger." With increased costs and scarcity of paper due to the war, many newspapers need some solutions to problem. Suggestion to try microphotography. Mentions "Mr. Langenheim,...has succeeded in impressing the whole of the Lord's prayer upon a photographic print scarcely larger than the head of a pin,..."]

ST2377 "Comic Photographs." AMERICAN JOURNAL OF PHOTOGRAPHY AND THE ALLIED ARTS AND SCIENCES n. s. vol. 7, no. 7 (Oct. 1, 1864): 158. [Notice taken from "The Eagle" discussing two comic composition photos of a political design. One represents McClellan, Fremont, Lincoln & Butler running through horse collars for the presidency... The other figure represents Jeff Davis & Satan playing chess while Lincoln observes.]

ST2378 [Wilson, Edward L.] "Things You Ought to Know." PHILADELPHIA PHOTOGRAPHER 1, no. 8 (Aug. 1864): 113-114. [General descriptions of various processes; advice to patrons on what to expect in a portrait studio,]

ST2379 "Contemporary Press: On Defects of Photographic Portraits, from a American Point of View; Portraits Devoid of Taste." BRITISH JOURNAL OF PHOTOGRAPHY 11, no. 222 (Aug. 5, 1864): 284. [From "Humphrey's Journal."]

ST2380 "The Tax Law and Photography." AMERICAN JOURNAL OF PHOTOGRAPHY AND THE ALLIED ARTS & SCIENCES n. s. vol. 7, no. 5 (Sept. 1, 1864): 117-118. [Details of the law.]

ST2381 "Government Tax on Photographs." HUMPHREY'S JOURNAL OF PHOTOGRAPHY, AND THE ALLIED ARTS AND SCIENCES 16, no. 9 (Sept. 1, 1864): 136-137. [Letters on the tax, from Bendann Brothers (Baltimore, MD), reply from E. A. Rollins, Deputy Commissioner, IRS.]

ST2382 "State of Trade." HUMPHREY'S JOURNAL OF PHOTOGRAPHY, AND THE ALLIED ARTS AND SCIENCES 16, no. 9 (Sept. 1, 1864): 143. [Business improved this quarter.]

ST2383 "Government Tax on Pictures." HUMPHREY'S JOURNAL OF PHOTOGRAPHY, AND THE ALLIED ARTS AND SCIENCES 16, no. 12 (Oct. 15, 1864): 181-182. [Letters from R. A. Lewis (New York, NY); J. C. Gray & Co. (Jamestown, NY); etc.]

ST2384 "State of Trade." HUMPHREY'S JOURNAL OF PHOTOGRAPHY, AND THE ALLIED ARTS AND SCIENCES 16, no. 15 (Dec. 1, 1864): 240. [Dull, slow season.]

ST2385 "Date Your Photographs." HUMPHREY'S JOURNAL OF PHOTOGRAPHY, AND THE ALLIED ARTS AND SCIENCES 16, no. 16 (Dec. 15, 1864): 254. [From "Harper's Monthly."]

USA: 1865.
BOOKS
ST2386 Century Association, New York. *The Bryant Festival at 'The Century';* Illustrated Edition. New York: Century Association, 1865. 88 pp. 13 b & w. [Original photos, one view, twelve portraits.]

PERIODICALS
ST2387 Seely, Charles A. "Editorial Department." AMERICAN JOURNAL OF PHOTOGRAPHY AND THE ALLIED ARTS & SCIENCES n. s. vol. 7, no. 13 (Jan. 1, 1865): 311. ["Photographs on white or opal glass seem lately to be much talked about...." About three years since Mr. J. W. Black, of Boston, made them a branch of his business. He was eminently successful, and his success induced others to follow in the same direction." Alex Hester (Chicago, IL), Thomas Faris (New York, NY), Wenderoth (Philadelphia, PA) etc.]

ST2388 Sellers, Coleman. "Foreign Correspondence." BRITISH JOURNAL OF PHOTOGRAPHY 12, no. 244-251, 259 (Jan. 6 - Feb. 24, Apr. 21, June 23, 1865): 34-35, 104, 210-211, 226, 333-334. [In the Feb. 24th issue, it is announced that Sellers was discontinuing his regular column, to be replaced by M. Carey Lea, but that he would continue to submit occasional articles.]

ST2389 "Rendering of Complexion in Photography." AMERICAN JOURNAL OF PHOTOGRAPHY AND THE ALLIED ARTS & SCIENCES n. s. vol. 7, no. 16 (Feb. 15, 1865): 364-365. [Quotes "Photo. News" (Nov. 11) and G. A. Sala in the "Daily Telegraph" (Nov. 23, 1864), who describes General McClellan's complexion as fair and how it is inevitably rendered as sallow and dark by the camera.]

ST2390 "The Dead Eye Again." AMERICAN JOURNAL OF PHOTOGRAPHY AND THE ALLIED ARTS & SCIENCES n. s. vol. 7, no. 16 (Feb. 15, 1865): 382-383. [From "NY Herald (Feb. 6, 1865)." Another repetition of the myth of the murderer's image retained in the retina of the murder victim.]

ST2391 "How to Dress for a Photograph." FRANK LESLIE'S ILLUSTRATED NEWSPAPER 19, no. 490 (Feb. 18, 1865): 349-350.

ST2392 Lea, M. Carey. "Foreign Correspondence." BRITISH JOURNAL OF PHOTOGRAPHY 12, no. 251-295 (Feb. 24 - Dec. 29, 1865): 104-105, 170-171, 193-194, 225-226, 237-238, 254, 306-307, 334-335, 345-346, 359, 371, 396-397, 444-445, 467-468, 492, 503, 515-516, 540, 551, 576-577, 600, 611-612, 622, 636-637, 649, 660-661. [M. Carey Lea replaced Coleman Sellers as the regular American columnist for the "BJP." His column contains information about activities and events, but, as was more common to the period, often shifted into discussion of technical and chemical matters.]

ST2393 Seely, Charles A. "Editorial Department." AMERICAN JOURNAL OF PHOTOGRAPHY AND THE ALLIED ARTS & SCIENCES n. s. vol. 7, no. 17 (Mar. 1, 1865): 407-408. ["Several of our city galleries have recently introduced, as a novelty, photographs showing two positions of the same person on one card, and printed from one negative."]

ST2394 "Photographing on Ice." HUMPHREY'S JOURNAL OF PHOTOGRAPHY, AND THE ALLIED ARTS AND SCIENCES 16, no. 21 (Mar. 1, 1865): 326-327. [An unnamed photographer photographs ice skaters on the 5th Avenue pond in New York, NY. He sounds a horn when he is ready, everyone freezes and he takes the photograph.]

ST2395 McQuillen, Dr. J. H. "Photography in Dentistry." PHILADELPHIA PHOTOGRAPHER 2, no. 16 (Apr. 1865): 57. [From

McQuillen's address "The Anatomy and Physiology of Expression," given to the Philadelphia Dental College.]

ST2396 "The Trials of the Wife of an Amateur Photographer." PHILADELPHIA PHOTOGRAPHER 2, no. 16 (Apr. 1865): 57-60. [Humorous letter, signed "A Sufferer."]

ST2397 "The Iowa Photographers in Convention at the Hub of Iowa." HUMPHREY'S JOURNAL OF PHOTOGRAPHY, AND THE ALLIED ARTS AND SCIENCES 17, no. 2 (May 15, 1865): 25-26. [Satiric profile of a typical report of a society meeting, with many puns.]

ST2398 "Female Employment in Coloring Photographs." HUMPHREY'S JOURNAL OF PHOTOGRAPHY, AND THE ALLIED ARTS AND SCIENCES 17, no. 2 (May 15, 1865): 31-32. [Report of a letter to the "Standard" by Madame Una Howard, proposing "that some systematic effort should by made to teach the art of coloring photographs to destitute ladies...."]

ST2399 P. P. P. "Novelties." AMERICAN JOURNAL OF PHOTOGRAPHY AND THE ALLIED ARTS & SCIENCES n. s. vol. 7, no. 23 (June 1, 1865): 536-538. [Comic satiric essay on process mongers.]

ST2400 "Photography for the Deaf and Dumb." AMERICAN JOURNAL OF PHOTOGRAPHY AND THE ALLIED ARTS & SCIENCES n. s. vol. 7, no. 23 (June 1, 1865): 539. [Note from H. L. Boltwood, late partner to Seely, now in New Orleans, that the Deaf and Dumb Asylum in Baton Rouge, La. teaching photography to its patients.]

ST2401 "History of a Carte de Visite." HARPER'S WEEKLY 9, no. 444 (July 1, 1865): 411. [A comic description, narrated by the carte, of its experiences.]

ST2402 "State of Trade." HUMPHREY'S JOURNAL OF PHOTOGRAPHY, AND THE ALLIED ARTS AND SCIENCES 17, no. 5 (July 1, 1865): 78. [Business improving. End of war is making it more easy to obtain certain materials. Expectation of more trade with the South, etc.]

ST2403 "Painting." AMERICAN JOURNAL OF PHOTOGRAPHY AND THE ALLIED ARTS & SCIENCES n. s. vol. 8, no. 2 (July 15, 1865): 31-32. [From "Frazer's Magazine." Discusses concepts of beauty in painting, etc.]

ST2404 "American Patents pertaining to Photography." AMERICAN JOURNAL OF PHOTOGRAPHY AND THE ALLIED ARTS & SCIENCES n. s. vol. 8, no. 2-19 (July 15, 1865 - Apr. 1, 1866): 46, 58-59, 131-132, 357-359, 419-421, 451-455.

ST2405 "Photography and the Affections." HUMPHREY'S JOURNAL OF PHOTOGRAPHY, AND THE ALLIED ARTS AND SCIENCES 17, no. 6 (July 15, 1865): 93.

ST2406 "The Story of a Carte-de-Visite." PHILADELPHIA PHOTOGRAPHER 2, no. 20 (Aug. 1865): 127-130.

ST2407 Seely, Charles A. "Editorial Department." AMERICAN JOURNAL OF PHOTOGRAPHY AND THE ALLIED ARTS & SCIENCES n. s. vol. 8, no. 3 (Aug. 1, 1865): 72. ["The war now being ended, we are anxiously looking after our former friends at the South, with whom we have been unable to communicate for the past few years...]

ST2408 "State of Trade." HUMPHREY'S JOURNAL OF PHOTOGRAPHY, AND THE ALLIED ARTS AND SCIENCES 17, no. 8 (Aug. 15, 1865): 127-128. [Business dull. Travelled to Boston, where the galleries were doing "a very moderate business." Prices of goods lower.]

ST2409 "Magnesium for Illuminating Purposes." HUMPHREY'S JOURNAL OF PHOTOGRAPHY, AND THE ALLIED ARTS AND SCIENCES 17, no. 9 (Sept. 1, 1865): 143. ["This metal is coming into great demand for Photographic purposes...."]

ST2410 "How to Dress for a Photograph." FRANK LESLIE'S ILLUSTRATED NEWSPAPER 20, no. 519 (Sept. 9, 1865): 391. [Advice on what to wear, etc.]

ST2411 "American Photographs in Germany." AMERICAN JOURNAL OF PHOTOGRAPHY AND THE ALLIED ARTS & SCIENCES n. s. vol. 8, no. 6 (Sept. 15, 1865): 135-136. [From "NY Herald Correspondence." Report of American participation of International Photographic Exhibition in Berlin. Prof. Joy, V. P. of Am. Photo. Soc. went to Berlin, brought works by Lewis M. Rutherford, (views of moon) and by Mr. Newton (views of Arsenal of New York shrouded at A. Lincoln's death).]

ST2412 "Decision in Reference to Photographs and other Sun Pictures." PHILADELPHIA PHOTOGRAPHER 2, no. 22 (Oct. 1865): 168-169. [Describes the stamp tax on photographs.]

ST2413 "Photography and Popularity." HUMPHREY'S JOURNAL OF PHOTOGRAPHY, AND THE ALLIED ARTS AND SCIENCES 17, no. 13 (Nov. 1, 1865): 207. [From "Daily Telegraph." "The moment anyone achieves a name, the public wants to have his portrait...."]

ST2414 "The Privileges of the Wife of an Amateur Photographer." PHILADELPHIA PHOTOGRAPHER 2, no. 24 (Dec. 1865): 194-195.

ST2415 "The Revenue Law and Photography - A Petition for Amendment." AMERICAN JOURNAL OF PHOTOGRAPHY AND THE ALLIED ARTS & SCIENCES n. s. vol. 8, no. 12 (Dec. 15, 1865): 283-285.

ST2416 "Elizabeth Street, Brownsville, Texas." HARPER'S WEEKLY 9, no. 468 (Dec. 16, 1865): 796. 1 illus. ["From a Photograph."]

ST2417 "The Stamp Nuisance." HUMPHREY'S JOURNAL OF PHOTOGRAPHY, AND THE ALLIED ARTS AND SCIENCES 17, no. 16 (Dec. 15, 1865): 246-248. [Petition of Photographers of Albany and Troy, NY, to abolish the tax. Signed by C. C. Schoonmaker, J. B. Bigelow, G. W. Pine and 33 others.]

USA: 1866.
BOOKS
ST2418 Dixon, Edward Henry. *Back-Bone; Photographed from "The Scalpel,"* by Edward H. Dixon. New York: R. M. De Witt, 1866. xviii, 396 pp. 1 b & w.

PERIODICALS
ST2419 Seely, Charles A. "Editorial Department." AMERICAN JOURNAL OF PHOTOGRAPHY AND THE ALLIED ARTS & SCIENCES n. s. vol. 8, no. 15 (Feb. 1, 1866): 360. [Commentary on the use of bromide in collodion. "Many persons think that we are on the eve of a revolution in our notions about collodion...."]

ST2420 "How to Sit, and What to Wear." PHILADELPHIA PHOTOGRAPHER 3, no. 26 (Feb. 1866): 48.

ST2421 "Can a Photograph be Copyrighted under the Old Law?" AMERICAN JOURNAL OF PHOTOGRAPHY AND THE ALLIED ARTS & SCIENCES n. s. vol. 8, no. 17 (Mar. 1, 1866): 404-405. [The New York Photographic Company (J. H. Wood & M. S. Abbott) vs. Joseph Hall (former partner). Case not yet decided.]

ST2422 "Taxes and Photographers." AMERICAN JOURNAL OF PHOTOGRAPHY AND THE ALLIED ARTS & SCIENCES n. s. vol. 8, no. 17 (Mar. 1, 1866): 405-407.

ST2423 "The Stamp Infliction." PHILADELPHIA PHOTOGRAPHER 3, no. 27 (Mar. 1866): 89-90. [Committee of photographers attempting to persuade Congress to abolish the stamp tax on photographs.]

ST2424 "Editor's Table: Artists vs. Photographers." PHILADELPHIA PHOTOGRAPHER 3, no. 28 (Apr. 1866): 128. [Mentions American painters who utilize photography: Wilcocks, the Morans, "Schessele accompanies Glover," etc.]

ST2425 "Repeal of the Stamp Act." PHILADELPHIA PHOTOGRAPHER 3, no. 28 (Apr. 1866): 115-116. [Includes a letter from G. H. Loomis (Boston, MA), a principle figure in fighting the law.]

ST2426 "The Revenue Tax upon Photographs." PHILADELPHIA PHOTOGRAPHER 3, no. 30 (June 1866): 174-175. [Includes a letter from G. H. Loomis, petitioning abolishment of the tax.]

ST2427 C. S., Jr. "Then and Now." PHILADELPHIA PHOTOGRAPHER 3, no. 30 (June 1866): 175-176. [Notes that 15,000 photo establishments existed in the USA in 1866. Remembers when, wishing to learn the daguerreotype process in 1842, he was dissuaded because Philadelphia, PA, already had one operator and he was advised in the course of a few months all the people who wanted daguerreotypes would be supplied and then the trade would die out.]

ST2428 "Copyrighting Photographs." HUMPHREY'S JOURNAL OF PHOTOGRAPHY, AND THE ALLIED ARTS AND SCIENCES 18, no. 5 (July 1, 1866): 73-74.

ST2429 "Death of the Stamp Nuisance." PHILADELPHIA PHOTOGRAPHER 3, no. 31 (July 1866): 217.

ST2430 "Catskill Mountains." HARPER'S WEEKLY 10, no. 499 (July 21, 1866): 456-457. 26 illus. [Double-page spread of 26 small sketches of views, recreational activities available in the Catskills, drawn by Thomas Nast. One of these sketches depicts a photographer, with his camera on a tripod, posing an outdoor group portrait of men and women hikers.]

ST2431 "American Patents pertaining to Photography." AMERICAN JOURNAL OF PHOTOGRAPHY AND THE ALLIED ARTS & SCIENCES n. s. vol. 9, no. 1 (Sept. 1, 1866): 6-8. [Continued from p. 455, vol. 8.]

ST2432 "Photographs not Entitled to Copyright under the Act of 1831. United States Circuit Court - Southern District of New York. Before Judge Shipman." AMERICAN JOURNAL OF PHOTOGRAPHY AND THE ALLIED ARTS & SCIENCES n. s. vol. 9, no. 1 (Sept. 1, 1866): 15-19.

ST2433 "The Stamp Nuisance Abolished!" HUMPHREY'S JOURNAL OF PHOTOGRAPHY, AND THE ALLIED ARTS AND SCIENCES 18, no. 9 (Sept. 1, 1866): 139.

ST2434 "The New Revenue Law." PHILADELPHIA PHOTOGRAPHER 3, no. 33 (Sept. 1866): 279-281.

ST2435 "Chattanooga, Tennessee, from Lookout Mountain." FRANK LESLIE'S ILLUSTRATED NEWSPAPER 22, no. 570 (Sept. 8, 1866): 392. 1 illus. [Distant view of the city, from a spot on the mountain, with a figure sitting in the foreground. This image not credited from a photograph, but it probably was.]

ST2436 "The Tax on Photographs." HUMPHREY'S JOURNAL OF PHOTOGRAPHY, AND THE ALLIED ARTS AND SCIENCES 18, no. 10 (Sept. 15, 1866): 159. [Apparently, there would be a tax of five per cent on photographs, not as previously stated.]

ST2437 "Our Southern Subscribers." HUMPHREY'S JOURNAL OF PHOTOGRAPHY, AND THE ALLIED ARTS AND SCIENCES 18, no. 10 (Sept. 15, 1866): 160. ["We are surprised on looking over our lists to notice how many of our Southern friends have found their way back to us....Let by-gones be by-gones, and let all support one Flag and one Constitution."]

ST2438 "The New Size." PHILADELPHIA PHOTOGRAPHER 3, no. 34 (Oct. 1866): 311-313. [Carte-de-visite diminishing popularity suggestion that the new cabinet size should be pushed to replace the carte-de-visite, as being done in England. Followed up with reply, page 357, November 1866 "Philadelphia Photographer," and more notes, page 390, December 1866 "Philadelphia Photographer."]

ST2439 "Photography as an Agent of the Police." AMERICAN JOURNAL OF PHOTOGRAPHY, AND THE ALLIED ARTS AND SCIENCES n. s. vol. 9, no. 4 (Oct. 15, 1866): 88-89. [Shoplifters in Albany, NY identified through "mug shots," apprehended.]

ST2440 K. H. W. [Wilson, Edward L.?] "A Day With the Camera." PHILADELPHIA PHOTOGRAPHER 3, no. 35 (Nov. 1866): 343-344. [Describes a photographic outing of four photographers, near Kibouren City, MI.]

ST2441 K. H. W. [Wilson, Edward L.?] "Westward." PHILADELPHIA PHOTOGRAPHER 3, no. 35 (Nov. 1866): 351-354. [Continuation of previous article, describes trip to Cleveland, OH, then to Chicago, IL; where J. Carbutt joined the party and accompanied them to WI.]

ST2442 "Editor's Table: The New Size." PHILADELPHIA PHOTOGRAPHER 3, no. 35 (Nov. 1866): 357. [Response and examples of the new Cabinet photos from photographers around the country.]

ST2443 Seely, Charles A. "Editorial Department." AMERICAN JOURNAL OF PHOTOGRAPHY, AND THE ALLIED ARTS AND SCIENCES n. s. vol. 9, no. 6 (Nov. 15, 1866): 139-140. [Discusses the popularity of the carte de visite and the growing popularity of the cabinet style. Discusses the American Magnesium Co., and potential for magnesium for photography.]

ST2444 "Stock Dealer Missing." HUMPHREY'S JOURNAL OF PHOTOGRAPHY, AND THE ALLIED ARTS AND SCIENCES 18, no. 14 (Nov. 15, 1866): 223. [A. J. Hoag, stock dealer in Toledo, Ohio disappeared while on trip to New York City to buy supplies. Feared to have been robbed and killed.]

ST2445 "Editor's Table: The New Cabinet Size." PHILADELPHIA PHOTOGRAPHER 3, no. 36 (Dec. 1866): 390.

ST2446 "Popularity of Photographic Portraits." FRANK LESLIE'S ILLUSTRATED NEWSPAPER 23, no. 584 (Dec. 8, 1866): 183.

ST2447 "Home Incidents and Experiments: Street Waif's." and "...School Severity." FRANK LESLIE'S ILLUSTRATED NEWSPAPER 23, no. 587 (Dec. 29, 1866): 237. 2 illus. [This occasional column featured brief local news notes and anecdotes, (many of them probably fictional), each illustrated with an engraved illustration. Occasionally, these engravings credited to a photograph, as were two separate items in this issue.]

USA: 1867.
ST2448 "'Photogram.'" HUMPHREY'S JOURNAL OF PHOTOGRAPHY, AND THE ALLIED ARTS AND SCIENCES 18, no. 18 (Jan. 15, 1867): 281. [From "Scientific American." Argument that the grammatically correct term would be "photogram," not "photograph."]

ST2449 "Off with the Tax." HUMPHREY'S JOURNAL OF PHOTOGRAPHY, AND THE ALLIED ARTS AND SCIENCES 18, no. 18 (Jan. 15, 1867): 284-285. [Petition of Photographers, from Northwestern Photographic Society, to U. S. Congress. Signed by J. M. Ingroham, Lucian J. Bisbee and P. B. Greene.]

ST2450 "Amateur." "Photographing Under Difficulties." PHILADELPHIA PHOTOGRAPHER 4, no. 38 (Feb. 1867): 47-48. [The author requested permission to photograph a church, experienced difficulties.]

ST2451 Seely, Charles A. "Editorial Department." AMERICAN JOURNAL OF PHOTOGRAPHY, AND THE ALLIED ARTS AND SCIENCES n. s. vol. 9, no. 8 (Mar. 1, 1867): 184. ["Those who are depending upon photography for money making are just now far from being in a cheerful mood. The complaint of dull business comes from all quarters..." Discusses photo-lithography.]

ST2452 "Editor's Table: The New Size." PHILADELPHIA PHOTOGRAPHER 4, no. 39 (Mar. 1867): 95-96.

ST2453 "Home Incidents, Accidents, &c.: Too Much For Her." FRANK LESLIE'S ILLUSTRATED NEWSPAPER 23, no. 597 (Mar. 9, 1867): 397. 1 illus. [Brief anecdote about a woman confounded at a photographer's studio. Illustration is of the woman peering into a camera.]

ST2454 Portraits. Woodcut engravings, credited "From a Photograph." HARPER'S WEEKLY 11, (1867) ["The New 'Derby' Cabinet, Great Britain (probably from the "ILN," taken without credit)." 11:533 (Mar. 16, 1867): 168-169. "Stots Bashi, the New Tycoon of Japan." 11:559 (Sept. 11, 1867): 589.]

ST2455 "Cabinet Portraits." PHILADELPHIA PHOTOGRAPHER 4, no. 40, 44 (Apr., Aug. 1867): 113-115, 247-249. [Notman, Carbutt, George Fennemore, J. B. Roberts, etc. mentioned.]

ST2456 "Cabinet Pictures." HUMPHREY'S JOURNAL OF PHOTOGRAPHY, AND THE ALLIED ARTS AND SCIENCES 18, no. 24 (Apr. 15, 1867): 378. ["We have remarked during the last three or four months a distinct improvement, a progress in art in our city galleries;..." Praise for Fredericks' gallery and Sarony.]

ST2457 "Hall's Intensifier." HUMPHREY'S JOURNAL OF PHOTOGRAPHY, AND THE ALLIED ARTS AND SCIENCES 18, no. 24 (Apr. 15, 1867): 383. [This is an advertisement. But mentions several figures using, praising this chemical. Henry T. Anthony; D. C.

Chapman (392 Bowery, New York, NY); H. T. Newton (amateur); Jordan's Gallery (229 Greenwich, New York, NY); S. A. Wood (Chambers St., New York, NY); Victor G. Bloede (Columbia Chemical Works, New York, NY); Gross & Becher (Atlantic St., Brooklyn, NY).]

ST2458 "Home Incidents, Accidents, &c.: I Don't if There is Folks Around." FRANK LESLIE'S ILLUSTRATED NEWSPAPER 24, no. 603 (Apr. 20, 1867): 75. 1 illus. [Short anecdote about a couple in a Chicago photographer's studio.]

ST2459 "The Trials of the Wife of an Amateur Photographer (continued)." PHILADELPHIA PHOTOGRAPHER 4, no. 45 (Sept. 1867): 292-295. [Humorous anecdotes.]

ST2460 M. "Novel Experiences, or Other Trials of a Photographer." PHILADELPHIA PHOTOGRAPHER 4, no. 46 (Oct. 1867): 329-331. [Humorous anecdotes of trials of landscape photography by an amateur photographer.]

ST2461 "Stereographs." PHILADELPHIA PHOTOGRAPHER 4, no. 46 (Oct. 1867): 332-333. [Mentions at length: G. W. Wilson (Aberdeen, Scotland), Ch. Bierstadt (formerly New Bedford, MA), A. F. Styles (Burlington, VT), H. R. Lindsley (Auburn, NY).]

USA: 1868.
ST2462 "New Year's Gossip." HUMPHREY'S JOURNAL OF PHOTOGRAPHY, AND THE ALLIED ARTS AND SCIENCES 19, no. 17 (Jan. 1, 1868): 264-266. [Discusses the stock houses - Scoville Manufacturing Company; E. & H. T. Anthony & Co; Willard Mfg. Co.; W. B. Holmes; Chapman & Wilcox; R. A. Lewis; R. V. Harnett.]

ST2463 "Bogus Conventions." HUMPHREY'S JOURNAL OF PHOTOGRAPHY, AND THE ALLIED ARTS AND SCIENCES 20, no. 17 (Jan. 15, 1868): 267-268. [Attack on the Photographic Convention in Philadelphia.]

ST2464 "Julie." "A Visit to a Country Gallery, and What it Prevented." PHILADELPHIA PHOTOGRAPHER 5, no. 49 (Jan. 1868): 9-12. [Anecdotal narrative.]

ST2465 "Petition to Congress for the Abolition of the Tax Upon 'Sun-Pictures'" PHILADELPHIA PHOTOGRAPHER 5, no. 49 (Jan. 1868): 19-20. ["We, the undersigned, photographic artists of San Francisco, CA. ...James C. Van Court, Sec. 'Signed by sixty-eight photographers'".]

ST2466 "Editor's Table." PHILADELPHIA PHOTOGRAPHER 5, no. 49 (Jan. 1868): 32-34. [J. W. Love (Portage City, WI); James Mullen (Lexington, KY); Charles Waldack (Cincinnati, OH); E. L. Allen (Boston); Robert Benecke (St. Louis, MO); A. J. Fox (St. Louis, MO); J. Carbutt (Chicago, IL); Charles Bierstadt (Niagara Falls, NY); French & Sawyer (Keene, NH); Dr. Ed. Curtis (USA).]

ST2467 "Photographing Our First-born." FRANK LESLIE'S ILLUSTRATED NEWSPAPER 25, no. 642 (Jan. 18, 1868): 278-279. [Fiction.]

ST2468 "Editor's Table." PHILADELPHIA PHOTOGRAPHER 5, no. 50 (Feb. 1868): 64-66. [J. H. Kent (Brockport, NY); John Carbutt (Chicago, IL); H. W. Immke (Princeton, IL) burned out; J. Reid (Paterson, NJ); Ranger & Elton (Palmyra, NY); F. B. Clench (Lockport, NY); D. W. S. Rawson (Peru, IL); H. L. Bingham (Kalamazoo, MI); E. W. Pierce (Galena, IL).]

ST2469 Willard, J. W. "A Letter from Mr. Willard." HUMPHREY'S JOURNAL OF PHOTOGRAPHY, AND THE ALLIED ARTS AND SCIENCES 19, no. 19 (Feb. 1, 1868): 299. [Willard was a photographic stock dealer, previously reported to be going into real estate. His letter is to inform the editor that he is remaining in business.]

ST2470 "Editor's Table." PHILADELPHIA PHOTOGRAPHER 5, no. 51 (Mar. 1868): 99-102. [Fox & Gates (Rochester, NY); J. Gurney & Son (New York, NY); L. E. Walker (Washington, DC); Bonta & Curtiss (Syracuse, NY); Eggleston & Co. (Chardon, OH); Mills & Son (Penn Yan, NY); others mentioned.]

ST2471 Fisk, S. R. "English Photographs by an American." HARPER'S MONTHLY 36-38, no. 215-223 (Apr. - Dec. 1868): (36) 654-657, (37) 111-115, 253-257, 415-420, (38) 93-99. [The term "photograph" is used metaphorically here, to describe the author's descriptive, detailed reports. The articles have nothing to do with actual photography.]

ST2472 "The Mass Convention - The Bromide Patent - Taxation." HUMPHREY'S JOURNAL OF PHOTOGRAPHY, AND THE ALLIED ARTS AND SCIENCES 19, no. 23 (Apr. 1, 1868): 358-360. [Text of a circular, signed by J. W. Black, G. H. Loomis, Bendann Brothers, E. & H. T. Anthony & Co., A. Bogardus and others, calling for a large meeting of the photographic community to be held in New York, NY to form a national organization. "Cutting is dead; he died in a mad-house, and left no heirs....However that may be,...no one has any legal right to speak for him...but there is nothing like keeping a good look out..." This meeting led to the formation of the National Photographers Association.]

ST2473 "Editor's Table." PHILADELPHIA PHOTOGRAPHER 5, no. 52 (Apr. 1868): 134. [J. F. Ryder (Cleveland, OH); Kilburn Brothers (Littleton, NH); Herrick & Dirr (Vicksburg, MS); Blackburn & Zimmer (Toledo, OH), burned out; J. Stehman (Lancaster, PA).]

ST2474 "Photographic Convention. First Day's Session - Second Day." HUMPHREY'S JOURNAL OF PHOTOGRAPHY, AND THE ALLIED ARTS AND SCIENCES 19, no. 24 (Apr. 15, 1868): 369-372. [Meeting held Apr 7, 1868 at Cooper Institute, New York, NY to oppose an extension of the Bromide patent and taxation. 100 delegates. Officers elected. A. Bogardus (New York, NY); Black (Boston); Whitney (Glenn's Falls, WI); Cremer (Phila) and "a few others." Committees formed, resolutions drawn up, etc.]

ST2475 "The Wing & Ormsbee Sliding Plateholder Patent." HUMPHREY'S JOURNAL OF PHOTOGRAPHY, AND THE ALLIED ARTS AND SCIENCES 19, no. 24 (Apr. 15, 1868): 381-382. [An announcement contesting this patent, signed by G. W. Pine, C. C. Schoonmaker, Wm. H. Bell, Asking for a united effort from the community.]

ST2476 "Photography in Politics." NATION *, no. * (Mar. 26, 1868): 248-249.

ST2477 "Editor's Table." PHILADELPHIA PHOTOGRAPHER 5, no. 53 (May 1868): 182-184. [Bromide Patent extended; New Cabinet size, from J. Inglis (Montreal, CAN); T. W. Bankes (Little Rock, AK); W. G. Entreken (Manayunk, PA); others mentioned.]

ST2478 Schoonmaker, C. C. "The Wing & Ormsbee Sliding Plateholder." HUMPHREY'S JOURNAL OF PHOTOGRAPHY, AND THE ALLIED ARTS AND SCIENCES 20, no. 2 (May 15, 1868): 24. [Patent is going to be renewed.]

ST2479 "Editor's Table." PHILADELPHIA PHOTOGRAPHER 5, no. 54 (June 1868): 214-216. [W. J. Baker (Buffalo, NY); J. D. Cadwallader (Marietta, OH); T. R. Burnham (Boston, MA); Upton & Simpson (Buffalo, NY); J. W. Johnson (Nashua, NH); J. Inglis (Montreal, CAN); G. O. Brown (Baltimore, MD), photographer of the Army Medical Museum; Mr. Haines (Albany, NY); others mentioned.]

ST2480 "Voices from the Craft." PHILADELPHIA PHOTOGRAPHER 5, no. 55 (July 1868): 243-245. ["Vox;" N. H. Busey; J. A. Kriss Krauss; Aug. Larcombe (Nashville, TN).]

ST2481 "Editor's Table." PHILADELPHIA PHOTOGRAPHER 5, no. 55 (July 1868): 247-248. [Bromide Patent extension; J. W. Black (Boston, MA) making anti-bromide pictures; J. Towler; Ellwood Garrett (Wilmington, DE).]

ST2482 "Editor's Table." PHILADELPHIA PHOTOGRAPHER 5, no. 56 (Aug. 1868): 277-280. [Death of the Bromide Patent; Sliding Box Patent; J. Landy (Cincinnati, OH); G. O. Brown (Baltimore, MD); J. Carbutt (Chicago, IL); J. Inglis; W. Kenyon (Crawfordsville, ID); C. C. Giers (Nashville, TN); Wellington Watson (Detroit, MI); A. E. Trumbull (Upper Sandusky, OH); G. O. Sweet (Gibson, PA); others mentioned.]

ST2483 "Editor's Table." PHILADELPHIA PHOTOGRAPHER 5, no. 57 (Sept. 1868): 344-346. [Bromide Patent; Eggleston & Co. (Chardon, OH) burned out; Boude & Miley (Lexington, VA); E. M. Van Aken (Lowville, NY); Munday & Williams (Utica, NY); John Nice (Williamsport, PA); C. F. Richardson (Wakefield, MA); A. F. Clough (Oxford, NH); H. L. Bingham (Kalamazoo, MI).]

ST2484 "'Technical But True'." HARPER'S WEEKLY 12, no. 613 (Sept. 26, 1868): 619. 1 illus. [Cartoon, with events taking place in a photographer's studio.]

ST2485 Hooper, Lucy Hamilton. "The Photographer's Story." LIPPINCOTT'S MAGAZINE OF LITERATURE, SCIENCE AND EDUCATION 2, no. 4 (Oct. 1868): 435-440. [Fictional short story.]

ST2486 "Editor's Table." PHILADELPHIA PHOTOGRAPHER 5, no. 58 (Oct. 1868): 376-378. [James Cramer (Philadelphia, PA); G. M. Elton (Palmyra, NY); M. N. Crocker (Perry, NY); J. Carbutt (Chicago, IL); E. H. Alley (Toledo, OH); Ellwood Garrett (Wilmington, DE). W. J. Baker (Buffalo, NY); William Aitken (Millville, NJ); W. E. Bowman (Ottawa, IL); C. S. Judd (Shelbyville, TN); others mentioned.]

ST2487 Knox, Thomas W. "The Chinese Embassy to the Foreign Powers." HARPER'S MONTHLY 37, no. 221 (Oct. 1868): 592-604. 9 illus. [Includes engraved portraits of the Chines ambassadors, some probably taken from photographs.]

ST2488 "Letter from a Convict." HUMPHREY'S JOURNAL OF PHOTOGRAPHY, AND THE ALLIED ARTS AND SCIENCES 20, no. 12 (Oct. 15, 1868): 182-183. [Letter, signed "Photo." from Sing Sing Prison, is in response to an earlier note on p. 175 about a subscription of the "HJ" going to the prison. The prisoner identifies himself as having taken "HJ" for thirteen years and as being innocent. (Could this be the person earlier arrested for counterfeiting stamps?)]

ST2489 "An Unknown Soldier." HARPER'S WEEKLY 12, no. 617 (Oct. 24, 1868): 679, 684. 1 illus. ["The Quarter-Master General has requested us to publish the portrait of the soldier who died...in the Armory Square Military Hospital in Washington...so weak could not give name...a sum of money and the ambrotype or ferrotype of a child were found. Surgeon D. W. Bliss...caused a photograph to be taken

after death...any information...be addressed to General M. C. Meiggs..."]

ST2490 "Editor's Table." PHILADELPHIA PHOTOGRAPHER 5, no. 59 (Nov. 1868): 410. [The National Union; A. F. Styles (Burlington, VT); G. O. Brown (Baltimore, MD).]

ST2491 "Editor's Table." PHILADELPHIA PHOTOGRAPHER 5, no. 60 (Dec. 1868): 441-442. [M. Carey Lea; Thomas Gaffeld (Boston, MA); Henszey & Co. (Philadelphia, PA) taken over by Guion & Jones; William Kurtz (New York, NY); S. M. Fassett (Chicago, IL); others mentioned.]

ST2492 "Report of the Great Convention: The Tooleyites in Council." HUMPHREY'S JOURNAL OF PHOTOGRAPHY, AND THE ALLIED ARTS AND SCIENCES 20, no. 16 (Dec. 15, 1868): 250-251. [Savage, sarcastic attack on "...the so-called Photographic Convention recently assembled in Philadelphia..." and on Ed. L. Wilson.]

ST2493 "How to Raise the Wind," "Tooley Street," "That Receipt for $32.00," "Low Fellows," and "Public Opinion." HUMPHREY'S JOURNAL OF PHOTOGRAPHY, AND THE ALLIED ARTS AND SCIENCES 20, no. 16 (Dec. 15, 1868): 253, 255, 256. [Further attacks on the Photographic Convention and on Ed. L. Wilson.]

USA: 1869.
BOOKS
ST2494 *The Hermean: From Its Infancy, to Times Within the Memory of Men now Living.* New York: Hermean Society, 1869. 215 pp. 22 l. of plates. 22 b & w. ["100 copies privately printed." Original photographs, portraits of the members.]

ST2495 Andersen, Hans Christian. *The Improvisatore:* From the Danish of Hans Christian Andersen; translated by Mary Howitt. New York: Harper & Brothers, 1869. 124 pp. 150 l. of plates. [At head of title: "Life in Italy." Original photographs. (1875). London: Ward, Lock & Co., 43 b & w, 1 illus.]

ST2496 Fagnani, Giuseppe. *American Beauty Personified as the Nine Muses.* Boston: A. A. Childs, 1869 ? n. p. b & w. [Original photographs, made from paintings.]

ST2497 King, Thomas Starr. *The White Hills: Their Legends, Landscapes and Poetry; with Photographs and Sixty Other Illustrations.* Boston: Woolworth, Ainsworth & Co., 1869. xv, 403 pp. 3 b & w. 60 illus. [Calotypes. (Dedicated to Edwin Percy Whipple.) GEH collection.]

ST2498 Nieriker, Abigail May Alcott. *Concord Sketches: Consisting of Twelve Photographs from Original Drawings, by May Alcott.* Boston: Fields, Osgood, 1869. 19 l. 12 l. of plates. 12 b & w.

ST2499 Potter, Edward Tuckermann. *World Pictures in Capitals.* By Edward Tuckermann Potter. With a Descriptive Legend, by Henry Coppee. Philadelphia: J. B. Lippincott & Co., 1869. 21 pp. 8 l. of plates. [Original photographs of architectural details. See also G. G. Rockwood for another similar work.]

ST2500 Thorneycroft, Thomas. *A Trip to America.* Wolverhampton: Steen & Blacket, 1869. n. p. 21 b & w. [Original photographs, of scenery and buildings.]

PERIODICALS
ST2501 "Editor's Table." PHILADELPHIA PHOTOGRAPHER 6, no. 61 (Jan. 1869): 31-32. [Anthony; W. J. Baker; S. M. Fassett (Chicago, IL); A. J. Riddle (Macon, GA); Frederick H. Eales (Rochester, NY).]

ST2502 "Editor's Table." PHILADELPHIA PHOTOGRAPHER 6, no. 62 (Feb. 1869): 62-64. [James Cremer; Geo. H. Fennemore formed partnership with F. S. Keeler (Philadelphia, PA); Wm. Bell opening studio (Philadelphia, PA); Wm. F. Osler (Philadelphia, PA); J. H. Bostwick (Bristol, PA); J. Gurney & Son; J. A. Palmer (Savannah, GA); Vernon Royle (Paterson, NJ); G. C. Robinson (Haverhill, MA); Williams & McDonald (Denver, CO); Louis Alman (Lake Mahopac, NY); S. A. Cohner (Havana, Cuba) killed in riot; others mentioned.]

ST2503 "The Exchange Club." HUMPHREY'S JOURNAL OF PHOTOGRAPHY, AND THE ALLIED ARTS AND SCIENCES 20, no. 18 (Feb. 15, 1869): 278. [Editor of "HJ" announcing that he intends to institute an exchange club.]

ST2504 "E. & H. T. Anthony & Co. - Holmes, Booth & Hayden - A. H. Baldwin." and "Philadelphia Stock Houses." HUMPHREY'S JOURNAL OF PHOTOGRAPHY, AND THE ALLIED ARTS AND SCIENCES 20, no. 18 (Feb. 15, 1869): 280-281, 286. [Report on current activities of the stock houses: E. & H. T. Anthony, Holmes, Booth & Hayden and A. H. Baldwin. This stock house (Holmes, Booth & Hayden) "...has quit the photographic business now and forever. Nothing shows the decline in the trade so much as this fact, 'H., B. & H.,' have given up!..." "...the decline of trade in photographic materials in Philadelphia is even worse..."]

ST2505 "Editor's Table." PHILADELPHIA PHOTOGRAPHER 6, no. 63 (Mar. 1869): 94-96. [F. A. Wenderoth (Philadelphia, PA); Richard Walzl (Baltimore, MD); Henry Merz (New York, NY); Thomas Gaffield; H. Noss (New Brighton, PA); F. B. Gage (St. Johnsbury, VT); H. W. Boozer (Grand Rapids, MI); J. Gurney & Son; E. Klauber (Louisville, KY); Albert Moore; others mentioned.]

ST2506 "General Grant, the New President of the United States." ILLUSTRATED LONDON NEWS 54, no. 1529 (Mar. 13, 1869): 260, 270. 1 illus.

ST2507 "A Tintyper, Mass." "A Story of a Tintype and the Good It Did." PHILADELPHIA PHOTOGRAPHER 6, no. 64 (Apr. 1869): 123-124. [Anecdote of how a tintype cured an alcoholic.]

ST2508 "Editor's Table." PHILADELPHIA PHOTOGRAPHER 6, no. 64 (Apr. 1869): 135-136. [D. H. Anderson (Richmond, VA) warns of swindler named Dempt; C. D. Fredericks & Co.; E & H. T. Anthony Co.; Richard Wearn (Columbia, SC) burned out; H. H. Cole (Peoria, IL) burned out; D. R. Clark (Lafayette, IN); N. S. Howe (Brattleboro, VT); S. W. Douglass (J. D. Cadwallader Studio, Marietta, OH); Holke & Benecke (St. Louis, MO); R. D. Ewing (Toronto, Ont.); H. B. Hillyer (Austin, TX); W. J. Baker; F. B. Gage (St. Johnsbury, VT); others mentioned.]

ST2509 "Editor's Table." PHILADELPHIA PHOTOGRAPHER 6, no. 65 (May 1869): 167-170. [Henry Morton; T. C. Matthewson (Tremont, IL); A. S. Southworth; Kilburn Brothers; Mumler; John A. Scholten (St. Louis, MO); H. Vogel; S. A. L. Hardinge (Brooklyn, NY); Willard Marshall (Guelph, Ontario); H. B. Hillyer (Austin, TX); Andrew Khrone (Bogardus Gallery); Joseph Voyle (Tuscaloosa, AL); M. Mould (Baraboo, WI); Thomas Fury (New York, NY); Well G. Singhi (Bainbridge, NY); Cramer & Gross (St. Louis, MO); E. S. M. Haines (Albany, NY); J. H. Fitzgibbon (St. Louis, MO); S. R. Shear (Ossian, IA); others mentioned.]

ST2510 "Submarine Divers Equipped for Their Descent." HARPER'S WEEKLY 13, no. 645 (May 8, 1869): 293, 295. 1 illus. ["Eight divers employed by E. P. Harrington, Submarine Engineer, engaged in laying the foundation of the Kansas City Bridge over the Missouri River."]

ST2511 "The Approaching Great National Peace Jubilee - Construction of the Coliseum at the St. James Park, Boston, Mass. - Raising the Trusses," "The Coliseum in Process of Construction," "General View of the Interior," "Interior View - From a Photograph by Our Special Photographer." FRANK LESLIE'S ILLUSTRATED NEWSPAPER 28, no. 712 (May 22, 1869): 149-150, 152-153. 5 illus. [One sketch, four views of the building under construction. "...we present this week ...sketches, from photographs by our artists, of the Coliseum..." (In spite of this statement, these seem to me to be very similar to photos of this taken by John A. Whipple.)]

ST2512 "Editor's Table." PHILADELPHIA PHOTOGRAPHER 6, no. 66 (June 1869): 203-204. [Geo. W. Lovejoy (Stepney Depot, CT); H. P. Macintosh (Newburyport, MA); St. Louis Photo Society formed; J. Carbutt, others mentioned.]

ST2513 "Editor's Table." PHILADELPHIA PHOTOGRAPHER 6, no. 67 (July 1869): 251-252. [E. L. Allen supplying stereos of the N. P. A. exhibition in Boston, MA. J. W. Black supplying a group portrait of participants; all proceeds to the Relief Fund; Joseph Dixon (Jersey City, NJ) died; J. Gurney & Son occupied new gallery in New York, NY; others mentioned.]

ST2514 "Westward Ho!" HUMPHREY'S JOURNAL OF PHOTOGRAPHY, AND THE ALLIED ARTS AND SCIENCES 20, no. 23 (July 15, 1869): 366. [Commentary about the transcontinental railroad being completed and how businessmen are going west to make their fortune. Then talks about George D. Wakely, who had been previously in Denver City, CO., New York, Washington, D.C. and now opening a stock business in Omaha, NB.]

ST2515 "Editor's Table." PHILADELPHIA PHOTOGRAPHER 6, no. 68 (Aug. 1869): 284. [Albert Moore, solar printer; E. L. Brand (Chicago, IL); A. F. Clough (Oxford, NH); Kilburn Bros.; Wm. Kurtz occupied his new studios in New York, NY; Wm. Notman (Montreal); others mentioned.]

ST2516 "Commencement Day at Dartmouth College, N. H. The College Grounds... - From Sketches and Photographs by Our Special Artist." FRANK LESLIE'S ILLUSTRATED NEWSPAPER 28, no. 724 (Aug. 14, 1869): 349. 5 illus. [Views, portraits. two probably from photos.]

ST2517 "Base Ball." HUMPHREY'S JOURNAL OF PHOTOGRAPHY, AND THE ALLIED ARTS AND SCIENCES 20, no. 24 (Aug. 15, 1869): 380. ["The great base ball furor has at length reached the photographic fraternity....The employees of Scoville Manufacturing Co. played those of Jordan & Co. Scoville won 40 to 25.]

ST2518 "Boat Race." HUMPHREY'S JOURNAL OF PHOTOGRAPHY, AND THE ALLIED ARTS AND SCIENCES 20, no. 24 (Aug. 15, 1869): 380-381. [The employees of E. & H. T. Anthony & Co. and those of J. Gurney & Son "had a lively three mile rowing match" - each side with three double scull boats. Anthony & Co. won.]

ST2519 G. "Clippings from the Journal of a Photographer: Parts 1 - 2.." PHILADELPHIA PHOTOGRAPHER 6, no. 69, 71 (Sept., Nov. 1869): 315, 383-384.

ST2520 "Editor's Table." PHILADELPHIA PHOTOGRAPHER 6, no. 69 (Sept. 1869): 323-324. [David Bendann; E. K. Trask (Philadelphia, PA); Schreiber & Son (Philadelphia, PA); baseball game between employees of Jordan & Co., photographers, and the Scoville Mfg. Co.; employees of J. Gurney & Son and E. & H. T. Anthony had a sculling race; Wellington Watson; W. E. Bowman; J. R. Gorgas (Madison, IN); H. B. Hillyer (Austin, TX); H. W. Seward (Utica, NY); others mentioned.]

ST2521 "Light Draught Snagboat Built for United States Government, and to be Used in the Arkansas River." FRANK LESLIE'S ILLUSTRATED NEWSPAPER 28, no. 728 (Sept. 11, 1869): 407, 413. 1 illus. [View. "The photograph from which our picture is engraved was taken... six miles below the city of Cincinnati."]

ST2522 "The Sliding Plate-Holder Patent Decision: Simeon Wing vs C. C. Schoonmaker." HUMPHREY'S JOURNAL OF PHOTOGRAPHY, AND THE ALLIED ARTS AND SCIENCES 20, no. 25 (Sept. 15, 1869): 387-388. [This patent not upheld. Some of the history of Simon Wing is given. He went to CA in the winter of 1848-49 and remained there two years, etc.]

ST2523 "Chips from an Old Block." HUMPHREY'S JOURNAL OF PHOTOGRAPHY, AND THE ALLIED ARTS AND SCIENCES 20, no. 25 (Sept. 15, 1869): 398-399. [Brief satiric or comic comments on current events within the field, here twitting J. W. Black's photo of the assembled photographers at the Boston convention, M. B. Brady, and others not now identifiable from the reference. These are probably by D. D. T. Davie.]

ST2524 "Editor's Table." PHILADELPHIA PHOTOGRAPHER 6, no. 70 (Oct. 1869): 356. [Wellington Watson; E. M. Van Aken (Lowville, NY); M. Griswold (Columbus, OH); S. F. Adams; George Barker; J. Douglass (Quebec); F. A. Pearsall & J. L. Forbes (Gurney & Sons); Wm. Bell using E. G. Fowx's patented "Porcelain Process;" D. W. S. Rawson (Peru, IL) died Aug. 24, 1869; views of Pennsylvania Central Railroad, issued by E. & H. T. Anthony Co.]

ST2525 "Award of the Prizes." PHILADELPHIA PHOTOGRAPHER 6, no. 71 (Nov. 1869): 358-362. [Portrait - Wellington Watson (Detroit, MI); genre - M. M. Griswold (Columbus, OH); landscape - E. M. Van Aken (Lowville, NY).]

ST2526 "Editor's Table." PHILADELPHIA PHOTOGRAPHER 6, no. 71 (Nov. 1869): 386-388. [Prof. Henry Morton; A. Matthews (Lisbon, AR) taking up photography as a profession at age 71; J. M. Elliott (Columbus, OH); G. Harvey (Minneapolis, MN) died July 18, 1869; John Dunmore [J. W. Black] just returned from Arctic regions; J. C. Browne; Wellington Watson (Detroit, MI); William B. Holmes (New York, NY); Wm. Kurtz; H. Noss (New Brighton, PA); others mentioned.]

ST2527 "Editor's Table." PHILADELPHIA PHOTOGRAPHER 6, no. 72 (Dec. 1869): 426-428. [Medals awarded at Mass. Charitable Mechanics Assoc. annual exhibition; J. M. Elliott (Columbus, OH); premiums awarded at American Institute Fair, NY; A. Lesage (Dublin, Ireland); Wm. Kurtz; J. H. Vail (Middletown, OH); Michel Clements (Sheboygan, WI) died Nov. 3, 1869; C. C. Shoomaker (Troy, NY); E. H. Alley (Toledo, OH); E. Baldwin (Lawrence, KS).]

ST2528 Campbell, William, of Hudson City, N.J. "Photographic Patents." HUMPHREY'S JOURNAL OF PHOTOGRAPHY, AND THE ALLIED ARTS AND SCIENCES 20, no. 28 (Dec. 15, 1869): 438-440. [A listing of all photographic patents granted in USA during the past

ten years. List goes from 1858 to 1861 and then was to be continued, but the cessation of the magazine came first.]

ST2529 "Correspondence." HUMPHREY'S JOURNAL OF PHOTOGRAPHY, AND THE ALLIED ARTS AND SCIENCES 20, no. 28 (Dec. 15, 1869): 441-442. [Letters from J. Thurlow (Peoria, IL); S. S. Richards; H. W. Immke (Princeton, IL); E. C. Kiblinger (LA); J. C. Potter (Elyria, OH); D. D. T. Davie (New York, NY); others.]

USA: 1869-1879. (WESTERN EXPANSION)
BOOKS

ST2530 Richardson, Albert D. *Beyond the Mississippi: From the Great River to the Great Ocean. Life and Adventure on the Prairies, Mountains, and Pacific Coast. With More Than Two Hundred Illustrations, From Photographs and Original Sketches, of the Prairies, Deserts, Mountains, Rivers... New Edition. Written Down to Summer of 1869.* Hartford, CT: American Publishing Co., 1869. 620 pp. 216 illus. [Woodcuts, some taken from photographs, portraits of individuals (Albert Bierstadt on p. 410), views, cities, etc. Brady credited with portrait of John Brown on p. 283; a "S. W. Y. Schimonsky, U. P. R. R." is credited with several views in Utah, etc on pp. 345, 347, 368. He may be a photographer, from which the artist drew the sketches. Watkins' views of Yosemite on pp. 424, 425, 428, 531, Bradley & Rulofson on p. 453; One image, "Hanging Rock", on p. 574 is not credited, but from A. J. Russell photo.]

ST2531 Strong, General William E. *A Trip to the Yellowstone National Park in July, August, and September, 1875.* Washington, DC: s. n., 1876. n. p. 7 b & w. [Original photos, portraits. NYPL Collection.]

ST2532 Andrews, Ralph Warren. *Picture Gallery Pioneers: First Photographers of the West. 1850 - 1875.* Seattle: Superior Publishing Co., 1964. 192 pp. b & w. illus.

ST2533 Andrews, Ralph Warren. *Photographers of the Frontier West; Their Lives and Works, 1875 to 1915.* Seattle: Superior Publishing Co., 1965. 182 pp. b & w. illus.

ST2534 National Anthropological Archives. *Indian Images: Photographs of North American Indians, 1847 - 1928, from the Smithsonian Institution, National Anthropological Archives.* Catalog by Joanna Cohan Scherer. Washington, DC: Smithsonian Institution Press, 1970. 31 pp. b & w. [Exhibition catalog: National Museum of Natural History, Smithsonian Institution, July - Aug. 1970.]

ST2535 Scherer, Joanna Cohan, with Jean Burton Walker. *Indians; the Great Photographs that reveal North American Indian Life, 1847 - 1929, from the Unique Collection of the Smithsonian Institution.* New York: Crown Publishers, 1973. 189 pp.

ST2536 Naef, Weston J., in collaboration with James N. Wood, with an essay by Theresa Thau Heyman. *Era of Exploration: The Rise of Landscape Photography in the American West, 1860 - 1885.* Boston: New York Graphic Society for the Albright-Knox Gallery, Buffalo, NY and the Metropolitan Museum of Art, New York, NY, 1975. 260 pp. 314 b & w. illus. ["Introduction," pp. 12-76; "Chronology," pp. 77-78; "Carleton E. Walkins 1829-1916," pp. 79-124; "Timothy H. O'Sullivan About 1840-1882," pp. 125-166; "Eadweard J. Muybridge 1830-1904", pp. 167-200; "Andrew Joseph Russell 1830-1902," pp. 210-218; "William Henry Jackson 1843-1942," pp. 219-250; "Notes and Bibliography," pp. 251-258.]

ST2537 Mautz, Carl E. *Checklist of Western Photographers.* Portland, OR: C. E. Mautz, 1976. n. p.

ST2538 Ostroff, Eugene. *Photographing the Frontier.* Washington, DC: Smithsonian Institution Press, 1976.

ST2539 Current, Karen. *Photography and the Old West.* Text by Karen Current; Photographs selected and Printed by William R. Current. New York: Harry N. Abrams, in association with the Amon Carter Museum of Western Art, 1978. 272 pp. 172 b & w. ["Carleton E. Watkins (1829-1916)," pp. 28-47; "Dr. William A. Bell (1841-1921)," pp. 48-55; "Timothy H. O'Sullivan (1840-1882)," pp.56-71; "Eadweard Muybridge (1830-1904)," pp. 72-87; "John K. Hillers (1843-1925)," pp. 88-103; "William Henry Jackson (1843-1942)," pp. 104-123; "Andrew J. Russell (1830-1902)," pp. 130-145; "Arundel C. Hull (1846-151)," pp. 146-151; "George Robertson (active c. 1868-74)," pp. 152-157; "Will Soule (1836-1908)," pp. 158-163; "Laton Alton Huffman (1834-1931)," pp. 164-174; "Solomon D. Butcher (1856-1927)," pp. 174-183; "George Edward Anderson (1860-1928)," pp. 184-197; "Andrew Alexander Forbes (1862-1921)," pp. 198-205; "Camillus S. Fly (1849-1901)," pp. 206-211; "John C. H. Grabhill (active ca. 1887-91)," pp. 212-221; "Charles F. Lummis (1859-1928)," pp. 228-235; "Adam Clark Vroman (1856-1916)," pp. 236-245; "Frederick I. Monsen (1865-1929)," pp. 236-245; "Chronology," pp. 256-263; "Selected Bibliography," pp. 264-268.]

ST2540 Ostroff, Eugene. *Western Views and Eastern Visions.* Washington, DC: Smithsonian Institution Traveling Exhibition Service, with the cooperation of the United States Geological Survey, 1981. 120 pp. [The 121 images in the exhibition are presented in the portfolio section, on pp. 25 to 115. The majority of these are photographs. Other illustrations in the essay as well. Bibliography on pp. 116-118.]

ST2541 *With Eagle Glance: American Indian Photographic Images, 1868 to 1931. An exhibition of selected photographs from the collection of Warren Adelson and Ira Spanierman.* Introduction by N. Scott Momaday. New York: Museum of the American Indian, 1982. 63 pp. 50 b & w. [Exhibition catalog, Museum of the American Indian, New York, 1982.]

ST2542 Katz, D. Mark. *Custer in Photographs.* Gettysburg, PA: Yo-Mark Production Co, for Americana Image Gallery, 1985. 150 pp. 155 b & w. [155 photographs of George A. Custer, taken throughout his lifetime. Edition of 1000.]

ST2543 Fleming, Paula Richardson and Judith Luskey. *The North American Indians in Early Photographs.* New York: Harper & Row, 1986. 256 pp. b & w. illus. [Nine chapters, "1. The Background," "2. Peaceful Encounters," "3. The Indian Wars," "4. Planning for the Future," " 5. Capturing the Golden Moment," "6. The Culture of Imagining," "7. Government Studios," "8. Independant Frontier Photographers," "9. Grand Endeavors." "Appendix 1. Delegation Photographers c. 1840 - c. 1900." Appendix 2. Selected Frontier Photographers c. 1840 - c. 1900."

ST2544 Palmquist, Peter E. "Photographic Essay on Studio Interiors, Photographers, Etc.," on pp. 82-101 in: *Photography in the West.* Edited by Peter E. Palmquist. Manhattan, KS: Sunflower University Press, 1987. 38 b & w. 5 illus. [Republished, with additions, from the "Journal of the West," (Apr. 1987). Portraits, travelling and stationary galleries, etc., of Western photographers from 1850s to 1940s. Peter Britt; R. H. Vance; P. M. Batchelder; Bradley & Rulofson; Lawrence & Houseworth; J. B. Silvis; T. H. O'Sullivan; Edgar H. Train; Carleton E. Watkins; Harry Thompson; Jacob Hansen; Don M. Leach; A. P. Flanglor; Charles L. Pond; George I. Davidson; F. J. Haynes; others.]

ST2545 Sandweiss, Martha A. "'As the Mementoes of the Race': Photographs of North American Indians," on pp. 73-78 in: *Sign Language*, edited by Skeet McAuley. New York: Aperture Press, 1989. 80 pp.

PERIODICALS

ST2546 "Government Photography." PHOTOGRAPHIC TIMES 4, no. 43 (July 1874): 101. [Excerpt from "The Nation," discussing fact that all major government expeditions now equipped with photographers, calling for a method of obtaining photos from the agencies. Mentions Hayden, Wheeler, Powell, King, Commodore Selfridge, Commander Lull, the United States Fish Commission.]

ST2547 "Government Photography in America." ANTHONY'S PHOTOGRAPHIC BULLETIN 5, no. 11 (Nov. 1874): 366. [From "New York Nation." Discussion of the active use of photographers on the exploratory surveys. Note that restrictions on the sale of these images recently lifted.]

ST2548 United States Government Surveys." FRANK LESLIE'S ILLUSTRATED NEWSPAPER 46, no. 1189 (July 13, 1878): 314-315. [Editorial, arguing that so many rival parties were exploring that confusions were resulting, and that the efforts should be centralized. "The ambitious leader of an expedition to the Rocky Mountains claimed to have been the first to visit a certain region, and in proof of his assertion published some fine photographs. Oddly enough, in the foreground of one of his prints was the figure of a man, and this man who was thus represented as complacently contemplating the landscape, proves to be a rival geologist who had photographed on the spot some years before."]

ST2549 "Little Wolf, a Chief of the Hostile Cheyennes, and His Captor, Lieutenant W. P. Clark, U.S.A." FRANK LESLIE'S ILLUSTRATED NEWSPAPER 48, no. 1239 (June 28, 1879): 277. 1 illus. [Uncredited studio portrait of the pair.]

ST2550 "Colorado. - The Late Ute Outbreak and Massacre at the White River Agency. - From Photographs Furnished by E. A. Barber and Lieutenant C. A. H. McCauley." FRANK LESLIE'S ILLUSTRATED NEWSPAPER 49, no. 1259 (Nov. 15, 1879): 179, 189. 8 illus. [Portraits of the Ute Indians, close-ups of tools and decorations.]

ST2551 Watson, Elmo Scott. "Shadow Catchers of the Red Man." WESTERNERS BRAND BOOK (DENVER) 6, (1950): 2 - 28. 5 b & w.

ST2552 Kozloff, Max. "The Box in the Wilderness." ARTFORUM 14, no. 2 (Oct. 1975): 60-65. 8 b & w. [Review of the exhibition and book "Era of Exploration." Photos by W. H. Jackson; T. H. O'Sullivan; A. J. Russell; E. J. Muybridge.]

ST2553 Novak, Barbara. "Landscape Permuted: From Painting to Photography." and "A Portfolio of Western Landscape Photographs." ARTFORUM 14, no. 2 (Oct. 1975): 46-59. 17 b & w. 3 illus. [Review of the exhibition and book "Era of Exploration." Photographs by E. J. Muybridge; C. E. Watkins; T. H. O'Sullivan; A. J. Russell; W. H. Jackson.]

ST2554 Gray, John S. "Itinerant Frontier Photographers and Images Lost, Strayed or Stolen." MONTANA 28, no. 2 (Apr. 1978): 2-15. 20 b & w. [Discusses the photographers William R. Pywell (Yellowstone Expedition, 1873), John H. Fouch (1870s), Stanley J. Morrow (1860s-1880s), Orlando Scott Goff and David F. Barry; principally concerning confusions surrounding their photographs of the Custer battlefield aftermath, etc.]

ST2555 Scherer, Joanna Cohan. "You Can't Believe Your Eyes: Inaccuracies in Photographs of North American Indians." EXPOSURE 16, no. 4 (Winter 1978): 6-19. 24 b & w. [Photographs by William Dinwiddie, John K. Hilliers, DeLancey Gill, Alexander Gardner, William Soule, E. Q. Bonine, Major Lee Moorhouse, and Christian Barthelmess.]

ST2556 West, Elliot. "The Saloon: A Frontier Institution." AMERICAN WEST 17, no. 1 (Jan. - Feb. 1980): 14-29. 21 b & w. [Portfolio of views of Saloon interiors.]

ST2557 Gamarekian, Barbara. "How Photography Aided in the Winning of the West." NEW YORK TIMES (Aug. 12, 1980): III, 9. 1 b & w. [Exhibition review: "Western Views and Eastern Visions," Smithsonian Institution's National Museum of History and Technology, Washington, DC.]

ST2558 Masteller, Richard N. "Western Views in Eastern Parlors: The Contribution of the Stereograph Photographer to the Conquest of the West." PROSPECTS: THE ANNUAL OF AMERICAN CULTURAL STUDIES 6, (1981): 55-72. [Discusses the geological surveys, in particular the expeditions of Powell and the photographs of John Hiller.]

ST2559 Palmquist, Peter E. "Westerners and Their Pets: Cherished companions from a bygone day." AMERICAN WEST 18, no. 1 (Jan. - Feb. 1981): 48-52. 8 b & w. [Short discussion of types of photography in 19th c., with portfolio of portraits of animals, people and animals.]

ST2560 Palmquist, Peter. "Western Photographers. I. Some Stories About Audacious Image Makers." AMERICAN WEST 18, no. 3 (May - June 1981): 38-47. 10 b & w. [Bibliography mentions Amasa Plummer Flanglor (1848-1918), Charles W. J. Johnston (1857-1898), George Fiske (1835-1918), Peter Britt (1819-1905), Mrs. M. E. Taylor.]

ST2561 Snell, Joseph W. "Who Says Pictures Never Lie? Historical Photographs Yield Secrets." AMERICAN WEST 18, no. 4 (July - Aug. 1981): 22-27. 7 illus. [Article discusses several acts of historical misconstruction, attributed to incorrectly reading historical photographs, including portraits of Indians dressed by the photographer, views by Solomon Butcher, etc.]

ST2562 Mangum, Neil. "Solving Custer Photo Puzzles: Some New Dates and Identifications." MONTANA 31, no. 4 (Oct. 1981): 24-31. 8 b & w. [The author has verified dates and names of individuals in group portraits of family and military individuals associated with General George Armstrong Custer in 1870s.]

ST2563 Palmquist, Peter E. "Photographers In Petticoats." JOURNAL OF THE WEST 21, no. 2 (Apr. 1982): 58-64. 18 b & w. [Discusses or mentions Julia Shannon; Miss Hudson & Co.; Mrs. Rudolph; Mrs. Julia A. French; Miss Anna McGinn; Mrs. Spatz; Mrs. Elizabeth J. Eames; Miss A. M. Tidd (all CA in 1850s - 1870s); Miss Mickel; Miss D. Ferris (all CO in 1860s). Discusses Mrs. E. W. Withington's landscape work in the 1870s. Discusses other, later women as well, Mary Winslow; Abbie E. Cardozo; Tabitha Kinsey and others.]

ST2564 Adams, Robert. "Towards a Proper Silence: Nineteenth-Century Photographs of the American Landscape." APERTURE no. 98 (Spring 1985): 4-11. 2 b & w. [Illustrations by T. O'Sullivan.]

ST2565 Palmquist, Peter E. "Behind the Scenes: A Potpourri of Western Photographic Studios and Darkrooms 1850 - 1950." THE PHOTOGRAPHIST no. 66 (Summer 1985): 10-25, plus covers. 38

illus. [Interiors, exteriors, and self-portraits by studio photographers. Include Vance's Premium Daguerrean Gallery (San Francisco, CA); Batchelder's Daguerrean Saloon; Jacob Hansen (Yreka, CA); Bradley & Rulofson (San Francisco, CA); Bundy & Train Gallery (Helena, MT); Dunham & Lathrop's Studio (Oakland, CA); J. J. Reilly (Marysville, CA); Charles Wallace Jacob Johnson (Monterey, CA); I. W. Taber (San Francisco, CA); and others.]

ST2566 Duncan, Robert G. "The Sioux War of 1876: Part 1. The Black Hills, the Custer Expedition and the Beginning of the War." PHOTOGRAPHIC HISTORIAN 6, no. 2 (Summer 1985): 6-13. 11 b & w. 1 illus. [Discusses work of William H. Illingworth, S. J. Morrow, O. S. Goff (Bismark, Dak. T.), D. B. Manville, and Upton (Minneapolis).]

ST2567 Duncan, Robert G. "The Sioux War of 1876. Part 2: The War Through the Custer Massacre." PHOTOGRAPHIC HISTORIAN 6, no. 3 (Autumn 1985): 16-20. 4 b & w. 2 illus. [Photos by Brady, Keystone View Co.]

ST2568 Duncan, Robert G. "The Sioux War of 1876. Part 3: The Army Victorious." PHOTOGRAPHIC HISTORIAN 6, no. 4 (Winter 1985-1986): 10-23. 15 b & w. [13 stereo views by S. J. Morrow and a portrait of Morrow.]

ST2569 Palmquist, Peter E. "A Portfolio: The Ubiquitous Western Tintype." JOURNAL OF THE WEST 28, no. 1 (Jan. 1989): 89-108. 64 b & w.

USA: 1870.

BOOKS

ST2570 Baldwin Locomotive Works. *Illustrated Catalogue of Locomotives.* Philadelphia: Burnham, Parry, Williams & Co., n. d. [ca. 1870]. 153 pp. 18 b & w. [Original photographs.]

PERIODICALS

ST2571 "Editor's Table." PHILADELPHIA PHOTOGRAPHER 7, no. 73 (Jan. 1870): 30-31. [William Delius (Waterbury, CT), photolithographs; E. L. Allen (Boston, MA); J. W. Hurt; E. Kilburn; D. C. Hawkins (Sheboygan, WI); J. Carbutt; Fred C. Low (Cambridge, MA); Charles Stafford; W. M. Knight (Buffalo, NY), burned out; Fred C. Lowe (East Cambridge, MA); Amos F. Clough (Orford, NH); J. W. and J. S. Moulton (Salem, NH); others mentioned.]

ST2572 "Editor's Table." PHILADELPHIA PHOTOGRAPHER 7, no. 74 (Feb. 1870): 62-64. [Fowx; Wm. Notman (Montreal, CAN); Whitney & Zimmerman (St. Paul, MN).]

ST2573 Portrait. Woodcut engraving, credited "...from a recent photograph." FRANK LESLIE'S ILLUSTRATED NEWSPAPER 29, (1870) ["Clara Louisa Kellogg, musician." 29:749 (Feb. 5, 1870): 357.]

ST2574 Tuckerman, H. T. "On a Photograph of Athens." HARPER'S MONTHLY 40, no. 238 (Mar. 1870): 604. [Narrative poem.]

ST2575 "Editor's Table." PHILADELPHIA PHOTOGRAPHER 7, no. 75 (Mar. 1870): 95-96. [John Carbutt selling his photo studio in Chicago; J. W. Black and J. L. Dunmore injured in an explosion; reports of the total eclipse of the sun.]

ST2576 "Editor's Table." PHILADELPHIA PHOTOGRAPHER 7, no. 76 (Apr. 1870): 142-143. [N. W. Pease (North Conway, NH); Prof. Morton; Suddards & Fennemore; J. F. Ryder; Thomas H. Johnson; George Barker (Niagara Falls, NY) burned out; Burnham (Portland, ME) burned out; F. W. Hardy (Bangor, ME); W. H. Sipperly

(Mechanicsville, NY); H. H. Bennett (Kilbourn City, WI); C. S. Cooper (Winooski Falls, VT); J. L. Knight (Topeka, KS); F. Thorp (Bucyrus, OH); J. A. Scholten (St. Louis, MO); Notman & Fraser (Toronto, Ont.); L. G. Frost (Sherburne, NY) died Feb. 14; Chas. Stafford (Norwich, CT) burned out; W. F. Osler (Philadelphia, PA); S. J. Morrow (Yankton, Dakota Territories); G. K. Proctor (Salem, MA); others mentioned.]

ST2577 "Stereoscopic Views." ANTHONY'S PHOTOGRAPHIC BULLETIN 1, no. 4 (May 1870): 74. [Announcement by Anthony Brothers of having received views by W. England, Francis Bedford and A. Braun.]

ST2578 "Julie." "The Sitter Hath Trial as Well; or, the Other 'Side'." PHILADELPHIA PHOTOGRAPHER 7, no. 77 (May 1870): 171-175. [Humorous anecdotes from the "sitter's" point of view.]

ST2579 "Editor's Table." PHILADELPHIA PHOTOGRAPHER 7, no. 77 (May 1870): 182-184. [Wm. Notman (Montreal); M. Carey Lea; Dr. Woodward; Toronto Photo. Soc.; S. W. Sawyer (Bangor, ME) burned out; R. Emery (Plymouth, OH) burned out; M. Moses (Trenton, NJ) burned out; A. E. Allen; F. W. Hardy (Bangor, ME); E. H. Alley (Toledo, OH); W. R. Gill (Lancaster, PA); E. F. Warrington (Philadelphia, PA) died Apr. 22; A. Bogardus; J. A. Schoelton; others mentioned.]

ST2580 "Mr. J. Walker, Artist, of New York." FRANK LESLIE'S ILLUSTRATED NEWSPAPER 30, no. 762 (May 7, 1870.): 117. 1 illus. [Biography of this artist. The illustration, which is of the painter sitting before an easel outdoors in the woods, is credited "From a Photograph taken at Lookout Mountain, TN." with the strong implication that it was taken while Walker was there during the Civil War.]

ST2581 "The Shaw vs. Wilcox Suit. Final Decision of Judge Blatchford." ANTHONY'S PHOTOGRAPHIC BULLETIN 1, no. 5 (June 1870): 78-79. [Lawsuit on recovering silver wastes.]

ST2582 "Editor's Table." PHILADELPHIA PHOTOGRAPHER 7, no. 78 (June 1870): 222-224. [J. W. Ryder; Wm. Bell (Philadelphia, PA); C. M. Van Orsdell's Gallery (wilmington, NC) struck by lightning; E. V. Seutter (Jackson, MS); C. R. Savage (Salt Lake City, UT); Bushby & Hart (Lynn, MA); J. Lee Knight (Topeka, KS); J. Inglis (Montreal); E. Long & Co. (Quincy, IL); A. F. Clough (Warren, NH); others mentioned.]

ST2583 "Editor's Table." PHILADELPHIA PHOTOGRAPHER 7, no. 79 (July 1870): 270-272. [Shaw Patent; A. Marshall (Boston, MA); Suddards & Fennemore (Philadelphia, PA) and W. L. Germon (Philadelphia, PA) won Photo-Crayon Prize Medals; J. F. Ryder's portrait of Dr. H. Vogel; Kilburn Brothers; Prof. Henry Morton; F. H. Houston (Pittsfield, MA) damaged by hail and rain; others mentioned.]

ST2584 "New Pictures." ANTHONY'S PHOTOGRAPHIC BULLETIN 1, no. 7 (Aug. 1870): 143. [James Landy (Cincinnati, OH); N. M. Pease (Conway, NH); I. W. Moore (Bellefonte, PA); E. Bergh.]

ST2585 "Editor's Table." PHILADELPHIA PHOTOGRAPHER 7, no. 80 (Aug. 1870): 304. [H. J. Newton; John Carbutt sold his studio to S. W. Sawyer (Bangor, ME) and will move to Philadelphia to manufacture plates; Sewell F. Graves (Howland Flat, CA) burned out; J. D. Marsters, Pres. of new St. John, New Brunswick Photo. Soc.; others mentioned.]

ST2586 "Editor's Table." PHILADELPHIA PHOTOGRAPHER 7, no. 80 (Aug. 1870): 304. [H. J. Newton; John Carbutt sold his studio to S. W. Sawyer of Bangor, ME and will move to Philadelphia to

manufacture plates; Sewell F. Graves (Howland Flat, CA), burned out; J. D. Marsters, Pres. of new St. John, N.B. photo society; others mentioned.]

ST2587 "Examples of American Photography." ANTHONY'S PHOTOGRAPHIC BULLETIN 1, no. 8 (Sept. 1870): 157-158. [From "London Photographic News." Discusses general trends. Mentions Kurtz (New York, NY); Baker (Buffalo, NY); Notman (Montreal, CAN); Loomis (Boston, MA); Keeler & Fennemore (Philadelphia, PA); Carbutt (Chicago, IL); Inglis (Montreal).]

ST2588 "Editor's Table." PHILADELPHIA PHOTOGRAPHER 7, no. 81 (Sept. 1870): 334-336. [G. H. Loomis in Europe; W. H. Jackson gone to the Rocky Mountains with Prof. F. V. Hayden; Wm. Kurtz; New Brunswick Photo. Soc. formed; process monger named Sprague around; Irish & Lawrence (Bridgeport, CT); R. Benecke (St. Louis, MO); S. F. Adams (New Bedford, MA); H. L. Bingham (Kalamazoo, MI); Kohl & Tyler (Cincinnati, OH); C. D. Fredericks & Co.; J. T. Upson (Upson & Simpson, Buffalo, NY) died in Aug., aged 41 yrs.; N. G. Burgess (Brooklyn, NY) died July 13, aged 56 yrs.]

ST2589 Vogel, Dr. Hermann. "Photography in America." ANTHONY'S PHOTOGRAPHIC BULLETIN 1, no. 9 (Oct. 1870): 176-178. [From "London Photographic News." Report of a conversation with Vogel, who had just visited USA to attend NPA convention. Another excerpt from Vogel, "Enlargements in the United States," on p. 178.]

ST2590 "Pictures." ANTHONY'S PHOTOGRAPHIC BULLETIN 1, no. 9 (Oct. 1870): 186. [Benj. F. Jones (Salem, MA); Lockwood & Ely (Racine, WI); Rees & Co. (Richmond, VA).]

ST2591 "Editor's Table." PHILADELPHIA PHOTOGRAPHER 7, no. 82 (Oct. 1870): 367-368. [Howard A. Kimball; John L. Gihon selling his gallery; Samuel Godshaw, Sr. mortally shot on Sept. 3; I. B. Webster (Louisville, KY); John A. Scholten; W. G. Entrekin (Manayunk, PA); W. A. Beers (New Haven, CT); Halsey & Coffin (Dutch Flat, CA); Jno. R. Moore (Trenton Falls, NY); Well G. Singhi (Bainbridge, NY); E. A. Staunton (Davenport, IA); M. H. Monroe (Rochester, NY); others mentioned.]

ST2592 "Pictures." ANTHONY'S PHOTOGRAPHIC BULLETIN 1, no. 10 (Nov. 1870): 207-208. [Ormsby (Stockton, CA); E. R. Curtiss (Madison, WI); C. C. Gardner (Bristol, NH); H. M. Patter; C. P. Thompson (Harlem, NY).]

ST2593 "Editor's Table." PHILADELPHIA PHOTOGRAPHER 7, no. 83 (Nov. 1870): 399-400. [Bailey & Scotford (Bay City, MI); V. Royle (Paterson, NJ); J. D. Cadwallader (Marietta, OH); F. G. Weller (Littleton, NH); H. Rocher (Chicago, IL); H. L. Bingham (Kalamazoo, MI); Heywood (Boston, MA) died; George H. Boynton (Boynton & Heald, Boston, MA) committed suicide; Alexander Krohne (at Bogardus' Gallery many years) died Oct. 2; R. Goebel (St. Charles, MO) opened gallery.]

ST2594 Vogel, H. "Studios in America." ANTHONY'S PHOTOGRAPHIC BULLETIN 1, no. 11 (Dec. 1870): 219-220. [From "Br J of Photo."]

ST2595 "Pictures." ANTHONY'S PHOTOGRAPHIC BULLETIN 1, no. 11 (Dec. 1870): 231-232. [D. B. Fisher, Carl Meinerth (Newburyport, RI); R. P. Young (Port Huron, MI); M. P. Simons (Philadelphia, PA); D. Sewell (Sonora, Mexico); E. L. Goss (Waltham, MA); J. Lee Knight (Topeka, KN).]

ST2596 "Editor's Table." PHILADELPHIA PHOTOGRAPHER 7, no. 84 (Dec. 1870): 431-432. [R. A. Lewis; Z. P. McMillan (Galesburg, IL) opened new rooms; A. F. Clough; Dr. Woodward's photo-micrographs; H. B. Hillyer (Austin, TX); H. O. Bly (Hanover, NH); E. R. Curtiss (Madison, WI); C. R. Savage, U.P.R.R. views; Jesse A. Graves (Delaware Water Gap, PA); R. S. Forbes (Eugene City, OR); W. H. Whitehead (Pittsburgh, PA); J. Landy (Cincinnati, OH); M. N. Crocker (Perry, NH); others mentioned.]

USA: 1871.

ST2597 "Editor's Table." PHILADELPHIA PHOTOGRAPHER 8, no. 85 (Jan. 1871): 30-32. [Dinmore & Wison (Baltimore, MD); Prof. Henry Morton; James Inglis (Montreal); Ernest Edwards (London); H. Merz (NY); A. E. Lesage (Dublin); S. W. Sawyer (Chicago, IL); J. J. Reilly & J. A. Spooner (Stockton, CA); Charles Wetherby (Iowa City, IO); W. E. Bowman (Ottawa, IL); J. B. Hamilton (Sioux City, IO); F. B. Clench (St. Catharines, Ontario); M. A. Kleckner (Bethlehem, PA); E. Decker (Cleveland, OH).]

ST2598 "Pictures." ANTHONY'S PHOTOGRAPHIC BULLETIN 2, no. 2 (Feb. 1871): 62-63. [E. M. Van Aken (Lowville, NY); H. Noss (New Brighton, PA); Dr. Mills (Penn Yan, NY); G. W. Goodrich (Newport, NH); S. H. Waite (Hartford, CT); C. & S. Hinkley (Geneva, NY); Handsome (Chicago, IL).]

ST2599 "Editor's Table." PHILADELPHIA PHOTOGRAPHER 8, no. 86 (Feb. 1871): 64. [D. C. Maxwell (Lynchburg, VA), died recently; L. C. Everett (Troy, NY) died Nov. 16, 1870.]

ST2600 "Defeat of the Sliding Box Patent." PHILADELPHIA PHOTOGRAPHER 8, no. 87 (Mar. 1871): 78-81. [Schoonmaker vs. Wing.]

ST2601 "Editor's Table." PHILADELPHIA PHOTOGRAPHER 8, no. 87 (Mar. 1871): 96. [J. P. Greenwald (Adrian, MI) died of consumption in Feb. "Eight years ago, we worked together under the same skylight."; E. M. Van Aken (Lowville, NY); R. Goebel (St. Charles, Mo.); W. G. Chamberlain's Catalogue of Colorado Scenery; H. A. Dirr, Texas views; Ormsby (Stockton CA); J. W. King (Honolulu); Lockwood & Ely; C. W. Stiff (Jones Gallery, Salem, MA); James L. Forbes "for many years at Gurney's Gallery, is now with William Kurtz...side by side with Elbert Anderson..."]

ST2602 Boozer, H. M. "Boozer's Idea Elucidated." ANTHONY'S PHOTOGRAPHIC BULLETIN 2, no. 4 (Apr. 1871): 101-102. [Plan for using photography in advertising. Boozer had earlier tried to sell the idea, without success. See earlier article, "Boozer's 'Idea,'" on p. 88 in Mar. 1871 issue.]

ST2603 "The Extension of Woodward's Patent for the Solar Camera." PHILADELPHIA PHOTOGRAPHER 8, no. 88 (Apr. 1871): 115-117.

ST2604 "Editor's Table." PHILADELPHIA PHOTOGRAPHER 8, no. 88 (Apr. 1871): 127-128. [H. L. Bingham (Kalamazoo, MI); R. Benecke (St. Louis, Mo.); Clough & Kimball (Concord, NH); F. G. Weller (Littleton, NH); E. H. Alley (Toledo, OH); J. C. Toler (Oxford, OH), burned out; R. Newell & Co. (Philadelphia, PA); J. MacIntosh (Rochester, NY); J. W. H. Campion (Barbadoes, W. I.); J. Merrill & F. M. Spencer; E. F. Lummis; C. E. Smith.]

ST2605 "New York City. - Photographs of the Jubilee - Review of the Procession from City Hall, Car with Dressmakers' Models, etc." and "...the Ivory Turners' Car, Elephant, etc." FRANK LESLIE'S ILLUSTRATED NEWSPAPER 32, no. 813 (Apr. 29, 1871): 97. 2 illus.

[Distant view of parade, with crowds. The Jubilee was celebrating peace between France and Germany.]

ST2606 "The Taking of Nancy, by an Eye-Witness." ANTHONY'S PHOTOGRAPHIC BULLETIN 2, no. 5 (May 1871): 156. [Poem.]

ST2607 "Editor's Table." PHILADELPHIA PHOTOGRAPHER 8, no. 89 (May 1871): 159-160. [B. W. Kilburn; H. Vogel, pictures of Mt. Etna; A. Douglass, previously working for C. W. Stevens (Chicago, IL), has become a partner; M. M. Griswold (Lancaster, OH); Wellington Watson (Grelling's Gallery, Detroit, MI); E. L. Willis (Milford, MA); Harry Gurlitz (Sparta, KY); others mentioned.]

ST2608 "Editor's Table." PHILADELPHIA PHOTOGRAPHER 8, no. 90 (June 1871): 192. [Ed. Boetteher (New York, NY); Austen & Oliver (Oswego, NY); E. A. Kusel (Oroville, CA); "the indefatigable" W. E. Bowman; Slee Brothers (Poughkeepsie, NY); Warren Wykes (Grand Rapids, MI); Davis Bros. (Portsmouth, NH); Well G. Singhi (Waverly, NY); J. H. Reed (Fulton, IL); Z. P. McMillan (Galesburg, IL); M. M. Griswold (Lancaster,OH).]

ST2609 "The Illinois and St. Louis Bridge." SCRIBNER'S MONTHLY 2, no. 2 (June 1871): 163-176. 9 illus. [Illustrations of the bridge under construction, of which at least five are from non-credited photographs (taken Sept. 20, 1870 and later.) Capt. James B. Eads was the Chief Engineer.]

ST2610 "Editor's Table." PHILADELPHIA PHOTOGRAPHER 8, no. 91 (July 1871): 247-248. [Well G. Singhi (Waverly, NY) burned out, started again; H. H. Snelling returning to write for the "Phila. Photo."; F. Gutekunst; Bailey & Cohen (Navosta, TX); J. H. Easton (Rochester, NY); C. H. Freeman (Montpelier, VT); Gay (Fall River, MA); Balch Bros.(Baltimore, MD).]

ST2611 "The Committee on the Scoville and Holmes Medals - Extracts from Their Proceedings." PHILADELPHIA PHOTOGRAPHER 8, no. 92 (Aug. 1871): 258-264.

ST2612 Vogel, Dr. H. "German Correspondence." PHILADELPHIA PHOTOGRAPHER 8, no. 92 (Aug. 1871): 273-275. [Technical; mentions use of magic lantern slides for educational purposes in the USA as opposed to Germany, where they were used in side shows.]

ST2613 "Editor's Table." PHILADELPHIA PHOTOGRAPHER 8, no. 92 (Aug. 1871): 278-280. [B. W. Kilburn; Porter & Winter (Cincinnati,OH), opened studio; A. H. Plecker (Salem, VA); R. J. Chute (Gutekunst's Studio, Philadelphia); S. F. B. Morse.]

ST2614 "Pictures." ANTHONY'S PHOTOGRAPHIC BULLETIN 2, no. 9 (Sept. 1871): 306. [M. M. Griswold (Lancaster, OH); Clough & Kimball; Frayser (Richmond, VA); Van Wagner (Nyack, NY); John Bachelder (W. Andover, NH); B. L. H. Dabbs (Pittsburgh, PA).]

ST2615 "Editor's Table." PHILADELPHIA PHOTOGRAPHER 8, no. 93 (Sept. 1871): 310-312. [Fennemore & Suddards; warning against a J. H. Dampf, thief; J. Nicholson (Bostrop, TX); F. Gutekunst; Bradley & Rulofson; H. B. Hillyer (Austin, TX); Lovejoy & Foster (Chicago, IL); J. W. Emery (Galva, IL); A. J. Riddle (Macon, GA); A. S. Barber (Willimantic, CT); Wm. Brown (Red Wing, MN); Gihon & Thompson; A. C. McIntire & Co. (Ogdensburg, NY).]

ST2616 "A New Want - An Assistance to Immortality." FRANK LESLIE'S ILLUSTRATED NEWSPAPER 32, no. 831 (Sept. 2, 1871): 414. illus. [Argument, I think, about the impacts of diffusion of photography and mass media.]

ST2617 "New Jersey. - Mysterious Explosion at the Corner of Montgomery and Washington Streets, Jersey City, August 14th. - Evidence Afforded by a Photographic View of the Ruins." FRANK LESLIE'S ILLUSTRATED NEWSPAPER 32, no. 831 (Sept. 2, 1871): 417. 1 illus.

ST2618 "Pictures." ANTHONY'S PHOTOGRAPHIC BULLETIN 2, no. 10 (Oct. 1871): 339. [E. M. Van Aken (Lowville, NY); Swaine & Mote (Richmond, VA); D. H. Anderson (Richmond, VA); J. S. Broadway; D. C. Dinsmore (Dover, ME); W. J. Land (Atlanta, GA).]

ST2619 "Bottling Sunbeams." CALIFORNIA MAIL BAG 1, no. 4 (Oct. - Nov. 1871): 64. [A Mr. Xamben de Prades is reported to have "...bottled sunbeams... shut them up - so as to render them serviceable when required to use, exactly like pickles and preserves, and cherry brandy..."]

ST2620 "Editor's Table." PHILADELPHIA PHOTOGRAPHER 8, no. 94 (Oct. 1871): 343-344. [S. F. B. Morse; A. Bogardus; F. G. Weller (Littleton, NH); J. F. Fitzgibbon (St. Louis, MO); B. W. Kilburn; Wm Kurtz; C. R. Rees & Co. (Richmond, VA), burned out; P. B. Jones & Son (Davenport, IO), burned out; G. L. Faulhaber (Sedalia, MO), burned out.]

ST2621 "Pictures." ANTHONY'S PHOTOGRAPHIC BULLETIN 2, no. 11 (Nov. 1871): 369. [Clough & Kimball; L. F. Tate (Oneida, IL).]

ST2622 "Editor's Table." PHILADELPHIA PHOTOGRAPHER 8, no. 95 (Nov. 1871): 375-376. [Alvah A. Pearsall; Games Cremer; Max Saettle (St. Louis, MO), burned out; W. P. Estell (Maxwell & Estell, Richmond, IN), died Oct. 13; G. L. Crosby (Hannibal, MO); John L. Gihon, illustrator of the "Photographic Review of Medicine and Surgery"; C. A. Kimball and A. F. Clough splitting up; W. H. Moyston & Bro. (Memphis, TN); A. Simpson (Buffalo, NY).]

ST2623 "A Good Half Length at Half the Money." ANTHONY'S PHOTOGRAPHIC BULLETIN 2, no. 12 (Dec. 1871): 395-396. [From "Exchange." Story, possibly apocryphal, about a photographer in California photographing the bottom half of a customer for half price. (This same story was told earlier by a photographer working in South America.)]

ST2624 "A Rambler." "Bobbing Around, or Visiting Galleries." ANTHONY'S PHOTOGRAPHIC BULLETIN 2, no. 12 (Dec. 1871): 400-402. [Anecdotes.]

ST2625 "Pictures." ANTHONY'S PHOTOGRAPHIC BULLETIN 2, no. 12 (Dec. 1871): 402. [Stereo views of CA by E. J. Muybridge; E. D. Ormsby (Stockton, CA); A. H. Lane (Waldoboro, ME); etc.]

USA:1872
BOOKS
ST2626 *From the Ocean to the Sea: Photographic Views of the Baltimore and Ohio Railroad and Its Branches*. Baltimore: B & O Railroad, 1872. n. p. b & w. [Album of original photographs, Library of Congress collection.]

ST2627 Flagg, Wilson. *The Woods and By-Ways of New England*. Boston: James R. Osgood, 1872. 442 pp. 22 b & w. [Twenty-two heliotypes of New England landscapes. One of first American books illustrated with heliotypes.]

ST2628 Lanman, Charles, Ed. *The Japanese in America*. New York: University Publishing Co., 1872. 382 pp. 3 b & w. [Photomechanical

reproductions, from negatives of Japanese Ambassador A. Mori, his party and a group of women.]

PERIODICALS

ST2629 "That's What's The Matter." ANTHONY'S PHOTOGRAPHIC BULLETIN 3, no. 1 (Jan. 1872): 433-434. [Poem, praising Anthony's cameras, etc.]

ST2630 "Editor's Table." PHILADELPHIA PHOTOGRAPHER 9, no. 97 (Jan. 1872): 30-32. [B. W. Kilburn; French & Sawyer; A. C. Partridge (Boston, MA); Jex Bardwell (Detroit, MI); C. H. Ravell (Lyons, NY); E. D. Ormsby (Stockton, CA); H. L. Bingham (Kalamazoo, MI); J. Lee Knight (Topeka, KA), scenes of a buffalo hunt, on the line of the U.P.R.R.; J. H. Kent; A. A. Pearsall (Brady Gallery, New York, NY), photographed the Duke Alexis, taking 10 negatives in 45 min.; H. A. Kimball (Concord, NH); Alfred Hall (Chicago, IL); P. B. Greene (Chicago, IL); Howard A. Kimball (Concord, NH); Copelin & Hine (Chicago, IL).]

ST2631 "Editor's Drawer." PHOTOGRAPHER'S FRIEND 2, no. 1 (Jan. 1872): 29-31. [Mentions work of Busey (Baltimore, MD); J. S. Broadway (Charlotte, NC); E. N. Medernach (Danville, VA); W. E. Bowman (Ottawa, IL); J. M. Mangold (Medora, IL); E. B. Ives (Niles, MI); R. H. Bliven (Toledo, OH); J. N. Hamilton (Sioux City, IO); Copelin & Hine (Chicago, IL); A. M. Giles; L. F. Tate (Oneida, IL); A. A. McGahey (Murphreysboro, IL); R. Hatch (Milford, MA); Dr. J. C. Mills (Pen Yang, NY); Schreiber & Son (Philadelphia, PA); J. Landy (Cincinnati, OH); J. H. Lamson (Portland, ME); E. M. Van Aken (Lowville, NY); W. M. Chase (Baltimore, MD); E. D. Ormsby (Stockton, CA); E. Sachse & Co. (Baltimore, MD); Bendann Brothers (Baltimore, MD).]

ST2632 "Editor's Table." PHILADELPHIA PHOTOGRAPHER 9, no. 98 (Feb. 1872): 63-64. [Bogardus and Bendann Brothers joined forces, opened Broadway gallery; Potter & Bro. (Mansfield, OH); H. Noss (New Brighton, PA); Copelin & Hine (Chicago, IL).]

ST2633 "Pictures." ANTHONY'S PHOTOGRAPHIC BULLETIN 3, no. 3 (Mar. 1872): 499-500. [T. A. Beach (Delaware, OH); T. W. Bankes (Little Rock, AK); B. N. Poor (Franklin, NH); Ely (Racine, WI).]

ST2634 "A Second Victory over the Shaw & Wilcox Co's 'Silver Saving Patent' and a Third!" PHILADELPHIA PHOTOGRAPHER 9, no. 99 (Mar. 1872): 84-87. [Judge's decisions, etc. Ezekiel Y. Bell vs. A. Bogardus; J. Shaw vs. Wm. Pendleton, etc.]

ST2635 "Editor's Table." PHILADELPHIA PHOTOGRAPHER 9, no. 99 (Mar. 1872): 95-96. [Walter C. North (Utica, NY); J. J. Reilly (Stockton, CA), views of Yosemite Valley; Jones & Stiff (Salem, MA); F. Thorp moving from Bucyrus, OH to Wash., DC; A. M. Tinkham (Pawtucket, RI); E. R. Burnham (Hannibal, MO); Richard Walzl (Baltimore MD), others mentioned.]

ST2636 "Pictures." ANTHONY'S PHOTOGRAPHIC BULLETIN 3, no. 4 (Apr. 1872): 531. [J. C. Scott (New Brunswick); Reid (Paterson, NJ); J. H. Blakeman; W. H. Sipperly (Schuylerville); Y. Day (Memphis, TN); F. M. Hayes (Danville, IL).]

ST2637 "Editor's Table." PHILADELPHIA PHOTOGRAPHER 9, no. 100 (Apr. 1872): 127-128. [Bogardus distributing his portrait of Sam. Morse to members of the N.P.A.; Bradley & Rulofson install an elevator in their gallery; C. Alfred and Thomas P. Garrett open a studio in Philadelphia; R. M. Linn (Lookout Mountain, TN) died; Menzis Dickson (Honolulu); W. G. C. Kimball (Concord, NH); Monfort & Hill (Burlington, IO); Mrs. W. E. Lockwood (Ripon, WI); W. H. Jackson (late of Omaha, NB), views of Yellowstone Region; J. J. Reilly (Stockton, CA); W. McLeish (St. Paul, MN); J. Perry Elliott (Indianapolis, ID); others mentioned.]

ST2638 "Editor's Drawer." PHOTOGRAPHER'S FRIEND 2, no. 2 (Apr. 1872): 60-63. [Mentions: F. G. Weller (Littleton, NH); Bradley & Rulofson (San Francisco, CA); Richard Walzl (Baltimore, MD); M. M. Griswold (Lancaster, OH); J. C. Potter (Elyria, OH); E. A. Brush (Niles, OH); H. G. White (Milwaukee, WI); Huster (Santa Fe, NM.); Julius Hall (Stockbridge, MA); Wenderoth; Capt. J. Lee Knight (Topeka, KA); N. H. Busey (Baltimore, MD); S. D. Wager (Erie, PA); Chas. C. Wetherby (Iowa City, IO); H. H. Bennett (Kilbourne City, WI); W. F. Webster (Oshkosh, WI); Will Chen??? (Blandensville, IL).]

ST2639 "Wrinkles and Dodges." PHILADELPHIA PHOTOGRAPHER 9, no. 101 (May 1872): 156-158. [Professional advice from H. B. Hillyer (Austin, TX); A. W. Cadman; B. Pennington; C. L. Curtis; A. Milton Lapham; J. P. Spooner; S. R. Harch.]

ST2640 "Editor's Table." PHILADELPHIA PHOTOGRAPHER 9, no. 101 (May 1872): 158-160. [Richardson & Broomhover (Lowell, MA); Andree (Buffalo, NY); Jones & Stiff (Salem, MA); Porter & Bro. (Mansfield, OH); Copelin & Hine (Chicago, IL); J. C. Potter (Elyria, OH); others mentioned.]

ST2641 "Massachusetts. - Experimental Explosion of a Torpedo from U. S. Steamer 'Wyoming' in Boston Harbor. - From an Instantaneous Photograph." FRANK LESLIE'S ILLUSTRATED NEWSPAPER 34, no. 867 (May 11, 1872): 141. 1 illus.

ST2642 "Editor's Table." PHILADELPHIA PHOTOGRAPHER 9, no. 102 (June 1872): 239-240. [Wilson visted several Chicago photographers; R. M. Linn's book, "Linn's Landscape Photography," published posthumously, available; Frank Pearsall (Brooklyn, NY); G. A. Barnard (Chicago, IL), views of Chicago; Ch. Waldack (Cincinnati, OH); A. J. T. Joslin (Gilman, IL); E. L. Eaton (Omaha, NB); R. Swain (Galena, IL); others mentioned.]

ST2643 "Editor's Table." PHILADELPHIA PHOTOGRAPHER 9, no. 103 (July 1872): 271-272. [Kilburn Brothers; E. T. Whitney (Norwalk, CT); Flower & Hawkins (St. Paul, MN); Alva A. Pearsall opens his own gallery in Brooklyn; E. W. Blake & Son (Milburn, NJ); Fred S. Baker (Parkersburg, WV), committed suicide; J. C. Kelley (Newport, NH); J. H. Blakemore (Mt. Airy, NC); Henry Rocher (Chicago, IL); others.]

ST2644 "Editor's Drawer." PHOTOGRAPHER'S FRIEND 2, no. 3 (July 1872): 96. [Lists photos received from several dozen photographers.]

ST2645 "Pictures." ANTHONY'S PHOTOGRAPHIC BULLETIN 3, no. 8 (Aug. 1872): 643. [Le Roy (Youngstown, OH); J. Freeman (Nantucket); J. C. Kelly (Newport, RI).]

ST2646 "Editor's Table." PHILADELPHIA PHOTOGRAPHER 9, no. 104 (Aug. 1872): 301-304. [Hesler & Sons opening a new gallery in Evanston, IL; J. G. Stewart (Carlinville, IL); C. A. Zimmerman, a photographer in St. Paul, MN, opens a stock house there with his brother; excursion of the Palette Club - Kurtz, Anderson, Sarony, etc.; B. M. Cliendist (Staunton, VA); Mssrs. Garretts opened studio in Philadelphia, PA; G. E. Curtis (Niagara Falls, NY); R. M. Linn (Lookout Mountain, TN); Potter & Co. (Mansfield, OH); A. A. Baldwin (Ludlow, VT); Charles Pollock (Boston); Blessing & Co. (Galveston, TX); Thomas Gaffield and A. Marshall sailed for Europe; others mentioned.]

ST2647 "U. S. G's Mental Photograph." FRANK LESLIE'S ILLUSTRATED NEWSPAPER 34, no. 883 (Aug. 31, 1872): 386. [Satiric essay opposing U. S. Grant, who was then running for President, opposed by this paper. "Photograph" is here used metaphorically.]

ST2648 "Editor's Table." PHILADELPHIA PHOTOGRAPHER 9, no. 105 (Sept. 1872): 334-336. [Kilburn Brothers; Hance's Photo Specialties; J. F. Ryder (Cleveland, OH); G. Frank Pearsall (Brooklyn, NY); W. W. Sloan (Jefferson, TX); E. Finch (Waxahachi, TX), attempting to organize a state photo assoc. for Texas; J. H. Lamson (Portland, ME); R. Newell & Son (Philadelphia, PA); W. L. Gill (Lancaster, PA); P. Smith & Co. purchased Charles Waldack's business in Cincinnati, OH; J. R. Tewksberry (Farmington, IO); A. A. Baldwin (Ludlow, VT); Jas. Howard (Plattsburgh, NY); John L. Gihon; James W. Black (Boston, MA); others mentioned.]

ST2649 "A Vexed Question." ANTHONY'S PHOTOGRAPHIC BULLETIN 3, no. 10 (Oct. 1872): 697-698. [From "N. Y. Times." Who has the rights to use an unsold photograph -the photographer or the sitter?]

ST2650 "Editor's Table." PHILADELPHIA PHOTOGRAPHER 9, no. 106 (Oct. 1872): 366-368. [John A. Scholten; S. M. Robinson, of Philadelphia, entering partnership with Trevor McClurg in Pittsburgh, PA; Thomas C. Maywell (IL), died young; letter from Thomas Gaffield; Augustus Marshall; Joseph Zentmeyer; R. Newell & Son; R. Channell (Phoenixville, PA) robbed of lenses; R. A. Lewis, the "Veteran photographer", opening a new gallery on Broadway; Wm. H. Rhodes (Philadelphia, PA); W. J. Baker (Buffalo, NY); J. Harper (Greenville, OH); W. H. Elliott (Marshalltown, IO); A. J. Webster; F. G. Weller; others mentioned.]

ST2651 "Editor's Drawer." PHOTOGRAPHER'S FRIEND 2, no. 4 (Oct. 1872): 126-128. [Describes work by R. Benecke (St. Louis, MO); Draper & Husted (Philadelphia, PA); F. G. Weller (Littleton, NH); Wm. Bell (Philadelphia, PA; going on government survey); G. F. Pearsall (Brooklyn, NY); Julius Hall (Stockbridge, MA).]

ST2652 "Champions of Reform in Pennsylvania." FRANK LESLIE'S ILLUSTRATED NEWSPAPER 35, no. 889 (Oct. 12, 1872): 72. 1 illus. [Full-page engraving, consisting of eight portraits, each represented as carte-de-visite photographs, appearing to be pinned to a wall.]

ST2653 "Pictures." ANTHONY'S PHOTOGRAPHIC BULLETIN 3, no. 11 (Nov. 1872): 751. [J. B. May (Watertown, WI); John A. Todd (Sacramento, CA); W. H. Dunwick (Sandusky, OH).]

ST2654 "Editor's Table." PHILADELPHIA PHOTOGRAPHER 9, no. 107 (Nov. 1872): 400. [J. Landy (Cincinnati, OH); R. F. Channell (Phoenixville, PA); Wm H. Rhodes (Philadelphia, Pa.); E. M. Van Aken (Lowville, NY); J. P. Whipple (White Water, WI); John Phillips (Madison, IO); F. G. Weller; L. D. Judkins; others mentioned.]

ST2655 "Personals." ANTHONY'S PHOTOGRAPHIC BULLETIN 3, no. 12 (Dec. 1872): 780. [Francis Hendricks (Syracuse, NY); T. W. Bankes, toured Europe, now opening a new gallery; D. K. Cady; Angell.]

ST2656 "Photographs." ANTHONY'S PHOTOGRAPHIC BULLETIN 3, no. 12 (Dec. 1872): 788. [Th. Houseworth & Co. (San Francisco, CA) views of Yosemite Valley; J. W. Black, views of the Boston fire.]

ST2657 "Editor's Table." PHILADELPHIA PHOTOGRAPHER 9, no. 108 (Dec. 1872): 438-440. [Prof. Morton's lecture; Albert Moore, *The* solar printer..." has made a 40" x 50" solar portrait of Well G.

Singhi; testimonial to John L. Gihon, as he left the C. D. Moser Gallery (Chicago, IL); Frank Jewell (Scranton, PA); W. E. Bowman (Ottawa, IL); Finley & Sons (Canadaigua, NY); C. P. Hibbard (Lisbon, NH); R. Poole (Nashville, TN); others mentioned.]

USA: 1873.
BOOKS
ST2658 Claften, Agnes Elizabeth. *From Shore to Shore; A Journey of Nineteen Years, by Agnes Elizabeth Claften, and edited with an account of her life by Christine Chaplin.* "Cambridge, MA" Riverside Press: 1873, vi, 383. b & w. [Illustrated with original photographs, tipped-in.]

ST2659 Freeman, Henry. *Wonders of the World: Places and Objects of Great Historic Interest, the Grandest Objects and Scenes in Nature, and Those Works of Art which have acquired a World-Wide Fame, are Here Described, for use in Schools and Families, Illustrated by Stereoscopic Views.* Boston: Alfred Mudge & Son, 1873.

PERIODICALS
ST2660 "The Art Student's Album." ANTHONY'S PHOTOGRAPHIC BULLETIN 4, no. 1 (Jan. 1873): 22-23. [From "NY Times." Students of NY Academy of Design obtained Mr. Frederick A. Constable, a wealthy amateur, to photograph their sketches for sale to raise funds for the academy.]

ST2661 "Pictures." ANTHONY'S PHOTOGRAPHIC BULLETIN 4, no. 1 (Jan. 1873): 32. [Mentions photos by: Ernest Edwards (Boston, MA); Dr. Mills (Penn Yan, NY); Bonfils (Beiruth, Syria.)]

ST2662 "The Photographic World." PHILADELPHIA PHOTOGRAPHER 10, no. 109-111 (Jan. - Mar. 1873): 26, 72, 79. ["We shall preserve the memory of our younger companion magazine, now deceased, by dedicating this department of the magazine to its memory." Then lists activities of photographers in USA and around the world.]

ST2663 "Editor's Table." PHILADELPHIA PHOTOGRAPHER 10, no. 109 (Jan. 1873): 31-32. [J. W. Black; J. Pitcher Spooner; lantern slide exhibition at the Franklin Institute, Philadelphia, PA, discussed.]

ST2664 "Photographers Burned Out." PHILADELPHIA PHOTOGRAPHER 10, no. 110 (Feb. 1873): 47. [B. Gray (Bloomington, IL); P. Olmstead (Davenport, IA); Z. P. McMillen (Gatesburg, IL); L. M. Neeley (Muncie, IN); W. Cutter (Galva, IL); Wm. Johnston (Abington, IL); Benj. Carr & E. P. Gould (Concord, NH).]

ST2665 "Editor's Table." PHILADELPHIA PHOTOGRAPHER 10, no. 110 (Feb. 1873): 63-64. [F. A. Constable (NY); J. Inglis (Montreal, CAN); Mrs. Raimhold (Marshalltown, IA); Walter C. North (Utica, NY); Marshall (Boston, MA); Frank Powell (Boston, MA); J. C. Toler; Joseph Zentmeyer; Louis Planque; John L. Gihon; Daniel Murphy; Coleman Sellers; Henry Biddle; Richard Walzl; G. O. Brown; Kilburn Bros.; Charles A. Saylor; Wm. H. Jackson; others mentioned.]

ST2666 Elliot, J. Perry. "What Mottoes Should We Hang In Our Galleries." ANTHONY'S PHOTOGRAPHIC BULLETIN 4, no. 3 (Mar. 1873): 13.

ST2667 "Pictures." ANTHONY'S PHOTOGRAPHIC BULLETIN 4, no. 3 (Mar. 1873): 95-96. [Photos briefly described: M. R. Lundy (West Liberty); C. A. Cahoon (Harwich, MA); M. Farington; Hall (Stockbridge, MA); F. M. Yeager (Reading, PA); photomicrograph; Mrs. Raimheld (Marshalltown, IO).]

ST2668 "Editor's Table." PHILADELPHIA PHOTOGRAPHER 10, no. 111 (Mar. 1873): 95-96. [E. Z. Webster (Norwich, CT); Blessing & Co. (Galveston, TX); W. H. Hodges (Johnston's Studio, Chicago); Smith & Motes (Atlanta, GA); G. L. Crawford (Georgetown, CA); Potter & Bro. (Mansfield, OH); H. J. Jacoby (St. Peter, MN); H. A. Kimball; C. M. Marsh (Havana, NY); Bogardus & Bendann Brothers partnership dissolved, Bendanns retiring; B. W. Kilburn sailed for Mexico; C. R. Savage; G. A. Douglass (Chicago, IL); J. W. Black; others mentioned.]

ST2669 "Spirit Photographs." ANTHONY'S PHOTOGRAPHIC BULLETIN 4, no. 4 (Apr. 1873): 117. [Report on a circular claiming to be able to teach anyone how to make spirit photographs.]

ST2670 "More Fires." PHILADELPHIA PHOTOGRAPHER 10, no. 112 (Apr. 1873): 122-123. [J. C. Potter (Elyria, OH) burned out.]

ST2671 "Pictures." ANTHONY'S PHOTOGRAPHIC BULLETIN 4, no. 4 (Apr. 1873): 128. [Photos briefly described: Hart & Anderson (Rockford, IL); O. Baston (Newport, NH); J. C. Dopp, (Ashley, IL); F. A. Kroneberger & Co. (Lambertville, NJ).]

ST2672 Howard, James. "Notes Gathered by the Wayside." PHILADELPHIA PHOTOGRAPHER 10, no. 112 (Apr. 1873): 108-109. [Tour of Midwest, discusses I. B. Webster and Frank Wybrunth in Louisville, KY. G. W. Finlay in OH. Judkins, Elliott, and Clark in Indianapolis, ID. Mr. Capper and Leo Daft in Troy, NY.]

ST2673 "Editor's Table." PHILADELPHIA PHOTOGRAPHER 10, no. 112 (Apr. 1873): 126-128. [Frank Jewell; J. W. King; J. P. Calvert; Abell J. McClure; Slee Bros.; S. L. Walker; C. E. Orr; J. M. Capper; Frank E. Pearsall; H. J. Rogers; John A. Todd (Sacramento, CA); H. T. Payne (Los Angeles, CA); J. W. Black; Wm. H. Rhodes copying by artificial light; H. L. Bingham (Kalamazoo, MI) wants to sell gallery; N. H. Busey opens gallery in Baltimore, MD; J. Holyland; T. P. Varley; W. F. Shorey; Wm. Kurtz; G. H. Train (Helena, MT); others mentioned.]

ST2674 "Pictures." ANTHONY'S PHOTOGRAPHIC BULLETIN 4, no. 5 (May 1873): 157. [Photos briefly discussed: Kroneberger (Lambertville, NJ.); E. P. Bushnell (Jefferson City, MO) members of the 27th General Assembly of Missouri, with Governor, etc.]

ST2675 "New Stereoscopic Pictures." ANTHONY'S PHOTOGRAPHIC BULLETIN 4, no. 5 (May 1873): 160. [Advertisement offering... "Beaman's Colorado and Arizona Series, Jackson's Yellowstone Series, Doremus's Midland Railroad, Roche's New Summer and Winter Niagara; Kimball's collection of White Mountains, New England and Canada."]

ST2676 "The Future of Photography to be in the Hands of the Gentler Sex." PHILADELPHIA PHOTOGRAPHER 10, no. 113 (May 1873): 129. [Comment that about 100 ladies were being taught photography by Prof. Hecker at the Cooper Union, NY.]

ST2677 "Editor's Table." PHILADELPHIA PHOTOGRAPHER 10, no. 113 (May 1873): 159-160. [Wm. H. Rhodes (Philadelphia, PA); H. Rocher (Chicago, IL); L. G. Bigelow (Grand Rapids, MI); William Bell (Philadelphia, PA) exhibiting his views of Colorado and Nevada scenery; Isa Black (Franklin, PA); M. A. Kleckner (Mauch Chunk, PA); J. J. Burke (Canton, MS); C. D. Moser; Wm. Kurtz; others mentioned.]

ST2678 "Editor's Table." PHILADELPHIA PHOTOGRAPHER 10, no. 114 (June 1873): 190-192. [Buchtel & Stolte (Portland, OR); E. P. Bushnell (Jefferson City, MO); Silas Selleck (San Francisco, CA); T. S. Johnson (Chicago, IL); L. C. Mundy (Utica, NY); J. W. Morgeneier; Doremus (Paterson, NJ); C. P. Hibbard (Lisbon, NH); H. P. MacIntosh (Newburyport, MA); C. H. Tallman (Batavia, NY); G. M. Edmondson (Plymouth, OH); Charles E. Wallin (Fort Wayne, IN); Victor M. Griswold died, not his brother, M. M. Griswold, as reported; Frank Jewell (Scranton, PA); J. G. Barrows; F. Gutekunst; others mentioned.]

ST2679 "Pictures." ANTHONY'S PHOTOGRAPHIC BULLETIN 4, no. 7 (July 1873): 219. [Mention of photographs by Lon N. Neeley; J. B. Webster (NC); W. E. Bowman (Ottawa, IL); J. R. Howerton (Fayetteville); J. F. Coonly; H. J. Rogers (Hartford, CT).]

ST2680 "Editor's Table." PHILADELPHIA PHOTOGRAPHER 10, no. 115 (July 1873): 223-224. [J. W. Black; J. J. Vanderweyde; Bendann Brothers purchased new Frederick's Gallery on Broadway; E. M. Van Aken (Lowville, NY) photos of chickens; L. E. Walker (Warsaw, NY); T. R. Burnham's gallery (Boston, MA) destroyed by fire; Well G. Singhi; W. J. Oliphent (Austin, TX); W. M. Lockwood and Mrs. E. N. Lockwood; J. Pitcher Spooner; G. H. Sherman (Elgin, IL); others mentioned.]

ST2681 "Pictures." ANTHONY'S PHOTOGRAPHIC BULLETIN 4, no. 8 (Aug. 1873): 250. [Photos mentioned: N. Winter (Cairo, IL); C. Ely (Racine, WI); I. A. Coombs (Wiscasset, ME) pictures of the Esquimaux family that accompanied Dr. Hall on his late Arctic expedition; Frank Bishop, Jr.; I. M. Van Wagner (Nyack, NY) landscapes; J. M. Capper, architectural subjects.]

ST2682 "Editor's Table." PHILADELPHIA PHOTOGRAPHER 10, no. 116 (Aug. 1873): 255-256. [Frank Jewell; Potter & Brother; J. A. W. Pittman; A. S. Barber; L. P. Vallee (Quebec, Canada); Isaac Chandlee; W. L. Gill (Lancaster, PA); R. Newell (Philadelphia, PA); W. L. Bailey (Jefferson City, MO) shot while helping sheriff arrest some desperadoes; Theo. N. Gates (Westboro, MA) burned out; George B. Ayres; R. H. Blair (Smyra, DE); Wing Patent suit revived in Michigan.]

ST2683 "Mr. Edward Anthony's Offer." ANTHONY'S PHOTOGRAPHIC BULLETIN 4, no. 9 (Sept. 1873): unnumbered leaf following p. 288. [Anthony offered $500 in prizes for best portraits, best landscape, to be judged and awarded by a committee selected by the National Photographic Association. There is also a holographic letter of three pages written by Samuel Morse in 1853, who acted as one of the judges in the first prize contest offered by Anthony, won by Jeremiah Gurney.]

ST2684 "Fisk University, Jubilee Hall." ILLUSTRATED LONDON NEWS 63, no. 1775 (Sept. 6, 1873): 231, 232. 2 illus. [Group portrait of "Jubilee Singers of Fisk University College, touring England, and a view of the building in Nashville, TN." Social documentary.]

ST2685 "The Edward Anthony Prizes." ANTHONY'S PHOTOGRAPHIC BULLETIN 4, no. 10 (Oct. 1873): 290-291. [Letters of acceptance by the judges printed. J. W. Draper, J. Borda, Coleman Sellers, F. F. Thompson, H. J. Newton asked by Pres. Bogardus of N.P.A. to perform the task.]

ST2686 "Pictures." ANTHONY'S PHOTOGRAPHIC BULLETIN 4, no. 12 (Dec. 1873): 376. [Descriptions of photos by J. A. Palmer (Aiken, SC); J. J. Vanderweyde (Montevideo, SA); E. W. Beckwith (Plymouth, PA); S. Anderson (New Orleans, LA).]

USA: 1874.
BOOKS
ST2687 National Album of the Pennsylvania Railroad. Philadelphia: W. P. Mange, 1874. n. p. b & w. [Original photographs.]

PERIODICALS

ST2688 Shaw, J. "The Shaw Controversy." ANTHONY'S PHOTOGRAPHIC BULLETIN 5, no. 1 (Jan. 1874): 66. [Letter from Shaw, copyright holder on a certain silver recovery process.]

ST2689 "Pictures." ANTHONY'S PHOTOGRAPHIC BULLETIN 5, no. 1 (Jan. 1874): 68. [J. Kirk (Newark, NJ); J. Edwards Smith; R. Morgan (Morgantown, NC); C. D. Moser (Chicago, IL).]

ST2690 "Editor's Table." PHILADELPHIA PHOTOGRAPHER 11, no. 121 (Jan. 1874): 32. [A. L. Allen and Frank Rowell formed a partnership in Boston, MA; H. L. Bingham moving from Kalamazoo, MI to San Antonio, TX; Alfred Hall (Chicago, IL); L. M. Melander opening a gallery in Chicago, IL; Lymann Shepard, an operator for Brown & Higgens (Wheeling, WV) committed suicide; James Landy; W. G. Starke (Zanesville, OH); C. D. Moser (Chicago, IL); J. W. & J. S. Moulton (Salem, MA); J. H. Fitzgibbon; others mentioned.]

ST2691 "The Shaw Patent." ANTHONY'S PHOTOGRAPHIC BULLETIN 5, no. 2 (Feb. 1874): 88.

ST2692 "Pictures." ANTHONY'S PHOTOGRAPHIC BULLETIN 5, no. 2 (Feb. 1874): 99. [Wm. England; Valentine Blanchard (GB). Frank M. Good; F. Hudson; A. Hesler (Evanston, IL); Barhydt and J. H. Kent mentioned. Letters from working photographers E. Decker (Cleveland, OH); W. W. Whiddit (Newburgh, NY); Oscar Kramer (Vienna); J. M. Van Wager (Nyack, NY); E. Z. Webster (Norwich, CT); A. O. Carpenter and H. H. Hannay on pp. 98-99 as well.]

ST2693 "Editor's Table." PHILADELPHIA PHOTOGRAPHER 11, no. 122 (Feb. 1874): 62-64. [Charles Bierstadt (Niagara Falls, NY); Elbert Anderson; H. F. Smith (operator for W. H. Rhoads); H. Krips (operator for Draper & Husted); L. E. Walker (Warsaw. NY); J. C. Potter (Elyria, OH); J. P. Doremus (Paterson, NJ); Alexander Gardner (Washington, DC); N. A. Robinson (Hillsboro, IL) died Sept. 17, 1873; Jas. L. Forbes (late of Gurney, now with MacGregor, Brooklyn, NY); Daniel Bendann opened new gallery in Baltimore, MD; J. Lee Knight (Topeka, KS); others mentioned.]

ST2694 "What They Say About It." ANTHONY'S PHOTOGRAPHIC BULLETIN 5, no. 3 (Mar. 1874): 101-104. [Letters from professionals subscribing to "A.P.B." H. Goodrich (Shawneetown, IL); L. H. Whitson (Columbia, MO); Fred H. Howell (Rochester, NY); W. S. Bradley (Rio Grande, TX); Wm. H. Lockhart (Bryan, OH); J. H. Wyckoff (Ripon, WI); J. A. Sherriff (San Francisco, CA); C. B. Mills (Fayette, MO); L. Poole (Fitzwilliam, NH); C. G. Carleton (Waterville, ME); J. R. Gorgas (Madison, ID); A. C. Black (Brighton, IO); A. B. Crockett (Norway, ME); Chas. L. Walker (Grinnell, IO); C. Kendig (Naperville, IL); F. Bishop & Son (Watertown, WI); Thos. C. Glen (Sandersville, GA); Jesse Tye (Beaver City, UT); J. H. Lamson (Portland, ME); Jno. Huettenmueller (Fort Fred Steele); S. H. Wise (Wilton, IO); B. McMahon (Mt. Pleasant, IO); W. C. R. Kemp (Orleans, IA); John R. P. Frasen (New Gleason, N. S.); J. A. Treat, M.D. (Champion, MI); L. Thompson (Norwich, CT); Mr. and Mrs. Hitchcock (Mt. Vernon, IL); S. M. Powell (Metamora, IL); C. H. Lanphear (Findlay, OH).] "Mr. Shaw's Agreement." ANTHONY'S PHOTOGRAPHIC BULLETIN 5, no. 3 (Mar. 1874): 117-118. [Text of contract between Shaw and customer for silver and gold recovering process.]

ST2695 "Editor's Table." PHILADELPHIA PHOTOGRAPHER 11, no. 123 (Mar. 1874): 94-96. [Wm. Bryan (Russellville, KY); J. F. Ryder (Cleveland, OH); F. Gutekunst; N. S. Hardy (Boston, MA); H. Rocher (Chicago, IL); H. L. Bingham (San Antonio, TX); R. Goebel (St. Charles, MO); Souder & Nowell (Philadelphia, PA); Russell & Stone (Boston, MA); W. C. Cain (Alpena, MI); C. E. Watkins (San Francisco, CA); J.

Pitcher Spooner (Stockton, CA); Long & Smith (Quincy, IL) selling gallery; others mentioned.]

ST2696 "The Prospect Ahead." PHOTOGRAPHIC TIMES 4, no. 40 (Apr. 1874): 50-51. [Editorial exhortation, belief that the "great financial storm that swept over the country has subsided..."]

ST2697 "Report of the Judges on the Edward Anthony Prizes." ANTHONY'S PHOTOGRAPHIC BULLETIN 5, no. 4 (Apr. 1874): 152-153. [Judges: J. W. Draper; Henry J. Newton; F. F. Thompson; E. Borda; Coleman Sellers; Joshua P. Cook, Jr.; Geo. A. Baker. Complicated judging, but J. Barhydt; F. Gutekunst; L. J. Bigelow; Alexander Henderson; B. Johannes (Bavaria); Boissonas (Geneva) all won awards or commendations.]

ST2698 "The Anthony Prizes." ANTHONY'S PHOTOGRAPHIC BULLETIN 5, no. 4 (Apr. 1874): 160. [List of prizewinners in each category. J. Barhydt (Rochester, NY); F. Gutekunst (Philadelphia, PA); M. Boissonas (Geneva, Switzerland); Alex Henderson (Montreal, Canada).]

ST2699 "Editor's Table." PHILADELPHIA PHOTOGRAPHER 11, no. 124 (Apr. 1874): 127-128. [Alva Pearsall (Brooklyn, NY); J. H. Kent (Rochester, NY); Hoard & Tenny (Winona, MN); O. C. Bundy (Montana); H. B. Hillyer (Austin, TX); William T. Cowey (Brookville, IN) died Feb. 18, 1874; A. C. McIntyre (Brockville, Ontario, CAN) opened gallery; Huntington (St. Paul, MN); others mentioned.]

ST2700 Browne, Junius Henri. "Social Photographs." APPLETON'S JOURNAL 11, no. 265, 269, 273 (Apr. 18, May 15, June 13, 1874): 492-494, 621-623, 750-752. ["Photograph" is used here metaphorically, in a literary essay of detailed comment on current social mores.]

ST2701 "Correspondence." ANTHONY'S PHOTOGRAPHIC BULLETIN 5, no. 5 (May 1874): 193-195. [Letters from A. O. Carpenter (Ukiah, CA); Ch. E. Bolles (Brooklyn, NY); M. P. Simons (Philadelphia, PA); F. Langenheim (Philadelphia, PA); J. H. Dampf (Corning, NY), sold gallery; Alfred Freeman (Dallas, TX); W. T. Watson (Hull, England); W. C. Phillips (High Point, NC); J. C. Mills (Penn Yann, NY); S. T. Bryan (Young America, IL); A. M. de Silva (New Haven, CT).]

ST2702 "Pictures." ANTHONY'S PHOTOGRAPHIC BULLETIN 5, no. 5 (May 1874): 196. [S. Rogers (Tarrytown); Spencer (Valparaiso).]

ST2703 "Class in Landscape Photography." PHILADELPHIA PHOTOGRAPHER 11, no. 125-130 (May - Oct. 1874): 132, 174-175, 214-215, 235-236, 279-280, 307-308. [General advice on equipment, processes, techniques necessary for landscape photography. Includes quotes and excerpts from practitioners: (June) A. S. Murray (Pittsburgh, PA, amateur); D. E. Smith (Oneida, NY) Stewart Merrill (Fort Riley, KS); J. W. Black (Boston, MA); (July) G. W. Wilson (Scotland); (Aug.) J. W. Black (Boston, MA); W. T. Wilkinson (GB).]

ST2704 "Editor's Table." PHILADELPHIA PHOTOGRAPHER 11, no. 125 (May 1874): 159-160. [W. M. Lockwood; Walter C. North sold his gallery to Wilhelm Fritz; F. Gutekunst; Ward V. Ranger teaching photography at Syracuse University; T. R. Burnham; W. J. Rawlins & Co. (Wooster, OH) burned out; G. K. Sherman (Elgin, IL) burned out; Well G. Singhi (Bingham, NY) burned out; L. M. Melander & Brother (Chicago, IL) opened new gallery; Smith & Courney (Canton, OH) formed partnership; R. Benecke (St. Louis, MO) views of Kansas Pacific R.R.; F. G. Weller (Littleton, NH); C. Seaver; Bushby & Hart (Lynn, MA); A. C. McIntyre & Co. (Alexandria Bay, NY); A. Bogardus

(New York, NY) E. J. Foss (Boston, MA); S. J. Morrow (Dakota Terr.); G. W. Edmondson (Plymouth, OH); E. H. Train (Helena, MT); others mentioned.]

ST2705 "Pictures." ANTHONY'S PHOTOGRAPHIC BULLETIN 5, no. 6 (June 1874): 227. [C. D. Moser (Chicago, IL); Van Wager (Nyack, NY).]

ST2706 "Editor's Table." PHILADELPHIA PHOTOGRAPHER 11, no. 126 (June 1874): 190-192. [C. W. Hearn; Charles Waldack, who worked in Cincinnati, OH for many years, returned to Ghent, Belgium and opened a gallery there; Prof. Samuel L. Walker (Poughkeepsie, NY) died Apr. 25. Wm. Langenheim (Philadelphia, PA) died May 4; Josiah Brown (East Mauch Chunk, PA) died Apr. 26; Kilburn Brothers; J. Loeffler (Tompkinsville, NY); J. H. Johnson (New Vienna, OH); W. H. Potter (Mansfield, OH); others mentioned.]

ST2707 "Editor's Table." PHILADELPHIA PHOTOGRAPHER 11, no. 127 (July 1874): 223-224. [A. Hesler gave a sciopticon exhibition to the Chicago Photographic Assoc.; A. C. Moser (Chicago, IL); Huntington & Bartram (St. Paul, MN), opened new gallery; W. H. Rulofson; Frank Jewell sold his gallery in Scranton, PA, formed partnership with Brownell and opened gallery, Brownell & Jewell, in New York, NY; F. Gutekunst; Schreiber & Sons; Walter C. North sold gallery, proposes to teach; others mentioned.]

ST2708 "The Camera Obscura at Central Park, New York City." FRANK LESLIE'S ILLUSTRATED NEWSPAPER 38, no. 982 (July 25, 1874): 309, 315. 1 illus. [Artist's sketch of a crowd surrounding a table, with an image projected on the surface, inside "...a little eight-sided building surmounted by a small turret, pierced with lenses..."]

ST2709 "Pictures." ANTHONY'S PHOTOGRAPHIC BULLETIN 5, no. 8 (Aug. 1874): 292. [S. H. Wise stereos of the Milton Mastodon; J. F. Coonley (Memphis, TN).]

ST2710 "Editor's Table." PHILADELPHIA PHOTOGRAPHER 11, no. 128 (Aug. 1874): 254-256. [Ed. L. Wilson made honorary member of the Berlin Photographic Society; A. Hesler; F. Gutekunst; Bradley & Rulofson; Julius Hall (Great Barrington, MA); Ormsby (Chicago, IL); J. Pitcher Spooner; James Howard (Plattsburg, NY).]

ST2711 "The Shaw & Wilcox Company against William Nims." ANTHONY'S PHOTOGRAPHIC BULLETIN 5, no. 8 (Aug. 1874): 287.

ST2712 "Correspondence." ANTHONY'S PHOTOGRAPHIC BULLETIN 5, no. 8 (Aug. 1874): 291-292. [Letters from Abm. M. de Silva (New Haven, CT); C. D. Mosher (Chicago, IL); Jas. W. Carmichael; F. M. Pickerill (Indianapolis, IN); etc.]

ST2713 "Popular Practice." ANTHONY'S PHOTOGRAPHIC BULLETIN 5, no. 9 (Sept. 1874): 294-308. [Anthony sent a letter to its subscribers asking for their processes and procedures. Replies by J. Barhydt (Rochester, NY); Wm. R. Howell (New York, NY); F. S. Crowel (Mt. Vernon, OH); J. Lee Knight (Topeka, KA); Albert Moore (Philadelphia, PA); B. F. Battells (Akron, OH); S. Root (Dubuque, IO); E. D. Ormsley (Chicago, IL); J. W. Black (Boston, MA); E. R. Weston (Bangor, ME); H. Rocher (Chicago, IL); D. K. Prescott (Boston, MA); Frank M. Pickerill (Indianapolis, IN); Bradley & Rulofson (San Francisco, CA); E. P. Libby (Keokuk); Chas. A. Zimmerman (St. Paul, MN); Hoard & Tenney (Winona, MN); Allen & Rowell (Boston, MA); S. M. Taylor (Berlin, WI); Milton T. Carter (Worcester, MA); C. D. Moser (Chicago, IL); C. Gentile (Chicago, IL); J. A. W. Pittman (Carthage, IL); E. L. Eaton (Omaha, NB); C. H. Lamphear (Findlay,

OH); J. Battersby (Chicago, IL); G. W. Edmondson (Plymouth, OH); Wm. M. Lockwood (Ripon, WI); A. J. Shepler (Canton, OH); L. W. Roberts (Urbana, OH); E. J. Mote (Richmond, ID); Monfort & Hill (Burlington, IO); Joslin & Phillips (Daville, IL); Daniel Bendann (Baltimore, MD); H. C. Wilt (Franklin, PA); F. M. Bell Smith (Hamilton)[includes essay on Composition Pictures]; R. Benecke (St. Louis, MO).]

ST2714 "Pictures." ANTHONY'S PHOTOGRAPHIC BULLETIN 5, no. 9 (Sept. 1874): 324. [E. V. Seutter (Jackson, MS); Edmundson (Plymouth, OH); I. B. Webster (Louisville, KY); J. E. Larkin (Elmira, NY).]

ST2715 "Editor's Table." PHILADELPHIA PHOTOGRAPHER 11, no. 129 (Sept. 1874): 286-288. [J. Barhydt (Rochester, NY); E. D. Ormsby; F. Gutekunst; Albert Moore; R. Benecke (St. Louis, MO), views of the Kansas Pacific R.R.; C. D. Mosher (Chicago, IL); J. A. Scholten (St. Louis, MO), opened new, larger gallery; J. Pitcher Spooner; C. D. Fredericks & Co; Bradley & Rulofson; Alvah Pearsall; E. J. Potter (Mansfield, OH); J. H. Folsom (Danbury, CT); H. W. Immke (Princeton, IL); G. D. Wakely (Kansas City, MO); J. Paul Martin (Boone, IA); others mentioned.]

ST2716 "Popular Practice." ANTHONY'S PHOTOGRAPHIC BULLETIN 5, no. 10 (Oct. 1874): 341-342. [J. C. Bilbrough (Dubuque, IA); H. O. Heichert (Frankford, IN); N. H. Busey (Baltimore, MD); A. W. Hardy (Boston, MA).]

ST2717 "Judge Westbrook's Opinion: Shaw & Wilcox Co. vs. Godfrey, Etc." ANTHONY'S PHOTOGRAPHIC BULLETIN 5, no. 10 (Oct. 1874): 346.

ST2718 "Editor's Table." PHILADELPHIA PHOTOGRAPHER 11, no. 130 (Oct. 1874): 318-320. [Julius Hall (Great Barrington, MA); Montfort & Hill (Burlington, IA); Duhem Brothers (Denver, CO); Bradley & Rulofson; Kilburn Brothers; J. Carbutt; A. W. Simon (Buffalo, NY); J. P. Doremus (Patterson, NJ), building a floating gallery to "do the Mississippi Valley,"; W. H. Illingworth (St. Paul, MN); Frank G. Weller; Walter C. North.]

ST2719 "Editor's Table." PHILADELPHIA PHOTOGRAPHER 11, no. 131 (Nov. 1874): 350-352. [Kilburn Brothers; W. E. Bowman (Ottawa, IL); Huntington & Bartram (St. Paul, MN), burned out; John R. Clemons (Philadelphia, PA), threatened by fire; D. H. Anderson (Richmond, VA), opened galley; Parker & Parker and C. P. Fessenden contributed 22 photos to a pamphlet, "The City of San Diego, California."; G. M. Elton (Palmyra, NY); Perry & Bohm (Denver, CO); Limpert & North (Columbus, OH); John A. Scholten (St. Louis, MO); F. G. Fuller; others mentioned.]

ST2720 "Some Successful Candidates in the Fall Elections." FRANK LESLIE'S ILLUSTRATED NEWSPAPER 39, no. 999 (Nov. 21, 1874): 169. 8 illus. [Eight noncredited portraits, from photographs, and presented as if they were a cluster of cabinet cards.]

ST2721 Spear, Ellis, Acting Commissioner. "Non-Extension of the Wing Patent. [Decision]" ANTHONY'S PHOTOGRAPHIC BULLETIN 5, no. 12 (Dec. 1874): 407-408.

ST2722 Stewart, E. J. "Correspondence." ANTHONY'S PHOTOGRAPHIC BULLETIN 5, no. 12 (Dec. 1874): 417-418. [Letter in response to article on Flatboat gallery. Describes others so engaged. Capt. Edwards (Bowling Green, KY) on the Ohio River "in Daguerreotype days." Wheeler & Brother (Portsmouth, OH), ran a Floating Palace 100'x20' for years on the Ohio, now in the Green

River country. Col. Gibson & Brother (Cincinnati, OH) worked on the "Lone Star," Mr. Coffin on the Lower Ohio, Mason on the Mississippi; Stewart & Co. (Evansville, ID) ran the "Comet" down to New Orleans in 1872, R. M. Wilson (Cincinnati, OH) ran the "Hattie" down the river, others afloat as well. Stewart himself from Uniontown, KY.]

ST2723 "Editor's Table." PHILADELPHIA PHOTOGRAPHER 11, no. 132 (Dec. 1874): 382-384. [Allen & Rowell (Boston, MA); Well G. Singhi (Binghamton, NY) offers his gallery for sale; Hurst & Son (Albany, NY); G. F. Flagg (Ovid, NY); J. F. Ryder; Albert S. Southworth; Charles Bierstadt; others mentioned.]

USA: 1875.
BOOKS
ST2724 Flagg, Wilson. *The Birds and Seasons of New England.* Boston: James R. Osgood, 1875. n. p. 12 illus. [Illus. by the heliotype process. Outdoor scenes, (not clear if from photos.)]

PERIODICALS
ST2725 Wilson, Edward L. "Photographic Items from 'The Great Republic.'" BRITISH JOURNAL PHOTOGRAPHIC ALMANAC 1875 (1875): 110-112. [Hints from John M. Blake; E. M. Estabrook; Alfred Hall; etc.]

ST2726 "Correspondence: Anthony's Extra Portrait Collodion." ANTHONY'S PHOTOGRAPHIC BULLETIN 6, no. 1 (Jan. 1875): 31-32. [Letters praising the product, from: A. J. Russell (New York, NY); Coleman & Remington (Providence, RI); W. R. Howell, with D. H. Crossin, operator (New York, NY); I. M. Van Wagner (Nyack, NY); George G. Rockwood (New York, NY); W. H. Cushing (St. Augustine, FL).]

ST2727 "The Wing Patent Extension Case." PHILADELPHIA PHOTOGRAPHER 12, no. 133 (Jan. 1875): 20-23. [Simon Wing (Boston, MA) patent for improvement to photographic camera (1860) challenged.]

ST2728 "Editor's Table: Pictures Received." PHILADELPHIA PHOTOGRAPHER 12, no. 133 (Jan. 1875): 30. [J. H. Lamson; Bradley & Rulofson; A. L. Moffit; G. D. Morse, J. W. Bettz; L. G. Bigelow, etc.]

ST2729 "Wrinkles and Dodges and Filterings from the Fraternity." PHILADELPHIA PHOTOGRAPHER 12, no. 133-144 (Jan. - Dec. 1875): 23-28, 60-62, 93-94, 164-168, 284-285. [Advice, suggestions from photographers. (Jan.) S. L. Walker; H. W. Immke; A. L. McKay; Capt. J. Lee Knight; J. Perry Elliott; J. M. Davidson; S. H. Parsons; L. G. Bigelow; George W. Leas, others. (Feb.) I. B. Webster; Myer Moss; Abram. Bogardus; Daniel Bendann.(Mar.) E. D. Ormsby; J. W. Morgeneier; F. M. Spencer. (June) A. M. Meltetal (Blanco, TX); E. M. Collins (Oswego, NY); J. Henry Whitehouse; W. A. Cox; Charles Gilli; E. F. Phillips (Little Rock, AK); Porter Bros. (Sept.) Myer Moss; D. E. Smith; Wilt Bros.]

ST2730 "This, That and the Other." ANTHONY'S PHOTOGRAPHIC BULLETIN 6, no. 2 (Feb. 1875): 51. [Correction of James - not John - Black, as previously printed. E. J. Foss (Boston); D. W. Butterfield (Boston); other matters.]

ST2731 "How the Bulletin Fares." ANTHONY'S PHOTOGRAPHIC BULLETIN 6, no. 2 (Feb. 1875): 62-63. [Letters from G. S. Spaulding (Punta Arenas, CA); John C. Gray (Jamestown, NY); Abm. M. De Silva (New Haven, CT); E. K. Hough (New York, NY); C. B. Mills (Manchester, IO); Garvey Donaldson (Harrietsville, OH).]

ST2732 "The Promenade Photograph - Another Argument in its Favor." PHILADELPHIA PHOTOGRAPHER 12, no. 134 (Feb. 1875): 51.

ST2733 "Editor's Table: Pictures Received." PHILADELPHIA PHOTOGRAPHER 12, no. 134 (Feb. 1875): 63. [R. B. Lewis (Hudson, MA); J.Pitcher Spooner; R. Benecke (St. Louis, MO); C. R. Savage; others. John Reid (Paterson, NJ) mentioned on p. 64.]

ST2734 "Editor's Table: Photographs Received." PHILADELPHIA PHOTOGRAPHER 12, no. 135 (Mar. 1875): 94-96. [A. Bogardus; L. Daft (Troy, NY); J. H. Oakley (Ravenna, OH); Frank Robbins (Oil City, PA); J. A. Palmer (Aiken, SC).]

ST2735 "Scoville Manufacturing Company." PHILADELPHIA PHOTOGRAPHER 12, no. 136 (Apr. 1875): 118-119. [Extracts from the Mar. 18th "Daily Graphic" article on Waterbury, CT, including the Scoville Manufacturing Co.]

ST2736 "Editor's Table: Pictures Received." PHILADELPHIA PHOTOGRAPHER 12, no. 136 (Apr. 1875): 128. [H. Rocher (Chicago, IL) discussed briefly; list of views by many others.]

ST2737 Myers, Carl. "A Tale of Tight Times." PHILADELPHIA PHOTOGRAPHER 12, no. 137 (May 1875): 143-146. [Narrative of problems of a small town photographer named "Jones."]

ST2738 "Editor's Table: Pictures Received." PHILADELPHIA PHOTOGRAPHER 12, no. 137 (May 1875): 159. [Chas. Bierstadt (Niagara Falls, NY); H. L. Bingham (San Antonio, TX); G. S. Lumpkin & Co. (Richmond, VA), others listed.]

ST2739 "Theatric Photography." PHOTOGRAPHIC TIMES 5, no. 53 (May 1875): 99-101. [From "NY World." Mentions Sarony's work, among a rather fulsome commentary about publicity photographs of actors and actresses.]

ST2740 "Correspondence." ANTHONY'S PHOTOGRAPHIC BULLETIN 6, no. 6 (June 1875): 188-190. [Letters from T. C. Roche; W. T. Bowers (Lynn, MA); Thos. Leatham; L. C. Dillon (Washington, DC); Alfred Freeman; T. P. Varley (Baltimore, MD); J. H. Swaine (Detroit, MI); H. Kraus (Wilmington, DE); F. M. Nichols (Perrysburg, OH); F. W. Plummer (Wheeling, WV); Geo. N. Shishmanian (Wilmington, NC).]

ST2741 "Pictures Received." ANTHONY'S PHOTOGRAPHIC BULLETIN 6, no. 6 (June 1875): 192. [Maynard (White Plains, NY); Leighton Bros.; C. E. Barton (Turner's Falls, MA); G. N. Barnard; J. T. Hicks (Liberty, MO.); H. B. Hillyer (Austin, TX).]

ST2742 "Editor's Table." PHILADELPHIA PHOTOGRAPHER 12, no. 138 (June 1875): 191. [A. M. Bachmann (Allentown, PA); Smith & Motes (Atlanta, GA); Capt. Marks (Austin, TX); James H. Steffey (Mt. Union, OH); Peter Neff (Gambier, OH); George M. Bretz (Pottsville, PA); B. W. Kilburn; others mentioned.]

ST2743 "Stereo: Home and School Art Exhibitions." ANTHONY'S PHOTOGRAPHIC BULLETIN 6, no. 7 (July 1875): 211. ["The growing demand for art entertainment both public and private... stimulated... production... of a more extensive and better supply of instrumental facilities, ...collection of stereographic views."]

ST2744 "Note." ANTHONY'S PHOTOGRAPHIC BULLETIN 6, no. 7 (July 1875): 218. [Gatchel & Hyatt (St. Louis, MO); D. A. Woodward (Maryland Institute, Baltimore, MD); Smith & Loquist (Peoria, IL).]

ST2745 "Pictures Received." ANTHONY'S PHOTOGRAPHIC BULLETIN 6, no. 7 (July 1875): 224. [Van Wagner (Nyack, NY); Furman (Para); J. Thurlow (formerly Peoria, IL) views of Colorado.]

ST2746 "Editor's Table." PHILADELPHIA PHOTOGRAPHER 12, no. 139 (July 1875): 223-224. [I. W. Taber & G. D. Morse (San Francisco, CA); H. J. Rodgers (Hartford, CT); John L. Gihon; W. E. Bowman (Ottawa, IL); J. T. Hicks (Liberty, MO); John A. Todd (Sacramento, CA); H. J. Newton (NY); Otto Lewin (NY); A. Hesler; Chas. W. Stiff (St. Paul, MN).]

ST2747 "On the Shore of the Lake - Photographing the Crew." FRANK LESLIE'S ILLUSTRATED NEWSPAPER 40, no. 1035 (July 31, 1875): 368. 1 illus. [This sketch is of a photographer photographing the Cornell University rowing crew at the lake, with a large camera propped on a barrel. Part of a larger article about the summer rowing races, which generated a lot of popular interest.]

ST2748 "Correspondence." ANTHONY'S PHOTOGRAPHIC BULLETIN 6, no. 8 (Aug. 1875): 254-256. [Letters from S. Singer (Milwaukee, WI); S. S. Perry (Nassau); Gudgeon & Riel (Senecaville, OH); A. S. Whitcomb (Rosario); H. J. Rodgers; C. M. Bell (Washington, DC); J. W. Watson (Raleigh, NC).]

ST2749 "New Pictures." ANTHONY'S PHOTOGRAPHIC BULLETIN 6, no. 8 (Aug. 1875): 256. [H. J. Rodgers (Hartford, CT); J. H. Fitzgibbon (St. Louis, MO).]

ST2750 "Editor's Table." PHILADELPHIA PHOTOGRAPHER 12, no. 140 (Aug. 1875): 254-256. [J. Carbutt; W. E. Bowman (Ottawa, IL); John A. Todd (Sacramento, CA); E. A. Kusel (Oroville, CA); Otto Lewin (NY); Core & Frees (Tiffin, OH); C. D. Mosher (Chicago, IL); L. W. Roberts (Urbanna, IL); E. H. Alley (Toledo, OH); E. T. Whitney (Norwalk, CT); E. W. Beckwith (Plymouth, PA); others.]

ST2751 "Wet Plate Photography at Cape May." ANTHONY'S PHOTOGRAPHIC BULLETIN 6, no. 9 (Sept. 1875): 268. [From "NY Times." Narrative about groups being photographed while on vacation, etc.]

ST2752 "Correspondence." ANTHONY'S PHOTOGRAPHIC BULLETIN 6, no. 9 (Sept. 1875): 284-285. [Letters from E. Bierstadt; Henry Draper; G. P. B. Hoyt (Washington, DC); Abm. M. De Silva; E. Clarke Hall (Brookville, PA); Wm. Frear (Auburn); Norris Peters (Washington DC); Almstaedt.]

ST2753 "Correspondence." ANTHONY'S PHOTOGRAPHIC BULLETIN 6, no. 10 (Oct. 1875): 319-320. [Letters from Jas. Fennemore (Beaver, UT); M. A. Morehouse (Stony Creek, NY) and W. H. Dunwick (Ft. Edward).]

ST2754 "Editor's Table." PHILADELPHIA PHOTOGRAPHER 12, no. 142 (Oct. 1875): 319-320. [D. C. Burnite (Harrisburg, PA); John Cadwallader (Indianapolis, IN); S. Root (IA); Jacoby (Minneapolis, MN); E. A. Kusel (Oroville, CA); Smith & Motes (Atlanta, GA); Ormsby (Chicago, IL); Bradley & Rulofson; Well G. Singhi; Julius Hall (Great Barrington, MA), others mentioned.]

ST2755 "Correspondence." ANTHONY'S PHOTOGRAPHIC BULLETIN 6, no. 11 (Nov. 1875): 350-351. [Letters from J. C. Mills (Penn Yan, NY); J. W. Black (Boston, MA); W. H. Dunwick (Ft. Edward); M. H. Albee (Marlboro); E. O. Eddy (Wallingford); O. F. Douglass (Fall River, MA); David F. Murphy (New York, NY); G. P. Shull (Cincinnati, OH).]

ST2756 "Editor's Table." PHILADELPHIA PHOTOGRAPHER 12, no. 143 (Nov. 1875): 351-352. [Thos. M. Saurman (Norristown); J. W. Husher (Terre Haute, IN); Frank Thomas (Columbia, MO); Capt. J. Lee Knight (Topeka, KN); Forrester Clark (Pittsfield, MA); Core & Frees (Tiffin, OH); S. R. Stoddard; Alex. Gardner (Washington, DC), etc.]

ST2757 "The War of the Burnishers: An Important Patent Case." PHOTOGRAPHIC TIMES 5, no. 59 (Nov. 1875): 271-272. [Joseph Bass (Bangor, ME) vs. John M. Peck (Portland, ME) on patent infringement on a print burnishing machine.]

ST2758 "Editor's Table." PHILADELPHIA PHOTOGRAPHER 12, no. 144 (Dec. 1875): 383-384. [C. C. Giers (Nashville, TN); C. R. Savage; W. D. Lockwood (Ripon, WI); E. H. Train (Helena, MT); L. G. Bigelow (Detroit, MI); Alfred Freeman (Dallas, TX); Frank Jewell (Hyde Park, PA); E. A. Scholfield (Mystic River, CT); J. Pitcher Spooner; others mentioned.]

USA: 1876.
BOOKS
ST2759 Biddle, Clement. *Poems.* Philadelphia: Lindsay & Baker, 1876. 115 pp. 10 b & w. [Original photographs. "Many of the poems and most of the plates (mounted photographs) appeared in 'Airdrie, and Other Fugitive Pieces,' by C. B., 1872."]

ST2760 Soley, James Russell. *Historical Sketch of the United States Naval Academy.* Washington, DC: Government Printing Office, 1876. 336 pp. 25 b & w. [Original photos, views of classrooms, cadets in training, etc.]

PERIODICALS
ST2761 "The Difficulty of Getting a Good Likeness." ANTHONY'S PHOTOGRAPHIC BULLETIN 7, no. 1 (Jan. 1876): 20. [From "Atlanta Constitution." Story, possibly apocryphal, of difficulties at portrait studio.]

ST2762 "Cosmos." "Photographer and Customer." ANTHONY'S PHOTOGRAPHIC BULLETIN 7, no. 1 (Jan. 1876): 22-23.

ST2763 "Correspondence." ANTHONY'S PHOTOGRAPHIC BULLETIN 7, no. 1 (Jan. 1876): 30-31. [Letters from H. J. Rogers, (Hartford, CT); A. M. Warner (Quincy, IL); Thos. Leatham (New York, NY).]

ST2764 "New Pictures." ANTHONY'S PHOTOGRAPHIC BULLETIN 7, no. 1 (Jan. 1876): 32. [F. Gutekunst; D. H. Brooks; J. S. Mason.]

ST2765 "Editor's Table: Pictures Received." PHILADELPHIA PHOTOGRAPHER 13, no. 145 (Jan. 1876): 32. [J. H. Lamson (Portland, ME); J. W. Husher (Greencastle, IN); Folsom (Katonah, NY).]

ST2766 "Talk and Tattle." PHILADELPHIA PHOTOGRAPHER 13, no. 145-156 (Jan. - Dec. 1876): 40-42, 65-68, 172-173, 231-234. [Letters from professionals: (Feb.) Walter C. North; L. G. Bigelow; D. E. Smith; H. K. Hough. (Mar.) Henry Rocher; M. H. Albee; A. Hesler; E. K. Hough; R. E. Wood (Santa Cruz, CA). (Aug.) George M. Urie (Paris, TX); A. Hinsey (Pontiac, IL); J. E. Small (CA); H. Butler (Vermillion, Dakota Terr.); Vac Friedl (Cleveland, OH).]

ST2767 "Wrinkles and Dodges." PHILADELPHIA PHOTOGRAPHER 13, no. 145-156 (Jan. - Dec. 1876): 54-55, 84-85, 107-108, 253-254. [Advice from professionals: (Feb.) J. C. Groetchius (Titusville, PA); H. C. Wilt (Franklin, PA); S. W. Crawford. (Mar.) Vanderweyde Studio (St. Paul, MN); A. St. Clair; D. P. Barr; A. Hesler; Irving Saunders. (Apr.)

E. K. Hough; Capt. Knight, etc. (May) H. M. Judd (Amherst, MA). (Aug.) A. A. Johnson (Cazenova, NY); A. Q. Routh (Thornton, IN).]

ST2768 "The Popular Commentary." ANTHONY'S PHOTOGRAPHIC BULLETIN 7, no. 2 (Feb. 1876): 33-35. [Letters from A. C. Varela (Los Angeles, CA); J. T. Chatterton (Woonsocket, RI); Chas. W. Teller (Newburgh); Geo. W. Collins (Urbana, OH); Geo. W. Copp (Fryburg); W. Blakeslee (Medota, IL); H. R. Marks (Austin, TX); Carrie Gordon (Salem-on-Erie); T. L. Phillips (Lowellville); E. D. Stoutenburgh (Sing-Sing); C. E. Wallin (Ft. Wayne); John C. Gray (Centralia); Geo. Miners (St. Mary's); C. H. Whitney (Cleveland, OH); B. A. Ford (McHenry); C. C. Wells (Coxsackie); D. C. Pratt (Aurora, IL); H. A. Potter (Warren); J. H. Griffiths (London); H. P. More (Indianapolis, IN); J. W. Mason (Neshannock); W. H. Albright (Newcastle); John Robertson (Platteville); Wm. A. Bigelow (Plattsburgh); Geo. W. Bew (Philadelphia, PA); Jno. C. French (Candor).]

ST2769 "Correspondence." ANTHONY'S PHOTOGRAPHIC BULLETIN 7, no. 2 (Feb. 1876): 61-62. [Letters by Selah (Pequot Harbor); G. P. Shull (Cincinnati, OH); W. H. Jackson (Washington, DC); Clifford & Pardoe (Newton, IA); G. W. Harbinson (Mound City); Joseph A. Maybin (Wilmington, DE); A. J. Russell (New York, NY).]

ST2770 "Editor's Table." PHILADELPHIA PHOTOGRAPHER 13, no. 146 (Feb. 1876): 63-64. [E. Z. Webster (Norwich, CT); G. M. Elton; A. S. Barber (Willimantic, CT); D. T. Burrell (Brockton, MA); A. G. DaLee (Lawrence, KN); L. G. Bigelow (Detroit, MI); Hurst & Son (Albany, NY); Mrs. E. W. Withington (Lone City, CA); others.]

ST2771 "Correspondence." ANTHONY'S PHOTOGRAPHIC BULLETIN 7, no. 3 (Mar. 1876): 95. [Letters from T. H. Lane (Somers Centre, NY); J. C. Swan (Denmark, IA); David Tucker & Co. (Buffalo, NY); D. C. Pratt (Aurora, IL); James Tripp (Coldwater, MI); I. W. Brown (Fort Russell).]

ST2772 "Editor's Table." PHILADELPHIA PHOTOGRAPHER 13, no. 147 (Mar. 1876): 96. [L. W. Roberts (Urbana, IL) moved to Springfield, IL. with Mr. Caskey to form Roberts & Caskey; James Mullen (Lexington, KY); Crosby (Lewiston, ME); H. L. Bingham (San Antonio, TX); J. Pitcher Spooner (Stockton, CA); others.]

ST2773 "The Latest Phase of Spirit Photography." ANTHONY'S PHOTOGRAPHIC BULLETIN 7, no. 4 (Apr. 1876): 118. [From " NY Post."]

ST2774 "Correspondence." ANTHONY'S PHOTOGRAPHIC BULLETIN 7, no. 4 (Apr. 1876): 128. [Letters from James Tripp (Cold Water, MI); J. H. Lamson (Portland); W. P. Hix (Columbia, SC); Wm. C. Thomas (Warwick, NY).]

ST2775 "Skylight Construction." PHILADELPHIA PHOTOGRAPHER 13, no. 148 (Apr. 1876): 101-103. 5 illus. [Various skylights in use. L. G. Bigelow, J. Landy, others, displayed.]

ST2776 "Editor's Table." PHILADELPHIA PHOTOGRAPHER 13, no. 148 (Apr. 1876): 127-128. [I. W. Taber; W. H. Jackson; J. G. Barrows; H. McMichael; V. H. Young (Lincoln, NB); B. W. Kilburn; Louis de Planque (Corpus Christi, TX); A. W. Kimball (Augusta, GA); Gentile (Chicago, IL); George N. Cobb (Binghamton, NY); others.]

ST2777 "Important Decision of the Circuit Court of the U. S. Western District of Mich.-In Equity. Simon Wing, Albert S. Southworth and Marcus Ormsbee vs. Joseph H. Tompkins." ANTHONY'S PHOTOGRAPHIC BULLETIN 7, no. 5 (May 1876): 146-148. [The report of this decision gives an account of Albert S. Southworth's career from c. 1846 through 1854, and W. A. Pratt's career from 1846-1865, as part of the testimony.]

ST2778 "Cosmos." "A Whisper to Country Artists." ANTHONY'S PHOTOGRAPHIC BULLETIN 7, no. 5 (May 1876): 151. [Suggestions on good management practices for the small gallery operator.]

ST2779 "Correspondence." ANTHONY'S PHOTOGRAPHIC BULLETIN 7, no. 5 (May 1876): 159. [Letters from E. Clark Hall (Brookville, PA); Howard A. Richardson (Boston, MA); E. Klauber (Louisville, KY); D. Burnett (Olney, IL); J. F. Ryder (Cleveland, OH); Ronald Douglass (Orange, NJ).]

ST2780 "Pictures Received." ANTHONY'S PHOTOGRAPHIC BULLETIN 7, no. 5 (May 1876): 160. [Smith & Motes (Atlanta, GA); Hoard & Tenney (Winona, MN).]

ST2781 "Correspondence." PHILADELPHIA PHOTOGRAPHER 13, no. 149 (May 1876): 135-136. [O. N. W. Baldwin (Knoxville, IA); Reuvers & Scarff (Pella, IA).]

ST2782 "An Important Patent Decision." PHILADELPHIA PHOTOGRAPHER 13, no. 149 (May 1876): 149-152. [Simon Wing, A. S. Southworth and Marcus Ormsbee vs. Joseph H. Tompkins. Decision, with a letter from Tompkins, the defendant, who won the decision.]

ST2783 "Editor's Table." PHILADELPHIA PHOTOGRAPHER 13, no. 149 (May 1876): 159-160. [Mrs. Barrett (Fort Dodge, IA) burned out, James Mullen (Lexington, KY) burned out. Wm. Curtis Taylor to create 100 portraits of prominent Philadelphians to exhibit at the Centennial; J. C. Browne not a judge at Centennial. H. Vogel to be a judge; pictures received from many others.]

ST2784 Stewart, E. J. "The Boys Afloat." ANTHONY'S PHOTOGRAPHIC BULLETIN 7, no. 6 (June 1876): 168. [Brickey Brothers on Mississippi River; J. Whitman on Sunflower River; Dennison; Wetzel; Spencer on the Yazoo River.]

ST2785 "Court-Room Mirth." ANTHONY'S PHOTOGRAPHIC BULLETIN 7, no. 6 (June 1876): 188. [From "NY World." Forged checks, handwriting analysis using magic lantern slides, etc.]

ST2786 "Correspondence." ANTHONY'S PHOTOGRAPHIC BULLETIN 7, no. 6 (June 1876): 191-192. [Letters from W. H. Dunwick (Washington, DC); E. C. Bridge (Chariton, IO); J. B. Bergstresser (Renovo, PA).]

ST2787 "Pictures Received." ANTHONY'S PHOTOGRAPHIC BULLETIN 7, no. 6 (June 1876): 192. [Chas. A. Meinerth; E. H. Albee; W. G. Smith (Cooperstown, NY); A. H. Beal; H. J. Rodgers; J. A. Palmer; Klauber; Leighton Brothers.]

ST2788 "Editor's Table." PHILADELPHIA PHOTOGRAPHER 13, no. 150 (June 1876): 191-192. [J. A. French (Keene, NH); John Cadwallader (Indianapolis, IN); Bradley & Rulofson (portraits of Dom Pedro, Emperor of Brazil); S. R. Stoddard.]

ST2789 T. H. K. "Who He Is." ANTHONY'S PHOTOGRAPHIC BULLETIN 7, no. 7 (July 1876): 224. [Poem.]

ST2790 "Editor's Table." PHILADELPHIA PHOTOGRAPHER 13, no. 151 (July 1876): 223-224. [Alva Pearsall (Brooklyn, NY); North & Oswald (Toledo, OH); Doerr (Louisville, KY); S. R. Stoddard;

Leisenring (Ft. Dodge, KS); Joshua Smith (Chicago, IL); W. T. Robertson (Asheville, NC); W. A. Bairstow (Parker City, PA); James Zellner (Mauch Chunk, PA); others.]

ST2791 "'Satisfaction or No Pay.'" PHILADELPHIA PHOTOGRAPHER 13, no. 152 (Aug. 1876): 240-242.

ST2792 "Editor's Table." PHILADELPHIA PHOTOGRAPHER 13, no. 152 (Aug. 1876): 255-256. [B. H. Gurnsey (Colorado Springs, CO); Frank French (Pecatonica, IL); J. J. Reilly (Stockton, CA); George R. Elliott & Co.; T. I. Bradshaw (Quincy, IL); J. W. Pendergast (Indianapolis, IN); W. M. Lockwood (Ripon, WI).]

ST2793 "Editor's Table." PHILADELPHIA PHOTOGRAPHER 13, no. 153 (Sept. 1876): 288. [J. Landy; Benecke & Goebel (St. Louis, MO) [new firm]; Train & Bundy [not Keim & Bundy as previously reported] (Helena, MT); Capt. H. R. Marks (Austin, TX) mentioned.]

ST2794 "Correspondence." ANTHONY'S PHOTOGRAPHIC BULLETIN 7, no. 11 (Nov. 1876): 349-350. [Letters from Frank A. Bowman (New Haven, CT); E. Bierstadt (New York, NY) discussing 3'x5' glass plate negatives made by J. A. Whipple "about ten years ago." A. S. Barber (Hartford, CT); Ernest I. Little (Oskaloosa, IA); J. Inglis (Montreal); Allen & Rowell (Boston, MA); Metcalf & Welldon (successors to Whipple [Boston]); A. Marshall (Boston, MA); D. K. Prescott (Boston, MA); Lamson (Portland, ME).]

ST2795 "Editor's Table." PHILADELPHIA PHOTOGRAPHER 13, no. 155 (Nov. 1876): 351-352. [Henry Rocher; Hastings, White & Fisher (Davenport, IA); W. Brown (Modesto, CA); Bradley & Rulofson; O. P. Frees (Tiffin, OH); Wm. Aitkin (Philadelphia, PA); H. Butler (Vermillion, Dakota Terr.); others mentioned.]

ST2796 "Correspondence." ANTHONY'S PHOTOGRAPHIC BULLETIN 7, no. 12 (Dec. 1876): 382-384. [Letters from Thos. H. McCollin (Philadelphia, PA); 13 Baltimore area photographers; F. Gutekunst (Philadelphia, PA); Potter & Pearson (Warren, OH); T. C. Roche; Theodore Lilienthal (New Orleans, LA); Alex. Henderson (Montreal); Chas. Paxton (New York, NY); C. E. Wallin; G. K. Warren (Cambridgeport, MA); W. Notman (Montreal); S. A. Thomas.]

ST2797 "Retrospective." PHILADELPHIA PHOTOGRAPHER 13, no. 156 (Dec. 1876): 354-357.

ST2798 "Mr. Lambert's Processes." PHILADELPHIA PHOTOGRAPHER 13, no. 156 (Dec. 1876): 375-383. [Extensive details of complicated copyright patent suit.]

ST2799 "Editor's Table." PHILADELPHIA PHOTOGRAPHER 13, no. 156 (Dec. 1876): 384. [E. M. Collins (Oswego, NY) burned out; A. Hesler, more awards listed; E. D. Ormsby (Chicago, IL); Frank Jewell, W. J. Rood (Spencer, IA); W. M. Lockwood (Ripon, WI); others listed.]

USA: 1877.
ST2800 "The Lambertype Prize Exhibition." [and] "The Exhibition of Permanent Photographs Produced by the Carbon and Lambertype Processes." ANTHONY'S PHOTOGRAPHIC BULLETIN 8, no. 1 (Jan. 1877): 19, 21. [List of 22 winners of awards, using Lambertype processes. Judges were Henry J. Newton, John C. Browne, and O. G. Mason. An exhibition of 355 prints was also held, described on p. 21.]

ST2801 "'Fire! Fire!'" ANTHONY'S PHOTOGRAPHIC BULLETIN 8, no. 1 (Jan. 1877): 23. [C. M. Van Orsdell (Wilmington, NC) burned out; C. D. Fredericks & Hugh O'Neil (New York, NY) burned.]

ST2802 "Correspondence." ANTHONY'S PHOTOGRAPHIC BULLETIN 8, no. 1 (Jan. 1877): 27-32. [Letters (many about the Lambert/Ed. Wilson controversy) from A. St. Clair (Topeka, KA); J. Towler (Geneva, NY); Theo. Lilienthal (New Orleans, LA); Chas. E. Wallin (Fort Wayne, IN); M. C. Dwight (Detroit, MI); H. B. Chamberlain (Mineral Point, WI); J. G. Vail (Geneva, NY); R. D. Summers (Waterloo, NY); D. C. Pratt (Aurora, IL); W. D. O'Donnell (Halifax, N.S.); W. V. Ranger (Syracuse, NY); G. W. Doty (Lancaster, OH); Busey (Baltimore, MD); Potter & Pearson (Warren, OH); E. K. Hough; Geo. B. Rieman (San Fransisco, CA); Carl Meinerath (Newburyport, MA); Charles E. Wallin (Fort Wayne, IN).]

ST2803 "Editor's Table: Pictures Received." PHILADELPHIA PHOTOGRAPHER 14, no. 157 (Jan. 1877): 31. [F. B. Clench; James & Sons (Iowa City, IA); T. Doney (Elgin, IL); L. H. Clark (Minonk, IL); E. H. Train; Mrs. E. W. Withington (Lone City, CA); William H. Rau (views of Chatham (Waikikaori) Island, South Pacific) during Venus Expedition of 1874, for which Mr. Rau was one of the photographers.]

ST2804 "Times Residues." PHOTOGRAPHIC TIMES 7, no. 73 (Jan. 1877): 14-16. [Anecdotes, hints and suggestions.]

ST2805 "Conflagrations in Photographic Galleries." ANTHONY'S PHOTOGRAPHIC BULLETIN 8, no. 2 (Feb. 1877): 60.

ST2806 "Correspondence." ANTHONY'S PHOTOGRAPHIC BULLETIN 8, no. 2 (Feb. 1877): 61-64. [Letters from J. Loeffler; E. C. Bridge (Chariton, IA); D. Bachrach, Jr. (Baltimore, MD); B. S. Vick (Alliance, OH); A. Hesler (Evanston, IL).]

ST2807 "Editor's Table: Pictures Received." PHILADELPHIA PHOTOGRAPHER 14, no. 158 (Feb. 1877): 62. [S. R. Stoddard (Glens Falls, NY); H. B. Hillyer (Austin, TX); J. W. Husher (Greencastle, IN); John F. Singhi (Rockland, ME).]

ST2808 "Latest From the Studios." PHILADELPHIA PHOTOGRAPHER 14, no. 159-162 (Mar. - Jun. 1877): 74-75, 131-134, 176-178. [Letters from practicing photographers, with hints, suggestions, problems. (Mar.) E. K. Hough (NY); R. B.; G. M. Groh (Grand Rapids, MI); Frank W. Carpenter; Neal P. Harrington; J. Pitcher Spooner; (May) T. M. Wells; S. L. Platt; Prof. W. Belts; R. W. Dawson; I. B. Webster; George Sperry; James O. Merrill; (June) T. M. Wells; George Sperry; S. L. Platt; J. Carbutt.]

ST2809 "Correspondence." ANTHONY'S PHOTOGRAPHIC BULLETIN 8, no. 3 (Mar. 1877): 94-95. [Letters from I. B. Webster (Louisville, KY); G. Hess, Jr. (Williamsport); V. E. Dake (Chilton, WI); A. M. Allen (Pottsville, PA); Geo. G. Rockwood (New York, NY).]

ST2810 "Editor's Table: Pictures Received." PHILADELPHIA PHOTOGRAPHER 14, no. 159 (Mar. 1877): 96. [E. D. Ormsby (Chicago, IL); G. M. Groh & Brother (Sheboygan, MI); L. A. Atwood (Burlington, VT); Mr. Gentile (Chicago, IL); G. Weingarth (Shelbyville, IN); R. A. Hickox (Emporia, KS); A. M. Allen (Pottsville, PA).]

ST2811 "Editor's Table: Pictures Received." PHILADELPHIA PHOTOGRAPHER 14, no. 159 (Mar. 1877): 96. [E. D. Ormsby (Chicago, IL); G. M. Groh & Brother (Sheboygan, MI); L. A. Atwood (Burlington, VT); Mr. Gentile (Chicago, IL); G. Weingarth (Shelbyville, IN); R. A. Hickox (Emporia, KS); A. M. Allen (Pottsville, PA).]

ST2812 "'Typing' on Wheels." ANTHONY'S PHOTOGRAPHIC BULLETIN 8, no. 4 (Apr. 1877): 112. [From "Boston Post."]

ST2813 Lambert. "The Lambert-P.P. Controversy." ANTHONY'S PHOTOGRAPHIC BULLETIN 8, no. 4 (Apr. 1877): 113-116. [Lambert attacks "Philadelphia Photographer," Wilson, Vogel, Gihon, and just about everyone else who expresses the slightest doubts about the Lambertype process.]

ST2814 "Correspondence." ANTHONY'S PHOTOGRAPHIC BULLETIN 8, no. 4 (Apr. 1877): 126-127. [Letters from E. K. Hough; E. C. Lewis (Jefferson, TX); C. F. Kimmaman (Findlay, OH); A. S. Barber (Hartford, CT); D. C. Pratt (Aurora, IL); Walter & Darvin (Manchester, IA).]

ST2815 "Editor's Table: Pictures Received." PHILADELPHIA PHOTOGRAPHER 14, no. 160 (Apr. 1877): 128. [Mssrs. Gentile (Chicago, IL); Broich & Kramer (Milwaukee, WI); Wykes (Quincy, IL); I. W. Taber (San Francisco, CA); etc.]

ST2816 "Business Prospects." PHOTOGRAPHIC TIMES 7, no. 76 (Apr. 1877): 73-74. [Business looking up from the Slump of 1875. Then lists a number of moves and changes among the larger galleries in New York, NY.]

ST2817 "Correspondence." ANTHONY'S PHOTOGRAPHIC BULLETIN 8, no. 5 (May 1877): 158-160. [Letters from I. B. Webster (Louisville, KY); J. C. Mills (Penn Yan, NY); C. T. Stuart (operator for G. W. Pach, New York, NY); Jas. Inglis (Montreal); W. M. Pound (Terre Haute, IN); Wm. E. Gilbert (Pittsburgh, PA).]

ST2818 "Correspondence." ANTHONY'S PHOTOGRAPHIC BULLETIN 8, no. 6 (June 1877): 190-192. [Letters from J. H. (Plattsburgh, NY); E. K. Hough (New York, NY); H. Rocher (Chicago, IL); E. L. Brand (Chicago, IL); M. H. Barnes (Bethany, MD); C. D. Mosher & Co. (Chicago, IL); Robert F. Hughes (Chicago, IL); Farmer Brothers (Ontario); J. M. Letts (Dundee, NY); E. D. Bangs (Milwaukee, WI).]

ST2819 "Editor's Table: Pictures Received." PHILADELPHIA PHOTOGRAPHER 14, no. 162 (June 1877): 191-192. [J. Pitcher Spooner (Stockton,CA); W. H. Cook (B. S. Williams Gallery, Tunkhannock, PA); Torrance & King (Brooklyn, NY); Gifford (Forrestdale, NY); Latour (Sedalia, MO); Well G. Singhi (Birmingham, NY); L. W. Clark (Streator, IL); R. W. Blair (Dawson, NB.); Kimball (Augusta, ME).]

ST2820 "Correspondence." ANTHONY'S PHOTOGRAPHIC BULLETIN 8, no. 7 (July 1877): 222-224. [Letters from B. J. Falk (New York, NY); C. F. Kinnaman (Upper Sandusky, OH); Wm. J. Land (Atlanta, GA); S. C. Graham (Beaver Dam); Louis de Planque (Corpus Christi, TX); Jos. Even (Peru, IL); Wm. H. Lockhart (Bryan, OH); W. H. Weaver (Watseka, IL); A. M. De Silva (New Haven, CT); C. C. Wells (Coxsackie); John B. May (Watertown, WI); E. S. Sterry (Saratoga Springs, NY); Joshua Smith (Chicago, IL); Hugh Bicket (Sparta, IL).]

ST2821 "Pictures Received." ANTHONY'S PHOTOGRAPHIC BULLETIN 8, no. 7 (July 1877): 224. [Gihon & Usher; Copelin (Chicago, IL); D. C. Dinmore (Dover, ME).]

ST2822 "Editor's Table: Pictures Received." PHILADELPHIA PHOTOGRAPHER 14, no. 163 (July 1877): 223. [Aaron Veeder (Albany, NY); Charles B. Melendy (Cedar Falls, IA); Robert Benecke (St. Louis, MO).]

ST2823 Clarke, W. H. "What a Flash of Lightning May Do." PHOTOGRAPHIC TIMES 7, no. 80 (Aug. 1877): 171-172. ["Extracts from an article on Spirit Photography." Quotes Prof. S. B. Brittan on

an incident where men killed by lightning had the representation of a nearby tree "drawn upon his body." The article also details the incident of Jeremiah Hayes, also struck by lightning, also displaying an "electric photograph" of a nearby chestnut tree.]

ST2824 "Spirit Photographs." ANTHONY'S PHOTOGRAPHIC BULLETIN 8, no. 8 (Aug. 1877): 232-234. [From "Springfield [MA] Republican." Charles Moore, of Moore Brothers, and James W. Black exposed a "spirit" photographer in Boston as a fraud.]

ST2825 "Correspondence." ANTHONY'S PHOTOGRAPHIC BULLETIN 8, no. 8 (Aug. 1877): 255-256. [Letters from M. A. Morehouse (Weavertown, NY); E. J. Betts (Dansville, NY); P. C. Duchochois (New York, NY); A. W. Paradise & E. T. Whitney (Norwalk, CT).]

ST2826 "Editor's Table: Pictures Received." PHILADELPHIA PHOTOGRAPHER 14, no. 164 (Aug. 1877): 255-256. [M. L. Daggett (photographer for Reed & Barton, Taunton, MA); G. M. Elton (Palmyra, NY); A. J. W. Copelin (Chicago, IL); Fosnot & Hunter (Keosauqua, IA).]

ST2827 "Working in Hot Weather." PHOTOGRAPHIC TIMES 7, no. 80 (Aug. 1877): 176-178. [Suggestions about working in studios and darkrooms in hot weather. J. R. Sawyer discussed.]

ST2828 "A Peripatetic Photographer." "Extracts from Notes on Passing Events." ANTHONY'S PHOTOGRAPHIC BULLETIN 8, no. 9 (Sept. 1877): 276. [From "Br. J. of Photo." Comments by the author on the value of small stereoscopic cameras and a note of the fact that "a bevy of girls" are used by the E. & H. T. Anthony Co. in the stereo department. Draws forth a waspish editorial comment from the editor, defending that action and praising the working efficiency of the women.]

ST2829 "Correspondence." ANTHONY'S PHOTOGRAPHIC BULLETIN 8, no. 9 (Sept. 1877): 287-288. [Letters from J. Inglis (Montreal); G. F. Maitland (Stratford, Ontario); J. M. Letts (Dundee, NY); Isa Black (Franklin, PA).]

ST2830 "Pictures Received." ANTHONY'S PHOTOGRAPHIC BULLETIN 8, no. 9 (Sept. 1877): 288. [W. H. Illingworth (St. Paul, WI); R. H. Furman (New York, NY, worked for years in Brazil, recently set up in Rochester, NY); H. R. Farr (Prairie du Chien).]

ST2831 "Editor's Table: Spirit Photography." PHILADELPHIA PHOTOGRAPHER 14, no. 165 (Sept. 1877): 288. [Moore (Springfield, MA) exposed as fraudulent a "spirit photographer" named Brown.]

ST2832 May, Norman. "Photography in America." ANTHONY'S PHOTOGRAPHIC BULLETIN 8, no. 9-12 (Sept. - Dec. 1877): 281-282, 291-292, 334-336, 359. [From "London Photo. News." May, from England, spent three years in Canada and USA. Writes about general conditions - no apprenticeship, short training, etc., compares the openness of the American photo community to that of England, etc.]

ST2833 "How is Business?" PHILADELPHIA PHOTOGRAPHER 14, no. 165-168 (Sept. - Dec. 1877): 257-266, 331, 361-362. [Letters reporting on state of affairs from E. L. Allen (Boston, MA); G. M. Carlisle (Providence, RI); E. T. Whitney (Norwalk, CT); H. L. Bingham (San Antonio, TX); Mrs. E. N. Lockwood (WI); H. Rocher (Chicago, IL); Chas. J. Stiff (St. Paul, MN); J. Perry Elliott (Indianapolis, IN). Further

letters from A. Simpson (Buffalo, NY) on p. 331 (Nov. issue); and A. Hesler (Chicago, IL) on pp. 361-362.]

ST2834 "The Matter of Prices." PHILADELPHIA PHOTOGRAPHER 14, no. 165 (Sept. 1877): 273-274.

ST2835 "A Photographic Educational Institution Probable." PHILADELPHIA PHOTOGRAPHER 14, no. 165 (Sept. 1877): 276-277. [Announcement of a possible forthcoming institution, not named.]

ST2836 "Correspondence." ANTHONY'S PHOTOGRAPHIC BULLETIN 8, no. 10 (Oct. 1877): 318-320. [Letters from Fred. Whitehead (L. S. Station No. 2, St. Lucia, FL); "three hundred miles the other side of nowhere;" A. Hesler (Evanston, IL); Abm. M. De Silva (New Haven, CT); D. R. Clark (Indianapolis, IN); Chas. Jewett (Brooklyn, NY).]

ST2837 "Pictures Received." ANTHONY'S PHOTOGRAPHIC BULLETIN 8, no. 10 (Oct. 1877): 320. [Von Sothen (Willets Point, L.I., NY), water spouts from torpedo explosions; Cook Ely (Oshkosh, WI); A. Hesler (Evanston, IL).]

ST2838 Smith, Walter. "Industrial Art Education Considered Economically." PHILADELPHIA PHOTOGRAPHER 14, no. 166 (Oct. 1877): 292-294. [Walter Smith, State Director of Art Education for MA., delivered lecture before PA. State Legislature. Excerpts from that speech, which discusses photography.]

ST2839 "Photographic News." PHILADELPHIA PHOTOGRAPHER 14, no. 166 (Oct. 1877): 317. [Mentions that Prof. Charles F. Himes of Dickinson College (Carlisle, PA) has organized a photographic class at the college.]

ST2840 "Editor's Table: Pictures Received." PHILADELPHIA PHOTOGRAPHER 14, no. 166 (Oct. 1877): 320. [H. R. Farr (Prairie du Chien, WI); Frank French (Pecatonica, IL); Mrs. E. M. Lockwood (Ripon, WI); J. B. Marshall (Gold Hill, NE); J. E. Beebe (Chicago, IL).]

ST2841 "Correspondence." ANTHONY'S PHOTOGRAPHIC BULLETIN 8, no. 11 (Nov. 1877): 348-349. [Letters from D. Bachrach, Jr.; Chas. A. Meinerth (Newburyport, MA); D. A. Clifford (St. Johnsbury, VT); Blessing & Brother (Galveston, TX); C. H. Caldwell (Oranges, TX).]

ST2842 "Correspondence." ANTHONY'S PHOTOGRAPHIC BULLETIN 8, no. 12 (Dec. 1877): Letters from Weber & Co. (Springfield, IL); G. M. Carlisle (Providence, RI); Karl von Stefanowski (Vienna, Austria); J. C. Mills (Penn Yan, NY); George G. Rockwood (New York, NY); Golder & Robinson (New York, NY); Bostwick & Bancker (New York, NY); Carl Schultze (New York, NY); Sarony (New York, NY); Andrew W. Jordan (New York, NY); Hough Brothers (New York, NY); Estabrooke & Naegell (New York, NY); Otto Wagner (New York, NY); Frederich Ulrich (New York, NY); D. K. Brownell (New York, NY).

ST2843 "The Biter Bit." PHILADELPHIA PHOTOGRAPHER 14, no. 168 (Dec. 1877): 377. [C. C. Cook (Van Buren, AR) took portraits of an individual who failed to pay, then took him to court.]

ST2844 "Editor's Table: Pictures Received." PHILADELPHIA PHOTOGRAPHER 14, no. 168 (Dec. 1877): 382. [J. E. Beebe (Chicago, IL); W. C. Tuttle (Belfast, ME); James O. Merrill (Rutland, VT); E. P. Libby (Keokuk, IO); Julius Hall (Great Barrington, VT); C. F. Richardson (Wakefield, MA); G. N. Pach (New York, NY); Charles

Knowlton (Kankakee, IL); D. W. Tallman (Batavia, NY); Alfred Freeman (Dallas, TX); Mr. and Mrs. W. M. Lockwood (Ripon, WI); Louis de Planque (Corpus Christi, TX).]

ST2845 "The Magic Lantern as a Detector of Forgery." FRANK LESLIE'S ILLUSTRATED NEWSPAPER 45, no. 1160 (Dec. 22, 1877): 259, 260. 1 illus. [Sketch of the demonstration in a courtroom.]

USA: 1878.
ST2846 "News Items." ANTHONY'S PHOTOGRAPHIC BULLETIN 9, no. 1 (Jan. 1878): 32. [A. M. Allen (Pottsville, PA); Moore Bros. (Springfield, MA); H. R. Marks (Austin, TX).]

ST2847 "Editor's Table: Pictures Received." PHILADELPHIA PHOTOGRAPHER 15, no. 169 (Jan. 1878): 31. [Alex. Martin (Boulder City, CO); T. N. Gates (Westboro, MA); Mrs. Lydia J. Cadwell (Chicago, IL); Frank Jewell (Scranton, PA); G. M. Elton (Palmyra, NY); Julius Hall (Great Barrington, CT), etc.]

ST2848 "Correspondence." ANTHONY'S PHOTOGRAPHIC BULLETIN 9, no. 2 (Feb. 1878): 61-62. [Letters from H. Rocher (Chicago, IL); J. J. Bardwell (Detroit, MI); Wm. Notman (Montreal); A. C. McIntyre (Brockville); W. Langdale (Ayton); A. J. Truan (Knoxville, TN); G. P. Shull (Cincinnati, OH); C. Seaver (Grantville, MA); Ira F. Collins (Zionsville, ID); H. C. Norman (Natchez, MS).]

ST2849 "Award of the Gold Medal Prize." PHILADELPHIA PHOTOGRAPHER 15, no. 170 (Feb. 1878): 57-60. [Award went to G. M. Elton (Palmyra, NY). Article includes descriptions of the work of thirteen other contestants as well.]

ST2850 "Editor's Table: Pictures Received." PHILADELPHIA PHOTOGRAPHER 15, no. 170 (Feb. 1878): 61. [A. Hesler (Evanston, IL); H. A. Jordan (Cedar Falls, IA); George H. Monroe (Rochester, NY); Frederick York (London).]

ST2851 "Class Photographs and Photographers." PHOTOGRAPHIC TIMES 8, no. 86 (Feb. 1878): 34-35. [Warren, Pach, Notman, etc. mentioned.]

ST2852 "Correspondence." ANTHONY'S PHOTOGRAPHIC BULLETIN 9, no. 3 (Mar. 1878): 94-95. [Letters from M. Carey Lea (Philadelphia, PA); N. S. Bowdish (Auburn); J. C. Scott (New Brunswick, NJ); John Gross (Alum Bank, PA); G. N. Barnard; Abm. Bogardus (New York, NY).]

ST2853 "Editor's Table: Pictures Received." PHILADELPHIA PHOTOGRAPHER 15, no. 171 (Mar. 1878): 95. [G. D. Ormsby (Chicago, now Oakland, CA); C. D. Mosher (Chicago, IL); G. M. Bretts (Pottsville, PA); Frank Jewell (Scranton, PA); J. P. Vail (Geneva, NY); J. S. Young (Rome, GA); R. N. Dawson (Blaire, NE); J. H. Hamilton, portraits of Indians (Sioux City, IA); Irving Saunders (Alfred Center, NY); N. R. Worden (New Britain, CT).]

ST2854 "Correspondence." ANTHONY'S PHOTOGRAPHIC BULLETIN 9, no. 4 (Apr. 1878): 127-128. [Letters from George G. Rockwood (New York, NY); J. S. Notman & Co. (Boston, MA); W. J. Baker (Buffalo, NY); Edw. S. Butler, etc.]

ST2855 "Criticisms By The Competitors; On The Prize Pictures." PHILADELPHIA PHOTOGRAPHER 15, no. 172 (Apr. 1878): 97-99. [Letters from D. H. Anderson (Richmond, VA); George M. Elton (Palmyra, NY); R. W. Dawson (Blair, NE); C. W. Tallman (Batavia, NY); Cook Ely (Oshkosh, WI).]

ST2856 "Editor's Table: Pictures Received." PHILADELPHIA PHOTOGRAPHER 15, no. 172 (Apr. 1878): 128. [S. N. Douglass (Evansville, IN); Cook Ely (Oshkosh, WI); R. Goebel (St. Charles, MO); Louis de Planque (Corpus Christi, TX); R. Maynard, portraits of Indians, miners, etc. (Victoria, B.C.).]

ST2857 "The Lightning Process." ANTHONY'S PHOTOGRAPHIC BULLETIN 9, no. 5 (May 1878): 152-153. [Quotes from photographers using the "Lightning Process," sold by Anthony Co. J. W. Black (Boston, MA); Henry Rocher (Chicago, IL); Boesel & Purpus (New Breman, OH); Carlisle (Providence, RI); Wm. Klauser (New York, NY); Henry Draper (New York, NY); D. J. Ryan (Savannah, GA); Dr. Mills (Penn Yan, NY); von Sothen (U.S. Army); G. Hess (Williamsport, PA); Alfred S. Johnson (Waupun, WI); A. R. Marks (Houston, TX); D. W. Wilson (Bridgeport, CT).]

ST2858 H. "Photography as an Art Teacher." PHILADELPHIA PHOTOGRAPHER 15, no. 173 (May 1878): 151. [From the "Richmond [VA] Transcript."]

ST2859 "Editor's Table: Pictures Received." PHILADELPHIA PHOTOGRAPHER 15, no. 173 (May 1878): 159. [G. M. Elton (Palmyra, NY); Julius Hall (Chicago, IL); J. W. Black (Boston, MA).]

ST2860 "Lambert's Lightning Process." ANTHONY'S PHOTOGRAPHIC BULLETIN 9, no. 6 (June 1878): 181-183. [Letters from Bettison (Bowling Green, KY); Lafayette W. Seavey (New York, NY); Lilienthal (New Orleans, LA); Forshew (Hudson, NY); Hardy (Bangor, ME); Alf. S. Johnson (Waupun, WI); Bankes (Little Rock, AK); Bigelow (Plattsburgh, NY); J. G. Stuart (Carlinville, IL); Sherman (Elgin, IL); G. W. Caddington (Middleton, OH); Judd (Chattanooga, TN); A. W. Paradise (Stamford, CT); R. Poole (Nashville, TN); Snooks (Canton, MS); etc.]

ST2861 "Getting Their Pictures Taken." ANTHONY'S PHOTOGRAPHIC BULLETIN 9, no. 6 (June 1878): 183-184. 1 illus. [From "Breakfast Table." Comic story.]

ST2862 "Editor's Table: Pictures Received." PHILADELPHIA PHOTOGRAPHER 15, no. 174 (June 1878): 192. [J. E. Beebe (Chicago, IL); Joshua Smith (Chicago, IL).]

ST2863 Riker, C. E. "In the Photographic Gallery." ANTHONY'S PHOTOGRAPHIC BULLETIN 9, no. 7 (July 1878): 196-198. [From "Sunday Times."]

ST2864 "Lightning." ANTHONY'S PHOTOGRAPHIC BULLETIN 9, no. 7 (July 1878): 215. [Letters from J. M. Letts (Dundee, NY); Wm. J. Land (Atlanta, GA); Karl Klauser (Farmington, CT); Ch. Ferris (Malone); Alfred S. Johnson (Waupun, WI) on the Lambert process.] Howson, H. "Patents and The Useful Arts." PHILADELPHIA PHOTOGRAPHER 15, no. 175 (July 1878): 206-209. [Extracted from Howson's brochure - Howson a lawyer.]

ST2865 "Wise Words from the Workers." PHILADELPHIA PHOTOGRAPHER 15, no. 175 (July 1878): 213-223. [Advice from professionals. Frank Robbins; J. E. Beebe; George M. Bretz; Garvey Donaldson; W. G. C. Kimball; S. M. Robinson; C. A. Zimmerman; S. R. Stoddard; John H. Henning; F. M. Spencer; "D."; E. K. Hough; A. W. Kimball; Julius Hall; Frank Jewell; J. E. Small; Forester Clark.]

ST2866 "Editor's Table: Pictures Received." PHILADELPHIA PHOTOGRAPHER 15, no. 175 (July 1878): 223. [I. W. Taber (San Francisco, CA); C. R. Savage (Salt Lake City, UT); Frank G. Abell (Portland, OR); E. D. Ormsby (Oakland, CA); John Pitcher Spooner (Stockton, CA); C. E. Orr (Sandwich, IL); J. E. Beebe (Chicago, IL); George Moore (Seattle, WA); F. Parker & C. Hasselman (Los Angeles, CA); A. Hesler (Chicago, IL).]

ST2867 "Fun with a Photograph." ANTHONY'S PHOTOGRAPHIC BULLETIN 9, no. 8 (Aug. 1878): 251. [From "Bridgeport [CT] Farmer." Prankster hanging crepe on studio portrait displayed in front of gallery, then placing it in wanted posters in the post office, etc.]

ST2868 "Correspondence." ANTHONY'S PHOTOGRAPHIC BULLETIN 9, no. 8 (Aug. 1878): 256. [Letters from J. H. Cole (New York, NY); Mueller Bros. (Baltimore, MD); D. C. Pratt (Aurora, IL); Chas. H. Whiting (Chicago, IL).]

ST2869 "Wise Words from the Workers." PHILADELPHIA PHOTOGRAPHER 15, no. 176 (Aug. 1878): 226-229. [Technical and practical suggestions from Frank Rowell (Boston, MA); Frank G. Abell (Portland, OR); J. Pitcher Spooner (Stockton, CA); C. M. French (Garrettsville, OH); E. P. Libby (Keokuk, IA); Charles W. Hearn (Rocher's Studio, Chicago, IL).]

ST2870 "Editor's Table: Pictures Received." PHILADELPHIA PHOTOGRAPHER 15, no. 176 (Aug. 1878): 256. [A. Hesler (Chicago, IL); George M. Cobb (Binghampton, NY); Andrew Price (Napa City, CA); W. H. Moore (Marion, OH); J. W. Husher (Greencastle, IN); Allen & Rowell (Boston, MA); Albert Levy (New York, NY); J. Pitcher Spooner (Stockton, CA); D. E. Smith (Oneida Community, NY).]

ST2871 "Wing et. al. vs. Tompkins." ANTHONY'S PHOTOGRAPHIC BULLETIN 9, no. 9 (Sept. 1878): 276. [Court decision, against Wing, Southworth and Ormsbee.]

ST2872 "Lightning Process." ANTHONY'S PHOTOGRAPHIC BULLETIN 9, no. 9 (Sept. 1878): 286. [Letters praising the process, from J. Robert Moore (Trenton Falls, NY); E. B. Hemingway (Cameron, MO); A. G. Da Lee (Lawrence, KS); Dr. Habishaw (New York, NY); Burrell (Brockton, MA); Wm. Notman (Montreal).]

ST2873 "Correspondence." ANTHONY'S PHOTOGRAPHIC BULLETIN 9, no. 9 (Sept. 1878): 287-288. [Letters from Blessing & Brother (Galveston, TX); Sarony (New York, NY); Geo. B. Ayres (Iowa); J. K. Bundy (New Haven, CT); T. C. Martin (Indianapolis, IN); Muybridge (San Francisco, CA).]

ST2874 "Wise Words from the Workers." PHILADELPHIA PHOTOGRAPHER 15, no. 177 (Sept. 1878): 257-258. [Advice from photographers: A. Hesler (Chicago, IL); Irving Saunders (Alfred Center, NY).]

ST2875 "Editor's Table: Pictures Received." PHILADELPHIA PHOTOGRAPHER 15, no. 177 (Sept. 1878): 286-287. [Frederick E. Ives (Ithica, NY); Julius Hall (Great Barrington, MA); D. C. Pratt (Aurora, IL); A. B. Comstock (Waverly, NY); Bradley & Rulofson (San Francisco, CA).]

ST2876 "The Lightning Process." and "What Others Say of It." ANTHONY'S PHOTOGRAPHIC BULLETIN 9, no. 10 (Oct. 1878): 317-318. [Editorial comment by E. & H. T. Anthony & Co. on their process, plus letters from Sarony, Notman, J. H. Lakin (Montgomery, AL); Moore Bros. (Springfield, MA); E. R. Wiley (Danville, IL); F. L. Stuber (Easton, PA); F. A. Simonds (Chillicothe, OH); J. H. Miller (Logansport, ID).]

ST2877 Carroll, Professor Charles. "New York in Summer." HARPER'S MONTHLY 57, no. 341 (Oct. 1878): 689-704. 17 illus. [Engravings of

leisure activities - swimming, etc. Includes an illustration of a commercial ferrotype portraitist attempting to work while being harassed by young boys, titled "Photographing Under Difficulties."]

ST2878 [Wilson, Edward L.] "Native Process-Mongers." PHILADELPHIA PHOTOGRAPHER 15, no. 178 (Oct. 1878): 297-299.

ST2879 "Wing vs. Anthony." ANTHONY'S PHOTOGRAPHIC BULLETIN 9, no. 10 (Oct. 1878): 319-320.

ST2880 "Editor's Table: Pictures Received." PHILADELPHIA PHOTOGRAPHER 15, no. 178 (Oct. 1878): 318-319. [W. F. Van Loo (Toledo, OH); Harry Sutter (Milwaukee, WI); Isa Black (Franklin, PA); M. L. Daggett (Taunton, MA); C. W. Hearn.]

ST2881 "Decision of U.S. Circuit Court, Southern District of New York. Simon Wing, Albert S. Southworth and Marcus Ormsbee vs. Edward Anthony, Henry T. Anthony and Vincent M. Wilcox." and "The Wing Suit." ANTHONY'S PHOTOGRAPHIC BULLETIN 9, no. 11 (Nov. 1878): 324-327, 343. [Text of decision, plus list of witnesses and statement on p. 343.]

ST2882 "The Lightning Process." ANTHONY'S PHOTOGRAPHIC BULLETIN 9, no. 11 (Nov. 1878): 351-352. [Letters from W. G. Frazer (Richmond, VA); W. H. Illingworth (St. Paul, MN); S. V. Allen (Freeport, IL); Ghegan (Newark, NJ); J. H. Miller (Logansport, ID); A. W. Wolever (Delphi, ID).]

ST2883 Benjamin, S. G. W. "The Sea Islands." HARPER'S MONTHLY 57, no. 342 (Nov. 1878): 839-861. 24 b & w. [Fort George Island, South Carolina. Negroes in the cotton fields, etc. Engraving, many from photographs.]

ST2884 "The Lightningelists." PHILADELPHIA PHOTOGRAPHER 15, no. 179 (Nov. 1878): 345-346. [Controversy raging throughout the year about a "lightning" developing process being sold, this time including a statement from the E. & H. T. Anthony Co.]

ST2885 "Editor's Table: Pictures Received." PHILADELPHIA PHOTOGRAPHER 15, no. 179 (Nov. 1878): 350. [Well G. Singhi; Charles A. Smith (Newton, NJ); C. Weitfte (Central City, CO); E. D. Ormsby (Oakland, CA); Clark (Pittsfield, MA); Isa Black (Franklin, PA).]

ST2886 "Correspondence." ANTHONY'S PHOTOGRAPHIC BULLETIN 9, no. 12 (Dec. 1878): 382-384. [Letters from H. J. Rogers (Hartford, CT); Artotype Co.; J. W. Storrs (Birmingham, CT); C. H. Muhrman (Cincinnati, OH); A. N. Callaway (Brenham, TX).]

ST2887 "Voices from the Craft." PHILADELPHIA PHOTOGRAPHER 15, no. 180 (Dec. 1878): 372-373. [S. V. Allen; E.D. Ormsby; J. S. Young (Rome, GA); M. F. Frey.]

ST2888 "Editor's Table: Pictures Received." PHILADELPHIA PHOTOGRAPHER 15, no. 180 (Dec. 1878): 383. [George H. Johnson (amateur at Bridgeport, CT); F. W. Oliver (Oswego, NY); John H. Henning (Johnstown, PA); Albert Levy (NY); Evans (Corning, NY); Chandler (St. Albins, VT).]

USA: 1879.
BOOKS
ST2889 Kingsley, William I., ed. *Yale College; A Sketch of Its History.* New York: Henry Holt, 1879. 2 vol. pp. 89 illus. [Vol. II contains eighty-nine heliotypes. Portraits, scenes.]

ST2890 Sweetser, Moses Foster. *Views in the White Mountains.* With Descriptions by M. F. Sweetser. Portland: Chisholm Brothers, 1879. 14 pp. 12 b & w. [Albertype illustrations.]

ST2891 Williamson, Andrew. *Sport and Photography in the Rocky Mountains.* Edinburgh: R. & R. Clark, D. Douglas, 1880. vi, 55 pp. 18 l. of plates. 18 b & w. [Clark publication has original photos, the Douglas publication has collotype reproductions.]

PERIODICALS
ST2892 "The Artotype Question." ANTHONY'S PHOTOGRAPHIC BULLETIN 10, no. 1 (Jan. 1879): 17-20. [Primarily an attack on Edward L. Wilson, "Phila. Photo." editor. Includes letters from the Artotype Co., W. Illingwoth & John Storrs, Edward L. Wilson and others.]

ST2893 "Correspondence." ANTHONY'S PHOTOGRAPHIC BULLETIN 10, no. 1 (Jan. 1879): 32. [Letters from H. Boisannas; Aaron Veeder (Albany, NY); Mora; W. Illingworth; Byron W. McLain; M. Carey Lea.]

ST2894 "Correspondence." ANTHONY'S PHOTOGRAPHIC BULLETIN 10, no. 2 (Feb. 1879): 63-64. [Letters from J. W. Storrs (Birmingham, CT); D. H. Brooks (Crete, IL); E. M. Estabrooke & C. A. Naegell (New York, NY); E. M. Collins (Oswego, NY); J. Howard (New York, NY).]

ST2895 "New York. - Grand Effects of the Severe Winter at Niagara Falls, Under the Sway of the Frost King." FRANK LESLIE'S ILLUSTRATED NEWSPAPER 47, no. 1221 (Feb. 22, 1879): 441-442. 3 illus. [Views, frost covered trees, etc. Not credited to photographs, even though in the text it states "...curious formations, which nothing less than the photographic camera can adequately picture."]

ST2896 "Virginia. - Civilizing the Red Men. - The Government School for the Education of Indian Youth at Hampton. - From Photographs." FRANK LESLIE'S ILLUSTRATED NEWSPAPER 47, no. 1222 (Mar. 1, 1879): 468. 5 illus. [Group portraits of Gros Ventres and Sioux Indian children in european clothing, etc. Refers to an earlier article on the Hampton School published in the Jan. 18 issue, which was illus. with sketches. Social documentary.]

ST2897 "Correspondence." ANTHONY'S PHOTOGRAPHIC BULLETIN 10, no. 3 (Mar. 1879): 90-94. [Letters from J. De Witt Brinckerhoff (Morrisania); John Carbutt; W. L. Estabrooke; J. F. Ryder; Peter Baab (New York, NY); E. Decker (Cleveland, OH); W. Heighway (London, ENG); W. H. Illingworth (St. Paul, MN); C. O. Lovell, Jr. (Amherst, MA); Ed. H. Fox (Danville, KY); Mead & Jennings (Lansing, MI); C. H. Muhrman (Cincinnati, OH); W. G. Chamberlain (Denver, CO); Joshua Appleby Williams (Newport, RI); G. F. Gates (Syracuse, NY); A. W. Judd (Chattanooga, TN); E. Klauber; Rockefellow & Oldroyd; J. F. Barker; J. B. Jennings; C. R. Savage (Salt Lake City, UT); John Rodgers (Naval Observatory, WA); W. F. Willett (WA); John Evan (Peru, IL); A. W. Wolever (Delphi, ID); J. P. Blessing (Galveston, TX); Geo. Adams (Uxbridge, MA); Jas. A. Bostwick (New York, NY).]

ST2898 "Massachusetts. - The Latest Novelty in Church Music - Substitution of the Magic-Lantern for the Hymn-Book, Boston. - From a Sketch by Charles W. Reed." FRANK LESLIE'S ILLUSTRATED NEWSPAPER 48, no. 1223 (Mar. 8, 1879): 5, 7. 1 illus. [Words to the hymns projected by the lantern.]

ST2899 "Correspondence." ANTHONY'S PHOTOGRAPHIC BULLETIN 10, no. 4 (Apr. 1879): 126-127. [Letters from R. Benecke; C. D. Fredericks and Hugh O'Neil (C. D. Fredericks & Co., New York,

NY); Frank A. Place (Warsaw, ID); B. F. Stevens (Lodi, CA); Ch. Bierstadt (Niagara Falls, NY); S. M. Gillespie; Rev. Mr. Charles Tanquerey (White Bluff, GA); Louis E. Levy (Philadelphia, PA).]

ST2900 "Class Photographs." PHOTOGRAPHIC TIMES 9, no. 100 (Apr. 1879): 91-92. [College graduating class photos. Warren, Notman, etc. mentioned. Reprinted from "The World," Feb. 24, 1879.]

ST2901 "The Artotype." ANTHONY'S PHOTOGRAPHIC BULLETIN 10, no. 5 (May 1879): 156-157. [Letters from A. M. Allen (Pottsville, PA); Notman (Montreal); Kurtz and Fredericks & Co.; Klauber; Stuber (Easton, PA); L. G. Bigelow (New York, NY); Theodore Lilienthal (New Orleans, LA); Muhrman (Cincinnati, OH); W. A. Mooers (Woodstock, NY); S. Swaine (Rochester, NY); R. H. Furman (Rochester, NY); Geo. Statler (Johnstown, PA); S. Wilcox (Lancaster, NH).]

ST2902 "Pictures Received." ANTHONY'S PHOTOGRAPHIC BULLETIN 10, no. 5 (May 1879): 160. [Photos from W. E. Armstrong (Nashville, TN); C. A. Smith (Newton, NJ).]

ST2903 "Spirit Photographs in Court." ANTHONY'S PHOTOGRAPHIC BULLETIN 10, no. 6 (June 1879): 176. [From "NY Times," in turn from "Rochester Union" May 16. R. L. Dorr (Dansville, NY), believing he captured some spirit photographs, is suing W. J. Lee, who claims that Dorr is misled.]

ST2904 "What is Said of the Artotype." ANTHONY'S PHOTOGRAPHIC BULLETIN 10, no. 6 (June 1879): 188-189. [Letters from Louis Moberly (McKinney, TX); Fox (Danville, KY); Doctor McLain (Wabash, ID); Schleier (Chattanooga, TN); W. J. Baker (Buffalo, NY).]

ST2905 "Correspondence." ANTHONY'S PHOTOGRAPHIC BULLETIN 10, no. 6 (June 1879): 190-191. [Letters from D. A. Woodward; Robert A. Goodwin (Syracuse, NY); D. C. Pratt (Aurora, NY); J. F. Gorber (Philadelphia, PA); T. O. Lyon (Ware, MA); C. W. Motes (Atlanta, GA).]

ST2906 "The Song of Photowatha." ANTHONY'S PHOTOGRAPHIC BULLETIN 10, no. 7 (July 1879): 202. [Burlesque poem.]

ST2907 "Spirit Photography. How Some Old Magazine Pictures Were Reproduced." ANTHONY'S PHOTOGRAPHIC BULLETIN 10, no. 7 (July 1879): 214. [From "Rochester Union." A gallery belonging to Miss Hedley, on State Street, produced "spirit photographs," which seem to have been copied from old magazines.]

ST2908 Taylor, J. Traill. "Trade Jealousies - The Atmosphere in N. Y. - Comparative Merits of English and American Photographs." ANTHONY'S PHOTOGRAPHIC BULLETIN 10, no. 7 (July 1879): 216-217. [From "Br J of Photo." Taylor's "NY correspondence" to BJP reprinted here.]

ST2909 "Correspondence." ANTHONY'S PHOTOGRAPHIC BULLETIN 10, no. 7 (July 1879): 224. [Letters from W. W. Whiddit (Newburgh); W. J. Baker (Buffalo, NY); E. T. Whitney (Norwalk, CT).]

ST2910 "Returning Prosperity." ANTHONY'S PHOTOGRAPHIC BULLETIN 10, no. 8 (Aug. 1879): 256. [Brief comment indicating that period of hard times for photographers seems on the way out.]

ST2911 "Rhode Island. - New Breakwater and Harbor of Refuge at Block Island. - From Photographs Furnished by General G. K. Warren."

FRANK LESLIE'S ILLUSTRATED NEWSPAPER 48, no. 1245 (Aug. 9, 1879): 380. 1 illus. [View.]

ST2912 "Photographic Eccentricities." ANTHONY'S PHOTOGRAPHIC BULLETIN 10, no. 9 (Sept. 1879): 264-265. [From "Exchange." "Next to having a tooth pulled or being hanged is to sit for a photograph...."]

ST2913 "The Camp Photographer at Work." FRANK LESLIE'S ILLUSTRATED NEWSPAPER 49, no. 1249 (Sept. 6, 1879): 8. 1 illus. [Sketch of a photographer taking portraits at the "Encampment of the G. A. R. of the Dept. of New Jersey at Skillman, August 26th-29th," presented with other activities of this outing.]

ST2914 "A Photograph Fraud." ANTHONY'S PHOTOGRAPHIC BULLETIN 10, no. 10 (Oct. 1879): 319.

ST2915 "Correspondence." ANTHONY'S PHOTOGRAPHIC BULLETIN 10, no. 10 (Oct. 1879): 320. [Letters from Frank A. Nims (Colorado Springs, CO); David Tucker & Co. (Buffalo, NY); D. Dean Crossin.]

ST2916 "Pictures Received." ANTHONY'S PHOTOGRAPHIC BULLETIN 10, no. 11 (Nov. 1879): 352. [R. Benecke (St. Louis, MO); J. W. Miller (Pittstown, PA); Heyl (Bermuda); George R. Elliott (Columbus, OH).]

ST2917 "How Business Is and What Of It. Responses to Our Circular Letter." PHILADELPHIA PHOTOGRAPHER 16, no. 192 (Dec. 1879): 375-379. [T. M. V. Doughty (CT), F. Richardson (MA), Walter C. North, (NY), J. F. Ryder (OH), S. M. Robinson (PA)]

USA: 1881.
ST2918 Ludlow, Helen W. "Indian Education at Hampton and Carlisle." HARPER'S MONTHLY 62, no. 371 (Apr. 1881): 659-675. 15 illus. [Social Documentary. Group portraits of Indian students, etc. Engravings from photographs.]

USA: 1882.
ST2919 Alcott, Amos Bronson. *Ralph Waldo Emerson: An Estimate of His Character and Genius,* in Prose and Verse. Boston: A. Williams & Co., 1882. 81 pp. b & w. [Original photos.]

ST2920 Alcott, Amos Bronson. *Sonnets and Canzonets.* Boston: Roberts Brothers, 1882. 151 pp. 23 l. of plates. [50 copies of this extra-illustrated edition.]

USA: BY STATE

USA: ALASKA: 19TH C.
ST2921 Wolfe, Laurance. "Stereo Gold: Stereography of Alaska, the Yukon, the Klondike - 1868 to 1987." STEREO WORLD 14, no. 3-4 (July - Aug. - Sept. - Oct. 1987): 3:4-16, 2; 4:4-15, 40. 34 b & w. 3 illus. [Views by Edweard Muybridge (1868); H. H. Brodeck; H. H. McIntire; T. W. Ingersoll; F. Jay Haynes; Underwood & Underwood; Keystone; Kilburn; Griffith & Griffith/William H. Rau; C. H. Graves; American Stereoscopic Co.; Tom Moore.]

USA: ALABAMA: 19TH C.
ST2922 McLaurin, Melton Alonza and Michael V. Thomason. *The Image of Progress: Alabama Photographs, 1872-1917.* University, AL: University of Alabama Press, 1980. xx, 220 pp. b & w. [Bibliography, pp. 215-218.]

USA: ALABAMA: 1854.

ST2923 "Peregrinations of a Wanderer: Montgomery, Ala, Jan. 1854." PHOTOGRAPHIC AND FINE ART JOURNAL 7, no. 3 (Mar. 1854): 71-72. [Will Frear opened gallery in Montgomery, AL.]

USA: ARIZONA: 19TH C.

BOOKS

ST2924 Conklin, Enoch. *Picturesque Arizona.* Illustrated by the Continent Stereoscopic Company. New York: Mining Record Printing Establishment, 1878. n. p. illus. [Illustrated with woodcuts, taken from photographs by Arizona photographers acquired by Conklin, a sketch artist and journalist for Frank Leslie's publications, who toured Arizona in 1877 as an operator for the Continent Stereoscopic Co. Photos by Henry Buehman, John K. Hillers, and others, and by Conklin himself.]

PERIODICALS

ST2925 Daniels, David. "Photography's Wet-Plate Interlude in Arizona Territory: 1864 - 1880." JOURNAL OF ARIZONA HISTORY 9, no. 4 (Winter 1968): 171-194. 9 b & w. [Mentions Charles Thomas Rogers (1864), J. G. Gaige (1869), John C. Preston (1870), William A. Bell (1867-68, Kansas Pacific R.R. Survey), E. O. Beaman & John K. Hillers (Powell Colorado River Survey, 1871-1872), Timothy O'Sullivan (Wheeler Surveys, 1871-1875), D. P. Flanders (1863), Henry Bushman (1874), E. M. Jennings, F. W. Moon (Company B, 11th U.S. Infantry), W. H. Williscraft (1876), Mr. Rothrock (1877), D. F. Mitchell, from San Francisco (1877), Camillus S. Fly (1878), Ben A. Wittick (1878), Carleton E. Watkins visited in 1880.]

ST2926 Brickerhoff, Sidney B. "Graphic Arts on the Arizona Frontier: Frontier Soldiers in Arizona." JOURNAL OF ARIZONA HISTORY 12, no. 3 (Autumn 1971): 167-182. 19 b & w. [Photos by Mitchell & Baer (Prescott, AZ), D. F. Mitchell, Christian Barthelmess, D. A. Markey, C. S. Fly, Henry Buehman.]

ST2927 Hooper, Bruce. "Arizona Territorial Stereography 1864 - 1906. Part I: The Early Years, 1864 - 1874." STEREO WORLD 13, no. 1 (Mar. - Apr. 1986): 4-7, 39. 5 b & w. 1 illus. [Illustrations are views by D. P. Flanders, taken in 1869 or 1874. Rudolph D'Heureuse; Alexander Gardner; F. A. Cook; Gentile; D. P. Flanders; W. H. Williscraft; H. Penelon; Adolfo Rodrigo; Henry Buehman; others mentioned or discussed.]

ST2928 Hooper, Bruce. "Arizona Territorial Stereography: Part II - The Rise of Stereography in Arizona 1875 - 1880. Part III - The Railroad Comes to Arizona Territory: Stereography along the Rails, 1880 - 1890." STEREO WORLD 13, no. 3 (July - Aug. 1986): 4-16, 40. 16 b & w. 4 illus. [Part II. Describes the careers and work of Henry Buehmann (b. 1851); W. H. Williscraft; George H. Rothrock (1843-1920). Illustrated with seven views or Indian portraits by Rothrock. Part III. Discusses the work of Carleton E. Watkins; J. C. Burge; George Benjamin Whittick; Hildreth & Burge; and others. Includes checklist of stereographs by D. P. Flanders, George H. Rothrock, J. C. Burge, W. H. Williscraft, D. F. Mitchell, and miscellaneous photographers. Illustrated with stereos by Ben Wittick; C. E. Watkins; Charles O. Farciot; Camilius S. Fly; J. C. Burge; Mitchell & Baer. (Parts IV and V of this series deal with the period 1890 to 1930, and will therefore be listed in a following volume of this bibliography.)]

ST2929 Hooper, Bruce. "Arizona Stereo: An Update." STEREO WORLD 14, no. 1 (Mar. - Apr. 1987): 19-21, 30. 2 b & w. [Additional information and checklists about stereomakers in 19th and 20th century Arizona.]

ST2930 Hooper, Bruce. "Camera on the Mogollon Rim: Nineteenth Century Photography in Flagstaff, Arizona Territory, 1867 - 1916."

HISTORY OF PHOTOGRAPHY 12, no. 1 (Jan. - Mar. 1988): 93-101. 9 b & w. [Lieut. Joseph Ives (1857); Rudolph D'Heureuse (1863); Francis Augustus Cook (1864); Alexander Gardner (1867); George B. Wittick; J. C. Burge; Flagstaff Art Gallery; Edward A. St. Clair; Joseph Pasevitch; Calvin Osbon; W. H. Jackson; others mentioned.]

ST2931 Spude, Robert L. "Shadow Catchers: A Portrait of Arizona's Pioneer Photographers, 1863 - 1893." JOURNAL OF ARIZONA HISTORY 30, no. 3 (Autumn 1989): 233-250. 4 b & w. 1 illus. [The author has identified eighty-seven photographers working in Arizona during the period of his survey. Most were white, male, and native born. Many were itinerant, or open for business for a short time only. Discusses George Rothrock (1870s); J. C. Burge (1880s); G. Edward Gommel (1890s); Henry Buehman (1870s); Camillus S. Fly (1870s); Cicero Grimes (1880s); others.]

USA: CALIFORNIA: 19TH C.

BOOKS

ST2932 Heyman, Therese Thau. *Mirror of California: Daguerreotypes.* Oakland, CA: The Oakland Museum, 1973. 32 pp. 16 b & w. 3 illus. [Exhibition catalog. The Oakland Museum, Oakland, CA, Nov. 6, 1973 - Jan. 27, 1974. 33 items listed in the checklist. "Bibliography," on pp. 26-27. Illustrations include a fold-out of six full-plate daguerreotype views comprising a panorama of San Francisco, taken in 1853, by an unknown photographer.]

ST2933 Mangan, Terry William and Laverne Mau Dicker. *California Photographers, 1852 - 1920: An Index of Photographers in the Paper Print Collection of the California Historical Society.* San Francisco, CA: California Historical Society, 1977.

ST2934 Palmquist, Peter, with Lincoln Kilian. *The Photographers of the Humboldt Bay Region, 1850 - 1865.* Vol. I. Arcata, CA: Peter E. Palmquist, 1985. 112 pp. 15 b & w. 70 illus. *The Photographers of the Humboldt Bay Region, 1865 - 1870.* Vol. II, 1986. 132 pp. 24 b & w. 46 illus. *The Photographers of the Humboldt Bay Region, 1870 - 1875.* Vol. III, 1986. 120 pp. 58 b & w. 50 illus. *The Photographers of the Humboldt Bay Region, 1875 - 1880.* Vol. IV, 1987. 116 pp. 68 b & w. 46 illus. *The Photographers of the Humboldt Bay Region, Vol. 5: Edgar Cherry & Co.* 1987. 116 pp. 129 b & w. 6 illus. *The Photographers of the Humboldt Bay Region, 1880 - 1885.* Vol. VI, 1988. 108 pp. 35 b & w. 55 illus.

ST2935 Palmquist, Peter E. *Return to El Dorado: A Century of California Stereographs.* Riverside, CA: California Museum of Photography, 1986. 32 pp. 44 b & w. [Exhibition catalog. Covers the period 1850 - 1950.]

ST2936 Orland, Ted. *Man & Yosemite: A Photographer's View of the Early Years.* Santa Cruz, CA: The Image Continium Press, *. 95 pp. 83 b & w. illus. [Survey of the history of artists and photographers at Yosemite from 1850s through 1900s. C. L. Weed (1850s), J. J. Reilly (1870s), Gustav Fagersteen (1870s-1880s), Carleton Watkins (1870s), George Fiske (1880s), Julius Boysen, others discussed.]

ST2937 Palmquist, Peter E. "19th Century Photographers," on pp. 282-293 in: *Yesterday and Tomorrow: California Women Artists,* edited by Sylvia Moore. New York: Midmarch Arts Press, 1989. n. p. illus. [Author states that a least 600 women photographers worked in California before 1901. Julia Shannon; Miss Hudson; Mrs. Julia A. Rudolph; Mrs. Godeus; Mrs. Eliza Withington; Mrs. Emily Eastman; others discussed.]

ST2938 Palmquist, Peter E. *Shadowcatchers: A Directory of Women in California Photography before 1900.* Arcata, CA: Peter E. Palmquist,

1990. 272 pp. 120 illus. [Entries for more than 850 women photographers. Life dates, life chronology, active dates, locations, portraits given.]

PERIODICALS

ST2939 Harris, C. A. "Days of Old and Days of Gold in California." PHOTO ERA 64, no. 3 (Mar. 1930): 122-128.

ST2940 Ventura, Anita. "Gold Rush Panoramas. San Francisco - 1850 to 1853." SEA LETTER (SAN FRANCISCO MARITIME MUSEUM) 2, no. 2-3 (Oct. 1964): 1-8. 19 b & w. 18 illus. [Panoramic, daguerreotype views of San Francisco, CA.]

ST2941 Weinstein, Robert A. "Gold Rush Daguerreotypes." AMERICAN WEST 4, no. 3 (Aug. 1967): 33-39, 71-72. 6 illus. [Panels of daguerreotype panoramas for illustrations. Survey of early California photographers.]

ST2942 Olmstead, Roger, Robert A. Weinstein and J. S. Holliday. "In San Francisco and the Mines, 1851-1856." AMERICAN WEST 4, no. 3 (Aug. 1967): 40-49. 15 b & w. [Portfolio of daguerreotypes taken in 1850s in California.]

ST2943 Smith, David S.; Photographs from the Peter Palmquist Collection. "History Through the Lens." PACIFICA: MAGAZINE OF THE NORTH COAST (Feb. 1973): 16-20. 6 b & w. 4 illus. [Part I - Humboldt's Pioneer Photographers. Thomas Bass; Joseph Pleasants; H. P. Norcross; H. Anderson; Augustus Ericson; others mentioned.]

ST2944 Palmquist, Peter E. "Professional Photographers Working in Humboldt County, California 1840-1940." REDWOOD RESEARCHER (NEWSLETTER OF THE REDWOOD GENEALOGICAL SOCIETY, FORTUNA, CA) 6, no. 4 (May 1974): 14-16. [List, with town and dates working, of 139 photographers.]

ST2945 Palmquist, Peter E. "Yesterday's Photographs: Reflections of the Past. The Photographers of Shasta County 1850 - 1870." THE COVERED WAGON (THE SHASTA HISTORICAL SOCIETY, REDDING, CA) (1977): 5-20. 8 b & w. 8 illus. [Short but good descriptions of the photographic types and processes in use during the period - daguerreotype, ambrotype, etc. Background essay on the photography of the time, with a time line of known practitioners. List of photographers, with biographical details when known. J. Ruth; Thomas Bass; Joseph P. Pleasants; E. B. Hendee, and his brother D. H. Hendee; S. F. Baker; Dr. J. C. Darragh; Dr. Darragh & Prof. Godfrey; M. A. McKinnon; John Oliver Welsh; J. B. Higinbotham; Mrs. Spatz; Mrs. Elizabeth J. Eames.]

ST2946 Palmquist, Peter E. "Yesterday's Photographs: Reflections of the Past. Part II. The Photographers of Shasta County 1870 - 1900." THE COVERED WAGON (THE SHASTA HISTORICAL SOCIETY, REDDING, CA) (1978): 33-50. 12 b & w. 6 illus. [Background essay on technical changes in the medium, and general information. List of photographers, with biographical information for each, when known. John Oliver Welsh; Benjamin Swasey; Louis Altpeter; Mark Meacham; J. W. Tollman. An alphabetical list of more than a hundred "Shasta County Photographers 1850 - 1900," with dates practicing and cities practiced in.]

ST2947 Curran, T. E. "The Miner." HISTORY OF PHOTOGRAPHY 3, no. 2 (Apr. 1978): 128. 2 b & w. [An occupational tintype portrait of a California gold miner ca. 1855.]

ST2948 Palmquist, Peter E. "Mirror of Our Conscience: Surviving Photographic Images of California Indians Produced Before 1860."

JOURNAL OF CALIFORNIA ANTHROPOLOGY 5, no. 2 (Winter 1978): 162-178. 6 b & w. 4 illus. [Discusses the few surviving daguerreotypes, tintypes and photographs of Indians taken before 1860, as well as the pencil drawings and engravings based on daguerreotypes no longer extant. Discusses the work of Robert H. Vance, John Wesley Jones, and William Shew.]

ST2949 Palmquist, Peter E. "The Photographers of Trinity County 1850-1900." TRINITY (OFFICIAL YEARBOOK, TRINITY COUNTY HISTORICAL SOCIETY, WEAVERVILLE, CA) (1979): 4-33. 18 b & w. 1 illus. [Discusses the works and careers of Oliver H. P. Norcross (d. 1871); John Oliver Welsh; Louis Armand Marie (ca. 1825-1875); William Thomas Worthington; George W. H. Budden (ca. 1830-1883); W. S. Valentine; Frank P. Eastburn; August W. Fetzer (1872-1956). A list of over fifty photographers working in Trinity County during the period is included.]

ST2950 Palmquist, Peter. "Gold and Silver." HISTORY OF PHOTOGRAPHY 3, no. 2 (Apr. 1979): 180. 1 illus. [Advertisement for Dentistry and Daguerreotyping at the same shop from "Yreka [CA] Weekly Union", July 2, 1859.]

ST2951 Palmquist, Peter E. "The Stereo Daguerreotype in San Francisco: A Short and Unsuccessful Career." STEREO WORLD 6, no. 2 (May - June 1979): 12-16. 1 b & w. 6 illus. [R. H. Vance; Ford's Daguerrean Gallery; Hamilton & Shew; Shew's· Daguerreotype Rooms; others offered this process briefly in the 1850s, just before the daguerreotype is replaced by other processes.]

ST2952 Palmquist, Peter E. "The California Indian in Three-Dimensional Photography." JOURNAL OF CALIFORNIA AND GREAT BASIN ANTHROPOLOGY 1, no. 1 (Summer 1979): 89-116. 22 b & w. [Survey of stereographs of Indians in California. Illustrations by Lawrence & Houseworth; Carleton E. Watkins; Eadweard Muybridge; E. & H. T. Anthony & Co.; William N. Tuttle; R. E. Wood; C. W. Mills; M. M. Hazeltine; J. T. Boysen; George Wharton James. The works of these and other photographers discussed. Bibliography on pp. 115-116.]

ST2953 Booth, Larry and Jane Booth. "A Glimpse of Nineteenth Century San Diego." AMERICAN WEST 16, no. 5 (Sept. - Oct. 1979): 20-29. 14 b & w. [Portfolio of photographs from the San Diego [CA] Historical Society Collections.]

ST2954 Palmquist, Peter E. "The Daguerreotype in San Francisco." HISTORY OF PHOTOGRAPHY 4, no. 3 (July 1980): 209-238. 30 b & w. 21 illus. [Robert H. Vance (6), William Shaw (7), Frederick Coombs (3), J. M. Ford (1), Seth Lewis Shaw and George H. Johnson (1), plus many advertising illustrations.]

ST2955 Palmquist, Peter E. "California Nineteenth Century Women Photographers." THE PHOTOGRAPHIC COLLECTOR 1, no. 3 (Fall 1980): 18-21. 1 b & w. [112 women listed, with addresses, dates.]

ST2956 Palmquist, Peter. "Sacramento City (California) During the Flood of 1862." STEREO WORLD 7, no. 6 (Jan. - Feb. 1981): 12-15. 4 b & w. 2 illus.

ST2957 Palmquist, Peter. "Revised Listing of Sacramento City During the Great Flood of 1862." STEREO WORLD 8, no. 2 (Mar. - June 1981): 17-18. 2 b & w.

ST2958 Palmquist, Peter E. "California Stereographs: A Checklist of Makers, Part I." THE PHOTOGRAPHIC COLLECTOR 2, no. 4 (Winter 1981/1982): 10-17. 13 illus.

ST2959 Palmquist, Peter E. "California Stereographs: A Checklist of Makers, Part II." THE PHOTOGRAPHIC COLLECTOR 3, no. 1 (Spring 1982): 18-25. 9 illus.

ST2960 Hickman, Paul. "Art, Information, and Evidence: Early Landscape Photographs of the Yosemite Region." EXPOSURE 22, no. 1 (Spring 1984): 26-29. 2 b & w. [W. Harris; M. M. Hazeltine; J. J. Reilly; Ch. Bierstadt; Ch. L. Weed; Watkins; and others mentioned.]

ST2961 Palmquist, Peter. "Silver Plates Among the Goldfields: The Photographers of Siskiyou County, 1850-1906." CALIFORNIA HISTORY. 65, no. 2 (June 1986): 114-125, 153-154. 21 b & w. 1 illus. [Between 1850 and World War II, 150 professional photographers practiced their trade in Siskiyou County region. F. E. Bosworth; Philip Castleman; Hendee Brothers; Louis Herman Heller (1839-1928); Jacob Hansen (c. 1828-1893); Carleton E. Watkins; others discussed.]

USA: CALIFORNIA: 1857.
ST2962 R. A. C. "Photography in California." PHOTOGRAPHIC AND FINE ART JOURNAL 10, no. 4 (Apr. 1857): 112-113. [R. H. Vance; J. M. Ford gallery now S. P. Howes; C. F. Hamilton; H. W. Bradley; C. R. Fardon; Johnson Brothers; Shew; Vance (brother to R. H.); Deconclois (who displays examples of photos by Whipple & Black (Boston); May & Fessenden; H. Bush (all working in San Francisco). Also mentions Valentine & Case, in Panama.]

ST2963 "Mormon Island, California." FRANK LESLIE'S NEW YORK JOURNAL n. s. 5, no. 5 (May 1857): 289. 1 illus. ["From a Daguerreotype taken in 1856." (May be from "Annals of San Francisco and California.")]

ST2964 "Merchant's Exchange, San Francisco, Cal." BALLOU'S PICTORIAL DRAWING-ROOM COMPANION [GLEASON'S] 12, no. 309 (May 23, 1857): 321. 1 illus. ["...executed expressly for the Pictorial from a photograph taken for us, and one of the finest specimens of the art we ever saw."]

ST2965 "View of San Francisco, California." BALLOU'S PICTORIAL DRAWING-ROOM COMPANION [GLEASON'S] 13, no. 318 (July 25, 1857): 49. 1 illus. ["...drawn from an admirable photograph, taken expressly for our Pictorial."]

USA: CALIFORNIA: 1858.
ST2966 "The Butterfield Overland Mail to California." HARPER'S WEEKLY 2, no. 102 (Dec. 11, 1858): 784-785. 1 illus. ["The Overland Mail Starting from San Francisco for the East - From a Photograph."]

USA: CALIFORNIA: 1864.
ST2967 "Greenbacks in California." HUMPHREY'S JOURNAL OF PHOTOGRAPHY, AND THE ALLIED ARTS AND SCIENCES 16, no. 9 (Sept. 1, 1864): 144. ["...we get ten dollars per dozen cards, twelve dollars for vignettes..." Photographer not identified.]

USA: CALIFORNIA: 1870.
ST2968 "California. - The Mayor and Supervisors of the City of San Francisco." FRANK LESLIE'S ILLUSTRATED NEWSPAPER 29, no. 747 (Jan. 22, 1870): 319, 320. [Thirteen portraits, not credited to a photograph, but arranged to resemble cartes-de-visite.]

USA: CALIFORNIA: 1874.
ST2969 Palou, Fr. Francisco. Noticias de la Nueva California, escritas por el Padre Fr. Francisco Palou. San Francisco: Eduoardo Bosqui y Cia, for the California Historical Society., 1874. 4 vols. Vol 1: xx, 270 pp. Vol 2: 302 pp. Vol. 3: 316 pp. Vol. 4: 254 pp. pp. 18 b & w. [100 numbered copies. Palou's 18th century texts are printed with eighteen

albumen photographs of California missions, taken by W. W. Stewart, John R. Jarbos, E. J. Muybridge, Parker & Parker, Bradley & Rulofson, and others.]

USA: CALIFORNIA: 1875.
BOOKS
ST2970 LeConte, Joseph. A Journal of Ramblings Through the High Sierras of California by the "University Excursion Party." San Francisco: Francis & Valentine, 1875. n. p. 9 b & w. [Original photos.]

PERIODICALS
ST2971 "Theo." "Photography in California." PHILADELPHIA PHOTOGRAPHER 12, no. 142 (Oct. 1875): 292-293. [G. D. Morse, Rulofson, I. W. Taber discussed.]

USA: COLORADO: 19TH C.
BOOKS
ST2972 Harber, Opal. Photographers on the Colorado Scene 1853 through 1900. Denver: Denver Public Library, Western History Department, 1961. 42 pp. illus. [Based on research by the author for a M.A. degree at the Univ. of Denver, 1956. An alphabetical list of photographers, their working locations, and working dates.]

ST2973 Mangan, Terry William. Colorado on Glass: Colorado's First Half Century as seen by the Camera, by Terry Wm. Mangan; with a Directory of Early Colorado Photographers by Opal Murray Harber. Denver, CO: Sundance, Ltd., 1975 . x, 406 pp. 1 l. of plates. b & w. illus.

PERIODICALS
ST2974 Harber, Opal M. "A Few Early Photographers of Colorado." COLORADO MAGAZINE 33, no. 4 (Oct. 1956): 284-295. 11 b & w. 1 illus. [Discusses careers of George D. Wakely (1860s), Henry Faul (1860s), William Gunnison Chamberlain (1860s), W. Delavan (1860s), Constant & Victor M. Dunham (1960s), Joseph Collier (1870s-1910).]

ST2975 Weinstein, Robert A. and Roger Olmsted. "Image Makers of the Colorado Canyons." AMERICAN WEST 4, no. 2 (May 1967): 28-39. 10 b & w. [Photographs by William Bell (1872), Timothy O'Sullivan (1871), John K. Hillers (1872), Henry G. Peabody (1900), Philip Hyde (1964).]

ST2976 Simmons, George C. and Virginia McConnell Simmons. "First Photographers of the Grand Canyon." AMERICAN WEST 14, no. 4 (July - Aug. 1977): 34-38. 61-63. 6 b & w. [Both J. W. Powell Colorado River Survey and G. M. Wheeler Survey of the 100th Meridian were in Grand Canyon area during 1871-1872. E. O. Beaman, William W. Bell, James Fennemore, John K. Hillers and Timothy O'Sullivan served on one or the other of these expeditions. Article clarifies who was where, when.]

USA: COLORADO: 1865 see also WAKELY, G. D.

USA: CONNECTICUT: 19TH C.
ST2977 Fuller, Sue E. "Checklist of Connecticut Photographers by Town: 1839-1889," and "Alphabetical Index of Connecticut Photographers 1839-1889" CONNECTICUT HISTORICAL SOCIETY BULLETIN 47, no. 4 (Winter 1982): 117-163.

USA: DELAWARE: 19TH C.
ST2978 Williams, John M. "Daguerreotypists, Ambrotypists, and Photographers in Wilmington, Delaware, 1842 - 1859." DELAWARE HISTORY 18, no. 3 (Spring-Summer 1979): 180-193. [Discusses or mentions C. P. Hogshead; W. K. Wolcott; Outten D. Jester (coroner and daguerreotypist —post mortums a speciality); Stoops &

SPECIAL TOPICS
HISTORY: BY COUNTRY: USA: DISTRICT OF COLUMBIA: 19TH C.

SPECIAL TOPICS
HISTORY: BY COUNTRY: USA: ILLINOIS: 1871.

Hartmann; Appleby & Hance; Samuel Broadbent; Ellwood Garrett; Benjamin Betts; Joseph Jeanes & Joseph Waith; B. T. Cox & B. A. Hudson; George W. Johnson; William H. Curry; and others.]

USA: DISTRICT OF COLUMBIA: 19TH C.
BOOKS
ST2979 Baty, Laurie Anne. *Photographers in Washington, D. C., 1870 -1885*. Washington, DC: George Washington University, 1979. iii, 143 l. pp. [M.A. Thesis, George Washington Univ., 1979. List of photographers, etc. IMP/GEH collection.]

PERIODICALS
ST2980 Busey, Samuel C., M.D. "Early History of Daguerreotypy in the City of Washington." RECORDS OF THE COLUMBIA HISTORICAL SOCIETY 3, (1900): 81-95. [John Plumbe, Jr.; Blanchard P. Paige; S. N. Carvalho; Bennett; C. H. Venable. Includes two letters from S. Rush Seibert, describing his own early experiences, mentioning George West and Root & Clark.]

ST2981 Waldsmith, John. "Washington City, D. C." STEREO WORLD 10, no. 3 (July - Aug. 1983): 14-21. 16 b & w. 1 illus. [Brief survey article with a listing of twenty-eight stereoscopic photographers of Washington, DC and sixteen stereoscopic photographers from outside the city who took views there. Illustrated with views by Anthony (1850s, 1860s); J. F. Jarvis; Strohmeyer & Wyman; Bell Brothers (1860s); Roberts & Fellows (1890s); E. W. Kelly (1900s); others.]

USA: DISTRICT OF COLUMBIA: 1856.
ST2982 "An Amateur." "The Washington Galleries." PHOTOGRAPHIC AND FINE ART JOURNAL 9, no. 10 (Oct. 1856): 317-318. [Mrs. Redman; Madge; Vanable; Root & Co.; Page; Vannerson; Whitehurst; Carthy.]

USA: DISTRICT OF COLUMBIA: 1857.
ST2983 J. R. J. "Washington Galleries." PHOTOGRAPHIC AND FINE ART JOURNAL 10, no. 10 (Oct. 1857): 306-307. [H. O'Neal and T. J. Simmond, operators at Whitehurst's Gallery; Walker, the portrait painter, opened a photo. gallery with James Cummings as his operator; McClees; Vannerson; Grannis has left the city; painters mentioned.]

ST2984 J. R. J. "Washington Galleries." PHOTOGRAPHIC AND FINE ART JOURNAL 10, no. 12 (Dec. 1857): 380. [Whitehurst's Gallery (O'Neil and Simons, operators); James McCleese (operator Samuel A. Cohner); others mentioned.]

USA: DISTRICT OF COLUMBIA: 1858.
ST2985 "Photography in Washington." PHOTOGRAPHIC AND FINE ART JOURNAL 11, no. 4 (Apr. 1858): 98-99. [Brady reopens gallery formerly occupied by Plumbe. Paige takes Root's old place; McClee Gallery (Samuel Croner, operator), group portraits of an Indian tribe; T. J. Nimmo at the Whitehurst Gallery; Henry O'Neil; Walker; Vannerson.]

USA: FLORIDA: 19TH C.
BOOKS
ST2986 Rinhart, Floyd and Marion Rinhart. *Victorian Florida: America's Last Frontier*. Atlanta: Peachtree Publishers, 1986. 214 pp. b & w. illus.

PERIODICALS
ST2987 Morton, Rev. H. J., D.D. "East Florida and Photography. Pts. 1 - 3." PHILADELPHIA PHOTOGRAPHER 4, no. 42, 44, 48 (June, Aug., Dec. 1867): 174-177, 257-259, 384-386.

USA: GEORGIA: 19TH C.
ST2988 Griffith, Michael W. "Before the Burning of Atlanta." STEREO WORLD 7, no. 5 (Nov. - Dec. 1980): 10-13. 6 b & w. [One stereo view by George N. Barnard and five by unknown maker.]

USA: GEORGIA: 1859.
ST2989 Pugh, J. A. "The Art in Georgia." HUMPHREY'S JOURNAL OF PHOTOGRAPHY, AND THE ALLIED ARTS AND SCIENCES 11, no. 14 (Nov. 15, 1859): 214-215. [Pugh is from Macon, GA. Report on photo exhibitors at the Southern Central Agricultural Society Annual Fair in Atlanta. W. C. Dill; W. H. De Shong; Tucker & Perkins; J. A. Pugh exhibited. Pugh showing stereoviews of Georgia scenes.]

USA: HAWAII: 19TH C.
BOOKS
ST2990 Davis, Lynn, ed. *Na Pa'i Ki'i: The Photographs of the Hawaiian Islands 1845 - 1900*. Honolulu, HI: Bishop Museum Press, 1980. 48 pp. 32 b & w. [Ex. cat., Bishop Museum, Honolulu, Dec. 3, 1980 - Aug. 31, 1981.]

PERIODICALS
ST2991 Schmitt, Robert C. "Notes on Hawaiian Photography before 1890." HAWAII HISTORICAL REVIEW (Oct. 1967): 409-416.

USA: HAWAII: 1873.
ST2992 Nordhoff, Charles. "Hawaii - Nei." HARPER'S MONTHLY 47, no. 279-280 (Aug. - Sept. 1873): 382-402, 544-559. 46 illus. [Views, portraits, etc. Engravings, some probably from photographs.]

USA: HAWAII: 1877.
ST2993 Portrait. Woodcut engraving, credited "From a Photograph." ILLUSTRATED LONDON NEWS 70, (1877) ["King Kalakua, Queen Kapiolani, and Prince Leleiohoku of the Hawaiian Islands." 70:1969 (Apr. 7, 1877): 325.]

USA: ILLINOIS: 19TH C.
BOOKS
ST2994 Chicago Historical Society. Print Department. *Chicago Photographers, 1847 through 1900*: As listed in Chicago city directories. Chicago: Chicago Historical Society Print Department, 1958. 175 pp.

ST2995 Czach, Marie, compiler. *A Directory of Early Illinois Photographers. Preliminary Investigations into Photography as Practiced in Illinois, Excluding Chicago, from circa 1846 to 1914. A Work in Progress Report*. ***: Western Illinois University, 1977.

PERIODICALS
ST2996 Holt, Glen E. "Chicago Through a Camera Lens: An Essay on Photography as History." CHICAGO HISTORY n. s. 1, no. 3 (Spring 1971): 158-168. 10 b & w. [Topographic views of Chicago, IL, 1870 - 1910 used as a basis for the author's commentary.]

ST2997 Waldsmith, John. "Chicago Through the Stereoscope: Before the Fire - The Great Fire - Rebuilt Chicago and... - The Interstate Industrial Exposition." STEREO WORLD 3, no. 4 (Sept. - Oct. 1976): 4-11. 17 b & w. [Views by J. Carbutt; Copelin & Melander; J. B. Pierce & Co.; P. B. Greene; Lovejoy & Foster; Woodward Stereoscopic Co.]

USA: ILLINOIS: 1871.
BOOKS
ST2998 *Chicago and the Great Conflagration*. With numerous illustrations by Chapin & Gulick from photographs taken on the spot. Cincinnati: C. F. Vent, 1871. 528 pp. illus. [Engravings, from photographs.]

PERIODICALS

ST2999 "Chicago in Ashes." ANTHONY'S PHOTOGRAPHIC BULLETIN 2, no. 10 (Oct. 1871): 338. [Early news of the disastrous Chicago, IL, fire. Comment by Mr. C. W. Stevens, a Chicago stockdealer restocking at Anthony's, which lists the photographers thought to be burnt out.]

ST3000 "The Great Fire at Chicago: Views in the City." ILLUSTRATED LONDON NEWS 59, no. 1675 (Oct. 21, 1871): 373, 382-383. 5 illus. [Four views of Chicago before the fire, probably from stereos.]

ST3001 "'The Fate of the Photographers in Chicago' - Letter from Mr. G. A. Douglass." PHILADELPHIA PHOTOGRAPHER 8, no. 95 (Nov. 1871): 365. [Includes a list of twenty photographers burned out by the Chicago, IL, fire.]

ST3002 "The Chicago Fire: Romance-Reality-Enterprise-Pluck." PHOTOGRAPHIC TIMES 1, no. 11 (Nov. 1871): 161-162. [Story of Mr. Charles Stevens, a photographic supply dealer from Chicago, IL, who arrived in New York, NY to resupply within 15 hours of being burned out.]

ST3003 Douglass, G. A. "Losses of Photographers in Chicago." PHOTOGRAPHIC WORLD 1, no. 11 (Nov. 1871): 338-339.

ST3004 "Chicago and Its Relief." ANTHONY'S PHOTOGRAPHIC BULLETIN 2, no. 11 (Nov. 1871): 366-367. [Stock dealers, photographers reopening. "Mr. Rocher...reopen one of the finest galleries...G. N. Barnard and Mr. Melander at work for the stereoscope."]

ST3005 "The Burning of Chicago." ILLUSTRATED LONDON NEWS 59, no. 1678 (Nov. 11, 1871): 446, 448-449. 11 illus. [Eight of the illustrations are views of the ruins, from photographs published in New York... for the benefit of the Chicago Relief Fund.]

ST3006 Elrod, J. C. "Correspondence: The Origin of the Chicago Fire Not In a Photographic Gallery." PHILADELPHIA PHOTOGRAPHER 8, no. 96 (Dec. 1871): 398.

ST3007 Hall, Alfred. "News from Chicago." PHILADELPHIA PHOTOGRAPHER 8, no. 96 (Dec. 1871): 398-399.

ST3008 "The Chicago Relief Fund." PHILADELPHIA PHOTOGRAPHER 8, no. 96 (Dec. 1871): 399-401. [Bradley & Rulofson of San Francisco, CA, organized a relief fund for the sufferers of the Chicago, IL, fire.]

ST3009 "Our Fraternity in Chicago - Their Need." PHILADELPHIA PHOTOGRAPHER 8, no. 96 (Dec. 1871): 402-404. [List of photographers in Chicago, IL, and estimated losses. Views of ruins mentioned in "Editor's Table," page 407 by Henry Rocher, P. B. Green, W. E. Bowman, Landy.]

ST3010 "Aid for Chicago." ANTHONY'S PHOTOGRAPHIC BULLETIN 2, no. 12 (Dec. 1871): 399. [Letters from J. H. Dallmeyer, J. B. Horton, Bendann Bros. (With a list of Baltimore photographers subscribing to relief fund).]

USA: ILLINOIS: 1872.

ST3011 "Chicago." PHOTOGRAPHER'S FRIEND 2, no. 1 (Jan. 1872): 12-14. [Letters and contributors of Chicago Relief Fund listed. Letters by Abraham Bogardus, H. Rocher, and Richard Walzl.]

USA: ILLINOIS: 1875.

ST3012 "Editor's Table: Sundries." PHILADELPHIA PHOTOGRAPHER 12, no. 135 (Mar. 1875): 95. [Comments on events in Chicago, mentions that the Feb. 20th edition of the "Chicago [IL] Tribune" devotes a large article to photographers there.]

USA: ILLINOIS: 1879.

ST3013 "Iowa." "Chicago." ANTHONY'S PHOTOGRAPHIC BULLETIN 10, no. 6 (June 1879): 182-184. [The author reports on his visit to Chicago. Discusses the Photographic Assoc. meeting, then visits several studios. Rocher; C. D. Mosher, and his operator, Mr. Kidney; Gentile Gallery (Mrs. Cadwell); Lydian Art Gallery (Klein, operator); Brand Gallery (Hodges, operator); Copelain Gallery; Joshua Smith, etc.]

ST3014 "Iowa." "Chicago." ANTHONY'S PHOTOGRAPHIC BULLETIN 10, no. 11 (Nov. 1879): 350-351. [Second report on trip to Chicago, IL; mentions C. Gentile, Douglass, Hesler, Rocher, etc.]

USA: IOWA: 19TH C.

ST3015 Vincent, John R. "Midwest Indians and Frontier Photography." ANNALS OF IOWA 38, no. 1 (Summer 1985): 26-35. 8 b & w. [Discusses eight photos of Indians taken in the area of IA before 1880, emphasis on identifying the Indians, virtually nothing said about the photographers, who are not named.]

USA: KANSAS: 19TH C.

ST3016 Taft, Robert. "A Photographic History of Early Kansas." KANSAS HISTORICAL QUARTERLY 3, no. 1 (Feb. 1934): 3-14. 7 b & w. [Includes a catalog of Gardner stereo views now in possession of the Kansas State Historical Society. Seven views of Kansas by Gardner. Mentions S. N. Carvahlo, Mr. Bomar, A. G. DaLee, Hathaway, W. H. Lamon, and others.]

ST3017 Taft, Robert. "A Photographic History of Early Kansas." STEREO WORLD 2-3, no. 6, 1-4 (Jan. - Feb. - Sept. - Oct. 1976): 6:3; 1:14; 2:4-5; 3:14; 4:21. [Article reprinted from "Kansas Historical Quarterly," (Feb. 1934, May 1937).]

USA: KENTUCKY: 19TH C.

ST3018 Coke, Van Deren. "When Photography Was a Marvel: Making of daguerreotypes thrived before Civil War in many Lexington galleries." LOUISVILLE COURIER (Apr. 19, 1959): 31-32, 34, 36. 6 b & w. 1 illus. [Discusses or mentions Dr. Robert Peter (at Translvania University); T. W. Cridland; Prof. Plumbe; Swaine & Hickey; Boswell; D. B. Elrod & Carr; John S. Wison (amateur).]

ST3019 Munoff, Gerald J. "Dr. Robert Peter and the Legacy of Photography in Kentucky." REGISTER OF THE KENTUCKY HISTORICAL SOCIETY 78, no. 3 (Summer 1980): 208-218. 2 illus. [Munoff's researches disprove the legend that Dr. Robert Peter, of the Medical Department of Transylvania University brought photography to Kentucky in 1839.]

USA: LOUISIANA: 19TH C.

BOOKS

ST3020 Smith, Margaret Denton and Mary Louise Tucker. *Photography in New Orleans: The Early Years 1840 - 1865.* Baton Rouge, LA: Louisiana State University Press, 1982. 172 pp. b & w. illus.

PERIODICALS

ST3021 Smith, Margaret Denton. "Checklist of Photographers Working In New Orleans, 1840-1865." LOUISIANA HISTORY 20, no.

4 (Fall 1979): 393-430. [List of more than 100 daguerreotypists and photographers, with some biographical data for most entries.]

USA: LOUISIANA: 1858.

ST3022 Carden, R. A. "New Orleans Photographic Galleries." PHOTOGRAPHIC AND FINE ART JOURNAL 11, no. 8 (Aug. 1858): 244-245. [Mentions J. H. Clark; Anderson & Blessing; F. Law (formerly Moissenet's); W. W. Washburn; Dobyns & Harrington (under Gray's management); E. Jacobs; C. Galvani; Moses.]

USA: MAINE: 19TH C.

ST3023 Avery, Myron H. "Nineteenth Century Photographers of Katahdin." APPALACHIA n. s. 12 (Dec. 1946): 218-224. 12 b & w. [James C. Stodder (Bangor, ME); A. L. Hinds (Benton, ME); F. W. Hardy, others.]

ST3024 Darrah, William C. "A Checklist of Maine Photographers who issued stereographs." MAINE HISTORICAL SOCIETY NEWSLETTER no. Special supplement (May 1967): 1-8.

ST3025 Shettleworth, Earle G., Jr. "The Daguerreotypists of Portland, Maine." 32 l. [Student research paper, Colby College, Jan. 1968. In IMP/GEH Information File. Thoroughly researched, well written, giving biographical information on Joseph Ropes (1812-1885); Samuel Lincoln Carleton (1822-1908); George M. Howe (1823-1887), and discussing Mrs. McFarland; Foster & Co.; Samuel Rowell; Henry B. Upton; Hough & Anthony; Marcus Ormsbee, then Ormsbee & Silsbee and others.]

USA: MAINE: 1868.

ST3026 DeCosta, Benjamin Franklin. Scenes in the Isle of Mount Desert, Coast of Maine. New York: A. D. F. Randolph & Co., 1868. 138 pp. 10 b & w. [Original photos. Another printing (1871), with variant title "Rambles in Mount Desert;..."]

USA: MAINE: 1871.

ST3027 DeCosta, Benjamin Franklin. Rambles in Mount Desert; with Sketches of Travel on the New England Coast, from Isles of Shoals to Grand Menan. New York; Boston: A. D. F. Randolph & Co.; A. Williams & Co., 1871. 280 pp. 10 b & w.

USA: MAINE: 1880.
BOOKS

ST3028 Martin, Mrs. Clara Barnes. Mount Desert on the Coast of Maine. "5th ed." Portland, ME: Loring, Short & Harmon, Printed by H. O. Houghton & Co., 1880. 103 pp. 6 b & w. 1 illus. [Several editions through 1870s. Original photographs tipped-in. Landscape views. Photographs are not credited, possibly by Loring, Short & Harmon.]

ST3029 Sweetser, Moses Foster. Picturesque Maine, with Descriptions by M. F. Sweetser. Portland, ME: Chisholm Brothers, 1880. 65 pp. 23 l. of plates. 23 b & w. [Collotypes.]

USA: MARYLAND: 19TH C.
BOOKS

ST3030 Kelbaugh, Ross J. Directory of Maryland Photographers, 1839 - 1900. Baltimore: Historic Graphics, 1988. 105 pp. [2nd ed. (1989) 112 pp. 16 illus. [Lists over 765 photographers, with their addresses. Biographies for David Bachrach (1845-1921), David Bendann (d. 1915), Daniel Bendann (d. 1914), Norval Busey (b. 1845), Charles Byerly (b. 1874), John Holyland (1841-1931), B. W. T. Phreaner (b. 1845), Henry Pollock (b. 1810), William F. Shorey (b. 1833), John Henry Walzl (b. 1833), Richard E. Walzl (1843-1899), Jesse Whitehurst (d. 1875), David A. Woodward (b. 1823).]

ST3031 Kelbaugh, Ross J. Directory of Baltimore Daguerreotypists. Baltimore: Historic Graphics, 1989. 43 pp.

PERIODICALS

ST3032 Kelbaugh, Ross J. "Dawn of the Daguerrean Era in Baltimore, 1839 - 1849." MARYLAND HISTORICAL MAGAZINE 84, no. 2 (Summer 1989): 101-118. 10 b & w.

USA: MARYLAND: 1857.

ST3033 "Rome." "Photography in Baltimore." PHOTOGRAPHIC AND FINE ART JOURNAL 10, no. 7 (July 1857): 202. [Pollock; P. L. Perkins (operator D. Cowell); Israel; Clark.]

ST3034 J. R. J. "Baltimore Galleries of Art." PHOTOGRAPHIC AND FINE ART JOURNAL 10, no. 8 (Aug. 1857): 252. [Clark; Israel; P. L. Perkins; Pollock; J. H. Whitehurst.]

ST3035 J. R. J. "Photographic Artists of Baltimore." PHOTOGRAPHIC AND FINE ART JOURNAL 10, no. 9 (Sept. 1857): 263-264. [Perkins; J. H. Whitehurst; Pollock; Israel; Woodward, other painter, sculptors, etc. mentioned.]

ST3036 J. R. J. "Baltimore Galleries." PHOTOGRAPHIC AND FINE ART JOURNAL 10, no. 10 (Oct. 1857): 311. [Whitehurst burned out; Hugh O'Neil now working for Pollack; P. L. Perkins; Israel; B. F. Hawks about to start again; Elisha Lee prepares canvas for photographic prints; etc.]

ST3037 J. R. J. "Baltimore Galleries." PHOTOGRAPHIC AND FINE ART JOURNAL 10, no. 11 (Nov. 1857): 331-332. [Describes the photos exhibited at the Maryland Institute Fair. Discusses events and personages in Baltimore.]

USA: MARYLAND: 1868.

ST3038 J. R. J. "Art in Baltimore." PHOTOGRAPHIC AND FINE ART JOURNAL 11, no. 2 (Feb. 1858): 56-57. [J. H. Whitehurst, (Dr. Bushnell is his operator); J. W. Perkins retired, replaced by Mr. Tuttle; B. F. Hawks; P. L. Perkins; Pollock; Israel; Davis; Morrow; Walzl; McCan; several painters mentioned.]

USA: MARYLAND: 1870.

ST3039 "Photography in Baltimore." PHILADELPHIA PHOTOGRAPHER 7, no. 83 (Nov. 1870): 386.

USA: MARYLAND: 1873.

ST3040 "Editor's Table: Photography in Baltimore." PHILADELPHIA PHOTOGRAPHER 10, no. 112 (Apr. 1873): 128. [Mentions N. H. Busey; J. Holyland; T. P. Varley; W. F. Shorey; E. G. Fowx; Walter Dinmore.]

USA: MASSACHUSETTS: 19TH C.
BOOKS

ST3041 Bunting, W. H., compiler and annotator. Portrait of a Port: Boston, 1852 - 1914. Cambridge, MA: Harvard Univ. Press, 1971. 576 pp. b & w. [Essentially this is an illustrated history of boats and shipping, but the photographs are credited and brief biographical remarks about the photographers are given in an appendix. Southwoth & Hawes; Nathaniel L. Stebbins; Thomas A. Luke; Baldwin Coolidge; Henry G. Peabody; George McQuesten; Richard Hildebrand.]

ST3042 Hoyle, Pamela. The Development of Photography in Boston, 1840 - 1875. Boston: The Boston Athenaeum, 1979. 64 pp. 33 b & w. 1 illus. [Exhibition Catalog; The Boston Athenaeum, June 27-July 31, 1979. "Introduction," pp. 5-18. "Catalogue of the Exhibition," of

85 prints on pp. 20-40. "A Select Bibliography," p. 41. Portfolio on pp. 43-64.]

ST3043 Hoyle, Pamela. *The Boston Ambience: An Exhibition of Nineteenth-Century Photographs*. Boston: The Boston Athenaeum, 1981. 44 pp. 25 b & w. [Exhibition Catalog; The Boston Athenaeum, Feb. 9 - Mar. 5, 1981. Checklist of 100 prints. Photos by Samuel Bemis; Southworth & Hawes; J. J. Hawes; Silsbee, Case & Co.; J. G. Case & Wm. Getchell; John A. Whipple; James W. Black; Edward L. Allen; Austin A. Turner; Augustine H. Folsom; Augustus Marshall; Notman Photographic Co.; James Notman. These and others discussed in the excellent survey essay of photography in Boston from 1840s through 1880s.]

ST3044 Rodgers, Patricia H. and Charles M. Sullivan. *A Photographic History of Cambridge*. Cambridge, MA: MIT Press, 1984. n. p. 85 b & w. [Photographs of Cambridge, MA from 1844 to 1946. Includes an essay on photography and photographers in Cambridge, a biography of George K. Warren (1834-1884), and an index to Cambridge commercial photographers, 1858 - 1945.]

ST3045 Polito, Ronald. *A Directory of Boston Photographers, 1840 - 1900*. Boston: University of Massachusetts at Boston, 1985. viii, 131 l. [2nd ed., rev.]

PERIODICALS
ST3046 Coffin, Edward F. "The Daguerreotype Art and Some of Its Early Exponents in Worcester." WORCESTER HISTORICAL SOCIETY PUBLICATIONS. n. s. 1, no. 8 (Apr. 1935): 433-439. [Read before the Worcester (MA) Historical Society, Jan. 21, 1921. Mentions G. Evans, William Walker, Wood & Knowles, George Adams, Andrew Wemple Van Alstin, White & Andrews, Moses Sanford Chapin, and others.]

ST3047 Bolt, Dick. "Daguerreotype Artists in Mass." PHOTO-NOSTALGIA. PHOTOGRAPHIC HISTORICAL SOCIETY OF NEW ENGLAND NEWSLETTER no. 11 (May 1974): 1-2. illus. [List, with business address, of over fourty daguerreotypists.]

ST3048 Varrell, William. "Newburyport: It's Pioneer Photographers." STEREO WORLD 2, no. 1-2 (Mar. - Apr. - May - June 1975): 1: 1, 16 ; 2:1, 11, 15-16. 2 b & w. [Illustrated with views by Reed's Photograph & Ferrotype Rooms (ca. 1880), and R. E. Mosley (1867). Meinerth & Thompson; Batchelder & Clement; Luther Dame; Philip Coombs (ca. 1840-1864) mentioned. W. C. Thompson; the Reed family; E. R. Perkins; Hiram P. MacIntosh; Robert Ellis Mosely (1817-1870) (b. GB, USA); Carl Meinerth (ca. 1836-1892) discussed.]

ST3049 Hoyle, Pamela. "Boston's First Photographers." VIEWS: THE JOURNAL OF PHOTOGRAPHY IN NEW ENGLAND 5, no. 3 (Spring 1984): 6-9. 11 b & w. [Photos by Samuel A. Bemis; John A. Whipple; Albert S. Southworth & Josiah J. Hawes. James Black, others also discussed.]

USA: MASSACHUSETTS: 1851.
ST3050 "Boston Daguerreotypists." DAGUERREAN JOURNAL 2, no. 4 (July 1, 1851): 114-115. [Mentions French, Sawyer, Hale, Whipple, Ives, Chase, Ormsbee & Silsbee, Southworth & Hawes.]

USA: MASSACHUSETTS: 1853.
ST3051 "Grand Panoramic View of the West Side of Washington Street, Boston, Mass.,..." GLEASON'S PICTORIAL DRAWING-ROOM COMPANION 4, no. 20 (May 14, 1853): 312-313. 3 illus. [An almost schematic sketch of the frontal view of the commercial buildings on the street. Trade signs are shown, and the

Curtis Looking Glass Daguerreotype Rooms and other galleries, not identified by name, are shown.]

USA: MASSACHUSETTS: 1854.
ST3052 "Daguerreotypes in Boston." HUMPHREY'S JOURNAL 5, no. 21 (Feb. 15, 1854): 331. [Letter from "S. B., A. M.," mentioning Whipple's moon photos; Olmsbee; Southworth & Hawes.]

USA: MASSACHUSETTS: 1855.
ST3053 "Daguerreotypes, Etc." BALLOU'S PICTORIAL DRAWING-ROOM COMPANION [GLEASON'S] 9, no. 8 (Aug. 25, 1855): 125. [Commentary on the omnipresence of daguerreotypists in Boston.]

ST3054 Root, M. A. "A Trip to Boston - Boston Artists." PHOTOGRAPHIC AND FINE ART JOURNAL 8, no. 8 (Aug. 1855): 246-247. [Mentions Southworth & Hawes; Whipple & Black; Cutting & Co.; Masury & Silsbee; Cahill; Hale; Chase.]

USA: MASSACHUSETTS: 1857.
ST3055 T. A. R. "History of Art in Boston." PHOTOGRAPHIC AND FINE ART JOURNAL 10, no. 1 (Jan. 1857): 8-10. [From "London Art J."]

USA: MASSACHUSETTS: 1860.
ST3056 Wilson, Edward L. "Letters to Jack - And Things Old and New." WILSON'S PHOTOGRAPHIC MAGAZINE 37, no. 522 (June 1900): 248-249. [Reminiscences about photography in Boston in the 1860s. Mentions James Black, John Whipple Southworth, the first exhibition of the National Photographic Assoc., held in Horticulture Hall in 1869.]

USA: MASSACHUSETTS: 1861.
ST3057 Seely, Charles. "Editorial Miscellany." AMERICAN JOURNAL OF PHOTOGRAPHY AND THE ALLIED ARTS & SCIENCES n. s. vol. 3, no. 20 (Mar. 15, 1861): 320. [Praise for Boston galleries, claims they display better quality than New York galleries.]

USA: MASSACHUSETTS: 1863.
ST3058 "Photography In Boston." AMERICAN JOURNAL OF PHOTOGRAPHY AND THE ALLIED ARTS & SCIENCES n. s. vol. 6, no. 14 (Jan. 15, 1864): 321-323. [J. W. Black has "the largest establishment in the city. 40,000 negatives stored. 60 hands, male and female, employed in the establishment. One room is devoted to copying, one to groups, one to ordinary card work. One operator coats the plates, another exposes them, Mr. Black himself attends to the positions, and another assistant develops....Nearly twenty tons of glass (negatives) must be stored away in this single establishment. Mr. Black also has rooms at Cambridge, near his residence." Mr. Whipple maintains his ancient fame, and keeps his old establishment at 96 Washington St....(More info. on Whipple.) Ormsbee and Burnham mentioned. Boston maintains about seventy galleries.]

USA: MASSACHUSETTS: 1864.
ST3059 "Photography in Boston." AMERICAN JOURNAL OF PHOTOGRAPHY AND THE ALLIED ARTS AND SCIENCES n. s. vol. 6, no. 14 (Jan. 15, 1864): 220-223. [Discusses James W. Black's studio operations, etc.]

ST3060 "Meeting of Photographers in Boston." HUMPHREY'S JOURNAL OF PHOTOGRAPHY, AND THE ALLIED ARTS AND SCIENCES 16, no. 2 (May 15, 1864): 24-25. [Meeting held May 27th to protest new tax on photography, reestablish a scale of prices in the city due to increased costs. Masury Chairman of the meeting, Loomis

as Secretary. J. W. Black, Case mentioned. Black suggested calling a second meeting to form a Photographic Society.]

USA: MASSACHUSETTS: 1865.
ST3061 Wilson, Edward L. "A Day or Two in Boston." PHILADELPHIA PHOTOGRAPHER 2, no. 14 (Feb. 1865): 27-28. [Wilson describes his visit to commercial firms, dealers, etc.]

ST3062 S. R. D. "A Visit to Boston." AMERICAN JOURNAL OF PHOTOGRAPHY AND THE ALLIED ARTS & SCIENCES n. s. vol. 7, no. 18 (Mar. 15, 1865): 410-412. [S. R. D., from New York, NY, visited Boston, MA., met Marshall, Whipple, Black and others. "Mr. Black very kindly conducted us through his immense photographic establishment....Mr. Black's business is colossal...Mr. Black has on hand nearly one hundred and fifty thousand negatives..."]

ST3063 Wilson, Edward L. "Here a Little and There a Little." PHILADELPHIA PHOTOGRAPHER 2, no. 23 (Nov. 1865): 179-181. [Wilson describes his visit to Boston, MA. Black & Case discussed on p. 181. Wilson states that Black was the first photographer to make porcelain photographs in the USA.]

USA: MASSACHUSETTS: 1866.
ST3064 Richards, William Carey. *Great in Goodness: A Memoir of George N. Briggs, Governor of the Commonwealth of Massachusetts, from 1844 - 1851.* Boston: Gould & Lincoln, 1866. iv, 451 pp. 5 l. of plates. [Original photographs tipped-in.]

USA: MASSACHUSETTS: 1871.
ST3065 Hallenbeck, J. H. "Boston Correspondence." PHOTOGRAPHIC TIMES 1, no. 12 (Dec. 1871): 374-375. [Mr. A. C. Partridge opening studio. J. W. Black giving series of lantern lectures. J. Whipple returned from yearly tour of foreign climes. Whipple's India ink work on plain paper. Augustus Marshall's popular Rembrandt's.]

USA: MASSACHUSETTS: 1872.
BOOKS
ST3066 Novak, Michael. *The Photographic Record of the Great Boston Fire of 1872.* Newport Beach, CA: Michael Novak, n. d. [ca. 1981]. 94 pp. [Listing of every known photographer to have produced stereographic images of the fire. At least 550 stereo views by more than seventy photographers.]

PERIODICALS
ST3067 Hallenbeck, J. H. "Boston Correspondence." PHOTOGRAPHIC TIMES 2, no. 16 (Apr. 1872): 52-54. [Mentions William H. Getchell ("that veteran in photography"), Allen, Loomis, Warren, the newcomers Ritz & Heintz, Frank Rowell, A. N. Hardy, E. J. Foss.]

ST3068 Hallenbeck, J. H. "Boston Correspondence." PHOTOGRAPHIC TIMES 2, no. 18 (July 1872): 101-102. [J. W. Black, A. S. Southworth, and Smith report on the forthcoming convention of the NPA to a large audience.]

ST3069 "The Boston Fire." PHILADELPHIA PHOTOGRAPHER 9, no. 108 (Dec. 1872): 420-421. [Report of the Boston, MA, fire, with letters from B. French, J. W. Black, and B. W. Kilburn, who had travelled to Boston to take photographs.]

ST3070 Fitch, Robert G. "The Great Boston Fire of 1872." NEW ENGLAND MAGAZINE 21, no. 3 (Nov. 1899): 358-377. 20 b & w. 2 illus. ["Illustrated chiefly from photographs in the Bostonian Society's and Mr. Charles Pollack's collections." Not identified, but photos by James W. Black and others.]

ST3071 Novak, Michael J. "The Great Fire in Boston, November 1872." STEREO WORLD 7, no. 5 (Nov. - Dec. 1980): 4-8. 7 b & w. 1 illus. [Stereo views by Kilburn Brothers; John P. Soule; Charles Pollock; J. W. & J. S. Moulton; Charles Taber; E. F. Smith.]

USA: MASSACHUSETTS: 1873.
ST3072 "Vox" [Hallenback, John H.] "Items from Boston." PHILADELPHIA PHOTOGRAPHER 10, no. 119 (Nov. 1873): 536-537.

USA: MASSACHUSETTS: 1874.
ST3073 Loomis, G. H. "Paragraphic Pencillings." ANTHONY'S PHOTOGRAPHIC BULLETIN 5, no. 12 (Dec. 1874): 398-399. [Visits Boston photographers, briefly describes the activities of Allen & Rowell; D. K. Prescott; A. N. Hardy; Augustus Marshall; D. W. Butterfield (Viewest); T. R. Burnham; Balch Brothers; H. G. Smith. (This was a companion article to the essay on J. W. Black, in the same issue.)]

USA: MASSACHUSETTS: 1875.
ST3074 "Pencillings from Boston." ANTHONY'S PHOTOGRAPHIC BULLETIN 6, no. 11 (Nov. 1875): 338-339. [Discusses the Balch Brothers, Warren, Allen & Rowell, J. W. Black, and Marshall.]

USA: MASSACHUSETTS: 1876.
ST3075 Loomis, G. H. "Boston Correspondence." ANTHONY'S PHOTOGRAPHIC BULLETIN 7, no. 1 (Jan. 1876): 20-21. [O. R. Blaisdell, stockdealer, died; Leland Balch, of Balch Brothers, died on Thanksgiving at age 42.]

USA: MASSACHUSETTS: 1877.
ST3076 Loomis, G. H. "Pencillings From Boston." ANTHONY'S PHOTOGRAPHIC BULLETIN 8, no. 1 (Jan. 1877): 22-23. [General news.]

ST3077 Loomis, G. H. "Boston Correspondence." ANTHONY'S PHOTOGRAPHIC BULLETIN. 8, no. 11 (Nov. 1877): 347-348. [Discusses Boston photographer's responses to the "trying times." Coolidge bought Marshall's Studio; Marshall moving to Newton; A. N. Hardy; Tom Burnham left photography, returned to Portland, ME; J. W. Turner; Allen & Rowell; Black.]

USA: MASSACHUSETTS: 1879.
BOOKS
ST3078 Osgood, Charles S. and H. M. Batchelder. *Historical Sketch of Salem.* Salem, MA: s. n., 1879. n. p. 45 b & w. [45 heliotypes. Views, scenes, etc.]

PERIODICALS
ST3079 "Photography in Boston." PHOTOGRAPHIC TIMES 9, no. 105 (Sept. 1879): 214. [Mentions A. N. Hardy's Gallery (operated by Mr. Chute); W. H. Clark & Co.; Allen & Rowell; McCormick & Heald; E. P. Hentz; Notman & Campbell.]

USA: MASSACHUSETTS: 1880.
ST3080 Massachusetts. *1880. Government of the Commonwealth of Massachusetts.* Historical, Descriptive, and Biographical Sketches by various authors. Boston: Osgood, 1880. 2 vol. pp. 236 illus. [236 heliotype illustrations, portraits and views, in two albums.]

USA: MICHIGAN: 19TH C.
ST3081 Welch, Richard W. *Sun Pictures in Kalamazoo: A History of Daguerreotype Photography in Kalamazoo County, Michigan 1839 - 1860.* Kalamazoo: Kalamazoo Public Museum, 1974.

ST3082 Lavigna, Arlene, compiler. "List of Photographers and dates active from City Directories, 1869 - 1877." Battle Creek, MI: Kimball House Historical Society of Battle Creek, February 22, 1979.

USA: MINNESOTA: 19TH C.
ST3083 Newhall, Beaumont. "Minnesota Daguerreotypes." MINNESOTA HISTORY 34, no. 1 (Spring 1954): 28-33. 7 b & w. [Discusses Joel E. Whitney and Alexander Hesler.]

ST3084 Woolworth, Alan R. "MHS Collections: Minnesota Indians. A Photographic Album." MINNESOTA HISTORY 47, no. 7 (Fall 1981): 292-295. 10 b & w. [Description of materials in the Minnesota History Society collections. Albums and photos by Joel E. Whitney (1860s), Martin's Gallery (1850s, 1860s), Benjamin F. Upton (1860s) James E. Martin (1860s), Adrian Ebell (1860s). Posed studio portraits and camp scenes.]

ST3085 Reichman, Jessica. "Nineteenth - Century Minnesota Women Photographers." JOURNAL OF THE WEST 28, no. 1 (Jan. 1989): 15-23. 11 b & w, 3 illus. [Sixty women photographers active from 1859 - 1900 listed. The first was Sara L. Judd, born CT, moved with parents to Stillwater, MN (Then Wisconsin Terr.) in 1846. Sara taught school and is also supposed to have taken daguerreotypes from 1848 to 1850. Olive E. Goodwin in Minneapolis in 1859. Others mentioned.]

USA: MISSOURI: 19TH C.
ST3086 "Photography in St. Louis." ENCYCLOPEDIA OF THE HISTORY OF ST. LOUIS 3, (1899): 1728-1729. [Brief survey. Mentions T. M. Easterly, Outley, Long, Hoelke & Benecke, Fox, Fitzgibbon, Scholten, Cramer, Guerin, Strauss, Rosch, Gross, Hammer, Holborn, and Parsons.]

ST3087 van Ravenswaay, Charles. "The Pioneer Photographers of St. Louis." MISSOURI HISTORICAL SOCIETY BULLETIN 10, no. 1 (Oct. 1953): 48-71. 8 b & w. [Brief discussion of photography in St. Louis, MO, from ca. 1841 to ca. 1865, then an appended "Checklist of St. Louis Photographers 1841-1865," which lists over one hundred photographers with their working dates and addresses. There are also biographical statements on Robert Benecke (1835-1903); Emil Boehl (1839-1919); Gustav Cramer (1838-1914); Thomas M. Easterly (1809-1882); John H. Fitzgibbon (ca. 1816-1882); Andrew J. Fox (1826-1919); L. N. Howard (b. 1823); Enoch Long (b. 1823); H. H. Long; John Plumbe (d. 1857); Max Saettele (d. 1880); John A. Scholten (1839-1886); William Troxel. Photos by Robert Benecke, Emil Boehl, A. Gardner, Julius C. Strauss, Rudolph H. Goekill reproduced.]

ST3088 Ciampoli, Judith. "Images as Chronicle ... The Pictorial History Collections." GATEWAY HERITAGE 1, no. 1 (Summer 1980): 20-33. 9 b & w. 4 illus. [Introduction to the collections at the Missouri Historical Society. Photos by Thomas Easterly, Will S. Soule, Oscar Kuehn, Emil Boehl, Julius Caesar Strauss (1857-1924) Dr. Charles Swamp printed.]

USA: MISSOURI: 1870.
ST3089 Chanute, Octave and George Morison. *The Kansas City Bridge, with an Account of the Regimen of the Missouri River and a Description of Methods Used for Founding in that River.* New York: D. van Dostrand, 1870. 140 pp. 14 b & w. [Fourteen photos of the construction of the bridge, taken in 1869.]

USA: MISSOURI: 1879.
ST3090 Benecke, R. "St. Louis Correspondence." PHILADELPHIA PHOTOGRAPHER 16, no. 183 (Mar. 1879): 81-83.

USA: MONTANA: 19TH C.
ST3091 Morrow, Delores J. "Female Photographers on the Frontier: Montana's Lady Photographic Artists, 1866-1900." MONTANA: THE MAGAZINE OF WESTERN HISTORY 31, no. 3 (Summer 1982): *.

USA: NEW ENGLAND: 19TH C.
BOOKS
ST3092 Robinson, William F. *A Certain Slant of Light: The First Hundred Years of New England Photography.* Boston: New York Graphic Society, 1980. 243 pp. 125 b & w.

USA: NEW HAMPSHIRE: 19TH C.
ST3093 Leavitt, Robert H., compiler. "List of photographers presently knoen to have worked in Lebanon, NH, c. 1849 - 1970." Lebanon, NH: Lebanon Historical Society, April 19, 1979.

ST3094 Griscom, Andrew. "John Merrill, the Philosopher of the Pool." STEREO WORLD 8, no. 4 (Sept. - Oct. 1981): 12-14. [The Pool at Franconia Notch, NH, with an eccentric guide, John Merrill, was celebrated from the 1850s through the 1880s, and attracted a substantial number of tourists (and stereo view makers.) Illustrated with views by H. S. Fitfield. List of over twenty stereo publishers with their views included.]

ST3095 Drake, Greg. "Nineteenth-Century Photography in the Upper Connecticut Valley: An Annotated Checklist." DARTMOUTH COLLEGE LIBRARY BULLETIN n. s. 25, no. 2 (Apr. 1985): 72-91. [Listing of approximately 125 commercial photographers working in NH and VT during the 19th century, drawn from a survey of business directories and other sources. Brief biographies given, when known.]

USA: NEW HAMPSHIRE: 1864.
ST3096 "Photography vs. Books." HUMPHREY'S JOURNAL OF PHOTOGRAPHY, AND THE ALLIED ARTS AND SCIENCES 16, no. 11 (Oct. 1, 1864): 173-174. [Letter describing "the attractions of Franconia," the value of photography in depicting them, and "a photographer has a little shop, where he repeats from hour to hour, not only the vista of the gorge, but all those groups of visitors who wish to be held in perpetual remembrance by their friends, for which they pay for each carte one dollar, federal money."]

USA: NEW JERSEY: 19TH C.
BOOKS
ST3097 Moss, George H., Jr. *Double Exposure: Early Stereoscopic Views of Historic Monmouth County, New Jersey and their Relationship to Pioneer Photography.* Seabright, NJ: Plowshare Press, 1971. 176 pp. illus.

USA: NEW MEXICO: 19TH C.
BOOKS
ST3098 Rudisill, Richard, comp. *Photographers of the New Mexico Territory, 1854 - 1912.* Santa Fe, NM: Museum of New Mexico, 1973. 74 pp.

ST3099 Coke, Van Deren. *Photography in New Mexico: From the Daguerreotype to the Present.* Foreword by Beaumont Newhall. Albuquerque, NM: Univ. of New Mexico Press, 1978. xi, 156 pp. [Bibliography on pp. 149-152.]

USA: NEW YORK: 19TH C.
BOOKS
ST3100 Greenhill, Ralph and Thomas D. Mahoney. *Niagara.* Toronto: University of Toronto Press, 1969. n. p. b & w. illus.

ST3101 Fordyce, Robert Penn. *Stereo Photography in Rochester, New York up to 1900: A Record of the Photographers and Publishers of Stereographs active in Rochester, New York, up to 1900.* Rochester, NY: Fordyce, 1975. 23 pp. [Includes biographical and commercial histories of Franklin W. Bacon (1820-1901); Charles Bierstadt; C. E. Buell; William F. Carnall; B. F. Chambers; Benjamin P. Crossman; William H. Dignum; J. D. Eagles; Frederick H. Eales (d. 1869); J. Marsden Fox (1825-1890); Menzo E. Gates; C. H. Graves; Benjamin F. Hale (1831-1900); Julius J. Kempe; John H. Kent (1828-1910); George Hubbard Monroe (1851-1916); Myron Hawley Monroe (1824-1912); John Robert Moore; A. Newton Oakley; Isaac H. Sanderson (1833-1891); Levi Sherman (1834-1901); Lewis E. Walker (Warsaw, NY); Charles R. Webster (d. 1918); Charles Warren Woodward (1836-1894); and others.]

ST3102 *Old Brooklyn in Early Photographs, 1865 - 1919: 157 Prints from the Collection of the Long Island Historical Society.* Selected by William Lee Younger. New York: Dover Publications, 1978. 163 pp. b & w. illus.

ST3103 Gabriel, Cleota Reed. "Photographers Who Practiced in Syracuse, New York 1841 - 1900," on pp. [3-11] in: *'Photographica': a resource guide,* compiled by the Onodaga County Public Library in cooperation with Light Work. Syracuse, NY: Onondaga County Public Library, [1979]. n. p.

ST3104 Van Horn, Ralph, compiler. "Study of photographers who worked in Little Falls as found in directories, 1869 - ." Little Falls, NY: Little Falls Historical Society, 1979.

ST3105 Smith, Mary E. *Behind the Lens: Nineteenth Century and Turn-of-the-Century Photographers of Western Monroe County, New York.* By Mary E. Smith, Hamlin Town Historian. Published by the Monroe County Photo-History Project. Rochester, NY: s. n., 1980. 39 pp. illus. [Includes a brief overview of the photographers working in Western Monroe County from the 1850s through the 1900s. Biographical and commercial histories are given for Dr. E. H. Mix; William H. Fuller; Mrs. S. F. Parker; Mrs. G. W. Storms; John H. Kent (1827-1910); Joseph Berson (1843-1888); William Brockenshire; William Johnstone; Noel B. Baker (1830-); A. E. Waters; and others.]

ST3106 Bannon, Anthony, with C. Robert McElroy. *The Taking of Niagara: A History of the Falls in Photography.* Buffalo, NY: Media Study, 1982. 48 pp. b & w.

PERIODICALS

ST3107 Newhall, Beaumont. "The Broadway Daguerreian Galleries." IMAGE 5, no. 2 (Feb. 1956): 27-37. 4 b & w. 7 illus. [New York, NY galleries, operated by M. Brady, J. Gurney, M. H. Lawrence, among others.]

ST3108 Vetter, Jacob B. "Early Photographers: Their Parlors and Galleries." CHEMUNG COUNTY HISTORICAL JOURNAL (June 1961): 853-860. 4 illus. [Survey of the photographers of Elmira, NY, with biographical information. W. A. Wellman (itinerant, 1846). Johnson (itinerant, 1847). Abraham Parmele Hart (1816-1893), born in Goshen, CT, to Elmira in 1837, travelled as daguerreotypist 1846-1850, settled in Elmira in 1850, worked there until his death in 1893. John Edward Larkin (1836-1924), born in Rome, NY, to Elmira in 1850s, where he began to work for William Moulton. Partnership Moulton & Larkin 1863-1868. Larkin alone from 1868 until retired from photography in 1881. Larkin was supposed to have made photographs of the Elmira Prison Camp which were later purchased by the government and added to the Brady Civil War collections. John Whitley (1831-1896), born at Candor, NY, learned photography at

Owego, NY, to Elmira about 1861 to work for Charles Doty, then Hart, then opened his own gallery. Worked in a variety of situations until his death in 1896. T. Clendenny (1860s). Elisha Van Aken (1828-1904), born at Rensselaerville, NY. Became a daguerreotype maker at Lowville, NY in early 1840s. Moved to Elmira in 1873, opened a gallery which he ran until his death. His son Charles continued the gallery afterward, until he died in 1952. Henry Sartor (1852-1947), born in Centerville, NY. Began photographing at age sixteen at Pike, NY in 1868. Travelled around New England states photographing rural families, etc. South America, etc., for the Union View Company, later opened his own gallery in Elmira. Others outside of this time period are also discussed.]

ST3109 Graver, Nicholas M. "Dry Dock, 1846 - 1847." HISTORY OF PHOTOGRAPHY 2, no. 4 (Oct. 1978): 334. 1 b & w. [Daguerreotype of Brooklyn, NY, Navy Yard, ca. 1846-1847.]

ST3110 Wilensky, Stuart. "'Daguerreville' Riddle Solved." PHOTOGRAPHICA 13, no. 8 (Oct. 1981): 8.

ST3111 Wilensky, Stuart. "The Men, the Camera and Their Factory." PHOTOGRAPHICA 13, no. 8 (Oct. 1981): 4-8. [Aaron F. Palmer and Joseph Longking, manufacturers of Daguerreotype cameras and apparatus in NY.]

ST3112 Gabriel, Cleota Reed. "A Bibliography of Early Syracuse Photographers." PHOTOGRAPHICA 13, no. 8 (Oct. 1981): 12-13. [List, with dates, of professional photographers working in Syracuse, NY, during the 19th century.]

ST3113 Wilensky, Stuart. "The Men, the Camera, and Their Factory: William Lewis, William H. Lewis, Aaron F. Palmer and Joseph Longking." PHOTOGRAPHICA 13, no. 9 (Nov. 1981): 6-8. [Article discusses the ownership of the Daguerreville factory, now in New Windsor, NY.]

ST3114 Camp, William L. "Early Photographers of Binghampton." BROOME COUNTY HISTORICAL SOCIETY NEWSLETTER (BINGHAMPTON, NY) (Spring 1989): 9-11. 1 b & w. [Illustration is a view of Binghampton, NY in the 1840s, by Charles E. Johnson. Article is a survey of the photographers working in Binghampton, NY from 1841 through 1857. Discusses Charles E. Johnson & J. G. Wolf (itinerant, 1841); Charles E. Johnson (itenerant, 1841-1847); O. B. Evans (itinerant, 1847); Mr. Appleby (1850); John Owen (1852); L. Thompson (1852); George J. Smith (1855); Lowell Gillmore & Francis W. Nixon (1855); A. B. Tubbs (1855). (The article mentions a compilation of the local photographers from 1857 to 1907, gathered by Marjory Hinman, presumably available at the Historical Society. A letter from Mr. Camp states that he has compiled additional information on photographers from 1841 to 1866, also at the Society.)]

USA: NEW YORK: 1850.

ST3115 "Daguerreotyping in New York." DAGUERREIAN JOURNAL 1, no. 2 (Nov. 15, 1850): 49-50. [Author reports that there are 71 "rooms" in New York City; 127 operators, 11 ladies and 46 boys employed. Rent of $25,500 per year, estimates of salaries, etc.]

USA: NEW YORK: 1851.

ST3116 "Daguerreotyping in New York." DAGUERREIAN JOURNAL 3, no. 1 (Nov. 15, 1851): 19. [From "La Lumiére." Note on the richness and comfort of American photographic studios.]

USA: NEW YORK: 1852.

ST3117 Lacan, Earnest. "Heliography in New York." PHOTOGRAPHIC ART JOURNAL 3, no. 1 (Jan. 1852): 22. [From "La

Lumiére." Claims New York, NY to have 71 studios, employing 127 men, 11 women, and 46 children.]

ST3118 Humphrey, S. D. "Editorial Correspondence." HUMPHREY'S JOURNAL 4, no. 6 (July 1, 1852): 90-92. [Letter describing his "western tour," visiting many daguerreotypists in upper New York State. Mentions Thompson (Albany, NY); Geer & Benedict (Syracuse, NY); B. L. Higgins; Davie Brothers; Lawyer; Gibbs, plus "four rotary establishments [ambulatory wagons]" all in Syracuse, NY; Senter; Sherwood; Stone (all in Auburn, NY); Finley (in Canandaigua, NY).]

USA: NEW YORK: 1854.
ST3119 "A Panoramic View of Broadway, New York City,..." GLEASON'S PICTORIAL DRAWING-ROOM COMPANION 6, no. 11 (Mar. 18, 1854): 168-169, 173. 1 illus. [Sketch shows a frontal view of the commercial buildings on Broadway. The Meade Brothers' American Daguerreotype Depot, Plumbe's National Daguerrean Gallery, J. T. Barnes' Daguerrean Gallery, Beckard & Paird, Holmes, Dobyn, Richardson & Co., Insley, Thompson shown.]

USA: NEW YORK: 1855.
ST3120 "Daguerreotype Movements: Daguerreotypists in New York." HUMPHREY'S JOURNAL 6, no. 20 (Feb. 1, 1855): 326-327. [S. Root; S. A. Holmes; J. W. Thompson; M. B. Brady; Gurney & Fredericks; M. M. Lawrence; H. E. Ilsey; A. Bogardus; Barnard; Meade Brothers, Haas.]

USA: NEW YORK: 1856.
ST3121 "Cinque Suum." "The Photographic Galleries of America. Number One - New York." PHOTOGRAPHIC AND FINE ART JOURNAL 9, no. 1 (Jan. 1856): 19-21. [Meade Brothers; Brady; Root; Gurney; M. M. Lawrence; Tomlinson;; N. G. Burgess; Bogardus; Lewis; M. L. Battel; Gaige; Quinby & Co.; Bedell; Kimball; Beckers & Piard; Insley; Farrand; J. T. Barnes; Hunter; Watson; and about 40 others briefly mentioned.]

USA: NEW YORK: 1858.
ST3122 J. R. J. "New York Photographic Galleries." PHOTOGRAPHIC AND FINE ART JOURNAL 11, no. 1 (Jan. 1858): 24-25. [T. Faris, late of Cincinnati, OH, now occupying rooms formerly held by Root; Johnston now the operator at Brady's old gallery at 205 Broadway; Brady's uptown Broadway gallery flourishing; Gurney; C. D. Fredericks; Meade Brothers; A. Powelson; C. F. Rockwell; Lawrence; Quimby; E. & H. T. Anthony.]

USA: NEW YORK: 1864.
ST3123 Wilson, Edward L. "A Day in New York." PHILADELPHIA PHOTOGRAPHER 1, no. 4 (Apr. 1864): 57-58.

USA: NEW YORK: 1867.
ST3124 "Freer's Watkins Glen." HUMPHREY'S JOURNAL OF PHOTOGRAPHY, AND THE ALLIED ARTS AND SCIENCES 19, no. 8 (Aug. 15, 1867): 119-120. ["Photographers are the pioneers of such regions,...Friend of Martin, of Albany, and ourselves were some of the first pioneers,...Mr. Krum...M. G. F. Gates stereographs are very beautiful...Mr. Haywood..."]

USA: NEW YORK: 1874.
ST3125 "College of Fine Arts of the Syracuse University." ANTHONY'S PHOTOGRAPHIC BULLETIN 5, no. 2 (Feb. 1874): 90. [Mr. Ward V. Ranger, appointed to Professorship of photography at Syracuse Univ.]

USA: NEW YORK: 1875.
ST3126 Guide Book to Lake Mohonk, New Paltz, Ulster Co., N. Y. Providence, RI: Rhode Island Printing Co., 1875. 52 pp. 30 l. of plates. [Original photographs.]

USA: OHIO: 19TH C.
BOOKS
ST3127 Fullerton, Richard D. 99 Years of Dayton Photographers. Dayton, OH: Richard D. Fullerton, 1982. 47 pp. illus.

PERIODICALS
ST3128 Waldsmith, John. "Stereo Views of Columbus and Vicinity." COLUMBUS AND CENTRAL OHIO HISTORIAN no. 2 (Nov. 1984): 47-56. 14 b & w. [Illustrated with stereo views by J. Q. A. Tresize (1857); William Oldroyd (1869); E. S. Walker (1865); A. H. Kelton (1878); William F. Stifel (1868); Neville & Saunders (1880); A. H. Kelton (1878); William G. Starke (1883); Kelton & Gares (1878); William H. Gates (1879); George R. Elliott (1878); others. Article consists of an introduction, then brief summaries of the activities in Columbus, OH, of the following photographers: Baker's Art Gallery; R. F. Bowdish; W. M. Chase; J. B. Clark; George R. Elliott; Gates Brothers; William H. Gates; E. W. Kelley; A. H. Kelton or Kelton & Gates; Keystone View Co.; Neville & Saunders; William Oldroyd, Oldroyd & Gates; William G. Starke; William F. Stifel; William J. Thompson; John Quincy Adams Tresize; E. S. Walker;]

USA: OHIO: 1856.
ST3129 O. J. W. "The Photographic Galleries of Cincinnati, OH." PHOTOGRAPHIC AND FINE ART JOURNAL 9, no. 9 (Sept. 1856): 285. [Faris, Porter, (formerly Fontayne & Porter) J. P. Ball.]

USA: OHIO: 1857.
ST3130 J. R. J. "Cincinnati Galleries." PHOTOGRAPHIC AND FINE ART JOURNAL 10, no. 12 (Dec. 1857): 377. [Porter; T. Faris; R. Harlan; Digins; J. P. Ball; others mentioned.]

USA: OHIO: 1858.
ST3131 Seebohm, Louis. "Personal & Art Intelligence." PHOTOGRAPHIC AND FINE ART JOURNAL 11, no. 11 (Nov. 1858): 352. [Letter explaining how the photographers of Dayton, OH, dealt with new photographers charging cut-rate prices.]

USA: OHIO: 1866.
ST3132 "The Cutting Patent in Cincinnati." AMERICAN JOURNAL OF PHOTOGRAPHY AND THE ALLIED ARTS & SCIENCES n. s. vol. 8, no. 18 (Mar. 15, 1866): 426-430. [Detailed recount of a protest meeting of nearly all Cincinnati photographers.]

USA: OHIO: 1871.
ST3133 "Perambulator." "Cincinnati Correspondence." PHILADELPHIA PHOTOGRAPHER 8, no. 89 (May 1871): 140-141.

ST3134 Thorp, F. "Buckeye Correspondence From the Backwoods." PHOTOGRAPHIC WORLD 1, no. 6 (June 1871): 173-175. [Is photography a fine art? Can it raise the public taste?]

USA: OHIO: 1872.
ST3135 Poole, William Frederick. The Tyler Davidson Fountain: Given by Mr. Henry Probasco to the City of Cincinnati. Cincinnati: R. Clarke, 1872. 118 pp. 14 l. of plates. 28 b & w. [Twenty-four views of the fountain, four views of Probasco's home.]

USA: OREGON: 19TH C.
ST3136 Goodman, Theodosia Teel. "Early Oregon Daguerreotypers and Portrait Photographers." OREGON HISTORICAL QUARTERLY

49, no. 1 (Mar. 1948): 30-49. [Mentions Wm. Jennings (1851), Smith (1851), L.H. Wakefield (1853), D.H. Hendee (1853) [Includes biography of Hendee], J. Wesley Jones offering to purchase views (1851), Mr. Joseph Buchtel (1853) [biography of Buchtel], George Irving Hazeltine (1853), Wily Kenyon, Philip Castleman (1854), Peter Britt [Includes biography], others named.]

ST3137 Culp, Edwin D. "Oregon Postcards." OREGON HISTORICAL QUARTERLY 66, no. 4 (Dec. 1965): 303-330. [Includes short biographies.]

USA: PENNSYLVANIA: 19TH C.
BOOKS
ST3138 Horner, Marian Sadtler. *Early Photography and the University of Pennsylvania.* s. l.: s. n., 1941. 12 pp. [Offprint from "General Magazine and Historical Chronicle," (Jan. 1941).]

ST3139 Looney, Robert F., compiler. *Old Philadelphia in Early Photographs 1839 - 1914.* 215 Prints from the Collection of the Free Library of Philadelphia. New York: Dover, in cooperation with the Free Library of Philadelphia, 1976. viii, 228 pp. 215 l. of plates.

ST3140 Finkel, Kenneth, compiler. *Nineteenth-Century Photography in Philadelphia.* 250 Historic Prints from the Library Company of Philadelphia. New York: Dover, with the Library Company of Philadelphia, 1980. xxviii, 226 pp. 250 b & w.

ST3141 Panzer, Mary. *Philadelphia Naturalistic Photography 1865 - 1906.* New Haven, CT: Yale University Art Gallery, 1982. 55 pp. 12 b & w. [Ex. cat., Yale University Art Gallery, Feb. 10 - Apr. 7, 1982. Essay on pp. 1-22. "Catalogue" on pp. 35-49. 75 prints by sixteen photographers. Focus of this effort in on amateur photography after the 1880s, but some earlier individuals are discussed. Edward Wilson's role as editor and influential member of the photographic community is stressed.]

ST3142 Ruby, Jay. *Reflections on 19th-Century Pennsylvania Landscape Photography.* Bethlehem, PA: Lehigh University Art Galleries, 1986. 24 pp. [Ex. cat., Lehigh University Art Galleries, Mar. 14 - May 14, 1986. "With contributions by Gerald Bastoni, Charles Isaacs." Artists discussed William Herman Rau (1855-1920); James Bartlett Rich (1866-1942); Francis Cooper (1874-1944).]

PERIODICALS
ST3143 Simons, M. P. "The Early Days of Daguerreotyping." ANTHONY'S PHOTOGRAPHIC BULLETIN 5, no. 9 (Sept. 1874): 309-311. [Early photography in Philadelphia, PA. Mentions Cornelius, Langenheim Brothers, himself.]

ST3144 Sachse, Julius F. "Philadelphia's Share in the Development of Photography." JOURNAL OF THE FRANKLIN INSTITUTE 135, (1893): 271-287.

ST3145 Heisey, M. Luther. "The Art of Photography in Lancaster." LANCASTER COUNTY HISTORICAL SOCIETY PAPERS no. 51 (1947): 93-113. [Includes checklist of Lancaster, PA, photographers.]

ST3146 Finkel, Kenneth. "Vintage Views of Historic Philadelphia: Antiquarian Photography, 1853 - 70." NINTEENTH CENTURY (VICTORIAN SOCIETY OF AMERICA) 6, no. 2 (Summer 1980): 52-56. 9 b & w. 4 illus. [Photos by John Moran, James F. McClees, Frederick DeBourg Richards, and Henry B. Odiorne.]

ST3147 Schreiber, Norman. "Pop Photo Snapshots." POPULAR PHOTOGRAPHY 86, no. 6 (June 1980): 82. [Ex. rev.: 19th Century

Photography in Philadelphia, Library Company of Philadelphia, Philadelphia, PA. 150 photos and daguerreotypes taken from Library Company's collections; dating primarily from the 1850s and 1860s.]

ST3148 Powell, Donald Walter. "Studio Photography in Northeastern Pennsylvania from 1839 to 1900. Part I." NORTHEASTERN PENNSYLVANIA (CARBONDALE, PA) 1, no. 4 (May 21, 1980): 1-24. 20 b & w. 1 illus. [Survey is arranged by county.]

ST3149 Powell, Donald Walter. "Studio Photography in Northeastern Pennsylvania from 1839 to 1900. Part II: Lacawanna County." NORTHEASTERN PENNSYLVANIA (CARBONDALE, PA) 2, no. 1 (Aug. 20, 1980): 1-24. [?] [Missing issue.]

ST3150 Powell, Donald Walter. "Update of the Information on Studio Photography in Northeastern Pennsylvania from 1839 to 1900. Part III." NORTHEASTERN PENNSYLVANIA (CARBONDALE, PA) 3, no. 1 (Aug. 19, 1981): 1-20. 19 b & w. 21 illus.

ST3151 Holloway, Lisabeth M., compiler. "'Secure the Shadow, ere the Substance Fade.' A Partial Chronicle of Germantown Photographers, Drawn Chiefly from the Collections of the Society." GERMANTOWN CRIER (GERMANTOWN HISTORICAL SOCIETY) 38, no. 1 (Winter 1985/86): 10-18. 22 b & w. [Biographical information on William H. Smith; Thomas L. Ennis; Walter Rogers Johnson (1794-1852); Charles Jones Wister, Jr. (1822-1910); Frederick DeBourg Richards (1822-1903); Enan McDermond; Thomas Brooks (1843?-1923); Constant Guillou (1812-1872); Frederick Gutekunst (1831-1912); David Hinkle (1836-1916); Williams; John Ball; Benjamin F. Dungan; Alfred Holden (1852-1926); and others.]

USA: PENNSYLVANIA: 1856.
ST3152 "Cuique Suum." "The Photographic Galleries of America. Number Two - Philadelphia." PHOTOGRAPHIC AND FINE ART JOURNAL 9, no. 4 (Apr. 1856): 124-126. [Lists over fifty photography galleries, with brief one-line comments on each. The larger galleries receive more commentary. Rehn; M. A. Root; McClees; Richardson; Van Loan; Shaw; others mentioned.]

USA: PENNSYLVANIA: 1862.
ST3153 "Scraps and Fragments: The Progress of Photography in Philadelphia." BRITISH JOURNAL OF PHOTOGRAPHY 9, no. 167 (June 2, 1862): 218. [From "Philadelphia Press."]

USA: PENNSYLVANIA: 1871.
ST3154 Vogel, Dr. "Photography in America." PHOTOGRAPHIC WORLD 1, no. 1 (Jan. 1871): 4-5. [State of the art report on photography in Philadelphia.]

ST3155 "Our Visit to Philadelphia." PHOTOGRAPHIC TIMES 1, no. 5 (May 1871): 66-68. [Detailed commentary upon stockhouses, companies in Philadelphia, PA.]

USA: PENNSYLVANIA: 1872.
ST3156 Philadelphia. Commissioners of Fairmount Park. *Fourth Annual Report of the Commissioners of Fairmount Park.* Philadelphia: King & Baird, 1872. 104 pp. 12 l. of plates. illus. [An original photograph, two photomechanical reproductions, and a chromolithograph.]

USA: PENNSYLVANIA: 1875.
ST3157 Clark, James Albert, ed. *The Wyoming Valley; Upper Waters of the Susquehanna, and the Lackawanna Coal Region, Including Views of the Natural Scenery of Northern Pennsylvania, from the Indian Occupancy to the Year 1875. Photographically Illustrated.*

Edited by J. A. Clark. Scranton, PA: J. A. Clark, 1875. viii, 236 pp. 26 b & w. [Photomechanical reproductions.]

USA: PENNSYLVANIA: 1878.
ST3158 Nichol, John, PH.D. "Transatlantic Notes." ANTHONY'S PHOTOGRAPHIC BULLETIN 9, no. 9 (Sept. 1878): 272-275. [From "Br. J. of Photo." Nichol, from England, visited the USA, gave his impressions. Here he describes his experiences in Philadelphia, where he met the amateurs Browne and Ellerslie Wallace. Discusses the professional, F. Gutekunst.]

USA: RHODE ISLAND: 19TH C.
ST3159 Taylor, Maureen. "'Nature Caught at the Twinkling of an Eye.': The Daguerreotype in Providence." RHODE ISLAND HISTORY 42, no. 4 (Nov. 1983): 111-122. 6 b & w. 3 illus. [Discusses or mentions François Gourand's visit to Providence in May 1840. Edwin Manchester; Henry Manchester; Elisha Baker; Samuel Masury; Samuel Hartshorn; George Rider; Hough & Anthony; (G. S. Hough & Charles T. Anthony); Cook & Emerson; Manchester & Chapin; Lydia White; others.]

USA: SOUTH DAKOTA: 1875.
ST3160 Turchen, Lesta V. and James McLaird. *The Black Hills Expedition of 1875.* Mitchell, SD: Dakota Wesleyan University Press, 1975. 126 pp. 54 b & w. 1 illus. [500 copies. Illustrated with half stereo views of events surrounding Walter P. Jenney's Black Hills Expedition of 1875. McGillicudy, photographer; Benecke publisher.]

USA: TEXAS: 19TH C.
ST3161 Sandweiss, Martha A., editor. *Historic Texas: A Photographic Portrait.* Austin: Texas Monthly Press, 1985. [Contains photographers' dates, etc.]

USA: TEXAS: 1872.
ST3162 Lynch. "Fourth Annual Meeting and Exhibition of the N.P.A. in St. Louis, Mo., May 1872: Photography in Texas." PHILADELPHIA PHOTOGRAPHER 9, no. 102 (June 1872): 213-215.

ST3163 W. H. M. "Photographing in Texas." PHOTOGRAPHIC TIMES 15, no. 212-213 (Oct. 9 - Oct. 16, 1885): 574-575, 588-589. [Describes a trip to San Antonio, TX in 1872, from WI.]

USA: UTAH: 19TH C.
BOOKS
ST3164 Carter, Kate B., compiler. *Early Pioneer Photographers.* Salt Lake City, UT: Daughters of Utah Pioneers, 1975. n. p.

ST3165 Wadsworth, Nelson B. *Through Camera Eyes.* Provo, UT: Brigham Young University Press, 1975. 180 pp. illus. [Includes biographies of Utah photographers.]

PERIODICALS
ST3166 Wadsworth, Nelson. "Zion's Cameramen: Early Photographers of Utah and the Mormons." UTAH HISTORICAL QUARTERLY 40, no. 1 (Winter 1972): 24-54. 19 b & w. [Photos illustrating early Mormon history, including some of Joseph Smith taken in Nauvoo, IL in 1844. Lucian R. Foster, C. W. Carter, Marsena Cannon and Charles R. Savage.]

USA: VIRGINIA: 19TH C.
BOOKS
ST3167 Ritter, Ben, compiler. "Photographers of the Shenandoah Valley and contiguous areas, 1839 - 1939." Winchester, VA: Frederick County Historical Society, 1979.

ST3168 Ginsberg, Louis. *Photographers in Virginia, 1839 - 1900: A Checklist.* Petersburg, VA: L. Ginsberg, 1985. 64 pp. 11 illus. [Alphabetical listing, with addresses, etc. Bibliography of sources included.]

ST3169 *Mirror of an Era. The Daguerreotype in Virginia.* Rawley, VA: The Chrysler Museum, 1989. 1 sheet, folded to make 12 pages. pp. [Exhibition checklist. (Feb. 26 - Apr. 23 1989) The Chrysler Museum. Johnson, Brooks introduction. "An Account of some Experiments made in the South of Virginia on the Light of the Sun." "Virginia Daguerreotypists." Checklist and Biographical information of Peter Gibbs, Joseph Hobday, H. B. Hull, J. Keagy, George W. Minnins, A. C. Partridge, Edwin M. Powers, William A. Pratt (b. 1818, GB), R. J. Rankin, W. A. Retzer, Montgomery Pike Simons (1817 - 1877), Jesse Harrison Whitehurst (ca. 1820/21 - 1875).]

PERIODICALS
ST3170 Waldsmith, R. M. "Mount Vernon Enshrined in Stereo." STEREO WORLD 6, no. 6 (Jan. - Feb. 1980): 4-13. 9 b & w. 2 illus. [Stereo views of Mount Vernon, VA, by Alexander Gardner; Langenheim Brothers; Bell & Brother; N. G. Johnson; Keystone View Co. Includes a checklist, "The Home of Washington Illustrated," of forty-five stereograph titles taken by Alexander Gardner for the Ladies' Mount Vernon Association in 1865, and Luke C. Dillon's 1886 list of his "Views of Mount Vernon."]

USA: VIRGINIA: 1856.
ST3171 "The Photographic Galleries of America. - No. III. The Richmond Galleries." PHOTOGRAPHIC AND FINE ART JOURNAL 9, no. 7 (July 1856): 217. [Mentions Bendon; Duke; Pratt's Gallery; Simons; Osborne; Gibbs.]

ST3172 Davis, J. A. "The Richmond Galleries: Answer to 'An Amateur.'" PHOTOGRAPHIC AND FINE ART JOURNAL 9, no. 9 (Sept. 1856): 285-286. [J. A. Davis' irritated response to previous article. In it he gives a brief biography of Osborn.]

USA: VERMONT: 19TH C.
ST3173 Drake, Greg. "Nineteenth-Century Photography in the Upper Connecticut Valley: An Annotated Checklist." DARTMOUTH COLLEGE LIBRARY BULLETIN n. s. 25, no. 2 (Apr. 1985): 72-91. [Listing of approximately 125 commercial photographers working in NH and VT during the 19th century, drawn from a survey of business directories and other sources. Brief biographies given, when known.]

URUGUAY: 1865.
ST3174 "The Bombardment of Paysandu, Uruguay, South America." ILLUSTRATED LONDON NEWS 46, no. 1306 (Mar. 18, 1865): 257, 262. 2 illus. ["We have received from one of our correspondents a series of photographs, taken immediately after the surrender of Paysandu, which show the effects of the terrible effects that the bombardment inflicted upon that unhappy town by the Brazilian squadron of Admiral Tamandré."]

ST3175 "The War in South America." HARPER'S WEEKLY 9, no. 432 (Apr. 8, 1865): 221. 4 illus. [Brazil, Paraguay and Uruguay fighting. Portrait of Leandro Gomez, two views of destruction in the town of Paysandu, Paraguay "from photographs" and a view of Montevideo.]

HISTORY:
APPARATUS, EQUIPMENT, CAMERAS & LENSES

APPARATUS
CAMERAS
LENSES
SOLAR CAMERAS

APPARATUS

APPARATUS see also BEAUFORD; BIRD; BURTON, H. J.; GAUDIN, MC.-A.; KRUGER; STOCK, JOHN; THOMPSON, J. A.; TOWLER, JOHN.

APPARATUS: 1858.
ST3176 "Family Cases." HUMPHREY'S JOURNAL OF PHOTOGRAPHY, AND THE ALLIED ARTS AND SCIENCES 10, no. 10 (Sept. 15, 1858): 147. 1 illus. [10 or 12 connected daguerreotypes or ambrotypes, kept in a morroco case (box).]

APPARATUS: 1868.
ST3177 "A New Optical Toy." HUMPHREY'S JOURNAL OF PHOTOGRAPHY, AND THE ALLIED ARTS AND SCIENCES 20, no. 9 (Sept. 1, 1868): 144. ["A new optical toy, called the kinescope, is being made in Paris...."]

ST3178 "Scoville's New Camera Stand." HUMPHREY'S JOURNAL OF PHOTOGRAPHY, AND THE ALLIED ARTS AND SCIENCES 20, no. 16 (Dec. 15, 1868): 256. 1 illus.

CAMERAS

CAMERAS see also ANTHONY, E. & H. T.; ATKINSON; BELHOMME; BERTSCH; BIERSTAEDT, EDWARD; CADETT; CEILEUR, A.; DANCER, J. B.; DORNBACH, L. M.; DUBRONI; FAST, FREDERICK; GARBANATI, H.; HARRISON, C. C.; HEADSMAN, SIMON; HELIO; JOHNSON; MARTENS, FREIDRICH VON; MELHUISH, A. J.; ORMSBEE; OTTEWILL, THOMAS; PEARSALL; ROETTGER, H.; ROSS, WILLIAM; ROWLAND, JOHN ALEXANDER; SKAIFE, THOMAS; TAYLOR, J. TRAILL; TOWLER; VANDERWEYDE; VOIGHTLANDER; WILLARD & CO.; WILLAT; WOLCOTT.

CAMERAS: 19TH C.
BOOKS
ST3179 Lothrop, Eaton S., Jr. *A Century of Cameras from the Collection of the International Museum of Photography at the George Eastman House.* New York: Morgan & Morgan, 1973. 150 pp. illus.

PERIODICALS
ST3180 "The Evolution of the Camera." PHOTOGRAPHIC TIMES 20, no. 443 (Mar. 14, 1890): 128-131. 6 illus. [From "Wilson's Photographic Magazine." Brief survey of cameras from 1830s to 1890s.]

ST3181 "Index to Resources: Daguerreotype Equipment." IMAGE 6, no. 1 (Jan. 1957): 18-19. [Cameras.]

ST3182 Newhall, Beaumont. "Precursors of the Sub-Miniature Camera." IMAGE 8, no. 4 (Dec. 1959): 212-219. 7 illus. [History of small cameras, 19th century.]

ST3183 Isenberg, Matthew. "Early Equipment, (part 1)." PHOTOGRAPHICA 10, no. 3 (Mar. 1978): 8-9. 5 b & w.

ST3184 Naylor, Jack. "The Secretan Tent Camera Obscura." PHOTOGRAPHICA 10, no. 6 (July - Aug. 1978): 6-7. 2 illus.

ST3185 Stevens, Horace N. "Double Lens Daguerreotype Camera." HISTORY OF PHOTOGRAPHY 4, no. 2 (Apr. 1980): 96. 1 b & w. 1 illus. [No texts. Illustration of a daguerreotype showing a double-lens daguerreotype camera and an advertisement featuring the instrument.]

ST3186 Davies, Tom. "Historical: The Earliest Cameras." PHOTOGRAPHER'S FORUM 2, no. 3 (May - June 1980): 19-24. 8 illus. [Examination of camera obscura and daguerreotype cameras.]

ST3187 Glanfield, Colin. "A Short History of Panoramic Cameras." PHOTOGRAPHIC COLLECTOR 3, no. 2 (Autumn 1982): 148-157. 18 illus. Jenkins, John. "Camera Collecting - Stereo Cameras." PHOTOGRAPHIC COLLECTOR 2, no. 3 (Autumn 1981): 98-104. 10 illus.

ST3188 Van Hasbroeck, Paul Henry. "Belgian Inventions and Their Impact Upon Photography." PHOTOGRAPHIC COLLECTOR 3, no. 3 (Winter 1982): 319-321. [Belgian Camera "Scenographe" produced 1875.]

ST3189 "Daguerre to Disc: The Evolution of the Camera." CALIFORNIA MUSEUM OF PHOTOGRAPHY BULLETIN 2, no. 1 (1983): 1 folded leaf. [The issue folds out to provide a graphic chart of cameras from 1830 to 1980. The back side consists of a check-list of the 100 items in the exhibition that this issue represented.]

ST3190 Spira, S. F. "The Jumelk de Nicour Camera." HISTORY OF PHOTOGRAPHY 8, no. 1 (Jan. - Mar. 1984): 53-56. 3 illus.

ST3191 Fenton, James. "The Great Union Camera Obscura Is Still With Us Today!" IMAGE 27, no. 4 (Dec. 1984): 9-15. 2 b & w. 5 illus. [History of specially designed walk-in camera/rooms, used as entertainment with peak of popularity in late 19th century.]

ST3192 Spira, S. F. "Early Camera Catalogue." HISTORY OF PHOTOGRAPHY 9, no. 4 (Oct. - Dec. 1985): 289-293. 5 illus. [Catalog of Horne & Co., London, 1848.]

CAMERAS: BY YEAR.
CAMERAS: 1853.
ST3193 "Science: The Photographic Camera." ILLUSTRATED LONDON NEWS 22, no. 620 (May 7, 1853): 359. 7 illus.

CAMERAS: 1866 see also HISTORY: USA for information on the Wing & Ormsbee patent controversy.

CAMERAS: 1866.
ST3194 "Improved Multiplying Camera Box." HUMPHREY'S JOURNAL OF PHOTOGRAPHY, AND THE ALLIED ARTS AND SCIENCES 17, no. 19 (Feb. 1, 1866): 299. [Dodge & Leahy (Boston stockhouse) issuing a camera felt not to infringe on the Wing & Ormsbee patent.]

CAMERAS: 1871.
ST3195 "Improvements." ANTHONY'S PHOTOGRAPHIC BULLETIN 2, no. 11 (Nov. 1871): 362-363. 3 illus. [Improvements in landscape view cameras, illustrated.]

CAMERAS: 1877.

ST3196 "A Simple and Effective 'Cloud Shutter.'" ANTHONY'S PHOTOGRAPHIC BULLETIN 8, no. 8 (Aug. 1877): 244-245. [From "Br. J. of Photo." "The increasing desire for pictures of a more artistic character...created a very general demand for a simple and effective "cloud shutter" or sky-shade..."]

ST3197 "Instantaneous Shutters." ANTHONY'S PHOTOGRAPHIC BULLETIN 8, no. 12 (Dec. 1877): 367-368. 1 illus. [From "Br J of Photo."]

LENSES

LENSES see also ANTHONY, E. & H. T.; BOW, ROBERT H.; BOYLE, C. B.; BREWSTER, DAVID; CEILEUR, A.; CHAPMAN & WILCOX; CHEVALIER, CHARLES; CLAUDET, ANTOINE; DALLMEYER, J. H.; GODDARD, JAMES T.; HARRISON, C. C.; HERSCHEL, JOHN, SIR; HILGARD, J. E.; HUMPHREY, S. D.; HUNT, ROBERT; MORRISON, R.; NEW YORK OPTICAL WORKS; PETZVAL; PRETSCH, PAUL; READ, W. J.; ROSS; STEINHEIL; SUTTON, THOMAS; TAYLOR, J. TRAILL; VANDERWEYDE; VOGEL, H.; VOIGHTLANDER; WENDEROTH, F. A.; WILLARD & CO.; ZENTMAYER, JOSEPH.

LENSES: 19TH C.

ST3198 Kingslake, Rudolph. "Early Landscape Lenses." IMAGE 4, no. 3 (Mar. 1955): 21-22. 5 illus.

ST3199 Kingston, Roger. "The "Cone Centralisateur" Lenses of Jamin and Darlot." IMAGE 11, no. 5 (1962): 22-24. 2 illus. [Parisian lens makers in the 1850s, 1860s.]

ST3200 Kingslake, Rudolf. "Unusual Early Lenses in the George Eastman House Collection." IMAGE 24, no. 2 (Dec. 1981): 10-17. 9 illus.

ST3201 Kingslake, Rudolph. "Some Colorful Personalities in Photographic Lens Design." IMAGE 28, no. 1 (Mar. 1985): 5-13. 31 illus.

ST3202 Dallmeyer, Thomas R. "A History of Lenses." NORTHLIGHT (JOURNAL OF THE PHOTOGRAPHIC HISTORICAL SOCIETY OF AMERICA) 2, no. 4 (Fall 1975): 4-6. [Reprint of report delivered by Thomas R. Dallmeyer to the Royal Photographic Society and first published in "The British Journal of Photography" (Oct. 10, 1900). A survey of landscape lenses, portrait lenses, triple lenses, doublets, and telephotographic lenses.]

LENSES: BY YEAR.
LENSES: 1852.

ST3203 "Gossip: French and German Lenses." PHOTOGRAPHIC ART JOURNAL 4, no. 2 (Aug. 1852): 130-131. [From "Cosmos." Discussion of the merits and flaws of each.]

LENSES: 1866.

ST3204 "On Some Landscape Lenses." PHILADELPHIA PHOTOGRAPHER 3, no. 25 (Jan. 1866): 21.

LENSES: 1871.

ST3205 "The Distortion of Single Landscape Lenses." ANTHONY'S PHOTOGRAPHIC BULLETIN 2, no. 11 (Nov. 1871): 351-352. [From "Br. J. of Photo."]

SOLAR CAMERAS

SOLAR CAMERAS see also W. A. F.; FONTAYNE, CHARLES; GALE; ROETTGER; SHADBOLT, GEORGE; SHRIVE; VANDERWEYDE, P. H.; WENDEROTH, F. A.; WOODWARD, D. A.

SOLAR CAMERAS: 19TH C.

ST3206 Welling, William. "Apropos: History: The Origins of Camera Enlarging." CAMERA (LUCERNE) 57, no. 7 (July 1978): 38-41. 2 illus. [From Welling's "Photography in America:...."]

SOLAR CAMERAS: BY YEAR.
SOLAR CAMERAS: 1864.

ST3207 "Enlarging by Solar Camera." HUMPHREY'S JOURNAL OF PHOTOGRAPHY, AND THE ALLIED ARTS AND SCIENCES 16, no. 7-8 (Aug. 1 - Aug. 15, 1864): 106-107, 119-120. [From "Photo. Notes."]

SOLAR CAMERAS: 1865.

ST3208 "The Solar Camera." HUMPHREY'S JOURNAL OF PHOTOGRAPHY, AND THE ALLIED ARTS AND SCIENCES 17, no. 16 (Dec. 15, 1865): 254.

SOLAR CAMERAS: 1879.

ST3209 "Solar Camera Enlargements." ANTHONY'S PHOTOGRAPHIC BULLETIN 1, no. 11 (Dec. 1870): 224-225. [From "London Photographic News." English review of exceptionally fine solar camera work of USA sent to them by E. L. Wilson. Enlargements by Albert Moore of Philadelphia, from negatives by J. C. Browne (views) and portraits by Moore.]

HISTORY:
BY APPLICATION OR USAGE

ASTRONOMICAL PHOTOGRAPHY
COLOR PHOTOGRAPHY
EXHIBITIONS
MAGIC LANTERN PHOTOGRAPHY
MICROPHOTOGRAPHY
ORGANIZATIONS AND SOCIETIES
PHOTOJOURNALISM AND MAGAZINES
PHOTOMECHANICAL REPRODUCTION
STEREOSCOPIC PHOTOGRAPHY

BY APPLICATION:
ASTRONOMICAL PHOTOGRAPHY

ASTRONOMICAL PHOTOGRAPHY see also BERTSCH & AR-NAULD; BLACK, J. W.; CHAPMAN, D. C.; CROOKES, WILLIAM; DALLMEYER; DE LA RUE, W.; DRAPER, H.; GLAISHER, J.; GRUBB, THOMAS; HARKNESS, WILLIAM; HARTNUP; HEISCH, CHAR-LES; JANSSEN, M.; JARMAN, A. J.; MORTON, HENRY; RUTHER-FORD, L. M.; SECCHI, FATHER; SELLACK, C. S.; SMYTH, C. P.; THOMPSON, H. I. B.; TILLMAN, SAMUEL D.; TITTERMAN; VOGEL, H.; WHIPPLE, J.A.; WILLIAMS, T. R.; WORTLEY, STUART.

ASTRONOMICAL: 19TH C.
BOOKS.
ST3210 Hoffleit, Dorrit. *Some Firsts in Astronomical Photography.* Cambridge, MA: Harvard College Observatory, 1950. 33 pp. illus.

PERIODICALS
ST3211 "Early Astronomical Photography." IMAGE 1, no. 1 (Jan. 1952): 1. 1 b & w. [Photograph by John A. Whipple.]

ASTRONOMICAL: BY YEAR.
ASTRONOMICAL: 1853.
ST3212 "Twenty-Third Meeting of the British Association for the Advancement of Science. Section A - Mathematical and Physical Science. Saturday. 'Report of the Committee...the Physical Character of the Moon's Surface, as compared to that of the Earth,' by Prof. Phillips and 'On Photographs of the Moon,' by Prof. Phillips." ATHENAEUM no. 1352 (Sept. 24, 1853): 1131-1132. [Phillips discussed early daguerreotypes of the moon by Prof. Bond, Mr. Whipple, De La Rue, then described his own attempts with the assistance of Mr. Bates, on July 15-18, 1853.]

ASTRONOMICAL: 1854.
ST3213 "Editorial: The Eclipse of the Sun." HUMPHREY'S JOURNAL 6, no. 5 (June 15, 1854): 73. [John Campbell (New York, NY) made 28 impressions of the various stages of the solar eclipse; John Kelsey (Rochester, NY) made four; George E. Hall (Detroit, MI); C. Barnes (Mobile, AL); others also made images.]

ASTRONOMICAL: 1857.
ST3214 "The Daguerreotype for Scientific Records." HUMPHREY'S JOURNAL 9, no. 15 (Dec. 1, 1857): 232. [From "Liverpool Photo. J." Kew Observatory report to the British Association mentions daguerreotype experiments "some years hence," by Mr. Ronalds, with Mr. Nicklin assisting as the photographer.]

ASTRONOMICAL: 1858.
ST3215 "Editor's Notes." LIVERPOOL & MANCHESTER PHOTOGRAPHIC JOURNAL [BRITISH JOURNAL OF PHOTOGRAPHY] n. s. 2, no. 7 (Apr. 1, 1858): 80-81. [General notes on current experiments in astronomical photography found in the editorial comments in this issue of the journal. Mentions Josiah Fedarb (Dover), Quinet (Paris), Emsley, John Spencer (Glasgow).]

ASTRONOMICAL: 1863.
ST3216 Forrest, J. A. "History of the Earliest Successful Experiments on Lunar Photography in England." BRITISH JOURNAL OF PHOTOGRAPHY 10, no. 191 (June 1, 1863): 225-226. [Forrest describes his experience, with assistance of G. R. Berry and Dr. Edwards. Mentions Prof. Bond (with John Whipple) of Cambridge, MA, then describes others work.]

ASTRONOMICAL: 1865.
ST3217 Seeley, Charles A. "Editorial Department." AMERICAN JOURNAL OF PHOTOGRAPHY AND THE ALLIED ARTS & SCIENCES n. s. vol. 8, no. 9 (Nov. 1, 1865): 214-215. [Discusses some of the photographers who photographed the solar eclipse in USA. Rockwood & Co.; Ormsbee; Rutherford; J. Reid (Paterson, NJ); etc.]

ASTRONOMICAL: 1869.
BOOKS
ST3218 Ashe, E. D. *The Proceedings of the Canadian Eclipse Party, 1869,* by Commander Ashe. Quebec: Middleton & Dawson, 1870. 23 pp. 5 l. of plates. 5 b & w.

ST3219 United States. Nautical Almanac Office. *Reports of Observations of the Total Eclipse of the Sun, August 7, 1869, Made by Paries under the General Direction of Professor J. H. C. Coffin, U.S.N., Superintendent of the American Ephemeris and Nautical Almanac.* Published by Authority of the Secretary of the Navy. Washington, DC: Government Printing Office, 1885. 158 pp. b & w. illus.

PERIODICALS
ST3220 "Editor's Table: Photos of the Eclipse." PHILADELPHIA PHOTOGRAPHER 6, no. 63 (Mar. 1869): 94.

ST3221 "Scientific Summary: Astronomy." POPULAR SCIENCE REVIEW 8, no. 31 (Apr. 1869): 178-179. [Discusses Warren De La Rue's plan to photograph the Transits of Venus, Major Tennant's photographs of the Great Eclipse from India.]

ST3222 "The Eclipse Expedition." PHILADELPHIA PHOTOGRAPHER 6, no. 68 (Aug. 1869): 271-272.

ST3223 "The Great Solar Eclipse." HUMPHREY'S JOURNAL OF PHOTOGRAPHY, AND THE ALLIED ARTS AND SCIENCES 20, no. 24 (Aug. 15, 1869): 382-384. [Description of the various teams observing and photographing the eclipse in the USA in 1869. Prof. Thatcher in New York, NY. Prof. Pearce in Springfield, IL, with J. W. Black taking 100 photos. Shelbyville, KY - had J. A. Whipple, Geo. Clark and J. Pendergast as photographers. Others mentioned.]

ST3224 Morton, Prof. "The Eclipse Expedition. Prof. Morton's Official Report." PHILADELPHIA PHOTOGRAPHER 6, no. 69 (Sept. 1869): 305-309.

ST3225 Curtis, Edward, Asst. Surgeon, U.S. Army. "The Des Moines Eclipse Expedition." PHILADELPHIA PHOTOGRAPHER 6, no. 69 (Sept. 1869): 309-310.

ST3226 Wilson, Edward L. "Photographing the Eclipse." PHILADELPHIA PHOTOGRAPHER 6, no. 69 (Sept. 1869): 285-292. [Parties of photographers were stationed all over the country to take views of the solar eclipse. For example, a party including J. C. Browne and W. J. Baker was at Ottumwa, Iowa; J. W. Black was at Springfield, IL, J. A. Whipple was at Shelbyville, KY, etc.]

ST3227 Wilson, Edward L. [?] "Photographing the Eclipse." FRANK LESLIE'S ILLUSTRATED NEWSPAPER 28, no. 727 (Sept. 4, 1869): 389, 397. 4 illus. [This unsigned article is told in the 1st person, and is probably by Edward L. Wilson. Illustrations : "Phases of the Eclipse of August 7, 1869, as Photographed by Edward L. Wilson, Accompanying the Government Astronomical Expedition, at Burlington, Iowa."]

ST3228 "The Total Eclipse of the Sun: Observatory of the Canadian Eclipse Expedition, at Jefferson City, Iowa." ILLUSTRATED LONDON NEWS 55, no. 1560/1561 (Oct. 9, 1869): 368-369. 2 illus. [Views of temporary observatory, members of the expedition. Brief article mentions that Dr. Curtiss took 120 photos at Des Moines, Mr. Black worked at Springfield and Mr. Whipple worked at Shelbyville.]

ASTRONOMICAL: 1870.
ST3229 "Editor's Table: Reports of the Total Eclipse of the Sun of August 7th, 1869." PHILADELPHIA PHOTOGRAPHER 7, no. 75 (Mar. 1870): 95. [Report of the various parties observing the eclipse, with Dr. Curtis's photographs of the eclipse.]

ST3230 Abbott, Jacob. "The Spots in the Sun." HARPER'S MONTHLY 40, no. 240 (May 1870): 818-825. 13 illus. [Illustrations are "...from drawings, copied from photographs, made under the direction of French astronomers."]

ASTRONOMICAL: 1871.
ST3231 Vogel, Hermann. "Astronomical Photography in America." PHOTOGRAPHIC NEWS 15, no. 646-647 (Jan. 20 - Jan. 27, 1871): 31-32, 39-40. [From "Photographische Mittheilungen." Rutherford, an American amateur, working ca. 1869, mentioned.]

ST3232 Pritchard, Rev. C., M.A., F.R.S. "Historical Sketch of Solar Eclipses: A Public Lecture, delivered in the University of Oxford." GOOD WORDS 12, no. 9 (Sept. 1871): 628-637. 8 illus. [Illustrations are from photographs by Walter De La Rue (1860), Mr. Brothers, and others.]

ST3233 Mann, Robert James, M.D. "Photographs of the Sun and Fixed Stars." ANTHONY'S PHOTOGRAPHIC BULLETIN 2, no. 9 (Sept. 1871): 290-292. [From "Br. J. of Photo."]

ST3234 Proctor, Richard A. "The Approaching Transit of Venus." ILLUSTRATED LONDON NEWS 62, no. 1756 (Apr. 26, 1873): 398-399. 5 illus. [Background information on the forthcoming event, which was thoroughly photographed by many scientific expeditions all over the world.]

ASTRONOMICAL: 1872.
ST3235 "The Eclipse Expedition in India." ILLUSTRATED LONDON NEWS 60, no. 1689 (Jan. 20, 1872): 61, 63. 2 illus. ['The Artist (for the British expedition) is Henry Holiday; the photographer, Mr. Henry Davis.' Views of the expedition.]

ASTRONOMICAL: 1873.
ST3236 Badeau, W. H. "From Across the Water." ANTHONY'S PHOTOGRAPHIC BULLETIN 4, no. 4 (Apr. 1873): 124-125.

[Discussion of preparations for forthcoming transits of Venus in Dec. 1874.]

ASTRONOMICAL: 1874.
ST3237 "The Coming Transit of Venus." ANTHONY'S PHOTOGRAPHIC BULLETIN 5, no. 4 (Apr. 1874): 144. [From "American Chemist." Janssen, at the Greenwich Observatory, discussed.]

ST3238 "The Coming Transit of Venus." ANTHONY'S PHOTOGRAPHIC BULLETIN 5, no. 4 (Apr. 1874): 144. [From "American Chemist." Janssen, at the Greenwich Observatory, discussed.]

ST3239 "The Transit of Venus. Preparations made for its Observation." ANTHONY'S PHOTOGRAPHIC BULLETIN 5, no. 6 (June 1874): 201-204. [From "NY Times." Extensive article on USA preparations, including a list of observation sites around the world, with the attendant personnel.]

ST3240 "The Expedition for the Observation of the Transit of Venus." PHOTOGRAPHIC TIMES 4, no. 43 (July 1874): 97-98. [Large team of American astronomers sailed for Southern Hemisphere, Russia, etc. About twenty photographers listed: J. Moran, D. R. Clark, Wm. Harkness, et al.]

ST3241 "Transit of Venus Expeditions." ANTHONY'S PHOTOGRAPHIC BULLETIN 5, no. 7 (July 1874): 255-256.

ST3242 "The Transit of Venus." PHILADELPHIA PHOTOGRAPHER 11, no. 127, 132 (July, Dec. 1874): 213-214, 363-366. [List of members, photographers on the eight exploration teams from the United States planning teams from the United States planning to observe the Transit of Venus in Dec. 1874, all over the world.]

ST3243 "Uncle Sam and Photography." PHOTOGRAPHIC TIMES 4, no. 44 (Aug. 1874): 121-222. [Letters praising Scoville Mfg. Co.'s equipment from W. V. Ranger, Professor of Photography at Syracuse University and Chief Photographer to the Peking, China station for the transit of Venus expedition, C. L. Phillippi, Chief Photographer to the New Zealand Station and J. W. Powell of Colorado River Survey.]

ST3244 "Photographic Requisites and Apparatus for Expeditions." PHOTOGRAPHIC TIMES 4, no. 44 (Aug. 1874): 122-123. [Discusses plans for equipping the United States Government Expedition for the observation of the transit of Venus. L. E. Walker, Chief Photographer of the United States Treasury, made out the list for Prof. Harkness, of the U.S. Naval Observatory, in charge.]

ST3245 "Preparations of the United States Government for Photographing the Transit of Venus." ANTHONY'S PHOTOGRAPHIC BULLETIN 5, no. 8 (Aug. 1874): 268-269.

ST3246 Abney, Capt., R.E., F.R.A.S., F.C.S. "On Photography in Relation to the Transit of Venus." ANTHONY'S PHOTOGRAPHIC BULLETIN 5, no. 11 (Nov. 1874): 361-362. [From "Br. J. of Photo."]

ST3247 Newcomb, Professor Simon. "The Coming Transit of Venus." HARPER'S MONTHLY 50, no. 295 (Dec. 1874): 25-35. 7 illus. [Discusses the plans for photographing the forthcoming transit of the planet Venus and describes the recent improvements in photography which made it possible. Includes a brief history of earlier astronomical photography in the USA.]

ST3248 "The Transit of Venus." ILLUSTRATED LONDON NEWS 65, no. 1842 (Dec. 12, 1874): 551, 552, 556. 2 illus. [Sketches of the station near Cairo, Egypt. Description of the expeditionary party.]

ASTRONOMICAL: 1875.
ST3249 "The Transit of Venus." ANTHONY'S PHOTOGRAPHIC BULLETIN 6, no. 1 (Jan. 1875): 1-6. [Summation of news from those world-wide posts documenting this event.]

ST3250 "Sketches of Stations Where the Transit of Venus was Observed." ILLUSTRATED LONDON NEWS 66, no. 1850 (Jan. 23, 1875): 72-73, 74. 2 illus. [Reports of the various expeditions to Mauritius, Honolulu, South America, etc.]

ST3251 "The Transit of Venus. - Photographic Apparatus Used by the French Observers on the Island of St. Paul, Indian Ocean." FRANK LESLIE'S ILLUSTRATED NEWSPAPER 39, no. 1013 (Feb. 27, 1875): 412. 1 illus.

ST3252 C. A. Y. "The Transit of Venus, as Observed by the Party Stationed at Peking." ANTHONY'S PHOTOGRAPHIC BULLETIN 6, no. 3 (Mar. 1875): 65-69. [Detailed account of the expedition. Mr. Ranger, Dr. Watson, and Mr. Conrad collaborated to make the photographs - 99 plates.]

ST3253 "The Transit of Venus [sic. The Solar Eclipse]." ILLUSTRATED LONDON NEWS 66, no. 1871 (June 19, 1875): 585, 591. 3 illus. [Views of the station set up at Chalei Point, in Siam, taken by Lieut. Henry N. Shorn, R.N., of "H.M.S. Lapwing." (This expedition was to observe the solar eclipse, not the transit of Venus, see p. 609).]

ST3254 "The Solar Eclipse Observatory, in the Nicobar Islands." ILLUSTRATED LONDON NEWS 66, no. 1872 (June 26, 1875): 601, 608-609. 6 illus. [Views of the station in the Nicobar Islands, India. This expedition had Prof. Hans Vogel, Prof. P. Tacchini and others along, but clouds obscured the sun so no eclipse photos were taken.]

ST3255 "The Eclipse Expedition in Siam." ILLUSTRATED LONDON NEWS 67, no. 1875 (July 17, 1875): 51, 52. 6 illus. ["Views, from photographs sent us by Lieut. Henry Shore, R.N."]

ST3256 "Our Foreign Make-Up: The Transit of Venus." PHOTOGRAPHIC TIMES 5, no. 59 (Nov. 1875): 268. [Rev. S. J. Perry, one of the observers of the British team on Kerguelen's Island.]

ASTRONOMICAL: 1876.
ST3257 "Royal Institution Lectures: The Transit of Venus." ILLUSTRATED LONDON NEWS 68, no. 1910 (Mar. 4, 1876): 234. [Rev. S. J. Perry, F.R.S., describes his and others experiences on the various Transit of Venus expeditions.]

ASTRONOMICAL: 1878.
ST3258 Capron, J. Rand. *Photographic Spectra. 136 Photographs of Metallic, Gaseous, and Other Spectra.* Printed by the Autotype Process. London: E. & F. Spon, 1878. 80 pp. 37 l. of plates.

BY APPLICATION: COLOR PHOTOGRAPHY

COLOR see also ALBERT, J.; BECQUEREL, EDMUND; BEYSE & JOSS; BOETTIGER; CALVERT, F. GRACE; CAMPBELL, JAMES; DE BEAUREGARD, TESTED; DE LOSTALOT, ALFRED; DE ST. FLORENT; EDWARDS, ERNEST; HENDERSON, P.; HILL, LEVI L; HORSLEY, J.; HUMPHREY, S. D.; HUNT, ROBERT; IVES, FREDERICK EUGENE; LEA, M. CAREY; LOCK, S. R.; MATHIOT, GEORGE; MORTON, H. J.; NEWELL, ROBERT; NIEPCE DE ST. VICTOR; PAAGE, A.; PLE, CHARLOT; POITEVIN; REYNOLDS, EMERSON J.; ROSS, WILLIAM; SNELLING, H. H.; SPOONER, D. B. & H. B. SPOONER; TAYLOR, J. TRAILL; TILLMAN, SAMUEL D.; WATERHOUSE, J., CAPT.; WERGE, JOHN; WILLOUGHBY;

COLOR: 19TH C.

ST3259 "By the Editor." "Photography in Natural Colours on Silver Plates." YEAR-BOOK OF PHOTOGRAPHY AND PHOTOGRAPHIC NEWS ALMANAC FOR 1890 (1890): 38-51. [Survey of the experiments in color photography throughout the 19th century.]

ST3260 Ehrmann, Charles. "Heliochromy." PHOTOGRAPHIC TIMES 22, no. 556 (May 13, 1892): 257-258. [A brief historical survey of color experiments from 1860s to 1890s.]

ST3261 Bolas, Thomas, F.C.S., F.I.C. "Contributions Towards the Bibliography of Photography in Colors." JOURNAL OF THE SOCIETY OF ARTS (LONDON) 45, no. 2318 (Apr. 23, 1897): 531-540. [Annotated bibliography of the experiments in color photography, arranged chronologically from 1810 to 1897.]

ST3262 Epstein, Edward and John Tennant. "The History of Color Photography." PHOTO-ENGRAVERS BULLETIN 23, no. 12 (July 1934): 3-15.

ST3263 Spencer, D. A. "The First Color Photograph." PENROSE ANNUAL 1940 42, (1940): 99-100, plus unnumbered page. [Clark Maxwell, 1859.] Marder, William and Estelle Marder. "Pioneers of Color Photography. Part III." PHOTOGRAPHIC HISTORIAN 6, no. 2 (Summer 1985): 3-5. 3 illus. [Part III: Thomas Young (1773-1829), Herman Von Helmholtz (1829-1894), John Frederick William Herschel (1742-1841).]

ST3264 Marder, William & Estelle Marder. "Pioneers of Color Photography: Part IV." PHOTOGRAPHIC HISTORIAN 6, no. 3 (Autumn 1985): 4-7, 15. 3 illus. [Part IV: Joseph Nicéphore Niepce, Louis J. M. Daguerre (1787-1851), Alexander E. Becquerel (1820-1891), Claude F. A. Niepce de St. Victor (1805-1870).]

COLOR: BY YEAR.
COLOR: 1853.

ST3265 "Daguerreotype Pictures with the Natural Colors of the Objects Represented." PHOTOGRAPHIC ART JOURNAL 5, no. 2 (Feb. 1853): 74-75. [From the "London-Art-Journal."]

ST3266 "Natural Color in Heliography." HUMPHREY'S JOURNAL 5, no. 13 (Oct. 15, 1853): 205-206. [Letter from "a skillful Daguerreotypist" - on the issue.]

COLOR: 1857.

ST3267 "Photography in Colors." HUMPHREY'S JOURNAL 9, no. 11 (Oct. 1, 1857): 169-171. [From "Photo. Notes."]

COLOR: 1859.
BOOKS

ST3268 How to Colour a Photograph; or Lessons on the Harmony and Contrast of Colour, Principally in their Application to Photography. Reprinted from the "Photographic News." London: Cassell, Peter, & Galpin, 1859. 64 pp.

PERIODICALS

ST3269 "Photography in Colors - A Fragment." AMERICAN JOURNAL OF PHOTOGRAPHY AND THE ALLIED ARTS & SCIENCES n. s. vol. 2, no. 7-8 (Sept. 1 - Sept. 15, 1859): 108-111, 126-127. ['A Member of the Edinburgh Photo. Society.' Suggests a variety of photo lithography.]

COLOR: 1860.

ST3270 "An Artist's Letter on Coloring Photographs." PHOTOGRAPHIC AND FINE ART JOURNAL 13, no. 3-6 (Mar. - June 1860): 68, 90-91, 102-104, 114-115, 117, 135-136, 165-167. [From "Photo. Notes." This article includes an aesthetic commentary on the value of color, impossibility of technical processes working and virtues of hand coloring.]

COLOR: 1875.

ST3271 "Foreign Notes and News. Photography in Natural Colors. Marbled Stains on Negatives." ANTHONY'S PHOTOGRAPHIC BULLETIN 6, no. 1 (Jan. 1875): 19-20. [From "Br. J. of Photo." Ducos du Hauron, Geymet and Lacan working out color discoveries.]

BY APPLICATION: EXHIBITIONS

THE EXHIBITIONS CATEGORY IS ARRANGED BY COUNTRY, THEN BY YEAR, THEN BY CITY, THEN BY ORGANIZATION OR SITE.

See also SOCIETIES & ORGANIZATIONS; HISTORY: BY COUNTRY; ETC.

AUSTRIA: 1873: VIENNA: VIENNA INTERNATIONAL.
BOOKS
ST3272 Doremus, C. A. *Vienna International Exhibition 1873. Photography at Vienna and Recent Improvements in Photography.* s. l.: s. n., 1875. n. p.

PERIODICALS
ST3273 Vogel, Dr. H. "German Correspondence." PHILADELPHIA PHOTOGRAPHER 10, no. 112 (Apr. 1873): 124-125. [The Vienna exhibition.]

ST3274 Badeau, W. H. "From Across the Water." ANTHONY'S PHOTOGRAPHIC BULLETIN 4, no. 6 - 9 (June - Sept. 1873): 185-187, 215-217, 246-247, 271-273. [Discussion of the Vienna World's Fair in 1873. Includes a speech by the chairman - Mr. Oscar Kramer, from the "Wochenschrift der. N. O. Grewerbe-Vereines."]

ST3275 "The Vienna Exposition: List of Successful British and American Competitors." ANTHONY'S PHOTOGRAPHIC BULLETIN 4, no. 9 (Sept. 1873): unpaged leaf following p. 288. [Awards and Medals, extracted from "Photographische Correspondenz."]

ST3276 Vogel, Dr. H. "German Correspondence - the Vienna Exhibition." PHILADELPHIA PHOTOGRAPHER 10, no. 117 (Sept. 1873): 469-472.

ST3277 "Medals Awarded at the Vienna Exhibition." PHILADELPHIA PHOTOGRAPHER 10, no. 118 (Oct. 1873): 487-488. [List of American winners.]

ST3278 Vogel, Dr. H. "Vienna Exhibition: France - Spain - Portugal - Switzerland - Sweden - Norway - Denmark - Italy - Holland - Belgium." PHILADELPHIA PHOTOGRAPHER 10, no. 118 (Oct. 1873): 508-511.

ST3279 "The Photographic Medals Awarded at Vienna." PHILADELPHIA PHOTOGRAPHER 10, no. 119 (Nov. 1873): 527-530. [Lists of winners.]

ST3280 Vogel, Dr. H. "Vienna Exhibition: German & Austrian Photographers." PHILADELPHIA PHOTOGRAPHER 10, no. 119 (Nov. 1873): 532-536.

ST3281 Vogel, Dr. H. "Vienna Exhibition: Hungary - Turkey - etc." PHILADELPHIA PHOTOGRAPHER 10, no. 120 (Dec. 1873): 555-558.

ST3282 "Group of Cincinnati Babies." ANTHONY'S PHOTOGRAPHIC BULLETIN 4, no. 12 (Dec. 1873): 358. [From "NY Herald." An anecdote of the German Emperor visiting the Vienna Exposition, being attracted to the composite portraits of American babies on display there, and was given the print.]

ST3283 Kramer, Oscar. "From Across the Water: Photography at the World's Exhibition at Vienna, 1873." ANTHONY'S PHOTOGRAPHIC BULLETIN 5, no. 7 (July 1874): 257-259.

AUSTRIA: 1874: VIENNA.
ST3284 Wilson, Edward L. "Views Abroad and Across. Pt. 5." PHILADELPHIA PHOTOGRAPHER 11, no. 125 (May 1874): 146-151. [Wilson visited many studios in extended visit to Europe. Includes discussion of photographic exhibits in Vienna.]

AUSTRIA: 1875: VIENNA: VIENNA INTERNATIONAL.
ST3285 "Photographic Exhibitions on the Continent." ANTHONY'S PHOTOGRAPHIC BULLETIN 6, no. 9 (Sept. 1875): 281. [From "London Photographic News."]

BELGIUM: 1856: BRUSSELS: UNIVERSAL EXHIBITION.
ST3286 "Universal Exhibition of Photography. Report by Dr. Phipson." JOURNAL OF THE PHOTOGRAPHIC SOCIETY OF LONDON 3, no. 47 (Oct. 21, 1856): 146-150. [From "Cosmos" of Oct. 2, 12.]

ST3287 Phipson, Dr. T. "Universal Exhibition of Photography, Brussels." PHOTOGRAPHIC AND FINE ART JOURNAL 9, no. 12 (Dec. 1856): 377-379. [From "Cosmos," Oct. 3, Oct. 12. Describes the works exhibited by the Belgian, French, British, and Italian photographers, in detail.]

ST3288 Phipson, Dr. "Photography and the Belgian Exhibitions." HUMPHREY'S JOURNAL 8, no. 15 (Dec. 1, 1856): 227-228. [Translated from "Cosmos." International exhibition, only eleven "proofs" from USA. Whipple's portrait of Harriet Beecher Stowe mentioned.]

BELGIUM: 1875: BRUSSELS: PHOTOGRAPHIC ASSOCIATION OF BELGIUM.
ST3289 "The Exhibition of the Belgian Photographic Association." PHILADELPHIA PHOTOGRAPHER 12, no. 143 (Nov. 1875): 347-348. [Gutekunst (Philadelphia, PA) in the exhibit.]

ST3290 "The Late Exhibition of the Photographic Association of Belgium." PHOTOGRAPHIC TIMES 5, no. 59 (Nov. 1875): 257-258. [List of award winners.]

FRANCE: 1854: PARIS: INTERNATIONAL EXHIBITION.
ST3291 "The Universal Exhibition at Paris." PHOTOGRAPHIC AND FINE ART JOURNAL 7, no. 7 (July 1854): 219-220. [From "London Art Journal."]

FRANCE: 1855: PARIS: INTERNATIONAL EXHIBITION.
ST3292 "Paris Exhibition of 1855." HUMPHREY'S JOURNAL 6, no. 12 (Oct. 1, 1854): 184. [From "J. of Photo. Soc., London." Rules for submission to the forthcoming Paris exhibition.]

ST3293 "Editor's Easy Chair: Our Foreign Gossip." HARPER'S MONTHLY 11, no. 62 (June 1855): 130. [Commentary of the weak showing of the United States at the International Exhibition in Paris. Brief note on "...the beautiful photographs that the French artist's are producing...," with descriptions of several landscapes.]

ST3294 "Opening of the Great Exhibition." PHOTOGRAPHIC AND FINE ART JOURNAL 8, no. 8 (Aug. 1855): 242. [From "La Lumiére."]

ST3295 Meade, Charles R. "Photography in Paris." PHOTOGRAPHIC AND FINE ART JOURNAL 8, no. 8 (Aug. 1855): 253-255. [Letter from Meade, who was at that time visiting Paris. States

that he was taking views for the "P & FAJ." Describes the Paris exhibition. Mentions Roger Fenton, Sherlock, William Newton, John Lamb, Maxwell Lyte, H. White, Thurston Thompson, J. Robertson, J. B. Reade, Davizielli, Artis, Bisson Frères, Baldus, Thompson & Bingham, Mayer & Pierson, V. Plumier, Niepce de St. Victor, Count Aguado, Rutlinger, Disderi, Belloc, J. Gurney, Meade Brothers.]

ST3296 "Photography at the French Exhibition." HUMPHREY'S JOURNAL 7, no. 13 (Nov. 1, 1855): 203. [Brief summation of larger review from "Liverpool Photo. J." with additional commentary by Humphrey exhorting American photographers to catch up to excellent French landscapists.]

FRANCE: 1857: PARIS: INTERNATIONAL EXHIBITION.
ST3297 "Extracts from Foreign Publications - French Exhibition of Photography." HUMPHREY'S JOURNAL 9, no. 2 (May 15, 1857): 18-19. [Le Grey seascape mentioned, Blanquart-Evrard Gothic Cathedral views, Pretsch photolithographs, etc.]

FRANCE: 1859: PARIS: SOCIÉTÉ FRANÇAISE DE PHOTO-GRAPHIE.
ST3298 Burty, Phillipe. "Exposition de la Société Française de Photographie." GAZETTE DES BEAUX-ARTS 1, no. 2 (May 15, 1859): 209-221.

ST3299 "The French Exhibition." PHOTOGRAPHIC NEWS 3, no. 59 (Oct. 21, 1859): 75.

FRANCE: 1861: PARIS: SOCIÉTÉ FRANÇAISE DE PHOTO-GRAPHIE.
ST3300 Lacan, Ernest. "Foreign Correspondence." BRITISH JOURNAL OF PHOTOGRAPHY 8, no. 142 (May 15, 1861): 191. [Brief review of the French Photographic Society exhibition, held at the Palace of Industry. Count Aguado; Edouard Delessert; Mayer Brothers; Pierre Petit; Alophe; Claudet; Bilordeau; Nadar, others mentioned.]

ST3301 "Exhibition: The Exhibition of the Photographic Society of Paris, Considered from an English Point of View." BRITISH JOURNAL OF PHOTOGRAPHY 8, no. 149-150 (Sept. 2 - Sept. 16, 1861): 311-312, 331-332.

FRANCE: 1862: PARIS: INTERNATIONAL EXHIBITION.
ST3302 Fierlants, M. E. "Photography at the International Exhibition from a French Point of View." BRITISH JOURNAL OF PHOTOGRAPHY 10, no. 182 (Jan. 15, 1863): 30.

FRANCE: 1863: PARIS: SOCIÉTÉ FRANÇAISE DE PHOTO-GRAPHIE.
ST3303 "Exhibitions: Exhibition of the French Photographic Society, considered from an English point of view." BRITISH JOURNAL OF PHOTOGRAPHY 10, no. 190-191 (May 15 - June 1, 1863): 212-213, 232-233.

FRANCE: 1864: PARIS: SOCIÉTÉ FRANÇAISE DE PHOTO-GRAPHIE.
ST3304 "Paris Photographic Exhibition." PHOTOGRAPHIC NEWS 8, no. 289 (Mar. 18, 1864): 140-141. [Discussion of establishing regulations for the forthcoming exhibition.]

ST3305 "The French Photographic Exhibition." PHOTOGRAPHIC NEWS 8, no. 299 (May 27, 1864): 257. [Sixth exhibition. Davanne; Ferrier; Rousset; Bayard; Berthall; Bourdier; Numa Blanc; Liebert; Count Arago; Cammas; others mentioned.]

ST3306 "The Exhibition of the French Photographic Society at the Palais de l'Industrie." BRITISH JOURNAL OF PHOTOGRAPHY 11, no. 215-218 (June 1 - July 8, 1864): 188, 209, 238.

FRANCE: 1865: PARIS: SOCIÉTÉ FRANÇAISE DE PHOTO-GRAPHIE.
ST3307 "French Photographic Society's Exhibition." BRITISH JOURNAL OF PHOTOGRAPHY 12, no. 263, 265 (May 19, June 2, 1865): 268-269, 292-293.

FRANCE: 1867: PARIS UNIVERSAL EXPOSITION.
ST3308 Berkowitz, Edward B. "1867 Paris World's Fair." STEREO WORLD 7, no. 6 (Jan. - Feb. 1981): 4-11. 13 b & w. 1 illus.

ST3309 Vogel, Dr. H. "Paris Correspondence." PHILADELPHIA PHOTOGRAPHER 4, no. 42 (June 1867): 172-174. [Notes about the Paris International Exhibition.]

ST3310 Conway, M. D. "The Great Show at Paris." HARPER'S MONTHLY 35, no. 206, 210 (July 1867, Nov. 1867): 238-253, 777-792. [Extensive description of the 1867 Paris Exhibition. Photographs were shown, and they are briefly discussed throughout the articles, particularly on p. 248 and pp. 779-780.]

ST3311 Vogel, Dr. H. "German Correspondence." PHILADELPHIA PHOTOGRAPHER 4, no. 43 (July 1867): 223-226.

ST3312 Simpson, G. Wharton, M.D. "Photography at the International Exhibition at Paris." PHILADELPHIA PHOTOGRAPHER 4, no. 43 (July 1867): 201-204.

ST3313 Vogel, Dr. H. "Further Reports on Paris Exhibition." PHILADELPHIA PHOTOGRAPHER 4, no. 44 (Aug. 1867): 262-264.

ST3314 Devylder, G. "Photography at the World's Fair, Paris, 1867." HUMPHREY'S JOURNAL OF PHOTOGRAPHY, AND THE ALLIED ARTS AND SCIENCES 19, no. 9 (Sept. 1, 1867): 134-136. [From "Bulletin Belge." Columns of figures of photographers represented at the Fair. 628 photographers; 175 from France, 121 from England, 19 from USA, etc. Further statistics also offered.]

ST3315 Diamond, Hugh W., M.D., F.S.A. "Paris International Exhibition. Reports on the Classes. Photographic Proofs and Apparatus. Class 9." ILLUSTRATED LONDON NEWS 51, no. 1445 (Sept. 14, 1867): 295-298. [Extensive, (for the time) informed review by Dr. Diamond.]

ST3316 Thompson, C. T. "Paris International Exhibition. Reports on the Classes Photography. - Class 9." ILLUSTRATED LONDON NEWS 50, no. 1445 (Sept. 14, 1867): 298-299.

ST3317 Lacan, Ernest. "IV: Photographie." L'EXPOSITION UNIVERSELLE DE 1867 ILLUSTREE no. 50 (Oct. 24, 1867): 308-311. 1 illus. [Issued in 60 parts of 16 pp. each during 1867, this journal offered survey reviews of various aspects of the exposition in each issue. The author discussed the exhibition of French photography, comparing their portrait and landscape photographs to the work of the British displayed in earlier exhibitions. Also discusses recent photoengraving processes on display. American photography and that of other nations, which may have been scattered around in other exhibits within this exposition is not discussed here. The illustration is a woodcut of the French Photographic exhibition gallery, with visitors, etc.]

SPECIAL TOPICS: EXHIBITIONS
FRANCE: 1874: PARIS: SOCIÉTÉ FRANÇAISE DE PHOTOGRAPHIE.

SPECIAL TOPICS: EXHIBITIONS
GB: 1851: LONDON: CRYSTAL PALACE.

ST3318 Remy, P. A. "Exposition universelle. Galerie des arts liberaux. IV. - La Photographie." L'ILLUSTRATION (Nov. 9 - Nov. 16, 1867): 303-304, 315-316.

ST3319 Berkowitz, Edward B. "1867 Paris World's Fair." STEREO WORLD 7, no. 6 (Jan. - Feb. 1981): 4-11. 12 b & w. 1 illus.

FRANCE: 1874: PARIS: SOCIÉTÉ FRANÇAISE DE PHOTOGRAPHIE.
ST3320 "Regulations of the Tenth Exhibition of the French Photographic Society." ANTHONY'S PHOTOGRAPHIC BULLETIN 5, no. 3 (Mar. 1874): 128-130. [List of regulations, Jury, etc. for forthcoming show at the Palace of Industry, Paris.]

FRANCE: 1878: PARIS: INTERNATIONAL EXHIBITION.
ST3321 "Photographers and the Coming International Exhibition." ANTHONY'S PHOTOGRAPHIC BULLETIN 9, no. 6 (June 1878): 167-168.

ST3322 "Dan." "At the Paris Show." PHILADELPHIA PHOTOGRAPHER 15, no. 177 (Sept. 1878): 272-276. [Extensive review of the photography at the Paris Exhibition of 1878. ("Lippincott's Magazine" (Aug. 1878) also reviewed the entire exhibition.)]

ST3323 Vogel, Dr. H. "Franco-German Correspondence." PHILADELPHIA PHOTOGRAPHER 15, no. 179 (Nov. 1878): 337-341. [Review of the Paris Exhibition.]

ST3324 Vogel, Dr. H. "German Correspondence: The Great Paris Exhibition." PHILADELPHIA PHOTOGRAPHER 15, no. 180 (Dec. 1878): 374-377. [Further review of the Paris Exhibition of 1878.]

ST3325 Vogel, H. "German Correspondence." PHILADELPHIA PHOTOGRAPHER 16, no. 181 (Jan. 1879): 9-11. [Awards of the International Exhib. of Paris, 1878.]

ST3326 Mansfield, George. "Photography at the Paris Exhibition." BRITISH JOURNAL PHOTOGRAPHIC ALMANAC 1879 (1879): 92-93.

GERMANY: 1865: BERLIN: BERLIN PHOTOGRAPHIC EXHIBITION.
ST3327 "Exhibition:Berlin Photographic Exhibition." BRITISH JOURNAL OF PHOTOGRAPHY 12, no. 274 (Aug. 4, 1865): 408. [Mahlknecht; Dr. Heyd, Ost, Jagmann, Angerer, Adele, Küss and Kabending, all of Vienna, mentioned. Discussion of British work shown. Rejlander, Cameron, Robinson, etc.]

ST3328 "American Photographs in Europe." HUMPHREY'S JOURNAL OF PHOTOGRAPHY, AND THE ALLIED ARTS AND SCIENCES 17, no. 8 (Aug. 15, 1865): 120-121. [Prof. Joy, V. P. of Am. Photo. Soc., travelled to Berlin and brought Lewis M. Rutherford's photo of the moon, Newton's views of the cemetery and arsenal of New York, NY, and others to the exhibit.]

ST3329 "The Late Berlin Photographic Exhibition." BRITISH JOURNAL OF PHOTOGRAPHY 12, no. 279 (Sept. 8, 1865): 464.

GB: 1851: LONDON: CRYSTAL PALACE.
BOOKS
ST3330 Glaisher, James. "Class X: Photography," on pp. 243-245 and pp. 274-279 and "Class X: Photography," on vol. 2, pp. 597-608 in: *Exhibition of the Works of Industry of All Nations 1851. Reports by the Juries on the Subjects in the Thirty Classes into which the Exhibition*

was divided. London: Spicer Brothers and Clowes & Sons, 1852. 4 vol. [Annotated descriptions of the presentations of each exhibitor. Calotypes by Henneman & Malone; Buckle; Ross & Thompson; Hill & Adamson; R. & L. Colls; Harmer; Owen; Collie; Rippingham; Bingham; Field & Son (all GB); Langenheim Brothers (USA); Bayard; Blanquart-Evrard; Martens; Flacheron-Hayard; Le Gray; Le Secq; Cousin; Albert; Chevalier; Mayer (all FR); Pretsch (AUSTRIA). Daguerreotypes by Claudet; Kilburn; Mayall; Beard; Laroche; Voightlander & Evans; Griffiths & Le Beau; Paine; Tyree; Craddock (all from Great Britain); Lawrence; Brady; Whipple; Mayall; Evans; Meade Brothers; Pratt, Richmond & Co.; Whitehurst; Gavit; Root; Hogg; Harrison; Fontayne & Porter (all USA); Thierry; Maucomble; Sabatier; Plaingol; Gouin (all France); Kohnke (Germany); Vogel (Austria).]

PERIODICALS
ST3331 "The World's Fair of 1851; Its Errors and Its Dangers." PHOTOGRAPHIC ART JOURNAL 1, no. 1-2 (Jan. - Feb. 1851): 53-58, 118-122. [From the "London Art Journal."]

ST3332 "Gossip." PHOTOGRAPHIC ART JOURNAL 1, no. 3 (Mar. 1851): 189-190. [Description of the various American entries to the World's Fair. Brady; Lawrence; Meade Brothers; Wm. Pratt & Co. (Richmond, VA); Root; Whitehurst. 12 views of Niagara Falls in double whole-size plates.]

ST3333 "A Guide to the Great Industrial Exhibition: Light and Its Applications." ILLUSTRATED LONDON NEWS 18, no. 485 (May 17, 1851): 424-425. [Description of this aspect of the Crystal Palace Exhibition, including a description of some of the photographs displayed. Mentions Whitehurst (Baltimore, MD); Harrison (New York, NY); Claudet (London); Mayall (London); Bingham (GB); Field (GB); Langenheim (Philadelphia, PA); P. V. Fry (GB); camera makers, etc. discussed.]

ST3334 Arnoux, J. J. "The World's Fair." PHOTOGRAPHIC ART JOURNAL 2, no. 3 (Sept. 1851): 153-156. [From "La Lumiére."]

ST3335 Snelling, J. Russell, trans. "The World's Fair." PHOTOGRAPHIC ART JOURNAL 2, no. 3 (Sept. 1851): 153. [From "La Lumiére."]

ST3336 "The Great Exhibition - Official Award of the Prizes. Class X. - Philosophical Instruments, and Processes Depending Upon their Use; Musical, Horological and Surgical Instruments." ILLUSTRATED LONDON NEWS 19, no. 524 (Oct. 18, 1851): 506. [Photography and photographic apparatus included in this class. Claudet; F. Martens; Ross & Thompson; H. Bayard; M. B. Brady; F. Flacheron; Henneman & Malone; Horne, Thornwaite & Wood; W. E. Kilburn; M. M. Lawrence; Negretti & Zambra; A. Plagnoil; Paul Pretsch; J. C. Schiertz; Valery & Son, J. A. Whipple won awards.]

ST3337 "Report of the World's Fair, London. Illustrated by Photography." DAGUERREAN JOURNAL 2, no. 12 (Nov. 1, 1851): 374. [From "La Lumiére."]

ST3338 "Photographic Items: The Great Exhibition." HUMPHREY'S JOURNAL 4, no. 10 (Sept. 1, 1852): 157. [Queen Victoria has instructed that 20 sets of photos illustrating the choicest works at the Crystal Palace be made up for distribution to "the principal potentates of Europe and other distinguished foreigners."]

ST3339 "Photography." HUMPHREY'S JOURNAL 4, no. 14 (Nov. 1, 1852): 213-214. [From "Lectures on the World's Fair." Describes photography at the exhibition in general. Mentions Mayall; Martens;

Bayard; Flacheron; Ross & Thompson; Buckle; Hill & Adamson; Henneman & Malone; Owen; Paul Pretsch by name.]

ST3340 "Heliography." HUMPHREY'S JOURNAL 4, no. 16 (Dec. 1, 1852): 243-248. [Extended review of the "Great Exhibition at London," with an appended historical survey. Source not mentioned.]

ST3341 "Photography in 1851." AMERICAN JOURNAL OF PHOTOGRAPHY AND THE ALLIED ARTS & SCIENCES n. s. vol. 3, no. 11 (Nov. 1, 1860): 161-165. ["The following is an extract from a lecture delivered by James Glaisher, F.R.S. on the occasion of the London World's Fair..." Describes the photographic displays. Whipple (Boston) discussed, others.]

ST3342 Peterich, Gerda. "Photography at the Great Exhibition, 1851." IMAGE 7, no. 3 (Mar. 1958): 53-58. 7 b & w. [Description of the eight volume "Reports by the Juries, 1851," illustrated with calotypes. Calotypes probably by N. Henneman, H. Owen, C. M. Ferrier, J. Mayall.]

ST3343 Berkowitz, Edward B. "London Exhibition 1851: The Crystal Palace." STEREO WORLD 5, no. 2 (May - June 1978): 8-11. 4 b & w.

ST3344 Keeler, Nancy B. "Illustrating the 'Reports by the Juries' of the Great Exhibition of 1851; Talbot, Henneman, and their Failed Commission." HISTORY OF PHOTOGRAPHY 6, no. 3 (July 1982): 257-272. 8 b & w. 6 illus.

GB: 1852: LONDON: SOCIETY OF ARTS.
BOOKS
ST3345 *A Catalogue of an Exhibition of Recent Specimens of Photography, with Notes on Apparatus and Processes.* London: Charles Whittingham, 1852. 42 pp. [Contains essay "On the Present Position and Future Prospects of the Art of Photography," by Robert Fenton.]

PERIODICALS
ST3346 "Exhibition of Recent Specimens of Photography." JOURNAL OF THE SOCIETY OF ARTS (LONDON) 1, no. 6 (Dec. 31, 1852): 61-63. [Joseph Cundall, Philip Delamotte and Roger Fenton organized this exhibition, which was the first of what would become the Royal Photographic Society annual exhibitions. Exhibitors mentioned, their works discussed.]

ST3347 "Fine Arts Exhibition of Photographic Pictures at the Society of Arts." ATHENAEUM no. 1314 (Jan. 1, 1853): 23-24. [774 works shown. Talbot, Ibbetson, Fenton, Sanford, Pecquerel, Delamotte, S. Buckle, LeSecq, Ferrier, Ross & Thompson, Martens, B. Jones, M. E. Constant, Balliere, Fry, H. Owen, DuCamp, Renard, Flacheron, Pretsch, Stewart, Regnault, G. Shaw, Sherlock, W. Newton, B. B. Turner, R. S. Bingham, A. L. Cocke, Wilks, Dr. Diamond, Count de Montizon, Cundall mentioned.]

ST3348 "Photography." ILLUSTRATED LONDON NEWS 22, no. 601 (Jan. 1, 1853): 11-12. 1 illus. [Engraving of the crowd at the photographic exhibition held at the Society of Arts, London.]

ST3349 "Exhibition of Recent Specimens of Photography of the Society of Arts." NOTES AND QUERIES 7, no. 166 (Jan 1, 1853): 22-23. [Mentions Turner, Stewart, Le Gray, Buckle, Fenton, Owen, Berger, Delamotte, Constant, Ferrier, Neville sisters.]

ST3350 Hunt, Robert. "Home Correspondence: The Photographic Exhibition." JOURNAL OF THE SOCIETY OF ARTS (LONDON) 1, no. 7 (Jan. 7, 1853): 78-79. [Letter from Hunt.]

ST3351 "Fine Arts: Exhibition of Photography." LITERARY GAZETTE, AND JOURNAL OF THE BELLES LETTRES No. 1877 (Jan. 15, 1853): 68-69. [First exhibition, held at the Society of Arts. Cundall & Delamotte, H. F. Talbot, H. Owen, Fry, Sherlock, G. Barker, B. Turner, S. W. Newton, Pretsch, DuCamp, Flacheron, Lodoisck, G. Shaw, Stewart, Rosling, Bingham, E. Constant, Berger, T. Sims, E. Becquerel, R. Fenton, M. E. M. Regnault, Ferrier, Goodeve, others mentioned. The Photographic Society would evolve out of this effort.]

ST3352 "Fine-Art Gossip." ATHENAEUM no. 1317 (Jan. 22, 1853): 114. [Exhibition highly successful, new prints have been added, extended to Jan. 29, 1853.]

ST3353 Glaisher, James, F.R.S. "On the Chief Points of Excellence in the Different Processes of Photography, as Illustrated by the Present Exhibition." JOURNAL OF THE SOCIETY OF ARTS (LONDON) 1, no. 10 (Jan. 28, 1853): 109-112.

ST3354 "Popular Science: Photography and the Photographic Exhibition." ILLUSTRATED LONDON NEWS 22, no. 605 (Jan. 29, 1853): 87.

ST3355 "Photographic Exhibition at the Society of Arts." ART JOURNAL (Feb. 1853): 54-56. [Extensive review of the exhibition. Includes a summary of Mr. Stewart's negative paper processes. H. Owen & M. Ferrier, Pretsch, Count de Montison, A. L. Cocke, R. C. Galton, M. E. Pecquerel, R. Fenton, Buckle, A. Rosling, Stewart, B. B. Turner, Shaw, Cundall, P. H. Delamotte, F. Flacheron, Ross & Thomas, P. W. Fry, others mentioned. H. F. Talbot sent volume on photoengraving process.]

ST3356 "Exhibition of Photographs." HUMPHREY'S JOURNAL 4, no. 20 (Feb. 1, 1853): 309-310. [From "London Times," Dec. 21, 1852.]

ST3357 "Scientific: Societies: Society of Arts - Jan. 26." ATHENAEUM no. 1322 (Feb 26, 1853): 262. [Brief summation of Glaisher's paper, "On the Chief Points of Excellence in the Different Processes of Photography, as illustrated by the present Exhibition." "Glaisher wrote the Juror's Report on the photographic pictures exhibited at the Great Exhibition (Crystal Palace, 1851) and it was desirable that he should examine the collection exhibited in the rooms of the Society..."]

ST3358 "Photographic Exhibition at the Society of Arts." PHOTOGRAPHIC ART JOURNAL 5, no. 3 (Mar. 1853): 155-161. [From "London Art Journal."]

ST3359 "Monthly Notes: Photographic Exhibition." PRACTICAL MECHANIC'S JOURNAL 5, no. 60 (Mar. 1853): 293.

ST3360 "Note." NOTES AND QUERIES 9, (Jan. 7, 1854): 16-17. [Mention of success of first exhibition of the Photographic Society.]

GB: 1853: LONDON: NEW BOND STREET.
BOOKS
ST3361 *A Catalogue of Photographic Pictures Exhibited at the Photographic Institution, 168 New Bond Street, May 1853.* London: G. Barclay, 1853. n. p.

PERIODICALS

ST3362 "Fine Arts: The Photographic Exhibition." ATHENAEUM no. 1331 (Apr. 30, 1853): 535. [Review of an exhibition of more than 250 prints on New Bond Street, organized by Philip Delamotte. Mentions works by Delamotte, M. Bresolin, R. Helle, F. Martens, H. Le Secq, R. J. Bingham.]

ST3363 "Note." ART JOURNAL (June 1853): 162, 179. [Note that an exhibition of photographs had opened No. 168 Bond Street. Included P. H. Delamotte, Bresolin, S. Buckle, G. Le Gray, H. Le Secq, R. Fenton, J. Cundall, etc. Further brief review on p. 179, July 1853 "Art Journal" mentions Owen, Buckle, and Roslyn.]

ST3364 "Photographic Institution." HUMPHREY'S JOURNAL 5, no. 9 (Aug. 15, 1853): 143. [Review of second exhibition, held after the Society of Arts Exhibit, of photographs, on Bond St., London. Mentions Martens, Delamotte, Owen, Buckle, Roslyn, others.]

GB: 1854: LONDON: PHOTOGRAPHIC SOCIETY.
BOOKS
ST3365 Photographic Society. *Exhibition of Photographs and Daguerreotypes*. London: Taylor & Francis, 1854. n. p.

PERIODICALS

ST3366 "Photographic Society." ATHENAEUM no. 1367 (Jan. 7, 1854): 23. [Review of the first exhibition, held at Gallery of the Society of British Artists. Llewelyn, Rosling, W. J. Newton, Viscount Vigier, Stewart, Fenton, Henna, Henneman, C. T. Thompson, Nevill Sisters, Count de Montizon, Dr. Diamond, Delves, Rev. Kingsley, Rev. J. B. Reade, Mayall, Claudet mentioned.]

ST3367 "The Exhibition of the Photographic Society." ART JOURNAL (Feb. 1854): 48-50. [First exhibition of the Photographic Society. Extensive review. 1500 photos. Sir William Newton, Count de Montizon, Viscount Vigier, Turner, Delamotte, Hugh Owen, Rosling, Roger Fenton, Ross & Thomas, Dillwyn Llewelyn, Dr. Becker, Dr. Diamond, Mayall, LaRoche, Bird, Tenison, Clifford, Baldus, Bisson Brothers, Henneman, Rev. W. I. Kingsley, F. Delves, Crooke, Stokes, Waring, Sir Thomas Wilson, C. T. Thompson, F. Bedford, P. W. Fry, W. H. F. Talbot mentioned.]

ST3368 "London Photographic Society." HUMPHREY'S JOURNAL 5, no. 21 (Feb. 15, 1854): 331. [Note that the first exhibition was held, attended by Queen Victoria and Prince Albert, etc.]

ST3369 "The Exhibition of the Photographic Society." PHOTOGRAPHIC AND FINE ART JOURNAL 7, no. 4 (Apr. 1854): 107-109. [From "London Art Journal."]

GB: 1855: LONDON: PHOTOGRAPHIC SOCIETY.
BOOKS
ST3370 Photographic Society. *Exhibition of Photographs and Daguerreotypes at the Gallery of the Society of Water Colour Painters, 1 Pall Mall East, Second Year*. London: Richard Barrett, 1855. n. p.

PERIODICALS

ST3371 "Photographic Society." ATHENAEUM no. 1421 (Jan. 20, 1855): 86. [Review of second annual exhibition. Sherlock, F. Bedford, Lake Price, H. Owen mentioned.]

ST3372 "Topics of the Week." LITERARY GAZETTE, AND JOURNAL OF THE BELLES LETTRES no. 1983 (Jan. 20, 1855): 43. [Note and brief review of the Photographic Society's second exhibition. Henry Tyler, T. C. Ponting, H. Owen, Rev. Kingsley, Sir W. J. Newton, Count

de Montizon, W. Sherlock, Laroche, Mayall. T. H. Hennah, Alfred Rosling missing.]

ST3373 "Fine Arts: Exhibition of the Photographic Society." ILLUSTRATED LONDON NEWS 26, no. 725, 727-728, 736 (Jan. 27, Feb. 10 - Feb. 17, Apr. 14, 1855): 95, 140-141, 164-166, 349. 3 illus. [The second notice (Feb. 10) is actually a reproduction of Lake Price's genre study "Genevra," with brief comment. The third notice (Feb. 17) contains a reproduction of Roger Fenton's landscape "Valley of the Wharfe," as well as a discussion of the exhibition. The last notice (Apr. 14) has a landscape by Llewelyn.]

ST3374 "The Second Exhibition of the London Photographic Society." PHOTOGRAPHIC AND FINE ART JOURNAL 8, no. 2 (Feb. 1855): 62-63. [Llewelyn; Roger Fenton; Lake Price; B. Turner; Philip Delamotte; Cundall; Bedford; Thurston Thompson; Kingley; Taylor; Robertson; Hugh Owen; Russell Sedgfield; George Barker; others mentioned.]

ST3375 "Photographic Society." THE CRAYON 1, no. 8 (Feb. 21, 1855): 120. [From "The Athenaeum." Brief review of the 2nd annual exhibition of the Photo. Society, London.]

ST3376 "Photographic Society Exhibition." ART JOURNAL (Mar. 1855): 85. [Second exhibition. Hugh Owen, Sedgfield, Fenton, Rev. Kingsley, B. B. Turner, Russell Sedgfield, Ponting, C. H. Waring, T. J. Backhouse, T. D. Llewelyn, Buckle, Stokes, Count de Montizon, Mayall, J. G. Tunney, Hennah mentioned.]

ST3377 Ross, William. "A French Critique of the Photographic Exhibition in London, 1855." HUMPHREY'S JOURNAL 6, no. 23 (Mar. 15, 1855): 373-374. [Excerpts culled from "La Lumiére," reviewing the exhibit.]

GB: 1855: LONDON: SOCIETY OF ARTS.
ST3378 "The Society of Arts Exhibition." PRACTICAL MECHANIC'S JOURNAL 8, no. 87-88 (June - July 1855): 52-55, 77-78. 1 illus. [Hooper & Co., coachbuilders, displayed record photos of their product; discussed on p. 52. A landscape view camera by T. E. Merritt is illustrated on p. 77.]

GB: 1856: LONDON: PHOTOGRAPHIC SOCIETY.
ST3379 "The Photographic Society." ATHENAEUM no. 1472-1473 (Jan. 12 - Jan. 19, 1856): 46-47, 78-79. [3rd exhibition. Lake Price and Riglander (sic Rejlander) praised. Watson, Fenton, Diamond, Shadbolt, Amdale, Archer, Prout, Frith, others mentioned. Mayall, Cundall, Rejlander, Diamond, B. Smith mentioned in pt. 2.]

ST3380 "The Photographic Society's Exhibition." ILLUSTRATED LONDON NEWS 28, no. 779-780 (Jan. 12 - Jan. 19, 1856): 42, 74. [3rd Annual Exhibition.]

ST3381 Hunt, Robert. "Photographic Exhibitions." ART JOURNAL (Feb. 1856): 49-50. [Third exhibition of the Photographic Society. Mentions: F. Hardwick, J. Knight, J. D. Llewelyn, T. W. Ramsden, F. Scott Archer, W. Pumphrey, G. Shadbolt, H. White, T. Cadby Ponting, Rev. H. Holder, A. F. Melhuish, F. Bedford, V. A. Prout, O. G. Rejlander, Lake Price, J. Watson & Co., Roger Fenton, Mrs. L. Leigh Sotheby, Dr. Diamond, C. Thurston Thompson.]

ST3382 "Photographic Exhibitions." HUMPHREY'S JOURNAL 7, no. 24 (Apr. 15, 1856): 389-391. [From "London Art Journal." Also mentions Fenton's and Robertson's exhibits of Crimean War photos.]

ST3383 Hunt, Robert. "Photographic Exhibitions." PHOTOGRAPHIC AND FINE ART JOURNAL 9, no. 5 (May 1856): 141-143. [From "London Art J." Review of 3rd exhibit of the Photo. Soc., analysis of processes favored by the photographers. 461 collodion, 78 calotype, 64 waxed paper, 3 daguerreotypes.]

GB: 1856: MANCHESTER: MANCHESTER PHOTO-GRAPHIC EXHIBITION.
ST3384 "Theta." "Review of the Manchester Photographic Exhibition." JOURNAL OF THE PHOTOGRAPHIC SOCIETY OF LONDON 3, no. 42 (May 21, 1856): 53-54.

GB: 1856: NORWICH: PHOTOGRAPHIC SOCIETY.
ST3385 *Exhibition of the Norfolk and Norwich Fine Arts' Association and of the Photographic Society at the Exhibition Rooms, Broad Street, St. Andrews', Norwich.* Norwich: Fletcher & Alexander, 1856. n. p.

GB: 1857: LONDON: CRYSTAL PALACE.
ST3386 "Crystal Palace Photographic Gallery." ILLUSTRATED LONDON NEWS 30, no. 843/844 (Feb. 7, 1857): 121. [Crystal Palace Gallery collection discussed. Works of art reproduced photographically. Gustave LeGray and Baldus mentioned.]

ST3387 "Photographs at the Crystal Palace." PHOTOGRAPHIC AND FINE ART JOURNAL 10, no. 6 (June 1857): 191. [From "London Times." "A numerous collection of photographs, chiefly by French artists, is now exhibited at the Sydenham Palace;..."]

GB: 1857: LONDON: PHOTOGRAPHIC SOCIETY.
ST3388 "The Photographic Society." ATHENAEUM no. 1524 (Jan. 10, 1857): 54-55. [Ex. rev. Works by exhibitors described.]

ST3389 "The Photographic Exhibition." JOURNAL OF THE PHOTOGRAPHIC SOCIETY OF LONDON 3, no. 50-51 (Jan. 21 - Feb. 21, 1857): 192-195, 213-217.

ST3390 "Fine Arts: The Photographic Exhibition." LITERARY GAZETTE, AND JOURNAL OF THE BELLES LETTRES no. 2086 (Jan. 10, 1857): 43-44. [Fourth exhibition of the Photographic Society. Lake Price, Rejlander, Fenton, C. S. Goodman, Joseph Cundall, Maull & Polyblank, Herbert Watkins, Thomas Sims, R. J. Bingham, Robert Howlett, Philip H. Delamotte, Russell Sedgfield, Rev. H. Holden, T. Grubb, Emil Braun, F. Frith, J. Robertson, Alinari Brothers, others mentioned.]

ST3391 "The Photographic Exhibition." ILLUSTRATED LONDON NEWS 30, no. 840-841 (Jan. 17 - Jan. 24, 1857): 41, 61.

ST3392 "Photographic Exhibition." ART JOURNAL (Feb. 1857): 40. [Mentions Rejlander, Fenton, Cundell, C. T. Thompson, Dr. Diamond, Robertson, Backhouse, Dr. Braun, Rev. Holden, Rosling, Bedford, Llewelyn, Gastineau, Percy and Spiller.]

ST3393 "The Photographic Exhibition." PHOTOGRAPHIC AND FINE ART JOURNAL 10, no. 2 (Feb. 1857): 51. [From "Illus. London News."]

ST3394 "Photographic Exhibition." PHOTOGRAPHIC AND FINE ART JOURNAL 10, no. 3 (Mar. 1857): 71-72. [From "London Art J." 4th Annual Exhibition.]

GB: 1857: MANCHESTER: MANCHESTER ART TREASURES.
ST3395 "The Art-Treasures Exhibition at Manchester." ILLUSTRATED LONDON NEWS 30, no. 856 (May 2, 1857): 400-401. [General

description of the exhibition, not yet opened. The Photographic Gallery is briefly described on p. 401.]

ST3396 "Exhibition of Art Treasures at Manchester." PHOTOGRAPHIC AND FINE ART JOURNAL 10, no. 7-9, (July - Sept. 1857): 216, 239-240, 285-286. [From "Liverpool Photo. J."]

ST3397 "Exhibition of Art Treasures at Manchester." PHOTOGRAPHIC AND FINE ART JOURNAL 10, no. 12 (Dec. 1857): 362-363. [From "Liverpool Photo. J."]

ST3398 "Manchester Art Exhibition." PHOTOGRAPHIC AND FINE ART JOURNAL 10, no. 12 (Dec. 1857): 378. [From "Liverpool Photo. J."]

GB: 1858.
ST3399 "Approaching Photographic Exhibitions. No. 1" PHOTOGRAPHIC NEWS 1, no. 4 (Oct. 1, 1858): 37-38.

ST3400 "Approaching Photographic Exhibitions. No. 2." PHOTOGRAPHIC NEWS 1, no. 11 (Nov. 19, 1858): 121-122.

ST3401 "Approaching Photographic Exhibitions. No. 3." PHOTOGRAPHIC NEWS 1, no. 17 (Dec. 31, 1858): 198.

GB: 1858: LEEDS: LEEDS PHOTOGRAPHIC SOCIETY.
ST3402 "Photographic Exhibition at Leeds." LIVERPOOL & MANCHESTER PHOTOGRAPHIC JOURNAL [BRITISH JOURNAL OF PHOTOGRAPHY] n. s. 2, no. 20, 22 (Oct. 15, Nov. 15, 1858): 255-256, 284-286. [Landscapes by local amateurs, Isaiah Dixon, Lyndon Smith, T. W. Stansford and W. S. Ward, featured. Others exhibited as well. In Nov., Robinson, Melhuish, Robertson's views of Lucknow, India, others...]

GB: 1858: LONDON: ARCHITECTURAL PHOTOGRAPHIC ASSOCIATION.
ST3403 "Exhibition of the Architectural Photographic Association. Parts 1-3." PHOTOGRAPHIC NEWS 1, no. 16-18 (Dec. 24, 1858 - Jan. 7, 1859): 185-186, 198-199, 207-208.

GB: 1858: LONDON: PHOTOGRAPHIC SOCIETY.
BOOKS
ST3404 Photographic Society. *Exhibition of Photographs and Daguerreotypes at the South Kensington Museum, 5th Year.* London: Taylor & Francis, 1858. 26 pp.

PERIODICALS
ST3405 "Fine Arts: Photographic Society." ATHENAEUM no. 1582 (Feb. 20, 1858): 246. [Fifth exhibition, at the South Kensington Museum, reviewed.]

ST3406 "Fine Arts: Exhibition of the Photographic Society." ILLUSTRATED LONDON NEWS 32, no. 905 (Feb. 27, 1858): 219.

ST3407 "Exhibition of Photographs at the South Kensington Museum." LIVERPOOL & MANCHESTER PHOTOGRAPHIC JOURNAL [BRITISH JOURNAL OF PHOTOGRAPHY] n. s. 2, no. 5, 7 (Mar. 1, Apr. 1, 1858): 61-63, 82-83. [Supplementary exhibition, held by the London Photo. Soc., for the winter months. 705 "frames" exhibited, 74 of which were copy prints of works of art. 185 portraits. Caldesi & Montecchi, R. Fenton, F. Bedford, C. Thurston Thompson, F. Frith, Negretti & Zambra, O. G. Rejlander, Lake Price, W. M. Grundy, Dr. Mansell, R. Howlett, A. J. Melhuish, T. R. Williams, others mentioned.]

ST3408 "The Photographic Exhibition." ART JOURNAL (Apr. 1858): 120-121. [Fifth exhibition. Roger Fenton, J. D. Llewelyn, F. Frith, Hale, Ross & Thomson, J. W. G. Gutch, O. G. Rejlander, Cundall, Maull & Polybank, C. Thurston Thompson, Caldesi, Montecchi, Col. James and the Ordnance Survey mentioned.]

ST3409 "Fine Arts: Photographic Society." ATHENAEUM no. 1596 (May 29, 1858): 692-693. [Fifth annual exhibition, at Coventry Street, Piccadilly. (Two exhibitions held in one year).]

ST3410 "The Exhibition." JOURNAL OF THE PHOTOGRAPHIC SOCIETY OF LONDON 4, no. 66 (May 21, 1858): 207-211.

ST3411 "The London Photographic Society's Fifth Annual Exhibition." LIVERPOOL & MANCHESTER PHOTOGRAPHIC JOURNAL [BRITISH JOURNAL OF PHOTOGRAPHY] n. s. 2, no. 12 (June 15, 1858): 153-155.

ST3412 "The London Exhibition." HUMPHREY'S JOURNAL OF PHOTOGRAPHY, AND THE ALLIED ARTS AND SCIENCES 10, no. 8 (Aug. 15, 1858): 128. [Brief extract of report of the exhibition. Grundy and Fenton mentioned.]

GB: 1858: SYDENHAM: CRYSTAL PALACE.
ST3413 "Critical Notices: The Photographic Exhibition at the Crystal Palace. Parts 1-3." PHOTOGRAPHIC NEWS 1, no. 3-5 (Sept. 24 - Oct 8, 1858): 29-31, 40-41, 52-53. [Mentioned: H. P. Robinson, Grundy, Turner, Fenton, Bedford, G. W. Wilson, etc.]

GB: 1859: ABERDEEN.
ST3414 "Exhibition of Photographs at Aberdeen." PHOTOGRAPHIC NEWS 3, no. 57 (Oct. 7, 1859): 51-52. [Caldesi & Montecchi, Rejlander, Bisson Brothers, Baldus are mentioned.]

GB: 1859: EDINBURGH:PHOTOGRAPHIC SOCIETY OF SCOTLAND.
ST3415 "Exhibition of the Photographic Society of Scotland." JOURNAL OF THE PHOTOGRAPHIC SOCIETY OF LONDON 5, no. 78 (Feb. 5, 1859): 178-181.

ST3416 "Sel D'Or." "Notes on the Exhibition of the Photographic Society of Scotland." PHOTOGRAPHIC AND FINE ART JOURNAL 12, no. 1 (June 1859): 3-4. [From "Photo. J."]

GB: 1859: LONDON: ARCHITECTURAL PHOTOGRAPHIC ASSOCIATION.
ST3417 "Architectural Photographic Association Exhibition." PHOTOGRAPHIC AND FINE ART JOURNAL 12, no. 1 (June 1859): 4-5. [From "Photo. J."]

GB: 1859: LONDON: PHOTOGRAPHIC SOCIETY.
ST3418 "Fine-Art Gossip." ATHENAEUM no. 1628 (Jan. 8, 1859): 55. [Brief review of Photo. Soc. exhibition. Fenton, Bedford, Caldesi & Montecchi, Roslyng mentioned.]

ST3419 "The Exhibition of the Photographic Society. Parts 1 - 4." PHOTOGRAPHIC NEWS 1, no. 19-22 (Jan. 14 - Feb. 4, 1859): 217-218,230-231, 241-242,254-255.

ST3420 "Fine-Arts. - Photographic Society." ATHENAEUM no. 1629 (Jan. 15, 1859): 86-87. [6th annual exhibition. Caldesi & Montecchi; Fenton; Diamond; Gutch; Bisson Frères; W. Hamilton Crake; Truefitt; Frith; Morris Moore; Sherlock; Choponin; Cruttenden; Bedford; Deleferier & Beer; R. Howlett; B. B. Turner; Cade; Rejlander; Dr.

Holden; Bingham; H. P. Robinson; J. H. Morgan; Delamotte; Maxwell Lyte; others mentioned.]

ST3421 "Fine Arts: Exhibition of the Photographic Society." ILLUSTRATED LONDON NEWS 34, no. 955-956 (Jan. 15 - Jan. 22, 1859): 59, 83.

ST3422 "The Exhibition in Suffolk Street." JOURNAL OF THE PHOTOGRAPHIC SOCIETY OF LONDON 5, no. 77 (Jan. 21, 1859): 143-150.

ST3423 "Photographic Exhibition." ART JOURNAL (Feb. 1859): 45-46. [Sixth exhibition. Caldesi & Montecchi, C. Thurston Thompson, O. G. Rejlander, De Ferrier & Beer, Roger Fenton, F. Frith, Hamilton Crake, Warren de la Rue, Charles Heisch, Sykes Ward, Pouncy mentioned.]

GB: 1859: NOTTINGHAM: NOTTINGHAM PHOTO-GRAPHIC SOCIETY.
ST3424 F. B. F. "Nottingham Photographic Society - Exhibition at the Exchange Hall." PHOTOGRAPHIC NEWS 1, no. 20 (Jan. 21, 1859): 237-238.

ST3425 "The Exhibition of Photographs at the Exchange Hall, Nottingham." JOURNAL OF THE PHOTOGRAPHIC SOCIETY OF LONDON 5, no. 77-78 (Jan. 21 - Feb. 5, 1859): 161, 182.

GB: 1860: EDINBURGH: PHOTOGRAPHIC SOCIETY OF SCOTLAND.
ST3426 "Sel D'Or." "Exhibition: Exhibition of the Photographic Society of Scotland." BRITISH JOURNAL OF PHOTOGRAPHY 7, no. 109, 112 (Jan. 1, Feb. 15, 1860): 13-14, 55-56. [M. Brady (New York, NY); H. P. Robinson; J. Mudd; J. Dixon Piper; Henry White; Maxwell Lyte; Morgan; Macpherson; Maull & Polyblank; Williamson (India); Charles Negre; Hay; Cramb Brothers; Ramage; Kirk; Zeigler; Walker; Roger; Moffats; Tunny; Valentine mentioned.]

GB: 1860: LIVERPOOL: LIVERPOOL SOCIETY OF FINE ARTS.
ST3427 "Exhibitions. Liverpool Society of Fine Arts. Exhibition of Paintings, Engravings, and Photographs, at the Queen's Hall, Liverpool." BRITISH JOURNAL OF PHOTOGRAPHY. 7, no. 117 (May 1, 1860): 136-137. [Rejlander, Robinson, Frith, Mudd, Fenton, Wm. Keith, Bedford, J. H. Morgan, Duckworth (India), W. G. Helsby (dags. of Tahiti, Copiapo, Chili and Bolivia) and "a Liverpool lady" mentioned.]

GB: 1860: LONDON: ARCHITECTURAL PHOTOGRAPHIC ASSOCIATION.
ST3428 "Fine Arts: Architectural Photographic Association." ATHENAEUM no. 1686 (Feb. 18, 1860): 243-244. [Review. Discusses work by Bisson, Cundall & Downes, Clifford, Ponti, Macpherson, Robertson & Beato, Melhuish, H. P. Robertson, Cade.]

ST3429 "Meetings of Societies: Architectural Photographic Association." BRITISH JOURNAL OF PHOTOGRAPHY 7, no. 112 (Feb. 15, 1860): 51-52. [Includes a paper by Prof. Donaldson, "Photography the Instructor of the Architect, and Architecture the Best Subject for the Photographer." This was, in effect, a precis of the Society's exhibition. Benford; Bent; Clifford; Cundall; Cocke; Downes; Fenton; Greenish; Macpherson; Melhuish; Ponti; others mentioned.]

SPECIAL TOPICS: EXHIBITIONS
GB: 1860: LONDON: PHOTOGRAPHIC SOCIETY.

SPECIAL TOPICS: EXHIBITIONS
GB: 1862: EDINBURGH: PHOTOGRAPHIC SOCIETY OF SCOTLAND.

ST3430 "Architectural Photographic Association: Third Annual Exhibition. Parts 1 - 2." PHOTOGRAPHIC NEWS 3, no. 78-79 (Mar. 2 - Mar. 9, 1860): 307-308, 319-320.

ST3431 "Exhibitions: Architectural Photographic Exhibition." BRITISH JOURNAL OF PHOTOGRAPHY 7, no. 114 (Mar. 15, 1860): 87-88.

GB: 1860: LONDON: PHOTOGRAPHIC SOCIETY.
ST3432 "Fine Arts: The Photographic Exhibition." ATHENAEUM no. 1682 (Jan. 21, 1860): 98-99. [Review.]

ST3433 "The Photographic Exhibition." PHOTOGRAPHIC NEWS 3, no. 73-74, 76-77 (Jan. 27 - Feb. 3, Feb. 17 - Feb. 24, 1860): 241-243, 253-255, 282-284, 294-296.

ST3434 "Exhibition: London Photographic Society's Exhibition." BRITISH JOURNAL OF PHOTOGRAPHY 7, no. 111, 113 (Feb. 1, Mar. 1, 1860): 41-42, 69-70. [Seventh Annual exhibition. Bedford; Fenton; Gutch; Hennah; John H. Morgan; H. P. Robinson; Rosling; Thompson; Williams; Henry White; F. M. Lyte; James Mudd; Lyndon Smith; Dixon Piper; J. Spode; Vernon Heath; A. J. Melhuish; Bisson Frères; Russell Sedgfield; Woodward; S. Bourne; Sykes Ward; Mrs. Verschoyl; others mentioned.]

ST3435 "Exhibition of the Photographic Society." ART JOURNAL (Mar. 1860): 71-72. [Seventh exhibition. Roger Fenton, C. Thurston Thompson, Lydon Smith, Alfred Rosling, F. Bedford, Cundall & Downes, Bisson Brothers, Henry P. Robinson, others mentioned.]

GB: 1860: SALFORD: PEEL PARK MUSEUM EXHIBITION.
ST3436 "Exhibition: Photographic Exhibition at Salford." BRITISH JOURNAL OF PHOTOGRAPHY. 7, no. 119 (June 1, 1860): 165-166. [Mudd, Wardley, Mabley, Higgins, Mann, Sidebotham, Compton, Thorpe, Young, others mentioned - primarily from the Manchester Photo. Society.]

GB: 1861.
ST3437 Cramb, John. "Photographic Competition. Award of Medals at Exhibitions and Elsewhere." BRITISH JOURNAL OF PHOTOGRAPHY 8, no. 154 (Nov. 15, 1861): 405-406.

ST3438 Brown, John Thomas. "Photographic Competition." BRITISH JOURNAL OF PHOTOGRAPHY 8, no. 155 (Dec. 2, 1861): 424-425.

GB: 1861: BIRMINGHAM: BIRMINGHAM PHOTOGRAPHIC SOCIETY.
ST3439 "Exhibition: Birmingham Photographic Society's Exhibition." BRITISH JOURNAL OF PHOTOGRAPHY 8, no. 143, 145, 147, 148, 155 (June 1, July 1, Aug. 1, Aug. 15, Dec. 2, 1861): 206, 238-239, 273-274, 293, 427.

GB: 1861: EDINBURGH: PHOTOGRAPHIC SOCIETY OF SCOTLAND.
ST3440 "Sel D'Or." "Exhibition of the Photographic Society of Scotland." BRITISH JOURNAL OF PHOTOGRAPHY 8, no. 136, 138 (Feb. 15, Mar. 15, 1861): 68-69, 109-110.

GB: 1861: LONDON.
ST3441 Thompson, S. "Notes on the Present Exhibitions." JOURNAL OF THE PHOTOGRAPHIC SOCIETY OF LONDON 7, no. 106 (Feb. 15, 1861): 110-113.

GB: 1861: LONDON:ARCHITECTURAL PHOTOGRAPHIC ASSOCIATION.
ST3442 "Fine Arts: Architectural Photographic Exhibition." ATHENAEUM no. 1735 (Jan. 26, 1861): 124-125. [Bisson Frères; Frith; Annan; Fenton; Bedford, others mentioned.]

ST3443 "The Exhibition of the Architectural Photographic Association." ART JOURNAL (Mar. 1861): 87-88.

GB: 1861: LONDON: PHOTOGRAPHIC SOCIETY.
ST3444 "Fine Arts: Photographic Society." ATHENAEUM no. 1734 (Jan. 19, 1861): 88-89. [600 photos in the annual exhibition. H. Hering; J. Macandrew; F. Mudd; R. Fenton; M. P. Dovizielli; the Earl of Caithness; Rev. J. M. Raven; R. Gordon; J. Cruttenden; Lyndon Smith; J. D. Piper; S. Thompson; others mentioned. Additional note on p. 232 (Feb. 16) mentioning that Prince Albert and Queen Victoria visited the exhibition and that "...the august visitors practice the art themselves."]

ST3445 "Fine Arts: The Photographic Societies." ILLUSTRATED LONDON NEWS 38, no. 1070 (Jan. 19, 1861): 68. [Photographic Society and the Architectural Photographic Association exhibition briefly reviewed.]

ST3446 "Exhibition: London Photographic Society's Exhibition." BRITISH JOURNAL OF PHOTOGRAPHY 8, no. 134, 136, 138 (Jan. 15, Feb. 15, Mar. 15, 1861.): 37-38, 67-68, 108-109. [Eighth annual exhibition.]

ST3447 "Criticisms on the Exhibition." JOURNAL OF THE PHOTOGRAPHIC SOCIETY OF LONDON 7, no. 106 (Feb. 15, 1861): 116-121.

ST3448 "Exhibition of the Photographic Society." ART JOURNAL (Feb. 1861): 47-48. [Eighth exhibition. Fenton, Bedford, Cundall & Downes, Caldesi, Maxwell Lyte, Vernon Heath, James Mudd, Maull & Polyblank, London Stereoscopic Co., Mayall, others mentioned.]

ST3449 "Limitation of Art by Photography." AMERICAN JOURNAL OF PHOTOGRAPHY AND THE ALLIED ARTS & SCIENCES n. s. vol. 4, no. 14 (Dec. 15, 1861): 320-321. [Excerpt of a review of the London Exhibition of 1861, from "Frazer's Magazine."]

GB: 1861: MANCHESTER: BRITISH ASSOCIATION.
ST3450 "The British Association at Manchester." JOURNAL OF THE PHOTOGRAPHIC SOCIETY OF LONDON 7, no. 113 (Sept. 15, 1861): 271-272.

ST3451 "Exhibitions: British Association for the Advancement of Science, by our eye-witness at Manchester." BRITISH JOURNAL OF PHOTOGRAPHY 8, no. 150-151 (Sept. 16 - Oct. 1, 1861): 330-331, 344-347. [Additional comments on the exhibition on p. 322.]

GB: 1862: EDINBURGH: PHOTOGRAPHIC SOCIETY OF SCOTLAND.
ST3452 "Sixth Exhibition of the Photographic Society of Scotland, at Edinburgh." JOURNAL OF THE PHOTOGRAPHIC SOCIETY OF LONDON 7, no. 117 (Jan. 15, 1862): 347-349.

ST3453 "Aur. Chl." "Exhibition: Sixth Annual Exhibition of the Photographic Society of Scotland." BRITISH JOURNAL OF PHOTOGRAPHY 9, no. 157 (Jan. 1, 1862): 10-11.

SPECIAL TOPICS: EXHIBITIONS
GB: 1862: LONDON: INTERNATIONAL EXHIBITION OF INDUSTRY.

SPECIAL TOPICS: EXHIBITIONS
GB: 1862: LONDON: INTERNATIONAL EXHIBITION OF INDUSTRY.

GB: 1862: LONDON: INTERNATIONAL EXHIBITION OF INDUSTRY.

BOOKS

ST3454 *Official Illustrated Catalogue of the International Exhibition. London, 1862.* The Illustrated Catalogue of the Industrial Department. British Division. Vols. I-II. London: Her Majesty's Printing Office, 1862. 4 vols. pp. [Illustrations of equipment and images, plus a listing, with information, of exhibitors. Photography was Class XIV, on pp. 47 - 63 in volume 2.]

PERIODICALS

ST3455 "Photography and the Exhibition of 1862." JOURNAL OF THE PHOTOGRAPHIC SOCIETY OF LONDON 7, no. 108 (Apr. 15, 1861): 147-149. [Dealing with the International Exhibition of Industry of 1862. Photographers noted.]

ST3456 "Editorial." BRITISH JOURNAL OF PHOTOGRAPHY 8, no. 141 (May 1, 1861): 157. [Bitter, sarcastic remarks about the managers of the forthcoming Exhibition of 1862, classing photographs with tools and not with the other art processes.]

ST3457 "Photography at the International Exhibition of 1862." BRITISH JOURNAL OF PHOTOGRAPHY 8, no. 142 (May 15, 1861): 180. [Exchange of letters between F. R. Sandford, Secretary of Her Majesty's Commissioners to the exhibition and Frederick Pollock; threatened boycott, etc., over the placing of photography among the tools. Additional information on p. 186.]

ST3458 "On the Classification of the International Exhibition of 1862 as Regards Photography." JOURNAL OF THE PHOTOGRAPHIC SOCIETY OF LONDON 7, no. 109 (May 15, 1861): 171-174. [The Commissioners of the International Exhibition decided to place photography in Section 2: "Photographic Apparatus and Photography" [technical], rather than in Section 4 [creative]. This decision created a storm of controversy that generated letters and statements from photographers and critics on the issue of whether photography was an art or not.]

ST3459 "On the Classification of the International Exhibition of 1862 as Regards Photography: Letters." JOURNAL OF THE PHOTOGRAPHIC SOCIETY OF LONDON 7, no. 110 (June 15, 1861): 195-197.

ST3460 "On the Classification of the International Exhibition of 1862 as Regards Photography: Articles from "Punch," "London Review."" JOURNAL OF THE PHOTOGRAPHIC SOCIETY OF LONDON 7, no. 110 (June 15, 1861): 204-206.

ST3461 "Note." ART JOURNAL (July 1861): 223. [Photographic Society complaining about being included in tools at the International Exhibit of 1862. Quotes from letter by Lord Chief Baron Sir F. Pollack.]

ST3462 "On the Classification of the International Exhibition of 1862 as Regards Photography: Letters." JOURNAL OF THE PHOTOGRAPHIC SOCIETY OF LONDON 7, no. 111 (July 15, 1861): 221-227.

ST3463 "Photography at the International Exhibition." BRITISH JOURNAL OF PHOTOGRAPHY 8, no. 146 (July 15, 1861): 247. [Editorial on controversy.]

ST3464 Claudet, A. "On the Classification of the International Exhibition of 1862 as Regards Photography: Letters." JOURNAL OF THE PHOTOGRAPHIC SOCIETY OF LONDON 7, no. 112 (Aug. 15, 1861): 240-244. [Letter from A. Claudet on the controversy.]

ST3465 "On the Classification of the International Exhibition of 1862 as Regards Photography." JOURNAL OF THE PHOTOGRAPHIC SOCIETY OF LONDON 7, no. 112 (Aug. 15, 1861): 255-256.

ST3466 "Photography at the Industrial Exhibition of 1862." BRITISH JOURNAL OF PHOTOGRAPHY 8, no. 147 (Aug. 1, 1861): 263-264, 266. [Commentary, letters on controversy. Additional letter on p. 266.]

ST3467 "A Suggestion to Artist-Photographers." BRITISH JOURNAL OF PHOTOGRAPHY 8, no. 148 (Aug. 15, 1861): 295. [Satiric commentary on the controversy.]

ST3468 Silvey, C. "On the Classification of the International Exhibition of 1862 as Regards Photography." JOURNAL OF THE PHOTOGRAPHIC SOCIETY OF LONDON 7, no. 113 (Sept. 16, 1861): 267-271.

ST3469 "On the Classification of the International Exhibition of 1862 as Regards Photography: Note about American Photography.." JOURNAL OF THE PHOTOGRAPHIC SOCIETY OF LONDON 7, no. 113 (Sept. 16, 1861): 272-273.

ST3470 "Photography at the International Exhibition." BRITISH JOURNAL OF PHOTOGRAPHY 8, no. 149 (Sept. 2, 1861): 299. [Bitter commentary on controversy.]

ST3471 Newton, W. J. "On the Classification of the International Exhibition of 1862 as Regards Photography: Photography and Fine Art." JOURNAL OF THE PHOTOGRAPHIC SOCIETY OF LONDON 7, no. 114 (Oct. 15, 1861): 279-280.

ST3472 Claudet, A. "On the Classification of the International Exhibition of 1862 as Regards Photography: Letter in Reply to Newton." JOURNAL OF THE PHOTOGRAPHIC SOCIETY OF LONDON 7, no. 114 (Oct. 15, 1861): 280-282.

ST3473 Hughes, C. Jabez. "The International Exhibition of 1862: What are the Arrangements made for Representing Photography There?" BRITISH JOURNAL OF PHOTOGRAPHY 8, no. 152 (Oct. 15, 1861): 359-361.

ST3474 "International Exhibition of 1862." BRITISH JOURNAL OF PHOTOGRAPHY 8, no. 153 (Nov. 1, 1861): 374-375. [Continued controversy.]

ST3475 "Photography at the International Exhibition." BRITISH JOURNAL OF PHOTOGRAPHY 8, no. 156 (Dec. 16, 1861): 435. [Committee appointed: the Earl of Caithness, Mr. Kater, Dr. Diamond, and Mr. P. Le Neve Foster.]

ST3476 Claudet, Antoine. "Supplementary Photographic Exhibition: Letter from M. Claudet to the Secretary of the London Photographic Society, on the question of a separate Exhibition of Photography as an Annex to the International Exhibition of 1862." BRITISH JOURNAL OF PHOTOGRAPHY 9, no. 162 (Mar. 15, 1862): 106-107.

ST3477 Wall, Alfred H. "Exhibition Gossip." BRITISH JOURNAL OF PHOTOGRAPHY 9, no. 163-176 (Apr. 1 - Oct. 15, 1862): 128-129, 149-151, 172-**, 186-**, 208-210, 230-231, 255-256, 273-274, 289, 316-317, 332-333, 351-352, 382-383. [** Missing issues.]

ST3478 "Photography at the International Exhibition." JOURNAL OF THE PHOTOGRAPHIC SOCIETY OF LONDON 8, no. 121 (May 15, 1862): 47-50.

SPECIAL TOPICS: EXHIBITIONS
GB: 1862: LONDON: SOUTH LONDON PHOTOGRAPHIC SOCIETY.

SPECIAL TOPICS: EXHIBITIONS
GB: 1863: LONDON: PHOTOGRAPHIC SOCIETY.

ST3479 "British Photography at the International Exhibition." BRITISH JOURNAL OF PHOTOGRAPHY 9, no. 168 (June 16, 1862): 231-232. [Extracted from the Official Catalogue of the photographs exhibited in the British Department. (Photographers were very bitter at how the fair officials had handled photography.)]

ST3480 "Photography at the International Exhibition." JOURNAL OF THE PHOTOGRAPHIC SOCIETY OF LONDON 8, no. 123 (July 15, 1862): 79-86. [List of prizewinners.]

ST3481 "'The Times' on Photography at the International Exhibition." JOURNAL OF THE PHOTOGRAPHIC SOCIETY OF LONDON 8, no. 124 (Aug. 15, 1862): 109-111.

ST3482 "Jurors' Awards in the Photographic Department of the International Exhibition." BRITISH JOURNAL OF PHOTOGRAPHY 9, no. 171 (Aug. 1, 1862): 290-292.

ST3483 "A Visit to London and the Exhibition, by a Scotch Photographer." BRITISH JOURNAL OF PHOTOGRAPHY 9, no. 172, 174, 177 (Aug. 15, Sept. 15, Nov. 1, 1862): 311-312, 352-353, 410-411.

ST3484 "Fading of Positive Views." AMERICAN JOURNAL OF PHOTOGRAPHY AND THE ALLIED ARTS & SCIENCES n. s. vol. 5, no. 3 (Aug. 1, 1862): 56-59. [From "Photo. News." Argument that bad exhibition situation at the London Exhibition injurious to the photographs.]

ST3485 Highley, Samuel. "International Exhibition: The Photographic Apparatus and Appliances." BRITISH JOURNAL OF PHOTOGRAPHY 9, no. 173, 175, 177-179 (Sept. 1, Oct. 1, Nov. 1, Nov. 15, Dec. 1, 1862): 331-332, 368-369, 413-414, 430-431, 450-451. [Four illustrations of the Ross panoramic camera, views taken by it, on p. 369.]

ST3486 "Photography at the International Exhibition." JOURNAL OF THE PHOTOGRAPHIC SOCIETY OF LONDON 8, no. 126 (Oct. 15, 1862): 153-155. [From the "London Times."]

ST3487 "Fine Arts: International Exposition: Photographs." ATHENAEUM no. 1825 (Oct. 18, 1862): 504-505. [Review of the exposition, critique of the works of the contributors. Negative comments about H. P. Robinson's "Holiday in the Wood."]

ST3488 "'The Times' on Photography at the International Exhibition." BRITISH JOURNAL OF PHOTOGRAPHY 9, no. 176 (Oct. 15, 1862): 395. [From "London Times."]

ST3489 "Report of Jurors of the International Exhibition. Class 14. Photography and Photographic Apparatus." JOURNAL OF THE PHOTOGRAPHIC SOCIETY OF LONDON 8, no. 128 (Dec. 15, 1862): 190-193. [History of photography from 1646 to 1852. Letter to W. H. F. Talbot for his permission to organize the Photo Club printed. (Talbot's copyright in 1850s could prohibit the organization.]

ST3490 "Report of Jurors of the International Exhibition. Class 14. Photography and Photographic Apparatus." JOURNAL OF THE PHOTOGRAPHIC SOCIETY OF LONDON 8, no. 135 (July 15, 1863): 321-324. [W. H. F. Talbot's reply to letter requesting permission to form club reprinted.]

ST3491 "Report of Jurors of the International Exhibition. Class 14. Photography and Photographic Apparatus." JOURNAL OF THE PHOTOGRAPHIC SOCIETY OF LONDON 8, no. 136 (Aug. 15, 1863): 339-346. [Apparatus detailed.]

ST3492 "Report of Jurors of the International Exhibition. Class 14. Photography and Photographic Apparatus." JOURNAL OF THE PHOTOGRAPHIC SOCIETY OF LONDON 8, no. 140-141 (Dec. 15, 1863, Jan. 15, 1864): 426-427, 447-448. [Apparatus detailed.]

GB: 1862: LONDON: SOUTH LONDON PHOTOGRAPHIC SOCIETY.
ST3493 R. A. S. "Exhibition: Exhibition of the South London Photographic Society." BRITISH JOURNAL OF PHOTOGRAPHY 9, no. 168, 172 (June 16, Aug. 15, 1862): 232-234, 315-316.

GB: 1863: EDINBURGH: PHOTOGRAPHIC SOCIETY OF SCOTLAND.
ST3494 "Aur. Chl." "Exhibition of the Photographic Society of Scotland." BRITISH JOURNAL OF PHOTOGRAPHY 10, no. 187 (Apr. 1, 1863): 145.

GB: 1863: FALMOUTH: ROYAL CORNWALL POLYTECHNIC SOCIETY: 1863.
ST3495 "Photography at the Exhibition of the Royal Cornwall Polytechnic Society." BRITISH JOURNAL OF PHOTOGRAPHY 10, no. 199 (Oct. 1, 1863): 390-391.

ST3496 "Miscellanea: Cornwall Polytechnic Society Prizes." JOURNAL OF THE PHOTOGRAPHIC SOCIETY OF LONDON 8, no. 138 (Oct. 15, 1863): 383. [Robinson: silver medal for best photo, Col. Stuart Wortley: silver medal for studies of sea & clouds, S. Thompson: bronze medal, S. H. Morgan, Clifton: bronze medal for trees, J. M. Tresidder, Esq. Surgeon, H.M.I.A. Prize for 3rd best amateur collection.]

GB: 1863: LONDON: PHOTOGRAPHIC SOCIETY.
ST3497 "Photography." ART JOURNAL (Jan. 1863): 38. [M. Claudet, Col. Stuart Wortley, Bedford, H. P. Robinson, others mentioned.]

ST3498 "Fine Arts: The Exhibition of the Photographic Society." ILLUSTRATED LONDON NEWS 42, no. 1184 - 1185 (Jan. 3, 1863): 66, 102-103. [Review of 9th exhibition.]

ST3499 "Exhibition: The Ninth Annual Exhibition of the Photographic Society (London)." BRITISH JOURNAL OF PHOTOGRAPHY 10, no. 182-185 (Jan. 15, - Mar. 2, 1863): 31-33, 53, 99-100. [Review of show; includes a poem written in response to H. P. Robinson's "Bringing Home the May," etc.]

ST3500 Fenton, R. and J. Durham. "Report of Committee to Award Medals in the Photographic Exhibition." JOURNAL OF THE PHOTOGRAPHIC SOCIETY OF LONDON 8, no. 130 (Feb. 15, 1863): 220-221. [Amateurs Medal: Lady Hawarden; Figure Composition: Robinson ("Bringing Home the May"); Reproductions: Thurston Thompson; Instantaneous views: Col. S. Wortley; Landscape Subjects: Bedford; Portraits: Claudet; Cartes-de-visite: Jubert.]

ST3501 "Award of Medals." BRITISH JOURNAL OF PHOTOGRAPHY 10, no. 184 (Feb. 16, 1863): 69-70. [Six medals awarded at the London Photo Soc. Exhibition to: A. Claudet, Francis Bedford, Lt. Col. Stuart Wortley, Lady Hawarden, H. P. Robinson and Thurston Thompson.]

SPECIAL TOPICS: EXHIBITIONS
GB: 1864: FALMOUTH: ROYAL CORNWALL POLYTECHNIC SOCIETY.

SPECIAL TOPICS: EXHIBITIONS
GB: 1872: LONDON: PHOTOGRAPHIC SOCIETY.

GB: 1864: FALMOUTH: ROYAL CORNWALL POLYTECHNIC SOCIETY.

ST3502 "The Royal Cornwall Polytechnic Society." BRITISH JOURNAL OF PHOTOGRAPHY 11, no. 228 (Sept. 16, 1864): 356. [Exhibition reviewed, list of award winners, etc.]

GB: 1864: LONDON: PHOTOGRAPHIC SOCIETY.

ST3503 "The Forthcoming Photographic Exhibition." PHOTOGRAPHIC NEWS 8, no. 289 (Mar. 18, 1864): 133-134. [Outlines categories acceptable, discusses controversial elimination of 'composite' category.]

ST3504 "Exhibition of the London Photographic Society." BRITISH JOURNAL OF PHOTOGRAPHY 11, no. 215, 220, 223 (June 1, July 22, Aug. 19, 1864): 187-188, 260-261, 301-302.

ST3505 "The Photographic Exhibition." PHOTOGRAPHIC NEWS 8, no. 300-306 (June 3 - July 15, 1864): 265-266, 302-303, 339-340. [10th annual exhibition. 267 "frames," all but one by the wet-collodion process. "Studies and Genre Subjects." H. P. Robinson and Viscountess Hawarden discussed. Henry Cooper; J. Hubbard; Ross & Thompson; (Rejlander did not exhibit.) mentioned (pp. 302-303) "Portraiture." Claudet; Joubert; Williams; Maull & Polyblank; H. P. Robinson, others mentioned (pp. 339-340).]

ST3506 "The Photographic Exhibition." ART JOURNAL (July 1864): 210. [H. P. Robinson, T. R. Williams, F. Joubert, Claudet, Lucas Brothers, Viscountess Hawarden, T. Annan, others mentioned.]

GB: 1865: DUBLIN: DUBLIN EXHIBITION.

ST3507 "Photography at the Dublin Exhibition." BRITISH JOURNAL OF PHOTOGRAPHY 12, no. 263-268 (May 19 - June 23, 1865): 268, 280-281, 291-292, 332-333.

ST3508 "Exhibitions: Photography at the Dublin Exhibition. Section XXX - Photography. List of Awards." BRITISH JOURNAL OF PHOTOGRAPHY 12, no. 283 (Oct. 6, 1865): 512-513.

GB: 1865: EDINBURGH: PHOTOGRAPHIC SOCIETY OF SCOTLAND.

ST3509 "Exhibition: Photographic Society of Scotland." BRITISH JOURNAL OF PHOTOGRAPHY 12, no. 245-248 (Jan. 13 - Feb. 3, 1865): 20, 30-31, 46, 60-61. [J. M. Cameron; H. P. Robinson; Adamson; W. Neilson; T. B. Johnston; Dalles; Mudd; W. H. Warner; Vernon Heath; Stephen Thompson; John Nicol; D. H. Macfarlane; John Peat; Fox Talbot; Pouncy; others mentioned. The third and fourth parts of the review discusses "The Artistic Side of the Question."]

GB: 1865: LONDON: PHOTOGRAPHIC SOCIETY.

ST3510 "The Photographic Exhibition." PHOTOGRAPHIC NEWS 9, no. 348-349 (May 5 - May 12, 1865): 205-206, 217-218. [11th annual exhibition. H. P. Robinson; Twyman; Blanchard; Silas Eastham; James Ross; Dr. Hemphill; H. Cooper; F. Bedford; J. Mudd; Wm. England; MacFarlane; Buxton; Dr. Maddox; G. Wharton Simpson; others mentioned.]

ST3511 "Exhibitions: The Photographic Society's Exhibition." BRITISH JOURNAL OF PHOTOGRAPHY 12, no. 263 (May 19, 1865): 267-268.

ST3512 "The London Photographic Exhibition." PHOTOGRAPHIC NEWS 9, no. 355 (June 30, 1865): 309-310. [From "Illus. London News."]

ST3513 "The Photographic Exhibition." ART JOURNAL (1865): 227. [Brief note.]

GB: 1865: LONDON: NORTH LONDON PHOTOGRAPHIC ASSOCIATION.

ST3514 "Exhibition: Exhibition of the North London Photographic Association." BRITISH JOURNAL OF PHOTOGRAPHY 12, no. 276-286 (Aug. 18 - Oct. 27, 1865): 431, 443-444, 454, 468-469, 473-474, 480-481, 493-494, 505-506, 513, 517, 541, 548-549, 553-554. [Includes storm of letters protesting the medals awarded.]

GB: 1865: LONDON: SOUTH-EASTERN INDUSTRIAL EXHIBITION.

ST3515 "South-Eastern Industrial Exhibition." BRITISH JOURNAL OF PHOTOGRAPHY 12, no. 295 (Dec. 29, 1865): 657. [Only half dozen exhibitors in photography: Sergeant White, Royal Artillery; Edwin Cocking; Cormack Brown; Hatt; Miss Colgate.]

GB: 1868: LONDON: ARCHITECTURAL PHOTOGRAPHIC ASSOCIATION.

ST3516 "Photographs of the Architectural Photographic Society." ART JOURNAL (Apr. 1868): 73-74.

GB: 1870: LONDON: PHOTOGRAPHIC SOCIETY.

ST3517 "The Exhibition of the Photographic Society." ART JOURNAL (1870): 376. [Col. Stuart Wortley, H. P. Robinson, J. M. Cameron, F. C. Earl, V. Heath, V. Blanchard, Slingsby, Warwick Brookes, W. D. Sanderson, Rejlander, T. M. Brownrigg, Dr. Wallich, Capt. E. D. Lyon, Stephen Thompson, others mentioned.]

ST3518 Simpson, G. Wharton. "The Annual Exhibition of the Photographic Society." ART PICTORIAL AND INDUSTRIAL 1, no. 6 (Dec. 1870): 125-127. ["The revival by the Photographic Society of the system of holding an annual exhibition, which for some years fell into disuse,..." V. Blanchard; B. J. Edwards; Robinson & Cherrill; Mrs. J. M. Cameron; Col. Wortley; Rejlander; W. Brookes; Hubbard; Earl; others mentioned.]

GB: 1871: LONDON: INTERNATIONAL EXHIBITION.

ST3519 Wortley, Lieut.-Colonel Stuart. "Official Reports on the International Exhibition." ART PICTORIAL AND INDUSTRIAL 2, no. 14 (1871): 49-53. [Excerpts from the "Official Reports," printed by J. M. Johnson & Sons. Wortley reported on "Photography" on pp. 52-53.]

ST3520 "Photography at the International Exhibition." ANTHONY'S PHOTOGRAPHIC BULLETIN 2, no. 11 (Nov. 1871): 341-342. [From "London Photo. News."]

GB: 1871: LONDON: PHOTOGRAPHIC SOCIETY.

ST3521 "The London Society's Annual Exhibition." ANTHONY'S PHOTOGRAPHIC BULLETIN 3, no. 1 (Jan. 1872): 411-413. [From "Photo. J."]

GB: 1872: LONDON: PHOTOGRAPHIC SOCIETY.

ST3522 "Minor Topics of the Month: The Photographic Society." ART JOURNAL (1872): 313. [Brief note of the exhibition.]

ST3523 Simpson, G. Wharton, M.A., F.S.A. "Notes In and Out of the Studio." PHILADELPHIA PHOTOGRAPHER 9, no. 97 (Jan. 1872): 19-21. [This article devoted to the Annual Exhibition at the Royal Photo. Soc.]

SPECIAL TOPICS: EXHIBITIONS
GB: 1873: LONDON: PHOTOGRAPHIC SOCIETY.

SPECIAL TOPICS: EXHIBITIONS
USA: 1847: BOSTON:MASSACHUSETTS CHARITABLE MECHANIC ASSOCIATION.

ST3524 Stillman, W. J. "Photographic Exhibitions." PHOTOGRAPHIC TIMES 2, no. 19 (July 1872): 103-104. [Review of the R.P.S. exhibition in London, from "The Nation."]

GB: 1873: LONDON: PHOTOGRAPHIC SOCIETY.
ST3525 "Exhibition of the Photographic Society, 9 Conduit Street." ART JOURNAL (1873): 20. [A. L. Henderson, Col. Stuart Wortley, A. Boucher, B. Scott & Son, Lock & Whitfield, Window & Grove, O. G. Rejlander, Robinson & Cherrill, G. Cooper, T. M. Brownrigg, Vernon Heath, others mentioned.]

ST3526 "The Winter Exhibitions: Photographic Society." ILLUSTRATED LONDON NEWS 63, no. 1784 (Nov. 8, 1873): 443.

GB: 1874: LONDON: PHOTOGRAPHIC SOCIETY.
ST3527 "Minor Topics of the Month: The Photographic Society." ART JOURNAL (1874): 350-351. [Brief note. Robinson & Cherrill, Col. H. Dixon, Pendryl Hall, O. G. Rejlander, R. Faulkner, others mentioned.]

ST3528 "The Photographic Exhibition - Final Notice - Enlargements." ANTHONY'S PHOTOGRAPHIC BULLETIN 5, no. 2 (Feb. 1874): 74-75. [From "London Photo. News." Starke (Zanesville, OH); Josiah Smith; A. Homer; Vernon Heath; Messrs. Downey; B. J. Edwards; Cox; Netterville Briggs; Wm. England; Hedges; Capt. Abney; Sebah (Constantinople); others mentioned.]

ST3529 "Fine Arts." ILLUSTRATED LONDON NEWS 65, no. 1834 (Oct. 17, 1874): 366. [Brief one paragraph comment on annual exhibition. "There seems to be nothing new and important to chronicle of the progress of photography, either regarded as art or science, during the past year."]

ST3530 "Exhibition of the Photographic Society." ANTHONY'S PHOTOGRAPHIC BULLETIN 5, no. 12 (Dec. 1874): 402-403. [From "London Graphic."]

GB: 1875: LONDON: PHOTOGRAPHIC SOCIETY.
ST3531 "The Photographic Society." ART JOURNAL (1875): 349. [Review of annual exhibition. J. A. Todd, Capt. Abney, Davanne, Hugo Thiele, V. Blanchard, R. Faulkner, Chaffin & Sons, O. G. Rejlander (posthumously), D. L. Mundy, Capt. Horatio Ross, R. T. Crawshay, G. W. Wilson, W. Bedford, others mentioned.]

ST3532 "Fine Arts. Exhibition of the Photographic Society." ILLUSTRATED LONDON NEWS 67, no. 1886 (Oct. 2, 1875): 330.

GB: 1876: LONDON: PHOTOGRAPHIC SOCIETY.
ST3533 "The Photographic Society's Exhibition." ART JOURNAL (1876): 350. [Col. S. Wortley, Wm. Bedford, Robert Crawshay, Royal Engineers (with Capt. Abney), A. Boucher, R. Faulkner & Co., J. M. Cameron, others mentioned.]

ST3534 "Fine Arts: The Photographic Society." ILLUSTRATED LONDON NEWS 69, no. 1938 (Sept. 16, 1876): 278.

GB: 1877: EDINBURGH: EDINBURGH PHOTOGRAPHIC SOCIETY.
ST3535 "Edinburgh Photographic Societies Exhibition." ANTHONY'S PHOTOGRAPHIC BULLETIN 7, no. 8 (Aug. 1876): 252. [Announcement, list of conditions, awards for the forthcoming exhibition.]

GB: 1877: LONDON: PHOTOGRAPHIC SOCIETY.
ST3536 "The Photographic Society." ART JOURNAL (1877): 350. [Royal Engineers School of Photography, Col. Stuart Wortley, R.

Slingsby, R. Faulkner, H. Baden Pritchard, F. Beasley, G. Nesbitt, H. P. Robinson, H. Painter, others mentioned.]

ST3537 "The Photographic Exhibition." NATURE 16, no. 416 (Oct. 18, 1877): 525-526.

GB: 1878: LONDON: PHOTOGRAPHIC SOCIETY.
ST3538 "The Photographic Society." ART JOURNAL (1878): 228. [Vernon Heath, P. Jennings, Bedford, England, Miss. A. W. Wilson, George Nesbitt, J. Chaffin, others mentioned.]

ST3539 "The London Press and the Photographic Exhibition." ANTHONY'S PHOTOGRAPHIC BULLETIN 9, no. 12 (Dec. 1878): 360-361. [From "London Photo. News."]

GB: 1879: LONDON: PHOTOGRAPHIC SOCIETY.
ST3540 "Photographic Exhibition." ART JOURNAL (1879): 276. [Payne Jennings, James Russell & Sons, Col. Stuart Wortley, Wratten & Wainwright, W. Willis Jr., A. T. Penn, I. Gale, Leon Warnecke, Lombardi, Lock & Whitfield, Thomas & Robert Annan, Rev. B. T. Thompson, others mentioned.]

ST3541 "Fine Arts. Photographic Exhibition." ILLUSTRATED LONDON NEWS. 75, no. 2104 (Oct. 11, 1879): 324-343.

INDIA: 1856: BOMBAY.
ST3542 "Exhibition of Photographs at Bombay." HUMPHREY'S JOURNAL 8, no. 15 (Dec. 1, 1856): 233-235. [From "Liverpool Photo. J." Mentions Capt. H. J. Barr; Capt. Biggs; Maj. Gill; Capt. A. J. Greenlaw; Dr. N. Dajee; Mr. W. H. S. Crawford; Mr. J. W. Robertson; W. Henderson; Mr. Hinton; W. Johnson; Dr. G. R. Ballingall; Mr. H. Chinatamon; J. Waterston; Mr. Henderson.]

INDIA: 1875: CALCUTTA: BENGAL PHOTOGRAPHIC SOCIETY.
ST3543 "Bengal Photographic Society: Rules for the Nineteenth Annual Exhibition, 1876." ANTHONY'S PHOTOGRAPHIC BULLETIN 6, no. 8 (Aug. 1875): 249-251.

USA: 1841: BOSTON: MASSACHUSETTS CHARITABLE MECHANIC ASSOCIATION.
ST3544 Massachusetts Charitable Mechanic Association. "Exhibition... [Reports of the judges, etc.] Third exhibition... held Sept. 20, 1841...: Fine Arts." Boston, (1841): 87-100. [Lists: Whipple; Southworth & Hawes; Gerrould & Smith; Huddleston; Keene & Cannon; H. I. Abel; M. N. Wesson; J. Plumbe; G. Evans; Hale & Smith.]

USA: 1844: BOSTON: MASSACHUSETTS CHARITABLE MECHANIC ASSOCIATION.
ST3545 Massachusetts Charitable Mechanic Association. "Exhibition... [Reports of the judges, etc.] Fourth exhibition... held Sept. 16, 1844...: Fine Arts." Boston, (1844): 22-37. [Mentions: Plumbe; Southworth; Long; Hale; Eames.]

USA: 1847: BOSTON:MASSACHUSETTS CHARITABLE MECHANIC ASSOCIATION.
ST3546 Massachusetts Charitable Mechanic Association. "Exhibition... [Reports of the judges, etc.] Fifth exhibition... held Sept. 1847...: Fine Arts." Boston, (1847): 18-31. [Mentions: Southworth & Hawes; J. A. Whipple; Lerow; Hale; Root; R. Plumbe; J. Plumbe; Pettee; Foss; Cannon; Miss N. N. Southworth; Shew.]

SPECIAL TOPICS: EXHIBITIONS
USA: 1850: BOSTON: MASSACHUSETTS CHARITABLE MECHANIC ASSOCIATION.

SPECIAL TOPICS: EXHIBITIONS
USA: 1853: NEW YORK: CRYSTAL PALACE.

USA: 1850: BOSTON: MASSACHUSETTS CHARITABLE MECHANIC ASSOCIATION.

ST3547 Massachusetts Charitable Mechanic Association. "Exhibition... [Reports of the judges, etc.] Sixth exhibition... held Sept. 1850...: Fine Arts." Boston, (1850): 147-150. [Mentions: Chase; Catham; Hale; Whipple; Southworth & Hawes; Upton; Thayer; Clark; Starkweather; Lancey & Co., Ives; Whipple & Jones; Perry.]

USA: 1850: NEW YORK: AMERICAN INSTITUTE FAIR.

ST3548 "American Institute." DAGUERREIAN JOURNAL 1, no. 1 (Nov. 1, 1850): 17. [Daguerreotypes by Gurney, Root, Meade Brothers, Gavit, and Cary displayed at the Fair.]

USA: 1851: CINCINNATI: OHIO MECHANICS INSTITUTE FAIR.

ST3549 Earl, Austin T. "Gossip: Letter." PHOTOGRAPHIC ART JOURNAL 2, no. 5 (Nov. 1851): 316-317. [Boyce; Hawkins; Faris; Fontayne & Porter, Lippencott & Carter mentioned.]

USA: 1851: NEW YORK: AMERICAN INSTITUTE FAIR.

ST3550 "Fair of the American Institute. Daguerreotypes." DAGUERREAN JOURNAL 2, no. 11 (Oct. 15, 1851): 340-342. [Extensive review.]

ST3551 "The Daguerrean Journal." DAGUERREAN JOURNAL 3, no. 1 (Nov. 15, 1851): 17-18. [Commentary on judging practices for the American Institute exhibitions.]

USA: 1851: ROCHESTER: NEW YORK STATE FAIR.

ST3552 "State Fair." DAGUERREAN JOURNAL 2, no. 10 (Oct. 1, 1851): 305. [Awards to O. B. Evans (Buffalo, NY); Whitney (Rochester, NY); McDonald (Buffalo, NY).]

USA: 1852: CLEVELAND: OHIO STATE FAIR.

ST3553 "State Fair of Ohio." HUMPHREY'S JOURNAL 4, no. 14 (Nov. 1, 1852): 219. [A. Bisbee (Dayton, OH) won first premium. M. A. & S. Root (New York, NY and Philadelphia, PA); Johnson & Fellows (Cleveland, OH); W. C. North (Cleveland, OH); Partridge (Wheeling, WV); McDonnell (Buffalo, NY) participated.]

USA: 1852: NEW YORK: AMERICAN INSTITUTE FAIR.

ST3554 "B." "Gossip: Daguerreotypes at the Fair." PHOTOGRAPHIC ART JOURNAL 4, no. 4 (Oct. 1852): 258-260. [Root, Gurney (won 1st prize), Meade Bro., Holmes, Insley, Brunkehoff & Co., Holt, Butler. The Fair of the American Institute reviewed.]

ST3555 Humphrey, S. D. "Editorial: The Annual Exhibition of the American Institute - List of Daguerreotypists exhibiting." HUMPHREY'S JOURNAL 4, no. 13 (Oct. 15, 1852): 201-202. [J. Gurney, H. E. Insley, Holmes, Root, Meade Brothers, L. L. Lewis, Thomson, Holt, Thomson & Davis listed.]

ST3556 Humphrey, S. D. "Editorial: Fair of the American Institute." HUMPHREY'S JOURNAL 4, no. 15 (Nov. 15, 1852): 233. [Commentary. Mentions J. Gurney; Meade Brothers; Insley; Harrison (cameramaker); Duryea (equipment).]

ST3557 "Daguerreotypes at the American Institute." HUMPHREY'S JOURNAL 4, no. 15 (Nov. 15, 1852): 234-235. [Gurney, Meade Brothers; S. Root; M. A. & S. Root; Thompson; Holmes; Brinkerhoff & Co. discussed.]

USA: 1852: PHILADELPHIA: FRANKLIN INSTITUTE FAIR.

ST3558 "Daguerreotypes at the Franklin Institute." HUMPHREY'S JOURNAL 4, no. 15 (Nov. 15, 1852): 238. [F. D. B. Richards; M. A.

Root; Broadbent & Co.; J. Woolen; C. M. Ising; L. Maester; Swift & Machan; R. M. Keely.]

USA: 1853: BOSTON: MASSACHUSETTS CHARITABLE MECHANIC ASSOCIATION.

ST3559 Massachusetts Charitable Mechanic Association. "Exhibition... [Reports of the judges, etc.] Seventh exhibition... held Sept. 1853...: Daguerreotypes." Boston, (1853): 104-105. [Mentions: G. K. Warren; J. A Whipple; Masury & Silsbee; C. Thayer; L. H. Hale; Southworth & Hawes; P. G. Clark.]

USA: 1853: CHICAGO: ILLINOIS MECHANICS FAIR.

ST3560 "Gossip." PHOTOGRAPHIC ART JOURNAL 6, no. 5 (Nov. 1853): 322-323. [Review, from the "Chicago Democratic Press," of the Illinois Mechanics Fair in Chicago. Discusses paintings by several individuals and mentions Alexander Hesler (Galena, IL); J. H. Taylor (Springfield, IL); C. C. Kelsey (Chicago, IL); P. Van Schneidau (Chicago, IL); W. G. Chamberlain (Chicago, IL); H. P. Danks (Chicago, IL); E. G. Stiles (Chicago, IL); and Miss Miller (Chicago, IL).]

USA: 1853: CINCINNATI: OHIO MECHANICS INSTITUTE FAIR.

ST3561 "Sidonia." "Communication: Fair of the Ohio Mechanics Institute. Dec. 15, 1852." PHOTOGRAPHIC ART JOURNAL 5, no. 1 (Jan. 1853): 15. [Diploma awarded: Thomas Faris, silver medal to E. C. Hawkins, Mentioned: Fontayne, Porter, Potter, Erwin Leppincott & Carter, Fithian, Davis, and the younger Hawkins as younger workers.]

USA: 1853: NEW YORK: CRYSTAL PALACE.

ST3562 "Daguerreotypes at the Crystal Palace." HUMPHREY'S JOURNAL 5, no. 9 (Aug. 15, 1853): 139-143. [Extended review from "NY Tribune."] "Gossip." PHOTOGRAPHIC ART JOURNAL 6, no. 3 (Sept. 1853): 191-194. [Mentions Lawrence; Gurney; D. Clark; Van Schneidau; J. Brown (Perry's Expedition to Japan); Haas; Harrison & Hill; Webster; A. Hesler; North; Bisbee; Williamson; Dobyns, Richardson & Co.; Long; Fitzgibbon; Masury & Silsbee; Whipple; McDonnell & Co.; Hawkins; Drummond; Whitehurst.]

ST3563 "Gossip." PHOTOGRAPHIC ART JOURNAL 6, no. 3 (Sept. 1853): 191-194. [Includes a review of the New York Crystal Palace Exhibition, titled 'American Art-Daguerreotypes.' From the "NY Herald Tribune," and a letter of reply from Gabriel Harrison on pp. 194-195. Lawrence; Gurney; D. Clark (New Brunswick, NJ); Van Schneidau; J. Brown; Haas; Webster (Louisville, KY); A. Hesler; Harrison & Hill; Long (St. Louis); North (Cleveland); Bisbee; Fitzgibbon; Masury & Silsbee (Boston); Whitehurst; Whipple; Williamson; Dobyns, Richardson & Co.; McDonnell & Co. (Buffalo); Hawkins; Drummond; mentioned.]

ST3564 "Jury on Daguerreotypes at the New York Crystal Palace." HUMPHREY'S JOURNAL 5, no. 15 (Nov. 15, 1853): 234. [List of 17 jurors of "Class Ten: Philosophical Instruments and Products resulting from their Use, Daguerreotypes, etc..." John W. Draper one of the jurors.]

ST3565 "Daguerreotypes at the World's Fair." PHOTOGRAPHIC AND FINE ART JOURNAL 7, no. 1 (Jan. 1854): 14-16. [Describes work of contributors: J. Gurney; Whipple; North (Cincinnati, OH); A. Bisbee (Dayton, OH); C. H. Williamson (S. Brooklyn, NY); James Brown; Clark (New Brunswick, NJ); Von Schneidau (Chicago, IL); Haas (New York, NY); Harrison & Hill (Brooklyn); A. Hesler (Galena, IL); Webster & Bro. (Louisville, KY); M. A. Root (Philadelphia, PA); S. Root (New York, NY); Mr. Kimball (Louisville, KY); E. Long (St. Louis, MO); Masbury & Silsbee (Boston, MA); M. M. Lawrence; Fitzgibbon (St. Louis, MO); Meade Brothers [Series, "7 Ages of Man," illust. of

SPECIAL TOPICS: EXHIBITIONS
USA: 1854: CHICAGO: CHICAGO MECHANICS INSTITUTE.

SPECIAL TOPICS: EXHIBITIONS
USA: 1860: BOSTON: MASSACHUSETTS CHARITABLE MECHANIC ASSOCIATION.

Shakespeare]; Howe (Portland, ME); Whitehurst (Baltimore, MD); M. B. Brady; also views of the Crystal Palace in London by Kilburn (London).]

ST3566 "New York Industrial Exhibition. Report of Jury. F. Class, 10. Daguerreotypes, etc." HUMPHREY'S JOURNAL 5, no. 19 (Jan. 15, 1854): 299. [List of winners, etc.]

ST3567 "By a New Contributor." "Daguerreotypes at the Crystal Palace, New York." PHOTOGRAPHIC AND FINE ART JOURNAL 7, no. 4 (Apr. 1854): 103-105.

ST3568 "Justice." "Justice's Reply to Mr. McDonald's Letter." PHOTOGRAPHIC AND FINE ART JOURNAL 7, no. 7 (July 1854): 220-221. [Reply to criticism of his criticism of the NY Crystal Palace exhibition.]

USA: 1854: CHICAGO: CHICAGO MECHANICS INSTITUTE.
ST3569 "State Fairs." PHOTOGRAPHIC AND FINE ART JOURNAL 7, no. 11 (Nov. 1854): 347-348. [Alex. Hesler, Von Schneidau, Kelsey, Chamberlain & Stiles exhibited.]

USA: 1855: NEW YORK: AMERICAN INSTITUTE FAIR.
ST3570 "A Visit to the Fair of the American Institute of 1855." PHOTOGRAPHIC AND FINE ART JOURNAL 8, no. 12 (Dec. 1855): 353-354.

USA: 1855: PHILADELPHIA: FRANKLIN INSTITUTE FAIR.
ST3571 "Mercury." "Fair of the Franklin Institute, Philadelphia, Pa." PHOTOGRAPHIC AND FINE ART JOURNAL 8, no. 1 (Jan. 1855): 23-24. [Richards; Meade & Brother; Root; Richards & Betts; Rhen; Weeks; Willard; Van Loan; Burns & Rust; Johnson & Long; Williams; Hoffy; Phillips; Brown; Masher; others mentioned.]

ST3572 "Mercury." "Fair of the Franklin Institute, Philadelphia, Pa." PHOTOGRAPHIC AND FINE ART JOURNAL 8, no. 1 (Jan. 1855): 23-24. [Richards; Meade & Brothers; Root; Richards & Betts; Rhen; Weeks; Willard; Van Loan; Burns & Rust; Johnson & Long; Williams; Hoffy; Phillips; Brown; Masher; others mentioned.]

ST3573 Root, Marcus A. "The Franklin Institute and State Fair Exhibitions." PHOTOGRAPHIC AND FINE ART JOURNAL 8, no. 2 (Feb. 1855): 57-59. [Criticisms of the awards. M. A. R. is Marcus A. Root.]

ST3574 Root, Marcus A. "The Franklin Institute and State Fair Exhibitions." PHOTOGRAPHIC AND FINE ART JOURNAL 8, no. 2 (Feb. 1855): 57-59. [Criticisms of the awards.]

ST3575 Richards, F. D. B. "The Franklin Institute Exhibitions. Reply to M. A. R." PHOTOGRAPHIC AND FINE ART JOURNAL 8, no. 3 (Mar. 1855): 77-78. [Exchange of grievances between Richards and M. A. Root, about alleged unfairness of judging.]

ST3576 "Philo Photas." "'Know Thyself.'" PHOTOGRAPHIC AND FINE ART JOURNAL 8, no. 3 (Mar. 1855): 87. [Further developments in M. A. Root, Richards controversy.]

ST3577 Root, M. A. "Know Thyself." PHOTOGRAPHIC AND FINE ART JOURNAL 8, no. 6 (June 1855): 190-191. [Letter replying to previous letters around the controversy of the judging of the Franklin Institute Fair Exhibition.]

USA: 1856: BOSTON: MASSACHUSETTS CHARITABLE MECHANIC ASSOCIATION.
ST3578 Massachusetts Charitable Mechanic Association. "Exhibition... [Reports of the judges, etc.] Eighth exhibition... held Sept. 1856...: Photography." Boston, (1856): 131-139. [Mentions: Masury, Silsbee & Case; Southworth & Hawes; Hester; Whipple & Black; D. W. Bowdoin; W. Winter; A. Hesler; M. S. Cahill; G. K. Warren; G. V. Allen; M. Ormsbee; Michael Woods (Daguerreotype Cases).]

USA: 1856: CLEVELAND: OHIO STATE FAIR.
ST3579 C. "Ohio State Fair." PHOTOGRAPHIC AND FINE ART JOURNAL 9, no. 11 (Nov. 1856): 349. [Ryder; North; Boisseau; Stimpson; Messrs. Short; Bisbee; Collins; Whitehurst.]

USA: 1856: NEW YORK: AMERICAN INSTITUTE FAIR.
ST3580 "Personal & Art Intelligence." PHOTOGRAPHIC AND FINE ART JOURNAL 9, no. 12 (Dec. 1856): 384. [List of award winners.]

USA: 1857: NEW YORK: AMERICAN INSTITUTE FAIR.
ST3581 "Fair of the American Institute for 1857. Photographic Department." PHOTOGRAPHIC AND FINE ART JOURNAL 10, no. 11 (Nov. 1857): 346-348. [Predominance of photography over daguerreotypes. S. A. Holmes; Hufnagel & Co.; C. D. Fredericks; Meade Brothers; J. Gurney; M. B. Brady; M. M. Lawrence; G. N. Barnard (exhibiting pictures on boxwood, for engraving); R. Newell & Co; C. J. B. Waters; A. Beckers; E. Anthony; C. C. Harrison; W. H. Lewis, etc.]

USA: 1858: BALTIMORE: MARYLAND INSTITUTE FAIR.
ST3582 J. R. J. "Photography at the Maryland Institute Fair." PHOTOGRAPHIC AND FINE ART JOURNAL 11, no. 1 (Jan. 1858): 12. [P. L. Perkins; J. H. Whitehurst; Israel; Pollock; B. F. Hawkes; Davis; Waltzl; Tuttle; Dan Stiltz; others mentioned.]

USA: 1858: NEW YORK: AMERICAN INSTITUTE FAIR.
ST3583 "Photography at the American Institute." AMERICAN JOURNAL OF PHOTOGRAPHY AND THE ALLIED ARTS AND SCIENCES n. s. vol. 1, no. 1 (June 1, 1858): 10-13.

ST3584 Seeley, Charles A. "Editorial Miscellany." AMERICAN JOURNAL OF PHOTOGRAPHY AND THE ALLIED ARTS AND SCIENCES n. s. vol. 1, no. 9 (Oct. 1, 1858): 145. [Criticism that the photography displayed at the American Institute Fair was much weaker than the previous year.]

USA: 1858: PHILADELPHIA: FRANKLIN INSTITUTE FAIR.
ST3585 "Junius." "Fair of the Franklin Institute - Heliographic Department." PHOTOGRAPHIC AND FINE ART JOURNAL 11, no. 11 (Nov. 1858): 346-347. [Mentions Richards; Walter Dinmore (taken by Dr. Langdell); Willard; Broadbent & Co.; Root Gallery (now run by Cook).]

USA: 1859: PHILADELPHIA: FRANKLIN INSTITUTE FAIR.
ST3586 "Justice." "Reply to "Junius."" PHOTOGRAPHIC AND FINE ART JOURNAL 12, no. 1 (June 1859): 10. [Letter discussing photographers exhibiting at the Franklin Inst. Fair, who were either ignored or slighted in an earlier review. Reimer; Dr. J. H. Bushnell; Cook's Gallery, under the management of Mr. McCormic.]

USA: 1860: BOSTON: MASSACHUSETTS CHARITABLE MECHANIC ASSOCIATION.
ST3587 Massachusetts Charitable Mechanic Association. "Exhibition... [Reports of the judges, etc.] Ninth exhibition... held Sept. 1860...: Photography." Boston, (1860): 120-123. [Mentions: Black &

SPECIAL TOPICS: EXHIBITIONS
USA: 1864: NEW YORK: METROPOLITAN FAIR.

SPECIAL TOPICS: EXHIBITIONS
USA: 1869: NEW YORK: AMERICAN INSTITUTE FAIR.

Bachelder; Southworth & Hawes; Whipple; Silsbee, Case & Co.; Deloss Barnum; Bierstadt Bros.; Samuel Masury.]

ST3588 "Ex-Photo." "The Mechanic's Fair in Boston." HUMPHREY'S JOURNAL OF PHOTOGRAPHY, AND THE ALLIED ARTS AND SCIENCES 12, no. 11 (Oct. 1, 1860): 163-164. [Exhibition review.: Hamilton; Masury; Whipple; Black & Batchelder; Silsbee & Co.; Heywood & Heard; and Southworth & Hawes were exhibitors.]

ST3589 "The 1860 Mechanics' Fair in Boston." HISTORY OF PHOTOGRAPHY 8, no. 2 (Apr. - June 1984.): 150-152. 3 b & w. [Reprinted from Oct. 1860 "Humphrey's Journal" with 3 photos of the Fair. Southworth & Hawes, Silsbee & Co., Masury, Hamilton, Whipple, Black & Batchelder, Heywood & Heard display works, each briefly discussed.]

USA: 1864: NEW YORK: METROPOLITAN FAIR.
ST3590 "The Metropolitan Fair: The Picture Gallery." HARPER'S WEEKLY 8, no. 381 (Apr. 16, 1864): 244, 246. 2 illus. [Fair held in New York, NY to raise funds for the Sanitary Commission (equivalent to Red Cross). Brief mention that photographs were exhibited with paintings and engravings in the picture gallery, but no photographers named.]

USA: 1864: PHILADELPHIA: CENTRAL FAIR OF THE SANITARY COMMISSION.
ST3591 "To the Fraternity." PHILADELPHIA PHOTOGRAPHER 1, no. 4 (Apr. 1864): 60-61, 63. [Request for contributions to the forthcoming Sanitary Commission Fair. Sanitary Commission was the equivalent of the Red Cross, providing medical services to sick and wounded soldiers during Civil War.]

ST3592 Sellers, Coleman. "Foreign Correspondence." BRITISH JOURNAL OF PHOTOGRAPHY 11, no. 217, 219 (July 1, July 15, 1864): 225, 250-251. [Sellers describes opening of the Sanitary Fair Exhibition, and the photographic exhibits there. Visit by President Lincoln. Views by Graff and by Borda & Fassitt, etc.]

ST3593 "The Photographic Department at the Great Central Fair." PHILADELPHIA PHOTOGRAPHER 1, no. 7 (July 1864): 106-108.

USA: 1865: BOSTON: MASSACHUSETTS CHARITABLE MECHANIC ASSOCIATION.
ST3594 Massachusetts Charitable Mechanic Association. "Exhibition... [Reports of the judges, etc.] Tenth exhibition... held Sept. 1865...: Photography." Boston, (1865): 138-140. [Mentions: Black & Case; Bierstadt Brothers; T. R. Burnham; Samuel Masury; A. Sonrel; Getchell & Browning; George H. Drew; Augustus Marshall; Fuller & Smith; Edward L. Allen; R. J. Chute; John P. Soule; John A. Whipple; G. M. Silsby; George L. D. Barton; Joseph L. Bates (stereoscopes).]

ST3595 "The Boston and New York Exhibitions." PHILADELPHIA PHOTOGRAPHER 2, no. 23 (Nov. 1865): 175-176. [Boston [MA] Mechanics Charitable Association: John A. Whipple, Allen, Burnham, Augustus Marshall, Sorrel, Fuller & Smith, Black & Case mentioned.]

USA: 1865: NEW YORK: AMERICAN INSTITUTE FAIR.
ST3596 "The Boston and New York Exhibitions." PHILADELPHIA PHOTOGRAPHER 2, no. 23 (Nov. 1865): 175-176. [American Institute, New York, NY: George G. Rockwood, Gurney, G. M. Powell & Co., Holmes, Gutekunst, Willard, Williamson of Brooklyn, NY, mentioned.]

USA: 1867: NEW YORK: AMERICAN INSTITUTE FAIR.
ST3597 Drummond, A. J. "Photographs at the Fair." HUMPHREY'S JOURNAL OF PHOTOGRAPHY, AND THE ALLIED ARTS AND SCIENCES 19, no. 13 (Nov. 1, 1867): 195-198. [Describes the exhibits.]

ST3598 Hull, C. Wager. "Photography at the Great Exhibition of the American Institute." PHILADELPHIA PHOTOGRAPHER 4, no. 47 (Nov. 1867): 358-360.

USA: 1869: BOSTON: MASSACHUSETTS CHARITABLE MECHANIC ASSOCIATION.
ST3599 Massachusetts Charitable Mechanic Association. "Exhibition... [Reports of the judges, etc.] Eleventh exhibition... held Sept. and Oct. 1869...: Photography." Boston, (1869): 166-167. [Mentions: Thomas Gaffield; T. R. Burnham; John A. Whipple; H. G. Smith; J. W. Black; E. L. Allen; G. H. Loomis; George K. Proctor; Charles Bierstadt.]

ST3600 "Exhibitions of the Massachusetts Charitable Mechanics Association, and the American Institute." PHILADELPHIA PHOTOGRAPHER 6, no. 70 (Oct. 1869): 331-333.

ST3601 "Editor's Table: Medals Awarded to Photographers by the Mass. Charitable Mechanics Assoc." PHILADELPHIA PHOTOGRAPHER 6, no. 72 (Dec. 1869): 426. [Gold medal: Black & Whipple; silver medal: E. L. Allen, Proctor; bronze medal: G. H. Loomis, H. G. Smith, Th. Gaffield; diploma: Ch. Bierstadt.]

USA: 1869 - 1879: NATIONAL PHOTOGRAPHIC ASSOCIATION see also SOCIETIES & ORGANIZATIONS: USA: NATIONAL PHO-TOGRAPHIC ASSOCIATION.

USA: 1869: BOSTON: NATIONAL PHOTOGRAPHIC AS-SOCIATION.
ST3602 "The Exhibition and Meetings of the National Photographic Association: The Exhibition." PHILADELPHIA PHOTOGRAPHER 6, no. 67 (July 1869): 218-221. [First annual meeting held in Horticultural Hall, Boston, MA.]

ST3603 "The Foreign Pictures Sent to the National Photographic Exhibition." PHILADELPHIA PHOTOGRAPHER 6, no. 70 (Oct. 1869): 348-349.

USA: 1869: NEW YORK: AMERICAN INSTITUTE FAIR.
ST3604 "Exhibition of Photographs at the Fair of the American Institute, by Our Own Reporter." HUMPHREY'S JOURNAL OF PHOTOGRAPHY, AND THE ALLIED ARTS AND SCIENCES 20, no. 27 (Nov. 15, 1869): 423-426. [First two pages of this three page review are devoted to a savage, sarcastic attack on "...those self-adorationists, who made such an immense display of their handiwork at the great International Fair at Boston..." (i.e. the photographers who attended the first meeting of the fledgling National Photographic Association.) Then briefly describes the exhibits of C. D. Fredericks & Co.; G. G. Rockwood; C. H. Williamson; W. Kurtz, and S. A. Holmes (the 25 cent Daguerreotype man). (This review, though unsigned, was probably by D. D. T. Davie.)]

ST3605 "Editor's Table: Premiums Awarded at the 38th Annual Fair of the American Institute, N.Y." PHILADELPHIA PHOTOGRAPHER 6, no. 72 (Dec. 1869): 426. [First Medal: Kurtz, Ch. Bierstadt, Fredericks, G. G. Rockwood, S. N. Carvalho. Second Medal: S. A. Holmes, Henry Merz, Peter Weil.]

SPECIAL TOPICS: EXHIBITIONS
USA: 1870.

SPECIAL TOPICS: EXHIBITIONS
USA: 1872: ST. LOUIS: NATIONAL PHOTOGRAPHIC ASSOCIATION.

USA: 1870.
ST3606 Cady, D. K. "Photographic Exhibitions." PHILADELPHIA PHOTOGRAPHER 7, no. 83 (Nov. 1870): 382-386. [Listings and reviews of exhibition of photos at the American Institute Fair, New York, NY, St. Louis [MO] Fair, Cincinnati [OH] Industrial Exposition.]

USA: 1870: CINCINNATI: CINCINNATI INDUSTRIAL EXHIBITION.
ST3607 "Industrial Exhibition in Cincinnati." ANTHONY'S PHOTOGRAPHIC BULLETIN 1, no. 9 (Oct. 1870): 179-181. [From "Cincinnati [OH] Daily Gazette." Landy, Porter, Vincent, Van Loo, Waldack (views), Walter, Nobel, mentioned.]

USA: 1870: CLEVELAND: NATIONAL PHOTOGRAPHIC ASSOCIATION.
ST3608 "The Cleveland Convention." ANTHONY'S PHOTOGRAPHIC BULLETIN 1, no. 6 (July 1870): 100-117. [2nd National Convention of Photographers met at Cleveland. Extensive report of activities and checklist of the exhibition accompanying convention on pp. 109-117.]

ST3609 Vogel, Dr. H. "Some Remarks on the Cleveland Exhibition." PHILADELPHIA PHOTOGRAPHER 7, no. 79 (July 1870): 259-261.

ST3610 "National Photographers' Convention." FRANK LESLIE'S ILLUSTRATED NEWSPAPER 30, no. 774 (July 30, 1870): 316-317. 1 illus. [Review of the exhibition in Cleveland, OH, associated with the annual meeting of the National Photographers Association. A. Braun, E. & H. T. Anthony & Co., Reutlinger, Holmes, Bogardus, Kurtz, Wilson, Wood & Co., J. W. Black, J. F. Ryder mentioned by name. Illustrated with a group portrait of the NPA membership, taken by T. H. Johnson.]

ST3611 Vogel, Hermann. "Dr. Vogel's Estimate of the Cleveland Exhibition." PHILADELPHIA PHOTOGRAPHER 7, no. 83 (Nov. 1870): 388-389.

USA: 1870: NEW YORK: AMERICAN INSTITUTE FAIR.
ST3612 "American Institute Fair." ANTHONY'S PHOTOGRAPHIC BULLETIN 1, no. 11 (Dec. 1870): 228. [List of exhibitors, 39th exhibition.]

USA: 1871: NEW YORK: AMERICAN INSTITUTE FAIR.
ST3613 "The Display of Photographs at the Industrial Exhibition at the American Institute, N.Y." PHILADELPHIA PHOTOGRAPHER 8, no. 94 (Oct. 1871): 336-337. [Article considers the work of Kurtz to be very fine.]

USA: 1871: PHILADELPHIA: NATIONAL PHOTOGRAPHIC ASSOCIATION.
ST3614 "The Exhibition." PHOTOGRAPHIC WORLD 1, no. 6 (June 1871): 187. [National Photographic Assoc. exhibition at Philadelphia, PA. "Mr. Black explained his method of working a weak silver solution, stereopticon exhib. conducted by J. W. Black, Esq. of Boston".]

ST3615 "Our Visit to the Exhibition in Philadelphia." PHOTOGRAPHIC TIMES 1, no. 7 (July 1871): 97-98.

ST3616 "The Exhibition of the National Photographic Association of Philadelphia." PHILADELPHIA PHOTOGRAPHER 8, no. 92 (Aug. 1871): 254-258. [Additional names listed on p. 312.]

ST3617 "The Foreign Pictures at the Exhibition." PHILADELPHIA PHOTOGRAPHER 8, no. 93 (Sept. 1871): 296-297. [N.P.A. exhibit in Philadelphia, PA.]

USA: 1871: SACRAMENTO: CALIFORNIA STATE FAIR.
ST3618 "The State Fair: Photographs." CALIFORNIA MAIL BAG 1, no. 4 (Oct.- Nov. 1871): xvii. ["Mr. Taber, as usual, carries off the palm for photographing, although the pictures exhibited by Mr. Todd, of Sacramento, are very good:..."]

USA: 1871: SAN FRANCISCO: MECHANIC'S INSTITUTE FAIR.
ST3619 "Industrial Fair: The Eighth Industrial Exhibition of the Mechanic's Institute: Photos." CALIFORNIA MAIL BAG 1, no. 3 (Aug. 1871): li, liv. [This section, pp. xxxii - li of the magazine, is actually a catalog of the exposition and it may have also been issued as a separate off-print. The catalog is divided into categories: "California Wine, Quicksilver Furnace," etc. Photographers mentioned are G. D. Morse, Bradley & Rulofson, Watkins. A separate "Supplementary Catalogue: Compiled for the 'Mail Bag' is on pp. lv -lvi.]

USA: 1872: BROOKLYN: BROOKLYN INDUSTRIAL FAIR.
ST3620 "Industrial Fair at Brooklyn, Long Island." ANTHONY'S PHOTOGRAPHIC BULLETIN 3, no. 11 (Nov. 1872): 747-748. [B. F. Troxell; A. A. Pearsall; F. E. Pearsall; Knowlton & McGregor; W. Kurtz; W. Richardon; Manning; Spitzer & Silver; Waterman exhibited.]

ST3621 "The Awards at the Brooklyn Fair." PHOTOGRAPHIC TIMES 2, no. 24 (Dec. 1872): 183.

USA: 1872: CINCINNATI: CINCINNATI INDUSTRIAL EXHIBITION.
ST3622 "The Cincinnati Exposition." ANTHONY'S PHOTOGRAPHIC BULLETIN 3, no. 10 (Oct. 1872): 705-706. [Landy; Waldack (Cincinnati) specializes in landscapes; Van Loo.]

USA: 1872: NEW YORK: AMERICAN INSTITUTE FAIR.
ST3623 "Photography at the American Institute Industrial Exhibition." PHOTOGRAPHIC TIMES 1, no. 10 (Oct. 1871): 152. [List of exhibitions: Kurtz, Weil, Holmes, Rockwood, Bierstadt, Wood, O'Neil, Murdock, Gurney & Son, Fredericks, Pearsall, Howell & Gubelman.]

ST3624 "Photography at the Exhibition of the American Institute." PHILADELPHIA PHOTOGRAPHER 9, no. 106 (Oct. 1872): 349-350. [List of exhibitors.]

ST3625 "Photography at the American Institute." PHOTOGRAPHIC TIMES 2, no. 23 (Nov. 1872): 164-165. [Reprinted from "Brooklyn [NY] Eagle." Kurtz, Howell, Gurney, Fredericks, Bogardus, Bendann Bros., Brady mentioned.]

ST3626 "Photography at the Fair of the American Institute." ANTHONY'S PHOTOGRAPHIC BULLETIN 3, no. 11 (Nov. 1872): 749-751. [B. J. Falk; A. B. Castello (Hudson City, NY); Gurney Brothers; C. D. Fredericks; John O'Neil; Bogardus; Bendann Brothers; Theo. Gubelman (Jersey City, NJ); M. B. Brady; Van Loo (Cincinnati, OH); J. Reid (Paterson, NJ); Estabrook; Kurtz; Rockwood; G. Pach; Howell; Otto Lewin; Schwind & Kruger, etc.]

USA: 1872: ST. LOUIS: NATIONAL PHOTOGRAPHIC ASSOCIATION.
ST3627 "The Exhibition." ANTHONY'S PHOTOGRAPHIC BULLETIN 3, no. 6 (June - July 1872): 565-566, 610-612. [4th Annual Exhibition of N.P.A., at the Masonic Hall, (St. Louis, MO) May, 1872. Includes list, with brief descriptions, of exhibitors.]

ST3628 "Fourth Annual Meeting and Exhibition of the N. P. A. in St. Louis, Mo., May 1872: The Exhibition." PHILADELPHIA PHOTOGRAPHER 9, no. 102 (June 1872): 228-231.

USA: 1873: BUFFALO: NATIONAL PHOTOGRAPHIC ASSOCIATION.
ST3629 "Fifth Annual Meeting and Exhibit of the National Photographic Association of the U.S., held in Buffalo, N.Y., beginning July 15, 1873: The Exhibition." PHILADELPHIA PHOTOGRAPHER 10, no. 117 (Sept. 1873): 465-467.

USA: 1873: NEW YORK: AMERICAN INSTITUTE FAIR.
ST3630 "Photography at the Annual Exhibition of the American Institute, N.Y." PHILADELPHIA PHOTOGRAPHER 10, no. 120 (Dec. 1873): 571-572, 580.

ST3631 "The Awards: Forty-Second Annual Fair of The American Institute." PHOTOGRAPHIC TIMES 4, no. 37 (Jan. 1874): 5. [List of 26 award winners, commercial photographers.]

USA: 1873: PHILADELPHIA: FRANKLIN INSTITUTE FAIR.
ST3632 "Editor's Table." PHILADELPHIA PHOTOGRAPHER 10, no. 109 (Jan. 1873): 32. [Admirable lantern exhibit at Franklin Institute Friday, Dec. 13, 1873...200 slides by many photographers shown included...frostwork on a window-pane by Wm. L. Shoemaker...Ruins of Boston Fire by James W. Black...Expressive Pets by Landy... Union Pacific Railroad views by Wm. H. Jackson, etc.]

USA: 1874: BOSTON:MASSACHUSETTS CHARITABLE MECHANIC ASSOCIATION.
ST3633 Massachusetts Charitable Mechanic Association. "Exhibition... [Reports of the judges, etc.] Twelfth exhibition... held Sept. and Oct. 1874...: Photography." Boston, (1874): 183-184. [Mentions: Allen & Rowell; J. W. Black & Co.; A. Marshall; Metcalf & Welldon; A. N. Hardy; D. K. Prescott; Geo. Barker; T. R. Burnham; A. C. Partridge; D. W. Butterfield; J. W. & J. S. Moulton & Co.; A. H. Folsom; Edgar R. Hills (amateur at Mass. Inst. of Tech.); George M. Woodward (amateur).]

ST3634 "Editor's Table." PHILADELPHIA PHOTOGRAPHER 11, no. 132 (Dec. 1874): 382-383. ["The Boston photographers who had enterprise enough to exhibit their best work at the fair of the Mass. Mechanics' Association fared well. Messrs. Allen & Rowell received a gold medal for their elegant carbon enlargements. Messrs. J. R. Osgood and Co., the same for heliotypes; and a silver medal was also awarded to Messrs. A. Marshall, J. W. Black, George Barker (of Niagara Falls), and D. W. Butterfield."]

USA: 1874: CHICAGO: NATIONAL PHOTOGRAPHIC ASSOCIATION.
ST3635 "The Exhibition at Chicago." PHILADELPHIA PHOTOGRAPHER 11, no. 129 (Sept. 1874): 277-278. [List of exhibitors.]

ST3636 "The Chicago Exhibition." PHOTOGRAPHIC TIMES 4, no. 45 (Sept. 1874): 138-139.

USA: 1874: CINCINNATI: CINCINNATI INDUSTRIAL EXHIBITION.
ST3637 "Industrial Exhibitions." PHILADELPHIA PHOTOGRAPHER 11, no. 130 (Oct. 1874): 315-316. [5th Annual Cincinnati [OH] Industrial Exhibition.]

USA: 1874: NEW YORK: AMERICAN INSTITUTE FAIR.
ST3638 "American Institute Fair." PHOTOGRAPHIC TIMES 4, no. 48 (Dec. 1874): 185. [Lists exhibitors, etc.]

USA: 1875: BOSTON: MASSACHUSETTS CHARITABLE MECHANICS ASSOCIATION.
ST3639 "Industrial Exhibitions." PHOTOGRAPHIC TIMES 5, no. 49 (Jan. 1875): 4-5. [12th exhibit of the Massachusetts Charitable Mechanics Association. Awards to James R. Osgood & Co., J. W. Black & Co., A. Marshall, G. W. Butterfield, George Barker, Allen & Rowell, and others.]

USA: 1875: NEW YORK: AMERICAN INSTITUTE FAIR.
ST3640 "The Awards. Forty-fourth Annual Fair of the American Institute." PHOTOGRAPHIC TIMES 5, no. 60 (Dec. 1875): 281. [List of winners.]

USA: 1875: PHILADELPHIA: FRANKLIN INSTITUTE FAIR.
ST3641 "Industrial Exhibitions." PHOTOGRAPHIC TIMES 5, no. 49 (Jan. 1875): 4-5. [Franklin Institute Exhibition: G. Gutekunst, A. H. Hemple, Broadbent & Phillips, Trask & Bacon, John Carbutt, James R. Osgood & Co., Suddards & Fennemore, James Cremer, F. Langenheim and others.]

USA: 1876: PHILADELPHIA: CENTENNIAL EXHIBITION.
BOOKS
ST3642 Philadelphia. Centennial Exposition of 1876. "Photography. No. 104.- Photographic Exhibition Building," on pp. 137-145 and "No. 110.- Centennial Photographic Association Building," on p. 110 in: *U. S. Centennial Commission International Exhibition 1876 Official Catalogue. Part II. Art Gallery, annexes, and outdoor works of art. Department IV. - Art.* "7th ed." Philadelphia: John R. Nagle & Co., 1876. [Lists 287 exhibitors, with their city, a brief description of materials exhibited, and where located.]

ST3643 Chute, Robert J. *The Centennial Photographic Diary. A Guide to Photography, a Guide to the Centennial, and a Memorandum Book.* Philadelphia: Benerman & Wilson, 1876. 96 pp.

ST3644 Ingram, J. S. *Centennial Exposition Described and Illustrated, Being a Concise and Graphic Description of this Grand Enterprise, Commemorative of the First Centenary of American Independence.* Philadelphia: Hubbard Brothers, 1876 {?]. 770 pp. illus.

ST3645 Ostroff, Eugene N. "Photography," on pp. 148-151 in: *1876. A Centennial Exhibition.* Edited by Robert C. Post. Washington, DC: National Museum of History and Technology. Smithsonian Institution., 1976. 223 pp. 6 b & w.

ST3646 "Masterpieces of Photography in the Centennial Exhibition," on pp. 332-342 in: *The Masterpieces of the Centennial International Exhibition.* "The Art Experience in Late Nineteenth-Century America." New York: Garland Pub., 1977. 3 vol. pp. [Reprint from the ed. published (1876) Philadelphia: Gebbie & Barrie.]

PERIODICALS
ST3647 "Photography at the Centennial Exhibition." PHOTOGRAPHIC TIMES 5, no. 56 (Aug. 1875): 185-186. [Plans for exhibitions at the forthcoming Centennial in Philadelphia in 1876.]

ST3648 "An Appeal To Photographic Patriotism: To Be Photographers of the United States in behalf of a separate Photographic Building at the Centennial Exhibition of 1876." ANTHONY'S PHOTOGRAPHIC BULLETIN 6, no. 8 (Aug. 1875): 252-253.

SPECIAL TOPICS: EXHIBITIONS
USA: 1877: NEW YORK: AMERICAN INSTITUTE FAIR.

SPECIAL TOPICS: EXHIBITIONS
USA: 1878: NEW YORK: AMERICAN INSTITUTE FAIR.

ST3649 "Photographic Hall." PHILADELPHIA PHOTOGRAPHER 13, no. 145-156 (Jan. - Dec. 1876): 42-43, 58-62, 124-126, 130-131, 157-158, 168-169, 222-223. [Articles dealing with the planning and construction of the Photographic Hall at the Phila. Centennial Exhibition. John Carbutt was the Superintendent of the Hall, John Sartain the Chief of the Art Bureau. Includes list of prospective exhibitors, etc.]

ST3650 "Photography in the Great Exhibition. Pts. 1-4." PHILADELPHIA PHOTOGRAPHER 13, no. 150-153 (June - Sept. 1876): 182-186, 196-202, 226-231, frontispiece, 258-263. 1 b & w. [The Sept. issue contains a frontispiece, which is an interior view of the Photographic Hall at the Philadelphia Centennial Exhibition. Excellent review of major exhibition.]

ST3651 "Centennial Exhibition." PHOTOGRAPHIC TIMEs 6, no. 66 (June 1876): 130-131. [From "NY Tribune." (May 25, 1876). Review of the photographers exhibited at the Centennial. Mentions John Carbutt; Alman & Co.; J. Landy; Wenderoth; Gutekunst; Broadbent & Phillips; Schreiber & Son; Kent; Rocher; Sarony; Joseph T. Brady; Anderson; W. A. Cox; Marshall; Ryder; Sweeney; Stillfried & Anderson (an American firm in Yokohama, Japan); Bradley & Rulofson; Hesler; Howell; Paxon & Brother.]

ST3652 Vogel, Dr. H. "Photographic Sketches From the Centennial Grounds. Pts. 1-3." PHILADELPHIA PHOTOGRAPHER 13, no. 151-153 (July - Sept. 1876): 213-215, 234-236, 284-287.

ST3653 Simons, M. P. "The Grand Display of Photographs at the World's Fair, Philadelphia." ANTHONY'S PHOTOGRAPHIC BULLETIN 7, no. 8 (Aug. 1876): 241-243. [Description, brief comments on the photographic displays of some thirty to forty exhibitors. Ryder (Cleveland); Good (England); Brady (Washington, DC); Landy (Cincinnati, OH), et al.]

ST3654 "Scattered Photography in Our World's Fair. Pts. 1-3." PHILADELPHIA PHOTOGRAPHER 13, no. 152-153, 155 (Aug. - Sept., Nov 1876): 245-246, 292-295, 341-343.

ST3655 "Our Picture." PHILADELPHIA PHOTOGRAPHER 13, no. 152 (Aug. 1876): frontispiece, 254. 1 b & w. [Main building at the Philadelphia Centennial Exhibition.]

ST3656 "Photographic Hall - Resume." PHILADELPHIA PHOTOGRAPHER 13, no. 153 (Sept. 1876): 290-292. [Centennial Exhib., Philadelphia, PA.]

ST3657 "Centennial Awards." PHILADELPHIA PHOTOGRAPHER 13, no. 154-156 (Oct. - Dec. 1876): frontispiece, 319, 321-323, 384. 1 b & w. [The frontispiece is an exterior view of the Photographic Hall at the Philadelphia Centennial Exhibition.]

ST3658 "Editor's Table." PHILADELPHIA PHOTOGRAPHER 13, no. 154 (Oct. 1876): 320. [Lantern slides, by Benerman & Wilson, shown to 274,919 people at the Fair on Sept. 28.]

ST3659 Carbutt, J. "List of Exhibitors in Photography and Apparatus." ANTHONY'S PHOTOGRAPHIC BULLETIN 7, no. 11 (Nov. 1876): 351-352.

ST3660 Protheroe, T. "Hints from America and the Philadelphia Exhibition." BRITISH JOURNAL PHOTOGRAPHIC ALMANAC 1877 (1877): 164-166.

ST3661 "Photographic Hall at the Centennial." ST. LOUIS PRACTICAL PHOTOGRAPHER 1, no. 1 (Jan. 1877): 3-4.

ST3662 "Broadbrim." "Centennial Sights: Sunlight and Shadow." ST. LOUIS PRACTICAL PHOTOGRAPHER 1, no. 1 (Jan. 1877): 8-10.

ST3663 "Editor's Table: The Jury at Photographic Hall." PHILADELPHIA PHOTOGRAPHER 14, no. 158 (Feb. 1877): 64. [Commentary on lack of a "practical" photographer on the jury at the Phila. Centennial - which included John Draper and H. Vogel.]

ST3664 Protheroe, T. "Hints from America and the Philadelphia Exhibition." ANTHONY'S PHOTOGRAPHIC BULLETIN 8, no. 4 (Apr. 1877): 104-105. [From "Br. J. Almanac." Notman (Montreal); Burrell (Brockton, MA); J. H. Folsom (Danbury, CT) mentioned.]

USA: 1877: NEW YORK: AMERICAN INSTITUTE FAIR.
ST3665 "Topics of the Times." PHOTOGRAPHIC TIMES 7, no. 84 (Dec. 1877): 280. [Brief list of awards given at the American Institute Fair.]

USA: 1877: NEW YORK: PERMANENT PRINTS.
ST3666 "Second Annual Exhibition of Permanent Prints." ANTHONY'S PHOTOGRAPHIC BULLETIN 9, no. 1 (Jan. 1878): 29-30. [Exhibition organized by Lambert, of the Lambertype carbon process, 1497 prints from 142 exhibitors. Committee for awards: Henry Draper, Henry J. Newton, Fred F. Thompson; T. C. Roche awarded prizes for improvements in carbon prints; 14 awards - Illingsworth; Roche; Henderson, etc.]

USA: 1878: BOSTON: MASSACHUSETTS CHARITABLE MECHANIC ASSOCIATION.
ST3667 Massachusetts Charitable Mechanic Association. "Exhibition... [Reports of the judges, etc.] Thirteenth exhibition... held Sept. and Oct. 1878...: 6. Chromes, Lithographs, Heliotypes, Photographs, etc." Boston, (1878): 61-65. [Mentions: Allen & Rowell; John P. Soule; McCormick & Heald; Joseph L. Bates; George K. Warren; O. F. Baxter & Co.; T. R. Burnham; Augustus H. Folsom; A. Bushby; W. M. Wires; M. T. Carter; A. N. Hardy; Metcalf & Weldon; Whipple; J. W. Black & Co.]

USA: 1878: NEW YORK: AMERICAN INSTITUTE FAIR.
ST3668 "Awards of the American Institute (List of Medals and Awards)." PHOTOGRAPHIC TIMES 8, no. 96 (Dec. 1878): 279. [Kurtz, Fredericks, Howell, Rockwood, Jordan, Dana, Gubelman, Pach, Schwind & Krueger, etc. mentioned.]

BY APPLICATION: MAGIC LANTERN PHOTOGRAPHY.

See also ANTHONY, E. & H. T.; HARDWICH, F.; HIGHLEY, SAMUEL; MARCEY, LORENZO J.; NICHOL, J.; ROOT, MARCUS A.; R. A. S.; TAYLOR, J. T.

MAGIC LANTERN: 19TH C.
ST3669 Shepard, Elizabeth. "The Magic Lantern Slide in Entertainment and Education, 1860 - 1920." HISTORY OF PHOTOGRAPHY 11, no. 2 (Apr. - June 1987): 91-108. 18 illus. [Discusses the Langenheim Brothers, the C. W. Briggs Co., and others.]

MAGIC LANTERN: BY YEAR
MAGIC LANTERN: 1839.
ST3670 "Science: Magic Lantern and Phantasmagoria." MAGAZINE OF SCIENCE, AND SCHOOL OF ARTS 1, no. 3, 5 (Apr. 20, May 4, 1839): 17-18, 35-37. 1 illus.

ST3671 "Moveable Magic Lantern Slides." MAGAZINE OF SCIENCE AND SCHOOL OF ARTS 1, no. 36 (Dec. 7, 1839): 281-283. 5 illus.

MAGIC LANTERN: 1841.
ST3672 "The Oxy-Hydrogen Microscope." MAGAZINE OF SCIENCE AND SCHOOL OF ARTS 2, no. 92, 94, 103 (Jan. 2, Jan. 16, Mar. 20, 1841): 313-316, 330-331, 401-403. 15 illus.

MAGIC LANTERN: 1859.
ST3673 "The Magic Lantern." FRANK LESLIE'S ILLUSTRATED NEWSPAPER 7, no. 164 (Jan. 22, 1859): 113. [General commentary on the entertainment and educational possibilities provided by magic lanterns.]

MAGIC LANTERN: 1872.
ST3674 "New York City. - Announcing the Election Returns by the Stereopticon, at the Corner of Broadway and Twenty-Second Street, on the Evening of November 5th, 1872." FRANK LESLIE'S ILLUSTRATED NEWSPAPER 35, no. 895 (Nov. 23, 1872): 161. 1 illus. [View of stereopticon projections onto the side of a large building, seen by large crowds in the street.]

MAGIC LANTERN: 1874.
ST3675 "The Best Way to View a Photograph." ANTHONY'S PHOTOGRAPHIC BULLETIN 5, no. 9 (Sept. 1874): 308. [From "London Photo. News." Lantern slides. Mentions Leon & Levy (Paris).]

MAGIC LANTERN: 1875.
ST3676 "The Magic Lantern: An Evening With The Benevolents." ANTHONY'S PHOTOGRAPHIC BULLETIN 6, no. 5 (May 1875): 149-150. [From "Br J of Photo." First annual meeting of the Photographer's Benevolent Assoc., illustrated with magic lantern lectures, musical performances, etc.]

ST3677 "The Magic Lantern: The Artopticon." ANTHONY'S PHOTOGRAPHIC BULLETIN 6, no. 6 (June 1875): 178-179. 1 illus.

ST3678 "The Magic Lantern." ANTHONY'S PHOTOGRAPHIC BULLETIN 6, no. 9 (Sept. 1875): 286-287.

ST3679 "Magic Lanterns. How to Give First-class Art Entertainments, and What to Say." ANTHONY'S PHOTOGRAPHIC BULLETIN 6, no. 12 (Dec. 1875): 372-377. [Actual script for a performance, drawn "from the celebrated work of Louis Figuier, passing through fourteen periods, called 'The World Before the Deluge, From Chaos to The Appearance of Man.'"]

ST3680 "Photography at the Polytechnic" ANTHONY'S PHOTOGRAPHIC BULLETIN 8, no. 12 (Dec. 1877): 360. [From "London Photographic News." Describes lantern slides, from photos by Wm. England and others, being displayed at the Polytechnic Institution, London.]

BY APPLICATION: MICROPHOTOGRAPHY

See also BONELLI, GAETAN; BRADY, GEORGE S.; BRIGGS, A.; DAGRON; FAYEL; GIRARD, M. J.; GOODE; HEISCH, CHARLES; HIGHLEY, SAMUEL, JR.; HISLOP; KEMPSTER, WALTER; KINGSLEY, W. TOWLER; MADDOX, R. L.; MATHIOT, GEORGE; MORROW, J. H.; NEYT, A. L; NICHOLLS, JAMES; OLLEY; ROOD, O. N.; SHADBOLT, GEORGE; SKAIFE, T.; TRAER, REEVES; WILLEMIN, ADOLPH; WILSON, EDWARD T.

MICROPHOTOGRAPHY: 19TH C.
ST3681 Mercer, A. Clifford. "The Indebtedness of Photography to Microscopy." AMERICAN ANNUAL OF PHOTOGRAPHY AND PHOTOGRAPHIC TIMES ALMANAC FOR 1887 (1887): 159-162. [Survey of early experiments. Wedgwood-Davy, Rev. J. B. Reede, Talbot, Etc.]

ST3682 Luther, Frederick. "The Earliest Experiments in Microphotography." ISIS: AN INTERNATIONAL REVIEW 41, no. 3-4 (Dec. 1950): 277-280. [John Benjamin Dancer (1812 - 1887) made the first photomicrograph in 1839. Includes a bibliography of thirty-five references.]

ST3683 Milligan, H. "On the Dating of Early Microphotographs." PHOTOHISTORIA no. 6-7 (Apr. 1980): 1-2.

ST3684 Knight, Hardwicke. "Early Photographs." HISTORY OF PHOTOGRAPHY 9, no. 4 (Oct. - Dec. 1985): 311-315. 5 illus. [Discusses John Benjamin Dancer (1812-1887) and Robert James Farrants (1811-1871).]

MICROPHOTOGRAPHY: BY YEAR.
MICROPHOTOGRAPHY: 1853.
ST3685 "Microscopical Daguerreotypes." HUMPHREY'S JOURNAL 4, no. 20 (Feb. 1, 1853): 311. [From the "Athenaeum."]

ST3686 "Application of Photography to the Representation of Microscopic Objects." HUMPHREY'S JOURNAL 5, no. 6 (July 1, 1853): 92-96. [From "Quarterly J. of Microscopic Science."]

SPECIAL TOPICS: ORGANIZATIONS & SOCIETIES
AUSTRIA: PHOTOGRAPHIC SOCIETY OF VIENNA: 1877.

SPECIAL TOPICS: ORGANIZATIONS & SOCIETIES
FRANCE: SOCIÉTÉ FRANÇAISE DE PHOTOGRAPHIE: 1877.

BY APPLICATION: ORGANIZATIONS & SOCIETIES

ORGANIZATIONS & SOCIETIES IS ARRANGED BY COUNTRY, THEN BY NAME OF THE ORGANIZATION, THEN BY YEAR.

See also EXHIBITIONS; HISTORY: BY COUNTRY; ETC.

AUSTRIA: PHOTOGRAPHIC SOCIETY OF VIENNA: 1877.
ST3687 "Prizes Offered by the Vienna Photographic Society." PHOTOGRAPHIC TIMES 7, no. 79 (July 1877): 158-159. [List of medals offered for solutions to fourteen problems - i.e. method of increasing sensitiveness of wet plates, to a collection of natural history studies, etc.]

ST3688 "Matters of the Month." PHOTOGRAPHIC TIMES 7, no. 81 (Sept. 1877): 208. ["Vienna Photographic Society has 332 ordinary and 13 honorary members..."]

AUSTRIA: PHOTOGRAPHIC SOCIETY OF VIENNA: 1879.
ST3689 "Photographic Society of Vienna." ANTHONY'S PHOTOGRAPHIC BULLETIN 10, no. 5 (May 1879): 153. [List of prizes to be awarded by the Society.]

BELGIUM: ASSOCIATION BELGE DE PHOTOGRAPHIE: 1875.
ST3690 "Association Belge de Photographie." ANTHONY'S PHOTOGRAPHIC BULLETIN 6, no. 6 (June 1875): 192. [From "London Photographic News." Society, only a few months old, has more than 200 members.]

CANADA: TORONTO PHOTOGRAPHIC SOCIETY: 1869.
ST3691 "Officers for the Toronto Photographic Society for year 1869." PHILADELPHIA PHOTOGRAPHER 6, no. 64 (Apr. 1869): 136. [Pres.: E. J. Palmer; 1st V.P.: R. E. Ewing; 2nd V.P.: J. Hay; Sec.: J. H. Noverre; Tres.: D. C. Butchart; Ex. Comm.: J. Turner, W. O'Connor, W. A. Cooper.]

FRANCE: SOCIÉTÉ HELIOGRAPHIQUE FRANÇAISE: 1851.
ST3692 Zeigler, J. "Of Societies in General and of the Heliographic Society in Particular." PHOTOGRAPHIC ART JOURNAL 2, no. 2 (Aug. 1851): 102-105. [From "La Lumiére." Contains a translation of the Heliographic Society's constitution and bylaws, and a list of the membership.]

ST3693 Snelling, J. Russell, trans. "The Heliographic Society of France." PHOTOGRAPHIC ART JOURNAL 2, no. 3-6 (Sept. - Dec. 1851): 147-150, 208-214, 272-275, 341-347. [Meetings translated from "La Lumiére".]

ST3694 Wey, Francois. "Album of the Heliographic Society of France." PHOTOGRAPHIC ART JOURNAL 2, no. 4 (Oct. 1851): 238-239.

FRANCE: SOCIÉTÉ HELIOGRAPHIQUE FRANÇAISE: 1852.
ST3695 Martin, L. A. "Heliographic Society of France." PHOTOGRAPHIC ART JOURNAL 3, no. 1-2 (Jan. - Feb. 1852): 23-25, 85-90. [From "La Lumiére."]

FRANCE: SOCIÉTÉ FRANÇAISE DE PHOTOGRAPHIE: 1855.
ST3696 "Reviews: The French Actinographic Society." HUMPHREY'S JOURNAL 7, no. 3 (June 1, 1855): 39. [Rev.: First three Bulletins of the French Photo Soc.]

FRANCE: SOCIÉTÉ FRANÇAISE DE PHOTOGRAPHIE: 1856.
ST3697 "Société Française de Photographie." HUMPHREY'S JOURNAL 7, no. 24 (Apr. 15, 1856): 385-388. [Report of a meeting of the society.]

FRANCE: SOCIÉTÉ FRANÇAISE DE PHOTOGRAPHIE: 1857.
ST3698 "Proceedings of the Photographic Society of France." HUMPHREY'S JOURNAL 9, no. 12 (Oct. 15, 1857): 184-186. [Papers by Violin, Tillard.]

ST3699 "Societe Française de Photographie." PHOTOGRAPHIC AND FINE ART JOURNAL 10, no. 11 (Nov. 1857): 327-328. [From "Bulletin de la Soc. Fr. de Photo."]

FRANCE: SOCIÉTÉ FRANÇAISE DE PHOTOGRAPHIE: 1858.
ST3700 "French Photographic Society." PHOTOGRAPHIC AND FINE ART JOURNAL 11, no. 1-12 (Jan. - Dec. 1858): 14-15, 105-106, 164, 266-267, 282-283, 379-380. [From "Liverpool Photo. J."]

ST3701 "French Photographic Society." HUMPHREY'S JOURNAL OF PHOTOGRAPHY, AND THE ALLIED ARTS AND SCIENCES 10, no. 3 (June 1, 1858): 40-41. [From "London Photo. J."]

ST3702 "French Photographic Society." HUMPHREY'S JOURNAL OF PHOTOGRAPHY, AND THE ALLIED ARTS AND SCIENCES 10, no. 10-11 (Sept. 15 - Oct. 1, 1858): 150-153, 168-171. [From "Liverpool Photo. J."]

ST3703 "Photographic Societies: French Photographic Society." PHOTOGRAPHIC NEWS 1, no. 16-24 (Dec. 24, 1858 - Feb. 18, 1859): 189-190, 250, 285-286.

FRANCE: SOCIÉTÉ FRANÇAISE DE PHOTOGRAPHIE: 1859.
ST3704 "Proceedings of the Societies: The French Photographic Society." PHOTOGRAPHIC NEWS 3, no. 66, 69 (Dec. 9, Dec. 30, 1859): 166-167, 202-203.

FRANCE: SOCIÉTÉ FRANÇAISE DE PHOTOGRAPHIE: 1860.
ST3705 "French Photographic Society." PHOTOGRAPHIC AND FINE ART JOURNAL 13, no. 1 (Jan. 1860): 12.

ST3706 "Proceedings of the Societies: The French Photographic Society." PHOTOGRAPHIC NEWS 3, no. 71 (Jan. 13, 1860): 226.

ST3707 "Proceedings of the Societies: The French Photographic Society." PHOTOGRAPHIC NEWS 3, no. 76 (Feb. 17, 1860): 291.

ST3708 "Proceedings of the Societies: The French Photographic Society." PHOTOGRAPHIC NEWS 4, no. 95 (June 29, 1860): 106-107.

ST3709 "Proceedings of the Societies: The French Photographic Society." PHOTOGRAPHIC NEWS 4, no. 102 (Aug. 17, 1860): 190-191.

FRANCE: SOCIÉTÉ FRANÇAISE DE PHOTOGRAPHIE: 1877.
ST3710 Harrison, W. "French Photographic Society." ANTHONY'S PHOTOGRAPHIC BULLETIN 8, no. 12 (Dec. 1877): 377-379. [From

"Br J of Photo." Seguin's cartes-de-visite; Martens' panoramic daguerreotype view of Paris and the Seine, taken in 1844, given to the Society; Chardon's landscape views; Davanne; l'Abbé Laborde; etc.]

ST3711 Lacan, Ernest. "French Correspondence." ANTHONY'S PHOTOGRAPHIC BULLETIN 8, no. 12 (Dec. 1877): 379-381. [From "London Photo. Notes." Mentions Davanne; l'Abbé Laborde; Leon Vidal; Gillot; etc.]

GREAT BRITAIN: 1852.
ST3712 "Our Weekly Gossip." ATHENAEUM no. 1272 (Mar. 13, 1852): 301. [Commentary on proposal to form a Photographic Society. Talbot "has expressed his desire to give every facility to the members in carrying out those processes which are connected with his patents."]

ST3713 "Gossip." PHOTOGRAPHIC ART JOURNAL 3, no. 5 (May 1852): 321-322. [Quotes from a statement of intent to form a photographic society in London. Source not given.]

GREAT BRITAIN: 1859.
ST3714 "Hints on the Formation of Photographic Societies." HUMPHREY'S JOURNAL OF PHOTOGRAPHY, AND THE ALLIED ARTS AND SCIENCES 10, no. 24 (Apr. 15, 1859): 379-380. [From "Liverpool Photo. J."]

ST3715 "Meetings of Societies." PHOTOGRAPHIC AND FINE ART JOURNAL 12, no. 1 (June 1859): 12-13. [From "Photo. News." Blackheath Photographic Society (pp. 12-13); Chorlton Photographic Assoc. (p. 13); Macclesfield Photographic Society.]

GREAT BRITAIN: 1875.
ST3716 Yerbury, E. R. "Society Work." PHOTOGRAPHIC TIMES 7, no. 73 (Jan. 1877): 9-10. [Paper read before the Edinburgh Photographic Society, recommending that photographic societies undertake certain actions for improvement.]

GB: AMATEUR PHOTOGRAPHIC ASSOCIATION: 1861.
ST3717 "A Photographic Society on a New Plan." AMERICAN JOURNAL OF PHOTOGRAPHY AND THE ALLIED ARTS & SCIENCES n. s. vol. 4, no. 1 (June 1, 1861): 20-22. [British Amateur Exchange Club described.]

ST3718 "Useful Facts, Recipes, Etc." AMERICAN JOURNAL OF PHOTOGRAPHY AND THE ALLIED ARTS & SCIENCES n. s. vol. 4, no. 14 (Dec. 15, 1861): 329. [From "London Review." stating that the Amateur Photographic Society formed, with 160 members around the world.]

GB: AMATEUR PHOTOGRAPHIC ASSOCIATION: 1862.
ST3719 "Royalty Honouring Photography." BRITISH JOURNAL OF PHOTOGRAPHY 9, no. 170 (July 15, 1862): 263. [H. R. H. the Prince of Wales accepts election as President of the Amateur Photographic Association.]

ST3720 "Note." ART JOURNAL (Aug. 1862): 178. [Note of meeting of the Amateur Photographic Association.]

ST3721 "Amateur Photographic Association." JOURNAL OF THE PHOTOGRAPHIC SOCIETY OF LONDON 8, no. 124-136 (Aug. 15, 1862 - Aug. 15, 1863): 105-106, 148, 166-167, 263-264, 328-329.

GB: AMATEUR PHOTOGRAPHIC ASSOCIATION: 1864.
ST3722 "Our Editorial Table: Pictures by the Amateur Photographic Association." BRITISH JOURNAL OF PHOTOGRAPHY 11, no. 235 (Nov. 4, 1864): 439.

GB: AMATEUR PHOTOGRAPHIC ASSOCIATION: 1865.
ST3723 "Note." ART JOURNAL (Apr. 1865): 125. [Note that a conversazione of the Amateur Photographic Association was held at end of March, in house of Arthur James Melhuish.]

GB: AMATEUR PHOTOGRAPHIC ASSOCIATION: 1869.
ST3724 "Proceedings of Societies: Amateur Photographic Assoc." PHOTOGRAPHIC NEWS 8, no. 278 (Jan. 1, 1869): 10.

GB: AMATEUR PHOTOGRAPHIC ASSOCIATION: 1871.
ST3725 Melhuish, A. J. "The Amateur Photographic Association." BRITISH JOURNAL PHOTOGRAPHIC ALMANAC 1871 (1871): 120-122.

GB: ARCHITECTURAL PHOTOGRAPHIC ASSOCIATION: 1857.
ST3726 "Architectural Photograph Association." ART JOURNAL (June, Oct. 1857): 198, 327.

GB: ARCHITECTURAL PHOTOGRAPHIC ASSOCIATION: 1858.
ST3727 "Architectural Photographic Association." PHOTOGRAPHIC AND FINE ART JOURNAL 11, no. 8 (Aug. 1858): 226-227. [From "London Art. J."]

GB: ARCHITECTURAL PHOTOGRAPHIC ASSOCIATION: 1860.
ST3728 "The Architectural Photographic Association." PHOTOGRAPHIC NEWS 3, no. 75 (Feb. 10, 1860): 265-267.

ST3729 "Proceedings of the Societies: Architectural Photographic Association." PHOTOGRAPHIC NEWS 3, no. 77 (Feb. 24, 1860): 303.

ST3730 "Note." ART JOURNAL (Mar. 1860): 95. [Architectural Photographic Association exhibition noted.]

ST3731 "Architectural Photographic Society." PHOTOGRAPHIC AND FINE ART JOURNAL 13, no. 3 (Mar. 1860): 70-71. [From "Br. J. of Photo."]

ST3732 "Proceedings of the Societies: Architectural Photographic Association." PHOTOGRAPHIC NEWS 3, no. 78 (Mar. 2, 1860): 313-314.

ST3733 "Proceedings of the Societies: Architectural Photographic Association." PHOTOGRAPHIC NEWS 3, no. 79 (Mar. 9, 1860): 329.

ST3734 "Fine-Art Gossip." ATHENAEUM no. 1708 (July 21, 1860): 100.

ST3735 "Proceedings of the Societies: Architectural Photographic Association." PHOTOGRAPHIC NEWS 4, no. 119 (Dec. 14, 1860): 393.

SPECIAL TOPICS: ORGANIZATIONS & SOCIETIES
GB: ARCHITECTURAL PHOTOGRAPHIC ASSOCIATION: 1861.

SPECIAL TOPICS: ORGANIZATIONS & SOCIETIES
GB: BRITISH ASSOCIATION FOR THE ADVANCEMENT OF SCIENCE: 1862.

GB: ARCHITECTURAL PHOTOGRAPHIC ASSOCIATION: 1861.

ST3736 "Architectural Photographic Association." JOURNAL OF THE PHOTOGRAPHIC SOCIETY OF LONDON 7, no. 114 (Oct. 15, 1861): 295. [Notice of dissolution of APA.]

ST3737 Elwall, Robert. "'The foe-to-graphic art': The rise and fall of the Architectural Photographic Association." PHOTOGRAPHIC COLLECTOR 5, no. 2 (1984): 142-163. 12 b & w. [First meeting 1857 of this British organization, to collect photographs "of architectural works of all countries." Held large annual exhibitions until 1861, then continued to function through late 1860s, when it finally collapsed. Illustrations by Edouard Baldus, Robert MacPherson, Roger Fenton, Bisson Freres, Carlo Ponti, Francis Bedford, Cundall & Fleming. Facsimile of the Catalogue of the Fourth Annual Exhibition (1861) on pp. 157-163.]

GB: BIRMINGHAM PHOTOGRAPHIC SOCIETY: 1857.

ST3738 "Birmingham Photographic Society." PHOTOGRAPHIC AND FINE ART JOURNAL 10, no. 1 (Jan. 1857): 18.

ST3739 "General Meeting of the Birmingham Photographic Society." HUMPHREY'S JOURNAL 9, no. 6 (July 15, 1857): 86-93. [From "Photographic Notes." Paper on "Negative Collodion Process" by W. Osborn. Comments by O. G. Rejlander, Beckingham, others. Rejlander displayed his "Two Roads of Life" composition print to the general applause.]

GB: BIRMINGHAM PHOTOGRAPHIC SOCIETY: 1858.

ST3740 "Birmingham Photographic Society." PHOTOGRAPHIC AND FINE ART JOURNAL 11, no. 5-12 (May - Dec. 1858): 139-140, 208, 237-239, 298-302, 339-340, 370.

GB: BIRMINGHAM PHOTOGRAPHIC SOCIETY: 1859.

ST3741 "Photographic Societies: Birmingham Photographic Society." PHOTOGRAPHIC NEWS 1, no. 20 (Jan. 21, 1859): 239.

ST3742 "Birmingham Photographic Society." PHOTOGRAPHIC AND FINE ART JOURNAL 12, no. 2 (July 1859): 45-48. [(July) C. L. Haines' "On the Uses and Abuses of Photography;" others.]

GB: BIRMINGHAM PHOTOGRAPHIC SOCIETY: 1860.

ST3743 "Birmingham Photographic Society." PHOTOGRAPHIC AND FINE ART JOURNAL 13, no. 1 (Jan. 1860): 8-9.

ST3744 "Birmingham Photographic Society." PHOTOGRAPHIC AND FINE ART JOURNAL 13, no. 3-7 (Mar. - July 1860): 69-70, 74, 119-120, 199-200. [From "B.J.P."]

ST3745 "Proceedings of the Societies: Birmingham Photographic Society." PHOTOGRAPHIC NEWS 3, no. 83 (Apr. 5, 1860): 377.

ST3746 "Proceedings of the Societies: Birmingham Photographic Society." PHOTOGRAPHIC NEWS 4, no. 115 (Nov. 16, 1860): 345.

GB: BLACKHEATH PHOTOGRAPHIC SOCIETY: 1858.

ST3747 "Blackheath Photographic Society." PHOTOGRAPHIC AND FINE ART JOURNAL 11, no. 2 (Feb. 1858): 58-59. [From the "J of the Royal Photographic Soc."]

ST3748 "Photographic Societies: Blackheath Photographic Society." PHOTOGRAPHIC NEWS 1, no. 17, 25 (Dec. 31, 1858, Feb. 25, 1859): 202, 296-297.

GB: BLACKHEATH PHOTOGRAPHIC SOCIETY: 1859.

ST3749 "Proceedings of the Societies: Blackheath Photographic Society." PHOTOGRAPHIC NEWS 3, no. 65-85 (Dec. 2, 1859 - Apr. 20, 1860): 153-154, 202, 263, 303, 351-353, 397-399.

GB: BLACKHEATH PHOTOGRAPHIC SOCIETY: 1860.

ST3750 "Blackheath Photographic Society." PHOTOGRAPHIC AND FINE ART JOURNAL 13, no. 5, 7 (May, July 1860): 117-118, 197-198. [From "Br. J. of Photo."]

ST3751 "Proceedings of the Societies: Blackheath Photographic Society." PHOTOGRAPHIC NEWS 4, no. 90-121 (May 25 - Dec 28, 1860): 43-45, 57-58, 92-93, 369-370, 416-417.

GB: BRITISH ASSOCIATION FOR THE ADVANCEMENT OF SCIENCE: 1858.

ST3752 "The British Association for the Advancement of Science. Pts. 1 - 2." PHOTOGRAPHIC NEWS 1, no. 5-6 (Oct. 8 - Oct. 15, 1858): 49-50, 63. [Papers by Herschel, Lyndon Smith, McCraw and Fowler.]

GB: BRITISH ASSOCIATION FOR THE ADVANCEMENT OF SCIENCE: 1859.

ST3753 "Meeting of the British Association, 2nd Notice." PHOTOGRAPHIC NEWS 3, no. 56 (Sept. 30, 1859): 37-39.

GB: BRITISH ASSOCIATION FOR THE ADVANCEMENT OF SCIENCE: 1860.

ST3754 "British Association 'Oxford Meeting, 1860.'" BRITISH JOURNAL OF PHOTOGRAPHY 7, no. 122 (July 16, 1860): 207-209. ["On the Principles of the Solar Camera," by A. Claudet; "On the Means of Increasing the Angle of Binocular Instruments, in order to obtain a Stereoscopic Effect in proportion to their Magnifying Power," by A. Claudet; "On a Reflecting Telescope for Celestial Photography, erecting at Hastings, near New York," by Henry Draper, M.D.]

ST3755 "Our Eye-Witness at Oxford." BRITISH JOURNAL OF PHOTOGRAPHY 7, no. 123 (Aug. 1, 1860): 220-221. [Description of events at the British Association meeting of 1860.]

GB: BRITISH ASSOCIATION FOR THE ADVANCEMENT OF SCIENCE: 1861.

ST3756 "British Association: Manchester Meeting, 1861." BRITISH JOURNAL OF PHOTOGRAPHY 8, no. 150 (Sept. 16, 1861): 322-329. [Papers of 31st meeting. Warren De la Rue "Report of the Progress of Celestial Photography Since the Meeting at Aberdeen," pp. 323-324; Sutton's "On Photographs of Different Spectra of the Electric Light," p. 325; Sir David Brewster's "On Binocular Lustre," on pp. 325-326 and "On Photographic Micrometers," on p. 326; Col. Sir Henry James "On Photozincography," on p. 326; Report of the Kew Committee, on p. 327; Prof. W. A. Miller's "On the Spectrum Analysis," on pp. 327-329.]

GB: BRITISH ASSOCIATION FOR THE ADVANCEMENT OF SCIENCE: 1862.

ST3757 "British Association. Cambridge Meeting, 1862." BRITISH JOURNAL OF PHOTOGRAPHY 9, no. 176 (Oct. 15, 1862): 384-390. [Papers: "On Autographs of the Sun," by Prof. Selwyn (photos by Mr. Titterton (Ely), p. 385; "On the Means of Following the Small Divisions of the Scale Regulating the Distances and Enlargement in the Solar Camera," by A. Claudet, pp. 385-386; "Experiments on Photography in Colour," by Rev. J. B. Reade, p. 366; "Description of a Rapid Dry Collodion Process," by Thomas Sutton, pp. 366-367; "Details of a Photolithographic Process, as Adopted by the Government of Victoria, for the Publication of Maps," by J. W. Osborne, pp. 387-389; "On

SPECIAL TOPICS: ORGANIZATIONS & SOCIETIES
GB: BRITISH ASSOCIATION FOR THE ADVANCEMENT OF SCIENCE: 1863.

SPECIAL TOPICS: ORGANIZATIONS & SOCIETIES
GB: DUMFRIES AND GALLOWAY PHOTOGRAPHIC SOCIETY: 1856.

Some of the Difficulties which Present Themselves in the Practice of Photography, and the Means of Avoiding Them," by F. Maxwell Lyte, pp. 389-390; "On a Simple Method of Taking Stereo-Photomicrographs," by Charles Heisch, p. 390.]

GB: BRITISH ASSOCIATION FOR THE ADVANCEMENT OF SCIENCE: 1863.

ST3758 "British Association. Newcastle-upon-Tyne Meeting, 1863." BRITISH JOURNAL OF PHOTOGRAPHY 10, no. 198 (Sept. 15, 1863): 364-369. [Annual meeting. Abstracts of papers: "On the Focal Adjustment of the Eye," by Barnard S. Proctor, pp. 365-366; "The Star 'Chromoscope:' An Instrument to Examine and Compare the Rays of the Stars," by A. Claudet, pp. 366-367; "On the Proof of the Dioptric and Actinic Quality of Atmosphere at a High Elevation," by C. Piazzi Smyth, pp. 367; "On a New Kind of Miniature, Possessing Apparent Solidity by Means of a Combination of Prisms in Contact Therewith," by Henry Swan, pp. 367-369; "On a New Method of Measuring the Chemical Action of a Sun's Rays," by Dr. F. L. Phipson, p. 369.]

GB: BRITISH ASSOCIATION FOR THE ADVANCEMENT OF SCIENCE: 1864.

ST3759 "British Association: Bath Meeting, 1864." BRITISH JOURNAL OF PHOTOGRAPHY 11, no. 229 (Sept. 23, 1864): 363-369. [Texts of lectures by: "On the Probability of Constructing Ellipsoidal Lenses," by Th. Furlong, pp. 864-865; "Photo Sculpture," by A. Claudet, pp. 365-366; "Contributions Towards the Foundation of Quantitative Photography," by Prof. Roscoe, p. 366; "On the Application of Photography and the Magic Lantern to Microscopic and Natural History Class Demonstrations," by Samuel Highley, pp. 366-367; "On the Chemical Properties of Light," by Prof. Roscoe, pp. 367-369.]

GB: BRITISH ASSOCIATION FOR THE ADVANCEMENT OF SCIENCE: 1865.

ST3760 "British Association. Birmingham Meeting, 1865." BRITISH JOURNAL OF PHOTOGRAPHY 12, no. 280 (Sept. 15, 1865): 474-478. [Papers "Moving Photographic Figures, Illustrating Some Phenomena of Vision Connected with the Combination of the Stereoscope and the Phenakistoscope by Means of Photography," by A. Claudet, pp. 475-476; "Recent Application of Magnesium," by William White, pp. 476-477.]

GB: BRITISH ASSOCIATION FOR THE ADVANCEMENT OF SCIENCE: 1879.

ST3761 "Sheffield Meeting of the British Association, 1879." ANTHONY'S PHOTOGRAPHIC BULLETIN 10, no. 10 (Oct. 1879): 313-316. [From "Br J of Photo." Report on photographic activities at the 49th annual meeting of the British Association for the Advancement of Science.]

GB: CALOTYPE CLUB.

ST3762 "A Reminiscence of the Calotype Club." ANTHONY'S PHOTOGRAPHIC BULLETIN 6, no. 9 (Sept. 1875): 266-267. [Prof. Cosmo Innes; Prof. Moir; Sheriff Kay; Sheriff Tennant; Sheriff Napier; Dean Montgomery; Robert Tennant and John Stewart of Natley Hall.]

ST3763 Meinwald, Dan. "The Calotype Clubs: Gentleman-Amateurs and the New 'Art-Science.'" AFTERIMAGE 3, no. 8 (Feb. 1976): 10-12. 6 b & w.

GB: CALOTYPE CLUB: 1847.

ST3764 "Fine Arts: The Calotype Society." ATHENAEUM no. 1051 (Dec. 18, 1847): 1304. [Note of meeting of a society composed of a dozen gentlemen amateurs associated together for the purpose of pursuing their experiments in this art science... at Mr. Fry's House. Fry, Owen mentioned by name.]

GB: CALOTYPE CLUB: 1849.

ST3765 "Minor Topics of the Month: The Photographic Club." ART JOURNAL (Aug. 1, 1849): 262.

ST3766 "Fine Art Gossip." ATHENAEUM no. 1156 (Dec. 22, 1849): 1311-1312. [Note that meeting of the Calotype Club was held. Owens and Cundall, Bingham, Sir Wm. Newton mentioned by name.]

GB: CHORLTON PHOTOGRAPHIC ASSOCIATION: 1857.

ST3767 "Chorlton Photographic Society." PHOTOGRAPHIC AND FINE ART JOURNAL 10, no. 12 (Dec. 1857): 365-367. [From "Liverpool Photo. J."]

GB: CHORLTON PHOTOGRAPHIC ASSOCIATION: 1858.

ST3768 "Chorlton Photographic Society." PHOTOGRAPHIC AND FINE ART JOURNAL 11, no. 1-12 (Jan. - Dec. 1858): 10-11, 43-45, 111-114, 315-316. [From "Liverpool Photo. J."]

GB: CHORLTON PHOTOGRAPHIC ASSOCIATION: 1860.

ST3769 "Chorlton Photographic Association." PHOTOGRAPHIC AND FINE ART JOURNAL 13, no. 7 (July 1860): 204-205. [From "Br. J. of Photo."] "Proceedings of the Societies: Chorlton Photographic Association." PHOTOGRAPHIC NEWS 4, no. 109 (Oct. 5, 1860): 274.

GB: CITY OF GLASGOW AND WEST OF SCOTLAND PHOTOGRAPHIC SOCIETY: 1860.

ST3770 "Proceedings of the Societies: City of Glasgow and West of Scotland Photographic Society." PHOTOGRAPHIC NEWS 4, no. 88-120 (May 11 - Dec. 21, 1860): 22-23, 287, 335, 406.

ST3771 "City of Glasgow and West of Scotland Photographic Society." PHOTOGRAPHIC AND FINE ART JOURNAL 13, no. 7 (July 1860): 200. [From "Br. J. of Photo."]

GB: DRY-PLATE CLUB: 1872.

ST3772 "The Dry-Plate Club." ANTHONY'S PHOTOGRAPHIC BULLETIN 3, no. 9 (Sept. 1872): 663-664. [From "London Photo. News." Inaugural address by Col. Stuart Wortley. Archbishop of York is Pres.]

GB: DUBLIN PHOTOGRAPHIC SOCIETY: 1855.

ST3773 "Proceedings of the Dublin Photographic Society." HUMPHREY'S JOURNAL 7, no. 5 (July 1, 1855): 83-84.

GB: DUBLIN PHOTOGRAPHIC SOCIETY: 1857.

ST3774 "Dublin Photographic Society." PHOTOGRAPHIC AND FINE ART JOURNAL 10, no. 1 (Jan. 1857): 18-19.

ST3775 "Dublin Photographic Society." PHOTOGRAPHIC AND FINE ART JOURNAL 10, no. 5 (May 1857): 139. [From "J. of Photo. Soc., London."]

ST3776 "Dublin Photographic Society." PHOTOGRAPHIC AND FINE ART JOURNAL 10, no. 6 (June 1857): 179-180. [Paper by T. Shaw Smith.]

GB: DUMFRIES AND GALLOWAY PHOTOGRAPHIC SOCIETY: 1856.

ST3777 "Dumfries and Galloway Photographic Society." PHOTOGRAPHIC AND FINE ART JOURNAL 9, no. 9 (Sept. 1856): 261-262.

GB: EDINBURGH PHOTOGRAPHIC SOCIETY: 1874.

ST3778 "Meeting of the Edinburgh Photographic Society." ANTHONY'S PHOTOGRAPHIC BULLETIN 5, no. 1 (Jan. 1874): 9-11. [From "Br. J. of Photo." Annual holiday excursion. Stewart; Hay; R. G. Muir; W. H. Davies; Dr. Nichol; Tunny; Lothian; Mitchell; Ross & Pringle mentioned.]

GB: GLASGOW PHOTOGRAPHIC ASSOCIATION: 1860.

ST3779 "Proceedings of the Societies: Glasgow Photographic Association." PHOTOGRAPHIC NEWS 3, no. 80 (Mar. 16, 1860): 339-341.

ST3780 "Proceedings of the Societies: Glasgow Photographic Association." PHOTOGRAPHIC NEWS 3, no. 85 (Apr. 20, 1860): 399-400.

GB: GLASGOW PHOTOGRAPHIC ASSOCIATION: 1864.

ST3781 "Proceedings of the Societies: Glasgow Photographic Association." PHOTOGRAPHIC NEWS 8, no. 285 (Feb. 19, 1864): 92-93.

GB: GLASGOW PHOTOGRAPHIC ASSOCIATION: 1879.

ST3782 "Glasgow Photographic Association." ANTHONY'S PHOTOGRAPHIC BULLETIN 10, no. 5 (May 1879): 154. [From "Br. J. of Photo."]

GB: HALIFAX LITERARY AND PHILOSOPHICAL SOCIETY: 1859.

ST3783 "Photographic Societies: Conversazione of the Halifax Literary and Philosophical Society." PHOTOGRAPHIC NEWS 1, no. 21 (Jan. 28, 1859): 249-250.

GB: LIVERPOOL AMATEUR PHOTOGRAPHIC ASSOCIATION: 1872.

ST3784 "Liverpool Amateur Photographic Association." ANTHONY'S PHOTOGRAPHIC BULLETIN 3, no. 7 (July 1872): 608-609. [From "Br. J. of Photo."]

GB: LIVERPOOL PHOTOGRAPHIC SOCIETY: 1853.

ST3785 "Liverpool Photographic Society." PHOTOGRAPHIC ART JOURNAL 6, no. 1 (July 1853): 49-50.

GB: LIVERPOOL PHOTOGRAPHIC SOCIETY: 1854.

ST3786 "Liverpool Photographic Society." PHOTOGRAPHIC AND FINE ART JOURNAL 7, no. 6 (June 1854): 168.

GB: LIVERPOOL PHOTOGRAPHIC SOCIETY: 1855.

ST3787 "Proceedings of the Liverpool Photographic Society: Ninth Monthly Meeting, Nov. 6, 1855." HUMPHREY'S JOURNAL 7, no. 16 (Dec. 15, 1855): 256-260. [From "Liverpool Photo. J." Texts of papers by Mr. Bell, McInness. Report of the meeting, etc.]

GB: LIVERPOOL PHOTOGRAPHIC SOCIETY: 1856.

ST3788 "Extracts from Foreign Publications: Liverpool Photographic Society: Tenth Monthly Meeting, Nov. 13, 1855." HUMPHREY'S JOURNAL 7, no. 18 (Jan. 15, 1856): 282-288. [Report of meeting, texts of reports by Mercer; Bell; Stansfeld.]

ST3789 "Extracts from Foreign Publications: Liverpool Photographic Society." HUMPHREY'S JOURNAL 7, no. 20 (Feb. 15, 1856): 316-325. [From "Liverpool Photo. J." Report of meeting, paper by Mr. Fitt (Norwich) on wax paper process, etc.]

ST3790 "Extracts from Foreign Publications: Liverpool Photographic Society." HUMPHREY'S JOURNAL 7, no. 22 (Mar. 15, 1856): 347-352. [Includes paper by Mr. Foard; Mr. Berry.]

ST3791 "Meeting of the Liverpool Photographic Society." HUMPHREY'S JOURNAL 8, no. 5 (July 1, 1856): 65-67.

ST3792 "Meeting of the Liverpool Photographic Society." HUMPHREY'S JOURNAL 8, no. 10 (Sept. 15, 1856): 146-150.

ST3793 "Liverpool Photographic Society." HUMPHREY'S JOURNAL 8, no. 13 (Nov. 1, 1856): 205-207.

GB: LIVERPOOL PHOTOGRAPHIC SOCIETY: 1857.

ST3794 "Liverpool Photographic Society." PHOTOGRAPHIC AND FINE ART JOURNAL 10, no. 1-12 (Jan. - Dec. 1857): 28-30, 73-74, 184-185, 201-202, 259, 360-362.

GB: LIVERPOOL PHOTOGRAPHIC SOCIETY: 1858.

ST3795 "Liverpool Photographic Society." PHOTOGRAPHIC AND FINE ART JOURNAL 11 , no. 1-4 (Jan. - Apr. 1858): 14-15, 33-36, 68-69, 97-98. [From "Liverpool Photo. J."]

GB: LIVERPOOL PHOTOGRAPHIC SOCIETY: 1860.

ST3796 "Proceedings of the Societies: Liverpool Photographic Club." PHOTOGRAPHIC NEWS 4, no. 107 (Sept. 21, 1860): 248.

GREAT BRITAIN: LONDON PHOTOGRAPHIC SOCIETY see PHOTOGRAPHIC SOCIETY.

GB: PHOTOGRAPHERS' PROVIDENT ASSOCIATION: 1873.

ST3797 Whiting, Matthew. "The Photographers' Provident Association of Great Britain." ANTHONY'S PHOTOGRAPHIC BULLETIN 4, no. 5 (May 1873): 133-134. [Discussion of plans to form the society, list of regulations suggested.]

GREAT BRITAIN: PHOTOGRAPHIC EXCHANGE CLUB see HISTORY: GREAT BRITAIN: GENERAL (Seiberling and Bloore, 1986)

GB: PHOTOGRAPHIC SOCIETY.
BOOKS
ST3798 Henfrey, Arthur, ed. *Journal of the Photographic Society of London Containing the Transactions of the Society and a General Record of the Photographic Art and Science.* 1978. [Facsimile edition of the 1854 reprint of volume one of the "Journal."]

PERIODICALS
ST3799 Foster, Peter Le Neve, M.A., F.R.S.A., A.R.P.S. "The Centenary of Photography: Early Associations of the Society of Art with Photography." JOURNAL OF THE ROYAL SOCIETY OF ARTS (LONDON) 87, no. 4518 (June 23, 1939): 818-825. 1 b & w. 1 illus. [History of the formation of the Photographic Society. Includes three appendices, of "Minutes," from earlier Society meetings. This essay also published in "Photographic Journal" (Sept. 1939).]

ST3800 Johnston, Dudley J., Hon. F.R.P.S. "The Origins of the Photographic Society." JOURNAL OF THE ROYAL SOCIETY OF ARTS (LONDON) 87, no. 4518 (June 23, 1939): 831-837. 1 b & w. []

ST3801 "Centenary of the R. P. S." IMAGE 2, no. 2 (Jan.- Feb. 1953): 2-4. 1 b & w. [Brief history of the Royal Photographic Society and its publication, the "Photographic Journal," started in 1853. Group portrait of members, c. 1856.]

GB: PHOTOGRAPHIC SOCIETY: 1852.
ST3802 "Note." ATHENAEUM no. 1272 (Mar. 13, 1852): 301.

ST3803 "The Photographic Society." ART JOURNAL (Apr. 1852): 103. [Announcement of intention to form a Photo Society.]

ST3804 "Humphrey's Journal: Photographical Society in London." HUMPHREY'S JOURNAL 4, no. 2 (May 1, 1852): 29-30. [Information about the proposed formation of a British photographic society - apparently taken from the "London Art Journal."]

ST3805 "Note." ATHENAEUM no. 1852 (May 29, 1852): 610. [Intention to form a Photograph Society and of Talbot's intention to release copyright so that it might be done.]

GB: PHOTOGRAPHIC SOCIETY: 1853.
ST3806 "Fine-Art Gossip." ATHENAEUM no. 1320 (Feb. 12, 1853): 200. [Note about formation of the Photographic Society. Pres. Sir Charles Eastlake; V. Pres. Lord Somers, Sir Wm. Newton, Prof. Wheatstone. Roger Fenton the Sec. Paper read by Dr. Percy.]

ST3807 "The Photograph Society." ART JOURNAL (Mar. 1853): 97. ["The inaugural meeting of the Society was held...June 20th."]

ST3808 "Fine-Art Gossip." ATHENAEUM no. 1324 (Mar. 12, 1853): 329. [Note that Society of Arts proposing to organize a photographic exhibition to circulate around England "to extend the knowledge and appreciation of the art of Photography..." Further note on p. 968 of the Aug. 13 issue states that this collection now available and that institutions desiring to exhibit the works should contact the secretary of the Council of the Society of Arts.]

ST3809 "Photography." ILLUSTRATED LONDON NEWS 22, no. 615 (Apr. 2, 1853): 254. [Report of the formation of the Photographic Society, abstracts of papers by Sir Wm. Newton, Dr. Percy, Robert Hunt, read at the first and second meetings.]

ST3810 "London Photographic Society. 2nd Ordinary Meeting. " PHOTOGRAPHIC ART JOURNAL 5, no. 5 (May 1853): 279-295. [From "J. of Photo. Soc." Two papers. Robert Hunt "On the principles upon which the construction of photographic lens should be regulated," Count de Montizon, "On the Collodion Process."]

ST3811 "The Photographic Society." ART JOURNAL (May 1853): 139. [Notes on the second meeting.]

ST3812 "London Photographic Society." PHOTOGRAPHIC ART JOURNAL 6, no. 3 (Sept. 1853): 157-169. [Papers read: Hershel. "On substitution of Bromine for iodine in photographic processes." Crookes. "On application of photo to study at certain phenomena of polarization." Leighton. "On photography as a means or an end relation of camera to science or art." R. W. Buss. "On use of photography to Artists."]

GB: PHOTOGRAPHIC SOCIETY: 1854.
ST3813 "London Photographic Society." PHOTOGRAPHIC AND FINE ART JOURNAL 7, no. 1 (Jan. 1854): 27-29. [Reports of Dr. Hugh Diamond's "On the Simplicity of the Collodion Process."]

ST3814 "London Photographic Society." PHOTOGRAPHIC AND FINE ART JOURNAL 7, no. 2 (Feb. 1854): 47-51. [Reports on Roger Fenton's "On the Nitrate Bath."]

ST3815 "London Photographic Society." PHOTOGRAPHIC AND FINE ART JOURNAL 7, no. 3 (Mar. 1854): 77-81. [Reports on F. H.

Wenham's "On the Method of Obtaining Enlarged Positive Impressions from Transparent Collodion or Albumen Negatives."; George Shadbolt's "On the Production of Enlarged Positive Copies from Negatives of Interior Dimensions."; William Crook's "On the Restoration of Old Collodion."; and W. H. Cooke's "On the Improved Camera." From the "J. of the Photo. Soc."]

ST3816 "The Photographic Society." PRACTICAL MECHANIC'S JOURNAL 7, no. 73 (Apr. 1854): 8-9. [Commentary on the foundation of the Photographic Society, with additional commentary on the role of photography in contemporary life.]

ST3817 "London Photographic Society." PHOTOGRAPHIC AND FINE ART JOURNAL 7, no. 5 (May 1854): 136-137. [Report to the Council.]

ST3818 "Report of the Council of the Anniversary Meeting of the Photographic Society - Thurs. Feb. 2, 1854." PHOTOGRAPHIC AND FINE ART JOURNAL 7, no. 5 (May 1854): 136-137. [From "Journal of Photo. Soc."]

ST3819 "Photographic Society." PHOTOGRAPHIC AND FINE ART JOURNAL 7, no. 6-10 (June - Oct. 1854): 170-172, 198-202, 235-237, 279-282, 312-313. [From "J. of Photo. Soc." (July) Papers by Edward Ash Hadow, Mr. Llewellyn on the calotype, John A. Spencer on stereoscopic pictures. (Aug.) papers by Hardwick and Spencer. (Sept.) Laroche addressed the Society on the copyright injunction brought against him by Talbot. Papers by G. Shadbolt, John Spiller and Wm. Crookes. (Oct.) W. J. Newton states his opinion of Talbot's contributions and his patent rights, etc.]

ST3820 "London Photographic Society. Ordinary Meeting, November 2d., 1854." PHOTOGRAPHIC AND FINE ART JOURNAL 8, no. 2 (Feb. 1855): 49-51. [Includes report given by Frederick Hardwich.]

GB: PHOTOGRAPHIC SOCIETY: 1855.
ST3821 "London Photographic Society: Annual General Meeting, Feb. 1, 1855." PHOTOGRAPHIC AND FINE ART JOURNAL 8, no. 5 (May 1855): 139-141. [Report of the Council, address by Sir W. J. Newton.]

ST3822 "London Photographic Society: Ordinary Meeting, Apr. 5, 1855." PHOTOGRAPHIC AND FINE ART JOURNAL 8, no. 7 (July 1855): 204-208. [From "J. of Photo. Soc., London." Paper by T. F. Hardwich.]

ST3823 "London Photographic Society: Ordinary Meeting, May 3, 1855." PHOTOGRAPHIC AND FINE ART JOURNAL 8, no. 8 (Aug. 1855): 235-237. [Papers by George Edwards, J. E. Mayall.]

ST3824 "London Photographic Society: Ordinary Meeting. June 7, 1855." PHOTOGRAPHIC AND FINE ART JOURNAL 8, no. 9 (Sept. 1855): 266-268. [From "J. of Photo. Soc., London." papers by Wm. J. Newton, F. Maxwell Lyte, Malone.]

ST3825 "Extracts from Foreign Publications: Photographic Society of London - Ordinary Meeting, Nov. 1, 1855." HUMPHREY'S JOURNAL 7, no. 17 (Jan. 1, 1856): 267-276. [Texts of papers by Rev. J. B. Reade; George Shadbolt. Report of the committee on fading of prints, etc.]

ST3826 "Photographic Society of London: Ordinary Meeting. Nov. 1, 1855." PHOTOGRAPHIC AND FINE ART JOURNAL 9, no. 1 (Jan. 1856): 24-26. [From "J. of Photo. Soc., London." Paper by J. B. Reade.]

GB: PHOTOGRAPHIC SOCIETY: 1856.

ST3827 "Societies: Photographic." ATHENAEUM no. 1478, 1499 (Feb. 23, July 19, 1856): 236, 901. [Annual meeting. Fenton retires as Secretary. Rev. J. R. Major elected Sec., and editor of "Journal." E. Contant, Hardwicke, Maxwell Lyte mentioned.]

ST3828 "Photographic Society of London: Ordinary Meeting, March 6, 1856." PHOTOGRAPHIC AND FINE ART JOURNAL 9, no. 5 (May 1856): 133-136.

ST3829 "London Photographic Society: Ordinary Meeting. March 6th, 1856." HUMPHREY'S JOURNAL 8, no. 2 (May 15, 1856): 18-25. [From "J. of Photo. Soc., London."]

ST3830 "London Photographic Society: Ordinary Meeting, May 1, 1856." PHOTOGRAPHIC AND FINE ART JOURNAL 9, no. 7 (July 1856): 199. [Fenton, Lake Price, Delamotte, Hardwich and Vignoles resigned over a matter of conflict of interest.]

ST3831 "London Photographic Society: Ordinary Meeting, June 5, 1856." PHOTOGRAPHIC AND FINE ART JOURNAL 9, no. 8 (Aug. 1856): 243-247. [From "J. of Photo. Soc., London." Includes paper by Paul Pretsch.]

ST3832 "Photographic Society of London: Ordinary Meeting, Nov. 6, 1856." PHOTOGRAPHIC AND FINE ART JOURNAL 10, no. 1 (Jan. 1857): 17-18.

GB: PHOTOGRAPHIC SOCIETY: 1857.

ST3833 "London Photographic Society." PHOTOGRAPHIC AND FINE ART JOURNAL 10, no. 4 (Apr. 1857): 103-104. [From "Liverpool Photo. J."]

ST3834 "London Photographic Society: Monthly Meeting." PHOTOGRAPHIC AND FINE ART JOURNAL 10, no. 5 (May 1857): 133-136. [From "Liverpool Photo. J." Papers by Hardwich, W. J. Newton.]

ST3835 "London Photographic Society: Ordinary Meeting, May 7, 1857." PHOTOGRAPHIC AND FINE ART JOURNAL 10, no. 7 (July 1857): 222-223. [From "Br. J. of Photo." Meeting was primarily concerned with setting up a committee to seek relief for the widow of Frederick Scott Archer. Includes a long statement about Archer by Mayall.]

ST3836 "London Photographic Society: Ordinary Meeting, June, 1857." PHOTOGRAPHIC AND FINE ART JOURNAL 10, no. 9 (Sept. 1857): 259-260. [From "J. of the Photo. Soc." More on providing support for F. S. Archer's widow and family. Rejlander displayed "Two Ways of Life." Discussion followed.]

GB: PHOTOGRAPHIC SOCIETY: 1858.

ST3837 "London Photographic Society." PHOTOGRAPHIC AND FINE ART JOURNAL 11, no. 1-12 (Jan. - Dec. 1858): 18-21, 49-52, 88-90, 121-123, 173-178, 328-332. [From "Liverpool Photo. J."]

ST3838 "Note." ART JOURNAL (Mar. 1858): 94-95. [The Photographic Society Club has just published issues of portraits of the members. Bedford, Delamotte, Diamond, Fenton, Dr. Percy, Dr. Hardwick, the sculptor Durham, Thomas - the editor of "Notes & Queries", Lord Chief Baron Pollack.]

ST3839 "The Photographic Society." PHOTOGRAPHIC NEWS 1, no. 9 (Nov. 5, 1858): 101.

ST3840 "Meeting of the Royal Photographic Society." PHOTOGRAPHIC NEWS 1, no. 9 (Nov. 5, 1858): 104-106.

ST3841 "Societies: Photographic - Nov. 2." ATHENAEUM no. 1619 (Nov. 6, 1858): 591. [Report of the meeting. Discussion of Talbot's photoglyphic engraving process, etc.]

ST3842 "Meeting of the Royal Photographic Society." PHOTOGRAPHIC NEWS 1, no. 14 (Dec. 10, 1858): 165. [Meeting of Dec. 7, 1858.]

GB: PHOTOGRAPHIC SOCIETY: 1859.

ST3843 "Photographic Societies: London Photographic Society." PHOTOGRAPHIC NEWS 1, no. 18 (Jan. 7, 1859): 213.

ST3844 "Photographic Societies: London Photographic Society." PHOTOGRAPHIC NEWS 1, no. 22 (Feb. 4, 1859): 261-262.

ST3845 "Photographic Societies: London Photographic Society." PHOTOGRAPHIC NEWS 3, no. 61 (Nov. 4, 1859): 106. [Fenton, Bedford, and Shadbolt mentioned, discussion on landscape lenses.]

ST3846 "Photographic Societies: London Photographic Society." PHOTOGRAPHIC NEWS 3, no. 66 (Dec. 9, 1859): 165-166. [Paper by Mr. Ennel.]

GB: PHOTOGRAPHIC SOCIETY: 1860.

ST3847 "Photographic Societies: London Photographic Society." PHOTOGRAPHIC NEWS 3-4, no. 70-121 (Jan. 6 - Dec. 28, 1860): (v. 3) 211-212, 277-280, 326-329, 374-377; (v. 4) 6-12, 70, 79-83, 332-335, 379-380, 391-393. [Heath, Hardwich, Barnes, etc.]

ST3848 "Photographic Society of London." PHOTOGRAPHIC AND FINE ART JOURNAL 13, no. 2-7 (Feb. - July 1860): 71-73, 121-129, 201-204, 207-210. [From "Photo. J." (May) T. Sutton "On Panoramic and Plane Perspective." Le Neuve Foster "The Production of Photographic Images on Plates of Glass on Porcelain,..." etc. Mayall mentions "a solar camera "created by Mr. Johnson in New York, NY in 1843 similar to Woodward's camera, then being touted as new. Sutton on panoramic lenses, etc.]

GB: PHOTOGRAPHIC SOCIETY: 1861.

ST3849 "Photographic Society of London: Annual general meeting. Report." JOURNAL OF THE PHOTOGRAPHIC SOCIETY OF LONDON 7, no. 106 (Feb. 15, 1861): 98-108.

ST3850 "Societies: Photographic - Feb. 5." ATHENAEUM no. 1738 (Feb. 16, 1861): 233. [Note of annual meeting, election of officers.]

GB: PHOTOGRAPHIC SOCIETY: 1862.

ST3851 "Photographic Society Meeting: Jan. 7, 1862." JOURNAL OF THE PHOTOGRAPHIC SOCIETY OF LONDON 7, no. 117 (Jan. 15, 1862): 343-345. [Meeting to send condolences to Queen Victoria on the death of Prince Albert.]

GB: PHOTOGRAPHIC SOCIETY: 1864.

ST3852 "Photographic Societies: London Photographic Society." PHOTOGRAPHIC NEWS 8, no. 279 (Jan. 8, 1864): 19-20. [Controversy over Talbot's claims of priority.]

ST3853 "Photographic Societies: London Photographic Society." PHOTOGRAPHIC NEWS 8, no. 287 (Mar. 4, 1864): 116.

SPECIAL TOPICS: ORGANIZATIONS & SOCIETIES
GB: PHOTOGRAPHIC SOCIETY: 1865.

SPECIAL TOPICS: ORGANIZATIONS & SOCIETIES
GB: NORTH LONDON PHOTOGRAPHIC ASSOCIATION: 1859.

GB: PHOTOGRAPHIC SOCIETY: 1865.
ST3854 "The Photographic Society." BRITISH JOURNAL OF PHOTOGRAPHY 12, no. 245 (Jan. 13, 1865): 13. [Mr. Glaisher attempting to revive the Photographic Society, considered moribund.]

ST3855 "The Photographic Society." BRITISH JOURNAL OF PHOTOGRAPHY 12, no. 247 (Jan. 27, 1865): 51. [Letters from dissatisfied members of the Society.]

ST3856 "The 'Rejected Addresses' at the Photographic Society." BRITISH JOURNAL OF PHOTOGRAPHY 12, no. 290 (Nov. 24, 1865): 595-597. [Major C. Russell and G. Dawson wrote letters protesting allegations made by the President Mr. Glaisher and the editor of the Society's journal "J. of Photo. Soc." in those days.]

GB: PHOTOGRAPHIC SOCIETY: 1872.
ST3857 "London Photographic Society." ANTHONY'S PHOTOGRAPHIC BULLETIN 3, no. 5 (May 1872): 552-553.

GB: PHOTOGRAPHIC SOCIETY: 1877.
ST3858 "Photographic Society of Great Britain." ANTHONY'S PHOTOGRAPHIC BULLETIN 8, no. 3 (Mar. 1877): 65-68. [From "Br. J. of Photo." Papers and discussions on carbon printing by Samuel Fry, Jabez Hughes, J. A. Spencer, etc.]

GB: PHOTOGRAPHIC SOCIETY: 1879.
ST3859 "Photographic Society of Great Britain." ANTHONY'S PHOTOGRAPHIC BULLETIN 10, no. 2-3 (Feb. - Mar. 1879): 59-60, 83-84.

GB: MACCLESFIELD PHOTOGRAPHIC SOCIETY: 1858.
ST3860 "Macclesfield Photographic Society." PHOTOGRAPHIC AND FINE ART JOURNAL 11 , no. 8-9 (Aug. - Sept. 1858): 249-250, 254-256. [From "Photo News." (Sept.) Thomas Sutton's paper "On the nature and properties of light."]

ST3861 "Photographic Societies: Macclesfield Photographic Society." PHOTOGRAPHIC NEWS 1, no. 16 (Dec. 24, 1858): 189.

GB: MACCLESFIELD PHOTOGRAPHIC SOCIETY: 1859.
ST3862 "Macclesfield Photographic Society." PHOTOGRAPHIC AND FINE ART JOURNAL 12, no. 1 (June 1859): 26. [From "Photo. Notes."]

GB: MANCHESTER PHOTOGRAPHIC SOCIETY: 1857.
ST3863 "Manchester Photographic Society." PHOTOGRAPHIC AND FINE ART JOURNAL 10, no. 3-10 (Mar. - Oct. 1857): 78, 102, 124-126, 151, 314.

GB: MANCHESTER PHOTOGRAPHIC SOCIETY: 1858.
ST3864 "Manchester Photographic Society." PHOTOGRAPHIC AND FINE ART JOURNAL 11, no. 1-12 (Jan. - Dec. 1858): 26-27, 56, 86-87, 265-266, 327-328. [From "Liverpool Photo. J."]

ST3865 "Photographic Societies: Manchester Photo Soc." PHOTOGRAPHIC NEWS 1, no. 10, 14 (Nov. 12, Dec. 10, 1858): 117-118, 165-166.

GB: MANCHESTER PHOTOGRAPHIC SOCIETY: 1859.
ST3866 "Photographic Societies: Manchester Photographic Society." PHOTOGRAPHIC NEWS 1, no. 19 (Jan. 14, Feb. 11, 1859): 226-227, 273.

ST3867 "Proceedings of the Societies: Manchester Photographic Society." PHOTOGRAPHIC NEWS 3, no. 62 (Nov. 11, 1859): 118.

GB: MANCHESTER PHOTOGRAPHIC SOCIETY: 1860.
ST3868 "Manchester Photographic Society." PHOTOGRAPHIC AND FINE ART JOURNAL 13, no. 3, 7 (Mar., July 1860): 74, 200-201. [From "Br. J. of Photo."]

ST3869 "Proceedings of the Societies: Manchester Photographic Society." PHOTOGRAPHIC NEWS 4, no. 104 (Aug. 31, 1860): 213-214.

ST3870 "Proceedings of the Societies: Manchester Photographic Society." PHOTOGRAPHIC NEWS 4, no. 107 (Sept. 21, 1860): 247-248.

ST3871 "Proceedings of the Societies: Manchester Photographic Society." PHOTOGRAPHIC NEWS 4, no. 111 (Oct. 19, 1860): 297-298.

ST3872 "Proceedings of the Societies: Manchester Photographic Society." PHOTOGRAPHIC NEWS 4, no. 115 (Nov. 16, 1860): 345.

ST3873 "Proceedings of the Societies: Manchester Photographic Society." PHOTOGRAPHIC NEWS 4, no. 120 (Dec. 21, 1860): 405-406.

GB: MANCHESTER PHOTOGRAPHIC SOCIETY: 1876.
ST3874 "Proceedings of the Manchester Photographic Society." ANTHONY'S PHOTOGRAPHIC BULLETIN 7, no. 2, 4 (Feb., Apr. 1876): 59-60, 122-123. [From "London Photo. News." Letter by Rev. S. Vincent Beechey, takes mountain views in England. (Apr.) D. Young exhibited, Pollitt, etc.]

GB: MANCHESTER PHOTOGRAPHIC SOCIETY: 1879.
ST3875 "Manchester Photographic Society." ANTHONY'S PHOTOGRAPHIC BULLETIN 10, no. 7 (July 1879): 207-208. [From "London Photographic News."]

GB: NORTH LONDON PHOTOGRAPHIC ASSOCIATION: 1858.
ST3876 "North London Photographic Society." PHOTOGRAPHIC AND FINE ART JOURNAL 11, no. 7 (July 1858): 204-205. [From "Liverpool Photo. J."]

ST3877 "Photographic Societies: North London Photo. Assoc., Myddelton Hall, Islington." PHOTOGRAPHIC NEWS 1, no. 8 (Oct. 29, 1858): 93.

ST3878 "North London Photographic Society." PHOTOGRAPHIC AND FINE ART JOURNAL 11, no. 11 (Nov. 1858): 332, 342. [From "Liverpool Photo. J."]

GB: NORTH LONDON PHOTOGRAPHIC ASSOCIATION: 1859.
ST3879 "Photographic Societies: North London Photo. Assoc., Myddelton Hall, Islington." PHOTOGRAPHIC NEWS 1, no. 20 (Jan. 21, 1859): 238-239.

ST3880 "Photographic Societies: North London Photo. Assoc., Myddelton Hall, Islington." PHOTOGRAPHIC NEWS 1, no. 22 (Feb. 4, 1859): 262.

ST3881 "Proceedings of the Societies: North London Photographic Association." PHOTOGRAPHIC NEWS 3, no. 69 (Dec. 30, 1859): 201-202.

SPECIAL TOPICS: ORGANIZATIONS & SOCIETIES
GB: NORTH LONDON PHOTOGRAPHIC ASSOCIATION: 1860.

SPECIAL TOPICS: ORGANIZATIONS & SOCIETIES
GB: SOUTH LONDON PHOTOGRAPHIC SOCIETY: 1864.

GB: NORTH LONDON PHOTOGRAPHIC ASSOCIATION: 1860.

ST3882 "Proceedings of the Societies: North London Photographic Association." PHOTOGRAPHIC NEWS 3-4, no. 70-121 (Jan. 6 - Dec. 28, 1860): (v. 3) 314-315, 363-365, 429; (v. 4) 58-59, 258-259, 320-322, 370-371.

GB: NORTH LONDON PHOTOGRAPHIC ASSOCIATION: 1860.

ST3883 "North London Photographic Society." PHOTOGRAPHIC AND FINE ART JOURNAL 13, no. 3, 7 (Mar., July 1860): 73, 205-207. [From "Br. J. of Photo."]

GB: NORTH LONDON PHOTOGRAPHIC ASSOCIATION: 1864.

ST3884 "Proceedings of the Societies: North London Photographic Association." PHOTOGRAPHIC NEWS 8, no. 278-291 (Jan. 29 - Apr. 1, 1864): 10, 56-57, 103, 163-164.

GB: NORWICH PHOTOGRAPHIC SOCIETY: 1855.

ST3885 "Norwich Photographic Society. Meeting held Nov. 9, 1855." HUMPHREY'S JOURNAL 7, no. 18 (Jan. 15, 1856): 288-289. [From "Liverpool Photo. J."]

GB: NORWICH PHOTOGRAPHIC SOCIETY: 1856.

ST3886 "Norwich Photographic Society." PHOTOGRAPHIC AND FINE ART JOURNAL 9, no. 8 (Aug. 1856): 247-248.

GB: NORWICH PHOTOGRAPHIC SOCIETY: 1857.

ST3887 "Norwich Photographic Society." PHOTOGRAPHIC AND FINE ART JOURNAL 10, no. 3, 7, 9 (Mar., July, Sept. 1857): 90, 217, 264. [From "J. of the Photo. Soc., London."]

GB: NOTTINGHAM PHOTOGRAPHIC SOCIETY: 1859.

ST3888 "Photographic Societies: Nottingham Photographic Society." PHOTOGRAPHIC NEWS 1, no. 19 (Jan. 14, 1859): 226.

GB: NOTTINGHAM PHOTOGRAPHIC SOCIETY: 1860.

ST3889 "Proceedings of the Societies: Nottingham Photographic Society." PHOTOGRAPHIC NEWS 3, no. 78 (Mar. 2, 1860): 315.

GB: PAISLEY PHOTOGRAPHIC SOCIETY: 1858.

ST3890 "Photographic Societies: Paisley Photographic Society." PHOTOGRAPHIC NEWS 1, no. 11 (Nov. 19, 1858): 130.

GB: PHOTOGRAPHIC SOCIETY OF IRELAND.

ST3891 Merne, Oscar S. The Story of the Photographic Society of Ireland, 1854 - 1954. Dublin: the Society, 1954. 28 pp. 2 l. of plates.

GB: PHOTOGRAPHIC SOCIETY OF SCOTLAND: 1856.

ST3892 "The Photographic Society of Scotland: 1st Monthly Meeting." PHOTOGRAPHIC AND FINE ART JOURNAL 9, no. 7 (July 1856): 207-208. [Includes an "Address" by Sir David Brewster.]

GB: PHOTOGRAPHIC SOCIETY OF SCOTLAND: 1857.

ST3893 "Photographic Society of Scotland." PHOTOGRAPHIC AND FINE ART JOURNAL 10, no. 6 (June 1857): 176-177. [From "Liverpool Photo. J." Paper by Burnett.]

ST3894 "Photographic Society of Scotland: Ordinary Meeting, May 12, 1857." PHOTOGRAPHIC AND FINE ART JOURNAL 10, no. 9 (Sept. 1857): 278. [From "J. of Photo. Soc., London."]

ST3895 "Proceedings of the Photographic Society of Scotland." HUMPHREY'S JOURNAL 9, no. 11 (Oct. 1, 1857): 166-171. [From "Photo. Notes." Papers by Cosmo Innes, Colin Sinclair and Mr. Lamb.]

ST3896 "Photographic Society of Scotland: Ordinary Meeting, July 14th, 1857." PHOTOGRAPHIC AND FINE ART JOURNAL 10, no. 11 (Nov. 1857): 344. [From "J. of the Photo. Soc."]

GB: PHOTOGRAPHIC SOCIETY OF SCOTLAND: 1858.

ST3897 "Photographic Society of Scotland." PHOTOGRAPHIC AND FINE ART JOURNAL 11, no. 1 (Jan. 1858): 11. [From the J. of the Photo. Soc."]

ST3898 "Photographic Societies: Photographic Society of Scotland." PHOTOGRAPHIC NEWS 1, no. 11 (Nov. 19, 1858): 129-130.

GB: PHOTOGRAPHIC SOCIETY OF SCOTLAND: 1859.

ST3899 "Photographic Societies: Photographic Society of Scotland." PHOTOGRAPHIC NEWS 1, no. 20 (Jan. 21, 1859): 239.

GB: PHOTOGRAPHIC SOCIETY OF SCOTLAND: 1860.

ST3900 "The Photographic Society of Scotland." PHOTOGRAPHIC AND FINE ART JOURNAL 13, no. 3-7 (Mar.- July 1860): 81-82, 118-119, 205. [From "Br. J. of Photo."]

ST3901 "Proceedings of the Societies: Photographic Society of Scotland." PHOTOGRAPHIC NEWS 4, no. 118-119 (Dec. 7 - Dec. 14, 1860): 380, 393.

GB: PHOTOGRAPHIC SOCIETY OF SCOTLAND: 1863.

ST3902 "Photographic Society of Scotland: Ordinary Meeting April 14, 1863." JOURNAL OF THE PHOTOGRAPHIC SOCIETY OF LONDON 8, no. 133 (May 15, 1863): 279-280. [Report of Prize Award Committee. Portrait of group: Robinson "Bringing Home the May"; Landscape: Maxwell Lyte, Vernon Heath, Carbon prints: Pouncy.]

GB: PHOTOGRAPHIC SOCIETY OF SCOTLAND: 1864.

ST3903 "Photographic Society of Scotland." HUMPHREY'S JOURNAL OF PHOTOGRAPHY, AND THE ALLIED ARTS AND SCIENCES 15, no. 24 (Apr. 15, 1864): 373-375. [From "Br. J. of Photo."]

GB: ROYAL PHOTOGRAPHIC SOCIETY see PHOTOGRAPHIC SOCIETY.

GB: SOUTH LONDON PHOTOGRAPHIC SOCIETY: 1859.

ST3904 "Proceedings of the Societies: South London Photographic Society." PHOTOGRAPHIC NEWS 3, no. 60, 64 (Oct. 28, Nov. 25, 1859): 93-95, 140-143.

GB: SOUTH LONDON PHOTOGRAPHIC SOCIETY: 1860.

ST3905 "Proceedings of the Societies: South London Photographic Society." PHOTOGRAPHIC NEWS 3-4, no. 70-121 (Jan. 6 - Dec. 28, 1860): (v. 3) 212-215, 290, 341-342, 400-401; (v. 4) 34-36, 45-47, 93-95, 245-247, 306-307, 355-357, 413-416. [1860/01]

ST3906 "South London Photographic Society." PHOTOGRAPHIC AND FINE ART JOURNAL 13, no. 7 (July 1860): 198-199. [From "Br. J. of Photo."]

GB: SOUTH LONDON PHOTOGRAPHIC SOCIETY: 1864.

ST3907 "Proceedings of the Societies: South London Photographic Society." PHOTOGRAPHIC NEWS 8, no. 281-289 (Jan. 22 - Mar. 18, 1864): 46-47, 69, 93, 142.

SPECIAL TOPICS: ORGANIZATIONS & SOCIETIES
GB: SOUTH LONDON PHOTOGRAPHIC SOCIETY: 1871.

SPECIAL TOPICS: ORGANIZATIONS & SOCIETIES
USA: AMATEUR PHOTOGRAPHIC EXCHANGE CLUB.

GB: SOUTH LONDON PHOTOGRAPHIC SOCIETY: 1871.
ST3908 "South London Photographic Society." ANTHONY'S PHOTOGRAPHIC BULLETIN 2, no. 12 (Dec. 1871): 388-389. [From "Br. J. of Photo."]

GB: SOUTH LONDON PHOTOGRAPHIC SOCIETY: 1872.
ST3909 "South London Photographic Society - Annual Dinner." PHILADELPHIA PHOTOGRAPHER 9, no. 98 (Feb. 1872): 41-45. [From "Photo. News." O. G. Rejlander extensively quoted, discussed. E. Cocking, Valentine Blanchard, Baynham Jones, others also discussed or quoted.]

GB: SOUTH LONDON PHOTOGRAPHIC SOCIETY: 1874.
ST3910 "Annual Dinner of the South London Photographic Society." ANTHONY'S PHOTOGRAPHIC BULLETIN 5, no. 2 (Feb. 1874): 80. [From "Br. J. of Photo."]

GB: STEREO EXCHANGE CLUB: 1860.
ST3911 "Stereoscopic Exchange Club." PHOTOGRAPHIC NEWS 4, no. 111 (Oct. 19, 1860): 300. [Promotion of a stereo exchange club, list of members p. 312, Oct. 26, 1860 issue.]

GERMANY: BERLIN PHOTOGRAPHIC SOCIETY: 1864.
ST3912 Osborne, J. W. "The Photographic Society in Berlin." PHOTOGRAPHIC NEWS 8, no. 289 (Mar. 18, 1864): 138-139.

GERMANY: BERLIN PHOTOGRAPHIC SOCIETY: 1871.
ST3913 "Society for the Advancement of Photography, Berlin." ANTHONY'S PHOTOGRAPHIC BULLETIN 2, no. 1 (Jan. 1871): 19-21. [From "Br J of Photo."]

ST3914 "Society for the Advancement of Photography, Berlin." ANTHONY'S PHOTOGRAPHIC BULLETIN 2, no. 4 (Apr. 1871): 117-120.

ST3915 "Our Picture - Members of the Berlin Society for the Advancement of Photography." PHILADELPHIA PHOTOGRAPHER 8, no. 95 (Nov. 1871): 373-375, plus unnumbered leaf. 1 b & w. [Actually thirty-three separate portraits of each member of the Society, taken by Glasshoff (Berlin, GER.]

GERMANY: BERLIN PHOTOGRAPHIC SOCIETY: 1873.
ST3916 "Extract from the Report of the Berlin Photographic Society." ANTHONY'S PHOTOGRAPHIC BULLETIN 4, no. 6 (June 1873): 184. [From "Br J of Photo."]

ST3917 "Extract from Report of the Photographic Society of Berlin." ANTHONY'S PHOTOGRAPHIC BULLETIN 4, no. 8 (Aug. 1873): 239-240. [From "Br J of Photo."]

ST3918 "Extract from Report of the Photographic Society of Berlin." ANTHONY'S PHOTOGRAPHIC BULLETIN 4, no. 8 (Aug. 1873): 239-240. [From "Br J of Photo."]

GERMANY: BERLIN PHOTOGRAPHIC SOCIETY: 1874.
ST3919 "Meeting of the Berlin Photographic Society." ANTHONY'S PHOTOGRAPHIC BULLETIN 5, no. 2 (Feb. 1874): 84-86. [From "Br. J. of Photo."]

GERMANY: BERLIN PHOTOGRAPHIC SOCIETY: 1875.
ST3920 "Extracts from the Proceedings at the Berlin Photographic Society." ANTHONY'S PHOTOGRAPHIC BULLETIN 6, no. 11 (Nov. 1875): 349-350. [Aubel & Kaiser; Hans, Jr.; etc.]

GERMANY: BERLIN PHOTOGRAPHIC SOCIETY: 1876.
ST3921 "Extracts from the Proceedings of the Berlin Photo. Society." ANTHONY'S PHOTOGRAPHIC BULLETIN 7, no. 8 (Aug. 1876): 244. [From "Br. J. of Photo."]

GERMANY: BERLIN PHOTOGRAPHIC SOCIETY: 1879.
ST3922 "Berlin Association for the Cultivation of Photography." ANTHONY'S PHOTOGRAPHIC BULLETIN 10, no. 2 (Feb. 1879): 60-61. [From "Br. J. of Photo."]

USA: 1850.
ST3923 "American Photographic Association." DAGUERREAN JOURNAL 1, no. 2 (Nov. 15, 1850): 48. [Announcement of imminent formation of the first professional association.]

USA: 1851.
ST3924 Snelling, H. H. "Photographic Re-Unions." PHOTOGRAPHIC ART JOURNAL 1, no. 2-3, 5 (Feb. - Mar., May 1851): 107-110, 139-141, 266-268 . [Call for the organization of a professional society.]

ST3925 "Gossip: At a Large and Enthusiastic Meeting." PHOTOGRAPHIC ART JOURNAL 2, no. 2 (Aug. 1851): 123-124. [New York photographers meet to plan formation of a national society.]

ST3926 "Notice." DAGUERREAN JOURNAL 2, no. 9 (Sept. 15, 1851): 273. [Note that the name of the just formed American Heliographic Association changed to the American Daguerre Association, in honor of the recently deceased Daguerre.]

ST3927 "Gossip." PHOTOGRAPHIC ART JOURNAL 2, no. 4 (Oct. 1851): 250-251. ["Gossip" devoted to announcing formation of the NY State Daguerrean Assoc., the American Daguerre Assoc., and the American Photographic Institute (another assoc.).]

USA: 1852.
ST3928 "Gossip." PHOTOGRAPHIC ART JOURNAL 3, no. 4 (Apr. 1852): 253-255. [Essay promoting the formation of professional organizations (i.e.: NY State Daguerrean Association).]

USA: 1856.
ST3929 Davie, D. D. T. "An Appeal to Photographers." PHOTOGRAPHIC AND FINE ART JOURNAL 9, no. 9 (Sept. 1856): 276-277. [Davie asking for the formation of a national photographic society.]

USA: 1858.
ST3930 F. J. E. "Suggestions for the Organization of a Photographic Society." PHOTOGRAPHIC AND FINE ART JOURNAL 11, no. 7 (July 1858): 219.

USA: 1874.
ST3931 "Society Gossip." PHILADELPHIA PHOTOGRAPHER 11, no. 121-132 (Jan. - Dec. 1874): 18-22, 60-61, 78-81, 113-115, 156-158, 183-187, 219-222, 316-317, 339-341, 373-375. [Reports on the meetings of various societies. Philadelphia, German Photo. Soc. of NY; Photographic Institute (Chicago, IL); Pennsylvania (Philadelphia, PA); Chicago Photo. Assoc.; NY Photo. Soc., etc.]

USA: AMATEUR PHOTOGRAPHIC EXCHANGE CLUB.
ST3932 Eskind, Robert Wall. The Amateur Photographic Exchange Club (1861 - 1863): The Profits of Association. Austin: University of Texas at Austin, 1982. 222 l. [M. A. Thesis. "List of Members," ll. 182-188. "Selected Bibliography." ll. 216-222. Anthony T. Anthony (1814-1884); Henry Bedlow (1821-1914); Eugene Borda (b. 1825);

SPECIAL TOPICS: ORGANIZATIONS & SOCIETIES
USA: AMATEUR PHOTOGRAPHIC EXCHANGE CLUB: 1861.

SPECIAL TOPICS: ORGANIZATIONS & SOCIETIES
USA: AMERICAN INSTITUTE, PHOTOGRAPHICAL SECTION: 1871.

Capt. T. J. Brereton; George Buchanan Coale (1819-1887); Samuel Fisher Corlies (1830-1888); Edward Laight Cottenet; Hugh Davids (d. 1872); John Dean (1831-1888); Edwin Emerson (1823-1908); Francis T. Fassitt (d. 1905); Frederick Graff (1817-1890); Constant Guillou (1812-1872); James H. Haight (b. ca. 1843); Charles Henry Hall (1820-1895); Charles Francis Himes (1838-1918); Charles Wager Hull (d. 1895); James Hunter (d. 1896); Dr. Stephen P. Leeds; John M. Masterton; Henry T. Martin; William Mead; Titian Ramsay Peale (1799-1885); Charles De Rham (1822-1909); Fairman Rogers (1833-1900); Ogden Nicholas Rood (1831-1907); Lewis Morris Rutherford (1816-1892); Coleman Sellers (1827-1907); Jonathan Dickinson Sergeant (b. 1822); Robert Shriver (1837-1912); Frederick Ferris Thompson (1836-1899); August Wetmore, Jr.]

USA: AMATEUR PHOTOGRAPHIC EXCHANGE CLUB: 1861.

ST3933 Sellers, Coleman, E.D., M. Inst. C.E. "An Old Photographic Club." ANTHONY'S PHOTOGRAPHIC BULLETIN 19, no. 10-13, 21 (May 26 - July 14, Nov. 10, 1888): 301-304, 338-341, 356-361, 403-406, 658-661. [History of the Amateur Photographic Exchange Club, founded in 1861 by Henry T. Anthony.]

ST3934 Sellers, Coleman. "The Story of the Amateur Exchange Club: An Old Photographic Club." STEREO WORLD 1, no. 2-6 (May - June 1974 - Jan. - Feb. 1975): 2:3, 3:4, 4:4, 5:6, 13, 6:10, 16. [Reprinted from "Anthony's Photographic Bulletin," (May 26 - Nov. 10, 1888). Describes the formation of the Amateur Photographic Exchange Club, founded by H. T. Anthony and others in 1861.]

USA: AMERICAN ART UNION: 1852.

ST3935 "American Art Union." PHOTOGRAPHIC ART JOURNAL 3, no. 1 (Jan. 1852): 45-47.

USA: AMERICAN CARBON ASSOCIATION: 1878.

ST3936 "American Carbon Association." ANTHONY'S PHOTOGRAPHIC BULLETIN 9, no. 2 (Feb. 1878): 60-61. [American Carbon Association formed, list of officers. C. Gentile, Pres., T. C. Roche, Treasurer, etc.]

USA: AMERICAN DAGUERRE ASSOCIATION: 1851.

ST3937 "American Daguerre Association." PHOTOGRAPHIC ART JOURNAL 2, no. 4 (Oct. 1851): 245-249. [Report of meeting to found the organization and write its constitution. M. M. Lawrence elected President. Vice Presidents were Guerney, Southworth, Fitzgibbon, Van Lorn, Nobyns, Faras...]

ST3938 "American Daguerre Association." DAGUERREAN JOURNAL 2, no. 11 (Oct. 15, 1851): 342-346. [Includes Constitution and By-laws.]

USA: AMERICAN INSTITUTE, PHOTOGRAPHIC SECTION see also USA: AMERICAN PHOTOGRAPHICAL SOCIETY

[The American Photographical Society was founded in 1859. In 1867 its Constitution and By-laws were amended so that it became a Section in the American Institute, in New York City.]

USA: AMERICAN INSTITUTE, PHOTOGRAPHICAL SECTION: 1867.

ST3939 "Photographical Section of the American Institute, Reported for Humphrey's Journal." HUMPHREY'S JOURNAL OF PHOTOGRAPHY, AND THE ALLIED ARTS AND SCIENCES 19, no. 16 (Dec. 15, 1867): 247-248. [Hull showed his own prints and photographs by B. F. Gage (St. Johnsbury, Vt.) Books illustrated by the American Photo-Lithographic Co. were displayed by Mr. Mason. Anthony, Hull, Chapman, Newton, Prof. Tillman discussed issues.]

ST3940 "Photographical Section: Proceedings," on pp. 1024-1035 in: ANNUAL REPORT OF THE AMERICAN INSTITUTE, OF THE CITY OF NEW YORK FOR THE YEAR 1867 - 68. Albany: The Argus Co., printers, 1868. [Minutes of the meetings from June 10, 1867 to Apr. 7, 1868.]

USA: AMERICAN INSTITUTE, PHOTOGRAPHICAL SECTION: 1868.

ST3941 Hull, C. Wager. "New York Correspondence." PHILADELPHIA PHOTOGRAPHER 5, no. 49-60 (Jan. - Dec. 1868): 52-54, 93-95, 125-128, 173-177, 195-199, 237-239, 408-409, 427-428.

ST3942 "Photographical Section of the American Institute." HUMPHREY'S JOURNAL OF PHOTOGRAPHY, AND THE ALLIED ARTS AND SCIENCES 19, no. 23-24 (Apr. 1 - Apr. 15, 1868): 357-358, 380-381. [Report of meetings, invitation to community.]

ST3943 "Photographical Section of the American Institute." HUMPHREY'S JOURNAL OF PHOTOGRAPHY, AND THE ALLIED ARTS AND SCIENCES 20, no. 1-4 (May 1 - June 15, 1868): 6-8, 19-20, 51-52. [(May 1) Complaints of V. M. Griswold about a previous report aired, answered by the editor. (May 15) E. Geo. Squire, the celebrated South American traveler, talked. A. J. Drummon exhibited carbon prints. (June 15) Chapman displayed instantaneous photos. Chemical matters discussed.]

ST3944 "Photographical Section: Proceedings," on pp. 1087-1116 in: TWENTY-NINTH ANNUAL REPORT OF THE AMERICAN INSTITUTE, OF THE CITY OF NEW YORK FOR THE YEAR 1868 - 69. Albany: The Argus Co., printers, 1869. [Minutes of the meetings from May 4, 1868 to Apr. 6, 1869.]

USA: AMERICAN INSTITUTE, PHOTOGRAPHICAL SECTION: 1869.

ST3945 "The American Photographical Society, by Our Own Reporter." HUMPHREY'S JOURNAL OF PHOTOGRAPHY, AND THE ALLIED ARTS AND SCIENCES 20, no. 28 (Dec. 15, 1869): 443-444. [Title may be misleading - this is the Photo. Section of the American Institute. Mr. Newton discussed processes. Prof. Tilman, Mr. Chapman, Mason contributing. Mr. Kurtz displayed a model reflector. Bierstadt exhibited prints from J. Albert of Munich. Hull miffed because one of his discoveries claimed in England, etc.]

ST3946 "Photographical Section: Proceedings," on pp. 1068-1087 in: THIRTIETH ANNUAL REPORT OF THE AMERICAN INSTITUTE, OF THE CITY OF NEW YORK FOR THE YEAR 1869 - 70. Albany: The Argus Co., printers, 1870. [Minutes of the meetings from May 4, 1869 to Apr. 5, 1870.]

USA: AMERICAN INSTITUTE, PHOTOGRAPHICAL SECTION: 1871.

ST3947 "The Photographical Section of the American Institute, New York." PHILADELPHIA PHOTOGRAPHER 8, no. 87, 90, 96 (Mar., June, Dec. 1871): 89-90, 185, 391-392. [Woodward Solar Camera discussed, (Mar. 1871).]

ST3948 Hull, C. Wager. "New York Correspondence." PHILADELPHIA PHOTOGRAPHER 8, no. 90, 96 (June, Dec. 1871): 185, 391-392.

SPECIAL TOPICS: ORGANIZATIONS & SOCIETIES
USA: AMERICAN INSTITUTE, PHOTOGRAPHICAL SECTION: 1872.

SPECIAL TOPICS: ORGANIZATIONS & SOCIETIES
USA: AMERICAN INSTITUTE, PHOTOGRAPHICAL SECTION: 1877.

ST3949 "Photographical Section: Proceedings," on pp. 1110-1127 in: THIRTY-FIRST ANNUAL REPORT OF THE AMERICAN INSTITUTE, OF THE CITY OF NEW YORK FOR THE YEAR 1870 - 71. Albany: The Argus Co., printers, 1871. [Minutes of the meetings from May 3, 1870 to Apr. 4, 1871.]

USA: AMERICAN INSTITUTE, PHOTOGRAPHICAL SECTION: 1872.

ST3950 Hull, Charles Wager. "New York Correspondence." PHILADELPHIA PHOTOGRAPHER 9, no. 99-103 (Mar. - July 1872): 77-78, 149-151, 253-255.

ST3951 "Photographical Section: Proceedings," on pp. 977-986 in: THIRTY-SECOND ANNUAL REPORT OF THE AMERICAN INSTITUTE, OF THE CITY OF NEW YORK FOR THE YEAR 1871 - 72. Albany: The Argus Co., printers, 1872. [Minutes of the meetings from Oct. 3, 1871 to Apr. 2, 1872.]

USA: AMERICAN INSTITUTE, PHOTOGRAPHICAL SECTION: 1873.

ST3952 "Report of the Photographical Section of the American Institute." ANTHONY'S PHOTOGRAPHIC BULLETIN 4, no. 1 - 12 (Jan. - Dec. 1873): 13-18, 51-56, 80-85, 119-122, 152-154, 180-183, 210-213, 297-299, 325-330, 366. [Report of the meetings, mostly technical information. A note that Pres. H. J. Newton displayed copies of engravings by Rembrandt to refute the notion that the popular portrait style called "Rembrandt Pictures," (Which consisted of extreme lighting and deep shadows on the face) was never used by Rembrandt, (Mar.); New daily paper "The Graphic" displayed, (Apr.); Talbot's "Pencil of Nature" displayed, (June); Muybridge's Yosemite views displayed, (Oct.).]

ST3953 "Photographical Section of the American Institute." PHILADELPHIA PHOTOGRAPHER 10, no. 110-111 (Feb. - Mar. 1873): 50-51, 81-83.

USA: AMERICAN INSTITUTE, PHOTOGRAPHICAL SECTION: 1874.

ST3954 "Report of the Photographical Section of the American Institute." ANTHONY'S PHOTOGRAPHIC BULLETIN 5, no. 1-12 (Jan. - Dec. 1874): 18, 91-05, 121-125, 156-159, 186-190, 219-222, 321, 348-352, 381-384, 411-414. [(Jan.) G. B. Shepherd; Mason on landscape backgrounds, on medical photography, on photo-lithography. (Feb.) D. C. Chapman, J. B. Gardner, Chisholm. (Apr.) H. T. Anthony; James Chisholm; E. O. Beaman exhibited stereopticon views of Colorado, etc; Henry Whitall. (May) H. T. Anthony; Charles B. Boyle. (June) Henry Gregson; Bierstadt; J. B. Gardner; Boyle. (Oct.) H. J. Newton on dry plate process. (Nov.) J. B. Gardner on removing hypo. (Dec.) Roche exhibited work. Chapman, Mason discussed it.]

ST3955 Anthony, H. T. "Photographical Section of the American Institute of New York." ANTHONY'S PHOTOGRAPHIC BULLETIN 5, no. 10 (Oct. 1874): 343.

USA: AMERICAN INSTITUTE, PHOTOGRAPHICAL SECTION: 1875.

ST3956 "Report of the Photographical Section of the American Institute." ANTHONY'S PHOTOGRAPHIC BULLETIN 6, no. 1-12 (Jan. - Dec. 1875): 27-29, 54-57, 86-90, 119-121, 154-155, 180-186, 218-221, 316-318, 342-349, 370-372. [(Mar.) Letter from Hans Breitman (which may be a spoof) read to the meeting by Wm. Kurtz. (Apr.) J. B. Gardner displayed "spirit pictures," taken by Mr. Evans in the Bowery. Mummler discussed. (May) "Spirit pictures" discussed again. (June) Paper calling for stronger photographic associations by

"Campaginator," with commentary by J. B. Gardiner. (Oct.) Speech from J. B. Gardiner on dangers of unchecked competition in the profession; Alex. Becker's talk. (Nov.) Disruption of a confidence game to trap photographers; Gardner on photographing on Sunday; technical articles. (Dec.) Captain Russell describes his experiences with dry plates. Wehle; Ch. Bierstadt; M. N. Miller; D. C. Chapman, O. G. Mason, etc. respond.]

ST3957 "Report of the Photographic Section of the American Institute." PHOTOGRAPHIC TIMES 5, no. 49-60 (Jan. - Dec. 1875): 7, 77-80, 103-107, 129-130, 163-168, 236-240, 258-259, 286-289. [(Mar.) Includes the presentation of some "Spirit Pictures," taken by a Mr. Evans, Washington DC., which led to a spirited discussion, including a discussion of Mummler's spirit photography practiced in Boston, MA, "a few years ago." (May) Further matters of the "Spirit Photographs." A Letter from "Campaginator," arguing for a professional photographers' association. (Oct.) Includes the details of a confidence trick being played on portrait photographers. Mostly chemical matters. (Dec.) Contains a paragraph about Captain Russell visiting the Scoville Manufacturing Co. to investigate the possibilities of dry-plates. The remainder mostly chemical.]

ST3958 "Report of the Photographic Section of the American Institute, The Chicago Photographic Association." PHOTOGRAPHIC TIMES 5, no. 50, 51 (Feb. - Mar. 1875): 30, 53-55.

USA: AMERICAN INSTITUTE, PHOTOGRAPHICAL SECTION: 1876.

ST3959 "Report of the Photographical Section of the American Institute." ANTHONY'S PHOTOGRAPHIC BULLETIN 7, no. 1-12 (Jan. - Dec. 1876): 28-29, 54-58, 124-125, 135-136, 154-159, 189-190, 220-224, 312-316, 346-348, 377-379. [(Feb.) H. T. Anthony read paper. Capt. Russell exhibited a portable camera, discussed processes, exhibited photos taken in Philadelphia; M. N. Miller, M. D. talked about Collodio-Bromide emulsions; Roche exhibited transparent views. (Apr.) E. Bierstadt, H. J. Newton; Dr. Miller; (May) Microphoto.; Leon Vidal's photo-chromos; etc. (June) H. J. Newton, T. C. Roche; E. Bierstadt, D. C. Chapman. (July) E. B. Barker shows carbon prints gathered in Europe from Liebert (Paris) and B. J. Edwards (London); H. J. Newton discusses prints from emulsion plates; (contains information about history of early experiments with dry plates by Newton and Charles Wager Hull); Dr. Adolphe Ott showed prints by Aubel & Kaiser (Cologne) discussed evolution of photo-mechanical printing; Spooner's (Stockton, CA) prints displayed. (Oct.) Dr. Adolphe Ott on carbon printing. (Nov.) Ott on polychrome prints, H. J. Newton, etc.]

ST3960 "Report of the Photographic Section of the American Institute." PHOTOGRAPHIC TIMES 6, no. 61-72 (Jan. - Dec. 1876): 31-36, 145-148, 331-336.

USA: AMERICAN INSTITUTE, PHOTOGRAPHICAL SECTION: 1877.

ST3961 "Report of the Photographical Section of the American Institute." ANTHONY'S PHOTOGRAPHIC BULLETIN 8, no. 1-12 (Jan. - Dec. 1877): 24-25, 55, 87-88, 121-122, 153-154, 188-190, 222, 315, 346-347, 376-377. [(Jan.) Mostly chemical matters; T. C. Roche gave a lantern exhibit of views taken in Washington, DC "last summer." (Feb.) Papers by J. B. Gardner, H. J. Newton, J. Chisholm and T. C. Roche. (Mar.) Roche exhibited lantern slides, discussed various processes. (Apr.) Becker's displayed his hand stereoscope. (May) General matters. (June) Chemical matters, H. J. Newton showed prints. (July) General matters. (Oct.) Chemical matters. (Nov.) T. C. Roche displayed photos made with dry plates. (Dec.) Edward Bierstadt displayed carbon prints, James Chisholm, J. B. Gardner.]

SPECIAL TOPICS: ORGANIZATIONS & SOCIETIES
USA: AMERICAN INSTITUTE, PHOTOGRAPHICAL SECTION: 1878.

SPECIAL TOPICS: ORGANIZATIONS & SOCIETIES
USA: AMERICAN PHOTOGRAPHICAL SOCIETY: 1859.

USA: AMERICAN INSTITUTE, PHOTOGRAPHICAL SECTION: 1878.

ST3962 "Report of the Photographical Section of the American Institute." ANTHONY'S PHOTOGRAPHIC BULLETIN 9, no. 1-12 (Jan. - Dec. 1878): 31-32, 58-60, 89-93, 121-124, 157-158, 186-188, 221-224, 345-351, 380-382. [Mostly chemical issues discussed throughout.]

USA: AMERICAN INSTITUTE, PHOTOGRAPHICAL SECTION: 1879.

ST3963 "Report of the Photographical Section of the American Institute." ANTHONY'S PHOTOGRAPHIC BULLETIN 10, no. 1-12 (Jan. - Dec. 1879): 26-31, 61-62, 123-125, 155-156, 186-188, 217-221, 317-319, 346-349, 373-376. [(Apr.) Vanderweyde's son (in London) experimenting with electric light photography, Officers elected, Mason displayed portraits of hospital patients at Bellevue Hospital. (July) Lantern slide exhibitions, etc. (Oct.) Obituary for Dr. J. V. C. Smith, American Institute member (not a photographer). Discussion of landscape work by Mr. Mason.]

ST3964 Hull, C. Wager. "New York Correspondence." PHILADELPHIA PHOTOGRAPHER 6, no. 61-66 (Jan. - June, 1869): 15-16, 48-49, 88-89, 127-129, 161-162, 199-203.

USA: AMERICAN PHOTOGRAPHIC EXCHANGE CLUB: 1861.

ST3965 "The American Photographic Exchange Club." AMERICAN JOURNAL OF PHOTOGRAPHY AND THE ALLIED ARTS & SCIENCES n. s. vol. 4, no. 14 (Dec. 15, 1861): 328. [Announcement of formation of the American Photographic Exchange Club, list of rules. Further note on p. 335.]

ST3966 "The American Photographic Exchange Club." IMAGE 1, no. 2 (Feb. 1952): 4. [First USA photo organization, founded by Henry T. Anthony and others in 1861. Lasted until 1863.]

USA: AMERICAN PHOTOGRAPHIC INSTITUTE: 1852.

ST3967 "Constitution and By-Laws of the American Photographic Institute." PHOTOGRAPHIC ART JOURNAL 3, no. 2 (Feb. 1852): 111-115.

USA: AMERICAN PHOTOGRAPHICAL SOCIETY see also USA: AMERICAN INSTITUTE, PHOTOGRAPHICAL SECTION

[The American Photographical Society was organized in 1859. In 1867 the constitution and by-laws were amended so that the Society became a Section of the American Institute, in New York City.]

USA: AMERICAN PHOTOGRAPHICAL SOCIETY.

ST3968 Warner, Deborah Jean. "The American Photographical Society and the Early History of Astronomical Photography in America." PHOTOGRAPHIC SCIENCE & ENGINEERING 11, no. 5 (Sept. - Oct. 1967): 342-347. 5 b & w. [Henry Draper; L. M. Rutherford; J. W. Draper; Henry Fitz.]

ST3969 "American Photographical Society: Charles Seely vs. 'Practical' Photographers and 'Humphrey's Journal.'" PHOTOGRAPHICA 12, no. 2 (Feb. 1980): 8. [Excerpted minutes of meeting of the American Photographical Society, New York.]

USA: AMERICAN PHOTOGRAPHICAL SOCIETY: 1859.

ST3970 "The American Photographical Society." AMERICAN JOURNAL OF PHOTOGRAPHY AND THE ALLIED ARTS AND SCIENCES n. s. vol. 1, no. 19-24 (Mar. 1, - May 15, 1859): 301-305, 334-336, 345-348, 377-381. [A meeting held at the American Institute, New York, to organize a photographic society of amateurs. Chairman, A. W. Whipple. M. Haskell, Sec., Joseph Dixon, Alex. Everett, P. C. Duchochois, John Campbell, Lewis Rutherford, Henry Scully, Benj. Frederick, Ch. Seely. At second meeting officers elected. Pres.: John W. Draper. V.P.s: Lewis M. Rutherford, Dr. R. Ogden Doremus, H. H. Scheffelin. Corr. Sec.: A. W. Whipple, Rec. Sec.: Dr. Isaiah Deck. Tres.: John Johnson. Thereafter the "A J of P" reported on the biweekly meetings of this organization in alternate issues of the journal for years.]

ST3971 Vanderweyde, P. H. "American Photographical Society." HUMPHREY'S JOURNAL OF PHOTOGRAPHY, AND THE ALLIED ARTS AND SCIENCES 11, no. 2 (May 15, 1859): 20-21. [Report of the meeting of the 9th of May. Rather sarcastic summary of the events.]

ST3972 "American Photographical Society." AMERICAN JOURNAL OF PHOTOGRAPHY AND THE ALLIED ARTS AND SCIENCES n. s. vol. 2, no. 1 - 18 (June 1, 1859 - Feb. 15, 1860): 27-30, 59-63, 89-93, 121-125, 149-153, 189-192, 218-222, 251-254, 286-288. [Reports of the meetings.]

ST3973 "Meeting for the Organization of a Photographic Society. - The Second Meeting." PHOTOGRAPHIC AND FINE ART JOURNAL 12, no. 1 (June 1859): 19-20, 20-21. [A number of amateurs met to consider forming an association in New York, NY. Seely; A. W. Whipple (Brooklyn, NY); M. Haskell; J. Dixon; Tillman; Garbanati; Deck; Johnson; Snelling; Everett; Cady; Campbell; Tinson. At second meeting determined the name American Photographical Society, constitution, by-laws, list of 62 members.]

ST3974 Van der Weyde, P. H., M.D. "American Photographical Society of New York." HUMPHREY'S JOURNAL OF PHOTOGRAPHY, AND THE ALLIED ARTS AND SCIENCES 11, no. 3 (June 1, 1859): 33-34. ["A few details concerning the beginning of this Society,...may not prove uninteresting..."]

ST3975 "American Photographical Society. First Regular Meeting. - Second Regular Meeting." PHOTOGRAPHIC AND FINE ART JOURNAL 12, no. 1 (June 1859): 22-26. [Charles A. Seely's "A Supposed Law of Color," P. C. Duchochois' "On a Dry Collodion Process." Joseph Dixon's "On Sensitizing Albumenized Paper." E. Garbanati's "On Washing Gun Cotton." Henry Draper's "On a New Method of Darkening Collodion." E. K. Hough's "Collodion Varnish."]

ST3976 "American Photographical Society." PHOTOGRAPHIC AND FINE ART JOURNAL 12, no. 2 (July 1859): 42-44, 54. [(July) Seely's "Printing in the Dark and Moser's Images." John C. Draper's "On the Determination of the Diurnal Amount of Light by the Precipitation of Gold."]

ST3977 "American Photographical Society of New York." HUMPHREY'S JOURNAL OF PHOTOGRAPHY, AND THE ALLIED ARTS AND SCIENCES 11, no. 6-24 (July 15 - Dec. 15, 1859): 83-84, 113-114, 244. [Reports on the monthly meetings.]

ST3978 Ceileur, A. "What is the Photographical Society? and who are the Photographers?" HUMPHREY'S JOURNAL OF PHOTOGRAPHY, AND THE ALLIED ARTS AND SCIENCES 11, no. 10 (Sept. 15, 1859): 145-146.

ST3979 Seely, George. "The Photographic Society and Practical Photographers." AMERICAN JOURNAL OF PHOTOGRAPHY AND THE ALLIED ARTS AND SCIENCES n. s. vol. 2, no. 10 (Oct. 15, 1859): 148-149. [Complaining that professionals not having anything to do with the society.]

ST3980 Van der Weyde, John J. "American Photographical Society." HUMPHREY'S JOURNAL OF PHOTOGRAPHY, AND THE ALLIED ARTS AND SCIENCES 11, no. 12 (Oct. 15, 1859): 178-179. [Letter protesting the criticisms in A Ceileur's earlier article, with a strong editorial response by Joseph H. Ladd, who felt the Society was elitist—comprised primarily of scientists and amateur photographers.]

ST3981 Ceileur, A. "The New York Photographical Society once more." HUMPHREY'S JOURNAL OF PHOTOGRAPHY, AND THE ALLIED ARTS AND SCIENCES 11, no. 13 (Nov. 1, 1859): 194-195.

ST3982 "The American Photographical Society. Fearful Denunciation of Photographers! - 'A lazy, stupid set'!! - 'Miserably fitted for their position!!!'" HUMPHREY'S JOURNAL OF PHOTOGRAPHY, AND THE ALLIED ARTS AND SCIENCES 11, no. 14 (Nov. 15, 1859): 211-212. [Quoting (without naming) Charles A. Seely, then savagely attacking him.]

ST3983 "Proceedings of the Societies: American Photographical Society." PHOTOGRAPHIC NEWS 3, no. 67 (Dec. 16, 1859): 178-179.

ST3984 Welling, William. "Founding of the American Photographical Society." PHOTOGRAPHICA 11, no. 1 (Jan. 1979): 8-10. [Background and excerpted minutes of meeting Feb. 26, 1859.]

ST3985 "Minutes of the Meeting, March 9, 1859." PHOTOGRAPHICA 11, no. 2 (Feb. 1979): 11. [Excerpted minutes of meeting of the American Photographical Society., New York.]

ST3986 "Minutes of the Meeting, March 26, 1859." PHOTOGRAPHICA 11, no. 3 (Mar. 1979): 9. 2 portraits b & w. [Excerpted minutes of meeting of the American Photographical Society, New York. POrtraits of J. W. Draper and John Johnson.]

ST3987 "Minutes of the Meeting, April 11, 1959." PHOTOGRAPHICA 11, no. 4 (Apr. 1979): 11. [Excerpted minutes of meeting of the American Photographical Society, New York.]

ST3988 "Minutes of the Meeting, June 13, 1859." PHOTOGRAPHICA 11, no. 5 (May 1979): 11. [Excerpted minutes of meeting of the American Photographical Society, New York.]

ST3989 "Minutes of the Meeting, July, 1859." PHOTOGRAPHICA 11, no. 6 (June - July 1979): 14. [Excerpted minutes of meeting of the American Photographical Society, New York.]

ST3990 "Minutes of the Meeting, August 8, 1859." PHOTOGRAPHICA 11, no. 7 (Aug. - Sept. 1979): 9-10. [Excerpted minutes of meeting of the American Photographical Society, New York.]

ST3991 "Minutes of the Meeting, September 12, 1859." PHOTOGRAPHICA 11, no. 8 (Oct. 1979): 11-12. [Excerpted minutes of meeting of the American Photographical Society, New York.]

ST3992 "Minutes of the Meeting, October 11, 1859." PHOTOGRAPHICA 11, no. 9 (Nov. 1979): 11-12. [Excerpted minutes of meeting of the American Photographical Society, New York.]

ST3993 "Minutes of the Meeting, November 14, 1859." PHOTOGRAPHICA 11, no. 10 (Dec. 1979): 12. [Excerpted minutes of meeting of the American Photographical Society, New York.]

ST3994 "Minutes of the Meeting, December 11, 1859." PHOTOGRAPHICA 12, no. 1 (Jan. 1980): 13. [Excerpted minutes of meeting of the American Photographical Society, New York.]

ST3995 "Minutes of the Meeting, February 13, 1860." PHOTOGRAPHICA 12, no. 4 (Apr. 1979): 11. 1 portrait b & w. [Excerpted minutes of meeting of the American Photographical Society, New York.]

USA: AMERICAN PHOTOGRAPHICAL SOCIETY: 1860.

ST3996 "American Photographical Society." PHOTOGRAPHIC AND FINE ART JOURNAL 13, no. 1 (Jan. 1860): 21-30. [(Jan.) S. D. Tillman's "Photo-Phosphorescence." George B. Coale on the Fothergill Process. Seely on "The Stereoscope." Prof. Reuben "Remarks on the Theory of Light." Johnson describes his portrait-taking activities in 1843 (on p. 28); other matters discussed in these reports of the 5th through 11th regular meetings of 1859. (The "P & FAJ" apparently had not been published from July 1859 to Jan. 1860.]

ST3997 "Proceedings of the Societies: American Photographical Society." PHOTOGRAPHIC NEWS 3, no. 71, 76 (Jan. 13, Feb. 17, 1860): 226-227, 284.

ST3998 "American Photographical Society." PHOTOGRAPHIC AND FINE ART JOURNAL 13, no. 2-7 (Feb. - July 1860): 53-56, 59-63, 93-94, 143-147, 150-152, 183-184. [(Feb.) Includes an address from the President, John W. Draper, on the state of the art of photography. The group decided to collect examples of each member's work. Photos displayed, including an "instantaneous view of a boat at sea, by James W. Black, considered to be exceptional. Cutting patents discussed. (Mar.) Address by Mr. Peil "On Light." (May) Duchochois volunteered to accompany government ship to Labrador to observe the total eclipse. (A Mr. Dodge, of Bellows Falls, VT, also sending a vessel, which would also visit Eskimo and Moravian settlements there.) Barnard's instantaneous photographs of Havana displayed to the society; Joseph Dixon's paper "Permanent Photographic Printing." S. D. Tillman's "The Harmonic Hypothesis;" panoramic views, other matters. (June) Mr. Hadfield died. More on finding a photographer to accompany the Arctic expedition, Washington Peale, now named. Dr. J. Milton Saunders (Madison, CT) paper on "Dry Collodion." Campbell (Jersey City) on "The Ectograph." (July) Charles Waldich (Cincinnati, OH) "Imperfections in the Collodion Film." Dr. Saunders (Madison, WI) "The Xantho-Collodion." Kuhn advanced the notion of a photographic college."]

ST3999 Draper, John W. "President Draper's Address before the Photographical Society." AMERICAN JOURNAL OF PHOTOGRAPHY AND THE ALLIED ARTS AND SCIENCES n. s. vol. 2, no. 18 (Feb. 15, 1860): 275-280. [Annual summary of events and activities of the members of the Society.]

ST4000 "The American Photographical Society." HUMPHREY'S JOURNAL OF PHOTOGRAPHY, AND THE ALLIED ARTS AND SCIENCES 11, no. 20 (Feb. 15, 1860): 310. [Annual meeting, election of officers. Pres.: John W. Draper. V. P.'s: L. M. Rutherford; C. A. Joy; J. Campbell. Corres. Sec.: A. W. Whipple. Rec. Sec.: L. W. Hall. Treas.: F. W. Geisenheimer.]

ST4001 Root, Marcus A. "The Photographical Society." AMERICAN JOURNAL OF PHOTOGRAPHY AND THE ALLIED ARTS AND SCIENCES n. s. vol. 2, no. 23 (May 1, 1860): 353-356. [History of the organization.]

ST4002 "American Photographical Society." AMERICAN JOURNAL OF PHOTOGRAPHY AND THE ALLIED ARTS & SCIENCES n. s. vol.

3, no. 1-24 (June 15, 1860 - Apr. 15, 1861): 26-28, 78-79, 106-107, 155-158, 204-206, 219, 253-254, 267-270, 281-284, 333-334, 348-349. [(June) 17th Meeting: Death of member, Charles Hadfield. Request from Dr. Hayes, preparing for his expedition to Arctic, to the Society to fund Washington Peale to accompany him. Committee formed to attempt to raise funds. Campbell (Jersey City) showed Ectograph process. W. S. Kuhns views of Cuba. (Aug.) 18th Meeting: Harvey Ross elected to membership; technical issues; proposal that the Society address Congress with a proposal that a photographic corps be established in the military. (Sept.) Duchochois' photos from Labrador expedition displayed Mr. Campbell displayed a "ghost" photo. C. Wager Hill (amateur) presented fifty stereo prints to the Society. (Oct.) 21st Meeting: Photo at the American Institute Fair; Photo counterfeiting; J. W. Black's balloon photos shown; chemical matters. (Dec. 1) 22nd Meeting: Lieut.-Gov. Butler G. Noble, of WI, elected honorary member. Formerly (20 years ago) a photographer. Mr. Johnson gathering materials for a photographic museum. Both James Black's and John Whipple's astronomical photos discussed. Werge (landscape views); exhibition planned. Johnson briefly described early experiences, etc. (Dec. 15) 23rd Meeting: Report that Frederick's Gallery's major business is in cartes-de-visite. Comment that four of five years ago the idea attempted and failed. Rutherford discussed photos of the sun. Babcock claims to have taken time exposures by moonlight from 1849 to 1853. Whipple, Fitzgibbon, others mentioned. (Jan.) 23rd Meeting (concluded): Seely on the stereoscope. Hill Norris's Dry Plates. (Feb. 1) 24th Meeting: E. T. Whitney, George W. Holt elected to Society; Rutherford wanted fuller reports printed; Harrison's new lenses; Wolcott & Johnson mentioned; etc. (Feb. 15) 25th Meeting: G. N. Barnard, Campbell Morfit, Geo. W. Houser, A. W. Paradise elected members. Officers elected. Pres.: John W. Draper; V. P.'s: Lewis M. Rutherford, Charles A. Joy, Robert L. Pell; Corres. Sec.: A. W. Whipple; Rec. Sec.: C. Wager Hull; Treas. F. W. Grissenhainer. Seely on toning and fixing prints. Johnson talked about fading Daguerreotypes - claimed to have 1000 taken before Fizeau process. (Apr. 1) 26th Meeting: Charles Fontayne's (Cincinnati, OH) printing machine exhibited, Fontayne described the process; Black & Batchelder (Boston, MA) contributed photos to the Society; Whipple (Boston, MA) did the same; Tillman's paper on the solar eclipse read. (Apr. 15) 27th Meeting: Harrison's new lens; Capt. N. Griffin elected corresponding member; Griffin taking portrait in 1841 and associated with Wolcott & Johnson then.]

ST4003 "American Photographical Society." HUMPHREY'S JOURNAL OF PHOTOGRAPHY, AND THE ALLIED ARTS AND SCIENCES 12, no. 4 (June 15, 1860): 57-58. ["This Institution 'still lives' not withstanding so few among our operators take any interest in its doings. Being composed principally of a few scientific men and amateurs, the photographers of the city take little or no notice of its proceedings." The meeting was concerned with the possibility of the Society supporting a photographer to accompany Dr. Hayes to the Arctic. Washington Peale stood ready to go.]

ST4004 "American Photographical Society." PHOTOGRAPHIC AND FINE ART JOURNAL 13, no. 8 (Aug. 1860): 221-223. [Photographs printed on a machine patented by Charles Fontayne (of Cincinnati, OH) that made 200 prints a minute; Paper by R. P. Stevens "On Geological Proof of Ancient Light."]

ST4005 "American Photographical Society." HUMPHREY'S JOURNAL OF PHOTOGRAPHY, AND THE ALLIED ARTS AND SCIENCES 12, no. 9 (Sept. 1, 1860): 130-131.

USA: AMERICAN PHOTOGRAPHICAL SOCIETY: 1861.
ST4006 "American Photographical Society." HUMPHREY'S JOURNAL OF PHOTOGRAPHY, AND THE ALLIED ARTS AND

SCIENCES 12, no. 22 (Mar. 15, 1861): 340-341. [Report of meeting. Charles Fontaine displayed his machine for creating 12,000 small images per hour. Snelling read a paper on toning. Black & Batchelder sent in photos of their balloon photos. "Much complaint was made against this Society at the commencement of its organization on account of its exclusiveness. We notice now, however, that they invite all interested in the art to be present at their meetings."]

ST4007 "American Photographical Society." AMERICAN JOURNAL OF PHOTOGRAPHY AND THE ALLIED ARTS & SCIENCES n. s. vol. 4, no. 1-24 (July 1, 1861 - June 15, 1862): 65-67, 213-214, 259-262, 285-286, 331-333, 352, 378-381, 400-402, 427-429, 476-479, 494-495, 546-549. [(July) 29th Meeting: A. Plunkett, A. Hoguet elected to Society. Postponed the exhibition, due to the war. Tillman read paper on artificial light. Seely suggested that the Society discuss the application of photography to military purposes. Garbanati, Babcock, Barnard, Kuhns, Tillman joined the discussion. Barnard stated that "photographers now in employ of the government are, one in Treasury, one in the Capitol Extension, one in the Navy Yard and the contract for the Patent Office given to Mr. Rehn, for $50,000." (Sept.) 30th Meeting: Letter from Society to War Dept. on usefulness of photography. Ladies invited to attend the Society's meetings. Recent progress in instantaneous exposures discussed. (Nov. 1) 31st Meeting: Technical, chemical. The Spectrascope. (Nov. 15) 32nd Meeting: Stock's dry plate box discussed, praised. Johnson presented a camera made in 1843. Oscar J. Wallis (Chicago) donated photos of Kalbach's series of Goethe illustrations, the negatives for which apparently were in Berlin by Albert. (Dec.) 33rd Meeting: chemical matters. (Jan. 1) 33rd Meeting (concluded). (Jan. 15) 34th Meeting: chemical matters, Rutherford describes his early (1857/58) attempts to photograph the moon on p. 381. (Feb. 1) 34th Meeting (concluded): Henry Draper, Rutherford, discuss astro. efforts. Johnson exhibited daguerreotypes and prints made from them on a copper plate press. (Feb. 15) 35th Meeting: Election of officers. Pres.: John W. Draper; V. P.'s: Lewis M Rutherford, Charles A. Joy, Nicholas Pike; Corres. Sec.: Alfred W. Whipple; Rec. Sec.: F. F. Thompson; Treas.: F. W. Geissenhaimer. The Rev. Dr. Moore, ex-Pres. of Columbia College, a pioneer amateur photographer talked. Dr. Henry D. Noyes exhibited photo of an eye. Henry Draper discussed his Tannin Process. Col. Pike exhibited an 1853 camera shield. (Mar.) 36th Meeting: Henry Draper's Hot Water Process, other chemical issues. (Apr.) 36th Meeting (concluded): Anthony's improved stereoscope displayed. Discussion of tannin dry plate process, etc. Victor Prevost gave the Society some waxed-paper negatives taken in 1856. Victor Piard, of Jersey City, NJ, gave prints. (May) 37th Meeting: Hull describes his process for outdoor photos. Tannin process discussed. The Secretary of the Society (Mr. Thompson) went for a photographic excursion in the neighborhood of Fort Hamilton, Long Island. Briefly arrested by soldiers.]

ST4008 "American Photographical Society." HUMPHREY'S JOURNAL OF PHOTOGRAPHY, AND THE ALLIED ARTS AND SCIENCES 13, no. 14 (Nov. 15, 1861): 210-211. [Meeting held. Brief description of events.]

USA: AMERICAN PHOTOGRAPHICAL SOCIETY: 1862.
ST4009 "The American Photographical Society." HUMPHREY'S JOURNAL OF PHOTOGRAPHY, AND THE ALLIED ARTS AND SCIENCES 13, no. 24 (Apr. 15, 1862): 369-370. [37th Meeting: John Matthews, Augustus Hawes, S. R. Divine, Mr. Blunt, Francis Schenck elected to Society. S. F. B. Morse elected honorary member. Chemical matters discussed.] "The American Photographical Society." AMERICAN JOURNAL OF PHOTOGRAPHY AND THE ALLIED ARTS & SCIENCES n. s. vol. 5, no. 1-24 (July 1, 1862 - June 15, 1863): 21-22, 141-142, 161-162, 233-234, 237-238, 258-260, 283-286,

422, 492-496, 519-522, 567-571. [(July) 39th Meeting: Chemical matters, mostly. (Sept.) 40th Meeting: F. F. Thompson's Milk and Sugar process discussed. (Oct.) 40th Meeting (concluded): F. F. Thompson paper on his photographic trip to PA read; Seely, Draper, Tillman and others discuss binocular vision. (Nov.) 41st Meeting: New members; microscopic photos; prints from zinc plates; Chiamenti stereoscopic pictures discussed. Victor Piard, Jersey City, NJ presented Society with views of interior of a green house. 42nd Meeting: Prof Emerson displayed new lenses by Ross of London, then he reported on the state of the art in Europe, which he had just visited. Oscar G. Mason elected to Society. Johnson presented the Society some of Wolcott & Johnson's daguerreotype apparatus, including a camera made by Fitz, who was present. (Dec. 1) 42nd Meeting (concluded): Wolcott & Johnson's daguerreotype camera and lenses. Microphotographs English photos exhibited - views of Cambridge by Mayland and composite photos by Rejlander. "Mr. Johnson exhibited some fine specimens of printing on opal glass, the work of J. W. Black, of Boston." (Dec. 15) 43rd Meeting: New Members, W. C. Crum (New York, NY); John Carbutt (Chicago, IL) and S. M. Fassitt (Chicago, IL). Tannin plates discussed. Mr. Franklin White (NH) exhibited White Mountain views. Mr. Smith (San Francisco, CA) displayed stereo views of California scenery. Carbutt display European views, acquired during his visit there. Other matters discussed. (Mar. 15) John M. Masterton, Bronxville, elected to Society. F. F. Thompson exhibited collodion films and a travelling camera. John Draper and Henry Draper discussed usefulness of washing plates in astronomical photography. Col. Pike, Prof. Seely, Mr. Tillman. (May 1) 47th Meeting: Printing and toning discussed by all. (May 15) 48th Meeting: Toning and Fixing discussed. (June 15) 49th Meeting: Mr. Crum described his processes to varnish negatives, note that Mr. Washington Peale is about to accompany Capt. Hall on another polar expedition, with Society support.]

USA: AMERICAN PHOTOGRAPHICAL SOCIETY: 1863.
ST4010 Draper, John W., Prof., M.D. "Annual Address Before the American Photographical Society." AMERICAN JOURNAL OF PHOTOGRAPHY AND THE ALLIED ARTS & SCIENCES n. s. vol. 5, no. 16 (Feb. 15, 1863): 377-383. [Describes discoveries and activities of the members of the Society during the past year.]

ST4011 "The American Photographical Society." AMERICAN JOURNAL OF PHOTOGRAPHY AND THE ALLIED ARTS & SCIENCES n. s. vol. 6, no. 1-24 (July 1, 1863-June 15, 1864): 207-209, 226-231, 304-308, 349-353, 378-380, 442-446, 541-544. [(Nov. 1) 50th Meeting: H. Draper read paper on Celestial Photography. John Johnson read paper on the effect of colored light on the germination of seeds, etc. C. W. Hull produced a photo., etc. New members: W. H. Gilder, H. J. Newton, H. L. Boltwood, Wm. Vollmer, A. Bogardus. Corres. member: Prof. John Towler (Geneva, NY). (Nov. 15) 51st Meeting: New Members: Dr. John B. Reilly, Dr. Dubois, D. Parmelee, Dr. Joseph A. Kerrigan, Robert Furman. Death of Henry Fitz. Geo. W. Everett's new photometer displayed. Hull displayed portable camera box. Seely described the theatrical "ghost" method, discussed potential uses. Thompson discussed lenses. (Jan. 1) 52nd Meeting: Whipple's views in Boston Common, taken at night presented to the Society. Vignettes by Merz & Ulrich, Mr. Ormsbee and Mr. Rockwood's views shown. Prevost explained his wax process. Lenses discussed again - arguments whether Harrison or Fitz lenses better. Mason's views of Oakwood Cemetery and groups at West Point shown. (Feb. 1) 53rd Meeting: John L. Jewett, Jr. elected member. A. Pirz showed work made with dry plates. The controversy of the discoverer of bromine discussed - Paul B. Goddard (Philadelphia); John Frederick Goddard (London); Robert Cornelius and Wolcott & Johnson all involved in the controversy. Lenses discussed. Skylights discussed. (Feb. 15) 54th Meeting: Election of new officers. Pres.: John W. Draper. V. P.'s: L. M. Rutherford, Prof. Chas. A. Joy, Abraham

Bogardus. Corres. Sec.: Nicholas Pike. Record. Sec.: Oscar G. Mason. Treas.: Henry L. Boltwood. Papers read by J. Johnson, H. J. Newton and Prof Seely. Mr. Crum described a situation photographing children, etc. (Apr. 1) 55th Meeting: New members: George Stacey, August Haas, Charles H. Williamson (Brooklyn, NY). The Metropolitan Sanitary Fair asked for donations of collections of photographs. A committee (Chas. W. Hull, Chas. A. Seely, L. M. Rutherford and A. Bogardus) formed to make a collection for donation. Prof. Joy, Seely discuss chemical matters. Obituary for the late Henry Rose, a chemist not directly concerned with photography. Duchochois read paper on fading of Albumen Prints. Mr. Weeks, Mr. Mason, Prof. Seely contribute discussion. (June 1) 56th Meeting: A. E. Beach elected to Society. H. J. Newton replaced Boltwood as Treasurer. (Boltwood had joined the U. S. Sanitary Commission, and been sent to New Orleans.) Dr. John Dean's (or Deane, both spellings used), "The Anatomy of the Medulla Oblongata" work, illustrated with photos, praised. Seely exhibited photos "taken in Hong Kong, China, and foreworded by Mr. Miller, of Vermont." Rutherford, Seely, Draper, Hull, Mason discuss carbon process, etc.]

USA: AMERICAN PHOTOGRAPHICAL SOCIETY: 1864.
ST4012 "Proceedings of the Societies: The American Photographical Society." PHOTOGRAPHIC NEWS 8, no. 279, 281, 288 (Jan. 8, Jan. 29, Mar. 11, 1864): 20-21, 57-58, 128-129. [From the "American J. of Photo."]

ST4013 Draper, John W., Prof., M. D. "The Annual Address Before the American Photographical Society." AMERICAN JOURNAL OF PHOTOGRAPHY AND THE ALLIED ARTS & SCIENCES n. s. vol. 6, no. 17 (Mar. 1, 1864): 385-392.

ST4014 "The American Photographical Society." AMERICAN JOURNAL OF PHOTOGRAPHY AND THE ALLIED ARTS & SCIENCES n. s. vol. 7, no. 1-24 (July 1, 1864 - June 15, 1865): 14-16, 190, 211-213, 277-278, 287, 406-407, 453-455, 472-473, 539-541. [(July 1) 57th Meeting: Charles A. Palmer and George H. Weeks elected to the Society. Chemical matters discussed. Photo of Shakespeare's death mask shown. Stock & Co.'s "Artists Camera" exhibited. (Nov. 1) Special Meeting: To hear a lecture by John W. Osborne, of London, who "...undoubtedly ranks first among photolithographers." Additional note on p. 216. (Dec. 15) 58th Meeting: Seely, John Draper discussed magnesium. Chapman, Hull, Divine, Johnson discussed chemical matters. Herman Roettger (Philadelphia, PA) donated views, taken with lenses of his own manufacture. (Dec. 15) 59th Meeting: "The meeting was almost exclusively occupied with the discussion of plans for the future welfare of the Society. As the Society's domestic affairs are of little moment to the public we omit details..." (Mar. 1) Annual Meeting: Election of officers. Pres.: John W. Draper. V. Ps: Lewis M. Rutherford, Charles A. Joy, Abraham Bogardus. Corr. Sec.: C. Wager Hull. Rec. Sec.: Oscar G. Mason. Treas.: Henry J. Newton. (Apr.15) 60th Meeting: D. C. Chapman and J. W. Morgan elected to the Society. President's address. Committee formed to assist the Berlin Photo Soc. exhibition, etc. Koonley's (sic Coonley) views of Georgia exhibited. (Apr. 15) Brief meeting, bad weather. C. D. Fredericks & Co.'s portraits, H. Draper's view of moon, views of ship, Gen Butler's Headquarters from H. T. Anthony given to Society. (June) 61st Meeting: Tillman, Joseph H. Ladd elected to Society. A. F. Styles (Burlington, VT) elected corresponding member. Arrangements for new quarters, questions on how to deal with the Society's collection. Hull presented twenty-four stereographs. Rutherford gave a print of the moon, described his activities.]

USA: AMERICAN PHOTOGRAPHICAL SOCIETY: 1865.

ST4015 "The American Photographical Society." AMERICAN JOURNAL OF PHOTOGRAPHY AND THE ALLIED ARTS & SCIENCES n. s. vol. 8, no. 1-24 (July 1, 1865-June 15, 1866): 35-38, 233-235, 281-283, 314-315, 355-357, 407-408, 476-479. [(July 15) 62nd Meeting: Mr. Tillman in chair. O. S. Follett, Henry Fitz elected to the Society. Weekes, Newton, Chapman contributed prints. Duchochois, Hull, Mason and others discussed chemical matters. (Nov. 15, 1865) 64th Meeting: Prof. Joy described his visit to the exhibition of the Berlin Photo. Soc. General discussions. (Dec. 15) 68th Meeting: J. Loeffler (Staten Island) elected to the Society. Pres. Draper, Prof. Joy, Duchochois, Seely discussed fading in daguerreotypes. Duchochois discussed his photographic trip to Illinois. Photographs by Loeffler and by J. Tresize (Zanesville, OH) presented to the Society. (Jan. 15) 69th Meeting: Wm. B. Carpenter (New York, NY) elected to the Society. Hull described his experiments with wet and dry processes during the summer. General discussion. (Feb. 1) 70th Meeting: Photo of moon, on silvered paper, by Dr. Henry Draper. Newton showed prints made with collodion without bromide. Mr. Hudson (Hingham, MA) displayed "a very ingenious apparatus for manipulating the wet process in the field, without the use of a dark-room or tent." (Mar. 1) Annual Meeting (71st): Election of officers. Pres.: Lewis M. Rutherford. V. P.'s: John W. Draper, Charles A. Joy, Abraham Bogardus. Corres. Sec.: C. Wager Hull. Rec. Sec.: Oscar G. Mason. Treasurer: Henry J. Newton. Further note on p. 408 by Seely, stating that the Society has been in existence six years and was successful, but needs new members. Regret that John W. Draper, the President for first six years was retiring to the country, and thus resigning. (Apr. 15) 72nd Meeting: Niepce de St. Victor's heliochromes exhibited by John Campbell. Prof Joy discussed color experimentation. Steinheil lens displayed. Pres. Rutherford displayed astronomical photographs. Landscape photos by Mr. Shepard (Providence, RI) shown.]

ST4016 "American Photographical Society." HUMPHREY'S JOURNAL OF PHOTOGRAPHY, AND THE ALLIED ARTS AND SCIENCES 17, no. 16 (Dec. 15, 1865): 255. [Brief summation of a regular meeting. Odd, since there were biweekly meetings and this is the only report for the year.]

USA: AMERICAN PHOTOGRAPHICAL SOCIETY: 1866.

ST4017 "American Photographical Society. (Reported Expressly for 'Humphrey's Journal.')" HUMPHREY'S JOURNAL OF PHOTOGRAPHY, AND THE ALLIED ARTS AND SCIENCES 17, no. 19 (Feb. 1, 1866): 296-297. [(Jan 15) Draper's paper "On the Use of Silvered Glass in the Daguerreotype Process." T. H. Johnson elected a member. Chemical matters discussed.]

ST4018 G. "A Visit to the American Photographical Society." AMERICAN JOURNAL OF PHOTOGRAPHY, AND THE ALLIED ARTS AND SCIENCES n. s. vol. 9, no. 4 (Oct. 15, 1866): 84-87. [75th meeting: Prof. John Towler, of Hobart College, read, "Upon a Modified Fothergill Dry Plate Process." Napoleon Sarony, "recently returned from Europe..." exhibited a series of photographs. Mr. Weeks exhibited a solar print. Prof. Joy displayed J. J. Woodward's microphotographs, etc.]

ST4019 Hull, Charles Wager. "American Photographical Society." HUMPHREY'S JOURNAL OF PHOTOGRAPHY, AND THE ALLIED ARTS AND SCIENCES 18, no. 13-24 (Nov. 1, 1866 - Apr. 15, 1867): 197-199, 237-240, 250-251, 269-271, 331-332, 359-360. [(Nov. 1) Archibald, Russell, John H. Hallenbeck, and Napoleon Sarony elected to the Society. J. J. Woodward's microphotographs displayed. Napoleon Sarony displayed photo studies. Towler's paper on "Gordon's Modified Fothergill Process" read. (Dec. 1) Tannin process discussed by Chapman, Weeks, Johnson, Seely and others. (Dec. 15) Newton's formula for silvering paper discussed. (Jan. 1) C. A. Francis elected to Society. J. Loeffer (Tompkinsville, S. I.) presented views of Catskills. Newton discussed paper prints and negatives Prof. Rood showed microphotos. Prof. Joy exhibited a glass negative, etc. (Feb. 1) Discussion on baths. (Mar. 1) Annual meeting, same officers reelected. Some chemical issues discussed. (Apr. 1) Griswold displayed Ferro-Carbon positives. Prof. Rood discussed Carbon prints, electric sparks, etc.]

ST4020 "The American Photographical Society." AMERICAN JOURNAL OF PHOTOGRAPHY, AND THE ALLIED ARTS AND SCIENCES n. s. vol. 9, no. 6-12 (Nov. 15, 1866 - June 1, 1867): 131-132, 177-179, 221-222, 224-226, 275-277. [(November Meeting) D. C. Chapman read paper, "How to Purify Water and the Tannin Process." John Johnson (of Saco, ME) discussed the issue, as did Mr. Weekes, Prof. Seely and others. (January Meeting) Eugene Hotchkiss, Kankakee, IL elected corresponding member. Hallenbeck described various chemical processes. Prof Joy exhibited photos of Siam, made by some members of the royal family in that country, now in collection of Dr. John Torrey. O. G. Mason presented two dozen stereo photographs of the silver mining districts in Mexico. Etc. (March Meeting) V. M. Griswold (Newburgh, NY) displayed opal ferrotypes. A. Runkel (New York, NY) displayed a large photo of N.Y. Court House. Discussion was on permanence of photographs. (April Meeting) Talked about syphons, printing frames, etc. Johnson "read and explained several historical items, in proof of the first daguerreotype ever taken from life,...by his former associate Mr. Wolcott and himself..." (May Meeting) Prof. Rood, Prof. Seely, Mr. Hall, Mr. Weeks, Mr. Thomas discussed chemical matters.]

USA: BOSTON PHOTOGRAPHIC ASSOCIATION: 1870.

ST4021 "Boston Photographic Society, New England Photographic Society." PHILADELPHIA PHOTOGRAPHER 7, no. 73-84 (Jan. - Dec. 1870): 12-13, 81-82, 112-113, 160-161, 214, 350-352.

USA: BOSTON PHOTOGRAPHIC ASSOCIATION: 1871.

ST4022 "Boston Photographic Association." PHILADELPHIA PHOTOGRAPHER 8, no. 89 (May 1871): 139-140.

ST4023 Smith, E. F., Secretary. "Boston Photographic Association. Minutes of regular monthly [May] meeting." PHOTOGRAPHIC WORLD 1, no. 6 (June 1871): 175. [J. W. Black, A. S. Southworth mentioned.]

USA: BOSTON PHOTOGRAPHIC ASSOCIATION: 1872.

ST4024 Richardson, C. F. and J. H. Hallenbeck. "Boston Photographic Association." PHILADELPHIA PHOTOGRAPHER 9, no. 103, 107 (July, Nov. 1872): 257, 384-385.

ST4025 Hallenbeck, J. H. "Boston Correspondence." PHOTOGRAPHIC TIMES. 2, no. 19 (July 1872): 101-102. [Report on the monthly meeting of Boston Photographers Assoc. given over to descriptions of the 4th Annual N. P. A. Convention at St. Louis by those who attended. J. W. Black was an entertaining narrator.]

USA: BOSTON PHOTOGRAPHIC ASSOCIATION: 1873.

ST4026 Hallenbeck, J. H. "Boston Correspondence." PHILADELPHIA PHOTOGRAPHER 10, no. 109-113 (Jan. - May 1873): 12-13, 51-52, 81, 148-149. [Reports of the meetings of the New England Photographic Association.]

USA: BOSTON PHOTOGRAPHIC ASSOCIATION: 1875.

ST4027 "Society Gossip." PHILADELPHIA PHOTOGRAPHER 12, no. 133-144 (Jan. - Dec. 1875): 13-14, 57, 78, 101-102, 148-149, 187-188, 215, 333-334, 368.

ST4028 Loomis, G. H. "Paragraphic Pencillings." ANTHONY'S PHOTOGRAPHIC BULLETIN 6, no. 2 (Feb. 1875): 50-51. [Report on a lecture on art given by Prof. Rimmer to the Boston Photographic Association.]

ST4029 "Boston Photographic Association." ANTHONY'S PHOTOGRAPHIC BULLETIN 6, no. 2-5 (Feb. - May 1875): 58, 92, 155-156. [(Feb.) List of new officers. (May) Discussion of N. P. A. problems, display of large (22"x42" negative size) landscape views by T. K. Burnham.]

USA: BOSTON PHOTOGRAPHIC ASSOCIATION: 1876.

ST4030 Hardy, A. N., Sec. "Society Gossip." PHILADELPHIA PHOTOGRAPHER 13, no. 145-156 (Jan. - Dec. 1876): 30, 91, 111-112, 143-145, 188, 212, 368-369. [E. H. Lincoln's address on the early history of photography reported on p. 145-146. (Very brief summation of known facts.)]

ST4031 "Boston Photo. Association." ANTHONY'S PHOTOGRAPHIC BULLETIN 7, no. 2 (Feb. 1876): 53. [Annual meeting, new officers selected. Pres. Benj. French, etc.]

ST4032 Loomis, G. H. "Boston Photographic Association." ANTHONY'S PHOTOGRAPHIC BULLETIN 7, no. 11 (Nov. 1876): 348.

USA: BOSTON PHOTOGRAPHIC. ASSOCIATION: 1877.

ST4033 "Boston Photo. Association." ANTHONY'S PHOTOGRAPHIC BULLETIN 8, no. 2-3 (Feb. - Mar. 1877): 58-59, 88. [(Feb.) Election of Officers. Frank Rowell, Pres. G. H. Loomis gave a talk summing up the eight-year history of the organization.]

ST4034 Hardy, A. N., Sec. and Ritz, Ernest F., Sec. "Society Gossip." PHILADELPHIA PHOTOGRAPHER 14, no. 157-168 (Jan. - Dec. 1877): 48-49, 84-85, 118, 178-180, 345-346. [(Mar.) Includes text of Pres. G. H. Loomis' speech; (June) Extracts from an address by A. S. Southworth.]

USA: BOSTON PHOTOGRAPHIC ASSOCIATION: 1878.

ST4035 Ritz, E. F., Sec. "Society Gossip." PHILADELPHIA PHOTOGRAPHER 15, no. 169-180 (Jan. - Dec. 1878): 20-21, 121-122.

ST4036 "Boston Photographic Association." ANTHONY'S PHOTOGRAPHIC BULLETIN 9, no. 3 (Mar. 1878): 93. [Ninth annual meeting. Officers elected. G. H. Loomis, Pres.; J. W. Black, Frank Rowell, A. N. Hardy Executive Committee, etc.]

USA: BOSTON PHOTOGRAPHIC ASSOCIATION 1879.

ST4037 "Society Gossip: Boston Photographic Society." PHILADELPHIA PHOTOGRAPHER 16, no. 184-186 (Apr. - June 1879): 116, 154-155, 183-184. [(Apr.) Society elected officers. Pres.: J. W. Black; Vice-Pres.: F. W. Low; Treas.: E. F. Smith; Sec.: J. H. Hallenbeck; Ex. Committee: Bowers, Burgham, Prescott.]

USA: BROOKLYN ART UNION: 1851.

ST4038 Harrison, Gabriel. "Brooklyn Art-Union." PHOTOGRAPHIC ART JOURNAL 2, no. 5 (Nov. 1851): 295-298.

USA: BROOKLYN PHOTOGRAPHIC ART ASSOCIATION: 1872.

ST4039 "Brooklyn Photographic Art Association." PHILADELPHIA PHOTOGRAPHER 9, no. 108 (Dec. 1872): 419. [Assoc. just formed.]

ST4040 "Meeting of Photographers." PHOTOGRAPHIC TIMES 2, no. 24 (Dec. 1872): 181-182. [Alva Pearsall, C. H. Williamson, Knowlton & MacGregor, Forbes, etc. met for the formation of Brooklyn Photo-Art Association.]

USA: BROOKLYN PHOTOGRAPHIC ART ASSOCIATION: 1873.

ST4041 "Brooklyn Photographic Art Association Institute." PHILADELPHIA PHOTOGRAPHER 10, no. 111-113 (Mar. - May 1873): 83, 117, 149-150.

USA: BROOKLYN PHOTOGRAPHIC ART ASSOCIATION: 1873.

ST4042 Troxell, B. F., Recording Secretary. "Brooklyn Photographic Art Association." ANTHONY'S PHOTOGRAPHIC BULLETIN 4, no. 1-12 (Jan. - Dec. 1873): 24-25, 61-62, 85-88, 123, 154-155, 183-184, 213-215, 299-300, 331-332, 366-368.

USA: BROOKLYN PHOTOGRAPHIC ART ASSOCIATION: 1874.

ST4043 "Brooklyn Photo. Art Association." ANTHONY'S PHOTOGRAPHIC BULLETIN 5, no. 1-12 (Jan. - Dec. 1874): 19-22, 95, 125-126, 159, 190, 222, 384. [(Jan.) Address by Hugh H. Hannay; Address "Free-Hand Drawing in Connection with Photo. Portraits," by A. Berger. (Nov.) Obituary notice for Charles H. Williamson; T. C. Roche exhibited works.]

USA: BROOKLYN PHOTOGRAPHIC ART ASSOCIATION: 1875.

ST4044 "Brooklyn Photo. Art Assoc." ANTHONY'S PHOTOGRAPHIC BULLETIN 6, no. 2-3 (Feb. - Mar. 1875): 57, 91-92. [(Feb.) List of new officers.]

USA: BROOKLYN PHOTOGRAPHIC SOCIETY: 1864.

ST4045 "The Brooklyn Photographic Society." AMERICAN JOURNAL OF PHOTOGRAPHY AND THE ALLIED ARTS & SCIENCES n. s. vol. 7, no. 4 (Aug. 15, 1864): 92-93. [Society formed, 1st meeting had fifty gentlemen present. Election of officers. Pres.: Nicholas Pike. V.P.: W. E. James. Record. Sec.: N. G. Burgess. Treas.: Aug. Moran.]

ST4046 "Brooklyn Photographic Society." HUMPHREY'S JOURNAL OF PHOTOGRAPHY, AND THE ALLIED ARTS AND SCIENCES 16, no. 9 (Sept. 1, 1864): 141. [Announcement of formation of the Brooklyn Photographic Society. Officers elected. Pres.: Nicholas Pike; V. P.: W. E. James; Record. Sec. N. G. Burgess; Treas.: Augustus Morand.]

ST4047 "Brooklyn Photographical Society." AMERICAN JOURNAL OF PHOTOGRAPHY AND THE ALLIED ARTS & SCIENCES n. s. vol. 7, no. 9 (Nov. 1, 1864): 214-215. [Pres. Col Nicholas Pike in chair. Mr. Williamson discussed prints, etc. Mrs. Palmer presented a model draft of a certificate of membership.]

USA: BROOKLYN PHOTOGRAPHIC SOCIETY: 1865.

ST4048 Burgess, N. G. "Brooklyn Photographic Society." HUMPHREY'S JOURNAL OF PHOTOGRAPHY, AND THE ALLIED ARTS AND SCIENCES 17, no. 5 (July 1, 1865): 71-73. [Election of officers. Pres.: Nicholas Pike. V. P.: Charles H. Williamson. Corres. Sec.: N. G. Burgess. Rec Sec.: John E. Swanton. Treas.: Wm. E. James.

SPECIAL TOPICS: ORGANIZATIONS & SOCIETIES
USA: BUFFALO PHOTOGRAPHIC ASSOCIATION: 1873.

SPECIAL TOPICS: ORGANIZATIONS & SOCIETIES
USA: FERROTYPERS' ASSOCIATION. OF PHILADELPHIA: 1871.

Pike, Shipman and Williamson showed photos. Portraits by Williamson shown and discussed.]

ST4049 "Brooklyn Photographic Society." HUMPHREY'S JOURNAL OF PHOTOGRAPHY, AND THE ALLIED ARTS AND SCIENCES 17, no. 9 (Sept. 1, 1865): 135-136. [Brief description of events occurring at the Society during the past year. Lectures by G. R. Tremaine, Chas. Williamson, Gabriel Harrison, James, L. M. Halsey, Alfred Beach, Shipman, Swanton, Burgess, Stewart, etc.]

USA: BUFFALO PHOTOGRAPHIC ASSOCIATION: 1873.
ST4050 "Buffalo Photographic Association." PHILADELPHIA PHOTOGRAPHER 10, no. 114 (June 1873): 180-181.

USA: CENTRAL OHIO PHOTOGRAPHIC SOCIETY: 1870.
ST4051 "Central Ohio Photographic Society." PHILADELPHIA PHOTOGRAPHER 7, no. 82 (Oct. 1870): 353.

USA: CHICAGO: 1873.
ST4052 "Another Society in Chicago." PHILADELPHIA PHOTOGRAPHER 10, no. 113 (May 1873): 146.

USA: CHICAGO PHOTOGRAPHIC ASSOCIATION: 1871.
ST4053 "The Chicago Photographic Association." PHILADELPHIA PHOTOGRAPHER 8, no. 88 (Apr. 1871): 120. [List of officers. Hesler mentioned.] "The Chicago Photographic Association." PHILADELPHIA PHOTOGRAPHER 8, no. 95 (Nov. 1871): 366-367.

ST4054 "The Chicago Photographic Association." PHILADELPHIA PHOTOGRAPHER 8, no. 96 (Dec. 1871): 401-402.

USA: CHICAGO PHOTOGRAPHIC ASSOCIATION: 1872.
ST4055 Ayers, George A. "Correspondence." ANTHONY'S PHOTOGRAPHIC BULLETIN 3, no. 1 (Jan. 1872): 429.

ST4056 Battersby, Joseph and G. A. Douglass. "Chicago Photographic Association." PHILADELPHIA PHOTOGRAPHER 9, no. 97-108 (Jan. - Dec. 1872): 28, 45, 76-77, 117-118, 143-144.

ST4057 "Report of the Chicago Photo. Association." ANTHONY'S PHOTOGRAPHIC BULLETIN 3, no. 2 (Feb. 1872): 466.

USA: CHICAGO PHOTOGRAPHIC ASSOCIATION: 1873.
ST4058 "Chicago Photographic Association." PHILADELPHIA PHOTOGRAPHER 10, no. 109-114 (Jan. - June 1873): 53, 84-90, 114-115, 143-146. [(Mar.) Includes paper by Hall quoting E. Anderson, H. Robinson supporting a paper by W. J. Baker titled "De Legibus' printed in "Photo Mosaics of 1873."]

ST4059 "Chicago Photographic Association." ANTHONY'S PHOTOGRAPHIC BULLETIN 4, no. 2 (Feb. 1873): 62. [List of elected officers for following year. Pres.: A. Mosler; 1st V. Pres.: Chas. W. Stevens; 2nd V. Pres.: P. B. Greene; etc.]

USA: CHICAGO PHOTOGRAPHIC ASSOCIATION: 1875.
ST4060 "Chicago Photographic Association." ANTHONY'S PHOTOGRAPHIC BULLETIN 6, no. 2 (Feb. 1875): 58. [List of new officers.]

ST4061 "Society Gossip." PHILADELPHIA PHOTOGRAPHER 12, no. 134 (Feb. 1875): 58.

ST4062 "Report of the Photographic Section of the American Institute, The Chicago Photographic Association." PHOTOGRAPHIC TIMES 5, no. 50-51 (Feb. - Mar. 1875): 30, 53-55.

USA: CHICAGO PHOTOGRAPHIC ASSOCIATION: 1876.
ST4063 "Society Gossip." PHILADELPHIA PHOTOGRAPHER 13, no. 145-156 (Jan. - Dec. 1876): 48-50, 91.

ST4064 Weaver, O. F. "Chicago Photographic Association." ANTHONY'S PHOTOGRAPHIC BULLETIN 7, no. 9-12 (Sept. - Dec. 1876): 287, 317, 379-380, 381. [Papers by P. B. Greene; R. W. Dawson; Ormsby; Shaw; etc.]

USA: CHICAGO PHOTOGRAPHIC ASSOCIATION: 1877.
ST4065 Weaver, O. F. "Chicago Photographic Association." ANTHONY'S PHOTOGRAPHIC BULLETIN 8, no. 1-6 (Jan. - June 1877): 25-26, 122-125, 155-158, 190. [(Jan.) New officers elected. (Apr.) Prof. Greene's paper "Can photography be classified with the fine arts?" (May) Greene's second paper on aesthetics, this time discussing several photographs from contemporary issues of "Phila. Photo." (June) C. Gentile replied to Greene's papers.]

USA: CHICAGO PHOTOGRAPHIC ASSOCIATION: 1878.
ST4066 Douglass, G. A., Sec. "Society Gossip." PHILADELPHIA PHOTOGRAPHER 15, no. 169-180 (Jan. - Dec. 1878): 57.

USA: CHICAGO PHOTOGRAPHIC ASSOCIATION: 1879.
ST4067 "Society Gossip: Chicago Photographic Society." PHILADELPHIA PHOTOGRAPHER 16, no. 180-192 (Jan. - Dec. 1879): 147-155, 176-183, 217-221, 251-253, 371-374.

USA: CINCINNATI PHOTOGRAPHIC SOCIETY: 1861.
ST4068 Johnson, C. A., Recording Sec. "The Cincinnati Photographic Society." AMERICAN JOURNAL OF PHOTOGRAPHY AND THE ALLIED ARTS & SCIENCES n. s. vol. 4, no. 2 (June 15, 1861): 37-38. [Pres. Charles Waldack.]

USA: DISTRICT OF COLUMBIA PHOTOGRAPHIC ASSOCIATION: 1872.
ST4069 Pulman, E. J. "Photographic Association of the District of Columbia." PHILADELPHIA PHOTOGRAPHER 9, no. 108 (Dec. 1872): 418-419. [Assoc. just formed. Pres. E. J. Ward. Other officers Julius Ulke, E. J. Pulman, C. M. Bell, J. O. Johnson.]

USA: DISTRICT OF COLUMBIA PHOTOGRAPHIC ASSOCIATION: 1873.
ST4070 "Photographic Association of the District of Columbia." PHILADELPHIA PHOTOGRAPHER 10, no. 109-114 (Jan. - June 1873): 15-16, 48, 80, 115, 146-147. [(Jan.) Includes poem "Two pictures; Rembrandtish & Otherwise," by Sec. E. J. Pulman.]

USA: EASTERN OHIO PHOTOGRAPHIC ASSOCIATION: 1875.
ST4071 "Society Gossip." PHILADELPHIA PHOTOGRAPHER 12, no. 139 (July 1875): 216.

USA: FERROTYPERS ASSOCIATION OF PHILADELPHIA: 1870.
ST4072 "Ferrotypers Association of Philadelphia." PHILADELPHIA PHOTOGRAPHER 7, no. 73-84 (Jan. - Dec. 1870): 11, 54, 78-79, 110, 161-162, 214-215, 257, 293, 325, 387-388.

USA: FERROTYPERS' ASSOCIATION. OF PHILADELPHIA: 1871.
ST4073 "Ferrotypers' Association of Philadelphia." PHILADELPHIA PHOTOGRAPHER 8, no. 85-96 (Jan. - Dec. 1871): 17-18, 77-78, 119-120, 368-369.

SPECIAL TOPICS: ORGANIZATIONS & SOCIETIES
USA: FERROTYPERS ASSOCIATION. OF PHILADELPHIA: 1872.

SPECIAL TOPICS: ORGANIZATIONS & SOCIETIES
USA: NATIONAL PHOTOGRAPHIC ASSOCIATION: 1868.

USA: FERROTYPERS ASSOCIATION. OF PHILADELPHIA: 1872.

ST4074 Lovejoy, Chas. M. "Ferrotypers Association of Philadelphia." PHILADELPHIA PHOTOGRAPHER 9, no. 97-108 (Jan. - Dec. 1872): 27, 46, 116-117, 143, 261.

USA: GERMAN PHOTOGRAPHERS SOCIETY OF NEW YORK: 1868.

ST4075 "The German Photographers' Society of New York." PHILADELPHIA PHOTOGRAPHER 5, no. 60 (Dec. 1868): 428.

USA: GERMAN PHOTOGRAPHERS SOCIETY OF NEW YORK: 1870.

ST4076 "The German Photographers' Society of New York." PHILADELPHIA PHOTOGRAPHER 7, no. 76, 84 (Apr., Dec. 1870): 111-112, 422.

ST4077 Boettcher, Edward, Sec. "German Photographic Society, N.Y." ANTHONY'S PHOTOGRAPHIC BULLETIN 1, no. 11 (Dec. 1870): 227-228.

USA: GERMAN PHOTOGRAPHERS SOCIETY OF NEW YORK: 1871.

ST4078 "German Photographic Society, New York." ANTHONY'S PHOTOGRAPHIC BULLETIN 2, no. 3 - 10 (Mar. - Oct. 1871): 87, 123, 153-154, 270-271, 299-301, 331-332.

ST4079 "German Photographers' Society, New York." PHILADELPHIA PHOTOGRAPHER 8, no. 85-96 (Jan. - Dec. 1871): 62-63, 186, 251, 299-300, 339-340.

USA: GERMAN PHOTOGRAPHERS SOCIETY OF NEW YORK: 1872.

ST4080 Boettcher, Edward. "German Photographic Society, New York." ANTHONY'S PHOTOGRAPHIC BULLETIN 3, no. 1, 4 (Jan., Apr. 1872): 431-432, 524-525.

ST4081 Boettcher, Edward, Sec. "German Photographer's Society, New York." PHILADELPHIA PHOTOGRAPHER 9, no. 97-108 (Jan. - Dec. 1872): 27-28, 78-79, 111, 148, 255-257.

ST4082 "Extracts from the Minutes of German Photographers' Society, N.Y." PHOTOGRAPHER'S FRIEND 2, no. 4 (Oct. 1872): 101-102.

USA: GERMAN PHOTOGRAPHERS SOCIETY OF NEW YORK: 1873.

ST4083 "German Photographers Society, New York." PHILADELPHIA PHOTOGRAPHER 10, no. 109-114 (Jan. - June 1873): 117-118, 147-148, 181-182.

USA: GERMAN PHOTOGRAPHERS SOCIETY OF NEW YORK: 1874.

ST4084 "German Photographic Association." ANTHONY'S PHOTOGRAPHIC BULLETIN 5, no. 4 (Apr. 1874): 160. [Election of Officers: W. Kurtz, Pres., etc., assets, etc. 71 members: 48 in New York, NY, 23 in other cities. $1326.72 in treasury. 615 photos, 200 bound journals and books, 150 unbound journals in library.]

USA: GERMAN PHOTOGRAPHERS SOCIETY OF NEW YORK: 1875.

ST4085 "Society Gossip." PHILADELPHIA PHOTOGRAPHER 12, no. 136 (Apr. 1875): 100-101.

USA: INDIANA PHOTOGRAPHIC ASSOCIATION: 1872.

ST4086 Dryer, G. W., Sec. "Indiana Photographic Association." PHILADELPHIA PHOTOGRAPHER 9, no. 99 (Mar. 1872): 77.

USA: INDIANA PHOTOGRAPHIC ASSOCIATION: 1873.

ST4087 "The Indiana Photographic Association. " PHILADELPHIA PHOTOGRAPHER 10, no. 109-114 (Jan. - June 1873): 14-15, 52, 84, 112, 146.

USA: INDIANA PHOTOGRAPHIC ASSOCIATION: 1875.

ST4088 "Society Gossip." PHILADELPHIA PHOTOGRAPHER 12, no. 133-144 (Jan. - Dec. 1875): 57-58, 78-79, 149, 187-188, 215-216.

USA: INDIANAPOLIS PHOTOGRAPHIC ASSOCIATION: 1871.

ST4089 "The Indianapolis Photographic Association." PHILADELPHIA PHOTOGRAPHER 8, no. 93 (Sept. 1871): 300-301.

USA: INDIANAPOLIS PHOTOGRAPHIC ASSOCIATION: 1877.

ST4090 Elliott, J. Perry, Sec., and Bishop, W. A. "Society Gossip." PHILADELPHIA PHOTOGRAPHER 14, no. 162-168 (June - Dec. 1877): 178, 211.

USA: MARYLAND PHOTOGRAPHERS' ASSOCIATION: 1872.

ST4091 "Maryland Photographers' Association." PHILADELPHIA PHOTOGRAPHER 9, no. 108 (Dec. 1872): 419. [Assoc. just formed. Pres. N. H. Busey. Other officers, P. L. Perkins, G. O. Brown, W. Dinmore.]

USA: MARYLAND PHOTOGRAPHIC ASSOCIATION: 1873.

ST4092 "Maryland Photographic Association." PHILADELPHIA PHOTOGRAPHER 10, no. 109-114 (Jan. - June 1873): 52, 83, 115-116, 147.

USA: MICHIGAN PHOTOGRAPHIC SOCIETY: 1866.

ST4093 "Editor's Table." PHILADELPHIA PHOTOGRAPHER 3, no. 31 (July 1866): 223. [Michigan State Photographic Society elected officers. President Jex Bardwell, etc.]

USA: NATIONAL ACADEMY OF DESIGN: 1854.

ST4094 "The National Academy of Design." PHOTOGRAPHIC AND FINE ART JOURNAL 7, no. 5 (May 1854): 154-159.

USA: NATIONAL PHOTOGRAPHIC ASSOCIATION: 1867.

ST4095 "The National Photographic Association." PHOTOGRAPHIC TIMES 16 , no. 237 (Apr. 2, 1886): 187-188. [At request, an outline of the events leading to the formation of the National Photographic Association in 1867 is given.]

USA: NATIONAL PHOTOGRAPHIC ASSOCIATION: 1868.

ST4096 "Proceedings of the National Photographic Convention Held in New York, April 7 & 8, 1868." PHILADELPHIA PHOTOGRAPHER 5, no. 52 (Apr. 1868): 135-150. [Speeches by Henry T. Anthony (p. 136); A. Bogardus (p. 136); committee reports (pp. 137-138); reports of the meeting (pp. 138-148); lists of committee members, contributors, officer's meeting, etc. (pp. 148-150).]

ST4097 "National Photographic Union." FRANK LESLIE'S ILLUSTRATED NEWSPAPER 26, no. 658 (May 9, 1868): 114. [Editorial announcing the forthcoming formation of the National

Photographers Association in opposition to Cutting's patent, wishing it success.]

ST4098 Ryder, J. F. "The National Photographic Union." PHILADELPHIA PHOTOGRAPHER 5, no. 56 (Aug. 1868): 250-252. [Letter.]

ST4099 Wilson, Edward L. "Report of the Secretary of the National Photographic Convention, held in New York, April 7th & 8th, 1868." PHILADELPHIA PHOTOGRAPHER 5, no. 56 (Aug. 1868): 281-314. [1st meeting was in opposition to the extension of the Cutting patent, the report deals with the trial testimony, etc.]

ST4100 "The National Photographic Convention Held in Philadelphia on Dec. 1 & 2, 1868." PHILADELPHIA PHOTOGRAPHER 6, no. 61 (Jan. 1869): 17-19. ["Our Aim" [statement of purpose] on page 19 same issue.]

USA: NATIONAL PHOTOGRAPHIC ASSOCIATION: 1869.
ST4101 "The National Photographic Association." PHILADELPHIA PHOTOGRAPHER 6, no. 62 (Feb. 1869): 55-56.

ST4102 "The Exhibition and Meetings of the National Photographic Association." PHILADELPHIA PHOTOGRAPHER 6, no. 67 (July 1869): 205-237. [First annual meeting held in Horticultural Hall, Boston, MA. Proceedings, pp. 206-218; Exhibition, pp. 210-221; John Towler's "Concentration of Ways and Means," pp. 222-234; Dr. Boynton's "Sunlight and Moonlight," p. 234; D. H. Willard's "Lantern Exhibition," p. 234; List of Members, pp. 234-237.]

ST4103 "Meeting of the Photographic Association." HUMPHREY'S JOURNAL OF PHOTOGRAPHY, AND THE ALLIED ARTS AND SCIENCES 20, no. 23 (July 15, 1869): 353-358. [Report on the meeting of photographers held in Boston on June 1. Sarcastic, negative commentary, claiming that only 150 photographers from all over the country showed up, followed by a vituperative attack on Edward L. Wilson again. Then a report of the meeting itself "By our own reporter," which was rather biased.]

USA: NATIONAL PHOTOGRAPHIC ASSOCIATION: 1870.
ST4104 "Proceedings of the National Photographic Association of the United States." PHILADELPHIA PHOTOGRAPHER 7, no. 79 (July 1870): 221-278. [Second meeting held in Cleveland, OH, on June 7 - 11, 1870.]

ST4105 "National Photographers' Convention." FRANK LESLIE'S ILLUSTRATED NEWSPAPER 30, no. 774 (July 30, 1870): 316-317. 1 illus. [Review of the exhibition in Cleveland, OH, associated with the annual meeting of the National Photographers Association. Illustrated with a group portrait of the NPA membership, taken by T. H. Johnson.]

ST4106 "The Exhibition of the National Photographic Association at Cleveland - Our Picture." PHILADELPHIA PHOTOGRAPHER 7, no. 80 (Aug. 1870): frontispiece, 276-281. 1 b & w. [Interior view of exhibition hall.]

ST4107 "Members of the National Photographic Association." PHILADELPHIA PHOTOGRAPHER 7, no. 80 (Aug. 1870): 291-292. [List of new members.]

ST4108 Wilson, Edward L., Sec. "Executive Committee of the National Photographic Association." ANTHONY'S PHOTOGRAPHIC BULLETIN 1, no. 7 (Aug. 1870): 141-142. [Meeting.]

ST4109 "Proceedings of the Executive Committee of the National Photographic Association." PHILADELPHIA PHOTOGRAPHER 7, no. 84 (Dec. 1870): 413-414.

ST4110 "The Monogram Trade-Mark of the National Photographic Association - Proceedings of the Executive Committee of the N. P. A." ANTHONY'S PHOTOGRAPHIC BULLETIN 1, no. 11 (Dec. 1870): 226-227. 1 illus.

USA: NATIONAL PHOTOGRAPHIC ASSOCIATION: 1871.
ST4111 "N. P. A. Gossip." PHILADELPHIA PHOTOGRAPHER 8, no. 87-90 (Mar. - June 1871): 71-72, 117-118, 191. [National Photographers Association news, lists of new members, etc.]

ST4112 "The National Photographic Association Convention." ANTHONY'S PHOTOGRAPHIC BULLETIN 2, no. 6 (June 1871): 185-187. [Brief report, in the absence of an official report of the proceedings.]

ST4113 "Proceedings of the National Photographic Association of the United States." ANTHONY'S PHOTOGRAPHIC BULLETIN 2, no. 7 (July 1871): 193-242. [Third annual Convention, held at Philadelphia. Speeches by W. H. Rhodes; Pres. A. Bogardus; H. Vogel; J. W. Black's lecture on new acid silver bath (pp. 197-199). Reports of various committees; speech by E. Y. Bell. Report of Committee on Progress of Photography: "America," by J. C. Browne (pp. 207-208); "England," by G. Wharton Simpson (pp. 208-211); "Germany," by Dr. H. Vogel (pp. 211-213). Lecture by J. H. Kent (Rochester, NY) (pp. 213-217); Southworth sliding box patent controversy aired; election of officers, with Bogardus elected again. Speeches by Bogardus, Samuel Holmes. Paper by Henry J. Newton (pp. 220-223); matters of early history brought up (pp. 227-228); lecture by R. J. Chute (pp. 234-236); list of exhibitors (pp.241-242).]

ST4114 "Proceedings of the National Photographic Association of the United States." PHILADELPHIA PHOTOGRAPHER 8, no. 91 (July 1871): 194-240. [Pres. Bogardus speech, p. 194; J. W. Black, demonstrates acid silver bath, p. 197; E. Y. Bell speech, p. 280; Report of the Committee of Progress of Photography; J. H. Kent's speech, p. 212; Annual election; Samuel Holmes' speech; Henry J. Newton's paper "If Not, Why Not?" p. 219; Bogardus' speech; Contentions and offers to resign; R.J. Chute's speech "Photographic Excellence," p. 233; Resolution to send a telegram to S. F. B. Morse gives rise to a reminiscence by Southworth about meeting Morse in Feb. 1840, p. 237.]

ST4115 "Reports of the National Photographic Association." ANTHONY'S PHOTOGRAPHIC BULLETIN 2, no. 8 (Aug. 1871): 245-259. ["The Committee on the Scovill and Holmes Medals: Extracts from their Proceedings." (Reports on Anthony's alum preparation by C. W. Hull and H. T. Anthony; "Porcelain Printing," by W. H. Sherman; "Pictorial Effect," by W. J. Baker; "On A Model Skylight," by A. K. P. Trask; lecture by Prof. Morton.]

ST4116 "The Executive Committee of the National Photographic Association." ANTHONY'S PHOTOGRAPHIC BULLETIN 2, no. 10-11 (Oct. - Nov. 1871): 333, 365-366. [Report of meetings.]

ST4117 "The Executive Committee of the N. P. A." PHILADELPHIA PHOTOGRAPHER 8, no. 95 (Nov. 1871): 363-364.

USA: NATIONAL PHOTOGRAPHIC ASSOCIATION: 1872.
ST4118 Wilson, Edward L., Sec. "Proceedings of the Executive Committee of the National Photographic Association." ANTHONY'S

PHOTOGRAPHIC BULLETIN 3, no. 1-4 (Jan. - Apr. 1872): 432-433, 499, 518-519.

ST4119 "Proceeding of the Executive Committee of the National Photographic Association. Matters of the NPA." PHILADELPHIA PHOTOGRAPHER 9, no. 97-108 (Jan. - Dec. 1872): 25-26, 50, 81-83, 237-238, 269-270, 297-298, 329-330, 354, 419-420. [Statement from Pres. Bogardus on pp. 82-83.]

ST4120 Fitzgibbon, J. H. "The Next National Convention of Photographers." ANTHONY'S PHOTOGRAPHIC BULLETIN 3, no. 2 (Feb. 1872): 465-466. [Fitzgibbon was Local Sec. for NPA for 1872. Letter reminding everyone to attend the meeting.]

ST4121 Fitzgibbon, J. H. "The Next Convention." PHILADELPHIA PHOTOGRAPHER 9, no. 98 (Feb. 1872): 36-37.

ST4122 "Official Proceedings of the N. P. A. of the United States. St. Louis, Mo. May 1872. (4th Annual Convention)." ANTHONY'S PHOTOGRAPHIC BULLETIN 3, no. 6 (June 1872): 581-596. [4th Annual Reception Wed. evening, May 8th, 1872. Programme No. 10: Grand Stereopticon exhibition by J. W. Black, of Boston.]

ST4123 "Fourth Annual Meeting and Exhibition of the N. P. A. in St. Louis, Mo., May 1872." PHILADELPHIA PHOTOGRAPHER 9, no. 102 (June 1872): 161-231. [J. H. Fitzgibbon's "Opening Remarks," p. 163; Award of the Scoville Medal, pp.168-169; Committee Reports, Exhibition, etc.]

ST4124 "Proceedings of the National Photographic Association of the United States." PHOTOGRAPHER'S FRIEND 2, no. 3 (July 1872): 70-95. [Speeches recorded by A. Bogardus, Dr. H. Vogel, G. O. Brown, J. H. Kent, S. F. B. Morse, F. Thorpe, J. C. Browne, J. H. Fitzgibbon, W. J. Baker, and a list of exhibitions given.]

ST4125 "Fourth Annual N. P. A. Convention in St. Louis." PHOTOGRAPHIC TIMES 2, no. 18 (June 1872): 81-83.

ST4126 Clemons, John R. "Eyes or No Eyes, Or the Act of Seeing." PHOTOGRAPHIC TIMES 2, no. 18 (June 1872): 83-86. [Affectionate memoirs of his visit to the 4th Annual Convention in St. Louis. J. W. Black and others are mentioned as agreeable traveling companions and fishermen.]

ST4127 "Proceedings of the N. P. A. of the United States. [Official]" ANTHONY'S PHOTOGRAPHIC BULLETIN 3, no. 6-10 (June - Oct. 1872): 581-596, 613-628, 645-660, 677-692, 713-724. [Speeches by J. H. Fitzgibbon; A. Bogardus; J. W. Black, "On the Acid Bath;" Sherman (Milwaukee) on his fixing bath; Annual Address by Bogardus; talks by Clemons; Hesler; Wilson Primm; E. Y. Bell, J. Lee Knight's poem; Council Report; plea for support for Henry R. Meade, father of the late Meade Brothers and for H. H. Snelling; Lynch's address "Photography in Texas;" poem by K. P. Johnston; letters from W. J. Baker and John A. Scholten; Reports of Committees; Report from J. C. Browne on "Landscape Photography;" Portraiture by W. J. Baker; "Germany," by H. Vogel; etc.; letters from G. O. Brown; L. G. Bigelow; "Address" by A. S. Southworth;; J. H. Kent; H. J. Newton; R. J. Chute; John L. Gihon; Albertype process; papers by H. H. Snelling; F. Thorp ; I. B. Webster; J. H. Fitzgibbon; A. E. Turnbull; Executive Committee Report.]

USA: NATIONAL PHOTOGRAPHIC ASSOCIATION: 1873.
ST4128 "Proceedings of the Executive Committee of the N. P. A." PHILADELPHIA PHOTOGRAPHER 10, no. 109-114 (Jan. - June 1873): 2, 70-72.

ST4129 Wilson, Edward L. "Proceedings of the Executive Committee of the N. P. A." ANTHONY'S PHOTOGRAPHIC BULLETIN 4, no. 1 (Jan. 1873): 10. [Includes Sec. W. J. Baker's letter extolling the membership to come to the national convention.]

ST4130 "Matters of the N. P. A." PHILADELPHIA PHOTOGRAPHER 10, no. 109-115 (Jan. - July 1873): 53-54, 91-92, 209-210.

ST4131 "Proceedings of the Executive Committee of the National Photographic Association. The Exhibition, Regulations and Arrangements." ANTHONY'S PHOTOGRAPHIC BULLETIN 4, no. 5 (May 1873): 145-146.

ST4132 "The National Photographic Association." ANTHONY'S PHOTOGRAPHIC BULLETIN 4, no. 8 (Aug. 1873): 225-226.

ST4133 "A Southwestern Photographer." "The Photographic Convention of Buffalo." ANTHONY'S PHOTOGRAPHIC BULLETIN 4, no. 8 (Aug. 1873): 226-227. [From the "St. Louis [MO] Democrat."]

ST4134 "Exhibition of Photographic Pictures and Materials in Chicago." ANTHONY'S PHOTOGRAPHIC BULLETIN 4, no. 8 (Aug. 1873): 227-228. [Announcement of the National Photographers' Association Convention planned for 1874 in Chicago.]

ST4135 "Fifth Annual Meeting and Exhibition of the National Photographic Association of the United States, Held in Buffalo, New York, beginning July 15, 1873." ANTHONY'S PHOTOGRAPHIC BULLETIN 4, no. 8 (Aug. 1873): 251-256. [Mr. Bakers' welcoming address, Pres. Bogardus's reply, report of the Executive Committee, 1873, report of the Committee on the Progress of Photography.]

ST4136 "The National Photographic Association." ANTHONY'S PHOTOGRAPHIC BULLETIN 4, no. 8 (Aug. 1873): 225-226.

ST4137 "The N. P. A. Report." ANTHONY'S PHOTOGRAPHIC BULLETIN 4, no. 9 (Sept. 1873): 257-258.

ST4138 "Fifth Annual Meeting and Exhibit of the National Photographic Association of the U.S., held in Buffalo, N.Y., beginning July 5, 1873." PHILADELPHIA PHOTOGRAPHER 10, no. 117 (Sept. 1873): 257-467. [President Baker's speech, pp. 259-260; Committee Reports, PP. 262-267; L. G. Bigelow, "Skylights," pp. 268-269; A. Hesler, "Posing, Lighting, and Expression," pp. 270-272; F. Jewell, "Posing, Lighting and Expression," pp. 273-276; A. S. Southworth, "Comments," pp. 277-287; Webster, "Skylight Construction," pp. 288-290; John L. Gihon, "A Contribution to the Pow Wow," pp. 291-295; A. Bogardus, "Annual Address," pp. 296-303; Committee Reports, pp. 304-312; R. J. Chute, "Art Education," pp. 313-314; George B. Ayers, "Relationship of the Photograph to the Artist," pp. 314-315; Baker, "Address by a Sculptor," pp. 316-319; E. T. Whitney, "Treatment of the Sitter," pp. 320-321; J. W. Black, "Acid Nitrate Bath," pp. 322-323; Elbert Anderson, "Negative Bath," pp. 324-326; L. C. Mundy, "Negative Bath," pp. 327-328; S. P. Wells, "To Manipulate with Iron," pp. 320-321; Webster, ""Manipulation Continued," pp. 332-335; F. G. Pearsall, "A New Train of Thought," pp. 340-345; [T. C.] Roach, "Landscape and Architectural Photography," pp. 346-352; Mrs. E. N. Lockwood, "Shall We Be Insured?" pp. 353-354; Committee Reports, pp. 354-362; Alva Pearsall, "Photographic Associations," pp. 363-365; L. G. Sellstedt, "Art and Its Relationship to Photographic Art," pp. 366-369; Baker, "Debate on the Fine Arts, " pp. 370-373; J. Carbutt, "How to make Albumen Positives for Reproducing Negatives," pp. 374-376; W. H. Sherman, "Printing, Toning, and Finishing," pp. 377-382; H. J. Rogers, "Printing and Toning," pp. 383-384; Ch. W. Hearn, "Printing, Toning, Washing and

Finishing Photographs," pp. 384-387; H. H. Snelling, "Beauty and Photography," pp. 388-393; W. J. Baker, "Lighting the Sitter," pp. 394-399; E. Wilson, "How to Manage the Lines," pp. 400; Alfred Hall, " On Copying Enlargements," pp. 424-428; Rev. Frothingham, "Address," pp. 431-432; A. S. Southworth, "The Use of the Camera," pp. 433-440; J. C. Potter, "What I Know about Outdoor Work," pp. 441-442; Husher, "Landscape Photography," pp. 443-444; James Mullen, "Landscape Photography," pp. 445-446; C. A. Zimmerman, "On Landscape Photography," pp. 447-448; Alf. L. Vance, "Collodion and Its Troubles," pp. 448-449; J. W. Morgeneier, "Retouching Negatives," pp. 450-451; Rbt. M. Morgeneier, "Ideas on Retouching Negatives," p. 451; N. H. Busey, "Retouching," pp. 451-460; Awards, pp. 461-464; List of Exhibitors, pp. 465-467.]

ST4139 "Fifth Annual Meeting and Exhibition of the National Photographic Association of the United States, Held in Buffalo, New York, beginning July 15, 1873. (Continued)." ANTHONY'S PHOTOGRAPHIC BULLETIN 4, no. 9-12 (Sept. - Dec. 1873): 277-287, 305-320, 337-352, 377-412. (Sept.) Report of the Committee on the Progress of Photography, "Germany" by H. Vogel, "Skylights" by L. G. Bigelow, "Posing, Lighting, and Expression," by A. Hesler, "Posing, Lighting, and Expression" by Frank Jewell. (Oct.) "On Skylight Constructions," by E. Z. Webster; "A Contribution to the Pow-Wow, by John L. Gihon; [mailed from S. America], "How Many Positions Shall We Make to Oblige the Fastidious Patrons of our Photographic Art?" by J. Pitcher Spooner; "Annual Address of the President," by A. Bogardus, other discussions. (Nov.) Discussion of members, letter from Jex Bardwell, "Art Education," by R. J. Chute, "The Relation of the Photographers and the Artist," by George B. Ayers, "Address by a Sculptor," by Mr. Baker. (Dec.) "The Treatment of the Sitter," by E. T. Whitney, "The Acid Nitrate Bath," by J. W. Black, "The Negative Bath," by Elbert Anderson, "Concerning the Negative Bath," by L. C. Mundy, "To Manipulate with Iron, by S. P. Wells, "Manipulations Continued," by I. B. Webster, "A New Train of Thought," by G. F. E. Pearsall, "Art and Its Relation to the Photographic Art," by L. G. Sellstedt, "The Fine Arts: A conversation between Mr. D. C. Fabronius and Mr. W. J. Baker," "Printing, Toning, and Finishing," by W. H. Sherman, "Printing, Toning, Etc.," by H. J. Rogers, "Printing, Toning, Washing, and Finishing Photographs," by Charles W. Hearn.]

ST4140 "Fifth Annual Meeting and Exhibition of the National Photographic Association of the United States." ANTHONY'S PHOTOGRAPHIC BULLETIN 5, no. 1 (Jan. 1874): 33-65. [Report carried over from vol. 4 (Dec. 1873) issue. W. J. Baker "Lighting the Sitter" (pp. 33-40); Ed. L. Wilson "How to Manage the Lines," (pp. 41-44); Hall "On Copying Enlarging, Etc." (pp. 45-48); Rev. Mr. Frothingham "Address" (pp. 48-51); J. C. Potter "What I Know About Outdoor Work (pp. 51-53); Husher "Landscape Photography" (pp. 54-56); Mullen "Landscape Photography" (pp. 56-58); C. A. Zimmerman "On Landscape Photography" (pp. 58-59); N. H. Busey "Retouching" (pp. 59-61); business; reports of the committees, (pp. 61-65).]

USA: NATIONAL PHOTOGRAPHIC ASSOCIATION: 1874.
ST4141 "Matters of the N. P. A." and "Proceedings of the Executive Committee of the N. P. A." PHILADELPHIA PHOTOGRAPHER 11, no. 121-132 (Jan. - Dec. 1874): 24-25, 59, 89-90, 115-116, 158-159, 188-189, 280-281, 317-318, 342-343, 371-373. [Jan. issue includes a letter from I. B. Webster on p. 25.]

ST4142 Fitzgibbon, J. H. "Convention Matters." ANTHONY'S PHOTOGRAPHIC BULLETIN 5, no. 5 (May 1874): 181-182.

ST4143 "Affairs of the N. P. A." ANTHONY'S PHOTOGRAPHIC BULLETIN 5, no. 7 (July 1874): 254-255. [Letters from Fitzgibbon, A.

T. Urie and others expressing dissatisfaction with current state of affairs.] "A Little Faith." PHOTOGRAPHIC TIMES 4, no. 43 (July 1874): 101. [Promoting the forthcoming Chicago Convention.]

ST4144 "The Craft at Chicago." ANTHONY'S PHOTOGRAPHIC BULLETIN 5, no. 8 (Aug. 1874): 261-267. [Summary of the annual NPA conference and list of exhibitors. Much briefer than previous reports.]

ST4145 "The Sixth Annual Convention and Exhibition of the N. P. A. [Chicago]." PHILADELPHIA PHOTOGRAPHER 11, no. 128 (Aug. 1874): 241-245. [Brief summary of the annual meeting. Not as extensively reviewed as in past for the Association voted to publish separate official report. This was, however, never accomplished.]

ST4146 "The Chicago Convention." PHOTOGRAPHIC TIMES 4, no. 44 (Aug. 1874): 125-126. [Brief report on events of the Chicago Convention of the N. P. A.]

ST4147 "Proceedings of the Executive Committee of the National Photographic Association." ANTHONY'S PHOTOGRAPHIC BULLETIN 5, no. 12 (Dec. 1874): 409-410.

USA: NATIONAL PHOTOGRAPHIC ASSOCIATION: 1875.
ST4148 Rulofson, Wm. H. "San Francisco and the Next Meeting of the N. P. A. Association." ANTHONY'S PHOTOGRAPHIC BULLETIN 6, no. 1 (Jan. 1875): 17-18.

ST4149 "Matters of the N. P. A. - The California Convention." PHILADELPHIA PHOTOGRAPHER 12, no. 133-144 (Jan.- Dec. 1875): 11-12, 87-88, 119-120, 149-153, 188-189, 219, 241-242, 245, 286-287, 314-317, 331-332, 345-346, 365-367. [Annual photographic convention, slated to be held in San Francisco, CA., postponed, in part due to poor economic year, in part to distance, in part to growing chaos within the NPA. In the Nov. issue the editor discusses the various confusions surrounding the attempts to publish the reports of the annual meetings in the "Phila. Photog." and elsewhere]

ST4150 Rulofson, W. H. "Preparations for Welcome." ANTHONY'S PHOTOGRAPHIC BULLETIN 6, no. 2 (Feb. 1875): 50. [Report of activities in San Francisco, preparing for the annual NPA conference.]

ST4151 Wilson, Edward L. "Proceedings of the Executive Committee of the National Photographic Association." ANTHONY'S PHOTOGRAPHIC BULLETIN 6, no. 3, 6, 9, 11 (Mar., June, Sept., Nov. 1875): 92-93, 177-178, 283, 340-341. [In Mar. resolved to hold annual meeting in San Francisco. In June, met to postpone the convention to 1877. In Nov. met to organize to plan a Photographic Hall in the forthcoming International Exhibition in Philadelphia in 1876.]

ST4152 Rulofson, Wm. H. "Proclamation." ANTHONY'S PHOTOGRAPHIC BULLETIN 6, no. 5 (May 1875): 145. [Letter from Rulofson inviting members to the N. P. A. convention in San Francisco, CA.]

ST4153 "The Convention of the National Photographic Association." ANTHONY'S PHOTOGRAPHIC BULLETIN 7, no. 9 (Sept. 1876): 280. [Brief report of N. P. A. convention; note that the official report to be published solely in the "Philadelphia Photographer" magazine; list of elected officers.]

ST4154 Fitzgibbon, J. H. "To the Members of the National Photographic Association." ANTHONY'S PHOTOGRAPHIC

SPECIAL TOPICS: ORGANIZATIONS & SOCIETIES
USA: NATIONAL PHOTOGRAPHIC ASSOCIATION: 1876.

SPECIAL TOPICS: ORGANIZATIONS & SOCIETIES
USA:NEW YORK STATE DAGUERREAN ASSOCIATION: 1851.

BULLETIN 7, no. 10 (Oct. 1876): 309-310. ["It is with pleasure I announce...the continued existence of the NPA, after a struggle for life in which the doctors seemingly had no remedy for the disease of decadence..."] "The Future of the National Photographic Association." PHILADELPHIA PHOTOGRAPHER 12, no. 142 (Oct. 1875): 316-317.

USA: NATIONAL PHOTOGRAPHIC ASSOCIATION: 1876.
ST4155 "The National Photographic Association." PHILADELPHIA PHOTOGRAPHER 13, no. 145-156 (Jan. - Dec. 1876): 39-40, 123-124, 129-130, 145-147, 161-164, 170-171, 193-195, 202-203, 221, 225-226, 250-252, 257. [Letters from J. S. Mason, J. A. W. Pittman, and President Wm. Rulofson on pp. 123-124; J. H. Fitzgibbon on pp. 129-130, and 163-164; Editor Wilson's comments on pp. 146-147; R. J. Chute and John Cadwallader on pp. 170-171; E. K. Hough on pp. 162-163, and 202-203; Mrs. E. N. Lockwood on p. 221.]

ST4156 Wilson, Edward L. "Proceedings of the Executive Committee of the N. P. A." ANTHONY'S PHOTOGRAPHIC BULLETIN 7, no. 5 (May 1876): 153. "The National Photographic Association - What Has It Accomplished?" PHILADELPHIA PHOTOGRAPHER 13, no. 151 (July 1876): 193-195.

ST4157 "Proceedings of the Seventh Annual Convention of the National Photographic Association Held in the Judge's Hall, Centennial Grounds, Phila., Commencing Tuesday, Aug. 15, 1876." PHILADELPHIA PHOTOGRAPHER 13, no. 153-155 (Sept. - Nov. 1876): 272-284, 303-314, 325-339. [Address by J. R. Hawley, p. 272; R. J. Chute, pp.273-274; Pres. Wm. H. Rulofson, p. 274; committee reports, pp. 274-277; speech by A. S. Southworth, pp. 277-278; "How to climb the ladder," by J. H. Fitzgibbon, pp. 278-279; "Photographic rights," by E. T. Whitney, pp. 279-280; "For the very best photographs go to Smith," by J. P. Spooner, pp. 280-281; "On insurance," by Mrs. E. N. Lockwood, pp.281-282; letter from Jacob Shew, p.283; Annual address by Pres. Rulofson, pp. 303-304; address by Dr. Vogel, pp. 304-305; talk by A. Bogardus, p. 306; address by L. W. Seavey, pp. 307-314; Business, pp.325-328; "On various distortions in photography," by Wm. Curtis Taylor, pp. 329-331; "Co-operative Photography," by E. K. Hough, pp. 331-33p; "Photography from a monetary standpoint," by H. B. Hillyer, pp. 332-337; "A plea for photographic Patentees, " by A. St. Clair, pp. 337-339.]

ST4158 "Convention of the N. P. A. at Philadelphia." PHOTOGRAPHIC TIMES 6, no. 69 (Sept. 1876): 199-202. [Extracted from "Philadelphia [PA] Public Ledger."]

USA: NATIONAL PHOTOGRAPHIC ASSOCIATION: 1877.
ST4159 Wilson, Edward L. "Photographic Societies." PHILADELPHIA PHOTOGRAPHER 14, no. 157 (Jan. 1877): 17-18. [Discussion of dissention, decline of the N. P. A.]

ST4160 Lockwood, Mrs. E. N. "Mrs. Lockwood Speaks." ST. LOUIS PRACTICAL PHOTOGRAPHER 1, no. 1 (Jan. 1877): 23-24. [Mrs. Lockwood defending the N. P. A.]

ST4161 "Matters of the N. P. A." PHILADELPHIA PHOTOGRAPHER 14, no. 160, 165 (Apr., Sept. 1877): 124-125, 270-271. [Questioning the level of activity of this beleaguered organization.]

USA: NATIONAL PHOTOGRAPHIC ASSOCIATION: 1878.
ST4162 Lockwood, E. N. "Shall We Sleep or Awake?" PHILADELPHIA PHOTOGRAPHER 15, no. 180 (Dec. 1878): 365-366.

USA: NATIONAL PHOTOGRAPHIC ASSOCIATION: 1879.
ST4163 Webster, I. B. "Let Us Have the N. P. A." PHILADELPHIA PHOTOGRAPHER 16, no. 189 (Sept. 1879): 258-259.

ST4164 "The National Photographic Association - Shall It Be Revived?" PHILADELPHIA PHOTOGRAPHER 16, no. 189 (Sept. 1879): 285-287.

ST4165 "The Photographic Association." ANTHONY'S PHOTOGRAPHIC BULLETIN 10, no. 10 (Oct. 1879): 316. ["A movement has recently been made for the purpose of reviving this defunct body..."]

ST4166 "Shall There Be a Convention of the N. P. A.?" PHILADELPHIA PHOTOGRAPHER 16, no. 190 (Oct. 1879): 298-300.

USA: NEW ENGLAND PHOTOGRAPHIC ASSOCIATION see BOSTON PHOTOGRAPHIC SOCIETY.

USA: NEW YORK PHOTOGRAPHIC SOCIETY: 1866.
ST4167 "Editor's Table." PHILADELPHIA PHOTOGRAPHER 3, no. 29 (May 1866): 157. [Election of officers of NY Photographic Society: President: Lewis Rutherford. Vice Presidents: J. Draper; Charles Joy; Abraham Bogardus. Corresponding Secretary: C. Wagner Hull. Recording Secretary: Oscar G. Mason. Treasurer: Henry J. Newton.] Hull, C. Wager. "New York Correspondence." PHILADELPHIA PHOTOGRAPHER 3, no. 36 (Dec. 1866): 385-387. [Discussion of Sarony's photographic studies.]

USA: NEW YORK PHOTOGRAPHIC SOCIETY: 1867.
ST4168 Hull, C. Wager. "New York Correspondence." PHILADELPHIA PHOTOGRAPHER 4, no. 42, 45, 48 (June, Sept., Dec. 1867): 185-189, 285-287, 388-389.

ST4169 "New York Correspondence." PHILADELPHIA PHOTOGRAPHER 4, no. 37-43 (Jan. - July 1867): 26-27, 56-58, 90-92, 121-122, 141-144.

USA: NEW YORK PHOTOGRAPHIC SOCIETY: 1870.
ST4170 Hull, C. Wager. "New York Correspondence." PHILADELPHIA PHOTOGRAPHER 7, no. 73-78, 80 (Jan. - June, Aug., 1870): 17-19, 51-53, 82-83, 158-159, 212-214, 292.

USA:NEW YORK STATE DAGUERREAN ASSOCIATION: 1851.
ST4171 "American Heliographic Association." DAGUERREAN JOURNAL 2, no. 5 (July 15, 1851): 147. [Announcement of forthcoming meeting of the New York Photographic Assoc. Association in process of forming. E. T. Whitney Chairman, C. B. Denny, F. J. Clark, B. L. Higgens, Secretaries. D. D. T. Davie, G. N. Barnard, P. H. Benedict, L. V. Parsons and L. V. Griffin on Committee to draft constitution.]

ST4172 "New York State Daguerrean Association." DAGUERREAN JOURNAL 2, no. 8 (Sept. 1, 1851): 248-249. [Proceedings of the meeting, held in Utica, NY on 20th Aug.]

ST4173 Parsons, L. V., Rec. Sec. "Official Report of the Proceedings of the New York State Daguerrean Association, Utica, N. Y., Aug. 20, 1851." PHOTOGRAPHIC ART JOURNAL 2, no. 3 (Sept. 1851): 169-171.

SPECIAL TOPICS: ORGANIZATIONS & SOCIETIES
USA: NEW YORK STATE DAGUERREAN ASSOCIATION: 1852.

SPECIAL TOPICS: ORGANIZATIONS & SOCIETIES
USA: PENNSYLVANIA PHOTOGRAPHIC ASSOCIATION: 1872.

ST4174 "Gossip." PHOTOGRAPHIC ART JOURNAL 2, no. 3 (Sept. 1851): 187-188. [Discusses formation of the N. Y. State Daguerrean Assoc.]

ST4175 Denny, C. B. "Official Report of the Proceedings of the New York State Daguerrean Association, Nov. 11th, 1851." PHOTOGRAPHIC ART JOURNAL 2, no. 5 (Nov. 1851): 298-300.

ST4176 "Popularity Assumed by an Editor." DAGUERREAN JOURNAL 3, no. 2 (Dec. 1, 1851): 57-58.

ST4177 "Constitution and By-Laws of the New York State Daguerrean Association." PHOTOGRAPHIC ART JOURNAL 2, no. 6 (Dec. 1851): 362-365.

USA: NEW YORK STATE DAGUERREAN ASSOCIATION: 1852.
ST4178 "New York State Daguerrean Association." PHOTOGRAPHIC ART JOURNAL 3, no. 5-6 (May - June 1852): 303-305, 372.

ST4179 "Gossip: The New York State Daguerrean Assoc." PHOTOGRAPHIC ART JOURNAL 4, no. 4 (Oct. 1852): 255-256. [Address by the president A. Morand printed.]

USA: NEW YORK STATE DAGUERREAN ASSOCIATION: 1853.
ST4180 "Minutes of the N.Y. State Daguerrean Association." PHOTOGRAPHIC ART JOURNAL 5, no. 2 (Feb. 1853): 112-113. [Election of officers noted. D. D. T. Davie elected President, G. N. Barnard elected Secretary, J. Davie elected Treasurer.]

USA: NEW YORK STATE DAGUERREAN ASSOCIATION: 1854.
ST4181 Davie, D. D. T. "The N.Y.S. Daguerrean Association." PHOTOGRAPHIC AND FINE ART JOURNAL 7, no. 8 (Aug. 1854): 235. [Letter from Davie, stating that the last annual meeting brought only three participants: Mrs. Barnes, U. Dunning of Utica, and himself. Call for more participation.]

ST4182 Davie, D. D. T. "N. Y. State Daguerrean Association." PHOTOGRAPHIC AND FINE ART JOURNAL 7, no. 9 (Sept. 1854): 271. [Davie resigns as President.]

USA: NORTHERN OHIO PHOTOGRAPHIC SOCIETY: 1868.
ST4183 "Northern Ohio Photographic Society." PHILADELPHIA PHOTOGRAPHER 5, no. 58, 60 (Oct., Dec. 1868): 374-375, 428-429.

USA: NORTHERN OHIO PHOTOGRAPHIC SOCIETY: 1869.
ST4184 "Northern Ohio Photographic Society, Cleveland." PHILADELPHIA PHOTOGRAPHER 6, no. 61, 70 (Jan., Oct. 1869): 17, 350-351.

USA: NORTHERN OHIO PHOTOGRAPHIC SOCIETY: 1870.
ST4185 "Northern Ohio Photographic Society." PHILADELPHIA PHOTOGRAPHER 7, no. 73 (Jan. 1870): 13.

USA: NORTHWESTERN PHOTOGRAPHIC SOCIETY: 1863.
ST4186 "North-Western Photographic Society, Constitution, and By-Laws." AMERICAN JOURNAL OF PHOTOGRAPHY AND THE ALLIED ARTS & SCIENCES n. s. vol. 5, no. 22 (May 15, 1863): 515-519. [Society formed in Chicago, IL. Pres: A. Hesler, V.P.'s: J. Carbutt and E. L. Brand, Corr. Sec.: S. R. Divine, Rec. Sec.: B. E. Terrill, Treas.: Joseph Bettersky. Others mentioned: W. N. Stoddard, S. M. Fassett and C. H. Lillibridge.]

USA: NORTHWESTERN PHOTOGRAPHIC SOCIETY: 1864.
ST4187 "Northwestern Photographic Society. Adjourned Annual Meeting - Election of Officers." PHILADELPHIA PHOTOGRAPHER 1, no. 9 (Sept. 1864): 141-142. [A. Hesler, J. Carbutt, E. L. Brand, Samuel Alschuler, Joseph Battersby, R. E. Tyrell, others mentioned.]

ST4188 "Northwestern Photographic Society." AMERICAN JOURNAL OF PHOTOGRAPHY AND THE ALLIED ARTS & SCIENCES n. s. vol. 7, no. 11 (Dec. 1, 1864): 261-263. [Chicago, IL, organization. Pres. E. L. Brand in chair. Joseph Hingley and C. W. Florence accepted into the Society. Oscar J. Bill accepted. Carbutt, Green, Worth, Shaw described processes, etc.]

ST4189 "Northwestern Photographic Society." HUMPHREY'S JOURNAL OF PHOTOGRAPHY, AND THE ALLIED ARTS AND SCIENCES 16, no. 15 (Dec. 1, 1864): 232-233. [First and second meetings of the season, in Chicago. Joseph Hingley, C. W. Florence, J. Oscar Bill elected to Society. Making negatives discussed.]

USA: NORTHWESTERN PHOTOGRAPHIC SOCIETY: 1865.
ST4190 "Northwestern Photographic Society, Chicago." PHILADELPHIA PHOTOGRAPHER 2, no. 13-24 (Jan. - Dec. 1865): 13, 29-30, 46-47, 63, 79-80, 184-186. [Report of the meetings.]

USA: NORTHWESTERN PHOTOGRAPHIC SOCIETY: 1867.
ST4191 Hall, B. F. "The North-Western Photographic Society of Chicago." HUMPHREY'S JOURNAL OF PHOTOGRAPHY, AND THE ALLIED ARTS AND SCIENCES 18, no. 21 (Mar. 1, 1867): 334-335. [H. S. White, H. Rocher and F. B. Sanborn elected to the Society. J. S. Miller read paper, "Making Negatives from Life."]

ST4192 "Northwestern Photographic Society, Chicago." PHILADELPHIA PHOTOGRAPHER 4, no. 39 (Mar. 1867): 92.

USA: PALETTE CLUB: 1872.
ST4193 "'Palette': Summer Nights Excursion on the Hudson." PHOTOGRAPHIC TIMES 2, no. 20 (Aug. 1872): 115-116. [1st annual moonlight excursion of the "Palette Club" of NY. Kurtz, Pres. Elroy Anderson, N. Sarony, Ch. Wager Hull, Edward L. Wilson.]

USA: PENNSYLVANIA PHOTOGRAPHIC ASSOCIATION: 1870.
ST4194 "Pennsylvania Photographic Association." PHILADELPHIA PHOTOGRAPHER 7, no. 80-84 (Aug. - Dec. 1870): 292-293, 349-350, 386-387, 420-421.

USA: PENNSYLVANIA PHOTOGRAPHIC ASSOCIATION: 1871.
ST4195 "Pennsylvania Photographic Association." PHILADELPHIA PHOTOGRAPHER 8, no. 85-96 (Jan. - Dec. 1871): 16-17, 44-47, 90-92, 118-119, 136-138, 187-188, 240, 340-341, 367-368, 394-395. [(Feb.) Includes secretary's annual report on a paper "On Positive Printing" by W. L. Shoemaker. Read before meeting on Jan. 9, 1871.]

USA: PENNSYLVANIA PHOTOGRAPHIC ASSOCIATION: 1872.
ST4196 Chute, R. J. "Pennsylvania Photographic Association." PHILADELPHIA PHOTOGRAPHER 9, no. 97-108 (Jan. - Dec. 1872):

26-27, 47-48, 80-81, 113-116, 142-143, 258-259, 352-353, 385-388, 417-418. [William H. Rhodes's experiments with camera lenses, discovering that a penny placed in the center sharpens the image discussed on p. 352. Further information on pp. 417-418.]

USA: PENNSYLVANIA PHOTOGRAPHIC ASSOCIATION: 1873.
ST4197 "Pennsylvania Photographic Association." PHILADELPHIA PHOTOGRAPHER 10, no. 109-112 (Jan. - Apr. 1873): 19, 49-50, 80, 116-117.

USA: PENNSYLVANIA PHOTOGRAPHIC ASSOCIATION: 1875.
ST4198 "Society Gossip." PHILADELPHIA PHOTOGRAPHER 12, no. 133-144 (Jan. - Dec. 1875): 13, 99-100, 146-147, 213-214, 310, 334-335, 370.

USA: PENNSYLVANIA PHOTOGRAPHIC ASSOCIATION: 1876.
ST4199 "Society Gossip." PHILADELPHIA PHOTOGRAPHER 13, no. 145-156 (Jan. - Dec. 1876): 29-30, 47, 90, 111, 143, 212.

USA: PENNSYLVANIA PHOTOGRAPHIC ASSOCIATION: 1877.
ST4200 Evans, Charles, Sec. "Society Gossip." PHILADELPHIA PHOTOGRAPHER 14, no. 157-168 (Jan. - Dec. 1877): 49, 117-118, 248-249, 371.

USA: PENNSYLVANIA PHOTOGRAPHIC ASSOCIATION: 1878.
ST4201 Mahan, Thomas T., Sec. "Society Gossip." PHILADELPHIA PHOTOGRAPHER 15, no. 169-180 (Jan. - Dec. 1878): 57.

USA: PHILADELPHIA PHOTOGRAPHIC SOCIETY.
BOOKS
ST4202 Photographic Society of Philadelphia. *History of the Photographic Society of Philadelphia:* Organized November 26, 1862: A Paper Read Before the Photographic Society, December 5, 1883, by John C. Browne. Philadelphia: Published by order of the Society, 1884. 36 pp.

PERIODICALS
USA: PHILADELPHIA PHOTOGRAPHIC SOCIETY: 1862.
ST4203 Seely, Charles A. "Editorial Department." AMERICAN JOURNAL OF PHOTOGRAPHY AND THE ALLIED ARTS & SCIENCES n. s. vol. 5, no. 12 (Dec. 15, 1862): 288. ["We are pleased to observe that a Photographic Society has been organized in Philadelphia.... Guillou; Emerson; Rogers; Sergeant; Corlies; Borda; Sellers, and Fassitt signed call for first meeting."]

USA: PHILADELPHIA PHOTOGRAPHIC SOCIETY: 1863.
ST4204 "Philadelphia Photographic Society." HUMPHREY'S JOURNAL OF PHOTOGRAPHY, AND THE ALLIED ARTS AND SCIENCES 15, no. 14 (Nov. 15, 1863): 215. [First year of the Society completed successfully. New officers elected. Pres.: Constant Guillou, V. P.'s: Frederick Graff, J. Dickerson Sergeant, Rec. Sec.: Craig D. Ritchie, Corresp. Sec.: Coleman Sellers, Treas.: S. Fisher Corlies.]

ST4205 "The Philadelphia Photographic Society." AMERICAN JOURNAL OF PHOTOGRAPHY AND THE ALLIED ARTS & SCIENCES n. s. vol. 5, no. 15, 17, 19 (Feb. 1, Mar. 1, Apr. 1, 1863): 356-359, 392-395, 451-453. [(Feb.) Pres. Constant Guillou, presiding. Prof. Emerson, Mr. Fassitt, Prof. Fairman Rogers, Coleman Sellers, Mr. Wenderoth, V.P. Sergeant discussed various matters. (Mar.) Letters

from Robert Shriver (Cumberland, MD); Charles Waldack (Ghent, Belgium); J. W. Black (Boston, MA); Seely & Bartlett (New York, NY) offering gifts and praise. Sect. J. C. Brown (sic Browne) read Dr. Child's letter on "spirit photographs." Browne and Fairman Rogers report on a photographic excursion. Hugh Davids, a landscape painter, displayed photos he had made. C. Sellers, E. Borda, Mr. Fassitt discussed lenses. (Apr.) Felix D. Crane, Richard D. Petit, John H. Simmond elected to the Society. Dr. Van Monckhoven elected corresponding member. Coleman Sellers, F. A. Wenderoth, Mr. Taylor, J. W. Hurne, Mr. Browne, Hugh Davids, Mr. Moran, Pres. Frederick Graef discuss matters.]

USA: PHILADELPHIA PHOTOGRAPHIC SOCIETY: 1864.
ST4206 "Photographic Society of Philadelphia." PHILADELPHIA PHOTOGRAPHER 1, no. 1-12 (Jan. - Dec. 1864): 12-13, 29-30, 38, 55-56, 77-79, 93-94, 110-111, 171-172, 187-189. [J. C. Browne, E. Borda, Constant Guillou, Coleman Sellers, Frederick Graff mentioned in first article.]

USA: PHILADELPHIA PHOTOGRAPHIC SOCIETY: 1865.
ST4207 "Photographic Society of Philadelphia." PHILADELPHIA PHOTOGRAPHER 2, no. 13-24 (Jan. - Dec. 1865): 14, 28-29, 45-46, 62-63, 79, 102, 119-121, 185-186, 203-204 .

USA: PHILADELPHIA PHOTOGRAPHIC SOCIETY: 1866.
ST4208 "Photographic Society of Philadelphia." PHILADELPHIA PHOTOGRAPHER 3, no. 25-36 (Jan. - Dec. 1866): 24-27, 57-59, 90-92, 123-125, 155-156, 188, 218-219, 355-356, 384-385.

USA: PHILADELPHIA PHOTOGRAPHIC SOCIETY: 1867.
ST4209 "Photographic Society of Philadelphia." PHILADELPHIA PHOTOGRAPHER 4, no. 37-48 (Jan. - Dec. 1867): 27-28, 58, 88-90, 119-121, 151, 189-190, 229-231, 363-364, 394-395. [Napoleon Sarony's studies discussed. Valentine Blanchard mentioned, (Jan.); election of officers, (Dec.).]

USA: PHILADELPHIA PHOTOGRAPHIC SOCIETY: 1868.
ST4210 "Photographic Society of Philadelphia." PHILADELPHIA PHOTOGRAPHER 5, no. 49-60 (Jan. - Dec. 1868): 24-25, 95-96, 128-130, 172-173, 199-200, 237, 429. [Mentions that E. Muybridge's prints of Yosemite Valley, CA, on display, (Apr.).]

USA: PHILADELPHIA PHOTOGRAPHIC SOCIETY: 1869.
ST4211 Hull, C. Wager. "Photographic Society of Philadelphia." PHILADELPHIA PHOTOGRAPHER 6, no. 61-72 (Jan. - Dec. 1869): 16-17, 44-45, 89-90, 126, 160-161, 198-199, 250-251, 373, 422.

USA: PHILADELPHIA PHOTOGRAPHIC SOCIETY: 1870.
ST4212 "Photographic Society of Philadelphia." PHILADELPHIA PHOTOGRAPHER 7, no. 73-84 (Jan. - Dec. 1870): 11-12, 53-54, 77-78, 110, 159-160, 257, 387, 421-422.

USA: PHILADELPHIA PHOTOGRAPHIC SOCIETY: 1871.
ST4213 "Photographic Society of Philadelphia." PHILADELPHIA PHOTOGRAPHER 8, no. 85-96 (Jan. - Dec. 1871): 15-16, 44, 90, 119, 138-139, 392-393.

USA: PHILADELPHIA PHOTOGRAPHIC SOCIETY: 1872.
ST4214 Wallace, Ellerslie, Jr., Sec. "Photographic Society of Philadelphia." PHILADELPHIA PHOTOGRAPHER 9, no. 97-108 (Jan. - Dec. 1872): 45-46, 79-80, 112-113, 142, 260-261, 383-384, 415-417.

SPECIAL TOPICS: ORGANIZATIONS & SOCIETIES
USA: PHILADELPHIA PHOTOGRAPHIC SOCIETY: 1873.

SPECIAL TOPICS: ORGANIZATIONS & SOCIETIES
USA: SAN FRANCISCO PHOTOGRAPHIC ARTISTS' ASSOCIATION: 1867.

USA: PHILADELPHIA PHOTOGRAPHIC SOCIETY: 1873.
ST4215 "Photographic Society of Philadelphia." PHILADELPHIA PHOTOGRAPHER 10, no. 109-113 (Jan. - May 1873): 13-14, 48-49, 80-81, 111-112, 143.

USA: PHILADELPHIA PHOTOGRAPHIC SOCIETY: 1875.
ST4216 "Society Gossip." PHILADELPHIA PHOTOGRAPHER 12, no. 133-144 (Jan. - Dec. 1875): 12-13, 60, 78, 100, 147-148, 188, 214, 332-333, 368-369.

ST4217 "Editor's Table." PHILADELPHIA PHOTOGRAPHER 12, no. 137 (May 1875): 158. [Review of the Photographic Society of Philadelphia's exhibition of lantern views - works by [Thomas H.] McCollin & Garrett (Philadelphia, PA), John Moran, others, shown.]

ST4218 Browne, John C. "Photographic Excursion to Glen Onoko." PHILADELPHIA PHOTOGRAPHER 12, no. 139-140 (July - Aug. 1875): 216-219, 228-229. [Annual outing of the Photographic Society of Philadelphia, PA.]

USA: PHILADELPHIA PHOTOGRAPHIC SOCIETY: 1876.
ST4219 Wallace, Ellerslie, Jr., Sec. "Society Gossip." PHILADELPHIA PHOTOGRAPHER 13, no. 145-156 (Jan. - Dec. 1876): 28-29, 44-46, 89-90, 110-111, 142-143, 187-188, 211-212, 212-213, 315-317.

USA: PHILADELPHIA PHOTOGRAPHIC SOCIETY: 1877.
ST4220 Wallace, Ellerslie, Jr., Sec. & Hewitt, Geo. W. "Society Gossip: Philadelphia Photographic Society." PHILADELPHIA PHOTOGRAPHER 14, no. 157-168 (Jan. - Dec. 1877): 16-17, 47-48, 83-84, 117, 153, 180, 211-212, 248, 345, 371.

ST4221 B. C. J. [Browne, John C.] "Excursion of the Photographic Society of Philadelphia." PHILADELPHIA PHOTOGRAPHER 14, no. 164 (Aug. 1877): 229-232.

USA: PHILADELPHIA PHOTOGRAPHIC SOCIETY: 1878.
ST4222 Partridge, D. Anson, Sec. "Society Gossip." PHILADELPHIA PHOTOGRAPHER 15, no. 169-180 (Jan. - Dec. 1878): 56-57, 84-85, 120-121, 152, 180-181, 282-283, 374.

ST4223 Browne, John C. "Excursion of the Photographic Society of Philadelphia." PHILADELPHIA PHOTOGRAPHER 15, no. 175 (July 1878): 193-195.

USA: PHILADELPHIA PHOTOGRAPHIC SOCIETY: 1879.
ST4224 "Society Gossip: Photographic Society of Philadelphia." PHILADELPHIA PHOTOGRAPHER 16, no. 181-192 (Jan. - Dec. 1879): 29-30, 48, 155, 183, 221-222, 336-337.

ST4225 "Fourth Annual Excursion of the Photographic Society of Philadelphia." PHILADELPHIA PHOTOGRAPHER 16, no. 187 (July 1879): 214-216.

USA: PHOTOGRAPHERS' ASSOCIATION OF AMERICA: 1880.
ST4226 "A Call from President Ryder." PHILADELPHIA PHOTOGRAPHER 17, no. 198 (June 1880): 186-187. [Announcement of Chicago, IL, convention, first meeting of Photographers' Association of America.]

USA: PHOTOGRAPHIC ART SOCIETY OF THE PACIFIC: 1875.
ST4227 "Society Gossip." PHILADELPHIA PHOTOGRAPHER 12, no. 133-144 (Jan. - Dec. 1875): 58-60, 308-310, 367-368, 369-370.

[Meeting to form San Francisco [CA] Photo. Assoc., became known as the Photographic Art Society of the Pacific.]

ST4228 "Photographic Art Society of the Pacific." PHOTOGRAPHIC TIMES 5, no. 55 (July 1875): 163-168. [The Photographic Art Society of the Pacific organized March 5, 1875 in San Francisco, CA.]

USA: PHOTOGRAPHIC ART SOCIETY OF THE PACIFIC: 1876.
ST4229 Rieman, Geo. B., Sec. "Society Gossip." PHILADELPHIA PHOTOGRAPHER 13, no. 145-156 (Jan. - Dec. 1876): 46-47, 47-48, 112-113.

ST4230 Shew, Jacob. "Report of the Photo. Art Society of the Pacific." ANTHONY'S PHOTOGRAPHIC BULLETIN 7, no. 4 (Apr. 1876): 121-122.

USA: PHOTOGRAPHIC ART SOCIETY OF THE PACIFIC: 1877.
ST4231 Rieman, George B., Sec. "Photographic Art Society of the Pacific." ANTHONY'S PHOTOGRAPHIC BULLETIN 8, no. 9 (Sept. 1877): 259. [Meeting, in San Francisco, CA.]

USA: PHOTOGRAPHIC EXCHANGE CLUB: 1855.
ST4232 C. G. "Photographic Exchange Club." PHOTOGRAPHIC AND FINE ART JOURNAL 8, no. 7 (July 1855): 222. [Proposal to form a photographic exchange club, by five Philadelphia amateurs.]

USA: PHOTOGRAPHIC EXCHANGE CLUB: 1861.
ST4233 "The American Photographic Exchange Club." IMAGE 1, no. 2 (Feb. 1952): 4. [Club existed from 1861-1863. Participants were 23 amateurs who published an occasional journal, the Amateur Photographic Print.]

USA: PORTLAND PHOTOGRAPHIC SOCIETY: 1872.
ST4234 "Editor's Table." PHILADELPHIA PHOTOGRAPHER 9, no. 101 (May 1872): 159. [Photo society formed in Portland, ME. Pres. A. M. McKenney. Other officers, H. H. Wilder, J. H. Lamson.]

USA: SAN FRANCISCO PHOTOGRAPHIC ARTISTS' ASSOCIATION: 1866.
ST4235 "San Francisco Photographic Artists Association." PHILADELPHIA PHOTOGRAPHER 3, no. 34 (Oct. 1866): 315-316.

ST4236 Bennett, H. C., Sec. "San Francisco Photographic Artists' Association." HUMPHREY'S JOURNAL OF PHOTOGRAPHY, AND THE ALLIED ARTS AND SCIENCES 18, no. 11 (Oct. 1, 1866): 174-175. [News of formation of organization.]

USA: SAN FRANCISCO PHOTOGRAPHIC ARTISTS' ASSOCIATION: 1867.
ST4237 "Election of Photographers' Association." HUMPHREY'S JOURNAL OF PHOTOGRAPHY, AND THE ALLIED ARTS AND SCIENCES 19, no. 12 (Oct. 15, 1867): 187. [Pres.: Silas Selleck. V.P.: Daniel Wright. Treas.: J. C. Chalmers. Sec.: James E. Van Court. Trustees: William Shew, D. H. Woods, William Dickman, Scott Tidball, B. F. Howland, Jacob Shew, Thomas Houseworth, J. C. Chalmers, W. H. Towne.]

ST4238 "Editorial Table: Election by Photographers Association." PHILADELPHIA PHOTOGRAPHER 4, no. 47 (Nov. 1867): 336. [Regular annual meeting of the San Francisco [CA] Photographic Artists' Association. Elected officers. Pres. Silas Selleck, Vice Pres. Daniel Wright, Treasurer J.C.Chalmers, Sec. James E. Van Court.]

SPECIAL TOPICS: ORGANIZATIONS & SOCIETIES
USA: ST. LOUIS PHOTOGRAPHIC SOCIETY: 1869.

SPECIAL TOPICS: ORGANIZATIONS & SOCIETIES
USA: WESTERN ILLINOIS PHOTOGRAPHIC ASSOCIATION: 1873.

USA: ST. LOUIS PHOTOGRAPHIC SOCIETY: 1869.
ST4239 "Editor's Table." PHILADELPHIA PHOTOGRAPHER 6, no. 66 (June 1869): 203. [Note that St. Louis [MO] Photographic Society has been organized. Pres.: A. J. Fox, Sec.: Robert Benecke.]

USA: WEST VIRGINIA PHOTOGRAPHIC ASSOCIATION: 1869.
ST4240 "West Virginia Photographic Association." PHILADELPHIA PHOTOGRAPHER 6, no. 67 (July 1869): 250-251. [Lists members. Pres.: A. C. Partridge (Wheeling, WV)]

USA: WESTERN ILLINOIS PHOTOGRAPHIC ASSOCIATION: 1873.
ST4241 "Photographic Association of Western Illinois." PHILADELPHIA PHOTOGRAPHER 10, no. 110, 113 (Feb., May 1873): 48, 143.

SPECIAL TOPICS: PHOTOJOURNALISM & MAGAZINES
MAGAZINES: GENERAL, BY COUNTRY, AND BY YEAR.

SPECIAL TOPICS: PHOTOJOURNALISM & MAGAZINES
MAGAZINES: USA: 19TH C.

BY APPLICATION: PHOTOJOURNALISM AND MAGAZINES

See also HISTORY: PHOTOMECHANICAL REPRODUCTION.

MAGAZINES: GENERAL, BY COUNTRY, AND BY YEAR.

ST4243 "Which is the Oldest!" HUMPHREY'S JOURNAL OF PHOTOGRAPHY, AND THE ALLIED ARTS AND SCIENCES 12, no. 23 (Apr. 1, 1861): 365-366. [A listing of the photographic periodicals given, with the dates they began. "Altogether there have appeared fifteen Journals of Photography and more than two hundred books...We now append a list of the journals, from Paul Liesegang's communication to the 'Notes.'...The above comprises a complete list of all the Photographic Journals ever established in the world according to Mr. Liesegang. We might add the names of one or two more, but they are merely advertising sheets, and are of no account in the Photographic World." (The last is a deliberate insult to the "American Journal of Photography," edited by Charles Seely, which is not listed here. The listing is otherwise also very inaccurate with its dates, etc.)]

ST4244 "Photographic Literature - The American Journal the Oldest Photographic Periodical." AMERICAN JOURNAL OF PHOTOGRAPHY AND THE ALLIED ARTS & SCIENCES n. s. vol. 3, no. 22 (Apr. 15, 1861): 342-343. [Claims to be the oldest photo journal still publishing, (by virtue of acquiring title to the "P & FAJ.") Article, gives a biased and inaccurate history of early American journal publications and a list of "all the Journals of Photography which have come to our knowledge." 19 titles listed.]

ST4245 Roskill, Mark. "New Horizons: The Early Life and Times of Photojournalism." VIEWS: THE JOURNAL OF PHOTOGRAPHY IN NEW ENGLAND 8, no. 2 (Winter 1987): 6-11. [Discusses illustrated journals (the "Illustrated London News," "Illustrated American," "Harper's Monthly," and others) in the early 1880's-1890's. Some reference to earlier illustrated press from the 1840's on.]

ST4246 Johnson, William S. "Back to the Future: Some Notes on Photojournalism Before the 1870s." VIEWS: THE JOURNAL OF PHOTOGRAPHY IN NEW ENGLAND 9, no. 2 (Winter 1988): 8-12. 8 illus. [Discusses the evolution of the use and impacts of photography on the illustrated magazines before the 1870s. Mentions the "Illus. London News," "Gleason's Pictorial," and others. Discusses the work of Alexander Gardner and his associates, as it was used by "Harper's Weekly" during the course of the American Civil War.]

MAGAZINES: 1866.

ST4247 "Defunct Photographic Journals." HUMPHREY'S JOURNAL OF PHOTOGRAPHY, AND THE ALLIED ARTS AND SCIENCES 18, no. 5 (July 1, 1866): 73. ["Within the past year the two Spanish photographic journals "El Eco" and "E Propagador," also two German monthly publications on photography, "Horn's Journal" and Bollman's Monatschaft," and one French photographic journal, the "Revue Photographique," have given up the ghost..."]

MAGAZINES: 1871.

ST4248 "Table Talk - the Influence of Photographic Journals." PHOTOGRAPHIC WORLD 1, no. 2 (Feb. 1871): 62.

MAGAZINES: CANADA: 19TH C.

ST4249 Schwartz, Joan M. and Jim Burant. *Aperu. The Archive looks... Behind the Lines. Art, Photography and the Pictorial Press.* Ottawa: Public Archives of Canada. Documentary Art and Photography Division., 1988. 1 folded sheet, making 6 pp. 2 b & w.

3 illus. [Exhibition handout. Public Archives of Canada, Ottawa, Nov. 7, 1988 - Feb. 3, 1989. Exhibition displaying woodcuts drawn from photographs which were published in the "Illustrated London News," "Canadian Illustrated News," "l'Opinion publique," etc. along with the original photographs which were their source. Brief essay in English and French.]

MAGAZINES: GREAT BRITAIN: 19TH C.

ST4250 Williamson, C. N. "Illustrated Journalism in England: Its Development." MAGAZINE OF ART 13, (1890): 297-301, 334-340, 391-396. 17 illus. [History of "Illustrated London News," "Graphic," "Pen and Pencil," "Pictorial Times," and others.]

MAGAZINES: GREAT BRITAIN: 1874.

ST4251 "Photography by Special Correspondents." ANTHONY'S PHOTOGRAPHIC BULLETIN 5, no. 7 (July 1874): 248. [From "London Photo. News." Prediction that soon correspondents for illustrated newspapers would carry "a reconnoiteur camera, with instantaneous dry plates."]

MAGAZINES: GREAT BRITAIN: 1877.

ST4252 Wall, A. H. "A Few of the Less Known Good Deeds of Photography." PHOTOGRAPHIC TIMES 7, no. 74 (Feb. 1877): 28-30. [Article is about the impact photography is having upon artists for the illustrated journals. Discusses "Graphic," "Illustrated London News," "Illustrated Sporting and Dramatic News." From "Br. J. of Photo."]

MAGAZINES: GREAT BRITAIN: 1879.

ST4253 "A New Application of Photography in Journalism." ANTHONY'S PHOTOGRAPHIC BULLETIN 10, no. 8 (Aug. 1879): 233. [From "London Photographic News." Youth publication "Prize Paper" ran a contest for best sketches, which are then photographed for reproduction.]

ST4254 "Newspaper Illustrations by Photography." ANTHONY'S PHOTOGRAPHIC BULLETIN 10, no. 11 (Nov. 1879): 332. [From "London Photographic News." "A new journal called "Life" is producing some fine photographic reproductions of paintings by a process termed phototypie...."]

PHOTOJOURNALISM: USA see also AUSTIN, W. B.; RUSSELL, ANDREW J.

MAGAZINES: USA: 19TH C.

ST4255 Horgan, Stephen H. "The Development of Illustration." WILSON'S PHOTOGRAPHIC MAGAZINE 37, no. 521 (May 1900): 231-232. [Excerpted from an illustrated review of the "Big Six's Printing Exposition, in the "N. Y. Tribune" by Stephen H. Horgan; head of the "Tribune" Art Department and himself among the pioneers of process work for illustrating newspapers. Survey of US magazines and newspapers from 1850's to the present (i.e. 1900).]

ST4256 Jones, Vincent S. "From Negative to Positive." IMAGE 2, no. 6 (Sept. 1953): 38-39. 1 b & w. 1 illus. [Brief commentary on newspapers' use of photography. Illustrations are a woodblock engraving of a photo by A. Gardner, published in "Harper's Weekly" in Apr. 8, 1865.]

ST4257 Hanson, David A. "The Beginnings of Photographic Reproduction in the USA." HISTORY OF PHOTOGRAPHY 12, no. 4 (Oct. - Dec. 1988): 357-376. 18 illus. [Discusses the reproduction of photographs in illustrated magazines and books from 1842 on. "The United States Magazine and Democratic Review" (1842); Mathew Brady's "The Rationale of Crime,..."; the "Plumbotype National

SPECIAL TOPICS: PHOTOJOURNALISM & MAGAZINES
MAGAZINES: USA: 1855.

SPECIAL TOPICS: PHOTOJOURNALISM & MAGAZINES
MAGAZINES: AMERICAN JOURNAL OF PHOTOGRAPHY: 1867.

Gallery"; Stephen's work in "Incidents of Travel in Yucatan; and others.]

MAGAZINES: USA: 1855.
ST4258 "Illustrated Literature." BALLOU'S PICTORIAL DRAWING-ROOM COMPANION [GLEASON'S] 8, no. 19 (May 12, 1855): 297. [From the "Boston Courier." Brief history of the recent growth of illustrated publishing, with strong praise for "Ballou's Pictorial."]

MAGAZINES: USA: 1856.
ST4259 "How Illustrated Newspapers Are Made." FRANK LESLIE'S ILLUSTRATED NEWSPAPER 2, no. 34 (Aug. 2, 1856): 124-125. 19 illus.

MAGAZINE: BY TITLE.

MAGAZINES: ALL THE YEAR ROUND: 1862.
ST4260 "Photography and Periodical Literature." BRITISH JOURNAL OF PHOTOGRAPHY 9, no. 167 (June 2, 1862): 203-204. [Editorial commentary on errors in an article titled "The Carte-de-Visite" in the Apr. 26, 1862 issue of "All the Year Round."]

MAGAZINES: AMERICAN JOURNAL OF PHOTOGRAPHY: 1860.
ST4261 "Extensive Scissoring." HUMPHREY'S JOURNAL OF PHOTOGRAPHY, AND THE ALLIED ARTS AND SCIENCES 11, no. 17 (Jan. 1, 1860): 262. [Repeats statement in the "Liverpool Photo. J." that twelve of the sixteen pages of a recent issue of the "Am. J. of Photo." were lifted from his journal without credit.]

ST4262 "Important Announcement. Perils of Photographic Publishing. - The Opening of a Volcano. - An Oasis in the Desert. - The acknowledged Organ of Operators." HUMPHREY'S JOURNAL OF PHOTOGRAPHY, AND THE ALLIED ARTS AND SCIENCES 12, no. 16 (Dec. 15, 1860): 241-243. [Sarcastic attack on the merging of the "P & FAJ" with the Am. J. of Photo." Critical of Snelling, the former editor of "P & FAJ" and of Seely, ed. of "AJP." Then self-praise for "HJ."]

MAGAZINES: AMERICAN JOURNAL OF PHOTOGRAPHY: 1862.
ST4263 "Editorial Department." AMERICAN JOURNAL OF PHOTOGRAPHY AND THE ALLIED ARTS & SCIENCES n. s. vol. 5, no. 1 (July 1, 1862): 22. [Decision to shift volumes to run from June 1 to July 1.]

MAGAZINES: AMERICAN JOURNAL OF PHOTOGRAPHY: 1864.
ST4264 Seely, Charles A. "Editorial Department." AMERICAN JOURNAL OF PHOTOGRAPHY AND THE ALLIED ARTS & SCIENCES n. s. vol. 6, no. 24 (June 15, 1864): 575-576. [End of volume causes the editor to survey the events of the past few years. "At the beginning of the rebellion we lost nearly half our subscribers. The value of our dollar for most purposes has depreciated to one-half. Yet under these very unfavorable circumstances, we have uniformly prospered,..." Double circulation of all other photo periodicals, etc. but planning to do better.]

ST4265 Seely, Charles A. "Editorial Department." AMERICAN JOURNAL OF PHOTOGRAPHY AND THE ALLIED ARTS & SCIENCES n. s. vol. 7, no. 11 (Dec. 1, 1864): 263. [Announcement that, due to costs from the war, the subscription price would have to be raised to $3.00 per year.]

MAGAZINES: AMERICAN JOURNAL OF PHOTOGRAPHY: 1865.
ST4266 Seely, Charles A. "Editorial Department." AMERICAN JOURNAL OF PHOTOGRAPHY AND THE ALLIED ARTS & SCIENCES n. s. vol. 7, no. 21 (May 1, 1865): 505. ["By reason of the death of the President, and the collapse of the rebellion ordinary business has been much interrupted during the past few weeks. Gentlemen in the country who have found their orders to city merchants delayed, will please bear the fact in mind, and growl as gently as possible. In addition to the general interruption, we have had in our own case the care of the removal of our business. We have found it impossible to attend to correspondents as promptly as usual."]

ST4267 Seely, Charles A. "Editorial Department." AMERICAN JOURNAL OF PHOTOGRAPHY AND THE ALLIED ARTS & SCIENCES n. s. vol. 7, no. 24 (June 15, 1865): 572. [Note that Seely retiring from the business of manufacturing and selling photographic materials. Selling to T. L. Olden and Dr. A. B. C. Sawyer.]

ST4268 Seely, Charles A. "Editorial Department." AMERICAN JOURNAL OF PHOTOGRAPHY AND THE ALLIED ARTS & SCIENCES n. s. vol. 8, no. 12 (Dec. 15, 1865): 287-288. [More comments on the attacks from "Humphrey's Journal" (see previous issue) and from Mr. H. M. Johnston (a process seller, whose work Seely had published for free). Plea for more support through subscriptions, etc.]

MAGAZINES: AMERICAN JOURNAL OF PHOTOGRAPHY: 1866.
ST4269 "The American Journal of Photography." HUMPHREY'S JOURNAL OF PHOTOGRAPHY, AND THE ALLIED ARTS AND SCIENCES 18, no. 8 (Aug. 15, 1866): 124. ["We have letters from subscribers...who say that there has been no numbers issued since April 1, 1866,...we consider it a foregone conclusion that the journal aforesaid is among the things that were...."]

ST4270 Seely, Charles A. "Editorial Department." AMERICAN JOURNAL OF PHOTOGRAPHY AND THE ALLIED ARTS & SCIENCES n. s. vol. 9, no. 1 (Sept. 1, 1866): 23-24. ["Four months since, on the 1st of May, we found it advisable to change the location of our office,...Our new address is No. 26 Pine Street....it was concluded to give the Journal a short vacation...has reached four months...suspended during May, June, July and August. The present issue commences vol. 9 and nos. 20 to 24 in vol. 8 are not yet published....Oscar G. Mason will superintend the department of advertising..."]

ST4271 "Editorial Department." AMERICAN JOURNAL OF PHOTOGRAPHY, AND THE ALLIED ARTS AND SCIENCES n. s. vol. 9, no. 3 (Oct. 1, 1866): 71-72. [Promotion for the Am. Photo. Soc. Defense against announcements of the Journal's decease in both "Humphrey's Journal" and in the "Br. J. of Photo."]

MAGAZINES: AMERICAN JOURNAL OF PHOTOGRAPHY: 1867.
ST4272 Maltbie, S. W. "Important to Every Photographer." AMERICAN JOURNAL OF PHOTOGRAPHY, AND THE ALLIED ARTS AND SCIENCES n. s. vol. 9, no. 11 (May. 15, 1867): n.p. [1 p.]. [Announcement that Maltbie has purchased the magazine, intends to make it better.]

ST4273 "The American Journal of Photography." HUMPHREY'S JOURNAL OF PHOTOGRAPHY, AND THE ALLIED ARTS AND SCIENCES 19, no. 11 (Oct. 1, 1867): 169. ["In August, 1866, we chronicled the death of the above Journal....about last May, we think,

SPECIAL TOPICS: PHOTOJOURNALISM & MAGAZINES
MAGAZINES: ANTHONY'S PHOTOGRAPHIC BULLETIN: 1870.

SPECIAL TOPICS: PHOTOJOURNALISM & MAGAZINES
MAGAZINES: DAGUERREAN JOURNAL: 1850.

a Mr. S. W. Maltbie commenced the publication of an 'American Journal of Photography,' he published a few numbers and then took in a Mr. Storrs as partner, and Maltbie & Storrs continued the publication until September 1, when the last number was issued."]

ST4274 "The American Journal of Photography." HUMPHREY'S JOURNAL OF PHOTOGRAPHY, AND THE ALLIED ARTS AND SCIENCES 19, no. 15 (Dec. 1, 1867): 235. ["H.J." took over the subscription of the defunct "Am. J. of Photo." Announcement, with a note from S. W. Maltbie (the last publisher) to that effect.]

MAGAZINES: ANTHONY'S PHOTOGRAPHIC BULLETIN: 1870.
ST4275 "Prospectus." ANTHONY'S PHOTOGRAPHIC BULLETIN 1, no. 1 (Feb. 1870): 1-2.

MAGAZINES: ANTHONY'S PHOTOGRAPHIC BULLETIN: 1879.
ST4276 Editor. "Slow and Sure." ANTHONY'S PHOTOGRAPHIC BULLETIN 10, no. 10 (Oct. 1879): 311. [Taylor apparently criticized the practice of N. Y. Photographic Society, and how the reports of their meetings were recorded in the "APB." This is a reply defending its practices.]

MAGAZINES: ART JOURNAL: 19TH C.
ST4277 Wilsher, Ann. "Hall of Fame." HISTORY OF PHOTOGRAPHY 3, no. 2 (Apr. 1979): 133-134. 2 illus. [About Samuel Carter Hall, founder of the periodical, "Art Union" (later called "Art Journal"), and the magazine's involvement with photography.]

MAGAZINES: BALLOU'S PICTORIAL: 1857.
ST4278 "Ballou's Publishing House," BALLOU'S PICTORIAL DRAWING-ROOM COMPANION [GLEASON'S] 12, no. 305 (Apr. 25, 1857): 263. [Description of Ballou's Publishing House: "Ballou's Pictorial," "The Flag of Our Union," "The Dollar Monthly"; size of circulations, staffs, with seven designers, thirty-eight engravers, $400 - $500 per week on engravings; twelve Adams presses constantly working.]

MAGAZINES: BALLOU'S PICTORIAL: 1859.
ST4279 "Our Illustrated Journal." BALLOU'S PICTORIAL DRAWING-ROOM COMPANION [GLEASON'S] 16, no. 393 (Jan. 1, 1859): 10. ["...we commence the sixteenth volume with a new heading and a new and improved style...larger amount of reading matter...printing the paper one week nearer its date...more attention to current matters of interest...more engravings each week,..." 12 engravings per issue, 1 full-page. Artists: Hill, Waud, Homer, Kilburn.]

MAGAZINES: BRITISH JOURNAL OF PHOTOGRAPHY: 19TH C.
ST4280 Bedding, Thomas. "The Story of the 'British Journal of Photography' and 'The Almanac." BRITISH JOURNAL PHOTOGRAPHIC ALMANAC 1904 (1905): 661-692. 11 b & w. [Includes portraits and biographies of the editors. Begins with the "Liverpool Journal" in 1853.]

MAGAZINES: BRITISH JOURNAL OF PHOTOGRAPHY: 1862.
ST4281 "A 'Note' on Literary 'Annexation.'" BRITISH JOURNAL OF PHOTOGRAPHY 9, no. 170-171 (July 15 - Aug. 1, 1862): 264-265, 283-284. [Editor complaining about both American and British periodicals copying, without credit, from the "BJP". This phenomena was so consistently practiced in American journals that it was sarcastically called "the American style" in England. A "Postscript" followed in the next issue.]

MAGAZINES: BRITISH JOURNAL OF PHOTOGRAPHY: 1863.
ST4282 "To Our Readers." and "Publisher's Notice." BRITISH JOURNAL OF PHOTOGRAPHY 10, no. 204 (Dec. 15, 1863): 479-480. [Announcement of going to weekly format, some history of the magazine.]

MAGAZINES: BRITISH JOURNAL OF PHOTOGRAPHY: 1864.
ST4283 Shadbolt, George. "Valedictory and Introductory." and "Salutatory." BRITISH JOURNAL OF PHOTOGRAPHY 11, no. 216-217 (June 15 - July 1, 1864): 199-200, 217-218. [George Shadbolt retires as editor at "BJP." Replaced by George Dawson, Edwin Emerson and J. T. Taylor. "BJP" moves to London, becomes a weekly.]

ST4284 "British Journal of Photography." HUMPHREY'S JOURNAL OF PHOTOGRAPHY, AND THE ALLIED ARTS AND SCIENCES 16, no. 6 (July 15, 1864): 89. [Note that current editor (unnamed) retiring. "Journal will now be published weekly with a corps or trio of editors...(including) Prof. E. Emerson, M.A., late of Troy University, NY."]

MAGAZINES: BRUXELLES-THEATRE: 1874.
ST4285 Joseph, Steven F. and Tristan Schwilden. "A Dramatic Duo." HISTORY OF PHOTOGRAPHY 11, no. 4 (Oct. - Dec. 1987): 325-327. 2 illus. ["Paris-Theatre," began publication in Paris on May 22, 1873. It was a weekly, containing a tipped-in woodburytype portrait of actors or actresses. The Lemercier firm in Paris supplied the prints. The magazine ran for seven years, with a later title of "Paris Portrait." "Bruxelles-Theatre," began publication in Jan. 11, 1874. It lasted for seventeen issues, then was revived in September, then lasted, with problems and changing issuance, etc, for another three years. "Bruxelles-Theatre" published negatives by H. De Saedeler, the Ghemar Brothers, A. Delabarre, and W. Damry.]

MAGAZINES: CALIFORNIA MAIL BAG: 1872.
ST4286 The general contents lists "Photographs - Mayor Alvord: The Hon. Board of the City Hall Commissioners,..." CALIFORNIA MAIL BAG 1, no. 6 (Jan. - Feb. 1872): frontispiece? ? b & w. [This copy doesn't have photos bound in - but the previous issue had an original photo bound in - so there may have been photos issued with the magazine originally. There are articles relating to the subjects listed in the contents statements, as was the practice of other issues.]

MAGAZINES: CANADIAN JOURNAL OF PHOTOGRAPHY: 1864.
ST4287 "The Canadian Journal of Photography." HUMPHREY'S JOURNAL OF PHOTOGRAPHY, AND THE ALLIED ARTS AND SCIENCES 16, no. 7 (Aug. 1, 1864): 112. ["The second number of the 'Canadian Journal of Photography' has just reached our Sanctum..."]

MAGAZINES: DAGUERREAN JOURNAL: 19TH C.
ST4288 Canfield, C. W. "American Bibliography of Photography. Class A. - Photographic Journals. 1st Article." PHOTOGRAPHIC TIMES 17, no. 327 (Dec. 23, 1887): 648-649. [Annotated descriptive survey of first American periodicals. Discusses the "Daguerrean Journal."]

MAGAZINES: DAGUERREAN JOURNAL: 1850.
ST4289 "Letter from an Old Artist." DAGUERREAN JOURNAL 1, no. 2 (Nov. 15, 1850): 44-45. [Signed "An Operator since 1840," the letter states the necessity for the journal.]

SPECIAL TOPICS: PHOTOJOURNALISM & MAGAZINES
MAGAZINES: DAGUERREAN JOURNAL: 1851.

SPECIAL TOPICS: PHOTOJOURNALISM & MAGAZINES
MAGAZINES: FRANK LESLIE'S ILLUSTRATED NEWSPAPER: 1864.

ST4290 "Letters From Our Friends." DAGUERREAN JOURNAL 1, no. 2 (Nov. 15, 1850): 52-53. [Scoville Mfg. Co.; L. Chapman; John Roach, optician; N. G. Burgess; Meade Brothers.]

ST4291 "To the Public." DAGUERREAN JOURNAL 1, no. 1 (Nov. 1, 1850): 15-16. [Statement of the magazine's intent.]

ST4292 "Note." DAGUERREAN JOURNAL 1, no. 3 (Dec. 2, 1850): 77-78. [Review of the "Daguerrean Journal," reprinted from the "Stamford [CT] Advocate."]

MAGAZINES: DAGUERREAN JOURNAL: 1851.
ST4293 Humphrey, S. D. "Editorial: Daguerreotype Repository." DAGUERREAN JOURNAL 1, no. 5 (Jan. 15, 1851): 145. [Statement of editor about his intent to publish or republish historical information.]

ST4294 Humphrey, S. D. "Editorial: Close of Volume I." DAGUERREAN JOURNAL 1, no. 12 (May 1, 1851): 369-370.

ST4295 "Editorship of the Daguerrean Journal." DAGUERREAN JOURNAL 2, no. 11 (Oct. 15, 1851): 339-340. [Announcement that Levi L. Hill has dropped his participation as co-editor of the "Daguerrean Journal," which had been minimal anyway. Includes a letter from Hill as well.]

MAGAZINES: EL ECO DE LA FOTOGRAFIA: 1864.
ST4296 "El Eco de la Fotografia." HUMPHREY'S JOURNAL OF PHOTOGRAPHY, AND THE ALLIED ARTS AND SCIENCES 15, no. 21 (Mar. 1, 1864): 326. [Announcement of new publication, from Cadiz.]

MAGAZINES: EL PROPAGADOR DE LA FOTOGRAFIA: 1864.
ST4297 "El Propagador de la Fotografia." HUMPHREY'S JOURNAL OF PHOTOGRAPHY, AND THE ALLIED ARTS AND SCIENCES 15, no. 17 (Jan. 1, 1864): 267. [Announcement of new Spanish journal. 12 pp., twice a month.]

MAGAZINES: FRANK LESLIE'S ILLUSTRATED NEWSPAPER: 19TH C.
ST4298 Gambee, Budd Leslie, Jr. Frank Leslie's Illustrated Newspaper, 1855 - 1860: Artistic and Technical Operations of a Pioneer Pictorial News Weekly in America. Ann Arbor, MI: University Microfilms International, 1980. x, 437 l. illus.

MAGAZINES: FRANK LESLIE'S ILLUSTRATED NEWSPAPER: 1855.
ST4299 "Pictorial Newspapers in America. The Failure of Our Predecessors and Our Own Prospects." FRANK LESLIE'S ILLUSTRATED NEWSPAPER 1, no. 1 (Dec. 15, 1855): 6.

MAGAZINES: FRANK LESLIE'S ILLUSTRATED NEWSPAPER: 1857.
ST4300 "Our Fourth Volume." FRANK LESLIE'S ILLUSTRATED NEWSPAPER 3, no. 77 (May 30, 1857): 405. ["Our example has created a host of imitators, and made illustrations almost as essential for newspapers as are types. Under our sway the arts in New York have received an impulse, that has put its professors upon the firm footing of supplying a real and never varying demand, and art knowledge and artistic ability are now as readily purchased as are the gross necessities of life."]

MAGAZINES: FRANK LESLIE'S ILLUSTRATED NEWSPAPER: 1857.
ST4301 "Engravers and Illustrated Papers." FRANK LESLIE'S ILLUSTRATED NEWSPAPER 4, no. 99 (Oct. 24, 1857): 321. [Editorial comment about financial slump affecting the wood engraving industry, and consequently, the number of original engravings appearing in the illustrated papers.]

MAGAZINES: FRANK LESLIE'S ILLUSTRATED NEWSPAPER: 1859.
ST4302 "Missing People and Defaulters." FRANK LESLIE'S ILLUSTRATED NEWSPAPER 7, no. 179 (May 7, 1859): 351. 1 illus. [In 1859 the "FLIN" began to run portraits of missing people, frequently taken from photographs, as a public service and as a circulation booster. This article, a portrait and description of a James R. Irving, is typical of the series, which continued sporadically at least into 1862. "FLIN" would also often print letters of praise from officials or reports of the success of this practice.]

MAGAZINES: FRANK LESLIE'S ILLUSTRATED NEWSPAPER: 1860.
ST4303 "Notice to Photographers." FRANK LESLIE'S ILLUSTRATED NEWSPAPER 10, no. 249 (Sept. 1, 1860): 224. ["We shall be much obliged to our photographic friends if they will write in pencil the name and description on the back of each picture, together with their own name and address. This notice is rendered necessary from the fact that so many photographs are sent to us from our friends throughout the country without one word of explanatory matter, they are giving us credit being in rapport with everything that transpires or exists in all parts of the United States. The columns of our paper prove that we are up with the times in almost everything which occurs of public importance throughout the world, still we are not so ubiquitous but that something may occur beyond the circuit of our far-reaching information. To save labor and insure accuracy, descriptions and names (as above indicated) should, in all cases, accompany photographic pictures or sketches." This notice was published periodically throughout the year.]

ST4304 Willis, N. P. "Frank Leslie. A Life-Lengthener. (From the "Home Journal.")" FRANK LESLIE'S ILLUSTRATED NEWSPAPER 11, no. 264 (Dec. 15, 1860): 53. 1 illus. [Praise for Leslie's publishing enterprises. View of the Frank Leslie's publication office building.]

MAGAZINES: FRANK LESLIE'S ILLUSTRATED NEWSPAPER: 1861.
ST4305 Leslie, Frank. "The Publisher of Frank Leslie's Newspaper to the Public." FRANK LESLIE'S ILLUSTRATED NEWSPAPER 12, no. 305 (Sept. 21, 1861): 289. [Announcement that E. G. Squire taking over the editorship of the paper. Leslie states that the illustrations "...would continue to receive his (Leslie's) constant and active attention."]

MAGAZINES: FRANK LESLIE'S ILLUSTRATED NEWSPAPER: 1864.
ST4306 "Frank Leslie's Artist's in the War." FRANK LESLIE'S ILLUSTRATED NEWSPAPER 18, no. 451 (May 21, 1864): 130. [Editorial defending the magazine against the charge of the NY Historical Society that "...the illustrated newspapers are full of sketches purporting to be pictures of important scenes, but the testimony of parties engaged shows that these representations, when they are not taken from photographs, are not always reliable."]

SPECIAL TOPICS: PHOTOJOURNALISM & MAGAZINES
MAGAZINES: FRANK LESLIE'S ILLUSTRATED NEWSPAPER: 1866.

SPECIAL TOPICS: PHOTOJOURNALISM & MAGAZINES
MAGAZINES: HUMPHREY'S JOURNAL: 1859.

MAGAZINES: FRANK LESLIE'S ILLUSTRATED NEWSPAPER: 1866.

ST4307 "Photographing on Wood." PHILADELPHIA PHOTOGRAPHER 3, no. 31 (July 1866): 215-216. [Describes the impact that photographing on wood for subsequent engraving has had on illustrated newspapers. Frank Leslie opened a department under the management under the direction of J. Wright. E. George Squire is Mr. Leslie's editor-in-chief. An image from the "Illus. London News" was photographed, reduced to the needed size, and recut in seven hours - a considerable savings in time.]

MAGAZINES: FRANK LESLIE'S ILLUSTRATED NEWSPAPER: 1869.

ST4308 "Illustrated Newspapers in Connection with Popular Education." FRANK LESLIE'S ILLUSTRATED NEWSPAPER 29, no. 738 (Nov. 20, 1869): 154.

MAGAZINES: FRANK LESLIE'S ILLUSTRATED NEWSPAPER: 1871.

ST4309 "Frank Leslie's Illustrated Newspaper." FRANK LESLIE'S ILLUSTRATED NEWSPAPER 32, no. 821 (June 24, 1871): 234. [Self-promotion. "Its immense array of artists and its system of ambulant photographers, added to the activity and prescience of its management, partly explain this evident superiority... No other establishment anywhere is able, from its own resources alone, to prepare pictures combining artistic beauty with photographic minuteness, such as are constantly given in this paper."]

ST4310 "Frank Leslie's Illustrated Newspaper." FRANK LESLIE'S ILLUSTRATED NEWSPAPER 33, no. 842 (Nov. 18, 1871): 146. ["It is the only paper in the world possessing a complete photographic establishment of its own, employing a number of the most skillful operators, and having facilities for photographing scenes in any part of the country." ("Leslie's" does demonstrate a clear growth in the amount and sophistication of its use of photography since the end of the Civil War, and this usage is indeed peaking in 1871. Unfortunately for the present-day scholar, the magazine was also beginning to be lax about assigning picture credits, with an increasing number of non-credited references which seem to be from photos.)]

MAGAZINES: FRANK LESLIE'S ILLUSTRATED NEWSPAPER: 1872.

ST4311 "Editor's Table: Unjust Proceeding On the Part of Publishers of Illustrated Newspapers." PHILADELPHIA PHOTOGRAPHER 9, no. 100 (Apr. 1872): 128. [Brief editorial comment, protesting "Frank Leslie's Illustrated Newspaper's" practice of copying from photographs without giving credit to the photographer. Cites several recent examples.]

MAGAZINES: FRANK LESLIE'S ILLUSTRATED NEWSPAPER: 1873.

ST4312 "Illustrated Journalism." FRANK LESLIE'S ILLUSTRATED NEWSPAPER 36, no. 923 (June 7, 1873): 198. [Editorial statement, claiming that accurate reporting, aided by accurate illustrations, was absolutely essential to the success of a current journal. "'Pen-Pictures' and 'word-painting' are comparatively insignificant beside camera-pictures and scene-painting..."]

MAGAZINES: FRANK LESLIE'S ILLUSTRATED NEWSPAPER: 1878.

ST4313 "A Printing House Afloat." FRANK LESLIE'S ILLUSTRATED NEWSPAPER 46, no. 1196 (Aug. 31, 1878): 433, 439. 6 illus. [Annual excursion and picnic of Frank Leslie's publishing house employees is described. A. J. Russell is listed as being a member of the organizing committee of this event.]

MAGAZINES: GLEASON'S PICTORIAL: 1867.

ST4314 "Frederick Gleason." FRANK LESLIE'S ILLUSTRATED NEWSPAPER 25, no. 625 (Sept. 21, 1867): 5, 6. 1 illus. [Portrait, brief biography of Frederick Gleason, publisher of "Gleason's Pictorial" and other magazines.]

MAGAZINES: HARPER'S WEEKLY: 1869.

ST4315 "Hon. James Harper, late Senior Member of Harper Brothers." FRANK LESLIE'S ILLUSTRATED NEWSPAPER 28, no. 707 (Apr. 17, 1869): 65, 67. 1 illus. [Obituary. Portrait by Rockwood.]

MAGAZINES: HARPER'S WEEKLY: 1875.

ST4316 "The Late John Harper." FRANK LESLIE'S ILLUSTRATED NEWSPAPER 40, no. 1024 (May 15, 1875): 161. 1 illus. [Brief obituary, praise, and biography of Harper, includes a brief description of the early history of Harper publishers.]

MAGAZINES: HARPER'S WEEKLY: 1877.

ST4317 "The Late Fletcher Harper." FRANK LESLIE'S ILLUSTRATED NEWSPAPER 44, no. 1133 (June 16, 1877): 249. 1 illus. [Obituary for Fletcher Harper, publisher-editor of "Harper's Weekly" and other magazines. Brief biography, portrait. (Not credited.)]

MAGAZINES: HUMPHREY'S JOURNAL: 19TH C.

ST4318 Canfield, C. W. "American Bibliography of Photography. 3rd Article." PHOTOGRAPHIC TIMES 18, no. 338 (Mar. 9, 1888): 112. ["Humphrey's Journal of Photography and the Allied Arts," vol. 4 (1852) - vol. 10 (Apr. 1859). Survey of the editorship and format. No discussion of the actual articles in the magazine.]

MAGAZINES: HUMPHREY'S JOURNAL: 1852.

ST4319 "Humphrey's Journal." HUMPHREY'S JOURNAL 4, no. 1 (Apr. 15, 1852): 9-10. [The editor, Humphrey, explains that he had sold his earlier publication, the "Daguerrean Journal" in 1851, on the basis that the new owners would continue to publish the journal. They failed to do so and Humphrey decided to start again, this time giving the publication his own name. Thus the first issue of "HJ" was numbered volume four, number one.]

ST4320 Humphrey, S. D. "Editorial: Humphrey's Journal - Close of Volume IV." HUMPHREY'S JOURNAL 4, no. 24 (Apr. 1, 1853): 377-378.

MAGAZINES: HUMPHREY'S JOURNAL: 1855.

ST4321 Humphrey, S. D. "Editorial: Address to Subscribers on Ending Our 6th Volume." HUMPHREY'S JOURNAL 6, no. 24 (Apr. 1, 1855): 381-383.

MAGAZINES: HUMPHREY'S JOURNAL: 1859.

ST4322 "Change of Proprietorship." HUMPHREY'S JOURNAL OF PHOTOGRAPHY, AND THE ALLIED ARTS AND SCIENCES 10, no. 23 (Apr. 1, 1859): 353. [Announcement that Joseph H. Ladd has purchased "Humphrey's Journal" from S. D. Humphrey and would take over the editorship.]

ST4323 "A Cosmopolite." "The Photographic Society." AMERICAN JOURNAL OF PHOTOGRAPHY AND THE ALLIED ARTS AND SCIENCES n. s. vol. 2, no. 12 (Nov. 15, 1859): 188-189. [Actually an attack, couched in the form of a letter, on the rival "Humphrey's Journal".]

SPECIAL TOPICS: PHOTOJOURNALISM & MAGAZINES
MAGAZINES: HUMPHREY'S JOURNAL: 1860.

SPECIAL TOPICS: PHOTOJOURNALISM & MAGAZINES
MAGAZINES: LA ANDALUCIA MEDICA: 19TH C.

ST4324 "Humphrey's Journal." AMERICAN JOURNAL OF PHOTOGRAPHY AND THE ALLIED ARTS AND SCIENCES n. s. vol. 2, no. 13 (Dec. 1, 1859): 193-197. [Attack on "Humphrey's Journal."]

ST4325 Vanderweyde, John J. "Humphrey's Journal." AMERICAN JOURNAL OF PHOTOGRAPHY AND THE ALLIED ARTS AND SCIENCES n. s. vol. 2, no. 14 (Dec. 15, 1859): 222-224. [Further letters on this topic, by John J. Van der Weyde.]

MAGAZINES: HUMPHREY'S JOURNAL: 1860.
ST4326 "Specimens of Correspondence." AMERICAN JOURNAL OF PHOTOGRAPHY AND THE ALLIED ARTS & SCIENCES n. s. vol. 2, no. 17 (Feb. 1, 1860): 264-266. [Letters attacking "Humphrey's Journal."]

ST4327 "Who Owns Humphrey's Journal." HUMPHREY'S JOURNAL OF PHOTOGRAPHY, AND THE ALLIED ARTS AND SCIENCES 12, no. 5 (July 1, 1860): 67-68. ["Mr. Humphrey has nothing whatever to do with this Journal - does not write for it, and has never written for it since the present proprietor bought out his entire interest nearly two years ago,...since February 1, 1859."]

MAGAZINES: HUMPHREY'S JOURNAL: 1862.
ST4328 Ladd, Joseph H. "Important Editorial Change." HUMPHREY'S JOURNAL OF PHOTOGRAPHY, AND THE ALLIED ARTS AND SCIENCES 14, no. 5 (July 1, 1862): 17-18. [Note that John Towler becoming the new editor of "Humphrey's Journal."]

ST4329 "Famine Prices." HUMPHREY'S JOURNAL OF PHOTOGRAPHY, AND THE ALLIED ARTS AND SCIENCES 14, no. 16 (Dec. 15, 1862): 207-208. ["Our Journal costs us a great deal more than ever before. We pay more than double for paper, we pay three times as much for original matter; more for composition, and, in fact, more for every department of labor connected with the Journal..."]

MAGAZINES: HUMPHREY'S JOURNAL: 1864.
ST4330 "Almanac Makers on the Rampage." AMERICAN JOURNAL OF PHOTOGRAPHY AND THE ALLIED ARTS & SCIENCES n. s. vol. 6, no. 20 [sic 21] (May 1, 1864): 503. [From "Humphrey's Journal." Reprinted, without comment, a scathing attack on him for commenting in an earlier issue, on the name and contents of the newly issued "American Photographic Almanac."]

MAGAZINES: HUMPHREY'S JOURNAL: 1865.
ST4331 "Funny! very funny! Transparent Positives for the Publiscope." HUMPHREY'S JOURNAL OF PHOTOGRAPHY, AND THE ALLIED ARTS AND SCIENCES 16, no. 19 (Feb. 1, 1865): 300-301. [Sarcastic commentary on how the "Repertoire de la Photographie," keeps reprinting Towler's articles without credit.]

MAGAZINES: HUMPHREY'S JOURNAL: 1866.
ST4332 "Removal to No. 600 Broadway." HUMPHREY'S JOURNAL OF PHOTOGRAPHY, AND THE ALLIED ARTS AND SCIENCES 17, no. 22 (Mar. 15, 1866): 352. [Office moved.]

ST4333 "No. 600 Broadway. Photographic Depot; Photographic Stock and Materials; Photographic Books and Literature; Helion Cotton; Exhibition of Celestin Francois." HUMPHREY'S JOURNAL OF PHOTOGRAPHY, AND THE ALLIED ARTS AND SCIENCES 18, no. 6 (July 15, 1866): 95-96. [Discusses the activities at the site of the publication's new address. H. C. Price & Co. stock company, D. D. T. Davie & Son, chemists (manufacturers of Helion Cotton) and the publishing office of the "Humphrey's Journal." Also, "the two celebrated paintings by Celestin Francois of Adam and Eve, a splendid work of art..." on display.]

ST4334 "Close of the Year." HUMPHREY'S JOURNAL OF PHOTOGRAPHY, AND THE ALLIED ARTS AND SCIENCES 18, no. 16 (Dec. 15, 1866): 252. [Summation of a year of the magazine disclosure of future intentions.]

MAGAZINES: HUMPHREY'S JOURNAL: 1867.
ST4335 "Our Editorial Corps." HUMPHREY'S JOURNAL OF PHOTOGRAPHY, AND THE ALLIED ARTS AND SCIENCES 19, no. 14 (Nov. 15, 1867): 224. ["We have discontinued publishing the name of Prof. Towler or that of any other editor on our title page...The office editor (the publisher, Joseph Ladd) has always had sole charge of the Journal, and has procured matter of interest from different writers..."]

MAGAZINES: HUMPHREY'S JOURNAL: 1869.
ST4336 "Our New Plan." HUMPHREY'S JOURNAL OF PHOTOGRAPHY, AND THE ALLIED ARTS AND SCIENCES 20, no. 20 (Apr. 15, 1869): 316. ["Our new arrangement of issuing the Journal monthly and charging for it only one dollar per year, takes well with the photographic community who are subscribing by the hundreds...we have engaged several new writers of note...expect to run our list up to several thousand before the year is out..."]

ILLUSTRATED LONDON NEWS see also DAWSON, GEORGE.

MAGAZINES: ILLUSTRATED LONDON NEWS: 19TH C.
ST4337 Vries, Leonard de, comp. *Panorama 1842 - 1865; The world of the early Victorians as seen through the eyes of the Illustrated London News*. Selected by Leonard de Vries. Foreword by Arthur Bryant. Introduction by W. H. Smith. Text abridged by Ursula Robertshaw. Boston: Houghton Mifflin Co., 1969. * pp. illus. [Original articles from the "ILN" reprinted. Introductory essay contains historical information about the founding and early years of the magazine.]

MAGAZINES: ILLUSTRATED LONDON NEWS: 1854.
ST4338 "To the 1,000,000 Readers." ILLUSTRATED LONDON NEWS 25, no. 719 (Dec. 23, 1854): 681. [Discusses how the magazine uses illustrations, and mentions photography's role.]

MAGAZINES: ILLUSTRATED LONDON NEWS: 1857.
ST4339 "Charles MacKay." FRANK LESLIE'S ILLUSTRATED NEWSPAPER 4, no. 100 (Oct. 31, 1857): 341. 1 illus. [Portrait, by Brady. Biography of MacKay, who was the editor of the "Illustrated London News," then visiting New York, NY. Born Perth, Scotland, in 1815. Family moved to London when he was a child. Military tradition in family, but he did not join the army. A student in Belgium during the "Revolution of 1830." Began to write at 16 and published a volume of poems at 20. Began to work for the "Morning Chronicle." Nine years there, then editor of the "Glasgow Argus." Produced many books of poetry, and musicology. Chief editor of the "ILN" since 1848.]

MAGAZINES: JOURNAL OF THE PHOTOGRAPHIC SOCIETY: 1853.
ST4340 "The Journal of the Photographic Society, London." HUMPHREY'S JOURNAL 5, no. 1 (Apr. 15, 1853): 10. [Announcement of first issue (Mar. 3rd).]

MAGAZINES: L'ILLUSTRATION: 19TH C.
ST4341 Aubrey, Yves. "l'Illustration." ZOOM (PARIS) no. 68 (1979): 40-49. 26 b & w. 3 illus. [Survey of the French illustrated weekly magazine "l'Illustration," which began publication on Mar. 4, 1843 and which continued until WWII.]

MAGAZINES: LA ANDALUCIA MEDICA: 19TH C.
ST4342 Torres, J. M. and F. J. Sancho. "La Andaluca Medca; the First Journal of Medical Photography in Spain." HISTORY OF

SPECIAL TOPICS: PHOTOJOURNALISM & MAGAZINES
MAGAZINES: LIFE ILLUSTRATED: 1854.

SPECIAL TOPICS: PHOTOJOURNALISM & MAGAZINES
MAGAZINES: PHOTOGRAPHIC AND FINE ART JOURNAL: 1860.

PHOTOGRAPHY 12, no. 2 (Apr. - June 1988): 161-163. 3 illus. [Journal, founded in Cordoba, Spain in 1876. A monthly, published until 1890. From Jan. 1876 to June 1878 it was illustrated with tipped-in photographs, many apparently taken by Dr. Juan Gin, of Partagas (Barcelona).]

MAGAZINES: LIFE ILLUSTRATED: 1854.
ST4343 "Review: Life Illustrated." HUMPHREY'S JOURNAL 6, no. 15 (Nov. 15, 1854): 238-239. [Review of the "Photography" department in the first issue of a newspaper, titled "Life Illustrated," published in New York, NY. Humphrey had a negative response, since his journal was not mentioned.]

MAGAZINES: LIVERPOOL & MANCHESTER PHOTO-GRAPHIC JOURNAL: 1858.
ST4344 "Editorial." LIVERPOOL & MANCHESTER PHOTOGRAPHIC JOURNAL [BRITISH JOURNAL OF PHOTOGRAPHY] n. s. 2, no. 24 (Dec. 15, 1858): 307. [Announcing name change to "The Photographic Journal," returning to earlier volume numbering, now concluding 5th year of publication.]

MAGAZINES: LUMIÉRE: 1878.
ST4345 "Editor's Table: A New Photographic Magazine." PHILADELPHIA PHOTOGRAPHER 15, no. 170 (Feb. 1878): 61. [Review of the new journal "Light" [La Lumiére] published monthly by the firm of Adolph Braun & Co., in French and German. Note on p. 160 (May 1878) that "La Lumiére," just founded, probably would be discontinued, due to A. Braun's death.]

MAGAZINES: MUSEUM OF FOREIGN LITERATURE, SCIENCE AND ART: 1839.
ST4346 "London Story on Daguerre Process found in March 1839, Issue of an Obscure Philadelphia Journal." PHOTOGRAPHICA 13, no. 7 (Aug. - Sept. 1981): 3, plus 2 pg. insert. [Includes a facsimile reprint of an article from the March 1839 issue of the "Museum of Foreign Literature, Science and Art."]

MAGAZINES: NEW YORK GRAPHIC: 1875.
ST4347 "Editor's Table." PHILADELPHIA PHOTOGRAPHER 13, no. 145 (Jan. 1876): 31. [Dec. 30, 1875 issue of "NY Graphic" devoted to photography.]

MAGAZINES: PARIS-THEATRE: 1873.
ST4348 Joseph, Steven F. and Tristan Schwilden. "A Dramatic Duo." HISTORY OF PHOTOGRAPHY 11, no. 4 (Oct. - Dec. 1987): 325-327. 2 illus. ["Paris-Theatre," began publication in Paris on May 22, 1873. It was a weekly, containing a tipped-in woodburytype portrait of actors or actresses. The Lemercier firm in Paris supplied the prints. The magazine ran for seven years, with a later title of "Paris Portrait." "Bruxelles-Theatre," began publication in Jan. 11, 1874. It lasted for seventeen issues, then was revived in September, then lasted, with problems and changing issuance, etc, for another three years. "Bruxelles-Theatre" published negatives by H. De Saedeler, the Ghemar Brothers, A. Delabarre, and W. Damry.]

MAGAZINES: PHILADELPHIA PHOTOGRAPHER: 19TH C.
ST4349 Caufield, C. W. "American Bibliography of Photography. 5th Article." PHOTOGRAPHIC TIMES 18, no. 359 (Aug. 3, 1888): 362-363. ["Philadelphia Photographer." Vol. 1-3, 1864-1865.]

ST4350 "Some Back Talk." WILSON'S PHOTOGRAPHIC MAGAZINE. 32, no. 457 (Jan. 1895): 26-27. [List of first advertisers in the magazine in 1864, stating their present activities, etc.]

MAGAZINES: PHILADELPHIA PHOTOGRAPHER: 1864.
ST4351 "The Philadelphia Photographer." HUMPHREY'S JOURNAL OF PHOTOGRAPHY, AND THE ALLIED ARTS AND SCIENCES 15, no. 17 (Jan. 1, 1864): 269. [Announcement of new periodical.]

MAGAZINES: PHILADELPHIA PHOTOGRAPHER: 1866.
ST4352 "Book Notices. - Photography." FRANK LESLIE'S ILLUSTRATED NEWSPAPER 21, no. 540 (Feb. 3, 1866): 307. [Favorable review of Edward Wilson's "Philadelphia Photographer" magazine, mentions "Photographic Mosaics," by M. Carey Lea and E. L. Wilson.]

MAGAZINES: PHILADELPHIA PHOTOGRAPHER: 1877.
ST4353 Wilson, Edward L. "Business Notices." PHILADELPHIA PHOTOGRAPHER 14, no. 166 (Oct. 1877): 305. [Announcement that M. F. Benerman of Benerman & Wilson, co-publishers of "Philadelphia Photographer," was withdrawing from the partnership.]

MAGAZINES: PHILADELPHIA PHOTOGRAPHER: 1879.
ST4354 PHILADELPHIA PHOTOGRAPHER 16, no. 190 (Oct. 1879) [The Oct. 1879 "Phila. Photo." was devoted to raising the quality of the field - included a copy of a painting by Munich painter, Anton Seitz "The Village Photographer," plus scores of articles extracted from books. Robinson's "Pictorial Effect in Photography" Burnett's "On Composition," Dwight "Study of Art," etc.]

MAGAZINES: PHOTOGRAPHIC AND FINE ART JOURNAL: 1854.
ST4355 "The Latest Excavations at Nineveh." PHOTOGRAPHIC AND FINE ART JOURNAL 7, no. 4 (Apr. 1854): 127. [From "The Builder."]

ST4356 O'Hara, Elizabeth. "A Chapter on Dress." PHOTOGRAPHIC AND FINE ART JOURNAL 7, no. 5 (May 1854): 138-139.

ST4357 "The Artist's First Work." PHOTOGRAPHIC AND FINE ART JOURNAL 7, no. 5 (May 1854): 150-152. [Short story of beginnings of the painter Canova.]

MAGAZINES: PHOTOGRAPHIC AND FINE ART JOURNAL: 1856.
ST4358 "Note." PHOTOGRAPHIC AND FINE ART JOURNAL 9, no. 2 (Feb. 1856): 62. [Editor discussing the need for support from the community to supply negatives for the photographic prints published in each issue.]

MAGAZINES: PHOTOGRAPHIC AND FINE ART JOURNAL: 1859.
ST4359 Root, M. A. "Our Philadelphia Editor's Table." PHOTOGRAPHIC AND FINE ART JOURNAL 12, no. 1 (June 1859): 11-12. [Apparently Marcus A. Root started to co-edit the P & FAJ with Snelling, when it began again in 1859, after a hiatus of six months.]

MAGAZINES: PHOTOGRAPHIC AND FINE ART JOURNAL: 1860.
ST4360 "Editorial Matters." PHOTOGRAPHIC AND FINE ART JOURNAL 13, no. 6 (June 1860): 179-180. [New publisher William Campbell & Co., Joseph Dixon will join Snelling as co-editor. Intent to include stereoscopic photos as illustrations, publish more original scientific matter, etc. (In reality the journal folded within two or three issues.)]

ST4361 "Editorial Matters." PHOTOGRAPHIC AND FINE ART JOURNAL 13, no. 7 (July 1860): 212. [Comments by J. Dixon, H. H.

SPECIAL TOPICS: PHOTOJOURNALISM & MAGAZINES
MAGAZINES: PHOTOGRAPHIC ART JOURNAL: 19TH C.

SPECIAL TOPICS: PHOTOJOURNALISM & MAGAZINES
MAGAZINES: YEARBOOK OF PHOTOGRAPHY: 1864.

Snelling, W. Campbell (publisher) on the new editorial staff and role of the magazine.]

ST4362 "Editorial Miscellany: Important Announcement." AMERICAN JOURNAL OF PHOTOGRAPHY AND THE ALLIED ARTS & SCIENCES n. s. vol. 3, no. 13 (Dec. 1, 1860): 207-208. ["Am. J. of Photo." acquired the "Photographic and Fine Arts Journal," founded and edited by H. H. Snelling.]

ST4363 "Important Announcement. Perils of Photographic Publishing. - The Opening of a Volcano. - An Oasis in the Desert. - The acknowledged Organ of Operators." HUMPHREY'S JOURNAL OF PHOTOGRAPHY, AND THE ALLIED ARTS AND SCIENCES 12, no. 16 (Dec. 15, 1860): 241-243. [Sarcastic attack on the merging of the "P & FAJ" with the Am. J. of Photo." Critical of Snelling, the former editor of "P & FAJ" and of Seely, ed. of "AJP." Then self-praise for "HJ."]

MAGAZINES: PHOTOGRAPHIC ART JOURNAL: 19TH C.
ST4364 Canfield, C. W. "American Bibliography of Photography. Class A. - Photographic Journals. 2nd Article." PHOTOGRAPHIC TIMES 18, no. 334 (Feb. 10, 1888): 64-66. ["Photographic Art Journal" 1851-1853 described.]

MAGAZINES: PHOTOGRAPHIC ART JOURNAL: 1850.
ST4365 "Fine-Art Gossip." ATHENAEUM no. 1609 (Aug. 28, 1858): 271-272. [Review of the first six numbers of the "Photographic Art Journal."]

MAGAZINES: PHOTOGRAPHIC ART JOURNAL: 1851.
ST4366 "Photographic Art Journal." DAGUERREAN JOURNAL 1, no. 11 (Apr. 15, 1851): 338. [Mention that the fourth issue has been received, encouragement for the editor.]

MAGAZINES: PHOTOGRAPHIC ART JOURNAL: 1852.
ST4367 "Gossip." PHOTOGRAPHIC ART JOURNAL 4, no. 5 (Nov. 1852): 324. [The editor, H. H. Snelling, offered three gold medals "for the best dissertation on the Daguerrean Art as practiced in the United States" (not less than twenty pages long), the best "original practical treatise on the daguerreotype," and the best article "on the value of the photographic art as compared with the fine arts generally."]

MAGAZINES: PHOTOGRAPHIC ART JOURNAL: 1870.
ST4368 "New Books." ANTHONY'S PHOTOGRAPHIC BULLETIN 1, no. 5 (June 1870): 96. [Review of second number of the "Photographic Art Journal," British publication designed to be illustrated "...solely by prints made by the mechanical processes." Four images in issue 2.]

ST4369 "Art: Pictorial and Industrial. An Illustrated Magazine." ANTHONY'S PHOTOGRAPHIC BULLETIN 1, no. 9 (Oct. 1870): 173-174. [Review of "Photographic Art Journal" (apparently called "Art, Pictorial and Industrial") nos. 1-3, published in London by Sampson, Low, Son and Marston. From "London Photographic News."]

MAGAZINES: PHOTOGRAPHIC JOURNAL: 1859.
ST4370 "Our Weekly Gossip." ATHENAEUM no. 1677 (Dec. 17, 1859): 816-817. [Report of a copyright infringement argument over the title "Photographic Journal" between the "Liverpool Photographic Journal" and the "Journal of the Royal Photographic Society."]

MAGAZINES: PHOTOGRAPHIC TIMES: 1875.
ST4371 "The Times Enlarged. " PHOTOGRAPHIC TIMES 5, no. 49 (Jan. 1875): 1. [Up to 24 pages, of which 16 is editorial matter. Still 6 1/2" x 9 1/2" page size.]

MAGAZINES: PHOTOGRAPHISCHE MITTHEILUNGEN: 1864.
ST4372 "Photographische Mittheilungen." HUMPHREY'S JOURNAL OF PHOTOGRAPHY, AND THE ALLIED ARTS AND SCIENCES 16, no. 6 (July 15, 1864): 85. [Note that Journal, published in Berlin, edited by Hermann Vogel, just started.]

MAGAZINES: ST. LOUIS PRACTICAL PHOTOGRAPHER: 1877.
ST4373 "A New Photographic Journal." ANTHONY'S PHOTOGRAPHIC BULLETIN 7, no. 12 (Dec. 1876): 375. [J. H. Fitzgibbon (St. Louis) starting the St. Louis Practical Photographer.]

ST4374 Fitzgibbon, J. H. "Salutation. A Happy New Year-To the Reader, a Long Life and a Prosperous One." ST. LOUIS PRACTICAL PHOTOGRAPHER 1, no. 1 (Jan. 1877): 1-2, plus frontispiece. 1 b & w. [Editorial statement of publication by its publisher, the photographer J. H. Fitzgibbon. Includes a portrait of Fitzgibbon by A. Bogardus as the frontispiece.]

ST4375 "Matters of the Month." PHOTOGRAPHIC TIMES 7, no. 74 (Feb. 1877): 36. ["St. Louis Practical Photographer," under the editorship of J. H. Fitzgibbon, begins.]

MAGAZINES: STEREOSCOPIC CABINET: 1859.
ST4376 "Critical Notices: The Stereoscopic Cabinet. Published by Lovell Reeve, Henrietta Street." PHOTOGRAPHIC NEWS 3, no. 63 (Nov. 18, 1859): 126. [Proposed monthly publication of three stereos. The first set includes a church view, by Howlett, statues from the British Museum, by R. Fenton, and a view from the deck of the "Maraquita," by Capt. Henry, on his voyage to Iceland.]

MAGAZINES: STEREOSCOPIC MAGAZINE: 19TH C.
ST4377 Symonds, K. C. M. "An Historic Landmark - 1858-1865: The Stereoscopic Magazine." STEREO WORLD 11, no. 4 (Sept. - Oct. 1984): 4-12, 37, plus cover. 12 b & w. 3 illus. ["The Stereoscopic Magazine" began publication in London in 1858. Three monthly parts, each containing three original stereo prints, each with letterpress. Article includes reproductions of both images and texts from an issue of volume 5. Six photos of India by Capt. Allan Scott, Madras Artillery, Hyderabad reproduced here, and four views of Brittany, which may be by Mr. Jephson.]

MAGAZINES: STEREOSCOPIC MAGAZINE: 1858.
ST4378 "Review." LIVERPOOL & MANCHESTER PHOTOGRAPHIC JOURNAL [BRITISH JOURNAL OF PHOTOGRAPHY] n. s. 2, no. 14 (July 15, 1858): 180. [Bk. rev.:"The Stereoscopic Magazine, a Gallery of Landscape Scenery, Architecture, Antiquities, and Natural History,..." ed. by Mr. Glaisher.]

MAGAZINES: WESTERN PHOTOGRAPHIC NEWS: 1874.
ST4379 "Matters of the Month: A New Photographic Journal." PHOTOGRAPHIC TIMES 4, no. 46 (Oct. 1874): 154. [The "Western Photographic News," a monthly of 40 pp., edited, published by Charles W. Stevens of the Great Central Photographic Warehouse, Chicago, IL.]

MAGAZINES: YEARBOOK OF PHOTOGRAPHY: 1864.
ST4380 "Critical Notices: "The Year Book of Photography and Photographic News Almanac by 1864." London: Thomas Piper." PHOTOGRAPHIC NEWS 8, no. 285 (Feb. 19, 1864): 87.

ST4381 "Critical Notices." PHOTOGRAPHIC NEWS 8, no. 285 (Feb. 19, 1864): 87. [Bk. Rev.: "The Yearbook of Photography and Photographic News Almanac for 1864." London: Thomas Piper.]

BY APPLICATION: PHOTOMECHANICAL REPRODUCTION

PHOTOMECHANICAL REPRODUCTION see also ALBERT; AMERICAN PHOTO-LITHOGRAPHIC CO.; AMERICAN PHOTOTYPE COMPANY; ASSER, E. J.; AUBEL; BALSAMO, J. E.; BAROUX, M. E.; BEATTY, F. S.; BEECHY, ST. VINCENT; BERCHTOLD; BERRES; BIERSTADT, EDWARD; BOULTON & WATT; BRAUN, ADOLPH; BRINCKERHOFF, J. DE WITT; BROWN, J. J.; BURNETT, J.; BURTON, CHARLES; CALDESI & LOMBARDI; CARPENTER, J.; CLAUDET, ANTOINE; COLLINS, H. G.; CONTENCIN, J.; CRAIG, WILLIAM; CROOKES, WILLIAM; CROSTHWAITE, J.; CUTTING & BRADFORD; DALGLISH; DALLAS; D'ARGE, CHARLES; DAWSON, GEORGE; D'ETTINGHAUSEN, C.; DEVERIL, HERBERT; DE VALICOURT, E.; DUNCAN, DAVID; EDWARDS, ERNEST; FARGIER; FISCAU. [FITZEAU ?]; FONTAYNE, CHARLES; GAGE, F. B.; GAUDIN, A.; GELDMACHER, W. F.; GILLOT, YVES & BARET; GOUPIL; GRIGGS, WILLIAM; GROVE, W. R.; GRUEN; HALL & GURNEY; HEATH, VERNON; HUMPHREY, S. D.; HUNT, ROBERT; HUSNIK, J.; IVES, F. E.; JACOBI; JACOBI & PRAGER; JACOBSON; JAMES, HENRY, COL. SIR; JOUBERT; KNIGHT, EDWARD H.; LALLEMAND; LAMBERT, LEON; LAMBERT, T. S.; LANGTON, ROBERT; LAVIS, JOSEPH; LEA, M. CAREY; LEMERCIER & CO.; LEVY & BACHRACH; LOWE; MACPHERSON, ROBERT; MALONE, THOMAS; MARION, A. & SON; MARIOT, EMANUEL; MARTIN, A.; MATHIEU, M. P. F.; MATHIOT, GEORGE; MEINERTH; MOSS, J. C.; MORVAN; MUMLER, W. H.; NIEPCE DE ST. VICTOR; OBERNETTER, J.; OSBORNE, JOHN WALTER; OTT, ADOLPHE; PATERSON; PHOTO-ENGRAVING CO.; PHOTO-GALVANO-GRAPHIC CO.; PLACET, PAUL EMILE; POITEVIN, L.-A.; POUNCY, J.; PRANG & CO.; PRETSCH, PAUL; QUAGLIO; RAMSEY; REEVE, LOVELL; ROBBIN, G.; ROCHE, T. C.; ROCKWOOD.; RODRIGUEZ, JOSE JULIO; RYE; RYLEY, J.; SALMON & GARNIER; SAWYER, J. R.; SCOTT, ALEXANDER DE COURCY; SEELY, CHARLES A.; SHARP, T.; SIMPSON, G. WHARTON; SMITH, WILLIAM HENRY; SOUTHWELL; SUTTON, THOMAS ; SWAN, J. W.; TALBOT, WILLIAM H. F.; TAYLOR, BENJAMIN J; TAYLOR, J. TRAILL; TESSIE DU MOTAY, C. M. & C. R. MARECHAL; TILLMAN, S. D.; TOOVEY, WILLIAM; TOWLER, JOHN; TURNER, A. WELLESLEY; VAIL, E.; VIDAL, LEON; VOGEL, HERMANN; WALKER, DELTENRE; WATERHOUSE, J.; WHITLOCK, BENJAMIN; WOODBURY, WALTER B.; WOTHLY; WRIGHT, J.

PHOTOMECHANICAL REPRODUCTION: 19TH C.
BOOKS
ST4382 Wood, Henry Trueman Wright, Sir. *Modern Methods of Illustrating Books.* London: E. Stock, 1887. vii, 247 pp.

ST4383 Boston. Museum of Fine Arts. Department of Prints. *Exhibition Illustrating the Technical Methods of the Reproductive Arts from the XV. Century to the Present Time, with Special Reference to the Photomechanical Processes.* Introduction by S. R. Koehler. Boston: Printed for the Museum by A. Mudge & Son, 1892. xi, 98 pp. [Exhibition catalog: Boston Museum of Fine Arts, Jan. 8 - Mar. 6, 1892.]

ST4384 Wakeman, Geoffrey. *Victorian Book Illustration, the Technical Revolution.* Detroit: Gale Research Co., 1973. 182 pp. [Includes chapters "The 'Sixties' - the Impact of Photography," "Prelude to the Photomechanical Revolution," " The Photomechanical Revolution," etc.]

ST4385 Jussim, Estelle. *Visual Communication and the Graphic Arts, Photographic Technologies in the Nineteenth Century.* New York: R. R. Bosker Co., 1974. 364 pp. illus.

ST4386 Lyons, Beauvais. *Photographic Methods in Lithography During the Nineteenth Century.* "History of Photography Monograph Series, No. 6." Tempe, AZ: Arizona State University, School of Art, 1983. 24 pp. 1 illus. [Contains "A Chronology of 19th Century Photo-lithography," "A Selected Chronology of Manuscripts which utilize Photo-lithography," and "Bibliography of Nineteenth Century Photo-lithography."]

PERIODICALS
ST4387 "Improvements in Photolithography." HUMPHREY'S JOURNAL OF PHOTOGRAPHY, AND THE ALLIED ARTS AND SCIENCES 14, no. 23 (Apr. 1, 1863): 310-311. [Includes a chronological listing of the discoveries in this process, from Niepce through 1860's.]

ST4388 "Photo-Mechanical Printing: Historical." PHILADELPHIA PHOTOGRAPHER 10, no. 116 (Aug. 1873): 241-244. [Summation of history of development from Mungo Ponton (1839); Poitevin (1855), Tessie du Mothay and Marechal (1863); Courteney; Albert (1869); Obernetter (1870); Ernest Edwards (1872). Accompanies article on the Heliotype process in the same issue.]

ST4389 "The Photo-Mechanical Processes." ANTHONY'S PHOTOGRAPHIC BULLETIN 6, no. 12 (Dec. 1875): 364-365. [From "Exchange." History and description of Photo-Lithography, the Albertype, Zinc Etching, Photo-Electrotype, etc.]

ST4390 Koehler, S. R. "Bibliography: Wood-Engraving." AMERICAN ART REVIEW 1, no. 3 (Jan. 1880): 123-125. [Review of several books, comments on the negative impacts of photography on engraving.]

ST4391 "A Symposium of Wood Engravers." HARPER'S MONTHLY 60, no. 357 (Feb. 1880): 442-453. [Interviews with A. V. S. Anthony, Timotheus Cole, John P. Davis, Frederick Juengling, Richard A. Mueller, John Tinkey, Henry Wolf. Background information about the state of the art of commercial illustration engraving, responses to photogravure, etc.]

ST4392 Wilson, Edward L. "Photo-Engraving and Wood-Engraving." WILSON'S PHOTOGRAPHIC MAGAZINE 32, no. 466 (Oct. 1895): 449-453, plus unnumbered leaf before p. 449. 1 b & w. 1 illus. [A photo by Wilson shown with a woodcut taken from that photo. Examples are from the book "In Scripture Lands." This article is not technical and it includes several excerpts from other magazines about the various inputs and uses of the printing processes.]

ST4393 Geddes, J. D. "Photography as Applied to Illustration and Printing. Lectures 1 - 3." JOURNAL OF THE SOCIETY OF ARTS (LONDON) 50, no. 2600-2602 (Sept. 19 - Oct. 3, 1902): 829-834, 842-846, 853-858. [Pt. 1: Block reproductions of line drawings, reproduction of wash drawings and photographs. Pt. 2: Photogravure, Collotype, Woodburytype. Pt. 3: Color.]

ST4394 Ivins, William M., Jr. "Photography and the 'Modern' Point of View. A Speculation in the History of Taste." METROPOLITAN MUSEUM STUDIES 1, (1928-1929): 16-24. 8 illus.

ST4395 Raynal, Maurice. "Photographie et gravure." ARTS ET METIERS GRAPHIQUES no. 64 (Sept. 15, 1938): 9-12. 4 b & w. 4 illus. [Photographs, by Carjat and others, compared to engravings made from these photographs.]

ST4396 Holm, Ed. "Collector's Choice: From Glass to Wood: Early Western Photojournalism." AMERICAN WEST 1, no. 14 (July 1974): 11-13. 1 illus. [Brief, popular discussion of newspaper's use of photography converted to wood-engraving for illustrations in 1860s - 1880s. Illustrated with one half of a W. H. Jackson photograph

adjacent to one half of the woodcut taken from it and published in "Harper's Weekly" (Sept. 25, 1886).]

ST4397 Hanson, David A. "The Beginnings of Photographic Reproduction in the USA." HISTORY OF PHOTOGRAPHY 12, no. 4 (Oct. - Dec. 1988): 357-376. 18 illus. [Discusses the reproduction of photographs in illustrated magazines and books from 1842 on. "The United States Magazine and Democratic Review" (1842); Mathew Brady's "The Rationale of Crime,..."; the "Plumbotype National Gallery"; Stephen's work in "Incidents of Travel in Yucatan; and others.]

PHOTOMECHANICAL REPRODUCTION: BY YEAR.
PHOTOMECHANICAL REPRODUCTION: 1841.
ST4398 "Electrotypes from Wood Engravings." AMERICAN REPERTORY OF ARTS, SCIENCES AND MANUFACTURES 3, no. 3 (Apr. 1841): 161-163. 2 illus.

ST4399 "New Discovery in Printing." MAGAZINE OF SCIENCE AND SCHOOL OF ARTS 3, no. 144 (Jan. 1, 1842): 316. [From the "Athenaeum." Secret process, from Berlin.]

PHOTOMECHANICAL REPRODUCTION: 1852.
ST4400 "Engraved Photographs - Bottier's Paper-Cutting Machine - Colt's Revolver." PRACTICAL MECHANIC'S JOURNAL 5, no. 50 (May 1852): 27-28. 2 illus. ["We may be wrong...but we believe the annexed engraving...to be the first published example of this branch of the economics of the atelier. We believe it to be the first engraving which has been produced after the 'pencillings of light.' "]

PHOTOMECHANICAL REPRODUCTION: 1853.
ST4401 "Science: Photography. Engraving on Steel by the Agency of the Solar Rays." ILLUSTRATED LONDON NEWS 22, no. 628 (June 18, 1853): 502. [Mentions and discusses Talbot, Niepce, Grove, and Claudet in brief survey.]

ST4402 "The Progress of Photography: Photo-Lithography. Photographic Pictures Etched on Metal Plates." ART JOURNAL (Aug. 1853): 181-183.

ST4403 "Engraving and Lithography by Light." HUMPHREY'S JOURNAL 5, no. 9 (Aug. 15, 1853): 143-144. [From "London Art Journal." Mentions Niepce de Saint-Victor, H. F. Talbot.]

ST4404 "Progress of Photography: Photo-Lithography - Photographic Pictures Etched on Metal Plates." HUMPHREY'S JOURNAL 5, no. 10 (Sept. 1, 1853): 155-160. [From "London Art Journal." Extended survey of experiments in this area. Author not credited.]

ST4405 "The Process of Photography. - Photo-Lithography." PHOTOGRAPHIC ART JOURNAL 6, no. 4 (Oct. 1853): 222-227. [From "London Art J."]

PHOTOMECHANICAL REPRODUCTION: 1854.
ST4406 "Photographs on Stone." HUMPHREY'S JOURNAL 5, no. 22 (Mar. 1, 1854): 350. [From "London Art Journal."]

ST4407 "Progress in Photography." HUMPHREY'S JOURNAL 6, no. 5 (June 15, 1854): 78-79. [From "J. of Photo. Soc." Further information on Mr. Elliott's experiments of photographing aboard ship. Also discussion of photoengraving experiments conducted by Niepce de Saint-Victor and by A. Baldus.]

ST4408 "Photo-Lithography; or, Photography on Stone." HUMPHREY'S JOURNAL 6, no. 9 (Aug. 15, 1854): 137-138. [From "Art of Photography, London."]

PHOTOMECHANICAL REPRODUCTION: 1855.
ST4409 "Photographic Pictures on Stone for Lithographic Printing." PHOTOGRAPHIC AND FINE ART JOURNAL 8, no. 6 (June 1855): 168-169. [From "London Pract. Mechanic's J."]

PHOTOMECHANICAL REPRODUCTION: 1856.
ST4410 "The Duc de Luynes's Premium." HUMPHREY'S JOURNAL 8, no. 10 (Sept. 15, 1856): 156-157. [From "Liverpool Photo. J." Describes the conditions of the prize offered by the Duc de Luynes (France) to anyone finding a usable photoengraving process.]

PHOTOMECHANICAL REPRODUCTION: 1857.
ST4411 "Photography on Wood." HUMPHREY'S JOURNAL 9, no. 12 (Oct. 15, 1857): 188. [Commentary of discussion of the problem by "Photographic Notes," with report of an individual claiming it could be easily accomplished.]

ST4412 "On Photo-Lithography, And an alleged New Process for Transferring the Daguerrean Image to Paper." PHOTOGRAPHIC AND FINE ART JOURNAL 10, no. 12 (Dec. 1857): 375-376. [From "Liverpool Photo. J." Poitevin's process. Edward's process. Lefevre's process. Pretsch mentioned. (Unclear, but this may be the process developed by G. Le Gray.]

PHOTOMECHANICAL REPRODUCTION: 1858.
ST4413 "Photo-Lithography." PHOTOGRAPHIC AND FINE ART JOURNAL 11, no. 8 (Aug. 1858): 252-253. [From "NY Times."]

ST4414 Horace Greeley." FRANK LESLIE'S ILLUSTRATED NEWSPAPER 6, no. 142 (Aug. 21, 1858): 187. 1 illus. [Portrait of Horace Greeley, "Engraved by Charles Weber, Photographed on Wood by Waters & Co., N. Y." The credit seems to be to the process engraver, not to anyone taking an original photograph. Only such case I've seen to date in this magazine.]

ST4415 "Carbon-Printing and Photo-Lithographs." PHOTOGRAPHIC AND FINE ART JOURNAL 11, no. 11 (Nov. 1858): 322-325. [From "Photo. Notes." Poucy's carbon printing process. Cutting, Bradford & Turner's photo-lithographic process. Joseph Dixon's photoengraving process.]

ST4416 "Art Journal Advertiser: Engraving as an Art and a Useful Science. (Editorial)." COSMOPOLITAN ART JOURNAL 3, no. 1 (Dec. 1858): n. p. [1 p.] following p. 72. [Advertisement by the engravers N. Orr & Co., consisting of an essay on the recent evolution of illustrative engraving. Discusses the use of daguerreotypes and photographs as sources. It is probable that several of the engraved portraits in the "Cosmopolitan Art Journal," (by N. Orr & Co.), are from photographs, although they are not so credited.]

PHOTOMECHANICAL REPRODUCTION: 1859.
ST4417 "Photography Upon Wood." PHOTOGRAPHIC AND FINE ART JOURNAL 12, no. 1 (June 1859): 28-29. [From "Photo. Notes."]

ST4418 "Photographic Print." ALL THE YEAR ROUND 1, no. 7 (June 11, 1859): 162-164. [Survey of experiments in photomechanical reproduction - Talbot; Fizeau; Negre; Poitevin; Crookes; Salmon & Garnier mentioned.]

ST4419 "The Luynes Prize." PHOTOGRAPHIC AND FINE ART JOURNAL 12, no. 2 (July 1859): 60. [From "Photo. Notes." Winners,

contestants for the Luynes Prize, an award for a successful photoengraving process. Poitevan, Davanne & Girard, Garnier and Pouncy won awards.]

PHOTOMECHANICAL REPRODUCTION: 1862.

ST4420 "A New Chapter in Photography." ONCE A WEEK 6, (June 14, 1862): 688-691. [Discusses Talbot's photoengraving experiments, Nicephore Niepce, Fitzeau, Poitevan.]

PHOTOMECHANICAL REPRODUCTION: 1863.

ST4421 Mayer, Heinrich, Dr. "Photography as a medium of Illustration." HUMPHREY'S JOURNAL OF PHOTOGRAPHY, AND THE ALLIED ARTS AND SCIENCES 14, no. 22 (Mar. 15, 1863): 293-296. [From "Zeitschrift für Fotografie und Stereoscopie." "The first important work in which photography was applied as a means of illustration instead of copperplate engravings, lithographic prints, and woodcuts was..." Lists and describes approximately a dozen books and articles illustrated with photos or photolithographs.]

ST4422 "Photographs in Printing Ink." AMERICAN JOURNAL OF PHOTOGRAPHY AND THE ALLIED ARTS & SCIENCES n. s. vol. 5, no. 18 (Mar. 15, 1863): 430-431.

PHOTOMECHANICAL REPRODUCTION: 1865.

BOOKS
ST4423 Bennett, Alfred W. *Search for a Publisher; Or, Councils for a Young Author.* London: A. W. Bennett, 1865. 60 pp. 1 b & w. illus. [Bennett was a book publisher who was an early and active user of original photographs for illustrations. He discusses photography's merits. 2nd printing, (1868) Provost & Co. (Provost & Co. succeeded Bennett, this is essentially the same book.]

PERIODICALS
ST4424 "A Blow at Wood-Engraving." BRITISH JOURNAL OF PHOTOGRAPHY 12, no. 261 (May 5, 1865): 231-232. 1 illus. [Graphotype engraving process.]

ST4425 "Photography and Wood Engraving." FRANK LESLIE'S ILLUSTRATED NEWSPAPER 21, no. 533 (Dec. 16, 1865): 193-194. 1 illus. [Reproduction of a painting, published with a description of the uses and usefulness of photography in reproducing artworks and other illustrations.]

PHOTOMECHANICAL REPRODUCTION: 1866.

ST4426 "On the Various Methods of Engraving Photographic Pictures Obtained upon Metals and Stone." AMERICAN JOURNAL OF PHOTOGRAPHY AND THE ALLIED ARTS & SCIENCES n. s. vol. 8, no. 13 (Jan. 1, 1866): 300-303. [From "Photographisches Monatsschrift."]

ST4427 "On the Various Methods of Engraving Photographic Pictures Obtained upon Metals and Stone." HUMPHREY'S JOURNAL OF PHOTOGRAPHY, AND THE ALLIED ARTS AND SCIENCES 17, no. 19 (Feb. 1, 1866): 300-302. [From "Photographisches Monatsschrift."]

PHOTOMECHANICAL REPRODUCTION: 1867.

ST4428 "Wood Engraving. A Critic Out of His Depth." FRANK LESLIE'S ILLUSTRATED NEWSPAPER 25, no. 633 (Nov. 16, 1867): 129-130. [Editorial against statements made by a critic in the "NY Evening Post" about virtues of steel engraving and wood engraving. The "FLIN" editor argues for the creative interpretation of the wood engraver.]

PHOTOMECHANICAL REPRODUCTION: 1869.

ST4429 "Photographic Wonders." CHAMBERS'S JOURNAL 46, no. 298 (Sept. 11, 1869): 585-586. [Description of photoengraving process.]

PHOTOMECHANICAL REPRODUCTION: 1871.

ST4430 "Editor's Scientific Record: Photographing on Wood for Engraving." HARPER'S MONTHLY 42, no. 248 (Jan. 1871): 307.

ST4431 "Durable Photographs." CHAMBERS'S JOURNAL OF POPULAR LITERATURE, SCIENCE, AND ART Ser. 4, no. 388 (June 3, 1871): 348-350. [Brief survey of experiments in the field.]

ST4432 "Heliotype Printing." ART PICTORIAL AND INDUSTRIAL 2, no. 14 (Aug. 1871): 33. [Actually a discussion of this magazine's use of heliotype printing for reproducing art works.]

PHOTOMECHANICAL REPRODUCTION: 1873.

ST4433 "Improvement in Photo-Lithography." ANTHONY'S PHOTOGRAPHIC BULLETIN 4, no. 4 (Apr. 1873): 104-105. [From the "Photo News."]

PHOTOMECHANICAL REPRODUCTION: 1875.

ST4434 "Tabular View of the Progress of Photo-Mechanical Printing. - Photomechanical Printing Processes, Correction." PHILADELPHIA PHOTOGRAPHER 12, no. 134-135 (Feb.- Mar. 1875): 47-48, 72-74. [A Mr. E. B. sent in a different chart, which he felt was more accurate.]

ST4435 "Photography and Wood Engraving." ANTHONY'S PHOTOGRAPHIC BULLETIN 6, no. 6 (June 1875): 167-168. [From "London Photographic News." Discussion of the practical difficulties of this process.]

ST4436 "Illustrated Journalism and the Progress of Wood Engraving." FRANK LESLIE'S ILLUSTRATED NEWSPAPER 41, no. 1055 (Dec. 18, 1875): 235. [Statement about growth of illustrated magazines linked to growth of wood engraving. Brief history of wood engraving. Self-praise for their special supplement, a view of the Philadelphia Centennial grounds, printed 18" x 52 1/2".]

PHOTOMECHANICAL REPRODUCTION: 1876.

ST4437 "An Improved Method of Printing on Wood Blocks." ANTHONY'S PHOTOGRAPHIC BULLETIN 7, no. 6 (June 1876): 177-178. [From "Br. J. of Photo."]

ST4438 "Chromotypes - By the Autotype Company." ANTHONY'S PHOTOGRAPHIC BULLETIN 7, no. 7 (July 1876): 212. [From "Br. J. of Photo."]

ST4439 "Photo-Engraving." PHILADELPHIA PHOTOGRAPHER 13, no. 155 (Nov. 1876): 323-324.

PHOTOMECHANICAL REPRODUCTION: 1877.

[During 1877 the PHILADELPHIA PHOTOGRAPHER is filled with articles debating the good and bad aspects of the carbon process. There was a heated debate between Edward L. Wilson, the editor of PP, and Mr. Lambert, inventor of the Lambertype, writing in ANTHONY'S. See also BRAUN, ADOLPH.]

ST4440 "About Cartography (Mapping)." ANTHONY'S PHOTOGRAPHIC BULLETIN 8, no. 1 (Jan. 1877): 3-5. [Topographic Office of the Dept. of War, in the Hague, maps of Java shown at Philadelphia Centennial. Discussed here.]

PHOTOMECHANICAL REPRODUCTION: 1878.

BOOKS

ST4441 Toschi, Paolo. *Toschi's Engravings from Frescos by Correggio and Parmegiano; Reproduced by the Heliotype Process from the Gray Collection of Engravings, Harvard University.* Boston: J. R. Osgood, 1878. 35 l. pp. 24 l. of plates. [Heliotype prints.]

PERIODICALS

ST4442 "Heliochromic Lichtdruck." ANTHONY'S PHOTOGRAPHIC BULLETIN 9, no. 4 (Apr. 1878): 117. [From "Photo. Mittheilungen." Albert process.]

PHOTOMECHANICAL REPRODUCTION: 1879.

BOOKS

ST4443 Hall, Charles Francis. *Narrative of the Second Arctic Expedition made by Charles F. Hall; His Voyage to Repulse Bay, Sledge Journeys to the Straits of Fury and Hecla and to King William's Land, and Residence among the Eskimos, During the Years 1864-69.* Edited under the Orders of the Hon. Secretary of the Navy, by Prof. J. E. Nourse, U.S.N., U.S. Naval Observatory, 1879. Washington, DC: Government Printing Office, 1879. xlviii, 644 pp. b & w. illus. ["U. S. Congress. 45th Cong. 3d. Sess. Senate. Ex Doc. 27) Illus. with photomechanical reproductions.]

ST4444 Linton, W. J. *Some Practical Hints on Wood-Engraving, for the Instruction of Reviewers and the Public.* Boston; New York: Lee & Shepherd; Chas. T. Dillingham, 1879. 92 pp. illus. [Includes chapter "Photography on Wood."]

PERIODICALS

ST4445 "Photography and Publishers." ANTHONY'S PHOTOGRAPHIC BULLETIN 10, no. 4 (Apr. 1879): 112. [From "London Photo. News." Photos for engravings, for illustrations.]

ST4446 "The 'Times' on Autotype." ANTHONY'S PHOTOGRAPHIC BULLETIN 10, no. 10 (Oct. 1879): 293-295. [From "London Photo. Times."]

ST4447 "The 'Times' on Autotypes." ANTHONY'S PHOTOGRAPHIC BULLETIN 10, no. 11 (Nov. 1879): 323-325. [From "Br. J. of Photo."]

BY APPLICATION:
STEREOGRAPHIC PHOTOGRAPHY

STEREO see also ALIQUIS; BECK, JOSEPH; BERGNER; BREWSTER, DAVID; CLAUDET, ANTOINE; COOLEY, W. DES-BOROUGH; CREMER, JAMES; DAVIS, T.; DICKSON, ROBERT; EMANUEL; EMERSON, EDWIN ; FALLON; FRASER, WILLIAM; A. B. G.; GAUDIN, MC.-A.; HALL, JAMES; HARE; HART, A., JR.; HENDERSON, JOHN; HIMES, CHARLES F.; HOLMES, OLIVER W.; HUGHES, C. J.; HUNT, ROBERT; JONES, E.; JONES, T. WHARTON; KNIGHT; L.; LANG, JOHN; LEIGHTON, JOHN; LORRIE, WILLIAM O.; LYMAN, J. B.; MALONE; MASCHER, JOHN F.; MAUDE, NEVILLE; MERRITT, T. L.; MOIGNO, ABBE; NEWTON, W. E. & F. NEWTON; D. P.; RAWSON; REEVE, LOVELL A.; REEVES, T.; REUBEN, LEVI; RICHARDS, F. D. B.; ROGERS, WILLIAM B.; ROSS, JAMES; ROSS, WILLIAM; SALOMON; SANG, JOHN; SEELY, CHARLES A.; SMITH, BECK & BECK; SUTTON, THOMAS; TIMBS, JOHN; TOWLER, J.; WHEATSTONE; WORDEN, JOHN. HISTORY: USA: 19TH C.

STEREO: 19TH C.
BOOKS

ST4448 Chadwick, William Isaac. *The Stereoscopic Manual.* "2nd ed." Manchester: J. Heywood, 189? 50 pp. illus.

ST4449 Jenkins, Harold F. *Two Points of View: The History of the Parlor Stereoscope.* Elmira, NY: World in Color Publications, 1957. 77 pp. illus.

ST4450 Darrah, William C. *Stereo Views: A History of Stereographs in America and Their Collection.* Gettysburg, PA: W. C. Darrah, 1964. 255 pp. illus.

ST4451 Darrah, William C. "Stereographs: A Neglected Source of History of Photography," on pp. 44-46 in: *One Hundred Years of Photographic History. Essays in Honor of Beaumont Newhall.* Edited by Van Deren Coke. Albuquerque, NM: University of New Mexico Press, 1975. 180 pp.

ST4452 *An Album of Stereographs: or, Our Country Victorious and Now a Happy Home.* From the Collections of William Culp Darrah and Richard Russack. Garden City, NY: Doubleday, 1977. 109 pp. b & w. illus.

ST4453 Darrah, William C. *The World of Stereographs.* Gettysburg, PA: W. C. Darrah, Publisher, 1977. 246 pp. b & w. illus. [Extensive survey, organized by generic subject content found in the stereo views; i.e. Botany, Civil War, South Africa, Yachting, etc. Each subject classification has a brief, informed essay about the photographers who worked in that area, with biographical information about the photographers and information about their works and published stereo series. Bibliography on pp. 238-242.]

ST4454 Earle, Edward W. ed. *Points of View: The Stereograph in America - A Cultural History,* Edited by Edward W. Earle. Foreword by Nathan Lyons. Rochester, NY: Visual Studies Workshop Press/Gallery Association of New York State, 1979. 119 pp. b & w. illus.

ST4455 Hastings Galleries. *The 'Darrah Collection of Stereo Views.* New York: Hastings Galleries Limited, 1979. 2 parts illus.

ST4456 Wilburn, John J. and T. K. Treadwell. *Stereo View Backlists.* Bryan, TX: National Stereoscopic Association, 1984. n. p. [ca. 90] pp. [An unbound set of xeroxed pages, consisting of a one page introduction, ten pages of alphabetical listings of stereo photographers, with their place of work, and then xeroxes of backlists (the reverse side of stereocards, with lists of prints available from each photographer. The intention was that additional sheets would be added from time to time, as they were gathered by the authors.]

PERIODICALS

ST4457 Stevens, W. Le Conte. "The Stereoscope: Its History." PHOTOGRAPHIC TIMES 12, no. 137 (May 1882): 145-152. [Address delivered before the Photographic Section of the American Institute, then published in the "Popular Science Monthly" in May 1882.]

ST4458 Stevens, W. Le Conte. "The Stereoscope: Its Theory. II." PHOTOGRAPHIC TIMES 12, no. 138 (June 1882): 190-195. 4 illus.

ST4459 Pratt, W. H. "Stereoscopic Vision." PHOTOGRAPHIC TIMES 17, no. 279 (Jan. 21, 1887): 35. [From "Science."]

ST4460 Stevens, W. Le Conte. "Stereoscopic Vision." PHOTOGRAPHIC TIMES 17, no. 280 (Jan. 28, 1887): 54. [From "Science." Reply to earlier article by Pratt.]

ST4461 Cheyney, W. A. "Stereoscopic Vision." PHOTOGRAPHIC TIMES 17, no. 282 (Feb. 11, 1887): 70-71.

ST4462 "The Stereoscope and Stereoscopic Photography." WILSON'S PHOTOGRAPHIC MAGAZINE 35, no. 502 (Oct. 1898): 472-275. [From: "Australasian Photographic Review." Brief survey of the evolution and demise of stereoscopic photography.]

ST4463 Boyer, Mildred. "The Stereoscope." AMERICAN ANNUAL OF PHOTOGRAPHY 1946 (1946): 160-166. illus.

ST4464 "Was It the First?" STEREO WORLD 1, no. 1 (Mar. - Apr. 1974): 12. 1 illus. [Illustration is of a stereo viewer, in the form of a book, manufactured by Langenheim & Loyd.]

ST4465 Darrah, William C. "American: Sentimental Stereographs." STEREO WORLD 1, no. 3 (July - Aug. 1974): 1, 10. 1 b & w. [Genre scene, by F. G. Weller in 1875. M. M. Griswold (Lancaster, OH); F. G. Weller (Littleton, NH); L. E. Walker (Warsaw, NY); Melander & Brother (Chicago, IL); A. P. Sherburne (Concord, NH); E. & H. T. Anthony; others discussed.]

ST4466 Bendix, Howard E. "Glass Stereo Views: A Statistical Review." STEREO WORLD 1, no. 3 (July - Aug. 1974): 2-4, 10. 1 b & w. [View of construction of the Suez Canal. Includes a table of 2870 pre-1870 glass stereo views held in American collections.]

ST4467 Russack, Rick. "Disasters." STEREO WORLD 1-2, no. 3-6, 1-2 (July - Aug. 1974 - May - June 1975): (vol. 1) 3:6, 4:11, 5:13, 6:12; (vol. 2) 1:5, 2:4. 1 b & w. [Illustration is of a fire, taken by E. Anthony or employee, in 1859. List of disaster views, arranged by state, then chronological.]

ST4468 Hoffman, Gordon. "Railroading in 3-D. Part I." STEREO WORLD 1, no. 4 (Sept. - Oct. 1974): 1, 5-9, 16. 13 b & w. [Illustrated with views by C. E. Watkins; Langenheim Brothers; Coleman Sellers; A. C. McIntyre; E. Anthony; W. M. Chase; C. W. Woodward; D. S. Damp; F. Jay Haynes; C. H. Freeman; R. B. Whittaker.]

ST4469 Hoffman, Gordon. "Railroading in 3-D. Part II." STEREO WORLD 1, no. 5 (Nov. - Dec. 1974): 2, 7-11, 13, 16. 13 b & w. [Illustrated with views by Alfred A. Hart; J. J. Reilly; Thomas Hous1eworth; E. & H. T. Anthony & Co.; Jackson Brothers; Charles

Weitfle; W. H. Lockwood; J. B. Silvis; Elmer & Tenney; J. Carbutt; Edward Clark; Underwood & Underwood. Views, from 1860s to 1900s.]

ST4470 Hoffman, Gordon. "Railroading in 3-D. Part III." STEREO WORLD 1, no. 6 (Jan. - Feb. 1975): 2, 5-9. 13 b & w. [Illustrated with views by A. J. Russell; Alfred A. Hart; C. R. Savage; Thomas Houseworth; Savage & Ottinger; Copelin & Melander. Views of the Union Pacific and Central Pacific railroads, taken in 1860s and 1870s.]

ST4471 Hoffman, Gordon D. "Stereo Celebrities of Times Gone By." STEREO WORLD 3, no. 1 (Mar. - Apr. 1976): 2-8. 17 b & w. [Stereo portraits by Moffat; London Stereoscopic Co.; E. & H. T. Anthony; J. Gurney; L. A. Richardson; M. H. Monroe; Sarony; C. Bierstaedt; others.]

ST4472 Hoffman, Gordon D. "Stereo Celebrities of Times Gone By." STEREO WORLD 3, no. 1 (Mar. - Apr. 1976): 2-8. 17 b & w. [Stereo portraits by Moffat; London Stereoscopic Co.; E. & H. T. Anthony; J. Gurney; L. A. Richardson; M. H. Monroe; Sarony; C. Bierstaedt; others.]

ST4473 Oestreicher, Richard. "Charlotte Kobogum et al v. the Jackson Iron Co." STEREO WORLD 3, no. 5 (Nov. - Dec. 1976): 16-17. 4 b & w. [Account of a legal battle between an iron mining company in Jackson, MI and a Chippawa Indian. Illustrated with a stereo portrait of the woman, and views of the mine, taken in the 1860s and 1870s by C. B. Brubaker, B. F. Childs and William B. Holmes]

ST4474 Oestreicher, Pam Holcomb. "Stereographs of American Indians." STEREO WORLD 4, no. 4 (Sept. - Oct. 1977): 12-17. 9 b & w. [Illustrated with stereos by S. J. Morrow (1880s); Bailey, Dix & Mead (1882); Bushman & Co. (1880s); T. H. O'Sullivan (1873); C. W. Carter (1880s); W. P. Bliss or Will Soule (1870s); Upton (1860s); George Barker (1880s).]

ST4475 Ryder, Richard C. "Environmental History in Stereo." STEREO WORLD 5, no. 3 (July - Aug. 1978): 4-16. 20 b & w. [Stereos of Buffalo, mining and timbering, etc. in the American West, by John P. Soule; J. J. Reilly; Keystone View Co.; R. P. Trivelpiece; N. A. Forsyth; H. C. White; Hillers; F. Jay Haynes; Charles R. Savage; Underwood & Underwood; others.]

ST4476 Rubin, Cynthia Elyce. "Shaker Stereo Views." STEREO WORLD 5, no. 6 (Jan. - Feb. 1979): 12-15. 7 b & w. [Views by E. T. Brigham (Lebanon, NH); James Irving (Troy, NY); H. A. Kimball (Concord, NH); W. G. C. Kimball (Concord, NH).]

ST4477 Waldsmith, John. "People Pictures of the Victorian Age: A Search for Examples." STEREO WORLD 6, no. 4 (Sept. - Oct. 1979): 12-15. 5 b & w. [Stereos by Edward Anthony; Keystone View; H. H. Bennett; M. M. Griswold.]

ST4478 Schear, A. F. "Building the Brooklyn Bridge." STEREO WORLD 10, no. 4 (Sept. - Oct. 1983): 4-15. 18 b & w. [Views of the bridge by Griffith & Griffith; Keystone Views, and others.]

ST4479 Ryder, Richard C. "Megatherium: Stereo's Most Photographed Fossil." STEREO WORLD 11, no. 2 (May - June 1984): 20-25, 33. 8 b & w. 1 illus. [Views by Salter & Judd; Centennial Photographic Co.; Charles Bierstadt; William J. Baker; J. L. Lovell; Knowlton Brothers; Royal H. Rose, and others.]

ST4480 Ryder, Richard C. "Dinosaurs Through the Stereoscope." STEREO WORLD 12, no. 1 (Mar. - Apr. 1985): 4-17, 39. 24 b & w.

[Illustrated with stereo views by the London Stereoscopic Co. (1860s); James Cremer (1876); Royal H. Rose (1876); Thomas W. Smillie (1870s); and later.]

ST4481 Rogers, Tom. "The Royal Botanical Gardens at Kew." STEREO WORLD 13, no. 3 (July - Aug. 1986): 33-35. 5 b & w. [Stereos by Valentine Blanchard; Griffith & Griffith; Stereoscopic Gems; B. W. Kilburn; Keystone.]

ST4482 Layer, Harold A. "The Literature of Stereoscopy: 1853 - 1986." STEREO WORLD 14, no. 1 (Mar. - Apr. 1987): 44-45. [Chronological listing of more than eighty books on stereoscopy.]

ST4483 Kerber, Roland A. "Stereo Plaster: The Rogers Groups." STEREO WORLD 14, no. 2 (May - June 1987): 4-12. 12 b & w. 2 illus. [Views of the genre statuary by John Rogers which was popular from 1860s through 1880s.]

ST4484 Hazen, Robert M. and Margaret H. Hazen. "American Brass Bands in Stereographs." STEREO WORLD 14, no. 2 (May - June 1987): 14-22. 15 b & w. 1 illus. [Stereos by P. G. Anderson (1870s); Wittick & Bliss (1880); Henry Bailey; W. M. Oldroyd; Robert M. Linn (1864); Barnum; Kilburn; Underwood & Underwood; others.]

ST4485 Carroll, Constance J. "A State Capitol's Stereo Record." STEREO WORLD 14, no. 6 (Jan. - Feb. 1988): 18-21, 2. 7 b & w. [Capitol building for New York State in Albany, NY. Views by Eugene Haines; H. C. White; Aaron Veeder.]

STEREO: BY YEAR
STEREO: 1851.
ST4486 "The Stereoscope." ATHENAEUM no. 1260 (Dec. 20, 1851): 1350.

STEREO: 1852.
ST4487 "The Stereoscope, Pseudoscope, and Solid Daguerreotypes." ILLUSTRATED LONDON NEWS 20, no. 524 (Jan. 24, 1852): 77-78. 18 illus. [Diagrams, etc. Includes review of Claudet's views of the Crystal Palace Exhibition.]

ST4488 "The Stereoscope, Pseudoscope and Solid Daguerreotype." PHOTOGRAPHIC ART JOURNAL 3, no. 3 (Mar. 1852): 173-178. [From "Illus. London News."]

ST4489 "The Stereoscope." ILLUSTRATED LONDON NEWS 20, no. 550 (Mar. 20, 1852): 229-230. 6 illus. [Diagrams.]

ST4490 "The Stereoscope." HUMPHREY'S JOURNAL 4, no. 1 (Apr. 15, 1852): 5-6. [From "The Athenaeum."]

ST4491 "The Stereoscope." PHOTOGRAPHIC ART JOURNAL 3, no. 5 (May 1852): 288-292. 7 illus. [From "Illustrated London News."]

ST4492 "Description of Several Prism-Stereoscopes and of a Simple Mirror-Stereoscope." HUMPHREY'S JOURNAL 4, no. 9 (Aug. 15, 1852): 139-142. [From "Philosophical Magazine." Author not credited.]

ST4493 "Description of Several Prism-Stereoscopes and a Simple Mirror-Stereoscope." PHOTOGRAPHIC ART JOURNAL 4, no. 3 (Sept. 1852): 155-157. [From "Philosophical Magazine."]

ST4494 "Vision with Two Eyes." HUMPHREY'S JOURNAL 4, no. 14 (Nov. 1, 1852): 216. [Brief survey of stereo experiments, mentioning Foucault and J. Regnault; Dove (1841).]

ST4495 "Improved Stereoscope." ART JOURNAL (July 1853): 177. 1 illus.

STEREO: 1855.

ST4496 "The Stereoscope, Pseudoscope, and Solid Daguerreotype." FRANK LESLIE'S NEW YORK JOURNAL n. s. 1, no. 3 (Mar. 1855): 172-174. 18 illus. [Taken, without credit, from the "Illustrated London News"(Jan. 24, 1852). Discusses Wheatstone's discoveries.]

STEREO: 1857.

ST4497 "Stereoscopic Pictures." PHOTOGRAPHIC AND FINE ART JOURNAL 10, no. 6 (June 1857): 180. [From "J. of Photo. Soc., London." No author given.]

ST4498 "The Stereoscope." PHOTOGRAPHIC AND FINE ART JOURNAL 10, no. 9 (Sept. 1857): 286. [From "Liverpool Photo. J."]

STEREO: 1858.

ST4499 "Stereoscopic Camera, Etc." PHOTOGRAPHIC AND FINE ART JOURNAL 11, no. 7 (July 1858): 220-221. [From "Liverpool Photo. J."]

ST4500 "The Stereoscope." PHOTOGRAPHIC AND FINE ART JOURNAL 11, no. 10 (Oct. 1858): 303-304. [Survey of activity in the field. Mentions the new New York Stereoscope Company. Then gives background on Ferrier (Paris); Clousard & Soulier (Paris); Croupier (Paris); London Stereoscopic Co. (London); Williams (London); Langenheim (Philadelphia); etc.]

STEREO: 1859.

ST4501 "The Stereoscope." ECLECTIC REVIEW n.s. 2 (110), (July 1859): 38-46. [Commentary on the stereoscope's impact, some early history.]

STEREO: 1860.

ST4502 "Stereoscopes for Amateurs - Process of Producing Stereoscopic Photographs." PHOTOGRAPHIC AND FINE ART JOURNAL 13, no. 5 (May 1860): 142-143. [From "Scientific American."]

ST4503 "Stereoscopes for Amateurs-Process of Producing Stereoscopic Photographs." AMERICAN JOURNAL OF PHOTOGRAPHY AND THE ALLIED ARTS & SCIENCES n. s. vol. 3, no. 1 (June 1, 1860): 14-16. [From Scientific American.]

ST4504 "Miscellaneous: Influence of the Stereoscope upon Popular Taste." PHOTOGRAPHIC NEWS 4, no. 95 (June 29, 1860): 107.

ST4505 "Our Illustrations. - II. Three Stereoscopic Views: - Leicester Hospital, Warwick; West Window, Banqueting Hall, Kenilworth Castle, and Brazenose College, Oxford." PHOTOGRAPHIC AND FINE ART JOURNAL 13, no. 7 (July 1860): Unnumbered page following 196; 212. 3 stereo b & w. [These are copies of English prints..."]

STEREO: 1861.

ST4506 "History and Discovery of the Stereoscope." HUMPHREY'S JOURNAL OF PHOTOGRAPHY, AND THE ALLIED ARTS AND SCIENCES 12, no. 21 (Mar. 1, 1861): 321-322.

STEREO: 1869.

ST4507 "The Eye and the Camera." HARPER'S MONTHLY MAGAZINE 39, no. 232 (Sept. 1869): 476-482. 11 illus.

STEREO: 1871.

ST4508 Clark, W. S. *Elements of Geography and History... Illustrated by Stereoscopic Views*. Rockford, IL: Clarke, Lake & Co., 1871. 401 pp. b & w.

STEREO: 1875.

ST4509 "The Renaissance of Stereoscopic Transparencies." ANTHONY'S PHOTOGRAPHIC BULLETIN 6, no. 7 (July 1875): 210. [From "Br J of Photo."]

STEREO: 1878.

ST4510 "The Stereoscope and Its Uses." PHILADELPHIA PHOTOGRAPHER 15, no. 175 (July 1878): 205-206. 2 illus. [From Dr. Von Bezold's "Theory of Color."]

INDEX TO AUTHORS

The main body of this reference work is organized alphabetically under the subject heading BY ARTIST OR AUTHOR. To avoid needless duplication, only books or articles which have a different author are listed here. For example, an article, authored by William Bell, which is located under *Bell, William A.* in the BY ARTIST OR AUTHOR section, will not be listed here. However, an article about William Bell, authored by John C. Browne, which is located under *Bell, William A.* in the BY ARTIST OR AUTHOR section, would be listed here as Browne, John C. see B613.

A

ABBOTT, JACOB see ST1521
ABEL, JOHN see H339
ABNEY, W. DE. W. see R343, ST3246
ACKLAND, W. see T626
ACKLEY, CLIFFORD S. see S924, ST617
ADAM, HANS CHRISTIAN see B470, S754, T302
ADAMS, JOHN COLEMAN see R39
ADAMS, ROBERT see ST2564
ADAMS, WASHINGTON IRVING LINCOLN see E64, F547, K129, K130, ST170
ADAMS, WASHINGTON IRVING see A366, C865
ADHÉMAR, JEAN see C221, N50, ST50
AIKMAN, JOHN L. see A284
AITKEN, CORA KENNEDY see ST1338
ALBERTOTTI, GIUSEPPE see T65
ALCOCK, SIR RUTHERFORD see B448
ALCOTT, AMOS BRONSON see ST2919, ST2920
ALDEN, HENRY M. see ST1480
ALDRIDGE, R. W. see ST1380
ALINDER, JAMES see W293
ALLEN, DANA L. see K200
ALLEN, H. see M1027, M1028
ALLEN, WILLIAM see S130, S963, ST1648
ALLISON, DAVID see S1221
AMBLER, JOHN see M72
ANDERSEN, HANS CHRISTIAN see ST2495
ANDERSON, NANCY see B776
ANDERSON, RALPH H. see W310
ANDERSON, ROBERT see ST577
ANDERSON, RUSS see W293
ANDERSON, WILLIAM see C702
ANDREW, ELLIOT see H612
ANDREWS, E. BENJAMIN see T37
ANDREWS, RALPH WARREN see ST2532, ST2533
ANGLE, PAUL see ST1712
ANNAN, J. CRAIG see H635
ANTHONY, E. & H. T. ANTHONY see B25, B1414, L44, L488, O45, W971
ANTHONY, EDWARD see C1048
ANTHONY, HENRY T. see M876, N172, R527, S1176, W1307, ST3955
ANTHONY, JOHN see P374
ANTISELL, THOMAS see H47
APPEL, ODETTE M. see S923
APPOLLO, KEN see S925, ST160
ARCHER, FANNY G. see A437, L211
ARCHER, TALBOT see C81, C82
[ARCHER, TALBOT was a pseudonym for W. JEROME HARRISON.]
ARMSTRONG, WALTER see H691, M1083
ARMYTAGE, DUDLEY see D614
ARNAKIS, GEORGE G. see S1098, S1100
ARNOLD, H. J. P. see T82

ARNOUX, J. J. see ST3334
ARTHUR, T. S. see R751, R753
ASH, RUSSELL see E185
ASHBEE, FELICITY see C240, C243
ASHE, E. D. see ST3218
ASQUITH, THOMAS see C1048, C1052, C1060
ATKINSON, J. BEAVINGTON see ST1259
ATKINSON, JOHN L. see ST1529
AUBREY, YVES see ST4341
AUCHINCLOSS, WILLIAM STUART see ST498
AUCHINLECK, FIELD-MARSHAL SIR CLAUDE see M28, ST1442
AUDSLEY, GEORGE ASHDOWN see ST1313
AVERELL, THOMAS W. see G623, S129
AVERY, MYRON H. see ST3023
AYERS, GEORGE A. see ST4055

B

BABBIT, JAMES E. see G160
BABCOCK, G. H. see F382, F383
BACHE, RENE see B598
BACHRACH, DAVID, JR. see C931, H761
BADEAU, ADAM see ST2273
BADEAU, W. H. see S231, S1039, ST473, ST1307, ST1308, ST1318, ST1333, ST1345, ST1356, ST3236, ST3274
BADGER, GERRY see F209, F211, K25, N322, W1180, ST577, ST619
BAEKELAND, LEO see B39
BAIER, W. see ST51
BAIRD, DONALD see R831
BAKER, W. J. see G421, M1002
BAKER, T. HERBERT see E61
BALDWIN, BROOKE EVANS see ST1760
BALDWIN, C. R. see T292
BALDWIN, GORDON see L197, ST565
BALLANTYNE, JAMES see H611
BALLANTYNE, ROBERT M. see B2053
BANGS, ELLA MATTHEWS see L53
BANNON, ANTHONY see ST3106
BANTA, MELISSA see ST151, ST1537
BARA, JANA see N444
BARGER, M. SUSAN see C801, ST18, ST160
BARKER, A. J. see F146
BARLOW, E. A. see ST1609
BARNARDO, MRS. SYRIE LOUISE see B245
BARNES, JOHN see ST116
BARR, PAT see ST1445
BARRETT, WAYNE see B1708
BARRIE, SANDY see ST459
BARROW, RICHARD W. see ST521
BARROW, THOMAS F. see C103
BARRY, PATRICK see ST1149
BARTRAM, MICHAEL see ST854
BATCHELDER, H. M. see ST3078
BATES, HENRY WALTER see B608
BATT, JOHN H. see B244
BATTERSBY, JOSEPH see ST4056
BATY, LAURIE ANNE see ST2979
BAUCHARD, RAOUL see D668
BAUDELAIRE, CHARLES see C222
BAUMANN, C. see A475
BAUMHOFER, HERMINE M. see O112
BEACH, REV. WILLIAM R. see T582
BEARD, WILLIAM HOLBROOK see M1030
BEATON, SIR CECIL see T86
BECCHETTI, PIERO see M108, ST1495

BECK, WALTER see D272
BECKER, WILLIAM B. see H693, H762, H764, ST107, ST159, ST265, ST880
BEDDING, THOMAS see ST4280
BEDE, CUTHBERT see T579
BEEBE, L. see J202
BELL, CLIVE see C48, C57
BELL, GEOFFREY see M1113
BELL, HENRY G. see A276
BELL, J. WHITFIELD see H805
BELL, MICHAEL see M733
BELLOC, AUGUSTE see T61
BELLOT, THOMAS see ST1428
BELLSMITH, P. R. see R1072
BELOUS, RUSSELL E. see S911, S914
BEMENT, WILLIAM B. see G641
BENDER, CHARLES see ST2288
BENDIX, HOWARD E. see A369, B786, ST4466
BENECKE, R. see ST3090
BENJAMIN, S. G. W. see ST2883
BENNETT, A. C. see B705
BENNETT, ALFRED W. see ST4423
BENNETT, GEORGE WHEATLEY see ST499
BENNETT, H. C. see ST4236
BENNETT, MIRIAM E. see B704
BENNETT, S. see F208
BENNETT, STUART see H850
BENSON, FRANCIS M. see M820
BENSUSAN, A. D. see ST444
BENTLEY, WILLIAM R. see W290
BENTON-HARRIS, JOHN see F214
BEREZIN, RONNA H. see B1226
BERKOWITZ, EDWARD B. see ST3308, ST3319, ST3343
BERLEPSCH, HERMANN ALEXANDER VON see ST1644
BERNHARDT, SARA see N22
BETJEMAN, SIR JOHN see C60, R127
BETTS, LILLIAN see N435
BEWICK, EILEEN see C263
BICKNELL, ANNA L. see B1752, D454
BIDDLE, CLEMENT see ST1314, ST2759
BIERSTADT, EDWARD see H171
BIGELOW, JACOB see ST1797
BILLING, ARCHIBALD see C688
BIRD, DR. GOLDING see ST909
BIRRELL, ANDREW see B122, B699, D135, H904, ST504, ST528
BISLAND, ELIZABETH see S1297
BISSON, GEORGE see N30
BLACK, CHARLES CHRISTOPHER see ST1353
BLACKBURN, MRS. J. see ST973
BLACKMAN, MARGARET B. see ST530
BLACKWELL, BASIL see R360
BLAIR, WILLIAM see P426
BLAKE, JAMES see W1121
BLAUROCK, CARL see J218
BLEILER, E. F. see G91
BLERY, GINETTE see N83
BLIVEN, FLOYD EDWARD see ST121
BLOCH, DON see P350
BLOORE, CAROLYN see D400, ST849, ST862
BLOSSOM, F. A. see J37
BLUMENFIELD, RALPH D. see S1211
BLUNT, WILFRED see C55
BOBIERRE, ADOLPHE see ST638
BOCHRAN, CARL M. see Q2
BOCKETT, JOHN see ST1207

BOERIO, LINA FIORE see T887
BOETTCHER, EDWARD see ST4077, ST4080, ST4081
BOGARDUS, JANET see ST3
BOLAND, JOHN F. see B1889
BOLAS, THOMAS see B1050, ST40, ST3261
BOLT, DICK see ST3047
BOND, W. C. see W653
BONI, ALBERT see ST12, ST16
BONNAR, THOMAS see H612
BONNEY, MABEL THÉÉRESE see ST573
BONNEY, T. G. see ST1644
BONOMI, JOSEPH see F572
BOORD, WILLIAM A. see C41
BOOTH, ARTHUR HAROLD see T71
BOOTH, JANE see ST2953
BOOTH, LARRY see ST18, ST2953
BOOZER, H. M. see ST2602
BORCOMAN, JAMES see H628, H682, N78, S26, ST839
BORDA, A. V. see R322
BORLAND, H. see J186
BOSSEN, HOWARD see J228
BOSWELL, see T864
BOTHAMLEY, C. H. see ST173
BOTT, RITA ELLEN see M612
BOUILHON, ED. see N308
BOULONGNE, A. see T60
BOWKER, R. R. see E209
BOX, JOHN see ST1298
BOYD, JOHN see ST190
BOYER, MILDRED see ST4463
BOYESEN, HJALMAR H. see J26, R670
BOYLE, C. B. see B935, M984
BOYLE, JOHN JR. see P161
BRADFORD, WILLIAM see D733
BRADY, THOMAS J. see B1690, F205
BRAINARD, CHARLES H. see V115, V116, V117
BRAIVE, MICHEL-FRANÇOIS see N43, N47, ST49, ST125, ST226, ST602
BRAMSEN, HENRIK BOE see ST122
BRANSON, DR. see ST1948
BREADY, JOHN see B246
BREISCH, KENNETH A. see P110
BRENBEAUX, PAULINE see W321
BRESEMANN, HANS-JOACHIM see ST20
BRETTELL, RICHARD R. see ST583, ST848
BREWSTER, SIR DAVID see C585, D776, T153
BREY, WILLIAM see B726, C150, C215, C216, C867, C869, D496, L110, M254, O121, R55, R56, W626
BRICKERHOFF, SIDNEY B. see ST2926
BRIDGEMAN, HARRIET see C55
BRIGGS, ASA see ST836
BRINKERHOFF, J. DEWITT see H183, H184
BRINTON, DR. D. G. see L241
BRION, GUSTAVE see T907
BRISBART-GOBERT, E. see ST639
BRIZZI, BRUNO see P108
BRODHEAD, LUKE WILLS see G425
BROECKER, WILLIAM L. see J54
BRONS, MARIEANNE see ST122
BROOKE, C. see ST938
BROUGHAM, LORD see ST1289
BROUGHTON, LORD HENRY see C461
BROWN, BRYAN see T333
BROWN, BUCKMINSTER see H297
BROWN, GEORGE see T264

BROWN, J. J. see T764
BROWN, J. T. see ST1024
BROWN, J. W. see H340
BROWN, JOHN THOMAS see ST3438
BROWN, LEWIS S. see M1037
BROWN, MARK HERBERT see H1039, H1040, H1044
BROWNE, G. WALDO see N445
BROWNE, JOHN C. see B613, B1606, C304, G132, H913, W164, ST4218, ST4221, ST4223
BROWNE, JUNIUS HENRI see ST1525, ST2700
BRUCE, DAVID see H624
BRUCE, JOHN see ST2103
BRUCE, JOSIAH see N343
BRUSHFIELD, T. N. see ST1015
BRYAN, TOM see B1705
BUBERGER, JOE see R925, ST258
BUCHANAN, GEORGE see H675
BUCHANAN, REV. R. see C830
BUCHANAN, WILLIAM see ST849
BUCKLAND, GAIL see F145, T84, T314, T315, ST129, ST137, ST836, ST1571
BUDGE, ADRIAN see ST845, ST897
BUEHMAN, ESTELLE M. see B1986
BUERGER, GOTTFRIED, see C37
BUERGER, JANET E. see B241, B658, D112, J227, L245, N74, P235, ST160, ST580, ST586, ST612
BUGEJA, VINCENT see ST194
BULL, A. J. see T269, T270, ST201
BULLINGTON, NEAL R. see S198
BULLOCK, JOHN G. see G399
BUNNELL, PETER C. see N440
BUNTING, W. H. see ST3041
BURANT, JIM see ST508, ST535, ST4249
BURCHARD, REV. S. D. see L160
BURGESS, JAMES see B1297, B1298, S1451, S1452
BURGESS, N. G. see P100, ST4048
BURKE, KEAST see S753
BURNETT, C. J. see H61, ST1037
BURNHAM, S. W. see B205, B206
BURNS, E. BRADFORD see M1046
BURNS, ROBERT see G84
BURNS, STANLEY B. see ST277, ST1665
BURR, S. J. see H202
BURRITT, ELIHU see ST1187
BURTON, LADY ISABEL see ST1586
BURTON, WILLIAM K. see P516
BURTY, PHILLIPE see ST697, ST3298
BUSEY, SAMUEL C. see ST2980
BUSS, R. W. see ST964
BUTTMANN, GUNTHER see H489
BYERS, S. H. M. see ST2269

C
CADY, D. K. see ST3606
CALHOUN, MAJOR A. R. see B609
CALMENSON, WENDY CUNKLE see S540
CAMINOS, RICARDO A. see T287
CAMERON, JOHN B. see ST159
CAMERON, NIGEL see ST544
CAMP, WALTER see P30
CAMP, WILLIAM L. see ST3114
CAMPBELL, CATHERINE H. see B787
CAMPBELL, RONALD see ST1031
CAMPBELL, W. see C1027
CAMPBELL, WILLIAM see ST2528

CANFIELD, C. W. see D89, D91, H39, ST34, ST35, ST36, ST37, ST38, ST39, ST591, ST1679, ST4288, ST4318, ST4350, ST4364
CANNON, MICHAEL see ST457
CAPRON, J. RAND see ST3258
CARBUTT, JOHN see ST3659
CARDEN, R. A. see 3022
CARELLA, ELIZABETH see B1217
CAREY, BRIAN see D499, ST517
CAREY, MISS ELIZABETH SHERIDAN see ST922
CAROLSFELD, JULIUS S. VON see A115
CARPENTER, JAMES see B1285, N68, W871
CARPENTER, WILLIAM B. see B1796
CARR, LYELL see S112
CARROLL, CONSTANCE see ST4485
CARROLL, PROF. CHARLES see ST2877
CARSON, MARIAN S. see C801, C803
CARTER, KATE B. see ST3164
CARTWRIGHT, H. MILLS see T268
CARVER, GEORGE T. see ST14
CARY, ELISABETH L. see C44
CARY, SAMUEL FELTON see W746, R776
CASE, RICHARD G. see B236
CASSELL & CO. see D553
CASSON, HERBERT N. see P44
CASTLE, PETER see ST127
CATE, PHILLIP DENNIS see ST611
CATO, JACK see ST456
CAVA, PAUL see L219
CAVELTI, JOHN see ST2165
CAW, JAMES L. see H612
CECIL, LORD DAVID see C59
CEILEUR, A. see ST3978, ST3981
CHADWICK, WILLIAM ISAAC see ST4448
CHAMBERLAYNE, REV. I. see ST460
CHAMBERLIN, GARNY N. see W765
CHAMBERS, ROBERT see H678
CHAMPNEY, J. WELLS see ST169
CHANAN, NOEL see ST893
CHANDLER, CHARLES F. see L83
CHANDLER, VIRGINIA see H193
CHANUTE, OCTAVE see ST3089
CHAPLIN, CHRISTINE see ST2659
CHAPMAN, HAROLD see F601
CHAPPELL, WALTER see R318
CHASE, ADELAIDE see ST41
CHATFIELD-TAYLOR, H. C. see S913
CHENEY, C. D. see F247
CHEVEDDEN, PAUL E. see B1223, ST1570, ST1578, ST1579
CHEVREUL, M. E. see N261, N287
CHEYNEY, W. A. see ST4461
CHIARENZA, CARL see ST131
CHISOM, C. R. & CO. see H420
CHITTENDON, L. E. see ST1693
ÇIZGEN, ENGIN see ST1646
CHRIST, YVAN see N321, ST594, ST604, ST606, ST607
CHRISTI, J. R. R. see B1737
CHUTE, ROBERT J. see G272, G274, ST3643, ST4196
CIAMPOLI, JUDITH see G147, G158, ST3088
CLAFIN see B901
CLAFTEN, AGNES ELIZABETH see ST2658
CLARK, CAROL see J56
CLARK, JAMES ALBERT see ST3157
CLARK, LYONEL see A27
CLARK, U. T. see F247
CLARK, W. S. see ST4508

CLARK, WALTER see ST586
CLARK-MAXWELL, PREBENDARY W. G. see T267
CLARKE, FRANK W. see B2062
CLARKE, MARY COWDEN see ST1406
CLARKE, THOMAS see ST1416
CLARKE, W. H. see ST2823
CLAUDET, ANTOINE see N312, ST3464, ST3472, ST3476
CLAUDY, C. H. see ST1699
CLEMONS, JOHN R. see A441, ST4126
CLOSS, G. see ST1644
CLOUTIER, NICOLE see ST537
COALE, GEORGE B. see W715
COAR, VALENCIA HOLLINS see ST1666
COBB, JOSEPHINE see B1682, G142, G143, ST2292
COBURN, ALVIN LANGDON see ST870
COCHRAN, CARL M. see Q2
CODMAN, JOHN see J104
COE, BRIAN W. see E185, S775, S776, T307, ST255
COFFIN, ROBERT BARRY see S788
COFFIN, EDWARD F. see ST3046
COHEN, MORTON N. see C251, C253, C254
COHEN, REV. A. D. see C733
COHN, ALAN M. see D426
COHN, MARJORIE B. see G428
COKE, VAN DEREN see C58, D781, E112, R967, ST67, ST123,
ST245, ST1723, ST3019, ST3099
COLAS, F. see C466
COLE, LIEUT. HENRY HARDY see B2031, S511, S614
COLE, TIMOTHY see S1087
COLERIDGE, SAMUEL TAYLOR see T59
COLLINGWOOD, STUART D. see C248, C250, C256
COLLINS, KATHLEEN FULLER see L432, ST148, ST901, ST1503,
ST2303, ST2309, ST2311, ST2312, ST2313, ST2315, ST2316
COLLINS, LYDIA see P74
COLLINS, TOM J. see ST255
COLLINS, WILKIE see C934
COLLMAN, MILDRED see J53
COLLMAN, RUSS see J49
COLSON, RENE see T64
COLTON, CAPT. W. F. see B609
COLVIN, SIDNEY see V12
COMBS, BARRY B. see R924
CONANT, BLANDINA see B1740
CONANT, S. S. see ST501
CONDAX, PHILIP L. see ST98
CONDUCHE, ERNEST see ST669
CONINGHAM, WILLIAM see ST1083
CONKLIN, ENOCH see ST2924
CONLEY, MRS. see R1085
CONSTABLE, A. G. see ST1482
CONSTANTINI, PAOLO see R916
CONTENCIN, JAMES see ST1061, ST1085
CONWAY, M. D. see ST3310
COOK, H. see R704
COOKE, GEORGE WILLIS see N349
COONEY, CHARLES F. see R970
COOPER, CHARLES H. see F569
COOPER, EVELYN S. see B1992, F370
COOPER, H., JR. see W1359
COOPER, H. STONEHEWER see ST1966
COOPER, J. D. see T565
COOPER, THOMPSON see L461
COOPER, W. A. see S120
COPPEE, HENRY see ST2498
COPJEC, JOAN see ST618

COPLANS, JOHN see W323
COPPENS, JAN see W1247
COPWAY, GEORGE see ST1830
CORBET, ROBERT ST. JOHN see ST1250
COREMANS, P. see ST476
CORTISSOZ, ROYAL see A153
COSTINESCU, PETER see S1273
COTTIN, MADELINE see D667
COTTINGTON, IAN E. see ST297
COULTER, EDITH M. see V47
COUPLAND, REGINALD see K198
COUSINS, THOMAS see L192
COWAN, AILEEN GIBSON see T616
COYNE & RELYEA see H953, W517
CRABTREE, J. I. see ST92
CRAIG, JOHN S. see B879, J319, S668, W1234, ST2296
CRAMB, JOHN see ST3437
CRAWFORD, ALISTAIR see T496
CRAWFORD, WILLIAM see ST142
CRCEVIC, NADA see ST554
CROFUTT, GEORGE A. see H955, S168, W289
CROMBIE, ISOBEL see B447
CROSSETTE, BARBARA see ST1755
CROSSWHITE, TERRY see N69
CROUCHER, J. H. see L194
CROUGHTON, GEORGE see S1301, ST1302
CROWLEY, WILLIAM see S1183
CRUIKSHANK, PERCY see D10
CULL, RICHARD see T256
CULP, EDWIN D. see ST3137
CULVER, D. JAY see J209, ST1717
CUMMINGS, THOMAS HARRISON see R515
CUNNINGHAM, A. see ST341
CUNNINGHAM, C. D. see A23
CURRAN, T. E. see ST2947
CURRAN, THOMAS see F263
CURRENT, KAREN see ST2539
CURRENT, WILLIAM R. see ST2539
CURSITER, STANLEY see H641
CURTIS, EDWARD see ST3225
CUTTING, JAMES see C1107
CZACH, MARIE see ST2995

D
DA CUNHA, JOSEPH GERSON see ST1488
DAFFORNE, JAMES see H687, H690
DAGUERRE, J. L. M. see ST1794, ST1798
DALLAS, DUNCAN C. see ST873
DALLENBAUGH, FREDERICK S. see H768
DALLMEYER, THOMAS R. see ST3202
DALTON, OSCAR G. see M276
DANA, CHARLES A. see ST2276
DANA, RICHARD HENRY see F66
DANCER, J. B. see B1290
DANIELS, DAVID see ST2925
DANLEY, SUSAN see R928
DARCEL, ALFRED see N16
DARRAH, WILLIAM CULP see B362, F127, H778, M640, ST143,
ST3024, ST4450, ST4451, ST4453, ST4465
DARWIN, CHARLES see R124, R125
DASS, MUNSHI BULAQUI see S479
DAUX, GEORGES see N320
DAVIDSON, CARLA see E9, ST1729
DAVIDSON, JAMES BRIDGE see F138
DAVIDSON, MARTHA see ST1561

DAVIE, D. D. T. see C1066, C1071, G604, H187, H756, S849, ST3929, ST4181, ST4182
DAVIES, ALAN see ST458
DAVIES, SAMUEL J. see S339
DAVIES, TOM see ST3186
DAVIES, W. H. see ST1180, ST1182
DAVIS, CHARLES see T593
DAVIS, MRS. D. T. see ST1686
DAVIS, DOUGLAS see C109
DAVIS, E. H. see S1006
DAVIS, HARTLEY see R49, R50
DAVIS, HUGH see B1937
DAVIS, J. A. see O71, ST3172
DAVIS, KEITH F. see B212, B240, B242, C342, ST266, ST2304
DAVIS, LYNN see ST2990
DAVIS, WILLIAM C. see C745, E116, ST2167, ST2169
DAVISON, J. ROBERT see ST511
DAVY, SIR HUMPHREY see W507, W513
DAWSON, GEORGE see H119, S1336, S1421
DAY, DIANE L. see ST1767
DE LA FIZOLIÉRE, ALBERT see ST639
DE MONTEBELLO, PHILIPPE see ST578
DE SAINT VICTOR, PAUL see B1739
DE SILVA, A. M. see L37
DE SORMO, MAITLAND D. see S1181, S1182
DE VRIES, LEONARD see F143
DEARSTYNE, HOWARD see C732
DEBELJKOVIC, BRANIBOR see ST1626
DECOSTA, BENJAMIN FRANKLIN see ST3026, ST3027
DEELY, CHARLES A. see P71
DEFOE, DANIEL see S1223
DEKOVEN, REGINALD see F46
DEKOVEN, MRS. REGINALD see R683, S1121
DELABORDE, HENRI see B859
DELAFFOYS see ST735
DELARIVIORRE, F. A. see C517
DELAROCHE, HIPPOLYTE see B859
DELLENBAUGH, FREDERICK S. see B355
DEMAILLIE, RAYMOND J. see G159
DENNIS, M. J. see C1089
DENNY, C. B. see ST4175
DERCUM, F. X. see M1028
DESCHIN, JACOB see C742
DESMOND, ARTHUR W. see ST2155
DESMOND, RAY see ST1443, ST1445, ST1447, ST1449
DETAILLE, ALBERT see N45, N48, N52
DETZER, K. see J185
DEUTELBAUM, MARSHALL see ST100
DEVYLDER, G. see ST3314
DEWAN, JANET see T869, T871, T872, T873
DEXTER, LORRAINE see G57
DIAMOND, HUGH W. see ST3315
DIBBLE, CHARLES E. see J203
DICKER, LAVERNE MAU see W321, ST2933
DIGUILIO, KATHERINE see ST858
DIMOCK, GEORGE see B1724, W298
DIMOND, FRANCES see ST863
DINGUS, RICK see O101
DISCH, THOMAS N. see C264
DIX, JOHN ROSS see J347
DIXON, EDWARD HENRY see ST2418
DIXON, HENRY see B919
DJORDJEVIC, MIODRAG see J377
DOBRAN, JOHN see M994
DOHERTY, AMY S. see W319

DONALD, DAVID see ST2158
DONALDSON, MARY KATHERINE see W161, W848
DONAGHE, M. VIRGINIA see J23
DONELLY, CAPT. see ST1069, ST1070, ST1071
DORÉ, GUSTAVE see T586
DOREMUS, C. A. see ST3272
DOTY, ROBERT see J213, O113, T609, ST224, ST600
DOUGLASS, G. A. see ST3001, ST3003, ST4056, ST4066
DOWER, JOHN W. see ST1534
DOWNING, J. DE GRAY see B1313
DOWSE, THOMAS STRETCH see L410
DRAKE, GREG see ST3095, ST3173
DRAKE, SAMUEL ADAMS see W236
DRAPER, E. see R181
DRAPER, H. see ST2038
DRAPER, JOHN W. see ST3999, ST4010, ST4013
DREW, FREDERICK see F592, F593
DRIGGS, HOWARD R. see J35, J38, J40
DRUCKERY, TIMOTHY see ST1787
DRUMMOND, A. J. see S1055, S1056, ST3597
DRURY, CLIFFORD MERRILL see P154
DRURY, ELIZABETH see C55
DRYER, G. W. see ST4086
DUBOIS, PATTERSON see ST1627
DUBY, ERNEST see J234
DUDLEY, R. see B500
DUHOUSSET see M1064
DUNBAR, ALEXANDER see H654
DUNCAN, R. BRUCE see P480, S236
DUNCAN, ROBERT G. see K92, M848, ST1777, ST2566, ST2567, ST2568
DUNWOODY, H. H. C. see S1229
DUPLESSIS, GEORGE see C960
DUPREZ, LOUIS see ST1288
DURHAM, J. see ST3500
DURRIE, DANIEL S. see J352
DUSSANCE, H. see C1106, C1108
DUTTON, CLARENCE EDWARD see H766, J16
DYER, THOMAS H. see ST1433

E
EARL MOUNTBATTEN OF BURMA see ST1444
EARL, AUSTIN T. see ST3549
EARLE, EDWARD W. see ST4454
EAST, CHARLES see ST2169
EDEL, CHANTAL see B420
EDER, JOSEF MARIA see N279, P540,
EDGE, SARAH see ST859
EDGERLY, JOSEPH G. see M949
EDIDIN, STEPHEN R. see B899
EDKINS, D. E. see J54
EDMUNDS, A. C. see E23
EDWARDS, CONLEY L., III see C743
EDWARDS, ELIZABETH see ST846
EDWARDS, GARY see ST156, ST1426
EDWARDS, R. see H663
EDWARDS, RICHARD see B1890
EGAN, JOSEPH B. see ST2155
EGERTON see ST942
EGERTON, J. see L363, L366
EHNINGER, JOHN W. see A105, B1411
EHRENKRANZ, ANNE see S1101
EHRLICH, GEORGE see ST1654
EHRMANN, CHARLES see C866 P12, S275, S276, S282, W752, ST162, ST163, ST164, ST179, ST1682, ST3260

EISENSTEIN, SERGEI M. see ST271, ST614
EISLER, COLIN see S1101
ELLIOTT, J. PERRY see ST2666, ST4090
ELLIS, JOSEPH see C468
ELLS, M. see G177
ELROD, J. C. see ST3006
ELSON, HENRY E. see ST2153
ELWALL, ROBERT see ST3737
ELZROTH, ELSBETH L. see ST1763
EMBREE, AINSLIE see ST1444
EMERSON, E. see B1805
EMERSON, PHILIP H. see C41, C83, R186
ENGLISH, DONALD E. see A395, ST584
ENGLISH, DUNN T. see ST1847
EPSTEIN, EDWARD see D100, N275, T265, ST197, ST202, ST3262
ESKILDSEN, U. see A129
ESKIND, ROBERT WALL see ST3932
EVANS, CHARLES see ST4200
EVANS, DAVID S. see H488, H489
EVANS, SUSAN see B1991
EVANS, THOMAS C. see ST497
EWERS, JOHN C. see E8

F

FABER, PAUL see B2071
FAGAN, BRIAN M. see F602, F628
FAGAN-KING, JULIA see C121
FAGNANI, GIUSEPPI see ST2496
FAIRBANKS, EDWARD T. see G7
FAIRMAN, CJARLES E. see J172, M621
FALCONER, JOHN see H902, P96, R890, ST541, ST892, ST1453
FALCONER, PAUL A. see M1116
FALKENER, EDWARD see ST1062
FALLAIZE, ELIZABETH see C217
FARGIER see F70
FARNHAM, REV. LUTHER see M295, S930, W698
FEATHERSTONE, DAVID see W293
FECHET, EDMUND G. see B295
FELDVEBEL, THOMAS P. see ST138
FELS, NORMAN B. see ST1783
FELS, THOMAS WESTON see M1045, R927, W295
FELTON, W. R. see H1039, H1040, H1044
FENTON, JAMES see ST3192
FENTON, LENA R. see F200
FENTON, ROGER see ST3500
FERBER, LINDA S. see S1101
FERGUSSON, JAMES see B840, B841, B842, B2009, G305, G306, L460, P287, W262
FERN, ALAN see P351, ST2165, ST2294
FERNANDEZ, RAMIRO A. see ST555, ST1561
FERREZ, GILBERTO see ST490
FERRIS, C. see C1082
FERTE, RENE DE LA see P242
FEVRET DE SAINT-MEMIN see G534
FIELD, RICHARD S. see ST1672
FIELDER, MILDRED see J47
FIELDING, A. G. see R199
FIERLANTS, M. E. see ST3302
FILIPPELLI, RONALD L. see D574
FINCK, HENRY T. see T5
FINDLAY, WILLIAM see W1177
FINK, DANIEL A. see ST97, ST267
FINK, MAURICE see B298
FINKEL, KENNETH see C805, L111, ST3140, ST3146

FINLEY, M. see H1125
FINNEY, W. E. ST. LAWRENCE see M1035
FISCH, MATHIAS S. see J221
FISCHER, HAL see M1117
FISHER, J. A. see A299
FISHWICK, MARSHALL see M686, M690
FISK, S. R. see ST2471
FITCH, GEORGE H. see T30
FITCH, ROBERT G. see ST3070
FITZGIBBON, J. H. see C1052, C1057, C1064, H720, H737, L596, ST4120, ST4121, ST4142, ST4154, ST4374
FLAGG, WILSON see ST2627, ST2724
FLATO, CHARLES see B1675
FLEMING, PAULA RICHARDSON see ST2543
FLETCHER, STEPHEN J. see W345
FLUCKINGER, ROY see B371, C469, S877, ST141, ST160, ST583, ST848, ST855
FONDILLER, HARVEY V. see C113
FONTANELLA, LEE see ST1630, ST1631
FONTAYNE, CHARLES see H572
FOOTE, KENNETH E. see D481
FORBES see K265
FORBES, ALEXANDER KINLOCH see J318
FORBES, ARCHIBALD see A393, A394
FORBES, JAMES W. see K268
FORD, COLIN J. see C56, C110, C112, H623, H625, ST883
FORDYCE, ROBERT PENN see ST3101
FOREST, WILLIAM S. see W777
FORREST, J. A. see ST3216
FORSEE, AYLESA see J48
FORSTER, REV. CHARLES see B1894
FORSTER-HAHN, FRANÇOISE see M1039, ST787
FORSYTH, SIR T. D. see C337, T877, ST1483
FORT, PAUL see D308, F215, F216, M36, R889, S1222
FOSKETT, ROBERT see K197
FOSTER, ALASDAIR see ST292
FOSTER, PETER LE NEVE see ST1409, ST3799
FOURDRIGNER, EDOUARD see ST85
FOWLER see F353
FOWLER, CATHERINE S. see H779
FOWLER, DON D. see H771, H772, H779
FOWLER, R. J. see ST723
FOX, GEORGE H. see B794
FRAENKEL, HERBERT E. see H614
FRALIN, FRANCES see ST149
FRANCIS, G. see ST306
FRANCIS, RELL G. see A258, A259
FRAMPTON, HOLLIS see M1112
FRANK, HANS see ST467
FRANKLIN, JOHN HOPE see L662
FRASER, ALEXANDER see A283, H612
FRASSANITO, WILLIAM A. see B1698, G157, O117, ST2163, ST2164, ST2167, ST2168, ST2169
FRAZER, J. F. see ST1794
FRAZIER, ARTHUR H. see S217, S219
FREDERICKS, CHARLES D. see C1073, C1075
FREEMAN, HENRY see ST2659
FREEMESSER, BERNARD L. see ST14
FREITAG, WOLFGANG M. see ST268
FREMONT, JOHN C. see C271
FRENCH, W. A. see D97
FREUND, GISÉLE see H643, ST579
FRICK, BERTHA M. see ST3
FRISWELL, J. HAIN see C938
FROEBE, TH. W. see S536, S537

FROELICHER, O. see ST1644
FROHMAN, DANIEL see F42
FROST, JOHN see ST1804
FRY, HERBERT see W359
FRY, PETER see W355
FRY, ROGER see C46, C51
FRYXELL, FRITIOF MELVIN see J45, J180, J184
FULLER, JOHN CHARLES see D579, R195, S1201, ST832, ST1727
FULLER, SUE E. see ST2977
FULLERTON, RICHARD D. see ST3127
FURNEAUX, J. H. see B304, B1303, D6, D246, N244, ST1441

G

GABRIEL, CLEOTA REED see ST3103, ST3112
GAFFIELD, THOMAS see M216
GAGE, F. B. see C1058, C1063
GALASSI, PETER see ST66
GALE, CHARLOTTE see R817, ST1776
GALE, DAVID M. see R817, ST1776
GALTON see ST1404
GALUSHA, HUBH D., JR. see H333
GAMAREKIAN, BARBARA see ST2557
GAMBEE, BUD LESLIE, JR. see ST4298
GAMGEE, J. S. see P234
GARBANATI, H. see C1026, C1029, D487
GARDNER, ALEXANDER see B208, M942, O90
GARDNER, J. B. see ST1680
GARDNER, JAMES T. see B188
GARNER, M. A. K. see W1377
GARNER, PHILLIPE see S578
GARZTECKI, JULIUSZ see ST1565, ST1613
GASPEY, WILLIAM see B370
GATCHEL, W. D. see S1271
GAUDIN, CHARLES see ST663
GAUDIN, MC.-A. see B1266
GAUTIER, THÉOPHILE see P298, ST675, ST1650
GAVIN, CARNEY E. S. see B1214, B1216, B1222, B1224, ST1577
GEDDES, J. D. see ST4393
GEORGE, HERFORD BROOKS see E60
GERNSHEIM, ALISON see F144, N276, S1057, ST120
GERNSHEIM, HELMUT see B489, C57, C249, C255, C638, D24, D25, F144, F201, H661, H1168, N276, N278, S1057, S1340, T284, T615, ST23, ST120, ST145, ST831
GERRY, ELBRIDGE T. see M980
GIBBS-SMITH, CHARLES H. see C58
GIBSON, H.L. see M1099
GIDAL, NACHUM T. see ST1572
GIDDENS, PAUL HENRY see M324
GIFFEN, HELEN S. see W311
GILBERT, GEORGE see O118, ST1757
GILDER, RICHARD WATSON see ST2281
GILHON, JOHN H. see S533
GILL, ARTHUR T. see B415, C744, F418, G355, H453, H454, H455, H517, M529, M531, R76, R517, T290, T291, T293 - T299, T301, T303, T304, T312, W1232, ST99, ST255, ST881
GILMAN, SANDER L. see D399
GIMON, GILBERT see I38
GINSBERG, LOUIS see ST3168
GIRARD, AIMÉ see R993
GIRARD, GERARD see ST450
GLADSTONE, WILLIAM see R968, ST1500, ST1780, ST2314
GLAISHER, JAMES see ST3330, ST3353
GLANFIELD, COLIN see ST3187
GLASSMAN, ELIZABETH see ST278
GLAZER, WALTER S. see W853

GLENN, JAMES R. see G303, M23, V120
GODDE, JULES see B856
GODFREY, E. S. see B294
GOLDMAN, RICHARD H. see B788
GOLDSCHMIDT, LUCIEN see ST19
GOLLIN, RITA K. see B1707
GOODMAN, THEODOSIA TEEL see ST3136
GOODRICH, ARTHUR see E212
GOODRICH, L. CARRINGTON see ST544
GORDON, MRS. see B1773
GORDON, DANIEL M. see S460
GORDON, GENERAL JOHN B. see ST2278, ST2279
GORRINGE, HENRY H. see B795, H247
GORSHINE, DOUGLAS see J48
GOSSER, H. MARK see T318
GOULD, ROBERT HOWE see ST1651
GRAHAM, DAN see M1108
GRAHAM, M. see T332
GRAHAM, ROBERT see B1811, B1812
GRANGEDOR, J. see ST732
GRANT, A. G. see ST1026
GRANT, M. see W676
GRAVER, NICHOLAS M. see ST113, ST616, ST3109
GRAY, JOHN MILLER see H612
GRAY, JOHN S. see ST2554
GRAY, MICHAEL see W1246
GRAY, PRISCILLA MARIE see M954
GRAY, THOMAS see ST1251
GRCEVIC, NADA see P98
GREEHILL, BASIL see F599
GREELY, GENERAL A. W. see ST2277
GREENHILL, GILLIAN B. see H1089, R522, W874
GREENHILL, RALPH see H801, ST503, ST504, ST3100
GREENLEAF, C. J. see J177, J178
GREENOUGH, J. B. see P23
GREENSHIELDS, E. B. see S1096
GREY, JAMES see G239
GRIERSON, S. see C257
GRIFFIN, SIR LEPAL H. see D245
GRIFFIS, WILLIAM E. see B441
GRIFFITH, MICHAEL W. see ST2988
GRIMMER, G. see N33, N34, N36
GRISCOM, ANDREW see ST3094
GRISWOLD, DR. C. D. see ST1979
GROENEVELD, ANNEKE see B2071, ST564, ST1574
GROMET, MICHAEL see ST1731
GROSS, M. see N274, ST89
GROSSCUP, JEFFREY P. see I12
GROVER, JAN ZITA see ST2310
GRUBEMAN, WILBER see A84
GUAY, LOUISE see H437
GUERNSEY, A. H. see P72
GUILBERT, EDMUND see R583
GUILIANO, EDWARD see C252
GUILLEMAIN, CHARLES see B46
GUNCKEL, LEWIS W. see J111
GUPTILL, A. B. see H331
GURTNER, H. see M1098
GUTEKUNST, F. see J23
GUTMAN, JUDITH MARA see ST1448
GUTMAN, KELLY O. see ST2166
GUTMAN, RICHARD J. S. see ST2166
GWYNNE, MRS. F. P. see A160

H

HINE, THOMAS CHAMBERS see ST1373, ST1407
HINSLEY, CURTIS M. see ST151
HIRN, SVEN see ST572
HISLOP, W. see ST1021, ST1023
HITCHCOCK, CHARLES H. see C646, C649, S1275
HITCHCOCK, EDWARD see L631, L633, M695, S1274, S1275
HITTELL, JOHN S. see M1020
HOBART, GEORGE see B1432
HOERNER, LUDWIG see H817, P246
HOFFENBERG, H. L. see ST2101
HOFFLEIT, DORRIT see W757, ST3210
HOFFMAN, GORDON see ST4468, ST4469, ST4470, ST4471, ST4472
HOGG, JAMES see H676
HOLDEN, EDWARD S. see C80
HOLLIDAY, J. S. see R924, ST2942
HOLLOWAY, LISABETH M. see ST3151
HOLM, ED see ST4396
HOLMES, JON see J220
HOLMES, OLIVER W. see B922, S1083
HOLT, GLEN E. see ST2996
HOLTERMANN, BERNARD OTTO see M658
HOLZER, HAROLD see ST2299, ST2300
HOMER, RACHEL JOHNSTON see H298
HOMER, WILLIAM I. see M1104, M1105
HOOBLER, DOROTHY see B1430
HOOBLER, JAMES A. see B211
HOOBLER, THOMAS see B1430
HOOD, MARY V. see M1106, W520
HOOPER, BRUCE H. see H781, M729, P114, W910, ST2927, ST2928, ST2929, ST2930
HOOPER, LUCY HAMILTON see ST2485
HOOPER, W. see ST63
HOOVER, CATHERINE see J351
HOPE, THEODORE C. see B840, L437
HOPKINS, HARRY see C107
HOPKINSON, AMANDA see C66
HORAN, JAMES D. see B1425, B1684, O97
HORCH, FRANK see B1363
HORGAN, STEPHEN H. see M1086, ST4255
HORNADAY, WILLIAM T. see H1042
HORNE, F. see T626
HORNER, MARIAN STADTLER see ST3138
HORNSTEIN, HUGH see J273
HORSFORD, E. N. see H709
HOUDIN, MAURICE see N277
HOUFE, S. see N250
HOUGH, EUGENE K. see K59, K65, M794
HOUGH, RICHARD see ST577
HOUSSAYE, ARSENE see N12
HOUSTON, JOHN see B1304, H97
HOW, JAMES see L193
HOWARD, F. see ST1371
HOWARD, FRANK see ST959
HOWARD, JAMES see ST2672
HOWARD, O. O. see ST2268
HOWARTH-LOOMES, B. E. C. see ST837
HOWE, HARTLEY see J191
HOWE, M. E. see ST193
HOWITT, MARY see B502, B505, B506, F139, F140, S329, S330, S331, W1109, ST1051, ST2495
HOYLE, PAMELA see ST3042, ST4043, ST3049
HOWITT, WILLIAM see B499, B502, B503, F137, F138, S329, S330, S331, S333, S334, S335, T553, W1109, W1112
HOWLAND, HAROLD J. see R51

HOYT, A. W. see C175
HUBBARD, BENJAMIN F. see ST539
HUBBARD, T. H. see C1093, C1094, C1095
HUBMANN, FRANZ see ST465
HUGHES, CORNELIUS JABEZ see G351, G352, G353, G354, L25, W581, ST1335, ST3473
HULL, CHARLES WAGER see A248, B1115, D584, D591, F520, K252, M989, S60, S1014, ST868, ST3599, ST3941, ST3948, ST3950, ST3964, ST4109, ST4168, ST4170, ST4211
HUMBERT, REV. LEWIS MACNAUGHTON see S201, S203
HUME, ALLAN O. see ST1483
HUMPHREY, S. D. see B1780, C993, C999, D504, H182, H702, H704, H705, H706, H708, H715, H719, H721, H748, H749, I31, N286, N288, P313, T199, W585, W709, ST1881, ST1900, ST1916, ST1966, ST3118, ST3555, ST4293, ST4294, ST4320, ST4321
HUNGERFORD, CONSTANCE CAIN see M241
HUNT, ROBERT see A421, H713, L100, L101, L101, L105, N303, P463, R309, T188, T229, T230, ST935, ST936, ST945, ST3350, ST3381, ST3383
HUNT, VIOLET see C98
HUNTINGTON, J. H. see C646, C649
HURT, WESLEY J. see M843
HUSEMAN, BEN W. see ST1805
HUTCHINGS, JAMES MASON see W515, W518
HUYDA, RICHARD see H799

I

ILLEX, M. see ST921
INGLIS, FRANCIS CAIRD see H637, H640
INGLIS, J. see I19, I24
INGRAM, J. S. see ST3644
IRVING, WASHINGTON see L514, S49, T908
ISAACS, CHARLES see ST1673
ISENBERG, MATTHEW R. see D148, R925, S925, S925, ST160, ST257, ST1672, ST3183
ISSAVERDENZ, DR. J. see ST1531
IVINS, WILLIAM M. see ST4394
IWASAKI, HARUKO see ST1537

J

J., B. C. was a pseudonom used by JOHN C. BROWNE
JACKSON, ARLENE M. see D427
JACKSON, CLARENCE S. see J41, J42, J44
JACKSON, CHRISTOPHER E. see ST509
JACOBSON, KEN see ST269
JAKOVSKY, ANATOLE see ST45
JAMES, COLONEL SIR HENRY see M32, M35, R891
JAMES, LAWRENCE see F148
JAMES, T. see ST1189
JAMESON, MRS. see ST1953
JAMMES, ANDRÉ see C102, F204, H621, N58, N81, R99, S1101, T75, T76, ST50, ST134, ST227, ST567, ST574, ST576, ST581, ST991
JAMMES, BRUNO see G444
JAMMES, ISABELLE see B1079
JAMMES, MARIE-THÉRSE see F204, ST134, ST567, ST576, ST991
JANIS, EUGENIA PARRY see L196, L243, ST581, ST585
JARECKIE, STEPHEN B. see ST1658
JARRETT, S. WILLIAM see C749
JARVIS, E. P. see S961
JAY, BILL see B557, F598, R197, S1205, W580, ST141, ST251, ST275, ST276, ST279, ST280, ST281, ST284, ST891, ST894
JEBOULT, EDWARD A. see ST1328
JEFFREY, IAN see ST838, ST849

JENKINS, C. FRANCIS see C797, M1097
JENKINS, HAROLD see ST4449
JENKINS, REESE V. see ST1657
JENKINS, WILLIAM see ST878
JENSEN, JAMES see B1342
JENSEN, LESLIE D. see E116, ST2167
JEPHSON, JOHN MOUNTENEY see E59, R89
JEZIERSKI, JOHN V. see G374
JOBLIN, MAURICE & CO. see K208, L57
JOCELYN, NASSAU see F232
JOHNSON, BROOKS see ST582, ST3169
JOHNSON, C. A. see ST4068
JOHNSON, D. B. see D177
JOHNSON, DR. LINDSAY see D95
JOHNSON, J. W. see W292
JOHNSON, JOHN see W1222, W1228, W1229
JOHNSON, R. F. see ST152
JOHNSON, WALTER A. see S462
JOHNSON, WILLIAM S. see B904, W670, ST4246
JOHNSTON, DUDLEY J. see ST3800
JOHNSTON, FRANCES BENJAMIN see D452
JOHNSTON, J. DUDLEY see C97, T273, T274
JONES, CHAPMAN see A45
JONES, EDGAR YOXALL see R126
JONES, ELIZABETH B. see J55
JONES, EMYR WYN see T497, T498, T499
JONES, HARRY C. see J26
JONES, OWEN see B498, B500
JONES, T. HERBERT see F213, H658
JONES, VINCENT S. see ST4256
JONES, WILLIAM A. see F128
JONES, WILLIAM C. see J55, J219
JOSEPH, STEVEN F. see B1887, F217, R95, W628, ST4285,
ST4348
JUODAKIS, V. see ST1564
JUSSIM, ESTELLE see ST4385

K
KAES, SIMON see D784
KAHAN, ROBERT S. see S877
KALAND, BILL see B1704
KANE, SIR ROBERT JOHN see D607
KANTOR, J. R. K. see M1118
KAPLAN, MILTON see H4, P351, ST2158
KARLOVITS, KAROLY see ST1435
KATZ, D. MARK see ST2542
KAYE, SIR JOHN WILLIAM see ST1980
KEAN, MANUEL see ST2167
KEARFUL, JEROME see W312
KEBLE, JOHN see ST1228
KEELER, NANCY B. see T320, ST583, ST848, ST3344
KEIM, JEAN A. see ST53, ST54, ST605
KELBAUGH, ROSS J. see C352, W465, ST3030, ST3031, ST3032
KELLER, JUDITH see P110
KELLER, ULRICH see D779, N60
KELTON, RUTH see ST1744
KEMP, GEORGE see ST1170
KEMPE, FRITZ see ST784
KENNEDY, ALEXANDER W. M. CLARK see ST1271
KENT, WILLIAM see B2026
KER, DAVID see ST1341
KERBER, ROLAND A. see ST4483
KERLIN, ISAAC N. see G638
KEYES, C. M. see P33
KEYES, DONALD S. see ST1734

KEYES, R. W. see H41
KIDDER, REV. J. P. see M823
KILBURN, W. E. see S1072
KILGO, DOLORES see L115
KILGORE, SYDNEY MALLET see ST583, ST848
KILIAN, LINCOLN see ST2934
KING, CLARENCE see O91, O95
KING, EDWARD see B679
KING, HORATIO C. see ST2284
KING, JOHN see P348
KING, PAULINE see ST1698
KING, SAMUEL A. see B916
KING, THOMAS STAR see ST2497
KINGSLAKE, RUDOLPH see G530, ST94, ST3198, ST3200,
ST3201
KINGSLEY, WILLIAM I. see ST2889
KINGSTON, ROGER see ST3199
KINLOCH, ALEXANDER see L645
KINZER, H. M. see N31
KISSICK, KATHLEEN see ST108
KLETT, MARK see J223
KLOOSWIIJ, ABRAM I. see W627
KLOSS, WILLIAM see M856
KNEELAND, SAMUEL see S899
KNIGHT, HARDWICKE see B186, B2070, B2071, B2072, C118,
M997, S358, ST1588, ST1591, ST1593, ST3684
KNIGHT, J. LEE see V44
KNOWLES, CHARLES D. see ST2251
KNOWLES, EDWARD HADAREZER see ST1315
KNOX, THOMAS W. see ST2487
KOCHER, ALFRED see C732
KOEHLER, S. R. see ST4383, ST4390
KOLTUN, LILLY see ST506, ST507, ST536
KOMROFF, MANUEL see B1426
KOSSOY, BORIS see A508, F364, F365, ST491, ST495, ST1561
KOSTER, JOHN see D15
KOZLOFF, MAX see N55, ST2552
KRACAUER, SIGFRIED see ST207
KRAINIK, CLIFF see H279, P352
KRAMER, OSCAR see ST3283
KRAUS, GEORGE see H253
KRAUS, HANS P. see L447, S1219, T88, T89, T324, ST850, ST864,
ST865
KRAUSE, HERBERT see I6
KRAUSS, ROLF H. see ST20, ST57, ST58, ST262, ST264
KRAUSS, ROSALIND see N57, ST287
KREICHBERGS, JANIS see ST1563
KRONE, PAUL R. see K243
KUEHN, HEINRICH see C96
KULTURMAN, PERIHAN see ST1647
KUMAR, ASOK see S656
KUNHARDT, DOROTHY M. see B1429, B1678
KUNHARDT, PHILIP B., JR. see B1429, B1695, B1696
KUNSTLER, CHARLES see N51
KURUTZ, GARY F. see ST55
KWASIGROH, DAVID see D112

L
LA MANNA, FRANK see B343
LABORDE, L'ABBE see N309, N310
LACAN, ERNEST see B109, F230, F461, H725, L400, N4, N17,
N18, N262, P366, P373, R220, T249, W186, ST547, ST666,
ST676, ST687, ST693, ST696, ST698, ST700, ST702, ST708,
ST715, ST745, ST750, ST753, ST754, ST757, ST758, ST762,
ST771, ST3117, ST3300, ST3317, ST3711

LADD, JOSEPH H. see C1084, S381, ST4328
LAIRD, EGERTON K. see ST1355
LAIRD, JOHN DAVID see H1249
LAMBERT, HERBERT see T268
LANDRETH, PETER E. see H612
LANDSELL, AVRIL see ST150
LANG, WILLIAM JR. see T262, ST81
LANGE, O. V. see S539
LANGFORD, N. P. see J59, J60, J68
LANIER, HENRY WYSHAM see B1673, ST2151, ST2152, ST2281
LANIER, ROBERT S. see ST2151
LANKESTER, SIR E. R. see M1033
LANMAN, CHARLES see ST1855, ST2628
LANYON, ANDREW see H117, T321
LASS, WILLIAM see M843, M846
LASSAM, ROBERT E. see S1220, T83, T86, T301, T309, T310
LATHROP, GEORGE PARSONS see G675, P59
LAUDY, L. C. see P298
LAUDY, L. H. see ST588, ST589
LAUSSEDAT, M. A. see ST688
LAVIGNA, ARLENE see ST3082
LAWRENCE, AMOS see ST2019
LAWRENCE, JAMES see F146
LAWRENCE, WILLIAM R. see ST2019
LAWSON, ELLEN MICKENZIE see L117
LAWSON, HENRY see ST1110, ST1134, ST1139, ST1153, ST1165, ST1167, ST1179, ST1192, ST1196, ST1200, ST1206, ST1209, ST1212, ST1218, ST1226, ST1231, ST1232, ST1234, ST1241, ST1257, ST1260, ST1263, ST1266, ST1274, ST1276, ST1277, ST1278, ST1281, ST1283, ST1284, ST1286, ST1291, ST1293, ST1295, ST1305
LAWSON, JOHN PARKER see H679
LAWSON, JULIE see C240, K201, R327, W1246, ST857
LAWTON, HARRY W. see B1179
LAWTON, S. K. see ST540
LAXTON, W. H. see ST1272
LAYER, HAROLD A. see ST62, ST4482
LAYNE, GEORGE S. see L112, L113, L116
LE BON, CHARLES DAVILLIER see T586
LE PLONGEON, ALICE see D477
LE POURHEIT, ALAIN see ST105, ST109
LE RIDER, GEORGES see ST578
LEA, M. CAREY see ST483, ST797, ST801, ST2392
LEAVITT, ROBERT H. see ST3093
LECONTE, JOSEPH see ST2970
LEE, W. HUNT see F63
LEHMANN-HAUPT, HELMUT see ST3
LEHR, JANET see T614, T615, ST273
LEIGHTON, HOWARD B. see I56
LEIGHTON, JOHN see ST963
LEITNER, GOTTLIEB WILLIAM see ST1491
LEMAGNY, JEAN-CLAUDE see ST609
LEREBOURS, N. P. see ST644, ST645
LESCO, DIANE see N85
LESLIE, FRANK see ST4305
LESLIE, MRS. FRANK see R973
LESTER, CHARLES EDWARDS see B1410, B1435
LEVINE, ROBERT M. see F550, ST552, ST1561, ST1562
LEWIS, JOSEPH see S1438
LIBBEY, WILLIAM, JR. see B2090
LIECHENSTEIN, MARIE H. N. see D345
LIESEGANG, PAUL E. see Q1, ST795, ST807
LIFSON, BEN see B239, M697, W322, W324, ST153
LIGHT, BIANCA see ST1329
LIGHTFOOT, FREDERICK S. see A354, ST2289

LIGO, LARRY L. see ST625, ST627, ST629, ST630
LINDQUIST-COCK, ELIZABETH see B785, S1174, ST126, ST263, ST1659, ST1730
LINTON, W. J. see ST4444
LIPSON, STANLEY H. see ST104
LITCHFIELD, RICHARD B. see W512
LIVINGSTON, JANE see ST149
LLEWELLYN, J. D. see M256
LLOYD, VALERIE see B247, F149, F210, ST849
LO DUCA, JOSEPH-MARIE see B333
LOCHMAN, CHARLES L. see ST185, ST1690
LOCKWOOD, E. N. see ST4162
LOCKWOOD, MRS. E. N. see ST4160
LOKUTA, DONALD P. see W758
LONGFELLOW, HENRY W. see F583, S1083
LOOMIS, G. H. see A218, B982, F330, R546, R566, R901, S76, W500, W536, ST3073, ST3075, ST3076, ST3077, ST4028, ST4032
LOONEY, ROBERT F. see ST3139
LORANT, STEFAN see G148, ST2156, ST2157
LOSSING, BENSON J. see M881, ST2153
LOTBINIERE-HARWOOD, SUSANNE see ST538
LOTHROP, EATON S., JR. see ST1737, ST3179
LOVEJOY, CHARLES M. see ST4074
LOVEJOY, EDWARD DALAND see ST1704
LOWDEN, RONALD D. see H592, W1322
LOWE, DENNIS E. see B1697, W1185, ST1806
LOWE, JAMES L. see D391
LOWE, R. L. see J217
LOWELL, JAMES RUSSELL see S1083, S1088
LOWENSTEIN, GEBRUDER see ST793
LUDLOW, HELEN W. see ST2918
LUKITSCH, JOANNE see C63, C122
LUND, PERCY see R511
LUSKEY, JUDITH see ST2543
LUTHER, FREDERICK see ST3682
LYNCH see ST3162
LYNCH, ARTHUR A. see D513
LYNCH, GEORGE see R44
LYON, CALEB see B1437
LYONS, BEAUVAIS see ST4386
LYONS, MARVIN see ST1617

MAC, MC [INTERFILED]
MCALPIN, DAVID H. see ST19
MCAULEY, SKEET see ST2545
MACBEAN, MAJOR see H845
MCCARTHY, JUSTIN see M765, ST869
MCCARTHY, W. JR. see H695
MCCAULEY, ELIZABETH ANNE see A478, D442, T42, ST139, ST621, ST622, ST628, ST882
MCCLAIN, GAIL see ST21
MCCLELLAN, GEORGE B. see ST569
MCCLELLAND, JAMES see ST1490
MCCLURE, COLONEL ALEXANDER K. see ST2270, ST2271
MCCOO, DONALD see ST852
MCCOY, DELL A. see J49
MCCULLOCH, LOU W. see ST144
MCDARRAH, FRED see O120
MACDONALD, HUGH see A275
MCDONALD, W. W. see B2090
MACDONNELL, KEVIN see M1038, R192
MCELROY, C. ROBERT see ST3106
MCELROY, DOUGLAS KEITH see P198, M945, R265, S1017, ST1602, ST1603, ST1605, ST1606, ST1607
MCGHIE, J. see H92

MCGLASHAN, ANDREW see H680
MCGOVERN, THOMAS see ST2181
MACKAY-SMITH, ALEXANDER see A128
MCKENDRY, JOHN J. see B1730, C49, H620
MCKENZIE, RAY see M29, M124, I22
MCLAIRD, JAMES see ST3160
MCLAURIN, MELTON ALONZO see ST2922
MCLEAN, RUARI see C961
MACLEOD, FIONA see V22
MACLEOD, NORMAN see B544, B546, B1305, G403, G405, S311
MCMAHON, TIMOTHY J. see C309, P62
MCMEADOWS, M. P. F. see M332
MACMILLAN, DAVID S. see S753
MCQUILLEN, DR. J. H. see ST2395
MACTEAR, ANDREW see ST1126

M

MAACK, DR. G. A. see M816, O106
MAAS, JEREMY see ST833, ST851
MADDER, MAX see D478
MADDOW, BEN see ST135, ST160
MAGELHAES, CLAUDE see F366, ST475
MAGNUM, NEIL see ST2562
MAHAN, THOMAS T. see ST4201
MAHONEY, THOMAS D. see ST3100
MAIN, WILLIAM see B1712, B1713, B1714, P566, ST900, ST1589, ST1590, ST1592
MAINCENT, PAUL see N40
MAISCH, FREDERICK D. see S276
MAITLAND, G. F. see I23
MALET, SIR ALEXANDER see A114
MALONE see ST940
MALONE, T. A. see C618, C619, C620, T156
MALTBIE, S. W. see ST4272
MAMASAKHLISI, A. V. see ST1620
MANCHESTER, ELLEN see H578
MANGAN, TERRY WILLIAM see J53, ST2933, ST2973
MANN, CHARLES W. see C111, C116, C261, C615, ST885, ST901, ST1790
MANN, H. J. see ST1331
MANN, MARGERY see J214
MANN, ROBERT JAMES see R1037, ST3233
MANNING, WILLIAM C. see O123
MANSFIELD, GEORGE see ST3326
MARABLE, DARWIN see ST295
MARBOT, BERNARD see L218, ST578
MARDER, ESTELLE see A311, ST3264
MARDER, WILLIAM see A311
MARDIROSIAN, MARTHA see ST566
MARIEN, MARY WARNER see D457, ST117
"MARK OUTE" see ST776
MARKHAM, G. see M119
MARKS, ALFRED H. see B1234, D479, ST1714
MARKS, W. D. see M1028
MARSHALL, ALBERT E. see B1075, ST9, ST43, ST44, ST872
MARSHALL, WILLIAM ELLIOT see B1296, N239
MARSTON, R. B. see L414
MARTIN, MRS. CLARA BARNES see ST3028
MARTIN, CHARLES W. see C927
MARTIN, CHARLOTTE M. see ST1697
MARTIN, EDWIN C. see C86
MARTIN, L. A. see ST3695
MARTINET, LOUIS see B857
MARTINEZ, R. E. see C101
MARTZ, JOHN see J230

MASON, DAVID see H612
MASON, EDWARD A. see ST2165
MASON, O. G. see C336, H1112, M699, R1038, R1039
MASTELLER, RICHARD N. see ST2558
MASURY, SAMUEL see C1067, C1068, S570
MATHEWS, OLIVER see ST128, ST130
MATHIOT, GEORGE see T232
MATTHEWS, G. E. see ST92
MATTISON, DAVID see G223, H337, H338, M544, M545, M548, ST59, ST523, ST524, ST526, ST532, ST533
MAUNER, GEORGE see ST283
MAUTZ, CARL E. see ST2537
MAY, NORMAN see ST2832
MAYER, HEINRICH see ST30, ST4421
MAYER, ROBERT A. see ST560, ST1772, ST1775
MAYER-WEGELIN, EBERHARD see B762
MAYHEW, HENRY see B368
MAYOR, A. HYATT see H653
MEADE, CHARLES R. see ST662, ST664, ST983, ST3295
MEDHURST, JOHN see ST2371
MEINWALD, DAN see B445, ST3763
MEISSONIER, JEAN LOUIS ERNST see B861
MEJIA, GERMAN RODRIGO see ST553
MELHUISH, A. J. see ST3725
MELLOR, DAVID see ST838
MEMES, J. S. see ST1797, ST1798
MENZIES, WILLIAM see C16
MERCALDO, VINCENT see J211
MERCER, A. CLIFFORD see ST3681
MEREDITH, ROY see B1422, B1423, B1428, B1431, B1679, B1688, ST2159
MERGEN, BERNARD see ST1736
MERNE, OSCAR S. see ST3891
MERRICK, JOAN S. see C272
MERRILL, SELAH see P75
MERRITT, J. I. see J224
METEYARD, ELIZA see W508, W509, W510, W511
METHUEN, LORD see T69
MICHAELS, BARBARA L. see C120, ST620
MICHAELSON, KATHERINE see H622, H627
MILHOLLEN, HIRST D. see B1677, ST2294, ST2158, ST2160
MILLARD, CHARLES W. see C104, W316, ST1733
MILLER, ALAN CLARK see B1828, G152
MILLER, ERNEST C. see M326, M327
MILLER, FRANCIS TREVELYN see ST2150, ST2151
MILLER, HELEN MARKLEY see J50
MILLER, KATHLEEN L. see ST1792
MILLER, M. N. see N186
MILLER, NINA HULL see H1090
MILLER, S. see T713
MILLER, STEVEN H. see H890
MILLIGAN, H. see M961, S554, ST3683
MILLWARD, MICHAEL see S775, S776
MINTO, C. S. see K20
MITCHELL, DONALD GRANT see R584
MITROVIC, R. see J376
MOBBS, LESLIE see ST510
MOELLING, EDWARD see V161
MOESHART, HERMAN J. see S227
MOLLOY, C. see A116
MOMADAY, N. SCOTT see ST2541
MONCKHOVEN, DESIRE VAN see P370
MONCRIEFF, ROBERT SCOTT see A282
MONEYHON, CARL see ST2171
MONKHOUSE, COSMO see ST1273

MONKHOUSE, W. see B493
MONROE, ROBERT D. see L134
MONTAGNA, A. see ST1526
MONTGOMERY, JAMES EGLINTON see S48
MONTI, NICHOLAS see ST445
MOOR, REV. J. FROWEN see S202, S203
MOORE, C. L. see S922
MOORE, CHARLES R. see S907
MOORE, GEORGE see ST742
MOORE, JAMES J. see ST1400
MORAN, THOMAS see J112
MORGAN, DALE L. see B362, D380, F127
MORGAN, EVELYN CLARK see P557
MORGAN, LEWIS H. see H767, H778
MORGAN, OCTAVIUS see ST11316
MORISON, GEORGE see ST3089
MORLEY, JAMES see ST748
MOROZOV, S. see ST1619
MORRELL, W. WILBERFORCE see M766
MORRIS, JAN see ST2074
MORRIS, RICHARD see L446, L452
MORRISON, R. see H189
MORRISON-LOW, A. D. see A102, B1775, C244
MORROW, DELORES J. see H336, ST3091
MORTON, DR. HENRY see S456, ST3224
MORTON, REV. HENRY J. see B1933, B1936, B1943, B1945,
B1957, C162, E74, W302, ST2987
MORTON, ROSALIE SLAUGHTER see S690
MOSS, GEORGE H., JR. see ST3097
MOTT, AUGUSTA see B508
MOUTARD-ULDRY, R. see B1753
MOWBRAY, GEORGE M. see D7
MOZLEY, ANITA VENTURA see A290, A297, A298, C52, M1039,
M1042
MUGRIDGE, DONALD H. see ST2160, ST2161
MUIR, JOHN see F264, F265
MULLEN, JAMES see C233
MULLER, ALAN CLARK see L617
MULLOOLY, JOSEPH see ST1518
MUNOFF, GERALD J. see ST3019
MUNOZ, LUIS LUJAN see M1044
MUNSON, DOUG see ST2165
MUNSTERBERG, MARJORIE see M124
MURE, ANDREW see ST1141
MURPHY, J. see B1689
MURRAY, ANDREW see T518
MURRAY, HUGH see ST860
MURRAY, JOAN see W327, ST1746
MUSPRATT, DR. S. see S1331
MUSTARDO, PETER J. see ST623
MYERS, CARL see ST2737

N
NADA, GRCEVIC see P89
NAEF, WESTON J. see C65, F363, ST19, ST158, ST292, ST296,
ST299, ST300, ST303, ST578, ST1662, ST2536
NAGIS, R. DE see E295
NALL, JOHN GREAVES see ST1253
NAPIAS, DR. H. see ST755
NAPIER, CHARLES O. GROOM see ST1289
NARES, CAPT. GEORGE STRONG see M732
NASSAU, WILLIAM E. see P73
NAWIGAMUNE, ANAKE see ST1645
NAYLOR, CHARLES see C264
NAYLOR, JACK see ST3184

NEEMS, CAROL V. see ST17
NEFF, PETER see W17
NEGRETTI & ZAMBRA see W1254
NEGRETTI, P. A see N124
NEITE, WERNER C. see S229, ST106
NELSON, CHARLES A. see L392
NEUTRAL TINT see L147
NEVE, CHRISTOPHER see H659
NEVINS, A. see J189
NEWCOMB, SIMON see ST3247
NEWHALL, BEAUMONT see A462, B210, C1115, D101, D102,
D780, G395, G445, J54, K23, M1100, M1102, N438, O98, S944,
T72, T74, T281, T282, T283, W877, W1178, ST196, ST198,
ST199, ST204, ST208, ST214, ST215, ST217, ST218, ST220,
ST228, ST229, ST246, ST293, ST1653, ST1705, ST1706, ST1707,
ST1711, ST1716, ST1722, ST1724, ST1725, ST2290, ST3083,
ST3107, ST3182
NEWHALL, JAMES R. see C705
NEWHALL, NANCY see O98
NEWMAN, GREGORY S. see F367
NEWSON, T. M. see I5
NEWTON, SIR CHARLES T. see B507
NEWTON, HENRY J. see T385
NEWTON, WILLIAM J. see T204, T214, ST954, ST3471
NIBBLEINK, DON see M884
NICHOL, JOHN see A353, B1968, D459, G667, S820, W1174,
ST1337, ST1375, ST1390, ST3158
NICKEL, HEINRICH L. see H618
NIERIKER, ABIGALE MAY ALCOTT see ST2498
NIGRO, CAROL A. see ST1673
NILSSON, STEN see B442
NIR, YESHAYAHU see ST1573
NISBET, JAMES see S533
NIXON, LEWIS see R47
NOBLOM, JULES see ST2143
NOBUO, INA see B443
NOLAN, EDWARD W. see H322
NORDHOFF, CHARLES see ST2992
NORMAN, MARTIN see T862
NORTH, WALTER C. see A59, R213
NORTON, RUSSELL see A371, M821, O116
NOVAK, BARBARA see ST2553
NOVAK, MICHAEL J. see ST3066, ST3071
NYE, WILBER STURTEVANT see S910

O
O'BRIEN, J. EMMET see K16
O'CONNELL, MICHAEL see ST856
O'CONNOR, V. C. SCOTT see C87, C88
O'DONNELL, JOAN KATHRYN see ST151
O'HARA, ELIZABETH see ST4356
OAKES-JONES, CAPT. H. see F199
OCHSNER, BJORN see ST122
ODGERS, STEPHEN L. see B414, W1233
OESTREICHER, RICHARD see ST4473, ST4474
OLIPHANT, DAVE see ST146
OLIPHANT, MARGARET see A149, D349
OLLMAN, ARTHUR see B1317, B1328
OLMSTEAD, A. J. see S876
OLMSTEAD, ROGER see R965, ST2942, ST2975
OLSON, GARY D. see I6
ONNE, EYAL see ST1569
ORLAND, TED see ST2936
ORVELL, MILES see ST1785
OSBORN, W. R. see ST1027

OSBORNE, J. W. see ST3912
OSCANYAN, C. see ST1583
OSCHSNER, BJORN see ST559
OSGOOD, CHARLES S. see ST3078
OSTBERG, CARL see E169
OSTENDORF, LLOYD see S506, ST2162, ST2167, ST2291, ST2300
OSTROFF, EUGENE N. see T285, T286, ST157, ST1773, ST2538, ST2540, ST3645
OTIS, GEORGE A. see B614, ST2144
OURDAN, J. P. see B2067
OVENDEN, GRAHAM see C59, H294, H626
OZAWA, TAKESHI see ST1536, ST1541

P
PACKARD, GAR see W1219
PACKARD, MAGGIE see W1219
PADDOCK, ERIC see J231
PAGE, PROF. see M857
PAGE, MARY ANN REYNOLDS see ST1871
PAGEL, B. E. J. see H489
PAJUNEN, TIMO TAUNO see M1111
PALMER, GENERAL W. J. see B609, G85
PALMQUIST, PETER E. see B1406, B1830, B2085, C750, C924, D111, D455, E302, F357, G414, H258, H411, H412, H976, J295, L153, L154, L155, M1114, O56, P395, R119, R120, R121, R122, S409, S903, S905, T43, V31, V71, V72, V73, W297, W299, W321, W328, W329, W330, W331, W332, W336, W337, W338, W341, W342, W346, W347, W521, W522, W1216, ST61, ST291, ST1674, ST1747, ST1751, ST1754, ST1759, ST1765, ST1768, ST1774, ST2544, ST2559, ST2560, ST2563, ST2565, ST2569, ST2934, ST2935, ST2937, ST2938, ST2944, ST2945, ST2946, ST2948, ST2949, ST2950, ST2951, ST2952, ST2954, ST2955, ST2956, ST2957, ST2958, ST2959, ST2961
PALOU, FR. FRANCISCO see ST2969
PANZER, MARY see J232, ST3141
PAPELL, BEN see D391
PARKER, ALICE LEE see B1685, R962, W313
PARKER, GEORGE F. see S1209
PARKER, WILLIAM E. see S239
PARMELEE, MOSES P. see B900
PARROTT, CARYL S. see R19
PARRY, ALBERT see ST1618
PARRY, C. C. see B609
PARSEY, ARTHUR see ST308
PARSONS, L. V. see ST4173
PARTRIDGE, D. ANSON see ST4222
PASCOE, CHARLES EYRE see ST1408
PASSAVANT, J. D. see ST1342
PATON, J. NOEL see A272
PATTERSON, NORMAN B. see G626, ST1782
PATTISON, WILLIAM D. see R963, R964, R966
PAYN, JAMES see G171, G172, O19, S1003
PAYNE, REV. ROBERT see L352, L353
PEALE, ALBERT CHARLES see P160
PEARSALL, A. A. see B1613
PEASE, A. G. see ST1331
PEASE, N. W. see B1000
PECK, WILLIAM H. see ST566
PEDZICH, JOAN see K67
PEGNATO, PAUL L. G. see B1862
PEREIRA, CECILIA DEPRAT DE BRITTO see K221
PEREZ, LOUIS, JR. see ST1561
PEREZ, NISSAN N. see R526, ST1575
PERKINS, FREDERICK B. see G515
PERL, JED see ST1538

PERLOFF, STEPHEN see C260
PETERICH, GERDA see B1057, B1077, F203, L194, W1179, ST225, ST3342
PETERS, MARSHA see ST1736
PETERSON, THOMAS H. see B1989
PETERSON, WILLIAM see S240
PETSCH, MAX see G419
PETTIT, H. D. see M1071
PFISTER, HAROLD FRANCIS see ST1660
PHELAN, ROBERT J. see M1045
PHILLIPS, C. J. see S545
PHILLIPS, CHRISTOPHER see S31, ST298, ST1778
PHILLIPS, JOHN R. see A161
PHILLIPS, SAMUEL see D337
PHILLIPS, SANDRA S. see ST1671
PHIPSON, DR. T. see ST3287, ST3288
PIERCE, SALLY see B904, W667, W670
PIERCY, F. see ST1883
PIETRANGELLI, CARLO see M108
PIETZ, GREGORY L. see W909
PIKE, NICHOLAS see ST178
PILLING, ARNOLD H. see ST250
PINE, LEIGHTON see G473
PITCAIRN, ROBERT see D577, S343
PITKETHLEY, ANNE see C15
PITKETHLEY, DON see C15, D247
PITTS, TERENCE R. see B619, F255
PLATT, S. L. see ST161
PLUMMER, JOHN see M996
PLUTECKA, GRAZYNA see D785
POESCH, JESSIE see P155
POLITO, RON see N443, ST3045
POLLACK, W. E. see A63
POLLARD, EDWIN ALFRED see ST2143
POOLE, WILLIAM FREDERICK see ST3135
POOLE, REGINALD STUART see F567
POOLE, MRS. SOPHIA see F567
POORE, BENJAMIN PERLEY see ST1880
POPE, FRANKLIN L. see M882
POPE, REV. G. U. see T865
POPE, MARION HOLLINGER see E112
PORCHER, E. A. see ST1584
PORTER, ALLAN see L109, ST249, ST1735
PORTER, GENERAL HORACE see ST2266
PORTER, RUSSELL W. see D768
POSTLETHWAITE, EDWARD see ST1434
POTTER, EDWARD TUCKERMAN see R580, ST2499
POWEL, DONALD WALTER see ST3148, ST3149, ST3150
POWELL, JOHN WESLEY see H770, H774, H776, J88
POWELL, TRISTRAM see C51, ST836
PRATT, W. H. see ST4459
PRESCOTT, GERTRUDE MAE see B1237
PRESSACCO, ALFREDO S. see F362
PRINET, JEAN see N46
PRINGLE, ANDREW see R352, R469
PRINGLE, THOMAS see R845, R849
PRIOR, HARRISON K. see J277
PRITCHARD, REV. C. see D288, ST3232
PRITCHARD, H. BADEN see M207, N269, W1273
PRITCHARD, MICHAEL see ST861, ST902
PROCTER, RICHARD A. see R1026, ST3234
PROGULSKE, DONALD see I7
PROST, CHARLES see A477
PROTHEROE, T. see ST3660, ST3664
PROWSE, DANIEL WOODLEY see P130

PUGH, J. A. see ST2989
PUGIN, AUGUSTUS W. see A496
PULMAN, E. J. see ST4069
PUTNAM, GEORGE HAVEN see E184, ST2283

Q
QUENNELL, PETER see F601

R
RACANICCHI, PIERO see J212
RACE, W. H. see M801
RALSTON, W. R. S. see C241, ST1275
RAMSEY, PROF. see M112
RAMSTEDT, NILS W. see L195, L221
RANANICCHI, PIERO see N44
RAPHAEL, GEORGE see ST2193
RAPIER, RICHARD CHRISTOPHER see ST552
RASKIN, NAUM MIKHAILOVICH see T73
RATH, SARA see B704
RAY, FREDERICK E. see G144, G145, O114, ST2167, ST2293, ST2295
RAYNAL, MAURICE see ST4395
REED, DAVID see F212
REEDY, WILLIAM MARION see S1239
REESE, BETSY see B701
REGISTER, SEELY see ST2348
REICHMAN, JESSICA see ST3085
REID, G. W. see T559
REID, JAMES D. see M855
REID, JOHN E. see A273
REILLY, BERNARD F., JR. see M822
REILLY, JAMES M. see ST140
REMY, P. A. see ST3318
RENWAR see ST1374
REPENSEK, THOMAS see N56
REVERLEY, HENRY see D341, H275
REYNES, GENEVIEVE see N59
REYNOLDS, HELEN WILKINSON see W82
REYNOLDS, LEONIEL see M529, M531
RICE, SHELLY see ST626
RICH, NANCY see R971
RICHARDS, F. D. B. see ST3575
RICHARDS, WILLIAM CAREY see ST3064
RICHARDSON, ALBERT D. see ST2530
RICHARDSON, C. F. see ST4024
RICHARDSON, JOANNA see N54
RICHMOND, ROBERT W. see G146
RICKETTS, JANE see M45
RIDEING, WILLIAM H. see O107, O108, O125
RIEMAN, GEORGE B. see ST4229, ST4231
RIFKIN, GLENN see J220
RIKER, C. E. see ST2863
RINHART, FLOYD see W1231, ST1655, ST1663, ST1726, ST2986
RINHART, MARION see W1231, ST1655, ST1663, ST1726, ST2986
RITCHIE, LADY ANNE T. see C42, C95
RITCHIE, THOMAS see B1218, B1219
RITTER, BEN see ST3167
RITZ, ERNEST F. see S957, ST4034, ST4035
ROBERTS, BOBBY see ST2711
ROBERTS, E. S. see N437
ROBERTS, EDWARD see T31
ROBERTS, K. see H660
ROBERTS, MARY FANTON see S128
ROBINSON, BONNELL D. see ST1537

ROBINSON, C. J. see ST949
ROBINSON, CHARLES D. see K39
ROBINSON, CHARLES S. see W1042
ROBINSON, HARRY B. see J206
ROBINSON, HENRY P. see A18
ROBINSON, J. C. see B500
ROBINSON, JOHN see P149
ROBINSON, SIR JOHN CHARLES see B496, T517, ST1002
ROBINSON, WILLIAM F. see ST3092
ROBISON, JOHN see D39, D66, D113
ROGER, ANDREW see T692, ST512
ROGERS, FAIRMAN see M1067
ROGERS, FRANCES see B1424
ROGERS, H. G. see W1292
ROGERS, PATRICIA H. see ST3044
ROGERS, TOM see ST4481
ROMBOUT, MELISSA K. see L246
ROMER, GRANT B. see H215, P143, ST160, ST253, ST1542, ST1749
ROOD, OGDEN N. see B1807
ROOSENS, CLAUDE see ST475
ROOSENS, LAURENT see B2080, C431, ST27
ROOT, MARCUS A. see A434, C1002, C1004, W673, ST3054, ST3573, ST3574, ST3577, ST4001, ST4359
ROS, FRED see ST1574
ROSENBLUM, NAOMI see B1758, B1759
ROSENFIELD, PAUL see H642
ROSKILL, MARK see ST4245
ROSS, JAMES see R834
ROSS, WILLIAM see D625, H434, W1223, ST3377
ROTH, KARL DE see R994
ROTH, NANCY ANN see D683
ROWE, JEREMY see W598
ROWLES, BRANDT see ST1732
ROY, CLAUDE see B1729, B1757
RUBIN, CYNTHIA ELYCE see ST4476
RUBY, JAY see ST1771, ST3142
RUDISILL, RICHARD see W321, ST1656, ST3098
RULE, AMY see C123
RULOFSON, WILLIAM H. see B1386, M1056, ST4152
RUNG, ALBERT M. see S218
RUSSACK, RICHARD see B1692, H318, L108, ST4467
RUSSELL, ANDREW J. see R556
RUSSELL, MAJOR C. see S1384
RUSSELL-JONES, PETER see M28
RYDER, JAMES F. see B169, B170, B171, B172, B176, F388, ST4098
RYDER, RICHARD C. see A356, A357, B692, B1709, C868, G622, G625, I13, L578, P263, S164, S904, T339, W1181, ST4475, ST4479, ST4480

S
SACHSE, JULIUS F. see D673, ST1687, ST3144
SADIK, MARVIN see ST1660
SADOUL, GEORGES see ST592
SAINT EDME, ERNEST see D259
SALMON, PERCY B. see ST191
SALSBURY, LORD see ST1190
SALU, LUC see ST27
SAMPSON, JOHN see O104
SAMPSON, MARMADUKE B. see B1409
SAN LAZZARO, G. DI see N29
SANBORN, F. B. see H301
SANCHO, F. J. see ST4342
SANDBERG, CARL see ST2285

TAYLOR, HENRY see C40
TAYLOR, J. TRAILL see A36, A82, A228, B589, B813, B1149, C17, C195, C741, D314, D321, E83, F340, G448, G676, H250, H285, H286, H683, H996, H1086, J303, K292, L408, M399, M763, M836, M928, M992, M1072, M1079, M1080, N187, N448, P513, P541, P553, R554, R555, S757, S1040, T25, T257, T258, T512, U18, W40, W213, W988, W1008, W1217, W1266, W1310, ST165, ST2908
TAYLOR, JOHN see R520
TAYLOR, MAUREEN see ST3159
TAYLOR, PHILIP MEADOWS see B841, B842, L460, P287
TAYLOR, ROGER see B1295, W1131, ST863
TAYLOR, SUSAN see ST1537
TAYLOR, WILLIAM MEADOWS see ST1440
TEDER, KALJULA see ST570, ST571
TEMPLER, SIR GERALD see M28, ST1442
TENDER, DAVID see J273
TENNANT, JOHN see ST197, ST3262
TENNYSON, ALFRED LORD see B1895, C62
TERRAINE, JOHN see ST2305
TESSIER, GUY see M682
THOMAS, ALAN see ST136, ST529
THOMAS, ANN see ST505
THOMAS, D. B. see T70, ST834, ST836
THOMAS, DAVID see T288
THOMAS, G. see C115, C124, D482, G307, H940, I15, M734, O86, S657, T870, T874, T929, ST1446, ST1450, ST1451, ST1454, ST1455
THOMAS, RICHARD W. see ST1504, ST1505, ST1506
THOMAS, RITCHIE see B1218, B1219, ST568
THOMASON, MICHAEL V. see ST2922
THOMPSON, C. T. see ST3316
THOMPSON, J. see D96
THOMPSON, S. see ST29, ST1124, ST3441
THOMSON, JOHN see R835, T664, T665
THOMSON, W. M. see B509
THORNBURY, WALTER see R297
THORNEYCROFT, THOMAS see ST2500
THORNTHWAITE, W. H. see M754, T212
THORNTON, GENE see B110
THORP, F. see ST3134
THRODE, JACKSON C. see J49
TILDEN, FREEMAN see H320
TIMBS, JOHN see C463
TISSANDIER, GASTON see T63, T588
TODD, DAVID P. see L637
TODD, JENNIFER see B1703
TOMLINSON see ST1103
TOMLINSON, CHARLES see B1287
TOMPKINS, H. H. see C1031
TOOMING, PEETER see T322
TOROSIAN, MICHAEL see B344
TORRES, J. M. see ST4342
TOSCHI, PAOLO see ST4441
TOWLER, JOHN see C331, C921, H28, M233, O83, R400, R534, R1003, S136, S1052, S1424, S1432, W1265, ST31, ST548, ST751, ST814, ST2199, ST2346
TOWNSEND, GEORGE A. see B1653, B1655
TRACHTENBERG, ALAN see ST160, ST1672, ST1675
TRACY, J. W. see D167
TRACY, REV. W. see T862, T866
TRAILL, JEFFREY see ST1176
TRAVIS, DAVID see ST134, ST576
TREADWELL, T. K. see K89, ST4456
TRIGGS, STANLEY G. see B1693, N374

TRISTRAM, H. B. see S1411
TROXELL, B. F. see H54, W902
TROYER, NANCY JANE GRAY see ST1496
TRUMP, RICHARD S. see B774
TUCKER, MARY LOUISE see ST3020
TUCKERMAN, H. T. see ST2574
TURCHEN, LESTA V. see ST3160
TURLEY, R. V. see C53
TURNER, DAVID see ST141
TURNER, GODFREY WORDSWORTH see ST1299
TURNER, HARRIET see O89
TURNER, JOHN B. see ST1587
TURNER, JOSEPH MALLORD WILLIAM see B749, B750, B751, B752, C937, C951, T519
TURRILL, CHARLES B. see W309
TYLOR, EDWARD B. see D143
TYLOR, WELD see ST971

U
UNDERWOOD, FRANCIS H. see H866
UNGER, FRANZ JOSEPH ANDREWS see S332

V
VACSEK, LOUIS see ST1571
VAIL, R. W. G. see V3, ST2288
VAN BUREN, J. T. see G532
VAN DER LINDEN, LIANE see ST564
VAN DYKE, HENRY see F626
VAN GRUISEN, N. L., JR. see ST1437
VAN HAAFTON, JULIA see F603, F629, F630, ST22, ST56, ST252
VAN HASBROECK, PAUL HENRY see O132, ST3188
VAN HORN, RALPH see ST3104
VAN NOSTRAND, JEANNE see J348, V47
VAN ORDEN, JAY see F372
VAN RAVENSWAAY, CHARLES see ST3087
VAN RENSSELAER, MRS. JOHN K. see B797
VANDERBILT, PAUL see B1683, J204, ST2286
VANDERWEYDE, JOHN J. see D424, ST3980, ST4325
VANDERWEYDE, P. H. see ST3971, ST3974
VANWEIKE, ROLAND was a pseudonom for R. J. CHUTE.
VARLEY, HELEN see E185
VARRELL, WILLIAM see ST3048
VASQUEZ, PEDRO see ST492
VATTEMARE, H. see T590, T591
VAUGHAN, THOMAS see F371
VENNOR, HENRY G. see N365
VENTIMIGLIA, TONY see ST1791
VENTURA, ANITA see ST2940
VERBURG, JO ANN see J223
VERKOREN, LUC see ST285
VERONESI, G. see N42
VESTAL, DAVID see J215, O115
VETTER, JACOB B. see ST3108
VIATOR see ST811
VICTORIA, QUEEN OF GREAT BRITAIN see W1123
VIDAL, LEON see A80, A81, M764
VINCENT, ST. JOHN see ST3015
VISKOCHIL, LARRY A. see M922, ST2301
VITET, L. see B862
VITZ, CARL see F379
VOGEL, HERMANN see A56, A68, B781, B946, B958, B1738, L501, M1052, N13, P247, P248, P249, P253, R1036, ST727, ST800, ST802, ST805, ST806, ST809, ST810, ST812, ST813, ST815, ST817, ST819, ST820, ST822, ST824, ST826, ST829, ST2589, ST2594, ST2612, ST3154, ST3231, ST3273, ST3276,

ST3278, ST3280, ST3281, ST3309, ST3311, ST3313, ST3323, ST3324, ST3325, ST3609, ST3611, ST3652
VOGEL, SIR JULIUS see ST1598
VOLKMER, LIEUT.-COL. OTTOMAR see M200
VON KRAMER, OSCAR see A125
VON RAVENSWAAY, CHARLES see B1727
VRIES, LEONARD DE see ST4337

W

WACHLIN, STEVEN see ST564, ST1574
WADE, NICHOLAS J. see B1774, W622
WADSWORTH, NELSON B. see ST3165, ST3166
WAKEMAN, GEOFFREY see ST4384
WALCOTT, MACKENZIE E. C. see ST1229
WALDACK, CHARLES see ST477, ST478, ST479, ST481, ST486, ST487, ST488, ST711
WALDSMITH, JOHN see B1346, G154, P315, R1112, R1113, S1277, T922, ST1741, ST2981, ST2997, ST3128, ST4477
WALDSMITH, R. M. see ST3170
WALDSMITH, THOMAS see G244, W526
WALFORD, EDWARD see E62
WALKER, FRANCIS see J171
WALKER, JAMES PERKINS see R579
WALKER, JEAN BURTON see ST2535
WALKER, L. E. see ST808
WALKER, RAY see P201
WALL, A. J., JR. see ST1702
WALL, ALFRED H. see R148, R184, R185, S1388, S1389, ST1162, ST3477, ST4252
WALL, E. J. see ST192
WALLACE, ELLERSLIE, JR. see ST4214, ST4219, ST4220
WALLER, BRET see C64
WALLER, DR. FRANZ V. see L619, L620
WALLFORD, E. see M380
WALLIS, GEORGE see B1291
WALLIS, OSCAR J. see ST791
WALSH, JOHN see C65
WALTER, JOHN JR. see T53
WALTER, THOMAS USTICK see W1245
WALTHER, SUSAN DANLEY see G92, R926, ST1664
WALTON, ELIJAH see G711
WARD, J. P. see T311
WARD, JOHN see H630, T87
WARD, JOHN MONTGOMERY see H63
WARE, JAMES REDDING see G359, S340
WARING, GEORGE E. see M1075, P26
WARING, JOHN BARLEY see B500, T552
WARNER, DEBORAH JEAN see R1040, ST3968
WARNER, JOHN see T612
WARNER, W. H. see ST1476
WARREN, MARY ELIZABETH see M687
WARREN, JOHN COLLINS see S569
WARRENDER, ANN see ST2320
WATERHOUSE, J. see ST187
WATSON, ELMO SCOTT see G345, ST2551
WATSON, DR. JOHN FORBES see ST1439, ST1440
WATSON, W. T. see R333
WATSON, WENDY M. see ST1497
WATTS, THEODORE see C84, C85
WAY, CHARLES JONES see N360
WEAVER, MIKE see C61, C65, ST849, ST898
WEAVER, O. F. see ST4064, ST4065
WEBER, J. P. H. see D496
WEBSTER, I. B. see K60, ST4163
WEINBERG, ADAM B. see H780, S890

WEINSTEIN, ROBERT A. see R965, S911, S914, V119, W320, ST1738, ST2941, ST2942, ST2975
WELCH, JANE MEADE see B191, B192
WELCH, RICHARD W. see ST3081
WELD, CHARLES RICHARD see S306, S307
WELFORD, WALTER D. see C611
WELLING, WILLIAM see A386, B1003, B1702, W759, ST133, ST1540, ST1661, ST1743, ST1762, ST3206, ST3984
WELLMONT, MRS. E. see ST1866
WELLS, HARRY L. see M1119
WELSH, ELYN see ST1561
WENDEROTH, F. A. see T255
WENHAM, F. H. see ST1166
WERGE, JOHN see H1054
WEST, CHARLES E. see D616, ST1677
WEST, ELLIOT see ST2556
WESTERBECK, COLIN L. see C114, T613
WESTFIELD, THOMAS CLARK see N88
WEY, FRANCIS see P312, ST642, ST656, ST3694
WHEATCROFT, ANDREW see C60, R127, ST2159
WHEATLEY, HENRY B. see D346
WHEELER, CAPT. GEORGE M. see B616, B617, B618, O92
WHEELER, JAMES T. see B1299
WHEELOCK, ARTHUR K. see ST102
WHEILDON, WILLIAM see B902
WHELPLEY, JAMES D. see A154
WHITE, DAVID O. see W258
WHITE, H. see T313
WHITE, HAROLD see T275
WHITE, HELEN MCCANN see F57
WHITE, JON E. MANCHIP see F603
WHITE, MINOR see R191, S942, ST574
WHITE, STEPHEN see B446, T353, T596
WHITE, WILLIAM ALLEN see S1243
WHITING, MATTHEW see ST3797
WHITLOCK, N. see T160
WHITNEY, E. T. see R568
WHITNEY, JOSIAH DWIGHT see W287
WHITTEMORE, HENRY see B803
WHITTIER, JOHN GREENLEAF see ST1254
WHYTE, WILLIAM & CO. see K17
WIGHT, G. W. see ST871
WIGHT, P. B. see S1022
WILBURN, JOHN J. see ST4456
WILCOX, COL. V. M. see G90
WILENSKY, STUART see ST3110, ST3111, ST3113
WILEY, BELL L. see ST2167
WILKS, CLAIRE WEISSMAN see M546
WILLARD, J. W. see ST2469
WILLETS, GILSON see S114, S117, S123, S146
WILLIAMS, JOHN M. see M534, ST2978
WILLIAMS, MAJOR GEORGE F. see ST2147
WILLIAMS, SUSAN L. see B1316
WILLIAMS, TALCOTT see M1088
WILLIAMS, VAL see C118
WILLIAMS, WILLIAM R. see H694
WILLIAMSON, ANDREW see ST2891
WILLIAMSON, C. N. see ST4250
WILLIAMSON, LYNNE see ST846
WILLIS, N. P. see ST4304
WILLIS-THOMAS, DEBORAH see B25, ST1669
WILLOUGHBY-OSBORNE, MRS. see ST1481
WILLS, CAMFIELD H. see ST1745
WILLS, DEIRDRE see ST1745
WILLUMSON, GLENN G. see H259

WILMERDING, JOHN see B1357, ST1662
WILSHER, ANN see C117, C262, C659, C660, C943, D109, D456, F548, F632, H74, N441, S156, S1213, S1286, ST107, ST111, ST259, ST624, ST789, ST888, ST1501, ST1761, ST1788, ST4277
WILSON, ANDREW see B449
WILSON, CAPT. CHARLES WILLIAM see M33, M34
WILSON, DEREK see F604
WILSON, EDWARD L. see A74, A101, B162, B185, B1741, B1938, C75, C93, C1113, D644, E48, F45, G341, G343, K50, K104, K109, K112, L125, L421, L653, L655, M98, N153, N154, P431, R21, R492, R495, R512, R877, S809, S1044, S1236, T24, V41, W731, W850, ST474, ST485, ST520, ST756, ST818, ST1351, ST1528, ST2378, ST2725, ST3056, ST3061, ST3063, ST3123, ST3226, ST3227, ST3284, ST4099, ST4108, ST4118, ST4129, ST4159, ST4353, ST4392
WILSON, FRANCESCA H. see ST1485
WILSON, J. see ST973
WILSON, JAMES GRANT see I11
WILSON, JOHN see H677, H678
WILSON, JOSEPH M. see G89, G138
WILSON, RICHARD BRIAN see O99
WING, PAUL see K1, K2, K3
WINTER, ANDREW see ST931
WINTER, G. see T308
WISTER, SALLY BUTLER see ST2140
WITHAM, GEORGE F. see ST2171
WOLF, DANIEL see ST1667
WOLFE, LAURANCE see K91, ST902, ST2921
WOLFF, ANTHONY see ST1576
WOLK, LINDA see H668
WOLLENBERG, CHARLES see W315
WOOD, SIR HENRY TRUEMAN WRIGHT see ST4382
WOOD, JAMES N. see ST2536
WOOD, JOHN see S925, ST160
WOOD, RUPERT DEREK see B417, H516, R75, T78, T289, ST884, ST886, ST889
WOOD, STANLEY see J24
WOODBURY, WALTER B. see ST816
WOODBURY, WALTER E. see F28, M1094
WOODWARD, J. J. see ST2144
WOODS, THOMAS see T171
WOOLEN, HILARY see T496
WOOLF, VIRGINIA see C46, C51
WOOLWORTH, ALAN R. see ST3084
WORDEN, JOHN see S1330
WORDSWORTH, WILLIAM see O24, O25
WORNUM, RALPH N. see C26, C27, ST654
WORSWICK, CLARK see ST545, ST1444, ST1533, ST1539
WORTLEY, STUART see ST3519
WRIGHT, ARCHDEACON H. P. see ST1332
WRIGHT, BONNIE see S1245
WRIGHT, DICK see B238
WRIGHT, H. C. see ST1158
WRIGHT, HELEN see ST1748
WRIGHT, HENDRICK BRADLEY see S291
WRIGHT, NELSON see S1053
WRIGHT, W. H. K. see ST1300
WRIGHT, WILLIAM SAMUEL see ST1255
WYATT, MATTHEW DIGBY see B496, B500, S976
WYNNE, JAMES see M866
WYNTER, ANDREW see ST1116, ST1122, ST1128, ST1129, ST1282

X
XANTHAKIS, ALKIS X. see ST1427

Y
YARNALL, JAMES L. see ST1781, ST1786
YATES, STEVE see ST302
YERBURY, E. R. see ST3716
YORK, F. see ST778
YOUNG, ALAN see T646
YOUNG, ALLEN see D313
YOUNG, WILLIAM see A288, T910
YOUNGER, DAN see ST155

Z
ZANNIER, ITALIO see B423, B444, N73, R916, T85
ZEIGENFUSS, C. O. see S1269
ZEIGLER, J. see ST641, ST3692
ZELEVANSKY, LYNN see A130
ZEVI, FILIPPO see A150
ZIGAL, THOMAS see ST146
ZILLMAN, LINDA GOFORTH see N199
ZIMMERMAN, J. ERNEST see D98
ZINKHAM, HELENA see B1710
ZUCHOLD, ERNST AMADUS see ST1
ZUNDT, E. A. see C837
ZWEERS, INEKE see ST564